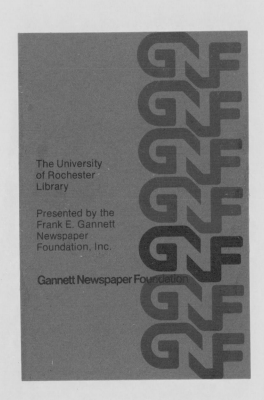

ARTIST BIOGRAPHIES
MASTER INDEX

The Gale Biographical Index Series

Biography and Genealogy Master Index
Second Edition, Supplements and Annual Volumes
(GBIS Number 1)

Children's Authors and Illustrators
Fourth Edition
(GBIS Number 2)

Author Biographies Master Index
Second Edition
(GBIS Number 3)

Journalist Biographies Master Index
(GBIS Number 4)

Performing Arts Biography Master Index
Second Edition
(GBIS Number 5)

Writers for Young Adults: Biographies Master Index
Second Edition
(GBIS Number 6)

Historical Biographical Dictionaries Master Index
(GBIS Number 7)

Twentieth-Century Author Biographies Master Index
(GBIS Number 8)

Artist Biographies Master Index
(GBIS Number 9)

Gale Biographical Index Series
Number 9

ARTIST BIOGRAPHIES MASTER INDEX

A consolidated index to
more than 275,000 biographical sketches
of artists living and dead, as they appear in
a selection of the principal current and retrospective
biographical dictionaries devoted to the fine and
applied arts, including painters, sculptors,
illustrators, designers, graphic artists,
craftsmen, architects, and photographers

FIRST EDITION

Barbara McNeil, Editor

Gale Research Company • Book Tower • Detroit, Michigan 48226

Editor: Barbara McNeil
Senior Assistant Editor: Amy L. Unterburger
Assistant Editor: Nancy E. Boocker
Editorial Assistant: David Segal

Proofreaders: Marie Devlin, Toni Grow, Mary Jo Todd

Editorial Data Entry Supervisor: Doris D. Goulart
Editorial Data Entry Associate: Jean Portfolio
Senior Data Entry Assistants: Dorothy Cotter, Sue Lynch,
Mildred Sherman, Joyce M. Stone, Anna Marie Woolard
Data Entry Assistants: Ann Blake, William P. Maher, Cindy L. Pragid,
Agnes T. Roland, Teri L. Slagle, Patricia Smith, Jeanette T. Thomas, Nancy E. Wright

External Production Supervisor: Mary Beth Trimper
Senior External Production Associate: Dorothy Kalleberg
Art Director: Art Chartow

Internal Production Supervisor: Laura Bryant
Senior Internal Production Assistant: Sandy Rock
Internal Production Assistant: Lisa R. Woods

Publisher: Frederick G. Ruffner
Editorial Director: Dedria Bryfonski
Associate Editorial Director: Ellen Crowley
Director, Literature Division: Christine Nasso
Senior Editor, Biography and Genealogy Master Index: Adele Sarkissian

Library of Congress Cataloging-in-Publication Data

Artist biographies master index.

(Gale biographical index series; no. 9)
"A consolidated index to more than 275,000
biographical sketches of artists living and dead, as
they appear in a selection of the principal current
and retrospective biographical dictionaries devoted
to the fine and applied arts, including painters,
sculptors, illustrators, designers, graphic
artists, craftsmen, architects, and photographers."
1. Artists—Biography—Indexes. I. McNeil, Barbara.
II. Series.
N40.A78 1986 016.70922 [B] 86-14955
ISBN 0-8103-2107-6

Computerized photocomposition by
Computer Composition Corporation
Madison Heights, Michigan

Printed in the United States

Contents

Introduction

Artist Biographies Master Index (Artist BMI) provides quick and easy access to more than 275,000 citations to the biographical information found in more than 90 volumes and editions of over 70 English-language reference books, both current and retrospective, covering artists of all nationalities and time periods.

Artist BMI is a new research tool that has been compiled especially for the many users in art libraries, museums, and the art reference sections of larger libraries who have a particular interest in locating information on fine and applied artists. This index is derived from material that has appeared or will appear in the more comprehensive index *Biography and Genealogy Master Index (BGMI)*, which contains almost six million references to individuals in all subject areas and all time periods. The aim of *Artist BMI* is to consolidate information on artists in an accessible and affordable format for the benefit of users who may not require the extensive coverage of *BGMI*.

Concept and Scope

Artist BMI enables the user to determine, without tedious searching, which edition (or editions) of which publication to consult for biographical information on an artist. Almost as helpful, it also reveals if there is no listing for a given individual in the sources indexed. In cases where *Artist BMI* shows multiple listings for the same artist, the user is able to choose which source is the most convenient or to locate multiple sketches to compare and expand information furnished by a single listing.

The reference books cited in *Artist BMI* are widely held in most art reference collections. While the works covered are of several distinct types (biographical dictionaries, encyclopedias, directories, indexes), all have one common characteristic: each includes at least a moderate amount of biographical or career-related information on artists.

Sources indexed in *Artist BMI* include general reference works (*McGraw-Hill Dictionary of Art, The Oxford Companion to Art*), current sources (*Contemporary Artists, Who's Who in American Art*), and retrospective sources (*Who Was Who in American Art*). Also included are many sources in special subject areas such as architecture (*Contemporary Architects, Macmillan Encyclopedia of Architects*), graphic art (*Contemporary Graphic Artists, Who's Who in Graphic Art*), illustration (*The Illustrator in America, The Great Bird Illustrators and Their Art*), and photography (*Contemporary Photographers, ICP Encyclopedia of Photography*). Other special subjects covered in *Artist BMI* include folk art, painting, antiques, ceramics, crafts, sculpture, and design.

How to Read a Citation

Each citation gives the artist's name followed by the years of birth and/or death as found in the source book. If a source has indicated that the dates may not be accurate, the questionable date(s) are followed by a question mark. If there is no year of birth, the death date is preceded by a lower case *d*. The codes for the books indexed follow the dates.

Wyck, Thomas 1616?-1677 *ClaDrA*

Hay, Jean M d1942 *ArtsAmW 3*

References to names which are identical in spelling and dates have been consolidated under a single name and date entry, as in the example below for *Robert M Watts*. When a name appears in more than one edition or volume of an indexed work, the title code for the book is given only once and is followed by the various codes for the editions in which the name appears.

Watts, Robert M 1923- *DcCAA 71, -77,*
WhoAmA 73, -76, -78, -80, -82, -84

Another feature of *Artist BMI* is the portrait indicator. The abbreviation *[port]* after a source code indicates that the source has a portrait or picture of the artist.

Fuller, Sue 1914- *WorArt [port]*

A list of the works indexed in *Artist BMI*, and the codes used to refer to them, is printed on the endsheets. Complete bibliographic citations to the titles indexed follow this introduction.

Editorial Practices

All names in an indexed work are included in *Artist BMI*. There is no need to consult the work itself if the name being researched is not found, since it is editorial policy to index every name in a particular book.

Many source books differ in their method of alphabetizing names. Therefore, some names may have an alphabetic position in a source book different from their position in this index.

Names appear in *Artist BMI* exactly as they are listed in the source books. No attempt has been made to determine whether names with closely similar spellings and dates refer to the same individual. With a file consisting of hundreds of thousands of names, it is not possible to edit each name thoroughly and still publish on a timely basis. Therefore, several listings for the same individual may sometimes be found:

> **Aalto,** Alvar 1898- *DcD&D [port]*
> **Aalto,** Alvar 1898-1976 *ConArch, ConDes,*
> *IlDcG, MacEA, OxArt, OxTwCA*
> **Aalto,** Hugo Alvar Henrik 1898- *McGDA*
> **Aalto,** Hugo Henrik Alvar 1898- *EncMA,*
> *OxDecA*
> **Aalto,** Hugo Henrik Alvar 1898-1976 *WhoArch*

Despite the variations in the form of the name, it is apparent that the same person is referred to in the above citations. The existence of such variations can be of importance to anyone attempting to determine biographical details about the individuals.

In many publications, portions of a name not used by the individual are placed in parentheses, e.g., *Outcault, R(ichard) F(elton)*. These parenthetical portions have been omitted except in those cases where the material in parentheses has been considered in alphabetizing by the source publication.

In a very few cases, extremely long names are shortened because of typesetting limitations. For example: *Krogh, Charlotte Sofie Christiane Rosine Von* would be shortened to:

> **Krogh,** Charlotte Sofie Christiane R Von

It is believed that such editing will not affect the usefulness of individual entries.

Research Aids

Researchers will need to look under all possible listings for a name, especially in the cases of:

1. Names with prefixes or suffixes:

> **Boissier,** Jacqueline DeLa
> **DeLaBoissier,** Jacqueline
> **LaBoissier,** Jacqueline De

2. Spanish names which may be entered in sources under either part of the surname:

> **DaSilva,** Maria Elena Vieira
> **Vieira DaSilva,** Maria Elena

3. Pseudonyms or nicknames:

> **Fellig,** Arthur
> **Weegee**

Moses, Anna Mary Robertson
Moses, Grandma

4. Names which may be entered in the sources both under the full name and either initials or part of the name:

Wyeth, N C
Wyeth, Newell Convers

Pollock, Jackson
Pollock, Paul Jackson

All cross-references appearing in indexed publications have been retained in *Artist BMI*, but in the form of regular citations, e.g., *Hirsch, Hanna SEE Pauli, Hanna* would appear in *Artist BMI* as *Hirsch, Hanna* followed by the source code. No additional cross-references have been added.

Suggestions Are Welcome

The editor welcomes comments and suggestions from users on the usefulness or any other aspect of *Artist BMI.*

Bibliographic Key to Source Codes

Code	Book Indexed
AfroAA RefE	*Afro-American Artists.* A bio-bibliographical directory. Compiled and edited by Theresa Dickason Cederholm. Boston: Trustees of the Boston Public Library, 1973. N6538 ,N5 C43
AmArch 70 RefD	*American Architects Directory.* Third edition. Edited by John F. Gane. New York: R.R. Bowker Co. (under the sponsorship of American Institute of Architects), 1970. NA53 ,A51 1970
AmArt O	*American Artists.* An illustrated survey of leading contemporary Americans. Edited by Les Krantz. New York: Facts on File Publications, 1985.
AmFkP Stack	*American Folk Painters of Three Centuries.* Edited by Jean Lipman and Tom Armstrong. New York: Hudson Hills Press (in association with the Whitney Museum of American Art), 1980. Distributed by Simon & Schuster, New York, New York. ND205.5.P74 A43
	Use the Index to locate biographies.
AmGrD O	*American Graphic Designers: Thirty Years of Design Imagery.* By RitaSue Siegel. New York: McGraw-Hill Book Co., 1985.
AntBDN O	*The Antique Buyer's Dictionary of Names.* By A.W. Coysh. Newton Abbot, England: David & Charles, 1970.

AntBDN A	The "Art Nouveau" section begins on page 13.
AntBDN B	The "Book Illustrations and Prints" section begins on page 23.
AntBDN C	The "Bronzes" section begins on page 48.
AntBDN D	The "Clocks and Barometers" section begins on page 59.
AntBDN E	The "Fashion Plates" section begins on page 81.
AntBDN F	The "Firearms" section begins on page 86.
AntBDN G	The "Furniture" section begins on page 98.
AntBDN H	The "Glass" section begins on page 123.
AntBDN I	The "Maps, Charts, and Globes" section begins on page 137.
AntBDN J	The "Miniatures" section begins on page 148.
AntBDN K	The "Musical Instruments" section begins on page 170.
AntBDN L	The "Netsuke" section begins on page 179.

AntBDN M	The "Pottery and Porcelain" section begins on page 185.
AntBDN N	The "Sheffield Plate" section begins on page 224.
AntBDN O	The "Silhouettes or Profiles" section begins on page 231.
AntBDN P	The "Silk Pictures, Portraits, and Bookmarks" section begins on page 243.
AntBDN Q	The "Silver" section begins on page 250.

ArtsAmW 1
Ref E
Artists of the American West. A biographical dictionary. Volume I. By Doris Ostrander Dawdy. Chicago: Swallow Press; Sage Books, 1974.
N6536 .D38 v.1

ArtsAmW 2
Ref E
Artists of the American West. A biographical dictionary. Volume II. By Doris Ostrander Dawdy. Chicago: Swallow Press; Sage Books, 1981.
N6536 .D38 v.2

ArtsAmW 3
Ref E
Artists of the American West. A biographical dictionary, artists born before 1900. Volume III. By Doris Ostrander Dawdy. Athens, Ohio: Ohio University Press; Swallow Press, 1985.
N6536 .D38 v.3

ArtsEM
stack
Artists of Early Michigan. A biographical dictionary of artists native to or active in Michigan 1701-1900. Compiled by Arthur Hopkin Gibson. Detroit: Wayne State University Press, 1975.
N6530.M5 G52

ArtsNiC
Stack
Artists of the Nineteenth Century and Their Works. A handbook containing two thousand and fifty biographical sketches. Revised edition. Two volumes. By Clara Erskine Clement and Laurence Hutton. Boston: J.R. Osgood & Co., 1885. Reprint, two volumes in one. St. Louis: North Point, 1969.
N40 .W32 a v.1 & v.2

BiDAmAr
Ref E
Biographical Dictionary of American Architects, Deceased. By Henry F. Withey and Elsie Rathburn Withey. Los Angeles: New Age Publishing Co., 1956.
NA736 .W82b 1970

BiDBrA
○
A Biographical Dictionary of British Architects 1600-1840. By Howard Colvin. New York: Facts on File, 1980.

"Appendix A," indicated in this index by the code *A*, begins on page 969.

BkIE
stack
Book Illustrators in Eighteenth-Century England. By Hanns Hammelmann. Edited and completed by T.S.R. Boase. New Haven, Connecticut: Yale University Press (for The Paul Mellon Centre for Studies in British Art, London), 1975.
NC978 .H28

BnEnAmA
Ref E
The Britannica Encyclopedia of American Art. Chicago: Encyclopaedia Britannica Educational Corp., 1973. Distributed by Simon & Schuster, New York, New York.
N6505 .B73

CabMA
○
The Cabinetmakers of America. Revised and corrected edition. By Ethel Hall Bjerkoe. Exton, Pennsylvania: Schiffer, 1978. Originally published by Doubleday & Co., 1957.

Biographies begin on page 19.

Cald 1938
Rhees/stack
Caldecott Medal Books: 1938-1957. With the artist's acceptance papers & related material chiefly from the *Horn Book Magazine.* Horn Book Papers, Volume II. Edited by Bertha Mahony Miller and Elinor Whitney Field. Boston: Horn Book, 1957. Z1035 .M21c

CenC
stack

A Century of Ceramics in the United States 1878-1978. A study of its development. By Garth Clark. New York: E.P. Dutton (in association with the Everson Museum of Art), 1979. NK 4007 .C56 1979

 Biographies begin on page 269.

ClaDrA
stack

The Classified Directory of Artists' Signatures, Symbols, & Monograms. Second edition, enlarged and revised. By H.H. Caplan. Detroit: Gale Research Co.; London: George Prior Publishers, 1982. N45 .C36 1982

ConArch

REF

Contemporary Architects. Edited by Muriel Emanuel. New York: St. Martin's Press, 1980. NA680 .C625

 The "Notes on Advisors and Contributors" section, indicated in this index by the code *A*, begins on page 927.

ConArt 77
RefE

Contemporary Artists. Edited by Colin Naylor and Genesis P-Orridge. London: St. James Press; New York: St. Martin's Press, 1977. N6490 .C6567

ConArt 83
MAG
REF

Contemporary Artists. Second edition. Edited by Muriel Emanuel et al. New York: St. Martin's Press, 1983. N6490 .C6567 1983

ConBrA 79
O

Contemporary British Artists. Edited by Charlotte Parry-Crooke. New York: St. Martin's Press, 1979.

ConDes
O

Contemporary Designers. Edited by Ann Lee Morgan. Detroit: Gale Research Co., 1984.

ConGrA 1
MAG
REF
v.3

Contemporary Graphic Artists. A biographical, bibliographical, and critical guide to current illustrators, animators, cartoonists, designers, and other graphic artists. Volume 1. Edited by Maurice Horn. Detroit: Gale Research Co., 1986. NC 999.2 C65 v.3

ConICB
RHEES/
Rare F

Contemporary Illustrators of Children's Books. Compiled by Bertha E. Mahony and Elinor Whitney. Boston: Bookshop for Boys and Girls, Women's Educational and Industrial Union, 1930. Reprint. Detroit: Gale Research Co., 1978. PZ86.1 1930 .M56

ConPhot
RefE

Contemporary Photographers. Edited by George Walsh, Colin Naylor, and Michael Held. New York: St. Martin's Press, 1982. TR139 .C66 1982

DcAmArt
stack &
RefE

Dictionary of American Art. By Matthew Baigell. New York: Harper & Row, Publishers, 1979. N6505 .B34 1979

DcBrA
stack

Dictionary of British Artists Working 1900-1950. Two volumes. By Grant M. Waters. Eastbourne, England: Eastbourne Fine Art Publications, 1975, 1976.

 DcBrA 1 N6768 .W26 Volume I, 1975
 DcBrA 2 Volume II, 1976

DcBrBI
O

The Dictionary of British Book Illustrators and Caricaturists, 1800-1914. With introductory chapters on the rise and progress of the art. By Simon Houfe. Woodbridge, England: Antique Collectors' Club, 1978. Distributed by Gale Research Co., Detroit, Michigan.

 Biographies begin on page 215.

DcBrECP
RefE

The Dictionary of British 18th Century Painters in Oils and Crayons. By Ellis Waterhouse. Woodbridge, England: Antique Collectors' Club, 1981. Distributed by Gale Research Co., Detroit, Michigan. NG766 .W29

DcBrWA
MAG
Ref

The Dictionary of British Watercolour Artists up to 1920. By H.L. Mallalieu. Woodbridge, England: Antique Collectors' Club, 1976. Distributed by Gale Research Co., Detroit, Michigan. ND1928 .M27 1979 (V. 1-3)

DcCAA
RefE

A Dictionary of Contemporary American Artists. By Paul Cummings. London: St. James Press; New York: St. Martin's Press, 1971, 1977.

DcCAA 71	Second edition, 1971
DcCAA 77 N6536 .C97d 1977	Third edition, 1977

DcCAr 81
RefE

Dictionary of Contemporary Artists. Edited by V. Babington Smith. Oxford: Clio Press, 1981. N40 .D54 1981

DcD&D
O

Dictionary of Design & Decoration. A Studio Book. New York: Viking Press, 1973.

DcNiCA
O

Dictionary of 19th Century Antiques and Later Objets d'Art. By George Savage. London: Barrie & Jenkins, 1978.

DcSeaP
MAG
Ref

Dictionary of Sea Painters. By E.H.H. Archibald. Woodbridge, England: Antique Collectors' Club, 1980. Distributed by Gale Research Co., Detroit, Michigan. Biographies begin on page 59. ND1374 .A72 1989

DcVicP
RefE

The Dictionary of Victorian Painters. By Christopher Wood. Woodbridge, England: Antique Collectors' Club, 1971, 1978. Distributed by Gale Research Co., Detroit, Michigan.

DcVicP	First edition, 1971
DcVicP 2 ND467 .W65 1978	Second edition, 1978

DcWomA
RefE

Dictionary of Women Artists. An international dictionary of women artists born before 1900. By Chris Petteys. Boston: G.K. Hall & Co., 1985. N43 .P47 1985

EarABI
RR- Ref &
RHEES/RareF
(both vols.)

Early American Book Illustrators and Wood Engravers, 1670-1870. A catalogue of a collection of American books illustrated for the most part with woodcuts and wood engravings in the Princeton University Library. By Sinclair Hamilton. Princeton, New Jersey: Princeton University Press, 1958, 1968.

EarABI	Volume I: Main Catalogue, 1958
EarABI SUP	Volume II: Supplement, 1968

EncAAr
RefE

Encyclopedia of American Architecture. By William Dudley Hunt, Jr. New York: McGraw-Hill Book Co., 1980. NA705 .H86

EncASM
MAG
Stack

Encyclopedia of American Silver Manufacturers. By Dorothy T. Rainwater. New York: Crown Publishers, 1975. NK7112 .R3 1986

EncMA
RefE

Encyclopedia of Modern Architecture. Edited by Wolfgang Pehnt. New York: Harry N. Abrams, 1964. NA680 .E56
Biographies begin on page 28.

FairDF
O

Fairchild's Dictionary of Fashion. By Charlotte Calasibetta. New York: Fairchild Publications, 1975.

Biographies are located in the "Fashion Designers" section which begins on page 547.

FairDF ENG	England section begins on page 548.
FairDF FIN	Finland section begins on page 553.
FairDF FRA	France section begins on page 554.
FairDF IRE	Ireland section begins on page 577.
FairDF ITA	Italy section begins on page 578.
FairDF JAP	Japan section begins on page 583.
FairDF SPA	Spain section begins on page 584.
FairDF US	United States section begins on page 585.

FolkA 86
RefE

Folk Artists Biographical Index. First edition. Edited by George H. Meyer. Detroit: Gale Research Co. (in association with the Museum of American Folk Art), 1986. NK805 .F63 1986

GrAmP
stack

Great American Prints, 1900-1950. 138 lithographs, etchings and woodcuts. By June Kraeft and Norman Kraeft. New York: Dover Publications, 1984.

Biographies begin on page 139. NE508 .K7 1984

GrBIl
O

The Great Bird Illustrators and Their Art, 1730-1930. By Peyton Skipwith. New York: Hamlyn Publishing Group, 1979.

ICPEnP
RefE

ICP Encyclopedia of Photography. New York: Crown Publishers, 1984.

The Appendix, indicated in this index by the code *A*, begins on page 576.

TR9 .I24 1984

IlBEAAW
O

The Illustrated Biographical Encyclopedia of Artists of the American West. By Peggy Samuels and Harold Samuels. Garden City, New York: Doubleday & Co., 1976.

IlDcG
O

An Illustrated Dictionary of Glass. 2,442 entries, including definitions of wares, materials, processes, forms, and decorative styles, and entries on principal glass-makers, decorators, and designers, from antiquity to the present. By Harold Newman. London: Thames & Hudson, 1977.

IlrAm
stack

The Illustrator in America, 1900-1960's. Compiled and edited by Walt Reed. New York: Reinhold Publishing Corp., 1966. NC975 .R32 i

IlrAm A	"The Decade: 1900-1910" begins on page 13.
IlrAm B	"The Decade: 1910-1920" begins on page 43.
IlrAm C	"The Decade: 1920-1930" begins on page 77.
IlrAm D	"The Decade: 1930-1940" begins on page 113.
IlrAm E	"The Decade: 1940-1950" begins on page 167.
IlrAm F	"The Decade: 1950-1960" begins on page 211.
IlrAm G	"The Decade: 1960's" begins on page 239.

IlrAm 1880
Stack

The Illustrator in America, 1880-1980. A century of illustration. By Walt Reed and Roger Reed. New York: Madison Square Press (for The Society of Illustrators), 1984. Distributed by Robert Silver Associates, New York, New York.

Use the Index to locate biographies. NC975 .R32 i 1984

IlsBYP
O

Illustrators of Books for Young People. Second edition. By Martha E. Ward and Dorothy A. Marquardt. Metuchen, New Jersey: Scarecrow Press, 1975.

IlsCB *Illustrators of Children's Books.* Boston: Horn Book, 1947, 1958, 1968, 1978.
Stack
 IlsCB 1744 *1744-1945.* Compiled by Bertha E. Mahony, Louise
 NC965 .M21i Payson Latimer, and Beulah Folmsbee, 1947.
 Biographies begin on page 267.

 IlsCB 1946 *1946-1956.* Compiled by Ruth Hill Viguers, Marcia
 NC965 .M21i Suppl. Dalphin, and Bertha Mahony Miller, 1958.
 Biographies begin on page 62.

 IlsCB 1957 *1957-1966.* Compiled by Lee Kingman, Joanna
 Foster, and Ruth Giles Lontoft, 1968.
 Biographies begin on page 70.

 IlsCB 1967 *1967-1976.* Compiled by Lee Kingman, Grace
 Allen Hogarth, and Harriet Quimby, 1978.
 Biographies begin on page 93.

MacBEP *Macmillan Biographical Encyclopedia of Photographic Artists & Innovators.* By
RefE Turner Browne and Elaine Partnow. New York: Macmillan Publishing Co.;
 London: Collier Macmillan Publishers, 1983. TR139 .B767 1983

MacEA *Macmillan Encyclopedia of Architects.* Four volumes. Edited by Adolf K. Placzek.
RefE New York: Macmillan Publishing Co., Free Press; London: Collier Macmillan
 Publishers, 1982. NA40 .M25 1982 (v.1-4)
 Use the "Index of Names," which begins on page 533 of Volume 4, to locate
 biographies.

MarqDCG 84 *Marquis Who's Who Directory of Computer Graphics.* First edition. Chicago:
PDA/Pref Marquis Who's Who, 1984. T385 .M3647

McGDA *McGraw-Hill Dictionary of Art.* Five volumes. Edited by Bernard S. Myers. New
RefE York: McGraw-Hill Book Co., 1969. N33 .M14 v.1-5

New YHSD *The New-York Historical Society's Dictionary of Artists in America, 1564-1860.*
O By George C. Groce and David H. Wallace. New Haven, Connecticut: Yale
 University Press, 1957.

OfPGCP 86 *The Official Price Guide to Collector Prints.* Seventh edition. By Ruth M. Pollard.
O Westminster, Maryland: House of Collectibles, 1986.

 OfPGCP 86 Listings begin on page 89.
 OfPGCP 86A The "Old Prints" section begins on page 15.

OxArt *The Oxford Companion to Art.* Edited by Harold Osborne. Oxford: Oxford
RR-REF/Ref University Press, Clarendon Press, 1970. N33 .O98

OxDecA *The Oxford Companion to the Decorative Arts.* Edited by Harold Osborne. Oxford:
O Oxford University Press, Clarendon Press, 1975.

OxTwCA *The Oxford Companion to Twentieth-Century Art.* Edited by Harold Osborne.
MAG Oxford: Oxford University Press, 1981. N6490 .O94

PhDcTCA 77 *Phaidon Dictionary of Twentieth-Century Art.* Second edition. Oxford: Phaidon
RefE Press; New York: E.P. Dutton, 1977. N6490 .P46

PrintW
MAG

The Printworld Directory of Contemporary Prints & Prices. Edited by Selma Smith. Bala Cynwyd, Pennsylvania: Printworld, 1983, 1985. Distributed by Gale Research Co., Detroit, Michigan.

　　PrintW 83 *NE491 .P77*　　　　　*1983/84, second edition; 1983*
　　PrintW 85　　　　　　　　　　　*1985/86, third edition; 1985*

Not in strict alphabetical order.

WhAmArt 85
RefE
(charge Desk)

Who Was Who in American Art. Compiled from the original thirty-four volumes of *American Art Annual: Who's Who in Art, Biographies of American Artists Active from 1898-1947.* Edited by Peter Hastings Falk. Madison, Connecticut: Sound View Press, 1985. *N6536.W56 1985*

The "European Teachers of American Artists" section, indicated in this index by the code *A*, begins on page xxxiii.

WhoAmA
RefE
(Charge Desk)

Who's Who in American Art. Edited by Jaques Cattell Press. New York: R.R. Bowker Co., 1973, 1976, 1978, 1980, 1982, 1984. *N6536 .W61*

　　WhoAmA 73　　　　　　　　　1973 edition
　　WhoAmA 76　　　　　　　　　1976 edition
　　WhoAmA 78　　　　　　　　　1978 edition
　　WhoAmA 80　　　　　　　　　1980 edition
　　WhoAmA 82　　　　　　　　　1982 edition
　　WhoAmA 84　　　　　　　　　1984 edition

The Necrology, indicated in this index by the code *N*, is located at the back of each volume.

WhoArch
O

Who's Who in Architecture from 1400 to the Present Day. Edited by J.M. Richards. London: Weidenfeld & Nicolson, 1977.

WhoArt
· *Ref E*
　(v. 19)
· *MAG Ref*
　(v. 2)

Who's Who in Art. Biographies of leading men and women in the world of art today —artists, designers, craftsmen, critics, writers, teachers and curators, with an appendix of signatures. Havant, England: Art Trade Press, 1980, 1982, 1984. Distributed by Gale Research Co., Detroit, Michigan.

　　WhoArt 80　　　　　　　　　19th edition, 1980
　　WhoArt 82　　　　　　　　　20th edition, 1982
　　WhoArt 84　　　　　　　　　21st edition, 1984

The Obituary section, indicated in this index by the code *N*, is located at the back of each volume. *N40 .W62 (v. 19 or v. 2)*

WhoGrA 62
O

Who's Who in Graphic Art. An illustrated book of reference to the world's leading graphic designers, illustrators, typographers and cartoonists. First edition. Edited by Walter Amstutz. Zurich: Amstutz & Herdeg Graphis Press, 1962. Distributed by Gale Research Co., Detroit, Michigan.

Use the "Index of Artists' Names," which begins on page 576, to locate biographies.

WhoGrA 82
O

Who's Who in Graphic Art. An illustrated world review of the leading contemporary graphic and typographic designers, illustrators and cartoonists. Volume Two. Edited and designed by Walter Amstutz. Dubendorf, Switzerland: De Clivo Press, 1982. Distributed by Gale Research Co., Detroit, Michigan.

Use the "Index of Artists' Names," which begins on page 886, to locate biographies.

WomArt *Women Artists: An Historical, Contemporary and Feminist Bibliography.* By
RefB Donna G. Bachmann and Sherry Piland. Metuchen, New Jersey: Scarecrow
 Press, 1978. ZN 8354 .B32

> **WomArt** Use the Table of Contents to locate biographies,
> which begin on page 47.
>
> **WomArt A** The Addenda begin on page 322.

WorArt *World Artists, 1950-1980.* An H.W. Wilson biographical dictionary. By Claude
Ref E Marks. New York: H.W. Wilson Co., 1984. N6489 .W67 1991

WorECar *The World Encyclopedia of Cartoons.* Two volumes. Edited by Maurice Horn.
RR-REF/Ref Detroit: Gale Research Co. (in association with Chelsea House Publishers, New
 York), 1980. NC1325 .W67 1980 v.1 & v.2

> The "Notes on the Contributors" section, indicated in this index by the code
> *A*, begins on page 631.

WorECom *The World Encyclopedia of Comics.* Two volumes. Edited by Maurice Horn. New
RR-REF/Ref York: Chelsea House Publishers, 1976. PN6710 .W6 1976b v.1 & v.2

> Biographies begin on page 65.

WorFshn *World of Fashion: People, Places, Resources.* By Eleanor Lambert. New York: R.R.
0 Bowker Co., 1976.

> Use the "Name Index," which begins on page 351, to locate biographies.

A

Aa, Boudewyn Pietersz VanDer *McGDA*
Aa, Dirk VanDer 1731-1809 *McGDA*
Aa, Hillebrand VanDer d1742 *McGDA*
Aa, Hillebrand VanDer 1659?-1721 *McGDA*
Aa, Jacob VanDer 1750?-1776? *McGDA*
Aa, Pieter Boudewyn VanDer *McGDA*
Aa Bronson 1946- *WhoAmA 76*
Aach, Herb 1923- *DcCAA 71, -77, WhoAmA 73, -76, -78, -80, -82, -84*
Aachen, Hans Von 1552-1615 *McGDA*
Aachen, Johann Von 1552-1616 *ClaDrA*
Aagot-Vangen, Miss *DcWomA*
Aakre, Richard B 1943- *WhoAmA 73*
Aaland, Mikkel F 1952- *ICPEnP A, MacBEP*
Aalbers, Ben *DcCAr 81*
Aalbu, Olaf *WhAmArt 85*
Aalto, Alvar 1898- *DcD&D[port]*
Aalto, Alvar 1898-1976 *ConArch, ConDes, IlDcG, MacEA, OxArt, OxTwCA*
Aalto, Hugo Alvar Henrik 1898- *McGDA*
Aalto, Hugo Henrik Alvar 1898- *EncMA, OxDecA*
Aalto, Hugo Henrik Alvar 1898-1976 *WhoArch*
Aaltonen, Waino 1894-1966 *OxArt, OxTwCA, PhDcTCA 77*
Aalund, Suzy *WhoAmA 76, -78, -80, -82, -84*
Aamand *NewYHSD*
Aamond *NewYHSD*
Aanes, Vincent G 1931- *AmArch 70*
Aangeenbrug, Robert T 1935- *MarqDCG 84*
Aanvik, Geir 1946- *DcCAr 81*
Aardema, Lyckle Gjalt 1950- *MarqDCG 84*
Aarnio, Eero 1932- *ConDes, DcD&D*
Aarnio, Reino 1912- *AmArch 70*
Aaron, Alan Leon 1935- *AmArch 70*
Aaron, Evalyn *WhoAmA 76, -78, -80, -82, -84*
Aaron, Jesse 1887-1979 *FolkA 86*
Aaron, John *CabMA*
Aaron, Mabel *DcWomA*
Aaron, May Todd *ArtsAmW 3, DcWomA, WhAmArt 85*
Aaron, Rachel *DcWomA*
Aarons, Anita *WhoAmA 76, -78, -80, -82, -84*
Aarons, George 1896- *WhAmArt 85, WhoAmA 73, -76, -78, -80*
Aarons, George 1896-1980 *WhoAmA 82N, -84N*
Aarons, Jacob D *ArtsEM*
Aartsen, Pieter 1507-1575 *ClaDrA*
Aasletten, E A *AmArch 70*
Aasnes, Hakon 1943- *WorECom*
Aba-Novak, Vilmos 1894-1941 *McGDA*
Abacco, Antonio Dall' 1495-1567? *MacEA*
Abada, Alexander 1934- *ICPEnP A*
Abadi, Fritzie *WhoAmA 80, -82, -84*
Abadie, Paul 1812-1884 *MacEA, McGDA*
Abadie, Paul 1812-1885 *WhoArch*
Abaisi, Arduino d1454 *McGDA*
Abakanowicz, Magdalena 1930- *ConArt 77, -83*
Abakanowitz, Magdalena 1930- *DcCAr 81*
Abany, Albert Charles 1921- *WhoAmA 73, -76, -78, -80, -82, -84*
Abarca, Maria De d1656? *DcWomA*
Abary, Marie Mathilde *DcWomA*
Abascal, Mary *DcWomA*
Abasch, Anna Barbara *DcWomA*
Abate, Samuel Paul 1930- *AmArch 70*
Abbas *MacEA*
Abbas 1944- *ICPEnP A*
Abbas, Fadil 1947- *DcCAr 81*
Abbate, Niccolo Dell' *OxArt*
Abbate, Niccolo Dell' 1509?-1571 *McGDA*

Abbate, Paolo 1884- *WhAmArt 85*
Abbate, Paul S 1884- *WhoAmA 73*
Abbate, Paul S 1884-1972 *WhoAmA 76N, -78N, -80N, -82N, -84N*
Abbatecola 1913- *WhoAmA 76, -78, -80*
Abbatt, A D 1847- *WhAmArt 85*
Abbatt, Agnes Dean 1847-1917 *DcWomA*
Abbayne, C *DcVicP 2*
Abbe, Alfriede Martha 1919- *WhAmArt 85*
Abbe, C H *AmArch 70*
Abbe, Elfriede Martha *WhoAmA 73, -76, -78, -80, -82, -84*
Abbe, Ernst 1840-1905 *ICPEnP, MacBEP*
Abbe, Frederick *FolkA 86*
Abbe, Hendrik 1639- *ClaDrA*
Abbe, James 1883-1973 *ConPhot, ICPEnP, MacBEP*
Abbe, John *FolkA 86*
Abbe, S B *DcWomA*
Abbell, Samuel 1925-1969 *WhoAmA 78N, -80N, -82N, -84N*
Abbema, Louise 1858-1927 *DcWomA*
Abben, Peer 1916- *AmArch 70*
Abbett, Robert *OfPGCP 86*
Abbett, Robert K 1926- *IlrAm G, -1880*
Abbett, Robert Kennedy 1926- *AmArt, WhoAmA 78, -80, -82, -84*
Abbey, Edwin A 1852- *ArtsNiC*
Abbey, Edwin A 1852-1911 *MacEA*
Abbey, Edwin Austin 1852-1911 *AntBDN B, BnEnAmA, ClaDrA, DcAmArt, DcBrA 1, DcBrBI, DcBrWA, DcVicP -2, IlrAm A, -1880, McGDA, WhAmArt 85, WorECar*
Abbey, Iva L 1882- *DcWomA, WhAmArt 85*
Abbey, Mary Gertrude d1931 *WhAmArt 85*
Abbey, Richard 1720-1807 *AntBDN M*
Abbo, Farcy 1921- *DcCAr 81*
Abbondi, Antonio DiPietro d1549 *MacEA*
Abbot, Agnes Anne 1897- *DcWomA, WhAmArt 85*
Abbot, Edith d1964 *WhoAmA 78N, -80N, -82N, -84N*
Abbot, Edith R d1964 *DcWomA, WhAmArt 85*
Abbot, Francis Lemuel 1760-1803 *McGDA*
Abbot, H L *AntBDN I*
Abbot, Hazel Newham 1894- *ArtsAmW 2*
Abbot, Hazel Newnham *WhoAmA 73, -76*
Abbot, Hazel Newnham 1894- *ArtsAmW 2, DcWomA, WhAmArt 85*
Abbot, Henry 1768-1840 *DcBrWA*
Abbot, Henry Munro 1770- *AmArch 70*
Abbot, Inez M *DcWomA*
Abbot, J C *FolkA 86*
Abbot, John 1884-1956 *ClaDrA*
Abbot, John Radford 1893- *AmArch 70*
Abbot, Katherine G *DcWomA*
Abbot, Lillian Elvira 1870-1944 *DcWomA*
Abbot, Lillian Elvira Moore d1944 *WhAmArt 85*
Abbott *EncASM*
Abbott, Anne Fuller *WhAmArt 85*
Abbott, Anne Fuller 1886-1973 *DcWomA*
Abbott, Berenice 1898- *BnEnAmA, ConPhot, ICPEnP, MacBEP, WhAmArt 85, WomArt*
Abbott, C W *AmArch 70*
Abbott, Carlton Sturges *AmArch 70*
Abbott, Daniel 1821?- *CabMA*
Abbott, Dora *DcWomA*
Abbott, Dorothy 1932- *WhoAmA 76*
Abbott, Dorothy 1935- *WhoAmA 73*
Abbott, Dorothy I 1932- *WhoAmA 78, -80*
Abbott, Edith Abigail *WhAmArt 85*
Abbott, Edith Abigail 1876?-1964 *DcWomA*
Abbott, Edith R *WhAmArt 85*

Abbott, Edward Roydon 1897- *ArtsAmW 2, WhAmArt 85*
Abbott, Edwin *DcVicP 2*
Abbott, Elenore Plaisted d1935 *WhAmArt 85*
Abbott, Elenore Plaisted 1875-1935 *DcWomA*
Abbott, Emily Louise 1900- *WhAmArt 85*
Abbott, Francis R *WhAmArt 85*
Abbott, Henry R *FolkA 86*
Abbott, Holker 1858-1930 *WhAmArt 85*
Abbott, J B *AmArch 70*
Abbott, J C *FolkA 86*
Abbott, James Carl, Jr. 1936- *AmArch 70*
Abbott, John 1884-1956 *DcBrA 1*
Abbott, John 1948- *DcCAr 81*
Abbott, John Evans d1952 *WhoAmA 78N, -80N, -82N, -84N*
Abbott, John Evans 1908-1952 *WhAmArt 85*
Abbott, John White 1763-1851 *DcBrECP, DcBrWA, OxArt*
Abbott, Katherine G *WhAmArt 85*
Abbott, Lemuel Francis 1760?-1802 *DcBrECP*
Abbott, Lemuel Francis 1760?-1803 *OxArt*
Abbott, Leslie VanArsdale, Jr. 1928- *AmArch 70*
Abbott, Levi 1821?- *CabMA*
Abbott, M E 1870- *DcWomA*
Abbott, Marguerite Elizabeth 1870- *ArtsAmW 2*
Abbott, Mary Ogden *WhAmArt 85*
Abbott, Maude Herman *DcWomA*
Abbott, Merle Verne 1909- *AmArch 70*
Abbott, R O *AmArch 70*
Abbott, Richmond *DcVicP 2*
Abbott, Sammie A *WhAmArt 85*
Abbott, Samuel Nelson 1874-1953 *IlrAm B, -1880*
Abbott, Samuel Nelson 1874-1955? *WhAmArt 85*
Abbott, W H *WhAmArt 85*
Abbott, William 1892- *WhAmArt 85*
Abbott, Yarnall d1938 *WhAmArt 85*
Abd Al-Karim 1570?-1648 *MacEA*
Abdalla, Nick 1939- *WhoAmA 73, -76, -78, -80, -82, -84*
Abdel-Rahman, Tarek Mohamed 1947- *MarqDCG 84*
Abdell, Douglas 1947- *DcCAr 81, WhoAmA 78, -80, -82, -84*
Abdo, Alexander 1865- *ClaDrA, DcBrA 1*
Abdulrashid, Eileen *AfroAA*
Abdus Samad *McGDA*
Abdy, Rowena Meeks 1887-1945 *ArtsAmW 1, DcWomA, IlBEAAW, WhAmArt 85*
Abdy, William *AntBDN Q*
A'Becket, Maria d1904 *WhAmArt 85*
A'Becket, Maria J C d1904 *DcWomA*
Abee, Dallas Carroll, Sr. 1910- *AmArch 70*
Abeele, Albijn VanDen 1835-1918 *OxTwCA*
Abeille, Joseph 1669?-1752? *MacEA*
Abeita, Jim 1947- *WhoAmA 78*
Abel, Christine Jeannette 1890- *WhAmArt 85*
Abel, Henry C *NewYHSD*
Abel, Ib Christian 1923- *AmArch 70*
Abel, J H *AmArch 70*
Abel, John 1578?-1675 *BiDBrA, MacEA*
Abel, John Fredrick 1940- *MarqDCG 84*
Abel, Louise 1894- *DcWomA, WhAmArt 85*
Abel, Myer *WhoAmA 78N, -80N, -82N, -84N*
Abel, Myer 1904-1948? *WhAmArt 85*
Abel, P *AmArch 70*
Abel, Ray 1919- *WhoAmA 78, -80, -82, -84*
Abel, Raymond *IlsCB 1967*
Abel, Robert Jay 1937- *MarqDCG 84*
Abel, Victor Darwin 1880-1949 *BiDAmAr*
Abel DePujol, Alexandre Denis 1785-1861 *ArtsNiC*
Abel-Truchet, Julia 1867- *DcWomA*

1

Abele, C Robert 1921- *AmArch 70*
Abele, Julian F *AfroAA*
Abele, Lanier Bradfield 1909- *WhAmArt 85*
Abeles, Kim Victoria 1952- *AmArt, WhoAmA 82, –84*
Abeles, Sigmund 1934- *PrintW 83, –85, WhoAmA 73, –76, –78, –80, –82, –84*
Abell, A S *AmArch 70*
Abell, Margaret Noel 1908- *WhAmArt 85*
Abell, Ralph E 1881-1947 *BiDAmAr*
Abell, Roy 1931- *WhoArt 80, –82, –84*
Abell, Sam 1945- *MacBEP*
Abell, Thornton Montaigne 1906- *AmArch 70*
Abell, Walter 1897-1956 *WhAmArt 85*
Abell, Walter Halsey 1897-1956 *WhoAmA 80N, –82N, –84N*
Abelman, Ida 1910- *WhAmArt 85*
Abelmann, Kate *DcWomA*
Abeloos, Sonia 1876- *DcWomA*
Abels, Jacobus Theodorus 1803-1866 *ClaDrA*
Abels, Jean 1905- *WhAmArt 85*
Abels, Lewis Gale 1927- *AmArch 70*
Abels, Peter Jusef 1954- *DcCAr 81*
Abelson, Evelyn 1886- *DcBrA 1, DcWomA*
Abelson, Evelyn 1886-1967 *DcBrA 2*
Abend, Stephen N 1939- *AmArch 70*
Abend, William Maurice 1931- *AmArch 70*
Abendroth, Helene *DcWomA*
Abendroth, U L *AmArch 70*
Abendschein, Albert 1860- *WhAmArt 85*
Aber, Ita 1932- *WhoAmA 82, –84*
Abercrombie, Douglas *DcCAr 81*
Abercrombie, Gertrude 1909- *WhAmArt 85*
Abercrombie, Julia Janet 1840-1915 *DcWomA*
Abercrombie, M C *DcWomA*
Abercrombie, Patrick 1879-1957 *MacEA*
Abercrombie, Sir Patrick 1879-1957 *DcD&D, OxArt*
Abercrombie, Stanley *ConArch A*
Abercrombie, Stanley E 1935- *AmArch 70*
Abercrombie, Thomas J 1932- *ICPEnP A*
Abercromby, John B *DcVicP 2*
Abercromby, Julia Janet 1840-1915 *DcWomA*
Abercromby, Robert *AntBDN Q*
Aberdeen, David DuRieu 1913- *EncMA*
Aberdeen, Ishbel Maria 1847-1939 *DcWomA*
Aberg, Ulrika Victoria 1824-1892 *DcWomA*
Aberlin, Jorg *McGDA*
Abernathy, Don Ernest 1933- *AmArch 70*
Abernethie, Thomas d1796? *NewYHSD*
Abernethy, Alfred Harvey 1906- *AmArch 70*
Abernethy, Carr Bolton 1939- *AmArch 70*
Abernethy, F C *AmArch 70*
Abernethy, Inez *DcWomA, WhAmArt 85*
Aberry, J *DcBrECP*
Abert, J J *AntBDN I*
Abert, James W 1820-1871 *ArtsAmW 1*
Abert, James William 1820-1871 *IlBEAAW, NewYHSD*
Abery, J *DcBrECP*
Abesch, Anna Barbara 1706-1760? *DcWomA*
Abey, Victoria *DcWomA*
Abeyta, Narciso *WhoAmA 78, –80*
Abeyta, Narciso Platero 1918- *IlBEAAW, WhAmArt 85*
Abid, Ann B 1942- *WhoAmA 80, –82, –84*
Abidi, Mohammad Ali-Anwar 1953- *MarqDCG 84*
Abig, Adolphus *FolkA 86*
Abildgaard, Nicolai Abraham 1743-1809 *McGDA*
Abish, Cecile *ConArt 77, DcCAr 81, WhoAmA 76, –78, –80, –82, –84*
Abler, Kenneth John 1934- *AmArch 70*
Ablett, Dorothy 1918- *WhoArt 80, –82, –84*
Ablett, Thomas Robert d1945 *DcBrA 1, DcVicP 2*
Ablett, William A d1936 *DcBrA 2*
Ablitzer, Alfred G 1889-1968 *WorECar*
Ablow, Joseph 1928- *WhoAmA 73, –76, –78, –80, –82, –84*
Ablow, Roselyn Karol *WhoAmA 84*
Abney, Hepzibah *DcBrWA*
Abney, William DeWiveleslie 1843-1920 *MacBEP*
Abney, Sir William DeWiveleslie 1843-1920 *ICPEnP*
Abney-Walker, Ethel *DcWomA*
Abno, Helene *DcWomA*
Abnous, Razmik 1957- *MarqDCG 84*
Abom, Anna Catharina *DcWomA*
Abom, Margaretha *DcWomA*
Aborn, James 1759?- *CabMA*
Aborn, John *DcBrA 1, DcVicP, –2*
Aboury, Marie *DcWomA*
Abplanalp, Norman Edward 1929- *AmArch 70*
Abraben, E *AmArch 70*
Abracheff, Ivan 1903-1960 *WhAmArt 85, WhoAmA 80N, –82N, –84N*
Abracheff, Nicolai 1897- *WhAmArt 85*
Abraham *McGDA*
Abraham, Alfred W 1836-1896 *ArtsEM*
Abraham, B *DcWomA*
Abraham, Carl *FolkA 86*
Abraham, Carol Jeanne 1949- *WhoAmA 82, –84*
Abraham, Frances *DcWomA*
Abraham, Francis Xavier Frank 1861-1932 *DcBrWA*

Abraham, Joy V 1943- *MarqDCG 84*
Abraham, Lilian *DcBrWA, DcVicP 2, DcWomA*
Abraham, Morris 1921- *AmArch 70*
Abraham, R *DcWomA*
Abraham, R F *DcVicP 2*
Abraham, R F d1896 *AntBDN M*
Abraham, Robert 1774-1850 *BiDBrA, MacEA*
Abraham, Robert Frederick 1827-1895 *DcNiCA*
Abraham, Robert J *DcVicP 2*
Abraham, Robert John 1850-1925 *DcNiCA*
Abraham, Solomon *NewYHSD*
Abrahami, Elie 1941- *PrintW 83, –85*
Abrahams, Anna Adelaide 1849-1930 *DcWomA*
Abrahams, Helen *DcWomA, WhAmArt 85*
Abrahams, Hilary Ruth *IlsCB 1967*
Abrahams, Hilary Ruth 1938- *IlsBYP, IlsCB 1957*
Abrahams, Ivor 1935- *ConArt 77, –83, ConBrA 79[port], DcCAr 81, PrintW 83, –85*
Abrahams, Joseph B 1884- *WhAmArt 85*
Abrahamsen, Christian 1887- *WhAmArt 85*
Abrahamsen, John Kare 1937- *AmArch 70*
Abrahamson, Bruce Arnold 1925- *AmArch 70*
Abrahamson, Charlotte *DcWomA*
Abrahamson, G W *AmArch 70*
Abrahamson, Robert Carl 1922- *AmArch 70*
Abrahamson, V *AmArch 70*
Abrahms, Nathaniel Milton 1930- *AmArch 70*
Abram, Marthe *DcWomA*
Abramochkin, Yuri V 1936- *ConPhot, ICPEnP A*
Abramofsky, Israel 1888- *WhAmArt 85*
Abramovic, Marina 1946- *ConArt 83*
Abramovitz, Albert 1879- *WhAmArt 85*
Abramovitz, M *AmArch 70*
Abramovitz, Max *McGDA*
Abramovitz, Max 1908- *ConArch, EncMA, MacEA, McGDA, WhoAmA 73, –76, –78, –80, WhoArch*
Abramovitz, Mrs. Max *WhoAmA 73, –76, –78, –80*
Abramowicz, Janet *WhoAmA 76, –78, –80, –82, –84*
Abramowitz, Benjamin 1917- *WhAmArt 85*
Abrams, Arthur Rosskam 1909- *WhAmArt 85*
Abrams, Edith Lillian *WhoAmA 82, –84*
Abrams, Eleanor *DcWomA, WhAmArt 85*
Abrams, G G *AmArch 70*
Abrams, Harry N 1905- *WhoAmA 73, –76, –78*
Abrams, Harry N 1905-1979 *WhoAmA 80N, –82N, –84N*
Abrams, Henry Jacob 1903- *AmArch 70*
Abrams, Herbert E 1921- *WhoAmA 73, –76, –78, –80, –82, –84*
Abrams, Jane 1940- *PrintW 83, –85*
Abrams, Jane-Eldora 1940- *WhoAmA 76*
Abrams, Jane Eldora 1940- *WhoAmA 78, –80, –82, –84*
Abrams, Lester *IlsBYP*
Abrams, Lionel *OxTwCA*
Abrams, Lucien 1870-1941 *ArtsAmW 2, WhAmArt 85*
Abrams, Ned Hyman 1915- *AmArch 70*
Abrams, Ruth *WhoAmA 73, –76, –78, –80, –82, –84*
Abrams, Ruth Davidson *AmArt*
Abrams, Vivien 1946- *WhoAmA 84*
Abramse, Eliza 1776-1865 *DcWomA, NewYHSD*
Abramson, J L *AmArch 70*
Abramson, Maurice 1908- *WhAmArt 85*
Abramson, Michael Henry 1944- *MacBEP*
Abramson, Rosalind 1901- *WhAmArt 85*
Abran, Marthe *DcWomA*
Abranz, Lucien *WhAmArt 85*
Abrash, Robert I 1933- *AmArch 70*
Abrecht, Albert *EncASM*
Abrecht And Sulsberger *EncASM*
Abrell, Hermann 1937- *DcCAr 81*
Abreu, Pamplona De 1936- *WorFshn*
Abreu De, Luis Filipe 1935- *WhoGrA 82[port]*
Abril, Ben 1923- *WhoAmA 80, –82, –84*
Abry, Leon Eugene Auguste 1857-1905 *ClaDrA*
Absalom *FolkA 86*
Absmeier, John Cecil 1918- *AmArch 70*
Absolon, Hugh Wolfgang *DcVicP 2*
Absolon, John 1815- *ArtsNiC*
Absolon, John 1815-1895 *DcBrBI, DcBrWA, DcVicP, –2*
Absolon, John DeMansfield *DcVicP 2*
Absolon, Kurt 1925-1958 *OxTwCA*
Absolon, Louis *DcVicP 2*
Absolon, William *IlDcG*
Absolon, William 1751-1815 *AntBDN H, –M*
Abst, Raymond Christian 1923- *AmArch 70*
Abstetar, Stanley 1916- *WhAmArt 85*
Abston, U C *FolkA 86*
Abt, Clark C 1929- *MarqDCG 84*
Abu'l Hasan *McGDA*
Abularach, Rodolfo *OxTwCA*
Abularach, Rodolfo 1933- *McGDA*
Abularach, Rodolfo Marco 1933- *WhoAmA 82, –84*
Aburdene, Maurice Felix 1946- *MarqDCG 84*
Abyberg, Eva 1588-1669 *DcWomA*
Abys-Lotz, Anna 1861- *DcWomA*
Acanfora, Lili Rosalia *DcWomA*

Accardi, Carla 1924- *ConArt 77, OxTwCA, PhDcTCA 77*
Accardo, Joseph J 1907- *AmArch 70*
Acconci, Vito 1940- *AmArt, ConArt 77, –83, DcAmArt, DcCAA 77, DcCAr 81, PrintW 83, –85, WhoAmA 73, –76, –78, –80, –82, –84*
Accurso, Anthony Salvatore 1940- *WhoAmA 76, –78, –80, –82, –84*
Acee, Blue Eagle 1910-1959 *WhAmArt 85*
Acerra, Mario John 1954- *MarqDCG 84*
Aceves, Jose 1909- *WhAmArt 85*
Ach, Johann Von 1552-1616 *ClaDrA*
Achard, Alexis Jean 1807-1884 *ArtsNiC*
Ache, H M *FolkA 86*
Achelis, Margaret *WhAmArt 85*
Achenbach, Andreas 1815- *ArtsNiC*
Achenbach, Andreas 1815-1910 *ClaDrA, DcSeaP, McGDA*
Achenbach, Gabrielle *DcWomA*
Achenbach, Oswald 1827- *ArtsNiC*
Achenbach, Oswald 1827-1905 *ClaDrA*
Achenbach, Philippine d1900? *DcWomA*
Achenbach, Rosa 1817- *DcWomA*
Achener, Maurice *WhAmArt 85*
Acheo Brothers *FolkA 86*
Achepohl, Keith Anden 1934- *WhoAmA 73, –76, –78, –80, –82, –84*
Achert, Fred *WhAmArt 85*
Acheson, Alice 1895- *DcWomA*
Acheson, Alice S 1895- *WhAmArt 85*
Acheson, Anne 1882-1962 *DcBrA 1*
Acheson, Anne Cranford 1882-1962 *DcWomA*
Acheson, Euphemia J *FolkA 86*
Acheson, Georgina Elliott *DcWomA, WhAmArt 85*
Acheson, Henry *NewYHSD*
Acheson, Jane *WorFshn*
Acheson, Joseph 1918- *DcBrA 1, WhoArt 80, –82, –84*
Acheson, William Robert 1931- *AmArch 70*
Achey, Mary E *ArtsAmW 1, FolkA 86, IlBEAAW*
Achey, Mary Elizabeth 1832-1886 *DcWomA*
Achiam, Israel 1916- *PhDcTCA 77*
Achille, Louis *AfroAA*
Achille-Fould, Georges *DcWomA*
Achille-Jacquet, Yvonne *DcWomA*
Achilles Painter *McGDA*
Achleitner, Friedrich *ConArch A*
Achleitner, Otto d1932 *ArtsAmW 1*
Achning, Estellyn Allday 1909- *WhAmArt 85*
Acht, Rene-Charles 1920- *PhDcTCA 77*
Achtermann, Guillaume 1799- *ArtsNiC*
Achtermann, Theodor Wilhelm 1799-1884 *McGDA*
Achtschellinck, Lucas 1626-1699 *McGDA*
Acier, Michel Victor *AntBDN M*
Ackein, Marcelle 1882- *DcWomA*
Acken, J *FolkA 86*
Acken, Joe B *WhAmArt 85*
Acker, Eleanor Beatrice 1907- *WhAmArt 85*
Acker, Frank 1947- *MarqDCG 84*
Acker, Geraldine D N 1895- *WhAmArt 85*
Acker, Herbert V B 1895- *WhAmArt 85*
Acker, Herbert VanBlarcom 1895- *ArtsAmW 2*
Acker, Marjorie *DcWomA, WhAmArt 85*
Acker, Perry Miles 1903- *WhoAmA 78, –80, –82, –84*
Acker, Perry Miles 1905- *WhoAmA 76*
Acker, William Reynolds Beal 1907- *WhAmArt 85*
Ackerberg, Sanders M 1923- *AmArch 70*
Ackerman, Douglas Maltby 1934- *AmArch 70*
Ackerman, Emil 1840- *NewYHSD*
Ackerman, Frank Edward 1933- *WhoAmA 76, –78, –80, –82, –84*
Ackerman, Frank Gail 1894- *AmArch 70*
Ackerman, Frederick Lee 1878-1950 *BiDAmAr*
Ackerman, Gerald Martin 1928- *WhoAmA 73, –76, –78, –80, –82, –84*
Ackerman, H H 1890?-1985 *FolkA 86*
Ackerman, Harry Gregory 1909- *WhAmArt 85*
Ackerman, Irene 1869- *DcWomA*
Ackerman, Jacob *FolkA 86*
Ackerman, James 1813?- *NewYHSD*
Ackerman, James S 1919- *WhoAmA 78, –80, –82, –84*
Ackerman, Joel Steen 1950- *MarqDCG 84*
Ackerman, John *FolkA 86*
Ackerman, Mark Steven 1954- *MarqDCG 84*
Ackerman, Olga M *ArtsAmW 2, DcWomA, WhAmArt 85*
Ackerman, Richard Edward 1924- *AmArch 70*
Ackerman, Robert *NewYHSD*
Ackerman, Rudy Schlegel 1933- *WhoAmA 80, –82, –84*
Ackerman, Samuel *NewYHSD*
Ackerman, Virginia 1893- *ArtsAmW 2, DcWomA*
Ackermann, Arthur Gerald 1876-1960 *DcBrA 1*
Ackermann, John Joseph d1950 *WhoAmA 78N, –80N, –82N, –84N*
Ackermann, John Joseph 1889-1950 *WhAmArt 85*
Ackermann, Kurt *ConArch A*
Ackermann, Kurt 1928- *ConArch*
Ackermann, Max 1887- *OxTwCA, PhDcTCA 77*
Ackermann, Peter 1934- *ConArt 77, DcCAr 81*
Ackermann, Robert F 1929- *AmArch 70*

Ackermann, Rudolph 1764-1834 DcD&D
Ackers NewYHSD
Ackerson, F G 1889- WhAmArt 85
Ackerson, James W, Jr. 1957- MarqDCG 84
Ackfeld, Bernd 1953- DcCAr 81
Ackins, Charles Alfred 1918- AmArch 70
Ackland, F DcBrBI
Ackland, Judith ClaDrA, DcBrA 1, DcWomA
Ackland, Judith 1892-1971 DcBrA 2
Ackley, Clark Russell 1911- AmArch 70
Ackley, Douglas 1923- AmArch 70
Ackley, Elting WhAmArt 85
Ackley, Herbert Mayhew 1905- WhAmArt 85
Ackley, John Brientnall CabMA
Ackley, R D FolkA 86
Ackley, Telka 1918- WhAmArt 85
Ackley, Thomas CabMA
Ackmann, David Alan 1948- MarqDCG 84
Ackroyd, Norman 1938- ClaDrA, DcCAr 81, WhoArt 84
Acland, Lady d1841 DcWomA
Acland, A DcVicP 2, DcWomA
Acland, Caroline DcBrWA
Acland, Sir Henry Wentworth 1815-1900 DcBrWA
Acland, Hugh Dyke 1778-1836 DcBrWA
Acland, Sir Thomas Dyke 1787-1871 DcBrWA
Acock, G W AmArch 70
Acock, W W DcVicP 2
Acock, Walter William d1933? DcBrWA
Acoquat, Louise Marie DcWomA
Acosta, H AmArch 70
Acosta, John Franklin, Jr. AmArch 70
Acosta, Manuel Gregorio 1921- IlBEAAW, WhoAmA 73, -76, -78, -80, -82, -84
Acosta, O AmArch 70
Acosta, Wladimiro 1900-1967 MacEA
Acqua, Cesare Felix Georges 1821-1904 ClaDrA
Acquavella, William R WhoAmA 80, -82
Acraman, B DcBrECP
Acraman, Edith DcVicP 2, DcWomA
Acraman, William Henry DcBrWA, DcVicP 2
Acres, George CabMA
Acret, John F DcVicP 2
Acruman, Paul 1910- WhAmArt 85
Acs, Laszlo Bela 1931- IlsCB 1967
Acton, Mrs. DcWomA
Acton, Arlo C 1933- DcCAA 71, -77, WhoAmA 73, -76, -78, -80, -82, -84
Acton, George James, Jr. AmArch 70
Acton, Prue WorFshn
Acton, Samuel 1773?-1837 BiDBrA
Acuna, Luis Alberto 1904- McGDA
Acuna, Victor Miguel 1939- WhoAmA 76, -78, -80
Adair WhoArt 80, -82, -84
Adair, Ione DcWomA
Adair, R D AmArch 70
Adair, Ruby 1899- ArtsAmW 1, WhAmArt 85
Adair, Ruby Prior 1899- DcWomA
Adal 1947- ICPEnP A, MacBEP
Adaline, M WhAmArt 85
Adam FolkA 86
Adam De Reims MacEA
Adam, The Elder McGDA
Adam, Albrecht 1782-1862 ArtsNiC
Adam, Albrecht 1786-1862 ClaDrA
Adam, Anais DcWomA
Adam, Clemence DcWomA
Adam, David Livingston 1883-1924 WhAmArt 85
Adam, Edmond DcSeaP
Adam, Edouard d1930? DcSeaP
Adam, Emil 1843- DcBrBI
Adam, Ethel Lucy DcBrA 1, DcWomA
Adam, Francois Gaspard 1710-1761 OxArt
Adam, Grace Mary Stanley DcWomA
Adam, Hans Christian 1948- MacBEP
Adam, Heindrich 1787-1862 ClaDrA
Adam, Henri-Georges 1904- McGDA
Adam, Henri-Georges 1904-1967 OxTwCA, PhDcTCA 77
Adam, James 1730-1794 DcBrWA, McGDA, OxArt, WhoArch
Adam, James 1732-1794 BiDBrA, MacEA
Adam, Jan 1948- DcCAr 81
Adam, Jean Victor 1801-1866 ArtsNiC
Adam, John McGDA, OxArt
Adam, John d1790 BiDBrA
Adam, John 1721-1792 BiDBrA, MacEA
Adam, Joseph DcVicP, -2
Adam, Joseph Denovan 1842-1896 DcBrWA, DcVicP, -2
Adam, Ken 1921- ConDes
Adam, Lambert Sigisbert 1700-1759 McGDA, OxArt
Adam, Lucie Sebastienne DcWomA
Adam, Nicolas Sebastien 1705-1778 OxArt
Adam, Patrick William 1854-1929 DcBrA 1, DcVicP 2
Adam, Robert McGDA
Adam, Robert 1728-1792 AntBDN H, BiDBrA, DcBrWA, DcD&D[port], IlDcG, MacEA, McGDA, OxArt, OxDecA, WhoArch

Adam, Robert Moyes 1885-1967 MacBEP
Adam, S F AmArch 70
Adam, S L DcWomA
Adam, Sinclair Agnew 1914- AmArch 70
Adam, Victor Jean 1802-1867 ClaDrA
Adam, Wilbur G 1898- ArtsAmW 3, WhAmArt 85
Adam, William McGDA
Adam, William d1822 McGDA
Adam, William 1688-1748 DcD&D
Adam, William 1689-1748 BiDBrA, MacEA, WhoArch
Adam, William 1738?-1822 OxArt
Adam, William 1846- ArtsAmW 1, IlBEAAW, WhAmArt 85
Adam Family DcD&D, MacEA
Adam-Laurens, Suzanne Nanny Adrienne 1861-1915 DcWomA
Adam LeNeru, E DcWomA
Adam-Salomon, Anthony-Samuel 1818-1881 ArtsNiC
Adam-Salomon, Antoine Samuel 1811-1881 ICPEnP A, MacBEP
Adam-Salomon, Georgine Cornelie d1878 DcWomA
Adam-Tessier, Maxime 1920- WhoArt 80, -82, -84
Adam-Vidard, Jeanne DcWomA
Adamescu, William F 1947- MarqDCG 84
Adami, Valerio 1935- ConArt 77, -83, OxTwCA, PhDcTCA 77, PrintW 83, -85
Adams DcBrECP
Adams, Mrs. DcWomA
Adams, A M ArtsEM, DcWomA
Adams, Abigail FolkA 86
Adams, Abigail Smith DcWomA
Adams, Adrienne IlsCB 1967
Adams, Adrienne 1906- IlsBYP, IlsCB 1946, -1957
Adams, Albert G DcVicP
Adams, Albert George DcBrWA, DcVicP 2
Adams, Alfred 1884- DcBrA 1
Adams, Alice 1930- BnEnAmA, WhoAmA 73, -76, -78, -80, -82, -84
Adams, Alice C 1877-1975 DcWomA
Adams, Alice M DcWomA
Adams, Angie M Phelps 1833-1918 DcWomA
Adams, Annie Brown DcWomA
Adams, Ansel 1902- ConPhot, DcAmArt, DcCAr 81
Adams, Ansel 1902-1984 ICPEnP, WhAmArt 85
Adams, Ansel Easton 1902- BnEnAmA, MacBEP, WhoAmA 76, -78, -80, -82, -84
Adams, Anthony Barbour 1936- AmArch 70
Adams, Arthur WhAmArt 85
Adams, Arthur Christopher 1867- DcBrA 1
Adams, Arthur Stanford 1935- AmArch 70
Adams, B FolkA 86
Adams, Beale d1939 DcBrA 2
Adams, Beatrice T DcWomA
Adams, Benjamin CabMA
Adams, Bernard d1965 DcBrA 1
Adams, Bertrand R 1907- WhAmArt 85
Adams, Bobbi 1939- AmArt, WhoAmA 82, -84
Adams, Caleb Cushing 1833-1893 EncASM
Adams, Carl D 1929- AmArch 70
Adams, Caroline DcBrWA, DcWomA
Adams, Cassily 1843-1921 ArtsAmW 1
Adams, Cassily 1843-1921 IlBEAAW
Adams, Celeste M 1947- WhoAmA 82
Adams, Celeste Marie 1947- WhoAmA 84
Adams, Charles NewYHSD
Adams, Charles Breckenridge 1942- AmArch 70
Adams, Mrs. Charles F d1921 WhAmArt 85
Adams, Charles James 1859-1931 DcBrA 1, DcBrWA, DcVicP, -2
Adams, Charles L 1857-1914 WhAmArt 85
Adams, Charles Partridge 1858-1942 ArtsAmW 1, IlBEAAW, WhAmArt 85
Adams, Charles R 1946- MarqDCG 84
Adams, Charlotte DcBrWA, DcVicP 2, DcWomA, FolkA 86
Adams, Chauncey M 1895- WhAmArt 85
Adams, Christopher NewYHSD
Adams, Clarissa M DcWomA
Adams, Clifton Emerson 1904- WhAmArt 85
Adams, Clinton 1918- DcCAA 71, -77, WhoAmA 73, -76, -78, -80, -82, -84
Adams, Clyde Smith 1871-1939 BiDAmAr
Adams, Constance Louisa DcWomA
Adams, Corrine D 1870- ArtsAmW 1, DcWomA
Adams, Cushing EncASM
Adams, Danton F 1904- DcBrA 1, WhoArt 80, -82, -84
Adams, David G 1939- MarqDCG 84
Adams, David Kyle 1930- AmArch 70
Adams, Dennis 1948- DcCAr 81
Adams, Doren D 1945- DcCAr 81
Adams, Douglas DcVicP, -2
Adams, Dunlap NewYHSD
Adams, E ArtsAmW 3, DcWomA, WhAmArt 85
Adams, E J AmArch 70
Adams, Eddie 1933- ICPEnP A, MacBEP
Adams, Mrs. Edgar F WhAmArt 85
Adams, Edith Gordon 1870-1938 WhAmArt 85
Adams, Edith Gordon 1870-1939? DcWomA
Adams, Edward Lester, III 1930- AmArch 70

Adams, Mrs. Edward S DcWomA, WhAmArt 85
Adams, Elinor Proby d1945 DcBrA 1, DcWomA
Adams, Eliott Ashfield DcVicP 2
Adams, Elisha CabMA
Adams, Elizabeth C DcWomA
Adams, Elizabeth Livingston DcWomA, WhAmArt 85
Adams, Elmer H 1907- AmArch 70
Adams, Enos FolkA 86
Adams, Ernest D 1884- ClaDrA, DcBrA 1
Adams, Eva Belle ArtsEM, DcWomA
Adams, Florence DcWomA
Adams, Florence Bowman 1902- WhAmArt 85
Adams, Frances Matilda 1784?-1863 DcWomA
Adams, Frank WhAmArt 85
Adams, Frank 1871-1944 FolkA 86
Adams, Frank H, Jr. AfroAA
Adams, Frederick 1880- ArtsAmW 3
Adams, Frederick James 1879-1945 BiDAmAr
Adams, Frederick Wildes, Jr. 1925- AmArch 70
Adams, G L AmArch 70
Adams, George C EncASM
Adams, George E 1814-1885 NewYHSD
Adams, George Edward EncASM
Adams, George G 1948- MarqDCG 84
Adams, George S EncASM
Adams, Glenn Nelson 1928- WhoAmA 73, -76, -78
Adams, Grace Arvilla Rice 1887-1972 ArtsAmW 2, DcWomA
Adams, H Isabel DcBrBI
Adams, H Lawson, Jr. WhAmArt 85
Adams, Harold Eugene 1926- AmArch 70
Adams, Harriet Dyer 1910- WhAmArt 85
Adams, Harriette DcWomA, WhAmArt 85
Adams, Harry Percy 1865-1930 MacEA
Adams, Harry William 1868- ClaDrA
Adams, Harry William 1868-1947 DcBrA 1, DcVicP 2
Adams, Henry FolkA 86
Adams, Henry 1858-1929 WhAmArt 85
Adams, Henry 1949- WhoAmA 84
Adams, Herbert 1858-1945 BnEnAmA, DcAmArt, OxArt, WhAmArt 85
Adams, Hervey DcCAr 81
Adams, Hervey 1903- WhoArt 80, -82, -84
Adams, Hervey Cadwallader 1903- DcBrA 1
Adams, Iris DcCAr 81
Adams, J DcSeaP
Adams, J F AmArch 70
Adams, J G DcWomA
Adams, Mrs. J G NewYHSD
Adams, J H AmArch 70
Adams, J Howard WhAmArt 85
Adams, J M AmArch 70
Adams, J Mack 1933- MarqDCG 84
Adams, J Q AmArch 70
Adams, J Seymour DcVicP 2
Adams, Jack AfroAA
Adams, James 1785- BiDBrA, DcBrWA
Adams, James Bruce 1921- AmArch 70
Adams, James Ellis 1921- AmArch 70
Adams, James Frederick 1914- ClaDrA, DcBrA 1, WhoArt 80, -82, -84
Adams, James Frederick 1927- WhoAmA 80, -82, -84
Adams, James L DcVicP 2
Adams, James Vincent 1934- AmArch 70
Adams, James W FolkA 86
Adams, Jane DcVicP 2, DcWomA
Adams, Jay H 1937- WhoAmA 80, -82, -84
Adams, Jean Crawford WhAmArt 85
Adams, Jean Crawford 1890- DcWomA
Adams, Joan DcVicP 2
Adams, Joan Clayton DcWomA
Adams, John AntBDN I, CabMA
Adams, John Alexander NewYHSD
Adams, John Clayton 1840-1906 DcBrA 1, DcBrWA, DcVicP, -2
Adams, John Eastridge BiDBrA
Adams, John Henry, Jr. AfroAA
Adams, John Howard 1876-1924 BiDAmAr
Adams, John Ottis 1851-1927 WhAmArt 85
Adams, John P EncASM
Adams, John Quincy d1919 WhAmArt 85
Adams, John Quincy d1933 DcBrA 2
Adams, John Quincy 1875-1933 WhAmArt 85
Adams, John Quincy, Jr. 1913- AmArch 70
Adams, John Squire 1912- WhAmArt 85
Adams, John Talbot DcVicP 2
Adams, John Wolcott 1874-1925 IlrAm B, -1880, WhAmArt 85
Adams, Joseph CabMA, FolkA 86
Adams, Joseph 1689-1783 NewYHSD
Adams, Joseph Alexander 1803-1880 EarABI, EarABI SUP, NewYHSD
Adams, Katharine Langhorne WhAmArt 85
Adams, Katherine DcWomA
Adams, Katherine Langhorne WhoAmA 73, -76, -78
Adams, Kenneth M 1897-1966 ArtsAmW 1
Adams, Kenneth Miller 1897-1966 IlBEAAW, WhAmArt 85
Adams, L IlDcG

Adlington, E C *DcVicP 2, DcWomA*
Adlmann, Jan Ernst 1936- *WhoAmA 76, -78, -80*
Adlon, Emma 1868- *ArtsAmW 2, DcWomA*
Adlow, Dorothy d1964 *WhAmArt 85, WhoAmA 78N, -80N, -82N, -84N*
Adlum, Margaret *DcWomA*
Adnan, Etal 1925- *DcCAr 81*
Adnel *DcBrECP*
Adney, Edwin Tappan 1868-1950 *IlBEAAW, WhAmArt 85*
Adolf, Charles 1815?- *FolkA 86*
Adolf, George 1822?- *FolkA 86*
Adolf, Henry 1815?- *FolkA 86*
Adolfo 1929- *FairDF US*
Adolfo 1933- *ConDes, WorFshn*
Adolph, Emmy Dorothea *DcWomA*
Adolph, Joseph Anton 1729-1765? *DcBrECP*
Adolph, Virginia *WhAmArt 85*
Adolph, Virginia 1880- *DcWomA*
Adolphe, Monsieur *AntBDN O*
Adolphe, Albert J 1865-1940 *WhAmArt 85*
Adolphus, Joseph Anton 1729-1765? *DcBrECP*
Adomeit, George G 1879- *WhAmArt 85*
Adomeit, George Gustav 1879- *ArtsAmW 3*
Adomeit, Otto *ArtsEM*
Adorne DeTscharner, Louise Egle *DcWomA*
Adour, Pauline Francoise *DcWomA*
Adreon, Harry Barnes, Jr. 1929- *AmArch 70*
Adri *WorFshn*
Adriaenssen, Alexander 1587-1661 *McGDA*
Adrian 1903-1959 *ConDes, WorFshn*
Adrian, Barbara 1931- *WhoAmA 73, -76, -78, -80, -82, -84*
Adrian, Gilbert 1903-1959 *FairDF US*
Adrian-Nilsson, Gosta 1884- *PhDcTCA 77*
Adriance, Mary Horton d1941 *WhAmArt 85*
Adriance, Mary Horton 1866?-1941 *DcWomA*
Adriance, Minnie H *DcWomA*
Adriani, Bruno 1881- *WhAmArt 85*
Adriano Fiorentino *McGDA*
Adrien, Caroline d1845 *DcWomA*
Adrien, Marie *DcWomA*
Adshead, Joseph *DcVicP 2*
Adshead, Mary *DcCAr 81*
Adshead, Mary 1904- *DcBrA 1, IlsCB 1946*
Adsit, Mabel Lawson *WhAmArt 85*
Adye, Sir John Miller 1819-1900 *DcBrWA*
Adzak, Roy 1927- *ConArt 77*
Aebi, Ernst Walter 1938- *WhoAmA 80, -82, -84*
Aeck, Richard L 1912- *AmArch 70*
Aegerter, Robert Ernest 1935- *AmArch 70*
Aehle, Norman George 1923- *AmArch 70*
Aeken, Hieronymus Van *McGDA*
Aelst, Pieter Coecke Van *OxDecA*
Aelst, Willem Van 1625?-1683? *McGDA*
Aelst, Willem Van 1626-1683 *ClaDrA*
Aeron, Idris *WhoArt 80, -82, -84*
Aerts, Antoine *McGDA*
Aerts, Hendrik *McGDA*
Aerts, Jean *McGDA*
Aerts, Joseph *ArtsEM*
Aerts, Josse *McGDA*
Aerts, Michael *McGDA*
Aerts, Michel *McGDA*
Aerts, Nicolas *McGDA*
Aerts And Vanderpoele *ArtsEM*
Aertsen, Aert Pietersz *OxArt*
Aertsen, Pieter 1508?-1575 *McGDA, OxArt*
Aertsen, Pieter Pietersz *OxArt*
Aertsz, Pieter *McGDA*
Aeschbacher, Hans 1906- *PhDcTCA 77*
Aetatis Sue Limner *BnEnAmA*
Aetion *McGDA*
Af Ekenstam, Marta 1880-1939 *DcWomA, WhAmArt 85*
Affaticati, Giuseppe Eugenio 1932- *MarqDCG 84*
Affick, William H *NewYHSD*
Affleck, Andrew F *DcBrA 2*
Affleck, Andrew F 1874- *DcBrA 2*
Affleck, Ray 1922- *ConArch*
Affleck, Raymond 1922- *MacEA*
Affleck, Thomas d1795 *AntBDN G, CabMA, OxDecA*
Affleck, Thomas 1740-1795 *DcD&D*
Affleck, William 1869- *DcBrA 1, DcVicP 2*
Affleck, William 1869-1909 *DcBrWA*
Afflighem, Steven Van *McGDA*
Affry, Adele D', Duchess *DcWomA*
Afinger, Bernard 1813-1883 *ArtsNiC*
Africano, Nicholas 1948- *ConArt 83, DcCAr 81, PrintW 83, -85*
Africano, Nicolas 1948- *AmArt*
Afro 1912- *McGDA, PhDcTCA 77*
Afro 1912-1976 *ConArt 83, OxTwCA, WorArt[port]*
Afroyim, Beys 1893- *WhAmArt 85*
Afseth, G N *AmArch 70*
Aga-Oglu, Mehmet d1948 *WhoAmA 78N, -80N, -82N, -84N*
Aga-Oglu, Mehmet 1896-1948 *WhAmArt 85*

Agabiti, Pietro Paolo 1470?-1540? *McGDA*
Agafonoff, Eugene Andrew 1879-1955? *WhAmArt 85*
Agam, Yaacov 1928- *ConArt 77, -83, McGDA, OxTwCA, PhDcTCA 77, PrintW 83, -85, WorArt[port]*
Agar *DcBrECP*
Agar, Eileen 1904- *DcBrA 1, OxTwCA, PhDcTCA 77, WhoArt 80, -82, -84*
Agar, Eunice Jane 1934- *WhoAmA 78, -80, -82, -84*
Agar, John Giraud 1856-1935 *WhAmArt 85*
Agar, John Samuel *AntBDN B*
Agar, Will McGaffey 1950- *MacBEP*
Agasias *McGDA*
Agassis, Louise *DcWomA*
Agate, Alfred T 1812-1846 *ArtsAmW 1, EarABI, IlBEAAW, NewYHSD*
Agate, Frederick Styles 1807-1844 *NewYHSD*
Agate, Miss H *NewYHSD*
Agate, Harriet *DcWomA*
Agatha, Saint *McGDA*
Agatharcus *McGDA*
Agatharcus Of Samos *OxArt*
Agbabian, H Hrant 1929- *AmArch 70*
Agee, Aubrey Caston 1918- *AmArch 70*
Agee, William C 1936- *WhoAmA 84*
Ageladas *McGDA*
Ageron, Blanche *DcWomA*
Agerskov, Kathinka Hedwig 1859-1890 *DcWomA*
Agg, James 1746?-1827 *MacEA*
Aggarwala, Rajendra Kumar 1931- *MarqDCG 84*
Aggas, Ralph 1540?-1621? *McGDA*
Aghayan, Ray *WorFshn*
Aghion, Janine *DcWomA*
Agle, Charles Klemm 1906- *AmArch 70*
Aglio, Agostino 1777-1857 *DcBrWA, DcVicP, -2*
Aglio, Agostino 1816-1885 *DcBrWA*
Aglio, Augustine *DcVicP 2, DcWomA*
Aglio, Mary Elisabeth *DcWomA*
Aglio, Mary Elizabeth *DcVicP 2*
Agnard DeCourcelles, Marguerite *DcWomA*
Agne, Jacob, Jr. 1869-1918 *BiDAmAr*
Agneesens, Edouard Joseph Alexander 1842-1885 *ClaDrA*
Agneni, Eugene 1819- *ArtsNiC*
Agneni, Eugenio 1832-1888 *DcVicP 2*
Agnes *FairDF FRA*
Agnes Of Quedlinburg *DcWomA*
Agnes Of Rome, Saint *McGDA*
Agnes B 1941- *ConDes*
Agnese Of Quedlinburg *DcWomA*
Agnetta, Miss *DcBrECP*
Agnetti, Vincenzo 1926- *ConArt 77*
Agnetti, Vincenzo 1926-1981 *ConArt 83*
Agnew, Caroline M *DcVicP 2, DcWomA*
Agnew, Chalmers, Jr. *WhAmArt 85*
Agnew, Clark M *WhAmArt 85*
Agnew, Constance *DcWomA*
Agnew, Eric Munro 1887- *DcBrA 1*
Agnew, Philip E 1926- *AmArch 70*
Agni 1937- *DcCAr 81*
Agnolo Di Ventura *McGDA*
Agnolo, Andrea D' 1487-1531 *ClaDrA*
Agnolo, Baccio D' *McGDA*
Agoos, Herbert M 1915- *WhoAmA 73, -76, -78, -80, -82, -84*
Agopoff, Agop Minass *WhoAmA 73, -76, -78, -80, -82*
Agopoff, Agop Minass d1983 *WhoAmA 84N*
Agoracritus *McGDA, OxArt*
Agostiello *McGDA*
Agostinelli, Mario 1923- *WhoAmA 73, -76, -78*
Agostini, Peter 1913- *BnEnAmA, DcAmArt, DcCAA 71, -77, DcCAr 81, OxTwCA, PhDcTCA 77, WhoAmA 73, -76, -78, -80, -82, -84*
Agostino Da Lodi *McGDA*
Agostino Di Duccio 1418-1481 *MacEA, McGDA, OxArt*
Agostino Di Giovanni *McGDA*
Agostino Di Guccio *McGDA*
Agostino Veneziano *McGDA*
Agotha, Margit 1938- *DcCAr 81*
Agoust, Loes 1940- *WhoArt 82, -84*
Agrarykh *OxTwCA*
Agrasot, Joaquin *ArtsNiC*
Agrate, Marco D' d1571? *McGDA*
Agrawal, Arun 1945- *MarqDCG 84*
Agrawal, Sunil Kumar 1952- *MarqDCG 84*
Agree, A Arnold 1923- *AmArch 70*
Agree, Charles Nathanial 1897- *AmArch 70*
Agren, Marianne 1943- *DcCAr 81*
Agresti, Livio 1500?-1580? *McGDA*
Agricola, Filippo 1795-1857 *ArtsNiC*
Agron, G A *AmArch 70*
Aguado, Olympe, Comte 1827-1894 *ICPEnP A*
Aguayo, Fermin *OxTwCA*
Aguayo, Oscar 1925- *WhoAmA 76, -78*
Agudelo-Botero, Orlando 1946- *PrintW 85*
Aguesca, Teresa 1654- *DcWomA*
Aguila, Dani 1928- *WorECom*

Aguilar, Sergi 1946- *DcCAr 81*
Aguilar DeMargaret *DcWomA*
Aguirre, Ignacio 1900- *McGDA*
Aguirre, John *AmArch 70*
Aguirre, Jose L 1949- *MarqDCG 84*
Aguirre, Juan Antonio *OxTwCA*
Aguirre, Pedro 1933- *AmArch 70*
Agujari, G *DcVicP 2*
Agur, Hezekiah *NewYHSD*
Agura, J D *AmArch 70*
Agusta, Philip Paul 1928- *AmArch 70*
Agutte, Georgette 1867-1922 *DcWomA*
Ahern, Andrew 1827?- *NewYHSD*
Ahern, Eugene 1896-1960 *WhoAmA 80N, -82N, -84N*
Ahern, Gene 1895-1960 *WorECom*
Ahern, Martin 1817?- *NewYHSD*
Ahern, William Warren 1925- *AmArch 70*
Ahfeld, Florence *DcWomA*
Ahgupuk, George *WhAmArt 85*
Ahl, Eleanor Curtis *DcWomA, WhAmArt 85*
Ahl, Henry C *WhoAmA 76, -78, -80, -82, -84*
Ahl, Henry Curtis 1905- *WhAmArt 85*
Ahl, Henry Hammond 1869-1953 *WhAmArt 85*
Ahlander, Leslie Judd *WhoAmA 76, -78, -80, -82, -84*
Ahlberg, Emil 1865- *WhAmArt 85*
Ahlberg, Florence Maria 1902- *WhAmArt 85*
Ahlberg, Hakon 1891- *MacEA*
Ahlborn, August Wilhelm Julius 1796-1857 *ArtsNiC*
Ahlborn, Emil *WhAmArt 85*
Ahlborn, Lea Fredrika 1826-1897 *DcWomA*
Ahlborn, Sophia *DcWomA*
Ahlers-Hestermann, Alexandra *DcWomA*
Ahlers-Hestermann, Frederich 1883- *ClaDrA*
Ahlers-Hestermann, Friedrich 1883- *McGDA, PhDcTCA 77*
Ahlfeld, Florence Tilton 1894- *WhAmArt 85*
Ahlfield, Florence *ArtsAmW 3*
Ahlgren, Roy B *WhoAmA 80, -82, -84*
Ahlgren, Roy B 1927- *WhoAmA 73, -76, -78*
Ahlm, Gerda Maria 1869- *DcWomA, WhAmArt 85*
Ahlman, Helmi *DcWomA*
Ahlmann, Lis 1894- *ConDes*
Ahlqvist, Gunnar 1942- *MarqDCG 84*
Ahlschlager, Frederick 1858-1905 *BiDAmAr*
Ahlsen, Erik 1901- *MacEA*
Ahlsen, Tore 1906- *MacEA*
Ahlskog, Sirkka 1917- *WhoAmA 73, -76, -78*
Ahlson, Frederick Theodore 1905- *AmArch 70*
Ahlsted, David R 1943- *WhoAmA 76*
Ahlstrom, Charles Albert 1935- *AmArch 70*
Ahlstrom, Lars *DcCAr 81*
Ahlstrom, Ronald Gustin 1922- *WhoAmA 73, -76, -78, -80, -82, -84*
Ahluwalia, Rashpal Singh 1946- *MarqDCG 84*
Ahmad, Syed Imtiaz 1941- *MarqDCG 84*
Ahmad, Ustad 1580?-1649 *MacEA*
Ahmad B Abi Bakr Al-Marandi *MacEA*
Ahmad B Ahmad B M At-Tuluni Family *MacEA*
Ahmad Ibn Baso *MacEA, OxArt*
Ahmad Ibn Mohammad At-Tabrizi *MacEA*
Ahmed, Samir Ahmed 1946- *MarqDCG 84*
Ahn, Don C 1937- *WhoAmA 76, -78, -80, -82, -84*
Ahneman, Leonard J 1914- *WhAmArt 85*
Ahnert, Elisabeth 1885-1966 *DcWomA*
Ahre, A G *AmArch 70*
Ahren, Uno 1897-1977 *MacEA*
Ahrenbeck, Amelia *DcWomA*
Ahrends, Peter *ConArch*
Ahrends, Steffen 1907- *ConArch*
Ahrends Burton And Koralek *ConArch*
Ahrendt, Christine *WhoAmA 76, -80, -82, -84*
Ahrendt, William G *EncASM*
Ahrendt And Kautzman *EncASM*
Ahrendt And Taylor *EncASM*
Ahrenhold, Novie Moffat *IlsBYP*
Ahrens, Carl *WhAmArt 85*
Ahrens, Carl Henry 1863-1936 *ArtsAmW 1*
Ahrens, Carl Henry Von 1863-1936 *ArtsAmW 3*
Ahrens, Ellen Wetherald 1859- *WhAmArt 85*
Ahrens, Ellen Wetherald 1859-1953 *DcWomA*
Ahrens, Hermann *NewYHSD*
Ahrens, Kent *WhoAmA 84*
Ahrens, Otto *FolkA 86*
Ahrens, R C *AmArch 70*
Ahrens, William H 1925- *AmArch 70*
Ahtiluoto, Anna-Liisa *WorFshn*
Ahuja, Narendra 1950- *MarqDCG 84*
Ahvakana, Ulaaq 1946- *WhoAmA 78, -80, -82, -84*
Ahysen, Harry Joseph *WhoAmA 73, -76, -78, -80, -82*
Ahysen, Harry Joseph 1928- *WhoAmA 84*
Aichel, Johann Blasius Santini- 1677-1723 *WhoArch*
Aichele, Kathryn Porter 1947- *WhoAmA 78, -80, -82*
Aicher, Otl 1922- *ConDes, WhoGrA 62, -82[port]*
Aichholz, Roger Raymond 1922- *AmArch 70*
Aichinger, Helga 1937- *IlsBYP, IlsCB 1967*
Aicken, George *AntBDN D*
Aid, George C 1872-1938 *WhAmArt 85*
Aida, Takefumi 1937- *ConArch*

Aidala, Thomas Richard 1933- *AmArch 70*
Aide, Charles Hamilton 1826-1906 *DcVicP 2*
Aidlin, Jerome 1935- *WhoAmA 76, –78, –80, –82, –84*
Aigner, Lucien 1901- *ConPhot, WhoAmA 84*
Aigner, Lucien L 1901- *ICPEnP A, MacBEP*
Aigroz, Marguerite 1862- *DcWomA*
Aiguier, Louis Auguste Laurent 1819-1865 *ClaDrA*
Aiken, Bertha *DcWomA*
Aiken, Charles d1965 *WhoAmA 78N, –80N, –82N, –84N*
Aiken, Charles Avery 1872-1965 *WhAmArt 85*
Aiken, Christopher K *ArtsEM*
Aiken, Frank A 1859-1933 *WhAmArt 85*
Aiken, Gayleen *FolkA 86*
Aiken H W *MacEA*
Aiken, Jessie *DcWomA*
Aiken, Jessie 1860-1947 *ArtsAmW 3*
Aiken, John 1950- *DcCAr 81*
Aiken, John Dary 1908- *WhAmArt 85*
Aiken, John Macdonald 1880-1961 *DcBrA 1*
Aiken, Mary Hoover 1907- *WhAmArt 85*
Aiken, May *DcWomA, WhAmArt 85*
Aiken, Walter Chetwood 1866-1899 *DcVicP 2*
Aiken, William A 1934- *WhoAmA 80, –82, –84*
Aiken, William M 1885-1908 *BiDAmAr*
Aikens, James *FolkA 86*
Aikin, Edmund 1780-1820 *BiDBrA, DcBrWA, MacEA*
Aikin, Roger Cushing 1947- *MacBEP*
Aikins, Mrs. *DcWomA*
Aikman, George 1830-1905 *DcBrA 1, DcBrWA, DcVicP 2*
Aikman, George W 1831-1905 *DcBrBI*
Aikman, Robert Allen, Jr. 1932- *AmArch 70*
Aikman, Walter M *NewYHSD*
Aikman, Walter M d1939 *WhAmArt 85*
Aikman, William 1682-1731 *DcBrECP*
Aillaud, Gilles 1928- *ConArt 77, DcCAr 81*
Ailliod, Clotilde d1887 *DcWomA*
Aiman, Pearl *DcWomA, WhAmArt 85*
Aimbez, Gil *ConDes*
Aimee, Louise *DcWomA*
Aimo, Domenico *McGDA*
Ain, G *AmArch 70*
Ain, Gregory 1908- *ConArch, MacEA*
Aine, Harry E 1956- *MarqDCG 84*
Ainger, Alfred 1797-1859 *BiDBrA*
Ainley, John Anthony 1931- *WhoArt 80, –82, –84*
Ainmiller, Max Emmanuel 1807-1870 *AntBDN M*
Ainmiller, Maximilian Emmanuel 1807-1870 *ArtsNiC*
Ainscow, George Frederick 1913- *WhoArt 82, –84*
Ainscow, Terence Noel 1934- *AmArch 70*
Ainslee, Henry Francis *FolkA 86*
Ainsley, Henry Francis 1805?-1879 *DcBrWA*
Ainsley, J *DcVicP 2*
Ainsley, Oliver *WhAmArt 85*
Ainsley, P *DcVicP 2*
Ainsley, Samuel James 1806-1874 *DcBrWA, DcVicP 2*
Ainslie, Miss *DcWomA*
Ainslie, John *AntBDN I*
Ainslie, Maud 1870-1960 *DcWomA, WhAmArt 85*
Ainslie, Peter 1925- *WhoArt 80, –82, –84*
Ainslie, Sarah 1952- *DcCAr 81*
Ainsworth, Ruth *DcWomA*
Aird *BiDBrA*
Aird, Edith d1920? *DcWomA*
Aird, Neil Carrick 1945- *WhoAmA 78, –80, –82, –84*
Aird, Reginald James Mitchell 1890- *ClaDrA, DcBrA 1*
Aireton, Edmund *AntBDN K*
Airey, F W *DcBrBI*
Airola, Angela Veronica d1670 *DcWomA*
Airola, Paavo *WhoAmA 73, –76, –78, –80, –82*
Airola, Paavo d1983 *WhoAmA 84N*
Airy, Anna 1882- *ClaDrA*
Airy, Anna 1882-1964 *DcBrA 1, DcWomA*
Airy, George Biddell 1802-1892 *AntBDN D*
Airy, John *NewYHSD*
Aislin *WorECar*
Aita DeLaPennuela, Mathilde *DcWomA*
Aitcherson, S *DcVicP 2, DcWomA*
Aitchison, Craigie 1926- *ConArt 77, ConBrA 79[port]*
Aitchison, George 1792-1861 *BiDBrA*
Aitchison, George 1825-1910 *DcBrA 1, MacEA*
Aitken, Irene Anabel 1907- *WhAmArt 85*
Aitken, James *DcBrA 1, DcVicP 2, NewYHSD*
Aitken, James Alfred 1846-1897 *DcBrWA, DcVicP 2*
Aitken, James Bertin 1919- *AmArch 70*
Aitken, Janet Macdonald *DcBrA 1, DcWomA*
Aitken, John *CabMA*
Aitken, John Ernest 1881-1957 *ClaDrA, DcBrA 1*
Aitken, Martin Inglis 1907- *AmArch 70*
Aitken, Melita 1866-1943? *DcWomA*
Aitken, Pauline 1893- *DcBrA 1, DcWomA*
Aitken, Peter 1858- *WhAmArt 85*
Aitken, R J *AmArch 70*
Aitken, Robert 1734-1802 *NewYHSD*
Aitken, Robert I 1878- *WhAmArt 85*
Aitken, Russell 1910- *CenC*

Aitken, Russell Barnett 1906- *WhAmArt 85*
Aitkens, Mae *ArtsEM, DcWomA*
Aitkin, E V *DcVicP 2*
Aitkin, Thomas *NewYHSD*
Aitkins, John *BiDBrA*
Aiton, Thomas *CabMA*
Aitson, Marland Konad 1928- *WhoAmA 76, –78, –80, –82*
Aivasovski, Ivan Konstantinovich 1817-1900 *McGDA*
Aivazoffski, Ivan Constantinowitsch 1817-1900 *DcSeaP*
Aivazouski, Ivan Constinowitch *DcSeaP*
Aizelin, Sophie d1882 *DcWomA*
Aizinas, S *AmArch 70*
Aizpiri, Paul Augustin 1919- *OxTwCA*
Ajami *McGDA*
Ajango, Helmut 1931- *AmArch 70*
Ajay, Abe 1919- *WhoAmA 78, –80, –82, –84*
Ajiajia *DcWomA*
Ajmone, Giuseppe 1923- *PhDcTCA 77*
Ajootian, Khosrov 1891-1958 *WhoAmA 80N, –82N, –84N*
Ajuria, Gregorio De *DcWomA*
Ajuria, Mrs. Gregorio De *WhAmArt 85*
Akaba, Seppo *WhAmArt 85*
Akagi, Raymond S 1908- *AmArch 70*
Akamu, Nina 1955- *WhoAmA 82, –84*
Akasegawa, Genpei 1937- *OxTwCA, PhDcTCA 77, WorECar*
Akatsuka, Fujio 1935- *WorECom*
Akawie, Thomas Frank 1935- *WhoAmA 78, –80, –82, –84*
Akawie, Tom 1935- *DcCAr 81*
Akbar *MacEA*
Aked, Aleen *WhAmArt 85*
Akeley, Carl Ethan 1864-1926 *WhAmArt 85*
Aken *DcBrECP*
Aken, Jan Van 1614- *ClaDrA*
Aken, Jan Van 1614-1661 *McGDA*
Aken, Leo Van 1857-1904 *ClaDrA*
Akerblad, Jeannette *DcWomA*
Akerbladh, Alexander 1886- *DcBrA 1*
Akerlof, Augusta Amalia Karolina 1829-1878 *DcWomA*
Akerlund, Emma Matilda Paulina 1857- *DcWomA*
Akerman, Jeanette *DcWomA*
Akerman, John *AntBDN H, IlDcG*
Akers, Anne *DcWomA*
Akers, Benjamin Paul 1825-1861 *DcAmArt, NewYHSD*
Akers, Charles 1835?-1906 *NewYHSD , WhAmArt 85*
Akers, Charles 1836- *ArtsNiC*
Akers, Charles R 1937- *AmArch 70*
Akers, Gary 1951- *WhoAmA 82, –84*
Akers, John *DcVicP 2*
Akers, John B 1948- *MarqDCG 84*
Akers, Paul 1825-1861 *ArtsNiC*
Akers, Vivian Milner 1886- *WhAmArt 85*
Akersloot-Berg, Betzy Rezora *DcWomA*
Akhenaten *McGDA*
Aki, Ryuzan 1942- *WorECar*
Akimov, Elisabeth *DcWomA*
Akin, Mrs. *DcWomA*
Akin, James 1773-1846 *EarABI, EarABI SUP, NewYHSD*
Akin, Mrs. James *NewYHSD*
Akin, John F *FolkA 86*
Akin, Louis B 1868-1913 *ArtsAmW 1, IlBEAAW, WhAmArt 85*
Akin, Mary *WhAmArt 85*
Akin, Phebe *FolkA 86*
Akino, Fuku *IlsCB 1967*
Akino, Fuku 1908- *IlsBYP, IlsCB 1957*
Akins, John 1827?- *NewYHSD*
Akis, Aivar 1934- *ICPEnP A*
Akitt, William Roy *AmArch 70*
Akiyama, Kenneth Kiyoshi 1920- *AmArch 70*
Akiyama, Ryoji 1942- *ICPEnP A*
Akiyoshi, Kaoru 1942- *WorECar*
Aklborn, Emil *WhAmArt 85*
Akner, Alfred John 1934- *AmArch 70*
Akoio, J B *AfroAA*
Akol, Haluk Alan 1925- *AmArch 70*
Akridge, Frances Goode 1939- *MarqDCG 84*
Akright, James G 1888- *ArtsAmW 3*
Akroyd, John 1556-1613 *BiDBrA*
Akston, James *WhoAmA 82, –84*
Akston, Joseph James *WhoAmA 73, –76, –78, –80*
Akubuiro, Dorothy *AfroAA*
Al-Azzawi, Dia 1939- *DcCAr 81*
Al-Douroubi, Hafidh 1914- *DcCAr 81*
Al-Jadir, Khalid *DcCAr 81*
Al-Jumaii, Salih 1939- *DcCAr 81*
Al-Kabi, Saadi 1937- *DcCAr 81*
Al-Mansur d775 *MacEA*
Al-Massoudy, Hasan 1944- *DcCAr 81*
Al-Naib, Khalid 1942- *DcCAr 81*
Al-Nasiri, Rafa 1940- *DcCAr 81*
Al-Rawi, Noori 1925- *DcCAr 81*
Al-Said, Isam 1939- *DcCAr 81*
Al-Said, Shakir Hasan 1925- *DcCAr 81*

Al-Shaykhal, Ismail 1927- *DcCAr 81*
Al-Timimi, Kais Abdulhadi 1945- *MarqDCG 84*
Al-Ubaida, Amer 1943- *DcCAr 81*
Al-Wasiti, Yahya Ibn-Mahmud *McGDA*
Ala, Charles J 1938- *AmArch 70*
Alabaster, H *DcVicP 2*
Alabaster, Mrs. Henry *DcVicP 2*
Alabaster, Mary Ann *DcVicP 2, DcWomA*
Alabaster, Palacia Emma *DcWomA*
Alain 1868-1951 *IlsBYP, IlsCB 1957*
Alain, D A 1904- *WhAmArt 85*
Alain, Marie Barrett *WhAmArt 85*
Alajalov, Constantin 1900- *IlrAm D, –1880, IlsBYP, IlsCB 1744, –1946, WhAmArt 85, WhoAmA 73, –76, –78, –80, –82, –84, WorECar*
Alajouanine-Aumont, Marie Jeanne 1893- *DcWomA*
Alamanno, Pietro *McGDA*
Alamaru, Lipa 1919- *WhoGrA 62*
Alan Of Walsingham *OxArt*
Alan, Jay d1965 *WhoAmA 78N, –80N, –82N, –84N*
Alan, Jay 1907-1965 *WhAmArt 85*
Alandy, Sydney *DcBrBI*
Alari-Bonacolsi, Pier Jacopo 1460-1528 *McGDA*
Alars, W *AntBDN E*
Alaupovic, Alexandra V 1921- *WhoAmA 73, –76, –78, –80, –82, –84*
Alaux, Aline *DcWomA*
Alaux, Fanny *DcWomA*
Alaux, Francois 1878- *ClaDrA*
Alava, Juan De *McGDA*
Alava, Juan De d1537 *OxArt*
Alavoine, Adele *DcWomA*
Alavoine, Jean Antoine 1777-1834 *MacEA*
Alazet-Rocamora, Dolorez 1878- *DcWomA*
Alba, Emilia *DcWomA*
Alba-Norega, Blanche *DcWomA*
Alback, John *FolkA 86*
Albaisa, A M *AmArch 70*
Alban *NewYHSD*
Alban Of Verulamium, Saint d303 *McGDA*
Albanese *WorFshn*
Albani, Cardinal Alessandro 1692-1779 *OxArt*
Albani, Francesco 1578-1660 *ClaDrA, McGDA, OxArt*
Albani, Matthias 1621-1673 *AntBDN K*
Albano, Francesco 1578-1660 *ClaDrA, OxArt*
Albano, J F *AmArch 70*
Albano, Salvatore *ArtsNiC*
Albarran, Eugenio Jorge 1917- *AmArch 70*
Albassam, Ahmed 1956- *MarqDCG 84*
Albazzi DeKwiatowska, Iza, Comtesse *DcWomA*
Albe, Gerhard *DcSeaP*
Albee, Grace A 1890- *WhAmArt 85*
Albee, Grace Thurston 1890- *DcWomA*
Albee, Grace Thurston Arnold 1890- *GrAmP, WhoAmA 73, –76*
Albee, Percy F 1883-1959 *WhAmArt 85*
Albee, Percy F 1885-1959 *WhoAmA 80N, –82N, –84N*
Albenberg, Jerome Myron 1937- *AmArch 70*
Albeniz, Laura 1890- *DcWomA*
Alber, Chad 1948- *MarqDCG 84*
Alberg, Arthur W 1926- *MarqDCG 84*
Alberga, Alta W *WhoAmA 76, –78, –80, –82, –84*
Alberga, Alta W 1923- *AmArt*
Albers, Anni *WhAmArt 85*
Albers, Anni 1899- *BnEnAmA, ConDes, DcWomA, PrintW 83, –85, WhoAmA 73, –76, –78, –80, –82, –84, WomArt*
Albers, Dorothy Marie 1916- *AmArch 70*
Albers, George Arthur 1935- *AmArch 70*
Albers, Josef 1888- *BnEnAmA, DcCAA 71, McGDA, WhAmArt 85, WhoAmA 73, –76*
Albers, Josef 1888-1976 *ConArt 77, –83, DcAmArt, DcCAA 77, MacEA, OxTwCA, PhDcTCA 77, PrintW 83, –85, WhoAmA 78N, –80N, –82N, –84N, WorArt[port]*
Albers, Margaretha 1881- *DcWomA*
Albers, Thos George 1935- *AmArch 70*
Albert *DcBrA 1, DcBrWA*
Albert Charles Augustus Emmanuel, Prince 1819-1861 *DcBrWA, DcBrBI*
Albert, A J *AmArch 70*
Albert, Annie Stewart *DcWomA*
Albert, B *DcVicP 2, DcWomA*
Albert, Beverly Foit 1938- *AmArch 70*
Albert, Calvin 1918- *DcCAA 71, –77, DcCAr 81, OxTwCA, PhDcTCA 77, WhAmArt 85, WhoAmA 73, –76, –78, –80, –82, –84*
Albert, Drusilla 1909- *WhAmArt 85*
Albert, E Maxwell 1890- *WhAmArt 85*
Albert, Edouard 1910-1968 *ConArch*
Albert, Elisabeth *DcWomA*
Albert, Ernest *DcVicP 2*
Albert, Ernest d1946 *WhAmArt 85*
Albert, Eugen 1856-1929 *MacBEP*
Albert, F *AmArch 70*
Albert, Gilbert *WorFshn*
Albert, Henry *FolkA 86*
Albert, Hermann 1937- *ConArt 77, DcCAr 81*

Albert, Herrmann 1937- *OxTwCA*
Albert, J P, Jr. *AmArch 70*
Albert, Jeffrey H 1946- *MarqDCG 84*
Albert, Josef 1825-1886 *MacBEP*
Albert, LeRoy Kreider 1910- *AmArch 70*
Albert, Mary 1910- *WhAmArt 85*
Albert, Paul 1947- *MacBEP*
Albert, Roy Irving 1924- *AmArch 70*
Albert, Theodore Merton 1927- *MarqDCG 84*
Albert, V *DcBrBI*
Albert, Virginia *WhAmArt 85*
Albert Brothers *EncASM*
Albert-Durade, Julie D' *DcWomA*
Albert-Lasard, Lou 1891?-1969 *DcWomA*
Albert-Lazard, Lou 1891?-1969 *DcWomA*
Albert-Lefeuvre, Louis-Etienne-Marie *ArtsNiC*
Albert-Martin, Antoinette *DcWomA*
Albertal, Josephine *DcWomA*
Albertarelli, Rino 1908-1974 *WorECom*
Albertazzi, Mario 1920- *WhoAmA 73, –76, –78, –80, –82, –84*
Alberthal, Josephine *DcWomA*
Alberti, Alberto 1525?-1599? *MacEA*
Alberti, Alessandro 1551-1596 *McGDA*
Alberti, Antonio *McGDA*
Alberti, Cherubino 1553-1615 *ClaDrA, McGDA*
Alberti, Chiara d1660 *DcWomA*
Alberti, Durante 1538-1613 *McGDA*
Alberti, Elisabetta 1555- *DcWomA*
Alberti, Giovanni 1558-1601 *McGDA*
Alberti, Juliette *DcWomA*
Alberti, Leon Baptista 1404-1472 *OxArt*
Alberti, Leon Battista 1404-1472 *MacEA, McGDA*
Alberti, Leone Battista 1404-1472 *DcD&D, WhoArch*
Alberti, Marie Agatha 1767-1810? *DcWomA*
Alberti, Matteo 1660?-1716 *MacEA*
Albertine *DcWomA*
Albertinelli, Mariotto 1471-1515 *McGDA*
Albertinelli, Mariotto 1474-1515 *ClaDrA, OxArt*
Alberto Da Campione II *McGDA*
Alberto Da Carrara *McGDA*
Alberts, Charles *ArtsEM*
Alberts, J Bernhard 1886- *WhAmArt 85*
Alberts, Sylvia 1928- *FolkA 86*
Alberts, Uga 1913- *AmArch 70*
Albertson, Erick *FolkA 86*
Albig, A E *AmArch 70*
Albiker, Helene 1878- *DcWomA*
Albiker, Karl 1878-1961 *McGDA, PhDcTCA 77*
Albin, Anna Fay Hanson *DcWomA*
Albin, Bertha *DcWomA*
Albin, Edgar A 1908- *WhAmArt 85, WhoAmA 73, –76, –78, –80, –82, –84*
Albin, Eleazar *DcBrWA*
Albin, Eleazer *GrBII[port]*
Albin, Elizabeth *DcWomA*
Albin, Wayne P 1939- *MarqDCG 84*
Albini, Franco 1905- *EncMA, WhoArch*
Albini, Franco 1905-1977 *ConArch, ConDes, MacEA*
Albini, Walter 1941- *WorFshn*
Albini, Walter 1941-1983 *ConDes*
Albinia, Countess Of Buckinghamshire *DcWomA*
Albinson, Dewey 1898- *WhAmArt 85*
Albinson, E Dewey 1898- *ArtsAmW 2*
Albion, Lee Smith *IlsBYP, IlsCB 1957*
Albon, William 1797?-1870 *BiDBrA*
Alboni, Rosa d1759 *DcWomA*
Albouy *FairDF FRA*
Albracht, Willem 1861- *ClaDrA*
Albrecht, Clarence John 1891- *WhAmArt 85*
Albrecht, Frederick E *WhAmArt 85*
Albrecht, Herbert 1927- *DcCAr 81*
Albrecht, John Frederick 1933- *AmArch 70*
Albrecht, Mary Dickson 1930- *WhoAmA 73, –76, –78, –80, –82, –84*
Albrecht, Paul A 1947- *MarqDCG 84*
Albrecht, Richard Zane 1926- *AmArch 70*
Albrecht, Robert A 1925- *WhoAmA 78, –80*
Albrecht, Robert Daniel 1921- *AmArch 70*
Albrecht D 1944- *ConArt 77*
Albright, Adam Emory 1862-1957 *ArtsAmW 3, WhAmArt 85, WhoAmA 80N, –82N, –84N*
Albright, Carol M *ArtsEM, DcWomA*
Albright, Chester *FolkA 86*
Albright, Daniel K *NewYHSD*
Albright, David Joseph 1932- *AmArch 70*
Albright, E *AmArch 70*
Albright, Floyd Thron 1897- *IlBEAAW, WhAmArt 85*
Albright, Gertrude P 1883-1959 *DcWomA*
Albright, Gertrude Partington *WhAmArt 85*
Albright, Gertrude Partington 1883- *ArtsAmW 1*
Albright, H O 1876- *WhAmArt 85*
Albright, Harrison 1866-1933 *BiDAmAr*
Albright, Hedwig Evelyn Gertrude 1911- *WhAmArt 85*
Albright, Henry J d1951 *WhoAmA 78N, –80N, –82N, –84N*
Albright, Henry J 1887-1951 *WhAmArt 85*
Albright, Henry James 1887- *WhAmArt 85*
Albright, Hermann Oliver 1876-1944 *ArtsAmW 1,*

IlBEAAW
Albright, Ivan 1897- *ConArt 83, OxArt*
Albright, Ivan 1897-1983 *WorArt[port]*
Albright, Ivan LeLorraine 1897- *ArtsAmW 3, BnEnAmA, DcAmArt, DcCAA 71, –77, DcCAr 81, McGDA, OxTwCA, PhDcTCA 77, WhAmArt 85, WhoAmA 73, –76, –78, –80, –82*
Albright, Ivan LeLorraine 1897-1983 *GrAmP, WhoAmA 84N*
Albright, John J 1848-1931 *WhAmArt 85*
Albright, Lloyd Lhron 1897- *ArtsAmW 2*
Albright, Malvin Marr 1897- *ArtsAmW 3, McGDA, WhAmArt 85, WhoAmA 73, –76, –78, –80, –82, –84*
Albright, Melvin Marr 1897- *ArtsAmW 3*
Albright, Thomas 1935- *WhoAmA 73, –76, –78, –80, –82, –84*
Albright, William *NewYHSD*
Albrizio, Conrad Alfred 1894- *WhAmArt 85*
Albrizio, Humbert 1901- *McGDA, WhAmArt 85*
Albrizzi, Baron Alexander R DeC 1934- *DcD&D*
Albro, Jeannette 1942- *WhoAmA 76, –78, –80*
Albro, John 1824?- *NewYHSD*
Albro, Lewis Colt 1876-1924 *BiDAmAr*
Albro, Maxine 1903- *WhAmArt 85*
Albro, T L 1806- *FolkA 86*
Albufera, Malvina, Duchesse D' *DcWomA*
Albuquerque, Francisco 1917- *ICPEnP A*
Albuquerque, Lita 1946- *AmArt, WhoAmA 78, –80, –82, –84*
Alburas, E C *AmArch 70*
Albyn, Richard Keith 1927- *AmArch 70*
Alcala, Alfredo P 1925- *WorECom*
Alcalay, Albert 1917- *DcCAA 71, –77*
Alcalay, Albert S 1917- *WhoAmA 73, –76, –78, –80, –82, –84*
Alcamenes *McGDA, OxArt*
Alcayde-Montoya, Julia *DcWomA*
Alciatore, Jerome Henri *AmArch 70*
Alcobier, H D *DcVicP 2*
Alcock, Edward *DcBrECP*
Alcock, Harriet *DcWomA*
Alcock, John *CabMA*
Alcock, Samuel *AntBDN M, DcBrECP, DcNiCA*
Alcock, William A *WhAmArt 85*
Alcopley, L 1910- *WhoAmA 73, –76, –78, –80, –82, –84*
Alcopley, Lewin 1910- *PhDcTCA 77*
Alcorn, Glen E *MarqDCG 84*
Alcorn, Mrs. Gordon Dee *WhAmArt 85*
Alcorn, John 1935- *AmArt, IlsBYP, IlsCB 1957*
Alcorta, Rodolfo 1876- *ClaDrA*
Alcott, Mary *DcVicP 2*
Alcott, May 1840-1879 *ArtsNiC, DcWomA, EarABI, NewYHSD*
Alcuaz, Aguilar 1932- *WhoAmA 76*
Alcuin Of York 735?-804 *McGDA*
Aldag, John Eldon 1950- *MarqDCG 84*
Aldarondo-Dros, Federico 1935- *AmArch 70*
Alday, Paul *DcBrWA*
Aldegrever, Heinrich 1502-1555? *McGDA, OxArt*
Aldegrever, Henry 1502-1566? *ClaDrA*
Alden, Arthur Harris, III 1936- *AmArch 70*
Alden, Frank E 1859-1908 *BiDAmAr*
Alden, G 1804-1862 *FolkA 86*
Alden, Gary Wade 1951- *WhoAmA 78, –80, –82, –84*
Alden, Henri Vere 1897- *WhAmArt 85*
Alden, Henry Bailey d1939 *BiDAmAr*
Alden, James 1810-1877 *ArtsAmW 1, NewYHSD*
Alden, James Madison 1834-1922 *ArtsAmW 1, IlBEAAW, NewYHSD*
Alden, John 1599-1687 *CabMA*
Alden, Katharine L 1893- *WhAmArt 85*
Alden, Lowell Wavel 1911- *WhAmArt 85*
Alden, Noah *FolkA 86*
Alden, Richard *WhoAmA 82, –84*
Alden, Richard 1942- *AmArt*
Alden, William C *NewYHSD*
Alden, William Lewis 1926- *MarqDCG 84*
Alder, Jamie 1951- *ConGrA 1*
Alder, Mary Ann d1952 *WhoAmA 78N, –80N, –82N, –84N*
Alder, W Brooke *DcBrBI*
Alderdice, Robert James 1929- *AmArch 70*
Alderman, Bissell 1912- *AmArch 70*
Alderman, Grace Eugenia Barr 1877- *DcWomA*
Alderman, Grace Eugenie Barr 1877- *ArtsAmW 3*
Alderman, J B *AmArch 70*
Alderman, W B *AmArch 70*
Aldershof, Kent Leroy 1936- *MarqDCG 84*
Alderson, E M *DcWomA*
Alderson, Moses Atha 1801-1869 *BiDBrA*
Alderson, N Virginia *DcWomA*
Alderson, R *AmArch 70*
Alderson, William d1835? *BiDBrA*
Alderton, Dorothy Eileen *DcWomA*
Alderton, H H *WhAmArt 85*
Alderton, William *NewYHSD*
Aldham, Harriet Kate *DcVicP 2*
Aldham, Kate *DcWomA*

Aldhouse, Francis *BiDBrA*
Aldich, Mrs. Richard *FolkA 86*
Aldin, Alfred *DcVicP 2*
Aldin, Cecil Charles Windsor 1870- *ClaDrA*
Aldin, Cecil Charles Windsor 1870-1935 *AntBDN B, ConICB, DcBrA 1, DcBrBI, DcBrWA*
Aldis, Arthur T d1933 *WhAmArt 85*
Aldis, C M *DcVicP 2*
Aldredge, Theoni Vachliotis 1932- *ConDes*
Aldrich, Adolf Degiani 1916- *WhAmArt 85*
Aldrich, Annie *DcWomA*
Aldrich, Annie E *WhAmArt 85*
Aldrich, Carol *MarqDCG 84*
Aldrich, Chester H 1871-1940 *McGDA*
Aldrich, Chester Holmes 1871-1940 *BiDAmAr, MacEA, WhoArch*
Aldrich, Clarence Nelson 1893-1954? *ArtsAmW 2*
Aldrich, Clarence Nelson 1893-1955? *WhAmArt 85*
Aldrich, Cornelia Ward *WhAmArt 85*
Aldrich, David 1907- *AmArch 70*
Aldrich, Emily *DcWomA*
Aldrich, F H 1866- *WhAmArt 85*
Aldrich, G James 1872-1941 *WhAmArt 85*
Aldrich, Harvey *WhAmArt 85*
Aldrich, Helen *DcWomA*
Aldrich, Henry 1648-1710 *BiDBrA, MacEA, OxArt*
Aldrich, John G *WhAmArt 85*
Aldrich, Larry *WhoAmA 73, –76, –78, –80, –82, –84*
Aldrich, M Azzi 1892- *WhAmArt 85*
Aldrich, Mary Austin *DcWomA*
Aldrich, Mary Austin 1884- *WhAmArt 85*
Aldrich, Mason Hosford 1919- *AmArch 70*
Aldrich, Nelson Wilmarth 1911- *AmArch 70*
Aldrich, Talbot Bailey *WhAmArt 85*
Aldrich, Will S 1862-1947 *BiDAmAr*
Aldrich, William T *WhAmArt 85*
Aldridge *FolkA 86*
Aldridge, Alan *DcCAr 81*
Aldridge, Alan 1943- *ConDes*
Aldridge, C Clay 1910- *WhAmArt 85*
Aldridge, Charles *AntBDN Q*
Aldridge, Edward Westfield 1739-1778? *DcBrECP*
Aldridge, Eileen *WhoArt 80*
Aldridge, Eileen 1916- *DcBrA 1*
Aldridge, Emily *DcVicP 2*
Aldridge, Frederick James *ClaDrA, DcVicP*
Aldridge, Frederick James 1849?-1933 *DcBrA 1*
Aldridge, Frederick James 1850-1933 *DcBrWA, DcSeaP, DcVicP 2*
Aldridge, John *BiDAmAr*
Aldridge, John 1905- *DcCAr 81*
Aldridge, John Arthur Malcolm *WhoArt 84N*
Aldridge, John Arthur Malcolm 1905- *ClaDrA, DcBrA 1, WhoArt 80, –82*
Aldridge, Sydney *DcBrBI*
Aldrin, Anders Gustave 1889- *WhAmArt 85*
Aldrin, Anders Gustave 1889-1970 *ArtsAmW 2*
Aldrin, Andrew Gustave 1889-1970 *ArtsAmW 2*
Aldus *OxDecA*
Aldwinckle, Eric 1909- *WhoAmA 73, –76, –78*
Aldwinckle, Eric 1909-1980 *WhoAmA 80N, –82N, –84N*
Aldworth, Mr. *NewYHSD*
Alechinsky, Pierre 1927- *ConArt 77, –83, DcCAr 81, McGDA, OxTwCA, PhDcTCA 77, PrintW 83, –85, WorArt[port]*
Alefounder, John d1795 *DcBrWA*
Alefounder, John 1732-1787 *BiDBrA*
Alefounder, John 1757-1794 *DcBrECP*
Alegre, A Villamor 1909- *WhAmArt 85*
Alegre, Albert William 1906- *AmArch 70*
Aleijadinho *OxArt*
Aleijadinho 1730?-1814 *McGDA*
Aleijadinho 1738-1814 *MacEA*
Aleijadinho, Antonio Francisco Lisboa 1738-1814 *DcD&D*
Aleijadinho, O 1738-1814 *WhoArch*
Alekseeva, Olga 1895- *DcWomA*
Alemagna, Giovanni D' *McGDA*
Alemayne, John *IlDcG*
Aleni, Tomaso *McGDA*
Alenza Y Nieto, Leonardo 1807-1845 *ClaDrA, McGDA*
Aleotti, Giovanni Battista 1546-1636 *MacEA, McGDA*
Alessandri, Franco 1936- *MarqDCG 84*
Alessandrini, Jean Antoine 1942- *WhoGrA 82[port]*
Alessandro, Andrea D' *McGDA*
Alessi, Galeazzo 1512-1572 *MacEA, McGDA, WhoArch*
Alessio, Antoinette *DcWomA*
Aleviz *OxArt*
Alevizo Friasin *OxArt*
Alewyn, Abraham 1673-1735 *ClaDrA*
Alex, Iris S 1926- *AmArch 70*
Alex, Kosta 1925- *PhDcTCA 77*
Alexander *DcWomA, NewYHSD*
Alexander, Miss *ArtsNiC, DcVicP 2*
Alexander Of Lincoln *McGDA*
Alexander, A H 1892- *WhAmArt 85*
Alexander, Albert 1943- *DcCAr 81*

Alexander, Albert Edward 1907- *AmArch 70*
Alexander, Sir Anthony d1637 *BiDBrA*
Alexander, Antonio *DcBrECP*
Alexander, Arthur L *ArtsEM*
Alexander, Billie *AfroAA*
Alexander, C *DcVicP 2*
Alexander, Cecil Abraham 1918- *AmArch 70*
Alexander, Charles *DcVicP 2*
Alexander, Charles A *BiDAmAr*
Alexander, Charles S d1897 *BiDAmAr*
Alexander, Christine 1893- *WhAmArt 85*
Alexander, Christine 1893-1975 *WhoAmA 76N, -78N, -80N, -82N, -84N*
Alexander, Christopher 1936- *ConArch*
Alexander, Clifford Grear 1870- *WhAmArt 85*
Alexander, Cosmo 1724?-1772 *DcAmArt, DcBrECP, NewYHSD*
Alexander, Cosmos 1724?-1772 *BnEnAmA*
Alexander, Daniel Asher 1768-1846 *BiDBrA, MacEA*
Alexander, Dora Block 1888- *ArtsAmW 2, WhAmArt 85*
Alexander, E M 1881- *DcBrA 1*
Alexander, Earle Straughan, Jr. 1931- *AmArch 70*
Alexander, Edmund Brooke 1937- *WhoAmA 80, -82, -84*
Alexander, Edwin 1870-1926 *ClaDrA, DcBrA 1, DcVicP, -2*
Alexander, Edwin John 1870-1926 *DcBrWA*
Alexander, Elizabeth A d1947 *WhAmArt 85*
Alexander, Elsie W M 1912- *WhoArt 80, -82, -84*
Alexander, Ernest *AfroAA*
Alexander, Eugene 1921- *AmArch 70*
Alexander, Eugenie 1919- *WhoArt 80, -82, -84*
Alexander, Lady Eveline Marie *DcWomA*
Alexander, F *DcWomA*
Alexander, F M *FolkA 86*
Alexander, Frances B 1911- *WhAmArt 85*
Alexander, Francesca 1837-1917 *DcWomA, NewYHSD*
Alexander, Francis 1800-1880 *ArtsNiC, BnEnAmA, DcAmArt, FolkA 86, NewYHSD*
Alexander, Frank *FolkA 86*
Alexander, Frank Eugene 1932- *AmArch 70*
Alexander, Franklin Osborne 1897- *WorECar*
Alexander, George *BiDBrA, DcVicP 2*
Alexander, George 1832-1913 *DcBrA 1*
Alexander, George Edward 1865-1931 *DcBrA 1*
Alexander, Giles 1751-1816 *CabMA*
Alexander, Hartley William 1941- *AmArch 70*
Alexander, Helen Douglas *WhAmArt 85*
Alexander, Henry 1860-1895 *ArtsAmW 1*
Alexander, Henry Crowell, Jr. *AmArch 70*
Alexander, Henry V 1866-1940 *ArtsEM*
Alexander, Herbert 1874-1946 *DcBrA 1, DcBrWA*
Alexander, Ida *AfroAA*
Alexander, J *DcVicP 2, DcWomA*
Alexander, J B *NewYHSD*
Alexander, J J *OfPGCP 86*
Alexander, Jacques 1863- *WhAmArt 85*
Alexander, James *CabMA*
Alexander, James 1770-1870 *FolkA 86*
Alexander, James Edward *DcBrBI*
Alexander, James Stuart Carnegie 1900- *DcBrA 1*
Alexander, Johanna S *DcWomA, WhAmArt 85*
Alexander, John *CabMA, DcBrWA, DcVicP 2, FolkA 86*
Alexander, John 1690?-1768? *DcBrECP[port]*
Alexander, John E 1945- *AmArt, WhoAmA 76, -78, -80, -82, -84*
Alexander, John White 1856-1915 *BnEnAmA, DcAmArt, McGDA, WhAmArt 85*
Alexander, Jon H 1905- *WhAmArt 85*
Alexander, Judith 1932- *WhoAmA 80, -82, -84*
Alexander, Judy 1947- *WhoAmA 80, -82, -84*
Alexander, Julia Standish *WhAmArt 85*
Alexander, Julia Standish 1882-1942 *DcWomA*
Alexander, Kay Edward 1933- *AmArch 70*
Alexander, Kenneth Arthur 1938- *AmArch 70*
Alexander, Kenneth Lewis 1924- *WhoAmA 76, -78, -80, -82, -84*
Alexander, L A, Jr. *AmArch 70*
Alexander, L B *AmArch 70*
Alexander, L H *AfroAA*
Alexander, L T *AmArch 70*
Alexander, Leah Ramsey *WhAmArt 85*
Alexander, Lena *DcWomA*
Alexander, Margaret Ames 1916- *WhoAmA 78, -80, -82, -84*
Alexander, Margo *WhAmArt 85*
Alexander, Marie Day 1887- *DcWomA, WhAmArt 85*
Alexander, Marion *DcVicP 2, DcWomA*
Alexander, Martha *DcWomA, IlsCB 1967*
Alexander, Martha Kathleen 1910- *IlsBYP*
Alexander, Mary A *ArtsEM, DcWomA*
Alexander, Mary Louise *DcWomA, WhAmArt 85*
Alexander, Michael 1807?- *NewYHSD*
Alexander, Naomi 1938- *WhoArt 84*
Alexander, Nelly Griggs *DcWomA*
Alexander, Peter *NewYHSD*
Alexander, Peter 1939- *AmArt, ConArt 77,*

DcCAr 81, PrintW 83, -85, WhoAmA 78, -80, -82, -84
Alexander, Robert 1801-1880 *FolkA 86*
Alexander, Robert E 1907- *ConArch*
Alexander, Robert Evans 1907- *AmArch 70*
Alexander, Robert G D d1945 *DcBrA 2*
Alexander, Robert Graham Dryden 1875-1945 *DcBrWA*
Alexander, Robert L 1840-1923 *DcBrA 1, DcVicP 2*
Alexander, Robert Seymour 1923- *WhoAmA 73, -76, -78, -80, -82, -84*
Alexander, Sara Dora Block 1888- *DcWomA*
Alexander, Stanley *FolkA 86*
Alexander, Terry Pink 1948- *WhoAmA 76*
Alexander, Thomas M 1813?- *FolkA 86*
Alexander, William *AntBDN D, CabMA, DcVicP 2*
Alexander, William 1766-1816 *DcBrBI*
Alexander, William 1767?-1815 *BkIE*
Alexander, William 1767-1816 *DcBrWA*
Alexander, William C 1935- *WhoAmA 78, -80*
Alexander, William H S 1883-1938 *WhAmArt 85*
Alexander, Woodrow W 1916- *AmArch 70*
Alexander-Greene, Grace George 1918- *WhoAmA 82, -84*
Alexander-Katz, Bianca *DcWomA*
Alexander-Sinclair, John 1906- *WhoArt 80, -82, -84*
Alexandersen, Genevieve Constance *WhAmArt 85*
Alexandre *WorFshn*
Alexandre, Mademoiselle *DcWomA*
Alexandre, Eva *DcWomA*
Alexandre, Louis Joseph 1867- *DcBrA 1*
Alexandre, Zeno 1873- *WhAmArt 85*
Alexandri, Sara 1913- *DcBrA 1, WhoArt 80, -82, -84*
Alexandridis, George G 1934- *MarqDCG 84*
Alexandrine Caroline *DcWomA*
Alexandropoulos, George James 1957- *MarqDCG 84*
Alexandrowicz-Homolacs, Nina *DcWomA*
Alexeieff, Alexander A 1901- *WhAmArt 85*
Alexeieff, Alexandre 1901- *WhoGrA 62, -82[port], WorECar*
Alexenberg, Melvin 1937- *WhoAmA 78, -80, -82*
Alexenberg, Melvin Leonard 1937- *WhoAmA 76*
Alexenberg, Menahem 1937- *WhoAmA 84*
Alexick, David Francis 1942- *WhoAmA 82, -84*
Alexis, Saint *McGDA*
Alexman, David 1933- *AmArch 70*
Aley, William *ArtsEM*
Alf, Martha Joanne 1930- *WhoAmA 76, -78, -80, -82, -84*
Alfani, Domenico DiParide 1479?-1553 *McGDA*
Alfani, Domenico DiParis 1483-1555? *ClaDrA*
Alfano, Carlo 1932- *ConArt 77*
Alfano, Frank Anthony 1927- *AmArch 70*
Alfano, M *AmArch 70*
Alfano, Vincenzo 1854- *WhAmArt 85*
Alfaro, Mitchell *AmArch 70*
Alferez, Enrique *WhAmArt 85*
Alfieri, Benedetto 1699-1767 *MacEA*
Alfonso, Carlos E 1924- *AmArch 70*
Alfonso, Cesar Placido 1926- *AmArch 70*
Alford *FolkA 86*
Alford, Agnes *DcVicP 2, DcWomA*
Alford, Arba, Jr. *CabMA*
Alford, Clarence Barton 1914- *AmArch 70*
Alford, Gloria K 1928- *WhoAmA 80, -82, -84*
Alford, Gloria K 1938- *WhoAmA 76, -78*
Alford, James Donald 1935- *AmArch 70*
Alford, John 1890- *WhAmArt 85*
Alford, John 1929-1960 *DcBrA 1*
Alford, Leonard C *DcVicP 2*
Alford, Marian Margaret, Viscountess 1817-1888 *DcWomA*
Alford, Marianne Margaret, Viscountess 1817-1888 *DcBrWA*
Alford, Robert S 1944- *MarqDCG 84*
Alford, S A *AmArch 70*
Alford, W *DcBrBI*
Alfray, Robert *BiDBrA*
Alfred, Cynthia *FolkA 86*
Alfred, Henry Jervis *DcVicP 2*
Alfred, Louisa 1808-1897 *FolkA 86*
Alfred, Nabby 1845- *FolkA 86*
Alfsen, John Martin d1972 *WhoAmA 78N, -80N, -82N, -84N*
Alfson, Robert Harold 1949- *MarqDCG 84*
Algardi, Alessandro 1595-1654 *McGDA, OxArt*
Algarotti, Francesco 1712-1764 *MacEA, OxArt*
Alger, John 1879- *WhAmArt 85*
Alger, Vivian C *DcVicP 2*
Alghisi, Galasso d1573 *MacEA*
Algie, Jessie *DcBrA 1, DcWomA*
Algoren, Lionel C 1896- *WhAmArt 85*
Alheim, Alexandrina *DcWomA*
Alhilali, Neda 1938- *WhoAmA 78, -80, -82, -84*
Alho, Asmo 1903-1975 *WorECar*
Ali, AlHaj Sheikh Nur 1928- *WhoArt 80*
Ali, Ben *NewYHSD*
Ali, Nawab 1932- *MarqDCG 84*
Alicandri, E *AmArch 70*

Alice Maud Mary, Princess 1843-1878 *DcBrWA*
Alice Maud Mary Of Hesse-Darmstadt 1843-1878 *DcWomA*
Alicea, Jose 1928- *WhoAmA 73, -76, -78, -80, -82, -84*
Aliense 1556-1629 *McGDA*
Aligny, Claude Felix T Caruelle D' 1798-1871 *ArtsNiC*
Aligny, Claude-Felix Theodore 1798-1871 *ClaDrA*
Aliki *IlsCB 1967, WhoAmA 78, -80, -82, -84*
Aliki 1929- *IlsCB 1957*
Alinari, Giuseppe 1836-1890 *ICPEnP*
Alinari, Leopoldo 1832-1865 *ICPEnP, MacBEP*
Alinari, Romualdo 1830-1891 *ICPEnP*
Alinder, James 1941- *ConPhot*
Alinder, James Gilbert 1941- *WhoAmA 78, -80, -82, -84*
Alinder, Jim *DcCAr 81*
Alinder, Jim 1941- *ICPEnP A, MacBEP*
Alington, W H *ConArch A*
Alington, W H 1929- *ConArch*
Aliogi, Andrea Di *McGDA*
Alioshin, G D *AmArch 70*
Aliot-Barban, Marie Juliette *DcWomA*
Alippi-Fabretti, Quirina 1849-1919 *DcWomA*
Alison, Archibald 1757-1839 *OxArt*
Alison, David 1882-1955 *DcBrA 1*
Alison, Henry Y *DcBrA 1*
Alison, M *DcVicP 2, DcWomA*
Alix *ConDes*
Alix DeMere *DcWomA*
Alix, Jeanne 1884- *DcWomA*
Alix, Laure Justine Josephine *DcWomA*
Alix, Yves 1890- *ClaDrA, OxTwCA*
Aljaman 1926- *WhoAmA 73, -76*
Alke, Elizabeth 1877-1938 *DcWomA*
Alke, Elizabeth Heil 1877-1938 *WhAmArt 85*
Alke, Stephen 1874-1941 *WhAmArt 85*
Alken, Henry 1784-1851 *AntBDN B, ClaDrA, McGDA*
Alken, Henry 1785-1851 *DcVicP, -2, OxArt*
Alken, Henry Gordon 1810-1892 *OxArt*
Alken, Henry Thomas 1785-1851 *DcBrBI, DcBrWA*
Alken, Samuel 1750?-1825? *AntBDN B*
Alken, Samuel 1756-1815 *DcBrWA*
Alken, Samuel 1784-1825 *DcBrWA*
Alken, Samuel, Jr. 1784-1825 *OxArt*
Alken, Samuel, Sr. 1750-1815 *OxArt*
Alken, Samuel Henry Gordon 1810-1894 *DcBrWA*
Alken, Seffrien 1821-1873 *DcBrWA*
Alken Family *OxArt*
Alkins, Anne Drayton *DcWomA, WhAmArt 85*
Alkins, Florence Elizabeth *WhAmArt 85*
Alkisthene *DcWomA*
Allabach, Philip *FolkA 86*
Alladin, M P 1919- *OxTwCA*
Alladio, Gian Giacomo D' *McGDA*
Allain, Leon Gregory 1924- *AmArch 70*
Allain, Pauline *DcWomA*
Allaire, Louise *DcWomA, WhAmArt 85*
Allaire, Robert George *MarqDCG 84*
Allais, Angelique *DcWomA*
Allais, Catherine Elisabeth *DcWomA*
Allais, Jenny Augustine *DcWomA*
Allam, M Mosaad 1940- *MarqDCG 84*
Allam And Caithness *AntBDN D*
Allamand, Jean Charlotte *DcWomA*
Allan, A F *DcWomA*
Allan, Mrs. A F *DcVicP 2*
Allan, Alexander 1914-1972 *DcBrA 2*
Allan, Sir Alexander 1764-1820 *DcBrWA*
Allan, Amy Nicholson *WhAmArt 85*
Allan, Andrew 1863- *DcBrA 1*
Allan, Archibald Russell Watson 1878-1959 *DcBrA 1*
Allan, C *DcVicP 2*
Allan, Mrs. Charles Beach 1874- *ArtsAmW 3, DcWomA, WhAmArt 85*
Allan, Christina *DcVicP 2, DcWomA*
Allan, David 1744-1796 *BkIE, DcBrECP[port], DcBrWA, OxArt*
Allan, E *DcWomA*
Allan, Eliza *DcVicP 2*
Allan, Eva Dorothy *DcBrA 1*
Allan, Eva Dorothy 1892- *DcWomA*
Allan, George Hasson 1930- *AmArch 70*
Allan, George R, Jr. 1925- *AmArch 70*
Allan, Henry 1865-1912 *DcBrA 2*
Allan, J *AmArch 70*
Allan, J McGregor *DcVicP 2, NewYHSD*
Allan, James *WhAmArt 85*
Allan, Jessy *DcWomA*
Allan, John James, III 1937- *MarqDCG 84*
Allan, Julian Phelps *DcWomA*
Allan, Julian Phelps 1892- *DcBrA 1*
Allan, Marie *DcWomA*
Allan, Mary R P 1917- *DcBrA 1*
Allan, Michele Biographiest 1944- *MacBEP*
Allan, Patrick *DcVicP 2*
Allan, R S *AmArch 70*
Allan, Robert Weir 1851-1942 *DcBrA 1, DcBrWA*
Allan, Robert Weir 1852-1942 *DcVicP 2*
Allan, Ronald 1900- *DcBrA 1*

Anderson, Fred Charles 1900- AmArch 70
Anderson, Freddie 1932- AfroAA
Anderson, Frederic A WhAmArt 85
Anderson, G Adolph 1877- WhAmArt 85
Anderson, G G DcBrA 2
Anderson, G W DcVicP 2
Anderson, Genevieve Dillaye 1900- WhAmArt 85
Anderson, George ArtsAmW 1
Anderson, George L DcVicP 2
Anderson, George M WhAmArt 85
Anderson, George M 1869-1916 BiDAmAr
Anderson, Gerald A 1895- AmArch 70
Anderson, Gerald I 1937- AmArch 70
Anderson, Gordon WhoAmA 76, -78, -80
Anderson, Gordon Franklin 1919- AmArch 70
Anderson, Gregory John MarqDCG 84
Anderson, Gunda J Evensen ArtsAmW 1
Anderson, Gunnar IlsBYP
Anderson, Gunnar Donald 1927- WhoAmA 73, -76, -78, -80, -82, -84
Anderson, Guy Irving 1906- DcCAA 71, -77, WhoAmA 73, -76, -78, -80, -82, -84
Anderson, Guy Orval 1928- AmArch 70
Anderson, Gwen 1915- WhAmArt 85
Anderson, Gwendolyn Orsinger WhoAmA 73, -76, -82, -84
Anderson, Gwendolyn Orsinger 1912- WhoAmA 78, -80
Anderson, H E 1899- WhAmArt 85
Anderson, H J AmArch 70
Anderson, Harold N 1894- IlrAm D, WhAmArt 85
Anderson, Harold N 1894-1973 IlrAm 1880
Anderson, Harriet DcWomA
Anderson, Harry 1906- IlrAm E, -1880
Anderson, Harry Frederick, Jr. 1927- AmArch 70
Anderson, Heath 1903- WhAmArt 85
Anderson, Helen DcWomA, WhAmArt 85
Anderson, Helge WhAmArt 85
Anderson, Hendrik Christian 1872-1940 WhAmArt 85
Anderson, Herbert Edwin 1927- MarqDCG 84
Anderson, Herbert R WhAmArt 85
Anderson, Hilda DcWomA
Anderson, Hildure E 1894- WhAmArt 85
Anderson, Horace G AfroAA
Anderson, Howard Benjamin 1903- WhAmArt 85, WhoAmA 73, -76, -78, -80, -82, -84
Anderson, Howard Leslie AmArch 70
Anderson, Hugh NewYHSD
Anderson, Hugh Pease 1936- AmArch 70
Anderson, Isabel DcWomA
Anderson, Ivan OfPGCP 86
Anderson, Ivan 1915- PrintW 83, -85
Anderson, Ivan Delos 1915- WhoAmA 76, -78, -80, -82, -84
Anderson, J NewYHSD
Anderson, J B NewYHSD
Anderson, J D AmArch 70
Anderson, J E AmArch 70
Anderson, J H AmArch 70, DcVicP 2
Anderson, J Timothy 1932- AmArch 70
Anderson, J W DcVicP 2
Anderson, Jacob S FolkA 86
Anderson, Jacob S d1857 NewYHSD
Anderson, James BiDAmAr, CabMA, FolkA 86
Anderson, James d1856? BiDBrA
Anderson, James A ArtsEM
Anderson, James A 1944- MarqDCG 84
Anderson, James Bell 1886-1938 DcBrA 1
Anderson, James M NewYHSD
Anderson, James P 1929- WhoAmA 76, -78, -80, -82, -84
Anderson, Jane FolkA 86
Anderson, Jay 1919- WorFshn
Anderson, Jay 1939- AmArch 70
Anderson, Jay Martin 1939- MarqDCG 84
Anderson, Jeremy 1921- OxTwCA
Anderson, Jeremy R 1921- DcCAA 71, -77
Anderson, Jeremy Radcliffe 1921- WhoAmA 73, -76, -78, -80, -82
Anderson, Jeremy Radcliffe 1921-1982 WhoAmA 84N
Anderson, Jerry 1938- PrintW 83, -85
Anderson, Jessica B 1890- DcWomA, WhAmArt 85
Anderson, Joel Randolph 1905- WhAmArt 85
Anderson, Johannes 1882- ArtsAmW 3
Anderson, John BiDBrA, CabMA, DcVicP, -2
Anderson, John 1835-1919 DcBrWA
Anderson, John Alexander, Jr. 1931- AmArch 70
Anderson, John Christ 1919- AmArch 70
Anderson, John Colin 1926- WhoArt 80, -82, -84
Anderson, John David 1926- AmArch 70
Anderson, John Eric 1921- AmArch 70
Anderson, John F DcVicP 2
Anderson, John K 1904- WhAmArt 85
Anderson, John M 1916- AmArch 70
Anderson, John MacVicar 1835-1915 DcVicP 2
Anderson, John O 1936- MarqDCG 84
Anderson, John S 1928- DcCAA 71, -77, WhoAmA 73, -76, -78, -80, -82, -84
Anderson, John Silvy DcVicP 2
Anderson, John Vincent 1913- AmArch 70
Anderson, John W 1834-1904 FolkA 86

Anderson, John W Carver NewYHSD
Anderson, John William 1938- AmArch 70
Anderson, Joyce M MarqDCG 84
Anderson, Julia 1871-1944 DcWomA, WhAmArt 85
Anderson, Karl 1874-1956 WhAmArt 85
Anderson, Karl C 1903- AmArch 70
Anderson, Kathleen 1878- DcWomA
Anderson, Kay 1902- DcBrA 1
Anderson, Kenneth Charles 1923- AmArch 70
Anderson, Kenneth Edmund 1950- WhoAmA 84
Anderson, Kenneth Eugene 1921- AmArch 70
Anderson, Kjell Ivan 1935- WhoGrA 82[port]
Anderson, Kurt McCallum 1937- AmArch 70
Anderson, L D AmArch 70
Anderson, L L AmArch 70
Anderson, Larry Arthur 1936- AmArch 70
Anderson, Laurie 1947- AmArt, ConArt 83[port], DcCAr 81, PrintW 85
Anderson, LaVerne A 1917- AmArch 70
Anderson, Lawrence B 1906- AmArch 70
Anderson, Leland Lowell 1923- AmArch 70
Anderson, Lennart 1928- DcCAA 71, -77, DcCAr 81, WhoAmA 73, -76, -78, -80, -82, -84
Anderson, Leonard W 1926- AmArch 70
Anderson, Leslie 1953- PrintW 85
Anderson, Leslie E 1903- WhAmArt 85
Anderson, Lewis WhAmArt 85
Anderson, Lloyd FolkA 86
Anderson, Louis Byron 1924- AmArch 70
Anderson, Louis D EncASM
Anderson, Louise Catherine Vallet d1944 ArtsAmW 2, DcWomA
Anderson, Loulie 1887- WhAmArt 85
Anderson, Lucy M 1881- DcWomA
Anderson, Lyman 1907- WhAmArt 85, WorECom
Anderson, Lyman Matthew 1907- IlrAm E, -1880
Anderson, Mrs. M C WhAmArt 85
Anderson, M L AmArch 70
Anderson, Margaret Denise 1926- WhoArt 84
Anderson, Margaret Pomeroy 1943- WhoAmA 84
Anderson, Maria 1805?- FolkA 86
Anderson, Martha Fannin Fort 1885- DcWomA
Anderson, Martha Fort 1885- WhAmArt 85
Anderson, Martin DcBrBI
Anderson, Martin 1854-1918? WorECar
Anderson, Martin Cynicus 1854-1932 DcBrA 2
Anderson, Martinus 1878- WhAmArt 85
Anderson, Mildred DcWomA
Anderson, Millicent DcWomA
Anderson, Milo Elvyn 1905- WhAmArt 85
Anderson, Murphy 1926- WorECom
Anderson, Natalia DcWomA
Anderson, Neil Donald 1940- AmArch 70
Anderson, Nels 1957- MarqDCG 84
Anderson, Norman J WhAmArt 85
Anderson, Norman Leigh 1949- MarqDCG 84
Anderson, Ollie Belle 1914- WhAmArt 85
Anderson, Oscar 1873- WhAmArt 85
Anderson, Othello PrintW 85
Anderson, P NewYHSD
Anderson, Mrs. Paul DcWomA
Anderson, Paul Lewis 1880-1956 MacBEP
Anderson, Peirce 1870-1924 BiDAmAr, MacEA
Anderson, Percy d1928 DcBrA 2
Anderson, Percy E WhAmArt 85
Anderson, Peter FolkA 86, NewYHSD
Anderson, Peter 1901- WhAmArt 85
Anderson, Peter Bernard 1898- WhAmArt 85
Anderson, Philip Burton 1936- AmArch 70
Anderson, R A, Jr. AmArch 70
Anderson, R D AmArch 70
Anderson, R Martin 1936- AmArch 70
Anderson, R N, Jr. AmArch 70
Anderson, R Rowand 1834-1921 MacEA
Anderson, Ray 1884- WhAmArt 85
Anderson, Richard MarqDCG 84
Anderson, Richard Lee 1928- AmArch 70
Anderson, Richard Leigh 1938- AmArch 70
Anderson, Robert 1842-1885 DcBrWA, DcVicP 2
Anderson, Robert 1905- PrintW 83, -85
Anderson, Robert Bradley 1957- MarqDCG 84
Anderson, Robert Carlton 1926- AmArch 70
Anderson, Robert D 1949- DcCAr 81
Anderson, Robert Graham AmArch 70
Anderson, Robert James 1939- AmArch 70
Anderson, Robert McCutcheon, Jr. 1936- AmArch 70
Anderson, Robert Raymond 1945- AmArt, WhoAmA 78, -80, -82, -84
Anderson, Robert Waldo 1932- AmArch 70
Anderson, Ronald 1886-1926 WhAmArt 85
Anderson, Ronald Trent 1938- WhoAmA 73
Anderson, Ross Cornelius 1951- WhoAmA 80, -82, -84
Anderson, Roy Edward 1922- AmArch 70
Anderson, Ruth A DcWomA, WhAmArt 85
Anderson, Ruth Bernice 1914- WhAmArt 85
Anderson, Ruthadell AmArt
Anderson, S DcVicP 2, DcWomA
Anderson, S McC DcWomA
Anderson, Mrs. S McC WhAmArt 85
Anderson, Sally 1942- PrintW 85

Anderson, Sally J 1942- WhoAmA 84
Anderson, Samuel CabMA
Anderson, Samuel Armistead, III 1933- AmArch 70
Anderson, Sarah Runyan FolkA 86
Anderson, Sophie NewYHSD
Anderson, Sophie 1823- WomArt
Anderson, Sophie 1823-1898? DcVicP, DcWomA
Anderson, Sophie 1823-1903 DcVicP 2
Anderson, Stanley 1884- ClaDrA
Anderson, T AntBDN D
Anderson, T W DcVicP 2
Anderson, Tennessee Mitchell d1929 DcWomA, WhAmArt 85
Anderson, Timothy Ray 1954- MarqDCG 84
Anderson, Tobey 1946- DcCAr 81
Anderson, Troy 1948- WhoAmA 82, -84
Anderson, V Helen ArtsAmW 3
Anderson, Vera DcWomA
Anderson, Vera Stevens WhAmArt 85
Anderson, Vernon R 1931- MarqDCG 84
Anderson, Victor C 1882-1937 IlrAm 1880
Anderson, Victor Coleman 1882-1937 WhAmArt 85
Anderson, Villette DcWomA
Anderson, Viola Helen ArtsAmW 3, WhAmArt 85
Anderson, W A AmArch 70
Anderson, W B AmArch 70
Anderson, W H CabMA
Anderson, Walter DcVicP 2, NewYHSD
Anderson, Walter Inglis 1903- WhAmArt 85
Anderson, Walter Milton 1942- MarqDCG 84
Anderson, Walter W NewYHSD
Anderson, Warren Harold 1925- WhoAmA 82, -84
Anderson, Wayne 1946- IlsCB 1967
Anderson, Will DcVicP 2
Anderson, William BiDBrA, ClaDrA, DcVicP 2
Anderson, William 1757-1837 DcBrECP, DcBrWA, DcSeaP
Anderson, William 1818?- NewYHSD
Anderson, William 1834?- NewYHSD
Anderson, William 1934- WhoAmA 78, -80
Anderson, Mrs. William DcWomA
Anderson, William A FolkA 86
Anderson, William J, Jr. 1940- AmArch 70
Anderson, William Montgomery 1905- AmArch 70
Anderson, William Thomas 1926- AmArt
Anderson, William Thomas 1936- WhoAmA 76, -78, -80, -82, -84
Anderson, Winfield Scott NewYHSD
Anderson, Winslow 1917- WhoAmA 76, -78, -80, -82, -84
Anderson, Zane Jacob 1933- AmArch 70
Anderson, Zanna 1917-1955 WhAmArt 85
Anderson And DeVan ArtsEM
Andersson, Oskar Emil 1877-1906 WorECar, WorECom
Andersson, Torsten 1926- OxTwCA, PhDcTCA 77
Anderton, Eileen 1924- WhoArt 80, -82, -84
Anderton, Francis Swithin 1868-1909 DcBrA 1
Anderton, G 1825?-1890? NewYHSD
Anderton, P F AmArch 70
Anderton, Thomas BiDBrA
Anderton, Tom 1894-1956 DcBrA 1
Andlau, M D' DcWomA
Andocides Painter McGDA
Andonian, David Aaron 1924- AmArch 70
Andonyadis, Avyeris H 1928- AmArch 70
Andover, Viscountess DcWomA
Andrade, Athene 1908- DcBrA 1
Andrade, C Preston, Jr. 1912- AmArch 70
Andrade, Edna Wright 1917- WhoAmA 73, -76, -78, -80, -82, -84
Andrade, Ellen DcVicP 2, DcWomA
Andrade, J DcVicP 2, DcWomA
Andrade, Kate L DcVicP 2, DcWomA
Andrade, Mary Fratz DcWomA, WhAmArt 85
Andrae, Elisabeth 1876- DcWomA
Andras, Catherine 1775?-1860 DcWomA
Andre, Madame DcWomA
Andre, Adele Gabrielle DcWomA
Andre, Albert 1869-1954 ClaDrA
Andre, Alexandrine DcWomA
Andre, Anette ArtsEM
Andre, Annette DcWomA
Andre, Carl 1935- AmArt, BnEnAmA, ConArt 77, -83, DcAmArt, DcCAA 71, -77, DcCAr 81, OxTwCA, WhoAmA 73, -76, -78, -80, -82, -84, WorArt
Andre, Dietrich Ernst 1680?-1734? DcBrECP
Andre, Emile 1861-1933 AntBDN A
Andre, Emile 1871- MacEA
Andre, Francoise 1926- WhoAmA 73
Andre, James Paul, Jr. DcVicP, -2
Andre, John OxDecA
Andre, John 1751-1780 AntBDN O, NewYHSD
Andre, Jules 1804-1869 ArtsNiC
Andre, Jules 1807-1869 ClaDrA
Andre, Marguerite DcWomA
Andre, Oscar DcWomA
Andre, R DcBrBI
Andre, Renee WhAmArt 85
Andre-Viollier, Eugenie 1844- DcWomA

Andrea Da Assisi *McGDA*
Andrea Da Bologna *McGDA*
Andrea Da Firenze *OxArt*
Andrea Da Firenze 1320?-1377? *McGDA*
Andrea Da Murano *McGDA*
Andrea Da Pontedera *McGDA*
Andrea Da Salerno *McGDA*
Andrea D'ancona Nella Marca *McGDA*
Andrea Del Castagno 1423?-1457 *OxArt*
Andrea DelCastagno *McGDA*
Andrea DelSarto *McGDA*
Andrea DelSarto 1486-1531 *OxArt*
Andrea Di Bartolo 1370?-1428 *McGDA*
Andrea Di Bartolo Di Bargilla 1423?-1457 *OxArt*
Andrea Di Cione *McGDA*
Andrea Di Giusto 1400?-1450 *McGDA*
Andrea Di Jacopo D'ognabene *McGDA*
Andrea Di Lazzaro Cavalcanti 1412-1462 *McGDA*
Andrea Di Niccolo Di Giacomo 1440?-1514 *McGDA*
Andrea Pisano 1290?-1349? *McGDA*
Andrea Tafi *McGDA*
Andrea, I 1946- *WhoAmA 84*
Andrea, Pat 1942- *DcCAr 81*
Andreae, Christopher 1940- *DcCAr 81*
Andreae, Conrad R 1871- *DcBrA 1*
Andreae, Conrad Rudolf 1871-1956 *DcBrA 2*
Andreae, Vera Romaine *WhAmArt 85*
Andreae, Willem Lodewijk 1817-1873 *DcSeaP*
Andreani, Andrea 1540?-1623 *McGDA*
Andreas, Jacob *FolkA 86*
Andreas-Tuzuner, Isik *DcCAr 81*
Andreasen, Signe 1853- *DcWomA*
Andreasen-Lindborg, Elna Ingeborg 1875?- *DcWomA*
Andreasen-Lindborg, Ingeborg 1876- *WhAmArt 85*
Andreasson, Rune 1925- *WorECom*
Andreatta, Ronald W 1952- *MarqDCG 84*
Andree, Miss *DcWomA*
Andree, Jeanne *DcWomA*
Andree, Marie *DcWomA*
Andree-Lenique, Clemence *DcWomA*
Andreen, Axel A *WhAmArt 85*
Andrees, Gerhard 1936- *DcCAr 81*
Andrei, Giovanni 1770-1824 *NewYHSD*
Andreiev, A A, Jr. *AmArch 70*
Andrejev, Andrei 1889-1966 *ConDes*
Andrejevic, Milet 1925- *DcCAA 71, -77,*
 WhoAmA 73, -76, -78, -80, -82, -84
Andren, Robert Laurence 1941- *AmArch 70*
Andreoli, Giorgio *McGDA*
Andreottola, Michael Anthony 1946- *MarqDCG 84*
Andreou, Constantin 1917- *OxTwCA, PhDcTCA 77*
Andres, Charles 1951- *MarqDCG 84*
Andres, Charles John 1913- *IlBEAAW,*
 WhAmArt 85
Andres, Glenn Merle 1941- *WhoAmA 80, -82, -84*
Andres, J J *AmArch 70*
Andresen, Lois E *WhAmArt 85*
Andresen, Momme 1857-1951 *MacBEP*
Andresen, Thorvald Andreas Rasmus 1892- *MacBEP*
Andreson, Carlos 1905- *WhAmArt 85*
Andreson, Laura 1902- *CenC[port]*
Andreson, Laura F 1902- *WhoAmA 80, -82, -84*
Andreu, Jose J 1924- *AmArch 70*
Andreuve, J *DcVicP 2*
Andrew, Saint d070? *McGDA*
Andrew, Benny 1930- *DcAmArt*
Andrew, C *DcVicP 2*
Andrew, David 1934- *DcCAr 81, PrintW 85*
Andrew, David Neville 1934- *WhoAmA 78, -80, -82,*
 -84
Andrew, F W, Jr. *DcVicP 2*
Andrew, Helen Kate 1854- *DcWomA*
Andrew, John 1815-1875 *EarABI SUP, NewYHSD*
Andrew, Jonathan *CabMA*
Andrew, Keith 1947- *WhoAmA 82, -84*
Andrew, Richard 1869- *WhAmArt 85*
Andrew, Rolly A 1918- *AmArch 70*
Andrewes, Miss D *DcBrBI*
Andrews *NewYHSD*
Andrews, Mrs. *DcBrECP*
Andrews, Ambrose *FolkA 86, NewYHSD*
Andrews, Arthur H 1906- *WhoArt 80, -82, -84*
Andrews, Arthur Henry 1906- *DcBrA 1*
Andrews, Asa *FolkA 86*
Andrews, Benny *IlsBYP*
Andrews, Benny 1930- *AfroAA, DcCAr 81,*
 OxTwCA, WhoAmA 73, -76, -78, -80, -82, -84,
 WorArt[port]
Andrews, Bernard *FolkA 86*
Andrews, Bernice *DcWomA, WhAmArt 85*
Andrews, Burr *FolkA 86*
Andrews, C Stephen 1946- *MarqDCG 84*
Andrews, C W *DcVicP 2*
Andrews, Carl Franklin 1923- *AmArch 70*
Andrews, Charles 1841?- *NewYHSD*
Andrews, Charles D *NewYHSD*
Andrews, Charles Sperry, III 1917- *WhAmArt 85*
Andrews, Claude Y *WhAmArt 85*
Andrews, Cora Mae 1860- *ArtsAmW 3*
Andrews, Craig Gray 1916- *AmArch 70*
Andrews, David *NewYHSD*

Andrews, Dorothy Eileen 1897- *DcBrA 1, DcWomA,*
 WhoArt 80, -82, -84
Andrews, Douglas Sharpus 1885-1944 *DcBrA 1*
Andrews, Mrs. E A *DcBrBI*
Andrews, E F *ArtsNiC*
Andrews, Edith Alice *DcBrA 1, DcWomA*
Andrews, Edith Lovell 1886- *DcBrA 1, DcWomA,*
 WhoArt 80, -82, -84
Andrews, Edna Rozina 1886- *DcWomA,*
 WhAmArt 85
Andrews, Edward William *DcVicP 2*
Andrews, Eliphalet Frazer 1835-1915 *NewYHSD*
Andrews, Eliphalet Frazer 1855-1915 *WhAmArt 85*
Andrews, Ellen R *DcWomA, WhAmArt 85*
Andrews, Emanuel *NewYHSD*
Andrews, Emily J *DcWomA*
Andrews, Emma *ArtsEM, DcWomA*
Andrews, Eugene R 1931- *MarqDCG 84*
Andrews, F *NewYHSD*
Andrews, Fannie *DcWomA*
Andrews, Fannie 1869- *ArtsAmW 3*
Andrews, Fanny *FolkA 86*
Andrews, Fanny 1869- *ArtsAmW 3*
Andrews, Felix Emile 1888- *DcBrA 1*
Andrews, Frank M 1867-1948 *MacEA*
Andrews, Frank Mills 1867-1948 *BiDAmAr*
Andrews, Gail Camille 1953- *WhoAmA 82*
Andrews, George *NewYHSD*
Andrews, George Henry 1816-1898 *DcBrBI, DcBrWA,*
 DcVicP 2, IlBEAAW
Andrews, Gilman D 1814- *CabMA*
Andrews, Gwynne M d1930 *WhAmArt 85*
Andrews, H *FolkA 86*
Andrews, Harold F 1883- *AmArch 70*
Andrews, Harry C *MarqDCG 84*
Andrews, Helen F 1872- *WhAmArt 85*
Andrews, Helen Frances 1872- *DcWomA*
Andrews, Henry *DcVicP, -2*
Andrews, Henry d1868 *DcBrWA*
Andrews, Iris *DcWomA*
Andrews, Iris M *WhAmArt 85*
Andrews, Israel D *AntBDN I*
Andrews, J Winthrop 1879- *WhAmArt 85*
Andrews, Jacob *FolkA 86*
Andrews, James *DcVicP 2*
Andrews, James Pettit 1737-1797 *DcBrWA*
Andrews, Jane Margaret 1792- *FolkA 86*
Andrews, Jessie d1935? *DcWomA*
Andrews, Jessie 1867-1919 *ArtsAmW 3*
Andrews, John *CabMA, DcVicP 2*
Andrews, John d1809 *AntBDN I*
Andrews, John 1933- *ConArch*
Andrews, John Richards 1929- *AmArch 70*
Andrews, Jon Philip 1938- *AmArch 70*
Andrews, Joseph 1805?-1873 *NewYHSD*
Andrews, Joseph 1806-1873 *ArtsNiC*
Andrews, Joseph 1874- *DcBrA 1*
Andrews, Joshua P 1800?- *NewYHSD*
Andrews, Kate F *DcWomA*
Andrews, L D *AmArch 70*
Andrews, L M *AmArch 70*
Andrews, Laddie E *WhoAmA 73*
Andrews, Leonard Gordon 1885-1960 *DcBrA 1*
Andrews, Lewis P 1911- *AmArch 70*
Andrews, Lilian 1878- *ClaDrA, DcBrA 1, DcWomA*
Andrews, M *FolkA 86*
Andrews, Marcia *WhoArt 80, -82, -84*
Andrews, Marietta 1869-1931 *DcWomA*
Andrews, Marietta Minnegerode 1869-1931
 WhAmArt 85
Andrews, Martha Bailey Hawkins 1908- *WhAmArt 85*
Andrews, Mary Ellen 1937- *ICPEnP A, MacBEP*
Andrews, Michael 1928- *ConArt 83,*
 ConBrA 79[port], DcBrA 2, DcCAr 81,
 OxTwCA, PhDcTCA 77
Andrews, Michael Frank 1916- *WhoAmA 76, -78, -80,*
 -82, -84
Andrews, Oliver *WhoAmA 73, -76, -78*
Andrews, Oliver 1925- *DcCAA 71, -77*
Andrews, Ophelia G *AfroAA*
Andrews, R *DcBrECP*
Andrews, R H *DcVicP 2*
Andrews, Ralph W 1897- *MacBEP*
Andrews, Richard Snowden 1830-1903 *BiDAmAr*
Andrews, Robert d1856? *NewYHSD*
Andrews, Robert Day 1857-1928 *BiDAmAr, MacEA*
Andrews, Robert Holman 1934- *AmArch 70*
Andrews, Rosemary 1949- *DcCAr 81*
Andrews, S Holmes *FolkA 86*
Andrews, Sybil *DcBrA 2*
Andrews, Sybil 1898- *DcWomA, WhoAmA 73, -76,*
 -78, -80, -82, -84
Andrews, T D *NewYHSD*
Andrews, T H *DcVicP 2*
Andrews, Victoria L 1950- *WhoAmA 76, -78, -80*
Andrews, Wayne George *AmArch 70*
Andrews, Will d1734 *CabMA*
Andrews, Willard H 1899?- *ArtsAmW 2*
Andrews, William *AntBDN P, -Q*
Andrews, Willis Wells 1932- *AmArch 70*
Andriazzi, Hercules *ArtsEM*

Andric, Branko 1942- *DcCAr 81*
Andriesse, Emmy 1914-1953 *ConPhot, ICPEnP A*
Andriessen, Anthony 1746-1813 *ClaDrA*
Andriessen, Christiaan 1775- *ClaDrA*
Andriessen, Jurriaen 1742-1819 *OxArt*
Andriessen, Mari Silvester 1897- *PhDcTCA 77*
Andrieu, Adolph *NewYHSD*
Andrieu, C *NewYHSD*
Andrieu, Jules 1844- *WhAmArt 85*
Andrieu, Mathuren Arthur d1896 *ArtsEM,*
 NewYHSD
Andring, Arnold Nickolas 1937- *AmArch 70*
Andrinos, Teodora Maria 1737-1761 *DcWomA*
Andriola, Alfred 1912- *WorECom*
Andriolo De Sanctis 1324?-1380? *McGDA*
Andriozzi, Hercules *ArtsEM*
Andris, Ruth Ingeborg 1933- *AmArt*
Andronikos Of Kyrrhos *MacEA*
Andross, Chester *FolkA 86*
Androuet Du Cerceau, Jacques, The Elder *McGDA*
Andrus, Alice *WhAmArt 85*
Andrus, J Roman 1907- *WhAmArt 85*
Andrus, James Roman 1907- *WhoAmA 73, -76, -78,*
 -80, -82, -84
Andrus, Moulton Loyal 1940- *WhoAmA 73*
Andrus, Vera 1896- *WhAmArt 85*
Andrus, Vera 1896-1979 *DcWomA*
Andrus, Vera Eugenia 1895- *WhoAmA 73*
Andrus, Zoray 1908- *WhAmArt 85*
Andruss, Mrs. W B *FolkA 86*
Andry, C G *AmArch 70*
Andrzejkowicz-Buttowt, Maria M Von 1852-
 DcWomA
Andujar, Claudia 1931- *ICPEnP A*
Andy, John Baptist *NewYHSD*
Andy, N *DcVicP 2*
Anelay, Henry 1817-1883 *DcBrBI, DcBrWA,*
 DcVicP, -2
Anelli, Francisco 1805?- *NewYHSD*
Anet, L *NewYHSD*
Anetal, Valentine D' *DcWomA*
Anethan, Alix D' 1848-1921 *DcWomA*
Anfray, Anne Marie Elisa *DcWomA*
Angadi, Patricia 1914- *DcBrA 1, WhoArt 80, -82,*
 -84
Angarola, Anthony 1893-1929 *WhAmArt 85*
Angas, George French 1822-1886 *DcBrBI, DcBrWA*
Angel, Felix 1949- *PrintW 83, -85*
Angel, Heather 1941- *ICPEnP A*
Angel, Herbert Walter 1925- *AmArch 70*
Angel, John 1881- *DcBrA 2*
Angel, John 1881-1960 *WhAmArt 85,*
 WhoAmA 80N, -82N, -84N
Angel, Joseph Martin 1928- *AmArch 70*
Angel, Marie 1923- *IlsBYP, WhoArt 80, -82, -84*
Angel, Marie Felicity 1923- *IlsCB 1967*
Angel, Philips 1616-1684 *ClaDrA*
Angel, Rifka 1899- *DcWomA, WhAmArt 85,*
 WhoAmA 73, -76, -78, -80, -82, -84
Angel, Robert J d1944 *DcBrA 2*
Angel, Sylvester C, Jr. 1931- *AmArch 70*
Angel, Zuzu *WorFshn*
Angela, Countess Of Antrim 1911- *WhoArt 80, -82,*
 -84
Angela De Ruccellai *DcWomA*
Angela Miniberti *DcWomA*
Angela, Emilio 1889- *WhAmArt 85*
Angelain, Antoine *NewYHSD*
Angeli, Franco 1935- *OxTwCA, PhDcTCA 77*
Angeli, Giuseppe 1709?-1798 *McGDA*
Angeli, Heinrich Von *ArtsNiC*
Angeli, Baron Heinrich Von 1840-1900? *DcVicP 2*
Angeli, Marguerite De *DcWomA*
Angeli, Marianna *DcWomA*
Angeli, Radovani Kosta 1916- *PhDcTCA 77*
Angelica Miniberti *DcWomA*
Angelica, Donna *DcWomA*
Angelico *DcBrA 1*
Angelico, Fra 1387-1455 *OxArt*
Angelico, Fra 1400?-1455? *McGDA*
Angelico Da Fiesole 1387-1455 *ClaDrA*
Angelico, Guido DiPietro 1387-1455 *OxArt*
Angelikis, Louis Monel, Jr. 1927- *AmArch 70*
Angelini, John Michael 1921- *WhoAmA 73, -76, -78,*
 -80, -82, -84
Angell, Clare *WhAmArt 85*
Angell, E Frank *DcVicP 2*
Angell, Ethel Elizabeth *DcBrA 1, DcWomA*
Angell, Eugene Franklin 1927- *AmArch 70*
Angell, Frank *DcVicP 2*
Angell, Frank W 1851- *BiDAmAr*
Angell, Frank W 1851-1943 *MacEA*
Angell, Gardiner 1913- *AmArch 70*
Angell, George *AntBDN Q*
Angell, Mrs. George R *WhAmArt 85*
Angell, Helen Cordelia 1847-1884 *DcBrWA,*
 DcWomA
Angell, Jessie Aline *DcWomA*
Angell, John *AntBDN Q*
Angell, Mrs. John 1847- *DcVicP, -2*

Angell, John Anthony d1756 *FolkA 86*
Angell, Joseph, Jr. 1922- *AmArch 70*
Angell, Louise M 1858- *DcWomA, WhAmArt 85*
Angell, Maude *DcVicP 2, DcWomA*
Angell, P V *AmArch 70*
Angell, Richard *FolkA 86*
Angell, Samuel 1800-1866 *BiDBrA*
Angell, T W *DcVicP 2*
Angell, Tony 1940- *WhoAmA 80, -82, -84*
Angell, Truman O *BiDAmAr*
Angell, Truman Osborn 1810-1887 *ArtsAmW 3, MacEA*
Angellis, Pierre *McGDA*
Angellis, Pieter 1685-1734 *DcBrECP*
Angello, Joseph Francis 1930- *AmArch 70*
Angelo Da Orvieto *MacEA*
Angelo, Anna Justine *DcWomA*
Angelo, Domenick Michael 1925- *WhoAmA 76, -78*
Angelo, Domenick Michael 1925-1976 *WhoAmA 80N, -82N, -84N*
Angelo, Emidio 1903- *WhAmArt 85, WhoAmA 73, -76, -78, -80, -82, -84*
Angelo, Marthe *DcWomA*
Angelo, Valenti *WhAmArt 85*
Angelo, Valenti 1897- *ArtsAmW 2, IlsCB 1744, -1946, -1957*
Angeloch, Robert 1922- *WhoAmA 73, -76, -78, -80, -82, -84*
Angelova-Vinarova, Victoria 1902-1947 *MacEA*
Angelucci, Augusto 1927- *AmArch 70*
Angelucci Cominazzini, Leandra 1890- *DcWomA*
Angeluccio *McGDA*
Angerer, Edward William 1927- *AmArch 70*
Angerer, Mea *WhoArt 82N*
Angerer, Mea 1905- *WhoArt 80*
Angerhofer, Norman Rae 1955- *MarqDCG 84*
Anghik, Abraham Aparkerk 1951- *DcCAr 81*
Angiboult, Francois 1887- *DcWomA*
Angier, Roswell 1940- *ICPEnP A, MacBEP*
Angillis, Pierre 1685-1734 *McGDA*
Angillis, Pieter 1685-1734 *DcBrECP*
Angilly, A O *AmArch 70*
Anglars, Marie D' *DcWomA*
Angle, Beatrice *DcWomA*
Angle, Earl Ellsworth 1922- *AmArch 70*
Angless, Violet *DcWomA*
Anglin, Betty Lockhart 1937- *WhoAmA 78, -80, -82, -84*
Anglo, Mick 1916- *WorECom*
Anglois, Esther *DcWomA*
Anglund, Joan Walsh 1926- *IlsCB 1957*
Angman, Alfons J 1883- *WhAmArt 85*
Angman, Alfons Julius 1883- *ArtsAmW 3*
Ango, Roger 1450?-1509 *McGDA*
Angoletta, Bruno 1899-1954 *WorECar*
Angolo Del Moro, Battista *McGDA*
Angolo Del Moro, Giulio 1555-1615? *McGDA*
Angolo Del Moro, Marco Dall' *McGDA*
Angood, Mary LaBarre *DcWomA*
Angood, May LaBarre *WhAmArt 85*
Angrand, Charles 1854-1926 *OxTwCA*
Angrand-Campenon, Sargines 1837- *DcWomA*
Angstad, Benjamin 1806?-1863 *FolkA 86*
Angstad, E *FolkA 86*
Angstadt, Nathaniel 1822?- *FolkA 86*
Anguiano, Raul 1915- *McGDA, PrintW 83, -85, WhoAmA 78, -80, -82, -84*
Anguier, Francois 1604?-1669 *McGDA, OxArt*
Anguier, Michel 1613?-1686 *McGDA, OxArt*
Anguissola, Anna Maria *DcWomA*
Anguissola, Elena *DcWomA*
Anguissola, Europa d1578? *DcWomA*
Anguissola, Lucia 1540?-1565 *DcWomA*
Anguissola, Minerva *DcWomA*
Anguissola, Sofonisba 1527-1625 *McGDA*
Anguissola, Sofonisba 1532?-1625 *DcWomA, WomArt*
Angulo, Chappie 1928- *WhoAmA 73, -76, -78, -80, -82, -84*
Angulo-Iniguez, Diego 1901- *WhoArt 80, -82, -84*
Angus, Christine *DcBrBI*
Angus, Christine 1880?-1924? *DcWomA*
Angus, Felicite *DcWomA*
Angus, George 1792?-1845 *BiDBrA*
Angus, James J 1919- *AmArch 70*
Angus, Maria *DcWomA*
Angus, Maria L *DcVicP 2*
Angus, William 1752-1821 *AntBDN B*
Anhalt, Anastasia, Prinzess Of *WhoArt 82N*
Anhalt, Anastasia, Prinzess Of 1901- *WhoArt 80*
Anhalt, Jacqueline Richards 1925- *WhoAmA 73, -76, -78, -80, -82, -84*
Anhalt-Dessau, Princess Marie E De *DcWomA*
Anie-Mouroux, Madame *DcWomA*
Aniram, Marina 1899- *DcWomA*
Anisdahl, Leif Frimann 1937- *WhoGrA 82[port]*
Anisfeld, Boris *WhAmArt 85*
Ankarcrona, Jeannette *DcWomA*
Ankcorn, J *DcVicP 2*
Ankeney, John S 1870-1946 *WhAmArt 85*
Ankeney, John Sites 1870-1946 *ArtsAmW 2*

Anker, Albert *ArtsNiC*
Anker, Albert 1831-1910 *ClaDrA, OxTwCA*
Anker, Annette 1851-1885 *DcWomA*
Anker, Suzanne *DcCAr 81*
Anker, Suzanne C 1946- *WhoAmA 78, -80, -82, -84*
Ankrom, Francis *WhAmArt 85*
Ankrum, Joan *WhoAmA 76, -78, -80, -82, -84*
Anliker, Roger 1924- *WhoAmA 73, -76, -78*
Anna Maria, Archduchess Of Austria *DcWomA*
Annala, Aaro Johannes 1920- *AmArch 70*
Annaly, Madame *DcWomA*
Annan, A Hawthorne *WhAmArt 85*
Annan, Abel H *WhAmArt 85*
Annan, Alice H *WhAmArt 85*
Annan, Alice Hawthorne *DcWomA*
Annan, Dorothy *WhoArt 80*
Annan, J Craig 1864-1946 *ICPEnP*
Annan, James Craig 1864-1946 *MacBEP*
Annan, Joseph Paul 1868-1936 *BiDAmAr*
Annan, Paul Gauss 1911- *AmArch 70*
Annan, Sylvester Papin 1865- *WhAmArt 85*
Annan, Thomas *MacBEP*
Annan, Thomas 1829-1887 *ICPEnP*
Annan, Thomas B 1837-1904 *BiDAmAr*
Annand, Douglas 1903- *WhoGrA 62*
Annand, John Davis 1907- *AmArch 70*
Annand, Louise R 1915- *DcBrA 1*
Anne, Princess Of Orange *DcWomA*
Anne, Saint *McGDA*
Anne, Marie *DcVicP 2, DcWomA*
Annen, Georgina Marie 1843- *DcWomA*
Annen, Helen Wann 1900- *WhAmArt 85*
Annen, J F *DcSeaP*
Annenkoff, Jurij 1890- *McGDA*
Annenkopf, Georges 1894- *PhDcTCA 77*
Annenkova, Maria Nikolajewna d1889 *DcWomA*
Annesley, Charles Francis 1787-1863 *DcBrWA*
Annesley, David 1936- *ConArt 77*
Annesley, Lady Mabel 1881- *DcWomA*
Anness, Samuel *NewYHSD*
Annetsberger, Franziska *DcWomA*
Annett, Ina 1901- *WhAmArt 85*
Annibale, George Oliver 1829?-1887 *NewYHSD*
Annigoni, Pietro 1910- *ClaDrA, DcBrA 1, WhoArt 80, -82, -84*
Annin, Lillian G *ArtsEM, DcWomA*
Annin, Phineas F *NewYHSD*
Annin, William B *NewYHSD*
Anning, Miss *DcBrECP*
Anning, F M *DcWomA*
Anning-Bell, Laura *DcWomA*
Anniquet, Charles *WhAmArt 85*
Annis, Clark 1805- *FolkA 86*
Annis, J *DcBrECP*
Annis, John B *WhAmArt 85*
Annis, Norman L 1931- *WhoAmA 80, -82, -84*
Annison, Edward S *DcBrBI, WhAmArt 85*
Anno, Mitsumasa 1920?- *IlsBYP*
Anno, Mitsumasa 1926- *IlsCB 1967*
Annois, Leonard Lloyd 1906-1966 *DcBrA 1*
Annot 1894- *WhAmArt 85*
Annunzio, Palma *DcWomA*
Annus, Bernard *NewYHSD*
Annus, John Augustus 1935- *WhoAmA 82, -84*
Anonsen, Sheldon Lee *AmArch 70*
Anovitz, Robert Arnold 1931- *AmArch 70*
Anquetin, Louis *OxTwCA*
Anquetin, Louis 1861-1932 *ClaDrA, PhDcTCA 77*
Anraat, Pieter Van d1678 *McGDA*
Anraedt, Pieter Van d1678 *ClaDrA*
Anreith, Anton 1754-1822 *MacEA*
Anrep, Boris 1883-1969 *DcBrA 1*
Anrooy, Anton Van 1870- *DcBrBI*
Ansano Di Pietro De Mencio *McGDA*
Ansbacher, Jessie d1964 *DcWomA, WhAmArt 85, WhoAmA 78N, -80N, -82N, -84N*
Anschutz, Ottomar 1846-1907 *ICPEnP*
Ansdell, Richard 1815- *ArtsNiC*
Ansdell, Richard 1815-1885 *ClaDrA, DcBrBI, DcVicP, -2*
Ansel, Ruth *AmGrD[port]*
Anselevicius G *AmArch 70*
Anselin, Jean Louis 1754-1823 *McGDA*
Ansell, Alice M *DcVicP 2, DcWomA*
Ansell, Charles d1795? *BkIE*
Ansell, Charles 1752?- *DcBrWA*
Ansell, George *DcVicP 2*
Ansell, Michael 1948- *PrintW 85*
Ansell, Norah 1906- *DcBrA 1, WhoArt 80, -82, -84*
Ansell, William Henry 1872-1959 *DcBrA 1*
Anselma, Marie *DcWomA*
Anselmi, Giuseppina *DcWomA*
Anselmi, Michelangelo 1492-1554 *McGDA*
Anselmo 1921- *WhoArt 80, -82, -84*
Anselmo, Giovanni 1934- *ConArt 77, -83, DcCAr 81*
Anselmo, Ricardo Delfin 1929- *AmArch 70*
Anshutz, Elsa Martin *WhAmArt 85*
Anshutz, Philip *FolkA 86*
Anshutz, Thomas 1851-1912 *McGDA*
Anshutz, Thomas Pollock 1851-1912 *BnEnAmA, DcAmArt, WhAmArt 85*

Ansiaux, Antoine Jean Joseph 1764-1840 *ClaDrA*
Ansingh, Maria Elisabeth Georgina 1875-1959 *DcWomA*
Ansley, Don L *WhAmArt 85*
Ansley, Mary Ann d1840 *DcWomA*
Anson, Anne Margaret Coke, Viscountess *DcWomA*
Anson, H L *AmArch 70*
Anson, James *FolkA 86*
Anson, Lesia 1946- *WhoAmA 84*
Anson, Minnie Walters 1875- *DcBrA 1, DcWomA*
Anson, Peter Frederick *WhoArt 80N*
Anson, Peter Frederick 1889- *DcBrA 1*
Anson, Peter Frederick 1889-1975 *DcBrA 2*
Anson, William *NewYHSD*
Anspach, Elizabeth Berkeley 1750-1828 *DcWomA*
Anspach, Ernst 1913- *WhoAmA 73, -76, -78, -80, -82, -84*
Ansted, H *DcBrBI*
Ansted, William Alexander *ClaDrA, DcBrBI*
Anstis, James Harold 1941- *AmArch 70*
Anstis, Stuart M 1934- *MarqDCG 84*
Ansuino Da Forli *McGDA*
Antaya, Maurice *WorFshn*
Antelami, Benedetto 1150?- *OxArt*
Antelami, Benedetto 1150?-1230? *MacEA*
Antelami, Benedetto 1150-1233? *McGDA*
Antenor *McGDA, OxArt*
Antes, Horst 1936- *ConArt 77, -83, DcCAr 81, OxTwCA, PhDcTCA 77*
Anthemios *MacEA*
Anthemius Of Tralles *OxArt*
Anthing, Johann Friedrich 1753?-1805 *OxDecA*
Anthon, Jane Marie 1924- *WhAmArt 85*
Anthoniet, Maistre *McGDA*
Anthonisen, George Rioch 1936- *WhoAmA 76, -78, -80, -82, -84*
Anthonissen, Arnoldus *DcSeaP*
Anthonissen, Hendrick Van 1606-1656? *DcSeaP*
Anthonissen, Hendrick Van 1606-1660 *ClaDrA*
Anthonisz, Aert 1579-1620 *DcSeaP*
Anthonisz, Cornelis 1499?- *OxArt*
Anthonisz, Cornelis 1499?-1556 *McGDA*
Anthonisz, Hendrick VanD' 1606?-1653 *McGDA*
Anthony, Andrew V S d1906 *WhAmArt 85*
Anthony, Andrew Varick Stout 1835- *ArtsNiC*
Anthony, Andrew Varick Stout 1835-1906 *EarABI, NewYHSD*
Anthony, Anne 1776-1796 *FolkA 86*
Anthony, Edward 1818-1888 *MacBEP*
Anthony, Edward 1819-1888 *ICPEnP*
Anthony, Elisabeth Mary 1904- *WhAmArt 85*
Anthony, Ernest Edwin 1894- *WhAmArt 85*
Anthony, George Wilfred 1800-1859 *DcBrWA*
Anthony, George Wilfrid 1800-1860 *DcVicP, -2*
Anthony, Gordon 1902- *MacBEP*
Anthony, Hale Bower 1900- *WhAmArt 85*
Anthony, Harry Antoniades 1922- *AmArch 70*
Anthony, Henry Mark 1817-1886 *DcBrWA, DcVicP, -2*
Anthony, Henry T *MacBEP*
Anthony, Henry T 1814-1884 *ICPEnP*
Anthony, J B *AmArch 70*
Anthony, John 1938- *FairDF US[port], WorFshn*
Anthony, Lawrence Kenneth 1934- *WhoAmA 73, -76, -78, -80, -82, -84*
Anthony, Mark 1817- *ArtsNiC*
Anthony, Mary B *DcWomA*
Anthony, Nicholas Paul, III 1942- *AmArch 70*
Anthony, Norman 1893-1968 *WorECar*
Anthony, R Z *AmArch 70*
Anthony, Richard *MacBEP*
Anthony, Ripley O *WhAmArt 85*
Anthony, T V, II *AmArch 70*
Anthony, Wilfrid E 1878-1948 *BiDAmAr*
Anthony, William E 1942- *MarqDCG 84*
Anthony, William Graham 1934- *WhoAmA 73, -76, -78, -80, -82, -84*
Anthoons, Willy 1911- *McGDA, PhDcTCA 77*
Antico *McGDA*
Antigna, Alexandre 1817-1878 *ClaDrA*
Antigna, Helene-Marie *ArtsNiC*
Antigna, Jean-Pierre-Alexander 1818-1878 *ArtsNiC*
Antigna, Marie Helene *DcWomA*
Antikainen, Kosti Aukusti 1930- *WhoGrA 62*
Antin, David A 1932- *WhoAmA 76, -78, -80, -82, -84*
Antin, Eleanor 1935- *ConArt 77, -83, PrintW 85, WhoAmA 76, -78, -80, -82, -84*
Antinori, Giovanni 1734-1792 *MacEA*
Antinous *McGDA*
Antinozzi, Daniel Paul 1920- *AmArch 70*
Antisdel, LaVerne Rogers d1907 *DcWomA*
Antisdel, LaVerne Rogers 1842-1907 *ArtsEM*
Antistates *MacEA*
Antlers, Max H 1873- *ArtsAmW 2, WhAmArt 85*
Antman, Jacob 1913- *WhAmArt 85*
Antognilli, David *NewYHSD*
Antoine, Jacques-Denis 1733-1801 *MacEA, McGDA, WhoArch*
Antoinnisen, E *ArtsEM*
Antokolski, Mark Matveevich 1843-1902 *McGDA*
Antolinez, Jose *McGDA*

Antolinez, Jose 1635-1675 *ClaDrA*
Antolinez Y Sarabia, Francisco 1644-1700 *McGDA*
Antolini, Giovanni Antonio 1756-1841 *MacEA*
Anton *WorECar*
Anton, Michael P 1956- *MarqDCG 84*
Anton, Saul Stewart 1932- *AmArch 70*
Anton, Vincent J *MarqDCG 84*
Anton-Koper, Frieda 1785- *DcWomA*
Antonacci, Peter Anthony 1957- *MarqDCG 84*
Antonakakis, Dimitris 1933- *ConArch*
Antonakakis, Suzana 1935- *ConArch*
Antonakos, Stephen 1925- *DcCAA 71*
Antonakos, Stephen 1926- *AmArt, BnEnAmA,
ConArt 77, -83, DcCAA 77, DcCAr 81,
PrintW 85, WhoAmA 73, -76, -78, -80, -82, -84*
Antonell, F R *AmArch 70*
Antonelli, Alessandro 1798-1880 *McGDA*
Antonelli, Alessandro 1798-1888 *EncMA, MacEA*
Antonelli, Maria *FairDF ITA[port]*
Antonello Da Messina 1414?-1493? *ClaDrA*
Antonello Da Messina 1430?-1479 *McGDA, OxArt*
Antonello De Saliba 1466?-1535? *McGDA*
Antonescu, Petre 1873-1965 *MacEA*
Antoni, Marie *DcWomA*
Antonia DeHohenzollern-Sigmaringen *DcWomA*
Antonia Maria, Princess Of Saxe *DcWomA*
Antonia, Amanda *NewYHSD*
Antonia, Tamara *WhAmArt 85*
Antoniades, Anthony C *ConArch A*
Antoniadis, Yiannis Byron 1936- *AmArch 70*
Antoniazzo Romano 1440?-1526? *McGDA*
Antonik, Joseph 1924- *AmArch 70*
Antonini, Antonio Sergio Mauro 1936- *ConArch*
Antonini Schon Zemborain *ConArch*
Antonino Di Niccolo Da Venezia *McGDA*
Antonio Da Fabriano *McGDA*
Antonio Da Faenza *McGDA*
Antonio Da Faenza 1456-1534 *McGDA*
Antonio Da Ferrara *McGDA*
Antonio Da Negroponte *McGDA*
Antonio Da Trento *McGDA*
Antonio Da Viterbo *McGDA*
Antonio De Bruxelas *McGDA*
Antonio Di Agostino Di Ser Giovanni *McGDA*
Antonio Di Federigo Dei Tolomei *McGDA*
Antonio Di Niccolo Da Venezia *McGDA*
Antonio Domenichi Di Mazzone *McGDA*
Antonio Massari Da Viterbo *McGDA*
Antonio Veneziano 1340?-1387? *McGDA*
Antonio, Donato Di Pascuccio D' *McGDA*
Antonisz, Cornelis *McGDA*
Antonova, L K *DcWomA*
Antonovici, Constantin 1911- *WhoAmA 73, -76, -78,
-80, -82, -84*
Antony Of Padua, Saint 1195-1231 *McGDA*
Antony, Saint *McGDA*
Antral, Louis Robert 1895-1939 *OxTwCA*
Antreasian, Garo 1922- *DcCAA 77*
Antreasian, Garo Zareh 1922- *AmArt, WhAmArt 85,
WhoAmA 76, -78, -80, -82, -84*
Antres, Charles *FolkA 86*
Antrim, Angela, Countess Of *WhoArt 80,
-82, -84*
Antrim, Angela Christina, Countess Of 1911- *DcBrA 1*
Antrim, Craig Keith 1942- *PrintW 85*
Antrim, Mary *FolkA 86*
Antrim, Mary V *DcWomA*
Antrim, Walter *AmArch 70*
Antrobus, A Lizzie *DcVicP 2, DcWomA*
Antrobus, Birdy *DcWomA*
Antrobus, Birdy 1874?- *ArtsEM*
Antrobus, E *DcWomA*
Antrobus, Edmund G *DcVicP 2*
Antrobus, John d1907 *WhAmArt 85*
Antrobus, John 1837?-1907 *ArtsEM, NewYHSD*
Antum, Aert Van *DcSeaP*
Antunez, Nemesio *OxTwCA*
Antunez, Nemesio 1918- *McGDA*
Antung, Ahmad *WhoAmA 76, -78, -80*
Antz, G *NewYHSD*
Anuskiewicz, Richard 1930- *ConArt 77, -83,
PhDcTCA 77*
Anuszkiewicz, Richard 1930- *BnEnAmA, DcAmArt,
DcCAA 71, -77, McGDA, OxTwCA, PrintW 83,
-85, WorArt[port]*
Anuszkiewicz, Richard J 1930- *WhoAmA 73*
Anuszkiewicz, Richard Joseph 1930- *WhoAmA 76,
-78, -80, -82, -84*
Anway, Ida A *ArtsEM, DcWomA*
Anyon, James *NewYHSD*
Anzelmo, N R *AmArch 70*
Anzingh, Lizzi *DcWomA*
Anzures, Rafael 1917- *WhoAmA 76, -78, -80, -82,
-84*
Aoki, Alfred Susumu *AmArch 70*
Aotani, Edward Ryoichi 1928- *AmArch 70*
Aoust, Gabrielle *DcWomA*
Apa *WorECar*
Aparicio, Gerardo 1943- *WhoAmA 73, -76, -78*
Apatini, P *AmArch 70*
Apaydin, Kaya 1925- *AmArch 70*

Apchie DeGrezels, Blanche Clementine M J *DcWomA*
Ape *DcBrBI, WorECar*
Ape Junior *DcBrBI*
Apegian, Avides M *WhAmArt 85*
Apel, Barbara Jean 1935- *WhoAmA 78, -80, -82, -84*
Apel, Marie *WhAmArt 85*
Apel, Marie 1888- *DcWomA*
Apeldoorn, Camille *DcWomA*
Apelles *McGDA, OxArt*
Apfel, Henry 1838- *NewYHSD*
Apgar, Nicolas Adam 1918- *WhAmArt 85,
WhoAmA 73, -76, -78, -80, -82, -84*
Apgar, T F *AmArch 70*
Apilado, Tony *IlsBYP*
Apkalis, Ilmar 1931- *ICPEnP A*
Apodaca, Manuelita *FolkA 86*
Apoil, Marie Marguerite *DcWomA*
Apoil, Rose Anna *DcWomA*
Apoil, Suzanne Estelle 1825-1874? *DcWomA*
Apolinar *DcCAr 81*
Apollinaire, Guillaume 1880-1918 *OxArt, OxTwCA,
PhDcTCA 77*
Apollodoro *McGDA*
Apollodorus *MacEA, OxArt*
Apollodorus Of Damascus *McGDA, OxArt*
Apolloni, Livio 1904- *WhoGrA 62*
Apollonia Of Alexandria, Saint d249 *McGDA*
Apollonio Di Giovanni 1415-1465 *McGDA*
Apollonio, Umbro *OxTwCA*
Apollonios *McGDA*
Aponte, Luis 1932- *AmArch 70*
Apostle, James 1917- *WhAmArt 85*
Apostoli, Roberto Santiago 1935- *MarqDCG 84*
Apostolides, Zoe *WhoAmA 73, -82*
Apostolou, P C *AmArch 70*
App, Timothy 1947- *WhoAmA 84*
Appel, Amalie 1757-1839? *DcWomA*
Appel, B R *AmArch 70*
Appel, Charles P 1857- *WhAmArt 85*
Appel, Eric A 1945- *WhoAmA 78, -80, -82, -84*
Appel, Jack 1911- *WhAmArt 85*
Appel, Jacob J 1940- *MarqDCG 84*
Appel, Karel 1921- *AmArt, DcCAr 81, McGDA,
OxArt, OxTwCA, PhDcTCA 77, PrintW 83,
-85, WhoAmA 73, -76, -78, -80, -82, -84,
WhoArt 80, -82, -84, WorArt[port]*
Appel, Karel 1925- *ConArt 77, -83*
Appel, Keith Kenneth 1934- *WhoAmA 73, -76, -78,
-80, -82, -84*
Appel, Marianne 1913- *WhAmArt 85*
Appel, Richard Amiel 1937- *AmArch 70*
Appel, Thelma 1940- *WhoAmA 80,
-82, -84*
Appel, Viola 1897- *DcWomA, WhAmArt 85*
Appelbaum, Stanley 1934- *WorECar A*
Appelbee, Leonard 1914- *ClaDrA, DcBrA 1,
WhoArt 82, -84*
Appelhof, Ruth A 1940- *WhoAmA 78*
Appelhof, Ruth A 1945- *WhoAmA 80, -82, -84*
Apperley, George Owen Wynne 1884-1960 *DcBrA 1*
Appert, Eugene 1820?-1867 *ArtsNiC*
Appert, Pauline 1810- *DcWomA*
Appia, Dominique 1926- *DcCAr 81*
Appia, Therese *DcWomA*
Appia-Dabit, Beatrice *DcVicP 2*
Appian, Adolphe *DcVicP 2*
Appiani, Andrea 1754-1817 *ClaDrA*
Appiani, Andrea 1812?-1866 *ArtsNiC*
Appiani, Andrea, The Elder 1754-1817 *McGDA*
Appiani, Giuseppe 1701?-1786 *MacEA*
Appier, William H 1925- *AmArch 70*
Apple, Billy 1935- *BnEnAmA*
Apple, Henry *FolkA 86*
Apple, Jacki *WhoAmA 78, -80, -82, -84*
Apple, Martin Allen 1938- *MarqDCG 84*
Apple, W *FolkA 86*
Applebaum, Hy 1934- *AmArch 70*
Applebee, Frank Woodberry 1902- *WhAmArt 85*
Applebey, Wilfred Crawford 1889- *DcBrA 1*
Applebroog, Ida *DcCAr 81, WhoAmA 84*
Applebroog, Ida H *WhoAmA 78, -80, -82*
Appleby, Ernest W *DcVicP 2*
Appleby, Leslie Vere 1931- *AmArch 70*
Appleby, Robert H 1931- *MarqDCG 84*
Appleby, Theodore 1923- *PhDcTCA 77*
Appleby, William A, Jr. 1921- *AmArch 70*
Applegarth, G A *AmArch 70*
Applegarth, R T, Jr. *AmArch 70*
Applegate, Frank G 1882-1931 *ArtsAmW 1, -2,
WhAmArt 85*
Applegate, Frank G 1882-1934? *IlBEAAW*
Applegate, John Burvell 1909- *AmArch 70*
Applegate, Joseph Robert 1955- *MarqDCG 84*
Applegate, K E *DcWomA*
Applegate, Robert Lee 1925- *AmArch 70*
Applegate, William *CabMA*
Appleman, David Earl 1943- *WhoAmA 78, -80, -82,
-84*
Appleman, Larry 1956- *MarqDCG 84*
Appleman, Ralph Fredrick 1916- *AmArch 70*
Appler, Mary C *DcWomA*

Appleton, A *AmArch 70*
Appleton, Benjamin d1798? *CabMA*
Appleton, C James, III 1932- *AmArch 70*
Appleton, Chris *FolkA 86*
Appleton, Daniel 1719?-1807 *CabMA*
Appleton, Eliza Bridgham 1882- *DcWomA*
Appleton, Eliza Haliburton 1882- *WhAmArt 85*
Appleton, George W *FolkA 86*
Appleton, George Washington 1805-1831 *EarABI SUP,
NewYHSD*
Appleton, H *DcWomA*
Appleton, Honor C *DcWomA*
Appleton, John *CabMA*
Appleton, M *DcWomA*
Appleton, Nathaniel *CabMA*
Appleton, Norman R 1899- *ArtsAmW 2*
Appleton, Richard William 1909- *DcBrA 1,
WhoArt 80, -82, -84*
Appleton, Robert *BiDBrA*
Appleton, Thomas *FolkA 86*
Appleton, Thomas 1772-1855 *CabMA*
Appleton, Thomas G 1812-1884 *ArtsNiC*
Appleton, Thomas Gold 1812-1884 *NewYHSD*
Appleton, W C *AmArch 70*
Appleton, William d1822 *CabMA*
Appleton, William 1737?-1807 *CabMA*
Appleton, William 1765-1822 *AntBDN G*
Appletown, William L *FolkA 86*
Appleyard, Dev *IlsBYP*
Appleyard, Fred 1874-1963 *DcBrA 1*
Appleyard, Joseph 1908- *ClaDrA*
Appleyard, Joseph 1908-1960 *DcBrA 1*
Aprahamian, Mirella *DcCAr 81*
ApRhys Pryce, Vivien Mary 1937- *WhoArt 84*
Apshoven, Ferdinand Van, II 1630-1694 *McGDA*
Apshoven, Thomas Van 1622-1664 *McGDA*
Apt, Charles 1933- *WhoAmA 73, -76, -78, -80, -82,
-84*
Apt, Ulrich, The Elder 1455?-1532 *McGDA*
Apt, Ulrich, The Elder 1465?-1532 *OxArt*
Apthorp, Louise L 1878- *DcWomA, WhAmArt 85*
Aqua Fresca, Matteo 1651-1738 *OxDecA*
Aqua Fresca, Pietro Antonio d1809 *OxDecA*
Aqua Fresca, Sebastano *OxDecA*
Aquadro, Frederica *WhAmArt 85*
Aquaro, Angelo Ralph 1921- *AmArch 70*
Aquilio, Antoniazzo Di Benedetto *McGDA*
Aquinas, Thomas, Saint *McGDA*
Aquino, Beverly Ann 1948- *MarqDCG 84*
Aquino, Edmundo 1938- *PrintW 83*
Aquino, Edmundo 1939- *PrintW 85, WhoAmA 73,
-76, -78, -80, -82, -84*
Ara *FolkA 86*
Arad, Shlomo 1937- *ICPEnP A*
Arago, Dominique Francois Jean 1786-1853 *ICPEnP*
Aragon, Fanny *DcWomA*
Aragon, Jose *FolkA 86*
Aragon, Jose Rafael 1795?-1862 *AmFkP, FolkA 86*
Aragon, Luis 1899-1977 *FolkA 86*
Aragon, Rafael *FolkA 86*
Aragones, Sergio 1937- *WorECom*
Aragones DeMendiola, J, Senora *DcWomA*
Arai, Katsuyoshi *ConArch A*
Arakawa 1936- *PrintW 83, -85, WhoAmA 76, -78,
-80, -82, -84*
Arakawa, Shusaku 1936- *AmArt, ConArt 77, -83,
DcCAA 77, DcCAr 81, OxTwCA,
PhDcTCA 77, WhoAmA 73*
Araki, Nobuyoshi 1940- *ICPEnP A*
Araldi, Alessandro 1483-1528 *McGDA*
Aram, E *FolkA 86*
Aramassa, Taku 1936- *MacBEP*
Arango, Jorge 1916- *AmArch 70*
Aranoff, Stephen P 1943- *MarqDCG 84*
Aranyi, Laszlo 1933- *AmArch 70*
Arapoff, Alexis 1904- *WhAmArt 85*
Arata, Giulio Ulisse 1881-1962 *MacEA*
Araujo, Zeka 1946- *ICPEnP A*
Arazi, Efraim Rafael 1937- *MarqDCG 84*
Arbab, Farhad 1952- *MarqDCG 84*
Arbeen, Lynn Andrew 1930- *AmArch 70*
Arbeit, Arnold A 1916- *AmArch 70, WhoAmA 73,
-76*
Arbery, William Clifford 1934- *AmArch 70*
Arbessier, F *NewYHSD*
Arbey, Gabrielle *DcWomA*
Arbey, Mathilde 1890- *DcWomA*
Arbo, Anna Eliza 1854- *DcWomA*
Arbo, Peter Nicolai 1831-1892 *ClaDrA*
Arbogast, Glenn Lawrence, Jr. 1920- *AmArch 70*
Arbouin, S *DcVicP 2*
Arbout, Jean Marie *DcWomA*
Arbuckle, Franklin *WhoAmA 73, -76, -78, -80, -82*
Arbuckle, Gladys *WhAmArt 85*
Arburn, R W *AmArch 70*
Arbus, Diane 1923-1971 *BnEnAmA, ConPhot,
DcAmArt, ICPEnP, MacBEP, WomArt*
Arbuthnot, George *DcVicP 2*
Arbuthnot, Malcolm 1874-1967 *DcBrA 1, MacBEP*
Arbuthnott, George 1803?- *DcBrWA*
Arc-Valette, Louise *DcWomA*

Armitage, Merle 1893-1975 *MacBEP*
Armitage, Robert Emery 1932- *AmArch 70*
Armitage, Thomas Liddall *DcVicP 2*
Armitage, William *DcVicP 2*
Armitage, William 1857- *DcBrA 1*
Armitage, William J *DcVicP 2*
Armitage, William J 1817-1890 *ArtsAmW 3*
Armitt, Joseph d1747 *CabMA*
Armitt, Stephen 1705-1762 *CabMA*
Armon, Dohn Raymon 1933- *AmArch 70*
Armoni, Abraham 1935- *MarqDCG 84*
Armor, Samuel *NewYHSD*
Armor, W R *AmArch 70*
Armour, Electa M *ArtsAmW 3*
Armour, G O *WhAmArt 85*
Armour, George Denholm 1864-1930 *DcBrWA*
Armour, George Denholm 1864-1949 *AntBDN B,*
 DcBrA 1, DcBrBI, DcVicP 2
Armour, Heda 1916- *DcBrA 1*
Armour, Jessie Lamont *DcBrBI*
Armour, Mary 1902- *WhoArt 80, -82, -84*
Armour, Mary Nicol Neill 1902- *DcBrA 1*
Armour, Samuel E 1890- *WhAmArt 85*
Armour, Spencer Allen, Jr. 1935- *AmArch 70*
Armour, William *WhoArt 82N*
Armour, William 1903- *DcBrA 1, WhoArt 80*
Arms, A H *AmArch 70*
Arms, Eleanor M 1864-1938 *WhAmArt 85*
Arms, J M *AmArch 70*
Arms, Jessie *DcWomA, WhAmArt 85*
Arms, John Taylor 1887- *WhAmArt 85*
Arms, John Taylor 1887-1953 *ArtsAmW 2, DcAmArt,*
 DcBrA 1, GrAmP, McGDA
Armstead *NewYHSD*
Armstead, Charlotte W *DcVicP 2, DcWomA*
Armstead, Henry Hugh 1828- *ArtsNiC*
Armstead, Henry Hugh 1828-1905 *DcBrA 1, DcBrBI*
Armstead, Hugh Wells 1865- *DcBrA 1*
Armstead, Lottie *DcVicP 2*
Armstrong, Addie *DcWomA*
Armstrong, Alice 1906- *WhAmArt 85*
Armstrong, Alixe Jean 1894- *DcWomA*
Armstrong, Alixe Jean Shearer 1894- *DcBrA 1*
Armstrong, Amos Lee 1899- *WhAmArt 85*
Armstrong, Andrew *AntBDN I*
Armstrong, Ann Johnson *FolkA 86*
Armstrong, Annie Langley *DcWomA*
Armstrong, Arthur 1798-1851 *NewYHSD*
Armstrong, Arthur Charlton 1924- *WhoArt 80, -82,*
 -84
Armstrong, Augustus *DcBrECP*
Armstrong, Barbara 1896- *DcWomA, WhAmArt 85*
Armstrong, Bill Howard 1926- *WhoAmA 78, -80, -82,*
 -84
Armstrong, Brady Douglas 1937- *AmArch 70*
Armstrong, C D *WhAmArt 85*
Armstrong, Caroline *DcBrA 1, DcWomA*
Armstrong, Carolyn Faught 1910- *WhAmArt 85*
Armstrong, Catherine B *WhAmArt 85*
Armstrong, Charles 1864- *DcBrA 1*
Armstrong, Charles R *WhAmArt 85*
Armstrong, Christopher *NewYHSD*
Armstrong, Clarissa Chapman 1805-1891 *DcWomA*
Armstrong, D E *AmArch 70*
Armstrong, D Maitland *ArtsNiC*
Armstrong, David Maitland 1836-1918 *NewYHSD,*
 WhAmArt 85
Armstrong, Dell Heizer *ArtsAmW 3*
Armstrong, E H *AmArch 70*
Armstrong, Earnest Robert 1921- *AmArch 70*
Armstrong, Elizabeth *DcWomA*
Armstrong, Elizabeth A *DcVicP, -2*
Armstrong, Elizabeth Adela *DcBrA 1*
Armstrong, Elizabeth Caroline 1860-1930 *DcBrA 2,*
 DcWomA
Armstrong, Emily S *DcVicP 2, DcWomA*
Armstrong, Estelle M 1884- *WhAmArt 85*
Armstrong, Estelle Ream Manon 1884- *DcWomA*
Armstrong, Estelle Rice *ArtsEM, DcWomA*
Armstrong, Fanny *DcBrWA, DcVicP 2, DcWomA*
Armstrong, Foster David 1936- *AmArch 70*
Armstrong, Francis Abel William Taylor 1849-1920
 DcBrA 1, DcBrBI, DcBrWA
Armstrong, Frank 1935- *MacBEP*
Armstrong, G Clair 1910- *AmArch 70*
Armstrong, Geoffrey 1928- *WhoAmA 84*
Armstrong, George F 1853?-1912 *ArtsAmW 3*
Armstrong, Hannah *DcWomA*
Armstrong, Harold Barry 1902- *WorECar*
Armstrong, Harris 1899- *AmArch 70*
Armstrong, Helen Maitland 1869-1948 *DcWomA*
Armstrong, J H *FolkA 86*
Armstrong, Mrs. James *NewYHSD*
Armstrong, James Cummings, Jr. 1916- *AmArch 70*
Armstrong, James L *FolkA 86*
Armstrong, James Tarbottom 1848-1933 *WhAmArt 85*
Armstrong, Jane Botsford 1921- *WhoAmA 76, -78,*
 -80, -82, -84
Armstrong, Janet Lieb 1908- *WhAmArt 85*
Armstrong, Jerome G 1908- *AmArch 70*
Armstrong, Jesse John 1924- *AmArch 70*

Armstrong, John *DcVicP 2*
Armstrong, John 1893- *McGDA, PhDcTCA 77*
Armstrong, John 1893-1973 *DcBrA 1, OxTwCA*
Armstrong, John Albert 1943- *WhoAmA 78*
Armstrong, John Taylor, Jr. *AmArch 70*
Armstrong, Kate *DcWomA*
Armstrong, Louise *WhAmArt 85*
Armstrong, M K 1832-1906 *IlBEAAW*
Armstrong, Margaret Neilson 1867-1944 *DcWomA,*
 WhAmArt 85
Armstrong, Martha *WhoAmA 82, -84*
Armstrong, Mostyn John *AntBDN I*
Armstrong, Q E *AmArch 70*
Armstrong, Robert Harold 1921- *MarqDCG 84*
Armstrong, Robert I *WhAmArt 85*
Armstrong, Roger Joseph 1917- *WhoAmA 73, -76,*
 -78, -80, -82, -84
Armstrong, Rolf 1890-1960 *IlrAm 1880*
Armstrong, Ronald George 1937- *AmArch 70*
Armstrong, Samuel 1893- *WhAmArt 85*
Armstrong, Samuel John 1893- *ArtsAmW 2*
Armstrong, Shearer *WhoArt 80, -82, -84*
Armstrong, Thomas *ArtsNiC, CabMA, NewYHSD*
Armstrong, Thomas 1818-1860 *ArtsAmW 1*
Armstrong, Thomas 1832-1911 *DcBrA 1, DcBrWA*
Armstrong, Thomas 1835-1911 *ClaDrA, DcVicP, -2*
Armstrong, Thomas Newton, III 1932- *WhoAmA 76,*
 -78, -80, -82, -84
Armstrong, Tiffany Haley 1929- *AmArch 70*
Armstrong, Timothy G 1912- *AmArch 70*
Armstrong, Tom *IlsBYP*
Armstrong, Voyle Neville 1891- *ArtsAmW 2,*
 WhAmArt 85
Armstrong, William d1858 *BiDBrA*
Armstrong, William G 1823-1890 *NewYHSD*
Armstrong, William T L 1881-1934 *WhAmArt 85*
Armstrong, William W 1822-1914 *ArtsAmW 1,*
 IlBEAAW, WhAmArt 85
Armstrong-Jones, Anthony C R *ICPEnP A, MacBEP*
Armstrong-Jones, Antony Charles Robert 1930-
 WorFshn
Armytage, Charles *ClaDrA, DcVicP 2*
Armytage, Charles 1835?- *DcBrWA*
Armytage, J Charles *DcBrBI*
Armytage, Lady Mary Elizabeth d1834 *DcBrWA*
Arnal, Enrique 1932- *McGDA*
Arnal, Francois 1924- *OxTwCA, PhDcTCA 77*
Arnald, George 1763-1841 *DcBrBI, DcBrECP,*
 DcBrWA, DcSeaP
Arnason, H Harvard 1909- *WhoAmA 73, -76, -78,*
 -80, -82, -84
Arnatt, Keith *OxTwCA*
Arnatt, Keith 1930- *ConBrA 79[port], DcCAr 81*
Arnatt, Raymond 1934- *ConBrA 79[port]*
Arnaud, Josephine *DcWomA*
Arnaud, Julie *DcWomA*
Arnaud, Leopold 1895- *AmArch 70*
Arnaud, Marie Felicie *DcWomA*
Arnautoff, Jacob Victor 1930- *WhoAmA 76, -78, -80,*
 -82, -84
Arnautoff, Victor Michail 1896- *ArtsAmW 2,*
 WhAmArt 85
Arnberg, Elise 1826-1891 *DcWomA*
Arndt, F *DcVicP 2*
Arndt, G G *AmArch 70*
Arndt, Gunter G 1903- *WhAmArt 85*
Arndt, H *DcWomA*
Arndt, Paul Wesley 1881- *WhAmArt 85*
Arndt, Ursula *IlsBYP*
Arndt, W *AntBDN E*
Arneill, Bruce Porter 1934- *AmArch 70*
Arnemann, Mathilde *DcWomA*
Arner, T F *AmArch 70*
Arnesen, Borghild 1872- *DcWomA*
Arnesen, Vilhelm Karl Ferdinand 1865- *DcSeaP*
Arnesen, Vilk *DcSeaP*
Arneson, Robert 1930- *AmArt, BnEnAmA, CenC,*
 ConArt 83, DcCAr 81, PrintW 83, -85,
 WhoAmA 80, -82, -84
Arneson, Robert Carston 1930- *WhoAmA 73, -76, -78*
Arneson, Thomas George, II 1942- *MarqDCG 84*
Arnest, Bernard 1917- *AmArt, WhoAmA 73, -76,*
 -78, -80, -82, -84
Arnest, Bernard Patrick 1917- *WhAmArt 85*
Arnett, Eleanor 1895- *DcWomA, WhAmArt 85*
Arnett, Paul Jones 1911- *AmArch 70*
Arnett, William T 1905- *AmArch 70*
Arnhardt-Deininger, Gabriele 1855- *DcWomA*
Arnheim, Rudolf 1904- *WhAmArt 85, WhoAmA 73,*
 -76, -78, -80, -82, -84
Arnhold, Hans *WhoAmA 73*
Arnhold, Mrs. Hans *WhoAmA 73*
Arnhold, Johann Samuel 1766-1827 *AntBDN M*
Arnholm, Ronald Fisher 1939- *WhoAmA 76, -78, -80,*
 -82, -84
Arnholt, Waldon Sylvester 1909- *WhAmArt 85,*
 WhoAmA 73, -76
Arnim, Bettina Von 1785-1859 *DcWomA*
Arnim, Bettina Von 1940- *DcCAr 81*
Arnim, Helene Von *DcWomA*
Arning, Eddie 1898- *FolkA 86*

Arnit, William *CabMA*
Arno, Enrico *IlsCB 1967*
Arno, Enrico 1913- *IlsBYP, IlsCB 1946, -1957*
Arno, Peter d1968 *WhoAmA 78N, -80N, -82N, -84N*
Arno, Peter 1904-1968 *WhAmArt 85, WorECar*
Arnold, Mrs. 1787-1867 *DcVicP, -2*
Arnold Of Westphalia 1430?-1480 *McGDA*
Arnold Von Westphalen *MacEA*
Arnold, A *FolkA 86*
Arnold, Aden F 1901- *WhAmArt 85*
Arnold, Agnes *DcWomA*
Arnold, Albert Heppenstall 1919- *AmArch 70*
Arnold, Alonzo *ArtsEM*
Arnold, Anne 1925- *DcCAA 77*
Arnold, Annie R Merrylees *DcWomA*
Arnold, Axel 1871- *WhAmArt 85*
Arnold, B S *AmArch 70*
Arnold, Bernard *NewYHSD*
Arnold, Charles Geoffrey 1915- *DcBrA 1,*
 WhoArt 80, -82, -84
Arnold, Charles Treat 1928- *AmArch 70*
Arnold, Christopher *ConArch A*
Arnold, Clara Maxfield 1879- *DcWomA,*
 WhAmArt 85
Arnold, Claris *ArtsEM*
Arnold, Cleon Mills 1920- *AmArch 70*
Arnold, Daisy *DcWomA*
Arnold, Daniel *FolkA 86*
Arnold, David C 1951- *MarqDCG 84*
Arnold, David James 1933- *AmArch 70*
Arnold, Don Louis 1938- *AmArch 70*
Arnold, Dorothy *WhAmArt 85*
Arnold, Edward *NewYHSD*
Arnold, Edward 1824-1866 *WhAmArt 85*
Arnold, Edward 1825?-1866 *DcSeaP*
Arnold, Mrs. Edwin *DcVicP 2*
Arnold, Elisabeth E *DcWomA*
Arnold, Elizabeth 1791-1877 *FolkA 86*
Arnold, Elizabeth A 1857- *DcWomA*
Arnold, Eve 1913- *ConPhot, ICPEnP A, MacBEP*
Arnold, Florence M 1900- *WhoAmA 73, -76, -78, -80,*
 -82, -84
Arnold, Frank McIntosh 1867-1932 *WhAmArt 85*
Arnold, Fred E 1920- *AmArch 70*
Arnold, Fred Lathrop *WhAmArt 85*
Arnold, George *NewYHSD*
Arnold, George 1753-1806 *DcBrECP*
Arnold, George G *NewYHSD*
Arnold, Grace Thurston *DcWomA*
Arnold, Grant 1904- *WhAmArt 85*
Arnold, Harriet *DcWomA*
Arnold, Harry *DcVicP 2, WhAmArt 85*
Arnold, Helen *DcWomA*
Arnold, Henry Meriwether 1918- *AmArch 70*
Arnold, Herbert R *ArtsEM*
Arnold, Howard Weston *WhAmArt 85*
Arnold, J 1827?- *NewYHSD*
Arnold, J J G *NewYHSD*
Arnold, Jack *WhoAmA 82, -84*
Arnold, James *CabMA*
Arnold, James Irza 1887- *WhAmArt 85*
Arnold, John *CabMA, DcBrECP*
Arnold, John 1736-1799 *AntBDN D, OxDecA*
Arnold, John James Trumbull *NewYHSD*
Arnold, John James Trumbull 1812-1865? *FolkA 86*
Arnold, John Knowlton 1834-1909 *NewYHSD,*
 WhAmArt 85
Arnold, John Roger *OxDecA*
Arnold, Jonas d1669 *ClaDrA*
Arnold, Karl 1883-1953 *McGDA, WorECar*
Arnold, L A *DcWomA*
Arnold, Laura Elizabeth 1916- *WhAmArt 85*
Arnold, Lorenz *FolkA 86*
Arnold, Lucetta *WhAmArt 85*
Arnold, Mary *DcCAr 81, DcWomA*
Arnold, May *DcWomA*
Arnold, Newell Hillis 1906- *WhAmArt 85*
Arnold, Nina J *DcWomA*
Arnold, Paul B 1918- *WhAmArt 85*
Arnold, Paul Beaver 1918- *WhoAmA 73, -76, -78, -80,*
 -82, -84
Arnold, Peter S 1941- *MarqDCG 84*
Arnold, Phyllis Anne 1938- *WhoArt 84*
Arnold, R W *AmArch 70*
Arnold, Ralph 1928- *AfroAA*
Arnold, Ralph Moffett 1928- *WhoAmA 73, -76, -78,*
 -80, -82, -84
Arnold, Reginald Edward 1853-1938 *DcBrA 1*
Arnold, Richard *DcBrECP*
Arnold, Richard Monroe 1927- *AmArch 70*
Arnold, Richard R 1923- *WhoAmA 73, -76, -78, -80,*
 -82, -84
Arnold, Robert Henry 1933- *MarqDCG 84*
Arnold, Robert Lloyd 1940- *WhoAmA 80, -82, -84*
Arnold, Robert S 1907- *AmArch 70*
Arnold, Scott Bowen 1926- *AmArch 70*
Arnold, Thomas *FolkA 86*
Arnold, William d1637? *BiDBrA*
Arnold, William Arthur *WhoArt 80N*
Arnold, William Arthur 1909- *DcBrA 2*
Arnold, William Robert 1945- *MarqDCG 84*

Arnoldi, Charles 1946- *PrintW 83, -85*
Arnoldi, Charles Arthur 1946- *AmArt, WhoAmA 84*
Arnolfo Di Cambio d1302? *OxArt*
Arnolfo Di Cambio 1245?-1310? *MacEA, McGDA*
Arnosky, James Edward 1946- *WhoAmA 78, -80, -82, -84*
Arnot, David H *NewYHSD*
Arnott, McLellan *DcVicP 2*
Arnould, Arthur, Madame *DcWomA*
Arnould, Jeanne Eugenie Laurence *DcWomA*
Arnould, Marian *DcWomA*
Arnould DeCool, Delphine *DcWomA*
Arnoult De Binche *MacEA*
Arnoux, Joseph-Leon-Francois 1816-1902 *DcNiCA*
Arnow, Jan 1947- *MacBEP*
Arnow, Matson *WhAmArt 85*
Arnsburg, Marie 1862- *DcWomA*
Arnsby, R M *AmArch 70*
Arnst, G Jeffrey 1952- *MarqDCG 84*
Arnstein, Gertrude *DcWomA, WhAmArt 85*
Arnstein, Helen *ArtsAmW 2, DcWomA, WhAmArt 85*
Arnt Von Dorenwerth *McGDA*
Arntzen, N G *AmArch 70*
Arntzenius, Pieter Florentius N Jacobus 1864-1925 *OxArt*
Aroch, Arie 1908- *PhDcTCA 77*
Aroch, Arieh 1908- *OxTwCA*
Aromatan, Dorotea *DcWomA*
Aromatari, Dorotea *DcWomA*
Aron, Kalman 1924- *WhoAmA 73, -76, -78, -80*
Aron-Caen, Louise *DcWomA*
Aronco, Raimondo D' 1857-1932 *EncMA*
Aronin, Jeffrey Ellis 1927- *AmArch 70*
Arons, Joyce 1948- *PrintW 83, -85*
Aronson, A *AmArch 70*
Aronson, Boris 1898-1980 *ConDes*
Aronson, Boris 1900- *McGDA, WhAmArt 85, WhoAmA 73, -76, -78, -80*
Aronson, Boris 1900-1980 *WhoAmA 82N, -84N*
Aronson, Cliff 1924- *WhoAmA 76, -78, -80, -82, -84*
Aronson, Cyril 1918- *WhAmArt 85*
Aronson, David 1923- *DcCAA 71, -77, McGDA, WhAmArt 85, WhoAmA 73, -76, -78, -80, -82, -84*
Aronson, Harry Harold *WhAmArt 85*
Aronson, Irene Hilde 1918- *WhoAmA 73, -76, -78, -80, -82, -84*
Aronson, Joseph 1898- *WhAmArt 85, WhoAmA 73, -76*
Aronson, Meta *DcVicP 2, DcWomA*
Aronson, Richard 1928- *AmArch 70*
Aronson, Sanda 1940- *WhoAmA 78, -80, -82, -84*
Aronson, Steven Morris 1949- *WhoAmA 80*
Aronson-Danzig, Marta *DcWomA*
Arootian, Mrs. Baidzar H 1899- *DcWomA, WhAmArt 85*
Arora, Dinesh K 1952- *MarqDCG 84*
Arosa, Marguerite *DcWomA*
Arosenius, Karin Magdalena 1851- *DcWomA*
Arouni, Lynette *WhAmArt 85*
Arouni, N G 1888- *ArtsAmW 3*
Arp, Hans 1886-1966 *ConArt 77, -83*
Arp, Hans 1887-1966 *PhDcTCA 77*
Arp, Hilda Dora 1909- *WhoAmA 73*
Arp, Jean 1887-1966 *McGDA, OxArt, OxTwCA, PhDcTCA 77, WorArt[port]*
Arp, Jean Hans 1887-1966 *ClaDrA*
Arp, Sophie Henriette *DcWomA*
Arpa, Jose 1862?-1952 *ArtsAmW 2*
Arpa, Jose 1868- *ArtsAmW 1, WhAmArt 85*
Arpa Y Perea, Jose 1868?- *IIBEAAW*
Arphe, Antonio De *McGDA*
Arpin, Raymond Anthony 1949- *MarqDCG 84*
Arpino, Cavaliere D' *OxArt*
Arpino, Il Cavaliere D' 1568?-1640 *McGDA*
Arps, John Eric 1957- *MarqDCG 84*
Arquin, Florence 1900- *WhAmArt 85*
Arquinvilliers, Rose *DcWomA*
Arrandale-Williams, Roger 1946- *MacBEP*
Arranz Bravo, Eduardo 1941- *ConArt 77*
Arregui, Romana 1875- *DcWomA*
Arriaga, Esteban 1922- *DcSeaP*
Arridge, Margaret Irene Chadwick 1921- *WhoArt 84*
Arrieta, Pedro De d1738 *MacEA*
Arrighi, Romilda 1868- *DcWomA*
Arrigo Fiammingo 1520?-1600? *McGDA*
Arrigo, A J *AmArch 70*
Arrigoni, Attilio *MacEA*
Arrigucci, Luigi 1575- *MacEA*
Arriola, Fortunato 1827-1872 *ArtsAmW 1, IIBEAAW, NewYHSD*
Arriola, Gus 1917- *WorECom*
Arris, John 1725?-1799 *McGDA*
Arrison, J B, III *AmArch 70*
Arrobus, Sydney 1901- *ClaDrA, DcBrA 1, WhoArt 80, -82, -84*
Arroll, Richard Hubbard 1853- *DcBrA 1*
Arroll, Richard Hubbard 1853-1931 *DcBrWA*
Arrow, James d1791 *BiDBrA*
Arrowsmith, Aaron 1750-1833 *AntBDN I*

Arrowsmith, H *DcVicP 2*
Arrowsmith, H J *DcVicP 2*
Arrowsmith, Hannah F *DcVicP 2, DcWomA*
Arrowsmith, Thomas 1772-1829? *DcBrECP*
Arroyo, Eduardo 1937- *ConArt 77, -83, DcCAr 81*
Arroyo, N R *AmArch 70*
Arruda, Diego De *WhoArch*
Arruda, Diogo De *OxArt*
Arruda, Francisco De *OxArt*
Arseneault, F F *AmArch 70*
Arsenicos, Rudolph M 1930- *AmArch 70*
Arsic, Milutin *OxTwCA*
Arson, Alphonse-Alexandre 1822-1880 *DcNiCA*
Arson, Olympe 1814-1870? *DcWomA*
Arsovski, Mihajlo 1937- *WhoGrA 82[port]*
Arsworth, Cynthia *FolkA 86*
Art, Berthe 1857- *ClaDrA, DcWomA*
Artan, Louis 1837-1890 *ClaDrA*
Artaria, Mathias 1815?- *ArtsNiC*
Artaria, Paul 1892-1959 *MacEA*
Artaud, Felicie *DcWomA*
Artaud, William 1763-1823 *DcBrECP*
Arteaga, Jorge Adolfo De 1926- *WhoGrA 62*
Arteche 1934- *WhoAmA 84*
Artemis, Maria 1945- *WhoAmA 82, -84*
Arter, Charles J d1923 *WhAmArt 85*
Arter, Dean Edwin 1927- *AmArch 70*
Arthois, Jacques D' 1613-1686 *McGDA, OxArt*
Arthois, Jacques Van 1613-1686? *ClaDrA*
Arthur, A E, Jr. *AmArch 70*
Arthur, Edouard 1917- *DcCAr 81*
Arthur, Eric Stafford 1894- *DcBrA 1*
Arthur, Harry H Gascoign 1920- *WhoArt 82, -84*
Arthur, Herbert Henry Gascoign 1920- *WhoArt 80*
Arthur, Ingrid 1960- *DcCAr 81*
Arthur, John C 1939- *WhoAmA 78*
Arthur, John H V *NewYHSD*
Arthur, Katherine *DcWomA*
Arthur, Paul Francis 1942- *MarqDCG 84*
Arthur, Reginald *DcVicP 2*
Arthur, Revington *WhAmArt 85*
Arthur, Robert *DcVicP 2*
Arthur, Robert 1850-1914 *WhAmArt 85*
Arthur, Stanley Houghton 1912- *AmArch 70*
Arthur, Sydney Watson 1881- *DcBrA 1*
Arthur, W H *NewYHSD*
Arthur, Winifred *DcVicP 2, DcWomA*
Arthurs, Annie J 1845-1927 *DcWomA*
Arthurs, Stanley 1877- *WhAmArt 85*
Arthurs, Stanley M 1877-1950 *IlrAm A*
Arthurs, Stanley Massey 1877-1950 *IIBEAAW, IlrAm 1880*
Artiaga, J M 1928- *AmArch 70*
Artif, L *DcWomA*
Artigas, Francisco 1916- *MacEA*
Artigues, Aime-Gabriel D' 1778-1848 *IldCg*
Artine *DcWomA*
Artingstall, Margaret 1883- *WhAmArt 85*
Artingstall, Margaret 1883-1951 *DcWomA*
Artinian, Artine 1907- *WhoAmA 78, -80, -82, -84*
Artioli, Alfonso 1913- *WhoGrA 62, -82[port]*
Artis, William E 1914- *AfroAA*
Artis, William Ellisworth 1914- *WhoAmA 73, -76*
Artis, William Ellisworth 1914-1977 *WhoAmA 78N, -80N, -82N, -84N*
Artis Gener, Aveli 1912- *WorECar*
Artman, Abraham *FolkA 86*
Artman, John *CabMA*
Artner, Alan Gustav 1947- *MacBEP*
Arto *DcCAr 81*
Artois, Mister *NewYHSD*
Artois, Jacques Van *ClaDrA*
Artschwager, Richard 1923- *PrintW 83, -85*
Artschwager, Richard 1924- *ConArt 83, DcCAA 71, -77, OxTwCA*
Artschwager, Richard Ernst 1923- *AmArt, WhoAmA 80, -82, -84*
Artschwager, Richard Ernst 1924- *ConArt 77, WhoAmA 73, -76, -78*
Artschwager, Richard Ernst 1926- *DcCAr 81*
Artsens, Isabella *DcWomA*
Artur, J *WorECar*
Artus, Lucile *DcWomA*
Artymowski, Roman 1919- *PhDcTCA 77*
Artz, Adolph *ArtsNiC*
Artz, David Adolf Constant 1837-1890 *ClaDrA*
Artz, Frederick B 1894- *WhoAmA 73, -76, -78, -80, -82*
Artz, Frederick B 1894-1983 *WhoAmA 84N*
Artz, William *FolkA 86*
Artzybasheff, Boris d1965 *WhoAmA 80N, -82N, -84N*
Artzybasheff, Boris d1965 *WhoAmA 78N*
Artzybasheff, Boris 1899-1965 *IlrAm D, -1880, WhAmArt 85*
Artzybasheff, Boris Mikhailovich 1899-1965 *ConICB, IlsCB 1744, WhoGrA 62*
Aruego, Jose *IlsCB 1967*
Aruego, Jose 1932- *IlsBYP*
Aruga, M *AmArch 70*
Arum, Barbara 1937- *WhoAmA 82, -84*

Arundale, Francis 1807-1853 *DcVicP*
Arundale, Mrs. Francis 1806?- *DcWomA*
Arundale, Francis Vyvyan Jago 1807-1853 *BiDBrA, DcBrBI, DcBrWA, DcVicP 2*
Arundel, James 1875- *DcBrA 1*
Arundel, Kate *DcVicP 2, DcWomA*
Arundel, Thomas Howard, Earl Of 1586-1646 *OxArt*
Arup, Sir Ove 1895- *ConArch, WhoArch*
Arup, Ove Nyquist 1895- *McGDA*
Arvai, Maureen *MarqDCG 84*
Arvesen, Agnes 1881- *DcWomA*
Arvidson, Christina *DcWomA*
Arwin, Kathleen G *WhoAmA 78, -80, -82*
Arwin, Lester B *WhoAmA 73, -76, -78, -80, -82*
Ary, Henry 1802?-1859 *NewYHSD*
Arye, Leonora E 1931- *WhoAmA 82, -84*
Arzere, Stefano Dell' *McGDA*
Arzt, Lubomir 1946- *DcCAr 81*
Asah, Spencer 1907?-1954 *IIBEAAW*
Asam, Cosmas Damian 1686-1739 *DcD&D, MacEA, McGDA, WhoArch*
Asam, Egid Quirin 1692-1750 *DcD&D, MacEA, McGDA, OxArt, WhoArch*
Asam, Hans Georg 1649-1711 *DcD&D*
Asam, Johanna Nepomucena *DcWomA*
Asam, Kosmas Damian 1686-1739 *OxArt*
Asamoto, N B *AmArch 70*
Asanger, Jacob 1887- *WhAmArt 85*
Asante, Kwasi Seitu 1942- *WhoAmA 78, -80*
Asante, Kwesi Seitu 1942- *WhoAmA 82*
Asawa, Ruth 1926- *DcCAr 81, WhoAmA 73, -76, -78, -80, -82, -84*
Asbel, Joseph 1921- *WhoAmA 76, -78, -80*
Asbjorsen, Sigvaid 1867- *WhAmArt 85*
Asbury, C E *AmArch 70*
Asbury, Dana 1953- *MacBEP*
Asbury, Lenore 1866-1933 *DcWomA*
Asbury, Louis H *AmArch 70*
Asbury, Louis H, Jr. 1912- *AmArch 70*
Asbury, U F *AmArch 70*
Ascenzo, Myrtle Goodwin D' *DcWomA*
Asch, Frank Edward 1946- *IlsCB 1967*
Asch, Pieter Jansz Van 1603-1678 *ClaDrA*
Asch, Stan 1911- *WhoAmA 76, -78, -80*
Asch, Stan William Joseph 1911- *WhAmArt 85*
Aschan, Marit Guinness *WhoArt 80, -82, -84*
Asche, Isabelle Catherine Van *DcWomA*
Aschehoug, Dina Engel Laurentse 1861- *DcWomA*
Aschenbach, Paul 1921- *WhoAmA 73, -76, -78, -80, -82, -84*
Aschenbrenner, Lennart 1943- *DcCAr 81*
Ascher, Mary *WhoAmA 76, -78, -80, -82, -84*
Ascher, Mary 1900- *AmArt*
Ascher, Mary G *WhoAmA 73*
Ascherman, Herbert, Jr. 1947- *MacBEP*
Ascherson, Pamela 1923- *DcBrA 1*
Aschert Brothers *FolkA 86*
Aschieri, Pietro 1889-1952 *MacEA*
Aschieri, Trabisonda *DcWomA*
Aschmeier, Stan William Joseph 1911- *WhAmArt 85*
Ascian 1943- *WhoAmA 82, -84*
Ascott, Roy 1934- *WhoAmA 76, -78, -80, -82*
Ascroft, William *DcVicP, -2*
Asencio, Jose L 1941- *MarqDCG 84*
Ash, Albert Edward *DcVicP 2*
Ash, Alfred Frank 1917- *AmArch 70*
Ash, Charles S 1917- *AmArch 70*
Ash, Chrissie *DcVicP 2*
Ash, Christie *DcWomA*
Ash, Donald 1890-1954 *DcBrA 1*
Ash, Gilbert 1717-1785 *AntBDN G, CabMA, OxDecA*
Ash, H *DcVicP 2*
Ash, Ivor Haig 1924- *AmArch 70*
Ash, John Willsteed *DcBrWA*
Ash, Jutta 1942- *IlsCB 1967*
Ash, Percy 1865-1933 *BiDAmAr*
Ash, Stuart B 1942- *WhoGrA 82[port]*
Ash, Thomas *CabMA, OxDecA*
Ash, Thomas Morris *DcVicP 2*
Ash, William *CabMA, OxDecA*
Ashbaugh, Dennis John 1946- *AmArt, WhoAmA 76, -78, -80, -82, -84*
Ashbaugh, Harry John 1922- *AmArch 70*
Ashbee, Agnes *DcWomA*
Ashbee, C R 1863-1942 *MacEA*
Ashbee, Charles Robert 1863-1942 *AntBDN A, -B, DcNiCA, OxArt, OxDecA, WhoArch*
Ashberry *FolkA 86*
Ashbery, John Lawrence 1927- *WhoAmA 78, -80, -82, -84*
Ashbrook, Carolyn S *WhAmArt 85*
Ashbrook, Paul 1867- *WhAmArt 85*
Ashburner, G *DcVicP 2*
Ashburner, Joseph H 1872-1939 *DcBrA 1*
Ashburnham, George Percy 1815?-1886? *DcBrWA*
Ashburnham, Nancy d1818 *DcWomA*
Ashburton, Mary *DcWomA, WhAmArt 85*
Ashby, Miss *DcVicP 2*
Ashby, Carl 1914- *WhoAmA 76, -78, -80, -82, -84*
Ashby, Caroline 1954- *DcCAr 81*

Ashby, Derek Joseph 1926- *WhoArt 80, –82, –84*
Ashby, H *DcVicP 2*
Ashby, H P *DcVicP, –2*
Ashby, Henry *DcBrECP*
Ashby, Henry Pollard 1809-1892 *DcBrWA*
Ashby, Ingabord Tames *ArtsAmW 3*
Ashby, Keith Hamilton 1921- *AmArch 70*
Ashby, Margaret E 1860- *DcBrA 1, DcWomA*
Ashby, Paul W 1893- *WhAmArt 85*
Ashby, Robert *DcVicP 2*
Ashby, Steve 1904?-1980 *FolkA 86*
Ashcroft, David P 1934- *AmArch 70*
Ashcroft, Nigel 1951- *DcCAr 81*
Ashcroft, Richard Thomas 1934- *MarqDCG 84*
Ashe, Edmund M *WhAmArt 85*
Ashe, Edmund M 1867-1941 *IlrAm B, –1880*
Ashe, Faith *WhoArt 80, –82, –84*
Ashe, J W L *DcVicP 2*
Ashe, John Grange, Jr. 1910- *AmArch 70*
Ashe, Margaret L *DcWomA, WhAmArt 85*
Ashe, Thomas *FolkA 86*
Ashe, William A *NewYHSD*
Ashelman, Walter A *WhAmArt 85*
Ashenden, Edward James 1896 *DcBrA 1*
Asher, Betty M *WhoAmA 73, –76, –78*
Asher, Elise *WhoAmA 80, –82, –84*
Asher, Elise 1914- *WhoAmA 76, –78*
Asher, Florence May *WhoArt 80N*
Asher, Florence May 1888- *DcBrA 1, DcWomA*
Asher, Frederick M 1941- *WhoAmA 73, –76, –80, –82, –84*
Asher, Lila Oliver *WhoAmA 73, –76, –78, –80, –82, –84*
Asher, Lila Oliver 1921- *AmArt, WhAmArt 85*
Asher, Michael 1943- *ConArt 77, –83, WhoAmA 78, –80, –82, –84*
Asherman, Edward H 1878- *WhAmArt 85*
Ashevak, Kenojuak *WhoAmA 78, –80*
Ashford, Bette Beggs *WhAmArt 85*
Ashford, Colin James 1919- *DcBrA 2*
Ashford, Daniel d1842 *DcBrWA*
Ashford, Drue *WhoAmA 80*
Ashford, Edith *DcWomA*
Ashford, Frank Clifford *WhAmArt 85*
Ashford, Frank Clifford 1880-1960 *ArtsAmW 2*
Ashford, Pearl J *WhoAmA 76, –80*
Ashford, Samuel Briggs 1932- *AmArch 70*
Ashford, Snowden 1866-1927 *BiDAmAr*
Ashford, William 1746?-1824 *DcBrECP, DcBrWA*
Ashforth, Ellis *AntBDN N*
Ashihara, Yoshinobu 1918- *ConArch*
Ashiwara, Ko *WhAmArt 85*
Ashiwara, Yoshinobu 1918- *MacEA*
Ashjian, H *AmArch 70*
Ashley *AntBDN N, ConDes, WhoGrA 62*
Ashley, Mrs. *DcBrECP*
Ashley, Alfred *DcBrBI, DcVicP 2*
Ashley, Anita C *DcWomA, WhAmArt 85*
Ashley, C E, Jr. *AmArch 70*
Ashley, Charles G *ArtsEM*
Ashley, Clifford W *FolkA 86*
Ashley, Clifford W 1881- *WhAmArt 85*
Ashley, Clifford Warren 1881-1947 *IlrAm B, –1880*
Ashley, D C *AmArch 70*
Ashley, F M *DcVicP 2*
Ashley, Fletcher *AmArch 70*
Ashley, Frank Nelson 1920- *WhoAmA 73*
Ashley, J *DcVicP 2*
Ashley, James Eaton 1926- *AmArch 70*
Ashley, L Seymour d1912 *WhAmArt 85*
Ashley, Laura *WorFshn*
Ashley, Laura 1926- *ConDes*
Ashley, Mary S *ArtsEM, DcWomA*
Ashley, Solomon *NewYHSD*
Ashley, Solomon 1754-1823 *FolkA 86*
Ashley, Warren Henry 1909- *AmArch 70*
Ashley, Mrs. William A *ArtsEM, DcWomA*
Ashlin, George C 1837-1922 *DcBrA 1*
Ashmann, Jon 1950- *MarqDCG 84*
Ashmead, M *DcWomA*
Ashmore, A P *FolkA 86*
Ashmore, Abraham V *FolkA 86*
Ashmore, Charles *DcVicP 2*
Ashmore, Charles d1925 *DcBrA 2*
Ashmore, Charles 1823?- *DcBrWA*
Ashmore, W *FolkA 86*
Ashor, Edward Ramses 1934- *AmArch 70*
Ashpitel, Arthur 1807-1869 *DcBrWA*
Ashpitel, William Hurst 1776-1852 *BiDBrA, DcBrWA*
Ashton, Lady *WorFshn*
Ashton, Auto *NewYHSD*
Ashton, Carol Ruth 1950- *MarqDCG 84*
Ashton, Dore *WhoAmA 80, –82, –84*
Ashton, Dore 1928- *WhoAmA 73, –76, –78*
Ashton, E *DcVicP 2*
Ashton, Ethel V *WhAmArt 85*
Ashton, Ethel V d1975 *WhoAmA 76N, –78N, –80N, –82N, –84N*
Ashton, G A *DcVicP 2*
Ashton, G F *DcVicP 2*
Ashton, G R *DcVicP 2*

Ashton, G Rossi *DcBrBI*
Ashton, George Rossi 1857- *DcBrA 2*
Ashton, Gertrude Annie d1918 *DcBrA 2*
Ashton, H *DcVicP 2*
Ashton, H S *CabMA*
Ashton, James 1860-1935 *DcSeaP*
Ashton, James Daniel 1875-1942 *DcSeaP*
Ashton, Sir John William 1881-1963 *DcBrA 1*
Ashton, Julian R *DcVicP, –2*
Ashton, Julian Rossi 1851-1942 *DcBrA 2, McGDA*
Ashton, Mal Stanhope 1878-1976 *WhoAmA 80N, –82N, –84N*
Ashton, Matthew *DcBrECP*
Ashton, May Malone d1976 *WhAmArt 85*
Ashton, May Stanhope 1878?-1976 *DcWomA, WhoAmA 78N*
Ashton, R J *AmArch 70*
Ashton, Robert E 1924- *AmArch 70*
Ashton, Thomas B *NewYHSD*
Ashton, William H *NewYHSD*
Ashton-Bostock, David A 1932- *WhoArt 80, –82, –84*
Ashur, Michael *DcCAr 81*
Ashwell, Miss *DcVicP 2*
Ashwell, Mrs. *DcVicP 2*
Ashwell, Ellen *DcVicP 2, DcWomA*
Ashwell, Lawrence Tom *DcVicP 2*
Ashwell, Thomas *BiDBrA*
Ashworth, Bradford 1892- *WhAmArt 85*
Ashworth, C S *AmArch 70*
Ashworth, Dell S 1923- *AmArch 70*
Ashworth, G *AntBDN N*
Ashworth, G B *WhAmArt 85*
Ashworth, George L *DcNiCA*
Ashworth, George Leach *DcNiCA*
Ashworth, Helen *FolkA 86*
Ashworth, Joe Harmon 1924- *AmArch 70*
Ashworth, John 1942- *DcCAr 81*
Ashworth, Susan A *DcVicP 2, DcWomA*
Ashworth, Taylor 1837-1910 *DcNiCA*
Asimov, Daniel Alan 1947- *MarqDCG 84*
Asinc, George William 1929- *AmArch 70*
Ask, Elaine 1952- *WhoArt 84*
Askenazy, Maurice 1888-1951 *WhAmArt 85*
Askenazy, Mischa 1888-1961 *ArtsAmW 1, WhoAmA 80N, –82N, –84N*
Askevold, Anders Monsen 1834-1900 *ClaDrA*
Askevold, David 1940- *ConArt 77, –83, WhoAmA 78, –80, –82, –84*
Askew, Felicity Katherine Sarah 1894- *ClaDrA, DcBrA 1, DcWomA*
Askew, Jack Grover 1923- *AmArch 70*
Askew, John *DcSeaP*
Askew, L H *AmArch 70*
Askew, Pamela *WhoAmA 76, –78, –80, –82, –84*
Askew, Richard *AntBDN M*
Askew, Richard J *DcVicP 2*
Askew, Victor *ClaDrA, WhoArt 80N*
Askew, Victor 1909- *DcBrA 1*
Askew, William *CabMA*
Askild, Anita *WhoAmA 76, –78, –80*
Askin, Arnold Samuel 1901- *WhoAmA 73, –76, –78, –80, –82*
Askin, Jules 1900- *WhAmArt 85*
Askin, Ralph J 1931- *AmArch 70*
Askin, Walter 1929- *PrintW 83, –85*
Askin, Walter Miller 1929- *WhoAmA 76, –78, –80, –82, –84*
Asklof, G C *AmArch 70*
Askman, Tom K 1941- *WhoAmA 78, –80, –82, –84*
Askren, Walter *WhAmArt 85*
Askue, Russell P *WhAmArt 85*
Aslesen, Herbert Matthew 1934- *AmArch 70*
Aslin, Charles Herbert 1893-1959 *ConArch, DcD&D[port], EncMA*
Asmar, Alice *AmArt, WhoAmA 73, –76, –78, –80, –82, –84*
Asmar, Alice 1929- *IlBEAAW*
Asmus, Dieter 1939- *OxTwCA*
Asmussen, Andreas 1913- *WorECar*
Asmussen, Des *IlsBYP*
Asoma, Tadashi 1923- *WhoAmA 73, –76, –78, –80, –82, –84*
Aspden, Ruth Spencer 1909- *DcBrA 1*
Aspell, Lillian d1944 *WhAmArt 85*
Aspell, R C *NewYHSD*
Aspell, Seddie B *WhAmArt 85*
Aspell, Seddie B d1927 *DcWomA*
Asper, Hans 1499-1571 *McGDA*
Asper, Hans John 1499-1571 *ClaDrA*
Asper, Hans Leu *McGDA*
Asper, Holbein *McGDA*
Aspertini, Amico 1478?-1552 *McGDA*
Aspetti, Tiziano 1565-1607 *McGDA*
Aspevig, Clyde *OfPGCP 86*
Aspgren, R E *AmArch 70*
Aspinal, George S *DcVicP 2*
Aspinall, J *DcBrWA*
Aspinall, James P *ArtsEM*
Aspinall, Philip *ArtsEM*
Aspinwall, Horatio G *NewYHSD*
Aspinwall, James L 1854-1936 *BiDAmAr, MacEA*

Aspinwall, Reginald 1858-1921 *DcBrA 1, DcBrWA, DcVicP 2*
Aspland, Theophilus Lindsey 1807-1890 *DcBrWA*
Asplund, Erik Gunnar 1885-1940 *EncMA, MacEA, McGDA, OxArt*
Asplund, Gunnar 1885-1940 *ConArch, DcD&D[port], WhoArch*
Asplund, Karl *WhoArt 80N*
Asplund, Maria *DcWomA*
Asplund, Tore *WhAmArt 85*
Aspney, Amelia *DcWomA*
Asprey, Amelia *DcVicP 2*
Asprucci, Antonio 1723-1808 *MacEA*
Asquith, Brian 1930- *ConDes*
Assche, Amelie Van 1804-1848? *DcWomA*
Assche, Isabelle Catherine Van 1794- *DcWomA*
Asscher, Sofy 1901- *DcBrA 1, WhoArt 80, –82, –84*
Asse, Genevieve 1923- *DcCAr 81*
Asselbergs, Alphonse 1839- *ClaDrA*
Asselijn, Jan 1615?-1652 *ClaDrA*
Asselin, Jan 1610-1652? *ClaDrA*
Asselin, Maurice 1882-1947 *ClaDrA, McGDA, OxTwCA*
Asselineau, Antoinette 1811- *DcWomA*
Asselyn, Jan 1610-1652? *ClaDrA*
Asselyn, Jan 1610-1652 *OxArt*
Assen, Jacob Walter Van 1475-1555 *ClaDrA*
Assen, Jan Van 1635?-1697 *ClaDrA*
Assenbaum, Fanny 1848- *DcWomA*
Asser, Richard Charles 1896- *DcBrA 1*
Assereto, Gioacchino 1600-1649 *McGDA*
Assheton, William 1758-1833 *DcBrWA*
Assinare, Constance 1868- *DcWomA*
Assis, Donna Branca *DcWomA*
Ast, Balthasar VanDer 1593?-1657 *OxArt*
Astbury, John 1688-1743 *AntBDN M, DcD&D*
Astbury, Thomas *AntBDN M*
Astengo, Giovanni 1915- *MacEA*
Astens, Thomas *CabMA*
Aster, George Harry 1932- *AmArch 70*
Asti, Sergio 1926- *ConDes*
Astin, John H *WhAmArt 85*
Astle, Neil 1933- *AmArch 70*
Astley, Henry *DcBrWA*
Astley, John 1724-1787 *DcBrECP*
Astley, John 1730?-1787 *BiDBrA*
Astley, Rhoda 1725-1757 *DcBrECP*
Astley, Robert Elleray 1944- *MarqDCG 84*
Astley-Bell, Rita Duis *WhoAmA 78, –80, –82, –84*
Astman, Barbara 1950- *ConPhot*
Astman, Barbara Ann 1950- *WhoAmA 80, –82, –84*
Astman, Barbara Anne 1950- *DcCAr 81, WhoAmA 78*
Aston, Charles Reginald *DcVicP*
Aston, Charles Reginald 1832-1908 *DcBrA 1, DcBrWA, DcVicP 2*
Aston, Evelin Winifred *WhoArt 80N*
Aston, Evelin Winifred d1975 *DcBrA 2*
Aston, J *DcVicP 2*
Aston, Lilias *DcVicP 2, DcWomA*
Aston, Miriam *WhoAmA 82, –84*
Astor *DcBrBI*
Astore, Pasqual T 1924- *AmArch 70*
Astori, K Astafieff *WhAmArt 85*
Astoud-Trolley, Louise 1828-1884 *DcWomA*
Astrid 1936- *MacBEP*
Astrom, Eva Matilda 1865- *DcWomA*
Astuto-Palli, Angela *DcWomA*
Aswegan, Galen Dean 1956- *MarqDCG 84*
Ata Allah d1665? *MacEA*
Atamanov, Lev Konstantinovich 1905- *WorECar*
Atche, Jane *DcWomA*
Atcherley, Ethel *DcVicP 2*
Atcheson, D L *FolkA 86*
Atcheson, H S *FolkA 86*
Atcheson, James Edward 1906- *AmArch 70*
Atchison, Joseph Anthony 1895- *WhAmArt 85*
Atchison, P *AmArch 70*
Atchison, Philip 1929- *AmArch 70*
Atchley, Whitney 1908- *WhAmArt 85*
Atelier Five *ConArch*
Atencio, Gilbert *WhAmArt 85*
Atencio, Gilbert Benjamin 1930- *IlBEAAW*
Atencio, Patricio *FolkA 86*
Atget, Eugene 1857-1927 *ConPhot, ICPEnP*
Atget, Jean-Eugene-Auguste 1856-1927 *MacBEP*
Atget, Jean-Eugene-Auguste 1857-1927 *PrintW 85*
Athalie, Mademoiselle *DcWomA*
Athanasius, Brother 1893- *WhAmArt 85*
Athanasius, Saint 296?-373 *McGDA*
Athar, Chiam 1902- *ClaDrA*
Athena 1928- *WhoAmA 76, –78*
Athenas, Anne *DcWomA*
Athenas, Emilie *DcWomA*
Atherton, Ezra *NewYHSD*
Atherton, J Carlton d1964 *WhoAmA 78N, –80N, –82N, –84N*
Atherton, J Carlton 1900-1964 *WhAmArt 85*
Atherton, John d1952 *WhoAmA 78N, –80N, –82N, –84N*
Atherton, John 1900-1952 *IlrAm E, –1880,*

WhAmArt 85
Atherton, John C 1900- *DcCAA 71*
Atherton, John C 1900-1952 *DcCAA 77*
Atherton, John Smith *ClaDrA, DcBrA 1*
Atherton, Olive E D 1905-1970 *DcBrA 2*
Atherton, Thomas H 1894- *AmArch 70*
Atherton, Thomas Jean 1919- *AmArch 70*
Atherton, Walter 1863-1945 *BiDAmAr*
Athes-Perrelet, Louise *DcWomA*
Athey, Ruth *DcWomA*
Athey, Ruth C 1892- *WhAmArt 85*
Athfield, Ian 1940- *ConArch*
Athol-Shmith, Louis 1914- *MacBEP*
Athow, T *DcBrWA*
Atinay, Elizabeth May 1940- *AmArch 70*
Atirnomis 1938- *PrintW 83, –85, WhoAmA 78, –80, –82, –84*
Atkenson, Peter *NewYHSD*
Atkin, Ann 1937- *WhoArt 80, –82, 84*
Atkin, James 1832?- *NewYHSD*
Atkin, John *DcBrWA*
Atkin, Liz 1951- *WhoArt 80, –82, –84*
Atkin, Mildred 1903- *WhAmArt 85*
Atkin, Peter 1926- *WhoArt 80, –82, –84*
Atkin, Ron 1938- *ClaDrA, WhoArt 80, –82, –84*
Atkin, William Gabriel 1897-1937 *DcBrA 1*
Atkins, A D W *FolkA 86*
Atkins, Alan 1910- *WhAmArt 85*
Atkins, Albert H d1951 *WhoAmA 78N, –80N, –82N, –84N*
Atkins, Albert Henry d1951 *WhAmArt 85*
Atkins, Albert W *ArtsEM*
Atkins, Arthur 1873-1899 *ArtsAmW 1, –3*
Atkins, Billy W 1943- *WhoAmA 78*
Atkins, Catherine J *DcBrA 1, DcVicP, –2, DcWomA*
Atkins, Catherine J 1846?- *DcBrWA*
Atkins, Clinton Paul 1909- *AmArch 70*
Atkins, David 1910- *WhAmArt 85, WhoAmA 73, –76*
Atkins, Dorothy 1936- *AfroAA*
Atkins, Edward M *DcVicP 2*
Atkins, Edwin Parker *AmArch 70*
Atkins, Elsie *DcWomA*
Atkins, Emmeline *DcBrWA, DcVicP 2, DcWomA*
Atkins, Florence Elizabeth *ArtsAmW 2*
Atkins, Florence Elizabeth d1946 *DcWomA, WhAmArt 85*
Atkins, G *DcWomA*
Atkins, George Henry *DcBrWA*
Atkins, George Henry 1811-1872 *DcSeaP*
Atkins, Gibbs 1739-1806 *CabMA*
Atkins, Gordon Lee 1937- *WhoAmA 76, –78, –80, –82, –84*
Atkins, Harry Joseph 1840-1916 *DcSeaP*
Atkins, Lloyd 1922- *IlDcG*
Atkins, Louise *DcWomA*
Atkins, Louise Allen *WhAmArt 85*
Atkins, Mary Elizabeth *DcBrA 1, DcWomA*
Atkins, Michael B 1941- *MarqDCG 84*
Atkins, Ollie 1916-1977 *ICPEnP A*
Atkins, Rosalie Marks 1921- *WhoAmA 76, –78, –80, –82, –84*
Atkins, Samuel *DcBrECP, DcBrWA, DcSeaP*
Atkins, Thomas *NewYHSD*
Atkins, William Edward 1842?-1910 *DcBrWA, DcSeaP*
Atkinson, Mister *NewYHSD*
Atkinson, Alice *DcWomA, WhAmArt 85*
Atkinson, Alice L M *DcWomA*
Atkinson, Alicia 1905- *WhAmArt 85*
Atkinson, Amy B *DcBrA 1, DcVicP 2, DcWomA*
Atkinson, Anthony 1929- *WhoArt 82, –84*
Atkinson, Anthony Claude 1929- *WhoArt 80*
Atkinson, Atmar Leonard 1914- *AmArch 70*
Atkinson, B T *DcVicP 2*
Atkinson, B W *DcVicP 2*
Atkinson, Carl N 1894- *AmArch 70*
Atkinson, Carl Napier, Jr. 1932- *AmArch 70*
Atkinson, Carla *WhAmArt 85*
Atkinson, Charles *BiDBrA, DcVicP 2*
Atkinson, Charles Gerard 1879- *DcBrA 1*
Atkinson, Charles Gerrard 1879- *ClaDrA*
Atkinson, Conrad 1940- *ConArt 77, –83, ConBrA 79[port], DcCAr 81*
Atkinson, Donald F 1931- *AmArch 70*
Atkinson, E *DcBrECP*
Atkinson, E H *WhAmArt 85*
Atkinson, E Marie *WhAmArt 85*
Atkinson, Edward 1929- *WhoArt 80, –82, –84*
Atkinson, Elizabeth H *DcWomA*
Atkinson, Eric Newton 1928- *DcBrA 1, WhoAmA 76, WhoArt 80, –82, –84*
Atkinson, Florence *DcWomA, WhAmArt 85*
Atkinson, Frederick *AntBDN O*
Atkinson, G B *DcWomA*
Atkinson, George *AntBDN O*
Atkinson, George 1880-1941 *DcBrA 1*
Atkinson, George 1915- *MacEA*
Atkinson, George Franklin 1822-1859 *DcBrBI, DcBrWA*

Atkinson, George Mounsey *DcVicP 2*
Atkinson, George Mounsey d1908 *DcBrWA*
Atkinson, George Mounsey Wheatley *DcVicP, –2*
Atkinson, George Mounsey Wheatley 1806?-1884 *DcBrWA*
Atkinson, H F *EncASM*
Atkinson, Herbert D *DcVicP 2*
Atkinson, Hilda Goffey *DcBrA 1, DcWomA*
Atkinson, J L *AmArch 70*
Atkinson, J M *DcVicP 2*
Atkinson, James *DcBrECP*
Atkinson, James 1780-1852 *DcBrWA, DcVicP 2*
Atkinson, Jane *DcBrWA*
Atkinson, John *BiDBrA, DcBrECP*
Atkinson, John 1805-1890 *ArtsEM*
Atkinson, John 1863-1924 *DcBrA 1, DcBrWA, DcVicP 2*
Atkinson, John Augustus 1775?-1833? *DcBrBI, DcBrWA*
Atkinson, John Gunson *DcVicP, –2*
Atkinson, John I *AfroAA*
Atkinson, John Ingliss 1909- *WhAmArt 85*
Atkinson, John Priestman *DcBrBI*
Atkinson, Kate E *DcVicP 2, DcWomA*
Atkinson, Kevin *OxTwCA*
Atkinson, Lawrence 1873-1931 *DcBrA 2, OxTwCA*
Atkinson, Leo F 1896- *WhAmArt 85*
Atkinson, Leo Franklin 1896- *ArtsAmW 2*
Atkinson, Lulu G *ArtsEM, DcWomA*
Atkinson, Marie *DcWomA*
Atkinson, Marion Koogler *ArtsAmW 3*
Atkinson, Marshall Forster 1913- *DcBrA 1, WhoArt 80, –82, –84*
Atkinson, Mary *DcVicP 2, DcWomA*
Atkinson, Mary B 1830?- *DcWomA, NewYHSD*
Atkinson, Mary Helena 1854-1888? *DcWomA*
Atkinson, Maud Tindall *DcWomA*
Atkinson, May *DcWomA*
Atkinson, Natalie Johnson 1898- *DcWomA, WhAmArt 85*
Atkinson, Parker 1780-1799 *CabMA*
Atkinson, Peter 1735-1805 *BiDBrA*
Atkinson, Peter, Jr. 1776?-1843 *BiDBrA*
Atkinson, R M *NewYHSD*
Atkinson, Richard 1750-1776 *DcBrECP*
Atkinson, Richard Peterson 1856?-1882 *DcBrWA*
Atkinson, Robert *DcBrWA*
Atkinson, Robert 1863-1896 *ClaDrA, DcBrWA, DcVicP 2*
Atkinson, Robert Anderson, Jr. 1923- *AmArch 70*
Atkinson, Sarah *DcWomA*
Atkinson, Sarah Weber *FolkA 86*
Atkinson, Sophia Mildred 1880-1972 *DcBrA 1, DcWomA*
Atkinson, Terrence Cloney 1915- *AmArch 70*
Atkinson, Terry 1939- *DcCAr 81*
Atkinson, Thomas 1729?-1798 *BiDBrA*
Atkinson, Thomas 1799-1861 *MacEA*
Atkinson, Thomas Witlam 1799?-1861 *DcBrBI, DcBrWA*
Atkinson, Tracy 1928- *WhoAmA 73, –76, –78, –80, –82, –84*
Atkinson, W A *ClaDrA, DcVicP, –2, FolkA 86*
Atkinson, W E *WhAmArt 85*
Atkinson, W E 1862- *DcBrA 2*
Atkinson, William 1773?-1839 *BiDBrA, DcBrWA, MacEA*
Atkinson, William Osborn 1913- *WhAmArt 85*
Atkinson, William Sackston 1864- *ArtsAmW 2*
Atkinson, Witlam 1773?-1861 *BiDBrA*
Atkinson And Baird *ArtsEM*
Atkinson And Godfrey *ArtsEM*
Atkinson And Parker *ArtsEM*
Atkyns, Lee 1913- *WhAmArt 85*
Atkyns, Lee, Jr. 1913- *WhoAmA 73, –76, –78, –80, –82, –84*
Atl, Doctor 1877-1964 *McGDA*
Atlan, Jean 1913-1960 *ConArt 77, –83, PhDcTCA 77*
Atlan, Jean-Michel 1913-1960 *OxTwCA*
Atlas, Liane W *WhoAmA 76, –78, –80, –82, –84*
Atlas, Martin *WhoAmA 76, –78, –80, –82, –84*
Atlee, Emilie DeS 1915- *WhoAmA 73*
Atlee, Emilie Des 1915- *AmArt, WhoAmA 76, –78, –80, –82, –84*
Atmar, R S *AmArch 70*
Atnanasov, Tordorce 1953- *DcCAr 81*
Atomi, Gyokushi 1859-1943 *DcWomA*
Atomi, Kakei 1840-1926 *DcWomA*
Atroshenko, Paul 1937- *DcCAr 81*
Attalai, Gabor 1934- *ConArt 77, –83*
Attalo *WorECar*
Attardi, Thomas 1900- *WhAmArt 85*
Attas, Benjamin 1921- *MacBEP*
Attavante Di Gabriello Vante F Bartolo 1452-1517 *McGDA*
Atterbury, Etta *WhAmArt 85*
Atterbury, Grosvenor 1869-1956 *BnEnAmA, MacEA*
Atterbury, Luffman d1796 *BiDBrA*
Attersee, Christian Ludwig 1941- *DcCAr 81*
Atteslander, Sofie Zo 1874- *DcWomA*

Attie, David Moses 1920- *MacBEP*
Attie, David Moses 1920-1983 *ICPEnP A*
Attie, Dotty 1938- *PrintW 83, –85, WhoAmA 76, –78, –80, –82, –84*
Attilio *WorECar*
Attinger, Lucie 1859- *DcWomA*
Attlee, Della *DcVicP 2, DcWomA*
Attlee, Kathleen Mabel *DcVicP 2, DcWomA*
Attlee, William *FolkA 86*
Attridge, Irma Gertrude 1894- *ArtsAmW 1, DcWomA, WhAmArt 85*
Attridge, K J *AmArch 70*
Attridge, Tom 1939- *PrintW 85*
Attwell, Emily A *DcBrBI*
Attwell, Mabel Lucie 1879- *DcBrBI*
Attwell, Mabel Lucie 1879-1964 *DcBrA 1, DcWomA, WorECar*
Attwell, Norman Stewart 1921- *DcBrA 1*
Attwood, E H *DcWomA*
Attwood, Miss E H *NewYHSD*
Attwood, Francis Gilbert 1856-1900 *WorECar*
Attwood, J M *FolkA 86*
Atwater, Caleb *FolkA 86*
Atwater, Edith *DcWomA*
Atwater, G Barry 1892-1956 *ArtsAmW 2*
Atwater, Grace E d1909 *WhAmArt 85*
Atwater, Grace Elisabeth d1909 *DcWomA*
Atwater, Ira *BiDAmAr*
Atwater, Jean Howe *WhAmArt 85*
Atwater, Joshua *FolkA 86*
Atwater, Mary 1878- *WhAmArt 85*
Atwell, Allen 1925- *WhoAmA 78, –80, –82, –84*
Atwell, Julia A Hill 1880-1930 *ArtsAmW 3*
Atwell, Julia Hill 1880-1930 *DcWomA, WhAmArt 85*
Atwell, Thomas B *WhAmArt 85*
Atwood, Annie K *DcWomA, WhAmArt 85*
Atwood, Charles B 1848-1895 *BiDAmAr, McGDA*
Atwood, Charles B 1849-1895 *MacEA*
Atwood, Clara *DcWomA*
Atwood, Clara E *WhAmArt 85*
Atwood, Clare 1866-1962 *DcBrA 1, DcWomA*
Atwood, Elbridge Laurence 1903- *AmArch 70*
Atwood, Francis Gilbert d1900 *WhAmArt 85*
Atwood, Glenn Arthur 1935- *MarqDCG 84*
Atwood, Helen *WhAmArt 85*
Atwood, Helen 1878- *DcWomA*
Atwood, J *NewYHSD*
Atwood, Jane Evelyn 1947- *ICPEnP A*
Atwood, Jeremiah *FolkA 86*
Atwood, Jesse 1802?-1854? *NewYHSD*
Atwood, John *DcBrECP*
Atwood, John Brett 1807- *CabMA*
Atwood, John M 1818?- *ArtsEM, NewYHSD*
Atwood, Lorena *DcWomA*
Atwood, Lorena F *WhAmArt 85*
Atwood, Mary Hall 1894- *ArtsAmW 2, DcWomA, WhAmArt 85*
Atwood, Robert 1892- *ArtsAmW 1, IlBEAAW, WhAmArt 85*
Atwood, Thomas *DcBrECP*
Atwood, Thomas Warr 1733?-1775 *BiDBrA*
Atwood, William A *ArtsEM*
Atwood, William C *NewYHSD*
Atwood, William E *WhAmArt 85*
Atwood, William F *NewYHSD*
Atwood Pinardi, Brenda 1941- *WhoAmA 84*
Atzenbeck, Charles Richard 1931- *MarqDCG 84*
Au, S W G *AmArch 70*
Aub, Jacob *NewYHSD*
Aub, M *DcWomA*
Aubain-Mounier, Therese 1877- *DcWomA*
Aubanel *NewYHSD*
Aubanel, Eugenie Etienette *DcWomA*
Aubaud, Marie Juliette *DcWomA*
Aube, Jean-Paul 1837- *ArtsNiC*
Aube, Marcelle *DcWomA*
Aube, Peter R *FolkA 86*
Auber, P *FolkA 86*
Auberg, John *NewYHSD*
Aubergeon, Marie Madeleine *DcWomA*
Auberger, Pidder 1946- *DcCAr 81*
Auberjonois, Rene 1872-1957 *McGDA, OxTwCA, PhDcTCA 77*
Aubert, Charles J *NewYHSD*
Aubert, Jean d1741 *MacEA, WhoArch*
Aubert, Jean-Ernest 1824- *ArtsNiC*
Aubert, Louis *McGDA*
Aubert, Mrs. Paul *ArtsAmW 3, DcWomA, NewYHSD*
Aubert, Stephanie *DcWomA*
Aubert-Gris, Jeanne Marcelle *DcWomA*
Aubertin, Bernard 1934- *ConArt 77, –83*
Aubertin, Jacques Marcel 1872-1926 *MacEA*
Aubery, Jean 1810-1893 *NewYHSD*
Aubin, Augustin *McGDA*
Aubin, Barbara 1928- *AmArt, WhoAmA 73, –76, –78, –80, –82, –84*
Aubin, Roland Mederic 1921- *AmArch 70*
Aubineau, Lewis *NewYHSD*
Aubinoe, A L *AmArch 70*

Aublet, Melanie Florence *DcWomA*
Aubock, Carl 1925- *ConDes*
Aubrey, Banquier Mortimer 1909- *AmArch 70*
Aubrey, H *DcVicP 2*
Aubrey, Mabel Kelley *DcWomA*, *WhAmArt 85*
Aubry *NewYHSD*
Aubry, Adolphe *NewYHSD*
Aubry, Alice *DcWomA*
Aubry, Clodagh 1937- *WorFshn*
Aubry, E E *AmArch 70*
Aubry, Etienne 1745-1781 *ClaDrA*, *McGDA*
Aubry, J *DcWomA*
Aubry, Jean *FolkA 86*
Aubry, Kirk *MarqDCG 84*
Aubry, Mathilde *DcWomA*
Aubry, Yvonne *DcWomA*
Aubry-Lecomte, Hyacinthe L W B 1787-1858 *McGDA*
Aubuchon, Joseph F 1953- *MarqDCG 84*
Auburn, Arthur Thomas 1907- *AmArch 70*
Aucello, Salvatore L 1903- *WhAmArt 85*
Auchiah, James 1906- *IlBEAAW*, *WhAmArt 85*
Auchmoody, Elaine Plishker 1910- *WhAmArt 85*
Auchy, Henry *FolkA 86*
Auckland, Fannie Louise 1868-1945 *DcWomA*
Audebert, Isaiah d1769 *CabMA*
Audebert, Marguerite *DcWomA*
Audebert, William A *NewYHSD*
Audebes, Rene 1921- *DcCAr 81*
Audemars, Marie Louise *DcWomA*
Audenaerde, Robert Van 1663-1743 *ClaDrA*, *McGDA*
Audet, Robert D 1951- *MarqDCG 84*
Audette, Anna Held *WhoAmA 82, -84*
Audette, Anna Held 1938- *PrintW 83, -85*
Audiat, Felicie *DcWomA*
Audibert, Louis 1818?- *NewYHSD*
Audibert, Nelda M *WhAmArt 85*
Audiffred, J *DcWomA*
Audigier, E D *WhAmArt 85*
Audin *NewYHSD*
Audin, Jr. *NewYHSD*
Audin, Anthony *FolkA 86*
Audley, Caroline 1864- *DcWomA*
Audra, Jeanne Jacqueline *DcWomA*
Audrain, Richard Owen, Jr. 1935- *AmArch 70*
Audran, Claude *OxDecA*
Audran, Claude, I *OxArt*
Audran, Claude, II *OxArt*, *OxDecA*
Audran, Claude, III 1658-1734 *McGDA*, *OxArt*, *OxDecA*
Audran, Coypel *OxDecA*
Audran, Errard *OxDecA*
Audran, Gerard 1640-1703 *McGDA*
Audran Family *OxArt*
Audsley, G A 1838-1925 *MacEA*
Audsley, George A 1838-1925 *BiDAmAr*
Audsley, Richard Eric 1911- *AmArch 70*
Audubon, Jean Jacques Fougere 1785-1851 *DcNiCA*
Audubon, John James 1782-1851 *ArtsNiC*
Audubon, John James 1785-1851 *AfroAA*, *AntBDN B*, *ArtsAmW 1*, *BnEnAmA*, *DcAmArt*, *GrBII[port]*, *IlBEAAW*, *McGDA*, *NewYHSD*, *OfPGCP 86A*, *OxArt*
Audubon, John Woodhouse 1812-1862 *ArtsAmW 1*, *IlBEAAW*, *NewYHSD*
Audubon, Lucy *DcWomA*
Audubon, Victor Gifford 1809-1860 *NewYHSD*
Audus, James 1781-1867 *BiDBrA*
Audy, Roy *NewYHSD*
Auegg-Dilg, Lory *DcWomA*
Auer, James Matthew 1928- *WhoAmA 76, -78, -80, -82, -84*
Auer, Lili *WhAmArt 85*
Auer, Nicolas *FolkA 86*
Auer, Susanna Maria Von *DcWomA*
Auer, William *WhAmArt 85*
Auerbach, Alice *DcWomA*
Auerbach, Arnold *WhoArt 82N*
Auerbach, Arnold 1898- *DcBrA 1*, *WhoArt 80*
Auerbach, Erich 1911-1977 *ConPhot*, *ICPEnP A*
Auerbach, Frank 1931- *ConArt 77, -83*, *ConBrA 79[port]*, *DcCAr 81*, *PhDcTCA 77*, *PrintW 83, -85*
Auerbach, Frank Helmuth 1931- *WhoArt 80, -82, -84*
Auerbach, Herbert Charles 1932- *AmArch 70*
Auerbach, M R *DcWomA*, *WhAmArt 85*
Auerbach, Marjorie 1932- *IlsCB 1957*
Auerbach, Seymour 1929- *AmArch 70*
Auerbach-Levy, William *WhoAmA 78N, -80N, -82N, -84N*
Auerbach-Levy, William 1889-1964 *WhAmArt 85*, *WorECar*
Auersperg, Wolfgang 1937- *DcCAr 81*
Aufeldt, Esther 1894- *DcWomA*
Aufenwerth, Johann d1728 *AntBDN M*
Auffenwerth, Sabina *DcWomA*
Aufray-Genestoux, Suzanne *DcWomA*
Augarde, Stephen Andre 1950- *IlsCB 1967*
Auge, Marie *DcWomA*
Augenblick, M S *AmArch 70*
Augenfeld, F *AmArch 70*
Auger *NewYHSD*

Auger, Aline *DcWomA*
Augero, Francesco *NewYHSD*
Augier, G L *AmArch 70*
Augsburg, D R *ArtsAmW 3*
Auguie, Aglae Louise *DcWomA*
Augur, Caroline Patience 1918- *WhAmArt 85*
Augur, Hezekiah 1791-1858 *ArtsNiC*, *BnEnAmA*, *DcAmArt*, *NewYHSD*
Augur, James McCuen 1935- *AmArch 70*
Augur, Ruth Monro *ArtsAmW 3*
August, Charles *CabMA*
August, William P 1842?- *NewYHSD*
Augusta, Princess Of Hesse-Kassel 1780-1841 *DcWomA*
Augusta Sophia 1768-1840 *DcWomA*
Augusta Sophia, Princess 1768-1840 *DcBrWA*
Augustabernard *FairDF FRA*, *WorFshn*
Auguste *AntBDN C*
Auguste, Jules-Robert 1789?-1850 *McGDA*
Auguste, T *AfroAA*
Auguste, Toussaint 1924- *McGDA*
Augustin, Edward Carl 1921- *AmArch 70*
Augustin, Jean Baptiste Jacques 1759-1832 *AntBDN J*, *ClaDrA*
Augustin, Baroness Maria 1810- *DcWomA*
Augustin, Pauline 1781-1865 *DcWomA*
Augustine Of Canterbury, Saint d605? *McGDA*
Augustine, Saint 354-430 *McGDA*
Augustson, Clyde Wilson 1935- *AmArch 70*
Augustus, Sampson d1811 *FolkA 86*
Aujame, Jean 1905-1965 *OxTwCA*
Aujard, Christian 1942- *FairDF FRA*
Aukerman, Elizabeth *WhAmArt 85*
Aukerman, Frank Charles, Jr. 1925- *AmArch 70*
Aul *NewYHSD*
Auld, John *DcVicP 2*
Auld, John Leslie 1914- *WhoArt 80*
Auld, John Leslie M 1914- *WhoArt 82, -84*
Auld, Patrick C *DcBrWA*, *DcVicP 2*
Auld, Wilberforce *FolkA 86*, *NewYHSD*
Auldridge, R L *AmArch 70*
Aulenti, Gae 1927- *ConArch*, *ConDes*
Aulich, Emma *DcWomA*, *WhAmArt 85*
Auliczek, Dominicus 1734- *AntBDN M*
Aulisio, Joseph P 1910-1974 *FolkA 86*
Aull, Jess Brown 1884- *WhAmArt 85*
Aull, Mrs. Jess Brown *DcWomA*
Aulman, Theodora 1882- *ArtsAmW 3*
Aulmann, Theodora *WhAmArt 85*
Aulmann, Theodora 1882- *ArtsAmW 3*, *DcWomA*
Aulmann, Theodore *WhAmArt 85*
Aulont, George 1888- *FolkA 86*
Ault *FolkA 86*
Ault, Charles H *WhAmArt 85*
Ault, Clarissa *DcNiCA*
Ault, George 1891-1948 *DcAmArt*, *OxTwCA*
Ault, George C 1891-1948 *DcCAA 71, -77*, *PhDcTCA 77*
Ault, George Christian 1891-1948 *IlBEAAW*
Ault, George Copeland d1948 *WhoAmA 78N, -80N, -82N, -84N*
Ault, George Copeland 1891-1948 *McGDA*, *WhAmArt 85*
Ault, Lee Addison 1915- *WhoAmA 73, -76, -78, -80, -82, -84*
Ault, Norman 1880-1950 *ConICB*, *DcBrBI*, *IlsCB 1744*
Ault, William 1841- *DcNiCA*
Aultman, Otis A 1874-1943 *MacBEP*
Auman, Fletcher *FolkA 86*
Aumonier, James 1832-1911 *DcBrA 1*, *DcBrWA*, *DcVicP, -2*
Aumonier, Louisa *DcVicP, -2*, *DcWomA*
Aumonier, Stacy *DcBrWA*
Aumont, Augustine *DcWomA*
Aumont, Louis Auguste Francois 1805-1879 *ClaDrA*
Aumont, Marie Suzanne *DcWomA*
Aunspaugh, V L *WhAmArt 85*
Aunspaugh, Vivian Louise *ArtsAmW 2*
Aunspaugh, Vivian Louise 1870-1960 *DcWomA*
Auping, Michael Graham 1949- *WhoAmA 80, -82, -84*
Auray, Mister *NewYHSD*
Aure, Mademoiselle D' *DcWomA*
Aures, Victor 1894- *WhAmArt 85*
Auria, Tom D' *WorFshn*
Auricoste, Emmanuel 1908- *OxTwCA*, *PhDcTCA 77*
Aurner, Kathryn 1898- *DcWomA*
Aurner, Kathryn Dayton 1898- *WhAmArt 85*
Aus, Carol 1868-1934 *DcWomA*, *WhAmArt 85*
Ausby, Ellsworth 1942- *AfroAA*
Ausby, Ellsworth Augustus 1942- *WhoAmA 80, -82, -84*
Auslander, Brenda J 1945- *WhoAmA 80*
Ausloos, Paul 1927- *ConPhot*, *ICPEnP A*
Ausse, Mrs. De *DcWomA*
Aust, Brother Gottfried *FolkA 86*
Austen, Alice *WhAmArt 85*
Austen, Alice 1866-1952 *ICPEnP A*, *MacBEP*
Austen, C 1917- *WhAmArt 85*
Austen, Cassandra Elizabeth *DcWomA*

Austen, Edward J 1850-1930 *ArtsAmW 2*
Austen, Henry Haversham Godwin- 1834-1923 *DcBrWA*
Austen, James 1765- *DcBrWA*
Austen, John 1886- *IlsCB 1744*
Austen, John A *DcBrA 1*
Austen, R *EarABI*, *NewYHSD*
Austen, Winifred Marie Louise *ClaDrA*
Austen, Winifred Marie Louise d1964 *DcBrA 1*, *DcWomA*
Austen, Winifred Marie Louise 1876-1964 *DcBrA 2*
Austin, Mrs. *DcVicP 2*, *DcWomA*
Austin, A A *FolkA 86*
Austin, A E *DcVicP 2*
Austin, Alan 1947- *MarqDCG 84*
Austin, Alexander *NewYHSD*
Austin, Amanda P 1856-1917 *WhAmArt 85*
Austin, Amanda Petronella d1917 *ArtsAmW 1*
Austin, Amanda Petronella 1856-1917 *DcWomA*, *IlBEAAW*
Austin, Anna Eleanor *DcWomA*
Austin, Arthur Everett, Jr. 1900- *WhAmArt 85*
Austin, Asa *CabMA*
Austin, Barbara Jean *WhoAmA 82, -84*
Austin, C M *AmArch 70*
Austin, Charles Percy 1883- *ArtsAmW 1*
Austin, Charles Percy 1883-1948 *IlBEAAW*, *WhAmArt 85*
Austin, Charles W *ArtsEM*
Austin, Christina *DcWomA*
Austin, Darrel 1907- *DcCAA 71, -77*, *WhAmArt 85*, *WhoAmA 73, -76, -78, -80, -82, -84*
Austin, David Etnier 1933- *AmArch 70*
Austin, Dorothy 1911- *WhAmArt 85*
Austin, Dorothy Elease 1926- *AfroAA*
Austin, Edmund James 1918- *AmArch 70*
Austin, Edward C *WhAmArt 85*
Austin, Ella M 1864- *ArtsAmW 2*, *DcWomA*
Austin, Emily *DcVicP 2*, *DcWomA*
Austin, Erma Fisk *DcWomA*
Austin, F Roberts *DcVicP 2*, *DcWomA*
Austin, Felix *DcNiCA*
Austin, Frederick George 1902- *DcBrA 1*
Austin, George 1787-1848 *BiDBrA*
Austin, H *DcBrWA*
Austin, Henry *DcBrBI*
Austin, Henry 1804-1891 *BiDAmAr*, *BnEnAmA*, *MacEA*
Austin, Howard B *WhAmArt 85*
Austin, Hubert J *DcVicP 2*
Austin, James 1788?- *CabMA*
Austin, Jessie 1806-1879 *AntBDN M*
Austin, Jo *AfroAA*
Austin, Jo-Anne Jordan 1925- *WhoAmA 76, -78, -80, -82, -84*
Austin, John, Jr. *CabMA*
Austin, John Vesper 1923- *AmArch 70*
Austin, Josiah 1740-1825 *CabMA*
Austin, Louise M 1903-1936 *WhAmArt 85*
Austin, Margaret Baer 1897- *DcWomA*, *WhAmArt 85*
Austin, Mary Fisher *DcWomA*, *WhAmArt 85*
Austin, Pat 1935- *WhoAmA 76*
Austin, Pat 1937- *WhoAmA 78, -80, -82, -84*
Austin, Peter H *FolkA 86*
Austin, Phil *IlsBYP*
Austin, Phil 1910- *WhoAmA 73, -76, -78, -80, -82, -84*
Austin, R O *AmArch 70*
Austin, Ralph John, Jr. 1925- *AmArch 70*
Austin, Raymond Follette 1903- *AmArch 70*
Austin, Richard 1688-1761 *CabMA*
Austin, Richard 1744-1826 *CabMA*
Austin, Robert Sargent 1895-1973 *DcBrA 1*
Austin, Roy *FolkA 86*
Austin, Samuel 1796-1834 *DcBrBI*, *DcBrWA*
Austin, Sarah 1843?-1909 *DcWomA*, *WhAmArt 85*
Austin, William *DcVicP 2*
Austin, William 1721-1820 *DcBrECP*, *DcBrWA*
Austin, William 1734- *CabMA*
Austin, William D 1856-1944 *BiDAmAr*
Austin, William Frederick 1833-1899 *DcBrWA*
Austin-Carter, Mathilde 1840- *DcBrA 2*, *DcWomA*
Austral *MacEA*
Austrian, Ben d1921 *WhAmArt 85*
Austrian, Florence 1889- *DcWomA*
Austrian, Florence H 1889- *WhAmArt 85*
Ausubel, Sheva 1896-1957 *DcWomA*, *WhAmArt 85*, *WhoAmA 80N, -82N, -84N*
Autant, Marie F *DcWomA*
Autenrieth, Charles *NewYHSD*
Autenrieth, Ludwig 1832?- *NewYHSD*
Autenrieth, W G *AmArch 70*
Auteroche, Eugenie Venot D' *DcWomA*
Auth, Robert R 1926- *WhoAmA 73, -76, -78, -80, -82, -84*
Auth, Susan Handler 1939- *WhoAmA 78, -80, -82, -84*
Auth, Tony 1942- *WhoAmA 78, -80*, *WorECar*
Auth, Tony, Jr. 1942- *WhoAmA 82, -84*
Authier, Henriette *DcWomA*

Autilio, Patrick Alan 1958- *MarqDCG 84*
Autio, Rudy 1926- *BnEnAmA, CenC[port], WhoAmA 80, -82, -84*
Autissier, Louis Marie 1772-1830 *AntBDN J*
Autorino, Anthony Michael 1937- *WhoAmA 73, -76*
Autreau, Louis 1692-1760 *ClaDrA*
Autry, Carolyn 1940- *WhoAmA 76, -78, -80, -82, -84*
Auty, Charles *DcVicP 2*
Auvera, Johann Wolfgang VanDer 1708?-1756 *McGDA*
Auvergne, Lina 1871- *DcWomA*
Auvil, Kenneth William 1925- *WhoAmA 73, -76, -78, -80, -82, -84*
Auzac DeLaMartinie, M D' *DcWomA*
Auzou, Pauline 1775-1835 *ClaDrA, DcWomA*
Avakian, John *AmArt, WhoAmA 73, -76, -78, -80, -82, -84*
Avancini, Bartolomeo 1600?-1658 *MacEA*
Avanessian, G S *AmArch 70*
Avanzi, Jacopo *McGDA*
Avanzini, Bartolommeo 1608?-1658 *McGDA*
Avanzo, Jacopo *McGDA*
Avanzo, Jacopo, Da Bologna *McGDA*
Avard, Berthe *DcWomA*
Avarne, Charlotte 1749-1826 *DcWomA*
Avati, James S 1912- *IlrAm 1880*
Avati, Mario 1921- *PrintW 85*
Aved, Anne Charlotte 1695- *DcWomA*
Aved, Jacques-Andre 1702-1766 *McGDA*
Aved, Jacques Andre Joseph 1702-1766 *ClaDrA*
Aved, Jacques Andre Joseph Camelot 1702-1766 *OxArt*
Avedisian, E *AmArch 70*
Avedisian, Edward 1935- *ConArt 77*
Avedisian, Edward 1936- *DcCAA 71, -77, DcCAr 81, OxTwCA, PrintW 83, -85, WhoAmA 73, -76, -78, -80, -82, -84*
Avedon, Barry 1941- *WhoAmA 84*
Avedon, Richard 1923- *AmArt, BnEnAmA, ConPhot, ICPEnP, MacBEP, WhoAmA 78, -80, -82, -84, WhoGrA 82[port], WorFshn*
Aveiro, Maria DeGuadelupe 1630?-1715 *DcWomA*
Aveis, A A *AmArch 70*
Aveline, The Elder 1656-1722 *McGDA*
Aveline, Josephine 1914- *WhoArt 82, -84*
Aveline, Josephine Elizabeth 1914- *ClaDrA*
Aveline, Pierre 1702?-1760? *McGDA*
Aveling, H J *DcVicP 2*
Avent, Mayna Treanor 1868- *DcWomA, WhAmArt 85*
Avera, John C *FolkA 86*
Averbeck, Ferdinand *ArtsEM*
Averbeck And Averbeck *EncASM*
Avercamp, Barent 1612?-1679 *McGDA*
Avercamp, Hendrick 1585-1634 *McGDA, OxArt*
Avercamp, Henri Van 1585-1663? *ClaDrA*
Averie, John *AntBDN Q*
Averill *NewYHSD*
Averill, Eliphalet *ArtsEM*
Averill, Esther Holden *IlsCB 1967*
Averill, Esther Holden 1902- *IlsCB 1946, -1957*
Averill, James K *CabMA*
Averill, Louise Hunt 1915- *WhAmArt 85*
Averill, Perry J *ArtsEM*
Averlino, Antonio *OxArt*
Averlino, Antonio Di Piero *McGDA*
Avermaete, Roger 1893- *WhoArt 80, -82, -84*
Avery, Anne N 1943- *WhoAmA 80, -82*
Avery, Claire 1879- *WhAmArt 85*
Avery, Claire 1879-1929 *DcWomA*
Avery, D S *AmArch 70*
Avery, Darleen Marie 1960- *MarqDCG 84*
Avery, Denis Frederick 1935- *MarqDCG 84*
Avery, Faith *DcWomA, WhAmArt 85*
Avery, Frances 1910- *WhAmArt 85*
Avery, Frederick Bean 1908- *WorECar*
Avery, Gilbert *FolkA 86*
Avery, Harold 1858-1927 *WhAmArt 85*
Avery, Henry 1906- *AfroAA*
Avery, Henry A 1902- *WhAmArt 85*
Avery, Henry O 1852-1890 *MacEA*
Avery, Henry Ogden 1852-1890 *BiDAmAr*
Avery, Hope *DcWomA, WhAmArt 85*
Avery, James *EncASM*
Avery, John *NewYHSD*
Avery, John 1790- *FolkA 86*
Avery, Kenneth Newell 1883- *ArtsAmW 2, ArtsEM, WhAmArt 85*
Avery, Mary *FolkA 86*
Avery, Milton 1885-1965 *WorArt[port]*
Avery, Milton 1893-1965 *BnEnAmA, ConArt 77, -83, DcAmArt, DcCAA 71, -77, GrAmP, McGDA, OxTwCA, PhDcTCA 77, WhAmArt 85, WhoAmA 78N, -80N, -82N, -84N*
Avery, Myrtilla d1959 *WhAmArt 85, WhoAmA 80N, -82N, -84N*
Avery, Oliver *CabMA*
Avery, Ralph H 1906-1976 *WhAmArt 85*
Avery, Ralph Hillyer 1906- *WhoAmA 73, -76*
Avery, Ralph Hillyer 1906-1976 *WhoAmA 78N, -80N, -82N, -84N*
Avery, Samuel Putnam 1822-1904 *NewYHSD ,*

Avery, Samuel Putnam, Jr. 1847-1920 *WhAmArt 85*
Avery, William *NewYHSD*
Aves, Edward Louis 1848-1925 *BiDAmAr*
Avey, Martha d1943 *ArtsAmW 2, DcWomA, WhAmArt 85*
Avia, Amalia *OxTwCA*
Aviani, Francesco *McGDA*
Avignon *NewYHSD*
Avignone, Antonio 1814?- *NewYHSD*
Aviles, Angel Negron *AmArch 70*
Avinoff, Andrey d1948 *WhoAmA 78N, -80N, -82N, -84N*
Avinoff, Andrey 1884- *IlsCB 1744*
Avinoff, Andrey 1884-1948 *WhAmArt 85*
Avison, David 1937- *ICPEnP A, MacBEP, WhoAmA 78, -80, -82, -84*
Avison, George 1885- *ConICB, IlsBYP, IlsCB 1744, -1946, WhAmArt 85*
Avisseau, Charles d1861 *DcNiCA*
Avisseau, M E *DcNiCA*
Avlon, Helen Daphnis 1932- *AmArt*
Avner, Elkan Avrom 1914- *AmArch 70*
Avog, Annie *DcWomA*
Avont, Pieter Van 1600-1652 *McGDA*
Avont, Pieter VanDer 1600-1632 *ClaDrA*
Avostalis DeSola, Ulrico d1597 *MacEA*
Avram, Nathaniel 1884-1907 *WhAmArt 85*
Avramidis, Joannis 1922- *OxTwCA, PhDcTCA 77*
Avril, Edouard Henri 1849-1928 *DcBrBI*
Avril, Victoire D' *DcWomA*
Avrin, Gerald Martin 1933- *AmArch 70*
Avy-Pregniard, Clotilde *DcWomA*
Awa, Tsireh 1895-1955 *WhAmArt 85*
Awa Tsireh *ArtsAmW 3*
Awa Tsireh 1895?-1955 *IlBEAAW*
Awashima, Masakichi 1914- *IlDcG*
Awazu, Kiyoshi 1929- *ConDes, WhoGrA 62, -82[port]*
Awsumb, R N *AmArch 70*
Awsumb, Wells 1915- *AmArch 70*
Axelrad, Stephen 1943- *MacBEP*
Axelrod, I *AmArch 70*
Axelrod, Miriam *WhoAmA 82, -84*
Axelson, Axel 1871- *WhAmArt 85*
Axeman, Lois *IlsBYP*
Axford, Edith *DcWomA*
Axon, Donald Carlton 1931- *AmArch 70*
Axson, Ellen Louise *DcWomA*
Axson, William, Jr. 1739-1800 *CabMA*
Axt, Charles 1935- *AfroAA*
Axt, G F *AmArch 70*
Axt, L A *AmArch 70*
Axtell, Francis *BiDBrA*
Axtell, Mary E *WhAmArt 85*
Axton, John *PrintW 85*
Axton, John 1947- *AmArt*
Ay-O 1931- *ConArt 77, -83, DcCAr 81, WhoAmA 73, -76*
Ayala, Josefa De 1630?-1684 *DcWomA*
Ayars, Alice Annie 1895- *WhAmArt 85*
Ayars, Beulah Schiller 1869-1960 *ArtsAmW 3*
Ayaso, Manuel 1934- *OxTwCA, WhoAmA 73, -76, -78, -80, -82, -84*
Aybar, Rene C 1924- *AmArch 70*
Aybar, Romeo 1930- *AmArch 70*
Ayckbower, J D *AntBDN H*
Ayckbowm, Dedereck *IlDcG*
Ayckbowm, Herman *IlDcG*
Ayckbowm, J D *IlDcG*
Aycock, Alice 1946- *AmArt, ConArt 77, -83, DcCAr 81, PrintW 83, -85, WhoAmA 78, -80, -82, -84*
Aycock, William Joseph 1933- *AmArch 70*
Aydelott, Alfred Lewis 1912- *AmArch 70*
Ayer, Charles 1841?- *NewYHSD*
Ayer, Elizabeth 1897- *AmArch 70*
Ayer, G Earle *WhAmArt 85*
Ayer, J C 1862- *WhAmArt 85*
Ayer, Jackie *WorFshn*
Ayer, Jacqueline Brandford *IlsCB 1967*
Ayer, Jacqueline Brandford 1930- *IlsBYP, IlsCB 1957*
Ayer, L *NewYHSD*
Ayer, Margaret *IlsBYP, IlsCB 1946, WhAmArt 85*
Ayer, Mary Lewis 1878- *WhAmArt 85*
Ayer, Nicolas *FolkA 86*
Ayer, Ralph Dwight 1909- *WhAmArt 85*
Ayers, Carol Lee 1929- *WhoAmA 82, -84*
Ayers, Charles *NewYHSD*
Ayers, Charles Robert 1788?-1845 *BiDBrA*
Ayers, Edmond Alfred, Jr. 1923- *AmArch 70*
Ayers, Eric 1921- *WhoArt 80, -82, -84*
Ayers, George B *ArtsEM*
Ayers, Hester Merwin 1902-1975 *WhoAmA 78N, -80N, -82N, -84N*
Ayers, Richard 1924- *WorECom*
Ayers, Richard Winston 1910- *AmArch 70*
Ayers, Roland 1932- *AfroAA*
Ayers, Susan C 1946- *MarqDCG 84*
Ayettes, J Des *DcWomA*

Ayles, Ellen *DcWomA*
Aylesford, Heneage Finch, Earl Of 1751-1812 *DcBrWA*
Aylesford, Heneage Finch, Earl Of 1786-1859 *DcBrWA*
Aylesford, Countess Louisa 1760-1832 *DcWomA*
Aylesford, Louisa, Countess Of d1832 *DcBrWA*
Ayling, Albert *DcVicP*
Ayling, Albert William *DcBrWA*
Ayling, Albert William d1905 *DcBrA 1, DcVicP 2*
Ayling, F *DcVicP 2*
Ayling, Florence *DcBrBI*
Ayling, George 1887- *DcBrA 1*
Ayling, George 1887-1960 *DcBrA 2, DcSeaP*
Ayling, J *DcVicP 2*
Ayling, Joan 1907- *DcBrA 1, WhoArt 80, -82, -84*
Ayling, Mildred Shoob 1912- *WhoAmA 73*
Aylmer, T B *DcVicP*
Aylmer, Thomas Brabazon *DcVicP 2*
Aylmer, Thomas Brabazon 1806-1856? *DcBrWA*
Aylon, Helane *WhoAmA 80, -82, -84*
Aylon, Helene *WhoAmA 73, -76, -78*
Aylon, Helene 1931- *AmArt*
Aylor, J H *AmArch 70*
Aylward, Ida *WhAmArt 85*
Aylward, William J *WhoAmA 80N, -82N, -84N*
Aylward, William James 1875- *IlsCB 1744*
Aylward, William James 1875-1956 *IlrAm B, -1880*
Aylward, William James 1875-1958? *WhAmArt 85*
Aymar, Gordon Christian 1893- *WhoAmA 73, -76, -78, -80, -82, -84*
Ayme, Francis *NewYHSD*
Aymon, Christine 1953- *DcCAr 81*
Aymonino, Carlo 1926- *ConArch*
Aynscomb-Harris, Martin John 1937- *WhoArt 82, -84*
Aynsley, John *AntBDN M*
Aynsley, John 1752-1829 *DcNiCA*
Ayoroa, Rodolfo E 1927- *WhoAmA 73, -76, -78, -80*
Ayoub, Moussa *DcWomA*
Ayr, John F *NewYHSD*
Ayrault, F A *WhAmArt 85*
Ayre, Minnie *DcVicP 2, DcWomA*
Ayre, Robert Hugh 1900- *WhoAmA 73*
Ayrer, Justine 1704- *DcWomA*
Ayres, Arthur James John 1902- *DcBrA 1, WhoArt 80, -82, -84*
Ayres, Clarence L *NewYHSD*
Ayres, Donald Port 1904- *AmArch 70*
Ayres, Gillian 1930- *ConBrA 79[port], OxTwCA, PhDcTCA 77, WhoArt 80, -82, -84*
Ayres, H M E *DcVicP 2*
Ayres, Helen *WhAmArt 85*
Ayres, Jacob 1820- *CabMA*
Ayres, L J 1874- *WhAmArt 85*
Ayres, Larry Marshall 1939- *WhoAmA 82, -84*
Ayres, Louis 1874-1947 *BiDAmAr, MacEA*
Ayres, Martha Oathout 1890- *DcWomA, WhAmArt 85*
Ayres, Robert Moss 1898- *AmArch 70*
Ayres, Thomas A d1858 *ArtsAmW 1*
Ayres, Thomas A 1820?-1858 *IlBEAAW, NewYHSD*
Ayrhart, Peter 1836?- *FolkA 86*
Ayrton, Annie *DcVicP 2*
Ayrton, Annie d1920? *DcWomA*
Ayrton, Michael *WhoArt 80N*
Ayrton, Michael 1921- *ClaDrA, DcBrA 1, McGDA, PhDcTCA 77*
Ayrton, Michael 1921-1975 *ConArt 77, -83, DcBrA 2*
Ayrton, Millicent E 1913- *DcBrA 1, WhoArt 80, -82, -84*
Ayrton, Oliver *DcVicP 2*
Ayrton, Sophia *DcBrWA, DcWomA*
Ayrton, W J *DcBrWA*
Ayton, Charles William *WhAmArt 85*
Ayton, William, Sr. *BiDBrA*
Ayvasowsky, John 1817- *ArtsNiC*
Azaceta, Luis Cruz 1942- *AmArt, WhoAmA 78, -80, -82, -84*
Azadigian, Manuel *WhAmArt 85*
Azar DuMarest, Laetitia *DcWomA*
Azara, Nancy J 1939- *WhoAmA 76, -78, -80, -82, -84*
Azeglio, Massimo D' 1798-1866 *ArtsNiC*
Azema, Leon 1898- *MacEA*
Azevedo, Diane Rosalie 1952- *MarqDCG 84*
Azile, B *DcVicP 2*
Azimzade, Azim Aslan Ogly 1880-1943 *WorECar*
Aziz, Philip 1923- *WhoArt 80, -82, -84*
Azuma, Kengiro 1926- *PhDcTCA 77*
Azuma, Kenjiro 1926- *OxTwCA*
Azuma, Norio 1928- *DcCAA 71, -77, WhoAmA 73, -76, -78, -80, -82, -84*
Azuma, Takamitsu 1933- *ConArch*
Azuz, David 1942- *PrintW 83, -85*
Azzaro, Loris *WorFshn*
Azzi, Marius A 1892- *WhAmArt 85*
Azzi, Robert 1943- *ICPEnP A*

B

B B P R *MacEA, WhoArch*
B G S *NewYHSD*
B, Agnes *ConDes*
Baade, Knud Andreassen 1808-1879 *ClaDrA*
Baader, Amalia Von 1763-1840 *DcWomA*
Baader, E J *AmArch 70*
Baader, Johannes *OxTwCA*
Baader, Louis Marie *ArtsNiC*
Baadsgaard, Alfrida Vilhelmine Ludovica 1839-
 DcWomA
Baagoe, Carl Emil 1829-1902 *DcSeaP*
Baak, Marie *DcWomA*
Baak, Tobias d1710 *BiDBrA*
Baar, Anna *DcWomA*
Baar, Edward Joseph 1913- *AmArch 70*
Baar, Marion 1898- *WhAmArt 85*
Baar-Stanfield, Marion 1895?- *DcWomA*
Baard, Henricus Petrus 1906- *WhoArt 80, -82, -84*
Baargeld, Johannes Theodor d1927 *OxTwCA,*
 PhDcTCA 77
Baars, Louis J 1911- *AmArch 70*
Baart, Kitti 1914- *WhAmArt 85*
Baas, Marie 1844- *DcWomA*
Baba, Noboru 1927- *WorECar*
Babaian, Arminia *DcWomA*
Babb, Charlotte E *DcBrWA, DcVicP 2*
Babb, Charlotte E 1830?-1906 *DcWomA*
Babb, Conrad *FolkA 86*
Babb, Ernest William, Jr. 1927- *AmArch 70*
Babb, George F *WhAmArt 85*
Babb, George Fletcher 1836-1915 *MacEA*
Babb, Gerald R 1946- *MarqDCG 84*
Babb, John Staines *DcBrWA, DcVicP 2*
Babb, Robert 1839?- *NewYHSD*
Babb, Stanley Nicholson 1874-1957 *DcBrA 1*
Babb Cook And Willard *MacEA*
Babbage, Herbert Ivan d1916 *DcBrA 2*
Babb'c *AfroAA*
Babbige, James Gardner 1844-1919 *WhAmArt 85*
Babbin, Robert 1930- *AmArch 70, MarqDCG 84*
Babbington, Helen Brett 1910- *WhAmArt 85*
Babbit, D K *AmArch 70*
Babbitt, George F *FolkA 86*
Babbitt, H T *AmArch 70*
Babbitt, Natalie *IlsCB 1967*
Babbitt, Platt D *ICPEnP A*
Babbitt, T C *AmArch 70*
Babbitt, T F *AmArch 70*
Babbott, Frank I 1854-1933 *WhAmArt 85*
Babbridge, Christopher J 1792?- *CabMA*
Babcock, Amory L *FolkA 86, NewYHSD*
Babcock, Catherine Evans 1921- *WhAmArt 85*
Babcock, Charles 1829-1913 *BiDAmAr, MacEA*
Babcock, Clara M *ArtsEM, DcWomA*
Babcock, Dean 1888- *IIBEAAW*
Babcock, Dean 1888-1969 *ArtsAmW 1, -2,*
 WhAmArt 85
Babcock, Elizabeth Jones 1887- *DcWomA,*
 WhAmArt 85
Babcock, Eugenia *WhAmArt 85*
Babcock, Fred Maxwell 1938- *AmArch 70*
Babcock, Ida Dobson 1870- *ArtsAmW 1, DcWomA,*
 IIBEAAW, WhAmArt 85
Babcock, J A *EncASM*
Babcock, James Albert 1935- *AmArch 70*
Babcock, Loren *WhAmArt 85*
Babcock, Loren Roberta *DcWomA*
Babcock, R Fayerweather 1887-1954 *WhAmArt 85*
Babcock, Richard L 1936- *AmArch 70*
Babcock, Roscoe Lloyd 1897- *ArtsAmW 2*
Babcock, Thomas d1899? *WhAmArt 85*

Babcock, Viola Ward 1919- *WhAmArt 85*
Babcock, W P *DcVicP 2*
Babcock, William P 1826-1899 *DcAmArt,*
 NewYHSD
Baber, Alice 1928- *AmArt, ConArt 77, DcCAA 71,*
 -77, PrintW 83, WhoAmA 73, -76, -78, -80, -82
Baber, Alice 1928-1982 *PrintW 85, WhoAmA 84N*
Baber, Dwight Roger 1933- *AmArch 70*
Baber, J *AmArch 70, DcVicP 2*
Babiano Y Mendez Nunez, Carmen *DcWomA*
Babich, Alan Francis 1943- *MarqDCG 84*
Babichev, Aleksei *OxTwCA*
Babin, Marguerite L *DcWomA*
Babington, P *DcVicP 2*
Babits, Tibor Michael 1930- *AmArch 70*
Baboulene, Eugene 1905- *OxTwCA*
Babson, R *NewYHSD*
Babson, Robert E *NewYHSD*
Babson, Seth -1907 *BiDAmAr*
Baburen, Dirck Van 1595?-1624 *McGDA*
Bac, Andree Clara 1895- *DcWomA*
Baca, H L *AmArch 70*
Baca, Lufina d1935? *WhAmArt 85*
Baca-Flor, Carlos *OxTwCA*
Bacallao, Mademoiselle *DcWomA*
Bacardi-Cape, Mimi *DcWomA*
Baccani, Italia *DcVicP 2*
Bacchiacca 1494-1557 *McGDA*
Bacchus, George *DcNiCA, IlDcG*
Bacci, Agnese *DcWomA*
Bacci, Alexander H 1904- *AmArch 70*
Bacciarelli, Anna *DcWomA*
Bacciarelli, Johanna Juliana Friederike 1733?-1812
 DcWomA
Baccio Bigio, Nanni Di *McGDA*
Baccio D'Agnolo 1462-1543 *McGDA*
Baccio Della Porta *McGDA*
Baccuni, E *DcVicP 2*
Bacerra, Ralph 1938- *CenC[port]*
Bach, Alfons *OfGCP 86*
Bach, Alfons 1904- *WhAmArt 85*
Bach, Alois 1809-1893 *ClaDrA*
Bach, Clarence A 1894-1970? *MacBEP*
Bach, Dirk 1939- *WhoAmA 73, -76, -78, -80, -82,*
 -84
Bach, Edward *DcVicP 2*
Bach, Ferdinand 1888-1967 *FolkA 86*
Bach, Ferdinand-Sigismond 1859-1952 *WorECar*
Bach, Florence Julia *WhAmArt 85*
Bach, Florence Julia 1887- *DcWomA*
Bach, Franz *DcVicP 2*
Bach, George W *FolkA 86*
Bach, Guido R d1905 *DcBrA 1, DcVicP 2*
Bach, Guido R 1828-1905 *DcBrWA*
Bach, Laurence 1947- *WhoAmA 84*
Bach, Madeline *DcWomA*
Bach, Marcel 1879- *ClaDrA*
Bach, Mickey 1909- *WhoAmA 76, -78*
Bach, Oscar Bruno 1884- *WhAmArt 85*
Bach, Otto Karl 1909- *WhAmArt 85, WhoAmA 73,*
 -76, -78, -80, -82, -84
Bach, Richard 1887-1968 *WhAmArt 85*
Bach, Richard F d1968 *WhoAmA 78N, -80N, -82N,*
 -84N
Bach, Robert Otto 1917- *WhAmArt 85*
Bach, Stephanie De *DcWomA*
Bach, William Henry *DcBrWA, DcVicP 2*
Bacharach, Elsie W 1899-1940 *DcWomA,*
 WhAmArt 85
Bacharach, Herman Ilfeld 1899- *ArtsAmW 2,*
 ConICB, WhAmArt 85

Bachardy, Don 1934- *WhoAmA 84*
Bache, Berta *DcWomA, WhAmArt 85*
Bache, John *AntBDN Q*
Bache, Jules S 1861-1944 *WhAmArt 85*
Bache, Martha 1893- *DcWomA*
Bache, Martha Moffett 1883- *ArtsEM*
Bache, Martha Moffett 1893- *WhAmArt 85*
Bache, William *AntBDN O*
Bache, William 1771-1845 *NewYHSD*
Bachelder, John Badger 1825-1894 *NewYHSD*
Bachelder, Jonathan Badger 1825-1894 *WhAmArt 85*
Bachelder, Oscar Louis 1852-1935 *WhAmArt 85*
Bacheler, Frances Hope 1889- *DcWomA,*
 WhAmArt 85
Bachelier, Jean Jacques d1791 *AntBDN M*
Bachelier, Jean Jacques 1724-1806 *ClaDrA*
Bachelier, Jean-Jacques 1724-1806 *McGDA*
Bachelier, Nicholas 1485?-1572? *McGDA*
Bachelier, Nicolas d1556 *MacEA*
Bacheller, Celestine 1850?-1900 *FolkA 86*
Bacheller, Lucinda *FolkA 86*
Bacheller, Theophilus 1751-1833 *CabMA*
Bachelor, Philip H Wilson *DcBrA 1*
Bachelor, Philip H Wilson d1944 *DcBrA 2*
Bachem, Bele *WhoGrA 62*
Bachem, Bele 1916- *WhoGrA 82[port]*
Bachem, Renate Gabriele 1916- *WhoGrA 62,*
 WorECar
Bacher, Otto Devereux 1892- *WhAmArt 85*
Bacher, Otto Henry 1856-1909 *WhAmArt 85*
Bacher, Will Low 1898- *WhAmArt 85*
Bacherini, Anna *DcWomA*
Bachert, Hildegard Gina 1921- *WhoAmA 82, -84*
Bachi, Roberto 1909- *MarqDCG 84*
Bachinski, Walter Joseph 1939- *WhoAmA 78, -80,*
 -82, -84
Bachinsky, Vladimir 1936- *AmArt*
Bachman, Anceneta *FolkA 86*
Bachman, C *NewYHSD*
Bachman, Christian *FolkA 86*
Bachman, Christian 1827-1901 *CabMA*
Bachman, Ellis 1856-1933 *CabMA*
Bachman, Henry 1838?- *NewYHSD*
Bachman, Ivan Clarke, Jr. 1925- *AmArch 70*
Bachman, Jacob 1798-1869 *CabMA*
Bachman, John *CabMA, NewYHSD*
Bachman, John, II 1746-1829 *CabMA*
Bachman, John, III 1775-1849 *CabMA*
Bachman, Leopold F *ArtsEM*
Bachman, Maria *DcWomA*
Bachman, Max 1862-1921 *WhAmArt 85*
Bachman, William J 1914- *AmArch 70*
Bachmann, Carl Ludwig 1716-1800 *AntBDN K*
Bachmann, Max 1862- *IIBEAAW*
Bachmentov, A N d1861? *IlDcG*
Bachmentov, Mrs. A N d1884 *IlDcG*
Bachmetov, A d1779 *IlDcG*
Bachofen, Max Albin 1903- *WhAmArt 85*
Bachop, Tobias d1710 *BiDBrA*
Bachot, Jacques *McGDA*
Bachrach, David 1906- *WhAmArt 85*
Bachrach, Gladys Wertheim 1909- *WhoAmA 73*
Bachrach And Freedman *EncASM*
Bachta, Eve *DcWomA*
Bachtell, Edward Keiffer, II 1937- *AmArch 70*
Bachynski, Morrel Paul 1930- *MarqDCG 84*
Baciccia, Giovanni Battista Gaulli 1639-1709 *OxArt*
Baciccio *McGDA*
Bacigalupa, Andrea 1923- *AmArt, WhoAmA 73, -76,*
 -78, -80, -82, -84
Back, Sir George 1796-1878 *DcBrWA*

25

Back, Joe 1899- *WhAmArt 85*
Back, Joe W 1899- *ArtsAmW 3, IlBEAAW*
Back, Robert 1922- *DcBrA 2, DcSeaP*
Back, W H *DcVicP 2*
Backer, Catharina 1689-1766 *DcWomA*
Backer, David Stanley *MarqDCG 84*
Backer, Harriet 1845-1932 *DcWomA*
Backer, Henk 1898- *WorECom*
Backer, Hiram *FolkA 86*
Backer, Jacob Adriaensz 1608-1651 *ClaDrA, McGDA, OxArt*
Backer, Marguerite De 1882- *DcWomA*
Backer, Pieter De *McGDA*
Backhoffner, Caroline *DcWomA*
Backhouse, Mrs. *DcBrWA*
Backhouse, David John 1941- *WhoArt 80, -82, -84*
Backhouse, Henry *DcVicP 2*
Backhouse, J *DcVicP 2*
Backhouse, James Edward 1808-1879 *DcBrWA, DcVicP 2*
Backhouse, Margaret 1818- *DcVicP 2, DcWomA*
Backhouse, Mary *DcVicP 2, DcWomA*
Backhouse, R William *BiDBrA*
Backhuysen, Ludolf *McGDA*
Backhuyzen, Gerardina *DcWomA*
Backlin, Archie Leonard 1926- *AmArch 70*
Backman, Henry G *FolkA 86*
Backman, Susan *DcCAr 81*
Backmeyer, Babette *DcWomA*
Backofen, Charles 1801?- *NewYHSD*
Backofen, Hans d1519 *OxArt*
Backoffen, Hans 1460?-1519 *McGDA*
Backshell, W *DcVicP 2*
Backstrom, Barbro *DcCAr 81*
Backstrom, Florence *WhoAmA 73, -76*
Backstrom, K A *AmArch 70*
Backstrom, Sven 1903- *ConArch, MacEA*
Backstrom, Wilbur August 1900- *AmArch 70*
Backus, Annie Elizabeth Fox *ArtsEM, DcWomA*
Backus, E M *DcWomA*
Backus, Fronie Edman 1860?- *ArtsEM, DcWomA*
Backus, G H *AntBDN G*
Backus, Mrs. George J *DcWomA, WhAmArt 85*
Backus, John J 1863-1937 *BiDAmAr*
Backus, Josefa Crosby 1875- *DcWomA, WhAmArt 85*
Backus, Mary G *WhAmArt 85*
Backus, Mary Gannett *ArtsAmW 3, DcWomA*
Backus, Standish, Jr. 1910- *WhAmArt 85, WhoAmA 73, -76, -78, -80, -82, -84*
Backus, Thaddeus *FolkA 86*
Bacle, Andrienne Pauline 1796-1855 *DcWomA*
Bacler D'Albe, Baron Louis A Guillain 1761-1848 *ClaDrA*
Baco, Jaime 1413?-1461 *McGDA, OxArt*
Bacon *FolkA 86*
Bacon, Alice Sutton 1907- *WhAmArt 85*
Bacon, Bruce 1935- *PrintW 83, -85*
Bacon, Cecil Walter 1905- *WhoArt 80, -82, -84*
Bacon, Charles 1784?-1818 *BiDBrA*
Bacon, Charles R 1868-1913 *WhAmArt 85*
Bacon, Charles R T 1929- *MarqDCG 84*
Bacon, D'Arcy *DcVicP 2*
Bacon, E F *NewYHSD*
Bacon, Edith Jane *DcWomA, WhAmArt 85*
Bacon, Edmund 1910- *MacEA*
Bacon, Edmund N *ConArch A*
Bacon, Edmund N 1910- *ConArch*
Bacon, Edmund Norwood 1910- *AmArch 70*
Bacon, Edwin Phillips 1873-1935 *BiDAmAr*
Bacon, Elisabeth *DcWomA*
Bacon, Elizabeth Driggs d1928 *DcWomA, WhAmArt 85*
Bacon, Francis 1909- *ConArt 77, -83, ConBrA 79[port], DcBrA 1, DcCAr 81, PhDcTCA 77, PrintW 85*
Bacon, Francis 1910- *McGDA, OxArt, OxTwCA, WorArt[port]*
Bacon, Francis H *WhAmArt 85*
Bacon, Frank *IlBEAAW*
Bacon, Frederick *AfroAA*
Bacon, George *NewYHSD*
Bacon, Mrs. George B *WhAmArt 85*
Bacon, George H 1861-1925 *FolkA 86*
Bacon, H D *DcVicP 2*
Bacon, H M *DcVicP 2, DcWomA*
Bacon, Helen Emmeline *DcWomA*
Bacon, Henry 1839- *ArtsNiC*
Bacon, Henry 1839-1912 *ArtsAmW 2, NewYHSD, WhAmArt 85*
Bacon, Henry 1866-1924 *BiDAmAr, EncAAr, MacEA, McGDA*
Bacon, Irving R 1875-1962 *ArtsAmW 1, IlBEAAW, WhAmArt 85*
Bacon, Irving Reuben 1875-1962 *ArtsEM*
Bacon, J P *DcVicP 2*
Bacon, John 1740-1799 *AntBDN M, OxArt*
Bacon, John 1777-1859 *OxArt*
Bacon, John, The Elder 1740-1799 *McGDA*
Bacon, John E *NewYHSD*
Bacon, John Henry F 1868-1914 *DcVicP, -2*

Bacon, John Henry Frederick 1865-1914 *DcBrA 1, DcBrBI, DcBrWA*
Bacon, John Henry Frederick 1868-1914 *ClaDrA*
Bacon, John Reuben 1866- *WhAmArt 85*
Bacon, Julia d1901 *DcWomA, WhAmArt 85*
Bacon, Kate L *WhAmArt 85*
Bacon, Kate Lee *DcWomA*
Bacon, Louis *NewYHSD*
Bacon, Lucy *ArtsEM, DcWomA*
Bacon, Marjorie May 1902- *DcBrA 1*
Bacon, Mary *FolkA 86*
Bacon, Mary Ann *DcWomA*
Bacon, Mary Ann 1787- *DcWomA, NewYHSD*
Bacon, Nathaniel *FolkA 86*
Bacon, Sir Nathaniel 1585-1627 *OxArt*
Bacon, Peggy *IlsCB 1967*
Bacon, Peggy 1895- *BnEnAmA, ConICB, DcAmArt, DcWomA, GrAmP, IlsBYP, IlsCB 1744, -1946, -1957, McGDA, WhAmArt 85, WhoAmA 73, -76, -78, -80, -82, -84*
Bacon, Peter James 1951- *WhoArt 80, -82, -84*
Bacon, Pierpont 1724-1800 *CabMA*
Bacon, T *DcVicP 2*
Bacon, T V *AmArch 70*
Bacon, Thomas *CabMA, DcBrWA*
Bacon, Viola J 1878- *DcWomA, WhAmArt 85*
Bacon, W E *DcVicP 2*
Bacon, Willard M 1860-1947 *BiDAmAr*
Bacon-Plimpton, Mabel *DcWomA*
Baconnier, Marguerite *DcWomA*
Bacot, Annabelle G *AfroAA*
Bacot, Henry Parrott 1941- *WhoAmA 76, -78, -80, -82, -84*
Bacot, Thomas J 1936- *MarqDCG 84*
Bacquoi, Pierre-Charles 1759-1829 *McGDA*
Baczek, Peter Gerard 1945- *WhoAmA 84*
Baczko, Margarete Von 1842- *DcWomA*
Baczkowska, Pamela 1938- *WhoArt 80, -82, -84*
Badajoz, Juan De *McGDA*
Badalamenti, Fred 1935- *PrintW 83, -85, WhoAmA 78, -80, -82, -84*
Badalocchio, Sisto 1585- *McGDA*
Badaloni, Paolo Di Stefano 1397-1478 *McGDA*
Badami, Andrea 1913- *FolkA 86*
Badani, Daniel 1914- *ConArch*
Badaracco, John Lee 1938- *AmArch 70*
Badarocco, Giovanni Raffaello 1648-1726 *ClaDrA*
Badash, Sandi Borr 1936- *WhoAmA 76, -78, -80, -82, -84*
Badcock, Isabel *DcVicP 2*
Badcock, K S *DcVicP 2, DcWomA*
Badcock, Leigh *DcVicP 2, DcWomA*
Badderston, Stephanie *DcWomA, WhAmArt 85*
Baddler *FolkA 86*
Badeau, Isaac *NewYHSD*
Badeau, Jonathan F *NewYHSD*
Badeley, Sir Henry John Fanshawe 1874-1951 *DcBrA 1*
Baden, C *FolkA 86*
Baden, Eric *DcCAr 81*
Baden, F H *AmArch 70*
Baden, Jan Jeuriansz Van 1604?-1663 *McGDA*
Baden, Karl 1952- *MacBEP*
Baden, Mowry 1936- *DcCAr 81*
Baden-Powell, Frank Smyth 1850-1933 *DcBrA 1, DcVicP 2*
Baden-Powell, Baron Robert 1857-1941 *DcBrBI*
Bader, Albert Kilian 1911- *AmArch 70*
Bader, B B *AmArch 70*
Bader, Caecilie *DcWomA*
Bader, Franz 1903- *WhoAmA 73, -76, -78, -80, -82, -84*
Baderian, Ruth 1927- *WhoAmA 73, -76*
Badeslade, Thomas *DcBrWA*
Badgeley, C Dale 1899- *AmArch 70*
Badger *FolkA 86*
Badger, Miss *DcWomA*
Badger, Clarissa *DcWomA*
Badger, Daniel D 1806-1884 *MacEA*
Badger, Francis S *WhAmArt 85*
Badger, Gerald David 1948- *MacBEP*
Badger, Gerry 1948- *ConPhot, ICPEnP A*
Badger, Hiram *FolkA 86*
Badger, James W *NewYHSD*
Badger, John C 1822?- *NewYHSD*
Badger, John Neal 1932- *AmArch 70*
Badger, Jonathan *CabMA, NewYHSD*
Badger, Joseph 1708-1763 *FolkA 86*
Badger, Joseph 1708-1765 *BnEnAmA, DcAmArt, McGDA, NewYHSD*
Badger, Joseph 1738-1817 *BiDBrA*
Badger, Joseph W *NewYHSD*
Badger, Mrs. Milton *NewYHSD*
Badger, Nancy *DcWomA, FolkA 86*
Badger, S *NewYHSD*
Badger, S F M *DcSeaP, FolkA 86*
Badger, Stephen *FolkA 86*
Badger, Thomas *FolkA 86*
Badger, Thomas 1792-1868 *NewYHSD*
Badger, Thomas H *NewYHSD*

Badger, William *NewYHSD*
Badgley, Azalea Green 1880-1971 *DcWomA*
Badgley, John Roy 1922- *AmArch 70*
Badgley, Sidney Rose 1859-1917? *BiDAmAr*
Badham, Edward Leslie 1873-1944 *DcBrA 1, DcVicP 2*
Badiale, Alessandro 1623-1668 *ClaDrA*
Badier, Florimond *OxDecA*
Badii, Libero *OxTwCA*
Badii, Libero 1916- *PhDcTCA 77*
Badile, Antonio 1480-1560 *ClaDrA*
Badile, Antonio 1518-1560 *McGDA*
Badin, Ferdinand 1897- *WhAmArt 85*
Badin, Jules *ArtsNiC*
Badlam *NewYHSD*
Badlam, Stephen, Jr. 1779- *CabMA*
Badlam, Stephen, Sr. 1751-1815 *CabMA*
Badler, Norman Ira 1948- *MarqDCG 84*
Badmin, S R 1906- *WhoArt 80, -82, -84*
Badmin, Stanley Roy 1906- *DcBrA 1, IlsCB 1946*
Badner, Mino 1940-1978 *WhoAmA 80N, -82N, -84N*
Badodi, Arnaldo *OxTwCA*
Badois, Jeanne *DcWomA*
Badovici, Jean 1893-1956 *MacEA*
Badrinarayan, M K 1953- *MarqDCG 84*
Badue, Daniel Serra *WhAmArt 85*
Badur, Frank 1944- *DcCAr 81*
Badura, Benjamin *WhAmArt 85*
Badura, Bernard 1896- *WhAmArt 85*
Badura, Dennis C 1942- *MarqDCG 84*
Badura, Faye Swengel *WhAmArt 85*
Badura, Michael 1938- *ConArt 77, DcCAr 81*
Baecher, Anthony W *FolkA 86*
Baecher, Crescenz *DcWomA*
Baecher, J W *FolkA 86*
Baechler, Donald *PrintW 85*
Baechlin, Henry F 1874-1936 *BiDAmAr*
Baecker, Ronald Michael 1942- *MarqDCG 84*
Baeder, John 1938- *AmArt, DcCAr 81, PrintW 83, -85, WhoAmA 76, -78, -80, -82, -84*
Baegert, Derick 1440?-1515 *McGDA*
Baehler, Wallace R *WhoAmA 76, -78*
Baehr, Frances Ernestine *WhAmArt 85*
Baehr, Francine 1897?- *DcWomA, WhAmArt 85*
Baehr, Georg 1666-1738 *OxArt*
Baehr, R C *AmArch 70*
Baehr, Ulrich 1938- *DcCAr 81*
Baekeland, Celine *WhAmArt 85*
Baekelmans, Guy 1940- *DcCAr 81*
Baen, Jan De 1633-1702 *McGDA, OxArt*
Baenninger, Otto Charles 1897- *OxTwCA*
Baenninger, Otto-Charles 1897- *PhDcTCA 77*
Baer *NewYHSD*
Baer, Alan 1931- *WhoAmA 73, -76, -78, -80*
Baer, Arthur Edward 1924- *AmArch 70*
Baer, Arthur F *WhAmArt 85*
Baer, David Clyde 1904- *AmArch 70*
Baer, Gabriel *FolkA 86*
Baer, George *WhAmArt 85*
Baer, Herbert M 1879- *WhAmArt 85*
Baer, Howard *WhAmArt 85*
Baer, Jo 1929- *ConArt 83, DcCAA 77, PrintW 83, -85, WhoAmA 73, -76, -78, -80, -82, -84*
Baer, John Miller 1886- *WhAmArt 85*
Baer, Kurt 1905- *WhAmArt 85*
Baer, Lillian 1887- *DcWomA, WhAmArt 85*
Baer, Martin *FolkA 86*
Baer, Martin 1890?-1961 *ArtsAmW 3*
Baer, Martin 1895- *WhAmArt 85*
Baer, Morley 1916- *ICPEnP A, MacBEP, WhoAmA 82, -84*
Baer, Norbert Sebastian 1938- *WhoAmA 78, -80, -82, -84*
Baer, Ora H *ArtsEM*
Baer, William J 1860-1941 *WhAmArt 85*
Baer, Wolfgang 1944- *MarqDCG 84*
Baerens, Magdalene Margrethe 1737-1808 *DcWomA*
Baerer, Henry 1837-1908 *NewYHSD , WhAmArt 85*
Baeriswyl, Bruno 1941- *DcCAr 81*
Baeriswyl, Marie Marguerite *DcWomA*
Baerlen, Hortense Van *DcWomA*
Baerman, Donald John 1931- *AmArch 70*
Baerman, L E 1879- *WhAmArt 85*
Baerresen, Vigo 1858-1940 *BiDAmAr*
Baertling, Olle 1911- *ConArt 77, OxTwCA, PhDcTCA 77*
Baertling, Olle 1911-1981 *ConArt 83*
Baertson, Albert *DcVicP 2*
Baertsoen, Albert 1866-1922 *ClaDrA*
Baerwald, Alexander 1877-1930 *MacEA*
Baerze, Jacques De *McGDA, OxArt*
Baes, Emile 1879- *ClaDrA*
Baesel, Stuart Oliver 1923- *AmArch 70*
Baesemann, Margaret Maassen *WhAmArt 85*
Baesten, Maria *DcWomA*
Baethke, Eugene Elmer 1935- *AmArch 70*
Baetschmann, Oskar 1943- *MacBEP*
Baey, Pierre *DcCAr 81*
Baey, Richard 1957- *MarqDCG 84*
Baffo, Giovanni *AntBDN K*
Baffoni, Pier Luigi 1932- *WhoArt 80, -82, -84*

Bagala, J A *AmArch 70*
Bagdapoulos, William Spencer 1888- *ArtsAmW 1*
Bagdatopolous, William Spencer 1888- *ClaDrA*
Bagdatopoulos, W S 1888- *WhAmArt 85*
Bager, Johann Daniel 1734-1815 *ClaDrA*
Bageris, John 1924- *WhoAmA 80, -82, -84*
Bagett, A *NewYHSD*
Bagg, Egbert, IV 1920- *AmArch 70*
Bagg, Henry Howard 1852-1928 *IlBEAAW,*
 WhAmArt 85
Bagg, Henry Howard 1853-1928 *ArtsAmW 1, -3*
Bagg, Lester H 1932- *AmArch 70*
Bagg, Louise Eleanora *DcWomA, WhAmArt 85*
Bagg, Olive *DcWomA*
Baggaley, Norman Reginald 1937- *WhoArt 84*
Bagge, Bertha 1859- *DcWomA*
Bagge, Eva 1871-1965? *DcWomA*
Bagge, F G *AmArch 70*
Bagge-Scott, Robert 1849-1925 *DcBrA 1, DcVicP 2*
Baggett, S *FolkA 86*
Baggott, W *FolkA 86*
Baggs, Arthur E 1886- *WhAmArt 85*
Baggs, Arthur Eugene 1886-1947 *CenC[port]*
Baghot DeLaBere, Stephen 1877-1927 *DcBrA 1*
Bagley, A J *AmArch 70*
Bagley, James M 1837-1910 *ArtsAmW 1, IlBEAAW,*
 WhAmArt 85
Bagley, Marion Leroy 1902- *AmArch 70*
Bagley, Ralph Leon 1913- *WhAmArt 85*
Bagley, S *FolkA 86*
Baglione, Giovanni 1571?-1644 *McGDA*
Baglioni Family *MacEA*
Bagnacavallo 1484-1542 *McGDA*
Bagnall, Benjamin 1689-1740 *AntBDN D, OxDecA*
Bagnall, George *FolkA 86*
Bagnall, John *AntBDN D*
Bagnall, Samuel *OxDecA*
Bagnall, W S *AmArch 70*
Bagnardi, J V *AmArch 70*
Bagnaschi, Charles 1907- *AmArch 70*
Bagnell, George *FolkA 86*
Bagnuolo, J W *AmArch 70*
Bagot, Richard *DcBrWA*
Bagshaw, Joseph Richard 1870-1909 *DcVicP 2*
Bagshaw, W Max 1937- *MarqDCG 84*
Bagshawe, Joseph John Richard 1870-1909 *DcSeaP*
Bagshawe, Joseph Richard 1870-1909 *DcBrA 2*
Baguley, Isaac *DcNiCA*
Bagwell, J W *AmArch 70*
Bahadur, Birendra 1949- *MarqDCG 84*
Bahar, Ardeshir 1934- *AmArch 70*
Bahin, Louis Joseph *NewYHSD*
Bahin, Louis Joseph 1813-1857 *FolkA 86*
Bahls, Ruth 1901- *WhAmArt 85*
Bahm, Henry 1920- *WhAmArt 85, WhoAmA 73,*
 -76, -78, -80, -82
Bahnc, Salcia 1898- *WhAmArt 85*
Bahr, C O *NewYHSD*
Bahr, Deon Franklin 1938- *AmArch 70*
Bahr, Florence Riefle 1909- *WhAmArt 85*
Bahr, Georg 1666-1738 *MacEA, McGDA, WhoArch*
Bahr, Leonard Marion 1905- *WhAmArt 85*
Bahramian, Hamlet 1922- *AmArch 70*
Bahri, Youssef S 1933- *AmArch 70*
Bahti, Tom *IlsBYP*
Bahuche, Marguerite *DcWomA*
Bahunek, Antun 1912- *OxTwCA*
Baien *DcWomA*
Baier, Jean 1930- *DcCAr 81*
Baigent, R *DcVicP 2*
Baigts, Juan 1946- *WhoAmA 78, -80, -82*
Baiitsu 1783-1856 *McGDA*
Bail, George Hamlin 1921- *AmArch 70*
Bail, Jean-Antoine *ArtsNiC*
Bail, Joseph 1862-1921 *ClaDrA, OxTwCA*
Bail, Louis *NewYHSD*
Bailard, Ida *ArtsEM, DcWomA*
Baildon, W A *DcVicP 2*
Bailes, Gordon Lee, Jr. 1946- *MarqDCG 84*
Bailey, A *NewYHSD*
Bailey, A C, Jr. *AmArch 70*
Bailey, A W *DcWomA*
Bailey, Abner *FolkA 86*
Bailey, Adolph 1822?- *NewYHSD*
Bailey, Albert E *DcBrA 1, DcVicP, -2*
Bailey, Alfred 1823- *NewYHSD*
Bailey, Alfred Charles 1883- *DcBrA 1*
Bailey, Amaziah 1797- *CabMA*
Bailey, Arthur *DcVicP 2, WhoArt 82N*
Bailey, Arthur 1903- *WhoArt 80*
Bailey, Benjamin *NewYHSD*
Bailey, Bessie *ArtsEM, DcWomA*
Bailey, Bradbury M 1824-1913 *EncASM*
Bailey, C *DcWomA*
Bailey, C J C *DcNiCA*
Bailey, Calvin 1915- *AfroAA*
Bailey, Carden 1911- *WhAmArt 85*
Bailey, Caroline M B 1905- *WhAmArt 85*
Bailey, Charles *BiDBrA, FolkA 86*
Bailey, Chase Bryan 1947- *MarqDCG 84*

Bailey, Clark T 1932- *WhoAmA 73, -76, -78*
Bailey, Clark T 1932-1978 *WhoAmA 80N, -82N,*
 -84N
Bailey, Clayton 1939- *CenC[port]*
Bailey, Clayton George 1939- *WhoAmA 80, -82, -84*
Bailey, Constant d1801 *CabMA*
Bailey, Cora Louise 1870- *WhAmArt 85*
Bailey, Cora Louise Corot 1870- *DcWomA*
Bailey, D W *AmArch 70*
Bailey, David *WorFshn*
Bailey, David 1938- *ConPhot, ICPEnP A, MacBEP*
Bailey, David 1949- *MarqDCG 84*
Bailey, Dennis *WhoGrA 62*
Bailey, Dennis 1931- *WhoGrA 82[port]*
Bailey, Donald G *AmArch 70*
Bailey, Donald Zachary 1924- *AmArch 70*
Bailey, E M, Jr. *AmArch 70*
Bailey, E W *EncASM*
Bailey, Earl Belden 1899- *AmArch 70*
Bailey, Earl Clifford 1909- *WhAmArt 85*
Bailey, Eldren *FolkA 86*
Bailey, Elizabeth *DcVicP 2*
Bailey, Elizabeth S *DcWomA*
Bailey, Evelyn 1912- *WhAmArt 85*
Bailey, Francis 1735?-1815 *NewYHSD*
Bailey, Francisco 1817?- *NewYHSD*
Bailey, G *AmArch 70*
Bailey, G Harold *WhAmArt 85*
Bailey, George 1792-1860 *BiDBrA*
Bailey, George Edward *AfroAA*
Bailey, George H *ArtsEM*
Bailey, George M *NewYHSD*
Bailey, George William 1880- *DcBrA 1*
Bailey, H Kofi *AfroAA*
Bailey, Harry L 1879-193-? *WhAmArt 85*
Bailey, Harry L 1879-1933 *ArtsAmW 3*
Bailey, Helen Virginia *WhAmArt 85*
Bailey, Henrietta Davidson *WhAmArt 85*
Bailey, Henrietta Davidson d1950 *DcWomA*
Bailey, Henry *DcBrA 1, DcVicP, -2*
Bailey, Henry Lewis *ArtsAmW 3, WhAmArt 85*
Bailey, Henry T 1865-1931 *WhAmArt 85*
Bailey, Herman *AfroAA*
Bailey, I Clarence *FolkA 86*
Bailey, J E *AmArch 70*
Bailey, J H *AmArch 70*
Bailey, Jack Kierulff, Jr. 1937- *AmArch 70*
Bailey, James *NewYHSD*
Bailey, James 1771?-1850 *BiDBrA*
Bailey, James 1951- *MacBEP*
Bailey, James Arlington, Jr. 1932- *WhoAmA 73, -76,*
 -78, -80
Bailey, James Bright 1908- *FolkA 86*
Bailey, James E 1885- *WhAmArt 85*
Bailey, James Russell 1905- *AmArch 70*
Bailey, Jimmy Earl 1927- *AmArch 70*
Bailey, John 1741-1826 *CabMA*
Bailey, John 1750-1819 *DcBrWA*
Bailey, John Haynes 1909- *WhAmArt 85*
Bailey, John M, Jr. 1925- *AmArch 70*
Bailey, John William 1831-1914 *DcBrA 2*
Bailey, Jonathan 1791- *CabMA*
Bailey, Joseph C *AfroAA*
Bailey, Joseph Trowbridge d1854 *EncASM*
Bailey, Joseph Trowbridge, II *EncASM*
Bailey, Joseph Walter 1903- *AmArch 70*
Bailey, Ken James 1916- *AmArch 70*
Bailey, L E *WhAmArt 85*
Bailey, LaForce 1893- *WhAmArt 85*
Bailey, Leonard 1825?- *CabMA*
Bailey, Lucy J *DcWomA*
Bailey, Malcolm 1947- *AfroAA*
Bailey, Malcolm C W 1947- *WhoAmA 73, -76, -78*
Bailey, Marcia Mead 1947- *WhoAmA 82, -84*
Bailey, Margaret *DcWomA*
Bailey, Mary *FolkA 86*
Bailey, Mary Ann *DcWomA*
Bailey, Merrill A 1909- *WhAmArt 85*
Bailey, Michael 1953- *MarqDCG 84*
Bailey, Minnie M 1890- *ArtsAmW 1*
Bailey, Minnie Moly 1890- *DcWomA, WhAmArt 85*
Bailey, Oscar 1925- *ConPhot, WhoAmA 78, -80, -82,*
 -84
Bailey, Oscar W 1925- *ICPEnP A, MacBEP*
Bailey, R H *DcVicP 2*
Bailey, R O *WhAmArt 85*
Bailey, Richard *CabMA*
Bailey, Richard H 1940- *WhoAmA 76, -78, -80, -82,*
 -84
Bailey, Robert *ArtsEM*
Bailey, Robert Howard 1929- *AmArch 70*
Bailey, Robert Lowell, Jr. 1959- *MarqDCG 84*
Bailey, Robert M *WhAmArt 85*
Bailey, Roger 1897- *AmArch 70, ArtsAmW 3*
Bailey, Roswell *EncASM*
Bailey, Ruby *DcWomA*
Bailey, Ruby Hyacinth 1908- *AfroAA*
Bailey, S T *WhAmArt 85*
Bailey, Samuel 1709-1796 *CabMA*
Bailey, Stephen Francis 1944- *MarqDCG 84*
Bailey, Mrs. Taylor *DcWomA*

Bailey, Ted N 1956- *MarqDCG 84*
Bailey, Thomas 1742-1825 *CabMA*
Bailey, Thomas Edward 1945- *MarqDCG 84*
Bailey, Thomas Jefferson 1804- *CabMA*
Bailey, Thomas S *CabMA*
Bailey, Tillinghast 1823?- *NewYHSD*
Bailey, V E *AmArch 70*
Bailey, Vernon Howe 1874-1953 *ArtsAmW 1,*
 WhAmArt 85
Bailey, Walter Alexander *WhoAmA 73, -76, -78, -80,*
 -82, -84
Bailey, Walter Alexander 1894- *ArtsAmW 2,*
 WhAmArt 85
Bailey, Walter C *NewYHSD*
Bailey, Weldon 1905- *WhAmArt 85*
Bailey, William *FolkA 86*
Bailey, William 1930- *AmArt, DcCAA 77,*
 PrintW 83, -85, WhoAmA 82, -84
Bailey, William A 1827?- *NewYHSD*
Bailey, William H *DcVicP 2*
Bailey, William H 1930- *WhoAmA 73, -76, -78, -80*
Bailey, William J 1902- *WhAmArt 85*
Bailey, Worth 1908- *WhAmArt 85, WhoAmA 73,*
 -76, -78, -80
Bailey, Worth 1908-1980 *WhoAmA 82N, -84N*
Bailey & Co. *DcNiCA*
Bailey And Kitchen *EncASM*
Bailey And Matthewson *NewYHSD*
Bailey Banks And Biddle *EncASM*
Bailey-Jones, Beryl 1912- *IlsBYP, IlsCB 1946*
Bailhache, Anne Dodge *ArtsAmW 2, WhAmArt 85*
Bailie, James *NewYHSD*
Bailin, David F 1959- *MarqDCG 84*
Bailin, Hella 1915- *WhoAmA 73, -76, -78, -80, -82,*
 -84
Baillairge, Charles 1826-1906 *MacEA*
Baillairge, Francois 1759-1830 *OxArt*
Baillairge, Jean 1726-1805 *OxArt*
Baillairge, Thomas 1791-1859 *OxArt*
Baillairge Family *OxArt*
Baillet, Marie Caroline E, Comtesse De 1821-1879*
 DcWomA
Bailleul, Aimee *DcWomA*
Bailleul, Marie *DcWomA*
Baillie, Caroline *DcBrWA, DcVicP 2, DcWomA*
Baillie, James S *NewYHSD*
Baillie, William 1723-1810 *McGDA*
Baillie, William 1905- *DcBrA 1*
Baillie Scott, M H 1865-1945 *MacEA*
Baillie-Scott, M H 1865-1945 *WhoArch*
Baillie-Scott, Mackay Hugh 1865-1945 *AntBDN A,*
 McGDA
Baillon, Jean Baptiste *AntBDN D*
Baillot-Jourdan, Cecile 1889- *DcWomA*
Bailly, A *NewYHSD*
Bailly, Alexis J *FolkA 86, NewYHSD*
Bailly, Alice 1872-1938 *DcWomA*
Bailly, Antoine Nicolas 1810- *ArtsNiC*
Bailly, Antoine-Nicolas 1810-1892 *MacEA*
Bailly, Caroline Berthe Alice *DcWomA*
Bailly, Joseph A d1883 *ArtsNiC*
Bailly, Joseph Alexis 1825-1883 *NewYHSD*
Bailly, Lucie *DcWomA*
Bailly, Paul Charles 1931- *AmArch 70*
Bailward, M B *DcVicP 2, DcWomA*
Baily, A *NewYHSD*
Baily, Caroline Berthe Alice *DcWomA*
Baily, E H 1788-1867 *DcNiCA*
Baily, Edward H 1788-1867 *ArtsNiC*
Baily, Edward Hodges 1788-1867 *OxArt*
Baily, Joseph *FolkA 86*
Baily, Julius T *NewYHSD*
Baily, Nicholas *CabMA*
Baily, R H *DcVicP 2*
Baily, R M *DcVicP 2*
Baily, William A *NewYHSD*
Baily, William Lloyd 1861-1947 *BiDAmAr*
Bain, Arthur Peter 1927- *ClaDrA*
Bain, Donald 1904- *DcBrA 1, WhoArt 80, -82, -84*
Bain, Harriet F *DcWomA, WhAmArt 85*
Bain, Joan 1910- *WhAmArt 85*
Bain, Leonard 1936- *AmArch 70*
Bain, Lilian Pherne *WhoAmA 78N, -80N, -82N,*
 -84N
Bain, Lilian Pherne 1873- *ArtsAmW 2*
Bain, Lilian Pherne 1873-1953? *DcWomA*
Bain, Lilian Pherne 1873-1950? *WhAmArt 85*
Bain, M A 1880- *ArtsAmW 3*
Bain, Mabel A 1880- *ArtsAmW 3*
Bain, Peter 1927- *WhoArt 80, -82, -84*
Bain, Thomas James Coutts 1896- *WhAmArt 85*
Bain, William J 1896- *AmArch 70*
Bain, William James, Jr. 1930- *AmArch 70*
Bainborough, William *NewYHSD*
Bainbridge, Arthur *DcVicP 2*
Bainbridge, F Edith 1886- *DcWomA, WhAmArt 85*
Bainbridge, Frederick Freeman, III 1927- *AmArch 70*
Bainbridge, Henry *ArtsAmW 2, NewYHSD*
Bainbridge, Kenneth 1908- *WhoArt 80, -82, -84*
Bainbridge, Mabel Foster 1885- *WhAmArt 85*
Bainbriggs, Philip *NewYHSD*

Baine, John *BiDBrA*
Baines, B Cooper *DcVicP 2*
Baines, Catherine *DcWomA*
Baines, Henry 1823-1894 *DcBrWA, DcVicP 2*
Baines, John Manwaring 1910- *WhoArt 80, -82*
Baines, Richard John Mainwaring 1940- *ClaDrA*
Baines, Richard John Manwaring 1940- *WhoArt 80, -82, -84*
Baines, Thomas 1820-1875 *DcBrWA*
Baines, Thomas 1822-1875 *DcBrBI*
Bains, Ethel Franklin *DcWomA*
Bains, Ethel Franklin Betts *WhAmArt 85*
Baionno, Anthony Thomas 1927- *AmArch 70*
Bair, Homer Franklin 1896- *WhAmArt 85*
Bair, Royden Stanley 1924- *AmArch 70*
Baird *FolkA 86*
Baird, Clarence 1895- *DcBrA 1*
Baird, Coe Manning d1942 *WhAmArt 85*
Baird, E G *DcWomA*
Baird, Edward 1904-1949 *DcBrA 1*
Baird, Eugene Q 1897- *WhAmArt 85*
Baird, Francis B *AfroAA*
Baird, G *FolkA 86*
Baird, George *ConArch A*
Baird, James *BiDBrA, FolkA 86*
Baird, James 1788?- *FolkA 86*
Baird, James Kenneth 1906- *AmArch 70*
Baird, John *ArtsEM*
Baird, John 1798-1859 *BiDBrA*
Baird, John Foster *DcVicP 2*
Baird, John Logie 1888-1946 *ICPEnP*
Baird, Johnstone *DcBrA 1*
Baird, Joseph Armstrong, Jr. 1922- *MacBEP, WhoAmA 73, -76, -78, -80, -82, -84*
Baird, Ken 1930- *ICPEnP A*
Baird, Kenneth Winston 1930- *MacBEP*
Baird, Louise S *DcWomA, WhAmArt 85*
Baird, M A *DcWomA*
Baird, Myra H *DcWomA, WhAmArt 85*
Baird, Nathaniel Hughes John 1865- *ClaDrA, DcBrA 1, DcVicP 2*
Baird, Nathaniel John Hughes 1865- *DcBrWA*
Baird, Mrs. Robert W *ArtsEM, DcWomA*
Baird, Robert Wallace *ArtsEM*
Baird, Roger Lee 1944- *WhoAmA 73, -76, -78*
Baird, Ruth Llewellyn 1888- *DcWomA, WhAmArt 85*
Baird, Sylvia A *ArtsEM, DcWomA*
Baird, Will *WhAmArt 85*
Baird, William B *WhAmArt 85*
Baird, William Baptiste *DcVicP, -2*
Baird-North *EncASM*
Bairnsfather, Arthur L 1883- *WhAmArt 85*
Bairnsfather, Bruce *WorECar*
Bairnsfather, Bruce 1888-1959 *DcBrA 1, DcBrBI*
Bairstow, Nancy *ClaDrA, DcBrA 1, DcWomA*
Baisden, Frank M 1904- *WhAmArt 85*
Baisley, Charles *WhAmArt 85*
Baitsell, Wilma Williamson 1918- *WhoAmA 78, -80, -82, -84*
Baiyerman, Eugenie *AfroAA*
Baize, Wayne *OfPGCP 86*
Baizerman, Eugenie 1899-1949 *DcWomA*
Baizerman, Saul 1889-1957 *DcAmArt, DcCAA 71, -77, McGDA, OxTwCA, PhDcTCA 77, WhoAmA 84N*
Baizerman, Saul 1898-1957 *WhoAmA 78N, -80N, -82N*
Baizerman, Saul L *WhAmArt 85*
Baj, Enrico *PrintW 85*
Baj, Enrico 1924- *ClaDrA, ConArt 77, -83, OxTwCA, PhDcTCA 77, WorArt[port]*
Bak, Dongkyu 1930- *AmArch 70*
Bakacs, George *IlsBYP*
Bakalowits, E *IlDcG*
Bakanowsky, Louis J 1930- *WhoAmA 73, -76, -78, -80, -82, -84*
Bakanowsky, Louis Joseph 1930- *AmArch 70*
Bakaty, Mike 1936- *WhoAmA 76, -78, -80, -82, -84*
Bakema, J B 1914- *DcD&D, WhoArch*
Bakema, Jacob 1914- *ConArch*
Bakema, Jacob B 1914- *EncMA, McGDA*
Bakema, Jacob B 1914-1981 *MacEA*
Baker *BiDBrA, FolkA 86*
Baker, Miss *DcWomA*
Baker, A C *AmArch 70*
Baker, Adelaide Clarissa *WhAmArt 85*
Baker, Aimee Cevilla 1870- *DcWomA*
Baker, Alexandra Clare 1947- *WhoArt 82, -84*
Baker, Alfred *DcBrWA*
Baker, Alfred 1825- *DcBrWA*
Baker, Alfred 1850-1872 *DcBrWA, DcVicP, -2*
Baker, Alfred E *NewYHSD*
Baker, Alfred Rawlings 1865- *DcBrA 1, DcVicP 2*
Baker, Alfred Zantzinger 1870-1933 *WorECar*
Baker, Alice *WhAmArt 85*
Baker, Alice E F *DcWomA*
Baker, Alice E J *DcVicP 2*
Baker, Alice M M *DcWomA*
Baker, Alvin H 1808?- *NewYHSD*
Baker, Anna 1862-1892 *DcWomA*

Baker, Anna P 1928- *WhoAmA 73, -76, -78*
Baker, Annabelle *AfroAA*
Baker, Annabelle 1925- *WhAmArt 85*
Baker, Annette *DcVicP 2, DcWomA*
Baker, Annie *DcBrBI, DcWomA*
Baker, Father Anselm 1834-1885 *DcBrWA*
Baker, Arthur *DcVicP 2*
Baker, Benjamin d1822 *CabMA*
Baker, Bernard Granville *DcBrBI*
Baker, Bernard W 1941- *MarqDCG 84*
Baker, Blanche *ClaDrA, DcBrA 1, DcVicP, DcWomA*
Baker, Blanche 1844-1929 *DcBrA 2, DcBrWA, DcVicP 2*
Baker, Bryant 1881- *WhAmArt 85*
Baker, Bryant 1881-1970 *DcBrA 2*
Baker, C F *AmArch 70*
Baker, C L *AmArch 70*
Baker, Carl Gene 1942- *AmArch 70*
Baker, Catherine *WhAmArt 85*
Baker, Catherine E *ArtsEM, DcWomA*
Baker, Charles *BiDBrA, NewYHSD*
Baker, Charles 1844-1906 *WhAmArt 85*
Baker, Charles Edwin 1902- *WhAmArt 85, WhoAmA 73*
Baker, Charles Edwin 1902-1971 *WhoAmA 76N, -78N, -80N, -82N, -84N*
Baker, Charles Henry Collins 1880-1959 *DcBrA 1*
Baker, Charles M d1931? *BiDAmAr*
Baker, Charlotte 1910- *IlsCB 1946*
Baker, Christina Asquith 1869-1955? *DcWomA*
Baker, Christopher William 1956- *WhoArt 84*
Baker, Conn *WhAmArt 85*
Baker, Constance Amelia *DcWomA*
Baker, Daniel, Jr. 1820-1905 *FolkA 86*
Baker, David 1816- *FolkA 86*
Baker, David 1917- *AmArch 70*
Baker, Deborah Frances 1954- *MacBEP*
Baker, Dennis Graham *MarqDCG 84*
Baker, Dina Gustin 1924- *WhoAmA 76, -78, -80, -82, -84*
Baker, Donald *WhAmArt 85*
Baker, Dorothy *FolkA 86*
Baker, Douglas Sterling 1917- *AmArch 70*
Baker, E *DcVicP 2*
Baker, E F *AmArch 70*
Baker, E W *AmArch 70*
Baker, Ebenezer *CabMA*
Baker, Edward Allen 1933- *AmArch 70*
Baker, Eliza Jane *FolkA 86*
Baker, Elizabeth 1860-1927 *DcWomA*
Baker, Elizabeth C *WhoAmA 78, -80, -82, -84*
Baker, Elizabeth Gowdy d1927 *WhAmArt 85*
Baker, Ella 1852- *DcWomA*
Baker, Ellen Kendall *DcWomA*
Baker, Ellen Kendall d1913 *WhAmArt 85*
Baker, Emilie H *WhAmArt 85*
Baker, Emilie H 1876- *DcWomA*
Baker, Emily *DcWomA, FolkA 86*
Baker, Ernest Hamlin *WhAmArt 85*
Baker, Ernest Hamlin 1889- *IlrAm D*
Baker, Ernest Hamlin 1889-1975 *IlrAm 1880*
Baker, Ethelwyn *ClaDrA*
Baker, Eugene *WhAmArt 85*
Baker, Eugene Ames 1928- *WhoAmA 73, -76, -78, -80, -82, -84N*
Baker, Evangeline *DcVicP 2*
Baker, Evangile *DcWomA*
Baker, Ezekiel *AntBDN F*
Baker, F *DcVicP 2, DcWomA*
Baker, F A Fuller *WhAmArt 85*
Baker, Frances Louise 1871- *DcWomA, WhAmArt 85*
Baker, Frank L d1939 *BiDAmAr*
Baker, Frederic VanVliet 1876- *WhAmArt 85*
Baker, Frederick W *DcVicP 2*
Baker, Frederick W, Jr. *DcVicP 2*
Baker, G *WhAmArt 85*
Baker, G H Massy *DcVicP 2*
Baker, Geoffrey Alan 1881- *DcBrA 1*
Baker, George 1882- *ArtsAmW 1, WhAmArt 85*
Baker, George 1915-1975 *WorECom*
Baker, George 1931- *DcCAr 81, WhoAmA 73, -76, -78, -80, -82, -84*
Baker, George A 1821-1880 *ArtsNiC*
Baker, George Arnald *DcVicP 2*
Baker, George Augustus 1760- *NewYHSD*
Baker, George Augustus 1821-1880 *NewYHSD*
Baker, George H 1878-1943 *WhAmArt 85*
Baker, George Holbrook 1827-1906 *ArtsAmW 1, EarABI SUP, IlBEAAW, NewYHSD, WhAmArt 85*
Baker, George J *NewYHSD*
Baker, George O 1882- *DcVicP 2*
Baker, Gladys M *WhAmArt 85*
Baker, Gladys Marguerite 1889- *DcBrA 1, DcWomA*
Baker, Grace *WhoAmA 73, -76, -78, -80*
Baker, Grace M 1876- *ArtsAmW 2, DcWomA, WhAmArt 85*
Baker, H *BiDBrA*
Baker, H Ray 1911- *IlBEAAW*

Baker, Harold Jewel 1911- *AmArch 70*
Baker, Harry 1849-1875 *DcBrWA*
Baker, Helen Josephine 1869- *DcWomA, WhAmArt 85*
Baker, Helena Seymour 1900- *WhAmArt 85*
Baker, Henry 1849-1875 *DcVicP, -2*
Baker, Henry M 1810-1874 *NewYHSD*
Baker, Herbert 1862-1946 *MacEA*
Baker, Sir Herbert 1862-1946 *ConArch, DcBrA 1, DcD&D, McGDA, WhoArch*
Baker, Horace 1833-1918 *NewYHSD, WhAmArt 85*
Baker, I H *NewYHSD*
Baker, Ida Strawn 1876- *DcWomA, WhAmArt 85*
Baker, Isaac C *NewYHSD*
Baker, Isham Owen 1929- *AmArch 70*
Baker, J *DcVicP 2*
Baker, J E *AmArch 70*
Baker, J Elder *WhAmArt 85*
Baker, Mrs. J Elder *DcWomA*
Baker, J F *NewYHSD*
Baker, J R *AmArch 70*
Baker, J S *AmArch 70*
Baker, J W *FolkA 86*
Baker, James *NewYHSD*
Baker, James B 1854-1918 *BiDAmAr*
Baker, James Barnes 1933- *AmArch 70*
Baker, James C *MarqDCG 84*
Baker, James Graham 1946- *MarqDCG 84*
Baker, Jean 1903- *WhAmArt 85*
Baker, Jean Jessie d1944 *DcWomA*
Baker, Jennet M *ArtsAmW 3*
Baker, Jessie E *WhAmArt 85*
Baker, Jill 1942- *WhoAmA 82, -84*
Baker, Jill Withrow 1942- *WhoAmA 78, -80*
Baker, John *AntBDN K, FolkA 86, NewYHSD*
Baker, John 1736-1771 *DcBrECP*
Baker, John B *FolkA 86*
Baker, John E 1857-1933 *BiDAmAr*
Baker, John Milnes 1932- *AmArch 70*
Baker, John S *NewYHSD*
Baker, Joseph *FolkA 86*
Baker, Joseph E *NewYHSD*
Baker, Julius Stafford 1869-1961 *WorECar*
Baker, L H *DcVicP 2, DcWomA*
Baker, Lamar 1908- *WhAmArt 85*
Baker, Lloyd A 1932- *AmArch 70*
Baker, M A *NewYHSD*
Baker, M K *DcWomA*
Baker, Miss M K *ArtsNiC*
Baker, M R *AmArch 70*
Baker, Margaret *DcWomA, WhAmArt 85*
Baker, Maria May 1890- *DcWomA, WhAmArt 85*
Baker, Martha Susan 1871- *WhAmArt 85*
Baker, Martha Susan 1871-1911 *DcWomA*
Baker, Mary *DcWomA*
Baker, Mary 1897- *ConICB, DcWomA, IlsCB 1744, -1946*
Baker, Mary Canfield Benedict *FolkA 86*
Baker, Mary F 1879-1943 *WhAmArt 85*
Baker, Mary Frances 1879-1943 *DcWomA*
Baker, Mary Hofstetter 1913- *WhAmArt 85*
Baker, Maureen *WorFshn*
Baker, Michael *FolkA 86*
Baker, Mildred 1905- *WhoAmA 73, -76*
Baker, Minnie *DcWomA*
Baker, Minnie 1901- *WhAmArt 85*
Baker, Nancy 1795-1837 *FolkA 86*
Baker, Nathan F 1822?- *NewYHSD*
Baker, Oliver *WhAmArt 85*
Baker, Oliver 1856- *DcBrWA*
Baker, Oliver 1856-1939 *DcBrA 1, DcVicP 2*
Baker, Oliver Mozart *WhAmArt 85*
Baker, Ollie James 1911- *AmArch 70*
Baker, Ora Phelps 1898- *ArtsAmW 3, WhAmArt 85*
Baker, P *FolkA 86*
Baker, Parham Henry 1930- *AmArch 70*
Baker, Percy Bryant 1881- *WhAmArt 85*
Baker, R E *DcSeaP*
Baker, Ralph Bernard 1932- *WhoAmA 76, -78, -80, -82, -84*
Baker, Raymond Nelson 1913- *WhAmArt 85*
Baker, Richard 1743-1803 *BiDBrA*
Baker, Richard 1822- *DcBrWA, DcVicP 2*
Baker, Richard A 1921- *AmArch 70*
Baker, Richard Albert, Jr. 1959- *MarqDCG 84*
Baker, Richard Brown 1912- *WhoAmA 73, -76, -78, -80, -82, -84*
Baker, Robert P 1886-1940 *WhAmArt 85*
Baker, Ronald G 1939- *MarqDCG 84*
Baker, S B 1882- *WhAmArt 85*
Baker, S H *WhAmArt 85*
Baker, S J *DcVicP 2*
Baker, S Oscar *WhAmArt 85*
Baker, Samuel Colwell 1874-1964 *FolkA 86*
Baker, Samuel F *NewYHSD*
Baker, Samuel Henry 1824-1909 *DcBrA 1, DcBrWA, DcVicP, -2*
Baker, Samuel Houston 1875-1947 *BiDAmAr*
Baker, Sir Samuel White 1821-1893 *DcBrBI*

Baker, Sarah M 1899- *DcWomA*, *WhAmArt 85*
Baker, Sarah Marimda 1899- *WhoAmA 78, –80, –82*
Baker, Seth, II *CabMA*
Baker, Sidney *DcVicP 2*
Baker, Stanley James 1932- *AmArch 70*
Baker, T Andre *WhAmArt 85*
Baker, Tamara Carol 1959- *MarqDCG 84*
Baker, Thomas *DcVicP 2*, *FolkA 86*
Baker, Thomas 1809-1869 *ClaDrA*, *DcBrWA*, *DcVicP, –2*
Baker, Thomas S 1907- *WhAmArt 85*
Baker, Tom *FolkA 86*
Baker, Vivian McLain 1924- *AmArch 70*
Baker, W *DcVicP 2*
Baker, W, Jr. *DcVicP 2*
Baker, W J *DcVicP 2*
Baker, W M *DcVicP 2*
Baker, W McNeill 1921- *AmArch 70*
Baker, W T *AmArch 70*
Baker, Walter C *WhoAmA 78, –80*
Baker, Mrs. Walter C *WhoAmA 73, –76*
Baker, Warren W *FolkA 86*
Baker, Wilbur A 1895-1968 *FolkA 86*
Baker, William *DcVicP 2*, *FolkA 86*, *McGDA*
Baker, William 1705-1771 *BiDBrA*
Baker, William D *NewYHSD*
Baker, William H 1825-1875 *ArtsNiC*, *NewYHSD*
Baker, William Henry 1899- *ArtsAmW 2*, *IlBEAAW*, *WhAmArt 85*
Baker, William Jay *NewYHSD*
Baker-Baker *WorECar*
Baker-Clack, Arthur d1955 *DcBrA 2*
Baker-Lockwood *FolkA 86*
Baker-Manchester *EncASM*
Bakewell, Benjamin *AntBDN H*
Bakewell, Esther M *DcVicP 2*, *DcWomA*
Bakewell, H *DcVicP 2*
Bakewell, H N *FolkA 86*
Bakewell, Henrietta *DcWomA*
Bakewell, Robert *DcBrBI*
Bakewell, Robert 1790?- *NewYHSD*
Bakewell And Brown *MacEA*
Bakewell, Pears & Company *DcNiCA*
Bakhmutsky, David 1947- *MarqDCG 84*
Bakhtadze, Nakhtang 1914- *WorECar*
Bakhuizen, Gerardina Jacoba VanDeSande 1826-1895 *DcWomA*
Bakhuysen, Ludolf 1631-1708 *McGDA*
Bakhuyzen, Ludolf 1631-1708 *ClaDrA*, *OxArt*
Bakic, Vojin 1915- *OxTwCA*, *PhDcTCA 77*
Bakie, Ernest Sanders 1921- *AmArch 70*
Bakkavold, Margaret *DcCAr 81*
Bakke, Anton E K 1911- *WhAmArt 85*
Bakke, H J *AmArch 70*
Bakke, Karen Lee 1942- *WhoAmA 78, –80, –82, –84*
Bakke, Larry Hubert 1932- *WhoAmA 73, –76, –78, –80, –82, –84*
Bakken, Haakon 1932- *WhoAmA 78, –80, –82, –84*
Bakker, Douwe Jan 1943- *ConArt 77*
Bakker, Gerhard H 1906- *WhAmArt 85*
Bakker, Kenneth *OxTwCA*
Bakker-Korff, Alexandre-Hugo 1824- *ArtsNiC*
Bakos, Joseph G 1891- *ArtsAmW 1*
Bakos, Joseph G 1891-1977 *ArtsAmW 3*
Bakos, Jozef G 1891- *IlBEAAW*, *WhAmArt 85*
Bakos, Jozef G 1891-1977 *ArtsAmW 3*
Bakos, Teresa *WhAmArt 85*
Baksa-Soos, Krisztina 1944- *DcCAr 81*
Bakshi, Ralph 1938- *WorECar*
Bakst, Leon 1866-1924 *McGDA*, *OxTwCA*, *PhDcTCA 77*
Bakst, Leon 1886-1925 *OxArt*
Bakst, Lev 1886-1925 *OxArt*
Balaban, Robert 1952- *MarqDCG 84*
Balabuck, Richard John 1952- *MarqDCG 84*
Baladi, Roland 1942- *ConArt 77*
Balaguer, Pedro *McGDA*
Balamut, Morris 1952- *MarqDCG 84*
Balamuth, Michael Lewis 1950- *MarqDCG 84*
Balan, Franco 1934- *WhoGrA 82[port]*
Balan, Maria *OxTwCA*
Balance, Jerrald Clark 1944- *WhoAmA 78, –80, –82, –84*
Balano, Paula Himmelsbach 1878- *DcWomA*, *WhAmArt 85*
Balantyne *FolkA 86*
Balantyne, Abraham 1835-1904 *FolkA 86*
Balantyne, John 1812?- *FolkA 86*
Balantyne, Samuel 1808-1861 *FolkA 86*
Balar, Joseph *FolkA 86*
Balart, Waldo 1931- *WhoAmA 73, –76*
Balasa, Sabin 1932- *WorECar*
Balat, Alphonse 1818-1895 *MacEA*, *McGDA*
Balaun, E P *AmArch 70*
Balay, Felicie 1940- *WhoAmA 80, –82, –84*
Balazer, Leonard P 1928- *MarqDCG 84*
Balazs, Gyongyi 1926- *WhoAmA 84*
Balazs-Pottasch, Gyongyi 1926- *WhoAmA 76, –78, –80, –82*
Balbas, Geronimo 1670?-1760? *McGDA*

Balcells Buigas, Eduardo Maria 1877-1965 *MacEA*
Balch, Clarissa 1772- *FolkA 86*
Balch, Daniel 1735-1790? *AntBDN D*
Balch, Edwin Swift d1927 *WhAmArt 85*
Balch, Eugene *NewYHSD*
Balch, Georgia W 1888- *DcWomA*, *WhAmArt 85*
Balch, Gertrude Howland 1909- *WhAmArt 85*
Balch, Leland, Jr. *NewYHSD*
Balch, Mary 1762-1831 *FolkA 86*
Balch, Percy I 1876-1936 *BiDAmAr*
Balch, Sarah Eaton *DcWomA*, *FolkA 86*
Balch, Vistus 1799-1884 *NewYHSD*
Balch, William Glenn 1901- *AmArch 70*
Balciar, Gerald George 1942- *AmArt*, *WhoAmA 82, –84*
Balcom, Lowell L 1887-1938 *WhAmArt 85*
Balcom, Lowell Leroy 1887-1938 *IlrAm D, –1880*
Balcomb, J T *DcBrBI*
Bald, J Dorsey 1826?-1878? *NewYHSD*
Bald, Kenneth 1920- *WorECom*
Bald, Robert 1793?-1856? *NewYHSD*
Bald, Robert L 1826?-1853? *NewYHSD*
Baldacci, Maria Maddalena 1718-1782 *DcWomA*
Baldaccini, Cesar *McGDA*
Baldassarre, Giovanni Di d1536 *McGDA*
Baldauf, Joseph *FolkA 86*
Baldaugh, Anni 1886- *ArtsAmW 2*, *DcWomA*, *WhAmArt 85*
Baldelli, Sister Maria Chiara d1805 *DcWomA*
Balderacchi, Arthur Eugene 1937- *WhoAmA 80, –82, –84*
Balderi, Michelangelo 1926- *AmArch 70*
Balderson, C J *AmArch 70*
Balderston, Anne *WhAmArt 85*
Baldessari, John 1931- *ConArt 77, –83*, *ConPhot*, *DcCAA 77*, *DcCAr 81*, *ICPEnP A*, *MacBEP*, *PrintW 83, –85*
Baldessari, John Anthony 1931- *AmArt*, *WhoAmA 76, –78, –80, –82, –84*
Baldessari, Luciano 1896- *EncMA*, *MacEA*
Baldessari, Mendel Louis 1913- *AmArch 70*
Baldeweg, Johanna *DcWomA*
Baldi, Bernardino 1553-1617 *MacEA*
Baldinger, Wallace Spencer 1905- *WhAmArt 85*
Baldini, Baccio *McGDA*
Baldini, T *DcVicP 2*
Baldino, J B *AmArch 70*
Baldino, Jno. Joseph 1904- *AmArch 70*
Baldinucci, Abate Filippo 1624-1696 *OxArt*
Baldock *DcNiCA*
Baldock, Charles E *DcVicP 2*
Baldock, Charles Edwin Markham 1878?-1941 *DcBrWA*
Baldock, James Walsham *DcVicP, –2*
Baldock, James Walsham 1822?-1898 *DcBrWA*
Baldovinetti, Alesso 1425-1499 *McGDA*
Baldovinetti, Alesso 1426?-1499 *OxArt*
Baldrey, Haynsworth 1885-1946 *WhAmArt 85*
Baldrey, John, Jr. 1758- *DcBrECP*
Baldrey, John, Sr. *DcBrECP*
Baldrey, John Kirby 1754-1828 *DcBrWA*
Baldrey, Samuel H *DcVicP 2*
Baldridge, Cyrus Leroy 1889- *AfroAA*, *ArtsAmW 1*, *IlBEAAW*
Baldridge, Cyrus LeRoy 1889- *IlsBYP*, *IlsCB 1744, –1946*, *WhAmArt 85*
Baldridge, Cyrus Leroy 1889-1975 *ArtsAmW 2*
Baldridge, James Noel 1943- *MarqDCG 84*
Baldridge, Mark S 1946- *WhoAmA 78, –80, –82, –84*
Baldrighi, Constanza *DcWomA*
Baldry, Alfred Lys 1858-1939 *DcBrA 1*, *DcVicP 2*
Baldry, Grace *DcVicP 2*
Baldry, Harry *DcVicP 2*
Balducci, Gregorio *DcBrECP*
Balducci, Matteo *McGDA*
Balduccio, Giovanni d1603 *McGDA*
Balduccio, Giovanni 1300?- *McGDA*
Balduccio, Giovanni Da *OxArt*
Baldung, Hans 1484?-1545 *OxArt*
Baldung-Grien, Hans 1480?-1545 *McGDA*
Baldus, Edouard-Denis 1813?-1882 *ICPEnP*
Baldus, Edouard-Denis 1820-1882 *MacBEP*
Baldwin *FolkA 86*
Baldwin, A C *DcWomA*
Baldwin, Mrs. A C *ArtsEM*
Baldwin, A J *ArtsEM*
Baldwin, Addie *DcWomA*
Baldwin, Almon *NewYHSD*
Baldwin, Archibald *DcVicP 2*
Baldwin, Arthur Mervyn 1934- *WhoArt 80, –82, –84*
Baldwin, Asa *FolkA 86*
Baldwin, B *DcVicP 2*
Baldwin, B J *AmArch 70*
Baldwin, Barbara 1914- *WhAmArt 85*
Baldwin, Benjamin 1913- *BnEnAmA*, *MacEA*, *McGDA*
Baldwin, Brake *DcBrA 1*
Baldwin, Burton Clarke 1891- *WhAmArt 85*
Baldwin, Charles B 1897- *WhAmArt 85*
Baldwin, Charles P -1929? *BiDAmAr*
Baldwin, Clarence E 1862- *WhAmArt 85*

Baldwin, Clifford Park 1889- *ArtsAmW 1*, *IlBEAAW*, *WhAmArt 85*
Baldwin, Donald Edwin 1930- *AmArch 70*
Baldwin, Dwight 1948- *MarqDCG 84*
Baldwin, Edith Ella 1870- *DcWomA*, *WhAmArt 85*
Baldwin, Edward Robinson 1935- *AmArch 70*
Baldwin, Enos *NewYHSD*
Baldwin, Ephraim Francis 1837-1916 *BiDAmAr*
Baldwin, Esther *WhAmArt 85*
Baldwin, Esther M *DcWomA*
Baldwin, Ethel 1878-1967 *DcWomA*
Baldwin, F D *AmArch 70*
Baldwin, Frances 1907- *WhAmArt 85*
Baldwin, Frank *FolkA 86*
Baldwin, Frank C 1869-1945 *BiDAmAr*
Baldwin, Frederick William 1899- *DcBrA 1*
Baldwin, George C 1818?-1879? *NewYHSD*
Baldwin, George D *NewYHSD*
Baldwin, Gordon 1932- *WhoArt 84*
Baldwin, Guy H 1912- *AmArch 70*
Baldwin, H *FolkA 86*
Baldwin, Hannah *FolkA 86*
Baldwin, Harold Fletcher 1923- *WhoAmA 76, –78, –80, –82, –84*
Baldwin, Harry, II *WhoAmA 78N, –80N, –82N, –84N*
Baldwin, Henry *FolkA 86*
Baldwin, Henry C *DcVicP 2*
Baldwin, Isaac *EncASM*
Baldwin, J *DcVicP 2*
Baldwin, J Brake 1885-1915 *DcBrA 2*
Baldwin, J E *AmArch 70*
Baldwin, J G *NewYHSD*
Baldwin, J L *NewYHSD*
Baldwin, James *NewYHSD*
Baldwin, Jane 1908- *WhAmArt 85*
Baldwin, Jim *WorFshn*
Baldwin, John 1922- *WhoAmA 78, –80, –82, –84*
Baldwin, John Lee 1868-1938 *FolkA 86*
Baldwin, Josephine K 1888- *WhAmArt 85*
Baldwin, Kate 1942- *MarqDCG 84*
Baldwin, Mary M *WhAmArt 85*
Baldwin, Michael 1719-1787 *FolkA 86*
Baldwin, Michael 1945- *DcCAr 81*
Baldwin, Milton d1939 *EncASM*
Baldwin, Muriel Frances *WhoAmA 78N, –80N, –82N, –84N*
Baldwin, Nancy 1935- *WhoArt 84*
Baldwin, Nixford *WhAmArt 85*
Baldwin, Polly *WhAmArt 85*
Baldwin, R Roberts *WhAmArt 85*
Baldwin, Richard Wood 1920- *WhoAmA 76, –78, –80, –82, –84*
Baldwin, Robert *BiDBrA*, *DcBrWA*
Baldwin, Roger Poole 1919- *AmArch 70*
Baldwin, Russell W 1933- *WhoAmA 76, –78, –80, –82, –84*
Baldwin, S R *FolkA 86*
Baldwin, Samuel *DcVicP, –2*
Baldwin, Sylvanus *BiDAmAr*
Baldwin, Thomas 1568-1641 *BiDBrA*
Baldwin, Thomas 1750-1820 *BiDBrA*
Baldwin, V *FolkA 86*
Baldwin, Wickliffe *EncASM*
Baldwin, William *DcD&D[port]*, *FolkA 86*, *NewYHSD*
Baldwin, William 1808?- *NewYHSD*
Baldwin And Durand *EncASM*
Baldwin And Jones *EncASM*
Baldwin And Miller *EncASM*
Baldwin Ford *EncASM*
Baldwin-Ford, Pamela *IlsBYP*
Baldwin Miller *EncASM*
Baldwyn, Charles H C *DcVicP 2*
Baldy, J M *WhAmArt 85*
Bale, A M E 1875-1955 *DcWomA*
Bale, C T *ClaDrA*, *DcVicP*
Bale, Charles Thomas *DcVicP 2*
Bale, Edwin 1838-1923 *DcBrA 1*, *DcBrWA*, *DcVicP 2*
Bale, J E *DcVicP 2*
Bale, James *NewYHSD*
Bale, Louis *NewYHSD*
Bale, T C *DcVicP 2*
Baleix, John 1928- *AmArch 70*
Balen, Hendrik Van 1575?-1632 *ClaDrA*
Balen, Hendrik Van, The Elder 1575-1632 *McGDA*
Balen, Jan Van 1611-1654 *McGDA*
Balen, Samuel Thomas 1931- *AmArch 70*
Balenciaga, Cristobal 1895-1972 *ConDes*, *FairDF FRA[port]*, *WorFshn*
Bales, George Carson 1920- *WhoAmA 73*
Bales, J 1946- *WhoAmA 76, –78*
Bales, Jewel 1911- *WhoAmA 73, –76, –78, –80, –82, –84*
Balestra, Antonio 1666-1740 *ClaDrA*, *McGDA*
Balestra, Renato *WorFshn*
Balet, Jan *IlsCB 1967*
Balet, Jan 1913- *PrintW 83, –85*
Balet, Jan B 1913- *IlsCB 1946*
Baley, Sarah 1727-1750 *FolkA 86*

Balfour, Miss *DcWomA*
Balfour, Alan *ConArch A*
Balfour, Helen 1857- *WhAmArt 85*
Balfour, Helen 1857-1925 *DcWomA*
Balfour, Helen Johnson 1857- *ArtsAmW 2*
Balfour, J Lawson *DcVicP 2*
Balfour, J Lawson 1870- *DcBrA 2*
Balfour, Katherine Jane *DcWomA*
Balfour, Maria 1934- *WhoArt 80, -82, -84*
Balfour, Maxwell *DcBrBI*
Balfour, Robert 1770?-1867 *BiDBrA*
Balfour, Roberta 1871- *ArtsAmW 2, DcWomA,*
WhAmArt 85
Balfour, Ronald E 1896-1941 *DcBrBI*
Balfour-Browne, Vincent R 1880-1963 *DcBrA 2*
Balgar, Nina 1957- *MarqDCG 84*
Balicki, Boguslaw 1937- *ConDes*
Balignant *NewYHSD*
Balink, Hendricus C 1882-1963 *WhAmArt 85*
Balink, Henry C 1882-1963 *ArtsAmW 1, IlBEAAW*
Balinsky, Al 1946- *MacBEP*
Baliot, Abraham *FolkA 86*
Balis, C *NewYHSD*
Baljeu, Joost 1925- *ConArt 77, DcCAr 81,*
OxTwCA
Balkan, Maury 1913- *WhAmArt 85*
Balke, Don *OfPGCP 86*
Balkin, Lance *DcBrBI*
Balkind, Alvin Louis 1921- *WhoAmA 73, -76, -78,*
-80, -82, -84
Balko, Gregg B 1951- *MarqDCG 84*
Ball, A J F *DcVicP 2*
Ball, Alec C *DcBrBI*
Ball, Alice Lynde Raymond 1870-1942 *DcWomA,*
WhAmArt 85
Ball, Alice Worthington d1929 *DcWomA,*
WhAmArt 85
Ball, Arthur E *DcVicP 2*
Ball, Bernard Raymond 1921- *WhoArt 80*
Ball, Caroline 1869-1938 *DcWomA*
Ball, Caroline Peddle 1869-1938 *WhAmArt 85*
Ball, Edward *EncASM*
Ball, Edwin Francis 1927- *AmArch 70*
Ball, Ezra H 1824?- *NewYHSD*
Ball, F Carlton 1911- *BnEnAmA, CenC*
Ball, Franklin *NewYHSD*
Ball, Fred H *DcBrBI*
Ball, Frederick Carlton 1911- *McGDA*
Ball, G Meyer *DcVicP 2*
Ball, George 1929- *DcCAr 81*
Ball, George A *ArtsEM*
Ball, George Edward 1875- *WhAmArt 85*
Ball, Gerald 1948- *WhoArt 82, -84*
Ball, H H *AmArch 70, FolkA 86*
Ball, Henry *EncASM*
Ball, Hugh Swinton d1838 *NewYHSD*
Ball, Hugo 1886-1927 *OxTwCA*
Ball, James Howell 1790-1857 *BiDBrA*
Ball, Janet Woodward *WhAmArt 85*
Ball, John *FolkA 86*
Ball, Katherine M *ArtsAmW 3*
Ball, Kenneth L 1934- *AmArch 70*
Ball, L Clarence 1858-1915 *WhAmArt 85*
Ball, Liberty P *NewYHSD*
Ball, Linn 1891- *WhAmArt 85*
Ball, Louisa d1863 *DcBrWA, DcWomA*
Ball, Luther 1827?- *NewYHSD*
Ball, Lyle V 1909- *WhoAmA 76, -78, -80, -82, -84*
Ball, Marcella *DcWomA*
Ball, Margaret *DcWomA, NewYHSD*
Ball, Martin 1948- *DcCAr 81*
Ball, Mary Roberts *DcWomA, WhAmArt 85*
Ball, Mary Wilson *WhAmArt 85*
Ball, Mary Wilson 1892- *DcWomA*
Ball, Maude Mary 1883- *DcWomA*
Ball, Nelson *FolkA 86*
Ball, Percy B 1879- *WhAmArt 85*
Ball, Peter *CabMA*
Ball, Peter Eugene 1943- *DcCAr 81*
Ball, Ralph M 1907- *AmArch 70*
Ball, Robert *IlsBYP, IlsCB 1946*
Ball, Robert 1918- *DcBrA 1, WhoArt 80, -82, -84*
Ball, Robert Edward, Jr. 1890- *WhAmArt 85*
Ball, Robert Herschal, Jr. 1923- *AmArch 70*
Ball, Ruth N *WhAmArt 85*
Ball, Ruth Norton *DcWomA*
Ball, S *NewYHSD*
Ball, Seymour Alling 1902- *WhAmArt 85*
Ball, Silas *FolkA 86*
Ball, Sophia *DcWomA, NewYHSD*
Ball, Stanley Crittenden 1885- *WhAmArt 85*
Ball, Stephen T *MarqDCG 84*
Ball, Thomas *ArtsNiC*
Ball, Thomas 1819-1911 *BnEnAmA, DcAmArt,*
McGDA, NewYHSD , OxArt, WhAmArt 85
Ball, Thomas Watson 1863-1934 *WhAmArt 85*
Ball, Tom 1888- *DcBrA 1*
Ball, W *NewYHSD*
Ball, Walter N 1930- *AmArt, WhoAmA 80, -82, -84*
Ball, Walter Neil 1930- *WhoAmA 78*
Ball, Wilfred Williams 1853-1917 *ClaDrA, DcBrA 1,*

DcBrBI, DcBrWA
Ball, Wilfrid Williams 1853-1917 *DcVicP, -2*
Ball, William, Jr. 1794?-1813 *NewYHSD*
Ball Black *EncASM*
Ball-Demont, Adrienne Elodie Clemence 1886-
DcWomA
Ball-Hughes, Georgiana 1828-1911 *DcWomA,*
WhAmArt 85
Ball-Hughes, Robert *McGDA*
Ball Tompkins And Black *EncASM*
Balla, Giacomo 1871-1958 *ConArt 77, -83, MacEA,*
McGDA, OxArt, OxTwCA, PhDcTCA 77
Ballach, Allen A 1947- *MarqDCG 84*
Ballagh, Robert 1943- *DcCAr 81, WhoGrA 82[port]*
Ballain, Nanine *DcWomA*
Ballaine, Jerry 1934- *DcCAr 81*
Ballance, Claflin A 1932- *AmArch 70*
Ballance, Percy DesCarrieres 1899- *ClaDrA,*
DcBrA 1
Balland, Jeanne Caroline Louise *DcWomA*
Ballantine, Edward James 1885- *WhAmArt 85*
Ballantine, John 1815-1897 *ClaDrA*
Ballantyne, Catherine Turk 1912- *WhoAmA 82, -84*
Ballantyne, David 1913- *WhoArt 80, -82, -84*
Ballantyne, Edith *DcWomA*
Ballantyne, John 1815-1897 *DcVicP, -2*
Ballantyne, Kenneth M *WhAmArt 85*
Ballantyre, K M *WhAmArt 85*
Ballard, A K *FolkA 86*
Ballard, Alice E *DcVicP 2*
Ballard, Arthur 1915- *WhoArt 80, -82, -84*
Ballard, Bettina 1908-1961 *WorFshn*
Ballard, Carl E 1923- *MarqDCG 84*
Ballard, Daniel *CabMA*
Ballard, Dora *ArtsEM*
Ballard, E Loretta *AfroAA*
Ballard, Frank Ingram 1924- *AmArch 70*
Ballard, George *NewYHSD*
Ballard, Lockett Ford, Jr. 1946- *WhoAmA 82, -84*
Ballard, Louise Elizabeth 1911- *WhAmArt 85*
Ballard, O L *FolkA 86*
Ballard, Otis A *NewYHSD*
Ballard, Roger Wood 1937- *AmArch 70*
Ballard, Thomas *DcVicP 2*
Ballard, W F *AmArch 70*
Ballarini, Anna De 1820-1906 *DcWomA*
Ballas, Oscar John 1914- *AmArch 70*
Ballator, John R 1909- *WhAmArt 85*
Ballatore, Sandra Lee 1941- *WhoAmA 78*
Ballatore-Nelson, Sandra Lee 1941- *WhoAmA 80, -82,*
-84
Ballay, Joseph M 1938- *MarqDCG 84*
Balle, August William 1882-1946 *BiDAmAr*
Ballenberger, Karl 1801-1860 *ClaDrA*
Ballentine, Jene 1942- *AfroAA*
Ballerini-Ball, N 1899- *WhAmArt 85*
Ballester, Anselmo 1897-1974 *WorECar*
Ballester, Joaquin 1741- *McGDA*
Ballester, Jorge *OxTwCA*
Ballet, Billie *WhAmArt 85*
Balleyguier-Duchatelet, Melanie *DcWomA*
Balli, Paola *DcWomA*
Ballin, Florence *DcWomA, WhAmArt 85*
Ballin, Hugo d1956 *WhoAmA 80N, -82N, -84N*
Ballin, Hugo 1879-1956 *ArtsAmW 1, WhAmArt 85*
Ballin, J *NewYHSD*
Balling, Ole Peter Hansen 1823-1906 *NewYHSD*
Ballingall, Alexander *DcVicP 2*
Ballinger, H R 1892- *WhAmArt 85*
Ballinger, Harry Russell 1892- *ArtsAmW 2,*
WhoAmA 73, -76
Ballinger, James K 1949- *WhoAmA 76, -82, -84*
Ballinger, Louise Bowen 1909- *WhAmArt 85,*
WhoAmA 73, -76, -78
Ballinger, Maxil 1914- *WhAmArt 85*
Ballinger, R *AmArch 70*
Ballinger, Robert Irving, Jr. 1918- *AmArch 70*
Ballini, Camillo *McGDA*
Ballman, A T *AmArch 70*
Ballmer, Walter 1923- *ConDes, WhoGrA 62,*
-82[port]
Ballo, Paula *DcWomA*
Ballot, Adelaide *DcWomA*
Ballot, Clementine 1879-1964 *DcWomA*
Ballot, Jacqueline Cecile Adelon *DcWomA*
Ballou *EncASM*
Ballou, A S *AmArch 70*
Ballou, Addie L 1837-1916 *ArtsAmW 1*
Ballou, Addie Lucia 1837-1916 *ArtsAmW 2*
Ballou, Adelaide 1895- *DcWomA*
Ballou, Anne MacDougall *WhoAmA 82, -84*
Ballou, Anne Macdougall 1944- *WhoAmA 76, -78,*
-80
Ballou, Bertha 1891- *ArtsAmW 1, DcWomA,*
IlBEAAW, WhAmArt 85
Ballou, Bertha 1891-1978 *ArtsAmW 3*
Ballou, Giddings Hyde 1820-1886 *NewYHSD*
Ballou, James Howland 1920- *AmArch 70*
Ballou, Louis Watkins 1904- *AmArch 70*
Ballou, P Irving *WhAmArt 85*
Ballowe, Jeff *MarqDCG 84*

Balls, William S *ArtsEM*
Ballu, Theodore 1817- *ArtsNiC*
Ballu, Theodore 1817-1885 *MacEA, McGDA,*
WhoArch
Ballue-Genevay, Blanche *DcWomA*
Balluff, Edward Louis 1930- *AmArch 70*
Bally, Alice *DcWomA*
Bally, Caroline *DcWomA*
Balmaceda, Margarita S 1933- *WhoAmA 78, -80, -82,*
-84
Balmain, Kenneth Field 1890- *DcBrA 1*
Balmain, Pierre 1914- *FairDF FRA[port], WorFshn*
Balmain, Pierre Alexandre Claudius 1914-1982 *ConDes*
Balmanno, Mrs. Robert *DcWomA, NewYHSD*
Balmer, Barbara 1929- *WhoArt 80*
Balmer, Clinton *ArtsAmW 3, WhAmArt 85*
Balmer, George 1805-1846 *DcVicP, -2*
Balmer, George 1806-1846 *DcBrWA*
Balmford, Hurst 1871- *DcBrA 1, DcBrWA*
Balmford, Mary *PhDcTCA 77*
Balobeck, J J, Jr. *AmArch 70*
Balodis, Leon 1939- *ICPEnP A*
Balodis, Lidija 1921- *AmArch 70*
Balog, Michael 1946- *ConArt 77, PrintW 83, -85,*
WhoAmA 73, -76, -78, -80, -82, -84
Balogh, Istvan 1924- *WhoGrA 82[port]*
Balogh, Tivadar 1926- *AmArch 70*
Baloghy, George 1950- *DcCAr 81*
Balossi, John 1931- *WhoAmA 73, -76, -78, -80, -82,*
-84
Balouzet, Anna Marie *DcWomA*
Balsamel, J V *AmArch 70*
Balsamo, S J *AmArch 70*
Balsbaugh, Allen 1934- *AmArch 70*
Balseiro, Ernesto *WhAmArt 85*
Balsh, Conrad *FolkA 86*
Balshaw, Fred *DcVicP 2*
Balsiger, Phillip Rowland 1921- *AmArch 70*
Balsley, John Gerald 1944- *WhoAmA 78, -80, -82,*
-84
Balson, A *DcVicP 2*
Balta, E Altan 1919- *AmArch 70*
Baltard, Louis Pierre 1764-1846 *MacEA, McGDA*
Baltard, Victor 1805-1874 *ArtsNiC, MacEA,*
McGDA, WhoArch
Baltauss, Richard 1946- *ConPhot, ICPEnP A*
Baltekal-Goodman, Michael 1903- *WhAmArt 85*
Balten, Pieter 1525-1598 *ClaDrA*
Baltermans, Dmitri 1912- *ConPhot*
Baltermants, Dmitri 1912- *ICPEnP*
Baltes-Chance *EncASM*
Balthasar, Sidonie d1840? *DcWomA*
Balthus 1908- *ConArt 77, -83, DcCAr 81, McGDA,*
OxTwCA, PhDcTCA 77, WorArt[port]
Baltkalns, Val 1921- *MacBEP*
Baltz, Lewis 1945- *ConPhot, DcCAr 81, ICPEnP A,*
MacBEP, WhoAmA 76, -78, -80, -82, -84
Baltz, W E *AmArch 70*
Baltzell, Marjorie 1891- *DcWomA, WhAmArt 85*
Baltzer, Donald Richard 1938- *AmArch 70*
Baltzer, Hans 1900- *IlsBYP, IlsCB 1957*
Balvanyos, Huba 1938- *DcCAr 81*
Balvay *McGDA*
Balze, Jean-Antoine-Raymond 1818- *ArtsNiC*
Balze, Jean-Etienne-Paul 1815-1884 *ArtsNiC*
Balzer, John 1899- *FolkA 86*
Balzer, Margaret 1914- *WhAmArt 85*
Balzhiser, Thomas Albert 1920- *AmArch 70*
Balzi, Juan Jose 1933- *WhoGrA 82[port]*
Bama, James *OfPGCP 86*
Bama, James E 1926- *AmArt, WhoAmA 76, -78,*
-80, -82
Bama, James Elliott 1926- *IlrAm 1880*
Bambaia, Il *McGDA*
Bambas, Thomas Reese 1938- *WhoAmA 76, -78, -80,*
-82, -84
Bamberger, Fritz 1814-1874 *ArtsNiC*
Bamberger, J H *AmArch 70*
Bamberger, Ruth *DcWomA, WhAmArt 85*
Bambini, Nicolo 1651-1736 *McGDA*
Bambocciate, Michelangelo Delle *McGDA*
Bamboccio *McGDA*
Bamborough, William 1792-1860 *NewYHSD*
Bambridge, Arthur L *DcVicP 2*
Bamburg, Marvin Arthur 1935- *AmArch 70*
Bamen, C A *EncASM*
Bamford, Alfred Bennett *DcVicP 2*
Bamford, Thomas *AntBDN Q*
Bamfylde, Coplestone Warre d1791 *DcSeaP*
Bamfylde, Coplestone Warre 1720-1791 *DcBrECP*
Bamfylde, Coplestone Warre 1719-1791 *BiDBrA*
Bampfylde, Coplestone Warre 1720-1791 *DcBrECP,*
DcBrWA
Bampiani, R *DcVicP 2*
Ban, A *AmArch 70*
Bana, Nasli Russi 1928- *AmArch 70*
Banana, Anna Lee 1940- *WhoAmA 80, -82, -84*
Banasewicz, Ignatius 1903- *WhAmArt 85*
Banbury, William 1871- *DcBrA 1*
Bancel, Henry A 1885- *WhAmArt 85*
Banchi, Francesco Di Antonio 1394?-1450? *McGDA*

Bancker, Adrian 1703-1772 *AntBDN Q*
Banckes, Matthew d1706 *BiDBrA*
Bancks, James Charles 1895-1952 *WorECom*
Banco *McGDA*
Banco, Ronald H 1938- *AmArch 70*
Bancroft, A L *DcWomA*
Bancroft, Albert Stokes 1890-1972 *ArtsAmW 1, IlBEAAW, WhAmArt 85*
Bancroft, E R *AmArch 70*
Bancroft, Elias Mollineaux *DcVicP*
Bancroft, Elias Mollineaux d1924 *DcBrA 1, DcVicP 2*
Bancroft, Elias Mollineaux 1846-1924 *DcBrWA*
Bancroft, F L *DcWomA*
Bancroft, Mrs. F L *ArtsEM*
Bancroft, G F *FolkA 86*
Bancroft, George W 1889-1979 *ArtsAmW 3*
Bancroft, H *WhAmArt 85*
Bancroft, Hester *WhAmArt 85*
Bancroft, Hester 1889- *DcWomA*
Bancroft, Lena T *DcWomA, WhAmArt 85*
Bancroft, Louisa Mary *DcBrA 1, DcBrWA, DcWomA*
Bancroft, Milton Herbert 1867- *WhAmArt 85*
Bancroft, Nancy *DcWomA*
Bancroft, Samuel, Jr. d1915 *WhAmArt 85*
Bancroft, William H 1862-1920 *ArtsAmW 1*
Bancroft, William Henry 1860-1932 *IlBEAAW*
Bancroft Redfield And Rice *EncASM*
Band, Max 1900- *WhAmArt 85, WhoAmA 73, –76, –78*
Banda, Pedro Salazar *WhoAmA 84*
Bandau, Joachim 1936- *OxTwCA*
Bandeira, Antonio 1922- *PhDcTCA 77*
Bandeira, D Laura Saurinet *DcWomA*
Bandel, Augustus *ArtsEM*
Bandel, C T *AmArch 70*
Bandel, Frederick *FolkA 86*
Bandel, Joseph Ernst Von 1800-1876 *ArtsNiC*
Bandel, Lennon Raymond 1906- *WhoAmA 76, –78, –80, –82, –84*
Bandell, Eugenie L 1863- *DcWomA*
Bandinelli, Baccio 1488-1559 *OxArt*
Bandinelli, Baccio 1488?-1560 *McGDA*
Bandinelli, Baccio 1493-1560 *MacEA*
Bandinelli, Bartolommeo 1488-1559 *OxArt*
Bandini, Giovanni 1540-1599 *McGDA*
Bandol, J *OxArt*
Bandol, Jean *McGDA*
Bandy, Gary 1944- *WhoAmA 82, –84*
Bandy, Mary Lea 1943- *WhoAmA 84*
Bandy, Ron F 1936- *WhoAmA 84*
Bane, McDonald 1928- *WhoAmA 82, –84*
Baner, Barbara A 1793?- *FolkA 86*
Banerjee 1939- *WhoAmA 76, –78, –80, –82, –84*
Banes, Frederick Mathias *DcVicP 2*
Banever, Gilbert 1913- *WhAmArt 85*
Baney, Ralph Ramoutar 1929- *WhoAmA 76, –78, –80, –82, –84*
Baney, Vera 1930- *WhoAmA 76, –78, –80, –82, –84*
Banfi, Gianluigi 1910-1945 *ConArch*
Banfi Belgiojoso Peressutti And Rogers *MacEA*
Banfils, Louise Marie Magdalene 1856- *DcWomA*
Banford, James 1758-1798? *AntBDN M*
Bang, Eleonore E *WhAmArt 85*
Bang, Henriette Marie De *DcWomA*
Bang, Ingeborg Marie 1833- *DcWomA*
Bang, Jacob E d1965 *IlDcG*
Bang, Ove 1895-1942 *ConArch*
Bang, Thomas 1938- *DcCAA 77*
Bang, Vilhelmine Marie 1848- *DcWomA*
Banga, Ferenc 1947- *DcCAr 81*
Bange, Louis C *WhAmArt 85*
Banger, Edgar Henry 1897-1968 *WorECom*
Banger, Edward *AntBDN D*
Bangert, Colette Stuebe 1934- *MarqDCG 84*
Bangert, Jeff 1938- *MarqDCG 84*
Bangerter, Anny 1883- *DcWomA*
Bangham, Humphrey 1957- *DcCAr 81*
Bangs, E G *AmArch 70*
Bangs, E Geoffrey 1889-1977 *ArtsAmW 3*
Bangs, Francis A 1836?- *NewYHSD*
Banham, Louis *WhAmArt 85*
Banham, Shirley Mary 1942- *WhoArt 82, –84*
Bani, J A *AmArch 70*
Banister, Mary W *WhAmArt 85*
Banister, Robert Barr 1921- *WhoAmA 73, –76, –78, –80*
Banjo, Casper *AfroAA*
Bank, Arnold 1908- *WhoGrA 62, –82[port]*
Bank, Patrick *CabMA*
Bankart, George Percy 1866-1929 *DcBrA 1*
Bankemper, C C *AmArch 70*
Banker, Elizabeth *FolkA 86*
Banker, Grace *WhAmArt 85*
Banker, Grace Wood *WhAmArt 85*
Banker, Hezekiah 1860- *NewYHSD*
Banker, Martha Calista Larkin *FolkA 86*
Banker, William Edwin 1908- *WhAmArt 85*
Bankes, Barry A 1932- *AmArch 70*
Banks, Miss *DcVicP 2, WhAmArt 85*

Banks, A F *ArtsEM*
Banks, Anne Johnson 1924- *WhoAmA 73, –76, –78, –80, –82, –84*
Banks, Benjamin 1727-1795 *AntBDN K*
Banks, Benjamin, Jr. 1754-1820 *AntBDN K*
Banks, Bill *AfroAA*
Banks, Brian 1939- *WhoArt 80, –82, –84*
Banks, C A *AmArch 70*
Banks, Catherine *DcVicP 2, DcWomA*
Banks, Edmund G *DcVicP 2*
Banks, Ellen *AfroAA*
Banks, H Reginald 1924- *AmArch 70*
Banks, Henry 1770-1830 *AntBDN K*
Banks, Herbert Lawrence 1938- *AmArch 70*
Banks, J J *DcVicP*
Banks, J Lisney *WhAmArt 85*
Banks, J O *DcVicP, –2*
Banks, James *NewYHSD*
Banks, James 1756-1831 *AntBDN K*
Banks, James Francis 1900- *WhAmArt 85*
Banks, Janette E 1934- *AfroAA*
Banks, Jesse *WhAmArt 85*
Banks, Mary *DcWomA*
Banks, Richard 1929- *WhoAmA 73, –76*
Banks, Robert Louis 1911- *WhoArt 80, –82, –84*
Banks, T *DcVicP 2*
Banks, Thomas 1735-1803 *OxArt*
Banks, Thomas 1735-1805 *McGDA*
Banks, Thomas J *DcVicP 2*
Banks, Violet 1896- *DcBrA 1, DcWomA*
Banks, Virginia 1920- *WhAmArt 85, WhoAmA 73, –76, –78, –80, –82, –84*
Banks, Walter R 1948- *MarqDCG 84*
Banks, William *DcVicP 2*
Banks, William Lawrence *DcVicP 2*
Bankson, G P 1890- *WhAmArt 85*
Bankson, Glen Peyton 1890- *ArtsAmW 2*
Bankson And Lawson *CabMA*
Bankson And Wilkinson *CabMA*
Bann, Charles 1826?- *NewYHSD*
Bannard, Darby 1931- *BnEnAmA, DcCAA 71*
Bannard, Darby 1934- *DcCAA 77*
Bannard, Walter Darby *WhoAmA 73, –76, –78*
Bannard, Walter Darby 1931- *DcCAr 81, OxTwCA*
Bannard, Walter Darby 1934- *AmArt, ConArt 77, –83, DcAmArt, PrintW 85, WhoAmA 80, –82, –84*
Bannarn, Henry W 1910- *AfroAA*
Bannarn, Henry Wilmer 1910- *WhAmArt 85*
Bannatyne, John James 1836-1911 *DcBrA 1, DcVicP, –2*
Bannenberg, Jon 1929- *DcD&D[port]*
Banner, Delmar Harmood *WhoArt 80, –82, –84*
Banner, Delmar Harmood 1896- *DcBrA 1*
Banner, Hugh Harmood 1865- *DcBrA 1*
Banner, J T *AmArch 70*
Banner, Joseph *DcVicP 2*
Banner, Peter *BiDAmAr*
Bannerman, Afrakuma 1950- *WhoArt 80, –82, –84*
Bannerman, Frances *DcVicP 2*
Bannerman, Frances M *DcWomA*
Bannerman, Frances M 1855-1940 *DcBrA 2*
Bannerman, Hamlet *DcVicP 2*
Bannerman, Helen Brodie Cowan 1862?-1946 *IlsCB 1744*
Bannerman, James *NewYHSD*
Bannerman, John *NewYHSD*
Bannerman, John B *NewYHSD*
Bannerman, William W *NewYHSD*
Bannin, Kate *DcWomA*
Banning, Beatrice Harper *WhoAmA 80N, –82N, –84N*
Banning, Beatrice Harper 1885-1959? *DcWomA*
Banning, Beatrice Harper 1885-1960? *WhAmArt 85*
Banning, George Vroom 1917- *AmArch 70*
Banning, Jack 1939- *WhoAmA 78, –80, –82*
Banning, Jack, Jr. 1939- *WhoAmA 84*
Banning, William J 1810-1856 *ArtsNiC, NewYHSD*
Bannister, C E *DcVicP 2*
Bannister, E M 1833- *ArtsNiC*
Bannister, Edward 1820-1916 *DcBrWA*
Bannister, Edward M 1833-1901 *NewYHSD, WhAmArt 85*
Bannister, Edward Mitchell 1828-1901 *AfroAA, WhoAmA 80N, –82N, –84N*
Bannister, Edwin 1823?- *NewYHSD*
Bannister, Eleanor C d1939 *WhAmArt 85*
Bannister, Eleanor Cunningham 1858-1939 *DcWomA*
Bannister, F *DcBrBI*
Bannister, Geoffrey Ernest John 1924- *WhoArt 80, –82, –84*
Bannister, James 1821-1901 *NewYHSD, WhAmArt 85*
Bannister, Jay Madison 1935- *AmArch 70*
Bannister, T C *AmArch 70*
Bannister, William P 1869-1939 *BiDAmAr*
Bannon, Anthony 1942- *MacBEP*
Bannon, Laura *WhAmArt 85*
Bannon, Laura May d1963 *IlsCB 1744, –1946, –1957*
Bannon, Lucas Edward 1902- *AmArch 70*
Bannon, Robert Thomas 1948- *MarqDCG 84*

Bannon, S S *FolkA 86*
Banoni *NewYHSD*
Banouard, Marthe Camille Alexandrine *DcWomA*
Bansemer, Roger Lewis 1948- *WhoAmA 80, –82, –84*
Bansi, Barb 1777-1863 *DcWomA*
Banta, E Zabriskie *WhoAmA 73, –76*
Banta, John W *FolkA 86*
Banta, Mattie Evelyn 1868-1956 *ArtsAmW 1, DcWomA*
Banta, Melissa Wickser 1925- *WhoAmA 80*
Banta, Melissa Wiekser 1925- *WhoAmA 78*
Banta, R *AmArch 70*
Banta, Theodore M *NewYHSD*
Banta, Weart *NewYHSD*
Banting, Ida N *DcWomA*
Banting, John 1902- *McGDA*
Banting, John 1902-1972 *DcBrA 1*
Banton, Donald Wesley 1929- *AmArch 70*
Banton, J *NewYHSD*
Banton, S *FolkA 86*
Banton, T S *NewYHSD*
Banton, Travis 1874-1958 *WorFshn*
Banton, Travis 1894-1958 *ConDes*
Bantz, David Frederick 1942- *MarqDCG 84*
Banuelos-Thorndike, Antonia De d1921? *DcWomA*
Banvard, David *FolkA 86*
Banvard, John 1815- *FolkA 86*
Banvard, John 1815-1891 *ArtsAmW 1, DcAmArt, IlBEAAW, NewYHSD*
Banwell, C A *AmArch 70*
Banwell, Richard S 1915- *AmArch 70*
Banwell, Roy W 1893- *AmArch 70*
Banwell, Roy Wendell, Jr. 1929- *AmArch 70*
Banz, George 1928- *WhoAmA 76, –78, –80, –82, –84*
Banzhaf, Mildred Foster 1915- *AmArch 70*
Baptiste, Jean *McGDA*
Baquero Y Rodado, Isabel *DcWomA*
Baquie, Suzanne *DcWomA*
Baquoy, Angelique Rosalie Adele 1796-1891 *DcWomA*
Baquoy, Louise Sebastienne 1792-1872 *DcWomA*
Baquoy, Pierre-Charles *McGDA*
Bar *NewYHSD*
Bar, Clementine De 1807-1856 *DcWomA*
Bar, Karola 1857- *DcWomA*
Bar-Am, Micha 1930- *ConPhot, ICPEnP A*
Bara *WorECom*
Barabas, Nicolas 1810- *ArtsNiC*
Barabino, Carlo Francesco 1768-1835 *MacEA*
Barabino, Carlo Francesco 1786-1835 *McGDA*
Barabino, Niccolo 1833- *ArtsNiC*
Baracchis, Andriola De *DcWomA*
Baragwanath, Mrs. John G *WhAmArt 85*
Baragwanath, Neysa Moran *DcWomA*
Baram, Jody Anne 1955- *MarqDCG 84*
Baran, Edward G 1922- *AmArch 70*
Baran, Ephraim 1921- *AmArch 70*
Baranano, Eduardo 1914- *AmArch 70*
Baranauskas, Marius 1931- *ICPEnP A*
Baranceanu, Belle 1905- *WhAmArt 85*
Barancik, Richard M 1924- *AmArch 70*
Baranik, Rudolf 1920- *ConArt 77, DcCAr 81, WhoAmA 73, –76, –78, –80, –82, –84*
Baranoff, Mort 1923- *WhoAmA 78*
Baranoff, Mort 1923-1978 *WhoAmA 80N, –82N, –84N*
Baranoff-Rossine, Vladimir 1888-1942 *OxTwCA, PhDcTCA 77*
Baranowska, Janina 1925- *WhoArt 80, –82, –84*
Barash, Albert 1925- *AmArch 70*
Barat, Leonie *DcWomA*
Baratella, Paolo 1935- *DcCAr 81*
Baratelli, Charles d1925 *WhAmArt 85*
Baratta, Antonio 1724-1787 *McGDA*
Baratta, Eumene 1825- *ArtsNiC*
Baratta, Francois 1805- *ArtsNiC*
Baratta, Count Giovanni DiIsidoro 1670-1747 *McGDA*
Baratte, John J 1940- *WhoAmA 76, –78*
Baratti, Antonio *McGDA*
Barazani, Morris 1924- *AmArt, WhoAmA 78, –80, –82, –84*
Barba, G A *AmArch 70*
Barba, Marie *DcWomA*
Barbachano, Ulysses Socrates 1915- *AmArch 70*
Barbalat, S *AmArch 70*
Barbara Of Nicomedia, Saint *McGDA*
Barbari, Jacopo De' d1516? *OxArt*
Barbari, Jacopo De' 1450?-1516? *McGDA*
Barbarigo, Ida 1925- *WhoArt 80, –82, –84*
Barbarin, Francis S 1833-1900 *WhAmArt 85*
Barbarino, J P *AmArch 70*
Barbarite, James Peter 1912- *WhAmArt 85*
Barbaro, Charles 1896- *WhAmArt 85*
Barbarossa, Theodore C *WhoAmA 80, –82, –84*
Barbarossa, Theodore C 1906- *WhoAmA 76, –78*
Barbarossa, Theodore Cotillo 1906- *WhAmArt 85*
Barbason, M *DcVicP 2*
Barbatelli, Bernardo *McGDA*
Barbaud, Auguste *NewYHSD*
Barbaud, J J A *NewYHSD*
Barbaud-Koch, Marthe Elisabeth *DcWomA*
Barbauld, Anna Laetitia *DcWomA*

Barkas, Henry Dawson 1858-1924 *DcBrA 2, DcBrWA*
Barkas, Herbert Atkinson 1870-1939 *DcBrWA*
Barkelow, Lou 1870?-1950? *FolkA 86*
Barkenburg, John *NewYHSD*
Barker, A C 1819-1873 *MacBEP*
Barker, A E *DcVicP 2, DcWomA*
Barker, Adeline Margery *DcBrA 1, DcWomA*
Barker, Agnes McMakin *DcWomA, WhAmArt 85*
Barker, Al C 1941- *AmArt, WhoAmA 82, -84*
Barker, Albert Winslow d1947 *WhoAmA 78N, -80N, -82N, -84N*
Barker, Albert Winslow 1874-1947 *GrAmP, WhAmArt 85*
Barker, Allen 1937- *WhoArt 80, -82, -84*
Barker, Anthony Raine 1880-1963 *DcBrA 1*
Barker, B *DcVicP 2*
Barker, Barry Edward 1943- *MarqDCG 84*
Barker, Benjamin d1817 *CabMA*
Barker, Benjamin 1776-1838 *DcBrWA*
Barker, Bianca Ann *DcWomA*
Barker, C E *EncASM*
Barker, C F *DcVicP 2*
Barker, Carol Minturn *IlsCB 1967*
Barker, Carol Minturn 1938- *IlsBYP, IlsCB 1957*
Barker, Charles F 1875- *IlBEAAW*
Barker, Cicely Mary 1895- *ClaDrA, DcBrA 1*
Barker, Cicely Mary 1895-1973 *DcWomA*
Barker, Clarissa *DcVicP 2, DcWomA*
Barker, Clive 1940- *ConArt 77, -83, WhoArt 80, -82, -84*
Barker, D E *AmArch 70*
Barker, David Charles 1912- *AmArch 70*
Barker, David R 1806-1881 *NewYHSD*
Barker, E C *AmArch 70*
Barker, E G *AmArch 70*
Barker, E J *DcWomA*
Barker, Miss E J *NewYHSD*
Barker, Edward *NewYHSD*
Barker, Elizabeth Ann *FolkA 86*
Barker, Ethel *DcWomA*
Barker, Ethel N *WhAmArt 85*
Barker, George 1882- *ArtsAmW 1*
Barker, George 1882-1965 *IlBEAAW, WhAmArt 85*
Barker, George, Jr. *WhAmArt 85*
Barker, Gordon King 1933- *AmArch 70*
Barker, Harriett Petrie *FolkA 86*
Barker, Henry Aston 1774?-1856 *DcBrWA*
Barker, Hildreth Laman 1934- *AmArch 70*
Barker, J J *NewYHSD*
Barker, J S *DcVicP 2*
Barker, James *CabMA*
Barker, James Thomas 1884- *ClaDrA, DcBrA 1*
Barker, John 1668-1727 *BiDBrA*
Barker, John Edward 1889-1953 *ClaDrA, DcBrA 1*
Barker, John Jesse *NewYHSD*
Barker, John Joseph *DcBrWA, DcVicP 2*
Barker, Joseph *DcVicP 2, NewYHSD*
Barker, Katherine 1891- *DcWomA, WhAmArt 85*
Barker, Kit 1916- *WhoArt 80, -82, -84*
Barker, Lucette E *DcVicP 2, DcWomA*
Barker, Lucy Hayward 1872- *DcWomA, WhAmArt 85*
Barker, M *NewYHSD*
Barker, M A *DcVicP 2, DcWomA*
Barker, Miss M A *NewYHSD*
Barker, M C 1856-1914 *WhAmArt 85*
Barker, M L *AmArch 70*
Barker, Margaret 1907- *DcBrA 1*
Barker, Marianne *DcWomA*
Barker, Marion *DcVicP 2, DcWomA*
Barker, Mary B *ArtsEM, DcWomA*
Barker, Mary Chamberlain 1856-1914 *DcWomA*
Barker, May *DcWomA, WhAmArt 85*
Barker, Melvern J 1907- *IlsCB 1946*
Barker, Olive d1962 *WhAmArt 85*
Barker, Olive Ruth 1885- *ArtsAmW 1, DcWomA, IlBEAAW*
Barker, Olympia Philomena 1881- *ArtsAmW 3*
Barker, Patricia Krebs *WhoAmA 82*
Barker, Peter *FolkA 86*
Barker, R A *AmArch 70*
Barker, Robert 1739-1806 *DcBrWA*
Barker, Selma E Calhoun 1893- *ArtsAmW 3*
Barker, Thomas d1706? *CabMA*
Barker, Thomas 1769-1847 *DcBrECP, DcBrWA, DcVicP, -2, McGDA, OxArt*
Barker, Thomas Edward *DcBrWA*
Barker, Thomas Jones 1815-1882 *ArtsNiC, DcVicP, -2*
Barker, Virgil d1964 *WhoAmA 78N, -80N, -82N, -84N*
Barker, Virgil 1890-1964 *WhAmArt 85*
Barker, W Bligh *DcVicP 2*
Barker, Mrs. W Bligh *DcVicP 2, DcWomA*
Barker, W D *DcVicP 2*
Barker, Walter William 1921- *WhoAmA 73, -76, -78, -80, -82, -84*
Barker, William *NewYHSD*
Barker, William Dean *DcBrWA*
Barker, William J *NewYHSD*

Barker, William Lee 1924- *AmArch 70*
Barker, Wright d1941 *DcBrA 1, DcVicP 2*
Barker Brothers *EncASM*
Barker-Mill, Peter *WhoArt 80, -82, -84*
Barker-Mill, Peter 1908- *DcBrA 1*
Barker Of Bath, Thomas 1769-1847 *DcBrECP*
Barkhaus-Wiesenhutten, Charlotte Von 1736-1804 *DcWomA*
Barkhaus-Wiesenhutten, Helene E Von 1734?-1804 *DcWomA*
Barkhaus-Wiesenhutten, Luise F A Van *DcWomA*
Barkis, Charles E *MarqDCG 84*
Barkkarie, D E *AmArch 70*
Barklam, Harold 1912- *DcBrA 1, WhoArt 80, -82, -84*
Barkley, C W *DcVicP 2*
Barkley, Howell *WhAmArt 85*
Barkley, Hugh *FolkA 86*
Barkley, James *IlsCB 1967*
Barkley, James Edward 1941- *IlsBYP*
Barkley, Paul Haley, Jr. *AmArch 70*
Barks, Carl 1901- *WorECom*
Barksdale, Charles d1757 *CabMA*
Barksdale, Ethel DuPont, Jr. *WhAmArt 85*
Barksdale, F C, Jr. *AmArch 70*
Barksdale, George Edward 1869- *WhAmArt 85*
Barksdale, William Edward 1927- *MacBEP*
Barkstrom, Robert Theodore 1939- *AmArch 70*
Barkus, Mariona Marcia 1948- *WhoAmA 82, -84*
Barkworth, Emma L *DcVicP 2, DcWomA*
Barkworth, Henry *DcSeaP*
Barkworth, Walter T *DcVicP 2*
Barlach, Ernst 1870-1938 *AntBDN A, DcNiCA, McGDA, OxArt, OxTwCA, PhDcTCA 77, WorECar*
Barlach, Friede *DcWomA*
Barland, Adam *ClaDrA, DcVicP, -2*
Barlangue-Champavier, Suzette 1890- *DcWomA*
Barletta, Sergio 1934- *WorECar*
Barli-Yoel, Esther 1895-1972 *DcWomA*
Barloga, Jesse A 1888-1947 *BiDAmAr*
Barloga, Viola H *WhoAmA 80N, -82N, -84N*
Barloga, Viola H 1890-1959? *DcWomA*
Barloga, Viola H 1890-1960? *WhAmArt 85*
Barlow *EarABI*
Barlow, Miss *DcVicP 2, DcWomA*
Barlow, A Ralph 1905- *AmArch 70*
Barlow, Arthur B *AntBDN M*
Barlow, B J *DcVicP 2*
Barlow, Charles Clarence 1930- *AmArch 70*
Barlow, Dale Ford 1922- *AmArch 70*
Barlow, Edward 1832?- *NewYHSD*
Barlow, Elsie *DcWomA*
Barlow, Emily S *DcVicP 2, DcWomA*
Barlow, Florence d1909 *AntBDN M, DcNiCA*
Barlow, Florence E *ClaDrA, DcVicP 2, DcWomA*
Barlow, Francis 1626-1702 *ClaDrA*
Barlow, Francis 1926?-1704 *DcBrWA*
Barlow, Gillian 1944- *DcCAr 81*
Barlow, Hannah 1851-1916 *DcNiCA*
Barlow, Hannah B 1851-1916 *AntBDN M*
Barlow, Hannah Bolton *DcWomA*
Barlow, Harriet May 1844-1934 *WhAmArt 85*
Barlow, Henry N 1824-1884 *NewYHSD*
Barlow, John *DcBrWA*
Barlow, John Noble 1861-1917 *DcBrA 1, DcVicP 2, WhAmArt 85*
Barlow, Lydia *FolkA 86*
Barlow, Marvin Kellogg 1906- *WhAmArt 85*
Barlow, Mary 1901- *ClaDrA, DcBrA 1*
Barlow, Mary Belle 1885- *WhAmArt 85*
Barlow, Myron *FolkA 86*
Barlow, Myron 1873-1937 *WhAmArt 85*
Barlow, Myron G 1873-1937 *ArtsEM[port]*
Barlow, Nicholas L *ArtsEM*
Barlow, Nina G *DcWomA, WhAmArt 85*
Barlow, Perry 1892-1977 *WorECar*
Barlow, Phyllida 1944- *ConArt 79[port], OxTwCA*
Barlow, Sibyl Margaret d1933 *DcBrA 1, DcWomA*
Barlow, Thomas d1730 *BiDBrA*
Barlow, Thomas Oldham 1824- *ArtsNiC*
Barlow, W H 1812-1902 *MacEA*
Barlow, Walter Jarvis, Jr. 1900- *WhAmArt 85*
Barloy, Paul *ArtsEM*
Barma *OxArt*
Barmakian, Norman *AmArch 70*
Barmann, Rudolf 1939- *MarqDCG 84*
Barna *OxArt*
Barna Da Siena *McGDA*
Barna, William *FolkA 86*
Barnaba Da Modena *McGDA*
Barnabas Of Cyprus, Saint d063 *McGDA*
Barnack, Oskar 1879-1936 *ICPEnP, MacBEP*
Barnard, Abner *CabMA*
Barnard, Ada *ArtsEM, DcWomA*
Barnard, Amelia Wright *DcWomA*
Barnard, Catherine *DcBrA 2, DcBrWA, DcWomA*
Barnard, E *AntBDN Q*
Barnard, Ebenezer *FolkA 86*
Barnard, Edward *AntBDN Q*
Barnard, Edward Herbert 1855-1909 *WhAmArt 85*

Barnard, Elinor M 1872-1942 *DcWomA*
Barnard, Elizabeth *DcWomA*
Barnard, Ellinor M 1872-1942 *WhAmArt 85*
Barnard, Emily *DcWomA*
Barnard, Frank *DcVicP 2*
Barnard, Fred 1846-1896 *AntBDN B*
Barnard, Frederick 1836?-1896 *DcBrWA*
Barnard, Frederick 1846-1896 *ClaDrA, DcBrBI, DcVicP, -2*
Barnard, Geoffrey *DcVicP 2*
Barnard, George *DcBrBI, DcVicP, -2*
Barnard, George d1890? *DcBrWA*
Barnard, George 1819-1902 *ICPEnP*
Barnard, George Gray 1863-1938 *McGDA*
Barnard, George Grey 1863-1938 *BnEnAmA, DcAmArt, OxArt, PhDcTCA 77, WhAmArt 85*
Barnard, George N 1819-1902 *BnEnAmA, DcAmArt, ICPEnP A*
Barnard, George N 1819-1920 *MacBEP*
Barnard, Gertrude *DcVicP 2, DcWomA*
Barnard, Gwen *DcCAr 81*
Barnard, Gwen 1912- *DcBrA 1, WhoArt 80, -82, -84*
Barnard, Mrs. H G *DcVicP 2*
Barnard, H G, Jr. *AmArch 70*
Barnard, Hebe *DcWomA*
Barnard, Henry S 1818?- *NewYHSD*
Barnard, Henry William *DcBrWA*
Barnard, J E *AmArch 70*
Barnard, J Langton 1853- *DcBrA 1, DcVicP, -2*
Barnard, Mrs. J Langton *DcVicP 2*
Barnard, James 1820?- *NewYHSD*
Barnard, James Kimball 1929- *AmArch 70*
Barnard, James M 1910- *WhAmArt 85*
Barnard, John *AntBDN Q, BiDBrA*
Barnard, Josephine W *WhAmArt 85*
Barnard, Josephine W 1869- *DcWomA*
Barnard, Julia E *DcWomA, WhAmArt 85*
Barnard, Julius *CabMA*
Barnard, Kenneth 1931- *AmArch 70*
Barnard, Louisa *DcVicP 2, DcWomA*
Barnard, Lucy *FolkA 86*
Barnard, Marjorie B *DcBrA 2*
Barnard, Mary B *DcVicP 2*
Barnard, Mary B 1870-1946 *DcWomA*
Barnard, Murray Kosiol 1930- *AmArch 70*
Barnard, Osbert Howard 1903- *WhoArt 80, -82, -84*
Barnard, S *NewYHSD*
Barnard, Thomas Henslow 1898- *DcBrA 1, WhoArt 80, -82, -84*
Barnard, Walter Saunders 1851-1930 *DcBrA 2*
Barnard, William *AntBDN Q, NewYHSD*
Barnard, Mrs. William *DcVicP 2*
Barnard, William Henry 1767-1818 *DcBrWA*
Barnard, William S 1809?- *NewYHSD*
Barnbaum, Bruce 1943- *ICPEnP A, MacBEP*
Barndt, Helen Grace *WhoArt 80, -82, -84*
Barne, George 1882- *DcBrA 1*
Barnekow, Brita 1868- *DcWomA*
Barner, D P *AmArch 70*
Barnes *NewYHSD*
Barnes, A W *DcVicP 2*
Barnes, Al *OfPGCP 86*
Barnes, Albert 1839?- *NewYHSD*
Barnes, Albert Hall, Jr. 1933- *AmArch 70*
Barnes, Alfred Richard Innott 1899- *ClaDrA, DcBrA 1*
Barnes, Ann Margaret 1951- *WhoArt 80, -82, -84*
Barnes, Anna Marye 1918- *WhoAmA 73*
Barnes, Archibald George 1887- *DcBrA 1*
Barnes, B 1769-1842 *DcNiCA*
Barnes, Blakeslee *FolkA 86*
Barnes, Burt 1879-1947 *WhAmArt 85*
Barnes, Carole D 1935- *WhoAmA 84*
Barnes, Carroll 1906- *WhoAmA 76, -78, -80, -82, -84*
Barnes, Catherine *WhAmArt 85*
Barnes, Catherine J 1918- *IlsBYP, IlsCB 1946, WhAmArt 85*
Barnes, Cliff 1940- *WhoAmA 84*
Barnes, Cornelia Baxter *DcWomA*
Barnes, Curt 1943- *WhoAmA 78, -80, -82, -84*
Barnes, David *BiDBrA*
Barnes, Desmond 1921- *DcBrA 1*
Barnes, Djuna 1892-1982 *DcWomA*
Barnes, Dorothy 1927- *DcCAr 81*
Barnes, E *DcVicP 2*
Barnes, E C *ClaDrA, DcVicP, -2*
Barnes, Edith Alice *DcWomA*
Barnes, Edward d1871 *FolkA 86*
Barnes, Edward Larabee 1915- *MacEA*
Barnes, Edward Larrabee 1915- *AmArch 70, BnEnAmA, McGDA, WhoAmA 80, -82, -84*
Barnes, Edward Larrabee 1922- *ConArch*
Barnes, Elizur *CabMA*
Barnes, Ernest Harrison *WhAmArt 85*
Barnes, Ernest Harrison 1873-1955 *ArtsEM*
Barnes, Ernie E, Jr. *AfroAA*
Barnes, Ethel 1879?- *DcWomA*
Barnes, Fay M *DcWomA, WhAmArt 85*
Barnes, G E *DcBrBI, DcVicP 2*

Barnes, George William 1909- *DcBrA 1*
Barnes, Gertrude J 1865- *WhAmArt 85*
Barnes, Gertrude Jameson 1865- *DcWomA*
Barnes, Halcyone D 1913- *WhoAmA 73, -76*
Barnes, Harman *AntBDN F*
Barnes, Helen Brooks 1889- *DcWomA, WhAmArt 85*
Barnes, Henry *FolkA 86*
Barnes, Henry Burt *WhAmArt 85*
Barnes, Herman Grady 1929- *AmArch 70*
Barnes, Hiram Putnam 1857- *WhAmArt 85*
Barnes, Holman John 1906- *AmArch 70*
Barnes, Isabella *DcBrA 1, DcWomA*
Barnes, Isabella d1955 *DcVicP 2*
Barnes, J E *AmArch 70*
Barnes, J W *DcVicP 2*
Barnes, James *CabMA, DcVicP 2*
Barnes, James Paul 1932- *AmArch 70*
Barnes, Jay William 1924- *AmArch 70*
Barnes, John Hughes 1932- *AmArch 70*
Barnes, John Pierce *WhAmArt 85*
Barnes, Joseph H *DcVicP 2*
Barnes, Kit 1946- *WhoAmA 84*
Barnes, Lee Carroll 1906- *WhAmArt 85*
Barnes, Lucinda Ann 1951- *WhoAmA 84*
Barnes, Lucius *FolkA 86*
Barnes, Mabel Catherine Robinson *DcWomA*
Barnes, Marian L *DcVicP 2, DcWomA*
Barnes, Mary *WhoAmA 76, -78, -80*
Barnes, Mary 1945- *DcCAr 81*
Barnes, Mathew Rackham 1880-1951 *ArtsAmW 1*
Barnes, Matthew Rackham 1880-1951 *ArtsAmW 3, IlBEAAW, WhAmArt 85*
Barnes, Maurice 1911- *DcBrA 1*
Barnes, Miller Davis 1909- *AmArch 70*
Barnes, Molly 1936- *WhoAmA 80, -82, -84*
Barnes, Nathaniel *CabMA*
Barnes, Mrs. Nevin C *WhAmArt 85*
Barnes, Paul Kenneth 1913- *AmArch 70*
Barnes, Penelope *DcWomA*
Barnes, Penelope Birch *NewYHSD*
Barnes, Philip *BiDBrA*
Barnes, R *DcWomA, FolkA 86*
Barnes, R D *AmArch 70*
Barnes, Read 1926- *AmArch 70*
Barnes, Renee 1886-1940 *DcWomA, WhAmArt 85*
Barnes, Richard Charles 1954- *MarqDCG 84*
Barnes, Robert *ClaDrA, DcVicP 2*
Barnes, Robert 1840-1895 *DcBrBI, DcBrWA*
Barnes, Robert 1934- *DcCAA 71, -77, DcCAr 81*
Barnes, Robert M 1934- *WhoAmA 73, -76, -78, -80, -82, -84*
Barnes, Roderic B *WhAmArt 85*
Barnes, Ronald W 1935- *MarqDCG 84*
Barnes, Ronnie L 1944- *MarqDCG 84*
Barnes, Samuel John 1847-1901 *DcVicP 2*
Barnes, Samuel T *FolkA 86*
Barnes, Sarah P *DcWomA*
Barnes, Sophia *DcWomA*
Barnes, Tamsin G 1934- *MarqDCG 84*
Barnes, Virginia 1895- *WhAmArt 85*
Barnes, Virginia White 1895- *DcWomA*
Barnes, W Rodway *DcVicP 2*
Barnes, Walter Mayhew 1871-1950 *DcBrA 2*
Barnes, William *FolkA 86*
Barnes, William 1916- *WhoArt 82, -84*
Barnes, William J 1925- *AmArch 70*
Barnes, Winifred 1898- *DcWomA*
Barnes, Zachariah *AntBDN M*
Barnet, Helen Brash *DcWomA*
Barnet, Howard J 1924- *WhoAmA 73*
Barnet, Mrs. Howard J *WhoAmA 73*
Barnet, Sampson *CabMA*
Barnet, W A *NewYHSD*
Barnet, Will 1911- *AmArt, DcAmArt, DcCAA 71, -77, PrintW 83, -85, WhAmArt 85, WhoAmA 73, -76, -78, -80, -82, -84*
Barnet, William Armand *NewYHSD*
Barnett *NewYHSD*
Barnett, Miss *DcWomA*
Barnett, Absalom d1918 *BiDAmAr*
Barnett, Alexander *CabMA*
Barnett, Alice May *DcWomA*
Barnett, Bion *WhAmArt 85*
Barnett, Carrie L *DcWomA*
Barnett, David J 1946- *WhoAmA 80, -82, -84*
Barnett, Doreen Elaine *WhoArt 80, -82, -84*
Barnett, Earl D *WhoAmA 76, -78, -80, -82, -84*
Barnett, Earl D 1917- *WhoAmA 73*
Barnett, Ed Willis 1899- *MacBEP, WhoAmA 76, -78, -80, -82, -84*
Barnett, Edward 1933- *AfroAA*
Barnett, Eugene A 1894- *WhAmArt 85*
Barnett, George Dennis 1863-1925? *BiDAmAr*
Barnett, George Ingham 1815-1898 *BiDAmAr*
Barnett, George J *WhAmArt 85*
Barnett, Grace T 1899- *ArtsAmW 3*
Barnett, Helmut 1946- *PrintW 85*
Barnett, Henrietta 1851- *DcBrA 1*
Barnett, Henrietta, Dame 1851- *DcWomA*
Barnett, Henrietta Octavia 1851-1936 *DcBrA 2*

Barnett, Henry 1916- *DcBrA 1*
Barnett, Herbert P 1910-1972 *WhoAmA 78N, -80N, -82N, -84N*
Barnett, Herbert Phillip 1910-1972 *WhAmArt 85*
Barnett, Isa 1924- *IlBEAAW, IlrAm F, -1880, WhAmArt 85*
Barnett, Jack 1944- *WhoAmA 82, -84*
Barnett, James D *DcBrWA, DcVicP, -2*
Barnett, Jay W 1897-1959 *ArtsAmW 2*
Barnett, John *AntBDN G*
Barnett, Jonathan *ConArch A*
Barnett, Jonathan 1937- *AmArch 70, ConArch*
Barnett, Joseph Townsend 1927- *AmArch 70*
Barnett, Leroy 1884-1920 *WhAmArt 85*
Barnett, Michael P 1929- *MarqDCG 84*
Barnett, Moneta *IlsBYP*
Barnett, Moneta d1976 *IlsCB 1967*
Barnett, Olaf Blayney 1911- *DcBrA 1*
Barnett, Olaf Blayney 1917- *WhoArt 80*
Barnett, R *AmArch 70*
Barnett, R C *DcBrBI, DcBrECP*
Barnett, Richard David 1909- *WhoArt 80, -82, -84*
Barnett, Rita Wolpe *AfroAA*
Barnett, Robert Louis 1924- *AmArch 70*
Barnett, Sanford 1946- *DcCAr 81*
Barnett, Solomon *ArtsEM*
Barnett, Tom P 1870-1929 *BiDAmAr, WhAmArt 85*
Barnett, Vivian Endicott 1944- *WhoAmA 84*
Barnett, W *DcVicP 2*
Barnett, Walter Durac 1876- *DcBrA 1*
Barnett, Will *DcCAr 81, OxTwCA*
Barnett, William Halbert 1915- *AmArch 70*
Barnette, Jack 1938- *MarqDCG 84*
Barney, Alice *WhAmArt 85*
Barney, Alice 1857?-1931 *DcWomA*
Barney, Alice Pike 1857-1931 *ArtsAmW 2*
Barney, Alice Pike 1860-1931 *WhAmArt 85*
Barney, Arthur L *WhAmArt 85*
Barney, Esther *DcWomA*
Barney, Esther Stevens *ArtsAmW 2*
Barney, Frank A 1862- *WhAmArt 85*
Barney, J Stewart 1869-1925 *WhAmArt 85*
Barney, John S 1869-1924 *BiDAmAr*
Barney, Joseph *DcBrWA*
Barney, Joseph 1751-1829 *DcBrECP*
Barney, Joseph W *DcVicP 2*
Barney, Maginal Wright d1966 *WhoAmA 78N, -80N, -82N, -84N*
Barney, Maginal Wright d1966 *WhAmArt 85*
Barney, Maginel Wright 1881- *IlsCB 1744*
Barney, Maginel Wright 1882-1966 *IlrAm C*
Barney, Maginel Wright Enright 1881-1966 *IlrAm 1880*
Barney, Maria *DcWomA*
Barney, Marian Greene *WhAmArt 85*
Barney, Phebe Fitzgerald *DcWomA*
Barney, R E *AmArch 70*
Barney, Mrs. Walter *WhAmArt 85*
Barngrover, G C *AmArch 70*
Barnham, Denis 1920- *DcBrA 1*
Barnham, Nicholas 1939- *DcCAr 81*
Barnhardt, John *FolkA 86*
Barnhardt, Laurence Julius 1925- *AmArch 70*
Barnhart, C Raymond 1903- *WhoAmA 76, -78, -80, -82, -84*
Barnhart, Nancy 1889- *IlsBYP, IlsCB 1744, -1946*
Barnhorn, Clement J 1857-1935 *WhAmArt 85*
Barnhott, Margaret 1819- *FolkA 86*
Barnicle, James *DcBrWA, DcVicP, -2*
Barnish, Edith Lilian *DcWomA*
Barnitt, Mary D *DcBrA 1*
Barnitt, Mary Dyson *DcWomA*
Barnitz, Henry Wilson 1864- *WhAmArt 85*
Barnitz, Myrtle Townsend *WhAmArt 85*
Barnouw, Adriaan J 1877- *WhAmArt 85*
Barnouw, Adriaan Jacob 1877-1968 *ArtsAmW 2, IlBEAAW*
Barns, Cornelia 1888- *ArtsAmW 2, WhAmArt 85*
Barns, Cornelia Baxter 1888- *DcWomA*
Barns, G *DcVicP 2*
Barns-Graham, Wilhelmina 1912- *DcBrA 2*
Barnsley, Edward 1900- *OxDecA*
Barnsley, Ernest 1863-1926 *AntBDN A*
Barnsley, Ernest Arthur 1863-1926 *OxDecA*
Barnsley, James M *WhAmArt 85*
Barnsley, James MacDonald *DcSeaP*
Barnsley, Sidney 1865-1926 *DcNiCA, OxDecA*
Barnsley, Sydney 1865-1926 *AntBDN A*
Barnstone, H *AmArch 70*
Barnum, E N *ArtsEM, DcWomA*
Barnum, E T *FolkA 86*
Barnum, Emily Keene 1874- *DcWomA, WhAmArt 85*
Barnum, Fayette *DcWomA, WhAmArt 85*
Barnum, Frank Seymour -1928? *BiDAmAr*
Barnum, G L *AmArch 70*
Barnum, J H *WhAmArt 85*
Barnum, Jay Hyde *IlsCB 1946*
Barnum, Julia Fuller *FolkA 86*
Barnum, P *AmArch 70*
Barnum, W J *AmArch 70*

Barnum, William Milo 1927- *AmArch 70*
Barnwell, F Edward 1921- *WhoAmA 78, -80, -82*
Barnwell, John L 1922- *WhoAmA 73, -76, -78, -80, -82, -84*
Baro, Gene 1924- *WhoAmA 76, -78*
Barocci, Ambrogio *McGDA*
Barocci, Federico 1526-1612 *OxArt*
Barocci, Federigo 1528-1615 *McGDA*
Barocci, Frederigo 1526-1612 *ClaDrA*
Barolet *NewYHSD*
Baron, Mademoiselle *DcWomA*
Baron, Clemire *NewYHSD*
Baron, Edward 1940- *MarqDCG 84*
Baron, Gerald Stuart 1932- *AmArch 70*
Baron, Hannelore 1926- *WhoAmA 76, -78, -80, -82, -84*
Baron, Helene *DcWomA*
Baron, Henri Charles Antoine 1816-1885 *ClaDrA*
Baron, Henri-Charles-Antoine 1817- *ArtsNiC*
Baron, Mrs. Kirk *WorFshn*
Baron, Marie Celine *DcWomA*
Baron, Theodore 1840-1899 *ClaDrA*
Baron-Puyplat, Marie Alice 1880- *DcWomA*
Baroncelli, Niccolo *McGDA*
Baroncelli-Javon, Henriette DeChazelles 1845-1906 *DcWomA*
Baroncello, Giovanni Francesco d1694 *MacEA*
Barone, Antonio 1889- *ArtsAmW 3, WhAmArt 85*
Barone, P V *AmArch 70*
Baroni, Helena *DcWomA*
Baroni, Monique *DcCAr 81*
Baroni-Turner, Tina Marie 1958- *MarqDCG 84*
Barons, Richard Irwin 1946- *WhoAmA 80, -82, -84*
Baronto, Louis *NewYHSD*
Baronzio, Giovanni 1300?-1362? *McGDA*
Barooshian, Martin 1929- *PrintW 83, -85, WhoAmA 73, -76, -78, -80, -82, -84*
Barou, Mrs. *DcWomA*
Barovetto, Silvio Louis 1908- *AmArch 70*
Barovier, Angelo d1460 *IlDcG*
Barovier, Angelo 1927- *IlDcG*
Barovier, Anzolo d1460 *IlDcG*
Barovier, Benvenuto *IlDcG*
Barovier, Ercole 1889-1974 *IlDcG*
Barovier, Ercole 1899- *DcNiCA*
Barovier And Toso *IlDcG*
Barowitz, Elliott 1936- *WhoAmA 78, -80, -82, -84*
Barozzi, Giacomo *McGDA*
Barr, Alfred Hamilton, Jr. *WhoArt 84N*
Barr, Alfred Hamilton, Jr. 1902- *WhoAmA 73, -76, -78, -80, WhoArt 80, -82*
Barr, Alfred Hamilton, Jr. 1902-1981 *WhoAmA 82N, -84N*
Barr, Allan 1890-1959 *WhoAmA 80N, -82N, -84N*
Barr, C S *AmArch 70*
Barr, Charles Hagan d1947 *WhAmArt 85*
Barr, Charles P 1940- *AmArch 70*
Barr, Charlotte M *DcWomA*
Barr, Clayre 1913- *WhAmArt 85*
Barr, David John 1939- *PrintW 83, -85, WhoAmA 73, -76, -78, -80, -82, -84*
Barr, Eliza *FolkA 86*
Barr, Elizabeth Quandt *WhoAmA 78, -80*
Barr, G R *DcSeaP*
Barr, Howard *WhAmArt 85*
Barr, Howard Raymond 1910- *AmArch 70*
Barr, James *FolkA 86*
Barr, James Henderson 1908- *AmArch 70*
Barr, John Robert 1947- *MarqDCG 84*
Barr, Julian Craig 1943- *MarqDCG 84*
Barr, Louise E *ArtsEM, DcWomA*
Barr, Macdonald 1934- *MarqDCG 84*
Barr, Martin *AntBDN M*
Barr, Norman 1908- *WhoAmA 76, -78, -80, -82, -84*
Barr, Paul E 1892-1953 *ArtsAmW 1, IlBEAAW, WhAmArt 85*
Barr, Paul Edward 1922- *AmArch 70*
Barr, Robina *DcWomA*
Barr, Roger 1921- *WhoAmA 80, -82*
Barr, Roger Terry 1921- *WhoAmA 73, -76, -78*
Barr, Ronald Edward 1946- *MarqDCG 84*
Barr, W *NewYHSD*
Barr, William 1867-1933 *ArtsAmW 1, IlBEAAW, WhAmArt 85*
Barr-Sharrar, Beryl *AmArt, WhoAmA 73, -76, -78, -80, -82, -84*
Barrable, Amalia *DcWomA*
Barrable, George Hamilton *DcVicP, -2*
Barrable, Millie *DcWomA*
Barrac *NewYHSD*
Barraclough, James P d1942 *DcBrA 1*
Barradas, Rafael Perez 1890-1929 *PhDcTCA 77*
Barraga, Mrs. *DcWomA*
Barragan, Julio 1928- *OxTwCA*
Barragan, Leopoldo Presas *OxTwCA*
Barragan, Luis 1901- *MacEA*
Barragan, Luis 1902- *ConArch*
Barralet, John James d1812? *BkIE*
Barralet, John James 1747-1815 *DcBrWA, NewYHSD*
Barralet, John Melchior 1750?-1787? *DcBrWA*

Barralett *NewYHSD*
Barran, Elaine 1892- *DcBrA 1*, *DcWomA*
Barrantes Manuel DeAragon, Maria DelC *DcWomA*
Barras, R E *AmArch 70*
Barratt, George W *WhAmArt 85*
Barratt, Henry *NewYHSD*
Barratt, Krome 1924- *ClaDrA*, *DcBrA 1*, *WhoArt 80*, *-82*, *-84*
Barratt, Louise Bascom *WhAmArt 85*
Barratt, Reginald 1861-1917 *DcBrWA*
Barratt, Reginald R 1861-1917 *DcBrA 1*, *DcVicP 2*
Barratt, Roswell Forman 1892- *AmArch 70*
Barratt, Thomas *DcVicP, -2*
Barratt, Thomas E 1814?- *NewYHSD*
Barratt, Watson 1884- *WhAmArt 85*
Barraud, A T *WhAmArt 85*
Barraud, Allan 1847-1913 *DcBrWA*
Barraud, Allan F *DcVicP, -2*
Barraud, Charles Decimus 1822-1897 *DcBrWA*, *OxArt*
Barraud, Charles James *DcVicP, -2*
Barraud, Charles James 1843-1894 *DcBrWA*
Barraud, Frances d1924 *DcBrBI*
Barraud, Francis d1924 *DcBrA 1*, *DcVicP 2*
Barraud, Francis P *DcVicP 2*
Barraud, Francis Philip 1824-1901 *DcBrWA*
Barraud, Francois Emile 1899-1934 *OxTwCA*
Barraud, Henry 1811-1874 *DcBrWA*, *DcVicP, -2*
Barraud, Maurice 1889-1854 *OxTwCA*
Barraud, Maurice 1889-1954 *PhDcTCA 77*
Barraud, Ronald 1906- *DcBrA 1*
Barraud, William 1810- *MacBEP*
Barraud, William 1810-1850 *DcBrWA*, *DcVicP, -2*
Barraude, Marie *DcWomA*
Barre *NewYHSD*
Barre, I *AmArch 70*
Barre, Jean Auguste 1811- *ArtsNiC*
Barre, Jean Benoit Vincent 1732?-1824 *MacEA*
Barre, Lyle Leon 1926- *AmArch 70*
Barre, Martin 1924- *OxTwCA*
Barre, Raoul *WhAmArt 85*
Barre, Raoul 1874-1932 *WorECar*
Barreau *AntBDN E*
Barreau DeChefdeville, Francois 1725-1765 *MacEA*
Barreaux, Adolphe 1900- *WhAmArt 85*
Barreda, Ernesto 1927- *McGDA*
Barrell, Bill 1932- *WhoAmA 80*, *-82*, *-84*
Barrera, M *AmArch 70*
Barrera-Bossi, Erma *DcWomA*
Barreres, Domingo 1941- *WhoAmA 78*, *-80*, *-82*, *-84*
Barret, Anthony *NewYHSD*
Barret, George 1728?-1784 *DcBrECP*
Barret, George 1732-1784 *DcBrWA*, *OxArt*
Barret, George 1767-1842 *DcBrWA*
Barret, George, Jr. 1767?-1842 *DcBrECP*, *DcVicP 2*
Barret, George, Sr. 1732-1784 *McGDA*
Barret, J V *DcVicP 2*
Barret, James *DcBrECP*, *DcBrWA*
Barret, Joseph *DcBrECP*
Barret, M d1836 *DcWomA*
Barret, Mary d1836 *DcBrWA*
Barret, Mary 1732-1784 *DcWomA*
Barreto, Benedito Bastos 1897-1947 *WorECar*
Barreto, Luiz Carlos 1929- *ICPEnP A*
Barrett *FolkA 86*
Barrett, A Marjorie *DcWomA*
Barrett, Alan *IlsBYP*
Barrett, Alexander 1833?- *NewYHSD*
Barrett, Barbara 1920- *WhoAmA 78*, *-80*
Barrett, Bill 1934- *WhoAmA 73*, *-76*, *-78*, *-80*, *-82*, *-84*
Barrett, C P *DcVicP 2*
Barrett, C R B *DcBrBI*
Barrett, Dennis Paul 1951- *MarqDCG 84*
Barrett, Edward P *FolkA 86*
Barrett, Elizabeth *DcWomA*
Barrett, Elizabeth Hunt 1863- *DcWomA*, *WhAmArt 85*
Barrett, Elsie May *WhoArt 80*, *-82*, *-84*
Barrett, Frank Joseph 1912- *AmArch 70*
Barrett, Franklin Allen 1906- *WhoArt 80*, *-82*, *-84*
Barrett, G D *AmArch 70*
Barrett, George *EncASM*
Barrett, George H, Jr. *WhAmArt 85*
Barrett, George Watson 1884?- *ArtsAmW 3*
Barrett, H J *AmArch 70*
Barrett, H M *AmArch 70*
Barrett, H Stanford 1909-1970 *WhoAmA 78N*, *-80N*, *-82N*, *-84N*
Barrett, Harry 1902- *AmArch 70*
Barrett, Jeremiah 1723?-1770 *DcBrECP*
Barrett, Jerry 1814-1906 *DcVicP*
Barrett, Jerry 1824-1906 *DcVicP 2*
Barrett, John *AntBDN K*, *DcVicP 2*
Barrett, John M *CabMA*
Barrett, Jonathan *FolkA 86*
Barrett, L M *AmArch 70*
Barrett, Laura A d1928 *DcWomA*, *WhAmArt 85*
Barrett, Lawrence 1897- *ArtsAmW 1*
Barrett, Lawrence 1897-1973 *ArtsAmW 3*, *WhAmArt 85*

Barrett, Lawrence Lorus 1897-1973 *IlBEAAW*
Barrett, Leni Mancuso *WhoAmA 78*, *-80*, *-82*, *-84*
Barrett, Lisbeth Stone 1904- *WhAmArt 85*
Barrett, M *DcVicP 2*, *FolkA 86*
Barrett, M d1836 *DcWomA*
Barrett, Marianne *DcWomA*
Barrett, Mildred *OfPGCP 86*
Barrett, Oliver O'Connor 1908- *DcBrA 1*, *WhAmArt 85*
Barrett, Pearce Lamkin 1925- *AmArch 70*
Barrett, Ranelagh d1768 *DcBrECP*
Barrett, Riva Helfond *WhAmArt 85*
Barrett, Robert D 1903- *WhAmArt 85*
Barrett, Robert Dumas 1903- *WhoAmA 78*, *-80*, *-82*, *-84*
Barrett, Roderic *WhoArt 80*, *-82*, *-84*
Barrett, Roderic 1920- *DcCAr 81*
Barrett, Roderic Westwood 1920- *DcBrA 1*
Barrett, Ron *IlsBYP*
Barrett, Ron 1937- *IlsCB 1967*
Barrett, Salley *FolkA 86*
Barrett, Sidney Ray 1933- *AmArch 70*
Barrett, Strait C *WhAmArt 85*
Barrett, T *AntBDN D*
Barrett, Thomas *CabMA*, *DcBrA 2*, *DcVicP 2*
Barrett, Thomas 1845-1924 *DcBrWA*
Barrett, Thomas R 1927- *WhoAmA 73*, *-76*, *-78*, *-80*, *-82*, *-84*
Barrett, Thomas Weeks d1947 *WhoAmA 78N*, *-80N*, *-82N*, *-84N*
Barrett, Thomas Weeks 1902-1947 *WhAmArt 85*
Barrett, William *DcVicP 2*
Barrett, William S 1854-1927 *WhAmArt 85*
Barrett, William Sterna 1853?-1927 *ArtsAmW 3*
Barrett And Rosendorn *EncASM*
Barrett-Du-Coudert, Marie Josephine *DcWomA*
Barrette, William *DcCAr 81*
Barretto, Anna Appleton 1891- *WhAmArt 85*
Barrias, Felix J 1822-1907 *DcBrBI*
Barrias, Felix-Joseph 1822- *ArtsNiC*
Barrias, Louis Ernest *ArtsNiC*
Barrias, Louis Ernest 1841-1905 *McGDA*
Barribal, W H *DcBrBI*
Barrick, N E *AmArch 70*
Barrick, Shirley Gordon 1885- *WhAmArt 85*
Barrie, Andrew *BiDBrA*
Barrie, Dennis Ray 1947- *WhoAmA 84*
Barrie, Erwin S 1886- *WhAmArt 85*, *WhoAmA 73*, *-76*, *-78*, *-80*, *-82*
Barrie, Erwin S 1886-1983 *WhoAmA 84N*
Barrie, May 1918- *DcCAr 81*
Barrie, Scott 1945- *WorFshn*
Barrie, Scott 1946- *ConDes*
Barriere, Madame *DcWomA*
Barriere, Alice *DcWomA*
Barringer, Ethel 1884-1925 *DcWomA*
Barringer, Gwendoline 1883-1960 *DcWomA*
Barrington, Amy L *DcWomA*, *WhAmArt 85*
Barrington, Arthur *DcVicP 2*
Barrington, George *ArtsAmW 1*
Barrington, W *DcVicP 2*
Barrington-Browne, W E 1908- *DcBrA 2*
Barrio, Raymond 1921- *WhoAmA 76*, *-78*, *-80*, *-82*, *-84*
Barrio-Garay, Jose Luis 1932- *WhoAmA 76*, *-78*, *-80*, *-82*, *-84*
Barrios, Alvaro 1945- *ConArt 77*
Barrios, Benny Perez 1925- *WhoAmA 80*, *-82*, *-84*
Barrios, David *IlsBYP*
Barriot, Judith 1881- *DcWomA*
Barrite, Gerred E *CabMA*
Barritt, Robert Carlyle 1898- *WhAmArt 85*
Barritt, William 1822?- *NewYHSD*
Barroeta *NewYHSD*
Barroll, Nina L *DcWomA*, *WhAmArt 85*
Barron, Dorothy Lois Hatch *WhAmArt 85*
Barron, Gladys Caroline d1967 *DcBrA 1*, *DcWomA*
Barron, Grace 1903- *WhAmArt 85*
Barron, Grace Allison 1899- *DcWomA*
Barron, Harris 1926- *WhoAmA 73*, *-76*
Barron, Howard 1900- *DcBrA 1*, *WhoAmA 80*, *-82*, *-84*
Barron, Hugh 1747-1791 *DcBrECP*
Barron, Jane Carson 1879- *WhAmArt 85*
Barron, John W 1826?- *NewYHSD*
Barron, Paul 1917- *WhoArt 80*, *-82*, *-84*
Barron, Phyllis 1890-1964 *ConDes*
Barron, Robert *OxDecA*
Barron, Ros 1933- *WhoAmA 73*, *-76*, *-78*, *-80*, *-82*, *-84*
Barron, Mrs. S Brooks 1902- *WhoAmA 73*, *-76*
Barron, William Augustus 1750- *DcBrWA*
Barron, William Augustus 1751-1806? *DcBrECP*
Barrow *DcBrBI*
Barrow, Lady Anna Maria *DcWomA*
Barrow, D B, Jr. *WhAmArt 85*
Barrow, Edith d1930 *ClaDrA*
Barrow, Edith Isabel d1930 *DcBrA 1*, *DcVicP 2*, *DcWomA*
Barrow, George A 1921- *AmArch 70*
Barrow, J L *NewYHSD*

Barrow, Jane *DcVicP 2*, *DcWomA*
Barrow, Janet *DcWomA*
Barrow, Sir John 1764-1848 *DcBrBI*
Barrow, John Dobson 1823-1907 *NewYHSD*
Barrow, John Sutcliff *FolkA 86*
Barrow, Joseph Charles *DcBrWA*
Barrow, Joseph Merton 1909- *AmArch 70*
Barrow, Katherine *DcWomA*
Barrow, R J *BiDBrA*
Barrow, Thomas *NewYHSD*
Barrow, Thomas 1749?-1778? *DcBrECP*
Barrow, Thomas F 1938- *ConPhot*, *ICPEnP A*, *MacBEP*
Barrow, Thomas Francis 1938- *WhoAmA 76*, *-78*, *-80*, *-82*, *-84*
Barrow, W H *DcVicP 2*
Barrows, A H *DcWomA*
Barrows, Albert *WhAmArt 85*
Barrows, Albert 1893- *ArtsAmW 2*
Barrows, Mrs. Albert *WhAmArt 85*
Barrows, Asahel *FolkA 86*
Barrows, B E *WhAmArt 85*
Barrows, C Storrs 1889- *AmArch 70*
Barrows, Elizabeth Bartlett 1872- *DcWomA*, *WhAmArt 85*
Barrows, Gridley 1912- *AmArch 70*
Barrows, H F *EncASM*
Barrows, Jeanette E *ArtsEM*, *DcWomA*
Barrows, M S *AmArch 70*
Barrows, Timothy Hollis 1931- *AmArch 70*
Barry, Anne Meredith 1932- *WhoAmA 78*, *-80*, *-82*, *-84*
Barry, Charles 1795-1860 *MacEA*
Barry, Charles 1820?- *NewYHSD*
Barry, Sir Charles 1795-1860 *BiDBrA*, *DcBrWA*, *DcD&D*, *McGDA*, *OxArt*, *WhoArch*
Barry, Charles, Jr. 1823-1900 *WhoArch*
Barry, Charles A 1830-1892 *EarABI*, *EarABI SUP*, *NewYHSD*
Barry, Daniel 1824?- *NewYHSD*
Barry, Daniel 1923- *WorECom*
Barry, David J *NewYHSD*
Barry, Desmond *DcVicP 2*
Barry, Dick *DcVicP 2*
Barry, Edith Cleaves *DcWomA*, *WhAmArt 85*
Barry, Edith M *DcVicP 2*, *DcWomA*
Barry, Edward M 1830-1880 *ArtsNiC*, *MacEA*
Barry, Edward Middleton 1830-1880 *McGDA*, *WhoArch*
Barry, Eleanor E *WhAmArt 85*
Barry, Ethelred Breeze 1870- *DcWomA*, *WhAmArt 85*
Barry, Sir Francis 1883-1970 *DcBrA 1*
Barry, Frank 1913- *WhoAmA 76*, *-78*, *-80*, *-82*, *-84*
Barry, Frederick *DcVicP 2*
Barry, Gerald Ward 1923- *AmArch 70*
Barry, J B *CabMA*
Barry, James 1741-1806 *DcBrECP*, *McGDA*, *OxArt*
Barry, James E *IlsBYP*
Barry, James Laurence 1926- *AmArch 70*
Barry, James M 1955- *MarqDCG 84*
Barry, Jo *DcCAr 81*
Barry, John *AntBDN J*
Barry, John J 1885- *WhAmArt 85*
Barry, John Joseph 1885- *ArtsAmW 3*
Barry, John Sean Alan, III 1934- *MarqDCG 84*
Barry, Sir John Wolfe 1836-1918 *WhoArch*
Barry, Katharina Watjen 1936- *IlsCB 1957*
Barry, Lily Emily Frances *DcWomA*
Barry, Marietta *WhAmArt 85*
Barry, Robert *OxTwCA*
Barry, Robert 1936- *ConArt 77*, *-83*, *DcCAA 77*
Barry, Robert E 1931- *WhoAmA 78*, *-80*, *-82*, *-84*
Barry, Robert Everett 1931- *IlsCB 1957*
Barry, Robert Thomas 1936- *PrintW 83*, *-85*, *WhoAmA 78*, *-80*, *-82*, *-84*
Barry, Ross William 1933- *AmArch 70*
Barry, Seymour 1928- *WorECom*
Barry, Theodore *NewYHSD*
Barry, Thomas *FolkA 86*
Barry, Thomas J 1834?- *NewYHSD*
Barry, Timothy *NewYHSD*
Barry, W Gerard *DcVicP 2*
Barry, William David 1946- *WhoAmA 78*
Barsac, Laure *DcWomA*
Barsac, Marie *DcWomA*
Barsac, Zulime 1809- *DcWomA*
Barsano, Ron 1945- *AmArt*, *WhoAmA 82*, *-84*
Barsch, Wulf E 1943- *PrintW 83*, *-85*
Barsch, Wulf Erich 1943- *WhoAmA 78*, *-80*, *-82*, *-84*
Barschel, H J 1912- *WhAmArt 85*, *WhoAmA 73*
Barschel, Hans J 1912- *WhoAmA 76*, *-78*, *-80*, *-82*, *-84*
Barse, George R, Jr. 1861-1938 *WhAmArt 85*
Barse, George Randall, Jr. 1861-1938 *ArtsEM*
Barse, George Randolph, Jr. 1861-1938 *ArtsAmW 3*, *IlBEAAW*
Barsento, Emilio Pucci Di 1914- *WorFshn*
Barsham, J W *NewYHSD*
Barsky, Brian A 1954- *MarqDCG 84*
Barsocchini, M E *AmArch 70*

Barsotte, Francisco *NewYHSD*
Barsotti, John Joseph 1914- *WhAmArt 85*
Barss, Peter *DcCAr 81*
Barss, William 1916- *IlsBYP*, *IlsCB 1957*
Barstow, Emma *DcWomA*
Barstow, Marion *DcWomA*
Barstow, Marion Huse *WhAmArt 85*
Barstow, Montagu *DcVicP 2*
Barstow, Montague *DcBrWA*
Barstow, Nathaniel *EncASM*
Barstow, S M *DcWomA*, *WhAmArt 85*
Barstow, Miss S M *NewYHSD*
Barstow, Salome *FolkA 86*
Barstow And Williams *EncASM*
Barstowe, H *DcVicP 2*
Bart, Daniel *FolkA 86*
Bart, Elizabeth *WhoAmA 78, -80, -82, -84*
Bart, Susanna *FolkA 86*
Bart-Gerald, E 1907- *WhAmArt 85*
Barta, Dorothy Elaine 1924- *AmArt*, *WhoAmA 82, -84*
Barta, Joseph Thomas 1904-1972 *FolkA 86*
Barta, Lazlo 1902- *OxTwCA*
Bartajago, E *DcVicP 2*
Bartanyi, Endre 1936- *AmArch 70*
Barte, Eleanore *WhAmArt 85*
Barteau, Charles F *WhoAmA 76*
Bartek, Tom 1932- *WhoAmA 82, -84*
Bartel, Sarah N *WhAmArt 85*
Bartell, Aaron 1951- *MarqDCG 84*
Bartell, C G *AmArch 70*
Bartell, Sarah *DcWomA*, *NewYHSD*
Bartelle, D W C *NewYHSD*
Bartello *NewYHSD*
Bartels, Elizabeth Clayton *DcWomA*
Bartels, Louisa M *NewYHSD*
Bartels, Louisa M 1835?- *DcWomA*
Bartels, Wera Von 1886- *DcWomA*
Barten, Peter G J 1927- *MarqDCG 84*
Barter, Gertrude Mary *DcVicP 2*, *DcWomA*
Barth, Alf O 1921- *AmArch 70*
Barth, Andrew *FolkA 86*
Barth, Bartholomew *FolkA 86*
Barth, C W *DcVicP 2*
Barth, Carl Wilhelm Bockmann 1847- *ClaDrA*
Barth, Charles 1942- *PrintW 83, -85*
Barth, Charles John 1942- *WhoAmA 78, -80, -82, -84*
Barth, Eugene F 1904- *WhAmArt 85*
Barth, Frances 1946- *AmArt*, *WhoAmA 76, -78, -80, -82, -84*
Barth, Frederick 1804?- *NewYHSD*
Barth, Herman 1868-1923 *BiDAmAr*
Barth, J S *DcBrWA*
Barth, Jack Alexander 1946- *WhoAmA 80, -82, -84*
Barth, Louis *FolkA 86*
Barth, Max 1907- *AmArch 70*
Barth, Miles *MacBEP*
Barth, Otto *FolkA 86*
Barth, Paul Basilius 1881-1955 *OxTwCA*
Barth, Rudolph F 1836?- *NewYHSD*
Barth, Signe Madeleine *DcWomA*
Barth, Valentine *NewYHSD*
Barth, Wilhelm *DcVicP 2*
Barthberger, Charles 1823-1896 *BiDAmAr*
Barthe, Richmond 1901- *AfroAA*, *WhAmArt 85*, *WhoAmA 82, -84*
Barthelme, Donald *AmArch 70*
Barthet, Jean 1920- *FairDF FRA*
Barthold, Manuel Loyola 1874- *WhAmArt 85*
Bartholdi, Frederic Auguste 1833- *ArtsNiC*
Bartholdi, Frederic Auguste 1834-1904 *McGDA*
Bartholet, Elizabeth Ives *WhoAmA 78, -80, -82, -84*
Bartholick, G R *AmArch 70*
Bartholome, Paul Albert 1848-1928 *McGDA*, *OxTwCA*
Bartholomew, Saint *McGDA*
Bartholomew, Alfred 1801-1845 *BiDBrA*
Bartholomew, Anne C 1800-1862 *ArtsNiC*
Bartholomew, Anne Charlotte 1800-1862 *DcBrWA*, *DcWomA*
Bartholomew, C B 1898- *ArtsAmW 3*
Bartholomew, Charles L 1869- *WhAmArt 85*
Bartholomew, Donald C 1883-1913 *WhAmArt 85*
Bartholomew, Edward S 1822-1858 *ArtsNiC*
Bartholomew, Edward Sheffield 1822-1858 *DcAmArt*, *McGDA*, *NewYHSD*
Bartholomew, Harry *DcVicP 2*
Bartholomew, Jacob, Jr. *FolkA 86*
Bartholomew, L M *ArtsEM*
Bartholomew, Norman Eugene 1933- *AmArch 70*
Bartholomew, Oswald Charles 1937- *AmArch 70*
Bartholomew, Paul A 1883- *AmArch 70*
Bartholomew, R P *AmArch 70*
Bartholomew, Samuel *FolkA 86*
Bartholomew, Truman C 1809-1867 *NewYHSD*
Bartholomew, Valentine 1799-1879 *DcBrWA*, *DcVicP, -2*
Bartholomew, Mrs. Valentine 1800-1862 *DcVicP 2*
Bartholomew, W N 1822-1898 *ArtsAmW 1*
Bartholomew, William Newton 1822-1898 *IlBEAAW*, *NewYHSD , WhAmArt 85*

Bartholomew, William Val 1799-1879 *ArtsNiC*
Bartholomew, Zou-Zou Elise 1911- *DcBrA 1*
Barthram, Frances *MacBEP*
Bartilotta, Samuel A 1900- *WhAmArt 85*
Bartkowski, Darrell 1949- *MarqDCG 84*
Bartlam, John *FolkA 86*
Bartle, Annette *WhoAmA 73, -76*
Bartle, Dorothy Budd 1924- *WhoAmA 78, -80, -82, -84*
Bartle, George P 1853-1918 *WhAmArt 85*
Bartle, Grace M 1889- *DcWomA*, *WhAmArt 85*
Bartle, Sara N *WhAmArt 85*
Bartle, Sara Norwood *DcWomA*
Bartleman *FolkA 86*
Bartler, Joseph *FolkA 86*
Bartleson, Malotte *WhAmArt 85*
Bartlet, Jerusha *FolkA 86*
Bartlett, Allen Lyman 1903- *AmArch 70*
Bartlett, Annie S *DcVicP 2*, *DcWomA*
Bartlett, B B *AmArch 70*
Bartlett, Catherine Calhoun *DcWomA*
Bartlett, Charles *DcCAr 81*
Bartlett, Charles 1921- *WhoArt 80, -82, -84*
Bartlett, Charles W *WhAmArt 85*
Bartlett, Charles William *DcBrA 1*
Bartlett, Christopher E 1944- *WhoAmA 80, -82, -84*
Bartlett, Clarence Drew 1860- *WhAmArt 85*
Bartlett, Dana d1957 *WhAmArt 85*
Bartlett, Dana 1878- *ArtsEM*
Bartlett, Dana 1878-1957 *ArtsAmW 1*, *IlBEAAW*
Bartlett, Dana 1882-1957 *WhoAmA 80N, -82N, -84N*
Bartlett, David Louis 1931- *AmArch 70*
Bartlett, Donald Loring 1927- *WhoAmA 76, -78, -80, -82, -84*
Bartlett, Elizabeth M P *DcWomA*, *WhAmArt 85*
Bartlett, Elwood Warren 1906- *WhAmArt 85*
Bartlett, Ethel G *DcWomA*, *WhAmArt 85*
Bartlett, Evelyn *WhAmArt 85*
Bartlett, F O *AmArch 70*
Bartlett, Francis d1913 *WhAmArt 85*
Bartlett, Fred Stewart 1905- *WhAmArt 85*, *WhoAmA 73, -76, -78, -80, -82, -84*
Bartlett, Frederic Clay 1873- *WhAmArt 85*
Bartlett, Frederic Clay, Jr. 1907- *WhAmArt 85*
Bartlett, Frederick Eugene 1852-1911 *WhAmArt 85*
Bartlett, G Waldron *WhAmArt 85*
Bartlett, George Marble 1872-1936 *BiDAmAr*
Bartlett, Gershom 1723-1798 *FolkA 86*
Bartlett, Grace Landell 1907- *WhAmArt 85*
Bartlett, Gray 1885-1951 *ArtsAmW 1*, *IlBEAAW*, *WhAmArt 85*
Bartlett, Harold Charles 1921- *DcBrA 1*
Bartlett, Helen B d1925 *WhAmArt 85*
Bartlett, I *FolkA 86*
Bartlett, Ivan 1908- *WhAmArt 85*
Bartlett, J E *BiDBrA*
Bartlett, J Hoxie *DcVicP 2*
Bartlett, Jane H *DcWomA*
Bartlett, Jason Robbins *NewYHSD*
Bartlett, Jennie E *DcWomA*
Bartlett, Jennifer 1941- *ConArt 83*, *DcCAr 81*, *PrintW 83, -85*
Bartlett, Jennifer Losch 1941- *AmArt*, *ConArt 77*, *WhoAmA 73, -76, -78, -80, -82, -84*
Bartlett, John R 1805-1886 *ArtsAmW 1*
Bartlett, John Russell 1805-1886 *IlBEAAW*, *NewYHSD*
Bartlett, John Warren 1927- *AmArch 70*
Bartlett, Jonathan Adams 1817-1902 *FolkA 86*
Bartlett, Joseph 1765-1810 *CabMA*
Bartlett, Josephine Hoxie 1870- *DcWomA*, *WhAmArt 85*
Bartlett, Julia M 1899- *WhAmArt 85*
Bartlett, Julia McMahon 1899- *DcWomA*
Bartlett, June Rosalyn 1947- *WhoArt 80, -82, -84*
Bartlett, Levi *CabMA*
Bartlett, Lucy *DcWomA*, *FolkA 86*
Bartlett, Madeline A *WhAmArt 85*
Bartlett, Madeleine Adelaide *DcWomA*
Bartlett, Mary E *ArtsEM*, *DcWomA*
Bartlett, Minnie E 1890- *DcWomA*
Bartlett, Minnie Ellsworth 1890- *WhAmArt 85*
Bartlett, Otto *WhAmArt 85*
Bartlett, P G *AmArch 70*
Bartlett, Paul 1881- *WhAmArt 85*
Bartlett, Paul W *DcBrA 2*
Bartlett, Paul W 1865-1925 *WhAmArt 85*
Bartlett, Paul Wayland 1865-1925 *BnEnAmA*, *DcAmArt*, *IlBEAAW*, *McGDA*
Bartlett, Richard Warren 1919- *AmArch 70*
Bartlett, Robert Webster 1922- *WhoAmA 73, -76, -78*
Bartlett, Robert Webster 1922-1979 *WhoAmA 80N, -82N, -84N*
Bartlett, Scott 1943- *MarqDCG 84*, *WhoAmA 76, -78, -80, -82, -84*
Bartlett, Truman H 1835- *ArtsNiC*, *WhAmArt 85*
Bartlett, Truman Howe 1835-1923 *McGDA*, *NewYHSD*
Bartlett, W H *FolkA 86*
Bartlett, William H *DcBrWA*

Bartlett, William H 1858- *ClaDrA*, *DcBrBI*, *DcVicP*
Bartlett, William H 1858-1932 *DcBrA 1*, *DcVicP 2*
Bartlett, William Henry 1809-1854 *AntBDN B*, *DcBrBI*, *DcBrWA*, *DcNiCA*, *DcVicP, -2*, *NewYHSD*
Bartlett-Merriman, Horace 1914- *WhoArt 80, -82, -84*
Bartlette, Mrs. *NewYHSD*
Bartley, J A *AmArch 70*
Bartley, T T, Jr. *AmArch 70*
Bartnett, Frances Griffiths 1861- *ArtsAmW 2*, *DcWomA*
Bartney, John *NewYHSD*
Bartnick, Harry William 1950- *AmArt*, *WhoAmA 78, -80, -82, -84*
Bartning, Otto 1883-1959 *ConArch*, *EncMA*, *MacEA*, *McGDA*, *WhoArch*
Barto, Emily 1896- *WhAmArt 85*
Barto, Emily Newton 1886- *DcWomA*
Bartok, J *AmArch 70*
Bartok, John Anthony 1938- *WhoAmA 73, -76*
Bartol, Elizabeth Howard 1842-1927 *DcWomA*, *WhAmArt 85*
Bartol, William Thompson *FolkA 86*
Bartolarchi, Sebastian *NewYHSD*
Bartoli, Carlo 1931- *ConDes*
Bartoli, F *NewYHSD*
Bartoli, Francesco 1675?-1730? *OxArt*
Bartoli, Francis 1765-1783 *DcBrECP*
Bartoli, G A *AmArch 70*
Bartoli, J *IlBEAAW*
Bartoli, Pietro Sante 1635?-1700 *OxArt*
Bartoli, W P *AmArch 70*
Bartoli Natinguerra, Amerigo 1890- *WhoGrA 62*
Bartolini, Lorenzo 1777-1850 *ArtsNiC*, *McGDA*
Bartolini, Louisa Grace 1818-1865 *DcWomA*
Bartolini, Luigi 1892- *PhDcTCA 77*
Bartolini, Luigi 1892-1963 *McGDA*
Bartoll, Samuel 1765?-1835 *NewYHSD*
Bartoll, William Thompson 1817-1859 *FolkA 86*
Bartoll, William Thompson 1817-1859? *NewYHSD*
Bartolo Di Fredi *OxArt*
Bartolo Di Fredi 1330?-1410 *McGDA*
Bartolo, Giovanni Di *McGDA*
Bartolo, Sebastiano Di *McGDA*, *OxArt*
Bartolo, Taddeo Di *McGDA*
Bartolo, Zanobi Di *McGDA*
Bartolome, Jaime 1927- *WhoArt 80, -82, -84*
Bartolommeo Bolgarini d1378 *McGDA*
Bartolommeo Della Gatta 1448-1502 *McGDA*
Bartolommeo Di Fruosino *McGDA*
Bartolommeo Di Maestro Gentile d1538? *McGDA*
Bartolommeo, Fra 1475-1517 *McGDA*
Bartolommeo Suardi *McGDA*
Bartolommeo Veneto *McGDA*, *OxArt*
Bartolommeo, Baccio Della Porta 1472?-1517 *OxArt*
Bartolommeo, Maso Di *McGDA*
Bartolozzi, Francesco 1725-1815 *AntBDN B*, *BkIE*, *ClaDrA*
Bartolozzi, Francesco 1727-1815 *McGDA*, *OxArt*
Bartolozzi, Rafael 1943- *ConArt 77*
Barton, A G *AmArch 70*
Barton, Alix Gres *WorFshn*
Barton, Ann Maria 1788-1868 *FolkA 86*
Barton, August Charles 1897- *WhAmArt 85*, *WhoAmA 73, -76, -78, -80, -82, -84*
Barton, Bruce Walter 1935- *WhoAmA 76, -78, -80, -82, -84*
Barton, Byron 1930- *IlsCB 1967*
Barton, C A *DcVicP 2*, *DcWomA*
Barton, Mrs. Caleb D *NewYHSD*
Barton, Carrie Moote *DcWomA*
Barton, Catherine Graeff 1904- *WhAmArt 85*
Barton, Charles C d1851 *NewYHSD*
Barton, Cleon Douglas 1912- *WhAmArt 85*
Barton, Donald B 1903- *WhAmArt 85*
Barton, Edgar F *NewYHSD*
Barton, Eleanor Dodge 1918- *WhoAmA 73, -76, -78*
Barton, Eleanor G *DcVicP 2*
Barton, Elizabeth *DcWomA*
Barton, Emma Clara *DcWomA*
Barton, Erastus *EncASM*
Barton, Ethel Rose *WhAmArt 85*
Barton, F Eugene d1944 *BiDAmAr*
Barton, G *WhAmArt 85*
Barton, Gene C 1950- *MarqDCG 84*
Barton, George E 1880?-1920? *BiDAmAr*
Barton, Georgie Read *WhoAmA 73, -76, -78, -80, -82, -84*
Barton, Harry 1876-1936? *BiDAmAr*
Barton, J *DcVicP 2*
Barton, James C *ArtsEM*
Barton, James Pierce 1817-1891 *NewYHSD*
Barton, Jean L 1924- *WhoAmA 76, -78, -80, -82*
Barton, John Murray 1921- *WhoAmA 73, -76, -78, -80, -82, -84*
Barton, L H *NewYHSD*
Barton, Larry *OfPGCP 86*
Barton, Leon S, Jr. 1906- *AmArch 70*
Barton, Leonard 1893-1971 *DcBrA 1*
Barton, Loren 1893- *WhAmArt 85*

Basu, Hella *WhoArt 84N*
Basu, Hella 1924- *WhoArt 80, –82*
Basu, Kanu 1924- *WhoGrA 62*
Basye, Joyce 1947- *FolkA 86*
Bat-Yosef, Myriam 1931- *ConArt 77*
Bataille, Nicolas *OxDecA*
Batave, Le *McGDA*
Batchelder *NewYHSD*
Batchelder, Alix *WhAmArt 85*
Batchelder, Christine *FolkA 86*
Batchelder, David 1939- *DcCAr 81*
Batchelder, E B L *WhAmArt 85*
Batchelder, Ernest A 1875-1957 *WhAmArt 85*
Batchelder, Evelyn Beatrice *DcWomA*
Batchelder, George 1768?- *CabMA*
Batchelder, John L, Jr. 1907- *WhAmArt 85*
Batchelder, Mrs. Nathaniel Horton *WhAmArt 85*
Batchelder, Nellie C *ArtsEM, DcWomA*
Batchelder, S J 1849-1932 *DcBrWA*
Batchelder, Stephen John 1849-1932 *DcBrA 1*
Batchelder, Theophilus 1751-1833 *CabMA*
Batcheler, George D, Jr. 1927- *AmArch 70*
Batcheller, Frederick S 1837-1889 *NewYHSD*
Batchellor, Anna S *ArtsEM*
Batchelor, Anthony John 1944- *WhoAmA 78, –80, –82, –84*
Batchelor, Bernard Philip 1924- *WhoAmA 80, –82, –84*
Batchelor, Bernard Phillip 1924- *DcBrA 1*
Batchelor, Bernard William Roland 1889- *DcBrA 1, WhoArt 80, –82, –84*
Batchelor, Betsy Ann 1952- *WhoAmA 84*
Batchelor, Clarence D d1977 *WhAmArt 85*
Batchelor, Clarence Daniel *WhoAmA 76*
Batchelor, Clarence Daniel d1977 *WhoAmA 78N, –80N, –82N, –84N*
Batchelor, Clarence Daniel 1888-1978 *WorECar*
Batchelor, Jonathan David 1913- *WhoAmA 73, –76*
Batchelor, Joy 1914- *WorECar*
Batchelor, Kate *DcVicP 2, DcWomA*
Batchelor, M H *DcVicP 2*
Batchelor, Peter 1934- *AmArch 70*
Batchelor, R P *AmArch 70*
Batchelor Flint, Ethel M 1883- *DcBrA 1, DcWomA*
Batdorff, Tude *DcWomA*
Bate, H Francis 1853-1950 *DcBrA 1, DcVicP 2*
Bate, Howard Edward Davis 1894- *DcBrA 1*
Bate, Norman Arthur 1916- *IlsCB 1946, WhoAmA 73, –76, –78, –80*
Bate, Norman Arthur 1916-1980 *WhoAmA 82N, –84N*
Bate, Rutledge 1891- *WhAmArt 85*
Bate, Stanley 1903- *WhAmArt 85, WhoAmA 73, –76*
Bateman *BiDBrA*
Bateman, Anne *AntBDN Q*
Bateman, Arthur 1883- *DcBrA 1*
Bateman, B Arthur *DcVicP 2*
Bateman, C E *BiDBrA*
Bateman, Charles 1890- *WhAmArt 85*
Bateman, Charles E *NewYHSD*
Bateman, Charles J, Sr. 1851-1940 *BiDAmAr*
Bateman, Henry Mayo 1887- *IlsCB 1744*
Bateman, Henry Mayo 1887-1970 *DcBrA 1, DcBrBI, WorECom*
Bateman, Hester *AntBDN Q*
Bateman, Hester 1740?-1790 *WomArt*
Bateman, James 1814-1849 *DcBrBI*
Bateman, James 1815-1849 *DcVicP, –2*
Bateman, James 1893-1959 *ClaDrA, DcBrA 1*
Bateman, John Jones d1903 *BiDBrA*
Bateman, John M 1877- *WhAmArt 85*
Bateman, Jonathan d1791 *AntBDN Q*
Bateman, Joseph d1811 *BiDBrA*
Bateman, Katherine Roberta 1940- *WhoAmA 80, –82*
Bateman, L *DcBrECP*
Bateman, Peter *AntBDN Q*
Bateman, Robert *DcBrBI, OfPGCP 86*
Bateman, Robert 1841?- *DcVicP 2*
Bateman, Robert McLellan 1930- *WhoAmA 78, –80, –82, –84*
Bateman, Ronald C 1947- *WhoAmA 78, –80, –82, –84*
Bateman, Samuel *DcVicP 2*
Bateman, Talbot *ArtsAmW 2*
Bateman, Thomas d1829 *BiDBrA*
Bateman, Thomas Joseph d1837 *BiDBrA*
Bateman, William *AntBDN Q, NewYHSD*
Bateman, William 1806-1833 *DcBrWA*
Batenham, G *AntBDN O*
Bates *NewYHSD*
Bates, A S *FolkA 86*
Bates, Alan Lawrence 1923- *AmArch 70*
Bates, B A *AmArch 70*
Bates, Bertha *DcWomA*
Bates, Bertha Corson Day 1875- *WhAmArt 85*
Bates, Betsey 1924- *WhoAmA 78, –80, –82, –84*
Bates, Bill 1930- *WhoAmA 76, –78, –80, –82, –84*
Bates, Carol *WhoAmA 80N, –82N, –84N*
Bates, Carol 1895-1958? *WhAmArt 85*
Bates, Charles Lyman 1929- *AmArch 70*
Bates, Charles T, Jr. 1942- *WhoAmA 73*
Bates, Clarence E 1910- *WhAmArt 85*

Bates, David *DcVicP*
Bates, David 1840-1921 *DcBrA 1, DcBrWA, DcVicP 2*
Bates, Dewey 1851- *ArtsNiC*
Bates, Dewey 1851-1899 *DcBrBI*
Bates, Earl Kenneth 1895-1973 *WhAmArt 85*
Bates, Edwin *DcVicP 2*
Bates, Eliza A *DcWomA*
Bates, Elliott Maxcy 1920- *AmArch 70*
Bates, Eugene F *ArtsEM*
Bates, Frederick D *DcBrBI*
Bates, Frederick Davenport 1867- *ClaDrA, DcBrA 1*
Bates, Gladys 1898-1944 *WhAmArt 85*
Bates, Gladys Bergh 1898-1944 *DcWomA*
Bates, Gladys Edgerly 1896- *DcWomA, WhAmArt 85, WhoAmA 73, –76, –78, –80, –82, –84*
Bates, H *AmArch 70*
Bates, Harold *EncASM*
Bates, Harry 1850-1898 *WhAmArt 85*
Bates, Henry W *DcVicP 2*
Bates, Isaac Comstock 1843-1913 *WhAmArt 85*
Bates, Isabel Miriam 1911- *WhAmArt 85*
Bates, J C *EncASM*
Bates, J E *AmArch 70*
Bates, Jessie F *DcVicP 2*
Bates, John *ConDes, FairDF ENG, WorFshn*
Bates, John Everts 1891- *WhAmArt 85*
Bates, Ken 1927- *WhoArt 80, –82, –84*
Bates, Kendall Powers 1926- *AmArch 70*
Bates, Kenneth 1895- *WhoAmA 73*
Bates, Kenneth 1895-1973 *WhoAmA 76N, –78N, –80N, –82N, –84N*
Bates, Kenneth Francis 1904- *WhAmArt 85, WhoAmA 73, –76, –78, –80, –82, –84*
Bates, Leo F d1957 *DcBrA 2*
Bates, Leo James 1944- *WhoAmA 84*
Bates, Lorita Frances *DcWomA*
Bates, Marjorie Christine *DcBrA 1, DcWomA*
Bates, Maxwell Bennett 1906- *DcCAr 81, WhoAmA 73, –76, –78, –80, –82*
Bates, Maxwell Bennett 1906-1980 *WhoAmA 84N*
Bates, Phillip Roy 1928- *AmArch 70*
Bates, R C *AmArch 70*
Bates, R E *WhAmArt 85*
Bates, Richard M, Jr. d1948 *BiDAmAr*
Bates, T E *AmArch 70*
Bates, W E *DcVicP, –2*
Bates, Waldo F, Jr. 1889- *WhAmArt 85*
Bates, William A 1853-1922 *BiDAmAr*
Bates And Klinke *EncASM*
Bates Elliot & Company *DcNiCA*
Bateson, Edith *ClaDrA, DcBrA 1, DcWomA*
Bateson, Edith d1938 *DcBrA 2*
Bateson, Plum *ArtsEM*
Batey, T E *AmArch 70*
Bath, W *DcVicP 2*
Bathe, Frank Anthony, Jr. 1932- *AmArch 70*
Bathe, J *DcVicP 2*
Bather, George 1826?- *NewYHSD*
Bathgate, Ellen *DcVicP 2, DcWomA*
Bathgate, George *DcVicP 2*
Bathgate, Joseph A 1909-1944 *WhAmArt 85*
Bathier, Madame *DcWomA, NewYHSD*
Bathilde, Louise *DcWomA*
Batho, Claude 1935- *MacBEP*
Batho, Claude 1935-1981 *ConPhot, ICPEnP A*
Batho, John 1939- *ConPhot, ICPEnP A*
Batho, John 1941- *DcCAr 81*
Bathurst, Charles 1790-1863 *DcBrWA*
Bathurst, Charles J *DcBrA 1*
Bathurst, Clyde C 1883-1938 *WhAmArt 85*
Bathurst, David C 1937- *WhoAmA 80, –82, –84*
Batista, Tomas 1935- *WhoAmA 76, –78*
Batka, Joseph 1907- *AmArch 70*
Batley, Marguerite E *DcVicP 2*
Batley, Walter Daniel 1850- *DcBrA 1, DcBrWA, DcVicP 2*
Batley, Walter Daniel 1850-1936 *DcBrA 2*
Batley, William 1594?-1674 *BiDBrA*
Batlle, Fernando A 1940- *AmArch 70*
Batlle, Georgette 1942- *PrintW 83, –85*
Batlle-Planas, Juan 1911-1966 *OxTwCA*
Batlle Planas, Juan 1911-1966 *PhDcTCA 77*
Batman, Isabel Lowry 1838-1925 *DcWomA*
Baton, Edgar F 1832?- *NewYHSD*
Baton, Henry C 1834?- *NewYHSD*
Batoni, Pompeo 1708-1787 *McGDA*
Batoni, Pompeo Girolamo 1708-1787 *OxArt*
Batson, A Wellesley *DcVicP 2*
Batson, Billy Bob 1933- *AmArch 70*
Batson, Frank *DcVicP 2*
Batson, H M *DcVicP 2*
Batson, Mary Jane *FolkA 86*
Batson, Melvina Hobson 1826-1853 *DcWomA, NewYHSD*
Batson, Sterling Edgar, Jr. 1920- *AmArch 70*
Batt, Arthur *DcVicP 2*
Batt, Arthur 1846-1911 *DcBrA 2*
Batt, Miles Girard 1933- *WhoAmA 76, –78, –80, –82, –84*

Battagio, Giovanni Di Domenico *McGDA*
Battaglia, Aurelius *IlsBYP*
Battaglia, Carlo 1933- *ConArt 77, –83*
Battaglia, Dino 1923- *WorECom*
Battaglia, Francesco 1710-1788 *MacEA*
Battaglia, Hipolito Fermin 1907- *AmArch 70*
Battaglia, L *AmArch 70*
Battaglia, Pasquale M d1959 *WhoAmA 80N, –82N, –84N*
Battaglia, Pasquale Michael 1905-1959 *WhAmArt 85*
Battaglia, Roberto 1923- *WorECom*
Battaglia, Salvatore *WhAmArt 85*
Battaglie, Michelangelo Delle *McGDA*
Battaille, Suzanne *DcWomA*
Battaini, Ambrose *WhAmArt 85*
Battam, Thomas 1810-1864 *DcNiCA*
Battcock, Gregory 1941- *WhoAmA 73, –76, –78, –80*
Battee, John O *NewYHSD*
Battelle, Kenneth *WorFshn*
Battem, Gerrit 1636?-1684 *ClaDrA, DcSeaP*
Battem, Gerrit Van 1636-1684 *McGDA*
Batten, John Dickson 1860-1932 *ClaDrA, DcBrA 1, DcVicP, –2*
Batten, John Dixon 1860-1932 *DcBrBI*
Batten, Mark *WhoArt 80, –82, –84*
Batten, Mark Wilfred 1905- *DcBrA 1*
Batten, Mary 1873- *DcWomA*
Batten, McLeod *ArtsAmW 3, WhAmArt 85*
Battenberg, John 1931- *WhoAmA 78, –80, –82, –84*
Battenfield, Jackie 1950- *WhoAmA 84*
Batterbury, Reg 1913- *WhoArt 84*
Battersby, Mrs. *DcVicP 2, DcWomA*
Battersby, James Merrill 1934- *AmArch 70*
Battershill, Norman James 1922- *ClaDrA, DcBrA 1, WhoArt 80, –82, –84*
Batterson, James *NewYHSD*
Batterton, J *NewYHSD*
Battese, Stanley 1936- *IIBEAAW*
Battey, C M *AfroAA*
Battier *NewYHSD*
Battier, Madame *DcWomA*
Battin *EncASM*
Battin, Howard H 1895- *AmArch 70*
Battin, John T 1805?- *NewYHSD*
Battin, T *NewYHSD*
Battipede, Frank G *AmArch 70*
Battiss, Walter Hall 1906- *OxTwCA*
Battista Da Vicenza d1438 *McGDA*
Battista Giovanni Del Cavaliere *McGDA*
Battista, Vito P 1908- *AmArch 70*
Battistello *McGDA, OxArt*
Battistone, A Louis 1929- *AmArch 70*
Battke, Heinz 1900-1966 *PhDcTCA 77*
Battle, Milan *NewYHSD*
Battle, T Q *ConArch A*
Battles, D Blake 1887- *WhAmArt 85*
Battles, Thomas Bernard 1932- *AmArch 70*
Battleway, James *NewYHSD*
Battley, John *BiDBrA*
Battmann, Alfred Otto Wolfgang Schulze *OxTwCA*
Battoglia, L *AmArch 70*
Batton *NewYHSD*
Batts, Waverly G 1901- *AmArch 70*
Battut, Michele *DcCAr 81*
Batty, Miss *DcWomA*
Batty, Edward *DcVicP 2*
Batty, Elizabeth Frances *DcBrWA, DcWomA*
Batty, John *DcBrECP, DcBrWA*
Batty, R *DcVicP 2*
Batty, Robert 1789-1848 *DcBrBI, DcBrWA, DcVicP 2*
Batty, Robert M *DcBrWA*
Baturone, Jose *NewYHSD*
Batuz *WhoAmA 78*
Batuz 1933- *WhoAmA 76, –80*
Batz, A De *NewYHSD*
Batz, Eugen 1905- *PhDcTCA 77*
Batzell, Edgar A, Jr. 1915- *WhAmArt 85*
Bau, Paul 1941- *MarqDCG 84*
Baubry-Vaillant, Marie Adelaide 1829- *DcWomA*
Bauch, Solomon Stan 1883- *WhAmArt 85*
Bauch, Stan *FolkA 86*
Bauchant, Andre 1873-1958 *McGDA, OxTwCA, PhDcTCA 77*
Bauchery, France *DcWomA*
Bauchman, Edward *NewYHSD*
Bauchop, Tobias *BiDBrA*
Bauchspies, Clarence Morrison 1906- *AmArch 70*
Bauck, Jeanna Maria Charlotta 1840?-1925 *DcWomA*
Baucom, Ivan C 1918- *AmArch 70*
Baud, Benjamin 1807?-1875 *BiDBrA*
Baude DeMeurceley, Helene *DcWomA*
Baudelaire, Charles 1821-1867 *OxArt*
Baudenbach, John *DcBrECP*
Bauderon-De-Vermeron, Leontine *DcWomA*
Bauders, F *FolkA 86*
Baudet, Etienne 1636-1711 *McGDA*
Baudet, Marie d1916 *DcWomA*
Baudier, Alexander *NewYHSD*
Baudier, Emilie *DcWomA*
Baudin, Madeleine *DcWomA*

Baudin, Suzanne *DcWomA*
Baudiot, S *DcWomA*
Baudische-Wittke, Gudrun 1907- *DcNiCA*
Baudit, Amedee 1825-1890 *ClaDrA*
Baudizzone, Miguel Andres Patricio *ConArch*
Baudizzone-Diaz-Erbin-Lestard-Varas *ConArch*
Baudoine, Charles A *DcNiCA*
Baudot, Anatole De 1834-1915 *EncMA*
Baudot, Anatole De 1863-1915 *McGDA*
Baudot, Jeanne 1877-1957 *DcWomA*
Baudot, Joseph Eugene Anatole De 1834-1915 *MacEA*
Baudouin, Eugene 1842-1893 *ClaDrA*
Baudouin, Jeanne *DcWomA*
Baudouin, Leonie Eugene Noel Parfait *DcWomA*
Baudouin, Louise *DcWomA*
Baudouin, Pierre Antoine 1723-1769 *ClaDrA*
Baudouin, Pierre-Antoine 1723-1769 *McGDA*
Baudry, Cecile Paule *DcWomA*
Baudry, Paul 1828-1886 *ClaDrA*, *McGDA*
Baudry, Paul-Jacques-Aime 1828- *ArtsNiC*
Baudry DeBalzac, Caroline *DcWomA*
Baudry DeBalzac, Therese 1774-1831 *DcWomA*
Bauer, A J *FolkA 86*
Bauer, Albert Bela 1898- *AmArch 70*
Bauer, Alexander H 1867-1945 *BiDAmAr*
Bauer, Andeas B *FolkA 86*
Bauer, Augustus 1827-1894 *BiDAmAr*
Bauer, Britta 1944- *WorFshn*
Bauer, Caroline *DcWomA*
Bauer, Catherine K 1905-1964 *MacEA*
Bauer, Charles H 1880-1939 *BiDAmAr*
Bauer, Charlotte Von *DcWomA*
Bauer, E L *AmArch 70*
Bauer, Ferdinand Lucas 1760-1826 *DcBrWA*
Bauer, Frank 1942- *DcCAr 81*
Bauer, Frans Andreas 1758-1840 *DcBrWA*
Bauer, Fred 1928- *WhoGrA 82[port]*
Bauer, Fred 1937- *CenC[port]*
Bauer, Frederick *NewYHSD*
Bauer, Frederick 1855?- *ArtsAmW 1*
Bauer, Frederick C *ArtsEM*
Bauer, Harold William 1937- *AmArch 70*
Bauer, Henry W *WhAmArt 85*
Bauer, Karl 1905- *DcCAr 81*
Bauer, L M *AmArch 70*
Bauer, Leopold 1872-1938 *DcNiCA*, *MacEA*
Bauer, Mari Alexander Jacques 1867-1932 *ClaDrA*
Bauer, Marta *DcWomA*
Bauer, O H *AmArch 70*
Bauer, Rolf Peter 1912-1960 *WorECar*
Bauer, Rudolf 1889-1954 *OxTwCA*
Bauer, Rudolph 1889-1954 *PhDcTCA 77*
Bauer, Sol A 1898- *WhAmArt 85*
Bauer, Theodore *WhAmArt 85*
Bauer, W C *WhAmArt 85*
Bauer, W C 1862-1904 *MacEA*
Bauer, William *FolkA 86*
Bauer, William 1888- *WhAmArt 85*, *WhoAmA 73*
Bauer-Nilsen, Otto 1926- *AmArch 70*
Bauer-Pezellen, Tina 1897- *DcWomA*
Bauer-Radnay, Elizabeth De 1897-1972 *DcWomA*
Bauerkeller, Rose *DcWomA*
Bauerle, Amelia *DcWomA*
Bauerle, Amelia M *DcBrA 1*, *DcVicP 2*
Bauerle, Amelia R E *DcBrBI*
Bauerle, Charles B *EarABI SUP*, *NewYHSD*
Bauerle, R K *AmArch 70*
Bauermeister, Mary 1934- *DcCAA 71, –77*
Bauermeister, Mary Hilde Ruth 1934- *WhoAmA 73, –76, –78, –80, –82*
Bauernschmidt, Marjorie 1926- *IlsBYP*, *IlsCB 1946*
Baugh, Dorothy Geraldine 1891- *ArtsAmW 3*, *DcWomA*
Baugh, Eugene Bibb 1923- *AmArch 70*
Baughan, Lowell Bradley 1938- *AmArch 70*
Baugher, Everett Earnest 1906- *WhAmArt 85*
Baugher, Robert Dale 1932- *AmArch 70*
Baughman, John *FolkA 86*
Baughman, Mary Barney *DcWomA*, *WhAmArt 85*
Baughton, H *DcVicP 2*
Baugin, Lubin 1610-1663 *ClaDrA*, *McGDA*
Baugniet, Charles 1814- *ArtsNiC*
Baugniet, Charles 1814-1886 *DcBrBI*
Bauhan, Louis *WhAmArt 85*
Bauhan, R *WhAmArt 85*
Baukhages, Frederick Edwin, IV 1938- *AmArch 70*
Baulinson, A S *WhAmArt 85*
Bault *NewYHSD*
Bauly, William *NewYHSD*
Baum, Albert *WhAmArt 85*
Baum, Don 1922- *AmArt*, *DcCAr 81*
Baum, Dwight J 1886-1939 *MacEA*
Baum, Dwight James 1886-1939 *BiDAmAr*
Baum, Flora B 1884-1970 *DcWomA*
Baum, Franz 1888- *ArtsAmW 3*, *WhAmArt 85*
Baum, Hank *WhoAmA 82, –84*
Baum, Hank 1932- *WhoAmA 76, –78, –80*
Baum, J H *FolkA 86*
Baum, Jayne H 1954- *WhoAmA 84*
Baum, Libbie H *ArtsEM*, *DcWomA*
Baum, Marilyn Ruth 1939- *WhoAmA 84*

Baum, Mark 1903- *FolkA 86*, *WhAmArt 85*
Baum, Monika 1943- *WhoGrA 82[port]*
Baum, Norbert 1940- *WhoGrA 82[port]*
Baum, Otto 1900- *McGDA*, *PhDcTCA 77*
Baum, S *AmArch 70*
Baum, Sanford L 1931- *AmArch 70*
Baum, Solomon 1918- *AmArch 70*
Baum, Timothy 1938- *WhoAmA 80, –82, –84*
Baum, Walter Emerson 1884-1956 *WhAmArt 85*
Baum, William 1921- *WhoAmA 73, –76*
Baum, Yngve 1945- *ConPhot*, *ICPEnP A*
Bauman, August *FolkA 86*
Bauman, Edward 1828-1889 *BiDAmAr*
Bauman, Frederick 1826-1921 *BiDAmAr*
Bauman, J *AntBDN P*
Bauman, Jacob *ArtsEM*
Bauman, Keith Stanley 1940- *AmArch 70*
Bauman, Leila T *DcWomA*, *FolkA 86*
Bauman, Lionel R *WhoAmA 73*
Bauman, S J *AmArch 70*
Bauman, Sylvia A 1957- *MarqDCG 84*
Baumann, A Hilda *DcVicP 2*, *DcWomA*
Baumann, Charles Hart 1892- *WhAmArt 85*
Baumann, Constance Amy Pauline *DcBrA 1*
Baumann, Elisabeth *DcWomA*
Baumann, Elisabeth Marie Anna *DcWomA*
Baumann, Frederick 1826-1921 *MacEA*
Baumann, Gustave 1881-1971 *ArtsAmW 1*, *IIBEAAW*, *WhAmArt 85*
Baumann, Hans Theodor 1924- *ConDes*
Baumann, Horst H 1934- *ConPhot*, *ICPEnP A*
Baumann, Ida *DcVicP 2*
Baumann, Ida 1864- *DcWomA*
Baumann, Jacob *ArtsEM*
Baumann, Karl Herman 1911- *WhAmArt 85*
Baumann, Povl 1878-1963 *MacEA*
Baumann, S *FolkA 86*
Baumbach, Harold 1903- *WhAmArt 85*
Baumbach, Harold 1905- *AmArt*, *WhoAmA 73, –76, –78, –80, –82, –84*
Baumback, Theodore *FolkA 86*
Baumberger, Otto 1889- *WhoGrA 62*
Baume, Berthe Marie DeLa 1860-1911 *DcWomA*
Baume, H B *AmArch 70*
Baumeister, Anna Berthe *DcWomA*
Baumeister, Reinhard 1833-1917 *MacEA*
Baumeister, Willi 1889-1955 *ConArt 77, –83*, *McGDA*, *OxTwCA*, *PhDcTCA 77*, *WorArt[port]*
Baumelou, Marie Gabrielle *DcWomA*
Baumer, H *AmArch 70*
Baumer, Julius H 1848-1917 *WhAmArt 85*
Baumer, Lewis 1870- *IlsCB 1744*
Baumer, Lewis C E 1870-1963 *DcBrBI*
Baumer, Lewis Christopher Edward 1870-1963 *DcBrA 1*, *DcVicP 2*
Baumgard, George *WhAmArt 85*
Baumgardt, Paul E 1909- *WhAmArt 85*
Baumgart, Isolde 1935- *WhoAmA 82*
Baumgarten, Bodo 1940- *DcCAr 81*
Baumgarten, Cecil *WhAmArt 85*
Baumgarten, G M *AmArch 70*
Baumgarten, Gustavus E 1837-1910 *NewYHSD*
Baumgarten, Julius 1835?- *NewYHSD*
Baumgarten, Lothar 1944- *DcCAr 81*
Baumgarten, Paul 1900- *ConArch*
Baumgarti, Monika 1942- *DcCAr 81*
Baumgartner, Doc *FolkA 86*
Baumgartner, Johann Wolfgang 1712-1761 *McGDA*
Baumgartner, John Jay 1865-1946 *ArtsAmW 2*
Baumgartner, N A *NewYHSD*
Baumgartner, Warren 1894-1963 *IlrAm E, –1880*
Baumgartner, Warren W d1963 *WhoAmA 78N, –80N, –82N, –84N*
Baumgartner, Warren W 1894-1963 *WhAmArt 85*
Baumgras, Peter 1827- *ArtsAmW 1*
Baumgras, Peter 1827-1903 *ArtsAmW 3*
Baumgras, Peter 1827-1904 *NewYHSD*, *WhAmArt 85*
Baumhauer, Edward Bishop 1925- *AmArch 70*
Baumhauer, Hans 1913- *IlsBYP*, *IlsCB 1946*
Baumhauer, Joseph d1772 *OxDecA*
Baumhofer, Walter M 1904- *IlrAm E, –1880*
Baumhofer, Walter Martin 1904- *IIBEAAW*, *WhoAmA 73, –76*
Baumhoffer, Walter M 1904- *WhAmArt 85*
Bauml, L F, Jr. *AmArch 70*
Baunach, Charles *NewYHSD*
Baur, Albert *ArtsNiC*
Baur, Ervin F 1904- *AmArch 70*
Baur, George A *NewYHSD*
Baur, John I H 1909- *WhAmArt 85*, *WhoAmA 73, –76, –78, –80, –82, –84*
Baur, John William 1600-1640 *ClaDrA*
Baur, Meta Tiarks *WhAmArt 85*
Baur, Nicolaus 1767-1820 *DcSeaP*
Baur, Theodore 1835- *IIBEAAW*
Bauret, Jean-Francois 1932- *ICPEnP A*
Baurichter, Fritz d1937 *FolkA 86*
Baury-Saurel, Madame *DcWomA*
Baus, Paul Jean 1914- *WhAmArt 85*

Baus, S P 1882- *WhAmArt 85*
Bause, Johann Friedrich 1738-1814 *McGDA*
Bause, Juliane Wilhelmine 1768-1837 *DcWomA*
Bause, K F *FolkA 86*
Bausman, Marian D *DcWomA*, *WhAmArt 85*
Bautebarne, E *DcVicP 2*
Bauten, Klaus 1939- *MarqDCG 84*
Bauviere, A M De *WhAmArt 85*
Bauzenberger, Nelson Edelman 1905- *AmArch 70*
Bavagnoli, Carlo 1932- *MacBEP*
Bavaro, Joseph D 1925- *AmArch 70*
Bavinger, Eugene Allen 1919- *AmArt*, *WhoAmA 73, –76, –78, –80, –82, –84*
Bawa, Geoffrey 1920- *WhoArch*
Bawden, Edward 1903- *ClaDrA*, *ConDes*, *DcBrA 1*, *DcD&D*, *IlsCB 1946*, *McGDA*, *OxArt*, *OxTwCA*, *PhDcTCA 77*, *WhoArt 84*, *WhoGrA 62*
Bawden, Jean 1935- *DcCAr 81*
Bawtree, John Andrew 1952- *WhoArt 84*
Baxaiti, Marco 1470?-1532? *ClaDrA*
Baxandall, David 1905- *WhoArt 80, –82, –84*
Baxendale, Leo 1930- *WorECom*
Baxley, Ellen Cooper 1860- *ArtsAmW 2*, *DcWomA*, *WhAmArt 85*
Baxter, Bertha *DcWomA*, *WhAmArt 85*
Baxter, Bonnie Jean 1946- *WhoAmA 84*
Baxter, C J *DcVicP 2*
Baxter, Charles 1809-1879 *ArtsNiC*, *ClaDrA*, *DcVicP, –2*
Baxter, Cyrus L 1912- *AmArch 70*
Baxter, Denis Charles Trevor 1936- *WhoArt 80, –82, –84*
Baxter, DeWitt C 1829?- *NewYHSD*
Baxter, Douglas Gordon *WhoArt 80, –82*
Baxter, Douglas Gordon 1920- *DcBrA 1*
Baxter, Douglas W 1949- *WhoAmA 78, –80, –82, –84*
Baxter, Edgar *ArtsAmW 3*, *NewYHSD*
Baxter, Edward Hart 1909- *AmArch 70*
Baxter, Edward Stuart 1938- *AmArch 70*
Baxter, Elijah 1849-1939 *WhAmArt 85*
Baxter, Elijah, Jr. 1849- *ArtsNiC*
Baxter, F Fleming 1873- *DcBrA 1*
Baxter, Frank 1865- *DcBrA 1*
Baxter, George 1804-1867 *AntBDN B*, *DcNiCA*, *DcVicP 2*
Baxter, George Prelaux *AmArch 70*
Baxter, Gerard Adams 1933- *AmArch 70*
Baxter, Iain 1936- *DcCAr 81*, *PrintW 83, –85*, *WhoAmA 76, –78*
Baxter, Ingrid 1938- *WhoAmA 76, –78*
Baxter, John *AntBDN Q*, *BiDBrA*
Baxter, John d1770? *BiDBrA*
Baxter, John d1798 *BiDBrA*, *MacEA*
Baxter, Leslie Robert 1893- *DcBrA 1*
Baxter, Martha 1869-1955 *ArtsAmW 1*
Baxter, Martha Wheeler *WhAmArt 85*
Baxter, Martha Wheeler 1869-1955 *DcWomA*
Baxter, Mehetabel Cummings Proctor 1837-1914 *DcWomA*
Baxter, Nellie *DcWomA*
Baxter, Patricia Huy 1945- *WhoAmA 76, –78, –80, –82, –84*
Baxter, Robert 1933- *PrintW 83, –85*
Baxter, Robert James 1933- *WhoAmA 76, –78, –80, –82, –84*
Baxter, Thomas *AntBDN M*
Baxter, Thomas 1782- *DcNiCA*
Baxter, Thomas 1782-1821 *DcBrWA*
Baxter, Thomas, Jr. 1782-1821 *AntBDN M*
Baxter, Thomas Tennant 1894-1947 *DcBrA 1*
Baxter, W C *AmArch 70*
Baxter, W G 1855?-1888 *DcBrWA*
Baxter, W H *NewYHSD*
Baxter, William Giles 1856-1888 *DcBrBI*, *WorECar*
Bay, Didier 1944- *DcCAr 81*
Bay, Howard 1912- *ConDes*, *WhAmArt 85*
Bayard, Clifford Adams 1892- *WhAmArt 85*
Bayard, Donald D 1904- *WhAmArt 85*
Bayard, Eleanor *DcWomA*, *WhAmArt 85*
Bayard, Emile *ArtsNiC*
Bayard, Emile 1837-1891 *ClaDrA*
Bayard, Emile Antoine 1837-1891 *DcBrBI*
Bayard, Hippolyte 1801-1887 *ICPEnP*, *MacBEP*
Bayard, Jacob *FolkA 86*
Bayard, Lucie *DcWomA*, *WhAmArt 85*
Bayard, Mary Ivy 1940- *WhoAmA 78, –80*
Bayardo, Nelson 1922- *MacEA*
Baychar *PrintW 85*
Bayefsky, Aba 1923- *WhoAmA 73, –76, –78, –80, –82, –84*
Bayek, C Frank 1917- *AmArch 70*
Bayer, Arlyne 1949- *WhoAmA 84*
Bayer, August Von 1803-1875 *ClaDrA*
Bayer, G Michael 1952- *MarqDCG 84*
Bayer, Herbert 1900- *ConArt 77, –83*, *ConDes*, *ConPhot*, *DcCAA 71, –77*, *ICPEnP*, *MacBEP*, *MacEA*, *McGDA*, *OxTwCA*, *PhDcTCA 77*, *PrintW 83, –85*, *WhoAmA 73, –76, –78, –80, –82, –84*, *WhoGrA 62*
Bayer, Jane *DcWomA*, *NewYHSD*

Bayer, Jeffrey Joshua 1942- *WhoAmA 76, –78, –80, –82, –84*
Bayer, Johann Christopher *AntBDN M*
Bayer, Jonathan Levy 1936- *MacBEP*
Bayer, Josh Samuel 1952- *MarqDCG 84*
Bayer, Justin *NewYHSD*
Bayer, Michael *FolkA 86*
Bayerl, Emil Oswald 1899- *AmArch 70*
Bayes, Alfred Walter d1909 *DcBrA 1*
Bayes, Alfred Walter 1832-1909 *DcBrBI, DcBrWA, DcVicP 2*
Bayes, Gilbert 1872-1953 *DcBrA 1, OxTwCA*
Bayes, Jessie *ClaDrA, DcBrA 1*
Bayes, Jessie 1890-1934 *DcWomA*
Bayes, Walter *ClaDrA*
Bayes, Walter 1869-1956 *OxTwCA*
Bayes, Walter John 1869-1956 *DcBrA 1, DcBrWA, DcVicP 2*
Bayeu Y Subias, Francisco 1734-1795 *McGDA, OxArt*
Bayeu Y Subias, Ramon 1746-1793 *McGDA*
Bayfield, Fanny Amelia 1814-1891 *DcWomA*
Bayfield, Fanny Jane *DcBrWA, DcVicP 2, DcWomA*
Bayfield, Henry d1929 *DcBrA 2*
Bayha, Edwin F *WhAmArt 85*
Baylat *NewYHSD*
Bayle, Elisabeth 1951- *MarqDCG 84*
Bayle, Gertrude E *DcBrBI*
Bayles, David 1948- *MacBEP*
Bayless, C N *AmArch 70*
Bayless, William Henry *NewYHSD*
Bayley, Charles *FolkA 86*
Bayley, Frank W 1863-1932 *WhAmArt 85*
Bayley, John B 1914- *MacEA*
Bayley, Moses 1744-1838 *CabMA*
Bayley, Nicola 1949- *IlsCB 1967*
Bayley, Richard *AntBDN Q*
Bayley, Stephen *ConArch A*
Bayley, William *NewYHSD*
Bayley-Paine, Mahlon *WhAmArt 85*
Baylinson, A S d1950 *WhoAmA 78N, –80N, –82N, –84N*
Baylinson, A S 1882-1950 *DcCAA 71, –77, WhAmArt 85*
Baylis, Charles Merritt 1956- *MarqDCG 84*
Baylis, Elvin Fred 1936- *AmArch 70*
Baylis, Richard *NewYHSD*
Bayliss, Charles 1850-1897 *MacBEP*
Bayliss, Edwin Butler 1874- *DcBrA 1, DcVicP 2*
Bayliss, Elise *DcVicP 2*
Bayliss, George 1931- *WhoAmA 76, –78, –80, –82, –84*
Bayliss, J B *DcVicP 2*
Bayliss, J C d1887? *DcVicP 2*
Bayliss, Lilian 1875- *DcWomA, WhAmArt 85*
Bayliss, Lillian 1875- *ArtsEM*
Bayliss, Sir Wyke 1835-1906 *DcBrA 1, DcBrWA, DcVicP, –2*
Baylor, Edna Ellis 1882- *DcWomA, WhAmArt 85*
Baylos, Zelma 1868-1948? *DcWomA*
Baylos, Zelma U *WhoAmA 78N, –80N, –82N, –84N*
Baylos, Zelma U d1950? *WhAmArt 85*
Bayly, Clifford John 1927- *WhoArt 84*
Bayman, Leo *WhAmArt 85*
Baynard, Ed 1940- *PrintW 83, –85, WhoAmA 78, –80, –82, –84*
Bayne, Eliza *DcWomA, NewYHSD*
Bayne, J M *AmArch 70*
Bayne, Mary *DcWomA, WhAmArt 85*
Bayne, W *DcVicP 2*
Bayne, Walter McPherson *DcVicP 2*
Bayne, Walter McPherson 1795-1859 *NewYHSD*
Baynes, A H *DcVicP 2*
Baynes, Frederick T *DcVicP*
Baynes, Frederick Thomas *DcBrWA*
Baynes, Frederick Thomas 1824-1874 *DcVicP 2*
Baynes, James 1766-1837 *DcBrWA*
Baynes, Keith Stuart *WhoArt 80N*
Baynes, Keith Stuart 1887- *DcBrA 1*
Baynes, Pauline Diana *IlsCB 1967*
Baynes, Pauline Diana 1922- *IlsBYP, IlsCB 1946, –1957, WhoArt 80, –82, –84*
Baynes, Philip *DcBrBI*
Baynes, Philip d1916 *DcBrA 2*
Baynes, Robert *DcVicP 2*
Baynes, Thomas Mann *DcVicP 2*
Baynes, Thomas Mann 1794-1854 *DcBrWA*
Baynham, T *DcVicP 2*
Baynton, Henry 1862-1926 *DcBrWA, DcVicP 2*
Bayol, Eugene West, Jr. 1926- *AmArch 70*
Bayton, Harry W *AfroAA*
Bayuk, Bruce L 1943- *MarqDCG 84*
Baz, Ben-Hur 1906- *WhAmArt 85*
Baz, Douglas Carl 1943- *ICPEnP A, MacBEP*
Baz, Marysole Worner 1936- *WhoAmA 76, –78, –80*
Bazaine, Jean 1904- *ConArt 83, McGDA, PhDcTCA 77, WhoArt 80, –82, –84, WorArt[port]*
Bazaine, Jean 1904-1975 *OxTwCA*
Bazan 1833-1897 *AntBDN L, OxDecA*
Bazan, Ignacio Ricardo *FolkA 86*

Bazan, Joaquin d1871 *FolkA 86*
Bazant, George *WhAmArt 85*
Bazarov, Konstantin *ConArch A*
Baze, Willi 1896- *DcWomA, WhAmArt 85*
Baze, Willi 1896-1947 *ArtsAmW 2*
Bazel, K P C De 1896-1923 *MacEA*
Bazellaire, Isabelle De *DcWomA*
Bazemore, Donald Christian 1930- *AmArch 70*
Bazemore, M J *AmArch 70*
Bazhenov, Vasili Ivanovich 1737-1799 *McGDA, WhoArch*
Bazile, Castera *OxTwCA*
Bazile, Castera 1923-1966 *McGDA*
Bazille, Frederic 1841-1870 *McGDA, OxArt*
Bazille, Jean Frederic 1841-1870 *ClaDrA*
Bazin, Eugenie Helene *DcWomA*
Bazin, Marguerite *DcWomA*
Baziotes, William 1912- *ConArt 77*
Baziotes, William 1912-1963 *BnEnAmA, ConArt 83, DcAmArt, McGDA, OxTwCA, PhDcTCA 77, WhoAmA 78N, –80N, –82N, –84N, WorArt[port]*
Baziotes, William A 1912-1963 *DcCAA 71, –77, WhAmArt 85*
Bazzani, Cesare 1873-1939 *MacEA*
Bazzani, Giuseppe 1690-1769 *McGDA*
Bazzi, Giovanni Antonio *McGDA, OxArt*
Bdogna, Frank *FolkA 86*
Be Dell, Dorothy Krippner *WhAmArt 85*
Bea, Jose-Maria 1942- *WorECom*
Bea, Josep Maria 1942- *ConGrA 1[port]*
Bea, Manuel 1934- *OxTwCA*
Beacall, J *DcVicP 2*
Beach, Alice *DcVicP 2*
Beach, Alice Mary *DcWomA*
Beach, Beata 1911- *WhAmArt 85*
Beach, Celia May Southworth 1872- *ArtsAmW 3*
Beach, Mrs. Charles *WhAmArt 85*
Beach, Chauncey *FolkA 86*
Beach, Chester 1881-1956 *WhAmArt 85*
Beach, D Antoinette *ArtsAmW 2, WhAmArt 85*
Beach, Elizabeth *DcWomA*
Beach, Elizabeth Wheldon *DcWomA*
Beach, Emma *DcWomA*
Beach, Ernest George 1865- *DcBrA 1, DcBrBI, DcBrWA, DcVicP 2*
Beach, G M *AmArch 70*
Beach, H P, Jr. *AmArch 70*
Beach, Howard D 1867- *WhAmArt 85*
Beach, James George 1872-1932? *BiDAmAr*
Beach, Leroy A, Jr. 1932- *AmArch 70*
Beach, Lucy *DcWomA*
Beach, Moses Y 1800-1868 *CabMA*
Beach, Richard Melvin 1917- *AmArch 70*
Beach, Sara Berman 1897- *DcWomA, WhAmArt 85*
Beach, Sarah E *WhAmArt 85*
Beach, Sharon Sickel 1946- *MarqDCG 84*
Beach, Thomas 1738-1806 *DcBrECP, DcBrWA*
Beach, Warren 1914- *WhAmArt 85, WhoAmA 73, –76, –78, –80, –82, –84*
Beacham, Eugene Walton 1907- *AmArch 70*
Beacham, Harriet T *WhAmArt 85*
Beacham, J W *AmArch 70*
Beacham, Oliver C 1862- *WhAmArt 85*
Beachcroft, C d1866 *BiDBrA*
Beachcroft, Samuel 1801?-1861 *BiDBrA*
Beachem, Neil Edgar 1939- *AmArch 70*
Beacher, Melvin M 1937- *AmArch 70*
Beachey, Margaret *DcWomA*
Beachler, Mark Henry 1938- *AmArch 70*
Beachum, Arnold Malcolm 1935- *AmArch 70*
Beacon, Charles *DcBrA 2*
Beadell, F *DcVicP 2*
Beadenkopf, Anne 1875- *DcWomA, WhAmArt 85*
Beadle, A N *AmArch 70*
Beadle, Edward *FolkA 86*
Beadle, F F, Jr. *AmArch 70*
Beadle, James Prinsep Barnes 1863-1947 *DcBrA 1, DcVicP 2*
Beadle, Leaman 1680-1717 *FolkA 86*
Beadle, Lemmon 1680-1717 *CabMA*
Beadle, Samuel J d1706 *CabMA*
Beadleston, William L 1938- *WhoAmA 82, –84*
Beagle, Louise *DcWomA*
Beal, Alger Dresel 1926- *AmArch 70*
Beal, Annie L *DcVicP 2, DcWomA*
Beal, George Malcolm 1899- *AmArch 70*
Beal, Gifford 1879-1956 *DcAmArt, DcCAA 71, –77, WhAmArt 85*
Beal, Gifford Reynolds 1879-1956 *McGDA*
Beal, Graham William John 1947- *WhoAmA 76, –78, –80, –82*
Beal, J Williams 1855-1919 *BiDAmAr*
Beal, Jack 1931- *AmArt, ConArt 77, –83, DcCAA 71, –77, DcCAr 81, OxTwCA, PrintW 83, –85, WhoAmA 73, –76, –78, –80, –82, –84*
Beal, John Woodbridge 1887- *AmArch 70*
Beal, Lisa Mae 1956- *MarqDCG 84*
Beal, Mack 1924- *WhoAmA 78, –80, –82, –84*
Beal, Reynolds d1951 *WhoAmA 78N, –80N, –82N,*

Beal, Reynolds 1867-1951 *WhAmArt 85*
Beal, Thaddeus R *WhAmArt 85*
Beale, Aileen Mary *DcWomA*
Beale, Anne *DcWomA*
Beale, Arthur C 1940- *WhoAmA 80, –82, –84*
Beale, Bertha F *WhAmArt 85*
Beale, Bertha Fitzgerald 1877- *DcWomA*
Beale, Charles 1660?-1694 *AntBDN J*
Beale, Elizabeth Helen 1946- *WhoArt 80*
Beale, Ellen *DcVicP 2, DcWomA*
Beale, Evelyn *DcBrBI*
Beale, G D *NewYHSD*
Beale, James 1798- *DcBrWA*
Beale, John Phillip 1947- *MarqDCG 84*
Beale, Margaret 1887- *DcWomA*
Beale, Margaret L C 1887- *DcBrA 1*
Beale, Mary 1632?-1699 *DcWomA, WomArt*
Beale, Mary 1633-1699 *AntBDN J, OxArt*
Beale, Richard *AntBDN Q*
Beale, Robert B 1943- *MarqDCG 84*
Beale, Sarah Sophia *DcVicP, –2, DcWomA*
Beale And Craven *NewYHSD*
Beales, Isaac B 1866- *WhAmArt 85*
Beales, J B *WhAmArt 85*
Beall, Adelaide Cole *DcWomA*
Beall, Burtch W, Jr. 1925- *AmArch 70*
Beall, Cecil Calvert 1892- *ArtsAmW 2, IlrAm D, WhAmArt 85*
Beall, Cecil Calvert 1892-1967 *IlrAm 1880*
Beall, Dennis Ray 1929- *WhoAmA 78, –80, –82, –84*
Beall, E D H *AmArch 70*
Beall, Gustavus *CabMA*
Beall, Joanna 1935- *DcCAr 81, WhoAmA 78, –80, –82, –84*
Beall, Karen F *WhoAmA 78, –80, –82*
Beall, Leah 1910- *WhAmArt 85*
Beall, Lester 1903- *McGDA, WhoGrA 62*
Beall, Lester Thomas 1902-1969 *WhoAmA 84N*
Beall, Lester Thomas 1903- *WhoAmA 73, –76*
Beall, Lester Thomas 1903-1969 *ConDes, WhAmArt 85, WhoAmA 78N, –80N, –82N*
Beall, William Chambers 1910- *AmArch 70*
Beall-Hammond, Jemima Ann *FolkA 86*
Bealle, Thomas Brown, Jr. 1928- *AmArch 70*
Bealmer, William 1919- *WhoAmA 73, –76, –78, –80, –82, –84*
Beals, Carrie *DcWomA, NewYHSD*
Beals, Gertrude *DcWomA, WhAmArt 85*
Beals, Grace Romney d1929 *DcWomA, WhAmArt 85*
Beals, Ira Douglas 1904- *AmArch 70*
Beals, Jessie Tarbox 1870-1942 *ICPEnP A, MacBEP*
Beals, Jessie Tarbox 1871-1942 *WhAmArt 85*
Beals, R L *AmArch 70*
Beals, Victor 1895- *WhAmArt 85*
Beam, Caroline *FolkA 86*
Beam, Eugene Allan 1934- *AmArch 70*
Beam, H A *AmArch 70*
Beam, James Lorn, Jr. 1918- *AmArch 70*
Beam, Mary Todd 1931- *WhoAmA 84*
Beam, Philip Conway 1910- *WhAmArt 85, WhoAmA 73, –76, –78, –80, –82, –84*
Beaman *NewYHSD*
Beaman, Gamaliel Waldo 1852-1937 *ArtsAmW 3*
Beaman, Richard Bancroft 1909- *ClaDrA, WhoAmA 73, –76, –78, –80, –82*
Beaman, Mrs. Robert P *WhAmArt 85*
Beament, Harold 1898- *WhoAmA 73, –76, –78, –80, –82, –84*
Beament, Thomas Harold 1898- *IlBEAAW*
Beament, Tib 1941- *PrintW 83, –85, WhoAmA 73, –76, –78, –80, –82, –84*
Beamer, James d1694? *CabMA*
Beames, S 1896- *WhAmArt 85*
Beamiss, Frederick Harold *WhoArt 82N*
Beamiss, Frederick Harold 1898- *WhoArt 80*
Bean, Mrs. *FolkA 86*
Bean, Ainslie H *DcBrWA, DcVicP 2*
Bean, Caroline VanH *WhAmArt 85*
Bean, Caroline VanHook 1879?-1980 *DcWomA*
Bean, Jacob 1923- *WhoAmA 73, –76, –78, –80, –82, –84*
Bean, James Harold 1937- *AmArch 70*
Bean, John *AfroAA*
Bean, Mary 1904- *WhAmArt 85*
Bean, Nellie F *DcWomA, WhAmArt 85*
Bean, W P *FolkA 86*
Bean, William Russell 1930- *AmArch 70*
Beanland, Frank Charles 1936- *WhoArt 80, –82, –84*
Beanlands, Sophie *DcWomA*
Bear, Alice *DcCAr 81*
Bear, Donald d1952 *WhoAmA 78N, –80N, –82N, –84N*
Bear, Donald 1905-1952 *WhAmArt 85*
Bear, George Telfer 1874- *DcBrA 1*
Bear, Joseph Thomas 1921- *AmArch 70*
Bear, Liza 1942- *WhoAmA 76*
Bear, Marcelle L 1917- *AmArt, WhoAmA 78, –80, –82, –84*
Bear, Reuben C 1905- *WhAmArt 85*

Bear, W K *AmArch 70*

Bearce, Jeana Dale 1929- *PrintW 83, –85, WhoAmA 82, –84*

Beard, Ada *DcVicP 2, DcWomA*

Beard, Adelia Belle d1920 *DcWomA, WhAmArt 85*

Beard, Alan Jennings *AmArch 70*

Beard, Alice *DcWomA, WhAmArt 85*

Beard, Beatrice *WhAmArt 85*

Beard, Dan-Carter 1850- *DcBrBI*

Beard, Daniel 1850-1941 *ArtsAmW 1*

Beard, Daniel Carter *AfroAA*

Beard, Daniel Carter 1850-1941 *IlBEAAW, IlrAm 1880, WhAmArt 85, WorECar*

Beard, Eva Rorty *WhAmArt 85*

Beard, Francis 1842-1905 *DcBrBI*

Beard, Frank 1842-1905 *WhAmArt 85, WorECar*

Beard, Frank-Thomas 1842-1905 *DcBrBI*

Beard, George *NewYHSD, WhAmArt 85*

Beard, George 1814-1889 *ArtsEM*

Beard, George 1855-1944 *ArtsAmW 1, IlBEAAW*

Beard, Harry *ArtsNiC*

Beard, James Carter 1837-1913 *ArtsAmW 1, EarABI, EarABI SUP, IlBEAAW, NewYHSD , WhAmArt 85*

Beard, James H 1814- *ArtsNiC*

Beard, James Henry 1812-1893 *ArtsAmW 1, BnEnAmA, DcAmArt, IlBEAAW, NewYHSD*

Beard, James M 1826?- *CabMA*

Beard, John 1943- *WhoArt 82, –84*

Beard, John Baron *BiDBrA*

Beard, Katherine L *DcVicP 2, DcWomA*

Beard, Lina *DcWomA, WhAmArt 85*

Beard, M *FolkA 86*

Beard, Margaret Evangeline *DcWomA*

Beard, Marion L Patterson *WhoAmA 73, –76, –78, –80, –82, –84*

Beard, Mark Leo *WhoArt 80, –82, –84*

Beard, Mary Caroline 1851?-1933 *DcWomA*

Beard, Mary Caroline 1852-1933 *WhAmArt 85*

Beard, Michael James 1947- *MacBEP*

Beard, Minnie A *ArtsEM, DcWomA*

Beard, Peter 1938- *ConPhot*

Beard, Peter Hill 1938- *ICPEnP A, MacBEP*

Beard, Richard 1801-1885 *ICPEnP*

Beard, Richard Elliott 1928- *WhoAmA 76, –78, –80, –82, –84*

Beard, Thomas Francis 1842-1905 *EarABI, IlBEAAW*

Beard, William *FolkA 86*

Beard, William C 1922- *AmArch 70*

Beard, William H *ArtsNiC*

Beard, William Holbrook 1824-1900 *BnEnAmA, DcAmArt, IlBEAAW, NewYHSD*

Beard, William Holbrook 1825-1900 *ArtsAmW 1, EarABI SUP, WhAmArt 85*

Bearden, Ed 1919- *WhAmArt 85*

Bearden, Romare 1912- *AfroAA*

Bearden, Romare 1914- *ConArt 83, DcAmArt, DcCAA 71, –77, DcCAr 81, OxTwCA, PrintW 83, –85, WorArt[port]*

Bearden, Romare Howard 1914- *AmArt, ConArt 77, WhoAmA 73, –76, –78, –80, –82, –84*

Beardslee, Charles Edward 1932- *AmArch 70*

Beardsley, Aubrey 1872-1898 *AntBDN A, –B, PhDcTCA 77*

Beardsley, Aubrey Vincent 1872-1898 *DcBrBI, DcBrWA, DcNiCA, McGDA, OxArt[port]*

Beardsley, Barbara H 1945- *WhoAmA 78, –80, –82, –84*

Beardsley, George O 1867?-1938 *ArtsAmW 3*

Beardsley, James Peck 1921- *AmArch 70*

Beardsley, Jefferson *IlBEAAW, NewYHSD*

Beardsley, Nellie *ArtsAmW 3, WhAmArt 85*

Beardsley, Rudolph 1875-1921 *WhAmArt 85*

Beardsley, Wallace Pearne, Jr. 1924- *AmArch 70*

Beardsley, William J 1877-1934 *BiDAmAr*

Beardsley Limner, The *AmFkP, BnEnAmA*

Beardsworth, R C *AmArch 70*

Beare, George *DcBrECP*

Beare, Josias Crocker 1881-1962 *DcBrA 1*

Beare, R S *BiDBrA*

Bearman, Jane Ruth *WhoAmA 78, –80, –82, –84*

Bearne, Catherine *DcWomA*

Bearne, Catherine Mary *DcBrWA*

Bearne, Mrs. Edward *DcVicP 2*

Bearne, Edward H *DcBrWA, DcVicP, –2*

Bears, O I *FolkA 86*

Beasley, Bruce 1939- *ConArt 77, DcCAA 77, WhoAmA 73, –76, –78, –80, –82, –84*

Beasley, Charles 1827-1913 *MacEA*

Beasley, O S *AmArch 70*

Beasley, Robert Jones 1913- *AmArch 70*

Beason, Donald Ray 1943- *WhoAmA 84*

Beastall *NewYHSD*

Beatien Yazz 1928- *IlBEAAW*

Beatien, Yazz 1928- *WhAmArt 85*

Beatly, Spencer *FolkA 86*

Beato, B *WhAmArt 85*

Beato, Felice A d1903 *MacBEP*

Beato, Felice A 1830?-1904? *ICPEnP, MacBEP*

Beaton, Cecil 1904-1980 *ConPhot, MacBEP*

Beaton, Sir Cecil *WhoArt 82N*

Beaton, Sir Cecil 1904- *WhoArt 80, WorFshn*

Beaton, Sir Cecil Walter Hardy 1904-1980 *ICPEnP*

Beatrice Mary Victoria Feodore, Princess 1857-1944 *DcBrWA*

Beatrice, Princess 1857-1944 *DcBrBI*

Beatrice, Princess Of England *DcWomA*

Beatrizet, Nicolas 1515?-1560 *McGDA*

Beatson, Helen 1763?- *DcWomA*

Beatson, Helena *NewYHSD*

Beatson, Helena 1763-1839 *DcBrECP*

Beattie, Arlo C 1930- *AmArch 70*

Beattie, Basil 1935- *ConBrA 79[port]*

Beattie, Edwin Robert 1845-1917 *DcBrA 1*

Beattie, George 1919- *DcCAA 71, –77, WhoAmA 73, –76, –78, –80, –82, –84*

Beattie, Kenneth P *WhAmArt 85*

Beattie, Paul 1924- *DcCAr 81*

Beattie, Ray 1949- *DcCAr 81*

Beattie, Robert 1924- *AmArch 70*

Beattie, Robert Clifford, Jr. 1931- *AmArch 70*

Beattie, William *DcNiCA*

Beattie-Brown, William *DcVicP 2*

Beattie-Brown, William 1831-1909 *DcBrA 1*

Beatty *FolkA 86*

Beatty, Frances Fielding Lewis 1948- *WhoAmA 78, –80, –82, –84*

Beatty, Frank Joseph Denis 1919- *AmArch 70*

Beatty, Gavin I *FolkA 86*

Beatty, George Edward 1902- *AmArch 70*

Beatty, George Edward, Jr. 1938- *AmArch 70*

Beatty, Hetty Burlingame d1971 *IlsCB 1967*

Beatty, Hetty Burlingame 1906- *WhAmArt 85*

Beatty, Hetty Burlingame 1907?-1971 *IlsCB 1946, –1957*

Beatty, Iris B *DcWomA*

Beatty, John L d1924 *BiDAmAr*

Beatty, John W 1850-1924 *WhAmArt 85*

Beatty, John William 1869-1941 *IlBEAAW*

Beatty, R F *AmArch 70*

Beatty, Richard *AfroAA*

Beatty, Richard R 1899- *WhAmArt 85*

Beatty, Robert Wade *AmArch 70*

Beatty, Sarah Blythe *DcWomA, WhAmArt 85*

Beatty, Spencer d1853 *FolkA 86*

Beatty, W Gedney *WhAmArt 85*

Beatus Of Liebana d798 *McGDA*

Beaty, James Mackay 1945- *MarqDCG 84*

Beaty, William H 1931- *AmArch 70*

Beau, John Anthony *NewYHSD*

Beau, Marie Louise Adrienne *DcWomA*

Beaubien, Charles *ArtsEM*

Beaubien, Jean-Pierre Luc 1954- *MarqDCG 84*

Beaubois DeMontoriol, Isabel 1876- *DcWomA*

Beaubrun, Charles 1604-1692 *McGDA*

Beaubrun, Henri 1603-1677 *McGDA*

Beauce *NewYHSD*

Beauce, Jean-Adophe 1818-1875 *DcBrBI*

Beauchamp, Celina *DcWomA*

Beauchamp, Charles 1949- *DcCAr 81*

Beauchamp, Eugenie *DcWomA*

Beauchamp, George 1933- *WhoAmA 84*

Beauchamp, John R 1923- *WhoAmA 78*

Beauchamp, John W 1906- *WhAmArt 85*

Beauchamp, M *DcVicP 2*

Beauchamp, Countess Mary Catherine *DcVicP 2, DcWomA*

Beauchamp, Paul *DcCAr 81*

Beauchamp, Robert 1923- *DcCAA 71, –77, OxTwCA, WhoAmA 80, –82, –84*

Beauchamp, William Millet *FolkA 86*

Beauchemin, Micheline 1930- *DcCAr 81*

Beauchemin, Micheline 1931- *WhoAmA 73, –76, –78, –80*

Beauchene, Alice Berg 1931- *MarqDCG 84*

Beauclair, Gotthard De 1907- *WhoGrA 62*

Beauclerck, Lady Diana 1734-1808 *DcBrECP*

Beauclerk, Diana 1734-1808 *DcWomA*

Beauclerk, Lady Diana 1734-1808 *DcBrWA, WomArt*

Beauclerk, Lady Diana DeVere 1734-1808 *BkIE*

Beaucourt, Francois *NewYHSD*

Beaucourt, Francois 1740-1794 *McGDA*

Beaudeneau, Marie Julie *DcWomA*

Beaudiekamp, B S *NewYHSD*

Beaudin, Andre 1895- *McGDA, PhDcTCA 77*

Beaudin, Andre 1895-1941 *OxTwCA*

Beaudin, Andre Gustave 1895- *DcCAr 81*

Beaudin, Denise 1930- *DcCAr 81*

Beaudin, Felicite *DcWomA*

Beaudin, Marcel 1930- *AmArch 70*

Beaudoin, Andre Eugene 1920- *WhoAmA 78, –80, –82, –84*

Beaudouin, Eugene 1898- *ConArch, EncMA*

Beaudouin, Frank 1885- *WhAmArt 85*

Beaufaux, Polydore 1829- *ClaDrA*

Beauferey, Louise Laure *DcWomA*

Beaufils, Eugenie *DcWomA*

Beaufond, Ines De *DcWomA*

Beauford, William H 1735-1819 *DcBrWA*

Beaufort, Jeanne, Vicomtesse De *DcWomA*

Beaufrere, Adolphe Marie Timothee 1876-1960 *ClaDrA*

Beaugrand, Guyot De d1551 *McGDA*

Beaugrant, Guyot De d1551 *OxArt*

Beaugureau, New *YHSD*

Beaugureau, Francis Henry 1920- *IlBEAAW*

Beaugureau, P H, Jr. *NewYHSD*

Beauharnais, Hortense De 1783-1837 *DcWomA*

Beaujolais, Louis Charles D'Orleans 1779-1808 *NewYHSD*

Beaujoy, Dennis *FolkA 86*

Beaulard *WorFshn*

Beaulaurier, Leo James 1912- *IlBEAAW, WhAmArt 85*

Beauley, William Jean 1874- *WhAmArt 85*

Beaulieu, Aline De *DcWomA*

Beaulieu, Emile F *EarABI, EarABI SUP, NewYHSD*

Beaulieu, Joseph H *ArtsEM*

Beaulieu, Marie Genevieve *DcWomA*

Beaume, Joseph 1798- *ArtsNiC*

Beaume, Juliette Emilie *DcWomA*

Beaumetz, Jean De 1360?-1396 *McGDA*

Beaumont, A *DcBrA 2, DcVicP 2*

Beaumont, Sir Albinus d1810? *DcBrWA*

Beaumont, Alfred *DcBrWA*

Beaumont, Anne *DcWomA*

Beaumont, Arthur Edwaine 1890- *ArtsAmW 1, WhAmArt 85*

Beaumont, Arthur J 1877-1956 *WhAmArt 85*

Beaumont, Charles *NewYHSD*

Beaumont, Mrs. Charles *NewYHSD*

Beaumont, Charles-Edouard De *ArtsNiC*

Beaumont, Charles Edouard De 1812-1888 *ClaDrA*

Beaumont, Ernest 1871-1933 *WhAmArt 85*

Beaumont, Frederick Samuel 1861- *DcBrA 1, DcVicP 2*

Beaumont, George 1854-1922 *BiDAmAr*

Beaumont, Sir George Howland 1753-1827 *DcBrECP, DcBrWA, OxArt*

Beaumont, Henrietta 1881- *WhAmArt 85*

Beaumont, Henrietta E 1881- *DcWomA*

Beaumont, J Herbert *DcBrBI*

Beaumont, Jerold *DcVicP 2*

Beaumont, John P *NewYHSD*

Beaumont, John Thomas Barker 1774-1841 *AntBDN J*

Beaumont, Laura Richards *DcWomA*

Beaumont, Leonard 1891- *DcBrA 1*

Beaumont, Lilian A d1922 *WhAmArt 85*

Beaumont, Lilian Adele 1880-1922 *DcWomA*

Beaumont, Lucy *DcWomA*

Beaumont, Mona 1927- *PrintW 83*

Beaumont, Mona 1932- *PrintW 85*

Beaumont, Mona M *WhoAmA 78, –80, –82, –84*

Beaumont, Pauline Bouthillier De 1846-1904 *DcWomA*

Beaumont, W *DcVicP 2*

Beaumont, W H *AntBDN O*

Beaumont-Castries, Jeanne De *DcWomA*

Beauneveu, Andre *OxArt*

Beauneveu, Andre 1330?-1416? *McGDA*

Beauparlant, Leonie Charlotte *DcWomA*

Beaupoil DeSaint Aulaire *NewYHSD*

Beaupre, Eugene *WhAmArt 85*

Beaupre, Georges 1937- *WhoGrA 82[port]*

Beauregard, C G *FolkA 86*

Beauregard, Donald 1884-1914 *ArtsAmW 1, IlBEAAW*

Beauregard, Donald 1884-1915 *WhAmArt 85*

Beaury-Saurel, Amelie 1848-1924 *DcWomA*

Beausire Family *MacEA*

Beauvais, Anais d1898 *DcWomA*

Beauvais, Arnold Victor 1886- *DcBrA 2*

Beauvalet, Jeanne *DcWomA*

Beauvarlet, Catherine Francoise 1737?-1769 *DcWomA*

Beauvarlet, Jacques Firmin 1731-1797 *McGDA*

Beauvarlet, Marie Catherine *DcWomA*

Beauverie, Charles Joseph *ArtsNiC*

Beaux, Cecilia *DcVicP 2*

Beaux, Cecilia d1942 *WhAmArt 85*

Beaux, Cecilia 1853-1942 *WomArt*

Beaux, Cecilia 1855-1942 *DcAmArt, DcWomA*

Beaux, Cecilia 1863-1942 *BnEnAmA, McGDA*

Beaver, Chief *FolkA 86*

Beaver, David *MarqDCG 84*

Beaver, Earle B 1918- *WhAmArt 85*

Beaver, Fred 1911- *IlBEAAW, WhoAmA 73, –76, –78, –80*

Beaver, Robert Atwood 1906- *WhoArt 80, –82, –84*

Beaver, Robert Atwood 1906-1975 *DcBrA 2*

Beaver, Tessa 1932- *DcCAr 81*

Beavers, B J *AmArch 70*

Beavers, Wayne L *MarqDCG 84*

Beavis, C *DcVicP 2*

Beavis, Maud *DcVicP 2, DcWomA*

Beavis, Richard 1824- *ArtsNiC*

Beavis, Richard 1824-1896 *ClaDrA, DcBrWA, DcVicP, –2*

Beazley *DcVicP 2*

Beazley, Charles 1760?-1829 *BiDBrA*

Beazley, Samuel 1786-1851 *BiDBrA, MacEA*

Beazley, William E, Jr. 1926- *AmArch 70*

Beazley, William G 1948- *MarqDCG 84*

Bebb, Charles H 1856-1942 *MacEA*

Bedells, Sheila 1916- *WhoArt 80, –82, –84*
Beder, Robert Matthew 1915- *AmArch 70*
Bederman, W Clive *DcVicP 2*
Bedford, B *DcVicP 2*
Bedford, Celia Frances 1904- *ClaDrA, DcBrA 1*
Bedford, Celia Frances 1904-1959 *DcBrA 2*
Bedford, Cornelia E 1867-1935 *DcWomA,*
 WhAmArt 85
Bedford, Ella M *DcVicP, –2, DcWomA*
Bedford, Francis *DcBrWA, MacBEP*
Bedford, Francis 1784-1858 *DcBrWA*
Bedford, Francis 1816?-1894 *ICPEnP A*
Bedford, Francis Donkin 1864- *DcBrBI, DcBrWA*
Bedford, Francis Donkin 1864-1950 *ConICB,*
 IlsCB 1744
Bedford, Francis Donkin 1864-1954 *DcBrA 2,*
 DcVicP 2
Bedford, Francis O 1784-1858 *MacEA*
Bedford, Francis Octavius 1784-1858 *BiDBrA*
Bedford, Francis William d1904 *DcVicP 2*
Bedford, Francis William 1867?-1904 *DcBrA 1*
Bedford, Sir Frederick George Denham 1838-1913
 DcBrWA
Bedford, George 1849-1920 *DcBrWA, DcVicP 2*
Bedford, Helen Catherine 1874- *DcBrA 1, DcWomA*
Bedford, Helen Catherine 1874-1949 *DcBrA 2*
Bedford, Helen DeWilton 1904-
 WhAmArt 85,
 WhoAmA 73, –76
Bedford, Henry E *DcVicP 2*
Bedford, Henry E 1860-1932 *WhAmArt 85*
Bedford, Herbert d1945 *DcBrA 2*
Bedford, J *BiDBrA*
Bedford, J B 1823- *ArtsNiC*
Bedford, John Bates 1823- *ClaDrA, DcBrWA,*
 DcVicP 2
Bedford, Oliver Herbert 1902- *DcBrA 1*
Bedford, Richard Perry 1883-1967 *DcBrA 1*
Bedger, Carl *FolkA 86*
Bedi, Mitter 1926- *ConPhot, ICPEnP A*
Bedie, Pierrette *DcWomA*
Bedien, Genevieve Philippine *DcWomA*
Bedik, Amy 1953- *DcCAr 81*
Bedingfeld, Richard T *DcVicP 2*
Bedingfield, J *DcVicP 2*
Bednar, Hermina Beidinger *WhAmArt 85*
Bednar, John James 1908- *WhAmArt 85*
Bednarski, John Francis 1927- *AmArch 70*
Bednarski, Stein *AmArch 70*
Bednarz, Adele *WhoAmA 76, –78*
Bedno, Edward 1925- *WhAmArt 85, WhoAmA 73,*
 –76, –78, –80, –82, –84
Bedoille, Louise *DcWomA*
Bedoli, Girolamo *McGDA*
Bedore, Anna Lou *DcWomA*
Bedore, Anna Lou Matthews *WhAmArt 85*
Bedore, Sidney N 1883-1955 *WhAmArt 85*
Bedot-Diodati, Marie 1866- *DcWomA*
Bedrick, John David 1957- *MarqDCG 84*
Beduschi, Angela *DcWomA*
Bedwell, Elias J *FolkA 86*
Bedwell, Emily P *DcVicP 2, DcWomA*
Bedwell, Frederick LeB *DcBrBI*
Bedwell, Thomas *NewYHSD*
Bee, John William 1883- *DcBrA 1*
Bee, Joyce 1920- *IlsCB 1967*
Bee, Lonie *WhAmArt 85*
Bee, Lonie 1902- *IlrAm E, –1880*
Beebe, Annie A *DcVicP 2, DcWomA*
Beebe, B W *AmArch 70*
Beebe, Dee *DcWomA, WhAmArt 85*
Beebe, Elizabeth *DcWomA, WhAmArt 85*
Beebe, Grace *DcWomA*
Beebe, Grace H *WhAmArt 85*
Beebe, James Harold 1940- *AmArch 70*
Beebe, Katharine 1884- *WhAmArt 85*
Beebe, Louise *DcWomA*
Beebe, Louise Oliver *WhAmArt 85*
Beebe, Mary Livingston 1940- *WhoAmA 82*
Beebe, Mary Livingstone 1940- *WhoAmA 76, –78, –80,*
 –84
Beebe, Milton Earl 1840- *BiDAmAr*
Beebe, Morton 1934- *ICPEnP A*
Beebe, Nelson H F 1948- *MarqDCG 84*
Beebe, Robert *WhAmArt 85*
Beebe, William L *ArtsEM*
Beebe And Bailey *ArtsEM*
Beeby, Elizabeth K *DcVicP 2, DcWomA*
Beeby, Thomas Hall 1941- *ConArch*
Beeby, William D *MarqDCG 84*
Beech, A J *DcVicP 2*
Beech, Herbert J G *DcVicP 2*
Beech, J *DcVicP 2*
Beech, Ralph Bagnall *FolkA 86*
Beecham, John *DcVicP 2*
Beecham, Tom *OfPGCP 86*
Beecher, Amariah Dwight 1839- *NewYHSD*
Beecher, Edward C *ArtsEM*
Beecher, Florence C *WhAmArt 85*
Beecher, Genevieve T 1888- *ArtsAmW 1*
Beecher, Genevieve Thompson 1888-1955 *DcWomA,*

WhAmArt 85
Beecher, Harold Kline 1912- *AmArch 70*
Beecher, Harriet 1854-1915 *DcWomA*
Beecher, Harriet Foster 1854-1915 *ArtsAmW 2*
Beecher, Laban S 1805?- *NewYHSD*
Beecher, Laban S 1805-1876 *FolkA 86*
Beecher, Mathew *WhAmArt 85*
Beecher, Philip 1835?- *NewYHSD*
Beecher, Roxana 1775- *NewYHSD*
Beecher, Roxana Foote 1775-1816 *DcWomA*
Beechey, Lady Anne Phyllis 1764-1834? *DcWomA*
Beechey, Augusta *DcVicP 2, DcWomA*
Beechey, Frances *DcVicP 2*
Beechey, Frederika *DcVicP 2, DcWomA*
Beechey, H *DcVicP 2*
Beechey, Henry W d1870 *DcBrBI*
Beechey, Richard Bridges 1808-1895 *DcBrWA*
Beechey, Richard Brydges 1808-1895 *ArtsAmW 1,*
 DcSeaP, DcVicP, –2
Beechey, S R *DcVicP 2*
Beechey, Sir William 1753-1839 *ClaDrA, DcBrECP,*
 McGDA, OxArt
Beeck, Jan Simonsz VanDer *McGDA*
Beeck, Jan VanDer *OxArt*
Beeck, Mrs. Kisa *WhAmArt 85*
Beecq, Jan Karel Donatus Van 1638-1722 *DcSeaP*
Beecroft, Glynis Margaret 1945- *WhoArt 84*
Beecroft, Herbert 1865- *DcBrA 2*
Beedzler, Caroline *ArtsEM, DcWomA*
Beedzler, Ruth *ArtsEM, DcWomA*
Beeghly, R R *AmArch 70*
Beehan *NewYHSD*
Beek, Alice D 1876- *DcWomA*
Beek, Alice D Engley 1867-1951 *ArtsAmW 1*
Beek, Alice D Engley 1876- *WhAmArt 85*
Beek, Anna *DcWomA*
Beekers, Hubertine *DcWomA*
Beekman, Florence *FolkA 86*
Beekman, Henry Rutgers 1880-1938 *WhAmArt 85*
Beeldemaeker, Adriaen Cornelisz 1618?-1707 *McGDA*
Beeler, Charles H *NewYHSD*
Beeler, Joe *OfPGCP 86*
Beeler, Joe 1931- *IlBEAAW, WhoAmA 76, –78, –80,*
 –82, –84
Beelke, Ralph G 1917- *WhoAmA 73, –76, –78, –80,*
 –82, –84
Beelman, Grace *DcWomA*
Beelt, Abraham *DcSeaP*
Beelt, Cornelis *McGDA*
Beem, Frances *WhAmArt 85*
Beem, Jerald Torrens 1900- *AmArch 70*
Beem, Paul Edward 1908- *WhAmArt 85*
Beeman, Reuben *CabMA*
Beeman, S *FolkA 86*
Beemer, Edwin F *WhAmArt 85*
Beemer, S *DcWomA*
Beene, Geoffrey 1927- *ConDes, FairDF US[port]*
Beene, Geoffrey 1928- *WorFshn*
Beenhouwer, Owen 1931- *AmArch 70*
Beer *FairDF FRA*
Beer, Amalia *DcWomA*
Beer, Antonia *DcWomA*
Beer, Arnould 1490?-1542 *ClaDrA*
Beer, David Wells 1934- *AmArch 70*
Beer, Henneken De 1475?- *McGDA*
Beer, John-Axel-Richard 1853-1906 *DcBrBI*
Beer, Kenneth John 1932- *WhoAmA 78, –80, –82, –84*
Beer, Maria Eugenia De *DcWomA*
Beer, Michael d1666 *MacEA*
Beer, Michael 1605?-1666 *WhoArch*
Beer, Richard *IlsBYP, IlsCB 1957*
Beer-Goertz, Ida 1878- *DcWomA*
Beerbauer, L S *FolkA 86*
Beerbaur, L S *FolkA 86*
Beerbohm, Marvin 1909- *WhAmArt 85*
Beerbohm, Max 1872-1956 *AntBDN B, ClaDrA*
Beerbohm, Sir Max 1872-1956 *DcBrA 1*
Beerbohm, Max 1872-1956 *McGDA*
Beerbohm, Sir Max 1872-1956 *DcBrBI, OxArt,*
 PhDcTCA 77, WorECar
Beerbower, L S *FolkA 86*
Beerbower, William *FolkA 86*
Beere, Daniel Manders 1833-1909 *MacBEP*
Beerman, Herbert 1926- *WhoAmA 73, –76, –78, –80*
Beerman, Miraim K *WhoAmA 82, –84*
Beerman, Miriam H *WhoAmA 73, –76, –78, –80*
Beerman, T *AmArch 70*
Beernaert, Euphrosine 1831-1901 *ClaDrA, DcWomA*
Beers, Alexander Richard 1882- *WhAmArt 85*
Beers, Fred Gordon 1924- *MarqDCG 84*
Beers, Jan Van 1852- *ClaDrA*
Beers, Julie Hart *DcWomA, NewYHSD*
Beers, Martha Stuart *DcWomA, FolkA 86*
Beers, N P *NewYHSD*
Beers, William Harmon 1891-1949 *BiDAmAr*
Beersman, Charles G 1888-1946 *BiDAmAr*
Beerstraaten, Jan Abraham 1622-1666 *DcSeaP*
Beerstraaten, Johannes *DcSeaP*
Beerstraten, Anthonie *OxArt*
Beerstraten, Jan Abraham 1622-1666 *ClaDrA*
Beerstraten, Jan Abrahamsz 1627-1666 *OxArt*

Beert, Osias 1580-1624 *McGDA, OxArt*
Beery, Arthur O 1930- *WhoAmA 73, –76, –78, –80,*
 –82, –84
Beery, Edgar Carroll, Jr. 1919- *AmArch 70*
Beery, Eugene Brian 1937- *WhoAmA 76, –78*
Beery, Noah *IlBEAAW*
Beese, H *NewYHSD*
Beesley, Ann *DcBrECP, DcWomA*
Beesley, John *DcBrECP*
Beesley, Robert *DcBrECP*
Beeson, Betty Z 1897- *WhAmArt 85*
Beeson, Betty Zimmerman 1897- *DcWomA*
Beeson, Carroll O 1898- *AmArch 70*
Beeson, Charles Richard 1909- *DcBrA 1*
Beeson, Charles Richard 1909-1975 *DcBrA 2*
Beeson, Donald Richard, Jr. 1921- *AmArch 70*
Beeson, Jane 1930- *WhoArt 80, –82, –84*
Beeson, Walter Woodward 1922- *AmArch 70*
Beest, Albert Van 1820-1860 *NewYHSD*
Beest, Albertus Van 1820-1860 *DcSeaP*
Beest, Sybrand Van 1610?-1674 *McGDA*
Beeston, Arthur *DcVicP 2*
Beeston, C W *AmArch 70*
Beet, Cornelius De 1772?- *NewYHSD*
Beetham, Isabella 1744- *AntBDN O*
Beetham, Isabella Robinson 1744- *OxDecA*
Beetham, Jane *DcWomA*
Beetham, Jane 1774- *DcBrECP*
Beetham, Mary Matilda *DcWomA*
Beetham, William *DcVicP 2*
Beetholme, Francis *DcBrWA*
Beetholme, George Law *DcBrWA, DcVicP 2*
Beetholme, George Law Francis, Jr. *DcVicP 2*
Beeton, Alan Edmund 1880-1942 *DcBrA 1*
Beetz, Carl Hugo 1911- *WhoAmA 73*
Beetz, Carl Hugo 1911-1974 *WhAmArt 85,*
 WhoAmA 76N, –78N, –80N, –82N, –84N
Beetz-Charpentier, Elisa *DcWomA*
Beeuwkes, Ernst Jan *WorFshn*
Beever, W A *DcBrBI*
Beezer, Louis 1869-1929 *BiDAmAr*
Beffin, Sarah *DcWomA*
Befort, Mademoiselle *DcWomA*
Beg, Rashid 1949- *MarqDCG 84*
Bega, Abraham Jansz *McGDA*
Bega, Cornelis 1620-1664 *ClaDrA*
Bega, Cornelis Pietersz 1631?-1664 *McGDA*
Bega, Melchiorre 1898-1976 *ConDes*
Begarelli, Antonio 1499-1565? *McGDA*
Begarelli, Lodovico 1524?-1577? *McGDA*
Begas, Adelbert-Franz Eugen 1836- *ArtsNiC*
Begas, Karl 1794-1854 *ArtsNiC*
Begas, Karl Joseph 1794-1854 *ClaDrA*
Begas, Oskar 1828-1883 *ArtsNiC*
Begas, Reinhold 1831- *ArtsNiC*
Begas, Reinhold 1831-1911 *McGDA*
Begas-Parmentier, Luise *DcWomA*
Begaud, Wilson *AfroAA*
Begay, Apie *IlBEAAW*
Begay, Apie d1936? *WhAmArt 85*
Begay, Harrison *IlsBYP*
Begay, Harrison 1917- *IlBEAAW, WhAmArt 85*
Begbie, Irene 1894- *DcBrA 1, DcWomA*
Begeijn, Abraham Jansz 1637-1697 *McGDA*
Begerly, Levi *FolkA 86*
Begeyn, Abraham Jansz 1637-1697 *ClaDrA*
Begg, James *BiDBrA*
Begg, John 1866-1937 *MacEA*
Begg, John 1903-1974 *WhAmArt 85*
Begg, John Alfred 1903- *WhoAmA 73*
Begg, John Alfred 1903-1974 *WhoAmA 76N, –78N,*
 –80N, –82N, –84N
Begg, Robert J d1926 *DcBrA 1*
Begg, Samuel *DcBrBI, DcVicP 2*
Beggrow-Hartmann, Olga 1862- *DcWomA*
Beggs, Bette 1915- *WhAmArt 85*
Beggs, Helene Warder *DcWomA, WhAmArt 85*
Beggs, Julia *ArtsEM, DcWomA*
Beggs, Thomas Montague 1899- *ArtsAmW 2,*
 WhAmArt 85, WhoAmA 73, –76, –78, –80, –82,
 –84, WhoArt 80, –82
Begic, Mirsad 1953- *DcCAr 81*
Begien, Jeanne 1913- *WhAmArt 85*
Beginin, Igor 1931- *WhoAmA 84*
Beginski, David 1952- *MarqDCG 84*
Begley, Henry *DcVicP 2*
Begley, Wayne E 1937- *WhoAmA 82, –84*
Begodon, Achilles 1816?-1899 *NewYHSD*
Begrow, Harold Jack 1930- *AmArch 70*
Begue, Hortense 1892- *DcWomA*
Beguer, S *OxTwCA*
Beha-Castagnole, Giovanna 1871- *DcWomA*
Behagle, Philippe 1684-1704 *OxDecA*
Beham, Bartel 1502-1540 *OxArt*
Beham, Barthel 1502-1540 *ClaDrA, McGDA*
Beham, Hans Sebald 1500-1550 *McGDA, OxArt*
Behan, Thomas *NewYHSD*
Behar, Ely M 1890- *WhAmArt 85*
Behault DeVarelles, Pauline *DcWomA*
Behee, Grant A C 1868-1943 *BiDAmAr*

Bennet, Cordelia Lathan 1798- *FolkA 86*
Bennet, Daniel *FolkA 86*
Bennet, Edwin *FolkA 86*
Bennet, Florence Emily *DcWomA*
Bennet, James S *FolkA 86*
Bennet, Julia *DcWomA*
Bennet, Theresa *DcWomA*
Bennett *DcBrECP*
Bennett, Miss *FolkA 86*
Bennett, Mrs. *DcWomA, FolkA 86*
Bennett, A A 1825-1890 *BiDAmAr*
Bennett, Aaron Lee 1817- *CabMA*
Bennett, Alfred *DcVicP 2*
Bennett, Alfred H 1891- *WhAmArt 85*
Bennett, Alice 1895- *FolkA 86*
Bennett, Ames 1921- *AmArch 70*
Bennett, Anne *DcWomA*
Bennett, Archie Wayne 1937- *MarqDCG 84*
Bennett, Belle *DcWomA, WhAmArt 85*
Bennett, Bertha 1883- *ArtsAmW 1, DcWomA, WhAmArt 85*
Bennett, Bertha Forbes 1886- *DcWomA, WhAmArt 85*
Bennett, Bessie *WhAmArt 85*
Bennett, Brad *OfPGCP 86*
Bennett, Brian Theodore Norton 1927- *WhoArt 80, -82, -84*
Bennett, Caroline *FolkA 86*
Bennett, Charles A 1864- *WhAmArt 85*
Bennett, Charles Harper 1840-1927 *MacBEP*
Bennett, Charles Henry 1829-1867 *DcBrBI*
Bennett, Charles Moon 1899- *EarABI SUP*
Bennett, Colton *CabMA*
Bennett, D J *AmArch 70*
Bennett, Daniel *FolkA 86*
Bennett, Daniel S 1829?- *NewYHSD*
Bennett, Derek 1944- *ConPhot, ICPEnP A*
Bennett, Derek Petersen 1944- *MacBEP*
Bennett, Don Bemco 1916- *WhoAmA 76, -78, -80, -82, -84*
Bennett, Dwight Edward 1937- *AmArch 70*
Bennett, E *WhAmArt 85*
Bennett, E V *FolkA 86*
Bennett, Edward H 1874-1954 *MacEA*
Bennett, Edward Herbert, Jr. 1915- *AmArch 70*
Bennett, Edward M 1933- *AmArch 70*
Bennett, Edwin *FolkA 86*
Bennett, Edwin 1818- *AntBDN M, DcNiCA*
Bennett, Elizabeth K *FolkA 86*
Bennett, Emma Dunbar *DcWomA*
Bennett, Emma-Sutton 1902- *WhAmArt 85*
Bennett, F R *FolkA 86*
Bennett, Florence E *DcBrA 2*
Bennett, Florence Emily *DcWomA*
Bennett, Francis I 1876- *WhAmArt 85*
Bennett, Frank Marion *DcBrWA*
Bennett, Frank Moss 1874-1953 *ClaDrA, DcBrA 1, DcBrWA, DcVicP 2*
Bennett, Franklin 1908- *WhAmArt 85*
Bennett, Fred *AfroAA, DcBrBI*
Bennett, Frederick *WhAmArt 85*
Bennett, G L *AmArch 70*
Bennett, G R *DcVicP 2*
Bennett, G Stacey 1916- *AmArch 70*
Bennett, George Osborne, Jr. 1945- *MacBEP*
Bennett, Georgia E *WhAmArt 85*
Bennett, Gertrude *DcWomA*
Bennett, Gertrude 1894- *ArtsAmW 1*
Bennett, Gwendolyn 1902- *AfroAA*
Bennett, H H 1863- *WhAmArt 85*
Bennett, H R *AmArch 70*
Bennett, Harriet *WhoAmA 73, -76, -78, -80, -82, -84*
Bennett, Harriet M *ClaDrA, DcBrWA, DcVicP 2, DcWomA*
Bennett, Hugh Henderson 1936- *AmArch 70*
Bennett, Isabel *DcVicP 2, DcWomA*
Bennett, Isabelle Jewel 1908- *WhAmArt 85*
Bennett, J A *DcVicP 2*
Bennett, J H *AmArch 70*
Bennett, J Houghton 1908- *AmArch 70*
Bennett, J L *AmArch 70*
Bennett, J Lovett *DcVicP 2*
Bennett, J P *AmArch 70*
Bennett, James *AntBDN M, DcNiCA*
Bennett, James A T 1833?- *NewYHSD*
Bennett, James Eugene 1929- *AmArch 70*
Bennett, James Lesesne 1923- *AmArch 70*
Bennett, James Murrell 1904- *AmArch 70*
Bennett, James S d1862 *FolkA 86*
Bennett, Jamie 1948- *WhoAmA 78, -80, -82, -84*
Bennett, Jill Crawford 1934- *IlsCB 1967*
Bennett, John *FolkA 86*
Bennett, John 1865- *WhAmArt 85*
Bennett, John 1865-1956 *ConICB, IlsCB 1744*
Bennett, John Hartwell, Jr. 1929- *AmArch 70*
Bennett, Joseph Arthur 1853-1929 *DcBrA 2*
Bennett, Joseph Hastings 1889- *ArtsAmW 1, -2, WhAmArt 85*
Bennett, Josh Charlton 1920- *AmArch 70*
Bennett, June 1935- *WhoArt 80, -82, -84*
Bennett, Kate *DcVicP 2*

Bennett, Mrs. Louis *WhAmArt 85*
Bennett, Lyle Hatcher 1903- *WhAmArt 85*
Bennett, M O *AmArch 70*
Bennett, Marguerite *DcWomA*
Bennett, Mary *DcVicP 2, DcWomA*
Bennett, Mary Elizabeth 1877- *DcWomA, WhAmArt 85*
Bennett, Michael *DcCAr 81, MacBEP*
Bennett, Michael 1934- *WhoArt 80, -82, -84*
Bennett, Newton *ClaDrA*
Bennett, Penelope 1931- *DcCAr 81*
Bennett, Philomene 1935- *WhoAmA 80, -82, -84*
Bennett, R *FolkA 86*
Bennett, R B, Jr. *AmArch 70*
Bennett, R E *AmArch 70*
Bennett, Rachelle 1929- *AmArch 70*
Bennett, Rainey *IlsCB 1967*
Bennett, Rainey 1907- *DcCAr 81, IlsBYP, IlsCB 1957, WhAmArt 85, WhoAmA 76, -78, -80, -82, -84*
Bennett, Reginald 1893- *WhAmArt 85*
Bennett, Reo *WhAmArt 85*
Bennett, Richard 1899- *IlsBYP, IlsCB 1744, -1946, WhAmArt 85*
Bennett, Richard 1899-1971 *ArtsAmW 3*
Bennett, Richard Alan 1948- *MarqDCG 84*
Bennett, Richard M 1907- *AmArch 70*
Bennett, Robert J 1920- *AmArch 70*
Bennett, Robert Mackenzie 1956- *MarqDCG 84*
Bennett, Robert Sherman 1927- *AmArch 70*
Bennett, Russell 1926- *FolkA 86*
Bennett, Russell Charles 1927- *AmArch 70*
Bennett, Ruth H 1883?-1947 *DcWomA, WhAmArt 85*
Bennett, Ruth M 1899-1960 *WhAmArt 85, WhoAmA 80N, -82N, -84N*
Bennett, Ruth Manerva 1899-1960 *ArtsAmW 2, DcWomA*
Bennett, S A *FolkA 86*
Bennett, S E *DcVicP 2*
Bennett, Samuel d1741 *AntBDN G*
Bennett, Susan *IlsBYP*
Bennett, Terry David 1948- *MarqDCG 84*
Bennett, Thomas *FolkA 86*
Bennett, Tim 1958- *AmArt*
Bennett, Violet 1902- *ClaDrA*
Bennett, Virginia Davisson d1944 *WhAmArt 85*
Bennett, W J 1787-1844 *AntBDN B*
Bennett, Ward 1917- *ConDes*
Bennett, William *DcVicP 2, FolkA 86*
Bennett, William 1811-1871 *DcBrWA, DcVicP 2*
Bennett, William 1917- *WhoArt 84*
Bennett, William B *DcVicP 2*
Bennett, William James 1787-1844 *ArtsEM, DcBrWA, NewYHSD*
Bennett, William Mineard 1778?-1858 *DcBrWA, DcVicP 2*
Bennett And Lacy *AntBDN F*
Bennett Brothers *FolkA 86*
Bennett-Merwin *EncASM*
Bennetter, Hendrik Wilhelm 1874- *DcSeaP*
Bennetter, Johan Jacob 1822-1904 *DcSeaP*
Bennetter, Johan Jakob 1822-1904 *ClaDrA*
Benney, Adrian Gerald Sallis 1930- *WhoArt 80, -82, -84*
Benney, Derek Ward Sallis 1924- *WhoArt 80*
Benney, Ernest Alfred Sallis 1894-1966 *DcBrA 1*
Benney, Gerald 1930- *DcD&D*
Benney, Robert *WhoAmA 73, -76, -78, -80, -82, -84*
Benney, Robert 1904- *IlrAm E, -1880*
Benney, Robert L 1904- *WhAmArt 85*
Bennighof, Robert Arthur 1924- *AmArch 70*
Bennin, Henriette 1826- *DcWomA*
Benning, Kurt 1945- *DcCAr 81*
Bennington, Wilbur J 1925- *AmArch 70*
Bennison, Appleton 1750?-1830 *BiDBrA*
Bennitt, Ward *DcBrBI*
Benno, Benjamin G 1901- *WhoAmA 73, -76, -78, -80, -82*
Benois, Aleksandr 1870-1960 *OxArt*
Benois, Alexandre 1870-1960 *McGDA, OxArt, OxTwCA, PhDcTCA 77*
Benois, Nadia 1896- *DcBrA 1, DcWomA*
Benois, Nadia 1896-1975 *DcBrA 2*
Benoist, Adele 1828- *DcWomA*
Benoist, Albert Spalding 1918- *AmArch 70*
Benoist, Alice *DcWomA*
Benoist, Marie Guillemine 1768-1826 *DcWomA*
Benoit, Camille 1820-1882 *ClaDrA*
Benoit, Jean 1922- *ConArt 77, WhoAmA 78, -80, -82*
Benoit, Marguerite Marie *DcWomA*
Benoit, Pauline *ArtsEM, DcWomA*
Benoit, Pedro 1836-1897 *MacEA*
Benoit, Rigaud 1911- *McGDA*
Benoit-Levy, Georges 1880-1971 *MacEA*
Benolken, Leonore 1896- *WhAmArt 85*
Benolken, Leonore 1896-1943 *DcWomA*
Benolken, Leonore Ethel 1896- *ArtsAmW 2*
Benoni *NewYHSD*
Benouville, Achille-Jean 1815- *ArtsNiC*

Benouville, Francois-Leon 1821-1859 *ArtsNiC*
Benouville, Nadegda *DcWomA*
Benozzo Gozzoli *McGDA*
Benrath, Frederic 1930- *ConArt 77*
Benrimo, Thomas D 1887-1958 *WhAmArt 85*
Benrimo, Thomas Duncan 1887-1958 *ArtsAmW 2, IlBEAAW*
Bens, Adolf 1894- *MacEA*
Bens, William *EncASM*
Bensadon, J *NewYHSD*
Bensco, Charles J 1894-1960 *ArtsAmW 2, WhAmArt 85, WhoAmA 80N, -82N, -84N*
Bense, Gerald Henry 1920- *AmArch 70*
Bensell, E B *EarABI, EarABI SUP*
Bensell, George Frederick 1837-1879 *IlBEAAW, NewYHSD*
Bensemann, Leo 1911- *DcCAr 81*
Bensen, Donald Hojkilde 1932- *AmArch 70*
Bensing, Dirick *FolkA 86*
Bensing, Frank C 1893- *IlrAm D, WhoAmA 73, -76*
Bensing, Frank C 1893-1983 *IlrAm 1880*
Bensing, Frank S 1893- *WhAmArt 85*
Bensinger, Amalie *DcWomA*
Bensinger, Anne Mosejiere 1906- *WhAmArt 85*
Bensinger, B Edward, III 1929- *WhoAmA 73, -76, -78, -80, -82*
Bensley, Martha S *DcWomA, WhAmArt 85*
Benso, Giulio 1601?-1668 *ClaDrA*
Benson *DcBrBI*
Benson, Abraham Harris 1878-1929 *DcBrA 1*
Benson, Agnes *DcWomA, WhAmArt 85*
Benson, Ambrosius d1550 *McGDA, OxArt*
Benson, Ben Albert 1901- *WhAmArt 85*
Benson, Benjamin W *NewYHSD*
Benson, Beth Ann 1957- *MarqDCG 84*
Benson, Charlotte E 1846-1893 *DcBrWA, DcVicP 2, DcWomA*
Benson, Dirick *FolkA 86*
Benson, Donald LeRoy 1930- *AmArch 70*
Benson, E E *AmArch 70*
Benson, Eda 1898- *DcWomA*
Benson, Eda Spoth 1898- *WhAmArt 85*
Benson, Edna Grace 1887- *ArtsAmW 3*
Benson, Elaine K G 1924- *WhoAmA 73, -76, -78, -80, -82, -84*
Benson, Eleanor B *DcVicP 2*
Benson, Elizabeth Polk 1924- *WhoAmA 82, -84*
Benson, Emanuel M 1904-1971 *WhoAmA 78N, -80N, -82N, -84N*
Benson, Emilie *DcWomA*
Benson, Eugene 1839- *ArtsNiC*
Benson, Eugene 1839?-1908 *EarABI, NewYHSD*
Benson, Eva E d1949 *DcWomA*
Benson, Frank *FolkA 86*
Benson, Frank W d1951 *WhoAmA 78N, -80N, -82N, -84N*
Benson, Frank W 1862-1951 *WhAmArt 85*
Benson, Frank Weston 1862-1951 *BnEnAmA, ClaDrA, DcAmArt, DcBrA 1, GrAmP, McGDA*
Benson, Gertrude Acherman 1904- *WhoAmA 73*
Benson, Gertrude Ackerman 1904- *WhoAmA 76, -78, -80, -82, -84*
Benson, H *DcVicP 2, DcWomA*
Benson, H R, Jr. *AmArch 70*
Benson, Hannah Nicholson *WhAmArt 85*
Benson, Harry 1929- *ICPEnP A*
Benson, Harry Joseph *MarqDCG 84*
Benson, Henrietta *DcVicP 2, DcWomA*
Benson, Henrietta Maria *DcWomA*
Benson, Henry *FolkA 86*
Benson, Jane *DcWomA*
Benson, John *NewYHSD*
Benson, John Harvey 1939- *AmArch 70*
Benson, John Howard 1901-1956 *WhAmArt 85*
Benson, John Leland 1898- *AmArch 70*
Benson, John P d1947 *WhoAmA 78N, -80N, -82N, -84N*
Benson, John P 1865-1947 *DcSeaP, WhAmArt 85*
Benson, John William 1904- *WhAmArt 85*
Benson, Joseph *NewYHSD*
Benson, Leslie L 1885- *WhAmArt 85*
Benson, Loren Martin 1937- *AmArch 70*
Benson, Martha J 1928- *WhoAmA 78, -80, -82, -84*
Benson, Mary K *DcBrBI, DcVicP 2*
Benson, Mary Kate *DcBrWA, DcWomA*
Benson, Neal A 1954- *MarqDCG 84*
Benson, Nellie *DcVicP 2*
Benson, Nesbit *WhAmArt 85*
Benson, Richard 1943- *ICPEnP A*
Benson, Robert *DcBrBI*
Benson, Robert, Lord Bingley 1676?-1731 *BiDBrA*
Benson, Robert Charles 1940- *AmArch 70*
Benson, Robert Franklin 1948- *WhoAmA 76, -78, -80, -82, -84*
Benson, Roger Norman 1938- *AmArch 70*
Benson, S E L *DcWomA*
Benson, S Patricia 1941- *WhoAmA 76, -78, -80, -82*
Benson, Stuart 1877- *WhAmArt 85*
Benson, Tressa Emerson 1896- *ArtsAmW 3, WhAmArt 85*
Benson, Tressa Pond Emerson 1896- *DcWomA*

Benson, William 1682-1754 *BiDBrA, MacEA*
Benson, William Arthur Smith 1854-1924 *DcNiCA*
Benson, William Edward 1923- *AmArch 70*
Bensted, J *DcVicP 2*
Bensusan, Arthur David 1921- *MacBEP*
Bensusan, Esther *DcWomA*
Bensusan-Butt, John Gordon 1911- *ClaDrA, DcBrA 1, WhoArt 80, –82, –84*
Bent, Everett *FolkA 86*
Bent, Henry *NewYHSD*
Bent, Johannes VanDe 1650?-1690 *McGDA*
Bent, Johannes VanDer 1651-1690 *ClaDrA*
Bent, Medora Heather *WhoArt 80, –82, –84*
Bent, Roy Sumner 1901- *AmArch 70*
Bent, Samuel *FolkA 86*
Bent, Thomas *CabMA*
Bentabole, Louis 1827-1880 *DcSeaP*
Bentel, Frederick Richard 1928- *AmArch 70*
Bentel, Maria Azzarone 1928- *AmArch 70*
Benthall, Larry E 1951- *MarqDCG 84*
Bentham, A W *DcVicP 2*
Bentham, Douglas Wayne 1947- *WhoAmA 73, –76, –78, –80, –82, –84*
Bentham, George 1850-1914 *WhAmArt 85*
Bentham, Graeme *DcCAr 81*
Bentham, Leonard 1948- *DcCAr 81*
Bentham, Percy George 1883-1936 *DcBrA 1*
Bentham, R H *DcVicP 2*
Benti, Donato d1536 *McGDA*
Bentinck, Betty *DcWomA*
Bentinck, Lady Charles d1875 *DcBrWA*
Bentinck, Harriet *DcWomA*
Bentley, Mrs. *DcVicP 2*
Bentley, Alfred *WhAmArt 85*
Bentley, Alfred d1923 *DcBrA 1*
Bentley, Benedict *WhAmArt 85*
Bentley, Charles 1806-1854 *DcBrWA, DcSeaP, DcVicP, –2*
Bentley, Charles Edward *DcBrA 1*
Bentley, Clarence Edwin 1932- *AmArch 70*
Bentley, Claude 1915- *WhoAmA 73, –76, –78, –80, –82, –84*
Bentley, Claude Ronald 1915- *WhAmArt 85*
Bentley, E W *FolkA 86*
Bentley, Edward d1882? *DcVicP 2*
Bentley, Galen W 1903- *AmArch 70*
Bentley, Harry H *WhAmArt 85*
Bentley, J *FolkA 86*
Bentley, J F 1839-1902 *DcD&D*
Bentley, J M *AmArch 70*
Bentley, J T *WhAmArt 85*
Bentley, John 1573?-1613 *BiDBrA*
Bentley, John Francis 1839-1902 *MacEA, McGDA, WhoArch*
Bentley, John William 1880- *WhAmArt 85*
Bentley, Joseph Clayton 1809-1851 *DcBrWA, DcVicP, –2*
Bentley, Joseph Herbert 1866- *DcBrA 1, DcVicP 2*
Bentley, Lester W 1908- *WhAmArt 85*
Bentley, Lucy *DcWomA*
Bentley, Nicolas 1907- *WhoArt 80*
Bentley, Nicolas Clerihew 1907- *IlsCB 1744*
Bentley, R C *AmArch 70*
Bentley, Rachel 1894- *ArtsAmW 2, DcWomA*
Bentley, Richard d1782 *BkIE, McGDA*
Bentley, Richard 1708-1782 *BiDBrA*
Bentley, Robert Wilson 1928- *AmArch 70*
Bentley, Thomas 1730-1780 *AntBDN M*
Benton, Arthur 1859-1927 *BiDAmAr*
Benton, D W *AmArch 70*
Benton, Dwight 1834- *NewYHSD*
Benton, F *AmArch 70*
Benton, Fletcher 1931- *ConArt 77, DcCAA 71, –77, DcCAr 81, WhoAmA 73, –76, –78, –80, –82, –84*
Benton, G *FolkA 86*
Benton, George Bernard 1872- *DcBrA 1, DcVicP 2*
Benton, Harry Stacy 1877- *WhAmArt 85*
Benton, James Gilchrist 1820-1881 *IlBEAAW*
Benton, James Howard 1920- *AmArch 70*
Benton, Jared *FolkA 86*
Benton, Julia L *DcVicP 2, DcWomA*
Benton, Margaret Peake *WhoAmA 73*
Benton, Margaret Peake d1975 *WhoAmA 76N, –78N, –80N, –82N, –84N*
Benton, Mary *WhAmArt 85*
Benton, Mary P S *ArtsAmW 1, NewYHSD*
Benton, Mary Park Seavy 1815-1910 *DcWomA*
Benton, Stephen Anthony 1941- *MacBEP*
Benton, Suzanne E 1936- *WhoAmA 78, –80, –82, –84*
Benton, Thomas Hart 1889- *ArtsAmW 1, DcCAA 71, McGDA, WhoAmA 73*
Benton, Thomas Hart 1889-1975 *ArtsAmW 2, BnEnAmA, DcAmArt, DcCAA 77, GrAmP, IlBEAAW, IlsCB 1744, –1946, OxTwCA, PhDcTCA 77, WhAmArt 85, WhoAmA 76N, –78N, –80N, –82N, –84N, WorArt[port]*
Benton, Walter Bradford 1950- *MarqDCG 84*
Benton, William 1900- *WhoAmA 73, –76, –78, –80*
Benton, William 1900-1973 *WhoAmA 82N, –84N*
Benton, William Dallas 1917- *AmArch 70*
Benton-Evans, Jessie *WhoAmA 82*

Benton-Harris, John 1939- *ConPhot, ICPEnP A, MacBEP*
Bentov, Mirtala 1929- *WhoAmA 73, –76, –78, –80, –82, –84*
Bentsen, Kenneth E 1926- *AmArch 70*
Bentz, C E *AmArch 70*
Bentz, Frederick *DcVicP 2*
Bentz, Frederick Jacob 1922- *AmArch 70*
Bentz, Harry Donald 1931- *WhoAmA 78, –80, –82, –84*
Bentz, John d1950 *WhAmArt 85, WhoAmA 78N, –80N, –82N, –84N*
Bentzinger, William Edward 1916- *AmArch 70*
Benuzzi, Edwin *DcVicP 2*
Benvenga, Clemens John 1924- *AmArch 70*
Benvenuti, Giovanni Battista *McGDA*
Benvenuti, Pietro 1769-1844 *ArtsNiC, McGDA*
Benvenuti, Robert *WhAmArt 85*
Benvenuto Di Giovanni 1438-1518? *McGDA*
Benwell, Mrs. *DcVicP 2*
Benwell, J Hodges 1762-1785 *DcBrECP*
Benwell, John Hodges 1764-1785 *DcBrWA*
Benwell, Joseph Austin *DcBrBI, DcBrWA, DcVicP 2*
Benwell, Mrs. Joseph Austin *DcWomA*
Benwell, Mary *DcBrECP*
Benwell, Mary 1739-1800? *DcWomA*
Benwell, Samuel *BiDBrA*
Beny, Roloff 1924- *ConArt 77, ConPhot, MacBEP, WhoAmA 73, –76, –78, –80, –82, –84*
Beny, Roloff 1924-1984 *ICPEnP A*
Benz, Donald James 1937- *AmArch 70*
Benz, John Douglas 1937- *AmArch 70*
Benz, Lee R *WhoAmA 73, –76, –78, –80, –82, –84*
Benz, Mildred Wiggins *WhAmArt 85*
Benz, Otto Charles 1882- *WhAmArt 85*
Benzenhoefer, Fred John, Jr. 1929- *AmArch 70*
Benziger, August 1867- *WhAmArt 85*
Benzing, Nelson Speer, Jr. 1935- *AmArch 70*
Benzinger, Ruth *WhAmArt 85*
Benzley, Steven *MarqDCG 84*
Beothy, Etienne 1897- *McGDA, PhDcTCA 77*
Beothy, Etienne 1897-1962 *OxTwCA*
Ber, Sophie Adele *DcWomA*
Beradino, Alfred C 1944- *MarqDCG 84*
Beraha, Enrique Misrachi 1925- *WhoAmA 73, –76, –78, –80*
Berain, Jean 1637-1711 *DcD&D*
Berain, Jean 1640-1711 *OxArt, OxDecA*
Berain, Jean I 1640-1711 *MacEA*
Beran, Ann Marie Karnik 1890- *ArtsAmW 3, DcWomA*
Beran, Edwin E 1924- *AmArch 70*
Beran, Lenore *OfPGCP 86*
Beranek, Leo L 1914- *MarqDCG 84*
Beranger, Gabriel 1729-1817 *DcBrWA*
Beranger, Suzanne Estelle *DcWomA*
Berard, Christian 1902-1949 *McGDA, OxTwCA, PhDcTCA 77, WorFshn*
Berard, Christian-Jacques 1902-1949 *ConDes*
Berard, Evremond De *DcBrBI*
Berard, Marius Honore 1896- *OxTwCA*
Berardinelli, Dennis 1897- *WhAmArt 85*
Berardinone, Valentina 1929- *ConArt 77*
Berarducci, Thomas Neal 1958- *MarqDCG 84*
Berat, Marie *DcWomA*
Beraud, Jean 1849-1936 *ClaDrA*
Berbank, Albert Edward 1896- *DcBrA 1*
Berce, Irma *DcWomA*
Berchem, Claes Pietersz 1620-1683 *McGDA*
Berchem, Nicolaes 1620-1683 *OxArt*
Berchem, Nicolaes 1620-1683 *ClaDrA*
Bercher, Henri Edouard 1877- *ClaDrA*
Berchere, Narcisse 1822- *ArtsNiC*
Berchet, Peter 1659-1720 *BkIE*
Berchet, Pierre 1659-1720? *DcBrECP*
Berck-Heyde, Gerard 1638-1698 *ClaDrA*
Berck-Heyde, Job 1630-1693 *ClaDrA*
Berckhardt *DcBrECP*
Berckheijde, Gerrit Adriaensz 1638-1698 *McGDA*
Berckheijde, Job Adriaensz 1630-1693 *McGDA*
Berckheyde, Gerrit Adriaensz 1638-1698 *OxArt*
Berckheyde, Job Adriaensz 1630-1693 *OxArt*
Berckholtz, Alexandra Van 1821-1899 *DcWomA*
Berckman, Hendrick 1629-1679 *ClaDrA*
Berckmans, Elizabeth 1842-1915 *DcWomA, WhAmArt 85*
Bercoli, Aug 1832?- *NewYHSD*
Berczy, Jean Charlotte 1760-1833? *DcWomA*
Berczy, Louise Amelie 1789-1862 *DcWomA*
Berczy, William *DcBrECP*
Berczy, William VonMoll 1748-1813 *McGDA*
Berd, Morris 1914- *WhAmArt 85, WhoAmA 73, –76, –78, –80, –82, –84*
Berdan, Anna R *DcWomA, WhAmArt 85*
Berdanier, Paul F, Sr. 1879- *WhAmArt 85*
Berdecio, Roberto *OxTwCA*
Berdecio, Roberto 1910- *McGDA*
Berdich, Vera *WhoAmA 73, –76, –78, –80*
Berdich, Vera 1915- *DcCAr 81*
Berdy, Jack *MarqDCG 84*

Berdyszak, Jan 1934- *ConArt 77, –83*
Berea, Dimitrie 1908- *ClaDrA*
Bereal, Edward 1937- *AfroAA*
Berelson, Howard 1940- *IlsBYP*
Bereman, John *FolkA 86*
Beren, Stanley O 1920- *WhoAmA 78, –80, –82, –84*
Berenbroick, Frederick *EncASM*
Berenbroick, Gottlieb d1889 *EncASM*
Berenbroick And Martin *EncASM*
Berend, Charlotte *WhAmArt 85*
Berend-Corinth, Charlotte 1880-1935 *WomArt*
Berend-Corinth, Charlotte 1880-1967 *DcWomA*
Berendsohn, Sigmond 1831?- *NewYHSD*
Berengo-Gardin, Gianni 1930- *ConPhot, ICPEnP A*
Berenguer, Francesco 1866-1914 *WhoArch*
Berenguer I Mestres, Francesco 1866-1914 *MacEA*
Berens, A H *DcVicP 2*
Berens, Stephen Lynn 1952- *MacBEP*
Berenson, Bernard 1865-1959 *McGDA, WhoAmA 80N, –82N, –84N*
Berenson, Bernhard 1865-1959 *OxArt*
Berenson, Bertram Melvin 1928- *AmArch 70*
Berenson, Elizabeth *WhAmArt 85*
Berenson, Sara Betty 1937- *MacBEP*
Berenstain, Janice *WorECar*
Berenstain, Stanley 1923- *WhoAmA 73, –76, WorECar*
Beres, Jerzy 1930- *PhDcTCA 77*
Beresford, Cecilia Melania *DcWomA*
Beresford, Cecilia Melanie *DcBrWA*
Beresford, Daisy Radcliffe *DcBrA 1, DcWomA*
Beresford, E M *DcVicP 2*
Beresford, Frank Ernest 1881-1967 *DcBrA 1*
Beresford, G D *DcBrBI*
Beresford, Helen Elizabeth 1900- *WhAmArt 85*
Beresford, P *DcVicP 2, DcWomA*
Beresford-Williams, Mary E 1931- *WhoArt 80, –82, –84*
Beretta, Anne-Marie *ConDes*
Beretta, J A *AmArch 70*
Berg, A T *NewYHSD*
Berg, Adrian 1929- *ConBrA 79[port], DcCAr 81, WhoArt 80, –82, –84*
Berg, Barry 1947- *WhoAmA 78*
Berg, Betzy Rezora 1850-1922 *DcWomA*
Berg, Bret Alan 1958- *MarqDCG 84*
Berg, Charles I 1856-1926 *BiDAmAr, MacEA*
Berg, Charles Robert 1952- *MarqDCG 84*
Berg, Claus d1591 *OxArt*
Berg, Claus 1508?-1532 *McGDA*
Berg, D O *AmArch 70*
Berg, Dave *ConGrA 1*
Berg, David 1920- *ConGrA 1[port], WorECom*
Berg, Edward A *AmArch 70*
Berg, Else 1877-1942 *DcWomA*
Berg, Else J 1890-1943? *DcWomA*
Berg, George Edward 1925- *AmArch 70*
Berg, George Lewis 1868-1941 *ArtsAmW 1*
Berg, George Louis 1868-1941 *WhAmArt 85*
Berg, Harvey Allen 1933- *AmArch 70*
Berg, J A *AmArch 70*
Berg, Joan *IlsCB 1957*
Berg, Johanne Louise *DcWomA*
Berg, John 1932- *AmGrD[port]*
Berg, John 1950- *DcCAr 81*
Berg, Karl 1943- *DcCAr 81*
Berg, L *AmArch 70*
Berg, Lotan Carl 1958- *MarqDCG 84*
Berg, Max 1870- *EncMA*
Berg, Max 1870-1947 *MacEA, McGDA, WhoArch*
Berg, O, Jr. *AmArch 70*
Berg, P Hoyt *AmArch 70*
Berg, Phil 1902- *WhoAmA 73, –76, –78, –80, –82, –84N*
Berg, Robert Olof 1930- *AmArch 70*
Berg, S L *AmArch 70*
Berg, Siegfried Kurt 1922- *MarqDCG 84*
Berg, Siri 1921- *WhoAmA 73, –76, –78, –80, –82, –84*
Berg, Siri 1921- *PrintW 83, –85*
Berg, Thomas 1943- *WhoAmA 78, –80*
Berg, Tom 1943- *WhoAmA 82, –84*
Berg, W J *AmArch 70*
Berg, Waldemar Gustave 1915- *WhAmArt 85*
Bergamaschi, A *AmArch 70*
Bergamasco, Il *McGDA*
Bergamin Gutierrez, Rafael 1891-1970 *MacEA*
Bergamini, John Van Wie 1887- *AmArch 70*
Bergamini-Tolmer, Blanche Frederique *DcWomA*
Bergamo, Dorothy Johnson 1912- *WhAmArt 85, WhoAmA 73, –76*
Bergdahl, Gustav Victor 1878-1939 *WorECom*
Berge, Auguste Charles DeLa 1807-1842 *ClaDrA*
Berge, Benjamin *FolkA 86*
Berge, Carol *WhoAmA 76, –78, –80*
Berge, Carol 1928- *WhoAmA 82*
Berge, Dorothy Alphena 1923- *WhoAmA 80, –82, –84*
Berge, Edward 1876-1924 *WhAmArt 85*
Berge, G B *AmArch 70*
Berge, Henry 1908- *WhAmArt 85, WhoAmA 73, –76, –78, –80, –82, –84*
Berge, Jacques 1693-1756 *McGDA*

Berge, Louis-Rene 1927- *DcCAr 81*
Berge, Olaf A 1898- *WhAmArt 85*
Berge, Pierre *FairDF FRA*
Berge, Stephens 1908- *WhAmArt 85*
Bergemann, William E 1923- *AmArch 70*
Bergen, Charles 1805?- *NewYHSD*
Bergen, Claus 1885-1964 *DcSeaP*
Bergen, D Thomas 1930- *WhoAmA 80, –82, –84*
Bergen, Dirck Van 1645-1690? *ClaDrA*
Bergen, Dirck VanDen 1640?-1690? *McGDA*
Bergen, George *WhAmArt 85*
Bergen, Johanna *FolkA 86*
Bergen, Peter G *NewYHSD*
Bergen, Sidney L 1922- *WhoAmA 73, –76, –78, –80, –82, –84*
Bergen, W P *AmArch 70*
Bergendahl, Hildegard Katarina *DcWomA*
Bergenty, Donald F *MarqDCG 84*
Berger, Albert C 1879-1940 *BiDAmAr*
Berger, Anthony 1832- *WhAmArt 85*
Berger, Anton *NewYHSD*
Berger, Bertrand 1945- *DcCAr 81*
Berger, Burton William 1930- *AmArch 70*
Berger, C T *AmArch 70*
Berger, Carl Hubert 1939- *AmArch 70*
Berger, Carl P 1873-1947 *BiDAmAr*
Berger, Charles F *NewYHSD*
Berger, Clementine d1891 *DcWomA*
Berger, Eileen 1943- *DcCAr 81*
Berger, Eileen K 1943- *MacBEP*
Berger, F E *AmArch 70*
Berger, Frank W 1846-1916 *WhAmArt 85*
Berger, Fred *DcCAr 81*
Berger, George *WhAmArt 85*
Berger, Gustav A 1920- *WhoAmA 80, –82, –84*
Berger, Hans 1882- *OxTwCA*
Berger, Henri d1920 *DcNiCA*
Berger, Henry *NewYHSD*
Berger, Howard 1948- *MarqDCG 84*
Berger, I J *AmArch 70*
Berger, Jacques *McGDA*
Berger, Jason 1924- *DcCAA 71, –77, WhoAmA 73, –76, –78, –80, –82, –84*
Berger, Jenny *DcWomA*
Berger, Jerry Allen 1943- *WhoAmA 78, –80, –82, –84*
Berger, Johan *DcVicP 2*
Berger, Johann Christian 1803-1871 *DcSeaP*
Berger, Karl 1924- *AmArch 70*
Berger, Klaus 1901- *WhoAmA 73*
Berger, L D *FolkA 86*
Berger, Leo V *AmArch 70*
Berger, Luise Dorothea Elisabeth *DcWomA*
Berger, Marc *MarqDCG 84*
Berger, Marcia E *WhAmArt 85*
Berger, Marie 1900- *WhAmArt 85*
Berger, Marie K *WhAmArt 85*
Berger, Maurice 1956- *WhoAmA 82, –84*
Berger, Melvin 1927- *MarqDCG 84*
Berger, Oscar 1901- *WhoAmA 76, –78, –80, –82, –84*
Berger, Paul 1948- *DcCAr 81*
Berger, Paul Eric 1948- *ICPEnP A, MacBEP, WhoAmA 80, –82, –84*
Berger, Rene 1915- *WhoArt 80*
Berger, Robert Jay 1955- *MarqDCG 84*
Berger, S *AmArch 70*
Berger, S L *AmArch 70*
Berger, Samuel A 1884- *WhoAmA 73*
Berger, Sophie *DcWomA*
Berger, Thomas Edward *AmArch 70*
Berger, Wallace Burton 1925- *AmArch 70*
Berger, William Merritt 1872- *ConICB, WhAmArt 85*
Bergerat, Emile, Madame *DcWomA*
Bergere, Richard *WhoAmA 73, –76, –78*
Bergere, Richard 1912- *WhAmArt 85*
Bergeret, Denis-Pierre *ArtsNiC*
Bergeron, Berthe *DcWomA*
Bergeron, Danny 1955- *MarqDCG 84*
Bergeron, Lyle Edward 1938- *AmArch 70*
Bergeron, Philippe 1959- *MarqDCG 84*
Bergeron, Suzanne 1930- *DcCAr 81*
Bergerot-Roblastre, Louise *DcWomA*
Bergerson, Dale Millian 1934- *AmArch 70*
Bergerson, Phillip 1947- *DcCAr 81*
Berges, Werner 1941- *DcCAr 81*
Bergeson, Edwin Berger, Jr 1926- *AmArch 70*
Berget, William B 1917- *AmArch 70*
Bergey, Benjamin *FolkA 86*
Bergey, Joseph K *FolkA 86*
Berggruen, John Henry 1943- *WhoAmA 73, –76, –78, –80, –82, –84*
Bergh, Asta *DcWomA*
Bergh, Edward 1828- *ArtsNiC*
Bergh, Elis 1881-1954 *IlDcG*
Bergh, Elisabeth Mathea 1861- *DcWomA*
Bergh, L DeCoppett 1856-1913 *BiDAmAr*
Berghash, Mark W 1935- *WhoAmA 82, –84*
Berghaus, Albert *IlBEAAW*
Berghauser, Donaldson 1913- *AmArch 70*
Berghe, Caroline Van Den *DcWomA*
Berghe, Frits VanDen 1883-1939 *OxArt, OxTwCA,*

PhDcTCA 77
Berghe, Fritz VanDen 1883-1939 *McGDA*
Berghem, Nicolas *ClaDrA*
Berghen, Dirck Van 1645-1690? *ClaDrA*
Berghorn, Gregory S 1950- *MarqDCG 84*
Berghuis, Jaap 1945- *ConArt 77, –83*
Bergier, Marguerite Juliette 1833-1878 *DcWomA*
Bergland, Robert Burdick 1914- *AmArch 70*
Bergler, Joseph 1753-1829 *ClaDrA*
Bergling, Virginia Catherine 1908- *WhoAmA 73, –76, –78, –80, –82, –84*
Berglund, Amanda 1879- *DcWomA, WhAmArt 85*
Berglund, Hilma L G 1886- *DcWomA, WhAmArt 85*
Bergman, Gustava Elisabeth 1842- *DcWomA*
Bergman, H P *AmArch 70*
Bergman, Karola 1902- *WhAmArt 85*
Bergman, Robert 1950- *DcCAr 81*
Bergman, Stephanie 1946- *DcCAr 81*
Bergman, William Edward 1913- *AmArch 70*
Bergmann, Anna-Eva 1909- *OxTwCA, PhDcTCA 77*
Bergmann, Benedicte 1931- *DcCAr 81*
Bergmann, Frank Walter 1898- *ArtsAmW 1*
Bergmann, Franz W 1898- *WhAmArt 85*
Bergmann, Gerhart 1922- *DcCAr 81*
Bergmann, Ignace 1797- *ArtsNiC*
Bergmann, Odo *EncASM*
Bergmann, Paula *DcWomA*
Bergmann, Richard Ronald 1935- *AmArch 70*
Bergmann, Stefan 1946- *DcCAr 81*
Bergmann-Michel, Ella 1896-1971 *DcWomA*
Bergmark, Edward Ralph 1925- *AmArch 70*
Bergmuller, John George 1688-1762 *ClaDrA*
Bergner, J Alfred *ArtsAmW 3*
Bergner, John Alfred *ArtsAmW 3*
Bergnes, G *WhAmArt 85*
Bergognone, Ambrogio *OxArt*
Bergognone, Ambrogio Da Fossano *McGDA*
Bergonzi, Carlo *AntBDN K*
Bergonzi, Michael Angelo *AntBDN K*
Bergoo, Karin 1859- *DcWomA*
Bergquist, F O 1890-1968 *ArtsAmW 2*
Bergquist, Lloyd Frederick 1929- *AmArch 70*
Bergren, G C *AmArch 70*
Bergsdottir, Valgerdur 1943- *DcCAr 81*
Bergslien, Knud Larsen 1827-1908 *ClaDrA*
Bergsma, Jody *OfPGCP 86*
Bergsma, Ralph James 1931- *AmArch 70*
Bergson, Mina *DcVicP 2*
Bergstedt, Milton Victor 1906- *AmArch 70*
Bergsten, Carl 1879-1935 *MacEA*
Bergstrand, Elisabeth *DcWomA*
Bergstrom, Donald Hill 1927- *AmArch 70*
Bergstrom, Edith Harrod *AmArt, WhoAmA 82, –84*
Bergstrom, Elizabeth T B *WhAmArt 85*
Bergstrom, Endis Ingeborg 1866- *DcWomA*
Berguson, Robert Jenkins 1944- *AmArt, WhoAmA 78, –80, –82, –84*
Berhang, Mattie *WhoAmA 84*
Berhanyer, Elio *FairDF SPA, WorFshn*
Berhard, Mrs. Richard J *WhoAmA 80N, –78N, –82N, –84N*
Bering, Joshua 1834?- *NewYHSD*
Bering, Thomas G *FolkA 86*
Berk, H A Gustav *ArtsAmW 3*
Berk, H A Gustave *ArtsAmW 3*
Berk, Toby Steven 1944- *MarqDCG 84*
Berkan, Otto 1832-1906 *WhAmArt 85*
Berkan, Otto 1834-1906 *NewYHSD*
Berke, Berenice 1920- *WhAmArt 85*
Berke, Ernest 1921- *IlBEAAW*
Berke, Hubert 1908- *OxTwCA, PhDcTCA 77*
Berkeley, Alfred R *MarqDCG 84*
Berkeley, Edith *DcWomA*
Berkeley, George 1685-1753 *OxArt*
Berkeley, Harriet *DcVicP 2*
Berkeley, Kirk 1936- *AmArch 70*
Berkeley, Martha S 1813- *DcWomA*
Berkeley, Stanley *ClaDrA, DcBrBI*
Berkeley, Stanley d1909 *DcBrA 1, DcVicP, –2, IlBEAAW*
Berkeley, William Noland 1867-1945 *WhAmArt 85*
Berkes, Ilona *DcWomA*
Berkey, Ben B 1907- *WhAmArt 85*
Berkey, John 1932- *IlrAm 1880*
Berkheyde *McGDA*
Berkley, M *DcVicP 2, DcWomA*
Berkman, Aaron 1900- *WhAmArt 85, WhoAmA 73, –76, –78, –80, –82, –84*
Berkman, Bernece 1911- *WhAmArt 85*
Berkman, Jack *WhAmArt 85*
Berkman, Lillian *WhoAmA 84*
Berkman-Hunter, Bernece 1911- *WhAmArt 85*
Berko, Bercici 1946- *DcCAr 81*
Berko, Ferenc 1916- *ConPhot, ICPEnP A, WhoAmA 84*
Berkon, Martin 1932- *WhoAmA 73, –76, –78, –80, –82, –84*
Berkowitz, Allan A 1913- *AmArch 70*
Berkowitz, Henry 1933- *WhoAmA 73, –76, –78, –80, –82, –84*
Berkowitz, Leon *WhoAmA 73, –76, –78, –80*

Berkowitz, Leon 1915- *ConArt 77*
Berkowitz, Leon 1919- *WhoAmA 82, –84*
Berkowitz, Roger M 1944- *WhoAmA 84*
Berkson, Mrs. Seymour *WorFshn*
Berla, Julian E 1902- *AmArch 70*
Berlage, H P 1856-1934 *MacEA*
Berlage, Hendrik Petrus 1856-1934 *ConArch, EncMA, McGDA, OxArt, WhoArch*
Berlaj, Jiri 1949- *DcCAr 81*
Berlandier, Jean Louis 1804?-1851 *ArtsAmW 1*
Berlandina, Jane 1898- *ArtsAmW 1, WhAmArt 85*
Berlandina, Jane 1898-1962 *DcWomA*
Berlant, Anthony 1941- *DcCAr 81*
Berlant, Tony 1941- *ConArt 77, WhoAmA 76, –78, –80, –82, –84*
Berle, Reidar Johan 1917- *WhoGrA 62, –82[port]*
Berlec, Alojz 1949- *DcCAr 81*
Berlendiz, Victor 1867- *WhAmArt 85*
Berlewi, Helene *DcWomA*
Berlewi, Henryk 1884-1967 *OxTwCA*
Berlewi, Henryk 1894-1967 *ConArt 77, –83, PhDcTCA 77*
Berlichen, Marie *DcWomA*
Berlin, Beatrice 1922- *WhoAmA 76*
Berlin, Beatrice Winn 1922- *WhoAmA 78, –80, –82, –84*
Berlin, Camille *DcWomA*
Berlin, Edwin Paul, Jr. 1957- *MarqDCG 84*
Berlin, Harry 1886- *ArtsAmW 2, WhAmArt 85*
Berlin, Q A, Jr. *AmArch 70*
Berlin, Robert C 1851-1937 *BiDAmAr*
Berlin, Sven 1911- *WhoArt 80, –82, –84*
Berlin, Sven Paul 1911- *ClaDrA, DcBrA 2*
Berlincioni, Maurizio 1943- *MacBEP*
Berlind, Robert 1938- *WhoAmA 73, –76, –78, –80, –82, –84*
Berliner, Barnett Bernard 1925- *AmArch 70*
Berlinger, J M *AmArch 70*
Berlinger, Louise *DcWomA*
Berlinghieri, Barone *OxArt*
Berlinghieri, Berlinghiero *OxArt*
Berlinghieri, Berlinghiero 1200?-1243? *McGDA*
Berlinghieri, Bonaventura *McGDA, OxArt*
Berlinghieri, Marco *OxArt*
Berlinghieri Family *OxArt*
Berlioz, Philip P 1959- *MarqDCG 84*
Berlow, Martin Warren 1928- *AmArch 70*
Berlow, Robert G 1928- *AmArch 70*
Berlowitz, Norman P 1913- *AmArch 70*
Berlyn, Sheldon 1929- *WhoAmA 76, –78, –80, –82, –84*
Berman, A B *AmArch 70*
Berman, Aaron 1922- *WhoAmA 78, –80, –82, –84*
Berman, Anni Radin 1914- *WhAmArt 85*
Berman, Ariane R 1937- *AmArt, PrintW 83, –85, WhoAmA 73, –76, –78, –80, –82, –84*
Berman, Bernard 1920- *WhoAmA 78, –80, –82, –84*
Berman, Cotelle R *WhAmArt 85*
Berman, Elliott Walter 1913- *WhAmArt 85*
Berman, Eugene 1899- *ConArt 77, DcCAA 71, McGDA*
Berman, Eugene 1899-1972 *ArtsAmW 2, BnEnAmA, DcCAA 77, OxTwCA, PhDcTCA 77, WhAmArt 85, WhoAmA 78N, –80N, –82N, –84N, WorArt[port]*
Berman, Fred J 1926- *AmArt, WhoAmA 78, –80, –82, –84*
Berman, Greta W *WhoAmA 82, –84*
Berman, H 1900-1932 *WhAmArt 85*
Berman, Leonid *McGDA, WhoAmA 73, –76*
Berman, M *AmArch 70*
Berman, Mieczyslaw 1903-1975 *ConArt 77, –83, ICPEnP A, MacBEP*
Berman, Muriel Mallin 1924- *WhoAmA 73, –76, –78, –80, –82, –84*
Berman, Nancy Mallin 1945- *WhoAmA 73, –76, –78, –80, –82*
Berman, Philip I 1915- *WhoAmA 73, –76, –78, –80, –82, –84*
Berman, Rebecca Robbins *WhoAmA 78*
Berman, Samuel *WhAmArt 85*
Berman, Sarah 1895- *DcWomA, WhAmArt 85*
Berman, Saul 1899- *WhAmArt 85*
Berman, Steven M 1947- *WhoAmA 76, –78, –80, –82, –84*
Berman, Vivian 1928- *WhoAmA 76, –78, –80, –82, –84*
Berman, Wallace 1926- *ConArt 77*
Berman, Zeke *MacBEP, PrintW 85*
Bermant, David V 1919- *WhoAmA 80, –82, –84*
Bermejo, Bartolome *McGDA, OxArt*
Bermejo-Alvarez, Pilar *DcWomA*
Bermingham, John C 1920- *WhoAmA 82, –84*
Bermingham, Peter 1937- *WhoAmA 80, –82, –84*
Bermond, Marie *DcWomA*
Bermond DeLaCombe, Josephine *DcWomA*
Bermudez, Cundo 1914- *DcCAr 81, McGDA*
Bermudez, Eugenia M *WhoAmA 73, –76, –78, –80, –82, –84*
Bermudez, Jose Ygnacio 1922- *WhoAmA 73, –76, –78, –80, –82, –84*

Bermudez, Ramon B *WhAmArt 85*
Berna Da Siena *McGDA*
Bernabe, Richard Oscar 1934- *AmArch 70*
Bernabei, Domenico *McGDA*
Bernadotte, Sigvard 1907- *McGDA*
Bernadotte, Prince Sigvard 1907- *ConDes*
Bernaerts, Nicasius 1620-1678 *ClaDrA*, *McGDA*
Bernal, Lucrecia Alejandra 1950- *WhoAmA 80, -82, -84*
Bernam, Andrew 1830?- *NewYHSD*
Bernamont, Clarisse *DcWomA*
Bernan, Charlotte A *DcVicP 2*
Bernard *NewYHSD*
Bernard De Soissons *MacEA*
Bernard Of Clairvaux, Saint 1090-1153 *McGDA*
Bernard, Adolphe 1812- *ClaDrA*
Bernard, Anais 1825- *DcWomA*
Bernard, Anthony *McGDA*
Bernard, Arnold 1815?- *NewYHSD*
Bernard, Augusta *WorFshn*
Bernard, Berenice Marshall 1923- *AmArch 70*
Bernard, David Edwin 1913- *WhAmArt 85, WhoAmA 73, -76, -78, -80, -82, -84*
Bernard, Delphine 1825-1864 *DcWomA*
Bernard, Denise *DcWomA*
Bernard, Denyse *DcWomA*
Bernard, E 1830?- *NewYHSD*
Bernard, Elisabeth *DcWomA*
Bernard, Elise *DcWomA*
Bernard, Emile 1868-1941 *McGDA, OxTwCA, PhDcTCA 77*
Bernard, Felix S 1919- *WhoAmA 78, -80, -82*
Bernard, Francis 1900- *WhoGrA 62*
Bernard, Francisco *NewYHSD*
Bernard, Franz 1934- *DcCAr 81*
Bernard, J *AmArch 70*
Bernard, J G *AmArch 70*
Bernard, Jeanne *DcWomA*
Bernard, Joseph 1866-1931 *OxTwCA*
Bernard, L C, Sr. *AmArch 70*
Bernard, Leon G 1907- *AmArch 70*
Bernard, Leslie Cosby, Jr. 1919- *AmArch 70*
Bernard, Margaret *DcVicP 2, DcWomA*
Bernard, Marguerite Mathilde Anna *DcWomA*
Bernard, Marie *DcWomA*
Bernard, Marie d1881 *DcWomA*
Bernard, Marie De *DcWomA*
Bernard, Marie Jeanne *DcWomA*
Bernard, Mathilde *DcWomA*
Bernard, Nicholas *CabMA*
Bernard, Sister Regina 1879-1947 *WhAmArt 85*
Bernard, Walter 1937- *AmGrD[port]*
Bernard-Beauvalet, Jeanne *DcWomA*
Bernard DuHautcilly, Auguste *NewYHSD*
Bernard-Paugoy, Raymonde 1891- *DcWomA*
Bernardelli, A *ArtsNiC*
Bernardes, Sergio 1919- *ConArch, MacEA*
Bernardet *NewYHSD*
Bernardi, Theodore C 1903- *AmArch 70*
Bernardin, Emilie Camille *DcWomA*
Bernardini, Orestes 1880-1957 *WhAmArt 85, WhoAmA 80N, -82N, -84N*
Bernardini, Piero 1891-1974 *WorECar*
Bernardino Da Novate *McGDA*
Bernardino Di Betto *McGDA, OxArt*
Bernardino Di Mariotto Dello Stagno 1478?-1566 *McGDA*
Bernardino Of Siena, Saint 1380-1444 *McGDA*
Bernardo Di Marco Renzi *McGDA*
Bernardo, J R *AmArch 70*
Bernardo, Jose Raul 1938- *AmArch 70*
Bernart, Adele M 1868- *ArtsEM, DcWomA*
Bernasconi, George H *DcVicP 2*
Bernasconi, Laura d1674? *DcWomA*
Bernat, Emile 1868- *WhAmArt 85*
Bernat, Martha Milligan 1912- *WhAmArt 85*
Bernath, Sandor 1892- *WhAmArt 85*
Bernau, Charlotte *DcVicP 2*
Bernay, Betti *WhoAmA 80, -82, -84*
Bernay, Betti 1926- *WhoAmA 73, -76, -78*
Bernbrock, William Frederick *AmArch 70*
Bernd-Cohen, Max 1899- *WhAmArt 85*
Berndt, Franklin 1953- *MarqDCG 84*
Berndt, Jerry 1943- *MacBEP*
Berndt, Peter 1937- *DcCAr 81*
Berndt, Walter 1899- *WorECom*
Berndt, Walter 1900-1979 *WhoAmA 80N, -82N, -84N*
Berndtson, P *AmArch 70*
Berne, Gustave Morton 1903- *WhoAmA 73, -76, -78*
Berne, Robert 1917- *AmArch 70*
Berne-Bellecour, Etienne-Prosper *ArtsNiC*
Bernea, Horia 1938- *ConArt 77*
Bernea, Horia 1939- *DcCAr 81*
Berneche, Jerry Douglas 1932- *WhoAmA 76, -78, -80, -82, -84*
Berneker, Louis F 1872-1937 *WhAmArt 85*
Berneker, Maud F 1882- *WhAmArt 85*
Berneker, Maud Fox 1882- *DcWomA*
Berner, Bernd 1930- *ConArt 77, OxTwCA*
Berner, Mrs. E *WhAmArt 85*

Berner, F A *AmArch 70*
Berner, Jeff 1940- *MacBEP*
Berners, Miss *DcWomA*
Berners, E H *AmArch 70*
Bernet, Jordi 1944- *ConGrA 1[port]*
Bernet, Otto 1881-1945 *WhAmArt 85*
Bernet-Rollande-Ferriere, Germaine L *DcWomA*
Bernett, Louis 1831?- *NewYHSD*
Berney, Bertram S *WhoAmA 78N, -80N, -82N, -84N*
Berney, Bertram S 1884-1950? *WhAmArt 85*
Berney, Theresa 1904- *WhAmArt 85*
Bernhard, Harold C 1904- *AmArch 70*
Bernhard, James V 1927- *AmArch 70*
Bernhard, Joseph L *WhAmArt 85*
Bernhard, Lucian 1883- *WhAmArt 85, WhoGrA 62*
Bernhard, Lucian 1883-1972 *ConDes*
Bernhard, Ruth 1905- *ConPhot, ICPEnP A, MacBEP, WhoAmA 84*
Bernhardt, Barbara 1913- *WhAmArt 85*
Bernhardt, Peter *FolkA 86*
Bernhardt, Sarah *ArtsNiC*
Bernhardt, Sarah Marie Henriette 1844-1923 *DcWomA*
Bernheimer, Franz Karl 1911- *WhAmArt 85*
Bernheimer, Richard 1907-1958 *WhAmArt 85, WhoAmA 80N, -82N, -84N*
Berni, Alan 1912- *WhAmArt 85*
Berni, Antonio 1905- *ConArt 83, McGDA, OxTwCA, PhDcTCA 77, WorArt[port]*
Bernier *FolkA 86*
Bernier, Camille *ArtsNiC*
Bernier, Camille 1823-1902? *ClaDrA*
Bernier, Jenny *DcWomA*
Bernik, Janez 1933- *OxTwCA, PhDcTCA 77*
Berninghaus, Julius Charles 1905- *IlBEAAW, WhAmArt 85*
Berninghaus, Oscar E d1952 *WhoAmA 78N, -80N, -82N, -84N*
Berninghaus, Oscar E 1874-1952 *ArtsAmW 1*
Berninghaus, Oscar Edmund 1874-1952 *IlBEAAW, WhAmArt 85*
Bernini, Gian Lorenzo 1598-1680 *McGDA*
Bernini, Gianlorenzo 1598-1680 *OxArt[port], WhoArch*
Bernini, Giovanni 1598-1680 *DcD&D*
Bernini, Giovanni Lorenzo 1598-1680 *MacEA*
Bernini, Pietro 1562-1629 *McGDA, OxArt*
Bernini, Rosalba *DcWomA*
Bernouard, Albertine *DcWomA*
Bernouard, Suzanne *DcWomA*
Bernoudy, W A *AmArch 70*
Bernoulli, Hans 1876-1959 *MacEA*
Berns, Pamela Kari 1947- *AmArt, WhoAmA 82, -84*
Bernson, Eugene Stromness 1924- *AmArch 70*
Bernstein, Aline *DcWomA, WhAmArt 85*
Bernstein, Benjamin D 1907- *WhoAmA 73, -76, -78, -80, -82, -84*
Bernstein, David Martin 1936- *MacBEP*
Bernstein, Edna L 1884- *DcWomA, WhAmArt 85*
Bernstein, Edward Harrison 1927- *AmArch 70*
Bernstein, Edward I 1917- *WhoAmA 80, -82, -84*
Bernstein, Ephraim *WhAmArt 85*
Bernstein, Eva 1871-1958 *WhoAmA 80N, -82N, -84N*
Bernstein, Gerald 1917- *WhoAmA 73, -76, -78, -80, -82, -84*
Bernstein, Henry 1912- *WhAmArt 85*
Bernstein, Joseph 1930- *WhoAmA 76, -78*
Bernstein, Judith 1942- *PrintW 83, -85, WhoAmA 76, -78, -80, -82, -84*
Bernstein, Lawrence 1931- *AmArch 70*
Bernstein, Lou 1911- *ICPEnP A*
Bernstein, Michael *WhAmArt 85*
Bernstein, Morris *McGDA*
Bernstein, Morton Arthur 1932- *AmArch 70*
Bernstein, Nathan 1913- *AmArch 70*
Bernstein, Richard 1942- *PrintW 83, -85*
Bernstein, Samuel E *EncASM*
Bernstein, Saralinda 1951- *WhoAmA 82, -84*
Bernstein, Saul 1872-1905 *WhAmArt 85*
Bernstein, Saul 1933- *MarqDCG 84*
Bernstein, Sheldon J 1922- *AmArch 70*
Bernstein, Sol Bernard 1908- *AmArch 70*
Bernstein, Sylvia 1918- *WhoAmA 73, -76, -78, -80, -82, -84*
Bernstein, Theresa *WhoAmA 73, -76, -78, -80, -82, -84*
Bernstein, Theresa F *DcWomA, WhAmArt 85*
Bernstein, William *MarqDCG 84*
Bernstein, William Joseph 1945- *WhoAmA 76, -78, -80, -82, -84*
Bernstein, Zena *IlsBYP*
Bernstrom, Victor 1845-1907 *WhAmArt 85*
Bernward, Bishop 960?-1023? *McGDA*
Bernzott, Robert A 1932- *AmArch 70*
Beroldingen, Countess Marie Von 1853- *DcWomA*
Berolzheimer, Myra 1889- *DcWomA*
BeRoth, Leon A 1895?-1980 *ArtsAmW 3*
Beroud, Louis 1852- *ClaDrA*
Beroujon, Claude *BiDAmAr*
Berovieri, Angelo *OxDecA*
Berque, Andree *DcWomA*

Berr DeTurique, Jane *DcWomA*
Berrall, James Lloyd 1903- *AmArch 70*
Berreau, Alfred James 1932- *AmArch 70*
Berrecci, Bartolommeo d1537 *MacEA*
Berrell, E *DcWomA*
Berresford, Benjamin *FolkA 86*
Berresford, Virginia *WhoAmA 73, -76, -78, -80, -82*
Berresford, Virginia 1904- *WhAmArt 85*
Berrett, James R *MarqDCG 84*
Berrettini, Pietro *McGDA*
Berrettini, Pietro 1596-1669 *ClaDrA*
Berrhagorry-Suair, Gabrielle 1873- *DcWomA*
Berri, Duc De *McGDA*
Berri, Marie Caroline F Louise DeBourbon 1798-1870 *DcWomA*
Berridge, John 1740- *DcBrECP*
Berridge, William Sidney *DcVicP, -2*
Berrie, John Archibald Alexander 1887- *ClaDrA*
Berrie, John Archibald Alexander 1887-1962 *DcBrA 1*
Berrill, Jacquelyn 1905- *IlsCB 1957*
Berrington, William 1873- *DcBrA 1*
Berrisford, Peter 1932- *ClaDrA, WhoArt 80, -82, -84*
Berrocal, Miguel 1933- *PhDcTCA 77*
Berrocal, Miguel-Ortiz 1933- *ConArt 77*
Berrugete, Alonso 1486-1561 *ClaDrA*
Berruguete, Alonso 1488?-1561 *McGDA, OxArt*
Berruguete, Pedro *McGDA*
Berruguete, Pedro d1503? *OxArt*
Berruguette, Alonso 1486-1561 *ClaDrA*
Berry *FolkA 86*
Berry, Mrs. *DcWomA*
Berry, Agnes *DcWomA*
Berry, Annabel Sedlle *WhAmArt 85*
Berry, Arthur 1923- *AfroAA*
Berry, C *AmArch 70*
Berry, Camelia 1918- *WhAmArt 85*
Berry, Carolyn 1930- *AmArt, WhoAmA 80, -82, -84*
Berry, Carroll Thayer 1886- *WhAmArt 85*
Berry, Ellen McClung *WhAmArt 85*
Berry, Erica *OxTwCA*
Berry, Erick 1892- *ConICB, IlsCB 1946*
Berry, Mrs. Erick 1892- *WhAmArt 85*
Berry, F H *ArtsEM, DcWomA*
Berry, Ferdinand *CabMA*
Berry, Glenn 1929- *WhoAmA 73, -76, -78, -80, -82, -84*
Berry, H A *AmArch 70*
Berry, Hans *FolkA 86*
Berry, Harry William 1924- *AmArch 70*
Berry, Helen Murrin 1900- *WhAmArt 85*
Berry, Hester *DcWomA*
Berry, Ian 1934- *ConPhot, ICPEnP A*
Berry, James 1805-1877 *FolkA 86*
Berry, James Lawrence 1875- *BiDAmAr*
Berry, James Richard 1932- *AmArch 70*
Berry, James Vernon 1957- *MarqDCG 84*
Berry, Jean, Duc De 1340-1416 *McGDA*
Berry, Jim 1932- *WorECar*
Berry, Jon Ronald 1932- *AmArch 70*
Berry, Jonnie E *FolkA 86*
Berry, June 1924- *WhoArt 80, -82, -84*
Berry, Kenneth Norman 1933- *AmArch 70*
Berry, M A *AmArch 70*
Berry, Marie Caroline F Louise DeBourbon 1798-1870 *DcWomA*
Berry, Martha 1916- *WhAmArt 85*
Berry, Mary Elizabeth *DcBrA 1, DcWomA*
Berry, Maud *DcWomA*
Berry, Maude *DcVicP 2*
Berry, Nathaniel L 1859- *WhAmArt 85*
Berry, Noah, Jr. 1916- *IlBEAAW*
Berry, O R *AmArch 70*
Berry, Patrick Vincent 1852-1922 *WhAmArt 85*
Berry, Phil *WhAmArt 85*
Berry, R L *AmArch 70*
Berry, Reuben 1923- *AfroAA*
Berry, Robert *CabMA*
Berry, Robert McConnell 1908- *AmArch 70*
Berry, Ruth Linnell 1909- *WhAmArt 85*
Berry, Sarah Nichols Page *DcWomA, NewYHSD*
Berry, Thomas *BiDBrA*
Berry, William A 1933- *ConGrA 1*
Berry, William Augustus 1933- *WhoAmA 80, -82, -84*
Berry, William David 1926- *IlsCB 1957, WhoAmA 78*
Berry, William David 1926-1979 *WhoAmA 80N, -82N, -84N*
Berry, Wils 1851- *WhAmArt 85*
Berry-Berry, Francis *DcVicP 2*
Berry-Hart, David James 1940- *WhoArt 80, -82, -84*
Berryhill, Mary A *ArtsEM, DcWomA*
Berryman, Clifford Kennedy d1949 *WhoAmA 78N, -80N, -82N, -84N*
Berryman, Clifford Kennedy 1869-1949 *WhAmArt 85, WorECar*
Berryman, Derek James 1926- *WhoArt 82, -84*
Berryman, Florence Seville *WhAmArt 85*
Berryman, James 1902-1976 *WorECar*
Berryman, James Thomas 1902- *WhAmArt 85*

Bickel, John Henry, III 1922- *AmArch 70*
Bickel, W *FolkA 86*
Bickerstaff, Glenn Arthur 1910- *AmArch 70*
Bickerton, Francis *BiDBrA*
Bickerton, Leonard Marshall 1914- *WhoArt 80, –82, –84*
Bickford, George Percival 1901- *WhoAmA 73, –76, –78, –80, –82, –84*
Bickford, Henry H 1863-1929 *BiDAmAr*
Bickford, Jackson Rockwell 1913- *AmArch 70*
Bickford, John Holden 1946- *MarqDCG 84*
Bickford, Nelson Norris 1846-1943 *WhAmArt 85*
Bickford, Robert Turner 1894- *AmArch 70*
Bickham, Mrs. *DcWomA, NewYHSD*
Bickham, George d1769 *BkIE*
Bickham, George 1684-1758 *AntBDN I*
Bickham, George 1684?-1769 *McGDA*
Bickham, George, Jr. d1749 *BkIE*
Bickle, Herbert William 1911- *DcBrA 1*
Bickley, Gary Steven 1953- *WhoAmA 82, –84*
Bickley, George H 1880-1938? *BiDAmAr*
Bickley, H M *DcVicP 2*
Bickman, Helen 1935- *DcCAr 81*
Bicknell, Mrs. *DcVicP 2*
Bicknell, Albion Harris 1837-1915 *NewYHSD, WhAmArt 85*
Bicknell, Bruce 1931- *AmArch 70*
Bicknell, Charlotte 1792-1848 *FolkA 86*
Bicknell, Emily E *DcWomA*
Bicknell, Evelyn M 1857-1936 *WhAmArt 85*
Bicknell, Frank A *WhAmArt 85*
Bicknell, W H W 1860- *WhAmArt 85*
Bickner, Sam *FolkA 86*
Bicksler, Charles Stoll 1919- *AmArch 70*
Bicksler, Jacob S *FolkA 86*
Bickstead, A E *FolkA 86*
Bida, Alexandre 1813- *ArtsNiC*
Bidau, J *DcVicP 2*
Bidauld, Jean Joseph Xavier 1758-1846 *ClaDrA*
Bidauld, Rosalie 1798-1876 *DcWomA*
Bidault, Lucie *DcWomA*
Biddard, C *DcBrBI*
Biddle, Beulah *FolkA 86*
Biddle, Edward 1851-1933 *WhAmArt 85*
Biddle, George *OxTwCA*
Biddle, George 1885- *ArtsAmW 1, DcCAA 71, McGDA, WhoAmA 73*
Biddle, George 1885-1973 *ArtsAmW 3, BnEnAmA, DcAmArt, DcCAA 77, IlBEAAW, WhAmArt 85, WhoAmA 76N, –78N, –80N, –82N, –84N*
Biddle, Mrs. George *WhAmArt 85*
Biddle, Helene *DcWomA*
Biddle, James 1929- *WhoAmA 73, –76, –78, –80, –82, –84*
Biddle, Livingston Ludlow, Jr. 1918- *WhoAmA 78, –80, –82, –84*
Biddle, R J *DcVicP 2*
Biddle, Robert Stone d1857? *NewYHSD*
Biddle, Robert W *FolkA 86*
Biddle, Violet *DcWomA*
Biddle, Winifred Percy 1878- *DcBrA 1, DcWomA*
Biddle, Winifred Percy 1878-1968 *DcBrA 2*
Biddlecombe, Walter *DcVicP 2*
Biddulph, Edith *DcVicP 2*
Biddulph, Elizabeth Mary 1927- *WhoArt 80, –82, –84*
Biddulph, Sir Michael A *DcVicP 2*
Biddulph, Sir Michael Anthony Shrapnel 1823-1904 *DcBrBI*
Bidell, Delia B *ArtsEM, DcWomA*
Biderman, Sam 1897- *AmArch 70*
Bidermanas, Israelis 1911-1980 *MacBEP*
Bidigare, Frederick Joseph 1941- *AmArch 70*
Bidlake, John *DcBrWA*
Bidlake, W H 1861-1938 *MacEA*
Bidner, Robert D H 1930- *WhoAmA 73, –76, –78, –80, –82, –84*
Bidoli Salvagnini, Ida 1866- *DcWomA*
Bidouz, J *DcVicP 2*
Bids *FolkA 86*
Bidstrup, Herluf 1912- *WorECar*
Bidwell, Alice *DcWomA*
Bidwell, Elizabeth Sullivan *FolkA 86*
Bidwell, Mary W *DcWomA, NewYHSD*
Bidwell, Raye *WhAmArt 85*
Bidwell, Thomas *NewYHSD*
Bidwell, Titus *FolkA 86*
Bidwell, Watson *WhoAmA 78N, –80N, –82N, –84N*
Bidwell, Watson 1904-1964? *WhAmArt 85*
Bie, Adrian De 1593-1668 *ClaDrA*
Bie, Cornelis De 1621-1654 *ClaDrA*
Bie, Katrine Hvidt *WhAmArt 85*
Biebel, Franklin M *WhoAmA 78N, –80N, –82N, –84N*
Biebel, Franklin Matthews 1908-1968? *WhAmArt 85*
Biebel, Harold Miller 1949- *MarqDCG 84*
Bieber, Elinore Maria Korow 1934- *WhoAmA 84*
Bieber, Margarete 1880-1978 *WhoAmA 78N, –80N, –82N, –84N*
Biebesheimer, Frederick Carl, III 1939- *AmArch 70*
Biederman, Charles 1906- *ConArt 77, –83,*

Biederman, Charles Joseph 1906- *DcCAA 71, –77, OxTwCA, PhDcTCA*
Biederman, Charles L *AmArch 70*
Biedermann, C *DcBrECP*
Biedermann, Eduard *WhAmArt 85*
Biedermann, Johann Jakob 1763-1830 *ClaDrA*
Biedermann, Max 1914- *WhoAmA 73, –76*
Biedermann, Wolfgang E 1940- *DcCAr 81*
Biedermann-Arendts, Hermine 1855- *DcWomA*
Biefve, Edouard De 1808-1882 *ArtsNiC, ClaDrA*
Bieganski, Piotr 1905- *MacEA*
Biegel, Peter 1913- *DcBrA 2*
Biehl, Arthur Oliver 1926- *WhoAmA 73*
Biehl, Godfrey F *WhAmArt 85*
Biehle, August *WhAmArt 85*
Biehn, Irving Lew 1900- *WhAmArt 85*
Biel *IlBEAAW*
Biel, Antonie 1830-1880 *DcWomA*
Biel, Egon Vitalis 1902- *WhAmArt 85*
Biel, Joseph 1891-1943 *WhAmArt 85*
Biel, Lena Gurr *WhAmArt 85*
Biel, Michael Von 1937- *DcCAr 81*
Bielecky, Stanley *WhAmArt 85*
Bielefeld, Otto F 1908- *WhAmArt 85*
Bielenberg, George *WhAmArt 85*
Bieler, Andre 1896- *ClaDrA*
Bieler, Andre Charles 1896- *WhoAmA 73, –76, –78, –80, –82, –84*
Bieler, Elisabeth *DcWomA*
Bieler, Helene *DcWomA*
Bieler, Nathalie *DcWomA*
Bieler, Ted Andre 1938- *WhoAmA 76, –78, –80, –82, –84*
Bieletto, Benedetto B *WhAmArt 85*
Bielfield, H *DcVicP 2*
Bielich, G A *AmArch 70*
Bielski, M *AmArch 70*
Biemann, Dominik 1800-1857 *IlDcG*
Bien, Ania *DcCAr 81*
Bien, Julius 1826-1909 *NewYHSD*
Bien, Julius 1829-1909 *AntBDN I*
Bien, Robert Lowell 1923- *AmArch 70*
Bienaime, Flore Amelie *DcWomA*
Bieniek, V J *WhAmArt 85*
Biennier, Marie 1886- *DcWomA*
Bienstock, Herbert 1931- *AmArch 70*
Bier, Justus 1899- *WhAmArt 85, WhoAmA 73, –76, –78, –80, –82, –84*
Bier, Wolfgang 1943- *DcCAr 81*
Bierach, S E 1872- *ArtsAmW 2, WhAmArt 85*
Biercher, Mathieu 1797- *ArtsNiC*
Bierhals, Otto 1879- *IlBEAAW, WhAmArt 85*
Biering, R O *AmArch 70*
Bierk, David 1944- *DcCAr 81*
Bierk, David Charles 1944- *WhoAmA 78, –80*
Bierkowska, Leona *DcWomA*
Bierly, Edward J *OfPGCP 86*
Bierly, Edward J 1920- *WhoAmA 82, –84*
Bierman, Fred *DcWomA*
Bierman, Samuel 1902-1978 *WhoAmA 80N, –82N, –84N*
Biermann, Aenne 1898-1933 *ConPhot, ICPEnP A*
Biermann, B E *ConArch A*
Biermann, Charles Edouard 1803- *ArtsNiC*
Biermann, Daisy 1874- *DcWomA*
Biernacka, Aniela Von *DcWomA*
Biernacki-Poray, Wlad Otton 1924- *AmArch 70*
Bierrum, William Charles 1936- *AmArch 70*
Bierschenk, Carl Arnold 1906- *AmArch 70*
Bierstadt, Albert 1829- *ArtsNiC*
Bierstadt, Albert 1830-1902 *ArtsAmW 1, BnEnAmA, DcAmArt, DcSeaP, EarABI, IlBEAAW, McGDA, NewYHSD, WhAmArt 85*
Bierstadt, Mary F Hicks Stewart 1837-1916 *WhAmArt 85*
Bieruma-Oosting, Jeanne *DcWomA*
Biery, R B *AmArch 70*
Biese, Helmi 1867- *DcWomA*
Biesecker, Jacob, Jr. 1806-1865 *FolkA 86*
Biesel, Charles 1865-1945 *ArtsAmW 3, WhAmArt 85*
Biesel, Frances *DcWomA*
Biesel, Fred 1893- *WhAmArt 85*
Biesel, Fred H 1893-1962? *ArtsAmW 3*
Bieser, Natalie 1948- *WhoAmA 76, –78, –80, –82, –84*
Biesiot, Elizabeth Kathleen Gall 1920- *WhAmArt 85*
Biester, Anthony 1837-1917 *WhAmArt 85*
Biester, Anthony 1840-1917 *NewYHSD*
Biet, Mademoiselle *DcWomA*
Bietry, Raymond Emile, Jr. 1945- *MarqDCG 84*
Bietz, Hugo H 1892- *WhAmArt 85*
Bievre, Marie De 1865- *DcWomA*
Bifelt *NewYHSD*
Biferie, Dan 1950- *MacBEP, PrintW 83, –85*
Biferie, Dan, Jr. 1950- *WhoAmA 82, –84*
Biffi, Gian Andrea 1570?-1631 *McGDA*
Biffin, Sarah 1784-1850 *DcBrWA, DcWomA*
Big Bow, Woodrow Wilson 1914- *IlBEAAW, WhAmArt 85*
Bigaglia, Pierre *AntBDN H*

Bigaglia, Pietro *IlDcG*
Bigarelli Da Arogno, Guido *McGDA*
Bigari, Angelo Maria *DcBrWA*
Bigari, Vittorio Maria 1692-1776 *McGDA*
Bigarny, Felipe De 1470?-1543 *McGDA*
Bigaud, Wilson *OxTwCA*
Bigaud, Wilson 1931- *McGDA*
Bigault, Louise *DcWomA*
Bigbee, Michael Henry 1954- *MarqDCG 84*
Bigbee, William Lynn 1927- *AmArch 70*
Bige, Marie Anne Herminie *DcWomA*
Bigelow, C B 1860- *WhAmArt 85*
Bigelow, Chandler, II 1937- *WhoAmA 76, –78*
Bigelow, Charles C 1891- *WhAmArt 85*
Bigelow, Constance *WhAmArt 85*
Bigelow, Daniel Folger 1823-1910 *NewYHSD, WhAmArt 85*
Bigelow, Florence Edgerton 1871- *DcWomA*
Bigelow, Henry Forbes 1867-1929 *BiDAmAr, MacEA*
Bigelow, James W *NewYHSD*
Bigelow, Mrs. James W *NewYHSD*
Bigelow, John *EncASM*
Bigelow, Kile 1925- *AmArch 70*
Bigelow, L Seymour, Jr. *WhAmArt 85*
Bigelow, Lyman G *ArtsEM*
Bigelow, Olive 1886- *WhAmArt 85*
Bigelow, Olive Tilton 1886-1980 *DcWomA*
Bigelow, P W *FolkA 86*
Bigelow, Robert Clayton 1940- *WhoAmA 84*
Bigelow, Samuel *NewYHSD*
Bigelow, Sophia B *DcWomA, NewYHSD*
Bigelow, William Sturgis 1850-1926 *WhAmArt 85*
Bigelow Kennard *EncASM*
Bigg, Charles O *DcVicP 2*
Bigg, William Redmore 1755-1828 *DcBrECP*
Biggar, Charles H 1882-1946 *BiDAmAr*
Biggar, Whitney 1920- *AmArch 70*
Biggard, John *CabMA*
Bigge, John 1892- *McGDA*
Bigge, John A 1892-1973 *OxTwCA*
Bigge, John A S 1892- *PhDcTCA 77*
Bigge, John Selby 1892- *DcBrA 1*
Bigger, Michael D 1937- *WhoAmA 84*
Bigger, Michael Dinsmore 1937- *WhoAmA 78, –80*
Bigger, Peacock *FolkA 86*
Biggers, Charles M *WhAmArt 85*
Biggers, Henry C, Jr. 1926- *AmArch 70*
Biggers, I *EncASM*
Biggers, J J *AmArch 70*
Biggers, John T 1924- *AfroAA*
Biggers, John Thomas 1924- *WhAmArt 85, WhoAmA 76, –78, –80, –82, –84*
Biggers, Mattie 1872- *ArtsAmW 3*
Biggie, Theodore Albert, Jr. 1933- *AmArch 70*
Biggin, E A *AmArch 70*
Biggin, Frederick C 1869-1948? *BiDAmAr*
Biggins, Henry *NewYHSD*
Biggins, Henry E *EncASM*
Biggins-Rodgers *EncASM*
Biggs, Charles Owen, III 1926- *AmArch 70*
Biggs, Geoffrey 1908- *IlrAm E, –1880, WhAmArt 85*
Biggs, J E *AmArch 70*
Biggs, John R 1909- *DcBrA 1, WhoArt 80, –82, –84*
Biggs, Les *DcCAr 81*
Biggs, Richard d1776 *BiDBrA*
Biggs, Thomas Jones 1912- *AmArch 70*
Biggs, Walter 1886- *IlrAm C, WhAmArt 85*
Biggs, Walter 1886-1968 *IlrAm 1880*
Bigio, Francesco 1482-1525 *ClaDrA*
Bigio, Nanni DiBaccio d1568 *MacEA*
Bigland, M B *DcBrWA*
Bigland, Mary B *DcVicP 2, DcWomA*
Bigland, Percy *WhAmArt 85*
Bigland, Percy d1926 *DcBrA 1, DcVicP 2*
Bigler, Mary Jane White *WhAmArt 85*
Bignardi, Secondo 1925- *WorECar*
Bignell, J E *AmArch 70*
Bignet, Elisabeth *DcWomA*
Bigoney, William Franc 1921- *AmArch 70*
Bigordi *OxArt*
Bigordi, Domenico *McGDA*
Bigot, Alexandre 1862-1927 *DcNiCA*
Bigot, Alphonse 1828?-1873? *NewYHSD*
Bigot, Charles *DcBrWA*
Bigot, Eugenie Victoire d1907 *DcWomA*
Bigot, Francis *NewYHSD*
Bigot, Gabrielle De *DcWomA*
Bigot, Toussaint Francois 1794-1869 *ArtsAmW 1, NewYHSD*
Biguerny *OxArt*
Biguerny, Felipe De *McGDA*
Bigwood, John 1822?- *CabMA*
Bihan, D L *DcVicP 2*
Biheron, Mademoiselle *DcWomA*
Bihlman, Carl 1898- *ArtsAmW 3*
Bihzad *McGDA*
Bihzad, Kamal Ud-Din 1460?-1535 *OxArt*
Bijelic, Jovan 1886-1964 *PhDcTCA 77*
Bijlert, Jan Van 1597?-1671 *McGDA*

Bijlsma, Ronald 1934- *WorECar*
Bijotat, Simon *FolkA 86*
Bijur, Nathan I 1875- *WhAmArt 85*
Biki *WorFshn*
Bilbie, James L *DcVicP 2*
Bilbro, Gerald Lee 1918- *AmArch 70*
Bilby, William *BiDBrA*
Bilcher, A Earle 1916- *WhoAmA 73, –76*
Bilde, Dana *DcWomA*
Bilden, Richard P 1937- *MarqDCG 84*
Bilderdijk, Katharina Wilhelmina 1777-1830 *DcWomA*
Bilders, J W *ArtsNiC*
Bilders VanBosse, Maria Philippina *DcWomA*
Bileck, Marvin 1920- *IlsBYP, IlsCB 1946, –1957, WhoAmA 73, –76*
Bilek, Franziska 1915?- *WorECar*
Bilfeldt, John Joseph 1793-1849? *NewYHSD*
Bilfield *NewYHSD*
Bilhamer, Joost Janszoon 1521-1590 *MacEA*
Bilibin, Alex *DcBrA 1*
Bilibin, Ivan Iakolevich 1876-1942 *WorECar*
Bilinska, Anna 1857?-1893 *DcWomA*
Bilivert, Giacomo 1550-1593 *McGDA*
Biliverti, Giovanni 1576-1644 *McGDA*
Bill, Carroll 1877- *WhAmArt 85*
Bill, John Gordon 1915- *ClaDrA, DcBrA 1, WhoArt 80, –82, –84*
Bill, Mary Florence *DcWomA*
Bill, Max 1908- *ClaDrA, ConArch, ConArt 77, –83, ConDes, DcCAr 81, EncMA, MacEA, McGDA, OxTwCA, PhDcTCA 77, PrintW 85, WhoArt 80, –82, –84, WhoGrA 62, WorArt*
Bill, Rosa *DcWomA*
Bill, Sally Cross *DcWomA, WhAmArt 85*
Billauer, Sophie *DcWomA*
Bille, Carle Ludvig 1815-1898 *DcSeaP*
Bille, Ejler 1910- *PhDcTCA 77*
Billeci, Andre George 1933- *WhoAmA 78, –80, –82, –84*
Biller, A *DcVicP 2*
Biller, C *DcVicP 2*
Billerbeck, E R *AmArch 70*
Billet, Pierre *ArtsNiC*
Billet, Pierre 1837-1922 *ClaDrA*
Billetdoux, Adrienne d1936 *DcWomA*
Billhardt, Carl F 1942- *MarqDCG 84*
Billhult, Sture 1930- *MarqDCG 84*
Billian, Cathey R 1946- *AmArt, WhoAmA 80, –82, –84*
Billich, Charles *DcCAr 81*
Billin, Edward S 1911- *DcBrA 1, WhoArt 80, –82, –84*
Billing *BiDBrA*
Billing, Anna *DcWomA*
Billing, Arthur 1824-1896 *BiDBrA*
Billing, Miss C *DcBrA 1*
Billing, Clara *DcWomA*
Billing, Frederick William 1835-1914 *ArtsAmW 2, –3*
Billing, Hermann 1867-1946 *MacEA*
Billing, John 1816-1863 *BiDBrA*
Billing, Richard, I 1747?-1826 *BiDBrA*
Billing, Richard, II 1785?-1853 *BiDBrA*
Billing, Richard, III 1815?-1884 *BiDBrA*
Billing, Russell Edgar 1926- *AmArch 70*
Billinghurst, Alfred John 1880-1963 *DcBrA 1*
Billinghurst, Percy J *DcBrBI*
Billings, A *NewYHSD*
Billings, E *NewYHSD*
Billings, Edwin T 1824-1893 *NewYHSD*
Billings, Hammatt d1874 *ArtsNiC*
Billings, Hammatt 1816-1874 *NewYHSD*
Billings, Hammatt 1818-1874 *EarABI, EarABI SUP, MacEA*
Billings, Hammatt 1818-1875 *BiDAmAr*
Billings, Henry 1901- *IlsCB 1946, WhAmArt 85, WhoAmA 73, –76, –78, –80, –82, –84*
Billings, Henry J 1894- *WhAmArt 85*
Billings, Howard Arthur 1943- *MarqDCG 84*
Billings, Joseph *NewYHSD*
Billings, Kathleen Wyatt *WhoArt 80, –82, –84*
Billings, Kathleen Wyatt 1911- *DcBrA 2*
Billings, Mary H *WhAmArt 85*
Billings, Mary Hathaway *DcWomA*
Billings, Moses 1809-1884 *NewYHSD*
Billings, Pheobe 1690-1775 *FolkA 86*
Billings, Richardson *NewYHSD*
Billings, Robert William 1815-1874 *DcBrBI, DcBrWA*
Billings, William *FolkA 86*
Billingsley, L C *AmArch 70*
Billingsley, Michael Cerulli 1946- *MacBEP*
Billingsley, William 1758?-1828 *AntBDN M*
Billingsley, William 1760-1828 *DcNiCA*
Billington *BiDBrA*
Billington, Dora May *DcNiCA*
Billington, John *BiDBrA*
Billington, John d1773 *BiDBrA*
Billington, John J 1900- *WhAmArt 85*
Billington, William d1835 *BiDBrA*
Billinton, John 1780?-1835 *BiDBrA*
Billman, Donald Jay 1924- *AmArch 70*
Billmeyer, C J *AmArch 70*

Billmeyer, William B 1877-1935 *BiDAmAr*
Billmyer, Charlotte Post 1901- *WhAmArt 85*
Billmyer, James Irwin 1897- *WhAmArt 85*
Billmyer, John Edward 1912- *WhoAmA 73, –76, –78, –80, –82, –84*
Billon, Daniel 1927- *WorECar*
Billop, William *BiDBrA*
Billotte, Rene 1846-1915 *ClaDrA*
Billquist, Thorsten E -1923 *BiDAmAr*
Bills, Chaplin Edward 1906- *AmArch 70*
Bills, John Marvin 1925- *AmArch 70*
Bills, John Paul 189?- *AmArch 70*
Billy, F De *DcWomA*
Billyard, Kenneth Harry *WhoArt 80N*
Billyeald, Arthur *DcVicP 2*
Bilmer, Colby *NewYHSD*
Bilodeau, Laura DuBarry 1896- *DcWomA, WhAmArt 85*
Bilotti, A G Hesse *WhAmArt 85*
Bilotti, Salvatore F d1953 *WhoAmA 78N, –80N, –82N, –84N*
Bilotti, Salvatore F 1879-1953 *WhAmArt 85*
Bilous, Priscilla Haley *WhoAmA 82, –84*
Bilsbie, Charles *DcBrBI*
Bilston, S *DcBrWA, DcVicP 2*
Bilton, A *DcVicP 2*
Bilyard, Richard Gordon 1923- *AmArch 70*
Bilzonis, Zigurd 1946- *ICPEnP A*
Bimann, Dominik 1800-1837 *DcNiCA*
Bimrose, Art 1912- *WorECar*
Bimrose, Arthur Sylvanus, Jr. 1912- *WhoAmA 76, –78, –80, –82, –84*
Binago, Lorenzo 1554-1629 *MacEA*
Binai, Paul Freye 1932- *WhoAmA 73, –76, –78, –80, –82, –84*
Binart, Adelaide *DcWomA*
Binay, Mathilde *DcWomA*
Binck, Jacob 1500?-1569 *McGDA*
Binck, Jakob 1500?-1569 *ClaDrA*
Binckes, Henry Ashby *DcVicP 2*
Binckley, Ellen *DcWomA*
Binckley, George *FolkA 86*
Binckley, Mary *DcWomA*
Binckley, Nella Fontaine *ArtsAmW 3, DcWomA*
Binckley, Nellie Fontaine *ArtsAmW 3*
Binda, G A *AmArch 70*
Binde, Gunar 1933- *ConPhot, ICPEnP A*
Binder, Carl F 1887- *WhAmArt 85*
Binder, D I *MarqDCG 84*
Binder, Erwin 1934- *PrintW 83, –85*
Binder, Harold 1924- *AmArch 70*
Binder, Jack 1902- *WorECom*
Binder, Jacob 1887- *WhAmArt 85*
Binder, Joseph 1898- *WhAmArt 85*
Binder, Joseph 1898-1972 *ConDes*
Binder, Joseph Frederick *WhoArt 80*
Binder, Otto O 1911-1974 *WorECom*
Binder, Pearl 1904- *IlsCB 1744, –1946*
Binder Brothers *EncASM*
Bindesboll, Gottlieb 1800-1856 *MacEA*
Bindesboll, Michael Gottlieb Birkner 1800-1856 *McGDA, WhoArch*
Bindig, Bob *ConGrA 1*
Bindig, Robert Kuhn 1920- *ConGrA 1[port]*
Binding, Solomon Gotlip *NewYHSD*
Bindley, Frank *DcVicP 2*
Bindon, Francis 1690?-1765 *DcBrECP*
Bindon, Leonard William 1899- *AmArch 70*
Bindrim, Theodore Edward 1934- *AmArch 70*
Bindrum, Elsie Spaney 1906- *WhAmArt 85*
Bindrum, John L 1907- *WhAmArt 85*
Bindschaedler, Emma 1852-1900 *DcWomA*
Bines, Mrs. Robert *DcWomA*
Binet, Alice Rose Laure *DcWomA*
Binet, Anne Marie 1835- *DcWomA*
Binet, Ellen *ArtsEM, DcWomA*
Binet, Moina *DcWomA*
Binet, Rene 1866-1911 *McGDA*
Binet, Sophie *DcWomA*
Binet, V *DcVicP 2*
Binet, Victor Jean Baptiste Barthelemy 1849-1924 *ClaDrA*
Binfield, E H *DcVicP 2*
Binfield, F D *DcVicP 2*
Binford, Alberta *DcWomA*
Binford, Julien 1908- *WhAmArt 85, WhoAmA 73, –76, –78, –80*
Bing *DcBrECP*
Bing, Alexander 1878-1959 *WhoAmA 80N, –82N, –84N*
Bing, Ilse 1899- *ICPEnP A, MacBEP*
Bing, Samuel *DcNiCA*
Bing, Valentin 1812- *ArtsNiC*
Bing & Grondahl *AntBDN M*
Bingen, Hildegard Von *DcWomA*
Binger, Bronson 1930- *AmArch 70*
Bingham, A Y *DcVicP 2*
Bingham, Albert Yelverton 1840-1907 *DcBrBI*
Bingham, Alice 1936- *WhoAmA 82, –84*
Bingham, David 1788-1847 *FolkA 86*
Bingham, Edith Farnum *ArtsEM, DcWomA*

Bingham, Erwin Wayne 1898- *AmArch 70*
Bingham, George Caleb 1811-1879 *ArtsAmW 1, BnEnAmA, DcAmArt, IlBEAAW, McGDA, NewYHSD, OxArt*
Bingham, Harriette G 1892- *WhAmArt 85*
Bingham, Harry Payne *WhoAmA 82*
Bingham, Mrs. Harry Payne *WhoAmA 73, –76, –78, –80*
Bingham, Henry Lee Tuck 1805- *CabMA*
Bingham, Mrs. Henry P *WhAmArt 85*
Bingham, Hiram 1789-1869 *EarABI, EarABI SUP, NewYHSD*
Bingham, James *EncASM*
Bingham, James R *WhAmArt 85*
Bingham, James R 1917- *IlrAm F*
Bingham, James R 1917-1971 *IlrAm 1880*
Bingham, John H *NewYHSD*
Bingham, Lavinia *DcWomA*
Bingham, Lois A 1913- *WhoAmA 73, –76, –78, –80, –82, –84*
Bingham, Luther *NewYHSD*
Bingham, Margaret *DcWomA*
Bingham, Paul O 1941- *WhoAmA 80, –82*
Bingham, Samuel *NewYHSD*
Bingham, Thomas T *NewYHSD*
Bingham W R *DcVicP 2*
Bingham, William *NewYHSD*
Bingham, William *NewYHSD*
Bingley, Lord *BiDBrA*
Bingley, George 1813?- *NewYHSD*
Bingley, James George *DcVicP*
Bingley, James George 1840-1920 *DcBrA 1, DcBrWA, DcVicP 2*
Bingley, Joseph 1805?- *NewYHSD*
Bingley, Thomas *NewYHSD*
Bingley, William *AntBDN N*
Bingman, Samuel Harrison 1835-1922 *FolkA 86*
Bingman, Yost 1812-1889 *FolkA 86*
Bings *DcBrECP*
Bininger, W B *NewYHSD*
Binje, Frans 1835-1900 *ClaDrA*
Bink, Harry L 1926- *AmArch 70*
Binkele, Robert M 1913- *AmArch 70*
Binkley, George *FolkA 86*
Binks, Ronald C 1934- *MacBEP, WhoAmA 82, –84*
Binks, Thomas 1799-1852 *DcSeaP, DcVicP*
Binks, Thomas A *DcSeaP*
Binks, Thomas A 1799-1852 *DcVicP 2*
Binn, Mark *IlsBYP*
Binner, Leslie *WhAmArt 85*
Binney, Don 1940- *DcCAr 81*
Binney, Hibbert C *DcBrA 2*
Binnicker, Ray R 1928- *AmArch 70*
Binnie, Frederick *DcBrECP*
Binning, A M *BiDBrA*
Binning, Bertram Charles 1909- *ClaDrA, WhoAmA 73, –76, WhoArt 80, –82, –84*
Binning, Bertram Charles 1909-1976 *WhoAmA 78N, –80N, –82N, –84N*
Binning, Charles Bertram 1909- *McGDA*
Binning, Robin 1909- *WhoAmA 76, –78, –80, –82, –84*
Binnings, W J *AmArch 70*
Binns, Charles Fergus 1857-1934 *CenC[port], DcNiCA, WhAmArt 85*
Binns, David *DcCAr 81*
Binns, David 1935- *WhoArt 84*
Binns, Elizabeth J *DcVicP 2*
Binns, Elizabeth Jane *DcWomA*
Binns, Elsie *DcWomA, WhAmArt 85*
Binns, Frances Rachael *DcWomA*
Binns, Frances Rachel *DcVicP 2*
Binns, Lorna 1914- *DcBrA 2, WhoArt 80, –82, –84*
Binns, R W *DcNiCA*
Binny, Graham d1929 *DcBrA 1*
Binon, J B *NewYHSD*
Binsse, Louis Francis DePaul 1774-1844 *NewYHSD*
Binswanger, Isidor *WhAmArt 85*
Bint *DcBrBI*
Bintliff, Ann Humphrey 1920- *AmArch 70*
Bintliff, Martha B 1869- *WhAmArt 85*
Bintliff, Martha Bradshaw 1869- *ArtsAmW 2, DcWomA*
Binyon, Mrs. Algernon *WhAmArt 85*
Binyon, Carolyn *DcWomA*
Binyon, Helen *WhoArt 82N*
Binyon, Helen 1904- *WhoArt 80*
Biole, B *AntBDN D*
Bion, Marie Louise Agnes 1858-1939 *DcWomA*
Biond, Lawrence Joseph 1933- *AmArch 70*
Bionda, Mario 1913- *PhDcTCA 77*
Biorn, Emil 1864- *WhAmArt 85*
Birabongse, Princess Ceril 1916- *DcBrA 1*
Birago, Giovanni Pietro *McGDA*
Birat, Amelie 1812- *DcWomA*
Birbeck, J *AntBDN M*
Birbeck, Thomas Towning 1902- *WhoArt 80*
Birch *NewYHSD*
Birch, Miss *DcWomA*
Birch, Annie *DcVicP 2*
Birch, B *NewYHSD*
Birch, Charles Bell 1832-1893 *DcBrBI*
Birch, Downard 1827-1897 *DcVicP, –2*

Birch, Emily L *DcWomA*
Birch, Fred M *EncASM*
Birch, George *NewYHSD*
Birch, Geraldine 1883- *WhAmArt 85*
Birch, Geraldine Rose 1883- *ArtsAmW 1*
Birch, Geraldine Rose 1883-1972 *DcWomA*
Birch, J *BiDBrA*, *NewYHSD*
Birch, John 1807-1857 *DcVicP 2*
Birch, Lionel *DcBrA 1*, *DcVicP 2*
Birch, Louise Steinmetz 1835-1921 *DcWomA*
Birch, M A *AmArch 70*
Birch, Penelope *DcWomA*
Birch, Ranice 1915- *WhAmArt 85*
Birch, Reginald *DcBrBI*
Birch, Reginald 1856-1943 *WhAmArt 85*
Birch, Reginald Bathurst 1856-1943 *ArtsAmW 1*,
 ConICB, *IlrAm A*, *-1880*, *WorECar*
Birch, S A *FolkA 86*
Birch, Samuel John Lamorna 1869-1955 *DcBrA 1*,
 DcBrWA
Birch, Sarah *DcVicP 2*, *DcWomA*
Birch, Thomas 1779-1851 *AntBDN B*, *ArtsNiC*,
 BnEnmA, *DcAmArt*, *DcSeaP*, *EarABI*,
 FolkA 86, *McGDA*, *NewYHSD*
Birch, William 1755-1834 *AntBDN B*
Birch, William Henry 1895-1968 *ClaDrA*
Birch, William Henry David 1895-1968 *DcBrA 1*
Birch, William Russell 1755-1834 *NewYHSD*
Birchall, William M 1884- *DcSeaP*
Birchall, William Minshall 1884- *DcBrA 1*
Bircham, J B *DcVicP 2*
Birchansky, Leo d1949 *WhoAmA 78N*, *-80N*, *-82N*,
 -84N
Birchansky, Leo 1887-1949 *WhAmArt 85*, *WorECar*
Bircher, James *AfroAA*
Birchett, Raymond 1902- *AmArch 70*
Birchim, Dorcas 1923- *IlBEAAW*
Birchman, Willis *WhAmArt 85*
Birckett, Anne Belle *WhoAmA 78*, *-80*, *-82*, *-84*
Bircsak, E F *AmArch 70*
Bird, Albert G 1800?- *NewYHSD*
Bird, Alice *IlsBYP*
Bird, Bessie *DcWomA*
Bird, C H *FolkA 86*
Bird, Charles *DcBrA 2*, *FolkA 86*
Bird, Clarance A *DcVicP 2*
Bird, Constance *DcBrA 1*, *DcWomA*
Bird, Cyril Kenneth 1887- *WorECar*
Bird, E *DcWomA*
Bird, E J *WhAmArt 85*
Bird, Edward 1772-1819 *DcBrWA*
Bird, Elisha Brown 1867-1943 *WhAmArt 85*
Bird, F 1869- *WhAmArt 85*
Bird, Francis 1667-1731 *McGDA*, *OxArt*
Bird, Frederick *NewYHSD*
Bird, George Frederick 1883- *DcBrA 1*
Bird, George Frederick 1883-1948 *DcBrA 2*
Bird, Gordon Johns 1919- *AmArch 70*
Bird, H D *DcVicP 2*
Bird, H M *DcVicP 2*
Bird, Hannah *DcWomA*
Bird, Harrington *DcVicP 2*
Bird, Harry 1887- *WhAmArt 85*
Bird, Henry Richard 1909- *DcBrA 1*, *WhoArt 80*,
 -82, *-84*
Bird, Horatio G 1824?- *NewYHSD*
Bird, Isaac F *DcVicP 2*
Bird, Isaac Faulkner *DcBrWA*
Bird, James Wright 1926- *AmArch 70*
Bird, Jim 1937- *PrintW 85*
Bird, John *NewYHSD*
Bird, John 1768-1826 *DcBrWA*
Bird, John 1768-1829 *BiDBrA*
Bird, John Alexander H 1846- *DcBrBI*
Bird, John Alexander Harington 1846-1936 *DcBrA 1*
Bird, John Edward 1957- *MarqDCG 84*
Bird, Jonathan 1777-1807 *CabMA*
Bird, L Pern *WhAmArt 85*
Bird, Margaret *DcVicP 2*, *DcWomA*
Bird, Mary Holden *ClaDrA*, *DcBrA 1*, *DcWomA*,
 WhoArt 80N
Bird, May *DcWomA*
Bird, Peter 1924- *WhoArt 80*, *-82*, *-84*
Bird, Randall R 1955- *MarqDCG 84*
Bird, Richard Albert 1926- *AmArch 70*
Bird, Richard D 1955- *MarqDCG 84*
Bird, Samuel C *DcVicP*, *-2*
Bird, W *DcBrBI*
Bird, W D *DcVicP 2*
Bird, William *BiDBrA*, *DcVicP 2*
Bird, William 1624- *BiDBrA*
Bird, William Edward Stockton 1920- *AmArch 70*
Birdman, Jerome M 1930- *WhoAmA 78*
Birdsall, Amos, Jr. 1865- *WhAmArt 85*
Birdsall, Byron 1937- *WhoAmA 78*, *-80*, *-82*, *-84*
Birdsall, Harry, Jr. 1909- *WhAmArt 85*
Birdsall, Jess *FolkA 86*
Birdsall, Timothy 1936-1963 *WorECar*
Birdsey, Jon Stratton 1942- *AmArch 70*
Birdseye, Dorothy Carroll *WhAmArt 85*
Bireline, George 1923- *DcCAA 71*, *-77*

Bireline, George Lee 1923- *WhoAmA 76*, *-78*, *-80*,
 -82, *-84*
Bireta, Robert James 1947- *MarqDCG 84*
Birge, Charles E 1871-1942 *BiDAmAr*
Birge, Laura C d1928? *DcWomA*
Birge, Mary Thompson 1872- *DcWomA*,
 WhAmArt 85
Birgfeld, Detlef 1937- *DcCAr 81*, *OxTwCA*
Birk, David 1939- *MarqDCG 84*
Birkbeck, Geoffrey 1875-1954 *DcBrA 1*
Birkbeck, Jane *DcWomA*
Birkenberger, William 1903- *WhAmArt 85*
Birkenruth, Adolph 1861-1940 *DcBrBI*
Birkenruth, Adolphus 1861-1940 *DcBrA 1*, *DcVicP 2*
Birkerts, Gunnar 1925- *AmArch 70*, *ConArch*
Birkett, B *DcVicP 2*
Birkett, P *DcVicP 2*
Birkett, S *DcBrWA*
Birkey, Melvin D 1935- *AmArch 70*
Birkhead, Benjamin 1780?-1858 *BiDBrA*
Birkhead, Margaret 1934- *ClaDrA*
Birkin, Morton 1919- *WhoAmA 76*, *-78*, *-80*, *-82*, *-84*
Birkmyer, James B *DcVicP 2*
Birks, Albion 1860-1940 *AntBDN M*
Birks, Alboin 1861-1941 *DcNiCA*
Birley, Ada Kate *DcBrWA*, *DcVicP 2*
Birley, Sir Oswald Hornby Joseph 1880-1952 *DcBrA 1*
Birmelin, A Robert 1933- *DcCAA 77*, *WhoAmA 80*,
 -82, *-84*
Birmelin, August Robert 1933- *WhoAmA 73*, *-76*, *-78*
Birnbaum, Abe 1899- *WhAmArt 85*
Birnbaum, Adolph 1865-1943 *WhAmArt 85*
Birnbaum, Dara 1946- *DcCAr 81*
Birnbaum, Mildred *WhoAmA 78*, *-80*, *-82*, *-84*
Birnberg, Gerald H 1931- *WhoAmA 78*, *-80*, *-82*, *-84*
Birnberg, Ruth Carrel 1933- *WhoAmA 78*, *-80*, *-82*,
 -84
Birney, William Verplanck 1858-1909 *WhAmArt 85*
Birnie, Elizabeth Annie 1851-1914? *DcWomA*
Birnie, Rix *DcVicP 2*
Biro, Balint S 1921- *IlsCB 1946*
Biro, Charles 1911-1972 *WorECom*
Biro, Val *IlsCB 1967*
Biro, Val 1921- *IlsBYP*, *IlsCB 1957*, *WhoArt 80*,
 -82, *-84*
Birolli, Renato 1906-1959 *McGDA*, *OxTwCA*,
 PhDcTCA 77
Bironneau-Dupre, Madame *DcWomA*
Birrell, Amy *DcWomA*
Birrell, Verla Leone 1903- *WhAmArt 85*
Birren, Joseph P 1864-1933 *ArtsAmW 1*, *-3*
Birren, Joseph P 1865-1933 *WhAmArt 85*
Birtles, Henry *DcVicP*
Birtles, Henry 1838-1907 *DcBrA 1*, *DcBrWA*,
 DcVicP 2
Birtwhistle, Cecil H 1910- *DcBrA 1*
Bisaccio, Philip 1907- *WhoAmA 73*
Bisant, L M *DcWomA*
Bisbal, Casilda *DcWomA*
Bisbee, Ezra *NewYHSD*
Bisbee, J J *ArtsEM*
Bisbee, John *NewYHSD*
Bisbee, T W *AmArch 70*
Bisbing, H Singlewood 1849-1933 *WhAmArt 85*
Bisbing, Henry Singlewood 1849-1933 *IlBEAAW*
Bisbrown, Cuthbert *BiDBrA*
Biscaino, Bartolommeo 1632-1657 *ClaDrA*
Biscarra, Antoinette 1833-1866 *DcWomA*
Biscarra, Giovanni Battista 1790-1851? *ClaDrA*
Bischebou *NewYHSD*
Bischof, Milton J, Jr. 1917- *AmArch 70*
Bischof, Peter 1934- *DcCAr 81*
Bischof, Severin 1893- *WhAmArt 85*
Bischof, Werner 1916-1954 *ConPhot*, *ICPEnP*
Bischof, Werner Adalbert 1916-1954 *MacBEP*
Bischoff, C F *DcVicP 2*
Bischoff, Elmer 1916- *BnEnmA*, *DcCAA 71*, *-77*,
 DcCAr 81, *OxTwCA*, *PhDcTCA 77*
Bischoff, Elmer Nelson 1916- *WhAmArt 85*,
 WhoAmA 73, *-76*, *-78*, *-80*, *-82*, *-84*
Bischoff, Eugene Henry 1880-1954 *ArtsAmW 1*,
 IlBEAAW
Bischoff, Franz A 1864-1929 *ArtsEM*, *WhAmArt 85*
Bischoff, Franz Albert 1864-1929 *ArtsAmW 1*
Bischoff, Frederick Christopher 1771-1834
 NewYHSD
Bischoff, Gilbert R 1912- *AmArch 70*
Bischoff, Helmut 1936- *WhoGrA 62*, *-82[port]*
Bischoff, Henry 1882- *ClaDrA*
Bischoff, Herman E *WhAmArt 85*
Bischoff, Ilse Martha 1903- *WhAmArt 85*
Bischoff, Ilse Marthe 1903?- *ConICB*, *IlsCB 1744*,
 -1946
Bischoff, Marie Evangeline *DcWomA*, *WhAmArt 85*
Bischoff, T J *AmArch 70*
Bischoff, William R *MarqDCG 84*
Bisco, Adaline *DcWomA*, *FolkA 86*
Bisdorf, Peter J *NewYHSD*
Biseglia, Mario *DcNiCA*
Biset, Charles Emmanuel 1633- *ClaDrA*
Biset, Karel Emmanuel 1633-1710? *McGDA*

Bisgard, James Dewey 1898- *WhoAmA 73*
Bisgard, James Dewey 1898-1975 *WhoAmA 76N*,
 -78N, *-80N*, *-82N*, *-84N*
Bisgyer, Barbara G 1933- *AmArt*, *WhoAmA 73*, *-76*,
 -78, *-80*, *-82*, *-84*
Bish, W H *FolkA 86*
Bishaboy *NewYHSD*
Bisharat, Victor H 1920- *AmArch 70*
Bishboy *NewYHSD*
Bishop *NewYHSD*
Bishop, A S *DcVicP 2*
Bishop, Abby 1781-1812 *FolkA 86*
Bishop, Alison *DcWomA*
Bishop, Amy *DcWomA*
Bishop, Angelica *DcWomA*, *NewYHSD*
Bishop, Annette *DcWomA*, *EarABI*, *NewYHSD*
Bishop, Anthony William 1944- *MarqDCG 84*
Bishop, Barbara Lee 1930- *WhoAmA 78*, *-80*
Bishop, Barbara Lee 1938- *MacBEP*, *WhoAmA 82*,
 -84
Bishop, Barry 1932- *ICPEnP A*
Bishop, Benjamin 1923- *WhoAmA 73*, *-76*, *-78*, *-80*,
 -82, *-84*
Bishop, Bert 1936- *AmArch 70*
Bishop, Budd Harris 1936- *WhoAmA 73*, *-76*, *-78*,
 -80, *-82*, *-84*
Bishop, Charles Edward 1915- *AmArch 70*
Bishop, Cortlandt Field 1870-1935 *WhAmArt 85*
Bishop, D W *AmArch 70*
Bishop, Donald S 1912- *AmArch 70*
Bishop, E E *AmArch 70*
Bishop, E H *AmArch 70*
Bishop, Edward 1902- *ClaDrA*, *DcBrA 1*,
 WhoArt 80, *-82*, *-84*
Bishop, Eloise 1921- *AfroAA*
Bishop, Emily Clayton 1883-1912 *DcWomA*
Bishop, Emily Clayton 1892-1912 *WhAmArt 85*
Bishop, Ethel Alicia 1892-1958 *DcBrA 2*, *DcWomA*
Bishop, F E *AmArch 70*
Bishop, Flora M *WhAmArt 85*
Bishop, Florence *DcWomA*
Bishop, G *DcVicP 2*
Bishop, H W *AmArch 70*
Bishop, Harold S 1884- *WhAmArt 85*
Bishop, Harry *DcVicP 2*
Bishop, Henry 1868-1939 *DcBrA 1*
Bishop, Hubert E 1869- *WhAmArt 85*
Bishop, Ian David 1949- *MarqDCG 84*
Bishop, Irene *DcWomA*, *WhAmArt 85*
Bishop, Isabel 1902- *AmArt*, *BnEnmA*, *ConArt 83*,
 DcAmArt, *DcCAA 71*, *-77*, *GrAmP*, *McGDA*,
 OxTwCA, *PhDcTCA 77*, *WhAmArt 85*,
 WhoAmA 73, *-76*, *-78*, *-80*, *-82*, *-84*, *WomArt*,
 WorArt[port]
Bishop, James 1927- *ConArt 83*, *DcCAA 77*,
 WhoAmA 78, *-80*, *-82*, *-84*
Bishop, James Allen 1922- *AmArch 70*
Bishop, Jeffrey Britton 1949- *WhoAmA 82*, *-84*
Bishop, Jerold 1936- *WhoAmA 82*, *-84*
Bishop, Katherine *WhAmArt 85*
Bishop, Katherine Bell 1883- *ArtsAmW 2*, *DcWomA*
Bishop, Lemuel *CabMA*
Bishop, Margaret C *DcWomA*
Bishop, Marjorie 1904- *WhAmArt 85*
Bishop, Marjorie Cutler *WhoAmA 73*, *-76*, *-78*, *-80*,
 -82, *-84*
Bishop, Mary A *DcWomA*
Bishop, Mattie White *DcWomA*, *WhAmArt 85*
Bishop, Max Delmer 1935- *AmArch 70*
Bishop, Michael 1946- *ConPhot*, *DcCAr 81*,
 ICPEnP A, *MacBEP*
Bishop, Minor L *AmArch 70*
Bishop, Molly *ClaDrA*, *DcBrA 1*
Bishop, Mrs. Morris *WhAmArt 85*
Bishop, Nathaniel *FolkA 86*
Bishop, P *FolkA 86*
Bishop, R E 1887- *WhAmArt 85*
Bishop, Richard *OfPGCP 86*
Bishop, Richard Edgar 1892- *AmArch 70*
Bishop, Richard Evett 1897-1975 *WhoAmA 76N*,
 -78N, *-80N*, *-82N*, *-84N*
Bishop, Robert Charles 1938- *WhoAmA 78*, *-80*, *-82*,
 -84
Bishop, Robert Forsythe 1908- *AmArch 70*
Bishop, Robert V 1922- *AmArch 70*
Bishop, Sally Foster 1785-1842 *FolkA 86*
Bishop, Thomas *NewYHSD*
Bishop, Thomas 1753?-1840? *NewYHSD*
Bishop, Uri *FolkA 86*
Bishop, Walter Follen 1856-1936 *DcBrA 1*, *DcVicP*,
 -2
Bishop, William Henry 1942- *WhoArt 84*
Bishopbois, August 1814?- *NewYHSD*
Bishopp, G *DcVicP 2*
Bishopp, Hawley *AntBDN H*, *IlDcG*
Bishopp, Patience E *DcVicP 2*
Bisi, Ernesta *DcWomA*
Bisi, Fulvia 1818-1911 *DcWomA*
Bisi, Giuseppe 1787-1869 *ArtsNiC*
Bisi, Luigi 1814- *ArtsNiC*
Bisilliat, Maureen 1931- *ICPEnP A*

Blakeney, Charlotte *DcVicP 2, DcWomA*
Blakeney, Rae *WhoAmA 82*
Blaker, Hugh d1936 *DcBrA 2*
Blaker, Michael 1928- *ClaDrA, DcBrA 1, WhoArt 80, -82, -84*
Blakeslee, Mrs. Horace W *WhAmArt 85*
Blakeslee, L Robert 1905- *AmArch 70*
Blakeslee, Sarah 1912- *WhoAmA 73, -76, -78, -80, -82, -84*
Blakeslee, Sarah Jane 1912- *WhAmArt 85*
Blakeslee, Walter 1852-1902 *WhAmArt 85*
Blakesley, Alicia *DcVicP 2, DcWomA*
Blakesley, Anna *DcWomA*
Blakeston, Oswell *WhoArt 80, -82, -84*
Blakey, N *DcBrECP*
Blakey, Nicholas *BkIE, DcBrWA*
Blakiston, Douglas Y 1810-1870 *DcVicP 2*
Blakiston, Duncan George 1869- *ArtsAmW 2*
Blakiston, Evelyn *DcVicP 2, DcWomA*
Blakley, Catherine S *WhAmArt 85*
Blakley, George R 1932- *MarqDCG 84*
Blaksley, M C *DcVicP 2, DcWomA*
Blameuser, Mary Fleurette *WhoAmA 73, -76, -78, -80, -82*
Blamey, Norman 1914- *ConBrA 79[port]*
Blamey, Norman Charles 1914- *DcBrA 1, WhoArt 80, -82, -84*
Blamire, W *DcVicP 2*
Blampied, Clifford G *DcBrA 1*
Blampied, Edmund 1886- *DcBrBI*
Blampied, Edmund 1886-1966 *DcBrA 1*
Blanc, Anthony *NewYHSD*
Blanc, Hippolyte Jean 1844-1917 *DcBrA 1*
Blanc, J *DcWomA*
Blanc, Louis Ammy 1810- *ArtsNiC*
Blanc, Lucie *DcWomA*
Blanc, Paul Joseph *ArtsNiC*
Blanc, Peter 1912- *WhoAmA 73, -76, -78, -80, -82, -84*
Blanch, Arnold d1968 *WhoAmA 78N, -80N, -82N, -84N*
Blanch, Arnold 1896-1968 *ArtsAmW 1, DcAmArt, DcCAA 71, -77, McGDA, WhAmArt 85*
Blanch, Lucile 1895- *DcWomA*
Blanch, Lucille 1895- *ArtsAmW 1, WhAmArt 85*
Blanchard, Miss *DcWomA*
Blanchard, Alonzo *NewYHSD*
Blanchard, Ann *DcWomA*
Blanchard, Auguste-Thomas-Marie 1819- *ArtsNiC*
Blanchard, Beckwith *DcBrWA*
Blanchard, Blanche Virginia 1866-1959 *DcWomA*
Blanchard, Carl Richard 1912- *AmArch 70*
Blanchard, Carol 1918- *WhoAmA 73, -76, -78, -80, -82, -84*
Blanchard, Charles *NewYHSD*
Blanchard, Charles 1688-1768 *AntBDN D*
Blanchard, Constance *DcWomA*
Blanchard, Daryl Richard 1934- *AmArch 70*
Blanchard, Edouard Theophile *ArtsNiC*
Blanchard, Eliza H *DcWomA, NewYHSD*
Blanchard, Elizabeth d1891 *NewYHSD*
Blanchard, Ethel *DcWomA*
Blanchard, Ethel C *WhAmArt 85*
Blanchard, F L *DcBrBI*
Blanchard, Gabriel *OxArt*
Blanchard, Helen *DcWomA, WhAmArt 85*
Blanchard, Henri-Petros-Leon-Pharamond 1805-1873 *ArtsNiC*
Blanchard, Howard Taft 1909- *AmArch 70*
Blanchard, J F *AmArch 70*
Blanchard, Jacques 1600-1638 *ClaDrA, McGDA, OxArt*
Blanchard, Jules *ArtsNiC*
Blanchard, Lyman Wallace 1883- *WhAmArt 85*
Blanchard, Maria 1881-1932 *ConArt 83, DcWomA, OxTwCA, PhDcTCA 77*
Blanchard, Maria Helene *DcWomA*
Blanchard, Marie 1881-1932 *WomArt*
Blanchard, N K *AmArch 70*
Blanchard, Ph *DcBrBI*
Blanchard, Porter *EncASM*
Blanchard, Porter 1886- *WhAmArt 85*
Blanchard, Richard 1934- *AmArch 70*
Blanchard, Rufus *CabMA*
Blanchard, Simon *CabMA*
Blanchard, Simone *DcWomA*
Blanchard, Stella *DcWomA*
Blanchard, Thomas *NewYHSD*
Blanchard, Washington 1808- *NewYHSD*
Blanche, Jacques 1861-1942 *WhAmArt 85A*
Blanche, Jacques Emile 1861-1942 *ClaDrA, McGDA, OxTwCA*
Blanche, John Frank 1918- *AmArch 70*
Blanche, Marilyn *WhoAmA 76, -78, -80*
Blanchet, Alexandre 1882-1961 *OxTwCA, PhDcTCA 77*
Blanchette, Mathilde DeLa *DcWomA*
Blanchett *NewYHSD*
Blanchette, Antoine *WhoAmA 80, -82, -84*
Blanchfield, Howard James 1896-1957 *WhAmArt 85, WhoAmA 80N, -82N, -84N*

Blanchon, Marguerite 1872- *DcWomA*
Blanchot, Gustave 1885-1968 *WorECar*
Blanchot, Jane *FairDF FRA*
Blanck, Jurian, Jr. 1645?-1714 *BnEnAmA*
Blanckley, Mrs. E *DcVicP 2*
Blanco, Dolores *DcWomA*
Blanco, Lazaro 1938- *ConPhot, ICPEnP A*
Blanco, Sylvia 1943- *WhoAmA 84*
Blanco, Teodoro Ramos 1901- *AfroAA*
Blanco-Fuentes, Lazaro 1938- *MacBEP*
Blancour, Marie *DcWomA*
Blancpain, Murrel 1904- *DcCAr 81*
Bland, Emily Beatrice 1864-1951 *DcBrA 1, DcVicP 2, DcWomA*
Bland, Garnet William 1903- *WhAmArt 85*
Bland, Garnett W *AfroAA*
Bland, James 1909- *AfroAA*
Bland, John Dietrich 1914- *AmArch 70*
Bland, John F *DcBrWA*
Bland, John H *DcVicP 2*
Bland, Sydney Frances Josephine 1883- *ClaDrA, DcBrA 1, DcWomA*
Blanden, L *DcVicP 2*
Blandin, Armande *DcWomA*
Blandin, Etienne 1903- *DcSeaP*
Blanding, Don d1957 *WhoAmA 80N, -82N, -84N*
Blandy, L V *DcVicP 2, DcWomA*
Blandy, Thomas Cruse 1932- *AmArch 70*
Blanes, Juan Manuel 1830-1901 *McGDA*
Blanes-Viale, Pedro *OxTwCA*
Blaney, David Harvey 1935- *MarqDCG 84*
Blaney, Dwight 1865-1944 *WhAmArt 85*
Blaney, Henry R 1855- *WhAmArt 85*
Blaney, Jonathan C 1777?-1844 *CabMA*
Blaney, Justus *FolkA 86*
Blank, Elizabeth *DcWomA*
Blank, Frederick Charles 1866- *WhAmArt 85*
Blank, George W 1945- *MarqDCG 84*
Blank, Ida 1913- *WhAmArt 85*
Blank, J Philip 1916- *WhAmArt 85*
Blank, Richard 1901- *WhoGrA 62*
Blanke, Esther 1882- *WhAmArt 85*
Blanke, Marie E *WhAmArt 85*
Blanke, Marie Elsa 1882-1961 *DcWomA*
Blankenberg, Alice I *WhAmArt 85*
Blankensee, John *FolkA 86*
Blankenship, Mary Almor Perritt 1878-1955 *ArtsAmW 3*
Blankenship, Roy 1943- *WhoAmA 73, -76*
Blankerhoff, Jan Heunisz 1628-1669 *DcSeaP*
Blankfort, Dorothy *WhoAmA 73, -76, -78, -80, -82*
Blankfort, Michael 1907- *WhoAmA 73, -76, -78, -80*
Blankinship, Richard Clyde 1933- *AmArch 70*
Blankstein, Helen *DcWomA*
Blanquart-Evrard, Louis-Desire 1802-1872 *ICPEnP, MacBEP*
Blanquet, Louis *WhAmArt 85*
Blanqui, Andres 1677-1740 *MacEA*
Blanton, Donald R 1941- *AfroAA*
Blanton, John Arthur 1928- *AmArch 70*
Blanton, McAllister 1925- *AmArch 70*
Blanton, P L *AmArch 70*
Blanton, Paul L 1936- *AfroAA*
Blanton, Paul Thompson 1920- *AmArch 70*
Blanvelt, Harmon *CabMA*
Blard, Delphine *DcWomA*
Blarenberghe, Helene Van *DcWomA*
Blarenberghe, Louis Nicolas Van 1716-1794 *ClaDrA*
Blarenberghe, Louis-Nicolas Van 1716-1794 *McGDA*
Blas, Camilo *OxTwCA*
Blas, Camilo 1903- *McGDA*
Blaschka, Leopold 1822-1895 *IlDcG*
Blaschka, Rudolf 1857-1939 *IlDcG*
Blasco, Jesus 1919- *WorECom*
Blasdell, Abner 1771-1812 *CabMA*
Blasdell, William E *MarqDCG 84*
Blase, Karl Oskar 1925- *ConDes, OxTwCA, WhoGrA 62, -82[port]*
Blaser, Gustav 1813-1874 *ArtsNiC*
Blaser, William Carl 1922- *AmArch 70*
Blash, Olin P *WhAmArt 85*
Blashfield, Albert Dodd 1860- *WhAmArt 85*
Blashfield, Albert Dodd 1860-1920 *WorECar*
Blashfield, Edwin H 1848- *ArtsNiC*
Blashfield, Edwin H 1848-1936 *WhAmArt 85*
Blashfield, Edwin Howland 1848-1936 *ArtsAmW 2, BnEnAmA, DcAmArt, McGDA*
Blashfield, Evangeline Wilbour 1881-1918 *WhAmArt 85*
Blashfield, John M *DcNiCA*
Blashki, M Evergood 1871- *WhAmArt 85*
Blasingame, Frank Marvin 1903- *WhAmArt 85*
Blasingame, Marguerite Louis 1906- *WhAmArt 85*
Blasingham, Katherine Groh 1893- *DcWomA, WhAmArt 85*
Blasius, Eleonora *DcWomA*
Blass, Bill 1922- *ConDes, FairDF US[port], WorFshn*
Blass, Charlotte L 1908- *WhAmArt 85*
Blass, Editha *DcWomA*
Blass, Karl 1815-1876 *ArtsNiC*

Blass, Noland, Jr. 1920- *AmArch 70*
Blass, Roy Burton 1907- *AmArch 70*
Blassel, Nicolas, The Younger 1600-1659 *McGDA*
Blassick, John Edward 1935- *AmArch 70*
Blaszkowski, Martin 1920- *WhoArt 80, -82, -84*
Blatas, Arbit *PrintW 83, -85*
Blatas, Arbit 1908- *WhAmArt 85, WhoAmA 76, -78*
Blatchford, Conway 1873- *DcBrA 1, DcBrWA*
Blatchford, Montagu *DcBrBI*
Blatchly, W D *WhAmArt 85*
Blatherwick, Charles d1895? *DcBrWA*
Blatherwick, Lily *DcBrWA*
Blatherwick, Lily d1934 *DcBrA 1*
Blatherwick, Lily 1854-1934 *DcBrA 2*
Blatherwick, Lily 1859?-1934 *DcWomA*
Blatner, Henry L 1911- *AmArch 70*
Blatt, Louis 1911- *WhAmArt 85*
Blatt, M *AmArch 70*
Blatter, Jacob *FolkA 86*
Blatter, Rudolf H 1898- *AmArch 70*
Blattner, Robert Henry 1906- *WhAmArt 85, WhoAmA 73, -76, -78, -80, -82, -84*
Blattner, Rose 1900- *WhAmArt 85*
Blatton, Slavomir Stanislas 1943- *WhoArt 80, -82*
Blau, Curtis L 1946- *MarqDCG 84*
Blau, Daniel 1894- *WhAmArt 85*
Blau-Lang, Tina 1845-1937 *DcWomA*
Blauch, Christian *FolkA 86*
Blauel, Charles *NewYHSD*
Blaufeux, H *AmArch 70*
Blaurock, Carlotta 1866- *DcWomA, WhAmArt 85*
Blaurock, Charlotta 1866- *ArtsAmW 3*
Blaustein, A A *AmArch 70*
Blaustein, Al 1924- *DcCAA 71, -77, WhoAmA 80, -82, -84*
Blaustein, Alfred H 1924- *WhoAmA 73, -76, -78*
Blauteau, E *NewYHSD*
Blauth, Allan Martin 1933- *AmArch 70*
Blauth, Robert Edward 1943- *MarqDCG 84*
Blauvelt, Charles F 1824- *ArtsNiC*
Blauvelt, Charles F 1824-1900 *NewYHSD, WhAmArt 85*
Blauvoet, Jacobus 1646-1701 *DcSeaP*
Blavier-Desgranges, Germaine *DcWomA*
Blavot, Marie Elisabeth *DcWomA*
Blaydon, F *AmArch 70*
Blaylock, T Todd *DcBrBI*
Blaylock, Thomas Todd 1876-1929 *DcBrA 1*
Blaymire, Jonas d1763 *DcBrWA*
Blayney, William Alvin 1917- *FolkA 86*
Blayton, Betty 1937- *AfroAA, WhoAmA 84*
Blaz, Georgia Lee *WhoAmA 80*
Blaz, Georgia Lee 1947- *WhoAmA 76, -78*
Blazeje, Zbigniew 1942- *WhoAmA 73, -76, -78, -80, -82, -84*
Blazek, Anton *WhAmArt 85*
Blazekovic, Milan 1940- *WorECar*
Blazer, Carel 1911-1980 *ConPhot, ICPEnP A*
Blazey, Lawrence 1902- *WhAmArt 85*
Blazey, Lawrence Edwin 1902- *WhoAmA 76, -78, -80, -82, -84*
Blazy, Sterling 1904- *WhAmArt 85*
Blazys, Alexander 1894- *WhAmArt 85*
Bleach, Bruce 1950- *PrintW 83, -85*
Bleaden, Mary *DcVicP 2, DcWomA*
Bleadon, Mary *DcWomA*
Blean, Harold Paul 1918- *AmArch 70*
Blech, C *DcWomA*
Blech, Miss C *NewYHSD*
Blechen, Karl 1798-1840 *McGDA, OxArt*
Blechman, R O 1930- *AmArt, ConGrA 1[port], WhoGrA 82[port]*
Blechman, Robert O 1930- *WorECar*
Blechynden, Richard d1822 *BiDBrA*
Bleck, James H 1954- *MarqDCG 84*
Bleck, Mietzi 1911- *WhAmArt 85*
Blecker, Gerrit Claesz d1656 *ClaDrA*
Bleckner, Ross 1949- *WhoAmA 84*
Blecksmith, Fred Rodrick, Jr. 1937- *AmArch 70*
Bledsoe, Alice E Collins Matthews 1872-1915 *ArtsAmW 3*
Bledsoe, Jane Kathryn 1937- *WhoAmA 76, -78, -80, -82, -84*
Bleecher, Margaret *FolkA 86*
Bleeck *DcBrECP*
Bleeck, Pieter Van 1700-1764 *ClaDrA*
Bleeck, Richard Van 1670-1733 *ClaDrA*
Bleecker, Dirck 1622?-1672? *McGDA*
Bleecker, John R *NewYHSD*
Bleeker, Dirck 1622?-1672 *ClaDrA*
Blegvad, Erik *IlsCB 1967*
Blegvad, Erik 1923- *IlsBYP, IlsCB 1946, -1957, WhoGrA 82[port]*
Blegvad, Julie *DcWomA*
Bleiberg, Jeffrey Joseph 1949- *MarqDCG 84*
Bleibtreu, Georg 1828- *ArtsNiC*
Bleicher, Francisca *DcWomA*
Bleichten, Franz Beer Von 1660-1726 *WhoArch*
Bleichten, Johann Michael Beer Von 1700-1767 *WhoArch*

Bleifeld, Stanley 1924- *DcCAA 71, –77, WhoAmA 73, –76, –78, –80, –82, –84*
Bleifer, Sandy 1940- *DcCAr 81*
Bleil, Charles George 1893- *ArtsAmW 2, WhAmArt 85*
Bleker, Dirck 1622?-1672 *ClaDrA*
Bleker, Gerrit Claesz d1656 *ClaDrA*
Bleker, Gerrit Claesz 1593?-1656 *McGDA*
Blencowe, S J *DcVicP 2*
Blender, Martin H 1929- *AmArch 70*
Blener, James 1834?- *NewYHSD*
Blenko, W H d1969 *IlDcG*
Blenko, W H, Jr. *IlDcG*
Blenko, William J 1855-1933 *IlDcG*
Blenner, Bruno 1929- *DcCAr 81*
Blenner, Carle Joan 1864-1952 *DcWomA*
Blenner, Carle John 1862- *WhAmArt 85*
Blenner, P *DcVicP 2*
Blensdorf, Ernst M *WhoArt 82N*
Blensdorf, Ernst M 1896- *WhoArt 80*
Blent, John *FolkA 86*
Blerot, Ernest 1870-1957 *MacEA*
Blery, Eugene 1808- *ArtsNiC*
Bles, David *DcVicP 2*
Bles, Hendrik De 1480?-1550? *ClaDrA*
Bles, Herri Met De *McGDA*
Bles, Herri Met De 1500?-1550? *OxArt*
Bles, Pseudo *McGDA*
Blesch, Clara *DcWomA, WhAmArt 85*
Blesch, Rudolph *ArtsAmW 2, WhAmArt 85*
Blesendorff, Elisabeth 1700?-1760? *DcWomA*
Blesky, Wiltold John 1934- *WhoArt 82, –84*
Blesky, Witold John 1934- *WhoArt 80*
Blessing, C A *AmArch 70*
Blessing, Charles 1912- *ConArch*
Blessing, James Henry 1931- *AmArch 70*
Blessing, R F, Jr. *AmArch 70*
Blessing, Wilfred Edwin 1923- *AmArch 70*
Blessum, Benjamin 1877- *WhAmArt 85*
Bleuze, A *DcWomA*
Bleve, Jean Louis d1807? *MacEA*
Blevens, Melvin LeRoy 1932- *AmArch 70*
Blevins, Albert H 1874-1946 *BiDAmAr*
Blevins, James Richard 1934- *WhoAmA 78, –80, –82, –84*
Blewett, Harold 1923- *AmArch 70*
Blewitt, R *DcVicP 2*
Bley, Elsa W 1903- *WhAmArt 85, WhoAmA 73, –76*
Bleyl, Fritz *OxTwCA*
Bleyl, Fritz 1881- *McGDA*
Blezard, C V *AmArch 70*
Blicker, George 1833?- *NewYHSD*
Blicker, Gerrit Claesz d1656 *ClaDrA*
Blieck, Daniel De d1673 *ClaDrA, McGDA*
Bliesath, Marsha D 1943- *MarqDCG 84*
Bliese, Angelika 1946- *DcCAr 81*
Bligh, E R *DcVicP 2*
Bligh, Jabez *DcBrWA, DcVicP, –2*
Blight, John Thomas *DcBrWA*
Blight-Thompson, Edith *DcWomA*
Blijk, Frans Jacobus VanDer 1806-1876 *DcSeaP*
Blijk, Jacobus VanDen 1736-1814 *IlDcG*
Blin, Adele *DcWomA*
Blin, Francois 1827-1866 *ClaDrA*
Blin, Peter 1639?- *FolkA 86*
Blind, Rudolph 1850-1916 *DcBrA 1, DcVicP 2*
Blinder, Martin S 1946- *WhoAmA 80, –82, –84*
Blinder, Richard Lewis 1935- *AmArch 70*
Blinderman, Barry Robert 1952- *WhoAmA 84*
Blinks, Thomas 1860-1912 *ClaDrA, DcBrA 1, DcVicP, –2*
Blinn, Caroline *DcWomA*
Blinn, Louise *WhAmArt 85*
Blinn, R W 1909- *WhAmArt 85*
Blish, Alan *AfroAA*
Blish, Carolyn *OfPGCP 86*
Blish, Carolyn Bullis 1928- *WhoAmA 73, –76*
Blish, H A *NewYHSD*
Bliss, Aaron 1730-1810 *FolkA 86*
Bliss, Alma Hirsig *DcWomA*
Bliss, Alma Hirsig 1875- *WhAmArt 85*
Bliss, Douglas Percy 1900- *DcBrA 1, DcCAr 81*
Bliss, E A d1911 *EncASM*
Bliss, Ebenezer d1824 *CabMA*
Bliss, Edward Newton 1890- *AmArch 70*
Bliss, Edwin F *AmArch 70*
Bliss, Elijah *CabMA*
Bliss, Elizabeth Sturtevant *DcWomA, WhAmArt 85*
Bliss, Florence M 1859- *DcWomA*
Bliss, Frank William 1940- *MarqDCG 84*
Bliss, Gertrude *DcWomA*
Bliss, H *FolkA 86*
Bliss, Horace G *NewYHSD*
Bliss, Lizzie P 1864-1931 *WhAmArt 85*
Bliss, Lucia Smith Carpenter 1823-1912 *DcWomA*
Bliss, M *DcVicP 2*
Bliss, Nettie G *ArtsEM, DcWomA*
Bliss, Pelatiah *CabMA*
Bliss, Richard Lawrence 1918- *AmArch 70*
Bliss, Robert Lewis 1921- *AmArch 70*

Bliss, Robert Woods d1962 *WhoAmA 80N, –82N, –84N*
Bliss, Mrs. Robert Woods d1969 *WhoAmA 80N, –78N, –82N, –84N*
Bliss, Roswell E *FolkA 86*
Blitch, James Buchanan 1923- *AmArch 70*
Blithe, Wesley L 1874-1946 *BiDAmAr*
Bliven, A Robert 1925- *AmArch 70*
Bliven, M A *DcWomA*
Bliven, Miss M A *NewYHSD*
Blix, Ragnvald 1882-1958 *WorECar*
Blizzard, Alan 1929- *WhoAmA 73, –76, –78, –80*
Blizzard, Alan 1939- *AmArt, PrintW 83, –85, WhoAmA 82, –84*
Blizzard, Georgia *FolkA 86*
Bloc, Andre 1896- *McGDA*
Bloc, Andre 1896-1966 *OxTwCA, PhDcTCA 77*
Bloc, Emma 1834- *DcWomA*
Bloch, Albert 1881-1961 *OxTwCA*
Bloch, Albert 1882- *WhAmArt 85*
Bloch, Albert 1882-1961 *ArtsAmW 1, DcCAA 71, –77, WhoAmA 78N, –80N, –82N, –84N*
Bloch, Arthur *WhAmArt 85*
Bloch, Benjamin Charles 1890- *AmArch 70*
Bloch, Bernard Jerome 1927- *AmArch 70*
Bloch, Cecil Joseph 1948- *MarqDCG 84*
Bloch, E Maurice *WhoAmA 73, –76, –78, –80, –82, –84*
Bloch, E Maurice 1916- *WhAmArt 85*
Bloch, Elisa 1848-1904 *DcWomA*
Bloch, Ernest 1880-1959 *ConPhot, ICPEnP A, MacBEP*
Bloch, F E *AmArch 70*
Bloch, Gunther 1916- *WhoArt 80, –82, –84*
Bloch, Julia 1903- *WhAmArt 85*
Bloch, Julius d1966 *WhoAmA 78N, –80N, –82N, –84N*
Bloch, Julius 1888-1966 *WhAmArt 85*
Bloch, L D *EncASM*
Bloch, Lucienne 1909- *DcAmArt, IlsBYP, IlsCB 1744, –1946, WhAmArt 85*
Bloch, Martin 1883-1954 *DcBrA 1, McGDA*
Bloch, Milton Joseph 1937- *WhoAmA 76, –78, –80, –82, –84*
Bloch, Pierette 1928- *DcCAr 81*
Bloch, Vitale 1900- *WhoArt 80, –82, –84*
Blocher, S *FolkA 86*
Block, Adolph 1906- *WhAmArt 85, WhoAmA 73, –76, –78*
Block, Adolph 1906-1978 *WhoAmA 80N, –82N, –84N*
Block, Amanda Roth 1912- *WhoAmA 73, –76, –78, –80, –82, –84*
Block, Andrew 1879-1969 *FolkA 86*
Block, Anna Katharina 1642-1719 *ClaDrA, DcWomA*
Block, Augusta *DcWomA*
Block, Benjamin Von 1631-1690 *ClaDrA*
Block, Dorothy 1904- *WhoAmA 82, –84*
Block, Elisa 1848-1904 *DcWomA*
Block, Eugene Francois De 1812- *ArtsNiC*
Block, Eugene Francois De 1812-1893 *ClaDrA*
Block, Fanny Rocker 1914- *WhAmArt 85*
Block, Gay 1942- *DcCAr 81, PrintW 83, –85, WhoAmA 82, –84*
Block, Gay Shlenker 1942- *MacBEP*
Block, H 1835?- *NewYHSD*
Block, Henry 1875-1938 *WhAmArt 85*
Block, Herbert Lawrence *WhoAmA 78, –80, –82*
Block, Herbert Lawrence 1907- *WhAmArt 85*
Block, Herbert Lawrence 1909- *WorECar*
Block, Huntington Turner 1924- *WhoAmA 78, –80*
Block, I A *WhAmArt 85*
Block, Irving Alexander *WhoAmA 78, –80, –82*
Block, Irving Alexander 1910- *WhoAmA 73*
Block, Irving Alexander 1912- *WhoAmA 76*
Block, J Mortimer *WhAmArt 85*
Block, Johanna *DcWomA*
Block, Joyce *WhoAmA 73, –76, –78, –80, –82, –84*
Block, L *DcVicP 2*
Block, Laurens *NewYHSD*
Block, Leigh B 1905- *WhoAmA 73, –76, –78, –80, –82*
Block, Mrs. Leigh B *WhoAmA 73, –76, 78, –80*
Block, Louis d1909 *DcBrA 2*
Block, Malu 1933- *WhoAmA 76*
Block, Maurice *WhAmArt 85*
Block, Nathaniel *CabMA*
Block, William Edgar 1929- *AmArch 70*
Blocker, W M, Jr. *AmArch 70*
Blockland, Anthonie VanMontfoort 1532?-1583 *ClaDrA*
Blockland VanMontfoort, Antonie Van 1534-1583 *McGDA*
Blockley, E *DcVicP 2*
Blockley, Gwillym John 1921- *WhoArt 80*
Blockley, Gwilym John 1921- *WhoArt 82, –84*
Blocksma, Dewey Douglas 1943- *FolkA 86*
Blocz, Lise *DcWomA*
Blodget, Samuel *NewYHSD*
Blodget, William Power 1885-1946 *BiDAmAr*
Blodgett, Anne Washington 1940- *WhoAmA 76, –78, –80, –82, –84*

Blodgett, Edmund Walton *WhoAmA 78N, –80N, –82N, –84N*
Blodgett, Edmund Walton 1908-1964? *WhAmArt 85*
Blodgett, George Winslow *WhoAmA 80N, –82N, –84N*
Blodgett, George Winslow 1888-1958? *WhAmArt 85*
Blodgett, Peter 1935- *WhoAmA 78, –80, –82, –84*
Blodgett, Samuel 1757-1814 *BiDAmAr*
Blodgett, Walton 1908- *WhAmArt 85*
Bloedel, Joan Ross 1942- *AmArt, WhoAmA 82, –84*
Bloedel, Joan Stuart Ross 1942- *WhoAmA 80*
Bloedel, Lawrence Hotchkiss 1902- *WhoAmA 73, –76*
Bloedel, Lawrence Hotchkiss 1902-1976 *WhoAmA 78N, –80N, –82N, –84N*
Bloemaert, Abraham 1564?-1651 *ClaDrA, McGDA, OxArt*
Bloemaert, Adrien 1609-1666 *ClaDrA*
Bloemaert, Frederick *OxArt*
Bloemaert, Hendrick 1601?-1672 *ClaDrA, McGDA*
Bloemen, Jan Frans Van 1662?-1749 *ClaDrA, McGDA*
Bloemen, Pieter Van 1649-1719 *ClaDrA*
Bloemen, Pieter Van 1657-1720 *McGDA*
Bloemers, Arnoldus 1786-1844 *ClaDrA*
Blofield, Z *DcVicP 2*
Blogg, H A *WhAmArt 85*
Blogg, William 1767?- *BiDBrA*
Blohm, C H *AmArch 70*
Blois, Flavia 1914- *DcBrA 1*
Blois, Lady Freda 1880- *DcBrA 1, DcWomA*
Blok, Johanna *DcWomA*
Blom, Eric D 1955- *MarqDCG 84*
Blom, Gerda Elisabeth *DcWomA*
Blom, Holger 1906- *ConArch*
Blom, Piet 1934- *ConArch*
Blomberg, K E *AmArch 70*
Blomberg, Ronald Eugene 1930- *AmArch 70*
Blomberg, Sigrid 1863- *DcWomA*
Blomberg, Sven 1920- *ICPEnP A*
Blome, Richard *AntBDN I*
Blomfield, Sir Arthur 1829-1899 *WhoArch*
Blomfield, Eardley W *DcVicP 2*
Blomfield, Reginald 1856-1942 *AntBDN A, MacEA*
Blomfield, Sir Reginald 1856-1942 *DcBrA 1, DcBrBI, WhoArch*
Blomfield, Sir Reginald 1856-1943 *McGDA*
Blomfield, Richard 1930- *DcCAr 81*
Blommen, Jan Frans Van 1662?-1749 *ClaDrA*
Blommers, Bart *WhAmArt 85*
Blommers, Caroline *DcWomA*
Blommers, Caroline Bean *WhAmArt 85*
Blomquist, James Carl 1937- *AmArch 70*
Blomstedt, Aulis 1906- *ConArch*
Blomstedt, Aulis 1906-1979 *MacEA*
Blomstedt, Yrjo Juhana 1937- *ConArt 77*
Blon, E Van *NewYHSD*
Blon, Jakob Chustof 1667-1741 *McGDA*
Blonay, Marguerite Anne De 1897- *DcWomA*
Blond, Maxwell *DcCAr 81*
Blond, Maxwell 1943- *WhoArt 80, –82, –84*
Blonde, Adolph 1812?- *NewYHSD*
Blonde, Geston 1839?- *NewYHSD*
Blondeau, Barbara 1938-1974 *ConPhot, ICPEnP A, MacBEP*
Blondeau, Georges 1929- *WorECar*
Blondeau, Lucie Jeanne Camille *DcWomA*
Blondeel, Lancelot 1495?-1581? *ClaDrA*
Blondeel, Lancelot 1496?-1561 *McGDA, OxArt*
Blondel, Elisa 1811-1845 *DcWomA*
Blondel, Emile 1893- *OxTwCA*
Blondel, Francois 1618-1686 *MacEA, McGDA, WhoArch*
Blondel, Gabrielle *DcWomA*
Blondel, Georges Francois 1730?- *BiDBrA*
Blondel, Georges Francois 1730?-1790? *MacEA*
Blondel, Jacob D 1817-1877 *ArtsNiC, NewYHSD*
Blondel, Jacques Francois 1705-1774 *MacEA, McGDA*
Blondel, Jacques-Francois 1705-1774 *OxArt, WhoArch*
Blondel, Jean-Francois 1663-1756 *WhoArch*
Blondel, Jean Francois 1683-1756 *MacEA*
Blondel, Leonie *DcWomA*
Blondel, Marie Michelle *DcWomA*
Blondel, Nicolas-Francois 1618-1686 *OxArt*
Blondelu, Constance Marie *DcWomA*
Blondheim, Adolphe 1888- *WhAmArt 85*
Blondheim, C A, Jr. *AmArch 70*
Blood, Mrs. B H *WhAmArt 85*
Blood, Ernest B 1944- *MarqDCG 84*
Blood, John H *NewYHSD*
Blood, M F *AmArch 70*
Blood, M J *FolkA 86*
Blood, Mary *DcWomA*
Bloodgood, John D 1931- *AmArch 70*
Bloodgood, M Seymour 1845-1920 *WhAmArt 85*
Bloodgood, Robert Fanshawe 1848-1930 *WhAmArt 85*
Bloodworth, R L *AmArch 70*
Bloom M *AmArch 70*
Bloom, Bernard 1910- *AmArch 70*

Bloom, Donald S 1932- *WhoAmA 84*
Bloom, Donald Stanley 1932- *WhoAmA 73, -76, -78, -80, -82*
Bloom, Douglas *MarqDCG 84*
Bloom, Edith Salvin 1917- *WhoAmA 84*
Bloom, Elsie E *WhAmArt 85*
Bloom, Gregory Louis 1947- *MarqDCG 84*
Bloom, Hyman 1913- *DcAmArt, DcCAA 71, -77, McGDA, OxTwCA, PhDcTCA 77, WhoAmA 78, -80, -82, -84*
Bloom, Jason 1947- *WhoAmA 78*
Bloom, John Vincent 1906- *WhAmArt 85*
Bloom, M E *WhAmArt 85*
Bloom, Michael Eugene 1947- *MarqDCG 84*
Bloom, Ronald Gene 1935- *AmArch 70*
Bloom, Suzanne 1943- *DcCAr 81*
Bloome, Robert *NewYHSD*
Bloomenthal, Jules 1951- *MarqDCG 84*
Bloomer, Amelia *DcNiCA*
Bloomer, Edward *NewYHSD*
Bloomer, H Reynolds *ArtsNiC, DcVicP 2*
Bloomer, Hiram Reynolds 1845- *WhAmArt 85*
Bloomer, Hiram Reynolds 1845-1910 *ArtsAmW 1*
Bloomfield, B C *AmArch 70*
Bloomfield, Elizabeth L *WhAmArt 85*
Bloomfield, Lisa Diane 1951- *WhoAmA 84*
Bloomfield, Peter 1946- *MarqDCG 84*
Bloomgarden, Judith Mary 1942- *WhoAmA 78, -80, -82, -84*
Bloomstein, Edward Nathaniel 1921- *AmArch 70*
Bloor, Alfred J 1828-1917 *BiDAmAr*
Bloor, Henry Pritchard 1827-1902 *WhAmArt 85*
Bloor, Robert d1846 *AntBDN M*
Bloor, William *FolkA 86*
Bloore, Ron *OxTwCA*
Bloore, Ronald Langley 1925- *WhoAmA 73, -76*
Bloosaerken *McGDA*
Bloot, Pieter Pietersz De 1601-1658 *McGDA*
Blooteling, Abraham 1640-1690? *McGDA*
Blooteling, Abraham 1640-1690 *OxArt*
Bloq-Ullmann, Lise *DcWomA*
Blore, Burton *DcVicP 2*
Blore, Edward 1787-1879 *BiDBrA, DcBrBI, MacEA, McGDA, OxArt, WhoArch*
Blore, Edward 1789-1879 *DcBrWA*
Blos, May 1906- *WhAmArt 85, WhoAmA 73, -76, -78, -80, -82, -84*
Blos, Peter W 1903- *WhAmArt 85, WhoAmA 73, -76, -78, -80, -82, -84*
Blosch, Laure 1863- *DcWomA*
Bloser, Florence Parker 1889- *WhAmArt 85*
Bloser, Florence Parker 1889-1935 *ArtsAmW 2, DcWomA*
Bloss, Michael *NewYHSD*
Blosser, Dale Alan 1927- *AmArch 70*
Blosser, Merrill 1892- *WorECom*
Blossfeldt, Karl 1865-1932 *ConPhot, ICPEnP, MacBEP*
Blossom, Christopher *OfPGCP 86*
Blossom, David 1927- *IlrAm G, -1880*
Blossom, Earl *WhAmArt 85*
Blossom, Earl 1891- *IlrAm D*
Blossom, Earl 1891-1970 *IlrAm 1880*
Blot, Angele Eugenie *DcWomA*
Blot, Laure *DcWomA*
Blot, Maria *DcWomA*
Blot, Xainte Edmee *DcWomA*
Blotnick, Elihu 1939- *MacBEP*
Blotta, Oscar 1918- *WorECom*
Blottiere, Betsy Marguerite *DcWomA*
Blouet, G Abel 1795-1853 *MacEA*
Blouet, Guillaume-Abel 1795-1853 *McGDA*
Blouet, Leontine *DcWomA*
Blount, Arthur David 1951- *ICPEnP A*
Blount, James Covert 1936- *AmArch 70*
Blount, Joseph Edward 1937- *AmArch 70*
Blount, Juliane *DcVicP 2*
Blount, Reginald *AfroAA*
Blount, Robert Edward 1895- *AmArch 70*
Blount, S Ellis 1896- *WhAmArt 85*
Blount, Samuel Ellis 1896- *AfroAA*
Blount, Stephen 1761-1804 *CabMA*
Blow, Detmar 1867-1939 *DcBrBI*
Blow, Richard 1904- *WhAmArt 85*
Blow, Sandra 1925- *ConBrA 79[port], DcBrA 1, DcCAr 81, OxTwCA, PhDcTCA 77*
Blow, Thomas R 1897- *WhAmArt 85*
Blower, David H 1901-1976 *WhAmArt 85*
Blower, David Harrison 1901- *WhoAmA 73, -76*
Blower, David Harrison 1901-1976 *WhoAmA 78N, -80N, -82N, -84N*
Bloxam, Ethel D'Arcourt 1871-1971 *DcWomA*
Bloxam, Joan Mary *DcWomA*
Bloxam, Mary A *DcWomA*
Bloxham *DcBrECP*
Bloxham, John d1715 *BiDBrA*
Bloxham, Mary A *DcVicP 2*
Blucher, Joseph 1810?- *NewYHSD*
Blucher, Xavier *NewYHSD*
Bluck, J *DcBrWA*
Blue, A Aladar *WhAmArt 85*

Blue, Carroll Parrott 1943- *MacBEP*
Blue, Patt 1945- *ICPEnP A, WhoAmA 84*
Blue, Ronald K 1945- *MarqDCG 84*
Blue, Sheldon August 1933- *AmArch 70*
Blue, Walter Emmette, Jr. 1923- *AmArch 70*
Blue Eagle, Acee *WhAmArt 85*
Blue Eagle, Acee 1907-1959 *IlBEAAW*
Bluemm, Harriet A *ArtsEM, DcWomA*
Bluemner, Oscar 1867-1938 *DcAmArt, DcCAA 71, -77, OxTwCA, PhDcTCA 77*
Bluemner, Oscar Florianus 1867-1938 *WhAmArt 85*
Bluestein, E *AmArch 70*
Bluestein, Marvin M 1936- *AmArch 70*
Bluhm, H Faber *DcVicP 2*
Bluhm, Norman 1920- *DcCAA 71, -77, DcCAr 81, OxTwCA, PhDcTCA 77, WhoAmA 73, -76, -78, -80, -82, -84*
Bluhova, Irena 1904- *MacBEP*
Blum, Alex A 1888- *WhAmArt 85*
Blum, Andrea 1950- *WhoAmA 80, -82, -84*
Blum, Carl Robert 1916- *AmArch 70*
Blum, David T 1955- *MarqDCG 84*
Blum, Edith C *WhAmArt 85*
Blum, Edward 1877-1944 *BiDAmAr*
Blum, Edward C 1863-1946 *WhAmArt 85*
Blum, Helaine Dorothy *WhoAmA 84*
Blum, Helen *DcWomA*
Blum, Helen A 1886- *WhAmArt 85*
Blum, Helen Abrahams 1886- *DcWomA*
Blum, Irving 1930- *WhoAmA 80*
Blum, Jerome S 1884- *IlBEAAW, WhAmArt 85*
Blum, Jerome S 1884-1956 *ArtsAmW 3*
Blum, Julius White 1930- *AmArch 70*
Blum, June 1939- *WhoAmA 80, -82, -84*
Blum, Lucile Swan *WhAmArt 85*
Blum, Norbert John 1932- *AmArch 70*
Blum, Robert D *NewYHSD*
Blum, Robert Frederick 1857-1903 *DcAmArt, DcBrBI, IlrAm A, -1880, McGDA, WhAmArt 85*
Blum, Robert H *DcVicP 2*
Blum, Shirley Neilsen 1932- *WhoAmA 73, -76, -78, -80, -82, -84*
Blum, Sigmund Francis 1926- *AmArch 70*
Blum, Walter E 1925- *AmArch 70*
Blum, William Henry, Jr. 1922- *AmArch 70*
Blum-Boris, Marguerite *DcWomA*
Blum-Lazarus, Sophie *DcWomA*
Blum-Samuel, Juliette *DcWomA*
Blumann, Sigismund 1872- *WhAmArt 85*
Blumberg, Barbara Griffiths 1920- *WhoAmA 76, -78, -80, -82, -84*
Blumberg, Donald 1935- *ConPhot*
Blumberg, Donald Robert 1935- *ICPEnP A, MacBEP*
Blumberg, Ludwick Theodore 1917- *AmArch 70*
Blumberg, M F *AmArch 70*
Blumberg, Robert L 1942- *MarqDCG 84*
Blumberg, Ron *WhoAmA 73, -76, -78, -80, -82, -84*
Blumberg, Sandra Trop *WhoAmA 82, -84*
Blumberg, Yuli d1964 *WhoAmA 78N, -80N, -82N, -84N*
Blumberg, Yuli 1894-1964 *DcWomA, WhAmArt 85*
Blumbergs, Janis 1947- *ICPEnP A*
Blume, Bernhard Johannes 1937- *DcCAr 81*
Blume, Edward Stewart, Jr. 1931- *AmArch 70*
Blume, L J *AmArch 70*
Blume, Melita *DcWomA, WhAmArt 85*
Blume, Michael A 1929- *MarqDCG 84*
Blume, Peter 1906- *BnEnAmA, ConArt 83, DcAmArt, DcCAA 71, -77, DcCAr 81, McGDA, OxTwCA, PhDcTCA 77, WhAmArt 85, WhoAmA 73, -76, -78, -80, -82, -84*
Blumenau, Lili *BnEnAmA*
Blumenfeld, Erwin 1897-1969 *ConPhot, ICPEnP, MacBEP*
Blumenfeld, Maurice *WhAmArt 85*
Blumenkranz, Joseph 1902- *AmArch 70*
Blumenschein, Ernest L 1874-1960 *DcAmArt*
Blumenschein, Ernest Leonard 1874-1960 *ArtsAmW 1, IlBEAAW, IlrAm B, -1880, McGDA, WhAmArt 85, WhoAmA 80N, -82N, -84N*
Blumenschein, Helen G 1909- *WhAmArt 85*
Blumenschein, Helen Greene 1909- *IlBEAAW*
Blumenschein, Mary Greene d1958 *WhoAmA 80N, -82N, -84N*
Blumenschein, Mary Greene 1869-1958 *WhAmArt 85*
Blumenschein, Mary Shepard 1869-1958 *DcWomA*
Blumenschein, Mary Shepard Greene 1868-1958 *ArtsAmW 1*
Blumenschein, Mary Shepard Greene 1869?-1958 *IlBEAAW*
Blumenstiel, Helen Alpiner 1899- *ArtsAmW 2, DcWomA, WhAmArt 85*
Blumenthal, Fritz 1913- *PrintW 83, -85, WhoAmA 76, -78, -80, -82, -84*
Blumenthal, Hermann 1905-1942 *McGDA, PhDcTCA 77*
Blumenthal, Margaret M 1905- *WhAmArt 85, WhoAmA 73, -76, -78, -80, -82, -84*
Blumenthal, Marjory S 1955- *MarqDCG 84*
Blumenthal, Moses L 1879- *WhAmArt 85*

Blumer, Elisabeth *DcWomA*
Blumer, Marguerite Barnett 1901- *WhAmArt 85*
Blumert, J M 1901- *WhAmArt 85*
Blumin, Robert 1936- *AmArch 70*
Blumin, Serge 1947- *DcCAr 81*
Blumler, George *WhAmArt 85*
Blumner, Frederick *NewYHSD*
Blumrich, Stephen 1941- *WhoAmA 80, -82, -84*
Blumue, Edna *DcWomA*
Blundell, Alfred Richard 1883- *DcBrA 1*
Blundell, Alfred Richard 1883-1968 *DcBrA 2*
Blundell, Grace E M *DcWomA*
Blundell, Kathleen *DcWomA*
Blundell, Margaret Leah 1907- *DcBrA 1*
Blundell Jones, Peter *ConArch A*
Blunden, Anna *DcWomA*
Blunden, Anna 1829- *DcVicP*
Blunden, Anna E 1830-1915 *DcVicP 2*
Blunden, Anna L 1829- *DcBrWA*
Blunden, John 1940- *MarqDCG 84*
Blundstone, Ferdinand Victor 1882-1951 *DcBrA 1*
Blunk, Robert Musser 1927- *AmArch 70*
Blunt, Lady Anne *DcVicP 2, DcWomA*
Blunt, Sir Anthony 1907- *WhoArt 80*
Blunt, Arthur Cadogan *DcVicP 2*
Blunt, Arthur Cadogan d1934 *DcBrA 2*
Blunt, Edmund *NewYHSD*
Blunt, Henry Bala *DcBrWA*
Blunt, James Tillyer 1765-1834 *DcBrWA*
Blunt, John S 1798-1835 *NewYHSD*
Blunt, John Samuel 1798-1835? *FolkA 86*
Blunt, John Silvester 1874-1943 *DcBrA 1, DcBrWA*
Blunt, John Sylvester 1874- *ClaDrA*
Blunt, Joseph S *NewYHSD*
Blunt, Simon F *NewYHSD*
Blunt, Sybil Allan 1880- *DcBrA 1, DcWomA*
Blunt, Wilfrid 1901- *WhoAmA 80, -82, -84*
Bluntschli, A F 1842- *MacEA*
Blurock, William Edward 1922- *AmArch 70*
Blust, Earl R *IlsBYP*
Bluth, Manfred 1926- *DcCAr 81, PhDcTCA 77*
Bly, J *DcVicP 2*
Blydenburg, S *NewYHSD*
Blyderburg, S *FolkA 86*
Blye, C M *AmArch 70*
Blyney, William *DcCAr 81*
Blyth, Benjamin *NewYHSD*
Blyth, Benjamin 1737-1803 *FolkA 86*
Blyth, Jessie Caroline Dunbar *DcWomA*
Blyth, John 1806-1878 *BiDBrA*
Blyth, Malcolm Scott 1940- *MarqDCG 84*
Blyth, Mary *DcWomA*
Blyth, Robert Henderson 1919- *ClaDrA*
Blyth, Robert Henderson 1919-1970 *DcBrA 1*
Blyth, S R *DcBrBI*
Blyth, Samuel d1795 *NewYHSD*
Blythe, David *FolkA 86*
Blythe, David Gilmor 1815-1865 *McGDA*
Blythe, David Gilmore 1815-1865 *BnEnAmA*
Blythe, David Gilmour 1815-1865 *DcAmArt, FolkA 86, NewYHSD*
Blythe, Thomas *CabMA*
Bo, Jorgen 1919- *ConArch*
Bo, Keitil 1940- *MarqDCG 84*
Boadle, William B d1916 *DcBrA 1, DcVicP 2*
Boag, James *BiDBrA*
Boak, Milvia W 1897- *ArtsAmW 2, DcWomA, WhAmArt 85*
Boak, R M *AmArch 70*
Boak, Robert Cresswell 1875- *DcBrA 1*
Boal, James McC 1800?-1862 *NewYHSD*
Boal, Sara Metzner 1896- *DcWomA, WhoAmA 73, -76, -78, -80, -82, -84*
Boall, Marian G *WhAmArt 85*
Boalt, James 1820?- *FolkA 86*
Board *FolkA 86*
Board, Edwin John 1886- *ClaDrA, DcBrA 1*
Board, Ernest 1877-1934 *DcBrA 1*
Boardley, B *NewYHSD*
Boardley, Peale *NewYHSD*
Boardley, Thomas 1813?- *NewYHSD*
Boardley, William *NewYHSD*
Boardman, Mrs. *DcWomA*
Boardman, Annette B *WhAmArt 85*
Boardman, E *FolkA 86*
Boardman, Frank Crawford *WhAmArt 85*
Boardman, G A *DcWomA*
Boardman, Mrs. G A *NewYHSD*
Boardman, Joseph C *EncASM*
Boardman, Langley 1760?-1829 *CabMA*
Boardman, Leonard C 1821?- *CabMA*
Boardman, Luther 1812-1887 *EncASM*
Boardman, Nell d1968 *WhoAmA 78N, -80N, -82N, -84N*
Boardman, Nell 1894-1968 *DcWomA*
Boardman, Norman S d1905 *EncASM*
Boardman, Richard A 1940- *WhoAmA 80*
Boardman, Robert Edwin 1926- *AmArch 70*
Boardman, Rosina Cox *DcWomA, WhAmArt 85*
Boardman, Seymour 1921- *DcCAA 71, -77, DcCAr 81, WhoAmA 73, -76, -78, -80, -82, -84*

Boardman, Thomas David 1942- *AmArch 70*
Boardman, Timothy 1754- *CabMA*
Boardman, William G 1815?- *NewYHSD*
Boardman, William H *NewYHSD*
Boari, Adamo 1865-1928 *MacEA*
Boas, Belle *WhAmArt 85*
Boas, Jacob *FolkA 86*
Boas, Simone Brangier 1895- *WhAmArt 85*
Boas, Simone Marthe 1895- *DcWomA*
Boatright, Elizabeth E 1897?- *DcWomA*
Boatwright, Cecil Miller, Jr. 1925- *AmArch 70*
Boaz, Joseph Nowlin 1917- *AmArch 70*
Boaz, William G 1926- *WhoAmA 73, -76*
Bob & Bob *WhoAmA 84*
Bob And Bob *WhoAmA 82*
Boba, George 1550?- *ClaDrA*
Bobak, Bruno Joseph 1923- *WhoAmA 80, -82, -84*
Bobak, Bruzio 1923- *DcCAr 81*
Bobak, Molly Lamb 1922- *DcCAr 81*
Bobb, Hickory Stick Vic *FolkA 86*
Bobb, Victor 1892-1978 *FolkA 86*
Bobbett, Albert 1824?-1888? *NewYHSD*
Bobbett, Alfred *NewYHSD*
Bobbitt, Vernon L 1911- *WhAmArt 85,*
 WhoAmA 73, -76
Bobbs, Ruth 1884- *DcWomA*
Bobbs, Ruth Pratt 1884- *WhAmArt 85*
Bobeczko, Michael Steven 1946- *MarqDCG 84*
Boberg, Anna Katarina 1864-1935 *DcWomA*
Boberg, Ferdinand 1860-1946 *MacEA*
Boberg, Gustaf Ferdinand 1860-1940 *McGDA*
Boberts, Carl *WhAmArt 85*
Bobick, Bruce 1941- *AmArt, WhoAmA 73, -76, -78, -80, -82, -84*
Bobick, M G *AmArch 70*
Bobillet, Etienne *McGDA*
Bobleter, Lowell Stanley 1902- *WhoAmA 73*
Bobleter, Lowell Stanley 1902-1973 *WhAmArt 85, WhoAmA 76N, -78N, -80N, -82N, -84N*
Boblinger, Hans 1412-1482 *MacEA*
Boblinger, Matthaus d1505 *MacEA*
Boblinger, Matthias 1450?-1505 *McGDA*
Bobovitch, V *AmArch 70*
Bobovnikoff, Emily 1876- *DcBrA 1, DcWomA*
Bobri, V 1898- *IlsBYP, IlsCB 1946, -1957*
Bobritsky, Vladimir 1898- *IlrAm D, -1880, IlsBYP, IlsCB 1744, -1946, -1957*
Bobritzky, George Victor 1917- *WhoAmA 76*
Bobrow, Michael Lawrence 1939- *AmArch 70*
Bobrowicz, Yvonne P 1928- *WhoAmA 78, -80, -82, -84*
Boccaccino, Boccaccio 1467?-1525? *McGDA*
Boccaccino, Camillo 1501-1546 *McGDA*
Boccador *McGDA*
Boccador, Le *OxArt*
Boccard, Antoinette De *DcWomA*
Boccard, Elisa De 1847-1925 *DcWomA*
Boccati Da Camerino, Giovanni 1420?- *McGDA*
Boccherini, Anna *DcWomA*
Bocchicchio, A *AmArch 70*
Boccia, Edward Eugene 1921- *AmArt, WhoAmA 73, -76, -78, -80, -82, -84*
Boccini, Manuel 1890- *WhAmArt 85*
Boccioni, Umberto 1882-1916 *ConArt 77, -83, McGDA, OxArt, OxTwCA, PhDcTCA 77*
Boch, Anna 1848-1933 *DcWomA*
Boch Freres *DcNiCA*
Bochand, Jeanne *DcWomA*
Bocher, Main Rousseau 1890- *WorFshn*
Bocher, Marie Louise Henri *DcWomA*
Bochero, Peter 1895?-1962 *FolkA 86*
Bochiardy, Howard Byron 1925- *AmArch 70*
Bochler *NewYHSD*
Bochner, Mel *OxTwCA*
Bochner, Mel 1940- *AmArt, ConArt 77, -83, DcAmArt, DcCAA 77, DcCAr 81, PrintW 83, -85, WhoAmA 78, -80, -82, -84*
Bochnik, Michael Joseph 1903- *AmArch 70*
Bock, Adeline H *ArtsEM*
Bock, Charles Peter 1872- *ArtsAmW 2, WhAmArt 85*
Bock, Frederick Stephen 1941- *MarqDCG 84*
Bock, Frederick William 1876- *WhAmArt 85*
Bock, G A *AmArch 70*
Bock, Hans 1550?-1624 *ClaDrA*
Bock, Hans, The Elder 1550?-1624? *McGDA*
Bock, Josef *DcNiCA*
Bock, Richard Walter 1865- *WhAmArt 85*
Bock, Theophile Emile Achille De 1851-1904 *ClaDrA*
Bock, Vera *ConICB, IlsBYP, IlsCB 1744, -1946, -1957, -1967, WhoAmA 73*
Bock, Vera 1905- *WhAmArt 85*
Bock, Mrs. William N *FolkA 86*
Bock, William Sauts *IlsBYP, IlsCB 1967*
Bock, William Sauts-Netamux'we 1939- *WhoAmA 78, -80, -82, -84*
Bockius, D L, Jr. *AmArch 70*
Bocklin, Arnold 1827- *ArtsNiC*
Bocklin, Arnold 1827-1901 *McGDA*
Bockman, Gerhard 1686-1773 *DcBrECP*
Bockmann, Charles G *WhAmArt 85*

Bockstiegel, Peter August 1889-1951 *OxTwCA, PhDcTCA 77*
Bocly, Mademoiselle *DcWomA*
Bocook, B H 1934- *AmArch 70*
Bocquet, Anna Rosalie *DcWomA*
Bocquet, Anna Van *DcWomA*
Bocquet, E *DcVicP 2*
Bocquet, Noemie *DcWomA*
Bocquillon, Antoinette Melanie *DcWomA*
Bocquillon, Berthe *DcWomA*
Bodart, Regine *DcWomA*
Boddaert, Sara Agatha 1790-1856 *DcWomA*
Boddington, Edwin H *DcVicP*
Boddington, Edwin Henry *ClaDrA*
Boddington, Edwin Henry 1836-1905? *DcVicP 2*
Boddington, Harriet Olivia *DcBrWA, DcWomA*
Boddington, Henry *DcBrA 2*
Boddington, Henry John 1811-1865 *DcVicP, -2*
Boddy, William J d1911 *DcBrA 2*
Boddy, William James 1832-1911 *DcBrWA, DcVicP 2*
Bode, Albert William 1932- *AmArch 70*
Bode, Catherine Burnaby *WhAmArt 85*
Bode, Charles A 1920- *AmArch 70*
Bode, David Mark 1932- *AmArch 70*
Bode, H E *AmArch 70*
Bode, Johann Christian 1675-1751 *IlDcG*
Bode, Robert William 1912- *WhoAmA 76, -78, -80, -82, -84*
Bode, Thomas William 1932- *AmArch 70*
Bodebender, Laura *DcWomA*
Bodebender, Laura 1900- *WhAmArt 85*
Bodecker, Nils Mogens *IlsCB 1967*
Bodecker, Nils Mogens 1922- *IlsBYP, IlsCB 1946, -1957*
Bodeghem, Louis Van 1470?-1540 *McGDA*
Bodelack, Adolph C *ArtsEM*
Bodelack, Louise A *ArtsEM, DcWomA*
Bodelack And Frayer *ArtsEM*
Bodelack And Vanselow *ArtsEM*
Bodell, Mark Robinson 1891- *WhAmArt 85*
Bodem, Dennis Richard 1937- *WhoAmA 78, -80, -82, -84*
Boden, C *FolkA 86*
Boden, Edward *NewYHSD*
Boden, George Alfred 1888-1956 *DcBrA 1*
Boden, Leonard 1911- *DcBrA 1, WhoArt 80, -82, -84*
Boden, Margaret *WhoArt 80, -82, -84*
Boden, Samuel Standige 1826-1896 *DcBrWA, DcVicP 2*
Boden, William 1840?-1920 *DcBrA 1*
Bodenbuhl, Peter *FolkA 86*
Bodenheim, Johanna Cornelia Hermana 1874-1951 *DcWomA*
Bodenmiller, Joseph P 1888-1947 *BiDAmAr*
Bodet, E *AmArch 70*
Bodfish, Evelin *DcWomA, WhAmArt 85*
Bodfish, William P *IlBEAAW*
Bodhidharma *McGDA*
Bodiansky, Vladimir 1894-1966 *ConArch*
Bodichon, Barbara 1827-1891 *DcBrWA*
Bodichon, Barbara Leigh *DcWomA*
Bodichon, Eugene, Madame 1827-1891 *DcVicP, -2*
Bodilly, Frank *DcVicP 2*
Bodilo *DcBrECP*
Bodin, A *AntBDN E*
Bodin, Louis *NewYHSD*
Bodin, Paul 1910- *DcCAA 71, -77, WhoAmA 73, -84*
Bodinat, Marguerite De *DcWomA*
Bodine, A Aubrey 1906-1970 *ICPEnP A, MacBEP*
Bodine, Helen *WhoAmA 80N, -82N, -84N*
Bodine, Helen d1956? *DcWomA*
Bodine, Helen d1958? *WhAmArt 85*
Bodine, J *FolkA 86*
Bodine, Michael M 1950- *MarqDCG 84*
Bodine, R H *FolkA 86*
Bodinger, A *AmArch 70*
Bodington, Bryan William 1911- *DcBrA 1*
Bodkin, Edwin *DcVicP 2*
Bodkin, Frederic E *DcBrA 1*
Bodkin, Frederick E *DcVicP, -2*
Bodkin, R *DcVicP 2*
Bodkin, Sally Grosz 1900- *WhAmArt 85*
Bodley, Edwin J D *DcNiCA*
Bodley, George F 1827-1907 *MacEA*
Bodley, George Frederick 1827-1907 *DcBrA 1, McGDA, WhoArch*
Bodley, Josselin 1893-1974 *DcBrA 1*
Bodman, Ralph 1903- *AmArch 70*
Bodmer, H Louis *AmArch 70*
Bodmer, Karl *DcVicP 2*
Bodmer, Karl 1805- *ArtsNiC*
Bodmer, Karl 1809-1893 *ArtsAmW 1, BnEnAmA, ClaDrA, DcAmArt, IlBEAAW, NewYHSD*
Bodmer, Paul 1886- *OxTwCA*
Bodmer, Walter 1902- *McGDA*
Bodmer, Walter 1903- *OxTwCA, PhDcTCA 77*
Bodnar, Peter 1928- *WhoAmA 76, -78, -80, -82, -84*
Bodnar, Thomas 1882- *WhAmArt 85*

Bodner, Karl *AntBDN B*
Bodo, Matthew 1912- *AmArch 70*
Bodo, Sandor 1920- *WhoAmA 73, -76, -78, -80, -82, -84*
Bodolai, Joseph Stephen 1948- *WhoAmA 73, -76, -78*
Bodoni, Giambattista 1740-1813 *OxDecA*
Bodouva, W N *AmArch 70*
Bodstein, Herman *NewYHSD*
Bodt, Jean De 1670-1745 *WhoArch*
Bodt, Johann Von 1670-1745 *BiDBrA*
Bodtker, Petrea 1850-1945 *DcWomA*
Body, J M *AmArch 70*
Bodzin, Henry Ezra 1947- *MarqDCG 84*
Boe, Francois Didier 1820- *ArtsNiC*
Boe, Franz Didrik 1820-1891 *ClaDrA*
Boe, Olive *WhAmArt 85*
Boe, Roger William 1940- *AmArch 70*
Boe, Roy Asbjorn 1919- *WhoAmA 73, -76, -78, -80N, -82N, -84N*
Boebinger, Charles William 1876- *WhAmArt 85*
Boeche, Guy A *WhAmArt 85*
Boeck, Felix De 1898- *OxTwCA*
Boeckel, Anna *DcWomA*
Boeckel, Theodore A *WhAmArt 85*
Boeckhorst, Johann 1605-1668 *ClaDrA, McGDA*
Boeckl, Herbert 1894- *PhDcTCA 77*
Boeckl, Herbert 1894-1966 *OxTwCA*
Boecklin, Arnold 1827-1901 *OxArt*
Boeckman, Carl L *WhAmArt 85*
Boeckman, Helga *DcWomA, WhAmArt 85*
Boeckmann, Carl Ludwig 1868- *ArtsAmW 3*
Boecop, Cornelia d1629? *DcWomA*
Boecop, Mechteld Toe *DcWomA*
Boedefeld, W *AmArch 70*
Boedeker, Arnold E 1893- *WhoAmA 73, -76, -78, -80, -82, -84*
Boedeker, Erich 1906-1971 *OxTwCA*
Boehk, Karl Ernst 1919- *AmArch 70*
Boehler, Albin *WhAmArt 85*
Boehler, Hans 1884-1961 *WhoAmA 80N, -82N, -84N*
Boehler, John E 1811?- *NewYHSD*
Boehm, A William *DcVicP 2*
Boehm, Elizaveta Merkurevna 1843- *DcWomA*
Boehm, Henry Richard 1870-1914 *WhAmArt 85*
Boehm, Joseph Edgar 1834- *ArtsNiC*
Boehm, Wolfgang *DcVicP 2*
Boehm, Wolfgang 1928- *MarqDCG 84*
Boehme, Frederik Vilhelm *DcSeaP*
Boehme, Hazel Fetterley 1900- *WhAmArt 85*
Boehme, Rachel Rosina *DcWomA*
Boehmer, Fritz 1875- *WhAmArt 85*
Boehmore, Francis 1828?- *NewYHSD*
Boehner, Margaret Huntington *WhAmArt 85*
Boehning, Joseph Frederick 1931- *AmArch 70*
Boeke, A *AmArch 70*
Boel, Pieter 1622-1674 *McGDA*
Boelema, Maarten d1664? *McGDA*
Boelen, Jacob 1654-1729 *AntBDN Q*
Boelhauwe, C T *AmArch 70*
Boell, William *NewYHSD*
Boellaard, Margaretha Cornelia 1795-1872 *ClaDrA, DcWomA*
Boemm, Ritta 1868- *DcWomA*
Boenisch, Gustav Adolf 1802- *ArtsNiC*
Boer, Saskia De 1946- *DcCAr 81*
Boerder, E F *AmArch 70*
Boerema, Robert Jay 1929- *AmArch 70*
Boerens, Mrs. M M *DcBrECP*
Boeri, Cini 1924- *ConDes*
Boericke, Johanna M 1868- *WhAmArt 85*
Boericke, Johanna Magdalene 1868- *DcWomA*
Boericke, Mildred McGeorge *WhAmArt 85*
Boering, Brooke W 1926- *MarqDCG 84*
Boerner, Amalie *DcWomA*
Boerner, Edward A 1902-1981 *WhAmArt 85*
Boerner, Eleonore Philippine Louise B d1834? *DcWomA*
Boerner, Herbert 1921- *AmArch 70*
Boero, Nilda *DcWomA*
Boers, Dieter *OxTwCA*
Boers, Marianne 1945- *PrintW 85*
Boerum, Simeon *NewYHSD*
Boesch, Marie 1916- *DcCAr 81*
Boeschenstein, Bernice d1951 *WhoAmA 78N, -80N, -82N, -84N*
Boeschenstein, Bernice 1906-1951 *WhAmArt 85*
Boese, Alvin William 1910- *WhoAmA 73, -76, -78, -80, -82, -84*
Boese, C O, Jr. *AmArch 70*
Boese, Henry *NewYHSD*
Boese, O *AmArch 70*
Boesefeldt, Jochen 1927- *MarqDCG 84*
Boesen, Laura Vilhelmine *DcWomA*
Boesen, Marie Dorthea *DcWomA*
Boesendahl, Howard 1928- *WhoAmA 76*
Boeshor, Heinrich *FolkA 86*
Boessenecker, J Henri 1883- *WhAmArt 85*
Boesser, H 1820?- *NewYHSD*
Boeswillwald, Emile 1815- *ArtsNiC*
Boething, Marjory Adele *WhAmArt 85*
Boething, Marjory Adele 1896- *ArtsAmW 2,*

DcWomA
Boethus McGDA, OxArt
Boettcher, C E AmArch 70
Boettcher, Clarence WhAmArt 85
Boettger, Adolph NewYHSD
Boettger, Carl 1823-1900 FolkA 86
Boetti, Alighiero E 1940- ConArt 77, -83, DcCAr 81
Boetticher, Otto 1816?- NewYHSD
Boetto, Grovenale 1603-1678 MacEA
Boetzel, Helene DcWomA
Boeve, Edgar Gene 1929- WhoAmA 78, -80, -82, -84
Boeyen, Mari 1951- ConArt 77, -83
Boeyermans, Theodor 1620?-1678 ClaDrA
Boeyermans, Theodore 1620-1678 McGDA
Boezem, Marinus 1934- ConArt 77, -83
Boezem, Marinus Lambertus VanDen 1934- PhDcTCA 77
Bofa 1885- OxTwCA
Bofa, Gus WorECar
Bofferding, James John 1919- AmArch 70
Boffrand, Gabriel 1667-1754 DcD&D
Boffrand, Gabriel-Germain 1667-1754 McGDA, OxArt
Boffrand, Germain 1667-1754 MacEA, WhoArch
Bofill, Antoine IlBEAAW
Bofill Levi, Ricardo 1939- ConArch
Bofis 1928- DcCAr 81
Bogaert, Martin VanDen McGDA
Bogaev, Ronni WhoAmA 76, -78, -80, -82, -84
Bogar, James Brooks 1921- AmArch 70
Bogard, Donald Warren 1926- AmArch 70
Bogard, R Ward, Jr. 1940- AmArch 70
Bogardus, Abram NewYHSD
Bogardus, James 1800-1874 BnEnAmA, EncAAr, EncMA, MacEA, McGDA, NewYHSD
Bogardus, Mrs. James 1804-1878 NewYHSD
Bogardus, John D NewYHSD
Bogardus, John S 1828-1903 BiDAmAr
Bogardus, Margaret 1804-1878 DcWomA
Bogardus, William NewYHSD
Bogardus, Mrs. William NewYHSD
Bogarin, Rafael 1946- WhoAmA 78, -80, -82, -84
Bogart, Bram 1921- OxTwCA, PhDcTCA 77, WhoArt 80, -82, -84
Bogart, Cynthia OfPGCP 86
Bogart, George A 1933- WhoAmA 73, -76, -78, -80, -82, -84
Bogart, George Hirst 1864-1923 WhAmArt 85
Bogart, Harriet 1917- WhAmArt 85
Bogart, J DcWomA
Bogart, Martin OxArt
Bogart, Maud Humphrey DcWomA, WhAmArt 85
Bogart, Michele Helene 1952- WhoAmA 82, -84
Bogart, Mitchell Yochanon 1952- MarqDCG 84
Bogart, Nancy Ann 1955- MarqDCG 84
Bogart, Paul 1931- AmArch 70
Bogart, Richard Jerome 1929- AmArt, WhoAmA 73, -76, -78, -80, -82, -84
Bogart, Robert M NewYHSD
Bogart, Stella M WhAmArt 85
Bogart, William Robert 1928- AmArch 70
Bogatay, Paul 1905- WhAmArt 85
Bogatay, Paul 1905-1972 CenC[port]
Bogdanove, A J 1888-1946 WhAmArt 85
Bogdanovic, Bogomir 1923- WhoAmA 76, -78, -80, -82, -84
Bogdanovich, Borislav 1899- WhAmArt 85
Bogdanovich, Borislav 1900-1970 IlBEAAW
Bogdanowicz, Anna DcWomA
Bogdany, Jakob d1724 ClaDrA
Bogdany, Jakob 1660-1724 DcBrECP
Bogen, Beverly WhoAmA 73, -76
Bogen, Herbert Louis 1920- AmArch 70
Bogen, Paul F 1917- AmArch 70
Boger, Fred 1857- WhAmArt 85
Bogert, Charles NewYHSD
Bogert, Cornelius VanReypen 1879- AmArch 70
Bogert, Cornelius VanReypen, Jr. 1911- AmArch 70
Bogert, David NewYHSD
Bogert, George Henry 1864-1944 WhAmArt 85
Bogert, George Hirst 1864-1944 ArtsAmW 1
Bogert, Grace Warren WhoAmA 73, -76
Bogert, J Augustus NewYHSD
Bogert, Julia DcWomA, WhAmArt 85
Boggeri, Antonio 1900- ConDes
Boggess, Edward Theodore 1932- AmArch 70
Boggio, Emilio OxTwCA
Boggio, Michael Anthony 1922- AmArch 70
Boggis, J H DcVicP 2
Boggis, M DcVicP 2
Boggs, Miss DcWomA
Boggs, Frank M 1855-1926 WhAmArt 85
Boggs, Franklin 1914- WhAmArt 85, WhoAmA 73, -76, -78, -80, -82, -84
Boggs, Jacob David Fine, Jr. 1926- AmArch 70
Boggs, James Dexter 1928- AmArch 70
Boggs, James Palmer 1906- AmArch 70
Boggs, Jean Sutherland 1922- WhoAmA 73, -76, -78, -80, -82, -84
Boggs, Mayo Mac 1942- WhoAmA 76, -78, -80, -82,

-84
Boggs, Robert R NewYHSD
Boggs, Walter James 1925- AmArch 70
Boggs, William Brenton 1809-1875 NewYHSD
Boggy, Horace E AmArch 70
Bogh, Naang Elisabeth Margrethe 1865- DcWomA
Boghem, Louis Van McGDA
Boghosian, Marvin Dean Krekor 1927- AmArch 70
Boghosian, Nounoufar 1894- FolkA 86
Boghosian, Varujan 1926- DcCAA 71, -77, DcCAr 81, WhoAmA 73, -76, -78, -80, -82, -84
Bogiages, Stephen Andrew 1947- MarqDCG 84
Bogle, James 1817-1873 ArtsNiC, NewYHSD
Bogle, John 1746?-1803 AntBDN J
Bogle, Robert 1817?- NewYHSD
Bogle, Robert Boyd, III 1934- AmArch 70
Bogle, W Lockhart DcVicP 2
Bogle, W Lockhart d1900 DcBrBI
Bogner, Betty DcWomA
Bogner, Fred Karl 1939- MarqDCG 84
Bogner, Walter Francis 1899- AmArch 70, MacEA
Bogner, Walter Penman 1935- AmArch 70
Bogner, Willi WorFshn
Bogoluboff, Alexis P ArtsNiC
Bogorad, Alan Dale 1915- WhoAmA 76, -78, -80, -82, -84
Bogott, Lawrence C AmArch 70
Bogounoff, Mollie 1920- WhoAmA 80, -82, -84
Bogucki 1932- WhoAmA 76, -78, -80, -82, -84
Bogue, John CabMA
Boguet, Nicolas Didier 1755-1839 ClaDrA
Bogun, Maceptaw 1917- FolkA 86
Bogus, Tom 1951- MarqDCG 84
Boguslavskaya, Kseniya Leonidovna 1892-1972 DcWomA
Bohacket, Albert FolkA 86
Bohan, E B DcWomA
Bohan, Marc FairDF FRA[port]
Bohan, Marc 1926- ConDes, WorFshn
Bohan, Peter John WhoAmA 73, -76, -78, -80
Bohan, R H WhAmArt 85
Bohan, Ruth d1981? DcWomA
Bohanon, Gloria AfroAA
Bohdziewicz, Emilia 1941- DcCAr 81
Bohigas, Oriol ConArch A
Bohigas Guardiola, Oriol 1925- ConArch
Bohigas Martorell And Mackay MacEA
Bohland, Gustav 1897-1959 WhAmArt 85, WhoAmA 80N, -82N, -84N
Bohland, Mrs. Gustav WhAmArt 85
Bohle, Hilmar 1953- DcCAr 81
Bohle, Paul WorFshn
Bohleman, Herman T 1872- ArtsAmW 2
Bohlen, A C AmArch 70
Bohlen, Diedrich A d1890 BiDAmAr
Bohlen, Nina 1931- WhoAmA 78, -80, -82, -84
Bohlen, Oscar D d1936 BiDAmAr
Bohler, Joseph Stephen 1938- WhoAmA 82, -84
Bohlin, Peter Quarfordt 1937- AmArch 70
Bohlke, John Henry 1937- AmArch 70
Bohlken, Johann H FolkA 86
Bohlman, Edgar Lemoine 1902- WhAmArt 85
Bohlman, Herman T 1872- ArtsAmW 2, WhAmArt 85
Bohly, Marie G DcWomA
Bohm, August 1812-1890 DcNiCA, IlDcG
Bohm, C Curry 1894- WhAmArt 85
Bohm, Dominikus 1880-1955 ConArch, EncMA, MacEA, McGDA
Bohm, Dorothy 1924- ICPEnP A, MacBEP
Bohm, G NewYHSD
Bohm, Gottfried 1920- ConArch, MacEA
Bohm, Marcus AntBDN D
Bohm, Max 1868-1923 WhAmArt 85
Bohm, Ronald J 1947- MarqDCG 84
Bohm, Victor 1900- AmArch 70
Bohme, Augusta DcWomA
Bohme, Karl Wilhelm AntBDN M
Bohme, Ottilia DcWomA
Bohme, Rachel Rosina DcWomA
Bohmer, Gunter 1911- WhoGrA 62, -82[port]
Bohmfield, A DcVicP 2
Bohn, Adam 1808?- FolkA 86
Bohn, Arthur 1862-1948 BiDAmAr
Bohn, C NewYHSD
Bohn, Clyde Walter 1928- AmArch 70
Bohn, Jacob W FolkA 86
Bohn, Richard Ake, Jr. 1924- AmArch 70
Bohnard, William A 1877- WhAmArt 85
Bohnen, Aloys L WhAmArt 85
Bohnen, Blythe 1940- DcCAr 81, WhoAmA 73, -76, -78, -80, -82, -84
Bohnen, Carl WhAmArt 85
Bohnenblust, Eleanor WhAmArt 85
Bohnenkamp, Leslie George 1943- WhoAmA 82, -84
Bohner, Marian A 1904- WhAmArt 85
Bohnert, Herbert d1967 WhoAmA 78N, -80N, -82N, -84N
Bohnert, Herbert 1890-1967 WhAmArt 85
Bohnert, Rosetta WhoAmA 73, -76
Bohnert, Rosetta 1885-1980 WhAmArt 85

Bohnert, Thom 1948- WhoAmA 82, -84
Bohnert, Thom R 1948- CenC
Bohney, Jessica 1886- ArtsAmW 3, DcWomA
Bohonon, Moses CabMA
Bohrer, Walter Elmer 1922- AmArch 70
Bohrmann, Karl 1928- DcCAr 81
Bohrod, Aaron 1907- AmArt, BnEnAmA, DcAmArt, DcCAA 71, -77, DcCAr 81, GrAmP, McGDA, WhAmArt 85, WhoAmA 73, -76, -78, -80, -82, -84
Bohurd, G A 1810?- NewYHSD
Bohus, Zoltan 1941- DcCAr 81
Boice, Miss DcWomA
Boichot, Guillaume 1735-1814 McGDA
Boichot, J DcWomA
Boiger, Peter 1941- WhoAmA 76, -78, -80
Boileau, James G 1840?- NewYHSD
Boileau, Louis Auguste 1812-1896 MacEA, WhoArch
Boileau, Louis Charles 1837-1910 WhoArch
Boileau, Philip 1864-1917 WhAmArt 85
Boillat, Lucie DcWomA
Boilly NewYHSD
Boilly, Julien Leopold 1796-1874 ClaDrA
Boilly, Louis Leopold 1761-1845 ClaDrA, WorECar
Boilly, Louis-Leopold 1761-1845 McGDA, OxArt
Boily, Anne 1738- DcWomA
Boily, Julie DcWomA
Boily, M Gervais, Madame DcWomA
Boirleau, Marie DcWomA
Boiron, Alexandre Emile 1859-1889 ClaDrA
Bois, Miss DcVicP 2, DcWomA
Bois, Catharina Du DcWomA
Bois, Roberte Du DcWomA
Boisfremont, Charles Boulanger De 1773-1838 ClaDrA
Boisragon, T S G DcVicP 2
Boisseau, Alfred 1823- IlBEAAW, NewYHSD
Boisseau, Leopoldine DcWomA
Boisseau, S D NewYHSD
Boisseree, Frederick DcBrWA, DcVicP 2
Boissie, Marie Gabrielle Pauline DcWomA
Boissier, Andre Claude 1760-1833 ClaDrA
Boissier, Julienne Marie 1777- DcWomA
Boissier, Maria DcWomA
Boissiere, Jacqueline DeLa DcWomA
Boissiere, Mathilde Marguerite Augustine DcWomA
Boissieu, Jean Jacques De 1736-1810 ClaDrA
Boissieu, Jean-Jacques De 1736-1810 McGDA
Boissieux, Berthe DcWomA
Boisson, Jean DcCAr 81
Boissonade, Julie DcWomA
Boissonnas, Caroline Sophie DcWomA
Boissonneau, Marguerite WhAmArt 85
Boit, Charles 1662?-1727 AntBDN J
Boit, Edward D ArtsNiC
Boit, Edward D 1842-1916 WhAmArt 85
Boit, Edward Darling 1840-1916 NewYHSD
Boitard, Francois 1670?-1717? BkIE
Boitard, Louis Philippe d1760? BkIE
Boitelet, Marie Louise DcWomA
Boito, Camillo 1836-1914 MacEA, WhoArch
Boivin, Jacques 1952- ConGrA 1[port]
Boize, Charles FolkA 86
Boizot, Marie Louise Adelaide 1744-1800 DcWomA
Boizot, Simon Louis 1743-1809 OxArt
Boje, Walter 1905- MacBEP
Bojesen, Bo 1923- WorECar
Bojorquez, Morgan 1950- MarqDCG 84
Bok, Hannes Vajn WhAmArt 85
Bokee, John FolkA 86
Bokenham, Barbara A DcWomA
Boker, F M AmArch 70
Boker, Irving IlsBYP
Boker, Steven Marshall 1952- MarqDCG 84
Boklund, Cecilia DcWomA
Boks, Evert Jan 1838- ClaDrA
Bol, Cornelis 1580?- DcSeaP
Bol, Ferdinand 1611-1680 ClaDrA
Bol, Ferdinand 1616-1680 McGDA
Bol, Ferdinand 1618-1680 OxArt
Bol, Hans 1534-1593 ClaDrA, McGDA
Bol, Pierre 1622?-1674? ClaDrA
Bolan, Sean Edward 1948- WhoArt 84
Boland, M L, Jr. AmArch 70
Bolander, Joseph FolkA 86
Bolander, Karl S 1893- WhAmArt 85
Bolas, Gerald Douglas 1949- WhoAmA 84
Bolcom, Seth CabMA
Bold, John 1895- DcBrA 1
Bolden, Joseph IlsBYP
Bolden, James E 1902- WhAmArt 85
Bolden, Robert H FolkA 86
Boldini, Andrea IlDcG
Boldini, Eleanor ArtsNiC
Boldini, Giovanni 1845-1931 McGDA
Boldini, Jean 1845-1931 ClaDrA
Boldon, Charles Morton 1933- AmArch 70
Boldrini, Nicolo McGDA
Bole, Bojan DcCAr 81
Bole, Jeanne d1883 DcWomA
Bolegard, Joseph WhAmArt 85

Booth, Edmund John, Sr. 1900- *AmArch 70*
Booth, Edward C *DcVicP, -2*
Booth, Elijah 1745-1823 *CabMA*
Booth, Elizabeth *DcVicP 2*
Booth, Eloise *WhAmArt 85*
Booth, Esther *DcWomA*
Booth, Eunice Ellenetta d1942 *ArtsAmW 2,*
 WhAmArt 85
Booth, Franklin *WhAmArt 85*
Booth, Franklin 1874-1948 *IlrAm B, -1880,*
 WorECar
Booth, George *DcVicP 2*
Booth, George 1926- *WorECar*
Booth, George N *NewYHSD*
Booth, George Warren *WhoAmA 76, -78, -80, -82*
Booth, George Warren 1917- *WhAmArt 85,*
 WhoAmA 84
Booth, Graham Charles *IlsCB 1967*
Booth, Graham Charles 1935- *IlsBYP, IlsCB 1957*
Booth, Hanson 1885-1944 *WhAmArt 85*
Booth, Herb *OfPGCP 86*
Booth, J L C *DcBrBI*
Booth, James *BiDBrA*
Booth, James Scripps 1888- *WhAmArt 85*
Booth, James Scripps 1888-1954 *ArtsAmW 3*
Booth, James William 1867-1953 *DcBrA 1, DcVicP 2*
Booth, Joel 1769-1794 *CabMA*
Booth, John 1760?-1843 *BiDBrA*
Booth, Judith Gayle 1942- *WhoAmA 76, -78, -80, -82,*
 -84
Booth, Kate L *ArtsEM, DcWomA*
Booth, Laura M *DcWomA, WhAmArt 85*
Booth, Laurence Ogden 1936- *AmArch 70,*
 WhoAmA 73, -76, -78, -80, -82, -84
Booth, Louis Strother 1908- *AmArch 70*
Booth, Louise Delmont 1875- *DcWomA*
Booth, Nina *ArtsEM, DcWomA*
Booth, Nina Mason *WhoAmA 80N, -82N, -84N*
Booth, Nina Mason 1884-1956? *DcWomA*
Booth, Nina Mason 1884-1957? *WhAmArt 85*
Booth, Peter 1940- *ConArt 83*
Booth, R E R *DcVicP 2*
Booth, Ralph Harman 1873-1931 *WhAmArt 85*
Booth, Richard *CabMA*
Booth, Richard Salvey 1765?-1807 *DcBrWA*
Booth, Robert Alan *WhoAmA 84*
Booth, Roger d1849 *FolkA 86*
Booth, S Lawson d1928 *DcBrA 1*
Booth, Salmon *FolkA 86*
Booth, T Dwight *NewYHSD*
Booth, Thomas *FolkA 86*
Booth, Walter 1892?-1971 *WorECom*
Booth, Walter R *WorECar*
Booth, William *DcBrWA*
Booth, William Joseph 1797?-1872 *BiDBrA*
Booth, William T 1921- *AmArch 70*
Booth, Zadie Cary 1905- *WhAmArt 85*
Booth Brothers *FolkA 86*
Booth Family *CabMA*
Booth-Owen, M 1942- *WhoAmA 82, -84*
Booth-Owen, Mary Ann 1942- *AmArt*
Boothe, Power 1945- *AmArt*
Boothe, Power Robert 1945- *WhoAmA 76, -78, -80,*
 -82, -84
Boothe, Sally Marie 1948- *MacBEP*
Bootle, H Gore *DcWomA*
Booton, Harold *ConArch A*
Boots, Max Devon 1926- *AmArch 70*
Boott, Elizabeth *ArtsNiC*
Boott, Elizabeth Otis Lyman 1846-1888 *DcWomA*
Booty, Edward *DcVicP 2*
Booty, Henry R *DcVicP 2*
Booye, Robert James 1933- *AmArch 70*
Booz, Charles *WhAmArt 85*
Boozer, Henry W *ArtsEM*
Boozer, S David 1936- *AmArch 70*
Booziotis, B C *AmArch 70*
Bopp, Emery 1924- *WhoAmA 73, -76, -78, -80, -82,*
 -84
Boquentin, Marie Amelie Julie Delphine *DcWomA*
Boquet, L A *DcWomA*
Boquet, Marie Virginie *DcWomA*
Boquet, Rose Jeanne *DcWomA*
Boqueta DeWoiseri, J L *NewYHSD*
Boqutea, I L *NewYHSD*
Bor, Paulus d1638 *ClaDrA*
Borack, Stan *OfPGCP 86*
Borah, Nixson *DcCAr 81*
Boratko, Andre 1912- *WhAmArt 85*
Borbals, Stanley 1907- *AmArch 70*
Borbas, Olga *DcWomA*
Borch *OxArt*
Borch, Elna Inger Cathrine 1869- *DcWomA*
Borch, Gerard 1617-1681 *ClaDrA*
Borch, Gesina Ter 1633-1690 *DcWomA*
Borch, Maria *DcWomA*
Borchard, Miss H *NewYHSD*
Borchard, Herminia *DcWomA*
Borchardt, K 1913- *WhoArt 80, -82*
Borchardt, Karolina 1913- *WhoArt 84*
Borchardt, Norman 1891- *WhAmArt 85*

Borchers, Kenneth *MarqDCG 84*
Borchert, Eva Margarethe *DcWomA*
Borcht, Hendrik VanDer 1583-1660 *ClaDrA*
Borcht, Hendrik VanDer 1614-1654 *ClaDrA*
Borcht, Peter VanDer 1600?-1633 *ClaDrA*
Borckhardt, C *DcBrECP*
Borcoman, James 1926- *WhoAmA 76, -78, -80, -82,*
 -84
Borda, Arturo 1883-1955 *OxTwCA*
Borda, Daniel J 1932- *MarqDCG 84*
Bordallo-Pinheiro, Maria Augusta *DcWomA*
Bordallo Pinheiro, Rafael 1846-1905 *WorECar*
Bordas, Herve 1954- *DcCAr 81*
Bordass, Dorothy Trotman 1905- *DcBrA 2,*
 WhoArt 80, -82, -84
Borde, Maud Cecile Yvonne *DcWomA*
Bordeaux, Jean Luc 1938- *WhoAmA 78, -80, -82, -84*
Bordeaux, Marie Marguerite Augustine *DcWomA*
Bordeleau, Claude 1950- *MarqDCG 84*
Borden, Bruce Charles 1947- *MarqDCG 84*
Borden, Delana 1801-1863 *FolkA 86*
Borden, E Shirley 1867- *WhAmArt 85*
Borden, F J *DcWomA*
Borden, Garrick Mallory d1912 *WhAmArt 85*
Borden, Ole 1922- *WorFshn*
Borden, Robert Scranton 1938- *MarqDCG 84*
Border, Ann Amelia Mathilda 1875- *FolkA 86*
Borders, Robert Stanley 1931- *AmArch 70*
Bordes, Adrienne 1935- *WhoAmA 82, -84*
Bordes-Guyon, Jeanne d1903 *DcWomA*
Bordewisch, Ferdinand F 1889- *WhAmArt 85*
Bordier, Jacqueline *DcWomA*
Bordley, John Beale 1727-1804 *NewYHSD*
Bordley, John Beale 1800-1882 *NewYHSD*
Bordley, Margaret C 1822?- *DcWomA, NewYHSD*
Bordner, Daniel 1807-1842 *FolkA 86*
Bordonaro, Sebastian J 1932- *AmArch 70*
Bordone, Paris 1500-1571 *ClaDrA, McGDA*
Borduas, Paul Emile d1960 *WhoAmA 78N, -80N,*
 -82N, -84N
Borduas, Paul-Emile 1905-1960 *ConArt 77, -83,*
 OxTwCA, PhDcTCA 77
Borduas, Paul-Emile 1906-1960 *McGDA*
Bordwell, Georgine Graves *DcWomA, WhAmArt 85*
Boreel, Wendela 1895- *ClaDrA, DcBrA 1,*
 DcWomA
Borein, Edward 1872- *WhAmArt 85*
Borein, Edward 1873-1945 *ArtsAmW 1*
Borein, John Edward 1872-1945 *IlBEAAW*
Borel, Anna Jeanne Charlotte 1869- *DcWomA*
Borel, Berta *DcWomA*
Borel, Henriette Marie Evelina 1871- *DcWomA*
Borella, Carlo 1661-1707 *MacEA*
Borelli-Vranska, Zoe De *DcWomA*
Boren, Esther Jones 1896- *WhAmArt 85*
Boren, James *OfPGCP 86*
Boren, James 1921- *IlBEAAW*
Boren, James Erwin 1921- *WhoAmA 76, -78, -80, -82,*
 -84
Boren, Jodie *OfPGCP 86*
Boren, T M *AmArch 70*
Borenstein, M *AmArch 70*
Bores, Francisco 1898- *OxTwCA, PhDcTCA 77*
Boretti, Renald John 1926- *AmArch 70*
Boretz, Naomi *WhoAmA 76, -78, -80, -82, -84*
Borg, C *DcSeaP*
Borg, Carl Oscar 1879-1947 *ArtsAmW 1, IlBEAAW,*
 WhAmArt 85
Borg, E H *AmArch 70*
Borgardus, James 1800-1874 *OxArt*
Borgatta, Isabel Case 1921- *WhoAmA 73, -76, -78,*
 -80, -82, -84
Borgatta, Robert Edward 1921- *WhoAmA 73, -76,*
 -78, -80, -82, -84
Borgeaud, Georges 1913- *DcCAr 81*
Borgeaud, Jean-Marie 1954- *DcCAr 81*
Borgek, Lydie *DcWomA*
Borgenicht, Grace 1915- *WhoAmA 73, -76, -78, -80,*
 -82, -84
Borgersen, Hans 1877- *WhAmArt 85*
Borges, Henry Florencio 1926- *AmArch 70*
Borges, Jacopo *OxTwCA*
Borges, Max E 1918- *AmArch 70*
Borges, Norah *OxTwCA*
Borgeson, C Richard 1937- *AmArch 70*
Borgeson, J W *WhAmArt 85*
Borget, Lloyd George 1913- *AmArch 70*
Borghegiano, Cherubino *ClaDrA*
Borghese, Florida *DcWomA*
Borghi, Guido Rinaldo 1903-1971 *WhAmArt 85,*
 WhoAmA 78N, -80N, -82N, -84N
Borghi, Lillian Lewis 1899- *ArtsAmW 2, DcWomA,*
 WhAmArt 85
Borgianni, Orazio 1578?-1616 *McGDA*
Borgino Dal Posso *McGDA*
Borglum, Elizabeth *WhAmArt 85*
Borglum, Elizabeth 1848?-1922 *DcWomA*
Borglum, Elizabeth 1849- *ArtsAmW 1*
Borglum, Gutsom 1867-1941 *OxArt*
Borglum, Gutzon 1867-1941 *ArtsAmW 1, BnEnAmA,*
 DcAmArt, McGDA, OxTwCA

Borglum, Gutzon 1871-1941 *WhAmArt 85*
Borglum, James Lincoln DeLaMothe 1912- *IlBEAAW,*
 WhoAmA 76, -78, -80, -82, -84
Borglum, John Gutzon DeLaMothe 1867-1941
 IlBEAAW
Borglum, Solon H 1868-1922 *WhAmArt 85*
Borglum, Solon Hannibal 1868-1922 *ArtsAmW 1,*
 BnEnAmA, DcAmArt, IlBEAAW, McGDA
Borgman, John 1834?- *NewYHSD*
Borgmann, Mark Laurence 1953- *MarqDCG 84*
Borgmeyer, Charles L d1918 *WhAmArt 85*
Borgnis, Giuseppe Maria 1701-1761 *DcBrECP*
Borgo, Francesco Del d1468 *MacEA*
Borgo, Louis J 1876- *WhAmArt 85*
Borgo, Ludovico 1930- *WhoAmA 78, -80, -82, -84*
Borgognone, Il *McGDA, OxArt*
Borgognone, A *OxArt*
Borgognone, Ambrogio *McGDA*
Borgognone, Ambrogio 1455-1523 *ClaDrA*
Borgognoni, Barbara *DcWomA*
Borgona, Juan De d1554 *OxArt*
Borgord, Martin 1869-1935 *ArtsAmW 3,*
 WhAmArt 85
Borgstedt, Douglas 1911- *WhAmArt 85*
Borgzinner, Jon 1938- *WhoAmA 73*
Boriani, Davide 1936- *OxTwCA, PhDcTCA 77*
Borican, John *AfroAA*
Borie, Adolphe 1877-1934 *WhAmArt 85*
Borie, Charles L, Jr. 1871-1943 *BiDAmAr*
Boring, Wayne 1916- *WorECom*
Boring, William A 1858-1937 *MacEA*
Boring, William A 1859-1937 *BiDAmAr*
Boris, Bessie *WhoAmA 76, -78, -80, -82, -84*
Boris, Bessie 1919- *WhoAmA 73*
Borisov-Morosov, Oleg 1919- *AmArch 70*
Borisov, Mrs. M E *WhAmArt 85*
Borja, Corinne And Robert *IlsBYP*
Borja, Robert *IlsBYP*
Borjesen, J *ArtsNiC*
Borjesson, Augusta Fredrika 1827-1900 *DcWomA*
Bork, Alfred 1926- *MarqDCG 84*
Bork, R R *AmArch 70*
Borkman, Gustaf 1842-1921 *WhAmArt 85*
Borkovich, George Stevan 1952- *MarqDCG 84*
Borkowski, Mary K 1916- *FolkA 86*
Borlach, John *BiDBrA*
Borland *NewYHSD*
Borland, M *DcWomA*
Borman, Jan 1479?-1520 *McGDA*
Borman, Jan, I *OxArt*
Borman, Jan, II *OxArt*
Borman, Pasquier *McGDA*
Bormann, Johann Balthasar 1725-1784 *AntBDN M*
Bormann, Zachariah 1738-1810 *AntBDN M*
Borms, Emma C 1867-1951 *DcWomA*
Born, Adolf 1930- *WhoGrA 82[port]*
Born, Adrian Matthew 1914- *AmArch 70*
Born, E *AmArch 70*
Born, Ernest 1898- *WhAmArt 85*
Born, Ernest Alexander 1898- *ArtsAmW 2*
Born, James E 1934- *WhoAmA 78, -80, -82, -84*
Born, Wolfgang *WhoAmA 78N, -80N, -82N, -84N*
Born, Wolfgang 1893-1950? *WhAmArt 85*
Born VanDen, Bob 1927- *WhoGrA 82[port]*
Bornarth, Mary S *WhAmArt 85*
Borne, Daisy Theresa 1906- *DcBrA 1*
Borne, Mortimer *WhoAmA 73, -76, -78, -80*
Borne, Mortimer 1902- *WhAmArt 85, WhoAmA 82,*
 -84
Borneman, F W *NewYHSD*
Borner, Amalie *DcWomA*
Borner, Elise *DcWomA*
Bornet, J *NewYHSD*
Bornfriend, Jacob *WhoArt 80N*
Bornfriend, Jacob 1904- *DcBrA 1*
Bornfriend, M I *AmArch 70*
Borngraber, Christian *ConArch A*
Bornheim, Carrie *DcWomA*
Bornhorst, David Joseph 1934- *AmArch 70*
Bornozi, Diana *DcWomA*
Borns, L F, Jr. *AmArch 70*
Bornschlegel, Ruth *IlsBYP*
Bornstein, Eli 1922- *WhoAmA 73, -76, -78, -80, -82,*
 -84
Bornstein, G *AmArch 70*
Bornstein, Marguerita 1950- *WorECar*
Bornstein, Ruth 1927- *IlsCB 1967*
Borochoff, Sloan *WhoAmA 73, -76, -78, -80, -84*
Borochoff, Sloan 1939- *WhoAmA 82*
Borofsky, Jon 1942- *ConArt 83, DcCAr 81,*
 WhoAmA 78, -80, -82, -84
Borofsky, Jonathan 1942- *PrintW 83, -85*
Borofsky, Jonathon 1942- *AmArt*
Boron, Vivian Browne 1902- *WhAmArt 85*
Boronda, Beonne 1911- *WhAmArt 85*
Boronda, Lester David 1886- *ArtsAmW 1, -3,*
 WhAmArt 85
Borop, Louis *DcVicP 2*
Boros, Billi *WhoAmA 73, -76, -78, -80*
Borough-Johnson, Ernest 1867- *ClaDrA*
Borough-Johnson, Esther *DcWomA*

Bott, Dennis Adrian Roxby 1948- *WhoArt 80, –82, –84*
Bott, Earle Wayne 1894- *WhAmArt 85*
Bott, Emil *NewYHSD*
Bott, Francis 1904- *PhDcTCA 77*
Bott, H J 1933- *WhoAmA 76, –78, –80, –82, –84*
Bott, Johann Von *BiDBrA*
Bott, Mabel Siegelin 1900- *WhAmArt 85*
Bott, Margaret Deats *WhoAmA 78, –80, –82, –84*
Bott, Patricia Allen *WhoAmA 78, –80, –82, –84*
Bott, R T *DcVicP 2*
Bott, Thomas 1829-1870 *AntBDN M, DcNiCA*
Bott, Thomas John 1854-1932 *DcNiCA*
Bott & Co. *DcNiCA*
Botta, A C *AmArch 70*
Bottali, Louis J 1951- *MarqDCG 84*
Bottaro, Luciano 1931- *WorECom*
Bottaro, Mario 1945- *MarqDCG 84*
Bottcher, John A *NewYHSD*
Bottcher, Klara Von *DcWomA*
Bottelli, Richard 1937- *AmArch 70*
Bottelli, Romolo, Jr. 1902- *AmArch 70*
Bottengruber, Ignaz *AntBDN M*
Bottger, Jacob Ahrend Heinrich 1781-1860 *DcSeaP*
Bottger, Johann Friedrich d1719 *OxDecA*
Bottger, Johann Friedrich 1682-1719 *AntBDN M*
Botti Scifoni, Ilda 1812-1844 *DcWomA*
Botticelli, Alessandro DiMariano F 1445-1510 *OxArt*
Botticelli, Sandro 1444-1510 *ClaDrA*
Botticelli, Sandro 1445?-1510 *McGDA, OxArt*
Botticher *NewYHSD*
Botticini, Francesco 1446-1497 *McGDA*
Botticini, Francesco DiGiovanni 1446?-1497 *OxArt*
Botticini, Raffaello 1477-1520? *McGDA*
Bottiger *NewYHSD*
Bottigheimer, Erna 1907- *WhAmArt 85*
Bottinelli, Antonio *ArtsNiC*
Bottinger, William James 1939- *MarqDCG 84*
Bottini, David 1945- *DcCAr 81*
Bottini, David M 1945- *WhoAmA 76, –78, –80, –82, –84*
Bottini, Georges 1873-1906 *ClaDrA*
Bottis, Hugh P d1964 *WhoAmA 78N, –80N, –82N, –84N*
Bottles, Joseph 1825?- *NewYHSD*
Botto, Otto 1903- *WhAmArt 85*
Botto, Richard Alfred 1931- *WhoAmA 73, –76, –78, –80, –82, –84*
Bottomley, Albert Ernest 1873-1950 *ClaDrA, DcBrA 1*
Bottomley, Edwin 1865-1929 *DcBrA 1*
Bottomley, Fred 1883-1960 *DcBrA 1*
Bottomley, John William 1816-1900 *ClaDrA, DcVicP, –2*
Bottomley, Joseph *BiDBrA*
Bottomley, Peter 1927- *WhoArt 80, –82, –84*
Bottomley, Reginald *DcVicP 2*
Bottorf, Edna Annabelle 1901- *WhAmArt 85*
Bottorff, William W 1940- *MarqDCG 84*
Botts, George 1829?- *NewYHSD*
Botts, Hugh 1903-1964 *WhAmArt 85*
Bottume, George F 1828- *NewYHSD*
Botwinick, Michael 1943- *WhoAmA 76, –78, –80, –82, –84*
Botwinik, Leon 1959- *MarqDCG 84*
Bouasse-Francine, Marie *DcWomA*
Boubat, Edouard 1923- *ConPhot, ICPEnP, MacBEP*
Bouchard, Adolph *NewYHSD*
Bouchard, Henri 1875- *McGDA*
Bouchard, Henri 1875-1960 *OxTwCA*
Bouchard, Laure *DcWomA*
Bouchard, Lorne Holland 1913- *WhoAmA 73, –76, –78*
Bouchard, Lorne Holland 1913-1978 *WhoAmA 80N, –82N, –84N*
Bouchardon, Edme 1698-1762 *McGDA, OxArt*
Bouchardon, Jacques-Philippe 1711-1753 *McGDA*
Bouchardy, Pauline *DcWomA*
Bouche *NewYHSD*
Bouche, Georges 1874-1941 *OxTwCA*
Bouche, Louis d1969 *WhoAmA 78N, –80N, –82N, –84N*
Bouche, Louis 1896- *McGDA, PhDcTCA 77*
Bouche, Louis 1896-1969 *DcCAA 71, –77, OxTwCA, WhAmArt 85*
Bouche, Louis Alexandre 1838-1911 *ClaDrA*
Bouche, Marian Wright 1895- *DcWomA, WhAmArt 85*
Bouche, Rene d1963 *WhoAmA 78N, –80N, –82N, –84N*
Boucher, Madame *DcWomA*
Boucher, Mademoiselle *DcWomA*
Boucher, Alfred *ArtsNiC*
Boucher, Alfred 1850-1934 *McGDA*
Boucher, Catherine *DcWomA*
Boucher, David *MarqDCG 84*
Boucher, Doris *FolkA 86*
Boucher, Francois 1703-1770 *ClaDrA, McGDA, OxArt, OxDecA*
Boucher, Graziella V 1906- *WhAmArt 85*
Boucher, Jeanne *DcWomA*

Boucher, Marie Jeanne 1716-1785? *DcWomA*
Boucher, Pierre 1908- *ConPhot, ICPEnP A*
Boucher, Tania Kunsky 1927- *WhoAmA 76, –78, –80, –82, –84*
Boucher, William H d1906 *DcBrBI*
Boucher DeLeomenil, Ambroisine Laure G *DcWomA*
Boucher-Desnoyers, Auguste-Gaspard-Louis 1779-1857 *McGDA*
Boucherette, Emilia *DcWomA*
Boucheron, Helene *DcWomA*
Bouchet, Elisabeth *DcWomA*
Bouchet, Marguerite *DcWomA*
Bouchet-Dedieu, Jane d1926 *DcWomA*
Bouchette, A *DcVicP 2*
Bouchette, Joseph *AntBDN I*
Bouchillon, Larry L 1933- *AmArch 70*
Bouchon-Claude, Lucienne d1932 *DcWomA*
Bouchor, Joseph Felix 1853-1937 *ClaDrA*
Bouchot, Claire d1938 *DcWomA*
Bouchot, Francois 1800-1842 *ClaDrA*
Boucicaut Master *McGDA*
Bouckaert, Harm J G 1934- *WhoAmA 82, –84*
Bouckel, Anna Van *DcWomA*
Bouckert, Anna Van *DcWomA*
Bouckhorst, Jan Philipsz Van 1588?-1631 *ClaDrA*
Boucle, Anna Van *DcWomA*
Bouclier, Marie Louise Amelie Cornelie *DcWomA*
Boucquet, Victor 1629-1677 *McGDA*
Boucquey, Omer 1921- *WorECar*
Boudard, Marguerite *DcWomA*
Bouden *NewYHSD*
Boudenes-Garcin, Jeanne *DcWomA*
Boudet, Miss *DcWomA, NewYHSD*
Boudet, Dominic W d1845 *NewYHSD*
Boudet, Nicholas Vincent *NewYHSD*
Boudet, William *NewYHSD*
Boudewijns, Adriaen Frans, I 1644-1711 *McGDA*
Boudewijns, Adriaen Frans, II 1673- *McGDA*
Boudewyns, Adriaen Frans 1644-1711 *ClaDrA*
Boudewyns, Nicolas 1760-1800 *ClaDrA*
Boudier, J J *NewYHSD*
Boudin, Eugene 1824-1898 *OxArt*
Boudin, Eugene Louis 1824-1898 *ClaDrA, McGDA*
Boudin, Eugene Louis 1825-1908 *DcSeaP*
Boudin, Thomas d1637 *McGDA*
Boudit *NewYHSD*
Boudkovski-Kibaltchitch, Nadejda 1876-1952 *DcWomA*
Boudon *NewYHSD*
Boudon, David *NewYHSD*
Boudon, Mathilde *DcWomA*
Boudreau, James Clayton 1891- *WhAmArt 85*
Boudreaux, John Armand 1942- *AmArch 70*
Boudreaux, R J *AmArch 70*
Boudro, Alexandr *FolkA 86*
Boudrou, Alexandre *FolkA 86*
Bouffard, Pierre *WhoArt 80, –82, –84*
Bouffay, Caroline *DcWomA*
Bouffay, Pauline *DcWomA*
Bouffe, Jenny Haquette *DcWomA*
Bouffe, Pauline *DcWomA*
Bouffier, Marguerite *DcWomA*
Bough, Martin *AfroAA*
Bough, Samuel 1822-1878 *ArtsNiC, DcBrBI, DcBrWA, DcSeaP, DcVicP, –2*
Boughner, A *FolkA 86*
Boughner, Alexander *FolkA 86*
Boughner, Daniel *FolkA 86*
Boughner, W *FolkA 86*
Boughton, Alice 1865-1943 *ICPEnP A, MacBEP, WhAmArt 85*
Boughton, Elizabeth *DcWomA*
Boughton, George H 1834- *ArtsNiC*
Boughton, George Henry 1833-1905 *ClaDrA, DcBrA 1, DcBrBI, DcBrWA, DcVicP, –2, NewYHSD*
Boughton, George Henry 1834-1905 *WhAmArt 85*
Boughton, H *DcVicP 2*
Boughton, T *DcVicP 2*
Boughton, William Harrison 1915- *WhAmArt 85, WhoAmA 73, –76, –78, –80, –82, –84*
Boughton-Leigh, Dora *DcBrA 1, DcWomA*
Bougleux, Marthe *DcWomA*
Bougourd, Cecile Augustine *DcWomA*
Bouguereau, Adolphe William 1825-1905 *McGDA*
Bouguereau, Elisabeth Gardner 1837-1922 *WhAmArt 85*
Bouguereau, Elizabeth 1837-1922 *DcWomA*
Bouguereau, Elizabeth Jane Gardner 1837-1922 *NewYHSD*
Bouguereau, P H, Jr. *NewYHSD*
Bouguereau, William Adolphe 1825- *ArtsNiC*
Bouguereau, William Adolphe 1825-1905 *ClaDrA, WhAmArt 85A*
Bouhot, Etienne 1780-1862 *ClaDrA*
Bouilh, Gabrielle Marie *DcWomA*
Bouilh, Marie Berthe *DcWomA*
Bouiller, Jule 1841?- *NewYHSD*
Bouillet, Angelique d1866 *DcWomA*
Bouillette, Alice 1878- *DcWomA*
Bouillier, Amable 1867- *DcWomA*

Bouillion, Elliott M 1952- *MarqDCG 84*
Bouillon, Mademoiselle 1867- *DcWomA*
Bouillon, Francois 1944- *DcCAr 81*
Bouillon, R *AmArch 70*
Bouilly, Angele 1861-1895 *DcWomA*
Bouisset-Mignon, Yvonne Suzanne *DcWomA*
Boulanger, Annette 1804-1853 *DcWomA*
Boulanger, Clement 1805-1842 *ClaDrA*
Boulanger, Graciela Rodo 1935- *PrintW 83, –85*
Boulanger, Gustave 1824-1888 *WhAmArt 85A*
Boulanger, Gustave-Rodolphe-Clarence 1824- *ArtsNiC*
Boulanger, John F *FolkA 86*
Boulanger, Louis 1806-1867 *ArtsNiC*
Boulanger, Louise 1900- *WorFshn*
Boulanger, Marie Elisabeth 1809- *DcWomA*
Boulard, Auguste 1825-1897 *ClaDrA*
Boulard, Konstancia d1904 *DcWomA*
Boulard, Marie *DcWomA*
Boulat, P *DcVicP 2*
Boulay, Elise *DcWomA*
Boulden, James *ArtsEM*
Boulderson, B *DcVicP 2*
Bouldin, Susie Vera 1888- *AfroAA*
Boulengier, Hans *McGDA*
Boulet, Alex 1818?- *NewYHSD*
Boulger, J H, Jr. *AmArch 70*
Boulger, Thomas *DcBrWA*
Boulian, Aline d1903 *DcWomA*
Bouliar, Marie Genevieve 1762-1825 *DcWomA*
Bouligny, E R *AmArch 70*
Bouligny DePizzaro, Clementina *DcWomA*
Boullata, Kamal 1942- *DcCAr 81*
Boulle, Andre-Charles *DcNiCA*
Boulle, Andre Charles 1642-1732 *DcD&D*
Boulle, Andre Charles 1642-1732 *AntBDN G, McGDA, OxDecA*
Boulle, Andre-Charles 1685-1745 *OxDecA*
Boulle, Charles-Joseph 1688-1754 *OxDecA*
Boulle, Jean-Philippe 1680-1744 *OxDecA*
Boulle, Pierre-Benoit 1682?-1741 *OxDecA*
Boullee, Etienne Louis 1728-1799 *MacEA*
Boullee, Etienne-Louis 1728-1799 *McGDA, OxArt, WhoArt*
Boullemier, Antoine 1840-1900 *DcNiCA*
Boullemier, Anton 1840-1900 *AntBDN M*
Boullemier, Henri *DcNiCA*
Boullemier, Lucien *DcNiCA*
Boullemier, Lucien 1869-1949 *AntBDN M*
Boullogne, Bon De 1649-1717 *McGDA*
Boullogne, Genevieve 1645-1708 *DcWomA*
Boullogne, Jean De *McGDA*
Boullogne, Madeleine 1646?-1710 *DcWomA*
Boullongne, Bon 1649-1717 *OxArt*
Boullongne, Genevieve *OxArt*
Boullongne, Genevieve 1645-1708 *DcWomA*
Boullongne, Louis 1654-1733 *OxArt*
Boullongne, Louis De 1609-1674 *OxArt*
Boullongne, Madeleine *OxArt*
Boullongne, Madeleine 1646?-1710 *DcWomA*
Boullongne, Genevieve 1645-1708 *DcWomA*
Boulogne, Jean *McGDA*
Boulogne, Jean Amel De d1395 *MacEA*
Boulogne, Louis De 1654-1733 *ClaDrA*
Boulogne, M *DcWomA*
Boulogne, Madeleine 1646?-1710 *DcWomA*
Boulsover, Thomas 1704-1788 *OxDecA*
Boult, A S *DcVicP 2*
Boult, Francis Cecil *DcVicP 2*
Boultbee, Constance M *DcWomA*
Boultbee, John 1753-1812 *DcBrECP*
Boultbee, Thomas 1753-1808 *DcBrECP*
Boulter, Charles *FolkA 86*
Boulter, Ida *DcWomA*
Boulton, C B *DcVicP 2*
Boulton, Doris *DcBrA 1, DcWomA*
Boulton, Frederick W 1904- *WhAmArt 85*
Boulton, G *EarABI*
Boulton, G d1833? *NewYHSD*
Boulton, Jack *WhoAmA 73, –76*
Boulton, Jack 1944- *WhoAmA 78*
Boulton, Joseph L 1896- *WhoAmA 73, –76, –78, –80, –82*
Boulton, Joseph Lorkowski 1896- *WhAmArt 85*
Boulton, Lela Frances 1881- *DcWomA*
Boulton, Matthew *AntBDN Q*
Boulton, Matthew 1728-1809 *AntBDN C, –G, –N, –Q, DcD&D, MacEA, OxDecA*
Boulton, Muriel Cameron Welsh 1881-1957 *DcWomA*
Boulton, William *FolkA 86*
Boulton And Watt *MacEA*
Boulware, Mrs. I W *WhAmArt 85*
Boulware, Lyle F 1901- *AmArch 70*
Boulye, Suzanne *DcWomA*
Bouman, Herman Henry 1916- *AmArch 70*
Bouman, Johanna Laura *DcWomA*
Boumphrey, Pauline 1886- *DcBrA 1, DcWomA*
Boundey, Burton S 1879-1962 *WhAmArt 85*
Boundey, Burton Shepard 1879-1962 *ArtsAmW 1, IlBEAAW*
Bounel DeLongchamps, Mathilde *DcWomA*
Bounell, W *FolkA 86*

Bounetheau, Mrs. H B *NewYHSD*
Bounetheau, Henry Breintnall 1797-1877 *NewYHSD*
Bounetheau, Mrs. J C *NewYHSD*
Bounetheau, Julia *DcWomA*
Bounieu, Emilie *DcWomA*
Bouquet *NewYHSD*
Bouquet, Gus 1915- *WhoAmA 73, -76*
Bouquet, Jean Louis 1936- *AmArch 70*
Bouras, Harry 1931- *AmArt*
Bouras, Harry D 1931- *WhoAmA 73, -76, -78*
Bourbon, Mademoiselle *DcWomA*
Bourbon, Isabelle Marie Louise *DcWomA*
Bourbon, Paz De *DcWomA*
Bourbonnais, Timothy Ross 1955- *MarqDCG 84*
Bource, Hans Joseph *DcVicP 2*
Bource, Henri 1816- *ArtsNiC*
Bource, Henri Jacques 1826?-1899 *ClaDrA*
Bourcicault, W S *DcVicP 2*
Bourdeau, Arthur William 1939- *MarqDCG 84*
Bourdeau, Robert 1931- *ConPhot, ICPEnP A*
Bourdeau, Robert Charles 1931- *MacBEP, WhoAmA 84*
Bourdell, Pierre VanParys d1966 *WhoAmA 78N, -80N, -82N, -84N*
Bourdelle, Antoine 1861-1929 *PhDcTCA 77*
Bourdelle, Emile 1861-1929 *WhAmArt 85A*
Bourdelle, Emile-Antoine 1861-1929 *OxArt, OxTwCA*
Bourdelle, Emile Antoine 1861-1930 *McGDA*
Bourdelle, Pierre d1966 *WhAmArt 85*
Bourdelle, Stephanie *DcWomA*
Bourdichon, Jean 1457?-1521 *McGDA, OxArt*
Bourdier, Elisa *DcWomA*
Bourdillon, Francis William 1852-1921 *DcBrA 2*
Bourdillon, Frank W *DcBrA 1, DcVicP 2*
Bourdin, Guy 1933- *ICPEnP*
Bourdin, Marie Maxime *DcWomA*
Bourdin, Michel, I *McGDA*
Bourdin, Michel, II 1609-1678 *McGDA*
Bourdon, Madame *DcWomA*
Bourdon, Adine *DcWomA*
Bourdon, Camille *DcWomA*
Bourdon, David *NewYHSD*
Bourdon, David 1934- *WhoAmA 76, -78, -80, -82, -84*
Bourdon, Eugene d1916 *DcBrA 2*
Bourdon, Louise *DcWomA*
Bourdon, Pierre Michel 1778-1841 *ClaDrA*
Bourdon, Robert Slayton 1947- *WhoAmA 82, -84*
Bourdon, Sebastien 1616-1671 *ClaDrA, McGDA, OxArt*
Boure, Antoine-Felix *ArtsNiC*
Boure, Jeanne *DcWomA*
Bourek, Zlatko 1929- *WorECar*
Bourgade, Augusta De d1969 *DcWomA*
Bourgain, G *DcVicP 2*
Bourgault-Ducoudray, Marie d1887 *DcWomA*
Bourge, Helene Charlotte Juliette 1812- *DcWomA*
Bourgeau, Victor 1809-1888 *MacEA*
Bourgeois, Alberic 1876-1962 *WorECar*
Bourgeois, Anna Louise *DcWomA*
Bourgeois, Caroline 1819-1900 *DcWomA*
Bourgeois, Charles Guillaume Alexandre 1759-1832 *ClaDrA*
Bourgeois, Florence 1904- *IlsCB 1744*
Bourgeois, Francis *NewYHSD*
Bourgeois, Sir Francis 1756-1811 *DcBrECP*
Bourgeois, Gary Grant 1934- *AmArch 70*
Bourgeois, Hortense 1833- *DcWomA*
Bourgeois, Leon-Pierre-Urbain *ArtsNiC*
Bourgeois, Louise *WhoAmA 73, -76, -78*
Bourgeois, Louise 1911- *AmArt, BnEnAmA, ConArt 77, -83, DcAmArt, DcCAA 71, -77, McGDA, OxTwCA, PhDcTCA 77, WhAmArt 85, WhoAmA 80, -82, -84, WomArt, WorArt[port]*
Bourgeois, Sir Peter Francis 1756-1811 *OxArt*
Bourgeois, Sophie *DcWomA*
Bourgeois, Victor 1897-1962 *ConArch, EncMA, MacEA*
Bourgeois DeGarenciere, Juliette *DcWomA*
Bourgeois DuCastelet, Florent Fidele C 1767-1836 *ClaDrA*
Bourgeoys, Marin Le 1550?-1634 *OxDecA*
Bourges, Felicite *DcWomA*
Bourges, Pauline Elise Leonide 1838-1910 *DcWomA*
Bourgogne, Pierre 1838-1904 *ClaDrA*
Bourgoin, A *DcVicP 2*
Bourgoin, Joseph *NewYHSD*
Bourgonnier, Berthe Claude d1922 *DcWomA*
Bourgot *DcWomA*
Bourguet, Marie Madeleine *DcWomA*
Bourguignon, Le *McGDA*
Bourguignon, H F *DcBrECP*
Bourguignon, Sophie 1856- *DcWomA*
Bouriello, Blanche *DcWomA*
Bourillon-Tournay, Jeanne 1867-1932 *DcWomA*
Bourke, Fergus 1934- *ICPEnP*
Bourke, Henry Oliver 1861-1939 *ArtsEM*
Bourke, Marian *WhAmArt 85*
Bourke, Thomas *NewYHSD*
Bourke-White, Margaret 1904-1971 *ConPhot,*

ICPEnP, *WhAmArt 85, WomArt*
Bourke-White, Margaret 1906-1971 *MacBEP*
Bourlet, Marie *DcWomA*
Bourlet DeLaValee, Esperance d1864 *DcWomA*
Bourlier, Alfred J B *NewYHSD*
Bourlier, Marie Anne *DcWomA*
Bourn, L L *AmArch 70*
Bournan, E G *DcVicP 2*
Bourne, Miss *DcWomA*
Bourne, Edmunda *DcVicP 2, DcWomA*
Bourne, Elizabeth *DcWomA*
Bourne, Emma Cartwright 1906- *WhAmArt 85*
Bourne, Evelin 1892- *DcWomA*
Bourne, Evelin Bodfish 1892- *WhAmArt 85*
Bourne, F *DcVicP 2, DcWomA*
Bourne, Frank A 1873-1936 *BiDAmAr*
Bourne, G W 1860?- *DcSeaP*
Bourne, Gertrude B *WhAmArt 85*
Bourne, Gertrude Beals *DcWomA*
Bourne, Harriet P *DcBrWA*
Bourne, James *DcBrBI*
Bourne, James 1773-1854 *DcBrWA*
Bourne, Jane *DcWomA*
Bourne, John Cooke 1814-1896 *DcBrBI, DcBrWA*
Bourne, John Cooke 1841-1896 *DcVicP 2*
Bourne, John Frye 1912- *DcBrA 1, WhoArt 80, -82, -84*
Bourne, Mercy *FolkA 86*
Bourne, Minerva *WhAmArt 85*
Bourne, Muriel *DcWomA*
Bourne, Olive Grace 1897- *DcBrA 1, DcWomA*
Bourne, Philip W 1907- *AmArch 70*
Bourne, Phyllis *DcWomA*
Bourne, Samuel *AntBDN M*
Bourne, Samuel 1834-1912 *ICPEnP, MacBEP*
Bourne, Samuel 1840?-1920 *DcBrWA, DcVicP 2*
Bouron, Helene *DcWomA*
Bourquin, Charles F 1800?- *NewYHSD*
Bourquin, D C *EncASM*
Bourquin, Frederick 1808- *NewYHSD*
Bourquin, J E *WhAmArt 85*
Bourscheidt, Dora *WhAmArt 85*
Bourse, Marie Louise Mathilde *DcWomA*
Boursier, Marthe J d1891 *DcWomA*
Boursier, Therese *DcWomA*
Boursse, Esaias 1631-1672 *McGDA*
Bouscaren, Jenny *DcWomA*
Bouschor, Donald Omer 1932- *AmArch 70*
Bouser, Lula Bissant *AfroAA*
Bousfield, H Mary *DcVicP 2*
Boush, Elizabeth 1753?- *FolkA 86*
Bousianis, George 1885-1959 *McGDA*
Bousquet, Helene Du *DcWomA*
Bousquet, Marie-Louise 1887-1975 *WorFshn*
Boussac, Marcel *FairDF FRA*
Boussard, Dana 1944- *WhoAmA 73, -76, -78, -80*
Boussingault, Jean Louis 1883-1943 *ClaDrA*
Boussingault, Jean-Louis 1883-1943 *OxTwCA*
Boussingault, Jean-Louis 1883-1944 *PhDcTCA 77*
Boussuge, Julienne Marie *DcWomA*
Bout, Peeter 1658-1702 *ClaDrA*
Bout, Pieter 1658-1719 *McGDA*
Boutan, Louis 1859-1934 *ICPEnP*
Boutcher, Catherine *DcWomA*
Bouteiller, Louise 1783-1828 *DcWomA*
Bouteiller, Sophie De *DcWomA*
Boutelle, DeWitt C 1820- *ArtsNiC*
Boutelle, DeWitt Clinton 1820-1884 *IlBEAAW, NewYHSD*
Boutellier, Jean Le d1370 *McGDA*
Boutelon, Madame *DcWomA*
Bouten, Charlotte 1871-1895 *DcWomA*
Bouterse, D R *AmArch 70*
Bouterwek, J Frederick *DcVicP 2*
Boutet, Nicolas 1761-1833 *AntBDN F*
Boutet, Nicolas-Noel 1761-1833 *OxDecA*
Boutet DeMonvel, Bernard 1884-1944 *WhAmArt 85A*
Boutflower, C *DcVicP 2*
Boutigny, Paul Emile 1854-1929 *ClaDrA*
Boutillier-Du-Retail, Berthe *DcWomA*
Boutilly, Marie Madeleine *DcWomA*
Boutin, Albertine Marie Anne *DcWomA*
Boutin, Harold L 1920- *AmArch 70*
Boutin, Lucie Alexandre Antoinette *DcWomA*
Boutis, Tom 1922- *WhoAmA 76, -78, -80, -82, -84*
Boutiu, Charlotte *DcWomA*
Bouton, G B *NewYHSD*
Bouton, Jean B *NewYHSD*
Bouton, John *CabMA*
Bouton, S S *FolkA 86*
Boutroux, Suzanne *DcWomA*
Boutry, Salesia *DcWomA*
Bouts, Aelbrecht d1548 *OxArt*
Bouts, Aelbrecht 1460?-1549 *McGDA*
Bouts, Dieric d1475 *OxArt*
Bouts, Dieric, The Younger d1490? *OxArt*
Bouts, Dirk d1475 *McGDA*
Boutte, Ronald *AfroAA*
Boutwell *FolkA 86*
Boutwell, Burr North 1931- *AmArch 70*
Boutwell, George *OfPGCP 86*

Boutwood, Charles Edward *DcVicP 2, WhAmArt 85*
Bouvais, Charlotte *DcWomA*
Bouve, Elisha W *NewYHSD*
Bouve, Ephraim 1817-1897 *NewYHSD*
Bouve, Rosamond Smith *DcWomA, WhAmArt 85*
Bouve, S R *FolkA 86*
Bouverie-Hoyton, Edward *DcBrA 1*
Bouvier *DcBrECP*
Bouvier, Adele *DcWomA*
Bouvier, Agnes Rose *DcVicP, -2*
Bouvier, Agnes Rose 1842- *DcWomA*
Bouvier, Agnes Rose 1842-1892? *DcBrWA*
Bouvier, Arthur *ArtsNiC, DcVicP 2*
Bouvier, Auguste Jules 1827-1881 *DcBrWA*
Bouvier, Augustus Jules 1827?-1881 *DcVicP 2*
Bouvier, Berthe 1868-1936 *DcWomA*
Bouvier, Gustavus A *DcBrWA, DcVicP*
Bouvier, Gustavus Arthur *DcVicP 2*
Bouvier, Joseph *DcBrWA, DcVicP, -2*
Bouvier, Jules 1800-1867 *DcBrWA*
Bouvier, Jules Senior 1800-1867 *DcVicP 2*
Bouvier, Julia *DcVicP 2, DcWomA*
Bouvier, Paul 1857- *ClaDrA*
Bouvier, Urbain James d1856 *DcVicP 2*
Bouvier, Victorine *DcWomA*
Bouvier-Peilon, Jeanne d1907 *DcWomA*
Bouvoisin, Catherine Helie 1788- *DcWomA*
Bouvret, Honorine *DcWomA*
Bouwens, Amata *DcWomA*
Bouwens, Mrs. T *DcVicP 2*
Bouwens VanDerBogen, Flora *DcWomA*
Bouwmeester, Cornelisz 1670-1733 *DcSeaP*
Bouyer, Marie *DcWomA*
Bouyssou, Jacques 1926- *DcCAr 81*
Bouzek, Cathryn 1898- *ArtsAmW 2, DcWomA*
Bouzonnet, Antoinette 1641-1676 *DcWomA*
Bouzonnet, Claudine 1636-1697 *DcWomA*
Bouzonnet, Francoise 1638-1692? *DcWomA*
Bova, Joe 1941- *WhoAmA 78, -80, -82, -84*
Bovard, William Robert 1886- *AmArch 70*
Bovarini, Maurizio 1934- *WorECar*
Bove, Richard 1920- *WhoAmA 76, -78, -80, -82, -84*
Bovee, I A *IlBEAAW*
Bovee, Mary E *ArtsEM, DcWomA*
Bovell, Thomas W *NewYHSD*
Boverat, Claire Louise Charlotte *DcWomA*
Boverat, Marguerite Eva *DcWomA*
Boverat, Marie Adrienne *DcWomA*
Boverman, Bentsion 1950- *MarqDCG 84*
Bovet, Sophie Vera 1865-1936 *DcWomA*
Bovett, Ami 1818?- *NewYHSD*
Bovi, Mariano 1758- *McGDA*
Bovie, Josephine Louise Virginia 1827-1887 *DcWomA*
Bovier-Lapierre, Jeanne *DcWomA*
Bovill, Percy C *DcVicP 2*
Bovy, Jean-Francois-Antoine 1803-1867 *ArtsNiC*
Bovy, Jeanne Caroline Louise 1809-1877 *DcWomA*
Bow, Charles *DcBrBI*
Bowa, Peter *NewYHSD*
Bowater, Marian 1924- *WhoAmA 78, -80, -82, -84*
Bowcher, Frank 1864-1938 *DcBrA 1*
Bowd, Edwyn Alfred 1865-1940 *BiDAmAr*
Bowden, Mrs. Ambrose *DcVicP 2*
Bowden, Beulah B 1875- *DcWomA*
Bowden, Beulah Beatrice 1875- *WhAmArt 85*
Bowden, E J *DcVicP 2*
Bowden, H 1907- *WhAmArt 85*
Bowden, Mary *DcWomA*
Bowden, Robert Chandler 1941- *MacBEP*
Bowden, William Anton, Jr. 1930- *AmArch 70*
Bowden-Smith, Daisy Beatrice 1882- *ClaDrA, DcBrA 1, DcWomA*
Bowdich, Sarah 1791-1856 *DcBrWA*
Bowdish, Edward Romaine 1856- *WhAmArt 85*
Bowdish, Nelson S 1831-1916 *NewYHSD, WhAmArt 85*
Bowditch, Eunice 1707?- *FolkA 86*
Bowditch, Mary *WhAmArt 85*
Bowditch, Mary O *DcWomA*
Bowdler, Michael C *AmArch 70*
Bowdoin, Harriette *WhoAmA 78N, -80N, -82N, -84N*
Bowdoin, Harriette d1947 *WhAmArt 85*
Bowdoin, Harriette d1948? *DcWomA*
Bowdoin, William G 1861-1947 *WhAmArt 85*
Bowe, Francis Domonic 1892- *DcBrA 1*
Bowe, H M *AmArch 70*
Bowe, John *AfroAA*
Bowell, Alfred John 1868-1941 *DcBrA 2*
Bowen, Miss *DcWomA*
Bowen, A W *AmArch 70*
Bowen, Abel 1790-1850 *EarABI, EarABI SUP, NewYHSD*
Bowen, Ashley *FolkA 86*
Bowen, B B *AmArch 70*
Bowen, Benjamin James 1859-1930 *WhAmArt 85*
Bowen, Charles C 1839?- *NewYHSD*
Bowen, Charles R 1926- *MarqDCG 84*
Bowen, Daniel 1760?-1856 *NewYHSD*
Bowen, David Michael 1936- *AmArch 70*
Bowen, Denis *DcCAr 81*

Bowen, Denis 1921- *WhoArt 80, -82, -84*
Bowen, Emanuel *AntBDN I*
Bowen, Ernest *WhAmArt 85*
Bowen, Eva *DcVicP 2*
Bowen, Ezra 1891-1945 *WhAmArt 85*
Bowen, George *CabMA*
Bowen, George P *NewYHSD*
Bowen, George W 1821?- *NewYHSD*
Bowen, H M *NewYHSD*
Bowen, Helen Eakins *WhoAmA 73, -76, -78, -80*
Bowen, Hugh *DcVicP 2*
Bowen, Irene *DcWomA*
Bowen, Irene 1892- *WhAmArt 85*
Bowen, John *BiDBrA, NewYHSD*
Bowen, John T 1801?-1856? *NewYHSD*
Bowen, Joyce *AfroAA*
Bowen, Lavinia 1820?- *DcWomA, NewYHSD*
Bowen, Lota *DcVicP 2*
Bowen, Lota d1934? *DcWomA*
Bowen, Nancy E 1940- *PrintW 85*
Bowen, Nathan 1752-1837 *CabMA*
Bowen, Owen 1873- *ClaDrA*
Bowen, Owen 1873-1967 *DcBrA 1, DcBrWA, DcVicP 2*
Bowen, R G *AmArch 70*
Bowen, R L *AmArch 70*
Bowen, Ralph *DcVicP 2*
Bowen, Richard Alan 1948- *MarqDCG 84*
Bowen, Richard Jerome 1933- *AmArch 70*
Bowen, Stella 1893-1947 *DcWomA*
Bowen, Stella Esther 1893-1947 *DcBrA 2*
Bowen, Thomas *CabMA*
Bowen, Thomas d1790 *NewYHSD*
Bowen, Thomas Alfred Edwin 1909- *WhoArt 80, -82, -84*
Bowen, Thomas M *ArtsEM*
Bowen, Wayne *WhoAmA 73, -76*
Bowen, William *CabMA*
Bowen, William Francis 1884- *AmArch 70*
Bower, Alexander d1952 *WhoAmA 78N, -80N, -82N, -84N*
Bower, Alexander 1875-1952 *WhAmArt 85*
Bower, Boyd Oliver 1932- *AmArch 70*
Bower, E L *AmArch 70*
Bower, Frances 1877- *ArtsAmW 2, DcWomA*
Bower, Frederick *WhAmArt 85*
Bower, Gary David 1940- *WhoAmA 76, -78, -80, -82, -84*
Bower, George *FolkA 86*
Bower, Helen 1896- *WhAmArt 85*
Bower, Helen Lane 1898- *DcWomA, WhAmArt 85*
Bower, J A, Jr. *AmArch 70*
Bower, John *NewYHSD*
Bower, John A, Jr. 1930- *AmArch 70*
Bower, John Arnold, Sr. 1901- *AmArch 70*
Bower, L *FolkA 86*
Bower, Lloyd D *WhAmArt 85*
Bower, Lucy Scott 1864-1934 *DcWomA, WhAmArt 85*
Bower, Mary *FolkA 86*
Bower, Maurice 1889-1980 *IlrAm 1880*
Bower, Maurice L *WhAmArt 85*
Bower, Philip 1895-1935 *WhAmArt 85*
Bower, W Frank 1904- *AmArch 70*
Bower, W M *FolkA 86*
Bower, William *NewYHSD*
Bowerley, Amelia M d1916 *DcBrA 1, DcVicP 2, DcWomA*
Bowerman, Bernard J W 1911- *DcBrA 1*
Bowerman, Ralph Justin 1919- *AmArch 70*
Bowers, Albert Edward *DcVicP 2*
Bowers, Beulah Sprague 1892- *ArtsAmW 2, DcWomA, WhAmArt 85*
Bowers, Charles 1889-1946 *WhAmArt 85*
Bowers, Charles Frederick *AmArch 70*
Bowers, Cheryl Olsen 1938- *WhoAmA 76, -78, -80, -82, -84*
Bowers, David Bustill 1820-1900 *AfroAA*
Bowers, E *FolkA 86*
Bowers, Edward 1822- *ArtsEM, NewYHSD*
Bowers, Ezekial *FolkA 86*
Bowers, Georgina *DcBrBI, DcBrWA*
Bowers, Georgina 1836-1912 *DcWomA*
Bowers, Gifford Donald 1925- *AmArch 70*
Bowers, H *DcVicP 2*
Bowers, H L *AmArch 70*
Bowers, Harry 1938- *ICPEnP A, MacBEP*
Bowers, J *FolkA 86*
Bowers, John *CabMA*
Bowers, Joseph *FolkA 86*
Bowers, Kendra Englert 1946- *WhoAmA 76*
Bowers, Lynn 1933- *AfroAA*
Bowers, Lynn Chuck 1932- *WhoAmA 76, -78, -80*
Bowers, P D, Jr. *AmArch 70*
Bowers, Reuben *FolkA 86*
Bowers, Robert L, Jr. 1935- *MarqDCG 84*
Bowers, Stephen *ClaDrA, DcVicP 2*
Bowers, Stephen J *DcBrWA*
Bowers, Thomas 1889-1946 *WorECar*
Bowers, Mrs. William *ArtsEM, DcWomA*
Bowersock, Warren Austin 1904- *AmArch 70*

Bowery, Thomas *NewYHSD*
Bowes, Mrs. *DcVicP 2*
Bowes, A Wentworth 1890- *WhAmArt 85*
Bowes, Betty Miller *WhoAmA 80, -82, -84*
Bowes, C Herbert 1920- *AmArch 70*
Bowes, Charles E *NewYHSD*
Bowes, Constance *DcVicP 2*
Bowes, Sir Jerome d1616 *IlDcG*
Bowes, John 1899- *DcBrA 1, WhoAmA 80, -82, -84*
Bowes, John A T *ArtsEM*
Bowes, Joseph *NewYHSD*
Bowes, Josephine *DcWomA*
Bowes, Julian 1893- *WhAmArt 85*
Bowett, Druie 1924- *WhoArt 80, -82, -84*
Bowey, Olwyn 1936- *WhoArt 80*
Bowhill, S A 1927- *MarqDCG 84*
Bowie, Alexander d1829? *BiDBrA*
Bowie, John d1941 *DcBrA 1*
Bowie, William 1926- *WhoAmA 73, -76, -78, -80, -82, -84*
Bowker, Alfred d1944 *DcBrA 2*
Bowker, Elizabeth *DcWomA*
Bowker, Leon Jack 1913- *AmArch 70*
Bowkett, Family Of *DcVicP 2*
Bowkett, A *DcVicP 2, DcWomA*
Bowkett, E M *DcVicP 2, DcWomA*
Bowkett, Jane Maria *ClaDrA, DcVicP, -2, DcWomA*
Bowkett, Jessie *DcVicP 2, DcWomA*
Bowkett, Kate *DcVicP 2, DcWomA*
Bowkett, L *DcVicP 2*
Bowkett, Leila *DcVicP 2*
Bowkett, Lilly *DcWomA*
Bowkett, Nora *DcWomA*
Bowlby, Annie E *DcVicP 2*
Bowlen, William C 1868- *WhAmArt 85*
Bowlend, George B *EarABI*
Bowler, Annie Elizabeth 1860- *DcBrA 1, DcVicP 2, DcWomA*
Bowler, Ellen A *DcVicP 2*
Bowler, Ellen Annie *DcWomA*
Bowler, Henry Alexander 1824-1903 *DcBrWA, DcVicP, -2*
Bowler, Joseph 1928- *IlrAm F, -1880*
Bowler, Joseph, Jr. 1928- *AmArt, WhoAmA 78, -80, -82, -84*
Bowler, Joshua Soule 1818-1847 *NewYHSD*
Bowler, Kevin J 1952- *MarqDCG 84*
Bowler, Moya 1940- *WorFshn*
Bowler, Sophia A *DcWomA, NewYHSD*
Bowler, Thomas William *DcVicP 2*
Bowler, Thomas William d1869 *DcBrBI*
Bowler And Burdick *EncASM*
Bowles, Amanda A *FolkA 86*
Bowles, Andrew Donald 1917- *AmArch 70*
Bowles, Benjamin *IlDcG*
Bowles, C, Jr. *AmArch 70*
Bowles, Caroline *WhAmArt 85*
Bowles, Caroline Hutchinson *ArtsAmW 2, DcWomA*
Bowles, Carrie C *DcWomA*
Bowles, Charles *DcBrWA*
Bowles, E *DcVicP 2, DcWomA*
Bowles, Esther A *ArtsEM, DcWomA*
Bowles, George *DcVicP 2*
Bowles, J G *DcVicP 2*
Bowles, James *DcVicP 2*
Bowles, Janet Payne d1948 *WhoAmA 78N, -80N, -82N, -84N*
Bowles, Janet Payne 1882-1948 *WhAmArt 85*
Bowles, John *AntBDN I*
Bowles, John 1640-1709 *IlDcG*
Bowles, Joshua *CabMA, NewYHSD*
Bowles, Joshua 1720-1794 *FolkA 86*
Bowles, M Andre 1864-1930 *WhAmArt 85*
Bowles, M L T *AmArch 70*
Bowles, Marianne VonRecklinghausen 1929- *AmArt, WhoAmA 82, -84*
Bowles, Oldfield 1739-1810 *DcBrWA*
Bowles, Oldfield 1740-1810 *DcBrECP[port]*
Bowles, R W *AmArch 70*
Bowles, Thomas *AntBDN I*
Bowles, Thomas Andrew, III 1939- *WhoAmA 76, -78, -80, -82*
Bowles, W A *AmArch 70*
Bowley, A L *DcBrBI*
Bowley, C *DcVicP 2*
Bowley, Charles G 1815?- *NewYHSD*
Bowley, Edward O *DcVicP 2*
Bowley, May *DcVicP 2*
Bowley, S *DcWomA*
Bowlin, Angela Clarke 1911- *WhAmArt 85*
Bowling, Charles T *WhAmArt 85*
Bowling, Charles Taylor 1891- *ArtsAmW 2*
Bowling, Frank 1936- *AfroAA, DcCAr 81, WhoAmA 76, -78, -80, -82, -84*
Bowling, H D *DcWomA*
Bowling, Mrs. H D *ArtsEM*
Bowling, Jack *EncASM*
Bowling, Jack 1903- *WhAmArt 85, WhoAmA 76, -78*
Bowling, Jack 1903-1979 *WhoAmA 80N, -82N, -84N*

Bowling, Richard Lee 1948- *MarqDCG 84*
Bowlt, John 1943- *WhoAmA 76, -78, -80, -82, -84*
Bowman, Albert George *DcVicP 2*
Bowman, Alexander 1823?- *NewYHSD*
Bowman, B E *DcWomA*
Bowman, Betty 1923- *WhoArt 80*
Bowman, Bruce 1938- *WhoAmA 78, -80, -82, -84*
Bowman, Carl Ray 1926- *AmArch 70*
Bowman, Don 1934- *AmArt*
Bowman, Dorothy 1927- *WhoAmA 73, -76, -78, -80, -82, -84*
Bowman, Dorothy Louise 1927- *AmArt*
Bowman, Ernest *DcVicP 2*
Bowman, Fielding L *AmArch 70*
Bowman, Frances T *WhAmArt 85*
Bowman, Geoffrey 1928- *DcCAA 71, -77*
Bowman, George L 1935- *WhoAmA 76*
Bowman, H Ernest *DcVicP 2*
Bowman, Helen L 1851-1931 *DcWomA*
Bowman, Henry B d1863 *FolkA 86*
Bowman, Irving Henry 1906- *AmArch 70*
Bowman, James 1793-1842 *ArtsEM, NewYHSD*
Bowman, Jean 1917- *WhoAmA 73, -76, -78*
Bowman, Jeff Ray 1943- *WhoAmA 76, -78, -80, -82, -84*
Bowman, Joel E 1915- *AmArch 70*
Bowman, John F 1950- *MacBEP*
Bowman, John Ronald 1930- *AmArch 70*
Bowman, Jon A 1921- *AmArch 70*
Bowman, Ken 1937- *DcCAr 81, WhoAmA 73, -76, -78, -80, -82, -84*
Bowman, M J *WhAmArt 85*
Bowman, Margaret H *DcBrA 1, DcWomA*
Bowman, Martha Musser *WhAmArt 85*
Bowman, Nora 1896- *DcBrA 1, DcWomA*
Bowman, Peggy Cochrane *AmArch 70*
Bowman, Richard 1918- *DcCAA 71, -77, WhoAmA 73, -76, -78, -80, -82, -84*
Bowman, Richard Irving 1918- *WhAmArt 85*
Bowman, Ruth 1923- *WhoAmA 73, -76, -78, -80, -82, -84*
Bowman, Thomas G *DcVicP 2*
Bowman, Thomas March 1931- *AmArch 70*
Bowman, William *FolkA 86*
Bowman, William A *ArtsEM*
Bown, P B *AmArch 70*
Bown, Roger Lee 1930- *AmArch 70*
Bowne, A *NewYHSD*
Bowne, Catherine *FolkA 86*
Bowne, James Dehart 1940- *WhoAmA 78, -80, -82, -84*
Bowne, John, Jr. *MarqDCG 84*
Bowne, John C 1934- *MarqDCG 84*
Bowne, William Calvin, Jr. 1931- *AmArch 70*
Bowness, Alan 1928- *WhoArt 80, -82, -84*
Bowness, William 1809-1867 *DcVicP, -2*
Bowness-Burton, W 1851-1923 *DcBrA 1*
Bowring, Emily Stuart 1835- *DcWomA*
Bowring, Larry *MarqDCG 84*
Bowring, W Arminger *DcBrBI*
Bowring, Walter Armiger 1874-1931 *DcBrA 1*
Bowring, William P *ArtsEM*
Bowron, Edgar Peters 1943- *WhoAmA 73, -76, -78, -80, -82, -84*
Bowser, David Bustille 1820-1900 *NewYHSD*
Bowser, Isabelle *DcWomA*
Bowser, Rose Maude *DcVicP 2, DcWomA*
Bowser, Waldo *WhAmArt 85*
Bowstead, John Allen *AmArch 70*
Bowyer, Adrian 1952- *MarqDCG 84*
Bowyer, Alan J *DcBrA 1*
Bowyer, Allen Frank 1932- *MarqDCG 84*
Bowyer, C L *AmArch 70*
Bowyer, Ellen *DcVicP 2, DcWomA*
Bowyer, John 1872- *DcBrA 1*
Bowyer, Michael H *NewYHSD*
Bowyer, Robert 1758-1834 *DcBrWA*
Box, Alfred *DcBrWA*
Box, Alfred Ashdown *DcBrWA, DcVicP 2*
Box, D H *AmArch 70*
Box, John 1920- *ConDes*
Box, John Harold 1929- *AmArch 70*
Boxall, Sir William 1800-1879 *DcBrWA, DcVicP, -2*
Boxall, Sir William 1801-1879 *ArtsNiC*
Boxer, Percy Noel 1886?- *DcBrA 2*
Boxer, Stanley 1926- *PrintW 83, -85, WhoAmA 73, -76, -78, -80, -82, -84*
Boxer, Stanley Robert 1926- *AmArt*
Boxsius, Sylvan G 1878- *DcBrA 1*
Boy, Agathe *DcWomA*
Boy, Godfrey 1701- *DcBrECP*
Boyadjian, Micheline 1923- *OxTwCA*
Boyar, Robert L 1935- *AmArch 70*
Boyce, Donald Rawdon 1916- *AmArch 70*
Boyce, George P 1826- *ArtsNiC*
Boyce, George Price 1826-1897 *DcBrWA, DcVicP, -2*
Boyce, Gerald G 1925- *WhoAmA 73, -76, -78, -80, -82, -84*
Boyce, Gideon Acland d1861 *BiDBrA*
Boyce, H *DcVicP 2*

Boyce, Herbert Walter 1883-1946 *DcBrA 1, DcBrWA*
Boyce, J A *AmArch 70*
Boyce, Joanna Mary *DcVicP 2, DcWomA*
Boyce, Norman Septimus 1895-1962 *DcBrA 1, DcBrWA*
Boyce, Richard 1920- *DcCAA 71, -77, WhoAmA 73, -76, -78, -80N, -82N, -84N*
Boyce, Richard Audley 1902- *WhAmArt 85*
Boyce, William G 1921- *WhoAmA 73, -76, -78, -80, -82, -84*
Boyce, William T N 1838-1911 *DcVicP*
Boyce, William Thomas Nicholas 1858-1911 *DcBrA 1, DcBrWA, DcVicP 2*
Boyce, William Thomas Nicholas 1867?-1911 *DcSeaP*
Boyceau, Jacques *MacEA*
Boycott-Brown, Hugh 1909- *DcBrA 1, DcSeaP, WhoArt 80, -82, -84*
Boyd, Major *DcVicP 2*
Boyd, A *DcVicP 2*
Boyd, Agnes S *DcVicP 2*
Boyd, Alexander Stuart 1854-1930 *DcBrA 1, DcBrBI, DcBrWA, DcVicP 2*
Boyd, Alice *DcBrWA, DcVicP 2, DcWomA*
Boyd, Ann *FolkA 86*
Boyd, Arthur 1920- *ConArt 77, -83, DcCAr 81, OxArt, OxTwCA, PhDcTCA 77*
Boyd, Arthur Merric 1920- *McGDA*
Boyd, Arthur Merric Bloomfield 1920- *WhoArt 80, -82, -84*
Boyd, Benjamin E *NewYHSD*
Boyd, Byron Bennett 1887- *ArtsAmW 2, WhAmArt 85*
Boyd, Charles Arthur 1926- *AmArch 70*
Boyd, Clare Shenehon 1895- *DcWomA, WhAmArt 85*
Boyd, D D *DcVicP 2*
Boyd, David Knickerbocker 1873-1944 *BiDAmAr*
Boyd, David Patterson 1913- *AfroAA*
Boyd, Donald Edgar 1934- *WhoAmA 73, -76, -78, -80, -82, -84*
Boyd, Doris 1883?-1960 *DcWomA*
Boyd, Doris 1909- *WhAmArt 85*
Boyd, E 1903- *WhoAmA 73*
Boyd, E 1903-1974 *WhoAmA 76N, -78N, -80N, -82N, -84N*
Boyd, E M *DcWomA*
Boyd, Mrs. E M *WhAmArt 85*
Boyd, Elizabeth Frances *DcWomA*
Boyd, Emma Minnie 1856?-1936 *DcWomA*
Boyd, F *ArtsEM*
Boyd, Fionnuala 1944- *ConBrA 79[port]*
Boyd, Fiske 1895-1975 *WhAmArt 85*
Boyd, Frank 1893- *ConICB*
Boyd, Fred Newell 1928- *AmArch 70*
Boyd, G *BiDBrA*
Boyd, G 1928- *WhoArt 80, -82, -84*
Boyd, George 1873-1941 *FolkA 86*
Boyd, George Joseph 1924- *AmArch 70*
Boyd, Gilbert N 1896-1981 *ArtsAmW 3*
Boyd, Helen E Walker 1897- *WhAmArt 85*
Boyd, Helen Edward Walker 1897- *DcWomA*
Boyd, Henry N *DcVicP 2*
Boyd, Ida E *DcWomA, WhAmArt 85*
Boyd, James *FolkA 86*
Boyd, James Davidson 1917- *WhoArt 80, -82, -84*
Boyd, James Henderson 1928- *DcCAr 81, WhoAmA 73, -76, -78, -80, -82, -84*
Boyd, Janet A *DcBrA 2, DcWomA*
Boyd, Jeanie L *DcWomA, WhAmArt 85*
Boyd, John *BiDBrA, NewYHSD*
Boyd, John Brooks 1931- *AmArch 70*
Boyd, John David 1939- *WhoAmA 76, -78, -80, -82, -84*
Boyd, John G 1940- *WhoArt 80, -82, -84*
Boyd, John Robert 1913- *AmArch 70*
Boyd, John Rutherford *WhAmArt 85*
Boyd, Karen White 1936- *WhoAmA 76, -78, -80, -82, -84*
Boyd, Lakin 1946- *WhoAmA 76, -78, -80, -82, -84*
Boyd, Lawrence 1874-1941 *BiDAmAr*
Boyd, Lula S *DcWomA*
Boyd, Margaret 1920- *DcBrA 1*
Boyd, Marion B *DcWomA*
Boyd, Michael 1936- *AmArt, WhoAmA 84*
Boyd, Michael Austin d1899 *DcBrWA*
Boyd, Monimia 1824-1862 *DcWomA*
Boyd, Moreon Beurnere *WhAmArt 85*
Boyd, Myra *DcWomA, WhAmArt 85*
Boyd, Phoebe Amelia 1875- *DcWomA, WhAmArt 85*
Boyd, Robin 1919-1971 *ConArch*
Boyd, Rutherford d1951 *WhAmArt 85, WhoAmA 78N, -80N, -82N, -84N*
Boyd, Samuel 1836?- *NewYHSD*
Boyd, Stuart d1916 *DcBrA 2*
Boyd, Theodore C *EarABI, EarABI SUP, NewYHSD*
Boyd, Theodore Penleigh 1890-1923 *DcBrA 2*
Boyd, Thomas d1902 *BiDAmAr*
Boyd, Thomas 1753?-1822 *BiDBrA*
Boyd, Thomas C *EarABI SUP, NewYHSD*

Boyd, Visscher *AmArch 70*
Boyd, W J *ArtsAmW 2, WhAmArt 85*
Boyd, W S *DcBrWA*
Boyd, Walter Scott *DcVicP 2*
Boyd, William d1795 *BiDBrA*
Boyd, William 1882- *WhAmArt 85*
Boyd, William 1882-1947 *BiDAmAr*
Boyd, William Dawson 1929- *AmArch 70*
Boyd And Evans *ConBrA 79[port]*
Boydell, Bertha Stanfield *WhoArt 80N*
Boydell, Creswick *DcVicP 2*
Boydell, John d1739 *EarABI SUP*
Boydell, John 1719-1804 *OxArt*
Boydell, Josiah 1752-1817 *DcBrECP*
Boydell, Philip 1896- *ClaDrA*
Boydell, Phillip 1896- *WhoArt 80, -82, -84*
Boyden *FolkA 86*
Boyden, Amos J 1853-1902 *BiDAmAr*
Boyden, Dwight Frederick 1860-1933 *WhAmArt 85*
Boyden, Elbridge 1819-1896 *BiDAmAr*
Boyden, Frank *PrintW 85*
Boyden, John 1942- *WhoArt 80, -82, -84*
Boyden, W L, Jr. *AmArch 70*
Boydstun, J B *AmArch 70*
Boye, Bertha M *WhAmArt 85*
Boye, Bertha Margaret 1883- *ArtsAmW 3*
Boye, Rose Marie Emma *DcWomA*
Boyer, Andrea Josephine *DcWomA*
Boyer, David Beryl 1932- *AmArch 70*
Boyer, Delford Ulysses 1917- *AmArch 70*
Boyer, Helen King 1919- *WhAmArt 85*
Boyer, Ida F d1915 *WhAmArt 85*
Boyer, Ida F 1859-1915 *DcWomA*
Boyer, India 1907- *AmArch 70*
Boyer, Jack K 1911- *WhoAmA 73, -76, -78, -80, -82, -84*
Boyer, Jane Allen *DcWomA, WhAmArt 85*
Boyer, John *FolkA 86*
Boyer, Louise 1890- *WhAmArt 85*
Boyer, Louise Rive-King Miller 1890- *DcWomA*
Boyer, Maria Leontine *DcWomA*
Boyer, Mary-Louise 1929- *AmArch 70*
Boyer, Michael *NewYHSD*
Boyer, P T *WhAmArt 85*
Boyer, Ralph Ludwig d1952 *WhoAmA 78N, -80N, -82N, -84N*
Boyer, Ralph Ludwig 1879-1952 *WhAmArt 85*
Boyer, Mrs. Richard C 1917- *WhoAmA 73, -76*
Boyer, Roger Owen 1936- *AmArch 70*
Boyer, Victor *DcNiCA*
Boyer-Breton, Marthe Marie Louise d1926 *DcWomA*
Boyer D'Aguilles, Jean Baptiste 1645-1709 *ClaDrA*
Boyers, D *BiDBrA*
Boyers, E *NewYHSD*
Boyes, M L *DcVicP 2*
Boyes, S *DcBrA 1*
Boyes, Sidney *DcBrA 2*
Boyhan, Matthew William *WhAmArt 85*
Boyington, Keith Thomas 1922- *AmArch 70*
Boyington, William W 1818-1898 *MacEA*
Boyington, William W 1839-1898 *BiDAmAr*
Boyken, R O *AmArch 70*
Boykin, Cloyd Lee 1877- *AfroAA*
Boykin, Ethel L *AfroAA*
Boykin, Henry Deas, II 1929- *AmArch 70*
Boyko, Fred d1951 *WhoAmA 78N, -80N, -82N, -84N*
Boyko, Fred S 1894-1951 *WhAmArt 85*
Boylan, John Jay 1942- *AmArch 70*
Boylan, John Lewis 1921- *WhoAmA 76, -78, -80, -82, -84*
Boylan, Stephen P 1954- *MarqDCG 84*
Boylan, W 1879- *WhAmArt 85*
Boyle, Alex *WhAmArt 85*
Boyle, Alicia *WhoArt 80, -82, -84*
Boyle, Beatrice A 1906- *WhAmArt 85*
Boyle, Caleb *NewYHSD*
Boyle, Cerise 1875- *DcBrA 1, DcWomA*
Boyle, Charles W d1925 *WhAmArt 85*
Boyle, Charlotte 1769-1831 *DcWomA*
Boyle, Eleanor Vere 1825-1916 *DcBrA 2, DcBrWA, DcWomA*
Boyle, Ferdinand T L 1820-1906 *FolkA 86*
Boyle, Ferdinand Thomas Lee 1820-1906 *IlBEAAW, NewYHSD, WhAmArt 85*
Boyle, George A *DcVicP 2*
Boyle, Gertrude *DcWomA, WhAmArt 85*
Boyle, Gertrude Farquharson *ArtsAmW 3*
Boyle, J M *DcVicP 2*
Boyle, James *NewYHSD*
Boyle, James A *NewYHSD*
Boyle, James Neil 1931- *IlrAm G, -1880*
Boyle, John d1846 *DcNiCA*
Boyle, John 1941- *DcCAr 81*
Boyle, John C 1815?- *NewYHSD*
Boyle, John J 1851-1917 *BnEnAmA, IlBEAAW*
Boyle, John J 1852-1917 *WhAmArt 85*
Boyle, John Joseph 1874-1911 *WhAmArt 85*
Boyle, K E *AmArch 70*
Boyle, Keith 1930- *DcCAA 71, -77, WhoAmA 73, -76, -78, -80, -82, -84*

Boyle, Kenneth Roy 1922- *AmArch 70*
Boyle, Lockhart *DcVicP 2*
Boyle, M *FolkA 86, NewYHSD*
Boyle, Mrs. M C *NewYHSD*
Boyle, Mark 1934- *ConArt 77, -83, ConBrA 79, DcCAr 81*
Boyle, Mark Patrick 1957- *MarqDCG 84*
Boyle, Neil *PrintW 85*
Boyle, Richard 1694-1753 *BiDBrA, WhoArch*
Boyle, Mrs. Richard 1825-1916 *DcBrBI, DcVicP 2*
Boyle, Richard, Earl Of Burlington 1694-1753 *McGDA*
Boyle, Richard J 1932- *WhoAmA 73, -76, -78, -80, -82, -84*
Boyle, Robert 1910- *ConDes*
Boyle, Sarah Yocum McF *WhAmArt 85*
Boyle, Sarah Yocum McFadden *DcWomA*
Boyle, Thomas 1827?- *NewYHSD*
Boyle, Vincent Taylor *AmArch 70*
Boyle, William *NewYHSD*
Boylen, Michael Edward 1935- *WhoAmA 78, -80, -82, -84*
Boyles, C A *AmArch 70*
Boylesve, Marie *DcWomA*
Boyley, Daniel *FolkA 86*
Boylston, John W 1852-1932 *BiDAmAr*
Boylston, Louis Holmes 1867-1924 *BiDAmAr*
Boyne, John 1750?-1810 *DcBrWA*
Boyns, Bessie *DcVicP 2*
Boynton *FolkA 86*
Boynton, Anna E *ArtsAmW 2, DcWomA*
Boynton, C *FolkA 86*
Boynton, George R d1945 *WhAmArt 85*
Boynton, George W d1884 *NewYHSD*
Boynton, Grace *DcWomA*
Boynton, Henry Bradley 1899- *AmArch 70*
Boynton, Jack W 1928- *WhoAmA 80, -82, -84*
Boynton, James W 1928- *DcCAA 71, -77, WhoAmA 73, -76, -78*
Boynton, Ray 1883-1951 *ArtsAmW 1*
Boynton, Ray Scepter 1883-1951 *IlBEAAW, WhAmArt 85*
Boynton, William N *EncASM*
Boys, George *OxTwCA*
Boys, Thomas S 1803- *ArtsNiC*
Boys, Thomas Shotter 1803-1874 *DcBrBI, DcBrWA, DcVicP 2, McGDA, OxArt*
Boyson, Robert Charles 1935- *AmArch 70*
Boytac, Diogo *McGDA, OxArt*
Boyte, Jack O 1920- *AmArch 70*
Boyter, James Estle 1935- *AmArch 70*
Boyvin, Rene 1525-1598? *McGDA*
Boz, Alex 1919- *WhoAmA 73, -76, -78, -80, -82, -84*
Boza, Daniel 1911- *WhAmArt 85*
Boza, Louis *WhAmArt 85*
Boza, Oliver *WhAmArt 85*
Bozalis, Dickinson *AmArch 70*
Bozalis, J *AmArch 70*
Boze, Calvin *IlsBYP*
Boze, Fanny d1856 *DcWomA*
Boze, Joseph 1744-1826 *ClaDrA*
Boze, Joseph 1746-1826 *AntBDN J*
Boze, Marie Claudine Ursule *DcWomA*
Bozeman, Earl Graham 1921- *AmArch 70*
Bozeman, Ralph Neil 1938- *AmArch 70*
Boznanska, Olga 1865-1945? *DcWomA*
Bozzetto, Bruno 1938- *ConDes, WorECar*
Bozzini, Candida Luigia 1853- *DcWomA*
Bozzo, Frank *IlsBYP*
Bozzo, Frank 1937- *IlsCB 1967*
Bozzolini, Isabella *DcWomA*
Bozzolini, Matilde 1811- *DcWomA*
Braakensiek, Johan 1858-1940 *WorECar*
Braaksma, Menno 1912- *AmArch 70*
Braan, Edward 1839?- *NewYHSD*
Braaq 1951- *DcCAr 81*
Braasch, Minna *DcWomA*
Brabant, Amelina *DcWomA*
Brabant, Rosemary *WhoArt 82, -84*
Brabant, Rosemary 1915- *WhoArt 80*
Brabazon, Hercules 1821-1906 *McGDA*
Brabazon, Hercules B 1821-1906 *ClaDrA*
Brabazon, Hercules Brabazon 1821-1906 *DcBrA 1, DcBrWA, DcVicP, -2*
Brabazon, Thomas *WhAmArt 85*
Braby, Dorothea 1909- *DcBrA 1, WhoArt 80, -82, -84*
Braby, Henry *NewYHSD*
Braby, Newton *DcVicP 2*
Braccesco, Carlo *McGDA*
Bracci, Pietro 1700-1773 *McGDA*
Brace, Deborah Loomis 1752-1839 *FolkA 86*
Brace, Eleanor *DcVicP 2, DcWomA*
Brace, Rodney *DcNiCA*
Bracebridge, Selina *DcBrWA*
Bracebridge, Selina d1874 *DcBrBI*
Bracey, Henry *AfroAA*
Brach, Malvina *DcWomA*
Brach, Paul 1924- *DcCAA 71, -77, PrintW 85*
Brach, Paul H 1924- *WhoAmA 73*
Brach, Paul Henry 1924- *WhoAmA 76, -78, -80, -82, -84*

Brach, W J AmArch 70
Bracher, William 1828?- NewYHSD
Brachlianoff, Arcady 1912- WorECar
Brack, John 1920- DcCAr 81
Brackbill, Eliza Ann FolkA 86
Bracke, Camiel Francis 1920- AmArch 70
Bracke, Hayes Miller AmArch 70
Bracken, A DcVicP 2
Bracken, Charles W 1909- WhAmArt 85
Bracken, Clio 1870-1925 DcWomA, WhAmArt 85
Bracken, Julia M DcWomA, WhAmArt 85
Bracken, Thomas FolkA 86
Brackenbury, Amy OfPGCP 86
Brackenbury, Ian F 1946- MarqDCG 84
Brackenridge, A NewYHSD
Brackenridge, Cornelia DcWomA, WhAmArt 85
Brackenridge, Henry M WhAmArt 85
Brackenridge, Marian 1903- WhAmArt 85
Bracker, Charles E 1895- WhAmArt 85
Bracker, Charles Eugene 1895- IlsCB 1744
Bracker, M Leone 1885-1937 WhAmArt 85
Bracker, William MarqDCG 84
Bracket, H V DcWomA
Brackett, Arthur Loring WhAmArt 85
Brackett, Christopher C NewYHSD
Brackett, Edward Augustus 1818- WhAmArt 85
Brackett, Edward Augustus 1818-1908 BnEnAmA, DcAmArt, McGDA, NewYHSD
Brackett, Edwin E 1819- ArtsNiC
Brackett, Miss H V NewYHSD
Brackett, M AfroAA
Brackett, M McDowell 1921- AmArch 70
Brackett, R P AmArch 70
Brackett, Sidney Lawrence WhAmArt 85
Brackett, Truman H, Jr. 1933- WhoAmA 73
Brackett, Walter M 1823- ArtsNiC
Brackett, Walter M 1823-1919 NewYHSD, WhAmArt 85
Brackett, Ward 1914- IlrAm F, -1880
Brackett, William Ernest, Jr. 1918- AmArch 70
Brackman, John NewYHSD
Brackman, Robert 1898- DcCAA 71, -77, McGDA, WhAmArt 85, WhoAmA 73, -76, -78, -80
Brackman, Robert 1898-1980 WhoAmA 82N, -84N
Brackmier, Herbert W 1909- WhAmArt 85
Bracony, Leopold WhAmArt 85
Bracquemond, Felix 1833- ArtsNiC
Bracquemond, Felix 1833-1914 AntBDN A, ClaDrA, DcNiCA, McGDA
Bracquemond, Marie ArtsNiC
Bracquemond, Marie De 1841-1916 DcWomA
Bracy, Frank C 1851-1931 ArtsEM
Bracy And Gibson ArtsEM
Bradberry, Thomas BiDBrA
Bradbury, Ian Westwood 1918- WhoArt 80, -82
Bradburg, Harriett FolkA 86
Bradburne, L DcVicP 2
Bradbury, A A DcVicP 2
Bradbury, A Thomas 1901- AmArch 70
Bradbury, C A AmArch 70
Bradbury, Charles Earl WhAmArt 85
Bradbury, Edith M 1910- WhAmArt 85
Bradbury, Edward NewYHSD
Bradbury, Ellen A 1940- WhoAmA 76, -78, -80, -82, -84
Bradbury, George Eric 1881-1954 DcBrA 1
Bradbury, Gideon FolkA 86
Bradbury, Harriet J d1930 WhAmArt 85
Bradbury, Keith Howard 1918- AmArch 70
Bradbury, Mary R DcWomA
Bradbury, Phil Wilson 1934- AmArch 70
Bradbury, Robert M, Jr. 1924- AmArch 70
Bradbury, Thomas AntBDN N, DcNiCA
Bradbury, William DcBrECP
Braddell, Kyo DcBrBI
Braddick, Jane DcWomA
Braddock, Effie Frances 1866- DcWomA
Braddock, Effie Francis 1866- WhAmArt 85
Braddock, Katherine 1870- ArtsAmW 2, DcWomA, WhAmArt 85
Braddock, Charles Edwin 1906- WhAmArt 85
Braddon, Paul DcBrWA, DcVicP 2
Braddy, Minton Venner 1920- AmArch 70
Braddyll, Thomas Richard Gale 1776-1862 DcBrBI
Braden, David Rice 1924- AmArch 70
Braden, James George AmArch 70
Braden, Karl DcVicP 2
Braden, Philip R 1920- AmArch 70
Bradfield, C P DcWomA
Bradfield, Mrs. C P ArtsAmW 3
Bradfield, Edward 1892- WhAmArt 85
Bradfield, Elizabeth Palmer DcWomA, WhAmArt 85
Bradfield, Margaret 1898- WhAmArt 85
Bradfield, Margaret Jewell 1898- DcWomA
Bradfield, Richard Harold 1933- AmArch 70
Bradford NewYHSD
Bradford, Miss DcWomA
Bradford, Benjamin W FolkA 86
Bradford, David Philip 1937- AfroAA
Bradford, Dorothy 1918- WhoArt 80, -82

Bradford, Dorothy Elizabeth DcBrA 1, DcWomA
Bradford, Esther S FolkA 86
Bradford, Francis Scott 1898-1961 WhAmArt 85, WhoAmA 80N, -82N, -84N
Bradford, Harriette DcVicP 2, DcWomA
Bradford, Harry WhAmArt 85
Bradford, Henry NewYHSD
Bradford, Howard 1919- PrintW 83, -85, WhoAmA 73, -76, -78, -80, -82, -84
Bradford, John BiDBrA
Bradford, John N WhAmArt 85
Bradford, Joseph FolkA 86
Bradford, Joseph Nelson 1860-1943 BiDAmAr
Bradford, Leroy Daniel 1923- AmArch 70
Bradford, Lodowick H 1815?- NewYHSD
Bradford, Louis King 1807-1862 DcBrWA, DcVicP 2
Bradford, M L AmArch 70
Bradford, Martha Jane 1912- WhAmArt 85
Bradford, Myrtle Taylor 1860- WhAmArt 85
Bradford, Myrtle Taylor 1886- DcWomA
Bradford, Robert 1945- WhoArt 80
Bradford, Stella 1920- WhAmArt 85
Bradford, Thomas d1799 CabMA
Bradford, W DcBrBI
Bradford, William BiDBrA
Bradford, William 1823?- FolkA 86
Bradford, William 1823-1892 ArtsAmW 1, BnEnAmA, DcAmArt, NewYHSD
Bradford, William 1827-1892 DcSeaP
Bradie, John BiDBrA
Bradish, Alvah 1806-1901 ArtsEM, NewYHSD, WhAmArt 85
Bradish, Ethelwyn 1882- DcWomA
Bradisk, Ethelwyn C 1882- WhAmArt 85
Bradlee, Nathaniel J 1829-1888 BiDAmAr, MacEA
Bradley, A M BiDAmAr
Bradley, Anne Cary 1884- DcWomA, WhAmArt 85
Bradley, B H AmArch 70
Bradley, Basil 1842- ArtsNiC
Bradley, Basil 1842-1904 ClaDrA, DcBrA 1, DcBrBI, DcBrWA, DcVicP, -2
Bradley, C H DcBrBI
Bradley, Carl Leroy 1930- AmArch 70
Bradley, Carolyn G WhAmArt 85
Bradley, Charles B 1883- WhAmArt 85
Bradley, Charles MacArthur 1918- AmArch 70
Bradley, Cuthbert DcBrBI
Bradley, David P 1954- AmArt, WhoAmA 82, -84
Bradley, Dorothy 1920- WhoAmA 78, -80, -82, -84
Bradley, E DcWomA
Bradley, Mrs. E DcVicP 2
Bradley, Edson 1852-1935 WhAmArt 85
Bradley, Edward DcVicP, -2
Bradley, Edward 1827-1889 DcBrWA
Bradley, Edward Eugene 1857-1938 WhAmArt 85
Bradley, Florence ClaDrA
Bradley, Florence 1902- DcBrA 1
Bradley, Florence A 1853- DcWomA, WhAmArt 85
Bradley, Frank 1903- ClaDrA, DcBrA 1, WhoArt 80, -82, -84
Bradley, Gary WorFshn
Bradley, George 1826-1898 BiDAmAr
Bradley, Geroge P WhAmArt 85
Bradley, Gertrude M DcBrBI, DcVicP 2
Bradley, Gordon DcBrWA, DcVicP 2
Bradley, Gordon William 1926- AmArch 70
Bradley, H AmArch 70
Bradley, H S AmArch 70
Bradley, H W AmArch 70, ArtsAmW 1, NewYHSD
Bradley, Harrison CabMA
Bradley, Mrs. Harry Lynde WhoAmA 80N, -73, -76, -78, -82N, -84N
Bradley, I d1874 FolkA 86
Bradley, I J H NewYHSD
Bradley, Ida Florence 1908- WhoAmA 73, -76, -78, -80
Bradley, J DcVicP 2
Bradley, J F AmArch 70
Bradley, Jack Ralph, Jr. 1923- AmArch 70
Bradley, James DcVicP 2
Bradley, John NewYHSD
Bradley, John Henry 1832- ArtsNiC, DcBrWA, DcVicP, -2
Bradley, John William, Jr. 1932- AmArch 70
Bradley, Joseph Crane 1919- WhAmArt 85
Bradley, Joseph Manton, Jr. 1935- AmArch 70
Bradley, Lewis NewYHSD
Bradley, Louise DcWomA
Bradley, Lucas BiDAmAr
Bradley, Lucas 1809-1889 MacEA
Bradley, Luther Daniels 1853-1917 WorECar
Bradley, M W DcWomA
Bradley, Mabel D WhAmArt 85
Bradley, Martin 1931- PhDcTCA 77
Bradley, Mary DcBrWA, DcWomA, FolkA 86, WhAmArt 85
Bradley, Michael Gene 1940- AmArch 70
Bradley, Omar AfroAA
Bradley, Paul M, Jr. 1922- AmArch 70
Bradley, Peter 1940- AfroAA

Bradley, Peter Alexander 1940- ConArt 77, WhoAmA 73, -76, -78, -80, -82
Bradley, Prentice 1906- AmArch 70
Bradley, Randy H 1948- MacBEP
Bradley, Relins 1831?- NewYHSD
Bradley, Robert 1813-1880? DcBrWA, DcVicP 2
Bradley, Sarah E DcWomA
Bradley, Susan 1851-1929 DcWomA
Bradley, Susan H 1851-1929 WhAmArt 85
Bradley, Thomas BiDBrA, FolkA 86
Bradley, Thomas 1838?- NewYHSD
Bradley, Thomas Graham 1927- AmArch 70
Bradley, W B 1890- WhAmArt 85
Bradley, Walter DcNiCA
Bradley, Will H 1868- WhAmArt 85
Bradley, Will H 1868-1962 IlrAm 1880
Bradley, William AfroAA, BiDBrA, DcVicP 2
Bradley, William 1801-1857 DcBrWA, DcVicP 2
Bradley, William George, Jr. 1931- AmArch 70
Bradley, William H 1868- DcBrBI, IlsCB 1744
Bradling, A DcVicP 2
Bradner, Mabel Drake 1891-1951 DcWomA
Bradshaw, Alexandra Christine WhAmArt 85
Bradshaw, Antonia Violet Hamilton DcBrA 1
Bradshaw, Brian WhoArt 82
Bradshaw, Brian 1923- ClaDrA, DcBrA 1, WhoArt 80
Bradshaw, Colin 1938- DcCAr 81
Bradshaw, Constance H d1961 DcBrA 1, DcWomA
Bradshaw, Dorothy Winifred 1897- WhoArt 80, -82, -84
Bradshaw, Dove 1949- WhoAmA 84
Bradshaw, Florence DcVicP 2
Bradshaw, George DcBrECP
Bradshaw, George A 1880- WhAmArt 85
Bradshaw, George Fagan 1887-1960 DcBrA 1
Bradshaw, Glenn Raymond 1922- WhoAmA 73, -76, -78, -80, -82, -84
Bradshaw, Gordon Alexander 1931- ClaDrA
Bradshaw, Harold C 1893-1943 DcBrA 2
Bradshaw, John H NewYHSD
Bradshaw, Kathleen M WhoArt 80, -82, -84
Bradshaw, Kathleen Marion 1904- DcBrA 2
Bradshaw, Laurence WhoArt 80N
Bradshaw, Laurence Henderson 1899- DcBrA 1
Bradshaw, Lawrence James 1945- WhoAmA 78, -80, -82, -84
Bradshaw, Maurice Bernard 1903- WhoArt 80, -82, -84
Bradshaw, N DcWomA
Bradshaw, Percival Vanner 1878-1965 WorECar
Bradshaw, Percy Venner DcBrBI
Bradshaw, Peter 1931- WhoArt 80, -82, -84
Bradshaw, Raymond Henry 1918- WhoArt 80, -82, -84
Bradshaw, Robert George 1915- WhoAmA 73, -76, -78, -80, -82, -84
Bradshaw, Ronald G 1935- AmArch 70
Bradshaw, Samuel DcVicP 2
Bradshaw, William BiDBrA
Bradshire, William CabMA
Bradstreet, E DcVicP 2, DcWomA
Bradstreet, Edward D 1878-1921 WhAmArt 85
Bradt, Delphine WhAmArt 85
Bradt, Delphine 1898- DcWomA
Bradt, Horace Greeley 1916- AmArch 70
Bradt, Jack MarqDCG 84
Bradt, Josephine DcWomA, WhAmArt 85
Bradt, Kethleen Weil-Garris WhoAmA 84
Bradt, Robert Andrew 1915- AmArch 70
Bradtke, Philip Joseph 1934- AmArch 70
Bradway, Florence 1897- WhAmArt 85
Bradway, Florence Dell 1897?- DcWomA
Bradwell, David BiDBrA
Bradwell, George W WhAmArt 85
Bradwood, John 1824?- NewYHSD
Bradwood, Thomas W 1814?- NewYHSD
Brady NewYHSD
Brady, Banister Allen 1920- AmArch 70
Brady, C Wynn 1931- AmArch 70
Brady, Carolyn 1937- PrintW 83, -85
Brady, Charles Michael 1926- WhoAmA 73, -76, -78, -80, -82, -84
Brady, Constance L 1931- AmArch 70
Brady, Emmet DcBrA 1
Brady, F C ArtsEM
Brady, Hiram FolkA 86
Brady, Howard Nelson 1956- MarqDCG 84
Brady, Irene 1943- IlsCB 1967
Brady, J E AmArch 70
Brady, J J AmArch 70
Brady, James NewYHSD
Brady, James 1839?- NewYHSD
Brady, John WhAmArt 85
Brady, Josiah R 1760?-1832 BiDAmAr, MacEA
Brady, Katherine DcWomA
Brady, Luther W 1925- WhoAmA 82, -84
Brady, Mabel Claire 1887- WhAmArt 85
Brady, Mary C ArtsAmW 2, DcWomA, WhAmArt 85
Brady, Mathew 1823-1896 ICPEnP

Brady, Mathew B 1823-1896 *BnEnAmA, DcAmArt, MacBEP, NewYHSD*
Brady, Michael Wade 1948- *MarqDCG 84*
Brady, Rufus Holland, Jr. 1925- *AmArch 70*
Brady, Susan *ArtsEM, DcWomA*
Brady, Walter d1940 *FolkA 86*
Braecke, Pierre 1859-1920 *McGDA*
Braekeleer *NewYHSD*
Braekeleer, Adrien Ferdinand De 1818-1904 *ClaDrA*
Braekeleer, Ferdinand De 1792-1883 *ArtsNiC, ClaDrA*
Braekeleer, Henri De 1840-1888 *ClaDrA, McGDA*
Braem, Renaat 1910- *MacEA*
Braendle, Fred Joseph 1845-1934 *WhAmArt 85*
Braendle, Josephine Anne *DcWomA*
Braga, Alfred Maynard 1911- *WhAmArt 85*
Braga, Donato *McGDA*
Bragaglia, Anton Giulio 1890-1960 *ICPEnP*
Bragar, Philip Frank 1925- *WhoAmA 78, -80, -82, -84*
Bragdon, Claude F 1866-1946 *BiDAmAr, MacEA*
Bragdon, Claude Fayette 1866- *WhAmArt 85*
Bragdon, Cora *DcWomA*
Bragdon, Mabel D *WhAmArt 85*
Bragdon, Melvin F *WhAmArt 85*
Brager, Jean Baptiste Henri Durand *DcSeaP*
Brager, Jean Baptiste Henri Durand 1814-1879 *DcBrBI*
Bragg, Charles *IlsBYP*
Bragg, Charles 1931- *PrintW 85*
Bragg, Charles William *DcBrWA, DcVicP 2*
Bragg, Dale Vernon 1928- *AmArch 70*
Bragg, Edward 1785-1875 *DcBrWA*
Bragg, Gerard *DcBrA 1*
Bragg, Gwendoline d1929 *DcWomA*
Bragg, Henry *DcBrWA*
Bragg, John *DcBrWA, DcVicP 2*
Bragg, Kendrick R, Jr. 1918- *AmArch 70*
Bragg, S R *AmArch 70*
Bragge, James 1833-1908 *MacBEP*
Bragger, Charles *DcVicP 2*
Braggins, A J *DcWomA*
Braghetta, Lulu H 1901- *WhAmArt 85*
Bragin, Ernest *WhAmArt 85*
Bragstad, Jeremiah O 1932- *MacBEP*
Braguin, Simeon 1907- *WhAmArt 85*
Braham, Irma *WhAmArt 85*
Brahm, B *FolkA 86*
Brahm, John *NewYHSD*
Brahmin, J I *AfroAA*
Braht, Fred W 1929- *AmArch 70*
Braiden, Rose Margaret J 1923- *WhoAmA 78, -80, -82, -84*
Braider, Donald d1977 *WhoAmA 78N, -80N, -82N, -84N*
Braidt, Frohica *FolkA 86*
Braidwood, Thomas W *NewYHSD*
Braig, Betty Lou 1931- *WhoAmA 84*
Braij, Dirck De *McGDA*
Braij, Jan Salomonsz De 1626?-1697 *McGDA*
Braij, Salomon De 1597-1664 *McGDA*
Brailas, A *AmArch 70*
Brailer, Augustin *FolkA 86*
Brailsford, Alfred 1888- *DcBrA 1*
Brain, Constance *DcVicP 2*
Brain, Edward *DcNiCA*
Brain, Elizabeth *WhAmArt 85*
Brain, Elizabeth Wheldon 1870-1960 *DcWomA*
Brain, F *DcVicP 2, DcWomA*
Brain, H *DcVicP 2*
Brainard, Charles Lewis 1903- *AmArch 70*
Brainard, Elizabeth Homes d1905 *DcWomA, WhAmArt 85*
Brainard, Grace M *DcWomA*
Brainard, Isaac *FolkA 86*
Brainard, Jehu *NewYHSD*
Brainard, Joe 1942- *DcCAA 77, DcCAr 81, WhoAmA 78, -80, -82, -84*
Brainard, M N *DcWomA*
Brainard, Mrs. M N *ArtsEM*
Brainard, Owen 1924- *WhoAmA 73, -76, -78, -80, -82, -84*
Brainard, W W *AmArch 70*
Brainard And Wilson *EncASM*
Braine, Mrs. 1780?- *DcWomA*
Braine, Alice *DcBrA 2*
Braine, B G *WhAmArt 85*
Braine, William *BiDBrA*
Brainerd, Miss *NewYHSD*
Brainerd, E I *AmArch 70*
Brainerd, H B *AmArch 70*
Brainerd, Owen 1856-1919 *BiDAmAr*
Brainerd, William H 1862-1941 *BiDAmAr*
Braithwaite, Charles d1941 *DcBrA 1*
Braithwaite, Sam Hartley 1883- *DcBrA 1*
Braithwaite, T R *WhAmArt 85*
Braitsch, W J *EncASM*
Braitstein, Marcel 1935- *WhoAmA 73, -76, -78, -80, -82, -84*
Brake, Brian 1927- *ConPhot, ICPEnP A, MacBEP*
Brakenburg, Richard 1650-1702 *ClaDrA, McGDA*
Brakhage, James Stanley 1933- *WhoAmA 76, -78,*

-80, -82, -84
Brakke, P Michael 1943- *WhoAmA 82, -84*
Brakken, Andrew *WhAmArt 85*
Bralds, Braldt 1951- *AmArt*
Braley, Clarence E *ArtsAmW 3, WhAmArt 85*
Braley, Jean *WhoAmA 84*
Braley, Jean Duffield *WhoAmA 78, -80, -82*
Braley, Robert J, Jr. 1943- *MarqDCG 84*
Brall, Ruth 1906- *WhAmArt 85*
Brally, James 1822?- *NewYHSD*
Bram, Jerri 1942- *MacBEP*
Brama, Gabriel, Madame 1846- *DcWomA*
Bramah, Joseph 1749-1814 *OxDecA*
Bramante, Donato 1444-1514 *DcD&D, MacEA, McGDA, WhoArch*
Bramante, Donato DiAngelo 1444-1514 *OxArt*
Bramantino *McGDA*
Bramantino 1455?-1536 *MacEA*
Bramantino, Bartolomeo Suardi 1466?-1536 *OxArt*
Bramantino, Bartolommeo 1450?-1529 *ClaDrA*
Bramberg, Lars 1920- *WhoGrA 62*
Bramble, Benjamin 1789?-1857 *BiDBrA*
Brameld, John Wager *AntBDN M*
Brameld, Thomas *AntBDN M*
Bramer, Leonaert 1596-1674 *OxArt*
Bramer, Leonard 1595?-1674 *McGDA*
Bramer, Leonard 1596-1674 *ClaDrA*
Bramhall, H *DcVicP 2*
Bramhall, Kib 1933- *WhoAmA 82, -84*
Bramlett, Betty Jane *WhoAmA 78, -80, -82, -84*
Bramlett, Betty Jane 1925- *AmArt*
Bramlett, James E 1932- *IlBEAAW*
Bramley, Frank 1857-1915 *DcBrA 1, DcVicP, -2*
Bramley, Frank 1857-1932 *ClaDrA*
Bramley, William *DcBrA 1*
Bramley-Moore, Millicent *DcBrA 2*
Brammar, Joseph *WhAmArt 85*
Brammer, Joseph 1833-1904 *NewYHSD*
Brammer, Leonard Griffith 1906- *DcBrA 1*
Brammer, Leonard Griffiths 1906- *WhoAmA 80, -82, -84*
Brammer, Robert d?-853 *NewYHSD*
Bramnick, David 1894- *WhAmArt 85*
Brampton, Herbert *DcVicP 2*
Brams, Joan *WhoAmA 80, -82, -84*
Brams, Joan 1928- *WhoAmA 73, -76, -78*
Bramson *NewYHSD*
Bramson, Phyllis *DcCAr 81*
Bramson, Phyllis 1941- *PrintW 85*
Bramson, Phyllis Halperin 1941- *AmArt, WhoAmA 78, -80, -82, -84*
Bramwell, Edward George 1865-1944 *DcBrA 1*
Bramwell, Southby *DcSeaP*
Branan, Cicero Franklin 1921- *AmArch 70*
Branca, Rio 1946- *ICPEnP A*
Branch, Barry Dale 1921- *AmArch 70*
Branch, Dan Paulk 1931- *AmArch 70*
Branch, Frederick Octavius 1926- *AmArch 70*
Branch, Grove R *WhAmArt 85*
Branch, Harrison 1947- *AfroAA, MacBEP*
Branch, James Elliott 1906- *AmArch 70*
Branch, K G *AmArch 70*
Branch, Robert James 1931- *MarqDCG 84*
Branch, Veronese Beatty *WhAmArt 85*
Branch, William L *CabMA*
Branchard, Emile Pierre 1881-1938 *FolkA 86, WhAmArt 85*
Brancho, Gabriel *OxTwCA*
Brancour-Lenique, Berthe Marie 1872- *DcWomA*
Brancusi, Constantin 1876-1957 *ConArt 77, -83, MacBEP, McGDA, OxArt, OxTwCA, PhDcTCA 77, WorArt[port]*
Brand, Cacilie *DcWomA*
Brand, Catharina *DcWomA*
Brand, Chris 1921- *WhoGrA 82[port]*
Brand, D *FolkA 86*
Brand, Ethel Brand Wise *WhAmArt 85*
Brand, Friedrich Auguste 1755-1806 *ClaDrA*
Brand, Ginna 1929- *DcCAr 81*
Brand, Gustave A 1863-1944 *WhAmArt 85*
Brand, Herbert Amery *AmArch 70*
Brand, Joel Stanley 1934- *AmArch 70*
Brand, Johann Christian 1722-1795 *ClaDrA*
Brand, Leon 1933- *AmArch 70*
Brand, Richard Anthony 1945- *MarqDCG 84*
Brand, Richard R 1940- *MarqDCG 84*
Brand, Russell L 1962- *MarqDCG 84*
Brand, Virginia 1892- *WhAmArt 85*
Branda, Gerald Emelyn 1924- *AmArch 70*
Brandais, Marie Elisabeth *DcWomA*
Brandard, Annie Caroline *DcVicP 2, DcWomA*
Brandard, Edward Paxman 1819-1898 *DcBrWA, DcVicP 2*
Brandard, Robert 1805-1862 *ArtsNiC, ClaDrA, DcBrBI, DcBrWA, DcVicP, -2*
Brandegee, Robert B d1922 *WhAmArt 85*
Brandeis, Antoinetta 1849- *DcWomA*
Brandel, Konrad 1838-1920 *ICPEnP*
Branden, W *AntBDN F*
Brandenberg, Aliki *WhoAmA 78, -80*
Brandenberg, Aliki Liacouras *WhoAmA 82, -84*

Brandenberg, Aliki Liacouras 1929- *IlsCB 1957*
Brandenburg, Dora *DcWomA*
Brandenburg, Gary Eldo 1951- *MarqDCG 84*
Brandenburg, Kenneth Earl 1938- *AmArch 70*
Brandenburg-Anspach, Elizabeth *DcWomA*
Brandenburger, Don Lee 1936- *AmArch 70*
Brandes *NewYHSD*
Brandfield, Kitty *WhoAmA 76, -78*
Brandford, Edward Joscelyn 1905- *AfroAA*
Brandi, Giacinto 1623-1691 *McGDA*
Brandis, Howard 1912- *AmArch 70*
Brandish, A *DcVicP 2*
Brandling, Henry Charles *DcBrBI, DcBrWA, DcVicP 2*
Brandner, Karl C 1898- *WhAmArt 85*
Brandoin, Michel Vincent Charles 1733-1807 *DcBrWA*
Brandon, Mrs. *DcVicP 2, DcWomA*
Brandon, Brumsic, Jr. *AfroAA*
Brandon, David 1813-1897 *MacEA, WhoArch*
Brandon, Dolly *DcVicP 2*
Brandon, E *ArtsNiC, DcVicP 2*
Brandon, Jacques Emile Edouard 1831-1897 *ClaDrA*
Brandon, John A 1870- *ArtsAmW 1, WhAmArt 85*
Brandon, Warren Eugene 1916- *WhoAmA 73, -76*
Brandon, Warren Eugene 1916-1977 *WhoAmA 78N, -80N, -82N, -84N*
Brandow, Theodore 1925- *AmArch 70*
Brandreth, Charles Avery 1932- *AmArch 70*
Brandreth, Virginia G *DcWomA, WhAmArt 85*
Brandriff, George Kennedy 1890-1936 *ArtsAmW 1, IlBEAAW, WhAmArt 85*
Brands, Eugene *OxTwCA*
Brandstatter, Hans *DcCAr 81*
Brandt, Aguete *DcWomA*
Brandt, Andreas 1935- *DcCAr 81*
Brandt, Asa *DcCAr 81*
Brandt, Balette 1827-1884 *DcWomA*
Brandt, Bill 1904- *ConPhot, DcCAr 81, PrintW 85*
Brandt, Bill 1904-1983 *ICPEnP*
Brandt, Bill 1905- *MacBEP*
Brandt, C F *AmArch 70*
Brandt, Carl Frederick, Jr. 1950- *MarqDCG 84*
Brandt, Carl L *ArtsNiC*
Brandt, Carl L 1831-1905 *WhAmArt 85*
Brandt, Carl Ludwig 1831-1905 *IlBEAAW, NewYHSD*
Brandt, Edwin 1942- *DcCAr 81*
Brandt, F O *AmArch 70*
Brandt, Frederick Robert 1936- *WhoAmA 73, -76, -78, -80, -82, -84*
Brandt, Grace Borgenicht *WhoAmA 73, -78, -80, -82, -84*
Brandt, Gustav 1861-1919 *WorECar*
Brandt, H George *WhAmArt 85*
Brandt, Henry 1862- *WhAmArt 85*
Brandt, Mrs. Henry *FolkA 86*
Brandt, Henry A 1862- *ArtsAmW 3*
Brandt, Henry H 1862- *ArtsAmW 3*
Brandt, Jack Thompson 1930- *AmArch 70*
Brandt, James Lewis *AmArch 70*
Brandt, Josef 1841- *ArtsNiC*
Brandt, Julie Charlotte *DcWomA*
Brandt, K H *AmArch 70*
Brandt, Karl Arthur 1939- *AmArch 70*
Brandt, Margit 1945- *WorFshn*
Brandt, Marianne 1893- *DcWomA, McGDA*
Brandt, Marianne 1893-1983 *ConDes*
Brandt, Otto *DcVicP 2*
Brandt, P *AmArch 70*
Brandt, Paul C H 1923- *AmArch 70*
Brandt, Peter Busch 1937- *AmArch 70*
Brandt, Rex 1914- *WhoAmA 84*
Brandt, Rexford 1914- *WhAmArt 85*
Brandt, Rexford Elson 1914- *WhoAmA 73, -76, -78, -80, -82*
Brandt, Ruth *WhAmArt 85*
Brandt, Warren 1918- *DcCAA 71, -77, WhoAmA 73, -76, -78, -80, -82, -84*
Brandt, William Frederick 1925- *AmArch 70*
Branegan, J F *DcBrWA, DcVicP 2*
Brangwin, Noah *DcVicP 2*
Brangwyn, Frank 1867-1956 *OxTwCA*
Brangwyn, Sir Frank 1867-1956 *AntBDN B, DcBrBI, DcNiCA, DcVicP, -2, McGDA, PhDcTCA 77, WhAmArt 85A*
Brangwyn, Sir Frank William 1867-1956 *DcBrA 1, ClaDrA, DcBrWA, DcSeaP, OxArt*
Brangwyn, Leslie Maurice Leopold 1896- *DcBrA 1*
Branham, Brad Hamilton 1957- *MarqDCG 84*
Branicka, Elise *DcWomA*
Branigan, Daniel Miller 1928- *AmArch 70*
Braniselj, Milena 1951- *DcCAr 81*
Brann, Esther *ConICB, WhAmArt 85*
Brann, Louise 1906- *WhAmArt 85*
Brannam, Charles H *DcNiCA*
Brannam, Thomas *DcNiCA*
Brannan, Daniel *FolkA 86*
Brannan, Edward Eaton 1886-1957 *DcBrA 1*
Brannan, J *DcVicP 2*
Brannan, Noel Rowston 1921- *DcBrA 1, WhoArt 80, -82, -84*

Brett, Rosa *DcBrWA*, *DcVicP*, *-2*, *DcWomA*
Brette, Professor *NewYHSD*
Brettell, Richard Robson 1949- *WhoAmA 78, -80, -82, -84*
Bretting, Rosina Barbara *DcWomA*
Brettingham, Matthew 1699-1769 *AntBDN G, BiDBrA, MacEA, OxArt*
Brettingham, Matthew 1725-1803 *BiDBrA, MacEA, OxArt*
Brettingham, Robert 1696-1768 *BiDBrA*
Brettingham, Robert 1755?-1820 *MacEA*
Brettingham, Robert William Furze 1750?-1820 *BiDBrA*
Bretz, Mary *DcWomA, WhAmArt 85*
Bretzfelder, Anne 1916- *WhAmArt 85*
Breu, Jorg 1480?-1537 *OxArt*
Breu, Jorg, The Elder 1475?-1537 *McGDA*
Breu, Jorg, The Younger d1547 *OxArt*
Breuer, Anna *DcWomA*
Breuer, H J 1860-1932 *WhAmArt 85*
Breuer, Henry Joseph 1860-1932 *ArtsAmW 1, IlBEAAW*
Breuer, Marcel 1902- *AmArch 70, BnEnAmA, ConArch, DcD&D[port], DcNiCA, EncMA, OxArt, OxDecA*
Breuer, Marcel 1902-1981 *MacEA*
Breuer, Marcel Lajko 1902-1981 *ConDes*
Breuer, Marcel Lajos 1902- *EncAAr, McGDA, WhoArch*
Breuer, Theodore Albert 1870- *WhAmArt 85*
Breugel *McGDA*
Breugger, Christian 1822-1895 *NewYHSD*
Breughel *OxArt*
Breughel, Abraham 1631-1690 *McGDA*
Breughel, Ambrosius 1617-1675 *McGDA*
Breughel, Anna *McGDA*
Breughel, Jan, I 1568-1625 *McGDA*
Breughel, Jan, II 1601-1678 *McGDA*
Breughel, Pieter, III 1589- *McGDA*
Breuhaus DeGroot, Frans Arnold 1824-1872 *DcSeaP*
Breuillaud, Andre-Francois 1898- *DcCAr 81*
Breuillier, Louise *DcWomA*
Breul, H *NewYHSD*
Breul, Harold G 1889- *WhAmArt 85*
Breull, Hugo 1854-1910 *WhAmArt 85*
Breun, John Ernest 1862-1921 *DcBrA 1, DcVicP 2*
Breunig, Joseph *NewYHSD*
Breuning, Konstanze Von 1856- *DcWomA*
Breuninger, Grace L *DcWomA*
Brevannes, Maurice 1904- *IlsBYP, IlsCB 1946*
Breverman, Harvey 1934- *PrintW 83, -85, WhoAmA 73, -76, -78, -80, -82, -84*
Brevetti, Albert Carl 1927- *AmArch 70*
Brevoort, James R 1832-1918 *WhAmArt 85*
Brevoort, James Renwick 1832- *ArtsNiC*
Brevoort, James Renwick 1832-1918 *EarABI, NewYHSD*
Brevoort, Marie Louise *DcWomA*
Brewer *FolkA 86*
Brewer, Adrian L 1891-1956 *WhAmArt 85*
Brewer, Adrian Louis 1891- *ArtsAmW 3*
Brewer, Alice Ham 1872- *DcWomA, WhAmArt 85*
Brewer, Amy Cobham *DcVicP 2*
Brewer, Ann *DcWomA*
Brewer, Anna *DcWomA*
Brewer, B E, Jr. *AmArch 70*
Brewer, Bessie Marsh d1952 *WhoAmA 78N, -80N, -82N, -84N*
Brewer, Bessie Marsh 1883?-1952 *DcWomA, WhAmArt 85*
Brewer, Bill *AmArt*
Brewer, Daniel 1699-1763 *FolkA 86*
Brewer, Donald J 1925- *WhoAmA 73, -76, -78, -80, -82*
Brewer, Edward Vincent 1883- *WhAmArt 85*
Brewer, Ella *ArtsEM, DcWomA*
Brewer, Emily *DcWomA*
Brewer, Ethellyn *DcWomA, WhAmArt 85*
Brewer, F A *ArtsEM*
Brewer, Floyd E 1899- *WhAmArt 85*
Brewer, George St. P 1814-1852 *NewYHSD*
Brewer, Gerald James 1932- *AmArch 70*
Brewer, Glenn Darrell 1929- *AmArch 70*
Brewer, H E *WhAmArt 85*
Brewer, Harriet E *WhAmArt 85*
Brewer, Henry Charles 1866- *DcBrA 1*
Brewer, Henry Charles 1866-1943 *DcBrBI, DcBrWA*
Brewer, Henry Charles 1866-1950 *DcBrA 2, DcVicP 2*
Brewer, Henry Charles 1866-1962 *ClaDrA*
Brewer, Henry William d1903 *ClaDrA, DcBrA 1, DcBrBI, DcBrWA, DcVicP, -2*
Brewer, Howard E 1930- *MarqDCG 84*
Brewer, J A *FolkA 86*
Brewer, J Alphege *DcBrBI*
Brewer, J D *FolkA 86*
Brewer, James Alphege *DcBrA 1*
Brewer, James Edward 1933- *AmArch 70*
Brewer, John d1815 *DcNiCA*
Brewer, John d1816 *AntBDN M*

Brewer, John 1764-1816 *DcBrWA*
Brewer, John S 1824?- *NewYHSD*
Brewer, Laurana Richards 1808-1843 *DcWomA, NewYHSD*
Brewer, Leland Britton 1906- *AmArch 70*
Brewer, Leonard 1875- *ClaDrA*
Brewer, Leonard 1875-1935 *DcBrA 1*
Brewer, Mary *DcWomA*
Brewer, Mary Locke *DcWomA*
Brewer, Maude *DcVicP 2, DcWomA*
Brewer, Nicholas Richard 1857-1949 *ArtsAmW 1, -3, IlBEAAW, WhAmArt 85*
Brewer, R A *AmArch 70*
Brewer, Robert *DcNiCA*
Brewer, Robert d1857 *AntBDN M*
Brewer, Robert 1775-1857 *DcBrECP, DcBrWA*
Brewer, Tunis *FolkA 86*
Brewer, W H *DcBrBI*
Brewers, R *DcBrECP*
Brewerton, George Douglas 1820?-1901 *NewYHSD*
Brewerton, George Douglas 1827?-1901 *IlBEAAW*
Brewerton, George Douglas 1820-1901 *ArtsAmW 1*
Brewington, Marion Vernon 1902- *WhoAmA 73*
Brewington, Marion Vernon 1902-1974 *WhoAmA 76N, -78N, -80N, -82N, -84N*
Brewster *NewYHSD*
Brewster, A W *DcWomA*
Brewster, Achsah d1945 *WhAmArt 85*
Brewster, Ada Agusta *WhAmArt 85*
Brewster, Ada Augusta *ArtsAmW 2, DcWomA*
Brewster, Amanda *WhAmArt 85*
Brewster, Anna Mary *DcWomA*
Brewster, Anna Richards 1870-1952 *WhAmArt 85*
Brewster, B S *AmArch 70*
Brewster, David 1781-1868 *MacBEP*
Brewster, Sir David 1781-1868 *ICPEnP*
Brewster, Earl H 1879- *WhAmArt 85*
Brewster, Edmund *NewYHSD*
Brewster, Elisha 1791-1880 *DcNiCA*
Brewster, Elisha C *FolkA 86*
Brewster, Elisha C 1791-1880 *AntBDN D*
Brewster, Eugene V 1871- *WhAmArt 85*
Brewster, Eugene V 1871-1939 *ArtsAmW 3*
Brewster, Eugene Valentine 1871-1939 *ArtsAmW 3*
Brewster, G D *NewYHSD*
Brewster, G L *AmArch 70*
Brewster, G W *AmArch 70*
Brewster, George T 1862- *WhAmArt 85*
Brewster, Herbert R d1937 *BiDAmAr*
Brewster, Isabel *WhAmArt 85*
Brewster, Isabelle *DcWomA*
Brewster, James 1805-1845? *BiDBrA*
Brewster, John, Jr. 1766-1846 *BnEnAmA, NewYHSD*
Brewster, John, Jr. 1766-1854 *AmFkP, FolkA 86*
Brewster, Julia *WhAmArt 85*
Brewster, Julia Newman *DcWomA*
Brewster, Lydia Amanda *DcWomA*
Brewster, Martin M 1951- *MarqDCG 84*
Brewster, Mary Hazelton *DcWomA*
Brewster, Mela Sedillo *WhAmArt 85*
Brewster, Michael 1946- *WhoAmA 78, -80, -82, -84*
Brewtnal, Edward Frederick 1846-1902 *ClaDrA*
Brewtnall, Edward Frederick 1846-1902 *DcBrA 1, DcBrBI, DcBrWA, DcVicP 2*
Brey, Charles *IlsBYP*
Brey, David Martin 1918- *AmArch 70*
Brey, Marga 1932- *DcCAr 81*
Breydel, Frans 1679-1750 *ClaDrA*
Breydel, Karel 1678?-1733 *ClaDrA*
Breyfogle, Evelyn *DcWomA*
Breyfogle, John Winstanley 1874- *WhAmArt 85*
Breyman, Edna Cranston *ArtsAmW 2, DcWomA, WhAmArt 85*
Breyman, William *ArtsAmW 2, NewYHSD*
Breynat-Baume, Louise Marie *DcWomA*
Brezee, Evelyn 1912- *WhAmArt 85*
Brezik, Hilarion 1910- *WhoAmA 73, -76, -78, -80, -82, -84*
Brezzo, Stephen Louis 1946- *WhoAmA 76*
Brezzo, Steven Louis *WhoAmA 84*
Brian, Julius *NewYHSD*
Brianchon, Jules *DcNiCA*
Brianchon, Maurice 1899- *McGDA, OxTwCA, PhDcTCA 77*
Briane, Mrs. *DcWomA*
Briane, Elizabeth *DcWomA*
Briane, Elizabeth Ann *DcWomA*
Brians, Audrey Lee 1934- *AmArch 70*
Briansky, Rita Prezament 1925- *WhoAmA 73, -76, -78, -80, -82, -84*
Briant, Henry *BiDBrA*
Briard, Gabriel 1729-1777 *ClaDrA*
Briati, Giuseppe d1772 *IlDcG*
Briault, Sidney Graham 1887- *ClaDrA*
Briault, Sydney Graham 1887-1955 *DcBrBI*
Bribes, Jeanne *DcWomA*
Bricard, Gertrude 1881-1963 *DcWomA*
Bricard-Lassudrie, Berengere *DcWomA*
Bricci, Plautilla *DcWomA*
Briccio, Plautilla *DcWomA*

Brice, Bruce 1943- *FolkA 86*
Brice, Bruce Raymond 1942- *WhoAmA 73, -76*
Brice, Charles Austin 1909- *AfroAA*
Brice, E Kington 1860- *DcVicP 2*
Brice, Edward Kington 1860- *DcBrA 1*
Brice, Laure *DcWomA*
Brice, Mary B *DcWomA*
Brice, Ralph Erwin 1931- *AmArch 70*
Brice, William 1921- *DcCAA 71, -77, WhoAmA 73, -76, -78, -80, -82, -84*
Briceau, Angelique *DcWomA*
Briceno, Beatrix 1911- *DcCAr 81*
Brichard, Gabrielle Jeanne *DcWomA*
Brichdel, Christian *FolkA 86*
Bricher, Albert T 1837- *ArtsNiC*
Bricher, Alfred Thompson 1837-1908 *BnEnAmA, DcAmArt, NewYHSD, WhAmArt 85*
Bricher, Alfred Thomson 1837-1908 *DcSeaP*
Bricher, Henry 1817?- *NewYHSD*
Bricherasio, Sofia Di, Contessa 1869- *DcWomA*
Bricheteau, Albanie *DcWomA*
Brichler, Marge *OfPGCP 86*
Brick, Harry 1882- *WhAmArt 85*
Brick, Zena *FolkA 86*
Bricka, Blanche *DcWomA*
Bricka, Marie Marguerite *DcWomA*
Brickbauer, Charles G 1930- *AmArch 70*
Brickdale, C F *DcVicP 2*
Brickdale, Eleanor Fortescue *IlsCB 1744*
Brickdale, Eleanor Fortescue 1871-1945 *ClaDrA, DcBrBI, DcVicP, -2, DcWomA*
Brickdale, Eleanor Fortescue- 1871-1945 *DcBrWA*
Bricker, Francis Walter 1920- *AmArch 70*
Bricker, Larry Lee 1943- *AmArch 70*
Bricker, Martin Rice 1930- *AmArch 70*
Brickert, J T *AmArch 70*
Brickey, W J *NewYHSD*
Brickmann, Maria Eva *DcWomA*
Brickner, John *FolkA 86*
Bricon, Fortunee Clotilde *DcWomA*
Bridaham, Lester Burbank 1899- *WhAmArt 85*
Briddell, Charles C *EncASM*
Bridden, John *DcBrWA*
Bride And Tinckler *EncASM*
Bridel, W *BiDBrA*
Bridell, Eliza Florence *DcBrWA*
Bridell, Frederick L 1831-1863 *ArtsNiC*
Bridell, Frederick Lee 1831-1863 *DcBrWA, DcVicP, -2*
Bridell-Fox, Eliza Florence *DcWomA*
Bridge, Aline Sybil *DcWomA*
Bridge, Annie *DcVicP 2*
Bridge, E M *AmArch 70*
Bridge, Evelyn *WhAmArt 85*
Bridge, Evelyn 1872- *DcWomA*
Bridge, Helen *WhAmArt 85*
Bridge, J *DcVicP 2*
Bridge, John *AntBDN Q, CabMA*
Bridge, John d1834 *AntBDN Q*
Bridge, Muriel Elisabeth 1934- *WhoArt 80, -82, -84*
Bridge, R H *AmArch 70*
Bridge, William *WhAmArt 85*
Bridge And Fessenden *CabMA*
Bridgeman, Charles d1738 *MacEA*
Bridgeman, John *WhoArt 80, -82, -84*
Bridgeman, John 1916- *DcBrA 1*
Bridgeman, Sarah *DcWomA*
Bridgens, Charles *NewYHSD*
Bridgens, Henry *NewYHSD*
Bridgens, Richard *DcBrBI*
Bridgens, Richard H *BiDBrA*
Bridgens, Robert *NewYHSD*
Bridgens, William Henry *NewYHSD*
Bridges, Alan Harold 1947- *MarqDCG 84*
Bridges, Alan L 1950- *MarqDCG 84*
Bridges, Appleton S 1848-1929 *WhAmArt 85*
Bridges, Chad Russell 1950- *MarqDCG 84*
Bridges, Charles *BnEnAmA, DcAmArt, DcBrECP, FolkA 86, McGDA, NewYHSD*
Bridges, Daniel Bryant 1930- *AmArch 70*
Bridges, E W *NewYHSD*
Bridges, Earl *NewYHSD*
Bridges, Fidelia *ArtsNiC*
Bridges, Fidelia 1834-1923 *DcWomA*
Bridges, Fidelia 1834-1924 *WhAmArt 85*
Bridges, Fidelia 1835-1923 *NewYHSD*
Bridges, Georges 1899- *WhAmArt 85*
Bridges, James *BiDBrA, DcBrWA, DcVicP, -2*
Bridges, Jim L 1931- *AmArch 70*
Bridges, John *DcVicP, -2*
Bridges, Kent W 1941- *MarqDCG 84*
Bridges, Leon 1932- *AmArch 70*
Bridges, R J *AmArch 70*
Bridges, R R *AmArch 70*
Bridges, Richard Chester 1931- *AmArch 70*
Bridges, Ruth *AfroAA*
Bridges, T F *AmArch 70*
Bridges, Wellington E *NewYHSD*
Bridget Of Sweden, Saint 1303-1373 *McGDA*

Brisset, Pierre-Nicolas 1810- *ArtsNiC*
Brisson, Mademoiselle *DcWomA*
Brissot, Frank *DcVicP 2*
Bristol, Edmund 1787-1876 *ArtsNiC*
Bristol, J Sherman *WhAmArt 85*
Bristol, John Bunyan 1826- *ArtsNiC*
Bristol, John Bunyan 1826-1909 *NewYHSD* ,
 WhAmArt 85
Bristol, Olive 1890?-1976 *ArtsAmW 3*
Bristol, Stone E *WhAmArt 85*
Bristol, Tanci 1915- *WhAmArt 85*
Bristow, Edmund 1787-1876 *DcBrWA*, *DcVicP, -2*
Bristow, George L *DcVicP 2*
Bristow, J *BiDBrA*
Bristow, James E 1936- *AmArch 70*
Bristow, Lily *DcVicP 2, DcWomA*
Bristow, S *DcBrWA*
Bristow, W H *DcVicP 2*
Bristow, William Arthur 1937- *AmArt, WhoAmA 76,*
 -78, -80, -82, -84
Bristowe, Beatrice M *DcVicP 2*
Bristowe, Ethel Susan Graham 1866-1952 *DcBrA 1,*
 DcWomA
Brite, James d1942 *BiDAmAr*
Brito E Cunha, Jose Carlos De 1884-1950 *WorECar*
Britsch, A G *WhAmArt 85*
Britsch, Carl C 1889- *AmArch 70*
Britsky, Nicholas 1913- *WhAmArt 85, WhoAmA 73,*
 -76, -78, -80, -82, -84
Britt *FolkA*
Britt, Al 1934- *WhoAmA 76, -78, -80, -82, -84*
Britt, Arthur L, Sr. 1934- *AfroAA*
Britt, Avery L *AfroAA*
Britt, B F *AmArch 70*
Britt, Benjamin 1923- *AfroAA*
Britt, Nelson Clark 1944- *WhoAmA 84*
Britt, Peter 1819- *NewYHSD*
Britt, Ralph M 1895- *WhAmArt 85*
Britt, Sam Glenn 1940- *WhoAmA 76, -78, -80, -82,*
 -84
Britt, William W 1820?- *NewYHSD*
Britta 1944- *WorFshn*
Brittain, I G *DcBrBI*
Brittain, Miller *OxTwCA*
Brittain, Miller G d1968 *WhoAmA 78N, -80N, -82N,*
 -84N
Brittain, Wilkinson And Brownhill *AntBDN N*
Brittan, Charles Edward 1837-1888 *DcBrWA,*
 DcVicP 2
Brittan, Charles Edward 1870- *DcBrA 1, IlsCB 1744*
Brittan, Charles Edward 1871- *DcBrWA*
Brittelle, William Miles, Jr. 1932- *AmArch 70*
Britten, William Edward Frank *DcBrBI, DcVicP*
Britten, William Edward Frank 1848-1916 *DcVicP 2*
Brittin, Arna T *WhAmArt 85*
Brittin, Sanford *FolkA 86*
Brittman, Stanley Selig 1938- *AmArch 70*
Britton, Alison 1949- *DcCAr 81*
Britton, Daniel Robert 1949- *WhoAmA 82, -84*
Britton, Edgar 1901- *WhAmArt 85, WhoAmA 73,*
 -76, -78
Britton, Harry 1879-1958 *WhAmArt 85,*
 WhoAmA 80N, -82N, -84N
Britton, Henrietta *DcWomA*
Britton, Isaac W *EarABI, NewYHSD*
Britton, James 1878-1936 *WhAmArt 85*
Britton, James, II 1915- *WhoAmA 80, -82*
Britton, James, II 1915-1983 *WhoAmA 84N*
Britton, James Albert 1900- *AmArch 70*
Britton, John *AfroAA, NewYHSD*
Britton, John 1771-1857 *DcBrBI, DcBrWA, MacEA*
Britton, John K *WhAmArt 85*
Britton, Joseph 1825-1901 *ArtsAmW 1, NewYHSD*
Britton, L N *WhAmArt 85*
Britton, Susan *DcCAr 81*
Britton, Sylvester 1926- *AfroAA*
Britton, William *FolkA 86*
Britz, Chris 1943- *DcCAr 81*
Briulov *OxArt*
Brivlauks, Nikolai 1929- *ICPEnP A*
Briwer And Rusher *EncASM*
Brixen, Martin 1927- *AmArch 70*
Brixius, Dorothy Ann 1916- *WhAmArt 85*
Brize, Cornelis 1622-1670 *ClaDrA*
Brizee, Bernard Nicholas 1928- *AmArch 70*
Brizio, Menichino Del *McGDA*
Brizzi, Ary *OxTwCA*
Brizzi, Ary 1930- *PhDcTCA 77*
Brkan, Braca 1920- *DcCAr 81*
Broackes, Nan 1908- *DcBrA 1*
Broad, Harry Andrew 1910- *WhAmArt 85*
Broad, John *AntBDN M*
Broad, Richard *BiDBrA*
Broad, Thomas D 1893- *ArtsAmW 3*
Broad, Thos D 1893- *AmArch 70*
Broadbelt, W *DcBrWA*
Broadbent, A d1919 *DcBrA 2*
Broadbent, John 1803-1842 *BiDBrA*
Broadbent, Samuel 1759-1828 *FolkA 86, NewYHSD*
Broadbridge, Alma *DcVicP 2*
Broadbridge, Anna *DcWomA*

Broadd, Harry Andrew 1910- *WhoAmA 73, -76, -78,*
 -80, -82, -84
Broadfield, Aubrey Alfred 1910- *WhoArt 80, -82, -84*
Broadfield, Robina Margaret *WhoArt 80, -82, -84*
Broadfoot, Albert Robert 1924- *AmArch 70*
Broadhead, Marion E *DcBrA 1, DcWomA*
Broadie, Barry 1940- *WhoArt 80*
Broadley, Hugh T 1922- *WhoAmA 73, -76, -78, -80,*
 -82, -84
Broadwell, J L, Jr. *AmArch 70*
Broadwood, John 1732-1812 *AntBDN K*
Broar, Benjamin 1850- *NewYHSD*
Brobbel, John Christopher 1950- *WhoArt 84*
Brobeck, Charles I 1888- *WhAmArt 85*
Brobst *NewYHSD*
Brocard, A *NewYHSD*
Brocard, Joseph *DcNiCA*
Brocard, Philippe-Joseph d1896 *IlDcG*
Brocas, Henry 1762-1837 *DcBrWA*
Brocas, Henry 1798-1873 *DcBrWA*
Brocas, Henry, Jr. 1798?-1873 *DcVicP 2*
Brocas, James Henry 1790?-1846 *DcBrWA,*
 DcVicP 2
Brocas, John *CabMA*
Brocas, Samuel Frederick 1792?-1847 *DcBrWA,*
 DcVicP 2
Brocas, Suzanne Marie Marguerite *DcWomA*
Brocas, William 1794?-1868 *DcBrWA, DcVicP 2*
Brocato, Joseph Myron 1917- *AmArch 70*
Brocaw, Larry Don 1938- *AmArch 70*
Broccardi, Dorotea *DcWomA*
Brocchini, R G *AmArch 70*
Brochard-Legost, Madame *DcWomA*
Brochart, Constant Joseph 1816-1899 *ClaDrA*
Brochaud, Joseph F *ArtsAmW 2, WhAmArt 85*
Brochstein, I S *WhoAmA 73*
Brock, Charles Edmond 1870-1938 *ClaDrA*
Brock, Charles Edmund 1870-1938 *AntBDN B,*
 DcBrA 1, DcBrBI, DcBrWA, DcVicP 2
Brock, Edmond *DcBrA 1*
Brock, Ellen *DcVicP 2, DcWomA*
Brock, Else *DcWomA*
Brock, Emma L *WhAmArt 85*
Brock, Emma L 1886- *DcWomA*
Brock, Emma Lillian 1886-1974 *ConICB, IlsCB 1744,*
 -1946
Brock, Esther *DcWomA, WhAmArt 85*
Brock, Fannie *DcVicP 2, DcWomA*
Brock, G S, Jr. *AmArch 70*
Brock, George Lee 1922- *AmArch 70*
Brock, Gustav Frederick 1881-1945 *WhAmArt 85*
Brock, Harriet E 1825-1850 *FolkA 86*
Brock, Henrietta M *WhAmArt 85*
Brock, Henrietta McElroy 1852- *DcWomA*
Brock, Henry Mathew 1875-1960 *AntBDN B*
Brock, Henry Matthew 1875- *ClaDrA*
Brock, Henry Matthew 1875-1960 *DcBrA 1, DcBrBI,*
 DcBrWA, IlsCB 1744
Brock, J L *DcVicP 2*
Brock, J S *DcVicP 2*
Brock, King *AfroAA*
Brock, Richard Henry *DcBrBI*
Brock, Robert W 1936- *WhoAmA 78, -80, -82, -84*
Brock, Sir Thomas 1847-1922 *DcBrA 1*
Brock, Victor 1902- *AmArch 70*
Brock, W O *AmArch 70*
Brock, William 1874- *DcBrA 1, DcVicP 2*
Brockbank, Albert Ernest 1862-1958 *DcBrA 1,*
 DcVicP 2
Brockbank, Elisabeth 1882- *DcBrA 1*
Brockbank, Marie Elisabeth 1882- *DcWomA*
Brockbanks And Atkins *AntBDN D*
Brockdorff, Herman 1907- *WhAmArt 85*
Brockedon, William 1787-1854 *DcBrWA*
Brockell, Jeannie F *DcVicP 2*
Brockenbrough, Eleanor *WhAmArt 85*
Brockenbrough, S N *DcWomA*
Brocker, R J *AmArch 70*
Brockett, John William 1925- *AmArch 70*
Brockett, Oscar G 1923- *WhoAmA 80*
Brockett, Virginia Mae Eveleth 1910- *WhAmArt 85*
Brockhurst, Gerald Leslie 1890- *DcBrA 1, McGDA*
Brockhurst, James Baldwin *WhAmArt 85*
Brockhusen, Marie Von 1868- *DcWomA*
Brockie, Arthur H 1875-1946 *BiDAmAr*
Brocklebank, John W R 1869-1926 *DcBrA 2*
Brocklesbury, Horace 1886- *DcBrA 1*
Brocklesby, William C 1841-1910 *BiDAmAr*
Brockman *FolkA 86*
Brockman, Ann 1899-1943 *ArtsAmW 1, DcWomA,*
 WhAmArt 85
Brockman, Charles Henry Drake *DcVicP 2*
Brockman, H A N *ConArch A*
Brockman, Harold James 1930- *AmArch 70*
Brockman, Paul *WhAmArt 85*
Brockman, Walter *DcVicP 2*
Brockmann, Elena *DcWomA*
Brocks, Theodore F A *ArtsEM*
Brockway, Albert L 1864-1933 *BiDAmAr*
Brockway, James 1872- *WhAmArt 85*
Brockway, Lee J 1932- *AmArch 70*

Brockway, Michael Gordon 1919- *WhoArt 80, -82,*
 -84
Brockway, Robert Young 1842-1933 *BiDAmAr*
Brockway, William Robert 1924- *AmArch 70*
Brocky, Charles 1807-1855 *DcBrWA, DcVicP, -2*
Brocquy, Louis Le *WorArt*
Brocquy Le, Louis 1916- *WhoGrA 82[port]*
Brod, Fritzi 1900- *WhAmArt 85*
Brod, Stan *OfPGCP 86*
Brod, Stanford 1932- *WhoAmA 76, -78, -80, -82, -84*
Brodbeck, J *DcWomA*
Brodbeck, Marie d1900 *DcWomA*
Brodeau, Anna Maria 1775-1865 *DcWomA,*
 NewYHSD
Brodel, Giovanni Vittorio *AntBDN M*
Broder, Patricia Janis 1935- *WhoAmA 80, -82, -84*
Broder, Richard 1932- *AmArch 70*
Broder, Robert Anthony 1937- *AmArch 70*
Broderick, Cuthbert 1822-1905 *MacEA*
Broderick, Ephraim *CabMA*
Broderick, Herbert Reginald, III 1945- *WhoAmA 84*
Broderick, James Allen 1939- *WhoAmA 80, -82, -84*
Broderick, John Carroll 1923- *AmArch 70*
Broderick, Mary *DcWomA*
Broderick, Robert W *WhAmArt 85*
Brodersen, Anne Marie Carl *DcWomA*
Broderson, Morris 1928- *AmArt, DcCAA 71, -77,*
 WhoAmA 73, -76, -78, -80, -82, -84
Broderson, Robert 1920- *WhoAmA 73, -76, -78, -80,*
 -82, -84
Broderson, Robert M 1920- *DcCAA 71, -77*
Brodeur, Clarence Arthur 1905- *WhAmArt 85*
Brodeur, Victor E, Jr. 1916- *AmArch 70*
Brodey, Stanley Carl 1920- *WhoAmA 73*
Brodhead, George Hamilton 1860- *WhAmArt 85*
Brodhead, Mary E *DcWomA*
Brodhead, Quita *AmArt, WhoAmA 80, -82, -84*
Brodhead, Quita 1901- *WhAmArt 85*
Brodie, A K *DcVicP 2*
Brodie, Agnes Hahn 1924- *WhoAmA 84*
Brodie, Gandy 1924- *DcCAA 73, WhoAmA 73*
Brodie, Gandy 1924-1975 *DcCAA 77,*
 WhoAmA 76N, -78N, -80N, -82N, -84N
Brodie, Howard Joseph 1916- *WhAmArt 85*
Brodie, James *DcBrECP*
Brodie, John Lamont *DcVicP, -2*
Brodie, Margaret *DcVicP 2*
Brodie, Menasha J 1936- *AmArch 70*
Brodie, Michael James 1954- *MarqDCG 84*
Brodie, Regis Conrad 1942- *WhoAmA 78, -80, -82,*
 -84
Brodie, Walter Scott 1911- *AmArch 70*
Brodie, William d1881 *ArtsNiC*
Brodle, L T *AmArch 70*
Brodnax, Auda Carroll 1923- *AmArch 70*
Brodney, Edward 1910- *WhAmArt 85*
Brodovitch, Alexey 1895-1971 *MacBEP*
Brodovitch, Alexey 1898- *WhAmArt 85*
Brodovitch, Alexey 1898-1971 *ConDes, ConPhot,*
 ICPEnP
Brodrick, Cuthbert 1822-1905 *McGDA, WhoArch*
Brodrick, Cuthbert 1822-1908 *DcD&D*
Brodrick, F W *AmArch 70*
Brodrick, Hermon Stephens 1917- *AmArch 70*
Brodrick, William *DcVicP 2*
Brodsky, Avrom David 1933- *AmArch 70*
Brodsky, Beverly *IlsCB 1967*
Brodsky, D W *AmArch 70*
Brodsky, George 1901- *WhAmArt 85*
Brodsky, Harry 1908- *WhAmArt 85, WhoAmA 84*
Brodsky, Judith Kapstein 1933- *WhoAmA 73, -76,*
 -78, -80, -82, -84
Brodsky, Michael 1953- *MacBEP*
Brodsky, Stan 1925- *AmArt, PrintW 83, -85,*
 WhoAmA 73, -76, -78, -80, -82, -84
Brodt, Helen Tanner 1834-1908 *ArtsAmW 1, -3*
Brodt, Helen Tanner 1838-1908 *DcWomA*
Brodwolf, Jurgen 1932- *DcCAr 81*
Brodwolf, Ludwig Gustav Eduard 1839- *ArtsNiC*
Brody, Arthur William 1943- *PrintW 83, -85,*
 WhoAmA 78, -80, -82, -84
Brody, Blanche *WhoAmA 82, -84*
Brody, Carol R 1943- *WhoArt 82, -84*
Brody, Frederick J 1914- *WhoArt 80, -82, -84*
Brody, Jacob Jerome 1929- *WhoAmA 73, -76, -78,*
 -80, -82, -84
Brody, Jacqueline 1932- *WhoAmA 78, -80, -82, -84*
Brody, L *AmArch 70*
Brody, Myron Roy 1940- *WhoAmA 76, -78, -80, -82,*
 -84
Brody, Philip Morton 1905- *WhAmArt 85*
Brody, Ruth 1917- *WhoAmA 82, -84*
Brody, Samuel 1926- *ConArch*
Brody, Samuel M 1926- *MacEA*
Brody, Samuel Mandell 1926- *AmArch 70*
Brody, Sidney F *WhoAmA 73, -76, -78, -80, -82*
Brody, Mrs. Sidney F *WhoAmA 73, -76, -78, -80,*
 -82
Brody, Steven *WorFshn*

Brodzky, H 1885- WhAmArt 85
Brodzky, Horace 1885-1969 DcBrA 1, OxTwCA
Brodzrsen, Anna d1939 DcWomA
Broebes, Jean Baptiste 1660?-1720 MacEA
Broeck, Barbara VanDen 1560- DcWomA
Broeck, Clemence VanDen 1843- DcWomA
Broeck, Crispin VanDen 1524-1589 ClaDrA
Broeck, Elias VanDen 1650?-1708 McGDA
Broeck, Hendrick VanDen McGDA
Broecker, E L AmArch 70
Broedel, Max 1870- WhAmArt 85
Broederlam, Melchior OxArt
Broederlam, Melchior 1385-1400 McGDA
Broek, J H VanDen 1898- EncMA, WhoArch
Broek, Johannes H VanDen 1898- McGDA
Broek D'Obrenau, Victorine VanDen DcWomA
Broek D'Orbeau, Victorine VanDen DcWomA
Broeke, Jan Ten WhoAmA 78, -80, -82
Broekhuysen, Martin John 1941- MarqDCG 84
Broemel, Carl W 1891- WhAmArt 85
Broemel, Carl William 1891- ArtsAmW 3,
 WhoAmA 73, -76, -78, -80, -82, -84
Broer, Roger L 1945- AmArt, WhoAmA 80, -82, -84
Broers, Jaspar 1682-1716 ClaDrA
Broers, Sara DcWomA
Broesche, T AmArch 70
Broesing, Andreas CabMA
Broeucq OxArt
Broeucq, Jacques Du McGDA
Brofeldt, Venny DcWomA
Brogan, Thomas F EncASM
Broger, Stig 1941- DcCAr 81
Broggi, Luigi 1851-1926 MacEA
Brogi, Giacomo MacBEP
Broglio, Edita Walterowna VonZur-Muehlen
 1880?-1977 DcWomA
Brogniart, Alexandre Theodore 1739-1813 McGDA
Brogniez, Raymond Hector 1918- AmArch 70
Broh, Minerva Leedy WhoAmA 73
Brohee, Louise 1875- DcWomA
Broich, Julia Von DcWomA
Broido, Lucy 1924- WhoAmA 80, -82, -84
Brokaw, Dura DcWomA
Brokaw, Irving 1871-1939 WhAmArt 85
Brokaw, J C AmArch 70
Brokaw, Lucile 1915- WhoAmA 73, -76, -78, -80,
 -82, -84
Broker, Karen PrintW 85
Broker, Karin 1950- WhoAmA 84
Brokman Davis, William David WhoArt 80, -82, -84
Brokman Davis, William David 1892- DcBrA 1
Brom, Pavel 1938- WhoGrA 82[port]
Brom, Richard Hovey 1925- AmArch 70
Bromberg, Alfred L WhoAmA 73
Bromberg, Mrs. Alfred L WhoAmA 73
Bromberg, Faith 1919- WhoAmA 76, -78, -80, -82,
 -84
Bromberg, Manuel WhAmArt 85
Brome, Charles 1774-1801 DcBrECP
Bromeis, August 1813-1881 ArtsNiC
Bromet, Mary d1937 DcBrA 1, DcWomA
Bromet, William DcVicP 2
Bromfield, Catherine DcWomA, FolkA 86
Bromfield, Joseph 1743?-1824 BiDBrA
Bromhall, Winifred ConICB, IlsBYP, IlsCB 1744,
 -1946, WhAmArt 85
Bromley, Alice Louisa Maria DcBrWA, DcWomA
Bromley, C Shailor DcVicP 2
Bromley, Clough W ClaDrA, DcBrA 1, DcBrBI,
 DcVicP, -2
Bromley, John DcBrWA
Bromley, John Mallard DcBrA 1, DcVicP, -2
Bromley, Josephine ArtsEM, DcWomA
Bromley, Thomas L ArtsAmW 1
Bromley, Valentine W 1848-1877 ArtsNiC
Bromley, Valentine Walter 1848-1877 ArtsAmW 1, -3,
 DcBrBI, DcVicP, -2, IlBEAAW
Bromley, Valentine Walter Lewis 1848-1877 DcBrWA
Bromley, Walter Louis DcVicP 2
Bromley, William ArtsNiC, ClaDrA, FolkA 86
Bromley, William, III DcVicP, -2
Bromm, Hal 1947- WhoAmA 78, -80, -82, -84
Brommer, Gerald F 1927- AmArt, WhoAmA 76, -78,
 -80, -82, -84
Bromova, Dagmar 1939- WhoGrA 82[port]
Brompton, Richard 1734?-1783 DcBrECP
Bromstead, Henry 1806?- NewYHSD
Bromund, Cal E 1903- WhoAmA 76, -78, -80, -82
Bromund, Cal E 1903-1979 WhoAmA 84N
Bromwell, Berton EncASM
Bromwell, D L EncASM
Bromwell, Dwight EncASM
Bromwell, Elizabeth Henrietta IlBEAAW
Bromwell, Elizabeth Henrietta 1859-1946 DcWomA
Bromwell, Henrietta ArtsAmW 1, WhAmArt 85
Bromwell, Henrietta Elizabeth 1859-1946 ArtsAmW 3
Bromwell, James d1907 EncASM
Bromwell, John T EncASM
Bromwell, T T EncASM
Bronckhorst, Gerrit 1637-1673 ClaDrA
Bronckhorst, Jan Gerritsz Van 1603-1661 McGDA

Bronckhorst, Jan Gerritsz Van 1603-1677 ClaDrA
Brondum, Anna Kirstine DcWomA
Brondum-Nielsen, Birgitte 1917- WhoArt 80, -82, -84
Broner, Robert 1922- DcCAA 71, -77, WhoAmA 73,
 -76, -78, -80, -82, -84
Bronesky, Rudolph WhAmArt 85
Bronesky, S S FolkA 86
Bronesky, Stephen G S 1890- WhAmArt 85
Bronger, John Turpie 1926- AmArch 70
Brongniart, Alexandre d1847 AntBDN M
Brongniart, Alexandre 1770-1847 DcNiCA
Brongniart, Alexandre Theodore 1739-1813 MacEA
Brongniart, Alexandre-Theodore 1739-1813 WhoArch
Broniatowski, Karol 1945- DcCAr 81
Broniewska, Janina De DcWomA
Bronikowski, J J AmArch 70
Bronson, A A 1946- WhoAmA 78, -80, -82, -84
Bronson, Asahel FolkA 86
Bronson, Clark Everice 1939- WhoAmA 76, -78, -80,
 -82, -84
Bronson, D NewYHSD
Bronson, Helen 1900- WhAmArt 85
Bronson, J FolkA 86
Bronson, Oliver FolkA 86
Bronson, R FolkA 86
Bronson, Samuel FolkA 86
Bronson, Silas FolkA 86
Bronson, Wilfred Swancourt 1894- IlsCB 1744, -1946
Bronte, Anne DcWomA
Bronte, Charlotte 1816-1855 DcWomA
Bronte, Emily Jane 1818-1848 DcWomA
Bronte Sisters DcWomA
Bronzino, Agnolo 1503-1572 McGDA
Bronzino, Agnolo Tori DiCosimo DiMoriano 1503-1572
 OxArt
Bronzino, Angiolo DiCosimo ClaDrA
Broodthaers, Marcel 1924-1976 ConArt 77, -83
Brook, Alexander 1898- BnEnAmA, DcCAA 71, -77,
 McGDA, PhDcTCA 77, WhAmArt 85,
 WhoAmA 73, -76, -78
Brook, Alexander 1898-1980 ArtsAmW 3,
 WhoAmA 80N, -82N, -84N
Brook, Mrs. Alexander WhAmArt 85
Brook, Arthur B 1867- DcBrA 2
Brook, Caroline W DcVicP 2, DcWomA
Brook, Eleanor Christina ClaDrA
Brook, Eva DcWomA
Brook, Gina DcWomA
Brook, Janet DcCAr 81
Brook, John 1924- ICPEnP A, MacBEP
Brook, Joseph d1728? DcBrECP
Brook, M FolkA 86
Brook, Maria Burnham DcVicP 2
Brook, Marian Burnham DcWomA
Brook, Peter 1927- WhoArt 80, -82, -84
Brook, Raymond Peter 1927- DcBrA 1
Brook, Ricardo DcBrBI
Brook, Mrs. T DcVicP 2
Brookbank, Maria DcWomA
Brookbank, Thomas Henry 1919- AmArch 70
Brookbank, W H DcVicP 2
Brookbank, William DcVicP 2
Brooke, Miss DcWomA
Brooke, A Newton DcBrWA
Brooke, Anne Isabella 1916- DcBrA 1, WhoArt 80,
 -82, -84
Brooke, Sir Arthur DeCapel 1791-1858 DcBrBI,
 DcBrWA
Brooke, C Gay WhAmArt 85
Brooke, David Stopford 1931- WhoAmA 73, -76, -78,
 -80, -82, -84
Brooke, Dora DcWomA
Brooke, E Adveno DcBrBI, DcVicP 2
Brooke, Edmund W DcVicP 2
Brooke, Edward DcVicP 2
Brooke, F William DcVicP 2
Brooke, Geoffrey Arthur George 1920- WhoArt 80,
 -82, -84
Brooke, H DcVicP 2
Brooke, Henry 1738-1806 DcBrECP, DcBrWA
Brooke, Humphrey 1914- WhoArt 82, -84
Brooke, J DcVicP 2
Brooke, James Leslie 1903- DcBrA 1
Brooke, John 1802?-1881? DcBrWA
Brooke, John William d1919 DcVicP 2
Brooke, John William 1854?-1919 DcBrA 1
Brooke, Lena DcWomA
Brooke, Lena R WhAmArt 85
Brooke, Leonard Leslie 1862-1940 ConICB, DcBrA 1,
 DcVicP 2, IlsBYP
Brooke, Leonard Leslie 1863-1940 DcBrBI, DcBrWA
Brooke, Pegan 1950- WhoAmA 84
Brooke, Percy DcVicP 2
Brooke, Richard Morris AfroAA
Brooke, Richard N 1847-1920 WhAmArt 85
Brooke, Robert AntBDN Q, DcBrECP, DcBrWA
Brooke, Thomas Humphrey 1914- WhoArt 80
Brooke, W DcBrECP
Brooke, William DcWomA
Brooke, William Henry 1772-1860 DcBrBI, DcBrWA,
 DcVicP 2

Brooker, Bertram OxTwCA
Brooker, Bertram 1888-1955 PhDcTCA 77
Brooker, Catherine P DcVicP 2, DcWomA
Brooker, E W DcVicP 2
Brooker, Harry DcVicP, -2
Brooker, J DcVicP 2
Brooker, L A AmArch 70
Brooker, Nell DcWomA
Brooker, Nell Danely 1875- WhAmArt 85
Brooker, Peter 1900- DcBrA 1
Brooker, Richard Irwin 1927- AmArch 70
Brooker, William WhoArt 84N
Brooker, William 1918- ClaDrA, DcBrA 1,
 WhoArt 80, -82
Brookes DcBrECP
Brookes, Daysi May 1888- DcBrA 1, DcWomA
Brookes, Kenneth 1897- DcBrA 1
Brookes, Lionel 1915- DcBrA 1
Brookes, Ronald E 1920- WhoArt 80, -82, -84
Brookes, Samuel Marsden 1816-1892 ArtsAmW 3,
 DcAmArt
Brookes, Samuel Marsdon 1816-1892 IlBEAAW,
 NewYHSD
Brookes, Warwick 1808-1882 DcBrBI, DcBrWA,
 DcVicP 2
Brookes, William AntBDN M
Brookes, William McIntosh d1849 BiDBrA
Brookfield, G P AmArch 70
Brookie, Dale Stuart AmArch 70
Brooking, Charles 1723-1759 BkIE, DcBrECP,
 DcBrWA, DcSeaP, OxArt
Brookins, Anita 1908- WhoAmA 76
Brookins, Jacob Boden 1935- AmArt, WhoAmA 76,
 -78, -80, -82, -84
Brookins, Marcia J 1947- AfroAA
Brookman, H AmArch 70
Brookman, Vera E d1964 DcBrA 2
Brooks NewYHSD
Brooks, A P AmArch 70
Brooks, Adele R 1873- WhAmArt 85
Brooks, Adele Richards 1873- DcWomA
Brooks, Alan 1931- WhoAmA 73, -76, -80, -82, -84
Brooks, Alden F 1840-1938? WhAmArt 85
Brooks, Alden Finney 1840- NewYHSD
Brooks, Alden Finney 1840-1932 ArtsAmW 3
Brooks, Allan Richard 1928- AmArch 70
Brooks, Allan Robert 1931- AmArch 70
Brooks, Amy DcWomA, WhAmArt 85
Brooks, Arthur D 1877- WhAmArt 85
Brooks, Arthur H, Jr. 1916- AmArch 70
Brooks, Bernard W AfroAA
Brooks, Bruce W 1948- WhoAmA 78, -80, -82, -84
Brooks, Bruce William 1948- WhoAmA 76
Brooks, Carol DcWomA, WhAmArt 85
Brooks, Caroline Shawk 1840- NewYHSD
Brooks, Caroline Shawk 1840-1900? DcWomA
Brooks, Charles Gordon 1920- WorECar
Brooks, Charles M, Jr. 1908- WhoAmA 73, -76
Brooks, Charlotte 1918- ICPEnP A
Brooks, Cora d1930 WhAmArt 85
Brooks, Cora Smalley d1930 DcWomA
Brooks, D R AmArch 70
Brooks, Daisy Chapman AfroAA
Brooks, Daniel Townley 1941- MarqDCG 84
Brooks, David B 1933- MacBEP
Brooks, David George 1925- AmArch 70
Brooks, David Michael 1947- MarqDCG 84
Brooks, Donald 1928- FairDF US[port], WorFshn
Brooks, E B AmArch 70
Brooks, Ellen 1949- ICPEnP A, MacBEP
Brooks, Erica May 1894- DcWomA, WhAmArt 85
Brooks, Eugene Nobles 1914- AmArch 70
Brooks, Eugene Tatum 1935- AmArch 70
Brooks, F C DcVicP 2
Brooks, Frances DcWomA
Brooks, Frances M WhAmArt 85
Brooks, Frank 1854-1937 DcBrA 1, DcVicP 2
Brooks, Frank D ArtsEM
Brooks, Frank Leonard 1911- WhoAmA 73, -76, -78,
 -80, -82
Brooks, G A AmArch 70
Brooks, Genevieve ArtsEM, DcWomA
Brooks, Mrs. George ArtsEM, DcWomA
Brooks, Grace E DcWomA, WhAmArt 85
Brooks, H Allen ConArch A
Brooks, H Allen 1925- WhoAmA 82, -84
Brooks, Henry DcVicP 2
Brooks, Henry Howard WhAmArt 85
Brooks, Henry Jermyn DcBrA 1, DcVicP, -2
Brooks, Hervey FolkA 86
Brooks, Howard AfroAA
Brooks, Howard 1915- WhAmArt 85
Brooks, Isabel DcWomA, WhAmArt 85
Brooks, J B, Jr. AmArch 70
Brooks, Jacob 1877- ClaDrA, DcBrA 1
Brooks, James AmArch 70
Brooks, James 1825-1901 MacEA, McGDA
Brooks, James 1906- BnEnAmA, ConArt 83,
 DcAmArt, DcCAA 71, -77, McGDA, OxTwCA,
 PhDcTCA 77, PrintW 85, WhoAmA 73, -76,
 -78, -80, -82, -84, WorArt[port]

Bruster, Edmund *NewYHSD*
Brustlein, Daniel 1904- *IlsBYP, IlsCB 1957,*
 WhoAmA 76, -78, -80, -82, -84
Brustolon, Andrea 1662-1732 *AntBDN G, OxDecA*
Brustolon, Giovanni Battista 1726- *McGDA*
Brutey, Robert S *DcVicP 2*
Bruti, Francesca *DcWomA*
Bruton, Bertram Alfred 1931- *AmArch 70*
Bruton, Esther *WhAmArt 85*
Bruton, Esther 1896- *ArtsAmW 1, DcWomA*
Bruton, Helen *WhAmArt 85*
Bruton, Helen 1898- *ArtsAmW 1, DcWomA*
Bruton, Margaret 1894- *ArtsAmW 1, DcWomA,*
 IlBEAAW, WhAmArt 85
Brutten, Milton 1922- *WhoAmA 82*
Bruun, Anne Marie *DcWomA*
Bruun, Erik 1926- *WhoGrA 62, -82[port]*
Brux, Olympe *DcWomA*
Bruycker, Francois Antoine 1816- *ArtsNiC*
Bruyere *FairDF FRA*
Bruyere, Elise 1776-1842 *DcWomA*
Bruyere, Madame Jacques DeLa *WorFshn*
Bruyere, Louis Y *WhAmArt 85*
Bruyn, Bartholomaeus 1493-1553? *ClaDrA*
Bruyn, Bartholomaus, The Elder 1493-1555 *McGDA*
Bruyn, Henry De *DcBrECP*
Bruyn, Johanna *DcWomA*
Bruyn, John De *DcBrECP*
Bruyn, Nicolaes De 1565-1652 *ClaDrA*
Bruyn, Theodore De 1730-1804 *DcBrECP*
Bruyn, Willem De 1649-1719 *MacEA*
Bruyns, Anna Francoise De 1605-1629? *DcWomA*
Bry, Edith 1898- *DcWomA, WhAmArt 85,*
 WhoAmA 78, -80, -82, -84
Bryan *BiDBrA*
Bryan, Alfred 1852-1899 *DcBrBI*
Bryan, Andrew J 1850-1921 *BiDAmAr*
Bryan, Ashley F 1923- *IlsCB 1967*
Bryan, Charles 1828?- *NewYHSD*
Bryan, Clinton Lee *AmArch 70*
Bryan, Edward B *NewYHSD*
Bryan, Garlan Diggs 1924- *AmArch 70*
Bryan, H *DcVicP 2*
Bryan, Henry E *WhAmArt 85*
Bryan, John *DcBrECP*
Bryan, John 1716-1787 *BiDBrA*
Bryan, John Albury 1890- *AmArch 70*
Bryan, Joseph 1682-1730 *BiDBrA*
Bryan, Joseph 1718-1779 *BiDBrA*
Bryan, Rollo K *ArtsEM*
Bryan, W E 1876- *WhAmArt 85*
Bryan, Wayne C 1934- *AmArch 70*
Bryan, Wilhelmus B 1898- *WhoAmA 73*
Bryan, William Edward 1876- *ArtsAmW 2,*
 IlBEAAW
Bryans, H W *DcVicP 2*
Bryans, John Armond 1925- *WhoAmA 80, -82, -84*
Bryant, Alice D *DcWomA*
Bryant, Andrew Daniel 1929- *AmArch 70*
Bryant, Annie B Matthews 1870?-1933 *DcWomA,*
 WhAmArt 85
Bryant, Arthur D *WhAmArt 85*
Bryant, Bernard Leslie 1944- *AmArch 70*
Bryant, C I *AmArch 70*
Bryant, Charles David Jones 1883-1937 *DcBrA 1,*
 DcSeaP
Bryant, Charles K 1872?-1935? *BiDAmAr*
Bryant, Daniel Currie 1913- *AmArch 70*
Bryant, Dena 1930- *WhoArt 80, -82, -84*
Bryant, Edward Albert 1928- *WhoAmA 76, -78, -80,*
 -82, -84
Bryant, Everett Lloyd 1864-1945 *ArtsAmW 2,*
 WhAmArt 85
Bryant, Ferrell Zane 1937- *MarqDCG 84*
Bryant, Florence *DcWomA*
Bryant, Florence L *WhAmArt 85*
Bryant, G J F *McGDA*
Bryant, Gridley J F 1816-1899 *MacEA*
Bryant, Gridley James Fox 1816-1899 *BiDAmAr,*
 McGDA
Bryant, H C *DcVicP 2*
Bryant, Harold Edward 1894-1950 *ArtsAmW 1,*
 IlBEAAW, WhAmArt 85
Bryant, Henry 1812-1881 *ArtsNiC, NewYHSD*
Bryant, Henry G *WhAmArt 85*
Bryant, J E *AmArch 70*
Bryant, Jack N 1911- *AmArch 70*
Bryant, Joan *AfroAA*
Bryant, John Cyprian 1917- *AmArch 70*
Bryant, John Frazier 1949- *MarqDCG 84*
Bryant, John Hulon 1941- *AmArch 70*
Bryant, Joshua *DcBrBI, DcBrWA*
Bryant, Julian *NewYHSD*
Bryant, Julian Edwards *FolkA 86*
Bryant, Lawrence, Sr. *AfroAA*
Bryant, Linda Goode 1949- *WhoAmA 78, -80, -82,*
 -84
Bryant, Lorinda Munson 1855-1933 *WhAmArt 85*
Bryant, Maribland *WhAmArt 85*
Bryant, Maud Drein 1880-1946 *DcWomA*
Bryant, Maude Drein 1880-1946 *WhAmArt 85*

Bryant, Nanna Matthews *DcWomA*
Bryant, Nathaniel 1784-1868 *CabMA*
Bryant, Olen L 1927- *WhoAmA 73, -76, -78, -80, -82,*
 -84
Bryant, Rebecca L 1903- *WhAmArt 85*
Bryant, Reginald *AfroAA*
Bryant, Richard Jennings 1932- *AmArch 70*
Bryant, Robert Edward 1931- *AmArch 70*
Bryant, Sarah *DcCAr 81*
Bryant, Stanley John 1946- *MarqDCG 84*
Bryant, Tamara Thompson *WhoAmA 78, -80, -82,*
 -84
Bryant, Trevor *DcCAr 81*
Bryant, Wallace *WhAmArt 85*
Bryant, Will *IlBEAAW*
Bryar, Norman Leon 1924- *AmArch 70*
Bryaxis *McGDA*
Bryce, Alexander Joshua Caleb 1868-1940 *DcBrA 1*
Bryce, C E *AmArch 70*
Bryce, Charles Fa 1947- *MarqDCG 84*
Bryce, David 1803-1876 *MacEA*
Bryce, Eileen Ann 1953- *WhoAmA 84*
Bryce, Helen Bryne *DcBrA 1, DcWomA*
Bryce, John 1805-1851 *BiDBrA*
Bryce, Mark Adams 1953- *PrintW 83, -85,*
 WhoAmA 84
Brycelea, Clifford 1953- *AmArt, WhoAmA 82, -84*
Brychtova, Jaroslava 1924- *DcCAr 81*
Brydall, Robert *DcVicP 2*
Bryden, Robert 1865-1939 *DcBrA 1, DcBrBI*
Brydon, J M 1840-1901 *MacEA*
Bryen, Camille 1907- *OxTwCA, PhDcTCA 77*
Bryggman, Erik 1891-1955 *ConArch, WhoArch*
Bryggman, Erik 1892-1955 *MacEA*
Bryggman, Erik William 1891-1955 *DcD&D, EncMA*
Brygider, Edward 1916- *WhAmArt 85*
Brygos *OxArt*
Brygos Painter *McGDA*
Bryhn, Carl F *WhAmArt 85*
Brylawski, Molly Schwartz 1920- *WhoAmA 76*
Brylka, Andreas 1931- *WhoGrA 62, -82[port]*
Brylka-Thieme, Gertraud 1933- *WhoGrA 62*
Brymner, William *DcVicP 2, WhAmArt 85*
Brymner, William 1855-1925 *McGDA*
Brynan, Karl Pavlovich 1799-1852 *OxArt*
Bryne, Joseph *FolkA 86*
Brynolfson, W B *AmArch 70*
Brys, Jules *WhAmArt 85*
Bryson, Bernarda *IlsCB 1967*
Bryson, Bernarda 1903- *IlsBYP, IlsCB 1946, -1957*
Bryson, Charles A *WhAmArt 85*
Bryson, Edward A *NewYHSD*
Bryson, Hope Mercereau 1877-1944 *ArtsAmW 2*
Bryson, Hope Mercereau 1887-1944 *DcWomA,*
 WhAmArt 85
Bryson, J Richard *MarqDCG 84*
Bryson, John 1923- *ICPEnP A*
Bryson, Joseph Henry *AmArch 70*
Bryson, Robert Alexander 1906- *WhAmArt 85*
Bryson, Robert Halsey 1875-1938 *BiDAmAr*
Bryson, Robert M *DcVicP 2*
Brysselbout, Paul Alphonse 1905- *AmArch 70*
Bryulov, Karl Pavlovich 1799-1852 *OxArt*
Brzozowski, Richard Joseph 1932- *WhoAmA 73, -76,*
 -78, -80, -82, -84
Brzozowski, Tadeusz 1918- *ConArt 83, OxTwCA,*
 PhDcTCA 77
Brzozowski, Tadeusz Alexander 1918- *ConArt 77*
Buat, Joseph *NewYHSD*
Buba, Joy Flinsch *IlsBYP, IlsCB 1946*
Buba, Joy Flinsch 1904- *WhoAmA 73, -76, -78, -80,*
 -82, -84
Buba, Margaret Flinsch 1914- *WhAmArt 85*
Bubb, Nancy 1945- *WhoAmA 76, -78, -80, -82*
Bubber, Jess S 1938- *MarqDCG 84*
Bubenik, Gernot 1942- *PhDcTCA 77*
Buberi, Caspar 1834-1899 *NewYHSD*
Buberl, Caspar 1834-1899 *NewYHSD ,*
 WhAmArt 85
Bubley, Esther 1921- *ICPEnP A*
Bucci, Andrew A 1922- *WhoAmA 73*
Bucci, Anselmo *OxTwCA*
Buccini, Alberta *WhAmArt 85*
Buccino, Joseph Harold 1957- *MarqDCG 84*
Buch, H C *WhAmArt 85*
Buchan, David *DcCAr 81*
Buchan, Marian *DcWomA*
Buchan, Marion *WhAmArt 85*
Buchanan, Bertram *DcBrA 2*
Buchanan, Beverly 1940- *AfroAA*
Buchanan, C R *AmArch 70*
Buchanan, Charles W 1854-1921 *BiDAmAr*
Buchanan, Sir Colin 1907- *DcD&D[port]*
Buchanan, Ella *ArtsAmW 2, WhAmArt 85*
Buchanan, Ella d1951 *DcWomA*
Buchanan, Elspeth 1915- *DcBrA 1, WhoArt 80, -82,*
 -84
Buchanan, Eugene Paul 1933- *AmArch 70*
Buchanan, Evelyne Oughtred 1883- *DcBrA 1,*
 DcWomA
Buchanan, Fred *DcBrBI*

Buchanan, G F *DcWomA*
Buchanan, George F *DcVicP 2*
Buchanan, Mrs. George F *DcVicP 2*
Buchanan, J *DcVicP 2*
Buchanan, J A *DcVicP 2*
Buchanan, J C, Jr. *AmArch 70*
Buchanan, J P *DcVicP 2*
Buchanan, James *DcVicP 2*
Buchanan, Mrs. John 1774-1830 *FolkA 86*
Buchanan, John Edward, Jr. 1953- *WhoAmA 84*
Buchanan, Laura *WhAmArt 85*
Buchanan, Loren Avery 1955- *MarqDCG 84*
Buchanan, Luvena *DcWomA, WhAmArt 85*
Buchanan, Mary *DcWomA*
Buchanan, Mrs. Percy *DcVicP 2*
Buchanan, Peter *DcVicP 2*
Buchanan, Sidney Arnold 1932- *WhoAmA 78, -80,*
 -82, -84
Buchanan, Thomas *FolkA 86*
Buchanan, William Jennings, Jr. 1925- *AmArch 70*
Buchannan, Andrew *NewYHSD*
Buchannon And Robb *CabMA*
Buchbinder, D G *WhAmArt 85*
Buchegger, Erich 1924- *WhoGrA 62, -82[port]*
Buchel, Charles A *DcBrA 2, DcVicP 2*
Buchel, Charles A 1872-1950 *DcBrBI*
Bucher, Bertha 1868- *DcWomA*
Bucher, Carl 1935- *ConArt 77*
Bucher, Francois 1927- *WhoAmA 84*
Bucher, Fred *EncASM*
Bucher, George Robert 1931- *WhoAmA 73, -76, -78,*
 -80, -82, -84
Bucher, Hortense *DcWomA*
Bucher, Walter Emil 1926- *AmArch 70*
Buchesne, T *NewYHSD*
Buchet, Madame *DcWomA*
Buchheister, Carl 1890-1964 *OxTwCA, PhDcTCA 77*
Buchholz, Emmaline *WhAmArt 85*
Buchholz, Erich 1891- *McGDA, OxTwCA,*
 PhDcTCA 77
Buchholz, Fred 1901- *WhAmArt 85*
Buchholz, Olive Miriam *WhAmArt 85*
Buchholz, Urszula *DcWomA*
Buchka-Lenbach, Emmy *DcWomA*
Buchli, Paul Eugene 1929- *AmArch 70*
Buchman *FolkA 86*
Buchman, Albert 1859-1936 *BiDAmAr*
Buchman, James Wallace 1948- *WhoAmA 76, -78,*
 -80, -82, -84
Buchmann, Helene 1843- *DcWomA*
Buchmueller, R Paul 1900- *AmArch 70*
Buchmueller, Roland Paul 1923- *AmArch 70*
Buchner, Agnes *DcWomA*
Buchner, Clark Alvarado, III 1938- *AmArch 70*
Buchner, Robert Earl 1915- *AmArch 70*
Buchoff, Leonard Sidney 1927- *MarqDCG 84*
Bucholaer, H *NewYHSD*
Buchon, Honorine *DcWomA*
Buchsbaum, Elizabeth *WhAmArt 85*
Buchsbaum, Emanuel V 1907- *AmArch 70*
Buchsbaum, Hanns 1390?-1456? *MacEA*
Buchser, E *DcVicP 2*
Buchser, Frank *DcVicP 2*
Buchser, Frank 1828-1890 *ArtsAmW 1, IlBEAAW*
Buchstetter, Gabriel David *AntBDN K*
Buchta, Anthony *WhAmArt 85*
Buchter, J J *AmArch 70*
Buchter, R A *AmArch 70*
Buchterkirch, Armin 1859- *WhAmArt 85*
Buchwalder, A *FolkA 86*
Buchweiler, S *NewYHSD*
Bucinskas, John 1915- *AmArch 70*
Buck, Adam 1759-1833 *AntBDN J, DcBrBI,*
 DcBrWA
Buck, Andrew E 1891- *AmArch 70*
Buck, Anne Lillias *DcBrA 1, DcWomA*
Buck, C D *AmArch 70*
Buck, Carl *WhAmArt 85*
Buck, Claude 1890- *ArtsAmW 3, WhAmArt 85*
Buck, Mrs. Claude *WhAmArt 85*
Buck, Clifford *WhAmArt 85*
Buck, Emma G 1888- *DcWomA, WhAmArt 85*
Buck, Frederick 1770?-1840? *AntBDN J*
Buck, Frederick 1771-1840 *DcBrWA*
Buck, George H *FolkA 86*
Buck, George Ralph 1933- *AmArch 70*
Buck, John E 1946- *DcCAr 81, PrintW 83, -85*
Buck, John Sandford 1896- *DcBrA 1, WhoArt 80,*
 -82, -84
Buck, Kirkland C *WhAmArt 85*
Buck, L Margaret *DcVicP 2*
Buck, Lawrence 1865-1929 *WhAmArt 85*
Buck, Leslie *WhAmArt 85*
Buck, Margaret Warriner 1857- *ArtsAmW 2,*
 DcWomA
Buck, Nathaniel *DcBrWA*
Buck, R V *AmArch 70*
Buck, Richard D 1903- *WhoAmA 73, -76*
Buck, Richard D 1903-1977 *WhoAmA 78N, -80N,*
 -82N, -84N
Buck, Richard David 1903- *WhAmArt 85*

Burgess, John Bagnold 1829-1897 *DcBrWA*
Burgess, John Bagnold 1830- *ArtsNiC*
Burgess, John Bagnold 1830-1897 *DcVicP, –2*
Burgess, John Cart 1798-1863 *DcBrWA, DcVicP 2*
Burgess, John Harold 1911- *AmArch 70*
Burgess, Joseph *CabMA*
Burgess, Joseph 1890-1961 *WhAmArt 85*
Burgess, Joseph E 1891-1961 *WhoAmA 80N, –82N, –84N*
Burgess, Joseph James, Jr. 1924- *WhoAmA 78, –80, –82, –84*
Burgess, Linda Suzanne 1954- *WhoAmA 84*
Burgess, Marguerite 1913- *WhAmArt 85*
Burgess, Muriel Kathleen *DcWomA*
Burgess, Owen D *EncASM*
Burgess, R T *WhAmArt 85*
Burgess, Rosamund *DcWomA*
Burgess, Ruth Payne d1934 *WhAmArt 85*
Burgess, Ruth Payne 1865-1934 *DcWomA*
Burgess, Thomas *DcBrWA*
Burgess, Thomas d1807 *DcBrECP, DcBrWA*
Burgess, Thomas 1730?-1791 *DcBrECP*
Burgess, W E *AmArch 70*
Burgess, Walter William *DcBrA 2*
Burgess, Walter William d1908 *DcBrBI*
Burgess, William *BiDBrA*
Burgess, William 1749-1812 *DcBrECP, DcBrWA*
Burgess, William 1805-1861 *DcBrWA, DcVicP 2*
Burgess, William Hubert d1893 *ArtsAmW 3*
Burget, C J *ArtsEM*
Burgett, Edgar William 1919- *AmArch 70*
Burggraf, Ray Lowell 1938- *WhoAmA 73, –76, –78, –80, –82, –84*
Burgh, Hendrick VanDer *McGDA*
Burgh, Thomas 1670-1730 *MacEA, WhoArch*
Burghardt, Fred Conrad 1934- *AmArch 70*
Burghers Of Calais *McGDA*
Burghers, Michael 1653?-1727 *BkIE*
Burghersh, Priscilla Anne *DcWomA*
Burgin, Daniel 1945- *DcCAr 81*
Burgin, George H 1930- *MarqDCG 84*
Burgin, Robert Harry 1934- *AmArch 70*
Burgin, Victor *OxTwCA*
Burgin, Victor 1941- *ConArt 77, –83, ConArt 79[port], ConPhot, ICPEnP A, MacBEP*
Burgis, William *BnEnAmA, NewYHSD*
Burgkan, Berthe d1938? *DcWomA*
Burgkly-Glimmer, E J *DcWomA*
Burgkmair, Hans, The Elder 1473-1531 *McGDA, OxArt*
Burgmann, William F *WhAmArt 85*
Burgos, Carl 1920?- *WorECom*
Burgoyne, Miss L *DcBrA 1*
Burgoyne, Lorna *DcWomA*
Burgoyne, Lorna d1961 *DcBrA 2*
Burgues, Irving Carl 1906- *WhoAmA 78, –80, –82, –84*
Burguignon, Hubert Francois *BkIE*
Burgum, John *FolkA 86*
Burgum, John 1826-1907 *NewYHSD*
Burgun, Joseph Armand 1925- *AmArch 70*
Burgy 1937- *WhoAmA 73, –76, –78, –80, –82*
Burgy, Don 1937- *ConArt 77*
Burgy, Frederick S *WhAmArt 85*
Buri, Max 1868-1915 *PhDcTCA 77*
Buri, Samuel *DcCAr 81*
Burian, Ivo 1939- *DcCAr 81*
Burickson, Zoel *WhoAmA 73, –76*
Burine *NewYHSD*
Burinsky, Joseph John 1939- *AmArch 70*
Burk, A Darlene 1929- *WhoAmA 80, –82, –84*
Burk, Anna Darlene *WhoAmA 76, –78*
Burk, E *CabMA*
Burk, Eldon *FolkA 86*
Burk, J O *AmArch 70*
Burk, Lou 1845-1914 *WhAmArt 85*
Burk, Thompson B 1914- *AmArch 70*
Burk, William Emmett, III 1939- *AmArch 70*
Burk, William Emmett, Jr. 1909- *AmArch 70, WhAmArt 85*
Burkart, James W 1929- *AmArch 70*
Burke *DcBrECP*
Burke, Addie *DcWomA*
Burke, Alfred F 1893-1936 *WhAmArt 85*
Burke, Arlene *AfroAA*
Burke, Augustus Nicholas 1838?-1891 *DcVicP, –2*
Burke, Brenda *ClaDrA*
Burke, Charles S 1815-1901 *BiDAmAr*
Burke, Daniel V 1942- *WhoAmA 73, –76, –78, –80, –82, –84*
Burke, E Ainslie 1922- *WhoAmA 73, –76, –78, –80, –82, –84*
Burke, Edgar *FolkA 86*
Burke, Edmund 1729-1797 *OxArt*
Burke, Edmund 1850-1919 *MacEA*
Burke, Edmund Raymond *WhAmArt 85*
Burke, Edward Michael 1930- *AmArch 70*
Burke, Eleanor W 1899- *WhAmArt 85*
Burke, F C *AmArch 70*
Burke, Frances *DcWomA*

Burke, G *NewYHSD*
Burke, Gary Spencer 1930- *AmArch 70*
Burke, Harold Arthur 1852- *ClaDrA*
Burke, Harold Arthur 1852-1942 *DcBrA 1, DcVicP 2*
Burke, J L, Jr. *AmArch 70*
Burke, James 1915-1964 *ICPEnP A*
Burke, James Donald 1939- *WhoAmA 76, –78, –80, –82, –84*
Burke, Jeremiah 1843?- *NewYHSD*
Burke, Joan 1904- *WhAmArt 85*
Burke, John 1946- *DcCAr 81*
Burke, John W 1847-1916 *WhAmArt 85*
Burke, Joseph T 1913- *WhoArt 80, –82, –84*
Burke, Margaret 1950- *WhoAmA 82, –84*
Burke, May Cornelia 1911- *WhAmArt 85*
Burke, Michael *FolkA 86*
Burke, P *DcBrECP*
Burke, Patrick *CabMA*
Burke, Peter 1944- *WhoArt 84*
Burke, Richard D 1929- *AmArch 70*
Burke, Robert E 1884- *WhAmArt 85*
Burke, Ronald Reed 1931- *AmArch 70*
Burke, Ruth *DcWomA, WhAmArt 85*
Burke, Selma Hortense *AfroAA*
Burke, Selma Hortense 1907- *WhAmArt 85*
Burke, Mrs. Stevenson 1841-1931 *WhAmArt 85*
Burke, Thomas 1749-1815 *McGDA*
Burke, Thomas John 1959- *MarqDCG 84*
Burke, Tom d1945 *DcBrA 2*
Burke, William Lozier Munro 1906-1961 *WhAmArt 85, WhoAmA 80N, –82N, –84N*
Burke-Rand, Ravinia *FolkA 86*
Burkehead, George W 1858-1931 *BiDAmAr*
Burkel, Henri 1802-1869 *ArtsNiC*
Burkelein, Friedrich 1813-1873 *McGDA*
Burkenroad, Flora Salinger 1873- *DcWomA, WhAmArt 85*
Burkerd, E *FolkA 86*
Burkerd, Peter 1818- *FolkA 86*
Burkert, Heribert 1953- *DcCAr 81*
Burkert, Nancy Ekholm *IlsCB 1967*
Burkert, Nancy Ekholm 1933- *IlsBYP, IlsCB 1957*
Burkert, Robert 1930- *PrintW 83, –85*
Burkert, Robert Randall 1930- *WhoAmA 73, –76, –78, –80, –82, –84*
Burkes, Eugene Alexander 1880- *AfroAA*
Burket, H E *AmArch 70*
Burkfeldt, August *FolkA 86*
Burkhalter, Geo N 1914- *AmArch 70*
Burkhard, Henri 1892- *WhAmArt 85*
Burkhard, P, Jr. *AmArch 70*
Burkhard, R H *AmArch 70*
Burkhard, Verona Lorraine *WhAmArt 85*
Burkhardt, Barbara F 1953- *MarqDCG 84*
Burkhardt, E Walter 1894- *AmArch 70*
Burkhardt, Emerson C 1905- *WhAmArt 85*
Burkhardt, Hans 1904- *PrintW 83, –85*
Burkhardt, Hans Gustav 1904- *DcCAA 71, –77, WhoAmA 73, –76, –78, –80, –82, –84*
Burkhardt, Hedwig 1863- *DcWomA*
Burkhardt, P H *FolkA 86*
Burkheimer, Lena W 1877- *DcWomA, WhAmArt 85*
Burkholder, Isaac 1801?- *FolkA 86*
Burkholder, J P *FolkA 86*
Burkholder, Lydia *FolkA 86*
Burkinshaw, Samuel *DcVicP 2*
Burklein, Friedrich 1813-1872 *MacEA*
Burkley, Richard M 1941- *MarqDCG 84*
Burklund, Herbert L *MarqDCG 84*
Burklund, W D *AmArch 70*
Burkly, Z *DcVicP 2*
Burko, Diane 1945- *PrintW 85, WhoAmA 76, –78, –80, –82, –84*
Burks, Garnett 1878- *ArtsAmW 2*
Burks, Max *ArtsEM*
Burks, Myrna R 1943- *WhoAmA 80, –82, –84*
Burks, Samuel Cabell *AmArch 70*
Burks, V I, Jr. *AmArch 70*
Burks, W C *AmArch 70*
Burks, Willard Reppard 1936- *AmArch 70*
Burlage, James Edward 1934- *AmArch 70*
Burland, Cottie A *WhoArt 84N*
Burland, Cottie A 1905- *WhoArt 80, –82*
Burle Marx, Roberto 1909- *ConArch, MacEA, OxArt*
Burleigh, Averil *ClaDrA*
Burleigh, Averil M *DcBrA 1*
Burleigh, Averil M d1949 *DcBrA 2*
Burleigh, Averil Mary *DcWomA*
Burleigh, Averil Mary d1949 *DcBrBI*
Burleigh, Bertha Bennet *DcWomA*
Burleigh, C H H d1956 *DcBrA 1, –2*
Burleigh, Charles H H d1956 *DcVicP 2*
Burleigh, Sydney Richmond 1853-1931 *WhAmArt 85*
Burleigh, Veronica 1909- *WhoArt 80, –82, –84*
Burleigh-Conkling, Paul *WhAmArt 85*
Burleson, J E, Sr. *AmArch 70*
Burlesson, Ebenezer 1710?- *CabMA*
Burlesson, Fearnot 1679-1732 *CabMA*
Burley, David W 1901- *WhoArt 80, –82, –84*
Burley, David William 1901- *DcBrA 1*

Burley, James L 1873-1942 *BiDAmAr*
Burley, John *FolkA 86*
Burley, Lazalier *FolkA 86*
Burley, R A *AmArch 70*
Burlin, H Paul 1886-1969 *ArtsAmW 1*
Burlin, Harry Paul 1886-1969 *IlBEAAW, WhAmArt 85*
Burlin, Natalie d1921 *DcWomA*
Burlin, Natalie Curtis d1921 *WhAmArt 85*
Burlin, Paul d1969 *WhoAmA 78N, –80N, –82N, –84N*
Burlin, Paul 1886- *McGDA*
Burlin, Paul 1886-1969 *DcCAA 71, –77, PhDcTCA 77*
Burlin, Richard *NewYHSD*
Burling, Edward 1819-1892 *BiDAmAr*
Burling, Gilbert 1843-1875 *ArtsNiC*
Burling, Thomas *AntBDN G, CabMA*
Burlingame, Charles Albert 1860-1930 *WhAmArt 85*
Burlingame, Dennis Meighan 1901- *WhAmArt 85*
Burlingame, Ethel R *WhAmArt 85*
Burlingame, Philip *FolkA 86*
Burlingame, Sheila 1894- *DcWomA*
Burlingame, Sheila Ellsworth *WhAmArt 85*
Burlingame, Sheila Ellsworth 1894- *ArtsAmW 3*
Burlingham, Ethel R *DcWomA*
Burlingham, Hiram 1867-1932 *WhAmArt 85*
Burlington, Earl Of *BiDBrA*
Burlington, Earl Of 1694-1753 *MacEA, WhoArch*
Burlington, Lord 1694-1753 *DcD&D*
Burlington, Countess Dorothy 1699-1758 *DcWomA*
Burlington, Dorothy, Countess Of 1699-1758 *DcBrECP*
Burlington, Richard Boyle, Earl Of 1694-1753 *OxArt*
Burlini, Alfred H 1933- *AmArch 70*
Burlison, George *BiDBrA*
Burlison, J *DcVicP 2*
Burliuk, David 1882- *WhAmArt 85*
Burliuk, David 1882-1967 *ArtsAmW 3, ConArt 83, DcCAA 71, –77, McGDA, WhoAmA 78N*
Burliuk, David Davidovich 1882-1967 *OxTwCA*
Burliuk, Davidovich 1882-1967 *ArtsAmW 3*
Burliuk, Vladimir Davidovich 1886-1916 *OxTwCA*
Burljuk, David 1882-1967 *PhDcTCA 77*
Burljuk, Vladimir 1886-1917 *PhDcTCA 77*
Burluik, David 1882-1967 *WhoAmA 80N, –82N, –84N*
Burman, Augustus *FolkA 86*
Burman, John *DcVicP 2*
Burman, R J *AmArch 70*
Burman, Russell *NewYHSD*
Burmantofts Pottery Co. *DcNiCA*
Burmeister, Carl F, Jr. 1923- *AmArch 70*
Burmeister, John Herbert 1910- *AmArch 70*
Burn, Boris 1923- *IlsCB 1957*
Burn, George *BiDBrA*
Burn, Gerald Maurice 1862- *DcBrA 1, DcBrWA*
Burn, Gerald Maurice 1862-1945 *DcBrA 2, DcVicP 2*
Burn, James *BiDBrA, CabMA*
Burn, Lee *ArtsEM*
Burn, Robert 1752-1815 *BiDBrA*
Burn, Rodney Joseph 1899- *ClaDrA, DcBrA 1, WhoArt 80, –82, –84*
Burn, Thomas F *DcBrWA, DcVicP 2*
Burn, William 1785-1875 *McGDA*
Burn, William 1789-1870 *BiDBrA, MacEA, WhoArch*
Burn-Murdoch, W G 1862-1939 *DcBrA 1*
Burnam, Benjamin 1729-1799 *CabMA*
Burnand, Geoffrey 1912- *DcBrA 1*
Burnand, Robert Alan Lewis 1929- *WhoArt 80, –82, –84*
Burnand, Victor Wyatt 1868-1940 *DcBrA 1, DcVicP 2*
Burnap, Daniel *FolkA 86, NewYHSD*
Burnap, Daniel 1760-1838 *AntBDN D, OxDecA*
Burnard, William S *NewYHSD*
Burnat, Ernest 1833- *ClaDrA*
Burnat-Provins, Marguerite *DcWomA*
Burnays, Daniel 1760-1838 *DcNiCA*
Burne, Ada Dora *DcWomA*
Burne, Winifred 1877- *ClaDrA, DcWomA*
Burne-Jones, Lady *DcWomA*
Burne-Jones, Edward *ArtsNiC*
Burne-Jones, Sir Edward 1833-1898 *AntBDN B*
Burne-Jones, Sir Edward Coley 1833-1898 *ClaDrA, DcBrBI, DcNiCA, DcVicP, –2, McGDA, OxArt*
Burne-Jones, Sir Philip 1861-1926 *DcBrA 1, ClaDrA, DcVicP 2*
Burne-Jones, Sir Philip 1862-1926 *DcBrBI*
Burnell, Benjamin 1769-1828 *DcBrECP*
Burnell, T *BiDBrA*
Burnes, E P *NewYHSD*
Burness, Peter 1910- *WorECar*
Burnet *FolkA 86*
Burnet, H *DcBrECP*
Burnet, J J 1857-1938 *MacEA*
Burnet, James M *DcBrECP*
Burnet, James M 1788-1816 *DcBrWA*
Burnet, John 1781-1868 *ArtsNiC*
Burnet, John 1784-1868 *DcBrWA, DcVicP 2*
Burnet, Sir John 1857-1938 *WhoArch*

Burnet, Sir John James 1857-1938 *DcBrA 1*
Burnet, John M *NewYHSD*
Burnett, Barbara Ann 1927- *WhoAmA 84*
Burnett, Blaine Evans 1954- *MarqDCG 84*
Burnett, Brian 1952- *DcCAr 81*
Burnett, Calvin 1921- *AfroAA, WhoAmA 73, –76, –78, –80, –82, –84*
Burnett, Calvin W 1921- *WhAmArt 85*
Burnett, Caroline C *WhAmArt 85*
Burnett, Caroline Currie *DcWomA*
Burnett, Cecil Ross 1872-1933 *DcBrA 1, DcVicP 2*
Burnett, Clyde 1928- *WhoAmA 76*
Burnett, David 1946- *ICPEnP A*
Burnett, David Grant 1940- *WhoAmA 78, –80, –82, –84*
Burnett, Edah Flower 1884- *WhAmArt 85*
Burnett, Eva Kottinger 1859-1916 *ArtsAmW 3*
Burnett, G R *DcVicP 2*
Burnett, Henry *FolkA 86*
Burnett, J L, Jr. *AmArch 70*
Burnett, Joseph Geddes 1923- *AmArch 70*
Burnett, Mrs. Louis A *WhAmArt 85*
Burnett, Louis Anthony 1907- *WhoAmA 73, –76*
Burnett, Norman F *WhAmArt 85*
Burnett, Patricia Hill *WhoAmA 76, –78, –80, –82, –84*
Burnett, R E *AmArch 70*
Burnett, Samuel Moody 1929- *AmArch 70*
Burnett, W C, Jr. 1928- *WhoAmA 78, –80, –82*
Burnett, Mrs. Walter D *DcWomA, NewYHSD*
Burnett, William Clyde 1930- *AmArch 70*
Burnett, William Hickling *DcBrWA, DcVicP 2*
Burnette, C H *AmArch 70*
Burnette, William Max 1950- *MarqDCG 84*
Burney, Edward Francesco 1760-1848 *BkIE, DcBrECP*
Burney, Edward Francis 1760-1848 *DcBrBI, DcBrWA*
Burney, J M *FolkA 86*
Burney, James *DcBrECP*
Burney, Mina 1891-1958 *WhAmArt 85*
Burney, Minna 1891-1958 *WhoAmA 80N, –82N, –84N*
Burnham *NewYHSD*
Burnham, A *AmArch 70*
Burnham, Aaron L *FolkA 86*
Burnham, Anita Willets 1880- *DcWomA, WhAmArt 85*
Burnham, Benjamin d1737 *CabMA*
Burnham, Benjamin 1729-1799 *CabMA*
Burnham, Carol-Lou 1908- *WhAmArt 85*
Burnham, Christopher Anthony 1956- *WhoArt 80, –82, –84*
Burnham, D H *BiDAmAr*
Burnham, Daniel H 1846-1912 *MacEA, McGDA*
Burnham, Daniel Hudson 1846-1912 *BiDAmAr, BnEnAmA, EncAAr, EncMA, McGDA, WhoArch*
Burnham, David H 1846-1912 *DcD&D*
Burnham, Elizabeth Louese *WhoAmA 78*
Burnham, Elizabeth Louise *WhoAmA 80*
Burnham, Franklin P d1909 *BiDAmAr*
Burnham, Frederic Lynden 1872-1911 *WhAmArt 85*
Burnham, H M *AmArch 70*
Burnham, Jack Wesley 1931- *WhoAmA 78, –80, –82, –84*
Burnham, L P *WhAmArt 85*
Burnham, Lee 1926- *WhoAmA 73, –76, –78, –80, –82*
Burnham, Linda Frye 1940- *WhoAmA 80, –82, –84*
Burnham, Mary Dodge *FolkA 86*
Burnham, Robert Hampton 1926- *AmArch 70*
Burnham, Roger Noble 1876- *WhAmArt 85*
Burnham, T H O P *ArtsEM, NewYHSD*
Burnham, Thomas Mickell 1818-1866 *NewYHSD*
Burnham, Wilbur Herbert 1887- *WhAmArt 85*
Burnham And Root *BiDAmAr, DcD&D, EncAAr*
Burningham, John Mackintosh *IlsCB 1967*
Burningham, John Mackintosh 1936- *IlsBYP, IlsCB 1957*
Burnley, Gary 1950- *PrintW 83, –85*
Burnley, John Edwin 1896- *ArtsAmW 3*
Burns, Aaron 1922- *ConDes*
Burns, Arthur Lee 1924- *AmArch 70*
Burns, Balfour *DcVicP 2*
Burns, C B *AmArch 70*
Burns, Cecil Laurence 1863-1929 *DcBrA 1, DcVicP 2*
Burns, Cecil Lawrence 1863?-1929 *DcBrBI*
Burns, Cecil Leonard 1863-1929 *DcVicP 2*
Burns, Charles M, Jr. *BiDAmAr*
Burns, Charles Marquadant, Jr. 1834?- *NewYHSD*
Burns, Clarence Laurence *DcVicP 2*
Burns, D Harrison 1946- *WhoAmA 82, –84*
Burns, David V 1911- *AmArch 70*
Burns, Edith Walker 1871- *DcWomA*
Burns, Elizabeth M *WhAmArt 85*
Burns, Fred 1890- *MacEA*
Burns, G Joan 1918- *WhoAmA 78, –80, –82, –84*
Burns, George *NewYHSD*
Burns, Georgiana *DcWomA, WhAmArt 85*
Burns, H E, Jr. *AmArch 70*
Burns, Harold Hugh 1925- *AmArch 70*
Burns, Irene *IlsBYP*

Burns, J Bradley 1951- *MacBEP*
Burns, J F *WhAmArt 85*
Burns, Jack K 1887- *AmArch 70*
Burns, James 1810?- *NewYHSD*
Burns, James 1819?- *FolkA 86*
Burns, James Thompson, Jr. 1926- *AmArch 70*
Burns, Jean Douglas 1903- *DcBrA 1*
Burns, Jerome 1919- *AmArt, WhoAmA 76, –78, –80, –82, –84*
Burns, Josephine 1917- *AmArt, WhoAmA 76, –78, –80, –82, –84*
Burns, M J *DcBrBI*
Burns, M S *DcWomA*
Burns, Margaret Delisle 1888- *DcBrA 1, DcWomA*
Burns, Mark A 1950- *CenC*
Burns, Marsha 1945- *ICPEnP A, MacBEP, WhoAmA 84*
Burns, Martin *FolkA 86*
Burns, Michael 1942- *ICPEnP A, MacBEP*
Burns, Milton J 1853-1933 *WhAmArt 85*
Burns, P D *AmArch 70*
Burns, Patrick Albert 1934- *AmArch 70*
Burns, Paul Callan *WhoAmA 78, –80, –82, –84*
Burns, Paul Callan 1910- *WhAmArt 85*
Burns, Pearl Robison 1903-1960 *WhAmArt 85*
Burns, R O, Jr. *AmArch 70*
Burns, Raymond Russell 1904- *AmArch 70*
Burns, Richard Lyons 1931- *MarqDCG 84*
Burns, Robert 1869-1941 *DcBrA 1, DcBrBI, DcBrWA, DcVicP 2*
Burns, Robert 1916- *AmArch 70*
Burns, Robert 1942- *ConDes*
Burns, Robert John 1942- *WhoGrA 82[port]*
Burns, Robert P 1933- *AmArch 70*
Burns, Sheila *WhoAmA 76, –78, –80, –82, –84*
Burns, Sid 1916- *WhoAmA 76, –78*
Burns, Sid 1916-1979 *WhoAmA 80N, –82N, –84N*
Burns, Silas R 1855-1940 *BiDAmAr*
Burns, Stan *WhoAmA 76, –78, –80, –82, –84*
Burns, T K *AmArch 70*
Burns, Thomas *BiDBrA*
Burns, Timothy Joseph 1950- *WhoAmA 84*
Burns, W F *FolkA 86*
Burns, W R, Jr. *AmArch 70*
Burns, William Alexander 1921-1972 *DcBrA 1*
Burns, William John 1907- *WhAmArt 85*
Burns McKeon, Katherine Balfour Kinnear 1925- *WhoArt 82, –84*
Burnshide, Katherine Talbott *WhoAmA 82N*
Burnside, Cameron d1952 *WhoAmA 78N, –80N, –82N, –84N*
Burnside, Cameron 1887-1952 *WhAmArt 85*
Burnside, H *DcVicP 2, DcWomA*
Burnside, H E S *AfroAA*
Burnside, Jackson, III *AfroAA*
Burnside, John 1784?- *FolkA 86*
Burnside, Katherine Talbott *WhoAmA 73, –76, –78, –80, –84N*
Burnside, Lucile d1927 *DcWomA*
Burnside, Lucile Hitt d1927 *WhAmArt 85*
Burnside, Wesley M 1918- *WhoAmA 76, –78, –80, –82, –84*
Burnstead, Josiah *CabMA*
Buros, Luella *WhAmArt 85, WhoAmA 73, –76, –78, –80, –82, –84*
Burow, Alfred H *ArtsEM*
Burow, Eldon Otto 1933- *AmArch 70*
Burpee, James Stanley 1938- *AmArt, WhoAmA 78, –80, –82, –84*
Burpee, Jeremiah *FolkA 86*
Burpee, Sophia *FolkA 86*
Burpee, Sophia 1788-1814 *DcWomA*
Burpee, W B, II *AmArch 70*
Burpee, William Partridge 1846- *WhAmArt 85*
Burr *NewYHSD*
Burr, A *FolkA 86*
Burr, A Margaretta *DcWomA*
Burr, A Margaretta Higford *DcBrWA*
Burr, Alexander H 1837- *ArtsNiC*
Burr, Alexander Hohenlohe 1835-1899 *DcVicP, –2*
Burr, Alexander Hohenlohe 1837-1899 *ClaDrA*
Burr, Annette W *ArtsEM, DcWomA*
Burr, Augustus *NewYHSD*
Burr, C *FolkA 86*
Burr, Mrs. C B *WhAmArt 85*
Burr, Charles H *FolkA 86*
Burr, Christopher *NewYHSD*
Burr, Cynthia 1770-1848 *FolkA 86*
Burr, David Joseph 1946- *MarqDCG 84*
Burr, Donald F 1922- *AmArch 70*
Burr, E *FolkA 86*
Burr, E L *DcWomA*
Burr, Edward Everett 1895- *WhAmArt 85*
Burr, Eliza J *DcWomA, NewYHSD*
Burr, Emerson *FolkA 86*
Burr, Eugene Edward 1934- *AmArch 70*
Burr, F C *WhAmArt 85*
Burr, Frances 1890- *DcWomA, WhAmArt 85*
Burr, G Gordon *DcBrWA*
Burr, George Brainerd *WhAmArt 85*
Burr, George Elbert 1859-1939 *ArtsAmW 1, GrAmP,*

IlBEAAW, *WhAmArt 85*
Burr, Mrs. Higford *DcVicP 2*
Burr, Hippolyte *NewYHSD*
Burr, Horace 1912- *WhoAmA 76, –78, –80, –82, –84*
Burr, Horace F 1844-1900 *BiDAmAr*
Burr, Jason *FolkA 86*
Burr, John 1831- *ArtsNiC*
Burr, John 1831-1893 *ClaDrA*
Burr, John 1834-1893 *DcVicP*
Burr, John P *AfroAA, FolkA 86*
Burr, John P 1831-1893 *DcVicP 2*
Burr, John R 1831-1893 *DcBrWA*
Burr, Julia *DcWomA, FolkA 86*
Burr, L E *DcWomA*
Burr, Mrs. L E *NewYHSD*
Burr, Laura E *ArtsEM, DcWomA*
Burr, Leonard *FolkA 86*
Burr, Leonard U *NewYHSD*
Burr, M *FolkA 86*
Burr, Russ *FolkA 86*
Burr, Saxton 1889- *WhAmArt 85*
Burr, Victor 1908- *DcBrA 1, WhoArt 80, –82, –84*
Burr, William Henry *EarABI, NewYHSD*
Burr, William W *CabMA*
Burr-Miller, Churchill 1904- *WhAmArt 85*
Burra, Edward 1905- *ClaDrA, DcBrA 1, McGDA, PhDcTCA 77*
Burra, Edward 1905-1976 *ConArt 77, –83*
Burra, Edward John 1905-1976 *OxTwCA*
Burrage, Barbara 1900- *WhAmArt 85*
Burrage, Mildred Giddings 1890- *DcWomA, WhAmArt 85*
Burrage, Thomas *CabMA*
Burran, James Albert, Jr. 1923- *AmArch 70*
Burrard, Sir Charles 1793-1870 *DcBrWA*
Burras, Caroline Agnes 1890- *ClaDrA, DcBrA 1, DcWomA*
Burrell *NewYHSD*
Burrell, Miss *DcWomA*
Burrell, A M *NewYHSD*
Burrell, Alfred Ray 1877- *ArtsAmW 1, WhAmArt 85*
Burrell, D D *WhAmArt 85*
Burrell, J E *DcVicP 2*
Burrell, J S *AmArch 70*
Burrell, James *DcSeaP, DcVicP 2*
Burrell, John *BiDBrA*
Burrell, Louise *WhAmArt 85*
Burrell, Louise H *ArtsAmW 2, DcWomA*
Burrell, Reuben *AfroAA*
Burrey, John Charles 1929- *AmArch 70*
Burri, Alberto 1915- *ConArt 77, –83, DcCAr 81, McGDA, OxTwCA, PhDcTCA 77, PrintW 85, WorArt[port]*
Burri, Rene 1933- *ConPhot, ICPEnP A, MacBEP*
Burridge *FolkA 86*
Burridge, Charles *NewYHSD*
Burridge, Frederick Vango 1869-1945 *DcBrA 1*
Burridge, Thomas H *NewYHSD*
Burridge, Walter W 1857- *WhAmArt 85*
Burridge, William H *NewYHSD*
Burrill, E *WhAmArt 85*
Burrill, Edward *NewYHSD*
Burrill, George d1721 *CabMA*
Burrill, Hannah 1758-1786 *FolkA 86*
Burrill, James S 1942- *MarqDCG 84*
Burrill, John Q 1841?- *NewYHSD*
Burrill, L S *AmArch 70*
Burrill, R *NewYHSD*
Burrill-Robinson, Henrietta *DcWomA*
Burrington, Arthur Alfred 1856-1924 *DcBrA 1, DcVicP 2*
Burris, Burmah *IlsBYP*
Burris, J C 1928- *FolkA 86*
Burris, J E *AmArch 70*
Burris, J H *AmArch 70*
Burris, John H 1932- *AmArch 70*
Burrough, Helen Mary 1917- *DcBrA 1, WhoArt 80, –82, –84*
Burrough, James 1691-1764 *MacEA*
Burrough, Sir James 1691-1764 *BiDBrA*
Burrough, Mark *FolkA 86*
Burrough, Thomas Hedley Bruce 1910- *DcBrA 1, WhoArt 80, –82, –84*
Burroughes, Dorothy Mary L d1963 *DcWomA*
Burroughes-Burroughes, Dorothy Mary d1963 *DcBrA 1*
Burroughs, Mrs. *DcVicP 2*
Burroughs, A Leicester *DcVicP 2*
Burroughs, Alan *WhAmArt 85*
Burroughs, Betty 1899- *DcWomA, WhAmArt 85*
Burroughs, Bryson 1869-1934 *McGDA, WhAmArt 85*
Burroughs, Charles W 1910- *AmArch 70*
Burroughs, Edith 1871-1916 *DcWomA*
Burroughs, Edith Woodman 1871-1916 *WhAmArt 85*
Burroughs, Edward R 1902- *WhAmArt 85*
Burroughs, Ezekiel *CabMA*
Burroughs, John Coleman 1913- *WhoAmA 78, –80*
Burroughs, John William 1927- *AmArch 70*
Burroughs, Louise *WhAmArt 85*
Burroughs, Margaret T G 1917- *WhoAmA 76, –78,*

–80, –82, –84
Burroughs, Margaret Taylor Goss 1917- *AfroAA*
Burroughs, Marion L *WhAmArt 85*
Burroughs, Molly *DcWomA*
Burroughs, Molly Luce *WhoAmA 82, –84*
Burroughs, Raymond L 1942- *AmArch 70*
Burroughs, Sara A *DcWomA*
Burroughs, Sarah A *FolkA 86, NewYHSD*
Burroughs, Victor Hugh Seamark *WhoArt 80N*
Burroughs, Victor Hugh Seamark 1900- *ClaDrA*
Burroughs-Fowler, Walter John 1860-1930 *DcBrA 1*
Burrow, C F Severn *DcVicP 2*
Burrow, Fred Dennis 1934- *AmArch 70*
Burrow, John Charles 1850-1914 *MacBEP*
Burrows, Edward Morris 1914- *AmArch 70*
Burrows, Ernest *DcBrA 1*
Burrows, Esther *FolkA 86*
Burrows, Gates W 1899- *AmArch 70*
Burrows, Harold L 1889- *WhAmArt 85*
Burrows, Harold Longmore 1889-1965 *ArtsAmW 3*
Burrows, Henry *NewYHSD*
Burrows, J C *DcWomA*
Burrows, Mrs. J C *ArtsEM*
Burrows, John Shober 1911- *AmArch 70*
Burrows, Larry 1926-1971 *ConPhot, ICPEnP,*
MacBEP
Burrows, Pearl *WhAmArt 85, WhoAmA 80N,*
–82N,
–84N
Burrows, Robert *DcVicP 2*
Burrows, Roy 1922- *WhoArt 80*
Burrows, Selig S 1913- *WhoAmA 73, –76, –78, –80,*
–82, –84
Burrows, Stephen 1943- *WorFshn*
Burrows, Stephen Gerald 1942- *ConDes*
Burrows, Tom 1940- *WhoAmA 73*
Burrus, James H 1894-1955 *WhAmArt 85*
Burrus, Thomas Marshall, Jr. 1922- *AmArch 70*
Burry, Louis *NewYHSD*
Burson, Rodger E *AmArch 70*
Burssens, Jan 1925- *OxTwCA, PhDcTCA 77*
Burstein, Gerald F 1939- *MarqDCG 84*
Bursztajn, Sherry 1946- *MarqDCG 84*
Burt, Addie 1861-1936 *ArtsEM*
Burt, Albin Robert 1784-1842 *DcBrWA*
Burt, Beatrice Milliken 1893- *DcWomA,*
WhAmArt 85
Burt, Benjamin 1729-1805 *BnEnAmA*
Burt, Charles Kennedy 1823-1892 *NewYHSD*
Burt, Charles Thomas 1823-1902 *DcBrWA, DcVicP,*
–2
Burt, Clyde Edwin *WhoAmA 78, –80, –82*
Burt, Clyde Edwin d1981 *WhoAmA 84N*
Burt, Dan 1930- *WhoAmA 76, –78, –80, –82, –84*
Burt, David Sill 1917- *WhoAmA 73, –76, –78, –80,*
–82, –84
Burt, Edith *DcWomA*
Burt, Edith Noonan *WhAmArt 85*
Burt, Elvin *AntBDN O*
Burt, Frederic 1876- *WhAmArt 85*
Burt, Gordon H *MacBEP*
Burt, H A B *DcVicP 2*
Burt, Harriet 1818-1888 *DcWomA*
Burt, Harriet Amsbry 1818-1888 *ArtsEM*
Burt, Henry d1884 *BiDBrA A*
Burt, Henry W *DcBrWA*
Burt, James *NewYHSD*
Burt, John 1691-1745 *AntBDN Q*
Burt, John 1693-1746 *BnEnAmA*
Burt, Laurie 1925- *DcCAr 81*
Burt, Lawrence 1925- *ConArt 77*
Burt, Louis 1900- *WhAmArt 85*
Burt, Margaret James *WhAmArt 85*
Burt, Maria E *DcWomA*
Burt, Marie *DcWomA*
Burt, Marie Bruner Haines *ArtsAmW 2*
Burt, Marie Haines *IlBEAAW*
Burt, Mary Jane Alden *FolkA 86*
Burt, Mary Theodora *DcWomA, WhAmArt 85*
Burt, Ralph Hervey 1923- *AmArch 70*
Burt, Samuel 1724-1754 *BnEnAmA*
Burt, William 1726-1751 *BnEnAmA*
Burtchaell, Deann *WhoAmA 76, –78, –80, –82, –84*
Burtin, Will 1908- *WhoGrA 62*
Burtin, Will 1908-1972 *ConDes*
Burtis, Jacob H *FolkA 86*
Burtis, Mary E 1878- *WhAmArt 85*
Burtis, Mary Elizabeth 1878- *DcWomA*
Burton, Miss *DcWomA*
Burton, Mrs. *DcVicP 2*
Burton, A F *DcVicP 2*
Burton, A M H *DcWomA*
Burton, Miss A M H *NewYHSD*
Burton, Alfred *WhAmArt 85*
Burton, Alfred Henry 1834-1914 *MacBEP*
Burton, Alice Mary 1893- *DcBrA 1, DcWomA*
Burton, Arthur Gibbes 1883- *WhAmArt 85*
Burton, Arthur P *DcVicP 2*
Burton, Caroline *DcWomA*
Burton, Charles *EarABI SUP, NewYHSD*
Burton, Charles W *NewYHSD*
Burton, D K *AmArch 70*

Burton, Decimus 1800-1881 *BiDBrA, DcD&D,*
MacEA, McGDA, OxArt, WhoArch
Burton, Dennis *OxTwCA*
Burton, E J *DcBrBI*
Burton, Elizabeth *WhAmArt 85*
Burton, F W *DcVicP 2*
Burton, Sir Frederick William 1816-1900 *ClaDrA,*
DcBrBI, DcBrWA, DcVicP, –2
Burton, Gloria *WhoAmA 76, –78, –80*
Burton, Harriet 1893- *WhAmArt 85*
Burton, Harriet B 1893- *DcWomA*
Burton, Henry *DcVicP 2*
Burton, J *DcVicP 2*
Burton, J A, IV *AmArch 70*
Burton, Jack Munson 1917- *WhAmArt 85*
Burton, James *DcVicP 2*
Burton, James 1761-1837 *BiDBrA, MacEA*
Burton, James H 1919- *AmArch 70*
Burton, James R *EarABI, NewYHSD*
Burton, John *DcBrECP, FolkA 86*
Burton, M R Hill *DcVicP 2, DcWomA*
Burton, Marjorie DeKrafft 1886- *DcWomA,*
WhAmArt 85
Burton, Mary Agnes Larrabee 1852- *DcWomA*
Burton, Mary W *DcWomA*
Burton, Nancy Jane *DcBrA 1*
Burton, Nancy Jane d1972 *DcWomA*
Burton, Nathan *NewYHSD*
Burton, Netta M *WhoAmA 80N, –82N, –84N*
Burton, Netta M d1960 *WhAmArt 85*
Burton, Paul 1931- *MarqDCG 84*
Burton, Philip John Kennedy 1936- *WhoArt 80, –82,*
–84
Burton, Rebecca *FolkA 86*
Burton, Sir Richard Francis 1821-1890 *DcBrBI*
Burton, Roger *AmArch 70*
Burton, S Chatwood 1881-1955? *WhAmArt 85*
Burton, Scott 1939- *DcCAr 81, WhoAmA 76, –78,*
–80, –82, –84
Burton, T *DcVicP 2*
Burton, Virginia Lee d1968 *IlsCB 1967*
Burton, Virginia Lee 1909-1968 *Cald 1938, IlsBYP,*
IlsCB 1744, –1946, –1957
Burton, W C *AmArch 70*
Burton, Walter J *MacBEP*
Burton, William *DcVicP 2, FolkA 86*
Burton, William Paton 1828-1883 *DcBrBI, DcBrWA,*
DcVicP, –2
Burton, William Shakespeare 1824-1916 *ClaDrA,*
DcVicP, –2
Burton, William Shakespeare 1826-1916 *DcBrA 1*
Burton, William Shakespeare 1830-1916 *DcBrBI,*
DcBrWA
Burton-Mund, Elsie Noble *DcWomA*
Burtonshaw, Keith 1930- *WhoArt 82, –84*
Buruch, Jacques Z *WhoAmA 80, –82*
Burwash, Nathaniel C 1906- *WhAmArt 85*
Burwash, William *AntBDN Q*
Burwell, Kate 1866- *DcWomA*
Burwell, William Ernst 1911- *ClaDrA, DcBrA 1*
Burwell, William Owings 1921- *AmArch 70*
Burwinkle, Joseph Bernard 1902- *AmArch 70*
Burwinkle, Joseph Bernard, Jr. *AmArch 70*
Burwood, G V *DcSeaP*
Bury, Viscount *DcBrBI, DcVicP 2*
Bury, Adrian 1891- *DcBrA 1, WhoArt 80, –82, –84*
Bury, Daniel 1802?- *FolkA 86*
Bury, Mrs. Edward *DcWomA*
Bury, Edward John 1790-1832 *DcBrBI*
Bury, Gaynor Elizabeth 1890- *DcBrA 1, DcWomA*
Bury, Jeanne Visart De *DcWomA*
Bury, John 1925- *ConDes*
Bury, John Jacob *NewYHSD*
Bury, Louise De *DcWomA*
Bury, Pol 1922- *ConArt 77, –83, DcCAr 81,*
OxTwCA, PhDcTCA 77, PrintW 83, –85
Bury, Thomas Talbot 1811-1877 *DcBrBI, DcBrWA*
Busa, Peter *WhAmArt 85*
Busa, Peter 1914- *WhoAmA 73, –76, –78, –80, –82,*
–84
Busalacchi, Gaetano 1887-1967 *WhAmArt 85*
Busbee, Juliana Royster 1877-1962 *WhoAmA 80N,*
–82N, –84N
Busby, Charles A *NewYHSD*
Busby, Charles Augustus 1788-1834 *BiDBrA, MacEA*
Busby, Dwight Leland 1922- *AmArch 70*
Busby, George Cecil 1926- *WhoArt 82, –84*
Busby, James L 1946- *MarqDCG 84*
Busby, John Arthur, Jr. 1933- *AmArch 70*
Busby, Thomas Lord *DcBrBI*
Buscaglia, Jose 1938- *WhoAmA 73, –76, –78, –80, –82,*
–84
Buscema, John 1927- *WorECom*
Busch, August Otto Ernst VonDem 1704-1779 *IlDcG*
Busch, Clarence F 1887- *WhAmArt 85*
Busch, Donald Kenneth 1930- *AmArch 70*
Busch, Elizabeth W 1897- *DcWomA, WhAmArt 85*
Busch, Frederik 1825-1883 *MacBEP*
Busch, Gerald Allen 1929- *AmArch 70*
Busch, Mrs. H M *DcVicP 2*
Busch, Hans *WhAmArt 85*

Busch, Joseph Frank 1932- *AmArch 70*
Busch, Julia M 1940- *WhoAmA 76, –78, –80, –82*
Busch, Julius Theodore 1821-1858 *NewYHSD*
Busch, Wendelin A 1872- *DcWomA*
Busch, Wilhelm 1832-1908 *McGDA, WorECom*
Buscheto *MacEA*
Buschman, Frederick *FolkA 86*
Buschmann, Florence K *DcWomA*
Buschor, Charles *FolkA 86*
Buschulte, Wilhelm 1923- *DcCAr 81*
Buseau, Marie Jeanne *DcWomA*
Busebaum, Richard *WhAmArt 85*
Busenbark, E J *WhAmArt 85*
Busenbenz-Scoville, V 1896- *WhAmArt 85*
Busenbenz-Scoville, Virginia 1896- *DcWomA*
Busey, Norval H 1845- *WhAmArt 85*
Busfield, William *AntBDN Q*
Bush, Agnes S *WhAmArt 85*
Bush, Agnes Selene *ArtsAmW 3, DcWomA*
Bush, Arthur H 1925- *AmArch 70*
Bush, Beverly *WhoAmA 73, –76, –78, –80, –82, –84*
Bush, Charles G *EarABI SUP*
Bush, Charles G 1842-1909 *WhAmArt 85*
Bush, Charles Green 1842-1909 *WorECar*
Bush, Charles Robert *WhoAmA 78, –80, –82, –84*
Bush, Donald John *WhoAmA 76, –78, –80, –82, –84*
Bush, Ella Shepard *ArtsAmW 1*
Bush, Ella Shepard 1863-1950? *WhAmArt 85*
Bush, Ella Shepard 1863-1953? *DcWomA*
Bush, Ella Shepart *WhoAmA 78N, –80N, –82N,*
–84N
Bush, Elwyn 1931- *AfroAA*
Bush, F W *AmArch 70*
Bush, Flora *DcBrA 1, DcBrWA, DcWomA*
Bush, G Felicity 1913- *DcBrA 1*
Bush, Gary G 1950- *MarqDCG 84*
Bush, Harry 1883-1957 *ClaDrA, DcBrA 1*
Bush, Jack 1909- *ConArt 77, WhoAmA 73, –76*
Bush, Jack 1909-1977 *ConArt 83, WhoAmA 78N,*
–80N, –82N, –84N
Bush, Jack Hamilton 1909-1977 *OxTwCA*
Bush, John A 1836-1865 *FolkA 86*
Bush, Joseph Henry 1793-1965 *NewYHSD*
Bush, Lucile Elizabeth 1904- *WhoAmA 73, –76, –78,*
–80, –82
Bush, Margaret Fairman *WhAmArt 85*
Bush, Margaret W *WhAmArt 85*
Bush, Marian Spore d1946 *WhAmArt 85*
Bush, Martin H 1930- *WhoAmA 82, –84*
Bush, Martin Harry 1930- *WhoAmA 76, –78, –80*
Bush, Noel Laura 1887-1956 *DcWomA*
Bush, Norton 1834- *ArtsNiC*
Bush, Norton 1834-1894 *ArtsAmW 1, EarABI,*
IlBEAAW, NewYHSD
Bush, Philip *NewYHSD*
Bush, Phyllis Madeleine Hylie 1896- *DcWomA*
Bush, Reginald Edgar James 1869- *ClaDrA*
Bush, Reginald Edgar James 1869-1956 *DcBrA 1,*
DcVicP 2
Bush, Richard J *ArtsAmW 1*
Bush, Robert Edward 1920- *AmArch 70*
Bush, Robert Lee 1923- *AmArch 70*
Bush, Thomas *BiDBrA*
Bush, Vanette Camp *DcWomA, WhAmArt 85*
Bush, W *FolkA 86*
Bush, William Broughton *WhoAmA 80N, –82N,*
–84N
Bush, William Broughton 1911-1960? *WhAmArt 85*
Bush, William H 1849-1931 *WhAmArt 85*
Bush-Brown, Albert 1926- *WhoAmA 73, –76, –78, –80,*
–82, –84
Bush-Brown, Harold 1888- *AmArch 70*
Bush-Brown, Henry K 1857-1935 *WhAmArt 85*
Bush-Brown, Henry Kirke 1857-1935 *BnEnAmA,*
IlBEAAW
Bush-Brown, Lydia 1887- *DcWomA, WhAmArt 85*
Bush-Brown, Margaret 1857-1944 *DcWomA*
Bush-Brown, Margaret Lesley 1857-1944*
WhAmArt 85
Bush-Brown, Marjorie *DcWomA*
Bush-Brown, Marjorie Conant *WhAmArt 85*
Bush-Buisson, Margaret Phillips *DcWomA*
Bushby, Annie Amelia *DcWomA*
Bushby, Asa *FolkA 86*
Bushby, Asa 1834-1897 *NewYHSD*
Bushby, Lady Frances 1838-1925 *DcBrBI*
Bushby, Thomas 1861-1918 *DcBrA 1, DcBrWA,*
DcVicP 2
Bushe, Frederick 1931- *WhoArt 80, –82, –84*
Bushe, Letitia d1757 *DcWomA*
Bushee, Helen E *DcWomA*
Bushell, A *DcWomA*
Bushell, Wayne Nelson 1948- *MarqDCG 84*
Busher, Charles *NewYHSD*
Bushey, George Weller 1929- *AmArch 70*
Bushka, Edward Bernard 1924- *AmArch 70*
Bushkin, Aleksandr Ivanovich 1896-1929 *WorECar*
Bushman, David Franklin 1945- *WhoAmA 76, –78,*
–80, –82, –84
Bushmiller, Ernest 1905- *WorECom*

Bushmiller, Ernest Paul 1905- *WhAmArt 85*
Bushmiller, Ernie Paul 1905- *WhoAmA 73, -76, -78, -80, -82, -84*
Bushnell, A *DcBrBI*
Bushnell, Adelyn *WhAmArt 85*
Bushnell, Della O *WhAmArt 85*
Bushnell, Della Otis 1858-1964 *ArtsAmW 3*
Bushnell, E L *NewYHSD*
Bushnell, John d1701 *OxArt*
Bushnell, Kenneth Wayne 1933- *WhoAmA 82, -84*
Bushnell, Marietta P 1932- *WhoAmA 78, -80, -82, -84*
Bushwry, Francis *NewYHSD*
Busi, Giovanni De *McGDA*
Busick, Edward L *MarqDCG 84*
Busing, D W *AmArch 70*
Busino, Orlando 1926- *ConGrA 1[port]*
Busino, Orlando Francis 1926- *WhoAmA 76, -78, -80, -82, -84, WorECar*
Busk, E M *ClaDrA, DcVicP 2, DcWomA*
Busk, William *DcVicP 2*
Busketter, Barbara *FolkA 86*
Buskirk, John A *NewYHSD*
Buskirk, P K *AmArch 70*
Buson 1716-1783 *McGDA*
Busoni, Rafaello 1900- *IlsCB 1744, -1946, -1957, WhAmArt 85*
Buss, C G *NewYHSD*
Buss, R W 1804-1875 *DcBrBI*
Buss, Robert William 1804-1874 *DcVicP, -2*
Buss, Robert William 1804-1875 *ArtsNiC, DcBrWA*
Buss, Septimus *DcVicP 2*
Bussabarger, Robert Franklin 1922- *WhoAmA 76, -78, -80, -82, -84*
Bussard, H Kennard 1936- *AmArch 70*
Busschop, Cornelis *McGDA*
Busse, Fritz 1903- *WhoGrA 62, -82[port]*
Busse, Herman *NewYHSD*
Busse, Jacques 1922- *OxTwCA*
Busse, Rido 1934- *ConDes*
Busse, William Hoff 1927- *AmArch 70*
Bussell, Joshua H *FolkA 86*
Busselle, A, Jr. *AmArch 70*
Busset, G *DcWomA*
Bussey, Reuben 1818-1893 *DcBrWA, DcVicP 2*
Bussi, Caterina Angiola *DcWomA*
Bussola, Dionigi 1612-1687 *McGDA*
Bussy, Simon 1870-1954 *DcBrA 2*
Bustard, R A *AmArch 70*
Bustelli, Franz Anton 1723-1763 *AntBDN M, DcD&D, McGDA, OxDecA*
Buster, Jacqueline Mary 1926- *WhoAmA 78, -80, -82, -84*
Busti, Agostino 1483-1548 *McGDA*
Bustin, Newell Newton *AmArch 70*
Bustino, Il *McGDA*
Bustion, Nathaniel 1942- *AfroAA*
Bustos, Hermenegildo 1832-1907 *McGDA*
Busvine *WorFshn*
Busy, Estelle *ArtsEM, DcWomA*
Buszko, Henry 1924- *ConArch*
Buszko And Franta *ConArch*
Butakov, Olga Nikolaiewna *DcWomA*
Butaud, Isaac *NewYHSD*
Butcher, Donald P 1934- *AmArch 70*
Butcher, Dora Keen 1905- *WhAmArt 85*
Butcher, Enid Constance *DcBrA 1*
Butcher, Gertrude Wiser 1898- *DcWomA, WhAmArt 85*
Butcher, Perry LaVerne 1936- *AmArch 70*
Butchkes, Sydney 1922- *AmArt, WhoAmA 73, -76, -78, -80, -82, -84*
Bute, Mary Ellen 1914?- *WorECar*
Buteaux, Abraham *AntBDN Q*
Butell, Bart 1947- *MarqDCG 84*
Butensky, Jules Leon 1871- *WhAmArt 85*
Butera, Anne Fabbri *WhoAmA 80, -82, -84*
Butera, Joseph 1905- *WhAmArt 85*
Butet, John Francis *NewYHSD*
Buthe, Michael 1944- *ConArt 77, -83, DcCAr 81*
Butin, Ulysse-Louis-Auguste d1883 *ArtsNiC*
Butin, Ulysse Louis Auguste 1837-1883 *ClaDrA*
Butina, Marko 1950- *DcCAr 81*
Butinone, Bernardino *McGDA*
Butland, David 1943- *MarqDCG 84*
Butland, G W *DcSeaP, DcVicP 2*
Butland, Judith *MarqDCG 84*
Butler *NewYHSD*
Butler, Lady 1846-1933 *DcBrBI*
Butler, A J *FolkA 86*
Butler, Aaron *FolkA 86*
Butler, Abel *FolkA 86*
Butler, Alice Caroline *WhoArt 80, -82, -84*
Butler, Alice Caroline 1909- *ClaDrA, DcBrA 1*
Butler, Andrew R 1896- *ArtsAmW 2, WhAmArt 85*
Butler, Andrew R 1896-1979? *GrAmP*
Butler, Ann 1813- *FolkA 86*
Butler, Anthony 1927- *WhoArt 80, -82, -84*
Butler, Arnette *DcWomA*
Butler, Arthur Stanley George 1888-1965 *DcBrA 1*
Butler, Auriol *WhoArt 80, -82, -84*

Butler, Auriol 1915- *DcBrA 1*
Butler, B D 1821?- *NewYHSD*
Butler, Benjamin F *NewYHSD*
Butler, Bessie Sanders *DcWomA*
Butler, Bessie Sanders 1868- *ArtsAmW 2*
Butler, Bessie Sandes *WhAmArt 85*
Butler, Bessie Sandes 1868- *ArtsAmW 2*
Butler, Bryon W 1949- *MarqDCG 84*
Butler, Byron C 1918- *WhoAmA 80, -82, -84*
Butler, Catherine *FolkA 86*
Butler, Charles Burgess *WhAmArt 85*
Butler, Charles Ernest 1864- *DcBrA 1*
Butler, Charles Ernest 1864-1918? *DcVicP 2*
Butler, Clehorow Caroline *DcWomA*
Butler, Courtland 1871- *ArtsAmW 2*
Butler, Courtland L 1871- *WhAmArt 85*
Butler, David 1898- *FolkA 86*
Butler, David Thomas 1928- *AmArch 70*
Butler, Dorothy Dennison *WhoAmA 78, -80, -82*
Butler, E F *DcVicP 2*
Butler, Edward B 1853-1928 *WhAmArt 85*
Butler, Edward Burgess 1853-1928 *ArtsAmW 2*
Butler, Edward Smith 1848- *WhAmArt 85*
Butler, Elizabeth Southerden 1850?-1933 *DcWomA*
Butler, Lady Elizabeth Southerden 1846-1933 *ClaDrA, DcBrA 1, DcBrWA, DcVicP, -2*
Butler, Lady Elizabeth Southerden T 1850-1933 *WomArt*
Butler, Esteria *FolkA 86, NewYHSD*
Butler, Esteria 1814-1891 *DcWomA*
Butler, F L *AmArch 70*
Butler, F P *NewYHSD*
Butler, Frances 1940- *ConDes*
Butler, Frank A *AntBDN M*
Butler, Gamaliel *CabMA*
Butler, Gaspar *DcSeaP*
Butler, George 1904- *DcBrA 1, WhoArt 80, -82, -84*
Butler, George B, Jr. *ArtsNiC*
Butler, George Bernard 1838-1907 *ArtsAmW 1, WhAmArt 85*
Butler, George Bernard, Jr. 1838-1907 *NewYHSD*
Butler, George Edmund 1872- *DcBrA 1*
Butler, George Edmund 1872-1936 *DcBrA 2*
Butler, George Keith *AmArch 70*
Butler, George Tyssen 1943- *ICPEnP A, MacBEP*
Butler, H H *WhAmArt 85*
Butler, Helen Sharples 1885- *DcWomA, WhAmArt 85*
Butler, Herbert E *DcBrA 2*
Butler, Herman John 1882- *WhAmArt 85*
Butler, Horacio 1897- *IlsCB 1744, McGDA, OxTwCA, PhDcTCA 77*
Butler, Howard *WhAmArt 85*
Butler, Howard Joe 1914- *AmArch 70*
Butler, Howard Russell 1856-1934 *ArtsAmW 2, IIBEAAW, WhAmArt 85*
Butler, J B *FolkA 86, NewYHSD*
Butler, J J P *WhAmArt 85*
Butler, J Stacey *DcVicP 2*
Butler, Jack 1947- *MacBEP*
Butler, James *DcBrECP, WhAmArt 85*
Butler, James 1931- *WhoArt 80, -82, -84*
Butler, James D 1945- *WhoAmA 78, -80, -82, -84*
Butler, Jerome Roger, Jr. 1928- *AmArch 70*
Butler, Jo 1937- *AfroAA*
Butler, John *WhAmArt 85*
Butler, John 1890- *WhAmArt 85*
Butler, John Ben 1948- *MarqDCG 84*
Butler, John C 1952- *ClaDrA*
Butler, John Davidson 1890- *ArtsAmW 3*
Butler, John M *NewYHSD*
Butler, Joline J *NewYHSD*
Butler, Jonathan Fairchild 1904- *AmArch 70*
Butler, Joseph 1901- *WhoAmA 73, -76, -78, -80, -82*
Butler, Joseph 1901-1981 *WhoAmA 84N*
Butler, Joseph G, Jr. 1840-1927 *WhAmArt 85*
Butler, Joseph Thomas 1932- *WhoAmA 73, -76, -78, -80, -82, -84*
Butler, L *FolkA 86*
Butler, Leonard C 1898- *WhAmArt 85*
Butler, M F *BiDAmAr*
Butler, Margaret 1890- *DcWomA*
Butler, Marigene H 1931- *WhoAmA 76, -78, -80, -82, -84*
Butler, Marilla *FolkA 86*
Butler, Martha 1717- *FolkA 86*
Butler, Mary d1946 *WhAmArt 85*
Butler, Mary 1865-1946 *ArtsAmW 2, DcWomA*
Butler, Mary E *DcBrWA, DcVicP 2, DcWomA*
Butler, Mildred Anne 1858-1941 *ClaDrA, DcBrA 1, DcBrWA, DcVicP, -2, DcWomA*
Butler, Minerva 1821-1912 *FolkA 86*
Butler, Neal Wendall 1918- *AmArch 70*
Butler, Nellie 1925- *FolkA 86*
Butler, Nina H *DcVicP 2, DcWomA*
Butler, O C, Jr. *AmArch 70*
Butler, Paul 1947- *DcCAr 81*
Butler, Paula *DcWomA*
Butler, Penelope *DcWomA*
Butler, Philip A *WhAmArt 85*

Butler, Reg *WhoArt 84N*
Butler, Reg 1913- *ConArt 77, ConBrA 79[port], DcCAr 81, OxArt, OxTwCA, PhDcTCA 77, WhoArt 80, -82, WorArt[port]*
Butler, Reg 1913-1981 *ConArt 83*
Butler, Reginald 1913- *DcBrA 1*
Butler, Reginald Cottrell 1913- *McGDA*
Butler, Reuben *FolkA 86*
Butler, Richard *DcVicP, -2*
Butler, Richard Gerald Ernest 1921- *DcBrA 1, WhoArt 80, -82, -84*
Butler, Robert Alcius 1887-1959 *ArtsAmW 3*
Butler, Mrs. Royal Oertie *WhAmArt 85*
Butler, Mrs. Royal Oertle *DcWomA*
Butler, Rozel Oertle *ArtsAmW 2*
Butler, Rudolph Maximilian 1872-1943 *DcBrA 1*
Butler, S A *DcVicP 2*
Butler, Samuel 1835-1902 *DcBrA 2*
Butler, Samuel 1836-1902 *DcVicP, -2*
Butler, Sharyle 1947- *AfroAA*
Butler, T J *AmArch 70*
Butler, T W G *DcVicP 2*
Butler, Theodore E 1861-1936 *WhAmArt 85*
Butler, Thomas *DcBrECP, FolkA 86*
Butler, Thomas C *FolkA 86*
Butler, Thomas R *NewYHSD*
Butler, Thomas W *NewYHSD*
Butler, Timothy *FolkA 86*
Butler, Vincent 1933- *WhoArt 80, -82, -84*
Butler, Violet Victoria *DcWomA*
Butler, W *FolkA 86*
Butler, Warren C 1826-1878 *NewYHSD*
Butler, William *FolkA 86*
Butler, William E *DcVicP 2*
Butler, William F 1867-1918 *MacEA*
Butman, Frederick A 1820-1871 *ArtsAmW 1, IIBEAAW, NewYHSD*
Butner, E S *AmArch 70*
Butner, Fred Washington, Jr. 1927- *AmArch 70*
Butner, Kathryn Elizabeth 1914- *WhAmArt 85*
Butsele, Gusta Van d1892? *DcWomA*
Butt, A W, Jr. *AmArch 70*
Butt, Arnold Frederick 1922- *AmArch 70*
Butt, Cecily Vivien 1886- *DcBrA 1, DcWomA*
Butt, Frederick *NewYHSD*
Butt, J Acton *DcVicP 2*
Butt, Lawson 1905- *AmArch 70*
Butt, Sidney 1953- *DcCAr 81*
Buttar, Edward James 1873- *DcBrA 1*
Buttenfield, Barbara Pfeil *MarqDCG 84*
Butter, Edward James 1873- *ClaDrA*
Butter, Tom 1952- *WhoAmA 82, -84*
Butterbaugh, Robert Clyde 1931- *WhoAmA 73, -76, -78, -80, -82, -84*
Butterfield, Clement *DcVicP 2*
Butterfield, Deborah 1949- *ConArt 83*
Butterfield, Deborah K 1949- *DcCAr 81*
Butterfield, Deborah Kay 1949- *AmArt, WhoAmA 80, -82, -84*
Butterfield, J *FolkA 86*
Butterfield, M *ArtsAmW 2*
Butterfield, Mellona Moulton 1853- *DcWomA*
Butterfield, R O *AmArch 70*
Butterfield, Richard David 1909- *AmArch 70*
Butterfield, Robert 1927- *AmArch 70*
Butterfield, Ron 1920- *WhoArt 80, -82, -84*
Butterfield, Samuel *FolkA 86*
Butterfield, Sarah Harriet Anne 1953- *WhoArt 84*
Butterfield, Wells D 1859-1936 *BiDAmAr*
Butterfield, Wells Duane 1859-1936 *ArtsEM*
Butterfield, William 1814-1900 *DcD&D, DcNiCA, MacEA, McGDA, OxArt, WhoArch*
Buttersworth, J E *DcVicP 2*
Buttersworth, James E 1817-1894 *BnEnAmA, FolkA 86, NewYHSD*
Buttersworth, James Edward 1817-1894 *DcAmArt, DcSeaP*
Buttersworth, Thomas *DcBrWA*
Buttersworth, Thomas 1768-1842 *DcSeaP*
Butterton, J *DcVicP 2*
Butterton, John *NewYHSD*
Butterton, Mary *DcVicP 2*
Butterworth, A H *NewYHSD*
Butterworth, Alice *DcWomA*
Butterworth, Blanche 1853-1915 *DcWomA*
Butterworth, Ellen 1873?-1959 *ArtsAmW 3*
Butterworth, George *DcVicP 2*
Butterworth, Grace Marie *ClaDrA*
Butterworth, J *DcVicP 2*
Butterworth, John *AntBDN O*
Butterworth, John Malcolm 1945- *WhoArt 80, -82, -84*
Butterworth, Joseph *BiDBrA*
Butterworth, Margaret *DcBrA 2*
Butterworth, Michael 1942- *MarqDCG 84*
Butterworth, Rod 1901- *WhAmArt 85*
Buttfield, Helen 1929- *ICPEnP A, MacBEP*
Buttgereit, Wilhelmine 1851- *DcWomA*
Butti, Guido *NewYHSD*
Buttlar, Augusta Von d1857 *DcWomA*
Buttles, Mary *DcWomA*

Buttling, Avery *FolkA 86*
Buttner, Helene 1861- *DcWomA*
Buttolph, Susy *DcWomA*
Button, Albert Prentice 1872- *WhAmArt 85*
Button, Charly Ronald 1955- *MarqDCG 84*
Button, John 1929- *DcCAA 77, PrintW 83,*
WhoAmA 73, –76
Button, John 1929-1982 *PrintW 85*
Button, Joseph J 1822?- *NewYHSD*
Button, Joseph P 1864-1931 *WhAmArt 85*
Button, Kate *DcVicP 2, DcWomA*
Button, Maud Ireland *DcWomA*
Button, S D 1813-1897 *MacEA*
Button, Stephen D 1803-1897 *BiDAmAr*
Buttram, Carrie *WhAmArt 85*
Buttre, John Chester 1821-1893 *NewYHSD*
Buttre, William *FolkA 86*
Buttrick, Frank *ArtsEM*
Buttrick, Harold Edgar 1931- *AmArch 70*
Buttrick, Nathan, Jr. 1811- *CabMA*
Buttrick, Stedman *WhAmArt 85*
Buttrick, Sue K 1883- *WhAmArt 85*
Buttrill, Lee Roy 1912- *AmArch 70*
Butts, Alfred M 1899- *WhAmArt 85*
Butts, Amanda E *DcWomA*
Butts, Amy *DcVicP 2, DcWomA*
Butts, F A *FolkA 86*
Butts, H Daniel, III 1939- *WhoAmA 78, –80, –82, –84*
Butts, John 1728?-1765 *DcBrECP*
Butts, Kenneth LeRoy 1924- *AmArch 70*
Butts, Porter 1903- *WhoAmA 73, –76, –78, –80, –82*
Butts, Porter Freeman 1903- *WhAmArt 85*
Butts, Ralph *NewYHSD*
Butts, Richard *NewYHSD*
Buttuls, Peter Imants 1937- *MarqDCG 84*
Buttura, M *DcVicP 2*
Butty, Francis *AntBDN Q*
Butyrin, Vitaly 1947- *ConPhot, ICPEnP A,*
MacBEP
Butz, Edward M 1859-1916 *BiDAmAr*
Butz, Jack Richard 1924- *AmArch 70*
Butz, Mary *FolkA 86*
Butzbach, Douglas Wayne 1932- *AmArch 70*
Butze Oliver, German 1912- *WorECom*
Butzow, Nathalie De *DcWomA*
Buxell, Irvin John, Jr. 1929- *AmArch 70*
Buxo Pla, Carlos A *AmArch 70*
Buxton, A *DcVicP 2*
Buxton, A J *DcVicP 2*
Buxton, Albert Sorby 1867-1932 *DcBrWA*
Buxton, Alfred 1883- *DcBrA 1*
Buxton, Amy L *DcVicP 2*
Buxton, Charles *NewYHSD*
Buxton, Dudley *DcBrBI, WorECar*
Buxton, Hannah P *DcWomA, FolkA 86*
Buxton, Jennifer 1937- *WhoArt 84*
Buxton, Jessamine Victoria Alexandrina 1894-1966
DcWomA
Buxton, John 1685-1731 *BiDBrA*
Buxton, Robert Hugh 1871- *DcBrA 1*
Buxton, William Graham *DcVicP 2*
Buyck, Edward P 1888- *WhAmArt 85*
Buyer, Alfred *FolkA 86*
Buyers, Donald Morison 1930- *WhoArt 82, –84*
Buys, Arthur Francis 1874-1924 *BiDAmAr*
Buys, Cornelis *OxArt*
Buys, Cornelis, II 1525?-1546 *ClaDrA*
Buys, Gertrude *DcWomA*
Buyskes, Johanna Helena 1840-1869 *DcWomA*
Buytewech, Willem 1591?-1624? *OxArt*
Buytewech, Willem Pieter 1585?-1628? *ClaDrA*
Buytewech, Willem Pietersz *McGDA*
Buzard, R T *AmArch 70*
Buzard, Richard Edward 1922- *AmArch 70*
Buzby, Rosella T 1867- *DcWomA, WhAmArt 85*
Buzek, Irene M 1891- *DcWomA, WhAmArt 85*
Buzkova, Helena 1931- *MarqDCG 84*
Buzzard, Roger Frederick 1925- *AmArch 70*
Buzzati, Dino 1906-1972 *IlsCB 1946*
Buzzell, Jim 1932- *MarqDCG 84*
Buzzelli, Guido 1927- *WorECom*
Buzzelli, Joseph Anthony 1907- *WhAmArt 85,*
WhoAmA 73, –76, –78, –80, –82, –84
By, Andre Bernard 1955- *MarqDCG 84*
By, John 1779-1836 *MacEA*
Byar, N G *AmArch 70*
Byard, Carole Marie 1941- *WhoAmA 76, –78, –80, –82, –84*
Byard, Dorothy Randolph *DcWomA, WhAmArt 85*
Byard, Florence *DcVicP 2*
Byard, Frederick *DcVicP 2*
Byars, Donna *WhoAmA 78, –80, –82, –84*
Byatt, Edwin 1888-1948 *DcBrA 1*
Bybee, Mrs. Addison *DcWomA, WhAmArt 85*
Byberin, Barbara *FolkA 86*
Bye, Arthur Edwin 1885- *WhAmArt 85*
Bye, Ranulph 1916- *AmArt, WhAmArt 85,*
WhoAmA 73, –76, –78, –80, –82, –84
Byer *NewYHSD*
Byer, Alexander *WhAmArt 85*
Byer, Samuel 1885- *WhAmArt 85*

Byerley, Edwin *FolkA 86*
Byerly, C H *AmArch 70*
Byers, Donovan Clark 1912- *AmArch 70*
Byers, Evelyn *WhAmArt 85*
Byers, Evelyne Bessell *DcWomA*
Byers, J W *AmArch 70*
Byers, James Lee 1932- *DcCAr 81*
Byers, Maryhelen 1902- *WhAmArt 85*
Byers, Michael Donovan 1940- *MarqDCG 84*
Byers, Ruth Felt 1888- *ArtsAmW 3, DcWomA,*
WhAmArt 85
Byers, William 1834?- *NewYHSD*
Byfield, Barbara Ninde 1930- *IlsBYP*
Byfield, Charles Howard, II 1908- *AmArch 70*
Byfield, George 1756?-1813 *BiDBrA*
Byfield, J *DcBrECP*
Byfield, Lionel E 1909- *AmArch 70*
Byfield, Mary *DcWomA*
Byfield, N *NewYHSD*
Bygate, Joseph E *DcVicP 2*
Bygland, Brian 1959- *MarqDCG 84*
Byington, Martin *FolkA 86*
Bykeepers, C *FolkA 86*
Bylert, Jan Van *McGDA*
Bylert, Jan Van 1603-1671 *ClaDrA*
Byles, Abgail 1746?- *FolkA 86*
Byles, H D *AmArch 70*
Byles, W Hounson *DcBrA 2*
Byles, W Housman *DcBrBI*
Byles, William Hownsom *DcVicP 2*
Bylina, Michal 1904- *WhoGrA 62*
Bynam, Benjamin *NewYHSD*
Byne, Arthur G 1884?-1935 *WhAmArt 85*
Byng, Edward 1676?-1753 *DcBrECP*
Byng, Leonard H R 1920- *DcBrA 1*
Byng, Leonard H R 1920-1974 *DcBrA 2*
Byng, Robert d1720 *DcBrECP*
Bynum, B *FolkA 86*
Bynum, E Anderson 1922- *WhoAmA 76, –78, –80, –82, –84*
Bynum, Muton Otto 1908- *AmArch 70*
Byram, Henry *ArtsEM*
Byram, Joseph H *NewYHSD*
Byram, Ralph S 1881- *WhAmArt 85*
Byramji, Homi M 1952- *MarqDCG 84*
Byrd, D Gibson 1923- *WhoAmA 73, –76, –78, –80, –82, –84*
Byrd, David Robert 1921- *AmArch 70*
Byrd, Eddie 1943- *AmGrD[port]*
Byrd, Frederick *NewYHSD*
Byrd, Grady *IlsBYP*
Byrd, Henry *NewYHSD*
Byrd, Jerry 1947- *AmArt*
Byrd, Mary *WhAmArt 85*
Byrd, Robert *IlsCB 1967*
Byrd, Robert John 1942- *WhoAmA 78, –80, –82, –84*
Byrd, William Hamilton 1935- *AmArch 70*
Byres, James 1734-1817 *BiDBrA, DcBrECP*
Byrley, Frank J 1906- *FolkA 86*
Byrne *NewYHSD*
Byrne, Anne Frances 1775-1837 *DcBrWA, DcWomA*
Byrne, Barry 1883-1968 *MacEA*
Byrne, Charles Joseph 1943- *WhoAmA 78, –80, –82, –84*
Byrne, Claude *DcBrBI*
Byrne, E R *DcBrBI*
Byrne, Elizabeth *DcVicP 2*
Byrne, Elizabeth 1784-1874 *DcWomA*
Byrne, Ellen A 1858- *WhAmArt 85*
Byrne, Ellen Abert 1858-1947 *DcWomA*
Byrne, Gustavus *AntBDN Q*
Byrne, J *DcVicP 2*
Byrne, James Richard 1950- *WhoAmA 78*
Byrne, John 1786-1847 *DcBrWA, DcVicP 2*
Byrne, John 1940- *WhoArt 80, –82, –84*
Byrne, Kiki 1937- *FairDF ENG*
Byrne, Letitia *DcBrWA, DcVicP*
Byrne, Letitia 1779-1849 *DcVicP 2, DcWomA*
Byrne, Mary 1776-1845 *DcWomA*
Byrne, Robert 1902- *WhAmArt 85*
Byrne, William S *DcVicP 2*
Byrnes, Caleb *CabMA*
Byrnes, Eugene 1889-1974 *WorECom*
Byrnes, Gene *WhAmArt 85*
Byrnes, James Bernard 1917- *WhoAmA 73, –76, –78, –80, –82, –84*
Byrnes, S P *WhAmArt 85*
Byrnes, Thomas John 1935- *MarqDCG 84*
Byroll-Schultheiss *DcWomA*
Byrom, William *BiDBrA*
Byron, Charles Anthony 1919- *WhoAmA 78, –80, –82, –84*
Byron, Charles Anthony 1920- *WhoAmA 73, –76*
Byron, Charles B *EncASM*
Byron, Frederick George 1764- *DcBrWA*
Byron, Frederick George 1764-1792 *DcBrECP*
Byron, Gene 1915- *WhoAmA 76, –78, –80*
Byron, Henry *NewYHSD*
Byron, Isabella *DcWomA*
Byron, John *DcBrWA*
Byron, Joseph 1846-1923 *MacBEP*

Byron, Percy Claude 1879-1959 *MacBEP*
Byron, Lord William 1669-1736 *DcBrECP, DcBrWA*
Byron And Vail *EncASM*
Byron-Browne, George 1908- *WhAmArt 85*
Byrum, Donald Roy 1942- *WhoAmA 80, –82, –84*
Byrum, Mary 1932- *WhoAmA 73, –76*
Byrum, Ruthven Holmes *WhoAmA 80N, –82N, –84N*
Byrum, Ruthven Holmes 1896-1960? *WhAmArt 85*
Byse, Fanny 1849- *DcWomA*
Bysel, Phillip *FolkA 86*
Byss, Maria Helena 1670-1726 *DcWomA*
Bystrom, C A *AmArch 70*
Byus, Ishmael Alan 1919- *AmArch 70*
Bywater, Elizabeth *DcVicP, –2, DcWomA*
Bywater, Katharine D M *DcVicP 2*
Bywater, Katherine D M *DcWomA*
Bywater, Marjorie 1905- *DcBrA 1*
Bywaters, Jerry 1906- *IIBEAAW, WhAmArt 85,*
WhoAmA 73, –76, –78, –80, –82, –84
Bywaters, Llewellyn *WhAmArt 85*
Byxbe, Lyman 1886- *ArtsAmW 1*
Byxbe, Lyman 1887- *WhAmArt 85*
Bzymek, Zbigniew Marian *MarqDCG 84*

C

Caffieri, Philippe 1634-1716 *OxDecA*
Caffieri, Philippe, II 1714-1774 *OxDecA*
Caffieri Family *OxArt*
Caffin, Charles Henry 1854-1918 *MacBEP*,
 WhAmArt 85
Caffrey, F *NewYHSD*
Caffrey, T *NewYHSD*
Caffyn, Mrs. John C *DcWomA*
Caffyn, Walter Wallor d1898 *DcVicP, −2*
Caffyn, William Waller *DcBrA 1*
Caflisch, Max 1915- *WhoGrA 82[port]*
Caflisch, Max 1916- *ConDes, WhoGrA 62*
Cafourek, Vaclav Vasco 1924- *AmArch 70*
Cafouros, Greg 1950- *MarqDCG 84*
Cafritz, Robert Conrad 1953- *WhoAmA 82, 84*
Cage, Curtis *AfroAA*
Cage, John 1912- *ConArt 83, DcCAr 81,*
 PrintW 83, −85, WhoAmA 80, −82, −84
Cage, Robert Fielding 1923- *WhoAmA 73, −76*
Cagle, Charles 1907- *WhAmArt 85*
Cagli, Corrado 1910- *McGDA, OxTwCA,*
 PhDcTCA 77, WhAmArt 85
Caglioti, Victor 1935- *WhoAmA 73,*
 −76, −78, −80
Cagnacci, Guido 1601-1663 *McGDA*
Cagnana, Caterina DiGiovanni Battista *DcWomA*
Cagnola, Luigi 1762-1833 *MacEA*
Cagnola, Marchese Luigi 1762-1833 *McGDA*
Cagnone, Angelo 1941- *DcCAr 81*
Cagnoni, Romano 1935- *ConPhot, ICPEnP A*
Cagwin, Leroy F *WhAmArt 85*
Cahan, Andrew 1949- *DcCAr 81*
Cahan, Samuel G d1974 *WhoAmA 76N, −78N, −80N,*
 −82N, −84N
Cahan, Samuel George d1974 *WhAmArt 85*
Cahen, E T *WhAmArt 85*
Cahen, Mathilde *DcWomA*
Cahen, Oscar *OxTwCA*
Cahen, Rosine *DcWomA*
Cahen, Sara Marguerite *DcWomA*
Cahero, Emilio G 1897- *ArtsAmW 3*
Cahill, Arthur 1879- *WhAmArt 85*
Cahill, Arthur James 1878- *ArtsAmW 1*
Cahill, Arthur James 1878-1970 *IlBEAAW*
Cahill, Bernard J S 1866-1944 *BiDAmAr*
Cahill, Clara B *ArtsEM, DcWomA*
Cahill, D B *AmArch 70*
Cahill, Helen A *WhAmArt 85*
Cahill, Holger 1893-1960 *WhoAmA 80N, −82N, −84N*
Cahill, James Francis 1926- *WhoAmA 73, −76, −78,*
 −80, −82, −84
Cahill, Katharine Kavanaugh 1890- *ArtsAmW 2*
Cahill, Katherine *DcWomA*
Cahill, Katherine Kavanaugh *WhAmArt 85*
Cahill, Richard S *DcBrWA*
Cahill, Richard Staunton *DcVicP 2*
Cahill, W H *WhAmArt 85*
Cahill, Mrs. W V *WhAmArt 85*
Cahill, William V d1924 *WhAmArt 85*
Cahill, William Vincent d1924 *ArtsAmW 1*
Cahn, Frederick 1942- *MarqDCG 84*
Cahn, H *AmArch 70*
Cahn, Marcelle 1895- *DcWomA*
Cahn, Morton S 1920- *AmArch 70*
Cahn, Samuel *WhAmArt 85*
Cahoon, Ebenezer *CabMA*
Cahoon, Hannah *FolkA 86*
Cahoon, John d1792 *CabMA*
Cahoon, Ralph *FolkA 86*
Cahoone, John Spear *CabMA*
Cahoone, Jonathan *CabMA*
Cahout, Alice France Drouart-Rousseau 1891-
 DcWomA
Cahrland, Phil *MarqDCG 84*
Cahusac, John Arthur 1802?-1866? *DcBrWA*
Cahusac, John Arthur 1802?-1867? *DcVicP 2*
Caigny, J De *DcWomA*
Caigny, Julie De *DcWomA*
Cail, C M, Jr. *AmArch 70*
Cail, William 1779- *DcBrWA*
Cailino, Angelique Rosalie Adele *DcWomA*
Caillard, Christian 1899- *DcCAr 81, OxTwCA*
Caillaud, Aristide 1902- *OxTwCA*
Caillault, Madame *DcWomA*
Caillaux, Clementine *DcWomA*
Caille, Fanny *DcWomA*
Caille, Joseph-Michel 1843-1881 *ArtsNiC*
Caille, Pierre 1912- *OxTwCA, PhDcTCA 77*
Cailleau, Mademoiselle *DcWomA*
Caillebotte, Gustave 1848-1894 *ClaDrA, McGDA,*
 OxArt
Caillet, Eulalie *DcWomA*
Cailteux, M J L *DcWomA*
Caimite 1922- *WhoAmA 76, −78, −80, −82, −84*
Cain *NewYHSD*
Cain, Abraham *FolkA 86*
Cain, August-Nicolas 1821-1894 *DcNiCA*
Cain, Auguste-Nicolas 1821-1894 *AntBDN C*
Cain, Auguste-Nicolas 1822-1894 *McGDA*
Cain, Charles William 1893- *DcBrA 1*
Cain, Charles William 1893-1962 *DcBrA 2*

Cain, David Paul 1928- *WhoAmA 82, −84*
Cain, Douglas E 1949- *MarqDCG 84*
Cain, Frank Davis, Jr. 1922- *AmArch 70*
Cain, Gerald Irwin 1923- *AmArch 70*
Cain, Howard Bruce 1918- *AmArch 70*
Cain, J Frederick, Jr. 1938- *WhoAmA 80, −82, −84*
Cain, James Frederick, Jr. 1938- *WhoAmA 73, −76,*
 −78
Cain, Jo 1904- *WhAmArt 85*
Cain, Mrs. Jo *WhAmArt 85*
Cain, John *FolkA 86*
Cain, John Donvie 1934- *AmArch 70*
Cain, Joseph 1904- *WhoAmA 73, −76*
Cain, Joseph Alexander 1920- *WhoAmA 73, −76, −78,*
 −80, −82, −84
Cain, Lillian Joy Martin 1911- *WhAmArt 85*
Cain, Martin *FolkA 86*
Cain, Michael Peter 1941- *WhoAmA 73, −76, −84*
Cain, Neville d1935 *WhAmArt 85*
Cain, Robert Buehler 1925- *AmArch 70*
Cain, Robert Sterling 1907- *WhAmArt 85*
Cain, Theron Irving 1893- *WhAmArt 85*
Cain, Walker O 1915- *AmArch 70*
Caine, Isaac *CabMA*
Caine, John *BiDBrA*
Caine, Osmund *WhoArt 80, −82, −84*
Caine, Osmund 1914- *ClaDrA, DcBrA 1*
Cains, F Blanche 1905- *WhoArt 80, −82, −84*
Cains, Gerald Albert 1932- *WhoArt 80, −82, −84*
Caircross, George d1819 *BiDBrA*
Caire *FolkA 86*
Caire, Adam *FolkA 86*
Caire, Frederick J *FolkA 86*
Caire, Jacob *FolkA 86*
Caire, John P *FolkA 86*
Caire, Marie *FolkA 86*
Caire, Nicholas John 1837-1918 *MacBEP*
Cairncross, Hugh d1808 *BiDBrA*
Cairns, Hugh *WhAmArt 85*
Cairns, John *BiDAmAr*
Cairo, Francesco Del 1598-1674 *McGDA*
Caiserman-Roth, Ghitta 1923- *DcCAr 81,*
 WhoAmA 73, −76, −78, −80, −82, −84
Caissy, Richard *DcCAr 81*
Cait, Caroline E *WhAmArt 85*
Caius, John 1510-1573 *MacEA*
Caixeiro, Joseph Lopes 1949- *MarqDCG 84*
Cajetan *WorECar*
Cajori, Charles 1921- *DcCAA 71, −77*
Cajori, Charles F 1921- *WhoAmA 73, −76, −78, −80,*
 −82, −84
Caker, Thomas 1825?- *NewYHSD*
Calabresi, Aldo 1930- *WhoGrA 62*
Calabretta, Samuel P 1923- *AmArch 70*
Calahan, James J 1841- *WhAmArt 85*
Calais, Henriette *DcWomA*
Calamar, Gloria 1921- *WhoAmA 73, −76, −84*
Calamatta, Josephine *ArtsNiC*
Calamatta, Josephine Raoul d1893 *DcWomA*
Calamatta, Luigi 1802-1869 *ArtsNiC*
Calame, Alexander 1810-1864 *McGDA*
Calame, Alexandre 1810-1864 *ArtsNiC, ClaDrA*
Calame, Juliette 1864- *DcWomA*
Calame, Justin L *NewYHSD*
Calame, Marie Anne 1775-1834 *DcWomA*
Calamech, Andrea 1514-1578 *MacEA*
Calamis *McGDA*
Calandrelli, Alexander 1834- *ArtsNiC*
Calandrino, Philip J 1925- *AmArch 70*
Calapai, Letterio *WhoAmA 73, −76, −80, −82,*
 −84
Calapai, Letterio 1903- *IlsCB 1946*
Calapai, Letterio 1904- *WhAmArt 85*
Calas, Nicolas 1907- *WhoAmA 73, −76, −78, −80, −82*
Calbert *EncASM*
Calcagni, Alfred Adolfo *AmArch 70*
Calcagno, Lawrence 1913- *AmArt, DcCAA 71, −77,*
 WhoAmA 73, −76, −78, −80, −82, −84
Calcar, Jan Stephan Of 1499-1550? *McGDA*
Calcia, Lillian Acton 1907- *WhoAmA 73*
Calcor, Gesina Van *DcWomA*
Calcott, J *DcVicP 2*
Caldara, Polidoro *McGDA*
Caldara, Polidoro 1492-1543 *ClaDrA*
Caldecott, Randolph 1846-1886 *AntBDN B, DcBrBI,*
 DcBrWA, DcVicP, −2, IlsBYP, McGDA, OxArt
Caldecott, William *AntBDN Q*
Caldelugh, Andrew *CabMA*
Calder, Alexander 1773-1849 *CabMA*
Calder, Alexander 1846-1923 *WhAmArt 85*
Calder, Alexander 1898- *BnEnAmA, ConArt 77,*
 DcCAA 71, McGDA, OxArt, WhoAmA 73, −76
Calder, Alexander 1898-1976 *ConArt 83, DcAmArt,*
 DcCAA 77, OxTwCA, PhDcTCA 77,
 PrintW 83, −85, WhAmArt 85, WhoAmA 78N,
 −80N, −82N, −84N, WorArt[port]
Calder, Alexander Milne 1846-1923 *BnEnAmA,*
 DcAmArt
Calder, Alexander Stirling 1870-1945 *BnEnAmA,*
 DcAmArt, WhAmArt 85
Calder, Clivia 1909- *WhAmArt 85*

Calder, Frank H *WhAmArt 85*
Calder, James 1790-1855 *CabMA*
Calder, James John 1907- *WhAmArt 85*
Calder, Josephine Ormond *DcWomA, WhAmArt 85*
Calder, May *DcWomA, NewYHSD*
Calder, Mildred Bussing 1907- *WhAmArt 85*
Calder, Nanette *DcWomA*
Calder, Nanette L *WhAmArt 85*
Calder, Nanette Lederer 1867?-1960 *ArtsAmW 3*
Calder, Norman Day *WhAmArt 85*
Calder, Ralph Milne 1884- *WhAmArt 85*
Calder, Scott *DcBrBI*
Calderara, Antonio 1903- *ConArt 77, OxTwCA,*
 PhDcTCA 77
Calderara, Antonio 1903-1978 *ConArt 83*
Calderari, Ottone 1730-1803 *MacEA*
Calderaro, Al 1950- *PrintW 83, −85*
Calderini, Guglielmo 1837-1916 *MacEA*
Calderon, Abelardo Alvarez *DcVicP 2*
Calderon, Juan 1938- *WhoAmA 78*
Calderon, Philip H 1833- *ArtsNiC*
Calderon, Philip Hermogenes 1833-1898 *ClaDrA,*
 DcVicP, −2
Calderon, William Frank 1865-1943 *DcBrA 1,*
 DcBrBI, DcVicP, −2
Calderwood, Kathleen 1945- *DcCAr 81*
Calderwood, Robert *AntBDN Q*
Calderwood, Ruth V *WhAmArt 85*
Calderwood, William Leadbetter 1865- *DcBrA 1*
Caldicott, H S 1870-1942 *DcBrA 1*
Caldicott, John *AntBDN P*
Caldwell, Doctor *NewYHSD*
Caldwell, Ada Bertha 1869-1937 *ArtsAmW 2,*
 DcWomA
Caldwell, Atha Haydock *DcWomA, WhAmArt 85*
Caldwell, Benjamin Hubbard, Jr. 1935- *WhoAmA 78,*
 −80, −82, −84
Caldwell, Blake Dee 1954- *MarqDCG 84*
Caldwell, Booth 1803-1872 *FolkA 86*
Caldwell, Charles H 1863-1932 *BiDAmAr*
Caldwell, Donald Henry, Jr. 1935- *AmArch 70*
Caldwell, Dorothy 1948- *DcCAr 81*
Caldwell, Edmund d1930 *DcBrA 1, DcBrBI,*
 DcVicP 2
Caldwell, Edmund 1852-1930 *ClaDrA*
Caldwell, Edward B, Jr. 1885-1945? *BiDAmAr*
Caldwell, Eleanor 1927- *WhoAmA 78, −80, −82, −84*
Caldwell, Eleanor B *DcWomA*
Caldwell, Elizabeth A *DcWomA*
Caldwell, George Walker 1866- *ArtsAmW 1*
Caldwell, H H, Jr. *AmArch 70*
Caldwell, Harry Noble 1923- *AmArch 70*
Caldwell, Helen Lee *WorFshn*
Caldwell, Henry Bryan 1918- *WhoAmA 73*
Caldwell, J E *EncASM*
Caldwell, James *FolkA 86*
Caldwell, James Thomas d1849 *DcBrWA*
Caldwell, John 1941- *WhoAmA 84*
Caldwell, John Thomas 1929- *AmArch 70*
Caldwell, Josiah *CabMA*
Caldwell, L Frank 1923- *AmArch 70*
Caldwell, L H *WhAmArt 85*
Caldwell, Martha Belle 1931- *WhoAmA 78, −80, −82,*
 −84
Caldwell, Mary Holden *DcWomA*
Caldwell, Patricia *MarqDCG 84*
Caldwell, Richard Lloyd 1939- *MarqDCG 84*
Caldwell, Robert *FolkA 86*
Caldwell, Sarah S *FolkA 86*
Caldwell, Susan Havens 1938- *WhoAmA 80, −82, −84*
Caldwell, W D *NewYHSD*
Caldwell, W H, Jr. *AmArch 70*
Caldwell, William H 1837-1899 *NewYHSD,*
 WhAmArt 85
Caldwell And Bennett *EncASM*
Cale, John W 1918- *MarqDCG 84*
Cale, Robert Allan 1940- *WhoAmA 73, −76, −78, −80,*
 −82, −84
Calef, Ebenezer 1739?-1807 *CabMA*
Calef, J H *AmArch 70*
Calegari, Antonio 1698-1777 *McGDA*
Calender, Melvin Leroy 1926- *AmArch 70*
Caler, W K *AmArch 70*
Calewaert, Louis H S *WhAmArt 85*
Caley, George Allison *DcBrWA*
Calfee, William H 1909- *WhAmArt 85*
Calfee, William Howard 1909- *WhoAmA 73, −76, −78,*
 −80, −82, −84
Calfee, William M 1910- *McGDA*
Calhoun, A R *IlBEAAW*
Calhoun, Dwight A 1948- *MarqDCG 84*
Calhoun, Eugene Harold 1906- *AmArch 70*
Calhoun, Frederic D 1883- *WhAmArt 85*
Calhoun, Larry Darryl 1937- *WhoAmA 78, −80, −82,*
 −84
Calhoun, Richard 1941- *WorECar A*
Cali, James 1921- *AmArch 70*
Caliari, Benedetto 1538-1598 *McGDA*
Caliari, Carletto 1570-1596 *McGDA*
Caliari, Carlo 1570-1596 *ClaDrA*
Caliari, Gabriele 1568-1631 *McGDA*

Caliari, Paolo *McGDA, OxArt*
Caliari, Paolo 1528-1588 *ClaDrA*
Caliari, Paolo Veronese *McGDA*
Caliendo, Frank 1927- *AmArch 70*
Califano, Edward Christopher *WhoAmA 78, -80, -82, -84*
Califano, Eugene 1893- *WhAmArt 85*
Califano, J *AfroAA*
Califano, John 1864- *WhAmArt 85*
Califano, Michael 1890- *WhAmArt 85*
Califf, John W, Jr. 1922- *AmArch 70*
Califf, Marilyn Iskiwitz 1932- *WhoAmA 73, -76, -78, -80, -82, -84*
Caliga, I H 1857- *WhAmArt 85*
Calister, James C *FolkA 86*
Calkin, Carleton Ivers 1914- *WhoAmA 73, -76, -78, -80, -82, -84*
Calkin, Lance 1859-1936 *DcBrA 1, DcBrBI, DcVicP 2*
Calkins, Bertis H 1882-1968 *ArtsAmW 2*
Calkins, Bruce Edgar 1952- *MarqDCG 84*
Calkins, D E *MarqDCG 84*
Calkins, Frank W *IlBEAAW*
Calkins, James Edwin 1923- *AmArch 70*
Calkins, Kingsley Mark 1917- *WhoAmA 76, -78, -80, -82, -84*
Calkins, Loring Gary 1884?-1960 *ArtsAmW 3*
Calkins, Loring Gary 1887-1960 *WhAmArt 85, WhoAmA 80N, -82N, -84N*
Calkins, Richard 1895-1962 *WorECom*
Calkins, Robert G 1932- *WhoAmA 78, -80, -82, -84*
Call, Charles *ArtsEM*
Call, H *FolkA 86*
Call, Joseph L 1942- *MarqDCG 84*
Call, Mary E *DcWomA, WhAmArt 85*
Call, Mary E 1874?-1967 *ArtsAmW 3*
Call, Max Lee 1925- *AmArch 70*
Call, R E *AmArch 70*
Call, Thomas 1689-1781 *CabMA*
Call, Timothy *CabMA*
Call, W *AmArch 70*
Callaghan, Charles Joseph, Jr. 1935- *AmArch 70*
Callaghan, Jerry Edward 1919- *MarqDCG 84*
Callaham, Richard *FolkA 86*
Callaham, V O, Jr. *AmArch 70*
Callahan, Caroline *ArtsAmW 2, WhAmArt 85*
Callahan, Caroline 1871- *DcWomA*
Callahan, Edgar M 1919- *AmArch 70*
Callahan, Harry 1912- *BnEnAmA, ConPhot, DcAmArt, DcCAr 81, ICPEnP, WhoAmA 78, -80, -82, -84*
Callahan, Harry M 1912- *AmArt, MacBEP*
Callahan, Jack 1911- *WhoAmA 73, -76*
Callahan, James E *DcVicP 2*
Callahan, Kenneth 1905- *DcAmArt, WhoAmA 73, -76, -78, -80, -82, -84*
Callahan, Kenneth 1906- *McGDA, PhDcTCA 77*
Callahan, Kenneth 1907- *DcCAA 71, -77*
Callahan, Kenneth L 1906- *WhAmArt 85*
Callahan, Lynn James 1928- *AmArch 70*
Callahan, Richard *FolkA 86*
Callahan, William *FolkA 86*
Callahan, William Park 1930- *AmArch 70*
Callam, Edward *ClaDrA, DcBrA 1, WhoArt 80, -82, -84*
Callan, Alice *WhAmArt 85*
Callan, Elizabeth Purvis *WhoAmA 73, -76*
Callan, James Frederick 1944- *MarqDCG 84*
Callan, James Ruskin 1932- *MarqDCG 84*
Callan, Mary Catherine 1871- *DcWomA, WhAmArt 85*
Callan, Robert B 1920- *AmArch 70*
Callanan, Richard *FolkA 86*
Callande DeChampmartin, Charles Emile 1797-1883 *ClaDrA*
Callander, Adam *DcBrECP, DcSeaP*
Callander, Henrietta Rose *DcWomA*
Callani, Maria 1778-1803 *DcWomA*
Callard, J Percy *DcVicP 2*
Callard, Lottie *DcVicP 2*
Callard, Lottie Charlotte *DcWomA*
Callard, Thomas d1774 *DcBrECP*
Callari, Barry Joseph 1929- *AmArch 70*
Callas *NewYHSD*
Callaut, Madame *DcWomA*
Callaut, Marie Juliette *DcWomA*
Callaway, Elizabeth R Jordan 1904- *WhAmArt 85*
Callaway, George *NewYHSD*
Callaway, R W *AmArch 70*
Callaway, William Frederick *DcBrBI, DcVicP 2*
Callcott, A *DcVicP 2*
Callcott, Sir Augustus Wall 1779-1844 *ClaDrA, DcBrWA, DcSeaP, DcVicP, -2, McGDA, OxArt*
Callcott, C *DcVicP 2*
Callcott, Charles *ClaDrA*
Callcott, Florence *DcBrA 1, DcWomA*
Callcott, Frank 1891- *ArtsAmW 3, WhAmArt 85, WhoAmA 73, -76*
Callcott, Frederick Thomas d1923 *DcBrA 1*
Callcott, J Stuart *DcVicP 2*

Callcott, Lady Maria 1785-1842 *DcBrWA, DcWomA*
Callcott, William *DcVicP 2*
Callcott, William J *DcVicP, -2*
Callcott, William James *DcBrWA, DcSeaP*
Calle, Josephine Antoinette DeLa *DcWomA*
Calle, Paul *OfPGCP 86*
Calle, Paul 1928- *IlrAm 1880, WhoAmA 76, -78, -80, -82, -84*
Callejo Borges, W F *AmArch 70*
Callender, Benjamin 1773-1856 *NewYHSD*
Callender, Bessie Stough 1889-1952 *DcWomA*
Callender, F Arthur *WhAmArt 85*
Callender, H R *DcBrWA*
Callender, Joseph 1751-1821 *NewYHSD*
Callender, William *CabMA*
Callery, Mary 1903- *DcCAA 71, -77, McGDA, OxTwCA, PhDcTCA 77, WhoAmA 73, -76*
Callery, Mary 1903-1977 *WhoAmA 78N, -80N, -82N, -84N, WorArt*
Callet, Antoine Francois 1741-1823 *ClaDrA*
Callias, Benigna De *DcWomA*
Callias, Marie De d1906 *DcWomA*
Callias, Suzanne De *DcWomA*
Callicot, J P *NewYHSD*
Callicott, Burton 1907- *WhAmArt 85*
Callicott, Burton Harry 1907- *WhoAmA 73, -76, -78, -80, -82, -84*
Callicrates *McGDA, OxArt*
Callihan, Hubert D 1942- *MarqDCG 84*
Callimachus *McGDA, OxArt*
Callingham, J *DcVicP 2*
Callins, Peter George 1924- *AmArch 70*
Callirhoe *DcWomA*
Callis, C Richard 1927- *MarqDCG 84*
Callis, Jo Ann 1940- *ConPhot, ICPEnP A, MacBEP*
Callis, Mary Eleanor 1877- *DcWomA*
Callisen, Sterling 1899- *WhoAmA 73, -76, -78, -80, -82, -84*
Callison, Anthony 1932- *AmArch 70*
Callison, E H *AmArch 70*
Callister, Charles Warren 1917- *ConArch*
Callistratus *OxArt*
Calliyannis, Manolis 1926- *OxTwCA*
Callmer, James Peter 1919- *AmArch 70*
Callner, Richard 1927- *WhoAmA 78, -80, -82, -84*
Callon, Colin J 1932- *DcCAr 81*
Callot, Jacques 1592-1635 *ClaDrA, McGDA, OxArt*
Callot Soeurs *FairDF FRA, WorFshn*
Callou, Mademoiselle *DcWomA*
Callow, George D *DcBrWA, DcVicP 2*
Callow, H *DcSeaP*
Callow, James W *DcVicP 2*
Callow, John 1822-1878 *ClaDrA, DcBrWA, DcSeaP, DcVicP, -2*
Callow, William 1812-1908 *ClaDrA, DcBrBI, DcBrWA, DcSeaP, DcVicP, -2, McGDA*
Callowhill, James *DcNiCA*
Callowhill, Thomas *DcNiCA*
Callwell, Anette *DcVicP 2, DcWomA*
Calm, Filen 1831?- *NewYHSD*
Calma, Monico C 1907- *WhAmArt 85*
Calman, Mel 1931- *WhoGrA 82[port]*
Calman, W 1947- *WhoAmA 84*
Calmbacher, Jeanne *DcWomA*
Calmelet, Hedwig 1814- *DcWomA*
Calmettes, Jean-Marie 1918- *OxTwCA*
Calmus, Castillio J *ArtsEM*
Calo, Aldo 1910- *OxTwCA, PhDcTCA 77*
Caloenesco, Aurelia *WhAmArt 85*
Caloenesco, Aurelia 1886-1960 *DcWomA*
Calor, Tom *DcBrBI*
Calosci, Arturo *DcVicP 2*
Calot, Marie *DcWomA*
Calot, Marie Elvina *DcWomA*
Caloutsis, Valerios 1927- *ConArt 77, -83*
Calpestri, Italo Albert, III 1933- *AmArch 70*
Calrow, Charles J 1877-1938 *BiDAmAr*
Calrow, Robert F 1916- *WhoAmA 76, -78, -80, -82, -84*
Cals, Adolphe Felix 1810-1880 *ClaDrA*
Calsbrese, Il Cavaliere *OxArt*
Calthrop, Claude Andrew 1845-1893 *DcVicP, -2*
Calthrop, Dion Clayton 1878-1937 *DcBrA 2, DcBrBI*
Calthrop, M A *DcWomA*
Calthrop, Mrs. M A *DcVicP 2*
Calvaert, Abraham Van 1642-1722 *McGDA*
Calvaert, Denis 1540-1619 *McGDA*
Calvaert, Denys 1540?-1619 *OxArt*
Calverley, Charles *ArtsNiC*
Calverley, Charles 1833-1914 *BnEnAmA, NewYHSD*
Calverly, Charles 1833-1914 *McGDA, WhAmArt 85*
Calvert, Bertha Winifred 1885- *DcWomA, WhAmArt 85*
Calvert, Charles 1785-1852 *DcBrWA, DcVicP 2*
Calvert, E 1850- *DcWomA*
Calvert, Edith L *DcBrBI, DcVicP 2*
Calvert, Edward 1799-1883 *DcBrWA, DcVicP, -2, McGDA, OxArt*
Calvert, Edwin Sherwood 1844-1898 *DcBrWA, DcVicP, -2*

Calvert, Frederick *ClaDrA, DcSeaP, DcVicP 2*
Calvert, Frederick d1845? *DcBrWA*
Calvert, Gwendoline May 1908- *WhoArt 84*
Calvert, Henry *DcVicP, -2*
Calvert, Jennie C *WhoAmA 78N, -80N, -82N, -84N*
Calvert, Jennie C 1878-1950 *WhAmArt 85*
Calvert, Jennie Cooper 1878-1948? *DcWomA*
Calvert, John *BiDBrA*
Calvert, Kenneth Elsworth 1928- *AmArch 70*
Calvert, Margaret Younglove *FolkA 86*
Calvert, Peter R 1855- *WhAmArt 85*
Calvert, Richard *NewYHSD*
Calvert, T L *AmArch 70*
Calvert, Thomas B *NewYHSD*
Calvert, Walter Lee 1932- *AmArch 70*
Calves, Marie Didiere 1883- *DcWomA*
Calvi, Lazzaro 1502-1587 *McGDA*
Calvi, Pietro *ArtsNiC*
Calvin, C C *WhAmArt 85*
Calvin, Katharine 1875- *DcWomA*
Calvin, Katherine 1875- *WhAmArt 85*
Calvin, Roy Everett 1920- *AmArch 70*
Calvo, Carmen 1950- *DcCAr 81*
Calvo, Edmond-Francois 1892-1958 *WorECom*
Calvo, Manuel *OxTwCA*
Calwil, Warren Wolfgang 1930- *AmArch 70*
Calyo, Hannibal W 1835?- *NewYHSD*
Calyo, John A 1818?-1893 *NewYHSD*
Calyo, Nicolino 1799-1884 *ArtsAmW 1, IlBEAAW, NewYHSD*
Calza *DcBrECP*
Calza-Bini, Alberto 1881-1957 *MacEA*
Calzamiglia, Francesca *DcWomA*
Calze *DcBrECP*
Calzolari, Pier Paolo 1943- *ConArt 77, -83*
Cam 1913- *IlsCB 1946*
Cam, Jean De la *IlDcG*
Cam, T V *AmArch 70*
Camacho, Jorge 1934- *ConArt 77*
Camacho, Paul 1929- *WhoAmA 73, -76*
Camaino, Tino Di *McGDA, OxArt*
Camarata, Martin L 1934- *WhoAmA 76, -78, -80, -82, -84*
Camarena, Jorge Gonzalez *McGDA, OxTwCA*
Camargo, Ibere 1914- *PhDcTCA 77*
Camargo, Sergio De *OxTwCA*
Camargo, Sergio De 1930- *ConArt 77, PhDcTCA 77*
Camaro, Alexander 1901- *McGDA, OxTwCA, PhDcTCA 77*
Camarra, David Richard 1945- *MarqDCG 84*
Camax-Zoegger, Marie Anne *DcWomA*
Cambeiro, Arturo B *AmArch 70*
Cambeiro, Domingo *AmArch 70*
Cambell *NewYHSD*
Cambell, Anna D *FolkA 86*
Cambell, George 1838?- *NewYHSD*
Cambi, Prudenza *DcWomA*
Cambi, Ulisse 1807- *ArtsNiC*
Cambiasi, Luca 1527-1585 *ClaDrA*
Cambiaso, Luca 1527-1585 *ClaDrA, McGDA*
Cambiaso, Luca 1527-1588 *OxArt*
Cambier, Juliette 1879- *DcWomA*
Camblin, Bob Bilyeu 1928- *WhoAmA 78, -80, -82, -84*
Cambon, Armand *ArtsNiC*
Cambos, Jules *ArtsNiC*
Cambrai, Jean De *McGDA*
Cambray, Marie De *DcWomA*
Cambridge Seven *ConArch*
Cambron, Ghislaine 1923- *WhoArt 80, -82, -84*
Cambronne, Jeanne Marie Leonie *DcWomA*
Cambruzzi, De *DcBrECP*
Camburas, P E *AmArch 70*
Cambuston, Henri d1861? *ArtsAmW 3*
Camden, Harry Poole, Jr. 1900-1943 *WhAmArt 85*
Camden, William *AntBDN D*
Camden, William 1551-1623 *AntBDN I*
Came, Kate E *DcWomA, WhAmArt 85*
Camelford, Lord *BiDBrA*
Camelin, Jean *McGDA*
Camerata, Giuseppe, II 1718-1803 *McGDA*
Camere, Mathilde d1906 *DcWomA*
Camerer, Eugene 1823-1898 *IlBEAAW, NewYHSD*
Camerer, Eugene 1830- *ArtsAmW 1*
Camerino, Roberta Di 1920- *WorFshn*
Camero, Blanche Gonzalez 1894- *DcWomA, WhAmArt 85*
Cameron *DcBrECP*
Cameron, Mrs. *WhAmArt 85*
Cameron, Alexander 1830-1890 *BiDAmAr*
Cameron, Anna Field 1849-1931 *ArtsAmW 1, DcWomA*
Cameron, B *DcWomA*
Cameron, Belle M *ArtsEM, DcWomA*
Cameron, Brooke Bulovsky *WhoAmA 78, -80, -82, -84*
Cameron, Mrs. Campbell *DcVicP 2, DcWomA*
Cameron, Charles 1740?-1812 *MacEA, McGDA, OxArt, WhoArch*
Cameron, Charles 1740?-1814 *DcD&D*
Cameron, Charles 1743?-1812 *BiDBrA*

Cameron, D A *AmArch 70*
Cameron, David Young 1865-1945 *ClaDrA*, *McGDA*
Cameron, Sir David Young 1865-1945 *DcBrA 1*, *DcBrBI*, *DcVicP*, *–2*, *PhDcTCA 77*
Cameron, Duncan *DcVicP*, *–2*
Cameron, Duncan F 1930- *WhoAmA 73*, *–80*, *–82*, *–84*
Cameron, Duryea 1923- *AmArch 70*
Cameron, Edgar S 1862-1944 *WhAmArt 85*
Cameron, Edgar Spier 1862-1944 *ArtsAmW 2*
Cameron, Elizabeth Wallace *DcWomA*, *WhAmArt 85*
Cameron, Ellen Elizabeth *DcWomA*
Cameron, Elsa S 1939- *WhoAmA 78*, *–80*, *–82*, *–84*
Cameron, Emma *DcWomA*, *NewYHSD*
Cameron, Eric 1935- *DcCAr 81*, *WhoAmA 78*, *–80*, *–82*, *–84*
Cameron, Glen *FolkA 86*
Cameron, Gordon Stewart 1916- *DcBrA 1*, *WhoArt 80*, *–82*, *–84*
Cameron, Hugh *ArtsNiC*
Cameron, Hugh 1835-1918 *DcBrA 1*, *DcBrBI*, *DcBrWA*, *DcVicP*, *–2*
Cameron, Hugh 1835-1920 *ClaDrA*
Cameron, James 1816?- *NewYHSD*
Cameron, James H *WhoAmA 82*, *–84*
Cameron, John *DcBrA 1*, *DcBrBI*
Cameron, John 1828?- *NewYHSD*
Cameron, John B 1830?- *NewYHSD*
Cameron, John Jackson 1872- *DcBrA 2*
Cameron, Josephine *DcWomA*
Cameron, Julia *DcVicP 2*, *DcWomA*
Cameron, Julia Margaret 1815-1879 *ICPEnP*, *MacBEP*, *WomArt*
Cameron, Katharine *IlsCB 1744*
Cameron, Katharine 1874-1965 *DcBrA 1*, *DcBrBI*
Cameron, Katherine 1874-1965 *DcWomA*
Cameron, Lilian T *DcWomA*
Cameron, Lynell Dane 1952- *MarqDCG 84*
Cameron, Margaret *DcWomA*
Cameron, Marie *DcWomA*
Cameron, Marie Gelon *WhAmArt 85*
Cameron, Mary d1921 *DcBrA 1*, *DcWomA*
Cameron, Mary Elizabeth *FolkA 86*
Cameron, Polly *IlsCB 1967*
Cameron, Polly 1928- *IlsCB 1957*
Cameron, R C *WhAmArt 85*
Cameron, R S *AmArch 70*
Cameron, Shirley 1944- *ConBrA 79[port]*
Cameron, Vincent G, Jr. *AmArch 70*
Cameron, W R 1893- *WhAmArt 85*
Cameron, William Ross 1893-1971 *ArtsAmW 2*
Cameron And Miller *ConBrA 79[port]*
Cameron-Menk, Hazel 1888- *DcWomA*, *WhAmArt 85*
Camersfelt, Anna Maria *DcWomA*
Cames, Vina 1908?- *IlBEAAW*, *WhAmArt 85*
Camesi, Gianfredo 1940- *ConArt 77*, *DcCAr 81*
Camfferman, Margaret Gove *DcWomA*
Camfferman, Margaret Gove 1895?- *DcWomA*, *IlBEAAW*
Camfferman, Margaret T Gove 1881-1964 *ArtsAmW 3*
Camfferman, Peter M 1890-1957 *ArtsAmW 1*
Camfferman, Peter Marienus 1890-1957 *IlBEAAW*, *WhAmArt 85*, *WhoAmA 80N*, *–84N*
Camfield, William Arnett 1934- *WhoAmA 78*, *–80*, *–82*, *–84*
Camhi, Morrie 1928- *MacBEP*, *WhoAmA 84*
Camiletti, Edmund *FolkA 86*
Camille, Sister 1901- *WhAmArt 85*
Caminiti, Frank 1927- *AmArch 70*
Camino Brent, Enrique *OxTwCA*
Camino Brent, Enrique 1909-1960 *McGDA*
Camins, Jacques Joseph 1904- *WhoAmA 73*, *–76*, *–78*, *–80*, *–82*, *–84*
Camirand, J D *EncASM*
Camizzi, F J *AmArch 70*
Camlet, J Thomas *AmArch 70*
Camlet, William Joseph 1930- *AmArch 70*
Camlin, James A 1918- *WhoAmA 76*, *–78*, *–80*, *–82*, *–84*
Cammarata, S J *AmArch 70*
Cammarota, S G *AmArch 70*
Cammas, Marie Anne Guilliomette G *DcWomA*
Cammell, Bernard E *DcVicP 2*
Cammerano, Michele *ArtsNiC*
Cammeyer, Augustus F *NewYHSD*
Cammeyer, DeWitt C 1828?- *NewYHSD*
Cammeyer, William, Jr. *NewYHSD*
Cammeyer, William, Sr. *NewYHSD*
Cammillieri, Nicholas *DcSeaP*
Camner, E I *AmArch 70*
Camoin, Charles 1879-1965 *ClaDrA*, *McGDA*, *OxTwCA*, *PhDcTCA 77*
Camoin, Robert J 1939- *MarqDCG 84*
Camore 1815?- *NewYHSD*
Camp, Ann 1924- *WhoArt 80*, *–82*, *–84*
Camp, Carlton Lewis 1914- *AmArch 70*
Camp, Ellen M *DcWomA*, *WhAmArt 85*
Camp, Emily *FolkA 86*

Camp, Harold M *WhAmArt 85*
Camp, Helen B *WhAmArt 85*
Camp, Helena L *DcWomA*, *WhAmArt 85*
Camp, Hiram 1811-1893 *AntBDN D*
Camp, Isabella *DcVicP 2*
Camp, Jeffery 1923- *ConBrA 79[port]*
Camp, Jeffery Bruce 1923- *WhoArt 80*, *–82*, *–84*
Camp, Jeffrey 1923- *DcCAr 81*
Camp, Jeffrey Bruce 1923- *DcBrA 1*
Camp, John Henry 1822-1881 *NewYHSD*
Camp, Karen S *MarqDCG 84*
Camp, Lucy *FolkA 86*
Camp, Robert *WhAmArt 85*
Camp, Roger 1945- *MacBEP*
Camp, William *CabMA*
Camp, William Hull 1915- *AmArch 70*
Campagna, Girolamo 1549?- *McGDA*
Campagna, Paul Rader 1917- *AmArch 70*
Campagnola, Domenico 1484-1550 *ClaDrA*
Campagnola, Domenico 1500-1552? *OxArt*
Campagnola, Domenico 1500?-1581 *McGDA*
Campagnola, Giulio 148?-1?00? *ClaDrA*
Campagnola, Giulio 1?00?-1?2? *McGDA*, *OxArt*
Campana, Antoni 190?-1?8? *?A*
Campana, Marie Chri... */omA*
Campana, Pedro 1503?- *McGDA*
Campanella, Catherine *DcVicP 2*, *DcWomA*
Campanella, Dominic Edward 1907- *AmArch 70*
Campanella, F M *AmArch 70*
Campanella, Vincent Richard *WhAmArt 85*
Campanelli, Dan 1949- *WhoAmA 80*, *–82*, *–84*
Campanelli, Daniel 1949- *WhoAmA 73*, *–76*
Campanelli, Pauline Eble *WhoAmA 82*, *–84*
Campanelli, Pauline Eble 1943- *WhoAmA 73*, *–76*
Campania, Pedro De 1503-1580 *OxArt*
Campanile, Dario 1948- *PrintW 85*
Campanini, Alfredo 1873-1926 *MacEA*
Camparet *IlBEAAW*
Campbell, John *WhAmArt 85*
Campbell *NewYHSD*
Campbell, A *EncASM*
Campbell, A G *NewYHSD*
Campbell, A S 1839-1912 *WhAmArt 85*
Campbell, Albert H 1826-1899 *ArtsAmW 1*, *IlBEAAW*, *NewYHSD*
Campbell, Alexander *NewYHSD*
Campbell, Alexander Buchanan 1914- *WhoArt 80*, *–82*, *–84*
Campbell, Alice 1908- *WhAmArt 85*
Campbell, Anne Barraud 1879-1927 *DcWomA*, *WhAmArt 85*
Campbell, Annie *DcWomA*, *WhAmArt 85*
Campbell, Archibald *DcVicP 2*
Campbell, Archibold *EncASM*
Campbell, Archie Reinald, Jr. 1932- *AmArch 70*
Campbell, Arnold James 1948- *MarqDCG 84*
Campbell, Arthur Lee 1916- *AmArch 70*
Campbell, Arthur T *MarqDCG 84*
Campbell, Barbara *IlsCB 1946*
Campbell, Benjamin 1935- *AfroAA*
Campbell, Blendon Reed 1872- *ArtsAmW 1*, *WhAmArt 85*
Campbell, Bryn 1933- *ConPhot*, *ICPEnP A*, *MacBEP*
Campbell, C Isabel *WhAmArt 85*
Campbell, C Isabel 1890- *DcWomA*
Campbell, Caecilia Margaret 1791-1857 *DcBrWA*, *DcVicP 2*
Campbell, Cecilia Margaret *DcWomA*
Campbell, Charles 1905- *WhAmArt 85*
Campbell, Charles Malcolm 1905- *WhoAmA 80*, *–82*, *–84*
Campbell, Charles Robert 1934- *AmArch 70*
Campbell, Christopher 1908- *DcBrA 1*
Campbell, Colen d1729 *DcD&D*, *OxArt*
Campbell, Colen 1676-1729 *BiDBrA*, *MacEA*, *WhoArch*
Campbell, Colin d1729 *BkIE*, *DcD&D*, *McGDA*
Campbell, Colin 1894- *DcBrA 1*
Campbell, Lady Colin *DcVicP 2*
Campbell, Colin Keith 1942- *WhoAmA 78*, *–80*, *–82*, *–84*
Campbell, Cora A 1873- *DcWomA*, *WhAmArt 85*
Campbell, Mrs. Corbett *DcVicP 2*
Campbell, D H *AmArch 70*
Campbell, Daniel *FolkA 86*
Campbell, Daniel A 1863- *NewYHSD*
Campbell, David Paul 1936- *WhoAmA 73*, *–76*, *–78*, *–84*
Campbell, Dewer *DcVicP 2*
Campbell, Donald *NewYHSD*
Campbell, Donald 1894- *AmArch 70*
Campbell, Dorothy Bostwick 1899- *DcWomA*, *WhoAmA 73*, *–76*, *–78*, *–80*, *–82*, *–84*
Campbell, Douglas A 1925- *AmArch 70*
Campbell, Douglas H *ArtsEM*
Campbell, Dugal d1757 *BiDBrA*
Campbell, Mrs. E *DcVicP 2*
Campbell, E Elmus *WhAmArt 85*
Campbell, E Simms *WhAmArt 85*
Campbell, Edmund S d1950 *WhoAmA 78N*, *–80N*,

–82N, –84N
Campbell, Edmund S 1884-1950 *WhAmArt 85*
Campbell, Edward Alfred 1915- *AmArch 70*
Campbell, Edward Morton *WhAmArt 85*
Campbell, Edward R 1820?- *NewYHSD*
Campbell, Elizabeth *DcWomA*
Campbell, Elizabeth Gratia *FolkA 86*
Campbell, Elmer Simms 1906- *AfroAA*
Campbell, Elmer Simms 1906-1971 *WorECar*
Campbell, Ernest W 1860- *EncASM*
Campbell, Ethel *WhAmArt 85*
Campbell, Fannie Soule *ArtsAmW 2*, *DcWomA*, *WhAmArt 85*
Campbell, Felicity *WhoArt 80*, *–82*
Campbell, Felicity 1909- *ClaDrA*
Campbell, Floy 1875- *WhAmArt 85*
Campbell, Frances Soule *ArtsAmW 2*
Campbell, Frederick 1926- *AfroAA*
Campbell, Gadella Graham *WhAmArt 85*
Campbell, George F *WhoArt 82N*
Campbell, George F 1917- *DcBrA 1*, *WhoArt 80*
Campbell, Georgine 1861-1931 *DcWomA*
Campbell, Gilbert William 1930- *AmArch 70*
Campbell, Gretna 1923- *WhoAmA 73*, *–76*, *–78*, *–80*, *–82*
Campbell, H *DcVicP 2*
Campbell, Mrs. H *DcVicP 2*
Campbell, Mrs. H M, Jr. *WhAmArt 85*
Campbell, Hamilton 1813?- *NewYHSD*
Campbell, Harriet Dunn *WhAmArt 85*
Campbell, Harriet Dunn 1873- *DcWomA*
Campbell, Harriet Julia *DcWomA*
Campbell, Hay *DcVicP 2*
Campbell, Helena E Ogden *WhAmArt 85*
Campbell, Helena Eastman Ogden 1879- *DcWomA*
Campbell, Heyworth 1886- *WhAmArt 85*
Campbell, Hugh Stuart *WhAmArt 85*
Campbell, I F 1874- *WhAmArt 85*
Campbell, Isabella Frowe 1874- *ArtsAmW 2*, *DcWomA*
Campbell, Isabella Graham *WhAmArt 85*
Campbell, J *NewYHSD*
Campbell, J A D *DcVicP 2*
Campbell, J Alan *NewYHSD*
Campbell, J B *DcWomA*
Campbell, J K *NewYHSD*
Campbell, J L *AmArch 70*
Campbell, J M, Jr. *AmArch 70*
Campbell, J R *AmArch 70*
Campbell, J S *AmArch 70*
Campbell, Jack *MarqDCG 84*
Campbell, Jack 1941- *MarqDCG 84*
Campbell, James *CabMA*, *FolkA 86*
Campbell, James d1809 *CabMA*
Campbell, James 1810?- *FolkA 86*
Campbell, James 1825?-1893 *DcVicP*, *–2*
Campbell, James I 1904- *AmArch 70*
Campbell, James J *EncASM*
Campbell, James Lawrence 1914- *WhoAmA 78*
Campbell, Jeanne *WorFshn*
Campbell, Jeanne Begien 1913- *WhoAmA 84*
Campbell, Jessie G *WhAmArt 85*
Campbell, Jewett 1912- *WhAmArt 85*, *WhoAmA 78*, *–80*, *–82*, *–84*
Campbell, Mrs. Jewett *WhAmArt 85*
Campbell, Joan Betty 1923- *WhoArt 82*, *–84*
Campbell, John *FolkA 86*, *NewYHSD*, *OfPGCP 86*
Campbell, John A *AmArch 70*
Campbell, John Archibald 1859-1909 *MacEA*
Campbell, John Carden 1914- *WhAmArt 85*
Campbell, John DeVries *AmArch 70*
Campbell, John Douglas 1918- *AmArch 70*
Campbell, John E *DcBrBI*
Campbell, John Francis 1822-1885 *DcBrWA*
Campbell, John Henry 1757-1828 *DcBrWA*
Campbell, John Hodgson 1855-1927 *DcBrA 1*, *DcBrWA*, *DcVicP 2*
Campbell, John P *DcBrBI*
Campbell, John Patrick *DcBrA 2*
Campbell, John Raymond 1944- *MarqDCG 84*
Campbell, Johnny *AfroAA*
Campbell, Justin *FolkA 86*
Campbell, K B *AmArch 70*
Campbell, Kenneth 1913- *WhoAmA 73*, *–76*, *–78*
Campbell, Kenneth Floyd 1925- *WhoAmA 84*
Campbell, Larry 1947- *FolkA 86*
Campbell, Lawrence 1914- *WhoAmA 73*, *–76*, *–80*, *–82*, *–84*
Campbell, Leroy Miller 1927- *AmArch 70*
Campbell, Louisa Dresser 1907- *WhoAmA 82*
Campbell, Malcolm 1934- *WhoAmA 73*, *–76*, *–78*, *–80*
Campbell, Margaret *DcWomA*
Campbell, Marion *DcWomA*
Campbell, Marjorie Dunn 1910- *WhAmArt 85*, *WhoAmA 73*, *–76*, *–78*, *–80*, *–82*, *–84*
Campbell, Mary *DcWomA*, *WhAmArt 85*
Campbell, Mary A d1919 *DcWomA*
Campbell, Mary E *DcWomA*
Campbell, Maud Hoskinson 1865- *DcWomA*
Campbell, Myfanwy *DcBrA 1*

Campbell, Myrtle Hoffman 1886- *ArtsAmW 2,*
DcWomA, WhAmArt 85
Campbell, Nora Molly *DcBrA 1, DcWomA*
Campbell, Orland 1890-1972 *WhAmArt 85,*
WhoAmA 78N, –80N, –82N, –84N
Campbell, Orson D 1876-1933 *ArtsAmW 1,*
IIBEAAW, NewYHSD , WhAmArt 85
Campbell, Oswald R *DcVicP 2*
Campbell, Patrick *NewYHSD*
Campbell, Paul *DcCAr 81*
Campbell, Pauline *DcWomA, WhAmArt 85*
Campbell, Peter *DcBrECP*
Campbell, Pryse *FolkA 86, NewYHSD*
Campbell, R E *AmArch 70*
Campbell, Reginald Henry 1877- *DcBrA 1*
Campbell, Richard Arthur 1930- *AmArch 70*
Campbell, Richard Bruce 1937- *AmArch 70*
Campbell, Richard Ernest 1931- *AmArch 70*
Campbell, Richard Horton 1921- *AmArt,*
WhoAmA 73, –76, –78, –80, –82, –84
Campbell, Richard Walter 1942- *AmArch 70*
Campbell, Robert *MarqDCG 84, NewYHSD*
Campbell, Robert L *NewYHSD*
Campbell, Ronald R 1921- *AmArch 70*
Campbell, Rosamond Sheila 1919- *WhoAmA 73*
Campbell, Samuel *DcVicP 2*
Campbell, Samuel K *EncASM*
Campbell, Sara Wendell d1960 *WhAmArt 85*
Campbell, Sara Wendell 1886-1960 *DcWomA,*
WhoAmA 80N, –82N, –84N
Campbell, Sarah *ConDes*
Campbell, Steven 1954- *PrintW 85*
Campbell, T H *DcVicP 2*
Campbell, T R *AmArch 70*
Campbell, Thomas *FolkA 86, NewYHSD ,*
WhAmArt 85
Campbell, Thomas 1790-1858 *NewYHSD*
Campbell, Thomas E 1833?- *NewYHSD*
Campbell, V Floyd d1906 *ArtsEM, WhAmArt 85*
Campbell, Virginia 1914- *IlsBYP, IlsCB 1946*
Campbell, Vivian 1919- *WhoAmA 73, –76, –78, –80,*
–82, –84
Campbell, W Addison, Jr. 1914- *WhAmArt 85*
Campbell, W Evans 1922- *AmArch 70*
Campbell, Walter Edward 1901- *AmArch 70*
Campbell, Wendell Jerome 1927- *AmArch 70*
Campbell, William 1826?- *NewYHSD*
Campbell, William 1833?- *NewYHSD*
Campbell, William B *NewYHSD*
Campbell, William Henry 1915- *WhoAmA 82, –84*
Campbell, William Patrick 1914- *WhoAmA 73, –76*
Campbell, William Patrick 1914-1976 *WhoAmA 78N,*
–80N, –82N, –84N
Campbell, William Ransom, Jr. 1920- *AmArch 70*
Campbell, William Walter, Jr. 1910- *AmArch 70*
Campbell, Yvonne Marjorie 1918- *DcBrA 2*
Campbell And Ward *CabMA*
Campbell-Brunton, Mary *DcWomA*
Campbell-Metcalf *EncASM*
Campbell-Quine, Nina 1911- *WhoArt 80, –82, –84*
Campbell-Stark, Laurel 1951- *DcCAr 81*
Campeau, N Joseph 1925- *AmArch 70*
Campen, Jacob Van 1595-1657 *DcD&D, McGDA,*
OxArt, WhoArch
Campendonk, Heinrich 1889-1957 *McGDA, OxTwCA,*
PhDcTCA 77
Campenon, Sargines *DcWomA*
Campeny, Damian 1771-1855 *McGDA*
Campero, Juan *McGDA*
Camphausen, Guillaume 1810- *ArtsNiC*
Camphuijsen, Govert Dircksz 1623?-1672 *McGDA*
Camphuijsen, Rafael Govertsz 1597?-1657 *McGDA*
Camphuysen, Dirk Rafelsz 1586-1627 *ClaDrA*
Camphuysen, Govert 1642?-1672 *OxArt*
Camphuysen, Govert Dircksz 1624?-1672 *ClaDrA*
Camphuysen, Raphael 1598-1657 *OxArt*
Campi, Antonio 1525?-1587 *McGDA*
Campi, Antonio 1536?-1591? *ClaDrA*
Campi, Bartolommeo d1573 *OxDecA*
Campi, Bernardino 1522-1591 *McGDA*
Campi, Galeazzo 1470?-1536 *McGDA*
Campi, Giulio 1500?-1572 *McGDA*
Campi, Vincenzo 1525?-1591 *McGDA*
Campigli, Massimo 1895- *ClaDrA, ConArt 77,*
McGDA
Campigli, Massimo 1895-1971 *OxTwCA,*
PhDcTCA 77, WorArt[port]
Campin, Robert *McGDA, OxArt*
Campini, Luigi 1817-1890 *McGDA*
Campini, Robert William 1920- *AmArch 70*
Campioli, Mario Ettore 1910- *AmArch 70*
Campion, George Bryant 1796-1870 *DcBrBI,*
DcBrWA, DcVicP 2
Campion, Mrs. Howard *DcVicP 2*
Campion, Howard T S *DcVicP 2*
Campion, S M *DcVicP 2*
Campion, Sarai M *DcWomA*
Campionesi, The *McGDA*
Campisi, John Vincent 1894- *AmArch 70*
Campitelli, A *AmArch 70*
Camplin, Forrest Ralph 1917- *AmArch 70*

Campling, James 1741?- *BiDBrA*
Campo, Maria *DcWomA*
Campoli, Cosmo 1922- *DcCAA 71, –77, DcCAr 81,*
WhoAmA 73, –76, –78, –80, –82, –84
Campoli, Cosmo Pietro 1922- *PhDcTCA 77*
Camporese Family *MacEA*
Campotosto, Henry d1910 *DcBrA 1, DcVicP, –2*
Campotosto, Octavia *DcVicP 2, DcWomA*
Camproger, Jeanne *DcWomA*
Camprubi, Leontine 1916- *WhAmArt 85*
Campton, James *WhAmArt 85*
Campus, Peter 1937- *ConArt 77, –83, WhoAmA 76,*
–78, –80, –82, –84
Camuccini, Vincenzo 1775-1844 *ArtsNiC*
Camurati, Albert 1917- *WhoAmA 73, –76*
Camus, Blanche Augustine *DcWomA*
Camuset, Gabrielle *DcWomA*
Camuset, Henriette *DcWomA*
Camuzet, J *DcWomA*
Canaday, John E 1907- *WhAmArt 85*
Canaday, John Edwin 1907- *WhoAmA 73, –76, –78,*
–80, –82, –84
Canaday, Ouida Gornto 1922- *WhoAmA 76, –78, –80,*
–82, –84
Canade, Eugene George 1914- *WhAmArt 85*
Canade, Vincent 1879- *WhAmArt 85*
Canade, Vincent 1880?-1961 *FolkA 86*
Canal, Antonio *McGDA*
Canal, Antonio 1697-1768 *ClaDrA*
Canal, Fabio 1703-1767 *McGDA*
Canal, Giovan Battista 1745-1825 *McGDA*
Canal, Giovanni Antonio 1697-1768 *OxArt*
Canale, Antonio 1915- *WorECom*
Canaletto *McGDA*
Canaletto 1697-1768 *DcBrECP, McGDA, OxArt*
Canaletto, Antonio 1697-1768 *ClaDrA*
Canard, Suzanne *DcWomA*
Canaris, Patti Ann 1919- *WhoAmA 76, –78, –80, –82*
Canarsac, Lafon De 1821-1905 *DcNiCA*
Canas-Herrera, Benjamin 1933- *DcCAr 81*
Canby, E Pontell *WhAmArt 85*
Canby, Ethel Poyntell 1877-1955 *DcWomA*
Canby, Jeanny Vorys 1929- *WhoAmA 76, –78, –80,*
–82, –84
Canby, Louise Prescott *DcWomA*
Cancalon, Marthe *DcWomA*
Cancellare, Frank 1910- *ICPEnP A*
Canchois, Henri *DcVicP 2*
Candau, Eugenie 1938- *WhoAmA 78, –80, –82, –84*
Candee, G E *FolkA 86*
Candee, George Edward 1838- *NewYHSD*
Candela, Felix 1910- *ConArch, DcD&D[port],*
EncMA, MacEA, McGDA, WhoArch
Candela, H F *AmArch 70*
Candell, Victor 1903- *DcCAA 71, –77, WhoAmA 73,*
–76
Candell, Victor 1903-1977 *WhAmArt 85,*
WhoAmA 78N, –80N, –82N, –84N
Candell, Victor G 1903- *ConICB*
Candelot, Marie Louise *DcWomA*
Candia, Domingo 1897- *OxTwCA*
Candid, Elia *McGDA*
Candid, Pietro *McGDA*
Candidi, Marianna *DcWomA*
Candilis, Georges *ConArch A*
Candilis, Georges 1913- *ConArch, EncMA*
Candilis Josic Woods *MacEA*
Candler, Eleanor d1947 *DcWomA*
Candler, Eleanor S *WhAmArt 85*
Candler, Mariam L d1931 *ArtsEM, DcWomA*
Candler, Marian *WhAmArt 85*
Candler, Miriam L *WhAmArt 85*
Candlin, Abbie 1885- *DcWomA, WhAmArt 85*
Candlin, Abigail 1885- *ArtsAmW 3*
Candreva, P J *AmArch 70*
Candy, Robert 1920- *IlsCB 1946*
Cane, Alice Norcross *WhAmArt 85*
Cane, Elsie M 1890- *DcWomA, WhAmArt 85*
Cane, Florence *WhAmArt 85*
Cane, Herbert Collins *DcVicP 2*
Cane, Louis 1943- *ConArt 77, –83, DcCAr 81*
Canelas, Manuel 1898- *AmArch 70*
Canella, Giuseppe 1788-1847 *ArtsNiC, ClaDrA*
Canellis, George William 1960- *MarqDCG 84*
Canemaker, John 1943- *ConGrA 1[port]*
Canepa, Angela *DcWomA*
Canepa, Anna L 1940- *WhoAmA 78, –80*
Canevari, Raffaele 1825-1900 *MacEA*
Caney, Eric 1908- *DcBrA 1, WhoArt 80, –82, –84*
Canfield *FolkA 86*
Canfield, Abijah 1769-1830 *FolkA 86, NewYHSD*
Canfield, Agnes *DcWomA, WhAmArt 85*
Canfield, Betsey *FolkA 86*
Canfield, Birtley King 1866-1912 *WhAmArt 85*
Canfield, Caroline *FolkA 86*
Canfield, Mrs. Cass *WhAmArt 85*
Canfield, Flavia 1844-1930 *DcWomA, WhAmArt 85*
Canfield, Fred Henry, III 1939- *MarqDCG 84*
Canfield, Ira B *EncASM*
Canfield, Jane *DcWomA*
Canfield, Jane 1897- *WhoAmA 73, –76, –78, –80, –82,*

–84
Canfield, Lucetta *DcWomA, WhAmArt 85*
Canfield, R L *AmArch 70*
Canfield, Richard d1914 *WhAmArt 85*
Canfield, Ruth 1896- *WhAmArt 85*
Canfield, William B *EncASM*
Canfield, William Newton 1920- *WhoAmA 76,*
WorECar
Canfield, William P *WhAmArt 85*
Cangiagio, Luca *ClaDrA*
Caniana, Caterina DiGiovanni Battista *DcWomA*
Caniaris, Vlassis 1928- *OxTwCA, PhDcTCA 77*
Caniff, Milton 1907- *WorECom*
Caniff, Milton A 1907- *WhAmArt 85*
Caniff, Milton Arthur 1907- *WhoAmA 73, –76, –78,*
–80, –82, –84
Canin, Martin 1927- *WhoAmA 73, –76, –78*
Canina, Luigi 1795-1856 *MacEA*
Canini, Giovanni Angelo 1617-1666 *McGDA*
Canizaro, J T *AmArch 70*
Canizaro, Robert Host 1938- *AmArch 70*
Cann, B I *AmArch 70*
Cannady, William Tillman 1937- *AmArch 70*
Cannamore, Ronald Truett 1935- *AmArch 70*
Cannard, Ruth E 1912- *WhAmArt 85*
Cannell, Edward Ashton 1927- *WhoArt 80, –82, –84*
Cannell, Joseph *WhAmArt 85*
Cannert, Jules 1890-1954 *WhAmArt 85*
Canney, Michael Richard Ladd 1923- *DcBrA 2,*
WhoArt 80, –82, –84
Canniff, Bryan Gregory 1948- *WhoAmA 80, –82, –84*
Canning, Viscountess 1817-1861 *DcVicP 2*
Canning, Lady Charlotte *DcWomA*
Canning, Charlotte, Viscountess 1817-1861 *DcBrWA*
Canning, J Cater *DcWomA*
Canning, Mrs. J Cater *DcVicP 2*
Canning, Mary G *DcVicP 2, DcWomA*
Cannizzo, Phillip 1945- *DcCAr 81*
Cannon, Beatrice 1875- *DcWomA, WhAmArt 85*
Cannon, Dorothy 1909- *WhAmArt 85*
Cannon, Edith M *DcVicP 2*
Cannon, Ernest Wayne 1935- *AmArch 70*
Cannon, Florence Carch *WhAmArt 85*
Cannon, Florence V *WhAmArt 85*
Cannon, Georgius Young 1892- *AmArch 70*
Cannon, Henry Cecil, Jr. 1935- *AmArch 70*
Cannon, Howell Quayle 1908- *AmArch 70*
Cannon, Hugh *FolkA 86*
Cannon, Hugh 1814?- *NewYHSD*
Cannon, Jennie Vennerstrom 1869- *ArtsAmW 2,*
DcWomA, WhAmArt 85
Cannon, K D *AmArch 70*
Cannon, Lewis T 1872-1946 *BiDAmAr*
Cannon, Lucy A *DcWomA*
Cannon, Margaret Erickson 1923- *WhoAmA 73, –76,*
–78
Cannon, Marian 1912- *WhAmArt 85*
Cannon, Robert 1910-1964 *WorECar*
Cannon, Robert Bryan, Jr. 1919- *AmArch 70*
Cannon, T C 1946- *WhoAmA 73, –76, –78*
Cannon, W A, Jr. *AmArch 70*
Cannon, Winthrop Peabody 1928- *AmArch 70*
Cannon-Brookes, Peter 1938- *WhoArt 80*
Cannuli, Richard Gerald 1947- *WhoAmA 84*
Cano, Alonso 1601-1667 *ClaDrA, MacEA, McGDA,*
WhoArch
Cano, Margarita 1932- *WhoAmA 78, –80, –82, –84*
Cano, Slonso 1601-1667 *OxArt*
Cano Lasso, Julio 1920- *MacEA*
Canoby, Madame *DcWomA*
Canoby, Elise *DcWomA*
Canogar, Rafael 1934- *OxTwCA, PhDcTCA 77*
Canogar, Rafael 1935- *ConArt 83, DcCAr 81*
Canogar, Rafael Garcia 1935- *ConArt 77*
Canonica, Luigi 1762-1844 *MacEA, McGDA*
Canossa-Scarselli, Maria Catarina *DcWomA*
Canova, Antonio 1757-1822 *DcNiCA, McGDA,*
OxArt
Canova, Dominico *NewYHSD*
Canovas, Antonio 1862-1933 *ICPEnP A*
Canright, Sarah Anne 1941- *WhoAmA 73, –76, –78,*
–80, –82, –84
Canstein, Maria, Freiherr Von d1893 *DcWomA*
Cantabrana, Emily De 1888-1980 *DcWomA*
Cantabrana, Emily Edwards *ArtsAmW 3*
Cantacuzino, Gheorghe Matei 1899-1960 *MacEA*
Cantagalli, Ulisse *DcNiCA*
Cantarella, Maria Boveri 1909- *WhAmArt 85*
Cantarini, Simone 1612-1648 *ClaDrA, McGDA*
Cantatore, Domenico 1906- *OxTwCA, PhDcTCA 77*
Cantelli, Angelica *DcWomA*
Cantelo, Ellen *DcVicP 2*
Canter, Albert M 1892- *WhAmArt 85*
Canter, Benjamin *CabMA*
Canter, James *DcBrECP*
Canter, Jean Mary 1943- *WhoArt 80, –82, –84*
Canter, John 1782?-1823 *NewYHSD*
Canter, Joshua d1826 *NewYHSD*
Canter, Newton Webb 1907- *WhAmArt 85*
Canteraine, Marguerite *DcWomA*
Canterbury, Michael Of *McGDA*

Canterbury, Ira *CabMA*
Canterson, J *NewYHSD*
Cantey, Maurine 1901- *WhAmArt 85*
Cantey, Sam Benton, III *WhoAmA 73, -76, -78, -80*
Cantey, Sam Benton, III d1973 *WhoAmA 82N, -84N*
Cantieni, Graham 1938- *PrintW 83, -85*
Cantieni, Graham Alfred 1938- *WhoAmA 78, -80, -82, -84*
Cantieni, Margaret Balzer *WhAmArt 85*
Cantin, A Mackenzie 1912- *AmArch 70*
Cantine, David 1939- *WhoAmA 78, -80, -82, -84*
Cantine, Jo *WhAmArt 85*
Cantini, Virgil D 1920- *WhoAmA 73, -76, -78, -80, -82, -84*
Cantir *NewYHSD*
Cantofoli, Ginevra 1608-1672 *DcWomA*
Canton, Susan Ruth *DcWomA*
Canton, Thomas 1815?- *NewYHSD*
Cantone, Vic 1933- *ConGrA 1[port], WhoAmA 80, -82, -84*
Cantoni, Pier Francesco *McGDA*
Cantor, B Gerald 1916- *WhoAmA 76, -78, -80, -82, -84*
Cantor, Fredrich 1944- *ICPEnP A, MacBEP, WhoAmA 82, -84*
Cantor, Marvin J 1930- *AmArch 70*
Cantor, Mira 1944- *WhoAmA 80, -82, -84*
Cantor, Nathan 1922- *AmArch 70*
Cantor, Robert Lloyd 1919- *WhAmArt 85, WhoAmA 73, -76, -78, -80, -82, -84*
Cantor-Piene, Mira *WhoAmA 80*
Cantrall, Harriet M *DcWomA, WhAmArt 85*
Cantre, Jozef 1890-1957 *OxTwCA*
Cantrell, B Royall 1904- *AmArch 70*
Cantrell, Bill Warren 1927- *AmArch 70*
Cantrell, Florence *DcWomA, WhAmArt 85*
Cantrell, Jeannette Louise *WhoAmA 78, -80*
Cantrell, Jim 1935- *WhoAmA 76, -78, -80, -82, -84*
Cantrell, R J *AmArch 70*
Cantrelle, Julie *DcWomA*
Cantu, Federico 1908- *McGDA*
Cantu, Rachele *DcWomA*
Cantwell, Edwin 1834?- *NewYHSD*
Cantwell, James *NewYHSD*
Cantwell, James 1856-1926 *WhAmArt 85*
Cantwell, Joseph 1750?-1828 *BiDBrA*
Cantwell, Robert 1792?-1858 *BiDBrA*
Canuet, Louise *DcWomA*
Canute, Gordon Wesley 1924- *AmArch 70*
Canuti, Domenico Maria 1620-1684 *ClaDrA, McGDA*
Cany, Harriet *DcWomA, NewYHSD*
Canyon, Nicholas L 1931- *AfroAA*
Canziani, Estella L M 1887- *ClaDrA, IlsCB 1744*
Canziani, Estella Louisa Michaela 1887-1964 *DcBrA 1, DcBrBI, DcWomA*
Canziani, Louisa *DcWomA*
Canziani, Louisa d1909 *DcBrA 2*
Canziani, Mrs. Starr *DcVicP 2*
Cao, Jose Maria 1862-1918 *WorECar*
Cao, Miaoqing *DcWomA*
Caolo, Vito 1927- *AmArch 70*
Cap, Constant Aime Marie 1842- *ClaDrA*
Capa, Cornell 1918- *ConPhot, MacBEP, WhoAmA 78, -80, -82, -84*
Capa, Robert 1913-1954 *ConPhot, ICPEnP, MacBEP*
Capalano, Anthony *FolkA 86*
Capamagian, Noemie *DcWomA*
Capanna, Puccio *McGDA*
Capano, J A *AmArch 70*
Caparn, Rhys 1909- *DcCAA 71, -77, McGDA, WhAmArt 85, WhoAmA 73, -76, -78, -80, -82, -84*
Caparn, W J *DcVicP 2*
Caparra, Il *McGDA*
Capdet-Brugnon, Raymonde Marie Louise *DcWomA*
Capdevielle, Lucienne *DcWomA*
Capdevila, Francisco Moreno 1926- *WhoAmA 82*
Cape, E J *DcVicP 2*
Cape, George William, Jr. 1935- *AmArch 70*
Capecchi, Joseph *WhAmArt 85*
Capehart, Elizabeth Scudder 1894- *DcWomA, WhAmArt 85*
Capek, Josef 1887-1945 *OxTwCA, PhDcTCA 77*
Capell, A *DcBrWA*
Capellano, Antonio *NewYHSD*
Capelle, Arthur John 1890- *AmArch 70*
Capelle, Jan VanDe 1624-1679 *DcSeaP*
Capelle, Jan VanDe 1630-1679 *ClaDrA*
Capelle, Johannes *McGDA*
Capelli, Ronald B 1951- *MarqDCG 84*
Capen, Azel *FolkA 86, NewYHSD*
Capen, John F 1865-1927? *BiDAmAr*
Capers, Harold H 1899- *WhAmArt 85*
Capes, Julia *DcWomA*
Capes, Mary *DcVicP 2, DcWomA*
Capes, Richard Edward 1942- *WhoAmA 84*
Capesius, F *DcWomA*
Capestony, Efram *AfroAA*
Capet, Marie Gabrielle 1761-1817 *DcWomA*
Capewell, Samuel *NewYHSD*

Capey, Reco 1895-1961 *DcBrA 2*
Capezio *WorFshn*
Capitel, Anton *ConArch A*
Capka, Joseph Richard 1949- *MarqDCG 84*
Caplan, David 1910- *WhoArt 80, -82, -84*
Caplan, Jerry L 1922- *WhoAmA 73, -76, -78, -80, -82, -84*
Caplan, Oscar *EncASM*
Caplan, Sandra *WhoAmA 84*
Caple, James Curtis 1938- *AmArch 70*
Caples, Barbara Barrett 1914- *WhoAmA 73, -76, -78, -80, -82, -84*
Caples, James Stephen 1911- *AmArch 70*
Caples, Robert Cole *IlBEAAW, WhAmArt 85*
Caplin, Alfred Gerald 1909- *WhAmArt 85*
Caplin, Elliot 1913- *WorECom*
Capobianco, Domenick 1926- *WhoAmA 82, -84*
Capobianco, Domenick 1938- *PrintW 85*
Capobianco, Louis *WhAmArt 85*
Capobianco, Maurice A 1907- *AmArch 70*
Capogrossi, Giuseppe 1900- *McGDA, OxTwCA, PhDcTCA 77*
Capogrossi, Giuseppe 1900-1972 *ConArt 77, -83, WorArt[port]*
Capolino, Gertrude Rowan 1899-1946 *DcWomA, WhAmArt 85*
Capolino, John Joseph 1896- *WhAmArt 85*
Capomazza, Luisa d1646 *DcWomA*
Capon, Charles R 1884-1955? *WhAmArt 85*
Capon, William 1757-1827 *BiDBrA, DcBrBI, DcBrWA*
Capone, Gaetano 1864-1920 *WhAmArt 85*
Caponi, Anthony 1921- *WhoAmA 73, -76, -78, -80, -82, -84*
Caponigro, Paul 1932- *AmArt, ConPhot, DcCAr 81, ICPEnP, MacBEP, WhoAmA 76, -78, -80, -82, -84*
Caponnetto, J *AmArch 70*
Caponnibus, Raphael De *McGDA*
Caporal, Patricia Marie 1954- *MarqDCG 84*
Caporali, Bartolommeo 1420?-1509 *McGDA*
Caporali, Giovan Battista 1476?-1560 *MacEA*
Caporina, Anthony Joseph 1938- *AmArch 70*
Capozzi, Julius E 1927- *AmArch 70*
Capp, Al *WhAmArt 85*
Capp, Al 1900- *WhoAmA 84N*
Capp, Al 1909- *WhoAmA 73, -76, -78, -80N, -82N, WorECom*
Cappa, Giofredo *AntBDN K*
Cappalli, Patti 1939- *WorFshn*
Cappanini, Santa 1803-1860 *DcWomA*
Cappanini, Teresa 1801-1826 *DcWomA*
Cappe, Gabriel 1760-1779 *DcBrECP*
Cappelaere, Henriette *DcWomA*
Cappella, Francesco 1714-1784 *McGDA*
Cappelle, Jan VanDe 1624?-1679 *McGDA, OxArt*
Cappelli *NewYHSD*
Cappelli, Blanche *DcWomA*
Cappello, Carmelo 1912- *OxTwCA, PhDcTCA 77*
Capper, Edith *DcVicP 2, DcWomA*
Capper, Hugh 1852?-1897 *ArtsEM*
Capper, J J *DcVicP 2*
Cappiello, Leonetto 1875-1942 *OxTwCA*
Capponi, Giuseppe 1893-1936 *MacEA*
Capps, Charles Merrick 1898- *ArtsAmW 1, -3, WhAmArt 85*
Capps, Ken 1939- *DcCAr 81*
Cappuccilli, A J *AmArch 70*
Cappuccino, Il *McGDA*
Capralos, Christos 1909- *ConArt 77*
Caprara, Julia Rosemary 1939- *WhoArt 80, -82, -84*
Capraro, Albert 1943- *WorFshn*
Caprarola *McGDA*
Caprarola, Cola Da d1518 *MacEA*
Capriani, Francesco *McGDA*
Capriano DaVolterra, Francesco 1535?-1595 *MacEA*
Caprichos, Los *McGDA*
Caprino, Meo Da 1430-1501 *MacEA*
Caprioli, Franco 1912-1974 *WorECom*
Capriolo, Domenico 1494-1528 *McGDA*
Capron, Adele 1806- *DcWomA*
Capron, Cynthia Jane Stevens *DcWomA*
Capron, Elizabeth W *FolkA 86*
Capron, Mary Sanford *DcWomA*
Capron, William *FolkA 86*
Caproni, J D *AmArch 70*
Caproni, Leo Francis 1888- *AmArch 70*
Caprotti, Jacopo Dei *McGDA*
Capsius, Margareta *DcWomA*
Capucci, Roberto *FairDF ITA, WorFshn*
Caputo, M V *AmArch 70*
Capwell, Josephine Edwards *ArtsAmW 2, DcWomA, WhAmArt 85*
Carabelli, Joseph 1850-1911 *WhAmArt 85*
Carabott, Frederick Vincent 1924- *WhoGrA 82[port]*
Caracci, Annibale 1560-1609 *ClaDrA*
Caracciolo, Giovanni Battista 1570-1637 *McGDA, OxArt*
Caradek, Lucie d1936 *DcWomA*
Caradeuc, James Achille De *NewYHSD*
Caradosso Cristoforo Foppa 1425?-1527? *McGDA*

Caraglio, Giovanni Jacopo 1500?-1565 *McGDA*
Caraman, Madame De *DcWomA*
Caraman, Ghislaine De, Comtesse *DcWomA*
Caramuel DeLobkowitz, Juan 1606-1682 *MacEA*
Caran, Steluca *OxTwCA*
Caran D'Ache *WorECar*
Caran D'Ache 1858-1909 *DcBrBI*
Carangi, Daniel *MarqDCG 84*
Caranicas, Paul 1946- *DcCAr 81*
Caranza, Amedee De *IlDcG*
Carasquilla, Isabel *DcWomA*
Caratini, Hector M Mendez 1949- *ICPEnP A, MacBEP*
Caraud, Joseph *ArtsNiC*
Carava, Roy De *AfroAA*
Caravaggio 1573-1610 *OxArt*
Caravaggio, Polidoro Da *McGDA*
Caravaggio, Michel-Angelo Merisi Da 1573-1610 *OxArt*
Caravaggio, Michelangelo Merisi 1562-1609 *ClaDrA*
Caravaggio, Michelangelo Merisi Da 1573-1610 *McGDA*
Caravaggio, Polidoro Da *ClaDrA*
Caravias, Thalia *DcWomA*
Carbajal G, Enrique *WhoAmA 82, -84*
Carbee, Clifton 1860-1946 *WhAmArt 85*
Carbentus, Anna Cornelia *DcWomA*
Carber, Nannie Z *DcWomA*
Carberry, James Francis 1939- *AmArch 70*
Carberry, James Joseph 1953- *MarqDCG 84*
Carberry, Thomas A 1953- *MarqDCG 84*
Carbin, Wilhelmine *DcWomA*
Carbonati, Antonio 1893- *ClaDrA*
Carbone, Francesco C 1921- *WhAmArt 85*
Carbone, John *WhAmArt 85*
Carbone, John A *MarqDCG 84*
Carbone, S Fred 1931- *AmArch 70*
Carbone, William A 1949- *MarqDCG 84*
Carbonell, Guillermo *McGDA*
Carbonell, Joseph Edward, Jr. 1911- *AmArch 70*
Carbonell, Justina De *DcWomA*
Carbonell, Nelson Alberto 1940- *AmArch 70*
Carboni, Erberto 1899- *WhoGrA 62, -82[port]*
Carbonnier, Mrs. *DcWomA*
Carbutt, John 1832-1905 *ICPEnP, MacBEP*
Carcan, Rene 1925- *PrintW 83, -85*
Carcani, Filippo *McGDA*
Carchidi, J G *AmArch 70*
Card, Greg S 1945- *DcCAr 81, PrintW 83, -85, WhoAmA 76, -78, -80, -82, -84*
Card, Judson d1933 *WhAmArt 85*
Card, Royden 1952- *PrintW 85*
Card, Wayne Prentice 1935- *AmArch 70*
Cardamone, Cecilia 1906- *WhAmArt 85*
Cardell, Mrs. Frank Hale 1853-1905 *DcWomA, WhAmArt 85*
Cardella, Juan *OxTwCA*
Cardella, Liberato *NewYHSD*
Cardella, Liberto *NewYHSD*
Cardelli, A B *AmArch 70*
Cardelli, Georgio 1791- *NewYHSD*
Cardelli, Pietro d1822 *NewYHSD*
Carden, Ruth 1930- *WhoAmA 76*
Cardenas, Agustin *AfroAA*
Cardenas, Agustin 1927- *OxTwCA*
Cardenas, Juan 1939- *DcCAr 81*
Cardenas, Santiago *OxTwCA*
Cardenas Bermejo, Bartolome *McGDA*
Carder, Frederick 1863-1963 *BnEnAmA, IlDcG, OxDecA*
Carder, Frederick 1864- *WhAmArt 85*
Carder, Frederick 1864-1963 *DcNiCA*
Carder, M O *AmArch 70*
Carder, Martha Worth 1939- *AmArch 70*
Cardero *NewYHSD*
Cardero, Jose *NewYHSD*
Cardew, Martha 1801-1883 *DcWomA*
Cardew, Michael 1900- *DcD&D*
Cardew, Michael 1901- *DcNiCA*
Cardheilac, Ernest d1904 *DcNiCA*
Cardheilac, Jacques *DcNiCA*
Cardheilac, Pierre *DcNiCA*
Cardheilac, Vital-Antoine *DcNiCA*
Cardi, Lodovico 1559-1613 *ClaDrA*
Cardi, Ludovico *OxArt*
Cardiff, Joseph A F 1882-1917 *BiDAmAr*
Cardin, Pierre 1922- *ConDes, FairDF FRA[port], WorFshn*
Cardin-Roussel, Madame *DcWomA*
Cardinal, Douglas 1934- *ConArch*
Cardinal, Douglas Joseph Henry 1934- *WhoAmA 78, -80*
Cardinal, Marcelin 1920- *WhoAmA 76, -78, -80, -82, -84*
Cardinall, Robert *DcBrECP*
Cardinaux, Rene Louis 1941- *AmArch 70*
Cardinaux, Sophie *DcWomA*
Cardman, Cecilia *WhoAmA 76, -78, -80, -82, -84*
Cardo, M A *AmArch 70*
Cardon, Anthony 1772-1813 *McGDA*

Carlson, Walter Clarence 1934- *AmArch 70*
Carlson, William D 1950- *WhoAmA 84*
Carlson, Zena Paulson 1894- *ArtsAmW 2, DcWomA*
Carlsson, Laurel E 1920- *AmArch 70*
Carlsson, Mina 1857-1943 *DcWomA*
Carlsson, Oscar T 1893- *WhAmArt 85*
Carlstadt, Johan Birger Jarl 1907- *OxTwCA*
Carlstedt, Birger 1907- *PhDcTCA 77*
Carlstedt, Kalle Frederik Oskar 1891- *ClaDrA*
Carlstrom, Lucinda 1950- *WhoAmA 82, -84*
Carlsund, Emma 1861- *DcWomA, WhAmArt 85*
Carlton, Brents *WhAmArt 85*
Carlton, C *DcVicP 2*
Carlton, David Hill, Jr. 1925- *AmArch 70*
Carlton, Eugene Tucker 1900- *AmArch 70*
Carlton, Fred Lewis 1910- *AmArch 70*
Carlton, William Tolman 1816-1888 *NewYHSD*
Carlu, Jacques 1890- *MacEA*
Carlu, Jean 1900- *OxTwCA*
Carlu, Jean Georges Leon 1900- *ConDes, WhoGrA 62*
Carlyle, Florence *DcVicP 2, WhAmArt 85*
Carlyle, Florence 1864?-1923 *DcWomA*
Carlyle, Julian 1942- *WhoAmA 76, -78, -80*
Carlyle, Robert 1773-1825 *DcBrWA*
Carlyon, Cecily K *DcBrA 1, DcWomA*
Carlyon, John *WhoArt 84N*
Carlyon, John 1917- *WhoArt 80, -82*
Carmack, Paul R 1895- *WhoAmA 73, -76*
Carmack, Paul R 1895-1977 *WhAmArt 85, WhoAmA 78N, -80N, -82N, -84N*
Carman, Andrew 1785-1806 *CabMA*
Carman, Byron Keith 1928- *AmArch 70*
Carman, Eva L *DcWomA, WhAmArt 85*
Carman, H A *DcVicP 2*
Carman, J *NewYHSD*
Carman, Radcliff *NewYHSD*
Carmean, E A, Jr. 1945- *WhoAmA 76, -78, -80, -82, -84*
Carmel, Charles *FolkA 86*
Carmel, Hilda Anne *WhoAmA 73, -76, -78, -80, -82*
Carmen, Caleb *FolkA 86*
Carmen, Elizabeth 1818-1875 *FolkA 86*
Carmen, H A, III *AmArch 70*
Carmen, T 1860- *FolkA 86*
Carmen, William Lucius 1924- *AmArch 70*
Carmer, Dorothy Ross 1883- *DcWomA, WhAmArt 85*
Carmer, Elizabeth Black 1904- *IlsCB 1946, WhAmArt 85*
Carmer, Henry *CabMA*
Carmi, Boris 1914- *ICPEnP A*
Carmi, Eugenio 1920- *ConArt 77, ConDes*
Carmi, Lisetta 1924- *ConPhot, ICPEnP A*
Carmi, Mrs. Z *WhoArt 80, -82, -84*
Carmichael, Albert Peter 1890-1917 *WorECar*
Carmichael, Dan A 1918- *AmArch 70*
Carmichael, Daniel C, Jr. 1922- *AmArch 70*
Carmichael, Donald Ray 1922- *WhoAmA 73, -76, -78, -80, -82, -84*
Carmichael, Elizabeth *DcBrECP, DcWomA*
Carmichael, Frank *OxTwCA*
Carmichael, Franklin 1890-1945 *McGDA*
Carmichael, Herbert *DcBrA 1*
Carmichael, Ida Barbour 1884- *DcWomA, WhAmArt 85*
Carmichael, J H *DcWomA*
Carmichael, J W *NewYHSD*
Carmichael, Jae 1925- *WhoAmA 73, -76, -78, -80, -82, -84*
Carmichael, James *DcBrECP*
Carmichael, Joe William 1928- *AmArch 70*
Carmichael, John Wilson 1800-1868 *DcBrBI, DcBrWA, DcSeaP, DcVicP, -2*
Carmichael, M D T *DcWomA*
Carmichael, Mrs. M D T *DcVicP 2*
Carmichael, Michael *BiDBrA*
Carmichael, Stewart Of Dundee 1867- *DcBrBI*
Carmichael, T J *NewYHSD*
Carmichael, Warree *WhAmArt 85*
Carmiencke, Johann Hermann 1810-1867 *NewYHSD*
Carmillion, Alice *DcWomA*
Carmin, B A *AmArch 70*
Carmody, Anna T *WhAmArt 85*
Carmona, Anna Maria *DcWomA*
Carmona, Luis Salvador *McGDA*
Carmona, Manuel Salvador 1734-1820 *McGDA*
Carmontelle 1717-1806 *McGDA*
Carmontelle, Louis Carrogis 1717-1806 *MacEA*
Carmosino, Roderick Louis 1924- *AmArch 70*
Carnaffan, Austin 1946- *MarqDCG 84*
Carnahan, Charles *NewYHSD*
Carnahan, D R *AmArch 70*
Carnall, James Linton *WhAmArt 85*
Carnase, Thomas Paul 1939- *WhoGrA 82[port]*
Carne, Frederick H 1927- *AmArch 70*
Carne, John *CabMA*
Carnegie, Lady Agnes *DcWomA*
Carnegie, Elizabeth *DcWomA*
Carnegie, Hattie 1886-1956 *FairDF US*
Carnegie, Hattie 1889-1956 *WorFshn*

Carnegie, Mary *DcWomA*
Carnegie, Rachel 1901- *DcBrA 1*
Carnegie, Rook *DcBrBI*
Carneiro, Dulce 1929- *ICPEnP A*
Carneiro, Luciano 1927- *ICPEnP A*
Carnell, Althea J *DcWomA, WhAmArt 85*
Carnell, John William 1952- *MacBEP*
Carnell, Jon *DcCAr 81*
Carnell, Samuel 1832-1920 *MacBEP*
Carnelli, Walter Antonius 1905- *WhAmArt 85*
Carneo, Antonio 1637-1692 *McGDA*
Carnes, James *NewYHSD*
Carnevale, Fra 1420?-1484 *McGDA*
Carnevale, Carmen Richard Mordecai 1909- *WhAmArt 85*
Carnevale, Pietro 1839-1895 *MacEA*
Carney, Allen Robins 1916- *AmArch 70*
Carney, Bob *OfPGCP 86*
Carney, Ellen *WhAmArt 85*
Carney, John Bernard 1920- *AmArch 70*
Carney, L A *AmArch 70*
Carnicero, Antonio 1748-1814 *McGDA*
Carnilivari, Matteo *MacEA*
Carnohan, Harry *WhAmArt 85*
Carnwath, Squeak 1947- *WhoAmA 84*
Caro, Anita *ClaDrA*
Caro, Anita De 1909- *OxTwCA*
Caro, Anthony 1924- *CenC[port], ConArt 77, -83, ConBrA 79[port], DcBrA 2, DcCAr 81, McGDA, OxTwCA, PhDcTCA 77, WhoArt 80, -82, -84, WorArt[port]*
Caro, Baldassare De *ClaDrA*
Caro, Francis 1938- *WhoAmA 78, -80, -82, -84*
Caro, Frank 1904- *WhoAmA 73, -76*
Caroggio, Rita 1881?- *DcWomA*
Carol-Chery, Andree *DcWomA*
Caroline Ferdinande Louise, Princess *DcWomA*
Caroline Mathilde *DcWomA*
Caroline, Princess *DcWomA*
Carolus-Duran, Charles Emile 1837-1917 *WhAmArt 85A*
Carolus-Duran, Charles Emile A Durand 1838-1917 *ClaDrA*
Carolus-Duran, Charles Emile Auguste 1838-1917 *OxArt*
Carolus-Duran, Pauline Marie Charlotte *DcWomA*
Caron, Adele *DcWomA*
Caron, Adolphe-Alexandre-Joseph 1797-1867 *ArtsNiC*
Caron, Antoine 1520?-1599? *McGDA*
Caron, Antoine 1520?-1600? *OxArt*
Caron, Antoine 1521-1599 *ClaDrA*
Caron, E Louis *MarqDCG 84*
Caron, Gilles 1939-1970 *ICPEnP A*
Caron, Josephine *DcWomA*
Caron, L *DcVicP 2, DcWomA*
Caron, Marcel 1890-1961 *OxTwCA*
Caron, Peter Auguste 1732-1799 *AntBDN D*
Caron, Rosalie *DcWomA*
Caron, S *DcWomA*
Caron Brothers *EncASM*
Caron-Langlois, Pauline *DcWomA*
Carone, Matthew David 1930- *WhoAmA 73, -76*
Caroni, Emmanuele *ArtsNiC*
Caroselli, Angelo 1585-1652 *McGDA*
Carothers, Frederick Lynn 1931- *AmArch 70*
Carothers, Rice *AfroAA*
Carothers, Sarah Pace 1910- *WhAmArt 85*
Caroto, Giovanni Francesco 1478-1555 *McGDA*
Carotto, Giovanni Francesco 1470-1546 *ClaDrA*
Carouget, Ernestine *DcWomA*
Carp, Robert *NewYHSD*
Carpaccio, Vittore *OxArt*
Carpaccio, Vittore 1465?-1526? *McGDA*
Carpanini, David 1946- *DcCAr 81*
Carpanini, David Lawrence 1946- *WhoArt 80, -82, -84*
Carpanini, Jane 1949- *DcCAr 81, WhoArt 82, -84*
Carpeaux, Charles *NewYHSD*
Carpeaux, Jean Baptiste 1827-1875 *ArtsNiC, ClaDrA, McGDA*
Carpeaux, Jean-Baptiste 1827-1875 *DcNiCA, OxArt*
Carpender, Alice Preble Tucker *DcWomA*
Carpender, Alice Preble Tucker d1920 *WhAmArt 85*
Carpenter, Miss *DcWomA, FolkA 86*
Carpenter, A *NewYHSD*
Carpenter, A M 1887- *ArtsAmW 2, DcWomA, WhAmArt 85*
Carpenter, A R *DcBrWA, DcVicP 2*
Carpenter, A T *AmArch 70*
Carpenter, Arthur 1920- *BnEnAmA*
Carpenter, Arthur Espenet *WhoAmA 82, -84*
Carpenter, Arthur Espenet 1920- *WhoAmA 78, -80*
Carpenter, B *NewYHSD*
Carpenter, Benjamin *NewYHSD*
Carpenter, Benjamin F *NewYHSD*
Carpenter, Bernard V d1936 *WhAmArt 85*
Carpenter, C Neal 1932- *AmArch 70*
Carpenter, Cato D *MarqDCG 84*
Carpenter, Charles E 1844-1923 *BiDAmAr*
Carpenter, Charles E 1845-1923 *WhAmArt 85*

Carpenter, Charles Everett 1936- *AmArch 70*
Carpenter, D J *AmArch 70*
Carpenter, Dennis Wilkinson 1947- *WhoAmA 84*
Carpenter, Donald Scheffel, Jr. 1927- *AmArch 70*
Carpenter, Dora *DcVicP 2, DcWomA*
Carpenter, Dudley Saltonstall 1870- *ArtsAmW 2, ArtsEM*
Carpenter, Dudley Saltonstall 1880- *WhAmArt 85*
Carpenter, E 1917- *WhoAmA 73, -76, -78, -80*
Carpenter, E H *DcWomA*
Carpenter, Miss E M 1831- *ArtsNiC*
Carpenter, Earl 1931- *IlBEAAW*
Carpenter, Earl L 1931- *AmArt, WhoAmA 76, -78, -80, -82, -84*
Carpenter, Ellen M 1831?-1909? *ArtsAmW 3*
Carpenter, Ellen Maria 1830-1909? *ArtsAmW 1*
Carpenter, Ellen Maria 1836-1909? *DcWomA, IlBEAAW, NewYHSD , WhAmArt 85*
Carpenter, Ethel 1917- *WhoAmA 82, -84*
Carpenter, Ethel D S *WhAmArt 85*
Carpenter, Eugene J d1922 *WhAmArt 85*
Carpenter, F H 1879- *WhAmArt 85*
Carpenter, Florence *DcWomA*
Carpenter, Florence A *WhAmArt 85*
Carpenter, Francis B 1830-1900 *WhAmArt 85*
Carpenter, Francis Bicknell 1830- *ArtsNiC*
Carpenter, Francis Bicknell 1830-1900 *NewYHSD*
Carpenter, Fred Green *WhAmArt 85*
Carpenter, Frederick *FolkA 86*
Carpenter, George M *WhAmArt 85*
Carpenter, Gilbert Frederick 1920- *WhoAmA 73, -76, -78, -80, -82, -84*
Carpenter, Grace *DcWomA*
Carpenter, H Barrett *DcVicP 2*
Carpenter, Hannah T 1874- *DcWomA, WhAmArt 85*
Carpenter, Harlow 1926- *WhoAmA 73, -76, -78*
Carpenter, Hattie L *DcWomA, WhAmArt 85*
Carpenter, Helen K 1881- *WhAmArt 85*
Carpenter, Helen Knipe 1881- *DcWomA*
Carpenter, Henrietta 1822-1895 *DcWomA*
Carpenter, Horace T 1858-1947 *WhAmArt 85*
Carpenter, J E R 1867-1932 *MacEA*
Carpenter, J Edwin R 1867-1932 *BiDAmAr*
Carpenter, J Lant *DcVicP 2*
Carpenter, J M *AmArch 70*
Carpenter, J S *WhAmArt 85*
Carpenter, J W *NewYHSD*
Carpenter, Jack Alan 1939- *AmArch 70*
Carpenter, Mrs. James *DcWomA*
Carpenter, James Morton 1914- *WhoAmA 73, -76, -78, -80, -82, -84*
Carpenter, John *DcBrWA*
Carpenter, Jon Calvin 1931- *AmArch 70*
Carpenter, June *AfroAA*
Carpenter, Kate Holston 1866- *DcWomA, WhAmArt 85*
Carpenter, Kenneth E 1938- *AmArch 70*
Carpenter, Loren *MarqDCG 84*
Carpenter, Louise *WhAmArt 85*
Carpenter, Louise 1865-1963 *ArtsAmW 2*
Carpenter, Louise M 1867-1963 *DcWomA*
Carpenter, Margaret *DcWomA, WhAmArt 85*
Carpenter, Margaret 1793-1872 *ArtsNiC*
Carpenter, Margaret Sarah 1793-1872 *ClaDrA, DcBrWA, DcVicP 2, DcWomA*
Carpenter, Marguerite *DcWomA, WhAmArt 85*
Carpenter, Mary Virginia *DcWomA*
Carpenter, Mia 1933- *IlrAm G, -1880*
Carpenter, Mildred B 1894- *DcWomA*
Carpenter, Mildred Bailey *WhAmArt 85*
Carpenter, Miles B 1889-1985 *FolkA 86*
Carpenter, N H *DcWomA*
Carpenter, Mrs. N H *WhAmArt 85*
Carpenter, Newton H 1853-1918 *WhAmArt 85*
Carpenter, Orpha *DcWomA*
Carpenter, Percy *DcVicP 2*
Carpenter, R C 1812-1855 *MacEA*
Carpenter, R R *NewYHSD*
Carpenter, Reuben 1827?- *NewYHSD*
Carpenter, Richard Cromwell 1812-1855 *McGDA*
Carpenter, Richard Lawrence 1934- *AmArch 70*
Carpenter, Roger Dale 1930- *AmArch 70*
Carpenter, Rue Winterbotham d1931 *DcWomA, WhAmArt 85*
Carpenter, Russel *WorFshn*
Carpenter, Samuel H 1798?- *NewYHSD*
Carpenter, Samuel H, Jr. 1832?- *NewYHSD*
Carpenter, Scot McDonald 1953- *MarqDCG 84*
Carpenter, Will A *WhAmArt 85*
Carpenter, William 1818-1899 *DcBrBI, DcBrWA, DcVicP, -2*
Carpenter, William John *DcBrWA*
Carpenter, William N 1816-1885 *ArtsEM*
Carpenter And Bliss *EncASM*
Carpentier, Evariste 1845- *ClaDrA*
Carpentier, Felix *DcVicP 2*
Carpentier, Jerome Edmund 1937- *MarqDCG 84*
Carpentier, Louise *DcWomA*
Carpentier, Madeleine 1865- *DcWomA*
Carpentier, Marguerite Jeanne *DcWomA*
Carpentier, Marie Paule 1876-1915 *DcWomA*

Centanni, E J *AmArch 70*
Centanni, J G *AmArch 70*
Centelles, Agusti 1909- *ICPEnP A*
Center, Edward Ken 1903- *DcBrA 1*
Center, John W 1946- *MarqDCG 84*
Center, Leslie Ralph 1933- *AmArch 70*
Cephisodotus *McGDA, OxArt*
Ceppi, Carlo 1829-1921 *MacEA*
Ceracchi, Giuseppe 1751-1802 *DcAmArt, NewYHSD*
Cerano, Il *McGDA*
Cerasini, John Francis 1919- *AmArch 70*
Cerci, Sharon L 1942- *WhoArt 84*
Cerda, Ildefonso 1815-1876 *MacEA*
Cerere, Pete 1940- *FolkA 86*
Ceresa, Carlo 1609-1679 *McGDA*
Cerezo, Mateo 1626?-1666 *McGDA*
Cerezo, Mateo 1635-1685 *ClaDrA*
Ceria, Edmond *OxTwCA*
Ceria, Edmond 1884-1955 *ClaDrA*
Ceribelli, Marguerite *DcWomA*
Cerio, Mabel Norman *DcWomA, WhAmArt 85*
Cermak, Jaroslav d1878 *ArtsNiC*
Cerna, D A *AmArch 70*
Cernel, Marie Louise Suzanne *DcWomA*
Cernigliaro, Salvatore *FolkA 86*
Cernik, Joseph August 1925- *AmArch 70*
Cernuschi, Alberto C *WhoAmA 73, –76, –78, –80, –82, –84*
Cerny, Frantisek M 1903-1978 *MacEA*
Cerny, George 1905- *WhAmArt 85*
Cerny, Richard Allen 1946- *MarqDCG 84*
Cerny, Robert George 1908- *AmArch 70*
Ceroli, Mario 1938- *ConArt 77, –83, OxTwCA, PhDcTCA 77*
Ceroni, Maria 1730-1772 *DcWomA*
Cerquozzi, Michelangelo 1602?-1660 *ClaDrA, McGDA, OxArt*
Cerra, Emilio A, Jr. 1938- *AmArch 70*
Cerres, Caroline 1799- *DcWomA*
Cerreta, Vincent Joseph 1910- *AmArch 70*
Cerroti, Violante Beatrice *DcWomA*
Certier, George 1831?- *NewYHSD*
Certowicz, Tola 1864- *DcWomA*
Ceruti, Giacomo *McGDA*
Ceruti, Giovanni 1842-1907 *MacEA*
Ceruti, Joseph 1912- *AmArch 70*
Cerutti-Simmons, Teresa *WhAmArt 85*
Cervan, John *DcBrECP*
Cervantes *FolkA 86*
Cervantes, Pedro 1933- *WhoAmA 73, –76, –78, –80, –82, –84*
Cervantez, Pedro 1915- *FolkA 86, WhAmArt 85*
Cerveau, Fermin *FolkA 86*
Cerveau, Joseph Louis Firman 1812-1896 *FolkA 86*
Cervellione, Maurice 1952- *MarqDCG 84*
Cervene, Richard *WhoAmA 84*
Cerveng, John *DcBrECP*
Cervenka, Barbara 1939- *WhoAmA 76, –78, –80, –82, –84*
Cervera, Roberto 1941- *AmArch 70*
Cervetti, Franklin Harry 1938- *AmArch 70*
Cesar 1921- *ConArt 77, –83, DcCAr 81, McGDA, OxTwCA, PhDcTCA 77, WorArt[port]*
Cesar, Gaston Gonzalez 1940- *WhoAmA 73, –76, –78, –80*
Cesar, Paulette *DcWomA*
Cesar, Rafael 1906- *WhAmArt 85*
Cesarani, Sal 1941- *WorFshn*
Cesare, O E *WhAmArt 85*
Cesare, Oscar Edward 1885-1948 *WorECar*
Cesaretti, Gusmano 1946- *MacBEP*
Cesari, Giuseppe *McGDA, OxArt*
Cesari, Giuseppe 1560?-1640 *ClaDrA*
Cesariano, Cesare DiLorenzo 1483-1543 *MacEA*
Ceschiatti, Alfredo *OxTwCA*
Cesetti, Giuseppe 1902- *PhDcTCA 77*
Cesi, Bartolommeo 1556-1629 *McGDA*
Cesnola, Luigi Palma 1832-1904 *WhAmArt 85*
Cespedes, Pablo De 1538-1608 *ClaDrA, McGDA*
Cessart, Louis Alexandre De 1719-1806 *MacEA*
Cetin, Anton 1936- *PrintW 83, –85, WhoAmA 82, –84*
Cetti, Lewis *NewYHSD*
Cetto, Max *ConArch A*
Cetto, Max 1903- *ConArch, MacEA*
Ceulen, Cornelis Jonson Van *McGDA*
Ceutsch, J H *FolkA 86*
Cezanne, Paul 1839-1906 *ClaDrA, McGDA, OxArt, PhDcTCA 77*
Cezard, Jean 1925- *WorECom*
Cezeron *FolkA 86*
Ch'a, Shih-Piao 1615-1698 *McGDA*
Chab, Victor 1930- *DcCAr 81*
Chabal-Dussurgey, Pierre-Adrien 1815?- *ArtsNiC*
Chabas, Marie S *DcWomA*
Chabas, Paul 1869-1937 *ClaDrA*
Chabassol, Marguerite *DcWomA*
Chabaud, Auguste 1882-1955 *OxTwCA, PhDcTCA 77*

Chabot, Duchesse De *DcWomA*
Chabot, A *DcVicP 2*
Chabot, Aurore 1949- *WhoAmA 84*
Chabot, Hendrik 1894-1949 *McGDA, OxArt, OxTwCA*
Chabot, John T *WhAmArt 85*
Chabot, Lucille Gloria 1908- *WhAmArt 85*
Chabot, Mary Vanderlip 1842-1929 *ArtsAmW 3, DcWomA*
Chabrol, Nelly De *DcWomA*
Chace, B C *WhAmArt 85*
Chace, Dorothea *WhAmArt 85*
Chace, Dorothea 1894- *DcWomA*
Chace, L *FolkA 86*
Chacere DeBeaurepaire, Louise *DcWomA*
Chachere, T G *AmArch 70*
Chacko, Rajah Verne 1959- *MarqDCG 84*
Chaconas, A N *AmArch 70*
Chadbourn, Alfred Cheney 1921- *WhoAmA 82, –84*
Chadburn, G H *DcVicP 2*
Chadburn, George Haworthe 1870-1950 *DcBrA 2*
Chadburn, Mabel *DcWomA*
Chaddlesone, Sherman 1947- *WhoAmA 84*
Chadeayne, Olive Kingsley 1904- *AmArch 70*
Chadeayne, Robert O 1897- *WhAmArt 85*
Chadeayne, Robert Osborne 1897- *WhoAmA 73, –76, –78, –80, –82, –84*
Chadenet-Huot, Marie *DcWomA*
Chadirji, Rifat 1926- *ConArch, MacEA*
Chadman, Mrs. *DcWomA*
Chadsey, Fred N 1932- *AmArch 70*
Chadwick *ArtsAmW 1, NewYHSD*
Chadwick, Arch D 1871- *WhAmArt 85*
Chadwick, C W 1861- *WhAmArt 85*
Chadwick, Emma *DcWomA*
Chadwick, Emma L *DcVicP 2*
Chadwick, Enid M 1902- *WhoArt 80, –82, –84*
Chadwick, Ernest Albert 1876-1955 *DcBrA 1*
Chadwick, Frederick Bruce 1935- *AmArch 70*
Chadwick, Grace Willard 1893- *ArtsAmW 2, DcWomA, WhAmArt 85*
Chadwick, H Keyes 1868-1959 *FolkA 86*
Chadwick, Henry Daniel *DcVicP 2*
Chadwick, Hulme *WhoArt 80N*
Chadwick, Hulme 1910- *DcD&D[port]*
Chadwick, John Herbert *WhAmArt 85*
Chadwick, Josh *NewYHSD*
Chadwick, Lynn 1914- *ConArt 77, –83, ConBrA 79[port], DcBrA 1, McGDA, OxArt, OxTwCA, PhDcTCA 77, WhoArt 80, –82, –84, WorArt[port]*
Chadwick, Nancy 1953- *PrintW 83, –85*
Chadwick, Paxton 1903-1961 *DcBrA 1*
Chadwick, Theodore A 1904- *AmArch 70*
Chadwick, Tom *DcBrA 1*
Chadwick, Tom 1914-1942 *DcBrA 2*
Chadwick, Whitney 1943- *WhoAmA 78, –80*
Chadwick, William *WhAmArt 85*
Chadwick, William F 1828?- *NewYHSD*
Chaed, Louise C *DcWomA, WhAmArt 85*
Chael, Frederick Paul 1924- *AmArch 70*
Chaet, Bernard 1924- *DcCAA 71, –77, WhoAmA 73, –76, –78, –80, –82, –84*
Chaet, Bernard Robert 1924- *WhAmArt 85*
Chafee, Judith Davidson 1932- *AmArch 70*
Chafee, Katharine 1945- *WhoAmA 82*
Chafee, William 1931- *AmArch 70*
Chafetz, Sidney 1922- *DcAmArt, WhoAmA 73, –76, –78, –80, –82, –84*
Chaffault, Marie L *DcWomA*
Chaffee, Ada Gilmore 1883-1955 *WhAmArt 85*
Chaffee, Adeliza B 1856-1916 *WhAmArt 85*
Chaffee, Mrs. Everitte S *DcWomA, WhAmArt 85*
Chaffee, John W 1931- *WhoAmA 78, –80*
Chaffee, Olive Holbert *WhAmArt 85*
Chaffee, Olive Holbert 1881-1944 *ArtsAmW 2*
Chaffee, Oliver N 1881-1944 *WhAmArt 85*
Chaffee, R O *AmArch 70*
Chaffee, Roger B 1940- *MarqDCG 84*
Chaffee, Roy *WhAmArt 85*
Chaffee, Walter G d1945 *BiDAmAr*
Chaffereau, Peter *NewYHSD*
Chaffey, Douglas H 1924- *WhoArt 80, –82, –84*
Chaffin, Lawrence, Jr. 1934- *AmArch 70*
Chaffitz, Ber *WhAmArt 85*
Chagall, Marc 1887- *ClaDrA, ConArt 77, –83, McGDA, OxArt, OxTwCA, PrintW 83, WhoGrA 82[port], WorArt[port]*
Chagall, Marc 1887-1985 *PrintW 85*
Chagall, Marc 1889- *OxArt, PhDcTCA 77, WhoGrA 62*
Chagnard, Ray *MarqDCG 84*
Chahroudi, Martha L 1946- *WhoAmA 84*
Chaiet, Louis Cameron 1904- *WhAmArt 85*
Chaigneau, Henry 1760?- *DcBrWA*
Chaigneau, Jean Ferdinand 1830-1906 *ClaDrA*
Chaiket, Arcadi Samoilovitch 1898- *ICPEnP A*
Chaikin, Alyce *WhoAmA 84*
Chaikin, George Merrill 1944- *MarqDCG 84*
Chaillery, Berthe *DcWomA*
Chaillery, Laure *DcWomA*

Chaillou, Elisabeth *DcWomA*
Chailly, Adele *DcWomA*
Chaim, Trude 1892-1952 *DcWomA*
Chaimowicz, Marc Camille 1947- *ConBrA 79[port]*
Chaimowitz, Marc 1947- *DcCAr 81*
Chain *FolkA 86*
Chain, Helen 1852-1892 *ArtsAmW 1, –2*
Chain, Helen Henderson 1848-1892 *DcWomA*
Chain, Mrs. James Albert 1852-1892 *IlBEAAW*
Chaine, Josephine 1847-1882 *DcWomA*
Chait, Daniel 1921- *AmArch 70*
Chaix, Alfred Valerian 1913- *AmArch 70*
Chaix, Desiree *DcWomA*
Chakos, Alex 1924- *AmArch 70*
Chalat Ziegler, Jacqueline *WhoAmA 78*
Chale, Ellen Wheeler *DcWomA, WhAmArt 85*
Chalee *IlBEAAW*
Chalette, Mademoiselle 1757?-1810? *DcWomA*
Chalfant, J D 1856-1931 *WhAmArt 85*
Chalfant, Jefferson David 1846-1931 *BnEnAmA*
Chalfant, Jefferson David 1856-1931 *DcAmArt*
Chalfant, R W *AmArch 70*
Chalfant, Richard David 1931- *AmArch 70*
Chalfant, W B *AmArch 70*
Chalfin, Paul 1874- *WhAmArt 85*
Chalgrin, Francois 1739-1811 *WhoArch*
Chalgrin, Jean Francois Therese 1739-1811 *MacEA*
Chalgrin, Jean-Francois-Therese 1739-1811 *McGDA*
Chaliapin, Boris *WhAmArt 85*
Chaliapin, Boris 1907-1979 *WhoAmA 80N, –82N, –84N*
Chalk, Hilda *DcVicP 2*
Chalk, O Roy *WhoAmA 73, –76, –78*
Chalk, Mrs. O Roy *WhoAmA 73, –76, –78*
Chalke, John 1940- *DcCAr 81, WhoAmA 78, –80, –82, –84*
Chalker, Cissie *DcBrA 2, DcWomA*
Chalker, Jack Bridger *DcBrA 2*
Chalker, Walter H *FolkA 86*
Chalkley, C *BiDBrA*
Chalkley, H E *DcVicP 2*
Chall, Alfred *NewYHSD*
Challand, Lydia 1843- *DcWomA*
Challe, Charles Michel Ange 1718-1778 *ClaDrA*
Challen, William *CabMA*
Challener, Frederick Sproston 1869-1959 *DcBrA 2*
Challenger, J *DcVicP 2*
Challenger, Michael 1939- *PrintW 83, –85*
Challenor, Frances C *DcWomA*
Challenor-Coan, Francis *WhAmArt 85*
Challes, Charles Michel Ange 1718-1778 *ClaDrA*
Challice, Annie Jane *DcVicP 2, DcWomA*
Challie, Alphonsine De *DcWomA*
Challinor, Taylor *AntBDN H*
Challis, Ebenezer *DcVicP 2*
Challis, Richard Bracebridge 1920- *WhoAmA 76, –78, –80, –82, –84*
Challiss, Charles A *DcVicP 2*
Challiss, Emily *DcWomA, WhAmArt 85*
Challoner, William *AntBDN D*
Challoner, William Lindsay 1852-1901 *ArtsAmW 3*
Chalmers, A *DcBrECP*
Chalmers, Audrey *WhAmArt 85*
Chalmers, Audrey 1899?-1957 *IlsCB 1744, –1946*
Chalmers, B 1906- *WhAmArt 85*
Chalmers, E Laurence, Jr. 1928- *WhoAmA 76, –78, –80, –82, –84*
Chalmers, G Paul 1836-1878 *ArtsNiC*
Chalmers, Sir George 1720?-1791 *DcBrECP*
Chalmers, George Paul 1833-1878 *DcVicP, –2*
Chalmers, George Paul 1836-1878 *DcBrWA*
Chalmers, Hector d1943 *DcBrA 2*
Chalmers, Helen Augusta 1880- *ArtsAmW 1, WhAmArt 85*
Chalmers, Helen Augusta 1880-1957? *DcWomA*
Chalmers, J *DcBrWA*
Chalmers, John *BiDBrA*
Chalmers, Mary Eileen *IlsCB 1967*
Chalmers, Mary Eileen 1927- *IlsCB 1946, –1957*
Chalmers, Mary Eilleen 1927- *WhoAmA 78, –80, –82*
Chalmers, Mary H *DcVicP 2*
Chalmers, R K *AmArch 70*
Chalmers, Sir Robert 1749-1807 *DcBrECP*
Chalmers, Robert Lamont, Jr. 1913- *AmArch 70*
Chalmers, W A *DcBrWA*
Chalmers, W A d1798? *BkIE*
Chalmers, William A 1768-1794? *DcBrECP*
Chalon, Alfred Edward 1780-1860 *ClaDrA, DcBrBI, DcBrWA, DcVicP, –2*
Chalon, Alfred Edward 1781-1860 *ArtsNiC*
Chalon, Christina 1748-1808 *DcWomA*
Chalon, Henry Bernard 1770-1849 *DcVicP, –2*
Chalon, Henry Bernard 1771-1849 *DcBrECP*
Chalon, John James 1778-1854 *ArtsNiC, DcBrBI, DcBrWA, DcSeaP, DcVicP, –2*
Chalon, Louis *DcNiCA*
Chalon, Maria A 1800?-1867 *DcWomA*
Chalon, Rosalie *DcWomA*
Chaloner, Holman Waldron 1851- *FolkA 86*
Chaloner, Walter L *WhAmArt 85*
Chalons, Simon De d1561? *McGDA*

Chandler, Creel Leon 1930- *AmArch 70*
Chandler, Cynthia Ann 1937- *WhoArt 82, –84*
Chandler, Dana C, Jr. *WhoAmA 76, –78, –80, –82*
Chandler, Dana C, Jr. 1941- *AfroAA*
Chandler, Daniel 1729-1790 *FolkA 86*
Chandler, Daniel, Jr. 1764-1853 *FolkA 86*
Chandler, David Paul 1923- *MarqDCG 84*
Chandler, Digby W 1856-1928 *WhAmArt 85*
Chandler, Donald Reed 1931- *AmArch 70*
Chandler, Elisabeth Gordon 1913- *WhoAmA 73, –76, –78, –80, –82, –84*
Chandler, Floyd C 1920- *IlBEAAW*
Chandler, Francis W 1844-1925 *BiDAmAr*
Chandler, G L *NewYHSD*
Chandler, George Walter *WhAmArt 85*
Chandler, Hattie M *ArtsEM, DcWomA*
Chandler, Helen Clark 1881- *ArtsAmW 2, DcWomA, WhAmArt 85*
Chandler, Helen M 1881- *WhAmArt 85*
Chandler, Houston E *AfroAA*
Chandler, Isaac N *NewYHSD*
Chandler, Izora d1906 *DcWomA, WhAmArt 85*
Chandler, James G 1856-1924 *BiDAmAr*
Chandler, John Edward 1943- *AfroAA*
Chandler, John Greene 1815-1879 *NewYHSD*
Chandler, Mrs. John Greene *NewYHSD*
Chandler, John Westbrooke 1764-1805? *DcBrECP*
Chandler, John William 1910- *WhAmArt 85, WhoAmA 73, –76, –78, –80, –82, –84*
Chandler, Joseph Everett 1864-1945 *BiDAmAr*
Chandler, Joseph Goodhue 1813-1880? *NewYHSD*
Chandler, Joseph Goodhue 1813-1884 *FolkA 86*
Chandler, Mrs. Joseph Goodhue 1820-1868 *NewYHSD*
Chandler, Katherine *WhAmArt 85*
Chandler, Lucretia Ann 1820-1868 *DcWomA*
Chandler, Lucretia Ann Waite 1820-1868 *FolkA 86*
Chandler, Rose M *DcBrWA, DcVicP 2, DcWomA*
Chandler, Samuel W 1803-1900 *NewYHSD*
Chandler, Sarah Ann *DcWomA*
Chandler, Theophilus P 1845-1928 *BiDAmAr*
Chandler, Thomas *FolkA 86*
Chandler, Victor L L 1836?- *NewYHSD*
Chandler, Virginia *DcWomA, WhAmArt 85*
Chandler, William *FolkA 86*
Chandler, Winfield 1841?- *NewYHSD*
Chandler, Winthrop 1747-1790 *AmFkP[port], BnEnAmA, DcAmArt, FolkA 86, NewYHSD*
Chandor, Douglas d1953 *DcBrA 2, WhoAmA 78N, –80N, –82N, –84N*
Chandor, Douglas 1897-1953 *ArtsAmW 3*
Chandra 1931- *WhoArt 80, –82*
Chanel, Gabrielle 1883-1971 *FairDF FRA[port], WorFshn*
Chanel, Gabrielle Bonheur 1883-1971 *ConDes*
Chaney, John Christopher 1949- *MarqDCG 84*
Chaney, Lester Joseph 1907- *WhAmArt 85*
Chaney, Mary Ann *DcWomA*
Chaney, Mary Ann Browne *NewYHSD*
Chaney, Robert Durland 1928- *AmArch 70*
Chaney, V C *AmArch 70*
Chang, Amos I T 1916- *AmArch 70*
Chang, Andrew K 1932- *AmArch 70*
Chang, Chien-Ying 1915- *ClaDrA, DcBrA 1, WhoArt 80, –82, –84*
Chang, Ching-Yu *ConArch A*
Chang, Dai-Chien 1899- *WhoAmA 76, –78, –80, WhoArt 80, –82, –84*
Chang, Darwin 1958- *MarqDCG 84*
Chang, David Ping-Chung 1929- *AmArch 70*
Chang, H, Jr. *AmArch 70*
Chang, Hsuan *McGDA, OxArt*
Chang, Lu *McGDA*
Chang, Ning-San 1951- *MarqDCG 84*
Chang, Robin 1951- *MarqDCG 84*
Chang, S *AmArch 70*
Chang, San-Cheng 1954- *MarqDCG 84*
Chang, Seng-Yu *McGDA*
Ch'ang, Sheng-Fo *McGDA*
Chang, Shu-Ch'i 1899-1957 *McGDA*
Chang, Ta-Ch'ien 1899- *McGDA*
Chang, Wey-Tyng 1942- *MarqDCG 84*
Chang, Yen-Yuan *McGDA*
Ch'ang-Kang *McGDA*
Ch'ang-Sha *McGDA*
Chanin, Abraham L *WhoAmA 78N, –80N, –82N, –84N*
Chanin, Abraham L d1967? *WhAmArt 85*
Chanler, Albert 1880- *DcBrA 1*
Chanler, Beatrice Ashley *DcWomA*
Chanler, Beatrice Ashley d1946 *WhAmArt 85*
Chanler, Robert W 1872-1930 *WhAmArt 85*
Chanler, Robert Winthrop 1872-1930 *IlBEAAW*
Chanler, Samuel *CabMA*
Chanler, W Astor *WhAmArt 85*
Chann, Earl Kai 1933- *AmArch 70*
Channel, A Elizabeth 1913- *WhAmArt 85*
Channer, C Alfreda *DcVicP 2*
Channer, Cecilia Alfreda *DcWomA*
Channing, Joel B 1940- *AmArch 70*
Channing, Jules P 1913- *AmArch 70*

Channing, Leslie Thomas 1916- *WhoArt 80, –82, –84*
Channing, Susan Rose 1943- *WhoAmA 78, –80, –82, –84*
Channing-Renton, Ernest Matthew 1895- *ClaDrA*
Channing-Renton, Ernest Matthews *WhoArt 82N*
Channing-Renton, Ernest Matthews 1895- *WhoArt 80*
Channon, John *AntBDN G*
Channon, M E *DcVicP 2, DcWomA*
Chanou, Julie *DcWomA*
Chant, Elizabeth A *WhAmArt 85*
Chant, J *DcVicP 2*
Chantereine, Camille De d1847 *DcWomA*
Chanteux, Berthe *DcWomA*
Chanton, Louise De 1847?-1899 *DcWomA*
Chantre, Aimee 1818-1899 *DcWomA*
Chantre, C *DcVicP 2*
Chantrel, Marie Madeleine *DcWomA*
Chantrell, Robert Dennis 1793-1872 *BiDBrA, MacEA*
Chantrey, Sir Francis Leggatt 1781-1841 *OxArt*
Chantrey, Sir Francis Leggatt 1781-1842 *DcBrWA*
Chantry, Sir Francis 1781-1841 *McGDA*
Chanu-Bauhain, Yvonne *DcWomA*
Chao, Ch'ang *McGDA*
Chao, Ling-Jan *McGDA*
Chao, Meng-Fu d?-322 *McGDA*
Chao, Meng-Fu 1254-1322 *OxArt*
Chao, Miao Ching *DcWomA*
Chao, Po-Chu *McGDA*
Chao, Shao-An 1905- *WhoArt 80, –82, –84*
Chao, Ta-Nien *McGDA*
Chao, Thomas S C 1950- *MarqDCG 84*
Chao, Tso *McGDA*
Chao, Tzu-Ang *McGDA*
Chao, Yung 1279- *McGDA*
Chapalay, Emily *DcWomA*
Chapel, Guy M 1871- *WhAmArt 85*
Chapel, Guy Martin 1871- *ArtsEM*
Chapelain, Luc *DcCAr 81*
Chapelain-Midy, Roger 1904- *DcCAr 81, OxTwCA*
Chapelet, Marie *DcWomA*
Chapellier, George 1890- *WhoAmA 73, –76*
Chapellier, George 1890-1978 *WhoAmA 78N, –80N, –82N, –84N*
Chapellier, Robert *WhoAmA 73*
Chapellier, Robert d1974 *WhoAmA 76N, –78N, –80N, –82N, –84N*
Chapelsky, R N *AmArch 70*
Chapian, Grieg Hovsep 1913- *WhoAmA 73, –76, –78, –80, –82, –84*
Chapin, Mrs. *DcWomA*
Chapin, Aaron 1751?-1838 *AntBDN G*
Chapin, Aaron 1753-1838 *CabMA*
Chapin, Alpheus 1787-1870 *FolkA 86, NewYHSD*
Chapin, Archibald B 1875- *WhAmArt 85*
Chapin, Benjamin M *NewYHSD*
Chapin, C H *ArtsAmW 3*
Chapin, Charles E *WhAmArt 85*
Chapin, Cornelia VanAuken *WhAmArt 85*
Chapin, Cornelia VanAuken 1893-1972 *DcWomA*
Chapin, Eliphalet 1741-1807 *AntBDN G, CabMA*
Chapin, Francis d1965 *WhoAmA 78N, –80N, –82N, –84N*
Chapin, Francis 1899-1965 *WhAmArt 85*
Chapin, Hubert *WhAmArt 85*
Chapin, James 1887- *WhAmArt 85*
Chapin, James Ormsbee 1887- *McGDA*
Chapin, Jane Catherine Louise Value 1814-1891 *DcWomA, NewYHSD*
Chapin, John R 1823- *EarABI, EarABI SUP*
Chapin, John R 1823-1904 *IlBEAAW, NewYHSD , WhAmArt 85*
Chapin, Joseph Hawley 1869-1939 *WhAmArt 85*
Chapin, Laertes 1778-1847 *CabMA*
Chapin, Louis 1918- *WhoAmA 73, –76, –78, –80, –82*
Chapin, Lucy Grosvenor *WhAmArt 85*
Chapin, Lucy Grosvenor 1873-1939 *DcWomA*
Chapin, Marie Louise *DcWomA*
Chapin, Mary S *FolkA 86*
Chapin, Myron Butman 1887-1958 *WhAmArt 85, WhoAmA 80N, –82N, –84N*
Chapin, S D *DcWomA*
Chapin, Sarah *WhAmArt 85*
Chapin, Silas 1793-1828 *CabMA*
Chapin, William 1802-1888 *NewYHSD*
Chapin And Hollister *EncASM*
Chaplain, D K *AmArch 70*
Chaplen, John *CabMA*
Chaplet, Ernest *AntBDN M*
Chaplet, Ernest 1835- *ArtsNiC*
Chaplet, Ernest 1835-1909 *AntBDN A*
Chaplet, Ernest 1836-1909 *DcNiCA*
Chaplin, A M *DcWomA*
Chaplin, Alice Mary *DcWomA*
Chaplin, Annie *DcVicP 2*
Chaplin, Bob 1947- *WhoArt 80, –82, –84*
Chaplin, C H A *DcWomA*
Chaplin, Charles 1825- *ArtsNiC*
Chaplin, Charles 1825-1891 *ClaDrA*
Chaplin, Christine *WhAmArt 85*
Chaplin, Christine 1842- *ArtsNiC, DcWomA*
Chaplin, Elisabeth *WhAmArt 85*

Chaplin, Florence *DcVicP 2*
Chaplin, Florence Eleanor *DcWomA*
Chaplin, Frank *DcVicP 2*
Chaplin, George Edwin 1931- *WhoAmA 73, –76, –78, –80, –82, –84*
Chaplin, Henry *DcVicP 2*
Chaplin, J G *AfroAA, FolkA 86*
Chaplin, J W *AfroAA*
Chaplin, James *WhAmArt 85*
Chaplin, Margaret *DcWomA, WhAmArt 85*
Chaplin, Michael James 1943- *WhoArt 80, –82, –84*
Chaplin, Millicent Mary *DcWomA*
Chaplin, Prescott 1897- *ArtsAmW 2, WhAmArt 85*
Chaplin, Robert *BiDBrA*
Chapman, Miss *DcWomA*
Chapman, Mrs. *DcWomA*
Chapman, A *FolkA 86*
Chapman, A B, III *AmArch 70*
Chapman, Abel 1851-1929 *DcBrWA, DcVicP 2*
Chapman, Abel Hugh, Jr. 1917- *AmArch 70*
Chapman, Allyn *CabMA*
Chapman, Alton James *WhoAmA 73, –76*
Chapman, Alva R *NewYHSD*
Chapman, Anne 1930- *WhoAmA 82, –84*
Chapman, Arthur Joseph 1946- *MarqDCG 84*
Chapman, C H *DcBrBI*
Chapman, Carlton T 1860-1925 *WhAmArt 85*
Chapman, Carlton Theodore 1860-1926 *DcSeaP*
Chapman, Catherine J *DcVicP 2, DcWomA*
Chapman, Cecil B 1876-1918 *BiDAmAr*
Chapman, Ceil 1912- *WorFshn*
Chapman, Charles *DcBrECP*
Chapman, Charles Shepard d1962 *WhoAmA 78N, –80N, –82N, –84N*
Chapman, Charles Shepard 1879- *IlrAm B*
Chapman, Charles Shepard 1879-1962 *ArtsAmW 3, IlBEAAW, IlrAm 1880, WhAmArt 85*
Chapman, Chris 1952- *MacBEP*
Chapman, Conrad Wise *DcSeaP*
Chapman, Conrad Wise 1842-1910 *DcAmArt, WhAmArt 85*
Chapman, Cyrus Durand 1856-1918 *WhAmArt 85*
Chapman, D S *AmArch 70*
Chapman, Dave 1909- *McGDA, WhAmArt 85, WhoAmA 73, –76, –78*
Chapman, David E 1938- *AmArch 70*
Chapman, Donald Douglas 1927- *AmArch 70*
Chapman, E F *DcBrBI*
Chapman, Elizabeth Maria *DcWomA*
Chapman, Ernest Zealand 1864- *WhAmArt 85*
Chapman, Ernst *FolkA 86*
Chapman, Esther I E 1862-1952 *DcWomA*
Chapman, Esther I E McCord *WhAmArt 85*
Chapman, F A 1818-1891 *EarABI SUP*
Chapman, F Burnham 1882-1935? *BiDAmAr*
Chapman, Frank C 1933- *AmArch 70*
Chapman, Frederic A 1818-1891 *IlBEAAW, NewYHSD*
Chapman, Frederick *WhAmArt 85*
Chapman, Frederick A 1870-1933 *WhAmArt 85*
Chapman, Frederick Trench 1887- *IlBEAAW, IlrAm D, IlsCB 1946*
Chapman, Frederick Trench 1887-1983 *IlrAm 1880*
Chapman, George 1908- *DcBrA 2*
Chapman, George R *DcBrBI, DcVicP, –2*
Chapman, Mrs. Gilbert W *WhoAmA 80, –73, –76, –78*
Chapman, Grosvenor 1911- *AmArch 70*
Chapman, H *DcVicP 2*
Chapman, H W *DcVicP 2*
Chapman, Henry Otis 1862-1929 *BiDAmAr*
Chapman, Henry Stow *AmArch 70*
Chapman, Herbert *ArtsEM*
Chapman, Hicks David *FolkA 86*
Chapman, Howard Eugene 1913- *WhAmArt 85, WhoAmA 73, –76, –78*
Chapman, Howard Eugene 1913-1977 *WhoAmA 80N, –82N, –84N*
Chapman, Israel *CabMA*
Chapman, J *DcVicP 2, FolkA 86*
Chapman, J G, Jr. *AmArch 70*
Chapman, J H d1895 *BiDAmAr*
Chapman, J L *AmArch 70*
Chapman, James Jeffries, Jr. 1908- *AmArch 70*
Chapman, James Piephoff 1938- *AmArch 70*
Chapman, John *BiDBrA*
Chapman, John Gadsby 1808-1889 *BnEnAmA*
Chapman, John Gadsby 1808- *ArtsNiC*
Chapman, John Gadsby 1808-1889 *ArtsAmW 2, DcAmArt, EarABI, EarABI SUP, IlBEAAW, NewYHSD*
Chapman, John Watkins *DcVicP, –2*
Chapman, Josephine E *ArtsAmW 2, DcWomA, WhAmArt 85*
Chapman, June Dianne 1939- *WhoArt 80, –82, –84*
Chapman, Kenneth M 1875- *WhAmArt 85*
Chapman, Kenneth Milton 1875-1968 *ArtsAmW 1, –3, IlBEAAW*
Chapman, M A *WhAmArt 85*
Chapman, Mary Berri *DcWomA*
Chapman, Mary Morton *DcWomA*
Chapman, Max 1911- *WhoArt 80, –82, –84*

Chapman, Max D 1934- *AmArch 70*
Chapman, Minerva 1858-1947 *WhAmArt 85*
Chapman, Minerva Josephine 1858-1947 *ArtsAmW 2, DcWomA*
Chapman, Mollie Lee *DcWomA*
Chapman, Moses *AntBDN O, OxDecA*
Chapman, Moses 1783-1821 *NewYHSD*
Chapman, Nathan *FolkA 86*
Chapman, Olive *DcBrA 2*
Chapman, Ottis F *ArtsAmW 3*
Chapman, Otto *ArtsAmW 3*
Chapman, Paul *WhAmArt 85*
Chapman, Peggy *IlsBYP*
Chapman, R H *AmArch 70*
Chapman, R Hamilton *DcVicP 2*
Chapman, R W *DcVicP, -2*
Chapman, Richard William 1954- *MarqDCG 84*
Chapman, Robert 1754?-1827 *BiDBrA*
Chapman, Robert 1933- *ClaDrA*
Chapman, Robert Gordon 1941- *WhoAmA 76, -78, -80, -82, -84*
Chapman, Samuel 1799- *BiDBrA*
Chapman, Stephen *DcBrA 1*
Chapman, T A *FolkA 86*
Chapman, W E *WhAmArt 85*
Chapman, Walter Howard 1912- *WhoAmA 78, -80, -82, -84*
Chapman, William *NewYHSD*
Chapman, William 1817-1879 *DcBrWA, DcVicP 2*
Chapman, William 1879-1929 *BiDAmAr*
Chapman And Barden *EncASM*
Chaponay, Marquise De *DcWomA*
Chapone, Mrs. *DcWomA*
Chaponniere, Marguerite *DcWomA*
Chapoton, Alexander, Jr. 1839-1906 *ArtsEM*
Chapoton And Hinsdale *ArtsEM*
Chapoval, Jules 1919-1951 *OxTwCA, PhDcTCA 77*
Chappee, Robert d1883? *ArtsEM*
Chappel, Alonzo 1828-1887 *IlBEAAW, NewYHSD*
Chappel, E *DcBrA 1*
Chappel, Edouard *DcVicP 2*
Chappel, Edouard 1859- *ClaDrA*
Chappel, M A *DcWomA*
Chappel, Mrs. M A *ArtsEM*
Chappel, William *NewYHSD*
Chappelear, John Willis, Jr. 1929- *AmArch 70*
Chappelear, Mary *FolkA 86*
Chappell, Berkley Warner 1934- *WhoAmA 76, -78, -80, -82, -84*
Chappell, Bill 1919- *IlBEAAW*
Chappell, Doyle W 1938- *AmArt*
Chappell, Gary *MarqDCG 84*
Chappell, George S *WhAmArt 85*
Chappell, Jesse *AfroAA*
Chappell, L S *AmArch 70*
Chappell, Miles Linwood 1939- *WhoAmA 84*
Chappell, Reuben 1870-1940 *DcBrWA, DcSeaP, DcVicP 2*
Chappell, Walter 1925- *ConPhot, ICPEnP A, MacBEP, WhoAmA 84*
Chappell, Warren *IlsCB 1967*
Chappell, Warren 1904- *IlsBYP, IlsCB 1744, -1946, -1957, WhAmArt 85, WhoAmA 73, -76, -78, WhoGrA 62*
Chappell, William *DcVicP 2, FolkA 86*
Chappelle, Jerry Leon 1939- *WhoAmA 76, -78, -80, -82, -84*
Chappelle, R N *AmArch 70*
Chappelsmith, J *DcVicP 2*
Chappelsmith, John 1807?-1883? *NewYHSD*
Chappet, M L *DcWomA*
Chapple, Charles *BiDBrA*
Chapple, Dave *OfPGCP 86*
Chapps, John 1941- *WhoAmA 73, -76*
Chappuis *AntBDN M*
Chapron, Marie Pauline *DcWomA*
Chapron, Nicolas 1612-1656 *ClaDrA*
Chapu, Henri 1833-1891 *WhAmArt 85A*
Chapu, Henri-Michel-Antoine *ArtsNiC*
Chapu, Henri Michel Antoine 1833-1891 *McGDA*
Chapuis, Marie *DcWomA*
Chapuis, Michel 1936- *DcCAr 81*
Chapurat, Aristide *DcSeaP*
Chapus, Berthe *DcWomA*
Chapus, Henri Michelle 1833-1891 *DcNiCA*
Charageat, Marguerite 1894- *WhoArt 80, -82, -84*
Charazac *OxTwCA*
Charbonneau, Michael Priest 1953- *MarqDCG 84*
Charbonnee, Angelique *DcWomA*
Charbonnier, Jean-Philippe 1921- *ConPhot, ICPEnP A, MacBEP*
Charbonnier, Pierre 1897-1978 *ConDes*
Charchoune, Serge 1888- *OxTwCA, PhDcTCA 77*
Charchoune, Serge Ivanovitch 1888- *ConArt 77*
Charchoune, Serve Ivanovitch 1888- *DcCAr 81*
Charcot, Meg Jean *DcWomA*
Chard, Louise Cable *DcWomA, WhAmArt 85*
Chard, Raymond George 1895- *WhAmArt 85*
Chard, Walter G 1880- *WhAmArt 85*
Charderon, Francine *DcWomA*
Chardigny, Barthelemy Francois 1757-1813 *McGDA*

Chardin, Jean Baptiste Simeon 1699-1779 *ClaDrA*
Chardin, Jean-Baptiste-Simeon 1699-1779 *McGDA, OxArt*
Chardin, Paul-Louis-Leger *ArtsNiC*
Chardon, Madame *DcWomA*
Chardon, Anna Etienne *DcWomA*
Chardon, Marguerite Virginie *DcWomA*
Chardonnet, A De *DcWomA*
Chareau, Pierre 1883-1950 *ConArch, MacEA*
Charen, Eugenie Marguerite H Lethiere *DcWomA*
Charenton, Enguerrand 1420?-1470? *McGDA*
Chares Of Lindos d270BC *MacEA*
Chargesheimer 1924-1972 *ConPhot, ICPEnP A*
Charle, E G *AmArch 70*
Charle *NewYHSD*
Charles Borromeo, Saint *McGDA*
Charles, Madame *DcWomA*
Charles The Painter *FolkA 86*
Charles, A *AntBDN O, OxDecA*
Charles, Agnes E *WhoArt 80, -82, -84*
Charles, Bernard Hugh *WhoArt 80, -82*
Charles, Claire Therese d1703 *DcWomA*
Charles, Clayton 1913- *WhoAmA 73, -76, -78N, -80N, -82N, -84N*
Charles, Donald *IlsBYP*
Charles, Durant *WhoAmA 82, -84*
Charles, Geraldine *AfroAA*
Charles, H *NewYHSD*
Charles, Harold Homer 1918- *AmArch 70*
Charles, James 1851-1906 *ClaDrA, DcBrA 1, DcVicP, -2*
Charles, Maurice *EarABI SUP, NewYHSD*
Charles, Mrs. R C *DcVicP 2*
Charles, Richard L *MarqDCG 84*
Charles, Robert Lonsdale 1906- *WhoArt 82N*
Charles, Robert Lonsdale 1916- *WhoArt 80*
Charles, S M *NewYHSD*
Charles, Sam d1887- *WhAmArt 85*
Charles, W *DcBrWA, DcVicP 2*
Charles, William d1820 *DcBrBI*
Charles, William 1776-1820 *NewYHSD , WorECar*
Charles-Smith, Donald 1935- *WhoAmA 84*
Charleson, M D 1888- *WhAmArt 85*
Charleston, Dodds Edward *AmArch 70*
Charleston, Robert Jesse 1916- *WhoArt 80, -82, -84*
Charlesworth, Alice *DcVicP 2, DcWomA*
Charlesworth, Eleanor *DcBrA 1*
Charlesworth, Sarah E 1947- *WhoAmA 84*
Charlet, Frantz 1862-1928 *ClaDrA*
Charlet, Nicolas Joussaint 1792-1845 *ClaDrA*
Charlet, Nicolas-Toussaint 1792-1845 *McGDA*
Charlie, Peter *FolkA 86*
Charlier, Guillaume 1854-1924 *McGDA*
Charlier, Jacques *ClaDrA*
Charlier, Jean-Michel 1924- *WorECom*
Charlip, Remy *IlsCB 1967*
Charlip, Remy 1929- *IlsCB 1946, -1957*
Charlot, Jean *IlsCB 1967*
Charlot, Jean 1898- *ArtsAmW 1, BnEnAmA, IlsBYP, IlsCB 1744, -1946, -1957, McGDA, WhAmArt 85, WhoAmA 73, -76, -78*
Charlot, Jean 1898-1978 *GrAmP*
Charlot, Jean 1898-1979 *WhoAmA 80N, -82N, -84N*
Charlot, Louis 1878-1951 *ClaDrA*
Charlot, Martin Day 1944- *AmArt, WhoAmA 76, -78, -80, -82, -84*
Charlotte, Archduchess Of Austria *DcWomA*
Charlotte Augusta 1796-1817 *DcWomA*
Charlotte Augusta Matilda 1766-1828 *DcWomA*
Charlotte Napoleon, Princess *DcWomA*
Charlotte, Princess *DcWomA*
Charlton, Alan 1948- *ConArt 77, -83, DcCAr 81*
Charlton, C Hedley *DcBrBI*
Charlton, Catherine *DcVicP 2, DcWomA*
Charlton, Edith M *DcWomA*
Charlton, Edward William *DcBrA 1*
Charlton, Edward William 1859-1925 *DcBrBI*
Charlton, Edward William 1859-1935 *DcBrA 2*
Charlton, Evan *DcCAr 81*
Charlton, F *FolkA 86*
Charlton, Frederic *FolkA 86*
Charlton, Gene 1909- *WhAmArt 85*
Charlton, George 1899- *DcBrA 1, WhoArt 80, -82, -84*
Charlton, Gertrude *DcBrBI*
Charlton, H V d1916 *DcBrA 2*
Charlton, J *AmArch 70*
Charlton, John d1917 *DcVicP*
Charlton, John 1849-1910? *IlBEAAW*
Charlton, John 1849-1917 *ClaDrA, DcBrA 1, DcBrBI, DcBrWA, DcVicP 2*
Charlton, Louisa *DcVicP 2, DcWomA*
Charlton, Michael Alan 1923- *IlsCB 1967*
Charlton, William Henry 1846-1918 *DcBrA 1, DcBrWA, DcVicP 2*
Charmaille, J B *NewYHSD*
Charman, Clifford 1910- *WhoArt 80, -82, -84*
Charman, Frederick Montague 1894- *WhAmArt 85*
Charman, Jessie 1895- *DcWomA, WhAmArt 85*
Charman, Laura B *DcWomA, WhAmArt 85*
Charmatz, Bill 1925- *WhoAmA 82, -84*

Charmeil, E *DcWomA*
Charmy, Emilie 1878-1974 *DcWomA*
Charnay, Armand *ArtsNiC*
Charnay-Crozet, Marie *DcWomA*
Charness, Michael Paul 1955- *MarqDCG 84*
Charney, Jack Allen *AmArch 70*
Charney, Melvin 1935- *ConArch*
Charnin, Murray 1919- *AmArch 70*
Charnock, Ellen *DcVicP 2, DcWomA*
Charnock, Thomas *CabMA*
Charonton, Enguerrand 1410?- *OxArt*
Charoux, Lothar *OxTwCA*
Charoux, Siegfried 1896- *WhoArt 80, -82, -84*
Charoux, Siegfried 1896-1967 *OxTwCA*
Charoux, Siegfried Joseph 1896-1967 *DcBrA 1*
Charpentier *IlDcG*
Charpentier, Desarnaud-, Madame *IlDcG*
Charpentier, Alexandre 1856-1909 *AntBDN A, DcNiCA*
Charpentier, Caroline De *DcWomA*
Charpentier, Constance Marie 1767-1849 *DcWomA*
Charpentier, Constance-Marie 1767-1849 *WomArt*
Charpentier, Eugenie *DcWomA*
Charpentier, Felix 1858-1924 *WhAmArt 85A*
Charpentier, Francine *DcWomA*
Charpentier, H P *DcWomA*
Charpentier, Julie d1843 *DcWomA*
Charpentiers *DcBrECP*
Charpin *DcBrECP*
Charpin, E *DcWomA*
Charpine, E *DcWomA*
Charpiot, Donald 1912- *WhAmArt 85*
Charraud, John J *NewYHSD*
Charretie, Anna Maria 1819-1875 *ArtsNiC, DcWomA*
Charretie, Mrs. John 1819-1875 *DcVicP 2*
Charreton, Victor 1864-1936 *WhAmArt 85A*
Charrier-Roy, Marguerite 1870- *DcWomA*
Charriere, Madame *DcWomA*
Charrin, Fanny d1854 *DcWomA*
Charrin, Sophie d1856 *DcWomA*
Charry, John 1909- *WhAmArt 85*
Charsley, Fanny Anne *DcWomA*
Charsley, Matilda *DcWomA*
Chart, Daphne *WhoArt 80, -82, -84*
Chartain, Alfred 1853-1931 *WhAmArt 85*
Charteris, Miss *DcVicP 2*
Charteris, F W *DcVicP 2*
Charteris, Louisa *DcWomA*
Charteris, Lady Louisa *DcVicP 2*
Chartier, Albert 1912- *WorECom*
Chartier, Alex Charles 1894- *ClaDrA*
Chartier, Henri Georges Jacques 1859-1924 *ClaDrA*
Chartier, Jeanne *DcWomA*
Chartier, Marie Jeanne *DcWomA*
Chartran, Theobald *ArtsNiC*
Chartran, Theobald 1849-1907 *DcBrBI*
Chartres, Susan *DcWomA*
Chartreuse, LaGrande *McGDA*
Charue, Pauline *DcWomA*
Charushin, Evgeny Ivanovich 1901- *WhoGrA 62*
Charvet, Alice 1851- *DcWomA*
Charvet, Marie *DcWomA*
Charyk, Joseph V *MarqDCG 84*
Chase, Adelaide 1868-1944 *DcWomA*
Chase, Adelaide Cole 1869-1944 *WhAmArt 85*
Chase, Alice *DcWomA*
Chase, Alice Elizabeth 1906- *WhAmArt 85, WhoAmA 73, -76, -78, -80, -82, -84*
Chase, Allan *WhoAmA 73, -76, -78, -80, -82, -84*
Chase, Althea *DcWomA, WhAmArt 85*
Chase, B G *FolkA 86*
Chase, Benjamin K *EncASM*
Chase, Beulah Dimmick 1901- *WhAmArt 85*
Chase, Beverley *NewYHSD*
Chase, Charles Simonson, III 1893- *AmArch 70*
Chase, Clarence M 1871- *WhAmArt 85*
Chase, Darius 1808?- *NewYHSD*
Chase, Doris 1923- *WhoAmA 73, -76, -78, -80, -82, -84*
Chase, E Gordon *DcWomA*
Chase, Edna Woolman 1877-1957 *WorFshn*
Chase, Edward d1965 *WhoAmA 78N, -80N, -82N, -84N*
Chase, Edward Leigh 1884-1965 *WhAmArt 85*
Chase, Elijah *FolkA 86*
Chase, Elisabeth *DcWomA*
Chase, Eliza B *WhAmArt 85*
Chase, Elizabeth Jane *WhAmArt 85*
Chase, Ellen Wheeler *DcWomA, WhAmArt 85*
Chase, Elsie Rowland 1863-1937 *DcWomA, WhAmArt 85*
Chase, Emily 1868- *DcWomA, WhAmArt 85*
Chase, Emmie Emilie *DcBrA 1, DcWomA*
Chase, Mrs. Francis Dane *WhAmArt 85*
Chase, Frank Davis 1877-1937 *BiDAmAr*
Chase, Frank M *DcBrWA, DcVicP 2*
Chase, Frank Swift 1886-1958 *WhAmArt 85, WhoAmA 80N, -82N, -84N*
Chase, George H d1952 *WhoAmA 78N, -80N, -82N, -84N*
Chase, George H 1874-1952 *WhAmArt 85*

Child, Charles Jesse 1901- IlsCB 1744
Child, Charles Koe d1935 DcBrA 2
Child, Edwin Burrage 1868-1937 WhAmArt 85
Child, Elizabeth Reynolds WhAmArt 85
Child, Heather WhoArt 80, -82, -84
Child, Helen 1884?- DcWomA
Child, Isaac 1792-1885 NewYHSD
Child, J H AmArch 70
Child, J M NewYHSD
Child, Jane Bridgham WhAmArt 85
Child, Jane Bridgham 1868- DcWomA
Child, John NewYHSD
Child, John d1868 BiDBrA
Child, Lewis 1781?-1829 NewYHSD
Child, R DcBrECP
Child, Robert Coleman 1872- WhAmArt 85
Child, Samuel EncASM
Child, Thomas FolkA 86
Child, Thomas d1706 NewYHSD
Child, W DcVicP 2
Child, Mrs. Willard DcWomA, NewYHSD
Child Viall And Wood CabMA
Childe, Elias DcVicP 2
Childe, Elias 1778-1862 DcBrWA
Childe, Ellen E DcVicP 2
Childe, Maria Louise DcWomA
Childers, Betty Bivins 1913- WhoAmA 78, -80, -82
Childers, Betty Bivins 1913-1982 WhoAmA 84N
Childers, C J, Jr. AmArch 70
Childers, Kenneth H 1931- AmArch 70
Childers, Louis Edward, Jr. 1929- AmArch 70
Childers, Louise DcVicP 2
Childers, Malcolm Graeme 1945- WhoAmA 78, -80, -82, -84
Childers, Marjorie H 1902- WhAmArt 85
Childers, Milly DcVicP 2, DcWomA
Childers, Paul WhAmArt 85
Childers, Richard Robin 1946- WhoAmA 78, -80, -82, -84
Childers, Russell 1915- FolkA 86
Childress, G C AmArch 70
Childress, Robert George 1927- AmArch 70
Childrey, Merrie WhAmArt 85
Childs, Agnes DcVicP 2, DcWomA
Childs, Alfred Edward DcVicP 2
Childs, Benjamin F 1814-1863 NewYHSD
Childs, Bernard 1910- WhoAmA 84
Childs, Catherine O WhoAmA 73, -76, -78, -80
Childs, Cephas Grier 1793-1871 NewYHSD
Childs, F NewYHSD
Childs, George DcBrWA, DcVicP, -2
Childs, George Henshaw 1890- WhAmArt 85
Childs, Hannah FolkA 86
Childs, John NewYHSD
Childs, Joseph 1869?-1909 WhAmArt 85
Childs, Joseph E 1954- MarqDCG 84
Childs, Julia DcVicP 2, DcWomA
Childs, Lillian E DcWomA, WhAmArt 85
Childs, Lotta ArtsEM, DcWomA
Childs, Maggie W 1874- DcWomA
Childs, Pierre Paul 1930- AmArch 70
Childs, Russell Coffin 1934- AmArch 70
Childs, Shubael D NewYHSD
Childs, Shubael D, Jr. NewYHSD
Childs-Clarke, Sophia DcVicP 2
Chiles, Howell Hugh 1956- MarqDCG 84
Chiljean, Roger Alan AmArch 70
Chillas, David NewYHSD
Chiller, Godfrey NewYHSD
Chillida, Eduardo 1924- ConArt 77, -83, DcCAr 81, McGDA, OxTwCA, PhDcTCA 77, PrintW 83, -85, WorArt[port]
Chillida, Gonzalo OxTwCA
Chillman, Edward 1841- WhAmArt 85
Chillman, James, Jr. 1891- AmArch 70, WhAmArt 85
Chillman, James, Jr. 1891-1972 ArtsAmW 2
Chillman, Philip Edward 1841- WhAmArt 85
Chillura, J, Jr. AmArch 70
Chilman, Lizzie DcVicP 2, DcWomA
Chilton, E DcVicP 2
Chilton, Elizabeth 1945- WhoArt 80, -82, -84
Chilton, Margaret Isabel DcBrA 1, DcWomA
Chilton, Thomas Howard 1909- AmArch 70
Chilton, William 1856-1939 WhAmArt 85
Chilvers, Thomas H ArtsEM
Chim ICPEnP
Chim 1911-1956 ConPhot
Chimay, Marie Antoinette Gabrielle DcWomA
Chimay, Princess Teresa 1773-1835 DcWomA
Chimenti, Jacopo 1554?-1640 McGDA
Chimes, Nick James 1924- AmArch 70
Chin, Calvin F 1921- AmArch 70
Chin, Chee 1896- ArtsAmW 1
Chin, Herbert Kum 1924- AmArch 70
Chin, Janet S 1949- MarqDCG 84
Chin, K AmArch 70
Chin, Nung 1687-1764? McGDA
Chin, Ric 1935- WhoAmA 76, -78, -80, -82, -84
Chin, Robert Wayming 1948- MarqDCG 84
Chin, Wing Chung 1929- AmArch 70

Chin, Yueh DcWomA
Chinard, Joseph 1756-1813 McGDA
Chincholle-Beaudouin, Marcelle DcWomA
Chinchwadkar, Vasant Narayan 1934- WhoArt 80, -82, -84
Chinery, Isaac NewYHSD
Chinery, James NewYHSD
Ching, Hao McGDA
Ching, Raymond OfPGCP 86
Chini & Co. DcNiCA
Chinmoy, Sri 1931- WhoAmA 80
Chinn, F L AmArch 70
Chinn, J G AmArch 70
Chinn, Roger 1933- AmArch 70
Chinn, Samuel DcVicP 2
Chinn, Yuen Yuey 1922- PrintW 83, -85, WhoAmA 76, -78, -80, -82, -84
Chinnaswamy, V 1934- MarqDCG 84
Chinner, J A DcBrBI
Chinnery, George 1774-1852 AntBDN J, DcBrECP, DcBrWA, OxArt
Chinni, Peter 1928- DcCAA 71, -77
Chinni, Peter Anthony 1928- WhoAmA 73, -76, -78, -80, -82, -84
Chino, T T AmArch 70
Chinorris OxTwCA
Chintamon, Hurrychund ICPEnP A
Chintreuil, Antoine 1814-1873 ArtsNiC
Chintreuil, Antoine 1816-1873 ClaDrA
Chiodo, Davis Anthony 1931- AmArch 70
Chiozzotto, Il McGDA
Chip WorECar
Chiparus, D H DcNiCA
Chipel, Aimable Marie DcWomA
Chipman FolkA 86, NewYHSD
Chipman, C Dean 1908- WhAmArt 85
Chipman, John 1746?-1819 CabMA
Chipman, Kate L DcWomA
Chipman, Wondley CabMA
Chipp, Allan Maurice 1929- AmArch 70
Chipp, Herbert DcBrWA, DcVicP 2
Chipp, Herschel Browning 1913- WhoAmA 73, -76, -78, -80, -82, -84
Chippendale, Thomas 1709?-1779 McGDA
Chippendale, Thomas 1718-1779 AntBDN G, DcD&D[port]
Chippendale, Thomas 1750?-1822? DcBrECP
Chippendale, Thomas, The Elder 1718-1779 OxDecA
Chippendale, Thomas, The Younger 1749-1822 AntBDN G, OxDecA
Chipperfield, Phyllis Ethel 1887- ClaDrA, DcBrA 1, DcWomA
Chiquet NewYHSD
Chirade-Devore, M D DcWomA
Chirat, Benoite Anais 1820- DcWomA
Chiriacka, Ernest 1920- IlBEAAW
Chiriani, Richard 1942- PrintW 85
Chirico, Giorgio De WorArt
Chirico, Giorgio De 1888- ClaDrA, ConArt 77, McGDA, OxArt, PhDcTCA 77
Chirico, Giorgio De 1888-1978 OxTwCA
Chirigos, M AmArch 70
Chirino, Martin 1925- ConArt 77, OxTwCA
Chisholm, Alexander 1792?-1847 DcBrWA, DcVicP 2
Chisholm, Annie DcWomA
Chisholm, Archibald CabMA
Chisholm, Helen DcVicP 2
Chisholm, James Chisholm Gooden- DcBrWA
Chisholm, John Francis AmArch 70
Chisholm, Mabel DcWomA
Chisholm, Margaret Sale WhAmArt 85
Chisholm, Marie Margaret 1900- WhAmArt 85
Chisholm, Peter DcBrA 1, DcVicP 2
Chisholm, Robert F 1840-1915 MacEA
Chisholm, Susanna Stewart DcBrWA
Chisholm And Waters CabMA
Chisholme, Alexander C DcVicP 2
Chisholme, John 1780?-1808 BiDBrA
Chisholme, R F DcVicP 2
Chislett, John BiDAmAr
Chislett, Mabel Clare DcWomA, WhAmArt 85
Chism, Mrs. Charles FolkA 86
Chisman, William WhAmArt 85
Chisolm, Mary B WhAmArt 85
Chisolm, V N WhAmArt 85
Chisom, Charles B 1940- AmArch 70
Chistiakova, Vera Egorovna 1848-1914 DcWomA
Chitei McGDA
Chiti, Guido OxTwCA
Chittenden, Alice B 1860- WhAmArt 85
Chittenden, Alice Brown 1860-1934 ArtsAmW 1, DcWomA
Chittenden, Katherine H DcWomA, WhAmArt 85
Chittenden, Larry IlBEAAW
Chittenden, T DcVicP 2
Chittock, Derek J 1922- DcBrA 1
Chitty, Lily Frances 1893- DcWomA
Chitwood, Frank Warren 1933- AmArch 70
Chiu, Alfred Kaiming 1898- WhAmArt 85
Chiu, Chin-Chiu 1949- MarqDCG 84
Ch'iu, Shih DcWomA

Chiu, Victor 1936- MarqDCG 84
Chiu, Ying OxArt
Ch'iu, Ying 1530-1555 McGDA
Chivers, H C WhAmArt 85
Chivetta, Anthony Joseph 1932- AmArch 70
Chizmark, Stephan 1898- WhAmArt 85
Chizzola, Giovanni NewYHSD
Chlebowska, Marie 1864- DcWomA
Chmiel, Leonard Kenneth 1942- WhoAmA 76
Chmielewski, Jan M 1903- WhAmArt 85
Chmielewski, Jan Olaf 1895-1974 MacEA
Cho, David 1950- WhoAmA 73, -76, -78, -80, -82, -84
Cho, Shinta WorECar
Cho, Sok 1595- McGDA
Cho Densu McGDA
Choat, Herbert William 1912- WhoArt 80, -82, -84
Choat, J CabMA
Choate, Florence ConICB, DcWomA, WhAmArt 85
Choate, John C FolkA 86
Choate, Nat 1899-1965 WhAmArt 85
Choate, Nathaniel d1965 WhoAmA 78N, -80N, -82N, -84N
Choate, Sarah DcWomA
Chocarne-Moreau, Paul Charles 1855-1931 ClaDrA
Chochol, Josef 1880-1956 MacEA, WhoArch
Chochola, Vaclav 1923- ConPhot, ICPEnP A, MacBEP
Chocholek, Raymond Stanely 1937- AmArch 70
Chock, Margaret 1944- MarqDCG 84
Chock, Owen G L 1934- AmArch 70
Chodkiewicz, Sofie DcWomA
Chodkowski, Henry, Jr. 1937- WhoAmA 76, -78, -80, -82, -84
Chodorow, Eugene 1910- WhAmArt 85
Chodowiecka, Jeannette DcWomA
Chodowiecka, L Wilhelmina DcWomA
Chodowiecka, Nanette DcWomA
Chodowiecka, Sophie Henriette 1770- DcWomA
Chodowiecka, Susanne 1763-1819 DcWomA
Chodowiecki, Daniel 1726-1801 WorECar
Chodowiecki, Daniel Nicholas 1726-1801 McGDA
Chodowiecki, Daniel Nicolas 1726-1801 ClaDrA
Chodowiecki, Daniel Nikolaus 1726-1801 OxArt
Chodowiecki-Gretschel, Marianne DcWomA
Chodzinski, Kasimir WhAmArt 85
Choel, Fideline DcWomA
Choffard, Pierre Philippe 1730-1809 ClaDrA, McGDA
Choh 1864?- IIBEAAW
Choinska, Marion 1897- DcWomA, WhAmArt 85
Choisy, Auguste 1841-1904 MacEA
Choisy-Crot, Jeanne Louise 1843- DcWomA
Choizeau, Camille DcWomA
Chojiro 1515-1592 McGDA
Chokei AntBDN L
Choki McGDA
Chokosai AntBDN L
Chokuan McGDA
Chol, A NewYHSD
Chole-Moutet, Celeste DcWomA
Cholet, Elisabeth Leonie DcWomA
Chollar, Thomas D FolkA 86
Chollet, Marcel De 1855- ClaDrA
Cholmelay, Isabel DcWomA
Cholmeley, Mrs. Francis DcWomA
Cholmondeley, Mrs. DcWomA
Cholmondely, R DcVicP 2
Chombert, Henri 1917- WorFshn
Chometon, Jean Baptiste 1789- ClaDrA
Chomicky, Yar Gregory 1921- WhoAmA 78, -80
Chomowicz, F AmArch 70
Chong, Son 1676-1759 McGDA
Choo, Chunghi 1938- WhoAmA 76, -78, -80, -82, -84
Chopas, John 1926- AmArch 70
Chope, Edward B 1815-1901 ArtsEM
Chopin, F AntBDN C, DcNiCA
Chopin, Henri 1922- ConArt 77, DcCAr 81
Chopmann NewYHSD
Choppa, Eugene Daniel, Jr. AmArch 70
Choppard-Mazeau, Caroline Leonie Jeanne DcWomA
Chorao, Kay 1936- IlsBYP
Chorao, Kay 1937- IlsCB 1967
Chore, L FolkA 86
Choris, Louis FolkA 86
Choris, Louis Andrevitch 1795-1828 IlBEAAW
Choris, Ludovik 1795-1828 ArtsAmW 1, NewYHSD
Chorley, Adrian William Herbert 1906- DcBrA 1
Chorley, John NewYHSD
Chorley, Mrs. John NewYHSD
Chorley, Margaret Byron DcWomA
Chorlton, Richard James 1916- AmArch 70
Chorman, Ernest C NewYHSD
Chorny, Daniel McGDA
Chornyak, John 1924- AmArch 70
Choshun 1683-1753 McGDA
Chosson DuColombier, Eugenie DcWomA
Chotek, Countess Maria Isabella 1774-1817 DcWomA
Chotel, Claire DcWomA
Chotenovsky, Zdenek 1929- WhoGrA 62, -82[port]
Chou, Ch'en McGDA
Chou, Chi-Ch'ang McGDA

Chou, Fang *McGDA*
Chou, Lien-Hsia 1909- *WhoArt 80, -82, -84*
Chou, Wen-Ching *McGDA*
Chou, Wen-Chu *McGDA*
Chouette, Pauline *DcWomA*
Chouinard, Mrs. Nelbert d1969 *WhoAmA 80N, -78N, -82N, -84N*
Chouinard, Nelbert Murphy 1879-1969 *ArtsAmW 1, -2, WhAmArt 85*
Chouquet, Gustave *NewYHSD*
Chouteau, Rene Auguste 1957- *MarqDCG 84*
Chouvet, Louise Adeline *DcWomA*
Chovanec, Paul 1925- *AmArch 70*
Chow, Chian-Chiu 1910- *WhoAmA 76, -78, -80, -82, -84*
Chow, Frank Hsian-Chia 1951- *MarqDCG 84*
Chow, Howard T 1923- *AmArch 70*
Chow, Leung Chen-Ying 1920- *WhoAmA 76, -78, -80, -82, -84*
Chow, T Ricky 1958- *MarqDCG 84*
Chowen, Gladys Hatch 1889-1981 *ArtsAmW 3*
Chowing, Henry C, Jr. *NewYHSD*
Chowne, Gerard 1875-1917 *DcBrA 1, DcBrWA, DcVicP 2*
Choy, A K *AmArch 70*
Choy, Eugene Kinn 1912- *AmArch 70*
Choy, M Y K *AmArch 70*
Choy, P P *AmArch 70*
Choy, Terence Tin-Ho 1941- *WhoAmA 78, -80, -82, -84*
Choy, Thomas Ming-Yone 1954- *MarqDCG 84*
Chreptowsky, Achilles N 1920- *WhoAmA 80, -82, -84*
Chretien, Felix 1500?-1575? *McGDA*
Chretien, G L 1754-1811 *OxDecA*
Chretien, Gilles-Louis 1754-1811 *ICPEnP*
Chretien-Colombe, C *DcWomA*
Chretin, Marie Josephine Lucille Amelie *DcWomA*
Chrimes, Louise A *WhAmArt 85*
Chrisfield, Absalom *CabMA*
Chrisman, K S *AmArch 70*
Chrisman, Norman, Jr. 1923- *AmArch 70*
Chrissinger, Mary Helen 1877- *DcWomA, WhAmArt 85*
Christ, Bernhard *NewYHSD*
Christ, Henry 1824?- *NewYHSD*
Christ, Rudolph *FolkA 86*
Christ-Janer, Albert William 1910- *WhoAmA 73*
Christ-Janer, Albert William 1910-1973 *WhAmArt 85, WhoAmA 76N, -78N, -80N, -82N, -84N*
Christ-Janer, Arland F 1922- *WhoAmA 73, -76, -78, -80, -82, -84*
Christ-Janer, V F *AmArch 70*
Christadoro, Charles *IlBEAAW*
Christaldi, Angeline A 1905- *WhAmArt 85*
Christen, Charles Lafayette 1928- *AmArch 70*
Christen, Jeanne 1894- *DcWomA*
Christen, Rosalie 1810-1880 *DcWomA*
Christenberry, William 1936- *DcCAr 81, ICPEnP A, MacBEP, WhoAmA 82, -84*
Christensen, A L *AmArch 70*
Christensen, Anthonie Eleonore 1849-1926 *DcWomA*
Christensen, Arent Laurits 1898- *ClaDrA*
Christensen, C C A 1831-1912 *ArtsAmW 1*
Christensen, Carl C A 1831-1912 *WhAmArt 85*
Christensen, Carl Christian Anton 1831-1912 *FolkA 86, IlBEAAW*
Christensen, Carl Torris 1937- *WhoGrA 82[port]*
Christensen, Dale Oliver 1945- *MarqDCG 84*
Christensen, Dan 1942- *AmArt, DcCAA 77, PrintW 83, -85, WhoAmA 76, -78, -80, -82, -84*
Christensen, Donald J 1934- *AmArch 70*
Christensen, Emiel J 1895- *AmArch 70*
Christensen, Emory C *MarqDCG 84*
Christensen, Erwin Ottomar 1890- *WhAmArt 85, WhoAmA 73, -76*
Christensen, Esther M 1895- *WhAmArt 85*
Christensen, Ethel Lenora 1896- *ArtsAmW 2, DcWomA, WhAmArt 85*
Christensen, Finn Birger 1926- *WorFshn*
Christensen, Florence *ArtsAmW 2, DcWomA, WhAmArt 85*
Christensen, G E *AmArch 70*
Christensen, G W *AmArch 70*
Christensen, Gardell Dano 1907- *IlsCB 1946*
Christensen, Haaken 1886- *IlsCB 1946*
Christensen, Hans *DcCAr 81*
Christensen, Hans-Jorgen Thorvald 1924- *WhoAmA 73, -76, -78, -80, -82, -84*
Christensen, Ingeborg *WhAmArt 85*
Christensen, J S *AmArch 70*
Christensen, John Esbern 1911- *WhAmArt 85*
Christensen, Kirsten 1943- *DcCAr 81*
Christensen, Larry R 1936- *WhoAmA 76, -78, -80, -82, -84*
Christensen, LuDeen *ArtsAmW 3*
Christensen, Murry Charles 1945- *MarqDCG 84*
Christensen, Ralph 1897-1961 *WhoAmA 80N, -82N, -84N*
Christensen, Ralph A 1886-1961 *WhAmArt 85*
Christensen, Ronald Julius 1923- *WhoAmA 76, -78,*

Christensen, Sharlene 1939- *WhoAmA 76, -78, -80, -82, -84*
Christensen, Ted 1911- *AmArt, WhoAmA 78, -80, -82, -84*
Christensen, Terry Lee 1945- *MarqDCG 84*
Christensen, Val Alan 1946- *WhoAmA 78, -80, -82, -84*
Christenson, Darrel Richard 1959- *MarqDCG 84*
Christenson, John Leonard 1922- *WhoAmA 76*
Christenson, Lars 1839-1910 *FolkA 86*
Christenson, T, Jr. *AmArch 70*
Christian IV, King Of Denmark 1588-1648 *WhoArch*
Christian, Charles 1926- *AmArch 70*
Christian, Clara J d1906 *DcWomA*
Christian, Clara L *DcVicP 2*
Christian, David *MarqDCG 84*
Christian, Desire 1846-1907 *DcNiCA*
Christian, Donald Jacobs 1951- *MarqDCG 84*
Christian, Elbon Lavohn 1928- *AmArch 70*
Christian, Eleanor E *DcWomA*
Christian, Gertrude *DcVicP 2*
Christian, Grant Wright 1911- *WhAmArt 85*
Christian, H E *AmArch 70*
Christian, J H *NewYHSD*
Christian, Joane Cromwell *WhAmArt 85*
Christian, Johann Joseph 1706-1777 *McGDA*
Christian, Nancy *FolkA 86*
Christian, Robert Henry 1922- *AmArch 70*
Christian, Rudolph *AfroAA*
Christian, S *AmArch 70*
Christian, W *AmArch 70*
Christian, W F D *DcBrBI*
Christian, William 1932- *WhoAmA 82, -84*
Christian, William E *ArtsEM*
Christiana, Edward 1912- *WhoAmA 73, -76, -78, -80, -82, -84*
Christiana, Edward L 1912- *WhAmArt 85*
Christiania, Joseph *NewYHSD*
Christiansen, Henry Nelson 1936- *MarqDCG 84*
Christiansen, Nils H *DcBrA 2*
Christiansen, P *WhAmArt 85*
Christianson, Paul Robert 1930- *AmArch 70*
Christie, Miss *DcWomA*
Christie, Alden Bradford 1935- *AmArch 70*
Christie, Alexander *NewYHSD*
Christie, Alexander 1807-1860 *ArtsNiC, DcVicP 2*
Christie, Alexander 1901- *DcBrA 1*
Christie, Archibald H *DcBrA 2, DcVicP 2*
Christie, Bernard *FolkA 86*
Christie, Ernest *DcVicP 2*
Christie, F *DcVicP 2*
Christie, F H *DcVicP 2*
Christie, Henry *FolkA 86*
Christie, I *FolkA 86*
Christie, J I *AmArch 70*
Christie, James Elder 1847-1914 *DcBrA 1, DcBrBI, DcVicP, -2*
Christie, James Elder 1847-1915 *ClaDrA*
Christie, Kenneth Scott 1956- *MarqDCG 84*
Christie, Lily *DcWomA*
Christie, Mae Allyn *WhAmArt 85*
Christie, Mae Allyn 1895- *ArtsAmW 2*
Christie, Mary *DcWomA*
Christie, May Allyn *DcWomA*
Christie, Peter Graham 1920- *AmArch 70*
Christie, Robert *DcBrA 2, DcVicP 2*
Christie, Robert Duncan 1946- *WhoAmA 84*
Christie, Ruth Vianco 1897- *DcWomA, WhAmArt 85*
Christie, Stephen *MarqDCG 84*
Christie, Vera *DcVicP 2*
Christie, William *FolkA 86*
Christina Of Bolsena, Saint *McGDA*
Christina, Queen Of Sweden 1626-1689 *DcWomA*
Christine Eleonora *DcWomA*
Christine, Princess Of Lippe 1744-1823 *DcWomA*
Christison, Mary Sympson 1850?-1879 *DcWomA*
Christison, Muriel B *WhoAmA 73, -76, -78, -80, -82, -84*
Christison, Muriel Branham 1911- *WhAmArt 85*
Christlin, Margaretha *DcWomA*
Christman, Alan M 1934- *MarqDCG 84*
Christman, Bert 1915-1942 *WhAmArt 85, WorECom*
Christman, Erwin S *WhAmArt 85*
Christman, G *FolkA 86*
Christman, John Christopher *DcBrECP*
Christman, Reid August 1948- *WhoAmA 73, -76*
Christmann, Gunter 1936- *DcCAr 81*
Christmas, E W *WhAmArt 85*
Christmas, E W d1918 *DcBrA 1*
Christmas, Edward *AfroAA*
Christmas, Garrett d1633 *OxArt*
Christmas, Gerard d1633 *OxArt*
Christmas, John *DcSeaP*
Christmas, Mattias d1654 *OxArt*
Christmas, W F *FolkA 86*
Christmas, W W *WhAmArt 85*
Christmas, Walter *AfroAA*
Christner, Mrs. John *FolkA 86*
Christo 1935- *AmArt, ConArt 77, -83, DcAmArt,*

DcCAA 77, DcCAr 81, OxTwCA, PrintW 83, -85, WhoAmA 73, -76, -78, -80, -82, -84, WorArt[port]
Christo, Jachareff 1935- *PhDcTCA 77*
Christoff, John Paul 1933- *AmArch 70*
Christofferson, W F *AmArch 70*
Christofides, Andrew 1946- *DcCAr 81*
Christofle, Charles *EncASM*
Christofle, Paul, Madame *DcWomA*
Christoforon 1921- *DcCAr 81*
Christoforou, John 1921- *ClaDrA, ConArt 77*
Christoph, Frank Henry, Jr. 1921- *AmArch 70*
Christoph, Henning 1944- *MacBEP*
Christophe *WorECom*
Christopher, Ann 1947- *WhoArt 80, -82, -84*
Christopher, James Walker 1930- *AmArch 70*
Christopher, William 1924- *DcCAA 71*
Christopher, William 1924-1973 *DcCAA 77*
Christopher, William R 1924- *WhoAmA 73, -76*
Christopher, William R 1924-1973 *WhoAmA 78N, -80N, -82N, -84N*
Christophers, J M *DcVicP 2*
Christophersen, Alejandro 1866-1946 *MacEA*
Christopherson, Bennett Lewis 1936- *AmArch 70*
Christopherson, Jose 1914- *DcBrA 1, WhoAmA 80, -82, -84*
Christus, Petrus d1473? *OxArt*
Christus, Petrus 1410?-1473? *McGDA*
Christy, Alexander *NewYHSD*
Christy, Frank R *WhAmArt 85*
Christy, Howard Chandler d1952 *WhoAmA 78N, -80N, -82N, -84N*
Christy, Howard Chandler 1872-1952 *WhAmArt 85*
Christy, Howard Chandler 1873-1952 *IlBEAAW, IlrAm B, -1880, IlsCB 1744*
Christy, Josephine *DcVicP 2*
Chromaster, W W *AmArch 70*
Chronister, D J *NewYHSD*
Chrysander, Amelie Ulrika Sofia *DcWomA*
Chrysler, Walter P, Jr. *WhoAmA 78, -80, -82, -84*
Chryssa 1933- *BnEnAmA, ConArt 83, DcAmArt, DcCAA 71, -77, OxTwCA, PhDcTCA 77, PrintW 83, -85, WhoAmA 78, -80, -82, -84*
Chryssa, Varda 1933- *ConArt 77, DcCAr 81, WhoAmA 73, -76*
Chrystie, Margaret H 1895- *DcWomA, WhAmArt 85*
Chu, Chong-Won 1932- *MarqDCG 84*
Chu, Gene 1936- *WhoAmA 76, -78, -80, -82, -84*
Chu, H Jor 1907- *WhAmArt 85*
Chu, Joe Ming 1936- *AmArch 70*
Chu, Morgan Yekung 1927- *AmArch 70*
Chu, Philip M 1919- *AmArch 70*
Chu, Ta *OxArt*
Chu, Ta 1625-1700? *McGDA*
Chu, Te-Jun 1294-1365 *McGDA*
Chu, Tuan *McGDA*
Chu, W *AmArch 70*
Chu, William Tongil 1934- *MarqDCG 84*
Chu, William W Y *MarqDCG 84*
Chu-Jan *McGDA*
Chua, Terence A 1956- *MarqDCG 84*
Chuah, Thean Teng 1914- *OxTwCA*
Chuang, Richard *MarqDCG 84*
Chuang, Yu-Tang 1954- *MarqDCG 84*
Chubb, Bryan 1947- *DcCAr 81*
Chubb, Charles *OxDecA*
Chubb, Charles St. John *WhAmArt 85*
Chubb, E R *DcWomA*
Chubb, Frances Fullerton 1913- *WhAmArt 85, WhoAmA 73, -76*
Chubb, Frederick Y 1838?- *NewYHSD*
Chubb, Ida 1875- *DcWomA*
Chubb, Jeremiah *OxDecA*
Chubb, John *OxDecA*
Chubb, John D 1869-1938 *BiDAmAr*
Chubb, Ralph Nicholas 1892-1960 *DcBrA 1*
Chubbard, Thomas 1738?-1809 *DcBrECP*
Chubbuck, Thomas d1888 *NewYHSD*
Chuey, Robert Arnold 1921- *WhoAmA 73, -76, -78, -80, -82, -84*
Chugg, Brian J 1926- *WhoArt 80, -82, -84*
Chulvick, Charles E 1947- *MarqDCG 84*
Chumley, John 1928-1984 *OfPGCP 86*
Chumley, John Wesley 1928- *WhoAmA 76, -78, -80, -82, -84*
Chumney, Pat Swearingen 1933- *AmArch 70*
Chumy-Chumez *WorECar*
Chun, David P *WhAmArt 85*
Chun, G *AmArch 70*
Chun, Wei Foo 1916- *AmArch 70*
Chung, Eric An-Chi 1932- *AmArch 70*
Chung, Roger K 1946- *WhoAmA 76, -78, -80*
Chung, W E *DcSeaP*
Chung, Won Lyang 1947- *MarqDCG 84*
Chupien, T *NewYHSD*
Churberg, Fanny 1845-1892 *DcWomA*
Churbuck, Leander M *WhAmArt 85*
Church, Angelica Schuyler 1878- *DcWomA, WhAmArt 85*

Church, Anthony Joseph Cioccia 1938- AmArch 70
Church, Sir Arthur Herbert DcVicP 2
Church, Sir Arthur Herbert 1834-1915 DcBrWA
Church, Bruce Richard 1906- AmArch 70
Church, C Howard 1904- WhoAmA 73, -76, -78, -80, -82, -84
Church, Charles Freeman 1874- WhAmArt 85
Church, David Carlton 1924- AmArch 70
Church, Dwight NewYHSD
Church, Elsie G 1897- ArtsAmW 3
Church, F Edwin 1876-1964? WhAmArt 85
Church, F S ArtsNiC
Church, Francis O'Connor 1910- AmArch 70
Church, Frederic E WhoAmA 78N, -80N, -84N
Church, Frederic Edwin 1826-1900 BnEnAmA, DcAmArt, NewYHSD
Church, Frederice WhoAmA 82N
Church, Frederick E 1826- ArtsNiC
Church, Frederick E 1826-1900 WhAmArt 85
Church, Frederick Edwin 1826-1900 DcSeaP, EarABI, McGDA
Church, Frederick S 1842-1923 WhAmArt 85
Church, Frederick Stuart 1842-1924 ArtsEM[port], IlrAm 1880
Church, Grace ArtsAmW 2, DcWomA, WhAmArt 85
Church, Hannah 1733- FolkA 86
Church, Henry 1836-1908 AmFkP[port], BnEnAmA, NewYHSD
Church, Henry, Jr. 1836-1908 FolkA 86
Church, Howard 1904- WhAmArt 85
Church, James Harrison 1910- AmArch 70
Church, K D AmArch 70
Church, Katherine 1910- DcBrA 1
Church, M E DcWomA
Church, Mrs. M E ArtsEM
Church, Mabel WhAmArt 85
Church, Richard Glenn AmArch 70
Church, Robert Benjamin, III 1930- AmArch 70
Church, Thomas D 1902-1978 ConArch, MacEA
Church, W C AmArch 70
Church, W E AmArch 70
Church And Rogers EncASM
Churcher, G P DcVicP 2
Churchill, Alfred V 1864- WhAmArt 85
Churchill, David Kent 1955- MarqDCG 84
Churchill, Diane 1941- WhoAmA 78, -80, -82, -84
Churchill, Dwight Owen 1930- AmArch 70
Churchill, Francis G 1876- WhAmArt 85
Churchill, H DcVicP 2
Churchill, H W NewYHSD
Churchill, J Edwin NewYHSD
Churchill, Lemuel CabMA, FolkA 86
Churchill, Letha E DcWomA, WhAmArt 85
Churchill, Lorey EncASM
Churchill, Rose 1878- DcWomA, WhAmArt 85
Churchill, William Arthur 1934- AmArch 70
Churchill, William W d1926 WhAmArt 85
Churchill, Sir Winston Leonard Spencer 1874-1965 DcBrA 1
Churchman, E Mendenhall WhAmArt 85
Churchman, Ella Mendenlhall DcWomA
Churchman, Isabelle DcWomA
Churchman, Isabelle Schultz 1896- WhAmArt 85
Churchyard, Anna 1832-1897 DcBrWA
Churchyard, Catherine 1839-1889 DcBrWA
Churchyard, Charles Isaac 1841-1929 DcBrWA
Churchyard, Elizabeth 1834-1913 DcBrWA
Churchyard, Ellen 1826-1909 DcBrWA
Churchyard, Emma 1828-1878 DcBrWA
Churchyard, Harriet d1927 DcBrA 1, DcWomA
Churchyard, Harriet 1836-1927 DcBrWA 2, DcBrWA
Churchyard, Laura 1830-1891 DcBrWA
Churchyard, Peter John 1958- MarqDCG 84
Churchyard, Thomas 1798-1865 DcBrWA, DcVicP 2
Churchyard, Thomas 1825- DcBrWA
Churriguera, Alberto De 1676-1750? OxArt
Churriguera, Joaquin De 1674-1724 OxArt
Churriguera, Jose Benito De 1665-1725? McGDA
Churriguera, Jose De 1665-1725 OxArt
Churriguera Family MacEA
Churriguerra, Alberto De 1676-1750 WhoArch
Chute, Bill 1929- FolkA 86
Chute, Desmond DcBrA 2
Chute, John 1701-1776 BiDBrA, MacEA
Chutjian, Seta Leonie WhoAmA 82, -84
Chwalinski, Joe Moore FolkA 86
Chwast, Jacqueline IlsCB 1967
Chwast, Jacqueline 1932- IlsBYP, IlsCB 1957
Chwast, Seymour IlsBYP
Chwast, Seymour 1931- AmGrD[port], ConDes, IlrAm 1880, IlsCB 1967, WhoAmA 78, -80, -82, -84, WhoGrA 82[port]
Chwistek, Leon 1884-1944 PhDcTCA 77
Chylinski, Richard James 1931- AmArch 70
Ciaffa, Michael Anthony 1925- AmArch 70
Ciampaglia, Carlo 1891-1975 WhAmArt 85, WhoAmA 76N, -78N, -80N, -82N, -84N
Ciampi, J J AmArch 70
Ciampi, Mario 1907- MacEA
Ciampi, Mario J 1907- ConArch

Cian, J DcWomA
Ciancio, June 1920- WhoAmA 82, -84
Cianfarini, Aristide Berto 1895- WhAmArt 85
Cianfichi, P D AmArch 70
Cianfoni, Emilio 1946- WhoAmA 78, -80, -82, -84
Ciani, Victor A WhAmArt 85
Ciardi, Emma 1879-1933 DcWomA
Ciardi, Guglielmo 1843-1917 ClaDrA
Ciarrochi, Ray WhoAmA 73, -76, -78, -80, -82, -84
Ciarrochi, Ray 1933- PrintW 83, -85
Ciarrochi, Sandra WhoAmA 84
Ciavarra, Pietro 1891- WhAmArt 85
Cibber, Caius Gabriel 1630-1700 BiDBrA, McGDA, OxArt
Cibber, Nicholas BiDBrA
Cibot, Francois-Barthelemy-Michel-E 1799-1876 ArtsNiC
Cibot, Marie DcWomA
Cibulka, Heinz 1943- DcCAr 81
Cicansky, Victor 1935- WhoAmA 78, -80, -82, -84
Cicchelli, J C AmArch 70
Ciccio, L'Abate OxArt
Cicco, Joseph Anthony 1903- AmArch 70
Ciccone, Amy Navratil 1950- WhoAmA 82, -84
Cicelsky, Norman 1931- AmArch 70
Ciceri NewYHSD
Cicero, Carmen L WhoAmA 76, -78, -80, -82, -84
Cicero, Carmen Louis 1926- DcCAA 71, -77, WhoAmA 73
Cicero, Jan WhoAmA 80, -82, -84
Cicerong NewYHSD
Cichello, Samuel Joseph 1931- AmArch 70
Cichocka, Wanda De DcWomA
Cid, Bernardo 1925- DcCAr 81
Ciechanowska, Helene DcWomA
Cierici, Fabricio 1913- PhDcTCA 77
Cieslewicz, Roman 1930- ConArt 83, ConDes, WhoGrA 62, -82[port]
Cifolelli, Alberta 1931- WhoAmA 80, -82, -84
Cifre, Guillermo 1922-1962 WorECom
Cifrondi, Antonio 1657-1730 McGDA
Cigler, Vaclav 1929- DcCAr 81
Cignani, Carlo 1628-1719 ClaDrA, McGDA
Cignaroli, Maria DcWomA
Cigoli, Il 1559-1613 OxArt
Cigoli, Lodovico ClaDrA
Cigoli, Lodovico Cardi Da 1559-1613 McGDA
Cikovsky, Nicolai 1894- DcCAA 71, -77, GrAmP, WhAmArt 85, WhoAmA 73, -78, -80, -82, -84
Cikovsky, Nicolai, Jr. 1933- WhoAmA 73, -76, -78, -80, -82, -84
Cil, Manuel NewYHSD
Cilfone, Gianni 1908- WhAmArt 85
Cilimberg, Vincent James, Jr. 1925- AmArch 70
Cilliers-Barnard, Bettie OxTwCA
Cima, Giovanni Battista 1460?-1518? McGDA
Cima DaConegliano McGDA
Cima DaConegliano, Giovanni Battista 1459?-1518? OxArt
Cimabue 1240?-1302? McGDA
Cimabue 1240?-1302 OxArt
Cimbalo, Robert W WhoAmA 73, -76, -78, -80, -82, -84
Cimini, B, Jr. AmArch 70
Cimino, D C AmArch 70
Cimino, Harry 1898- WhAmArt 85
Cimiotti, Emil 1927- DcCAr 81, OxTwCA, PhDcTCA 77
Cimiotti, Gustave 1875- WhAmArt 85
Cimmarrusti, V AmArch 70
Cimon Of Cleonae OxArt
Cimpellin, Leone 1926- WorECom
Cina, Colin 1943- ConArt 77, ConBrA 79[port]
Cinamon, Gerald 1930- WhoGrA 82[port]
Cinatl, Ludwig John 1914- WhAmArt 85
Cincannon NewYHSD
Cindric, Michael Anthony 1947- WhoAmA 78, -80, -82, -84
Cingoli, Giulio IlsBYP, IlsCB 1957
Cingria, Karolina DcWomA
Cini, Egisto 1891- WhAmArt 85
Cini, Guglielmo 1903- WhAmArt 85
Cintoli, Claudio OxTwCA
Cintron, Joseph 1921- WhoAmA 76, -78
Cintron, Joseph M 1921- WhoAmA 80, -82, -84
Cioban, Mrs. Edward WhAmArt 85
Ciobotaru, Gillian Wise 1936- ConBrA 79[port]
Ciocca, Walter 1910- WorECom
Cione, Andrea Di McGDA, OxArt
Cione, Jacopo Di McGDA, OxArt
Cione, Nardo Di McGDA, OxArt
Cioni, Andrea DiMichele DiFrancesco OxArt
Ciotti, W A AmArch 70
Cipnic, Monica 1950- MacBEP
Cipolla, P C AmArch 70
Cipollini, B R 1889- WhAmArt 85
Cipriani, Giambattista 1727-1785 AntBDN G
Cipriani, Giovanni Battista 1726-1785 McGDA
Cipriani, Giovanni Battista 1727-1785 BkIE, ClaDrA, DcBrECP, DcBrWA, OxArt

Cipriani, Henry DcBrECP
Cipriani, Sir Henry DcBrWA
Cipriani-Bond, Douglas 1928- WhoArt 80, -82, -84
Cipriano, Anthony Galen 1937- WhoAmA 73, -76
Ciprico, Marguerite Freytag 1891-1973 ArtsAmW 2, DcWomA
Cipullo, Aldo WorFshn
Circignani, Antonio 1570-1630? McGDA
Circignani, Nicolo McGDA
Ciresi, Anthony David 1907- AmArch 70
Ciresi, Anthony Salvatore 1906- AmArch 70
Cirici Alomar, Cristian 1941- ConArch
Ciriclio, S E 1946- MacBEP
Cirino, Antonio 1889- WhAmArt 85
Cironi, Samaritana DcWomA
Ciry, Michel 1919- ClaDrA
Cislak, Gregory Noble 1956- MarqDCG 84
Cislo, Robert Alexander 1942- MarqDCG 84
Cismondi, Ed 1917- MacBEP
Cisneros, Florencio Garcia WhoAmA 82, -84
Cisneros, Florencio Garcia 1924- WhoAmA 73, -76, -80
Cisneros, Jose 1910- IlBEAAW
Cist, Jacob 1782-1825 NewYHSD
Cistello, Julie DeLaBourdonnay DcWomA
Citaroto, John NewYHSD
Citrin, Judith 1934- WhoAmA 82, -84
Citroen, Paul 1896- ConPhot, ICPEnP A
Citron, Minna 1896- DcWomA, WhAmArt 85
Citron, Minna Wright 1896- GrAmP, WhoAmA 73, -76, -78, -80, -82, -84, WhoArt 80, -82, -84
Citron, Robert William 1929- AmArch 70
Cittato, Giulio 1936- WhoGrA 82[port]
Citti, John NewYHSD
Citti, Louis 1827?- NewYHSD
Citti, Orelius NewYHSD
Ciuca, Eugen 1913- WhoAmA 78, -80, -82, -84
Ciucci, J V, Jr. AmArch 70
Ciucurencu, Alexandru 1903- PhDcTCA 77
Ciuffagni, Bernardo Di Piero 1381-1457 McGDA
Ciurlionis, Mikolojus Konstantus 1875-1911 OxTwCA
Ciurlionis, Mykolas Konstantas 1875-1911 PhDcTCA 77
Civale, Biagio A 1935- WhoAmA 84
Civerchio, Vincenzo McGDA
Civet, Andre OxTwCA
Civetta OxArt
Civey, George Arnott, III 1944- MarqDCG 84
Cividanes-Freiria, Emilio 1932- AmArch 70
Civitali, Matteo Di Giovanni 1436-1501 McGDA, MacEA
Civitali, Nicolo 1482-1560 McGDA
Civitali Family MacEA
Civitello, John Patrick 1939- AmArt, WhoAmA 73, -76, -78, -80, -82, -84
Cizancourt, M A De DcWomA
Cizek, Eugene Darwin 1940- AmArch 70
Cizek, Franz 1865-1946 OxTwCA
Claass, Arnaud 1949- ConPhot, ICPEnP A
Clabaugh, William Rush 1923- AmArch 70
Clabburn, Arthur E DcVicP 2
Clack, Clyde Clifton 1896-1955 ArtsAmW 2, WhAmArt 85
Clack, Richard Augustus DcVicP 2
Clack, Thomas AntBDN P
Clack, Thomas 1830-1907 DcBrWA, DcVicP 2
Clacy, Ellen ClaDrA, DcVicP, -2, DcWomA
Claes, Constant 1826- ArtsNiC
Claesen, Dirick FolkA 86
Claessen, Alart McGDA
Claessen, Cornelisz DcSeaP
Claessen, George 1909- DcBrA 1, WhoArt 80, -82, -84
Claessens, Pieter, II 1550?-1623 McGDA
Claesson, Gosta 1942- DcCAr 81
Claesz, Alart McGDA
Claesz, Anthony, II 1616-1652? McGDA
Claesz, Anthony I 1592-1636 McGDA
Claesz, Pieter 1590-1661 ClaDrA
Claesz, Pieter 1596?-1661 OxArt
Claesz, Pieter 1597?-1661? McGDA
Claeu, Jacques McGDA
Claeyssens, P AmArch 70
Claff, William J 1953- MarqDCG 84
Claflin, Larry Wayne 1943- MarqDCG 84
Claggett, Thomas AntBDN D
Claggett, William 1696-1749 AntBDN D
Claghorn, Joseph C 1869- WhAmArt 85
Clague, Daisy Radcliffe DcWomA
Clague, John Rogers 1928- WhoAmA 73, -76, -78, -80, -82, -84
Clague, Richard 1816-1878 NewYHSD
Clague, Richard 1821-1873 DcAmArt
Claiborne, Duain Franklyn 1929- AmArch 70
Claire FolkA 86
Claire, Charles ClaDrA
Claire, E E WhoAmA 76
Clairin, Georges Jules Victor 1843-1919 ClaDrA
Clairmont, Louise Bartley 1910- WhAmArt 85
Clairval, Marie Therese, Vicomtesse H De DcWomA
Clairville, William H NewYHSD

Clampett, Bob *ConGrA 1*
Clampett, Robert 1910?- *WorECar*
Clampett, Robert 1914?-1984 *ConGrA 1*
Clampitt, Sarah *DcWomA*
Clancy, Eliza R *ArtsAmW 3, WhAmArt 85*
Clancy, Joe Wheeler 1896- *WhAmArt 85*
Clancy, John *WhoAmA 73, -76, -78, -80*
Clancy, John d1981 *WhoAmA 82N, -84N*
Clancy, John Martin 1929- *AmArch 70*
Clancy, Patrick 1941- *WhoAmA 76, -78, -80, -82, -84*
Clancy, Peter 1841?- *NewYHSD*
Clap, Miss *DcWomA, NewYHSD*
Clap, John *CabMA*
Claperos, Antonio, The Elder *McGDA*
Clapham *DcBrECP*
Clapham, J *FolkA 86*
Clapham, James T *DcVicP 2*
Clapham, Mary *DcVicP 2*
Claphamson, Samuel *CabMA*
Clapier, Marguerite *DcWomA*
Clapp, Elizabeth Anna 1885- *DcBrA 1, DcWomA*
Clapp, Frederick Mortimer 1879- *WhAmArt 85*
Clapp, H *NewYHSD*
Clapp, J F, Jr. *AmArch 70*
Clapp, James C *NewYHSD*
Clapp, James Ford d1941 *BiDAmAr*
Clapp, Marcia 1907- *WhAmArt 85*
Clapp, Marvin H 1907- *AmArch 70*
Clapp, Maude Caroline Ede 1876-1960 *WhoAmA 80N, -82N, -84N*
Clapp, William Henry 1879- *WhAmArt 85*
Clapp, William Henry 1879-1954 *ArtsAmW 2*
Clapp, Zebulon *CabMA*
Clapperton, Thomas John 1879-1962 *DcBrA 2*
Clapperton, William R *FolkA 86, NewYHSD*
Claps, Anthony *WhAmArt 85*
Clapsaddle, Jerry 1941- *WhoAmA 78, -80, -82, -84*
Clar, Sophie Usiglio *DcWomA*
Clara Ayats, Josep 1878-1958 *PhDcTCA 77*
Clarage, James Braun 1938- *AmArch 70*
Clare, Miss *DcVicP 2, DcWomA*
Clare, Fred J 1942- *MarqDCG 84*
Clare, George *ClaDrA, DcVicP, -2*
Clare, Joseph *AntBDN Q*
Clare, Joseph 1846-1917 *WhAmArt 85*
Clare, Oliver *DcVicP*
Clare, Oliver 1853?-1927 *DcBrA 1, DcVicP 2*
Clare, Stewart 1913- *WhoAmA 73, -76, -78, -80, -82, -84*
Clare, Vincent 1855?-1925 *DcBrA 1*
Clare, Vincent 1855?-1930 *DcVicP 2*
Claret, Joan *OxTwCA*
Claret, Joan 1929- *PhDcTCA 77*
Claricia *DcWomA*
Claridge, John 1944- *ConPhot, ICPEnP A*
Claridge, T W *AmArch 70*
Claris, Antoine Gabriel Gaston 1843-1899 *ClaDrA*
Claris, F G *DcVicP 2*
Clark *BiDBrA, FolkA 86, NewYHSD*
Clark, Lord *WhoArt 84N*
Clark, Lord 1903- *WhoArt 80, -82*
Clark, Abna *FolkA 86*
Clark, Adele *DcWomA, WhAmArt 85*
Clark, Alan Lee 1951- *MarqDCG 84*
Clark, Albert *DcBrA 2*
Clark, Alfred Houghton 1868- *WhAmArt 85*
Clark, Allan d1950 *WhoAmA 78N, -80N, -82N, -84N*
Clark, Allan 1896- *ArtsAmW 1*
Clark, Allan 1896-1950 *WhAmArt 85*
Clark, Allan 1898?-1950 *IlBEAAW*
Clark, Alonzo Webster, III 1906- *AmArch 70*
Clark, Alson *ConArch A*
Clark, Alson Skinner d1949 *WhoAmA 78N, -80N, -82N, -84N*
Clark, Alson Skinner 1876-1949 *ArtsAmW 1, IlBEAAW, WhAmArt 85*
Clark, Alvan 1804-1864 *FolkA 86*
Clark, Alvan 1804-1887 *NewYHSD*
Clark, Ann Eliza d1860 *FolkA 86*
Clark, Anson 1783- *FolkA 86*
Clark, Anthony Morris 1923- *WhoAmA 73, -76*
Clark, Anthony Morris 1923-1976 *WhoAmA 78N, -80N, -82N, -84N*
Clark, Arthur Bridgman 1866- *WhAmArt 85*
Clark, Arthur Bridgman 1866-1948 *ArtsAmW 2*
Clark, Mrs. Arthur E *WhAmArt 85*
Clark, Arthur F *WhAmArt 85*
Clark, Arthur T 1864- *WhAmArt 85*
Clark, Arthur W *ArtsAmW 3*
Clark, Asahel *NewYHSD*
Clark, B *DcVicP 2*
Clark, B Preston, Jr. *WhAmArt 85*
Clark, Beatrice Smith *WhAmArt 85*
Clark, Benjamin *AfroAA, EncASM, FolkA 86*
Clark, Benton 1895-1964 *ArtsAmW 1, IlrAm D, -1880*
Clark, Benton H 1895-1964 *WhAmArt 85*

Clark, Benton Henderson 1895?-1964 *IlBEAAW*
Clark, Birge Malcolm 1893- *AmArch 70*
Clark, Bruce Michael 1937- *WhoArt 80, -82, -84*
Clark, C *DcSeaP*
Clark, C H *WhAmArt 85*
Clark, C Myron 1876-1925 *DcSeaP*
Clark, C W *AmArch 70, DcVicP 2*
Clark, Carol Canda 1947- *WhoAmA 78, -80, -82, -84*
Clark, Carroll 1894-1968 *ConDes*
Clark, Cecil *DcWomA*
Clark, Charles *FolkA 86*
Clark, Charles Cameron *WhAmArt 85*
Clark, Charles D 1917- *WhoAmA 84*
Clark, Charles E *WhAmArt 85*
Clark, Charles Herbert 1890- *DcBrA 1*
Clark, Charles W *NewYHSD*
Clark, Charles W 1854-1911 *BiDAmAr*
Clark, Chester 1828?- *NewYHSD*
Clark, Chevis Delwin 1922- *WhoAmA 73, -76, -78, -80*
Clark, Christopher 1875- *DcBrBI*
Clark, Christopher 1875-1942 *DcBrA 1, DcBrWA, DcVicP 2*
Clark, Christopher 1903- *WhAmArt 85*
Clark, Claude 1915- *WhoAmA 76, -78, -80, -82, -84*
Clark, Claude, Sr. 1914- *AfroAA*
Clark, Claude Lockhart, Jr. 1945- *AfroAA*
Clark, Clifton Gilbert 1922- *AmArch 70*
Clark, Daniel 1760-1830 *DcNiCA*
Clark, Daniel 1768-1830 *AntBDN G*
Clark, David L 1942- *MarqDCG 84*
Clark, David Presbury 1907- *AmArch 70*
Clark, Decius W *FolkA 86*
Clark, Dennis Blake 1934- *AmArch 70*
Clark, Dixon *DcBrA 1, DcVicP, -2*
Clark, Donald Eugene 1921- *AmArch 70*
Clark, Donald James 1925- *AmArch 70*
Clark, E *DcWomA*
Clark, E Terry 1940- *AmArch 70*
Clark, Edward *NewYHSD*
Clark, Edward 1822-1902 *BiDAmAr*
Clark, Edward 1911- *ICPEnP A*
Clark, Edward 1926- *AfroAA*
Clark, Egbert Norman 1872- *WhAmArt 85*
Clark, Eliot 1883-1980 *WhAmArt 85*
Clark, Eliot Candee 1883- *IlBEAAW, WhoAmA 73, -76, -78, -80*
Clark, Eliot Candee 1883-1979 *ArtsAmW 3*
Clark, Eliot Candee 1883-1980 *WhoAmA 82N, -84N*
Clark, Elisabeth Sherras 1936- *WhoArt 80, -82, -84*
Clark, Elisha *FolkA 86*
Clark, Eliz Potter *DcWomA*
Clark, Elizabeth L *WhAmArt 85*
Clark, Elizabeth Potter *FolkA 86*
Clark, Elon B, Jr. 1925- *AmArch 70*
Clark, Elsie Southwick *WhAmArt 85*
Clark, Elsie Whitmore 1881- *DcWomA*
Clark, Emelia M 1869-1955 *DcWomA*
Clark, Emelia M Goldsworthy 1869-1956? *ArtsAmW 1*
Clark, Emilia Goldsworthy 1869-1955? *WhAmArt 85*
Clark, Emily 1820?- *FolkA 86*
Clark, Emily J d1929 *WhAmArt 85*
Clark, Emma E 1883-1930 *DcWomA, WhAmArt 85*
Clark, Enos *FolkA 86*
Clark, Ernest Ellis d1932 *DcBrWA*
Clark, Erroll Rowe 1914- *AmArch 70*
Clark, F *ArtsEM*
Clark, F C *FolkA 86*
Clark, F E, Jr. *AmArch 70*
Clark, Falconer *DcVicP 2*
Clark, Fanny *DcWomA*
Clark, Fletcher 1899- *WhAmArt 85*
Clark, Floyd 1913- *FolkA 86*
Clark, Frances *DcWomA*
Clark, Frances 1835-1916 *DcWomA, FolkA 86*
Clark, Francis *DcVicP 2*
Clark, Frank Justus 1924- *AmArch 70*
Clark, Frank Scott *WhAmArt 85*
Clark, Frank Scott 1865-1937 *ArtsEM*
Clark, Mrs. Frank T *FolkA 86*
Clark, Franklin B *WhAmArt 85*
Clark, Franklin Jacob 1937- *AmArch 70*
Clark, Fred, Jr. 1911- *WhoAmA 78, -80*
Clark, Frederick H *EncASM*
Clark, Frederick H 1862-1947 *WhAmArt 85*
Clark, Freeman *WhAmArt 85*
Clark, G Fletcher 1899- *WhoAmA 73, -76, -78, -80, -82*
Clark, G Fletcher 1899-1982 *WhoAmA 84N*
Clark, G H *ArtsEM*
Clark, G L *AmArch 70*
Clark, G W *AmArch 70, FolkA 86, NewYHSD*
Clark, Gabriel D 1813-1896 *EncASM*
Clark, Garth Reginald 1947- *WhoAmA 82, -84*
Clark, George *AfroAA, NewYHSD*
Clark, George Edward *EarABI SUP*
Clark, George M *WhAmArt 85*
Clark, George Mason 1923- *AmArch 70*
Clark, George R *WhAmArt 85*
Clark, George S *FolkA 86*
Clark, George W *ArtsEM*

Clark, George W d1862 *ArtsEM*
Clark, Georgia Lawrence *DcWomA, WhAmArt 85*
Clark, Grace S *WhAmArt 85*
Clark, Graydon, Jr. 1926- *AmArch 70*
Clark, Guy Gayler 1882- *WhAmArt 85*
Clark, H *DcWomA*
Clark, Harriette A 1876- *DcWomA, WhAmArt 85*
Clark, Harrison *WhAmArt 85*
Clark, Harry A *FolkA 86, NewYHSD*
Clark, Helen Bard Merrill 1858-1951 *ArtsAmW 2*
Clark, Helen Caroline 1884- *WhAmArt 85*
Clark, Henry *AntBDN M*
Clark, Henry Hunt *WhAmArt 85*
Clark, Herbert Francis 1876- *WhAmArt 85*
Clark, Herbert W, Jr. *WhAmArt 85*
Clark, Hervey Parke 1899- *AmArch 70*
Clark, Hewitt Hale 1920- *AmArch 70*
Clark, Homer *WhAmArt 85*
Clark, Irene *FolkA 86*
Clark, Irene 1927- *AfroAA*
Clark, Isaac *FolkA 86*
Clark, Isaac Carpenter 1892- *WhAmArt 85*
Clark, J *FolkA 86*
Clark, J G *DcWomA*
Clark, J H *AmArch 70*
Clark, J P *AmArch 70*
Clark, J R *NewYHSD*
Clark, J W *AmArch 70*
Clark, J Wait *DcVicP 2*
Clark, Jacob 1819?- *NewYHSD*
Clark, Jacob N *FolkA 86*
Clark, James *BiDAmAr*
Clark, James 1816?- *NewYHSD*
Clark, James 1858-1943 *DcBrA 1, DcBrWA, DcVicP 2*
Clark, James Alfred 1886- *WorECar*
Clark, James Allan 1909- *AmArch 70*
Clark, James H *DcBrA 1*
Clark, James Ingraham 1918- *AmArch 70*
Clark, James Lippitt 1883- *WhAmArt 85*
Clark, James Lippitt 1883-1969 *IlBEAAW*
Clark, Jean Manson 1902- *DcBrA 1, WhoArt 80, -82, -84*
Clark, Job *CabMA*
Clark, Joe Morris, Jr. 1923- *AmArch 70*
Clark, John *CabMA, DcCAr 81, FolkA 86, NewYHSD, WhAmArt 85*
Clark, John d1857 *BiDBrA*
Clark, John 1585?-1624 *BiDBrA*
Clark, John Clem 1937- *DcCAr 81*
Clark, John Cosmo 1897-1967 *DcBrA 1*
Clark, John Dewitt *WhoAmA 73, -76, -78, -80, -82, -84*
Clark, John Franklin, Jr. 1918- *AmArch 70*
Clark, John H 1920- *AmArch 70*
Clark, John Heaviside 1771?-1863 *DcBrBI*
Clark, John Heaviside Waterloo 1771?-1863 *DcBrWA*
Clark, John Louis 1881-1970 *ArtsAmW 3*
Clark, John M *ArtsEM*
Clark, John M'Kenzie 1928- *WhoArt 80, -82, -84*
Clark, John W *FolkA 86, NewYHSD*
Clark, Jon Frederic 1947- *WhoAmA 78, -80, -82, -84*
Clark, Joseph *BiDAmAr*
Clark, Joseph 1834-1912? *DcVicP*
Clark, Joseph 1834-1926 *DcBrA 1, DcBrBI, DcVicP 2*
Clark, Joseph 1835- *ArtsNiC*
Clark, Joseph 1835-1926 *DcBrWA*
Clark, Joseph Benwell *DcVicP 2*
Clark, Joseph Benwell 1857- *DcBrBI, DcBrWA*
Clark, Joseph C *CabMA*
Clark, Josiah *CabMA*
Clark, Judy *OxTwCA*
Clark, Kate Freeman 1875-1957 *DcWomA*
Clark, Kenneth d1931 *WhAmArt 85*
Clark, Kenneth Bowhay 1914- *AmArch 70*
Clark, Kenneth Inman Carr 1922- *WhoArt 80, -82, -84*
Clark, Kenneth Sears 1909- *AmArch 70*
Clark, Larry 1943- *ConPhot, ICPEnP A, MacBEP*
Clark, Laurence 1881- *WhAmArt 85*
Clark, Leon 1906- *FolkA 86*
Clark, Levin P *FolkA 86*
Clark, Lola *DcWomA*
Clark, Louisa *DcWomA, NewYHSD*
Clark, Louisa Campbell *DcWomA*
Clark, Louise Bennet *WhAmArt 85*
Clark, Lucille 1897- *ArtsAmW 3*
Clark, Lygia 1920- *ConArt 77, -83, McGDA*
Clark, Lygia 1921- *OxTwCA, PhDcTCA 77*
Clark, M M *NewYHSD*
Clark, M Walden *DcWomA*
Clark, Mrs. M Walden *ArtsEM*
Clark, Mabel Beatrice Smith d1957 *WhoAmA 80N, -82N, -84N*
Clark, Mabel Beatrice Smith 1882-1957 *DcWomA*
Clark, Marc 1923- *DcCAr 81*
Clark, Mark A 1931- *WhoAmA 73, -76, -78, -80, -82, -84*
Clark, Martin Van 1926- *AmArch 70*
Clark, Mary *DcVicP 2*

Clark, Mary Ann *FolkA 86*
Clark, Mary Brodie *DcVicP 2*
Clark, Mary J *DcWomA*
Clark, Mary Rosalie *DcWomA*
Clark, Mason *FolkA 86*
Clark, Matt 1903- *IlBEAAW, IlrAm D, WhAmArt 85*
Clark, Matt 1903-1972 *IlrAm 1880*
Clark, Matthew 1810?- *NewYHSD*
Clark, Maud J *WhAmArt 85*
Clark, Merriweather Lewis *BiDAmAr*
Clark, Michael 1918- *DcBrA 1, WhoArt 80, –82, –84*
Clark, Michael Vinson 1946- *PrintW 85, WhoAmA 78, –80, –82, –84*
Clark, Mildred Foster 1923-1980? *FolkA 86*
Clark, Minerva *DcWomA, FolkA 86*
Clark, N *FolkA 86*
Clark, Nancy Kissel 1919- *WhoAmA 76, –78, –80, –82, –84*
Clark, Nathan *FolkA 86*
Clark, Nathan, Jr. *FolkA 86*
Clark, Nathaniel *AfroAA, FolkA 86*
Clark, Norman Alexander 1913- *DcBrA 1, WhoArt 80, –82, –84*
Clark, Octavius T 1850-1921 *DcBrA 1*
Clark, Oliver 1774- *CabMA*
Clark, Ossie 1942- *FairDF ENG[port], WorFshn*
Clark, Paraskeva *OxTwCA*
Clark, Paraskeva 1898- *DcWomA, WhoAmA 73, –76, –78, –80*
Clark, Pat *AfroAA*
Clark, Patrick *FolkA 86*
Clark, Pendleton Scott 1895- *AmArch 70*
Clark, Perry Spencer 1920- *AmArch 70*
Clark, Peter *FolkA 86*
Clark, Peter 1796?- *NewYHSD*
Clark, Peter, III *FolkA 86*
Clark, Peter Christian 1950- *WhoArt 80, –82, –84*
Clark, R *FolkA 86*
Clark, R C *AmArch 70*
Clark, R Dane 1934- *WhoAmA 76, –78, –80*
Clark, R J *AmArch 70*
Clark, Ralph Samuel 1895- *WhAmArt 85*
Clark, Richard Shaw 1924- *AmArch 70*
Clark, Richard T *NewYHSD*
Clark, Robert *OfPGCP 86*
Clark, Robert 1775-1846 *CabMA*
Clark, Robert Charles 1920- *WhoAmA 73, –76, –78, –80, –82, –84*
Clark, Robert Foerst 1927- *AmArch 70*
Clark, Robert Hugh 1915- *AmArch 70*
Clark, Robert Kendall 1931- *MarqDCG 84*
Clark, Robert Lee 1927- *AmArch 70*
Clark, Robert Taylor 1920- *AmArch 70*
Clark, Robert W 1930- *AmArch 70*
Clark, Roberta Carter 1924- *WhoAmA 84*
Clark, Roland 1874-1957 *WhAmArt 85, WhoAmA 80N, –82N, –84N*
Clark, Ronald Baxter 1936- *AmArch 70*
Clark, Rose *WhAmArt 85*
Clark, Rose 1852-1942 *DcWomA*
Clark, Roy C 1889- *WhAmArt 85*
Clark, S D *DcWomA*
Clark, Miss S D *NewYHSD*
Clark, S J *DcVicP 2*
Clark, Sally 1883- *WhAmArt 85*
Clark, Sally Harfield 1883-1981 *DcWomA*
Clark, Samuel *CabMA, FolkA 86*
Clark, Samuel 1805- *CabMA*
Clark, Samuel 1927- *AfroAA*
Clark, Samuel C *NewYHSD*
Clark, Sarah Ann 1943- *WhoAmA 78*
Clark, Sarah L 1869-1936 *DcWomA, WhAmArt 85*
Clark, Selden McKinley 1903- *WhAmArt 85*
Clark, Seth A *NewYHSD*
Clark, Seth H *NewYHSD*
Clark, Sheldon P *WhAmArt 85*
Clark, Silas C *NewYHSD*
Clark, Tanner *WhAmArt 85*
Clark, Theodore Minot 1845-1909 *BiDAmAr*
Clark, Thomas d1775? *DcBrECP*
Clark, Thomas d1875 *ArtsNiC*
Clark, Thomas 1820-1876 *DcBrWA, DcVicP, –2*
Clark, Thomas Edward 1916- *AmArch 70*
Clark, Thomas Humphrey 1921- *WhoArt 80, –82, –84*
Clark, Thomas Joseph, Jr. 1941- *AmArch 70*
Clark, Timothy John 1951- *WhoAmA 82, –84*
Clark, Vera *DcWomA*
Clark, Vera I *WhAmArt 85*
Clark, Vicky A *WhoAmA 82, –84*
Clark, Virginia 1878- *DcWomA*
Clark, Virginia Keep 1878- *WhAmArt 85*
Clark, W B, Jr. *AmArch 70*
Clark, W F *DcVicP 2*
Clark, W M, Jr. *AmArch 70*
Clark, W M A *FolkA 86*
Clark, Walter 1848-1917 *WhAmArt 85*
Clark, Walter Appleton 1876-1906 *IlrAm A, –1880,*

WhAmArt 85
Clark, Walter Leighton 1859-1935 *WhAmArt 85*
Clark, William *DcVicP 2, FolkA 86*
Clark, William d1883 *DcVicP 2*
Clark, William 1803-1883 *DcSeaP*
Clark, William, Jr. *DcVicP*
Clark, William, Sr. *DcVicP*
Clark, William A d1925 *WhAmArt 85*
Clark, Mrs. William Bullock *WhAmArt 85*
Clark, William C *CabMA*
Clark, William Edward 1911- *MacBEP*
Clark, William W 1940- *WhoAmA 78, –80, –82, –84*
Clark And Noon *EncASM*
Clarke *BiDBrA*
Clarke, Miss *DcVicP 2, DcWomA*
Clarke, A F Graham *DcVicP 2*
Clarke, A T *DcVicP 2*
Clarke, Ada *DcVicP 2*
Clarke, Alfred Alexander *DcVicP 2*
Clarke, Angelica *DcBrWA*
Clarke, Ann 1944- *DcCAr 81, WhoAmA 80, –82, –84*
Clarke, Annie *DcWomA*
Clarke, Arthur d1912? *DcBrBI*
Clarke, Audrey M 1926- *ClaDrA, WhoArt 80, –82, –84*
Clarke, Bethia *DcVicP 2*
Clarke, Bethia d1958 *DcBrA 1, DcWomA*
Clarke, Bud 1941- *WhoAmA 80, –82, –84*
Clarke, C Macdonald *DcVicP 2*
Clarke, Carl Dame 1904- *WhAmArt 85*
Clarke, Caspar *DcVicP 2*
Clarke, Sir Caspar Purdon 1846-1911 *WhAmArt 85*
Clarke, Charles B 1836-1899 *BiDAmAr*
Clarke, Charles Julian 1836-1908 *BiDAmAr*
Clarke, Christopher Thomas *CabMA*
Clarke, Collins 1842?- *NewYHSD*
Clarke, Corneille *WhAmArt 85*
Clarke, Curtis Glenn 1937- *AmArch 70*
Clarke, Daisy E *DcWomA*
Clarke, Dan *MarqDCG 84*
Clarke, Daniel 1768-1830 *CabMA*
Clarke, David *FolkA 86*
Clarke, Dora *DcBrA 1, DcWomA, WhoArt 80, –82, –84*
Clarke, E *DcVicP 2*
Clarke, Edward Daniel 1769-1822 *DcBrWA*
Clarke, Edward Francis C *DcBrBI*
Clarke, Elsie W *WhAmArt 85*
Clarke, F F *AmArch 70*
Clarke, Frank 1885-1973 *ArtsAmW 2*
Clarke, Frederick *DcVicP 2*
Clarke, Frederick Benjamin 1874-1943 *WhAmArt 85*
Clarke, G Somers 1825-1882 *MacEA*
Clarke, Geoffrey 1924- *DcCAr 81, OxTwCA, PhDcTCA 77, WhoArt 80, –82, –84*
Clarke, Geoffrey Petts 1924- *DcBrA 1*
Clarke, George 1661-1736 *BiDBrA, MacEA*
Clarke, George Frederick *DcVicP 2*
Clarke, George Frederick 1823-1906 *DcBrA 2*
Clarke, George Row *DcBrWA, DcVicP 2*
Clarke, George W *ArtsEM*
Clarke, Geraldine *AfroAA*
Clarke, Gladys Dunham 1899- *DcWomA, WhAmArt 85*
Clarke, Grace Olmstead *WhAmArt 85*
Clarke, H Savile *DcWomA*
Clarke, Mrs. H Savile *DcVicP 2*
Clarke, Harriet *WhAmArt 85*
Clarke, Harriet B *DcWomA, FolkA 86*
Clarke, Harriet Ludlow d1866 *DcWomA*
Clarke, Harry 1890- *ConICB*
Clarke, Harry 1890-1931 *DcBrA 1, DcBrBI*
Clarke, Harry Harvey 1869- *DcBrA 1*
Clarke, Harry Harvey 1869-1948 *DcBrA 2*
Clarke, Hilda Margery 1926- *WhoArt 80, –82, –84*
Clarke, Hugh C 1905- *AmArch 70*
Clarke, Isaac Edwards 1830-1907 *WhAmArt 85*
Clarke, J *DcVicP 2*
Clarke, J C *DcWomA*
Clarke, J F Mowbray *WhAmArt 85*
Clarke, J R *DcVicP 2*
Clarke, J W *WhAmArt 85*
Clarke, James *BiDBrA*
Clarke, James 1745?-1799 *DcBrECP*
Clarke, Jane *DcVicP 2*
Clarke, Joan 1913- *WhoArt 80, –82, –84*
Clarke, John *CabMA*
Clarke, John 1585?-1624 *BiDBrA*
Clarke, John Clem *WhoAmA 80*
Clarke, John Clem 1937- *ConArt 77, –83, DcCAA 77, WhoAmA 73, –76, –78, –80, –82, –84*
Clarke, John Henrik *AfroAA*
Clarke, John L 1881-1970 *WhAmArt 85*
Clarke, John Louis 1881-1970 *ArtsAmW 3, IlBEAAW*
Clarke, John Moulding 1889- *DcBrA 1*
Clarke, John R 1945- *WhoAmA 84*
Clarke, Joseph *DcVicP, –2*
Clarke, Joseph Clayton *DcBrBI*
Clarke, K T *DcWomA*

Clarke, Kate *DcVicP 2, DcWomA*
Clarke, L J Graham- *DcVicP 2*
Clarke, L P *AmArch 70*
Clarke, Laura Etta *FolkA 86*
Clarke, Leroy 1938- *AfroAA*
Clarke, Lilian *DcWomA*
Clarke, Lillian Gertrude *WhAmArt 85*
Clarke, Louise Waldorf 1838- *DcWomA*
Clarke, Marion Alexandra *DcWomA*
Clarke, Marjorie Rowland 1908- *WhAmArt 85*
Clarke, Marshall Fenn 1940- *AmArch 70*
Clarke, Mary C *DcVicP 2*
Clarke, Mary Dale 1875-1936 *WhAmArt 85*
Clarke, Maud V *DcBrBI*
Clarke, Minnie E *DcBrA 1, DcVicP 2, DcWomA*
Clarke, Myrtell A *ArtsEM, DcWomA*
Clarke, P T *AmArch 70*
Clarke, Pat *WhoArt 80, –82, –84*
Clarke, Paul Montem 1915- *DcBrA 1*
Clarke, Peter John 1927- *WhoArt 80, –82, –84*
Clarke, Polly *DcVicP 2, DcWomA*
Clarke, Prescott O *WhAmArt 85*
Clarke, Prescott O 1858-1935 *BiDAmAr*
Clarke, R *DcVicP 2*
Clarke, Rebecca S *DcWomA*
Clarke, Rene *WhAmArt 85*
Clarke, Rene 1886- *IlrAm C*
Clarke, Rene 1886-1969 *IlrAm 1880*
Clarke, Richard Cambridge 1909- *WhoArt 80, –82, –84*
Clarke, Richard Hugo 1955- *DcCAr 81*
Clarke, Robert A *EarABI SUP*
Clarke, Robert A 1817?- *NewYHSD*
Clarke, Robert James 1926- *WorECar*
Clarke, Ruth Abbott 1909- *WhoAmA 73, –76*
Clarke, S *DcVicP 2*
Clarke, S S *FolkA 86*
Clarke, Samuel Barling *DcVicP, –2*
Clarke, Sara Ann 1808-1888? *NewYHSD*
Clarke, Sarah Ann Freeman 1808-1890? *DcWomA*
Clarke, Sarah L *WhAmArt 85*
Clarke, Terence 1953- *DcCAr 81*
Clarke, Theophilus 1776-1831 *DcBrWA*
Clarke, Theophilus 1776-1832? *DcBrECP*
Clarke, Thomas *NewYHSD*
Clarke, Thomas B 1849-1931 *WhAmArt 85*
Clarke, Thomas Flowerday *DcBrA 1*
Clarke, Thomas Hutchings *BiDBrA*
Clarke, Thomas Shields 1860-1920 *WhAmArt 85*
Clarke, Una Atherton *DcWomA*
Clarke, Una C *WhAmArt 85*
Clarke, W D *DcVicP 2*
Clarke, Warren *FolkA 86*
Clarke, William *BiDBrA, NewYHSD*
Clarke, William d1878 *MacEA*
Clarke, William B 1890-1944? *BiDAmAr*
Clarke, William Barnard *BiDBrA*
Clarke, William Hanna 1882-1924 *DcBrA 1*
Clarke And Bell *MacEA*
Clarkson, A *DcWomA*
Clarkson, Charles 1825?- *NewYHSD*
Clarkson, Edward *NewYHSD*
Clarkson, Ella J 1871- *DcWomA*
Clarkson, Harvey Perrier 1914- *AmArch 70*
Clarkson, Helen Shelton *DcWomA, WhAmArt 85*
Clarkson, Jack 1906- *DcBrA 1, WhoArt 80, –82, –84*
Clarkson, James F *ArtsEM*
Clarkson, Jane *DcVicP 2*
Clarkson, John *NewYHSD*
Clarkson, John d1798 *BiDBrA*
Clarkson, John D 1916- *WhAmArt 85*
Clarkson, Marion F *DcVicP 2*
Clarkson, Nathaniel 1724-1795 *DcBrECP*
Clarkson, Ralph 1861-1942 *WhAmArt 85*
Clarkson, Ralph Elmer 1861-1942 *ArtsAmW 3*
Clarkson, Richard C 1932- *ICPEnP A, MacBEP*
Clarkson, Robert *DcVicP 2*
Clarkson, Thomas B, III *MarqDCG 84*
Clarkson, W H d1944? *DcBrA 1*
Clarkson, William Herbert 1872-1944 *DcVicP 2*
Clary, Letillier Du *NewYHSD*
Clary, Moodye Robbins 1933- *AmArch 70*
Clas, A R *AmArch 70*
Clas, Alfred C 1860-1942 *BiDAmAr*
Clasebull, Joseph H *NewYHSD*
Clasgens, Frederic *WhAmArt 85*
Clason, Isak Gustaf 1856-1930 *MacEA*
Clason, Isak Gustav 1856-1930 *WhoArch*
Clasper, Louise Crosbie *WhAmArt 85*
Class, Robert Allan 1915- *AmArch 70*
Classen, James M *NewYHSD*
Classen, William M *NewYHSD*
Clater, Frederick R *DcVicP 2*
Clater, J *DcVicP 2*
Clater, T B *DcVicP 2*
Clater, Thomas 1789-1867 *DcVicP, –2*
Clattenburg, Theodore 1910- *AmArch 70*
Clatworthy, Richard Newton 1917- *AmArch 70*
Clatworthy, Robert 1928- *ConBrA 79[port], DcBrA 2, OxTwCA, PhDcTCA 77, WhoArt 80, –82, –84*

Clemes, Emily *DcWomA*
Cleminshaw, M Isabella *DcVicP 2*
Cleminson, Robert *DcVicP, -2*
Clemmer, Leon 1926- *AmArch 70*
Clemmer, Robert Lee 1903- *AmArch 70*
Clemmer, V D, Jr. *AmArch 70*
Clemmitt, Mary *WhAmArt 85*
Clemmons, David Ray 1938- *MarqDCG 84*
Clemmons, James P *CabMA*
Clemmons, T L *AmArch 70*
Clemons, Joseph Newton 1925- *AmArch 70*
Clench, Harriet *DcWomA*
Clendaniel, R Calvin 1926- *AmArch 70*
Clendenin, Eve *WhoAmA 73, -76*
Clendenin, Eve 1900- *WhAmArt 85*
Clendinning, Max 1924- *DcD&D[port]*
Cleneay, W Allen 1910- *AmArch 70*
Clennell, Luke 1781-1840 *DcBrBI, DcBrWA, McGDA*
Cleophrades Painter *McGDA*
Clephan, James *BiDBrA*
Clephan, Lewis *NewYHSD*
Clephane, Lewis Painter 1869- *WhAmArt 85*
Clephane, Rosebud 1898- *WhAmArt 85*
Clephane, Rosebud 1899-1972 *DcWomA*
Clerc, Martha *DcWomA*
Clerc, Sofia *DcWomA*
Clerck, Hendrick De 1570?-1629? *ClaDrA*
Clerck, Hendrik De 1565?-1629 *McGDA*
Clerck, Hendrik De 1570-1629 *OxArt*
Clere, F DeJ 1856-1952 *MacEA*
Clere, Hazel *WhAmArt 85*
Clere, Vera *WhAmArt 85*
Clerge, Auguste Joseph 1891- *ClaDrA*
Clerget, Adele *DcWomA*
Clerget, Blanche *DcWomA*
Clergue, Lucien 1934- *ConPhot, ICPEnP, -A*
Clergue, Lucien G 1934- *MacBEP*
Clerian, Josephine *DcWomA*
Clerici, Fabrizio 1913- *WhoGrA 62*
Clerihew, William *DcBrWA*
Clerion, Genevieve *DcWomA*
Clerisseau, Charles-Louis 1721-1820 *MacEA*
Clerisseau, Charles-Louis 1722-1820 *McGDA*
Clerisseau, Jacques Louis 1721-1820 *WhoArch*
Clerk, Alexander *DcBrECP*
Clerk, Andrew *BiDBrA*
Clerk, Henry H *NewYHSD*
Clerk, Sir James 1709-1782 *BiDBrA*
Clerk, Sir James 1710-1782 *DcBrECP*
Clerk, John 1728-1812 *DcBrWA*
Clerk, Sir John 1676-1755 *BiDBrA*
Clerk, John, Lord Eldin 1757-1832 *DcBrWA*
Clerk, Pierre 1928- *ConArt 77, DcCAA 77, PrintW 83, -85, WhoAmA 73, -76, -78, -80, -82, -84*
Clerk, Simon *OxArt*
Clerk, William *BiDBrA*
Clerk Maxwell, James *ICPEnP*
Clerk-Maxwell Of Penicuik, Sir George 1715-1784 *DcBrWA*
Clermont, Mademoiselle *DcWomA*
Clermont, Andien De d1783 *DcBrECP*
Clermont, Ghislain 1940- *WhoAmA 76, -78, -80, -82, -84*
Clery, Meg Jean *DcWomA*
Clesinger, Jean Baptiste 1814-1883 *ClaDrA, McGDA*
Clesinger, Jean-Baptiste-Auguste 1820?-1883 *ArtsNiC*
Cleve, Corneille Van *McGDA*
Cleve, Cornelis Van *McGDA*
Cleve, Hendrick Van, III 1525-1589 *ClaDrA*
Cleve, Jan Van *McGDA*
Cleve, Joos Van 1485?-1540 *McGDA*
Cleveland, Mrs. *FolkA 86*
Cleveland, A V, III *AmArch 70*
Cleveland, Agnes *ArtsEM, DcWomA*
Cleveland, Charles Stewart 1918- *AmArch 70*
Cleveland, Cyrus *CabMA*
Cleveland, Florence K 1894?-1976 *DcWomA*
Cleveland, Frank E 1878-1950 *BiDAmAr*
Cleveland, George E *CabMA*
Cleveland, Helen Barth *WhoAmA 73, -76, -78, -80, -82, -84*
Cleveland, J R *DcWomA*
Cleveland, Mrs. J R *NewYHSD*
Cleveland, James A 1811-1859? *NewYHSD*
Cleveland, James May 1922- *AmArch 70*
Cleveland, Ladybird 1927- *AfroAA*
Cleveland, Lorenzo 1820-1905 *BiDAmAr*
Cleveland, M B *AmArch 70*
Cleveland, Margaret *WhAmArt 85*
Cleveland, R *AmArch 70*
Cleveland, Rhodes Mortimer 1917- *AmArch 70*
Cleveland, Robert Earl 1936- *WhoAmA 78, -80, -82, -84*
Cleveland, Robert Harold 1930- *AmArch 70*
Cleveland, Samuel 1704- *CabMA*
Cleveland, Sydney Dyson 1898- *WhoArt 80, -82, -84*
Cleveland, Walter G *WhAmArt 85*
Cleveland, William *FolkA 86*
Cleveland, William 1777-1845 *NewYHSD*

Cleveland, William S *MarqDCG 84*
Cleveley, James *DcBrWA*
Cleveley, John d1782? *DcBrWA*
Cleveley, John 1747-1786 *DcBrWA, NewYHSD*
Cleveley, John, Jr. 1747-1786 *DcBrECP*
Cleveley, John, Sr. d1777 *DcBrECP*
Cleveley, John, The Elder 1712?-1777 *DcSeaP*
Cleveley, John, The Younger 1747-1786 *DcSeaP*
Cleveley, Robert d1809? *BkIE*
Cleveley, Robert 1747-1809 *DcBrECP, DcBrWA, DcSeaP*
Clevenger, Shobal Vail 1812-1843 *BnEnAmA, DcAmArt, McGDA, NewYHSD*
Clever, Donald G 1916- *MarqDCG 84*
Cleverley, Charles F M *DcVicP 2*
Cleverly, Charles F M *DcBrA 2*
Clewell, Charles Walter 1876- *WhAmArt 85*
Clews, Henry, Jr. 1876-1937 *WhAmArt 85*
Clews, James *DcNiCA, FolkA 86*
Clews, Ralph *DcNiCA*
Cleyn, Magdalen *DcWomA*
Cleyn, Penelope *DcWomA*
Cleyn, Sarah *DcWomA*
Click, Lyle Hill 1910- *AmArch 70*
Cliff, Clarice 1900- *DcNiCA*
Cliff, Denis Antony 1942- *WhoAmA 84*
Cliff, Ursula *ConArch A*
Cliff, William 1775-1849 *DcBrWA*
Clifford, Chandler R 1858-1935 *WhAmArt 85*
Clifford, Charles d1863 *ICPEnP A*
Clifford, Lady Clare *WhoArt 82N*
Clifford, Lady Clare 1894- *WhoArt 80*
Clifford, Clare Mary 1894- *DcWomA*
Clifford, Lady Clare Mary 1894- *DcBrA 1*
Clifford, E 1844- *ArtsNiC*
Clifford, Edward 1844-1907 *DcBrA 1, DcBrWA, DcVicP, -2*
Clifford, Edward C *DcVicP 2*
Clifford, Edward C 1844-1907 *ClaDrA*
Clifford, Edward Charles 1858-1910 *DcBrA 1, DcBrWA*
Clifford, Edward M *FolkA 86*
Clifford, Harry P *DcBrBI*
Clifford, Harry Percy *DcBrA 1*
Clifford, Henry *DcSeaP, DcVicP 2*
Clifford, Henry Charles 1861-1947 *DcBrA 1, DcVicP 2*
Clifford, James *CabMA*
Clifford, John Henry 1879- *WhAmArt 85*
Clifford, Judy 1946- *AmArt*
Clifford, Jutta *WhoAmA 78, -80, -82, -84*
Clifford, Keith 1942- *MarqDCG 84*
Clifford, Lois Irene 1892- *WhAmArt 85*
Clifford, Maurice *DcBrBI, DcVicP 2*
Clifford, R A *NewYHSD*
Clifford, Robert *FolkA 86*
Clifford, Robin 1907- *ClaDrA, DcBrA 1*
Clifford, William 1858-1942 *WhAmArt 85*
Clift, A *DcVicP 2*
Clift, Stephen *DcVicP 2*
Clift, W H *AmArch 70*
Clift, William 1944- *ConPhot, DcCAr 81*
Clift, William Brooks 1944- *ICPEnP A, WhoAmA 84*
Clift, William Brooks, III 1944- *MacBEP*
Clifton, Adele R 1875- *WhAmArt 85*
Clifton, Adele Rollins 1875- *DcWomA*
Clifton, David James 1938- *WhoArt 80, -82, -84*
Clifton, Henry d1771 *CabMA*
Clifton, J *DcVicP 2*
Clifton, Jack Whitney 1912- *WhoAmA 78, -80, -82, -84*
Clifton, John S *DcVicP 2*
Clifton, Louisa *DcWomA*
Clifton, Mary *DcWomA*
Clifton, Michelle Gamm 1944- *WhoAmA 78, -80, -82, -84*
Clifton, William *DcVicP 2*
Clilverd, Graham Barry 1883- *DcBrA 1*
Clime, Winfield Scott 1881-1958 *WhAmArt 85, WhoAmA 80N, -82N, -84N*
Clinch, Christine *DcCAr 81*
Cline, C E *AmArch 70*
Cline, Clinton C 1934- *WhoAmA 80, -82, -84*
Cline, Craig Emerson 1951- *MarqDCG 84*
Cline, Elizabeth Ann *FolkA 86*
Cline, Glen Edwin 1920- *AmArch 70*
Cline, N L *AmArch 70*
Cline, Robert Wayne 1928- *AmArch 70*
Clinedinst, B West 1859-1931 *WhAmArt 85*
Clinedinst, Benjamin West 1859-1931 *IlrAm A, -1880*
Clinedinst, Katherine Parsons 1903- *WhoAmA 76, -78, -80, -82, -84*
Clinedinst, M S 1887-1960? *WhAmArt 85*
Clinedinst, May Spear *WhoAmA 80N, -82N, -84N*
Clinedinst, May Spear 1887-1961? *DcWomA*
Clingan, Alton B, Jr. 1936- *AmArch 70*
Clinger, M A *AmArch 70*
Clink, Isabel M *DcVicP 2*
Clink, Matilda J *DcVicP 2*
Clinker, L C *WhAmArt 85*

Clint, Alfred 1807-1883 *ArtsNiC, DcBrWA, DcSeaP, DcVicP, -2*
Clint, George *DcBrWA*
Clint, George 1770-1854 *ArtsNiC, DcBrBI, DcBrWA, DcVicP 2*
Clint, Raphael *DcVicP 2*
Clinton, C W *EarABI*
Clinton, Charles W 1838-1910 *BiDAmAr, MacEA*
Clinton, DeWitt *NewYHSD*
Clinton, George d1850 *BiDBrA*
Clinton, George H *FolkA 86*
Clinton, H T, III *AmArch 70*
Clinton, Paul Arthur 1942- *WhoAmA 82, -84*
Clinton And Russell *MacEA*
Clippard, Samuel Ebbert 1907- *AmArch 70*
Clippele, Elise *DcWomA*
Clipsham, Jacqueline Ann 1936- *WhoAmA 78, -80, -82, -84*
Clique, The *DcVicP*
Cliquot, Antoinette *DcWomA*
Clirehugh, A LaV *WhAmArt 85*
Clirehugh, W S *NewYHSD*
Clisbee, George H H H 1895-1936 *WhAmArt 85*
Clisby, Roger David 1939- *WhoAmA 78, -80, -82, -84*
Clisby, T W *BiDBrA*
Clise, Jocelyn 1923- *WhAmArt 85*
Clive 1933- *WorFshn*
Clive, Alan Butler 1746-1810 *DcBrWA*
Clive, Charles *DcBrECP*
Clive, Richard R 1912- *WhoAmA 73, -76, -78, -80, -82, -84*
Clive, T *DcVicP 2*
Cliver, Kendra-Jean *WhoAmA 80, -82, -84*
Clivette, Merton 1868-1931 *WhAmArt 85*
Cloake, George 1761?-1812 *BiDBrA*
Cloar, Carroll 1913- *DcCAA 71, -77, WhoAmA 82, -84*
Cloar, Carroll 1918- *WhoAmA 73, -76, -78, -80*
Clochey, Daniel 1943- *DcCAr 81*
Clodagh *FairDF IRE*
Clodagh 1937- *WorFshn*
Clodfelter, Clifford C 1922- *AmArch 70*
Clodion 1738-1814 *McGDA, OxArt*
Clodion, Claude Michel 1738-1814 *DcNiCA*
Clodt-Jurgensbourg, Baron Peter 1805- *ArtsNiC*
Cloetingh, James H 1894- *WhAmArt 85*
Clogston, Evelyn Belle 1906- *WhAmArt 85*
Cloister, Ephrata *FolkA 86*
Clomesnil, E De *DcWomA*
Clomp, Albert Jansz *McGDA*
Clonney, James Goodwyn 1812-1867 *BnEnAmA, DcAmArt, NewYHSD*
Clontz, Jack William 1926- *AmArch 70*
Clopath, Henriette *WhAmArt 85*
Clopath, Henriette 1862-1936 *ArtsAmW 2, DcWomA*
Clopton, Robert Bradford 1920- *AmArch 70*
Cloquet, Louis 1849-1920 *MacEA*
Cloriviere, Joseph-P P DeLimoelan De 1768-1826 *NewYHSD*
Close, A P *EarABI, EarABI SUP*
Close, Chuck 1940- *AmArt, ConArt 77, -83, DcAmArt, DcCAA 77, DcCAr 81, PrintW 83, -85, WhoAmA 73, -76, -78, -80, -82, -84, WorArt[port]*
Close, Dean Purdy *WhoAmA 76, -78, -80, -82, -84*
Close, Dean Purdy 1905- *WhAmArt 85*
Close, Elizabeth Scheu 1912- *AmArch 70*
Close, Marjorie 1899- *WhoAmA 73, -76, -78*
Close, Marjorie 1899-1978 *WhoAmA 80N, -82N, -84N*
Close, May Lewis 1886- *DcWomA, WhAmArt 85*
Close, Samuel P *DcBrA 2*
Close, Winston Arthur 1906- *AmArch 70*
Closmeuil, Florensa De *AntBDN E*
Closson, Nanci Blair *PrintW 85*
Closson, William B 1848-1926 *WhAmArt 85*
Clotet Ballus, Lluis 1941- *ConArch*
Clotfelter, J B *AmArch 70*
Clothier, J R 1936- *AmArch 70*
Clothier, Peter Dean 1936- *WhoAmA 78, -80, -82, -84*
Clothier, Robert *DcVicP 2*
Cloud, Ada A 1852- *DcWomA*
Cloud, C W *AmArch 70*
Cloud, J Lizzie *DcVicP 2*
Cloud, Jack L 1925- *WhoAmA 78, -80, -82, -84*
Cloud, L D *AmArch 70*
Cloud, Robert Kent *AmArch 70*
Cloud, Teresa *DcWomA*
Cloudman, J D *ArtsAmW 1*
Cloudman, John Greenleaf 1813-1892 *ArtsAmW 3*
Cloudman, John J *NewYHSD*
Clouet, Fernand, Madame *WorFshn*
Clouet, Francois 1510?-1572 *McGDA, OxArt*
Clouet, Francois 1522?-1572 *ClaDrA*
Clouet, Janet 1485?-1541 *OxArt*
Clouet, Jean d1540 *McGDA*
Clouet, Jean 1485?-1541 *OxArt*
Clouet, Jean, The Elder 1420?- *OxArt*
Clouet DeNavarre *McGDA*

Clouet Family OxArt
Clough, Charles S 1951- DcCAr 81
Clough, Charles Sidney 1951- WhoAmA 82, –84
Clough, Ebenezer CabMA, FolkA 86
Clough, George A 1843-1916? BiDAmAr
Clough, George L 1824-1901 NewYHSD ,
 WhAmArt 85
Clough, Jane B 1881- DcWomA, WhAmArt 85
Clough, Jessie L WhAmArt 85
Clough, Prunella 1919- ConBrA 79, DcBrA 1,
 DcCAr 81, PhDcTCA 77
Clough, Stanley T 1905- WhAmArt 85
Clough, Thomas WhAmArt 85
Clough, Thomas Collingwood WhoArt 80, –82N
Clough, Thomas Collingwood 1903- DcBrA 1
Clough, Tom 1867-1943 DcBrA 1, DcVicP 2
Clouse, Raymond Edward 1913- AmArch 70
Clouston, Robert S d1911 DcBrA 2
Cloutier, Francois OfPGCP 86
Cloutier, Joseph Jack 1922- AmArch 70
Clover, James B 1938- WhoAmA 73, –76, –78
Clover, Jeanne C DcWomA
Clover, Joseph 1779-1853 DcBrWA
Clover, Lewis Peter, Jr. 1819-1896 NewYHSD
Clover, Philip 1832-1905 NewYHSD
Clover, Philip 1842-1905 WhAmArt 85
Clover, Susan AmArt
Clover, William C NewYHSD
Clover-Bew, Mattie 1865- ArtsAmW 2
Clover-Bew, May 1865- ArtsAmW 2, DcWomA,
 WhAmArt 85
Clovio, Giulio 1488-1578 McGDA
Clovio, Giulio 1498-1578 OxArt
Clow, Florence DcVicP 2
Clowdsley, J U AmArch 70
Clowdsley, John Upton 1926- AmArch 70
Clowes, Allen Whitehill 1917- WhoAmA 73, –76, –78,
 –80, –82, –84
Clowes, C DcVicP 2, DcWomA
Clowes, E A DcBrWA
Clowes, Harriett Mary DcBrWA, DcVicP 2
Clowes, John AntBDN D
Clows, John NewYHSD
Cloyd, Thomas Earl 1944- MarqDCG 84
Cloyes, Eugene Herbert 1921- AmArch 70
Cloyes, Frederick 1828?- NewYHSD
Clozel, Mister NewYHSD
Clozel, Mrs. DcWomA, NewYHSD
Clubb, John Scott 1875-1934 WhAmArt 85
Cluczs, H FolkA 86
Cluff, Elsie M DcVicP 2
Cluff, Warren Y WhAmArt 85
Cluff, William NewYHSD
Clules, John NewYHSD
Clulow, Freda DcWomA
Clunie, Margaret 1950- WhoAmA 80
Clunie, Robert 1885- ArtsAmW 1
Clunie, Robert 1895?- IIBEAAW, WhAmArt 85
Clurman, Irene 1947- WhoAmA 78, –80, –82, –84
Cluskey, Charles B 1806?-1871 MacEA
Clusky, C C BiDAmAr
Clusmann, William 1859-1927 WhAmArt 85
Cluss, Adolph 1825-1905 BiDAmAr
Clute, Beulah Mitchell 1873- ArtsAmW 2, DcWomA,
 WhAmArt 85
Clute, Carrie 1890- WhAmArt 85
Clute, Carrie Elizabeth 1890- DcWomA
Clute, Edward C NewYHSD
Clute, Walter Marshall 1870-1915 WhAmArt 85
Clutterbuck, Jan 1919- WhoArt 80, –82, –84
Clutterbuck, Julia E DcBrA 1
Clutterbuck, Julia Emily DcWomA
Clutton, Henry 1819-1893 DcBrBI, McGDA
Clutton-Brock, Alan Francis 1904- DcBrA 1
Clutts, Carey M 1956- MarqDCG 84
Clutts, James Arthur 1925- AmArch 70
Clutz, William 1933- DcCAA 71, –77, WhoAmA 73,
 –76, –78, –80, –82, –84
Cluysenaar, J P 1811-1880 MacEA
Cluysenaar, Jean Andre Alfred 1837-1902 ClaDrA
Cluysenaar, John 1899- WhoArt 80, –82, –84
Clyde, Andrew Jackson 1922- AmArch 70
Clyma, William Maurice, Jr. 1937- AmArch 70
Clymer, Albert Anderson 1942- AmArt,
 WhoAmA 78, –80, –82, –84
Clymer, Edwin Swift WhAmArt 85
Clymer, J Floyd 1893- WhAmArt 85
Clymer, John 1907- IIBEAAW, IlrAm E, –1880
Clymer, John 1915- AmArch 70
Clymer, John F 1907- WhoAmA 73, –76, –78, –80,
 –82, –84
Clyne, Evelyn DcWomA
Clyne, Henry Horne 1930- WhoArt 80, –82, –84
Clyne, Thora 1937- WhoArt 80, –82, –84
Cnoop, Cornelia DcWomA
Coab, Joseph FolkA 86
Coade, Eleanor DcWomA
Coade, Eleanor d1796 McGDA
Coade & Sealy DcNiCA
Coady, J M AmArch 70
Coady, Robert J 1881-1921 WhAmArt 85

Coakley, Bernard Allan, Jr. 1927- AmArch 70
Coale, Donald V 1906- WhAmArt 85
Coale, Griffith Baily 1890- WhAmArt 85
Coale, Walter Irving WhAmArt 85
Coalson, Glo IlsBYP, IlsCB 1967
Coan, C Arthur 1867- WhAmArt 85
Coan, Frances C WhAmArt 85
Coan, Frances Catherine Challenor 1872- DcWomA
Coan, Helen E WhAmArt 85
Coan, Helen E 1859-1938 ArtsAmW 2, DcWomA
Coan, William Gerard 1942- MarqDCG 84
Coast, Oscar R 1851-1931 WhAmArt 85
Coast, Oscar Regan 1851-1931 ArtsAmW 1,
 IIBEAAW
Coate, H W WhAmArt 85
Coate, Peter 1926- WhoArt 80, –82, –84
Coate, R E, Jr. AmArch 70
Coate, S NewYHSD
Coates, Ann S WhoAmA 78, –80, –82, –84
Coates, Bob MarqDCG 84
Coates, Del MarqDCG 84
Coates, Dora DcWomA
Coates, Dorothy Marie Anderson DcBrA 1,
 DcWomA
Coates, E C NewYHSD
Coates, Edward Hornor 1846-1921 WhAmArt 85
Coates, Frederick NewYHSD
Coates, George James 1869-1930 DcBrA 1
Coates, Hilda WhAmArt 85
Coates, Ida M ArtsAmW 3
Coates, J d1739 CabMA
Coates, Kate Belford DcVicP 2
Coates, Minnie Darlington WhAmArt 85
Coates, N W AmArch 70
Coates, Nancy 1805?- DcWomA, NewYHSD
Coates, P N, Jr. AmArch 70
Coates, Palgrave Holmes 1911- WhAmArt 85
Coates, R L AmArch 70
Coates, Robert M 1897- WhAmArt 85,
 WhoAmA 73, –76, –78N, –80N, –82N, –84N
Coates, Ross 1932- DcCAA 71, –77
Coates, Ross Alexander 1932- WhoAmA 76, –78, –80,
 –82, –84
Coates, Thomas John 1941- ClaDrA
Coates, Wells 1895-1958 ConArch, MacEA
Coates, Wells W 1895-1958 McGDA
Coates, Wells Wintemute 1895-1958 ConDes,
 WhoArch
Coatman, Maureen Margaret 1919- WhoArt 80, –82
Coats, Alice M 1905- IlsCB 1744
Coats, Claude 1913- WhAmArt 85
Coats, Joshua F d1819 CabMA
Coats, Mary ClaDrA
Coats, Randolph 1891- WhAmArt 85
Coaxum, Bea FolkA 86
Cobas, Jaime, Jr. 1939- AmArch 70
Cobb, Albert M 1868-1941 BiDAmAr
Cobb, Alfred F DcVicP 2
Cobb, Anna C FolkA 86
Cobb, Arthur FolkA 86
Cobb, Mrs. Arthur Murray WhAmArt 85
Cobb, C S DcWomA
Cobb, Mrs. C S NewYHSD
Cobb, Charles David 1921- DcBrA 1, DcSeaP
Cobb, Cyrus 1834- ArtsNiC
Cobb, Cyrus 1834-1903 EarABI SUP, NewYHSD ,
 WhAmArt 85
Cobb, Cyrus 1834-1905 FolkA 86
Cobb, Darius 1834- ArtsNiC
Cobb, Darius 1834-1919 EarABI SUP, FolkA 86,
 NewYHSD , WhAmArt 85
Cobb, David WhoArt 82, –84
Cobb, David 1921- WhoArt 80
Cobb, Doyle Lee 1923- AmArch 70
Cobb, E 1852-1943 FolkA 86
Cobb, E D NewYHSD
Cobb, Edward F DcVicP 2
Cobb, Elijah FolkA 86
Cobb, Ethelyn Pratt WhAmArt 85
Cobb, George T 1828?- NewYHSD
Cobb, Gershom 1780?-1824 EarABI SUP,
 NewYHSD
Cobb, H E AmArch 70
Cobb, Helen McCall ArtsEM, DcWomA
Cobb, Henry Ives 1859-1931 BiDAmAr,
 WhAmArt 85
Cobb, Henry Nichols 1926- AmArch 70
Cobb, J E AmArch 70
Cobb, J W AmArch 70
Cobb, John d1778 AntBDN G, OxDecA
Cobb, John 1946- DcCAr 81
Cobb, Kate McKinley 1888- DcWomA,
 WhAmArt 85
Cobb, Katharine M 1873- DcWomA, WhAmArt 85
Cobb, Lawrence Waldron 1915- AmArch 70
Cobb, N, Jr. FolkA 86
Cobb, Oscar 1842-1908 BiDAmAr
Cobb, Ruth DcBrBI
Cobb, Ruth 1914- WhoAmA 73, –76, –78, –80, –82,
 –84
Cobb, Sidney W 1932- AmArch 70

Cobb, T P DcVicP 2
Cobb, Virginia Horton 1933- WhoAmA 76, –78, –80,
 –82, –84
Cobb, Zenas NewYHSD
Cobb Gould EncASM
Cobbaert, Jan 1909- PhDcTCA 77
Cobban, C AmArch 70
Cobbe, H Bernard DcVicP 2
Cobbel, R G AmArch 70
Cobbett, Edward J 1815- ArtsNiC
Cobbett, Edward John 1815-1899 DcBrWA, DcVicP,
 –2
Cobbett, Hilary Dulcie 1885- DcBrA 1, DcWomA,
 WhoArt 80, –82
Cobbett, Phoebe M DcVicP 2
Cobbett, William V H DcVicP 2
Cobden, Frederick 1833?- NewYHSD
Cobden-Sanderson, T J 1840-1922 AntBDN B
Cobean, Sam 1917-1951 WorECar
Cobeen, D L AmArch 70
Cober, Alan E IlsCB 1967
Cober, Alan E 1935- AmArt, IlrAm G, –1880,
 WhoAmA 80, –82, –84, WhoGrA 82[port]
Cober, Alan Edwin 1935- IlsBYP, IlsCB 1957
Cobergher, Wenzel MacEA
Cobern, William Vernal 1924- AmArch 70
Cobham, Ethel Rundquist WhAmArt 85
Coble, Henry K FolkA 86
Coble, J P AmArch 70
Coble, Joseph Franklin 1930- AmArch 70
Coble, Robert Lynn 1922- AmArch 70
Coblegers, Anna DcWomA
Cobley, Florence DcVicP 2
Coblin, William Granville 1918- AmArch 70
Coborn, Ralph 1923- DcCAr 81
Coburn, A J ArtsEM
Coburn, Alvin Langdon 1882-1966 ConPhot,
 DcAmArt, ICPEnP, MacBEP, WhAmArt 85
Coburn, Bette Lee Dobry WhoAmA 73, –76, –78, –80,
 –82
Coburn, Frank ArtsAmW 2
Coburn, Frederick Simpson 1871- IlsCB 1744
Coburn, Frederick William 1870-1953 WhAmArt 85
Coburn, Julia L WhAmArt 85
Coburn, Lee L AmArch 70
Coburn, Mrs. Lewis Larned d1932 WhAmArt 85
Coburn, Ralph 1923- WhoAmA 78, –80, –84
Coburn, Ruth Winoma 1904- WhAmArt 85
Coccaro, Debbie Marie 1952- MarqDCG 84
Cocceius Auctus, Lucius d010BC MacEA
Cocchi, Jacint NewYHSD
Cochard, John NewYHSD
Cochard, Rojer 1932- DcCAr 81
Cochet, Augustine 1788-1832 DcWomA
Cochet, Louise Marie Hortense DcWomA
Cocheu, Henry NewYHSD
Cochin, Charles-Nicolas 1715-1790 OxArt
Cochin, Charles Nicolas, The Elder 1688-1754 McGDA
Cochin, Charles Nicolas, The Younger 1715-1790
 McGDA
Cochin, Louise Madeleine DcWomA
Cochran BiDAmAr
Cochran, Agnes Lynde DcWomA
Cochran, Alexander Smith 1913- AmArch 70
Cochran, Allen D 1888- WhAmArt 85
Cochran, Barbara WhAmArt 85
Cochran, D C AmArch 70
Cochran, Dewees 1892- WhoAmA 76, –78, –80, –82,
 –84
Cochran, Dewees 1902- WhAmArt 85
Cochran, Donald Robb 1897- AmArch 70
Cochran, Duane Robert 1951- MarqDCG 84
Cochran, Eliza DcWomA, NewYHSD
Cochran, Fan A 1899- ArtsAmW 3
Cochran, Frank Lee 1913- AmArch 70
Cochran, George Dewar 1848-1935 WhAmArt 85
Cochran, George McKee 1908- WhoAmA 76, –78, –80,
 –82, –84
Cochran, Gifford A 1906- WhAmArt 85
Cochran, Gifford Alexander WhoAmA 73
Cochran, Gordon Kee 1923- AmArch 70
Cochran, Hazel FolkA 86
Cochran, J T WhAmArt 85
Cochran, James A 1933- MarqDCG 84
Cochran, James J 1938- AmArch 70
Cochran, Negley 1913- WorECar
Cochran, R W AmArch 70
Cochran, Robert FolkA 86
Cochran, Robert Dale 1931- AmArch 70
Cochran, Robert Morris 1943- MarqDCG 84
Cochran, Walter H 1906- AmArch 70
Cochran, William 1738-1785 DcBrECP
Cochran, William J 1820?- NewYHSD
Cochrane, Bertha L DcWomA
Cochrane, Constance DcWomA, WhAmArt 85
Cochrane, Doris WhAmArt 85
Cochrane, Grace H H 1881- DcWomA,
 WhAmArt 85
Cochrane, Helen Lavinia d1946 DcBrA 1
Cochrane, Helen Lavinia 1868-1946 DcBrWA,
 DcVicP 2, DcWomA

Cochrane, John Arthur 1927- *AmArch 70*
Cochrane, John C 1835-1887 *BiDAmAr*, *MacEA*
Cochrane, John Peter Warren 1913- *WhoArt 80*, *-82*, *-84*
Cochrane, Josephine G *DcWomA*, *WhAmArt 85*
Cochrane, Peggy *ConArch A*
Cochrane And Piquenard *MacEA*
Cock, Cesar De 1823-1904 *ClaDrA*
Cock, Eianley *DcBrBI*
Cock, Elisabeth De *DcWomA*
Cock, Hieronymus 1510?-1570 *McGDA*
Cock, Jan *McGDA*
Cock, Joos De 1934- *DcCAr 81*
Cock, Julia Elisabeth De 1840- *DcWomA*
Cock, Mathys Wellens De 1509?-1548 *McGDA*
Cock, Pieter 1502-1550 *DcSeaP*, *OxArt*
Cock, Walter Brown *BiDBrA*
Cock, Xavier De 1818-1896 *ClaDrA*
Cockburn, Edwin *DcBrWA*, *DcVicP 2*
Cockburn, F M *DcVicP 2*
Cockburn, Florence Mary *DcWomA*
Cockburn, James Pattison 1779?-1847 *NewYHSD*
Cockburn, James Pattison 1779?-1849 *DcBrWA*
Cockburn, Jean *DcWomA*
Cockburn, Laelia Armine *DcBrA 1*, *DcWomA*
Cockburn, Madeline *DcWomA*
Cockburn, W A *DcVicP 2*
Cockburn, William *DcVicP 2*
Cockcroft, E Verian *WhAmArt 85*
Cockcroft, Edith Varian 1881- *DcWomA*
Cockcroft, Edythe 1881- *ArtsAmW 1*
Cocke, Bartlett 1901- *AmArch 70*
Cocke, J W, Jr. *AmArch 70*
Cocker, Barbara J 1923- *WhoAmA 73*, *-76*
Cocker, Doug 1945- *DcCAr 81*
Cocker, George *NewYHSD*
Cockerell, C R 1788-1863 *MacEA*
Cockerell, Charles Robert 1788-1863 *BiDBrA*,
 DcBrBI, *DcD&D*, *McGDA*, *OxArt*, *WhoArch*
Cockerell, Christabel A *DcWomA*
Cockerell, Christabel A 1860- *DcVicP 2*
Cockerell, Edward A *DcVicP 2*
Cockerell, Florence *DcWomA*
Cockerell, Samuel Pepys 1753-1827 *BiDBrA*
Cockerell, Samuel Pepys 1754?-1827 *DcD&D*,
 MacEA, *WhoArch*
Cockerell, Samuel Pepys 1844- *DcBrA 1*, *DcVicP*, *-2*
Cockerell, Sydney Morris 1906- *WhoArt 80*, *-82*, *-84*
Cockerill, Alice M *DcVicP 2*
Cockett, Marguerite *DcWomA*
Cockett, Marguerite S *WhAmArt 85*
Cocking, Edward *DcVicP 2*
Cocking, Gretta 1894- *DcWomA*, *WhAmArt 85*
Cocking, Mar Gretta 1894- *ArtsAmW 2*
Cocking, R *DcVicP 2*
Cocking, Thomas *DcBrWA*
Cockram, George 1861-1950 *ClaDrA*, *DcBrA 1*,
 DcBrWA, *DcVicP*, *-2*
Cockram, K F *AmArch 70*
Cockran, Henrietta *DcVicP 2*
Cockran, Jessie *DcBrWA*, *DcVicP 2*
Cockrell, Charles Robert 1788-1863 *DcBrWA*
Cockrell, Dura 1877- *DcWomA*
Cockrell, Dura Brokaw 1877- *ArtsAmW 2*,
 WhAmArt 85
Cockrell, Louis *DcVicP 2*
Cockrill, Sherna *WhoAmA 76*, *-78*, *-80*, *-82*, *-84*
Cocks, B H 1883- *DcBrA 1*
Cocks, Myra *ConICB*
Cockshaw, Herbert, Jr. *EncASM*
Cockson, Thomas 1591?-1636 *McGDA*
Coclers, Jean Baptiste Bernard 1741-1817 *ClaDrA*
Coclers, Maria Lambertine 1761- *DcWomA*
Coco, Salvatore 1930- *AmArch 70*
CoConis, Ted *IlsBYP*,
 IlsCB 1967
CoConis, Ted C 1927- *IlrAm G*, *-1880*
Cocq, Suzanne Marie Marguerite 1894- *DcWomA*
Cocteau, Jean 1889-1963 *PhDcTCA 77*, *WhoGrA 62*
Cocteau, Jean 1892-1963 *McGDA*
Codd, Mary Elizabeth 1954- *MarqDCG 84*
Codde, Pieter 1599-1678 *OxArt*
Codde, Pieter Jacobs 1599-1678 *ClaDrA*
Codde, Pieter Jacobsz 1599-1678 *McGDA*
Codding, Arthur E *EncASM*
Codding, D D *EncASM*
Codding, Edwin A *EncASM*
Codding, James A *EncASM*
Coddington, Gilbert Harold 1907- *AmArch 70*
Code, Mrs. *DcBrECP*
Code, Audrey 1937- *WhoAmA 82*, *-84*
Code, Mary *DcWomA*
Codecasa, Louise 1856- *DcWomA*
Codell, Julie Francia 1945- *WhoAmA 84*
Codella, Frank Leonard 1926- *AmArch 70*
Coderch Y DeSentmenat, Jose A 1913- *ConArch*
Coderch Y DeSentmenat, Jose Antonio 1913- *MacEA*
Codesido, Julia 1892- *DcWomA*, *McGDA*,
 OxTwCA
Codezo, Thomas 1839- *ArtsNiC*
Codier *AntBDN E*

Codina, Victoriano *DcVicP 2*
Codling, Richard B 1931- *MarqDCG 84*
Codman, Charles *FolkA 86*
Codman, Charles 1800-1842 *BnEnAmA*, *DcAmArt*,
 NewYHSD
Codman, Edwin E *WhAmArt 85*
Codman, John Amory 1824-1886 *NewYHSD*
Codman, Ogden, Jr. 1868-1951 *MacEA*
Codman, William P *FolkA 86*, *NewYHSD*
Codner, Abraham d1750 *FolkA 86*
Codner, John d1770? *FolkA 86*
Codner, John 1913- *WhoArt 80*, *-82*, *-84*
Codner, John Whitlock 1913- *DcBrA 1*
Codner, Maurice Frederick 1888- *ClaDrA*
Codner, Maurice Frederick 1888-1958 *DcBrA 1*
Codner, Stephen Milton 1952- *WhoArt 80*, *-82*, *-84*
Codner, William 1709-1769 *FolkA 86*, *NewYHSD*
Codrington, Isabel *DcBrA 1*, *DcWomA*
Codrington, Isabel 1874-1943 *DcBrA 2*
Codrington, Isabel 1894- *ClaDrA*
Codrington Forsyth, James *ConArch A*
Coducci, Mauro 1440?-1504 *MacEA*, *WhoArch*
Coducci, Mauro Di Martino 1440?-1504 *McGDA*
Codwise, Jane R *DcWomA*
Cody, Charles Paxton 1854-1936 *BiDAmAr*
Cody, George Lenier, Jr. 1933- *AmArch 70*
Cody, John 1948- *WhoAmA 78*, *-80*, *-82*
Cody, John J 1925- *AmArch 70*
Cody, William Francis 1916- *AmArch 70*
Coe, Adam S 1782-1862 *CabMA*
Coe, Anne Elizabeth *WhoAmA 84*
Coe, Benjamin Hutchins 1799-1883? *NewYHSD*
Coe, Brian Walter 1930- *MacBEP*
Coe, Charles 1902- *WhAmArt 85*
Coe, Clark *FolkA 86*
Coe, E O *DcVicP 2*
Coe, Elias V *FolkA 86*
Coe, Ethel Louise d1938 *ArtsAmW 1*, *WhAmArt 85*
Coe, Ethel Louise 1880-1938 *ArtsAmW 3*, *DcWomA*,
 IlBEAAW
Coe, Harry Arthur *AmArch 70*
Coe, Helen A *WhAmArt 85*
Coe, Herring 1907- *WhAmArt 85*
Coe, Lindsley Julie *WhAmArt 85*
Coe, Lloyd 1899- *IlsCB 1946*, *WhoAmA 76*
Coe, Lloyd 1899-1977 *WhAmArt 85*, *WhoAmA 78N*,
 -80N, *-82N*, *-84N*
Coe, Matchett Herring 1907- *WhoAmA 73*, *-76*, *-78*,
 -80, *-82*, *-84*
Coe, Miriam *WhoArt 84*
Coe, Ralph Tracy 1929- *WhoAmA 80*, *-82*, *-84*
Coe, Richard Blauvelt 1904- *WhAmArt 85*
Coe, Roland *WhoAmA 78N*, *-80N*, *-82N*, *-84N*
Coe, Sue *PrintW 85*
Coe, Theodore 1866- *WhAmArt 85*
Coebler, E A *AmArch 70*
Coecke, Pieter 1502-1550 *OxArt*
Coecke VanAelst, Marie *DcWomA*
Coecke VanAelst, Pieter 1502-1550 *McGDA*
Coeckelberghs, Luc 1953- *DcCAr 81*
Coeffier, Marie Pauline Adrienne 1814-1900 *DcWomA*
Coeke VanAelst, Pieter 1502-1550 *OxArt*
Coelho, Eduardo Teixeira 1919- *WorECar*
Coelho, Luiz Carlos 1935- *WhoAmA 78*, *-80*
Coello, Alonso Sanchez 1515-1590 *ClaDrA*
Coello, Claudio 1630-1693 *ClaDrA*
Coello, Claudio 1642-1693 *McGDA*, *OxArt*
Coello, Isabel *DcWomA*
Coen, Arnaldo 1940- *WhoAmA 76*, *-78*, *-80*
Coen, Eleanor 1916- *DcCAr 81*
Coen, Robert *WhAmArt 85*
Coene, Jacques *McGDA*
Coenen, Lucien Charles, Jr. 1945- *MarqDCG 84*
Coentgen, Elisabetha 1752-1783 *DcWomA*
Coes, Kent Day 1910- *WhAmArt 85*, *WhoAmA 73*,
 -76, *-78*, *-80*, *-82*, *-84*
Coester, Anna Helena d1862? *DcWomA*
Coetzee, Christo *OxTwCA*
Coetzee, Christo 1930- *PhDcTCA 77*
Coeurderoy, Marie *DcWomA*
Coeurt, Mary *DcWomA*
Coffee, P H *ArtsEM*
Coffee, Robert Franklin 1933- *AmArch 70*
Coffee, Thomas 1800?- *NewYHSD*
Coffee, Thomas, Jr. 1839?- *NewYHSD*
Coffee, Will *WhAmArt 85*
Coffee, William *AntBDN M*
Coffee, William J *WhAmArt 85*
Coffee, William J 1774?-1846? *NewYHSD*
Coffee, William John 1774?-1846? *McGDA*
Coffelt, Beth 1929- *WhoAmA 76*, *-78*
Coffermans, Isabella *DcWomA*
Coffey, Alfred I 1866-1931 *BiDAmAr*
Coffey, Catherine Marie 1954- *MarqDCG 84*
Coffey, Douglas Robert 1937- *WhoAmA 73*, *-76*, *-78*,
 -80, *-82*, *-84*
Coffey, John William, II 1954- *WhoAmA 84*
Coffey, Karita Joyce 1947- *WhoAmA 73*
Coffey, Mabel *WhoAmA 78N*, *-80N*, *-82N*, *-84N*
Coffey, Mabel 1874-1949 *WhAmArt 85*
Coffey, Mabel 1874-1953? *DcWomA*

Coffey, W J *AmArch 70*
Coffey, William Daniel, Jr. 1927- *AmArch 70*
Coffin, Arthur S 1857-1938 *BiDAmAr*
Coffin, Edward *PrintW 85*
Coffin, Elizabeth R *WhAmArt 85*
Coffin, Elizabeth Rebecca 1850?-1930 *DcWomA*
Coffin, Esther *WhAmArt 85*
Coffin, Esther L *DcWomA*
Coffin, Frederick M *NewYHSD*
Coffin, Frederick M 1822- *EarABI*, *EarABI SUP*
Coffin, George Albert 1856-1922 *WhAmArt 85*
Coffin, H E *AmArch 70*
Coffin, Henry *FolkA 86*
Coffin, Isabel C d1912 *DcWomA*, *WhAmArt 85*
Coffin, J Edward 1860-1905 *WhAmArt 85*
Coffin, Robert M *WhAmArt 85*
Coffin, Robert P Tristram 1892-1955 *WhAmArt 85*
Coffin, Robert Parker 1917- *AmArch 70*
Coffin, Sarah Taber 1844-1928 *DcWomA*,
 WhAmArt 85
Coffin, W H *NewYHSD*
Coffin, W Haskell 1878-1941 *WhAmArt 85*
Coffin, William *CabMA*
Coffin, William A *FolkA 86*, *NewYHSD*
Coffin, William A 1855-1925 *WhAmArt 85*
Coffin, William Sloane 1879-1933 *WhAmArt 85*
Coffman, Hal 1883-1958 *WhoAmA 80N*, *-82N*, *-84N*
Coffman, Lara Rawlins *ArtsAmW 3*
Coffman, Michael R *MarqDCG 84*
Coffman, Page *WhAmArt 85*
Cofield, Myrtle Hedrick 1880- *DcWomA*
Cogan, Bruce C 1941- *MarqDCG 84*
Cogan, Kenneth Woodrow 1925- *AmArch 70*
Cogburn, Cecelia *AfroAA*
Cogdell, John Stevens 1778-1847 *BnEnAmA*,
 NewYHSD
Cogels, Joseph Charles 1786-1831 *ClaDrA*
Coggan, Donald Albert 1944- *MarqDCG 84*
Cogger, Edward P *NewYHSD*
Coggeshall, Calvert 1907- *WhoAmA 73*, *-76*, *-78*, *-80*,
 -82, *-84*
Coggeshall, Eliza 1773- *FolkA 86*
Coggeshall, Esther 1764- *FolkA 86*
Coggeshall, John I 1856-1927 *WhAmArt 85*
Coggeshall, Martha *FolkA 86*
Coggeshall, Mary *FolkA 86*
Coggeshall, Nathaniel d1826 *CabMA*
Coggeshall, Patty 1780-1797 *FolkA 86*
Coggeshall, Polly 1777- *FolkA 86*
Coggeswell, William 1824?-1906 *NewYHSD*,
 WhAmArt 85
Coggin, Jeannie *DcVicP 2*
Coggins, Edward H *NewYHSD*
Coggins, Herbert Lawrence 1898- *AmArch 70*
Coggins, Jack Banham 1914- *WhoAmA 82*, *-84*
Coggins, Robert P 1924- *WhoAmA 80*, *-82*, *-84*
Coghetti, Francesco 1804-1875 *ArtsNiC*
Coghlan, Owen *WhAmArt 85*
Coghlan, R R, Jr. *AmArch 70*
Cogill, Emily *DcVicP 2*
Cogle, Henry George 1875- *DcBrA 1*
Cognet, Catherine Caroline 1813-1892 *DcWomA*
Cogniet, Leon 1794-1880 *ArtsNiC*, *ClaDrA*
Cogniet, Marie Amelie 1789-1869 *ClaDrA*
Cogniet, Marie Amelie 1798-1869 *DcWomA*
Cogswell, Arthur R 1930- *AmArch 70*
Cogswell, Charles N 1865-1941 *BiDAmAr*
Cogswell, Charlotte *DcWomA*
Cogswell, Dorothy McIntosh 1909- *WhAmArt 85*,
 WhoAmA 73, *-76*, *-78*, *-80*, *-82*, *-84*
Cogswell, James *CabMA*
Cogswell, John *CabMA*, *NewYHSD*
Cogswell, Margaret Price 1925- *WhoAmA 73*, *-76*,
 -78, *-80*, *-82*, *-84*
Cogswell, Ruth McIntosh 1885- *DcWomA*,
 WhAmArt 85
Cogswell, Theresa *WhAmArt 85*
Cogswell, William F 1819-1903 *ArtsAmW 1*,
 NewYHSD
Cohagen, Chandler Carroll 1889- *AmArch 70*
Cohalan, Michael Joseph 1939- *AmArch 70*
Cohan, G R *AmArch 70*
Cohan, Timothy 1935- *AmArch 70*
Cohee, Marion M 1896- *DcWomA*, *WhAmArt 85*
Coheil, Charles *NewYHSD*
Coheil, John S *NewYHSD*
Coheleach, Guy *OfPGCP 86*
Coheleach, Guy Joseph *WhoAmA 73*, *-76*, *-78*, *-80*,
 -82, *-84*
Cohen, A *AmArch 70*, *DcWomA*
Cohen, Abby Joseph 1952- *MarqDCG 84*
Cohen, Abraham *EncASM*
Cohen, Adele *WhoAmA 76*, *-78*, *-80*, *-82*, *-84*
Cohen, Alan B 1952- *MarqDCG 84*
Cohen, Alan Barry 1943- *MacBEP*
Cohen, Aldin Marshall 1934- *MarqDCG 84*
Cohen, Alfred *FolkA 86*, *NewYHSD*
Cohen, Alvin Jay 1936- *AmArch 70*
Cohen, Andrew *MarqDCG 84*
Cohen, Andrew Stuart 1930- *AmArch 70*

Cole, –2
Cole, George Austin 1932- *AmArch 70*
Cole, George T *WhAmArt 85*
Cole, George Townsend 1874-1937 *ArtsAmW 1, –3*
Cole, George Vicat 1833-1893 *ClaDrA, DcBrWA, DcVicP, –2*
Cole, Gladys *ArtsAmW 3, WhAmArt 85*
Cole, H *DcVicP 2, DcWomA*
Cole, H M *AmArch 70*
Cole, Harold David 1940- *WhoAmA 78, –80, –82, –84*
Cole, Henry 1808-1882 *MacEA*
Cole, Sir Henry 1808-1882 *DcBrWA, DcVicP 2*
Cole, Sir Henry 1808-1883 *DcNiCA*
Cole, Herbert 1867-1930 *DcBrBI*
Cole, Herbert Milton 1935- *WhoAmA 80, –82, –84*
Cole, Isaac P *NewYHSD*
Cole, J C *FolkA 86*
Cole, J Foxcroft *DcVicP 2*
Cole, J Foxcroft 1837- *ArtsNiC*
Cole, Jack 1918-1958 *WorEcom*
Cole, Jacob *CabMA*
Cole, James *DcVicP 2*
Cole, James A 1939- *MarqDCG 84*
Cole, James Ferguson 1799-1880 *AntBDN D*
Cole, Jessie Duncan Savage 1858- *DcWomA*
Cole, Jessie Savage 1858-1940 *WhAmArt 85*
Cole, John *CabMA, FolkA 86*
Cole, John 1811?-1840 *CabMA*
Cole, John H *DcVicP, –2*
Cole, John Vicat 1903- *DcBrA 1*
Cole, John Vicat 1903-1975 *DcBrA 2*
Cole, John W 1921- *AmArch 70*
Cole, Joseph *CabMA, DcBrECP*
Cole, Joseph Foxcroft 1837-1892 *ArtsAmW 3, IlBEAAW, NewYHSD*
Cole, Joseph Greenleaf 1803-1858 *FolkA 86*
Cole, Joseph Greenleaf 1806-1858 *NewYHSD*
Cole, Joyce *WhoAmA 84*
Cole, Joyce 1939- *WhoAmA 76, –78, –80, –82*
Cole, Katharine P 1896- *DcWomA, WhAmArt 85*
Cole, Kenneth Duane 1932- *AmArch 70*
Cole, Klynn Lawrence 1934- *AmArch 70*
Cole, L S *AmArch 70*
Cole, Laurie 1890- *DcBrA 1, DcWomA*
Cole, Leslie 1910- *DcBrA 1*
Cole, Lyman Emerson *FolkA 86*
Cole, Lyman Emerson 1812-1878? *NewYHSD*
Cole, M M *DcVicP 2*
Cole, Major *FolkA 86, NewYHSD*
Cole, Margaret W *WhAmArt 85*
Cole, Marguerite *DcWomA*
Cole, Maria *DcWomA, FolkA 86*
Cole, Mary Ann *DcVicP 2, DcWomA*
Cole, Mary Caroline 1912- *AmArch 70*
Cole, Matthew d1692 *BiDBrA*
Cole, Max 1937- *PrintW 83, –85, WhoAmA 76, –78, –80, –82, –84*
Cole, Moses Dupre 1783-1849 *NewYHSD*
Cole, Myra *DcWomA*
Cole, N A *AmArch 70*
Cole, Nelson Delano 1933- *AmArch 70*
Cole, Pat 1951- *MarqDCG 84*
Cole, Philip Tennyson *ClaDrA, DcVicP 2*
Cole, Philip William 1884- *ClaDrA, DcBrA 1*
Cole, Preston Mansfield 1908- *AmArch 70*
Cole, R I *AmArch 70*
Cole, Ralph Lester 1928- *AmArch 70*
Cole, Reginald Rex Vicat 1870-1940 *DcVicP 2*
Cole, Rex Vicat *DcBrWA*
Cole, Rex Vicat 1870-1940 *DcBrA 1*
Cole, Richard 1932-1971 *FolkA 86*
Cole, Richard Elton 1932- *AmArch 70*
Cole, Robert *MarqDCG 84*
Cole, Robert F 1936- *AmArch 70*
Cole, Rufus 1804- *FolkA 86*
Cole, Sarah *NewYHSD*
Cole, Sarah 1805-1857 *DcWomA*
Cole, Sidney Herman 1865- *ArtsAmW 3*
Cole, Solomon *DcVicP 2*
Cole, Stanley M 1924- *AmArch 70*
Cole, Stephanie Kirschen 1945- *WhoAmA 82, –84*
Cole, Sylvan, Jr. 1918- *WhoAmA 73, –76, –78, –80, –82, –84*
Cole, Thomas 1800-1864 *DcNiCA*
Cole, Thomas 1801-1848 *ArtsNiC, BnEnAmA, DcAmArt, DcSeaP, IlBEAAW, McGDA, NewYHSD, OxArt*
Cole, Thomas Casilear *WhoAmA 73, –76*
Cole, Thomas Casilear 1888-1976 *WhAmArt 85*
Cole, Thomas Ferguson 1935- *AmArch 70*
Cole, Thomas William 1857- *DcBrA 1, DcVicP 2*
Cole, Timothy 1852-1931 *WhAmArt 85*
Cole, V Thurman *WhAmArt 85*
Cole, Vicat 1833- *ArtsNiC*
Cole, Violet Maud Mary Vicat 1886-1955 *DcBrA 1, DcWomA*
Cole, W O *NewYHSD*
Cole, Walter *WhAmArt 85*
Cole, Walter 1891- *IlsCB 1744*
Cole, Weedon 1800?- *CabMA*

Cole, William 1800-1892 *BiDBrA*
Cole, William George 1927- *AmArch 70*
Cole, William H *EncASM*
Cole, Yvonne 1953- *DcCAr 81*
Cole And Brother *CabMA*
Colean, Miles Lanier *AmArch 70*
Coleborn, Keith *WhoArt 80, –82, –84*
Colebrook, Alex *WhAmArt 85*
Colebrooke, Robert Hyde 1762-1808 *DcBrWA*
Colegrove, John W 1863-1930 *WhAmArt 85*
Colehandler, George A 1825?- *NewYHSD*
Coleman *FolkA 86, NewYHSD*
Coleman, A D *MacBEP*
Coleman, A D 1943- *WhoAmA 80, –82, –84*
Coleman, A G *DcVicP 2*
Coleman, Aaron H 1918- *MarqDCG 84*
Coleman, Alan 1920- *DcBrA 1, WhoArt 80, –82, –84*
Coleman, Alvin *FolkA 86*
Coleman, Arthur Philemon 1852-1939 *IlBEAAW*
Coleman, C C 1840-1928 *WhAmArt 85*
Coleman, Carrie B *DcWomA*
Coleman, Caruthers Askew, Jr. 1929- *AmArch 70*
Coleman, Charles *DcVicP 2*
Coleman, Charles d1874 *NewYHSD*
Coleman, Charles 1838?- *NewYHSD*
Coleman, Charles C 1840- *ArtsNiC*
Coleman, Charles Caryl *DcVicP 2*
Coleman, Charles Caryl 1840-1928 *NewYHSD*
Coleman, Clifford LeRoy 1916- *AmArch 70*
Coleman, Edgar L 1918- *AmArch 70*
Coleman, Edmund Thomas *DcBrBI*
Coleman, Edmund Thomas 1823-1892 *ArtsAmW 1, IlBEAAW*
Coleman, Edward d1867 *DcVicP, –2*
Coleman, Edward A 1860- *NewYHSD*
Coleman, Edward H 1928- *WhoAmA 80, –82, –84*
Coleman, Edward Thomas *DcVicP 2*
Coleman, Felton *AfroAA*
Coleman, Floyd W 1937- *AfroAA*
Coleman, Floyd Willis 1939- *WhoAmA 82, –84*
Coleman, Frank *DcVicP 2*
Coleman, Frederick W *WhAmArt 85*
Coleman, G D 1795-1844 *MacEA*
Coleman, Gayle 1954- *WhoAmA 82, –84*
Coleman, Gertrude *DcVicP 2, DcWomA*
Coleman, Glenn O 1887-1932 *DcAmArt, GrAmP, McGDA, PhDcTCA 77, WhAmArt 85*
Coleman, Harvey B *ArtsAmW 3*
Coleman, Helen Cordelia *DcVicP, –2, DcWomA*
Coleman, Henry *DcVicP 2*
Coleman, Herbert 1883-1925 *WhAmArt 85*
Coleman, Hezekiah *FolkA 86*
Coleman, Jacqui 1927- *WhoAmA 82, –84*
Coleman, James 1941- *ConArt 77, –83*
Coleman, Jeffrey Thomas 1949- *MarqDCG 84*
Coleman, John Russell 1951- *MarqDCG 84*
Coleman, Joseph Russell 1922- *AmArch 70*
Coleman, K E *AmArch 70*
Coleman, Laura Alexander 1914- *WhAmArt 85*
Coleman, Laurence Vail 1893- *WhAmArt 85*
Coleman, M L 1941- *WhoAmA 82, –84*
Coleman, Marion Drewe d1925 *ArtsAmW 3*
Coleman, Mary Darter *WhAmArt 85*
Coleman, Mary Darter 1894- *IlBEAAW*
Coleman, Mary Sue Darter 1894- *ArtsAmW 3, DcWomA*
Coleman, Melissa Minnich 1917- *AmArch 70*
Coleman, Michael 1946- *WhoAmA 73, –76, –78, –80, –82, –84*
Coleman, Michael 1951- *DcCAr 81*
Coleman, Michael John 1953- *MarqDCG 84*
Coleman, Phebe 1890- *DcWomA*
Coleman, Phebe R 1890- *WhAmArt 85*
Coleman, Prescott W *AmArch 70*
Coleman, R *AfroAA*
Coleman, Ralph P d1968 *WhoAmA 78N, –80N, –82N, –84N*
Coleman, Ralph Pallen 1892- *IlrAm D*
Coleman, Ralph Pallen 1892-1968 *IlrAm 1880, WhAmArt 85*
Coleman, Rebecca *DcVicP 2*
Coleman, Rebecca d1884? *DcWomA*
Coleman, Rebecca 1840?- *DcBrWA*
Coleman, Robert Micheaux 1924- *AmArch 70*
Coleman, Ronald Lou 1930- *MarqDCG 84*
Coleman, Samuel 1832-1920 *NewYHSD*
Coleman, Sarah Whinery *FolkA 86*
Coleman, Silas A *NewYHSD*
Coleman, Simon 1916- *DcBrA 1*
Coleman, Vernon Herbert 1898- *WhAmArt 85*
Coleman, William *FolkA 86*
Coleman, William d1718 *BiDBrA*
Coleman, William Augustus 1911- *AmArch 70*
Coleman, William David 1915- *AmArch 70*
Coleman, William Stephen 1829-1904 *AntBDN M, DcBrA 1, DcBrBI, DcBrWA, DcNiCA, DcVicP 2*
Coleman-Smith, Pamela *DcBrBI*
Colen, John H *NewYHSD*

Colenbrander, Theodorus A C 1841-1930 *AntBDN A*
Colepeper, H *DcVicP 2*
Coler, Stella C 1892- *DcWomA, WhAmArt 85*
Coleridge, Lady d1878 *DcVicP 2*
Coleridge, F G *DcVicP 2*
Coleridge, Jane Fortescue d1878 *DcWomA*
Coleridge, Maud *DcWomA*
Coleridge, Stephen 1854-1936 *DcBrA 1, DcVicP 2*
Coles, Albert d1886 *EncASM*
Coles, Ann 1882- *WhAmArt 85*
Coles, Ann Cadwallader 1882- *DcWomA*
Coles, Donald E 1947- *AfroAA*
Coles, E *DcBrBI*
Coles, J Ackerman 1843-1925 *WhAmArt 85*
Coles, John, Jr. *NewYHSD*
Coles, John, Jr. 1776?-1854 *NewYHSD*
Coles, John, Sr. 1749?-1809 *NewYHSD*
Coles, Mary *DcVicP 2, DcWomA*
Coles, Mary Drake 1903- *WhAmArt 85*
Coles, Robert John 1930- *AmArch 70*
Coles, Robert Traynham 1929- *AmArch 70*
Coles, Roswell Strong 1904- *WhAmArt 85*
Coles, T G *AmArch 70*
Coles, W *CabMA*
Coles, William C *DcVicP 2*
Colescott, Robert H 1925- *WhoAmA 76, –78, –80, –82, –84*
Colescott, Warrington W 1921- *WhoAmA 73, –76, –78, –80, –82, –84*
Colet, Colette Germaine Caen *DcWomA*
Coletti, B D *AmArch 70*
Coletti, Joseph Arthur 1898- *WhoAmA 73*
Coletti, Joseph Arthur 1898-1973 *WhAmArt 85, WhoAmA 76N, –78N, –80N, –82N, –84N*
Coletti, P A *AmArch 70*
Coley, Alice Maria 1882- *ClaDrA, DcBrA 1, DcWomA*
Coley, Hilda *DcBrWA*
Colgan, J M *AmArch 70*
Colgrove, Ada *ArtsEM, DcWomA*
Colgrove, Ronald B 1930- *WhoAmA 73, –76*
Coligny, Jeanne De *DcWomA*
Colijer, Edwaert d1702? *McGDA*
Colin, Adele Anais 1822-1899 *DcWomA*
Colin, Alexandre 1527?-1612 *McGDA*
Colin, Alexandre-Marie 1798-1875 *ArtsNiC*
Colin, E *DcNiCA*
Colin, Edward C 1926- *AmArch 70*
Colin, Georgia T *WhoAmA 73, –76, –78, –80, –82, –84*
Colin, Gustave Henri 1828-1910 *ClaDrA*
Colin, Heloise Suzanne 1820-1874? *DcWomA*
Colin, Jean 1912- *WhoGrA 62, –82[port]*
Colin, Laure 1827-1878 *DcWomA*
Colin, Paul *ArtsNiC*
Colin, Paul 1892- *ClaDrA, WhoGrA 62*
Colin, Paul Emile 1877-1947? *McGDA*
Colin, Paul Hubert 1892- *ConDes*
Colin, Ralph Frederick 1900- *WhoAmA 73, –76, –78, –80, –82, –84*
Colin-Lefrancq, Helene *DcWomA*
Colin-Libour, Uranie Alphonsine 1833- *DcWomA*
Colin-Martel *DcWomA*
Colina, Armando G 1935- *WhoAmA 76, –78, –80, –82, –84*
Colinet, Claire Jeanne Roberte *DcWomA*
Colinet Family *IlDcG*
Colish, Aaron 1910- *AmArch 70*
Colizzi, Gioacchino 1894- *WorECar*
Colker, Edward 1927- *WhoAmA 73, –76, –78, –80, –82, –84*
Colkett, Samuel David 1800-1863 *DcBrWA, DcVicP, –2*
Colkett, Victoria S *DcVicP 2*
Colkett, Victoria Susanna 1840-1926 *DcWomA*
Coll, Charles J, Jr. *WhAmArt 85*
Coll, David Clarence 1933- *MarqDCG 84*
Coll, Francis A 1884- *WhAmArt 85*
Coll, Joseph C 1881-1921 *WhAmArt 85*
Coll, Joseph Clement 1881-1921 *IlrAm A, –1880*
Coll Y Coll, Jose 1923- *WorECar*
Colla, Ettore 1896-1968 *ConArt 83*
Colla, Ettore 1899-1968 *ConArt 77, PhDcTCA 77*
Colla, Ettori 1899-1968 *OxTwCA*
Collander, Mrs. Helmi *WhAmArt 85*
Collander, Mrs. Helmi 1881- *DcWomA*
Collantes, Francisco 1599-1656 *ClaDrA, McGDA*
Collard, Derek *IlsBYP*
Collard, Derek 1936- *IlsCB 1967*
Collard, Harold Eugene 1919- *AmArch 70*
Collard, John *NewYHSD*
Collard, Marie Anne Herminie d1871 *DcWomA*
Collard, W *NewYHSD*
Collart, Marie 1842- *ClaDrA*
Collart, Marie 1842-1911 *DcWomA*
Collas, Achille *DcNiCA*
Collas, Elise *DcWomA*
Collas, Louis Antoine 1775- *NewYHSD*
Collas, Paule *DcWomA*
Collazo, Carlos Erick 1956- *WhoAmA 84*
Collazo, Jose Luis 1936- *AmArch 70*

Collins, William Wiehe 1862-1951 *DcBrA 1, DcBrBI, DcBrWA*
Collins, William Wiehe 1862-1952 *DcVicP 2*
Collins, Zerubbabel 1733-1797 *FolkA 86*
Collinson, Captain *NewYHSD*
Collinson, Eliza *DcWomA*
Collinson, Harold F 1886- *WhAmArt 85*
Collinson, Hugh 1909- *DcBrA 1*
Collinson, James 1825-1881 *DcBrWA, DcVicP, -2*
Collinson, Robert 1832- *ArtsNiC, DcVicP, -2*
Collinson, Mrs. Robert *DcVicP 2*
Collinson & Lock *DcNiCA*
Collis, Miss *DcWomA, FolkA 86*
Collis, A P *DcVicP 2*
Collis, George S *NewYHSD*
Collis, J *AntBDN F*
Collis, James d1886 *BiDBrA*
Collis, S C *FolkA 86*
Collishonn, Nanette *DcWomA*
Collison, Helen F *WhAmArt 85*
Collison, Marjory 1902- *WhAmArt 85*
Collister, Alfred James 1869- *DcBrA 1*
Collister, Alfred James 1869-1964 *DcBrA 2*
Collister, Thomas *CabMA*
Collman, Gideon 1831?- *NewYHSD*
Collomb-Agassis, Louise 1857- *DcWomA*
Collona, Eugene *AntBDN A*
Collopy, Timothy d1810? *DcBrECP*
Collot, George Henri Victor *FolkA 86*
Collot, George Henri Victor 1751?-1805 *NewYHSD*
Collot, Marie Anne 1748-1821 *DcWomA*
Collot, Marie-Anne 1748-1821 *McGDA, WomArt*
Collow, Jean Dee *WhAmArt 85*
Colls, Ebenezer *DcSeaP, DcVicP 2*
Colls, Harry *DcVicP 2*
Colls, Richard *DcVicP 2*
Collter, Estelle E 1881- *WhAmArt 85*
Collucci, Z *DcVicP 2*
Collum, John *NewYHSD*
Collver, Ethel Blanchard *WhAmArt 85*
Collver, Ethel Blanchard 1875-1955 *DcWomA*
Collyer, H H 1863-1947 *DcBrWA, DcVicP 2*
Collyer, Joseph 1748-1827 *McGDA*
Collyer, Kate Winifred *DcWomA*
Collyer, Margaret *DcVicP 2*
Collyer, Nora Frances Elizabeth 1898- *DcWomA*
Collyer, Robin *DcCAr 81*
Collyer, Robin 1949- *WhoAmA 80, -82, -84*
Collyer, Thomas *FolkA 86*
Collymore, Peter *ConArch A*
Colman *OxDecA*
Colman, Anne d1938 *WhAmArt 85*
Colman, Anne 1899-1938 *DcWomA*
Colman, Blanche Emily *WhAmArt 85*
Colman, Blanche Emily 1874- *DcWomA*
Colman, Braley *WhAmArt 85*
Colman, Charles 1818?- *NewYHSD*
Colman, Charles C 1890- *AmArch 70, WhAmArt 85*
Colman, George Sumner 1881- *WhAmArt 85*
Colman, Peter *FolkA 86*
Colman, R Clarkson 1884- *ArtsAmW 1*
Colman, Roi Clarkson 1884-1945? *WhAmArt 85*
Colman, S G *DcVicP 2*
Colman, Samuel *DcVicP 2*
Colman, Samuel 1832-1920 *ArtsAmW 1, -3, DcAmArt, EarABI, WhAmArt 85*
Colman, Samuel 1833- *ArtsNiC*
Colman, Samuel, Jr. 1832-1920 *BnEnAmA, IlBEAAW, NewYHSD*
Colman, Virginia O'Connell *WhoAmA 82, -84*
Colman, William 1822?- *NewYHSD*
Colman-Smith, Pamela *DcWomA*
Colmore, Nina 1889- *ClaDrA, DcBrA 1, DcWomA*
Colmore, Nina 1889-1973 *DcBrA 2*
Colmorgan, Paul 1903- *WhAmArt 85*
Colnet Family *IlDcG*
Colnik, Cyril 1871- *WhAmArt 85*
Colo *DcCAr 81*
Colo-Lepage, Celine *DcWomA*
Colom, Maria Josefa 1926- *WhoArt 80, -82, -84*
Colomb, Christophe *NewYHSD*
Colomb, Georges 1856-1945 *WorECom*
Colomb, Wellington *DcBrBI, DcVicP 2*
Colomba, Giovanni Battista Innocenzo 1717-1793 *DcBrECP*
Colombani, Darius 1850-1900 *WhAmArt 85*
Colombano, Antonio Maria *ClaDrA*
Colombara, C *NewYHSD*
Colombat DeL'Isere, Laure 1798- *DcWomA*
Colombe, Jean *McGDA*
Colombe, Michel 1430?-1515? *OxArt*
Colombe, Michel 1431?-1512? *McGDA*
Colombel, Berthe *DcWomA*
Colombel, Nicolas 1644-1717 *ClaDrA*
Colombet, Cecile *DcWomA*
Colombet, Marie *DcWomA*
Colombier, Mademoiselle *DcWomA*
Colombier, Amelie *DcWomA*
Colombier, Janet *FairDF FRA*
Colombini, Susan Murphy *WhoAmA 84*
Colombo, Charles 1927- *WhoAmA 76, -78, -80, -82, -84*

Colombo, D *AmArch 70*
Colombo, Gianni *OxTwCA*
Colombo, Gianni 1937- *ConArt 77, -83, DcCAr 81*
Colombo, Giovanni Battista Innocenzo 1717-1793 *DcBrECP*
Colombo, J M *AmArch 70*
Colombo, Joe 1930-1971 *ConDes, DcD&D[port]*
Colombo, Joseph 1926- *AmArch 70*
Colon, A *NewYHSD*
Colon-Morales, Rafael 1941- *WhoAmA 78, -80, -82*
Colonia, Francisco De d1542? *OxArt*
Colonia, Juan De d1481 *OxArt*
Colonia, Simon De d1511? *OxArt*
Colonia Family *MacEA*
Colonna, Adele *DcWomA*
Colonna, Edward 1862-1948 *MacEA*
Colonna, Eugene *DcNiCA*
Colonna, Francesco 1433-1527 *MacEA*
Colonna, Jean-Francois 1947- *MarqDCG 84*
Colonna DeCesari Rocca, Countess Camille *DcWomA*
Colony, F H *AmArch 70*
Colorado, Charlotte 1920- *WhoAmA 76, -78, -80, -82, -84*
Colosi, N J *AmArch 70*
Colotte, Aristide 1885-1959 *DcNiCA*
Colp, Norman B 1944- *ICPEnP A, MacBEP*
Colquhon, Annie T *DcVicP 2*
Colquhoun *NewYHSD*
Colquhoun, Alan *ConArch*
Colquhoun, Ithel 1906- *ClaDrA*
Colquhoun, Ithell *WhoArt 80, -82, -84*
Colquhoun, Ithell 1906- *DcBrA 1*
Colquhoun, Robert 1914-1962 *ConArt 83, DcBrA 1, McGDA, OxTwCA, PhDcTCA 77*
Colquhoun And Miller *ConArch*
Colson, Miss *DcVicP 2*
Colson, Chester E 1917- *WhoAmA 73, -76, -78, -80, -82, -84*
Colson, Ellicot R 1871-1923 *BiDAmAr*
Colson, Frank V 1894- *WhAmArt 85*
Colson, Guillaume Francois 1785-1850 *ClaDrA*
Colson, Julia 1867- *DcBrA 1, DcWomA*
Colson, William B 1943- *MarqDCG 84*
Colston, Marianne *DcWomA*
Colston, Richard *AntBDN D*
Colston, Thomas James 1929- *AmArch 70*
Colt, Arthur N 1889-1972 *WhAmArt 85*
Colt, John Nicholson 1925- *WhoAmA 73, -76, -78, -80, -82, -84*
Colt, Joseph Lee 1929- *AmArch 70*
Colt, Julia *WhAmArt 85*
Colt, Martha Cox 1877- *DcWomA, WhAmArt 85*
Colt, Mary *DcWomA, NewYHSD*
Colt, Maximilian *OxArt*
Colt, Morgan 1876-1926 *WhAmArt 85*
Colt, Priscilla C *WhoAmA 76, -78, -80, -82*
Colt, Priscilla C 1917- *WhoAmA 73*
Colt, Samuel 1814-1862 *AntBDN F, OxDecA*
Colt, Stockton B 1863-1937 *BiDAmAr*
Colt, Thomas C, Jr. 1905- *WhAmArt 85, WhoAmA 73, -76, -78, -80, -82*
Coltellacci, Giulio 1916- *WhoGrA 62*
Coltellini, Mademoiselle *DcWomA*
Coltellini, Constantina *DcWomA*
Colter, Mary 1869-1958 *MacEA*
Colthurst, Francis Edward 1874- *DcBrA 1*
Coltman, Ora 1858- *WhAmArt 85*
Colton, A F *ArtsEM*
Colton, A M F 1823?-1896 *BiDAmAr*
Colton, Aaron 1758-1840 *CabMA*
Colton, Bernard William 1923- *AmArch 70*
Colton, Gordon W 1877- *WhAmArt 85*
Colton, H L *AmArch 70*
Colton, Harriett 1910- *WhAmArt 85*
Colton, Judith 1943- *WhoAmA 82, -84*
Colton, Lucretia 1788- *FolkA 86*
Colton, Mary Russell 1889- *ArtsAmW 1*
Colton, Mary Russell 1889-1971 *DcWomA*
Colton, Mary Russell Ferrell 1889- *IlBEAAW*
Colton, Mary-Russell Ferrell 1889- *WhAmArt 85*
Colton, Mary-Russell Ferrell 1889-1971 *ArtsAmW 2*
Colton, S *FolkA 86*
Colton, W Robert 1867-1921 *DcBrA 1*
Colton, Walter 1797-1851 *ArtsAmW 1, IlBEAAW, NewYHSD*
Coltrane, N M, Jr. *AmArch 70*
Columbani, Placido 1744?- *BiDBrA*
Coluzzi, Howard *WhAmArt 85*
Colverson, Ian 1940- *WhoAmA 78, -80*
Colvig, Kirk F 1934- *AmArch 70*
Colville, Alex 1920- *ConArt 77, -83, DcCAr 81, McGDA, PhDcTCA 77*
Colville, Alexander 1920- *WhoAmA 73, -76, -78, -80, -82, -84*
Colville, Baron Charles John *DcVicP 2*
Colville, David Alexander 1920- *OxTwCA*
Colville, E *DcVicP 2, DcWomA*
Colville, Gertrude *DcWomA*
Colville, Mrs. L H *WhAmArt 85*
Colvin, Benjamin *CabMA*

Colvin, Brenda *ConArch A*
Colvin, Brenda 1897- *ConArch*
Colvin, Brenda 1897-1981 *MacEA*
Colvin, Carroll Prowse 1930- *AmArch 70*
Colvin, Frederick Huston 1908- *AmArch 70*
Colvin, George William, Jr. 1932- *AmArch 70*
Colvin, Marta 1917- *OxTwCA, PhDcTCA 77*
Colvine, A H *NewYHSD*
Colway, James R 1920- *AmArt, WhoAmA 73, -76, -78, -80, -82, -84*
Colwell, Charles Leslie 1906- *AmArch 70*
Colwell, Elizabeth 1881- *DcWomA, WhAmArt 85*
Colwell, Worth *WhAmArt 85*
Colyer, Edwaert *McGDA*
Colyer, Joel *NewYHSD*
Colyer, Vincent 1825- *ArtsNiC*
Colyer, Vincent 1825-1888 *ArtsAmW 1, IlBEAAW, NewYHSD*
Com, Mo 1901- *WhAmArt 85*
Coman, Charlotte 1833-1924 *DcWomA*
Coman, Charlotte B *ArtsNiC, DcVicP 2*
Coman, Charlotte B 1833-1925 *WhAmArt 85*
Coman, Charlotte Buell 1833-1924 *NewYHSD*
Coman, Harriet *DcWomA*
Coman, William Leroy 1948- *MarqDCG 84*
Comandini, Peter 1860-1935 *WhAmArt 85*
Comb, Gordon MacCallum 1912- *AmArch 70*
Comb, Voltaire *WhAmArt 85*
Comba, Paul G 1926- *MarqDCG 84*
Combe, Miss *DcWomA*
Combe, E *DcWomA*
Combe, L Ella *DcWomA*
Combe, Mary Postell *WhAmArt 85*
Comber, Mary E *DcBrWA, DcVicP 2*
Comberousse, Josephine De *DcWomA*
Combes, Alice H *DcVicP 2*
Combes, Edward *DcVicP 2*
Combes, Emily *DcWomA*
Combes, Mrs. G E *DcVicP 2*
Combes, Grace Emily *DcVicP 2, DcWomA*
Combes, Lenora Fees 1919- *WhAmArt 85*
Combes, Louis 1762-1816 *MacEA*
Combes, Marie Clementine *DcWomA*
Combes, Simon *OfPGCP 86*
Combes, Willard Wetmore 1901- *WhAmArt 85, WhoAmA 76, -78, -80, -82, -84*
Combs, Earl Burns 1931- *AmArch 70*
Combs, Frances Hungerford *DcWomA*
Combs, Frances Hungerford 1876-1973 *DcWomA*
Combs, Frank *FolkA 86*
Combs, J *AmArch 70*
Combs, John Craig 1941- *AmArch 70*
Combs, W G *AmArch 70*
Come, Harriet *DcWomA*
Comeau, Annette C *MarqDCG 84*
Comeau, Jeanine Manzi 1933- *MarqDCG 84*
Comegys, George H *NewYHSD*
Comer, John *DcBrECP*
Comer, Sarah Ryel 1881- *WhAmArt 85*
Comerford, Mrs. *DcWomA*
Comerford, Helen 1945- *DcCAr 81*
Comerford, John 1773-1832 *AntBDN J*
Comerre, Leon-Francois *ArtsNiC*
Comerre, Leon Francois 1850-1916 *ClaDrA*
Comerre-Paton, Jacqueline 1859- *DcWomA*
Comerro, Harold James 1922- *AmArch 70*
Comes, John T 1873-1922 *BiDAmAr*
Comes, Marcella *WhoAmA 76, -78, -80, -82, -84*
Comes, Marcella 1905- *WhAmArt 85*
Comesana, Eduardo 1940- *ICPEnP A, MacBEP*
Comey, Arthur Coleman 1886-1954 *MacEA*
Comfort, Barbara *WhAmArt 85*
Comfort, Barbara 1916- *IlsCB 1946*
Comfort, Charles *OxTwCA*
Comfort, Charles Fraser 1900- *McGDA*
Comfort, George Fisk 1834-1910 *WhAmArt 85*
Comfort, Tom Tyrone 1909-1939 *WhAmArt 85*
Comgmacker, August 1825?- *NewYHSD*
Cominazzo, Angelo Lazarino *OxDecA*
Comingor, Ada Marian *WhAmArt 85*
Comingore, Ada Marian *DcWomA*
Comings, Henry Emerson, Jr. 1925- *AmArch 70*
Comini, Alessandra 1936- *WhoAmA 76, -78, -80, -82, -84*
Comins, Alice R *ArtsAmW 3, DcWomA, WhAmArt 85*
Comins, Eben F 1875- *WhAmArt 85*
Comins, Eben Farrington 1875-1949 *ArtsAmW 3*
Comins, Lizbeth B *DcWomA*
Comish, Hugh Tucker, Jr. 1934- *AmArch 70*
Comito, Nicholas U 1906- *WhAmArt 85, WhoAmA 78, -80, -82, -84*
Comito, Nicolas U 1906- *WhoAmA 76*
Comley, James Walter *DcBrA 2*
Comly, Ethan *NewYHSD*
Comly, Thomas 1826?- *NewYHSD*
Comm, Daniel 1925- *AmArch 70*
Commandaros, George Constantine 1924- *AmArch 70*
Commanville, Caroline *DcWomA*
Commeraw, Thomas H *FolkA 86*
Commiller, Lewis *FolkA 86*

Comminazzo, Lazarino 1563-1646 *AntBDN F*
Commons, Donald Gregor Grant 1855-1942 *DcSeaP*
Como, Guido Da *McGDA*
Comolera, Melani De *DcVicP 2*
Comolera, Melanie De *DcWomA*
Comolera, Paul 1818-1897 *AntBDN C*, *DcNiCA*
Comparet, Adrienne Jeanne Marie 1742-1820 *DcWomA*
Comparet, Alexis 1850-1906 *ArtsAmW 1*
Comparet, John B 1796-1844 *ArtsEM*
Comparetto, Joseph 1923- *AmArch 70*
Compe, Jan Ten 1713-1761 *ClaDrA*
Comper, John Ninian 1864-1960 *MacEA*
Comper, Sir John Ninian 1864-1960 *OxArt*
Comper, Sir Ninian 1864-1960 *WhoArch*
Compera, Alexis 1856-1906 *IlBEAAW*, *WhAmArt 85*
Compere, Janet *IlsBYP*
Complin, George *AntBDN M*
Compris, Maurice 1885-1939 *WhAmArt 85*
Compt-Calex 1813-1875 *AntBDN E*
Compte, Pedro d1506 *McGDA*
Compte-Calix, Celeste *DcWomA*
Compte-Calix, Francois Claudius 1813-1880 *ArtsNiC*
Compton, A *DcVicP 2*
Compton, Anna 1853-1928 *DcWomA*
Compton, Carl Benton 1905- *WhAmArt 85*
Compton, Caroline Russell 1907- *WhAmArt 85*
Compton, Charles 1828-1884 *DcVicP 2*
Compton, D E *AmArch 70*
Compton, Dora *DcWomA*
Compton, Dorothy Dumesnie 1917- *WhAmArt 85*
Compton, E H *DcVicP 2*
Compton, Edward Harrison 1881- *DcBrA 1*
Compton, Edward Theodore 1849- *DcBrBI*, *DcBrWA*
Compton, Edward Thomas 1849- *DcVicP, -2*
Compton, Henry E *DcBrA 1*
Compton, J H *AmArch 70*
Compton, James H *NewYHSD*
Compton, Lawrence *AfroAA*
Compton, Marian Margaret *DcWomA*
Compton, Richard J 1891-1951 *NewYHSD*
Compton, Selden Spencer *AmArch 70*
Compton, Theodore *DcVicP 2*
Compton, William Lawrence *AfroAA*
Compton-Smith, Cecilia *DcWomA*
Comri 1815?- *NewYHSD*
Comstock, A G *ArtsEM*
Comstock, Mrs. Alexander G *DcWomA*
Comstock, Anna 1854-1930 *DcWomA*
Comstock, Anna B 1854-1930 *WhAmArt 85*
Comstock, Anna Botsford 1854-1930 *ArtsAmW 3*
Comstock, Enos B 1879-1945 *WhAmArt 85*
Comstock, Enos Benjamin 1879-1945 *IlBEAAW*
Comstock, Frances Bassett 1881- *DcWomA*, *WhAmArt 85*
Comstock, Francis Adams 1897- *WhAmArt 85*
Comstock, Frederick R 1866-1942 *BiDAmAr*
Comstock, Gayle 1954- *MarqDCG 84*
Comstock, John *WhAmArt 85*
Comstock, John Adams 1882-1970 *ArtsAmW 3*
Comstock, John C *NewYHSD*
Comstock, Mary *FolkA 86*
Comstock, Samuel S *NewYHSD*
Comte, J *DcWomA*
Comte, Pierre *DcCAr 81*
Comte, Pierre-Charles 1815- *ArtsNiC*
Comte, Virginie *DcWomA*
Comte, Yvonne *DcWomA*
Comtois, Louis 1945- *WhoAmA 84*
Cona *FolkA 86*
Conable, George W 1866-1933 *BiDAmAr*
Conacher, John *WhAmArt 85*
Conacher, John 1876-1947 *WorECar*
Conan, Laura *DcWomA*
Conant, A *NewYHSD*
Conant, A J 1821-1915 *WhAmArt 85*
Conant, Alban Jasper 1821-1915 *NewYHSD*
Conant, Amy L E *DcVicP 2*
Conant, Arthur P *WhAmArt 85*
Conant, C W *WhAmArt 85*
Conant, Cornelia W *DcWomA*
Conant, Edwin A *NewYHSD*
Conant, Homer B 1880?-1927 *ArtsAmW 2*
Conant, Homer B 1887-1927 *WhAmArt 85*
Conant, Howard S 1921- *WhAmArt 85*
Conant, Howard Somers 1921- *WhoAmA 73, -76, -78, -80, -82, -84*
Conant, Howell 1919- *ICPEnP A*
Conant, Jan Royce 1930- *WhoAmA 82, -84*
Conant, Lucy Scarborough 1867-1920 *ArtsAmW 3*
Conant, Lucy Scarborough 1867-1921 *DcWomA*, *WhAmArt 85*
Conant, Maria *DcWomA*, *NewYHSD*
Conant, Maria T *FolkA 86*
Conant, Marjorie 1885- *DcWomA*, *WhAmArt 85*
Conant, Patti Rose 1888- *DcWomA*
Conant, S *FolkA 86*
Conard, Elizabeth *WhAmArt 85*
Conard, Grace Dodge 1885- *DcWomA*, *WhAmArt 85*

Conarroe, George W 1803-1882 *NewYHSD*
Conaughy, Clarence W *WhAmArt 85*
Conaway, Gerald 1933- *WhoAmA 76, -78, -80, -82, -84*
Conaway, H P *AmArch 70*
Conaway, James D 1932- *WhoAmA 76, -78, -80, -82, -84*
Conca, Sebastiano 1679?-1764 *ClaDrA*, *McGDA*
Conca, Sebastiano 1680-1764 *OxArt*
Concanen, Alfred 1835-1886 *DcBrBI*
Concannon, Thomas 1841?- *NewYHSD*
Concannon, Winifred B *DcWomA*
Conch, Francis P *AfroAA*
Concha, Jerry 1935- *DcCAr 81*
Conchillos Y Falco, Juan 1641-1711 *ClaDrA*
Concholar, Dan 1939- *AfroAA*
Concklin *FolkA 86*
Concklin, Jeremiah *NewYHSD*
Concolino, William Dominic, Jr. 1914- *AmArch 70*
Conconi, Maur 1815?- *ArtsNiC*
Condak, Cliff 1930- *IlrAm 1880*, *PrintW 83, -85*
Condamin, Jeanne *DcWomA*
Cond'Amin, Jeanne *DcWomA*
Conde, Charlotte Godefroide Elisabeth 1737-1760 *DcWomA*
Conde, Emilie Catherine *DcWomA*
Conde, J M *WhAmArt 85*
Conde, John *McGDA*
Conder, Charles 1868-1909 *DcVicP, -2*, *McGDA*, *PhDcTCA 77*
Conder, Charles Edward *OxTwCA*
Conder, Charles Edward 1868-1909 *DcBrA 1*, *DcBrBI*, *DcBrWA*
Conder, H Louise *DcBrA 2*, *DcVicP 2*
Conder, Helen E *DcBrA 1*, *DcWomA*
Conder, Josiah *DcVicP 2*
Conder, Josiah 1852-1920 *MacEA*
Conder, Neville 1900- *DcD&D*
Conder, Roger T *DcVicP 2*
Conder, Verne Edward 1924- *AmArch 70*
Condeso, Orlando 1947- *WhoAmA 78, -80, -82, -84*
Condict, Rupert D 1936- *AmArch 70*
Condie, Ella *DcWomA*
Condit, C L 1863- *ArtsAmW 2*
Condit, Mrs. C L 1863- *WhAmArt 85*
Condit, Mrs. Charles L 1863- *ArtsAmW 2*
Condit, Cora L 1863- *DcWomA*
Condit, J L *WhAmArt 85*
Condit, Louise 1914- *WhoAmA 73, -76, -78, -80, -82*
Condivi, Ascanio d1574 *OxArt*
Condon, Bill 1923- *AmArch 70*
Condon, Catherine 1892- *DcWomA*
Condon, Catherine F 1892- *WhAmArt 85*
Condon, D H *AmArch 70*
Condon, Florence B *DcWomA*
Condon, Grattan 1887- *WhAmArt 85*
Condon, Grattan 1887-1966 *IlrAm D, -1880*
Condon, Harriet D *WhAmArt 85*
Condon, James *NewYHSD*
Condon, Lawrence James 1925- *WhoAmA 76, -78, -80*
Condon, Maggie *DcWomA*
Condon, Stella C 1889- *ArtsAmW 3*
Condon, Wanda 1951- *DcCAr 81*
Condon, William *NewYHSD*
Condopoulos, Alecos 1905- *PhDcTCA 77*
Condorcet, Marie Louise S, Marquise De 1764-1822 *DcWomA*
Condoret, Jon Andre 1934- *AmArch 70*
Condron, Brian 1949- *MacBEP*
Condron, Brian James 1949- *WhoAmA 84*
Condy, Mrs. *FolkA 86*
Condy, Nicholas 1793-1857 *DcBrWA*, *DcVicP*
Condy, Nicholas 1799-1857 *DcVicP 2*
Condy, Nicholas, The Elder 1799-1857 *DcSeaP*
Condy, Nicholas Matthew 1816-1851 *DcVicP 2*
Condy, Nicholas Matthew 1818-1851 *DcBrBI*, *DcBrWA*, *DcVicP*
Condy, Nicholas Matthew, The Younger 1818-1851 *DcSeaP*
Cone, C A *AmArch 70*
Cone, Donald Roy 1921- *MarqDCG 84*
Cone, E Richard 1905- *AmArch 70*
Cone, Florence M Curtis *ArtsAmW 3*
Cone, George M *NewYHSD*
Cone, George W *WhAmArt 85*
Cone, Gerrit Craig 1947- *WhoAmA 76, -78, -80, -82, -84*
Cone, Grace C *WhAmArt 85*
Cone, Grace Cotton *DcWomA*
Cone, John A *ArtsEM*
Cone, John Paine, Jr. 1927- *AmArch 70*
Cone, Joseph *NewYHSD*
Cone, Louise *WhAmArt 85*
Cone, Martella Lydia *ArtsAmW 3*
Cone, Marvin d1964 *WhoAmA 78N, -80N, -82N, -84N*
Cone, Marvin 1891-1964 *WhAmArt 85*
Cone, Miriam 1892- *DcWomA*, *WhAmArt 85*
Cone, Spencer Burtis 1910- *AmArch 70*
Cone-Skelton, Annette 1942- *WhoAmA 78, -80, -82, -84*

Conely, Katherine *DcWomA*
Conely, Katherine I *ArtsEM*
Conely, William B 1830-1911 *NewYHSD*, *WhAmArt 85*
Conely, William Brewster 1830-1911 *ArtsEM[port]*
Cones, Nancy Ford 1869-1962 *MacBEP*
Cones, Nancy Ford 1870-1962 *WhAmArt 85*
Conesa, Miguel A 1952- *WhoAmA 82, -84*
Coney, John 1655-1722 *AntBDN Q*, *NewYHSD*, *OxDecA*
Coney, John 1656-1722 *BnEnAmA*
Coney, John 1786-1833 *DcBrWA*
Coney, John J 1907- *WhoArt 80, -82, -84*
Coney, R H *DcVicP 2*
Coney, Rosamond *DcWomA*, *WhAmArt 85*
Coney, William Bingham 1929- *AmArch 70*
Confalonieri, Giulio 1926- *WhoGrA 62, -82[port]*
Confalonieri, Giulio 1936- *ConDes*
Confalonieri E Negri *WhoGrA 62*
Confer, F L *AmArch 70*
Confer, Ross McCauley 1933- *AmArch 70*
Conforte, Renee *WhoAmA 78, -80, -82, -84*
Conforti, Michael Peter 1945- *WhoAmA 82, -84*
Congdon, Adairene Vose *WhAmArt 85*
Congdon, Adairene Vose 1865- *DcWomA*
Congdon, Allen Ramsdell 1906- *AmArch 70*
Congdon, Anne 1873-1958 *DcWomA*
Congdon, Catharine 1763-1833 *FolkA 86*
Congdon, Henry M 1834-1922 *BiDAmAr*, *MacEA*
Congdon, Samuel B *NewYHSD*
Congdon, Thomas R 1862?-1917 *WhAmArt 85*
Congdon, William 1912- *ClaDrA*, *DcCAA 71, -77*, *WhoAmA 73, -76, -78, -80, -82, -84*, *WhoArt 80*
Congdon, William Grosvenor 1912- *WhAmArt 85*
Conger, Clement E 1912- *WhoAmA 78, -80, -82, -84*
Conger, Daniel 1813?- *FolkA 86*
Conger, Hallie 1874-1977 *DcWomA*
Conger, J *FolkA 86*
Conger, John *FolkA 86*
Conger, Jonathan *FolkA 86*
Conger, Thomas Deckman 1927- *AmArch 70*
Conger, William 1937- *AmArt*, *WhoAmA 80, -82, -84*
Congers, Louis *WhAmArt 85*
Congnet, Gillis 1538-1599 *ClaDrA*, *McGDA*
Congreve, Frances Dora 1869- *DcBrA 1*, *DcWomA*
Conian, P T *FolkA 86*
Coniers *DcBrECP*
Conigliaro, Laura *MarqDCG 84*
Conin, Jane *DcWomA*
Coninck, Pierre Louis Joseph De 1828-1910 *ClaDrA*
Coninck, Regina De *DcWomA*
Coning, Daniel De 1668- *DcBrECP*
Coninxloo, Cornelis Van *McGDA*
Coninxloo, Gillis 1544-1607 *OxArt*
Coninxloo, Gillis Van 1544-1607 *McGDA*
Coninxloo, Gillis Van, III 1544-1607 *ClaDrA*
Conjola, Carl 1773-1831 *ClaDrA*
Conkey, Samuel 1830-1904 *ArtsEM*, *NewYHSD*, *WhAmArt 85*
Conklin, Ananias *FolkA 86*
Conklin, David Bruce *WhAmArt 85*
Conklin, G P 1830?- *NewYHSD*
Conklin, G W *AmArch 70*
Conklin, Gloria Zamko 1925- *WhoAmA 82, -84*
Conklin, Hurley *FolkA 86*
Conklin, Margaret *WhAmArt 85*
Conklin, R G *AmArch 70*
Conklin, Richard James 1935- *AmArch 70*
Conklin, Roy *FolkA 86*
Conklin, William J 1923- *AmArch 70*
Conkling, Mabel 1871- *WhAmArt 85*
Conkling, Mabel Viola 1871- *DcWomA*
Conkling, Paul 1871-1926 *WhAmArt 85*
Conkright, Charlotte *DcWomA*
Conley, Alonzo G *ArtsEM*
Conley, Michael *AfroAA*
Conley, R H *AmArch 70*
Conley, Sarah Ward 1861- *DcWomA*, *WhAmArt 85*
Conley, William 1849?-1909 *WhAmArt 85*
Conley, Zeb Bristol, Jr. 1936- *WhoAmA 76, -78, -80, -82, -84*
Conlin, John S *NewYHSD*
Conlin, William P *MarqDCG 84*
Conlon, Donald Robert 1931- *AmArch 70*
Conlon, George *WhAmArt 85*
Conlon, George 1888- *WhoAmA 73, -76*
Conlon, Mrs. J H P *WhAmArt 85*
Conlon, James Edward 1935- *WhoAmA 76, -78, -80, -82, -84*
Conlon, James H P 1894- *WhAmArt 85*
Conlon, William 1941- *DcCAr 81*, *WhoAmA 73, -76*
Conn, David Edward 1941- *WhoAmA 78, -80, -82, -84*
Conn, James *NewYHSD*
Conn, Richard George 1928- *WhoAmA 80, -82, -84*
Conn, Robbins Lewis 1894- *AmArch 70*
Connah, Douglas John 1871-1941 *WhAmArt 85*
Connah, J Douglas *DcVicP 2*
Connally, W B, Jr. *AmArch 70*

Cooperman, James Morris 1925- *AmArch 70*
Coopersmith, Georgia A 1950- *WhoAmA 82, -84*
Coopse, Pieter *ClaDrA, DcSeaP*
Coosemans, Alexander 1627?-1689 *ClaDrA, McGDA*
Coosemans, Joseph Theodore 1828-1904 *ClaDrA*
Coote, Mark 1932- *DcCAr 81*
Coote, Mary *DcWomA*
Coote, Robert James 1931- *AmArch 70*
Coote, Sarah *DcWomA*
Cootes, F Graham 1879- *WhAmArt 85*
Cootes, Frank Graham 1879-1960 *WhoAmA 80N, -82N, -84N*
Coots, Howard M *WhAmArt 85*
Coover, Nell *WhAmArt 85*
Coover, Nell B *ArtsAmW 2, DcWomA*
Coover, Nella B *ArtsAmW 2*
Cope, Sir Arthur Stockdale 1857-1940 *DcBrA 1, ClaDrA, DcVicP, -2*
Cope, Charles d1827 *DcBrWA*
Cope, Charles Gretter *AntBDN N*
Cope, Charles West 1811- *ArtsNiC*
Cope, Charles West 1811-1890 *ClaDrA, DcBrBI, DcBrWA, DcVicP, -2*
Cope, Dorothy 1915- *WhoAmA 73, -76*
Cope, Enos *FolkA 86*
Cope, G M *AmArch 70*
Cope, George 1855-1929 *ArtsAmW 2, BnEnAmA, DcAmArt*
Cope, Gordon Nicholson 1906- *IlBEAAW, WhAmArt 85*
Cope, J T *DcVicP 2*
Cope, Louise Todd *WhoAmA 78, -80, -82*
Cope, Louise Todd 1930- *WhoAmA 84*
Cope, Margaretta Porter 1905- *WhAmArt 85*
Cope, P M, Jr. *AmArch 70*
Cope, Sebon Leroy 1930- *AmArch 70*
Cope, Thomas *FolkA 86, NewYHSD*
Cope, Thomas Pym 1897- *AmArch 70*
Cope, W Henry *DcVicP 2*
Cope, Walter 1860-1902 *BiDAmAr*
Cope And Stewardson *MacEA*
Copeland, Mister *NewYHSD*
Copeland, A J *DcVicP 2*
Copeland, Alfred Bryant *ArtsNiC*
Copeland, Alfred Bryant 1840-1909 *NewYHSD , WhAmArt 85*
Copeland, Charles 1858- *WhAmArt 85*
Copeland, Charles Everett 1937- *AmArch 70*
Copeland, Eleanor R 1875- *WhAmArt 85*
Copeland, Eleanor Rogers 1875- *DcWomA*
Copeland, Elizabeth E *WhAmArt 85*
Copeland, Ernest d1929 *WhAmArt 85*
Copeland, Eugene H, Jr. 1934- *AmArch 70*
Copeland, Jo *WorFshn*
Copeland, Joseph Frank 1872- *WhAmArt 85*
Copeland, L G *AmArch 70*
Copeland, Lawrence Gill 1922- *WhoAmA 73, -76, -78, -80, WhoArt 80, -82, -84*
Copeland, Lila *WhoAmA 73, -76, -78, -80, -82, -84*
Copeland, Lila 1912- *WhAmArt 85*
Copeland, M B *DcWomA*
Copeland, M Baynon *WhAmArt 85*
Copeland, P *AmArch 70*
Copeland, R W, Jr. *AmArch 70*
Copeland, S *ArtsEM*
Copeland, William *DcNiCA*
Copeland, William Taylor *AntBDN M*
Copeland, William Taylor 1797-1868 *DcNiCA*
Copelin, John Knowles 1935- *AmArch 70*
Copeman, Constance Gertrude 1864- *DcBrA 1, DcWomA*
Copenhaver, Laura 1868- *WhAmArt 85*
Copenhaver, Matt 1920- *AmArch 70*
Coperslagere, Jacob De *McGDA*
Copestick, Alfred *EarABI, NewYHSD*
Copich, William Joseph 1925- *AmArch 70*
Copier, Andries Dirk 1901- *DcNiCA, IlDcG*
Coplan, Kate M 1901- *WhoAmA 73*
Copland, Alexander 1774?-1834 *BiDBrA*
Copland, Charles *DcBrWA*
Copland, Henry *AntBDN G, OxDecA*
Copland, L *DcVicP 2*
Copland, Patrick Forbes d1933 *DcBrA 2*
Coplans, John 1920- *ICPEnP A, WhoAmA 73, -76, -78, -80, -82, -84, WhoArt 80, -82*
Coplea, Leo M 1939- *MarqDCG 84*
Coples, N *AmArch 70*
Copley, Charles *NewYHSD*
Copley, Claire Strohn 1948- *WhoAmA 78, -80*
Copley, Ethel Leontine *DcWomA*
Copley, Frederick S *NewYHSD*
Copley, Heather 1920- *IlsCB 1957*
Copley, John 1875-1950 *DcBrA 1*
Copley, John Singleton 1738-1815 *AntBDN J, BnEnAmA, DcAmArt, DcBrECP, McGDA, NewYHSD , OxArt*
Copley, Richard Glen 1929- *AmArch 70*
Copley, William N 1919- *DcCAr 81*
Copley, William Nelson 1919- *AmArt, ConArt 77, -83, PrintW 83, -85, WhoAmA 76, -78, -80, -82, -84*

Copmann, P *NewYHSD*
Copnall, Edward Bainbridge 1903-1973 *DcBrA 1*
Copnall, Frank T 1870- *DcSeaP*
Copnall, Frank T 1870-1948? *DcBrA 1*
Copnall, John 1928- *ConBrA 79[port], WhoArt 80, -82, -84*
Copnall, Theresa Nora 1882- *ClaDrA*
Copnall, Theresa Norah 1882- *DcBrA 1, DcWomA*
Copomazza, Luisa *DcWomA*
Copp, Ellen Rankin 1853- *WhAmArt 85*
Copp, Gertrude M 1874- *WhAmArt 85*
Copp, Gertrude Mae 1874- *DcWomA*
Copp, Helen Rankin *DcWomA*
Coppage, Mabel *WhAmArt 85*
Coppard, C Law *DcVicP 2*
Coppedge, Arthur 1938- *AfroAA*
Coppedge, Arthur L 1938- *WhoAmA 80, -82, -84*
Coppedge, Fern 1883?-1951 *DcWomA*
Coppedge, Fern Isabel *WhAmArt 85*
Coppedge, Fern Isabel 1883-1951 *ArtsAmW 3*
Coppedge, James Carroll 1927- *AmArch 70*
Coppedge, R *DcWomA*
Coppedge, Mrs. Robert *WhAmArt 85*
Coppee, Annette *DcWomA*
Coppel, Jeanne 1896-1971 *DcWomA*
Coppens, Edith M *ArtsEM, DcWomA*
Coppens, Emma M *ArtsEM, DcWomA*
Copper, Craig Mangan 1931- *AmArch 70*
Copper, John C *NewYHSD*
Copper, Munroe Walker, Jr. 1897- *AmArch 70*
Copperman, Turner 1906- *WhAmArt 85*
Coppieters, Alberie 1878-1902 *DcWomA*
Coppin, Daniel 1770?-1822 *DcBrWA*
Coppin, Mrs. Daniel *DcWomA*
Coppin, Emily *DcWomA*
Coppin, Jeanne *DcWomA*
Coppin, John S 1904- *WhAmArt 85*
Copping, Harold 1863-1932 *DcBrA 1, DcBrBI, DcVicP 2*
Coppinger, Frances *DcWomA*
Coppini, Pompeo Luigi 1870- *WhAmArt 85*
Coppini, Pompeo Luigi 1870-1957 *ArtsAmW 3, WhoAmA 80N, -82N, -84N*
Coppo Di Marcovaldo *McGDA*
Coppo Di Marcovaldo 1225?- *OxArt*
Coppock, W L *AmArch 70*
Coppola, Alphonse 1938- *FolkA 86*
Coppola, Andrew 1941- *WhoAmA 76, -78, -80, -82, -84*
Coppola, Silvio 1920- *WhoGrA 82[port]*
Coppolino, Joseph 1908- *WhAmArt 85*
Copsey, Helen Dorothy 1888- *DcBrA 1, DcWomA*
Copson, Horace 1903- *ClaDrA, DcBrA 1, WhoArt 80, -82, -84*
Copson, Octar H *ArtsEM*
Coquard, Leon 1860-1926? *BiDAmAr*
Coquardon, A *NewYHSD*
Coquelet, Alexandrine *DcWomA*
Coquereau, Charles *CabMA*
Coques, Gonzales 1614?-1684 *McGDA, OxArt*
Coquet-Collignon, Anna 1832-1899 *DcWomA*
Coradi, L *NewYHSD*
Corah, William J *DcVicP 2*
Coral R 1929- *WhoAmA 84*
Coram, Thomas 1757-1811 *NewYHSD*
Corasick, William W 1907- *WhAmArt 85*
Corazzi, Giulietta 1866- *DcWomA*
Corbato, Jose M *AmArch 70*
Corbaux, Fanny 1812-1883 *DcVicP, -2, DcWomA*
Corbaux, Louisa 1808- *DcBrBI, DcBrWA, DcVicP, -2, DcWomA*
Corbaux, Marie Francoise C Doetter 1812-1883 *DcBrBI*
Corbaux, Marie Francoise C Doetter Fanny 1812-1883 *DcBrWA*
Corbelletti, Raniero 1922- *AmArch 70*
Corbellini, Louisa *DcWomA*
Corben, Richard V 1940- *ConGrA 1[port]*
Corben, Richard Vance 1940- *WorECom*
Corbertt, Gail Sherman d1952 *WhoAmA 82N*
Corbet, D *DcVicP 2*
Corbet, Edith *DcBrA 2, DcWomA*
Corbet, Matthew Ridley 1850-1902 *ClaDrA, DcBrA 1, DcBrWA, DcVicP, -2*
Corbet, Mrs. Matthew Ridley *DcVicP 2*
Corbet, Philip *DcVicP 2*
Corbett, Albert Edward 1873-1916 *MacEA*
Corbett, Bertha *DcWomA*
Corbett, Bertha L 1872- *WhAmArt 85*
Corbett, Edward 1919-1971 *DcCAA 71, -77, OxTwCA*
Corbett, Edward M 1919-1971 *WhoAmA 78N, -80N, -82N, -84N*
Corbett, F *DcVicP 2*
Corbett, Gail 1871?-1952 *DcWomA*
Corbett, Gail Sherman d1952 *WhoAmA 78N, -80N, -84N*
Corbett, Gail Sherman 1871-1952 *WhAmArt 85*
Corbett, George *MarqDCG 84, NewYHSD*
Corbett, Harvey Wiley 1873-1954 *MacEA, McGDA*
Corbett, Lee Thurston, Jr. 1936- *AmArch 70*

Corbett, Mario 1901- *McGDA*
Corbett, Oliver J 1886- *WhAmArt 85*
Corbett, Robert Waldron 1928- *AmArch 70*
Corbett, S Bertha *DcVicP 2*
Corbett, Thomas H *NewYHSD*
Corbett, William 1912- *AmArch 70*
Corbin *FolkA 86, NewYHSD*
Corbin, Aline *DcWomA*
Corbin, Beresford St. C 1919- *AfroAA*
Corbin, George Allen 1941- *WhoAmA 78, -80, -82, -84*
Corbin, Hannah *FolkA 86*
Corbin, Rosa H *DcVicP 2*
Corbino, John d1964 *WhoAmA 78N, -80N, -82N, -84N*
Corbino, Jon 1905-1964 *DcCAA 71, -77, McGDA, WhAmArt 85*
Corbino, Marcia Norcross *WhoAmA 82, -84*
Corbion, Mademoiselle *DcWomA*
Corbishley, Harriet *ArtsEM, DcWomA*
Corbit, Mary Pennell *FolkA 86*
Corbou *ConGrA 1*
Corbould, Alfred *DcVicP, -2*
Corbould, Alfred Chantrey *DcBrWA, DcVicP 2*
Corbould, Alfred Chantrey d1920 *DcBrA 1*
Corbould, Alfred Hitchens *DcBrWA, DcVicP 2*
Corbould, Anne Rose *DcBrWA*
Corbould, Aster Chantrey d1920 *DcBrBI, DcBrWA*
Corbould, Aster R C *DcBrWA, DcVicP, -2*
Corbould, Aster Richard Chantrey *DcBrWA*
Corbould, Edward H 1815-1844 *ArtsNiC*
Corbould, Edward Henry 1815-1905 *DcBrBI, DcBrWA, DcVicP, -2*
Corbould, Edward Henry 1815-1915 *ClaDrA*
Corbould, Henry 1787-1844 *DcBrBI, DcBrWA*
Corbould, Richard 1757-1831 *BkIE, DcBrBI, DcBrECP, DcBrWA*
Corbould, Walter E 1859- *DcBrWA*
Corbould, Walter Edward *DcVicP 2*
Corbould-Ellis, Eveline M *DcBrA 2, DcWomA*
Corbould-Haywood, Evelyn *DcVicP 2*
Corbridge, Edgar *WhAmArt 85*
Corbusier, John W C 1873-1928 *BiDAmAr*
Corbusier, Le *OxTwCA*
Corby, Adele May Bachman *DcWomA*
Corby, J W *DcSeaP*
Corbyn, Lydia *DcWomA*
Corbynprice, Frank *DcVicP 2*
Corcia, Agnese La *DcWomA*
Corcos, Lucille d1973 *IlsCB 1967*
Corcos, Lucille 1908- *WhoAmA 73*
Corcos, Lucille 1908-1973 *IlsCB 1946, -1957, WhAmArt 85, WhoAmA 76N, -78N, -80N, -82N, -84N*
Cord, Barry 1943- *WorFshn*
Cord, Orlando 1922- *WhoAmA 73, -76, -78, -80*
Corda, Ettore 1941- *MarqDCG 84*
Cordano *NewYHSD*
Cordasco, J V *AmArch 70*
Cordeiro, Calisto 1877-1957 *WorECar*
Cordeiro, Waldemar *OxTwCA*
Cordeliaghi *McGDA*
Cordelier DeLaNoue, Amelie *DcWomA*
Cordell, L C 1808-1870 *NewYHSD*
Cordemoy, Jean Louis De *MacEA*
Corden, Victor Milton 1860- *DcBrA 1*
Corden, Victor Milton 1860-1939 *DcBrA 2*
Corden, Walter J *ArtsEM*
Corden, William, Jr. *DcVicP 2*
Corder, C E *DcVicP 2*
Corder, Elene Moffett 1887- *ArtsAmW 2*
Corder, Rosa *DcVicP 2, DcWomA*
Cordero, Helen 1916- *FolkA 86*
Cordero, Jose *IlBEAAW, NewYHSD*
Cordero, Jose 1768- *ArtsAmW 1, -2*
Cordero, Josef 1768- *ArtsAmW 2*
Cordero, Juan 1824-1884 *McGDA*
Cordero, Vincente Sanidad 1933- *AmArch 70*
Cordery, Peter Frederick 1929- *AmArch 70*
Cordery, William *FolkA 86*
Cordes, E H *AmArch 70*
Cordes, Ernest W 1850- *BiDAmAr*
Cordes, Eva *DcWomA*
Cordes, H T A *NewYHSD*
Cordes, Olga 1868- *DcWomA*
Cordes, Roger L, Jr. 1954- *MarqDCG 84*
Cordes, Walter William 1896- *AmArch 70*
Cordes, Winston Albert *AmArch 70*
Cordier, Charles-Henri-Joseph 1827-1905 *McGDA*
Cordier, David *FolkA 86*
Cordier, Henri-Joseph-Charles 1827- *ArtsNiC*
Cordier, Marie Louise d1927 *DcWomA*
Cordier, Pierre 1933- *ConPhot, DcCAr 81, ICPEnP A, MacBEP*
Cordiner, Charles 1746-1794 *DcBrECP*
Cordiner, James 1775-1836 *DcBrBI*
Cording, Glenn W 1925- *AmArch 70*
Cordingley, Georges R *DcVicP 2*
Cordingley, Mary Bowles 1918- *WhoAmA 73, -76, -78, -80, -82, -84*
Cordioli, Marco 1934- *ConArt 77*

Cortese, P Giacomo *McGDA*
Cortez, Maxine *FolkA 86*
Corthell, Evelyn *DcWomA*
Corthren, Michael Watt 1951- *WhoAmA 82*
Corti, Costantino 1823-1873 *ArtsNiC*
Cortiglia, Niccolo 1893- *WhAmArt 85*,
 WhoAmA 80, -82, -84N
Cortijo, Francisco *OxTwCA*
Cortini, Publio 1802-1888 *MacEA*
Cortissos, Charles *DcVicP 2*
Cortissoz, Royal *WhAmArt 85*
Cortizas, Antonio *WhAmArt 85*
Cortlan *EncASM*
Cortlandt, Lyn *WhoAmA 73, -76, -78, -80,*
 WhoArt 80, -82, -84
Cortlandt, Lyn 1926- *ClaDrA*
Cortona, Domenico Da *McGDA*
Cortona, Pietro Berrettini Da 1596-1669 *MacEA,*
 OxArt
Cortona, Pietro Da *ClaDrA*
Cortona, Pietro Da 1596-1669 *DcD&D, McGDA,*
 WhoArch
Cortor, Eldzier 1915- *AfroAA*
Cortor, Eldzier 1916- *WhAmArt 85, WhoAmA 82,*
 -84
Cortot, Jean 1925- *OxTwCA*
Cortot, Jean Pierre 1787-1843 *McGDA*
Cortright, Hazel Packer *DcWomA, WhAmArt 85*
Cortright, Steven M 1942- *DcCAr 81, WhoAmA 76,*
 -78, -80, -82, -84
Cortrite, Antoinette *FolkA 86*
Cortrite, Nettie *DcWomA, FolkA 86*
Cortwright, J D *FolkA 86, NewYHSD*
Corvina, Maddalena *DcWomA*
Corvini, Maddalena *DcWomA*
Corvino, Maddalena *DcWomA*
Corvinus, Bernard 1892-1945 *WhAmArt 85*
Corvinus, Christina Rosina *DcWomA*
Corvus, Joannes *OxArt*
Corwick, Andrew 1790?-1863 *FolkA 86*
Corwin, Charles Abel 1857-1938 *ArtsAmW 1,*
 IlBEAAW, WhAmArt 85
Corwin, E F, Jr. 1928- *AmArch 70*
Corwin, Eugene Delbert *AmArch 70*
Corwin, James Jay 1952- *MarqDCG 84*
Corwin, John Raymond *AmArch 70*
Corwin, June Atkin *IlsCB 1967*
Corwin, June Atkin 1935- *IlsCB 1957*
Corwin, Margaret *DcWomA*
Corwin, Ralph D 1921- *AmArch 70*
Corwin, Salmon 1902- *FolkA 86*
Corwin, Sophia M *WhoAmA 73, -76, -78, -80, -82,*
 -84
Corwin, Thomas Emery 1924- *AmArch 70*
Corwin, Wilbur A *FolkA 86*
Corwin, Wilbur R *FolkA 86*
Corwine, Aaron H 1802-1830 *NewYHSD*
Cory, Edward J 1912- *WhoAmA 80*
Cory, F Y *WhAmArt 85*
Cory, Fanny Y 1877-1972 *ArtsAmW 2*
Cory, Fanny Young 1877-1972 *DcWomA,*
 IlrAm 1880, WorECom
Cory, Florence Elizabeth d1902 *WhAmArt 85*
Cory, J Campbell 1867-1925? *WorECar*
Cory, John Campbell *WhAmArt 85*
Cory, Kate T 1861- *IlBEAAW, WhAmArt 85*
Cory, Kate T 1861-1958 *ArtsAmW 1*
Cory, Kate Thompson 1861-1958 *DcWomA*
Cory, Leslie William 1919- *AmArch 70*
Cory, Loretta 1859-1917 *DcWomA*
Cory, Michael 1941- *MarqDCG 84*
Cory, Russell G 1882-1946 *BiDAmAr*
Cory, Sarah 1852-1915 *DcWomA*
Cory, Sarah Morris 1855-1915 *WhAmArt 85*
Cory, W F *EncASM*
Coryell, Virginia *WhAmArt 85*
Coryn, C E *WhAmArt 85*
Corzas, Francisco 1936- *WhoAmA 73, -76, -78, -80,*
 -82
Corzilius, Alvin B, Jr. 1933- *AmArch 70*
Cosbie, S *DcVicP 2*
Cosci *McGDA*
Coselli, F J, Jr. *AmArch 70*
Cosentino, Oronzo *WhAmArt 85*
Cosenza, Luigi *MacEA*
Cosgrave, Earle M d1915 *WhAmArt 85*
Cosgrave, J O'Hara, II d1968 *WhoAmA 78N, -80N,*
 -82N, -84N
Cosgrave, John O'Hara, II d1968 *IlsCB 1967*
Cosgrave, John O'Hara, II 1908- *IlsBYP, IlsCB 1744,*
 -1946, -1957
Cosgrave, John O'Hara, II 1908-1968 *WhAmArt 85*
Cosgrove, Alice Ericson 1909- *WhAmArt 85*
Cosgrove, B G *NewYHSD*
Cosgrove, Earle M d1915 *ArtsAmW 2*
Cosgrove, James Harvey 1926- *AmArch 70*
Cosgrove, John 1938- *MarqDCG 84*
Cosgrove, Margaret Leota *IlsCB 1967*
Cosgrove, Margaret Leota 1926- *IlsCB 1957*
Cosgrove, Stanley 1911- *ClaDrA, WhoAmA 73, -76,*
 -78, -80, -82, -84

Cosgrove, Stanley M 1911- *DcCAr 81*
Cosgrove, Stanley Morel 1911- *McGDA*
Cosimini, Roland F 1898- *WhAmArt 85*
Cosimo, Piero Di *McGDA*
Cosindas, Marie 1925- *ConPhot, ICPEnP, MacBEP*
Cosini, Silvio 1495-1547? *McGDA*
Cosla, O K *WhoAmA 76N, -78N, -80N, -82N, -84N*
Cosla, O K 1899- *WhoAmA 73*
Cosla, Mrs. O K *WhoAmA 73*
Cosler, William 1825?- *NewYHSD*
Cosley, Dennis 1816-1904 *FolkA 86*
Cosley, G *FolkA 86*
Cosman, Milein *WhoArt 80, -82, -84*
Cosmas *McGDA*
Cosner, Jack Richards 1935- *AmArch 70*
Cosnett, Jennie M *WhAmArt 85*
Cosper *WorECar*
Cossa, Francesco Del 1435?-1477 *McGDA*
Cossa, Francesco Del 1435?-1477? *OxArt*
Cossard, Mademoiselle *DcWomA*
Cosse-Brissac, Comtesse De *DcWomA*
Cossel, Doris Elisabeth Von *DcWomA*
Cossett, M *FolkA 86*
Cossiau, Jan Joost Von 1660?-1734? *ClaDrA*
Cossiau, Johannes 1660?-1734? *McGDA*
Cossiers, Jan 1600-1671 *ClaDrA, McGDA*
Cossington, Grace *DcWomA*
Cossio, Carlo 1907-1964 *WorECar, WorECom*
Cossio, Vittorio 1911- *WorECar*
Cossitt, Franklin D 1927- *WhoAmA 78, -80, -82, -84*
Cosson, Annette 1899- *DcWomA*
Cossutius *MacEA, OxArt*
Cossutta, Araldo Alfred 1925- *AmArch 70*
Cost, James Peter 1923- *WhoAmA 76, -78, -80, -82,*
 -84
Cost, Shelley Anne 1953- *AmArt*
Costa, Albert, Jr. 1931- *AmArch 70*
Costa, Catherina Da *DcWomA*
Costa, Claudio 1942- *ConArt 77, -83*
Costa, D F, Jr. *AmArch 70*
Costa, Da *IlDcG*
Costa, Gianfrancesco 1711-1773 *McGDA*
Costa, Giovanni Antonio *OxTwCA*
Costa, Hector 1903- *WhAmArt 85*
Costa, John Da *DcVicP 2*
Costa, Joseph 1904- *ICPEnP A*
Costa, Lorenzo 1460?-1535 *ClaDrA, McGDA,*
 OxArt
Costa, Lucio 1902- *ConArch, DcD&D[port],*
 MacEA, McGDA, WhoArch
Costa, Lucio 1902-1963 *OxArt*
Costa, Olga 1913- *WhoAmA 73, -76, -78, -80*
Costa, Pietro *ArtsNiC*
Costa, Victor 1935- *WorFshn*
Costa, Walter Henry 1924- *AmArch 70*
Costadau, Berthe *DcWomA*
Costagini, Philippo 1839-1904 *WhAmArt 85*
Costagni, Philippo 1839-1904 *NewYHSD*
Costaguta, Andrea *MacEA*
Costall, Brian 1943- *WhoArt 80, -82*
Costantini, Flavio 1926- *ConArt 77, WhoGrA 62,*
 -82[port]
Costantini, Virgil 1882- *ClaDrA, DcBrA 1*
Costanza, John Joseph 1924- *WhoAmA 80, -82, -84*
Costanza, Joseph, Jr. 1930- *AmArch 70*
Costanzo, Dino *OfPGCP 86*
Costanzo, Tony 1948- *CenC[port]*
Costar, George 1839?- *NewYHSD*
Costas, Carlos H 1934- *AmArch 70*
Coste, L R *AmArch 70*
Coste, Louise Zoe *DcWomA*
Costeker, Jane O *DcVicP 2*
Costello, Dennis P 1956- *MarqDCG 84*
Costello, Donald Francis 1934- *MarqDCG 84*
Costello, Dudley 1803-1865 *DcBrWA*
Costello, Henry *DcVicP 2*
Costello, Jensine 1886- *DcBrA 1, DcWomA*
Costello, Jerry 1897- *WhAmArt 85*
Costello, Joseph G 1836?- *NewYHSD*
Costello, Louisa Stuart 1799-1870 *DcWomA*
Costello, Michael *NewYHSD*
Costello, Val *WhAmArt 85*
Costello, Val 1875-1937 *ArtsAmW 2*
Costello, William *NewYHSD*
Costenoble, Anna 1866- *DcWomA*
Coster, Adam De 1586-1643 *McGDA*
Coster, Anne *DcWomA*
Coster, Germaine Marguerite De 1895- *DcWomA*
Coster, Howard 1885-1959 *ICPEnP A, MacBEP*
Coster, Salomon *AntBDN D*
Costigan, Constance Christian 1935- *WhoAmA 78,*
 -80, -82, -84
Costigan, Daniel *NewYHSD*
Costigan, Francis 1810-1865 *BiDAmAr, MacEA*
Costigan, Ida *WhAmArt 85*
Costigan, Ida 1885- *WhAmArt 85*
Costigan, John E 1888-1972 *WhAmArt 85*
Costigan, John Edward 1888- *McGDA*
Costigan, John Edward 1888-1972 *GrAmP,*
 WhoAmA 78N, -80N, -82N, -84N

Costigan, Thomas *WhAmArt 85*
Costin, Frank *WhoAmA 84*
Costley, Anna E *AfroAA*
Costley-Jacobs, Averille Esther 1947- *WhoAmA 84*
Costoli, Aristodeme 1803-1871 *ArtsNiC*
Coston, Clara M *ArtsEM, DcWomA*
Coston, T H *AmArch 70*
Cosway, Maria 1759-1838 *DcBrECP*
Cosway, Maria Cecilia Louisa Catherine 1759-1838
 ClaDrA
Cosway, Maria Hadfield 1759-1838 *WomArt*
Cosway, Maria Louisa Catherine Cecilia 1759-1838
 DcWomA
Cosway, Richard 1740-1821 *DcBrWA*
Cosway, Richard 1742?-1821 *AntBDN J, ClaDrA,*
 DcBrECP, McGDA, OxArt
Cot, Pierre-Auguste d1883 *ArtsNiC*
Cot, Pierre Auguste 1837-1883 *ClaDrA*
Cotan, Juan Sanchez *OxArt*
Cotard-Dupre, Therese Marthe Francoise 1877-
 DcWomA
Cotchett, T *DcVicP 2*
Cotchett, Valentine *ArtsEM*
Cote, Adelard 1889-1974 *FolkA 86*
Cote, Alan 1937- *WhoAmA 73, -76, -78*
Cote, Claude *FolkA 86*
Cote, Duane Kieth 1927- *AmArch 70*
Cote, M A Suzor *WhAmArt 85*
Cote, Paul 1948- *MarqDCG 84*
Cote, Richard William 1924- *AmArch 70*
Coter, Colijn 1455?-1538 *McGDA*
Cotes, Francis 1726-1770 *DcBrECP, McGDA,*
 OxArt
Cotes, P B *BiDBrA*
Cotes, Penelope *DcWomA*
Cotes, Samuel 1734-1818 *AntBDN J*
Cotes, Sarah *DcWomA*
Cotesworth, Lillias E *DcVicP 2, DcWomA*
Cotharin, Kate Leah 1866- *ArtsEM, DcWomA,*
 WhAmArt 85
Cothead, Phoebe *FolkA 86*
Cother, McVey *WhAmArt 85*
Cothern, John Mack 1929- *AmArch 70*
Cothran, Thomas White 1902- *AmArch 70*
Cothren, Michael Watt 1951- *WhoAmA 84*
Cotman, Anne 1812-1862 *DcWomA*
Cotman, Frederic George 1850-1920 *DcBrA 1*
Cotman, Frederick George 1850-1920 *ClaDrA,*
 DcBrBI, DcBrWA, DcVicP, -2
Cotman, John Joseph 1814-1878 *DcBrWA, DcVicP,*
 -2
Cotman, John Sell 1782-1842 *ClaDrA, DcBrBI,*
 DcBrWA, McGDA, OxArt
Cotman, Miles Edmund 1810-1858 *DcBrWA, DcSeaP,*
 DcVicP, -2
Cotrim, Alvaro 1904- *WorECar*
Cotsworth, Staats 1908- *WhAmArt 85,*
 WhoAmA 73, -76, -78
Cotsworth, Staats 1908-1979 *WhoAmA 80N, -82N,*
 -84N
Cottam, Ellen *DcVicP 2*
Cotte, Marie 1872-1943 *DcWomA*
Cotte, Robert De *McGDA*
Cotte, Robert De 1656-1735 *OxArt, OxDecA*
Cottell, Amelia C *DcWomA, WhAmArt 85*
Cotten, Lynne 1944- *DcCAr 81*
Cotter, Edward d1917 *WhAmArt 85*
Cotter, Holland 1947- *WhoAmA 84*
Cotter, Laurens Paul 1906- *AmArch 70*
Cotter, Nellie *ArtsEM*
Cotter, Sarah Cecilia *DcWomA, WhAmArt 85*
Cotter, Sheila L *MarqDCG 84*
Cotterell, Arthur George 1917- *WhoArt 80, -82, -84*
Cotterell, William 1835?- *NewYHSD*
Cotteret, Henriette *DcWomA*
Cotterill, Allan 1913- *DcBrA 2*
Cotterill, Edmund 1795-1858 *DcNiCA*
Cotterman, Charles J 1926- *AmArch 70*
Cottet, Charles 1863-1924 *ClaDrA*
Cottet, Charles 1863-1924? *WhAmArt 85A*
Cottet, Charles 1863-1925 *McGDA*
Cottey, Abel *AntBDN D*
Cottier, Glenn Gordon 1901- *AmArch 70*
Cottier, Keith E 1938- *ConArch*
Cotting, Roger Bruce 1931- *AmArch 70*
Cottingham, Lewis Nockalls 1787-1847 *BiDBrA*
Cottingham, Robert 1935- *AmArt, ConArt 77, -83,*
 DcCAA 77, DcCAr 81, PrintW 83, -85,
 WhoAmA 78, -80, -82, -84
Cottle, Richard Elliot 1936- *AmArch 70*
Cottle, Shubael *EncASM*
Cotton, Miss *DcWomA*
Cotton, Charles *DcBrWA*
Cotton, Dorothy *FolkA 86*
Cotton, Henry Charles 1805?-1873 *BiDBrA*
Cotton, Henry Robert *DcVicP 2*
Cotton, Ira *MarqDCG 84*
Cotton, J S *DcBrBI, NewYHSD*
Cotton, John W 1868-1931 *WhAmArt 85*
Cotton, John Wesley 1868-1931 *IlBEAAW*
Cotton, John Wesley 1868-1932 *ArtsAmW 1*

Cotton, Leo 1880- *ArtsAmW 3*, *WhAmArt 85*
Cotton, Mrs. Leslie *DcVicP 2*
Cotton, Lillian d1962 *WhoAmA 78N*, *-80N*, *-82N*, *-84N*
Cotton, Lillian 1901-1962 *WhAmArt 85*
Cotton, Lillian Impey 1892-1962 *DcWomA*
Cotton, Marietta *WhAmArt 85*
Cotton, Mariette Leslie *DcWomA*
Cotton, R C *DcBrWA*
Cotton, R Leo 1880- *ArtsAmW 3*
Cotton, Robert Turner 1774?-1850 *BiDBrA*
Cotton, Shubael Banks *FolkA 86*
Cotton, Violet Laura Caroline 1867- *DcWomA*
Cotton, W *DcVicP 2*
Cotton, William *AntBDN M*
Cotton, William Henry 1880- *WhAmArt 85*
Cotton, William Henry 1880-1958 *WhoAmA 80N*, *-82N*, *-84N*
Cotton, William Philip, Jr. 1932- *AmArch 70*
Cottrell, Arthur Wellesley *DcBrWA*, *DcVicP 2*
Cottrell, Henry J *DcBrWA*, *DcVicP 2*
Cottrell, Wellesley *DcVicP 2*
Cottu, Mister *NewYHSD*
Cotty, Madeleine *DcWomA*
Couard, Alexander P 1891- *WhAmArt 85*
Coubertin, Marie Marcelle De 1889- *DcWomA*
Coubine, O 1883- *ClaDrA*
Coubine, Othon 1883- *McGDA*, *PhDcTCA 77*
Couch, Frank B *WhAmArt 85*
Couch, Franklin Norman 1937- *AmArch 70*
Couch, John Edward 1937- *MarqDCG 84*
Couch, Lester S 1866-1939 *BiDAmAr*
Couch, Louis C 1928- *AmArch 70*
Couch, Maude C *ArtsAmW 3*
Couch, N J *AmArch 70*
Couch, Urban 1927- *WhoAmA 73*, *-76*, *-78*, *-80*, *-82*, *-84*
Couchman, Florence A *DcVicP 2*, *DcWomA*
Couchman, Henry 1738-1803 *BiDBrA*
Couder, Alexandre-Jean-Remy 1808-1879 *ArtsNiC*
Couder, Jean Alexandre Remy 1808-1879 *ClaDrA*
Couder, Jean-Baptiste-Amedee 1797-1865 *ArtsNiC*
Couder, Louis Charles Auguste 1790-1873 *ArtsNiC*, *ClaDrA*
Couder, Stephanie d1865? *DcWomA*
Coudert, Amalia 1873?-1932 *DcWomA*
Coudert, Amalia Kussner 1873-1932 *WhAmArt 85*
Coudon, Joseph *FolkA 86*
Coudrain, Brigitte 1934- *PrintW 83*, *-85*
Coueignoux, Philippe Jean-Marie 1949- *MarqDCG 84*
Couen, M L *DcWomA*
Couet, Louise Sebastienne *DcWomA*
Coughlan, A T *ArtsAmW 3*
Coughlan, Jeremiah *NewYHSD*
Coughlan, Jeremiah A *NewYHSD*
Coughlin, Jack 1932- *PrintW 85*, *WhoAmA 73*, *-76*, *-78*, *-80*, *-82*, *-84*
Coughlin, John Bernard 1914- *AmArch 70*
Coughlin, Marietta Ayres 1875?-1915 *DcWomA*, *WhAmArt 85*
Coughlin, Mildred 1896- *WhAmArt 85*
Coughlin, Mildred Marion 1895- *ArtsAmW 2*, *DcWomA*
Coughlin, S J, Jr. *AmArch 70*
Coughtrie, James B *DcVicP 2*
Coughtry, Graham *DcVicP 2*
Coughtry, Graham 1931- *DcCAr 81*, *McGDA*, *PrintW 83*, *-85*, *WhoAmA 84*
Coughtry, John Graham 1931- *WhoAmA 73*, *-76*, *-78*, *-80*
Cougny, Elisa *DcWomA*
Cougny, Julie *DcWomA*
Coulaud, Leonie *DcWomA*
Couldery, B A *DcVicP 2*
Couldery, C A *DcVicP 2*
Couldery, Horatio Henry 1832- *ClaDrA*, *DcVicP*, *-2*
Couldery, R, Jr. *DcVicP 2*
Couldery, Thomas W *DcBrBI*, *DcVicP 2*
Coulentianos, Costas 1918- *PhDcTCA 77*
Coulet, Anne Philiberte 1736- *DcWomA*
Coulet DeBeauregard, Marie Louise d1794? *DcWomA*
Coulin-Moinot, Marie Eugenie *DcWomA*
Couling, Arthur Vivian 1890- *DcBrA 1*
Couling, Gordon Robert 1913- *WhoAmA 73*, *-76*
Coullon, John *NewYHSD*
Coulon, Augusta De 1838-1897 *DcWomA*
Coulon, George David 1823?-1904? *NewYHSD*
Coulon, James *DcVicP 2*
Coulouris, Mary Louise 1939- *WhoArt 80*, *-82*, *-84*
Couloy, Isadore *FolkA 86*
Coulson, Gerald Davison 1926- *DcBrA 2*
Coulson, J *DcVicP 2*
Coulson, John *DcVicP 2*
Coulson, S *DcWomA*
Coultaus, Harry K 1863-1923 *WhAmArt 85*
Coulter, Charles J 1925- *MarqDCG 84*
Coulter, George *FolkA 86*
Coulter, Imogen Adams *DcWomA*, *WhAmArt 85*
Coulter, Lillian *WhAmArt 85*
Coulter, Mary J *ArtsAmW 1*
Coulter, Mary J d1966 *WhAmArt 85*

Coulter, Mary J 1880-1966 *ArtsAmW 3*
Coulter, Mary Jenks 1880-1966 *DcWomA*
Coulter, William *DcVicP 2*
Coulter, William A 1849-1936 *WhAmArt 85*
Coulter, William Alexander 1849-1936 *ArtsAmW 1*, *DcSeaP*
Coulthart, William *BiDBrA*
Coulthurst, Samuel Laurence 1867-1937 *MacBEP*
Coultre, Colijn Van *McGDA*
Coultry, P L *FolkA 86*
Counce, Harvey 1821- *NewYHSD* , *WhAmArt 85*
Counce, Harvey P 1821- *FolkA 86*
Counce, L W *AmArch 70*
Counce, R H *FolkA 86*
Councell, Charles Clemmens 1896- *WhAmArt 85*
Counihan, Noel 1913- *McGDA*, *OxTwCA*
Counihan, Noel Jack 1913- *WorECar*
Counis, Elise 1812-1848 *DcWomA*
Counsel, Frederick Alan 1913- *WhAmArt 85*
Countee, Samuel 1909- *AfroAA*
Countryman, Anna R 1863- *DcWomA*, *WhAmArt 85*
Counts, Charles *FolkA 86*
Countze, Frederick 1773-1799? *DcBrECP*
Coupard, D N *AmArch 70*
Couper, Mrs. B King 1867- *DcWomA*
Couper, Charles Alexander 1924- *WhoAmA 76*, *-78*, *-80*, *-82*, *-84*
Couper, J S 1867- *WhAmArt 85*
Couper, James *IlDcG*
Couper, James & Sons *DcNiCA*
Couper, James Hamilton *BiDAmAr*
Couper, James M 1937- *WhoAmA 73*, *-76*, *-78*, *-80*, *-82*, *-84*
Couper, Richard H 1886-1918 *WhAmArt 85*
Couper, William 1853- *WhAmArt 85*
Coupette, Fanny 1854- *DcWomA*
Coupigny, Louise Blanche *DcWomA*
Coupland, Robert Saunders, Jr. 1899- *AmArch 70*
Courajod, Louise *DcWomA*
Courant, Maurice Francois Auguste 1847-1925 *ClaDrA*
Couraye-Du-Parc, Marguerite *DcWomA*
Courbe, Marie Emilie Eugenie 1841-1880? *DcWomA*
Courbe, Mathilde Isabelle *DcWomA*
Courbe, Nathalie Blandine *DcWomA*
Courbe, Paule Marie Alice *DcWomA*
Courbet, Gustave 1819-1877 *ArtsNiC*, *ClaDrA*, *McGDA*, *OxArt[port]*
Courbot, Louise *DcWomA*
Courcelles, Pauline De *DcWomA*
Courdouan, Vincent Joseph Francois 1810-1893 *ClaDrA*
Courdouan, Vincent-Joseph-Francois 1816- *ArtsNiC*
Couriard, Pelagia Petrowna 1848-1898? *DcWomA*
Courier, Paul Louis, Madame *DcWomA*
Courland, Raphael Hirsch 1917- *AmArch 70*
Couronne, Louisa Forbes 1810-1897 *DcWomA*
Courpas, Constantine Angelo 1930- *AmArch 70*
Courreges, Andre 1923- *ConDes*, *FairDF FRA[port]*, *WorFshn*
Courselles-Dumont, S *DcWomA*
Coursen, A B *NewYHSD*
Coursen, Louise 1866- *WhAmArt 85*
Court, Catharina DeLa *DcWomA*
Court, Catherine Payn *DcVicP 2*
Court, Emily *ClaDrA*
Court, Emily G d1957 *DcBrA 1*, *DcWomA*
Court, Ethol 1898- *DcBrA 1*, *DcWomA*
Court, Lee Winslow 1903- *PrintW 83*, *-85*, *WhoAmA 73*, *-76*, *-78*, *-80*, *-82*, *-84*
Court, Lewis *FolkA 86*
Court, Suzanne De *DcWomA*
Court, W *DcBrECP*
Court VanDenVoort, Catherine A DeLa *DcWomA*
Courtat, Louis *ArtsNiC*
Courtauld, Miss *NewYHSD*
Courtauld, Augustine *AntBDN Q*
Courtauld, Edith *DcVicP 2*, *DcWomA*
Courtauld, Mrs. S L *NewYHSD*
Courtauld, Samuel *AntBDN Q*
Courtauld, Samuel 1876-1947 *OxArt*
Courte, F C *ArtsEM*
Courtenay, Hercules *CabMA*
Courtenay, T E *NewYHSD*
Courtens, Franz 1854- *ClaDrA*
Courtepee, Laure *DcWomA*
Courter, Franklin C 1854- *ArtsEM*
Courtet, Emile 1857-1938 *WorECar*
Courteys, Pierre I 1520?-1591 *McGDA*
Courti, F C *ArtsEM*
Courtice, Rody Kenny *WhoAmA 73*
Courtice, Rody Kenny d1973 *WhoAmA 76N*, *-78N*, *-80N*, *-82N*, *-84N*
Courtice, Rody Kenny 1895- *WhoAmA 73*
Courtin, Caroline *DcWomA*
Courtin, Caroline De *DcWomA*
Courtin, Jacques Francois 1672-1752 *ClaDrA*
Courtney, Barbara Wood 1929- *WhoAmA 84*
Courtney, Frederic E 1901- *DcBrA 1*, *WhoArt 80*, *-82*, *-84*
Courtney, G W *AmArch 70*
Courtney, Ja 1943- *MarqDCG 84*

Courtney, John H 1956- *MarqDCG 84*
Courtney, Keith Townsend 1949- *WhoAmA 76*, *-78*, *-80*, *-82*, *-84*
Courtney, Leo 1890- *ArtsAmW 2*, *WhAmArt 85*
Courtney, Marjorie *DcWomA*
Courtney, Robert 1829?- *NewYHSD*
Courtois, Anna *OxArt*
Courtois, Antonio *OxArt*
Courtois, Guillaume 1628-1679 *McGDA*, *OxArt*
Courtois, Gustave *ArtsNiC*
Courtois, Gustave 1853-1923 *WhAmArt 85A*
Courtois, Gustave Claude Etienne 1853-1924 *ClaDrA*
Courtois, Jacques 1621-1675 *OxArt*
Courtois, Jacques 1621-1676 *ClaDrA*, *McGDA*
Courtois, Maria *DcWomA*
Courtois, Marie *DcWomA*
Courtois, Marie 1655-1703 *AntBDN J*
Courtois-Valpincon, Celine *DcWomA*
Courtoisnon, Berthe *DcWomA*
Courtonne, Jean 1671-1739 *MacEA*
Courtright, Robert 1926- *DcCAr 81*, *WhoAmA 82*, *-84*
Courtrode, M A *EncASM*
Courvoisier, Henry *NewYHSD*
Couse, E Irving 1866-1936 *WhAmArt 85*
Couse, Eanger Irving 1866-1936 *ArtsEM[port]*, *IlBEAAW*
Couse, Irving 1866-1936 *ArtsAmW 1*
Couse, Kenton 1721-1790 *BiDBrA*, *MacEA*
Couse, William Percy 1898- *WhAmArt 85*
Cousen, Alfred *ArtsEM*
Cousen, Charles *DcVicP 2*
Cousen, John *DcVicP 2*
Cousen, Marian E *ArtsEM*, *DcWomA*
Cousin, Henriette *DcWomA*
Cousin, Jean 1490?-1560 *OxArt*
Cousin, Jean 1522?-1594? *ClaDrA*
Cousin, Jean 1522-1594 *OxArt*
Cousin, Jean, The Elder 1490?-1560? *McGDA*
Cousin, Jean, The Younger 1522?-1594? *McGDA*
Cousin, Louis *McGDA*
Cousineau, Penny Vickers 1947- *MacBEP*
Cousineau, Sylvain 1949- *DcCAr 81*
Cousinet, Catherine Elisabeth *DcWomA*
Cousins, Charles *DcVicP 2*
Cousins, Clara Lea 1894- *DcWomA*, *WhAmArt 85*
Cousins, Harold *AfroAA*
Cousins, Harold 1916- *McGDA*, *PhDcTCA 77*
Cousins, Robert Bruce 1937- *AmArch 70*
Cousins, Samuel 1801- *ArtsNiC*
Cousins, Samuel 1801-1887 *DcBrWA*, *McGDA*
Cousins, T S *DcVicP 2*
Cousins, V S *AmArch 70*
Cousland, William 1825?- *NewYHSD*
Coussin, Mister *NewYHSD*
Coussin, Laure 1808- *DcWomA*
Coussolle Y Astie, Marie Alice 1876- *DcWomA*
Coustou, Guillaume 1677-1746 *McGDA*
Coustou, Guillaume, I 1677-1746 *OxArt*
Coustou, Guillaume, II 1716-1777 *OxArt*
Coustou, Nicolas 1658-1733 *McGDA*, *OxArt*
Cousturier, Lucie 1876-1925 *DcWomA*
Coutan, Suzanne Emilie *DcWomA*
Coutan-Montorgueil, Laure 1855-1914? *DcWomA*
Coutance, Josephine *DcWomA*
Coutant, Nelly *DcWomA*
Coutant, W H *NewYHSD*
Coutaud, Lucien 1904- *McGDA*, *OxTwCA*, *PhDcTCA 77*
Coutaud, Lucien 1904-1977 *ConDes*
Coutellier, Francis 1945- *DcCAr 81*
Coutellier, Georgine Cornelie *DcWomA*
Coutere, Colijn Van *McGDA*
Couthouy, J P *ArtsAmW 1*, *NewYHSD*
Coutis, T W *FolkA 86*
Coutouly, Mademoiselle *DcWomA*
Coutts, Alice *ArtsAmW 1*, *IlBEAAW*, *WhAmArt 85*
Coutts, Alice Hobbs 1865-1937 *DcWomA*
Coutts, Gordon 1868-1937 *ArtsAmW 3*, *IlBEAAW*
Coutts, Gordon 1875-1943 *DcBrA 2*
Coutts, Gordon 1880-1937 *ArtsAmW 1*, *WhAmArt 85*
Coutts, Herbert d1921 *DcBrWA*
Coutts, Hubert d1921 *DcBrA 1*
Coutts, Hubert Herbert *DcVicP*
Coutts, Hubert Herbert d1921 *DcVicP 2*
Coutts-Smith, Kenneth 1929- *WhoArt 80*, *-82*
Coutu, Jack 1924- *WhoArt 80*, *-82*, *-84*
Couture, Guillaume Martin 1732-1799 *MacEA*
Couture, Ronald David 1944- *MarqDCG 84*
Couture, Thomas 1815-1879 *ArtsNiC*, *ClaDrA*, *McGDA*, *OxArt*, *WhAmArt 85*
Couturier, Hendrick d1684? *NewYHSD*
Couturier, Leon Antoine Lucien 1842-1935 *ClaDrA*
Couturier, Marion B *WhoAmA 78*, *-80*, *-82*, *-84*
Couturier, Philebert Leon *WhAmArt 85*
Couturier, Philibert Leon 1823-1901 *ClaDrA*
Couturier, Robert 1905- *McGDA*, *OxTwCA*, *PhDcTCA 77*

Couve DeMurville-Desenne, Lucie-Renee 1920-
 ClaDrA, *WhoArt 80*, *−82*, *−84*
Couverchel, Claire *DcWomA*
Couwenbergh, Christiaen Van 1604-1667 *McGDA*
Couzens, Julian Wallace 1909- *AmArch 70*
Couzens, Thomas Francis 1931- *AmArch 70*
Couzijn, Wessel 1912- *OxTwCA*, *PhDcTCA 77*
Covais, Anthony Charles 1931- *AmArch 70*
Covarrubias, Alonso De 1488?-
Covarrubias, Alonso De 1488-1570 *MacEA*, *McGDA*,
 WhoArch
Covarrubias, Miguel 1904-1957 *ConArt 83*, *McGDA*,
 WorECar
Covarrubias, Miguel 1905?-1958 *IlsCB 1744*, *−1946*
Covart, W A *FolkA 86*
Cove, Mrs. John Alfred *DcWomA*, *WhAmArt 85*
Cove, Rosemary 1936- *WhoAmA 80*, *−82*, *−84*
Covell, Margaret *DcWomA*
Covell, Margaret S *WhAmArt 85*
Covell, S E *DcWomA*
Covelle, Julie *DcWomA*
Coveney, Pam *AfroAA*
Covenhoven, John *CabMA*
Coventry, Frederick Halford *WhoArt 80*, *−82*, *−84*
Coventry, Frederick Halford 1905- *DcBrA 1*
Coventry, Gertrude Mary 1886- *DcBrA 1*, *DcWomA*
Coventry, James *DcVicP 2*
Coventry, Robert McGowan 1855-1914 *DcBrWA*,
 DcVicP 2
Coventry, Robert McGown 1855-1914 *ClaDrA*,
 DcBrA 1
Cover, John 1882- *McGDA*
Cover, Sallie *DcWomA*, *FolkA 86*
Coveri, Enrico 1952- *ConDes*
Coverley-Price, Victor 1901- *DcBrA 1*, *WhoArt 80*,
 −82, *−84*
Covert, F D *AmArch 70*
Covert, Isaac *CabMA*
Covert, John 1882-1960 *DcCAA 71*, *−77*, *OxTwCA*,
 WhoAmA 78N, *−80N*, *−82N*, *−84N*
Covert, John R 1882-1960 *DcAmArt*, *WhAmArt 85*
Covert, Lewis B *NewYHSD*
Covey, Arthur 1877-1960 *WhAmArt 85*
Covey, Arthur 1878-1960 *WhoAmA 80N*, *−82N*, *−84N*
Covey, Mrs. Arthur *WhAmArt 85*
Covey, Arthur Sinclair 1877-1960 *ArtsAmW 3*
Covey, Harriet *FolkA 86*
Covey, Lois *DcWomA*
Covey, Margaret Sale 1909- *WhAmArt 85*
Covey, Molly Sale 1880-1917 *DcWomA*,
 WhAmArt 85
Covey, Victor Charles B 1916- *WhoAmA 76*, *−78*, *−80*,
 −82, *−84*
Covi, Dario A 1920- *WhoAmA 73*, *−76*, *−78*, *−80*, *−82*,
 −84
Covill, H E *FolkA 86*
Coville, A M *FolkA 86*
Covington, Annette 1872- *DcWomA*, *WhAmArt 85*
Covington, C David *MarqDCG 84*
Covington, Harrison Wall 1924- *WhoAmA 73*, *−76*,
 −78, *−80*, *−82*, *−84*
Covington, Loren 1885-1970 *ArtsAmW 3*
Covington, R E *AmArch 70*
Covington, R L *AmArch 70*
Covington, Wickliffe C 1867-1938 *WhAmArt 85*
Covvey, H Dominic J 1944- *MarqDCG 84*
Cowam, Donald *FolkA 86*
Cowan, Aileen Hooper 1926- *WhoAmA 82*, *−84*
Cowan, C A *DcVicP 2*
Cowan, Cora E *DcWomA*, *WhAmArt 85*
Cowan, Edith C *DcVicP 2*
Cowan, Elizabeth 1863-1932 *WhAmArt 85*
Cowan, Elizabeth VanOsdel 1863-1932 *DcWomA*
Cowan, George *BiDBrA*, *NewYHSD*
Cowan, Henry *ConArt A*
Cowan, James *AntBDN D*
Cowan, James Douglas 1920- *AmArch 70*
Cowan, James M d1930 *WhAmArt 85*
Cowan, Janet D *DcVicP 2*
Cowan, Jean Hunter *DcBrA 1*
Cowan, Jean Hunter d1967? *DcWomA*
Cowan, John 1790-1850 *CabMA*
Cowan, John P *OfPGCP 86*
Cowan, Lee S *AfroAA*
Cowan, Nat 1903- *MacBEP*
Cowan, R Gray 1884-1957 *DcNiCA*
Cowan, R Guy 1884- *WhAmArt 85*
Cowan, R Guy 1884-1957 *CenC*
Cowan, R W *AmArch 70*
Cowan, Ralph Wolfe 1931- *WhoArt 84*
Cowan, Richard Harvey 1927- *AmArch 70*
Cowan, Robert d1846 *NewYHSD*
Cowan, Robert 1762-1846 *FolkA 86*
Cowan, Sarah Eakin d1958 *WhAmArt 85*
Cowan, Sarah Eakin 1875-1958 *DcWomA*
Cowan, Theodora 1850?- *DcWomA*
Cowan, Thomas Bruce 1947- *WhoAmA 76*, *−78*, *−80*,
 −82
Cowan, William Lawrence 1922- *AmArch 70*
Cowan, Woodson Messick 1886- *WhoAmA 73*, *−76*
Cowan, Woodson Messick 1886-1977 *WhoAmA 78N*,

Cowan, Woodson Messick 1889-1977 *WhAmArt 85*
Cowans, Adger W 1936- *ICPEnP A*, *MacBEP*
Coward, Eleanor L *DcWomA*, *FolkA 86*
Cowden, Minnie *DcWomA*
Cowderoy, Kate E *DcWomA*
Cowderoy, William *DcVicP 2*
Cowdery, Corene 1893- *DcWomA*, *WhAmArt 85*
Cowdery, Eva D *DcWomA*, *WhAmArt 85*
Cowdrey, Bartlett 1910-1974 *WhAmArt 85*
Cowdrey, Mary Bartlett 1910- *WhoAmA 73*
Cowdrey, Mary Bartlett 1910-1974 *WhoAmA 76N*,
 −78N, *−80N*, *−82N*, *−84N*
Cowell, Benjamin *FolkA 86*
Cowell, C Herbert 1913- *AmArch 70*
Cowell, E J H 1908- *AmArch 70*
Cowell, Edwin, Jr. *DcVicP 2*
Cowell, Emma *DcVicP 2*, *DcWomA*
Cowell, G H Sydney *DcBrBI*, *DcVicP 2*
Cowell, Grace Charlotte *DcWomA*
Cowell, H B *DcVicP 2*
Cowell, Joseph Goss 1886- *WhAmArt 85*
Cowell, Joseph Leathley 1792-1863 *NewYHSD*
Cowell, Joseph S *NewYHSD*
Cowell, Thomas J *NewYHSD*
Cowell, William 1682-1736 *AntBDN Q*
Cowell, William Wilson 1856- *WhAmArt 85*
Cowen, A Marian *WhAmArt 85*
Cowen, Lewis *WhAmArt 85*
Cowen, Lionel J *DcVicP 2*
Cowen, Nettie Meyerhuber 1906- *WhAmArt 85*
Cowen, Percy Elton 1883-1923 *WhAmArt 85*
Cowen, Percy Elton 1888-1923 *DcSeaP*
Cowen, William *AntBDN M*
Cowen, William 1797-1861 *DcBrWA*
Cowen, William 1797-1861? *DcVicP*
Cowen, William 1797-1861 *DcVicP 2*
Cowern, Jenny Alexandra 1943- *DcCAr 81*
Cowern, Raymond Teague 1913- *DcBrA 1*,
 WhoArt 80, *−82*, *−84*
Cowgill, C H *AmArch 70*
Cowham, Hilda d1964 *DcBrA 1*, *DcBrWA*,
 DcWomA
Cowham, Hilda Gertrude 1873-1964 *DcBrBI*
Cowherd, Barney 1922-1972 *ICPEnP A*
Cowherd, Carol Leonard 1946- *MarqDCG 84*
Cowhey, Kenneth *WhAmArt 85*
Cowie, Bel 1943- *WhoArt 82*, *−84*
Cowie, Frederick *DcVicP 2*
Cowie, James 1886-1956 *DcBrA 1*
Cowieson, Agnes M *DcWomA*
Cowin, Eileen 1947- *ICPEnP A*, *MacBEP*,
 WhoAmA 84
Cowin, Julian Raymond 1903- *AmArch 70*
Cowin, Lorilla Rice *WhAmArt 85*
Cowing, William R 1920- *WhoAmA 73*, *−76*
Cowles, Barbara 1898- *DcBrA 2*
Cowles, Calvin *FolkA 86*
Cowles, Charles 1941- *WhoAmA 73*, *−76*, *−78*
Cowles, Clarence L 1869-1925? *BiDAmAr*
Cowles, Cornelia *DcWomA*, *WhAmArt 85*
Cowles, Edith V 1874- *DcWomA*, *WhAmArt 85*
Cowles, Elisha *FolkA 86*
Cowles, Elisha 1750-1799 *FolkA 86*
Cowles, Fleur *WhoAmA 76*, *−78*, *−80*, *−84*
Cowles, Fluer *WhoAmA 82*
Cowles, Frank W *WhAmArt 85*
Cowles, Gardner 1903- *WhoAmA 73*, *−76*, *−78*, *−80*
Cowles, Mrs. Gardner *WhoAmA 73*, *−76*
Cowles, Mrs. Gardner 1918- *WhoAmA 78*, *−80*
Cowles, Genevieve A 1871- *WhAmArt 85*
Cowles, Genevieve Almeda 1871- *DcWomA*
Cowles, Josiah *FolkA 86*
Cowles, L *AmArch 70*
Cowles, Maud Alice 1871-1905 *DcWomA*
Cowles, Maude Alice 1871-1905 *WhAmArt 85*
Cowles, Mildred Lancaster 1876-1929 *DcWomA*,
 WhAmArt 85
Cowles, Russell 1887- *ArtsAmW 1*, *DcCAA 71*, *−77*,
 IlBEAAW, *WhAmArt 85*, *WhoAmA 73*, *−76*,
 −78
Cowles, Russell 1887-1979 *ArtsAmW 3*,
 WhoAmA 80N, *−82N*, *−84N*
Cowles, Seth 1766-1843 *FolkA 86*
Cowles, Thomas *FolkA 86*
Cowles, W d1917 *DcBrA 2*
Cowles, W S, Jr. *AmArch 70*
Cowles, Whitfield *EncASM*
Cowles, William B *EncASM*
Cowley, Edward P 1925- *WhoAmA 73*, *−76*, *−78*, *−80*,
 −82, *−84*
Cowley, William *BiDBrA*
Cowling, Dan Campbell, Jr. 1928- *AmArch 70*
Cowling, Richard Lloyd 1937- *AmArch 70*
Cowling, Robert 1924- *AmArch 70*
Cowling, Robert James 1926- *AmArch 70*
Cowlishaw, W I *EncASM*
Cowlman, Emma L *DcBrA 1*, *DcWomA*
Cowlman, John E *DcBrA 1*
Cowper, Anna *DcVicP 2*, *DcWomA*

Cowper, Douglas *DcVicP 2*
Cowper, Frank Cadogan 1877- *DcVicP*
Cowper, Frank Cadogan 1877-1958 *ClaDrA*,
 DcBrA 1, *DcBrBI*, *DcBrWA*, *DcVicP 2*
Cowper, John *BiDBrA*
Cowper, M E *DcVicP 2*
Cowper, Max *DcBrBI*
Cowper, Richard *DcVicP 2*
Cowper, T A 1781-1825 *MacEA*
Cowper, Thomas *DcVicP 2*
Cowper, William *DcBrWA*
Cowperthwaite, John K *AntBDN G*
Cox, A H *DcVicP 2*
Cox, Abbie Rose 1906- *WhAmArt 85*
Cox, Adela Leader *DcWomA*
Cox, Albert J *DcVicP 2*
Cox, Albert Scott *WhAmArt 85*
Cox, Alfred Wilson 1820?-1888? *DcBrWA*, *DcVicP 2*
Cox, Allen Howard 1873-1944 *BiDAmAr*
Cox, Allyn 1896- *WhAmArt 85*, *WhoAmA 73*, *−76*,
 −78, *−80*, *−82*
Cox, Allyn 1896-1982 *WhoAmA 84N*
Cox, Alva M 1895- *DcWomA*
Cox, Amy E *DcWomA*
Cox, Arthur *DcVicP 2*
Cox, Arthur Leonard 1879- *DcBrA 2*
Cox, Benjamin V 1934- *MarqDCG 84*
Cox, Bertram *DcVicP 2*
Cox, Billy Jess 1929- *AmArch 70*
Cox, C F *AmArch 70*
Cox, C H *DcVicP 2*
Cox, Charles Brinton 1864- *WhAmArt 85*
Cox, Charles Brinton 1864-1905 *ArtsAmW 1*,
 IlBEAAW
Cox, Charles Edward *DcVicP 2*
Cox, Charles Hudson 1829-1901 *ArtsAmW 2*,
 IlBEAAW, *NewYHSD*, *WhAmArt 85*
Cox, Charles M *WhAmArt 85*
Cox, Clark *IlBEAAW*
Cox, Clark 1850?- *WhAmArt 85*
Cox, David 1783-1859 *ArtsNiC*, *ClaDrA*, *DcBrBI*,
 DcBrWA, *DcSeaP*, *DcVicP*, *−2*, *McGDA*,
 OxArt
Cox, David 1809-1885 *ClaDrA*, *DcBrWA*
Cox, David 1914- *ClaDrA*, *DcBrA 1*
Cox, David, Jr. *ArtsNiC*
Cox, David, Jr. 1809-1885 *DcVicP*, *−2*
Cox, Doris E 1904- *WhAmArt 85*
Cox, Dorothy 1882- *DcBrA 1*, *DcBrWA*
Cox, Dorothy E *WhAmArt 85*
Cox, Dorothy M 1882- *DcWomA*
Cox, E Albert 1876- *IlsCB 1744*
Cox, E Albert 1876-1955 *DcBrA 1*
Cox, E Dean 1937- *AmArch 70*
Cox, E Morris 1903- *WhoAmA 73*, *−76*, *−78*, *−80*, *−82*,
 −84
Cox, Edmund VanDyke 1926- *AmArch 70*
Cox, Eleanor 1914- *WhAmArt 85*
Cox, Ernest Lee 1937- *WhoAmA 78*, *−80*, *−82*, *−84*
Cox, Ernest Moses 1885- *ClaDrA*
Cox, Eva *WhAmArt 85*
Cox, Everard Morant *DcBrBI*, *DcVicP 2*
Cox, Fannie *DcWomA*
Cox, Frank *WhAmArt 85*
Cox, Frank E *DcVicP 2*
Cox, Frederic Hamilton, Jr. 1933- *AmArch 70*
Cox, G W *AmArch 70*
Cox, Gardner 1906- *WhAmArt 85*, *WhoAmA 73*,
 −76, *−78*, *−80*, *−82*, *−84*
Cox, Garstin 1892-1933 *DcBrA 1*
Cox, George J *WhAmArt 85*
Cox, Sir George W *DcVicP 2*
Cox, George William 1932- *AmArch 70*
Cox, Gerald Burton 1922- *AmArch 70*
Cox, Gertrude Florence Mary *DcBrA 1*, *WhoArt 80*,
 −82N
Cox, H *BiDBrA*, *DcVicP 2*
Cox, H F *NewYHSD*
Cox, H N *AmArch 70*
Cox, Harold Wayne 1935- *AmArch 70*
Cox, Hebe *WhoArt 80*, *−82*, *−84*
Cox, Helen Morton 1869- *WhAmArt 85*
Cox, Helen Morton 1869-1946 *DcWomA*
Cox, Henry F *FolkA 86*
Cox, Herman G 1907- *AmArch 70*
Cox, J A *AmArch 70*
Cox, J B *AmArch 70*
Cox, J Halley *WhoAmA 76N*, *−78N*, *−80N*, *−82N*,
 −84N
Cox, J Halley 1910- *WhAmArt 85*, *WhoAmA 73*
Cox, J Morgan 1926- *AmArch 70*
Cox, J R *AmArch 70*
Cox, J V *AmArch 70*
Cox, J W *AmArch 70*
Cox, J W S 1911- *WhoAmA 73*, *−76*, *−78*, *−80*
Cox, Jack M 1921- *AmArch 70*
Cox, Jacob 1810-1892 *NewYHSD*
Cox, Jacob 1812-1892 *IlBEAAW*
Cox, James *AntBDN D*
Cox, James 1751-1834 *NewYHSD*
Cox, James 1838?- *NewYHSD*

Cox, James Alexander 1937- *AmArch 70*
Cox, James David 1945- *WhoAmA 80*
Cox, Jan 1919- *McGDA, OxTwCA, PhDcTCA 77, WhoAmA 73*
Cox, Jane Wells *DcVicP 2, DcWomA*
Cox, Joe M 1918- *AmArch 70*
Cox, John *DcBrA 1, WhAmArt 85*
Cox, John Rogers 1915- *GrAmP, WhAmArt 85, WhoAmA 76, -78, -80, -82, -84*
Cox, Joseph *CabMA*
Cox, Joseph 1757-1793? *DcBrECP*
Cox, Joseph H 1915- *WhAmArt 85, WhoAmA 73, -76*
Cox, Julia Mary *DcWomA*
Cox, Katherine G 1867- *DcWomA*
Cox, Katherine G Abbot 1867- *WhAmArt 85*
Cox, Kenelm 1927-1968 *OxTwCA*
Cox, Kenyon 1856- *WhAmArt 85*
Cox, Kenyon 1856-1919 *ArtsAmW 1, BnEnAmA, DcAmArt, McGDA*
Cox, Lawrence Henry 1947- *MarqDCG 84*
Cox, Louisa E 1850?-1910 *DcWomA*
Cox, Louise 1865- *WhAmArt 85*
Cox, Louise Howland 1865-1945 *DcWomA*
Cox, Louise Howland King 1865-1945 *ArtsAmW 1*
Cox, Lyda 1881- *WhAmArt 85*
Cox, Lyda Morgan 1881- *ArtsAmW 3, DcWomA*
Cox, Lyle Ashton, Jr. 1949- *MarqDCG 84*
Cox, Marion Averal *WhoAmA 76, -78, -80, -82, -84*
Cox, Mary Constance *DcBrA 1, DcWomA*
Cox, Nancy *WhAmArt 85*
Cox, Miss O S *DcBrA 1*
Cox, Palmer 1840-1924 *ArtsAmW 1, WhAmArt 85, WorECar*
Cox, Paul 1940- *ICPEnP A, MacBEP*
Cox, Philip 1939- *ConArch*
Cox, R S *AntBDN P*
Cox, R T *AmArch 70*
Cox, Richard 1950- *DcCAr 81*
Cox, Richard William 1942- *WhoAmA 78, -80, -82, -84*
Cox, Robert *NewYHSD*
Cox, Robert Theodore 1917- *AmArch 70*
Cox, Roland *WhAmArt 85*
Cox, S *DcWomA*
Cox, Stephen Bernard 1950- *WhoArt 80*
Cox, Stephen Edward James *MarqDCG 84*
Cox, Sue 1951- *DcCAr 81*
Cox, Susanna *FolkA 86*
Cox, Thomas, Jr. 1831?- *NewYHSD*
Cox, Tim *OfPGCP 86*
Cox, Sir Trenchard 1905- *WhoArt 80, -82, -84*
Cox, Virginia 1929- *AfroAA*
Cox, W A *AmArch 70, FolkA 86*
Cox, W E *AmArch 70*
Cox, Mrs. W H D *WhAmArt 85*
Cox, W H M *ArtsAmW 1, IlBEAAW, WhAmArt 85*
Cox, W L *AmArch 70*
Cox, W R 1829-1873 *NewYHSD*
Cox, Walter d1930 *DcBrA 2*
Cox, Walter B 1872- *WhAmArt 85*
Cox, Walter I 1866-1930 *WhAmArt 85*
Cox, Warren Earle 1895- *WhAmArt 85, WhoAmA 73, -76*
Cox, Warren J 1935- *ConArch*
Cox, Warren Jacob 1935- *AmArch 70*
Cox, Whitson W 1921- *AmArch 70*
Cox, William *CabMA*
Cox, William d1921 *BiDAmAr*
Cox, William Newton 1912- *AmArch 70*
Cox, William P 1915- *AmArch 70*
Cox, Wilson *DcVicP 2*
Cox-McCormack, Nancy 1885- *DcWomA, WhAmArt 85*
Cox-Nevetz, Stephen Bernard 1950- *WhoArt 82, -84*
Coxe, Daniel *FolkA 86*
Coxe, Eliza Middleton 1875- *DcWomA, WhAmArt 85*
Coxe, G Caliman *AfroAA*
Coxe, Mary Bowman d1921 *DcWomA, WhAmArt 85*
Coxe, Philip A *AfroAA*
Coxe, R Cleveland 1855- *ArtsAmW 1, WhAmArt 85*
Coxedge, J *BiDBrA*
Coxen, Elizabeth *DcWomA*
Coxen, Forrest Richard 1925- *AmArch 70*
Coxeter, Nicholas *AntBDN D*
Coxhead, Ernest 1863-1933 *BiDAmAr, MacEA*
Coxhead, Frank A *MacBEP*
Coxhead, John H 1863-1943 *BiDAmAr*
Coxie, Anna De 1547?-1595? *DcWomA*
Coxie, Michiel I 1499-1592 *ClaDrA, McGDA*
Coxon, Raymond James 1896- *DcBrA 1, WhoArt 80, -82, -84*
Coxwell, A F *DcVicP 2*
Coy, Anna 1851-1930 *WhAmArt 85*
Coy, C Lynn 1889- *WhAmArt 85*
Coy, Elizabeth Anna 1851-1930 *DcWomA*
Coy, Horace Milton 1905- *AmArch 70*
Coy, James 1750?-1780? *DcBrECP*

Coy, Josiah 1796-1823 *CabMA*
Coy, William *NewYHSD*
Coye, Lee Brown 1907- *WhAmArt 85*
Coyer, Max R 1954- *WhoAmA 82, -84*
Coyle, Carlos Cortes 1871-1962 *FolkA 86*
Coyle, James *FolkA 86*
Coyle, James 1798-1828 *NewYHSD*
Coyle, John Edward 1919- *AmArch 70*
Coyle, Joseph Edward 1903- *WhAmArt 85*
Coyle, Richard William 1920- *AmArch 70*
Coyne, Elizabeth K *WhAmArt 85*
Coyne, Elizabeth Kitchenman *DcWomA*
Coyne, Joan Joseph 1895-1930 *DcWomA, WhAmArt 85*
Coyne, John Michael 1950- *WhoAmA 82, -84*
Coyne, Sara Elizabeth 1876-1939 *DcWomA*
Coyne, Will Valentine 1895- *WhAmArt 85*
Coypel, Anne Francoise *DcWomA*
Coypel, Antoine 1661-1722 *ClaDrA, McGDA, OxArt*
Coypel, Charles Antoine 1694-1752 *ClaDrA*
Coypel, Charles-Antoine 1694-1752 *McGDA*
Coypel, Charles-Antoine 1696-1751 *OxArt*
Coypel, Noel 1628-1707 *ClaDrA, McGDA, OxArt*
Coypel, Noel Nicolas 1690-1734 *ClaDrA*
Coypel Family *OxArt*
Coypel-Herault, Madeleine *DcWomA*
Coysevox, Antoine 1640-1720 *OxArt*
Coysevox, Antoine 1640-1721 *McGDA*
Coywell *EncASM*
Cozby, Grady Ray, Jr. 1935- *AmArch 70*
Coze, Paul 1903-1975 *IlBEAAW, WhAmArt 85*
Coze-Dabija *WhAmArt 85*
Coze-Dabija, Paul 1903- *WhoAmA 73*
Coze-Dabija, Paul 1903-1975 *WhoAmA 76N, -78N, -80N, -82N, -84N*
Cozens, Alexander 1717?-1786 *DcBrECP, DcBrWA, McGDA, OxArt*
Cozens, John Robert 1752-1797 *DcBrECP, DcBrWA, McGDA, OxArt*
Cozens, John Robert 1752-1799 *ClaDrA*
Cozza, Francesco 1605-1682 *McGDA*
Cozzarelli, Giacomo 1453-1515 *MacEA, McGDA*
Cozzarelli, Guidoccio Di Giovanni *McGDA*
Cozzens, Eliza 1785-1885 *FolkA 86*
Cozzens, Evangeline Chapman 1895- *DcWomA, WhAmArt 85*
Cozzens, Frederick S 1846-1928 *WhAmArt 85*
Cozzens, Frederick Schiller 1856-1928 *DcSeaP*
Cozzens, Frederick Swartwout 1818-1869 *EarABI*
Cozzi, Geminiano *AntBDN M*
Cozzolino, Ferdinand Frank 1936- *AmArch 70*
Crabb, Miss *DcWomA*
Crabb, Harriet *DcWomA*
Crabb, Robert James 1888- *ArtsAmW 2, WhAmArt 85*
Crabb, W A *DcVicP 2*
Crabb, William 1811-1876 *DcVicP 2*
Crabbe, Frans 1480?-1553 *McGDA*
Crabbe, Herbert G *DcVicP 2*
Crabbe, Richard Markham 1927- *WhoArt 80, -82, -84*
Crabbels, Florent Nicolas 1829-1896 *ClaDrA*
Crabbs, Maude Ide 1890- *WhAmArt 85*
Crabeth, Dirk d1577 *OxArt*
Crabeth, Wouter d1590? *OxArt*
Crabeth, Wouter Pietersz, The Younger 1593?-1644 *McGDA*
Crabill, B F *AmArch 70*
Crable, James Harbour 1939- *WhoAmA 78, -80, -82, -84*
Crabtree, Bruce Isbester, Jr. 1923- *AmArch 70*
Crabtree, Catherine Calhoun *DcWomA*
Crabtree, Chris 1948- *DcCAr 81*
Crabtree, Jack 1938- *DcCAr 81*
Crabtree, Jan French 1943- *AmArt*
Crabtree, John *CabMA*
Crabtree, Malcolm Norton 1923- *AmArch 70*
Crabtree, Philippa *DcWomA*
Crabtree, W P, III *AmArch 70*
Crabtree, W P, Jr. *AmArch 70*
Crace, Frederick 1779-1859 *DcBrWA*
Crace, J G *DcNiCA*
Crace, John Dibblee 1838-1919 *DcVicP 2*
Crace, John S *DcNiCA*
Cracium, Trajen 1922- *AmArch 70*
Cracker Jack Kid 1948- *WhoAmA 84*
Cracklow, Charles Thomas *BiDBrA*
Cracknall, John *AntBDN N*
Cracknell, Thomas C *DcVicP 2*
Craddock, Joseph *AntBDN Q*
Craddock, Theresa 1937- *AfroAA*
Cradock, Marmaduke 1660?-1716 *DcBrWA*
Cradock, Marmaduke 1660?-1717? *DcBrECP*
Cradock, Mary *DcWomA*
Cradwick, Peter Denys Gulliver 1943- *MarqDCG 84*
Craen, Laurens *ClaDrA*
Craenhals, Francois 1926- *WorECom*
Craesbeeck, Joos Van 1606?-1654 *McGDA*
Craesbeeck, Joos Van 1608?-1661? *ClaDrA*
Craey, Dirck d1666 *ClaDrA*

Crafft, R B *FolkA 86*
Craft, Chester Lee, Jr. *AmArch 70*
Craft, David Ralph 1945- *WhoAmA 84*
Craft, Douglas D 1924- *WhoAmA 73, -76, -78, -80, -82, -84*
Craft, G E *AmArch 70*
Craft, John Richard 1909- *WhAmArt 85, WhoAmA 73, -76, -78, -80, -82, -84*
Craft, Kinuko Yamabe 1940- *ConGrA 1*
Craft, Paul 1904- *WhAmArt 85*
Craft, Percy Robert 1856-1934 *DcBrA 1, DcBrBI, DcVicP 2*
Craft, R B *NewYHSD*
Craft, William *FolkA 86*
Crafton, Richard *DcVicP 2*
Crafts, Caleb *FolkA 86*
Crafts, Edward A *FolkA 86*
Crafts, Elbridge *FolkA 86*
Crafts, Frederick, Jr. *NewYHSD*
Crafts, Martin *FolkA 86*
Crafts, Mary S 1788- *FolkA 86*
Crafts, Thomas *FolkA 86*
Crafty *DcBrBI*
Cragg, Tony 1949- *DcCAr 81*
Craghead, Elizabeth *FolkA 86*
Cragin, Henrietta Foxhall *DcWomA*
Cragin, William Joseph 1928- *AmArch 70*
Crahay, Jules Francois *FairDF FRA*
Crahay, Jules Francois 1917- *WorFshn*
Craig *EncASM*
Craig, A L, Jr. *AmArch 70*
Craig, Alexander d1878 *DcVicP 2*
Craig, Alice d1961 *ArtsAmW 3*
Craig, Anderson 1904- *WhAmArt 85*
Craig, Anna Belle 1878- *DcWomA, WhAmArt 85*
Craig, Beatrice Doane *DcWomA, WhAmArt 85*
Craig, Burlon *FolkA 86*
Craig, C F *AmArch 70*
Craig, Calvin C, Jr. 1920- *AmArch 70*
Craig, Charles 1846-1931 *ArtsAmW 1, IlBEAAW, WhAmArt 85*
Craig, Charles Alexander 1754?-1833 *BiDBrA*
Craig, Chase 1910- *WorECom*
Craig, Colin S 1872?-1914 *WhAmArt 85*
Craig, Della Vernon *ArtsAmW 3*
Craig, E *DcWomA*
Craig, Edward Anthony 1904- *DcBrA 2*
Craig, Edward Gordon 1872-1966 *DcBrA 1, DcBrBI, McGDA*
Craig, Emmett J 1878- *WhAmArt 85*
Craig, Eugene 1916- *WhoAmA 73, -76, -78, -80, -82*
Craig, F W *AmArch 70*
Craig, Frank *WhAmArt 85*
Craig, Frank 1874-1918 *ClaDrA, DcBrA 1, DcBrBI, DcVicP 2*
Craig, Frank Barrington 1902-1951 *DcBrA 1*
Craig, Gordon 1872-1966 *OxTwCA, PhDcTCA 77*
Craig, Isaac Eugene *ArtsNiC*
Craig, Isaac Eugene 1830- *NewYHSD*
Craig, J Humbert d1944 *DcBrA 1*
Craig, James d1795 *McGDA*
Craig, James d1922 *BiDAmAr*
Craig, James 1744-1795 *BiDBrA, MacEA*
Craig, James 1819-1896 *FolkA 86*
Craig, James 1823-1889 *FolkA 86*
Craig, James Stephenson *ClaDrA, DcVicP 2*
Craig, John *BiDBrA*
Craig, John 1828?- *FolkA 86*
Craig, John 1926- *WorECom*
Craig, John Dean 1947- *MacBEP*
Craig, Kirk Robins 1929- *AmArch 70*
Craig, Margaret *WhAmArt 85*
Craig, Margaret Bell 1876- *DcWomA*
Craig, Margaret H 1853-1951 *DcWomA*
Craig, Marie Jackson 1908- *WhAmArt 85*
Craig, Martin 1906- *WhAmArt 85, WhoAmA 73, -76, -78, -80, -82*
Craig, Nancy Ellen *WhoAmA 73, -76, -78, -80, -82, -84*
Craig, Netta *DcWomA, WhAmArt 85*
Craig, Phillip *DcVicP 2*
Craig, Ralph Spann 1908- *WhAmArt 85*
Craig, Randall J *AfroAA*
Craig, Robert *WhAmArt 85*
Craig, Robert 1802?- *FolkA 86*
Craig, Robertson H 1916- *DcBrA 2*
Craig, Samuel *NewYHSD*
Craig, Susan V 1948- *WhoAmA 84*
Craig, Teryl Timothy 1947- *MarqDCG 84*
Craig, Theodore B *WhAmArt 85*
Craig, Thomas B 1849-1924 *WhAmArt 85*
Craig, Thomas Bigelow 1849-1924 *ArtsAmW 1*
Craig, Tom 1909- *WhAmArt 85*
Craig, William *AfroAA*
Craig, William 1829- *ArtsNiC*
Craig, William 1829-1875 *DcBrWA, DcVicP 2*
Craig, William, Jr. 1824- *FolkA 86*
Craig, William, Sr. 1800-1880 *FolkA 86*
Craig, William Marshall 1765?-1834? *DcBrBI, DcBrWA*

Crawford, Ebenezer *DcVicP 2*
Crawford, Edgar A *WhAmArt 85*
Crawford, Edmund Thornton 1806-1885 *ClaDrA, DcBrWA, DcVicP, -2*
Crawford, Emily *DcWomA*
Crawford, Esther Mabel 1872- *WhAmArt 85*
Crawford, Esther Mabel 1872-1958 *ArtsAmW 2, DcWomA*
Crawford, Ethelbert Baldwin 1872-1921 *ArtsAmW 3*
Crawford, Eugene Eleuthere 1918- *AmArch 70*
Crawford, Eugenia N *DcWomA*
Crawford, G *DcBrECP*
Crawford, G A *AmArch 70*
Crawford, Harold Hamilton 1888- *AmArch 70*
Crawford, Homer *AfroAA*
Crawford, Hugh Adam 1898- *DcBrA 1*
Crawford, Isabel *DcWomA, WhAmArt 85*
Crawford, Jacob *CabMA*
Crawford, James Logan 1949- *MarqDCG 84*
Crawford, Joan Margaret Caldwell *WhoArt 80, -82, -84*
Crawford, John 1838?- *NewYHSD*
Crawford, John Gardiner 1941- *WhoArt 82, -84*
Crawford, John McAllister, Jr. 1913- *WhoAmA 73, -76, -78, -80, -82, -84*
Crawford, John Wickham 1936- *AmArch 70*
Crawford, Josephine 1878-1952 *DcWomA*
Crawford, Julia Tilley 1896- *DcWomA*
Crawford, Katherine Penn 1865- *WhAmArt 85*
Crawford, Leonard 1920- *McGDA*
Crawford, Lesley *WhAmArt 85*
Crawford, Louis N 1890-1946 *BiDAmAr*
Crawford, Mary Ann Elizabeth 1901- *AmArch 70*
Crawford, Mel 1925- *WhoAmA 76, -78, -80, -82*
Crawford, Neelon *PrintW 85*
Crawford, R H *AmArch 70*
Crawford, R O *AmArch 70*
Crawford, Ralph Herbert 1931- *AmArch 70*
Crawford, Ralston 1906- *BnEnAmA, DcAmArt, DcCAA 71, -77, McGDA, OxTwCA,. PhDcTCA 77, WhAmArt 85, WhoAmA 73, -76, -78*
Crawford, Ralston 1906-1977 *WhoAmA 80N, -82N, -84N*
Crawford, Ralston 1906-1978 *WorArt[port]*
Crawford, Robert Brandon 1927- *AmArch 70*
Crawford, Robert Cree 1842-1924 *DcBrA 1, DcVicP 2*
Crawford, Susan Fletcher d1919 *DcBrA 1*
Crawford, Susan Fletcher 1868-1919 *DcWomA*
Crawford, Thomas *DcBrECP*
Crawford, Thomas 1813-1857 *BnEnAmA, DcAmArt, IlBEAAW, OxArt*
Crawford, Thomas 1814-1857 *ArtsNiC, McGDA, NewYHSD*
Crawford, Thomas Hamilton *DcBrA 1, DcVicP 2*
Crawford, Thomas Hamilton d1948 *DcBrA 2*
Crawford, W G *AmArch 70*
Crawford, Mrs. W L *ArtsAmW 3*
Crawford, Will *ConICB*
Crawford, Will 1869-1944 *ArtsAmW 1, IlBEAAW, IlrAm A, -1880, WhAmArt 85, WorECar*
Crawford, William *ArtsNiC*
Crawford, William d1869 *ArtsNiC*
Crawford, William 1825-1869 *DcVicP 2*
Crawford, William Galbraith 1894- *IlrAm D, -1880*
Crawford, William Graves 1907- *AmArch 70*
Crawford, William H 1913- *WhAmArt 85, WhoAmA 73, -76, -78, -80, -82N, -84N, WorECar*
Crawford, William Lee 1932- *MarqDCG 84*
Crawfurd, Eileen Mary 1916- *WhoArt 80*
Crawhall, Joseph 1821-1896 *DcBrBI, DcBrWA, DcVicP 2*
Crawhall, Joseph 1860-1913 *ClaDrA*
Crawhall, Joseph 1861-1913 *DcBrA 1, DcVicP, -2, McGDA*
Crawhall, Joseph Creeps 1861-1913 *DcBrWA*
Crawhall, Joseph E 1861-1913 *DcBrBI*
Crawhall, W *DcVicP 2*
Crawley, Davie Garman 1931- *AmArch 70*
Crawley, Edmund *DcBrECP*
Crawley, Ida Jolly 1867- *DcWomA, WhAmArt 85*
Crawley, James *WhoArt 80, -82, -84*
Crawley, John 1784- *NewYHSD*
Crawley, John R, Jr. *NewYHSD*
Crawley, Wesley V 1922- *WhoAmA 73, -76, -78, -80, -82, -84*
Crawshaw, Alwyn 1934- *WhoArt 80, -82, -84*
Crawshaw, Frances 1876- *DcBrA 1, DcWomA*
Crawshaw, Francis 1876- *ClaDrA*
Crawshaw, J E *DcBrBI*
Crawshaw, Lionel Townsend *ClaDrA*
Crawshaw, Lionel Townsend d1949 *DcBrA 1*
Crawshaw, Lionel Townsend 1864-1949 *DcBrA 2*
Crawshaw, Luke 1856- *WhAmArt 85*
Craxton, John 1922- *DcBrA 1, PhDcTCA 77, WhoArt 80, -82, -84*
Craycroft, T V *AmArch 70*
Crayer, Gaspard De 1584?-1669 *McGDA*
Crayer, Jasper De 1584-1669 *ClaDrA*
Creager, Charles ▲ 1808-1896 *BiDAmAr*

Creager, Frederick Leon 1926- *AmArch 70*
Creal, J P, Jr. 1903-1933 *WhAmArt 85*
Creal, Thomas Knapp, III *AmArch 70*
Crealock, Henry Hope 1831-1891 *DcBrBI, DcBrWA*
Crealock, John Mansfield 1871-1959 *DcBrA 1*
Creamer, David H 1957- *ConGrA 1[port]*
Creamer, Paul Lyle 1928- *WhoAmA 73, -76, -78*
Creamer, Peter Tyrrell 1933- *AmArch 70*
Creamer, Susan *FolkA 86*
Creanga, Horia 1893-1943 *MacEA*
Creange, Henry *WhAmArt 85*
Crease, Barbara Lindley *DcWomA*
Crease, Josephine 1864-1947 *DcWomA*
Crease, Mary Maberly 1854-1915 *DcWomA*
Crease, Lady Sarah 1826-1922 *DcWomA*
Crease, Sarah Lindley 1867-1940 *DcWomA*
Crease, Susan Reynolds 1855-1947 *DcWomA*
Crease Sisters *DcWomA*
Creaser, Gerald Van *MarqDCG 84*
Creaser, W H *AmArch 70*
Creasey, Maria *DcVicP 2*
Creasy, Mrs. *DcVicP 2, DcWomA*
Creasy, John L *DcBrWA*
Creatore, Mary-Alice 1920- *WhoAmA 76, -78, -80, -82, -84*
Crebassol, Prosper *NewYHSD*
Crecelius, Ludwig *FolkA 86*
Credi, Lorenzo Di 1458?-1537 *McGDA, OxArt*
Credi, Lorenzo Di 1459-1527 *ClaDrA*
Credle, Ellis 1902- *IlsCB 1744, -1946*
Cree, Alexander 1929- *WhoArt 80, -82, -84*
Cree, Edward Hodges d1869? *DcBrWA*
Cree, Janet 1910- *DcBrA 1*
Cree, Matilda *FolkA 86*
Creech, Franklin Underwood 1941- *WhoAmA 73, -76, -78, -80, -82, -84*
Creech, Homer E 1948- *FolkA 86*
Creecy, Mrs. E T *WhAmArt 85*
Creecy, Emma T *DcWomA*
Creecy, Herbert Lee 1939- *WhoAmA 73*
Creecy, Herbert Lee, Jr. 1939- *ConArt 77, WhoAmA 78*
Creed *WorFshn*
Creed, Charles 1908-1966 *FairDF ENG*
Creed, Elizabeth 1642-1728 *DcBrECP, DcWomA*
Creed, Lilla P *DcWomA*
Creed, William *NewYHSD*
Creeft, Jose De *WorArt*
Creeft, Jose De 1884- *OxTwCA, PhDcTCA 77*
Creek Charlie *FolkA 86*
Creekbaum, Cornell Franklyn 1922- *AmArch 70*
Creekmore, Raymond 1905- *IlsCB 1946*
Creekmore, Raymond L 1905- *WhAmArt 85*
Creel, Harold Lee 1952- *MarqDCG 84*
Creel, Wrenn Miller 1925- *AmArch 70*
Creer, Philip Douglas 1903- *AmArch 70*
Crees, James Leslie *DcBrWA*
Crees, W H *DcVicP 2*
Creese, Walter Littlefield 1919- *WhoAmA 73, -76, -78, -80, -82, -84*
Creffield, Dennis 1931- *ConBrA 79[port], DcCAr 81, WhoArt 80, -82, -84*
Cregeen, Bertha C *DcVicP 2*
Cregeen, Emily A *DcVicP 2*
Cregeen, Nesey Isabel *DcVicP 2*
Crego, David Groves 1929- *AmArch 70*
Crehen, Charles G 1829- *NewYHSD*
Crehen, E *NewYHSD*
Crehen, Lewis E *NewYHSD*
Crehore, S *FolkA 86*
Crehores *CabMA*
Creifelds, Richard 1853-1939 *WhAmArt 85*
Creifield *NewYHSD*
Creiger, Augustus *FolkA 86*
Creighton, Bessy 1884- *DcWomA, WhAmArt 85*
Creighton, Caroline Elizabeth M Stuart *DcWomA*
Creighton, Gwen Lux *WhoAmA 78, -80, -82, -84*
Creighton, James E 1856-1946 *BiDAmAr*
Creighton, Thomas Hawk 1904- *AmArch 70*
Creighton, W *NewYHSD*
Creixell, Rosario *WorFshn*
Creker *NewYHSD*
Crelinger, Marie *DcWomA*
Crelly, William Richard 1924- *WhoAmA 80, -82, -84*
Cremean, Robert 1932- *DcCAA 71, -77, WhoAmA 73, -76, -78*
Cremer, Fritz 1906- *McGDA*
Cremer, Marva 1942- *AfroAA*
Cremonini, Leonardo 1925- *ConArt 77, -83, McGDA, PhDcTCA 77, WorArt[port]*
Crenier, Henri 1873- *WhAmArt 85*
Crennen, Martin William 1930- *AmArch 70*
Crenshaw, Karen Bruce 1952- *WhoAmA 82, -84*
Crenshaw, Thomas Thompson 1909- *AmArch 70*
Creo, Leonard E 1923- *WhoAmA 73*
Crepax, Guido 1933- *ConGrA 1, WorECom*
Crepin, Louis Philippe 1772-1851 *DcSeaP*
Crepin, Suzanne *DcWomA*
Crepson, Leonard 1837?- *NewYHSD*
Crescent, Francine *WorFshn*
Cresci, Mario 1942- *MacBEP*

Cresilas *McGDA*
Cresind *NewYHSD*
Crespel, Berthe Marie Henriette *DcWomA*
Crespi, Antonio Maria *McGDA*
Crespi, Countess Consuelo *WorFshn*
Crespi, Daniele 1590-1630 *ClaDrA*
Crespi, Daniele 1600?-1630 *McGDA*
Crespi, Giovanni Battista 1575-1632 *McGDA*
Crespi, Giuseppe Maria 1664-1747 *McGDA*
Crespi, Giuseppe Maria 1665-1747 *OxArt*
Crespi, Pachita 1900-1971 *WhAmArt 85, WhoAmA 78N, -80N, -82N, -84N*
Crespigny, Cerise De *DcWomA*
Crespin, Leslie 1947- *AmArt*
Crespin, Paul *AntBDN Q*
Crespo, Beth 1954- *MarqDCG 84*
Crespo, Michael Lowe 1947- *WhoAmA 78, -80, -82, -84*
Crespo DeReigon, Asuncion *DcWomA*
Cress, Carl Duval, Jr. 1924- *AmArch 70*
Cress, Edward 1906- *FolkA 86*
Cress, George Ayers 1921- *WhAmArt 85, WhoAmA 73, -76, -78, -80, -82, -84*
Cressent, Charles 1685-1768 *AntBDN G, DcD&D, McGDA, OxDecA*
Cressey, Blanche George d1930 *WhAmArt 85*
Cressey, Meta 1882-1964 *DcWomA*
Cressey, Susan K d1942 *WhAmArt 85*
Cressey, Thomas 1842-1909 *BiDAmAr*
Cressman, Jack Edward 1938- *AmArch 70*
Cressman, Wayne E 1883- *WhAmArt 85*
Cresson, Cornelia 1915- *WhAmArt 85*
Cresson, James 1709- *CabMA*
Cresson, Jeremiah *CabMA*
Cresson, Margaret 1889-1973 *DcWomA, WhoAmA 76N, -78N, -80N, -82N, -84N*
Cresson, Margaret French 1889- *WhoAmA 73*
Cresson, Margaret French 1889-1973 *WhAmArt 85*
Cresson, Solomon *CabMA*
Cresswell, A E B *DcVicP 2*
Cresswell, Charles T *WhAmArt 85*
Cresswell, Henrietta *DcVicP 2*
Cresswell, William Nichol 1822-1888 *ArtsAmW 3*
Cressy, Bert *WhAmArt 85*
Cressy, Bert 1883-1944 *ArtsAmW 2*
Cressy, Birl 1883-1944 *ArtsAmW 2*
Cressy, F A *DcWomA*
Cressy, Mrs. F A *ArtsEM*
Cressy, Henry 1809- *CabMA*
Cressy, Josiah Perkins 1814- *ArtsAmW 2, NewYHSD*
Cressy, Meta *WhAmArt 85*
Cressy, Meta 1882-1964 *ArtsAmW 2*
Cressy, Susan K d1942 *DcWomA*
Cresti, Domenico *McGDA*
Creswell, Emily Grace 1889- *ClaDrA, DcBrA 1, DcWomA*
Creswell, H B 1869-1960 *MacEA*
Creswell, Henrietta *DcWomA*
Creswell, J *DcVicP 2*
Creswell, William d1819 *BiDBrA*
Creswick, Mrs. *DcVicP 2, DcWomA*
Creswick, H G *DcVicP 2*
Creswick, James *AntBDN N*
Creswick, Mortimer *DcVicP 2*
Creswick, Thomas *AntBDN N*
Creswick, Thomas 1811-1869 *ClaDrA, DcBrBI, DcBrWA, DcVicP, -2*
Creswick, Thomas 1811-1870 *ArtsNiC*
Cresy, Edward 1792-1858 *BiDBrA*
Cret, Paul Philippe 1876-1945 *MacEA*
Cret, Paul Phillippe 1876-1945 *BiDAmAr, EncAAr*
Cretara, Domenic Anthony 1946- *WhoAmA 78, -80, -82, -84*
Creti, Donato 1671-1749 *ClaDrA*
Creti, Ersilia 1720?-1777 *DcWomA*
Cretius, Constantine Johann Franz 1814- *ArtsNiC*
Creus, William *FolkA 86*
Creusy, Caroline *DcWomA*
Creutfelder, Johann 1570-1636 *ClaDrA*
Creutzburg, Caspar *IlDcG*
Creutzer, John A d1929? *BiDAmAr*
Creutzfeldt, Benjamin d1853 *IlBEAAW*
Creveling, Leala *WhAmArt 85*
Crevoisier, Marie Jeanne 1755-1790 *DcWomA*
Crew, Miss *DcWomA*
Crew, Emma *DcWomA*
Crew, John Thistlewood *BiDBrA*
Crew, Katherin *ArtsAmW 2, DcWomA, WhAmArt 85*
Crew, Mayo 1903- *WhAmArt 85*
Crew, Ronald C 1934- *MarqDCG 84*
Crews, Donald *IlsBYP, IlsCB 1967*
Crews, Monte 1888-1946 *WhAmArt 85*
Crews, Seth Floyd 1885?- *ArtsAmW 3, IlBEAAW, WhAmArt 85*
Crezee, Marion *DcCAr 81*
Cribb, Preston 1876-1937 *DcBrA 1*
Cribben, A J, Jr. *AmArch 70*
Cribbs, Daniel *FolkA 86*

Cribbs, George A 1886- *WhAmArt 85*
Cribbs, Peter *FolkA 86*
Crichlow, Ernest 1914- *AfroAA*
Crichlow, Ernest T *IlsCB 1967*
Crichlow, Ernest T 1914- *IlsBYP, IlsCB 1957*
Crichton, N S *DcVicP 2*
Crichton, Richard 1771?-1817 *BiDBrA*
Crickmay, Anthony 1937- *MacBEP*
Criddle, Mrs. Harry 1805-1880 *DcVicP 2*
Criddle, Mary Ann 1805-1880 *DcBrWA, DcWomA*
Crider, Edward Samuel 1925- *AmArch 70*
Crider, P E *AmArch 70*
Crider, Susy A *FolkA 86*
Cridland, Charles E *FolkA 86, NewYHSD*
Cridland, Helen *DcVicP 2*
Cridland, Leander, Jr. 1841?- *NewYHSD*
Crier, J S *AmArch 70*
Crighton, Hugh Ford *DcVicP 2*
Crile, Susan 1942- *DcCAr 81, PrintW 83, -85, WhoAmA 78, -80, -82, -84*
Criley, Theodore 1880- *ArtsAmW 2, WhAmArt 85*
Criley, Theodore, Jr. 1905- *AmArch 70*
Crim, Walter H, Jr. 1879-1930 *BiDAmAr*
Crimi, Alfred D 1924- *WhoAmA 73, -76, -78, -80, -82, -84*
Crimi, Alfredo DeGiorgio 1900- *WhAmArt 85*
Crimmins, Jerry 1940- *WhoAmA 80, -82, -84*
Crimp, Douglas 1944- *WhoAmA 78, -80, -82, -84*
Crimp, F W *AmArch 70*
Cripe, Jack *FolkA 86*
Crippa, Josephine *DcWomA*
Crippa, Roberto 1912-1972 *ConArt 77*
Crippa, Roberto 1921- *PhDcTCA 77*
Crippa, Roberto 1921-1972 *ConArt 83, OxTwCA*
Crippen, Robert Earl 1922- *AmArch 70*
Crippen, Robert Edward 1952- *MarqDCG 84*
Cripps, Michael P 1947- *MarqDCG 84*
Cripps, William *AntBDN Q*
Criquette *WhoAmA 73, -76, -78, -80, -82, -84*
Crisand, Emil *NewYHSD*
Criscuolo, Mariangiola 1548- *DcWomA*
Crise, Stewart Stroud 1886- *WhAmArt 85*
Crisera, Joseph John 1907- *WhAmArt 85*
Crisler, Richard 1908- *WhAmArt 85*
Crisman, W H *FolkA 86*
Crisp, Anna E *DcWomA*
Crisp, Arthur 1881- *WhAmArt 85*
Crisp, Donald Gilliam, Jr. 1924- *AmArch 70*
Crisp, F E F d1915 *DcBrA 2*
Crisp, Frank E F d1915 *DcBrBI*
Crisp, H *DcVicP 2*
Crisp, Herbert G 1867-1939 *BiDAmAr*
Crisp, Mary Ellen 1896- *WhAmArt 85*
Crisp, William *CabMA*
Crispe, Leila Constance *DcVicP 2, DcWomA*
Crispell, John H *FolkA 86*
Crispi, Richard John 1936- *AmArch 70*
Crispin *McGDA*
Crispinian *McGDA*
Crispo, Andrew J 1945- *WhoAmA 80, -82, -84*
Crispo, Andrew John 1945- *WhoAmA 73, -76, -78*
Crispo, Dick 1945- *AmArt, WhoAmA 76, -78, -80, -82, -84*
Criss, Francis 1901-1973 *WhAmArt 85*
Criss, Francis H 1901- *DcCAA 71*
Criss, Francis H 1901-1973 *DcCAA 77, WhoAmA 78N, -80N, -82N, -84N*
Criss, Norma 1942- *AfroAA*
Crissay, Marguerite 1874-1945 *DcWomA*
Crissey, Thomas Henry 1875- *WhAmArt 85*
Crist, Richard 1909- *WhoAmA 73*
Crist, Richard Harrison 1909- *WhAmArt 85*
Crist, William Gary 1937- *WhoAmA 78, -80, -82, -84*
Cristall, Elizabeth 1770?-1851? *DcWomA*
Cristall, Joshua 1767-1847 *ClaDrA, DcBrWA, McGDA*
Cristiani, Elisabeth *DcWomA*
Cristiani, Giovanni *McGDA*
Cristin-Poucher, Lilli Fong 1947- *WhoAmA 82, -84*
Cristofani, Buonamico *McGDA*
Cristofano, Francesco Di *McGDA*
Cristofano, Francisco Di *OxArt*
Cristoforo, Eusebio Di Giacomo Di *McGDA*
Cristoforo Fini, Tommaso Di *McGDA*
Cristy, Joseph H *NewYHSD*
Criswell, William *BiDBrA*
Critcher, Catharine Carter 1868- *ArtsAmW 1*
Critcher, Catharine Carter 1868-1964 *ArtsAmW 3, DcWomA*
Critcher, Catherine C 1868?- *WhAmArt 85*
Critcher, Catherine Carter 1879?- *IlBEAAW*
Critchett, Naomi Azalia *AfroAA*
Critchfield, Harry G 1940- *MacBEP*
Critchley, John York 1916- *AmArch 70*
Crite, Allan *FolkA 86*
Crite, Allan Rohan 1910- *AfroAA, WhAmArt 85, WhoAmA 73, -76, -78, -80, -82, -84*
Crites, Cyrus *FolkA 86*
Crites, Eldon C 1936- *MarqDCG 84*
Crites, Raymond David 1925- *AmArch 70*
Critius *McGDA, OxArt*

Crittenden, Mrs. C D *WhAmArt 85*
Crittenden, Dora E *DcVicP 2*
Crittenden, E B *AmArch 70*
Crittenden, Elizabeth C *ArtsEM, DcWomA*
Crittenden, Ethel Stuart 1894- *ArtsAmW 2, DcWomA, WhAmArt 85*
Crittenden, John William Neil 1939- *WhoAmA 78, -80, -82*
Crittenden, Lilian Haines d1919 *DcWomA*
Crittenden, Lillian d1919 *WhAmArt 85*
Crittenden, N W *AmArch 70*
Crittenden, Richard 1764- *CabMA*
Crittenden, S Virginia *DcWomA*
Critz, Richard Laurens 1922- *AmArch 70*
Crivale, Countess *DcWomA*
Crivelli, Carlo *McGDA, OxArt*
Crivelli, Carlo 1435?-1494? *ClaDrA*
Crivelli, Taddeo 1425?-1485 *McGDA*
Crivelli, Vittorio d1502? *McGDA*
Crivello, Joe *MarqDCG 84*
Criz, A *AmArch 70*
Crocca, William Thomas 1944- *MarqDCG 84*
Crocco, John Edward 1922- *AmArch 70*
Croce, Benedetto 1866-1952 *McGDA, OxArt*
Croce, Chester 1904- *AmArch 70*
Croce, Giancarlo 1945- *ConArt 77*
Croce, Isabel M *WhAmArt 85*
Croce, J *AntBDN D*
Crochet, Suzanne *DcWomA*
Crochez, T *DcVicP 2*
Crock, Charles *FolkA 86*
Crocken, William Edward 1932- *MarqDCG 84*
Crocker, Mister *NewYHSD*
Crocker, Mrs. *NewYHSD*
Crocker, A C *DcVicP 2*
Crocker, A L *DcWomA*
Crocker, Mrs. A L *WhAmArt 85*
Crocker, Barbara 1910- *DcBrA 1, WhoArt 80, -82, -84*
Crocker, Charles Mathew *ArtsAmW 1*
Crocker, Charles Mathew 1877-1951? *ArtsAmW 3*
Crocker, Charles Matthew *WhAmArt 85*
Crocker, Charles Matthew 1877-1951? *ArtsAmW 3*
Crocker, Edward 1757?-1836 *BiDBrA*
Crocker, Ephraim *FolkA 86*
Crocker, J Denison 1823- *NewYHSD*
Crocker, James Benjamin 1920- *AmArch 70*
Crocker, John W *NewYHSD*
Crocker, Kezia *WhAmArt 85*
Crocker, Marion E *WhAmArt 85*
Crocker, Martha 1883- *WhAmArt 85*
Crocker, Martha E 1883- *DcWomA*
Crocker, Theodore Eustace 1911- *AmArch 70*
Crocker, W H 1856-1928 *WhAmArt 85*
Crocket, Henry Edgar 1870-1926 *DcBrWA*
Crocket, Henry Edgar 1874-1926 *DcBrA 1*
Crockett, David W 1924- *AmArch 70*
Crockett, Gib 1912- *WhoAmA 82, -84*
Crockett, Gibson M 1912- *WhoAmA 76, -78, -80*
Crockett, Gibson Milton 1912- *WorECar*
Crockett, Lucy Herndon 1914- *IlsCB 1744, -1946*
Crockett, Otto *FolkA 86*
Crockett, Samuel Lane 1822-1855 *NewYHSD*
Crockett, Thomas *CabMA*
Crockford, Miss *DcVicP 2*
Crockford, F *DcVicP 2*
Crockford, George *DcVicP, -2*
Crockwell, Douglas d1968 *WhoAmA 78N, -80N, -82N, -84N*
Crockwell, Douglass 1904-1968 *IlrAm 1880, WhAmArt 85*
Crocov, P G *WhAmArt 85*
Crodel, Carl 1894- *McGDA*
Crofoot, Joseph *FolkA 86*
Croft, Arthur *DcVicP, -2*
Croft, Arthur 1828- *DcBrWA, DcVicP 2*
Croft, Charles Benjamin *AmArch 70*
Croft, Ivor John 1923- *WhoArt 80, -82, -84*
Croft, John *DcVicP 2*
Croft, John Ernest *DcBrWA, DcVicP 2*
Croft, John James, Jr. 1913- *AmArch 70*
Croft, Lewis Scott 1911- *WhoAmA 73, -76, -78, -80*
Croft, M E *DcWomA*
Croft, Marian *DcBrWA, DcVicP 2, DcWomA*
Croft, Marjorie 1889- *DcWomA*
Croft, Mary Anne *DcWomA*
Croft, Maxwell *WorFshn*
Croft, Michael Flynt 1941- *WhoAmA 78, -80, -82, -84*
Croft, Richard *DcCAr 81*
Croft, Richard John 1935- *ClaDrA, WhoArt 80, -82, -84*
Croft, W H *AmArch 70*
Croft-Murray, Edward *WhoArt 82N*
Croft-Murray, Edward 1907- *WhoArt 80*
Crofton, Cora *DcWomA*
Crofts, Ernest 1847- *ArtsNiC*
Crofts, Ernest 1847-1911 *DcBrA 1, DcVicP, -2*
Crofts, Ernest 1847-1911 *ClaDrA*
Crofts, Stella Rebecca 1898- *DcBrA 1*
Crofts, Stella Rebecca 1898-1964 *DcWomA*

Crofut, Bob *ConGrA 1*
Crofut, Robert 1951- *IlrAm 1880*
Crofut, Robert Joel 1951- *ConGrA 1[port]*
Crogan, Andrew *NewYHSD*
Croggan, William *DcNiCA*
Croisier, Marie Anne 1765-1812 *DcWomA*
Croissant, Michel 1928- *DcCAr 81*
Croix, Jeanne DeLa *DcWomA*
Croix, Madeleine Ursule DeLa *DcWomA*
Croix, Pierre Frederik DeLa 1709?-1782 *ClaDrA*
Croix, Susanna DeLa *DcWomA*
Croizette, Pauline Marie Charlotte *DcWomA*
Croke, Lewis Edmund 1875- *ClaDrA*
Croker, Marianne *DcWomA*
Crola, Elise 1809-1878 *DcWomA*
Crolius, Clarkson, I 1773-1843 *FolkA 86*
Crolius, Clarkson, II 1806-1887 *FolkA 86*
Crolius, George *FolkA 86*
Crolius, John *FolkA 86*
Crolius, Peter *FolkA 86*
Crolius, William 1700- *FolkA 86*
Croll, Douglas E 1922- *AmArch 70*
Croll, John *FolkA 86*
Crom, Lillian Hobbes *DcWomA, WhAmArt 85*
Cromar, Theodore Robb, Jr. 1924- *AmArch 70*
Cromarty, Margaret A 1873- *DcWomA, WhAmArt 85*
Crombe, J G *AmArch 70*
Crombie, Alexander 1709?-1785 *BiDBrA*
Crombie, Benjamin William 1803-1847 *DcBrBI*
Crombie, Charles *DcBrBI*
Crombie, Elizabeth E *DcVicP 2, DcWomA*
Crombie, Ruth E *DcWomA, WhAmArt 85*
Crombie, Samuel B 1818- *CabMA*
Crome, Emily 1801-1833 *DcBrWA, DcWomA*
Crome, Frederick James 1796-1831 *DcBrWA*
Crome, John 1768-1821 *ClaDrA, DcBrWA, McGDA, OxArt*
Crome, John Bernay 1794-1842 *McGDA*
Crome, John Berney 1794-1842 *DcBrWA, DcVicP 2*
Crome, Vivian *DcVicP, -2*
Crome, William Henry 1806-1873 *ClaDrA, DcBrWA, DcVicP 2*
Cromek, Thomas Hartley 1809-1873 *ArtsNiC, DcBrWA, DcVicP 2*
Cromer, J B *DcVicP 2*
Cromer, James Harold 1959- *MarqDCG 84*
Cromie, Victor Hugh 1930- *AmArch 70*
Crommelin, M *DcVicP 2*
Crommelynck, Landa *IlsBYP*
Crommie, Michael James 1889- *WhAmArt 85*
Crompton, D E *AmArch 70*
Crompton, Gertrude 1874- *ClaDrA, DcBrA 1, DcWomA*
Crompton, James Shaw 1853-1916 *DcBrA 1, DcBrWA, DcVicP 2*
Crompton, John *DcVicP 2*
Crompton, John d1927 *DcBrA 2*
Crompton, Mildred Roberts *DcVicP 2*
Crompton, Samuel 1735-1827 *OxDecA*
Cromwell *NewYHSD*
Cromwell, C I *AmArch 70*
Cromwell, Edwin Boykin 1909- *AmArch 70*
Cromwell, George R *NewYHSD*
Cromwell, Joane *WhAmArt 85*
Cromwell, Joane d1966 *DcWomA*
Cromwell, John L *NewYHSD*
Cromwell, John L 1805-1873 *FolkA 86*
Cromwell, Russell Vernon 1931- *AmArch 70*
Cromwell, Stephen *FolkA 86*
Cromwell, Thomas *CabMA*
Cron, Nina Nash 1883- *WhAmArt 85*
Cron, Nina R 1883- *DcWomA*
Cronaca 1457-1508 *WhoArch*
Cronaca, Il 1457-1508 *MacEA, McGDA*
Cronan, Julie 1845- *DcWomA*
Cronau, Rudolf Daniel Ludwig 1855-1939 *ArtsAmW 2*
Cronbach, Robert M 1908- *DcCAA 71, -77, WhAmArt 85, WhoAmA 73, -76, -78, -80, -82, -84*
Crone, Robert d1779 *DcBrWA*
Crone, Robert 1718?-1779 *DcBrECP*
Crone, Wesley James 1925- *AmArch 70*
Cronenburch, Anna Van *DcWomA*
Cronenburg, Anna Van *DcWomA*
Cronenwett, Clare *ArtsAmW 3, WhAmArt 85*
Crongeyer, Theodore *FolkA 86*
Crongeyer, Theodore E *ArtsEM*
Crongeyer And Averbeck *ArtsEM*
Crongeyer And Kuntze *ArtsEM*
Cronheim, Nathan 1908- *AmArch 70*
Cronin, David Edward 1839-1925 *NewYHSD, WhAmArt 85*
Cronin, J R *AmArch 70*
Cronin, Marie *ArtsAmW 2, DcWomA, WhAmArt 85*
Cronin, Robert 1936- *WhoAmA 73, -76, -78, -80, -82, -84*
Cronin, Robert Zimmerman 1951- *DcCAr 81*
Cronin, Tony d1979 *WhoAmA 80N, -82N, -84N*
Cronk, D *DcWomA*

Cronk, Mrs. D ArtsEM
Cronk, Leslie J 1924- AmArch 70
Cronk, Marian 1906- WhAmArt 85
Cronk, T J FolkA 86
Cronqvist, Lena 1938- DcCAr 81
Cronshagen, Eugene Richard 1950- MarqDCG 84
Cronshaw, James Henry 1859- ClaDrA, DcBrA 1, DcBrWA, DcVicP 2
Cronyn, George W ArtsAmW 3, WhAmArt 85
Cronyn, Hugh Verschoyle WhoArt 80, -82, -84
Cronyn, Hugh Verschoyle 1905- DcBrA 1
Cronyn, Randolph E 1901- WhAmArt 85
Cronyon, V DcWomA
Crook, A R d1930 WhAmArt 85
Crook, Gordon Stephen 1921- ClaDrA
Crook, James 1759-1781? DcBrECP
Crook, John Charles 1925- AmArch 70
Crook, Kenneth E 1899- WhAmArt 85
Crook, Russell Gerry 1869- WhAmArt 85
Crook, Susan Lee WhAmArt 85
Crook, Thomas Mewburn 1869-1949 DcBrA 1
Crook, Vicki AfroAA
Crook, Walter CabMA
Crooke, James Joseph, Jr. 1921- AmArch 70
Crooke, John DcVicP 2
Crooke, Muriel Elise 1901- DcBrA 1
Crooke, Ray Austin 1922- OxTwCA
Crooke, W DcVicP 2
Crooks FolkA 86
Crooks, Arthur d1888 BiDAmAr
Crooks, Barbara Gwendolen Anne 1904- WhoArt 80, -82, -84
Crooks, Floyd FolkA 86
Crooks, Forrest C 1893- WhAmArt 85
Crooks, John Marion WhAmArt 85
Crooks, Thomas 1941- MarqDCG 84
Crooks, W Spencer 1917- WhoAmA 76, -78, -80, -82, -84
Crooks, Wilfred Speaker AmArch 70
Crooks, William Ryffle, Jr. 1940- AmArch 70
Croom, C E AmArch 70
Croome, C J DcVicP 2
Croome, George L NewYHSD
Croome, J D DcVicP 2
Croome, William 1790-1860 EarABI, EarABI SUP, NewYHSD
Croonquist, Alfred H 1924- AmArch 70
Croos, Antonie Jansz VanDer 1606?-1662? McGDA
Croos, Jacob Van 1637?- DcSeaP
Croos, Jacob VanDer d1690? McGDA
Croos, Pieter VanDer 1610?-1677 DcSeaP
Cropley, Miss DcWomA
Cropper, Harvey Tristan 1931- AfroAA
Cropper, M Elizabeth 1944- WhoAmA 84
Cropsey, Jasper F 1823- ArtsNiC
Cropsey, Jasper F 1823-1900 DcAmArt, DcBrBI, EarABI, WhAmArt 85
Cropsey, Jasper Francis 1823-1900 BnEnAmA, McGDA, NewYHSD
Croquet, Francoise DcWomA
Croquis, Alfred OxArt
Cros, Charles Emile-Hortensius 1842-1888 MacBEP
Cros, Henri 1840-1907 DcNiCA, IlDcG
Cros, Jean IlDcG
Crosato, Giambattista 1685?-1758 McGDA
Crosbie, Helen Blair WhoAmA 78, -80, -82, -84
Crosbie, William 1915- DcBrA 1
Crosby, C Wellington WhAmArt 85
Crosby, Caresse 1892- DcWomA
Crosby, Charles H 1819-1896 NewYHSD
Crosby, Charles James 1809-1890 DcBrWA
Crosby, Donald Alton AmArch 70
Crosby, Gertrude DcWomA
Crosby, Gertrude Volz WhAmArt 85
Crosby, H AmArch 70
Crosby, Harold Dana, Jr. 1922- AmArch 70
Crosby, Henry Barrett d1945 BiDAmAr
Crosby, James L NewYHSD
Crosby, John Campbell 1912- IlsBYP
Crosby, Katharine V R 1897- WhAmArt 85
Crosby, Katherine VanRensellaer 1897- DcWomA
Crosby, Maria NewYHSD
Crosby, Percy L WhAmArt 85
Crosby, Percy Leo 1891-1964 WorECom
Crosby, Ralph Mitchell 1894- AmArch 70
Crosby, Ranice 1915- WhoAmA 73
Crosby, Ranice W 1915- WhoAmA 76, -78, -80, -82, -84
Crosby, Raymond Moreau 1876-1945 WhAmArt 85
Crosby, Robert E 1928- MarqDCG 84
Crosby, Sumner McKnight 1909- WhoAmA 73, -76, -78, -80, -82
Crosby, Sumner McKnight 1909-1982 WhoAmA 84N
Crosby, Suzanne Camp 1948- MacBEP
Crosby, Theo 1925- ConArch, ConDes, WhoArt 80, -82, -84
Crosby, Thomas, Jr. WhAmArt 85
Crosby, William DcVicP 2
Crosby, William 1764-1800 FolkA 86
Crosby, William 1830-1910 DcBrWA
Croshaw, T DcVicP 2

Crosier, Paul Eugene 1917- AmArch 70
Crosier, S D WhAmArt 85
Croskey, L D AmArch 70
Crosland, Enoch 1860- DcBrA 1, DcVicP 2
Crosland, Robert Elder AmArch 70
Crosley, Edith A DcVicP 2
Croslin, Norman E 1929- AmArch 70
Crosman, Christopher Byron 1946- WhoAmA 82, -84
Crosman, John Henry 1897- IlrAm D
Crosman, John Henry 1897-1970 IlrAm 1880
Crosman, Robert 1707-1799 CabMA, FolkA 86
Cross, A B NewYHSD
Cross, A Campbell DcBrBI
Cross, Adelyne Schaefer 1905- WhAmArt 85
Cross, Amy 1856-1939 DcWomA
Cross, Amy 1865-1939 WhAmArt 85
Cross, Anson K 1862-1944 WhAmArt 85
Cross, Asa Bebee 1826-1894 BiDAmAr
Cross, Bernice Francene 1912- WhAmArt 85
Cross, Dave Gardner 1935- AmArch 70
Cross, Eason, Jr. 1925- AmArch 70
Cross, Ernest ArtsAmW 2
Cross, Ethel Hendy 1892- DcWomA, WhAmArt 85
Cross, Frederick George 1881-1941 IlBEAAW
Cross, George 1838?- NewYHSD
Cross, George O 1825- CabMA
Cross, Henri-Edmond 1856-1910 McGDA, PhDcTCA 77
Cross, Henry H 1837-1918 ArtsAmW 1, IlBEAAW, NewYHSD , WhAmArt 85
Cross, Herbert Richard 1877- WhAmArt 85
Cross, Hiram NewYHSD
Cross, Howard Page 1910- AmArch 70
Cross, J E FolkA 86
Cross, J George FolkA 86
Cross, James AmGrD[port]
Cross, Jay R AmArch 70
Cross, Jim D 1941- AmArch 70
Cross, John 1819-1861 ArtsNiC, DcVicP 2
Cross, John 1935- FolkA 86
Cross, John K 1901- AmArch 70
Cross, Joseph DcVicP 2
Cross, Kenneth James 1951- MarqDCG 84
Cross, Larry Lee 1933- AmArch 70
Cross, Lawrence 1653?-1724 AntBDN J
Cross, Lewis L ArtsEM
Cross, Louise 1896- DcWomA, WhAmArt 85
Cross, Maria Concetta 1911- WhoAmA 73, -76, -78, -80, -82
Cross, Marian Leigh 1900- WhAmArt 85
Cross, Marsha Jane 1954- MarqDCG 84
Cross, Nathaniel AntBDN K
Cross, Nicolette Elizabeth 1930- WhoArt 80, -82, -84
Cross, Osborne 1803-1876 NewYHSD
Cross, Peter FolkA 86
Cross, Peter 1630?-1716? AntBDN J
Cross, Peter F 1820?-1856 NewYHSD
Cross, Richard d1837 BiDBrA
Cross, Robert Nicholson 1867-1936 WhAmArt 85
Cross, Ronald G 1948- MarqDCG 84
Cross, Roy 1924- DcSeaP, WhoArt 80, -82, -84
Cross, Sally DcWomA, WhAmArt 85
Cross, Stanley DcBrBI
Cross, Stanley George 1888- WorECom
Cross, Thomas 1695?-1772 CabMA
Cross, Verna M WhAmArt 85
Cross, Watson, Jr. 1918- WhAmArt 85, WhoAmA 73, -76, -78, -80, -82, -84
Cross, William DcVicP 2
Cross, William Amos 1888- DcBrA 1
Cross, William McDonald 1934- AmArch 70
Cross And Cross MacEA
Crossan, Denis 1958- DcCAr 81
Crossan, Mary DcWomA
Crosscup, Daniel E 1841?- NewYHSD
Crosscup, George W 1843?- NewYHSD
Crosse, Edwin Reeve DcVicP 2
Crosse, Lawrence 1650?-1724 DcBrWA
Crosse, Richard 1742-1810 AntBDN J, DcBrECP
Crossen, J E AmArch 70
Crosser, Hazel F 1894- DcWomA, WhAmArt 85
Crossett, Alexander NewYHSD
Crossgrove, Roger Lynn 1921- WhoAmA 73, -76, -78, -80, -82, -84
Crossland, James Henry 1852- DcBrA 1, DcVicP 2
Crossland, John Michael 1800-1858 DcVicP 2
Crossley, Bob 1912- DcBrA 2, WhoArt 80, -82, -84
Crossley, Cuthbert 1883- ClaDrA, DcBrA 1
Crossley, Harold 1900- WhoArt 80, -82, -84
Crossley, Robert FolkA 86
Crossman, Mrs. DcWomA
Crossman, Abner 1847-1932 WhAmArt 85
Crossman, Charles NewYHSD
Crossman, G AmArch 70, FolkA 86
Crossman, John NewYHSD
Crossman, John C 1806?- NewYHSD
Crossman, Royce C MarqDCG 84
Crossman, William H 1896- WhAmArt 85
Crosson, Esther DcWomA
Crosthwait, David N, Jr. AfroAA
Crosthwaite, Daniel DcVicP 2

Croston, Merwyn Ernest, Jr. 1926- AmArch 70
Crotch, William 1775-1847 DcBrWA
Crothers, Edward Kenney 1889- AmArch 70
Crothers, John H NewYHSD
Crothers, Samuel FolkA 86
Crothers, Samuel 1927- AmArch 70
Crotti, Jean 1878-1958 ClaDrA, OxTwCA
Crotto, Paul 1922- WhoAmA 73, -76, -78, -80, -82, -84
Crotwell, William Richard 1931- AmArch 70
Crouan, Julie DcWomA
Crouch, Arthur 1898- WhAmArt 85
Crouch, Bill, Jr. 1949- WorECar A
Crouch, Emily H DcWomA, WhAmArt 85
Crouch, Henry FolkA 86
Crouch, John AntBDN Q
Crouch, Mary Crete d1931 ArtsAmW 3, WhAmArt 85
Crouch, Mary Crete 1867-1931 DcWomA
Crouch, Ned Philbrick 1948- WhoAmA 78, -80, -82, -84
Crouch, Penelope Thomas ArtsAmW 3
Crouch, W DcBrECP
Crouch, William DcBrWA
Croudace, Mrs. E H DcVicP 2
Crouffond, George Henri ArtsEM
Croughton, Amy H d1951 WhoAmA 78N, -80N, -82N, -84N
Croughton, Amy H 1880-1951 WhAmArt 85
Croughton, G Hanmer 1843- WhAmArt 85
Croughton, George DcVicP 2
Crouse, John Emerson 1935- AmArch 70
Crouse, John L 1949- WhoAmA 78, -80
Crouse, John L, Jr. 1949- MacBEP
Crouse, Lewis 1830?- NewYHSD
Crouse, Michael Glenn 1949- WhoAmA 84
Crouta, John 1805?- NewYHSD
Crouton, Francois 1921- WhoAmA 76, -78, -80, -82, -84
Crouton-LaFortune, Francois 1921- MacBEP
Crouwel, Wim 1928- ConDes, WhoGrA 82[port]
Crouwel, Wim Hendrik 1928- WhoGrA 62
Crovello, William George 1929- WhoAmA 73, -76, -78, -80
Crow DcBrBI
Crow, Barbara Joan 1942- WhoArt 84
Crow, Carol 1915- WhoAmA 82, -84
Crow, D A AmArch 70
Crow, Henry E 1873-1926? BiDAmAr
Crow, J Claude 1912- WhAmArt 85
Crow, J N FolkA 86
Crow, J W AmArch 70
Crow, Louise 1891- ArtsAmW 2, DcWomA, WhAmArt 85
Crow, Margaret G DcVicP 2
Crow, Marie Francis 1870-1949 DcWomA
Crow, Patricia F MarqDCG 84
Crow, Mrs. Phil M d1942 WhAmArt 85
Crow, S N FolkA 86
Crow, William NewYHSD
Crowcroft, Ronald Bryan 1953- WhoArt 80
Crowdace, Mrs. W A H DcVicP 2
Crowder, Conrad William 1915- WhAmArt 85
Crowder, William 1882- ArtsAmW 2
Crowdy, Fanny DcVicP 2
Crowdy, Rose DcVicP 2
Crowe, C A AmArch 70
Crowe, Eyre 1824- ArtsNiC
Crowe, Eyre 1824-1910 DcBrA 1, DcBrBI, DcBrWA, DcVicP, -2, NewYHSD
Crowe, Eyrielle Jane DcWomA
Crowe, Ira W 1950- MarqDCG 84
Crowe, J A DcBrBI
Crowe, Jocelyn 1906- IlsCB 1744
Crowe, Maida 1915- WhoArt 80, -82, -84
Crowe, Patrick Shay 1941- MacBEP
Crowe, Ray Nelson 1924- AmArch 70
Crowe, Robert E 1881-1944 BiDAmAr
Crowe, Ron G 1946- MarqDCG 84
Crowe, Sylvia 1901- ConArch, MacEA
Crowe, T DcVicP 2
Crowe, T Phillip OfPGCP 86
Crowe, Victoria Elizabeth 1945- WhoArt 82, -84
Crowe, William 1745-1829 BiDBrA
Crowell, A E 1862-1952 FolkA 86
Crowell, Andrew FolkA 86
Crowell, Annie 1862?-1949 ArtsAmW 3
Crowell, Charles 1815?- CabMA
Crowell, David Lee 1940- WhoAmA 82, -84
Crowell, Emily DcWomA
Crowell, John M 1942- MarqDCG 84
Crowell, Kleon FolkA 86
Crowell, Lucius 1911- WhoAmA 78, -80, -82, -84
Crowell, Margaret ArtsAmW 2, DcWomA, WhAmArt 85
Crowell, Pers 1910- IlsBYP, IlsCB 1946
Crowell, Peter M 1943- MarqDCG 84
Crowell, Reginald Bulkley 1923- AmArch 70
Crowell, Reid Kendrick 1911- WhAmArt 85
Crowell, S Fiske, Jr. ConArch A
Crowell, Stephen Foss 1951- MarqDCG 84

Crowen, Samuel N 1872-1935 *BiDAmAr*
Crowhurst, George *AntBDN O*
Crowley, Donald V *OfPGCP 86*
Crowley, F X *AmArch 70*
Crowley, Grace 1890-1979 *DcWomA*
Crowley, Graham 1950- *DcCAr 81*
Crowley, Mrs. Gray Price *DcWomA*
Crowley, Mrs. Gray Price 1884- *WhAmArt 85*
Crowley, Herbert *WhAmArt 85*
Crowley, J M *FolkA 86*
Crowley, Nicholas J 1813-1857 *DcBrBI*
Crowley, Nicholas Joseph 1813-1857 *DcVicP, -2*
Crowley, Patrick Jay 1932- *AmArch 70*
Crowley, Robert Emery 1932- *MarqDCG 84*
Crowley, Timothy F 1874-1943 *WhAmArt 85*
Crowley, Walter *DcVicP 2*
Crowley, Wendell 1921-1970 *WorECom*
Crowley, William *NewYHSD*
Crowley, William M *NewYHSD*
Crowman, Rose *WhAmArt 85*
Crown, John *WhAmArt 85*
Crown, Keith Allen 1918- *WhoAmA 73, -76, -78, -80, -82, -84*
Crown, P T *AmArch 70*
Crownfeld, Mrs. David *WhAmArt 85*
Crownfeld, Mrs. Davis *DcWomA*
Crownfield, Mrs. Davis *DcWomA*
Crownfield, Eleanor F *WhAmArt 85*
Crowningshield, Hannah 1789-1834 *FolkA 86*
Crowningshield, Maria *FolkA 86*
Crowninshield, Abraham *CabMA*
Crowninshield, Frederic *ArtsNiC*
Crowninshield, Frederic 1845-1918 *WhAmArt 85*
Crowninshield, Hannah *FolkA 86*
Crowninshield, Hannah 1789-1834 *DcWomA, NewYHSD*
Crowninshield, Maria *FolkA 86*
Crowninshield, Ralph Gilmore 1908- *WhAmArt 85*
Crowquill, Alfred *DcVicP 2*
Crowquill, Alfred 1804-1872 *DcBrBI*
Crowther, Deryck Stephen 1922- *ClaDrA, DcBrA 1*
Crowther, George H *NewYHSD*
Crowther, Henry *NewYHSD*
Crowther, Hugh Melvill 1914- *WhoArt 80, -82, -84*
Crowther, Hugh Melville 1914- *ClaDrA*
Crowther, John *DcBrWA, DcVicP 2*
Crowther, John Hassan 1932- *AmArch 70*
Crowther, Kruse McWilliams *AmArch 70*
Crowther, Michael 1946- *DcCAr 81*
Crowther, Mollie L *WhAmArt 85*
Crowther, Mollie L d1930? *DcWomA*
Crowther, Mollie L Vining 1867-1927 *ArtsAmW 3*
Crowther, N Denis 1944- *MarqDCG 84*
Crowther, R L *AmArch 70*
Crowther, Robert W 1902- *IlrAm D, WhAmArt 85*
Crowther, Robert W 1902-1978 *IlrAm 1880*
Crowther, Stephen 1922- *WhoArt 80, -82, -84*
Crowther, T S C *DcBrBI*
Croxall, John W *FolkA 86*
Croxall, Thomas *FolkA 86*
Croxford, Thomas Swainson *DcVicP 2*
Croxford, William Edwards *DcBrWA, DcVicP 2*
Croxton, Rushie E *AfroAA*
Croxton, Walter *FolkA 86*
Croy, Marie Therese *DcWomA*
Croydon, Michael Benet 1931- *WhoAmA 80, -82, -84*
Croydon, W J *DcVicP 2*
Croyeau, Augustin *NewYHSD*
Croylas, William *FolkA 86*
Crozet, Alix, Marquise De *DcWomA*
Crozier, Anne Jane 1824- *DcVicP 2, DcWomA*
Crozier, David Oliver 1943- *MarqDCG 84*
Crozier, George d1914 *DcBrA 1, DcVicP 2*
Crozier, J G *AmArch 70*
Crozier, John *FolkA 86*
Crozier, Richard Lewis 1944- *AmArt, WhoAmA 82, -84*
Crozier, Robert *DcVicP 2*
Crozier, Robert 1815-1891 *DcBrWA, DcVicP 2*
Crozier, Robert W 1921- *AmArch 70*
Crozier, William 1893-1930 *DcBrA 1*
Crozier, William 1930- *ConBrA 79[port]*
Crozier, William 1942- *AmArt*
Crozier, William K, Jr. 1926- *WhoAmA 76, -78, -80, -82, -84*
Crozzoli, B J *AmArch 70*
Cruchet, Jean-Denis *WhoAmA 84*
Cruchet, Jean-Denis 1939- *WhoAmA 80, -82*
Crucy, Mathurin 1749-1826 *MacEA*
Cruden, John 1740-1828? *AntBDN G*
Crudup, Doris 1933- *AfroAA*
Crudupt, Early Burnard 1918- *AmArch 70*
Cruess, Marie 1894- *DcWomA, WhAmArt 85*
Cruess, Marie Gleason 1894- *ArtsAmW 2*
Cruet, Pauline Du *DcWomA*
Cruice, Alice M *WhAmArt 85*
Cruickshank, Catherinie Gertrude *DcWomA*
Cruickshank, Collin J *ArtsEM*
Cruickshank, E J *DcWomA*
Cruickshank, Francis *DcVicP 2*
Cruickshank, Frederick 1800-1868 *DcBrWA,*

DcVicP 2
Cruickshank, Grace *DcWomA*
Cruickshank, H S *AmArch 70*
Cruickshank, William *DcBrWA, DcVicP 2*
Cruickshank And Lempke *ArtsEM*
Cruikshank, David William 1946- *MarqDCG 84*
Cruikshank, Dora *DcVicP 2*
Cruikshank, George 1792-1878 *AntBDN B, ArtsNiC, ClaDrA, DcBrWA, DcVicP 2, IlsBYP, McGDA, OxArt, WorECom*
Cruikshank, George, Jr. *DcBrBI*
Cruikshank, George, Sr. 1792-1878 *DcBrBI*
Cruikshank, Helen *DcWomA, WhAmArt 85*
Cruikshank, Isaac 1756?-1810? *BkIE*
Cruikshank, Isaac 1756-1811 *DcBrWA*
Cruikshank, Isaac Robert 1789-1856 *DcBrWA, DcVicP 2*
Cruikshank, Percy *DcBrBI*
Cruikshank, Robert 1786-1856 *DcBrBI*
Cruikshank, Sally 1949- *ConGrA 1[port]*
Cruikshank, William *DcVicP*
Cruise, Boyd 1909- *WhAmArt 85*
Cruise, John *DcBrWA*
Cruise, Stephen 1949- *DcCAr 81*
Cruisin, C 1812?- *NewYHSD*
Crum, Jason Roger 1935- *WhoAmA 76, -78, -80, -82*
Crum, L P *DcWomA*
Crum, Mrs. L P *ArtsEM*
Crum, Priscilla 1917- *WhAmArt 85*
Crumb, Charles H 1840- *FolkA 86*
Crumb, Charles P 1874- *WhAmArt 85*
Crumb, Robert 1943- *WorECom*
Crumbie, W D *NewYHSD*
Crumbling, Joseph Charles 1931- *AmArch 70*
Crumbo, Minisa 1942- *WhoAmA 78, -80, -82, -84*
Crumbo, Woodrow Wilson 1912- *IlBEAAW, WhAmArt 85*
Crumbo, Woody 1912- *WhoAmA 78, -80, -82, -84*
Crume, Gregg 1931- *WhoAmA 76, -78, -80*
Crume, Herbert C 1921- *AmArch 70*
Crume, J W *AmArch 70*
Crumley, George Daniel 1901- *AmArch 70*
Crumling, Wayne K 1896- *WhAmArt 85*
Crumlish, Brian John 1928- *AmArch 70*
Crummer, Mary Worthington *DcWomA, WhAmArt 85*
Crump, Francis *AntBDN Q*
Crump, Iris *AfroAA*
Crump, John d1892 *BiDAmAr*
Crump, Kathleen *DcWomA*
Crump, Kathleen 1884-1977 *WhoAmA 78N, -80N, -82N, -84N*
Crump, Kathleen Wheeler *WhAmArt 85*
Crump, Leslie 1894-1962 *WhAmArt 85*
Crump, R F *AmArch 70*
Crump, R W *AmArch 70*
Crump, Richard 1805?- *NewYHSD*
Crump, Robert *AfroAA, NewYHSD*
Crump, Robert Green, Jr. 1904- *AmArch 70*
Crump, Samuel *NewYHSD*
Crump, W Leslie d1962 *WhoAmA 78N, -80N, -82N, -84N*
Crump, Walter 1941- *PrintW 83, -85*
Crump, Walter Moore 1941- *WhoAmA 78, -80*
Crump, Walter Moore, Jr. 1941- *WhoAmA 82, -84*
Crumpacker, Grace Dauchy 1881- *DcWomA, WhAmArt 85*
Crumpler, Dewey *AfroAA*
Crumplin, Colin Frederick 1946- *ClaDrA*
Crumpton, C L *AmArch 70*
Crunden, John 1740-1828? *DcD&D*
Crunden, John 1745?-1835 *BiDBrA, MacEA*
Crunelle, Leonard 1872-1944 *WhAmArt 85*
Cruse, Edward *NewYHSD*
Cruse, Howard 1944- *ConGrA 1[port]*
Crusius, Carl Leberecht 1740-1779 *McGDA*
Cruspinera, Joan 1945- *DcCAr 81*
Crutcher, J W *AmArch 70*
Crutcher, L *AmArch 70*
Crutchfield, William 1932- *PrintW 85*
Crutchfield, William Richard 1932- *WhoAmA 73, -76, -78, -80, -82, -84*
Cruthers, E D *AmArch 70*
Cruttwell, Maud *DcVicP 2*
Cruxent, Jose Maria 1911- *PhDcTCA 77*
Cruyl, Lievin 1640-1720 *ClaDrA*
Cruz, A R *AmArch 70*
Cruz, Diego De La *McGDA*
Cruz, Emilio 1938- *AfroAA, WhoAmA 73, -76, -78, -80, -82*
Cruz, Hector 1933- *WhoAmA 73, -76, -78*
Cruz, J R *AmArch 70*
Cruz, Juana Ines DeLa 1648-1695 *DcWomA*
Cruz, Luis Hernandez 1936- *PrintW 83, -85*
Cruz, Maria Da d1619 *DcWomA*
Cruz, Phillip 1955- *MarqDCG 84*
Cruz, Ray 1933- *IlsBYP, IlsCB 1967*
Cruz Diaz, Jose *OxTwCA*
Cruz-Diez, Carlos 1923- *ConArt 77, -83, DcCAr 81, OxTwCA, PhDcTCA 77, WhoGrA 62*
Cruz Novillo, Jose 1936- *WhoGrA 82[port]*

Cryderman, Mackie *WhoAmA 73, -76*
Crygier, Ealli *FolkA 86*
Crystal, Boris 1931- *WhoAmA 78, -80, -82, -84*
Crystal, Margaret *DcWomA*
Csaky, Joseph 1888- *McGDA, PhDcTCA 77*
Csaky, Joseph 1888-1971 *OxTwCA*
Csala, Gottfried P 1922- *AmArch 70*
Csech, Helene 1921- *DcCAr 81*
Csernus, Tibor 1927- *WhoGrA 82[port]*
Csohany, Kalman 1925- *DcCAr 81*
Csok, Istvan 1865-1961 *McGDA*
Csoka, Stephen 1897- *WhAmArt 85, WhoAmA 73, -76, -78, -80, -82, -84*
Csontvary-Kosztka, Tibor 1853-1919 *OxTwCA*
Csosz, John 1897- *WhAmArt 85*
Csuri, Charles *MarqDCG 84*
Csuzy, Luma Von *DcWomA*
Cuallado, Gabriel 1925- *ICPEnP A*
Cuba, Ivan *WhoArt 80, -82, -84*
Cubberley, Francis Joy 1930- *AmArch 70*
Cubert, Rob 1948- *MarqDCG 84*
Cubitt, Charlotte L *DcWomA*
Cubitt, Edith Alice *DcBrBI, DcWomA*
Cubitt, James 1914- *ConArch, McGDA*
Cubitt, Lewis 1799- *WhoArch*
Cubitt, Lewis 1799-1883 *BiDBrA, DcD&D, McGDA*
Cubitt, Thomas 1757-1778? *DcBrECP*
Cubitt, Thomas 1788-1855 *BiDBrA, DcD&D[port], MacEA, McGDA, WhoArch*
Cubitt, William 1791-1863 *DcD&D[port]*
Cubitt, Sir William 1785-1861 *DcD&D*
Cubley, Henry Hadfield *DcVicP 2*
Cubley, W H 1816-1896 *DcBrWA, DcVicP 2*
Cucchi, Enzo 1950- *ConArt 83, DcCAr 81, PrintW 83, -85*
Cucci, Adolph Michael *AmArch 70*
Cuccio, David 1956- *ConGrA 1[port]*
Cucuel, Edward 1875- *DcBrBI*
Cucuel, Edward 1879- *WhAmArt 85*
Cucuzzella, Vincent J *MarqDCG 84*
Cuddy, Louise J *DcWomA, WhAmArt 85*
Cude, Reginald Hodgin 1936- *AmArch 70*
Cudell, Adolph 1850-1910 *BiDAmAr*
Cudmore, Mary A *DcWomA*
Cudworth, E M *AmArch 70*
Cudworth, Harriet Amsbry *DcWomA*
Cudworth, Harriet Amsbry Burt *ArtsEM*
Cudworth, Nick 1947- *DcCAr 81, WhoArt 80, -82, -84*
Cue, Harold James 1887-1961 *IlBEAAW, WhAmArt 85*
Cuellar Serrano And Gomez *MacEA*
Cueman, R R *AmArch 70*
Cuenca, Juan *OxTwCA*
Cuesta, J Christopher *MarqDCG 84*
Cuetara, Edward A 1924- *AmArch 70*
Cueto, German *OxTwCA*
Cueva Benavidas Y Barradas, M DeLa *DcWomA*
Cueva Benavides Y Barradas, M DeLa *DcWomA*
Cuevas, G A *AmArch 70*
Cuevas, Herbert 1936- *AmArch 70*
Cuevas, Jose Luis 1933- *DcCAr 81, McGDA, PhDcTCA 77, PrintW 85, WhoGrA 62*
Cuevas, Jose Luis 1934- *ConArt 77, -83, OxTwCA, WhoAmA 73, -76, -78, -80, -82, -84*
Cufaude, Francis *DcBrECP*
Cuffari, Richard *IlsBYP*
Cuffari, Richard 1925- *IlsBYP*
Cuffari, Richard J 1925- *WhoAmA 78, -80, -82*
Cugat, Frances C *WhAmArt 85*
Cugini, G R *AmArch 70*
Cugnot, Louis-Leon *ArtsNiC*
Cuijlenburgh, Abraham Van 1620?-1658 *McGDA*
Cuijp, Aelbert 1620-1691 *McGDA*
Cuijp, Benjamin Gerritsz 1612-1652 *McGDA*
Cuijp, Jacob Gerritsz 1594-1651 *McGDA*
Cuijpers, Petrus Josephus Hubertus 1827-1921 *EncMA, McGDA*
Cuiner, W *NewYHSD*
Cuipers, Peter *NewYHSD*
Cuirblanc, Berthe *DcWomA*
Cuitt, George 1743-1818 *DcBrECP, DcBrA*
Cuitt, George 1779-1854 *DcBrBI, DcBrWA, DcVicP 2*
Cuitt, George, Jr. 1779-1854 *DcBrECP*
Cuixart, Modesto 1925- *OxTwCA, PhDcTCA 77*
Cukrowicz, Marie d1899 *DcWomA*
Culbert, Bill 1935- *DcCAr 81*
Culbert, Samuel L 1822?- *NewYHSD*
Culbertson, J M 1852- *WhAmArt 85*
Culbertson, James Thomas 1911- *MarqDCG 84*
Culbertson, Janet Lynn 1932- *WhoAmA 73, -76, -78, -80, -82, -84*
Culbertson, Josephine M 1852- *ArtsAmW 2, DcWomA*
Culbertson, Linn 1890- *DcWomA, WhAmArt 85*
Culbertson, Mary 1846-1913 *DcWomA*
Culbertson, Queenie *DcWomA, WhAmArt 85*
Culbertson, Thomas Means 1915- *AmArch 70*
Culbreth, Carl R 1952- *WhoAmA 84*

Cureton, William McDow 1922- *AmArch 70*
Curie, Adine *DcWomA*
Curjel, E *ArtsAmW 2, WhAmArt 85*
Curl, Gilbert W, Jr. 1943- *MarqDCG 84*
Curl, James Stevens *ConArch A*
Curlett, Alexander 1880-1942 *BiDAmAr*
Curlett, Thomas *FolkA 86*
Curlett, William 1845-1914 *BiDAmAr*
Curley, Donald H *OfPGCP 86*
Curlin, F H *AmArch 70*
Curling, Robert B *IlDcG*
Curman, Carl 1833-1913 *ICPEnP A*
Curman, William Alan 1949- *ClaDrA*
Curmano, Billy 1949- *WhoAmA 84, WhoArt 80, -82, -84*
Curnock, J Jackson 1839- *ArtsNiC*
Curnock, James 1812-1869? *DcVicP 2*
Curnock, James Jackson 1839-1889? *DcVicP, -2*
Curnock, James Jackson 1839-1891 *DcBrWA*
Curnoe, Greg 1936- *ConArt 77, -83*
Curnoe, Gregory Richard 1936- *OxTwCA*
Curot-Barberel, M L *DcWomA*
Curran *FolkA 86*
Curran, Amelia 1775-1847 *DcWomA*
Curran, Charles C 1861-1942 *WhAmArt 85*
Curran, Darryl J 1935- *ICPEnP A, MacBEP, PrintW 83, -85*
Curran, Darryl Joseph 1935- *WhoAmA 78, -80, -82, -84*
Curran, Douglas Edward 1952- *WhoAmA 84*
Curran, J F *EncASM*
Curran, Louis W *WhAmArt 85*
Curran, Mary E *WhAmArt 85*
Curran, Mary E d1930 *DcWomA*
Curran, Mary Eleanor d1930 *ArtsAmW 3*
Curran, P K *AmArch 70*
Curren, R C *AmArch 70*
Current, William 1923- *ICPEnP A*
Currer, R W *DcVicP 2*
Currey, Ada *DcVicP 2*
Currey, Esme 1883?-1973 *DcBrA 1*
Currey, Esme Mary Evelyn 1883-1973 *DcWomA*
Currey, Fanny *DcWomA*
Currey, Fanny W *DcBrWA, DcVicP 2*
Currie, Miss *DcWomA*
Currie, Bessie Bangs *DcWomA, WhAmArt 85*
Currie, Bruce 1911- *WhoAmA 73, -76, -78, -80, -82, -84*
Currie, C B *DcWomA*
Currie, David Garfield 1941- *ICPEnP A, MacBEP*
Currie, E *DcWomA*
Currie, J F *AmArch 70*
Currie, Jane Eliza *DcWomA*
Currie, Jessie *DcVicP 2*
Currie, John A *NewYHSD*
Currie, John S 1884?-1914 *DcBrA 1*
Currie, Juan *NewYHSD*
Currie, Leonard James 1913- *AmArch 70*
Currie, R G *AmArch 70*
Currie, R L *AmArch 70*
Currie, R W *DcVicP 2*
Currie, Robert *CabMA, DcVicP 2*
Currie, Sidney *DcBrA 1, DcVicP 2*
Currie, Thomas Thoburn 1906- *AmArch 70*
Currie, William *CabMA, NewYHSD*
Currier, Albert Worl *ArtsEM*
Currier, Alexander *FolkA 86*
Currier, Allen Dale 1893- *WhAmArt 85*
Currier, Amos M 1825- *CabMA*
Currier, Anne 1950- *DcCAr 81*
Currier, Charles 1818-1887 *NewYHSD*
Currier, Cyrus Bates *WhoAmA 78N, -80N, -82N, -84N*
Currier, Cyrus Bates 1868- *ArtsAmW 1, WhAmArt 85*
Currier, E W 1857-1918 *WhAmArt 85*
Currier, Edward Wilson 1857-1918 *ArtsAmW 1, IlBEAAW*
Currier, Ernest M *EncASM*
Currier, Ernest M 1867?-1936 *WhAmArt 85*
Currier, Everett *WhAmArt 85*
Currier, George H *WhAmArt 85*
Currier, J Frank *ArtsNiC*
Currier, J Frank 1843-1909 *WhAmArt 85*
Currier, Jacob Bayley d1814 *CabMA*
Currier, Joseph Frank 1843-1909 *DcAmArt*
Currier, Nathaniel *AntBDN B, DcNiCA*
Currier, Nathaniel 1803-1887 *OxArt*
Currier, Nathaniel 1813-1888 *BnEnAmA, DcD&D, McGDA, NewYHSD, WhAmArt 85*
Currier, Richard 1903- *WhAmArt 85*
Currier, Seth S 1816- *CabMA*
Currier, Walter B 1879-1934 *ArtsAmW 1*
Currier, Walter Barron 1879-1934 *IlBEAAW, WhAmArt 85*
Currier & Ives *DcNiCA*
Currier And Ives *BnEnAmA, DcD&D, OfPGCP 86A, OxArt, WorECar*
Currier And Roby *EncASM*

Curry, Alison B, Jr. *WhAmArt. 85*
Curry, Carol Kay 1957- *MarqDCG 84*
Curry, Charles Birney 1921- *AmArch 70*
Curry, Charles F, Jr. 1926- *AmArch 70*
Curry, Don Arthur 1927- *AmArch 70*
Curry, Elizabeth Eleanor 1864-1941 *DcWomA*
Curry, Gael Alan 1947- *MarqDCG 84*
Curry, Grant, Jr. 1917- *AmArch 70*
Curry, James *DcBrECP*
Curry, John *NewYHSD*
Curry, John Allen 1923- *AmArch 70*
Curry, John J *NewYHSD*
Curry, John Steuart 1897-1946 *ArtsAmW 1, -2, BnEnAmA, DcAmArt, DcCAA 71, -77, GrAmP, IlBEAAW, IlsCB 1744, McGDA, OxTwCA, PhDcTCA 77, WhAmArt 85*
Curry, Larry 1950- *AfroAA*
Curry, Noble *WhAmArt 85*
Curry, Noble Wilbur 1894- *WhoAmA 78, -80, -82*
Curry, Roland A 1884-1947 *BiDAmAr*
Curry, Sam *FolkA 86*
Curry, Timothy Jon 1943- *MarqDCG 84*
Curry, William *NewYHSD*
Cursiter, Stanley 1887- *DcBrA 1*
Cursiter, Stanley 1887-1976 *DcBrA 2*
Curt, Edith *WhAmArt 85*
Curtes, Henry 1831?- *NewYHSD*
Curtin, Cornelius 1853-1926 *BiDAmAr*
Curtin, J D *AmArch 70*
Curtin, Michael J 1939- *MarqDCG 84*
Curtin And Clake *EncASM*
Curtis, Mrs. *DcVicP 2*
Curtis, Alice Marian 1847-1911 *DcWomA*
Curtis, Alice Marion 1847-1911 *WhAmArt 85*
Curtis, Anne *FolkA 86*
Curtis, Anthony Ewart 1928- *ClaDrA, WhoArt 80, -82, -84*
Curtis, Asahel 1874-1941 *MacBEP*
Curtis, Benjamin B 1795?- *NewYHSD*
Curtis, Bessie M *ArtsEM, DcWomA*
Curtis, C J *AmArch 70*
Curtis, C R *AmArch 70*
Curtis, Calvin 1822- *ArtsNiC*
Curtis, Calvin 1822-1893 *NewYHSD*
Curtis, Charles *FolkA 86, NewYHSD*
Curtis, Charles B 1827-1905 *WhAmArt 85*
Curtis, Clarence James 1904- *WhAmArt 85*
Curtis, Constance *WhAmArt 85*
Curtis, Constance d1959 *DcWomA, WhoAmA 80N, -82N, -84N*
Curtis, D W *AmArch 70*
Curtis, Daniel *FolkA 86*
Curtis, Dock 1906- *WhAmArt 85*
Curtis, Dolly Powers 1942- *WhoAmA 84*
Curtis, Dora *DcBrBI*
Curtis, Edmond L *ArtsEM*
Curtis, Edmund DeForest 1884- *WhAmArt 85*
Curtis, Edward S 1868-1952 *WhAmArt 85*
Curtis, Edward Sheriff 1868-1952 *ICPEnP*
Curtis, Edward Sheriff 1868-1954 *MacBEP*
Curtis, Edwin 1885-1943 *WhAmArt 85*
Curtis, Eleanor Park 1779-1852 *AntBDN O*
Curtis, Elizabeth *ArtsAmW 2, ConICB, DcWomA, WhAmArt 85*
Curtis, Elizabeth L 1892- *ArtsAmW 3*
Curtis, Emory *FolkA 86*
Curtis, Floyd Edward 1894- *WhAmArt 85*
Curtis, Frederick *EncASM*
Curtis, George 1826-1881 *NewYHSD*
Curtis, George D *DcVicP 2*
Curtis, George E 1947- *MarqDCG 84*
Curtis, George V 1859-1943 *WhAmArt 85*
Curtis, George Warrington 1869-1927 *WhAmArt 85*
Curtis, Gertrude M *DcWomA*
Curtis, H B *FolkA 86*
Curtis, H H *EncASM*
Curtis, Helen 1864- *WhAmArt 85*
Curtis, I Maynard 1860- *WhAmArt 85*
Curtis, Ida Maynard 1860-1959 *ArtsAmW 2, DcWomA*
Curtis, Isaac A *FolkA 86*
Curtis, Isabel C *DcVicP 2, DcWomA*
Curtis, J *McGDA*
Curtis, J Digby 1775?-1837 *DcBrWA*
Curtis, J Nick 1952- *MarqDCG 84*
Curtis, Jack Paul *AmArch 70*
Curtis, James *EncASM*
Curtis, Jane *DcWomA*
Curtis, Jane Bridgham *WhAmArt 85*
Curtis, Jessie *DcWomA*
Curtis, John *DcBrECP, FolkA 86*
Curtis, John M *BiDAmAr*
Curtis, Joseph S *EncASM*
Curtis, Kent Krueger 1927- *MarqDCG 84*
Curtis, Leila *DcWomA*
Curtis, Leland 1897- *ArtsAmW 1, IlBEAAW, WhAmArt 85*
Curtis, Leland S 1897- *ArtsAmW 3*
Curtis, Lemuel *EncASM*
Curtis, Lemuel 1790-1857 *AntBDN D, DcNiCA*
Curtis, Leona 1908- *WhAmArt 85*

Curtis, Louis *BiDAmAr*
Curtis, Marian 1912- *WhAmArt 85*
Curtis, Marjory *DcWomA, WhAmArt 85*
Curtis, Mary *DcWomA*
Curtis, Mary Carroll 1896- *DcWomA, WhAmArt 85*
Curtis, Mary Cranfill 1925- *WhoAmA 76, -78, -80, -82, -84*
Curtis, N S *AmArch 70*
Curtis, Natalie *DcWomA*
Curtis, Nathaniel Cortlandt 1881- *WhAmArt 85*
Curtis, Nathaniel Cortlandt, Jr. 1917- *AmArch 70*
Curtis, Philip Campbell 1907- *IlBEAAW, WhAmArt 85, WhoAmA 73, -76, -78, -80, -82, -84*
Curtis, Phillip Houston 1945- *WhoAmA 78, -80, -82*
Curtis, R F *DcVicP 2*
Curtis, Ralph Wormeley 1854-1922 *DcVicP 2*
Curtis, Robert D 1948- *WhoAmA 82, -84*
Curtis, Robert J 1816?- *NewYHSD*
Curtis, Robert James 1927- *AmArch 70*
Curtis, Roger William 1910- *WhoAmA 76, -78, -80, -82, -84*
Curtis, Ronald S 1950- *MarqDCG 84*
Curtis, Rosa M 1894- *ArtsAmW 2*
Curtis, Sarah d1743? *DcBrECP*
Curtis, Sarah 1676-1743 *DcWomA*
Curtis, Sidney W *WhAmArt 85*
Curtis, Stanley P 1951- *MarqDCG 84*
Curtis, Ted 1937- *AmArch 70*
Curtis, Thomas *AntBDN M*
Curtis, Thomas S *FolkA 86*
Curtis, V A *AmArch 70*
Curtis, Vera F 1916- *DcBrA 2*
Curtis, Vera G *ClaDrA*
Curtis, Sir W *DcVicP 2*
Curtis, William 1939- *AfroAA*
Curtis, William A 1935- *AmArch 70*
Curtis, William C *MarqDCG 84*
Curtis, William Fuller 1873- *WhAmArt 85*
Curtis, William J R *ConArch A*
Curtis And Dunning *EncASM*
Curtis And Hubbard *CabMA*
Curtis-Brown, Mary Seymour 1888- *WhAmArt 85*
Curtis-Huxley, Claire A *DcWomA*
Curtiss, Christine Tuche *WhAmArt 85*
Curtiss, F W *DcWomA*
Curtiss, George Curt 1911- *AmArt, WhoAmA 76, -78*
Curtiss, H W *FolkA 86*
Curtiss, Lucy *FolkA 86*
Curtiss-Truetsch, George Curt *WhoAmA 80, -82, -84*
Curtois, Dering *DcVicP 2*
Curtois, Ella Rose 1860-1944 *DcBrA 1, DcWomA*
Curtois, Mary Henrietta Dering 1854-1929 *DcBrA 1, DcWomA*
Curtsinger, William R 1946- *ICPEnP A, MacBEP*
Curzon, Joseph *BiDAmAr*
Curzon, Paul Alfred De 1820- *ArtsNiC*
Curzon, Paul Alfred De 1820-1895 *ClaDrA*
Cusachs, Philip Alain 1888-1931 *BiDAmAr*
Cusack, Helen Woodbury *WhAmArt 85*
Cusack, Margaret 1945- *AmArt*
Cusack, Ralph 1912- *DcBrA 1*
Cusack, Victor Aubrey 1915- *AmArch 70*
Cushing, Mrs. *DcWomA*
Cushing, Barbara 1948- *WhoAmA 80, -82, -84*
Cushing, Ellen Watson *DcWomA, WhAmArt 85*
Cushing, Frank 1916-1975 *MacBEP*
Cushing, George 1906- *WhoAmA 73, -76*
Cushing, Henry *FolkA 86*
Cushing, Howard Gardiner 1869-1916 *WhAmArt 85*
Cushing, Howard Gardner 1869-1916 *IlBEAAW*
Cushing, Jere C *FolkA 86*
Cushing, Jeremiah C *FolkA 86*
Cushing, Josiah *CabMA*
Cushing, Levi L *FolkA 86*
Cushing, Mary A *DcWomA*
Cushing, Otho 1871-1942 *WhAmArt 85, WorECar*
Cushing, Paul Edward, Jr. *AmArch 70*
Cushing, R F *AmArch 70*
Cushing, Ralph H 1903- *AmArch 70*
Cushing, Mrs. Thomas *FolkA 86*
Cushing, Val Murat 1931- *CenC[port]*
Cushing, W T *NewYHSD*
Cushman, Alice 1854- *DcWomA, WhAmArt 85*
Cushman, Alonzo C *NewYHSD*
Cushman, Mrs. Charles T *WhAmArt 85*
Cushman, Charlotte 1816-1878 *DcNiCA*
Cushman, Cordelia H *WhAmArt 85*
Cushman, Edward Leonard 1918- *AmArch 70*
Cushman, George H 1814-1876 *EarABI*
Cushman, George Hewitt 1814-1876 *NewYHSD*
Cushman, Henry 1859- *WhAmArt 85*
Cushman, Lillian *DcWomA*
Cushman, Lillian S *WhAmArt 85*
Cushman, Mary *DcWomA, FolkA 86*
Cushman, Nancy *DcWomA*
Cushman, Noah 1745-1818 *FolkA 86*
Cushman, Paul *FolkA 86*
Cushman, Susan 1822-1859 *DcNiCA*
Cushman, T J *AmArch 70*

Cushman, Thomas Hastings 1815-1841 *NewYHSD*
Cushman, Warren S d1926 *FolkA 86*
Cushman, William 1720-1768 *FolkA 86*
Cusick, Cornelius C *ArtsEM*
Cusick, Nancy Taylor *WhoAmA 73, –76, –78, –80, –84*
Cusie, Ray 1937- *FolkA 86*
Cusmano, Anthony *MarqDCG 84*
Cust *DcBrECP*
Cust, Emmeline Mary Elizabeth 1867- *DcWomA*
Custance, William *BiDBrA*
Custard, A Marsh *DcBrWA*, *DcVicP 2*
Custer, B L *AmArch 70*
Custer, Bernadine *WhAmArt 85*
Custer, E A *WhAmArt 85*
Custer, Edward L 1837-1881 *NewYHSD*
Custer, Jacob D 1805-1872 *AntBDN D*
Custer, John W *ArtsEM*
Custin, Mildred *WorFshn*
Custis, Eleanor Parke *WhAmArt 85*
Custis, Eleanor Parke 1779-1852 *DcWomA*, *NewYHSD*
Custis, Eleanor Parke 1897- *DcWomA*
Custis, Mrs. John Keith *WhAmArt 85*
Custis, Nelly *FolkA 86*
Cusumano, Stefano 1912- *DcCAA 71, –77, WhoAmA 73, –76*
Cusumano, Stefano 1912-1975 *WhAmArt 85, WhoAmA 78N, –80N, –82N, –84N*
Cusworth, Joseph *BiDBrA*
Cutbush, Edward *NewYHSD*
Cutbush, Edward d178-? *FolkA 86*
Cutbush, Samuel *FolkA 86, NewYHSD*
Cutcheon, Anna M *ArtsEM*
Cutcheon, Frederica Ritter 1904- *WhAmArt 85*
Cutforth, Roger 1944- *ConArt 83, WhoAmA 82, –84*
Cuthbert, Alexander James 1906- *AmArch 70*
Cuthbert, Alfred Edward 1898-1966 *DcBrA 1*
Cuthbert, E S *DcBrBI*
Cuthbert, John P *WhAmArt 85*
Cuthbert, John Spreckley *DcVicP 2*
Cuthbert, Julia *DcWomA*
Cuthbert, Margot Lindsey 1893- *DcBrA 1, DcWomA*
Cuthbert, Virginia 1908- *WhAmArt 85, WhoAmA 73, –76, –78, –80, –82, –84*
Cuthbertson, Frederick J 1946- *MarqDCG 84*
Cuthbertson, William J 1850-1925 *BiDAmAr*
Cutler, Carl Gordon 1873-1945 *WhAmArt 85*
Cutler, Cecil E L *DcVicP 2*
Cutler, Cecil E L 1934- *DcBrA 1*
Cutler, Charles Gordon 1914- *WhAmArt 85*
Cutler, Ernest J H *DcVicP 2*
Cutler, Ethel Rose 1915- *WhoAmA 73, –76, –78, –80, –82, –84*
Cutler, Frank E *ArtsAmW 2*
Cutler, George Younglove d1834 *NewYHSD*
Cutler, Grayce E *WhoAmA 73, –76, –78, –80, –82, –84*
Cutler, Howard Wright d1948 *BiDAmAr*
Cutler, James Gould 1848-1927 *BiDAmAr*
Cutler, Jervis 1768-1846 *NewYHSD*
Cutler, John Padgitt 1917- *AmArch 70*
Cutler, L A *AmArch 70*
Cutler, Martha Hill 1874- *WhAmArt 85*
Cutler, Merrit *WhAmArt 85*
Cutler, Robert W 1905- *AmArch 70*
Cutler, Ronnie 1924- *WhoAmA 82, –84*
Cutler, William H 1874-1907 *BiDAmAr*
Cutler-Shaw, Joyce *WhoAmA 82, –84*
Cutner, Herbert 1881-1969 *DcBrA 1*
Cutter, Christiana 1893-1969 *DcBrA 2*
Cutter, Kirtland K 1860-1939 *BiDAmAr, MacEA*
Cuttica, Teresa, Marchesa *DcWomA*
Cutting, Amos F d1896 *BiDAmAr*
Cutting, Donald Wayne 1935- *AmArch 70*
Cutting, Francis Harvey *ArtsAmW 1*
Cutting, James Ambrose 1814-1867 *ICPEnP*
Cutting, Malcolm McKenzie 1927- *AmArch 70*
Cuttler, Charles David 1913- *WhAmArt 85, WhoAmA 73, –76, –78, –80, –82, –84*
Cutts, Elizabeth 1787- *FolkA 86*
Cutts, G Berthoy *WhAmArt 85*
Cutts, Gertrude *DcWomA*
Cutts, James *DcNiCA*
Cutts, John *AntBDN M*
Cutts, John 1772-1851 *DcNiCA*
Cutts, John 1794?- *NewYHSD*
Cutts, John, Jr. *NewYHSD*
Cutts, John T *DcVicP 2*
Cutts, Love Pickman d1873 *NewYHSD*
Cutts, Orillio *NewYHSD*
Cutzescu, Cecilia *DcWomA*
Cuvillier, Marie *DcWomA*
Cuvillies, Francois 1695-1768 *MacEA, WhoArch*
Cuvillies, Francois, The Elder 1695-1768 *OxDecA*
Cuvillies, Francois De 1698-1768 *DcD&D*
Cuvillies, Francois De, The Elder 1695-1768 *McGDA*
Cuvillies, Jean Francois De 1698-1767 *OxArt*
Cuyck, Catharina *DcWomA*
Cuyck, Cornelia Pieternella Van 1749- *DcWomA*
Cuyck, Maria Kristina Van 1711-1783? *DcWomA*

Cuyjet, Helen Cornele 1921- *AfroAA*
Cuylenborch, Abraham Van *McGDA*
Cuylenborch, Abraham Van 1620?-1658 *ClaDrA*
Cuyler, Harriet E 1853- *ArtsEM*
Cuyp, Aelbert 1620-1691 *OxArt*
Cuyp, Aelbrecht 1620-1691 *ClaDrA*
Cuyp, Albert 1620-1691 *DcSeaP*
Cuyp, Benjamin Gerritsz 1612-1652 *OxArt*
Cuyp, Jacob Gerritsz 1594-1652? *OxArt*
Cuypers, Eduard 1859-1927 *MacEA*
Cuypers, F H *NewYHSD*
Cuypers, Francis A *NewYHSD*
Cuypers, P J H 1827-1921 *MacEA*
Cuypers, Petrus Josephus Hubertus 1827-1921 *OxArt, WhoArch*
Cvijan *AmArch 70*
Cvijanovic, Alex 1923- *AmArch 70*
Cyane, Madame *DcWomA*
Cybul, D N *AmArch 70*
Cyffle, Paul-Louis *AntBDN M*
Cynicus *DcBrBI, WorECar*
Cyr, L G *AmArch 70*
Cyren, Gunnar 1931- *IlDcG*
Cyril *WhoAmA 73*
Cyril, R *WhoAmA 76, –78, –80, –82, –84*
Cyrus, Joseph *CabMA*
Cyrus, Richard *CabMA*
Czach, Marie 1945- *WhoAmA 78, –80, –82*
Czacka, Beata d1824 *DcWomA*
Czacka, Countess Konstancja *DcWomA*
Czacka, Countess Kunegunde *DcWomA*
Czajkowska, Marie 1879- *DcWomA*
Czajkowski, Jorge *ConArch A*
Czako, Gabor Leslie 1930- *AmArch 70*
Czaplinska-Archer, Teresa *ConArch A*
Czarniecki, M J, III 1948- *WhoAmA 80, –82, –84*
Czarnowski, Norbert 1897- *WhAmArt 85*
Czartoryska, Princess Marie *DcWomA*
Czechowicz, Simon 1689-1775 *ClaDrA*
Czegka, Bertha 1880- *DcWomA*
Czeizing, Lajos 1922- *ICPEnP A*
Czekanski, Daniel Barney 1932- *AmArch 70*
Czepay, Katalin *DcWomA*
Czernin VonChudenitz, Countess Maria T 1758- *DcWomA*
Czerwinke, Tadeusz 1936- *WhoArt 82, –84*
Czerwinski, K G *WhAmArt 85*
Czerwinski, Mark G 1953- *MarqDCG 84*
Czestochowski, Joseph Stephen 1950- *WhoAmA 76, –78, –80, –82, –84*
Czimbalmos, Magdolna Paal *ClaDrA, WhoAmA 76, –78, –80, –82, –84, WhoArt 80, –82, –84*
Czimbalmos, Szabo Kalman 1914- *ClaDrA, WhoAmA 76, –78, –80, –82, –84, WhoArt 80, –82, –84*
Czinke, Ferenc 1926- *DcCAr 81*
Czipek, Ferry *DcWomA*
Czober, Tadeusz 1948- *DcCAr 81*
Czuchryj, Stanislaw Stefan 1924- *AmArch 70*
Czufin, Rudolf 1901-1979 *WhoAmA 80N, –82N, –84N*
Czuma, Stanislaw J 1935- *WhoAmA 73, –76, –78, –80, –82, –84*
Czurles, Stanley A 1908- *WhAmArt 85, WhoAmA 73, –76*
Czyzewski, Tytus 1880-1945 *PhDcTCA 77*

D

D, H P *DcBrBI*
Dabac, Petar 1942- *ICPEnP A*
Dabac, Toso 1907-1970 *ConPhot, ICPEnP A*
Dabbert, J H *AmArch 70*
Dabelstein, William F *WhAmArt 85*
Dabelstein, William F d1971? *ArtsAmW 3*
Dabich, George 1922- *IlBEAAW*
Dabis, Anna *DcWomA*
Dablow, Dean 1946- *MacBEP*
Dablow, Dean Clint 1946- *WhoAmA 82, –84*
Dabney, Charlotte *FolkA 86*
Dabney, Julia Parker 1850- *DcWomA*
Dabney, Katherine M *DcWomA*
Dabney, Robert Louis 1933- *AmArch 70*
Dabney, William H 1855-1897 *BiDAmAr*
Dabo, Leon 1868-1960 *ArtsEM[port], McGDA, WhAmArt 85, WhoAmA 80N, –82N, –84N*
Dabo, T Scott 1877- *WhAmArt 85*
Dabo, Theodore Scott 1870- *ArtsEM*
Dabos, Jeanne 1763-1842 *DcWomA*
Dabos, Laurent 1761-1835 *ClaDrA*
Dabour, John d1905 *WhAmArt 85*
Dabour, John 1837- *ArtsNiC*
Dabrowska, Casimire 1890- *DcWomA*
Dabrowska, Waleria *DcWomA*
Dabrowski, Adam 1880- *WhAmArt 85*
Dabry, Jenny *DcWomA*
Dacey, William 1907- *WhAmArt 85*
Dachaueur, Paul Leonard 1933- *AmArch 70*
Dache, Lilly *FairDF US, WorFshn*
DaCosta, Catherina *DcWomA*
DaCosta, John *WhAmArt 85*
DaCosta, John 1867-1931 *ClaDrA, DcBrA 1, DcBrBI, DcVicP 2*
Dacosta, Milton 1915- *PhDcTCA 77*
Dacosta, Stella May *WhAmArt 85*
Dacre, Barbarina Brand 1768-1854 *DcWomA*
Dacre, Henry 1820?- *NewYHSD*
Dacre, Susan Isabel *DcVicP 2*
Dacre, Susan Isabel 1844-1933 *DcWomA*
Dacre, Winifred *DcWomA, OxTwCA, PhDcTCA 77*
DaCunha, Julio 1929- *WhoAmA 78, –80, –82, –84*
Dadamaino *OxTwCA*
Dadamaino 1935- *ConArt 77*
Dadd, Frank 1851-1929 *ClaDrA, DcBrA 1, DcBrBI, DcBrWA, DcVicP, –2*
Dadd, Philip d1916 *DcBrBI*
Dadd, Philip J S d1916 *DcBrA 2*
Dadd, Richard 1817-1886 *DcBrBI, DcBrWA*
Dadd, Richard 1819-1887 *DcVicP, –2*
Dadd, Stephen T *DcBrBI, DcVicP 2*
Daddi, Bernado 1512?-1570 *ClaDrA*
Daddi, Bernardo *OxArt*
Daddi, Bernardo 1290-1348 *McGDA*
Daddy Bill *FolkA 86*
Dade, Ernest *DcBrWA, DcVicP*
Dade, Ernest 1868- *DcBrA 1, DcVicP 2*
Dadford, Thomas *BiDBrA*
Dadie-Roberg, Dagmar 1897- *DcWomA*
Dadkhah, Bahman 1942- *WhoGrA 82[port]*
Dado 1933- *ConArt 77, –83, DcCAr 81*
Dadras, A S *AmArch 70*
Dady, William St. Alban Rae 1938- *WhoArt 82, –84*
Dae, E *DcVicP 2*
Daege, Eduard 1805-1883 *ArtsNiC, ClaDrA*
Dael, Jan Franz Van 1764-1840 *ArtsNiC*
Daen, Lindsay 1923- *DcCAr 81*
Daeuble, Louis 1912- *AmArch 70*
Daeye, Hippolyte 1873- *ClaDrA*
Daeye, Hippolyte 1873-1952 *OxTwCA, PhDcTCA 77*

DaFano, Dorothea Natalie Sophia d1941 *DcBrA 1, DcWomA*
Daffarn, Alice *DcVicP 2*
Daffarn, William George *DcBrA 1, DcVicP, –2*
Daffin, C E *AmArch 70*
Daffinger, Moriz Michael 1790-1849 *AntBDN J*
Dafforne, James *DcVicP 2*
Dafte, John *AntBDN F*
Dag, Kenneth D 1931- *MarqDCG 84*
Dagand, Adele d1864 *DcWomA*
D'Agar, Charles 1669-1723 *DcBrECP*
Dageforde, John Robert 1923- *AmArch 70*
Daggett, Alfred 1799-1872 *NewYHSD*
Daggett, Clarissa 1784-1816 *FolkA 86*
Daggett, Dann M 1958- *MarqDCG 84*
Daggett, Grace E 1867- *DcWomA, WhAmArt 85*
Daggett, Maud 1883- *WhAmArt 85*
Daggett, Maud 1883-1941 *DcWomA*
Daggett, Noel 1925- *PrintW 83, –85*
Daggett, Robert Frost, Jr. 1912- *AmArch 70*
Daggett, Robert Platt 1837-1915 *BiDAmAr*
Daggett, Vivian Sloan 1895- *ArtsAmW 3*
Daggy, A Smith 1858-1942 *WorECar*
Daggy, Augustus Smith 1858-1942 *WhAmArt 85*
Daggy, Richard S 1892- *WhAmArt 85*
D'Agincourt, Jean-Baptiste Seroux 1730-1814 *MacEA*
Dagit, A F *AmArch 70*
Dagit, Charles Edward 1902- *AmArch 70*
Dagit, Henry D 1865-1929 *BiDAmAr*
Dagit, Henry D, III 1931- *AmArch 70*
Dagit, Leonard H 1933- *AmArch 70*
Dagley, Richard *DcBrECP*
Dagley, Richard 1765?-1841 *DcBrWA*
Daglish, Eric Fitch 1892- *ConICB, IlsCB 1744, –1946*
Daglish, Eric Fitch 1894- *DcBrA 1*
Daglish, Peter 1930- *DcCAr 81*
Dagmez-Lefevre, Emilienne Louise 1888- *DcWomA*
Dagnall, T W *DcVicP 2*
Dagnan, Isidore 1794-1873 *ArtsNiC*
Dagnan-Bouveret, Pascal 1852-1929 *WhAmArt 85A*
Dagnan-Bouveret, Pascal-Adolphe-Jean *ArtsNiC*
Dagnan-Bouveret, Pascal Adolphe Jean 1852-1929 *ClaDrA, McGDA*
Dagnaux, Albert Marie 1861- *ClaDrA*
Dagnez-Lefevre, Emilienne Louise 1888- *DcWomA*
Dagnia *AntBDN H*
Dagnia, Edward *IlDcG*
Dagnia, John *IlDcG*
Dagnia, Onesiphorous *IlDcG*
Dagnia Family *IlDcG*
Dagnia-Williams *IlDcG*
D'Agostino, Peter Pasquale 1945- *WhoAmA 80, –82, –84*
D'Agostino, R J *AmArch 70*
D'Agostino, Salvatore A 1956- *MarqDCG 84*
D'Agostino, Vincent 1896?- *ArtsAmW 3*
D'Agostino, Vincent 1898- *WhAmArt 85, WhoAmA 73, –76, –78, –80*
Dagrada, Mario 1934- *WhoGrA 62*
Dagradi, Donald *WhAmArt 85*
D'Agrosa, R *AmArch 70*
Daguerre, Dominique *OxDecA*
Daguerre, Louis Jacques Mande 1787-1851 *ICPEnP*
Daguerre, Louis-Jacques-Mande 1787-1851 *MacBEP*
D'Aguilar, Michael 1924- *WhoArt 80, –82, –84*
D'Aguilar, Michael 1928- *DcBrA 2*
D'Aguilar, Paul 1924- *DcBrA 2*
D'Aguilar, Paul 1927- *WhoArt 80, –82, –84*
Dagys, Jacob 1905- *WhoAmA 73, –76, –78, –80, –82, –84*

Dahan, Fernand William 1933- *AmArch 70*
Dahill, Thomas Henry, Jr. 1925- *AmArt, WhoAmA 73, –76, –78, –80, –82, –84*
Dahinden, Justus *ConArch A*
Dahinden, Justus 1925- *ConArch*
Dahl, Bernhoff A 1938- *MarqDCG 84*
Dahl, Bertha 1891- *ArtsAmW 3*
Dahl, Cecilie 1858- *DcWomA*
Dahl, Chrix 1906- *WhoArt 80, –82, –84*
Dahl, Francis W 1907- *WhoAmA 73*
Dahl, Francis W 1907-1973 *WhAmArt 85, WhoAmA 76N, –78N, –80N, –82N, –84N*
Dahl, George Leighton 1894- *AmArch 70*
Dahl, Johan Christian 1788-1857 *OxArt*
Dahl, Johan Christian Clausen 1788-1857 *ClaDrA, DcSeaP*
Dahl, Johann Christian 1788-1857 *McGDA*
Dahl, Michael 1659?-1743 *DcBrECP, OxArt*
Dahl, Niels Carl Flindt 1812-1865 *DcSeaP*
Dahl, William Henry 1927- *AmArch 70*
Dahl-Wolfe, Louise 1895- *ConPhot, ICPEnP, MacBEP, WhAmArt 85*
Dahlberg, Edwin Lennart 1901- *WhAmArt 85, WhoAmA 73, –76, –78, –80, –82, –84*
Dahlberg, Erik 1622-1703 *WhoArch*
Dahlen, Charles Raymond 1932- *AmArch 70*
Dahlen, Dennis Robert 1949- *MarqDCG 84*
Dahler, Warren 1887- *WhAmArt 85*
Dahler, Warren 1897-1961 *WhoAmA 80N, –82N, –84N*
Dahlgreen, Charles William 1864-1955 *ArtsAmW 3, WhAmArt 85*
Dahlgren, Carl 1841-1920 *ArtsAmW 1*
Dahlgren, Carl Christian 1841-1920 *IlBEAAW, WhAmArt 85*
Dahlgren, Marius 1844-1920 *ArtsAmW 1, IlBEAAW, WhAmArt 85*
Dahlquist, C L *AmArch 70*
Dahlquist, Ronald C 1935- *AmArch 70*
Dahlquist, T K *AmArch 70*
Dahlskog, Ewald 1894-1950 *IlDcG*
Dahlstroem, Jan-Haakan 1947- *ICPEnP A*
Dahlstrom, Robert Edward 1937- *AmArch 70*
Dahm, Helene 1878- *DcWomA*
Dahmen, K F 1917-1981 *ConArt 83*
Dahmen, Karl Fred 1917- *ConArt 77, DcCAr 81, OxTwCA, PhDcTCA 77*
Dahn, Walter 1954- *DcCAr 81*
Dahn-Fries, Sophie 1835-1898 *DcWomA*
Daht, Louis *DcBrECP*
Dai-Chien, Chang *WhoArt 80, –82, –84*
Daic, George Franklin 1925- *AmArch 70*
Daidone, Joseph Anthony 1930- *AmArch 70*
Dailey, Anne 1872- *WhAmArt 85*
Dailey, Anne Emily 1872-1935 *ArtsAmW 2, DcWomA*
Dailey, Annie Emily 1872-1935 *ArtsAmW 2*
Dailey, Charles Andrew 1935- *WhoAmA 73, –76, –78, –80, –82*
Dailey, Chuck 1935- *WhoAmA 84*
Dailey, Dan 1947- *WhoAmA 82, –84*
Dailey, Daniel Owen 1947- *WhoAmA 78, –80*
Dailey, F B *AmArch 70*
Dailey, Gardner A 1894- *McGDA*
Dailey, Jacob *CabMA*
Dailey, Joseph Charles *WhoAmA 73, –76, –78, –80, –82, –84*
Dailey, Michael Dennis 1938- *WhoAmA 73, –76, –78, –80, –82, –84*
Dailey, Victoria Keilus 1948- *WhoAmA 82, –84*
Dailey, Virginia Augusta 1954- *MarqDCG 84*

Daillion, Palma 1863- *DcWomA*
Daily, Evelynne B 1903- *WhoAmA 73, –76, –78, –80*
Daily, Evelynne Mess 1903- *AmArt, WhoAmA 82, –84*
Daily, Michael I 1949- *MarqDCG 84*
Daily, W H *AmArch 70*
Daingerfield, Elliott 1859-1932 *ArtsAmW 2, IIBEAAW, WhAmArt 85*
Daingerfield, Marjorie d1977 *WhAmArt 85*
Daingerfield, Marjorie Jay *WhoAmA 73, –76*
Daingerfield, Marjorie Jay d1977 *WhoAmA 78N, –80N, –82N, –84N*
Daintree, Richard 1832-1878 *MacBEP*
Daintrey, Adrian Maurice 1902- *ClaDrA, DcBrA 1, WhoArt 80, –82, –84*
Daintrey, Alice S *DcVicP 2, DcWomA*
Dainty, S *NewYHSD*
Daisy *WhoAmA 76, –78, –80, –82*
Daiwaille, Elize Therese *DcWomA*
Dajety, F *NewYHSD*
Dake, Carel L, Jr. *ArtsAmW 3*
Dake, Gesina 1871-1911 *DcWomA*
Dake, Thomas Royal *BiDAmAr*
Dake, Zahad *ArtsAmW 3*
Daken, James *AntBDN D*
Daker, R Grace *ArtsEM, DcWomA*
Dakeyne, Gabriel 1916- *ClaDrA, WhoArt 80, –82, –84*
Dakin, Cecilia Viets *DcWomA*
Dakin, Charles B 1810?-1839 *BiDAmAr*
Dakin, James 1806-1852 *MacEA*
Dakin, James H 1808-1852 *BiDAmAr*
Dakin, James Harrison 1806-1852 *NewYHSD*
Dakin, Joseph *DcVicP 2*
Dakin, L F *AmArch 70*
Dakin, Rose Mabel *DcBrA 1, DcWomA*
Dakin, Sidney Tilden 1876-1935 *ArtsAmW 1*
Dakin, Sylvia C *DcVicP 2*
Daland, Andrew 1927- *AmArch 70*
Daland, Katharine Maynadier Browne 1883- *DcWomA*
Daland, Katharine Maynadler 1883- *WhAmArt 85*
Dalbang, Marthe *DcWomA*
Dalbert, Yolande *DcWomA*
Dalbey, A L *NewYHSD*
Dalboy, Blanche *DcWomA*
Dalby, Arthur 1900-1961 *DcBrA 1*
Dalby, Claire 1944- *ClaDrA, WhoArt 80, –82, –84*
Dalby, David *DcVicP, –2*
Dalby, John *DcVicP, –2*
Dale, Annie *DcVicP 2*
Dale, Antony 1912- *WhoArt 80, –82, –84*
Dale, Archibald 1882-1962 *WorECar*
Dale, Ben 1889-1951 *WhAmArt 85*
Dale, Benjamin Moran d1951 *WhoAmA 78N, –80N, –82N, –84N*
Dale, Bruce 1938- *ICPEnP A*
Dale, Constantia M M *DcVicP 2*
Dale, E *DcVicP 2*
Dale, Ellen M 1850-1922 *WhAmArt 85*
Dale, F C *WhAmArt 85*
Dale, George Edward 1840-1873 *NewYHSD*
Dale, Gertrude 1851-1927 *DcWomA*
Dale, H *DcVicP 2*
Dale, Harriet *DcWomA*
Dale, Henry Sheppard 1852-1921 *DcBrA 1, DcVicP 2*
Dale, Horace Alan, Jr. 1927- *AmArch 70*
Dale, John B d1848 *ArtsAmW 1, IIBEAAW, NewYHSD*
Dale, Lawrence *DcBrBI*
Dale, Maud *DcWomA, WhAmArt 85*
Dale, Stanley *WhAmArt 85*
Dale, Tom 1935- *WhoArt 84*
Dale, William Scott Abell 1921- *WhoAmA 73, –76, –78, –80, –82, –84, WhoArt 80, –82, –84*
Dale, Wilton 1818?- *NewYHSD*
Dalee, Justus *FolkA 86*
Daleiden, Jerome John 1944- *MarqDCG 84*
Dalem, Hans Van *ClaDrA*
Dalens, Dirck 1600?-1676 *McGDA*
D'Alessandro, Robert 1942- *ConPhot, ICPEnP A, MacBEP*
D'Alessio, Gregory 1904- *WhAmArt 85, WhoAmA 78, –80, –82, –84, WorECar*
D'Alessio, Hilda 1914- *ConGrA 1[port]*
D'Alessio, Hilda Terry *WhoAmA 78, –80, –82, –84*
Daley, Joann Imeldine 1904- *WhoAmA 76*
Daley, R H, Sr. *AmArch 70*
Daley, R T *AmArch 70*
Daley, William 1925- *CenC[port]*
Daley, William P 1925- *WhoAmA 78, –80, –82, –84*
DalFabbro, Mario 1913- *WhoAmA 73, –76, –78, –80, –82, –84*
Dalgleish, William 1860-1909 *DcBrWA, DcVicP 2*
Dalgliesh, Theodore Irving 1855-1941 *DcBrA 1*
Dalglish, William d1909 *DcBrA 1*
Dalglish, William 1860?-1909 *ClaDrA*
Dali, Salvador 1904- *ClaDrA, ConArt 77, –83, DcCAr 81, McGDA, OxArt, OxTwCA, PhDcTCA 77, PrintW 83, –85, WhoAmA 76, –78, –80, –82, –84, WhoGrA 62, WorArt[port]*

Dali, Salvador Jacinto Felipe 1904- *WhoGrA 82[port]*
Dalke, Harold Edwin 1921- *AmArch 70*
Dall, A B *AmArch 70*
Dall, Humphry *DcBrECP*
Dall, Nicholas Thomas d1776 *DcBrECP*
Dalla Costa, Amleto 1929- *PrintW 83, –85*
Dalla Valle, Miha 1949- *DcCAr 81*
Dallaire, Jean 1916- *McGDA*
Dallam, Elizabeth Forbes 1875?- *DcWomA, WhAmArt 85*
Dallas, Ann Chassar *DcBrA 1, DcWomA*
Dallas, E W *DcVicP 2*
Dallas, Frederick *FolkA 86*
Dallas, Jacob A 1825-1857 *EarABI, EarABI SUP, NewYHSD*
Dallas, John E S 1883- *DcBrA 1*
Dalle Masegne *McGDA*
Dallemagne, Augustine 1821-1875 *DcWomA*
Dallenbach, Robert H 1936- *MarqDCG 84*
D'Allesandro, J R *AmArch 70*
Dalley, N S *AmArch 70*
Dallin, Arthur 1897-1940 *WhAmArt 85*
Dallin, Cyrus E 1861-1940 *McGDA, WhAmArt 85*
Dallin, Cyrus Edwin 1861-1943 *IIBEAAW*
Dallin, Cyrus Edwin 1861-1944 *BnEnAmA, DcAmArt*
Dallinger VonDalling, Alexander Johann 1783-1844 *ClaDrA*
Dallis, Nicholas 1911- *WorECom*
Dallison, Ken 1933- *IlrAm 1880*
Dallmann, Daniel Forbes 1942- *WhoAmA 80, –82, –84*
Dallmeyer, John Henry 1830-1883 *ICPEnP, MacBEP*
Dallmeyer, Thomas Ross 1859-1906 *ICPEnP*
Dallmeyer, Thomas Rudolph 1859-1906 *MacBEP*
Dall'Oca Bianca, Angelo 1858-1930 *ClaDrA*
Dall'Oglio, Egidio 1705-1784 *McGDA*
Dallos, Jeno 1940- *WorECar*
Dallut, Madame *DcWomA*
Dally, W J *AmArch 70*
Dally, William James 1960- *MarqDCG 84*
D'Almaine, George d1893 *ArtsEM, NewYHSD*
D'Almaine, William Frederick *DcVicP 2*
Dalmas, F E DeSt. *DcVicP 2*
Dalmasio, Lippo *McGDA*
Dalmata, Giovanni 1440?-1509? *McGDA*
Dalmau, Luis *McGDA, OxArt*
Dalmazzoni, Angelo *AntBDN M*
D'Almeida, George 1934- *WhoAmA 73, –76, –78, –80, –82, –84*
D'Almeida, W B *DcVicP 2*
Dalmer, Dora 1857- *DcWomA*
Dalou, Aime-Jules 1838-1902 *McGDA, OxArt*
Dalou, Jules 1838- *ArtsNiC*
Dalou, Jules 1838-1902 *AntBDN C, DcNiCA*
Dalpayrat, Adrien-Pierre 1844- *DcNiCA*
Dalpayrat, Anna *DcWomA*
DalPozzo, Isabella *DcWomA*
Dalrymple, Amy Florence *WhAmArt 85*
Dalrymple, Harriet d1823 *DcWomA*
Dalrymple, Louis 1861-1905 *WorECar*
Dalrymple, Louis 1865-1905 *WhAmArt 85*
Dalrymple, Lucille Stevenson 1882- *DcWomA, WhAmArt 85*
Dalsey, Harry *WhAmArt 85*
Dalston, Alfred *NewYHSD*
Dalston, William B *NewYHSD*
Dalstrom, Frances *DcWomA*
Dalstrom, Mrs. Gustaf *WhAmArt 85*
Dalstrom, Gustaf O 1893- *WhAmArt 85*
Dalton, Anne 1948- *IlsCB 1967*
Dalton, Barton *AntBDN P*
Dalton, Byron 1889- *AmArch 70*
Dalton, David T 1943- *MarqDCG 84*
Dalton, Dorothea *DcWomA*
Dalton, E *NewYHSD*
Dalton, E, Madame *DcWomA*
Dalton, E C *DcVicP 2*
Dalton, Edwin *DcVicP 2*
Dalton, F T *DcBrBI*
Dalton, Frances L 1906- *WhAmArt 85*
Dalton, Frances Louisa 1906- *WhoAmA 73*
Dalton, George Francis, III 1915- *AmArch 70*
Dalton, Harry L 1898- *WhoAmA 73, –76, –78, –80, –82, –84*
Dalton, James *NewYHSD*
Dalton, James Arthur 1918- *AmArch 70*
Dalton, John 1927- *ConArch, MacEA*
Dalton, John Joseph 1856-1935 *IIBEAAW*
Dalton, Mrs. M *DcVicP 2*
Dalton, P H *WhAmArt 85*
Dalton, Peter 1894- *WhAmArt 85*
Dalton, Mrs. Peter *WhAmArt 85*
Dalton, Richard 1715?-1791 *DcBrECP*
Dalton, Richard 1720-1791 *DcBrWA*
Dalton, S *DcWomA*
Dalton, Stephen 1937- *ICPEnP A*
Dalton, Stephen Neale 1937- *MacBEP*
Dalton, William Carlford 1884- *WhAmArt 85*
Dalwood, Hubert 1924- *McGDA, PhDcTCA 77*
Dalwood, Hubert 1924-1976 *OxTwCA*
Dalwood, Hubert Cyril 1924- *DcBrA 1*
Daly, A W *AmArch 70*

Daly, Barbara *WorFshn*
Daly, Cesar 1811-1894 *MacEA*
Daly, David Raymond *WhAmArt 85*
Daly, Ernest Leopoldo Abreu 1913- *AmArch 70*
Daly, Jehan Emile 1918- *ClaDrA, DcBrA 1*
Daly, Jim *OfPGCP 86*
Daly, John Thomas 1932- *AmArch 70*
Daly, Kathleen 1898- *DcWomA, WhoAmA 73, –76, –78, –80, –82, –84*
Daly, Leo Anthony 1917- *AmArch 70*
Daly, Matt A 1860-1937 *WhAmArt 85*
Daly, Matthew A 1860-1937 *CenC[port]*
Daly, Norman 1911- *WhoAmA 76, –78, –80, –82, –84*
Daly, Norman David 1911- *WhAmArt 85, WhoAmA 73, –76*
Daly, Olga Geneva *DcWomA*
Daly, R L *AmArch 70*
Daly, Rosmond *WhAmArt 85*
Daly, Stephen Jeffrey 1942- *WhoAmA 82, –84*
Daly, Thomas F 1908- *WhAmArt 85*
Daly, Tom 1938- *AmArt*
Daly, William Edward 1887-1962 *DcBrA 2*
Daly, William T 1919- *AmArch 70*
Dalyell, Amy *DcBrA 1*
Dalyell, Amy d1962 *DcWomA*
Dalzell, Gary *MarqDCG 84*
Dalzell, Jeanne A 1929- *WhoAmA 76*
Dalzell, K W *AmArch 70*
Dalzell, Kenneth Whitney, Jr. 1915- *AmArch 70*
Dalzell, M J *FolkA 86*
Dalziel, Edward *McGDA*
Dalziel, Edward 1817-1905 *AntBDN B, DcBrBI, DcVicP 2*
Dalziel, Edward Gurden 1849-1888 *DcVicP 2*
Dalziel, Edward Gurden 1849-1889 *ClaDrA, DcBrWA*
Dalziel, Edward Gurdon 1849-1889 *DcBrBI*
Dalziel, George *McGDA*
Dalziel, George 1815-1903 *AntBDN B*
Dalziel, Gilbert 1853-1930 *DcBrA 1, DcVicP 2*
Dalziel, Herbert 1853-1941 *DcVicP 2*
Dalziel, James B *DcVicP 2*
Dalziel, John *McGDA*
Dalziel, John Sanderson 1839-1937 *ArtsAmW 3, WhAmArt 85*
Dalziel, Margaret Jane 1819-1894 *DcWomA*
Dalziel, Owen 1861-1942 *DcVicP 2*
Dalziel, Robert 1810-1842 *DcVicP 2*
Dalziel, Sheila 1916- *DcBrA 1*
Dalziel, Thomas Bolton *McGDA*
Dalziel, Thomas Bolton Gilchrist S 1823-1906 *DcBrBI, DcVicP 2*
Dalziel, William 1805-1873 *DcVicP 2*
Dalziel Family *DcVicP 2*
Dam, C W 1883- *WhAmArt 85*
Dam, Corry Van *DcWomA*
Dam, Stephen Marshall 1928- *AmArch 70*
Dam, William d1755 *CabMA*
Dam VanIsselt, Lucie Van 1871- *DcWomA*
Damaks *EncASM*
Daman, Desire Ells *FolkA 86*
Daman, Ruth Tilden *FolkA 86*
Damart, Henriette Marguerite Blanche *DcWomA*
Damast, Elba Cecilia 1944- *WhoAmA 80, –82, –84*
D'Amato, Janet Potter *WhoAmA 78, –80, –82, –84*
D'Amato, R F *AmArch 70*
Damaz, Paul F 1917- *AmArch 70, WhoAmA 73, –76, –78, –80, –82, –84*
Damberg, John P 1930- *AmArch 70*
Damberg, P S *AmArch 70*
Damberg, R P *AmArch 70*
Dambeza, Elisabeth E 1875- *DcWomA*
Dambock, Adam *FolkA 86*
Dambowic, D *AmArch 70*
Dambrans, Juris 1932- *AmArch 70*
Dambrun, Jean 1741?-1814? *McGDA*
Dame, Ernest *ArtsNiC*
Dame, Lawrence 1898- *WhoAmA 73, –76, –78, –80*
Dame, William d1755 *CabMA*
D'Amelio, Joseph Andrew 1932- *AmArch 70*
Damer, Anne Seymour 1748?-1828 *DcWomA, McGDA, WomArt*
Dameron, Emile Charles *ArtsNiC*
Dameron, Emile Charles 1848-1908 *ClaDrA*
Damery, Walthere 1614-1678 *McGDA*
Dames, Chester *AfroAA*
Damesme, Louis Emmanuel Aime 1767-1822 *MacEA*
Damgard, Bodil 1942- *DcCAr 81*
Damian *McGDA*
Damian, Ascanio 1914- *MacEA*
Damian, Horia 1922- *PhDcTCA 77*
Damian, Horia 1932- *DcCAr 81*
Damianakes, Cleo *WhAmArt 85*
Damianos, Sylvester 1933- *AmArch 70*
Damianov, Angel 1909- *MacEA*
D'Amico, Alicia 1933- *ConPhot, ICPEnP A*
D'Amico, Augustine A 1905- *WhoAmA 73, –76, –78, –80, –82, –84*
D'Amico, Henry 1921- *AmArch 70*
Damico, John Joseph *AmArch 70*
D'Amico, Michael 1936- *AmArch 70*

D'Amico, S V *AmArch 70*
D'Amico, Victor E 1904- *WhAmArt 85*
D'Amico, Victor Edmond 1904- *WhoAmA 73, -76*
Damini, Damina *DcWomA*
Damini, Vincenzo *DcBrECP, McGDA*
Damis, J *DcVicP 2*
Damiset, Charlotte Rebekka *DcWomA*
Damitz, Ernst 1805-1883 *FolkA 86*
Damke, Berne 1939- *DcCAr 81*
Damm, T H *AmArch 70*
Damman, M F *AmArch 70*
Dammartin, Drouet De d1413 *McGDA*
Dammartin, Guy De d1398? *McGDA*
Dammartin, Jean De d1454 *McGDA*
Dammartin Family *MacEA*
Dammouse, Albert 1848-1926 *DcNiCA*
Dammouse, Albert Louis 1848-1926 *IlDcG*
Dammoux, Gabrielle Claire Iules *DcWomA*
Damnjanovic 1936- *PhDcTCA 77*
Damnjanovic, Radomir 1936- *OxTwCA*
Damon *FolkA 86*
Damon, Austin George 1906- *AmArch 70*
Damon, Benjamin *FolkA 86*
Damon, Craig Wilson 1935- *AmArch 70*
Damon, Herbert Walter 1901- *AmArch 70*
Damon, Isaac 1783- *BiDAmAr*
Damon, Joseph *WhAmArt 85*
Damon, Louis d1947 *DcNiCA*
Damon, Louise Wheelwright 1889- *DcWomA, WhAmArt 85*
Damonte Taborda, Raul 1939- *WorECom*
Damora, R *AmArch 70*
D'Amore, S Vincent 1926- *AmArch 70*
Damoreau, Charles F *NewYHSD*
Damourette, Augustine Agathe 1837- *DcWomA*
Damoye, Pierre Emmanuel 1847-1916 *ClaDrA*
Dampier, Arthur *DcVicP 2*
Dampierre, Ernestine De, Comtesse *DcWomA*
Dampt, Aurelie *DcWomA*
Dampt, Jean 1853-1946 *WhAmArt 85A*
Dampt, Jean 1854-1946 *AntBDN A*
Dampt, Marie Celine *DcWomA*
Damron, John Clarence *WhoAmA 73, -76, -78, -80, -82, -84*
Damrosch, Helen *DcWomA*
Damrosch, Helen T *WhAmArt 85*
Damrose, Arturs 1910- *AmArch 70*
Damrow, Charles 1916- *IlBEAAW*
Damuck, Walter Edward 1917- *AmArch 70*
Damuth, C A *AmArch 70*
Dan, Johanne Pedersen *DcWomA*
Dana, Charles Edmund 1843-1914 *WhAmArt 85*
Dana, Edmund Trowbridge 1779-1859 *NewYHSD*
Dana, Eugene 1912- *WhAmArt 85*
Dana, Gladys Elizabeth 1896- *ArtsAmW 2, DcWomA, WhAmArt 85*
Dana, Irving Romine, Jr. 1926- *AmArch 70*
Dana, J F *NewYHSD*
Dana, James Dwight 1813-1895 *NewYHSD*
Dana, John Cotton 1856-1929 *WhAmArt 85*
Dana, Lucinda 1792-1826 *FolkA 86*
Dana, Mary Pepperell 1914- *WhAmArt 85*
Dana, R *AmArch 70*
Dana, Richard Henry, Jr. 1879-1933 *BiDAmAr*
Dana, Sara H *DcWomA, FolkA 86*
Dana, W P W 1833-1927 *WhAmArt 85*
Dana, William P W 1833- *ArtsNiC*
Dana, William Parsons Winchester 1833-1927 *DcVicP 2, NewYHSD*
Danaher, Mary Byington *DcWomA, WhAmArt 85*
Danaher, May d1931 *DcWomA, WhAmArt 85*
Danas, John *FolkA 86*
D'Anastasio, Dante John 1914- *AmArch 70*
Danby, Collinson *DcVicP 2*
Danby, Francis 1793-1861 *ArtsNiC, ClaDrA, DcBrWA, DcSeaP, DcVicP, -2, OxArt*
Danby, Frederick *DcVicP 2*
Danby, Jacob C *DcVicP 2*
Danby, James *ArtsNiC*
Danby, James Francis 1816-1875 *DcBrWA, DcSeaP, DcVicP, -2*
Danby, Joseph *DcVicP 2*
Danby, Ken 1940- *ConArt 77, -83, WhoAmA 73, -76, -78, -80, -82, -84*
Danby, Thomas *ArtsNiC*
Danby, Thomas 1817?-1886 *DcVicP, -2*
Danby, Thomas 1818?-1866 *DcSeaP*
Danby, Thomas 1818?-1886 *DcBrWA*
Dance, Elizabeth J 1901- *WhAmArt 85*
Dance, George 1695-1768 *MacEA*
Dance, George 1700?-1768 *DcD&D, WhoArch*
Dance, George 1741-1825 *DcBrWA, MacEA, OxArt, WhoArch*
Dance, George, Jr. 1741-1825 *BiDBrA*
Dance, George, Sr. 1695-1768 *BiDBrA, OxArt*
Dance, George, The Elder 1695?-1768 *McGDA*
Dance, George, The Younger 1741-1825 *DcD&D[port], McGDA*
Dance, Nathaniel 1735-1811 *DcBrECP*
Dance, Nathaniel 1736-1811 *OxArt*
Dance, Sir Nathaniel 1734-1811 *DcBrBI*

Dance, Robert B *OfPGCP 86*
Dance, Robert Bartlett 1934- *WhoAmA 78, -80, -82, -84*
Dance, Thomas d1733 *BiDBrA*
Dance-Darbour, Anna *DcWomA*
Dancer, John Benjamin 1812-1887 *ICPEnP*
Danchov, Ivan Petkov 1893-1972 *MacEA*
Danckaerts, Jasper *NewYHSD*
D'Ancona, Mirella Levi *WhoAmA 84*
D'Ancona, T *DcVicP 2*
D'Ancona, V *DcVicP 2*
Dandelot, Elisabeth *DcWomA*
Dandelot, Louise *DcWomA*
Dando, Susie May 1873- *ArtsAmW 2, WhAmArt 85*
Dando, Susie May Berry 1873-1934 *DcWomA*
D'Andrea, Albert Philip 1897- *WhAmArt 85, WhoAmA 73, -76, -78, -80, -82, WhoArt 80, -82, -84*
D'Andrea, Albert Philip 1897-1983 *WhoAmA 84N*
D'Andrea, Bernard 1923- *IlrAm F, -1880*
D'Andrea, Italo Eugenio Camerini 1919- *WhAmArt 85*
D'Andrea, Jeanne 1925- *WhoAmA 76, -78, -80, -82, -84*
Dandridge, Bartholomew 1691-1754? *OxArt*
Dandridge, Bartholomew 1691-1755? *DcBrECP*
Dandridge, Bartholomew 1691-1763? *BkIE*
Dane, Bill 1938- *WhoAmA 80, -82, -84*
Dane, Bill Zulpo 1938- *MacBEP*
Dane, John 1749-1829 *CabMA*
Dane, Samuel d1777 *CabMA*
Dane, William Jerald 1925- *WhoAmA 73, -76, -78, -80, -82, -84*
Danehower, Dorothy 1880- *WhAmArt 85*
Danenberg, Bernard *WhoAmA 73, -76, -78*
Daneri, Luigi Carlo 1900- *MacEA*
Danes, Gibson 1910- *WhAmArt 85*
Danes, Gibson Andrew 1910- *WhoAmA 73, -76, -78, -80, -82*
Danet, Marie Marcelle 1877-1958 *DcWomA*
Daney, T *NewYHSD*
Danford, Charles G *DcVicP 2*
Danford, John Alexander 1913- *DcBrA 1*
Danforth *EncASM*
Danforth, Charles Austin *WhAmArt 85*
Danforth, Edward J *NewYHSD*
Danforth, G E *AmArch 70*
Danforth, George Girdler 1818-1849 *CabMA*
Danforth, J B *NewYHSD*
Danforth, Jeremiah 1809- *CabMA*
Danforth, M I *ArtsNiC*
Danforth, Madeleine Adelaide *DcWomA*
Danforth, Margaret *WhAmArt 85*
Danforth, Marie *DcWomA, WhAmArt 85*
Danforth, Moseley Isaac 1800-1862 *NewYHSD*
Danforth, S Chester 1896- *WhAmArt 85*
Danforth, Stephen, Jr. 1799- *CabMA*
Dangar, Anne *DcWomA*
Dangelo, Sergio 1931- *OxTwCA, PhDcTCA 77*
Dangerfield, A D *NewYHSD*
Dangerfield, Edwin J *BiDBrA*
D'Angicourt, Pierre *MacEA*
Dangler, John *FolkA 86*
Dangler, Samuel *FolkA 86*
Dangon, Jeanne 1873- *DcWomA*
Danhausen, Eldon *WhoAmA 73, -76, -78, -80, -82, -84*
Danhauser, Joseph 1805-1845 *McGDA*
Danhouse, F *FolkA 86*
Daniche, Monique 1736- *DcWomA*
Daniche, Ursule 1741- *DcWomA*
Daniel *DcBrECP*
Daniel, A S W *DcWomA*
Daniel, Abraham d1806 *AntBDN J*
Daniel, Albert *AfroAA*
Daniel, Alice Laura 1892- *DcBrA 1, DcWomA*
Daniel, Alice Maud Mary *DcWomA*
Daniel, C G *DcVicP 2*
Daniel, Clarke 1911- *WhAmArt 85*
Daniel, Darrell Wayne 1929- *AmArch 70*
Daniel, Delma J, Jr. 1919- *AmArch 70*
Daniel, Emily *DcWomA*
Daniel, H F *AmArch 70*
Daniel, Hans W 1941- *MarqDCG 84*
Daniel, Henri Joseph DuCommun DuLocle 1804-1884 *ArtsNiC*
Daniel, Henry d1841 *AntBDN M*
Daniel, Henry 1765-1841 *DcNiCA*
Daniel, Holy *FolkA 86, NewYHSD*
Daniel, J 1835?- *NewYHSD*
Daniel, J R *AmArch 70*
Daniel, Joseph 1760-1803 *AntBDN J*
Daniel, Kevin *OfPGCP 86*
Daniel, L *DcWomA*
Daniel, Lewis C d1952 *WhoAmA 78N, -80N, -82N, -84N*
Daniel, Lewis C 1901-1952 *WhAmArt 85*
Daniel, Littleton 1939- *MarqDCG 84*
Daniel, M F *DcWomA*
Daniel, Mary *DcWomA*
Daniel, Mary Reed *AfroAA*

Daniel, Mell *WhAmArt 85*
Daniel, Naomi M *DcWomA*
Daniel, P A *DcVicP 2*
Daniel, R *DcNiCA*
Daniel, Ronnie Eugene 1940- *AmArch 70*
Daniel, Roxanne 1927- *WhoAmA 73*
Daniel, Suzanne Garrigues 1945- *WhoAmA 78, -80, -82, -84*
Daniel, Ursual M *CabMA*
Daniel And Arter *EncASM*
Daniel-Klein, Stephanie *DcWomA*
Daniele-Hoffe, Jane 1885- *DcWomA*
Danieli, Fidel Angelo 1938- *WhoAmA 76, -78, -80, -82, -84*
Danielian, Arthur Calvin 1935- *AmArch 70*
Danielis, Friedrich *DcCAr 81*
Daniell *DcNiCA*
Daniell, Edward Thomas 1804-1842 *DcBrWA, DcVicP 2*
Daniell, Frank *DcVicP 2*
Daniell, Frank Robinson 1868-1932 *DcBrA 2*
Daniell, Gustaf R 1925- *AmArch 70*
Daniell, S M *DcVicP 2*
Daniell, Samuel 1775?-1811 *DcBrBI, DcBrECP, DcBrWA*
Daniell, Sophia S *DcWomA*
Daniell, Thomas 1749-1840 *DcBrBI, DcBrECP, DcBrWA, DcSeaP, MacEA*
Daniell, William 1769-1837 *DcBrBI, DcBrECP, DcBrWA, DcSeaP, McGDA*
Daniell, William Swift 1865- *WhAmArt 85*
Daniell, William Swift 1865-1933 *ArtsAmW 2*
Daniels, Alfred 1924- *WhoArt 80, -82, -84*
Daniels, Amy *DcVicP 2, DcWomA*
Daniels, Anson 1813-1884 *NewYHSD*
Daniels, Charles H *NewYHSD*
Daniels, David M 1927- *WhoAmA 73, -76, -78, -80, -82, -84*
Daniels, Eleazar 1788-1858 *CabMA*
Daniels, Elmer Harland 1905- *WhAmArt 85*
Daniels, George 1854-1917? *DcBrBI*
Daniels, George Fisher 1821-1879? *NewYHSD*
Daniels, George Nelson 1927- *AmArch 70*
Daniels, Harvey Morton 1936- *WhoArt 80*
Daniels, Howard *BiDAmAr*
Daniels, J B 1846- *WhAmArt 85*
Daniels, Jeffery 1932- *WhoArt 80, -82, -84*
Daniels, John H *NewYHSD*
Daniels, John K 1875- *WhAmArt 85*
Daniels, Jonathan Russell 1961- *MarqDCG 84*
Daniels, Julia *WhAmArt 85*
Daniels, Maria *DcWomA*
Daniels, Michael G 1948- *MarqDCG 84*
Daniels, Raymond H 1944- *AfroAA*
Daniels, Robert Lemuel 1922- *AmArch 70*
Daniels, Stanley Lee 1937- *AmArch 70*
Daniels, Stephen Harland 1935- *AmArch 70*
Daniels, Thomas Harding 1926- *AmArch 70*
Daniels, Walter *NewYHSD*
Daniels, William 1813-1880 *DcVicP, -2*
Daniels, Z A *DcWomA*
Danielson, J J *AmArch 70*
Danielson, John George 1910- *AmArch 70*
Danielson, Phyllis I *WhoAmA 78, -80, -82, -84*
Danielson, Richard Duane 1937- *AmArch 70*
Danielson, William Douglas 1926- *AmArch 70*
Danielson-Gambogi, Elin Kleopatra 1861- *DcWomA*
Danikian, Caron LeBrun 1942- *WhoAmA 73, -76, -78, -80, -82, -84*
Daniloff, N N *AmArch 70*
Danin, Alex 1919- *AmArch 70*
Dank, Leonard Dewey 1929- *WhoAmA 78, -80, -82, -84*
Dankert, William Leroy 1934- *AmArch 70*
Danko, Natalia Iakovlevna 1892-1942 *DcWomA*
Danko, Stefan 1912- *OxTwCA*
Danks, Benjamin 1758-1790 *DcBrECP*
Dankworth, Frederick 1804?- *NewYHSD*
Danloux, Henri Pierre 1753-1809 *ClaDrA*
Danloux, Henri-Pierre 1753-1809 *DcBrECP*
Dann, Anna Katharine *DcWomA*
Dann, David Phillips 1925- *AmArch 70*
Dann, Frode N 1892- *IlBEAAW*
Dann, Frode Neilsen 1892- *WhAmArt 85*
Dann, Frode Nielsen 1892- *ArtsAmW 1*
Danna, C *AmArch 70*
Danna, J B *AmArch 70*
Dannat, William T 1853- *ArtsNiC*
Dannat, William T 1853-1929 *WhAmArt 85*
Dannatt, George 1915- *WhoArt 84*
Dannatt, Trevor 1920- *ConArch, DcD&D, MacEA*
Dannecker, Johann Heinrich Von 1758-1841 *McGDA*
Dannehl, Luise 1864- *DcWomA*
Danneman, L *NewYHSD*
Dannenberg, Alice 1861- *DcWomA*
Dannenberg, C F *DcSeaP*
Dannenburg, C F *FolkA 86*
Danner, Adam *NewYHSD*
Danner, J A *NewYHSD*
Danner, Philip *FolkA 86*
Danner, Sara Kolb *WhAmArt 85*

Danner, Sara Kolb 1894- *ArtsAmW 1, DcWomA*
Dannert, Henry 1790?- *FolkA 86*
Dannet, Jacqueline *DcWomA*
Dannhoffer, Joseph Philipp 1712- *AntBDN M*
D'Annunzio, Palma *DcWomA*
Danoff, I Michael 1940- *WhoAmA 76, -78, -80, -82, -84*
Danos, H J *AmArch 70*
Danovich, Francis Edward 1920- *WhAmArt 85*
Dansby, R E *AmArch 70*
Danse, Louise *DcWomA*
Danse, Marie 1867- *DcWomA*
Dansereau, Mireille 1943- *WhoAmA 76, -78, -80, -82*
Danska, Herbert *IlsCB 1967*
Danska, Herbert 1927?- *IlsBYP, IlsCB 1946, -1957*
Danson, Edward B 1915- *WhoAmA 73*
Danson, Edward B 1916- *WhoAmA 76*
Danson, Elsa 1885- *DcWomA*
Danson, George 1799-1881 *DcBrWA, DcVicP 2*
Danson, R *DcVicP 2*
Danson, Thomas *DcVicP 2*
Dansse DeRomilly, Madame *DcWomA*
Dantan, Antoine Laurent 1798-1878 *ArtsNiC*
Dantan, Jean-Pierre 1800-1869 *ArtsNiC*
Dante, Giglio Raphael 1916- *WhAmArt 85*
Dante, Vincenzo 1530-1576 *OxArt*
Danti, Teodora 1498-1573 *DcWomA*
Danti, Vincenzo 1530-1576 *McGDA, OxArt*
Danti Family *MacEA*
Dantonet, A *NewYHSD*
D'Antoni, Gaitan B 1953- *MarqDCG 84*
Dantzic, Cynthia Maris 1933- *WhoAmA 84*
Dantzic, Jerry 1925- *ICPEnP A, MacBEP*
Dantzig, Meyer *WhAmArt 85*
Dantzig, Rachel Margaretha Van 1878- *DcWomA*
Dantziger, Ytshak 1916- *OxTwCA*
Danvers, Joan 1919- *WhoArt 80, -82, -84*
Danvin, Constance Amelie 1810- *DcWomA*
Danyell, Herbert *DcVicP 2*
Danze, L P *AmArch 70*
Danziger, Abraham 1867?- *ArtsAmW 3*
Danziger, Avery C 1953- *WhoAmA 84*
Danziger, Avery Coffey 1953- *ICPEnP A, MacBEP*
Danziger, Joan 1934- *WhoAmA 80, -82, -84*
Danziger, Louis 1923- *ConDes, WhoGrA 62, -82[port]*
Danziger, Ytshak 1916- *PhDcTCA 77*
Daoust, Sylvia 1902- *WhoAmA 73, -76, -78, -80*
Daphne, Annette *WhoAmA 73, -76*
Daphnis Of Miletos d300BC *MacEA*
Daphnis, Nasso 1914- *DcCAA 77*
Daphnis, Nassos 1914- *AmArt, ConArt 77, -83, DcCAA 71, OxTwCA, PrintW 85, WhAmArt 85, WhoAmA 73, -76, -78, -80, -82, -84*
Daphnis-Avlon, Helen 1932- *WhoAmA 73, -76, -78, -80, -82*
Daplyn, A J *DcVicP 2*
Dapper, Martha *ArtsEM, DcWomA*
Dapprich, Helen 1879- *DcWomA*
DaPredis *McGDA*
Daprich, Helen 1879- *WhAmArt 85*
D'Aquino, Francisco Thomaz 1921- *AmArch 70*
Darach, Peter 1940- *DcCAr 81*
Daragnes, Jean Gabriel 1886-1950 *ClaDrA*
Daraio, Innocenzo 1903- *WhAmArt 85*
Daraniyagala, Justin Pieris 1903- *OxTwCA*
Daras, Leontine Julie Sophie *DcWomA*
D'Arazian, Arthur 1914- *ICPEnP A*
Darbishire, H A *MacEA*
Darbishire, Sophia *DcWomA*
Darbois, Madame *DcWomA*
Darbon, William *DcVicP 2*
Darbour, Marguerite Mary *DcWomA*
Darboven, Hanne 1941- *ConArt 77, -83, DcCAr 81, WhoAmA 78, -80, -82, -84*
Darby, A *DcWomA*
Darby, A J, Jr. *AmArch 70*
Darby, Abraham 1678-1717 *OxDecA*
Darby, Abraham 1711-1763 *OxDecA*
Darby, Abraham, III 1750-1789 *MacEA*
Darby, Elizabeth d1906 *DcWomA, WhAmArt 85*
Darby, Henry F 1831- *FolkA 86, NewYHSD*
Darby, J G *NewYHSD*
Darby, Mathias d1780? *AntBDN G*
Darby, Philip 1938- *WhoArt 84*
Darby, Robert Fred 1923- *AmArch 70*
Darby, Samuel Norman 1934- *AmArch 70*
Darbyshire, J A *DcBrBI*
D'Arc, A Jerome *ArtsAmW 3*
D'Arcangelo, Allan 1930- *ConArt 77, -83, DcCAA 71, -77, DcCAr 81, OxTwCA, PrintW 83, -85, WorECar[port]*
D'Arcangelo, Allan M 1930- *WhoAmA 73, -76, -78, -80, -82, -84*
D'Arce, C *DcWomA*
Darce, Virginia 1910- *WhAmArt 85*
Darche, Jacques 1920-1965 *ConPhot, ICPEnP A*
Darcis, Louis d1801? *McGDA*
Darcy, Laura *DcVicP 2, DcWomA*

Darcy, Thomas 1932- *WorECar*
Dardel, Madame *DcWomA*
Dardel, Nils Von 1888-1943 *PhDcTCA 77*
Dardel, Renee Helene Tolla 1891- *DcWomA*
Darden, Edwin Speight 1920- *AmArch 70*
Dardenne, Louise Victoire *DcWomA*
Dardick, Samuel Ian 1933- *AmArch 70*
Dards, Mrs. *DcWomA*
Dare, Charles W F *FolkA 86*
Dare, J *DcBrECP*
Dare, Robert 1800?-1839? *FolkA 86*
Darena, Madame *DcWomA*
Daressy-Menon, M *DcWomA*
Daret, Jacques 1404?- *McGDA*
Daret, Jacques 1406-1468 *OxArt*
Daret, Jean 1613-1668 *McGDA*
Daret, Pierre 1604?-1678 *McGDA*
Daret, Suzanne A A 1882- *DcWomA*
Darge, Fred 1900- *IlBEAAW, WhAmArt 85*
Dargent, E Yan *ArtsNiC*
Dargent, Julie *DcWomA*
D'Argenta *McGDA*
Dargental, Aimee 1890?- *DcWomA*
Darger, Henry 1892-1973 *FolkA 86*
Dargie, Sir William Alexander 1912- *DcBrA 1, WhoArt 80*
Darier, Marguerite *DcWomA*
Darier, Nancy 1816-1888 *DcWomA*
Darier-Guignon, Jenny 1845- *DcWomA*
Darier-Wolfsberger, Emma 1850- *DcWomA*
D'Arista, Robert 1929- *DcCAA 71, -77, WhoAmA 73, -76, -78, -80, -82, -84*
Darius, Denyll 1942- *WhoAmA 73, -76*
Darius, Denyll 1942-1976 *WhoAmA 78N, -80N, -82N, -84N*
Dark, Bernard Frankland *McGDA*
Dark, Bernard Frankland 1903- *McGDA*
Darley, E H *NewYHSD*
Darley, Felix O C 1822- *ArtsNiC*
Darley, Felix Octavius Carr 1822-1888 *BnEnAmA, DcAmArt, EarABI, EarABI SUP, IlBEAAW, IlrAm 1880, NewYHSD*
Darley, J F d1932 *DcBrA 1, DcVicP 2*
Darley, J Felix d1932 *DcBrBI*
Darley, James d1822 *BiDBrA*
Darley, Jane Cooper 1807-1877 *NewYHSD*
Darley, John Clarendon 1808?- *NewYHSD*
Darley, Matthew *BkIE, DcBrWA*
Darley, Mrs. W H W *NewYHSD*
Darley, William H *DcVicP 2*
Darling, Aaron E *AfroAA*
Darling, Carlos C *CabMA*
Darling, Charles James 1938- *AmArch 70*
Darling, Dorothy Anne *WhAmArt 85*
Darling, Frank 1850-1923 *MacEA*
Darling, George Channing d1939? *WhAmArt 85*
Darling, Gilbert *WhAmArt 85*
Darling, Grace Horsley 1815-1842 *DcNiCA*
Darling, J *NewYHSD*
Darling, Jay Norwood 1876- *WhAmArt 85*
Darling, Jay Norwood 1876-1962 *WhoAmA 80N, -82N, -84N, WorECar*
Darling, Kenneth Thomas 1932- *AmArch 70*
Darling, Lois Macintyre *IlsCB 1967*
Darling, Lois MacIntyre 1917- *IlsCB 1957*
Darling, Louis d1970 *IlsCB 1967*
Darling, Louis 1916-1970 *IlsCB 1946, -1957*
Darling, Martha 1806-1883 *DcWomA*
Darling, Michael 1923- *ClaDrA*
Darling, Robert *FolkA 86*
Darling, Sanford 1894-1973 *FolkA 86*
Darling, Sharon Sandling 1943- *WhoAmA 78, -80, -82, -84*
Darling, Sumner Earle 1934- *AmArch 70*
Darling, Mrs. Thomas *DcWomA*
Darling, Tony Peter 1952- *MarqDCG 84*
Darling, Wilder M 1856-1933 *WhAmArt 85*
Darling, William S 1882-1963 *ArtsAmW 3*
Darlington, Alice L 1854-1941 *DcWomA*
Darlington, Amos *CabMA*
Darlington, Amos, Jr. 1792- *CabMA*
Darlington, Mabel Kratz 1871- *ArtsAmW 3*
Darlington, Mary O'Hara *WhAmArt 85*
Darlington, Robert Palmer 1923- *AmArch 70*
Darlinson, G *AntBDN P*
Darly, Mary *DcWomA*
Darly, Mathias *BiDBrA*
Darly, Matthew d1780? *OxDecA*
D'Armagnac, Ben 1940-1978 *ConArt 83*
Darmesteter, Helena Arsene *DcWomA*
Darms, David John 1938- *AmArch 70*
D'Arms, Edward F, Jr. 1937- *MacBEP*
Darnaud, Cecile *DcWomA*
Darnault, Florence Malcolm 1905- *WhAmArt 85*
Darneille, Benjamin *FolkA 86*
Darneille, Grace P *DcWomA*
Darnell, Dorothy *DcWomA*
Daroche, Frank *FolkA 86*
DaRoit, Fiore 1913- *AmArch 70*
Daron, Jacob 1805?- *FolkA 86*
D'Aronco, Raimondo 1857-1932 *MacEA, McGDA,*

WhoArch
Darondeau, Stanislas Henri Benoit 1807-1841 *ClaDrA*
Daroux, Lenora 1886- *DcWomA*
Daroux, Leonora 1886- *ArtsAmW 2, WhAmArt 85*
DaRoza, Gustavo 1933- *ConArch*
D'Arpino, Giuseppe Cesari 1568?-1640 *ClaDrA*
Darr, William Humiston 1920- *WhoAmA 78, -80, -82*
Darrach, Fanny *DcWomA*
Darrach, James A 1875-1912 *BiDAmAr*
Darragh, John *CabMA, NewYHSD*
Darragh, L H *DcWomA*
D'Arragh, Marion *WhAmArt 85*
Darrah, Ann Clarke *WhoAmA 80*
Darrah, Ann Clarke 1944- *WhoAmA 78*
Darrah, Ann Sophia 1819-1881 *DcWomA*
Darrah, Ann Sophia Towne 1819-1881 *NewYHSD*
Darrah, Frank J *WhAmArt 85*
Darrah, Mrs. S T d1881 *ArtsNiC*
Darras, Leontine *DcWomA*
Darre, G *DcBrBI*
Darrell, David Choate 1927- *AmArch 70*
Darrell, G C *AmArch 70*
Darrell, George Albert 1931- *AmArch 70*
Darrell, Sir Harry Francis Colville 1814-1853 *DcBrWA*
Darrell, Sir Harry Verelst 1768-1828 *DcBrWA*
Darrell, Margaret *WhAmArt 85*
Darriau, Jean-Paul 1929- *WhoAmA 84*
Darricarrere, Roger Dominique 1912- *WhoAmA 73, -76, -78, -80, -82, -84*
Darriet, Leontine 1872- *DcWomA*
Darro, Peter *OfPGCP 86*
Darrough, James Thomas 1927- *AmArch 70*
Darrow, Elijah *FolkA 86*
Darrow, J M *FolkA 86*
Darrow, John *FolkA 86*
Darrow, K L *AmArch 70*
Darrow, Lee Stuart 1927- *AmArch 70*
Darrow, Mrs. Newton *FolkA 86*
Darrow, Paul Gardner *WhoAmA 73, -76, -78, -80, -82, -84*
Darrow, Paul Gardner 1921- *DcCAA 71, -77*
Darrow, Paul W *WhAmArt 85*
Darrow, R L *AmArch 70*
Darrow, T H *NewYHSD*
Darrow, Whitney, Jr. 1909- *WhAmArt 85, WhoAmA 73, -76, -78, -80, -82, -84, WorECar*
Darrow, Mrs. Whitney, Jr. *WhAmArt 85*
Darru, Louise *DcWomA*
Dart, Cora D *ArtsEM, DcWomA*
Dart, Edward Dupaquier 1922- *AmArch 70*
Dart, Edward N *WhAmArt 85*
Dart, Frederick *NewYHSD*
Dart, Harry G 1870-1938 *WhAmArt 85*
Dart, Harry Grant 1869-1938 *IlrAm 1880, WorECar*
Dart, Henry G *WhAmArt 85*
Dart, Hester Wilson d1913 *DcWomA, WhAmArt 85*
Dart, Michael S *ArtsEM*
Darter, Mary Sue *ArtsAmW 3*
Darter, Mary Sue 1894- *WhAmArt 85*
Dartiguenave, P *DcVicP 2*
Dartiguenave, Paul 1862-1918 *WhAmArt 85*
Dartiguenave, Victor *DcVicP 2*
D'Artois, Jacques *McGDA*
Darton, Arthur B 1909- *AmArch 70*
Darton, Christopher 1945- *WhoAmA 76, -78, -80, -82, -84*
Darton, W D *FolkA 86*
Darton, William *DcVicP 2*
Darvall, Charles G *DcVicP 2*
Darvall, Frank *DcVicP 2*
Darvall, Henry *DcVicP 2*
Darvas, Arpad 1927- *WhoGrA 62*
Darvc *ConGrA 1*
Darvin, Erasmus *NewYHSD*
Darviot, Cecile 1899- *DcWomA*
Darwin, Beatrice *IlsBYP*
Darwin, Elinor Mary *ClaDrA, DcBrA 1, DcWomA*
Darwin, Elinor May d1954 *ConICB, IlsCB 1744, -1946*
Darwin, Gwendolen *DcWomA*
Darwin, Leonard 1850- *IlsBYP*
Darwin, Sir Robin 1910- *DcBrA 1*
Darwin, Sir Robin 1910-1974 *DcBrA 2*
Darwin, Ruth *DcWomA*
Das, Elsie Jensen 1903- *WhAmArt 85*
Das, Jatin 1941- *WhoArt 80, -82, -84*
Das, Mihir K *MarqDCG 84*
Das, Satyen Kumar 1947- *MarqDCG 84*
Das, Sunil Ranjan 1936- *MarqDCG 84*
Dasarathy, Belur Venkatachalan 1944- *MarqDCG 84*
Dasburg, Andrew 1887- *DcAmArt, DcCAA 71, -77, OxTwCA*
Dasburg, Andrew Michael 1887- *ArtsAmW 1, BnEnAmA, IlBEAAW, McGDA, WhAmArt 85, WhoAmA 73, -76, -78*
Dasburg, Andrew Michael 1887-1979 *WhoAmA 80N, -82N, -84N*
Dasburg, Andrew Michel 1887- *ArtsAmW 2*
Dasburg, Grace *DcWomA*
Dasburg, Grace Mott Johnson *WhAmArt 85*

D'Ascenzo, Myrtle Goodwin 1864- *WhAmArt 85*
D'Ascenzo, Myrtle Goodwin 1864-1954 *DcWomA*
D'Ascenzo, Nicola 1871- *WhAmArt 85*
Daschblach, A C *WhAmArt 85*
Daseking, William H 1914- *AmArch 70*
Dasenbrock, Doris Voss 1939- *WhoAmA 82, -84*
Dash, Harvey Dwight 1924- *WhoAmA 73, -76, -78, -80, -82, -84*
Dash, John Baltus *FolkA 86*
Dash, Robert 1931- *PrintW 83, -85*
Dash, Robert 1932- *DcCAA 71*
Dash, Robert 1934- *DcCAA 77, WhoAmA 73, -76, -78, -80, -82, -84*
Dashiell, Margaret May *DcWomA, WhAmArt 85*
D'Ashnash-Tosi 1939- *WhoAmA 84*
Dashwood, Lady *DcWomA*
Dashwood, Georgiana *DcBrWA*
Dashwood, J *DcBrECP*
Dashwood, R *DcBrECP*
Dasilva, H C *DcVicP 2*
DaSilva, Maria Elena Vieira *WorArt*
DaSilva, Peter Nolasco 1938- *AmArch 70*
DaSilva, Vitor 1932- *WhoGrA 82[port]*
Daskaloff, Gyorgy 1923- *WhoAmA 76, -78, -80, -82, -84*
Dass, Dean Allen 1955- *WhoAmA 84*
Dassel, Herminia d1857 *DcWomA*
Dassel, Herminia Borchard d1857 *NewYHSD*
Dasson, Pierre *DcNiCA*
Dasveldt, Jan H 1770-1850 *ClaDrA*
Daswick, P *AmArch 70*
Daszkowski, Richard Joseph 1954- *MarqDCG 84*
Dat, Simone *OxTwCA*
Data, Arthur Joseph 1950- *MarqDCG 84*
Date, Kotaro *WhAmArt 85*
Date, S Daniel 1917- *AmArch 70*
Dater, Judy 1941- *ConPhot, ICPEnP A, MacBEP, PrintW 85, WhoAmA 80, -82, -84*
Dates, Dwight E 1940- *AfroAA*
Dathan, Johann Georg 1703-1748? *McGDA*
D'Atri, Jean 1946- *MarqDCG 84*
Datskevich, Sergei Ignatievich 1919- *WhoGrA 62*
D'Attilio, Anthony *IlsBYP*
D'Attilio, Anthony 1909- *WhAmArt 85*
Dattner, Richard 1937- *AmArch 70*
Dattola, Elmer, Jr. 1921- *AmArch 70*
Datus, Jay 1914- *WhoAmA 73*
Datus, Jay 1914-1974 *IlBEAAW, WhAmArt 85, WhoAmA 76N, -78N, -80N, -82N, -84N*
Datus, Mrs. Jay *WhAmArt 85*
Datz, A Mark *WhoAmA 78N, -80N, -82N, -84N*
Datz, A Mark 1889- *WhAmArt 85*
Datz, Abraham *WhAmArt 85*
Daub, Gerald M 1925- *AmArch 70*
Dauban, Jules-Joseph 1822- *ArtsNiC*
Dauban, May Lilian 1907- *WhoArt 80, -82, -84*
Dauber, Edwin J 1922- *AmArch 70*
Daubigny, Amelie 1793?-1861 *DcWomA*
Daubigny, Charles Francois 1817-1878 *ArtsNiC, ClaDrA*
Daubigny, Charles-Francois 1817-1878 *McGDA*
Daubigny, Charles-Francois 1817-1879 *OxArt*
Daubigny, Edme-Francois *OxArt*
Daubigny, Karl Pierre *ArtsNiC*
Daubigny, Karl Pierre 1846-1886 *ClaDrA*
Daubrawa, De *DcVicP 2*
Daubre, Alfred d1885 *AntBDN C*
Daubresse, T *AmArch 70*
Daubrive, Angele *DcWomA*
Dauby, Maria *DcWomA*
Daucher, Adolf d1524 *OxArt*
Daucher, Adolf 1460?-1524? *McGDA*
Daucher, Hans 1485?-1538 *McGDA, OxArt*
Dauchez, Andre 1870-1943 *ClaDrA*
Dauchez, Berthe Marie Henriette *DcWomA*
Dauchez, Jeanne *DcWomA*
Daudelin, Charles 1920- *WhoAmA 84*
Daudet, Berthe d1889 *DcWomA*
Daudignac, Clemence Sophie 1767-1850 *DcWomA*
Daudis, Jose *ArtsAmW 3*
Daugherty, Charles M *WhAmArt 85*
Daugherty, Charles Michael 1914- *IlsCB 1946*
Daugherty, Harry R *WhAmArt 85*
Daugherty, Harry R 1883- *IlsCB 1946*
Daugherty, James *WorFshn*
Daugherty, James Henry d1974 *IlsCB 1967*
Daugherty, James Henry 1889- *WhoAmA 73*
Daugherty, James Henry 1889-1974 *IlBEAAW, IlsCB 1744, -1946, -1957, WhAmArt 85*
Daugherty, James Henry 1898-1974 *WhoAmA 76N, -78N, -80N, -82N, -84N*
Daugherty, Marshall Harrison 1915- *WhoAmA 78, -80, -82, -84*
Daugherty, Michael F 1942- *WhoAmA 78, -80, -82, -84*
Daugherty, Nancy Lauriene 1890- *DcWomA, WhAmArt 85*
Daugherty, S *FolkA 86*
Daugherty, William *BiDAmAr*
Daughn, G E *AmArch 70*
Daughters, Robert A 1929- *AmArt, WhoAmA 82, -84*

Daughtry, Leon Edward 1930- *AmArch 70*
D'Aulaire, Edgar Parin *IlsCB 1967*
D'Aulaire, Edgar Parin 1898- *ConICB, IlsBYP, IlsCB 1744, -1946, -1957, WhoAmA 73, -76, -78, -80, -82, -84*
D'Aulaire, Edgar Parin 1905- *WhAmArt 85*
D'Aulaire, Ingri 1904- *IlsBYP, IlsCB 1744, -1946, -1957, WhoAmA 76*
D'Aulaire, Ingri And Edgar Parin *Cald 1938*
D'Aulaire, Ingri Mortenson Parin *IlsCB 1967*
D'Aulaire, Ingri Parin 1904- *WhoAmA 73, -78, -80, -82, -84*
Daulceur, Louise Le *DcWomA*
Daulle, Claire Marie 1827-1869 *DcWomA*
Daulle, Jean 1703-1763 *McGDA*
Daum, Antonin *AntBDN H*
Daum, Antonin 1864-1930 *AntBDN A, DcNiCA*
Daum, Arnold Edward 1917- *MarqDCG 84*
Daum, Auguste 1853-1909 *DcNiCA*
Daum, Henri 1894-1966 *IlDcG*
Daum, Jacques 1919- *IlDcG*
Daum, Jan *DcBrA 1*
Daum, Jean 1825-1885 *IlDcG*
Daum, Jean-Antonin 1864-1930 *IlDcG*
Daum, Jean-Louis Auguste 1853-1909 *IlDcG*
Daum, Michel 1900- *IlDcG*
Daum, Paul 1890-1944 *IlDcG*
Daum Freres *IlDcG*
Dauman, Henri 1933- *ICPEnP A*
Daumier, Honore 1808-1879 *ClaDrA, McGDA, WorECar*
Daumier, Honore 1810-1879 *OxArt*
Daumit, N David 1909- *AmArch 70*
Daun, A N *AmArch 70*
Daun, B *DcVicP 2*
Dauney, William *BiDBrA*
Dauphin, Jane *DcWomA*
Dauphin, Madeleine *DcWomA*
D'Auria, Tom *WorFshn*
Daus, Rudolph L 1854-1916 *BiDAmAr*
Dausse, Elise *DcWomA*
Dautel, Amelie *DcWomA*
Dautel, Henriette Virginie 1803- *DcWomA*
Dautel, John Daniel *WhAmArt 85*
Dauterman, Carl Christian *WhoAmA 73, -76, -78, -80, -82, -84*
D'Autilia, Frank 1924- *AmArch 70*
Dauvergne, Emilie *DcWomA*
Daux, Henriette 1866- *DcWomA*
Dauzats, Adrien 1804-1868 *ClaDrA*
Dauzats, Adrien 1808-1868 *ArtsNiC*
Davant, John d1733 *CabMA*
DaVanzo, Jacopo *McGDA*
Dave *FolkA 86*
Dave, Pauline Aglae De *DcWomA*
Daveler, Joseph *FolkA 86*
Davenport, A F *FolkA 86*
Davenport, Adam *CabMA*
Davenport, Alma 1949- *MacBEP*
Davenport, Brewster d1927 *WhAmArt 85*
Davenport, Burrage *AntBDN Q*
Davenport, C Talbot *DcVicP 2*
Davenport, Carson S 1908- *WhAmArt 85*
Davenport, E Fairfax 1880- *WhAmArt 85*
Davenport, Ebenezer *CabMA*
Davenport, Edith Fairfax 1880-1957 *DcWomA, WhoAmA 80N, -82N, -84N*
Davenport, Ethel *WhAmArt 85*
Davenport, Frank William Leslie 1905-1973 *DcBrA 1*
Davenport, H D *DcVicP 2*
Davenport, Henry 1882- *WhAmArt 85*
Davenport, Homer Calvin 1867-1912 *ArtsAmW 1, WhAmArt 85, WorECar*
Davenport, Jane 1897- *DcWomA, WhAmArt 85*
Davenport, John *DcBrWA, NewYHSD*
Davenport, John d1848 *AntBDN M*
Davenport, John 1791-1842 *CabMA*
Davenport, John Byron 1914- *WhAmArt 85*
Davenport, John D *NewYHSD*
Davenport, Louis 1829-1879 *ArtsEM*
Davenport, MacHarg 1891-1941 *ArtsAmW 2*
Davenport, Maria *DcWomA, FolkA 86*
Davenport, McHarg 1891-1941 *ArtsAmW 2, WhAmArt 85*
Davenport, Patrick Henry 1803- *FolkA 86*
Davenport, Patrick Henry 1803-1890 *NewYHSD*
Davenport, Perry M 1848- *ArtsEM*
Davenport, Ray *OfPGCP 86*
Davenport, Ray 1926- *WhoAmA 84*
Davenport, Rebecca Read 1943- *WhoAmA 82, -84*
Davenport, Rollin W *ArtsEM*
Davenport, Thomas d1745 *CabMA*
Davenport, Thomas 1805?- *NewYHSD*
Davenport, W *DcBrBI*
Davenport, William 1738- *FolkA 86*
Davenport Brothers *ArtsEM*
Davent, Leon *McGDA*
Daverman, Herbert George 1913- *AmArch 70*
Daverman, J T *AmArch 70*
Daverman, Jacob H 1847-1914 *BiDAmAr*

Daves, Delmer *WhoAmA 73*
Daves, Donald T *AmArch 70*
Daves, Francis Marion 1903- *AmArch 70*
Daves, Jessica 1898-1974 *WorFshn*
Davesies DePontes, Catherine *DcWomA*
Davey, Clara *ArtsAmW 3, WhAmArt 85*
Davey, Edith Mary *DcBrA 1, DcWomA*
Davey, Florence *DcVicP 2, DcWomA*
Davey, George *DcBrBI*
Davey, George William *NewYHSD*
Davey, H F *DcBrBI*
Davey, Henry *CabMA*
Davey, Ira Howard 1902- *AmArch 70*
Davey, John *CabMA*
Davey, Leonard John 1913- *WhoArt 80, -82, -84*
Davey, Randall d1964 *WhoAmA 78N, -80N, -82N, -84N*
Davey, Randall 1887-1964 *ArtsAmW 1, -2, DcCAA 71, -77, IlBEAAW, WhAmArt 85*
Davey, Robert d1793 *DcBrWA*
Davey, Ronald A *WhoAmA 73, -76, -78, -80, -82, -84*
Davey, William *DcBrWA*
Daviau, Melina Eudoxie 1874-1961 *DcWomA*
David, Mademoiselle *DcWomA*
David, Alexander 1908- *WhAmArt 85*
David, Allen 1936- *WhoAmA 76*
David, Anita *DcAr 81*
David, Anna 1855-1929? *DcWomA*
David, Antonio 1698- *ClaDrA*
David, Barbara 1498?- *DcWomA*
David, Berthe M J *DcWomA*
David, Cornelia *DcWomA*
David, Cyril 1920- *DcAr 81*
David, Cyril Frank 1920- *WhoAmA 82, -84*
David, Dianne 1938- *WhoAmA 73*
David, Dianne 1939- *WhoAmA 76, -78*
David, Don Raymond 1906- *WhAmArt 85*
David, Don Raymond 1910- *WhoAmA 73, -76, -78, -80, -82, -84*
David, Euphemie Therese 1823- *DcWomA*
David, Florence *DcWomA*
David, Gabrielle Henriette Marie 1884-1959 *DcWomA*
David, Gerard d1523 *OxArt*
David, Gerard 1460?-1523 *McGDA*
David, Hannah *FolkA 86*
David, Hermine 1886- *ClaDrA*
David, Hermine 1886-1971 *DcWomA*
David, Honore Salmi 1931- *WhoAmA 78, -80*
David, Illtyd 1906- *WhoArt 82, -84*
David, Jacques Louis 1748-1825 *ClaDrA*
David, Jacques-Louis 1748-1825 *McGDA, OxArt*
David, Jean 1908- *WhoGrA 62, -82[port]*
David, Jon R 1941- *MarqDCG 84*
David, Jules 1808-1892 *AntBDN E*
David, L *NewYHSD*
David, Leonie *DcWomA*
David, Lorene 1897- *ArtsAmW 1, DcWomA, WhAmArt 85*
David, Louis P *NewYHSD*
David, Maria Caterina 1765- *DcWomA*
David, Marie *DcWomA*
David, Mary R *DcVicP 2*
David, Pierre-Jean 1788-1856 *OxArt*
David, R B *DcVicP 2*
David, S *DcBrBI*
David, S S *EarABI, NewYHSD*
David D'Angers 1788-1856 *OxArt*
David D'Angers, Pierre-Jean 1788-1856 *McGDA*
David D'Angers, Pierre-Jean 1789-1856 *ArtsNiC*
David DeMayrena, Jeanne Clemence *DcWomA*
David-Fugere, Claudia *DcWomA*
David-West, Haig 1946- *ConDes*
Davidek, Stefan 1924- *WhoAmA 76, -78, -80, -82, -84*
Davidek, William Stefan 1924- *WhoAmA 73*
Davidica, Sister M *WhAmArt 85*
Davidis, A E *DcVicP 2*
Davidoff, Nathalie *DcWomA*
Davidovich, Jaime 1936- *WhoAmA 73, -80, -82, -84*
Davidovich, Jaime 1936- *AmArt*
Davidovitch, Jaime 1936- *WhoAmA 76, -78*
Davidowitz, Moshe 1934- *WhoAmA 82, -84*
Davids, Miss *DcWomA*
Davids, A J *NewYHSD*
Davids, Marie 1847- *DcWomA*
Davids, Renee 1877- *DcWomA*
Davidson, Miss *DcWomA*
Davidson, A W *DcBrA 1*
Davidson, Abraham A 1935- *WhoAmA 73, -76, -78, -80, -82, -84*
Davidson, Alexander 1838-1887 *DcBrBI, DcBrWA, DcVicP 2*
Davidson, Allan Albert 1913- *WhoAmA 73, -76, -78, -80, -82, -84*
Davidson, Allan Douglas 1873-1932 *DcBrA 1*
Davidson, Allen Douglas 1873-1932 *ClaDrA*
Davidson, Archibald *FolkA 86*
Davidson, B M *AmArch 70*
Davidson, Bessie *WhAmArt 85*
Davidson, Bessie 1879?-1965 *DcWomA*

Davidson, Betsy W *FolkA 86*
Davidson, Bruce 1933- *ConPhot, ICPEnP, MacBEP*
Davidson, Bruce 1934- *BnEnAmA*
Davidson, Mrs. C D *DcVicP 2*
Davidson, Carl Hoth 1881- *WhAmArt 85*
Davidson, Caroline *DcBrWA*
Davidson, Charles 1820-1902 *DcVicP 2*
Davidson, Charles 1824-1902 *DcBrWA*
Davidson, Charles Topham 1848- *DcBrA 1, DcBrWA, DcVicP, -2*
Davidson, Charles Topham 1848-1902 *ClaDrA*
Davidson, Clara D 1874- *WhAmArt 85*
Davidson, Clara D 1874?-1962 *DcWomA*
Davidson, Dan A 1940- *MarqDCG 84*
Davidson, Daniel Pender 1885- *ClaDrA, DcBrA 1*
Davidson, David *CabMA*
Davidson, Mrs. David *DcWomA*
Davidson, David Scott 1925- *AmArch 70*
Davidson, Dorothy Mary *WhAmArt 85*
Davidson, Dorothy Mary 1889?- *DcWomA*
Davidson, Duncan 1876- *ArtsAmW 3*
Davidson, Elizabeth H Donnally 1948- *WhoAmA 84*
Davidson, Ezechiel 1792- *ClaDrA*
Davidson, F E *AmArch 70*
Davidson, Florence A 1888- *WhAmArt 85*
Davidson, G J *AmArch 70*
Davidson, George *AntBDN H, DcNiCA, FolkA 86*
Davidson, George d1800 *NewYHSD*
Davidson, George 1889- *WhAmArt 85*
Davidson, George Dutch 1879-1901 *DcBrWA, DcVicP 2*
Davidson, Harry 1858-1924 *WhAmArt 85*
Davidson, Herbert Laurence 1930- *AmArt, WhoAmA 73, -76, -78, -80, -82, -84*
Davidson, Ian J 1925- *WhoAmA 76, -78, -80, -82, -84*
Davidson, Ian Stuart 1936- *WhoArt 80, -82, -84*
Davidson, J *FolkA 86*
Davidson, J B *AmArch 70*
Davidson, J LeRoy 1908- *WhoAmA 73*
Davidson, J Leroy 1908- *WhoAmA 76, -78, -80, -82, -84*
Davidson, J M *FolkA 86*
Davidson, J Nina 1895- *ClaDrA, DcBrA 1, DcWomA*
Davidson, J R 1889-1977 *ConArch, MacEA*
Davidson, James *CabMA*
Davidson, Jessie Y *DcVicP 2*
Davidson, Jo d1952 *WhoAmA 78N, -80N, -82N, -84N*
Davidson, Jo 1883-1952 *BnEnAmA, DcAmArt, McGDA, WhAmArt 85*
Davidson, John *DcVicP 2*
Davidson, John 1890- *ArtsAmW 2, WhAmArt 85*
Davidson, John M 1876- *WhAmArt 85*
Davidson, Julian O 1853-1893 *WhAmArt 85*
Davidson, Lawrence W 1913- *AmArch 70*
Davidson, Lilian d1953 *DcBrA 2*
Davidson, Lilian Lucy *ClaDrA, DcBrA 1, DcWomA*
Davidson, Lillian Margaret 1896- *DcWomA*
Davidson, Marshall Bowman 1907- *WhoAmA 73, -76, -78, -80, -82, -84*
Davidson, Mary C *DcBrA 1*
Davidson, Mary C d1950 *DcWomA*
Davidson, Maxwell, III 1939- *WhoAmA 78, -80, -82, -84*
Davidson, Morris 1898- *WhAmArt 85, WhoAmA 73, -76, -78*
Davidson, Morris 1898-1979 *WhoAmA 80N, -82N, -84N*
Davidson, Nancy *WhoAmA 84*
Davidson, Nancy B 1943- *DcCAr 81*
Davidson, O H, Jr. *MarqDCG 84*
Davidson, Ocyp *WhAmArt 85*
Davidson, Ola McNeil 1884- *ArtsAmW 3*
Davidson, Ola McNeill *WhAmArt 85*
Davidson, Ola McNeill 1884- *ArtsAmW 3*
Davidson, Oscar L 1875-1922 *WhAmArt 85*
Davidson, Phyllis 1938- *WhoAmA 76*
Davidson, Robert 1904- *WhAmArt 85*
Davidson, Robert William 1904- *WhoAmA 76, -78, -80, -82*
Davidson, Seth *FolkA 86*
Davidson, Stanley Edmund 1902- *AmArch 70*
Davidson, Suzette Morton 1911- *WhoAmA 73, -76, -78, -80, -82, -84*
Davidson, Thomas *ClaDrA, DcBrBI, DcVicP, -2*
Davidson, Thyra 1926- *WhoAmA 82, -84*
Davidson, W D *AmArch 70*
Davidson, W H *DcWomA*
Davidson, William *FolkA 86*
Davidson, William Pickett, Jr. 1924- *AmArch 70*
Davidson-Houston, Aubrey Claud 1906- *DcBrA 1, WhoArt 80, -82, -84*
Davidson-Houston, Aubrey Claude 1906- *ClaDrA*
Davie, Alan 1920- *ConArt 77, -83, ConBrA 79[port], DcBrA 1, DcCAr 81, McGDA, OxArt, OxTwCA, PhDcTCA 77, WorArt[port]*
Davie, James William 1889- *DcBrA 1*
Daviee, Jerry Michael 1947- *WhoAmA 78, -80, -82, -84*

Daviel, Leon *DcBrBI, DcVicP 2*
Davies, A R *AmArch 70*
Davies, Albert Webster 1889-1967 *FolkA 86*
Davies, Alfred *DcVicP 2*
Davies, Antoni Douglas 1946- *WhoArt 80, -82, -84*
Davies, Arthur B 1862-1928 *DcAmArt, WhAmArt 85*
Davies, Arthur Bowen 1862-1928 *ArtsAmW 1, BnEnAmA, GrAmP, IlBEAAW, McGDA, OxArt, OxTwCA, PhDcTCA 77*
Davies, Arthur Edward 1893- *ClaDrA, DcBrA 1, WhoArt 80, -82, -84*
Davies, Austin Howard 1926- *ClaDrA*
Davies, Barrett Raymond 1927- *AmArch 70*
Davies, Bevan 1941- *ConPhot, DcCAr 81, ICPEnP A*
Davies, Bevan O 1941- *MacBEP*
Davies, C *DcVicP 2*
Davies, D Julian M 1945- *MarqDCG 84*
Davies, Daniel d1819 *BiDBrA*
Davies, David 1862-1939 *DcBrA 2*
Davies, David 1864- *DcBrA 1*
Davies, David 1876-1921 *WhAmArt 85*
Davies, David L *NewYHSD*
Davies, Donald *FairDF IRE, WorFshn*
Davies, Edgar W *DcBrBI*
Davies, Edward *DcBrWA*
Davies, Edward 1841-1920 *DcBrA 1*
Davies, Edward 1843-1912 *DcBrWA, DcVicP, -2*
Davies, Edward David 1911- *AmArch 70*
Davies, Emrys *DcBrA 1, WhoArt 80, -82, -84*
Davies, Ernest R 1898- *ArtsAmW 3*
Davies, Ethel *DcWomA*
Davies, Frank Lubbock, Jr. 1927- *AmArch 70*
Davies, G S *DcVicP 2*
Davies, Gay *WhAmArt 85*
Davies, Gay Williams *ArtsAmW 3*
Davies, George Christopher 1849-1922 *ICPEnP A, MacBEP*
Davies, George E *DcVicP 2*
Davies, Haydn Llewellyn 1921- *WhoAmA 80, -82, -84*
Davies, Henry Casson 1831-1868 *DcBrWA*
Davies, Henry F 1822-1885? *NewYHSD*
Davies, Hugh Marlais 1948- *WhoAmA 76, -78, -80, -82, -84*
Davies, Ivor *DcCAr 81*
Davies, J L *AmArch 70*
Davies, James Henry *DcVicP 2*
Davies, James Hey 1844- *DcBrA 1, DcVicP 2*
Davies, Janet *DcWomA*
Davies, John *CabMA, DcBrWA, DcVicP 2*
Davies, John d1865 *BiDBrA*
Davies, John 1946- *ConArt 77, -83, DcCAr 81, OxTwCA*
Davies, John A 1901- *WhoArt 80*
Davies, John A 1949- *ICPEnP A*
Davies, John Alfred 1913- *DcBrA 2*
Davies, John Arthur 1949- *MacBEP*
Davies, Jonathan Richard James 1953- *MarqDCG 84*
Davies, Jordan 1941- *PrintW 85*
Davies, Jordan Alan 1941- *WhoAmA 73, -76*
Davies, Kenneth Southworth 1925- *WhoAmA 73, -76, -78, -80, -82, -84*
Davies, M I *DcVicP 2*
Davies, Malcolm Leslie 1946- *MarqDCG 84*
Davies, Marie Gertrude *DcBrA 1, DcWomA*
Davies, Mary Clare 1928- *ClaDrA*
Davies, Norman John 1937- *AmArch 70*
Davies, Norman Prescott- *DcBrWA*
Davies, Norman Prescott *DcVicP 2*
Davies, Norman Prescott 1862-1915 *DcBrA 1*
Davies, P M, Jr. *AmArch 70*
Davies, R *DcBrECP*
Davies, Robert Arthur 1951- *MarqDCG 84*
Davies, Roland 1910- *WorECom*
Davies, Samuel *CabMA*
Davies, Scrope *DcBrBI*
Davies, Stephanie Joyce *WhoArt 80, -82, -84*
Davies, Stephanie Joyce 1910- *ClaDrA, DcBrA 1*
Davies, Ted 1928- *PrintW 83, -85*
Davies, Theodore Peter 1928- *MacBEP, WhoAmA 73, -76, -78, -80, -82, -84*
Davies, Thomas *NewYHSD , WhoArt 82N*
Davies, Thomas 1737?-1812 *DcBrWA, McGDA*
Davies, Thomas 1899- *ClaDrA, WhoArt 80*
Davies, Thomas J *FolkA 86*
Davies, Thomas Landon 1943- *MacBEP*
Davies, W Mitford 1895- *ClaDrA, DcBrA 1*
Davies, W W *AmArch 70*
Davies, William *DcVicP 2*
Davies, William 1903- *AmArch 70*
Davies, William Teeple *WhAmArt 85*
Daviess, Maria Thompson 1872-1924 *DcWomA, WhAmArt 85*
D'Avignon, Francis 1814?- *NewYHSD*
D'Avila, Antonio Carlos 1955- *ICPEnP A*
Davila, Carlos 1935- *PrintW 83, -85, WhoAmA 73, -76, -78, -80, -82, -84*
Daviler, Charles 1653-1700 *MacEA*
Davin, Cesarine Henriette Flore 1773-1844 *DcWomA*
DaVinci, L *DcVicP 2*

DaVinci, Mona 1940- *WhoAmA 80, -82*
DaVinci, Pierino 1530?-1553 *McGDA*
Davioud, Gabriel 1823-1881 *MacEA*
Davioud, Gabriel-Jean-Antoine 1823-1881 *ArtsNiC*
Davioud, Gabriel Jean Antoine 1823-1881 *McGDA*
Davis *NewYHSD*
Davis, Miss *DcWomA*
Davis, A *ArtsAmW 3, DcWomA, EncASM*
Davis, A Jackson 1919- *AmArch 70*
Davis, A L *DcBrBI*
Davis, A M *AmArch 70*
Davis, A W *AmArch 70*
Davis, Albert Egerton 1866-1929 *BiDAmAr*
Davis, Albert Eggerdon 1866-1929 *WhAmArt 85*
Davis, Albon W d1946 *BiDAmAr*
Davis, Alexander Jackson 1803-1892 *BiDAmAr, BnEnAmA, DcD&D, EarABI SUP, MacEA, McGDA, NewYHSD , OxArt, WhoArch*
Davis, Alexander Schenck 1930- *AmArch 70*
Davis, Alfred *DcVicP 2*
Davis, Alfred 1880-1967 *FolkA 86*
Davis, Alfred Claude 1926- *AmArch 70*
Davis, Alice 1905- *WhAmArt 85, WhoAmA 73, -76*
Davis, Allen 1937- *AmArch 70*
Davis, Alonzo Joseph 1942- *AfroAA, WhoAmA 78, -80, -82, -84*
Davis, Amee *WhAmArt 85*
Davis, Ann 1946- *WhoAmA 76, -78, -80, -82*
Davis, Anna B 1866-1941 *ArtsEM, DcWomA*
Davis, Anna M *DcWomA*
Davis, Annie *DcVicP 2*
Davis, Archie Royal 1907- *AmArch 70*
Davis, Arthur Alfred *DcVicP 2*
Davis, Arthur F 1863- *WhAmArt 85*
Davis, Arthur H *DcVicP 2*
Davis, Arthur Henry 1917- *AmArch 70*
Davis, Arthur Joseph 1878-1951 *DcBrA 1, MacEA*
Davis, Arthur Lewis 1918- *AmArch 70*
Davis, Arthur Paul 1897- *AmArch 70*
Davis, Arthur Quentin 1930- *AmArch 70*
Davis, Arthur Seward, Jr. 1906- *AmArch 70*
Davis, Ben *FolkA 86*
Davis, Ben H 1947- *WhoAmA 78, -80, -82, -84*
Davis, Benjamin d1718 *CabMA*
Davis, Bertha 1918- *WhoAmA 84*
Davis, Betsy *FolkA 86*
Davis, Bette *IlsBYP*
Davis, Bing 1937- *AfroAA*
Davis, Bob 1944- *ConPhot, ICPEnP A, MacBEP*
Davis, Brad 1942- *DcCAr 81, PrintW 83, -85, WhoAmA 84*
Davis, Bradley Darius 1942- *WhoAmA 73, -76, -78, -80, -82*
Davis, Brian *WhoArt 80, -82, -84*
Davis, C A *AmArch 70*
Davis, C D *DcVicP 2*
Davis, C F *AmArch 70*
Davis, C G *AmArch 70*
Davis, C L *DcVicP 2*
Davis, C W *AmArch 70*
Davis, Caleb F *NewYHSD*
Davis, Caleb F, Jr. 1831?- *ArtsEM*
Davis, Caleb F, Sr. 1810- *ArtsEM*
Davis, Carrie E *DcWomA*
Davis, Catherine *DcWomA, NewYHSD*
Davis, Cecil 1877-1955 *DcWomA*
Davis, Cecil Clark 1877-1955 *ArtsAmW 1*
Davis, Mrs. Cecil Clark 1877- *WhAmArt 85*
Davis, Celia *DcVicP 2*
Davis, Charles *FolkA 86, MarqDCG 84*
Davis, Charles 1741-1805 *DcBrECP*
Davis, Charles 1912- *AfroAA*
Davis, Charles A *WhAmArt 85*
Davis, Charles Craig, Jr. 1919- *AmArch 70*
Davis, Charles F *WhAmArt 85*
Davis, Charles Francis, Jr. 1908- *AmArch 70*
Davis, Charles H *DcVicP 2*
Davis, Charles H 1845-1921 *WhAmArt 85*
Davis, Charles H 1856-1933 *WhAmArt 85*
Davis, Mrs. Charles H *DcWomA, WhAmArt 85*
Davis, Charles M 1934- *AmArch 70*
Davis, Charles Percy *WhAmArt 85*
Davis, Charles Vincent 1912- *WhAmArt 85*
Davis, Charles Walker, Jr. 1923- *AmArch 70*
Davis, Charles Wellington 1826-1897 *BiDAmAr*
Davis, Cornelia Cassady 1868?-1920 *DcWomA*
Davis, Cornelia Cassady 1870-1920 *ArtsAmW 1, -2, IlBEAAW, WhAmArt 85*
Davis, D Jack 1938- *WhoAmA 78, -80, -82, -84*
Davis, D P, Jr. *AmArch 70*
Davis, Dale B 1945- *AfroAA*
Davis, David *NewYHSD*
Davis, David Ensos 1920- *DcCAr 81, WhoAmA 73, -76, -78, -80, -82, -84*
Davis, Derek Maynard 1926- *WhoArt 80, -82, -84*
Davis, Dimitris 1905- *IlsCB 1957*
Davis, Donald Adams, III 1919- *AmArch 70*
Davis, Donald Allen 1922- *AmArch 70*
Davis, Donald Jack 1938- *WhoAmA 78*
Davis, Donald L 1935- *MarqDCG 84*
Davis, Donald Robert 1909- *WhoAmA 73, -76, -78,*

Davis, Vaughan *DcBrBI*
Davis, Vestie 1903-1978 *FolkA 86*
Davis, Virgil *FolkA 86*
Davis, Virginia *DcWomA*, *WhAmArt 85*
Davis, W Bruce *AfroAA*
Davis, W D *AmArch 70*
Davis, W D B *DcBrA 1*
Davis, W E *AmArch 70*
Davis, W F *AfroAA*
Davis, W H *AmArch 70*, *DcVicP 2*
Davis, W J *DcVicP 2*
Davis, W Paul *DcVicP 2*
Davis, Walter *AfroAA*, *WhoAmA 73, –76, –78, –80, –82, –84*
Davis, Mrs. Walter *WhoAmA 73, –76, –78, –80, –82, –84*
Davis, Walter Lewis 1937- *WhoAmA 76, –78, –80, –82, –84*
Davis, Warren 1865-1928 *WhAmArt 85*
Davis, Wayne Alton 1931- *MarqDCG 84*
Davis, Wayne Lambert 1904- *IlBEAAW, WhAmArt 85, WhoAmA 73, –76, –78, –80, –82, –84*
Davis, Will Rowland 1879- *WhAmArt 85*
Davis, William *CabMA*, *NewYHSD*
Davis, William 1812-1873 *ClaDrA*, *DcVicP, –2*
Davis, William D 1936- *WhoAmA 84*
Davis, William Edward 1906- *AmArch 70*
Davis, William Henry *DcVicP 2*
Davis, William J *NewYHSD*
Davis, William Kase, III 1937- *AmArch 70*
Davis, William M 1829- *WhAmArt 85*
Davis, William Steeple 1884- *WhAmArt 85*
Davis, William Steeple 1884-1961 *WhoAmA 80N, –82N, –84N*
Davis, William Thomas 1938- *AmArch 70*
Davis, William Triplett *WhAmArt 85*
Davis, Willis Bing 1937- *WhoAmA 78, –80*
Davis, Willis E *ArtsAmW 2*
Davis, Willis E d1910 *WhAmArt 85*
Davis, Zachary Taylor 1872-1946 *BiDAmAr*
Davis And Galt *EncASM*
Davis Brody And Associates *MacEA*
Davison *DcBrECP*
Davison, Allen Lape 1913- *AmArch 70*
Davison, Austin L 1909- *WhAmArt 85*
Davison, Bill 1941- *WhoAmA 82, –84*
Davison, Darius Jarvis 1828-1904 *ArtsEM*
Davison, Donald John 1935- *AmArch 70*
Davison, E Eleanor *DcVicP 2*
Davison, E L *WhAmArt 85*
Davison, Edward L *ArtsAmW 3*
Davison, Eleanor *DcWomA*
Davison, Francis *DcCAr 81*
Davison, Frederick Charles 1902- *DcBrA 1*
Davison, George 1854-1930 *MacBEP*
Davison, H *DcVicP 2*
Davison, Jeremiah 1695?-1745 *DcBrECP*
Davison, L A 1872- *WhAmArt 85*
Davison, Minnie Dibden *DcWomA*
Davison, Minnie Dibdin *ClaDrA*
Davison, Mrs. Munro *DcVicP 2*
Davison, Nora *DcBrA 1*, *DcVicP 2*, *DcWomA*
Davison, O H, Jr. 1929- *MarqDCG 84*
Davison, Pamela J 1957- *MarqDCG 84*
Davison, Richard L 1938- *MarqDCG 84*
Davison, Robert 1922- *WhoAmA 73, –76, –78, –80*
Davison, Samuel *CabMA*
Davison, Thomas Raffles 1853-1937 *DcBrA 1*
Davison, William *BiDBrA*, *DcBrWA*, *DcVicP 2*
Davisson, Darrell 1937- *WhoAmA 76, –78, –80*
Davisson, H G 1866- *WhAmArt 85*
Davisson, Homer G *WhoAmA 80N, –82N, –84N*
Davoine, Jeannie *DcWomA*
Davol, Joseph B 1864-1923 *WhAmArt 85*
Davring, Heinrich 1894- *PhDcTCA 77*
Davringhausen, Heinrich *OxTwCA*
Davringhausen, Heinrich Maria 1894- *McGDA*
Davud Agha d1599? *MacEA*
Davy, C *DcBrBI*
D'Avy, C J, Jr. *AmArch 70*
Davy, C R *DcBrWA*
Davy, Christopher 1803?-1849 *BiDBrA*
Davy, Cristina Busaue 1954- *MarqDCG 84*
Davy, Evelyn *DcWomA*
Davy, George Mark Oswald 1898- *WhoArt 80, –82, –84*
Davy, Henry d1832? *DcBrWA*
Davy, Sir Humphry 1778-1829 *ICPEnP*
Davy, James Benjamin 1913- *WhAmArt 85*
Davy, Jean *McGDA*
Davy, Robert d1793 *DcBrECP*
Daw, John Lawrence 1927- *AmArch 70*
Dawant, Albert Pierre 1852-1923 *ClaDrA*
Dawbarn, Mrs. A G *DcVicP 2*
Dawbarn, Joseph Yelverton *DcBrA 1*, *DcVicP 2*
Dawbarn, M *DcWomA*
Dawber, Sir Edward Guy 1861-1938 *DcBrA 1*
Dawdy, Doris Ostrander *WhoAmA 76, –78, –80, –82, –84*
Dawe, Elizabeth *DcWomA*

Dawe, Frederick 1933- *AmArch 70*
Dawe, Gladys Cole 1898- *ArtsAmW 3*
Dawe, Neil Llewellyn 1957- *MarqDCG 84*
Dawe, Philipp 1750?-1785? *McGDA*
Dawes, Alan *MarqDCG 84*
Dawes, Dexter B 1872- *WhAmArt 85*
Dawes, E M 1872- *WhAmArt 85*
Dawes, Edwin M 1872-1945 *ArtsAmW 1*
Dawes, Edwin Munott 1872-1945 *ArtsAmW 3*
Dawes, H M *NewYHSD*
Dawes, Marjorie Lilian *DcWomA*
Dawes, Pansy 1883?- *DcWomA*, *WhAmArt 85*
Dawes, Pansy 1885- *ArtsAmW 2*
Dawes, Philip *DcBrECP*
Dawes, Ruth Wilcox *WhAmArt 85*
Dawes, Thomas 1731-1809 *FolkA 86*, *MacEA*
Dawid 1949- *MacBEP*
Dawis, Germaine *DcWomA*
Dawkins, Henry *EarABI SUP*, *FolkA 86*
Dawkins, Henry d1786? *BnEnAmA*, *NewYHSD*
Dawkins, P W *AfroAA*
Dawley, Herbert M 1880- *WhAmArt 85*
Dawley, Joseph William 1936- *WhoAmA 73, –76, –78, –80, –82, –84*
Dawley, Robert E 1928- *AmArch 70*
Dawlson, Sidney 1917- *WhoArt 80, –82, –84*
Dawnay, Denis 1920- *DcBrA 2*
Daws, C *DcVicP 2*
Daws, Frederick Thomas 1878- *DcBrA 1*
Daws, J *DcBrWA*
Daws, Philip *DcVicP 2*
Dawsey, T L, Jr. *AmArch 70*
Dawson, Alfred *ClaDrA*, *DcBrBI*, *DcVicP, –2*
Dawson, Alva Mary Elizabeth 1915- *WhoArt 80, –82, –84*
Dawson, Amy *DcVicP 2*, *DcWomA*
Dawson, Arthur 1859-1922 *WhAmArt 85*
Dawson, Mrs. B *DcVicP, –2*
Dawson, Bernard Maurice 1898- *AmArch 70*
Dawson, Bess Phipps *WhoAmA 73, –76, –78, –80, –82, –84*
Dawson, Bess Phipps 1914- *AmArt*
Dawson, Byron Eric 1896-1968 *DcBrA 1*
Dawson, Charles C 1889- *AfroAA*
Dawson, Charles Clarence 1889- *WhAmArt 85*
Dawson, Charles Frederick *ClaDrA*, *DcBrA 1*, *DcBrBI*
Dawson, Charles W 1867-1928? *BiDAmAr*
Dawson, Chester *DcVicP 2*
Dawson, Doug 1944- *AmArt*
Dawson, Edith Brearey *DcBrA 2*, *DcWomA*
Dawson, Elizabeth *DcWomA*
Dawson, Elsie May *DcWomA*
Dawson, Eugenie Wireman *WhAmArt 85*
Dawson, Eve *WhoAmA 73, –76, –78, –80, –82, –84N*
Dawson, Fanny M *DcWomA*
Dawson, Frank Robertson, Jr. 1953- *MarqDCG 84*
Dawson, Fred T 1930- *MarqDCG 84*
Dawson, George Walter 1870-1938 *WhAmArt 85*
Dawson, Gladys *WhoArt 80, –82, –84*
Dawson, Gladys 1909- *DcBrA 1*
Dawson, Henry 1811-1878 *ClaDrA*, *DcBrWA*, *DcSeaP*, *DcVicP, –2*
Dawson, Henry T *DcSeaP*
Dawson, Henry Thomas *ClaDrA*, *DcVicP, –2*
Dawson, Irwin H *EncASM*
Dawson, J C *DcVicP 2*
Dawson, J W *AmArch 70*
Dawson, James J *EncASM*
Dawson, John d1959 *FolkA 86*
Dawson, John Allan 1946- *WhoAmA 76, –78, –80, –82, –84*
Dawson, John Frederick 1930- *AmArch 70*
Dawson, John W 1888- *WhAmArt 85*
Dawson, Joseph *FolkA 86*
Dawson, Joshua 1812?- *BiDBrA*
Dawson, Lucy d1958 *DcBrA 1*
Dawson, Mabel *DcVicP 2*
Dawson, Mabel 1887- *ClaDrA*, *DcBrA 1*
Dawson, Mabel 1887-1965 *DcWomA*
Dawson, Manierre 1887-1969 *DcAmArt*
Dawson, Marion *DcWomA*
Dawson, Mary Elizabeth *DcWomA*
Dawson, Montague *ClaDrA*
Dawson, Montague 1895-1973 *DcSeaP*
Dawson, Montague J 1894?-1973 *DcBrA 1*
Dawson, Morris 1928- *AfroAA*
Dawnay, Muriel *DcBrA 1*
Dawson, Nelson 1859-1941 *DcBrA 1*, *DcBrWA*, *DcSeaP*, *DcVicP, –2*
Dawson, Patricia Vaughan 1925- *WhoArt 80, –82, –84*
Dawson, R W *FolkA 86*
Dawson, Robert 1776-1860 *DcBrWA*
Dawson, Robert Arthur d1948 *DcBrA 1*
Dawson, Robert Bennit *WhAmArt 85*
Dawson, Robert Charles 1930- *AmArch 70*
Dawson, Robert Kearsley 1798-1861 *DcBrWA*
Dawson, Russell *DcVicP 2*
Dawson, Thomas 1800?- *NewYHSD*
Dawson, Tube *FolkA 86*
Dawson, William *DcBrWA*, *DcVicP 2*

Dawson, William 1901- *FolkA 86*
Dawson-Watson, Dawson 1864-1939 *ArtsAmW 1*, *IlBEAAW*, *WhAmArt 85*
Day *FolkA 86*
Day, A W *AmArch 70*
Day, Aaron *NewYHSD*
Day, Arthur *WhAmArt 85*
Day, Augustus *NewYHSD*
Day, Barclay *DcVicP 2*
Day, Beaver Wade 1884-1932? *BiDAmAr*
Day, Benjamin *NewYHSD*
Day, Benjamin H, Jr. 1838-1916 *EarABI*, *EarABI SUP*
Day, Benjamin Henry, Jr. 1838- *WhAmArt 85*
Day, Benjamin Henry, Jr. 1838-1916 *IlBEAAW*, *NewYHSD*
Day, Bertha C *WhAmArt 85*
Day, Bertha Corson 1875-1968 *DcWomA*
Day, Carl E 1934- *AmArch 70*
Day, Catherine *DcWomA*
Day, Charles *BiDBrA*
Day, Charles William *NewYHSD*
Day, Chauncey Addison 1907- *WorECar*
Day, Chon *WhAmArt 85*, *WorECar*
Day, Chon 1907- *WhoAmA 73, –76, –78, –80, –82, –84*
Day, Clare Henry 1920- *AmArch 70*
Day, Clinton 1846-1916 *BiDAmAr*
Day, Crane 1937- *WhoAmA 80, –82*
Day, Elizabeth *DcWomA*, *FolkA 86*
Day, Ellen *DcWomA*
Day, Emily *NewYHSD*
Day, Emily 1839?- *DcWomA*
Day, Emily Atkins 1903- *WhAmArt 85*
Day, Fannie M *DcWomA*
Day, Frances S *DcWomA*
Day, Frank Leveva 1902?-1976 *FolkA 86*
Day, Frank Miles 1861-1918 *BiDAmAr*, *MacEA*
Day, Fred Holland 1864-1933 *MacBEP*, *WhAmArt 85*
Day, Fred Winfield 1926- *AmArch 70*
Day, Frederic Lansing, Jr. 1915- *AmArch 70*
Day, Frederick Holland 1864-1933 *ICPEnP*
Day, G F *DcVicP 2*
Day, Gary Lewis 1950- *WhoAmA 82, –84*
Day, George Edward, Jr. 1934- *AmArch 70*
Day, H S *DcVicP 2*
Day, H Summerfield 1910- *AmArch 70*
Day, Hallie *DcWomA*, *WhAmArt 85*
Day, Hannah *DcVicP 2*
Day, Harold Armstrong Edward 1924- *DcBrA 1*
Day, Helena *WhAmArt 85*
Day, Henry *NewYHSD*
Day, Henry E *NewYHSD*
Day, Holliday T *WhoAmA 80, –82, –84*
Day, Mrs. Horace T *WhAmArt 85*
Day, Horace Talmage 1909- *WhAmArt 85*, *WhoAmA 73, –76, –78, –80, –82, –84*
Day, Mrs. Howard D *WhAmArt 85*
Day, Isaac Sewell 1813- *CabMA*
Day, James Francis 1863-1942 *WhAmArt 85*
Day, John 1932- *WhoAmA 78, –80, –82, –84*
Day, John Griffith 1937- *AmArch 70*
Day, Juette Johnson *AfroAA*
Day, Katharine Seymour *DcWomA*, *WhAmArt 85*
Day, Larry 1921- *WhoAmA 78, –80, –82, –84*
Day, Lewis F 1845-1910 *DcNiCA*
Day, Lewis Foreman 1845-1910 *DcBrA 1*
Day, Lucien B *WhoAmA 76, –78, –80, –82*
Day, Lucienne 1917- *ConDes*, *DcD&D*, *WhoArt 80, –82, –84*
Day, Mabel K *WhoAmA 80N, –82N, –84N*
Day, Mabel K 1884- *WhAmArt 85*
Day, Mabel K 1884-1959? *DcWomA*
Day, Malvina *DcWomA*
Day, Malvina 1826- *NewYHSD*
Day, Marion M *NewYHSD*
Day, Martha B Willson *DcWomA*
Day, Martha B Willson 1885- *WhAmArt 85*, *WhoAmA 73, –76, –78, –80*
Day, Mary Barker *WhAmArt 85*
Day, Maurice *ConICB*
Day, Maurice 1892- *IlsCB 1744*
Day, Nathan *FolkA 86*
Day, Norman Gustavus Apgar 1926- *AmArch 70*
Day, Oriana *ArtsAmW 3*
Day, R *BiDBrA*
Day, R H *AmArch 70*
Day, Ray *OfPGCP 86*
Day, Richard 1896-1972 *ConDes*
Day, Richard W 1896-1972 *ArtsAmW 2*
Day, Robert Harold 1949- *MarqDCG 84*
Day, Robert James 1900- *WhAmArt 85*, *WhoAmA 73, –76, –78, –80, –82, –84*, *WorECar*
Day, Robin 1915- *ConDes*, *DcD&D*, *WhoArt 80, –82, –84*
Day, Selma *AfroAA*
Day, Thomas *AfroAA*, *DcBrECP*, *FolkA 86*
Day, Thomas 1732-1807 *AntBDN J*
Day, Thomas 1733?-1808? *DcBrECP*
Day, W C *DcWomA*

Day, William 1764-1807 *DcBrWA*
Day, William C *AmArch 70*
Day, William Cave 1862-1924 *DcBrA 1, DcVicP 2*
Day, William E 1937- *AfroAA*
Day, Worden 1916- *DcCAA 71, –77, WhAmArt 85, WhoAmA 73, –76, –78, –80, –82, –84*
Day Clark *EncASM*
Dayal, Lalla Deen 1844-1910 *ICPEnP*
Dayan, A *AmArch 70*
Dayanova, Regina 1943- *DcCAr 81*
Daye, Thomas J *NewYHSD*
Dayes, Edward 1763-1804 *BkIE, ClaDrA, DcBrWA, McGDA, OxArt*
Dayes, Mrs. Edward *DcWomA*
Dayez, Georges *OxTwCA*
Dayman, Francis S *DcVicP 2*
Daynes-Grassot-Solin, Suzanne 1884- *DcWomA*
Dayson, L J *DcVicP 2*
Dayton, B *FolkA 86*
Dayton, Bruce B 1918- *WhoAmA 73*
Dayton, C W *AmArch 70*
Dayton, Deane Kraybill 1949- *MarqDCG 84*
Dayton, F E *WhAmArt 85*
Dayton, Helena Smith *WhAmArt 85*
Dayton, Lillian *WhAmArt 85*
Dayton, Richard L 1934- *AmArch 70*
DeAbreu, Luis Filipe 1935- *WhoGrA 82[port]*
DeAbreu, Pamplona 1936- *WorFshn*
Deachman, Nelly 1895- *DcWomA, WhAmArt 85*
Deacon, Augustus Oakley *DcVicP*
Deacon, Augustus Oakley 1819-1899 *DcBrWA, DcVicP 2*
Deacon, Charles Ernest *DcBrA 1*
Deacon, Eugene L *EncASM*
Deacon, G S *DcVicP 2*
Deacon, Henry D *DcVicP 2*
Deacon, James 1728?-1750 *DcBrWA*
Deacon, Jane M *ArtsEM, DcWomA*
Deacon, Richard *DcCAr 81*
Deacon, Virginia *DcVicP 2, DcWomA*
Deaderick, Joseph 1930- *WhoAmA 73, –76, –78, –80, –82, –84*
Deadmore, L C *AmArch 70*
Deady, Stephen *FolkA 86*
Deak, Edit 1948- *WhoAmA 76, –78, –80, –82, –84*
Deak-Ebner, Ilona 1913- *WhAmArt 85*
Deakin, Andrew *DcVicP 2*
Deakin, Charles Dean 1924- *AmArch 70*
Deakin, Edwin 1838-1923 *ArtsAmW 1, IlBEAAW, WhAmArt 85*
Deakin, Elizabeth 1929- *WhoArt 82, –84*
Deakin, Jane *DcBrWA, DcVicP 2, DcWomA*
Deakin, John *AntBDN N*
Deakin, Peter *DcBrWA, DcVicP, –2*
Deakin, Smith *AntBDN N*
Deakins, Cyril Edward 1916- *DcBrA 1, WhoArt 80, –82, –84*
Deakins, George Richard *WhoArt 84N*
Deakins, George Richard 1911- *ClaDrA, WhoArt 80, –82*
Deal, A H *AmArch 70*
Deal, Joe 1947- *ConPhot, ICPEnP A, MacBEP, WhoAmA 78, –80, –82, –84*
Dealer, Joseph *FolkA 86*
DeAlmeida, Helio 1944- *WhoGrA 82[port]*
DeAlteriis, A J *AmArch 70*
Dealy, Jane M *DcBrWA, DcVicP, –2*
Dealy, Jane M d1939 *DcBrA 1, DcWomA*
Deam, A F *AmArch 70*
DeAmarel, Olga Ceballos *WorFshn*
Dean, Miss *DcVicP 2*
Dean, A L *AmArch 70*
Dean, Abigail 1789-1854 *FolkA 86*
Dean, Abner *WhoAmA 73, –76, –78, –80, –82, WorECar*
Dean, Abner 1910- *WhAmArt 85*
Dean, Alvar Antonio 1959- *MarqDCG 84*
Dean, Alwyn 1921- *DcBrA 1*
Dean, Benjamin 1794?-1866 *NewYHSD*
Dean, Benjamin Sagar *MacEA*
Dean, Beryl 1911- *WhoArt 80, –82, –84*
Dean, C W *DcWomA*
Dean, Catherine 1905- *DcBrA 1*
Dean, Charles Hermon, Jr. 1910- *AmArch 70*
Dean, Charles S *ArtsEM*
Dean, Christopher *DcBrBI*
Dean, D F, Jr. *AmArch 70*
Dean, Darrell R *MarqDCG 84*
Dean, Earl Leslie 1942- *MarqDCG 84*
Dean, Edgar W *WhAmArt 85*
Dean, Edmond *AfroAA*
Dean, Edward C *WhAmArt 85*
Dean, Eiland Keith 1926- *AmArch 70*
Dean, Elizabeth M *DcWomA, WhAmArt 85*
Dean, Emeline *FolkA 86*
Dean, Ernest Wilfrid *WhoAmA 78N, –80N, –82N, –84N*
Dean, Eva 1871- *WhAmArt 85*
Dean, Eva Ellen 1871-1954 *ArtsAmW 2, DcWomA*
Dean, F E *AmArch 70*

Dean, Frances E 1826?- *FolkA 86*
Dean, Frank 1865- *DcBrA 1, DcBrBI, DcVicP, –2*
Dean, Frank 1865-1947 *DcBrWA*
Dean, George S 1864-1919 *BiDAmAr*
Dean, Gladys Jessie *WhAmArt 85*
Dean, Grace Rhoades 1878- *DcWomA, WhAmArt 85*
Dean, Graham 1951- *DcCAr 81*
Dean, H Shelby 1927- *AmArch 70*
Dean, Helga Haugan *DcWomA, WhAmArt 85*
Dean, Herman E *WhAmArt 85*
Dean, Hilliard *AfroAA*
Dean, Horace W *ArtsEM*
Dean, Hugh Primrose d1784? *DcBrECP*
Dean, J E *AntBDN M*
Dean, J Ernest 1871-1933 *WhAmArt 85*
Dean, James *NewYHSD*
Dean, James 1931- *WhoAmA 76, –78, –80, –82, –84*
Dean, John *NewYHSD*
Dean, John 1750-1798 *McGDA*
Dean, John 1754-1798 *DcBrECP*
Dean, John H W 1930- *WhoArt 84*
Dean, Larry Craig 1925- *AmArch 70*
Dean, Lillian Reubena *DcWomA*
Dean, Loomis 1917- *ICPEnP A*
Dean, Louis Abbott 1912- *AmArch 70*
Dean, Mallette 1907- *WhAmArt 85*
Dean, Mary T *AfroAA*
Dean, Max 1949- *DcCAr 81*
Dean, Michael Wayne 1945- *MarqDCG 84*
Dean, Nat 1956- *AmArt, WhoAmA 82, –84*
Dean, Nicholas 1933- *ICPEnP A, MacBEP*
Dean, Nicholas Brice 1933- *WhoAmA 78, –80, –82, –84*
Dean, Orville B *NewYHSD*
Dean, P *DcBrECP*
Dean, Patrick Donovan 1939- *AmArch 70*
Dean, Peter 1934- *OxTwCA*
Dean, Peter 1939- *PrintW 85, WhoAmA 73, –76, –78, –80, –82, –84*
Dean, Polly C *DcWomA, FolkA 86*
Dean, Reuben *NewYHSD*
Dean, Richmond Leslie Stansmore 1864?-1944 *DcWomA*
Dean, Robert Charles 1903- *AmArch 70*
Dean, Ronald Herbert 1929- *WhoArt 80, –82, –84*
Dean, Sagar 1805?-1874 *NewYHSD*
Dean, Sebren Brooks 1920- *AmArch 70*
Dean, Thomas *FolkA 86*
Dean, Thomas Scott 1924- *AmArch 70*
Dean, W J *AmArch 70*
Dean, Walter Lofthouse 1854-1912 *WhAmArt 85*
DeAndino, Jean-Pierre M 1946- *WhoAmA 80, –82, –84*
DeAndrade, Alecio 1942- *ICPEnP A*
DeAndrea, John 1941- *ConArt 83, DcCAA 77, DcCAr 81*
DeAndrea, John Louis 1941- *AmArt, ConArt 77, WhoAmA 73*
Deandrea, John Louis 1941- *WhoAmA 76, –78*
Deane, Charles *DcVicP, –2*
Deane, Charles Norman 1921- *AmArch 70*
Deane, Dennis Wood *DcVicP, –2*
Deane, Dennis Wood 1820?- *DcBrWA*
Deane, E *NewYHSD*
Deane, Emmeline *DcVicP 2, DcWomA*
Deane, Granville M *ArtsAmW 3*
Deane, James 1699?-1765 *BiDBrA*
Deane, John *BiDBrA*
Deane, John Wood *DcBrWA*
Deane, Keith R *ArtsAmW 2, WhAmArt 85*
Deane, L *DcVicP 2*
Deane, L Reubena 1881- *WhAmArt 85*
Deane, Lillian Reubena 1881- *ArtsAmW 2, DcWomA*
Deane, Lionel 1861- *ArtsAmW 3, WhAmArt 85*
Deane, Thomas 1792-1871 *MacEA*
Deane, Sir Thomas *McGDA*
Deane, Sir Thomas 1792-1871 *McGDA*
Deane, Sir Thomas Manly 1851-1933 *DcBrA 2*
Deane, Thomas Newenham 1828-1899 *MacEA*
Deane, Sir Thomas Newenham 1828-1899 *WhoArch*
Deane, W L *AmArch 70*
Deane, William Wood 1825-1873 *ArtsNiC, DcBrBI, DcBrWA, DcVicP, –2*
Deane And Woodward *MacEA*
Deane-Drummond, Sophie *DcWomA*
Deanes, Edward *DcVicP 2*
Deanes, Mary *DcVicP 2, DcWomA*
DeAngeli, Marguerite 1889- *DcWomA, WhoAmA 73, –76*
DeAngeli, Marguerite Lofft *IlsCB 1967*
DeAngeli, Marguerite Lofft 1889- *ConICB, IlsCB 1744, –1946, –1957*
DeAngelis, Clotilde *DcWomA*
DeAngelis, Deiva d192-? *DcWomA*
DeAngelis, Giulio 1850-1906 *MacEA*
Deangelis, Joseph Rocco 1938- *WhoAmA 82, –84*
DeAngelo, E *WhAmArt 85*
Deans, D *DcVicP 2*

Deans, Robert *CabMA*
Deans, Sarah Ann Curry 1802?-1860 *FolkA 86*
Dear, Mary E *DcBrBI, DcVicP 2, DcWomA*
Dearborn, Annie F *ArtsAmW 2, DcWomA, WhAmArt 85*
Dearborn, Eustis 1910- *AmArch 70*
Dearborn, Nathaniel 1786-1852 *EarABI, EarABI SUP, NewYHSD*
Dearborn, Nathaniel S *NewYHSD*
Dearborn, Samuel H *NewYHSD*
DeArcangelis, Gloria 1957- *WhoAmA 84*
Dearden, A *DcVicP 2*
Dearden, Harold 1888-1962 *DcBrA 1*
Dearden, William James 1920- *AmArch 70*
Deardorf, Carlotta *DcWomA*
Deardorff, F M *AmArch 70*
Deare, Margaret *DcVicP 2*
DeArellano, L R *AmArch 70*
Dearing, Michael Paul 1948- *MarqDCG 84*
Dearing, William *NewYHSD*
Dearle, John *DcVicP 2*
Dearle, John H *DcVicP 2*
Dearle, John H 1860- *DcVicP*
Dearman, Elisabeth J *DcWomA*
Dearman, Elizabeth J *DcVicP 2*
Dearman, John *DcVicP, –2*
Dearman, M *DcVicP 2, DcWomA*
Dearman, Mary A *DcWomA*
DeArmas, Emile 1911- *AmArch 70*
Dearmer, Mabel 1872-1915 *DcWomA*
Dearmer, Mrs. Percy 1872-1915 *DcBrBI*
Dearmer, Thomas *DcVicP, –2*
DeArmond, Dale B *WhoAmA 78, –80, –82, –84*
DeArmond, John Courtney 1946- *MarqDCG 84*
Dearn, Thomas Downes Wilmot 1777-1853 *BiDBrA*
Dearstyne, Howard Best 1903- *AmArch 70*
Dearth, Henry Golden 1864-1918 *WhAmArt 85*
Deas, Charles 1818- *ArtsNiC*
Deas, Charles 1818-1867 *ArtsAmW 1, BnEnAmA, DcAmArt, IlBEAAW, NewYHSD*
Deas, D L 1957- *MarqDCG 84*
Deas, Kenneth *DcVicP 2*
Deas, R H *NewYHSD*
Deas, Thornton Meadows 1913- *AmArch 70*
Deas, William 1876- *DcBrA 1*
Deasy, Cornelius Michael 1918- *AmArch 70*
Death, D *DcVicP 2*
Deatherage, Philip Roy 1948- *MarqDCG 84*
Deaton, Charles 1921- *WhoAmA 73, –76, –78, –80, –82, –84*
Deats, Margaret 1942- *WhoAmA 78, –80, –82, –84*
D'Eaubonne, Jean 1903-1971 *ConDes*
Deaver, Iva S McDonald 1893- *ArtsAmW 3, DcWomA*
Deaves, Edwin F *NewYHSD*
Deavler, Joseph 1809-1886 *FolkA 86*
Debabov, Dmitri Guerguevitch 1901-1949 *ICPEnP A*
Debacker, Marguerite 1882- *DcWomA*
Debaines, Alfred Brunet- *DcVicP 2*
DeBar, B 1814?- *NewYHSD*
DeBarentzen, Patrick *WorFshn*
DeBarentzen, Patrick 1933- *FairDF ITA*
DeBarkow, Ilona 1894- *WhAmArt 85*
DeBarrac, Henry d1800 *NewYHSD*
DeBarre, Joseph 1806?- *NewYHSD*
DeBarry, Charles O 1902- *AmArch 70*
DeBartolo, Jack, Jr. 1938- *AmArch 70*
DeBassi, Sofia Celorio *WhoAmA 82, –84*
Debassige, Blake R 1956- *WhoAmA 78, –80, –82*
Debat-Ponsan, Edouard Bernard 1847-1913 *ClaDrA*
DeBatz *NewYHSD*
DeBatz, Alexander 1685?- *IlBEAAW*
DeBaudot, Anatole 1834-1915 *WhoArch*
DeBault, Charles *FolkA 86, NewYHSD*
DeBaun, Etta V 1902- *WhAmArt 85*
Debay, Auguste Hyacinthe 1804-1865 *ArtsNiC*
DeBay, Caroline Louise Emma 1809-1832 *DcWomA*
Debay, Jean-Baptiste-Joseph 1779-1863 *ArtsNiC*
DeBazel, Karel P C 1869-1923 *WhoArch*
DeBeaumont, Charles Edouard 1821-1888 *IlBEAAW*
DeBeaurepaire, Mademoiselle *DcWomA*
DeBeck, Billy 1890-1942 *WorECom*
DeBeck, William Morgan 1890-1942 *WhAmArt 85*
DeBeer, Maria Eugenia *DcWomA*
Debeerski, John *NewYHSD*
Debeet *FolkA 86*
DeBellis, Hannibal 1894- *WhoAmA 73, –76, –78, –80, –82, –84*
Debenedittis, Joseph L 1949- *MarqDCG 84*
DeBenkelear, Laura Halliday 1885- *ArtsAmW 3*
Debereiner, George 1860-1939? *WhAmArt 85*
DeBerlain, D *BiDBrA*
DeBernhardt, Mrs. *DcVicP 2*
Debes, Juliette Emilie 1889- *DcWomA*
Debes, Marthe 1893- *DcWomA*
DeBeukelaer, Laura Halliday 1885- *ArtsAmW 3, DcWomA, WhAmArt 85*
DeBibory *NewYHSD*
Debienne, Noemie *DcWomA*
Debillemont-Chardin, Gabrielle 1860-1957 *WhAmArt 85A*

Debillemont-Chardon, Gabrielle 1860?-1957 *DcWomA*
DeBittio *DcBrECP*
DeBlas, Romualdo Jose *AmArch 70*
DeBlasi, Anthony Armando 1933- *WhoAmA 73, –76, –78, –80, –82, –84*
DeBlasio, L D *AmArch 70*
DeBlois, Josephine *DcWomA*
Deblois, L *DcWomA*
DeBlois, Miss L *NewYHSD*
DeBlois, N G *AmArch 70*
DeBlonay, R *AmArch 70*
Debloois, Richard J 1940- *MarqDCG 84*
Deblos, C Edmund *WhAmArt 85*
Debo, Leon *ArtsEM*
Debo, Theodore Scott *ArtsEM*
DeBodt, Jean 1670-1745 *MacEA*
DeBohus, Irene *WhAmArt 85*
DeBois, J A *AmArch 70*
Debon, Maria *DcWomA*
Debon, Sophie 1787-1848? *DcWomA*
DeBoni, Jose Alberto 1951- *ICPEnP A*
Debonnet, M G 1871-1946 *WhAmArt 85*
DeBorhegyi, Stephan 1921- *WhoAmA 73*
DeBorhegyi, Stephan 1921-1969 *WhoAmA 76N*
DeBorhegyi, Stephen 1921-1969 *WhoAmA 78N, –80N, –82N, –84N*
DeBorhegyi, Suzanne Sims *WhoAmA 78, –80*
DeBoronda, Tulita 1894- *ArtsAmW 2, DcWomA, WhAmArt 85*
DeBoschnek, Chris 1947- *WhoAmA 82, –84*
DeBotton, Jean Philippe *WhoAmA 73, –76, –78*
DeBotton, Jean Philippe d1978 *WhoAmA 80N, –82N, –84N*
Debourg, Victoria *DcWomA*
DeBouthillier, Guy *WhAmArt 85*
Debouzek, J A *ArtsAmW 2, WhAmArt 85*
DeBow, Constance *WhAmArt 85*
DeBoyedon, O H 1882- *WhAmArt 85*
DeBra, Mabel Mason 1895?-1950 *DcWomA*
DeBra, Mabel Mason 1899- *WhAmArt 85*
DeBraekeleer, Ferdinand, Jr. 1828-1857 *NewYHSD*
Debras-Quenelle, Madeleine 1887- *DcWomA*
Debre, Olivier 1920- *ConArt 77*
DeBreanski, A, Jr. d1945? *DcVicP 2*
DeBreanski, Alfred *DcVicP*
DeBreanski, Alfred 1852-1928 *DcVicP 2*
DeBreanski, Alfred, Jr. 1877- *DcBrA 2*
DeBreanski, Alfred Fontville 1877-1945? *DcVicP 2*
DeBreanski, Gustave *DcVicP*
DeBreanski, Gustave 1856?-1898 *DcVicP 2*
DeBreda *DcBrECP*
DeBree, Anthony *DcVicP 2*
DeBrehan, Marchioness *DcWomA*
DeBrennecke, Nena 1888- *WhAmArt 85*
DeBrer, Jacques Marcel 1935- *AmArch 70*
Debret, Jean-Baptiste 1768-1848 *McGDA*
DeBretteville, Sheila Levrant 1940- *AmGrD[port], WhoAmA 76, –78, –80, –82, –84*
Debrie-Bulo, Delphine *DcWomA*
DeBrosse, Jean d1584 *McGDA*
DeBrosse, Paul *McGDA*
DeBrosse, Salomon 1571?-1626 *MacEA, McGDA, WhoArch*
DeBruhl, Michael Samuel *NewYHSD*
DeBruls, Michael *NewYHSD*
DeBrulye, John C 1931- *AmArch 70*
DeBrun *OxArt*
DeBrun, Elsa *WhoAmA 73, –76, –78, –80, –82*
DeBruyn *DcBrECP*
DeBruyn, Erich C 1911- *WhAmArt 85*
DeBruyn, F E *AmArch 70*
Debruyne, Pieter 1928- *MarqDCG 84*
Debry, Sophie Victoire *DcWomA*
Debuchy, Amielle 1889- *DcWomA*
Debucourt, Philibert-Louis 1755-1832 *McGDA, WorECar*
DeBurgh, Lydia 1923- *WhoArt 84*
DeBylandt, A *DcVicP 2*
Decagny, Virginie *DcWomA*
Decaisne, Henry 1799-1852 *ArtsNiC*
DeCamargo, Sergio 1930- *ConArt 83*
DeCambrey, Leonne 1877- *WhAmArt 85*
DeCambruzzi *DcBrECP*
DeCamillis, Laurie 1951- *DcCAr 81*
DeCamp, Harold Sydney 1903- *WhAmArt 85*
DeCamp, Joseph 1858-1923 *WhAmArt 85*
DeCamp, Joseph Rodefer 1858-1923 *DcAmArt*
DeCamp, Michael 1928- *PrintW 83, –85*
DeCamp, Ralph 1858-1936 *ArtsAmW 1*
DeCamp, Ralph Earl 1858-1936 *ArtsAmW 3*
DeCamp, Ralph Earll 1858-1936 *IlBEAAW, WhAmArt 85*
Decamp, Rena *DcWomA, WhAmArt 85*
Decamps, Alexandre Gabriel 1803-1860 *ArtsNiC*
Decamps, Alexandre-Gabriel 1803-1860 *McGDA, WorECar*
Decamps, Gabriel Alexandre 1803-1860 *ClaDrA*
Decanis, Theophile Henry 1848- *ClaDrA*
Decaprio, Alice 1919- *WhoAmA 76, –78, –80, –82*
DeCaprio, Alice 1919- *WhoAmA 84*
DeCarava, Roy *AfroAA*

DeCarava, Roy 1919- *ConPhot, DcCAr 81, ICPEnP*
DeCarava, Roy Rudolph 1919- *MacBEP, WhoAmA 84*
Decarli, Margaret Marie 1959- *MarqDCG 84*
DeCarlo, Giancarlo 1919- *ConArch, MacEA*
DeCaro, Anita 1909- *WhAmArt 85*
DeCastelbajac, Jean-Charles 1949- *ConDes*
DeCastro, Mrs. *DcWomA*
DeCastro, A P *AmArch 70*
DeCastro, Harry M *DcVicP 2*
DeCastro, Mary Beatrice 1870- *DcBrA 1, DcWomA*
DeCaus, Isaac *BiDBrA*
DeCaus, Isaac d1656? *MacEA*
DeCausse, Mrs. James Francis *WhAmArt 85*
Decaux, Fanny *DcWomA*
Decaux, Iphigenie, Vicomtesse 1780- *DcWomA*
DeCaux, Isaac *BiDBrA*
DeCell, John Eldridge, III 1936- *AmArch 70*
DeCelle, Edmond Carl 1889- *WhAmArt 85*
DeCesare, John *WhAmArt 85*
DeCesare, John 1935- *AmGrD[port]*
DeCesare, John A 1935- *ConGrA 1[port]*
DeCesare, Raymond Anthony 1936- *AmArch 70*
DeCesare, Sam 1920- *WhoAmA 73, –76*
DeChamplain, Vera Chopak *WhoAmA 73, –76, –78, –80, –82, –84*
Dechant, Miles B 1890-1942? *BiDAmAr*
Dechant, Miles Boyer 1890- *WhAmArt 85*
Dechar, Peter 1942- *WhoAmA 73, –76, –78, –80, –82, –84*
Decharmes, Simon *AntBDN D*
DeChatillon, Simon *NewYHSD*
Dechelette, Louis-Auguste 1894-1964 *OxTwCA*
DeChellis, Rudolph Valentino 1931- *AmArch 70*
Dechelminski, Jan V d1925 *WhAmArt 85*
Dechenaud, Adolphe 1868-1929 *ClaDrA*
Decherches, Catherine *DcWomA*
DeChirico, Giorgio 1888-1978 *ConArt 83, WorArt[port]*
DeChristopher, Eugene Louis 1918- *WhoAmA 73, –76*
Deck, Theodore d1891 *OxDecA*
Deck, Theodore 1823-1891 *DcNiCA*
Deckbar, G T *AmArch 70*
Deckel, Friederich Wilhelm 1871-1948 *MacBEP*
Deckel, Friedrich 1871-1948 *ICPEnP*
Decker, A D *AmArch 70*
Decker, Alice 1901- *WhAmArt 85*
Decker, Charles F *FolkA 86*
Decker, Christa *MarqDCG 84*
Decker, Cornelis Gerritsz d1678 *ClaDrA*
Decker, Cornelis Gerritsz 1623-1678 *McGDA*
Decker, Cornelis Gerritsz 1643?-1678 *OxArt*
Decker, E Bennett 1869-1936 *WhAmArt 85*
Decker, Effie Bennett 1869-1936? *DcWomA*
Decker, Elizabeth *DcBrA 2*
Decker, Ernest G *NewYHSD*
Decker, Evan 1912-1981 *FolkA 86*
Decker, Fritz *FolkA 86*
Decker, H C *AmArch 70*
Decker, Harold *WhAmArt 85*
Decker, Howard Grant 1919- *AmArch 70*
Decker, Jefford M *CabMA*
Decker, John *WhoAmA 78N, –80N, –82N, –84N*
Decker, John 1895- *ArtsAmW 3, WhAmArt 85*
Decker, Jon Hill 1941- *AmArch 70*
Decker, Joseph 1853-1924 *BnEnAmA, DcAmArt, WhAmArt 85*
Decker, Lindsey 1923- *DcCAA 71, –77, WhoAmA 78, –80, –82*
Decker, Louis *FolkA 86*
Decker, Paul *BiDBrA*
Decker, Paul 1677-1713 *MacEA*
Decker, Ralf E 1911- *AmArch 70*
Decker, Richard *WhAmArt 85*
Decker, Richard 1907- *WorECar*
Decker, Robert M *FolkA 86*
Decker, Robert M 1824?- *CabMA*
Decker, Robert M 1847- *WhAmArt 85*
Decker, William *CabMA*
DeClifford, Lady *DcWomA*
Declomesnil, E *DcWomA*
DeClorivere *NewYHSD*
DeCock, Cesar *ArtsNiC*
Decock, Gilbert 1928- *DcCAr 81*
DeCock, Henry *ArtsEM*
DeCock, Liliane 1939- *ConPhot, ICPEnP A*
Decock, Liliane 1939- *WhoAmA 84*
DeCoe, G *FolkA 86*
Decoeur, Emile 1876-1953 *DcNiCA*
Decoeur, Marie Elisabeth 1891- *DcWomA*
Decohorne, Gabrielle 1881- *DcWomA*
DeCointet, Guy 1940- *PrintW 83, –85*
DeComberousse, Josephine *DcWomA*
Decombes *NewYHSD*
Decombes, Emilie Elizabeth d1905 *DcWomA*
Decombes, J Mc *NewYHSD*
DeComps, Eugene *WhAmArt 85*
DeConinck, Pierre *ArtsNiC*
DeConing *DcBrECP*
DeConte, Fortune d1897 *ArtsAmW 2*

DeConti, Ferruccio Peter 1927- *AmArch 70*
DeCora, Angel 1871-1919 *ArtsAmW 1, DcWomA, IlBEAAW, WhAmArt 85*
Decorchement, Francois Emile 1880-1971 *DcNiCA, IlDcG*
Decorchemont, Emile *ArtsNiC*
DeCordoba, Mathilde 1871-1942 *WhAmArt 85*
DeCordoba, Mathilde J 1871-1942 *DcWomA*
DeCordova, Julian 1851-1945 *WhAmArt 85*
DeCoriche, Mireio *WhAmArt 85*
DeCorini, M 1902- *WhAmArt 85*
DeCort *DcBrECP*
DeCort, Henry Francis 1742-1810 *DcBrWA*
DeCossy, Edwin *WhAmArt 85*
DeCossy, Edwin William 1929- *AmArch 70*
DeCosta, Arthur 1921- *WhoAmA 73, –76*
Decoste, Dennis 1945- *MarqDCG 84*
DeCoster, Germaine Marguerite *DcWomA*
Decoto, Sarah 1863- *WhAmArt 85*
Decoto, Sarah Horner 1863- *ArtsAmW 3*
DeCotte, Robert 1656-1735 *MacEA, McGDA, WhoArch*
DeCoucy, Robert d1311 *McGDA*
Decoudu, N *DcWomA*
DeCoursey, John Edward 1930- *WhoAmA 78, –80, –82*
DeCourt, Suzanne *WomArt*
DeCoux, Janet *WhAmArt 85, WhoAmA 73, –76, –78, –80, –82, –84*
Decraene, Florentina 1833- *DcWomA*
DeCrano, Felix F d1908 *WhAmArt 85*
Decredico, Alfred 1944- *DcCAr 81*
DeCreeft, Alice *DcWomA*
DeCreeft, Jose 1884- *BnEnAmA, DcAmArt, DcCAA 71, –77, McGDA, WhAmArt 85, WhoAmA 73, –76, –78, –80, –82*
DeCreeft, Jose 1884-1982 *WhoAmA 84N, WorArt[port]*
DeCreeft, Mrs. Jose *WhAmArt 85*
DeCreeft, Lorrie J *WhoAmA 78, –80, –82, –84*
Decret, E *DcWomA*
Decrianus d130 *MacEA*
DeCritz, Emmanuel 1609?-1655 *OxArt*
DeCritz, John 1552?-1642 *OxArt*
Decroy, Harvey *DcWomA*
Decroze, Lucienne Alice 1899- *DcWomA*
DeCubas Y Gonzalez-Montes, Francisco 1826-1899 *MacEA*
Decuir, Joseph 1950- *MarqDCG 84*
DeCyanere, Cor 1877- *WhAmArt 85*
DeDaubrawa, Henry *DcVicP 2*
DeDiego, Julio 1900- *McGDA, WhAmArt 85, WhoAmA 73, –76, –78*
DeDiego, Julio 1900-1979 *WhoAmA 80N, –82N, –84N*
Dedieu, Cecile *DcCAr 81*
Dedina, Jean 1870- *ClaDrA*
Dedini, Eldon Lawrence 1921- *ConGrA 1[port], WhoAmA 73, –76, –78, –80, –82, –84, WorECar*
DeDominicis, Gino 1947- *ConArt 83*
DeDonato, Louis 1934- *WhoAmA 82, –84*
DeDonato, Louis John 1934- *WhoAmA 73, –76*
Dedorin, Jeanne *DcWomA*
Dedreux, Alfred 1812-1860 *ArtsNiC*
DeDreux, Louise Marie *DcWomA*
Dedrick, Warren 1891- *AmArch 70*
Dedwylder, Rozier Tyrone 1922- *AmArch 70*
Dee, Elaine Evans 1924- *WhoAmA 78, –80, –82, –84*
Dee, Leo Joseph 1931- *WhoAmA 73, –76, –78, –80, –82, –84*
Dee, William M *FolkA 86*
Deeble, E J, Jr. *AmArch 70*
Deeble, Florence *FolkA 86*
Deeds, William 1808?- *FolkA 86*
Deegan, Bill *FolkA 86*
Deegan, John William 1918- *AmArch 70*
Deel, Guy 1933- *IlrAm G, –1880*
Deelen, Dirck Van 1605-1671 *McGDA*
Deeley, Caleb *NewYHSD*
Deeley, Paul McKnight, Jr. 1926- *AmArch 70*
Deem, George *WhoAmA 80, –82*
Deem, George 1932- *ConArt 77, –83, DcCAA 71, –77, PrintW 83, –85, WhoAmA 78, –84*
Deem, Mary Goodrich 1868- *ArtsAmW 3*
Deems, Ward Wyatt 1929- *AmArch 70*
Deen, Carl Rupert, Jr. 1926- *AmArch 70*
Deen, Harriet 1883- *DcWomA*
Deen, Harriet Ogden 1883- *WhAmArt 85*
Deen, James 1927- *AmArch 70, MarqDCG 84*
Deen, Kenneth L 1952- *MarqDCG 84*
Deene, John *FolkA 86*
DeEnzling *NewYHSD*
DeErdely, Francis 1904-1959 *DcCAA 71, –77, WhAmArt 85, WhoAmA 78N, –80N, –82N, –84N*
Deering, J P *BiDBrA*
Deering, Roger 1904- *WhAmArt 85, WhoAmA 73, –76*
Deering, William 1706- *FolkA 86*
Deering, William, Jr. 1741- *FolkA 86*
Dees, Herbert Bewick 1892-1951 *DcBrA 1*
Dees, John Arthur 1876-1959 *DcBrA 1*

Dejarnette, C W AmArch 70
DeJerf, Donald Arthur 1927- AmArch 70
DeJoiner, L E 1886- WhAmArt 85
DeJoiner, Luther Evans 1886-1955 ArtsAmW 2
DeJong, Betty 1886-1917 ArtsAmW 1, DcWomA,
 WhAmArt 85
DeJong, Catherine Elizabeth 1954- MarqDCG 84
DeJong, Gerrit, Jr. 1892- WhoAmA 73, -76, -78
DeJong, Gerrit, Jr. 1892-1979 WhoAmA 80N, -82N,
 -84N
DeJong, P DeJosselin DcVicP 2
DeJong, Thom 1940- PrintW 83, -85
DeJonghe, Gustave DcVicP 2
DeJonghe, Gustave 1828- ArtsNiC
Dejonghe, John Baptist 1788-1844 ArtsNiC
DeKanelba, Sita Gomez 1932- WhoAmA 73
DeKanter, T J 1934- AmArch 70
DeKatow, P DcVicP 2
DeKatow, Paul De 1834-1897 DcBrBI
DeKay, Charles 1848-1935 MacBEP, WhAmArt 85
DeKay, Helena ArtsNiC, WhAmArt 85
DeKay, Helena 1848-1916 DcWomA
DeKay, John 1932- WhoAmA 73
Dekay, John 1932- WhoAmA 76, -78, -80, -82
DeKeisar DcWomA
DeKelly, Hilda O'Farrill WorFshn
Deken, Marthe De 1879- DcWomA
Deker, Francis Jacob d1924 FolkA 86
DeKergommeaux, Duncan 1927- WhoAmA 76, -78,
 -80, -82, -84
DeKey, Lieven 1560?-1627 MacEA, WhoArch
DeKeyser DcWomA
DeKeyser, Hendrick 1565-1621 MacEA
DeKeyser, Hendrick 1568-1621 WhoArch
DeKeyser, Hendrik BiDBrA
DeKeyser, Raoul 1930- ConArt 77, -83
DeKeyser, Willem 1603- BiDBrA
DeKeyzer, H L AmArch 70
Dekk, Dorrit 1917- WhoArt 80, -82, -84
Dekker, Arthur W 1922- AmArch 70
Dekkers, Ad 1938- ConArt 77
Dekkers, Ad 1938-1974 ConArt 83
Dekkers, Adrian 1938-1974 OxTwCA, PhDcTCA 77
Dekkers, Ger 1929- ConArt 83, ConPhot,
 ICPEnP A
Dekle, Clayton B 1922- AmArch 70
DeKlerk, Michel 1884-1923 ConArch, MacEA,
 WhoArch
DeKlyn, Charles F WhAmArt 85
Deknatel, Frederick Brockway 1905- WhoAmA 73
Deknatel, Frederick Brockway 1905-1973
 WhoAmA 76N, -78N, -80N, -82N, -84N
DeKnatel, W F AmArch 70
DeKnight, Avel 1933- AfroAA, DcCAA 77,
 WhoAmA 73, -76, -78, -80, -82, -84
DeKolb, Eric 1916- WhoAmA 73, -76, -78
DeKoninck, Louis Herman 1896- MacEA
DeKonschin, V E AmArch 70
DeKooning, Elaine 1920- DcCAA 71, -77,
 DcCAr 81, WorArt[port]
DeKooning, Elaine Marie Catherine 1920-
 WhoAmA 73, -76, -78, -80, -82, -84
DeKooning, Willem 1904- AmArt, BnEnAmA,
 ConArt 77, -83, DcAmArt, DcCAA 71, -77,
 DcCAr 81, McGDA, OxArt, OxTwCA,
 PrintW 83, -85, WhoAmA 73, -76, -78, -80, -82,
 -84, WorArt[port]
DeKosenko, Stepan 1865-1932 WhAmArt 85
DeKovic, C W, Jr. AmArch 70
DeKrafft, Marjorie WhAmArt 85
DeKraft, Charles NewYHSD
DeKruif, Henry Gilbert 1882-1944 ArtsAmW 1,
 WhAmArt 85
DeKruif, Jan 1940- MarqDCG 84
DeKryzanovsky, Roman 1885- WhAmArt 85
DeKuper, Merle Portnoy 1910- WhoAmA 76, -78, -80
Delabaere, C DcWomA
DeLaBere, Stephen Baghot 1877-1927 DcBrBI
DeLaBoissiere, Jacqueline DcWomA
DeLaBorde, Mademoiselle DcWomA
Delaborde, Henri, Viscount 1811- ArtsNiC
Delabre, Marie Louise DcWomA
DeLabriere, Alexandre Louis BiDBrA
Delabriere, Paul Edouard 1829-1912 DcNiCA
Delabrierre, Paul-Edouard 1829-1912 AntBDN C
DeLaBruyere, Madame Jacques WorFshn
Delac, Vladimir 1927-1969 WorECom
Delacazette, Sophie Clemence 1774-1854 AntBDN J,
 DcWomA
DeLacey, Charles John DcBrBI
DeLaclotte, Jean Hyacinthe 1766-1829 FolkA 86
DeLaCondamine, E J DcVicP 2
DeLaCour, B DcBrWA
DeLaCour, Clementine DcWomA
DeLaCour, F J DcBrWA
Delacour, William d1767 DcBrECP[port]
Delacour, William d1768 DcBrWA
Delacroix, C I NewYHSD
Delacroix, Emilienne 1893- DcWomA
Delacroix, Eugene 1798-1863 McGDA

Delacroix, Ferdinand Victor Eugene 1798-1863 ClaDrA
Delacroix, Ferdinand-Victor-Eugene 1798-1863
 ArtsNiC, OxArt
Delacroix, Henri McGDA
Delacroix, Henri Eugene ArtsNiC
Delacroix, Joseph C NewYHSD
Delacroix, Louise DcWomA
Delacroix, Marthe 1898- DcWomA
Delacroix, Michel 1933- PrintW 83, -85
Delacroix-Garnier, Pauline 1863-1912 DcWomA
DeLaCrouee, H DcVicP 2
DeLacy, Charles J DcBrWA
DeLacy, Charles John DcBrA 1, DcVicP 2
DeLacy, Charles John 1860?-1936 DcSeaP
DeLacy, Eva WhAmArt 85
DeLaFalaise, Maxime WorFshn
Delafield Dubois, Mary Ann DcWomA
DeLafollie, A DcVicP 2
Delafond, Aurore Etiennette DcWomA
Delafontaine, Rosalie DcWomA
Delafosse, Jean-Baptiste 1721-1775 McGDA
Delafosse, Jean Charles 1734-1791 MacEA
DeLaFosse, Louis Remy 1666-1726 MacEA
DeLaFougere, Lucette WhoArt 80, -82, -84
DeLaFougere, Lucette 1923- DcBrA 1
Delage, Marguerite d1936 DcWomA
Delage, Marie DcWomA
DeLagerberg, Lucy DcWomA, WhAmArt 85
Delagrand, Samuel CabMA
DeLaHarpe, Joseph 1850?-1901 ArtsAmW 2,
 WhAmArt 85
Delahaut, Jo 1911- OxTwCA, PhDcTCA 77
Delahaye, Adrienne DcWomA
Delahays, Eugenie DcWomA
Delahays, Marie DcWomA
Delaherche, Auguste 1857-1940 AntBDN A,
 DcNiCA
Delahousie, Ronald Joseph 1935- AmArch 70
D'Elaine 1932- WhoAmA 82, -84
DeLair, Ronald H AmArch 70
DeLaittre, Eleanor 1911- WhAmArt 85
Delalain, Henriette 1885- DcWomA
DeLaMa, Alberto PrintW 83, -85, WhoAmA 73, -76,
 -78, -80, -82, -84
Delamair, Pierre Alexis 1676-1745 MacEA
Delamaire, Pierre-Alexis 1675-1745 WhoArch
Delamaire, Rene Alexis 1675-1745 McGDA
Delamano, William NewYHSD
DeLaMare, A DcVicP 2
Delamarre, J L AmArch 70
Delamarre, Madeleine 1879- DcWomA
DeLamater, Edgar 1859- ArtsAmW 1
DeLaMatyr, Marietta Osborn DcWomA
Delamere NewYHSD
DeLamerie, Paul 1688-1751 DcD&D
Delamonce, Ferdinand 1678-1753 MacEA
Delamonica, Roberto WhoAmA 78
Delamonica, Roberto 1933- WhoAmA 80, -82
DeLamonica, Roberto 1933- WhoAmA 84
Delamontre, Marie Julie DcWomA
DeLaMoreux, Dwight 1841-1917 WhAmArt 85
DeLamotte, Caroline J 1889- DcWomA,
 WhAmArt 85
Delamotte, E DcBrBI
DeLaMotte, George Orleans DcBrWA
Delamotte, Philip Henry d1889 DcBrWA
Delamotte, Philip Henry 1820-1889 DcVicP 2
Delamotte, Philip Henry 1821-1889 ICPEnP A,
 MacBEP
DelaMotte, Raymond Bernard 1913- AmArch 70
DeLamotte, W A EarABI
Delamotte, William 1775-1863 DcVicP
Delamotte, William Alfred 1775-1863 DcBrBI,
 DcBrWA, DcVicP 2
DeLaNauze, Alexander 1704-1767 DcBrECP
Delance, Paul 1848-1924 WhAmArt 85A
Delance-Feurgard, Julie 1859?-1892 DcWomA
DeLancey, Oliver S 1922- AmArch 70
DeLand, Clyde Osmer 1872-1947 WhAmArt 85
Deland, Eugenie DcWomA
DeLand, Eugenie WhAmArt 85
Delander, Daniel AntBDN D
Delane, Solomon d1812 DcBrECP
Delaney, Beauford 1902-1979 WhoAmA 80N, -82N,
 -84N
Delaney, Beauford 1910- AfroAA
Delaney, J E NewYHSD
Delaney, James AfroAA, NewYHSD
Delaney, James J, II 1931- MarqDCG 84
Delaney, John Joseph 1921- AmArch 70
Delaney, Joseph 1904- AfroAA, WhAmArt 85,
 WhoAmA 73, -76, -78, -80, -82
Delaney, Ronald Delbert 1946- MarqDCG 84
DeLangley, Helen Haas WhoAmA 78, -80
DeLannoy NewYHSD
Delannoy, Aristide 1874-1911 WorECar
Delano, Annita 1894- ArtsAmW 2, WhAmArt 85
Delano, Annita 1894-1979 DcWomA
Delano, Elizabeth T WhAmArt 85
Delano, Gerard Curtis 1890- IlBEAAW,

WhAmArt 85
Delano, Gerard Curtis 1890-1972 ArtsAmW 1
Delano, Jack 1914- ConPhot, ICPEnP A, MacBEP,
 WhoAmA 78, -80, -82, -84
Delano, Joseph FolkA 86
Delano, Milton FolkA 86
Delano, Temperance FolkA 86
Delano, Ward P d1915 BiDAmAr
Delano, William A 1874-1960 McGDA
Delano, William Adams 1874-1960 BnEnAmA,
 MacEA, WhoArch
Delano And Aldrich BnEnAmA
Delanois, Louis 1731-1792 OxDecA
Delanoy, Abraham 1742-1795 DcAmArt, FolkA 86
Delanoy, Abraham, Jr. 1742-1795 NewYHSD
Delanoy, Hippolyte Pierre 1849-1899 ClaDrA
DeLanux DcWomA
Delany, Inez Livingston WhAmArt 85
Delany, Mary 1700-1788 DcWomA
Delany, Solomon d1812 DcBrECP
Delap, Mrs. DcWomA
DeLap, R K AmArch 70
Delap, Tony 1927- AmArt,
 PrintW 83, -85
DeLap, Tony 1927- DcCAA 71, -77,
 DcCAr 81, WhoAmA 73,
 -76, -78, -80, -82,
 -84
Delaplace, Marie Josephine DcWomA
Delaplain, Joshua CabMA
Delaplanche, Eugene 1836- ArtsNiC
Delaporte, Eugenie DcWomA
Delaporte, Roland McGDA
Delaporte, Rosine Antoinette 1807-1876 DcWomA
Delapoterie, Paul 1930- DcCAr 81
DeLapp, John Michael 1937- AmArch 70
Delapp, Richard William 1933- AmArch 70
Delappa, William DcCAr 81
DeLappa, William 1943- ICPEnP A
DeLappe, Phyllis WhAmArt 85
Delaquiert, Jules NewYHSD
DeLaQuintna, Jaime E 1934- MarqDCG 84
DeLara NewYHSD
Delaram, Francis 1590?-1627 McGDA
DeLaRenta, Oscar 1932- ConDes, WorFshn
DeLaRenta, Oscar 1933- FairDF US[port]
DeLarios, Dora 1933- WhoAmA 78, -80, -82, -84
DeLaRoche, Charles Ferdinand ClaDrA
Delaroche, Hippolyte 1797-1856 ArtsNiC
Delaroche, Marguerite 1873-1963 DcWomA
Delaroche, Paul 1797-1856 McGDA, WhAmArt 85A
DeLaRoche, Peter BiDBrA
Delaroche-Unsterller, Helene Marie L DcWomA
Delarque, Lucretia Catherine DcWomA
DeLarrea, Victoria IlsBYP
Delarue, Louise Sophie Jeanne DcWomA
Delarue-Lefebvre, Cecile 1869- DcWomA
Delarue-Mardrus, Lucie 1884-1945 DcWomA
Delasalle, Angele 1867-1938 ClaDrA
Delasalle, Angele 1867-1938? DcWomA
DeLaSonnette, Georges McGDA
DeLaSonnette, Jean Michel McGDA
DeLaSota Martinez, Alejandro 1913- ConArch
DeLasRios NewYHSD
DeLatour NewYHSD
DeLaTour, Marie Elisabeth DcWomA
DeLaTour D'Auvergne, Bernard 1923-1976 ConArch,
 MacEA
DeLatre DcVicP 2
Delatre, Jean Marie 1745-1840 McGDA
Delatre, Luise DcWomA
Delattre, Henri 1801?-1867 NewYHSD
Delattre, Mathilde Henriette 1871- DcWomA
Delattre, Therese DcWomA
Delaulne, L A DcWomA
Delaunay, Claire Leonie DcWomA
Delaunay, Jules NewYHSD
Delaunay, Jules Elie ArtsNiC
Delaunay, Jules Elie 1828-1891 ClaDrA
Delaunay, Marguerite Therese DcWomA
Delaunay, Paul 1883- WhAmArt 85
Delaunay, Robert 1885-1941 ClaDrA, ConArt 77, -83,
 McGDA, OxArt, OxTwCA, PhDcTCA 77
Delaunay, Sonia WomArt A
Delaunay, Sonia 1885- ConArt 77, WomArt
Delaunay, Sonia 1885-1979 ConArt 83, ConDes,
 PrintW 85, WorArt[port]
Delaunay-Terk, Sonia 1885- PhDcTCA 77
Delaunay-Terk, Sonia 1885-1979 DcWomA, OxTwCA
DeLaune, C D F DcVicP 2
Delaune, Etienne 1518?-1583 McGDA
Delaune, Zoe Laure DcWomA
DeLauny NewYHSD
DeLaurier, Thomas G 1872-1934 WhAmArt 85
DeLauro, Joseph Nicola 1916- WhoAmA 73,
 -76, -78, -80, -82, -84
Delautel, Anna DcWomA

DeLuna, Francis P 1891- *WhAmArt 85*
DeLuna, Tony *IlsCB 1967*
DeLuze, Grace Schuyler d1924 *WhAmArt 85*
Delval, Robert *DcCAr 81*
DelValle, Joseph Bourke 1919- *WhoAmA 76, -78, -80, -82, -84*
Delvaux, Laurence *DcWomA*
Delvaux, Laurent 1696-1778 *McGDA*
Delvaux, Marie Augustine 1786- *DcWomA*
Delvaux, Paul 1897- *ConArt 77, -83, DcCAr 81, McGDA, OxArt, OxTwCA, PhDcTCA 77, PrintW 85, WorArt[port]*
Delville-Cordier, Aimee Eugenie d1899 *DcWomA*
DeLyoncourt, Baron Hubard *DcVicP 2*
Delzant, Andree Marie 1877- *DcWomA*
Dem, Erna 1889-1943? *DcWomA*
DeMacedo, F Wolfango 1931- *MarqDCG 84*
Demachy, Robert 1859-1936 *ConPhot, MacBEP*
Demachy, Robert 1859-1937 *ICPEnP*
Demadieres, Josephine *DcWomA*
Demadieres, Juliette *DcWomA*
DeMaestri *McGDA*
Demagnez, Marie Antoinette *DcWomA*
Demain-Hammond, Christine M *DcVicP 2*
Demain-Hammond, Gertrude C *DcVicP 2*
DeMaine, A *DcVicP 2*
Demaine, G *DcVicP 2*
DeMaine, George Frederick 1892- *DcBrA 1*
DeMaine, Harry 1880- *WhAmArt 85*
Demaire, Douglas 1923- *MarqDCG 84*
DeMajo, W M 1917- *ConDes, WhoGrA 62*
DeMajo, William 1917- *McGDA*
DeMajo, Willy M 1917- *WhoArt 80, -82, -84*
DeMajo, Willy Maks 1917- *WhoGrA 82[port]*
Deman, Paule 1886-1966 *DcWomA*
Demanara, H *DcVicP 2*
DeMance, Henri d1948 *WhoAmA 78N, -80N, -82N, -84N*
DeMance, Henri 1871-1948 *WhAmArt 85*
Demanche, Blanche Marguerite 1868- *DcWomA*
Demane, John *NewYHSD*
Demangel, Andree 1889- *DcWomA*
Demangen, Charles *CabMA*
Demant-Hansen, Emilie 1873- *DcWomA*
DeMar, John L 1865-1926 *WhAmArt 85*
Demarcay, Camille *DcWomA*
DeMarco, C A *AmArch 70*
Demarco, Hugo *OxTwCA*
Demarco, Hugo 1932- *ConArt 77, -83*
Demarco, Hugo Rodolfo 1932- *PhDcTCA 77*
DeMarco, Jean 1898- *WhAmArt 85*
DeMarco, Jean Antoine 1898- *WhoAmA 73, -76, -78, -80, -82, -84*
DeMarco, Joseph L 1907- *AmArch 70*
Demarco, Richard 1930- *WhoArt 80, -82, -84*
Demarcy, Antoinette Louise 1788-1859 *DcWomA*
DeMare, Eric *ConArch A*
DeMare, George 1863-1907 *WhAmArt 85*
DeMare, John *NewYHSD*
Demaree, Betty 1918- *WhoAmA 80, -82*
Demaree, Betty 1918- *WhoAmA 84*
DeMaree, Elizabeth Ann 1918- *WhoAmA 73*
Demaree, Elizabeth Ann 1918- *WhoAmA 76, -78*
Demarest, Abraham *NewYHSD*
Demarest, Alex *NewYHSD*
Demarest, Andrew J *NewYHSD*
D'Emarest, E *DcVicP 2*
Demarest, Eda Lord 1881- *DcWomA, WhAmArt 85*
Demarest, Virginia B *DcWomA*
DeMaria, Guido 1932- *WorECar*
DeMaria, Nicola 1954- *ConArt 83, DcCAr 81*
DeMaria, Walter 1935- *ConArt 77, -83, DcCAA 71, -77, DcCAr 81, OxTwCA, WhoAmA 73, -76, -78, -80, -82, -84*
DeMaris, Walter 1877-1947 *WhAmArt 85*
Demarne, Caroline *DcWomA*
Demarne, Jean Louis 1744-1829 *ClaDrA*
Demarquet-Crauk, Irma *DcWomA*
DeMars, C T *AmArch 70*
Demars, V *AmArch 70*
DeMars, Vernon 1908- *ConArch, McGDA*
Demarteau, Gilles 1722-1776 *McGDA*
DeMartelly, John Stockton 1903- *IlsCB 1744, WhAmArt 85, WhoAmA 78, -80*
DeMartelly, John Stockton 1903-1980 *GrAmP, WhoAmA 82N, -84N*
DeMartin, E A *AmArch 70*
Demartini, Hugo 1931- *ConArt 77*
DeMartini, Joseph 1896- *DcCAA 71, -77, WhAmArt 85, WhoAmA 73, -76, -78, -80, -82, -84*
DeMartino, Eduardo 1834-1912 *DcBrBI*
DeMartino, Edward *DcVicP 2*
Demartis, James J 1926- *WhoAmA 76, -78, -80, -82, -84*
Demas, C *AmArch 70*
Demasi, V J *AmArch 70*
Demasur, Marie Mathilde Virginie *DcWomA*
Dematties, Nick 1939- *AmArt, WhoAmA 80, -82*
DeMatties, Nick 1939- *WhoAmA 84*

DeMatties, Nick Frank 1939- *WhoAmA 73*
Dematties, Nick Frank 1939- *WhoAmA 76, -78*
Demattio, Bruno 1938- *ConArt 77*
DeMauro, Don 1936- *IlrAm G*
DeMay, Kenneth 1932- *AmArch 70*
Dembling, D M *AmArch 70*
Dembowska, Sophie *DcWomA*
Dembowska, Wanda 1820-1858 *DcWomA*
Demchick, I *AmArch 70*
DeMejo, Oscar 1911- *FolkA 86*
Demel, Richard 1921- *ClaDrA, WhoArt 80, -82, -84*
DeMelero, Elviro M *WhAmArt 85*
Demelt, Anthony *CabMA*
DeMenil, John 1904- *WhoAmA 73*
DeMenil, John 1904-1973 *WhoAmA 76N, -78N, -80N, -82N, -84N*
DeMeo, Victor Anthony 1882-1947 *WhAmArt 85*
Demeranville, Mark Irving 1952- *MarqDCG 84*
DeMeric, Rosalie 1916- *WhoArt 80, -82, -84*
Demeriett, Elizabeth J *FolkA 86*
DeMerlier, Franz 1878- *WhAmArt 85*
DeMers, Joe 1910- *IlrAm F*
DeMers, Joe 1910-1984 *IlrAm 1880*
DeMers, L L, Jr. *AmArch 70*
Demers, Michel 1949- *WorECar*
DeMessieres, Olivier E 1926- *AmArch 70*
Demeter, S J *AmArch 70*
Demetrescu, Mihai Constantin 1929- *MarqDCG 84*
Demetrescu, Stefan G 1957- *MarqDCG 84*
Demetrion, James Thomas 1930- *WhoAmA 73, -76, -78, -80, -82, -84*
Demetrios, George d1974 *WhoAmA 76N, -78N, -80N, -82N, -84N*
Demetrios, George 1896-1974 *WhAmArt 85*
Demetriou, A C *AmArch 70*
DeMetz, Jeanne Francoise *DcWomA*
DeMeyer, Adolf 1868-1949 *MacBEP*
DeMeyer, Baron Adolf 1868-1946 *ICPEnP*
DeMeyer, Baron Adolf Gayne 1868-1946 *WhAmArt 85*
DeMeyer, Baron Gayne 1868?-1946 *WorFshn*
Demi, Emilio 1798- *ArtsNiC*
Demianoff, Renee Lockhart 1910-1962 *WhoAmA 80N, -82N, -84N*
DeMichele, L J *AmArch 70*
Demichelis, Piero *WorFshn*
Demidoff *DcNiCA*
Demiene, William Lloyd 1932- *AmArch 70*
DeMilhau, Zella *DcWomA, WhAmArt 85*
DeMille, Leslie Benjamin 1927- *WhoAmA 73, -76, -78, -80, -82, -84*
Demilliere, Ann *NewYHSD*
Demilliere, Auguste *NewYHSD*
Demilliere, Auguste, Jr. *NewYHSD*
Deming, Adelaide 1864- *WhAmArt 85*
Deming, Adelaide 1864-1956 *DcWomA*
Deming, Charlotte *DcWomA, NewYHSD*
Deming, David Lawson 1943- *WhoAmA 76, -78, -80, -82, -84*
Deming, E W 1860-1942 *WhAmArt 85*
Deming, Edith G *DcWomA*
Deming, Edwin Willard 1860- *DcWomA*
Deming, Edwin Willard 1860-1942 *ArtsAmW 1, IlBEAAW*
Deming, Eleanor 1879- *DcWomA, WhAmArt 85*
Deming, Elizabeth *WhAmArt 85*
Deming, Horace *FolkA 86*
Deming, Levi *FolkA 86*
Deming, Luther *FolkA 86*
Deming, Mabel Reed 1874- *ArtsAmW 2, DcWomA, WhAmArt 85*
Deming, Richard Edward 1932- *AmArch 70*
Deming, Roger *FolkA 86*
Deming, Simeon *CabMA*
Deming, William I 1871-1939? *BiDAmAr*
DeMiskey, Julian *WhoAmA 76, -78, -80, -82, -84*
DeMiskey, Julian d1976 *IlsCB 1967*
DeMiskey, Julian 1908- *IlsCB 1957*
Demity, Joseph J 1956- *MarqDCG 84*
Demkin, Joseph Armand 1937- *AmArch 70*
Demme, William *NewYHSD*
Demmler, Fred A 1888-1918 *WhAmArt 85*
Demmler, Georg Adolph 1804-1886 *MacEA*
DeMoll, John David 1922- *AmArch 70*
DeMoll, Louis 1924- *AmArch 70*
DeMoll, Mary Hitchner 1884- *DcWomA, WhAmArt 85*
Demonet, Inez 1897- *DcWomA, WhAmArt 85*
DeMonfreid, Henri 1879-1974 *MacBEP*
Demont, Adrien Louis 1851-1928 *ClaDrA*
Demont, Adrienne Elodie Clemence *DcWomA*
Demont-Breton, Virginie 1859-1935 *ClaDrA*
Demont-Breton, Virginie Elodie 1859-1935 *DcWomA*
DeMontaigu, Amiel *ArtsEM*
DeMontaigu, Emil *ArtsEM*
DeMontaigu, Emile *ArtsEM*
DeMonte, Claudia 1947- *DcCAr 81, WhoAmA 78, -80, -82, -84*

DeMonte, L A *AmArch 70*
DeMontebello, Guy-Philippe Lannes 1936- *WhoAmA 82*
DeMontebello, Guy-Philippe Lannes 1939- *WhoAmA 73, -76, -78, -80*
DeMontebello, Philippe Lannes 1936- *WhoAmA 84*
DeMontenack, Miss *DcWomA*
DeMontfort, Lisa 1906- *DcBrA 1*
DeMontmorency, Lily *DcBrBI*
DeMontpreville *NewYHSD*
Demontreuil, Hortense *DcWomA*
Demontrond, Jeanne Felicie Francoise *DcWomA*
DeMontule *NewYHSD*
Demopulos, Dimitri 1927- *AmArch 70*
Demorest, Mrs. Clyde S *ArtsEM, DcWomA*
DeMorgan, Evelyn 1855-1919 *DcVicP, -2, DcWomA*
DeMorgan, Mary Evelyn 1855-1919 *DcBrA 1*
DeMorgan, William *DcNiCA*
DeMorgan, William 1839-1917 *DcBrBI, DcVicP, -2*
DeMorgan, William F 1839-1917 *DcBrA 1*
DeMorgan, William Frend 1839-1917 *AntBDN M, DcD&D*
Demory, Charles Theophile 1833-1895 *ClaDrA*
Demos, Gary Alfred 1950- *MarqDCG 84*
Demosthenes, H J *AmArch 70*
DeMoulpied, Deborah 1933- *DcCAA 71, -77*
DeMoura Sobral, Luis 1943- *WhoAmA 84*
Demprin, Henriette *DcWomA*
Dempsey, Bruce Harvey 1941- *WhoAmA 76, -78, -80, -82, -84*
Dempsey, C P *AmArch 70*
Dempsey, Charles W *DcVicP 2*
Dempsey, John *AntBDN O, NewYHSD*
Dempsey, Richard Burton 1933- *AmArch 70*
Dempsey, Richard W 1909- *AfroAA*
Dempsey, Richard William 1909- *WhoAmA 82, -84*
Dempsey, William H *NewYHSD*
Dempster *ClaDrA, WhoArt 80, -82, -84*
Dempster, George *BiDBrA*
Dempster, James *BiDBrA*
Dempster, Margaret *DcVicP 2*
Dempwolf, John A 1848-1928 *BiDAmAr*
Demsar, Tone 1946- *DcCAr 81*
Demsky, Herbert M 1945- *MarqDCG 84*
DeMunbrun, Richard Ronald 1933- *AmArch 70*
DeMuranyi, Gustave *ArtsEM*
Demus, Otto 1902- *WhoArt 80, -82, -84*
Demuth, Anni Von 1866- *DcWomA*
Demuth, Charles 1883-1935 *BnEnAmA, ConArt 77, DcAmArt, DcCAA 71, -77, McGDA, OxTwCA, PhDcTCA 77, WhAmArt 85*
Demuth, Charles 1883-1939 *OxArt*
DeMuth, Flora Nash 1888- *IlsCB 1946*
Demuth, John 1770?-1820 *NewYHSD*
Demuth, John J 1899- *AmArch 70*
Demuth, Martin 1895- *WhAmArt 85*
Demuth, William *FolkA 86*
DeMyrosh, Michael 1898- *WhAmArt 85*
Dena *ICPEnP A, MacBEP*
DeNagy, Eva *WhoAmA 73, -76, -78, -80, -82, -84*
DeNagy, Laszlo 1906?-1944 *WhAmArt 85*
DeNagy, Tibor 1910- *WhoAmA 76, -78, -80, -82, -84*
DeNardo, Antonio *WhAmArt 85*
Denato, Francesco *ClaDrA*
Denbigh, Countess Mary Elizabeth 1798-1842 *DcWomA*
Denbrook, Craig Leslie 1953- *MarqDCG 84*
Denbrook, Myron Elwood 1922- *AmArch 70*
Denbrook, Patricia Sue 1953- *MarqDCG 84*
Denby, Edwin Hooper 1873- *WhAmArt 85*
Denby, Jillian *PrintW 83, -85, WhoAmA 76, -78, -80, -82*
Denby, William *DcVicP 2*
Dencler, John A *AmArch 70*
Dendy, G *DcVicP 2*
Dendy, J Brooks, III *AfroAA*
Dendy, Walter C *DcVicP 2*
Deneau, P H *AmArch 70*
Denechaud, Celesta *NewYHSD*
Denechaud, Celesta 1823?- *DcWomA*
Denecheau, Elisabeth Felicite *DcWomA*
Deneff, W W *AmArch 70*
Denegan, Samuel *NewYHSD*
Dener 1936- *WorFshn*
Denes, Agnes 1938- *ConArt 83, DcCAr 81, PrintW 83, -85*
Denes, Agnes C *WhoAmA 73, -76, -84*
Denes, Agnes C 1938- *WhoAmA 78, -80, -82*
Denes, Agnes Cecilia 1938- *AmArt, ConArt 77*
Denes, Valeria *DcWomA*
Denes, William *DcBrECP*
DeNesti, Adolfo 1870- *WhAmArt 85*
Denew, Richard *DcVicP 2*
Deneyn, Pieter *McGDA*
Denghausen, Alfred L F 1906- *WhAmArt 85*
Denghausen, Franz H 1911- *WhAmArt 85*
Dengler, B H *AmArch 70*
Dengler, Franz X 1853- *ArtsNiC*
Dengler, J *FolkA 86*
Dengler, John 1812?- *FolkA 86*

Dengrove, Ida L 1918- *WhAmArt 85*
Denham, Mrs. d1782 *DcWomA*
Denham, B W d1946 *BiDAmAr*
Denham, Dan *MarqDCG 84*
Denham, Daniel 1769?-1855 *CabMA*
Denham, Henry James 1893- *DcBrA 1*
Denham, Sir John 1615-1669 *BiDBrA*
Denham, John Charles *DcBrWA, DcVicP 2*
Denham, Louis W *NewYHSD*
DenHartog, Maarten Dirk 1927- *AmArch 70*
DenHollander, Paul 1950- *ConPhot, ICPEnP A*
Denholm, John *FolkA 86*
Deni *WorECar*
DeNicola, Henry Joseph 1922- *AmArch 70*
Denig, Ludwig *FolkA 86*
DeNigris, Victor L 1923- *AmArch 70*
DeNike, J G *AmArch 70*
DeNike, Michael Nicholas 1923- *WhoAmA 73, -76, -78, -80, -82, -84*
Dening, Charles Frederick William 1876- *DcBrA 1*
DeNiro, Robert 1922- *DcCAA 71, -77, WhoAmA 73, -76, -78, -80*
Denis, Mademoiselle *DcWomA*
Denis Of Paris, Saint *McGDA*
Denis, D A *AmArch 70*
Denis, Julian N 1829?- *NewYHSD*
Denis, Leonard *WhAmArt 85*
Denis, Maurice 1870-1943 *ClaDrA, McGDA, OxArt, OxTwCA, PhDcTCA 77*
Denis, Paul Andre *WhoAmA 80*
Denis, Paul Andre S 1938- *WhoAmA 78*
Denis, Simon Joseph Alexander Clement 1755-1813 *ClaDrA*
Denis, V *DcVicP 2*
DeNisco, Fred Angelo 1923- *AmArch 70*
Denise, Ira Condit 1840- *NewYHSD*
Denison, Miss *DcWomA*
Denison, D E *AmArch 70*
Denison, David 1939- *WhoArt 82, -84*
Denison, George Henry 1867-1944 *WhAmArt 85*
Denison, Harold 1887-1940 *WhAmArt 85*
Denison, Harold Thomas 1887-1940 *IlrAm C, -1880*
Denison, Harriet *FolkA 86*
Denison, J *DcVicP 2*
Denison, Lucy Dunbar *ArtsAmW 3*
Denison, M A *DcWomA*
Denison, Mrs. M A *NewYHSD*
Denison, Marcia 1825- *FolkA 86*
Denison, Nancy Noyes *FolkA 86*
Denison, Stephen 1909- *DcBrA 1*
Denisov, Viktor Nikolayevich 1893-1946 *WorECar*
Denivelle, Paul E 1872-1936 *WhAmArt 85*
Denizart, Hugo 1946- *ICPEnP A*
Denler, Joseph *FolkA 86*
Denlinger, David *FolkA 86*
Denman, David *FolkA 86*
Denman, Gladys 1900- *ClaDrA, WhoArt 80, -82, -84*
Denman, Herbert 1855-1903 *WhAmArt 85*
Denman, Marie 1776?-1861 *DcWomA*
Denman, Richard A 1910- *AmArch 70*
Denman-Jones, Gladys 1900- *DcBrA 1*
Denmark, James 1936- *AfroAA*
Denmead, John *CabMA*
Denn, A *DcVicP 2*
Denne, Rosa *DcWomA*
Denne-Baron, Sophie 1785-1861 *DcWomA*
Denneman *NewYHSD*
Denner, Balthasar 1685-1749 *McGDA*
Denner, Balthazar 1685-1749 *ClaDrA*
Denner, Catharina *DcWomA*
Denner, Catharina 1723?-1744 *DcWomA*
Denner, Esther *DcWomA*
Denner, Maria *DcWomA*
Dennes, Noel 1908- *WhoArt 80, -82, -84*
Dennes, Noel Frank Bevan 1908- *DcBrA 1*
Dennes, Thomas 1638?-1706 *CabMA*
Dennett, A H *DcWomA*
Dennett, Miss A H *NewYHSD*
Dennett, Mary Ware *WhAmArt 85*
Dennett, Olive *FolkA 86*
Dennett, William H 1870-1936 *BiDAmAr*
Denneulin, Jules *ArtsNiC*
Denneulin, Jules 1835-1904 *ClaDrA*
Denney, Benjamin Paris 1921- *AmArch 70*
Denney, Carl W 1907- *AmArch 70*
Denney, Gladys A 1898- *DcWomA*
Denney, Irene *DcWomA, WhAmArt 85*
Denney, Jim 1953- *WhoAmA 84*
Denney, Roy Lumpkin, Jr. 1942- *AmArch 70*
Denning *NewYHSD*
Denning, Charlotte *DcWomA*
Denning, Edward Patrick 1926- *AmArch 70*
Denning, Estella L 1888- *ArtsAmW 3*
Denning, Stephen Poyntz 1795-1864 *DcBrWA, DcVicP 2*
Dennis *NewYHSD*
Dennis, Miss *DcVicP 2*
Dennis, A M *AmArch 70*
Dennis, Ada *DcBrA 1, DcVicP 2, DcWomA*
Dennis, Burt Morgan 1892-1960 *WhoAmA 80N, -82N, -84N*

Dennis, C W *AmArch 70*
Dennis, Charles Houston 1921- *WhoAmA 73, -76, -78, -80, -82, -84*
Dennis, Charles Warren 1898- *WhAmArt 85*
Dennis, Cherre Nixon *WhoAmA 73, -76, -78, -80, -82, -84*
Dennis, Cherry Velma Nixon *WhAmArt 85*
Dennis, Don W 1923- *AmArt, WhoAmA 80, -82, -84*
Dennis, Donald Thomas 1928- *AmArch 70*
Dennis, Donna 1942- *AmArt, DcCAr 81, PrintW 83, -85*
Dennis, Donna Frances 1942- *WhoAmA 82, -84*
Dennis, E M *AmArch 70*
Dennis, Edgar *NewYHSD*
Dennis, F Madeline *DcBrA 1*
Dennis, George B *WhAmArt 85*
Dennis, Gertrude Weyhe *WhoAmA 82, -84*
Dennis, James M 1840- *NewYHSD , WhAmArt 85*
Dennis, James M 1841-1918 *ArtsEM*
Dennis, Jeannelle Wilson d1933 *DcWomA, WhAmArt 85*
Dennis, John 1672-1757 *CabMA*
Dennis, John, Jr. 1921- *AmArch 70*
Dennis, L M *AmArch 70*
Dennis, Morgan 1892?-1960 *IlsCB 1744, -1946, WhAmArt 85*
Dennis, Oliver Perry 1858- *BiDAmAr*
Dennis, Peter E 1854-1929 *BiDAmAr*
Dennis, R L *AmArch 70*
Dennis, R S *AmArch 70*
Dennis, Richard C *CabMA*
Dennis, Richard Norval 1914- *AmArch 70*
Dennis, Roger Wilson 1902- *WhoAmA 73, -76, -78, -80, -82, -84*
Dennis, S A *FolkA 86*
Dennis, Thomas 1638 *DcD&D*
Dennis, Thomas 1638?-1706 *AntBDN G, BnEnAmA, CabMA, FolkA 86*
Dennis, Thomas 1733-1760 *CabMA*
Dennis, Thomas, Jr. 1669-1703? *CabMA*
Dennis, Thomas Ward 1904- *AmArch 70*
Dennis, W E *AmArch 70*
Dennis, W T *DcVicP 2*
Dennis, Wesley 1903-1966 *IlsCB 1744, -1946, -1957*
Dennis, William *CabMA, DcVicP 2, FolkA 86*
Dennison *NewYHSD*
Dennison, Aaron L *AntBDN D*
Dennison, Christabel *DcWomA*
Dennison, Dorothy 1908- *WhoAmA 73, -76, -78, -80, -82*
Dennison, Elizabeth *DcWomA*
Dennison, Emily L *DcWomA*
Dennison, Ethan Allen 1881- *WhAmArt 85*
Dennison, Ethan Allen 1914- *AmArch 70*
Dennison, George Austin 1873- *ArtsAmW 1*
Dennison, Keith Elkins 1939- *WhoAmA 73, -76, -78, -80, -82, -84*
Dennison, Lucy 1902- *WhAmArt 85*
Dennison, M A *DcWomA*
Dennison, Roger McGill 1925- *AmArch 70*
Dennison, Thomas Davis 193?- *AmArch 70*
Denniston, Douglas 1921- *WhoAmA 78, -80, -82, -84*
Dennistoun, William 1838-1884 *DcBrWA, DcVicP 2*
Denny, Clifton Enyart, Jr. 1931- *AmArch 70*
Denny, Edward Curtis 1928- *MarqDCG 84*
Denny, Emily Inez 1853-1918 *ArtsAmW 3*
Denny, Gideon Jacques 1830-1886 *ArtsAmW 1*
Denny, Gladys A 1898- *DcWomA, WhAmArt 85*
Denny, Irene *WhAmArt 85*
Denny, J G 1830-1886 *IlBEAAW*
Denny, Madge Decatur *ArtsAmW 3*
Denny, Milo B 1887- *ArtsAmW 3, WhAmArt 85*
Denny, Robyn 1930- *ConBrA 79[port], DcCAr 81, OxTwCA, PhDcTCA 77, PrintW 83, -85*
Denny, Robyn 1931- *ConArt 77*
Denny, Samuel d1935 *FolkA 86*
Denny, Sara *FolkA 86*
Denny, Willis Franklin 1872-1905 *BiDAmAr*
Deno, Paul 1897- *AmArch 70*
DeNoielle, Peter *CabMA*
DeNoijer, Paul 1943- *ICPEnP A*
Denois, Lucile *DcWomA*
Denon, Dominique Vivant 1747-1825 *McGDA*
DeNooijer, Paul 1943- *ConPhot*
DeNoon, Charles *NewYHSD*
DeNormandie, Elizabeth K *DcWomA*
DeNoronha, Maria M *WhoAmA 73, -76, -78, -80*
DenOuden, Aart 1943- *MarqDCG 84*
Denous-Dubois, Louise *DcWomA*
Densler, William d1811 *CabMA*
Denslow, Dorothea Henrietta 1900-1971 *WhAmArt 85, WhoAmA 78N, -80N, -82N, -84N*
Denslow, Henry Carey 1867-1944 *WhAmArt 85*
Denslow, William Wallace 1856- *WhAmArt 85*
Denslow, William Wallace 1856-1915 *ArtsAmW 3*
Densmore, Austa *DcWomA*
Densmore, Edward Dana 1871-1925 *BiDAmAr*
Densmore, Eva *ArtsEM*
Dent, Aileen Rose *WhoArt 80N*
Dent, Aileen Rose 1890-1979 *DcWomA*

Dent, Dorothy *DcWomA, WhAmArt 85*
Dent, Edward John 1790-1853 *AntBDN D*
Dent, J *DcVicP 2*
Dent, Richard *WhoArt 84N*
Dent, Richard 1902- *WhoArt 80, -82*
Dent, Robert Stanley Gorrell 1909- *DcBrA 1, WhoArt 80, -82, -84*
Dent, Rupert Arthur *DcVicP 2*
Dentandt, Don 1947- *MarqDCG 84*
Dentigny, Henriette 1824- *DcWomA*
Denton, Alonzo *ArtsEM*
Denton, F W *DcVicP 2*
Denton, Jack Leonard 1930- *AmArch 70*
Denton, Jon Richard *WhoAmA 76*
Denton, Kenneth 1932- *ClaDrA, DcSeaP*
Denton, Kenneth Raymond 1932- *WhoArt 80, -82, -84*
Denton, Pat 1943- *AmArt, PrintW 83, -85, WhoAmA 76, -78, -80, -82, -84*
Dentone, Giovanni *McGDA*
DEntremont, Paul T *AmArch 70*
Dentzel, Carl Schaefer 1913- *WhoAmA 73, -76, -78, -80*
Dentzel, Carl Schaefer 1913-1980 *WhoAmA 82N, -84N*
Dentzel, Gustav A d1909 *FolkA 86*
Dentzel, William d1928 *FolkA 86*
Denune, Peter *DcBrECP*
Denune, William *DcBrECP*
Denvil, Angele 1887- *DcWomA*
Denvil, Angele Blanche 1874?- *DcWomA*
Denvil-Lupin, Alice 1881- *DcWomA*
Deny, Jeanne 1749-1815? *DcWomA*
Denyer, Alfred *DcVicP 2*
Denyer, Robert J *NewYHSD*
Denyes, H M, Jr. *AmArch 70*
Denys, George Frederick 1946- *WhoAmA 73, -76*
Denys, Peter *DcBrECP*
Denzer, Donald William 1923- *AmArch 70*
Denzilow, John *AntBDN Q*
Denzler, D *AmArch 70*
Denzler, Mary Grace 1892- *DcWomA*
Deo, Marjoree Nee 1907- *WhoAmA 84*
Deodato Orlandi *McGDA*
Deonon, Vivant Dominique 1747-1825 *ClaDrA*
DeOrlov, Lino S *WhAmArt 85*
Depace, A J *AmArch 70*
DEpagnier, John Aarnold *AmArch 70*
DePaola, Tomie *IlsBYP, IlsCB 1957, -1967*
DePaola, Tomie 1934- *WhoAmA 76, -78, -80, -82, -84*
Depardon, Raymond 1942- *ConPhot, ICPEnP A*
DeParis, Alphonse G *DcBrBI*
DeParys, Alphonse G *DcBrBI*
DePasquale, Frank Albert 1925- *AmArch 70*
Depasse *EncASM*
Depasse Pearsall *EncASM*
Depau, Louise 1874-1966 *DcWomA*
Depaulis, Richard Anthony 1953- *MarqDCG 84*
DePauw, Victor 1902- *WhAmArt 85, WhoAmA 73, -76*
Depearson, Daniel *AfroAA*
DePedery-Hunt, Dora 1913- *WhoAmA 73, -76, -78, -80, -82, -84*
Depero, Fortunato 1892-1960 *OxTwCA*
Depesseville *NewYHSD*
DePeter, Joseph 1908- *AmArch 70*
Depew, Don D 1921- *AmArch 70*
Depew, Viola 1894- *DcWomA*
DePeyster, Gerard Beekman 1834-1870 *NewYHSD*
DePicciotto, Sol 1937- *MarqDCG 84*
DePierpont, Benoit 1937- *WhoGrA 82[port]*
DePierro, John Joseph 1923- *AmArch 70*
DePiles, Roger 1635-1709 *OxArt*
DePillars, Murry N *AfroAA*
Depillars, Murry N 1938- *WhoAmA 76, -78, -80, -82, -84*
D'Epinay *DcBrBI*
DePinna, Vivian 1883-1978 *WhoAmA 80N, -82N, -84N*
DePisis, Filippo *McGDA*
Deplanche, Gabrielle Marguerite 1875-1945 *DcWomA*
Deplanque, Marguerite *DcWomA*
Deplante, Berthe 1869- *DcWomA*
DePlas, Josephine *DcWomA*
DePoix-Tyrel, Edmond *DcVicP 2*
DePol, Enzo *AmArch 70*
DePol, John 1913- *WhoAmA 73, -76, -78, -80, -82, -84*
DePolgary, Geza 1862-1919 *WhAmArt 85*
DePolo, H R *AmArch 70*
DePoncy, Alfred V *DcVicP 2*
Depond, Moise 1917- *WorECar*
DePontelli *NewYHSD*
DePouilly *BiDAmAr*
Deppe, Edward D 1956- *MarqDCG 84*
Deppe, Ferdinand *ArtsAmW 1*
Deppe, Gustav 1913- *DcCAr 81*
Deppermann, Henriette 1860- *DcWomA*
DePrades, A F *DcVicP 2*
DePrades, Frank *DcVicP 2*
DePre, Grace Annette *WhAmArt 85*

Deson, Marianne *WhoAmA 80, –82, –84*
Desoras, Jenny *DcWomA*
DeSoto, Minnie B Hall *DcWomA*
DeSoto, Minnie B Hall 1864- *WhAmArt 85*
Desoto, Rafael M *WhoAmA 76, –78, –80, –82, –84*
Desouches, Leonie *DcWomA*
DeSouza, Pascoal 1928- *WhoArt 80, –82, –84*
Desperais, Julie Francoise 1777- *DcWomA*
Desperieres, Madame 1787- *DcWomA*
Despiau, Charles 1874-1946 *McGDA, OxArt, OxTwCA, PhDcTCA 77, WhAmArt 85A*
Despierre, Jacques 1912- *OxTwCA*
Despierres, Adele 1837- *DcWomA*
Desplaces, Louis 1682-1739 *McGDA*
Despois, Madame 1795- *DcWomA*
Desportes, Alexandre-Francois 1661-1740 *OxArt*
Desportes, Alexandre Francois 1661-1743 *ClaDrA*
Desportes, Alexandre-Francois 1661-1743 *McGDA*
Desportes, Francois 1661-1743 *DcBrECP*
Desportes, Henrietta *DcWomA, NewYHSD*
Desportes, Henriette Jeanne 1877- *DcWomA*
Desportes, Melanie *DcWomA*
Desportes, Ulysse Gandvier 1920- *WhoAmA 73, –76, –78, –80, –82, –84*
Desportes DeLaFosse, Andree Emma F 1810-1869 *DcWomA*
D'Esposito, G *DcSeaP*
Despradelle, Constant Desire 1862-1912 *BiDAmAr*
DesPres, Francois M T *AfroAA*
Despres, Jean *WorFshn*
Despret, Georges *DcNiCA*
Despret, Georges 1862-1952 *IlDcG*
Despret, Hector *DcNiCA*
Desprey, Louis Jean 1749-1804 *DcSeaP*
Desprez *DcNiCA*
Desprez, Barthelemy *IlDcG*
Desprez, Jean-Louis 1737-1804 *WhoArch*
Desprez, Jean Louis 1743-1803 *McGDA*
Desprez, Louis 1799-1870? *ArtsNiC*
Desprez, Marguerite *DcWomA*
Desprez, Simone 1882-1970 *DcWomA*
Desprez-Bourdon, Jeanne Claire A 1876- *DcWomA*
Despujols, Jean 1886- *WhAmArt 85A*
Desrais *AntBDN E*
DesRioux, Deena 1941- *WhoAmA 78, –80, –82, –84*
Desrivieres, Elisa d1891 *DcWomA*
Dessalle, Mademoiselle *DcWomA*
Dessar, Louis Paul d1952 *WhoAmA 78N, –80N, –82N, –84N*
Dessar, Louis Paul 1867-1952 *WhAmArt 85*
Dessarts, C *NewYHSD*
Dessau, Paul Lucien 1909- *DcBrA 1*
Dessauer, William 1882-1943 *WhAmArt 85*
Dessaules, Madame *DcWomA*
Dessaur, Ferdinand *NewYHSD*
Dessaux, Berthe Augustine Aimee *DcWomA*
Desser, Maxwell Milton *WhoAmA 80, –82, –84*
Desses, Jean 1904-1970 *FairDF FRA, WorFshn*
Dessez, Leon E 1858-1918 *BiDAmAr*
Dessner, Murray 1934- *WhoAmA 73, –76, –78, –80, –82, –84*
Dessurne, Mark 1825- *DcVicP 2*
DeSt. Dalmas, F Emeric *DcVicP 2*
DeStaebler, Stephen 1933- *CenC[port]*
DeStael, Nicolas *McGDA, OxTwCA*
DeStael, Nicolas 1914-1955 *ConArt 77, –83, WorArt*
DeStafano, J R *AmArch 70*
Destailleur, Gabrielle Emma *DcWomA*
Destailleur, Helene Charlotte *DcWomA*
Destailleur, Hippolyte-Alexandre-Gabriel 1822-1893 *MacEA*
Destailleur-Sevrin, Jeanne *DcWomA*
Destefanis, G A *AmArch 70*
Destefano, D A *AmArch 70*
DeSteiger, Isabel *DcVicP 2*
DeSteiguer, Ida *ArtsAmW 3*
Destigny, Lucie *DcWomA*
DeStijl *OxArt, OxTwCA*
Destours, Mademoiselle *DcWomA*
Destree, Jean-Pierre 1945- *MarqDCG 84*
Destree-Danse, Marie *DcWomA*
D'Estrella, Theophilus Hope 1851-1929 *MacBEP*
DeSuria, Tomas *NewYHSD*
DeSuria, Tomas 1761- *ArtsAmW 1*
Desvallieres, George 1861-1950 *OxTwCA*
Desvallieres, Georges 1861-1950 *ClaDrA, PhDcTCA 77*
Desvallieres, Georges Olivier 1861-1950 *McGDA*
Desvarreux-Larpenteur, James 1847- *WhAmArt 85*
Desvignes, Emily *DcWomA*
Desvignes, Emily E *DcVicP 2*
Desvignes, F C *DcVicP 2*
Desvignes, Gabrielle Marie Therese *DcWomA*
Desvignes, Herbert Clayton *DcVicP, –2*
Desvignes, Peter Hubert 1804?-1883 *BiDBrA*
DeTabley, Sir John Fleming Leicester 1762-1827 *DcBrWA*
DeTahy, John *WhAmArt 85*
Detaille, Edouard 1848-1912 *McGDA*
Detaille, Jean-Baptiste-Edouard 1848- *ArtsNiC*
Detaille, Jean Baptiste Edouard 1848-1912 *ClaDrA*

DeTakach, Bela *WhAmArt 85*
Detanger-Nermord, Reine Anne Louise *DcWomA*
DeTarnowsky, Michael *WhAmArt 85*
Dete, Jeanne Flore *DcWomA*
Deteau, Clarence Harold 1926- *AmArch 70*
DeTeissier, H P *DcVicP 2*
DeTessier, Isabelle Emilie *DcVicP 2*
DeTessier, Isabelle Emilie 1851- *DcBrWA*
DeThannberg, Count L *DcVicP 2*
Dethlefs, David Guild 1922- *AmArch 70*
Dethloff, Peter H 1869- *WhAmArt 85*
Dethloff, Peter Hans 1869- *ArtsAmW 2*
Dethoff, Donald Comppen 1916- *AmArch 70*
DeThulstrup, Thure 1848-1930 *IlBEAAW, WhAmArt 85*
DeTirtoff, Romain 1892- *WorFshn*
Detlie, J S *AmArch 70*
Detmer, William C 1953- *MarqDCG 84*
Detmers, William Raymond 1942- *WhoAmA 80, –82, –84*
Detmold, Charles Maurice 1883-1908 *DcBrA 1, DcBrBI, DcBrWA, DcVicP 2*
Detmold, Edward J 1883?- *ConICB*
Detmold, Edward Julian 1883-1957 *DcBrA 1, DcVicP 2*
Detmold, Edward Julius *DcBrWA*
Detmold, Edward Julius 1883-1957 *ClaDrA, DcBrA 2, DcBrBI*
Detmold, Henry E 1854- *DcVicP 2*
DeTolla, Frank L 1928- *MarqDCG 84*
DeTolnay, Charles *WhoArt 82N*
DeTolnay, Charles 1899- *WhAmArt 85, WhoAmA 73, –76, –78, –80, WhoArt 80*
DeTomasi, Jane *WhAmArt 85*
DeTonnancour, Jacques G 1917- *WhoAmA 73, –76, –78*
DeTore, John E 1902- *WhoAmA 73, –76*
DeTore, John E 1902-1975 *WhoAmA 78N, –80N, –82N, –84N*
Detre-Bocquet, Berthe d1905 *DcWomA*
Detreville, Richard 1854-1929 *ArtsAmW 3*
DeTrey, Marianne *DcCAr 81*
Detrez, Ambroise 1811-1863 *ClaDrA*
DeTriville, Richard 1854-1929 *ArtsAmW 3*
DeTrobiand, Regis Denis DeKeredern 1816-1897 *WhAmArt 85*
DeTrobriand, Regis Denis DeKeredern 1816-1897 *IlBEAAW*
Detrois, Alba 1863- *DcWomA*
D'Ette, Caroline *DcWomA*
Detterick, George *FolkA 86*
Detthow, Eric 1893- *ClaDrA*
Dettmann, Edith 1898- *DcWomA*
Dettmann, Ludwig Julius Christian 1865- *ClaDrA*
Dettor, C F *AmArch 70*
Dettrith, William *NewYHSD*
DeTurck, Ethel Ellis *WhAmArt 85*
DeTurczynowicz, Wanda 1908- *WhoAmA 76, –78, –80, –82, –84*
DeTurkheim, Helene *WorFshn*
Detweiler, John H *FolkA 86*
Detweiller, Martin M *FolkA 86*
Detwiler, Charles H 1864-1940 *BiDAmAr*
Detwiller, Charles H, Jr. *AmArch 70*
Detwiller, F K 1882- *WhAmArt 85*
Deuchen, Robert *NewYHSD*
Deuel, Elizabeth *FolkA 86*
Deuler, Joseph *FolkA 86*
Deupert, Adam *EncASM*
Deurbergue, Ida Louise 1857- *DcWomA*
Deurs, Caroline Van 1860- *DcWomA*
DeUrzaiz, Elizabeth 1896- *DcWomA, WhAmArt 85*
Deuschinski, Joe *WhAmArt 85*
Deuss, Otto A *WhAmArt 85*
Deutmann, F *DcVicP 2*
Deutsch, Boris 1892- *ArtsAmW 2, WhAmArt 85*
Deutsch, David 1943- *ConArt 77*
Deutsch, Hilda 1911- *WhAmArt 85*
Deutsch, Larry-Stuart 1947- *MarqDCG 84*
Deutsch, Niklaus Manuel 1484?-1530 *OxArt*
Deutsch, Nikolaus *McGDA*
Deutsch, Peter Andrew 1926- *WhoAmA 73, –76, –78, –80, –82*
Deutsch, Richard 1953- *PrintW 83, –85*
Deutschman, Louise Tolliver 1921- *WhoAmA 80, –82, –84*
Deutschmann, Joseph Adam 1717-1787 *McGDA*
Deux, Fred 1924- *DcCAr 81*
Dev, Parvati *MarqDCG 84*
Devade, Marc 1943- *ConArt 83*
Devaeke, Lucie V *DcWomA*
Devambez, Andre Victor Edouard 1867-1943 *ClaDrA, DcBrBI*
DeVan, Charles E *ArtsEM*
Devane, John 1954- *DcCAr 81*
Devannie, Francis *NewYHSD*
Devaranne, S P *DcNiCA*
DeVarreux, Camille *DcNiCA*
DeVarroc, E *DcVicP 2*
Devas, Anthony 1911-1958 *DcBrA 1*

DeVasconcellos, Josephina *WhoArt 80, –82, –84*
DeVaudricourt *NewYHSD*
DeVaudricourt, A *IlBEAAW*
DeVault, David Sullins 1876- *WhAmArt 85*
DeVaux, A R Grant *DcVicP 2*
Devaux, Louise *DcWomA*
Devaux, Martin *McGDA*
Devaux, Therese *DcWomA*
Deve, Agathe *DcWomA*
Deveaud-Fabre, Henriette 1866- *DcWomA*
Deveaux, David H *NewYHSD*
Deveaux, Jacques Martial 1825-1891 *NewYHSD*
Deveaux, James 1812-1844 *NewYHSD*
DeVeck, L *DcVicP 2*
DeVecsey, Esther Barbara 1944- *WhoAmA 82, –84*
Devedeux, Louis 1820-1874 *ClaDrA*
DeVega, Pedro *DcVicP 2*
Devegatales, Jugo 1946- *WhoAmA 82, –84*
Develle, J *NewYHSD*
Devendorf, J C *AmArch 70*
Devenney, E L *AmArch 70*
Devens, Richard *CabMA*
Deventer, J F Van *ArtsNiC*
Deventer, Willem Antonie Van 1824-1893 *DcSeaP*
Dever, Alfred *DcVicP 2*
Dever, Michael Kent 1951- *MarqDCG 84*
DeVere, J *IlBEAAW, NewYHSD*
DeVere, William Louis *AmArch 70*
Deverell, Timothy 1939- *WhoAmA 73, –76*
Deverell, Walter Howell 1827-1854 *DcVicP, –2, McGDA, OxArt*
Deverelle, Mademoiselle *DcWomA*
Devereux, George T 1810?- *EarABI, EarABI SUP, NewYHSD*
Devereux, John 1817?- *NewYHSD*
Devereux, Margo 1946- *WhoAmA 76*
Devereux, Nicholson B 1813?- *NewYHSD*
Deveria, Achille 1800-1857 *WorECar*
Deveria, Achille 1800-1859 *McGDA*
Deveria, Achille Jacques Jean Marie 1800-1857 *ClaDrA*
Deveria, Eugene-Francois-Marie-Joseph 1805-1865 *ArtsNiC*
Deveria, Laure 1813-1838 *DcWomA*
DeVerley, Ivy *DcWomA*
DeVerti, Adolphe *WhAmArt 85*
DeVette, Marinus Antonie 1937- *MarqDCG 84*
Devey, George 1820-1886 *MacEA*
Devey, Phyllis 1907- *DcBrA 1, WhoArt 80, –82*
DeVeyrac, Robert 1901- *IlsCB 1744*
Devi, Sukumari d1938 *DcWomA*
DeVido, Alfred Edward 1932- *AmArch 70*
Devigne, Paul *ArtsNiC*
Devigne, Pierre 1814-1877 *ArtsNiC*
Devilbiss, I E 1874- *WhAmArt 85*
Devilbiss, Ida E 1874- *DcWomA*
DeVillalobos, A *DcVicP 2*
DeVille, E George 1890-1960 *ArtsAmW 2*
Deville, Felix 1820?- *NewYHSD*
Deville, H *WhAmArt 85*
Deville, J *NewYHSD*
DeVille, James 1776-1846 *DcNiCA*
DeVille, Joseph Vickers 1856-1925 *DcBrA 1, DcVicP 2*
DeVille, Pamela Fay 1923- *WhoArt 84*
DeVillier, C *AmArch 70*
Devillier, Charles Arthur 1951- *WhoAmA 80, –82, –84*
DeVillis, Clinton *AfroAA*
Devilly, Louis Theodore 1818-1886 *ClaDrA*
Devina, Jeanne 1863- *DcWomA*
Devine, Bernard 1884- *WhAmArt 85*
Devine, Bess A *WhAmArt 85*
Devine, J E 1944- *MacBEP*
Devine, John Michael 1946- *MarqDCG 84*
Devine, Mary *DcWomA*
Devine, Mary Elizabeth *ConArch A*
Devine, Sylvia Brenner *WhAmArt 85*
Devine, William Charles 1932- *WhoAmA 78, –80, –82, –84*
Deviney, Jess *WhAmArt 85*
DeVinna, Maurice 1907- *WhoAmA 73, –76*
DeVinney, Laura Laurett *WhAmArt 85*
Devins, Linda C *OfPGCP 86*
Devis, Anthony 1729?-1816 *DcBrECP, OxArt*
Devis, Anthony 1729-1817 *DcBrWA*
Devis, Arthur *DcBrWA*
Devis, Arthur 1711?-1787 *DcBrECP, McGDA, OxArt*
Devis, Arthur William 1762-1822 *DcBrECP, OxArt*
Devis, Thomas Anthony *DcBrWA*
Devis, Thomas Anthony 1757-1810 *DcBrECP*
DeVis-Norton, Mary M 1914- *WhoAmA 73*
Devis-Norton, Mary M 1914- *WhoAmA 76*
DeVisser, John 1930- *ICPEnP A, MacBEP*
DeVitis, Themis 1905- *WhoAmA 73, –76*
DeVito, Anthony P 1925- *AmArch 70*
DeVito, Ferdinand A 1926- *WhoAmA 73, –76*
DeVitry, J J *AmArch 70*
Devlan, Francis Daniel 1835-1870 *NewYHSD*
Devler, Joseph *FolkA 86*

Devlin, Charles H 1858-1928 *BiDAmAr*
Devlin, George 1937- *WhoArt 80, -82, -84*
Devlin, Mrs. George M *ArtsEM, DcWomA*
Devlin, Harold James 1927- *AmArch 70*
Devlin, Harry *IlsBYP*
Devlin, Harry 1918- *ConGrA 1[port], WhoAmA 78, -80, -82, -84, WhoArt 84*
Devlin, Lucinda Alice 1947- *MacBEP*
Devlin, May *DcBrA 1*
Devlin, Stuart 1913- *DcD&D*
Devlin, Wende And Harry *IlsBYP*
Devoe, R C *AmArch 70*
Devol *FolkA 86*
DeVol, Eugene *WhAmArt 85*
DeVol, Pauline Hamill *DcWomA*
DeVol, Pauline Hamill 1893- *ArtsAmW 1*
Devol, Pauline Hamill 1893- *WhAmArt 85*
DeVoll, F Usher 1873-1941 *WhAmArt 85*
DeVolld, Thomas Virgil 1931- *AmArch 70*
Devolve-Carriere, Lisbeth *DcWomA*
Devore, Gerald L 1949- *MarqDCG 84*
DeVore, Richard E 1933- *CenC[port]*
Devore, Robert W 1940- *AmArch 70*
Devore-Chirade, M D *DcWomA*
Devorn, Oleg J 1910- *AmArch 70*
DeVos, Florence M 1892- *WhAmArt 85*
Devosge, Claude Francois, III 1732-1811 *ClaDrA*
Devosge, Eugenie *DcWomA*
Devoto, James d1752? *BkIE*
Devoto, John *DcBrECP, DcBrWA*
Devoto, John d1752? *BkIE*
Devree, Howard d1966 *WhoAmA 78N, -80N, -82N, -84N*
DeVree, Paul 1909- *ConArt 77, -83*
DeVrees, John *WhAmArt 85*
Devriendt, Clementine *DcWomA*
DeVries, Bernard Jerin 1909- *AmArch 70*
DeVries, David L *MacBEP*
DeVries, Dora 1909- *WhAmArt 85*
DeVries, Erwin Jules 1929- *ConArt 77*
DeVries, Herman 1931- *ConArt 77, -83, DcCAr 81*
Devries, J 1930- *MarqDCG 84*
Devries, Joseph C 1820?- *NewYHSD*
Devriese, Louise 1880- *DcWomA*
Devriese, R H *AmArch 70*
Devy, Helen *DcWomA*
Dew, Henrietta 1894- *WhAmArt 85*
Dew, James Edward 1922- *WhoAmA 73, -76, -78, -80, -82*
Dew, William Bland, Jr. 1908- *AmArch 70*
DeWaal, Ronald Burt 1932- *WhoAmA 73, -76, -78, -80, -82, -84*
DeWailly, Charles 1730-1798 *MacEA*
DeWalt, A R *AmArch 70*
DeWalton, J *DcVicP 2*
DeWalton, John Ambrose 1874- *DcBrA 1*
Dewar, DeCourcy Lethwaite 1882?-1959 *DcWomA*
Dewar, Robert Earl 1943- *MarqDCG 84*
Dewar, William Jesmond *DcBrBI*
DeWarville, F Brissot *DcVicP 2*
Dewasne, Jean 1921- *ConArt 77, -83, OxTwCA, PhDcTCA 77, WorArt[port]*
Dewberry, Sidney O *MarqDCG 84*
Dewe, N *DcVicP 2*
DeWees, George M *FolkA 86*
DeWeldon, Felix George Weihs *WhoAmA 73, -76, -78, -80, -82, -84*
DeWeldon, Felix Weihs 1907- *WhAmArt 85*
DeWende, Daisy Urquiola *WorFshn*
DeWentworth, Cecile d1933 *WhAmArt 85*
DeWentworth, Cecile, Marquise *DcWomA*
Dewerff, John *MarqDCG 84*
DeWet, Hugh Oloff 1912-1975 *DcBrA 2*
DeWette, Aug *DcVicP 2*
Dewey *FolkA 86*
Dewey, Alfred J *WhAmArt 85*
Dewey, Alfred James 1874- *ArtsAmW 1, -2*
Dewey, Ariane *IlsCB 1967*
Dewey, Ariane 1937- *IlsBYP*
Dewey, Bruce R 1937- *MarqDCG 84*
Dewey, C Forbes, Jr. 1935- *MarqDCG 84*
Dewey, Charles A 1888-1946 *BiDAmAr*
Dewey, Charles H *WhAmArt 85*
Dewey, Charles M 1849-1937 *WhAmArt 85*
Dewey, Charles S 1880- *WhAmArt 85*
Dewey, Charles S, Jr. *WhoAmA 73*
Dewey, Mrs. Charles S, Jr. *WhoAmA 73*
Dewey, D E *AmArch 70*
Dewey, Daniel *CabMA*
Dewey, Francis Henshaw 1856-1933 *WhAmArt 85*
Dewey, George *CabMA*
Dewey, John 1747-1807 *CabMA*
Dewey, John Lynn 1938- *AmArch 70*
Dewey, Julia d1928 *DcWomA*
Dewey, Julia Henshaw d1928 *WhAmArt 85*
Dewey, Julius E 1831?- *NewYHSD*
Dewey, Kenneth Francis 1940- *WhoAmA 73, -76, -78*
Dewey, Ormand Sales *FolkA 86*
Dewey, Robert Tempest 1934- *AmArch 70*
Dewey, Silas *NewYHSD*
Dewez, Laurent Benoit 1731-1812 *MacEA*

Dewhurst, John *BiDBrA*
Dewhurst, Wynford 1864- *ClaDrA, DcBrA 1*
Dewhurst, Wynford 1864-1941 *DcBrA 2*
DeWild, Carel F L d1922 *WhAmArt 85*
DeWilde, Miss *DcVicP 2*
DeWilde, G J *DcVicP 2*
DeWilde, Maria *DcWomA*
DeWilde, Samuel 1748-1832 *DcBrBI, DcBrWA*
DeWilde, Samuel 1751-1832 *DcBrECP*
DeWilde, Victor 1903- *WhAmArt 85*
DeWilstar, John Jacob *BiDBrA*
Dewing, Francis *CabMA*
Dewing, Francis d1745? *NewYHSD*
Dewing, Maria Oakey 1845-1927 *DcAmArt*
Dewing, Maria Oakey 1845-1928 *WhAmArt 85*
Dewing, Maria Oakey Richards 1845-1927 *DcWomA*
Dewing, T W *ArtsNiC, OxTwCA*
Dewing, T W 1851-1938 *WhAmArt 85*
Dewing, Thomas Wilmer 1851-1938 *BnEnAmA, DcAmArt, McGDA, PhDcTCA 77*
Dewing-Woodward *DcWomA*
Dewing-Woodward, Miss *WhAmArt 85*
DeWinne, Lisette *OfPGCP 86*
DeWint, Peter 1784-1849 *DcBrWA, DcVicP 2, McGDA, OxArt*
DeWinter, Carl 1934- *WhoArt 80, -82, -84*
DeWinter, Marvin Jay 1932- *AmArch 70*
Dewit, Floyd Tennison 1934- *WhoAmA 76, -78, -80*
DeWitt, C *NewYHSD*
DeWitt, Caroline Pennoyer 1859- *WhAmArt 85*
DeWitt, Cornelius Hugh 1905- *IlsCB 1744, -1946, WhAmArt 85*
DeWitt, Floyd Tennison 1934- *WhoAmA 73*
DeWitt, Gerard *WhAmArt 85*
DeWitt, Henry *NewYHSD*
DeWitt, Jerome Pennington 1895-1940 *WhAmArt 85*
DeWitt, John *AntBDN G, CabMA*
Dewitt, Lyle Vinson 1915- *AmArch 70*
DeWitt, Roscoe P *AmArch 70*
Dewitt, Thomas David *MarqDCG 84*
Dewitt, William Homer 1909- *MarqDCG 84*
Dewlin, O *AmArch 70*
Dewling, A *DcVicP 2*
DeWolf, Bradford Colt 1927- *AmArch 70*
DeWolf, Edward Hugo 1917- *AmArch 70*
DeWolf, Howard Eugene 1922- *AmArch 70*
DeWolf, Wallace L 1854-1930 *ArtsAmW 1, WhAmArt 85*
DeWolf, Wallace Leroy 1854-1930 *IlBEAAW*
DeWolfe, Elsie 1870?-1950 *DcD&D*
DeWolfe, Sarah B *WhAmArt 85*
DeWolfe, Sarah Bender *ArtsAmW 2*
DeWolfe, Sarah Bender 1885-1915 *DcWomA*
DeWolff, Carlton Edward *AmArch 70*
DeWolff, Sarah Bender 1885-1915 *DcWomA*
DeWoody, Jim *PrintW 85*
Dewsbury, David *DcNiCA*
Dexel, Walter 1890- *PhDcTCA 77*
Dexel, Walter 1890-1973 *OxTwCA*
Dexter, Abby *FolkA 86*
Dexter, Dana *CabMA*
Dexter, E *WhAmArt 85*
Dexter, Franklin 1793-1857 *NewYHSD*
Dexter, George M d1856 *BiDAmAr*
Dexter, George Minot 1802-1872 *MacEA*
Dexter, Henry *ArtsNiC*
Dexter, Henry 1806-1876 *BnEnAmA, NewYHSD*
Dexter, James Henry 1912- *WhoArt 80, -82, -84*
Dexter, Mansell Lee 1910- *AmArch 70*
Dexter, Marie C *ArtsEM, DcWomA*
Dexter, Mary L *DcWomA, WhAmArt 85*
Dexter, Nabby 1775-1826 *FolkA 86*
Dexter, Walter 1876-1958 *ClaDrA, DcBrA 1*
Dexter, Wilson 1881-1921 *WhAmArt 85*
Dey, G *AmArch 70*
Dey, Henry Ellinwood 1865-1942 *WhAmArt 85*
Dey, Jack 1915- *FolkA 86*
Dey, John William *FolkA 86*
Dey, Kris 1949- *WhoAmA 76, -78*
Dey, Maurice Robert 1900- *WhAmArt 85*
Dey, Sophie 1872- *DcWomA*
Deyarmon, Abraham *FolkA 86*
Deykes, John *BiDBrA*
Deykin, Henry Cotterill 1905- *DcBrA 1, WhoArt 80, -82, -84*
Deynum, Maria Van *DcWomA*
DeYong, Joe 1894- *ArtsAmW 1*
DeYong, Joe 1894-1975 *IlBEAAW, WhAmArt 85*
DeYongh, John 1856-1917 *WhAmArt 85*
DeYoung, H A 1893-1956 *WhAmArt 85*
DeYoung, Harry Anthony 1893-1956 *ArtsAmW 1, -2, IlBEAAW*
DeYoung, J R *NewYHSD*
DeYoung, P *AmArch 70*
Deyrieux, Georges 1820-1868 *ClaDrA*
Deyrolle, Jean-Jacques 1911-1967 *OxTwCA*
Deyrolle, Jean Jacques 1911-1967 *PhDcTCA 77*
Deyrolle, Theophile Louis d1923 *ClaDrA*
Deyster, Anne Louise De 1690-1747 *DcWomA*
Deyster, Louis De *McGDA*
Deytard DeGrandson, Marie 1825-1891 *DcWomA*

DeYturbe, Alejandra R *WhoAmA 84*
DeZayas, G 1895- *WhAmArt 85*
Dezeuze, Daniel 1942- *ConArt 77, -83*
DeZoro-Dei Cappeller, E 1894- *WhAmArt 85*
Dezur, R D *AmArch 70*
Dezyick, Albert 1825?- *NewYHSD*
Dhaemers, Robert August 1926- *WhoAmA 76, -78, -80, -82, -84*
D'Haene, Nobyn H *AmArch 70*
D'Harnoncourt, Anne 1943- *WhoAmA 76, -78, -80, -82, -84*
D'Harnoncourt, Rene 1901- *IlsCB 1744, WhAmArt 85*
Dhonan, W *WhAmArt 85*
D'Hue, Robert Raleigh, Jr. 1917- *AfroAA*
Dhunbai, Banazi *DcWomA*
Diaghilev, Sergei Pavlovich 1872-1929 *OxTwCA*
Diakoff, Filetre *DcBrECP*
Dial, Robert B 1934- *MarqDCG 84*
Diamant, David S 1849-1912 *WhAmArt 85*
Diamant, Robert 1922- *AmArch 70*
Diamant-Berger, Renee *ConArch A*
Diamante, Fra 1430-1498? *McGDA*
Diament, Rafail 1907- *ICPEnP A*
Diamond, A J 1932- *ConArch*
Diamond, Abel Joseph 1932- *WhoAmA 78, -80, -82*
Diamond, Donna 1950- *IlsCB 1967*
Diamond, George A 1923- *AmArch 70*
Diamond, H Louis 1904-1966 *WorECom*
Diamond, Harold Elias 1924- *AmArch 70*
Diamond, Hugh Welch 1809-1886 *ICPEnP A, MacBEP*
Diamond, Lisa 1949- *MarqDCG 84*
Diamond, M S *AmArch 70*
Diamond, Martha 1944- *PrintW 83, -85*
Diamond, Paul 1942- *ICPEnP A, MacBEP, WhoAmA 78, -80, -82, -84*
Diamond, Philip J 1922- *AmArch 70*
Diamond, Robert 1929- *MarqDCG 84*
Diamond, Stuart *DcCAr 81*
Diamondstein, David *WhAmArt 85*
Diamonstein, Barbaralee *WhoAmA 82, -84*
Diana, Bartolommeo *McGDA*
Diana, Paul 1913- *WhAmArt 85*
Diao, David 1943- *DcCAr 81, WhoAmA 73, -76, -78, -80, -82, -84*
Diaper, Frederic 1810-1906 *MacEA*
Diaper, Frederick 1810-1905 *BiDAmAr*
Dias, Antonio 1944- *ConArt 77, -83*
Dias, Cicero 1908- *PhDcTCA 77*
Dias, Pavel 1938- *ConPhot, ICPEnP A*
Diaz, Cristobal *ArtsAmW 1, IlBEAAW, NewYHSD*
Diaz, Horacio 1923- *AmArch 70*
Diaz DeLaPena, Narcisse Virgile 1807-1876 *ClaDrA*
Diaz DeLaPena, Narcisse-Virgile 1807-1876 *ArtsNiC, OxArt*
Diaz DeLaPena, Narcisse Virgile 1808-1876 *McGDA*
Diaz DeLeon, Francisco 1897- *McGDA*
Diaz Rivera, Lope Max *WhoAmA 84*
DiBarsento, Emilio Pucci 1914- *WorFshn*
DiBartolomeo, Patrick Anthony 1928- *AmArch 70*
Dibbets, Gerardus Johannes Maria 1941- *PhDcTCA 77*
Dibbets, Jan 1941- *ConArt 77, -83, ConPhot, DcCAr 81, ICPEnP A, PrintW 83, -85, WhoAmA 76, -78, WorArt[port]*
Dibbits, Jan *OxTwCA*
Dibble, Charles Ryder 1920- *WhoAmA 76, -78, -80, -82, -84*
Dibble, George 1904- *WhoAmA 78, -80, -82, -84*
Dibble, George Smith *WhAmArt 85*
Dibble, George Smith 1904- *IlBEAAW*
Dibble, Philo *FolkA 86*
Dibble, Thomas, Jr. 1898- *WhAmArt 85*
Dibblee, Anita L *WhAmArt 85*
Dibblee, Henry *FolkA 86*
Dibdin, Charles *DcBrWA*
Dibdin, Henry Edward 1813-1866 *DcBrWA*
Dibdin, Marian Alice *DcWomA*
Dibdin, Sara Beatrice 1874- *DcWomA*
Dibdin, Thomas Colman 1810-1893 *ClaDrA, DcBrBI, DcBrWA, DcVicP 2*
DiBenedetto, A P 1922- *AmArch 70*
DiBenedetto, Angelo 1913- *WhAmArt 85*
Dibert, Claudette Bargreen 1942-1982 *MacBEP*
Dibert, George Chalmers 1901-1974 *MacBEP*
Dibert, Kenneth D 1945- *MacBEP*
Dibert, Louis DeSauque 1878-1936 *MacBEP*
Dibert, Rita Jean 1946- *WhoAmA 84*
DiBiase, Michael 1925- *ICPEnP A, MacBEP*
DiBiccardi, Adio *WhAmArt 85*
Diblee *FolkA 86*
Dibner, David Robert 1926- *AmArch 70*
Dibner, Martin 1911- *WhoAmA 78, -80, -82*
Diboll, C C *AmArch 70*
Dibona, Anthony *WhoAmA 78N, -80N, -82N, -84N*
DiBona, Anthony 1896- *WhAmArt 85*
DiCamerino, Roberta 1920- *WorFshn*
DiCamillo, A *AmArch 70*
Dicanzio, Albert George 1942- *MarqDCG 84*

Dingelden, August *EncASM*
Dinger, Fred Peter 1928- *AmArch 70*
Dingertz, Marie *DcWomA*
Dingle, Adrian 1911- *WhoAmA 73, -76*
Dingle, Adrian 1912-1974 *WorECom*
Dingle, Edward VonSiebold *WhAmArt 85*
Dingle, Thomas *DcBrWA, DcVicP 2*
Dingle, Thomas, Jr. *DcVicP 2*
Dingley, Mrs. H M *WhAmArt 85*
Dingley, Robert 1708-1781 *BiDBrA*
Dinglinger, Johann Melchior 1664-1731 *McGDA*
Dinglinger, Sophie Friederike 1739-1791 *DcWomA*
Dingman, Charles Wesley 1907- *AmArch 70*
Dingus, Phillip Rick 1951- *MacBEP*
Dingus, Rick 1951- *WhoAmA 84*
Dini, M V *AmArch 70*
Dini, Mario Victorio 1916- *WhAmArt 85*
Dininno, Frank *DcCAr 81*
Dinion, H *AmArch 70*
Diniz, D P *AmArch 70*
Dinkel, Ernest Michael 1894- *ClaDrA, DcBrA 1, WhoArt 80, -82, -84*
Dinkel, J *DcVicP 2*
Dinkel, Joseph *DcBrBI*
Dinkel Keet, Emmy Gerarda Mary 1908- *WhoArt 84*
Dinkelberg, Frederick P 1861-1935 *BiDAmAr*
Dinkelberg, Frederick Philip 1861-1935 *WhAmArt 85*
Dinkeloo, John 1918- *ConArch*
Dinkeloo, John 1918-1981 *MacEA*
Dinkeloo, John Gerard 1918- *AmArch 70*
Dinkins, Stephanie *MacBEP*
Dinnan, Terence 1950- *DcCAr 81*
Dinneen, Alice 1908- *WhAmArt 85*
Dinnerstein, Harvey 1928- *WhoAmA 80, -82, -84*
Dinnerstein, Lois 1932- *WhoAmA 80, -82, -84*
Dinnerstein, Simon A 1943- *WhoAmA 76, -78, -80, -82, -84*
Dinning, Robert James *WhAmArt 85*
Dinning, Robert James 1887- *ArtsAmW 1*
Dinninghof, Barnard *BiDBrA*
D'Innocenzo, Nick Jerome 1934- *WhoAmA 80, -82, -84*
Dinoble, Al *MarqDCG 84*
Dinov, Todor Georgiev 1919- *WorECar*
Dinsdale, George *DcBrBI*
Dinsdale, John *DcBrBI, DcVicP 2*
Dinsdale, Mary *IlsCB 1967*
Dinsmoor, S P 1843-1932 *FolkA 86*
Dinsmore, E J *WhAmArt 85*
Dintenfass, Marylyn 1943- *WhoAmA 80, -82, -84*
Dintenfass, Terry *WhoAmA 73, -76, -78, -80, -82, -84*
Dinwiddie, John Ekin 1902-1959 *McGDA*
Dinwiddie, Kendall Lochridge 1937- *MarqDCG 84*
Dinyes, Mary Ann 1826?- *FolkA 86*
Dioda, Adolph 1915- *WhAmArt 85*
Dioda, Adolph T 1915- *WhoAmA 73, -76, -78, -80, -82, -84*
Diodato, Baldo 1938- *WhoAmA 76, -78, -80, -82, -84*
Dion, Guy 1950- *MarqDCG 84*
Dion, Joseph Gerard 1921- *AmArch 70*
Dion, Robert Roger 1933- *AmArch 70*
Dionigi, Marianna 1756-1826 *DcWomA*
Dionis, Simon *NewYHSD*
Dionis DuSejour, Marie Therese 1884- *DcWomA*
Dionisy, Jan Michiel 1794- *ClaDrA*
Dionne, Robert 1950- *MarqDCG 84*
Dionysius *McGDA*
Dionysius Of Fourna *McGDA*
Dionysius, The Areopagite *McGDA*
Dionysius, Dooley 1907- *WhAmArt 85*
Dior, Christian 1905-1957 *ConDes, FairDF FRA[port], WorFshn*
DiOrio, Louis Carl 1935- *AmArch 70*
Dipadova, Nicholas 1931- *MarqDCG 84*
DiPalma, Joseph Alfred 1928- *AmArch 70*
DiPaola, B *AmArch 70*
DiPaola, Raymond Ross 1927- *AmArch 70*
DiPaolo, Louis *MarqDCG 84*
Dipasquale, Dominic Theodore 1932- *WhoAmA 76, -78, -80, -82, -84*
DiPerna, Frank P 1947- *MacBEP*
DiPerna, Frank Paul 1947- *WhoAmA 78, -80, -82*
DiPerna, Frank Paul 1947- *WhoAmA 84*
Dipiano, Walter M 1957- *MarqDCG 84*
Dipner, Wayne Elroy 1925- *AmArch 70*
Dippel, Don 1947- *DcCAr 81*
Dippel, Ferdinand *FolkA 86*
Dipple, A G Curtain *FolkA 86*
Dipple, Anna Margretta *FolkA 86*
Dippy, Rhobena *DcWomA*
Dipre, Nicolas *McGDA*
Dircks, Johann Peter 1813-1888? *DcSeaP*
Dircksz, Angela Maria d1679? *DcWomA*
Dircx, Angela Maria d1679? *DcWomA*
Dirdorff, Abraham *FolkA 86*
DiRienzo, Emilio John 1907- *AmArch 70*
Dirk, Nathaniel 1895- *WhAmArt 85*
Dirk, Nathaniel 1896-1961 *WhoAmA 80N, -82N, -84N*
Dirkes, G *AmArch 70*

Dirks, Gus 1879?-1903 *WorECar*
Dirks, Gustavus d1902 *WhAmArt 85*
Dirks, John 1917- *WorECom*
Dirks, Randolph *WhAmArt 85*
Dirks, Rudolph d1968 *WhAmArt 85, WhoAmA 78N, -80N, -82N, -84N*
Dirks, Rudolph 1877-1968 *WorECom*
Dirksen, Gerritt 1818-1903 *EncASM*
Dirksen, John *EncASM*
Dirksen, Ralph Edward 1941- *MarqDCG 84*
Dirksen, Richard D *EncASM*
Dirlam, Arland Augustus 1905- *AmArch 70*
Dirmer-Sevrin, Jeanne *DcWomA*
Dirnfeld, Frederick Arnold 1889- *WhAmArt 85*
Dirsa, Mitchell Paul 1913- *AmArch 70*
Dirtinger, Wolfgang Felix 1944- *DcCAr 81*
Dirube, Rolando L 1928- *PrintW 83, -85*
Dirube, Rolando Lopez 1928- *WhoAmA 73, -76, -78, -80, -82, -84*
DiSaia, K A *AmArch 70*
DiSaia, O *AmArch 70*
DiSaia, R O *AmArch 70*
DiSant' Angelo, Giorgio 1939- *FairDF US[port]*
DiSant'Angelo, Giorgio 1936- *WorFshn*
DiSanto, A J *AmArch 70*
Disbrow, Charles *FolkA 86*
Disbrow, John B *NewYHSD*
Disbrowe, Nicholas 1612-1683 *AntBDN G, CabMA, OxDecA*
Discalzi, Pellegrina d1515? *DcWomA*
Discalzi-Mazzoni, Isabella *DcWomA*
Disderi, Andre-Adolphe-Eugene 1819-1889 *ICPEnP*
Disderi, Andre Adolphe-Eugene 1819-1890? *MacBEP*
Disdorf, Peter J *NewYHSD*
Disfarmer, Michael 1884-1959 *MacBEP*
Disfarmer, Michael 1894-1959 *ConPhot, ICPEnP A*
Disi, Achilles G *WhAmArt 85*
DiSilvestro, Leonard Joseph 1931- *AmArch 70*
Diska *WhoAmA 78, -80, -82, -84*
Disler, Martin 1949- *DcCAr 81, PrintW 85*
Dismant, Marion *WhAmArt 85*
Dismorr, Jessica 1885-1939 *OxTwCA*
Dismorr, Jessica Stewart 1885-1939 *DcWomA*
Dismorr, Jessie 1885-1939 *DcBrA 1*
Dismukes, Adolyn Gale *WhAmArt 85*
Dismukes, Mrs. E *ArtsAmW 3*
Dismukes, Mary Ethel d1952 *WhAmArt 85, WhoAmA 78N, -80N, -82N, -84N*
Disney, Walt 1901-1966 *WhoGrA 62, WorECom*
Disney, Walt E 1901-1966 *WhAmArt 85*
Disney, Walter Elias 1901-1966 *WorECar*
DiSpigna, Tony 1943- *WhoGrA 82[port]*
Disraeli, Robert 1905- *ICPEnP A*
Dissard, Clementine 1890- *DcWomA*
Dissett, George C *WhAmArt 85*
Dissman, G R *AmArch 70*
Distefano, C *AmArch 70*
Distefano, David Anthony 1954- *MarqDCG 84*
DiStefano, Joseph, Jr. 1906- *AmArch 70*
Distefano, Juan Carlos 1933- *WhoGrA 62, -82[port]*
Disteli, Martin 1802-1844 *WorECar*
Distin Family, The *DcNiCA*
Diston, A *DcBrBI*
DiSuvero, Mark *WhoAmA 73, -76, -78, -80, -82, -84*
DiSuvero, Mark 1933- *AmArt, BnEnAmA, ConArt 77, -83, DcAmArt, DcCAA 71, -77, DcCAr 81, PrintW 83, -85, WorArt[port]*
Disz, Terrence L 1945- *MarqDCG 84*
Ditchfield, Arthur 1842-1888 *DcBrWA, DcVicP, -2*
Ditchfield, John *DcCAr 81*
Ditko, Steve 1927- *WorECom*
Ditmars, Isaac E 1850-1934 *BiDAmAr*
Ditmars, Peter *FolkA 86*
Dittenberger, Gustav 1794-1879 *ClaDrA*
Dittmer, Ralph Theobald 1901- *AmArch 70*
Dittoe, Louis E 1870-1947 *BiDAmAr*
Dittrich, Walter Charles 1933- *AmArch 70*
Ditzion, Grace *WhoAmA 84*
Ditzler, Jacob *FolkA 86*
Ditzler, William Edward 1933- *AmArch 70*
Ditzler, William Franklin 1934- *MarqDCG 84*
Diuguid, Mary Sampson 1885?- *DcWomA, WhAmArt 85*
DiValentin, Louis 1908- *WhAmArt 85*
Divekar, Dileep 1949- *MarqDCG 84*
Divine, George Whitney 1914- *AmArch 70*
Divine, William *CabMA*
Divino, El *McGDA*
Divito, Guillermo 1914-1969 *WorECom*
Divola, John 1949- *DcCAr 81*
Divola, John M 1949- *ICPEnP A, PrintW 83, -85*
Divola, John Manford, Jr. 1949- *WhoAmA 76, -78, -80, -82, -84*
Divvens, James Lawrence 1910- *AmArch 70*
Dix, Mrs. *DcVicP 2, DcWomA*
Dix, Charles T 1840-1873 *EarAD*
Dix, Charles Temple *DcVicP 2*
Dix, Charles Temple 1840-1873 *ArtsNiC, NewYHSD*
Dix, Cuno *ArtsEM, NewYHSD*
Dix, Eulabee *WhAmArt 85*

Dix, Eulabee 1878-1961 *ArtsEM, DcWomA*
Dix, Eulalee *DcBrA 2*
Dix, George Evertson 1912- *WhoAmA 73, -76*
Dix, Harry *WhAmArt 85*
Dix, John Adams 1881-1945 *WhAmArt 85*
Dix, Kathleen Mary *DcWomA*
Dix, Otto 1891- *McGDA, OxArt*
Dix, Otto 1891-1969 *ConArt 77, -83, OxTwCA, PhDcTCA 77, WorArt[port]*
Dix, R G, Jr. *AmArch 70*
Dix, Rollin Cumming 1936- *MarqDCG 84*
Dix, Samuel *CabMA*
Dixcee, T *DcVicP 2*
Dixey, Ellen Sturgis *DcWomA, WhAmArt 85*
Dixey, Frederick Charles *DcBrA 1, DcBrWA, DcVicP 2*
Dixey, George d1853? *NewYHSD*
Dixey, George Raymond 1926- *MarqDCG 84*
Dixey, John 1760?-1820 *NewYHSD*
Dixey, John 1770?-1820 *McGDA*
Dixey, John V *NewYHSD*
Dixie, Ethel May 1876- *DcWomA*
D'Ixnard, Michel 1726-1798 *MacEA*
Dixon *AntBDN N, NewYHSD*
Dixon, Miss *DcBrECP, DcWomA*
Dixon, Albert George, III 1935- *WhoAmA 76, -78, -80, -82*
Dixon, Alfred *DcVicP 2*
Dixon, Anna *ClaDrA*
Dixon, Anna d1959 *DcBrA 1, DcWomA*
Dixon, Annie *AntBDN J*
Dixon, Annie 1817-1901 *DcWomA*
Dixon, Arthur A *DcBrA 1, DcVicP 2*
Dixon, Austin & Co. *DcNiCA*
Dixon, Bruce Royden 1923- *AmArch 70*
Dixon, Charles 1776-1852 *AntBDN N*
Dixon, Charles 1872-1934 *ClaDrA, DcBrA 1, DcSeaP*
Dixon, Charles Carlisle, Jr. 1939- *AmArch 70*
Dixon, Charles Edward 1872-1934 *DcBrBI, DcBrWA, DcVicP 2*
Dixon, Charles M *DcBrA 1*
Dixon, Charles Thomas *DcVicP 2*
Dixon, Cornelius *BiDBrA*
Dixon, Douglas F *MarqDCG 84*
Dixon, E *DcVicP 2*
Dixon, E H *DcVicP 2*
Dixon, Elijah *NewYHSD*
Dixon, Eliza *DcWomA*
Dixon, Ella Hepworth *DcVicP 2, DcWomA*
Dixon, Emily *DcVicP 2, DcWomA*
Dixon, Ethel d1916 *ArtsAmW 2, DcWomA*
Dixon, F J *AmArch 70*
Dixon, Francis S d1967 *WhoAmA 78N, -80N, -82N, -84N*
Dixon, Francis Stilwell 1879-1967 *WhAmArt 85*
Dixon, Frederick Clifford 1902- *DcBrA 1*
Dixon, George *NewYHSD*
Dixon, Grace Charlotte *DcWomA*
Dixon, Harry 1861-1942 *DcBrA 1*
Dixon, Harry St. John 1890- *WhAmArt 85*
Dixon, Henry d1859 *BiDBrA*
Dixon, Henry 1820-1893 *ICPEnP A*
Dixon, Hodgkin *DcBrA 1*
Dixon, Mrs. Homer *DcWomA*
Dixon, J *DcBrWA*
Dixon, J F *FolkA 86*
Dixon, J H *MarqDCG 84*
Dixon, James *AntBDN N, DcNiCA, EncASM*
Dixon, James M *EncASM*
Dixon, James Scott 1950- *MarqDCG 84*
Dixon, Jane F *DcWomA*
Dixon, Jenny 1950- *WhoAmA 80, -82, -84*
Dixon, Jesse Garnett, Jr. 1914- *AmArch 70*
Dixon, John *AntBDN O, BiDBrA, DcBrWA, DcVicP 2*
Dixon, John 1740?-1800 *McGDA*
Dixon, John 1869- *DcBrA 1*
Dixon, John Dangar 1929- *WorECom*
Dixon, Mrs. John J *WhAmArt 85*
Dixon, John J A 1888- *WhAmArt 85*
Dixon, John Morris 1933- *AmArch 70*
Dixon, Joseph *BiDBrA*
Dixon, Joseph d1787 *BiDBrA*
Dixon, Kenneth Ray 1943- *WhoAmA 78, -80, -82, -84*
Dixon, L E *AmArch 70*
Dixon, L M, Jr. *AmArch 70*
Dixon, Lafayette Maynard 1875-1946 *DcAmArt, IIBEAAW*
Dixon, Logan Bleckley, Jr. 1923- *AmArch 70*
Dixon, Lovatt B 1834- *BiDAmAr*
Dixon, Mabel E *WhAmArt 85*
Dixon, Maria R *DcWomA*
Dixon, Mark G 1953- *MarqDCG 84*
Dixon, May *DcBrBI*
Dixon, Maynard 1875-1946 *ArtsAmW 1, WhAmArt 85*
Dixon, Mrs. Maynard *WhAmArt 85*
Dixon, Nicholas *AntBDN J*

Dixon, Nicholas 1665-1708 *McGDA*
Dixon, O Murray *DcBrBI*
Dixon, Pelham 1859-1898 *DcVicP 2*
Dixon, Percy 1862-1924 *DcBrA 1, DcBrWA, DcVicP 2*
Dixon, Rachel *WhAmArt 85*
Dixon, Rex Matthew 1939- *WhoArt 80, -82, -84*
Dixon, Robert 1780-1815 *DcBrWA*
Dixon, Robert C, Jr. 1862-1933 *BiDAmAr*
Dixon, Sally Foy *WhoAmA 73, -76, -78, -80*
Dixon, Samuel d1769 *DcBrWA*
Dixon, Su 1945- *DcCAr 81*
Dixon, Theodore William 1926- *AmArch 70*
Dixon, Thomas *AntBDN M, BiDAmAr*
Dixon, Thomas Fletcher *FolkA 86*
Dixon, Tod O 1938- *MarqDCG 84*
Dixon, W A *AmArch 70*
Dixon, W H *DcVicP 2*
Dixon, W I *AmArch 70*
Dixon, W J *AmArch 70*
Dixon, Warren Arthur 1934- *AmArch 70*
Dixon, Willard 1942- *AmArt*
Dixon, William *AntBDN M*
Dixon, William 1774-1827? *DcSeaP*
Dixon And Allyn *CabMA*
Dixsee, F H *DcVicP 2*
Dixson, Robert *CabMA*
Dixwell, Anna P 1846?-1885 *WhAmArt 85*
Dixwell, Anna Parker 1846?-1885 *DcWomA*
Dixwell, John 1680-1723? *AntBDN Q*
Dize, C William 1914- *AmArch 70*
Dize, Elwood *FolkA 86*
Dizney, O V *AmArch 70*
Djanira *OxTwCA*
Djerejian, Robert A 1931- *AmArch 70*
D'Jerf, Roy Mansfield 1910- *AmArch 70*
D'Jock, Dennis Frank 1928- *AmArch 70*
Djordjevic, Miodrag 1919- *ConPhot, ICPEnP A*
Djordjevic, Mrodrag *DcCAr 81*
D'Lamater, Abraham *CabMA*
Dlofi, K *DcVicP 2*
Dlubak, Zbigniew 1921- *ConPhot, ICPEnP A*
Dlugolenski, Stanley E 1954- *MarqDCG 84*
Dlugosz, Louis Frank 1915- *WhAmArt 85*
Dmitri, Ivan 1900-1968 *ICPEnP*
Dmitrieff, Nataniel *WhAmArt 85*
Dmitrienko *PrintW 83, -85*
Dmitrienko, Pierre 1925-1974 *OxTwCA*
Dmochowski *NewYHSD*
Dmytruk, Ihor 1938- *WhoAmA 73, -76, -78, -80, -82, -84*
Doak, John 1903- *AmArch 70*
Doak, William *CabMA*
Doan, Thornton F d1930 *BiDAmAr*
Doane, Mr. *FolkA 86*
Doane, C *DcVicP 2*
Doane, George *FolkA 86*
Doane, James *FolkA 86*
Doane, Norman H 1904- *WhAmArt 85*
Doane, Pelagie 1906- *WhAmArt 85*
Doane, Pelagie 1906-1966 *IlsCB 1744, -1946*
Doane, Ralph Harrington 1886-1941 *BiDAmAr*
Doar, M Wilson 1898- *ClaDrA, DcBrA 1, DcWomA*
Doat, Taxile 1851- *DcNiCA*
Doat, Taxile 1851-1939 *CenC*
Dobard, Raymond Gerard 1947- *WhoAmA 82, -84*
Dobberman, David R 1936- *AmArch 70*
Dobberman, M R 1909- *AmArch 70*
Dobbertin, Otto *WhAmArt 85*
Dobbin, John 1815-1884 *DcVicP, -2*
Dobbin, John 1815-1888 *DcBrWA*
Dobbin, Kate *DcWomA*
Dobbins *NewYHSD*
Dobbins, Helen E 1885- *DcWomA, WhAmArt 85*
Dobbins, James Andrew Hamilton 1939- *MarqDCG 84*
Dobbins, James J 1924- *WorECar*
Dobbins, James Joseph 1924- *WhoAmA 76, -78, -80*
Dobbins, John *CabMA*
Dobbins And M'Elhinny *CabMA*
Dobbs, Ella Victoria d1952 *WhoAmA 78N, -80N, -82N, -84N*
Dobbs, Ella Victoria 1866-1952 *WhAmArt 85*
Dobbs, Henrietta *DcWomA*
Dobbs, Honor *WhoArt 80, -82, -84*
Dobbs, John Barnes 1931- *WhoAmA 73, -76, -78, -80, -82, -84*
Dobbs, R H *AmArch 70*
Dobbs, Sarah *DcWomA*
Dobell, Alice *DcVicP 2, DcWomA*
Dobell, Clarence M *DcBrBI, DcVicP 2*
Dobell, Richard Allan 1937- *AmArch 70*
Dobell, William 1899- *OxArt*
Dobell, William 1899-1970 *OxTwCA*
Dobell, Sir William 1899- *McGDA*
Dobell, Sir William 1899-1970 *DcBrA 1*
Dober, Virginia *FolkA 86*
Dobias, Frank 1902- *ConICB, IlsCB 1744*
Dobie, Beatrix Charlotte *DcWomA*
Dobie, Beatrix Charlotte 1887- *DcBrA 1*

Dobie, Jeanne *WhoAmA 78, -80, -82, -84*
Dobiecki, Henry Stanley 1924- *AmArch 70*
Dobinson, Eric Arthur 1927- *WhoArt 80, -82, -84*
Dobinson, W *DcVicP 2*
Dobkin, Alexander 1908- *DcCAA 71, WhoAmA 73*
Dobkin, Alexander 1908-1975 *DcCAA 77, IlsCB 1946, WhAmArt 85, WhoAmA 76N, -78N, -80N, -82N, -84N*
Dobkin, John Howard 1942- *WhoAmA 78, -80, -82, -84*
Doble, Frank Sellar 1898- *ClaDrA, DcBrA 1*
Dobler, Louise Suzanne *DcWomA*
Dobler, Maud A 1885- *DcWomA, WhAmArt 85*
Doblin, Jay 1920- *ConDes, McGDA*
Dobos, Andrew 1897- *ArtsAmW 3*
DoBos, Andrew 1897- *WhAmArt 85*
Dobree, Edwin DeS *DcVicP 2*
Dobric, Milorad 1924- *WorECom*
Dobrilovich, G M *DcSeaP*
Dobrin, Arnold Jack *IlsCB 1967*
Dobrin, Arnold Jack 1928- *IlsCB 1957, WhoAmA 78, -80*
Dobroth, Richard Edward 1929- *AmArch 70*
Dobrusky, T A *AmArch 70*
Dobson *NewYHSD*
Dobson 1883- *WhAmArt 85*
Dobson 1891- *FolkA 86*
Dobson, Annie *DcWomA*
Dobson, C B *AmArch 70*
Dobson, Cowan 1893- *DcBrA 1*
Dobson, David Irving 1883-1957 *WhoAmA 80N, -82N, -84N*
Dobson, Edmund A *DcVicP 2*
Dobson, Edward Scott 1918- *DcBrA 1*
Dobson, Eugie Parks, Jr. 1924- *AmArch 70*
Dobson, Frank *DcCAr 81*
Dobson, Frank 1886-1963 *OxArt, OxTwCA, PhDcTCA 77*
Dobson, Frank 1887-1963 *McGDA*
Dobson, Frank 1888-1963 *DcBrA 1*
Dobson, Henry John 1858- *DcVicP, -2*
Dobson, Henry John 1858-1928 *DcBrA 1, DcBrWA*
Dobson, Isaac *FolkA 86*
Dobson, John 1787-1865 *BiDBrA, DcBrWA, MacEA, McGDA, WhoArch*
Dobson, Margaret A 1888- *ArtsAmW 1, DcWomA, WhAmArt 85*
Dobson, Margaret Stirling *DcBrA 1, DcWomA*
Dobson, Martin 1947- *DcCAr 81*
Dobson, Mary *WhoArt 80, -82, -84*
Dobson, Michael Wayne 1946- *MarqDCG 84*
Dobson, Raeburn 1901- *DcBrA 1*
Dobson, Robert *DcBrWA, DcVicP 2*
Dobson, William 1610-1646 *OxArt*
Dobson, William 1611-1646 *McGDA*
Dobson, William C T 1817- *ArtsNiC*
Dobson, William Charles Thomas 1817-1898 *ClaDrA, DcBrWA, DcVicP, -2*
Dobson, William Thomas Charles 1817-1898 *DcBrBI*
Dobujinsky, Mstislav 1875-1957 *McGDA*
Dobuzhinskii, Mstislav Valerianovich 1875- *IlsCB 1744*
Dobuzhinskii, Mstislav Valerianovich 1875-1957 *WorECar*
Docharty, Alexander Brownlie 1862-1940 *DcBrA 1, DcBrWA, DcVicP 2*
Docharty, James 1829-1878 *ArtsNiC, DcVicP, -2*
Dock, Christopher d1771 *FolkA 86*
Docker, Edward *DcVicP 2*
Docker, Richard 1894-1968 *ConArch, MacEA*
Dockery, James Willis, Jr. 1929- *AmArch 70*
Dockree, Mark Edwin *DcVicP, -2*
Dockstader, E E *AmArch 70*
Dockstader, S M *FolkA 86*
Dockstader, Frederick J 1919- *WhoAmA 73, -76, -78, -80, -82, -84*
Docktor, Irv 1918- *IlsCB 1946*
Dockum, S M *FolkA 86*
Dockum, Samuel M *FolkA 86*
Doctor Seuss *WhoAmA 76*
Doczi, George F 1909- *AmArch 70*
Dod, P S *AmArch 70*
Dod, Samuel Bayard 1847-1907 *WhAmArt 85*
Dodd, A W *DcBrBI*
Dodd, Alan 1942- *WhoArt 80, -82, -84*
Dodd, Arthur Charles *DcBrWA, DcVicP 2*
Dodd, B C *AmArch 70*
Dodd, Barrodall Robert *DcBrWA*
Dodd, Charles Tattershall *DcBrWA*
Dodd, Charles Tattershall d1949 *DcBrA 2*
Dodd, Charles Tattershall 1815-1878 *DcBrWA, DcVicP 2*
Dodd, Charles Tattershall, Jr. *DcVicP 2*
Dodd, D P *DcBrECP*
Dodd, Daniel *DcBrECP, DcBrWA*
Dodd, Daniel d1793? *BkIE*
Dodd, Ed 1902- *WhoAmA 78, -80, -82*
Dodd, Edward Benton 1902- *WhoAmA 76, WorECom*
Dodd, Eric M *WhoAmA 73, -76, -78, -80, -82, -84*
Dodd, Francis 1874-1949 *ClaDrA*
Dodd, Francis H 1874-1949 *DcBrA 1*

Dodd, James Charles 1923- *AmArch 70*
Dodd, Jane Porter Hart 1824-1911 *DcWomA*
Dodd, Jessie Hart 1863?-1911 *DcWomA, WhAmArt 85*
Dodd, John Bruce 1918- *AmArch 70*
Dodd, Joseph *AntBDN M*
Dodd, Joseph Josiah 1809-1880 *DcBrWA, DcVicP 2*
Dodd, Joseph Tattershall *DcBrWA*
Dodd, Lamar 1909- *DcCAA 71, -77, WhAmArt 85, WhoAmA 73, -76, -78, -80, -82, -84*
Dodd, Lois 1927- *DcCAA 71, -77, WhoAmA 73, -76, -78, -80, -82, -84*
Dodd, Louis *DcSeaP*
Dodd, Luis 1927- *DcCAr 81*
Dodd, M *DcWomA*
Dodd, Margaret 1941- *CenC, DcCAr 81*
Dodd, Mark Dixon 1888- *WhAmArt 85*
Dodd, Peggy 1900- *WhAmArt 85*
Dodd, R *DcBrECP*
Dodd, Ralph *DcBrECP*
Dodd, Ralph 1756?-1817 *DcSeaP*
Dodd, Robert 1748-1815 *DcBrECP, DcSeaP*
Dodd, Samuel 1797-1862 *NewYHSD*
Dodd, W *DcVicP 2*
Dodd, William 1908- *ClaDrA, DcBrA 1*
Dodd, William H C *NewYHSD*
Dodd, William Henry *NewYHSD*
Dodd, William J 1862-1930 *BiDAmAr*
Dodds, Albert Charles 1888- *DcBrA 1*
Dodds, Andrew 1927- *WhoArt 80, -82, -84*
Dodds, Annie *DcVicP 2, DcWomA*
Dodds, Arthur Ernest William 1908- *AmArch 70*
Dodds, John *BiDBrA, DcVicP 2*
Dodds, Joseph *BiDBrA*
Dodds, Robert Elihu 1903- *WhAmArt 85*
Dodds, Robert J, III 1943- *WhoAmA 84*
Dodds, Will G *DcVicP 2*
Doddy, G J *AmArch 70*
Doddy, Reginald Nathaniel 1952- *MarqDCG 84*
Dodeigne, Eugene 1923- *PhDcTCA 77*
Dodge, Alice M 1865- *DcWomA*
Dodge, Anna J *ArtsEM, DcWomA*
Dodge, Arthur B *WhAmArt 85*
Dodge, Arthur Burnside 1865-1952 *ArtsAmW 2*
Dodge, Asa *FolkA 86*
Dodge, Aydee *IlBEAAW*
Dodge, C *NewYHSD*
Dodge, Charles J 1806-1886 *FolkA 86, NewYHSD*
Dodge, Chester L 1880- *WhAmArt 85*
Dodge, Clarissa *DcWomA*
Dodge, Cyrus 1814- *CabMA*
Dodge, David 1813-1837 *CabMA*
Dodge, Donald 1907- *AmArch 70*
Dodge, Edward Samuel 1816-1857 *NewYHSD*
Dodge, Edwin Sherrill 1874-1938 *BiDAmAr*
Dodge, Eliza Rathbone *FolkA 86*
Dodge, Ephraim *CabMA*
Dodge, Ephraim J *FolkA 86*
Dodge, Ernest Stanley 1913- *WhoAmA 73*
Dodge, F Farrand 1878- *WhAmArt 85*
Dodge, Frances Farrand 1878- *DcWomA*
Dodge, George A d1919 *BiDAmAr*
Dodge, George Burton 1945- *WhoArt 80, -82, -84*
Dodge, Hazel 1903-1957 *WhoAmA 80N, -82N, -84N*
Dodge, J T *DcSeaP*
Dodge, Jabesh *FolkA 86*
Dodge, Jasper N d1907 *FolkA 86*
Dodge, Jeremiah *FolkA 86*
Dodge, Jeremiah 1781-1860 *NewYHSD*
Dodge, John Wood 1807-1893 *NewYHSD*
Dodge, Jonathan Stanwood 1821- *CabMA*
Dodge, Joseph Jeffers 1917- *WhAmArt 85, WhoAmA 73, -76, -78, -80, -82, -84*
Dodge, Mira Reab *WhAmArt 85*
Dodge, Mira Reab 1849- *DcWomA*
Dodge, Moses 1739?-1776 *CabMA*
Dodge, Nathan *FolkA 86*
Dodge, Ozias 1868-1925 *WhAmArt 85*
Dodge, Peter 1929- *AmArch 70*
Dodge, Regina Lunt *ArtsAmW 3*
Dodge, Richard 1918- *WhAmArt 85*
Dodge, Richard W 1934- *AmArch 70*
Dodge, Rufus *FolkA 86*
Dodge, Samuel *FolkA 86, NewYHSD*
Dodge, W DeLeftwich 1867-1935 *ArtsAmW 2, WhAmArt 85*
Dodge, W P *AmArch 70*
Dodge, William d1810 *CabMA*
Dodge, William DeLeftwich 1867-1935 *IlBEAAW*
Dodge, William L 1867-1935 *ArtsAmW 2*
Dodge, William W, III *AmArch 70*
Dodge, William Waldo, Jr. 1895- *AmArch 70, WhAmArt 85*
Dodgshun, Mrs. A VanCleef *DcWomA*
Dodgson, Charles Lutwidge *ICPEnP A*
Dodgson, Charles Lutwidge 1832-1898 *DcBrBI, MacBEP*
Dodgson, Eveline 1901- *DcBrA 1*
Dodgson, G *DcVicP 2*
Dodgson, George Haydock 1811-1880 *DcBrBI, DcBrWA, DcVicP 2*

Donahey, James Harrison *WhoAmA 78N, –80N, –82N, –84N*
Donahey, James Harrison 1875-1949 *WorECar*
Donahue, James G 1935- *MarqDCG 84*
Donahue, Joseph A 1922- *AmArch 70*
Donahue, Kenneth 1915- *WhoAmA 73, –76, –78, –80*
Donahue, Philip Richard 1943- *WhoAmA 82, –84*
Donahue, Vic 1917- *IlBEAAW*
Donahue, William Francis, Jr. 1958- *MarqDCG 84*
Donahue, William Howard 1891- *WhAmArt 85*
Donald, Bruce R 1958- *MarqDCG 84*
Donald, David *DcBrA 2*
Donald, Emily *DcVicP 2*
Donald, John Milne 1817-1866 *DcBrWA*
Donald, John Milne 1819-1866 *ArtsNiC, DcVicP 2*
Donald, R E *AmArch 70*
Donald, Tom *DcVicP 2*
Donald, William Unger 1939- *AmArch 70*
Donald-Smith, Helen *DcBrA 1, DcVicP 2, DcWomA*
Donaldson, Alice Willits 1885- *DcWomA, WhAmArt 85*
Donaldson, Andrew 1790-1846 *DcBrWA, DcVicP 2*
Donaldson, Andrew B 1840-1919 *DcBrA 2*
Donaldson, Andrew Benjamin 1840- *DcVicP, –2*
Donaldson, Andrew Benjamin 1840-1919 *DcBrWA*
Donaldson, Anne D *WhAmArt 85*
Donaldson, Anthony 1939- *DcCAr 81*
Donaldson, Antony 1939- *ConArt 77, PhDcTCA 77*
Donaldson, Augustine 1843?- *DcWomA, NewYHSD*
Donaldson, Catherine 1901- *DcBrA 1*
Donaldson, David Abercrombie 1916- *DcBrA 1*
Donaldson, David L 1809?- *NewYHSD*
Donaldson, Douglas 1882- *WhAmArt 85*
Donaldson, Elise *WhAmArt 85*
Donaldson, Hugh *FolkA 86*
Donaldson, James 1756?-1843 *BiDBrA*
Donaldson, James H *DcVicP 2*
Donaldson, James Storck 1920- *AmArch 70*
Donaldson, Jeff *AfroAA*
Donaldson, Jeff R 1932- *WhoAmA 78, –80, –82, –84*
Donaldson, Jerry *MarqDCG 84*
Donaldson, John *WhAmArt 85*
Donaldson, John 1737-1801 *AntBDN J, –M, DcBrWA*
Donaldson, Mrs. John A *WhAmArt 85*
Donaldson, John M 1854-1941 *ArtsEM, BiDAmAr*
Donaldson, Marjory 1926- *WhoAmA 78, –80, –82, –84*
Donaldson, Millard Eugene 1896- *AmArch 70*
Donaldson, Olive *ArtsAmW 3*
Donaldson, Sidnor 1813?- *NewYHSD*
Donaldson, Thomas Leverton 1795-1885 *BiDBrA, MacEA*
Donas, Marthe 1885-1967 *DcWomA*
Donat, Walter Scott 1917- *AmArch 70*
Donatello 1382?-1466 *McGDA*
Donatello, Donato DiNiccolo 1386-1466 *OxArt*
Donath, Clarence Edgar 1912- *AmArch 70*
Donati, Danilo 1926- *ConDes*
Donati, Enrico 1909- *DcCAA 71, –77, OxTwCA, PhDcTCA 77, WhoAmA 73, –76, –78, –80, –82, –84*
Donati, Valentina 1897- *DcWomA*
Donato DiSan Vitale d1388? *McGDA*
Donato, Giuseppe d1965 *WhoAmA 78N, –80N, –82N, –84N*
Donato, Giuseppe 1881-1965 *WhAmArt 85*
Donato, Louis Nicholas 1913- *WhAmArt 85*
Donaudy, Donald M 1930- *AmArch 70*
Donawa, Edward L 1931- *AfroAA*
Donchin, Mark Erwin 1936- *AmArch 70*
Doncre, Guillaume Dominique Jacques 1743-1820 *ClaDrA*
Donde, Olga 1935- *WhoAmA 76, –78*
Donde, Olga 1937- *WhoAmA 80, –82, –84*
Donders, Mrs. *DcVicP 2*
Donders, Amalda Bramine Louise *DcWomA*
Dondi, Giovanni De 1318-1389 *OxDecA*
Dondo, Mathurin M 1884- *ArtsAmW 3, WhAmArt 85*
Dondoli, Caterina *DcWomA*
Dondoli, Maria 1703?- *DcWomA*
Donducci, Giovanni Andrea *McGDA*
Done, A E *DcVicP 2*
Doneaud, Jacqueline Cecile *DcWomA*
Donegan, James *FolkA 86*
Donella *DcWomA*
Donelson, Earl Tomlinson 1908- *WhAmArt 85*
Donelson, Mary Hooper 1906- *WhAmArt 85*
Doner, Michele Oka 1945- *WhoAmA 80*
Doney, Donald L 1933- *AmArch 70*
Doney, Thomas *NewYHSD*
Dongen, Kees Van 1877- *ClaDrA, OxArt*
Dongen, Kees Van 1877-1968 *McGDA, OxTwCA, PhDcTCA 77*
Dongerow, William 1858?-1922 *ArtsEM*
Donghi, Antonio 1897- *OxTwCA*
Dongworth, Winifred Cecile 1893- *DcBrA 1, DcWomA*
Donhauser, Paul Stefan 1936- *WhoAmA 78, –80, –82,*

–84
Doniach, Thea 1907- *WhoArt 80, –82, –84*
Donington, Mary 1909- *DcBrA 1, WhoArt 80, –82, –84*
Doniphan, Dorsey 1897- *WhAmArt 85*
Donker, Pieter 1635?-1668 *ClaDrA*
Donker, S M, Jr. *AmArch 70*
Donker-VanDerHoff, Jeanne 1862- *DcWomA*
Donkervoet, Richard Cornelius 1930- *AmArch 70*
Donkin, Miss *DcWomA*
Donkin, Alice E *DcVicP 2*
Donkin, Alice Emily *DcWomA*
Donkin, John *DcVicP 2*
Donkin, W F d1889 *MacBEP*
Donkle, George *FolkA 86*
Donlevy, Alice H 1846-1929 *WhAmArt 85*
Donlevy, Alice Heighes 1846-1929 *DcBrA 1, DcWomA*
Donley, Roy William 1913- *AmArch 70*
Donlon, Joseph Gerard 1922- *AmArch 70*
Donlon, Louis J *WhAmArt 85*
Donly, Eva 1867-1941 *DcWomA*
Donly, Eva Brook 1867- *WhAmArt 85*
Donn, William *DcWomA*
Donnadieu, Jeanne 1864- *DcWomA*
Donnahower, Michael *FolkA 86*
Donnally, Elizabeth Harkness 1948- *WhoAmA 80, –82*
Donnally, M Louise *DcWomA*
Donnavan, C *NewYHSD*
Donne, Benjamin Donisthorpe Allsop 1856-1907 *DcBrWA*
Donne, Benjamin John Merifield 1831-1928 *DcBrWA, DcVicP 2*
Donne, J M *DcVicP 2*
Donne, Leonard David 1926- *WhoArt 80, –82, –84*
Donne, Peter Ivan 1927- *ClaDrA*
Donne, Walter 1867- *ClaDrA*
Donne, Walter J *DcBrA 2*
Donne, Walter J 1867- *DcVicP 2*
Donnell *BiDAmAr*
Donnell, Carson *WhAmArt 85*
Donnell, M E *DcWomA*
Donnell, S H *NewYHSD*
Donnell, William Tinsley 1930- *AmArch 70*
Donnelly, C P *AmArch 70*
Donnelly, J H *AmArch 70*
Donnelly, John *MarqDCG 84*
Donnelly, John James 1899- *WhAmArt 85*
Donnelly, Joseph Christopher 1948- *MarqDCG 84*
Donnelly, Marian Card 1923- *WhoAmA 78, –80, –82, –84*
Donnelly, Mary E 1898- *WhAmArt 85*
Donnelly, Mary E 1898-1961 *DcWomA*
Donnelly, Mary E 1898-1963 *WhoAmA 80N, –82N, –84N*
Donnelly, Orville George 1922- *AmArch 70*
Donnelly, T J *ArtsAmW 1, NewYHSD*
Donnelly, Thomas 1893- *WhAmArt 85*
Donnelly, Mrs. Thomas H *WhAmArt 85*
Donnelly, W A *DcBrBI*
Donnelson, J L *NewYHSD*
Donner, Georg Raphael 1693-1741 *McGDA, OxArt*
Donneson, Seena *WhoAmA 73, –76, –78, –80, –82, –84*
Donnet-Thurninger, Therese *DcWomA*
Donnier, Marie Cecile *DcWomA*
Donnison, Phillis *DcWomA*
Donnison, T E *DcBrBI*
Dono, Paolo Di *OxArt*
Donoahue, James Thomas 1934- *WhoGrA 82[port]*
D'Onofrio, Anthony P 1938- *AmArch 70*
Donofro, J L *AmArch 70*
Donofro, Paul A *AmArch 70*
Donofro, Paul Anthony 1931- *AmArch 70*
Donoghue, J P *DcVicP 2*
Donoghue, John *WhAmArt 85*
Donoghue, John 1853-1903 *WhAmArt 85*
Donoho, David Leigh 1957- *MarqDCG 84*
Donoho, Ruger 1857-1916 *WhAmArt 85*
Donohoe, Richard Powell 1933- *AmArch 70*
Donohoe, Victoria *WhoAmA 73, –76, –78, –80, –82, –84*
Donohoo, R A *AmArch 70*
Donohue, Bonnie J 1946- *ICPEnP A, MacBEP*
Donohue, J William d1941 *BiDAmAr*
Donohue, T M *AmArch 70*
Donovan *AntBDN M*
Donovan, Cecil Vincent 1896- *WhAmArt 85*
Donovan, Ellen *AfroAA*
Donovan, Ellen 1903- *WhAmArt 85*
Donovan, James *AntBDN H, IlDcG*
Donovan, John Ambrose 1871-1941 *ArtsAmW 3*
Donovan, John J 1875-1949 *BiDAmAr*
Donovan, Kevin Dennis 1959- *MarqDCG 84*
Donovan, Michael R O *NewYHSD*
Donovan, Robert 1921- *WorECar*
Donowell, John *BiDBrA, DcBrWA*
Donselaer, Barbara Josephine 1813-1883 *DcWomA*
Donselaer, Therese Jeanne 1811-1876 *DcWomA*
Donsereau, V J *AmArch 70*
Donshea, Clement *IlBEAAW*

Donson, Jerome Allan 1924- *WhoAmA 73, –76, –78, –80, –82, –84*
Donthorn, W J 1799-1859 *MacEA*
Donthorn, William John 1799-1859 *BiDBrA*
Donzel, Eugenie 1860- *DcWomA*
Donzella *DcWomA*
Donzelli, Rinaldo 1921- *ConDes*
Donzello, Piero Del 1452-1509? *McGDA*
Doo, George Thomas 1800- *ArtsNiC*
Doo Da Post 1949- *WhoAmA 82, –84*
Dooley, Helen Bertha 1907- *AmArt, WhAmArt 85, WhoAmA 73, –76, –78, –80, –82, –84*
Dooley, Marianne *MarqDCG 84*
Dooley, Nancy *WhAmArt 85*
Dooley, Thomas M 1899- *WhAmArt 85*
Doolin, James Lawrence 1932- *WhoAmA 78, –80, –82, –84*
Doolin, Mary N 1926- *WhoAmA 78, –80*
Dooling, C M *AmArch 70*
Doolittle *FolkA 86*
Doolittle, A B *NewYHSD*
Doolittle, Amos 1754-1832 *FolkA 86, NewYHSD*
Doolittle, Bev *OfPGCP 86*
Doolittle, C E *WhAmArt 85*
Doolittle, Curtis M *NewYHSD*
Doolittle, Edwin Stafford 1843- *ArtsNiC*
Doolittle, Harold L 1883- *ArtsAmW 1, WhAmArt 85*
Doolittle, Horace 1792- *NewYHSD*
Doolittle, Isaac *NewYHSD*
Doolittle, Marjorie *DcWomA*
Doolittle, Marjorie Hodges 1888?-1972 *ArtsAmW 1*
Doolittle, S C *NewYHSD*
Doolittle, Samuel *NewYHSD*
Doolittle, Warren Ford, Jr. 1911- *WhAmArt 85, WhoAmA 73, –76, –78*
Doomer, Gertrud *DcWomA*
Doomer, Lambert 1622?-1700 *McGDA*
Dooner, Clara *WhAmArt 85*
Dooner, Emilie Zeckwer 1877?- *DcWomA, WhAmArt 85*
Dooner, R T 1878- *WhAmArt 85*
Door *DcBrECP*
Door, Edward *FolkA 86*
Doorhein, Jeannettie 1906- *WhAmArt 85*
Doraku *AntBDN L*
Doran *FolkA 86*
Doran, J T *AmArch 70*
Doran, James *NewYHSD*
Doran, James M 1941- *MarqDCG 84*
Doran, John B *FolkA 86*
Doran, John C 1826?- *NewYHSD*
Doran, John David 1937- *AmArch 70*
Doran, Michael John 1929- *AmArch 70*
Doran, Robert C 1889- *ArtsAmW 2, WhAmArt 85*
Doratt, Charles *NewYHSD*
Doray, Yvonne 1892- *DcWomA*
Dorazio, P A *AmArch 70*
Dorazio, Piero 1927- *ConArt 77, –83, DcCAr 81, OxTwCA, PhDcTCA 77, PrintW 85*
D'Orbay, Francois 1634-1697 *MacEA*
Dorbec-Charvot, Henriette 1867- *DcWomA*
Dorbeck, Franz *WorECar*
Dorbritz, Marguerite 1886- *DcWomA*
Dorch, Celestine Johnston *AfroAA*
Dorcy, Dan *WhAmArt 85*
Dorcy, Irene Shurr *WhAmArt 85*
Dore, A E *AmArch 70*
Dore, Calla Tubbs 1864- *DcWomA*
Dore, Calla Tubbs 1875- *WhAmArt 85*
Dore, Gustav 1833-1883 *AntBDN B*
Dore, Gustave 1832-1883 *ConGrA 1, IlsBYP, OxArt, WorECar*
Dore, Gustave Paul G 1832-1883 *McGDA*
Dore, Isabelle *DcWomA*
Dore, L C Paul Gustave 1833-1883 *ArtsNiC*
Dore, Louis, Madame *DcWomA*
Dore, Louis August Gustave 1833-1883 *DcNiCA*
Dore, Marie Helene *DcWomA*
Dore, Paul Gustave Louis Christophe 1832-1883 *ClaDrA, DcBrBI*
Doremus, Robert *IlsBYP*
Doren, A 1935- *MacBEP*
Doren, Harold Van *McGDA*
Dorence, Marie Jeanne *DcWomA*
Dorendorf, D *FolkA 86*
Dorenz, David 1896- *WhAmArt 85*
Doreson, Nathan 1918- *AmArch 70*
Dorf, Barbara *WhoArt 80, –82, –84*
Dorffling, Auguste 1813-1868 *DcWomA*
Dorflein, Philip 1816-1896 *AntBDN H, DcNiCA*
Dorflinger, Christian 1828-1915 *IlDcG*
Dorfman, Bruce 1936- *WhoAmA 73, –76, –78, –80, –82, –84*
Dorfman, Elsa 1937- *ICPEnP A, MacBEP*
Dorfman, Fred 1946- *WhoAmA 82, –84*
Dorfman, Fred David 1946- *WhoAmA 80*
Dorfman, Julius 1913- *MarqDCG 84*
Dorfsman, Louis *AmGrD[port]*
Dorfsman, Louis 1918- *ConDes, McGDA,*

WhoGrA 62, –82[port]
Dorgan, S E *AmArch* 70
Dorgan, Thomas Aloysius 1877-1929 *ArtsAmW 1,*
WhAmArt 85, WorECom
D'Orge, Jeanne *ArtsAmW 3*
D'Orgeix, Christian 1927- *PhDcTCA 77*
Dorgeloh, Marguerite Redman 1890- *ArtsAmW 2,*
DcWomA, WhAmArt 85
Dorgelon, Marguerite Redman 1890- *ArtsAmW 2*
Dorgny, Jacqueline *DcWomA*
Dorian, Garo N 1920- *AmArch* 70
Doriani, William 1891- *FolkA 86*
Dorigny, Genevieve *DcWomA*
Dorigny, Jacqueline *DcWomA*
Dorigny, Michel 1617-1685 *McGDA*
Dorigny, Nicolas 1652-1746 *ClaDrA*
Doring, Adolph G *DcBrBI*
Dorius, Kermit Parrish 1926- *AmArch* 70
Dorival, John *NewYHSD*
Dorival, Louise 1894- *DcWomA*
Dorival-Naude, Marie Therese *DcWomA*
D'Orleans, Antoine Philippe *NewYHSD*
D'Orleans, Louis Charles *NewYHSD*
Dorlet-Meunier, Marthe 1899- *DcWomA*
Dorling *EncASM*
Dormael, Marie Louise Van 1886- *DcWomA*
Dorman, Charles Jerome 1908- *AmArch* 70
Dorman, J J *DcVicP 2*
Dorman, Richard Lee 1922- *AmArch* 70
Dorman, Robert 1885-1958 *MacBEP*
Dorman, S *DcVicP 2*
Dormer, Henry d1727 *BiDBrA*
Dormer, Louise *DcVicP 2*
Dormont, Phillip *WhAmArt 85*
Dorn, Charles Meeker 1927- *WhoAmA 73*
Dorn, Fred B 1881-1934 *BiDAmAr*
Dorn, Joseph 1759-1841 *ClaDrA*
Dorn, Leo F 1879- *WhAmArt 85*
Dorn, Marion V *ArtsAmW 3, WhAmArt 85*
Dorn, Marion Victoria 1899-1964 *ConDes*
Dorn, Peter Klaus 1932- *WhoAmA* 76, –78, –80, –82,
–84
Dorn, Rosalie 1741-1830 *DcWomA*
Dorn, Ruth 1925- *WhoAmA 78, –80, –82, –84*
Dornbach, Samuel 1796?- *FolkA 86*
Dornberg, Emma, Freiin Von 1864- *DcWomA*
Dornberger, W W *AmArch* 70
Dornbusch, Charles Henry 1899- *AmArch* 70
Dornbush, Adrian J 1900- *WhAmArt 85*
Dorne, Albert 1904- *WhAmArt 85*
Dorne, Albert 1904-1965 *IlrAm E, –1880*
Dornel, Jacques 1775-1852 *ClaDrA*
Dorner, Alexander *WhoAmA 80N, –82N, –84N*
Dorner, Alexander A 1893- *WhAmArt 85*
Dorner, Johann Jakob 1741-1813 *ClaDrA*
Dornerin, Philiberte d1792 *DcWomA*
Dorney, Genevieve 1898-1965 *ArtsAmW 2, DcWomA*
Dorns, Francis 1815?- *NewYHSD*
Dorny, Bertrand *DcCAr 81*
Dorny, Jacqueline *DcWomA*
Dorothea Von Riethain *DcWomA*
Dorothea, Lucy *DcVicP 2*
Dorothee Bis *FairDF FRA*
Dorothy Of Cappadocia, Saint d304 *McGDA*
Dorothy, Esther *WorFshn*
Dorph, Bertha 1875- *DcWomA*
Dorr, D M *AmArch* 70
Dorr, Goldthwaite Higginson, III 1932- *WhoAmA 73,*
–76, –78
Dorr, Louis L 1881-1940 *BiDAmAr*
Dorr, Nell 1893- *ICPEnP A, WhoAmA 82, –84*
Dorr, Mrs. Roy Linwood *WhAmArt 85*
Dorr, William Shepherd *WhoAmA 73, –76*
Dorra, Henri 1924- *WhoAmA 73, –76, –78, –80, –82,*
–84
Dorrance, Nesta *WhoAmA 73*
Dorrance, W H *NewYHSD*
Dorrell, Edmund 1778-1857 *DcBrWA*
Dorrien, Carlos Guillermo 1948- *WhoAmA 82, –84*
Dorrien-Smith, Mary L H *DcWomA*
Dorronsoro, Maria Antonia *DcWomA*
D'Orsay, Count Alfred 1801-1852 *DcVicP 2*
D'Orsay, Count Alfred Guillaume Gabriel 1801-1852
DcBrWA
Dorsch, A G *AmArch* 70
Dorsch, Christoph 1676-1732 *IlDcG*
Dorsch, Edward 1822-1887 *ArtsEM*
Dorsch, Erhard 1649-1712 *IlDcG*
Dorsch, Susanna Maria 1701-1765 *DcWomA*
Dorsch, Walburga *DcWomA*
Dorschlag, Anna 1869- *DcWomA*
Dorschweller, H *DcVicP 2*
Dorsett, C H *AmArch* 70
Dorsett, Charles Barclay 1927- *AmArch* 70
Dorsey, E Deborah 1950- *MarqDCG 84*
Dorsey, Edith *FolkA 86*
Dorsey, Harold *AfroAA*
Dorsey, Hebe *WorFshn*
Dorsey, Henry d1962 *FolkA 86*
Dorsey, John *CabMA, NewYHSD*
Dorsey, John Syng 1783-1818 *NewYHSD*

Dorsey, Katherine *AfroAA*
Dorsey, Lillian A 1912- *AfroAA*
Dorsey, S D *AmArch* 70
Dorsey, Stanton Lindsey 1890- *WhAmArt 85*
Dorsey, Tarp 1847-1925 *FolkA 86*
Dorsey, Thomas *NewYHSD*
Dorsey, Thomas 1920- *WhAmArt 85*
Dorsey, W F *FolkA 86*
Dorsey, William *AfroAA*
Dorsey, William H *FolkA 86*
D'Orsi, John 1907- *AmArch* 70
D'Orsi, Michael Richard 1910- *AmArch* 70
Dorsky, Morris 1918- *WhoAmA 78, –80, –82, –84*
Dorsky, Samuel 1914- *WhoAmA 80, –82, –84*
Dorsky, William 1932- *AmArch* 70
Dorst *EncASM*
Dorst, Claire V 1922- *WhoAmA 73, –76, –78, –80,*
–82, –84
Dorst, Mary Crowe *WhoAmA 78, –80, –82, –84*
Dorste, Thomas Charles 1923- *AmArch* 70
Dortsman, Adriaen 1625-1682 *MacEA*
Dorus, Eulalie *DcWomA*
Dorward, John 1812?-1861? *FolkA 86*
Dorward, Joshua 1835?- *FolkA 86*
Doryphorus *OxArt*
Dorys, Benedykt Jersy 1901- *ICPEnP A*
Dorys, Benedykt Jerzy 1901- *ConPhot*
Dosch, Henry *ArtsEM*
Dosch, Nicholas *ArtsEM*
Dosch, Roswell *ArtsAmW 2, WhAmArt 85*
Doscher, Henry L, Jr. *WhAmArt 85*
Dosh *WorECar*
Doshi, B V 1927- *ConArch*
Doshi, Balkrishna Vithaldas 1927- *WhoArch*
Dosho *AntBDN L*
Dosio, Dorastante Maria *McGDA*
Dosio, Giovanni Antonio 1533-1609 *McGDA*
Doskow, David *EncASM*
Doskow, Israel 1881- *WhAmArt 85*
Doskow, Lenore *EncASM*
DosPassos, John *DcCAr 81*
DosPrazeres, Heiter *OxTwCA*
Doss, Darwin Vernon 1941- *AmArch* 70
DosSantos, Bartolomeu *DcCAr 81*
Dossena, Alceo 1878-1936 *McGDA*
Dossert, Norma Barton 1893- *DcWomA,*
WhAmArt 85
Dossi, Battista d1548 *OxArt*
Dossi, Battista 1474?-1548 *ClaDrA*
Dossi, Dosso Giovanni Luteri 1474?-1542 *OxArt*
Dossi, Giovanni 1479?-1542 *ClaDrA*
Dossi, Ugo 1943- *DcCAr 81*
Dosso 1490?-1542 *McGDA*
Dosso, Battista Del *McGDA*
Doster, Rose Wilhelm 1938- *WhoAmA 73*
Dotchen, John *BiDBrA*
D'Othon, A H *NewYHSD*
Dotremont, Christian *DcCAr 81*
Dotter, Cornelius *FolkA 86*
Dotter, Earl 1943- *ICPEnP A*
Dotterer, Charles *FolkA 86*
Dotti, Carlo Francesco 1670-1759 *MacEA, McGDA*
Dottori, Gerardo 1888-1977 *OxTwCA*
Dottori, Gherardo 1888- *PhDcTCA 77*
Doty, David C 1957- *MarqDCG 84*
Doty, Kathlyn Elaine 1948- *MarqDCG 84*
Doty, Robert McIntyre 1933- *WhoAmA 73, –76, –78,*
–80, –82, –84
Doty, Roy 1922- *IlsBYP, WorECar*
Doty, Russell *MarqDCG 84*
Doty, Warren S *NewYHSD*
Dotzenko, Grisha *IlsBYP*
Dou, Gerrit 1613-1675 *ClaDrA, McGDA, OxArt*
Douaihy, Saliba 1915- *WhoAmA 78, –80, –82, –84*
Douanier, Le *McGDA*
Douard, Cecile 1866- *DcWomA*
Doub, Florence W 1852-1932 *WhAmArt 85*
Doubble, Dorothy 1886-1974 *DcWomA*
Doubilet, David 1947- *ICPEnP A*
Doubleday, F G *WhAmArt 85*
Doubleday, John 1947- *DcCAr 81, WhoArt 80, –82,*
–84
Doublemard, Amedee Donatien -1879 *ArtsNiC*
Doublet, Marie Anne 1677-1768 *DcWomA*
Doubrava, Jan 1912- *WhoAmA 73, –76*
Doubting, James *DcVicP 2*
Doucere, Marguerite *DcWomA*
Doucet, Henri Lucien 1856-1895 *ClaDrA*
Doucet, Jacques *FairDF FRA*
Doucet, Jacques, Jr. 1860?-1932? *WorFshn*
Doucet, Lucien *DcVicP 2*
Doucet, Lucien 1856-1895 *WhAmArt 85A*
Doucet, Sarah *DcWomA*
Doucet-Clementz, Marguerite 1876- *DcWomA*
Doucet DeSuriny, J *DcWomA*
Doucette, Adrian Robert 1920- *MarqDCG 84*
Doucette, David Robert 1946- *MarqDCG 84*
Doucette, Edward Bernard 1907- *AmArch* 70
Douchez-Vandelen, Cornille *DcWomA*
Doud, Delia Ann 1837-1926 *FolkA 86*
Doud, George *CabMA*

Doud, Isabel *DcWomA*
Doud, Isabel Cohen 1867-1945 *WhAmArt 85*
Douden, H C *AmArch* 70
Douden, May 1859?- *DcWomA*
Douden, William 1869-1946 *BiDAmAr*
Doudera, Gerard 1932- *WhoAmA 76, –78, –80, –82,*
–84
Doudna, Richard M 1923- *AmArch* 70
Doudna, William L 1905- *WhAmArt 85*
Doudney, Henry Eric John 1905- *DcBrA 1,*
WhoArt 80, –82, –84
Doue, Olga Julievna *DcWomA*
Douffet, Gerard 1594-1665? *McGDA*
Dougal, William H 1822-1895 *ArtsAmW 1,*
IlBEAAW, NewYHSD
Dougan, A *DcVicP 2*
Dougan, D L *AmArch* 70
Dougan, L L *AmArch* 70
Dougher, J A *AmArch* 70
Dougherty, Alice *DcWomA*
Dougherty, Bertha Hurlbut 1883- *DcWomA,*
WhAmArt 85
Dougherty, Charles Nelson 1922- *AmArch* 70
Dougherty, Edward 1876-1944? *BiDAmAr*
Dougherty, Gary Robert 1943- *MarqDCG 84*
Dougherty, Hugh 1843?-1925 *NewYHSD*
Dougherty, Ida *WhAmArt 85*
Dougherty, Ida 1878- *DcWomA*
Dougherty, J W *DcWomA*
Dougherty, James *WhAmArt 85*
Dougherty, James 1841?- *NewYHSD*
Dougherty, John *CabMA*
Dougherty, Louis R 1874- *WhAmArt 85*
Dougherty, Parke C 1867- *WhAmArt 85*
Dougherty, Paul 1877-1947 *ArtsAmW 1, –3,*
IlBEAAW, WhAmArt 85
Dougherty, Ray 1942- *WhoAmA 80, –82, –84*
Dougherty, William 1832?- *NewYHSD*
Dougherty, William John 1933- *AmArch* 70
Doughten, Alice B 1880- *DcWomA, WhAmArt 85*
Doughtie, Symond Elbert 1921- *AmArch* 70
Doughty, Charles Edward, Sr. 1932- *AmArch* 70
Doughty, Dorothy 1892-1962 *DcNiCA*
Doughty, Edmund *NewYHSD*
Doughty, Eleanor F M *DcVicP 2*
Doughty, Frank L *AmArch* 70
Doughty, John H *FolkA 86*
Doughty, Lloyd Alling 1914- *AmArch* 70
Doughty, Richard E 1929- *AmArch* 70
Doughty, Thomas 1793-1856 *ArtsNiC, BnEnAmA,*
DcAmArt, DcSeaP, McGDA, NewYHSD
Doughty, Thomas, Jr. *NewYHSD*
Doughty, William 1755?-1782 *McGDA*
Doughty, William 1757-1782 *DcBrECP*
Douglas, Aaron 1898-1979 *DcAmArt*
Douglas, Aaron 1899- *AfroAA, ArtsAmW 2,*
WhAmArt 85
Douglas, Aaron 1900-1979 *WhoAmA 80N, –82N,*
–84N
Douglas, Allen Edmund 1835-1894 *DcBrWA*
Douglas, Andrew 1870-1935 *DcBrA 1*
Douglas, Archibald Ramsay 1807-1886 *DcWomA*
Douglas, Arthur *DcVicP 2*
Douglas, Caroline Lucy 1784-1857 *DcWomA*
Douglas, Charles *FolkA 86*
Douglas, Chester 1902- *WhAmArt 85*
Douglas, Ed 1943- *ConPhot, ICPEnP A*
Douglas, Edward Algernon Stuart *DcVicP 2*
Douglas, Edward Bruce 1886-1946 *WhAmArt 85*
Douglas, Edwin 1848- *ArtsNiC, ClaDrA, DcVicP,*
–2
Douglas, Edwin 1848-1914 *DcBrBI*
Douglas, Edwin Perry 1935- *WhoAmA 73, –76, –78,*
–80, –82, –84
Douglas, Eleanor *DcWomA, WhAmArt 85*
Douglas, Frederic Huntington *WhoAmA 80N, –82N,*
–84N
Douglas, Frederic Huntington 1897- *WhAmArt 85*
Douglas, Haldane 1893- *ArtsAmW 2, WhAmArt 85*
Douglas, Harold *WhAmArt 85*
Douglas, Harry *WhAmArt 85*
Douglas, Helen Atwood *WhAmArt 85*
Douglas, Hope 1883- *DcBrA 1*
Douglas, Hope Toulmin 1883- *DcWomA*
Douglas, James *CabMA, DcVicP 2*
Douglas, James 1753-1819 *DcBrWA*
Douglas, James 1858-1911 *DcBrWA*
Douglas, John *BiDBrA*
Douglas, John 1773- *CabMA*
Douglas, John 1800?-1862 *BiDBrA*
Douglas, John 1826?- *NewYHSD*
Douglas, John 1867- *DcBrA 1, DcBrWA, DcVicP 2*
Douglas, Kate d1937 *ArtsEM, DcWomA*
Douglas, Laura *DcWomA*
Douglas, Laura Glenn 1896- *DcWomA,*
WhAmArt 85
Douglas, Lester 1893- *WhAmArt 85*
Douglas, Lester 1894-1961 *WhoAmA 80N, –82N,*
–84N
Douglas, Lucille Sinclair d1935 *WhAmArt 85*
Douglas, Lucy *DcWomA, FolkA 86, NewYHSD*

Douglas, M Bruce *WhAmArt 85*
Douglas, Margaret Ann 1944- *MarqDCG 84*
Douglas, Marguerite France 1918- *WhoArt 80, –82, –84*
Douglas, Marilyn *MarqDCG 84*
Douglas, Martha *DcWomA*
Douglas, Mary Ann *DcWomA*
Douglas, Marya *FolkA 86*
Douglas, Michael Stephen 1951- *MarqDCG 84*
Douglas, Phoebe Lawson 1906- *WhoArt 80, –82, –84*
Douglas, Robert *NewYHSD*
Douglas, Robert Conrad 1923- *AmArch 70*
Douglas, Robert Langton d1951 *WhoAmA 78N, –80N, –82N, –84N*
Douglas, W C *AmArch 70*
Douglas, Walter 1868- *WhAmArt 85*
Douglas, Sir William Fettes 1822-1891 *ClaDrA, DcBrWA, DcVicP, –2*
Douglas, Sir William Fettes 1823- *ArtsNiC*
Douglas-Hamilton, R *DcVicP 2*
Douglas-Irvine, Lucy Christina 1874- *DcBrA 1, DcWomA*
Douglass *NewYHSD , WhAmArt 85*
Douglass, Alonzo 1815?-1886 *NewYHSD*
Douglass, Arthur Sylvester, Jr. 1915- *AmArch 70*
Douglass, Calvin 1931- *AfroAA*
Douglass, Caroline *NewYHSD*
Douglass, Craig Bruce 1956- *MarqDCG 84*
Douglass, David Bates 1790-1849 *NewYHSD*
Douglass, Debra Renee 1959- *MarqDCG 84*
Douglass, Eleanor *DcWomA*
Douglass, Emma Simpson *ArtsAmW 3*
Douglass, H Robert 1937- *AmArch 70*
Douglass, Helen *DcWomA*
Douglass, Helen Wright 1910- *WhAmArt 85*
Douglass, Kenneth E 1925- *AmArch 70*
Douglass, Lathrop 1907- *AmArch 70*
Douglass, Lucille Sinclair d1935 *DcWomA*
Douglass, R H *WhAmArt 85*
Douglass, Ralph 1895- *IlsCB 1744, –1946*
Douglass, Ralph Waddell 1895- *WhAmArt 85*
Douglass, Ralph Waddell 1895-1971 *ArtsAmW 2*
Douglass, Richard *DcVicP 2*
Douglass, Robert M, Jr. 1809- *AfroAA*
Douglass, Robert M, Jr. 1809-1887 *FolkA 86*
Douglass, Robert M J 1809-1887 *NewYHSD*
Douglass, Rush *NewYHSD*
Douglass, W J *AmArch 70*
Douglass, William N *CabMA*
Douillet, Adele *DcWomA*
Douke, Daniel 1943- *DcCAr 81*
Douke, Daniel W 1943- *AmArt, WhoAmA 78, –80, –82, –84*
Doulberry, Frank R *WhAmArt 85*
Douliot, Marie Anais 1834- *DcWomA*
Doull, Mary Allison *WhAmArt 85*
Doull, Mary Allison 1866-1953 *DcWomA*
Doull, William 1793?- *BiDBrA*
Doulson, Ella *DcWomA*
Doulton, Henry *DcNiCA*
Doulton, Sir Henry 1820-1897 *AntBDN M*
Doulton, John 1793-1873 *AntBDN M, DcD&D, DcNiCA*
Doumato, Lamia 1947- *WhoAmA 78, –80, –82, –84*
Doumichaud DeLaChassagne-Grosse, L *DcWomA*
Douris *McGDA, OxArt*
Douritch, Francis 1825?- *NewYHSD*
Dournovo, Madame *DcWomA*
Dousa, Henry 1820-1885? *FolkA 86*
D'Ouseley, Sophia *DcVicP 2*
D'Ouseley, Sophie *DcWomA*
Dousset-Rugel, G C D *DcWomA*
Doust, W H *DcVicP 2*
Douthat, Milton 1905- *WhAmArt 85*
Douthat, Rifka *DcWomA*
Douthwaite, Richard W *BiDBrA*
Douton, Isabel F *DcBrA 2*
Doutreleau, Agathe *DcWomA*
Douttiel, N G *AmArch 70*
Douty, T B *AmArch 70*
Douven, Bartholomeus 1688-1726? *McGDA*
Douvillier *NewYHSD*
Douwermann, Heinrich *McGDA*
Doux, Lucile *DcWomA*
Doux, Mary F *WhAmArt 85*
Douzette, Louis 1834- *ClaDrA*
Dov, Gerrit 1613-1675 *ClaDrA*
Dova, Gianni 1925- *OxTwCA, PhDcTCA 77*
Dovaston, Margaret 1884- *DcBrA 2*
Dove, Mrs. *DcWomA, NewYHSD*
Dove, Arthur 1880-1946 *OxArt*
Dove, Arthur G 1880-1946 *DcAmArt, DcCAA 71, –77, WhAmArt 85*
Dove, Arthur Garfield 1880- *WhoAmA 76*
Dove, Arthur Garfield 1880-1946 *BnEnAmA, ConArt 77, McGDA, OxTwCA, PhDcTCA 77, WhoAmA 78N, –80N, –82N, –84N*
Dove, Carroll Reginald *AmArch 70*
Dove, Helen *DcWomA*
Dove, Thomas *BiDBrA*
Dove, Toni 1946- *PrintW 83, –85*

Dove, W *DcVicP 2*
Dove, Walter DeSales 1927- *AmArch 70*
Dove, William House 1933- *AmArch 70*
Dovers, H A *DcWomA*
Dovers, Mrs. H A *DcVicP 2*
Dovey, Ione *ArtsAmW 3*
Dovgalev, Marfa 1798- *DcWomA*
Dovnikovic, Borivoj 1930- *WorECar, WorECom*
Dow, Alden B 1904- *MacEA*
Dow, Alden Ball 1904- *AmArch 70*
Dow, Alexander Warren 1873-1948 *DcBrA 1, DcBrWA*
Dow, Arthur W 1857-1922 *WhAmArt 85*
Dow, Arthur Wesley 1857-1922 *ArtsAmW 1, DcAmArt, IlBEAAW*
Dow, Bruce R 1937- *MarqDCG 84*
Dow, George Francis 1868-1936 *WhAmArt 85*
Dow, H C *AmArch 70*
Dow, Harold James 1902- *DcBrA 1*
Dow, Helen Jeannette 1926- *WhoAmA 82, –84*
Dow, James Weston 1947- *MarqDCG 84*
Dow, John 1770-1862 *FolkA 86*
Dow, Joy Wheeler 1861-1937 *BiDAmAr*
Dow, Lelia A 1864-1930 *DcWomA, WhAmArt 85*
Dow, Lumley *DcVicP 2*
Dow, Peter 1822-1919 *WhAmArt 85*
Dow, Thomas, Jr. 1820- *CabMA*
Dow, Thomas Millie 1848-1919 *ClaDrA, DcBrA 1, DcVicP 2*
Dow, William F 1844-1906 *ArtsEM*
Dowbiggin *BiDBrA*
Dowbiggin, Launcelot 1689?-1759 *BiDBrA*
Dowbiggin, Samuel 1724?-1809 *BiDBrA*
Dowd, A W *ArtsAmW 3*
Dowd, Gorda C *WhAmArt 85*
Dowd, James H 1884-1956 *DcBrA 1, DcBrBI*
Dowd, Roland Hall 1896- *DcBrA 1*
Dowd, Victor *IlsBYP*
Dowd-Rodgers *EncASM*
Dowdall, Edward 1856-1932 *WhAmArt 85*
Dowden, Anne Ophelia *OfPGCP 86*
Dowden, Anne Ophelia Todd 1907- *IlsCB 1967, WhoAmA 73, –76, –78, –80, –82, –84*
Dowden, James Franklin 1929- *AmArch 70*
Dowden, Raymond Baxter 1905- *WhAmArt 85*
Dowdney *DcBrECP*
Dowdney, Nathaniel 1736?-1793? *CabMA*
Dowell, Charles R *DcBrA 1*
Dowell, John *AfroAA*
Dowell, John E, Jr. 1941- *WhoAmA 80, –82, –84*
Dower, James Daniel, Jr. 1917- *AmArch 70*
Dower, Walter H 1883-1934 *WhAmArt 85*
Dowiatt, Dorothy *WhAmArt 85*
Dowie, Reta M *WhAmArt 85*
Dowie, Sybil M *DcVicP 2*
Dowinar, B M *DcSeaP*
Dowis, William Shafer, Jr. 1923- *AmArch 70*
Dowler, Charles Parker 1841-1931 *FolkA 86*
Dowler, David P 1944- *WhoAmA 82, –84*
Dowler, William Cleland 1912- *AmArch 70*
Dowley, C *DcVicP 2*
Dowling, Colista *WhAmArt 85*
Dowling, Daniel B 1906- *WorECar*
Dowling, Daniel Blair 1906- *WhoAmA 73, –76, –78, –80*
Dowling, Mary *DcWomA*
Dowling, R B *DcVicP 2*
Dowling, Robert 1827-1886 *DcVicP 2*
Dowling, Robert W *WhoAmA 76N, –78N, –80N, –82N, –84N*
Dowling, Robert W 1895- *WhoAmA 73*
Dowling, Steve 1904- *WorECom*
Dowling, Victor J 1906- *IlsBYP, IlsCB 1946*
Dowman, Isabella *DcWomA*
Down, Avril 1900- *WhoArt 80*
Down, Frederick *NewYHSD*
Down, Marion *WhAmArt 85*
Down, Richard *BiDBrA*
Down, Thomas *CabMA*
Down, Vera Emily 1888- *DcBrA 1, DcWomA*
Downard, Ebenezer Newman *ClaDrA, DcBrBI, DcVicP, –2*
Downe, Edward *BiDBrA*
Downer, Nathan *DcBrECP*
Downer, Ruth *DcWomA, FolkA 86*
Downer, Una Stella 1871-1955 *DcWomA*
Downes, Ada E *DcVicP 2*
Downes, Annabel *DcVicP 2, DcWomA*
Downes, Bernard *DcBrECP*
Downes, J *EarABI, EarABI SUP, NewYHSD*
Downes, Jerome I H *WhAmArt 85*
Downes, John I H 1861-1933 *WhAmArt 85*
Downes, John Ireland Howe 1861-1933 *ArtsAmW 2*
Downes, M S *AmArch 70*
Downes, P S *FolkA 86*
Downes, Peter B *FolkA 86*
Downes, Rackstraw 1939- *AmArt, DcCAr 81, WhoAmA 82, –84*
Downes, Thomas Price *DcVicP, –2*
Downes, William Howe 1855-1941 *WhAmArt 85*
Downey, D Robert 1927- *AmArch 70*

Downey, Frank *WhAmArt 85*
Downey, James *WhoAmA 76, –78, –80*
Downey, Juan 1940- *ConArt 77, WhoAmA 73, –76, –78, –80, –82, –84*
Downey, Mark Karl 1958- *MarqDCG 84*
Downey, Mary V 1881-1976 *DcWomA*
Downey, Sabien B *NewYHSD*
Downey, Thomas *DcBrBI*
Downham, Charles Thaddeus 1934- *AmArch 70*
Downie, Janet *ArtsAmW 3*
Downie, Janet 1854- *DcWomA*
Downie, John P 1871-1945 *DcBrA 1*
Downie, Mary *ArtsAmW 3, DcWomA*
Downie, Patrick *ClaDrA*
Downie, Patrick 1854-1945 *DcBrA 1, DcBrWA, DcVicP 2*
Downie, T D *WhAmArt 85*
Downing, A J 1815-1852 *MacEA*
Downing, Alfred *ArtsAmW 3*
Downing, Andrew Jackson 1815-1852 *BnEnAmA, DcD&D, McGDA, OxArt*
Downing, Charles Palmer *DcVicP 2*
Downing, Delapoer *DcVicP 2*
Downing, Edith E 1857- *DcWomA*
Downing, George Elliot 1904- *WhAmArt 85*
Downing, George Elliott 1904- *WhoAmA 73*
Downing, George Henry 1878-1940 *DcBrA 1*
Downing, H E d1835 *DcBrWA*
Downing, Henry Philip Burke 1865- *DcBrBI*
Downing, Holly 1948- *DcCAr 81*
Downing, Howard Stanley, Jr. 1935- *AmArch 70*
Downing, Joe 1925- *DcCAr 81*
Downing, Marguerite *DcWomA*
Downing, Mary *FolkA 86*
Downing, Richard Francis 1929- *AmArch 70*
Downing, Robert James 1935- *WhoAmA 84*
Downing, S Boardman *NewYHSD*
Downing, Thomas 1928- *AmArt, DcCAA 71, –77, OxTwCA, WhoAmA 78*
Downing, W S, Jr. *AmArch 70*
Downman, John 1750-1824 *AntBDN J, DcBrECP, DcBrWA, McGDA, OxArt*
Downs, Barry 1930- *ConArch*
Downs, Edgar 1876-1963 *DcBrA 1*
Downs, Ephraim *AntBDN D*
Downs, Felicie *DcWomA*
Downs, J *DcVicP 2*
Downs, Lawrence Livingston *AmArch 70*
Downs, Linda Anne 1945- *WhoAmA 78, –80, –82, –84*
Downs, P T *FolkA 86*
Downs, Thomas Henry 1892-1972 *DcBrA 1*
Downs, William Troy 1937- *AmArch 70*
Dows, Olin 1904- *WhAmArt 85*
Dowse, Jonathan *CabMA*
Dowson, Philip 1924- *ConArch, WhoArch*
Dowson, Russell *DcBrA 2, DcVicP 2*
Dowton, C *DcVicP 2*
Dox, H B *AmArch 70*
Doxford, James 1899- *DcBrA 1, WhoArt 80, –82, –84*
Doxiadis, Constantinos A 1913-1975 *MacEA*
Doyen, Gabriel Francois 1726-1806 *ClaDrA*
Doyle, A M *AmArch 70*
Doyle, Agnes Ellen 1873- *DcWomA, WhAmArt 85*
Doyle, Albert E 1877-1928 *BiDAmAr, MacEA*
Doyle, Alexander 1857-1922 *WhAmArt 85*
Doyle, B *FolkA 86*
Doyle, Bentinck Cavendish *ClaDrA, DcBrA 1*
Doyle, Charles 1832-1893 *DcVicP*
Doyle, Charles Altamont 1832-1893 *DcBrBI, DcVicP 2*
Doyle, Charles Altimont 1832-1893 *DcBrWA*
Doyle, Daniel D 1860- *WhAmArt 85*
Doyle, Edward A 1914- *WhoAmA 73*
Doyle, Florence Watkins *ArtsAmW 3*
Doyle, Francis Eugene *AmArch 70*
Doyle, Gerald Austin 1922- *AmArch 70*
Doyle, Gertrude *DcWomA, WhAmArt 85*
Doyle, Henry Edward 1827-1892 *DcBrBI, DcBrWA, DcVicP 2*
Doyle, J F 1840-1913 *MacEA*
Doyle, James *WhAmArt 85*
Doyle, James J *WhAmArt 85*
Doyle, James William Edmund 1822-1892 *DcBrBI, DcBrWA*
Doyle, Jerry 1898- *WhAmArt 85*
Doyle, Joe 1941- *DcCAr 81, WhoAmA 80, –82, –84*
Doyle, John 1797-1868 *AntBDN B, DcBrBI, DcVicP 2*
Doyle, John 1928- *WhoArt 82, –84*
Doyle, John H B 1797-1868 *DcBrWA*
Doyle, John Lawrence 1939- *WhoAmA 78, –80, –82, –84*
Doyle, John M *FolkA 86*
Doyle, John Pleasants 1933- *AmArch 70*
Doyle, John Thomas 1920- *AmArch 70*
Doyle, Margaret Byron *DcWomA, NewYHSD*
Doyle, Peter Gerald 1941- *AmArch 70*
Doyle, Richard 1824-1883 *AntBDN B, ClaDrA, DcBrBI, DcBrWA, DcVicP, –2, McGDA, OxArt, WorECar*

Doyle, Richard 1826-1883 *ArtsNiC*
Doyle, Richard Lee 1919- *AmArch 70*
Doyle, Robert Joseph 1912- *WhAmArt 85*
Doyle, Sam 1906-1985 *FolkA 86*
Doyle, Thomas J 1928- *WhoAmA 73, -76, -78*
Doyle, Tom 1928- *DcCAA 71, -77, OxTwCA,*
WhoAmA 80, -82, -84
Doyle, Walter J 1935- *MarqDCG 84*
Doyle, William *NewYHSD*
Doyle, William 1756-1828 *AntBDN O*
Doyle, William G *FolkA 86*
Doyle, William M S *FolkA 86*
Doyle, William M S 1769-1828 *NewYHSD*
Doyle-Jones, F W d1938 *DcBrA 1*
D'Oyly, Sir Charles 1781-1845 *DcBrBI, DcBrWA*
D'Oyly, Lady Elizabeth Jane d1875 *DcBrWA*
Doyon, Gerard Maurice 1923- *WhoAmA 73, -76, -78,*
-80, -82, -84
Doyre, Marie Juliette *DcWomA*
Dozance, Berthe *DcWomA*
Dozia *WorFshn*
Dozier, Kenneth Edward, Jr. 1947- *MarqDCG 84*
Dozier, Otis 1904- *IlBEAAW, WhAmArt 85,*
WhoAmA 73, -76, -78, -80
Dr. Brute 1940- *WhoAmA 84*
Dr. Seuss *WhoAmA 78, -80, -82*
Drabble, J D *DcVicP 2*
Drabble, James *AntBDN N*
Drabble, Richard R *DcVicP 2*
Drabkin, Stella 1906- *WhoAmA 73, -76*
Drabkin, Stella 1906-1976 *WhAmArt 85,*
WhoAmA 78N, -80N, -82N, -84N
Drach, Gustave W 1861-1940? *BiDAmAr*
Drach, Rudolf *FolkA 86*
Drach, S *NewYHSD*
Draddy, John G 1833-1904 *NewYHSD ,*
WhAmArt 85
Draddy, Vincent DePaul *WorFshn*
Draeger, E J *AmArch 70*
Drafts, John Thomas 1927- *AmArch 70*
Drage, J Henry *DcVicP 2*
Drage, Mildred Frances *DcVicP 2*
Drage, Mildred Francis *DcWomA*
Drager, Bertha 1905- *WhoArt 84*
Drager, Brett *WhoArt 84*
Draggan, Egbert *AfroAA*
Dragic, Nedeljko 1936- *WorECar*
Drago, Gabrielle D *WhoAmA 73, -76*
Dragoo, Raymond C, Jr. 1927- *AmArch 70*
Dragul, Sandra Kaplan 1943- *WhoAmA 76, -78, -80,*
-82
Drahonovsky, Josef 1877- *IldcG*
Drahos, Tom *DcCAr 81*
Drahos, Tom 1947- *ConPhot, ICPEnP A*
Drain, Frederick L 1958- *MarqDCG 84*
Drain, Lillian *DcWomA*
Draitschiow, Viktor 1957- *ICPEnP A*
Drake, Miss *DcWomA*
Drake, A T *AmArch 70*
Drake, Ada Brooke *WhAmArt 85*
Drake, Albert W 1928- *AmArch 70*
Drake, Alexander 1843-1916 *WhAmArt 85*
Drake, Anna Belle *WhAmArt 85*
Drake, Bertram Delaney 1880-1930 *WhAmArt 85*
Drake, Cecil Ray 1910- *AmArch 70*
Drake, Charles *WhAmArt 85*
Drake, Charles Henry 1903- *AmArch 70*
Drake, Douglas 1925- *AmArch 70*
Drake, Douglas Arnold 1943- *WhoAmA 80, -82, -84*
Drake, Ebenezer 1729?- *FolkA 86*
Drake, Elizabeth 1866- *DcBrA 1*
Drake, Elizabeth 1866-1954 *DcWomA*
Drake, Florence Bonn 1885-1958 *ArtsAmW 3*
Drake, Frank C 1868-1922 *WhAmArt 85*
Drake, Frank John 1934- *AmArch 70*
Drake, Friedrich Johann Heinrich 1805-1882 *ArtsNiC*
Drake, G E *AmArch 70*
Drake, H L *AmArch 70*
Drake, Hilah *DcWomA*
Drake, Hilah T *WhAmArt 85*
Drake, James 1946- *WhoAmA 76, -78, -80, -82, -84*
Drake, Johann Friedrich 1805-1882 *McGDA*
Drake, John Poad 1794?-1883 *NewYHSD*
Drake, Lawrence 1941- *AmArch 70*
Drake, Louis Allen 1922- *AmArch 70*
Drake, Millicent *DcWomA, WhAmArt 85*
Drake, Nathan 1728?-1778 *DcBrECP, DcBrWA*
Drake, Nathaniel, Jr. *FolkA 86*
Drake, Paul Woodhull 1897- *AmArch 70*
Drake, Peter Woodhull 1930- *AmArch 70*
Drake, Ruth H *WhAmArt 85*
Drake, Samuel Gardiner *FolkA 86*
Drake, Silas *FolkA 86*
Drake, Stanley 1921- *WorECom*
Drake, Vernon Leslie 1922- *AmArch 70*
Drake, W *DcVicP 2*
Drake, W K *AmArch 70*
Drake, Will H 1856-1926 *WhAmArt 85*
Drake, Will Henry 1856-1926 *ArtsAmW 2*
Drake, William *NewYHSD*
Drake, William A 1891- *WhAmArt 85*

Drake, William Henry 1856- *DcBrBI*
Drakos, Louis John 1918- *AmArch 70*
Drane, Bernard King 1929- *AmArch 70*
Drane, Clara *DcWomA*
Drane, Herbert Cecil *DcVicP 2*
Drane, Louis Edward, Jr. 1922- *AmArch 70*
Draney, John P 1880-1938 *BiDAmAr*
Drapell, Joseph 1940- *DcCAr 81, WhoAmA 84*
Draper, Augusta *DcWomA, FolkA 86*
Draper, Charles F *DcVicP 2*
Draper, D W *AmArch 70*
Draper, Dorothy 1889-1969 *DcD&D[port]*
Draper, Earle Sumner, Jr. 1919- *AmArch 70*
Draper, Francis *WhAmArt 85*
Draper, George *BiDBrA*
Draper, Harriette Elza *DcWomA, WhAmArt 85*
Draper, Herbert James 1863-1920 *DcBrA 1*
Draper, Herbert James 1864-1920 *ClaDrA, DcBrBI,*
DcVicP, -2
Draper, John *NewYHSD*
Draper, John William 1811-1882 *ICPEnP*
Draper, Josiah Everett 1915- *WhoAmA 76, -78, -80,*
-82, -84
Draper, Ken 1944- *ConBrA 79[port]*
Draper, Kenneth 1944- *DcCAr 81*
Draper, Line Bloom *WhoAmA 73, -76*
Draper, Richard *CabMA*
Draper, Robert 1820?- *NewYHSD*
Draper, Robert Sargent 1920- *WhoAmA 73, -76*
Draper, William *NewYHSD*
Draper, Mrs. William *DcBrECP*
Draper, William Franklin 1912- *WhAmArt 85,*
WhoAmA 73, -76, -78, -80, -82, -84
Drapier, Marie Josephine *DcWomA*
Drasbek, Ib *WorFshn*
Drasbek, Sos 1938- *WorFshn*
Drasnin, S M *AmArch 70*
Dravneek, Henry *WhAmArt 85*
Draw *DcBrBI*
Draw, Florence *DcVicP 2*
Draw, H *DcVicP 2*
Drawbridge, John 1930- *DcCAr 81*
Drawbridge, William S *FolkA 86*
Drawneek, Edward Alexander 1945- *MarqDCG 84*
Drax, Miss *DcWomA*
Drayer, Donald Hudson 1909- *AmArch 70*
Drayton, Emily *DcWomA, WhAmArt 85*
Drayton, G G 1877-1936 *WhAmArt 85*
Drayton, Grace 1877-1936 *WorECom*
Drayton, Grace Wiederseim 1875?-1936 *DcWomA*
Drayton, J *NewYHSD*
Drayton, John *NewYHSD*
Drayton, John 1766-1822 *NewYHSD*
Drayton, Joseph *ArtsAmW 1, EarABI, IlBEAAW,*
NewYHSD
Drayton, L *DcVicP 2*
Drayton, Michael 1563-1631 *AntBDN I*
Drayton, William J 1732-1790 *BiDAmAr*
Draz, F K *AmArch 70*
Dreaper, Richard Edward 1935- *WhoAmA 78, -80,*
-82, -84
Drebbers, Maria *DcWomA*
Dreber, Heinrich 1822-1875 *ArtsNiC*
Drebestare, E M *DcWomA*
Drechsel, Johanne 1867- *DcWomA*
Drechsler, Johann Baptist 1756-1811 *ClaDrA*
Drecoll *FairDF FRA, WorFshn*
Dredge, Miss *DcWomA*
Dreese, Thomas *FolkA 86*
Dreger, Garvin Taylor 1932- *AmArch 70*
Dreghorn, Allan 1706-1764 *BiDBrA*
Dreher, E *NewYHSD*
Dreher, Frederick W 1867- *ArtsEM*
Dreher, Leo O 1911- *AmArch 70*
Drehmann, Oscar A *WhAmArt 85*
Dreiband, Laurence 1944- *WhoAmA 73, -76, -78, -80,*
-82, -84
Dreibholz, Christiaan Lodewijk Willem 1799-1874 *DcSeaP*
Dreier, D A *WhAmArt 85*
Dreier, Dorothea A d1923 *WhAmArt 85*
Dreier, Dorothea A 1870-1923 *DcWomA*
Dreier, Hans 1885-1966 *ConDes*
Dreier, Katherine S d1952 *WhoAmA 78N, -80N,*
-82N, -84N
Dreier, Katherine S 1877-1952 *OxTwCA,*
WhAmArt 85
Dreier, Katherine Sophie 1877-1952 *DcWomA*
Dreifoos, Byron G 1890- *WhAmArt 85*
Dreifus, Henry N *MarqDCG 84*
Dreisbach, Clarence Ira 1903- *WhoAmA 73, -76*
Dreiser, Peter 1936- *WhoArt 80, -82, -84*
Dreitzer, Albert J 1902- *WhoAmA 73, -76, -78, -80,*
-82
Dreizler, Anne Carol 1955- *MarqDCG 84*
Dreka, Louis 1839?- *NewYHSD*
Drenan, Lawrence A 1954- *MarqDCG 84*
Drennan, Georgia Bertha *DcWomA, WhAmArt 85*
Drennan, O E, Jr. *AmArch 70*
Drennan, Vincent Joseph 1902- *WhAmArt 85*
Dreppert, C W 1892- *WhAmArt 85*

Dresch, Augusta M *DcVicP 2*
Dreschel, Alfred *FolkA 86*
Drescher, Irving Earl 1922- *AmArch 70*
Dresel, Emil *IlBEAAW, NewYHSD*
Dresel, Louisa *DcWomA, WhAmArt 85*
Dreser, William 1820?- *NewYHSD*
Dreskin, Jeanet Elizabeth 1952- *WhoAmA 76*
Dreskin, Jeanet Steckler 1921- *WhoAmA 73, -76, -78,*
-80, -82, -84
Dreskin, Sanford A 1936- *MarqDCG 84*
Dreskin-Haig, Jeanet Elizabeth 1952- *WhoAmA 78,*
-80, -82, -84
Dresner, Bernard Milton 1917- *MarqDCG 84*
Dressel, Clara 1856- *DcWomA*
Dressel, Emil *ArtsAmW 1*
Dressel, John *FolkA 86*
Dressel, Kister And Company *DcNiCA*
Dressel, L, Jr. *AmArch 70*
Dresser, Aileen King *WhAmArt 85*
Dresser, Arthur *DcVicP 2*
Dresser, Mrs. Arthur *DcVicP 2*
Dresser, Christopher *AntBDN M*
Dresser, Christopher 1834-1904 *AntBDN A,*
DcNiCA, IlDcG, MacEA
Dresser, Genevieve Tyler 1856- *DcWomA,*
WhAmArt 85
Dresser, George Cuthbert 1872-1951 *DcBrA 1*
Dresser, Harvey 1789-1835 *FolkA 86*
Dresser, Jane *WhAmArt 85*
Dresser, Lawrence *IlsBYP*
Dresser, Lawrence Tyler *WhAmArt 85*
Dresser, Louisa 1907- *WhAmArt 85, WhoAmA 73,*
-76, -78, -80, -84
Dresser, R H *AmArch 70*
Dressler, Ada *DcVicP 2*
Dressler, Bertha *DcWomA, WhAmArt 85*
Dressler, Conrad 1856-1940 *DcBrA 1, DcNiCA*
Dressler, Edward James 1859- *WhAmArt 85*
Dressler, Edward James 1859-1907 *ArtsAmW 3*
Dressler, Emil *WhAmArt 85*
Dressler, Otto 1930- *ConArt 77*
Dressler, S O *FolkA 86*
Dreux, Louise Marie De *DcWomA*
Drever, Adrian Van *ClaDrA*
Drever, Richard Alston, Jr. 1936- *AmArch 70*
Drevet, Angelique Marie *DcWomA*
Drevet, Claude 1697-1781 *McGDA*
Drevet, Jean Baptiste 1854- *ClaDrA*
Drevet, Pierre 1663-1738 *McGDA*
Drevet, Pierre Imbert 1697-1739 *McGDA*
Drevo, William Luk, Sr. 1905- *AmArch 70*
Drew *FolkA 86*
Drew, A Farnsworth 1866-1941 *WhAmArt 85*
Drew, Alvin *FolkA 86*
Drew, Antoinette Farnsworth 1866-1941 *DcWomA*
Drew, Clement *NewYHSD*
Drew, Clement 1806-1889 *DcSeaP, FolkA 86,*
WhAmArt 85
Drew, Edward *AntBDN D, NewYHSD*
Drew, George H 1833?- *NewYHSD*
Drew, George W 1875- *WhAmArt 85*
Drew, Herbert J *DcBrA 1*
Drew, J D *AmArch 70*
Drew, J P *DcVicP, -2*
Drew, Jacob 1909- *DcBrA 1*
Drew, Jane B 1911- *ConArch, MacEA*
Drew, Jane Beverly 1911- *DcD&D[port], EncMA*
Drew, Joan 1916- *WhoAmA 73, -76, -78*
Drew, Lewis *NewYHSD*
Drew, Lewis 1885-1915 *WhAmArt 85*
Drew, Mary *DcVicP 2, DcWomA*
Drew, Pamela 1910- *DcBrA 1, WhoArt 80, -82, -84*
Drew, Philip *ConArch A*
Drew, R L *AmArch 70*
Drew, Roy Morse 1913- *AmArch 70*
Drew, S J *DcVicP 2*
Drew, Thomas *BiDBrA*
Drew, Sir Thomas 1838-1910 *DcBrA 2*
Drew, W H *FolkA 86*
Drew, William Winter 1882-1933 *WhAmArt 85*
Drew-Bear, Jessie Henderson 1877?-1962 *DcWomA*
Drewal, Henry John 1943- *WhoAmA 78, -80, -82,*
-84
Drewe, Reginald Frank Knowles 1878- *DcBrA 1*
Drewelowe, Eve *WhoAmA 73, -76, -78, -80, -82, -84*
Drewes, Curt J H *WhAmArt 85*
Drewes, Werner 1899- *ArtsAmW 3, DcCAA 71, -77,*
WhAmArt 85, WhoAmA 73, -76, -78, -80, -82,
-84
Drewes, Wolfram U 1929- *MarqDCG 84*
Drewitt, Geoffrey Crellin 1921- *DcBrA 1,*
WhoArt 80, -82, -84
Drewry, John Boleyn 1917- *AmArch 70*
Drews, Donald Frederick 1928- *AmArch 70*
Drexel, Anthony *FolkA 86, NewYHSD*
Drexel, Antony *NewYHSD*
Drexel, Francis Martin 1792-1863 *NewYHSD*
Drexler, Arthur Justin 1925- *WhoAmA 80, -82, -84*
Drexler, Lynne *WhoAmA 73, -76, -78, -80, -82, -84*
Drexler, Paul Eugene 1940- *WhoAmA 76, -78, -80*
Drexler, Seymour 1924- *AmArch 70*

Drey, Agnes *DcBrA 2*
Drey, John *FolkA 86*
Dreyer, Alvin 1933- *AmArch 70*
Dreyer, Benedictus *McGDA*
Dreyer, Gay 1915- *WhoAmA 82, -84*
Dreyer, Margaret Webb *WhoAmA 73, -76, -78, -80, -82*
Dreyer, Paul Uwe 1939- *DcCAr 81*
Dreyer, Rudolph Simon 1934- *AmArch 70*
Dreyfous, Felix Julius 1896- *AmArch 70*
Dreyfous, Florence *DcWomA, WhAmArt 85*
Dreyfus, Isidora C 1896- *DcWomA, WhAmArt 85*
Dreyfus, Marguerite 1879- *DcWomA*
Dreyfus, Maria *DcWomA*
Dreyfuss, Albert 1880- *WhAmArt 85*
Dreyfuss, Albert M 1920- *AmArch 70*
Dreyfuss, Caril E *WhoAmA 76*
Dreyfuss, Edmund Woog 1914- *AmArch 70*
Dreyfuss, Henry 1904- *McGDA, WhAmArt 85*
Dreyfuss, Henry 1904-1972 *ConDes*
Drielenburg, Willem Van 1632-1677? *McGDA*
Drielsma, J A *AmArch 70*
Drielst, Egbert Van 1746-1818 *ClaDrA*
Drier, Dorothea A *WhAmArt 85*
Dries, Antoon 1910- *ConPhot, ICPEnP A*
Driesbach, David F 1922- *PrintW 83, -85*
Driesbach, David Fraiser 1922- *WhoAmA 73, -76, -78, -80, -82, -84*
Driesbach, Walter Clark, Jr. 1929- *WhoAmA 73, -76, -78, -80, -82, -84*
Driese, Louise K *WhAmArt 85*
Driessen, Angela Kosta *WhoAmA 82, -84*
Driesten, Marie Fernande *DcWomA*
Driffield, Vero Charles 1848-1915 *ICPEnP, MacBEP*
Drift, Johannes Adrianus VanDer 1808-1883 *ClaDrA*
Driggs, Mrs. *DcWomA*
Driggs, Beth *DcWomA, WhAmArt 85*
Driggs, Elsie 1898- *DcWomA, WhAmArt 85, WhoAmA 73, -76, -78, -80, -82, -84*
Driggs, H S, Jr. *AmArch 70*
Driggs, M L *DcWomA*
Driggs, Mrs. M L *ArtsEM*
Drimmel, Edwin J, Jr. 1932- *AmArch 70*
Dring, Dennis William 1904- *ClaDrA, DcBrA 1*
Dring, James 1905- *ClaDrA, WhoArt 80, -82, -84*
Dring, James Grinard 1905- *DcBrA 1*
Dring, Lilian M 1908- *WhoArt 80, -82, -84*
Dring, W 1904- *WhoArt 80, -82, -84*
Drinker, Catharine Ann Janvier 1841-1922 *DcWomA*
Drinker, Elizabeth *FolkA 86*
Drinker, John *FolkA 86, NewYHSD*
Drinker, Philip *FolkA 86*
Drinkhouse, John N *FolkA 86*
Drinkhouse, William H *FolkA 86*
Drinkwater, *BiDDBA*
Drinkwater, G Nevin 1904- *WhoArt 80, -82*
Drinkwater, George Carr 1880-1941 *DcBrA 1*
Drinnan, Charles H 1944- *MarqDCG 84*
Dripps, Clara Reinicke 1885- *ArtsAmW 1, DcWomA*
Drisch, Russell 1944- *DcCAr 81, MacBEP*
Driscoll, Barry *IlsCB 1957*
Driscoll, D J *AmArch 70*
Driscoll, Dale Joseph 1906- *WhAmArt 85*
Driscoll, Donald Bruce 1933- *AmArch 70*
Driscoll, Edgar Joseph, Jr. 1920- *WhoAmA 73, -76, -78, -80, -82, -84*
Driscoll, G Griffin 1900- *WhAmArt 85*
Driscoll, H 1819?- *NewYHSD*
Driscoll, John Paul 1949- *WhoAmA 80, -82, -84*
Driscoll, Sidney Porter, Jr. 1920- *AmArch 70*
Driskel, J R *AmArch 70*
Driskell, David Clyde 1931- *AfroAA, WhoAmA 73, -76, -78, -80, -82, -84*
Drissell, John *FolkA 86*
Driukow, German 1934- *ICPEnP A*
Driver, James 1859-1923 *BiDAmAr*
Driver, Morley-Brooke Lister 1913- *WhoAmA 73, -76, -78*
Driver, Samuel d1779 *BiDBrA*
Driver, Sydney Amos 1865- *DcBrA 1*
Driver, Walter E 1944- *MarqDCG 84*
Drljacha, Zorica 1942- *WhoArt 80, -82, -84*
Drob, Pearl *AfroAA*
Drobek, Carol Marie 1949- *MacBEP*
Drobenare Brothers *EncASM*
Drobnik, Antonin 1925- *DcCAr 81*
Droege, Anthony Joseph, II 1943- *WhoAmA 76, -78, -80, -82, -84*
Droese, Lizzie L *ArtsEM, DcWomA*
Droeshout, Martin 1601- *OxArt*
Droffig, J J *DcVicP 2*
Drogkamp, Charles *WhAmArt 85*
Drogkamp, Charles d1958 *WhoAmA 80N, -82N, -84N*
Drogseth, Eistein Olaf *WhAmArt 85*
Drohojowska, Hunter 1952- *WhoAmA 82, -84*
Droisy, Emma Marie T 1868- *DcWomA*
Drojat, Elisa 1828- *DcWomA*
Droll, Donald E *WhoAmA 78, -80*
Drolling, Louise Adeone 1797- *DcWomA*
Drolling, Martin 1752-1817 *ClaDrA, McGDA*

Drolling, Michel Martin 1786-1851 *ClaDrA*
Drolshagen, Henry B *ArtsEM*
Dronberger, Merrill Dale 1923- *AmArch 70*
Dronsfield, John L 1900-1951 *OxArt*
Drooch Sloot, Joost Cornelisz 1586-1666 *ClaDrA*
Drooghsloot, Joost Cornelisz 1586-1666 *McGDA*
Droogsloot, Joost Cornelisz 1586-1666 *ClaDrA*
Droost, Jan Van 1638-1694 *ClaDrA*
Dropping, Anton Edward 1917- *AmArch 70*
Drossaert, Jacob *ClaDrA*
Drost, Willem *OxArt*
Droste, Peter Carl 1948- *MarqDCG 84*
Drouaillet, Gustav *NewYHSD*
Drouais, Francois-Hubert 1727-1775 *McGDA, OxArt*
Drouais, Hubert 1699-1767 *McGDA*
Drouais, Jean Germain 1763-1788 *ClaDrA*
Drouais, Jean-Germain 1763-1788 *McGDA*
Drouart-Rousseau, Alice *DcWomA*
Drouault, Berthe Marie *DcWomA*
Drouault, Marie Julia 1853- *DcWomA*
Droucker, Leon *WhAmArt 85*
Drouet, Madame *DcWomA*
Drouet, Bessie Clarke 1879-1940 *DcWomA*
Drouet, Clarke 1879-1940 *WhAmArt 85*
Drouet-Cordier, Suzanne 1885- *DcWomA*
Droughman, Edwin F *WhAmArt 85*
Drouin, Madame *DcWomA*
Drouin, Barbara Von d1796 *DcWomA*
Drouin, Raymond Lucien 1925- *AmArch 70*
Droulers, Robert 1920- *DcCAr 81*
Drover, Richard Edward 1913- *AmArch 70*
Drower, Sara Ruth 1938- *WhoAmA 76, -78, -80, -82, -84*
Drown, W Staples d1915 *WhAmArt 85*
Drowne, Deacon Shem 1683-1774 *FolkA 86*
Drowne, Shem 1683-1774 *NewYHSD*
Drowne, Thomas *FolkA 86*
Droz, A *NewYHSD*
Droz, Jules-Antoine 1807-1871? *ArtsNiC*
Drozda, Thomas Joseph 1951- *MarqDCG 84*
Drtikol, Frantisek 1883-1961 *ConPhot, ICPEnP, MacBEP*
Druce, Elsie *DcBrA 1*
Druce, Elsie d1965? *DcWomA*
Druce, Helen *DcVicP 2, DcWomA*
Druce, R *DcVicP 2*
Drucez, P J *NewYHSD*
Druck-VonStockmayer, Elise 1862- *DcWomA*
Drucker, Amy Julia *DcBrA 1, DcWomA*
Drucker, Boris 1920- *WorECar*
Drucker, Mort 1929- *ConGrA 1[port], WorECar*
Drucker, Robert Leonard 1926- *AmArch 70*
Druckman, Paul Jay 1952- *MarqDCG 84*
Druid, Daniel T B 1946- *MarqDCG 84*
Druillet, Philippe 1944- *WorECom*
Druitt, Emily *DcVicP 2*
Drum, Sydney 1952- *DcCAr 81*
Drum, Sydney Maria 1952- *PrintW 83, -85, WhoAmA 82, -84*
Drumaux, Angelina 1881-1959 *DcWomA*
Drumm, Don 1935- *WhoAmA 73, -76, -78, -80, -82, -84*
Drumm, Larry E 1946- *MarqDCG 84*
Drummer, John E 1935- *DcCAr 81*
Drummer, William Richard 1925- *WhoAmA 82, -84*
Drummey, W W *AmArch 70*
Drummond 1923- *WhoAmA 73, -76, -78, -80*
Drummond, A A 1856- *DcWomA*
Drummond, A A 1891-1978? *WhAmArt 85*
Drummond, Mrs. A A 1856- *ArtsAmW 3*
Drummond, Arthur 1871-1951 *DcBrA 1, DcVicP 2*
Drummond, Arthur 1891- *WhoAmA 73, -76, -78N, -80N, -82N, -84N*
Drummond, Mrs. Charles *WhAmArt 85*
Drummond, Donald Foster 1930- *AmArch 70*
Drummond, E *DcVicP 2*
Drummond, E D *AmArch 70*
Drummond, Eliza *DcWomA*
Drummond, Eliza A *DcWomA*
Drummond, F Ellen *DcWomA*
Drummond, G *DcVicP 2*
Drummond, Gordon L T 1921- *ClaDrA*
Drummond, H *DcVicP 2*
Drummond, Harriett D *DcWomA*
Drummond, J Nelson *DcWomA*
Drummond, James 1816-1877 *ArtsNiC, ClaDrA, DcBrBI, DcBrWA, DcVicP, -2*
Drummond, James F *WhAmArt 85*
Drummond, Jane *DcWomA*
Drummond, Jeanne Redpath *DcWomA*
Drummond, John *CabMA*
Drummond, John Murray 1802-1889 *DcBrWA, DcVicP 2*
Drummond, Julian *DcVicP 2*
Drummond, Julian E *DcBrWA, DcVicP 2*
Drummond, Larry Edward 1941- *MarqDCG 84*
Drummond, M J *FolkA 86*
Drummond, Malcolm *OxTwCA*
Drummond, Malcolm 1880-1945 *DcBrA 1*
Drummond, Nadine 1912- *WhAmArt 85*
Drummond, Rosabella *DcWomA*

Drummond, Rose Emma *DcWomA, FolkA 86*
Drummond, Rose Myra *DcWomA*
Drummond, Sally Hazelet 1924- *DcCAA 71, -77, WhoAmA 73, -76, -78, -80, -82, -84*
Drummond, Samuel 1765-1844 *DcBrWA, DcSeaP*
Drummond, Samuel 1770?-1844 *DcBrECP*
Drummond, Miss V H 1911- *DcBrA 2*
Drummond, V H 1911- *WhoArt 80, -82, -84*
Drummond, Violet Hilda *IlsCB 1967*
Drummond, Violet Hilda 1911- *IlsBYP, IlsCB 1946, -1957*
Drummond, W *DcVicP 2*
Drummond, William *DcBrWA*
Drummond-Davies, Mrs. 1862-1949 *DcWomA*
Drumont, Honorine *DcWomA*
Druon, Germaine *DcWomA*
Drury, Ada *DcVicP 2*
Drury, Alfred 1859-1944 *OxTwCA*
Drury, Alfred Paul Dalou 1903- *DcBrA 1*
Drury, Edward Alfred Briscoe 1856-1944 *DcBrA 1*
Drury, Felix Ralph Reinhold 1928- *AmArch 70*
Drury, George Murlin 1905- *AmArch 70*
Drury, Herbert R 1873- *WhAmArt 85*
Drury, Hope Curtis 1889- *DcWomA, WhAmArt 85*
Drury, J H 1816- *ArtsNiC*
Drury, John H 1816- *NewYHSD , WhAmArt 85*
Drury, Lynn J *AmArch 70*
Drury, N S *ArtsEM*
Drury, Paul Dalou 1903- *ClaDrA, WhoArt 80, -82, -84*
Drury, R R *AmArch 70*
Drury, Susan O'Rourke *DcWomA*
Drury, Susanna *DcBrWA, DcWomA*
Drury, William H 1888- *WhAmArt 85*
Drury, William H 1888-1960 *WhoAmA 80N, -82N, -84N*
Drutt, Helen Williams 1930- *WhoAmA 78, -80, -82, -84*
Drutz, June 1920- *WhoAmA 73, -76, -78, -80, -82, -84*
Dry, Daniel *FolkA 86*
Dry, James Richard 1926- *AmArch 70*
Dry, John *FolkA 86*
Dry, Lewis *FolkA 86*
Dry, Nathaniel *FolkA 86*
Dry DeSennecy, Fanny *DcWomA*
Dryansky, Gerald Y *WorFshn*
Dryden, A N *AmArch 70*
Dryden, A N, Jr. *AmArch 70*
Dryden, H E, Jr. *AmArch 70*
Dryden, Helen *WhAmArt 85*
Dryden, Helen 1887- *DcWomA*
Dryden, Ray Edward 1910- *AmArch 70*
Dryer, Della Frances *WhAmArt 85*
Dryer, Leona M *WhAmArt 85*
Dryer, Leona N *DcWomA*
Dryer, Rufus J *WhAmArt 85*
Dryfoos, Nancy *AmArt, WhoAmA 73, -76, -78, -80, -82, -84*
Drynan, Douglas H 1917- *AmArch 70*
Drysdale, Alexander John 1870-1934 *WhAmArt 85*
Drysdale, George Russell 1912- *DcBrA 1, McGDA, OxArt*
Drysdale, Harold 1927- *AfroAA*
Drysdale, J T *DcVicP 2*
Drysdale, Mary *DcVicP 2, DcWomA*
Drysdale, Nancy McIntosh 1931- *WhoAmA 82, -84*
Drysdale, Russell 1912- *ConArt 77, DcCAr 81, OxTwCA*
Drysdale, Russell 1912-1981 *ConArt 83*
D'Sa, Alwyn Patrick *MarqDCG 84*
Dshgupova, Maria 1897- *DcWomA*
Dt Coochsiwukioma 1946- *WhoAmA 76*
Duane, Anne Deas *WhAmArt 85*
Duane, Frank James 1902- *AmArch 70*
Duane, Franklin James 1932- *AmArch 70*
Duane, James *NewYHSD*
Duane, Josann Watkins 1944- *MarqDCG 84*
Duane, Tanya *WhoAmA 76, -78, -80N, -82N, -84N*
Duane, William *DcBrBI*
Duart, Angel *OxTwCA*
Duarte, Clementina *WorFshn*
Duarte, Jose *OxTwCA*
Duassut, Curtius *DcVicP 2*
Dub, Jaroslav 1878- *DcBrA 1*
Dubach, David *BiDAmAr*
Duback, Charles S 1926- *WhoAmA 78, -80, -82, -84*
Duban, Felix 1797-1870 *MacEA*
Duban, Jacques Felix 1797-1870 *McGDA*
Duban, Jacques-Felix 1797-1871? *ArtsNiC*
Dubaniewicz, Peter Paul 1913- *WhoAmA 73, -76, -78, -80, -82, -84*
Dubasky, Valentina 1951- *PrintW 85*
Dubasty, E *DcWomA*
Dubasty, Henry *DcVicP 2*
Dubaut, Jane 1885- *DcWomA*
Dubbels, Hendrick-Jacobsz 1620?-1676 *DcSeaP*
Dubbels, Hendrick Jacobsz 1620?-1676 *McGDA*
Dubbels, Hendrik Jacobsz 1621?-1676? *ClaDrA*
Dubbels, Jan *ClaDrA*

Dubbs, Helen Miller *DcWomA*
Dubbs, Isaac *FolkA 86*
Dube, Mrs. *DcWomA*
Dube, Louis Theodore 1861- *IlBEAAW*
Dube, Mattie 1861- *DcWomA, WhAmArt 85*
Dube, Robert Jonathan 1954- *MarqDCG 84*
Dube, Stanley Robert 1919- *AmArch 70*
Dubertrand-Schiff, Jeanne Marie H *DcWomA*
Dubin, A D *AmArch 70*
Dubin, Martin David 1927- *AmArch 70*
Dubin, Ralph 1918- *WhoAmA 73, -76, -78, -80, -82,*
 -84
Dubinsky, David 1892- *WorFshn*
Dubinsky, David Alexandrovich 1920- *WhoGrA 62*
Dubitsky, S T *AmArch 70*
Dublac, Robert Revak 1938- *WhoAmA 82, -84*
DuBlaisel, H *DcWomA*
Duble, Jonathan *FolkA 86*
Duble, Lu 1896- *McGDA*
Duble, Lu 1896-1970 *DcWomA, WhAmArt 85,*
 WhoAmA 78N, -80N, -82N, -84N
Dubnoff, Ena Marie 1938- *AmArch 70*
Duboc, M A *DcVicP 2*
DuBois, Abraham *AntBDN Q*
DuBois, Aime *CabMA*
DuBois, Alan Beckman 1935- *MacBEP*
DuBois, Alan Beekman 1935- *WhoAmA 84*
DuBois, Albert 1831?- *NewYHSD*
Dubois, Ambroise 1543-1614 *McGDA*
Dubois, Anne *DcWomA*
Dubois, C E *AmArch 70*
Dubois, Catharina d1776 *DcWomA*
Dubois, Charles E *ArtsNiC*
Dubois, Charlotte *DcWomA*
Dubois, Constance 1840- *DcWomA*
DuBois, Mrs. Cornelius *NewYHSD*
Dubois, D B *AmArch 70*
DuBois, Daniel N 1802?-1846 *NewYHSD*
DuBois, Desire d1889 *ClaDrA*
Dubois, Francois 1790-1871 *ClaDrA*
DuBois, George *NewYHSD*
Dubois, German *AntBDN D*
Dubois, Guillem 1610?-1680 *McGDA*
DuBois, Guy Pene 1884-1958 *BnEnAmA, DcCAA 71,*
 -77, McGDA, PhDcTCA 77, WhAmArt 85,
 WhoAmA 80N, -82N, -84N
DuBois, H W *NewYHSD*
DuBois, Henri Pene 1859-1906 *WhAmArt 85*
Dubois, Jacques 1693?-1763 *AntBDN G, OxDecA*
Dubois, Jacques 1912- *WhoGrA 62*
Dubois, Jacques Eugene Joseph 1912-
 WhoGrA 82[port]
DuBois, Macy 1929-
 ConArch, WhoAmA 76, -78, -80, -82,
 -84
Dubois, Madeleine *DcWomA*
Dubois, Marguerite 1883- *DcWomA*
Dubois, Maria *DcWomA*
DuBois, Mary Ann 1813-1888 *DcWomA*
DuBois, Mary Ann Delafield 1813-1888 *NewYHSD*
Dubois, Nicholas 1665?-1735 *BiDBrA*
DuBois, Patterson 1847-1917 *ArtsAmW 1,*
 WhAmArt 85
Dubois, Paul 1829- *ArtsNiC*
Dubois, Paul 1829-1905 *ClaDrA, McGDA*
DuBois, R P *NewYHSD*
DuBois, Raoul Henri Pene 1912- *WhAmArt 85*
DuBois, Raoul Pene 1914- *ConDes*
Dubois, Rene 1757-1798 *OxDecA*
DuBois, Roberte *DcWomA*
DuBois, Samuel F 1805-1889 *NewYHSD*
DuBois, William Pene *IlsCB 1967*
DuBois, William Pene 1916- *IlsCB 1744, -1946, -1957*
DuBois, Yvonne Pene 1913- *WhAmArt 85*
Dubois-Davesne, Marguerite Fanny 1832-1900
 DcWomA
Dubois DeLestang, Adele, Comtesse d1868 *DcWomA*
Dubois DeNiermont, Laure Marie P Henri *DcWomA*
Dubois-Ponsot, M Eva *DcWomA*
Dubois-Trinquier, Suzanne *DcWomA*
Dubordieu, Pieter d1679? *ClaDrA*
Dubors, Oliver *FolkA 86*
Dubos, Angele 1844- *DcWomA*
Dubos, Marie Jeanne 1700?- *DcWomA*
Duboscq, Louis Jules 1817-1886 *MacBEP*
DuBose, Charles 1908- *AmArch 70, WhAmArt 85*
Dubost, R *DcWomA*
Dubouche, Theolinde *DcWomA*
Duboulan, Jeanne 1861- *DcWomA*
Dubouloz, Sophava *DcWomA*
Dubourcq, Pierre Louis 1815-1873 *ClaDrA*
DuBourdieu, Charles William, Jr. 1936- *AmArch 70*
DuBourg, Louis Fabricius 1693-1775 *ClaDrA*
DuBourg, M *DcBrECP*
Dubourg, Victoria *DcWomA*
Dubourg, Victoria 1840- *DcVicP 2*
Dubourg, Victoria 1840-1926 *WhoArt*
Dubourjal, Edme Savinien 1795-1865 *NewYHSD*
Dubourjal, Savinien Edme 1795-1865 *NewYHSD*
DuBousquet, Eugene *NewYHSD*
DuBousquet, Helene *DcWomA*

Dubout, Albert 1905-1976 *WorECar*
Duboy, Paul *WhAmArt 85*
Duboys, Eugenie *DcWomA*
DuBrau, Gertrud *WhAmArt 85*
DuBrau, Gertrud Margarete Kogler 1889- *DcWomA*
Dubray, Charlotte Gabrielle *ArtsNiC, DcWomA*
Dubray, Eugenie Giovanna *ArtsNiC*
Dubray, Gabriel-Vital 1818?- *DcWomA*
Dubray, Severine 1858- *DcWomA*
Dubreau, Louise *DcWomA*
Dubreuil, Cheri *DcSeaP*
Dubreuil, Marie 1849?- *DcWomA*
Dubreuil, Toussaint 1561?-1602 *McGDA, OxArt*
Dubreuil, Victor *DcAmArt*
Dubreuil-Myszkovska, Marie *DcWomA*
Dubroca, Manuel Alise *DcWomA*
Dubroeucq, Jacques 1500?-1584 *McGDA, OxArt*
Dubron, Pauline 1852- *DcWomA*
Dubrow, Elaine *WhoAmA 80*
Dubrul *FolkA 86*
Dubsky, Vali 1929- *WorFshn*
Dubucand, Alfred 1828- *AntBDN C, DcNiCA*
Dubucquoy, Marguerite Pallu *DcWomA*
Dubufe, Claude Marie 1790-1864 *NewYHSD*
Dubufe, Claude-Marie 1793-1864 *ArtsNiC*
Dubufe, Edouard 1818?-1883 *ArtsNiC*
Dubufe, Guillaume *ArtsNiC*
Dubufe, Juliette *DcWomA*
Dubufe, Louis Edouard *DcVicP 2*
Dubufe-Wehrle, Juliette 1879- *DcWomA*
Dubuffet, Jean 1901- *ConArt 77, -83, DcCAr 81,*
 McGDA, OxArt, OxTwCA, PhDcTCA 77,
 PrintW 83, WhoArt 80, -82, -84, WorArt[port]
Dubuffet, Jean 1901-1985 *PrintW 85*
Dubuisson, Miss *DcVicP 2*
Dubuisson, E *DcWomA*
Dubuisson, Marguerite *DcWomA*
Dubuisson, Marie Isabelle *DcWomA*
DuBuque, David L 1949- *MacBEP*
Dubuque, Edward W 1900- *WhAmArt 85*
Dubuque, Richard John 1924- *AmArch 70*
Duburg, Amelie *DcWomA*
Duc, Joseph Louis 1802-1879 *ArtsNiC, McGDA,*
 WhoArch
Duc, Louis 1802-1879 *MacEA*
Duca, Alfred Milton 1920- *AmArt, WhoAmA 73,*
 -76, -78, -80, -82, -84
Duca, Giacomo Del 1520?- *OxArt*
DuCamp, Maxime 1822-1894 *ICPEnP, MacBEP*
DuCane, Ella *DcBrA 2*
Ducane, Ella *DcVicP 2, DcWomA*
Ducarre-Bussienne, Daisy *DcWomA*
Ducasse, Mabel 1895-1976 *DcWomA*
Ducasse, Mabel Lisle 1895- *ArtsAmW 1,*
 WhAmArt 85
Duccio Di Buoninsegna d1319? *OxArt*
Duccio DiBuoninsegna 1255?-1319 *McGDA*
DuCerceau, Baptiste *McGDA*
DuCerceau, Baptiste 1545?-1590 *OxArt*
DuCerceau, Baptiste 1545?-1590 *WhoArch*
DuCerceau, Charles d1606 *OxArt*
DuCerceau, Jacques 1550?-1614 *McGDA*
DuCerceau, Jacques 1550?-1614 *OxArt*
DuCerceau, Jacques Androuet 1510?-1584 *OxDecA*
DuCerceau, Jacques Androuet 1520?-1584? *McGDA,*
 WhoArch
DuCerceau, Jacques Androuet 1550?-1614 *WhoArch*
Ducerceau, Jacques Androuet, The Elder 1520?-1584?
 OxArt
DuCerceau, Jean 1585?- *WhoArch*
DuCerceau, Jean 1585?-1647? *McGDA*
Ducerceau, Jean 1585?-1649? *OxArt*
DuCerceau Family *MacEA*
DuChaffault, Marie L *DcWomA*
Duchamp, Gaston *McGDA*
Duchamp, Gaston 1875-1963 *WorECar*
Duchamp, Helen *FolkA 86*
Duchamp, Marcel 1887-1967 *BnEnAmA*
Duchamp, Marcel 1887-1968 *ConArt 77, -83[port],*
 DcCAA 71, -77, McGDA, OxArt, OxTwCA,
 PhDcTCA 77, WorArt[port]
Duchamp, Suzanne 1889-1963 *DcWomA*
Duchamp-Villon, Pierre-Maurice-Raymond 1876-1918
 OxTwCA
Duchamp-Villon, Raymond 1876-1918 *McGDA,*
 PhDcTCA 77
Duchange, Louise Jeanne *DcWomA*
Duchassey, M J *NewYHSD*
Duchateau, Madame *DcWomA*
Duchateau, Hugo *DcCAr 81*
Duchateau, Marie Therese 1870-1953 *DcWomA*
Duchatel, Frans 1625-1694? *McGDA*
Duchatel, Marie d1697 *DcWomA*
DuChattel, F J *DcVicP 2*
Duche, Andrew *FolkA 86*
Duche, Andrew 1710-1778 *AntBDN M*
Duche, Anthony *FolkA 86*
Duche, Thomas Spence, Jr. 1763-1790 *NewYHSD*
Duche DeVancy, Gaspard d1788 *NewYHSD*
Duchemin, Catherine 1630-1698 *DcWomA*
Duchemin, Isaak *ClaDrA*

Duchemin, Victoire *DcWomA*
Duchemin-Illaire, Mathilde Jenny *DcWomA*
Duchene, Cecilia 1770?- *DcWomA*
Duchenne DeBoulogne, Gillaume-Benjamin A 1806-1875
 MacBEP
Duchesnay, Henriette 1813-1873 *DcWomA*
Duchesne, Mrs. *DcWomA, NewYHSD*
Duchesne, Anais *DcWomA*
Duchesne, Catherine *DcWomA*
Duchesne, Janet *IlsCB 1967*
Duchesne, Janet 1930- *IlsCB 1957*
Duchesne, Valentine *DcWomA*
Duchon, Honorine *DcWomA*
Duchow, Achim 1948- *DcCAr 81*
Duchynska, Marie Helene 1852- *DcWomA*
Duchysarska, Marie Helene 1852- *DcWomA*
Ducis, Louis 1775-1847 *ClaDrA*
Duck, Jacob 1600?-1661? *ClaDrA*
Duck, Jacob 1600?-1667 *McGDA*
Ducker, Clara Estelle 1886- *ArtsAmW 3*
Ducker, Eugene 1841- *ArtsNiC*
Ducker, Marie 1847- *DcWomA*
Ducket, Maxim A *ArtsEM*
Duckett, Lady *DcVicP 2*
Duckett, Albert 1907- *WhAmArt 85*
Duckett, Ernest John
 WhoArt 80, -82, -84
Duckett, Ernest John 1916- *DcBrA 1*
Duckett, Lady Isabella *DcBrWA, DcWomA*
Duckett, Mathilde 1844- *DcWomA*
Duckett, R *DcBrA 2*
Duckett, Vernon Francis 1911- *WhAmArt 85*
Duckworth, Barbara 1913- *WhoArt 80, -82, -84*
Duckworth, Ruth 1919- *CenC, DcBrA 1, DcCAr 81,*
 WhoAmA 76, -78, -80, -82, -84
Duclary, Lepelletier 1824?- *NewYHSD*
Duclos, Antoine Jean 1742-1795 *McGDA*
DuClos, Ethel *DcWomA*
Duclos, Irene Anna *DcWomA*
Duclos, M A P *DcWomA*
Duclos, Marie Adelaide Louise *DcWomA*
Duclos-Cahon, Marie 1845- *DcWomA*
Ducloux, Madeleine *DcWomA*
Ducluseau, Zodalie Michel *DcWomA*
Ducluzeau, Marie Adelaide 1787-1849 *ClaDrA,*
 DcWomA
Ducmelic, Zdravko 1923- *OxTwCA*
Ducollet, Josephine *DcWomA*
Ducornet, Louis Joseph Cesar 1806-1856 *ClaDrA*
Ducos, Bathilde, Madame *DcWomA*
Ducos DuHauron, Louis 1837-1920 *ICPEnP,*
 MacBEP[port]
Ducoudray, Marie *DcWomA*
Ducq, Jan Le 1630?-1676 *ClaDrA*
Ducre *DcWomA*
DuCret, Dudley Vaughan 1919- *WhoAmA 73, -76*
Ducreux, Antoinette Clemence *DcWomA*
Ducreux, Joseph 1735-1802 *ClaDrA*
Ducreux, Joseph 1737-1802 *DcBrECP*
Ducreux, Baron Joseph 1735-1802 *McGDA*
Ducreux, Rose d1802 *DcWomA*
Ducros, Eleonore Francoise, Comtesse *DcWomA*
Ducrot, Jerome 1935- *ICPEnP A*
Ducrot-Icard, Francine *DcWomA*
Ducruet, Pauline *DcWomA*
Duczynska, Helene Von *DcWomA*
Duczynska, Irma Von 1869- *DcWomA*
Duczynska VonDuczta, Emilie *DcWomA*
Duda, Stanislav 1921- *WhoGrA 62, -82[port]*
Dudani, Sahib *MarqDCG 84*
Dudant, Roger 1929- *PhDcTCA 77*
Duddell *BiDBrA*
Duddell, James *CabMA*
Dudding, E B *DcVicP 2*
Duddles, R M, Jr. *AmArch 70*
Duddleson, C *FolkA 86*
Dudenbostel, Delbert Louis 1927- *AmArch 70*
Dudeney, Wilfred 1911- *DcBrA 1, WhoArt 80*
Dudensing, F Valentine 1901- *WhAmArt 85*
Dudensing, Richard d1899 *NewYHSD ,*
 WhAmArt 85
Dudgeon, Dorothea *DcVicP 2*
Dudgeon, E *DcVicP 2*
Dudgeon, Louisa *DcVicP 2, DcWomA*
Dudik, Marianne Catherine 1949- *MarqDCG 84*
Dudkin, Anatoli 1935- *ICPEnP A*
Dudley, Ambrose *DcBrBI, DcVicP 2*
Dudley, Arthur *DcVicP 2*
Dudley, Cameron Rigby 1921- *AmArch 70*
Dudley, Carol Reid d1908 *WhAmArt 85*
Dudley, Colin Joseph 1923- *DcBrA 1, WhoArt 80,*
 -82, -84
Dudley, Dan 1930- *DcCAr 81*
Dudley, Dorothy 1892- *DcWomA, WhAmArt 85*
Dudley, Fanny *WhAmArt 85*
Dudley, Frank V 1868- *WhAmArt 85*
Dudley, Gary J 1955- *MarqDCG 84*
Dudley, George A 1914- *AmArch 70*
Dudley, George Donald 1931- *AmArch 70*
Dudley, H R, Jr. *AmArch 70*

Dudley, Henry 1813-1894 *MacEA*
Dudley, Henry C *BiDAmAr*
Dudley, Jack *IlBEAAW*
Dudley, John 1915- *ClaDrA, WhoArt 84*
Dudley, John Richard 1931- *AmArch 70*
Dudley, Joseph *CabMA*
Dudley, Justin Z *ArtsEM*
Dudley, Katherine *WhAmArt 85*
Dudley, Katherine 1884- *ArtsAmW 2, DcWomA*
Dudley, Lee 1860-1940 *FolkA 86*
Dudley, Lem 1861-1932 *FolkA 86*
Dudley, R E *AmArch 70*
Dudley, Richard Hamilton 1931- *AmArch 70*
Dudley, Robert *DcBrBI, DcBrWA, DcVicP 2*
Dudley, Sir Robert 1573-1649 *AntBDN I*
Dudley, Robert Charles *DcVicP 2*
Dudley, Roy 1935- *DcCAr 81*
Dudley, Samantha Charlotte *FolkA 86*
Dudley, Thomas *DcBrWA, DcVicP 2*
Dudley, William Harold 1890- *DcBrA 1*
Dudley Neill, Anna 1935- *WhoArt 82, -84*
Dudok, Marinus 1884-1974 *WhoArch*
Dudok, W M 1884-1974 *MacEA*
Dudok, Willem 1884-1974 *ConArch*
Dudok, Willem Marinus 1884- *DcD&D[port], EncMA, McGDA, OxArt*
Dudreville, Leonardo *OxTwCA*
Dudson *FolkA 86*
Dueker, Kenneth John 1937- *MarqDCG 84*
Duell, Katherine *DcWomA*
Duell, Randall 1903- *AmArch 70*
Duer, Ben F 1888- *ArtsAmW 3*
Duer, Benjamin Franklin 1888- *ArtsAmW 3*
Duer, Douglas 1887-1964 *IlBEAAW, WhAmArt 85*
Duer, Henrietta A *WhAmArt 85*
Duer, W Richard 1921- *AmArch 70*
Duerr, Edward Harold 1924- *AmArch 70*
Duerschner, Arthur Erwin 1922- *AmArch 70*
Duerst, Roger Wayne 1931- *AmArch 70*
Duesberg, Otto *WhAmArt 85*
Duesbury, William 1725-1786 *AntBDN M*
Duez, Ernest Ange 1843-1896 *ClaDrA*
DuFaget, Athalie Josephine Melanie 1811- *DcWomA*
DuFais, John 1855-1935 *BiDAmAr, WhAmArt 85*
Dufau, Clementine Helene 1869- *ClaDrA, DcWomA*
Dufau, Fortune 1770-1821 *ClaDrA*
Dufault, Joseph *IlBEAAW*
Dufault, William James 1892-1942 *IlrAm D, -1880*
Dufaur, Marguerite *DcWomA*
Dufetre, Pauline *DcWomA*
Dufeu, Therese Francoise *DcWomA*
Duff, Ann Macintosh *WhoAmA 76, -78, -80, -82, -84*
Duff, Sir C G *DcBrBI*
Duff, C W *AmArch 70*
Duff, Dillard H 1909- *AmArch 70*
Duff, George 1888- *DcBrA 1*
Duff, Heather Mary Abercromby *DcWomA*
Duff, James H 1943- *WhoAmA 78, -80, -82, -84*
Duff, John 1943- *DcCAr 81*
Duff, John Ewing 1943- *PrintW 85, WhoAmA 76, -78, -80, -82, -84*
Duff, John Robert Keitley 1862- *ClaDrA*
Duff, John Robert Keitley 1862-1938 *DcBrA 1, DcBrWA, DcVicP 2*
Duff, John T *NewYHSD*
Duff, Jon M 1948- *MarqDCG 84*
Duff, Margery F *DcVicP 2, DcWomA*
Duff, Ned *NewYHSD*
Duff, Pernot Stewart 1898- *ArtsAmW 3*
Duff, Walter R *WhAmArt 85*
Duff, William Morris, II 1934- *AmArch 70*
Duff-Gordon, Lady 1864?-1935 *WorFshn*
Duffaud, Prefete *OxTwCA*
Duffey, E B *DcWomA*
Duffield, C M *DcVicP 2, DcWomA*
Duffield, E R *AmArch 70*
Duffield, Edward *NewYHSD*
Duffield, Mary Elizabeth 1819-1914 *DcBrWA, DcWomA*
Duffield, Peter L 1938- *MarqDCG 84*
Duffield, William 1816-1863 *ArtsNiC, DcBrWA, DcVicP, -2*
Duffield, Mrs. William *ArtsNiC*
Duffield, Mrs. William 1819- *DcVicP, -2*
Duffield, William L *DcVicP 2*
Duffies, Stanley Brittain, II 1931- *AmArch 70*
Duffin, J L *AmArch 70*
Duffin, Paul *DcBrECP*
Duffy, Betty Minor *WhoAmA 78, -80, -82, -84*
Duffy, Daniel J *DcBrA 1*
Duffy, Edmund d1962 *WhoAmA 78N, -80N, -82N, -84N*
Duffy, Edmund 1899-1962 *WhAmArt 85, WorECar*
Duffy, Emlyn Arthur Joseph 1916- *WhoArt 80, -82, -84*
Duffy, J A *AmArch 70*
Duffy, James Michael 1927- *AmArch 70*
Duffy, Mary *WhAmArt 85*
Duffy, Patrick Vincent 1832-1909 *DcBrA 2*
Duffy, Patrick Vincent 1836-1909 *DcBrA 1, DcVicP, -2*

Duffy, Richard 1832?- *NewYHSD*
Duffy, Richard H 1881- *WhAmArt 85*
Duffy, William 1830?- *NewYHSD*
Duflos, Elisabeth *DcWomA*
Duflos, Philothee Francois 1710-1746 *ClaDrA*
Duflot-Bailliere, Georgette 1885- *DcWomA*
Dufner, Edward 1871-1957 *WhAmArt 85, WhoAmA 80N, -82N, -84N*
Dufour, Alexander *BiDBrA*
Dufour, Anne Octavie *DcWomA*
Dufour, Augustine 1797- *DcWomA*
Dufour, Bernard 1922- *OxTwCA*
Dufour, Charles *DcBrECP*
Dufour, Elise 1824-1900? *DcWomA*
Dufour, Melina *DcWomA*
Dufour, Paul Arthur 1922- *WhoAmA 73, -76, -78, -80, -82, -84*
Dufour, Selima *DcWomA*
Dufour, William *DcBrECP*
Dufour-Neuhauser, Madame *DcWomA*
Dufourcq, A *DcVicP 2*
Dufourny, Leon 1754-1818 *MacEA*
Dufrechou, L F *AmArch 70*
Dufrene, Edward *NewYHSD*
Dufrene, Francois 1930- *PhDcTCA 77*
Dufrene, Maurice 1876-1955 *DcNiCA*
Dufrene, Thomas *NewYHSD*
Dufreney, Marie Amicie *DcWomA*
Dufrenoy, Georges Leon 1870-1942 *ClaDrA*
Dufresne, Augustine 1789-1842 *DcWomA*
Dufresne, Charles 1876-1938 *McGDA, OxTwCA, PhDcTCA 77*
Dufresne, Clemence *DcWomA*
Dufresne, Genevieve 1892- *DcWomA*
Dufresnoy, Charles Alphonse 1611-1668 *McGDA, OxArt*
Dufretay, L 1771-1802 *DcBrECP*
Dufty, Arthur Richard 1911- *WhoArt 80, -82, -84*
Dufy, Raoul 1877-1953 *ClaDrA, McGDA, OxArt, OxTwCA, PhDcTCA 77, WorArt[port]*
Dugan, Augustine A *NewYHSD*
Dugan, Blanche *DcWomA*
Dugan, Irvin 1892- *WhAmArt 85*
Dugan, Roger Craig 1950- *MarqDCG 84*
Dugan, Thomas 1938- *MacBEP*
Dugary *NewYHSD*
Dugdale, Amy Katherine *DcWomA*
Dugdale, J *BiDBrA*
Dugdale, Rebecca *DcWomA*
Dugdale, Thomas Cantrell 1880-1952 *DcBrA 1, DcBrBI*
Duggan, Blanche *DcWomA*
Duggan, Patrick *DcBrWA*
Duggan, Paul Peter d1861 *NewYHSD*
Duggan, Peter Paul d1861 *ArtsNiC, EarABI, EarABI SUP*
Duggan, Peter Paul 1810?-1861 *NewYHSD*
Duggan, William J 1957- *MarqDCG 84*
Duggan-Cronin, Alfred Martin 1874-1954 *MacBEP*
Duggar, Marie R d1922 *DcWomA, WhAmArt 85*
Dugger, J E *AmArch 70*
Duggin, Charles 1830-1916 *BiDAmAr*
Duggins, James Edward 1881- *DcBrA 1*
Dughet, Gaspard 1613-1675 *McGDA*
Dughet, Gaspard 1615-1675 *ClaDrA, OxArt*
Duglas, Thomas *CabMA*
Dugmore, Arthur Radclyffe 1870- *WhAmArt 85*
Dugmore, Arthur Radclyffe 1870-1955 *DcBrA 1*
Dugmore, Edward 1915- *DcCAA 71, -77, OxTwCA, WhoAmA 73, -76, -78, -80, -82, -84*
Dugmore, John 1793-1871 *DcBrWA*
Dugosh, Ruby Evelyn 1907- *WhAmArt 85*
Dugourc, Jean Demosthene 1749-1825 *MacEA*
Dugourd-Martinet, Marie Elisabeth *DcWomA*
DuGue, Madame *DcVicP 2*
Dugue, Melle Louise *DcWomA*
Duguet, Madame *DcWomA*
Duguid, Allan 1955- *MarqDCG 84*
Duguid, Henry G *DcBrWA, DcVicP 2*
Duhameau, Hortensine Celine *DcWomA*
DuHamel, Elizabeth A *DcWomA*
Duhamel, Guillaume *DcBrECP*
Duhamel, Marie Marguerite *DcWomA*
Duhamel-Hormain, Jeanne Adele Marie *DcWomA*
Duhanot, Euphemie *DcWomA*
Duhart, Emilio 1917- *MacEA*
Duhaut-Cilly, Bernard Auguste 1790-1849 *ArtsAmW 1*
DuHautcilly *NewYHSD*
Duhem, Henri Aime 1860- *ClaDrA*
Duhem, Louise *DcWomA*
Duhem, Marie Genevieve *DcWomA*
Duhme, H Richard, Jr. 1914- *WhAmArt 85, WhoAmA 73, -76, -78, -80, -82, -84*
Duhme, Herman 1819- *EncASM*
Duhms, Martin 1947- *MarqDCG 84*
Duhrkoop, Rudolph 1848-1918 *MacBEP*
Duhy, John *CabMA*
Duijnen, Isaak Van 1630?-1681? *McGDA*
Duijster, Willem Cornelisz 1599?-1635 *McGDA*
Duiker, Johannes 1890-1935 *ConArch, EncMA, MacEA, WhoArch*

Duimstra, David Allen 1937- *AmArch 70*
Duis, Rita *WhoAmA 76, -78, -80, -82, -84*
Duittez, Juliane Lily 1884- *DcWomA*
Duittoz, Juliane Lily 1884- *DcWomA*
Dujardin, Charlotte *DcWomA*
DuJardin, Edward 1817-1889 *ClaDrA*
DuJardin, Gussie 1918- *WhoAmA 73, -76, -78, -80, -82, -84*
Dujardin, John *DcVicP 2*
Dujardin, John, Jr. *DcVicP 2*
DuJardin, Karel 1622-1678 *ClaDrA*
Dujardin, Karel 1622?-1678 *McGDA, OxArt*
Dujardin, Louise *DcWomA*
Dujardin, Victoire Augustine *DcWomA*
Dujardin-Beaumetz, Marie d1893 *DcWomA*
Dujardin-Beaumetz, Rose *DcWomA*
Dujovny, Gregorio 1925- *ConArt 77*
Dukakis, Arthur G 1930- *MarqDCG 84*
Duke, Buford Woodrow, Jr. 1938- *AmArch 70*
Duke, Chris 1951- *AmArt*
Duke, G L *AmArch 70*
Duke, J B *AmArch 70*
Duke, Sir James *DcNiCA*
Duke, Peter R *MarqDCG 84*
Duke, Richard *AntBDN K*
Duke, W Medleycott *DcVicP 2*
Dukehart, Henry *CabMA*
Dukenfield, Mrs. *DcVicP 2*
Dukes, Charles *DcVicP, -2*
Dukes, J *NewYHSD*
Dukesell, Eleanor *DcVicP 2, DcWomA*
Dukov, Stoyan 1931- *WorECar*
Dukszynska VonDukszta, Emilie 1847-1898 *DcWomA*
Dulac, Edmund 1882-1953 *AntBDN B, DcBrA 1, DcBrBI, IlsCB 1744*
Dulac, Margarita Walker *WhoAmA 73, -76, -78, -80, -82, -84*
Dulac, Marguerite 1918- *WhAmArt 85*
Dulaney, W Patrick 1928- *AmArch 70*
Dulany, Caroline *DcWomA*
Dulas, Madame *DcWomA*
Dulcan, Caril E 1933- *WhoAmA 73*
Duleba, Marie 1862- *DcWomA*
Dulebianka, Marie 1862- *DcWomA*
Dulex, Helene *DcWomA*
Dulfer, Martin 1859-1942 *MacEA*
Dulgeroff, S A *AmArch 70*
Dulgeroff, V H *AmArch 70*
Dulheuer, Henrich *FolkA 86*
Dulin, James Harvey 1883- *WhAmArt 85*
Dulin, Jown W, Jr. 1950- *MarqDCG 84*
Dulin, Nicolas 1670-1751 *MacEA*
Dulin, Norman M *WhAmArt 85*
Dulk, Robert 1863-1923 *WhAmArt 85*
Dull, Christa 1925- *DcCAr 81*
Dull, Christian L 1902- *WhAmArt 85*
Dull, John J 1859- *WhAmArt 85*
Dullen, C *FolkA 86*
Dulmen, Gerd Van 1939- *DcCAr 81*
Dulon, Madame *DcWomA*
Dulongpre, Louis 1754-1843 *McGDA, NewYHSD*
Dulout, Marie 1870- *DcWomA*
Duluc, Andrew *NewYHSD*
Dumaige, Marie Louise *DcWomA*
Dumail, Jeanne 1876- *DcWomA*
Dumand-Saint Hubert, Marthe Yvonne 1892- *DcWomA*
Dumandre, Hubert 1701-1781 *McGDA*
DuManoir, Elizabeth Althea 1910- *WhoArt 82, -84*
Dumas, Aimee *DcWomA*
Dumas, Alice Dick 1878- *DcWomA*
Dumas, Amelie 1835-1869 *DcWomA*
Dumas, Antoine *DcCAr 81*
Dumas, Antoine 1932- *WhoAmA 84*
Dumas, Christ John 1926- *MarqDCG 84*
Dumas, Elee C 1952- *MarqDCG 84*
Dumas, Elisabeth 1852- *DcWomA*
Dumas, Esther *DcWomA*
Dumas, Gerald 1930- *WorECom*
Dumas, Jack *OfPGCP 86*
Dumas, Jack 1916- *IlBEAAW, IlrAm G, -1880, WhAmArt 85*
Dumas, Jacques 1904- *WorECom*
Dumas, Jean 1890- *WhAmArt 85*
Dumas, Michel *ArtsNiC*
Dumas, Valsin *NewYHSD*
DuMaurier, George 1834-1896 *McGDA*
DuMaurier, George B 1834- *ArtsNiC*
DuMaurier, George Louis Palmella Busson 1834-1896 *AntBDN B, DcBrBI, DcBrWA, DcVicP, -2*
DuMaurier, George Louis Palmella Busson 1854-1896 *WorECar*
Dumbay, Harriet *FolkA 86*
Dumbell, Alice Ruth 1855- *DcWomA*
Dumcke, John D *NewYHSD*
Dumee, Nicholas *AntBDN Q*
Dumeray, Madame *DcWomA*
Dumesnil, Mademoiselle *DcWomA*
Dumesnil, Marie 1850- *DcWomA*
Dumesnil, Pauline d1897 *DcWomA*

Dunn, Constance *DcVicP 2, DcWomA*
Dunn, Daniel *NewYHSD*
Dunn, Delphine *DcWomA, WhAmArt 85*
Dunn, Donald Omar 1892-1932 *BiDAmAr*
Dunn, Edith *DcBrBI, DcVicP, -2, DcWomA*
Dunn, Edna Marie *WhAmArt 85*
Dunn, Edward W *NewYHSD*
Dunn, Elizabeth Otis *WhAmArt 85*
Dunn, Emelene Abbey 1859-1929 *DcWomA, WhAmArt 85*
Dunn, Eugenia V 1918-1971 *AfroAA*
Dunn, Ezra *FolkA 86*
Dunn, F W *AmArch 70*
Dunn, Frances Cecilia Troyte 1878- *ClaDrA, DcWomA*
Dunn, Frank *WhAmArt 85*
Dunn, G W *AmArch 70*
Dunn, George *NewYHSD*
Dunn, George Carroll 1913- *WhAmArt 85*
Dunn, George Lewis 1907- *AmArch 70*
Dunn, Harvey 1884-1952 *IlrAm B, -1880*
Dunn, Harvey Hopkins 1879- *WhAmArt 85*
Dunn, Harvey T d1952 *WhoAmA 78N, -80N, -82N, -84N*
Dunn, Harvey T 1884- *IlsCB 1744*
Dunn, Harvey T 1884-1952 *ArtsAmW 1, IlBEAAW, WhAmArt 85*
Dunn, Helen 1914- *FolkA 86*
Dunn, Henrietta *DcWomA*
Dunn, Henry Treffry 1838-1899 *DcVicP, -2*
Dunn, Howard Mayer 1928- *AmArch 70*
Dunn, Ingeborg Wolf 1948- *WhoAmA 76*
Dunn, J Stewart 1941- *MarqDCG 84*
Dunn, James Bow 1861-1930 *DcBrA 1*
Dunn, James Elton 1945- *MarqDCG 84*
Dunn, John *DcVicP 2*
Dunn, John Gibson 1826?-1858? *NewYHSD*
Dunn, John Morris *AfroAA*
Dunn, Joseph *NewYHSD*
Dunn, Justus *FolkA 86*
Dunn, Kathy N 1954- *MarqDCG 84*
Dunn, L F *EncASM*
Dunn, Lawson *DcSeaP*
Dunn, Lena Simons *WhAmArt 85*
Dunn, Leslie Rae 1952- *MarqDCG 84*
Dunn, Leverett H *NewYHSD*
Dunn, Louise M 1875- *DcWomA, WhAmArt 85*
Dunn, Marjorie Cline 1894- *ArtsAmW 1, DcWomA, WhAmArt 85*
Dunn, Mary *FolkA 86*
Dunn, Montfort 1907- *WhAmArt 85*
Dunn, Nat *WhAmArt 85*
Dunn, Nate 1896- *WhoAmA 73, -76, -78, -80, -82, -84*
Dunn, Noel *OfPGCP 86*
Dunn, O Coleman 1902- *WhoAmA 73, -76, -78, -80, -82*
Dunn, Phillip Charles 1947- *WhoAmA 82, -84*
Dunn, Reginald George 1907- *WhoArt 80, -82, -84*
Dunn, Robert *WhAmArt 85*
Dunn, Robert Joseph, Jr. 1908- *WorECar*
Dunn, Robert M 1937- *MarqDCG 84*
Dunn, Roger Terry 1946- *WhoAmA 76, -78, -80, -82, -84*
Dunn, Stuart Thomas 1940- *MarqDCG 84*
Dunn, Ted C 1930- *MarqDCG 84*
Dunn, Thomas W *NewYHSD*
Dunn, Tom *MarqDCG 84*
Dunn, W A *AmArch 70*
Dunn, William 1862- *DcBrA 1*
Dunne, Berthold 1924- *WhoArt 80, -82, -84*
Dunne, Isaac *DcVicP 2*
Dunne, Lawrence Francis 1898-1937 *WorECar*
Dunne, Margaret *WhAmArt 85*
Dunne, Robert F 1954- *MarqDCG 84*
Dunnell, Elbridge G *NewYHSD*
Dunnell, John H *NewYHSD*
Dunnell, John Henry 1813-1904 *ArtsAmW 1, IlBEAAW, NewYHSD, WhAmArt 85*
Dunnell, Warren B 1851- *BiDAmAr*
Dunnell, William N *NewYHSD*
Dunnigan, Mary Catherine 1922- *WhoAmA 78, -80, -82, -84*
Dunning, Agnes *DcVicP 2*
Dunning, Arthur R *WhAmArt 85*
Dunning, Edward Gore 1884-1931 *WhAmArt 85*
Dunning, George 1920-1978 *WorECar*
Dunning, James C *MarqDCG 84*
Dunning, John Thomson 1851-1931 *DcBrA 1, DcVicP 2*
Dunning, M Kelso *WhAmArt 85*
Dunning, Max 1873-1945 *BiDAmAr*
Dunning, Robert S 1829-1905 *NewYHSD*
Dunning, Robert Spear 1829-1905 *DcAmArt, WhAmArt 85*
Dunnington, Tom *IlsBYP, OfPGCP 86*
Dunnington, Walter Grey 1910- *WhoAmA 82, -84*
Dunnington, Mrs. Walter Grey 1910- *WhoAmA 73, -76, -78, -80*

Dunouy, Alexandre Hyacinthe 1757-1841 *ClaDrA*
Dunovan, Mrs. *DcWomA*
DuNoyer, George Victor 1817-1869 *DcBrWA, DcVicP 2*
Dunoyer DeSegonzac, Andre 1884-1974 *OxArt, OxTwCA, PhDcTCA 77, WhoGrA 62*
Dunoyer DeSegonzac, Andre Albert Marie 1884- *ClaDrA*
Dunphy, Nicholas 1891- *WhAmArt 85*
Dunphy, Nicholas 1891-1955 *ArtsAmW 1*
Dunphy, Richard L *NewYHSD*
Dunphy, Uriah *NewYHSD*
Dunscombe, Hannah *FolkA 86*
Dunsmore, Bruce R 1922- *AmArch 70*
Dunsmore, Corrine *ArtsEM, DcWomA*
Dunsmore, Donald 1941- *DcCAr 81*
Dunsmore, John Ward *DcVicP 2*
Dunsmore, John Ward 1856-1945 *ArtsEM, WhAmArt 85*
Dunstan, Bernard 1920- *ConBrA 79[port], DcBrA 1, WhoArt 80, -82, -84*
Dunthorne, James 1730-1815 *DcBrECP, DcBrWA*
Dunthorne, James 1758?-1793? *DcBrWA*
Dunthorne, John d1792? *BkIE*
Dunthorne, John 1770-1844 *DcBrWA*
Dunthorne, John 1798-1832 *DcBrWA*
Dunton, Ebenezer *CabMA*
Dunton, W Herbert 1878-1936 *ArtsAmW 1, WhAmArt 85*
Dunton, William Herbert 1878-1936 *IlBEAAW, IlrAm B, -1880*
Dunwege, Heinrich *McGDA*
Dunwege, Victor *McGDA*
Dunwiddie, Charlotte *WhoAmA 73, -76, -78, -80, -82, -84*
Dunwiddie, F W *AmArch 70*
Dunwody, E C *AmArch 70*
Dunwody, William Elliott, Jr. 1893- *AmArch 70*
Dunwoody, William Hood d1914 *WhAmArt 85*
Dunz, Ida 1864- *DcWomA*
Dunz, Johannes 1644-1736 *ClaDrA*
Dupaigne-Domergue, Jeanne *DcWomA*
Dupain, E *DcWomA*
Dupain, Edmond-Louis *ArtsNiC*
Dupain, Max 1911- *ConPhot, ICPEnP A, MacBEP*
Dupalais, Virginia Poullard 1804-1864 *DcWomA, NewYHSD*
DuPan, Barthelemy 1712-1763 *DcBrECP*
Dupan, Marie 1810- *DcWomA*
DuPaquier, Claudius Innocentius *AntBDN M*
DuParc, Mrs. *DcBrECP*
Duparc, Francoise 1726-1778 *DcWomA, WomArt*
Duparc, Josephe Antonia 1728-1757? *DcWomA*
Duparcq, Marie Madeleine 1849- *DcWomA*
Duparque, Paul *WhAmArt 85*
Dupasquier, Chloe *DcWomA*
Dupaty, Eleonore *DcWomA*
DuPay, Ella *DcWomA*
DuPee, Isaac *FolkA 86*
DuPen, Everett George 1912- *WhAmArt 85, WhoAmA 73, -76, -78, -80, -82, -84*
Duperac, Etienne 1525?-1604 *MacEA*
Duperly, Armand *NewYHSD*
Duperon, Marie Marguerite *DcWomA*
Dupertuis, H *AmArch 70*
Dupeux, Joseph *DcVicP 2*
Duphiney, Wilfred I 1884- *WhAmArt 85*
Dupiery, Madame *DcWomA*
Dupile, Madame *DcWomA*
Dupin, Aurore Amantine Lucile *DcWomA*
Dupin, Etiennette Octavie *DcWomA*
Duplain, Agathe *DcWomA*
Duplanty, David Roger *AmArch 70*
Duplay, Eleonore *DcWomA*
Duplessi-Bertaux, Jean 1750-1820 *McGDA*
Duplessis, Mademoiselle *DcWomA*
Duplessis, Claude-Thomas *AntBDN M*
DuPlessis, H E 1894- *DcBrA 1*
Duplessis, J C d1774 *AntBDN C*
Duplessis, Joseph Siffred 1725-1802 *McGDA*
Duplessis, Joseph Siffrein 1725-1802 *ClaDrA*
Duplessis-Bonjour, Therese Victorine De *DcWomA*
Duponchel, Felix *NewYHSD*
Duponchel, Marie Louise *DcWomA*
Dupont, Madame *DcWomA*
Dupont, Madame 1696-1750? *DcWomA*
Dupont, Francois Leonard 1756-1821 *ClaDrA*
Dupont, Gainsborough 1754-1797 *DcBrECP, OxArt*
Dupont, Genevieve *DcWomA*
DuPont, Helen A *DcWomA, WhAmArt 85*
Dupont, Henry F d1969 *WhoAmA 78N, -80N, -82N, -84N*
Dupont, Jacques M 1955- *MarqDCG 84*
Dupont, Julie *DcWomA*
Dupont, Kedma 1901- *WhAmArt 85*
Dupont, Louise 1849- *DcWomA*
Dupont, Madeleine Etiennette *DcWomA*
Dupont, Richard John Munro 1920- *DcBrA 1*
DuPont, Samuel Francis 1803-1865 *NewYHSD*
Dupont, Yvonne E M 1897- *DcWomA*
Dupont-Binard, G *DcWomA*

Duport, Adrienne *DcWomA*
DuPortail *NewYHSD*
Dupouy, A L *NewYHSD*
Duppa, Bryan Edward *DcVicP 2*
Dupperon, Mademoiselle *DcWomA*
Dupras, Pierre 1937- *WorECar*
Duprat, Sophie *DcWomA*
Dupratz, Antoine Simon LePage 1689-1775 *NewYHSD*
Dupray, Louis-Henry *ArtsNiC*
Dupre, A J *AmArch 70*
Dupre, Amalia 1845?-1928 *DcWomA*
Dupre, Angelique *DcWomA*
Dupre, Augustin *NewYHSD*
Dupre, E *WhAmArt 85*
Dupre, Eugene Charles *NewYHSD*
Dupre, Felicie *DcWomA*
Dupre, Giovanni 1817-1882 *ArtsNiC, McGDA*
DuPre, Grace Annette *WhoAmA 73, -76, -78, -80*
Dupre, Grace Annette d1984 *DcWomA*
Dupre, Jules 1811-1889 *ClaDrA, McGDA*
Dupre, Jules 1812- *ArtsNiC*
Dupre, Julia Clarkson *DcWomA, NewYHSD*
Dupre, Julien 1851-1910 *ClaDrA, WhAmArt 85A*
Dupre, Mrs. L B *WhAmArt 85*
Dupre, Leon Victor 1848-1879 *ArtsNiC*
Dupre, Mrs. S *DcVicP 2*
Duprez, Alexandre Julie *DcWomA*
Duprez, Elizabeth 1876- *DcWomA*
Duprez, Elizabeth F Kruseman VanElten *WhAmArt 85*
Duprez, Marguerite *DcWomA*
Dupue *FolkA 86*
Dupuich, Blanche *DcWomA*
Dupuis, L A *DcWomA*
Dupuis, Louise Catherine *DcWomA*
Dupuis, Philippe Felix *DcVicP 2*
Dupuy, Amelie *DcWomA*
Dupuy, Ella *DcWomA*
DuPuy, Ella M *WhAmArt 85*
Dupuy, Emma *DcWomA*
Dupuy, Jean 1925- *ConArt 77, WhoAmA 78, -80, -82, -84*
Dupuy, Laurence *DcWomA*
Dupuy, Marie Louise *DcWomA*
Dupuy, Marthe *DcWomA*
Dupuy, Noemie Marguerite 1850- *DcWomA*
Dupuy, Paul Michel 1869- *ClaDrA*
Dupuy, S *DcVicP 2*
Dupuy DesIslets, Mademoiselle *DcWomA*
Duque, Francis 1832-1915 *WhAmArt 85*
Duque Cornejo, Pedro 1677-1757 *McGDA*
Duque Cornejo, Pedro 1678-1757 *OxArt*
Duquemy, John D *NewYHSD*
Duquesnoy, Mademoiselle *DcWomA*
Duquesnoy, Francis 1594-1643 *OxArt*
Duquesnoy, Francois 1594-1643 *McGDA*
Duquesnoy, Frans 1594-1643 *OxArt*
Duquesnoy, Jeanne Amelie 1872- *DcWomA*
Duquesnoy, Jerome, The Elder 1570?-1641 *McGDA*
Duquesnoy, Jerome, The Younger 1602-1654 *McGDA*
Duquette, Mae 1892- *DcWomA*
Duquette, W L *AmArch 70*
Dura, Arthur Urben 1931- *AmArch 70*
Durade, J B *DcBrECP*
Duramano, Madame *DcWomA*
Durameau, Louis-Jean-Jacques 1733-1796 *McGDA*
Duran, Carolus 1838- *ArtsNiC*
Duran, Charles-Auguste-Emile 1838-1917 *McGDA*
Duran, Damian *FolkA 86*
Duran, Francisca DePaula *DcWomA*
Duran, Gilbert *OfPGCP 86*
Duran, Jeanne M *DcWomA*
Duran, John *NewYHSD*
Duran, Pauline *DcWomA*
Duran, Robert 1938- *DcCAA 77, WhoAmA 78*
Duranceau, F J, Jr. *AmArch 70*
Durand, Mademoiselle *DcWomA*
Durand, Albert G *NewYHSD*
Durand, Alfred B 1826?- *NewYHSD*
Durand, Asher B 1796- *ArtsNiC*
Durand, Asher Brown 1796-1886 *BnEnAmA, DcAmArt, EarABI, EncASM, McGDA, NewYHSD*
Durand, Bennett 1906- *WhAmArt 85*
Durand, Cecile Madeleine *DcWomA*
Durand, Cyrus 1787-1868 *NewYHSD*
Durand, E L *WhAmArt 85*
Durand, Elias W *NewYHSD*
Durand, Eugene *NewYHSD*
Durand, Flavie *DcWomA*
Durand, Francois *DcNiCA*
Durand, George 1850-1889 *MacEA*
Durand, Godfroy 1832- *DcBrBI*
Durand, Godfrey *DcVicP 2*
Durand, Harry *EncASM*
Durand, Harry, Jr. *EncASM*
Durand, Helen *FolkA 86*
Durand, Helene D'Espagnac 1841- *DcWomA*
Durand, Henriette *DcWomA*
Durand, Henry *EncASM*

Durand, Honorine DcWomA
Durand, J N L 1760-1834 MacEA
Durand, James Madison EncASM
Durand, Jean 1667-1727 EncASM
Durand, Jean Nicholas Louis 1760-1834 McGDA
Durand, Jeanne DcWomA
Durand, John BnEnAmA, DcBrECP, EncASM,
 FolkA 86, NewYHSD
Durand, Louisa Forbes DcWomA
Durand, Lucille Murphy WhoAmA 73, -76
Durand, Ludovic ArtsNiC
Durand, Marie DcWomA
Durand, Marie 1854-1890 DcWomA
Durand, Marie Adelaide DcWomA
Durand, Samuel 1713-1787 EncASM
Durand, Silas NewYHSD
Durand, Simon ArtsNiC
Durand, Theodore NewYHSD
Durand, Wallace EncASM
Durand, Wickliffe Baldwin EncASM
Durand, William NewYHSD
Durand And Annin EncASM
Durand-Brager, Jean-Baptiste-Henri 1814-1879
 ArtsNiC
Durand-Brager, Jean Baptiste Henri 1814-1879 DcSeaP
Durand-Cambuzat, Lucie DcWomA
Durand Carter EncASM
Durand-Durangel, Antoine Victor Leopold 1828-1898?
 ClaDrA
Durand-Ruel, Joseph d1928 WhAmArt 85
Durand-Ruel, Paul 1831-1922 WhAmArt 85
Durandi, Giovanna DcWomA
Durando, Andre 1869-1945 WhAmArt 85
Durando, Giovanna DcWomA
Durandus, William, The Elder 1230-1296 McGDA
Durang, E F NewYHSD
Durant, Charles F NewYHSD
Durant, John 1770-1797 DcBrECP
Durant, John Waldo 1774?-1832 NewYHSD
Durant, Susan D d1873 ArtsNiC
Durant, Susan D 1820?-1873 DcWomA
DuRant, William Eugene 1912- AmArch 70
Duranta, Giovanna DcWomA
Duranti, Giovanna DcWomA
Duranti, Rosalia DcWomA
Duranton, Jeanne Marie Celine DcWomA
Duranty, Charles DcCAr 81
Duranty, Charles Henry 1918- WhoArt 80, -82, -84
Duranty, Edmond 1833-1880 OxArt
Durasova, Mary 1898- DcWomA
Durat NewYHSD
Durazzo, Angela DcWomA
D'Urban, William DcVicP 2
Durbin, Leslie 1913- WhoArt 80, -82, -84
Durchanek, Louis W 1902- WhAmArt 85
Durchanek, Ludvik 1902- DcCAr 81
Durden, James 1878- ClaDrA
Durden, James 1878-1964 DcBrA 1, DcBrBI
Durehed, Lennart 1950- MacBEP
Durell, A C DcVicP 2
Durell, Amy DcVicP 2
Duren, Stephen D 1948- WhoAmA 84
Duren, Terence Romaine 1906- WhoAmA 73, -76
Duren, Terence Romaine 1907- WhAmArt 85
Durer, Albrecht 1471-1528 ClaDrA, McGDA,
 OxArt[port]
Duret, Francisque-Joseph 1804-1865 ArtsNiC
Duret, Francisque Joseph 1804-1865 McGDA
Durfee, Charles 1793-1849 NewYHSD
Durfee, Chiselie WhAmArt 85
Durfee, Daniel A 1929- AmArch 70
Durfee, George H FolkA 86
Durfee, Hazard WhAmArt 85
Durfee, M Lucille 1908- WhAmArt 85
Durgan, J C AmArch 70
Durgin, Alvah CabMA
Durgin, Freeman A EncASM
Durgin, Harriet T WhAmArt 85
Durgin, Harriet Thayer 1848- DcWomA
Durgin, Lyle WhAmArt 85
Durgin, Lyle 1850- DcWomA
Durgin, William B 1833-1905 EncASM
Durgin And Burtt EncASM
Durham EncASM
Durham, Beryl 1934- AmArch 70
Durham, C Anthony 1938- MarqDCG 84
Durham, C B DcWomA
Durham, Mrs. C B DcVicP 2
Durham, C J DcVicP 2
Durham, C J d1889 DcBrBI
Durham, Charles 1860-1932 WhAmArt 85
Durham, E L AmArch 70
Durham, Joseph 1821-1877 ArtsNiC
Durham, Mary Edith 1863-1944 DcBrA 1, DcVicP 2,
 DcWomA
Durham, Robert Lewis 1912- AmArch 70
Durham, Thomas NewYHSD
Durham, Tyler NewYHSD
Durham, William 1937- WhoAmA 76, -78, -80, -82,
 -84
Durhan, E A AmArch 70

Durholz, Auguste NewYHSD
Durieu, Eugene 1800-1874 ICPEnP A, MacBEP
Durieu, Virginie 1820- DcWomA
Durieux, Caroline 1896- DcWomA, McGDA,
 WhAmArt 85
Durieux, Caroline Wogan 1896- GrAmP,
 WhoAmA 73, -76, -78, -80, -82, -84
Durieux, Marie Adelaide DcWomA
Durieux, Pierre WhAmArt 85
Durin, Marie Melanie 1879- DcWomA
Duringer, Daniel 1720-1786 ClaDrA
Durinski, Art 1947- MarqDCG 84
Durkee, Almon James 1920- AmArch 70
Durkee, Helen Winslow DcWomA, WhAmArt 85
Durkee, Stephen CabMA
Durkin, John 1868-1903 IlBEAAW, WhAmArt 85
Durkin, John 1941- MarqDCG 84
Durlacher, Ruth G 1912- WhAmArt 85
Durler, Sophia L DcWomA
Durling-Shyduroff, Richard Leo 1947- MarqDCG 84
Durnford, F Andrew DcVicP 2
Durnford, Jane DcWomA
Durnford, Lucy DcVicP 2, DcWomA
Durno, James 1745?-1795 DcBrECP
Durnovo, Madame DcWomA
Duron, Jorge 1930- PrintW 83, -85
Durosey, Julie DcWomA
Durosey, Sophie DcWomA
Duroure, Susanna DcWomA
Durr, Loren David 1925- AmArch 70
Durr, Pat WhoAmA 82, -84
Durrani, B DcVicP 2
Durrant, G DcVicP 2
Durrant, J G AmArch 70
Durrant, Jennifer DcCAr 81
Durrant, Jennifer 1942- ConBrA 79[port]
Durrant, Roy Turner 1925- ClaDrA, DcBrA 1,
 WhoArt 80, -82, -84
Durrell, Jonathan FolkA 86
Durrenberger, Robert Scott 1952- MarqDCG 84
Durrie, George Henry 1820-1863 BnEnAmA,
 DcAmArt, McGDA, NewYHSD
Durrie, John 1818- NewYHSD
Durruthy-Layrle, Zelie 1872- DcWomA
D'Urso, Joseph Paul 1943- ConDes
Durst, Alan Lydiat 1883-1970 DcBrA 1
Durst, Andre 1907-1949 ICPEnP A
Durst, David 1911- WhAmArt 85
Durst, R W AmArch 70
Durussel, Jeanne Louise DcWomA
Durvis, Marie DcWomA
Durward, Bernard Isaac 1817-1902 NewYHSD ,
 WhAmArt 85
Dury, George 1817-1894 NewYHSD
Dury, Loraine Lucille WhAmArt 85
DuRy Family MacEA
Dury-Vasselon, Hortense M G DcWomA
DuSang, George Compton, Jr. 1933- AmArch 70
Dusard, Jay 1937- MacBEP, WhoAmA 84
Dusart, Cornelis 1660-1704 ClaDrA, McGDA,
 OxArt
Dusart, Francois d1661 McGDA
Duschek, Karl 1947- ConDes
Duschene, Cecilia DcWomA
Dusel, A AmArch 70
Dusenbery, Walter 1939- WhoAmA 82, -84
Dusenbury, J F AmArch 70
Dushinsky, Joseph WhAmArt 85
Dusign, Dederick d1770 DcBrECP
DuSimitiere, Pierre Eugene 1736?-1784 NewYHSD
DusmetDeSmours, Luigi AmArch 70
Duson, W W, III AmArch 70
D'Usseau, Leon WhAmArt 85
Dusseuil, Leonie 1843-1912 DcWomA
Dussieux, Louise Stephanie DcWomA
Dussoix, Andre 1944- DcCAr 81
Dustan, Isaac K NewYHSD
Duster, C E AmArch 70
Dustin, Silas S WhAmArt 85
Dustin, Silas S 1855-1940 ArtsAmW 2
DuSuaw NewYHSD
Duszak, Robert Michael 1935- AmArch 70
Duszek, Roman 1935- ConDes
Dutanda, Mademoiselle DcWomA
DuTant, Charles 1908- IlBEAAW
Dutary, Alberto 1932- McGDA
Dutch, George Sheldon 1891- WhAmArt 85
Dutch, Nathaniel 1714-1795 CabMA
Dutcher, W R AmArch 70
Dutczynska, Irma Von DcWomA
Duteil, J H AmArch 70
Duteis, Ixia DcWomA
Duterrier, Jeanne Francoise Alzire 1805-1868
 DcWomA
Dutert, Charles Louis Ferdinand 1845-1906 MacEA
DuTheil, Anna DcWomA
Duthie, A Spottiswoode DcBrA 2
Duthie, James NewYHSD
Duthie, Spottiswoode DcVicP 2
Duthoit, Edmond 1837-1889 MacEA
Duthoit, Elizabeth Emma DcVicP 2

Duthoit, Florence DcWomA
Duthoit, J DcVicP 2
Duthoit, Paul Maurice 1858- ClaDrA
Duthweiler, Ludwig Eduard 1934- AmArch 70
Dutilleux, Henri Joseph Constant 1807-1865 ClaDrA
Dutkin, H L AmArch 70
Dutra, C D AmArch 70
Dutta, Girindra Mohini Devi 1858-1924 DcWomA
Duttenhofer, Christiane Luise 1776-1829 DcWomA
Dutter, R T AmArch 70
Duttmann, Werner 1921- ConArch
Dutton, Miss DcWomA
Dutton, Alice M DcWomA, WhAmArt 85
Dutton, Allen A 1922- ConPhot, ICPEnP A,
 MacBEP, WhoAmA 84
Dutton, Bertha P 1903- WhoAmA 73, -76
Dutton, Constance DcWomA
Dutton, Geoffrey 1944- MarqDCG 84
Dutton, Harold John 1889- ClaDrA, DcBrA 1
Dutton, John Frederick Harrison DcVicP 2
Dutton, Mary Martha DcVicP 2, DcWomA
Dutton, Pauline Mae WhoAmA 78, -80, -82, -84
Dutton, Thomas NewYHSD
Dutton, Thomas G DcBrBI
Dutton, Thomas Goldsworth d1891 DcBrWA,
 DcVicP 2
Dutton, Thomas Goldsworth 1819?-1891 DcSeaP
Dutton, W E DcVicP 2
Dutton, William AntBDN D
Duturcq, Madame DcVicP 2
Duturcq, T DcVicP 2, DcWomA
Dutye, Henre FolkA 86
Dutz, Charles Lew 1934- AmArch 70
Dutzer, Frederick NewYHSD
Duval, A DcVicP 2
Duval, Alix 1848- DcWomA
Duval, Ambrose NewYHSD
Duval, Caroline DcWomA
Duval, Charles Allen 1808-1872 DcVicP, -2
Duval, Dorothy Zinaida 1917- DcBrA 1, WhoArt 80,
 -82, -84
Duval, E DcVicP 2, NewYHSD
Duval, Edward J DcVicP 2
Duval, Elisabeth DcWomA
Duval, Ella Moss 1843-1911 ArtsAmW 1, -3,
 DcWomA
Duval, Ida ArtsEM, DcWomA
Duval, J NewYHSD
Duval, J C A DcVicP 2
Duval, John DcVicP, -2, NewYHSD
Duval, Marie DcBrBI, DcBrWA, DcVicP 2
Duval, Marie 1850?- DcWomA
Duval, Peter S NewYHSD
Duval, S E AmArch 70
Duval, Stephen NewYHSD
Duval, Stephen Orr 1832?- NewYHSD
Duval, W C, III AmArch 70
Duval-Daussin, Jeanne DcWomA
Duval-Le-Camus, Jules-Alexandre 1817-1878 ArtsNiC
Duval-Le-Camus, Pierre 1790-1854 ArtsNiC
Duvall, Fannie Eliza 1861- ArtsAmW 1
Duvall, Fanny E 1861-1939? WhAmArt 85
Duvall, Fanny Eliza 1861-1934 DcWomA
Duvall, Flo FolkA 86
DuVall, H A WhAmArt 85
Duvall, John 1816-1892 DcVicP 2
DuVall, Kenneth Alyn 1931- AmArch 70
Duvall, Linda DcCAr 81
Duvall, Matilda E DcWomA
Duvall, R C WhAmArt 85
Duvall, Taiwo AfroAA
Duvall, Thomas George DcVicP 2
Duvaux, Marie DcWomA
Duveen, Charles J 1872-1940 WhAmArt 85
Duveen, Henry J 1854-1919 WhAmArt 85
Duveen, Joseph 1869-1939 WhAmArt 85
Duveen, Louis J 1875-1920 WhAmArt 85
Duveneck, Elizabeth DcWomA
Duveneck, Elizabeth Boot 1846-1888 WhAmArt 85
Duveneck, Frank 1848- ArtsNiC
Duveneck, Frank 1848-1919 BnEnAmA, DcAmArt,
 McGDA, WhAmArt 85
Duverger, Julio 1934- AfroAA
Duverger, Paul NewYHSD
Duverger, Theophile Emmanuel ArtsNiC
Duvet, Jean 1485-1561? McGDA
Duvet, Jean 1485?-1561 OxArt
Duvidal DeMontferrier, Louise Rose Julie 1797-1869
 DcWomA
DuVigneau, Louise Suzanne DcWomA
Duvillier, Kirby 1939- AfroAA
Duvivier, Aimee DcWomA
Duvivier, Antoinette 1894- DcWomA
Duvivier, Claire 1846-1897 DcWomA
Duvivier, Fidele AntBDN M
Duvivier, Henri-Joseph 1740- AntBDN M
Duvivier, Jeanne Louise Francoise DcWomA
Duvivier, William d1755 AntBDN M
Duvivier And Son NewYHSD
Duvoisin, Jean Andre, III 1949- MarqDCG 84
Duvoisin, Marie DcWomA

Duvoisin, Roger 1904- *WhoAmA 73, -76, -78, -80*
Duvoisin, Roger 1904-1980 *WhoAmA 82N, -84N*
Duvoisin, Roger Antoine *IlsCB 1967*
Duvoisin, Roger Antoine 1904- *WhAmArt 85*
Duvoisin, Roger Antoine 1904-1968 *Cald 1938, IlsBYP, IlsCB 1744, -1946, -1957, WhoGrA 62*
Duwal, Klaus 1940- *DcCAr 81*
Duwe, Harald 1926- *DcCAr 81*
Duy, H D *AmArch 70*
Duyckinck, Evert 1621-1702 *DcAmArt, NewYHSD*
Duyckinck, Evert, I *McGDA*
Duyckinck, Evert, I 1620?-1703? *McGDA*
Duyckinck, Evert, II 1650-1680 *DcAmArt*
Duyckinck, Evert, III 1677-1727 *DcAmArt*
Duyckinck, Evert, III 1677-1727? *McGDA*
Duyckinck, Evert, III 1677?-1727 *NewYHSD*
Duyckinck, Gerardus 1695-1746 *DcAmArt*
Duyckinck, Gerardus 1695-1746? *NewYHSD*
Duyckinck, Gerardus I *FolkA 86*
Duyckinck, Gerardus, I d1746? *McGDA*
Duyckinck, Gerardus, II 1723-1797 *DcAmArt, McGDA, NewYHSD*
Duyckinck, Gerret 1660-1710 *FolkA 86*
Duyckinck, Gerrit d1712? *McGDA*
Duyckinck, Gerrit 1660-1710 *DcAmArt*
Duyckinck, Gerrit 1663-1710? *NewYHSD*
Duyckinck, I Evert *FolkA 86*
Duyckinck Family *DcAmArt*
Duyl, Therese *DcWomA*
Duynen, Isaak Van *McGDA*
Duyster, Willem Cornelisz *McGDA*
Duyster, Willem Cornelisz 1599-1635 *OxArt*
Duyts, Gustave Den 1850-1897 *ClaDrA*
Duyts, Jan Den 1629-1676 *McGDA*
Duzdein, John A *NewYHSD*
Dvorak, Franz 1862- *ArtsEM*
Dvorak, Steve, Jr. 1945- *MarqDCG 84*
Dvoretzky, Eugene Nathan 1927- *AmArch 70*
Dweck, E M *AmArch 70*
Dwig *WorECom*
Dwiggins, Clare 1874-1958 *WhoAmA 80N, -82N, -84N*
Dwiggins, Clare Victor 1874-1959 *WorECom*
Dwiggins, William Addison 1880- *WhAmArt 85*
Dwiggins, William Addison 1880-1956 *ConDes, IlsCB 1744, -1946, OxDecA, WhoAmA 80N, -82N, -84N*
Dwight, Miss *DcWomA, NewYHSD*
Dwight, Antoinette Merwin *WhAmArt 85*
Dwight, Benjamin Franklin d1893 *BiDAmAr*
Dwight, Edward Harold 1919- *WhoAmA 73, -76, -78, -80*
Dwight, Edward Harold 1919-1981 *WhoAmA 82N, -84N*
Dwight, John 1640?-1703 *AntBDN M*
Dwight, John 1740-1816 *FolkA 86*
Dwight, Julia S L 1870- *DcWomA, WhAmArt 85*
Dwight, Mabel 1876- *WhAmArt 85*
Dwight, Mabel 1876-1955 *ArtsAmW 3, DcWomA, GrAmP*
Dwight, Mable 1876-1955 *WomArt*
Dwight, N W *NewYHSD*
Dwight, Samuel *FolkA 86*
Dwight, Stephen *FolkA 86, NewYHSD*
Dwight, Timothy 1654-1691 *AntBDN Q*
Dwinell, Hezekiah *FolkA 86*
Dworkin, Philip 1920- *AmArch 70*
Dworsky, Daniel Leonard 1927- *AmArch 70*
Dworzan, George R 1924- *WhoAmA 73, -76, -78, -80, -82, -84*
Dwoskin, Stephen John 1939- *WhoGrA 82[port]*
Dwyer, Adelaide *WhAmArt 85*
Dwyer, Adelaide 1896- *DcWomA*
Dwyer, Charles Steven 1948- *MarqDCG 84*
Dwyer, Dale E 1925- *AmArch 70*
Dwyer, Eugene Joseph 1943- *WhoAmA 76, -78, -80, -82, -84*
Dwyer, Gary Colburn 1943- *WhoAmA 84*
Dwyer, James 1880?- *ArtsAmW 3*
Dwyer, James 1921- *WhoAmA 80, -82, -84*
Dwyer, James Eugene 1921- *WhoAmA 78*
Dwyer, John *WhAmArt 85*
Dwyer, Marguerite M *ArtsEM, DcWomA*
Dwyer, Mary *ArtsEM, DcWomA*
Dwyer, Melva Jean 1919- *WhoAmA 78, -80, -82, -84*
Dwyer, R W *AmArch 70*
Dwyer, Robert Emmett 1924- *AmArch 70*
Dwyer, Susie *ArtsEM, DcWomA*
Dwyer, T A *AmArch 70*
Dwyer, William J 1911- *FolkA 86*
Dwyer, William R *AmArch 70*
Dyal, John Wesley 1934- *AmArch 70*
Dyar, Joseph 1804-1851 *EncASM*
Dyason, E H *DcVicP 2*
Dyce, Alexander 1798-1869 *DcBrWA*
Dyce, J Stirling *DcVicP 2*
Dyce, William 1806-1864 *ArtsNiC, ClaDrA, DcBrWA, DcVicP, -2, McGDA, OxArt*
Dyck, Abraham Van *McGDA*
Dyck, Anthony Van 1599-1641 *McGDA*

Dyck, Sir Anthony Van 1599-1641 *OxArt*
Dyck, Anton Van 1599-1641 *ClaDrA*
Dyck, Daniel VanDen d1670 *ClaDrA*
Dyck, Floris Claesz Van *McGDA*
Dyck, Floris Van 1575-1651 *ClaDrA*
Dyck, Josephine Van *DcWomA*
Dyck, Justina Van 1641-1690 *DcWomA*
Dyck, Lucrezia *DcWomA*
Dyck, Paul 1917- *IlBEAAW, WhAmArt 85, WhoAmA 73, -76, -78, -80, -82, -84*
Dyck, Pauline Van *DcWomA*
Dyckmans, Josef Laurens 1811- *ArtsNiC*
Dyckmans, Josephus Laurentius 1811-1888 *ClaDrA*
Dyczkowski, Eugene Matthew 1899- *WhAmArt 85*
Dye, Ben *FolkA 86*
Dye, Burton *OfPGCP 86*
Dye, Charlie 1906-1972 *IlBEAAW, WhAmArt 85*
Dye, Clarkson 1869- *ArtsAmW 1, WhAmArt 85*
Dye, David 1945- *ConArt 77, -83, ConBrA 79[port]*
Dye, J E *AmArch 70*
Dye, John Theodore 1927- *AmArch 70*
Dye, Olive 1889- *DcWomA*
Dye, Olive Bagg 1889- *ArtsAmW 1, WhAmArt 85*
Dye, Olive Leland Bagg 1889- *ArtsAmW 3*
Dye, William Newton, Jr. 1933- *AmArch 70*
Dyens, George *DcCAr 81*
Dyens, Georges Maurice 1932- *WhoAmA 82, -84*
Dyer, Agnes S 1887- *ArtsAmW 1, DcWomA, WhAmArt 85*
Dyer, Albert H 1853-1926? *BiDAmAr*
Dyer, Anson 1876-1962 *WorECar*
Dyer, Becky Shawn 1953- *MarqDCG 84*
Dyer, Ben Hopson 1906- *AmArch 70*
Dyer, Benjamin 1778-1856 *FolkA 86*
Dyer, Briggs 1911- *WhAmArt 85*
Dyer, Candace *FolkA 86*
Dyer, Carlos 1917- *WhAmArt 85*
Dyer, Carolyn Price 1931- *WhoAmA 78, -80, -82, -84*
Dyer, Charles 1794-1848 *BiDBrA*
Dyer, Charles B 1878- *WhAmArt 85*
Dyer, Charles G *DcVicP 2*
Dyer, Charles Gifford 1846- *ArtsNiC*
Dyer, Charles Gifford 1851-1912 *WhAmArt 85*
Dyer, Don Wells 1955- *MarqDCG 84*
Dyer, Donald 1924- *AmArch 70*
Dyer, E A *DcWomA*
Dyer, Eleanor H *DcWomA*
Dyer, Elliot 1937- *AfroAA*
Dyer, G G *AmArch 70*
Dyer, George *BiDBrA*
Dyer, Gertrude *DcWomA*
Dyer, Gertrude M *DcVicP 2*
Dyer, H Anthony 1872-1943 *WhAmArt 85*
Dyer, Harry W 1871-1936 *WhAmArt 85*
Dyer, Henry *FolkA 86*
Dyer, Herrmann 1916- *WhAmArt 85*
Dyer, James Arthur 1932- *MarqDCG 84*
Dyer, Lowell *DcVicP 2*
Dyer, Lowell 1856- *WhAmArt 85*
Dyer, Nancy A 1903- *WhAmArt 85*
Dyer, Nathaniel 1752?-1833 *BiDBrA*
Dyer, Nora Ellen 1871- *WhAmArt 85*
Dyer, R W *AmArch 70*
Dyer, Richard *NewYHSD*
Dyer, Sophia 1805?- *FolkA 86*
Dyer, Theresa Sylvester *DcWomA*
Dyer, William *BiDBrA*
Dyer, Wilson *DcVicP 2*
Dyer-Bennet, Frederick 1918- *AmArch 70*
Dyf, Marcel *DcCAr 81*
Dykaar, Moses W d1933 *WhAmArt 85*
Dyke, A L *FolkA 86*
Dyke, Eleanor Hart- *DcVicP 2*
Dyke, John C A 1923- *WhoArt 80, -82, -84*
Dyke, Larry *OfPGCP 86*
Dyke, Louise Catherine 1874- *DcBrA 1, DcWomA*
Dyke, Mary Christina *DcWomA*
Dyke, R H *DcVicP 2*
Dyke, Samuel *FolkA 86*
Dyke, Samuel P *NewYHSD*
Dykeman, David Weston, Jr. 1919- *AmArch 70*
Dyker, Henry *FolkA 86*
Dykes, A O, Jr. *AmArch 70*
Dykes, DeWitt Sanford 1903- *AmArch 70*
Dykes, E W *AmArch 70*
Dykes, Robert Lee 1937- *AmArch 70*
Dykinga, Jack 1943- *MacBEP*
Dykman, Harry S 1918- *AmArch 70*
Dykman-Lemonnier, Jeanne 1872- *DcWomA*
Dyksterhouse, John Raymond 1937- *AmArch 70*
Dymond, George 1797?-1835 *BiDBrA*
Dyneley, A F *DcWomA*
Dynevor, Lady *WhoArt 80*
Dynevor, Lucy 1934- *WhoArt 82, -84*
Dyott, Michael *IlDcG*
Dyott, Thomas W 1771-1861 *DcNiCA, IlDcG*
Dyrenforth, Noel 1936- *WhoArt 80, -82, -84*
Dyring, Moya 1908-1967 *DcBrA 2*
Dysart, Cabot 1920- *AmArch 70*
Dysart, Thomas *NewYHSD*
Dysert, G *AmArch 70*

Dysinger, Susan Jane 1944- *WhoAmA 76*
Dyson, Brian 1944- *WhoAmA 80, -82, -84*
Dyson, Douglas Kerr 1918- *WhoArt 80, -82, -84*
Dyson, John Holroyd 1910- *WhoAmA 78, -80, -82, -84*
Dyson, Ruby *DcWomA*
Dyson, William Henry 1880-1938 *WorECar*
Dyson, William Henry 1883-1938 *DcBrA 2, DcBrBI*
Dyyon, Frazier 1946- *AmArt, WhoAmA 84*
Dzamonja, Dusan 1928- *OxTwCA, PhDcTCA 77*
Dziacko, S J *AmArch 70*
Dziekanski, J *AmArch 70*
Dziekonskaja, Casimira 1851?-1934 *DcWomA, WhAmArt 85*
Dziekouska, Kasimir *WhAmArt 85*
Dzierski, Vincent 1930- *AmArt*
Dzigurski, Alex 1911- *WhoAmA 78, -80, -82, -84*
Dziuba, John A *AmArch 70*
Dzubas, Friedel 1905- *DcCAr 81*
Dzubas, Friedel 1915- *CenC, ConArt 77, -83, DcCAA 71, -77, OxTwCA, WhoAmA 73, -76, -78, -80, -82, -84*

E

E *AmArch 70*
E H *ArtsEM*
Eaches, Hector 1840-1873 *NewYHSD*
Eaches, James 1817-1847 *NewYHSD*
Eacobacci, Nicholas A 1891- *WhAmArt 85*
Eades, Luis Eric 1923- *WhoAmA 73, –76, –78, –80, –82, –84*
Eades, Stanley C *DcBrA 1*
Eades, William Richards, Jr. 1922- *AmArch 70*
Eadie, John Albert 1948- *MarqDCG 84*
Eadie, Riley Daniel 1912- *WhAmArt 85*
Eadie, Robert 1877-1954 *DcBrA 1*
Eads, James Buchanan 1820-1887 *MacEA*
Eads, John *BiDBrA*
Eads, Thomas Clark 1931- *AmArch 70*
Eady, David *MarqDCG 84*
Eady, Millicent *WhAmArt 85*
Eagan, Joseph B 1906- *WhAmArt 85*
Eagan, Thomas J *WhAmArt 85*
Eagar, Richard Michael Cardwell 1919- *WhoArt 80, –82, –84*
Eager, A Wesley 1864-1930 *BiDAmAr*
Eager, Frank S *NewYHSD*
Eager, Helen 1952- *DcCAr 81*
Eager, William Earl 1946- *MarqDCG 84*
Eagerton, Mari M *WhoAmA 76, –78, –80*
Eagerton, Robert Pierce 1940- *WhoAmA 73, –76, –78, –80, –82, –84*
Eagle, Arnold 1909- *ICPEnP A*
Eagle, Clara M 1908- *WhoAmA 73, –76*
Eagle, Edward d1910 *DcBrA 2*
Eagle, W *DcVicP 2*
Eagle, Walter Edgar 1934- *AmArch 70*
Eagleboy, Wayne 1946- *WhoAmA 78, –80*
Eagles, Edmund *DcVicP 2*
Eagles, Edward Bampfylde d1866? *DcBrWA*
Eagles, John 1783-1855 *DcBrWA, DcVicP 2*
Eagleton, Aileen C *WhoArt 80, –82, –84*
Eagleton, Aileen C 1902- *DcBrA 1*
Eaker, Jerry Jan 1934- *AmArch 70*
Eakins, George *EncASM*
Eakins, Susan Hannah 1851-1938 *DcWomA*
Eakins, Susan Hannah Macdowell 1851-1938 *DcAmArt*
Eakins, Susan Hannah MacDowell 1851-1938 *WomArt*
Eakins, Susan MacDowell 1851-1938 *WhAmArt 85*
Eakins, Thomas 1844- *ArtsNiC*
Eakins, Thomas 1844-1916 *ArtsAmW 1, BnEnAmA, DcAmArt, DcSeaP, ICPEnP A, IlBEAAW, MacBEP, OxArt, OxTwCA, WhAmArt 85*
Eakins, Thomas Cowperthwaite 1844-1916 *McGDA*
Eakle, Thomas William 1945- *MarqDCG 84*
Eald, Peter *NewYHSD*
Eales, M *DcVicP 2*
Ealy, Adolphus *AfroAA*
Eames *AntBDN Q, NewYHSD*
Eames, Charles 1907- *BnEnAmA, DcD&D[port], EncMA, McGDA*
Eames, Charles 1907-1978 *ConArch, ConDes*
Eames, Charles O 1907-1978 *MacEA*
Eames, John Heagan 1900- *WhAmArt 85, WhoAmA 73, –76, –78, –80, –82, –84*
Eames, Ray *ConDes*
Eames, Mrs. Richard *WhAmArt 85*
Eames, William E 1859-1915 *BiDAmAr*
Eames, William S 1857-1915 *MacEA*
Eamonson, S *DcVicP 2*
Eaneragy *CabMA*
Eardley, Enid Mary *WhoArt 80, –82, –84*
Eardley, Joan 1921-1963 *PhDcTCA 77*
Eardley, Joan Kathleen Harding 1921-1963 *DcBrA 1*

Eardley, John *FolkA 86*
Earhart, John Franklin 1853- *WhAmArt 85*
Earl, Augustus *DcAmArt*
Earl, Augustus 1793-1833? *NewYHSD*
Earl, C P *AmArch 70*
Earl, F *DcVicP 2*
Earl, F C *WhAmArt 85*
Earl, George *DcVicP, –2*
Earl, George W *NewYHSD*
Earl, Glenn Maury 1932- *AmArch 70*
Earl, Harley 1893- *McGDA*
Earl, Harley 1893-1969 *ConDes*
Earl, Jack 1934- *CenC*
Earl, Jack Eugene 1934- *WhoAmA 73, –76, –78, –80, –82, –84*
Earl, James 1761-1796 *DcAmArt, DcBrECP, NewYHSD*
Earl, M E *ArtsEM*
Earl, Maud *ClaDrA, DcVicP*
Earl, Maud d1943 *DcBrA 1, DcVicP 2, WhAmArt 85*
Earl, Maud 1848-1943 *DcWomA*
Earl, Phoebe *DcAmArt*
Earl, Ralph 1751-1801 *BnEnAmA, DcAmArt, DcBrECP, FolkA 86, McGDA, NewYHSD, OxArt*
Earl, Ralph E W 1785?-1838 *DcAmArt*
Earl, Ralph E W 1788-1838 *FolkA 86*
Earl, Ralph Eleaser Whiteside 1785?-1838 *NewYHSD*
Earl, S F *NewYHSD*
Earl, Tarleton B *ArtsEM, FolkA 86*
Earl, Thomas *DcVicP, –2*
Earl, William *CabMA*
Earl, William A 1931- *MarqDCG 84*
Earl, William Robert *DcBrWA, DcVicP, –2*
Earl Family *DcAmArt*
Earle *NewYHSD*
Earle, Annette 1910- *WhAmArt 85*
Earle, Augustus *DcVicP 2*
Earle, Augustus 1793-1838 *DcBrBI, DcBrWA*
Earle, Mrs. C W *DcVicP 2*
Earle, Charles 1830?-1893 *DcVicP*
Earle, Charles 1832-1893 *DcBrWA, DcVicP 2*
Earle, Cornelia 1863- *DcWomA, WhAmArt 85*
Earle, Donald Maurice 1928- *WhoArt 80, –82, –84*
Earle, Edward George 1939- *MarqDCG 84*
Earle, Edward W 1951- *WhoAmA 84*
Earle, Edwin 1904- *WhAmArt 85*
Earle, Elinor *DcWomA, WhAmArt 85*
Earle, Elsie *DcWomA, NewYHSD*
Earle, Eyvind *OfPGCP 86*
Earle, Eyvind 1916- *IlBEAAW, IlsCB 1946, PrintW 83, –85*
Earle, F *DcVicP 2*
Earle, George Frederic 1913- *WhAmArt 85*
Earle, Henry *NewYHSD*
Earle, J H *DcVicP 2*
Earle, James *FolkA 86*
Earle, James 1761-1796 *DcBrECP*
Earle, John 1779?-1863 *BiDBrA*
Earle, Joseph *NewYHSD*
Earle, Kate *DcVicP 2, DcWomA*
Earle, L C 1845-1921 *WhAmArt 85*
Earle, Lawrence Carmichael 1845-1921 *ArtsEM, IlBEAAW*
Earle, Maria Theresa *DcWomA*
Earle, Olive 1888- *WhAmArt 85*
Earle, Olive Lydia *IlsBYP, IlsCB 1946, –1957, –1967*
Earle, Olive Lydia 1888- *DcWomA*
Earle, Paul B *WhAmArt 85*

Earle, Percy *DcBrBI*
Earle, Robert Maxwell 1918- *WhAmArt 85*
Earle, Samuel Broadus, Jr. 1909- *AmArch 70*
Earle, Stephen C 1839-1913 *BiDAmAr*
Earle, Thomas 1811-1876 *ArtsNiC*
Earle, Vana 1917- *IlsCB 1946*
Earle, William *NewYHSD*
Earle, Mrs. William *NewYHSD*
Earle, William Henry 1925- *WhoAmA 80, –82, –84*
Earle, Winthrop 1870-1902 *WhAmArt 85*
Earles, Chester *DcVicP 2*
Earley, Charles 1949- *AfroAA*
Earley, James Farrington 1856- *WhAmArt 85*
Earley, John Joseph *WhAmArt 85*
Earley, Mary 1900- *WhAmArt 85*
Earley, Walter *WhAmArt 85*
Earll, John *NewYHSD*
Earlom, Richard 1743-1822 *McGDA, OxArt*
Earls, Paul 1934- *WhoAmA 84*
Earlygrow, Raven B 1946- *MarqDCG 84*
Earman, John *CabMA*
Earnest, Joseph *FolkA 86*
Earnest, Lester D 1930- *MarqDCG 84*
Earnheart, Robert Eugene *AmArch 70*
Earnist, Florence Reinhold *WhAmArt 85*
Earnshaw, Harold *DcBrBI*
Earnshaw, Mabel Lucie *DcWomA*
Earnshaw, Mary Harriot *DcVicP 2*
Earnshaw, Rae Alfred 1944- *MarqDCG 84*
Earnshaw, Thomas 1749-1829 *AntBDN D, OxDecA*
Earp, Edwin *DcBrA 1, DcBrWA*
Earp, Edwin 1851-1945 *BiDAmAr*
Earp, Frederick 1828-1914 *DcBrWA*
Earp, George *DcBrWA*
Earp, Henry 1831-1914 *DcBrWA, DcVicP 2*
Earp, Henry, Sr. 1831-1914 *DcBrA 1*
Earp, Vernon *DcBrWA*
Earp, W H *DcBrA 1*
Earp, William Henry *DcBrWA*
Earthman, John Alfred 1938- *AmArch 70*
Earthrowl, Eliab George 1878- *DcBrA 1*
Easby, Dudley T, Jr. 1905- *WhoAmA 73*
Easby, Dudley T, Jr. 1905-1973 *WhoAmA 76N, –78N, –80N, –82N, –84N*
Easby-Smith, Elizabeth H *DcWomA*
Eash, Lydia *FolkA 86*
Eash, Orus Orville 1915- *AmArch 70*
Easley, J *WhAmArt 85*
Easley, Loyce Rogers 1918- *WhoAmA 73, –76, –78*
Easley, Thomas 1949- *WhoArt 84*
Eason, W J *AmArch 70*
Easson, James *FolkA 86*
East, Sir Alfred 1849-1913 *DcBrA 1, ClaDrA, DcBrBI, DcBrWA, DcVicP, –2*
East, Edward 1602-1697 *OxDecA*
East, Edward 1612?-1697? *AntBDN D*
East, Mary *DcVicP 2, DcWomA*
East, N S, Jr. 1936- *WhoAmA 73, –76, –78, –80, –82, –84*
East, Pattie Richardson 1894- *ArtsAmW 1, –2, DcWomA, IlBEAAW, WhAmArt 85*
East, William H *DcVicP 2*
East, William J 1865-1936 *BiDAmAr*
Easter, Charles B *WhAmArt 85*
Easter, J F, Jr. *AmArch 70*
Easter, Jacob *FolkA 86*
Easterday, Sybil Unis 1876-1961 *ArtsAmW 2, DcWomA*
Easterling, Julia *WhoArt 82*
Easterwood, Henry Lewis 1934- *WhoAmA 76, –78, –80, –82, –84*

Eastes, Mrs. W T *WhAmArt 85*
Easthead, Harriet *DcWomA*
Eastlake, Mrs. *DcVicP 2*
Eastlake, Caroline H *DcBrWA, DcVicP 2, DcWomA*
Eastlake, Charles Herbert *DcBrA 1, DcBrWA, DcVicP 2*
Eastlake, Charles Lock 1833-1906 *DcD&D*
Eastlake, Charles Lock 1836-1906 *DcNiCA, OxDecA*
Eastlake, Sir Charles Lock 1793-1865 *ArtsNiC, DcBrWA, DcNiCA, DcVicP, -2, McGDA, OxArt*
Eastlake, Charles Locke *OxArt*
Eastlake, Elizabeth 1809-1893 *DcWomA*
Eastlake, Elizabeth R *DcVicP 2*
Eastlake, Elizabeth Rigby 1809-1893 *DcBrWA*
Eastlake, Mary *DcWomA*
Eastlake, Mary Alexandra 1864-1951 *DcWomA*
Eastlake, W *DcVicP 2*
Eastman, Abiel *CabMA*
Eastman, Albert Reyner 1900- *AmArch 70*
Eastman, Alvin Clark 1894-1959 *WhoAmA 80N, -82N, -84N*
Eastman, Charles M 1940- *MarqDCG 84*
Eastman, Charlotte Fuller *WhAmArt 85*
Eastman, Emily 1804- *DcWomA, FolkA 86*
Eastman, Frank Samuel 1878- *DcBrA 2*
Eastman, Gene M 1926- *WhoAmA 78, -80, -82, -84*
Eastman, George 1854-1932 *ICPEnP*
Eastman, George 1854-1934 *MacBEP*
Eastman, Harrison 1823- *ArtsAmW 1, EarABI, EarABI SUP*
Eastman, Harrison 1823?-1886? *IlBEAAW, NewYHSD*
Eastman, J Frederick *NewYHSD*
Eastman, John, Jr. 1916- *WhoAmA 76, -78, -80, -82*
Eastman, Maud *DcWomA*
Eastman, P D 1909- *IlsCB 1957*
Eastman, R C *AmArch 70*
Eastman, R E *AmArch 70*
Eastman, Ruth *DcWomA, WhAmArt 85*
Eastman, Seth 1808-1875 *ArtsAmW 1, BnEnAmA, DcAmArt, FolkA 86, IlBEAAW, McGDA, NewYHSD*
Eastman, William Joseph d1950 *WhoAmA 78N, -80N, -82N, -84N*
Eastman, William Joseph 1881-1950 *WhAmArt 85*
Eastmond, C Deitra *AfroAA*
Eastmond, E H 1876-1936 *ArtsAmW 1*
Eastmond, Elbert Hindley 1876-1936 *IlBEAAW, WhAmArt 85*
Easton, Arthur Frederick 1939- *WhoArt 80, -82, -84*
Easton, Edward, III 1936- *AmArch 70*
Easton, Elizabeth 1783-1868 *FolkA 86*
Easton, Frank Lorence *WhoAmA 78N, -80N, -82N, -84N*
Easton, Frank Lorence 1884- *WhAmArt 85*
Easton, Frank Lorence 1884-1952? *ArtsAmW 2*
Easton, John Murray 1889- *DcD&D*
Easton, Linwood 1892-1939 *WhAmArt 85*
Easton, Mary 1721-1737 *FolkA 86*
Easton, R J *AmArch 70*
Easton, Reginald 1807-1893 *AntBDN J*
Easton, Spencer G *WhAmArt 85*
Easton, W W *NewYHSD*
Easton, William George 1879- *DcBrA 1*
Eastop, Geoffrey *DcCAr 81*
Eastop, Geoffrey Frank 1921- *WhoArt 80, -82, -84*
Eastwood, Francis H *DcVicP 2*
Eastwood, R J 1898- *WhAmArt 85*
Eastwood, Raymond James 1898- *ArtsAmW 2*
Eastwood, Sidney Kingman *WhAmArt 85*
Eastwood, Walter 1867-1943 *DcBrA 1, DcBrWA, DcVicP 2*
Eaton, Ada T 1871- *WhAmArt 85*
Eaton, Alfred J *WhAmArt 85*
Eaton, Allen Hendershott d1962 *WhoAmA 78N, -80N, -82N, -84N*
Eaton, Allen Hendershott 1878-1962 *WhAmArt 85*
Eaton, Brevet *EarABI SUP*
Eaton, C Harry 1850-1901 *WhAmArt 85*
Eaton, Charles Frederick 1842- *ArtsAmW 1*
Eaton, Charles Harry 1850-1901 *ArtsAmW 1, ArtsEM*
Eaton, Charles Henry 1850-1901 *IlBEAAW*
Eaton, Charles Warren 1857-1937 *ArtsAmW 3, NewYHSD, WhAmArt 85*
Eaton, Clarissa *DcWomA*
Eaton, D Cady 1838-1912 *WhAmArt 85*
Eaton, Dorothy 1893- *DcWomA, WhAmArt 85*
Eaton, Eleanor R *DcWomA, WhAmArt 85*
Eaton, Elizabeth *DcWomA*
Eaton, Elizabeth K *DcWomA, WhAmArt 85*
Eaton, Ellen *DcWomA*
Eaton, Ellen M M *DcBrA 1, DcVicP 2, DcWomA*
Eaton, G C *DcVicP 2*
Eaton, George *BiDBrA, DcVicP 2*
Eaton, Harold Hubert 1906- *AmArch 70*
Eaton, Hattie *ArtsEM*
Eaton, Hugh McDougal 1865-1924 *WhAmArt 85*
Eaton, Isabella Graham 1845- *DcWomA*

Eaton, J F *AmArch 70*
Eaton, J N *FolkA 86, NewYHSD*
Eaton, Jacob *FolkA 86*
Eaton, John 1942- *IlsBYP*
Eaton, Joseph Horace 1815-1896 *NewYHSD*
Eaton, Joseph O 1829-1875 *ArtsNiC*
Eaton, Joseph Oriel 1829-1875 *NewYHSD*
Eaton, Louise *DcWomA*
Eaton, Louise Herreshoff *WhAmArt 85*
Eaton, Lynedon Stanley 1922- *AmArch 70*
Eaton, Margaret Fernie 1871- *WhAmArt 85*
Eaton, Margaret Fernie Norris 1871- *DcWomA*
Eaton, Marguerite *WhAmArt 85*
Eaton, Maria *DcWomA*
Eaton, Mary *FolkA 86*
Eaton, Mary B *ArtsEM, DcWomA*
Eaton, Mary Emily 1873- *DcWomA*
Eaton, Moses, Jr. 1796-1886 *FolkA 86*
Eaton, Moses, Sr. 1753-1833 *FolkA 86*
Eaton, Myrwyn Lake 1904- *WhoAmA 73*
Eaton, Norman 1902-1966 *ConArch*
Eaton, Pauline 1935- *WhoAmA 82, -84*
Eaton, Sarah *DcWomA*
Eaton, Serana D *NewYHSD*
Eaton, Stephen O *DcVicP 2*
Eaton, Thomas Newton 1940- *WhoAmA 78, -80, -82, -84*
Eaton, Tom 1940- *ConGrA 1[port], IlsBYP*
Eaton, W B *AmArch 70*
Eaton, W P *DcVicP 2, FolkA 86*
Eaton, W R 1850-1922 *ArtsAmW 1*
Eaton, William *CabMA*
Eaton, William 1836-1896 *DcSeaP*
Eaton, William Bradley 1836-1896 *NewYHSD, WhAmArt 85*
Eaton, William S 1861- *WhAmArt 85*
Eaton, Wyatt *ArtsNiC*
Eaton, Wyatt 1849-1896 *BnEnAmA*
Eatough, C W *AmArch 70*
Eauclaire, Sally 1950- *MacBEP, WhoAmA 82, -84*
Eavens, Ella A *ArtsEM, DcWomA*
Eaves, John *NewYHSD*
Eaves, John 1929- *WhoArt 80, -82, -84*
Eaves, William *NewYHSD*
Eayre, Thomas 1691-1757 *BiDBrA*
Ebbecke, Hela *DcWomA*
Ebbels, Robert d1860 *BiDBrA*
Ebbels, Victoria 1900- *WhAmArt 85*
Ebbeson, G E *AmArch 70*
Ebbs, John *AntBDN Q*
Ebbutt, Phil *DcBrBI*
Ebdon, Christopher 1744?-1824 *BiDBrA*
Ebdon, Christopher 1745?-1810 *DcBrWA*
Ebejer, Thomas Matthew 1938- *AmArch 70*
Ebel, Fritz Carl Werner 1835-1895 *ClaDrA*
Ebel, Valentine *WhAmArt 85*
Ebeling, Kenneth Arnold 1942- *MarqDCG 84*
Ebendorf, Robert 1938- *DcCAr 81*
Eber, Elk 1892-1944 *IlBEAAW*
Eberbach, Alice Kinsey *WhAmArt 85*
Eberbach, Alice Kinsey 1872- *DcWomA*
Eberhard, John *NewYHSD*
Eberhard, John Paul *AmArch 70*
Eberhard, Robert Georges 1884- *WhAmArt 85*
Eberhardt, Eugenia McCorkle *ArtsAmW 3, DcWomA, WhAmArt 85*
Eberhardt, John Thomas 1894- *AfroAA*
Eberhart, Robert Clare 1933- *AmArch 70*
Eberharth, Augusta 1856- *DcWomA*
Eberl, David Eugene 1937- *AmArch 70*
Eberle, Abastenia Saint Leger 1878-1942 *WomArt*
Eberle, Abastenia St. Leger 1878-1942 *DcAmArt, WhAmArt 85*
Eberle, Adolf 1843-1914 *ClaDrA*
Eberle, Edward *DcCAr 81*
Eberle, Elizabeth *DcWomA, WhAmArt 85*
Eberle, Mark *FolkA 86*
Eberle, Mary Abastenia St. Leger 1878-1942 *DcWomA*
Eberle, Merab *WhAmArt 85*
Eberle, Merab d1959 *WhoAmA 80N, -82N, -84N*
Eberle, Ulric *AntBDN K*
Eberle, Urs *DcCAr 81*
Eberlein, Ernest d1931 *WhAmArt 85*
Eberlein, Gustav Heinrich 1847-1926 *McGDA*
Eberlein, Johann Friedrich *AntBDN M*
Eberlein, Michael *ArtsEM*
Eberley, Jacob J *FolkA 86*
Eberly, Jacob *FolkA 86*
Eberman, Edwin 1905- *WhAmArt 85, WhoAmA 73, -76, -78, -80, -82, -84*
Ebers, Emile 1807- *ArtsNiC*
Ebersberger, Therese *DcWomA*
Ebersole, Mabel Helen *WhAmArt 85*
Ebersole, Mabel Helen 1885- *DcWomA*
Eberson, Drew Calvin *AmArch 70*
Eberstadt, Rudolph 1856-1922 *MacEA*
Ebert, C J *AmArch 70*
Ebert, Caroline *NewYHSD*
Ebert, Caroline 1812?- *DcWomA*
Ebert, Charles H 1873-1959 *WhAmArt 85*
Ebert, Derry B 1924- *AmArch 70*

Ebert, Edward Gordon 1958- *MarqDCG 84*
Ebert, Mary Roberts 1873- *DcWomA*
Ebert, Mary Roberts 1873-1956 *WhAmArt 85*
Ebert, Selma Ruth 1893- *DcWomA*
Eberting, Corwin Henry, Jr. 1924- *AmArch 70*
Eberts, J L *AmArch 70*
Eberz, Josef 1880-1942 *McGDA*
Ebey, George *FolkA 86*
Ebey, John Neff *FolkA 86*
Ebey, Marjorie *DcWomA, WhAmArt 85*
Ebie, William Dennis 1942- *WhoAmA 73, -76, -78, -80, -82, -84*
Ebinger, John 1924- *AmArch 70*
Ebner, Lewis F *DcVicP 2*
Eboral, William d1795 *BiDBrA*
Ebsen, Alf K 1908- *WhoAmA 76, -78, -80, -82, -84*
Eburne, Emma *DcVicP, -2*
Eburne, Emma S *DcWomA*
Eby, Donald Eugene 1926- *AmArch 70*
Eby, Kerr 1889-1946 *GrAmP, WhAmArt 85*
Eby, Robert Wilbur 1926- *AmArch 70*
Eccard, John Giles d1779 *DcBrECP*
Eccardt, Miss *DcWomA*
Eccles, Miss *DcWomA*
Eccles, Reverend Mr. *DcBrECP*
Eccles, David *MarqDCG 84*
Eccles, J Evans *DcVicP 2*
Eccleston, Harry Norman 1923- *DcBrA 1, WhoArt 80, -82, -84*
Echague, Jose Ortiz 1886-1980 *MacBEP*
Echave, Isabel De *DcWomA*
Echave Ibia, Baltasar De 1590?-1650? *McGDA*
Echave Y Orio, Baltasar De 1548?-1623? *McGDA*
Echert, Florence *DcWomA, WhAmArt 85*
Echlin, Roger Joseph 1838?-1920 *ArtsEM*
Echohawk, Brummett 1920?- *IlBEAAW*
Echohawk, Brummett 1922- *WhoAmA 82, -84*
Echols, Alice *FolkA 86*
Echols, Ralph Gordon *AmArch 70*
Echols, William Gordon, Jr. 1922- *AmArch 70*
Echols, William Walker 1920- *AmArch 70*
Echstein, John *FolkA 86*
Echtermeyer, Karl 1845- *ArtsNiC*
Echternach, T N *AmArch 70*
Eck, John C, Jr. 1941- *MarqDCG 84*
Eck, Vincent J 1893-1938 *BiDAmAr*
Eck, William 1824?- *NewYHSD*
Eckart, E *DcBrECP*
Eckart, Ruth Virginia 1911- *AmArch 70*
Eckberg, Adrian 1878- *WhAmArt 85*
Eckberg, John E *WhAmArt 85*
Eckbo, Garrett *ConArch A*
Eckbo, Garrett 1910- *ConArch, MacEA*
Ecke, Betty Tseng Yu-Ho *WhoAmA 80, -82, -84*
Ecke, Betty Tseng Yu-Ho 1923- *WhoAmA 73, -76, -78*
Ecke, Gustav d1971 *WhoAmA 78N, -80N, -82N, -84N*
Eckel, E J 1845-1934 *MacEA*
Eckel, Edmond Jacques 1845-1934 *BiDAmAr*
Eckel, G R *AmArch 70*
Eckel, J L *NewYHSD*
Eckel, Julia *WhAmArt 85*
Eckelberry, Don Richard *OfPGCP 86*
Eckelberry, Don Richard 1921- *WhoAmA 76, -78, -80, -82, -84*
Eckenbrecher, Karl Themistocles Von 1842- *ClaDrA*
Eckendorf, George *NewYHSD*
Eckersberg, Christoffer Wilhelm 1783-1853 *DcSeaP, OxArt*
Eckersberg, Christopher Wilhelm 1783-1853 *McGDA*
Eckersberg, John Frederick 1822-1870 *ArtsNiC*
Eckersley, Thomas 1914- *WhoGrA 62*
Eckersley, Thomas Cyril 1941- *WhoAmA 76, -78, -80, -82, -84*
Eckersley, Tom 1914- *ConDes, WhoGrA 82[port]*
Eckerson, Margaret 1883- *DcWomA, WhAmArt 85*
Eckert, A F *AmArch 70*
Eckert, E E 1915- *WhAmArt 85*
Eckert, Edwin O 1926- *AmArch 70*
Eckert, Gottlieb 1809?- *FolkA 86*
Eckert, Henri Amros 1807-1840 *ClaDrA*
Eckert, Josephine 1916- *WhAmArt 85*
Eckert, Katherine Bird *WhAmArt 85*
Eckert, Lou 1928- *WhoAmA 76, -78, -80, -82, -84*
Eckert, N G *AmArch 70*
Eckert, R A *AmArch 70*
Eckert, Richard Hollinger 1920- *AmArch 70*
Eckert, William Dean 1927- *WhoAmA 73, -76, -78, -80, -82, -84*
Eckfeldt And Ackley *EncASM*
Eckford, Jessiejo 1895- *ArtsAmW 2, DcWomA, IlBEAAW, WhAmArt 85*
Eckhardt, Edris 1906- *WhAmArt 85*
Eckhardt, Edris 1907- *CenC*
Eckhardt, Edris 1910- *IlDcG*
Eckhardt, Ferdinand *WhoAmA 73, -76, -78, -80, -82, -84*
Eckhardt, Jenny 1816-1850 *DcWomA*
Eckhardt, Johannes Aegidius *DcBrECP*
Eckhardt, Oscar *DcBrBI*

Edson, T A *AmArch 70*
Edson, Tracy Robinson 1809-1881 *NewYHSD*
Edstrom, David 1873-1938 *WhAmArt 85*
Eduin, Marie Elisabeth *DcWomA*
Edvi Illes, Emma *WhoAmA 76, -78, -80, -82, -84*
Edvi Illes, George 1911- *WhoAmA 76, -78, -80, -82, -84, WhoArt 80, -82, -84*
Edvy, Julius 1878- *WhAmArt 85*
Edward VI, King 1537-1553 *DcBrWA*
Edward, Albert *DcVicP 2*
Edward, Alexander *NewYHSD*
Edward, Alexander 1651-1708 *BiDBrA*
Edward, Alfred S 1852-1915 *DcBrA 1, DcVicP 2*
Edward, Berthe *DcWomA*
Edward, C *DcVicP 2*
Edwards, Clara *DcBrA 1, DcWomA*
Edwardes, Elizabeth *DcWomA*
Edwardes, Elizabeth 1840-1911 *DcBrWA*
Edwardes, May DeMontravel *DcBrA 1, DcWomA*
Edwardes, May DeMontravel 1887- *ClaDrA*
Edwards *BiDBrA*
Edwards, Lieutenant *DcVicP 2*
Edwards, A *DcVicP 2*
Edwards, A B *WhAmArt 85*
Edwards, A Elsie *WhAmArt 85*
Edwards, A G *DcVicP 2*
Edwards, Abraham 1761-1840 *DcNiCA*
Edwards, Alexander *CabMA*
Edwards, Alice Elsie *DcWomA*
Edwards, Allan W 1915- *WhoAmA 78, -80, -82*
Edwards, Amelia B *DcBrBI, DcVicP 2*
Edwards, Annie *DcWomA*
Edwards, Arthur Emlyn 1916- *AmArch 70*
Edwards, Arthur Sherwood 1887- *DcBrA 1*
Edwards, Benjamin *AntBDN H, CabMA*
Edwards, Benjamin, Jr. *IlDcG*
Edwards, Benjamin, Sr. d1812 *IlDcG*
Edwards, Beulah Eliza 1892- *DcWomA*
Edwards, Brooks Noyes 1923- *AmArch 70*
Edwards, C A *DcBrECP, DcWomA*
Edwards, Calvin *DcNiCA*
Edwards, Carl J 1914- *WhoArt 80, -82, -84*
Edwards, Catherine Adelaide *DcVicP, -2, DcWomA*
Edwards, Charles 1797-1868 *NewYHSD*
Edwards, Charlotte E *ArtsEM*
Edwards, Clement R *NewYHSD*
Edwards, Cyril W 1902- *DcBrA 1*
Edwards, D *DcBrBI*
Edwards, D J, Jr. *AmArch 70*
Edwards, D L *AmArch 70*
Edwards, E 1766-1849 *DcBrBI*
Edwards, E E *DcVicP 2*
Edwards, E K *AmArch 70*
Edwards, Edward *AntBDN Q, BiDBrA*
Edwards, Edward 1738-1806 *BkIE, DcBrECP, DcBrWA, OxArt*
Edwards, Edward 1766-1849 *DcBrWA*
Edwards, Edward B 1873- *WhAmArt 85*
Edwards, Edwin 1823-1879 *ArtsNiC, DcBrWA, DcVicP, -2*
Edwards, Eleanor McGavic 1906- *WhAmArt 85*
Edwards, Ellender Morgan *WhoAmA 73, -76, -78, -80, -82, -84*
Edwards, Ellender Victorine *MacBEP*
Edwards, Ellin H *DcVicP 2*
Edwards, Emily *ArtsAmW 3, DcWomA*
Edwards, Emily 1888-1980 *WhAmArt 85*
Edwards, Emily J *AntBDN M, DcNiCA*
Edwards, Emily J d1876 *DcWomA*
Edwards, Emma *DcWomA*
Edwards, Emmet 1906- *WhAmArt 85*
Edwards, Ethel *WhAmArt 85, WhoAmA 73, -76, -78, -80, -82, -84*
Edwards, Ethel Emett *WhAmArt 85*
Edwards, F *DcVicP 2*
Edwards, Frances 1786- *DcWomA*
Edwards, Francis 1784-1857 *BiDBrA*
Edwards, G *DcWomA*
Edwards, G H *DcVicP 2*
Edwards, George 1694-1773 *DcBrWA*
Edwards, George D *ArtsEM*
Edwards, George Hay *DcVicP 2*
Edwards, George Henry *DcBrBI, DcBrWA, DcVicP 2*
Edwards, George W 1915- *AmArch 70*
Edwards, George Wharton d1950 *WhoAmA 78N, -80N, -82N, -84N*
Edwards, George Wharton 1859?-1950 *IlsCB 1744*
Edwards, George Wharton 1869-1950 *WhAmArt 85*
Edwards, Grace Dawson 1879?-1943 *DcWomA, WhAmArt 85*
Edwards, Gunvor *IlsCB 1967*
Edwards, Gwendolyn Tyner 1933- *WhoAmA 78*
Edwards, H Arden *WhAmArt 85*
Edwards, H Arden 1884-1953 *ArtsAmW 3*
Edwards, H C 1868-1922 *WhAmArt 85*
Edwards, H Griffith 1907- *AmArch 70*
Edwards, Harry C 1868-1922 *IlBEAAW*
Edwards, Helen Constance Pym 1882- *DcBrA 1, DcWomA*
Edwards, Henrietta 1849-1931 *DcWomA*

Edwards, Henry *BiDBrA*
Edwards, Henry Sutherland 1828- *DcBrBI*
Edwards, Henry Turberville *BiDBrA*
Edwards, Hugh *IlDcG*
Edwards, Hugh 1904- *ICPEnP*
Edwards, Ida *DcWomA*
Edwards, Inez C Stanley *DcWomA*
Edwards, Iorwerth Eiddon Stephen 1909- *WhoArt 80, -82, -84*
Edwards, J I *AmArch 70*
Edwards, J L *WhAmArt 85*
Edwards, J Paul 1941- *MarqDCG 84*
Edwards, James *AfroAA, BiDBrA, DcBrWA, DcVicP 2*
Edwards, James F 1948- *WhoAmA 78, -80, -82, -84*
Edwards, Jeffery 1945- *DcCAr 81*
Edwards, Jessie A *DcVicP 2*
Edwards, John *DcBrECP, IlDcG*
Edwards, John 1670-1746 *AntBDN Q*
Edwards, John 1671?-1746 *BnEnAmA*
Edwards, John 1938- *ConBrA 79[port], DcCAr 81*
Edwards, John Colin 1940- *WhoArt 80, -82, -84*
Edwards, John Philip 1925- *AmArch 70*
Edwards, Joseph, Jr. 1737-1783 *BnEnAmA*
Edwards, Joseph Jean, III 1943- *MarqDCG 84*
Edwards, Joy M 1919- *WhoAmA 76, -78, -80*
Edwards, Kate *DcBrBI*
Edwards, Kate F *WhAmArt 85*
Edwards, Kate Flournoy 1877- *WhoAmA 73, -76*
Edwards, Kate Flournoy 1877-1980 *DcWomA*
Edwards, Kate J *DcVicP 2*
Edwards, L E *AmArch 70*
Edwards, Lionel D R 1878- *ClaDrA*
Edwards, Lionel Dalhousie Robertson 1878- *IlsCB 1744, -1946*
Edwards, Lionel Dalhousie Robertson 1878-1966 *DcBrA 1, DcBrBI*
Edwards, Lonnie Joe *IlBEAAW*
Edwards, Louis *DcBrBI*
Edwards, Louisa *DcVicP 2, DcWomA*
Edwards, Louisa E *AntBDN M, DcNiCA, DcWomA*
Edwards, Mabel 1884- *DcBrA 1, DcWomA*
Edwards, Maeble *WhAmArt 85*
Edwards, Maisic *DcWomA*
Edwards, Marian *DcVicP 2*
Edwards, Mark 1947- *ConPhot, ICPEnP A*
Edwards, Mary *DcWomA*
Edwards, Mary Ellen *DcVicP, -2*
Edwards, Mary Ellen 1839-1908? *DcBrWA, DcWomA*
Edwards, Mary Ellen 1839-1910? *DcBrBI*
Edwards, Mary L *DcWomA, WhAmArt 85*
Edwards, Mary Stella 1898- *DcBrA 2*
Edwards, Melvin 1937- *AfroAA*
Edwards, Mia *DcVicP 2*
Edwards, Nancy Bixby 1882- *DcWomA, WhAmArt 85*
Edwards, O E *DcWomA*
Edwards, P *AmArch 70*
Edwards, Paul Burgess *WhoAmA 76, -78, -80, -82*
Edwards, Paul Burgess 1934- *WhoAmA 84*
Edwards, Peter 1934- *IlsBYP*
Edwards, Peter William 1934- *IlsCB 1967*
Edwards, Pryce Carter *DcBrWA*
Edwards, R R *AmArch 70*
Edwards, Ralph *WhoArt 80N*
Edwards, Ralph Arnold 1925- *AmArch 70*
Edwards, Robert d1948 *WhoAmA 78N, -80N, -82N, -84N*
Edwards, Robert 1879-1948 *WhAmArt 85*
Edwards, Robert Glen 1922- *AmArch 70*
Edwards, Robert William 1930- *AmArch 70*
Edwards, Ronald Frank 1941- *AmArch 70*
Edwards, Ryland Patterson 1923- *AmArch 70*
Edwards, Samuel *DcBrECP*
Edwards, Samuel 1705-1762 *BnEnAmA*
Edwards, Sara *AfroAA*
Edwards, Stanley 1941- *AmArt*
Edwards, Stanley Dean 1941- *WhoAmA 73, -76, -78, -80, -82, -84*
Edwards, Stephen Lane *BiDBrA*
Edwards, Sydenham Teak 1769?-1819 *DcBrWA*
Edwards, T W *DcVicP 2*
Edwards, Thomas *CabMA, DcBrECP, NewYHSD*
Edwards, Thomas d1775 *BiDBrA*
Edwards, Thomas 1701?-1755 *BnEnAmA*
Edwards, V Ash *DcBrA 2*
Edwards, Victor E *WhoArt 80, -82, -84*
Edwards, W *DcVicP 2, NewYHSD*
Edwards, W C *DcWomA*
Edwards, Mrs. W C *WhAmArt 85*
Edwards, W Croxford *DcVicP 2*
Edwards, W H *DcVicP 2*
Edwards, Mrs. W H *DcVicP 2, DcWomA*
Edwards, W J *AmArch 70*
Edwards, William 1719-1789 *BiDBrA*
Edwards, William A 1866-1939 *BiDAmAr*
Edwards, William Andrew, Jr. 1930- *AmArch 70*
Edwards, William Croxford *DcBrWA*
Edwards Horton And Edwards *EncASM*

Edwards Of Halifax *OxDecA*
Edwards-Tucker, Yvonne 1941- *WhoAmA 84*
Edwardson, Laurence Christie 1904- *WhAmArt 85*
Edwell, Beatrice *DcWomA*
Edwell, Bernice 1880- *DcBrA 1, DcWomA*
Edwin, David 1776-1841 *NewYHSD*
Edwin, Horace *DcVicP 2*
Edwin, Mary *DcVicP 2*
Edwin, Richard d1778 *BiDBrA*
Edwina *WorECom*
Edy, John William 1760-1802 *DcBrECP*
Edy-Legrand 1893- *IlsCB 1946*
Edyburn, Dave Lee 1957- *MarqDCG 84*
Edzard, Dietz 1893-1963 *McGDA*
Eecke, Jan Van *ClaDrA*
Eeckele, Jan Van *ClaDrA*
Eeckhoudt, Jean VanDen 1875-1946 *OxTwCA*
Eeckhout, Gerbrand VanDen 1621-1674 *ClaDrA*
Eeckhout, Gerbrandt VanDen 1621-1674 *McGDA, OxArt*
Eeckhout, Jakob Joseph 1793-1861 *ClaDrA*
Eeckhout, Jan *NewYHSD*
Eedes, R *DcVicP 2*
Eek, Ann Christine 1948- *MacBEP*
Eemont, Maria d1667 *DcWomA*
Eertvelt, Andries Van 1590-1652 *DcSeaP*
Eesteren, C Van 1897- *WhoArch*
Eesteren, Cor Van 1897- *EncMA*
Eesteren, Cornelis Van 1897- *McGDA*
Eeuwouts, Hans *McGDA*
Effel, Jean *WhoGrA 62, WorECar*
Effel, Jean 1908- *WhoGrA 82[port]*
Effie, William *NewYHSD*
Effinger, Margaretha Charlotte *DcWomA*
Effingham, Eliza, Countess Of d1894 *DcWomA*
Effner, Joseph 1687-1745 *MacEA, WhoArch*
Efimov, Boris Efimovich 1900- *WorECar*
Eflin, Robert Dean 1929- *AmArch 70*
Efrat, Benni 1935- *ConArt 77, -83*
Efrat, Benni 1936- *WhoAmA 78, -80, -82, -84*
Efron, Albert 1929- *AmArch 70*
Efthemiou, R W *AmArch 70*
Egan, A *CabMA*
Egan, Alice Mary *DcWomA*
Egan, Charles 1911- *WhoAmA 73*
Egan, D *CabMA*
Egan, Eloise *WhAmArt 85*
Egan, Felim 1952- *DcCAr 81*
Egan, Harold *WhAmArt 85*
Egan, James J 1839-1914 *BiDAmAr*
Egan, John Frederick 1935- *MarqDCG 84*
Egan, John J *FolkA 86, IlBEAAW, NewYHSD*
Egan, John Thomas 1937- *MarqDCG 84*
Egan, Joseph Byron 1906- *WhAmArt 85*
Egan, L G *WhAmArt 85*
Egan, R M *AmArch 70*
Egan, Rod *MarqDCG 84*
Egan, Thomas H *NewYHSD*
Egas, Anton *OxArt*
Egas, Camilo d1962 *WhoAmA 78N, -80N, -82N, -84N*
Egas, Egas d1495 *OxArt*
Egas, Enrique d1534 *MacEA, OxArt*
Egas, Enrique 1455?-1534 *McGDA*
Egas, Enrique De d1534? *WhoArch*
Egas, Hanequin d1475? *OxArt*
Egbert, Charles Force Deems 1932- *AmArch 70*
Egbert, H, Jr. 1826-1900 *EarABI, EarABI SUP*
Egbert, Henry 1826-1900 *NewYHSD, WhAmArt 85*
Egbert, Lynn *WhAmArt 85*
Egbert, Smith *ArtsEM*
Ege, Eduard 1893- *WhoGrA 82[port]*
Ege, Ole 1934- *MacBEP*
Ege, Otto F d1951 *WhoAmA 78N, -80N, -82N, -84N*
Ege, Otto F 1888-1951 *WhAmArt 85*
Egeli, Bjorn P 1900- *WhAmArt 85*
Egeli, Peter Even 1934- *WhoAmA 76, -78, -80, -82, -84*
Egell, Paul 1691-1752 *McGDA*
Egelmann, Carl Friederich *FolkA 86*
Egeressy, A E *AmArch 70*
Egerhazy, Joseph Bela 1932- *AmArch 70*
Egermann, Anton Ambros d1888 *IlDcG*
Egermann, Friedrich 1777-1864 *DcNiCA, IlDcG*
Egerton, Miss *DcBrECP, DcWomA*
Egerton, A *DcVicP 2*
Egerton, Alice Mary 1830?-1868 *DcBrWA*
Egerton, Daniel Thomas d1842 *DcVicP 2*
Egerton, Jane Sophia *DcBrWA, DcWomA*
Egerton, John C *DcVicP 2*
Egerton, M *DcBrBI*
Egerton, Matthew d1787 *AntBDN G*
Egerton, Matthew, Jr. *AntBDN G*
Egerton, Matthew, Jr. d1837 *CabMA*
Egerton, Matthew, Sr. d1802 *CabMA*
Egerton, Will *DcVicP 2*
Egg, Augustus L 1816-1863 *ArtsNiC*
Egg, Augustus Leopold 1816-1863 *DcVicP, -2*
Egg, Durs 1745-1834 *OxDecA*
Egg, Durs 1750-1834 *AntBDN F*

Ellerhusen, Florence 1888-1950 *DcWomA*

Ellerhusen, Florence Cooney d1950 *WhoAmA 78N, -80N, -82N, -84N*

Ellerhusen, Ulric H 1879- *WhAmArt 85*

Ellerhusen, Ulric H 1879-1957 *WhoAmA 80N, -82N, -84N*

Ellertson, Homer F 1892-1935 *WhAmArt 85*

Ellery, Richard V 1909- *WhAmArt 85*

Ellesmere, Francis, Earl Of *DcBrBI*

Elleson, G *DcVicP 2*

Ellett *DcBrBI*

Ellfeldt, Walter Charles 1909- *WhAmArt 85*

Ellice, Katherine Jane *DcWomA*

Ellice-Hopkins, Francis *DcBrA 1*

Ellicombe, Sir Charles Grene 1783-1871 *DcBrWA*

Ellicott, Henry J 1848-1901 *WhAmArt 85*

Ellicott, John *AntBDN D*

Ellicott, John 1706-1772 *AntBDN D*

Ellicott, William B 1853-1944 *BiDAmAr*

Elliger, Christiana Maria 1732- *DcWomA*

Ellinger, Carlton D *WhAmArt 85*

Ellinger, David *FolkA 86*

Ellinger, G E *AmArch 70*

Ellinger, Ilona E *WhAmArt 85*

Ellinger, Ilona E 1913- *WhoAmA 73, -76, -78, -80, -82, -84*

Ellingham, Clifford A 1917- *AmArch 70*

Ellingson, William John 1933- *WhoAmA 78, -80, -82, -84*

Ellington, Ferdinand W 1894- *AfroAA*

Ellingwood, Nanette B *ArtsEM, DcWomA*

Ellins, James *BiDBrA*

Elliot, Andrew 1821- *CabMA*

Elliot, Archibald 1760-1823 *BiDBrA*

Elliot, Archibald 1761-1823 *WhoArch*

Elliot, Archibald, Jr. d1843 *BiDBrA*

Elliot, Bert d1931 *WhAmArt 85*

Elliot, Cathy J 1947- *WhoAmA 80, -82, -84*

Elliot, Charles *AntBDN G*

Elliot, Dorothy M *DcBrA 2*

Elliot, Edward *DcBrA 2*

Elliot, Frank 1858- *ClaDrA*

Elliot, George *DcVicP 2*

Elliot, George 1776-1852 *NewYHSD*

Elliot, James *DcVicP 2*

Elliot, James 1770-1810 *BiDBrA*

Elliot, John *FolkA 86*

Elliot, John 1713-1791 *AntBDN G*

Elliot, John Theodore 1929- *WhoAmA 80, -82, -84*

Elliot, Leo *EarABI SUP*

Elliot, Nathan *FolkA 86*

Elliot, R P *FolkA 86*

Elliot, Rebecca *DcWomA*

Elliot, Richard *DcVicP 2*

Elliot, Thomas *DcSeaP*

Elliot, W P *NewYHSD*

Elliot, William *BiDBrA*

Elliott, Aileen Mary 1896- *DcBrA 1, DcWomA*

Elliott, Allen Dean 1941- *AmArch 70*

Elliott, Alma *DcBrBI*

Elliott, Anthony Lewis 1847?-1909 *DcBrWA*

Elliott, Arthur 1870-1938 *MacBEP*

Elliott, B Charles, Jr. 1924- *WhoAmA 73, -76, -78, -80, -82, -84*

Elliott, Benjamin F 1829-1870 *NewYHSD*

Elliott, Benjamin Paul 1920- *AmArch 70*

Elliott, Bruce Roger 1938- *WhoAmA 73, -76, -78, -80, -82, -84*

Elliott, C Eugene 1935- *AmArch 70*

Elliott, C G, Jr. *AmArch 70*

Elliott, Charles *DcVicP 2*

Elliott, Charles Loring 1812-1868 *ArtsNiC, BnEnAmA, DcAmArt, EarABI, McGDA, NewYHSD*

Elliott, D A *AmArch 70*

Elliott, David 1944- *MacBEP*

Elliott, David Allen 1952- *MarqDCG 84*

Elliott, Donald 1945- *MarqDCG 84*

Elliott, Dorothy Baden 1914- *WhoAmA 80, -82, -84*

Elliott, E G *DcBrBI*

Elliott, Edward Procter 1916- *AmArch 70*

Elliott, Elizabeth *DcWomA*

Elliott, Elizabeth Shippen Green *IlsCB 1744, WhAmArt 85*

Elliott, Emily Louise 1867- *DcWomA*

Elliott, Fanny *DcWomA*

Elliott, Florence 1856-1942 *ArtsAmW 1, DcWomA*

Elliott, Frances Gray 1900- *WhAmArt 85*

Elliott, Francis Edward 1929- *AmArch 70*

Elliott, Frank *DcVicP 2*

Elliott, Frank 1858- *DcBrA 1*

Elliott, H G, Jr. *AmArch 70*

Elliott, Hannah 1876- *WhAmArt 85*

Elliott, Hannah 1876-1956 *DcWomA*

Elliott, Henry *AntBDN D*

Elliott, Henry Wood 1846- *ArtsAmW 1, IlBEAAW*

Elliott, Henry Wood 1846-193-? *WhAmArt 85*

Elliott, Henry Wood 1846-1930 *ArtsAmW 3*

Elliott, Huger *WhAmArt 85*

Elliott, James *DcVicP 2, NewYHSD*

Elliott, James Gordon 1903- *AmArch 70*

Elliott, James Heyer 1924- *WhoAmA 73, -76, -78, -80, -82, -84*

Elliott, John *BiDBrA*

Elliott, John 1858-1925 *WhAmArt 85*

Elliott, John, Jr. *CabMA*

Elliott, John, Sr. 1713-1791 *CabMA*

Elliott, Julian *ConArch A*

Elliott, Julian 1928- *ConArch*

Elliott, Leo 1814- *EarABI, NewYHSD*

Elliott, Lillian *WhoAmA 73, -76, -78, -80, -82, -84*

Elliott, Lillian 1930- *DcCAr 81*

Elliott, Martha Beggs 1892- *ClaDrA, DcWomA, WhAmArt 85, WhoArt 80, -82, -84*

Elliott, Mrs. Philip C *WhAmArt 85*

Elliott, Philip Clarkson 1903- *WhAmArt 85, WhoAmA 73, -76, -78, -80, -82, -84*

Elliott, Raymond L 1937- *MarqDCG 84*

Elliott, Rebecca *DcVicP 2*

Elliott, Robert James d1849 *DcBrWA*

Elliott, Robert R *WhAmArt 85*

Elliott, Robert S *ArtsEM*

Elliott, Robert T d1841 *BiDAmAr*

Elliott, Robinson 1814-1894 *ClaDrA, DcBrWA, DcVicP, -2*

Elliott, Ronnie 1916- *DcCAA 71, -77, WhoAmA 78, -80, -82, -84*

Elliott, Ronnie Rose 1910- *WhAmArt 85*

Elliott, Ronnie Rose 1916- *WhoAmA 73, -76*

Elliott, Russ *OfPGCP 86*

Elliott, Ruth C 1891- *WhAmArt 85*

Elliott, Ruth Cass 1891- *ArtsAmW 1, DcWomA*

Elliott, Scott Cameron 1941- *WhoAmA 78*

Elliott, W *NewYHSD*

Elliott, Walter Albert 1930- *ClaDrA*

Elliott, William *AntBDN Q, DcBrECP, DcSeaP*

Elliott, William F *BiDAmAr*

Elliott, William Horace 1908- *AmArch 70*

Elliott, William Hudson, Jr. 1917- *AmArch 70*

Elliott And Denton *ArtsEM*

Ellis *EncASM, FolkA 86*

Ellis, A *FolkA 86*

Ellis, A S *AmArch 70*

Ellis, Ada Leslie 1862?-1939 *DcWomA*

Ellis, Adelina Blanche *DcWomA*

Ellis, Alice Blanche *DcVicP 2, DcWomA*

Ellis, Annie Edith *DcWomA*

Ellis, Anthony 1620-1671 *BiDBrA*

Ellis, Arthur 1856-1918 *DcBrA 1, DcVicP 2*

Ellis, Bert *DcVicP 2*

Ellis, Betty Corson 1917- *WhAmArt 85*

Ellis, Blakely D *AmArch 70*

Ellis, C L, Sr. *AmArch 70*

Ellis, C R *AmArch 70*

Ellis, C Wynn *DcVicP 2*

Ellis, C Wynne d1915 *DcBrA 2*

Ellis, Carl Eugene 1932- *WhoAmA 73, -76*

Ellis, Carl Eugene 1932-1977 *WhoAmA 78N, -80N, -82N, -84N*

Ellis, Charles *WhAmArt 85*

Ellis, Clarence 1934-1971 *FolkA 86*

Ellis, Clyde Garfield 1879- *WhAmArt 85*

Ellis, Clyde Garfield 1879-1970 *ArtsAmW 2*

Ellis, Constance *DcWomA*

Ellis, Donald J 1931- *AmArch 70*

Ellis, E G *DcVicP 2*

Ellis, E M *AmArch 70*

Ellis, Edith Kingdon- *DcVicP 2*

Ellis, Edmund L 1872- *WhAmArt 85*

Ellis, Edwin 1841-1895 *DcVicP, -2*

Ellis, Edwin Charles 1917- *WhoAmA 73, -76, -78, -80, -82*

Ellis, Edwin John *DcVicP 2*

Ellis, Edwin John 1841-1895 *DcBrBI, DcBrWA, DcSeaP*

Ellis, Edwin M *NewYHSD*

Ellis, Elizabeth *DcWomA*

Ellis, Ernest G *DcVicP 2*

Ellis, Eveline Corbould *DcWomA*

Ellis, F E *AmArch 70*

Ellis, Freeman *FolkA 86*

Ellis, Fremont F 1897- *ArtsAmW 1, IlBEAAW, WhAmArt 85, WhoAmA 73, -76, -78, -80, -82, -84*

Ellis, Gene Dirk 1938- *AmArch 70*

Ellis, George B *NewYHSD*

Ellis, George Richard 1937- *WhoAmA 73, -76, -78, -80, -82, -84*

Ellis, H *DcVicP 2*

Ellis, H W *AmArch 70*

Ellis, Harold 1917- *WhoArt 80, -82, -84*

Ellis, Harriet A 1886- *DcWomA, WhAmArt 85*

Ellis, Harvey 1852-1904 *ArtsAmW 3, MacEA, WhAmArt 85*

Ellis, Helen E 1889- *DcWomA, WhAmArt 85*

Ellis, James E *EncASM*

Ellis, Jeanie Wright *ClaDrA*

Ellis, Jerry 1936- *AmArch 70*

Ellis, John *DcVicP 2, FolkA 86, WhAmArt 85*

Ellis, John, Jr. *FolkA 86*

Ellis, John D *NewYHSD*

Ellis, Joseph Bailey *WhoAmA 78N, -80N, -82N, -84N*

Ellis, Joseph Bailey 1890- *WhAmArt 85*

Ellis, Joseph F 1783?-1848 *DcSeaP*

Ellis, Larry L 1936- *AmArch 70*

Ellis, Leigh *WhAmArt 85*

Ellis, Levi *FolkA 86*

Ellis, Lionel 1903- *DcBrA 1, WhoArt 80, -82*

Ellis, Lucebra *FolkA 86*

Ellis, Lucy *DcWomA*

Ellis, M A *AmArch 70*

Ellis, Margaret B *DcWomA*

Ellis, Marion Lee 1904- *AmArch 70*

Ellis, Mary *DcWomA*

Ellis, Matthew *CabMA*

Ellis, Matthew C *EncASM*

Ellis, Mattie *ArtsEM, DcWomA*

Ellis, Maude Martin 1892- *WhAmArt 85*

Ellis, Monte *OfPGCP 86*

Ellis, Noel 1917- *DcBrA 1, WhoArt 80, -82, -84*

Ellis, Norman Ernest 1913- *DcBrA 1, WhoArt 80, -82, -84*

Ellis, Paul H *DcVicP 2*

Ellis, Perry Edwin 1940- *ConDes*

Ellis, Peter 1804-1884 *MacEA*

Ellis, Philip W *EncASM*

Ellis, R E *AmArch 70*

Ellis, R L *AmArch 70*

Ellis, Rachel E *DcWomA, FolkA 86*

Ellis, Ralph Gordon 1885-1963 *DcBrA 2*

Ellis, Ray G 1921- *WhoAmA 73, -76, -80, -82, -84*

Ellis, Rennie 1940- *ConPhot, ICPEnP A, MacBEP*

Ellis, Richard *AntBDN N, OfPGCP 86*

Ellis, Richard 1938- *WhoAmA 78, -80, -82, -84*

Ellis, Richard A *MarqDCG 84*

Ellis, Robert *BiDBrA*

Ellis, Robert 1929- *WhoArt 84*

Ellis, Robert Allen 1938- *MarqDCG 84*

Ellis, Robert Carroll 1923- *WhoAmA 78*

Ellis, Robert Carroll 1923-1979 *WhoAmA 80N, -82N, -84N*

Ellis, Salathiel 1860- *NewYHSD*

Ellis, T H *AmArch 70, DcWomA*

Ellis, Mrs. T H *DcVicP 2*

Ellis, T J *DcVicP 2*

Ellis, Thomas *BiDBrA, DcVicP 2*

Ellis, Tristram J 1844-1922 *ClaDrA, DcBrA 1, DcVicP, -2*

Ellis, Tristram James 1844-1922 *DcBrBI, DcBrWA*

Ellis, Vernon 1885-1944 *WhAmArt 85*

Ellis, Vic 1921- *DcSeaP*

Ellis, W *DcBrWA*

Ellis, William *DcVicP 2*

Ellis, William 1747-1810 *DcBrWA*

Ellis, William Cox 1787-1871 *NewYHSD*

Ellis, William H *NewYHSD*

Ellis, William Henry 1915- *AmArch 70*

Ellis, William John 1944- *WhoArt 80, -82, -84*

Ellison, Edith *DcVicP 2*

Ellison, J Milford 1909- *WhAmArt 85, WhoAmA 73, -76*

Ellison, J W *AmArch 70*

Ellison, Nancy *DcCAr 81*

Ellison, Nancy 1936- *AmArt, MacBEP, WhoAmA 78, -80, -82, -84*

Ellison, Orrin B *FolkA 86*

Ellison, Robert W 1946- *WhoAmA 82, -84*

Ellison, Thomas 1866-1942? *DcBrA 1*

Ellison, Walter W 1900- *AfroAA, WhAmArt 85*

Ellissen, Irene *DcWomA*

Elliston, Robert A 1849-1915 *FolkA 86*

Ellmore, Richard H *NewYHSD*

Ellms, Charles *EarABI, NewYHSD*

Ellner, A, Jr. *AmArch 70*

Elloian, Carolyn Autry *WhoAmA 78, -80, -82, -84*

Elloian, Peter 1936- *WhoAmA 76, -78, -80, -82, -84*

Ellson, John *DcVicP 2*

Ellsworth, Clarence A 1885-1961 *WhoAmA 80N, -82N, -84N*

Ellsworth, Clarence Arthur 1885-1961 *ArtsAmW 1, IlBEAAW, WhAmArt 85*

Ellsworth, Edyth Glover 1879- *ArtsAmW 3*

Ellsworth, Eleanor Stillman *DcWomA*

Ellsworth, Elmer *WhAmArt 85*

Ellsworth, George *ArtsEM*

Ellsworth, George Canning *NewYHSD*

Ellsworth, James *FolkA 86*

Ellsworth, James Sanford 1802?-1874 *AmFkP, BnEnAmA, FolkA 86, NewYHSD*

Ellwell, Emma S *DcWomA*

Ellwood, Craig 1921- *EncMA*

Ellwood, Craig 1922- *ConArch*

Ellwood, E E *AmArch 70*

Ellwood, George Montagu 1875-1955 *DcBrBI*

Ellwood, George Montague 1875-1955 *DcBrA 1*

Ellys, John 1701?-1757 *DcBrECP*

Elmaghraby, Adel S 1951- *MarqDCG 84*

Elman, Emily *WhoAmA 78, -80, -82, -84*

Elmanis, Alexander 1916- *AmArch 70*

Elmaraghy, Hoda A *MarqDCG 84*

Elmendorf, A A *NewYHSD*

Elmendorf, Dwight Lathrop 1859-1929 *MacBEP*

Column 1

Elmendorf, J A *AmArch 70*
Elmendorf, Stella *DcWomA, WhAmArt 85*
Elmendorf, Stella T *ArtsAmW 3*
Elmer, Edwin Romanzo 1850-1923 *BnEnAmA, FolkA 86*
Elmer, J *AmArch 70*
Elmer, Rachel 1878- *DcWomA*
Elmer, Rachel Robinson *WhAmArt 85*
Elmer, Stephen 1714?-1796 *DcBrECP*
Elmer, Stephen John 1953- *MarqDCG 84*
Elmer, W *FolkA 86*
Elmer, William 1762-1799 *DcBrECP*
Elmes, Harvey Lonsdale 1814-1847 *BiDBrA, MacEA, McGDA, WhoArch*
Elmes, Harvey Lonsdale 1815-1847 *OxArt*
Elmes, James 1782-1862 *BiDBrA*
Elmes, W *DcBrECP*
Elmo, Saint *McGDA*
Elmo, James *WhoAmA 78*
Elmore, Alfred 1815-1881 *ArtsNiC, ClaDrA, DcBrBI, DcBrWA*
Elmore, Alfred W 1815-1881 *DcVicP, -2*
Elmore, Edith *DcVicP 2, DcWomA*
Elmore, Elizabeth *WhAmArt 85*
Elmore, Elizabeth Tinker 1874-1933 *DcWomA, WhAmArt 85*
Elmore, Fanny *DcVicP 2*
Elmore, Fanny Mary *DcWomA*
Elmore, Frances Mary *DcVicP 2*
Elmore, James Walter 1917- *AmArch 70*
Elmore, Pat 1937- *WhoArt 84*
Elmore, Richard *ClaDrA, DcVicP 2*
Elmore, T J *DcVicP 2*
Elmore, T W *DcVicP 2*
Elmore, V C *AmArch 70*
Elmore, Willard P *ArtsEM*
Elmquist-Wichmann, Erna 1869- *DcWomA*
Elms, Willard F *ArtsAmW 2, WhAmArt 85*
Elmslie, George G *McGDA*
Elmslie, George Grant 1871-1952 *MacEA*
Elouis, Jean-Pierre-Henri 1755-1840 *DcBrECP*
Elouis, Jean Pierre Henri 1755-1840 *NewYHSD*
Eloul, Kosso 1920- *WhoAmA 73, -76, -78, -80, -82, -84*
Elowitch, Annette 1942- *WhoAmA 78, -80, -82, -84*
Elowitch, Robert Jason 1943- *WhoAmA 76, -78, -80, -82, -84*
Elozua, Raymon 1947- *DcCAr 81*
Elphege, Saint *McGDA*
Elphick, Jean *WhoAmA 78, -80*
Elphinston, William Graham d1952 *DcBrA 1*
Elphinstone, Archibald H 1865-1936 *DcVicP 2*
Elphinstone, Archibald Howard L 1865-1936 *DcBrA 1*
Elphinstone, J *DcBrWA*
Elphinstone, Mary *DcWomA*
Elrington, H H *DcVicP 2*
Elsaesser, Martin 1884-1957 *MacEA*
Elsam, Richard *BiDBrA*
Elsasser, Frederick Adolph 1897- *AmArch 70*
Elsberry, P V, Jr. *AmArch 70*
Else, Donald Peter 1932- *AmArch 70*
Else, Joseph 1874-1955 *DcBrA 1*
Else, Robert John 1918- *WhoAmA 78, -80, -82, -84*
Elsen, Albert Edward 1927- *WhoAmA 73, -76, -78, -80, -82, -84*
Elsen, Alfred 1850-1900 *ClaDrA*
Elsheimer, Adam 1578-1610 *McGDA, OxArt*
Elsheimer, Adam 1578?-1620 *ClaDrA*
Elshin, Jacob 1892- *WhAmArt 85*
Elshin, Jacob Alexander 1892- *ArtsAmW 2*
Elshin, Jacob Alexandrovitch 1892- *ArtsAmW 2*
Elsholtz, Ludwig 1805-1850 *ArtsNiC*
Elsky, Herb 1942- *WhoAmA 76, -78, -80, -82*
Elsky, Herb 1944- *WhoAmA 73*
Elsley, Arthur John 1861- *DcVicP 2*
Elsley, J *DcVicP 2*
Elsner, Larry Edward 1930- *WhoAmA 73, -76, -78, -80, -82, -84*
Elster, Toni 1862- *DcWomA*
Elston, John *AntBDN Q*
Elston, Thomas Sidney, Jr. 1912- *AmArch 70*
Elston, William 1895- *DcBrA 1*
Elstrack, Renold *OxArt*
Elswood, Elwin Sidney 1922- *AmArch 70*
Elsworth, Ashuerus *CabMA*
Elsworth, George *CabMA*
Elting, Thomas Henry 1934- *AmArch 70*
Elton, A H *DcVicP 2*
Elton, Sir Edmund d1920 *DcNiCA*
Elton, H C *AmArch 70*
Elton, K *DcVicP 2*
Elton, Maria *DcWomA*
Elton, Mary *WhAmArt 85*
Elton, Robert H *NewYHSD*
Elton, Samuel Averill 1827-1886 *DcBrWA, DcVicP 2*
Eltonhead, Arnold *EncASM*
Eltonhead, Frank 1902- *WhAmArt 85*
Eltze, Fritz d1870 *DcBrBI*
Eluard, Paul 1895-1952 *OxTwCA*
Elverson, Thomas *FolkA 86*
Elvert, Lewis *NewYHSD*

Column 2

Elvery, Beatrice *DcWomA*
Elvery, Beatrice Moss 1883-1970 *DcBrBI*
Elvery, Dorothy *DcWomA*
Elvery, J *DcBrECP*
Elvidge, Anita Miller 1895- *ArtsAmW 3*
Elvin, Kenneth Proctor 1921- *AmArch 70*
Elvins, George D *FolkA 86*
Elvins, Thomas d1802 *BiDBrA*
Elvira, Paco 1948- *MacBEP*
Elves, William *CabMA*
Elwell, Chip 1940- *WhoAmA 78, -80, -82, -84*
Elwell, D Gerome 1857-1912 *WhAmArt 85*
Elwell, Mrs. E S *WhAmArt 85*
Elwell, Emma S *DcWomA*
Elwell, F Edwin 1858-1922 *WhAmArt 85*
Elwell, Frederick William 1870-1958 *DcBrA 1, DcVicP 2*
Elwell, Henry, Jr. *CabMA*
Elwell, Jerome D 1847-1912 *WhAmArt 85*
Elwell, John H 1878- *WhAmArt 85*
Elwell, R Farrington 1874-1962 *ArtsAmW 1*
Elwell, Robert Farrington 1874-1962 *IlBEAAW, WhAmArt 85*
Elwell, Roy A 1889- *WhAmArt 85*
Elwell, S Bruce 1886- *WhAmArt 85*
Elwell, Samuel, III *FolkA 86*
Elwell, Stanley Bruce 1886-1936 *BiDAmAr*
Elwell, William S 1810-1881 *FolkA 86, NewYHSD*
Elwes, Alfred Thomas *DcBrBI*
Elwes, Cecilia 1874-1952 *DcBrA 1, DcWomA*
Elwes, F C *DcVicP 2*
Elwes, R *DcVicP 2*
Elwes, Robert *DcBrBI*
Elwes, Simon 1902- *ClaDrA, DcBrA 1*
Elwes, Simon Edmund Vincent Paul 1902-1975 *DcBrA 2*
Elwin, Emma *DcWomA*
Elwood, Ernest Hernandez 1924- *AmArch 70*
Elwood, J *DcBrWA*
Elwood, Mattie C *ArtsEM*
Elworth, Lennart 1927- *WorECom*
Elwyn, John 1916- *ClaDrA, DcBrA 1, WhoArt 80, -82, -84*
Ely, Miss *DcWomA, FolkA 86*
Ely, Mrs. *ArtsEM, DcWomA*
Ely, A *NewYHSD*
Ely, Abraham *FolkA 86*
Ely, Caroline Alden 1884-1974 *DcWomA*
Ely, Charles Hardy 1875-1929 *BiDAmAr*
Ely, Donald H *WhAmArt 85*
Ely, Edward F 1858-1920 *BiDAmAr*
Ely, Edward Francis *WhAmArt 85*
Ely, Edwin *FolkA 86*
Ely, Fanny G 1879-1961 *WhoAmA 80N, -82N, -84N*
Ely, Fanny Griswold *WhAmArt 85*
Ely, Fanny Griswold 1877-1961 *DcWomA*
Ely, Frances *DcWomA*
Ely, Frances Burr *WhAmArt 85*
Ely, Frances Campbell *WhAmArt 85*
Ely, Fred C 1924- *AmArch 70*
Ely, Jack Douglas 1926- *AmArch 70*
Ely, John *FolkA 86*
Ely, John 1735- *FolkA 86*
Ely, Mrs. John A *WhAmArt 85*
Ely, John Carl 1899-1929 *WhAmArt 85*
Ely, John H 1851-1932 *BiDAmAr*
Ely, Letitia 1886-1967 *DcWomA*
Ely, Letitia Maxwell *WhAmArt 85*
Ely, Lydia d1914 *DcWomA, NewYHSD, WhAmArt 85*
Ely, Mary *DcWomA*
Ely, S H, Jr. *AmArch 70*
Ely, Sarah Weir *FolkA 86*
Ely-Rodrigues, Jeanne Emma *DcWomA*
Elzea, Rowland Procter 1931- *WhoAmA 73, -76, -78, -80, -82, -84*
Elzer, Hendrik Jacob 1808-1844? *DcSeaP*
Elzevier, Abraham, II d1712 *OxDecA*
Elzevier, Daniel d1680 *OxDecA*
Elzevier, Isaac *OxDecA*
Elzevier, Johannes *OxDecA*
Elzevier, Louis *OxDecA*
Elzey, Richard Paul 1927- *AmArch 70*
Elzner, A O *WhAmArt 85*
Elzner, Alfred O 1845-1935 *BiDAmAr*
Em, David Robert 1952- *MarqDCG 84*
Emanuel, Frank Lewis 1865-1948 *DcBrA 1, DcBrBI, DcBrWA, DcVicP 2*
Emanuel, Hugh *AfroAA*
Emanuel, Lydia *DcWomA*
Emanuel, Muriel *ConArch A*
Emanuel, Walter Lewis d1915 *DcBrA 2*
Emany, Venkateswara Rao 1952- *MarqDCG 84*
Embde, Caroline VonDerKlauhold 1812- *DcWomA*
Embde, Ernestine Emiliie VonDer 1816-1904 *DcWomA*
Embe, VonDerKer *DcVicP 2*
Emberley, Ed *IlsCB 1967*
Emberley, Ed 1931- *IlsBYP, IlsCB 1957*
Emberley, Lee Wade 1942- *MarqDCG 84*
Emberres, Gil De *McGDA*

Column 3

Emberson, Richard Maury, Jr. 1950- *MarqDCG 84*
Emberton, John Reed 1933- *AmArch 70*
Emberton, Joseph 1889-1956 *MacEA, WhoArch*
Embler, A H *NewYHSD*
Embleton, Ronald S 1930- *WorECom*
Embree, John *BiDBrA*
Embrey, Carl Rice 1938- *WhoAmA 80, -82, -84*
Embriachi *McGDA*
Embring, Margaretha Christina 1756-1843 *DcWomA*
Embry, J A *AmArch 70*
Embry, Lloyd Bowers 1913- *WhoAmA 76*
Embry, Norris 1921- *WhoAmA 73, -76, -78, -80*
Embry, Norris 1921-1981 *WhoAmA 82N, -84N*
Embury, Edward Coe 1906- *AmArch 70*
Emch, Frederick 1925- *MarqDCG 84*
Emens, Homer *FolkA 86*
Emens, Homer F *WhAmArt 85*
Emeree, Berla Ione 1899- *DcWomA, IlBEAAW, WhAmArt 85*
Emeree, Berla Iyone 1899- *ArtsAmW 1*
Emeric, F J *DcSeaP*
Emeric, Honorine 1814- *DcWomA*
Emeric, Louise *DcWomA*
Emerick, G L *AmArch 70*
Emeris, Frances *DcVicP 2*
Emerson, Alfred *WhAmArt 85*
Emerson, Arthur Webster 1885- *WhAmArt 85*
Emerson, Belle *DcWomA, WhAmArt 85*
Emerson, C Chase d1922 *WhAmArt 85*
Emerson, C E *DcVicP 2*
Emerson, Edith *WhAmArt 85, WhoAmA 73, -76, -78, -80*
Emerson, Edith 1888- *DcWomA, WhoAmA 82*
Emerson, Francis C *WhAmArt 85*
Emerson, I L *FolkA 86*
Emerson, J *EarABI, NewYHSD*
Emerson, Julia E *DcWomA*
Emerson, Louise Harrington 1901- *WhAmArt 85*
Emerson, Peter Henry 1856-1936 *ICPEnP, MacBEP*
Emerson, R Don 1933- *AmArch 70*
Emerson, Robert E 1920?- *IlBEAAW*
Emerson, Robert Jackson 1878-1944 *DcBrA 1*
Emerson, Roberta Shinn 1922- *WhoAmA 73, -76, -78, -80, -82, -84*
Emerson, Sterling Deal 1917- *WhoAmA 73, -76*
Emerson, Sybil *WhAmArt 85*
Emerson, Sybil 1895- *IlsCB 1744*
Emerson, Sybil Davis 1892?- *ArtsAmW 3*
Emerson, T B *AmArch 70*
Emerson, W C *WhAmArt 85*
Emerson, Walter Caruth 1912- *WhoAmA 76, -78, -80, -82, -84*
Emerson, William *DcVicP 2*
Emerson, William Otto *ArtsAmW 3*
Emerson, William Ralph d1917 *BiDAmAr*
Emerson, William Ralph 1833-1917 *MacEA*
Emerson, William Ralph 1833-1918 *McGDA*
Emert, Paul *NewYHSD*
Emert, Paul 1826-1867 *ArtsAmW 3*
Emerton, James H 1847-1930 *WhAmArt 85*
Emery, Amos Barton 1895- *AmArch 70*
Emery, Arthur George Stevenson 1896- *DcBrA 1, WhoArt 80*
Emery, Betsy Eugenie 1838- *DcWomA*
Emery, Calvin 1821- *CabMA*
Emery, Charles *FolkA 86*
Emery, Charles Anthony 1919- *WhoAmA 73, -76, -78, -80*
Emery, David F 1828?- *NewYHSD*
Emery, E E 1931- *AmArch 70*
Emery, Eliza *DcWomA, NewYHSD*
Emery, G C *AmArch 70*
Emery, Henry A 1926- *MarqDCG 84*
Emery, Irene 1900- *WhAmArt 85*
Emery, Josiah *AntBDN D*
Emery, L *FolkA 86*
Emery, Lin *WhoAmA 73, -76, -78, -80, -82, -84*
Emery, Margaret Rose 1907- *WhAmArt 85*
Emery, Nellie Augusta *WhAmArt 85*
Emery, Nellie Augusta d1934 *ArtsAmW 3, DcWomA*
Emery, Rufus H *NewYHSD*
Emery, Stephen *CabMA*
Emery, Steven *MarqDCG 84*
Emery, William B *NewYHSD*
Emery, Mrs. William Henry *WhAmArt 85*
Emery, William Walter 1913- *WhoArt 80, -82, -84*
Emes, John *AntBDN Q*
Emes, John d1809 *DcBrWA*
Emes, John 1762-1809? *DcBrECP*
Emes, Rebecca *AntBDN Q*
Emett, Edith *DcWomA*
Emett, Rowland *WhoArt 80, -82, -84, WhoGrA 82[port]*
Emett, Rowland 1906- *IlsCB 1946, WhoGrA 62, WorECar*
Emett, Thomas, Sr. *BiDBrA*
Emig, Adolph P *WhAmArt 85*
Emigh, Mary *FolkA 86*
Emil, Allan D 1898- *WhoAmA 73, -76, -78N, -80N, -82N, -84N*

Emil, Arthur D 1924- *WhoAmA* 73, –76, –78, –80, –82, –84
Emilian, Celine *DcWomA*
Emilie *DcWomA*
Eminger, Helen 1858- *DcWomA*
Emlyn, Henry 1729?-1815 *BiDBrA*
Emm, Peter 1799-1873 *AntBDN J*
Emma, Albert Joseph, Jr. 1946- *MarqDCG* 84
Emma, Thomas Alva 1923- *AmArch* 70
Emmaline 1836- *FolkA* 86
Emmaure, J *DcVicP* 2
Emmerich, Andre 1924- *WhoAmA* 73, –76, –78, –80, –82, –84
Emmerich, Eugene William 1930- *MarqDCG* 84
Emmerich, Irene Hillebrand *WhoAmA* 80N, –82N, –84N
Emmerich, Mary *WhAmArt* 85
Emmerich, Mary Ashburton Pew *DcWomA*
Emmerson, Henry H 1831-1895 *DcVicP*
Emmerson, Henry Hetherington 1831-1895 *DcVicP* 2
Emmerson, Mary W *DcWomA*
Emmerson, W H *DcVicP* 2
Emmert *NewYHSD*
Emmert, Paul 1826-1867 *ArtsAmW* 3
Emmerton, William Henry 1828- *NewYHSD*
Emmes, Henry *NewYHSD*
Emmes, Henry 1716?- *FolkA* 86
Emmes, Joshua 1719-1772 *FolkA* 86
Emmes, Nathaniel 1690-1750 *FolkA* 86
Emmes, Thomas *BnEnAmA, NewYHSD*
Emmet, Edith Leslie 1877- *DcWomA, WhAmArt* 85
Emmet, Elizabeth *DcWomA, NewYHSD*
Emmet, Ellen G *DcWomA, WhAmArt* 85
Emmet, Jane Erin *WhAmArt* 85
Emmet, Jane Erin 1873- *DcWomA*
Emmet, John M 1811?- *NewYHSD*
Emmet, John Patten 1797-1842 *NewYHSD*
Emmet, Leslie *WhAmArt* 85
Emmet, Lily Cushing *WhAmArt* 85
Emmet, Lydia Field d1952 *WhoAmA* 78N, –80N, –82N, –84N
Emmet, Lydia Field 1866-1952 *DcWomA*
Emmet, Lydia Field 1886-1952 *WhAmArt* 85
Emmet, Rosina *WhAmArt* 85
Emmet, Rosina Sherwood 1854-1948 *DcWomA*
Emmett, Bruce 1949- *ConGrA* 1[port]
Emmett, Burton 1872-1935 *WhAmArt* 85
Emmett, John 1804?-1853 *NewYHSD*
Emmett, John 1834- *NewYHSD*
Emmett, John T 1828-1898 *MacEA*
Emmett, Maurice 1646?-1694 *BiDBrA*
Emmett, Richard Frank 1946- *MarqDCG* 84
Emmett, William 1671-1736 *BiDBrA*
Emmons, A *AmArch* 70
Emmons, Alexander Hamilton 1816- *NewYHSD*
Emmons, Alexander Hamilton 1816-1879 *FolkA* 86
Emmons, Bertha E *DcWomA, WhAmArt* 85
Emmons, C S 1858-1937 *WhAmArt* 85
Emmons, Chansonetta Stanley 1858-1937 *DcWomA*
Emmons, Chansonette Stanley 1858-1937 *ICPEnP A, MacBEP*
Emmons, Donn 1910- *AmArch* 70
Emmons, Dorothy Stanley 1891- *DcWomA, WhAmArt* 85
Emmons, Ebenezer, Jr. *NewYHSD*
Emmons, Frederick Earl 1907- *AmArch* 70
Emmons, George *NewYHSD*
Emmons, Hattie *ArtsEM, DcWomA*
Emmons, Mary 1736- *FolkA* 86
Emmons, Nathanial 1704-1740 *BnEnAmA*
Emmons, Nathaniel 1704-1740 *NewYHSD*
Emmons, Sylvia 1938- *DcCAr* 81
Emmons, Thomas *CabMA*
Emmons, William *NewYHSD*
Emmrich, J W *AmArch* 70
Emms, John 1843-1912 *DcBrA* 1, *DcVicP*, –2
Emms, John Victor 1912- *DcBrA* 1, *WhoArt* 80, –82, –84
Emmwood *WorECar*
Emon, Blanche *DcWomA*
Emont, Deborah 1951- *WhoAmA* 80, –82
Emont-Scott, Deborah 1951- *WhoAmA* 84
Emori, Eiko *WhoAmA* 78, –80, –82
Emory, Ella *DcWomA, FolkA* 86
Emory, Hopper 1881- *WhAmArt* 85
Emory, Walter Leavitt 1868-1929 *BiDAmAr*
Emory, William H, Jr. 1870-1936 *BiDAmAr*
Empie, Hal H 1909- *WhAmArt* 85
Empis, Catherine Edmee Simonis 1796-1879 *DcWomA*
Empoli, Jacopo 1554-1640 *ClaDrA*
Empoli, Jacopo Da *McGDA*
Emrath, Volkert 1945- *DcCAr* 81
Emrich, G E *AmArch* 70
Emrich, Harvey 1884- *WhAmArt* 85
Emshwiller, Ed 1925- *MarqDCG* 84
Emsinger, A *FolkA* 86
Emsley, Walter *DcVicP* 2
Emslie, Alfred Edward *ClaDrA*
Emslie, Alfred Edward 1848- *DcVicP*, –2
Emslie, Alfred Edward 1848-1917 *DcBrA* 1, *DcBrWA*

Emslie, Alfred Edward 1848-1918 *DcBrBI*
Emslie, John Philip 1839-1914 *DcBrA* 2
Emslie, John Phillip 1839-1913 *DcBrWA*
Emslie, John Phillipps 1839-1913 *DcVicP* 2
Emslie, Rosalie 1891- *DcBrA* 1, *DcWomA*
Emslie, Rosalie M 1854-1932 *DcBrA* 1
Emslie, Rosalie M 1854-1932? *DcWomA*
Emver, Anthony *WhAmArt* 85
Emy, Josephine *DcWomA*
Enander, Ada *WhAmArt* 85
Enaud, Zoe *DcWomA*
Enault, Alix-Louise d1913 *DcWomA*
Encarnacano, Josel 1941- *MarqDCG* 84
Enckell, Knut Magnus *OxTwCA*
Enckell, Magnus 1870-1925 *PhDcTCA* 77
Endaurov, Elizaveta *DcWomA*
Ende *DcWomA*
Ende 975?- *WomArt*
Ende, Doris 1854?- *DcWomA*
Ende, Edgar 1901-1965 *OxTwCA*, *PhDcTCA* 77
Ende, Louis *NewYHSD*
Endell, August 1871-1912 *WhoArch*
Endell, August 1871-1924 *MacEA*
Endell, August 1871-1925 *EncMA, McGDA, OxArt*
Endell, Martha *DcWomA*
Endelmanis, Vita 1933- *DcCAr* 81
Ender, Kseniia Vladimirovna 1895-1955 *DcWomA*
Ender, Otto *WorFshn*
Ender, Thomas 1793-1875 *ArtsNiC*
Enderby, Samuel G *DcVicP* 2
Enderle, Gunter 1944- *MarqDCG* 84
Enderling, Wayne Wilbur 1934- *AmArch* 70
Enders, Frank *WhAmArt* 85
Enders, Henry 1828-1902 *FolkA* 86
Enders, Oscar 1866-1926 *BiDAmAr*
Enderton, S B *IlBEAAW*
Endicott, Charles W 1913- *AmArch* 70
Endicott, Francis 1832?- *NewYHSD*
Endicott, G *NewYHSD*
Endicott, George 1802-1848 *NewYHSD*
Endicott, George R *ArtsEM*
Endicott, Israel *NewYHSD*
Endicott, Sarah L *NewYHSD*
Endicott, W *NewYHSD*
Endicott, William 1816-1851 *NewYHSD*
Endicott, William Crowninshield d1936 *WhAmArt* 85
Endo, Robert Akira 1948- *WhoAmA* 78, –80
Endoios *OxArt*
Endres, Louis J *WhAmArt* 85
Endriss, George *FolkA* 86
Endsley, Fred Starr 1949- *WhoAmA* 76, –78, –80, –82
Endter, Susanna Maria *DcWomA*
Endy, Benjamin 1811-1879 *FolkA* 86
Enebuske, C C *AmArch* 70
Enersen, Lawrence Albert 1909- *AmArch* 70
Enferna-Goutel, Germaine Antoinette N D' 1890- *DcWomA*
Enferna-Goutil, Germaine Antoinette N D' 1890- *DcWomA*
Enfield, Harry 1906-1958 *WhoAmA* 80N, –82N, –84N
Enfield, Henry 1830?-1900? *DcBrWA*
Enfield, Henry 1849- *DcVicP* 2
Enfield, Mary P *DcBrA* 2
Enfield, Mary P 1860?-1920 *DcWomA*
Enfield, Raymond Lee 1938- *AmArch* 70
Enfield, Mrs. William *DcBrWA, DcVicP* 2
Enfinger, Francis Adrian 1945- *MarqDCG* 84
Eng, D *AmArch* 70
Eng, W *AmArch* 70
Eng-, Tom *ConGrA* 1
Engaliere, Marius 1824-1857 *ClaDrA*
Engard, Robert Oliver 1915- *WhAmArt* 85
Engberg, Arne George 1912- *AmArch* 70
Engberg, H W *AmArch* 70
Engdahl, David Lynn 1940- *AmArch* 70
Engebrechtsz, Cornelis 1468-1533 *McGDA*
Engel, Betty Lee 1947- *WhoAmA* 80
Engel, Carl Ludwig 1778-1840 *MacEA, WhoArch*
Engel, G *FolkA* 86
Engel, George Leslie 1911- *WhAmArt* 85
Engel, Harry 1901-1970 *WhAmArt* 85, *WhoAmA* 78N, –80N, –82N, –84N
Engel, Johanna *DcWomA*
Engel, Jules 1915- *DcCAA* 71, –77
Engel, Martha *DcWomA*
Engel, Michael, Jr. 1919- *WhAmArt* 85
Engel, Michael M d1969 *WhoAmA* 78N, –80N, –82N, –84N
Engel, Michael Martin, II 1919- *AmArt, WhoAmA* 73, –76, –78, –80, –82, –84
Engel, Michael Martin, Sr. 1896-1969 *WhAmArt* 85
Engel, Morris 1918- *ICPEnP A, MacBEP*
Engel, Richard Drum 1879- *WhAmArt* 85
Engel, Robert Walter 1936- *AmArch* 70
Engel, S, Jr. *AmArch* 70
Engel, Scott D 1948- *MacBEP*
Engel, Walter F 1908- *WhoAmA* 76, –78, –80, –82, –84
Engel, Wilhelmina 1871- *DcWomA, WhAmArt* 85
Engel, William *NewYHSD*
Engel-Leisinger, Irma 1908- *WhAmArt* 85

Engelbach, Florence 1872-1951 *DcBrA* 1, *DcWomA*
Engelbertsz, Cornelis 1468?-1533 *ClaDrA*
Engelbertsz, Luc 1495-1522 *ClaDrA*
Engelbrecht, Carl Walter 1913- *AmArch* 70
Engelbrecht, M C *AmArch* 70
Engelbrecht, Robert Martin 1923- *AmArch* 70
Engelbrechten, Alma Von 1857- *DcWomA*
Engelbrechtsen, Cornelis 1468-1533 *OxArt*
Engelen, Antoine Francois Louis Van 1856- *ClaDrA*
Engelen, Piet Van 1863- *ClaDrA*
Engelhard, Charles *WhoAmA* 73, –76, –78, –80, –82
Engelhard, Mrs. Charles *WhoAmA* 73, –76, –78, –80, –82
Engelhard, Elizabeth *WhAmArt* 85
Engelhard, Elizabeth 1893- *DcWomA*
Engelhardt, Thomas Alexander 1930- *WhoAmA* 76, –78, –80, –82, –84
Engelhardt, Tom 1930- *ConGrA* 1[port]
Engelhardt, W E *AmArch* 70
Engelhart, Catherine Caroline 1845- *DcWomA*
Engelke, Robert Richard 1937- *AmArch* 70
Engelke, William D 1951- *MarqDCG* 84
Engelking, Robert Sigismund 1915- *AmArch* 70
Engelman, Edmund 1907- *MacBEP*
Engelmann, C F *NewYHSD*
Engelmann, Martin 1924- *OxTwCA, PhDcTCA* 77
Engelmann, Michael 1928- *WhoGrA* 62
Engels, Charles *WhAmArt* 85
Engels, Pieter 1938- *ConArt* 77, –83
Engels, Pieter Gerardus Maria 1938- *OxTwCA, PhDcTCA* 77
Engelsher, Charles 1948- *MarqDCG* 84
Engelson, Carol 1944- *WhoAmA* 76, –78, –80
Engelson, Jerrald H 1952- *MarqDCG* 84
Engelstad, Robert Duane 1928- *AmArch* 70
Engen, Donal DeVere 1922- *AmArch* 70
Enger, Ulla 1949- *DcCAr* 81
Engeran, Whitney John, Jr. 1934- *WhoAmA* 76, –78, –80, –82, –84
Enggass, Robert 1921- *WhoAmA* 73, –76, –78, –80, –82, –84
Engholm, Kaj 1906- *WorECom*
Engl, Josef Benedikt 1867-1907 *WorECar*
England, Ann E *FolkA* 86
England, B A, Jr. *AmArch* 70
England, Frederick John 1939- *WhoArt* 80, –82, –84
England, J *DcBrWA*
England, Nick 1947- *MarqDCG* 84
England, Nora 1890- *DcBrA* 1, *DcWomA*
England, Paul 1918- *WhAmArt* 85
England, Paul Grady 1918- *AmArt, WhoAmA* 73, –76, –78, –80, –82, –84
England, Richard *ConArch A*
England, Richard 1937- *ConArch*
England, W *DcVicP* 2
Englander, Anna *DcWomA, WhAmArt* 85
Englander, Gertrud 1904- *WhoAmA* 73, –76, –78, –80, –82, –84
Engle, Amos W *WhAmArt* 85
Engle, Barbara Jean *WhoAmA* 73, –76, –78, –80, –82, –84
Engle, Chet 1918- *WhoAmA* 76, –78, –80, –82, –84
Engle, Duane Raymond 1936- *AmArch* 70
Engle, G *FolkA* 86
Engle, George Richard 1932- *WhoAmA* 78, –80
Engle, H *WhAmArt* 85
Engle, Nita *OfPGCP* 86
Engle, Raleigh Paul 1923- *AmArch* 70
Engle, Robert Stanley 1933- *AmArch* 70
Engle, Sarah Ann *FolkA* 86
Englebert, Joseph *WhAmArt* 85
Engledow, Charles O 1898- *ArtsAmW* 3
Englefield, Arthur 1855- *DcBrA* 2, *DcVicP* 2
Englefield, Cicely 1893- *IlsCB* 1744
Englefield, Sir Henry Charles 1752-1822 *DcBrWA*
Englehardt, J *ArtsAmW* 3
Englehardt, Joseph *ArtsAmW* 3
Englehardt, Ted 1898- *AmArch* 70
Englehardt, Thomas Alexander 1930- *WorECar*
Englehart, Catherine *DcVicP* 2
Englehart, John *ArtsAmW* 3
Englehart, Joseph E *ArtsAmW* 1
Englehart, Nick *FolkA* 86
Engleheart, George 1750-1829 *AntBDN J*
Engleheart, George 1752-1839 *DcBrWA*
Engleheart, John Cox Dillman 1784-1862 *AntBDN J*
Englehorn, David Wesley 1925- *AmArch* 70
Engleken, Jacob *NewYHSD*
Engler, Arthur 1885- *WhAmArt* 85
Engler, Richard Leo *AmArch* 70
Engler, Ulrich 1925- *AmArch* 70
Englesmith, George 1914- *WhoArt* 80, –82, –84
Englesmith, Tejas 1941- *WhoArt* 80
Engley, Alice D *DcWomA, WhAmArt* 85
English, Dan *FolkA* 86
English, Frank F 1854- *WhAmArt* 85
English, Grace d1956 *DcBrA* 1, *DcWomA*
English, Grace 1891-1956 *DcBrA* 1
English, Harold M 1890- *ArtsAmW* 1, *WhAmArt* 85
English, Hugh 1921- *AmArch* 70

English, Ian 1950- *DcCAr 81*
English, J *NewYHSD*
English, James Turner 1916- *DcBrA 1, WhoArt 84*
English, John *FolkA 86*
English, John Arbogast 1913- *WhoAmA 76, -78, -80,*
 -82, -84
English, Mabel Bacon Plimpton 1861- *DcWomA,*
 WhAmArt 85
English, Margaret Morris *DcWomA*
English, Mark *FolkA 86*
English, Mark 1933- *IlrAm G, -1880*
English, Mrs. Robert B *WhAmArt 85*
English, Stanley Louis 1920- *AmArch 70*
English, Stanley Sydney Smith 1908- *DcBrA 1*
English, William *CabMA*
English, William F 1933- *AmArch 70*
Englund, C M *AmArch 70*
Englund, Lars 1933- *DcCAr 81*
Engman, Anders 1933- *ICPEnP A*
Engman, Robert 1927- *DcCAA 71, -77, DcCAr 81*
Engonopoulos, Nicos 1910- *OxTwCA, PhDcTCA 77*
Engrand, Felicie 1889- *DcWomA*
Engrand, Georges *ArtsNiC*
Engstroem, Matz 1948- *MarqDCG 84*
Engstrom, A B *NewYHSD*
Engstrom, Albert 1869-1940 *WorECar*
Engstrom, Harold D 1928- *AmArch 70*
Engstrom, Leander 1886-1927 *PhDcTCA 77*
Enhuber, Carl Von 1811-1867 *ArtsNiC*
Enke, Ludwig *NewYHSD*
Enloe, Hansell Porter 1928- *AmArch 70*
Enman, Tom Kenneth 1928- *WhoAmA 73, -76, -78,*
 -80, -82, -84
Enneking, John J 1841- *ArtsNiC*
Enneking, John J 1841-1916 *WhAmArt 85*
Enneking, John Joseph 1841-1916 *DcAmArt*
Enneking, Joseph Eliot *WhAmArt 85*
Enness, Augustus W 1876- *DcBrA 1*
Enness, Augustus W 1876-1948 *DcBrA 2*
Ennin, Joseph G *FolkA 86*
Ennion *IlDcG*
Ennis, F Lyman 1920- *AmArch 70*
Ennis, George *NewYHSD*
Ennis, George Pearse d1936 *WhAmArt 85*
Ennis, Georgia L *WhAmArt 85*
Ennis, Gladys Atwood *WhAmArt 85*
Ennis, Jacob 1728-1770 *DcBrECP*
Ennis, Sue Ann *DcWomA*
Eno, Chester *FolkA 86*
Eno, Ira *FolkA 86*
Eno, James Lorne d1952 *WhoAmA 78N, -80N, -82N,*
 -84N
Eno, James Lorne 1887-1952 *WhAmArt 85*
Eno, Reuben *FolkA 86*
Eno, William 1795?-1838 *FolkA 86*
Enoch, Charles W, Jr. *AfroAA*
Enock, Arthur Henry *DcBrWA, DcVicP 2*
Enomoto, G T *AmArch 70*
Enos, Chris 1944- *ICPEnP A, MacBEP,*
 WhoAmA 78, -80, -82, -84
Enos, E Marguerite *WhAmArt 85*
Enos, John *FolkA 86*
Enos, Randall 1936- *ConGrA 1, IlrAm 1880,*
 WhoGrA 82[port]
Enquist, Mary B *DcWomA, WhAmArt 85*
Enraght-Moony, Robert James *ClaDrA, DcBrA 1*
Enri, Helene Berlewi *DcWomA*
Enright, Elizabeth 1909-1968 *IlsCB 1744, -1946*
Enright, Maginel 1877?-1966 *DcWomA*
Enright, Maginel Wright *WhAmArt 85*
Enright, Maginel Wright 1881-1966 *IlrAm 1880*
Enright, Walter J 1879- *WhAmArt 85*
Enrile Y Florez DeGutierrez, Emilia *DcWomA*
Enrique d1277 *McGDA*
Enrique, Master d1277 *OxArt*
Enriquez, Carlos 1900- *McGDA*
Enriquez, Gaspar 1942- *WhoAmA 73, -76, -78, -80,*
 -82, -84
Enriquez Y Ferrer, Maria Carmen *DcWomA*
Enschede, Adriana Maria 1864- *DcWomA*
Enschede, Catharina Jacoba Abrahamina 1828-1883
 DcWomA
Enschede, Christina Gerarda 1791-1873 *ClaDrA,*
 DcWomA
Enschede, Sandrina Christina Elizabeth *DcWomA*
Ensel, Henry *WhAmArt 85*
Enser, George 1889- *WhAmArt 85*
Enser, George 1890-1961 *WhoAmA 80N, -82N, -84N*
Enser, John F 1898- *ArtsAmW 2, WhAmArt 85*
Enshu 1579-1647 *McGDA*
Ensign, Conrad Hill 1933- *AmArch 70*
Ensign, Edward *NewYHSD*
Ensign, M H *AmArch 70*
Ensign, Moses *FolkA 86*
Ensign, Raymond P 1883- *WhAmArt 85*
Ensign, Robert Datus 1932- *AmArch 70*
Ensign, Timothy 1795?-1849 *NewYHSD*
Ensign, William H *WhAmArt 85*
Ensign, William Lloyd 1928- *AmArch 70*
Ensikat, Klaus 1937- *WhoGrA 82[port]*
Ensingen, Ulrich Von *McGDA*

Ensingen, Ulrich Von 1350?-1419 *MacEA, OxArt*
Ensinger, Matthaus 1390?-1463 *MacEA*
Ensley, Annette Lewis 1948- *AfroAA*
Ensor, Arthur John 1905- *DcBrA 1, IlBEAAW*
Ensor, James 1860-1949 *ClaDrA, McGDA, OxArt,*
 OxTwCA, WorECar
Ensor, Baron James 1860-1949 *PhDcTCA 77*
Ensor, Joseph H *WhAmArt 85*
Ensor, Mary *DcVicP, -2, DcWomA*
Ensrud, E Wayne 1934- *AmArt, PrintW 85*
Ensrud, Wayne 1934- *PrintW 83, WhoAmA 82, -84*
Enstice, Wayne 1943- *WhoAmA 84*
Enstice, Wayne Edward 1943- *WhoAmA 82*
Ensworth, Augusta *ArtsEM, DcWomA*
Ente, Lily 1905- *WhoAmA 78, -80, -82, -84*
Enters, Angna 1907- *WhAmArt 85*
Enthoven, Julia *DcVicP 2*
Enthoven, Roderick Eustace 1900- *WhoArt 80, -82,*
 -84
Entler, Kathryn Estelle *DcWomA, WhAmArt 85*
Entrekin, Walter Eugene, Jr. 1925- *AmArch 70*
Entress, Albert *WhAmArt 85*
Entrikin, G W *AmArch 70*
Entwistle, Frederick Turner, Jr. 1929- *AmArch 70*
Entwistle, N B *AmArch 70*
Entz, Marian W *DcWomA, WhAmArt 85*
Entzeroth, R E *AmArch 70*
Enwonwu, Ben 1921- *OxTwCA*
Enyeart, James L 1943- *MacBEP*
Enyeart, James Lyle 1943- *WhoAmA 78, -80, -82,*
 -84
Enyeart, Mana *WhAmArt 85*
Enzing-Muller, Johann Michael 1804-1888
 NewYHSD
Enzinger, Gertrude Cole *WhAmArt 85*
Enzling, Monsieur De *NewYHSD*
Enzmann, H K *AmArch 70*
Eosander, Johann Friedrich 1670?-1729 *MacEA*
Eottes, Hans *McGDA*
Ephrath, Arye R 1942- *MarqDCG 84*
Epifanov, Gennadi Dmitrievich 1900- *WhoGrA 62*
Epinay, Marie D' *DcWomA*
Epinay, Prosper,Comte D' 1836- *DcBrBI*
Epinay, Prosper E D' *ArtsNiC*
Epinette, Marie *DcVicP 2, DcWomA*
Epiphanius Of Evesham 1570-1633? *OxArt*
Episcopius, Johannes 1628-1671 *ClaDrA*
Epler, Venetia *WhoAmA 76, -78, -80, -82*
Eppard, Cliff 1935- *MarqDCG 84*
Eppens, William H 1885- *WhAmArt 85*
Eppenstein, M C *EncASM*
Eppensteiner, John Joseph 1893- *WhAmArt 85*
Epperly, Don 1906- *AmArch 70*
Epperson, K A *AmArch 70*
Epperson, Samuel Swanson 1938- *AmArch 70*
Eppes, Bill Gorton 1931- *AmArch 70*
Epping, Franc 1910- *WhAmArt 85*
Epping, Theodore Carl 1923- *AmArch 70*
Eppink, Helen B 1910- *WhAmArt 85*
Eppink, Helen Brenan 1910- *WhoAmA 73, -76, -78,*
 -80, -82, -84
Eppink, Norman R 1906- *WhAmArt 85,*
 WhoAmA 73, -76, -78, -80, -82, -84
Epple, Edward Charles 1883- *AmArch 70*
Eppler, George 1828- *FolkA 86*
Epply, Lorinda 1874-1951 *DcWomA*
Eppridge, Bill 1938- *ICPEnP A*
Epps, E *DcVicP 2*
Epps, Emily *DcVicP 2*
Epps, J W *AmArch 70*
Epps, Jessie Katharine *DcWomA*
Epps, Laura T *DcVicP 2*
Epps, Laura Theresa *DcWomA*
Epps, N *DcVicP 2*
Epps, Nellie *DcVicP 2, DcWomA*
Epps, Thomas Byrd 1896- *AmArch 70*
Epron, M Lucienna 1876- *DcWomA*
Epstein, Abner 1910- *WorECar*
Epstein, Annabel Wharton *WhoAmA 78, -80, -82,*
 -84
Epstein, Elisabeth *DcWomA*
Epstein, Ernest *WhAmArt 85*
Epstein, Ethel S *WhoAmA 78N, -80N, -82N, -84N*
Epstein, Herbert 1922- *AmArch 70*
Epstein, Jacob 1864-1945 *WhAmArt 85*
Epstein, Jacob 1880- *WhAmArt 85*
Epstein, Jacob 1880-1959 *ConArt 77, -83*
 McGDA
Epstein, Sir Jacob 1880-1959 *DcBrA 1*
 DcNiCA, OxArt,
 OxTwCA, PhDcTCA 77, WorArt[port]
Epstein, John 1937- *DcCAr 81*
Epstein, Mitch 1952- *WhoAmA 82, -84*
Epstein, Mitchell 1952- *ICPEnP A, MacBEP*
Epstein, Murray 1910- *AmArch 70*
Epstein, S B *AmArch 70*
Epstein, Sheldon Lee 1938- *MarqDCG 84*
Epstein, Warren Martin 1935- *AmArch 70*
Epstein, Yale *PrintW 85*
Epting, Marion A 1940- *AfroAA*
Epting, Marion Austin 1940- *WhoAmA 76, -78, -80,*

 -82, -84
Equipo Cronica *ConArt 83*
Equipo Cronica 1940- *ConArt 77*
Erasmus Of Gaeta, Saint d301? *McGDA*
Erat-Oudet, Marie Augustine Clementine *DcWomA*
Erb, C R, Jr. *AmArch 70*
Erb, Daisy E *DcWomA, WhAmArt 85*
Erb, George *WhAmArt 85*
Erba, Gaspar *NewYHSD*
Erbach, T J *AmArch 70*
Erbaugh, Ralph 1885- *WhAmArt 85*
Erbe, Gary Thomas 1944- *WhoAmA 76*
Erbe, Joan 1926- *WhoAmA 73, -76, -78, -80, -82,*
 -84
Erbel, Don H 1938- *MarqDCG 84*
Erben, Josef 1936- *DcCAr 81*
Erber, Wolfram 1939- *DcCAr 81*
Erbes, John R 1946- *MarqDCG 84*
Erbes, Roslyn Maria *WhoAmA 78, -80, -82, -84*
Erbest, John *FolkA 86*
Erbsloh, Adolf *OxTwCA*
Erbsloh, Adolf 1881-1947 *PhDcTCA 77*
Erbsloh, Adolf 1888-1947 *McGDA*
Erceg, Rose 1898- *FolkA 86*
Erceville, Helene D' *DcWomA*
Erchul, J Thomas 1918- *AmArch 70*
Ercolani, Lucian R 1888- *DcD&D[port]*
Ercole *OxArt*
Ercoli, Alcide Carlo *DcVicP 2*
Erdelac, Joseph Mark *WhoAmA 78, -80, -82, -84*
Erdely, Alexander 1922- *AmArch 70*
Erdle, Rob 1949- *WhoAmA 78, -80, -82, -84*
Erdman, Barbara 1936- *AmArt*
Erdman, Michael P 1935- *AmArch 70*
Erdman, R H Donnelley 1938- *AmArch 70,*
 WhoAmA 73, -76, -78, -80
Erdmann, Charles R *WhAmArt 85*
Erdmann, R Frederick 1894- *WhAmArt 85*
Erdmann, Richard Frederick 1894- *ArtsAmW 3*
Erdmannsdorf, Friedrich W Freiherr Von 1726-1800
 OxArt
Erdmannsdorff, Friedrich Wilhelm Von 1736-1800
 MacEA
Erdoes, Richard 1912- *IlsBYP, IlsCB 1957*
Erdstein, George 1938- *AmArch 70*
Eres, Eugenia 1928- *AmArt, WhoAmA 76, -78, -80,*
 -82, -84
Eresby, Eloise L Breese De *WhAmArt 85*
Eresby, Eloise Lawrence Breese De d1953 *DcWomA*
Eresch, Josie 1894- *ArtsAmW 2, DcWomA,*
 WhAmArt 85
Erfurth, Hugo 1874- *MacBEP*
Erfurth, Hugo 1874-1948 *ConPhot, ICPEnP*
Erganian, Sarkis *WhAmArt 85*
Ergotimos *McGDA*
Erhard, Walter 1920- *IlsCB 1957*
Erhardt, Hans Martin 1935- *OxTwCA*
Erhart, F J *AmArch 70*
Erhart, Gregor d1540 *McGDA*
Eric 1891-1958 *WorFshn*
Eric, F *DcVicP 2*
Eric, Milan 1956- *DcCAr 81*
Erichsen, Margrethe *DcWomA*
Erichsen, Nelly *DcBrBI, DcWomA*
Erichsen, Thorvald 1868-1939 *PhDcTCA 77*
Erichsen, Thyra *DcWomA*
Erichson, Nelly *DcVicP 2*
Ericksen, Craig G 1947- *MarqDCG 84*
Erickson, Arthur 1924- *ConArch, MacEA*
Erickson, Arthur Charles 1924- *WhoArch*
Erickson, Arthur Lawrence *WhAmArt 85*
Erickson, Barden Gene 1930- *AmArch 70*
Erickson, Bruce Ernst 1934- *AmArch 70*
Erickson, C O *WhAmArt 85*
Erickson, Carl *WhAmArt 85*
Erickson, Carl 1891-1958 *WorFshn*
Erickson, Carl Oscar August 1891-1958 *IlrAm D,*
 -1880
Erickson, D M *AmArch 70*
Erickson, Delano DelRay 1936- *AmArch 70*
Erickson, Donald Edward 1929- *AmArch 70*
Erickson, E R *AmArch 70*
Erickson, E V *AmArch 70*
Erickson, Elizabeth Richards 1935- *MarqDCG 84*
Erickson, Eric 1878- *ArtsAmW 3*
Erickson, Ernest C *WhAmArt 85*
Erickson, Ernie Oliver 1931- *AmArch 70*
Erickson, George C *EncASM*
Erickson, Gerald 1914- *AmArch 70*
Erickson, H W *AmArch 70*
Erickson, J A *AmArch 70*
Erickson, Larry Neil 1936- *AmArch 70*
Erickson, Oscar B *WhAmArt 85*
Erickson, Phoebe 1907- *IlsCB 1946*
Erickson, R A *AmArch 70*
Erickson, William Paul, Jr. 1923- *AmArch 70*
Ericson, Beatrice *WhoAmA 73, -76, -78, -80, -82,*
 -84
Ericson, David 1870- *WhAmArt 85*
Ericson, Dick 1916- *WhoAmA 73, -76, -78, -80*
Ericson, Donald Robert 1924- *AmArch 70*

Ericson, Eric 1914- *WhAmArt 85*
Ericson, Ernest *WhoAmA 73, -76, -78, -80*
Ericson, Ernest d1981 *WhoAmA 82N, -84N*
Ericson, Everett W 1930- *AmArch 70*
Ericson, George M 1893- *WhAmArt 85*
Ericson, Jon Eric *AmArch 70*
Ericson, Mauritz A 1836-1912 *NewYHSD ,
 WhAmArt 85*
Ericson, Paul Nathan 1924- *AmArch 70*
Ericson, Sigfrid 1879-1958 *MacEA*
Ericson, Susan Kunce 1927- *WhoAmA 73, -76*
Ericson-Molard, Ida 1853- *DcWomA*
Ericsson, Anna Maria *DcWomA*
Ericsson, Henry 1898-1933 *IlDcG*
Erik-Alt, Lenore 1910- *WhAmArt 85*
Eriksen, Gary 1943- *WhoAmA 84*
Eriksen, Jens d1920 *ArtsAmW 3*
Eriksen, John M 1884-1918 *WhAmArt 85*
Erikson, Mel *IlsBYP*
Erikson, Oscar Walter 1909- *AmArch 70*
Eriksson, Archie 1900- *WhAmArt 85*
Eriksson, Elis 1906- *OxTwCA, PhDcTCA 77*
Eriksson, Ulf 1942- *PrintW 83, -85*
Eriquezzo, Lee M *WhoAmA 76, -78, -80, -82, -84*
Eristov-Kasak, Marie d1934 *DcWomA*
Erith, Raymond Charles 1904- *DcD&D[port]*
Erith, Raymond Charles 1904-1974 *DcBrA 1*
Erixson, Sven 1899- *McGDA, PhDcTCA 77*
Erla, Karen *PrintW 85*
Erlach, Baroness Von *DcWomA*
Erlach, Anna Elisabeth Von 1856-1906 *DcWomA*
Erlach, Gertrud Von 1861- *DcWomA*
Erlach VonHindelbank, Countess Ada Von 1853-1907
 DcWomA
Erlach VonHindelbank, Sophie Maria 1829-1911
 DcWomA
Erlam, Samuel B *BiDBrA*
Erlanger, Elizabeth N 1901- *WhoAmA 73*
Erlanger, Elizabeth N 1901-1975 *WhoAmA 76N,
 -78N, -80N, -82N, -84N*
Erle-Saghaphi, Annette 1910- *WhAmArt 85*
Erlebacher, Martha Mayer 1937- *AmArt, PrintW 85*
Erlebacher, Martin 1930- *AmArch 70*
Erler, Fritz 1868-1940 *ClaDrA*
Erler, Margarethe *DcWomA*
Erlien, Nancy Beth 1954- *WhoAmA 80, -82, -84*
Erman, Robert J 1928- *AmArch 70*
Ermeler, Caroline *DcWomA*
Ermels, Johann Franciscus 1621-1693 *ClaDrA*
Ermilov, Vasilii Dmitrievich 1894-1968 *OxTwCA*
Ermolaeva, Vera Mikhailovna 1893-1938 *DcWomA*
Ernest, Mrs. Austin *FolkA 86*
Ernest, Julius 1831?- *NewYHSD*
Ernesti, Ethel H 1880- *ArtsAmW 3*
Ernesti, Richard 1856- *ArtsAmW 3, IlBEAAW,
 WhAmArt 85*
Ernestine, Princess Of Nassau-Hadamar d1668
 DcWomA
Erni, Hans *OfPGCP 86*
Erni, Hans 1909- *ConDes, McGDA, PhDcTCA 77,
 WhoArt 80, -82, -84, WhoGrA 62, -82[port]*
Ernle, Lady Barbara *ClaDrA*
Ernst, Father *NewYHSD*
Ernst, Amelie 1834- *DcWomA*
Ernst, Augusta *DcWomA*
Ernst, Carl *FolkA 86*
Ernst, Carl William Jr. 1917- *AmArch 70*
Ernst, E U *AmArch 70*
Ernst, Ethel M *DcWomA, WhAmArt 85*
Ernst, F Gene 1929- *AmArch 70*
Ernst, James Arnold 1916- *WhoAmA 73, -76, -78,
 -80, -82, -84*
Ernst, Jimmy 1920- *DcCAA 71, -77, McGDA,
 OxTwCA, PhDcTCA 77, WhoAmA 73, -76, -78,
 -80, -82, -84*
Ernst, Jimmy 1920-1984 *WorArt[port]*
Ernst, Julius 1831?- *NewYHSD*
Ernst, Junes *WhAmArt 85*
Ernst, Ken 1918-1985 *ConGrA 1*
Ernst, Kenneth 1918- *WorECom*
Ernst, Martha Christina Von 1774-1854 *DcWomA*
Ernst, Max 1891- *McGDA*
Ernst, Max 1891-1976 *ArtsAmW 2, ConArt 77, -83,
 OxArt, OxTwCA, PhDcTCA 77,
 WhoAmA 78N, -80N, -82N, -84N, WorArt[port]*
Ernst, Rudolph 1854- *ClaDrA*
Ernst, Stephen Richard 1939- *MarqDCG 84*
Ernst, Thomas J 1829?- *NewYHSD*
Ernsthausen, Roger E 1934- *MarqDCG 84*
Ernsting, Volker 1941- *WorECom*
Erny, Gilles 1946- *DcCAr 81*
Ernyei, Sandor 1924- *WhoGrA 62, -82[port]*
Ero, Johan W 1938- *MarqDCG 84*
Eroh, E P *AmArch 70*
Erotico, Carmelo *DcCAr 81*
Errard, Charles 1606-1689 *OxArt*
Erri, Agnolo *McGDA*
Erri, Bartolommeo *McGDA*
Erri, Ippolita Degli d1661 *DcWomA*
Errico, Antonio D' *McGDA*
Errington, Isabella *DcVicP 2*

Erro 1932- *ConArt 77, -83, DcCAr 81*
Ersek, Joseph Francis 1912- *WhAmArt 85*
Erskine, Colin 1704?- *DcBrECP*
Erskine, Edith E *DcVicP 2*
Erskine, Graham 1911- *AmArch 70*
Erskine, Harold Perry d1951 *WhoAmA 78N, -80N,
 -82N, -84N*
Erskine, Harold Perry 1879-1951 *WhAmArt 85*
Erskine, John, Earl of Mar 1675-1732 *BiDBrA*
Erskine, R B *AmArch 70*
Erskine, Ralph 1914- *ConArch, DcD&D[port],
 MacEA*
Erskine, W C *AmArch 70*
Erskine, W C C *DcVicP 2*
Erstaphieve, C J *WhAmArt 85*
Erte *OfPGCP 86*
Erte 1892- *ConDes, PrintW 83, -85, WorFshn*
Erte-DeTirtoff, Roman 1892- *WhoArt 80, -82, -84*
Ertel, Mengu 1931- *WhoGrA 82[port]*
Erteszek, Olga *WorFshn*
Ertl, Marie 1837- *DcWomA*
Ertle, Sebastian 1570?- *McGDA*
Ertman, Earl Leslie 1932- *WhoAmA 78, -80, -82, -84*
Ertman, Gardner *AmArch 70*
Ertvelt, Andries Van *DcSeaP*
Ertz, Bruno 1873- *WhAmArt 85*
Ertz, Bruno 1873-1956 *ArtsEM*
Ertz, Charles Walter *AmArch 70*
Ertz, Edward 1862- *WhAmArt 85*
Ertz, Edward Frederick 1862- *ArtsAmW 1,
 IlBEAAW*
Ertz, Edward Frederick 1862-1954 *ClaDrA, DcBrA 1,
 DcVicP 2*
Ertz, Ethel Margaret 1871- *DcWomA*
Ertz, Ethel Margaret 1871-1919 *DcBrA 2*
Ertz, Ethel Margaret Horsfall 1871-1919 *DcBrA 2*
Ertz, Gordon 1891- *WhAmArt 85*
Erus, John *NewYHSD*
Ervi, Aarne 1910- *EncMA*
Ervi, Aarne 1910-1977 *ConArch, MacEA*
Ervin, Calvin Bruce 1924- *AmArch 70*
Ervin, Don *AmGrD[port]*
Ervin, Gladys Dee 1887- *WhAmArt 85*
Ervin, Robert William 1930- *AmArch 70*
Ervin, Stephen McTee 1951- *MarqDCG 84*
Erwin Von Steinbach d1318 *MacEA, OxArt*
Erwin, Benoni *NewYHSD*
Erwin, Elsie *DcWomA*
Erwin, Emmett MacDonald, Jr. 1920- *AmArch 70*
Erwin, Margaret D *ArtsAmW 3*
Erwin, Will *ConGrA 1, WorECom*
Erwitt, Elliott 1928- *ConPhot, DcCAr 81, ICPEnP*
Erwitt, Elliott R 1928- *MacBEP*
Erwood, A *DcVicP 2*
Erythropel, Ilse *WhAmArt 85*
Es, Jacob Fossens Van d1666 *McGDA*
Esaki, Yasuhiro 1941- *AmArt, WhoAmA 80, -82,
 -84*
Esau, Erika 1949- *WhoAmA 82, -84*
Escalante, Juan Antonio 1633-1670 *McGDA*
Escalier, Eleonore 1827-1888 *DcNiCA*
Escalier, Marguerite *DcWomA*
Escallier, Eleonore *AntBDN M*
Escallier, Eleonore 1827-1888 *DcWomA*
Escard, Adele Josephine Genevieve *DcWomA*
Escassut, Anna 1878- *DcWomA*
Escazena, J M *DcVicP 2*
Esch, Anna Barbara *DcWomA*
Esch, Mathilde 1820?- *DcWomA*
Esch, Richard E 1939- *MarqDCG 84*
Eschenbach, B *AmArch 70*
Eschenbach, Paul 1867- *WhAmArt 85*
Eschenbrenner, Emilie Louise 1880- *DcWomA*
Eschenburg, Marianne Von 1856- *DcWomA*
Escher, Clementine *DcWomA*
Escher, Gertrud 1875- *DcWomA*
Escher, Gielijn 1945- *WhoGrA 82[port]*
Escher, Karoly 1890-1966 *ICPEnP*
Escher, Maurits Cornelis 1898-1972 *OxTwCA,
 PhDcTCA 77*
Escher, Reinhold 1905- *WorECom*
Escher, Rolf 1936- *DcCAr 81*
Escher-Schultheiss *DcWomA*
Escherich, Catharina *DcWomA*
Escherich, Elsa F 1888- *ArtsAmW 2, WhAmArt 85*
Escherich, Elsa Falk 1888- *DcWomA*
Escherick, A W *NewYHSD*
Escherick, Elsa Falk 1888- *DcWomA*
Eschke, Wilhelm Benjamin Hermann 1823-1900
 DcSeaP
Eschliman, Richard Wendel 1925- *AmArch 70*
Eschmann, Jean Charles 1896- *WhAmArt 85*
Eschmann, Jean Charles 1896-1961 *WhoAmA 80N,
 -82N, -84N*
Escholier, Marie 1856?- *DcWomA*
Eschrisch, Catharina *DcWomA*
Eschweiler, Alexander C 1865-1940 *BiDAmAr*
Eschweiler, C F *AmArch 70*
Eschweiler, Thomas Lincoln 1921- *AmArch 70*
Esclusa Canals, Manel 1952- *MacBEP*
Escobar, Mario 1952- *MarqDCG 84*
Escobar, Marisol *WorArt*

Escobedo, Augusto Ortega 1914- *WhoAmA 73, -76,
 -78, -80, -82*
Escobedo, Helen 1936- *WhoAmA 73, -76, -78, -80,
 -82, -84*
Escoffier, John *NewYHSD*
Escolier, Marie 1856?- *DcWomA*
Escombe, Anne *DcVicP 2, DcWomA*
Escombe, Jane *DcVicP 2*
Escosura, Ignace DeLeon Y *ArtsNiC*
Escribano Y Paul, Maria DelPilar *DcWomA*
Escudero, Maria Pastora *DcWomA*
Esders, Madeleine 1891- *DcWomA*
Eseler, Niclaus, The Elder *McGDA*
Esenwein, August C 1856-1926 *BiDAmAr*
Eshbach, William Wallace 1917- *AmArch 70*
Eshel, Abe 1933- *MarqDCG 84*
Esherick, Joseph 1911- *McGDA*
Esherick, Joseph 1914- *AmArch 70, ConArch,
 MacEA*
Esherick, Wharton 1887-1970 *BnEnAmA,
 WhAmArt 85, WhoAmA 78N, -80N, -82N, -84N*
Eshleman, Aaron 1827- *NewYHSD*
Eshner, Ann *WhAmArt 85*
Eshoo, Robert 1926- *WhoAmA 73, -76, -78, -80, -82,
 -84*
Eshraw, Ra 1926- *WhoAmA 76, -78, -80*
Esinger, Adele 1846- *DcWomA*
Eskey, William A 1891- *WhAmArt 85*
Eskildsen, Ute 1947- *MacBEP*
Eskridge, Robert Lee 1891- *ArtsAmW 3,
 WhAmArt 85*
Eskridge, Robert Thomas 1929- *AmArch 70*
Eskridge, Thomas *AfroAA*
Esler, John Kenneth 1933- *WhoAmA 73, -76, -78,
 -80, -82, -84*
Esman, Betty *WhoAmA 73, -76*
Esman, Rosa M 1927- *WhoAmA 73, -76, -78, -80,
 -82, -84*
Esmenard, Ines D' *DcWomA*
Esmenard, Nathalie D' *DcWomA*
Esmond, Ethel *DcWomA*
Esnault, Louise *DcWomA*
Esnee-Perrin, Marthe 1845- *DcWomA*
Esner, Arthur L 1902- *WhAmArt 85*
Espada, Frank 1930- *ICPEnP A*
Espagnat, Georges D' 1870-1950 *ClaDrA*
Espanol, Pedro *McGDA*
Espedahl, Kaare S 1901- *AmArch 70*
Espenan-Cresson, Marguerite 1867- *DcWomA*
Espenet 1920- *WhoAmA 82, -84*
Espenlaub, Lloyd P 1945- *MarqDCG 84*
Espenshade, Edward Bowman, Jr. 1910- *MarqDCG 84*
Esperandieu, Jacques Henry 1829-1874 *MacEA*
Espey, Josie S *DcWomA*
Espiennes, Countess *DcWomA*
Espin, Thomas 1767-1822 *BiDBrA*
Espin, Thomas 1768?-1822 *DcBrWA*
Espinet, Caroline *DcWomA*
Espinosa *DcWomA*
Espinosa, Jacinto Geronimo De 1600-1680 *ClaDrA*
Espinosa, Jeronimo Jacinto 1600-1680 *McGDA*
Espiritu, Christian 1934- *WorFshn*
Esposito, Nicholas 1927- *DcCAr 81*
Espoy, Angel DeSarna *ArtsAmW 3*
Esputa, Susan Adel *FolkA 86*
Esqueda, Xavier 1943- *DcCAr 81*
Esquibel, Felix *FolkA 86*
Esquivel, Antonio Maria 1806-1857 *McGDA, OxArt*
Essche, Maurice Van *OxTwCA*
Esselens, Jacob 1626-1687 *ClaDrA, McGDA*
Esselink, Leonard 1944- *MarqDCG 84*
Esser, Janet Brody *WhoAmA 80, -82, -84*
Esserman, Ruth 1927- *WhoAmA 73, -76, -78*
Essert, F P *AmArch 70*
Essex, Charles *AntBDN G*
Essex, E H *AmArch 70*
Essex, Hannah *DcWomA*
Essex, James 1722-1784 *BiDBrA, MacEA*
Essex, Joseph Michael 1947- *WhoGrA 82[port]*
Essex, Richard Hamilton 1802-1855 *DcBrWA,
 DcVicP 2*
Essig, George E 1883- *WhAmArt 85*
Essig, George Emerick 1838- *NewYHSD*
Essinger, James Henry 1925- *AmArch 70*
Essington, Edwin *WhAmArt 85*
Esslinger, Anna Barbara 1792-1868 *DcWomA*
Essoc, Marie 1867- *DcWomA*
Estabrook, Florence C *WhAmArt 85*
Estabrook, Gertrude *WhAmArt 85*
Estabrook, Reed 1944- *ICPEnP A, MacBEP,
 WhoAmA 78, -80, -82, -84*
Estabrooks, Gertrude *DcWomA*
Estabrooks, John F *NewYHSD*
Estall, William Charles 1857-1897 *DcBrWA,
 DcVicP 2*
Estcourt, Caroline Bucknall d1886 *DcWomA*
Estcourt, F J *DcVicP 2*
Estcourt, Miss K B *DcBrA 2*
Este, Alfonso 1486-1534 *OxArt*

Este, Borso 1413-1471 *OxArt*
Este, Ercole 1431-1505 *OxArt*
Este, Florence 1860-1926 *DcWomA,* *WhAmArt 85*
Este, Francesco, I 1610-1658 *OxArt*
Este, Francesco, III *OxArt*
Este, Isabella *OxArt*
Este, Leonello 1407-1450 *OxArt*
Esteban *WorFshn*
Estebo, William Julius 1925- *AmArch 70*
Esteline, Martha *DcWomA, FolkA 86*
Estelle, Wesley William *ArtsEM*
Esten, Edwin *FolkA 86*
Esten, H L *AmArch 70*
Estenson, H A *AmArch 70*
Esterbrucks, Richard *FolkA 86*
Esterel, Jacques 1918-1974 *FairDF FRA*
Esterheld, John Jacob 1898- *AmArch 70*
Esterl, Martin 1947- *DcCAr 81*
Esterly, Alburt Cassius 1911- *AmArch 70*
Estern, Neil 1926- *WhoAmA 76, -78, -80, -82, -84*
Esterow, Milton 1928- *WhoAmA 76, -78, -80, -82, -84*
Estes, Charles Edwin 1928- *AmArch 70*
Estes, Eleanor 1906- *IlsCB 1946*
Estes, Mark D *MarqDCG 84*
Estes, Richard 1936- *AmArt, ConArt 77, -83, DcAmArt, DcCAA 77, DcCAr 81, PrintW 83, -85, WhoAmA 76, -78, -80, -82, -84, WorArt[port]*
Estes, Thomas *NewYHSD*
Esteve, Agustin 1753-1809? *McGDA*
Esteve, Maurice 1904- *ConArt 83, McGDA, OxTwCA, PhDcTCA 77, WorArt[port]*
Esteve Y Vilela, Rafael 1772-1847 *McGDA*
Estevenot, Louisa *DcWomA*
Esteverena, Rolando C 1943- *MarqDCG 84*
Esteves, Antonio 1910-1983 *FolkA 86*
Esteves, Michael Kent 1947- *AfroAA*
Estevez, Luis 1930- *FairDF US, WorFshn*
Estey, A Genevieve *WhAmArt 85*
Estey, Alexander R 1826-1881 *BiDAmAr, MacEA*
Estheham, Andrew *NewYHSD*
Esther, Sister 1901- *WhAmArt 85*
Estienne, Robert 1503-1559 *OxDecA*
Estill, Mrs. John Wilmott *DcWomA*
Estoppey, Leonie 1852-1896 *DcWomA*
Estrada, Jose Maria *McGDA*
Estrada, Robert M 1938- *MarqDCG 84*
Estrada, Romolo *WorFshn*
Estrees, Therese D' 1874- *DcWomA*
Estridge, Loraine *DcVicP 2*
Estrin, Emilee Ridgway 1948- *MarqDCG 84*
Estrin, Mary Lloyd 1944- *ICPEnP A, MacBEP*
Etchells, Frederick 1886-1973 *DcBrA 1, OxTwCA, PhDcTCA 77*
Etchells, Peter Allen 1949- *MarqDCG 84*
Etcheverry, Hubert Denis 1867- *ClaDrA*
Etchison, Bruce 1918- *WhoAmA 76, -78, -80, -82, -84*
Eteson, Audrey Constance 1899-1930 *DcBrA 1, DcWomA*
Eteve, Aline Marie 1898- *DcWomA*
Etex, Antoine 1808- *ArtsNiC*
Ethelson, Edmund *DcVicP 2*
Etheredge, L U *AmArch 70*
Etheredge, Talmage 1940- *WhoAmA 76*
Etheridge, William d1776 *BiDBrA*
Etherington, A Bruce 1924- *AmArch 70*
Etherington, C *WhAmArt 85*
Etherington, George *AntBDN D*
Etherington, Lilian M *DcVicP 2*
Etherington, Lilian Mary *DcWomA*
Etherton, Thomas James 1925- *AmArch 70*
Ethiou, Adele *DcWomA*
Ethover, T *DcVicP 2*
Ethridge, H A *DcVicP 2*
Ethridge, W B *NewYHSD*
Etienne, Guillermo C 1938- *WhoAmA 82, -84*
Etienne-Martin 1913- *PhDcTCA 77, WorArt*
Etner, Reuben *FolkA 86*
Etnier, Stephen Morgan 1903- *WhAmArt 85, WhoAmA 73, -76, -78, -80, -82, -84*
Eton *EncASM*
Etranger And Graines *NewYHSD*
Etrog, Sorel 1933- *ConArt 77, WhoAmA 73, -76, -78, -80, -82, -84*
Ets, Marie Hall *IlsCB 1967*
Ets, Marie Hall 1893- *WhoAmA 84*
Ets, Marie Hall 1895- *IlsBYP, IlsCB 1744, -1946, -1957, WhAmArt 85, WhoAmA 73, -76, -78, -80, -82*
Ets, Ray *MarqDCG 84*
Ettenberg, Eugene M 1903- *WhAmArt 85, WhoAmA 73, -76*
Ettenberg, Franklin Joseph 1945- *WhoAmA 73, -76, -78, -80, -82, -84*
Etter, Charles G *AmArch 70*
Etter, David Rent 1807-1881 *NewYHSD*
Etter, Elizabeth Davidson *FolkA 86*
Etter, Howard Lee 1931- *WhoAmA 76, -78, -80, -82, -84*

Etter, J H *AmArch 70*
Etter, J Ulrich *ArtsEM*
Etting, Emlen 1905- *DcCAA 71, -77, WhAmArt 85, WhoAmA 73, -76, -78, -80, -82, -84*
Ettinger, Emanuel 1801-1889 *FolkA 86*
Ettinger, John *FolkA 86*
Ettinger, Josef Carl 1805-1860 *ClaDrA*
Ettinger, Ronald Alan 1932- *AmArch 70*
Ettinger, Susi Steinitz 1922- *WhoAmA 76, -78, -80, -82, -84*
Ettinger, William *FolkA 86*
Ettinger, William 1825?- *FolkA 86*
Ettinghausen, Richard 1906- *WhAmArt 85, WhoAmA 73, -76, -78, -80N, -82N, -84N*
Ettl, Alex J 1898- *WhAmArt 85*
Ettl, Georg 1931- *WhoAmA 84*
Ettl, John 1872-1940 *WhAmArt 85*
Ettling, Ruth 1910- *WhoAmA 73, -76, -78, -80, -82, -84*
Ettlinger, Leopold David 1913- *WhoAmA 78, -80, -82, -84*
Etty, John *DcBrECP*
Etty, John 1634?-1708 *BiDBrA*
Etty, William 1675?-1734 *BiDBrA*
Etty, William 1787-1849 *ArtsNiC, DcBrWA, DcVicP, -2, McGDA, OxArt*
Etz, Pearl *DcWomA*
Etz, Pearl Potter *WhAmArt 85*
Etzold, Theodore William *ArtsEM*
Eubank, Joseph P, Jr. 1933- *AmArch 70*
Eubank, T Neel 1908- *AmArch 70*
Eubanks, Clifford, Jr. 1944- *AfroAA*
Eubanks, Henry Otis, Jr. 1929- *AmArch 70*
Eubanks, Jonathan 1927- *AfroAA*
Eubanks, Tony *OfPGCP 86*
Eubanks, William H 1921- *MarqDCG 84*
Eubele, M *FolkA 86*
Eudene, S *AmArch 70*
Eudes DeMontereau *McGDA*
Eudes DeGuimard, Louise 1827-1904 *DcWomA*
Eugene, Frank 1865-1936 *ICPEnP, MacBEP, WhAmArt 85*
Eugenides, John James 1928- *AmArch 70*
Eugenie 1913- *WhoAmA 73, -76*
Euker, Roy Allen 1932- *AmArch 70*
Eulaluis *MacEA*
Eulberg, Veronica Appollonia 1905- *WhAmArt 85*
Eulenburg, Countess Olga De 1848- *DcWomA*
Euler, Charles 1815- *NewYHSD*
Euler, Edwin *WhAmArt 85*
Euler, Margaret Ida *DcBrA 1, WhoArt 80, -82, -84*
Euler, Reeves 1896- *ArtsAmW 2, WhAmArt 85*
Euphranor *McGDA*
Euphranor Of Corinth *OxArt*
Eupolemos Of Argos *MacEA*
Eurich, Frank, Jr. d1924 *BiDAmAr*
Eurich, Richard 1903- *ConArt 79[port]*
Eurich, Richard Ernst 1903- *ClaDrA, DcBrA 1, DcSeaP, WhoArt 80, -82, -84*
Eusebio DiSan Giorgio 1467?-1540? *McGDA*
Eustace Of Rome, Saint *McGDA*
Eustace, Violet 1875- *DcBrA 1, DcWomA*
Eustache, Georgette 1874- *DcWomA*
Eustachio, Fra 1473-1555 *McGDA*
Eustice, Brocky Clifford 1933- *AmArch 70*
Eustis, Ebenezer *CabMA*
Euston, Andrew Francis 1902- *AmArch 70*
Euston, Andrew Francis 1934- *AmArch 70*
Euston, Jacob Howard 1892- *WhAmArt 85*
Eutatse, John *FolkA 86*
Euthycrates *McGDA*
Euthymides *McGDA*
Eutychides *McGDA*
Euwer, Anthony Henderson 1877- *ArtsAmW 1, WhAmArt 85*
Evalenko, George A *WhAmArt 85*
Evangelista, Joseph P 1912- *AmArch 70*
Evanoff, L G *AmArch 70*
Evans *DcBrECP, FolkA 86*
Evans, Adam *DcVicP 2*
Evans, Allen 1845-1925 *WhoArch*
Evans, Allen 1849-1925 *BiDAmAr*
Evans, Amy *DcVicP 2, DcWomA*
Evans, Anne *ArtsAmW 2, WhAmArt 85*
Evans, Anne 1871-1941 *DcWomA*
Evans, Sir Arthur 1851-1941 *McGDA*
Evans, Arthur Benoni 1781-1854 *DcBrWA*
Evans, Arthur C 1921- *AmArch 70*
Evans, B R *NewYHSD*
Evans, Barnaby 1953- *MacBEP*
Evans, Benjamin Hampton 1926- *AmArch 70*
Evans, Bernard *NewYHSD*
Evans, Bernard 1929- *WhoArt 84*
Evans, Mrs. Bernard *DcVicP 2*
Evans, Bernard Walter 1843-1922 *DcBrA 1*
Evans, Bernard Walter 1848-1922 *DcBrWA, DcVicP 2*
Evans, Blanche B *DcWomA*
Evans, Blanche Rumsey 1880- *DcWomA, WhAmArt 85*
Evans, Bob *DcCAr 81*

Evans, Bob 1947- *OxTwCA*
Evans, Bruce 1950- *DcCAr 81*
Evans, Bruce Haselton 1939- *WhoAmA 73, -76, -78, -80, -82, -84*
Evans, Buford E 1931- *AfroAA*
Evans, Burford Elonzo 1931- *WhoAmA 76, -78, -80, -82, -84*
Evans, Charles *AfroAA, BiDBrA*
Evans, Charles A *NewYHSD*
Evans, D *EncASM*
Evans, Daniel *FolkA 86*
Evans, Daniel 1769?-1846 *BiDBrA*
Evans, David *CabMA*
Evans, David d1814 *DcNiCA*
Evans, David 1895- *DcBrA 1*
Evans, David 1942- *DcCAr 81*
Evans, David A *AntBDN K*
Evans, David C 1924- *MarqDCG 84*
Evans, David Lloyd 1916- *ClaDrA, DcBrA 1*
Evans, David Walters 1922- *MarqDCG 84*
Evans, DeScott 1847- *ArtsNiC*
Evans, DeScott 1847-1898 *DcAmArt, WhAmArt 85*
Evans, Dick 1941- *WhoAmA 80, -82, -84*
Evans, Donald 1946-1977 *WhoAmA 78N, -80N, -82N, -84N*
Evans, Donald Ray 1936- *AmArch 70*
Evans, Dorothy *DcWomA*
Evans, Dulah Llan *WhAmArt 85*
Evans, Dulah Marie *DcWomA*
Evans, E H *DcVicP 2*
Evans, E S *NewYHSD*
Evans, Mrs. E S *WhAmArt 85*
Evans, Edgar *AfroAA*
Evans, Edgar Samuel 1852-1919 *WhAmArt 85*
Evans, Edith 1886-1932 *WhAmArt 85*
Evans, Edith R *DcWomA*
Evans, Edmund C 1878-1934 *BiDAmAr*
Evans, Edmund William 1858- *DcVicP 2*
Evans, Edward *BnEnAmA, DcVicP 2*
Evans, Edward Arthur 1895- *WhoAmA 73*
Evans, Edwin 1860-1946 *ArtsAmW 1, IlBEAAW, WhAmArt 85*
Evans, Elizabeth *DcWomA*
Evans, Elizabeth E 1908- *WhAmArt 85*
Evans, Elizabeth H 1896- *WhAmArt 85*
Evans, Ephraim *CabMA*
Evans, Ethel 1866-1929 *DcWomA, WhAmArt 85*
Evans, Ethel Wisner 1888- *ArtsAmW 3*
Evans, Etienne *AntBDN M*
Evans, Eva Clemence *WhAmArt 85*
Evans, Evelyn *DcCAr 81*
Evans, Evelyn 1915- *DcBrA 1*
Evans, F L 1833?- *DcWomA*
Evans, F M *DcWomA*
Evans, Fannie *DcWomA, WhAmArt 85*
Evans, Fay A, Jr. 1916- *AmArch 70*
Evans, Francis *WhAmArt 85*
Evans, Fred Lawrence 1939- *AmArch 70*
Evans, Mrs. Fred M *DcVicP 2*
Evans, Mrs. Frederick *WhAmArt 85*
Evans, Frederick H 1853-1943 *ICPEnP, MacBEP*
Evans, Frederick James McNamara *DcBrA 1*
Evans, Frederick M *DcBrWA, DcVicP 2*
Evans, G *DcVicP 2*
Evans, G Gerald *WhAmArt 85*
Evans, G H *DcVicP 2*
Evans, Garth 1934- *ConArt 77, ConBrA 79[port], DcCAr 81, OxTwCA, WhoArt 80, -82, -84*
Evans, George *DcBrECP, WhAmArt 85*
Evans, George 1920- *WorECom*
Evans, Glenn *AfroAA*
Evans, Grace French *WhAmArt 85*
Evans, Grace Hamilton 1887-1953 *DcWomA*
Evans, Grace L 1877- *WhAmArt 85*
Evans, Grace Lydia 1877- *DcWomA*
Evans, Graham Lambeth, Jr. 1934- *AmArch 70*
Evans, Grose 1916- *WhoAmA 73, -76, -78, -80, -82, -84*
Evans, Gwendoline Edith Marion 1898- *DcBrA 1, DcWomA*
Evans, H *DcBrBI*
Evans, Hannah 1801-1860 *NewYHSD*
Evans, Hannah Slaymaker 1801-1860 *DcWomA*
Evans, Harold E *WhAmArt 85*
Evans, Helen B *AfroAA*
Evans, Helena M *DcVicP 2, DcWomA*
Evans, Henry *EncASM*
Evans, Henry 1918- *WhoAmA 73, -76, -78, -80, -82, -84*
Evans, Herbert Davies *DcVicP 2*
Evans, Herbert E *DcVicP 2*
Evans, J *AmArch 70, FolkA 86*
Evans, J A *AmArch 70*
Evans, J D *AmArch 70*
Evans, J G *NewYHSD*
Evans, J M *FolkA 86, NewYHSD*
Evans, J W *DcVicP 2*
Evans, James *NewYHSD*
Evans, James 1759-1781 *DcBrECP*
Evans, James B 1829?- *NewYHSD*
Evans, James Guy *FolkA 86*

Evans, James I *FolkA 86*
Evans, James William 1926- *AmArch 70*
Evans, Jessie Benton *WhoAmA 84*
Evans, Jessie Benton 1866- *IlBEAAW, WhAmArt 85*
Evans, Jessie Benton 1866-1954 *ArtsAmW 1, -2, DcWomA*
Evans, Joe 1857-1898 *WhAmArt 85*
Evans, Joe M 1924- *AmArch 70*
Evans, John *DcVicP 2, FolkA 86, NewYHSD*
Evans, John 1932- *AmArt, WhoAmA 78, -80, -82, -84*
Evans, John B 1938- *AmArch 70*
Evans, John H V 1914- *AmArch 70*
Evans, John Lane 1902- *AmArch 70*
Evans, John Quentin 1933- *WorFshn*
Evans, John T *FolkA 86, NewYHSD*
Evans, John W *NewYHSD*
Evans, John W 1855- *WhAmArt 85*
Evans, Jonathan William 1913- *AmArch 70*
Evans, Joseph Orme 1923- *AmArch 70*
Evans, K H *AmArch 70*
Evans, Kate *DcVicP 2, DcWomA*
Evans, Katherine Floyd 1901-1964 *IlsCB 1957*
Evans, Lawrence Benjamin 1930- *AmArch 70*
Evans, Lena M *DcVicP 2, DcWomA*
Evans, Lewy, Jr. 1924- *AmArch 70*
Evans, Lucile 1894- *WhoAmA 82, -84*
Evans, Lucille 1894- *DcWomA*
Evans, Lucius Russell 1932- *AmArch 70*
Evans, M A *DcWomA*
Evans, M E *DcVicP 2, WhAmArt 85*
Evans, M Eleanor *DcWomA*
Evans, M K *AmArch 70*
Evans, M R *AmArch 70*
Evans, Margaret *WhAmArt 85*
Evans, Marjorie *DcVicP 2, DcWomA*
Evans, Marlene Breaux 1955- *MarqDCG 84*
Evans, Merlyn 1910-1973 *PhDcTCA 77*
Evans, Merlyn Oliver 1910-1973 *DcBrA 1*
Evans, Michael 1944- *ICPEnP A*
Evans, Minnie *AfroAA*
Evans, Minnie 1892- *DcWomA, FolkA 86, WhoAmA 73, -76, -78, -80, -82, -84*
Evans, Nancy *WhoAmA 76, -78, -80*
Evans, Nathaniel, Jr. *NewYHSD*
Evans, Nicholas *WhoArt 82, -84*
Evans, Nicholas 1907- *DcCAr 81*
Evans, Nina *DcWomA*
Evans, P K *AmArch 70*
Evans, Paul Fredric 1937- *WhoAmA 76, -78, -80*
Evans, Percy Cornelius 1904- *AfroAA*
Evans, Powys Arthur Lenthall 1899- *DcBrA 1*
Evans, Ralph Folland 1939- *AmArch 70*
Evans, Randolph 1901- *AmArch 70*
Evans, Ray 1920- *ClaDrA, DcBrA 1, WhoArt 80, -82, -84*
Evans, Raymond Oscar 1887-1954 *WorECar*
Evans, Regina Neville 1862- *DcWomA*
Evans, Richard 1784-1871 *DcBrWA, DcVicP 2*
Evans, Richard 1923- *IlBEAAW, WhoAmA 73, -76, -78, -80, -82, -84*
Evans, Richard O 1907- *AmArch 70*
Evans, Robert *FolkA 86*
Evans, Robert Graves 1944- *WhoAmA 76, -78, -80, -82, -84*
Evans, Robert James 1914- *AmArch 70*
Evans, Robert James 1944- *WhoAmA 73, -76, -78, -80, -82, -84*
Evans, Rudolph 1878- *WhAmArt 85*
Evans, Rudulph 1879-1960 *WhoAmA 80N, -82N, -84N*
Evans, Rufus W *WhAmArt 85*
Evans, S F *AmArch 70*
Evans, S J *WhAmArt 85*
Evans, Samuel *AntBDN N, DcBrWA*
Evans, Samuel T G *ArtsNiC*
Evans, Samuel T G 1829-1904 *DcBrA 1*
Evans, Samuel Thomas George 1829-1904 *DcBrWA, DcVicP 2*
Evans, Sarah J 1870- *DcWomA*
Evans, Sebastian *DcVicP 2*
Evans, Seth Thomas 1937- *AmArch 70*
Evans, Sophia Wilhelmina *DcWomA*
Evans, T A *AmArch 70*
Evans, Terry Hoyt 1944- *MacBEP*
Evans, Theodore *EncASM*
Evans, Thomas *NewYHSD*
Evans, Thomas 1784?-1874 *BiDBrA*
Evans, Thomas D 1844-1903 *BiDAmAr*
Evans, Thomas Leonard *ClaDrA*
Evans, Tim *DcBrA 1*
Evans, Vincent 1896- *DcBrA 1*
Evans, Virginia Bargar *WhAmArt 85*
Evans, W D *FolkA 86*
Evans, W J 1919- *AmArch 70*
Evans, Walker 1903-1975 *BnEnAmA, ConPhot, DcAmArt, ICPEnP, MacBEP, WhAmArt 85*
Evans, Walter *NewYHSD*
Evans, Walter 1872- *FolkA 86*
Evans, Wilfred *DcVicP 2*
Evans, Wilfred Muir *DcVicP 2*

Evans, Wilfrid Muir *WhAmArt 85*
Evans, Will *DcBrA 1*
Evans, William *DcBrBI, DcBrECP, DcBrWA, NewYHSD*
Evans, William 1764?-1842 *BiDBrA*
Evans, William 1798-1876 *ArtsNiC*
Evans, William 1798-1877 *DcBrWA, DcVicP 2*
Evans, William 1809-1858 *DcBrBI, DcBrWA, DcVicP 2*
Evans, William 1811-1859 *ArtsNiC*
Evans, William B *FolkA 86*
Evans, William Charles 1911- *DcBrA 1, WhoArt 80*
Evans, William Dennis 1951- *MarqDCG 84*
Evans, William E *DcVicP 2*
Evans, William Henry 1873-1934 *DcBrA 1*
Evans, William Richards 1923- *AmArch 70*
Evans, William Spearing 1913- *AmArch 70*
Evans, William T 1843-1918 *WhAmArt 85*
Evans And Anderson *EncASM*
Evans-Freed, Nancy Jane 1942- *MarqDCG 84*
Evanson, Lelia L *WhAmArt 85*
Evantash, Leonard 1924- *AmArch 70*
Evarest, H G *NewYHSD*
Evatt, Harriet 1895- *WhAmArt 85*
Evatt, Harriett 1895?- *DcWomA*
Eve, Clovis *OxDecA*
Eve, Esme Frances *WhoArt 80, -82, -84*
Eve, Esme Frances 1920- *DcBrA 1*
Eve, George W d1914 *WhAmArt 85*
Eve, Jean 1900-1968 *OxTwCA*
Eve, Nicolas *OxDecA*
Eve, William Davies 1907- *AmArch 70*
Eveleigh, Fanny *DcBrA 2*
Eveleigh, John d1802 *MacEA*
Eveleth, Lolita *WhAmArt 85*
Eveling, Frederick *FolkA 86*
Evelyn, Edith M *DcVicP 2*
Evelyn, John 1620-1706 *BiDBrA*
Evelyn, Mary 1635?-1709? *DcWomA*
Evelyn, Susanna 1669-1754 *DcBrECP*
Even, Louis *NewYHSD*
Even, Lucas *NewYHSD*
Even, Robert Lawrence 1929- *WhoAmA 76, -78, -80, -82, -84*
Evenepoel, Henri 1872-1899 *McGDA, OxArt, PhDcTCA 77*
Evengelisti, Carlo John 1936- *MarqDCG 84*
Evengton, Mardum V *CabMA*
Evenpoel, Henri 1872-1899 *OxTwCA*
Evens, Platt, Jr. *NewYHSD*
Evens, Theodore A *NewYHSD*
Evensen, Alf John 1938- *MarqDCG 84*
Eventon, Mardan Vaghn *CabMA*
Everard, Bertha 1873-1965 *DcWomA*
Everard, J *DcVicP 2*
Everard, Ruth *DcWomA*
Everard, William 1723-1792 *BiDBrA*
Everart, Marthe 1874- *DcWomA*
Everdell, Charles *NewYHSD*
Everdell, Frank *NewYHSD*
Everdell, George *NewYHSD*
Everdell, Henry *NewYHSD*
Everdell, James 1819?- *NewYHSD*
Everdell, Martin *NewYHSD*
Everdell, William *NewYHSD*
Everdell, William 1799?- *NewYHSD*
Everdell, William, Jr. *NewYHSD*
Everdingen, A Van *DcVicP 2*
Everdingen, Albert Van 1621-1675 *ClaDrA*
Everdingen, Allaert Van 1621-1675 *DcSeaP*
Everdingen, Allart Van 1621-1675 *McGDA, OxArt*
Everdingen, Cesar Boetius Van 1617?-1678 *ClaDrA*
Everdingen, Cesar Pietersz Van 1616?-1678 *McGDA*
Everds, J H *AmArch 70*
Everett, A E, Jr. *AmArch 70*
Everett, Arthur Greene 1855-1925 *BiDAmAr*
Everett, Bill 1917-1973 *WorECom*
Everett, C G *AmArch 70*
Everett, Caroline Mills d1921 *DcWomA, WhAmArt 85*
Everett, E M Leeson 1881- *WhAmArt 85*
Everett, Edward 1818-1900? *NewYHSD*
Everett, Edward D 1818- *WhAmArt 85*
Everett, Edwin W *DcVicP 2*
Everett, Elizabeth Rinehart *ArtsAmW 2, DcWomA, WhAmArt 85*
Everett, Ethel F *ClaDrA, DcBrA 1, DcWomA*
Everett, Ethel Fanny *DcBrBI*
Everett, Eugenia 1908- *WhAmArt 85*
Everett, Florence *WhAmArt 85*
Everett, Frederic *DcVicP 2*
Everett, George Clowes 1865-1926 *WhAmArt 85*
Everett, H F *AmArch 70*
Everett, Herbert 1876-1949 *DcSeaP*
Everett, Mrs. Herbert D *DcWomA*
Everett, Herbert Edward 1873 *WhAmArt 85*
Everett, Joseph A F 1884-1945 *WhAmArt 85*
Everett, Joseph Alma Freestone 1883?-1945 *IlBEAAW*
Everett, Joseph Alma Freestone 1884-1945 *ArtsAmW 1*
Everett, L C *AmArch 70*

Everett, Len G *WhoAmA 73, -76, -78, -80, -82, -84*
Everett, Lena *DcWomA*
Everett, Lena Mills *WhAmArt 85*
Everett, Lily 1889- *WhAmArt 85*
Everett, Louise *DcWomA*
Everett, Louise 1899- *WhAmArt 85*
Everett, Mary 1876- *ArtsAmW 1*
Everett, Mary O d1948 *WhoAmA 78N, -80N, -82N, -84N*
Everett, Mary O 1876-1948 *WhAmArt 85*
Everett, Mary Orwig 1876-1948 *DcWomA*
Everett, Minnie *DcVicP 2, DcWomA*
Everett, Raymond 1885- *ArtsAmW 1, -2, IlBEAAW, WhAmArt 85*
Everett, Richard, Jr. 1902- *AmArch 70*
Everett, Roberta 1911- *WhAmArt 85*
Everett, Roberta G 1906- *DcBrA 1, WhoArt 80, -82, -84*
Everett, Russell Henry 1952- *WhoAmA 84*
Everett, Walter H *IlrAm C, WhAmArt 85*
Everett, Walter H 1880- *IlrAm 1880*
Everett, William Carter 1935- *MarqDCG 84*
Everett, William Edward 1922- *AmArch 70*
Evergood, Miles 1871- *WhAmArt 85*
Evergood, Philip 1901- *McGDA, OxTwCA, PhDcTCA 77, WhoAmA 73*
Evergood, Philip 1901-1973 *BnEnAmA, ConArt 83, WhAmArt 85, WhoAmA 76N, -78N, -80N, -82N, -84N, WorArt[port]*
Evergood, Philip 1901-1975 *DcAmArt*
Evergood, Philip Howard Francis 1901-1973 *GrAmP*
Evergood, Philip Howard Francis Dixon 1901- *DcCAA 71*
Evergood, Philip Howard Francis Dixon 1901-1973 *DcCAA 77*
Everhard, J W *AmArch 70*
Everhart, Adelaide 1865- *WhAmArt 85*
Everhart, Don, Jr. 1949- *WhoAmA 84*
Everhart, Florence A 1894-1975 *DcWomA*
Everhart, H L *AmArch 70*
Everhart, W L *AmArch 70*
Everingham, Millard *WhoAmA 78N, -80N, -82N, -84N*
Everingham, Millard 1912- *WhAmArt 85*
Everite, G *NewYHSD*
Everitt, Allen Edward 1824-1882 *DcBrWA, DcVicP 2*
Everitt, Edward *DcVicP 2*
Everitt, Paulina *WhAmArt 85*
Everitt, R S *AmArch 70*
Everley, Cecil *OfPGCP 86*
Everly, Morton *NewYHSD*
Evers, Albert John 1888- *AmArch 70*
Evers, Carl *OfPGCP 86*
Evers, Carl G *DcSeaP*
Evers, Ivar Eils 1866- *WhAmArt 85*
Evers, John 1797-1884 *NewYHSD*
Evers, Theodore *NewYHSD*
Evershed, Ada *DcWomA*
Evershed, Arthur 1836-1919 *DcBrA 1, DcVicP, -2*
Eversley, Frederick John 1941- *AfroAA, AmArt, WhoAmA 73, -76, -78, -80, -82, -84*
Everson, Raymond Leroy 1924- *AmArch 70*
Everton, Louise Smith 1920- *WhAmArt 85*
Everts, Connor 1926- *WhoAmA 78, -80, -82, -84*
Eves, Reginald Granville 1876-1941 *DcVicP 2*
Eves, Reginald Grenville 1876-1941 *DcBrA 1*
Evett, Kenneth *WhAmArt 85*
Evett, Kenneth Warnock 1913- *WhoAmA 73, -76, -78, -80, -82, -84*
Evetts, Leonard Charles 1909- *DcBrA 2, WhoArt 80, -82, -84*
Evins, David *WorFshn*
Evins, W H *AmArch 70*
Evison, G Henry *DcBrBI*
Evjen, Richard Menard 1932- *AmArch 70*
Evjen, Rudolph Berndt 1930- *WhoAmA 76, -78, -80*
Evrard, Adele 1792-1889 *DcWomA*
Ewald, Clara 1859- *DcWomA*
Ewald, Elin Lake *WhoAmA 78, -80, -82, -84*
Ewald, Ernst Deodat Paul Ferdinand 1836- *ArtsNiC*
Ewald, Laurence 1907- *AmArch 70*
Ewald, Louis *WhAmArt 85*
Ewald, Louis 1891- *WhoAmA 73, -76, -78, -80, -82*
Ewald, Marion Butler 1910-1944 *WhAmArt 85*
Ewald, Wendy Taylor *ICPEnP A, MacBEP*
Ewald, William Rudolph 1923- *MarqDCG 84*
Ewan, Frances *DcBrBI*
Ewart, Miss *DcWomA*
Ewart, Charles Joseph Frederick 1816-1884 *DcBrWA*
Ewart, David Shanks 1901-1965 *DcBrA 1*
Ewart, Mary F R *DcWomA*
Ewart, Mary F R Clay *WhAmArt 85*
Ewart, Robert Wallace 1938- *MarqDCG 84*
Ewart, Thomas Edwin, Jr. 1924- *AmArch 70*
Ewart, W *DcVicP 2*
Ewbank, James L *NewYHSD*
Ewbank, John Wilson 1779-1847 *DcVicP, -2*
Ewbank, John Wilson 1799-1847 *DcBrWA*
Ewbank, R W *AmArch 70*
Ewbank, T John *DcVicP 2*
Ewell, Miss *WhAmArt 85*

Ewell, Hazel Crow 1888- DcWomA, WhAmArt 85
Ewell, James Cady WhAmArt 85
Ewen, John, Jr. FolkA 86
Ewen, Paterson 1925- DcCAr 81, WhoAmA 78, –80,
 –82, –84
Ewens, Homer WhAmArt 85
Ewens, Val 1946- DcCAr 81
Ewer, William Hanson 1942- MarqDCG 84
Ewertz, Henry WhAmArt 85
Ewing, Alberta F AfroAA
Ewing, Alexander 1921- AmArch 70
Ewing, Alice B WhAmArt 85
Ewing, Bayard 1916- WhoAmA 76, –78, –80, –82, –84
Ewing, Charles WhAmArt 85
Ewing, Charles Kermit 1910- WhAmArt 85,
 WhoAmA 73, –76
Ewing, E A DcWomA
Ewing, Edgar WhAmArt 85
Ewing, Edgar Louis 1913- DcCAr 81, WhoAmA 73,
 –76, –78, –80, –82, –84
Ewing, George M 1888- AmArch 70
Ewing, J C, Sr. AmArch 70
Ewing, Kathleen M H 1947- MacBEP
Ewing, Lauren DcCAr 81
Ewing, Martin B NewYHSD
Ewing, Robert Russell 1917- AmArch 70
Ewing, Thomas R 1935- WhoAmA 73, –76, –78, –80,
 –82, –84
Ewing, U C AmArch 70
EWK 1918- WhoGrA 82[port]
Eworth, Hans 1515?-1573? McGDA
Eworth, Hans 1520?-1573? OxArt
Ewouts, Hans 1520?-1573? OxArt
Excoffon, Roger 1910- WhoGrA 62, –82[port]
Execias McGDA, OxArt
Exerjian, M AmArch 70
Exilious, John G NewYHSD
Exley, Elwood L 1911- AmArch 70
Exley, F FolkA 86
Exley, James Robert Granville 1878- ClaDrA
Exley, James Robert Granville 1878-1967 DcBrA 1
Exline, Gerald L 1937- AmArch 70
Exnar, Jan 1951- DcCAr 81
Exner, Carl NewYHSD
Exner, Nora DcWomA
Export, Valie 1940- DcCAr 81
Exshaw, Charles d1771 DcBrECP
Exshaw, Lily F DcWomA
Exter, Aleksandra Aleksandrovna 1882-1949 OxTwCA
Exter, Alexandra 1882-1949 ConArt 77, WomArt
Exter, Alexandra Alexandrovna 1882-1949 DcWomA
Exter, Judith Anna DcWomA
Ey, Christian Kane 1937- AmArch 70
Eyck, Charles Hubert 1897-1962 OxArt
Eyck, Gaspar Van 1613-1673 DcSeaP
Eyck, Hubert Van McGDA, OxArt
Eyck, Jan Van McGDA, OxArt
Eyck, Jan Van 1385?-1441 ClaDrA
Eyck, Margaret Van DcWomA
Eycken, Catharina DcWomA
Eycken, Julie Anne Marie Van DcWomA
Eyden, William Arnold 1893- WhAmArt 85
Eyden, William T 1859-1919 WhAmArt 85
Eyen, Richard J 1930- WhoAmA 73, –76, –78, –80,
 –82, –84
Eyer, Johann Adam FolkA 86
Eyerman, J R 1906- ICPEnP A, MacBEP
Eyerman, Robert A 1908- AmArch 70
Eyerman, Thomas J AmArch 70
Eyes, Charles 1754?-1803 BiDBrA
Eykyn, Roger 1725?-1795 BiDBrA
Eyle, Gabrielle DcWomA
Eyles, Charles DcVicP 2
Eyles, Charles 1851- ClaDrA, DcBrA 1
Eyles, Henry DcNiCA
Eyman, Earl FolkA 86
Eymard DeLanchatres, Jeanne Clemence DcWomA
Eymundsson, Sigufs 1837-1911 ICPEnP A
Eynard-Chatelain, Suzanne Elisabeth 1775-1844
 DcWomA
Eynard-Lullin, Anne Charlotte Adelaide 1793-1868
 DcWomA
Eynard-Mercier, Marguerite 1876- DcWomA
Eyre, Lady Alice DcVicP 2
Eyre, Edward DcBrWA
Eyre, Ivan 1935- PrintW 83, –85, WhoAmA 76, –78,
 –80, –82, –84
Eyre, J DcBrBI
Eyre, James 1802- DcVicP 2
Eyre, James 1807-1838 DcBrWA
Eyre, John FolkA 86
Eyre, John d1927 DcBrA 1, DcBrBI, DcVicP 2
Eyre, Louisa 1872- WhAmArt 85
Eyre, Louisa 1872-1953 DcWomA
Eyre, R H AmArch 70
Eyre, Vincent DcBrBI
Eyre, Wilson WhAmArt 85
Eyre, Wilson 1858-1944 BnEnAmA, MacEA,
 McGDA
Eyre, Wison 1858-1944 BiDAmAr
Eyre DeLanux 1894- DcWomA

Eyres, Emily DcVicP 2
Eyres, John W DcVicP 2
Eyssenhardt, Mathilde DcWomA
Eyster, Elizabeth FolkA 86
Eytel, Carl 1862-1925 ArtsAmW 1, IlBEAAW
Eyth, Louis 1838-1889? IlBEAAW
Eytinge, Clarence NewYHSD
Eytinge, Robert NewYHSD
Eytinge, Sol 1833-1905 WhAmArt 85
Eytinge, Sol, Jr. 1833-1905 EarABI, EarABI SUP
Eytinge, Solomon, Jr. 1833-1905 IlBEAAW,
 NewYHSD
Eyton, Anthony 1923- ConBrA 79[port], DcBrA 1,
 DcCAr 81, WhoArt 80, –82, –84
Ezekiel, Moses 1844-1917 WhAmArt 85
Ezekiel, Moses Jacob 1844- ArtsNiC
Ezekiel, Moses Jacob 1844-1917 DcAmArt

F

F C G *WorECar*
Fa-Ch'ang *McGDA*
Faaberg, Finn 1902- *PhDcTCA 77*
Faatz, Donald B 1957- *MarqDCG 84*
Fabbri, Agenore 1911- *McGDA, OxTwCA*
Fabbri, Nancy Rash 1940- *WhoAmA 82*
Fabbro, Richard Arthur 1935- *AmArch 70*
Fabe, Robert 1917- *WhoAmA 73, -76, -78, -80, -82, -84*
Faber, Andrew Solomon 1955- *MarqDCG 84*
Faber, Arthur 1898- *WhAmArt 85*
Faber, Cornelia *DcWomA*
Faber, Eugene James 1910- *WhAmArt 85*
Faber, Harman 1832-1913 *EarABI SUP, NewYHSD , WhAmArt 85*
Faber, Johann Ludwig *IlDcG*
Faber, John d1906 *WhAmArt 85*
Faber, John 1918- *ICPEnP A*
Faber, Josepha 1781-1847 *DcWomA*
Faber, Ludwig E 1855-1913 *WhAmArt 85*
Faber, Otto G *EncASM*
Faber, Tobias *ConArch A*
Faber, Wilhelmus Antonius *FolkA 86*
Faber, William *EncASM*
Faberge, Carl 1846-1920 *DcD&D[port]*
Faberge, Gustave *DcNiCA*
Faberge, Peter Carl *OxDecA*
Faberge, Peter Carl 1848-1920 *DcNiCA*
Fabert, Jacques 1925- *WhoAmA 80, -82, -84*
Fabian, Caroline Broughton *FolkA 86*
Fabian, E F *DcBrA 1*
Fabian, Gisela 1943- *FolkA 86*
Fabian, Gottfried *DcCAr 81*
Fabian, J *DcBrBI*
Fabian, Lydia Dunham 1857- *ArtsAmW 2*
Fabian, Lydia Dunham 1867- *DcWomA, WhAmArt 85*
Fabiani, Alberto *FairDF ITA, WorFshn*
Fabiani, Max 1865-1947 *McGDA*
Fabiani, Max 1865-1962 *MacEA*
Fabien, Z H *WhAmArt 85*
Fabigan, Hans 1901- *WhoGrA 62*
Fabio, Cyril 1921- *AfroAA*
Fabion, John 1905- *WhAmArt 85, WhoAmA 76, -78, -80, -82*
Fabos, Julius Gy 1932- *MarqDCG 84*
Fabre, Francois Xavier 1766-1837 *ClaDrA*
Fabre, Jaime *McGDA, OxArt*
Fabre, Jaume *OxArt*
Fabre, Lucian *NewYHSD*
Fabre-Bonifay, Joseph, Madame 1874- *DcWomA*
Fabre D'Olivet, Julie *DcWomA*
Fabres, Oscar 1895-1961 *WhoAmA 80N, -82N, -84N*
Fabres, Oscar 1900- *IlsBYP, IlsCB 1946*
Fabretti, Quirina *DcWomA*
Fabri, Agenore 1911- *PhDcTCA 77*
Fabri, Ludovick *NewYHSD*
Fabri, Maria *DcWomA*
Fabri, Ralph 1894- *WhoAmA 73*
Fabri, Ralph 1894-1975 *WhAmArt 85, WhoAmA 76N, -78N, -80N, -82N, -84N*
Fabri, Vincenza *DcWomA*
Fabriano, Gentile Da *McGDA*
Fabrice, Ilka, Freiin Von 1846-1907 *DcWomA*
Fabricius, Johan Wigmore 1899- *IlsCB 1744*
Fabris, Emilio De 1808-1883 *MacEA*
Fabritius, Barent 1624-1673 *McGDA, OxArt*
Fabritius, Carel 1622-1654 *McGDA, OxArt*
Fabro, Luciano 1936- *ConArt 77, -83*
Fabroni, Fabian 1800?- *NewYHSD*
Fabronius, Christian 1804?- *NewYHSD*

Fabronius, Dominique C *NewYHSD*
Fabry, Alois, Jr. *WhAmArt 85*
Facci, Domenico 1916- *WhAmArt 85, WhoAmA 73, -76, -78, -80, -82, -84*
Faccini, Pietro 1560-1602 *ClaDrA*
Faccinto, Victor Paul 1945- *WhoAmA 82, -84*
Faccioli, Orsola *DcWomA*
Facey, Martin 1948- *AmArt*
Facinetti, Simon *AmArch 70*
Facio, Sara 1932- *ConPhot, ICPEnP A, MacBEP*
Facio DeDuillier, Nicolas 1664-1753 *OxDecA*
Facius, Angelica 1806-1887 *DcWomA*
Fackert, Oscar William 1891- *WhAmArt 85*
Facon, E *DcVicP 2*
Faconnet, Marie Anne Eugenie *DcWomA*
Factor, James Dennis 1950- *MarqDCG 84*
Factor, Yale 1951- *AmArt*
Faddis, Edward Leroy 1925- *AmArch 70*
Faddis, George 1920- *WhoAmA 82, -84*
Faden, Lawrence Steven 1942- *PrintW 83, -85, WhoAmA 76, -78, -80, -82, -84*
Faden, William 1750-1836 *AntBDN I*
Fader, Fernando *OxTwCA*
Fader, Fernando 1882-1935 *McGDA*
Fadino *McGDA*
Fadrusz, Janos 1858-1903 *McGDA*
Faed, H *DcVicP 2*
Faed, James *ArtsNiC*
Faed, James d1920 *DcBrWA*
Faed, James 1821-1911 *DcBrA 2, DcBrWA*
Faed, James, Jr. d1920 *DcBrA 1*
Faed, James, Jr. 1857-1920 *DcVicP 2*
Faed, James, Sr. 1821-1911 *DcVicP 2*
Faed, John 1819-1902 *AntBDN J, DcBrWA*
Faed, John 1820- *ArtsNiC*
Faed, John 1820-1902 *DcVicP, -2*
Faed, John Francis *DcVicP 2*
Faed, John Francis 1860?- *DcBrWA*
Faed, S *DcVicP 2*
Faed, Thomas 1826- *ArtsNiC*
Faed, Thomas 1826-1900 *DcBrWA, DcVicP, -2*
Faed, William C *DcVicP 2*
Faefferd, Edmund *NewYHSD*
Faelten, Otto 1884-1945 *BiDAmAr*
Faerber, N A *AmArch 70*
Faes, Peter VanDer *McGDA*
Fafard, Joe 1942- *DcCAr 81, WhoAmA 76, -78, -80, -82, -84*
Faford, Paul Michael 1944- *MarqDCG 84*
Faford, Peter R 1944- *MarqDCG 84*
Fagaly, William Arthur 1938- *WhoAmA 84*
Fagan, Betty Maud Christian d1932 *DcBrA 1, DcWomA*
Fagan, George Lawrence 1949- *MarqDCG 84*
Fagan, James 1864- *WhAmArt 85*
Fagan, Lawrence *NewYHSD*
Fagan, Louis Alexander 1845-1903 *DcBrWA, DcVicP 2*
Fagan, Louis Alexander 1846-1903 *DcBrA 2*
Fagan, Robert 1761-1816 *DcBrECP*
Fagan, William Bateman 1860-1948 *DcBrA 1*
Fagan, Willis Endford *AmArch 70*
Fagard, Virginie 1829- *DcWomA*
Fager, Charles J 1936- *WhoAmA 78, -80, -82, -84*
Fagerlin, F J *ArtsNiC*
Fagerstrom, S D *AmArch 70*
Faget, Athalie Josephine Melanie Du *DcWomA*
Fagg, H G *AmArch 70*
Fagg, Kenneth 1901- *WhoAmA 73, -76, -78, -80*
Fagg, Kenneth S 1901- *WhAmArt 85*
Faggi, Alfeo 1885- *WhAmArt 85*

Fagin, Charles F *WhAmArt 85*
Fagin, Ella Woodward *DcWomA*
Fagin, I *NewYHSD*
Fagioli, D *AntBDN D*
Fagler, Amel *NewYHSD*
Fagley, S *FolkA 86*
Fagnani, Giuseppe 1819-1873 *NewYHSD*
Fagnani, Guiseppe 1819-1873 *DcVicP 2*
Fagnani, Joseph 1819-1873 *NewYHSD*
Fagnani, L N *AmArch 70*
Fagnani, Nina *DcWomA, WhAmArt 85*
Fagniez, Francois-Xavier 1936- *DcCAr 81*
Faguet, Adrienne *DcWomA*
Fagundes, Guiomar 1896- *DcWomA*
Fagus Werke, Alfeld *McGDA*
Fahey, A Esther Edwards *WhAmArt 85*
Fahey, Edward H 1844- *ArtsNiC*
Fahey, Edward Henry 1844-1907 *DcBrA 1, DcBrBI, DcBrWA, DcVicP 2*
Fahey, Esther *DcWomA*
Fahey, James 1804- *ArtsNiC*
Fahey, James 1804-1885 *DcBrWA, DcVicP 2*
Fahey, Palacia Emma *DcVicP 2, DcWomA*
Fahey, Thomas Richard 1896- *AmArch 70*
Fahey, W *AmArch 70*
Fahlander, Olov 1948- *MarqDCG 84*
Fahlen, Charles 1939- *WhoAmA 78, -80, -82*
Fahlstrom, Oyvind 1928- *DcCAA 77, OxTwCA, PhDcTCA 77, WhoAmA 73, -76*
Fahlstrom, Oyvind 1928-1976 *ConArt 77, -83, WhoAmA 78N, -80N, -82N, -84N, WorArt[port]*
Fahne, Julie *DcWomA*
Fahnestock, John *NewYHSD*
Fahnestock, Wallace Weir 1877- *WhAmArt 85*
Fahr, Abraham *FolkA 86*
Fahre, Abraham *FolkA 86*
Fahrenberg, Albert *NewYHSD*
Fahrenbruch, Lottie *WhAmArt 85*
Fahrenbruch, Lottie L d1976 *DcWomA*
Fahrenkamp, Emil 1885-1966 *MacEA*
Fahri, Jean-Claude *DcCAr 81*
Fahrner, Vera *DcWomA*
Fahys, Joseph *EncASM*
Faience, Grueby *FolkA 86*
Faiers, Edward Spencer 1908- *WhoAmA 76, -78, -80, -82*
Faiers, Ted 1908- *WhoAmA 84*
Faig, Frances Wiley *DcWomA, WhAmArt 85*
Failing, Frances E *WhAmArt 85*
Failing, Frances Elizabeth *WhoAmA 76*
Failing, Frances Elizabeth 1897- *DcWomA*
Failing, Francis Elizabeth *WhoAmA 73*
Failing, Ida *WhAmArt 85*
Failing, Ida C *ArtsAmW 2, DcWomA*
Faillace, Frank A 1910- *AmArch 70*
Faille, Carl Arthur 1883-1952? *ArtsAmW 2*
Faille, Carl Arthur 1884- *WhAmArt 85*
Faina, Giuseppina d1872 *DcWomA*
Faint, J B d1915 *WhAmArt 85*
Fainter, Robert A 1942- *WhoAmA 76, -78*
Fainter, Robert A 1942-1978 *WhoAmA 80N, -82N, -84N*
Fair, Hannah *FolkA 86*
Fair, Harold J 1926- *AmArch 70*
Fair, Henry *FolkA 86*
Fair, Josephine *AfroAA*
Fair, Paul J *WhAmArt 85*
Fair, Robert 1847-1907 *WhAmArt 85*
Fairam *DcBrECP*
Fairbairn, George *AntBDN N*
Fairbairn, Hilda *DcBrBI, DcVicP 2*

Farrier, Robert 1796-1879 *DcBrWA, DcVicP, -2*
Farrill, Otto *AfroAA*
Farrington, Anna Putney *FolkA 86*
Farrington, Daniel 1733-1807 *FolkA 86*
Farrington, David *NewYHSD*
Farrington, E W *FolkA 86*
Farrington, Florence *DcWomA*
Farrington, Katherine 1877- *DcWomA,*
WhAmArt 85
Farrington, Walter 1874- *ArtsAmW 2,*
WhAmArt 85
Farrington And Hunnewell *EncASM*
Farris, Constance *DcWomA*
Farris, John Robertson 1909- *AmArch 70*
Farris, Joseph 1924- *ConGrA 1[port], WhoAmA 76,*
-78, -80, -82, -84, WorECar
Farris, Joseph G 1924- *WhoAmA 73*
Farris, Keith E *AmArch 70*
Farris, Keith Edward 1928- *AmArch 70*
Farris, Linda B 1944- *WhoAmA 80, -82, -84*
Farris, Rolland Francis 1926- *MarqDCG 84*
Farris-Larson, Gail 1947- *WhoAmA 82, -84*
Farron, Lulu *DcWomA*
Farrow, Charles *CabMA*
Farrow, Patrick Villiers 1942- *WhoAmA 84*
Farrow, W M 1885- *WhAmArt 85*
Farrow, William John *DcVicP 2*
Farrow, William McKnight 1885- *AfroAA*
Farruggio, Dominick Thomas 1936- *AmArch 70*
Farruggio, Remo Michael 1906- *WhoAmA 73, -76,*
-78, -80, -82, -84
Farson, John *CabMA*
Faruffini, Federigo 1833-1870 *ArtsNiC*
Farwell, Miss *DcVicP 2*
Farwell, Beatrice *WhoAmA 78, -80*
Farwell, Beatrice 1920- *WhoAmA 82, -84*
Farwell, Lyman 1865-1933 *BiDAmAr*
Farwell, W H *AmArch 70*
Farwell, William W *NewYHSD*
Fasanella, Ralph *OfPGCP 86*
Fasanella, Ralph 1914- *FolkA 86*
Fasano, Clara *WhoAmA 73, -76, -78, -80, -82, -84*
Fasano, Clara 1900- *WhAmArt 85*
Fasbender, Walter *WhoAmA 73, -76*
Fasel, George Wilhelm *NewYHSD*
Fash, R D *AmArch 70*
Fash, William B *FolkA 86*
Fasi, Julie *DcWomA*
Fasig, A *FolkA 86*
Fasig, Christian 1825?- *FolkA 86*
Fasig, William 1801?- *FolkA 86*
Fasnacht, C W *WhAmArt 85*
Fasnacht, Heide Ann 1951- *WhoAmA 82, -84*
Fasnacht, T E *AmArch 70*
Fasolato, Agostino *McGDA*
Fasolo, Giovanni Antonio 1530-1572 *McGDA*
Fasquet, Marguerite Claude *DcWomA*
Fass, Carl George 1899- *AmArch 70*
Fassbender, Joseph 1903- *McGDA, OxTwCA,*
PhDcTCA 77
Fasse, Carl Henry 1911- *AmArch 70*
Fassett, Adaline M d1898 *WhAmArt 85*
Fassett, C Adele 1831- *ArtsNiC*
Fassett, Cornelia Adele 1831-1898 *DcWomA*
Fassett, Cornelia Adele Strong 1831-1898 *NewYHSD*
Fassett, Elisha S d1903 *ArtsAmW 3*
Fassett, Francis Henry d1908? *BiDAmAr*
Fassett, Gerald L 1932- *AmArch 70*
Fassett, Kaffe Havrah 1937- *WhoAmA 78, -80*
Fassett, Truman E 1885- *WhAmArt 85*
Fassett-Kent, Rose Isabella *DcWomA*
Fassilat, Henry *NewYHSD*
Fassin, Adolphe *ArtsNiC*
Fassitt, Miss *WhAmArt 85*
Fassler, N J *AmArch 70*
Fassolas, John 1947- *DcCAr 81*
Fast, Francis 1889- *WhAmArt 85*
Fastnedge, Ralph William 1913- *WhoArt 80, -82, -84*
Fastove, Aaron 1898- *WhoAmA 73, -76, -78*
Fastove, Aaron 1898-1979 *WhoAmA 80N, -82N,*
-84N
Fastovsky, Aaron 1898-1979 *WhoAmA 84N*
Fasullo, George 1914- *AmArch 70*
Fately, Robert Gordon 1956- *MarqDCG 84*
Fath, Jacques 1912-1954 *FairDF FRA, WorFshn*
Fathers, George R 1898- *DcBrA 1*
Fathy, Hassan 1898- *ConArch*
Fathy, Hassan 1900- *MacEA*
Fatio, Maurice 1897-1943 *MacEA*
Fatio, Morel *DcBrBI*
Fatouros, Dimitris A *ConArch A*
Fatsinger, Adam *FolkA 86*
Fattore, Il *McGDA*
Fattori, Giovanni *ArtsNiC*
Fattori, Giovanni 1825-1908 *McGDA*
Fattorino, Bartolommeo Del *McGDA*
Fatzer, Conrad *NewYHSD*
Fau, Fernand *DcBrBI*
Fauber, Joseph Everette, Jr. 1908- *AmArch 70*
Fauber, Josph Everette, III 1938- *AmArch 70*
Faucett, Robert *ArtsEM*

Faucett, Thomas R 1920- *MarqDCG 84*
Faucher, Herminie *DcWomA*
Faucher, Lisa *DcWomA*
Fauchery, Antoine 1827?-1861 *MacBEP*
Fauchery, Augustine 1803- *DcWomA*
Fauchet, Charlotte 1888- *DcWomA*
Faucheur, Leonie Eugenie 1873- *DcWomA*
Fauchier, Herminie *DcWomA*
Fauchot-Baillion, Juliette *DcWomA*
Faucon, Bernard 1950- *ConPhot, ICPEnP A*
Faucon, Bernard 1959- *DcCAr 81*
Faucon, Marie Celestine 1811-1859 *DcWomA*
Fauconnet, Guy Pierre 1882-1920 *DcBrBI*
Fauconnier, Laurence, Madame *DcWomA*
Fauconnier-Clerget, Berthe 1882- *DcWomA*
Faudie, Fred 1941- *WhoAmA 84*
Faugere, Monsieur *NewYHSD*
Faught, Elizabeth J 1883- *WhAmArt 85*
Faught, Elizabeth Jean 1883- *DcWomA*
Faul, Henry *ArtsAmW 3*
Faul, Roberta Heller 1946- *WhoAmA 73, -76, -78,*
-80
Faulcon, Louise Adele 1817-1897 *DcWomA*
Faulconer, Lillie Emmons 1877-1910 *ArtsEM,*
DcWomA
Faulconer, Mary *WhoAmA 73, -76, -78, -80, -82,*
-84
Faulconer, Philip William 1919- *AmArch 70*
Faulds, James *DcBrBI*
Faulds, James Alexander 1949- *WhoArt 84*
Fauley, Albert C 1858-1919 *WhAmArt 85*
Fauley, Lucy S *WhAmArt 85*
Fauley, Lucy Stanberry d1926 *DcWomA*
Faulhaber, Francis A 1914- *AmArch 70*
Faulk, J Hays 1918- *AmArch 70*
Faulk, John Foster 1925- *AmArch 70*
Faulker, Eunice Florence *WhAmArt 85*
Faulkner, A M *DcBrBI*
Faulkner, Avery Coonley 1929- *AmArch 70*
Faulkner, Barry *WhoAmA 78N, -80N, -82N, -84N*
Faulkner, Barry 1881-1966 *IlBEAAW, WhAmArt 85*
Faulkner, Benjamin Rawlinson 1787-1849 *DcVicP 2*
Faulkner, C *DcVicP 2*
Faulkner, Charles Draper 1890- *AmArch 70*
Faulkner, Charles J *DcNiCA*
Faulkner, D J *AmArch 70*
Faulkner, Douglas 1937- *ICPEnP A, MacBEP*
Faulkner, Mrs. E D *WhAmArt 85*
Faulkner, Eunice F *WhAmArt 85*
Faulkner, Florence *DcWomA*
Faulkner, Frank 1946- *DcCAr 81, PrintW 85,*
WhoAmA 78, -80, -82, -84
Faulkner, Frederick L 1925- *MarqDCG 84*
Faulkner, Herbert W 1860- *WhAmArt 85*
Faulkner, Howard 1894- *WhoArt 80*
Faulkner, Howard Bertram 1894- *DcBrA 1*
Faulkner, James *OfPGCP 86*
Faulkner, John *CabMA, IlsBYP*
Faulkner, John 1785-1823 *CabMA*
Faulkner, John 1830?-1888? *DcBrWA*
Faulkner, John 1830?-1888 *DcVicP 2*
Faulkner, Kady B 1901- *WhoAmA 73, -76*
Faulkner, Kady B 1901-1977 *WhAmArt 85,*
WhoAmA 78N, -80N, -82N, -84N
Faulkner, Kate d1898 *DcNiCA, DcWomA*
Faulkner, Lewis L, Jr. 1937- *AmArch 70*
Faulkner, Lucy *DcNiCA, DcWomA*
Faulkner, Mary *DcVicP 2, DcWomA*
Faulkner, Nina *DcWomA*
Faulkner, Paul W 1913- *WhAmArt 85*
Faulkner, R Lloyd *WhAmArt 85*
Faulkner, Ray 1906- *WhAmArt 85*
Faulkner, Ray N 1906- *WhoAmA 73*
Faulkner, Ray N 1906-1975 *WhoAmA 76N, -78N,*
-80N, -82N, -84N
Faulkner, Richard 1917- *DcBrA 1*
Faulkner, Robert *DcVicP 2*
Faulkner, Robert Trevor 1929- *WhoArt 80, -82, -84*
Faulkner, Sarah Mills 1909- *WhAmArt 85*
Faulkner, Thomas *BiDBrA*
Faulkner, Waldron 1898- *AmArch 70*
Faulkner, Winthrop Waldron 1931- *AmArch 70*
Faulque, Louise *DcWomA*
Faulte, Michel *ClaDrA*
Faunce, Mrs. *DcVicP 2*
Faunce, Ethel A *DcWomA*
Faunce, Sarah Cushing 1929- *WhoAmA 73, -78, -80,*
-82, -84
Faune, Sarah Cushing 1929- *WhoAmA 76*
Faunthorpe, Mrs. *DcVicP 2, DcWomA*
Fauntleroy, C S *DcWomA*
Fauntleroy, Mrs. C S *DcVicP 2*
Fauntleroy, Martha Lorimer 1910- *WhAmArt 85*
Fauquet, Louise *DcWomA*
Faur, Aurel-Sebastian 1918- *WhoArt 82, -84*
Faure, Anne *DcWomA*
Faure, Helene 1878-1932 *DcWomA*
Faure, Octavie 1810?- *DcWomA*
Faure, Mrs. Rene B *WhAmArt 85*
Faurer, Louis 1916- *ICPEnP A, MacBEP,*
WhoAmA 78, -80, -82, -84

Fauron, M *DcWomA*
Fauser, Arthur 1911- *DcCAr 81*
Fausett, Dean 1913- *WhoAmA 73, -76, -78, -80, -82,*
-84
Fausett, James G 1939- *AmArch 70*
Fausett, Lynn 1894- *ArtsAmW 1, IlBEAAW,*
WhoAmA 73, -76
Fausett, Lynn 1894-1977 *WhAmArt 85,*
WhoAmA 78N, -80N, -82N, -84N
Fausett, William Dean 1913- *WhAmArt 85*
Fausset, Shelley 1920- *WhoArt 80, -82, -84*
Faust, Allen M *MarqDCG 84*
Faust, Angus Auren 1937- *MarqDCG 84*
Faust, Pat *WhoArt 80, -82, -84*
Faust, W A, Jr. *AmArch 70*
Faust, William *NewYHSD*
Faustina, James 1876- *WhAmArt 85*
Fauteux, Jacques Mercier 1927- *AmArch 70*
Fautrier, Jean 1898-1964 *ConArt 77, -83, McGDA,*
OxTwCA, PhDcTCA 77, WorArt
Fauveau, Felicie De 1799-1886 *WomArt*
Fauveau, Felicie De 1802-1886 *DcWomA*
Fauvel, Louise *DcWomA*
Fauvelle, Henry *DcVicP 2*
Fauverge, Caroline Stephanie *DcWomA*
Faux, F W *DcBrBI*
Faux-Froidure, Eugenie Juliette *DcWomA*
Fava, Countess Brigida *DcWomA*
Fava, R H *AmArch 70*
Fava, Rita 1932- *IlsCB 1946, -1957*
Favarger, Lison 1925- *DcCAr 81*
Favart, Antoine Pierre Charles 1784-1867 *ClaDrA*
Favart, Genevieve *DcWomA*
Faventinus *MacEA*
Faverie, Nadine *DcWomA*
Favero, V D *AmArch 70*
Favier, Jeanne Magdeleine d1902 *DcWomA*
Favier, Philiberte *DcWomA*
Faville, William B 1866-1947 *BiDAmAr*
Favorite, Elias 1796?- *FolkA 86*
Favorski, Vladimir 1886-1964 *ConArt 77*
Favorsky, Vladimir 1886- *WhoArt 80, -82*
Favorsky, Vladimir 1886-1964 *ConArt 83*
Favorsky, Vladimir Andreyevich 1886- *WhoGrA 62*
Favory, Andre 1888-1937 *ClaDrA*
Favour, Frank *WhAmArt 85*
Favran, Jaume *McGDA*
Favre, Genevieve *DcWomA*
Favre, Louis-Paul 1922- *DcCAr 81*
Favre, Pierrette 1827- *DcWomA*
Favre-Guillarmod, Marie 1824-1872 *DcWomA*
Favreau, Catherine Jeannine 1957- *MarqDCG 84*
Favro, Murray 1940- *ConArt 77, -83, DcCAr 81,*
WhoAmA 78, -80, -82, -84
Favrot, Charles Allen 1866-1939 *BiDAmAr*
Favrot, Henri Mortimer, Jr. 1930- *AmArch 70*
Fawcett, Chris *ConArch A*
Fawcett, David John 1945- *MarqDCG 84*
Fawcett, Emily Addis *DcWomA*
Fawcett, George 1877-1944 *WhAmArt 85*
Fawcett, N M *WhAmArt 85*
Fawcett, Robert *ArtsEM*
Fawcett, Robert d1967 *WhoAmA 78N, -80N, -82N,*
-84N
Fawcett, Robert 1903- *IlrAm E*
Fawcett, Robert 1903-1967 *IlrAm 1880,*
WhAmArt 85
Fawinkel, Magdalen Von *DcVicP 2*
Fawkes, Francis Hawksworth 1797-1871 *DcBrBI,*
DcBrWA
Fawkes, L G *DcBrBI*
Fawkes, Lionel Grimston 1849-1931 *DcVicP 2*
Fawkes, Madeline C *DcBrA 1, DcWomA*
Fawkes, Walter Ernest 1924- *WorECar*
Fawssett, Ann *WhoArt 80, -82, -84*
Fawssett, Ann 1937- *ClaDrA*
Fawssett, Gertrude Alice 1891- *DcWomA*
Fax, Elton C *IlsCB 1967*
Fax, Elton Clay 1909- *AfroAA, WhoAmA 73, -76,*
-78, -80, -82, -84
Faxon, Amelie *DcWomA*
Faxon, Charles Edward 1845-1918 *WhAmArt 85*
Faxon, Elihu J *NewYHSD*
Faxon, John L 1851- *BiDAmAr*
Faxon, John Lyman 1851- *WhAmArt 85*
Faxon, L H *AmArch 70*
Faxon, R E *AmArch 70*
Faxon, Richard *DcSeaP*
Faxon, William Bailey 1849-1941 *WhAmArt 85*
Fay *NewYHSD*
Fay, Augustus 1824?- *NewYHSD*
Fay, Benjamin F *ArtsEM*
Fay, Charlotte *DcWomA*
Fay, Clark *IlrAm C, WhAmArt 85*
Fay, Clark 1894-1956 *IlrAm 1880*
Fay, F T *AmArch 70*
Fay, Gaston *EarABI, EarABI SUP*
Fay, Ida Hottendorf *WhAmArt 85*
Fay, J A *AmArch 70*
Fay, Jean Bradford 1904- *WhAmArt 85*
Fay, Joe 1950- *WhoAmA 78*

Feldman, Paul 1926- *AmArch 70*
Feldman, Richard J 1939- *MarqDCG 84*
Feldman, Ronald *WhoAmA 73, -76, -78, -80, -82, -84*
Feldman, Walter 1925- *WhoAmA 73, -76, -78, -80, -82, -84*
Feldmann, Claire *WhAmArt 85*
Feldmann, Hans Peter 1941- *DcCAr 81*
Feldner, R B *AmArch 70*
Feldstein, Albert 1925- *WorECom*
Feldstein, Herman H 1904- *AmArch 70*
Feldstein, Mark 1937- *ICPEnP A, MacBEP*
Feldstein, Mary 1951- *WhoAmA 78, -80, -82, -84*
Feldt-Lutkens, Irene 1904- *DcCAr 81*
Felguerez, Manuel *OxTwCA*
Felguerez, Manuel 1928- *WhoAmA 73, -76, -78, -80, -82*
Felibien DesAvaux, Andre 1619-1695 *MacEA, OxArt*
Felibien DesAvaux, Jean Francois 1656?-1733 *MacEA*
Felin, Jean De *McGDA*
Feline, Edward *AntBDN Q*
Felipe DeBorgona *McGDA*
Felix, Anna Desiree 1827-1863 *DcWomA*
Felix, Franz 1892- *WhAmArt 85*
Felix, Juliette 1869- *DcWomA*
Felix, Marie Emelie *DcWomA*
Felix, Nannette *DcWomA*
Felix, Rebecca *DcWomA*
Felix Summery's Art Manufacture *DcNiCA*
Felixmuller, Conrad 1897- *McGDA, PhDcTCA 77*
Felixmuller-Reuss, Eva 1922- *DcCAr 81*
Felkel, Carl F *WhoArt 84N*
Felkel, Carl F 1896- *DcBrA 1, WhoArt 80, -82*
Felker, John C *CabMA*
Felker, Ruth Kate 1889- *DcWomA, WhAmArt 85*
Felker, Theodore Edwin 1925- *AmArch 70*
Fell, Amy Watson *DcWomA*
Fell, E *DcVicP 2*
Fell, Eleanor d1946 *DcBrA 1, DcWomA*
Fell, Herbert Granville 1872-1951 *DcBrA 1, DcBrBI, DcVicP 2*
Fell, Isaac 1759-1818 *CabMA*
Fell, Olive 1900?- *DcWomA, IlBEAAW, WhAmArt 85*
Fell, Phyllis 1901- *DcBrA 1*
Fell, Sheila 1931- *ConBrA 79[port], PhDcTCA 77*
Fell, Sheila Mary 1931- *WhoArt 80, -82, -84*
Fell, Thomas *DcNiCA*
Fell, W H *DcVicP 2*
Feller, F 1848-1908 *DcBrBI*
Feller, Robert L 1919- *WhoAmA 76, -78, -80, -82, -84*
Fellger, Charles J *WhAmArt 85*
Fellheimer, Alfred T 1875-1959 *McGDA*
Fellig, Arthur *ICPEnP, MacBEP, WhAmArt 85*
Fellini, Giulio Cesare 1600?-1656 *ClaDrA*
Fellini, William d1965 *FolkA 86*
Fellman, Raymond F 1925- *AmArch 70*
Fellman, Sandi 1952- *ICPEnP A*
Fellman, Sandra Lee 1952- *MacBEP*
Fellnagel, Dorothy Darling 1913- *WhAmArt 85*
Fellner, Ferdinand 1847-1916 *MacEA*
Fellner, Ferdinand August Michael 1799-1859 *ClaDrA*
Fellner, Frank T 1886- *WhAmArt 85*
Fellowes, Arthur *DcVicP 2*
Fellowes, C A *DcWomA*
Fellowes, Frank Wayland 1833-1900 *NewYHSD, WhAmArt 85*
Fellowes, James *DcBrECP*
Fellowes, William Dorset *DcBrBI*
Fellowes-Prynne *DcVicP 2*
Fellows, A P 1864- *WhAmArt 85*
Fellows, Cornelia Faber *WhAmArt 85*
Fellows, Cornelia Faber 1857- *DcWomA*
Fellows, Eleanor Caroline 1831-1926 *DcWomA*
Fellows, Fred *OfPGCP 86*
Fellows, Fred 1934- *AmArt, WhoAmA 76, -78, -80, -82, -84*
Fellows, Fred 1935- *IlBEAAW*
Fellows, Henry *DcBrBI*
Fellows, Israel 1816- *CabMA*
Fellows, Jane Eliza 1828-1905 *DcWomA*
Fellows, Laurence 1885-1964 *IlrAm C, -1880, WorECar*
Fellows, Lawrence *WhAmArt 85*
Fellows, W *BiDBrA*
Fellows, William K 1870- *WhAmArt 85*
Fellows, William K 1870-1948 *BiDAmAr*
Fells, Augusta Christine *DcWomA*
Felon, Joseph 1818-1896 *ClaDrA*
Feloney, Paul Gerard 1926- *AmArch 70*
Fels, C P 1912- *WhAmArt 85, WhoAmA 76, -78, -80, -82, -84*
Fels, Elias 1614-1655 *ClaDrA*
Felsberg, N *AmArch 70*
Felsenberg, Maria Anna *DcWomA*
Felsenfeld, Rosella L 1941- *MacBEP*
Felsing, Jacob 1802-1883 *ArtsNiC*
Felski, Albina 1925- *FolkA 86*
Felson, R L *AmArch 70*
Felt, Irving Mitchell *WhoAmA 73, -76, -78, -80,

Felt, Mrs. Irving Mitchell *WhoAmA 73, -76, -78, -80, -82*
Felt, J H 1867-1938 *BiDAmAr*
Felt, Nathaniel, Jr. 1751?-1792 *CabMA*
Felt, Samuel 1698?-1788 *CabMA*
Felt, Sue 1924- *IlsCB 1946*
Feltault, R F *AmArch 70*
Felten, Edith Regina 1876- *DcWomA*
Felten, Frances *EncASM*
Felter, Durand *WhAmArt 85*
Felter, James Warren 1943- *WhoAmA 76, -78, -80, -82, -84*
Felter, John D 1825?- *NewYHSD*
Feltman, Bernhard *NewYHSD*
Feltner, Jim 1908- *FolkA 86*
Felton, Benjamin 1613?-1688 *CabMA*
Felton, Charles B 1793?- *NewYHSD*
Felton, Ebenezer d1741? *FolkA 86*
Felton, Edith Regina 1876- *DcWomA*
Felton, Lydia M *DcVicP 2*
Felton, Major *WhAmArt 85*
Felton, Robert *NewYHSD*
Feltus, Alan Evan 1943- *AmArt, PrintW 83, -85, WhoAmA 80, -82, -84*
Feltz, C *AmArch 70*
Fenaillon, Madeleine 1889- *DcWomA*
Fenci, Renzo 1914- *WhoAmA 73, -76, -78, -80, -82, -84*
Fencl, Cletus Marcellin 1923- *AmArch 70*
Fendell, Jonas J *WhoAmA 73, -76, -78, -80, -82, -84*
Fender, Maggie F *DcVicP 2*
Fender, Tom Mac 1946- *WhoAmA 76, -78, -80, -82, -84*
Fenderich, Charles *ArtsAmW 1, NewYHSD*
Fenderich, Charles 1805-1887 *ArtsAmW 3*
Fenderson, Anne M d1934? *DcWomA*
Fenderson, Annie M *WhAmArt 85*
Fenderson, Mark 1873-1944 *WhAmArt 85, WorECar*
Fendi *WorFshn*
Fendrich, Mary E 1830?- *DcWomA*
Fendrick, Barbara Cooper *WhoAmA 73, -76, -78, -80, -82*
Fendt, Bernhard 1756-1832 *AntBDN K*
Fendt, Rene 1948- *WhoArt 80, -82, -84*
Fenelle, Stanford 1909- *WhAmArt 85*
Fenellosa, Ernest Francisco 1853-1908 *WhAmArt 85*
Fener, Tamas 1938- *ICPEnP A*
Fenerty, Agnes Lawson *WhAmArt 85*
Fenerty, Agnes Lawson 1885- *DcWomA*
Fenety, F M *WhAmArt 85*
Fenger, Ludvig 1833-1905 *MacEA*
Fenhagen, G Corner, Jr. 1912- *AmArch 70*
Fenical, Marlin E 1907- *WhoAmA 73, -76, -78, -80, -82*
Fenical, Marlin E 1907-1983 *WhoAmA 84N*
Fenichel, Lilly R *AmArt*
Fenimore, Ida Estelle *WhAmArt 85*
Fenimore, James S *NewYHSD*
Fenimore, Janice 1924- *FolkA 86*
Fenn *FolkA 86*
Fenn, A S Manville *DcVicP 2*
Fenn, Albert 1912- *ICPEnP A, MacBEP*
Fenn, Elizabeth 1914- *WhoAmA 84*
Fenn, Frederick C M *NewYHSD*
Fenn, G *DcVicP 2*
Fenn, Harry 1838-1911 *ArtsAmW 1, IlBEAAW, IlrAm 1880*
Fenn, Harry 1845-1911 *EarABI, EarABI SUP, WhAmArt 85*
Fenn, W J *WhAmArt 85*
Fenn, William Wilthieu d1906 *DcVicP 2*
Fennamore *NewYHSD*
Fennebresque-Moring, Marie Felicie *DcWomA*
Fennel, J E *AmArch 70*
Fennell, John G 1807-1885 *DcBrBI*
Fennell, John Greville 1807-1885 *DcBrWA, DcVicP 2*
Fennell, Louisa 1847-1930 *DcBrWA, DcVicP 2*
Fennell, Michael 1826?- *FolkA 86*
Fennell, Richard *AntBDN D*
Fennell, Thomas E 1934- *AmArch 70*
Fennemore *NewYHSD*
Fenner, Bert *MacEA*
Fenner, Bert L 1869-1926 *BiDAmAr*
Fenner, Carol Elizabeth *IlsCB 1967*
Fenner, Carol Elizabeth 1929- *IlsCB 1957*
Fenner, Charles *DcVicP 2*
Fenner, J *DcVicP 2*
Fenner, Maude Richmond 1868- *DcWomA, WhAmArt 85*
Fenner, Ward Wadsworth 1902- *AmArch 70*
Fenney, William H *NewYHSD*
Fenniman *EncASM*
Fenning, Wilson *DcBrBI*
Fenno, Almira T *DcWomA*
Fenno, Charles Horace *NewYHSD*
Fenno, S H *AmArch 70*
Fenno-Gendrot, Almira T *WhAmArt 85*
Fenosa, Apel Les 1899- *DcCAr 81*
Fenosa, Apeles 1899- *PhDcTCA 77*
Fenosa, Apelles 1899- *OxTwCA*

Fenoulet, W *DcVicP 2*
Fenske, Paula *WhAmArt 85*
Fenske, Paula 1882- *DcWomA*
Fenster, Fred *DcCAr 81*
Fenton *FolkA 86*
Fenton, Alan 1927- *DcCAA 71, -77, WhoAmA 73, -76, -78, -80, -82, -84*
Fenton, Annie Grace *DcVicP 2, DcWomA*
Fenton, Beatrice 1887- *WhAmArt 85, WhoAmA 73, -76, -78, -80, -82*
Fenton, Beatrice 1887-1983 *DcWomA, WhoAmA 84N*
Fenton, C L *FolkA 86*
Fenton, Charles L 1808?-1877 *NewYHSD*
Fenton, Christopher Webber *FolkA 86*
Fenton, Christopher Webber 1806-1865 *AntBDN M, DcNiCA*
Fenton, E H *AmArch 70*
Fenton, Enos *DcVicP 2*
Fenton, Eva R *DcVicP 2*
Fenton, F *DcVicP 2*
Fenton, Hallie Champlin 1880-1935 *WhAmArt 85*
Fenton, Hallie Elizabeth Champlin 1880-1935 *DcWomA*
Fenton, Howard Carter 1910- *WhoAmA 73, -76, -78, -80, -82, -84*
Fenton, J H *FolkA 86*
Fenton, Jacob *FolkA 86*
Fenton, James 1805?-1875 *BiDBrA*
Fenton, John Nathaniel 1912- *WhoAmA 73, -76*
Fenton, John Nathaniel 1912-1977 *WhoAmA 78N, -80N, -82N, -84N*
Fenton, John William 1875-1939 *WhAmArt 85*
Fenton, Jonathan *FolkA 86*
Fenton, Julia Ann 1937- *WhoAmA 78, -80, -82, -84*
Fenton, Katherine *WhoArt 80, -82, -84*
Fenton, L W *FolkA 86*
Fenton, Marvin William 1909- *AmArch 70*
Fenton, Matthew *AntBDN N*
Fenton, Michael Irwin 1942- *WhoAmA 73, -76*
Fenton, Richard L *FolkA 86*
Fenton, Richard Webber *FolkA 86*
Fenton, Robert *NewYHSD*
Fenton, Roger *DcVicP 2*
Fenton, Roger 1819-1869 *ICPEnP, MacBEP*
Fenton, Rose M *DcVicP 2*
Fenton, T H *FolkA 86*
Fenton, William Milton 1925- *AmArch 70*
Fenwick, Charles H B *NewYHSD*
Fenwick, Roly 1932- *WhoAmA 84*
Fenyes, Eva Scott 1846-1930 *ArtsAmW 2, DcWomA*
Feodorova, Marie Alexserevna 1859- *DcWomA*
Feodotov, Pavel 1815-1852 *OxArt*
Ferar, Montgomery 1909- *WhAmArt 85*
Ferat, Serge 1881-1958 *PhDcTCA 77*
Ferat, Serge Jastrebzoff 1881-1958 *OxTwCA*
Feraud, Madame *DcWomA*
Feraud, Louis *FairDF FRA, WorFshn*
Feraud, Thomas, Jr. *NewYHSD*
Feray, Madame *DcWomA*
Ferber, Elise VanHook *WhoAmA 76, -78, -80, -82, -84*
Ferber, Harvey Charles 1934- *AmArch 70*
Ferber, Herbert 1906- *AmArt, BnEnAmA, DcAmArt, DcCAA 71, -77, DcCAr 81, McGDA, OxTwCA, PhDcTCA 77, WhAmArt 85, WhoAmA 73, -76, -78, -80, -82, -84, WorArt[port]*
Ferber, Lee Allan 1941- *WhoAmA 80, -82, -84*
Ferber, Linda S 1944- *WhoAmA 82, -84*
Ferdinand, John E *WhAmArt 85*
Ferebee, Stephen Scott, Jr. 1921- *AmArch 70*
Fereday, Cyril Lawrence 1917- *DcBrA 1*
Fereday, Joseph 1917- *WhoArt 80, -82, -84*
Ference, Cynthia *WhoAmA 80, -82, -84*
Ferenczy, Karoly 1862-1917 *McGDA*
Ferendino, Andrew John 1909- *AmArch 70*
Ferento, August *NewYHSD*
Ferey, Coralie *DcWomA*
Ferey, Louise Renee *DcWomA*
Ferg, Frank X *WhAmArt 85*
Ferg, Franz DePaula 1689-1737 *DcBrECP*
Ferg, Franz DePaula 1689-1740 *ClaDrA*
Ferg, Henry *FolkA 86*
Fergus, John *BiDBrA*
Fergus, Robert *DcVicP 2*
Fergus, W E, Jr. *AmArch 70*
Ferguson *FolkA 86*
Ferguson, Mrs. *DcVicP 2, FolkA 86*
Ferguson, Mrs. A *DcVicP 2*
Ferguson, Adaline M 1809?- *FolkA 86*
Ferguson, Agnes Howell 1895- *DcWomA, WhAmArt 85*
Ferguson, Alice L L *WhAmArt 85*
Ferguson, Alice Liczinska 1881-1951 *DcWomA*
Ferguson, Barclay 1924- *AmArt, WhoAmA 80, -82, -84*
Ferguson, Bernard LaMarr 1911- *WhAmArt 85*
Ferguson, Brian John 1952- *MarqDCG 84*
Ferguson, C Eugene *WhAmArt 85*
Ferguson, Charles *AfroAA*

Ferris, Lehman Ashmead 1893- *AmArch 70*
Ferris, Mary Danforth *WhAmArt 85*
Ferris, Mary L *WhAmArt 85*
Ferris, May Electa *DcWomA*
Ferris, R Statira *WhAmArt 85*
Ferris, Robert Donald 1926- *AmArch 70*
Ferris, Stephen James 1835-1915 *NewYHSD* , *WhAmArt 85*
Ferris, Warren W 1890- *WhAmArt 85*
Ferriss, Hugh 1889- *WhAmArt 85*
Ferriss, Hugh 1889-1962 *BnEnAmA*, *MacEA*, *McGDA*
Ferrit, Madame De *DcWomA*, *NewYHSD*
Ferriter, Clare *WhAmArt 85*
Ferriter, Clare 1913- *WhoAmA 73, -76, -78, -80, -82, -84*
Ferriter, Roger *AmGrD[port]*
Ferro, Charles M *WhAmArt 85*
Ferro, Gregorio De 1742-1812 *McGDA*
Ferro, Walter *WhoAmA 73, -76, -78, -80, -82, -84*
Ferron, Marcelle *WhoAmA 78, -80, -82, -84*
Ferron DeLaVillaudon, Louise *DcWomA*
Ferroni, Violante 1720- *DcWomA*
Ferrucci, Andrea 1465-1526 *McGDA*
Ferrucci, Francesco DiSimone 1437-1493 *McGDA*
Ferry, Annie E *DcWomA*
Ferry, C E *DcVicP 2*
Ferry, Donald Eugene 1932- *AmArch 70*
Ferry, Frances *WhAmArt 85*
Ferry, Francis *NewYHSD*
Ferry, George *BiDBrA*
Ferry, George B 1851-1918 *BiDAmAr*
Ferry, Isabelle H d1937 *DcWomA*
Ferry, Isabelle H d1937? *WhAmArt 85*
Ferry, James Alexander *WhoArt 80, -82, -84*
Ferry, LeRoy Quintin 1904- *AmArch 70*
Ferry-Humblot, Guite 1897- *DcWomA*
Fersinger, Caroline *DcWomA*
Ferstadt, Louis 1900- *WhAmArt 85*
Ferstel, Heinrich 1828-1883 *WhoArch*
Ferstel, Heinrich Von *McGDA*
Ferstel, Heinrich Von 1828-1883 *MacEA*
Fery, John 1865?-1934 *ArtsAmW 1*, *IlBEAAW*, *WhAmArt 85*
Fery, Louise Lucie 1848- *DcWomA*
Feselen, Melchior d1538 *ClaDrA*
Fesquet, Jules *ArtsNiC*
Fessard, Madeleine Henriette Louise 1873- *DcWomA*
Fessenden, Benjamin 1809?- *NewYHSD*
Fessenden, Dewitt Harvey 1884- *WhAmArt 85*
Fessenden, Thomas F *EncASM*
Fessenden, William B *EncASM*
Fessenden, William P *EncASM*
Fesser, Edward 1863- *WhAmArt 85*
Fessler, Ann Helene 1949- *WhoAmA 84*
Fessler, F *AmArch 70*
Fessler, Mary Thomasita *WhoAmA 73, -76, -78, -80*
Fessler, Mary Thomasita 1912- *WhoAmA 84*
Fest, Adam *NewYHSD*
Festa, Bianca *DcWomA*
Festa, Domenica *DcWomA*
Festa, G J *AmArch 70*
Festa, Mathilde *DcWomA*
Festa, Tano 1938- *PhDcTCA 77*
Festner, Frederick C *NewYHSD*
Feszel, Frigyes *McGDA*
Feszl, Frigyes 1821-1884 *MacEA*
Feszty, Rosa *DcWomA*
Fetch, Myron Lester 1931- *AmArch 70*
Feters, W T *NewYHSD*
Feti, Domenico 1589-1623 *McGDA*
Feti, Domenico 1589-1624 *ClaDrA*, *OxArt*
Fetner, S R *AmArch 70*
Fetridge, J R *AmArch 70*
Fetsch, *NewYHSD*
Fetscher, Charles W *WhAmArt 85*
Fett, William 1918- *WhAmArt 85*
Fett, William F 1918- *WhoAmA 78, -80, -82, -84*
Fette, Henry Gerhard *NewYHSD*
Fetter, E *FolkA 86*
Fetter, George *NewYHSD*
Fetter, Jacob *CabMA*
Fetter, William Allan 1928- *MarqDCG 84*
Fetti, Domenico *McGDA*
Fetti, Domenico 1589-1624 *OxArt*
Fetti, Giovanni DiFrancesco *McGDA*
Fetti, Lucrina *DcWomA*
Fetting, Rainer 1949- *ConArt 83*
Fettweis, Leopold *WhAmArt 85*
Fetz, Ingrid *IlsCB 1967*
Fetz, Ingrid 1915- *IlsBYP*, *IlsCB 1957*
Fetzer, E B *AmArch 70*
Fetzer, Henry Peter 1906- *AmArch 70*
Fetzer, John Baer 1911- *AmArch 70*
Fetzer, Margaret Steenrod 1906- *WhAmArt 85*
Feuchter, Louis 1885-1957 *WhAmArt 85*
Feuchtmayer, Joseph Anton 1696-1770 *McGDA*
Feudel, Alma L M A *WhAmArt 85*
Feudel, Alma L M A 1867- *DcWomA*
Feudel, Arthur 1857- *WhAmArt 85*
Feuerbach, Anselm 1829-1880 *ArtsNiC*, *McGDA*,

Feuerbach, Anselme 1829-1880 *ClaDrA*
Feuerherm, Kurt K 1925- *WhoAmA 78, -80, -82, -84*
Feuerman, Carole Jeane *PrintW 85*
Feuerstein, Bedrich 1892-1936 *MacEA*
Feuerstein, Roberta 1950- *WhoAmA 76, -78, -80, -82, -84*
Feugere-Mouton, Marguerite 1876-1971 *DcWomA*
Feuillas-Creusy, Caroline 1861- *DcWomA*
Feuillatre, Eugene 1870-1916 *DcNiCA*
Feuille, J F *NewYHSD*
Feuilloux, Camille *DcWomA*
Feurer, Charles F 1861-1935 *WhAmArt 85*
Feurer, Karl *ArtsAmW 1*, *WhAmArt 85*
Feurer, Rene 1940- *DcCAr 81*
Feurgard, Julie *DcWomA*
Feuser, Franz Josef 1931- *DcCAr 81*
Feustmann, Maurice M 1870-1943 *BiDAmAr*
Few, C *DcWomA*
Few, Elsie 1909- *DcBrA 1*
Fewkes, E *FolkA 86*
Fewkes, J *FolkA 86*
Fewsmith, Hazeltine *WhAmArt 85*
Fewsmith, Henry 1821-1846 *NewYHSD*
Fey, Charles *NewYHSD*
Fey, Earl A 1931- *AmArch 70*
Fey, Lester Paul 1901- *AmArch 70*
Fey, W H *AmArch 70*
Feydeau, Anne De *DcWomA*
Feydeau, Diane *DcWomA*
Feyen, Jacques Eugene 1815-1908 *ClaDrA*
Feyen-Perrin *DcVicP 2*
Feyen-Perrin, Francois Nicolas Augustin *ArtsNiC*
Feyerabend, Anna Magdalena *DcWomA*
Feylde, De *DcVicP 2*
Feytaud, Sophie *DcWomA*
Ffarington *DcBrECP*
Ffitch, G S *DcVicP 2*
Ffolkes, Michael 1925- *WhoArt 80, -82, -84*
Ffoulke, Charles Mather 1841-1909 *WhAmArt 85*
Ffoulkes, Caroline Mary 1779-1854 *DcWomA*
Ffoulkes, Charles J *DcVicP 2*
Ffoulkes, Charles John 1868-1947 *DcBrA 2*, *DcBrBI*
Ffrench 1921- *WhoAmA 73, -76*
Fialetti, Odoardo 1573-1638 *ClaDrA*
Fialka, Olga Von *DcWomA*
Fiamberti, Tommaso d1525 *McGDA*
Fiaminghi, Hermelindo *OxTwCA*
Fiammenghi, Gioia *IlsCB 1967*
Fiammenghi, Gioia 1929- *IlsBYP*, *IlsCB 1946, -1957*
Fiammenghino, Il *McGDA*
Fiammingo, Il *McGDA*
Fiammingo, Dionisio *OxArt*
Fiasella, Domenico 1589-1669 *McGDA*
Fibich, R *FolkA 86*, *NewYHSD*
Fichard, Baron De *DcVicP 2*
Fichel, Benjamin Eugene 1826-1895 *ClaDrA*
Fichel, Eugene Benjamin *ArtsNiC*
Fichel, Jeanne *DcWomA*
Fichera, Richard M 1950- *MarqDCG 84*
Fichet, Gabriel *DcWomA*
Fichet, Pierre 1927- *DcCAr 81*
Fichot, Michel-Charles 1817-1903 *DcBrBI*
Ficht, Hartman *NewYHSD*
Ficht, John H *NewYHSD*
Ficht, Otto C *ArtsAmW 3*, *NewYHSD*
Fichter, Herbert Francis 1920- *WhoAmA 78, -80, -82, -84*
Fichter, Robert *WhoAmA 78*
Fichter, Robert 1939- *DcCAr 81*
Fichter, Robert W 1939- *ConPhot*, *ICPEnP A*, *MacBEP*, *WhoAmA 80, -82, -84*
Fichtmueller, Eleonore 1904- *WhAmArt 85*
Fichu, Madame *DcWomA*
Fick, August C *ArtsEM*
Fick And Ingersoll *ArtsEM*
Fickbohm, Sallie I *WhAmArt 85*
Ficke, S B *AmArch 70*
Ficker, Peter 1885- *AmArch 70*
Ficker, W P *AmArch 70*
Fickes, E W, Jr. *AmArch 70*
Fickes, Frank B *NewYHSD*
Fickes, James Torrens 1921- *AmArch 70*
Fickett, Edward Hale 1916- *AmArch 70*
Ficklen, Jack Howells 1911- *WhoAmA 76, -78, -80*
Ficklen, Jack Howells 1911-1980 *WhoAmA 82N, -84N*
Ficklin, Alfred *DcVicP 2*
Ficklin, George *DcVicP 2*
Ficklin, R *DcVicP 2*
Fico, Louis M *MarqDCG 84*
Ficquet, Etienne 1719-1794 *McGDA*
Fidance, Thomas Paul 1926- *AmArch 70*
Fidaroff, Senia *WhAmArt 85*
Fiddian, Emmil *DcBrBI*
Fiddler, Jerry 1951- *MarqDCG 84*
Fidel, John 1733?-1806 *BiDBrA*
Fidide, Marie Madeleine *DcWomA*
Fidler, A H *AmArch 70*
Fidler, Alwyn G Sheppard 1909- *WhoArt 80, -82, -84*
Fidler, Constance Louise 1904- *ClaDrA*, *DcBrA 1*

Fidler, Gideon 1857-1942 *DcBrWA*
Fidler, Gideon M *DcBrA 1*, *DcBrBI*
Fidler, Gideon M 1857-1942 *DcVicP 2*
Fidler, Harry d1935 *ClaDrA*, *DcBrA 1*, *DcVicP 2*
Fidler, J *BiDBrA*, *DcBrECP*
Fidler, J W *AntBDN O*
Fidler, Spencer D 1944- *WhoAmA 82, -84*
Fidlor, I *DcBrWA*
Fidlor, J H *DcBrWA*
Fiebig, Eberhard 1930- *DcCAr 81*
Fiebrich, Rolf-Dieter 1945- *MarqDCG 84*
Fieder, Louis *CabMA*
Fiedler, Albert H 1907- *AmArch 70*
Fiedler, Bernhard 1816- *ArtsNiC*
Fiedler, Katharina *DcWomA*
Fiedler, Konrad 1841-1895 *OxArt*
Fiedler, L Eric 1955- *MarqDCG 84*
Fiedler, Marianne 1864-1904 *DcWomA*
Fiedler, Richard Paul *AmArch 70*
Fiedler, W G *AmArch 70*
Fiedler, William A 1843-1903 *BiDAmAr*
Fieff, Olson *DcWomA*
Fiege, Herbert Frederick 1909- *AmArch 70*
Fieger, Erwin 1928- *ConPhot*, *ICPEnP A*
Field, Anna *DcWomA*
Field, Beatrice 1888- *DcWomA*
Field, Benjamin *CabMA*
Field, Charlotte E 1838-1920 *DcWomA*, *NewYHSD* , *WhAmArt 85*
Field, Dick 1912- *DcBrA 1*
Field, Dora *DcVicP 2*
Field, E W *DcWomA*
Field, Edward 1858- *WhAmArt 85*
Field, Edward Loyal 1856-1914 *WhAmArt 85*
Field, Edward R *NewYHSD*
Field, Edwin Wilkins 1804-1871 *DcBrWA*, *DcVicP 2*
Field, Erastus Salisbury 1805-1900 *AmFkP[port]*, *BnEnAmA*, *DcAmArt*, *FolkA 86*, *NewYHSD* , *WhAmArt 85*
Field, Mrs. Erastus Salisbury *NewYHSD*
Field, Frances A *DcVicP 2*, *DcWomA*
Field, Fred H 1928- *AmArch 70*
Field, Freke *DcVicP 2*
Field, G d1859 *EarABI*
Field, G C *DcBrBI*
Field, H *AmArch 70*
Field, Hamilton Easter 1873-1922 *WhAmArt 85*
Field, Mrs. Heman H 1864-1931 *ArtsAmW 3*
Field, Henrietta 1813?-1875 *DcWomA*
Field, Mrs. Henry Martyn 1813?-1875 *NewYHSD*
Field, Hermann Haviland 1910- *AmArch 70*
Field, Isabel Osbourne 1858-1953 *WhAmArt 85*
Field, J A *FolkA 86*, *NewYHSD*
Field, J M *WhAmArt 85*
Field, James *BiDBrA*
Field, John *BiDBrA*
Field, John 1771-1841 *AntBDN O*, *DcBrWA*, *OxDecA*
Field, John Louis 1930- *AmArch 70*
Field, John M 1771-1841 *DcVicP 2*
Field, Julia A *DcWomA*, *NewYHSD*
Field, L F *FolkA 86*
Field, Laurence B *WhAmArt 85*
Field, Laurence B 1905?- *IlBEAAW*
Field, Leonard H 1873-1944? *BiDAmAr*
Field, Louise Blodgett *DcWomA*, *WhAmArt 85*
Field, Lyman 1914- *WhoAmA 76, -78, -80, -82, -84*
Field, M 1864-1931 *ArtsAmW 3*, *DcWomA*, *WhAmArt 85*
Field, Marian 1885- *ArtsAmW 3*
Field, Marriott *NewYHSD*
Field, Marriott 1803?- *BiDBrA*
Field, Marshall *EncASM*
Field, Mary *DcWomA*, *WhAmArt 85*
Field, Mary F *DcVicP 2*
Field, Mary Hickson *DcWomA*
Field, Molly 1912- *DcBrA 1*
Field, Natalie *WhoArt 82N*
Field, Natalie 1898- *WhoArt 80*
Field, Nora *DcVicP 2*
Field, Orrin Douglas 1918- *AmArch 70*
Field, Mrs. P G d1859 *NewYHSD*
Field, Peter L 1920- *DcBrA 1*, *WhoArt 80, -82, -84*
Field, Phebe d1859 *DcWomA*
Field, Philip Sidney 1942- *WhoAmA 78, -80, -82, -84*
Field, Rachel *DcWomA*
Field, Rachel 1894-1942 *ConICB*
Field, Rebecca *FolkA 86*
Field, Richard Sampson 1931- *WhoAmA 76, -78, -80, -82, -84*
Field, Robert 1769?-1819 *McGDA*, *NewYHSD*
Field, Robert Alexander 1902- *AmArch 70*
Field, Robert David 1925- *AmArch 70*
Field, Robert James *WhoAmA 76, -78, -80, -82, -84*
Field, Sarah Isabella *DcWomA*, *WhAmArt 85*
Field, Saul 1912- *WhoAmA 84*
Field, Thomas Harold 1951- *MarqDCG 84*
Field, W A, III *AmArch 70*
Field, W B *AmArch 70*
Field, Walter 1837-1901 *DcBrA 2*, *DcBrWA*, *DcVicP 2*

Finical, Irvin E 1926- *AmArch 70*
Finiguerra, Maso 1426-1464 *McGDA,* *OxArt*
Finisy, Morris Neil 1929- *AmArch 70*
Fink, A H *AmArch 70*
Fink, Aaron 1955- *PrintW 85*
Fink, Aimee M *WhAmArt 85*
Fink, Alan 1925- *WhoAmA 73, -76, -78, -80, -82,*
 -84
Fink, Bob *WhAmArt 85*
Fink, Charles B 1932- *AmArch 70*
Fink, Denman 1880- *WhAmArt 85*
Fink, Frederick 1817-1849 *NewYHSD*
Fink, H G, Sr. *AmArch 70*
Fink, Harvey Allen 1922- *AmArch 70*
Fink, Herbert Lewis 1921- *WhoAmA 73, -76, -78,*
 -80, -82, -84
Fink, Ira Stephen 1937- *AmArch 70*
Fink, Larry 1941- *ConPhot, DcCAr 81, ICPEnP A,*
 PrintW 85, WhoAmA 84
Fink, Laurence 1941- *MacBEP*
Fink, Laurence B 1941- *WhoAmA 78, -80, -82*
Fink, Lois Marie 1927- *WhoAmA 84*
Fink, Louis R 1925- *WhoAmA 76, -78, -80, -82*
Fink, Louis R 1925-1980 *WhoAmA 84N*
Fink, Lucille 1910- *WhAmArt 85*
Fink, Philip *DcVicP 2*
Fink, Ray 1922- *WhoAmA 78, -80, -82, -84*
Fink, Robert Richard 1909- *WhAmArt 85*
Fink, Sam 1916- *WhoAmA 73*
Fink, Tone 1944- *DcCAr 81*
Fink, Willie Sharpe *FolkA 86*
Fink, Z Alan 1950- *MarqDCG 84*
Finke, Jochen 1941- *ConDes*
Finke, Leonda Froelich 1922- *WhoAmA 73, -76, -78,*
 -80, -82, -84
Finkel, Ben E 1951- *MarqDCG 84*
Finkel, Bill *FolkA 86*
Finkel, Candida 1947- *MacBEP*
Finkel, Jean Fenton 1921- *AmArch 70*
Finkel, Lawrence David 1959- *MarqDCG 84*
Finkel, Warren Edward 1920- *AmArch 70*
Finkeldey, John Frederick *NewYHSD*
Finkelgreen, David 1888-1931 *WhAmArt 85*
Finkelnburg, Augusta *DcWomA, WhAmArt 85*
Finkelstein, Clara S 1885- *DcWomA, WhAmArt 85*
Finkelstein, Louis 1923- *WhoAmA 76, -78, -80, -82,*
 -84
Finkelstein, Maria Hamel *WhAmArt 85*
Finkelstein, Max 1915- *WhoAmA 73, -76, -78, -80,*
 -82, -84
Finkenauer, George *NewYHSD*
Finkernagel, Ernest *NewYHSD*
Finkle, Melik 1885- *WhAmArt 85*
Finkle, Robert Melik 1936- *AmArch 70*
Finkler, Robert Allan 1936- *WhoAmA 78, -80, -82,*
 -84
Finlay, A *DcVicP 2*
Finlay, Alexander *DcVicP 2*
Finlay, Anne *DcBrA 2*
Finlay, Anne 1953- *DcCAr 81*
Finlay, Hugh *CabMA, FolkA 86*
Finlay, Ian *WhoArt 80, -82, -84*
Finlay, Ian Hamilton 1925- *ConArt 77, -83,*
 ConBrA 79[port]
Finlay, John *CabMA, FolkA 86*
Finlay, K J *DcVicP 2*
Finlayson, Mrs. *DcWomA*
Finlayson, Alfred *DcVicP 2*
Finlayson, Donald Lord 1897- *WhAmArt 85*
Finlayson, Donald Lord 1897-1960 *WhoAmA 80N,*
 -82N, -84N
Finlayson, Hugh R 1852?-1896 *ArtsEM*
Finlayson, Isobel G *DcWomA*
Finlayson, Mungo d1793 *CabMA*
Finlayson, Mungo Graeme 1776?-1799 *CabMA*
Finlayson And Fairley *CabMA*
Finley, A Clemens *WhAmArt 85*
Finley, Anthony *NewYHSD*
Finley, Arthur *WhAmArt 85*
Finley, C L *DcWomA*
Finley, Charles *WhAmArt 85*
Finley, David Edward *WhoArt 80N*
Finley, David Edward 1890- *WhoAmA 73, -76*
Finley, David Edward 1890-1977 *WhoAmA 78N,*
 -80N, -82N, -84N
Finley, Donny *OfPGCP 86*
Finley, Donny Lamenda 1951- *WhoAmA 80, -82, -84*
Finley, Elizabeth R *DcWomA, WhAmArt 85*
Finley, Ella *WhAmArt 85*
Finley, Ella 1868- *DcWomA*
Finley, Gail *AfroAA*
Finley, Gerald Eric 1931- *WhoAmA 76, -78, -80, -82,*
 -84
Finley, John T 1945- *MarqDCG 84*
Finley, Lottie K *ArtsEM, DcWomA*
Finley, Mary L d1964 *WhoAmA 78N, -80N, -82N,*
 -84N
Finley, Vernon B *WhAmArt 85*
Finlinson, Edith M *DcVicP 2*
Finn, Albert G *EncASM*
Finn, David 1921- *WhoAmA 78, -80, -82, -84*

Finn, Edward J 1913- *AmArch 70*
Finn, Henry James William 1787-1840 *NewYHSD*
Finn, Herbert John 1861- *DcBrA 1, DcBrWA,*
 DcVicP 2
Finn, Herbert John 1861-1942 *DcBrA 2*
Finn, James Wall d1913 *WhAmArt 85*
Finn, John Thomas 1948- *MarqDCG 84*
Finn, Kathleen Macy 1896- *DcWomA, WhAmArt 85*
Finn, Leonard John 1891- *DcBrA 1*
Finn, Leonard Richard 1891- *DcBrA 2*
Finn, Marvin 1917- *FolkA 86*
Finn, Matthew D *NewYHSD*
Finn, Michael 1921- *DcBrA 2*
Finn, Nancy B 1943- *MarqDCG 84*
Finne, Augusta 1868- *DcWomA*
Finne, Henry William 1914- *AmArch 70*
Finne, Walter C 1925- *AmArch 70*
Finnegan, Gladys Louise Brown 1903- *WhAmArt 85*
Finnegan, John *NewYHSD*
Finnegan, Maurice J, Jr. 1927- *AmArch 70*
Finnegan, Sharyn Marie 1946- *WhoAmA 78, -80, -82,*
 -84
Finnemore, Joseph 1860-1939 *ClaDrA, DcBrA 1,*
 DcBrBI, DcBrWA, DcVicP 2
Finnerard, M T *FolkA 86*
Finney, Charles Edwin 1911- *AmArch 70*
Finney, Clarence J *WhAmArt 85*
Finney, Elizabeth *FolkA 86*
Finney, Grace *DcWomA*
Finney, Joseph *BiDBrA*
Finney, Mary Alice *ArtsEM, DcWomA*
Finney, May F *ArtsEM, DcWomA*
Finney, Virginia *DcWomA*
Finnie, John 1829-1907 *ClaDrA, DcBrA 1, DcBrWA,*
 DcVicP, -2
Finocchiaro, Pino *PrintW 85*
Finseth, J *AmArch 70*
Finsler, Hans 1891-1972 *ConPhot, ICPEnP,*
 MacBEP
Finson, Hildred A 1910- *WhoAmA 78, -80, -82, -84*
Finsonius, Lodovicus 1580?-1632? *McGDA*
Finster, Howard 1916- *FolkA 86*
Finsterlin, Hermann 1887-1973 *MacEA, WhoArch*
Finsterwald, Corinne *DcWomA*
Finsterwald, Corrine 1894-1965 *WhAmArt 85*
Finta, Alexander *WhoAmA 80N, -82N, -84N*
Finta, Alexander 1881- *IlsCB 1744, WhAmArt 85*
Finta, Alexander S 1881-1958 *ArtsAmW 2*
Finta, Joseph 1931- *WhoGrA 82[port]*
Finta, Jozsef 1935- *ConArch*
Finzelberg, Lilli *DcWomA*
Fiocchi, Annibale 1915- *EncMA*
Fiorato, Noe *WhAmArt 85*
Fioravanti, Aristotele 1415?-1485? *OxArt*
Fioravanti, Aristotele 1415?-1486? *MacEA*
Fiore, Anthony Joseph 1912- *WhAmArt 85*
Fiore, Ernesto De 1884-1945 *McGDA*
Fiore, Jacobello Del *McGDA*
Fiore, Joseph A 1925- *WhoAmA 73, -76, -78, -80,*
 -82, -84
Fiore, Nicholas J 1917- *AmArch 70*
Fiore, Rosario Russell 1908- *WhAmArt 85,*
 WhoAmA 76, -78, -80, -82, -84
Fiorentini, Aurelia 1587?-1675 *DcWomA*
Fiorentino, Domenico *McGDA*
Fiorentino, Francesco *McGDA*
Fiorentino, Mario 1918- *MacEA*
Fiorentino, Niccolo 1430-1514 *McGDA*
Fiorentino, Nicolao *McGDA*
Fiorentino-Valle, Maude Richmond *DcWomA,*
 WhAmArt 85
Fiorenzo DiLorenzo 1440?-1525? *McGDA*
Fiorenzuola, Giovanni *McGDA*
Fiori, Dennis Andrew 1949- *WhoAmA 78, -80*
Fiori, Ernesto Di 1884-1945 *PhDcTCA 77*
Fiori, Frederigo *ClaDrA*
Fioriglio, Michael *WhAmArt 85*
Fioroni, Giosetta *OxTwCA*
Fioroni, Teresa *DcWomA*
Fioroni-Narducci, Enrica 1806-1892 *DcWomA*
Fiorucci, Elio 1935- *ConDes*
Fiot, M *AntBDN C*
Fiquemont, Marie 1880- *DcWomA*
Firant, E R *AmArch 70*
Firebaugh, Nettie King *ArtsAmW 2, DcWomA,*
 WhAmArt 85
Firenze, Frate Giovanni Da *McGDA*
Firestein, Cecily Barth 1933- *WhoAmA 82, -84*
Firestone, C E *AmArch 70*
Firestone, C E, II *AmArch 70*
Firestone, I L 1894- *WhAmArt 85*
Firestone, Nathaniel 1926- *AmArch 70*
Firestone, R E *AmArch 70*
Firfires, Nicholas S 1917- *IlBEAAW*
Firfires, Nicholas Samuel 1917- *AmArt,*
 WhoAmA 76, -78, -80, -82, -84
Firks, Henry *ArtsAmW 2, IlBEAAW, NewYHSD*
Firmadge, William 1755-1836 *BiDBrA*
Firmin, A E 1890- *WhAmArt 85*
Firmin, J L *AmArch 70*
Firmin-Badois, Jeanne *DcWomA*

Firminger, Thomas Augustus Charles 1812-1884
 DcBrWA, DcVicP 2
Firnhaber, Elise *DcWomA*
Firth, Allan H 1932- *MarqDCG 84*
Firth, E F *FolkA 86*
Firth, Karl W 1911- *WhAmArt 85*
Firth, Pauline *DcWomA*
Firth, Sir Raymond William 1901- *WhoArt 80, -82,*
 -84
Firth, Susannah *DcWomA*
Firth, Tazeena *ConDes*
Fisac Serna, Miguel 1913- *MacEA*
Fisch, Arline M 1931- *DcCAr 81*
Fisch, Arline Marie *WhoAmA 73, -76, -78, -80, -82,*
 -84
Fisch, Olga Anhalzer 1901- *WhoAmA 82*
Fisch, Steven M 1940- *MarqDCG 84*
Fischbach, Katharina *DcWomA*
Fischbach, Marilyn Cole *WhoAmA 73, -76, -78, -80,*
 -82, -84
Fische, William *FolkA 86*
Fischer, *NewYHSD*
Fischer, Albert 1792-1863 *FolkA 86*
Fischer, Ann A *IlsBYP*
Fischer, Anna Katharina *DcWomA*
Fischer, Anton Otto 1882- *IlsCB 1744, -1946*
Fischer, Anton Otto 1882-1962 *DcSeaP, IlBEAAW,*
 IlrAm C, -1880, WhAmArt 85, WorECar
Fischer, Arno 1925- *AmArch 70*
Fischer, August Ferdinand 1805-1866 *ArtsNiC*
Fischer, B *AmArch 70*
Fischer, Bertha 1864- *DcWomA*
Fischer, C *DcVicP 2*
Fischer, Carl 1924- *ICPEnP A, MacBEP*
Fischer, Charles *FolkA 86, NewYHSD*
Fischer, Charles Henry *FolkA 86, NewYHSD*
Fischer, Christa 1940- *DcCAr 81*
Fischer, Clara Elisabet 1856- *DcWomA*
Fischer, Donald Alexander 1936- *AmArch 70*
Fischer, Donald David 1925- *AmArch 70*
Fischer, E *AmArch 70*
Fischer, Elise *DcWomA*
Fischer, Elmer Carl, Jr. 1939- *AmArch 70*
Fischer, Emil C 1907- *AmArch 70*
Fischer, Ernst Georg 1815-1874 *NewYHSD*
Fischer, Frank H 1914- *AmArch 70*
Fischer, Frederick *NewYHSD*
Fischer, Frederick Norman 1928- *AmArch 70*
Fischer, George 1844-1914 *WhAmArt 85*
Fischer, George Eckerson 1907- *AmArch 70*
Fischer, H *WhAmArt 85*
Fischer, Hal 1950- *ICPEnP A, MacBEP,*
 WhoAmA 82, -84
Fischer, Hans 1909-1958 *McGDA*
Fischer, Hans Erich 1909-1958 *IlsBYP, IlsCB 1946,*
 -1957
Fischer, Hans J 1932- *AmArch 70*
Fischer, Helene Von 1843- *DcWomA*
Fischer, Henrietta C 1881- *WhAmArt 85*
Fischer, Henry *DcVicP 2*
Fischer, Henry George 1923- *WhoAmA 80, -82, -84*
Fischer, Herbert Max 1934- *AmArch 70*
Fischer, Herve 1941- *ConArt 77*
Fischer, Hulda 1892- *DcWomA*
Fischer, Hulda Rotier 1893- *WhAmArt 85*
Fischer, J F *NewYHSD*
Fischer, Jo 1904- *WhoAmA 76, -78, -80, -82*
Fischer, Johann Martin 1741-1820 *McGDA*
Fischer, Johann Michael 1691-1766 *McGDA*
Fischer, Johann Michael 1692-1766 *MacEA, OxArt,*
 WhoArch
Fischer, John 1736-1808 *NewYHSD*
Fischer, John Frederick 1919- *AmArch 70*
Fischer, John G *NewYHSD*
Fischer, John George Paul 1786-1875 *DcBrWA,*
 DcVicP 2
Fischer, John J 1930- *WhoAmA 73, -76, -78*
Fischer, Joseph 1769-1822 *ClaDrA*
Fischer, Karl Von 1782-1820 *MacEA, McGDA*
Fischer, Leo L 1914- *AmArch 70*
Fischer, Lewis *NewYHSD*
Fischer, Lothar 1933- *DcCAr 81, OxTwCA*
Fischer, M *AmArch 70*
Fischer, Magnella Kirstine *DcWomA*
Fischer, Maria Anna 1785- *DcWomA*
Fischer, Martha *DcWomA*
Fischer, Martin 1879- *WhAmArt 85*
Fischer, Mary Ellen 1876-1960 *DcWomA*
Fischer, Mary Ellen Sigsbee 1876- *WhAmArt 85*
Fischer, Maya *DcCAr 81*
Fischer, Mildred 1907- *WhoAmA 73, -76, -78, -80,*
 -82, -84
Fischer, Ned Emil 1922- *AmArch 70*
Fischer, P *DcVicP 2*
Fischer, Philip *NewYHSD*
Fischer, R M 1947- *WhoAmA 82, -84*
Fischer, Richard 1935- *ConDes*
Fischer, Richard L 1928- *AmArch 70*
Fischer, Rudolf 1881-1957 *ICPEnP, MacBEP*
Fischer, Samuel *FolkA 86*
Fischer, Susanna 1600?-1674 *DcWomA*

Fiske, Gertrude Horsford 1878?-1961 *DcWomA*
Fiske, J W *FolkA 86*
Fiske, Joseph W 1959- *MarqDCG 84*
Fiske, Marie Antoinette *DcWomA, NewYHSD*
Fiske, Samuel d1797 *CabMA*
Fiske, W *EarABI, EarABI SUP, NewYHSD*
Fiske, William *CabMA*
Fiske, William H *NewYHSD*
Fisken, Jessie 1860- *ArtsAmW 2, DcWomA, WhAmArt 85*
Fisker, Kay 1893- *EncMA, McGDA*
Fisker, Kay 1893-1965 *ConArch, MacEA, WhoArch*
Fiskin, Judith Anne 1945- *MacBEP*
Fiskin, Judy 1945- *WhoAmA 82, -84*
Fitch, Benjamin Herbert 1873- *WhAmArt 85*
Fitch, Beriah *NewYHSD*
Fitch, C, Jr. *AmArch 70*
Fitch, C A *AmArch 70*
Fitch, Dale Alston 1924- *AmArch 70*
Fitch, Eugene C *WhAmArt 85*
Fitch, Evelyn *WhAmArt 85*
Fitch, George Hopper 1909- *WhoAmA 73, -76, -80, -82, -84*
Fitch, Gladys Kelley 1896- *WhAmArt 85*
Fitch, Isaac *FolkA 86*
Fitch, James Marston 1909- *MacEA*
Fitch, Jeanette E 1874?-1963 *ArtsEM, DcWomA*
Fitch, John 1642-1706 *BiDBrA*
Fitch, John 1743-1798 *NewYHSD*
Fitch, John L 1836- *ArtsNiC*
Fitch, John Lee 1836-1895 *NewYHSD , WhAmArt 85*
Fitch, Marvin 1916- *AmArch 70*
Fitch, Simon 1758-1835 *BnEnAmA, FolkA 86*
Fitch, Steve 1949- *ConPhot, WhoAmA 84*
Fitch, Steven Ralph 1949- *ICPEnP A, MacBEP*
Fitch, Sir Thomas 1637-1688 *BiDBrA*
Fitch, Walter *DcBrWA, DcVicP 2, WhAmArt 85*
Fitch, Winifred Emily *DcWomA*
Fitchen, J F, III *AmArch 70*
Fitchen, Peter F 1935- *AmArch 70*
Fitches, William 1945- *DcCAr 81*
Fitchew, Dorothy *DcBrBI*
Fitchew, E H *DcBrBI*
Fitchew, Edward H d1934 *DcBrA 2*
Fite, Anne *DcWomA*
Fite, Mrs. Frank E *WhAmArt 85*
Fite, Harvey 1903- *WhoAmA 73, -76*
Fite, Harvey 1903-1976 *WhAmArt 85, WhoAmA 78N, -80N, -82N, -84N*
Fithian, Edith *DcVicP 2*
Fithian, Frank Livingston 1865-1935 *WhAmArt 85*
Fithian, Josiah *CabMA*
Fitler, Claude Raguet *DcWomA*
Fitler, Mrs. W C *WhAmArt 85*
Fitler, William Crothers 1857- *WhAmArt 85*
Fitsch, Eugene C 1892- *WhAmArt 85*
Fitsgerald, Miss *DcWomA*
Fittler, James 1758-1835 *BkIE*
Fitton, Hedley 1857-1929 *DcBrA 1*
Fitton, Hedley 1859-1929 *DcBrBI, DcBrWA*
Fitton, James 1899- *ConBrA 79[port], DcBrA 1*
Fitton, Margaret Mary Elizabeth *DcBrA 2*
Fitton, Paul *MarqDCG 84*
Fitts, Clara Atwood 1874- *DcWomA, WhAmArt 85*
Fitts, James Harris, III 1927- *AmArch 70*
Fitz, William *DcVicP 2*
Fitz-Gibbon, Thomas David 1895- *AmArch 70*
Fitz-Marshall *DcVicP 2*
Fitz-Randolph, Grace d1917 *DcWomA, WhAmArt 85*
Fitzadam, A *DcVicP 2*
Fitzclarence, George A, Earl Of Munster 1794-1842 *DcBrBI*
Fitzcock, Henry 1824- *DcBrBI*
Fitzcook, A *DcVicP 2*
Fitzcook, Henry 1824- *DcVicP 2*
Fitzer, Karl H 1896- *WhAmArt 85*
Fitzgerald, Lady *DcVicP 2*
Fitzgerald, Miss *DcWomA*
Fitzgerald, Astrid 1938- *AmArt, PrintW 83, -85, WhoAmA 80, -82, -84*
Fitzgerald, Beatrice E d1944 *WhAmArt 85*
Fitzgerald, Claude J *DcVicP 2*
Fitzgerald, D J *NewYHSD*
Fitzgerald, Desmond 1846-1926 *WhAmArt 85*
Fitzgerald, Edith *DcVicP 2*
Fitzgerald, Edmond James 1912- *WhAmArt 85, WhoAmA 76, -78, -80, -82, -84*
Fitzgerald, Edward 1809-1883 *DcVicP 2*
Fitzgerald, Edward Kenneth *AmArch 70*
Fitzgerald, F *DcVicP 2*
Fitzgerald, Florence *DcVicP 2*
Fitzgerald, Florence d1927 *DcBrA 1, DcWomA*
Fitzgerald, Frederick R *DcBrWA, DcVicP 2*
Fitzgerald, Lord Gerald 1821-1886 *DcBrBI*
Fitzgerald, H *DcVicP 2*
Fitzgerald, H Jane *DcVicP 2*
Fitzgerald, Harriet 1904- *WhoAmA 73, -76, -84*
Fitzgerald, Harrington 1847-1930 *WhAmArt 85*
Fitzgerald, Lady Henry *DcWomA*

Fitzgerald, Irene Catharine 1895- *WhAmArt 85*
Fitzgerald, J Edward 1923-1977 *WhoAmA 78N, -80N, -82N, -84N*
FitzGerald, J Maurice 1899- *ArtsAmW 3*
Fitzgerald, J St. M *DcBrBI*
Fitzgerald, James *DcVicP 2*
Fitzgerald, James 1899- *ArtsAmW 2, WhAmArt 85*
Fitzgerald, James Arthur 1938- *AmArch 70*
Fitzgerald, James Herbert 1910- *WhAmArt 85*
Fitzgerald, James Thomas 1934- *AmArch 70*
Fitzgerald, Jean Banks 1908- *WhAmArt 85*
Fitzgerald, John *DcWomA*
Fitzgerald, John Anster 1832-1906 *DcBrBI, DcVicP*
Fitzgerald, John Anster 1832-1909? *DcBrA 1*
Fitzgerald, John Austen 1832-1906 *DcVicP 2*
Fitzgerald, John Philip 1950- *WhoAmA 82, -84*
Fitzgerald, Joseph Farley 1928- *AmArch 70*
Fitzgerald, Mrs. Joshua *FolkA 86*
Fitzgerald, K *DcVicP 2, DcWomA*
Fitzgerald, Laura *DcWomA, WhAmArt 85*
Fitzgerald, Lionel LeMoine 1890-1956 *IlBEAAW*
Fitzgerald, Lionel Lemoine 1890-1956 *McGDA, OxTwCA*
Fitzgerald, Mary M 1889- *DcWomA, WhAmArt 85*
Fitzgerald, May Eastman 1894- *ArtsAmW 3*
Fitzgerald, Michael *DcBrBI, DcVicP 2*
Fitzgerald, Peggy Gwendoline 1923- *WhoArt 80, -82*
Fitzgerald, Percy Hetherington 1829?-1925 *DcVicP 2*
Fitzgerald, Pitt Loofbourrow 1893- *IlBEAAW, WhAmArt 85*
Fitzgerald, R R *AmArch 70*
Fitzgerald, Reuben Eugene 1925- *AmArch 70*
Fitzgerald, Richard Allen 1929- *AmArch 70*
Fitzgerald, Sue Crane *MarqDCG 84*
Fitzgibbon, Agnes Dunbar *DcWomA*
Fitzgibbon, Elizabeth T *ArtsEM, DcWomA*
Fitzgibbon, Geraldine *WhAmArt 85*
Fitzgibbon, J L *WhAmArt 85*
Fitzgibbon, J W *AmArch 70*
Fitzgibbon, James L *ArtsAmW 3*
Fitzhenry, S *DcVicP 2*
Fitzherbert, Elizabeth 1923- *ClaDrA*
Fitzhorn, Patrick 1952- *MarqDCG 84*
Fitzhugh, Thornton 1864-1933 *BiDAmAr*
Fitzjames, Anna Maria *DcBrWA, DcVicP 2, DcWomA*
Fitzjohn, E *DcVicP 2*
Fitzkee, Eunice Ailes 1946- *WhoAmA 82, -84*
Fitzmaurice, F *BkIE*
Fitzmaurice, William Edward 1805-1889 *DcBrBI*
Fitzpatrick, Arthur *DcVicP 2*
Fitzpatrick, C A *AmArch 70*
Fitzpatrick, Daniel Robert 1891- *WhAmArt 85*
Fitzpatrick, Daniel Robert 1891-1969 *WorECar*
Fitzpatrick, Edmond *DcBrBI*
Fitzpatrick, Edmund *DcVicP 2*
Fitzpatrick, Grace Marie 1897- *DcWomA, WhAmArt 85*
Fitzpatrick, Helena Way 1889- *DcWomA, WhAmArt 85*
Fitzpatrick, John C 1876- *WhAmArt 85*
Fitzpatrick, John Kelly 1888- *WhAmArt 85*
Fitzpatrick, Joseph Cyril 1909- *WhoAmA 80, -82, -84*
Fitzpatrick, Kirby Ward 1935- *AmArch 70*
Fitzpatrick, L *WhAmArt 85*
Fitzpatrick, Laura E *DcWomA*
Fitzpatrick, Louise d1911? *DcWomA*
Fitzpatrick, Martin R *AmArch 70*
Fitzpatrick, Robert John 1940- *WhoAmA 76, -78, -80, -82, -84*
Fitzpatrick, Thomas 1860-1912 *DcBrA 2, DcBrBI, DcBrWA*
Fitzpatrick, Thomas Kevin 1910- *AmArch 70*
FitzRoy, Caroline Blanche Elizabeth *DcWomA*
Fitzsimmons, James Joseph 1908- *WhoAmA 73, -76, -78N, -80N, -82N, -84N*
Fitzwilliams, Sarah E R 1840-1918 *WhAmArt 85*
Fitzwilson, George W *NewYHSD*
Fiveash, Rosa Catherine 1854?-1938 *DcWomA*
Fivian, David John 1950- *MarqDCG 84*
Fix, David 1932- *AmArch 70*
Fix, John Robert 1934- *AmArt, WhoAmA 76, -78, -80, -82, -84*
Fix, Louis *NewYHSD*
Fix-Adam, Lina *DcWomA*
Fix-Masseau, Pierre 1905- *WhoGrA 82[port]*
Fizaine, Marie Gabrielle *DcWomA*
Fizeau, Armand Hippolyte Louis 1819-1896 *ICPEnP, MacBEP*
Fizeliere-Ritti, Marthe DeLa *DcWomA*
Fjaestad, Kerstin Maria 1873- *DcWomA*
Fjelde, Paul 1892- *WhAmArt 85*
Fjell, Kai 1907- *PhDcTCA 77*
Fjellboe, Paul *ArtsAmW 2, WhAmArt 85*
Fjelsted, Orlen S 1934- *AmArch 70*
Flaad, Barbara Black 1903- *WhAmArt 85*
Flach, Victor H 1929- *WhoAmA 76, -78, -80, -82, -84*
Flacher, Lothar 1933- *DcCAr 81*
Flack, Arthur W 1878- *WhAmArt 85*
Flack, Audrey 1931- *DcCAr 81, PrintW 85*

Flack, Audrey L 1931- *AmArt, WhoAmA 73, -76, -78, -80, -82, -84*
Flack, Charles *DcVicP 2*
Flack, Edith Mary *DcVicP 2*
Flack, James Richard 1935- *MarqDCG 84*
Flack, Marjorie 1897-1958 *IlsCB 1744, -1946*
Flack, Thomas 1771-1844 *DcBrWA, DcVicP 2*
Flack, William Barber 1912- *AmArch 70*
Flad, Georg 1853-1913 *ClaDrA*
Flad, Joseph Hilar 1922- *AmArch 70*
Flad, Thomas Hilary 1914- *AmArch 70*
Flaeschner, Julius *NewYHSD*
Flag *EarABI SUP*
Flagel-Carrette, Henriette 1883- *DcWomA*
Flagella, Victor *NewYHSD*
Flagg, Abijah *FolkA 86*
Flagg, Charles Noel 1848-1916 *WhAmArt 85*
Flagg, E *DcBrBI*
Flagg, Edwin H *FolkA 86*
Flagg, Ernest 1857-1947 *BiDAmAr, BnEnAmA, MacEA, McGDA*
Flagg, George W 1816- *ArtsNiC*
Flagg, George Whiting 1816-1897 *NewYHSD*
Flagg, H Peabody 1859- *WhAmArt 85*
Flagg, Henry Collins 1811-1862 *NewYHSD*
Flagg, J Montgomery 1877-1960 *WhAmArt 85*
Flagg, J P *NewYHSD*
Flagg, James Montgomery d1960 *WhoAmA 80N, -82N, -84N*
Flagg, James Montgomery 1877-1960 *IlrAm B, -1880, WorECar*
Flagg, Jared B 1820- *ArtsNiC*
Flagg, Jared Bradley 1820-1899 *NewYHSD , WhAmArt 85*
Flagg, Josiah, Jr. *NewYHSD*
Flagg, Josiah Foster 1788-1853 *NewYHSD*
Flagg, Montague 1842-1915 *WhAmArt 85*
Flagg, Montague 1883-1924 *BiDAmAr*
Flagg, Nellie McCormick d1923 *WhAmArt 85*
Flagg, Richard B 1906- *WhoAmA 73, -76, -78, -80, -82*
Flagg, Mrs. Richard B *WhoAmA 73, -76, -78, -80, -82*
Flagg, W F *AmArch 70*
Flagg, William *CabMA*
Flagg And Homan *EncASM*
Flahaut, Leon *ArtsNiC*
Flaherty, Frances Hubbard 1886?-1972 *ICPEnP A, MacBEP*
Flaherty, J C *AmArch 70*
Flaherty, Robert Joseph 1884-1951 *ICPEnP A, MacBEP*
Flair, E H *AmArch 70*
Flakey Rose Hip 1935- *WhoAmA 76, -78, -80, -82, -84*
Flaks, Francis A 1886-1945 *BiDAmAr*
Flam, Jack D 1940- *WhoAmA 82, -84*
Flam, Marvin Arnold 1934- *AmArch 70*
Flamand, Albert *ClaDrA*
Flamand, Francois *McGDA*
Flambeau, Viktor *WhAmArt 85*
Flamen, Albert *ClaDrA*
Flameng, Elise *DcWomA*
Flameng, Francois 1856-1923 *McGDA, WhAmArt 85A*
Flameng, Leopold 1831- *ArtsNiC*
Flameng, Leopold 1831-1911 *ClaDrA*
Flament, Mademoiselle *DcWomA*
Flamour, LeSieur *NewYHSD*
Flanagan, Albert E 1886- *WhAmArt 85*
Flanagan, Barry 1941- *ConArt 77, -83, ConBrA 79[port], DcCAr 81, PrintW 83, -85*
Flanagan, Eileen M 1958- *MarqDCG 84*
Flanagan, Francis *WhAmArt 85*
Flanagan, John *FolkA 86*
Flanagan, John d1952 *WhoAmA 78N, -80N, -82N, -84N*
Flanagan, John F 1898-1952 *WhAmArt 85*
Flanagan, John Richard *WhAmArt 85*
Flanagan, John Richard 1895-1964 *IlrAm C, -1880*
Flanagan, P E *AmArch 70*
Flanagan, R V *AmArch 70*
Flanagan, Thomas Jefferson *AfroAA*
Flanagan, Thomas Jefferson 1896- *FolkA 86*
Flanagin, James *CabMA*
Flanders, Charles 1907-1973 *WorECom*
Flanders, Dennis 1915- *ClaDrA, DcBrA 1, WhoArt 80, -82, -84*
Flanders, French *DcVicP 2*
Flanders, John 1787?-1840 *CabMA*
Flanders, John J 1847-1914 *BiDAmAr*
Flanders, Raymond A 1931- *AmArch 70*
Flandes, Juan De *McGDA*
Flandin, Eugene Napoleon 1803-1876 *ClaDrA*
Flandin, Eugene Napoleon 1809-1875 *ArtsNiC*
Flandreaux, Ethel Kerns 1895-1932 *DcWomA, WhAmArt 85*
Flandres, Marie, Comtesse De *DcWomA*
Flandrin, Auguste 1804-1844 *ArtsNiC*
Flandrin, Hippolyte 1809-1864 *McGDA*
Flandrin, Hippolyte Jean 1809-1864 *ClaDrA*

Fliehr, Charles B 1824?-1885 *FolkA 86*
Flieman *FolkA 86*
Flierl, Frank 1855?-1892 *ArtsEM*
Fliermans, Constant *ArtsEM*
Flieser, Jeanne 1917- *DcCAr 81*
Flight, Claude 1881-1955 *McGDA*
Flight, Thomas *AntBDN M*
Flight, W Claude 1881-1955 *DcBrA 1*
Flin, John d1747 *DcBrECP*
Flinck, Govert 1615-1660 *ClaDrA, McGDA, OxArt*
Flink, Govert 1615-1660 *ClaDrA*
Flink-VanHemert, Ellen 1937- *DcCAr 81*
Flinn, Elizabeth Haight *WhoAmA 78, -80, -82, -84*
Flinsch, Harold, Jr. 1938- *WhoAmA 73, -76*
Flint, Alice d1945 *WhAmArt 85*
Flint, Alice Morland 1857?-1933 *DcWomA, WhAmArt 85*
Flint, Archelaus *CabMA*
Flint, Betty *WhAmArt 85*
Flint, David 1795?-1835? *CabMA*
Flint, Erastus *CabMA*
Flint, Francis Murray Russell 1915- *DcBrA 1, WhoArt 80, -82, -84*
Flint, Helen *DcWomA*
Flint, Janet Altic 1935- *WhoAmA 73, -76, -78, -80, -82, -84*
Flint, LeRoy 1909- *WhAmArt 85*
Flint, Leroy W 1909- *WhoAmA 73, -76, -78*
Flint, Ralph 1885- *WhAmArt 85*
Flint, Robert 1880- *DcBrA 1*
Flint, Robert Purves 1883-1947 *DcBrA 1, DcBrWA*
Flint, Savile Lumley William *DcBrA 2, DcVicP 2*
Flint, Sir W Russell 1880-1969 *WhAmArt 85A*
Flint, William 1801-1862 *BiDBrA*
Flint, Sir William Russell 1880-1969 *DcBrA 1, ClaDrA, DcBrBI, DcBrWA*
Flint And Ames *CabMA*
Flint Jack 1815- *DcNiCA*
Flintoft, Robert B 1866-1946 *WhAmArt 85*
Flippo, William Lloyd 1926- *AmArch 70*
Flisher, Edith E 1890- *DcWomA, WhAmArt 85*
Flitcroft, Henry 1697-1769 *BiDBrA, DcD&D, MacEA, OxArt, WhoArch*
Flitz, Dora *DcWomA*
Fllenwider, Donald Randall 1943- *MarqDCG 84*
Flobert, Charlotte *DcWomA*
Floch, Joseph 1895- *DcCAA 71, -77, WhoAmA 73, -76*
Floch, Joseph 1895-1977 *WhAmArt 85, WhoAmA 78N, -80N, -82N, -84N*
Flocher, S *FolkA 86*
Flockton, F *DcVicP 2*
Flockton, William 1804-1864 *BiDBrA*
Flodin, Ferdinand 1863-1935 *ICPEnP A*
Flodin-Rissanen, Hilda Maria 1877- *DcWomA*
Floegel, Alfred E 1894- *WhAmArt 85*
Floet, Lydia *DcWomA*
Floeter, Kent 1937- *WhoAmA 78, -80, -82, -84*
Floethe, Richard *IlsCB 1967*
Floethe, Richard 1901- *IlsCB 1744, -1946, -1957, WhAmArt 85, WhoAmA 73, -76, -78, -80, -82, -84*
Floherty, John J, Jr. 1907- *IlrAm D, WhAmArt 85*
Flohri, Emil 1869-1938 *WorECar*
Floie, Mrs. Arthur Bull *DcWomA*
Floki, Alfred 1938- *WhoGrA 82[port]*
Flom, Gordon Alan *AmArch 70*
Flom, John M 1927- *AmArch 70*
Flomen, Michael 1952- *ICPEnP A*
Flomenhaft, Eleanor 1933- *WhoAmA 82, -84*
Flood, A J *DcVicP 2*
Flood, Curt *AfroAA*
Flood, David Jay 1933- *AmArch 70*
Flood, Edward C 1944- *PrintW 85, WhoAmA 82, -84*
Flood, Harold Frank 1905- *AmArch 70*
Flood, Mary Emma *WhAmArt 85*
Flood, Rex Grattan 1928- *ClaDrA*
Flood, Richard Sidney 1943- *WhoAmA 82, -84*
Flooks, John Harris *BiDBrA*
Floote, Mrs. A A *FolkA 86*
Flor, Ferdinand 1793-1881 *DcVicP 2*
Flor-David, Florence 1891-1958 *DcWomA*
Flora, James *IlsCB 1967*
Flora, James 1914- *IlsBYP, IlsCB 1946, -1957*
Flora, James Royer 1914- *WhoAmA 78, -80, -82, -84*
Flora, Paul 1922- *DcCAr 81, WhoGrA 62, -82[port], WorECar*
Flora-Caravias, Thalia 1875- *DcWomA*
Florance, Colden L'Hommedieu Ruggles 1931- *AmArch 70*
Florance, Eustace Lee *WhAmArt 85*
Florat, Anne Elisabeth *DcWomA*
Florat, J A De *NewYHSD*
Floren, Robert Arthur 1919- *AmArch 70*
Florence *IlsBYP*
Florence, Albert Lewis, Jr. 1918- *AmArch 70*
Florence, Antoine Hercules Romuald 1804-1879 *ICPEnP*
Florence, Edward Vance *AmArch 70*
Florence, H L 1841-1916 *MacEA*

Florence, Louise Anne *DcWomA*
Florence, Mary 1857-1954 *DcVicP 2*
Florence, Mary Sargant 1857-1954 *DcBrA 1, DcBrBI, DcWomA*
Florence, Mrs. Sargent *WhAmArt 85*
Florentia, Raphael De *McGDA*
Florentin, Dominique *McGDA*
Florentin Y Torrigiani, Pedro *McGDA*
Flores, Ivan 1923- *MarqDCG 84*
Flores, Jorge *DcCAr 81*
Flores, Luis Molinari *OxTwCA*
Flores, Miguel Angelo 1937- *AmArch 70*
Flores-Jenkins, Hannibal 1922- *AmArch 70*
Floret, Lydia *WhAmArt 85*
Florian *NewYHSD*
Florian, Gordon William 1909- *WhAmArt 85*
Florian, Olga *DcWomA*
Florian, Walter 1878-1909 *WhAmArt 85*
Floriane, P 1878- *DcWomA*
Florimont, Austin *NewYHSD*
Florio, S E 1895- *WhAmArt 85*
Florio, Sal Erseny 1890- *WhoAmA 73*
Florio, Sal Erseny 1899- *WhoAmA 76, -78, -80*
Floris, Cornelis 1514-1575 *OxArt, WhoArch*
Floris, Cornelis, II 1514-1575 *MacEA*
Floris, Frans 1516-1570 *McGDA, OxArt*
Floris, Frans, I 1516-1570 *ClaDrA*
Floris DeVriendt, Cornelius 1514-1575 *McGDA*
Floris Family *OxArt*
Florjancic, Pavel 1947- *DcCAr 81*
Florsheim, Richard A 1916- *PrintW 83, -85, WhAmArt 85, WhoAmA 73, -76, -78*
Florsheim, Richard A 1916-1979 *WhoAmA 80N, -82N, -84N*
Flory, Arthur L 1914-1972 *WhAmArt 85, WhoAmA 78N, -80N, -82N, -84N*
Flory, John *FolkA 86*
Florys, William *FolkA 86*
Flotner, Peter 1490?-1546 *McGDA*
Flotow, Mathilda De *DcWomA*
Flotree, Irving J 1919- *AmArch 70*
Flotte, Mademoiselle DeLa *DcWomA*
Floud, M C F *DcVicP 2*
Flouquet, Pierre-Louis 1900-1967 *OxTwCA*
Flournoy, Benjamin C 1876-1939? *BiDAmAr*
Flournoy, Jeanette *DcWomA*
Flower, Alice *DcWomA*
Flower, Ann *FolkA 86*
Flower, Charles Edwin 1871- *DcBrA 1, DcBrWA, DcVicP 2*
Flower, Clement *DcBrBI, DcVicP 2*
Flower, E Wickham *DcWomA*
Flower, Mrs. E Wickham *DcVicP 2*
Flower, Edgar *DcVicP 2*
Flower, Elizabeth *DcBrWA*
Flower, Forrest *WhAmArt 85*
Flower, George 1787-1862 *FolkA 86, NewYHSD*
Flower, John 1793-1861 *DcBrWA, DcVicP 2*
Flower, Marmaduke C William d1910 *DcBrA 1, DcVicP 2*
Flower, Mary Elizabeth *FolkA 86*
Flower, Noel *DcVicP 2*
Flower, Sherwood 1878- *WhAmArt 85*
Flowers, B W 1947- *MarqDCG 84*
Flowers, E B *AmArch 70*
Flowers, Elizabeth *ArtsEM, DcWomA*
Flowers, Erlene *AfroAA*
Flowers, J E, Jr. *AmArch 70*
Flowers, J R *AmArch 70*
Flowers, Jean *AfroAA*
Flowers, L Philip 1926- *AmArch 70*
Flowers, Margot 1951- *MarqDCG 84*
Flowers, Peter 1805?- *FolkA 86*
Flowers, Peter 1916-1950 *DcBrA 1*
Flowers, Thomas Earl 1928- *WhoAmA 73, -76, -78, -80, -82, -84*
Flowers, William H 1813- *CabMA*
Floyd *DcBrECP*
Floyd, Miss *DcWomA*
Floyd, Caleb *FolkA 86*
Floyd, Carl Leo 1936- *WhoAmA 80, -82, -84*
Floyd, Charles Ranaldo 1796?-1845 *NewYHSD*
Floyd, E B *EncASM*
Floyd, Gareth *IlsBYP*
Floyd, Gareth 1940- *IlsCB 1967*
Floyd, Harry *DcVicP 2, WhAmArt 85*
Floyd, Henry *WhAmArt 85*
Floyd, M A *AmArch 70*
Floyd, Mildred *WhAmArt 85*
Floyd, Peter Leal 1922- *AmArch 70*
Floyd, Richard Frederick 1933- *AmArch 70*
Floyd, Rickt *AfroAA*
Floyd, Thomas *FolkA 86*
Floyd, William Harrell 1951- *MarqDCG 84*
Fluckiger, Adolf 1917- *WhoGrA 62, -82[port]*
Fluckiger, Arnold Burton 1926- *AmArch 70*
Fludd, Reginald Joseph 1938- *WhoAmA 76, -78, -80, -82, -84*
Fluek, Toby 1926- *WhoAmA 73, -76, -78, -80, -82, -84*
Flugge, Henny *DcWomA*

Fluggen, Joseph *ArtsNiC*
Fluker, T S *AmArch 70*
Flum, Donald F 1933- *MarqDCG 84*
Flume, Violet Sigoloff *WhoAmA 80, -82, -84*
Fly *AfroAA*
Fly, Buck 1849-1901 *ICPEnP A*
Fly, Camillus Sidney 1849-1901 *MacBEP*
Flye, Grace Houghton *WhAmArt 85*
Flyn, Alexander 1887- *WhAmArt 85*
Flynn, Miss *DcWomA*
Flynn, Mrs. *DcWomA*
Flynn, Arthur Morrell 1923- *AmArch 70*
Flynn, Charles Harold, Jr. 1923- *AmArch 70*
Flynn, Edward Albert 1910- *AmArch 70*
Flynn, Eugene George 1918- *AmArch 70*
Flynn, Henry Mayo, Jr. 1935- *AmArch 70*
Flynn, J T *AmArch 70*
Flynn, John Edward 1930- *AmArch 70*
Flynn, L B *AmArch 70*
Flynn, Lawrence Patrick 1937- *MarqDCG 84*
Flynn, Ruby M 1895- *ArtsAmW 3*
Flynn, William Vincent 1911- *AmArch 70*
Flynt, Clifton William 1953- *MarqDCG 84*
Fo-Hsiang-Ko *McGDA*
Foale And Tuffin *FairDF ENG*
Fobert, Joseph A 1880-1946 *WhAmArt 85*
Fobes, Elizabeth C *WhAmArt 85*
Focca, Italia *DcWomA*
Fockens, Elisabeth Geertrude *DcWomA*
Focosi, Alessandro 1839-1869 *ArtsNiC*
Fodor, John Joseph, Jr. 1924- *AmArch 70*
Fodor, Richard L 1946- *FolkA 86*
Foeller, Peter 1945- *DcCAr 81*
Foerster, A M *WhAmArt 85*
Foerster, Bernd 1923- *AmArch 70*
Foerster, Emil 1822-1906 *NewYHSD*
Foerster, John Francis 1930- *AmArch 70*
Foerster, Ludwig Von 1797-1863 *WhoArch*
Foersterling, Kathe *DcWomA*
Foerstock, George M *WhAmArt 85*
Foertmeyer, Emma 1866-1895 *DcWomA*
Fogarty, Ann 1919- *FairDF US*
Fogarty, Anne 1926- *WorFshn*
Fogarty, Frank 1887- *WhAmArt 85*
Fogarty, Jack Elmon 1945- *MarqDCG 84*
Fogarty, Thomas 1873-1938 *IlrAm A, -1880, WhAmArt 85*
Fogarty, Thomas J, Jr. *WhAmArt 85*
Fogel, Reuben W *WhAmArt 85*
Fogel, Seymour 1911- *AmArt, ClaDrA, WhAmArt 85, WhoAmA 73, -76, -78, -80, -82, -84, WhoArt 80, -82, -84*
Fogelberg, Ola 1894-1952 *WorECar*
Fogelburg, Andrew *AntBDN Q*
Fogeli *WorECar*
Fogg, Joseph *NewYHSD*
Fogg, Margaret Galloway *DcWomA, WhAmArt 85*
Fogg, Mary *FolkA 86*
Fogg, Mary 1918- *WhoArt 80, -82, -84*
Fogg, Mercy *FolkA 86*
Fogg-Gerber, Monica *WhoAmA 82, -84*
Foggie, David 1878-1948 *ClaDrA, DcBrA 1*
Foggini, Giovanni Battista 1652-1725 *McGDA*
Foggo, George 1793-1869 *DcVicP 2*
Foggo, James 1790-1860 *DcVicP 2*
Fogle, Lewis *FolkA 86*
Foglesong, Christopher *FolkA 86*
Foglesong, Mattie *DcWomA*
Fogliani, J R *AmArch 70*
Fogliardi, J B *NewYHSD*
Fogolino, Marcello *McGDA*
Fohl, Helga 1935- *DcCAr 81*
Fohn, Sofie 1899- *DcWomA*
Fohr, Jenny *WhoAmA 76, -78, -80, -82, -84*
Fohr, Karl Philipp 1795-1818 *McGDA*
Foirestier, Laure Marie *DcWomA*
Foit, F F *AmArch 70*
Fokke, Simon 1712-1784 *McGDA*
Folawn, Thomas Jefferson d1934 *WhAmArt 85*
Folawn, Thomas Jefferson 1876- *ArtsAmW 2*
Folayemi, Babatunde 1942- *AfroAA*
Folberg, Neil H 1950- *ICPEnP A, MacBEP*
Folcheri, Giuseppina *DcWomA*
Folchi, William Louis 1938- *MarqDCG 84*
Folck, Ella A *DcWomA*
Folda, Jaroslav 1940- *WhoAmA 78, -80*
Folda, Jaroslav, III 1940- *WhoAmA 82, -84*
Foldes, Lenke *DcWomA*
Foldes, Peter 1924-1977 *WorECar*
Folds, Thomas McKey 1908- *WhAmArt 85, WhoAmA 73, -76, -78, -80, -82, -84*
Foldsone, Anne *DcWomA*
Foldsone, John d1784 *DcBrECP*
Foldstone, Anne 1770?-1851 *AntBDN J*
Foley, Charles Vandeleur d1868 *DcVicP 2*
Foley, Cletis Roy 1913- *AmArch 70*
Foley, Cornelia Macintyre 1909- *WhAmArt 85*
Foley, G C E *DcVicP 2*
Foley, H W *DcVicP 2*
Foley, J B *DcBrWA*
Foley, J J *AmArch 70*

Foley, James *NewYHSD*
Foley, James David 1942- *MarqDCG 84*
Foley, James J 1922- *AmArch 70*
Foley, John *CabMA*
Foley, John H 1818-1875 *ArtsNiC*
Foley, John J *MarqDCG 84*
Foley, John J d1946 *BiDAmAr*
Foley, Joseph B *DcVicP 2*
Foley, Kathy Kelsey 1952- *WhoAmA 78, –80, –82, –84*
Foley, Kyoko Y 1928- *WhoAmA 76*
Foley, Kyoko Y 1933- *WhoAmA 78, –80, –82, –84*
Foley, Margaret 1820?-1877 *DcAmArt, WomArt*
Foley, Margaret 1827-1877 *DcWomA*
Foley, Margaret E d1877 *ArtsNiC*
Foley, Margaret F d1877 *NewYHSD*
Foley, Maurice E 1932- *MarqDCG 84*
Foley, Nicholas *FolkA 86, NewYHSD*
Foley, Theodore H *FolkA 86*
Foley, Timothy *CabMA*
Foley China Works *DcNiCA*
Foley Pottery *DcNiCA*
Folger, Alice Adele *DcWomA, WhAmArt 85*
Folger, Annie B *WhAmArt 85*
Folger, Annie Barker 1852-1941 *DcWomA*
Folger, David *FolkA 86*
Folger, Edwin G *NewYHSD*
Folger, Evans 1923- *AmArch 70*
Folger, Franklin 1919- *WorECar*
Folger, George 1927- *FolkA 86*
Folger, L *NewYHSD*
Folger, Marvin Young, Jr. 1932- *AmArch 70*
Folger, Phebe *DcWomA*
Folger, R *FolkA 86*
Folger, Richard T 1898- *WhAmArt 85*
Folger, Ruth Angell d1951 *DcWomA*
Folger, Ruth Angell d1955? *WhAmArt 85*
Folger, William B *NewYHSD*
Folgers, Kenneth N 1935- *AmArch 70*
Folguera Grassi, Francisco 1891-1960 *MacEA*
Folgueras, Lucine Ann 1947- *WhoAmA 80*
Foli, Rosita *DcVicP 2*
Folie, A P *NewYHSD*
Foligno *McGDA*
Folingsby, Clara *DcWomA*
Folingsby, George Frederick 1828-1891 *DcVicP 2*
Folingsby, George Frederick 1830-1891 *DcBrWA, NewYHSD*
Folingsby, Mrs. George Frederick *NewYHSD*
Folinsbee, John 1892- *WhAmArt 85*
Folk, D D, Jr. *AmArch 70*
Folk, John *FolkA 86*
Folkard, B *DcVicP 2*
Folkard, Charles James 1878- *DcBrBI*
Folkard, Charles James 1878-1963 *ConICB, DcBrA 1, IlsCB 1744*
Folkard, Edward 1911- *DcBrA 1*
Folkard, Elizabeth F *DcVicP 2, DcWomA*
Folkard, Julia Bracewell 1849-1933 *DcBrA 1, DcVicP 2, DcWomA*
Folkard, W *NewYHSD*
Folkard, W A *DcBrBI*
Folkee, L H *AmArch 70*
Folkema, Anna 1695-1768 *DcWomA*
Folkema, Fopje *DcWomA*
Folker, D L *AmArch 70*
Folkert, Melvin Burtus 1925- *MarqDCG 84*
Folkes, Peter L 1923- *ClaDrA*
Folkes, Peter Leonard 1923- *DcBrA 1, WhoArt 80, –82, –84*
Folks, F C *DcVicP 2*
Folkus, Dan 1946- *WhoAmA 80, –82, –84*
Folland, Ronald Norman 1932- *WhoArt 82, –84*
Follet, Mary 1790- *FolkA 86*
Follett, Cathleen S *DcWomA*
Follett, Foster *WhAmArt 85*
Follett, Georgina 1949- *DcCAr 81*
Follett, J L *AmArch 70*
Follett, Jean F 1917- *DcCAA 71, –77*
Follett, Jean Frances 1917- *WhoAmA 78, –80, –82, –84*
Follett, T *FolkA 86*
Folleville, Marie Madeleine *DcWomA*
Folley, Milo D 1915- *AmArch 70*
Follis, John *AmGrD[port]*
Follis, Mark B 1926- *AmArch 70*
Follot, Helene *DcWomA*
Follot, Paul 1877-1941 *DcNiCA*
Follrath, Darwin 1909- *WhAmArt 85*
Folon, Jean-Michel 1934- *ConDes, DcCAr 81, PrintW 83, WorECar*
Folon, Jean Michel 1934- *PrintW 85, WhoGrA 82[port]*
Folse, Byron Thomas 1938- *AmArch 70*
Folse, Henrietta Winifred 1910- *WhAmArt 85*
Folse, S J, Jr. *AmArch 70*
Folsom, Mrs. *FolkA 86*
Folsom, Abraham 1805-1886 *NewYHSD*
Folsom, C A *NewYHSD*
Folsom, Clara M *FolkA 86*

Folsom, Elizabeth A 1812-1899 *DcWomA, NewYHSD*
Folsom, Ethel F *DcWomA, WhAmArt 85*
Folsom, F J *DcWomA*
Folsom, Frances *WhAmArt 85*
Folsom, George 1859-1919 *WhAmArt 85*
Folsom, George W *WhAmArt 85*
Folsom, Janet 1905- *WhAmArt 85*
Folsom, John Robert 1935- *AmArch 70*
Folsom, Karl Leroy 1938- *WhoAmA 76, –78, –80, –82, –84*
Folsom, R Bruce 1910- *AmArch 70*
Folsom, R G *AmArch 70*
Folson, Abraham *FolkA 86*
Folson, E F *WhAmArt 85*
Foltyn, Petr 1941- *DcCAr 81*
Foltz, Frederick L 1843-1916 *BiDAmAr*
Foltz, Harry *FolkA 86*
Foltz, Herbert W 1867-1947? *BiDAmAr*
Foltz, Josephine Kieffer 1880- *DcWomA, WhAmArt 85*
Foltz, Karoline 1852- *DcWomA*
Foltz, Lloyd C 1897- *WhAmArt 85*
Foltz, Lloyd Chester 1897- *ArtsAmW 2*
Foltz, Philippe 1805- *ArtsNiC*
Foltz, Robert E 1922- *AmArch 70*
Foltz, Walter W 1923- *AmArch 70*
Folwell, G *NewYHSD*
Folwell, J D *AmArch 70*
Folwell, John *CabMA*
Folwell, Samuel 1765-1813 *AntBDN O, NewYHSD*
Fomin, Ivan A 1872-1936 *MacEA*
Fomina, Iraida 1906- *WhoGrA 62*
Fon, Jade 1911- *WhoAmA 76, –78, –80, –82, –84*
Fon, W W *WhAmArt 85*
Fonbonne, Anne *DcWomA*
Fond, Etienne Antoinette *DcWomA*
Fonda, H S *WhAmArt 85*
Fonda, Harry Stuart 1863-1942 *ArtsAmW 1*
Fonda, Mina M *DcWomA, WhAmArt 85*
Fonda-Bonardi, Giusto *MarqDCG 84*
Fonde, C *NewYHSD*
Fondiller, Harvey V 1920- *MacBEP*
Fondren, Harold M 1922- *WhoAmA 73, –76, –78, –80, –82, –84*
Fonduti, Agostino Dei *McGDA*
Fonelli, J Vincent 1906- *WhoAmA 73, –76*
Foner, Liza 1912- *WhoAmA 76*
Fong, Allen Don 1931- *AmArch 70*
Fong, B H *AmArch 70*
Fong, Brian E 1960- *MarqDCG 84*
Fong, Clarence Hunky *AmArch 70*
Fong, Freddie 1952- *DcCAr 81*
Fong, Miller Yee 1941- *AmArch 70*
Fong, Wylog *WhAmArt 85*
Fonnereau, Thomas George 1789-1850 *DcBrWA*
Fonoyll, Raynard *McGDA*
Fonquergne, M 1878- *DcWomA*
Fonseca, Antoine-Manoel Da 1795?- *ArtsNiC*
Fonseca, Gonzalo *OxTwCA*
Fonssagrives, Lisa 1911- *WorFshn*
Font, Miguel 1936- *AmArch 70*
Font Guma, Jose 1860-1922 *MacEA*
Font I Carreras, August 1846-1924 *MacEA*
Fontaine, Mademoiselle *DcWomA*
Fontaine, B E *AfroAA*
Fontaine, Christian Jean 1945- *MarqDCG 84*
Fontaine, Genevieve *DcWomA*
Fontaine, H 1912?- *AfroAA*
Fontaine, Jacques-Francois-Joseph *McGDA*
Fontaine, Jenny 1862- *DcWomA*
Fontaine, Marie Antoinette *DcWomA*
Fontaine, Marie Claire *DcWomA*
Fontaine, Marie Emilie 1816-1877 *DcWomA*
Fontaine, Oliver Walter 1900- *AmArch 70*
Fontaine, Paul *WhAmArt 85*
Fontaine, Pierre *McGDA*
Fontaine, Pierre 1762-1853 *MacEA*
Fontaine, Pierre-Francois *OxArt*
Fontaine, Pierre-Francois Leonard *OxDecA*
Fontaine, Pierre Francois Leonard 1762-1853 *DcD&D*
Fontaine, Pierre Leonard 1762-1845 *WhoArch*
Fontaine, Walter Francis 1871-1938 *BiDAmAr*
Fontan, Marie Louise 1863- *DcWomA*
Fontan, Pierre *WhAmArt 85*
Fontana, Annibale 1540-1587 *McGDA*
Fontana, Bianca *DcWomA*
Fontana, Bill Patrick 1947- *WhoAmA 84*
Fontana, Carlo 1634-1714 *DcD&D, McGDA, OxArt*
Fontana, Carlo 1638-1714 *MacEA, WhoArch*
Fontana, Domenico 1543-1607 *DcD&D, MacEA, McGDA, OxArt*
Fontana, Franco 1933- *ConPhot, ICPEnP A, MacBEP*
Fontana, Giovanni 1540-1614 *MacEA*
Fontana, Lavinia 1552-1602 *ClaDrA*
Fontana, Lavinia 1552-1614 *DcWomA, WomArt*
Fontana, Lucio 1899-1968 *ConArt 77, –83, McGDA, OxTwCA, PhDcTCA 77*
Fontana, Orazio *McGDA*
Fontana, Prospero 1512-1597 *McGDA, OxArt*

Fontana, Roberto *ArtsNiC*
Fontana, Ruben 1942- *WhoGrA 82[port]*
Fontana, Sorelle *FairDF ITA*
Fontana, V *DcVicP 2*
Fontana, Veronica 1651-1690 *DcWomA*
Fontanelli, Carlo 1755-1780 *DcBrECP*
Fontanes, Louise Mechin *DcWomA*
Fontanese, Alvin Thomas 1930- *AmArch 70*
Fontanez, Carmelo 1945- *WhoAmA 73, –76, –78*
Fontanills, P *AmArch 70*
Fontanini, Clare *WhoAmA 73, –76, –78, –80, –82, –84*
Fontass, Jean *NewYHSD*
Fontcuberta, Joan 1955- *ConPhot, ICPEnP A, MacBEP*
Fontelli, L De *NewYHSD*
Fontenay, Louis Henri De 1800- *ClaDrA*
Fontsere Mestres, Jose 1829-1897 *MacEA*
Fontville, A *DcVicP 2*
Fonville, Horace *ArtsNiC*
Fonyat, Bina 1945- *ICPEnP A*
Fookes, Charles B *BiDBrA*
Foolery, Tom 1947- *WhoAmA 82, –84*
Foolery, Tom 1949- *AmArt*
Foord, F A *AmArch 70*
Foord, J *DcWomA*
Foort, Karel 1510-1562 *ClaDrA*
Foosaner, Judith 1940- *WhoAmA 82, –84*
Foosaner, Judith Ann 1940- *WhoAmA 73, –76, –78*
Foose, Richard Mansfield, Jr. 1930- *AmArch 70*
Foose, Robert James 1938- *WhoAmA 76, –78, –80, –82, –84*
Foot, Abigail *FolkA 86*
Foot, D *FolkA 86*
Foot, Elizabeth *FolkA 86*
Foot, F *DcVicP 2*
Foot, F H *FolkA 86*
Foot, Fanny 1811- *FolkA 86*
Foot, Jane E *DcWomA*
Foot, Lewis 1789-1831 *FolkA 86*
Foot, Lucy *FolkA 86*
Foot, Mary *FolkA 86*
Foot, Rita 1886-1965 *DcBrA 2*
Foot, Thomas *CabMA*
Foot, Victorine Anne 1920- *DcBrA 1, WhoArt 80, –82, –84*
Foot, William Yates *DcVicP 2*
Foot And Colson *EncASM*
Foote, Abigail *FolkA 86*
Foote, Bessie *DcWomA*
Foote, D J *AmArch 70*
Foote, Edward K *DcVicP 2*
Foote, Elizabeth *FolkA 86*
Foote, Howard Reed 1936- *WhoAmA 78, –80, –82, –84*
Foote, J Mike 1923- *AmArch 70*
Foote, Jim *FolkA 86*
Foote, John, Jr. d1968 *WhoAmA 78N, –80N, –82N, –84N*
Foote, John Parsons 1783-1865 *NewYHSD*
Foote, Jonathan Lipe 1935- *AmArch 70*
Foote, Josephine J *DcWomA, WhAmArt 85*
Foote, Kimberly *MarqDCG 84*
Foote, Lewis *FolkA 86*
Foote, Mary *FolkA 86*
Foote, Mary 1872-1968 *DcWomA, WhAmArt 85*
Foote, Mary Anna 1847-1938 *DcWomA*
Foote, Mary Hallock *ArtsNiC*
Foote, Mary Hallock 1847-1938 *ArtsAmW 1, EarABI, EarABI SUP, IlBEAAW, IlrAm 1880, WhAmArt 85*
Foote, Mary Turner *WhAmArt 85*
Foote, Nancy *WhoAmA 78*
Foote, Robert *BiDBrA*
Foote, Will Howe d1965 *WhoAmA 78N, –80N, –82N, –84N*
Foote, Will Howe 1874- *ArtsEM*
Foote, Will Howe 1874-1965 *WhAmArt 85*
Footner, Frances Amicia DeBiden *DcBrA 1, DcWomA*
Footner, William 1799-1872 *MacEA*
Foottet, Frederick Francis 1850-1935 *DcBrA 1*
Foottit, F *DcVicP 2*
Foppa, Cristoforo *McGDA*
Foppa, Vincenzio 1427?-1515 *OxArt*
Foppa, Vincenzo 1427?-1516? *McGDA*
Fora, Louis *NewYHSD*
Forain, Jean Louis 1852-1931 *ClaDrA, McGDA, OxArt*
Forain, Jean-Louis 1852-1931 *OxTwCA, PhDcTCA 77, WorECar*
Forakis, Peter 1927- *DcCAA 71, –77, WhoAmA 73, –76, –78, –80, –82, –84*
Foran, W J *AmArch 70*
Foraner, Robert *FolkA 86*
Forattini, Giorgio 1932- *WorECar*
Forbat, Fred 1897-1972 *MacEA*
Forbell, Charles 1886-1946 *WhAmArt 85*
Forbell, Charles H 1886-1946 *WorECar*
Forberg, Ati *IlsCB 1967*
Forberg, Ati 1925- *IlsCB 1957*

Forbes *EncASM*
Forbes, Anne 1745-1834 *DcBrECP*, *DcWomA*
Forbes, Arthur Graham 1927- *AmArch 70*
Forbes, Bart *OfPGCP 86*
Forbes, Bart 1939- *IlrAm 1880*
Forbes, C *DcWomA*
Forbes, Charles F *WhAmArt 85*
Forbes, Charles S *WhAmArt 85*
Forbes, Charles Stuart 1856-1926 *DcVicP 2*
Forbes, Colin 1928- *ConDes*, *WhoGrA 82[port]*
Forbes, Donald 1952- *WhoArt 84*
Forbes, Donna Marie 1929- *WhoAmA 78*, *-80*, *-82*, *-84*
Forbes, Mrs. E Armstrong *WhAmArt 85*
Forbes, Edward W d1969 *WhoAmA 78N*, *-80N*, *-82N*, *-84N*
Forbes, Edward Waldo 1873-1969 *WhAmArt 85*
Forbes, Edwin 1839- *ArtsNiC*
Forbes, Edwin 1839-1895 *EarABI*, *EarABI SUP*, *IlBEAAW*, *NewYHSD*
Forbes, Edwin C 1839-1895 *WhAmArt 85*
Forbes, Edwin M 1899- *AmArch 70*
Forbes, Elisha *EarABI SUP*, *NewYHSD*
Forbes, Elizabeth Adela 1859-1912 *ClaDrA*, *DcBrBI*
Forbes, Elizabeth Adela Stanhope 1859-1912 *DcBrA 1*, *DcBrWA*, *DcWomA*
Forbes, Ernest *DcBrA 1*
Forbes, Gaylord H, Jr. 1938- *AmArch 70*
Forbes, H *DcVicP 2*
Forbes, Hannah Lucinda *DcWomA*, *FolkA 86*, *NewYHSD*
Forbes, Heather Mary 1948- *MacBEP*
Forbes, Helen 1891- *WhAmArt 85*
Forbes, Helen K 1891-1945 *ArtsAmW 1*
Forbes, Helen Katharine 1891-1945 *DcWomA*
Forbes, Helen Katherine 1891- *IlBEAAW*
Forbes, J *DcBrBI*
Forbes, J Colin *WhAmArt 85*
Forbes, J M *AmArch 70*
Forbes, Jack *FolkA 86*
Forbes, James 1749-1819 *DcBrWA*
Forbes, James David 1809-1868 *DcBrBI*
Forbes, James G 1800- *DcVicP 2*
Forbes, John 1795- *WhoArch*
Forbes, John Allison 1922- *WhoAmA 84*
Forbes, John B *BiDBrA*
Forbes, John Colin 1846-1925 *DcBrA 2*
Forbes, Julia O *DcWomA*
Forbes, Katharine Greeley 1902- *WhAmArt 85*
Forbes, Laura S *WhAmArt 85*
Forbes, Lionel C V 1898- *WhAmArt 85*
Forbes, Miss M *DcBrA 1*
Forbes, Maud C Stanhope *DcWomA*
Forbes, Patrick Lewis *DcVicP 2*
Forbes, Ronald 1947- *WhoArt 80*, *-82*, *-84*
Forbes, Stanhope *OxTwCA*
Forbes, Mrs. Stanhope 1859-1912 *DcVicP*, *-2*
Forbes, Stanhope Alexander 1857-1947 *DcBrA 1*, *DcVicP*, *-2*
Forbes, Vivian 1891-1937 *DcBrA 1*, *DcWomA*
Forbes, W N 1796-1855 *MacEA*
Forbes-Dalrymple, Arthur Ewan 1912- *DcBrA 1*
Forbes-Oliver, H 1908- *WhAmArt 85*
Forbes-Robertson *DcVicP 2*
Forbes-Robertson, Eric J 1865-1935 *DcBrA 1*
Forbes-Robertson, Frances *DcWomA*
Forbes-Robertson, Frances 1866-1956 *DcBrA 2*
Forbes-Robertson, Margaret *DcWomA*
Forbin, Louis Nicolas Philippe Auguste 1777-1841 *ClaDrA*
Forbis, Steve *OfPGCP 86*
Forbriger, Adolf *NewYHSD*
Forbriger, Adolphus *NewYHSD*
Forbriger, C A *WhAmArt 85*
Forbush, Gary D 1933- *AmArch 70*
Forbush, Marie R *ArtsAmW 3*
Forbush, Mrs. William Byron *DcWomA*, *WhAmArt 85*
Force, Anne 1884- *ArtsAmW 3*
Force, Clara G 1852-1939 *ArtsAmW 2*, *DcWomA*, *WhAmArt 85*
Force, Frances P *ArtsEM*, *DcWomA*
Force, Juliana R d1948 *WhoAmA 78N*, *-80N*, *-82N*, *-84N*
Force, Roland Wynfield 1924- *WhoAmA 82*, *-84*
Forceville, M J Emilie 1867- *DcWomA*
Forchhammer, Emilie 1850-1912 *DcWomA*
Ford, Miss *DcBrECP*, *DcWomA*
Ford, A *NewYHSD*
Ford, Arva 1890- *ArtsAmW 3*
Ford, B *DcVicP 2*
Ford, Barbara J 1956- *MarqDCG 84*
Ford, Bonnie 1945- *MacBEP*
Ford, Brian H *MarqDCG 84*
Ford, Celinda *DcWomA*
Ford, Charles Henri *WhoAmA 73*, *-76*, *-78*, *-80*, *-82*, *-84*
Ford, Cherry *DcWomA*
Ford, Claude Arnold 1928- *AmArch 70*
Ford, Clement J 1906- *AmArch 70*
Ford, E Onslow 1852-1901 *AntBDN C*

Ford, E R, Jr. *AmArch 70*
Ford, Edward Onslow 1852-1901 *DcBrA 1*, *McGDA*
Ford, Edwin Joseph 1914- *WhAmArt 85*
Ford, Eleanor Clay 1896-1976 *WhoAmA 78N*, *-80N*, *-82N*, *-84N*
Ford, Elizabeth Merrill 1904- *WhAmArt 85*
Ford, Elsie Mae *WhAmArt 85*
Ford, Emily S *DcVicP 2*
Ford, F *DcBrWA*, *DcVicP 2*
Ford, F J *DcVicP 2*
Ford, F L *AmArch 70*
Ford, Frank Raymond 1909- *AmArch 70*
Ford, G C *DcWomA*
Ford, Gary L 1950- *MarqDCG 84*
Ford, George *AfroAA*, *IlsCB 1967*
Ford, George B 1879-1930 *BiDAmAr*
Ford, George H *ArtsEM*
Ford, George Henry *WhoAmA 80N*
Ford, George Henry 1912- *DcBrA 1*
Ford, Grace W *ArtsEM*, *DcWomA*
Ford, H L *AmArch 70*
Ford, Harriet *DcVicP 2*, *DcWomA*
Ford, Harriet 1806-1837 *DcBrWA*
Ford, Harriet Mary 1859-1939 *DcWomA*
Ford, Harry Xavier 1921- *WhoAmA 78*, *-80*, *-82*, *-84*
Ford, Helen Louise 1879- *ArtsAmW 1*, *DcWomA*
Ford, Henry Chapman 1828-1894 *ArtsAmW 1*, *IlBEAAW*, *NewYHSD*
Ford, Henry Justice 1860-1941 *ClaDrA*, *DcBrA 1*, *DcBrBI*, *DcVicP*, *-2*
Ford, Henry Penn 1916- *AmArch 70*
Ford, J *DcBrWA*
Ford, J A *DcVicP 2*
Ford, J S *FolkA 86*
Ford, James d1781 *NewYHSD*
Ford, James Andrew, Jr. 1942- *MarqDCG 84*
Ford, James Elliott 1926- *AmArch 70*
Ford, James W d1866 *NewYHSD*
Ford, Jenifer 1934- *WhoArt 80*, *-82*, *-84*
Ford, Jeremiah, III 1932- *AmArch 70*
Ford, John 1950- *WhoAmA 84*
Ford, John Charles 1929- *WhoAmA 73*, *-76*, *-78*, *-80*, *-82*, *-84*
Ford, John Gilmore *WhoAmA 78*, *-80*, *-82*, *-84*
Ford, John Gilmore 1928- *WhoAmA 73*, *-76*
Ford, Kathleen Marie Bourdelaise 1954- *MarqDCG 84*
Ford, L W Neilson d1931 *DcWomA*, *WhAmArt 85*
Ford, Lauren 1891- *IlsCB 1744*, *-1946*, *WhAmArt 85*
Ford, Lauren 1891-1973 *DcWomA*
Ford, Leslie 1885-1959 *DcBrA 1*
Ford, M L *AmArch 70*
Ford, Marcus Holley 1914- *DcBrA 1*
Ford, Michael 1920- *DcBrA 1*, *WhoArt 80*, *-82*, *-84*
Ford, Olga Gemes *WhoArt 80*, *-82*, *-84*
Ford, O'Neil 1905- *AmArch 70*, *ConArch*
Ford, O'Neil 1905-1982 *MacEA*
Ford, R G *AmArch 70*
Ford, R Onslow *DcVicP 2*
Ford, Richard 1796-1858 *DcBrWA*
Ford, Robert MacDonald, III 1934- *AmArch 70*
Ford, Ronald Williams 1933- *AmArch 70*
Ford, Ruth 1897?- *DcWomA*
Ford, Ruth VanSickle 1897- *WhAmArt 85*, *WhoAmA 73*, *-76*, *-78*, *-80*, *-82*, *-84*
Ford, Saddie *FolkA 86*
Ford, Sherwood D 1872-1948 *BiDAmAr*
Ford, Stephen Kent 1941- *AmArch 70*
Ford, Trevor Nelson 1953- *MacBEP*
Ford, W A *ArtsEM*
Ford, W L *AmArch 70*
Ford, William *NewYHSD*
Ford, Mrs. William B *WhAmArt 85*
Ford, William Bishop 1832-1922 *DcBrA 2*
Ford, Winifred 1879- *DcWomA*, *WhAmArt 85*
Ford, Wolfram Onslow *DcBrA 1*, *DcVicP 2*
Ford And Carpenter *EncASM*
Ford Smith, James William 1939- *WhoArt 80*, *-82*, *-84*
Forde, Ed 1945- *DcCAr 81*
Forde, Samuel 1805-1828 *DcBrWA*
Forden, E *FolkA 86*
Fordenbach, E *FolkA 86*
Forder, George d1864 *BiDBrA*
Fordet, Comtesse De *DcWomA*
Fordham, Elijah 1798-1879 *NewYHSD*
Fordham, Elwood James 1913- *WhAmArt 85*
Fordham, George W *NewYHSD*
Fordham, H *FolkA 86*
Fordham, Hubbard L *NewYHSD*
Fordice, Dave 1957- *MarqDCG 84*
Fordyce, A Grant *AmArch 70*
Fordyce, J D *DcWomA*
Fore, Anna McC *WhAmArt 85*
Forehand, Roy Earl 1927- *AmArch 70*
Forel, Emmeline 1860- *DcWomA*
Forel, Oscar-Louis 1891- *MacBEP*

Foreman, Agnes Emily *DcWomA*
Foreman, Alice Emily 1865-1920? *DcBrA 1*, *DcWomA*
Foreman, Clifford Glenn *AmArch 70*
Foreman, Doyle 1933- *AfroAA*
Foreman, Edgar W *NewYHSD*
Foreman, Joseph *NewYHSD*
Foreman, Margaret *DcCAr 81*
Foreman, Mary Lou *FolkA 86*
Foreman, Michael 1938- *IlsCB 1967*, *WhoGrA 82[port]*
Foreman, Regina *FolkA 86*
Foreman, Roland M 1917- *AmArch 70*
Foreman, S N *DcWomA*
Foreman, Miss S N *NewYHSD*
Fores, Mary H *DcVicP 2*
Foresman, Alice C 1868- *WhAmArt 85*
Foresman, Alice Carter 1868- *ArtsAmW 2*, *DcWomA*
Forest, Eugene Hippolyte 1808- *DcBrBI*
Forest, Fred 1933- *ConArt 77*
Forest, H *DcVicP 2*
Forest, Jean-Claude 1930- *WorECom*
Forest, John *CabMA*
Forest, Katherine d1955? *WhAmArt 85*
Forester, J J *NewYHSD*
Forester, Paul Peter 1925- *WhoAmA 76*
Forester, R *AmArch 70*
Forester, Russell 1920- *WhoAmA 78*, *-80*, *-82*, *-84*
Forestier, A *DcVicP 2*
Forestier, Alice De *DcVicP 2*, *DcWomA*
Forestier, Jeanne J G *DcWomA*
Forestier, Lucienne *DcWomA*
Forestier, Marie Anne Julie 1789- *DcWomA*
Forestier-Barbe, Andree *DcWomA*
Forestier-Walker, Mollie 1912- *ClaDrA*, *DcBrA 1*
Forestiere, Baldasare 1879-1946 *MacEA*
Forfar, D H *AmArch 70*
Forg, P *FolkA 86*
Forge, Andrew Murray 1923- *DcBrA 1*, *WhoAmA 78*, *-80*, *-82*, *-84*, *WhoArt 80*, *-82*, *-84*
Forge, Del 1938- *MarqDCG 84*
Forget, Marie Therese *DcWomA*
Forgey, Benjamin F 1938- *WhoAmA 82*, *-84*
Forgue, Apollonie De *DcWomA*
Forgy, J R *AmArch 70*
Foringer, A E 1878- *WhAmArt 85*
Foris, T N *AmArch 70*
Forkert, Otto Maurice 1901- *WhAmArt 85*
Forkner, Edgar d1945 *WhAmArt 85*
Forkner, Edgar 1867-1945 *ArtsAmW 2*
Forlani, Louis G *MarqDCG 84*
Forleo-Brayda, Francesca 1779-1820 *DcWomA*
Forlidas, Angelo John 1927- *AmArch 70*
Forman, Albert J 1928- *MarqDCG 84*
Forman, Alice 1931- *AmArt*, *WhoAmA 73*, *-76*, *-78*, *-80*, *-82*, *-84*
Forman, Ben *EncASM*
Forman, H Chandlee *AmArch 70*
Forman, Helen *WhAmArt 85*
Forman, Henry Chandlee 1904- *WhAmArt 85*
Forman, Irene B *FolkA 86*
Forman, Kenneth Warner 1925- *WhoAmA 73*, *-76*, *-78*, *-80*, *-82*, *-84*
Forman, Kerr S 1889- *WhAmArt 85*
Forman, Kerr Smith 1889- *ArtsAmW 2*
Forman, Mary *DcWomA*
Forman, Nessa Ruth 1943- *WhoAmA 76*, *-78*, *-80*, *-82*
Forman, Stanley 1945- *ICPEnP A*
Forman, Stanley J 1945- *MacBEP*
Forman, W E *AmArch 70*
Forment, Damian d1540 *OxArt*
Forment, Damian 1475?-1540 *McGDA*
Formentin, Mademoiselle *DcWomA*
Formica, Frank 1915- *AmArch 70*
Formicola, John Joseph 1941- *WhoAmA 82*, *-84*
Formige, Marie Emma *DcWomA*
Formigoni, Mauri Monihon 1941- *WhoAmA 80*, *-82*, *-84*
Formigoni, Maurie Monihon 1941- *WhoAmA 76*, *-78*
Formilli, C *DcVicP 2*
Formilli, T G Cesare *DcVicP 2*
Formstecher, Anna 1848- *DcWomA*
Formstecher, Bertha *DcWomA*
Formstecher, Emma *DcWomA*
Formstecher, Helene 1852- *DcWomA*
Formwalt, John McClellan 1915- *MarqDCG 84*
Fornara, J A *AmArch 70*
Fornara, Elisa 1724-1796 *DcWomA*
Fornaro, Marie Louise 1812-1840 *DcWomA*
Fornas, Leander 1925- *WhoAmA 76*, *-78*, *-80*, *-82*, *-84*
Fornasetti, Piero 1913- *DcD&D*, *WhoGrA 62*
Fornelli, Joseph 1943- *WhoAmA 82*, *-84*
Forner, Raquel 1902- *McGDA*, *OxTwCA*, *PhDcTCA 77*
Forney *NewYHSD*
Forney, Clarisse *DcWomA*
Forney, Henry *FolkA 86*
Forni, Lucrezia *DcWomA*

Fornier, Kitty d1908? *DcWomA*
Fornier DeViolet, Clotilde *DcWomA*
Forquet, Federico *FairDF ITA*
Forrer, Johann *FolkA 86*
Forrer, Martin 1815?-1890 *FolkA 86*
Forrer, Mary Pierce *DcWomA*
Forrest, A *DcVicP 2*
Forrest, Archibald Robin 1943- *MarqDCG 84*
Forrest, Archibald Stevenson 1864- *DcBrBI*
Forrest, Archibald Stevenson 1869-1963 *DcBrA 1, DcVicP 2*
Forrest, Brian *DcCAr 81*
Forrest, Charles *DcBrECP, NewYHSD*
Forrest, Charles 1748?- *DcBrWA*
Forrest, Christopher P *OfPGCP 86*
Forrest, Christopher Patrick 1946- *WhoAmA 84*
Forrest, Don *OfPGCP 86*
Forrest, Edward 1919- *MarqDCG 84*
Forrest, Gordon Anderson 1938- *AmArch 70*
Forrest, Haughton 1825-1924 *DcSeaP*
Forrest, Isabelle *DcBrBI*
Forrest, James Taylor 1921- *WhoAmA 76, -78, -80, -82, -84*
Forrest, John B 1814?-1870 *NewYHSD*
Forrest, John Steven 1937- *AmArch 70*
Forrest, Linn A, Sr. 1905- *AmArch 70*
Forrest, Nita *DcCAr 81*
Forrest, Norman John 1898- *DcBrA 1*
Forrest, Thomas Theodosius 1728-1784 *DcBrECP, DcBrWA*
Forrest, W S *DcVicP 2*
Forrest, William O'Fallon 1897-1947 *WhAmArt 85*
Forrestall, Thomas DeVany 1936- *DcCAr 81, WhoAmA 73, -76, -78, -80, -82, -84*
Forrestall, Tom *OxTwCA*
Forrester, Alfred Henry 1804-1872 *DcVicP 2*
Forrester, Alfred Henry 1806-1872 *ArtsNiC*
Forrester, Anna Hardie 1875- *DcWomA*
Forrester, Charles Howard 1928- *WhoAmA 78, -80, -82, -84*
Forrester, H S *AmArch 70*
Forrester, James *DcBrWA*
Forrester, James 1730-1776 *DcBrECP*
Forrester, John 1922- *PhDcTCA 77*
Forrester, Joseph James, Baron De 1809-1861 *DcBrWA*
Forrester, Laura Pope *FolkA 86*
Forrester, Patricia Tobacco 1940- *AmArt, WhoAmA 84*
Forrester, Terry Norman 1935- *AmArch 70*
Forrestier, Alfred Henry *DcBrBI*
Forrestier, Amedee 1854-1930 *DcBrBI*
Forrette, Clayton H 1929- *AmArch 70*
Forry, Rudolph 1827-1914 *FolkA 86*
Forsberg, Elmer A 1883- *ArtsAmW 3, WhAmArt 85*
Forsberg, James Alfred 1919- *WhoAmA 73*
Forsberg, Jim 1919- *WhoAmA 76, -78, -80*
Forsboom, Maria Anna Franziska *DcWomA*
Forsdick, Horace 1840?- *ArtsEM*
Forsell, Jacob 1942- *ICPEnP A*
Forselles, Sigrid Maria Rosina 1860- *DcWomA*
Forshall, Francis S Hyde *DcVicP 2*
Forshey, W *NewYHSD*
Forslund, A 1891- *ArtsAmW 3*
Forslund, Carl Victor, Jr. 1927- *WhoAmA 76*
Forslund, Mrs. Victor 1891- *ArtsAmW 3*
Forsman, Alina 1845- *DcWomA*
Forsman, Chuck 1944- *WhoAmA 78, -80, -82, -84*
Forsmann, Abel Margaretha Sophia 1753-1836 *DcWomA*
Forsmann, Alina 1845- *DcWomA*
Forsmann, Franz Gustav Joachim 1795-1878 *MacEA*
Forssell, Eugenie 1808-1833 *DcWomA*
Forst, D M *AmArch 70*
Forst, Miles 1923- *DcCAA 71, -77, WhoAmA 73, -76, -78, -80, -82, -84*
Forster, Miss *DcWomA*
Forster, Mrs. *DcWomA*
Forster, Abraham *CabMA*
Forster, C *DcVicP 2*
Forster, C F, Sr. *DcVicP 2*
Forster, Charles 1789-1866 *CabMA*
Forster, Charles, Jr. *DcVicP 2*
Forster, Emil Von 1838-1909 *MacEA*
Forster, Emilie *WhAmArt 85*
Forster, Emily *DcVicP 2, DcWomA*
Forster, Ernest *ArtsEM*
Forster, Ernst Joachim 1800-1885 *ClaDrA*
Forster, F L M *DcBrA 1*
Forster, F V *DcVicP 2*
Forster, Francois 1790- *ArtsNiC*
Forster, Frank Joseph 1886-1948 *BiDAmAr*
Forster, Hannah Von *DcWomA*
Forster, J *DcBrWA, DcVicP 2, DcWomA*
Forster, Jacob 1764-1838 *CabMA*
Forster, Joseph Wilson *DcVicP 2*
Forster, Juliana 1943- *WhoArt 80, -82, -84*
Forster, Ludwig 1797-1863 *McGDA*
Forster, Ludwig Von 1797-1863 *MacEA*
Forster, M W *DcWomA, WhAmArt 85*
Forster, Mary *DcVicP 2, DcWomA*
Forster, Noel 1932- *ConBrA 79[port], DcCAr 81*

Forster, P *DcVicP 2*
Forster, Peggy Lucille 1925- *WhoAmA 73*
Forster, R Patrick *MarqDCG 84*
Forster, Selina *DcVicP 2*
Forster, T B W *DcVicP 2*
Forster, Thomas 1677?- *AntBDN J*
Forster, Washburne 1884- *ArtsAmW 2*
Forster, William *FolkA 86*
Forster, William 1739-1808 *AntBDN K*
Forster And Lawrence *CabMA*
Forstl, M *AmArch 70*
Forsyth, Adam *DcBrBI, DcVicP 2*
Forsyth, Alexander John 1768-1843 *AntBDN F*
Forsyth, Alice Atkinson *DcWomA*
Forsyth, Cecilia *DcWomA*
Forsyth, Constance 1903- *WhAmArt 85, WhoAmA 73, -76, -78, -80, -82, -84*
Forsyth, Elizabeth Villere 1911- *WhAmArt 85*
Forsyth, Gordon M 1879-1952 *ClaDrA*
Forsyth, Gordon Mitchell 1879-1952 *DcBrA 1*
Forsyth, Ilene H 1928- *WhoAmA 84*
Forsyth, James Nesfield 1864- *DcBrA 1*
Forsyth, James William Alexander 1910- *DcBrA 1, WhoArt 80, -82*
Forsyth, John *NewYHSD*
Forsyth, M C *AmArch 70*
Forsyth, Moira 1905- *WhoArt 80, -82, -84*
Forsyth, Raymond *NewYHSD*
Forsyth, Robert *NewYHSD*
Forsyth, Robert Joseph 1921- *WhoAmA 73, -76, -78, -80, -82*
Forsyth, W *DcVicP 2*
Forsyth, William 1854-1935 *WhAmArt 85*
Forsyth, William H 1906- *WhoAmA 73, -76*
Forsythe, Clyde 1885-1962 *ArtsAmW 1*
Forsythe, J E *WhAmArt 85*
Forsythe, Richard Adams 1929- *AmArch 70*
Forsythe, Robert Edwin 1924- *AmArch 70*
Forsythe, Victor Clyde 1885-1962 *IlBEAAW, WhAmArt 85*
Fort, Alexander 1645?-1706 *BiDBrA*
Fort, Evelyn Corlett 1895- *WhAmArt 85*
Fort, Gladys C 1891- *WhAmArt 85*
Fort, Martha *DcWomA*
Fort, Martha F *WhAmArt 85*
Fort, Thomas d1745 *BiDBrA*
Fort-Brescia, Bernardo M 1951- *WhoAmA 82, -84*
Fort-Simeon, Elisabeth *DcWomA*
Forte, Vicente *OxTwCA*
Fortescu, Lady *DcWomA*
Fortescue, Henrietta Anne d1841 *DcBrWA*
Fortescue, W B d1924 *DcBrA 1*
Fortescue, William B d1924 *DcVicP 2*
Fortescue-Brickdale, Eleanor *DcVicP, -2, DcWomA*
Fortescue-Brickdale, Eleanor 1871-1945 *DcBrA 1*
Fortess, Karl E 1907- *DcCAA 71, -77, WhoAmA 78, -80, -82, -84*
Fortess, Karl Eugene 1907- *WhAmArt 85, WhoAmA 73, -76*
Forth, Catherine Mary 1954- *MarqDCG 84*
Forth, Dorothea *DcWomA*
Forthet, John *CabMA*
Fortie, John *DcVicP 2*
Fortin, Charles 1815-1865 *ArtsNiC, ClaDrA*
Fortin, Delphine *DcWomA*
Fortin, Helene *DcWomA*
Fortin, Jeanne Mathilde Marie *DcWomA*
Fortin, Josephine *DcWomA*
Fortin, Marc Aurele 1888- *DcCAr 81*
Fortinelli *DcBrECP*
Fortini, Charles *NewYHSD*
Fortner, Myrtle M *FolkA 86*
Fortner, Myrtle Mae 1880-1967 *DcWomA*
Fortney, R B *AmArch 70*
Fortnum, Peggy *IlsCB 1967*
Fortnum, Peggy 1919- *IlsBYP, IlsCB 1946, -1957, WhoArt 80, -82, -84*
Forton, Louis 1879-1934 *WorECom*
Fortt, Frederick *DcVicP 2*
Fortuna, Ben M 1916- *WhAmArt 85*
Fortune, E Charlton 1885- *WhAmArt 85*
Fortune, E Charlton 1885-1969 *ArtsAmW 1*
Fortune, Euphemia Charlton 1885-1969 *DcWomA*
Fortune, J E *AmArch 70*
Fortuny 1871-1949 *WorFshn*
Fortuny, Mariano 1838-1874 *ArtsNiC*
Fortuny, Mariano 1871-1949 *FairDF ITA*
Fortuny Y Carbo *McGDA*
Fortuny Y Carbo, Mariano 1838-1874 *ClaDrA*
Fortuny Y Carbo, Mariano Jose Bernardo 1838-1874 *OxArt*
Fortuny Y Madrazo, Mariano 1871-1949 *McGDA*
Fortuny Y Marsal, Mariano J M Bernardo 1838-1874 *McGDA*
Fortye, W H *DcVicP 2*
Forward, Chauncey B 1924- *AmArch 70*
Forward, Hubert W F 1927- *WhoArt 82, -84*
Fosbery, Ernest 1874- *WhAmArt 85*
Fosbrooke, Leonard *DcBrWA, DcVicP 2*
Fosburgh, James Whitney 1910- *WhoAmA 73, -76, -78*

Fosburgh, James Whitney 1910-1978 *WhoAmA 80N, -82N, -84N*
Foschini, Arnaldo 1884-1968 *MacEA*
Foscue-Johnson, Ellen Valworth 1938- *MacBEP*
Fosdick, Gertrude Christian 1862- *DcWomA, WhAmArt 85*
Fosdick, J William 1858- *WhAmArt 85*
Fosdick, Marion Lawrence 1888- *WhAmArt 85*
Fosdick, Marion Lawrence 1888-1973 *CenC[port]*
Fosdick, Sina G *WhoAmA 78, -80, -82*
Fosdick, Sina G d1983 *WhoAmA 84N*
Foshag, Merle *WhoAmA 76, -78, -80*
Foshag, Merle 1899?-1977 *DcWomA*
Foshko, Josef *WhAmArt 85*
Fosie, Elisabeth *DcWomA*
Fosie, Johanne Marie 1726-1764 *DcWomA*
Foskey, Harry *DcVicP 2*
Fosmire, Cyrus *WhAmArt 85*
Fosner, Louis R 1918- *AmArch 70*
Foss, Annie E *DcWomA*
Foss, Chris *DcCAr 81*
Foss, Florence Winslow 1882- *WhAmArt 85*
Foss, Florence Winslow 1882-1968 *DcWomA*
Foss, H B *AmArch 70*
Foss, Harriet Campbell *WhAmArt 85*
Foss, Harriet Campbell 1860?- *DcWomA*
Foss, John 1745-1827 *BiDBrA*
Foss, Julia O *DcWomA*
Foss, Leonard C 1823?- *CabMA*
Foss, M O *AmArch 70*
Foss And Rowles *CabMA*
Fossano, Ambrogio Da *ClaDrA, McGDA*
Fossard, G F M De *ClaDrA*
Fossat, Yvonne 1894- *DcWomA*
Fossati, Davide Antonio 1708-1780 *ClaDrA*
Fossati, Pedro *MacEA*
Fossbender, N *FolkA 86*
Fosse, William Harold 1937- *AmArch 70*
Fossella, Gregory 1933- *ConDes*
Fossett, Robert *ArtsEM*
Fossette, H *NewYHSD*
Fossum, Sydney 1909- *WhoAmA 73, -76*
Fossum, Sydney Glen 1909- *WhAmArt 85*
Fossy, John *AntBDN Q*
Foster, Abraham 1744?- *CabMA*
Foster, Alan 1892- *WhAmArt 85*
Foster, Alice *WhAmArt 85*
Foster, Alice C 1873- *DcWomA*
Foster, Amy H *DcVicP 2, DcWomA*
Foster, Anna *DcWomA, WhAmArt 85*
Foster, Anne S Hobbs 1861- *DcWomA, WhAmArt 85*
Foster, April 1947- *WhoAmA 76, -78, -80, -82, -84*
Foster, Arthur J *DcVicP 2*
Foster, Arthur Turner 1877- *ArtsAmW 3, WhAmArt 85*
Foster, Barbara 1947- *DcCAr 81*
Foster, Barbara Lynn 1947- *WhoAmA 76, -78, -80*
Foster, Ben 1852-1926 *ArtsAmW 1, -3, WhAmArt 85*
Foster, Benjamin d1844? *CabMA*
Foster, Benjamin 1852-1926 *IlBEAAW*
Foster, Bertha Knox 1896- *ArtsAmW 2, DcWomA, WhAmArt 85*
Foster, Betty *WhAmArt 85*
Foster, Betty 1910- *WhAmArt 85*
Foster, Birket 1825- *ArtsNiC*
Foster, Birkett 1825-1899 *AntBDN B*
Foster, Brad W 1955- *ConGrA 1*
Foster, C *FolkA 86*
Foster, C E *DcVicP 2*
Foster, Mrs. C Rosenberg *AfroAA*
Foster, Charles *NewYHSD*
Foster, Charles 1798-1866 *CabMA*
Foster, Charles 1850-1931 *WhAmArt 85*
Foster, Charles Andrew 1817-1886 *NewYHSD*
Foster, Colley *DcWomA*
Foster, Dales Young 1922- *AmArch 70*
Foster, David Calvin *CabMA*
Foster, Deryck 1924- *DcBrA 1, DcSeaP, WhoArt 80, -82, -84*
Foster, Deryck Arthur 1924- *ClaDrA*
Foster, Don 1932- *WhoAmA 82, -84*
Foster, Donald Isle 1925- *WhoAmA 78, -80, -82, -84*
Foster, Dorothea *DcVicP 2*
Foster, Edward 1762-1866 *AntBDN O*
Foster, Elizabeth H 1900- *WhAmArt 85*
Foster, Emilie *WhAmArt 85*
Foster, Enid 1896- *WhAmArt 85*
Foster, Ethel Elizabeth *DcWomA, WhAmArt 85*
Foster, F E *DcVicP 2, DcWomA*
Foster, Frank *BiDAmAr*
Foster, Frank A 1953- *MarqDCG 84*
Foster, Frederick *DcVicP 2*
Foster, Frederick L 1842?- *ArtsEM*
Foster, G D *AmArch 70*
Foster, Genevieve *IlsCB 1967*
Foster, Genevieve 1893- *IlsCB 1946, -1957*
Foster, Genevieve 1893-1979 *WhoAmA 80N, -82N, -84N*
Foster, George G 1897- *AmArch 70*

Frazier, Paul D 1922- *WhoAmA* 73, −76, −78, −80, −82, −84
Frazier, Richard Ben 1921- *AmArch* 70
Frazier, Richard Williams 1922- *WhoAmA* 82
Frazier, Richard Williams 1922-1983 *WhoAmA* 84N
Frazier, Robert Eugene 1930- *AmArch* 70
Frazier, S 1908- *WhAmArt* 85
Frazier, Stephen *FolkA* 86
Frazier, Susan 1900- *WhAmArt* 85
Frazier, Thelma *WhAmArt* 85
Frazier, Walter S 1895- *AmArch* 70
Freake, Mrs. *DcVicP* 2
Freake Master *McGDA*
Fream, Leslie Alfred 1920- *AmArch* 70
Frearson, John 1762-1831 *DcBrECP*
Freas, Lenwood *IlsBYP*
Frech, Howard *WhAmArt* 85
Frechet, Annie 1880-1973 *DcWomA*
Frechette, M-M 1884- *WhAmArt* 85
Frechette, Marie Marguerite 1884- *DcWomA*
Freckelton, Sandra 1936- *DcCAr* 81
Freckelton, Sondra 1936- *PrintW* 83, −85, *WhoAmA* 82, −84
Freckleton, Sondra 1936- *AmArt*
Freckleton, Vera 1899- *WhoArt* 80, −82, −84
Fred *WorECar*
Freda, Carl F *MarqDCG* 84
Freda, R F *AmArch* 70
Freddie 1909- *PhDcTCA* 77
Fredenburg, George *FolkA* 86, *NewYHSD*
Fredenthal, David *WhoAmA* 80N, −82N, −84N
Fredenthal, David 1914-1958 *McGDA*, *WhAmArt* 85
Freder, Frederick C 1895-1954 *WhAmArt* 85
Frederic, Leon Henri Marie 1856- *ClaDrA*
Frederick *FolkA* 86
Frederick, Empress Of Germany *DcWomA*
Frederick, Carroll Glenn 1905- *WhAmArt* 85
Frederick, Charles *NewYHSD*
Frederick, Sir Charles 1709-1785 *BiDBrA*
Frederick, Deloras Ann 1942- *WhoAmA* 82, −84
Frederick, Edmund 1870- *WhAmArt* 85
Frederick, Eugene Wallace 1927- *WhoAmA* 80, −82, −84
Frederick, Frank F 1866- *WhAmArt* 85
Frederick, George 1889- *ArtsAmW* 3
Frederick, George A 1842-1924 *BiDAmAr*
Frederick, George Francis 1900- *AmArch* 70, *WhAmArt* 85
Frederick, Harold Renton, Jr. 1923- *AmArch* 70
Frederick, Henry K *FolkA* 86
Frederick, Henry T 1813?- *FolkA* 86
Frederick, John *FolkA* 86
Frederick, John L 1797?-1881? *NewYHSD*
Frederick, Lawrence William 1946- *MarqDCG* 84
Frederick, M Hamilton 1933- *AmArch* 70
Frederick, Millie Bruhl 1878- *WhAmArt* 85
Frederick, Millie Bruhl 1878-1962 *DcWomA*
Frederick, Montgomery L *NewYHSD*
Frederick, Rod *OfPGCP* 86
Frederick, Saradell Ard *WhoAmA* 82, −84
Frederick, Tony 1955- *MacBEP*
Fredericks, Alfred *EarABI*, *EarABI SUP*, *NewYHSD* , *WhAmArt* 85
Fredericks, H *AmArch* 70
Fredericks, Harold 1929- *WorECom*
Fredericks, J *AmArch* 70, *DcVicP* 2
Fredericks, Marshall Maynard 1908- *WhAmArt* 85, *WhoAmA* 73, −76, −78, −80, −82, −84
Fredericksen, Burton Baum 1934- *WhoAmA* 76, −78, −80, −82, −84
Frederickson, Alan Porter 1927- *AmArch* 70
Frederickson, Beatrice *DcWomA*
Frederickson, Frederick Lyder 1905- *WhAmArt* 85
Frederics, A *DcBrBI*, *DcVicP* 2
Frederiksen, Erik Ellegaard 1924- *WhoGrA* 62, −82[port]
Frederiksen, Mary 1869- *ArtsAmW* 1, *WhAmArt* 85
Frederiksen, Mary Monrad 1869- *IlBEAAW*
Frederiksen, Mary Monrad 1869-1947 *DcWomA*
Frederycks, Kryn *NewYHSD*
Fredet, Denise Claudia *DcWomA*
Fredic, S 1899- *DcWomA*
Fredman, Faiya R 1925- *WhoAmA* 73, −76, −78, −80, −82, −84
Fredo, Arthur John 1931- *MarqDCG* 84
Fredou, Marie Catherine *DcWomA*
Fredrick, E G *AmArch* 70
Fredrick, Eugene Wallace 1927- *WhoAmA* 78
Fredrick, Millie Bruhl 1878-1962 *DcWomA*
Fredrick, W F *WhAmArt* 85
Fredricks, David A *MarqDCG* 84
Fredrickson, Daniel Alan *WhoAmA* 80, −82, −84
Fredrickson, Steven J *MarqDCG* 84
Fredsall, Ralph Waldo *WhAmArt* 85
Fredyna, Katerina 1906- *WhoArt* 80, −82, −84
Free, John D 1929- *IlBEAAW*, *WhoAmA* 76, −78, −80, −82
Free, John Martin 1923- *AmArch* 70
Free, Karl R 1903-1947 *WhAmArt* 85
Free, Mary Arnold 1895- *ArtsAmW* 2, *DcWomA*, *WhAmArt* 85

Freebairn, Charles *BiDBrA*
Freebairn, Robert 1764-1808 *DcBrECP*
Freebairn, Robert 1765-1808 *DcBrWA*
Freeberg, Roger Charles 1939- *AmArch* 70
Freeborn, E I *AmArch* 70
Freeborn, S M *WhAmArt* 85
Freeborn, William *DcBrWA*
Freeborne, Sarah Malcolm 1861?-1906 *DcWomA*
Freeborne, Zara Malcolm 1861-1906 *WhAmArt* 85
Freeburg, Charles Robert 1924- *AmArch* 70
Freeburg, R A *AmArch* 70
Freed, Aaron David 1922- *AmArch* 70
Freed, David 1936- *PrintW* 83, −85, *WhoAmA* 73, −76, −78, −80, −82, −84
Freed, Douglass Lynn 1944- *WhoAmA* 80, −82, −84
Freed, Ernest Bradfield *WhoAmA* 76N, −78N, −80N, −82N, −84N
Freed, Ernest Bradfield 1908- *WhAmArt* 85, *WhoAmA* 73
Freed, Hermine 1940- *MacBEP*, *WhoAmA* 76, −78, −80, −82, −84
Freed, James Ingo 1930- *AmArch* 70
Freed, Leonard 1929- *ConPhot*, *ICPEnP A*, *MacBEP*
Freed, Maurice *WhAmArt* 85
Freed, Richard 1927- *AmArch* 70
Freed, William 1902- *WhoAmA* 76, −78, −80, −82, −84
Freed, William 1904- *WhAmArt* 85
Freed, William J 1898- *AmArch* 70
Freedberg, Sydney Joseph 1914- *WhoAmA* 73, −76, −78, −80, −82, −84
Freedlander, Arthur R d1940 *WhAmArt* 85
Freedlander, Joseph Henry 1870-1943 *MacEA*
Freedley, Elizabeth C *DcWomA*
Freedly, Elizabeth *WhAmArt* 85
Freedman, Barnett 1901- *IlsCB* 1744, −1946
Freedman, Barnett 1901-1958 *DcBrA* 1
Freedman, Beatrice Claudia 1904- *DcBrA* 1
Freedman, Constance Esther 1935- *WhoArt* 82, −84
Freedman, David 1914- *AmArch* 70
Freedman, Doris C 1928- *WhoAmA* 73, −76, −78
Freedman, Henry Bernard 1952- *MarqDCG* 84
Freedman, Jill 1939- *ConPhot*, *ICPEnP A*, *MacBEP*
Freedman, Louise A 1915- *WhAmArt* 85
Freedman, M 1938- *MarqDCG* 84
Freedman, Maurice 1904- *WhAmArt* 85, *WhoAmA* 73, −76, −78, −80, −82, −84
Freedman, Norman Harold 1927- *AmArch* 70
Freedman, Robert J *WhoAmA* 73
Freedman, Ruth 1899- *ArtsAmW* 3, *DcWomA*, *WhAmArt* 85
Freedman, Sarah *DcWomA*
Freedman, V *AmArch* 70
Freedolin, Vladimir 1879-1934 *WhAmArt* 85
Freedom, Mr. *WorFshn*
Freehof, James Neil 1928- *AmArch* 70
Freehof, Mortimer Edgar 1893- *AmArch* 70
Freeland, Anna C *FolkA* 86, *WhAmArt* 85
Freeland, Anna C 1837-1911 *DcWomA*, *NewYHSD*
Freeland, Henry C *FolkA* 86
Freeland, O S *NewYHSD*
Freeland, Theodore *NewYHSD*
Freeland, Timothy Allen 1957- *MarqDCG* 84
Freeland, W B *ArtsEM*
Freeland, William Lee 1929- *WhoAmA* 73, −76, −78, −80, −82, −84
Freelander, Joseph H 1870-1943 *BiDAmAr*
Freeling, K T *DcVicP* 2
Freelon, Allan R 1895- *AfroAA*
Freelon, Allan Randall 1895- *WhAmArt* 85
Freelove, James *CabMA*
Freels, E A *AmArch* 70
Freels, L L *AmArch* 70
Freely, John *NewYHSD*
Freeman, Mr. *FolkA* 86
Freeman, A Albert 1905- *WhAmArt* 85
Freeman, Alice Imogene 1876- *WhAmArt* 85
Freeman, Anna Mary *DcWomA*, *NewYHSD*
Freeman, Augusta 1826- *DcWomA*
Freeman, B *AmArch* 70
Freeman, Beverly L 1923- *AmArch* 70
Freeman, Bradford *NewYHSD*
Freeman, C H 1859-1918 *WhAmArt* 85
Freeman, Clara E *WhAmArt* 85
Freeman, D C *AmArch* 70
Freeman, David Dean 1928- *AmArch* 70
Freeman, David L 1937- *WhoAmA* 73, −76, −78, −80, −82, −84
Freeman, Don *IlsCB* 1967
Freeman, Don 1908- *IlsCB* 1946, −1957
Freeman, Don 1908-1978 *GrAmP*, *WhAmArt* 85
Freeman, Don 1909-1978 *WhoAmA* 78N, −80N, −82N, −84N
Freeman, Donald Liggett 1915- *AmArch* 70
Freeman, Dorothy *WhAmArt* 85
Freeman, E O *NewYHSD*
Freeman, Edith Emogene *WhAmArt* 85
Freeman, Edith Emogene 1876- *DcWomA*
Freeman, Emma Belle 1880-1927 *DcWomA*
Freeman, Florence 1836- *ArtsNiC*, *NewYHSD*
Freeman, Florence 1836-1876 *DcWomA*

Freeman, Francis O *NewYHSD*
Freeman, Frank 1862-1940 *BnEnAmA*
Freeman, Frank 1901- *ClaDrA*
Freeman, Fred *WhAmArt* 85
Freeman, Fred 1906- *IlrAm E*, −1880, *WhoAmA* 82
Freeman, George d1906 *WhAmArt* 85
Freeman, George 1789-1868 *NewYHSD*
Freeman, George A 1859-1934 *BiDAmAr*
Freeman, Gertrude *WhoAmA* 78
Freeman, Gertrude 1927- *WhoAmA* 80, −82, −84
Freeman, Harris 1933- *MarqDCG* 84
Freeman, Henry *DcVicP* 2
Freeman, Herbert 1925- *MarqDCG* 84
Freeman, Horace G 1915- *AmArch* 70
Freeman, Howard Benton 1878-1937 *WhAmArt* 85
Freeman, Inez *WhAmArt* 85
Freeman, James *NewYHSD*
Freeman, James E *ArtsNiC*
Freeman, Mrs. James E *ArtsNiC*
Freeman, James Edward 1808-1884 *NewYHSD*
Freeman, James Edward 1927- *AmArch* 70
Freeman, Jane d1963 *WhoAmA* 78N, −80N, −82N, −84N
Freeman, Jane 1871?-1963 *DcWomA*
Freeman, Jane 1885-1963 *WhAmArt* 85
Freeman, Jessie B *ArtsEM*
Freeman, John 1689?-1752 *BiDBrA*
Freeman, John, Jr. 1923- *AmArch* 70
Freeman, Joseph d1799 *DcBrECP*
Freeman, Joseph L *FolkA* 86
Freeman, Josh 1949- *MarqDCG* 84
Freeman, Kenneth *OfPGCP* 86
Freeman, Lorena 1889?-1962 *DcWomA*
Freeman, Lorena E *WhAmArt* 85
Freeman, Lou Blackstone d1905 *WhAmArt* 85
Freeman, M D, Jr. *AmArch* 70
Freeman, M Winefride *DcBrA* 2
Freeman, Madge 1895- *DcWomA*
Freeman, Mallory Bruce 1938- *WhoAmA* 80, −82, −84
Freeman, Margaret *WhAmArt* 85
Freeman, Margaret 1893- *ConICB*, *IlsCB* 1744
Freeman, Margaret 1893-1942 *DcWomA*
Freeman, Margaret B *WhoAmA* 73, −76, −78, −80
Freeman, Marion Delamater *WhAmArt* 85
Freeman, Mark 1908- *WhoAmA* 84
Freeman, Mark 1909- *WhoAmA* 73, −76, −78, −80, −82
Freeman, Mary Winefride *DcVicP* 2
Freeman, Mary Winifride *DcWomA*
Freeman, Pauline *DcVicP* 2, *DcWomA*
Freeman, Phyllis 1928- *WhoAmA* 78, −80, −82
Freeman, Richard Borden 1908- *WhoAmA* 73, −76, −78, −80, −82
Freeman, Richard Oliver 1915- *AmArch* 70
Freeman, Robert *AfroAA*
Freeman, Robert L 1925- *AmArch* 70
Freeman, Robert Lee 1939- *WhoAmA* 76, −78, −80, −82, −84
Freeman, Roger 1945- *ICPEnP A*, *MacBEP*
Freeman, Roland 1936- *ICPEnP A*
Freeman, Roland Leon 1936- *MacBEP*
Freeman, Sara *WhoAmA* 82, −84
Freeman, T W *NewYHSD*
Freeman, Terence Reginald 1909- *IlsCB* 1946
Freeman, Tevis Cooper 1931- *AmArch* 70
Freeman, Thomas *FolkA* 86
Freeman, Thomas 1757-1780 *DcBrECP*
Freeman, Tina 1951- *MacBEP*, *WhoAmA* 80, −82, −84
Freeman, Vida 1937- *MacBEP*
Freeman, W E 1927- *IlBEAAW*
Freeman, W F *AmArch* 70
Freeman, W R 1820?-1906? *ArtsAmW* 1
Freeman, Walter C *NewYHSD*
Freeman, William *CabMA*
Freeman, William, Jr. *DcVicP* 2
Freeman, William Ernest, Jr. 1913- *AmArch* 70
Freeman, William Henry *ClaDrA*, *DcVicP* 2
Freeman, William Philip Barnes 1813-1897 *DcBrWA*, *DcVicP* 2
Freeman, William R 1820?-1906? *NewYHSD* , *WhAmArt* 85
Freeman, William Wallstone 1908- *AmArch* 70
Freeman And Saverin *CabMA*
Freeman-Appelbaum, Margery *WhoAmA* 82, −84
Freeman-Gell, Ada *DcWomA*
Freemesser, Bernard Lawrence 1926-1977 *MacBEP*
Freer, Allen *DcCAr* 81
Freer, Charles Lang 1856-1919 *WhAmArt* 85
Freer, Cora Fredericka *DcWomA*, *WhAmArt* 85
Freer, Frederick Warren 1849-1908 *WhAmArt* 85
Freer, Howard Mortimer 1904-1960 *WhAmArt* 85, *WhoAmA* 80N, −82N, −84N
Freer, Mrs. John *DcVicP* 2
Freer, Mary Ellen *DcBrBI*, *DcWomA*
Freerks, E L *AmArch* 70
Freese, Johann Oskar Hermann 1813-1871 *ArtsNiC*
Freese, N *DcBrECP*
Freesz, Tibor 1905- *AmArch* 70
Freeth, Douglas William 1906- *AmArch* 70
Freeth, H Andrew 1912- *ClaDrA*, *DcBrA* 1,

WhoArt 80, –82, –84
Freeth, Henry AntBDN N
Freeth, James Wilfred 1872- ClaDrA, DcBrA 1
Freeth, Peter DcCAr 81
Freezor, Mrs. DcVicP 2
Freezor, George Augustus ClaDrA, DcVicP, –2
Frega, John Victor 1931- AmArch 70
Fregeau, Philip Benoit 1928- AmArch 70
Frehm, Paul WhAmArt 85
Frei, Adolph C 1854-1935 WhAmArt 85
Frei, Emil, Jr. WhAmArt 85
Frei, Linae M WhoAmA 80
Frei, Werner 1945- MarqDCG 84
Freibach, Carl DcWomA
Freiberg, Maria Von DcWomA
Freidin, Jack 1930- AmArch 70
Freidin, Jonathan Frederick 1958- MarqDCG 84
Freifeld, Eric 1919- WhoAmA 73, –76, –78, –80, –82, –84
Freigang, Paul 1886- WhAmArt 85
Freilich, Ann WhoAmA 73, –76, –78, –80, –82, –84
Freilich, Michael L 1912-1975 WhoAmA 76N, –78N, –80N, –82N, –84N
Freilich, Michael Leon 1912- WhoAmA 73
Freilicher, Hy 1907- WhAmArt 85
Freilicher, Jane 1924- DcCAA 71, –77, DcCAr 81, OxTwCA, PrintW 85, WhoAmA 73, –76, –78, –80, –82, –84
Freiman, Robert J 1917- AmArt, WhoAmA 82, –84
Freimann, Christoph 1940- OxTwCA
Freimark, Bob 1922- PrintW 83, –85
Freimark, Robert 1922- AmArt, WhoAmA 73, –76, –78, –80, –82, –84
Freitag, C DcSeaP
Freitag, Conrad d1894 WhAmArt 85
Freitag, William Herbert 1921- AmArch 70
Freitag, Wolfgang Martin 1924- WhoAmA 76, –78, –80, –82, –84
Freitag-Loringhoven, Mathilde Von DcWomA
Freitas, Jon WhAmArt 85
Freixa, Ferran 1950- ConPhot, ICPEnP A
Frel, Jiri WhoAmA 78, –80, –82, –84
Freleigh, Margaret Ann FolkA 86
Freleng, Isadore 1905?- WorECar
Frelich, L F AmArch 70
Frelinghuysen, C Maria DcWomA, NewYHSD
Frelinghuysen, George G, Jr. 1911- WhAmArt 85
Frelinghuysen, Peter H B, Jr. WhoAmA 73, –76, –78
Frelinghuysen, Mrs. Peter H B, Jr. WhoAmA 73, –76, –78
Frell, John FolkA 86
Fremiet, Emmanuel 1824- ArtsNiC
Fremiet, Emmanuel 1824-1910 AntBDN C, DcNiCA, McGDA, WhAmArt 85A
Fremiet, Marie DcWomA
Fremiet, Sophie DcWomA
Fremin, Rene 1672-1744 McGDA
Freminet, Martin 1564-1619 McGDA
Freminet, Martin 1567-1619 ClaDrA, OxArt
Fremond, C R AmArch 70
Fremont, Camille Desiree Suzanne 1876-1962 DcWomA
Fremont, Caroline Celine Gabrielle 1850?- DcWomA
Fremont, John 1813-1890 ArtsAmW 1
Fremont, John Charles 1813-1890 NewYHSD
Fremont-Chervier, Suzanne 1895- DcWomA
Fremont DeSeriere, Juliette Marceline DcWomA
Fremura, Alberto 1935- WorECar
Fremy, Mademoiselle DcWomA
Fremy, Zoe DcWomA
Frenaye, Mathilda M M DeLa DcWomA
French, Alfred W, III 1935- AmArch 70
French, Alice Helm 1864- WhAmArt 85
French, Alice Helm 1864-1953? DcWomA
French, Allen WhAmArt 85
French, Annie DcBrBI, DcVicP 2, DcWomA
French, Annie 1872-1965 DcBrA 2, DcWomA
French, Arthur E 1876-1929 BiDAmAr
French, Arthur Sheldon WhAmArt 85
French, Asa FolkA 86
French, B FolkA 86
French, Bessie Foster DcWomA
French, C FolkA 86, NewYHSD
French, Daniel Chester FolkA 86
French, Daniel Chester 1850- ArtsNiC
French, Daniel Chester 1850-1931 AntBDN C, BnEnAmA, DcAmArt, McGDA, OxArt, PhDcTCA 77, WhAmArt 85
French, David M 1827-1910 NewYHSD , WhAmArt 85
French, Dick DcCAr 81
French, Dick 1946- WhoArt 80, –82, –84
French, E R, Jr. AmArch 70
French, Eben FolkA 86
French, Edwin Charles 1909- AmArch 70
French, Edwin Davis 1851-1906 WhAmArt 85
French, Elizabeth D L 1877-1943 WhAmArt 85
French, Elizabeth D L 1878-1943 DcWomA
French, Fiona Mary 1944- IlsCB 1967
French, Frank 1850-1933 WhAmArt 85
French, G H EncASM

French, George R NewYHSD
French, George Russell 1803-1881 BiDBrA
French, Grace Ann 1858-1942 ArtsAmW 2, DcWomA
French, Hazel Blake 1890- WhAmArt 85
French, Helen Douglass AmArch 70
French, Henry DcBrBI, DcBrECP, DcVicP 2
French, Hiram Taylor 1937- MarqDCG 84
French, Howard B DcSeaP
French, Howard Barclay 1906- WhAmArt 85
French, J H NewYHSD
French, James C 1907- WhoAmA 73
French, Jane Kathleen DcWomA
French, Jared WhoAmA 73, –76
French, Jared 1905- ConArt 77, DcCAA 71, –77, McGDA, WhAmArt 85, WhoAmA 78, –80, –82, –84
French, Mrs. Jared WhAmArt 85
French, John CabMA
French, John 1762- CabMA
French, John, II CabMA
French, John Charles, Jr. 1903- AmArch 70
French, John Gerald 1956- MarqDCG 84
French, John T NewYHSD
French, Joseph Nathaneil 1888- AmArch 70
French, Leigh H, Jr. 1894-1946 BiDAmAr
French, Leonard DcCAr 81
French, Leonard 1928- McGDA, OxTwCA
French, M D DcWomA
French, Margaret DcWomA
French, Margaret Anne 1860-1927 DcWomA
French, Mary L ArtsEM, DcWomA
French, Myrtle Meritt 1886- WhAmArt 85
French, P FolkA 86
French, P C DcVicP 2
French, Percy 1854-1920 DcBrA 2
French, Ray H 1919- WhoAmA 78, –80, –82, –84
French, Richard Horne 1920- AmArch 70
French, Robert 1841-1917 MacBEP
French, Robert 1909- AmArch 70
French, S J AmArch 70
French, Susan 1912- ClaDrA
French, Thomas d1803 DcBrECP
French, Thomas 1778-1862 AntBDN F
French, Thomas E WhAmArt 85
French, William B FolkA 86
French, William Merchant Richardson 1843-1914 WhAmArt 85
French, William Percy 1854-1920 DcBrWA
French And Franklin EncASM
French And Way CabMA
Frenkiel, Stanislaw 1918- ConArt 77, WhoArt 80, –82, –84
Frenzel, Fridolin 1930- DcCAr 81
Frenzel, Joseph WhAmArt 85
Frenzeny, Paul DcBrBI, EarABI SUP
Frenzeny, Paul 1840- ArtsAmW 1
Frenzeny, Paul 1840?-1902 IIBEAAW, WhAmArt 85
Frere, Augusta DcVicP 2
Frere, Charles-Edouard ArtsNiC
Frere, Charles Theodore 1814-1888 ClaDrA
Frere, Charles Theodore 1815- ArtsNiC
Frere, Jean-Jules ArtsNiC
Frere, Pierre Edouard 1819- ArtsNiC
Frere, Thomas NewYHSD
Frere DeMontizon, Flore 1794- DcWomA
Frere DeMontizon, Therese Justine 1792- DcWomA
Freret, Douglass Vincent 1903- AmArch 70
Freret, Emily M WhAmArt 85
Freret, Jack Bradburn 1930- AmArch 70
Freret, James 1839-1897 BiDAmAr
Freret, William A 1833- BiDAmAr
Frerichs, Ruth Colcord WhoAmA 73, –76, –78, –80, –82, –84
Frerichs, William C A 1829-1905 WhAmArt 85
Frerichs, William Charles Anthony 1829?-1905 NewYHSD
Frerot, Marie DcWomA
Freschieri, Giuseppe 1810- ArtsNiC
Frescoe, Helene 1947- DcCAr 81
Frese, R K AmArch 70
Freshwater, Fayne Feibel 1903- AmArch 70
Freshwater, Sally 1958- DcCAr 81
Fresnaye, Marie Alphonsine DcWomA
Fresnaye, Roger DeLa McGDA, OxTwCA, PhDcTCA 77
Fresney-Touvenaint, Marie DcWomA
Freson, Lancelot 1615?- BiDBrA
Fresquis, Pedro Antonio 1749-1831 FolkA 86
Fresson, Theodore-Henri MacBEP
Fretelliere, Louise Andree 1856-1940 ArtsAmW 3
Fretin, Henriette 1865- DcWomA
Frets, Jack Eldon 1924- AmArch 70
Fretz, J FolkA 86
Fretzinger FolkA 86
Freud, Lucian 1922- ConArt 77, –83, ConBrA 79, DcBrA 1, DcCAr 81, OxTwCA, PhDcTCA 77, WorArt[port]
Freudenberg, E G NewYHSD
Freudenberger, Sigmund 1745-1801 McGDA
Freudenheim, Nina WhoAmA 80, –82, –84

Freudenheim, Tom Lippmann 1937- WhoAmA 73, –76, –78, –80, –82, –84
Freudenreich, Marie Pierrette Amelie Von 1786-1831 DcWomA
Freund, Arthur WhAmArt 85
Freund, David 1937- MacBEP
Freund, Ernest Arthur Paul 1890- WhAmArt 85
Freund, Frank 1937- ICPEnP A
Freund, Gisele DcCAr 81
Freund, Gisele 1912- ConPhot, ICPEnP, MacBEP
Freund, Harry Louis 1905- WhAmArt 85, WhoAmA 73, –76, –78, –80, –82, –84
Freund, Henry NewYHSD
Freund, Rudolf 1915- IlsBYP, IlsCB 1744, –1946
Freund, Tibor 1910- WhoAmA 73, –76, –78, –80, –82, –84
Freund, Will Frederick 1916- WhoAmA 73, –76, –78, –80, –82, –84
Freundlich, August L 1924- WhoAmA 73, –76, –78, –80, –82, –84
Freundlich, Otto 1878-1943 ConArt 77, McGDA, OxTwCA, PhDcTCA 77
Frevert, Wesley David 1921- AmArch 70
Frew, Alexander d1908 DcBrA 1, DcVicP 2
Frew, Bessie DcWomA
Frew, John 1776-1799 CabMA
Frew, William WhAmArt 85
Frewen, Clare Consuelo DcWomA
Frewen, Frank W 1887-1937 BiDAmAr
Frey, Abraham d1860? FolkA 86
Frey, Albert 1903- AmArch 70, MacEA
Frey, Alice 1895- DcWomA
Frey, Anna d1808 DcWomA
Frey, Charles D 1881- WhAmArt 85
Frey, Charles Daniel 1881-1959 ArtsAmW 2
Frey, Christian 1811-1888 FolkA 86
Frey, Christian 1911- AmArch 70
Frey, Erwin F d1967 WhoAmA 78N, –80N, –82N, –84N
Frey, Erwin F 1892-1967 WhAmArt 85
Frey, Friederike DcWomA
Frey, G T AmArch 70
Frey, Gail M 1951- MarqDCG 84
Frey, George FolkA 86
Frey, Henry NewYHSD
Frey, Jacob CabMA
Frey, Johann Jacob AntBDN F
Frey, Johann Michael 1750-1813 ClaDrA
Frey, Louis James 1933- AmArch 70
Frey, N J, Jr. AmArch 70
Frey, Robert A WhAmArt 85
Frey, Robert Widmer 1923- AmArch 70
Frey, Samuel B d1871? FolkA 86
Frey, Viola 1933- CenC, WhoAmA 80, –82, –84
Frey, Viola 1937- WhoAmA 76, –78
Frey-Surbeck, Marguerite 1886- DcWomA
Frey-Surbek, Marguerite 1886- WhoArt 80, –82
Frey-Surber, Marguerite WhoArt 84N
Freyberg, Maria Electrina Von 1797-1847 ClaDrA, DcWomA
Freyberg-Eisenberg, Charlotte DcWomA
Freyberger, Ruth Matilda 1912- WhoAmA 73
Freyburg, Frank P DcVicP 2
Freyer, Achim 1934- ConDes
Freyman, Gertrude WhAmArt 85
Freyse, Bill 1898-1969 WorECom
Freyssinet, Eugene 1879-1962 ConArch, EncMA, MacEA, McGDA, WhoArch
Freystein, Johanna Marianne 1760-1807 DcWomA
Freytag, Daniel FolkA 86
Freytag, Ferd E 1902- AmArch 70
Freytag, Karl John 1920- AmArch 70
Freytag, Philip Ferdinand 1935- AmArch 70
Freytag-Loringhoven, Baroness Elsa Von 1874-1927 DcWomA
Freytag-Loringhoven, Mathilde Von 1860- DcWomA
Frezier, Amedee Francois 1682-1773 MacEA
Friant, Emile 1863-1932 ClaDrA
Frias, Juan Antonio De McGDA
Friberg, Arnold 1913- IIBEAAW, WhoAmA 73, –76, –78, –80, –82, –84
Friberg, Mauritz Emil 1893- AmArch 70
Fribert, Charles WhAmArt 85
Friborg, Harold Fritz 1938- AmArch 70
Fricano, Tom S 1930- WhoAmA 76, –78, –80, –82, –84
Fricant, Luce 1889- DcWomA
Frick, A A AmArch 70
Frick, E G AmArch 70
Frick, E L AmArch 70
Frick, Gretchen WhAmArt 85
Frick, Helen Clay WhoAmA 73, –76, –78, –80, –82
Frick, Henry Clay 1849-1919 WhAmArt 85
Frick, Joan DcCAr 81
Frick, Joan 1942- WhoAmA 84
Frick, Richard Paul 1930- AmArch 70
Frick, Robert Oliver 1920- WhoAmA 76, –78, –80, –82, –84
Frick, Winifred Marie Louise ClaDrA, DcWomA
Fricke, John Frederick FolkA 86
Fricquegnon, Suzanne 1897- DcWomA

Froelich, Paul *WhoAmA 78N, –80N, –82N, –84N*
Froelich, Paul 1897-1968? *WhAmArt 85*
Froggatt, Coldwell And Lean *AntBDN N*
Froggatt, T *DcVicP 2*
Frohawk, F W *DcBrBI*
Frohawk, Frederick William 1861-1946 *DcBrA 1*
Frohlich, Anton 1776-1841 *ClaDrA*
Frohlich, Betty Bogner 1798-1878 *DcWomA*
Frohlich, Caroline Lili Bume *WhoArt 84N*
Frohlich, Caroline Lili Bume 1886- *WhoAmA 80, –82*
Frohlich, Johann *WorFshn*
Frohlich, Lorens 1820-1908 *DcBrBI*
Frohlich, M L *WhoAmA 82, –84*
Frohman, Philip Hubert 1887- *AmArch 70*
Frohner, Adolf 1934- *DcCAr 81*
Froidure DePellport, Ernestine *DcWomA*
Froisse, Elisabeth *DcWomA*
Froisse, Marie Marguerite *DcWomA*
Frojen, Leonard Allen 1930- *AmArch 70*
Frola, Joseph R 1904- *WhAmArt 85*
Frolic, Peter 1949- *DcCAr 81*
Frolich, F *DcVicP 2*
Frolich, Finn Haakon 1868- *WhAmArt 85*
Frolich, Vilhelmine Edma Cornelia 1859- *DcWomA*
Froman, Ann 1942- *WhoAmA 82, –84*
Froman, Ramon Mitchell 1908- *WhoAmA 73, –76, –78, –80*
Froman, Ramon Mitchell 1908-1980 *WhoAmA 82N, –84N*
Fromanteel, Ahasuerus *AntBDN D, OxDecA*
Fromanteel, Johannes *OxDecA*
Fromberg, Gerald 1925- *WhoAmA 76, –78N, –80N, –82N, –84N*
Fromberg, Laverne Ray 1930- *WhoAmA 76, –78, –80, –82, –84*
Fromboluti, Sideo 1920- *WhoAmA 76, –78, –80, –82, –84*
Frome, W *BiDBrA*
Fromen, Agnes Valborg Erica 1868-1956 *DcWomA*
Fromen, Agnes Valbourg 1868- *WhAmArt 85*
Froment, Jacques Victor Eugene 1820-1900 *IlBEAAW*
Froment, Marie Emilie Lucie 1891- *DcWomA*
Froment, Nicolas *McGDA, OxArt*
Froment-Delormel, Jacques Victor Eugene 1820-1900 *ArtsAmW 1*
Froment-Guieysse, Simone 1887- *DcWomA*
Froment-Meurice, F D 1802-1855 *DcNiCA*
Froment-Meurice, Francois Desire 1802-1855 *AntBDN Q*
Fromentin, Eugene 1820-1876 *ArtsNiC, ClaDrA, McGDA, OxArt*
Fromer, Mrs. Leon *WhoAmA 73, –76, –78, –80, –82*
Fromfield, William *FolkA 86*
Fromhagen, Frederick N *NewYHSD*
Fromkes, Maurice 1872-1931 *WhAmArt 85*
Fromm, Frank H, Jr. 1905- *AmArch 70*
Fromm, Lilo *IlsBYP, IlsCB 1967*
Frommann, Alwine 1800-1875 *DcWomA*
Frommann, Johanna Charlotte 1765-1831 *DcWomA*
Fromme, Frederick W *NewYHSD*
Frommer, Esther Maria *DcWomA*
Frommer, Marie *AmArch 70*
Fromont, Charles H *NewYHSD*
Fromuth, Charles H 1861-1937 *WhAmArt 85*
Fronek, Donald Karel 1937- *MarqDCG 84*
Froning, D J *AmArch 70*
Fronius, Hans 1903- *WhoGrA 62, –82[port]*
Front, Charles 1930- *IlsCB 1967*
Frontier, Jean Charles 1701-1763 *ClaDrA*
Frontinus *IlDcG*
Frontinus, Sextus Julius 035?-105 *MacEA*
Frontzou, Amalia *WorFshn*
Fronzoni, A G 1923- *ConDes*
Frood, Hester 1882-1971 *DcBrA 1, DcWomA*
Froom, Roy Ramsey 1924- *AmArch 70*
Froriep, Bertha 1833- *DcWomA*
Froshaug, Anthony 1920-1984 *ConDes*
Frost, A Corwin 1934- *AmArch 70*
Frost, Alec Calhoun 1932- *AmArch 70*
Frost, Alice L *ArtsEM, DcWomA*
Frost, Anna *DcWomA, WhAmArt 85*
Frost, Anthony 1951- *WhoArt 84*
Frost, Antony *DcCAr 81*
Frost, Arthur B 1851-1928 *WhAmArt 85*
Frost, Arthur Burdett *OxTwCA*
Frost, Arthur Burdett 1851-1928 *ArtsAmW 1, DcBrBI, IlBEAAW, IlrAm A, –1880, WorECar*
Frost, Arthur Burdett 1887-1917 *PhDcTCA 77*
Frost, Arthur Burdett, Jr. 1887-1917 *DcAmArt*
Frost, C K *NewYHSD*
Frost, C R *NewYHSD*
Frost, Charles S 1856-1932 *MacEA*
Frost, Charles Sumner 1856-1931 *BiDAmAr*
Frost, Cyril James 1885- *DcBrA 1*
Frost, Dennis *WhoArt 84N*
Frost, Dennis 1925- *WhoArt 80, –82*
Frost, Edith *WhoArt 80, –82*
Frost, Francis S 1825-1902 *ArtsAmW 2*
Frost, Frederick George, Jr. 1907- *AmArch 70*
Frost, G Lewis *DcBrA 1*
Frost, George 1734-1821 *DcBrWA*

Frost, George Albert 1843- *ArtsAmW 1, WhAmArt 85*
Frost, Guy Ladd 1934- *AmArch 70*
Frost, H *DcVicP 2, DcWomA*
Frost, H L *AmArch 70*
Frost, Harry T 1887-1943 *MacEA*
Frost, Harry Talford 1886-1943 *BiDAmAr*
Frost, J O J 1852-1928 *AmFkP[port], FolkA 86*
Frost, James *CabMA*
Frost, John *DcBrECP*
Frost, John 1800-1859 *NewYHSD*
Frost, John 1890-1937 *ArtsAmW 1, IlBEAAW, WhAmArt 85*
Frost, John Orne Johnson 1852-1928 *BnEnAmA*
Frost, John Orne Johnson 1852-1952 *WhAmArt 85*
Frost, Joshua *NewYHSD*
Frost, Julius H 1867-1934 *WhAmArt 85*
Frost, Kathleen Margaret *WhoArt 80*
Frost, Louisa *DcVicP 2*
Frost, Mabelle G *WhAmArt 85*
Frost, Mildred 1865-1946 *ArtsEM, DcWomA*
Frost, Minnie P *DcVicP 2*
Frost, Paul Arthur 1938- *MarqDCG 84*
Frost, R *DcVicP 2*
Frost, R M *AmArch 70*
Frost, Ralph James, Jr. 1930- *AmArch 70*
Frost, Robert Davey 1908- *WhAmArt 85*
Frost, Robert Dewey 1923- *AmArch 70*
Frost, Ruth Sterling 1873- *DcWomA, WhAmArt 85*
Frost, Shirley Jane 1935- *WhoArt 80, –82*
Frost, Stuart Homer 1925- *WhoAmA 76, –78, –80, –82, –84*
Frost, Terry 1915- *ConArt 77, –83, ConBrA 79[port], DcBrA 1, DcCAr 81, OxTwCA, PhDcTCA 77*
Frost, Thomas Robert, Jr. 1940- *AmArch 70*
Frost, W H *AmArch 70*
Frost, William Edward 1810-1877 *ArtsNiC, DcBrWA, DcVicP, –2*
Frosterus, Sigurd 1876-1956 *WhoArch*
Frosterus-Saltin, Alexandra Theodora 1837- *DcWomA*
Frosterus-Segerstrale, Johanna W 1867- *DcWomA*
Frothingham, Benjamin 1734-1809 *AntBDN G*
Frothingham, Benjamin, III 1774-1832 *CabMA*
Frothingham, Benjamin, Jr. 1734-1809 *BnEnAmA, CabMA, OxDecA*
Frothingham, Benjamin, Sr. 1708-1765 *CabMA*
Frothingham, Donald McLeod 1928- *AmArch 70*
Frothingham, James 1786-1864 *DcAmArt, FolkA 86, NewYHSD*
Frothingham, Joseph 1677- *CabMA*
Frothingham, Nathaniel 1671-1730 *CabMA*
Frothingham, Samuel *CabMA*
Frothingham, Sara C 1821-1861 *NewYHSD*
Frothingham, Sarah C 1821-1861 *DcWomA*
Frothingham, Thomas 1713-1775 *CabMA*
Frothingham, Walter *CabMA*
Frouchtben, Bernard 1870- *FolkA 86*
Frouchtben, Bernard 1872-1956 *WhAmArt 85*
Frouchtben, Bernard 1878-1956 *WhoAmA 80N, –82N, –84N*
Froud, Brian *IlsCB 1967*
Froude, Robert Hurrell 1779-1859 *DcBrWA*
Froula, Joseph *WhAmArt 85*
Frowd, Thomas T J *DcVicP 2*
Froy, Martin 1926- *DcBrA 1, WhoArt 80, –82, –84*
Fruchard, Amelie *DcWomA*
Frudakis, Anthony 1953- *WhoAmA 84*
Frudakis, Evangelos William 1921- *WhoAmA 73, –76, –78, –80, –82, –84*
Frudakis, Zenos 1951- *WhoAmA 82, –84*
Frueauf, Rueland, The Elder 1440?-1507 *McGDA*
Frueh, Alfred 1880- *WhAmArt 85*
Frueh, Alfred 1880-1968 *WorECar*
Frueh, Joanna 1948- *WhoAmA 84*
Fruh, Eugen 1914- *ClaDrA, WhoArt 80, –82, –84*
Fruhauf, Aline 1907- *WhAmArt 85, WhoAmA 73, –76, –78*
Fruhauf, Aline 1907-1978 *WhoAmA 80N, –82N, –84N*
Fruhmann, Johann 1928- *OxTwCA, WhoArt 80, –82, –84*
Fruhtrunk, Guenter 1923- *ConArt 77*
Fruhtrunk, Gunter 1923- *ConArt 83, DcCAr 81*
Fruhtrunk, Gunther 1923- *PhDcTCA 77*
Fruhurn, G *WhAmArt 85*
Fruiht, Thomas Herman 1919- *AmArch 70*
Frullini, Luigi *ArtsNiC*
Frumerie, Agnes De 1869-1937 *DcWomA*
Frumkin, Allan 1926- *WhoAmA 73, –76, –78, –80, –82, –84*
Frune, George W *FolkA 86, NewYHSD*
Frutchey, Jere 1934- *WhoAmA 82, –84*
Frutiger, Adrian 1928- *ConDes, WhoGrA 62, –82[port]*
Fruytier, Wil 1915- *DcCAr 81*
Fruytiers, Philip 1610-1666 *ClaDrA*
Fry, Anne Frances *WhAmArt 85*
Fry, Anthony 1927- *DcBrA 1*
Fry, Arthur Malcolm 1909- *DcBrA 1, WhoArt 80, –82, –84*

Fry, Benjamin J *NewYHSD*
Fry, Caroline *DcWomA*
Fry, Charles Eugene 1906- *AmArch 70*
Fry, David 1924- *MarqDCG 84*
Fry, Douglas 1872-1911 *DcBrA 2*
Fry, E Maxwell 1899- *ClaDrA, ConArch*
Fry, Edith M *DcBrA 2, DcWomA*
Fry, Edward Fort 1935- *WhoAmA 76, –78, –80*
Fry, Edwin Maxwell 1899- *DcD&D[port], EncMA, MacEA, McGDA, OxArt, WhoArch*
Fry, Eleanora *DcWomA, WhAmArt 85*
Fry, Finley 1908- *WhAmArt 85*
Fry, George *FolkA 86*
Fry, Georgia 1864-1921 *DcWomA*
Fry, Georgia Timken 1864-1921 *WhAmArt 85*
Fry, Gladys Windsor *WhoArt 80, –82, –84*
Fry, Gladys Windsor 1890- *DcBrA 1, DcWomA*
Fry, Guy 1903- *WhoAmA 76, –78*
Fry, Guy Edgar 1903- *WhAmArt 85*
Fry, H C 1840-1929 *IlDcG*
Fry, H Windsor *DcVicP 2*
Fry, Harry Windsor 1862-1947 *DcBrA 1*
Fry, J *DcBrECP*
Fry, J K *AmArch 70*
Fry, James William 1910- *DcBrA 2, WhoArt 80, –82, –84*
Fry, John *FolkA 86*
Fry, John H 1861-1946 *WhAmArt 85*
Fry, L E *AmArch 70*
Fry, L W *AmArch 70*
Fry, Laura *WhAmArt 85*
Fry, Laura Ann 1857-1943 *DcWomA*
Fry, Laura Anne 1857-1943 *CenC*
Fry, Lena J *ArtsEM, DcWomA*
Fry, Lewis George 1860-1933 *DcBrA 1, DcVicP 2*
Fry, Louis Edwin, Jr. 1928- *AmArch 70*
Fry, Marshal 1878- *WhAmArt 85*
Fry, Mary H 1890- *WhAmArt 85*
Fry, Mary L Finley 1908- *WhAmArt 85*
Fry, Maxwell 1899- *WhoArt 84*
Fry, Roger 1866-1934 *DcBrA 1, DcVicP 2, McGDA, PhDcTCA 77*
Fry, Roger Eliot 1866-1934 *OxArt, OxTwCA*
Fry, Roger Eliot 1866-1934 *WhAmArt 85*
Fry, Roger Elliott 1866-1934 *DcBrBI*
Fry, Rosalie Kingsmill *IlsCB 1967*
Fry, Rosalie Kingsmill 1911- *IlsCB 1946, –1957*
Fry, Rowena *WhAmArt 85*
Fry, Mrs. Samuel *DcVicP 2*
Fry, Sherry E 1879- *WhAmArt 85*
Fry, Sherry Edmundson 1879- *DcWomA*
Fry, Thomas *DcBrECP*
Fry, W J *NewYHSD*
Fry, Mrs. Waylande *WhAmArt 85*
Fry, William Arthur 1865- *ClaDrA, DcBrA 1, DcBrWA, DcVicP 2*
Fry, William C 1822?- *NewYHSD*
Fry, William H 1830-1929 *FolkA 86, WhAmArt 85*
Fry, Windsor *DcBrBI*
Fryar, Joe E 1932- *AmArch 70*
Fryar, Kenneth Osborn 1924- *AmArch 70*
Fryberger, Betsy G 1935- *WhoAmA 80, –82, –84*
Frye, Allen Deane 1929- *AmArch 70*
Frye, Anne 1945- *DcCAr 81*
Frye, George *AfroAA*
Frye, Jack Richardson 1922- *AmArch 70*
Frye, Jason William 1933- *AmArch 70*
Frye, Mary *FolkA 86*
Frye, Mary Hamilton 1890- *DcWomA*
Frye, Nathaniel 1786-1822 *CabMA*
Frye, Norma Tanguay *MarqDCG 84*
Frye, Thomas 1710-1762 *AntBDN M, ClaDrA, DcBrECP*
Frye, Thomas 1883- *WhAmArt 85*
Frye, William *NewYHSD*
Frye, William 1821-1872 *FolkA 86*
Fryer *DcBrECP*
Fryer, Bryant W *WhAmArt 85*
Fryer, E L *DcVicP 2*
Fryer, Edward H *DcVicP 2*
Fryer, Flora 1892- *FolkA 86*
Fryer, Frederick Lear 1918- *AmArch 70*
Fryer, H *DcVicP 2*
Fryer, James *FolkA 86*
Fryer, John Graham 1946- *MarqDCG 84*
Fryer, Katherine Mary 1910- *DcBrA 1*
Fryer, Robert Randall 1927- *AmArch 70*
Fryer, Rose *DcVicP 2*
Fryer, Stan 1906- *DcBrA 1, WhoArt 80, –82, –84*
Fryer, W S *AmArch 70*
Fryer, Wilfred Moody 1891- *ClaDrA, DcBrA 1*
Fryett, Mrs. *DcWomA, NewYHSD*
Frymeier, G *NewYHSD*
Frymier, Jacob *FolkA 86*
Frymire, Jacob 1765?-1822 *FolkA 86*
Frysinger, Steven Paul 1957- *MarqDCG 84*
Frytom, Joanna Van *DcWomA*
Fu, Pao-Shih 1904- *McGDA*
Fuarez, Anne 1878?- *DcWomA*
Fuchino, W K *AmArch 70*
Fuchs, Bernard 1932- *IlrAm G, –1880[port]*

Fuchs, Bohuslav 1895-1972 ConArch, MacEA
Fuchs, Emil 1866-1929 DcBrA 2, WhAmArt 85
Fuchs, Erika 1906- WorECom
Fuchs, Ernst 1930- ConArt 77, OxTwCA, PhDcTCA 77
Fuchs, Ernst 1940- ConArt 83
Fuchs, F NewYHSD
Fuchs, F J AmArch 70
Fuchs, Feodor IlBEAAW
Fuchs, Ferdinand EncASM
Fuchs, Gustave d1905 WhAmArt 85
Fuchs, Helen F WhAmArt 85
Fuchs, Lodewijk Juliaan 1814-1873 ClaDrA
Fuchs, Mary Tharsilla 1912- WhoAmA 73, -76, -78, -80, -82, -84
Fuchs, O AmArch 70
Fuchs, Otto 1839-1906 NewYHSD , WhAmArt 85
Fuchs, Richard EncASM
Fuchs, Rudolph EncASM
Fuchs, Theo NewYHSD
Fuchs, William L 1865-1930? BiDAmAr
Fuchs And Beiderhase EncASM
Fuchsel, Franz 1927- WorECar
Fuchslin, Elise DcWomA
Fucigna, V A WhAmArt 85
Fucito, L R AmArch 70
Fudge, Alvin E 1948- AfroAA
Fudge, Barbara AfroAA
Fudge, Donald Graves AmArch 70
Fudge, J DcVicP 2
Fudge, John 1941- AfroAA
Fudji, Gazo 1851?-1915? WhAmArt 85
Fuechsel, Herman 1833-1915 WhAmArt 85
Fuechsel, Hermann 1833-1915 NewYHSD
Fuehrer, T AmArch 70
Fuelling, Annie M DcWomA
Fuente, Maria Ignazia DeLa DcWomA
Fuentes, Lucas FolkA 86
Fuentes-Crespo, Ismael 1956- MarqDCG 84
Fuerst, Shirley 1928- PrintW 83, -85
Fuerst, Shirley Miller 1928- AmArt, WhoAmA 76, -78, -80, -82, -84
Fuerstenberg, Paul W 1875-1953 WhAmArt 85
Fuerstenburg, Paul W d1953 WhoAmA 78N, -80N, -82N, -84N
Fuertes, Louis Agassiz 1874-1927 ArtsAmW 2, WhAmArt 85
Fues, Christian Friedrich 1772-1836 ClaDrA
Fuesler, W F AmArch 70
Fueter, Charlotte 1804-1880 DcWomA
Fuetsch, Charles WhAmArt 85
Fuga, Ferdinando 1699-1781 MacEA, OxArt
Fuga, Ferdinando 1699-1782 McGDA
Fugagli, Alfonso 1912- WhoAmA 73
Fugard, J R, Jr. AmArch 70
Fugate, E L, III AmArch 70
Fugate-Wilcox, Terry 1944- WhoAmA 76, -78, -80, -82, -84
Fugatt, Carl Rayburn 1938- AmArch 70
Fuge, James DcVicP 2
Fuge, James d1838 DcBrWA
Fuge, Paul H 1946- WhoAmA 73, -76, -78, -80, -82
Fuge, W H DcVicP 2
Fugelso, Norman K 1911- AmArch 70
Fuger, Friedrich Heinrich 1751-1818 ClaDrA
Fuger, Val Eugene 1934- AmArch 70
Fugere, Claudia DcWomA
Fugleberg, Lyle Parnell 1931- AmArch 70
Fuglister, Fritz 1909- WhAmArt 85
Fuher, Richard George 1937- AmArch 70
Fuhr, C Clarence WhAmArt 85
Fuhr, Ernest 1874-1933 IlrAm C, -1880, WhAmArt 85
Fuhr, Xaver 1898- McGDA, PhDcTCA 77
Fuhr, Xavier 1898- OxTwCA
Fuhrer, Eugene 1902- AmArch 70
Fuhrer, Ruth Frieder 1903- WhAmArt 85
Fuhrich, Josef Von 1800-1876 ClaDrA
Fuhrich, Joseph 1800-1876 OxArt
Fuhrick, Joseph 1809-1876 ArtsNiC
Fuhrman, Esther 1939- WhoAmA 73, -76, -78, -80, -82, -84
Fuhrmann, Ernst 1886-1956 ICPEnP
Fuhrmann, Otto W 1889- WhAmArt 85
Fuhs, Allen Eugene 1927- MarqDCG 84
Fuidge, Edwin DcVicP 2
Fujii, H H AmArch 70
Fujii, Hideki 1934- ConPhot, ICPEnP A
Fujii, Hiromi 1935- ConArch
Fujii, Kenneth Sho 1938- AmArch 70
Fujii, R I AmArch 70
Fujii, Takuichi 1892- WhAmArt 85
Fujikawa, Gyo IlsBYP, IlsCB 1957, -1967
Fujikawa, Joseph Yusuru 1922- AmArch 70
Fujimoto, Walter 1925- AmArch 70
Fujita, S Neil 1921- ConDes
Fujita, Tsuguji McGDA
Fujiwara, Shinya 1944- MacBEP
Fuka, Eva ICPEnP A, MacBEP
Fuka, Vladimir 1926- WhoGrA 62
Fukano, Tadasu 1929- WhoGrA 82[port]

Fukase, Masahisa 1934- ConPhot, ICPEnP A
Fukuda, Heichachiro 1892-1972 OxTwCA
Fukuda, Katsuji 1898- MacBEP
Fukuda, Shigeo 1932- ConDes
Fukuda, Tom Tomiji 1927- AmArch 70
Fukuhara, Henry 1913- AmArt, WhoAmA 82, -84
Fukui, Nobu 1942- WhoAmA 73, -76, -78, -80, -82, -84
Fukushima, Noriaki 1940- OxTwCA, PhDcTCA 77
Fulcher, Norah DcVicP 2
Fulcher, Seth McCallen 1914- AmArch 70
Fulcher, Thomas 1737?-1803 BiDBrA
Fulchino, Philip Ralph 1953- MarqDCG 84
Fulchiron, Madame DcWomA
Fulchram, Jean Harriet DcWomA
Fulco, Joseph Thomas 1926- AmArch 70
Fulda, E Rungius 1879- WhAmArt 85
Fulda, Elizabeth Rungius 1879-1968 DcWomA
Fulde, Edward B WhAmArt 85
Fulford, Miss DcWomA
Fulghum, Caroline Mercer 1873- DcWomA, WhAmArt 85
Fulham FolkA 86
Fuligny-Damas, Charlotte Eustache Sophie DcWomA
Fulivier, James FolkA 86
Fulkes, Thomas BiDBrA
Fullager, H DcVicP 2
Fullard, George 1923-1973 ConArt 77, DcBrA 2
Fullenwider, Donald Randall 1943- MarqDCG 84
Fuller, A H AmArch 70
Fuller, Adelaide P WhoAmA 73, -76, -78, -80, -82
Fuller, Adella Ryan ArtsEM
Fuller, Adella Ryan 1861?- ArtsAmW 2, DcWomA
Fuller, Albert W 1854-1934 BiDAmAr
Fuller, Alfred 1817-1893 NewYHSD
Fuller, Alfred 1899- ArtsAmW 2, WhAmArt 85
Fuller, Andrew Daniel, Jr. 1903- WhAmArt 85
Fuller, Arthur D 1889- IlrAm C, WhAmArt 85
Fuller, Arthur D 1889-1966 IlrAm 1880
Fuller, Augustus 1812-1873? FolkA 86
Fuller, Augustus 1812-1873 NewYHSD
Fuller, Buckminster 1895- ConArch, McGDA
Fuller, Charles A NewYHSD
Fuller, Charles Irving 1956- MarqDCG 84
Fuller, Crispin 1778?-1827 AntBDN Q
Fuller, Cynthia DcWomA
Fuller, Diana 1931- WhoAmA 73, -76, -78, -80, -82, -84
Fuller, Douglas Berryman 1938- AmArch 70
Fuller, Mrs. E G WhoArt 80, -82, -84
Fuller, E M AmArch 70
Fuller, Earl Martin 1890- WhAmArt 85
Fuller, Earnest Melvin 1905- AmArch 70
Fuller, Edith DcVicP 2
Fuller, Edmund G DcBrA 1, DcSeaP, DcVicP 2
Fuller, Elijah K FolkA 86
Fuller, Elizabeth Douglas 1897- WhAmArt 85
Fuller, Emily 1941- WhoAmA 78, -80, -82, -84
Fuller, Florence A DcVicP 2
Fuller, Florence Ada 1867-1918 DcWomA
Fuller, Francis Marvin 1935- AmArch 70
Fuller, George 1822- FolkA 86
Fuller, George 1822-1884 ArtsNiC, BnEnAmA, DcAmArt, McGDA, NewYHSD , OxArt, WhAmArt 85
Fuller, Harvey Kenneth 1918- WhoAmA 73, -76
Fuller, Helen WhAmArt 85
Fuller, Henry B 1857-1929 WhAmArt 85
Fuller, Henry B 1867-1934 WhAmArt 85
Fuller, Horace DcVicP 2
Fuller, I C NewYHSD
Fuller, Isaac 1606?-1672 OxArt
Fuller, J NewYHSD
Fuller, J C NewYHSD
Fuller, James NewYHSD
Fuller, James E 1836-1901 BiDAmAr
Fuller, Jeffrey P 1950- WhoAmA 84
Fuller, John FolkA 86
Fuller, John Charles 1937- ICPEnP A, MacBEP, WhoAmA 78, -80, -82, -84
Fuller, John Merriman 1924- AmArch 70
Fuller, Joseph 1926- AmArch 70
Fuller, K R AmArch 70
Fuller, Kathleen Collins 1947- MacBEP
Fuller, L DcWomA
Fuller, Leonard John 1891- ClaDrA
Fuller, Leonard John 1891-1973 DcBrA 1
Fuller, Loie DcNiCA
Fuller, Lola A DcWomA
Fuller, Louise F DcWomA
Fuller, Lucia 1870-1924 DcWomA
Fuller, Lucia Fairchild 1872-1924 WhAmArt 85
Fuller, Lucy Moore 1846-1928 DcWomA
Fuller, Margaret DcWomA, WhAmArt 85
Fuller, Marjorie DcWomA
Fuller, Martha DcWomA
Fuller, Martin 1943- DcCAr 81, WhoArt 84
Fuller, Mary 1922- WhoAmA 76, -78, -80, -82, -84
Fuller, Meta Vaux 1877-1968 DcWomA
Fuller, Meta Vaux Warrick 1877- WhAmArt 85
Fuller, Meta Vaux Warrick 1877-1967 AfroAA

Fuller, Meta Vaux Warrick 1877-1968 WhoAmA 80N, -82N, -84N
Fuller, Minnie DcWomA
Fuller, Moss 1937- DcCAr 81
Fuller, Munford Gregg 1934- AmArch 70
Fuller, Nathaniel 1687-1750 FolkA 86
Fuller, Perry J 1916- AfroAA
Fuller, Pope Huguley 1916- AmArch 70
Fuller, Q R AmArch 70
Fuller, Queenie AfroAA
Fuller, R Buckminster 1895- BnEnAmA, MacEA, WhoAmA 78, -80, -82
Fuller, R Buckminster 1895-1983 WhoAmA 84N
Fuller, R H d1871 ArtsNiC
Fuller, Ralph Briggs 1890- WhAmArt 85
Fuller, Ralph Briggs 1890-1963 WorECom
Fuller, Reed Blackinton 1911- AmArch 70
Fuller, Richard Buckminster 1895- DcD&D[port], EncAAr, EncMA, WhoArch
Fuller, Richard Buckminster 1895-1983 ConDes
Fuller, Richard Eugene 1897- WhoAmA 73, -76
Fuller, Richard Eugene 1897-1976 WhoAmA 78N, -80N, -82N, -84N
Fuller, Richard Henry 1822-1871 NewYHSD
Fuller, Ruth B 1893- ArtsAmW 3
Fuller, S P DcVicP 2
Fuller, Samuel A NewYHSD
Fuller, Samuel W NewYHSD
Fuller, Santry Clay 1918- AmArch 70
Fuller, Sarah E 1829?-1901 DcWomA, WhAmArt 85
Fuller, Sarah E 1829?-1902 NewYHSD
Fuller, Spencer 1863-1911 WhAmArt 85
Fuller, Sue 1914- DcCAA 71, -77, OxTwCA, WhAmArt 85, WorArt[port]
Fuller, Susan E W d1907 NewYHSD , WhAmArt 85
Fuller, Susan E W 1831-1907 DcWomA
Fuller, Thomas 1822-1898 MacEA
Fuller, Thomas W 1822- BiDAmAr
Fuller, Thomas W 1822-1898 McGDA
Fuller, Violet 1920- DcBrA 2, WhoArt 80, -82, -84
Fuller, Violet Overton DcBrA 1
Fuller, Walter B 1881- WhAmArt 85
Fuller, William ArtsAmW 3
Fuller, William Marshall WhoAmA 73, -76, -78, -80, -82
Fuller-Largent, Lydia WhAmArt 85
Fuller-Maitland, Alexander 1851-1920 DcBrA 2
Fullerton, Alice V WhAmArt 85
Fullerton, Alice V 1854-1950 ArtsAmW 3
Fullerton, Carrie Q WhAmArt 85
Fullerton, Elizabeth S DcVicP 2, DcWomA
Fullerton, Howard N, Jr. 1938- MarqDCG 84
Fullerton, Hugh FolkA 86
Fullerton, Nathaniel NewYHSD
Fullerton, R D WhAmArt 85
Fullerton, W A AmArch 70
Fullerton, William d1750 CabMA
Fullerton, William B, Jr. 1916- AmArch 70
Fulleylove, John 1845-1908 ClaDrA, DcBrA 1, DcBrBI, DcVicP
Fulleylove, John 1847-1908 DcBrWA, DcVicP 2
Fullingim, Earl Payton 1926- AmArch 70
Fullwood, Albert Henry 1863- DcBrA 1, DcVicP 2
Fullwood, Albert Henry 1863-1930 DcBrA 2
Fullwood, Albert Henry 1864- DcBrWA
Fullwood, Charles DcVicP 2
Fullwood, John d1931 DcBrA 1, DcBrWA, DcVicP 2
Fullwood, John 1931- ClaDrA
Fulop, Karoly WhAmArt 85
Fulop, Karoly 1898- ArtsAmW 2
Fulop, Koroly 1898- ArtsAmW 2
Fulop, Laszlo Gyorgy 1934- AmArch 70
Fulop, Leslie WorFshn
Fulper, Abraham FolkA 86
Fulper, William H 1872-1928 CenC
Fulpius, Elisabeth Caroline 1878- DcWomA
Fulton WorECom
Fulton, A Fraser 1898- WhAmArt 85
Fulton, Agnes Fraser 1898- DcWomA
Fulton, Antoinette Willner 1882- DcWomA, WhAmArt 85
Fulton, Cyrus James d1949 WhoAmA 78N, -80N, -82N, -84N
Fulton, Cyrus James 1873-1949 ArtsAmW 2, WhAmArt 85
Fulton, David 1848-1930 DcBrA 1, DcBrWA, DcVicP 2
Fulton, Don Hendry 1925- ConArch
Fulton, Dorothy 1896?- DcWomA, WhAmArt 85
Fulton, Dorothy E WhAmArt 85
Fulton, E Donald WhAmArt 85
Fulton, Ellen 1887- WhAmArt 85
Fulton, Fitch 1879- ArtsAmW 1
Fulton, Fitch B WhAmArt 85
Fulton, Florence Wellsman WhAmArt 85
Fulton, Fred Franklin 1920- WhoAmA 76, -78, -80, -82, -84
Fulton, G L WhAmArt 85
Fulton, Guy C AmArch 70

G

G F F *EarABI*
Gaal, Barend 1620?-1703? *ClaDrA*
Gaal, Barent *McGDA*
Gaal, Steven *WhAmArt 85*
Gaarder, LeRoy 1891- *AmArch 70*
Gaastra, Bonney Royal *ArtsAmW 3*
Gaastra, Bonnie Royla *ArtsAmW 3*
Gaastra, Jan Tabe 1904- *AmArch 70*
Gaba, A Lester 1907- *WhAmArt 85*
Gabain, Ethel Leontine 1883-1950 *DcBrA 1,*
 DcWomA
Gabassi, Margerita 1663?-1734 *DcWomA*
Gabay, Esperanza *DcWomA, WhAmArt 85*
Gabbiani, Antonio Domenico 1652-1726 *ClaDrA,*
 McGDA
Gabe, Ron *WhoAmA 84*
Gabel, Matthes d1574 *McGDA*
Gaber, Aimee 1834-1863 *DcWomA*
Gabert, Edward William 1922- *AmArch 70*
Gabert, L *AmArch 70*
Gabillot, Louise Van *DcWomA*
Gabin, George Joseph 1931- *PrintW 85,*
 WhoAmA 73, -76, -78, -80, -82, -84
Gabino, Amadeo 1922- *ConArt 77*
Gabiou, Jeanne Elizabeth *DcWomA*
Gable, Amos 1840- *NewYHSD*
Gable, Charles Greenlee 1914- *AmArch 70*
Gable, John Oglesby 1944- *WhoAmA 84*
Gabler, Cornelius Leighton Twing 1902- *AmArch 70*
Gablik, Suzi 1934- *WhoAmA 73, -76, -78, -80, -82,*
 -84
Gabo, Naum 1890- *BnEnAmA, ConArt 77,*
 McGDA, OxArt, PhDcTCA 77, WhoAmA 76,
 WhoArch
Gabo, Naum 1890-1977 *ConArt 83, OxTwCA,*
 WhoAmA 78N, -80N, -82N, -84N, WorArt[port]
Gabo, Naum Neemia Pevsner 1890- *DcCAA 71, -77*
Gabor, Dennis 1900-1979 *ICPEnP, MacBEP*
Gabourd, Irma *DcWomA*
Gabrie, Marie Maurel 1867- *DcWomA*
Gabriel, Ada V 1898- *WhAmArt 85*
Gabriel, Ada Vorhaus 1898- *DcWomA*
Gabriel, Ange-Antoine 1735-1781 *DcD&D*
Gabriel, Ange Jacques 1698-1782 *MacEA*
Gabriel, Ange-Jacques 1698-1782 *McGDA, OxArt,*
 WhoArch
Gabriel, C Wallis *DcVicP 2*
Gabriel, Caroline S *WhoArt 80, -82, -84*
Gabriel, Caroline S 1912- *DcBrA 1*
Gabriel, Edith M *DcBrA 1*
Gabriel, G L 1958- *DcCAr 81*
Gabriel, H James 1932- *AmArch 70*
Gabriel, Hannelore *WhoAmA 76, -78, -80, -82, -84*
Gabriel, Henry 1812-1887 *FolkA 86*
Gabriel, Henry Robert 1926- *AmArch 70*
Gabriel, Jacky 1949- *DcCAr 81*
Gabriel, Jacques *DcD&D*
Gabriel, Jacques 1667-1742 *MacEA, OxArt*
Gabriel, Jacques, IV d1686 *WhoArch*
Gabriel, Jacques, V 1667-1742 *WhoArch*
Gabriel, Jacques-Ange 1698-1782 *DcD&D*
Gabriel, Jacques Jules 1667-1742 *DcD&D*
Gabriel, Jacques-Jules 1667-1742 *McGDA*
Gabriel, Janice 1948- *DcCAr 81*
Gabriel, John Milton 1911- *AmArch 70*
Gabriel, Joseph M 1928- *AmArch 70*
Gabriel, Michael 1948- *DcCAr 81*
Gabriel, Paul Joseph Constantin 1828-1903 *OxArt*
Gabriel, Paul Joseph Constantine *ArtsNiC*
Gabriel, Raymond *AfroAA*
Gabriel, Robert A 1931- *WhoAmA 73, -76, -78, -80,*
 -82
Gabriel, Romano 1888-1977 *FolkA 86*
Gabriel, W J *AmArch 70*
Gabriel, William Lenard 1936- *AmArch 70*
Gabriel Family *DcD&D, OxArt*
Gabriele, Gabrielle 1906- *WhAmArt 85*
Gabriele, Julius C 1925- *AmArch 70*
Gabrielle, Marie *DcWomA*
Gabrielson, Walter Oscar 1935- *WhoAmA 80, -82,*
 -84
Gabron, Willem 1619-1678 *McGDA*
Gach, George 1909- *WhoAmA 73, -76, -78, -80, -82,*
 -84
Gachot, A M *NewYHSD*
Gadamus, Jerry *OfPGCP 86*
Gadbois, Marie Marguerite Louise 1896- *DcWomA*
Gadbury, Harry Lee 1890- *WhAmArt 85*
Gaddi, Agnolo *McGDA, OxArt*
Gaddi, Gaddo 1250?-1330? *McGDA*
Gaddi, Taddeo *MacEA*
Gaddi, Taddeo 1300?-1366 *ClaDrA, McGDA*
Gaddi, Taddeo 1300?-1366? *OxArt*
Gaddis, Hugh Hamilton 1927- *AmArch 70*
Gaddis, John W 1856-1931? *BiDAmAr*
Gaddis, Norris Milden 1915- *AmArch 70*
Gaddis, Terry Alan 1943- *MarqDCG 84*
Gaddo DiZanobi *McGDA*
Gade, John 1870- *WhAmArt 85*
Gade, Lilla Pauline Emilie 1852- *DcWomA*
Gade, William R *DcVicP 2*
Gado, T K *WhAmArt 85*
Gadou-Royer, Jeanne d1907 *DcWomA*
Gadsby, James *DcVicP 2*
Gadsby, William H *DcVicP*
Gadsby, William Hippon 1844-1924 *DcBrA 1,*
 DcBrWA, DcVicP 2
Gadsdon, Isaac *BiDBrA*
Gadson, James *AfroAA*
Gady, William Henry 1928- *AmArch 70*
Gaebler, Carl Frederick *FolkA 86*
Gaebler, William *FolkA 86*
Gaede, Carl Dean 1936- *AmArch 70*
Gaede, Lilla Pauline Emilie 1852- *DcWomA*
Gaede, Robert Curtis 1920- *AmArch 70*
Gael, Barend 1620?-1703? *ClaDrA*
Gael, Barent 1630?-1681? *McGDA*
Gaensen, Frederick B 1870-1941 *BiDAmAr*
Gaensslen, Otto Robert 1876- *WhAmArt 85*
Gaer, Fay *WhAmArt 85*
Gaer, Fay 1899- *DcWomA*
Gaertner, Carl F 1898- *WhAmArt 85*
Gaertner, Lillian V 1906- *WhAmArt 85*
Gaesbeeck, Adriaen Van 1621?-1650 *McGDA*
Gaetano, Il *McGDA*
Gaffeney, Charles Henry 1924- *AmArch 70*
Gaffney, Claribel Honor 1901- *WhAmArt 85*
Gaffney, Edward Kelly *AmArch 70*
Gaffney, Richard Walter 1928- *AmArch 70*
Gaffney, W M *AmArch 70*
Gafford, Alice 1886- *AfroAA*
Gaffron, Horace *WhAmArt 85*
Gafgen, Wolfgang *PrintW 85*
Gafgen, Wolfgang 1936- *ConArt 77*
Gafill, Mrs. John J *WhAmArt 85*
Gag, Flavia 1907- *IlsCB 1744, -1946*
Gag, Wanda 1893-1946 *ConICB, DcWomA, GrAmP,*
 IlsCB 1744, McGDA, WhAmArt 85
Gagarin, Frank Paul 1939- *AmArch 70*
Gagarina-Stourdza, Princess Carmina 1868-1918
 DcWomA
Gage, Mrs. Alex *DcWomA*
Gage, Benjamin F *NewYHSD*
Gage, Edward Arthur 1925- *DcBrA 1, WhoArt 80,*
 -82, -84
Gage, Frances M 1924- *WhoAmA 73, -76, -78, -80,*
 -82, -84
Gage, George W 1887- *WhAmArt 85*
Gage, George William 1887- *IlBEAAW*
Gage, Harry 1887- *WhoAmA 73, -76, -78*
Gage, Harry Lawrence 1887- *WhAmArt 85*
Gage, Henry L *WhAmArt 85*
Gage, Jane 1914- *WhAmArt 85*
Gage, Martha *FolkA 86*
Gage, Merrell 1892- *WhAmArt 85*
Gage, Nancy 1787-1845 *DcWomA, FolkA 86,*
 NewYHSD
Gage, Samuel E d1943 *BiDAmAr*
Gage, Sir Thomas 1780?-1820 *DcBrWA*
Gagelin, Sidonie *DcWomA*
Gagen, Caroline S *DcWomA*
Gager, Oliver A *FolkA 86*
Gagern, Verena Von 1946- *MacBEP*
Gaggero, Giancarlo 1939- *MarqDCG 84*
Gaggin, T Walter 1880-1945 *BiDAmAr*
Gaggini, Antonello 1478-1536 *McGDA*
Gaggini, Beltrame d1476? *McGDA*
Gaggini, Giovanni d1517 *McGDA*
Gaggini, Pace *McGDA*
Gaggiotti-Richards, Emma 1825-1912 *DcWomA*
Gagini, Domenico d1492 *McGDA*
Gagliani, Oliver 1917- *ConPhot, WhoAmA 76, -78,*
 -80, -82
Gagliani, Oliver L 1917- *ICPEnP A, MacBEP,*
 PrintW 85
Gagliano, Alessandro 1640-1725 *AntBDN K*
Gagliano, Antonio d1860 *AntBDN K*
Gagliano, Ferninando 1706-1781 *AntBDN K*
Gagliano, Gennaro 1695-1750 *AntBDN K*
Gagliano, Giovanni d1806 *AntBDN K*
Gagliano, Giuseppe d1793 *AntBDN K*
Gagliano, Joseph A N, Sr. 1934- *MarqDCG 84*
Gagliano, Nicolas 1665-1740 *AntBDN K*
Gagliano, Raffael *AntBDN K*
Gagliardi, Rosario 1698?-1762? *MacEA*
Gagliardi, Tommaso 1820-1895 *NewYHSD*
Gagliardini, Julien Gustave 1846-1927 *ClaDrA*
Gaglio, Salvatore 1954- *MarqDCG 84*
Gagnereaux, Benigne 1756-1795 *ClaDrA*
Gagnet, G Peter, III *MarqDCG 84*
Gagnier, Mrs. John *DcBrECP*
Gagnon, Charles 1934- *ConPhot, DcCAr 81,*
 ICPEnP A, MacBEP, WhoAmA 82, -84
Gagnon, Charles Eugene 1934- *WhoAmA 76, -78, -80,*
 -82, -84
Gagnon, Clarence *OxTwCA*
Gagnon, Clarence A 1881- *WhAmArt 85*
Gagnon, Clarence A 1881-1942 *McGDA*
Gagnon, Mario 1950- *MarqDCG 84*
Gagnon, Thomas C *ArtsEM*
Gahagan, James 1927- *WhoAmA 80*
Gahagan, James, Jr. 1927- *WhoAmA 82, -84*
Gahagan, Sarah 1866- *DcWomA*
Gahan, George Wilkie 1871- *DcBrA 1*
Gahery, Gendrot *FolkA 86*
Gahery-Ulric, Angele *DcWomA*
Gahl, Robert Allen 1933- *AmArch 70*
Gahman, Floyd *WhoAmA 73, -76, -78, -80*
Gahman, Floyd 1899- *WhAmArt 85*
Gahman, John *FolkA 86*
Gahs, Elsie M 1907- *WhAmArt 85*
Gahtan, R *AmArch 70*
Gai, Antonio 1686-1769 *McGDA*

Gallwey, Antoinette Celestine *DcWomA*
Gallwey, Emmeline Henriette *DcWomA*
Gally, Thomas J *FolkA 86*
Galos, Ben d1963 *WhoAmA 78N, –80N, –82N, –84N*
Galow, August H 1892-1934 *BiDAmAr*
Galpin, Cromwell *IlBEAAW*
Galpin, Will Dixon *DcBrBI*
Galpin, William Dixon *DcVicP 2*
Galque, Adrian Sanchez *McGDA*
Galster, Robert Miller 1928- *IlsBYP, IlsCB 1957*
Galsworthy, G C *DcBrA 2*
Galsworthy, Gordon C *DcVicP 2*
Galsworthy, W H *DcVicP 2*
Galt, Alexander 1827-1863 *DcAmArt, NewYHSD*
Galt, Charles F 1884- *WhAmArt 85*
Galt, James d1847 *EncASM*
Galt, M W *EncASM*
Galt, Norman d1908 *EncASM*
Galt, William *EncASM*
Galter, Irwin B 1924- *MarqDCG 84*
Galtier-Boissiere, Elisabeth Marie V Zoe *DcWomA*
Galtier-Boissiere, Louise *DcWomA*
Galton, Ada *DcBrA 2, DcVicP 2*
Galton, Ada Mary *DcWomA*
Galton, J *DcBrWA*
Galucci, Niccolo D'Andrea DiPasquale *McGDA*
Galusha, Elijah 1804-1871 *CabMA, DcNiCA*
Galusha, Gordon Bohannan 1926- *AmArch 70*
Galvan, Jesus Gerrero *WhoAmA 82N, –84N*
Galvan, Jesus Guerrero *WhoAmA 76N, –78N, –80N*
Galvani, Charles 1805?- *NewYHSD*
Galvez, Mariana De *DcWomA*
Galvez, Richard Villanueva 1930- *AmArch 70*
Galvin, Francys *WhAmArt 85*
Galvin, John Christopher 1929- *AmArch 70*
Galvin, T F *AmArch 70*
Galvin, William Lawrence 1902- *AmArch 70*
Galyardt, Gary Evan Michael 1934- *AmArch 70*
Gamain, Louis Honore Frederic 1803-1871 *DcSeaP*
Gamarra, Jose 1934- *DcCAr 81, McGDA*
Gambach, Roberto J 1935- *AmArch 70*
Gambara, Lattanzio 1530-1574 *McGDA*
Gambardella, Spiridione *DcVicP 2, NewYHSD*
Gambaro, E J *AmArch 70*
Gambaro, Lattanzio 1530?-1574? *ClaDrA*
Gambart, Jean Joseph Ernest Theodore 1814-1902 *DcNiCA*
Gambee, Martin 1905- *IlBEAAW, WhAmArt 85*
Gambel, J *FolkA 86*
Gambel, W *NewYHSD*
Gamber, M G *FolkA 86*
Gamberini, Domenico *NewYHSD*
Gambier-Parry, Ernest 1853-1936 *DcBrA 2*
Gambino, Katherine R *MarqDCG 84*
Gamble, C *AmArch 70*
Gamble, David *NewYHSD*
Gamble, Dora *DcWomA*
Gamble, Edna 1861?-1935 *DcWomA*
Gamble, Edwin 1876- *WhAmArt 85*
Gamble, Eugene Bryant 1914- *AmArch 70*
Gamble, J *FolkA 86*
Gamble, J A *FolkA 86*
Gamble, James *WhAmArt 85*
Gamble, John Marshall 1863- *WhAmArt 85*
Gamble, John Marshall 1864-1957 *ArtsAmW 1*
Gamble, Kathryn Elizabeth 1915- *WhoAmA 73, –76, –78, –80, –82, –84*
Gamble, Louisa *DcWomA*
Gamble, Morris Mackintosh 1925- *AmArch 70*
Gamble, Roy C 1887- *WhAmArt 85*
Gamble, Roy C 1887-1972 *ArtsEM*
Gamble, Sam *FolkA 86*
Gamble, Sarah E *FolkA 86*
Gamble, William *AntBDN Q*
Gamblin, Thomas Allen 1938- *AmArch 70*
Gambogi, Elin *DcWomA*
Gambogi, Fanny *DcWomA*
Gambrell, Reuben *WhAmArt 85*
Gambrill, Charles D 1832-1880 *BiDAmAr*
Gambun *AntBDN L*
Gamelin, M *DcWomA*
Gamertsfelder, Robert Hehn 1920- *AmArch 70*
Games, Abram 1914- *ConDes, WhoArt 80, –82, –84, WhoGrA 62, –82[port]*
Gamitzer Family *McGDA*
Gamlen, Mary 1913- *WhoArt 82, –84*
Gamley, Andrew Archer *DcBrA 1*
Gamley, Henry Snell 1865-1928 *DcBrA 1*
Gamm, James Howard 1958- *MarqDCG 84*
Gammage, Emma *DcVicP 2, DcWomA*
Gammel, Nora *DcWomA*
Gammell, Linda K 1948- *MacBEP*
Gammell, R H Ives 1893- *WhAmArt 85*
Gammell, Sydney A *DcBrA 1*
Gammius, Helene 1854- *DcWomA*
Gammon, Estella 1895- *DcWomA*
Gammon, Estella M 1895- *ArtsAmW 3*
Gammon, Juanita-LaVerne *WhoAmA 73, –76, –78, –80, –82, –84*
Gammon, Reginald 1894- *DcBrBI*

Gammon, Reginald 1921- *AfroAA*
Gammon, Reginald Adolphus 1921- *WhoAmA 76, –78, –80, –82, –84*
Gammon, Reginald William 1894- *DcBrA 1, WhoArt 80, –82, –84*
Gammons, Molly Nye *WhAmArt 85*
Gamon, Edwin R 1933- *AmArch 70*
Gamond, Elisa De *DcWomA*
Gamp, L W *AmArch 70*
Gampe, Daniel *IlDcG*
Gampe, Gottfried *IlDcG*
Gampe, Hans Gregor *IlDcG*
Gampe, Samuel Gottlieb *IlDcG*
Gamza, Arleen S *AmArch 70*
Ganaway, King Daniel *AfroAA*
Gancedo, Teresa 1937- *DcCAr 81*
Ganchequi, Luis Pena 1926- *MacEA*
Gandara 1862-1917 *WhAmArt 85A*
Gandara, Antoine DeLa 1862-1917 *McGDA*
Gandara, Antonio DeLa 1862-1917 *ClaDrA*
Gandee, N Kent 1935- *AmArch 70*
Gander, E W *AmArch 70*
Gander, J J *AmArch 70*
Gander, John A 1924- *AmArch 70*
Gandl, Warren Joseph 1925- *AmArch 70*
Gandler, Harvey M 1938- *AmArch 70*
Gandola, P M 1889- *WhAmArt 85*
Gandolfi, Camilla d1865? *DcWomA*
Gandolfi, Clementina *DcWomA*
Gandolfi, Democrito 1797-1874 *McGDA*
Gandolfi, Gaetano 1734-1802 *ClaDrA, McGDA*
Gandolfi, Lelli *McGDA*
Gandolfi, Mauro 1764-1834 *McGDA, NewYHSD*
Gandolfi, Menozzi *McGDA*
Gandolfi, Ubalde 1728-1781 *McGDA*
Gandolfo, Ronald Patrick 1932- *AmArch 70*
Gandon, James 1742-1823 *MacEA*
Gandon, James 1743-1823 *BiDBrA, DcBrWA, DcD&D, OxArt, WhoArch*
Gandon, Mary Ann *DcWomA*
Gandy *DcBrECP*
Gandy, Ada *DcVicP 2*
Gandy, Celia *DcWomA*
Gandy, Hannah *DcWomA*
Gandy, Herbert *DcBrA 1, DcBrBI*
Gandy, Herbert d1920? *DcVicP 2*
Gandy, J M 1771-1843 *MacEA*
Gandy, John Peter 1787-1850 *BiDBrA*
Gandy, John Ramage 1934- *AmArch 70*
Gandy, Joseph Michael 1771-1843 *BiDBrA, DcBrWA*
Gandy, T *DcVicP 2*
Gandy, Walton *DcVicP 2*
Gandy, William 1655?-1729 *DcBrECP*
Gandy-Deering, John Peter 1787-1850 *MacEA*
Gane, Jesse 1798?-1855 *BiDBrA*
Gane, John Frederick 1908- *AmArch 70*
Gangalen, Van *DcVicP 2*
Ganger, George F 1923- *AmArch 70*
Gangewer, Ida A *DcWomA*
Gangewere, Dana Wayne 1928- *AmArch 70*
Ganghofer, Jorg d1488 *MacEA, McGDA*
Gangle, Martina Marie 1906- *WhAmArt 85*
Gangloff, Maria 1877- *DcWomA*
Gangnes, Arnold Gordon 1918- *AmArch 70*
Gangoly, Orun Coomar 1920- *WhoGrA 62*
Ganiere, George Etienne 1865-1935 *WhAmArt 85*
Ganine, Peter 1900- *WhAmArt 85*
Ganis, John B 1951- *MacBEP*
Ganku 1756-1838 *McGDA*
Ganly, Rosaleen Brigid 1909- *DcBrA 1, WhoArt 80, –82, –84*
Gannam, John d1965 *WhoAmA 78N, –80N, –82N, –84N*
Gannam, John 1907-1965 *IlBEAAW, IlrAm E, –1880, WhAmArt 85*
Gannam, Nicholas 1919- *MarqDCG 84*
Gannaway, A G *AmArch 70*
Gannaway, Charles Burrell, III 1928- *AmArch 70*
Gannett *FolkA 86*
Gannett, B J *AmArch 70*
Gannett, Mary *DcWomA*
Gannett, Mary C *WhAmArt 85*
Gannett, Ruth Chrisman 1896- *WhAmArt 85*
Gannett, Ruth Chrisman 1896-1979 *DcWomA*
Gannett, Ruth Chrisman Arens 1896- *ArtsAmW 3, IlsCB 1946*
Gannon, Albert J *EncASM*
Gannon, P J *AmArch 70*
Gano DaSiena *McGDA*
Gano, Katharine V 1884- *DcWomA, WhAmArt 85*
Ganor, Avi 1950- *ConPhot, ICPEnP A*
Gans, F C *AmArch 70*
Gans, H *FolkA 86*
Gans, Lucy C 1949- *WhoAmA 84*
Ganser, Ivan L 1906- *WhAmArt 85*
Ganso, Emil 1895-1941 *DcCAA 71, –77, GrAmP, WhAmArt 85*
Ganster, William Allaman 1908- *AmArch 70*
Ganstrom, H W *AmArch 70*
Gant, James Y *DcVicP 2*
Gant, Rus *MarqDCG 84*

Gant, Thomas *CabMA*
Ganter, Daniel *NewYHSD*
Ganthiers, Louise Marie 1907- *WhoAmA 76, –78, –80, –82*
Ganthoney, R *DcVicP 2*
Gantt, James Britton 1909- *WhAmArt 85*
Gantz, Ann Cushing 1935- *PrintW 85, WhoAmA 78, –80, –82, –84*
Gantz, Frederick *FolkA 86*
Gantz, Jeanne *PrintW 85*
Gantz, Jeanne A 1929- *WhoAmA 76, –78, –80, –82, –84*
Gantz, John 1772-1853 *DcBrWA*
Gantz, Justinian 1802-1862 *DcBrWA*
Ganz, Henry F W *DcVicP 2*
Ganz, Sylvia Squires *WhoAmA 82, –84*
Ganzel, Robert *MarqDCG 84*
Gaona, Guy 1950- *MarqDCG 84*
Gaona, Jose Julio 1943- *WhoAmA 82*
Gaona Adame, Jose Julio 1943- *WhoAmA 84*
Gapp, John *AntBDN O*
Gapper, Robert Lambert *WhoArt 80, –82, –84*
Gara, Calista *DcWomA*
Gara, Mrs. Isaac B *NewYHSD*
Garabedian, Charles *DcCAr 81*
Garabedian, Charles 1923- *PrintW 83, –85*
Garabedian, Charles 1924- *AmArt*
Garache, Claude 1930- *PrintW 83, –85*
Garafulic, Lili *OxTwCA*
Garamond, Claude d1561 *OxDecA*
Garanin, Anatoli 1912- *ConPhot*
Garanin, Anatolij S 1912- *ICPEnP A*
Garant, Carl G 1947- *MarqDCG 84*
Garavaglia, Giovita 1790-1835 *McGDA*
Garavani, Valentino 1932- *WorFshn*
Garay, Camilla *DcWomA*
Garay, Epifanio 1849-1903 *McGDA*
Garay, Marie 1861- *DcWomA*
Garbaty, Eugene L d1966 *WhoAmA 78N, –80N, –82N, –84N*
Garbaty, Marie Louise 1910- *WhoAmA 76, –78, –80, –82*
Garbaty, Marie-Louise 1910- *WhoAmA 84*
Garbayo, Fermin Hernandez 1929- *WhoGrA 62, –82[port]*
Garbe, Emy *DcWomA*
Garbe, Herbert 1888-1945 *McGDA*
Garbe, Louis Richard 1876-1957 *DcBrA 1*
Garbe, Raymond W 1906- *AmArch 70*
Garbee, R H *AmArch 70*
Garbeille, Philip *NewYHSD*
Garbely, Edward 1909- *WhAmArt 85*
Garber, Albert *DcCAr 81*
Garber, C *FolkA 86*
Garber, Daniel 1880-1958 *WhAmArt 85, WhoAmA 80N, –82N, –84N*
Garber, Hugh 1945- *WorFshn*
Garber, Jonathan *FolkA 86*
Garber, M J *AmArch 70*
Garber, Susan R 1950- *WhoAmA 76, –78, –80, –82*
Garber, Virginia Wright *DcWomA, WhAmArt 85*
Garber, W *AmArch 70*
Garbett, C *WhAmArt 85*
Garbett, Cornelia *DcWomA*
Garbett, Cornelia Barns *ArtsAmW 2*
Garbett, Edward Lacy d1898 *MacEA*
Garbett, Edward William *BiDBrA*
Garbett, Meta 1881- *DcBrA 1, DcWomA*
Garbett, William 1770?-1834 *BiDBrA*
Garbisch, Bernice Chrysler *WhoAmA 73, –76, –78, –80N, –82N, –84N*
Garbisch, Edgar William 1899- *WhoAmA 73, –76, –78*
Garbisch, Edgar William 1899-1979 *WhoAmA 80N, –82N, –84N*
Garbo, Raffaellino Del *McGDA*
Garbrand, Caleb John 1748-1794 *DcBrECP*
Garbut, Joseph *DcVicP 2*
Garbut, Joseph Putty *DcBrWA*
Garbutt, Bernard 1900- *IlsCB 1946*
Garceau, Harry J 1876-1954 *WhAmArt 85*
Garchik, Morton Lloyd 1929- *WhoAmA 76, –78, –80, –82, –84*
Garcia *FolkA 86*
Garcia, A M *NewYHSD*
Garcia, Alberto Schommer DeLaPena 1928- *ICPEnP A*
Garcia, Andres *FolkA 86*
Garcia, Antonio Carlos 1925- *WhoGrA 62*
Garcia, Antonio E 1901- *WhAmArt 85*
Garcia, Ballesta Raul 1954- *MarqDCG 84*
Garcia, Carolina *DcWomA*
Garcia, Danny 1929- *WhoAmA 76, –78, –80, –82*
Garcia, Frank *WhoAmA 76*
Garcia, Frank 1924- *WhoAmA 82, –84*
Garcia, Genaro, Jr. 1935- *AmArch 70*
Garcia, J *AmArch 70*
Garcia, J A *AmArch 70*
Garcia, Joe *OfPGCP 86*
Garcia, Jose *WhoAmA 76, –78, –80*
Garcia, Josefa *DcWomA*

Garcia, Juana *DcWomA*
Garcia, Lawrence Arthur 1922- *AmArch 70*
Garcia, Max Rodriguez 1924- *AmArch 70*
Garcia, Miguel *NewYHSD*
Garcia, Ofelia 1941- *WhoAmA 78, -80, -82, -84*
Garcia, P L *AmArch 70*
Garcia, Pablo *FolkA 86*
Garcia, Rupert 1941- *WhoAmA 80, -82, -84*
Garcia, Wifredo 1935- *MacBEP*
Garcia Cabral, Ernesto 1890-1968 *WorECar*
Garcia-Courel Y DeMendoza, Jose 1942-
 MarqDCG 84
Garcia DeLaPena, Alberto Schommer 1928- *MacBEP*
Garcia DeParedes, Jose Maria 1924- *MacEA*
Garcia-Junceda I Supervia, Joan 1881-1948 *WorECar*
Garcia Mercadal, Fernando 1896- *MacEA*
Garcia-Mora, Ricardo 1952- *DcCAr 81*
Garcia Nunez, Julian 1875-1944 *MacEA*
Garcia Ochoa, Luis 1920- *OxTwCA*
Garcia Ortega, Jose 1921- *OxTwCA*
Garcia Ponce, Fernando 1933- *WhoAmA 76, -78, -80,*
 -82
Garcia Ramos, Pedro Antonio *OxTwCA*
Garcia-Rossi, Horacio 1929- *OxTwCA,*
 PhDcTCA 77
Garcia Y Ramos, Dolores d1871 *DcWomA*
Garcia Y Torrebesano, Petronila *DcWomA*
Garcin, Germaine Marie 1891- *DcWomA*
Garcin, Jeanne *DcWomA*
Garcin, Jenny Laure 1896- *DcWomA*
Garcin, Rosine *DcWomA*
Gard, Robert L 1936- *MarqDCG 84*
Gardavska, Marie 1871- *DcWomA*
Gardaya, Victor 1945- *MacBEP*
Garde, C J *WhAmArt 85*
Gardel, Bernard 1951- *MacBEP*
Gardel-Leiser, Emma 1866-1964 *DcWomA*
Gardell, Anna Maria 1853-1939 *DcWomA*
Gardella, Ignazio 1905- *ConArch, EncMA, McGDA*
Gardelle, Charlotte 1879- *DcWomA*
Gardelle, Robert 1682-1766 *ClaDrA*
Garden, Edward G 1871-1924 *BiDAmAr*
Garden, Francis *NewYHSD*
Garden, G M *DcBrBI*
Garden, Louisa E *DcVicP 2*
Garden, Phillips *AntBDN Q*
Garden, W F *DcBrWA*
Garden, William Fraser *DcVicP 2*
Garden-Macleod, L E 1864- *WhAmArt 85*
Garden-Macleod, Louise E *ArtsAmW 2*
Gardener, Mrs. Hugh *WhAmArt 85*
Gardet, Georges 1863-1939 *AntBDN C, DcNiCA,*
 McGDA
Gardie, Mrs. *DcWomA*
Gardin, Alice Tilton 1859- *WhAmArt 85*
Gardin, Alice Tilton 1859-1949 *DcWomA*
Gardin, Francis *NewYHSD*
Gardin, Laura *DcWomA, WhAmArt 85*
Gardiner, Clive 1891-1960 *DcBrA 2*
Gardiner, E *DcVicP 2*
Gardiner, Eliza *DcWomA*
Gardiner, Eliza Draper 1871-1955 *DcWomA,*
 WhAmArt 85
Gardiner, Frederic M 1887- *WhAmArt 85*
Gardiner, Gerald 1902- *ClaDrA, DcBrA 1*
Gardiner, Henry Gilbert 1927- *WhoAmA 73, -76, -78,*
 -80, -82
Gardiner, John *FolkA 86*
Gardiner, John Bull 1786-1867 *BiDBrA*
Gardiner, Mary *DcBrECP*
Gardiner, Robert David Lion *WhoAmA 73, -76, -78,*
 -80, -82
Gardiner, Sir Robert William 1781-1864 *DcBrWA*
Gardiner, S W *DcWomA*
Gardiner, Mrs. S W *NewYHSD*
Gardiner, Samuel *CabMA*
Gardiner, Sarah *DcWomA*
Gardiner, Sarah D *WhAmArt 85*
Gardiner, Sidney 1788?-1827 *BnEnAmA*
Gardiner, Stanley Horace 1887- *DcBrA 1*
Gardiner, Terry John 1947- *MarqDCG 84*
Gardiner, William George 1923- *MarqDCG 84*
Gardiner, William Nelson 1766-1814 *BkIE, DcBrECP,*
 DcBrWA
Gardner *FolkA 86*
Gardner, Lord *DcVicP 2*
Gardner, Adelaide *DcWomA*
Gardner, Adelaide Morris *WhAmArt 85*
Gardner, Alexander 1821-1882 *BnEnAmA, DcAmArt,*
 ICPEnP, MacBEP
Gardner, Andrew *FolkA 86*
Gardner, Andrew Bradford 1937- *WhoAmA 73, -76,*
 -78, -80, -82, -84
Gardner, Annette 1920- *WhoArt 80, -82, -84*
Gardner, B *NewYHSD*
Gardner, B Sturtevant 1893- *WhAmArt 85*
Gardner, Beatrice Sturtevant 1893- *DcWomA*
Gardner, C *DcVicP 2*
Gardner, C R *AmArch 70*
Gardner, Charles 1803?-1863? *CabMA*
Gardner, Charles David 1926- *AmArch 70*

Gardner, Charles Reed 1901- *WhAmArt 85*
Gardner, Clyde A *WhAmArt 85*
Gardner, Daniel 1750?-1805 *DcBrECP*
Gardner, Delphis 1900- *DcBrA 1*
Gardner, Derek George Montague 1914- *DcBrA 1,*
 DcSeaP, WhoArt 80, -82, -84
Gardner, Donald *WhAmArt 85*
Gardner, E M d1915 *DcWomA*
Gardner, Mrs. E M d1915 *WhAmArt 85*
Gardner, Edwin C *DcVicP 2*
Gardner, Elizabeth Jane *ArtsNiC, DcWomA*
Gardner, Elizabeth Jane 1837-1922 *NewYHSD*
Gardner, Elizabeth Jeanne *WhAmArt 85*
Gardner, Elizabeth Randolph 1882- *DcWomA,*
 WhAmArt 85
Gardner, Emma E *DcVicP 2*
Gardner, Eugene C 1836-1915 *BiDAmAr*
Gardner, Eugene D 1861-1937 *WhAmArt 85*
Gardner, F *DcBrA 1*
Gardner, Francis *OxDecA*
Gardner, Fred 1880- *WhAmArt 85*
Gardner, Mrs. Fred T *DcWomA*
Gardner, G *DcVicP 2*
Gardner, G Ward 1913- *WhAmArt 85*
Gardner, George Balthazar 1835-1905 *ArtsEM*
Gardner, George Clarence 1865-1930 *BiDAmAr*
Gardner, George W 1940- *ICPEnP A, MacBEP*
Gardner, Gertrude G *WhAmArt 85*
Gardner, Gertrude Gazelle 1878-1975 *ArtsAmW 3,*
 DcWomA
Gardner, Hamlin *WhAmArt 85*
Gardner, Helen d1946 *WhAmArt 85*
Gardner, Isabella Stewart 1840-1924 *WhAmArt 85*
Gardner, J L *DcVicP 2*
Gardner, J P *WhAmArt 85*
Gardner, Jack David 1932- *AmArch 70*
Gardner, James *NewYHSD*
Gardner, James 1907- *ConDes, DcD&D[port]*
Gardner, James Edward 1937- *AmArch 70*
Gardner, Joan 1933- *PrintW 83, -85*
Gardner, Joan A 1933- *AmArt, WhoAmA 73, -76,*
 -78, -80, -82, -84
Gardner, John *FolkA 86*
Gardner, John D 1943- *MarqDCG 84*
Gardner, Joseph *NewYHSD*
Gardner, Judson Morgan 1923- *AmArch 70*
Gardner, Julius M *AfroAA*
Gardner, Kenley A *AfroAA*
Gardner, Lehi Robert 1918- *AmArch 70*
Gardner, Leonard Burton 1927- *MarqDCG 84*
Gardner, Lester *FolkA 86*
Gardner, Louis 1918- *AmArch 70*
Gardner, Mabel *DcVicP 2, DcWomA*
Gardner, Mabel 1892- *WhAmArt 85*
Gardner, Maude *WhAmArt 85*
Gardner, Mrs. Miles T *ArtsEM*
Gardner, Pam 1920- *WhoArt 82, -84*
Gardner, Patrick *NewYHSD*
Gardner, Peter 1921- *WhoArt 80, -82*
Gardner, Phyllis 1890- *ClaDrA, DcBrA 1,*
 DcWomA
Gardner, R *DcWomA*
Gardner, Mrs. R *ArtsEM*
Gardner, Reg 1948- *DcCAr 81*
Gardner, Rick 1943- *DcCAr 81*
Gardner, Robert Angus 1931- *AmArch 70*
Gardner, Robert Earl 1919- *WhoAmA 73, -76, -78,*
 -80, -82, -84
Gardner, Robert N *AfroAA*
Gardner, Robert W 1866-1937 *BiDAmAr*
Gardner, Sally *DcWomA, NewYHSD*
Gardner, Sarah M *ArtsEM, DcWomA*
Gardner, Sidney *DcVicP 2*
Gardner, Susan Ross 1941- *WhoAmA 76, -78, -80,*
 -82, -84
Gardner, Thomas 1737?-1804 *BiDBrA*
Gardner, W Biscombe 1849?-1919 *DcBrBI*
Gardner, W H *AmArch 70*
Gardner, Walter Henry 1902- *WhAmArt 85*
Gardner, Willa *WhAmArt 85*
Gardner, William *FolkA 86*
Gardner, William Biscombe 1847?-1919 *DcBrA 1,*
 DcBrWA, DcVicP 2
Gardner, William Biscombe 1848?-1919 *ClaDrA*
Gardner, William H 1914- *AmArch 70*
Gardner, William M 1914- *WhoArt 80, -82, -84*
Gardner, Xavier *FolkA 86*
Gardner-Soper, James H 1877- *WhAmArt 85*
Gardnier, Sally *FolkA 86*
Gardnor, John 1729-1808 *DcBrECP, DcBrWA*
Gardnor, Richard *DcBrECP*
Gardom, Barbara Cronhelm *DcBrA 1*
Gardosh, Kariel 1921- *WorECar*
Gardstein, Jasper Norman 1908- *AmArch 70*
Gareis, Pius 1804- *ClaDrA*
Garel, Leo 1917- *AmArt, IlBEAAW, WhoAmA 76,*
 -78, -80, -82, -84, WorECar
Garelli, Franco 1909- *McGDA, PhDcTCA 77*
Garesche, Marie R 1864- *DcWomA, WhAmArt 85*
Garet, Jedd 1955- *AmArt, DcCAr 81, PrintW 83,*
 -85

Garets, Odette De *DcWomA*
Garetz, William V 1947- *MarqDCG 84*
Garey, K E *DcWomA*
Garey, Pat 1932- *WhoAmA 76, -78, -80, -82, -84*
Garfield, Alan J 1950- *MarqDCG 84*
Garfield, Arne Ward 1923- *AmArch 70*
Garfield, Gerald *WhoAmA 80*
Garfield, John Robinson 1924- *AmArch 70*
Garfield, Marjorie Stuart 1903- *WhAmArt 85*
Garfinkel, M *AmArch 70*
Garfinkle, George Lawrence 1935- *AmArch 70*
Garfinkle, Leonard 1898- *WhAmArt 85*
Gargallo, Pablo 1881-1934 *McGDA, OxTwCA*
Gargallo, Pablo 1891-1934 *PhDcTCA 77*
Gargano, Ronald M 1934- *AmArch 70*
Garhart, Martin J 1946- *WhoAmA 76, -78, -80, -82,*
 -84
Garibaldi, Giuseppe 1807-1882 *DcNiCA*
Garibaldi, Lucinda *NewYHSD*
Garibaldi, Lucinda 1822?- *DcWomA*
Garibaldi, Pietro A *NewYHSD*
Garibaldi, Mrs. Pietro A 1822?- *NewYHSD*
Garikes, Arthur George 1908- *AmArch 70*
Garin Ortiz DeTaranco, Felipe Maria 1908-
 WhoArt 80, -82, -84
Garing, Christian *FolkA 86*
Garios, William *CabMA*
Garis, John 1810?- *FolkA 86*
Garland, Archie M, III 1961- *WhoArt 84*
Garland, Brad 1955- *MarqDCG 84*
Garland, Charles Trevor *DcBrA 1, DcBrBI, DcVicP,*
 -2
Garland, Christine *WhAmArt 85*
Garland, George *WhAmArt 85*
Garland, Henry *DcBrBI, DcVicP, -2*
Garland, Ida *DcWomA*
Garland, James Edward 1918- *AmArch 70*
Garland, James Thomas 1949- *MarqDCG 84*
Garland, Ken 1929- *ConDes*
Garland, Leon 1896-1941 *WhAmArt 85*
Garland, Madge *WorFshn*
Garland, Margaret Vallis Mary Lester *DcBrA 1*
Garland, Marie T 1870- *ArtsAmW 2, DcWomA*
Garland, Mollie 1920- *DcBrA 1*
Garland, P *AmArch 70*
Garland, Robert 1808?- *DcBrBI*
Garland, Robert 1808?-1863 *BiDBrA*
Garland, Robert, Jr. 1927- *AmArch 70*
Garland, Robert D, Jr. 1926- *AmArch 70*
Garland, Sadie Ellis 1900- *WhAmArt 85*
Garland, Valentine Thomas *DcBrA 1, DcVicP, -2*
Garland, Wilbur Blaine, Jr. 1937- *AmArch 70*
Garland, William d1882 *DcVicP 2*
Garland, Zulime *DcWomA*
Garlick, Kenneth John 1916- *WhoArt 80, -82, -84*
Garlick, Theodatus 1805-1884 *NewYHSD*
Garling, Frederick 1806-1873 *DcSeaP*
Garling, Henry 1789-1870 *BiDBrA*
Garling, Henry B 1822-1904 *MacEA*
Garlive, John *BiDBrA*
Garlonn 1946- *DcCAr 81*
Garman, Ed 1914- *WhoAmA 76, -78, -80, -82, -84*
Garman, Evelyn Daphne 1912- *WhoArt 80*
Garman, Evelyn Daphne 1913- *WhoArt 82, -84*
Garman, Mabel *DcVicP 2*
Garman, R D *AmArch 70*
Garman, Thomas Benner 1900- *AmArch 70*
Garmendia, Nesbitt A 1930- *AmArch 70*
Garmons, William *FolkA 86*
Garn, Gordon Richard 1931- *AmArch 70*
Garnain, Louis *DcSeaP*
Garner, Alfred John 1930- *AmArch 70*
Garner, Archibald 1904- *WhAmArt 85*
Garner, Archibald 1904-1970 *WhoAmA 80N, -82N,*
 -84N
Garner, Barry Jardine 1937- *MarqDCG 84*
Garner, C E *AmArch 70*
Garner, Charles *WhAmArt 85*
Garner, Charles S, Jr. 1890-1933 *WhAmArt 85*
Garner, Edith Mary *DcBrA 1*
Garner, Edith Mary 1881- *DcWomA*
Garner, Elvira 1895- *IlsCB 1744*
Garner, Frances Carns *WhAmArt 85*
Garner, Franklin J 1950- *MarqDCG 84*
Garner, Frederick J *WhAmArt 85*
Garner, H *DcWomA*
Garner, Jacob *FolkA 86*
Garner, Lota H *ArtsEM, DcWomA*
Garner, R R *AmArch 70*
Garner, Thomas 1839-1906 *MacEA, WhoArch*
Garner, Thomas Edwin 1919- *AmArch 70*
Garner-Watts, Gladys Ethel *DcWomA*
Garneray, Ambroise Louis 1783-1857 *ClaDrA,*
 DcSeaP
Garneray, Ambrose Louis 1783-1857 *ArtsNiC,*
 NewYHSD
Garneray, Pauline *DcWomA*
Garnerey *NewYHSD*
Garnery, Priori *DcBrECP*
Garnett, Alfred Payne *DcVicP 2*
Garnett, Catherine Grace *DcWomA*

Garnett, Eve *WhoArt 80, -82, -84*
Garnett, Eve C R *DcBrA 1, IlsCB 1744, -1946*
Garnett, Ruth *DcVicP 2*
Garnett, William *AntBDN N*
Garnett, William A 1916- *ConPhot, ICPEnP*
Garnett, William Ashford 1916- *WhoAmA 76, -78, -80, -82, -84*
Garnham, G R *DcVicP 2*
Garnier, Charles 1825-1898 *DcD&D, MacEA, McGDA*
Garnier, Emilie *DcWomA*
Garnier, Etienne Barthelemy 1759-1849 *ClaDrA*
Garnier, Francois 1627?-1658? *McGDA*
Garnier, Geoffrey Sneyd 1889- *DcBrA 1*
Garnier, Jacquemijntje *DcWomA*
Garnier, Jean *CabMA*
Garnier, Jean-Louis-Charles 1825- *ArtsNiC*
Garnier, Jean Louis Charles 1825-1898 *WhoArch*
Garnier, Jessie Caroline Dunbar 1890- *DcBrA 1, DcWomA*
Garnier, Jules Arsene 1847-1889 *ClaDrA*
Garnier, Marie *DcWomA*
Garnier, Pauline *DcWomA*
Garnier, Therese 1776- *DcWomA*
Garnier, Tony 1867-1948 *McGDA*
Garnier, Tony 1869-1948 *ConArch, EncMA, MacEA, OxArt, WhoArch*
Garnier-Rafat, Emilie L A *DcWomA*
Garnot, Lucie *DcWomA*
Garnot-Beaupere, Marguerite *DcWomA*
Garns, H S *AmArch 70*
Garnsey, Clarke Henderson 1913- *WhAmArt 85, WhoAmA 76, -78, -80, -82, -84*
Garnsey, Elmer E 1862-1946 *WhAmArt 85*
Garnsey, Julian Ellsworth 1887- *ArtsAmW 2, WhAmArt 85*
Garo, J H 1870-1939 *ICPEnP A*
Garo, John H *WhAmArt 85*
Garofalo 1481-1559 *McGDA*
Garofalo, Benvenuto *ClaDrA*
Garofalo, Benvenuto Tisi 1481-1559 *OxArt*
Garon, Peter *AntBDN D*
Garove, Michelangelo 1650-1713 *MacEA*
Garr, De *DcBrECP*
Garr, Sarah Crain 1862- *FolkA 86*
Garrand, Marc 1561-1635 *ClaDrA*
Garrard, George 1760-1826 *DcBrECP, DcBrWA*
Garrard, James *DcNiCA*
Garrard, Mary Dubose 1937- *WhoAmA 76, -78, -80, -82, -84*
Garrard, Peter John 1929- *DcBrA 1, WhoArt 80, -82, -84*
Garrard, Robert *AntBDN Q*
Garrard, Robert d1818 *DcNiCA*
Garrard, Robert 1793-1887 *DcNiCA*
Garrard, Sebastian *DcNiCA*
Garrat, Arthur *WhAmArt 85*
Garratt, Agnes M *DcVicP 2*
Garratt, Arthur P *DcVicP 2*
Garratt, Arthur Paine 1873- *DcBrA 1, DcBrBI*
Garratt, Eliza *DcVicP 2, DcWomA*
Garratt, John Geoffrey 1914- *WhoArt 80, -82, -84*
Garratt, Samuel 1865-1947 *DcBrA 1*
Garraway, Edward *DcVicP 2*
Garraway, George Hervey 1846- *DcBrA 1, DcVicP 2*
Garrer, J *DcVicP 2*
Garret, Thomas *FolkA 86*
Garretson, Albert M 1877- *WhAmArt 85*
Garretson, D *DcWomA*
Garretson, Mrs. D *ArtsEM*
Garretson, Della 1859-1940 *ArtsEM, DcWomA*
Garretson, Della 1860- *WhAmArt 85*
Garretson, Lillie *WhAmArt 85*
Garretson, Lillie 1859-1939 *ArtsEM, DcWomA*
Garrett *EncASM*
Garrett, Adams Wirt 1908- *WhAmArt 85*
Garrett, Alan Thomas 1941- *WhoAmA 76, -78*
Garrett, Albert Charles *WhoArt 84N*
Garrett, Albert Charles 1915- *DcBrA 1, WhoArt 80, -82*
Garrett, Anna *WhAmArt 85*
Garrett, Carlton Elonzo 1900?- *FolkA 86*
Garrett, Clara Maria 1882- *DcWomA*
Garrett, Clara Pfeifer 1882- *WhAmArt 85*
Garrett, Daniel d1753 *BiDBrA, MacEA*
Garrett, Dorothy Mabel Ellen 1908- *DcBrA 1*
Garrett, Edmund H 1853-1929 *WhAmArt 85*
Garrett, Edmund Henry 1853- *DcBrBI*
Garrett, Erastus R *NewYHSD*
Garrett, George *NewYHSD*
Garrett, James *BiDBrA*
Garrett, John *WhoArt 80*
Garrett, John E 1817?- *NewYHSD*
Garrett, John W *WhAmArt 85*
Garrett, Mrs. John W *WhAmArt 85*
Garrett, John W B *NewYHSD*
Garrett, Kathy Carson 1947- *MarqDCG 84*
Garrett, Mary H *WhAmArt 85*
Garrett, Mary Hibberd *FolkA 86*
Garrett, Priscilla Longshore 1907- *WhAmArt 85*
Garrett, R S, Jr. *AmArch 70*
Garrett, Stephen *WhoAmA 78, -80, -82, -84*

Garrett, Stuart Grayson *WhoAmA 80, -82, -84*
Garrett, Stuart Grayson, Jr. *WhoAmA 73, -76, -78*
Garrett, Terry J 1936- *AmArch 70*
Garrett, Theresa A 1884- *DcWomA, WhAmArt 85*
Garrett, Thomas *FolkA 86*
Garrett, Thomas 1891-1917 *WhAmArt 85*
Garrett, Wilbur E 1930- *ICPEnP A*
Garrett-Brown, Lee *DcWomA*
Garretto, Paolo Federico 1903- *WhoGrA 62*
Garri, Colomba *DcWomA*
Garrick, Donald Keith 1939- *MarqDCG 84*
Garrick, Joseph Edward 1909- *AmArch 70*
Garrido, L R *WhAmArt 85*
Garrido, Leandro Ramon 1869-1909 *DcBrA 2*
Garrido, Luis *OxTwCA*
Garrido Y Agudo, Maria DeLaSoledad *DcWomA*
Garrie, R *DcVicP 2*
Garrigues, Edith H *DcWomA*
Garrigues, Ruth 1890- *DcWomA*
Garriott, Hubert Marion 1894- *AmArch 70*
Garris, Kathleen *WhoAmA 78, -80*
Garrish, Francis B *CabMA*
Garrison, Aubrey Marvin, III 1943- *AmArch 70*
Garrison, B *NewYHSD*
Garrison, C E *AmArch 70*
Garrison, Eve *WhAmArt 85*
Garrison, Eve 1908- *WhoAmA 73, -76, -78, -82, -84*
Garrison, J *DcBrECP*
Garrison, Mrs. J J *WhAmArt 85*
Garrison, James Arthur 1931- *AmArch 70*
Garrison, Jesse Janes *WhoAmA 80N, -82N, -84N*
Garrison, Jesse Janes 1901-1957? *WhAmArt 85*
Garrison, John Fleming, Jr. 1918- *AmArch 70*
Garrison, John L 1867- *WhAmArt 85*
Garrison, K D *AmArch 70*
Garrison, Martha H 1874- *WhAmArt 85*
Garrison, Martha Hicks 1874- *ArtsAmW 2, DcWomA*
Garrison, Minta H 1874- *WhAmArt 85*
Garrison, Nicholas, Jr. *NewYHSD*
Garrison, R N *AmArch 70*
Garrison, Robert 1895- *WhAmArt 85*
Garrison, Truitt B 1936- *AmArch 70*
Garrity, James *NewYHSD*
Garrity, William Francis, Jr. 1914- *AmArch 70*
Garrod, Edith *DcVicP 2*
Garrod, Richard Milton 1924- *MacBEP*
Garrod, Violet Nellie 1898- *DcBrA 1, DcWomA, WhoArt 80, -82, -84*
Garrone, Josephine d1888? *DcWomA*
Garrott, J H *AmArch 70*
Garrow, James *NewYHSD*
Garshou, M *NewYHSD*
Garside, Helen 1893- *DcWomA*
Garside, Oswald 1879-1942 *DcBrA 1*
Garson, Etta Corbett 1898-1968 *DcWomA*
Garson, Inez 1915- *WhoAmA 78, -80, -82*
Garstecki, Walter F 1890- *AmArch 70*
Garstin, Alethea *DcBrA 1, DcWomA, WhoArt 80, -82N*
Garstin, Alethea 1894- *DcBrA 2*
Garstin, Elizabeth W 1897- *WhAmArt 85*
Garstin, Elizabeth Williams 1897- *DcWomA*
Garstin, John 1756-1820 *MacEA*
Garstin, Norman 1847-1926 *DcBrA 2*
Garstin, Norman 1855-1926 *DcBrA 1, DcVicP 2*
Garston, Gerald Drexler 1925- *WhoAmA 73, -76, -78, -80, -82, -84*
Garte, Maria Elisabeth *DcWomA*
Gartel, Laurence M 1956- *WhoAmA 82, -84*
Gartenberg, Philip Alvin 1955- *MarqDCG 84*
Garth, B *DcBrECP*
Garth, John 1894-1971 *ArtsAmW 2, WhAmArt 85, WhoAmA 78N, -80N, -82N, -84N*
Garthwaite, Ernest P 1940- *PrintW 85*
Garthwaite, W *DcSeaP*
Garthwaite, William *DcVicP 2*
Garthwaite, Wymond Bradbury 1895- *ConICB*
Garties, G *AmArch 70*
Gartner, Alexander Abraham 1915- *AmArch 70*
Gartner, Friedrich Von 1792-1847 *MacEA, McGDA, WhoArch*
Gartner, Hermine 1850?-1905 *DcWomA*
Gartner, Howard Ernest 1921- *AmArch 70*
Gartner, Johann Philipp Eduard 1801- *ArtsNiC*
Gartner, John B, Jr. 1932- *AmArch 70*
Gartner, Joseph R 1930- *MarqDCG 84*
Gartner, Lloyd 1905- *AmArch 70*
Garton, Joseph *NewYHSD*
Garvan, Beatrice Bronson 1929- *WhoAmA 78, -80, -82, -84*
Garvani *AntBDN E*
Garver, Edward Bruce *AmArch 70*
Garver, Jack 1921- *WhoAmA 76, -78, -80*
Garver, Jacob *FolkA 86*
Garver, Thomas H 1934- *WhoAmA 73, -76, -78, -80, -82, -84*
Garver, Walter Raymond 1927- *WhoAmA 76, -78, -80, -82, -84*
Garvey, Clara *DcVicP 2*
Garvey, Edmund d1813 *DcBrECP, DcBrWA*

Garvey, Eleanor *WhoAmA 73, -76, -78*
Garvey, Frank Kevin 1947- *MarqDCG 84*
Garvey, Fred Kesler, Jr. 1927- *AmArch 70*
Garvey, Henry *NewYHSD*
Garvey, Joseph M 1877- *WhAmArt 85*
Garvey, William 1906-1925 *WhAmArt 85*
Garvey DeSan Juan, Maria *DcWomA*
Garvie, Thomas Bowman 1859- *DcBrA 1, DcVicP 2*
Garville, Madame De *DcWomA*
Garvin, Jay Ward 1940- *AmArch 70*
Garvin, William Lawrence 1924- *AmArch 70*
Garwood, Audrey 1927- *WhoAmA 73, -76, -78, -80, -82, -84*
Garwood, W G *AmArch 70*
Gary, Dorothy Hales 1917- *WhoAmA 73, -76, -78, -80, -82, -84*
Gary, Mrs. James A *FolkA 86*
Gary, Jan 1925- *WhoAmA 73, -76, -78, -80, -82, -84*
Gary, Jim *AfroAA*
Gary, John William 1924- *AmArch 70*
Gary, Louisa M 1888- *WhAmArt 85*
Gary, Louisa Macgill 1888- *DcWomA*
Gary, Wilmuth *DcWomA*
Garza, G *AmArch 70*
Garza, R C *AmArch 70*
Garzia, Ricardo Francisco 1926- *MarqDCG 84*
Garzon-Blanco, Armando 1941- *WhoAmA 78, -80, -82, -84*
Garzoni, Giovanna 1600-1670 *DcWomA, WomArt*
Gasaway, Andrew, Jr. 1937- *AmArch 70*
Gasaway, John W *WhAmArt 85*
Gasbarro, Nicola *WhAmArt 85*
Gasc, Anna Rosina De *DcWomA*
Gascard, Gilbert 1931- *WorECom*
Gasch, Herman E *WhAmArt 85*
Gascogne, Ethel Slade *DcWomA*
Gascoigne, Mrs. *DcVicP 2*
Gascoigne, Ethel Slade *DcWomA*
Gascoigne, John *DcBrBI*
Gascoyne, Ethel Slade *DcWomA*
Gascoyne, George 1862-1933 *DcBrA 1, DcVicP 2*
Gash, Chester Alan 1906- *WhAmArt 85*
Gash, Walter Bonner 1869-1928 *DcBrA 1, DcVicP 2*
Gaskell, George Arthur *DcVicP 2*
Gaskell, George Percival 1868-1934 *DcBrA 1*
Gaskell, Henry Melville 1879-1954 *DcBrA 1*
Gaskell, William J C d1966 *DcBrA 1*
Gaskill, Marion Hendricks *DcWomA, WhAmArt 85*
Gaskill, Tom 1879-1932 *FolkA 86*
Gaskill, William Harry 1922- *AmArch 70*
Gaskill, William T C 1930- *MarqDCG 84*
Gaskin, Mrs. Arthur *DcBrBI*
Gaskin, Arthur Joseph 1862-1928 *DcBrA 1, DcBrBI, DcVicP 2*
Gaskin, Charles A 1933- *AmArch 70*
Gaskin, Franklin 1933- *AfroAA*
Gaskin, Georgina *DcWomA*
Gaskin, Leroy *AfroAA*
Gaskin, William 1892- *ArtsAmW 2*
Gaskings, John A *NewYHSD*
Gasner, George 1811-1861 *FolkA 86, NewYHSD*
Gaspar, Miklos 1885-1946 *WhAmArt 85*
Gaspard, Jules Maurice 1862-1919 *WhAmArt 85*
Gaspard, Leon 1882-1964 *ArtsAmW 1, IlBEAAW, WhAmArt 85*
Gaspare Dagli Occhiali *McGDA*
Gasparella, J R *AmArch 70*
Gaspari, Antonio 1658?-1738 *MacEA*
Gaspari, Antonio 1670-1730 *McGDA*
Gaspari, Giovanni Pietro 1720-1785 *McGDA*
Gaspari, James Sigmund 1933- *AmArch 70*
Gaspari, P G *FolkA 86*
Gasparian, Armen Tigran 1933- *WhoAmA 76, -78, -80, -82, -84*
Gasparo, Oronzo Vito 1903- *WhAmArt 85*
Gasparro, Frank 1909- *WhAmArt 85, WhoAmA 73, -76, -78, -80, -82, -84*
Gasperini-Lillaz, Germaine *DcWomA*
Gaspoel, Susanna *DcWomA*
Gasque, R B, Jr. *AmArch 70*
Gasquy, Marius *DcSeaP*
Gass, Alan Golin 1931- *AmArch 70*
Gass, John B *DcVicP 2*
Gass, Marjorie Earle 1889-1928 *DcWomA*
Gass, Patrick 1771-1870 *NewYHSD*
Gassel, Lucas 1500?-1570? *McGDA*
Gasser, Henry Martin 1909- *WhoAmA 73, -76, -78, -80, -82*
Gasser, Henry Martin 1909-1981 *WhAmArt 85, WhoAmA 84N*
Gasser-Jacob, Jenny *DcWomA*
Gassert, Robert Frank 1936- *AmArch 70*
Gasset-Housset, Helene 1889-1966 *DcWomA*
Gassette, Grace *DcWomA, WhAmArt 85*
Gassies, Jean Bruno 1786-1832 *ClaDrA*
Gassiot, H *DcVicP 2*
Gasslander, Karl 1905- *WhAmArt 85*
Gassman, Gerry *MarqDCG 84*
Gassman, Richard Oliver 1916- *AmArch 70*
Gassman, Stephan Ulrich 1931- *AmArch 70*
Gassner, Francis Paul 1926- *AmArch 70*

WhoAmA 78, –80, –82, –84 WorECar
Geisel, Theodore Seuss 1904- *WhoAmA 73, –76*
Geiser, Bernard 1887- *ArtsAmW 2, WhAmArt 85*
Geiser, Karl 1889-1957 *PhDcTCA 77*
Geisert, Arthur 1941- *PrintW 83, –85*
Geisert, Arthur Frederick 1941- *WhoAmA 80, –82, –84*
Geisler, C *DcVicP 2*
Geisler, Charles Frederick 1923- *AmArch 70*
Geisler, Frank E 1867-1935 *WhAmArt 85*
Geisler, Howard William 1937- *AmArch 70*
Geisler, Joseph *NewYHSD*
Geismar, Miriam C *DcWomA, WhAmArt 85*
Geismar, Thomas *ConDes*
Geismar, Thomas H 1931- *WhoGrA 82[port]*
Geiss, M *DcNiCA*
Geissbuhler, Arnold 1897- *WhAmArt 85, WhoAmA 73, –76, –78, –80, –82*
Geissbuhler, Karl Domenig 1932- *WhoGrA 82[port]*
Geissbuhler, Steff 1942- *ConDes*
Geissbuhler, Stephan 1942- *AmGrD[port]*
Geisser, George John 1899- *AmArch 70*
Geissler, J Martin Friedrich 1778-1853 *ClaDrA*
Geissler, William H *DcBrA 1*
Geissman, Robert *WhAmArt 85*
Geissman, Robert Glenn 1910- *WhoAmA 76, –78*
Geist, August Christian 1835-1868 *ArtsNiC*
Geist, Gilbert Allen d1937 *WhAmArt 85*
Geist, Sidney 1914- *WhoAmA 73, –76, –78, –80, –82, –84*
Geistlich, J C *NewYHSD*
Geistweite, George *FolkA 86*
Geiszel, John H 1892- *WhAmArt 85*
Geitlinger, Ernst 1895- *OxTwCA, PhDcTCA 77*
Geizsel, Margaret Malpass *WhAmArt 85*
Gekiere, Madeleine *WhoAmA 80, –82, –84*
Gekiere, Madeleine 1919- *IlsBYP, IlsCB 1946, –1957, WhoAmA 73, –76, –78*
Gekkei *McGDA*
Gelabert, Florence *AfroAA*
Gelatt, M L *AmArch 70*
Gelb, Jan 1906- *DcCAA 71, –77, WhAmArt 85, WhoAmA 73, –76, –78*
Gelb, Jan 1906-1978 *WhoAmA 80N, –82N, –84N*
Gelbart, Dan 1918- *WhoGrA 62*
Gelber, Martin Benjamin 1936- *AmArch 70*
Gelber, Samuel 1929- *WhoAmA 73, –76, –78, –80, –82, –84*
Gelberg, Larry Marc 1958- *MarqDCG 84*
Gelburd, Gail Enid 1954- *WhoAmA 84*
Geldart, Mary E *DcWomA*
Geldart, William 1936- *WhoArt 84*
Geldbaugh, G Richard 1938- *AmArch 70*
Gelder, Aart De 1645-1727 *ClaDrA*
Gelder, Aert De 1645-1727 *McGDA, OxArt*
Gelder, J *DcVicP 2*
Gelder, Lucie Mathielde Von 1865-1899 *DcWomA*
Gelder, Nicolaes Van 1623?-1677 *McGDA*
Gelder, Nicolaes Van 1625?-1677 *ClaDrA*
Geldhart, Joseph 1808-1882 *DcBrWA*
Geldorp, Goltzius 1553-1618 *McGDA*
Geldorp, Gortzius 1553-1618 *ClaDrA*
Geldzahler, Henry 1935- *WhoAmA 73, –76, –78, –80, –82, –84*
Gelee, Isabelle 1874- *DcWomA*
Gelert, J 1852-1923 *WhAmArt 85*
Gelhaar, E *WhAmArt 85*
Gelick, Michael *AmArch 70*
Gelin, S M *AmArch 70*
Gelinas, Robert William 1931- *WhoAmA 73, –76, –80, –82, –84*
Gell, Ada Freeman *DcWomA*
Gell, Ronald Walter 1937- *AmArch 70*
Gell, Sir William 1774-1836 *DcBrBI*
Gell, Sir William 1777-1836 *DcBrWA*
Gellatly, John 1853-1931 *WhAmArt 85*
Gellee, Claude *McGDA*
Gellee, Claude 1600-1682 *ClaDrA, DcSeaP*
Gellenbeck, Ann P *ArtsAmW 2, WhAmArt 85*
Gellenbeck, Anna P *ArtsAmW 2, DcWomA*
Gellenbeck, Edith *DcWomA*
Gellenbeck, Edith Catherine *WhAmArt 85*
Geller, A W *AmArch 70*
Geller, Adam 1804?- *FolkA 86*
Geller, Adrienne Van *DcWomA*
Geller, Angelina *DcVicP 2, DcWomA*
Geller, Esther 1921- *WhoAmA 73, –76, –78, –80, –82, –84*
Geller, Todros 1889- *WhAmArt 85*
Geller, W Henry *DcVicP 2*
Geller, William Jasper 1930- *WhoArt 82, –84*
Gellert, Emery 1889- *ArtsAmW 1, WhAmArt 85*
Gellert, F *AmArch 70*
Gellert, Hugo 1892- *WhAmArt 85*
Gellert, S M 1884- *ArtsAmW 3*
Gelletly, May Florence 1886-1955? *WhAmArt 85*
Gelletly, May Florence 1886-1956? *DcWomA*
Gellian, Eugenie *DcWomA*
Gellis, Sandy L *WhoAmA 80, –82, –84*
Gellis, Sandy L 1940- *WhoAmA 78*
Gellman, Beah 1904- *WhoAmA 73, –76, –78, –80*

Gelman, Aaron 1899- *WhAmArt 85*
Gelman, Bob M 1954- *MarqDCG 84*
Gelman, Milton 1914- *WhoAmA 76, –78, –80, –82, –84*
Gelon, Marie *DcWomA, WhAmArt 85*
Gelpi, Rene Guillermo 1946- *MacBEP*
Gelsavage, John Zygmund 1909- *WhAmArt 85*
Gelston, Thomas *FolkA 86*
Gelston And Gould *EncASM*
Geluk, Hans 1938- *MarqDCG 84*
Gelwicks, Mrs. D W *WhAmArt 85*
Gelwicks, Frances Slater d1915 *ArtsAmW 2, DcWomA*
Gelwicks, Louis Edwin 1928- *AmArch 70*
Gely, Leonard *AntBDN M, DcNiCA*
Gely, Marie 1850- *DcWomA*
Geman, Stuart Alan 1949- *MarqDCG 84*
Gemberling, Grace Thorp 1903- *WhAmArt 85*
Gemell *DcBrECP*
Gemin, Louise Adele *DcWomA*
Gemin, Walter Lawrence, Jr. 1959- *MarqDCG 84*
Gemito, Vincenzo *ArtsNiC*
Gemito, Vincenzo 1852-1929 *McGDA*
Gemmel, J *DcWomA*
Gemmel, Joseph Arthur 1931- *AmArch 70*
Gemmel, Matthew *AntBDN D*
Gemmel, Minna *DcWomA*
Gemmell, John *NewYHSD*
Gemmell, Marion *DcVicP 2*
Gemmell, Mary *DcVicP 2*
Gemmell, Mary R *DcWomA*
Gemmil, George F 1876-1930 *BiDAmAr*
Gemmill, James William 1930- *AmArch 70*
Gemmill, Jill Bette 1950- *MarqDCG 84*
Gemmill, Robert MacDonald 1905- *AmArch 70*
Gemperle, Albert Richard, Jr. 1940- *AmArch 70*
Gemunden, Caroline Von 1808?- *DcWomA*
Genauer, Emily *WhoAmA 73, –76, –78, –80, –82, –84*
Genauer, Emily 1911- *WhAmArt 85*
Genaut, Clemence Isaure *DcWomA*
Genaw, Ernest F 1952- *MarqDCG 84*
Genchek, Robert Anthony 1929- *AmArch 70*
Gencorelli, Francis W 1937- *AmArch 70*
Gendall, John 1790-1865 *DcBrBI, DcBrWA, DcVicP, –2*
Gende-Rote, Valeri 1926- *ICPEnP A*
Gendell, Agnes *DcWomA, WhAmArt 85*
Genders, Richard Atherstone 1919- *WhoAmA 73, –76, –78, –80, –82, –84*
Gendhart, Edward *NewYHSD*
Gendhart, Herman *NewYHSD*
Gendhart, John W *NewYHSD*
Gendron, Auguste 1818-1881 *ArtsNiC*
Gendron, Gabrielle Marie *DcWomA*
Gendrot, Felix Albert 1866- *WhAmArt 85*
Gendt, A L Van 1835-1901 *MacEA*
Gendusa, Anthony Joseph, Jr. 1932- *AmArch 70*
Geneau, Louise 1838-1867 *DcWomA*
Genelli, Johann Bonaventura 1803-1868 *ArtsNiC*
General Idea *ConArt 83, DcCAr 81*
Generalic, Ivan 1914- *OxTwCA, PhDcTCA 77*
Generalic, Josip 1936- *OxTwCA*
Generelly, Fleury *NewYHSD*
Geneslaw, Ruth 1938- *DcCAr 81*
Genest, Louis 1852-1895 *ArtsEM*
Geneste, Eugenie *DcWomA*
Genet, Paulette 1890?- *DcWomA*
Genevay, C 1833- *DcWomA*
Genever, Margaret *WhoArt 80, –82, –84*
Genevieve Of Paris, Saint 422?-500? *McGDA*
Geney-Laukens, Anne Fanny 1875-1966 *DcWomA*
Genga, Girolamo 1476-1551 *MacEA, McGDA*
Gengembre, Charles Antoine Colomb 1790-1863 *NewYHSD*
Gengembre, Miss S *NewYHSD*
Gengembre, Sophie *DcWomA, EarABI*
Genia 1930- *IlsBYP, IlsCB 1957*
Genillion, Jean Baptiste Francois 1750-1829 *ClaDrA*
Genin, Sylvester 1822-1850 *NewYHSD*
Geniole, Alfred Andre 1813-1861 *DcBrBI*
Genius, Jeannette *WhoAmA 73, –76, –78, –80, –82, –84*
Geniusz, Robert Myles 1948- *WhoAmA 80, –82, –84*
Genkosai *AntBDN L*
Genlis, Pauline *DcWomA*
Genn, Nancy *WhoAmA 78, –80, –82, –84*
Gennadios, Cleonice *DcWomA*
Gennari, Benedetto 1570-1610 *ClaDrA*
Gennari, Benedetto, II 1633-1715 *McGDA*
Gennari, Teresa *DcWomA*
Genoels, Abraham 1640-1723 *ClaDrA, McGDA*
Genot, Sebastian *NewYHSD*
Genotin, Frederick *DcVicP 2*
Genouille, Noemie 1856- *DcWomA*
Genoves, Juan 1930- *ConArt 77, –83, OxTwCA, PhDcTCA 77, PrintW 83, –85*
Genovese, Il *McGDA*
Genovese, Anthony Vincent 1932- *AmArch 70*
Genovese, Gaetano 1795-1860 *McGDA*
Gensler, Millard Arthur, Jr. 1935- *AmArch 70*

Gensmann, Michaele 1954- *DcCAr 81*
Gensollen, Victor Emmanuel 1859-1897 *ClaDrA*
Gensoul-Desfonts, Antoinette *DcWomA*
Gent, G W *DcBrWA*
Gent, Sophia S 1818?- *DcWomA*
Gent, Sophia S Daniell 1818?- *NewYHSD*
Genter, Paul Huntington *WhAmArt 85*
Genter, Paul Huntington 1888- *ArtsAmW 2*
Genth, Lillian d1953 *WhAmArt 85*
Genth, Lillian Matilde 1876-1953 *DcWomA*
Genthe, Arnold 1869-1942 *ConPhot, ICPEnP, MacBEP, WhAmArt 85*
Genthe, Julie 1869- *DcWomA*
Genther, Charles Booher 1907- *AmArch 70*
Gentile Da Fabriano 1370?-1427 *McGDA, OxArt*
Gentile, Edward 1890- *WhAmArt 85*
Gentile, Gloria Irene *WhoAmA 76, –78, –80, –82, –84*
Gentile, Joseph Thomas 1924- *AmArch 70*
Gentile, Luigi 1606-1668? *McGDA*
Gentile DaFabriano, Francesco Di *McGDA*
Gentilesca, Sofonista d1587 *DcWomA*
Gentileschi, Artemisia 1593-1652? *WomArt*
Gentileschi, Artemisia 1593-1653? *DcWomA*
Gentileschi, Artemisia 1597-1651? *McGDA, OxArt*
Gentileschi, Orazio 1563?-1639 *McGDA*
Gentileschi, Orazio 1563-1647? *OxArt*
Gentileschi, Prudentia *DcWomA*
Gentili, Antonio 1519-1607 *McGDA*
Gentili, Bernardino, II d1683 *McGDA*
Gentili, Bernardino, III 1727-1813 *McGDA*
Gentili, Carmine 1678-1763 *McGDA*
Gentili, Giacomo, I 1668-1713 *McGDA*
Gentili, Giacomo Il Giovane 1717- *McGDA*
Gentilini, Franco 1909- *ConArt 77, PhDcTCA 77*
Gentilini, Joseph *NewYHSD*
Gentilli, Jeremy 1926- *ClaDrA*
Gentils *NewYHSD*
Gentils, Victor 1919- *OxTwCA*
Gentils, Victor A 1919- *PhDcTCA 77*
Gentiluomo, Guiseppe *WhAmArt 85*
Gentilz, Jean Louis Theodore 1819-1906 *IlBEAAW*
Gentilz, Theodore 1819-1906 *ArtsAmW 1, FolkA 86, WhAmArt 85*
Gentilz, Theodore 1820?-1906 *NewYHSD*
Gentinetta, Bruno 1937- *DcCAr 81*
Gentle, Bernard 1913- *DcBrA 1*
Gentle, E *DcVicP 2*
Gentle, Esther 1905- *WhoAmA 80, –82, –84*
Gentleman, David *DcCAr 81, IlsCB 1967*
Gentleman, David William 1930- *IlsBYP, WhoGrA 62, –82[port]*
Gentler, Paul Huntington 1888- *ArtsAmW 2*
Gentles, Michael E *MarqDCG 84*
Gentner, George Henry *FolkA 86*
Gentry 1927- *WhoAmA 76, –78, –80*
Gentry, Jr. 1927- *WhoAmA 82, –84*
Gentry, Carl R 1888- *WhAmArt 85*
Gentry, Charles Franklyn, Jr. 1937- *AmArch 70*
Gentry, Helen 1897- *WhAmArt 85*
Gentry, Herbert 1919- *WhoAmA 76, –78, –80, –82, –84*
Gentry, Herbert 1921- *AfroAA*
Gentry, Lawrence Wayne 1909- *AmArch 70*
Gentry, Warren Miller 1921- *WhoAmA 73, –76, –78, –80, –82, –84*
Genty, Marie *DcWomA*
Gentz, Heinrich 1766-1811 *MacEA, OxArt, WhoArch*
Gentz, Wilhelm Karl 1822- *ArtsNiC*
Gentzler, Edwin *WhAmArt 85*
Genung, Robert *WhAmArt 85*
Genz, F C *AmArch 70*
Genzmer, Felix 1856- *MacEA*
Geo-Si, Cecile Marthe 1886- *DcWomA*
Geoffrey, Iqbal 1939- *OxTwCA*
Geoffrey, Sayyid Iqbal 1939- *WhoAmA 84*
Geoffrey, Syed Iqbal 1939- *WhoAmA 76, –78, –80, –82*
Geoffrion, L O *AmArch 70*
Geoffroi, Harry *DcVicP 2*
Geoffroy, Madame *DcWomA*
Geoffroy, Mademoiselle *DcWomA*
Geoffroy, Arthur R *EncASM*
Geoffroy, Charlotte Karsch *DcWomA*
Geoffroy, Jean *DcVicP 2*
Geoffroy, Stephen E 1955- *MarqDCG 84*
Geoghegan, Edith Barry *DcWomA*
Geoghegan, Walter *WhAmArt 85*
George 1942- *ConArt 77, ConBrA 79[port]*
George IV, King 1762-1830 *DcBrWA*
George, St. *DcVicP 2*
George, A O, Jr. *AmArch 70*
George, Archibald *NewYHSD*
George, Charles Vincent 1935- *AmArch 70*
George, Dan 1943- *WhoAmA 82, –84*
George, David Webb 1922- *AmArch 70*
George, Dorothy Hills 1898- *DcWomA, WhAmArt 85*
George, Elsie *DcWomA, WhAmArt 85*
George, Eric 1881- *DcBrA 1*

Gerstenberger, Am 1954- *MarqDCG 84*
Gerstenfeld, Floyd 1942- *MarqDCG 84*
Gerstenheim, Louis 1890- *WhAmArt 85*
Gerster, Georg 1928- *ConPhot, ICPEnP A,*
MacBEP
Gerster, Maria 1843- *DcWomA*
Gerstl, Richard 1883-1908 *OxTwCA*
Gerstle, Miriam Alice 1898- *ArtsAmW 2,*
WhAmArt 85
Gerstle, William Lewis 1868- *WhAmArt 85*
Gerstle Warnum, Miriam Alice 1898- *DcWomA*
Gerstner, Karl 1930- *ConArt 77, -83, ConDes,*
OxTwCA, PhDcTCA 77, WhoGrA 62
Gerstner, Luise *DcWomA*
Gerstung, John *FolkA 86*
Gerten, John 1888- *ArtsAmW 3*
Gerth, Ruth d1952 *WhAmArt 85, WhoAmA 78N,*
-80N, -82N, -84N
Gerthner, Xavier *FolkA 86*
Gertler, Mark 1891-1939 *DcBrA 1, OxTwCA,*
PhDcTCA 77
Gertler, Mark 1892-1939 *ClaDrA, OxArt*
Gertsch, Franz 1930- *ConArt 77, -83, DcCAr 81*
Gerttula, Russell J 1946- *MarqDCG 84*
Gerung, Matthias 1500?-1570? *ClaDrA*
Gervais, Raymond 1946- *DcCAr 81*
Gervase Of Canterbury 1141?-1210 *McGDA*
Gervasi, Frank 1895- *ArtsAmW 3, WhAmArt 85,*
WhoAmA 76, -78, -80, -82, -84
Gervasoni, Federica Giuseppina *DcWomA*
Gervex, Henri *ArtsNiC*
Gervex, Henri 1852-1929 *ClaDrA*
Gervin, G C *AmArch 70*
Gervin, Margaret *DcWomA*
Gervis, Ruth S 1894- *IlsCB 1744*
Gerwer, Sophie Elisa 1816-1861 *DcWomA*
Gerwig, Bruce E 1929- *AmArch 70*
Gery, Louis 1830?- *NewYHSD*
Gerz, Jochen 1940- *ConArt 77, -83, DcCAr 81*
Gerzso, Gunther *OxTwCA*
Gerzso, Gunther 1915- *McGDA, WhoAmA 76, -78,*
-80, -82, -84
Gerzso, John Michael 1946- *MarqDCG 84*
Gescheidt, Alfred 1926- *ICPEnP A, MacBEP*
Gescheidt, Morris *NewYHSD*
Geschwindt *NewYHSD*
Gesellius, Herman 1874-1916 *MacEA, McGDA,*
WhoArch
Geschwind, David M 1952- *MarqDCG 84*
Geske, Norman Albert 1915- *WhoAmA 73, -76, -78,*
-80, -82, -84
Geslain, The Younger *NewYHSD*
Gesler, Michael Eugene 1937- *AmArch 70*
Gesleur, Clement *NewYHSD*
Gessel, H B *AmArch 70*
Gessel, Verl LeRoy 1923- *AmArch 70*
Gessford, Richard Lee 1944- *AmArch 70*
Gessi, Francesco 1588-1649 *McGDA*
Gessler, Marie De *DcWomA*
Gessner, Johann Conrad 1764-1826 *DcBrWA,*
McGDA
Gessner, Johann Konrad 1764-1826 *DcBrECP*
Gessner, Robert S 1908- *WhoArt 80, -82, -84*
Gessner, Salomon 1730-1780 *McGDA*
Gessner, Salomon 1730-1788 *OxArt*
Gessuys, Jeanne *DcWomA*
Gest, J H 1859-1935 *WhAmArt 85*
Gest, Margaret Ralston 1900- *WhAmArt 85*
Gest, Mary T *WhAmArt 85*
Gestel, Leendert 1881-1941 *PhDcTCA 77*
Gestel, Leo 1881-1941 *ConArt 77, McGDA, OxArt*
Geston, Magnus 1923- *AmArch 70*
Gesu, Al *IlDcG*
Getchell, Edith Loring 1855- *WhAmArt 85*
Getchell, Edith Loring Peirce *DcWomA*
Geter, Tyrone *WhoAmA 80*
Gethin, John 1757-1831 *BiDBrA*
Gethin, Percy Francis 1874-1916 *DcBrA 1, DcVicP 2*
Gethin, Percy Francis 1875-1916 *DcBrWA*
Getler, Helen 1925- *WhoAmA 80, -82, -84*
Getschko, Demi 1953- *MarqDCG 84*
Getsinger, Joseph *OfPGCP 86*
Gette, Paul Armand *DcCAr 81*
Getterman, Orla 1913- *WorECar*
Gettier, C R *WhAmArt 85*
Gettier, G Wilmer 1877- *WhAmArt 85*
Gettinger, Edmond Walter 1941- *WhoAmA 76, -78,*
-80, -82, -84
Getty, A *FolkA 86*
Getty, A W *DcWomA*
Getty, Francis E *WhAmArt 85*
Getty, J A *FolkA 86*
Getty, J Paul 1892- *WhoAmA 73, -76*
Getty, J Paul 1892-1976 *WhoAmA 78N, -80N, -82N,*
-84N
Getty, James *FolkA 86*
Getty, John *FolkA 86*
Getty, Marshall *FolkA 86*
Getty, Nilda Fernandez 1936- *WhoAmA 78, -80, -82,*
-84
Getty, Robert *FolkA 86*

Getz *FolkA 86*
Getz, Arthur *WhAmArt 85*
Getz, Mrs. Arthur *WhAmArt 85*
Getz, Charles S *NewYHSD*
Getz, Dorothy 1901- *WhoAmA 73, -76, -78, -80*
Getz, Ilse 1917- *WhoAmA 73, -76, -78, -80, -82, -84*
Getz, Ilse 1933- *PrintW 83, -85*
Getz, J S *NewYHSD*
Getz, John *FolkA 86*
Getz, John 1854-1928 *WhAmArt 85*
Getz, Summers *NewYHSD*
Geudtner, Anna 1844- *DcWomA*
Geudtner, Elise 1857- *DcWomA*
Geudtner, Robert Paul 1927- *AmArch 70*
Gevaert, Lieven 1863-1935 *MacBEP*
Gevelot, Nicholas *NewYHSD*
Gevers, Helene *DcWomA*
Gey-Heinze, Marie 1881-1908 *DcWomA*
Geydushek-Geydon, Mrs. E A 1893- *DcBrA 1*
Geydushek-Geydon, E A 1893- *DcWomA*
Geyer, C E, Sr. *AmArch 70*
Geyer, Frederick *NewYHSD*
Geyer, Gerald John, Jr. 1957- *MarqDCG 84*
Geyer, Harold C *WhAmArt 85*
Geyer, Harold Car 1905- *WhoAmA 76*
Geyer, Henry Christian *NewYHSD*
Geyer, Henry Christian d1793? *FolkA 86*
Geyer, Howard William 1922- *AmArch 70*
Geyer, John Just *FolkA 86*
Geyer, Joseph M 1911- *WhAmArt 85*
Geyer, Karl Ludwig Otto 1843- *ArtsNiC*
Geyer, Lothar 1950- *MarqDCG 84*
Geyer, Luise Margot 1923- *WhoAmA 76, -78*
Geyer, Mina *DcWomA*
Geyler, Ida L 1905- *WhAmArt 85*
Geyser, Christian Gottlieb 1742-1803 *McGDA*
Geyser, Richard P 1925- *AmArch 70*
Geyser, Wilhelmine *DcWomA*
Ghambarelli Family *MacEA*
Gharibjanians, Haroutoun 1949- *MarqDCG 84*
Gharis, Charles 1910- *WhAmArt 85*
Gheeraerts, Marcus, I 1525?-1599? *McGDA*
Gheeraerts, Marcus, II 1561-1636? *McGDA*
Gheeraerts, Marcus, The Elder 1516?-1604? *OxArt*
Gheeraerts, Marcus, The Younger 1561-1635 *OxArt*
Ghent, Henri 1926- *WhoAmA 73, -76, -78, -80, -82,*
-84
Ghent, Peter 1856-1911 *DcVicP 2*
Gherardi, Antonio 1644-1702 *MacEA*
Gherardi, Harry Taylor 1906- *AmArch 70*
Gherardi, Piero 1909-1971 *ConDes*
Gherardini, Alessandro 1655-1726 *McGDA*
Gherardo DiGiovanni DiMiniato 1446-1497 *McGDA*
Gherardo DiJacopo *McGDA*
Ghermandi, Quinto 1916- *PhDcTCA 77*
Gheyn, Jacob De, II 1565-1629 *McGDA*
Gheyn, Jacques De, I *OxArt*
Gheyn, Jacques De, II 1565-1629 *OxArt*
Gheyn, Jacques De, III 1596?-1641 *OxArt*
Ghez, Oscar 1905- *WhoAmA 73, -76*
Ghezzi, Antonio *OxTwCA*
Ghezzi, Edward Marion 1922- *AmArch 70*
Ghezzi, Frank A 1930- *AmArch 70*
Ghiandoni, Getullio 1922- *WhoGrA 82[port]*
Ghiberti, Lorenzo 1378?-1455 *MacEA, McGDA,*
OxArt
Ghiberti, Vittorio 1416-1496 *McGDA*
Ghibu, Costin V 1941- *MarqDCG 84*
Ghica-Budesti, Nicolae 1869-1943 *MacEA*
Ghika, Nickolas 1906- *PhDcTCA 77*
Ghika, Nicolas 1909- *ConArt 77*
Ghika, Niko 1906- *WhoArt 80, -82, -84*
Ghika, Nikolas Hadjikyriakos 1906- *OxTwCA*
Ghikas, Panos 1923- *IlsCB 1946*
Ghikas, Panos George *WhoAmA 73, -76, -78, -80,*
-82, -84
Ghikas, Patience Haley *WhoAmA 82, -84*
Ghilchik, David 1892- *DcBrA 1*
Ghirardelli, Alida *ArtsAmW 2, DcWomA,*
WhAmArt 85
Ghirardelli, Angela 1859-1936 *DcWomA*
Ghirlandaio, Domenico Bigordi 1448?-1494 *OxArt*
Ghirlandaio, Ridolfo 1483-1561 *OxArt*
Ghirlandajo, Benedetto DiTommaso 1458-1497
McGDA
Ghirlandajo, Davide 1452-1525 *McGDA*
Ghirlandajo, Domenico 1449-1494 *McGDA*
Ghirlandajo, Michele DiRidolfo Del *McGDA*
Ghirlandajo, Ridolfo 1483-1561 *McGDA*
Ghirri, Luigi *DcCAr 81*
Ghirri, Luigi 1943- *ConPhot, ICPEnP A*
Ghiselin, Cesar d1733 *AntBDN Q*
Ghiselin, Reverdy *CabMA*
Ghisi, Adamo 1530?-1574 *ClaDrA*
Ghisi, Diana *DcWomA*
Ghisi, Diana 1536?-1590 *ClaDrA*
Ghisi, Giorgio 1520-1582 *McGDA*
Ghislandi, Giuseppe 1655-1743 *McGDA*
Ghislina, Giustina *DcWomA*
Ghisolfi, Giorgio 1950- *MarqDCG 84*
Ghisolfi, Giovanni 1632?-1683 *ClaDrA*

Ghissi, Francescuccio *McGDA*
Ghiyas, Mirak Mirza d1565? *MacEA*
Ghobad, Shiva 1941- *WhoGrA 82[port]*
Ghormley, Miss *DcWomA*
Ghosh, Chinmoy Kumar 1931- *WhoArt 82, -84*
Ghosh, Sri Chinmoy Kumar 1931- *WhoArt 80*
Ghosn, Assad 1877- *WhAmArt 85*
Giacalone, Louis Paul 1942- *AmArch 70*
Giacalone, Vito *WhoAmA 84*
Giachi, F *DcVicP 2*
Giachino, James Jerome 1938- *AmArch 70*
Giacobbe, A *AmArch 70*
Giacoboni, Angiolina 1734-1796 *DcWomA*
Giacomantonio, Archimedes 1906- *WhoAmA 82, -84*
Giacomantonio, Archimedes Aristedes M 1906-
WhAmArt 85
Giacomantonio, Archimedes Aristides *WhoAmA 73,*
-76, -78, -80
Giacomelli, Mario 1925- *ConPhot, ICPEnP,*
MacBEP
Giacomelli, Sophie *DcWomA*
Giacometti, Alberto 1901-1966 *ConArt 77, -83,*
McGDA, OxArt, OxTwCA, PhDcTCA 77,
WorArt[port]
Giacometti, Augusto 1887-1947 *OxTwCA,*
PhDcTCA 77
Giacometti, Giovanni 1868-1933 *OxTwCA,*
PhDcTCA 77
Giacomotti, Felix Henri 1828- *ArtsNiC*
Giacomotti, Felix Henri 1828-1909 *ClaDrA*
Giacopelli, James J 1921- *AmArch 70*
Giacosa, Dante 1905- *ConDes*
Gialdini, Michael Joseph 1946- *MarqDCG 84*
Giamberti, Antonio, The Elder *McGDA*
Giamberti, Antonio, The Younger *McGDA*
Giamberti, Francesco *McGDA*
Giamberti, Giuliano *McGDA*
Giambertone, Paul *WhoAmA 73, -76, -78, -80, -82,*
-84
Giambologna *McGDA, OxArt*
Giambono, Michele *McGDA*
Giambruni, Tio 1925- *DcCAA 71, WhoAmA 73*
Giambruni, Tio 1925-1971 *DcCAA 77,*
WhoAmA 76N, -78N, -80N, -82N, -84N
Giammartini, Achille 1861-1929 *WhAmArt 85*
Giampaoli, Dominicus *NewYHSD*
Giampaoli, James Francis 1937- *WhoAmA 78, -80,*
-82
Giampietri, Madame *DcVicP 2*
Giampietri, Amy *DcWomA*
Giampetrino *McGDA*
Giampietro, Isabel *WhoAmA 84*
Gian Giacomo D'Alladio *McGDA*
Gianakos, Cristos 1934- *AmArt, WhoAmA 78, -80,*
-82, -84
Gianakos, Steve 1938- *PrintW 83, -85, WhoAmA 78,*
-80, -82, -84
Gianattasio, Frank Joseph 1934- *MarqDCG 84*
Gianella, Victor 1918- *ConPhot, ICPEnP A*
Gianelli *DcBrECP*
Gianelli, Frostino *NewYHSD*
Gianelli, R J *AmArch 70*
Gianetti, Flavie *DcWomA*
Giangiulio, Sandra *OfPGCP 86*
Gianini, Giulo 1927- *WorECar*
Gianlisi, Antonia *DcWomA*
Giannasca, Edward Vincent 1931- *AmArch 70*
Gianni, G *DcSeaP*
Gianni, Mal Joseph 1908- *AmArch 70*
Giannicola *McGDA*
Giannini, Joseph *NewYHSD*
Giannini, Ward Michael 1956- *MarqDCG 84*
Giannotti, John J 1945- *WhoAmA 78, -80, -82*
Giantvalley, Elinor T *WhAmArt 85*
Giaquinto, Robert 1954- *MarqDCG 84*
Giard, Claire *DcWomA*
Giardelli, Arthur 1911- *DcBrA 2, WhoArt 80, -82,*
-84
Giardini, Adolph G *ArtsEM*
Giattina, Joseph Paul, Jr. 1939- *AmArch 70*
Gibala, Louise 1897- *WhoAmA 84*
Gibans, James David 1930- *AmArch 70*
Gibb, Avril V *WhoArt 84*
Gibb, Bill 1943- *ConDes, WorFshn*
Gibb, Lewis Taylor *DcBrA 1*
Gibb, Phelan 1870-1948 *DcBrA 1, DcVicP 2*
Gibb, R B *AmArch 70*
Gibb, Robert 1801-1837 *DcBrWA*
Gibb, Robert 1845-1932 *DcBrA 1, DcBrWA,*
DcVicP, -2
Gibb, Stanley Watson 1898- *DcBrA 1*
Gibb, Stanley Watson 1898-1973 *DcBrA 2*
Gibb, William 1839-1929 *DcBrA 1, DcBrWA,*
DcVicP 2
Gibb, William R 1888- *WhAmArt 85*
Gibbard, Caroline *DcWomA*
Gibbard, Elizabeth *WhoArt 84N*
Gibbard, Elizabeth 1913- *WhoArt 80, -82*
Gibbens, Mary Barr *DcWomA*
Gibberd, Eric Waters 1897- *ArtsAmW 1*
Gibberd, Eric Waters 1897-1972 *IlBEAAW,*

Gilmore, O C 1890- *WhAmArt 85*
Gilmore, Octavia C 1890- *DcWomA*
Gilmore, P C *AmArch 70*
Gilmore, Priscilla Alden *WhAmArt 85*
Gilmore, Roger 1932- *WhoAmA 73, -76, -78, -80,*
 -82, -84
Gilmore, Sidney 1923- *WhoArt 80, -82, -84*
Gilmore, Thomas 1813?- *FolkA 86*
Gilmore, William 1807?- *FolkA 86*
Gilmour, Miss *DcVicP 2*
Gilmour, Mrs. *DcWomA*
Gilmour, Albert Edward 1923- *WhoArt 80, -82, -84*
Gilmour, B P *AmArch 70*
Gilmour, Elaine 1931- *WhoArt 80, -82, -84*
Gilmour, Gabriel *FolkA 86*
Gilmour, George Fisher *DcBrA 1, WhoArt 80, -82,*
 -84
Gilmour, Iain M 1936- *MarqDCG 84*
Gilmour, James Lowell 1928- *AmArch 70*
Gilmour, John *MarqDCG 84*
Gilmour, Joseph *FolkA 86*
Gilmour, K *DcWomA*
Gilmour, May 1819-1907 *DcWomA*
Gilmour, Thomas *FolkA 86*
Gilmour, William *FolkA 86*
Gilossi, G *DcVicP 2*
Gilow, Ruth *WhoAmA 73*
Gilpin, A W S *FolkA 86*
Gilpin, Charles Armour 1867- *WhAmArt 85*
Gilpin, Eliza *DcWomA*
Gilpin, Henry B 1922- *ICPEnP A*
Gilpin, Henry E 1922- *MacBEP*
Gilpin, Henry Edmund 1922- *WhoAmA 84*
Gilpin, Howard Lee 1934- *AmArch 70*
Gilpin, John Bernard 1701-1776 *DcBrWA*
Gilpin, Laura 1891- *WhoAmA 76, -78*
Gilpin, Laura 1891-1979 *ConPhot, ICPEnP,*
 MacBEP, WhoAmA 80N, -82N, -84N
Gilpin, Laura 1891-1980 *WhAmArt 85*
Gilpin, Sawrey 1733-1807 *DcBrECP, DcBrWA,*
 OxArt
Gilpin, William 1724-1804 *BkIE, DcBrWA, OxArt*
Gilpin, William Sawrey 1762-1843 *DcBrWA, OxArt*
Gilrin, Theodore H d1967 *WhoAmA 78N, -80N,*
 -82N, -84N
Gilroy, John T Young 1898- *DcBrA 1*
Gilroy, John W *DcVicP 2*
Gilroy, W A, Jr. *AmArch 70*
Gilruth, May Hardman *WhAmArt 85*
Gilson, Irene *WhAmArt 85*
Gilson, Isaac C *CabMA*
Gilson, K *WhAmArt 85*
Gilson, Richard C *CabMA*
Gilsoul, Victor Olivier 1867- *ClaDrA*
Gilsoul-Hoppe, Ketty 1868- *DcWomA*
Gilstrap, W H 1840-1914 *ArtsAmW 1, -3,*
 NewYHSD , WhAmArt 85
Giltner, Daniel 1800- *CabMA*
Gilvarry, James *WhoAmA 73, -76, -78, -80, -82*
Gimbel, Mrs. Bernard F *WhoAmA 73, -76, -78*
Gimbel, Sophie *WorFshn*
Gimber, Stephen Henry *EarABI SUP*
Gimber, Stephen Henry 1806?-1862 *NewYHSD*
Gimberman, Francois *NewYHSD*
Gimblett, Max *PrintW 85*
Gimblett, Max 1935- *WhoAmA 82, -84*
Gimbrede, Joseph Napoleon 1820- *NewYHSD*
Gimbrede, Thomas 1781-1832 *NewYHSD*
Gimenez, Carlos 1941- *ConGrA 1*
Gimeno, Harold 1896- *AmArch 70*
Gimeno, Harold 1897- *ArtsAmW 2, WhAmArt 85*
Gimeno, P 1865- *WhAmArt 85*
Gimeno, Patricio 1865- *ArtsAmW 2*
Gimignani, Giacinto 1611-1681 *ClaDrA*
Gimmi, Wilhelm 1886-1965 *PhDcTCA 77*
Gimond, Marcel 1894-1961 *OxTwCA*
Gimpey *NewYHSD*
Gimson, Ernest 1864-1919 *DcBrA 2, DcD&D,*
 McGDA, OxDecA
Gimson, Ernest 1864-1920 *DcNiCA*
Gimucio Y Grinda, Josefa *DcWomA*
Gin, Jackson 1934- *AmArch 70*
Gin, Walter F 1927- *AmArch 70*
Gina, Francis Xavier *AmArch 70*
Gindele, Mathias 1851-1930 *WhAmArt 85*
Gindele, William E 1925- *AmArch 70*
Gindhart, Francis Xavier *NewYHSD*
Gindrez, Adele *DcWomA*
Gindroz, Raymond Leroy 1940- *AmArch 70*
Ginenback, John V *NewYHSD*
Gines, Jose 1768-1823 *McGDA*
Gines Y Ortiz, Adela *DcWomA*
Ginesi, Edna 1902- *DcBrA 1, WhoArt 80, -82, -84*
Ginestet, Jacques Paul 1955- *MarqDCG 84*
Gingelen, Jacques Van 1801- *ClaDrA*
Gingell, A E *DcWomA*
Gingell, Mrs. M E *DcVicP 2*
Gingell, William Bruce 1819-1900 *MacEA*
Ginger, Phyllis Ethel 1907- *DcBrA 1, WhoArt 80,*
 -82, -84
Gingerich, Zach *FolkA 86*

Gingles, P M *AmArch 70*
Gingold, B A, Jr. *AmArch 70*
Gingrich, Arnold 1903- *WorFshn*
Ginisty, Delphine Julienne Alice *DcWomA*
Ginley, J J, Jr. *AmArch 70*
Ginn, Robert 1805- *FolkA 86*
Ginn, Ronn 1933- *AmArch 70*
Ginna-Corradini, Arnaldo *OxTwCA*
Ginnasi, Caterina De 1590-1660 *DcWomA*
Ginnell *EncASM*
Ginner, Charles 1878-1952 *McGDA, OxTwCA,*
 PhDcTCA 77
Ginner, Charles 1879-1952 *OxArt*
Ginner, Isaac Charles 1878-1952 *DcBrA 1*
Ginnett, Louis 1875-1946 *DcBrA 1, DcVicP 2*
Ginnever, Charles 1931- *DcCAA 77, DcCAr 81,*
 WhoAmA 73, -76, -78, -80, -82, -84
Ginno, Elizabeth DeGebele 1911- *WhAmArt 85*
Ginnow, R D *AmArch 70*
Ginocchio, Martin Hannibal 1931- *AmArch 70*
Ginocchio, Stephen John 1929- *AmArch 70*
Ginsberg, Anthony Michael 1944- *MarqDCG 84*
Ginsberg, B A *AmArch 70*
Ginsberg, David Lawrence 1932- *AmArch 70*
Ginsberg, Jean 1905- *ConArch*
Ginsberg, Marvin A 1932- *AmArch 70*
Ginsbern, Frederick Morton 1919- *AmArch 70*
Ginsborg, Michael 1943- *DcCAr 81*
Ginsburg, A *WhAmArt 85*
Ginsburg, Estelle 1924- *WhoAmA 78, -80, -82, -84*
Ginsburg, Jacob J *WhAmArt 85*
Ginsburg, Max 1931- *AmArt, WhoAmA 73, -76, -78,*
 -80, -82, -84
Ginsburg, Moisei Yakovlevich 1892-1946 *MacEA*
Ginsburg, N R *AmArch 70*
Ginther, Mary Pemberton *WhAmArt 85*
Ginther, Mary Pemberton 1869-1959 *DcWomA*
Ginther, Roland Debs 1907-1969 *FolkA 86*
Ginther, Walter K 1894- *WhAmArt 85*
Gintoff, John 1947- *MacBEP*
Ginzburg, Carlos 1946- *DcCAr 81*
Ginzburg, Yankel 1945- *PrintW 83, -85,*
 WhoAmA 76, -84
Ginzel, Roland 1921- *AmArt, DcCAr 81,*
 WhoAmA 73, -76, -78, -80, -82, -84
Giobbi, Edward 1926- *DcCAA 71, -77*
Giobbi, Edward Gioachino 1926- *ConArt 77,*
 WhoAmA 73, -76, -78, -80, -82, -84
Giocondo, Giovanni 1433-1515 *MacEA*
Giocondo, Giovanni, Fra 1433?-1515*
 McGDA, OxArt
Giolfino, Niccolo 1476-1555 *McGDA*
Gioli, Paolo 1942- *ConPhot, ICPEnP A*
Gionfridda, Joseph M 1907- *WhAmArt 85*
Gionta, R L *AmArch 70*
Giordana, Edward Carl 1909- *WhAmArt 85*
Giordano, Joseph *PrintW 85*
Giordano, Luca 1632-1705 *ClaDrA, McGDA*
Giordano, Luca 1634-1705 *OxArt*
Giordano, Richard 1932- *WorECom*
Giordano, Sofia 1779-1829 *DcWomA*
Giorgi, Bruno 1905- *OxTwCA*
Giorgi, Bruno 1908- *PhDcTCA 77*
Giorgi, Giorgio De 1918- *McGDA*
Giorgi, Vita *WhoAmA 73, -76, -78*
Giorgini, Aldo 1934- *MarqDCG 84*
Giorgio Da Sebenico d1475 *MacEA*
Giorgio Del Castelfranco 1475-1510 *OxArt*
Giorgio, Maestro *McGDA*
Giorgio, Francesco Di *McGDA*
Giorgione 1477?-1510 *McGDA*
Giorgione, Giorgio Barbarelli 1475-1510 *OxArt*
Giorio, Rosa *DcWomA*
Giot, Jenny 1876- *DcWomA*
Giottino *McGDA*
Giotto Di Bondone 1267?-1337 *MacEA ,*
 McGDA, OxArt
Giotto DiMaestro Stefano *McGDA*
Giovannetti, Pericle Luigi 1916- *WhoGrA 62*
Giovanni Angelo DiAntonio DaCamerino *McGDA*
Giovanni Antonio De'Sacchi *McGDA*
Giovanni Battista DiJacopo DiGaspare *McGDA*
Giovanni Bologna *McGDA*
Giovanni Bonsi *McGDA*
Giovanni Da Maiano *OxArt*
Giovanni DaCampione *McGDA*
Giovanni DaFaenza *McGDA*
Giovanni DaFiesole *McGDA*
Giovanni D'Alemagna d1450 *McGDA*
Giovanni DaMaiano *McGDA*
Giovanni DaMilano *McGDA*
Giovanni DaOriolo *McGDA*
Giovanni DaPistoia *McGDA*
Giovanni DaSanGiovanni *McGDA*
Giovanni DaTrau *McGDA*
Giovanni DaUdine 1487-1564 *McGDA*
Giovanni DaVerona, Fra 1457?-1525 *McGDA*
Giovanni DelBiondo DalCasentino *McGDA*
Giovanni Dell'Opera *McGDA*
Giovanni DelPoggio *McGDA*

Giovanni DelPonte 1385-1437 *McGDA*
Giovanni Di Paolo *OxArt*
Giovanni DiBartolommeo Cristiani *McGDA*
Giovanni DiBenedetto DaComo *McGDA*
Giovanni DiComo *McGDA*
Giovanni DiFrancesco DelCervelliera 1428?-1459*
 McGDA
Giovanni DiGiuliano Savoretti *McGDA*
Giovanni DiJacopo DiG DaCaversaccio *McGDA*
Giovanni DiMarco *McGDA*
Giovanni DiMichele S DaLarciano *McGDA*
Giovanni DiNicola *McGDA*
Giovanni DiPaolo 1403-1483 *McGDA*
Giovanni DiPietro DaNapoli *McGDA*
Giovanni Francesco DaRimini d1470? *McGDA*
Giovanni Marcio *McGDA*
Giovanni Maria *McGDA*
Giovanni Maria DaPadova *McGDA*
Giovanni Pisano 1250?-1314? *McGDA*
Giovanni, Jean *McGDA*
Giovanni, Paolo Di *McGDA*
Giovanni, Stefano Di *McGDA*
Giovanni, Tedesco *McGDA*
Giovannini, Bianca d1744 *DcWomA*
Giovannino De'Grassi 1340?-1398 *McGDA*
Giovannoni, Gustavo 1873-1947 *MacEA*
Giovanopoulos, Paul 1939- *IlrAm 1880*
Giovanopoulos, Paul Arthur 1939- *IlsBYP*
Giovenone, Girolamo 1486?-1555 *McGDA*
Gippius, Natalia Nicolaievna 1880- *DcWomA*
Gippius, Tatiana Nicolaievna 1877- *DcWomA*
Gips, Philip *AmGrD[port]*
Gips, Wilhelmine 1897- *DcWomA*
Gir *WorECom*
Giradot, C E *DcVicP 2*
Giradot, Jean Edine *DcVicP 2*
Giral Family *MacEA*
Giraldi, Mademoiselle *DcWomA*
Giraldi, Guglielmo *McGDA*
Giralt Miracle, Ricardo 1911- *WhoGrA 62*
Giralte, Francisco *McGDA*
Girandole, Bernardo Delle *McGDA*
Girard D'Orleans d1361 *McGDA*
Girard, Mademoiselle *DcWomA*
Girard, Alexander 1907- *ConDes*
Girard, Alexander H 1907- *AmArch 70, BnEnAmA*
Girard, Alexander Hayden 1907- *DcD&D*
Girard, Firmin *ArtsNiC*
Girard, Jack 1951- *WhoAmA 84*
Girard, Joseph Basil 1846-1918 *ArtsAmW 3*
Girard, Laure *DcWomA*
Girard, Louise *DcWomA*
Girard, Marie *DcWomA*
Girard, Paul Albert 1839-1920 *ClaDrA*
Girard-Condamin, Jeanne *DcWomA*
Girard-Rabache, Helene *DcWomA*
Girardet, Berthe 1867?- *DcWomA*
Girardet, Edouard-Henri 1819- *ArtsNiC*
Girardet, Eugene Alexis 1853-1907 *ClaDrA*
Girardet, Jules 1856- *ClaDrA*
Girardet, Julie Charlotte 1769- *DcWomA*
Girardet, Karl 1810-1871? *ArtsNiC*
Girardet, Paul 1821- *ArtsNiC*
Girardi, Michael Joseph 1927- *AmArch 70*
Girardier, Jeanne *DcWomA*
Girardin, Frank J 1856- *WhAmArt 85*
Girardin, Frank J 1856-1945 *ArtsAmW 2*
Girardin, P, Madame *DcVicP 2*
Girardin, Pauline 1818- *DcWomA*
Girardin, Rene Louis 1735-1808 *MacEA*
Girardon, Catherine *DcWomA*
Girardon, Francois 1628-1715 *McGDA, OxArt*
Girardot, Alfred C *DcVicP 2*
Girardot, Ernest Gustave *DcVicP 2*
Girardot, Helene *DcWomA*
Girardot, Louis 1856-1933 *WhAmArt 85A*
Girardy, J De *DcBrECP*
Girardy, S De *DcBrECP*
Girau, Leisan *AfroAA*
Giraud, Jean 1938- *WorECom*
Giraud, Jean-Baptiste 1752-1830 *McGDA*
Giraud, Jenny *DcWomA*
Giraud, Louis Matthieux *NewYHSD*
Giraud, Louise Emilie *DcWomA*
Giraud, Marie *DcWomA*
Giraud, Marthe *DcWomA*
Giraud, Nathalie *DcWomA*
Giraud, Pierre-Francois-Eugene 1806-1881 *ArtsNiC*
Giraud, Pierre-Francois-Gregoire 1783-1836 *McGDA*
Giraud, Rosine *DcWomA*
Giraud, Sebastien-Charles 1819- *ArtsNiC*
Giraud, Victor 1840-1871 *ArtsNiC*
Giraud, Victor Julien 1840-1871 *ClaDrA*
Giraudet, Antonio 1926- *WhoAmA 73, -76, -78, -80,*
 -82, -84
Giraudo, Albert B 1929- *AmArch 70*
Girault, Augustine Lesourd-Delisle 1810- *DcWomA*
Girault, Charles 1851-1932 *WhoArch*
Girault, Charles-Louis 1851-1932 *MacEA*
Girault, Louis Matthieux *NewYHSD*
Girault DeSaint-Fargeau, Amanda *DcWomA*

Glauber, Robert H 1920- *WhoAmA 76, -78, -80, -82, -84*
Glaubrecht, George J *NewYHSD*
Glaus, C R *AmArch 70*
Glave, James Millard 1933- *AmArch 70*
Glazebrook, Ellen L *DcBrA 2*
Glazebrook, Hugh DeTenebrokes 1855-1937 *DcBrA 1*
Glazebrook, Hugh DeTwenebrokes 1855-1937 *DcVicP 2*
Glazer, Howard Leonard 1923- *AmArch 70*
Glazier, Henry *FolkA 86*
Glazier, Louise M *DcBrBI*
Glazier, Nancy *OfPGCP 86*
Glazner, Victor Wallis 1941- *AmArch 70*
Gleadall, W C *DcVicP 2*
Gleadowe, Richard Morier Yorke 1888-1944 *DcBrA 2*
Gleason *FolkA 86*
Gleason, Benjamin A *FolkA 86*
Gleason, Charles *FolkA 86*
Gleason, Duncan 1881-1959 *ArtsAmW 1, WhAmArt 85*
Gleason, Henry *FolkA 86*
Gleason, Joe Duncan 1879-1959 *WhoAmA 80N, -82N, -84N*
Gleason, Mrs. L *FolkA 86*
Gleason, Paul M 1940- *ConGrA 1*
Gleason, Roswell *EncASM*
Gleason, Samuel W *FolkA 86*
Gleason, T L *AmArch 70*
Gleason, W G *FolkA 86*
Gleason, William B *NewYHSD*
Gleason, William B 1800- *FolkA 86*
Gleave, John W *NewYHSD*
Gleaves, John W *NewYHSD*
Gleaves, William H *WhAmArt 85*
Gleber, Conrad Joseph, Jr. 1949- *MacBEP*
Glebova, Anna Ivanovna *DcWomA*
Gleckman, William Barnett 1931- *AmArch 70*
Gledhill, Wayne F 1943- *WhoAmA 76*
Gledstanes, Elsie *ClaDrA, WhoArt 80, -82, -84N*
Gledstanes, Elsie 1891- *DcBrA 1, DcWomA*
Gleeson, Adele *DcWomA*
Gleeson, Agnes *ArtsEM, DcWomA*
Gleeson, Charles K 1878- *WhAmArt 85*
Gleeson, Mrs. Charles K *WhAmArt 85*
Gleeson, J M 1861- *WhAmArt 85*
Glehn, Jane De *DcWomA*
Glehn, Wilfred Gabriel De 1870- *ClaDrA*
Gleich, Rosalie *DcWomA*
Gleichen, Countess Feodora 1861-1922 *DcWomA*
Gleichen, Lady Feodore 1861-1922 *DcBrA 1*
Gleichen, Lady Helena d1947 *DcBrA 1*
Gleichen, Countess Helena 1873-1947 *DcWomA*
Gleicher, Howard Roy 1959- *MarqDCG 84*
Gleichmann, Otto 1887-1963 *PhDcTCA 77*
Gleitsmann, Raphael 1910- *WhAmArt 85*
Gleizds, Janis 1924- *ICPEnP A*
Gleizes, Albert 1881-1953 *ClaDrA, ConArt 77, -83, McGDA, OxArt, OxTwCA, PhDcTCA 77*
Gleizes, Juliette *DcWomA*
Glen, Graham *DcBrA 2*
Glen, Hugh *FolkA 86*
Glen, John *DcBrWA*
Glen, Olive B *ArtsEM, DcWomA*
Glenavy, Beatrice 1883-1970 *DcWomA*
Glendening, Alfred, Jr. d1907 *ClaDrA, DcVicP*
Glendening, Alfred, Jr. 1861-1907 *DcBrA 1, DcVicP 2*
Glendening, Alfred Augustus *DcBrA 2, DcVicP, -2*
Glendening, Everett A 1929- *AmArch 70*
Glendenning, Alfred Augustus 1861-1907 *DcBrWA*
Glendenning, Herman W *EncASM*
Glendinen, J Y *ArtsAmW 3*
Glendinning, Peter 1951- *MacBEP, WhoAmA 82, -84*
Glenn, Constance White 1933- *WhoAmA 76, -78, -80, -82, -84*
Glenn, D F *AmArch 70*
Glenn, Rotell *AfroAA*
Glenn, Sollace J 1905- *AfroAA*
Glenn, William *FolkA 86*
Glenn, William V, Jr. *MarqDCG 84*
Glennan, Mary Emilie 1855- *DcWomA*
Glennie, Arthur 1803-1890 *DcBrWA, DcVicP 2*
Glennie, George F *DcVicP, -2*
Glennie, J D 1796-1874 *DcBrBI*
Glennie, J S *NewYHSD*
Glenny, Alice Russell 1858- *WhAmArt 85*
Glenny, Alice Russell 1858-1924 *DcWomA*
Glenny, Anna *WhAmArt 85*
Glenny, Anna 1888- *DcWomA*
Glenny, Bryant B *EncASM*
Glenny, Edmund J 1928- *AmArch 70*
Glenny, W Henry *EncASM*
Glenny, William H *EncASM*
Glenny, William J *DcVicP 2*
Glenton *NewYHSD*
Glentworth, Harvey *NewYHSD*
Glessing, Thomas B 1817-1882 *NewYHSD*
Glessner, Agnes C *WhAmArt 85*
Glessner, John J 1843-1936 *WhAmArt 85*

Glessner, Thomas John 1926- *AmArch 70*
Glexer, Nechemia 1910- *WhoAmA 73*
Gleyre, Jessie M *WhAmArt 85*
Gleyre, Marc 1808-1874 *WhAmArt 85A*
Gleyre, Marc Charles-Gabriel 1806-1874 *ArtsNiC*
Glezer, Nechemia 1910- *WhoAmA 76, -78, -80, -82, -84*
Glicenstein, Enrico 1870-1942 *McGDA, WhAmArt 85*
Glick *DcBrBI*
Glick, Barry Jay 1953- *MarqDCG 84*
Glick, Herman 1895- *FolkA 86*
Glick, John Parker 1938- *CenC[port]*
Glick, Paula Florence *WhoAmA 80, -82, -84*
Glick, Paula Florence 1936- *WhoAmA 73, -76, -78*
Glicker, Benjamin C 1914- *WhAmArt 85*
Glickman, Arthur 1923- *WhoAmA 82, -84*
Glickman, Hal 1937- *WhoAmA 76, -78, -80, -82*
Glickman, Maurice 1906- *WhAmArt 85, WhoAmA 73, -76, -78, -80, -82, -84*
Glicksman, Jay 1953- *MarqDCG 84*
Glidden, Carlton *WhAmArt 85*
Glidden, Edward H d1924 *BiDAmAr*
Glidden, Edward Hughes, Jr. 1901- *AmArch 70*
Glidden, John 1794-1846 *CabMA*
Glidden, Stanley Irvin 1927- *AmArch 70*
Gliddon, Anna *DcWomA, NewYHSD*
Gliddon, Anne *DcWomA*
Gliddon, Charles *DcBrBI*
Gliddon, Katie Edith 1883- *DcBrA 1, DcWomA*
Gliha, Oton 1914- *PhDcTCA 77*
Gliko, Carl Albert 1941- *WhoAmA 76, -78, -80, -82*
Glimcher, Arnold B 1938- *WhoAmA 73, -76, -78, -80, -82, -84*
Glindon, Paul *DcVicP 2*
Glindoni, Henry Gillard 1852- *DcVicP*
Glindoni, Henry Gillard 1852-1912 *DcBrWA*
Glindoni, Henry Gillard 1852-1913 *DcBrA 1, DcVicP 2*
Glines, Ellen d1951 *WhAmArt 85, WhoAmA 78N, -80N, -82N, -84N*
Glink, Franz Xavier 1795-1873 *ClaDrA*
Glinn, Burt 1925- *ConPhot, ICPEnP A*
Glinskas, Tony 1942- *MarqDCG 84*
Glinsky, Vincent 1895- *McGDA, WhoAmA 73*
Glinsky, Vincent 1895-1975 *WhAmArt 85, WhoAmA 76N, -78N, -80N, -82N, -84N*
Glintenkamp, Hendrik 1887-1946 *WhAmArt 85*
Glisczinski, Thomas J 1942- *MarqDCG 84*
Glitchman, A *NewYHSD*
Glizman, Adolfo 1943- *MarqDCG 84*
Gloag, H *DcVicP 2*
Gloag, Isobel Lilian 1865-1917 *DcBrA 1, DcBrBI, DcBrWA, DcVicP 2, DcWomA*
Gloag, J L *DcVicP 2*
Gloag, Mrs. W D *DcVicP 2*
Gloaguen, Herve 1937- *ConPhot, ICPEnP A*
Globig, Christiane Benedictine Johanna *DcWomA*
Globus, Dorothy Twining *WhoAmA 78, -80, -82, -84*
Globus, Gary L 1944- *MarqDCG 84*
Glockendon, Albrecht d1545 *McGDA*
Glockendon, Nikolaus d1534 *McGDA*
Gloe, Olive 1896- *ArtsAmW 1, DcWomA*
Gloeden, Wilhelm Von 1856-1931 *MacBEP*
Gloetzner, Josephine M 1877- *DcWomA*
Gloetzner, Josephine F *WhAmArt 85*
Glogger, John N *NewYHSD*
Glomy, Jean-Baptiste d1786 *OxDecA*
Gloor, Christoph 1936- *WhoGrA 82[port]*
Gloria, Germaine *DcWomA*
Gloria, Marie Berthe *DcWomA*
Glorig, Ostor 1919- *WhoAmA 73, -76, -78, -80, -82, -84*
Glosenkamp, Herman *McGDA*
Glossop, Allerley 1872-1955 *DcWomA*
Glossop, G P P *DcVicP 2*
Gloster, Amos E 1917- *AmArch 70*
Gloster, Charles D 1922- *AmArch 70*
Gloster, Dorothy L *AfroAA*
Glotter, Joel Harvey 1925- *AmArch 70*
Gloudeman, J F *MarqDCG 84*
Glover, B B *AmArch 70*
Glover, Bertram *WhAmArt 85*
Glover, DeLay 1783?-1863? *NewYHSD*
Glover, DeLloyd Gage *NewYHSD*
Glover, Dennet *ArtsEM*
Glover, DeWitt Clinton 1817-1836 *NewYHSD*
Glover, Donald Mitchell 1930- *WhoAmA 73, -76*
Glover, Edwin S 1845-1919 *ArtsAmW 3, IlBEAAW, WhAmArt 85*
Glover, Elizabeth 1824-1845 *FolkA 86*
Glover, Emily *DcVicP 2*
Glover, Euphemia W *WhoAmA 73, -76*
Glover, Frederick W *WhAmArt 85*
Glover, G C *DcBrBI*
Glover, Gordon D 1957- *MarqDCG 84*
Glover, Hannah *DcVicP 2*
Glover, Ichabod 1747?-1801 *CabMA*
Glover, John *CabMA, DcBrWA, FolkA 86*
Glover, John 1767-1849 *BkIE, DcBrECP, DcBrWA, McGDA*

Glover, John Ainsworth 1949- *WhoArt 80, -82, -84*
Glover, Joseph 1771-1808 *CabMA*
Glover, Joseph T 1906- *WhAmArt 85*
Glover, Lloyd 1826- *NewYHSD*
Glover, Louis Henry Horace *WhoArt 84N*
Glover, Louis Henry Horace 1912- *WhoArt 80, -82*
Glover, M J *DcWomA*
Glover, Mrs. M J *ArtsEM*
Glover, Robert 1941- *AfroAA*
Glover, Robert Leon 1936- *AmArt, WhoAmA 76, -78, -80, -82*
Glover, Mrs. S Albertson *WhAmArt 85*
Glover, Samuel Newhall 1807?-1845 *CabMA*
Glover, Sybil Mullen *DcBrA 2, DcSeaP*
Glover, Thomas 1639?-1707 *BiDBrA*
Glover, William *CabMA, DcBrWA*
Glovinsky, N M *AmArch 70*
Gloyeske, Robert Kenneth 1926- *AmArch 70*
Gluck 1895- *ConArt 77*
Gluck, Anselm 1950- *DcCAr 81*
Gluck, B *NewYHSD*
Gluck, Heidi 1944- *WhoAmA 82, -84*
Gluckman, Morris 1894- *WhoAmA 73, -76, -78*
Gluckmann, Grigory 1898- *ArtsAmW 3, WhAmArt 85*
Glucksman, Harold D 1912- *AmArch 70*
Glucksman, Leon *AmArch 70*
Glueck, Charles M *WhAmArt 85*
Glueck, Dee Louis 1931- *AmArch 70*
Glueck, Grace *WhoAmA 73, -76, -78, -80*
Gluhman, Joseph Walter 1934- *WhoAmA 80, -82, -84*
Gluhman, Margaret A *WhoAmA 84*
Glusberg, Jorge *ConArch A*
Glushakow, Jacob 1914- *WhAmArt 85*
Glyde, Henry George 1906- *WhoAmA 73, -76, -78, -80, -82, -84*
Glyn, Prudence *WorFshn*
Glynn, John *DcBrA 2*
Gmelin, Markus L 1955- *MarqDCG 84*
Gmelin, Paul 1859-1937 *BiDAmAr, MacEA*
G'Miglio 1949- *WhoAmA 76, -78*
Gminder, Gottlieb *FolkA 86*
Gminder, Jacob *EncASM*
Gnam, Hugo, Jr. 1900- *WhAmArt 85*
Gnant, Erich 1920- *AmArch 70*
Gnatek, Michael *OfPGCP 86*
Gnevashev, Igor 1941- *ConPhot, ICPEnP A*
Gnidziejko, Alex 1943- *IlrAm 1880*
Gnisyuk, Mikola 1944- *ConPhot, ICPEnP A*
Gnoli, Domenico 1933-1970 *ConArt 77, -83, OxTwCA, PhDcTCA 77*
Gnoli, Count Domenico 1838-1915 *IlsCB 1957*
Gnosspelins, Barbara Crystal *DcWomA*
Goaman, Michael 1921- *WhoArt 80, -82, -84*
Goaman, Sylvia 1924- *WhoArt 82, -84*
Goas, Thomas S 1937- *AmArch 70*
Goater, John H *EarABI, EarABI SUP, NewYHSD*
Goatley, John *DcVicP 2*
Gobbato, Imero *IlsCB 1967*
Gobbato, Imero 1923- *IlsBYP, IlsCB 1957*
Gobbo, Il *McGDA*
Gobbo, Elvia *WorFshn*
Gobel, Heinz 1947- *DcCAr 81*
Gobel, Marie 1863-1908 *DcWomA*
Gober, Terry M 1939- *AmArch 70*
Gobert, Elisabeth Marie 1844- *DcWomA*
Gobert, Julie *DcWomA*
Gobhai, Mahlli *DcCAr 81*
Gobhai, Mehlli *IlsCB 1967*
Gobillard, Paule d1946 *DcWomA*
Gobin, Henry 1941- *WhoAmA 73, -76, -78, -80, -82, -84*
Gobl, Camilla 1871- *DcWomA*
Goblain, Bathilde *DcWomA*
Goblain, Emilie *DcWomA*
Goble, Anthony Barton 1943- *WhoArt 82, -84*
Goble, Conrad *NewYHSD*
Goble, Flora I *DcWomA*
Goble, Paul 1933- *IlsCB 1967*
Goble, Warwick *ConICB, DcBrBI, IlsCB 1744*
Goble, Warwick d1943 *DcBrA 1, DcVicP 2*
Goblet, Mademoiselle *DcWomA*
Goblin, Marguerite Stephanie 1822- *DcWomA*
Gobrecht, Christian 1785-1844 *EarABI SUP, NewYHSD*
Gobuzas, Aldona M *WhoAmA 80, -82, -84*
Gocar, Josef 1880-1945 *MacEA*
Gocar, Josef 1880-1954 *ConArch*
Goch, Johann Von *McGDA*
Gochnour, Harry Donald 1910- *AmArch 70*
Gockel, J A *AmArch 70*
Godard, Augustine *DcWomA*
Godard, E H *DcVicP 2*
Godart, Thomas *DcVicP 2*
Godbey, Luther David 1938- *AmArch 70*
Godbold *FolkA 86*
Godbold, Samuel Berry *DcVicP 2*
Goddard, A G *DcVicP 2*
Goddard, Charles *DcVicP 2*

Gogo, Vao 1924- *WhoGrA 62*
Goguen, Jean *OxTwCA*
Goheen, Ellen Rozanne 1944- *WhoAmA 78, −80, −82, −84*
Gohin, Emilie *DcWomA*
Gohl, Edward Heinrich 1862- *WhAmArt 85*
Gohli *DcBrECP*
Gohlke, Frank 1942- *ConPhot, DcCAr 81*
Gohlke, Frank William 1942- *ICPEnP A, MacBEP*
Gohmert, Louis B 1926- *AmArch 70*
Goho *AntBDN L*
Gohs, Rolf 1933- *WorECom*
Goichot, Louise *DcWomA*
Goijen, Jan Josephsz Van 1596-1656 *McGDA*
Going, Margaret Hamel 1860-1936 *DcWomA*
Goings, Martha Henderson 1911- *WhAmArt 85*
Goings, Ralph 1928- *ConArt, ConArt 83, DcCAA 77, DcCAr 81, WhoAmA 78, −80, −82, −84*
Goings, Ralph Ladell 1928- *AmArt, ConArt 77, WhoAmA 73*
Goins, Luther *FolkA 86*
Goitein, Michael 1939- *MarqDCG 84*
Goitia, Francisco *OxTwCA*
Goitia, Francisco 1882- *McGDA*
Gokbelen, N *AmArch 70*
Gokhale, James V 1952- *MarqDCG 84*
Gol, Jose Maria *IlDcG*
Golabowski, J T *AmArch 70*
Golay, Mary *DcWomA*
Golbin, Andree 1923- *WhoAmA 76, −78, −80, −82, −84*
Golcher, James *FolkA 86*
Gold *DcBrECP*
Gold, Albert 1906- *WhAmArt 85*
Gold, Albert 1916- *IlrAm F, −1880, WhAmArt 85, WhoAmA 73, −76, −78, −80, −82, −84*
Gold, Bernard 1931- *AmArch 70*
Gold, Betty 1932- *WhoAmA 76, −78, −80, −82, −84*
Gold, Debra Lynn 1951- *WhoAmA 78*
Gold, Fay *WhoAmA 73*
Gold, James *BiDBrA*
Gold, Leah *WhoAmA 73, −76, −78, −80, −82, −84*
Gold, Martha B 1938- *WhoAmA 82, −84*
Gold, Phillip 1937- *AmArch 70*
Gold, Sharon Cecile 1949- *WhoAmA 78, −80, −82, −84*
Gold, Thomas 1733-1800 *FolkA 86*
Gold Star 1947- *WhoAmA 82, −84*
Goldasich, Michael Ross 1938- *AmArch 70*
Goldbacker, Barbara 1826?- *DcWomA, NewYHSD*
Goldbacker, Isaac 1834?- *NewYHSD*
Goldbeck, E O *DcCAr 81*
Goldbeck, E O 1891- *ICPEnP A*
Goldbeck, W D 1882-1925 *WhAmArt 85*
Goldbecker, H J *AmArch 70*
Goldberg, A *AmArch 70*
Goldberg, A I *AmArch 70*
Goldberg, Abraham J 1921- *AmArch 70*
Goldberg, Arnold Herbert 1933- *WhoAmA 76, −78, −80, −82, −84*
Goldberg, Bertrand 1913- *AmArch 70, ConArch, MacEA*
Goldberg, Beryl M 1942- *MacBEP*
Goldberg, Carney 1907- *AmArch 70*
Goldberg, Chaim 1917- *WhoAmA 76, −80, −82, −84*
Goldberg, Chaim Leib 1917- *WhoAmA 73*
Goldberg, David Isaac 1906- *AmArch 70*
Goldberg, Dora *DcWomA*
Goldberg, Elias 1887-1978 *WhoAmA 78N, −80N, −82N, −84N*
Goldberg, Emanuel 1881- *MacBEP*
Goldberg, Emily *WhAmArt 85*
Goldberg, Eric 1890- *WhAmArt 85*
Goldberg, Eric M *MarqDCG 84*
Goldberg, Frederick Ira 1943- *AmArch 70*
Goldberg, Gary Michael 1952- *MacBEP*
Goldberg, James March 1934- *AmArch 70*
Goldberg, Jay 1931- *AmArch 70*
Goldberg, Joseph Wallace 1947- *WhoAmA 73, −76, −78*
Goldberg, Judith 1947- *WhoAmA 82, −84*
Goldberg, Kenneth Paul 1949- *WhoAmA 78, −80, −82*
Goldberg, L A *AmArch 70*
Goldberg, Lenore 1923- *AmArt*
Goldberg, Michael 1924- *AmArt, DcCAA 71, −77, DcCAr 81, OxTwCA, PhDcTCA 77, PrintW 83, −85, WhoAmA 76, −78, −80, −82, −84*
Goldberg, Norman Lewis 1906- *WhoAmA 73, −76, −78, −80, −82*
Goldberg, Norman Lewis 1906-1982 *WhoAmA 84N*
Goldberg, Raymond Robert 1911- *WhoAmA 73, −76*
Goldberg, Regina Seiden 1897- *DcWomA*
Goldberg, Reuben Lucius 1883-1970 *ArtsAmW 2, WorECom*
Goldberg, Ronald Ray 1936- *AmArch 70*
Goldberg, Rosalind 1907- *WhAmArt 85*
Goldberg, Roselee *WhoAmA 80, −84*
Goldberg, Roselee 1968- *WhoAmA 82*
Goldberg, Rube 1883-1970 *WhAmArt 85*
Goldberg, S E *AmArch 70*
Goldberg, Seymour 1933- *AmArch 70*
Goldberg, Stanley Mason 1928- *AmArch 70*

Goldberg, Vicki *MacBEP*
Goldberg, Virginia Eagan 1914- *WhoAmA 73, −76*
Goldberg, Wallace 1924- *WhoAmA 73*
Goldberger, Edward *WhoAmA 73, −76, −78, −80*
Goldberger, Mrs. Edward *WhoAmA 80*
Goldberger, Edward *WhoAmA 82*
Goldberger, Mrs. Edward *WhoAmA 73, −76, −78, −82*
Goldblatt, David 1930- *ICPEnP A, MacBEP*
Goldblatt, W *AmArch 70*
Goldbourne, Selvin *AfroAA*
Golde, R P *WhAmArt 85*
Goldeen, Dorothy A 1948- *WhoAmA 76, −78, −80, −82, −84*
Golden, Charles O 1899- *ArtsAmW 1, −3, WhAmArt 85*
Golden, D J *AmArch 70*
Golden, Eunice *AmArt, WhoAmA 76, −78, −80, −82, −84*
Golden, Francis *OfPGCP 86*
Golden, Grace 1904- *DcBrA 1, WhoArt 80, −82, −84*
Golden, Judith 1934- *ConPhot, ICPEnP A, MacBEP, WhoAmA 82, −84*
Golden, Leonard Stuart 1937- *AmArch 70*
Golden, Libby *WhoAmA 84*
Golden, Libby 1913- *PrintW 83, −85, WhoAmA 73, −76, −78, −80, −82*
Golden, M H *AmArch 70*
Golden, Robert 1738?-1809 *BiDBrA*
Golden, Rolland Harve 1931- *WhoAmA 76, −78, −80, −82, −84*
Golden, Teresa V 1955- *MarqDCG 84*
Golden, William 1911- *WhoGrA 62*
Golden, William 1911-1959 *ConDes*
Goldenberg, Tsvi 1949- *MarqDCG 84*
Golder, C H *FolkA 86*
Golder, Robert Mars 1931- *AmArch 70*
Goldes, David 1947- *MacBEP*
Goldfarb, Benjamin 1929- *AmArch 70*
Goldfarb, Eve *MarqDCG 84*
Goldfarb, Ira Arnold 1938- *AmArch 70*
Goldfarb, L A *AmArch 70*
Goldfarb, Roz 1936- *WhoAmA 76, −78, −80, −82*
Goldfarb, Shirley *DcCAr 81*
Goldfeder, R N *AmArch 70*
Goldfeder, Sol *EncASM*
Goldfield, Mark Forrest 1960- *MarqDCG 84*
Goldfield, Edward L 1930- *WhoAmA 82, −84*
Goldfinger, Eliot 1950- *WhoAmA 82, −84*
Goldfinger, Erno 1902- *ConArch, ConDes, DcD&D, WhoArt 80, −82, −84*
Goldfinger, M H *AmArch 70*
Goldhamer, Charles 1903- *WhoAmA 73, −76, −78, −80, −82*
Goldhamer, Iva 1917- *WhAmArt 85*
Goldhamer, Mark H 1954- *MarqDCG 84*
Goldicutt, John 1793-1842 *BiDBrA, DcBrWA*
Goldie, Charles *ClaDrA, DcVicP, −2*
Goldie, Charles Frederick 1870-1947 *OxArt*
Goldie, Cyril *DcBrBI*
Goldie, E J *DcWomA*
Goldie, J Liddell 1892- *WhAmArt 85*
Goldie, Lancelot Lyttelton 1872- *DcBrA 1*
Goldie, Lancelot Lyttleton 1872- *DcVicP 2*
Goldin, Alan *WorFshn*
Goldin, Amy *WhoAmA 76*
Goldin, Amy 1926-1978 *WhoAmA 78N, −80N, −82N, −84N*
Goldin, Elizabeth Ann *FolkA 86*
Goldin, Leon 1923- *DcCAA 71, −77, WhoAmA 73, −76, −78, −80, −82, −84*
Goldin, Stanley Val 1926- *AmArch 70*
Golding, Cecil *WhAmArt 85*
Golding, John *FolkA 86*
Golding, John 1929- *ConBrA 79[port], DcCAr 81*
Golding, William O 1874-1943 *FolkA 86*
Goldingham, James A *DcVicP 2*
Goldingham, John 1767-1844 *MacEA*
Goldman *EncASM*
Goldman, Aaron Gerald 1930- *AmArch 70*
Goldman, Alexander *EncASM*
Goldman, D R *AmArch 70*
Goldman, Harold James 1930- *AmArch 70*
Goldman, Jack Mitchel 1925- *AmArch 70*
Goldman, James Phillips 1937- *AmArch 70*
Goldman, Jane E 1951- *PrintW 85*
Goldman, Judith *WhoAmA 80, −82, −84*
Goldman, Julia *WhAmArt 85*
Goldman, Lester 1942- *WhoAmA 78, −80, −82*
Goldman, Louis 1925- *MacBEP*
Goldman, Louis 1925- *WhoAmA 78, −80, −82*
Goldman, M A *AmArch 70*
Goldman, Rachel Bok 1937- *WhoAmA 84*
Goldman, Robert Douglas 1908- *WhAmArt 85*
Goldman, Ronald Edward 1939- *AmArch 70*
Goldman, Ronald Neil 1947- *MarqDCG 84*
Goldman, Sanford Maurice 1934- *AmArch 70*
Goldman, Sondra *WhoAmA 78, −80, −82*
Goldner, Polyxene *DcWomA*
Goldner, Stephen Mark 1932- *AmArch 70*
Goldowsky, Noah 1909- *WhoAmA 73, −76, −78, −80N, −82N, −84N*

Goldring, Elizabeth 1945- *WhoAmA 80, −82, −84*
Goldring, George *BiDBrA*
Goldring, Nancy Deborah 1945- *WhoAmA 78, −80, −82, −84*
Goldsamt, Alan Burt 1931- *AmArch 70*
Goldsborough, Moria T *FolkA 86*
Goldsborough, Nannie Cox d1923 *DcWomA, WhAmArt 85*
Goldscheider, Alois *DcNiCA*
Goldscheider, Friedrich 1845-1897 *DcNiCA*
Goldscheider, Marcel *DcNiCA*
Goldscheider, Walter *DcNiCA*
Goldschmidt, Anna *DcWomA*
Goldschmidt, Caroline d1828 *DcWomA*
Goldschmidt, Lotte 1871- *DcWomA*
Goldschmidt, Lucien 1912- *WhoAmA 73, −76, −78, −80, −82, −84*
Goldschmidt, Margaret *DcWomA, WhAmArt 85*
Goldschmidt, Susanna 1872- *DcWomA*
Goldsleger, Cheryl 1951- *WhoAmA 84*
Goldsmid, C *DcVicP 2*
Goldsmith, Mrs. *DcWomA*
Goldsmith, Alice Halleck *WhAmArt 85*
Goldsmith, Arthur Austin 1926- *MacBEP*
Goldsmith, Barbara 1931- *WhoAmA 73, −76, −78, −80, −82, −84*
Goldsmith, Barry 1938- *AmArch 70*
Goldsmith, Benedict Isaac 1916- *WhoAmA 76, −78, −80, −82, −84*
Goldsmith, C Gerald 1928- *WhoAmA 73, −76, −78*
Goldsmith, Charles Brandt 1926- *AmArch 70*
Goldsmith, Deborah 1808-1836 *DcWomA, FolkA 86, NewYHSD*
Goldsmith, Donald Henry 1903- *AmArch 70*
Goldsmith, E D *AmArch 70*
Goldsmith, Elsa M 1920- *WhoAmA 76, −78, −80, −82, −84*
Goldsmith, Georgina S *DcVicP 2*
Goldsmith, J *DcBrBI*
Goldsmith, Jeremiah *CabMA*
Goldsmith, Jonathan 1783-1847 *BiDAmAr*
Goldsmith, Lauren Holmes 1929- *AmArch 70*
Goldsmith, Lawrence Charles 1916- *WhoAmA 80, −82, −84*
Goldsmith, M *AmArch 70*
Goldsmith, M J 1854- *WhAmArt 85*
Goldsmith, Marcus T *EncASM*
Goldsmith, Morton Ralph 1882- *WhoAmA 73*
Goldsmith, Morton Ralph 1882-1971 *WhoAmA 76N, −78N, −80N, −82N, −84N*
Goldsmith, Moses *EncASM*
Goldsmith, Myron 1918- *ConArch*
Goldsmith, Oliver B *FolkA 86*
Goldsmith, Robert *BiDBrA*
Goldsmith, Roger Allen 1946- *MarqDCG 84*
Goldsmith, Simon *EncASM*
Goldsmith, Wallace 1873-1945 *WhAmArt 85*
Goldsmith, Walter H *DcBrWA, DcVicP, −2*
Goldsmith, William *AfroAA, NewYHSD*
Goldsmith, William 1931- *ClaDrA*
Goldsmith, William E *NewYHSD*
Goldsteen, Joel 1939- *AmArch 70*
Goldstein, Barbara *OfPGCP 86*
Goldstein, Carl 1938- *WhoAmA 84*
Goldstein, Daniel Joshua 1950- *PrintW 85, WhoAmA 78, −80, −82, −84*
Goldstein, Donald Jay 1955- *MarqDCG 84*
Goldstein, Gary L 1936- *AmArch 70*
Goldstein, Gladys Hack *WhoAmA 76, −78, −80, −82, −84*
Goldstein, H S *AmArch 70*
Goldstein, Harry *FolkA 86*
Goldstein, Howard 1933- *WhoAmA 78, −80, −82, −84*
Goldstein, Howard Elliot 1941- *AmArch 70*
Goldstein, Irving *MarqDCG 84*
Goldstein, Jack *PrintW 85*
Goldstein, Jack 1945- *WhoAmA 78, −80, −82, −84*
Goldstein, Julius 1918- *WhoAmA 76, −78, −80, −82, −84*
Goldstein, L A *AmArch 70*
Goldstein, Louise Marks 1899- *ArtsAmW 2, DcWomA, WhAmArt 85*
Goldstein, Marc Evan 1935- *AmArch 70*
Goldstein, Milton 1914- *WhoAmA 73, −76, −78, −80, −82, −84*
Goldstein, Moise Herbert 1882- *AmArch 70*
Goldstein, Nathan 1927- *IlsBYP, WhoAmA 78, −80, −82, −84*
Goldstein, Perry Baily 1926- *AmArch 70*
Goldstein, Philip 1930- *MarqDCG 84*
Goldstein, S *AmArch 70*
Goldstein, Samuel 1925- *MarqDCG 84*
Goldstein, Stanley James 1926- *AmArch 70*
Goldstein And Swank *EncASM*
Goldstein Swank And Gordon *EncASM*
Goldstone, Harmon H 1911- *AmArch 70*
Goldstone, Herbert *WhoAmA 73, −76, −78, −80, −82*
Goldstone, Mrs. Herbert *WhoAmA 73, −76, −78, −80, −82*
Goldstone, S A *AmArch 70*

Goldstone, Tobias 1892- AmArch 70
Goldsworthy, C B AmArch 70
Goldsworthy, Emelia M DcWomA
Goldsworthy, Emelia M 1869- WhAmArt 85
Goldszer, Bath-Sheba WhoAmA 76, –78
Goldszer, Bath-Sheba 1932- WhoAmA 80, –82, –84
Goldt, J H AntBDN K
Goldthwait, G H NewYHSD
Goldthwait, Harold DcVicP 2
Goldthwaite, Anne 1875?-1944 WomArt
Goldthwaite, Anne Wilson 1869-1944 DcWomA
Goldthwaite, Martha C DcWomA
Goldthwaite, R Olmsted 1951- MarqDCG 84
Goldthwaite, William FolkA 86
Goldwaite, Ann 1875-1944 WhAmArt 85
Goldwasser, Marcy Alan 1931- AmArch 70
Goldwater, Robert 1907- WhoAmA 73
Goldwater, Robert 1907-1973 WhAmArt 85,
 WhoAmA 76N, –78N, –80N, –82N, –84N
Goldworthy, Andy 1956- DcCAr 81
Goldworthy, Philoma 1895?- ArtsAmW 3
Goldyne, Joseph PrintW 85
Gole, Alfred DcVicP 2
Gole, Jacob 1660-1737 McGDA
Golemon, Albert Sidney 1904- AmArch 70
Golemon, Harry Abbott 1926- AmArch 70
Golemon, Harry William 1906- AmArch 70
Golen, Steven Paul 1947- MarqDCG 84
Golinkin, Joseph Webster 1896- WhAmArt 85,
 WhoAmA 76, –78, –80, –82
Golinkin, Joseph Webster 1896-1977 WhoAmA 84N
Golins, Claire Emilie Josephine De DcWomA
Golinski, S W AmArch 70
Golinsky, Rosa DcWomA
Goll, Frederick P, Jr. NewYHSD
Gollenhofer, Judique DcWomA
Goller, Bruno 1901- DcCAr 81, PhDcTCA 77
Goller, Mandell Joseph 1936- MarqDCG 84
Goller, Raymond Dale 1897- AmArch 70
Gollin, Joshua A 1905- WhoAmA 73, –76, –78, –80N,
 –82N, –84N
Gollin, Mrs. Joshua A WhoAmA 73, –76, –78
Gollings, Elling William 1878-1932 ArtsAmW 1,
 IlBEAAW, WhAmArt 85
Gollins, Frank ConArch, EncMA, MacEA
Gollins, Frank 1910- DcD&D
Gollins, Ormond Edwin 1870- DcBrA 1, DcVicP 2
Gollins Melvin And Ward EncMA
Gollins Melvin Ward ConArch, DcD&D, MacEA
Gollmann, Julius d1898 NewYHSD
Gollop, George BiDBrA
Golob, Gerald Sy 1935- AmArch 70
Golonko, Joe FolkA 86
Golosov, Ilya 1883-1945 MacEA
Golosov, Pantelemon 1882-1945 MacEA
Golovin, Alexander 1863-1930 PhDcTCA 77
Golt, Rick S 1937- MacBEP
Goltdammer-Dupont, Zelie Louise Jeanne 1874-
 DcWomA
Golton, Glenn WhAmArt 85
Golton, Glenn 1897- ArtsAmW 2
Goltz, Walter 1875-1956 WhAmArt 85
Goltzius, Hendrick 1558-1617 McGDA, OxArt
Goltzius, Hendrik 1558-1616 ClaDrA
Goltzius, Hubert 1526-1583 ClaDrA, McGDA
Golub, Leon 1922- ConArt 83, DcAmArt,
 DcCAA 71, –77, McGDA, OxTwCA,
 PhDcTCA 77, PrintW 85
Golub, Leon Albert 1922- AmArt, ConArt 77,
 DcCAr 81, WhoAmA 73, –76, –78, –80, –82, –84
Golub, William 1928- AmArch 70
Golubew, Saweli 1935- ICPEnP A
Golubic, Theodore 1928- WhoAmA 78, –80, –82, –84
Golubic, Theodore Roy 1928- WhoAmA 73, –76
Golubjatnikov, Ole 1930- MarqDCG 84
Golubkina, Anna Semenovna 1864-1924 DcWomA
Golubov, Maurice 1905- WhoAmA 82, –84
Golz, Julius, Jr. 1878- WhAmArt 85
Goma, Michel WorFshn
Goma, Michel 1931- FairDF FRA
Gombarts, George K 1877- WhAmArt 85
Gombos, Lilly 1897- DcWomA
Gombrich, Sir Ernst Hans 1909- WhoArt 80, –82, –84
Gomer, John R NewYHSD
Gomersall, Richard Howells 1916- AmArch 70
Gomes, Mark DcCAr 81
Gomez, Alberto Flavio 1933- AmArch 70
Gomez, Djina DcWomA
Gomez, Jose M 1936- AmArch 70
Gomez, Manuel Albert AfroAA
Gomez, Marco Antonio 1910-1972 IlBEAAW,
 WhAmArt 85
Gomez, Pablo S 1931- WorEComm
Gomez, Raymond Vasquez, Jr. 1939- AmArch 70
Gomez, Sita 1932- WhoAmA 76, –78
Gomez Perez Rosado 1952- MacBEP
Gomez-Quiroz, Juan Manuel 1939- WhoAmA 73, –76,
 –78, –80, –82, –84
Gomez-Sicre, Jose 1916- WhoAmA 73, –76, –78, –80,
 –82, –84
Gomez Y Pastor, Jacinto 1746-1812 ClaDrA

Gomier, Marie Eugenie DcWomA
Gomme, Sir Bernard De 1620-1685 BiDBrA
Gomme, E DcD&D
Gommon, David 1912- DcBrA 2
Gomon, Maria DcWomA
Gomon, William Rawle 1918- AmArch 70
Gompert, William H 1875-1946 BiDAmAr
Gompertz, E DcVicP 2
Gompertz, G DcVicP 2
Goncalves, Nuno McGDA, OxArt
Goncharov, Andrei OxTwCA
Goncharova, Natalia 1881-1962 WomArt
Goncharova, Natalia Sergeevna 1881-1962 DcWomA,
 OxTwCA
Gonci, Sandor 1907- ICPEnP A
Goncourt, Edmond Huot De 1822-1896 OxArt
Goncourt, Jules 1830-1870 OxArt
Gondeck, E R AmArch 70
Gondelach, Franz 1663-1726 IlDcG
Gondelach, Georg IlDcG
Gondelach, Johann Heinrich IlDcG
Gondert, Steven John 1953- MarqDCG 84
Gondoin, Jacques 1737-1818 McGDA, WhoArch
Gondolfi, Monro NewYHSD
Gondos, V, Jr. AmArch 70
Gondouin, Emmanuel 1883-1934 ClaDrA
Gondouin, Jacques 1737-1818 MacEA
Gonet, Marie De 1869- DcWomA
Gong, Suran DcWomA
Gong, W AmArch 70
Gongora, Leonel WhoAmA 73, –76, –78, –80, –82, –84
Goniea, John Stanley 1925- AmArch 70
Gonin, Caroline DcWomA
Gonne, Anne 1816- DcBrWA, DcVicP 2, DcWomA
Gonon, Eugene DcNiCA
Gonon, Honore DcNiCA
Gonord, Francois OxDecA
Gonsalves, Alexander Henry 1944- MarqDCG 84
Gonsalves, Frank Rapheal 1927- AmArch 70
Gonschior, Kuno 1935- DcCAr 81
Gonser, Maude Kershaw 1901- WhAmArt 85
Gonske, Walt AmArt
Gontard, Karl Von 1731-1791 MacEA, McGDA
Gontcharova, Natalia 1881-1962 ConArt 77, –83,
 PhDcTCA 77
Gontcharova, Natalie 1881-1962 McGDA
Gontcharova, Nathalie 1881-1962 ClaDrA
Gonyn DeLirieux, Adele DcWomA
Gonzaga OxArt
Gonzaga, Federico 1519-1540 OxArt
Gonzaga, Ferdinando 1612-1626 OxArt
Gonzaga, Francesco, II OxArt
Gonzaga, Lodorico 1445-1478 OxArt
Gonzaga, Vincenzo, I 1587-1612 OxArt
Gonzaga, Vincenzo, II OxArt
Gonzales, August D WhAmArt 85
Gonzales, Bennie Montague 1924- AmArch 70
Gonzales, Boyer 1878-1934 ArtsAmW 2, IlBEAAW,
 WhAmArt 85
Gonzales, Boyer 1909- WhoAmA 73, –76, –78, –80,
 –82, –84
Gonzales, Boyer, Jr. 1909- WhAmArt 85
Gonzales, Carlotta 1910- WhAmArt 85,
 WhoAmA 73, –76, –78, –80, –82, –84
Gonzales, Elidio 1923- FolkA 86
Gonzales, Eva 1849-1883 DcWomA, WomArt
Gonzales, Jeanne DcWomA
Gonzales, Jose DeGarcia FolkA 86
Gonzales, Juan Antonio 1842- ClaDrA
Gonzales, Juan Francisco OxTwCA
Gonzales, Shirley 1935- WhoAmA 76, –78, –80, –82
Gonzales, Xavier 1898- ArtsAmW 2
Gonzalez, Bartolome 1564-1627 McGDA
Gonzalez, Boyer 1878-1934 ArtsAmW 2
Gonzalez, Carmelo AfroAA
Gonzalez, Christopher F AfroAA
Gonzalez, Emilie Catherine 1847- DcWomA
Gonzalez, Ines DcWomA
Gonzalez, Jose 1939- ConGrA 1
Gonzalez, Jose Gamaliel 1933- WhoAmA 78, –80, –82,
 –84
Gonzalez, Jose Luis 1939- WhoAmA 76, –78, –80, –82
Gonzalez, Jose Victoriano McGDA, OxArt
Gonzalez, Jose Victoriano 1887-1927 WorECar
Gonzalez, Juan 1945- DcCAr 81
Gonzalez, Juan Francisco 1853-1933 McGDA
Gonzalez, Juan J 1945- WhoAmA 84
Gonzalez, Juanita 1903-1935 WhAmArt 85
Gonzalez, Julio 1876-1942 ConArt 77, –83, McGDA,
 OxArt, OxTwCA, PhDcTCA 77
Gonzalez, Mario Flores 1925- AmArch 70
Gonzalez, Pepe ConGrA 1
Gonzalez, R C 1942- MarqDCG 84
Gonzalez, Xavier IlsBYP
Gonzalez, Xavier 1898- ArtsAmW 2, DcCAA 71,
 –77, IlBEAAW, WhAmArt 85, WhoAmA 73,
 –76, –78, –80, –82, –84
Gonzalez Camarena, Jorge 1908- McGDA
Gonzalez Castrillo, Jose Maria 1930- WorECar
Gonzalez DeLeon, Teodoro 1926- ConArch
Gonzalez DeMenchada, Petronila d1880 DcWomA

Gonzalez DeSepulveda, Maria DeLoreto 1753-1772
 DcWomA
Gonzalez Ruiz, Guillermo 1937- ConDes
Gonzalez Seijo, Gilberto 1907- AmArch 70
Gonzalez-Tores, M E AmArch 70
Gonzalez-Tornero, Sergio WhoAmA 78, –80, –82, –84
Gonzalez Y Alvare-Ossorio, Anibal 1876-1929 MacEA
Gonzalvo, Perez Pablo ArtsNiC
Goo, Benjamin 1922- WhoAmA 73, –76, –78, –80, –82,
 –84
Goo, Donald Wah Yung 1934- AmArch 70
Gooch, Craig Harris 1955- MarqDCG 84
Gooch, Donald Burnette 1907- AmArt, WhoAmA 73,
 –76, –78, –80, –82, –84
Gooch, Edward DcVicP 2
Gooch, Gerald 1933- WhoAmA 73, –76, –78
Gooch, James DcBrWA, DcVicP 2
Gooch, John DcBrWA
Gooch, Mary Ann DcVicP 2, DcWomA
Gooch, Matilda DcVicP 2
Gooch, Millard Earl 1923- AmArch 70
Gooch, R A C DcVicP 2
Gooch, Thomas 1750-1802 DcBrECP
Good, Bernard Stafford 1893- WhAmArt 85
Good, C Stephen DcBrA 1
Good, Clements 1810-1896 DcBrWA, DcVicP 2
Good, George White 1901- WhAmArt 85
Good, J Willis DcNiCA
Good, Jacob 1800?- FolkA 86
Good, Joseph Henry 1775-1857 BiDBrA, DcD&D
Good, Leonard 1907- WhAmArt 85, WhoAmA 73,
 –76, –78, –80, –82, –84
Good, Minnetta d1946 WhAmArt 85
Good, Minnetta 1895-1946 DcWomA
Good, Richard L AfroAA
Good, Stafford 1890- ConICB
Good, Thomas Sword 1789-1872 ArtsNiC, DcBrWA,
 DcVicP, –2
Goodacre, Glenna 1939- AmArt, WhoAmA 76, –78,
 –80, –82, –84
Goodacre, Grace DcWomA
Goodacre, William NewYHSD
Goodale, C F AmArch 70
Goodale, Carrie 1855- DcWomA
Goodale, Daniel, Jr. FolkA 86
Goodale, L WhAmArt 85
Goodall, Albert Gallatin 1826-1887 NewYHSD
Goodall, Alice DcWomA
Goodall, Donald Bannard 1912- WhoAmA 73, –76,
 –78
Goodall, Edward CabMA
Goodall, Edward 1795-1870 ArtsNiC, DcVicP 2
Goodall, Edward A ArtsNiC
Goodall, Edward Alfred 1819-1908 ClaDrA, DcVicP,
 –2
Goodall, Edward Angelo DcVicP 2
Goodall, Edward Angelo 1819-1908 DcBrBI, DcBrWA
Goodall, Eliza DcVicP 2, DcWomA
Goodall, Florence DcVicP 2
Goodall, Frederick 1822- ArtsNiC
Goodall, Frederick 1822-1904 ClaDrA, DcBrA 1,
 DcBrBI, DcBrWA, DcVicP, –2
Goodall, Frederick Trevelyan DcVicP 2
Goodall, Frederick Trevelyan 1848-1871 DcBrWA
Goodall, Herbert d1907 DcVicP 2
Goodall, Herbert Howard 1850-1874 DcBrWA
Goodall, Howard 1850-1874 DcVicP 2
Goodall, John Edward DcVicP 2
Goodall, John Strickland IlsCB 1967
Goodall, John Strickland 1908- ClaDrA, DcBrA 1,
 IlsCB 1946, WhoArt 80, –82, –84
Goodall, May DcWomA
Goodall, Peter C CabMA
Goodall, Premella FolkA 86
Goodall, Thomas F DcVicP
Goodall, Thomas F 1856?-1944 DcBrA 1, DcVicP 2
Goodall, Walter ArtsNiC
Goodall, Walter 1830-1889 DcBrBI, DcBrWA,
 DcVicP 2
Goodan, Tillman P 1896-1958 ArtsAmW 2
Goodan, William 1919- DcCAr 81
Goodbred, Ray E 1929- WhoAmA 82
Goodbred, Ray Edw 1929- WhoAmA 73, –76, –78, –80
Goodchild, Cecil Wray 1901- WhAmArt 85
Goodchild, Emily DcVicP 2
Goodchild, Florence A DcWomA
Goodchild, Francis Philip 1904- DcBrA 1,
 WhoArt 80, –82, –84
Goodchild, John Charles 1898- DcBrA 2
Goodden, Robert Yorke 1909- DcD&D
Goode, David Rex, Jr. 1920- AmArch 70
Goode, Diane Capuozzo 1949- IlsCB 1967
Goode, Joe WhoAmA 73, –78, –80, –82, –84
Goode, Joe 1937- ConArt 77, –83, DcCAA 77,
 OxTwCA, PrintW 83, –85
Goode, Joseph Collin, Sr. 1936- AmArch 70
Goode, Larry 1937- MarqDCG 84
Goode, Louise DcVicP, –2, DcWomA
Goode, Mervyn 1948- WhoArt 80, –82, –84
Goode, Thomas DcNiCA
Goode, W DcVicP 2

Goode, W E *DcVicP 2*
Goode, William James d1892 *DcNiCA*
Goodell, Alice *WhAmArt 85*
Goodell, E B, Jr. *AmArch 70*
Goodell, Ira C 1810?- *NewYHSD*
Goodell, Ira Chaffee 1800-1875 *FolkA 86*
Goodell, J C *FolkA 86*
Goodell, Mary Elizabeth 1888- *DcWomA*
Goodell, William Newport 1908- *WhAmArt 85*
Goodelman, Aaron J 1890- *WhAmArt 85, WhoAmA 78*
Goodelman, Aaron J 1890-1978 *WhoAmA 80N, -82N*
Goodelman, Aaron J 1891-1978 *WhoAmA 84N*
Gooden, B *DcBrECP*
Gooden, Donald *AfroAA*
Gooden, James Chisholm *DcVicP, -2*
Gooden, Phyllis *AfroAA*
Gooden, Stephen 1892-1944 *McGDA*
Gooden, Stephen Frederick 1892-1955 *DcBrA 1*
Goodenberger, R A *AmArch 70*
Goodenow, Earle *IlsCB 1967*
Goodenow, Earle 1913- *IlsCB 1946, WhAmArt 85*
Goodenow, Girard 1912- *IlsBYP, IlsCB 1946*
Goodenow, Robert H 1921- *AmArch 70*
Goodenow, Rolf Julian 1910- *WhAmArt 85*
Goodenow, Taliaferro *WhAmArt 85*
Gooderson, Emily *DcVicP 2*
Gooderson, Mrs. T *DcVicP 2*
Gooderson, Thomas Youngman *DcVicP, -2*
Goodes, Edward A *NewYHSD*
Goodfellow, Ronald Davidson 1929- *AmArch 70*
Goodfriend, Arthur *WhAmArt 85*
Goodhall, Mary C *DcVicP 2*
Goodhart, Anna *DcWomA*
Goodhart-Rendel, H S 1887-1959 *MacEA*
Goodhart-Rendel, Harry Stuart 1887-1959 *DcD&D*
Goodheart, Anna *WhAmArt 85*
Goodheart, William R 1880-1933 *WhAmArt 85*
Goodhue, A E *EncASM*
Goodhue, Alice Fuller 1900- *WhAmArt 85*
Goodhue, Bertram G *WhAmArt 85*
Goodhue, Bertram Grosvenor 1869-1924 *BiDAmAr, BnEnAmA, DcD&D, MacEA, McGDA, WhoArch*
Goodhue, Donald Bruce 1932- *AmArch 70*
Goodhue, Francis *CabMA*
Goodhue, Harry Wright 1905-1932 *WhAmArt 85*
Goodhue, Jonathan d1770? *CabMA*
Goodier, Arthur *DcVicP 2*
Goodin, Robert Harold 1935- *AmArch 70*
Goodin, William Rex 1947- *MarqDCG 84*
Gooding, Charles Gustavus 1834-1903 *FolkA 86*
Gooding, George *BiDBrA*
Gooding, H I *DcWomA*
Gooding, William C 1775-1861 *NewYHSD*
Gooding, William T *FolkA 86*
Goodison, Benjamin *DcD&D*
Goodison, Benjamin d1767 *AntBDN G, OxDecA*
Goodison, Jack Weatherburn 1903- *WhoArt 80, -82, -84*
Goodison, John 1834-1892 *ArtsEM*
Goodliff, John 1828?- *NewYHSD*
Goodloe, N S *AmArch 70*
Goodloe, Nellie 1862- *DcWomA*
Goodloe, Nellie Sterns *ArtsAmW 3*
Goodloe, Mrs. Paul *ArtsAmW 3, WhAmArt 85*
Goodman, A Maude d1938 *DcBrA 2*
Goodman, A R, II *AmArch 70*
Goodman, Abraham 1930- *AmArch 70*
Goodman, Alexander *AntBDN N*
Goodman, Ann Bedford 1896- *DcWomA, WhAmArt 85*
Goodman, Ann Taube 1905- *WhAmArt 85*
Goodman, Arthur J *ArtsEM*
Goodman, Arthur Jule *DcBrBI*
Goodman, Arthur Jule d1926 *WhAmArt 85*
Goodman, Benjamin 1904- *WhoAmA 73, -76, -78, -80, -82, -84*
Goodman, Bertram 1904- *WhAmArt 85, WhoAmA 76, -78, -80, -82, -84*
Goodman, Brenda Joyce 1943- *WhoAmA 76, -78*
Goodman, Calvin Jerome 1922- *WhoAmA 73, -76, -78, -80, -82, -84*
Goodman, Charles 1796-1835 *NewYHSD*
Goodman, Charles Morton 1906- *AmArch 70*
Goodman, Christian *NewYHSD*
Goodman, Clara M *ArtsEM, DcWomA*
Goodman, Daniel 1800?- *FolkA 86*
Goodman, Erik *MarqDCG 84*
Goodman, Ernestine A *WhAmArt 85*
Goodman, Estelle *WhoAmA 73, -76*
Goodman, Fredric Arthur 1942- *AmArch 70*
Goodman, Gershon 1935- *AmArch 70*
Goodman, H K *FolkA 86*
Goodman, Hezekiah *FolkA 86*
Goodman, Irven Francis 1913- *AmArch 70*
Goodman, J Reginald *FolkA 86*
Goodman, James Neil 1929- *WhoAmA 73, -76, -78, -80, -82, -84*
Goodman, John *CabMA, NewYHSD*
Goodman, John Reginald 1878- *DcBrA 1*

Goodman, John S *FolkA 86*
Goodman, Julia 1812-1906 *DcWomA*
Goodman, Julius Earle *ArtsEM*
Goodman, Kathleen Mary 1879- *DcBrA 1, DcWomA*
Goodman, Mrs. L 1812-1906 *DcVicP 2*
Goodman, Louis 1934- *AmArch 70*
Goodman, M E *AmArch 70*
Goodman, Marian 1928- *WhoAmA 76, -78, -80, -82, -84*
Goodman, Mark 1946- *ICPEnP A, MacBEP, WhoAmA 84*
Goodman, Marvin David 1933- *AmArch 70*
Goodman, Maude *DcVicP, -2, DcWomA*
Goodman, Michael A 1903- *AmArch 70*
Goodman, Percival 1904- *AmArch 70, MacEA, McGDA*
Goodman, Peter 1783?- *FolkA 86*
Goodman, R E *AmArch 70*
Goodman, Robert Gwelo d1939 *DcBrA 2*
Goodman, Robert Gwelo 1871- *DcVicP 2*
Goodman, Robert Mitchell 1953- *MarqDCG 84*
Goodman, Ronald David 1936- *AmArch 70*
Goodman, Shirley *WorFshn*
Goodman, Sidney 1936- *DcCAA 71, -77, WhoAmA 73, -76, -78, -80, -82, -84*
Goodman, Thomas Warner *DcVicP 2*
Goodman, Walter 1838- *ClaDrA, DcBrBI, DcVicP 2*
Goodman, William Owen 1849-1936 *WhAmArt 85*
Goodnough, Robert 1917- *BnEnAmA, ConArt 83, DcAmArt, DcCAA 71, OxTwCA, WhoAmA 73, -76, -78, -80, -82*
Goodnough, Robert 1923- *WhoAmA 84*
Goodnough, Robert Arthur 1917- *AmArt, ConArt 77*
Goodnough, Robert B 1917- *DcCAA 77*
Goodnow, Catherine Spencer 1904- *WhAmArt 85*
Goodnow, Frank A 1923- *WhoAmA 73, -76, -78, -80, -82, -84*
Goodnow, Marjorie *WhAmArt 85*
Goodnow, Walter R *EncASM*
Goodnow And Jenks *EncASM*
Goodpastor, Denzil 1908?- *FolkA 86*
Goodrich, Ada Porter *WhAmArt 85*
Goodrich, Agatha *WhAmArt 85*
Goodrich, Alice 1881-1920 *DcWomA*
Goodrich, Alice D 1881-1920 *WhAmArt 85*
Goodrich, Ansel 1773?-1803 *CabMA*
Goodrich, Asahel *FolkA 86*
Goodrich, Asaph *FolkA 86*
Goodrich, B J *AmArch 70*
Goodrich, Charles H *WhAmArt 85*
Goodrich, Mrs. E H *WhAmArt 85*
Goodrich, Gertrude 1914- *WhAmArt 85*
Goodrich, Henry O 1814-1834 *FolkA 86, NewYHSD*
Goodrich, Ira B, Jr. *WhAmArt 85*
Goodrich, J H 1878- *WhAmArt 85*
Goodrich, J W *AmArch 70*
Goodrich, James B *DcVicP 2*
Goodrich, Jerome *DcVicP 2*
Goodrich, John J *FolkA 86*
Goodrich, Levi *NewYHSD*
Goodrich, Levi 1822-1887 *BiDAmAr*
Goodrich, Lloyd 1897- *WhAmArt 85, WhoAmA 73, -76, -78, -80, -82, -84*
Goodrich, Mahala *FolkA 86*
Goodrich, Matilda Antoinette *WhAmArt 85*
Goodrich, Nathan *FolkA 86*
Goodrich, Samuel *FolkA 86*
Goodrich, Sarah 1788-1853 *WomArt*
Goodrich, Seth *FolkA 86*
Goodrich, Susan 1933- *WhoAmA 78, -80, -82, -84*
Goodrich, W R E 1886?- *DcBrA 2*
Goodrich, Wallace L *ArtsEM*
Goodrich, Walter 1802-1869 *FolkA 86*
Goodrich, William Henry *BiDAmAr*
Goodridge, Christopher William *DcBrA 1*
Goodridge, Elinor 1886- *DcWomA, WhAmArt 85*
Goodridge, Eliza 1798-1882 *DcWomA, NewYHSD*
Goodridge, Henry Edmund 1797-1864 *BiDBrA*
Goodridge, Henry Edmund 1800?-1863 *DcD&D*
Goodridge, Lawrence Wayne 1941- *WhoAmA 73, -76, -78, -80, -82, -84*
Goodridge, Paul E *WhAmArt 85*
Goodridge, Sarah 1788-1853 *BnEnAmA, DcAmArt, DcWomA, NewYHSD*
Goodsell, Josephine 1860- *DcWomA*
Goodsell, Josephine B 1860- *WhAmArt 85*
Goodsir, Agnes Noyes *DcBrA 1*
Goodsir, Agnes Noyes 1864-1939 *DcWomA*
Goodspeed, Douglas Kenneth 1917- *AmArch 70*
Goodspeed, David Henry 1948- *MarqDCG 84*
Goodstein, Joseph Samuel 1925- *AmArch 70*
Goodstein-Shapiro *WhoAmA 73*
Goodwane, Mrs. *NewYHSD*
Goodwillie, Frank 1866-1929 *BiDAmAr*
Goodwin *FolkA 86, NewYHSD*
Goodwin, Albert 1845-1932 *ClaDrA, DcBrA 1, DcBrWA, DcVicP, -2*
Goodwin, Alfred 1914- *WhoAmA 73*
Goodwin, Alice Hathaway Hapgood 1893- *DcWomA, WhAmArt 85*

Goodwin, Archie 1937- *WorECom*
Goodwin, Arthur C 1864-1929 *WhAmArt 85*
Goodwin, Belle *WhAmArt 85*
Goodwin, Belle d1928 *DcWomA*
Goodwin, Betty 1923- *DcCAr 81*
Goodwin, Bruce Merriman 1954- *MarqDCG 84*
Goodwin, Carlton Theodore 1928- *AmArch 70*
Goodwin, Caroline Love *DcWomA, WhAmArt 85*
Goodwin, Mrs. Charles A *WhAmArt 85*
Goodwin, Clara L *WhAmArt 85*
Goodwin, Clinton Foster 1894- *AmArch 70*
Goodwin, D L *AmArch 70*
Goodwin, D W *AmArch 70*
Goodwin, E J, Jr. *AmArch 70*
Goodwin, E S *DcWomA*
Goodwin, E W *FolkA 86*
Goodwin, Edward *AntBDN N, DcBrWA*
Goodwin, Edwin Weyburn 1800-1845 *NewYHSD*
Goodwin, Edytha M *DcWomA*
Goodwin, Elizabeth Thayer Abbott 1887- *WhAmArt 85*
Goodwin, Ernest *DcBrBI*
Goodwin, F W *DcVicP 2, FolkA 86, NewYHSD*
Goodwin, Frances d1929 *WhAmArt 85*
Goodwin, Frances M d1929 *DcWomA*
Goodwin, Francis 1784-1835 *BiDBrA, DcBrWA, DcD&D, MacEA, McGDA*
Goodwin, Frank 1848?-1873 *DcBrWA*
Goodwin, Frank A 1848-1873? *DcVicP 2*
Goodwin, Fredrika *DcWomA*
Goodwin, George F *CabMA*
Goodwin, Gilberta Daniels 1890- *DcWomA, WhAmArt 85*
Goodwin, H S *AmArch 70*
Goodwin, Hannibal 1822-1900 *ICPEnP*
Goodwin, Harmon *FolkA 86*
Goodwin, Harold *WhAmArt 85*
Goodwin, Harold 1858-1931 *WhAmArt 85*
Goodwin, Harold 1919- *IlsBYP*
Goodwin, Harry *DcVicP*
Goodwin, Harry d1925 *ClaDrA, DcBrA 1, DcBrWA*
Goodwin, Harry d1932 *DcVicP 2*
Goodwin, Mrs. Harry *DcVicP 2*
Goodwin, Harvey *FolkA 86*
Goodwin, Helen A *WhAmArt 85*
Goodwin, Helen Angel *DcWomA*
Goodwin, Helen M *DcWomA, WhAmArt 85*
Goodwin, Henry 1878-1931 *MacBEP*
Goodwin, Henry B 1878-1931 *ConPhot, ICPEnP*
Goodwin, Horace *FolkA 86*
Goodwin, J B *NewYHSD*
Goodwin, J C *DcVicP 2*
Goodwin, J Walter 1913- *WhAmArt 85*
Goodwin, James *CabMA*
Goodwin, Jessie S *WhAmArt 85*
Goodwin, John *FolkA 86*
Goodwin, John 1928- *AmArch 70*
Goodwin, John Edward 1867-1949 *DcNiCA*
Goodwin, Joseph *CabMA*
Goodwin, Kate *DcWomA*
Goodwin, Kemper 1906- *AmArch 70*
Goodwin, Mrs. L *DcVicP 2*
Goodwin, Lamira *WhAmArt 85*
Goodwin, Louis Payne 1922- *WhoAmA 76, -78, -80, -82, -84*
Goodwin, Lyle 1931- *AmArch 70*
Goodwin, M *AmArch 70*
Goodwin, Michael Kemper 1939- *AmArch 70*
Goodwin, Myrtle *DcWomA, WhAmArt 85*
Goodwin, Philip L 1885-1958 *MacEA*
Goodwin, Philip Lippincott 1885-1957 *McGDA*
Goodwin, Philip R 1882-1935 *IlrAm A, -1880, WhAmArt 85*
Goodwin, Philip Russell 1882-1935 *ArtsAmW 2, IlBEAAW*
Goodwin, R D *AmArch 70*
Goodwin, Richard LaBarre 1840-1910 *ArtsAmW 1, DcAmArt, IlBEAAW, NewYHSD, WhAmArt 85*
Goodwin, Robert Clark 1936- *AmArch 70*
Goodwin, Robert L 1958- *MarqDCG 84*
Goodwin, Robert Lawrence 1934- *WhoAmA 73*
Goodwin, Russell F *FolkA 86*
Goodwin, Samuel *NewYHSD*
Goodwin, Seth *FolkA 86*
Goodwin, Sydney 1867-1944 *DcBrA 1, DcBrWA, DcVicP 2*
Goodwin, T A *DcVicP 2*
Goodwin, Thomas *FolkA 86, NewYHSD*
Goodwin, Timothy *CabMA*
Goodwin, W Kate *DcBrWA*
Goodwin, W S d1916 *DcBrWA, DcVicP 2*
Goodwin, Webster *FolkA 86*
Goodwin, William *FolkA 86*
Goodwin, William F *FolkA 86*
Goodwin Brothers *FolkA 86*
Goodwin-Paine, Helen M *DcWomA*
Goodwine, S *DcBrECP*
Goody, Florence P *DcBrA 1, DcVicP 2, DcWomA*
Goody, Marvin Edward 1929- *AmArch 70*
Goodyear, Clara *DcWomA, WhAmArt 85*

Goodyear, Frank H 1944- *WhoAmA 76*
Goodyear, Frank H, Jr. 1944- *WhoAmA 78, –80, –82, –84*
Goodyear, Grace Rumsey *WhAmArt 85*
Goodyear, John 1930- *DcCAA 71, –77, DcCAr 81*
Goodyear, John L 1930- *WhoAmA 78, –80, –82, –84*
Goodyear, William H 1846-1923 *WhAmArt 85*
Googerty, Thomas F 1865-1944 *WhAmArt 85*
Gookin, Frederick William 1854-1936 *WhAmArt 85*
Gookin, Rebecca *DcWomA*
Gookin, William S *FolkA 86*
Gookin, William Stoodley 1799- *NewYHSD*
Gookins, James F 1840-1904 *ArtsAmW 1*
Gookins, James Farrington 1840-1904 *IlBEAAW, NewYHSD , WhAmArt 85*
Gool, Jan Van 1685-1763 *ClaDrA*
Goold, Paul 1875-1925 *WorECar*
Goome, Stephen d1858 *BiDBrA*
Goor, Cornelia Van *DcWomA*
Goorskey, Jack Norman 1928- *AmArch 70*
Goosey, G Turland *WhAmArt 85*
Goossen, Eugene Coons 1920- *WhoAmA 73, –76, –78, –80, –82, –84*
Goossens, John 1887- *WhAmArt 85*
Goosson, Stephen 1889-1973 *ConDes*
Goovaerts *McGDA*
Goquelat, Marie *DcWomA*
Gora, David Roy 1951- *MarqDCG 84*
Goraleigh, Gilbert *AfroAA*
Goram, J *FolkA 86*
Goram, Thomas *NewYHSD*
Goransson, Ake Gunnar 1923- *AmArch 70*
Goray, John C 1912- *WhoAmA 78, –80*
Gorbett, W B *NewYHSD*
Gorbitz, Johan 1782-1853 *ClaDrA*
Gorbut, Robert *FolkA 86*
Gorbutt, John D, Jr. 1904- *WhAmArt 85*
Gorchov, Perry 1948- *MarqDCG 84*
Gorchov, Ron 1930- *ConArt 83, DcCAA 71, –77, DcCAr 81, PrintW 83, –85, WhoAmA 73, –76, –78, –80, –82, –84*
Gorder, Clayton J 1936- *WhoAmA 73, –76, –78, –80, –82, –84*
Gordigiani, Eduardo *WhAmArt 85*
Gordigiani, Michele *WhAmArt 85*
Gordigiani, Michele 1828- *ArtsNiC*
Gordijn, Herman 1932- *DcCAr 81*
Gordin, Sidney 1918- *DcCAA 71, –77, OxTwCA, PhDcTCA 77, WhoAmA 78, –80, –82, –84*
Gordine, Dora 1906- *DcBrA 1*
Gordley, Marilyn Classe 1929- *WhoAmA 82, –84*
Gordley, Marilyn F M 1929- *WhoAmA 76, –78, –80*
Gordley, Metz Tranbarger 1932- *WhoAmA 73, –76, –78, –80, –82, –84*
Gordon *NewYHSD*
Gordon, Albert F 1934- *WhoAmA 78, –80, –82, –84*
Gordon, Alexander *AntBDN D, DcVicP 2*
Gordon, Alexander 1692?-1754 *NewYHSD*
Gordon, Anne W 1933- *WhoAmA 78*
Gordon, Bernard *WhAmArt 85*
Gordon, Bonnie 1941- *DcCAr 81, MacBEP*
Gordon, Lady Caroline *DcBrWA*
Gordon, Charles Kent 1932- *AmArch 70*
Gordon, Cora Josephine d1950 *DcBrA 1, DcWomA*
Gordon, David 1931- *AmArch 70*
Gordon, David 1952- *DcCAr 81*
Gordon, Deborah *WhoAmA 76*
Gordon, Donald Edward 1931- *WhoAmA 80, –82, –84*
Gordon, Dorothy *AfroAA*
Gordon, Edward Francis 1922- *AmArch 70*
Gordon, Edwin Seamer 1867-1932 *BiDAmAr*
Gordon, Eleanor Vere *DcWomA*
Gordon, Elizabeth Stith 1898- *DcWomA, WhAmArt 85*
Gordon, Emeline H 1877- *DcWomA, WhAmArt 85*
Gordon, Emma M *WhAmArt 85*
Gordon, Esme 1910- *WhoArt 80, –82, –84*
Gordon, Ezra 1921- *AmArch 70*
Gordon, F C 1856-1924 *WhAmArt 85*
Gordon, Frederick *ArtsEM, EncASM*
Gordon, G *DcVicP 2*
Gordon, G A *DcBrBI*
Gordon, G C *DcVicP 2*
Gordon, Gene Paul 1930- *AmArch 70*
Gordon, Godfrey Jervis 1882-1944 *DcBrBI*
Gordon, Grace *WhAmArt 85*
Gordon, H L *AmArch 70*
Gordon, H P *DcVicP 2*
Gordon, Hilda May 1874-1972 *DcBrA 1, DcVicP 2, DcWomA*
Gordon, Hortense *OxTwCA*
Gordon, Hortense 1887-1961 *DcWomA*
Gordon, Isobel *DcWomA*
Gordon, J *DcWomA*
Gordon, J P *AmArch 70*
Gordon, J Riely 1863-1937 *MacEA*
Gordon, Jaime 1949- *MarqDCG 84*
Gordon, James Riely 1863-1937 *BiDAmAr*
Gordon, James Willoughby 1772- *DcBrWA*
Gordon, Jan 1882-1944 *DcBrA 1*

Gordon, Jerome J 1949- *ICPEnP A*
Gordon, Jerome J, II 1949- *MacBEP*
Gordon, Jessie Fairfield 1877- *WhAmArt 85*
Gordon, John *MarqDCG 84*
Gordon, John 1912- *WhoAmA 73, –76, –78*
Gordon, John 1912-1978 *WhoAmA 80N, –82N, –84N*
Gordon, John 1921- *WhoAmA 76, –78, –80*
Gordon, John G *NewYHSD*
Gordon, John H *CabMA*
Gordon, John Keith 1925- *AmArch 70*
Gordon, John Ross 1890- *DcBrA 1*
Gordon, John S 1946- *WhoAmA 76, –78, –80, –82, –84*
Gordon, Sir John Watson 1788-1864 *DcVicP, –2*
Gordon, Sir John Watson 1798-1864 *ArtsNiC*
Gordon, Joni 1936- *WhoAmA 78, –80*
Gordon, Joseph Furbee 1922- *AmArch 70*
Gordon, Josephine *WhoAmA 76, –78, –80, –82, –84*
Gordon, Joy L 1933- *WhoAmA 76, –78, –80, –82, –84*
Gordon, Julia *DcWomA*
Gordon, Julia Emily 1810-1896 *DcBrWA*
Gordon, Lady Julia Isabella Levina 1772-1867 *DcBrWA*
Gordon, Kathleen Isabella *DcBrWA*
Gordon, Keith *MarqDCG 84*
Gordon, L *FolkA 86*
Gordon, Leah Shanks 1934- *WhoAmA 76, –78, –80, –82, –84*
Gordon, Leon 1889-1943 *WhAmArt 85*
Gordon, M *DcWomA*
Gordon, M B *AmArch 70*
Gordon, M C *DcWomA*
Gordon, Margaret Anna *IlsCB 1967*
Gordon, Margaret Anna 1939- *IlsBYP, IlsCB 1957*
Gordon, Mark *MarqDCG 84*
Gordon, Martin 1939- *WhoAmA 76, –78, –80, –82, –84*
Gordon, Maurice 1914- *WhAmArt 85*
Gordon, Maxwell 1910- *WhAmArt 85, WhoAmA 73, –76, –78, –80, –82*
Gordon, Maxwell 1910-1982 *WhoAmA 84N*
Gordon, Michael Franklin 1950- *MarqDCG 84*
Gordon, Morris 1908-1971 *ICPEnP A*
Gordon, Morris 1911- *WhAmArt 85*
Gordon, Nora Mary *DcBrA 1, DcWomA*
Gordon, Paula *AfroAA*
Gordon, Peter *NewYHSD*
Gordon, Pryse Lockhart 1762-1834 *DcBrWA*
Gordon, R G *DcVicP 2*
Gordon, Rachel Emily, Lady Hamilton- d1889 *DcBrWA*
Gordon, Richard 1943- *MarqDCG 84*
Gordon, Richard Harvey 1947- *MarqDCG 84*
Gordon, Robert 1854-1904 *WhAmArt 85*
Gordon, Robert Franklin 1924- *AmArch 70*
Gordon, Robert Gary *AfroAA*
Gordon, Robert James *ClaDrA, DcVicP, –2*
Gordon, Ronald David 1952- *MarqDCG 84*
Gordon, Russell T 1932- *AfroAA*
Gordon, Russell T 1941- *PrintW 85*
Gordon, Russell Talbert 1936- *WhoAmA 84*
Gordon, Samuel *DcVicP 2*
Gordon, Samuel L 1956- *MarqDCG 84*
Gordon, Susan 1942- *WhoArt 80, –82*
Gordon, Mrs. T *DcVicP 2*
Gordon, Theodore 1924- *FolkA 86*
Gordon, Theresa *DcWomA*
Gordon, Thomas Clarkson 1841-1922 *FolkA 86*
Gordon, Violet 1907- *WhoAmA 76, –78, –80, –82, –84*
Gordon, Walter Lyle 1907- *AmArch 70*
Gordon, William *DcVicP 2*
Gordon, William d1853 *DcBrWA*
Gordon, William Stanly 1922- *AmArch 70*
Gordon, Witold *WhAmArt 85*
Gordon And Bankson *CabMA*
Gordon-Bell, Joan Ophelia 1915- *DcBrA 1*
Gordon-Bell, Joan Ophelia 1915-1975 *DcBrA 2*
Gordon-Cumming, Constance Frederica 1837-1924 *ArtsAmW 1, –3, DcWomA*
Gordon-Cummings, Constance Frederica 1837-1924 *IlBEAAW*
Gordon-Lazareff, Helene *WorFshn*
Gordon-Squier, Donald *WhAmArt 85*
Gordrain, Mademoiselle *DcWomA*
Gordy, D X *FolkA 86*
Gordy, Marvin Keith 1937- *AmArch 70*
Gordy, Robert *DcCAr 81*
Gordy, Robert 1933- *ConArt 77, –83, PrintW 85*
Gordy, Robert P 1933- *WhoAmA 73, –76, –78, –80, –82, –84*
Gordy, William J *FolkA 86*
Gordy, William Thomas Belah *FolkA 86*
Gore *ConGrA 1*
Gore, Arnold S 1935- *PrintW 83, –85*
Gore, Charles 1729-1807 *DcBrWA, DcSeaP*
Gore, Elisa 1755?- *DcWomA*
Gore, Elizabeth M *DcVicP 2*
Gore, Ellen *MarqDCG 84*
Gore, Emilia 1760?-1802 *DcWomA*
Gore, Frederick 1913- *ConBrA 79[port]*
Gore, Frederick Spencer 1878-1914 *ClaDrA*

Gore, Jefferson Anderson 1943- *WhoAmA 84*
Gore, John *FolkA 86*
Gore, John 1718-1796 *NewYHSD*
Gore, John Christopher *NewYHSD*
Gore, John Christopher 1806-1867 *ArtsAmW 3*
Gore, John W *AfroAA*
Gore, Joshua *FolkA 86, NewYHSD*
Gore, Ken 1911- *WhoAmA 84*
Gore, Ralph *NewYHSD*
Gore, Samuel *FolkA 86*
Gore, Samuel 1750?-1831 *NewYHSD*
Gore, Samuel Marshall 1927- *WhoAmA 76, –78, –80, –82, –84*
Gore, Spencer Frederick 1878-1914 *DcBrA 1, DcBrWA, McGDA, OxArt, OxTwCA, PhDcTCA 77*
Gore, Thomas H 1863-1937 *WhAmArt 85*
Gore, Tom 1946- *MacBEP, PrintW 83, –85, WhoAmA 78, –80, –82, –84*
Gore, William Crampton Crawford 1871- *DcBrA 1*
Gore, William Henry *DcBrA 1, DcVicP 2*
Goree, F H, Jr. *AmArch 70*
Goree, Gary Paul 1951- *WhoAmA 82, –84*
Goreleigh, Rex 1902- *AfroAA, WhAmArt 85, WhoAmA 76, –78, –80, –82, –84*
Gorelick, Shirley 1924- *WhoAmA 76, –78, –80, –82, –84*
Gorelik, Mordecai 1899- *ConDes*
Gorella, Arwed D 1937- *DcCAr 81*
Goren, Bruce Neal 1956- *MarqDCG 84*
Gorenec, Bojan 1956- *DcCAr 81*
Gores, Landes 1919- *MacEA*
Gores, Landis 1919- *AmArch 70*
Gores, Walter W J 1894- *WhAmArt 85*
Goret, Peter *CabMA*
Gorey, Christopher 1950- *DcCAr 81*
Gorey, D E *AmArch 70*
Gorey, Edward 1925- *WhoGrA 82[port]*
Gorey, Edward St. John *IlsCB 1967*
Gorey, Edward St. John 1925- *IlsBYP, IlsCB 1957*
Gorges, Raymond C H 1877-1943 *WhAmArt 85*
Gorgoni, Gianfranco *ICPEnP A*
Gorham, Bethiah 1789-1821 *FolkA 86*
Gorham, Edith *DcWomA*
Gorham, Fred P *NewYHSD*
Gorham, Jabez *DcNiCA*
Gorham, Jabez 1792- *EncASM*
Gorham, Jay Charles 1918- *MarqDCG 84*
Gorham, Jemima 1775-1798 *FolkA 86*
Gorham, John *EncASM*
Gorham, John d1801 *BiDBrA*
Gorham, Joshua *FolkA 86*
Gorham, Sidney d1947 *WhoAmA 78N, –80N, –82N, –84N*
Gorham, Sydney 1870-1947 *WhAmArt 85*
Gori, Ottaviano *NewYHSD*
Gori, Rosalba *DcWomA*
Goriaev, Vitaly Nikolayevich 1910- *WorECar*
Goriansky, Lev Vladimir 1897- *WhAmArt 85*
Goribar, Nicolas Javier De *McGDA*
Gorin, Jean 1899- *DcCAr 81, McGDA, OxTwCA, PhDcTCA 77*
Gorio, Federico 1915- *MacEA*
Goris, Andrew 1955- *MarqDCG 84*
Gorky, Arshile 1904-1948 *BnEnAmA, ConArt 77, –83, McGDA, WhAmArt 85*
Gorky, Arshile 1905-1948 *DcAmArt, DcCAA 71, –77, OxTwCA, PhDcTCA 77*
Gorlich, Marie 1851-1896 *DcWomA*
Gorlich, Sophie 1855-1893 *DcWomA*
Gorlich, Ulrich 1952- *MacBEP*
Gorman, Carl Nelson 1907- *WhoAmA 73, –76, –78, –80, –82*
Gorman, David *NewYHSD*
Gorman, David Walter 1918- *AmArch 70*
Gorman, Ernest Hamilton 1869- *DcBrA 1, DcVicP 2*
Gorman, Frederick Wilfrid 1950- *MarqDCG 84*
Gorman, James O *NewYHSD*
Gorman, Michael 1938- *DcCAr 81*
Gorman, R C 1933- *AmArt, PrintW 83, –85, WhoAmA 73, –76, –78, –80, –82, –84*
Gorman, Richard *OxTwCA*
Gorman, Terry *IlsBYP, IlsCB 1946*
Gorman, William D 1925- *WhoAmA 73, –76, –78, –80, –82, –84*
Gormley, Anna *DcWomA*
Gorney, Jay Philip 1952- *WhoAmA 76, –78, –80, –82, –84*
Gornik, April 1953- *WhoAmA 82, –84*
Gorny, Peter Hanns 1935- *MarqDCG 84*
Goro, Fritz 1901- *ConPhot, ICPEnP*
Gorog, Lajos 1927- *WhoGrA 82[port]*
Gorowski, Mieczyslaw 1941- *ConDes*
Gorrara, Mary 1923- *WhoArt 80, –82, –84*
Gorrell, Arthur Avriell, Jr. 1925- *AmArch 70*
Gorris, Jose Maria *DcWomA*
Gorska, Tamara *DcWomA*
Gorski, Belle Silveira 1877- *DcWomA, WhAmArt 85*
Gorski, Daniel Alexander 1939- *WhoAmA 73, –76, –78, –80, –82, –84*
Gorski, Richard Kenny 1923- *WhoAmA 78, –80, –82,*

–84
Gorski, Stanislas 1854-1923 *WhAmArt 85*
Gorsline, Douglas Warner *IlsCB 1967*
Gorsline, Douglas Warner 1913- *GrAmP, IlsBYP, IlsCB 1946, –1957, WhAmArt 85, WhoAmA 73, –76, –78, –80, –82, –84*
Gorson, Aaron Harry 1872-1933 *WhAmArt 85*
Gorst, Bertha 1873- *DcBrA 1, DcWomA*
Gorst, Mrs. H C *DcVicP 2*
Gorst, Hester Gaskell 1887- *DcBrA 1, DcWomA*
Gorstin, A *DcVicP 2*
Gorsuch, Marie Theresa *DcWomA*
Gortner, Willis Alway, II 1939- *AmArch 70*
Gorton, C *DcVicP 2*
Gortz, Jeanette d1853 *DcWomA*
Goruep, Thomaz 1950- *DcCAr 81*
Gory, Emanuel G *NewYHSD*
Goschel, Eberhard 1943- *DcCAr 81*
Goscinny, Rene 1926- *WorECom*
Gosewitz, Ludwig 1936- *ConArt 77, –83, DcCAr 81*
Gosheron, Miss M *DcBrA 1*
Goshorn, A T d1902 *WhAmArt 85*
Goshorn, John T 1870- *WhAmArt 85*
Goshun 1752-1811 *McGDA*
Goskowicz, Tim A 1953- *MarqDCG 84*
Goslin, Beatrice L 1905- *WhAmArt 85*
Goslin, John 1907- *WhAmArt 85*
Gosline, Richard Cornwall 1905- *AmArch 70*
Gosling, Charles Flick d1865 *BiDAmAr*
Gosling, Jessie W *DcVicP 2, DcWomA*
Gosling, William d1883 *ArtsNiC*
Gosling, William W 1824-1883 *DcBrWA, DcVicP, –2*
Gosman, Lillian 1889?-1976 *DcWomA*
Gosnell, Clyde Wilson, Jr. 1930- *AmArch 70*
Gosnell, Duncan H *DcVicP 2*
Goss, Alice *WhAmArt 85*
Goss, Bernard 1913- *AfroAA*
Goss, Calvin Wendol 1917- *AmArch 70*
Goss, D C *AmArch 70*
Goss, D R *AmArch 70*
Goss, Dale *WhAmArt 85*
Goss, Eliot Porter 1936- *AmArch 70*
Goss, Ezekiel 1814- *CabMA*
Goss, George *CabMA*
Goss, John *WhoAmA 78N, –80N, –82N, –84N*
Goss, John 1886-1964? *WhAmArt 85*
Goss, Louise H *ArtsAmW 2, DcWomA, WhAmArt 85*
Goss, Margaret Taylor *AfroAA*
Goss, Margaret Taylor 1916- *WhAmArt 85*
Goss, W A *AmArch 70*
Goss, William Henry 1833-1906 *DcD&D, DcNiCA*
Goss, William Thompson 1894- *AfroAA*
Gossaert, Jan 1478?-1533 *McGDA*
Gossaert, Jan 1478?-1536? *OxArt*
Gossage, John 1946- *DcCAr 81*
Gossage, John R 1946- *ConPhot, ICPEnP A, MacBEP*
Gossage, John Ralph 1946- *WhoAmA 84*
Gosse, Mrs. Edmund *DcVicP 2*
Gosse, Laura Sylvia 1881- *ClaDrA*
Gosse, Laura Sylvia 1881-1968 *DcBrA 1, DcWomA*
Gosse, Nellie 1850- *DcWomA*
Gosse, Nicolas-Louis-Francois 1787- *ArtsNiC*
Gosse, Philip Henry 1810-1888 *DcBrBI*
Gosse, W *DcVicP 2*
Gosselin, Celestine *DcWomA*
Gosselin, Charles 1834-1892 *ClaDrA*
Gosselin, Joshua 1739-1813 *DcBrWA*
Gosselin, Joshua 1763-1789 *DcBrWA*
Gosselin, Lucien H 1883- *WhAmArt 85*
Gosselin, Marie Josephe 1898- *DcWomA*
Gosselmann, Margarethe 1864- *DcWomA*
Gossen, Gerald Millard 1927- *AmArch 70*
Gossen, Stephen D 1939- *AmArch 70*
Gosset, M C *DcVicP 2*
Gosset DeGuines, Louis 1840-1885 *WorECar*
Gossett, Amariah *FolkA 86*
Gossett, Henry *FolkA 86*
Gossett, Lee Roy 1877-1926 *WhAmArt 85*
Gossop, Robert Percy *DcBrBI*
Gossy, W W *AmArch 70*
Gostelowe, Jonathan 1744-1806 *AntBDN G*
Gostelowe, Jonathan 1745-1795 *CabMA*
Gostomski, Richard L 1936- *AmArch 70*
Gostomski, Zbigniew 1932- *OxTwCA, PhDcTCA 77*
Goswell, John T *EncASM*
Goszleth, Istvan 1850-1913 *ICPEnP A*
Goszoler *NewYHSD*
Gotbut, Edward *NewYHSD*
Gotch, Bernard Cecil 1876- *DcBrA 1*
Gotch, Caroline Burland *DcWomA*
Gotch, Oliver Horsley 1889- *DcBrA 1*
Gotch, Thomas Cooper 1854-1931 *ClaDrA, DcBrA 1, DcBrWA, DcVicP, –2*
Gotch, Mrs. Thomas Cooper *DcVicP 2*
Gotcliffe, Sid 1899-1969 *WhAmArt 85*
Goth, Marie *WhAmArt 85, WhoAmA 73*
Goth, Marie 1887- *WhAmArt 85*
Gothard, William Harry 1908- *WhAmArt 85*
Gothelf, Louis 1901- *WhAmArt 85*

Gotlib, Henri 1892- *ClaDrA*
Gotlib, Henryk 1890-1966 *ConArt 77, DcBrA 1*
Gotlieb, Jules 1897- *IlrAm D, –1880*
Gotlin, Curt 1900- *ICPEnP A*
Gotlosen, Mademoiselle *DcWomA*
Goto, Joseph 1916- *DcCAr 81*
Goto, Joseph 1920- *BnEnAmA, DcCAA 71, –77, WhoAmA 73, –76, –78, –80, –82, –84*
Goto, K *AmArch 70*
Goto, Thomas 1924- *AmArch 70*
Gotsch, Friedrich Karl 1900- *PhDcTCA 77*
Gotschall, I W *WhAmArt 85*
Gott, Jackson C 1828-1909 *BiDAmAr*
Gott, John 1720-1793 *BiDAmAr*
Gott, John 1785-1860 *NewYHSD*
Gott, John William *DcVicP 2*
Gottefried, A *DcVicP 2*
Gotteland, R J *AmArch 70*
Gottfredson, Floyd 1907- *WorECom*
Gottfried, Alexander *NewYHSD*
Gottfried, Jacob L 1932- *AmArch 70*
Gottfried, T *AmArch 70*
Gotthold, Florence 1858-1930 *DcWomA*
Gotthold, Florence W 1858-1930 *WhAmArt 85*
Gotthold, Rozel 1886- *WhAmArt 85*
Gottier, Edward *FolkA 86*
Gottlicher, Erhard 1946- *DcCAr 81, WhoGrA 82[port]*
Gottlieb, Abe 1908- *WhoAmA 73, –76, –78*
Gottlieb, Adolph 1903- *DcCAA 71, McGDA, WhoAmA 73*
Gottlieb, Adolph 1903-1973 *PhDcTCA 77*
Gottlieb, Adolph 1903-1974 *BnEnAmA, ConArt 77, –83, DcAmArt, DcCAA 77, OxTwCA, PrintW 83, –85, WhAmArt 85, WhoAmA 76N, –78N, –80N, –82N, –84N, WorArt[port]*
Gottlieb, Albert S 1870-1942 *BiDAmAr*
Gottlieb, Carla 1912- *WhoAmA 84*
Gottlieb, Ferdinand 1919- *AmArch 70*
Gottlieb, Frederick H 1852-1929 *WhAmArt 85*
Gottlieb, Harry 1895- *WhAmArt 85*
Gottlieb, Leah *WorFshn*
Gottlieb, Leopold 1883-1930 *ClaDrA*
Gottlieb, Maxim B 1903- *WhAmArt 85*
Gottlieb, Peter 1935- *MarqDCG 84*
Gottlieb, R *AmArch 70*
Gotto, Basil 1866-1954 *DcBrA 1*
Gotto, Ray 1916- *WorECar*
Gottschalk, Blanche *DcVicP 2*
Gottschalk, Charles E 1864-1929 *BiDAmAr*
Gottschalk, Fritz 1937- *WhoAmA 78, –80, –82, –84, WhoGrA 82[port]*
Gottschalk, Jules 1909- *WhAmArt 85*
Gottschalk, Max *WhAmArt 85*
Gottschalk, Max Jules 1909- *WhoAmA 76, –78, –80, –82, –84*
Gottschall, Edward Maurice 1915- *MarqDCG 84*
Gottschall, Octavia *DcWomA*
Gottstein, Franz *IlDcG*
Gottwald, Frederick Carl 1860-1941 *WhAmArt 85*
Gotwals, M *FolkA 86*
Gotz, Karl Otto 1914- *DcCAr 81, OxTwCA, PhDcTCA 77*
Gotzel-Sepolina, J *DcWomA*
Gotzenberg, F *DcVicP 2*
Gotzsche, Kai 1886- *WhAmArt 85*
Gotzsche, Kai G 1886- *ArtsAmW 1, IlBEAAW*
Goubau, Antoon 1616-1698 *McGDA*
Goubaut, Jeanne 1880- *DcWomA*
Goubert, Delnoce Whitney 1929- *AmArch 70*
Goubie, Jean-Richard *ArtsNiC*
Goubie, Jean Richard 1842-1899 *ClaDrA*
Goud, Anthony *BiDBrA*
Goudeket, William, Jr. 1924- *AmArch 70*
Goudman, Paul L 1873-1937 *WhAmArt 85*
Goudt, Hendrick 1585-1648 *McGDA*
Goudy, Bertha M Sprinks d1935 *WhAmArt 85*
Goudy, Frederic W 1865-1947 *OxDecA, WhAmArt 85*
Gouey, Henriette 1884- *DcWomA*
Gouge, Edward d1735 *DcBrECP*
Gouge, F H d1928? *BiDAmAr*
Gouge, Marguerite 1874- *DcWomA*
Gougeon, J A *AmArch 70*
Gouget, Marie *DcWomA*
Gough, Anne *DcWomA*
Gough, Arthur J *DcBrBI*
Gough, Clarence Ray 1919- *WhoAmA 80, –82*
Gough, Edward Connell, Jr. 1951- *MarqDCG 84*
Gough, Georgia Belle 1880- *WhoAmA 82, –84*
Gough, James Douglas, Jr. 1929- *AmArch 70*
Gough, Philip *IlsCB 1967*
Gough, Philip 1908- *IlsCB 1946*
Gough, Robert Alan 1931- *WhoAmA 73, –76, –78, –80, –82, –84*
Goujon, Eugenie *DcWomA*
Goujon, Jean 1510?-1568? *MacEA, McGDA*
Goujon, Jean 1510?-1568 *OxArt*
Goujon, Pauline *DcWomA*
Goulard, David *NewYHSD*
Goulart, Gilbert Walter 1915- *AmArch 70*

Gould, A Warren d1922 *BiDAmAr*
Gould, Aaron R 1854-1930 *BiDAmAr*
Gould, Mrs. Alan *WhAmArt 85*
Gould, Albert 1916- *WhAmArt 85*
Gould, Alec Carruthers 1870-1948 *DcBrA 1, DcBrWA*
Gould, Alexander Carruthers 1870-1948 *DcVicP 2*
Gould, Allan 1908- *WhAmArt 85*
Gould, Annunziata *WhAmArt 85*
Gould, C *DcVicP 2*
Gould, Carl F 1877-1939 *BiDAmAr, MacEA*
Gould, Carl F 1916- *AmArch 70*
Gould, Carl Frelinghuysen 1873- *WhAmArt 85*
Gould, Carl Frelinghuysen 1873-1939 *ArtsAmW 3*
Gould, Cecil Hilton Monk 1918- *WhoArt 80, –82, –84*
Gould, Charles 1925- *WhoArt 84*
Gould, Chester *WhAmArt 85*
Gould, Chester 1900- *WhoAmA 76, –78, –80, –82, WorECom*
Gould, Chester 1900-1985 *ConGrA 1*
Gould, Christopher *AntBDN D*
Gould, Elizabeth 1804-1841 *DcBrBI, DcBrWA, DcWomA*
Gould, Sir Francis Carruthers 1844-1925 *DcBrA 1, DcBrBI, DcBrWA, DcVicP 2, WorECar*
Gould, G R *AmArch 70*
Gould, George *NewYHSD*
Gould, George A *FolkA 86*
Gould, H *DcVicP 2*
Gould, Hal D 1920- *MacBEP*
Gould, Mrs. Irving *WhAmArt 85*
Gould, J H *AmArch 70*
Gould, J J *WhAmArt 85*
Gould, James *AntBDN Q, EncASM*
Gould, James d1734 *BiDBrA*
Gould, Janet 1899- *DcWomA, WhAmArt 85*
Gould, John 1804-1881 *GrBII[port]*
Gould, John, Jr. *CabMA*
Gould, John F *WhAmArt 85*
Gould, John F 1906- *IlrAm E, –1880*
Gould, John Howard 1929- *WhoAmA 73, –76, –78, –80, –82, –84*
Gould, Karen Keel 1946- *WhoAmA 84*
Gould, M H *FolkA 86*
Gould, Mabel Saxe *WhAmArt 85*
Gould, Nathaniel *CabMA*
Gould, Nathaniel 1734?-1781? *CabMA*
Gould, Northam R *WhAmArt 85*
Gould, Philip 1922- *WhoAmA 84*
Gould, R H, Jr. *AmArch 70*
Gould, R L *AmArch 70*
Gould, S R *AmArch 70*
Gould, St. John 1793-1840 *DcNiCA*
Gould, Stanley George 1929- *AmArch 70*
Gould, Stella Evelyn *DcWomA*
Gould, Stephen 1909- *WhoAmA 73, –76, –78, –80, –82, –84*
Gould, Theodore A *NewYHSD*
Gould, Thomas J 1849- *BiDAmAr*
Gould, Thomas R 1818-1881 *ArtsNiC*
Gould, Thomas Ridgeway 1818-1881 *BnEnAmA, DcAmArt, NewYHSD*
Gould, Walter 1829- *ArtsNiC*
Gould, Walter 1829-1893 *NewYHSD*
Gould, Will 1911- *WorECom*
Gould, William *AntBDN Q*
Gould, William Allen 1930- *AmArch 70*
Gould And Ward *EncASM*
Gould Stowell And Ward *EncASM*
Goulden, Gontran *ConArch A*
Goulden, Richard Reginald d1932 *DcBrA 1*
Goulding, Tim 1945- *DcCAr 81*
Goulds, Peter J 1948- *WhoAmA 78, –80, –82, –84*
Gouldsmith, Edmund 1852-1932 *ClaDrA, DcBrA 1, DcVicP 2*
Gouldsmith, Harriet 1786?-1863 *DcWomA*
Gouldsmith, Harriet 1787-1863 *DcBrWA*
Gouldsmith, Harriett 1786-1863 *DcVicP, –2*
Goulet, Claude 1925- *DcCAr 81, WhoAmA 78, –80, –82, –84*
Goulet, Lorrie 1925- *DcCAA 71, –77, WhoAmA 73, –76, –78, –80, –82, –84*
Goulette, Abe *FolkA 86*
Goulier, Kate De *DcWomA*
Goulinat, Jean Gabriel 1883- *ClaDrA*
Goulley, Marg *DcWomA*
Gouma-Peterson, Thalia 1933- *WhoAmA 78, –80, –82, –84*
Goun, Roger H 1950- *MarqDCG 84*
Gounin, Marguerite *DcWomA*
Gounod, Victoire *DcWomA*
Goupil, Jules d1883 *ArtsNiC*
Goupil, Leon Lucien 1834-1890 *ClaDrA*
Goupil, Marie Mathilde *DcWomA*
Goupy, Apolline *DcWomA*
Goupy, Joseph d1763 *DcBrWA*
Goupy, Joseph 1680?-1763? *BkIE*
Goupy, Joseph 1680?-1770? *DcBrECP*
Goupy, Louis *BkIE*
Goupy, Louis 1670?-1747 *DcBrECP*
Goupy, Marcel 1886- *DcNiCA*

Gouraud, Henri 1944- *MarqDCG 84*
Gourden, Jean *NewYHSD*
Gourdie, Thomas 1913- *DcBrA 1, WhoArt 80, –82, –84*
Goureau, Helene *DcWomA*
Gourevitch, Jacqueline 1933- *WhoAmA 73, –76, –78, –80, –82, –84*
Gourlay, E C *DcWomA*
Gourley, Alan Stenhouse 1909- *DcBrA 1, WhoArt 80, –82, –84*
Gourley, Bess E *ArtsAmW 1, –3, DcWomA*
Gourley, Ronald Robert 1919- *AmArch 70*
Gourlie, Edith *DcVicP 2*
Gournay, H G De 1881- *DcWomA*
Goursat, George *DcBrBI*
Goursat, Georges 1863-1934 *DcVicP 2, WorECar*
Goury, Alexina *DcWomA*
Goury, Juliette 1878- *DcWomA*
Goussaincourt DeGauvain, Louise De *DcWomA*
Gouteris, Maria *DcWomA*
Gouteus, Maria *DcWomA*
Gouthiere, Pierre 1732-1813 *AntBDN G, DcNiCA*
Gouthiere, Pierre 1732-1814? *OxDecA*
Gouthiere, Pierre 1740-1806 *DcD&D*
Goutink, Edward *ArtsEM*
Goutman, Dolya 1918- *WhoAmA 84*
Gouveia, Clem Albert *WhoAmA 73, –76*
Gouverneur, Maria Monroe *FolkA 86*
Gouverneur, Simon 1934- *DcCAr 81*
Gouvis, Arthur A 1934- *AmArch 70*
Gouy, Marie *DcWomA*
Gouy-Barrot, Jeanne *DcWomA*
Gouyt, Theodore *NewYHSD*
Govaert, Guido G 1947- *MarqDCG 84*
Govaerts, Abraham 1589-1626 *McGDA*
Govaerts, Hendrik 1669-1720 *McGDA*
Govan, Francis Hawks 1916- *WhoAmA 73, –76, –78, –80, –82, –84*
Govan, Mary M *DcVicP 2*
Govan, Mary Maitland *DcBrA 1, DcWomA*
Gove, Aaron A 1867- *BiDAmAr*
Gove, Eban Frank 1885-1938 *ArtsAmW 3*
Gove, Elma Mary *DcWomA, NewYHSD*
Gove, Geoffrey R 1943- *MacBEP*
Gove, Jane *FolkA 86*
Gove, Mary Breed 1814?- *FolkA 86*
Govela-Thomae, Alfonso 1950- *MarqDCG 84*
Gover, Mary Edith *DcVicP 2*
Gover, Samuel H *CabMA*
Gover, William *BiDBrA*
Gover, William C *NewYHSD*
Govett, W R *DcVicP 2*
Govier, Gordon 1946- *DcCAr 81*
Govier, James Henry 1910- *DcBrA 1, WhoArt 80, –82, –84*
Gow *NewYHSD*
Gow, Andrew C *ArtsNiC*
Gow, Andrew Carrick 1848-1920 *DcBrA 1, DcBrWA, DcVicP, –2*
Gow, Andrew Garrick 1848-1920 *ClaDrA*
Gow, Charles *DcVicP 2*
Gow, David *DcVicP 2*
Gow, James *DcVicP, –2*
Gow, James F Macintosh *DcVicP 2*
Gow, Lucienne *DcBrA 1*
Gow, Mary 1851-1929 *DcBrA 1*
Gow, Mary L 1851-1929 *DcBrBI, DcBrWA, DcVicP 2, DcWomA*
Gow-Stewart, Alice Majory *DcWomA*
Gowan, Alexander *NewYHSD*
Gowan, George d1843 *BiDBrA*
Gowan, James *ConArch A*
Gowan, James 1923- *ConArch, MacEA*
Gowan, James 1924- *WhoArch*
Gowan, William *BiDBrA*
Gowans, Alan 1923- *WhoAmA 73, –76*
Gowans, George Russell 1843-1924 *DcBrA 1, DcBrWA, DcVicP 2*
Gowell, Prudentiss *WhAmArt 85*
Gowen, Elwyn George 1895- *WhAmArt 85*
Gower, Charlotte *DcBrBI*
Gower, F Leveson, Earl Of Ellesmere 1800-1857 *DcBrBI*
Gower, Florence *DcWomA*
Gower, George *OxArt*
Gower, Lord Ronald Leveson *ArtsNiC*
Gower, S J *DcBrBI*
Gowers, David *DcBrECP*
Gowers, W R *DcVicP 2*
Gowin, Emmet 1941- *ConPhot, ICPEnP A, MacBEP*
Gowing, Lawrence 1918- *ConBrA 79[port], McGDA*
Gowing, Lawrence Burnett 1918- *DcBrA 1*
Gowland, John *DcBrWA*
Gowland, Peter 1916- *ICPEnP A, MacBEP*
Goy, Jeanne Jacqueline 1805-1862 *DcWomA*
Goya Y Lucientes, Francisco De 1746-1828 *WorECar*
Goya Y Lucientes, Francisco Jose 1746-1828 *McGDA, OxArt[port]*

Goya Y Lucientes, Francisco Jose De 1746-1828 *ClaDrA*
Goyder, Alice Kirkby 1875- *ClaDrA, DcBrA 1, DcWomA*
Goyen, Jan Josefoz Van 1596-1665 *ClaDrA*
Goyen, Jan Josephsz Van *McGDA*
Goyen, Jan Van 1596-1656 *OxArt*
Goyen, Jan Van 1596-1666 *DcSeaP*
Goyet, Jeanne Zoe d1869 *DcWomA*
Goyette, Robert Leo 1925- *AmArch 70*
Goyon, Countess Marie d1889 *DcWomA*
Gozzi, Maria Maddalena *DcWomA*
Gozzoli 1421?-1497 *OxArt*
Gozzoli, Benozzo 1420-1497 *ClaDrA, McGDA*
Gozzoli, Laure Marie *DcWomA*
Graat, Barent 1628-1709 *McGDA*
Grab, Berta Von 1846- *DcWomA*
Grab, Walter 1927- *DcCAr 81*
Grabach, John R *WhoAmA 73, –76, –78, –80*
Grabach, John R 1880-1981 *WhoAmA 82N, –84N*
Grabach, John R 1886- *DcCAr 81, WhAmArt 85*
Grabau, John F 1878- *WhAmArt 85*
Grabel, David *MarqDCG 84*
Graber, Jeffrey Alan 1951- *MarqDCG 84*
Grabhorn, Edwin *OxDecA*
Grabhorn, Robert *OxDecA*
Grabianski, Janusz d1976 *IlsCB 1967*
Grabianski, Janusz 1929- *IlsBYP, IlsCB 1957*
Grabill, Nora Kain Nichols 1882- *ArtsAmW 3*
Grabill, Vin 1949- *WhoAmA 84*
Graboff, Abner 1919- *IlsBYP, IlsCB 1957*
Grabow, E C *AmArch 70*
Grabow, William Edmund 1924- *AmArch 70*
Grabowska, Caroline *DcWomA*
Grabowski, Mateusz Bronislaw 1904- *WhoArt 80, –82, –84*
Grace, Alfred Fitzwalter 1844-1903 *ClaDrA, DcBrA 1, DcBrWA, DcVicP, –2*
Grace, Charles M 1926- *WhoAmA 73*
Grace, Daniel *FolkA 86*
Grace, Denise Y 1952- *AfroAA*
Grace, Emily M *DcWomA*
Grace, Frances Lily *DcVicP 2, DcWomA*
Grace, Fred J, III 1940- *AmArch 70*
Grace, Harriette Edith *DcVicP 2*
Grace, Harriette Edith 1860-1932 *DcBrWA, DcWomA*
Grace, J D *NewYHSD*
Grace, Mrs. James E *DcVicP 2*
Grace, James Edward 1850-1908 *DcBrA 1*
Grace, James Edward 1851-1908 *DcBrWA, DcVicP, –2*
Grace, John C *NewYHSD*
Grace, L A *DcVicP 2*
Grace, L K *AmArch 70*
Grace, Louise N *WhAmArt 85*
Grace, Mary *DcWomA*
Grace, Mary d1786? *DcBrECP*
Grace, Mary 1786?- *DcWomA*
Grace, Thomas Peter 1955- *MarqDCG 84*
Gracer, Herbert 1928- *AmArch 70*
Gracey, William *FolkA 86*
Grad, Bernard John 1908- *AmArch 70*
Grad, Wendy Susan 1955- *MacBEP*
Graddy, Warren Mercer 1941- *AmArch 70*
Grade, Friederike *DcWomA*
Gradmann, Erwin 1908- *WhoArt 80, –82, –84*
Grado, Angelo John 1922- *WhoAmA 73, –76, –78, –80, –82, –84*
Gradovsky, Maria N *DcWomA*
Gradus, Ari 1943- *PrintW 83, –85*
Grady, Edward *AfroAA*
Grady, J A *AmArch 70*
Grady, Martin Duane 1917- *AmArch 70*
Grady, Robert Emmet 1903- *AmArch 70*
Grady, Ruby McLain 1934- *WhoAmA 76, –78*
Grady, Ruby McLain 1944- *WhoAmA 80, –82, –84*
Grady, William Francis, Jr. 1931- *AmArch 70*
Graeb, Karl-Georg-Anton 1816- *ArtsNiC*
Graeber, D C *AmArch 70*
Graeber, George Conrad 1910- *AmArch 70*
Graeber, John Adams 1871- *WhAmArt 85*
Graef, Gustav 1821- *ArtsNiC*
Graef, Gustave *DcVicP 2*
Graef, H H, III *AmArch 70*
Graef, Manfred 1928- *DcCAr 81*
Graef, Robert A *WhAmArt 85*
Graef, Sabine *DcWomA*
Graef, William *WhAmArt 85*
Graeff, Celestine *NewYHSD*
Graeff, Celestine 1830?- *DcWomA*
Graefle, Albert 1807-1889 *DcVicP 2*
Graese, Judy 1940- *AmArt, WhoAmA 76, –78, –80, –82, –84*
Graesser, Albert J 1903- *AmArch 70*
Graevenitz, Gerhard Von 1934- *ConArt 77, DcCAr 81, OxTwCA, PhDcTCA 77*
Graf, Alfred John 1931- *AmArch 70*
Graf, Antoine 1736-1813 *ClaDrA*
Graf, Burket Eugene 1918- *AmArch 70*
Graf, Caecilie 1868- *DcWomA*

Graf, Carl C 1890-1947 *WhAmArt 85*
Graf, Christine *PrintW 83, –85*
Graf, Gladys H 1898- *ArtsAmW 2, DcWomA, WhAmArt 85*
Graf, Horace Kingsland 1930- *AmArch 70*
Graf, Oskar 1873-1957 *McGDA*
Graf, R G *AmArch 70*
Graf, Sabine *DcWomA*
Graf, Susanna Maria *DcWomA*
Graf, Urs *ConArch A*
Graf, Urs 1485?-1528? *McGDA, OxArt*
Graf, Werner Herman 1931- *AmArch 70*
Graf And Neimann *EncASM*
Graf-Pfaff, Caecilie 1868- *DcWomA*
Graf-Reinhart, Anna Emilie 1809-1884 *DcWomA*
Grafe, C Paul *WhAmArt 85*
Graff *FolkA 86, NewYHSD*
Graff, Alexander M *NewYHSD*
Graff, Antoine 1736-1813 *ClaDrA*
Graff, Anton 1736-1813 *McGDA, OxArt*
Graff, Charles d1931 *EncASM*
Graff, Dorothea Maria Henrietta 1678-1743 *DcWomA*
Graff, J *FolkA 86*
Graff, Johann Andreas 1637-1701 *ClaDrA*
Graff, Johanna Maria Helena 1668- *DcWomA*
Graff, Maria Sibylla *DcWomA*
Graff, Mel 1907-1975 *WorECom*
Graff, Raymond Kenneth 1911- *AmArch 70*
Graff, W V *WhAmArt 85*
Graff, William 1925- *AmArch 70*
Graff Washbourne And Dunn *EncASM*
Graffart, Charles 1893-1967 *IIDcG*
Graffenried, Christoph Von 1661-1743 *NewYHSD*
Graffione 1455-1527 *McGDA*
Graffunder, Carl O 1919- *AmArch 70*
Grafly, Charles 1862-1929 *McGDA, WhAmArt 85*
Grafly, Dorothy 1896- *WhAmArt 85, WhoAmA 73, –76*
Grafstrom, Olaf 1855-1933 *ArtsAmW 1*
Grafstrom, Olaf Jonas 1855-1933 *ArtsAmW 3*
Grafstrom, Olof Jonas 1855-1933 *ArtsAmW 3*
Grafstrom, Ruth Sigrid 1905- *IlrAm D, –1880, WhAmArt 85*
Grafton *DcBrECP*
Grafton, Edward Graham 1923- *AmArch 70*
Grafton, Elbridge Derry 1817-1900 *WhAmArt 85*
Grafton, John d1775 *NewYHSD*
Grafton, Rick 1952- *WhoAmA 84*
Grafton, Robert W 1876-1936 *WhAmArt 85*
Gragg, Hugh Ernest 1919- *AmArch 70*
Gragg, Samuel *FolkA 86*
Graham *NewYHSD*
Graham, A W *NewYHSD*
Graham, Alexander 1858- *DcBrWA*
Graham, Allan J 1943- *DcCAr 81*
Graham, B *FolkA 86*
Graham, B C *AmArch 70*
Graham, B J *AmArch 70*
Graham, Bill 1920- *WhoAmA 73, –76, –78, –80, –82, –84*
Graham, Bruce J 1925- *ConArch*
Graham, Bruce John 1925- *MacEA*
Graham, C *DcVicP 2*
Graham, C M *DcWomA*
Graham, Cecilia B 1905- *WhAmArt 85*
Graham, Channell A 1927- *AmArch 70*
Graham, Charles *FolkA 86*
Graham, Charles 1852-1911 *ArtsAmW 1, IIBEAAW*
Graham, Charles S 1852-1911 *WhAmArt 85*
Graham, Curtis Burr 1814-1890 *NewYHSD*
Graham, Dan *OxTwCA*
Graham, Dan 1942- *AmArt, ConArt 77, –83*
Graham, Daniel H 1942- *WhoAmA 76, –78, –80, –82, –84*
Graham, David 1926- *DcBrA 1, WhoArt 80, –82, –84*
Graham, Donald Ray 1932- *AmArch 70*
Graham, Douglas J M *WhoAmA 80, –82, –84*
Graham, Elizabeth Sutherland *WhAmArt 85*
Graham, Ernest R 1866-1936 *MacEA*
Graham, Ernest Robert 1868-1936 *BiDAmAr, WhAmArt 85*
Graham, F Lanier 1940- *WhoAmA 73, –76, –78, –80, –82, –84*
Graham, Florence E *DcVicP 2*
Graham, Francis *FolkA 86*
Graham, Frank P 1923- *WhoAmA 73, –76*
Graham, Frederick *CabMA*
Graham, Frederick Hinton 1912- *AmArch 70*
Graham, George *DcBrECP, NewYHSD*
Graham, George 1673-1751 *AntBDN D*
Graham, George 1674-1751 *OxDecA*
Graham, George 1881-1949 *DcBrA 1*
Graham, George Alexander, Jr. 1919- *AmArch 70*
Graham, Harold E 1904- *WhAmArt 85*
Graham, Henry *DcBrWA*
Graham, Henry 1795?-1819 *BiDBrA*
Graham, Hugh *BiDAmAr*
Graham, J *AmArch 70, DcBrBI, DcVicP 2*
Graham, J H *AmArch 70*
Graham, James *WhoAmA 73, –76, –78, –80, –82*

Graham, James Gillespie 1776-1855 *BiDBrA, MacEA*
Graham, James Hunter- *DcVicP 2*
Graham, James MacMahon 1938- *AmArch 70*
Graham, James Raymond 1928- *AmArch 70*
Graham, Jean Douglas *DcVicP 2*
Graham, John d1805 *FolkA 86*
Graham, John 1706?-1775? *DcBrECP*
Graham, John 1754?-1817 *BkIE*
Graham, John 1755-1817 *DcBrECP*
Graham, John 1798?- *FolkA 86*
Graham, John 1881-1961 *BnEnAmA, ConArt 77, DcAmArt, OxTwCA*
Graham, John B *NewYHSD*
Graham, John D 1881-1961 *DcCAA 71, -77, WhoAmA 78N, -80N, -82N, -84N*
Graham, John D 1891-1961 *WhAmArt 85*
Graham, John Hans 1912- *AmArch 70*
Graham, John James 1929- *AmArch 70*
Graham, John Lewis, III 1934- *AmArch 70*
Graham, John Meredith, II 1905- *WhoAmA 73, -76, -78, -80, -82*
Graham, John Requa 1818-1909 *NewYHSD*
Graham, Josephine *DcWomA*
Graham, K M 1913- *WhoAmA 78, -80, -82, -84*
Graham, Kay 1913- *WhoAmA 76*
Graham, Laura Margaret 1912- *WhAmArt 85*
Graham, Lilias Jane *DcWomA*
Graham, Lois 1930- *WhoAmA 84*
Graham, Lois M Gord 1930- *WhoAmA 82*
Graham, Margaret Bloy *IlsCB 1967*
Graham, Margaret Bloy 1920- *IlsBYP, IlsCB 1946, -1957, WhoAmA 78, -80, -82, -84*
Graham, Margaret Nowell *WhAmArt 85*
Graham, Maria *DcWomA*
Graham, Marshall A 1924- *MarqDCG 84*
Graham, Marta *MarqDCG 84*
Graham, Lord Montagu William 1807-1878 *DcBrWA*
Graham, Norman *DcVicP 2*
Graham, Orval Herbert 1919- *AmArch 70*
Graham, Patrick *NewYHSD*
Graham, Payson 1878- *DcWomA, WhAmArt 85*
Graham, Peter 1836- *ArtsNiC*
Graham, Peter 1836-1921 *ClaDrA, DcBrA 1, DcBrBI, DcBrWA, DcVicP, -2*
Graham, R E *AmArch 70*
Graham, Ralph *WhAmArt 85*
Graham, Raymond Wilfred 1919- *AmArch 70*
Graham, Richard Marston 1939- *WhoAmA 76, -78, -80, -82, -84*
Graham, Robert 1938- *ConArt 77, -83, DcCAA 71, -77, DcCAr 81, WhoAmA 78, -80, -82, -84*
Graham, Robert A *NewYHSD*
Graham, Robert Alexander 1873-1946 *ArtsAmW 1, -3, WhAmArt 85*
Graham, Robert C, Jr. 1941- *WhoAmA 82, -84*
Graham, Robert Claberhouse 1913- *WhoAmA 73, -76*
Graham, Robert Claverhouse 1913- *WhoAmA 78, -80, -82, -84*
Graham, Robert Macdonald, Jr. 1919- *WhoAmA 80, -82*
Graham, Robert MacDonald, Jr. 1919- *WhoAmA 84*
Graham, Robert R 1891-1943 *BiDAmAr*
Graham, Sadie 1931- *AfroAA*
Graham, Samuel 1805-1871 *FolkA 86*
Graham, Thomas *ArtsNiC, FolkA 86*
Graham, Thomas Alexander Ferguson 1840-1906 *ClaDrA, DcBrA 1, DcBrBI, DcVicP, -2*
Graham, Tom 1942- *MarqDCG 84*
Graham, Mrs. W J *DcVicP 2*
Graham, Walter 1903- *WhoAmA 78, -80, -82, -84*
Graham, William *ArtsNiC, NewYHSD, WhAmArt 85*
Graham, William 1832-1911 *ArtsAmW 1*
Graham, William Andrew 1939- *WhoAmA 82, -84*
Graham, William Henry 1837-1888 *DcBrWA*
Graham, Winifred *DcBrBI*
Graham Anderson Probst And White *MacEA*
Graham-Buxton, W *DcVicP 2*
Graham-Clarke, L J *DcVicP 2*
Graham-Collier, Alan *WhoAmA 76, -78, -80*
Graham-Gilbert, John 1794-1866 *ArtsNiC*
Graham-Robertson, Walford *DcVicP 2*
Graham-Yooll, Miss *DcVicP 2*
Grahame, A B *DcVicP 2*
Grahame, James B *DcVicP 2*
Grahame, John B *DcVicP 2*
Grahame-Thomson, Leslie *DcBrA 1*
Graheck, Bill Jack 1918- *AmArch 70*
Grain, Frederick *ArtsAmW 2, NewYHSD*
Grain, George *NewYHSD*
Grain, Marguerite 1899- *DcWomA*
Grain, Peter, Jr. *NewYHSD*
Grain, Peter, Sr. 1786?- *NewYHSD*
Grain, Robert A *NewYHSD*
Grain, Urban A *NewYHSD*
Graindorge, Mathilde 1842- *DcWomA*
Grainger, Bernard Montague *WhoAmA 82, -84*
Grainger, Bernard Montague 1907- *WhoArt 80*
Grainger, Dale Louis 1939- *AmArch 70*
Grainger, Edward *DcVicP 2*
Grainger, George *DcNiCA*

Grainger, Ian *DcCAr 81*
Grainger, Richard 1797-1861 *BiDBrA*
Grainger, Richard 1798-1861 *DcD&D*
Grainger, Rowan *DcCAr 81*
Grainger, Thomas d1839 *AntBDN M, DcNiCA*
Grainger, William d1793? *BkIE*
Grajales, Elizabeth 1952- *AmArt*
Graley, Gary James 1951- *WhoAmA 82, -84*
Gralla, Stan William 1939- *AmArch 70*
Gram, Charles F *ArtsEM*
Gramalich, John *FolkA 86*
Graman, T A *AmArch 70*
Gramann, Robert Edward *AmArch 70*
Gramatky, Hardie *IlsCB 1967*
Gramatky, Hardie 1907- *IlrAm E, IlsCB 1744, -1946, -1957, WhAmArt 85, WhoAmA 73, -76, -78*
Gramatky, Hardie 1907-1979 *IlrAm 1880, WhoAmA 80N, -82N, -84N, WorECar*
Gramatyka-Ostrowska, Anna 1884- *DcWomA*
Grambay, E A *NewYHSD*
Gramberg, Liliana *WhoAmA 73, -76, -78, -80, -82, -84*
Grambs, Blanche *AfroAA, WhAmArt 85*
Gramley, William Ellis, Jr. 1924- *AmArch 70*
Gramlic, John *FolkA 86*
Gramling, J A *AmArch 70*
Gramling, Marta Johnston 1912- *WhAmArt 85*
Gramlyg, John 1805?- *FolkA 86*
Grammatica, Antiveduto 1571-1626 *McGDA*
Grammont, Genevieve 1898- *DcWomA*
Grampietri, Sellimo, Madame *DcVicP 2*
Gran, Enrique *OxTwCA*
Granacci, Francesco 1477-1543 *McGDA*
Granada, Nina *WhAmArt 85*
Granados, Marta 1944- *WhoGrA 82[port]*
Granahan, Mrs. David *WhAmArt 85*
Granahan, David Milton 1909- *WhAmArt 85*
Granat Brothers *EncASM*
Granata, Angelo John 1922- *McGDA*
Granbery, E Carleton, Jr. 1913- *AmArch 70*
Granbery, George 1794-1815 *NewYHSD*
Granbery, Henrietta Augusta 1829-1927 *DcWomA, NewYHSD , WhAmArt 85*
Granbery, Molly Lee *DcWomA*
Granbery, Virginia 1831-1921 *DcWomA, NewYHSD , WhAmArt 85*
Granby, Marchioness Of *DcVicP 2*
Granby, The Marchioness Of *DcBrBI*
Granby, Marion Margaret Violet *DcWomA*
Grancino, Paolo *AntBDN K*
Grand, John L R 1909- *AmArch 70*
Grand, Thomas *NewYHSD*
Grand, Toni 1935- *DcCAr 81*
Granda, Julio *IlsBYP*
Grande, D W *AmArch 70*
Grande, Helene *DcWomA*
Grandee, Joe Ruiz 1929- *AmArt, IlBEAAW, WhoAmA 73, -76, -78, -80, -82, -84*
Grandel, E *NewYHSD*
Grandeville 1803-1847 *OxArt*
Grandhomme, Julie *DcWomA*
Grandi, Ercole *McGDA*
Grandi, Ercole DiGiulio Cesare 1465?-1531 *ClaDrA*
Grandi, Paolina *DcWomA*
Grandi, Vincenzo d1562 *McGDA*
Grandin, Elizabeth *DcWomA, WhAmArt 85*
Grandin, Eugene *DcSeaP*
Grandjean, Mrs. Arthur *DcWomA*
Grandjean, Austin 1930- *WhoGrA 82[port]*
Grandjean, Jehanne 1880- *DcWomA*
Grandjean DeMontigny, Auguste-H-Victor 1776-1850 *MacEA, McGDA*
Grandjouan, Jules-Felix 1875-1968 *WorECar*
Grandma Moses *FolkA 86, OxTwCA, PhDcTCA 77, WorArt*
Grandmaison, Louise *DcWomA*
Grandmaison, Nickola De 1892- *ArtsAmW 1*
Grandmont-Hubrecht, Amalda Bramine L *DcWomA*
Grandmougin, Marie d1909 *DcWomA*
Grandpierre-Deverzy, Adrienne Marie L 1798- *DcWomA*
Grandsire, Celestine *DcWomA*
Grandsire, Eugene *ArtsNiC*
Grandstaff, Harriet Phillips 1895- *ArtsAmW 2, DcWomA, WhAmArt 85*
Grandval, Corinne 1945- *WorFshn*
Grandville *WorECar*
Grandville, Jean-Ignace Isidore Gerard 1803-1847 *DcBrBI*
Grandville, Sean 1803-1847 *McGDA*
Grandy, A 1890-1951 *FolkA 86*
Grandy, Julia Selden 1903- *WhAmArt 85*
Grandy, Winfred Milton 1899- *WhAmArt 85*
Graner, Luis d1929 *WhAmArt 85*
Graner, Luis 1867-1929 *ArtsAmW 3*
Granes, Jeanne *DcWomA*
Granet, Francois Marius 1775-1849 *ClaDrA, McGDA*
Granet, Francois-Marius 1775-1849 *OxArt*
Grange, Cornelius 1895-1933 *WhAmArt 85*
Grange, Gerhard 1922- *AmArch 70*

Grange, Kenneth Henry 1929- *ConDes, WhoArt 80, -82, -84*
Granger, Madame *DcWomA*
Granger, A T *AmArch 70*
Granger, Abner 1735- *CabMA*
Granger, Alfred Hoyt 1867-1939 *BiDAmAr*
Granger, Bildad 1741-1780 *CabMA*
Granger, Caroline Gibbons 1889- *DcWomA, WhAmArt 85*
Granger, Charles H *FolkA 86, NewYHSD*
Granger, FitzHenry *NewYHSD*
Granger, Francis H *NewYHSD*
Granger, Genevieve 1877-1967 *DcWomA*
Granger, Henry *NewYHSD*
Granger, James *NewYHSD*
Granger, Kathleen Buehr *WhAmArt 85*
Granger, Lee W *ArtsEM*
Granger, Merton Elwood 1882- *AmArch 70*
Granger, S S *AmArch 70*
Grangeret *DcWomA*
Granier, Augusta *DcWomA*
Granier, Julia *DcWomA*
Granier, Marie Jeanne *DcWomA*
Granirer, Martus 1933- *ICPEnP A, MacBEP*
Granitsch, Susanna Renate 1869- *DcWomA*
Granlund, Paul 1925- *DcCAA 71, -77*
Granlund, Paul Theodore 1925- *WhoAmA 73, -76, -78, -80, -82, -84*
Grannacci, Francesco 1477-1543 *OxArt*
Granner, Olga 1874-1967 *DcWomA*
Grannis, Dorothy Eckert 1938- *MarqDCG 84*
Granold, J George *FolkA 86*
Granpre Moliere, M J 1883- *MacEA*
Granpre-Moliere, M J 1883- *McGDA*
Granstaff, Bill *OfPGCP 86*
Granstaff, William Boyd 1925- *WhoAmA 73, -76, -78, -80, -82, -84*
Granstedt, Hilda Eloise 1841- *DcWomA*
Grant, Miss *DcBrWA*
Grant, Alexander H 1926- *AmArch 70*
Grant, Alfred Watts 1900- *AmArch 70*
Grant, Alice *DcVicP 2, DcWomA*
Grant, Alistair 1925- *DcBrA 1, DcCAr 81*
Grant, Allan 1920- *ICPEnP A*
Grant, Ariel *WhAmArt 85*
Grant, Art 1927- *WhoAmA 84*
Grant, Arthur Joe, Jr. 1933- *AmArch 70*
Grant, Aug R *DcVicP 2*
Grant, Austin 1918- *AmArch 70*
Grant, Blanche Chloe 1874-1948 *ArtsAmW 1, DcWomA, IIBEAAW, WhAmArt 85*
Grant, C M *AmArch 70*
Grant, Carleton *DcBrA 2, DcVicP 2*
Grant, Catharine Harley 1897-1954 *WhAmArt 85*
Grant, Catherine Harley 1897-1954 *DcWomA*
Grant, Cecil Vezin 1880- *WhAmArt 85*
Grant, Charles *DcBrWA, DcVicP 2*
Grant, Charles H 1866-1938? *WhAmArt 85*
Grant, Charles Henry 1866-1939 *ArtsAmW 1*
Grant, Charles Jameson *DcBrBI*
Grant, Clement R 1849- *ArtsNiC*
Grant, Clement R 1849-1893 *WhAmArt 85*
Grant, Colesworthy 1813-1880 *DcBrWA*
Grant, Daniel *NewYHSD*
Grant, Dorothy Mengis 1911- *WhAmArt 85*
Grant, Douglas M 1894- *WhAmArt 85*
Grant, Duncan 1885- *ConArt 77, DcD&D, McGDA, OxArt, PhDcTCA 77*
Grant, Duncan 1885-1978 *WorArt[port]*
Grant, Duncan James 1885- *ClaDrA*
Grant, Duncan James Corrowr 1885- *DcBrA 1, WhoArt 80, -82*
Grant, Duncan James Corrowr 1885-1978 *OxTwCA*
Grant, Edward E 1860-1932 *BiDAmAr*
Grant, Edward Lynam 1907- *WhAmArt 85*
Grant, Elizabeth 1894- *WhAmArt 85*
Grant, Elizabeth Johnston 1894- *DcWomA*
Grant, Emily *DcVicP 2*
Grant, Erastus *CabMA*
Grant, Sir Francis 1803-1878 *ArtsNiC, DcVicP, -2*
Grant, Sir Francis 1805-1878 *OxArt*
Grant, Sir Francis 1810-1878? *ClaDrA*
Grant, Frederic M 1886- *WhAmArt 85*
Grant, Frederick Milton 1886-1959 *ArtsAmW 3*
Grant, Frederick Milton 1886-1959 *ArtsAmW 3*
Grant, Gordon 1875-1962 *WhAmArt 85*
Grant, Gordon 1875-1962 *IlsCB 1744, -1946*
Grant, Gordon Hope d1962 *WhoAmA 78N, -80N, -82N, -84N*
Grant, Gordon Hope 1875-1962 *ArtsAmW 3, DcSeaP, GrAmP, IlrAm C, -1880, WorECar*
Grant, H *AmArch 70*
Grant, H B, Jr. *AmArch 70*
Grant, H R *WhAmArt 85*
Grant, Helen Peabody 1861- *DcWomA, WhAmArt 85*
Grant, Henry *CabMA, DcVicP 2*
Grant, Henry 1860-1924 *FolkA 86*
Grant, Iain 1951- *MarqDCG 84*
Grant, Ian Macdonald 1904- *DcBrA 1*

Green, Emma d1942 *DcWomA*
Green, Emma Edwards d1942 *ArtsAmW 2*
Green, Mrs. Erik H *WhAmArt 85*
Green, Felicity *WorFshn*
Green, Florence *DcBrA 2*
Green, Florence Topping 1882-1945 *DcWomA,*
WhAmArt 85
Green, Francis G *NewYHSD*
Green, Frank G *WhAmArt 85*
Green, Frank Russell 1856-1940 *WhAmArt 85*
Green, G *FolkA 86*
Green, G L *AmArch 70*
Green, George *AfroAA*
Green, George D 1943- *DcCAr 81, WhoAmA 78,*
-80, -82, -84
Green, George Pycock Everett *DcBrWA, DcVicP 2*
Green, George Thurman 1942- *DcCAr 81,*
WhoAmA 76, -78, -80, -82
Green, George W *FolkA 86*
Green, Glenda 1945- *WhoAmA 82, -84*
Green, H F *AmArch 70*
Green, H Towneley *DcVicP*
Green, H Vaughan *DcVicP 2*
Green, Harold Abbott 1883- *WhAmArt 85*
Green, Harriet *DcBrWA*
Green, Harriet 1751-1807? *DcWomA*
Green, Harry 1920- *AmArch 70*
Green, Henry *FolkA 86*
Green, Henry F *NewYHSD*
Green, Henry J *NewYHSD*
Green, Henry Towneley 1836-1899 *ClaDrA, DcBrBI,*
DcBrWA, DcVicP 2
Green, Hiram H 1865-1930 *WhAmArt 85*
Green, Hiram Harold 1865-1930 *ArtsAmW 2,*
IIBEAAW
Green, Howard Carl 1939- *AmArch 70*
Green, Isaac 1924- *AmArch 70*
Green, Isabella *DcVicP 2, DcWomA*
Green, J *DcBrWA*
Green, J B *AmArch 70*
Green, J Crawford *CabMA*
Green, J D *FolkA 86*
Green, James d1757? *BkIE*
Green, James 1771-1834 *DcBrECP, DcBrWA*
Green, James 1781-1849 *BiDBrA*
Green, James 1939- *AfroAA*
Green, James Leahan 1911- *WhAmArt 85*
Green, James Robert 1932- *AmArch 70*
Green, Jasha 1927- *PrintW 83, -85, WhoAmA 80,*
-82, -84
Green, Jasper 1829-1910 *NewYHSD , WhAmArt 85*
Green, Jay S 1892-1984 *ArtsAmW 3*
Green, Jerome 1923- *MarqDCG 84*
Green, John *AntBDN H, -N, -Q, BiDBrA, CabMA,*
DcBrWA, OfPGCP 86
Green, John d1802 *NewYHSD*
Green, John 1787-1852 *BiDBrA*
Green, John H *FolkA 86*
Green, Johnny *DcBrWA*
Green, Jonathan 1939- *DcCAr 81*
Green, Jonathan W 1939- *ICPEnP A, MacBEP*
Green, Joseph *AntBDN N, CabMA*
Green, Joshua *DcBrWA*
Green, Josiah *DcVicP 2*
Green, June *DcCAr 81*
Green, Kenneth 1916- *DcBrA 1*
Green, Kenneth 1946- *AfroAA*
Green, L J *DcVicP 2*
Green, Lawrence Sydney 1932- *MarqDCG 84*
Green, Letitia Jane *DcWomA*
Green, Lilian *DcWomA*
Green, Lilian Bayliss 1875- *WhAmArt 85*
Green, Lucy A *ArtsEM, DcWomA*
Green, Lydia M *DcWomA*
Green, M Edwin 1896- *AmArch 70*
Green, M Helen *DcVicP 2, DcWomA*
Green, Mabel *DcVicP 2, DcWomA*
Green, Madeleine *DcWomA*
Green, Mark William 1955- *MarqDCG 84*
Green, Martin 1936- *PrintW 83, -85*
Green, Martin Leonard 1936- *AmArt, WhoAmA 78,*
-80, -82, -84
Green, Mary *DcWomA*
Green, Mary C *DcVicP 2*
Green, Melvin *AfroAA*
Green, Mildred C *WhAmArt 85*
Green, Mildred C 1874- *DcWomA*
Green, Morris Baldwin 1928- *WhoAmA 76, -78, -80*
Green, Nathaniel Everett d1899 *DcBrWA*
Green, Nathaniel Everett 1833?-1899 *DcVicP 2*
Green, Olive Dutton d1930 *DcWomA*
Green, P *DcVicP 2*
Green, Paul Anthony 1946- *MarqDCG 84*
Green, Mrs. R *DcVicP 2*
Green, R H *AmArch 70*
Green, Reginald H *DcBrA 1*
Green, Rena 1874- *ArtsAmW 1*
Green, Rena Maverick 1874- *DcWomA,*
WhAmArt 85
Green, Richard Crafton 1848- *DcBrA 1, DcVicP 2*
Green, Robert Frederick 1923- *MacBEP*

Green, Robert H, Jr. 1930- *AfroAA*
Green, Robert L *WorFshn*
Green, Robert Miller 1935- *AmArch 70*
Green, Roland 1896-1972 *DcBrA 1*
Green, Rose *AfroAA*
Green, Samuel L *AfroAA*
Green, Samuel M 1909- *WhAmArt 85*
Green, Samuel Magee 1909- *WhoAmA 73, -76, -78,*
-80, -82
Green, Sarah *DcWomA*
Green, Sarah Morris *DcWomA*
Green, Stephen *DcNiCA*
Green, Tennyson P E H *DcBrA 1, DcWomA*
Green, Thomas David *AmArch 70*
Green, Thomas George 1931- *AmArch 70*
Green, Tom 1942- *WhoAmA 76, -78, -80, -82, -84*
Green, Valentine 1739-1813 *McGDA, OxArt*
Green, Virginia *FolkA 86*
Green, W *AntBDN N*
Green, W E *AmArch 70*
Green, W P *DcVicP 2*
Green, W T *NewYHSD*
Green, Walter Edgar, Jr. 1930- *AmArch 70*
Green, Warren Buckelew *AmArch 70*
Green, Wilder 1927- *WhoAmA 73, -76, -78, -80, -82,*
-84
Green, William *BkIE, CabMA, NewYHSD*
Green, William 1761-1823 *DcBrECP, DcBrWA*
Green, William Bradford 1871-1945 *WhAmArt 85*
Green, William Curtis 1875-1960 *DcBrA 1, DcBrBI,*
MacEA, McGDA
Green, William Ellis 1923- *WorECar*
Green, William H *NewYHSD*
Green-Field, Albert *WhoAmA 78N, -80N, -82N,*
-84N
Green Of Oxford *DcBrECP*
Green-Smith *EncASM*
Greenamyer, George Mossman 1939- *WhoAmA 73,*
-76, -78, -80, -82, -84
Greenamyer, Leah J *WhAmArt 85*
Greenamyer, Leah J 1891- *DcWomA*
Greenawalt, Frank F *WhAmArt 85*
Greenawalt, Katie *FolkA 86*
Greenaway, Catherine 1846-1901 *OxArt*
Greenaway, David Stuart 1934- *MarqDCG 84*
Greenaway, F W *DcVicP 2*
Greenaway, Kate 1846-1901 *ClaDrA, DcBrA 1,*
DcBrBI, DcBrWA, DcVicP 2, DcWomA,
McGDA, OxArt, WomArt
Greenaway, Katherine 1846-1901 *AntBDN B,*
DcNiCA
Greenbank, Arthur *DcBrWA, DcVicP 2*
Greenbaum, Delphine Bradt *WhAmArt 85*
Greenbaum, Dorothea 1893- *DcWomA, McGDA*
Greenbaum, Dorothea Schwarcz 1893- *WhAmArt 85,*
WhoAmA 73, -76, -78, -80, -82, -84
Greenbaum, Joseph *WhAmArt 85*
Greenbaum, Joseph 1864- *ArtsAmW 1*
Greenbaum, Joseph 1864-1940 *ArtsAmW 3*
Greenbaum, Marty 1934- *WhoAmA 78, -80, -82, -84*
Greenbaum, Robert Bernard 1929- *AmArch 70*
Greenberg, A *WhAmArt 85*
Greenberg, A J *AmArch 70*
Greenberg, Benjamin *WhAmArt 85*
Greenberg, Blue 1926- *WhoAmA 84*
Greenberg, Clement 1909- *WhAmArt 85,*
WhoAmA 73, -76, -78, -80
Greenberg, Elenor Siminow 1914- *WhoAmA 82, -84*
Greenberg, Gloria 1932- *ConArt 77, -83,*
WhoAmA 73, -76, -78, -80, -82, -84
Greenberg, Irwin 1922- *WhoAmA 78, -80, -82, -84*
Greenberg, Maurice 1893- *WhAmArt 85*
Greenberg, Morris *WhAmArt 85*
Greenberg, Ronald K 1937- *WhoAmA 80, -82, -84*
Greenberg, Shirlee Bernice 1925- *WhoAmA 73, -76*
Greenbie, Barry *WhAmArt 85*
Greenbowe, F Douglas 1921- *WhoAmA 73, -76, -78,*
-80, -82, -84
Greenburg, Samuel 1905- *WhAmArt 85*
Greenburgh, Gilbert Adrian 1903-1959 *WorFshn*
Greenbury, George C *ArtsAmW 3*
Greenbury, Judith Pamela 1924- *WhoArt 80, -82, -84*
Greenbury, William *ArtsAmW 3*
Greene *NewYHSD*
Greene, Albert V 1887- *WhAmArt 85*
Greene, Alice *DcVicP 2, DcWomA*
Greene, Allen L 1929- *AmArch 70*
Greene, Anne 1878- *DcWomA*
Greene, Anne Bosworth *WhAmArt 85*
Greene, Balcomb 1904- *BnEnAmA, ConArt 83,*
DcAmArt, DcCAA 71, -77, McGDA, OxTwCA,
PhDcTCA 77, WhAmArt 85, WhoAmA 73, -76,
-78, -80, -82, -84
Greene, Belle *DcWomA, WhAmArt 85*
Greene, Beryl Morse 1895- *WhAmArt 85*
Greene, Bob *AfroAA*
Greene, Charles S 1868-1957 *McGDA*
Greene, Charles Sumner 1868-1957 *BnEnAmA,*
ConArch, EncAAr, EncMA, MacEA, WhoArch
Greene, Clifton 1948- *AfroAA*
Greene, Daniel E 1934- *WhoAmA 73, -76, -78, -80*

Greene, Donald O 1940- *AfroAA*
Greene, E 1830?- *ArtsAmW 3*
Greene, E DeChois *FolkA 86*
Greene, E Lonzo 1931- *AmArch 70*
Greene, Edward D E 1823-1879 *NewYHSD*
Greene, Elmer Westley d1964 *WhoAmA 78N, -80N,*
-82N, -84N
Greene, Elmer Westley, Jr. 1907-1964 *WhAmArt 85*
Greene, Ernest S 1864-1936 *BiDAmAr*
Greene, Ethel Maud 1912- *WhoAmA 73, -76, -78,*
-80, -82, -84
Greene, Fred Stewart 1876-1946 *WhAmArt 85*
Greene, Gertrude *DcWomA*
Greene, Gertrude 1904-1956 *WhoAmA 80N, -82N,*
-84N
Greene, Gertrude 1911-1956 *WhAmArt 85*
Greene, H G *AmArch 70*
Greene, H J *AmArch 70*
Greene, Hamilton 1904- *IIBEAAW, IlrAm E*
Greene, Hamilton 1904-1966 *IlrAm 1880*
Greene, Harold Joseph 1916- *AmArch 70*
Greene, Helen *WhAmArt 85*
Greene, Henry *AntBDN Q*
Greene, Henry F *NewYHSD*
Greene, Henry M 1870-1954 *McGDA*
Greene, Henry Mather 1870-1954 *BnEnAmA,*
ConArch, EncAAr, MacEA, WhoArch
Greene, Herb 1929- *ConArch*
Greene, Herbert M d1931? *BiDAmAr*
Greene, J Barry d1966 *WhoAmA 78N, -80N, -82N,*
-84N
Greene, J Barry 1895-1966 *WhAmArt 85*
Greene, James Allen 1934- *AmArch 70*
Greene, Jennie *WhoAmA 73*
Greene, John d1703 *IllDcG*
Greene, John A *WhoArt 80, -82, -84*
Greene, John B 1832-1856 *ICPEnP A, MacBEP*
Greene, John Holden 1777-1850 *BiDAmAr, MacEA*
Greene, Joseph T 1862-1911 *BiDAmAr*
Greene, Kenneth 1902- *WhAmArt 85*
Greene, Larry C 1945- *AfroAA*
Greene, Lawrence A, Jr. 1933- *AmArch 70*
Greene, LeRoy E 1893- *ArtsAmW 1, IIBEAAW,*
WhAmArt 85
Greene, Lois D 1924- *WhoAmA 78, -80, -82, -84*
Greene, Marion Y 1888- *DcWomA, WhAmArt 85*
Greene, Mary Amory *DcWomA*
Greene, Mary Charlotte 1860- *ClaDrA, DcBrA 1,*
DcWomA
Greene, Mary Charlotte 1860?-1951 *DcBrWA,*
DcVicP 2
Greene, Mary Shepard *DcWomA, WhAmArt 85*
Greene, Michael B 1943- *AfroAA*
Greene, Montgomery Adams 1932- *AmArch 70*
Greene, Mosely *NewYHSD*
Greene, N *DcWomA*
Greene, Mrs. N *NewYHSD*
Greene, Neil Richard 1933- *AmArch 70*
Greene, Patricia Margaret *WhoArt 80, -82, -84*
Greene, Phillip James 1932- *AmArch 70*
Greene, Richard Massy *DcVicP 2*
Greene, Richard Max 1932- *AmArch 70*
Greene, Samuel *FolkA 86*
Greene, Samuel P 1928- *AfroAA*
Greene, Sarah Morris *WhAmArt 85*
Greene, Sarah Morris 1877-1919 *DcWomA*
Greene, Simon 1905- *WhAmArt 85*
Greene, Stanley Norman, Jr. 1949- *MacBEP*
Greene, Stephen *AfroAA, OxTwCA*
Greene, Stephen 1917- *WhAmArt 85*
Greene, Stephen 1918- *AmArt, DcAmArt,*
DcCAA 71, -77, McGDA, WhoAmA 73, -76,
-78, -80, -82, -84
Greene, Theodore R 1919- *WhoAmA 78, -80, -82*
Greene, Vernon VanAtta d1965 *WhoAmA 78N, -80N,*
-82N, -84N
Greene, Vernon VanAtta 1908-1965 *WorECom*
Greene, Walter Farrar, Jr. 1926- *AmArch 70*
Greene, Walter L *WhAmArt 85*
Greene, William C *NewYHSD*
Greene, William H 1865-1937 *MacEA*
Greene And Greene *EncAAr*
Greene-Mercier, Marie Zoe 1911- *WhoAmA 73, -76,*
-78, -80, -82, -84
Greene Of Oxford *DcBrECP*
Greener, Charles T 1870- *WhAmArt 85*
Greener, Charles Theodore 1870-1935 *ArtsAmW 2*
Greener, Charles William 1940- *AmArch 70*
Greener, George Courbright *WhAmArt 85*
Greener, Henry *AntBDN H, DcNiCA*
Greener, J *DcVicP 2*
Greener, Mary Ann *DcWomA*
Greenes, Rhoda 1926-1979 *WhoAmA 80N, -82N,*
-84N
Greenfield, Alec Taylor 1920- *AmArch 70*
Greenfield, Amy 1940- *WhoAmA 84*
Greenfield, Arthur David 1925- *AmArch 70*
Greenfield, E J Forrest 1866- *WhAmArt 85*
Greenfield, E Latham *DcVicP 2*
Greenfield, Mrs. E Latham *DcWomA*
Greenfield, Karl Robert 1932- *AmArch 70*

Greenfield, Mrs. Latham *DcVicP 2*
Greenfield, Richard Scott 1942- *MarqDCG 84*
Greenfield, S 1931- *MarqDCG 84*
Greenfield, Sanford Raymond 1926- *AmArch 70*
Greenfield, Stuart E 1929- *AmArch 70*
Greenfield-Sanders, Timothy 1952- *WhoAmA 82, -84*
Greengard, B C *WhAmArt 85*
Greenham, Peter George 1909- *DcBrA 1*
Greenham, Robert Duckworth *WhoArt 80N*
Greenham, Robert Duckworth 1906- *ClaDrA, DcBrA 1*
Greenham, Robert Duckworth 1906-1976 *DcBrA 2*
Greenhaus, Frank 1923- *AmArch 70*
Greenhead, Miss *DcWomA*
Greenhill, Alexander McDonald 1907- *DcBrA 1*
Greenhill, John 1644?-1676 *OxArt*
Greenhill, M E *DcVicP 2*
Greenhouse, Howard Richard 1925- *AmArch 70*
Greening, Harry Cornell 1876- *WhAmArt 85*
Greening, Harry Cornell 1876-1930? *WorECar*
Greening, Josie A *ArtsEM, DcWomA*
Greening, William P 1924- *AmArch 70*
Greenish, Florence E *DcVicP 2, DcWomA*
Greenland, Miss *DcWomA*
Greenland, N W *FolkA 86*
Greenland, Walter *CabMA*
Greenlaw, Emma V *WhAmArt 85*
Greenleaf, Benjamin 1786-1864 *FolkA 86, NewYHSD*
Greenleaf, Esther *WhoAmA 73, -76, -78, -80, -82, -84*
Greenleaf, Helen 1885- *DcWomA, WhAmArt 85*
Greenleaf, Ida Lynde *WhAmArt 85*
Greenleaf, Jacob I 1887- *WhAmArt 85*
Greenleaf, Jonathan *CabMA*
Greenleaf, Kenneth Lee 1945- *WhoAmA 76, -78, -80, -82, -84*
Greenleaf, Ray d1950 *WhAmArt 85, WhoAmA 78N, -80N, -82N, -84N*
Greenleaf, Richard C 1887- *WhAmArt 85*
Greenleaf, Viola M *WhAmArt 85*
Greenleaf, Virginia *WhoAmA 80, -82, -84*
Greenlee, James Wallace 1933- *MarqDCG 84*
Greenlee, William Ward 1923- *AmArch 70*
Greenlees, Georgina Mossman *DcVicP 2, DcWomA*
Greenlees, Robert 1820-1904 *ClaDrA*
Greenlees, Robert M *DcVicP 2*
Greenless, Kenneth *FolkA 86*
Greenless, Richard Henry 1913- *AmArch 70*
Greenley, Miss *DcBrECP*
Greenley, Howard 1874- *WhAmArt 85*
Greenly, B *DcWomA*
Greenly, B Colin 1928- *MacBEP*
Greenly, Colin 1928- *AmArt, DcCAA 71, -77, WhoAmA 76, -78, -80, -82, -84*
Greenman, Charles A *ArtsEM*
Greenman, Edwin *WhoArt 80, -82, -84*
Greenman, Edwin 1909- *DcBrA 1*
Greenman, Frances Cranmer 1890- *WhAmArt 85*
Greenman, Frances Cranmer 1890-1981 *DcWomA*
Greenman And Dosch *ArtsEM*
Greenough *NewYHSD*
Greenough, Benjamin F *NewYHSD*
Greenough, Beulah *DcWomA*
Greenough, Buhler *WhAmArt 85*
Greenough, Carroll 1863-1941 *BiDAmAr*
Greenough, Mrs. Charles Pelham, III *WhAmArt 85*
Greenough, Cornelia *WhAmArt 85*
Greenough, David Stoddard 1752-1826 *EarABI*
Greenough, David Stoddard 1787-1830 *EarABI*
Greenough, Dorothy Garrison 1904- *WhAmArt 85*
Greenough, E K *WhAmArt 85*
Greenough, G *DcVicP 2*
Greenough, Henry 1807-1883 *BiDAmAr*
Greenough, Horatio 1805-1852 *ArtsNiC, BnEnAmA, DcAmArt, McGDA, NewYHSD, OxArt*
Greenough, J *DcVicP 2*
Greenough, J James *NewYHSD*
Greenough, John 1801-1852 *NewYHSD*
Greenough, Richard S *ArtsNiC*
Greenough, Richard Saltonstall 1819-1904 *BnEnAmA, DcAmArt, NewYHSD, WhAmArt 85*
Greenshields, Robert Victor 1930- *MarqDCG 84*
Greenshields, Thomas 1800?-1845 *BiDBrA*
Greenslade, James Thomas *DcVicP 2*
Greensmith, John Hiram 1932- *WhoArt 82, -84*
Greenspan, George 1900- *WhoAmA 73, -76, -78, -80, -82, -84*
Greenspan, Mrs. George *WhoAmA 76, -78, -80, -82*
Greenspan, Judith L 1953- *MarqDCG 84*
Greenspun, Regina Ruth 1934- *WhoAmA 80, -82, -84*
Greenstein, Benjamin 1901- *WhAmArt 85*
Greenstein, Ilise 1928- *WhoAmA 84*
Greenstein, L *AmArch 70*
Greenstein, Ronni Bogaev *WhoAmA 78, -80*
Greenstein, S Robert 1924- *AmArch 70*
Greenstone, Marion 1925- *WhoAmA 84*
Greenup, J d1946? *DcBrA 1*
Greenup, Joseph d1946? *DcBrA 2*
Greenwald *NewYHSD*

Greenwald, Alice 1952- *WhoAmA 78, -80, -82, -84*
Greenwald, Charles D *WhoAmA 78, -80*
Greenwald, Charles D 1908- *WhoAmA 73, -76*
Greenwald, Dorothy Kirstein *WhoAmA 78, -80*
Greenwald, Dorothy Kirstein 1917- *WhoAmA 73, -76*
Greenwald, John W 1812?-1865 *FolkA 86*
Greenwald, Leslie J *AmArch 70*
Greenwald, Pat *WhoAmA 82, -84*
Greenwald, Sheila 1934- *IlsBYP, IlsCB 1957*
Greenwald, Sheila Ellen 1934- *WhoAmA 78, -80, -82, -84*
Greenwalt, John *NewYHSD*
Greenwalt, Maria B *FolkA 86*
Greenway, Francis 1777?-1837 *MacEA*
Greenway, Francis Howard 1777-1837 *BiDBrA, DcD&D, OxArt, WhoArch*
Greenway, Henry *AntBDN Q*
Greenway, Olive *OxArt*
Greenway, Thomas *BiDBrA*
Greenwood *NewYHSD*
Greenwood, B F, Jr. *AmArch 70*
Greenwood, Beatrice *DcVicP 2*
Greenwood, Charlotte *DcWomA*
Greenwood, Colin H *DcVicP 2*
Greenwood, Cora 1872- *WhAmArt 85*
Greenwood, Eileen Constance 1915- *DcBrA 1*
Greenwood, Ernest 1913- *DcBrA 1, WhoArt 80, -82, -84*
Greenwood, Ethan Allan 1779-1856 *FolkA 86*
Greenwood, Ethan Allen 1779-1856 *NewYHSD*
Greenwood, F *DcVicP 2*
Greenwood, Frans 1680-1761 *AntBDN H, IlDcG, OxDecA*
Greenwood, George Arthur 1915- *WhAmArt 85*
Greenwood, George Parker *DcSeaP*
Greenwood, Grace 1905- *WhAmArt 85*
Greenwood, Ida *ArtsEM, DcWomA*
Greenwood, Isabella *DcVicP 2, DcWomA*
Greenwood, John 1727-1792 *BnEnAmA, DcAmArt, DcBrECP, DcBrWA, FolkA 86, McGDA, NewYHSD*
Greenwood, John Frederic 1885-1954 *DcBrA 1*
Greenwood, Joseph H 1857-1927 *WhAmArt 85*
Greenwood, Laura M 1897- *DcWomA, WhAmArt 85*
Greenwood, Marion 1909-1970 *WhAmArt 85, WhoAmA 78N, -80N, -82N, -84N*
Greenwood, Mary Fitch 1886- *DcWomA*
Greenwood, Orlando *DcBrA 1*
Greenwood, Paul Anthony 1921- *WhoAmA 73, -76, -78*
Greenwood, Philip John 1943- *WhoArt 84*
Greenwood, Sydney 1913- *DcBrA 1, WhoArt 80, -82, -84*
Greenwood, Ted 1930- *IlsCB 1967*
Greenwood, William James 1944- *WhoAmA 76, -78*
Greenwood, William Russell 1906- *WhAmArt 85*
Greer, A D 1904- *AmArt*
Greer, Blanche 1883- *WhAmArt 85*
Greer, Blanche 1884- *DcWomA*
Greer, D H *AmArch 70*
Greer, Dupuy *WhAmArt 85*
Greer, Exell *FolkA 86*
Greer, F L, II *AmArch 70*
Greer, James *FolkA 86*
Greer, James E *IlBEAAW*
Greer, Jefferson E 1905- *IlBEAAW, WhAmArt 85*
Greer, John Only 1933- *AmArch 70*
Greer, John Sydney 1944- *WhoAmA 78, -80, -82, -84*
Greer, Joseph Epps 1923- *AmArch 70*
Greer, R *FolkA 86*
Greer, Walter 1920- *WhoAmA 82, -84*
Greer, Walter Marion 1920- *WhoAmA 73, -76, -78, -80*
Greeven, Alton E 1907- *AmArch 70*
Greff, Marguerite *DcWomA*
Greg *WorECom*
Greg, Barbara 1900- *DcBrA 1, WhoArt 80, -82, -84*
Greg, Margaret *DcBrA 2*
Gregan, John Edgar 1813-1865 *DcBrWA*
Greger, Karl 1923- *MarqDCG 84*
Gregersen, Julius 1860-1935 *DcSeaP*
Gregg *EncASM*
Gregg, A W *WhAmArt 85*
Gregg, Frederick James 1865-1928 *WhAmArt 85*
Gregg, G *DcWomA*
Gregg, Glenn Hudson 1941- *AmArch 70*
Gregg, J *DcBrECP*
Gregg, Mrs. Kenneth *WhAmArt 85*
Gregg, Kenneth Roger 1913- *WhAmArt 85*
Gregg, L B *AmArch 70*
Gregg, Laicita Warburton *DcWomA*
Gregg, Lewis C 1880- *WhAmArt 85*
Gregg, Paul 1876-1949 *ArtsAmW 1, -2*
Gregg, Raymond Edward *WhAmArt 85*
Gregg, Richard Nelson 1926- *WhoAmA 73, -76, -78, -80, -82, -84*
Gregg, Samuel *CabMA*
Gregg, Thomas Henry *DcVicP 2*
Gregoire, Alice d1903 *DcWomA*
Gregoire, Blanche *DcWomA*
Gregoire, Paul Norman 1926- *AmArch 70*

Gregor, Albert 1937- *AmArch 70*
Gregor, Harold Laurence 1929- *AmArt, WhoAmA 76, -78, -80, -82, -84*
Gregor, Helen Frances 1921- *WhoAmA 73, -76, -78, -80, -82, -84*
Gregor, Helen Francis *DcCAr 81*
Gregorcic, Eka 1948- *DcCAr 81*
Gregorcic, Milena 1953- *DcCAr 81*
Gregorini, Domenico 1690?-1777 *MacEA*
Gregorio DiCecco DiLuca 1389-1423 *McGDA*
Gregoropoulos, John 1921- *WhoAmA 73, -76, -78, -80, -82, -84*
Gregorovius, Gertrud *DcWomA*
Gregory Of Nazianzus, Saint 329-389 *McGDA*
Gregory I, The Great, Saint 540?-604 *McGDA*
Gregory, Angela 1903- *WhAmArt 85, WhoAmA 73, -76, -78, -80, -82, -84*
Gregory, Anne 1939- *WhoAmA 84*
Gregory, Anne L *WhAmArt 85*
Gregory, Anne Louise *DcWomA*
Gregory, Arthur Victor 1869-1957 *DcSeaP*
Gregory, Bessie Denton 1893- *DcBrA 1, DcWomA*
Gregory, Bruce 1917- *WhoAmA 76, -78, -80, -82, -84*
Gregory, C *ArtsEM*
Gregory, C A *AmArch 70*
Gregory, Charles *ClaDrA, DcVicP*
Gregory, Charles 1810-1896 *DcBrWA, DcVicP 2*
Gregory, Charles 1849-1920 *DcBrBI, DcBrWA*
Gregory, Charles 1850-1920 *DcBrA 1, DcVicP 2*
Gregory, Charles Dickson 1850- *DcSeaP*
Gregory, Christine *DcBrA 1, DcWomA*
Gregory, Daniel *ConArch A*
Gregory, Dorothy Lake 1893- *DcWomA, WhAmArt 85*
Gregory, Edith M *DcVicP 2*
Gregory, Edward John 1850-1909 *ClaDrA, DcBrA 1, DcBrBI, DcBrWA, DcVicP, -2*
Gregory, Eleanor Anne 1939- *WhoAmA 82, -84*
Gregory, Eliot *NewYHSD*
Gregory, Eliot 1854-1915 *WhAmArt 85*
Gregory, Ellna Kay 1943- *WhoAmA 80, -82, -84*
Gregory, Elsie *DcWomA*
Gregory, F L *EncASM*
Gregory, George 1849-1938 *DcBrWA, DcVicP 2*
Gregory, George F 1815-1885 *DcSeaP*
Gregory, Grady P, Jr. 1930- *AmArch 70*
Gregory, Helen Barber *DcWomA, WhAmArt 85*
Gregory, Ina *DcWomA*
Gregory, J *AmArch 70, DcVicP 2, DcWomA*
Gregory, Jack Gordon 1957- *MarqDCG 84*
Gregory, Joan 1930- *WhoAmA 73, -76, -78, -80, -82, -84*
Gregory, John 1879-1958 *WhAmArt 85, WhoAmA 80N, -82N, -84N*
Gregory, John Worthington 1903- *WhAmArt 85*
Gregory, Katharine V R 1897- *WhAmArt 85*
Gregory, Katherine 1897- *DcWomA*
Gregory, Larry 1943- *MacBEP*
Gregory, Mrs. Lovrien Price *WhAmArt 85*
Gregory, Malcolm 1934- *WhoArt 80, -82, -84*
Gregory, Margaret *DcBrBI*
Gregory, Mary *AntBDN H*
Gregory, Mary F *DcVicP 2, DcWomA*
Gregory, Mary Frances *DcWomA*
Gregory, Peter Ronald 1947- *IlsCB 1967*
Gregory, Quinten *OfPGCP 86*
Gregory, Ralph Carr 1937- *AmArch 70*
Gregory, Thomas Lawton, Jr. 1939- *AmArch 70*
Gregory, Waylande 1905-1971 *WhAmArt 85, WhoAmA 78N, -80N, -82N, -84N*
Gregory, Waylande DeSantis 1905-1971 *CenC*
Gregory, William *DcSeaP*
Gregory, William C *NewYHSD*
Gregory, William S 1865-1949 *BiDAmAr*
Gregory Brothers *FolkA 86*
Gregotti, Vittorio 1927- *ConArch, ConDes*
Gregson, James *NewYHSD*
Gregson, John *NewYHSD*
Gregson, Marie E 1888- *WhAmArt 85*
Gregson, Marie Evangeline 1888- *DcWomA*
Gregson, Sally 1939- *DcCAr 81*
Greguss, Gizella *DcWomA*
Grehan, Farrell 1926- *ICPEnP A*
Greif, Alfred, Jr. 1921- *AmArch 70*
Greife, R P *AmArch 70*
Greiffenhagen, Maurice *WhAmArt 85*
Greiffenhagen, Maurice 1862-1931 *DcBrBI*
Greiffenhagen, Maurice William 1862-1931 *ClaDrA, DcBrA 1, DcVicP, -2*
Greig *FolkA 86*
Greig, Donald 1916- *WhoArt 84*
Greig, Doreen *ConArch A*
Greig, E S *DcVicP 2*
Greig, George M d1867 *DcBrWA, DcVicP 2*
Greig, James 1861-1941 *DcBrA 1, DcBrBI, DcVicP 2*
Greig, John *DcBrBI, DcBrWA*
Greig, John Russell 1870- *DcBrA 1, DcVicP 2*
Greig, M A *DcWomA*
Greig, Rita *WhoArt 84*

Griffin, Rachael S d1983 *WhoAmA 84N*
Griffin, Raymond Watson 1937- *AmArch 70*
Griffin, Richard J 1929- *AmArch 70*
Griffin, Robert *CabMA*
Griffin, Ron 1938- *AfroAA*
Griffin, Sydney B *ArtsEM*
Griffin, Sydney B 1854-1910? *WorECar*
Griffin, Thomas B *WhAmArt 85*
Griffin, V Murray 1903- *DcCAr 81*
Griffin, W Abbott *WhAmArt 85*
Griffin, Walter 1861-1935 *ArtsAmW 3, WhAmArt 85*
Griffin, Walter Burley d1937 *BiDAmAr*
Griffin, Walter Burley 1876-1937 *ConArch, MacEA, OxArt, WhoArch*
Griffin, Wesley A *WhAmArt 85*
Griffin, Will W 1901- *AmArch 70*
Griffin, William *DcSeaP, DcVicP 2*
Griffin, William 1751-1772 *DcBrECP*
Griffin, William Barwick 1917- *AmArch 70*
Griffin, William Francis 1921- *AmArch 70*
Griffin, Worth D 1892- *WhAmArt 85*
Griffin, Worth Dickman 1892- *ArtsAmW 2*
Griffing, Martin *FolkA 86*
Griffing, Martin 1784-1859 *NewYHSD*
Griffing, Robert Perkins, Jr. 1914- *WhoArt 80, -82, -84*
Griffing, S R *AmArch 70*
Griffing, Tracy Arlington 1890- *WhAmArt 85*
Griffini, Enrico Agostino 1887-1952 *MacEA*
Griffith, Agnes *DcVicP 2*
Griffith, Armand Harold 1860-1930 *ArtsAmW 3, ArtsEM*
Griffith, Armond Harrold 1859-1930 *WhAmArt 85*
Griffith, Beatrice Fox 1890- *DcWomA*
Griffith, Cecil Troyte 1928- *AmArch 70*
Griffith, Cecilia Beatrice Bickerton Fox 1890- *WhAmArt 85*
Griffith, Charles Walker 1909- *AmArch 70*
Griffith, Conway d1924 *WhAmArt 85*
Griffith, Conway 1863-1924 *ArtsAmW 2*
Griffith, David, Jr. 1949- *MarqDCG 84*
Griffith, Don 1905- *WhAmArt 85*
Griffith, Edward N *WhAmArt 85*
Griffith, Ella N *DcWomA*
Griffith, Emily *DcWomA*
Griffith, F I *AmArch 70*
Griffith, Frank *DcBrA 2*
Griffith, Gerald Irving 1909- *AmArch 70*
Griffith, H Russell 1947- *MarqDCG 84*
Griffith, Helene *DcWomA*
Griffith, Howard Asa, Jr. 1909- *AmArch 70*
Griffith, James *NewYHSD*
Griffith, James 1761-1821 *BiDBrA*
Griffith, James Raymond 1937- *MarqDCG 84*
Griffith, Jarrett Friesth 1939- *AmArch 70*
Griffith, John William 1790?-1855 *BiDBrA*
Griffith, Josia *NewYHSD*
Griffith, Julia S d1945 *WhAmArt 85*
Griffith, Kate *DcVicP 2, DcWomA*
Griffith, Lillian 1889- *ArtsAmW 2, DcWomA*
Griffith, Lillian Bonita 1889- *WhAmArt 85*
Griffith, Lillian E A 1877- *DcBrA 1*
Griffith, Lillian E A 1877-1967? *DcWomA*
Griffith, Louis Oscar 1875-1956 *ArtsAmW 2, IlBEAAW, WhAmArt 85, WhoAmA 80N, -82N, -84N*
Griffith, M *DcVicP 2*
Griffith, M A *WhAmArt 85*
Griffith, Marie Henrietta *DcWomA*
Griffith, Marie Osthaus *WhAmArt 85*
Griffith, Mary *DcVicP 2*
Griffith, Moses 1747-1819 *DcBrECP, DcBrWA*
Griffith, Moses 1749-1809? *BkIE*
Griffith, O K *AmArch 70*
Griffith, R R *AmArch 70*
Griffith, Raymond S 1924- *AmArch 70*
Griffith, Reginald Wilbert 1930- *AmArch 70*
Griffith, Rosa B 1867-1927 *WhAmArt 85*
Griffith, Rosa B 1868-1927 *DcWomA*
Griffith, Stanford Friests 1940- *AmArch 70*
Griffith, Stanford Wells 1915- *AmArch 70*
Griffith, Thomas *FolkA 86*
Griffith, Vera Alice 1906- *WhAmArt 85*
Griffith, Verlyn Edward 1923- *AmArch 70*
Griffith, W A 1866- *WhAmArt 85*
Griffith, William *DcVicP 2, FolkA 86*
Griffith, William Alexander 1866-1940 *ArtsAmW 1, -3*
Griffith Brothers *FolkA 86*
Griffiths, Arthur *DcVicP 2*
Griffiths, Elsa Churchill *DcWomA, WhAmArt 85*
Griffiths, Eugene Arvon 1917- *AmArch 70*
Griffiths, Gwenny 1867- *ClaDrA, DcBrA 1, DcVicP 2, DcWomA*
Griffiths, Hugh 1916- *DcBrA 1*
Griffiths, J *BiDBrA*
Griffiths, Jennifer *DcCAr 81*
Griffiths, Jennifer 1950- *MacBEP*
Griffiths, John *DcBrECP*
Griffiths, John 1837-1918 *DcBrWA, DcVicP 2*

Griffiths, John 1838-1918 *DcBrA 2*
Griffiths, Katherine M *WhAmArt 85*
Griffiths, Philip Jones *ConPhot*
Griffiths, R E *AmArch 70*
Griffiths, Tom *ClaDrA, DcBrBI, DcVicP 2, WhoArt 80, -82, -84*
Griffiths, Mrs. W *WhAmArt 85*
Griffiths, W T *DcVicP 2*
Grigalis, Zigurds 1934- *AmArch 70*
Grigaut, Paul L d1969 *WhoAmA 78N, -80N, -82N, -84N*
Griger, Mary J *WhAmArt 85*
Grigg, F R *DcVicP 2*
Grigg, Joanna S *ArtsAmW 2, -3, DcWomA, WhAmArt 85*
Grigg, Mabel 1885-1969 *DcWomA*
Grigg, Milton LaTour 1905- *AmArch 70*
Grigg, Thomas, Jr. *CabMA*
Grigg, Thomas, Sr. *CabMA*
Griggs *NewYHSD*
Griggs, F H *AmArch 70*
Griggs, Fanny 1852- *ArtsEM, DcWomA*
Griggs, Frederick Landseer Maur 1876-1938 *ClaDrA, DcBrA 1, DcBrBI, DcBrWA*
Griggs, J, III *AmArch 70*
Griggs, Joseph O C 1932- *AmArch 70*
Griggs, Maitland Lee 1902- *WhoAmA 73, -76, -78, -80, -82, -84*
Griggs, Martha E *DcWomA, WhAmArt 85*
Griggs, Samuel W d1898 *NewYHSD , WhAmArt 85*
Griggs, Thomas, Jr. *CabMA*
Griggs, Thomas, Sr. *CabMA*
Grignani, Franco 1908- *ConArt 77, ConDes, ConPhot, ICPEnP A, WhoGrA 62, -82[port]*
Grignion, Charles 1721-1810 *BkIE*
Grignion, Charles 1752-1804 *DcBrECP*
Grignola, John *WhAmArt 85*
Grignon, V J *DcWomA*
Grigoletti, Michel-Ange 1801- *ArtsNiC*
Grigor, Margaret C *WhAmArt 85*
Grigor, Margaret Christian 1912- *WhoAmA 73, -76, -78, -80*
Grigor, Margaret Christian 1912-1981 *WhoAmA 82N, -84N*
Grigoriadis, Mary 1942- *WhoAmA 76, -78, -80, -82, -84*
Grigsby, J Eugene, Jr. 1918- *AfroAA*
Grigsby, Jefferson Eugene, Jr. 1918- *WhoAmA 76, -78, -80, -82, -84*
Grigsby, John Higham 1940- *WhoArt 80, -82, -84*
Grigware, Edward T 1889- *ArtsAmW 1*
Grigware, Edward T 1889-1960 *IlBEAAW, WhAmArt 85*
Grigware, Edward Thomas 1889-1960 *ArtsAmW 3*
Grijn, Erik Adriaan VanDer 1941- *DcCAr 81*
Grill, Lovisa Augusta *DcWomA*
Grillandaio, Domenico *McGDA*
Grillet, Michel 1956- *DcCAr 81*
Grilley, Robert L 1920- *WhoAmA 73, -76*
Grilli-Rossi, Anna *DcWomA*
Grillias, Savage Alves *AmArch 70*
Grillias, Sotiros Peter 1926- *AmArch 70*
Grillo, John 1917- *DcCAA 71, -77, PrintW 83, -85, WhoAmA 73, -76, -78*
Grillo, S *AmArch 70*
Grillot, Alice 1877-1969 *DcWomA*
Grilo, Sarah 1920- *McGDA*
Grilo, Sarah 1921- *OxTwCA*
Grim, Belle T *DcWomA*
Grim, Florence M *DcWomA*
Grim, George William 1926- *AmArch 70*
Grim, T *FolkA 86*
Grimaldi, Argenta Louisa 1884- *DcBrA 2*
Grimaldi, Francesco 1545-1630? *McGDA*
Grimaldi, Frank 1924- *AmArch 70*
Grimaldi, Giovanni Francesco 1543-1613? *MacEA*
Grimaldi, Giovanni Francesco 1606-1680 *ClaDrA, McGDA, OxArt*
Grimaldi, John Edward 1938- *MarqDCG 84*
Grimaldi, John J 1914- *AmArch 70*
Grimaldi, Count Stanislav *AntBDN C*
Grimaldi, William, Marquis 1751-1830 *AntBDN J*
Grimaldi, William N 1957- *MarqDCG 84*
Grimaud, Josephine 1826-1875 *DcWomA*
Grimaud, Marguerite *DcWomA*
Grimault, Paul 1905- *WorECar*
Grimbaldeston, Walter d1738? *DcBrECP*
Grimball, H G *AmArch 70*
Grimbert, Marguerite *DcWomA*
Grime, Marie Salome *DcWomA*
Grimelund, Johannes Martin 1842- *DcSeaP*
Grimer, Abel 1573-1618? *ClaDrA*
Grimer, Jakob 1526-1590? *ClaDrA*
Grimes, C H *AmArch 70*
Grimes, Florence F *DcWomA*
Grimes, Frances d1963 *WhoAmA 78N, -80N, -82N, -84N*
Grimes, Frances 1869-1963 *DcWomA*
Grimes, Frances Taft 1869-1963 *WhAmArt 85*
Grimes, G M *AmArch 70*
Grimes, Jack D *MarqDCG 84*

Grimes, John *FolkA 86*
Grimes, John C 1804-1837 *NewYHSD*
Grimes, Leslie d1968 *FolkA 86*
Grimes, Margaret W *WhoAmA 84*
Grimes, Mary Hearn *WhAmArt 85*
Grimes, William *FolkA 86*
Grimley, Oliver Fetterolf 1920- *WhoAmA 73, -76, -78, -80, -82, -84*
Grimm, Clyde Edward 1922- *AmArch 70*
Grimm, Constantine Von *DcBrBI*
Grimm, Curt *FolkA 86*
Grimm, Floyd H *WhAmArt 85*
Grimm, J P P *NewYHSD*
Grimm, Lucille Davis 1929- *AmArt, WhoAmA 82, -84*
Grimm, Ludwig Emil 1790-1863 *McGDA*
Grimm, Luise Dorothea Elisabeth 1805-1850? *DcWomA*
Grimm, Paul *IlBEAAW*
Grimm, Paul 1892-1974 *ArtsAmW 3*
Grimm, Peter 1832-1914 *FolkA 86*
Grimm, Raymond Max 1924- *WhoAmA 80, -82, -84*
Grimm, Rudi Friedrich Wilhelm 1947- *MarqDCG 84*
Grimm, Samuel Hieronymus 1733-1794 *BkIE, DcBrECP, DcBrWA, OxArt*
Grimm, Stanley A 1891- *ClaDrA*
Grimm, Stanley A 1891-1966 *DcBrA 1*
Grimmer, Abel 1570?-1619? *OxArt*
Grimmer, Abel 1573-1618? *ClaDrA*
Grimmer, Abel 1573?-1619? *McGDA*
Grimmer, Jacob 1526?-1590 *McGDA, OxArt*
Grimmer, Vernon *WhAmArt 85*
Grimmond, William *DcVicP 2*
Grimmond, William 1884- *DcBrA 1*
Grimmons, Charles *NewYHSD*
Grimms, Howard Allen 1924- *AmArch 70*
Grimond, Marcel-Antoine 1894-1961 *PhDcTCA 77*
Grimou, Alexis 1678-1733 *McGDA*
Grimshaw, Arthur 1868-1913 *DcBrA 1, DcVicP, -2*
Grimshaw, Atkinson *DcVicP 2*
Grimshaw, Eva M *DcVicP 2*
Grimshaw, Gladys *WhoArt 80, -82, -84*
Grimshaw, John Atkinson 1836-1893 *ClaDrA, DcBrWA, DcVicP, -2*
Grimshaw, John Oliver 1910- *AmArch 70*
Grimshaw, Louis H 1870-1943? *DcBrA 1, DcVicP, -2*
Grimshaw, Reginald 1910- *DcBrA 1, WhoArt 80, -82, -84*
Grimshaw, W H Murphy *DcVicP 2*
Grimshawe, Thomas *DcVicP 2*
Grimsich, Daniel Albert 1931- *AmArch 70*
Grimson, Malvina *DcWomA*
Grimson, Mrs. Samuel *WhAmArt 85*
Grimston, Lady Katherine d1874 *DcBrWA*
Grimstone, Edward *DcVicP 2*
Grimstone, Mary *DcVicP 2*
Grimwood, Brian *DcCAr 81*
Grinager, Alexander d1949 *WhoAmA 78N, -80N, -82N, -84N*
Grinager, Alexander 1865-1949 *WhAmArt 85*
Grincourt, Zelie *DcWomA*
Grindling, Alice G *DcVicP 2*
Grindstaff, William *FolkA 86*
Grineau, Bryan De 1883-1957 *DcBrA 2*
Griner, Ned H 1928- *WhoAmA 73, -76, -78, -80, -82, -84*
Gringoire, Pierrette *DcWomA*
Grinling, Alice G *DcWomA*
Grinling, Anthony Gibbons *WhoArt 84N*
Grinling, Antony Gibbons 1896- *DcBrA 1, WhoArt 80, -82*
Grinnell, Alexander 1935- *AmArch 70*
Grinnell, Frank J *ArtsEM*
Grinnell, G Victor *WhAmArt 85*
Grinnell, Mrs. L G *WhAmArt 85*
Grinnell, Max *NewYHSD*
Grinnett, Max *NewYHSD*
Grinnis, Charles *NewYHSD*
Grinniss, Charles *FolkA 86*
Grinsfelder, A R *AmArch 70*
Grinstead, John *WhoArt 80, -82, -84*
Grinstein, Georges G 1946- *MarqDCG 84*
Grinway, Francis Howard *BiDBrA*
Grip *DcBrBI*
Gripe, Harald *IlsCB 1967*
Gripon, Paul, Madame *WhAmArt 85*
Grippe, Florence 1912- *WhoAmA 73, -76, -78, -80, -82, -84*
Grippe, Peter 1912- *DcCAA 71, -77, PhDcTCA 77, WhAmArt 85, WhoAmA 84*
Grippe, Peter J 1912- *WhoAmA 73, -76, -78, -80, -82*
Grippen, A W *NewYHSD*
Grippi, Salvatore 1921- *AmArt*
Grippi, Salvatore William 1921- *WhoAmA 73, -76, -78, -80, -82, -84*
Grippo, Victor 1936- *ConArt 77, -83*
Gris, Jose Victoriano Gonzales 1887-1927 *ClaDrA*
Gris, Juan *WorECar*
Gris, Juan 1887-1927 *ConArt 77, -83, McGDA, OxArt, OxTwCA, PhDcTCA 77*
Griscom, Lloyd C 1872- *WhAmArt 85*

Grunewald, Eleanor Mavis 1931- *WhoArt 80, -82, -84*
Grunewald, Gustav 1805- *ArtsNiC*
Grunewald, Gustavus 1805-1878 *NewYHSD*
Grunewald, Isaac 1889-1946 *McGDA, OxTwCA, PhDcTCA 77*
Grunewald, John W *FolkA 86*
Grunewald, Mathias 1460?-1528 *OxArt*
Grunewald, Mathias 1470?-1528 *McGDA*
Grunewald, Sigrid *DcWomA*
Grunig, Joseph Calvin 1923- *AmArch 70*
Grunsfeld, Ernest Alton, III 1929- *AmArch 70*
Grunsfeld, Ernest Alton, Jr. 1897- *AmArch 70*
Grunsky, Carl Ewald 1855-1934 *ArtsAmW 1*
Grunvald, Samuel 1893- *WhAmArt 85*
Grunwald, G O *AmArch 70*
Grunwald, Helen Mary *WhoArt 84*
Grunwald, Helen Mary 1925- *WhoArt 80, -82*
Grunwald, Joseph Achim 1915- *MarqDCG 84*
Grunwald, Margarete 1864- *DcWomA*
Gruny, Suzanne 1880- *DcWomA*
Grupello, Gabriel 1644-1730 *McGDA*
Grupp, Carl Alf 1939- *WhoAmA 76, -78, -80, -82, -84*
Gruppe, C P 1860-1940 *WhAmArt 85*
Gruppe, Charles 1928- *WhoAmA 73, -76, -78, -80, -82, -84*
Gruppe, Emil Albert 1896-1978 *WhoAmA 80N, -82N, -84N*
Gruppe, Emile Albert 1896- *WhAmArt 85, WhoAmA 76, -78*
Gruppe, Karl H 1893- *WhAmArt 85*
Gruppe, Karl Heinrich 1893- *WhoAmA 73, -76, -78, -80, -82*
Gruppe, Karl Heinrich 1893-1982 *WhoAmA 84N*
Gruppe, Virginia Helena 1907- *WhAmArt 85*
Grushkin, Philip 1921- *WhoAmA 73, -76, -78, -80, -82, -84*
Gruskin, Mary Josephine *WhoAmA 73, -76, -78, -80, -82, -84*
Grutsch, L P *AmArch 70*
Gruttner, Rudolf 1933- *WhoGrA 82[port]*
Grutzke, Johannes 1937- *ConArt 77, -83, DcCAr 81*
Gruver, William A 1941- *MarqDCG 84*
Gruyaert, Harry 1941- *ICPEnP A*
Gruyer, Eugenie Claire 1837- *DcWomA*
Gruyer-Cailleaux, Marie *DcWomA*
Gruyer-Herbemont, Gabrielle 1875- *DcWomA*
Gruyere, Theodore-Charles 1813- *ArtsNiC*
Gruys, F *AmArch 70*
Gruyter, Jacob De *DcSeaP*
Gruyter, Willem, Jr. 1817-1880 *DcSeaP*
Gruzen, B Sumner 1903- *AmArch 70*
Gruzen, Barnett 1903-1974 *ConArch*
Gruzen, Benjamin Macson 1910- *AmArch 70*
Gruzen, J L *AmArch 70*
Gruzewska, Z Antoinette *DcWomA*
Grygar, Milan 1926- *WhoGrA 82[port]*
Grygotis, P M *AmArch 70*
Grygutis, Barbara 1946- *WhoAmA 76, -78, -80, -82, -84*
Grylls, Cecil *ArtsEM*
Grylls, Cecil 1864?-1958 *DcWomA*
Grylls, H J Maxwell 1865-1942 *BiDAmAr*
Grylls, Mary *DcBrA 1, DcWomA*
Grypa, Martha N 1954- *MarqDCG 84*
Gschwindt, Robert *NewYHSD*
Gsell, Dorothea Maria Henrietta *DcWomA*
Guaccero, I Vincent *WhAmArt 85*
Guadagnini, Giovanni Battista *AntBDN K*
Guadagnini, Lorenzo *AntBDN K*
Guadagnoli, Nello T 1929- *WhoAmA 78, -80, -82, -84*
Guadet, Julien 1834-1908 *MacEA*
Guadlupe, Maria De *DcWomA*
Guaita, Maria Anna Franziska Von 1825-1855 *DcWomA*
Gualdi, Antonio *NewYHSD*
Gualtieri DiGiovanni DaPisa *McGDA*
Gualtieri, Joseph P 1916- *WhoAmA 78, -80, -82, -84*
Gualtieri, Joseph Peter 1916- *WhAmArt 85*
Guaragno, John P 1959- *MarqDCG 84*
Guarana, Jacopo 1727-1808 *McGDA*
Guarana, Vincenzo 1753-1815 *McGDA*
Guard, Shirley R *WhAmArt 85*
Guardi, Francesco 1712-1793 *ClaDrA, McGDA, OxArt*
Guardi, Giacomo 1678-1716 *OxArt*
Guardi, Giacomo 1764-1835 *McGDA*
Guardi, Gian-Antonio 1699-1760 *OxArt*
Guardi, Gianantonio 1699-1760 *McGDA*
Guardia, Marguerite *DcWomA*
Guardineer, Frederic 1913- *WorECom*
Guareschi, Giovanni 1908-1968 *WorECar*
Guarienti-Gazzola, Countess Massimiliana *DcWomA*
Guariento 1338-1370? *McGDA*
Guarina, Salvatore Anthony 1883- *WhAmArt 85*
Guarini, Guarino 1624-1683 *DcD&D, MacEA, McGDA, OxArt, WhoArch*
Guarino, J *AmArch 70*
Guarlotti-Rossi, Serafina *DcWomA*

Guarnera, Aldo 1937- *DcCAr 81*
Guarnerio, Pietro *ArtsNiC*
Guarnerius, Andreas 1626?-1698 *AntBDN K*
Guarraia, Joseph Anthony 1911- *AmArch 70*
Guarrera, John *MarqDCG 84*
Guas, Juan *McGDA*
Guas, Juan d1496 *OxArt, WhoArch*
Guas, Juan 1433?-1496 *MacEA*
Guasco DiSolero, Cristina d1812 *DcWomA*
Guaspre, Le *McGDA*
Guastavino Y Esposito, Rafael 1872-1950 *MacEA*
Guastavino Y Moreno, Rafael 1842-1908 *MacEA*
Guastella, C Dennis 1947- *WhoAmA 82, -84*
Guatala, Louis *NewYHSD*
Guay, Gabriel *ArtsNiC*
Guay, Nancy Allen 1945- *WhoAmA 84*
Guay, Raymond Gilbert 1922- *AmArch 70*
Guay, Roger Raymond 1929- *AmArch 70*
Guayasamin, Oswaldo 1919- *OxTwCA*
Guayasamin Calero, Oswaldo 1919- *McGDA*
Guba, S R *AmArch 70*
Gubbins, Henrietta *DcWomA*
Guberman, Sidney Thomas 1936- *WhoAmA 76, -82, -84*
Gubler, Max 1898- *PhDcTCA 77*
Gubler, Max Paul 1898-1971 *OxTwCA*
Gucci *WorFshn*
Gucci, Aldo 1907- *FairDF ITA[port]*
Guck, Edna 1904- *WhAmArt 85*
Guckenheimer, Sam 1956- *MarqDCG 84*
Guda Of Schwarzenthann *DcWomA*
Guda, Neil William 1934- *AmArch 70*
Gudac, Vlado 1951- *DcCAr 81*
Gudaitis, Pranas 1948- *ICPEnP A*
Gude, Hans 1825-1903 *McGDA*
Gude, Hans Frederic *ArtsNiC*
Gude, Hans Frederick 1825-1903 *DcSeaP*
Gude, Hans Fredrik 1825-1903 *ClaDrA*
Gudebrod, Charles A *WhAmArt 85*
Gudebrod, Louis A 1872- *WhAmArt 85*
Guder, Ada 1857- *DcWomA*
Guderna, Ladislav 1921- *PhDcTCA 77, WhoAmA 76, -78, -80, -82, -84*
Gudgell, Henry *AfroAA, FolkA 86*
Gudgeon, Ralston *DcBrA 1*
Gudin, Herminie *DcWomA*
Gudin, Jacques Jerome *AntBDN D*
Gudin, Jean-Antoine-Theodore 1802-1880 *ArtsNiC*
Gudin, Jean Antoine Theodore 1802-1880 *ClaDrA*
Gudin, Baron Jean Antoine Theodore 1802-1880 *DcSeaP*
Gudmundsson, Gudmunder *DcCAr 81*
Gudmundsson, Sigurdur 1942- *DcCAr 81*
Gudnason, Svavar 1909- *OxTwCA, PhDcTCA 77*
Gudy, Ernest *FolkA 86*
Gue, Mademoiselle *DcWomA*
Gue, D J 1836-1917 *WhAmArt 85*
Gue, David John 1836-1917 *NewYHSD*
Gue-Bourelly, Odile 1885- *DcWomA*
Guedes, Amancio 1925- *ConArch, MacEA*
Guedes, Joaquim 1932- *ConArch*
Gueldry, Ferdinand Joseph 1858- *ClaDrA*
Guelpa, Jean B *NewYHSD*
Guenard, H *NewYHSD*
Guener, Mademoiselle De *DcWomA*
Guenez, Berthe *DcWomA*
Guenez, Clotilde 1848- *DcWomA*
Guenot, Marie Claudine Felicie 1812- *DcWomA*
Guenther, B W *AmArch 70*
Guenther, Carl Frederic 1909- *AmArch 70*
Guenther, Felix 1843-1928 *WhAmArt 85*
Guenther, Lambert *WhAmArt 85*
Guenther, Pearl Harder 1882- *ArtsAmW 1, DcWomA*
Guenther, Peter W 1920- *WhoAmA 78, -80, -82, -84*
Guenther, Stephen M *DcCAr 81*
Guenther, Sue Cory 1875-1948 *DcWomA*
Guenther, Sue Cory 1875-1955? *WhAmArt 85*
Guenther, Werner 1915- *AmArch 70*
Guepiere, Philippe DeLa 1715-1773 *McGDA*
Guerard, Eugene Charles Francois 1821-1866 *DcBrBI*
Guerard, Eugene Von 1814- *ArtsNiC*
Guerard, Eugenie *DcWomA*
Guerard, Eva *DcWomA*
Guerard, Henri Charles 1846-1897 *ClaDrA*
Guerard, Jeanne *DcWomA*
Guerard, Nicolas *OxDecA*
Guerazzi, Lucie Honiss *WhAmArt 85*
Guercino 1591-1666 *McGDA, OxArt*
Guercino, Giovanni Francesco Barbieri 1591-1666 *ClaDrA*
Gueret Sisters *DcWomA*
Guerin, Anna Maria *DcWomA*
Guerin, Cecile *DcWomA*
Guerin, Charles 1875-1939 *WhAmArt 85A*
Guerin, Charles Francois Prosper 1875-1939 *ClaDrA*
Guerin, Eulalie *DcWomA*
Guerin, Gilles 1609?-1678 *McGDA*
Guerin, John William 1920- *WhoAmA 73, -76, -78, -80, -82, -84*
Guerin, Joseph 1889- *WhAmArt 85*

Guerin, Jules 1866-1946 *ArtsAmW 3, IlrAm 1880, WhAmArt 85*
Guerin, Marie *DcWomA*
Guerin, Marie Louise Anna *DcWomA*
Guerin, Marie Therese 1890- *DcWomA*
Guerin, Marie Victorine 1858- *DcWomA*
Guerin, Pierre Narcisse 1774-1833 *ClaDrA*
Guerin, Pierre-Narcisse 1774-1833 *McGDA*
Guerin, Stephanie *DcWomA*
Guerin, Therese *DcWomA*
Guerin, W L *AmArch 70*
Guerin, Mrs. William Collings Lubis *DcVicP 2*
Guerin, William Halsey 1917- *AmArch 70*
Guerin-Billet, Aline *DcWomA*
Guerin DeBelleit, Renee 1880- *DcWomA*
Guerin-Lemaitre, Elise A *DcWomA*
Guermonprez, Trude *BnEnAmA*
Guernier, Louis Du 1687-1716? *BkIE*
Guernsey, Eleanor Louise 1878- *DcWomA, WhAmArt 85*
Guernsey, James *FolkA 86*
Gueron, Henri Charles 1936- *AmArch 70*
Guerra, Jorge 1936- *MacBEP*
Guerra, Noemia 1920- *OxTwCA*
Guerra Family *MacEA*
Guerrant, R F *AmArch 70*
Guerreiro, Joan *WorFshn*
Guerrerio, Henry *DcCAr 81*
Guerrero, Jose 1914- *ConArt 77, DcCAA 71, -77, OxTwCA, WhoAmA 73, -76, -78, -80, -82, -84*
Guerrero, Raul 1945- *PrintW 83, -85*
Guerrero, Xavier 1896- *McGDA*
Guerrero Galvan, Jesus 1910- *McGDA*
Guerrero Y Torres, Francisco Antonio d1792 *OxArt*
Guerrero Y Torres, Francisco Antonio 1720?-1792 *WhoArch*
Guerrero Y Torres, Francisco Antonio 1749?-1792 *McGDA*
Guerrieri, Camilla 1628-1664? *DcWomA*
Guerrieri, Ernesto *MarqDCG 84*
Guerriero, Henry E *WhoAmA 82, -84*
Guerriero, Henry Edward *WhoAmA 80*
Guerriero, Henry Edward 1939- *WhoAmA 76, -78*
Guerrilla Art Action Group *ConArt 77*
Guerrini, Lorenzo 1914- *McGDA, PhDcTCA 77*
Guersant, Anna *DcWomA*
Guerzoni, Stephanie 1887- *DcWomA*
Guessous, Zina *WorFshn*
Guest, Agnes W *DcVicP 2*
Guest, Alan Sexty 1920- *WhoArt 80, -82, -84*
Guest, Albert Waldo *ArtsEM*
Guest, Douglas *DcVicP 2*
Guest, George 1864- *WhAmArt 85*
Guest, George 1939- *ClaDrA*
Guest, H *DcVicP 2*
Guest, Marie Oliva *DcWomA*
Guest, Thomas Douglass 1781- *DcBrWA*
Guet, Edmond Georges 1829- *ClaDrA*
Guetary, Helene 1957- *PrintW 83, -85*
Guevara, A A *AmArch 70*
Guevara, Alvaro 1894-1951 *DcBrA 1, OxTwCA*
Guevara, Jose 1928- *WhoArt 80, -82, -84*
Gueydan, Marie *WhAmArt 85*
Gueydan DeMouraigne, Marie *DcWomA*
Gueyton, A *DcNiCA*
Gueyton, Charles *DcNiCA*
Guffens, Godefroid 1803- *ArtsNiC*
Guffens, Godfried Egide 1823-1901 *ClaDrA*
Guffin, Lotta Hillis 1844-1896 *DcWomA*
Gugelot, Hans 1920-1965 *ConDes*
Gugenheim, Constance Alice *Des*
Guggenheim, Alis 1896- *DcWomA*
Guggenheim, Hans 1924- *IlsCB 1957*
Guggenheim, Harry Frank 1890-1971 *WhoAmA 78N, -80N, -82N, -84N*
Guggenheim, Peggy *WhoArt 82N*
Guggenheim, Peggy 1898- *BnEnAmA, WhoAmA 73, -76, -78, WhoArt 80*
Guggenheim, Peggy 1898-1979 *WhoAmA 80N, -82N, -84N*
Guggenheim, Willy 1900- *PhDcTCA 77*
Guggenheimer, Richard Henry 1906- *WhoAmA 73, -76*
Guggenheimer, Richard Henry 1906-1977 *WhAmArt 85, WhoAmA 78N, -80N, -82N, -84N*
Gugler, E *AmArch 70*
Gugler, Eric 1889-1974 *MacEA*
Gugler, Frida *WhAmArt 85*
Gugler, Frida 1874-1966 *DcWomA*
Gugler, Henry 1816-1880 *NewYHSD*
Guglielmi, Louis O 1906-1956 *WhAmArt 85, WhoAmA 80N, -82N, -84N*
Guglielmi, O Louis 1906-1956 *BnEnAmA, DcAmArt, DcCAA 71, -77, McGDA, PhDcTCA 77*
Guglielmo DaModena *McGDA*
Guglielmo DellaPorta 1500?-1577 *OxArt*
Guglielmo DelPiombo, Fra *McGDA*
Guglielmo, Fra 1238?-1312 *McGDA*
Guglielmo, F A *AmArch 70*
Gugliotta, Paul F 1931- *AmArch 70*
Gugnon, Louise *DcWomA*

-80, -82

Gunning, Frank *DcVicP 2*
Gunning, Robert Bell 1830?-1907 *DcBrA 2*
Gunnington *NewYHSD*
Gunnis, Louis J *DcBrBI, DcVicP 2*
Gunshor, Ruth *WhoAmA 82, -84*
Gunson, J H *DcBrWA*
Gunston, W *DcVicP 2*
Gunsul, Brooks R W 1928- *AmArch 70*
Gunter, Charlotte G Frietsch 1896- *DcWomA, WhAmArt 85*
Gunter, Frank Elliott 1934- *WhoAmA 76, -78, -80, -82, -84*
Gunter, Frederick *NewYHSD*
Gunther, Edith *DcBrA 2*
Gunther, Ignaz 1725-1775 *MacEA, McGDA, OxArt*
Gunther, Julie 1855- *DcWomA*
Gunther, Matthaus 1705-1788 *MacEA, McGDA*
Gunther, Matthaus Matha 1705-1788 *ClaDrA*
Gunther, Otto Edmond 1838-1884 *ArtsNiC*
Gunther, R M *DcWomA*
Gunthorp, Beatrice *DcBrA 1, DcWomA*
Gunthorpe, Henry *DcBrA 2*
Gunthrop, Doris 1894- *DcWomA, WhAmArt 85*
Guntrum, Emilie Ida *WhAmArt 85*
Gunuk *McGDA*
Gunzburg, Baron Nicolas De *WorFshn*
Guptill, Arthur L 1891-1956 *WhAmArt 85*
Guptill, Thomas Henry 1868- *ArtsAmW 3*
Gurawski, Jerzy 1935- *ConDes*
Gurd, John 1870-1924 *BiDAmAr*
Gurda, F S *AmArch 70*
Gurden, Lovel *DcVicP 2*
Gurdon, Nora *DcWomA*
Gurenstone, T *DcVicP 2*
Gurewitsch, Edna P *WhoAmA 78, -80, -82, -84*
Gurland, Gerald 1935- *AmArch 70*
Gurlet-Hey, Elise 1869- *DcWomA*
Gurley, James J *MarqDCG 84*
Gurley, Royal *NewYHSD*
Gurlitt, Cornelius 1850-1938 *MacEA*
Gurlitt, Louis 1812- *ArtsNiC*
Gurlitz, Seymour Daniel 1921- *AmArch 70*
Gurnee, Daniel *CabMA*
Gurnee, Marie Belle d1915 *DcWomA, WhAmArt 85*
Gurney, Alexander George 1902-1955 *WorECom*
Gurney, Benjamin *ICPEnP A*
Gurney, Eric 1920?- *WorECar*
Gurney, Ernest T *DcBrBI, DcVicP 2*
Gurney, G H *AmArch 70*
Gurney, Jeremiah *ICPEnP A*
Gurney, P Thompson *FolkA 86*
Gurney, Richard *AntBDN Q*
Gurney, Susan Rothwell 1951- *WhoAmA 84*
Gurney, George 1939- *WhoAmA 80, -82, -84*
Gurney, Thomas *FolkA 86*
Gurney, Wilson d1929 *WhAmArt 85*
Guro, Elena *OxTwCA*
Guro, Elena Genrikhovna 1877-1913? *DcWomA*
Gurr, George Albert *WhoArt 80N*
Gurr, George Albert 1911- *DcBrA 1*
Gurr, Lena 1897- *DcWomA, WhAmArt 85, WhoAmA 73, -76, -78, -80, -82, -84*
Gurrey, Hartley Fletcher 1907- *WhAmArt 85*
Gurria, Angela *WhoAmA 76, -78, -80, -82, -84*
Gurschner, Herbert 1901- *DcBrA 1*
Gurska, Helana *DcWomA*
Gursoy, Ahmet 1929- *WhoAmA 73, -76, -78, -80, -82, -84*
Gurtler, Maria Catharina *DcWomA*
Gurtman, Nathan Jacob 1912- *AmArch 70*
Gurtner, Eugene A 1922- *AmArch 70*
Gurvich, Jose *OxTwCA*
Gusel, Lewis *NewYHSD*
Gusella, Ernest 1941- *WhoAmA 78, -80, -82, -84*
Gush, Frederick *DcVicP 2*
Gush, R *DcWomA*
Gush, William *DcVicP, -2*
Guson, J E *DcWomA*
Guss, R D, Jr. *AmArch 70*
Gussman, Herbert 1911- *WhoAmA 73, -76, -78, -80, -82*
Gussman, Martin T 1946- *MarqDCG 84*
Gussow, Alan 1931- *DcCAA 71, -77, WhoAmA 73, -76, -78, -80, -82, -84*
Gussow, Bernard 1881- *WhAmArt 85*
Gussow, Carl 1844- *ArtsNiC*
Gussow, Roy 1918- *BnEnAmA, DcCAA 71, -77, DcCAr 81, WhoAmA 73, -76, -78, -80, -82, -84*
Gussow, Sue Ferguson 1935- *WhoAmA 80, -82, -84*
Gustafson, Donald P 1928- *AmArch 70*
Gustafson, Dwight Leonard 1930- *WhoAmA 73*
Gustafson, Francis Wayne 1927- *AmArch 70*
Gustafson, Frank G 1863- *WhAmArt 85*
Gustafson, Paul 1916- *WorECom*
Gustafson, R L *AmArch 70*
Gustafson, Richard Erwin 1923- *AmArch 70*
Gustafson, Robert Gustav 1914- *AmArch 70*
Gustafson, W O *AmArch 70*
Gustaveson, Earl *OfPGCP 86*

Gustavino *WorECar*
Gustavson, A R *AmArch 70*
Gustavson, Dean Leonard 1924- *AmArch 70*
Gustavson, Henry 1864-1912 *ArtsAmW 3*
Gustavson, Lealand d1966 *WhoAmA 78N*
Gustavson, Lealand R 1899-1966 *IlrAm E, -1880*
Gustavson, Leland d1966 *WhoAmA 80N, -82N, -84N*
Gustavus, A O *NewYHSD*
Gusten, Theodore J H *WhoAmA 73*
Gustin, Paul Morgan 1866- *ArtsAmW 1*
Gustin, Paul Morgan 1886- *WhAmArt 85*
Gustin, Paul Morgan 1886-1974 *ArtsAmW 3*
Gustin, Robert A 1938- *MarqDCG 84*
Gustin, Russell Thomas 1945- *MarqDCG 84*
Guston, Philip 1912- *DcCAr 81, McGDA, WhAmArt 85*
Guston, Philip 1913- *BnEnAmA, ConArt 77, DcAmArt, DcCAA 71, -77, PhDcTCA 77, WhoAmA 73, -76, -78, -80*
Guston, Philip 1913-1980 *ConArt 83, OxTwCA, WhoAmA 82N, -84N, WorArt[port]*
Gutbrod, Rolf 1910- *ConArch, MacEA*
Gutch, George 1790?-1874 *BiDBrA*
Gute, Herbert Jacob 1907- *WhoAmA 73, -76*
Gute, Herbert Jacob 1907-1977 *WhoAmA 78N, -80N, -82N*
Gute, Herbert Jacob 1908-1977 *WhAmArt 85*
Gutekunst, Frederick 1831-1917 *NewYHSD, WhAmArt 85*
Guteman, Ernest *WhAmArt 85*
Gutenberg, Johann d1468? *OxDecA*
Gutersloh, Albert Paris 1887- *OxTwCA*
Gutfreund, Otto 1889-1927 *OxTwCA, PhDcTCA 77*
Guth, Alexander C 1884-1943 *BiDAmAr*
Guth, Jean Baptiste *DcBrBI*
Guthbert, Geraldine R 1931- *MarqDCG 84*
Guthers, Carl 1844- *ArtsNiC*
Gutherson, F Gerome *WhAmArt 85*
Gutherz, Carl 1844-1907 *WhAmArt 85*
Gutherz, Susanne *DcWomA*
Guthman, Belle *DcWomA*
Guthman, Leo S *WhoAmA 73, -76, -78, -80, -82, -84*
Guthrie, A M, Jr. *AmArch 70*
Guthrie, Derek 1936- *WhoAmA 76, -78*
Guthrie, E *DcVicP 2*
Guthrie, Elwood *FolkA 86*
Guthrie, Hugh W 1863-1945 *BiDAmAr*
Guthrie, Sir James *OxTwCA*
Guthrie, Sir James 1859-1930 *ClaDrA, DcBrA 1, DcBrWA, DcVicP, -2*
Guthrie, James Joshua 1874-1952 *DcBrA 1, DcBrBI, DcVicP 2*
Guthrie, Jane Gordon 1927- *WhoArt 80, -82, -84*
Guthrie, Joe Edward 1930- *AmArch 70*
Guthrie, John *DcVicP 2*
Guthrie, Kate Blaisdell 1948- *MarqDCG 84*
Guthrie, Kathleen *WhoArt 80, -82, -84N*
Guthrie, Kathleen 1905- *DcBrA 1*
Guthrie, Perri Pizer 1958- *WhoAmA 84*
Guthrie, Robin Craig 1902-1971 *DcBrA 1*
Guthrie, Ron *OfPGCP 86*
Guthrie, W D *DcVicP 2*
Guthrie, Woody *FolkA 86*
Gutierrez, Alberto Diaz 1928- *ICPEnP A*
Gutierrez, Enrique Hiram 1931- *AmArch 70*
Gutierrez, Francisco 1723?-1782 *McGDA*
Gutierrez, Jose Luis 1900-1968 *McGDA*
Gutierriez-Blanchard, Maria *DcWomA*
Gutkin, Peter 1944- *DcCAr 81, WhoAmA 73, -76, -78, -80, -82, -84*
Gutman, Elizabeth *WhAmArt 85*
Gutman, Jose 1957- *MarqDCG 84*
Gutman, Judith Mara 1928- *MacBEP*
Gutman, Nachum *WhoArt 82N*
Gutman, Nachum 1893- *ClaDrA*
Gutman, Nachum 1898- *WhoArt 80*
Gutman, Oscar 1955- *DcCAr 81*
Gutmann, Bernhard 1869-1936 *WhAmArt 85*
Gutmann, Bessie Collins Pease *DcWomA*
Gutmann, Bessie Pease *WhAmArt 85*
Gutmann, Carl O, Jr. *AmArch 70*
Gutmann, John 1905- *ICPEnP A, MacBEP, WhAmArt 85, WhoAmA 73, -76, -78, -80, -82, -84*
Gutmann, Joseph 1923- *WhoAmA 84*
Gutnayer, J M *AmArch 70*
Gutsche, Clara 1949- *MacBEP*
Gutsche, Paul *WhAmArt 85*
Gutsell, Ida Squier *DcWomA, WhAmArt 85*
Gutt, Romuald 1888-1974 *MacEA*
Guttag, Karl Marion 1954- *MarqDCG 84*
Gutten, Ernest *NewYHSD*
Guttenberg, Carl Gottlieb 1743-1790 *McGDA*
Guttenbrunn, Ludwig *DcBrECP*
Guttersen, A G *AmArch 70*
Gutti, Rosina Mantovani *DcWomA*
Guttman, Herman 1918- *AmArch 70*
Guttmann, Robert 1880-1942 *OxTwCA*
Gutton, Henri B 1851-1933 *MacEA*
Guttridge, Eleanor N 1901- *WhAmArt 85*

Guttuso, Renato 1912- *ConArt 77, -83, McGDA, OxArt, OxTwCA, PhDcTCA 77, WhoGrA 62, WorArt[port]*
Gutwein, Johann Balthasar 1702-1785 *McGDA*
Gutzeit, Fred *WhoAmA 84*
Gutzeit, R F *AmArch 70*
Gutzmann, D H *AmArch 70*
Gutzwiller, Margaretha Charlotte 1823-1903 *DcWomA*
Guy, Amy L *DcWomA, WhAmArt 85*
Guy, Carlisle B 1919- *AmArch 70*
Guy, Catherine Julie *DcWomA*
Guy, Edna W 1897- *ClaDrA, DcBrA 1, DcWomA*
Guy, Francis d1820 *FolkA 86*
Guy, Francis 1760?-1820 *BnEnAmA, DcAmArt, NewYHSD*
Guy, Francis 1760-1826 *McGDA*
Guy, Gerald Eugene 1928- *AmArch 70*
Guy, J W *DcVicP 2*
Guy, James 1910- *DcCAA 71, -77*
Guy, James M 1909- *WhAmArt 85*
Guy, James M 1910- *WhoAmA 73, -76, -78, -80, -82*
Guy, James M 1910-1983 *WhoAmA 84N*
Guy, Joseph 1943- *DcCAr 81*
Guy, Maria *FairDF FRA*
Guy, Michael *DcCAr 81*
Guy, Osmond Sublett 1933- *WhoAmA 73*
Guy, Seymour J 1824-1910 *EarABI*
Guy, Seymour Joseph 1824- *ArtsNiC*
Guy, Seymour Joseph 1824-1910 *NewYHSD, WhAmArt 85*
Guyard, Alice *DcWomA*
Guyard, H *DcVicP 2*
Guyard, Hannah *DcWomA*
Guyart, Marie *DcWomA*
Guyatt, Richard 1914- *DcD&D*
Guyer, Irving *WhAmArt 85*
Guyer, J P *AmArch 70*
Guyette, Persis A *ArtsEM, DcWomA*
Guynet-Pechadre, Madeleine 1905- *WhoArt 80, -82, -84*
Guynier, Claudius *DcBrECP*
Guyol DeGuiran, Francois M *NewYHSD*
Guyon, Jeanne *DcWomA*
Guyon, Maximilienne 1868-1903 *DcWomA*
Guyot DeBeaugrand *McGDA*
Guyot, Georges Lucien 1885- *ClaDrA*
Guyot, Louise 1820?- *DcWomA*
Guyot, Louise Marie Victorine *DcWomA*
Guys, Constantin 1805-1892 *OxArt*
Guys, Constantin Ernest Adolphe H 1802-1892 *DcBrBI*
Guys, Ernest Adolphe H Constantin 1805-1892 *McGDA*
Guysi, Alice Viola d1940? *WhAmArt 85*
Guysi, Alice Viola 1863-1940 *ArtsEM, DcWomA*
Guysi, Jeanette d1940 *WhAmArt 85*
Guysi, Jeanette 1873-1966 *ArtsEM, DcWomA*
Guyton, F F, Jr. *AmArch 70*
Guzek, William Kenneth 1956- *MarqDCG 84*
Guzevich, Kreszenz 1923- *WhoAmA 73, -76, -78, -80*
Guzevich-Sommers, Kreszenz 1923- *WhoAmA 82, -84*
Guzman, Navarrete Alejandro 1944- *MarqDCG 84*
Guzman DeRojas, Cecilio *OxTwCA*
Guzman DeRojas, Cecilio 1900- *McGDA*
Guzman-Forbes, Robert 1929- *WhoAmA 76, -78, -80, -82, -84*
Guzzardi, Baroness Elena *WhoAmA 80, -78, -82, -84*
Guzzo, S M *AmArch 70*
Gwathmey, Cabell 1902- *AmArch 70*
Gwathmey, Charles 1938- *AmArch 70, ConArch*
Gwathmey, E M, Jr. *AmArch 70*
Gwathmey, Robert 1903- *BnEnAmA, DcAmArt, DcCAA 71, -77, McGDA, OxTwCA, PhDcTCA 77, WhAmArt 85, WhoAmA 73, -76, -78, -80, -82, -84, WorArt[port]*
Gwatkin, Joshua Reynolds *DcVicP 2*
Gwatkin, Mary Theophila 1757?-1848 *DcWomA*
Gwatkin, Stewart Beauchamp *DcVicP 2*
Gwennap, A *DcWomA*
Gwennap, Mrs. Thomas I *DcWomA*
Gwennett, W Gunn *DcBrBI*
Gwichtmacherin, Barbara *DcWomA*
Gwillim, Elizabeth 1763-1807 *DcWomA*
Gwillim, Elizabeth Postuma *DcWomA*
Gwilt, George 1746-1807 *BiDBrA*
Gwilt, George 1775-1856 *BiDBrA*
Gwilt, Joseph 1784-1863 *BiDBrA, MacEA*
Gwinn, Robert L 1910- *AmArch 70*
Gwozdecki, Gustaw *WhAmArt 85*
Gwyn-Jeffreys, Miss *DcWomA*
Gwynn, John d1786 *DcD&D[port]*
Gwynn, John 1713-1786 *BiDBrA, MacEA*
Gwynne, Edmund L *NewYHSD*
Gwynne, Fred *IlsBYP*
Gwynne, Marjorie Campbell 1886-1958 *DcWomA*
Gwynne, Patrick 1913- *ConArch*
Gwynne-Evans, Hester *DcWomA*
Gwynne-Jones, Allan *WhoArt 84N*
Gwynne-Jones, Allan 1892- *DcBrA 1, WhoArt 80, -82*
Gwynne-Jones, Allan 1894- *ClaDrA*
Gyberson, Indiana *WhAmArt 85*

Gyenes, Gitta 1888- *DcWomA*
Gyer, E H, Jr. 1900- *WhAmArt 85*
Gyermek, Stephen A 1930- *WhoAmA 73, −76, −78, −80, −82, −84*
Gyertyanffy DeBobda, Bertha *DcWomA*
Gyfford, Edward 1772-1834 *DcBrBI, DcBrWA*
Gyfford, Edward 1773-1856 *BiDBrA*
Gyfford, Edward A *DcBrWA*
Gyfford, S *DcVicP 2*
Gygi, H A *AmArch 70*
Gylbert 1944- *AfroAA*
Gylden, Emma VonSchantz 1835-1874 *DcWomA*
Gylden, Eva Maria 1885- *DcWomA*
Gylding, Amalie Christine *DcWomA*
Gyles, Reverend Mr. *DcBrECP*
Gyllenborg, Richard E 1922- *AmArch 70*
Gyngell, Albert E *DcVicP 2*
Gyngell, Edmund *DcVicP 2*
Gyokksai *AntBDN L*
Gyokudo 1745-1820 *McGDA*
Gyokuhosai, Ryuchin *AntBDN L*
Gyokuon *DcWomA*
Gyokuran, Ikeno Machi 1728-1784 *DcWomA*
Gyokuyosai *AntBDN L*
Gyokuzan, Asahi 1842-1943 *AntBDN L*
Gyongyossy, Berta 1873- *DcWomA*
Gyongyviragi, Eugenia 1854- *DcWomA*
Gyory, Esther 1944- *FolkA 86*
Gyp 1849?-1932 *DcWomA*
Gyra, Francis Joseph, Jr. 1914- *WhAmArt 85, WhoAmA 73, −76, −78, −80, −82, −84*
Gysbrechts, Cornelis Norbertus *McGDA*
Gysels, Frans, II d1660 *ClaDrA*
Gysels, Pieter 1621-1690? *McGDA*
Gysi-Roth, Jenny 1863- *DcWomA*
Gysin, Brion 1916- *ConArt 77, −83, WhoAmA 78, −80, −82, −84*
Gysis, Nicholas 1842-1901 *WhAmArt 85A*
Gysis, Nicolas *ArtsNiC*
Gyulai, Liviusz 1937- *WhoGrA 82[port]*

H

Ha-So-De 1918- *WhoAmA 76, -78, -80, -82, -84*
Haack, Cynthia R *WhoAmA 82, -84*
Haack, Cynthia Roach *WhoAmA 73, -76*
Haack, O E *AmArch 70*
Haacke, Hans 1936- *ConArt 77, -83, DcCAr 81, OxTwCA, PrintW 83, -85, WorArt*
Haacke, Hans Christoph 1936- *AmArt, WhoAmA 76, -78, -80, -82, -84*
Haag, Carl 1820- *ArtsNiC*
Haag, Carl 1820-1915 *ClaDrA, DcBrBI, DcBrWA, DcVicP, -2*
Haag, Charles 1867-1933 *WhAmArt 85*
Haag, E K *AmArch 70*
Haag, G Harold W 1910- *AmArch 70*
Haag, Herman H 1871-1895 *ArtsAmW 1, IlBEAAW*
Haag, Jacob 1812?- *FolkA 86*
Haag, Jonathan *FolkA 86*
Haage, Sixten 1926- *DcCAr 81*
Haagen, Joris VanDer 1615?-1669 *McGDA*
Haak, Monroe Schoener 1916- *AmArch 70*
Haakman, C M *DcWomA*
Haan, Jacob Meyer De *McGDA*
Haanel, Florence Eugenie 1867?-1950 *DcWomA*
Haanen, Adriana Johanna 1814-1895 *DcWomA*
Haanen, Elisabeth Alida 1809-1845 *DcWomA*
Haanen, Remi A Van 1812- *ArtsNiC*
Haapala, Kaarl Verner 1905- *AmArch 70*
Haapanen, John N 1891- *WhAmArt 85*
Haar, Anna Charlotte VanDer 1748-1802 *DcWomA*
Haar, Francis 1908- *ICPEnP A, MacBEP, WhoAmA 73, -76, -78, -80, -82, -84*
Haar, Tom 1941- *WhoAmA 82, -84*
Haaren, C F *AmArch 70*
Haarlem, Cornelis Cornelisz Van 1562-1638 *McGDA*
Haarstick, Donald Sydney 1915- *AmArch 70*
Haas *NewYHSD*
Haas, Alice Preble Tucker De *DcWomA*
Haas, Arthur 1925- *AmArch 70*
Haas, Charles Richard 1925- *AmArch 70*
Haas, Clara 1895- *DcWomA*
Haas, Ernst 1921- *AmArt, ConPhot, ICPEnP, MacBEP, WhoAmA 80, -82, -84*
Haas, Fridolin *WhAmArt 85*
Haas, Harry, Jr. 1914- *AmArch 70*
Haas, Helen *WhAmArt 85, WhoAmA 76, -78, -80, -82*
Haas, Hermine VanDer 1843- *DcWomA*
Haas, Irene 1929- *IlsBYP, IlsCB 1946, -1957, -1967*
Haas, J Brooks 1923- *AmArch 70*
Haas, Johannes Hubertus Leonardus De 1832-1908 *ClaDrA*
Haas, John Clifford 1934- *AmArch 70*
Haas, Leo 1901- *WorECar*
Haas, Lester Carl 1913- *AmArch 70*
Haas, Lez 1911- *WhoAmA 73, -76, -78, -80, -82*
Haas, Lisette *DcWomA*
Haas, Lotta L *DcWomA*
Haas, Lucie *DcWomA*
Haas, M F H *WhAmArt 85*
Haas, Max Peter 1907-1966 *ICPEnP A*
Haas, P *NewYHSD*
Haas, Paul Thomas 1909- *WhAmArt 85*
Haas, Peter *FolkA 86*
Haas, Richard 1936- *DcCAA 77, PrintW 83, -85*
Haas, Richard John 1936- *AmArt, DcCAr 81, WhoAmA 73, -76, -78, -80, -82, -84*
Haas, Runi L *WhAmArt 85*
Haas, Sidney J *BiDAmAr*
Haas, Solomon *NewYHSD*
Haas, W F *WhAmArt 85*
Haas, Wallace L, Jr. 1929- *AmArch 70*

Haas, William Huntley 1949- *MarqDCG 84*
Haase, J Roy 1907- *AmArch 70*
Haase, R W *AmArch 70*
Haaualdsen, Erik Nels 1955- *MarqDCG 84*
Haavardsholm, Froydis 1896- *DcWomA*
Haavardsholm, Magnhild Karoline 1880- *DcWomA*
Habben, Joseph E 1895- *WhAmArt 85*
Habbitt, James *NewYHSD*
Habboosh, Namir W 1961- *MarqDCG 84*
Habecker, David 1800-1889 *FolkA 86*
Habeeb, Thomas Anthony, Jr. *AmArch 70*
Habeger, Ruth 1895- *ArtsAmW 2*
Habel, Robert Edward 1932- *AmArch 70*
Habelt, Elisabeth *DcWomA*
Haber, Barry Maxwell 1938- *AmArch 70*
Haber, Ira Joel 1947- *WhoAmA 76, -78, -80, -82, -84*
Haber, Leonard 1920- *WhoAmA 73, -76, -78, -80, -82*
Haber, Shamai 1922- *OxTwCA, PhDcTCA 77*
Haber, William 1921- *WhoAmA 78, -80, -82, -84*
Haberer, C Winston 1905- *WhAmArt 85*
Habergritz, George Joseph 1909- *WhoAmA 73, -76, -78, -80, -82, -84*
Haberkone, Adelaide *DcWomA*
Haberkone, Adelaide D *WhAmArt 85*
Haberkorn, Adelaide *DcWomA*
Haberl, Sophie *DcWomA*
Haberlan, Jimmy L 1935- *AmArch 70*
Haberland, Benno *FolkA 86*
Haberle, John 1853-1933 *BnEnAmA, DcAmArt*
Habermaas, Edward W *WhAmArt 85*
Haberman, Eugene 1934- *AmArch 70*
Haberman, Jim 1949- *MacBEP*
Haberman, P L *AmArch 70*
Habermann, Hugo Van 1849- *ClaDrA*
Habermas, C R *AmArch 70*
Habersham, Robert W *NewYHSD*
Habershon, Matthew 1789-1852 *BiDBrA*
Haberstroh, Albert *WhAmArt 85*
Haberstroh, Ernest J 1904- *AmArch 70*
Habert, Jeanne Mathilde *DcWomA*
Habert, Madeleine *DcWomA*
Habich, William *NewYHSD*
Habicher, Sebastian 1805- *NewYHSD*
Hablik, Wenzel 1881-1934 *MacEA*
Habra, Nadim Robert 1948- *MarqDCG 84*
Habraken, N J 1928- *MacEA*
Habraken, N John 1928- *ConArch*
Haccou, Johannes Cornelis 1798-1839 *DcBrWA, DcSeaP, DcVicP 2*
Haccou, Lodewijk Gillis 1792- *DcSeaP*
Haccuria, Maurice 1919- *ClaDrA, WhoArt 80, -82, -84*
Hachet, Marie *DcWomA*
Hachich, Waldemar 1950- *MarqDCG 84*
Hacht, Tobias Van *McGDA*
Hack, Gwendolyn Dunlevy Kelley 1877- *DcWomA, WhAmArt 85*
Hack, Howard Edwin 1932- *WhoAmA 73, -76, -78, -80, -82*
Hack, Patricia Y 1926- *WhoAmA 73, -76, -78, -80, -82, -84*
Hack, Phillip S 1916- *WhoAmA 73, -76, -78, -80, -82, -84*
Hackaert, Jan 1628-1699 *OxArt*
Hackaert, Jan Jansz 1628?-1685? *McGDA*
Hackenberg, L M *AmArch 70*
Hackenberger, J M *AmArch 70*
Hackenbroch, Yvonne Alix 1912- *WhoAmA 73, -76, -78, -80, -82, -84*
Hacker, Arthur 1858-1919 *ClaDrA, DcBrA 1,*

DcBrBI, DcBrWA, DcVicP, -2
Hacker, Bernard 1919- *AmArch 70*
Hacker, Blanche *DcBrA 1, DcWomA*
Hacker, Dieter 1942- *DcCAr 81*
Hacker, Frederick *BiDBrA*
Hacker, I C *AmArch 70*
Hacker, Maria 1886- *DcWomA*
Hacker, Samuel *BiDBrA*
Hacker, Theodore S *NewYHSD*
Hackert, J P *DcBrECP*
Hackert, Jacob Philipp 1737-1807 *McGDA*
Hackert, Jacob Philippe 1737-1807 *DcSeaP*
Hackert, Jakob Philipp 1737-1807 *OxArt*
Hackert, Johann Gottlieb 1744-1773? *ClaDrA*
Hackert, Johann Gottlieb 1744-1773 *DcBrECP*
Hackert, Johann Gottlieb 1744-1793 *DcBrWA*
Hackert, Philip *DcBrECP*
Hacket, James M *NewYHSD*
Hackett, C A *ArtsEM*
Hackett, Frank *WhoArt 80, -82, -84*
Hackett, Grace E *WhAmArt 85*
Hackett, Grace Edith 1874-1956? *DcWomA*
Hackett, Horatio B 1880-1941 *BiDAmAr*
Hackett, Malcolm 1903- *WhAmArt 85*
Hackett, Mickey *OfPGCP 86, WhoAmA 82, -84*
Hackett, Nelson G *WhAmArt 85*
Hackett, Owen Francis, Jr. 1921- *AmArch 70*
Hackett, U E, Jr. *AmArch 70*
Hacking, E *DcVicP 2*
Hacking, Frederic Sidney 1873- *DcBrA 1*
Hacking, Frederick Sidney 1873- *DcVicP 2*
Hacking, Nicholas 1947- *DcCAr 81*
Hackl, Donald John 1934- *AmArch 70*
Hackler, John Byron 1925- *AmArch 70*
Hacklin, Allan 1943- *ConArt 77*
Hacklin, Allan Dave 1943- *WhoAmA 73, -76, -78, -80, -82, -84*
Hackman, L *FolkA 86*
Hackman, Vida *PrintW 85*
Hackner, R B *AmArch 70*
Hackney, Alfred 1926- *DcBrA 1, WhoArt 80, -82, -84*
Hackney, Allen L 1938- *WhoAmA 82, -84*
Hackney, Arthur 1925- *ClaDrA, DcBrA 1, WhoArt 80, -82, -84*
Hackney, George Franklin 1905- *AmArch 70*
Hackney, John Halbert 1932- *AmArch 70*
Hackney, W F 1854-1899 *BiDAmAr*
Hackstoun, William 1855-1921 *DcBrWA, DcVicP 2*
Hackwood, Harriet Chapin McKinlay 1874- *ArtsAmW 3*
Hackwood, William *DcNiCA*
Hackworth, H A *AmArch 70*
Hacon, Jessie *DcVicP 2*
Hadalski, John Michael, Jr. 1947- *MarqDCG 84*
Hadank, O H W 1889- *WhoGrA 62*
Hadaway, Julia Peck *WhAmArt 85*
Haddad, Claire *WorFshn*
Haddad, Samuel 1937- *WhoAmA 73*
Haddan, Percy *DcVicP 2*
Hadden, Elias W *FolkA 86*
Hadden, Ellen *WhAmArt 85*
Hadden, George Daniel 1950- *MarqDCG 84*
Hadden, Nellie *DcBrA 1, DcVicP 2*
Hadden, Nellie d1917? *DcWomA*
Haddick, Gabriel *CabMA*
Haddix, P L *AmArch 70*
Haddo, Lord George *DcVicP 2*
Haddoca, A *NewYHSD*
Haddock *NewYHSD*
Haddock, Aldridge 1931- *WhoArt 82, -84*

255

Hamburger, Wayne Scott 1954- *MarqDCG 84*
Hamby, Charles *ArtsEM*
Hamby, William 1902- *AmArch 70*
Hamed, Nader 1929- *AmArch 70*
Hameel, Alart Du 1449?-1509 *McGDA*
Hamel *NewYHSD*
Hamel, Bernard Franklin 1933- *WhoAmA 78, -80, -82, -84*
Hamel, Margaret *DcWomA*
Hamel, Theophile 1817-1870 *McGDA, OxArt*
Hamelin 1790?-1843? *DcWomA*
Hamelin, Ella 1867- *DcWomA*
Hamelton, John *FolkA 86*
Hamen Y Leon, Juan VanDer 1596-1631 *McGDA*
Hamer, Charles James 1931- *WhoAmA 82, -84*
Hamer, J *DcVicP 2*
Hamer, John *DcVicP 2*
Hamer, Marilou Heilman 1922- *WhoAmA 78, -80, -82*
Hamer, Rawthmall *NewYHSD*
Hameran, Anna Cecilia 1642?-1678? *DcWomA*
Hameran, Beatrice 1677-1704 *DcWomA*
Hamerani, Anna Cecilia 1642?-1678? *DcWomA*
Hamerani, Beatrice 1677-1704 *DcWomA*
Hamersky, Albert Charles 1924- *AmArch 70*
Hamersley, Constance *DcBrA 1, DcWomA*
Hamersly, Howard William 1934- *AmArch 70*
Hamerton, Philip G 1834- *ArtsNiC*
Hamerton, Philip Gilbert *DcVicP 2*
Hamerton, Philip Gilbert 1834-1891 *ClaDrA*
Hamerton, Robert Jacob *DcBrBI, DcBrWA, DcVicP 2*
Hames, Carl Martin 1938- *WhoAmA 78, -80, -82, -84*
Hamill, Charles W 1845- *EncASM*
Hamill, D P *AmArch 70*
Hamill, E *DcVicP 2*
Hamill, Lafayette C 1873- *WhAmArt 85*
Hamill, Robert Louis, Jr. 1925- *AmArch 70*
Hamill, Samuel Wood 1903- *AmArch 70*
Hamill, Tim J 1942- *WhoAmA 82, -84*
Hamill, Virginia *WhAmArt 85*
Hamill, William *NewYHSD*
Hamilton *FolkA 86*
Hamilton, Mrs. *DcWomA*
Hamilton, Agnes *DcWomA, WhAmArt 85*
Hamilton, Alexander *DcVicP 2*
Hamilton, Alexander 1712-1756 *NewYHSD*
Hamilton, Alexander R *ArtsEM*
Hamilton, Amos *FolkA 86, NewYHSD*
Hamilton, Andrew *DcVicP 2*
Hamilton, Andrew d1741 *BiDAmAr*
Hamilton, Andrew 1676?-1741 *MacEA*
Hamilton, Anne 1766-1846 *DcWomA*
Hamilton, Lady Anne 1766-1846 *DcBrBI*
Hamilton, Augusta D *DcVicP 2*
Hamilton, Blanche 1880- *DcWomA, WhAmArt 85*
Hamilton, C E *AmArch 70*
Hamilton, C P *AmArch 70*
Hamilton, Carl Wilhelm De 1668-1754 *ClaDrA*
Hamilton, Cecilia Viets *DcWomA*
Hamilton, Charles *DcVicP, -2, NewYHSD*
Hamilton, Charles Alfred *EncASM*
Hamilton, Charles F 1947- *WhoAmA 82, -84*
Hamilton, Charles J 1832- *FolkA 86*
Hamilton, Clara Laughlin 1872- *DcWomA, WhAmArt 85*
Hamilton, Clem *FolkA 86*
Hamilton, Cuthbert d1928 *DcBrA 1, DcVicP 2*
Hamilton, Cuthbert 1884-1959 *OxTwCA*
Hamilton, Cuthbert 1885-1959 *DcBrA 2*
Hamilton, D A *AmArch 70, WhAmArt 85*
Hamilton, Dale Conway 1925- *AmArch 70*
Hamilton, David *DcCAr 81*
Hamilton, David 1768-1843 *BiDBrA, MacEA*
Hamilton, David 1933- *ConPhot, ICPEnP A*
Hamilton, David Osborne 1893-1955? *WhAmArt 85*
Hamilton, Diane 1899- *DcWomA*
Hamilton, Doris W *ArtsAmW 3*
Hamilton, Dorothea d1780 *DcWomA*
Hamilton, E *DcVicP 2*
Hamilton, E B *DcVicP 2*
Hamilton, Earle Grady, Jr. 1920- *AmArch 70*
Hamilton, Edgar Scudder 1869-1903 *ArtsAmW 2, WhAmArt 85*
Hamilton, Edward W D *WhAmArt 85*
Hamilton, Eleanor G *ClaDrA*
Hamilton, Elizabeth Robeson *FolkA 86*
Hamilton, Ethel Heaven 1871-1936 *WhAmArt 85*
Hamilton, Ethel R Heaven 1870?-1936 *DcWomA*
Hamilton, Eva Henrietta 1880-1959 *DcBrA 1, DcWomA*
Hamilton, F F 1853-1899 *BiDAmAr*
Hamilton, Ferdinand Philipp De 1664-1750 *ClaDrA*
Hamilton, Frank Moss 1930- *WhoAmA 76, -78, -80, -82, -84*
Hamilton, Fred A *WhAmArt 85*
Hamilton, Fred B 1844-1928 *BiDAmAr*
Hamilton, Gavin 1723-1798 *DcBrECP, McGDA, OxArt*
Hamilton, Gawen 1697?-1737 *DcBrECP*

Hamilton, Genevieve Bartlett *WhAmArt 85*
Hamilton, George *CabMA*
Hamilton, George 1882- *WhAmArt 85*
Hamilton, George Earl 1934- *WhoAmA 82, -84*
Hamilton, George Ernest *BiDBrA*
Hamilton, George Heard 1910- *WhoAmA 73, -76, -78, -80, -82, -84*
Hamilton, George W *NewYHSD*
Hamilton, Grant 1862-1920? *WorECar*
Hamilton, Grant E 1862- *WhAmArt 85*
Hamilton, Gustavus 1739-1775 *AntBDN J*
Hamilton, H L, Jr. *AmArch 70*
Hamilton, Hamilton 1847-1928 *ArtsAmW 1, WhAmArt 85*
Hamilton, Harriott 1769?- *DcBrECP, DcWomA*
Hamilton, Helen *WhAmArt 85*
Hamilton, Henry R P 1858-1943 *BiDAmAr*
Hamilton, Hildegard Hume 1906- *WhAmArt 85*
Hamilton, Hugh Douglas 1736-1808 *DcBrECP*
Hamilton, I G *AmArch 70*
Hamilton, J *DcVicP 2, DcWomA*
Hamilton, J C *DcVicP 2*
Hamilton, J McLure 1853- *ArtsNiC*
Hamilton, J R *BiDAmAr*
Hamilton, James *BiDBrA, FolkA 86, NewYHSD*
Hamilton, James 1819-1878 *ArtsAmW 1, ArtsNiC, BnEnAmA, DcAmArt, DcBrBI, DcSeaP, EarABI, EarABI SUP, IIBEAAW, NewYHSD, WhAmArt 85*
Hamilton, James 1832- *FolkA 86*
Hamilton, James 1853-1894 *DcVicP 2*
Hamilton, James 1946- *ICPEnP A, MacBEP*
Hamilton, James Francis 1927- *MarqDCG 84*
Hamilton, James M 1873-1941 *BiDAmAr*
Hamilton, James Whitelaw 1860- *WhAmArt 85*
Hamilton, James Whitelaw 1860-1932 *DcBrA 1, DcBrWA, DcVicP 2*
Hamilton, Jane *DcCAr 81, DcWomA*
Hamilton, Jefferson Merritt 1891- *AmArch 70*
Hamilton, Jessie *DcWomA, WhAmArt 85*
Hamilton, Johann Georg De 1672-1737 *ClaDrA*
Hamilton, John *DcBrECP, DcBrWA, FolkA 86, WhoAmA 78, -80*
Hamilton, John 1919- *DcCAr 81*
Hamilton, John McLure 1853-1936 *DcBrA 1, WhAmArt 85*
Hamilton, John Patrick 1938- *AmArch 70*
Hamilton, Joseph Starke, Jr. 1919- *AmArch 70*
Hamilton, Kate W *DcWomA*
Hamilton, Kathleen *DcVicP 2*
Hamilton, Leah Rinne *WhAmArt 85*
Hamilton, Letitia Marion *DcBrA 1*
Hamilton, Letitia Marion d1965? *DcWomA*
Hamilton, Letitia Marion 1879-1964 *DcBrA 2*
Hamilton, Lilian V 1865- *DcBrA 1*
Hamilton, Lilian Vereker 1865- *DcWomA*
Hamilton, Lydia *NewYHSD*
Hamilton, Lydia 1837?- *DcWomA*
Hamilton, Lydia 1947- *WhoAmA 82, -84*
Hamilton, Maggie 1867-1952 *DcWomA*
Hamilton, Maria *DcWomA*
Hamilton, Marjorie Lang 1908- *WhAmArt 85*
Hamilton, Mary d1938 *DcWomA*
Hamilton, Mary 1794- *FolkA 86*
Hamilton, Mary Elizabeth *DcBrA 1, DcWomA*
Hamilton, Mary F *DcWomA*
Hamilton, Mary Riter 1873?-1954 *DcWomA*
Hamilton, Mary W *WhAmArt 85*
Hamilton, Matthew F *EncASM*
Hamilton, May Stuart *WhAmArt 85*
Hamilton, Michael 1929- *AmArch 70*
Hamilton, Minerva Bartlett 1864- *ArtsAmW 1, DcWomA*
Hamilton, Norah 1873- *DcWomA, WhAmArt 85*
Hamilton, Olivia *DcBrA 2*
Hamilton, Patricia *WhoArt 84*
Hamilton, Patricia Rose 1948- *WhoAmA 76, -78, -80, -82, -84*
Hamilton, Patrick *DcCAr 81*
Hamilton, Philippe Van 1664-1750 *ClaDrA*
Hamilton, Ralph S, Jr. *EncASM*
Hamilton, Ralph Spence 1829- *EncASM*
Hamilton, Rebecca Stickney *WorFshn*
Hamilton, Rebexy Gray *FolkA 86*
Hamilton, Richard 1922- *ConArt 77, -83, ConBrA 79[port], DcCAr 81, OxTwCA, PhDcTCA 77, PrintW 83, -85, WorArt[port]*
Hamilton, Robert *WhAmArt 85*
Hamilton, Robert LeRoy 1929- *AmArch 70*
Hamilton, S *DcWomA*
Hamilton, Sam Wacey 1933- *AmArch 70*
Hamilton, Sophia *DcWomA*
Hamilton, Sophie *DcWomA, FolkA 86, NewYHSD*
Hamilton, Stephen P *ConArch A*
Hamilton, Susan 1949- *WhoAmA 80, -82, -84*
Hamilton, Thomas 1784-1858 *BiDBrA, MacEA, OxArt, WhoArch*
Hamilton, Thomas 1785-1858 *McGDA*
Hamilton, Thomas T *DcVicP 2*
Hamilton, Vereker Monteith *DcVicP, -2*

Hamilton, Vereker Monteith 1856-1931 *DcBrA 1*
Hamilton, W L *FolkA 86*
Hamilton, W Paul C 1938- *WhoAmA 82, -84*
Hamilton, Wayne Richard 1926- *AmArch 70*
Hamilton, Wilbur Dean 1864- *WhAmArt 85*
Hamilton, William *BiDBrA*
Hamilton, William 1750?-1801 *DcBrECP*
Hamilton, William 1751-1801 *BkIE, DcBrWA*
Hamilton, William 1939- *ConGrA 1[port], WorECar*
Hamilton, William E *DcVicP 2*
Hamilton, William Louis *AmArch 70*
Hamilton, William M 1810?- *NewYHSD*
Hamilton, William R 1810?- *NewYHSD*
Hamilton And Diesinger *EncASM*
Hamilton And Hamilton *EncASM*
Hamilton Brothers *FolkA 86*
Hamilton-Fraser, Donald 1929- *ClaDrA*
Hamilton Fraser, Donald 1929- *PhDcTCA 77*
Hamilton Mack, Mary 1903- *DcBrA 1*
Hamilton-Wood, Sydney Ernest 1918- *DcBrA 2*
Hamlen, F R *AmArch 70*
Hamlet, William *AntBDN O*
Hamlett, Dale Edward 1921- *WhoAmA 76, -78, -80, -82, -84*
Hamley, Charles *ArtsEM*
Hamley, Sir Edward Bruce 1824-1893 *DcBrBI*
Hamlin, A C *NewYHSD*
Hamlin, A D F 1855-1926 *MacEA*
Hamlin, Alfred Dwight Foster 1855-1926 *BiDAmAr*
Hamlin, Augustus Choate 1829-1905 *EarABI SUP*
Hamlin, C K *AmArch 70*
Hamlin, Edith A 1902- *WhAmArt 85*
Hamlin, Genevieve Karr 1896- *DcWomA, WhAmArt 85*
Hamlin, Griffith A, Jr. 1945- *MarqDCG 84*
Hamlin, H H, Jr. *AmArch 70*
Hamlin, H J *AmArch 70*
Hamlin, Isaac 1742-1810 *FolkA 86*
Hamlin, James B *EncASM*
Hamlin, John 1658-1733 *FolkA 86*
Hamlin, Marston *WhAmArt 85*
Hamlin, Samuel E 1771-1841 *FolkA 86*
Hamlin, Talbot F 1889-1956 *MacEA*
Hamlin, Talbot Faulkner 1889- *WhAmArt 85*
Hamlin, Vincent T 1900- *WorECom*
Hamlin, William 1772-1869 *NewYHSD*
Hamlyn, George *FolkA 86*
Hamlyn, George, II *FolkA 86*
Hamlyn, Jane T *DcWomA*
Hamm, Beth Creevey 1885-1958 *DcWomA, WhAmArt 85*
Hamm, Beth Creevy 1885-1958 *WhoAmA 80N, -82N, -84N*
Hamm, Lillian *FolkA 86*
Hamm, Phineas Eldridge 1799-1861 *NewYHSD*
Hamm, T Z 1924- *AmArch 70*
Hamm, Vernon Alfred 1916- *AmArch 70*
Hammack, Robert L 1931- *MarqDCG 84*
Hamman, Alice *DcWomA*
Hamman, Edouard Jean Conrad 1819-1888 *ClaDrA*
Hamman, Eduard-Jean-Conrad 1819- *ArtsNiC*
Hamman, Elias *FolkA 86*
Hamman, Grace 1895- *DcWomA*
Hamman-Moeschlin, Elsa 1879- *DcWomA*
Hammann, C F *WhAmArt 85*
Hammar, George D *NewYHSD*
Hammarberg, Paul 1912- *AmArch 70*
Hammargren, F E 1892- *WhAmArt 85*
Hammarskiold, Hans 1925- *ConPhot, ICPEnP A, MacBEP*
Hammarskjold, Edward 1924- *AmArch 70*
Hammarsten, Signe *DcWomA*
Hammarstom, H *WhAmArt 85*
Hammarstrom, H C *ArtsAmW 3*
Hammat, Edward S 1856-1907 *BiDAmAr*
Hammatt, Fanny Rand 1801?- *FolkA 86*
Hammel, Richard Frank 1923- *AmArch 70*
Hammelew, C *DcSeaP*
Hammell, A H *NewYHSD*
Hammell, Elizabeth Lansdell 1889- *DcWomA, WhAmArt 85*
Hammell, George M *WhAmArt 85*
Hammell, Mrs. George M *DcWomA, WhAmArt 85*
Hammell, Guarner 1840-1939 *FolkA 86*
Hammell, Will 1888- *WhAmArt 85*
Hammen, Elias *FolkA 86*
Hammer, Alfred Emil 1925- *WhoAmA 73, -76, -78, -80, -82, -84*
Hammer, Armand 1898- *WhoAmA 78, -80, -82, -84*
Hammer, Carla Louise 1960- *MarqDCG 84*
Hammer, Jacob *OxDecA*
Hammer, John *WhAmArt 85*
Hammer, Juliane Henriette 1861-1895 *DcWomA*
Hammer, Oscar F *WhAmArt 85*
Hammer, Trygve 1878-1947 *WhAmArt 85*
Hammer, Victor 1882-1967 *DcWomA*
Hammer, Victor J 1901- *WhoAmA 73, -76, -78, -80, -82, -84*
Hammer, Victor Karl d1967 *WhoAmA 78N, -80N, -82N, -84N*
Hammerbeck, Wanda Lee 1945- *ICPEnP A,*

Hanelsack, Daniel FolkA 86
Hanelton, Peter NewYHSD
Hanemann, J Theodore WhAmArt 85
Hanequin OxArt
Hanes, James 1924- WhoAmA 73, –76, –78, –80, –82, –84
Hanes, Murray S 1887- AmArch 70
Hanes, Myrl Juadean 1924- AmArch 70
Hanes, Samuel J 1862-1946 BiDAmAr
Hanes, Ursula Ann 1932- WhoAmA 73
Hanes, Willis Russell 1925- AmArch 70
Haney, Clyde 1910- FolkA 86
Haney, Donald Lee 1944- MarqDCG 84
Haney, Ella DcWomA
Haney, Enoch Kelly OfPGCP 86
Haney, Irene W 1890- DcWomA, WhAmArt 85
Haney, James Parton 1869-1923 WhAmArt 85
Haney, S H AmArch 70
Haney, Wayne Henry 1933- AmArch 70
Haney, Wilbur AfroAA
Haney, William H 1950- WhoAmA 80, –82, –84
Haney, William L 1939- AmArt
Hanfmann, George M A 1911- WhoAmA 73, –76, –78, –80, –82, –84
Hanford, Isaac FolkA 86
Hanfstaengl, Franz 1804-1877 ICPEnP
Hangen, Heijo 1927- DcCAr 81
Hanhart DcVicP 2
Hanhart, Henry A F DcVicP 2
Hanhart, Michael DcVicP 2
Hanicotte, Augustin 1870- ClaDrA
Hanigan, Francis Lawrence 1935- MarqDCG 84
Hanin, Jeanne 1880- DcWomA
Hanin, Marguerite 1899- DcWomA
Hanington, Henry NewYHSD
Hanington, Robert NewYHSD
Hanington, William J NewYHSD
Hankammer, John O 1925- AmArch 70
Hankar, Paul 1859-1901 EncMA, MacEA
Hankar, Paul 1861-1901 McGDA
Hanke, Reinhold DcNiCA
Hankes, Master 1828?- FolkA 86
Hankes, J F DcVicP, –2
Hankes, Louis C 1882-1943 WhAmArt 85
Hankey, Mabel d1943 DcBrA 1, –2, DcWomA
Hankey, William Lee 1869- IlsCB 1744
Hankey, William Lee 1869-1952 DcBrBI
Hankey, William Lee- 1869-1952 DcBrWA
Hankins, Cornelius 1864-1946 WhAmArt 85
Hankins, Ezra FolkA 86
Hankins, George DcVicP 2
Hankins, Harold Charles 1930- MarqDCG 84
Hankins, Marie Louise EarABI SUP
Hankins, Vina S 1878- ArtsAmW 3, DcWomA
Hanks, David Allen 1940- WhoAmA 78, –80, –82, –84
Hanks, Emily Grace WhAmArt 85
Hanks, Jarvis F 1799- NewYHSD
Hanks, Jervis F 1799- EarABI
Hanks, Nancy 1927- WhoAmA 78, –80, –82
Hanks, Nancy 1927-1983 WhoAmA 84N
Hanks, Owen G 1815?-1865? NewYHSD
Hanle, A L EncASM
Hanle And Debler EncASM
Hanlen, Bernard FolkA 86
Hanlen, John 1922- WhoAmA 78, –80, –82, –84
Hanley, Edgar DcVicP 2
Hanley, Francis Joseph 1913- WhAmArt 85
Hanley, Harriet Clark DcWomA, WhAmArt 85
Hanley, L C DcWomA
Hanley, Mrs. L C ArtsEM
Hanley, Liam Powys 1933- WhoArt 80, –82, –84
Hanley, Meredith WhAmArt 85
Hanley, Sarah E d1958 WhAmArt 85
Hanley, T Edward d1969 WhoAmA 78N, –80N, –82N, –84N
Hanley, Walter NewYHSD
Hanley, William H NewYHSD
Hanlin, Corna Searcy WhAmArt 85
Hanlon, Daniel 1819-1901 DcBrWA
Hanlon, James Richard 1910- AmArch 70
Hanlon, Kathleen Marie 1956- MarqDCG 84
Hanlon, Louis Wilfred James 1882-1955? WhAmArt 85
Hanly, Daithi Patrick 1917- WhoArt 80, –82, –84
Hanly, George NewYHSD
Hann, Judy DcCAr 81
Hann, W F FolkA 86
Hann, Walter DcVicP 2
Hanna, Boyd 1907- PrintW 83, –85
Hanna, Boyd Everett 1907- WhoAmA 73, –76, –78, –80, –82, –84
Hanna, Charles Franklin 1938- AmArch 70
Hanna, Edith Margaret 1895- DcWomA
Hanna, Ellen DcWomA
Hanna, Forman 1882-1950 MacBEP
Hanna, Issa 1919- DcCAr 81
Hanna, James Edward 1858-1920 ArtsEM
Hanna, Katherine 1913- WhoAmA 73, –76, –78, –80, –82, –84
Hanna, Lineen AmArch 70
Hanna, Paul Dean, Jr. WhoAmA 76, –78, –80, –82, –84

Hanna, Paul M 1943- MarqDCG 84
Hanna, R NewYHSD
Hanna, Richard Taylor 1918- AmArch 70
Hanna, Robert Leroy 1939- AmArch 70
Hanna, Samir L MarqDCG 84
Hanna, Theodore WhAmArt 85
Hanna, Thomas King d1951 WhoAmA 78N, –80N, –82N, –84N
Hanna, Thomas King 1872-1951 IlrAm A, –1880, WhAmArt 85
Hanna, Thomas King, Jr. 1872-1951 IlBEAAW
Hanna, William Denby 1910- WorECar
Hanna, William M 1855- WhAmArt 85
Hannafin, Arthur Alfred 1931- AmArch 70
Hannaford, Alice S Ide 1888- WhAmArt 85
Hannaford, Alice Steele Ide 1888-1975 DcWomA
Hannaford, Charles Arthur 1887-1972 DcBrA 1
Hannaford, Charles E 1859-1936 BiDAmAr
Hannaford, Charles E 1863-1955 DcBrA 1, DcVicP 2
Hannaford, Charles E 1865-1955 DcBrWA
Hannaford, Edith F DcWomA
Hannaford, H E AmArch 70
Hannaford, Joseph BiDBrA
Hannaford, Samuel 1835-1910 BiDAmAr
Hannah, Caleb CabMA
Hannah, Duncan WhoAmA 84
Hannah, Edwin NewYHSD
Hannah, Joel AfroAA
Hannah, John Junior 1923- WhoAmA 76, –78, –80, –82, –84
Hannah, Leonie DcWomA
Hannah, Marsha Jo MarqDCG 84
Hannah, Muriel WhAmArt 85
Hannah, Robert 1812-1909 DcVicP, –2
Hannah, William M 1855-1927 WhAmArt 85
Hannam, Thomas AntBDN Q
Hannan, Andrew 1907- ClaDrA
Hannan, C D AmArch 70
Hannan, John J NewYHSD
Hannan, William d1775? DcBrECP
Hannan, William d1775 DcBrWA
Hannay, E W D DcVicP 2
Hannay, Mrs. Elliot DcVicP 2
Hannay, Jann 1933- AmArt
Hannay, Walter DcVicP 2
Hannell, H 1895- WhAmArt 85
Hannell, Hazel Johnson 1895- DcWomA
Hannell, V M S 1896- WhAmArt 85
Hannell, Vinol WhAmArt 85
Hanneman, Adriaen 1601?-1671 McGDA, OxArt
Hannenberg, Walter Carl 1934- MarqDCG 84
Hannequand, Daniel DcCAr 81
Hannequand, Leonide DcWomA
Hannequart, Jehan McGDA
Hanner, Verdell 1922- AmArch 70
Hannes, Morris 1894- AmArch 70
Hanney, Clifford ClaDrA
Hanney, Clifford 1890- DcBrA 1, WhoArt 80, –82, –84
Hanney, W L AmArch 70
Hannibal, Joseph Harry 1945- WhoAmA 78, –80, –82, –84
Hanniford, M WhAmArt 85
Hannis, Geneva Grippen 1868- ArtsAmW 3
Hannis, Genevra Grippen 1868- DcWomA
Hannon, John Louis 1910- AmArch 70
Hannon, Olga Ross 1890- ArtsAmW 2, DcWomA, WhAmArt 85
Hannong, Paul-Antoine AntBDN M
Hannot, Johannes McGDA
Hanns, James Edward 1929- AmArch 70
Hannum, David Lawrence 1945- MarqDCG 84
Hanny, William F WhAmArt 85
Hanoteau, Hector 1820- ArtsNiC
Hanoteau, Hector Charles Auguste Octave 1823-1890 ClaDrA
Hanoute, David Lee 1935- AmArch 70
Hanoway, John NewYHSD
Hanray, Margaret Delisle DcWomA
Hanriot-Giraud, Yvonne 1898- DcWomA
Hans Of Cologne 1410?-1481? McGDA
Hans VonTubingen McGDA
Hans, G E AmArch 70
Hans, Joseph, Jr. 1926- AmArch 70
Hansard, Freda DcVicP 2
Hansbury, John FolkA 86
Hansch, Auguste Adolphine Wilhelmine 1856-1911 DcWomA
Hansche, Ronald D 1937- AmArch 70
Hanscom, Adelaide DcBrBI
Hanscom, Lena E DcWomA
Hanscom, Trude 1898- ArtsAmW 1, DcWomA, WhAmArt 85
Hansee, Willard S FolkA 86
Hansel, Caroline WhAmArt 85
Hansel, H M DcWomA
Hansel, Miss H M NewYHSD
Hansel, James C 1954- MarqDCG 84
Hansel, Joseph L ArtsEM
Hansell, Freya PrintW 85

Hansell, George H NewYHSD
Hansell, Ingeborg WhAmArt 85
Hansen, A B AmArch 70
Hansen, Ane Marie 1852- DcWomA
Hansen, Anna Louise Brigitte DcWomA
Hansen, Armin Carl 1886-1957 ArtsAmW 1, IlBEAAW, WhAmArt 85, WhoAmA 80N, –82N, –84N
Hansen, Armin O 1893-1976 WhAmArt 85
Hansen, Arne Rae 1940- WhoAmA 78, –80, –82, –84
Hansen, Bertha J WhAmArt 85
Hansen, Carl Frederik Sundt 1841-1907 ClaDrA
Hansen, Carl Thomas 1938- MarqDCG 84
Hansen, Christian Frederik 1746-1845 MacEA
Hansen, Christian Frederik 1756-1845 McGDA, WhoArch
Hansen, Claude Milton AmArch 70
Hansen, Demont B WhAmArt 85
Hansen, Derk OfPGCP 86
Hansen, Doug 1952- ConGrA 1[port]
Hansen, Douglas Reid 1900- WhAmArt 85
Hansen, Duane 1925- DcCAr 81
Hansen, E O AmArch 70
Hansen, Ed G, Jr. 1952- MarqDCG 84
Hansen, Einer WhAmArt 85
Hansen, Ejnar 1884- ArtsAmW 1, WhAmArt 85
Hansen, Eleonore Christine DcWomA
Hansen, Elise 1858- DcWomA
Hansen, Emil McGDA, OxTwCA
Hansen, Eugene Marvin 1926- AmArch 70
Hansen, Florence Froney 1892- DcWomA
Hansen, Frances Frakes WhoAmA 73, –76, –78, –80, –82, –84
Hansen, Frances Frakes 1915- WhAmArt 85
Hansen, Gary Valentine 1935- AmArch 70
Hansen, Gaylen Capener 1921- WhoAmA 84
Hansen, Georg E 1833-1891 MacBEP
Hansen, Hans 1853-1947 DcBrA 1, DcVicP 2
Hansen, Hans Christian 1803-1883 MacEA
Hansen, Hans Nicolai 1853-1923 ClaDrA
Hansen, Hans Peter 1881- WhAmArt 85
Hansen, Harold John 1942- WhoAmA 78, –80, –82, –84
Hansen, Herman W 1854-1924 ArtsAmW 1
Hansen, Herman Wendelborg 1854-1924 IlBEAAW
Hansen, Herman Wendleborg 1854-1924 WhAmArt 85
Hansen, J AmArch 70, DcSeaP
Hansen, James L WhAmArt 85
Hansen, James Lee 1925- DcCAA 71, –77, WhoAmA 73, –76, –78, –80, –82, –84
Hansen, John NewYHSD
Hansen, John D DcCAr 81
Hansen, John Westland 1927- AmArch 70
Hansen, Kenneth T 1940- WhoAmA 80
Hansen, L W AmArch 70
Hansen, Louise Christiane Ravn 1849-1909 DcWomA
Hansen, Maurice Neal 1921- AmArch 70
Hansen, O M AmArch 70
Hansen, Oscar J W 1892-1962 WhAmArt 85
Hansen, Oscar J W 1892-1971 IlBEAAW
Hansen, Oskar 1922- ConArch
Hansen, P L AmArch 70
Hansen, P W AmArch 70
Hansen, R E AmArch 70
Hansen, Richard Fred 1932- AmArch 70
Hansen, Robert 1924- DcCAA 71, –77, WhoAmA 76, –78, –80, –82, –84
Hansen, Robert D MarqDCG 84
Hansen, Robert William 1924- WhoAmA 73
Hansen, Sigvard Marius 1859- ClaDrA
Hansen, Sine 1942- OxTwCA
Hansen, Soren 1939- MarqDCG 84
Hansen, Stephen 1950- AmArt
Hansen, T L AmArch 70
Hansen, Theo Brooke DcVicP 2
Hansen, Theophil Von 1813-1891 McGDA, WhoArch
Hansen, Theophilus 1813-1891 MacEA
Hansen, Walter Alan 1932- AmArch 70
Hansen, Walter C 1914- AmArch 70
Hansen, Wanda 1935- WhoAmA 73, –76, –78
Hansen, Wiig DcCAr 81
Hansen-Bay, Celia 1875- DcBrA 1, DcVicP 2, DcWomA
Hansenclever, Peter FolkA 86
Hanshaw, William G 1938- AmArch 70
Hansmann, Charlotte DcWomA
Hansmann, Paula DcWomA
Hansom, J T DcVicP 2
Hansom, Joseph A 1803-1882 MacEA
Hansom, Joseph Aloysius 1803-1882 BiDBrA, WhoArch
Hanson FolkA 86
Hanson, A W 1911- DcCAr 81
Hanson, Albert J DcVicP 2
Hanson, Albert J 1866-1914 DcBrA 2, DcSeaP
Hanson, Anne Coffin 1921- WhoAmA 80, –82, –84
Hanson, Arnold Lewis 1942- AmArch 70
Hanson, Arthur C WhAmArt 85
Hanson, B K WhAmArt 85
Hanson, Bernard A 1922- WhoAmA 78

Hanson, Berta M 1876- *DcWomA, WhAmArt 85*
Hanson, Christina Ramberg *WhoAmA 78, –80*
Hanson, D D *AmArch 70*
Hanson, Daniel Roger 1923- *AmArch 70*
Hanson, Duane 1925- *AmArt, ConArt 77, –83, DcAmArt, DcCAA 77, WhoAmA 73, –76, –78, –80, –82, –84, WorArt*
Hanson, E A *AmArch 70*
Hanson, E E *AmArch 70*
Hanson, Edward W 1908- *AmArch 70*
Hanson, Floy Katherine *WhAmArt 85*
Hanson, Gary Burton 1937- *AmArch 70*
Hanson, Harold E 1914- *AmArch 70*
Hanson, Henry T 1888- *WhAmArt 85*
Hanson, Herbert C *AmArch 70*
Hanson, J *DcVicP 2*
Hanson, J B 1946- *WhoAmA 82, –84*
Hanson, J G *AmArch 70*
Hanson, James Edwin, Jr. *AmArch 70*
Hanson, Jean 1934- *WhoAmA 73, –76, –78, –80, –82, –84*
Hanson, Jo *WhoAmA 80, –82, –84*
Hanson, Judy *WhoAmA 80, –82, –84*
Hanson, Lawrence 1936- *WhoAmA 76, –78, –80, –82, –84*
Hanson, Lowell James 1937- *AmArch 70*
Hanson, M W *AmArch 70*
Hanson, Matthias *AntBDN N*
Hanson, Maude *WhAmArt 85*
Hanson, Norman 1909- *ConArch*
Hanson, Oscar *WhAmArt 85*
Hanson, Peter 1821-1887 *NewYHSD*
Hanson, Peter Raymond 1926- *AmArch 70*
Hanson, Philip 1943- *DcCAr 81*
Hanson, Philip Holton 1943- *AmArt, WhoAmA 73, –76, –78, –80, –82, –84*
Hanson, Ralph Lynn 1931- *AmArch 70*
Hanson, Richard Charles *AmArch 70*
Hanson, Robert Donald 1924- *AmArch 70*
Hanson, W S *AmArch 70*
Hansson, Olof 1919- *MacEA*
Hansteen, Asta 1824-1908 *ClaDrA, DcWomA*
Hansteen, Nils Severin Lynge 1855-1912 *DcSeaP*
Hantai, Simon 1922- *DcCAr 81, OxTwCA, PhDcTCA 77*
Hantelmann, Emmy *DcWomA*
Hantman, Alan M 1942- *MarqDCG 84*
Hanton, Andrew *NewYHSD*
Hantz, Jacob F 1831-1887 *NewYHSD*
Hanus, Vaclav 1924- *DcCAr 81*
Hanwell, T *WhAmArt 85*
Haozous, Robert L 1943- *WhoAmA 76, –78*
HAP 1909-1981 *WhoGrA 82[port]*
Hapgood, Alice *WhAmArt 85*
Hapgood, Alice Hathaway *DcWomA*
Hapgood, David Goodwin 1930- *AmArch 70*
Hapgood, Dorothy Alden 1892- *DcWomA, WhAmArt 85*
Hapgood, Edward T -1915? *BiDAmAr*
Hapgood, Theodore B 1871-1938 *WhAmArt 85*
Hapke, Paul Frederick 1922- *WhoAmA 76, –78, –80, –82, –84*
Hapke, R L *AmArch 70*
Haplacher, George I *NewYHSD*
Happek, Jerry 1921- *AmArch 70*
Happel, Carl 1819- *IIBEAAW*
Happersberger, Paula *WhAmArt 85*
Happersburger, Frank 1859- *WhAmArt 85*
Happley, Richard Jerome 1930- *AmArch 70*
Hapsis, George E 1933- *AmArch 70*
Haque, Promod 1948- *MarqDCG 84*
Haquette, Georges Jean Marie 1854-1906 *ClaDrA*
Haquette-Bouffe, Jenny *DcWomA*
Hara, Cristobal 1946- *MacBEP*
Hara, Ernest Hideo 1909- *AmArch 70*
Hara, Hiromu 1903- *WhoGrA 62, –82[port]*
Hara, Hiroshi 1936- *ConArch*
Hara, Keiko *PrintW 83, WhoAmA 82, –84*
Hara, Keiko 1942- *AmArt, PrintW 85*
Hara, Teruo 1929- *WhoAmA 73, –76, –78, –80, –82*
Harabin, Randy John 1949- *MarqDCG 84*
Harache, Pierre *AntBDN Q*
Harache, Pierre d1700 *OxDecA*
Harache, Pierre, Jr. *AntBDN Q*
Haradynsky, E *ArtsAmW 3*
Haraguchi, Nonyuki 1946- *DcCAr 81*
Harak De, Rudolph 1924- *WhoGrA 82[port]*
Harari, Hananiah 1912- *WhAmArt 85, WhoAmA 76, –78, –80, –82, –84*
Harasymiak, Ireneus 1938- *AmArch 70*
Haraszty, Istvan 1934- *DcCAr 81*
Haraux, Alfred *NewYHSD*
Harbach, Horatio M *NewYHSD*
Harbach, Paul Hyde 1893- *AmArch 70*
Harbach, Wendell McIntosh 1923- *AmArch 70*
Harbart, Gertrude Felton *WhoAmA 73, –76, –78, –80, –82*
Harbart, Gertrude Felton 1908- *WhoAmA 84*
Harbaugh, Marjorie Warvelle 1897- *WhAmArt 85*
Harber, W V *AmArch 70*
Harberton, Fairlie *DcWomA*

Harbeson, Benjamin *FolkA 86*
Harbeson, Georgiana Brown *FolkA 86*
Harbeson, Georgiana Brown 1894- *WhAmArt 85*
Harbeson, Georgiana Newcomb Brown 1894-1980 *DcWomA*
Harbeson, James P *NewYHSD*
Harbeson, John Frederick 1888- *AmArch 70*
Harbeson, Paul Cret 1919- *AmArch 70*
Harbison, William *CabMA*
Harbor, Royce Dalton 1940- *MarqDCG 84*
Harburger, Edmund 1846-1906 *WorECar*
Harburn, Gerald Eugene 1931- *AmArch 70*
Harbutt, Charles 1935- *ConPhot, ICPEnP A, MacBEP, WhoAmA 84*
Harbutt, Elisabeth *DcWomA*
Harbutt, W *DcVicP 2*
Harch, J *FolkA 86*
Harchies, Amelie D' *DcWomA*
Harcoff, Lyla Marshall *WhAmArt 85*
Harcourt, Mrs. 1750-1833 *DcBrECP*
Harcourt, Anne *DcBrA 1*
Harcourt, Anne 1917- *WhoArt 82, –84*
Harcourt, Charles *BiDBrA*
Harcourt, Elisabeth 1739-1811 *DcWomA*
Harcourt, George 1868-1947 *DcBrA 1*
Harcourt, George 1869-1947 *DcVicP 2*
Harcourt, Mrs. George *DcVicP 2*
Harcourt, George E 1897- *WhAmArt 85*
Harcourt, George Simon 1736-1809 *DcBrECP*
Harcourt, George Simon, Earl Of 1736-1809 *DcBrWA*
Harcourt, Mary d1833 *DcWomA*
Harcourt, Mary, Countess Of d1833 *DcBrWA*
Harcourt, Mary Edeva *DcBrA 1*
Harcourt, Mary Lascelles *DcWomA*
Harcourt, Millicent Gifford 1889- *DcWomA, WhAmArt 85*
Harcuba, Jiri 1928- *DcCAr 81*
Harcus, Portia Gwen *WhoAmA 84*
Hardaway, Joseph Benson 1891-1957 *WorECar*
Hardaway, Pearl 1917- *WhoAmA 76, –78, –80, –82, –84*
Hardcastle, Charlotte *DcVicP 2, DcWomA*
Hardcastle, Corinne B d1941 *WhAmArt 85*
Hardcastle, Henry *FolkA 86*
Hardee, Rodney 1954- *FolkA 86*
Hardeman, W H *AmArch 70*
Hardeman, Watson A 1929- *AmArch 70*
Harden, E D *AmArch 70*
Harden, Edmund Harris *DcVicP, –2*
Harden, F J *AmArch 70*
Harden, Gerald A 1909- *WhoArt 82*
Harden, Gerald A C 1909- *ClaDrA, WhoArt 80, –84*
Harden, J Lynn 1935- *AmArch 70*
Harden, James *MarqDCG 84*
Harden, John 1772-1847 *DcBrWA*
Harden, Marvin *AfroAA, PrintW 83, –85, WhoAmA 76, –78, –80, –82, –84*
Harden, Richard *PrintW 85*
Hardenberg, Elizabeth Rutgers *DcWomA*
Hardenbergh, C M *AmArch 70*
Hardenbergh, Elizabeth R *WhAmArt 85*
Hardenbergh, Elizabeth Rutgers *DcWomA*
Hardenbergh, Gerard Rutgers 1855-1915 *WhAmArt 85*
Hardenbergh, Henry J 1847-1918 *BiDAmAr*
Hardenbergh, Henry Janeway 1847-1918 *BnEnAmA, MacEA*
Hardenbergh, Thomas Eddy, III 1933- *AmArch 70*
Harder, Charles M 1889-1959 *CenC[port]*
Harder, Charles M 1899-1959 *WhAmArt 85*
Harder, Charles Mabry 1899-1959 *WhoAmA 80N, –82N, –84N*
Harder, D H *AmArch 70*
Harder, Nicholas *WhAmArt 85*
Harder, Rolf 1929- *WhoGrA 82[port]*
Harder, Rolf Peter 1929- *WhoAmA 76, –78, –80, –82, –84*
Harder, Theodore Ray 1929- *AmArch 70*
Harder, W H *AmArch 70*
Hardess, Maria A *DcVicP 2, DcWomA*
Hardie, Alan 1946- *DcCAr 81*
Hardie, Alexander Merrie 1910- *WhoArt 80, –82, –84*
Hardie, Arthur 1930- *AfroAA*
Hardie, Charles Martin 1858-1916 *ClaDrA, DcBrA 1, DcVicP 2*
Hardie, Charles Martin 1858-1917 *DcBrWA*
Hardie, Fernando *NewYHSD*
Hardie, James Watterston 1938- *WhoArt 80*
Hardie, Lorenzo, Jr. *NewYHSD*
Hardie, Lorenzo, Sr. *NewYHSD*
Hardie, Martin 1875-1952 *ClaDrA, DcBrA 1*
Hardie, Robert Gordon 1854-1904 *WhAmArt 85*
Hardiman, Alfred Frank 1891-1949 *DcBrA 1*
Hardime, Pieter 1677-1758 *ClaDrA*
Hardin, Adlai S 1901- *WhAmArt 85, WhoAmA 73, –76, –78, –80, –82, –84*
Hardin, Ernest R 1902- *WhAmArt 85*
Hardin, Esther McGrew *FolkA 86*
Hardin, Helen 1943- *WhoAmA 78, –80, –82, –84*
Hardin, Shirley G *WhoAmA 73, –76, –78, –80, –82, –84*

–84
Harding, Alfred *NewYHSD*
Harding, Ann 1942- *WhoAmA 84*
Harding, Anne Seamon 1887?-1936 *DcWomA, WhAmArt 85*
Harding, Blanche Lillibridge 1909- *WhAmArt 85*
Harding, C *AmArch 70*
Harding, Charles *DcVicP 2*
Harding, Charlotte *DcWomA, WhAmArt 85*
Harding, Charlotte 1873- *IlsCB 1744*
Harding, Charlotte 1873-1951 *IlrAm A, –1880*
Harding, Chester 1792-1866 *ArtsNiC, BnEnAmA, DcAmArt, FolkA 86, IlBEAAW, McGDA, NewYHSD*
Harding, Chester 1866-1937 *WhAmArt 85*
Harding, Christopher *NewYHSD*
Harding, Constance 1890- *DcWomA, WhAmArt 85*
Harding, Dexter 1796-1862 *NewYHSD*
Harding, Dorothea 1898- *ClaDrA, DcBrA 1, DcWomA*
Harding, Dorothy Sturgis 1891- *DcWomA, WhAmArt 85*
Harding, Edward J 1804-1870 *DcBrWA, DcVicP 2*
Harding, Elizabeth M *ArtsEM, DcWomA*
Harding, Emily J *DcBrBI, DcWomA*
Harding, Fannie *ArtsEM, DcWomA*
Harding, Francis *DcBrECP*
Harding, Frank *DcVicP 2*
Harding, George d1959 *WhAmArt 85, WhoAmA 80N, –82N, –84N*
Harding, George 1882-1959 *IlrAm B*
Harding, George C 1867-1921 *BiDAmAr*
Harding, George E 1843-1907 *BiDAmAr*
Harding, George Frederick Morris 1874-1964 *DcBrA 1*
Harding, George Matthews 1882-1959 *IlrAm 1880*
Harding, George Perfect d1853 *DcBrWA, DcVicP 2*
Harding, Goldie Powell 1892- *ArtsAmW 1, DcWomA, WhAmArt 85*
Harding, Goodwin Warner 1947- *ICPEnP A, MacBEP*
Harding, Grace M *WhAmArt 85*
Harding, H K *AmArch 70*
Harding, Harvey A *NewYHSD*
Harding, Henry H *NewYHSD*
Harding, Horace 1794-1857? *NewYHSD*
Harding, J *DcBrECP*
Harding, J C *NewYHSD*
Harding, J Horace 1863-1929 *WhAmArt 85*
Harding, J W *BkIE*
Harding, James *AntBDN F, BiDBrA*
Harding, James D 1798-1863 *ArtsNiC*
Harding, James Duffield 1797-1863 *DcBrWA, McGDA*
Harding, James Duffield 1798-1863 *ClaDrA, DcBrBI, DcVicP, –2*
Harding, Jane *FolkA 86*
Harding, Jeremiah d1830 *NewYHSD*
Harding, Jeremiah L *FolkA 86*
Harding, John *DcBrWA*
Harding, John L *NewYHSD*
Harding, John T *FolkA 86*
Harding, Lewis 1806-1893 *MacBEP*
Harding, Luiz Fernando Bernils 1946- *MarqDCG 84*
Harding, Mary E *DcVicP 2, DcWomA*
Harding, Nelson 1876-1944 *WhAmArt 85*
Harding, Nelson 1877-1944 *WorECar*
Harding, Neva Whealey 1872- *ArtsAmW 2, DcWomA*
Harding, Newell 1796- *EncASM*
Harding, Noel Robert 1945- *WhoAmA 78, –80, –82, –84*
Harding, O *DcBrECP*
Harding, Patty *DcBrWA, DcWomA*
Harding, Richard H *FolkA 86*
Harding, Robert Crowninshield 1920- *AmArch 70*
Harding, S *DcWomA*
Harding, Samuel *FolkA 86*
Harding, Samuel A *DcBrA 1*
Harding, Spencer S *NewYHSD*
Harding, Spencer S 1808- *ArtsEM*
Harding, Sylvester 1745-1809 *BkIE, DcBrWA*
Harding, T *DcBrECP*
Harding, Thomas 1838-1895 *BiDAmAr*
Harding, Thomas Timothy 1939- *MarqDCG 84*
Harding, W *DcBrWA*
Harding, William James 1826-1899 *MacBEP*
Hardinge, Viscount 1822-1894 *DcVicP 2*
Hardinge Of Lahore, Henry, Viscount 1785-1856 *DcBrWA*
Hardison, Buist *AfroAA*
Hardison, Donald Leigh 1916- *AmArch 70*
Hardison, Inge *AfroAA*
Hardman, Berkeley Reede 1896- *AmArch 70*
Hardman, Catherine Virginia 1863- *DcWomA*
Hardman, Charles *WhAmArt 85*
Hardman, E Chambre 1898- *MacBEP*
Hardman, Mrs. Edwin *FolkA 86*
Hardman, Emma Louise *DcBrA 1, DcWomA*
Hardman, John *DcNiCA*
Hardman, Maud R *ArtsAmW 3*
Hardman, Minnie J *DcVicP 2*

–84

Harris, Arthur *DcVicP 2*
Harris, Barry *MarqDCG 84*
Harris, Belinda *DcWomA, NewYHSD*
Harris, Ben Jorj 1904-1957 *WhAmArt 85, WhoAmA 80N, –82N, –84N*
Harris, Benjamin *NewYHSD*
Harris, Bernard Phillip 1928- *AmArch 70*
Harris, Bess Larkin 1890-1969 *DcWomA*
Harris, C Hartman K d1909 *WhAmArt 85*
Harris, C M *AmArch 70*
Harris, C N *WhAmArt 85*
Harris, Candie 1957- *MarqDCG 84*
Harris, Caroline Estelle 1908- *WhAmArt 85*
Harris, Caroline R *DcWomA, WhAmArt 85*
Harris, Caryl 1884- *WhAmArt 85*
Harris, Charles *DcBrECP*
Harris, Charles Gordon 1891- *WhAmArt 85*
Harris, Charles S *WhAmArt 85*
Harris, Charles X 1856- *WhAmArt 85*
Harris, Clara Isabella 1887- *DcWomA*
Harris, Clarence *AfroAA*
Harris, Clarke Edgar 1906- *AmArch 70*
Harris, Conley 1943- *WhoAmA 82, –84*
Harris, Cyril M 1917- *MacEA*
Harris, Daniel *DcBrWA, FolkA 86*
Harris, Daniel d1835? *BiDBrA*
Harris, Daniel 1699?-1752 *CabMA*
Harris, Daniel Albert 1914- *WhAmArt 85*
Harris, David 1929- *ICPEnP A*
Harris, Dolores Ashley *WhoAmA 84*
Harris, Dora Ballard *ArtsEM, DcWomA*
Harris, Doug *AfroAA*
Harris, E, Jr. *AmArch 70*
Harris, E Vincent 1876-1971 *MacEA*
Harris, Edith Maud *WhAmArt 85*
Harris, Edith Maude *DcWomA*
Harris, Edward *CabMA*
Harris, Edwin 1831- *EncASM*
Harris, Edwin 1855-1906 *DcBrA 1, DcVicP 2*
Harris, Edwin F, Jr. 1934- *AmArch 70*
Harris, Edwin Lawson James 1891- *DcBrA 1*
Harris, Edwin Lawson James 1891-1961 *DcBrA 2*
Harris, Elbridge 1817?- *NewYHSD*
Harris, Elihu *FolkA 86*
Harris, Emanuel Vincent 1879-1971 *DcBrA 1*
Harris, Ernest Edward 1930- *AmArch 70*
Harris, Florence E *DcWomA, WhAmArt 85*
Harris, Frances Elizabeth Louise 1822-1873? *DcWomA*
Harris, Frederick *DcVicP 2*
Harris, Frederick G *DcVicP 2*
Harris, G K, Jr. *AmArch 70*
Harris, Geoffrey 1928- *WhoArt 80, –82, –84*
Harris, George *DcVicP 2, FolkA 86, NewYHSD*
Harris, George A 1913- *WhAmArt 85*
Harris, George D *NewYHSD*
Harris, George E 1898-1938? *WhAmArt 85*
Harris, George Walter *DcVicP, –2*
Harris, Georgia Maverick 1889- *ArtsAmW 2, DcWomA, WhAmArt 85*
Harris, Gerald Francis 1949- *MarqDCG 84*
Harris, Gilbert S 1931- *AfroAA*
Harris, Gloriane 1947- *WhoAmA 80, –82, –84*
Harris, Glynn Lovett 1915- *AmArch 70*
Harris, Grace Griffith 1885- *ArtsAmW 1, DcWomA*
Harris, Gregory Carr 1951- *MarqDCG 84*
Harris, Greta *ArtsAmW 2, DcWomA, WhAmArt 85*
Harris, Harriet A *DcWomA, FolkA 86*
Harris, Harvey Sherman 1915- *WhoAmA 76, –78, –80, –82, –84*
Harris, Harwell Hamilton 1903- *AmArch 70, ConArch, MacEA, McGDA*
Harris, Henry Alfred 1871- *DcBrA 1, DcVicP 2*
Harris, Henry H *ArtsEM*
Harris, Henry Hotham 1805-1865 *DcBrWA, DcVicP 2*
Harris, Mrs. Irving D 1905-1958 *WorFshn*
Harris, Isabella M *DcVicP 2*
Harris, J C *DcBrWA*
Harris, J H *AmArch 70*
Harris, J S *AmArch 70*
Harris, Jack *AfroAA*
Harris, James *DcBrWA, FolkA 86, NewYHSD*
Harris, James 1808?-1846 *NewYHSD*
Harris, James 1810-1887 *DcSeaP, DcVicP, –2*
Harris, Sir James C 1831-1904 *DcBrWA, DcVicP 2*
Harris, James F *NewYHSD*
Harris, James Martin 1928- *AmArch 70*
Harris, Jane *DcWomA*
Harris, Jane M 1846-1936 *ArtsEM, DcWomA*
Harris, Jennie *DcWomA*
Harris, Jim *MarqDCG 84*
Harris, John *CabMA, DcBrECP*
Harris, John *Scotland AfroAA*
Harris, John d1775 *CabMA*
Harris, John d1834 *DcBrWA*
Harris, John 1791-1873 *DcBrWA*
Harris, John, II 1791-1873 *DcVicP 2*
Harris, John B *CabMA*
Harris, John L 1772?- *CabMA*

Harris, John Rolla 1888- *WhAmArt 85*
Harris, John Taylor 1908- *AfroAA, WhAmArt 85*
Harris, Jon 1943- *DcCAr 81*
Harris, Joseph Edwin 1926- *MarqDCG 84*
Harris, Joseph T *NewYHSD*
Harris, Josephine *WhoArt 80, –82, –84*
Harris, Josephine Marie 1911- *WhoAmA 73, –76, –78, –80*
Harris, Julian Hoke 1906- *WhAmArt 85, WhoAmA 73, –76, –78, –80, –82, –84*
Harris, Kaija Sanelma *DcCAr 81*
Harris, Kathryn Mary 1956- *MarqDCG 84*
Harris, Ken *FolkA 86*
Harris, Kennard 1930- *DcCAr 81*
Harris, L Frank 1922- *AmArch 70*
Harris, Lander S 1868-1920 *ArtsEM*
Harris, Lawren Phillips 1910- *DcCAr 81, WhoAmA 73, –76, –78, –80, –82, –84*
Harris, Lawren Stewart 1885- *McGDA*
Harris, Lawren Stewart 1885-1970 *ArtsAmW 3, IlBEAAW, OxTwCA*
Harris, Leon A, Jr. 1926- *WhoAmA 73, –76, –78, –80, –82, –84*
Harris, Louis 1902- *WhAmArt 85*
Harris, Lucille *WhoAmA 73, –76*
Harris, Lucille S 1914- *WhoAmA 84*
Harris, Lyndon Goodwin 1928- *DcBrA 1, WhoArt 80, –82, –84*
Harris, M *AmArch 70*
Harris, M M *AmArch 70*
Harris, Margie Coleman *WhoAmA 78N, –80N, –82N, –84N*
Harris, Margie Coleman 1891-1966? *DcWomA*
Harris, Margie Coleman 1891-1968? *WhAmArt 85*
Harris, Margo Liebes *WhoAmA 73, –76, –78, –80*
Harris, Marian D 1904- *WhAmArt 85, WhoAmA 73, –76, –78, –80, –82, –84*
Harris, Martha 1854-1933 *DcWomA*
Harris, Martin S, Jr. 1932- *AmArch 70*
Harris, Mary Aubin 1864- *DcWomA, WhAmArt 85*
Harris, Mary Packer 1891- *DcWomA, WhoArt 80, –82, –84*
Harris, Mrs. Mason Dix *WhoAmA 73*
Harris, Maude E *DcVicP 2, DcWomA*
Harris, Maude M *DcVicP 2*
Harris, Max L 1921- *AmArch 70*
Harris, May *DcWomA*
Harris, Moses 1731-1785? *DcBrWA*
Harris, Murray A 1911- *WhoAmA 76, –78, –80*
Harris, N A *AmArch 70*
Harris, O H *AmArch 70*
Harris, Obleton *AfroAA*
Harris, P H *AmArch 70*
Harris, Pamela 1940- *MacBEP*
Harris, Pat *DcCAr 81*
Harris, Paul *WhoAmA 73, –76, –78*
Harris, Paul 1925- *DcCAA 71, –77, WhoAmA 80, –82, –84*
Harris, Paul Rogers 1933- *WhoAmA 78, –80, –82, –84*
Harris, Paul Stewart 1906- *WhoAmA 73, –76, –78, –80, –82, –84*
Harris, Peter 1943- *MarqDCG 84*
Harris, Philip Spooner 1824-1884 *NewYHSD*
Harris, Phyllis 1925- *WhoArt 80, –82, –84*
Harris, R *EncASM*
Harris, R A *AmArch 70*
Harris, R P *DcBrWA*
Harris, R S *AmArch 70*
Harris, Rae Amelia 1905- *WhoArt 84*
Harris, Ralph Everett 1938- *AmArch 70*
Harris, Raymond 1951- *MarqDCG 84*
Harris, Mrs. Reginald G *WhAmArt 85*
Harris, Robert *CabMA*
Harris, Robert 1849-1919 *DcVicP 2, McGDA*
Harris, Robert Blair 1927- *AmArch 70*
Harris, Robert Dunlop 1934- *AmArch 70*
Harris, Robert George 1911- *IlBEAAW, IlrAm E, –1880, WhAmArt 85, WhoAmA 73, –76, –78, –80, –82, –84*
Harris, Romaine *AfroAA*
Harris, Russell Courtney 1925- *AmArch 70*
Harris, S Elliott *WhoAmA 76, –78, –80, –82*
Harris, Mrs. S Elliott *WhoAmA 76, –78, –80, –82*
Harris, S G *DcWomA*
Harris, Saide *WhAmArt 85*
Harris, Saide G *DcWomA*
Harris, Sam H *WhAmArt 85*
Harris, Samuel *CabMA*
Harris, Samuel 1783-1810 *NewYHSD*
Harris, Samuel Hyde 1889- *ArtsAmW 2*
Harris, Sarah Eliza 1886- *DcBrA 1, DcWomA*
Harris, Sarah L *WhAmArt 85*
Harris, Sedrick Paul 1940- *MarqDCG 84*
Harris, Sharon 1935- *WorFshn*
Harris, Stanley 2- *AmArch 70*
Harris, Suzanne C 1909- *ClaDrA*
Harris, Thomas *DcCAr 81, FolkA 86*
Harris, Thomas 1688?-1763 *BiDBrA*

Harris, Thomas 1829-1900 *McGDA*
Harris, Thomas 1830-1900 *MacEA*
Harris, Thomas David 1933- *AmArch 70*
Harris, Thomas Liston *AfroAA*
Harris, Tomas 1908- *ClaDrA*
Harris, Vera Furneaux 1904- *DcBrA 1*
Harris, W C *AmArch 70*
Harris, W J *AmArch 70*
Harris, W P *FolkA 86*
Harris, W R, III *AmArch 70*
Harris, Warren *AfroAA*
Harris, Wilbur Thomas 1922- *AmArch 70*
Harris, William *BiDBrA, CabMA, DcSeaP*
Harris, William d1863 *BiDBrA*
Harris, William 1796?-1823 *BiDBrA*
Harris, William, Jr. *CabMA*
Harris, William Clarence, Jr. 1920- *AmArch 70*
Harris, William Critchlow 1854-1913 *MacEA*
Harris, William E *DcBrWA, DcVicP 2*
Harris, William Laurel 1870-1924 *WhAmArt 85*
Harris, William W *CabMA*
Harris, William Wadsworth 1927- *WhoAmA 76*
Harris, William Wadsworth, II 1927- *WhoAmA 78, –80, –82, –84*
Harris And Appleton *CabMA*
Harris And Schafer *EncASM*
Harrisman, Mehitable *FolkA 86*
Harrison, Mrs. 1788-1875 *DcVicP, –2*
Harrison, A B *AmArch 70*
Harrison, Addie *ArtsEM*
Harrison, Alexander *DcVicP 2*
Harrison, Allan 1911- *WhoAmA 82, –84*
Harrison, Anna Maria *DcVicP 2, DcWomA*
Harrison, Annie Jane *DcWomA*
Harrison, Arthur d1922 *DcBrA 1, DcVicP 2*
Harrison, B J *AmArch 70*
Harrison, Benjamin J *FolkA 86, NewYHSD*
Harrison, Bernard *DcVicP 2*
Harrison, Birge 1854-1929 *ArtsAmW 3*
Harrison, Brook *DcVicP 2*
Harrison, C N *WhAmArt 85*
Harrison, C R *FolkA 86*
Harrison, Carole 1933- *WhoAmA 78, –80, –84*
Harrison, Caroline Lavinia Scott d1892 *DcWomA*
Harrison, Catherine *DcWomA*
Harrison, Charles *DcBrBI, NewYHSD*
Harrison, Charles d1943 *DcBrA 2*
Harrison, Charles 1949- *AmArt*
Harrison, Charles Harmony 1842-1902 *DcBrA 1, DcBrWA, DcVicP 2*
Harrison, Charles P 1783-1854 *NewYHSD*
Harrison, Christopher 1775-1863 *NewYHSD*
Harrison, Claude 1922- *WhoArt 80, –82, –84*
Harrison, Claude William 1922- *DcBrA 1*
Harrison, Colin 1939- *DcCAr 81*
Harrison, D G *AmArch 70*
Harrison, Darent *DcVicP 2*
Harrison, David 1903- *AmArch 70*
Harrison, David R *NewYHSD*
Harrison, Diana 1950- *DcCAr 81*
Harrison, Dorothy *WhAmArt 85*
Harrison, Dorothy 1895- *DcWomA*
Harrison, Edith 1879- *DcWomA, WhAmArt 85*
Harrison, Edward Stroud 1879- *ClaDrA, DcBrA 1*
Harrison, Elbert Iredell 1897- *AmArch 70*
Harrison, Emily H *DcVicP 2, DcWomA*
Harrison, Emily M *DcVicP 2*
Harrison, Emma Florence *DcBrBI, DcVicP 2*
Harrison, Eric 1919- *WhoArt 80, –82, –84*
Harrison, F E *DcVicP 2*
Harrison, Fanny *DcVicP 2, DcWomA*
Harrison, Fielding T *FolkA 86*
Harrison, Fred Lawton, Jr. 1924- *AmArch 70*
Harrison, Frederick *DcVicP 2*
Harrison, G J *DcVicP 2*
Harrison, Gabriel 1818-1902 *NewYHSD , WhAmArt 85*
Harrison, George *DcVicP 2*
Harrison, George d1830 *NewYHSD*
Harrison, Mrs. George *DcVicP 2*
Harrison, George Henry 1816-1846 *DcBrWA, DcVicP, –2*
Harrison, George L *ClaDrA, DcBrBI, DcVicP 2*
Harrison, Gerald E *DcVicP 2*
Harrison, Grace Earle *DcWomA, WhAmArt 85*
Harrison, Hannah *DcWomA*
Harrison, Harriet *DcBrWA, DcVicP 2, DcWomA*
Harrison, Harriet N *DcWomA*
Harrison, Harry Robert 1923- *AmArch 70*
Harrison, Hazel W *DcBrA 1*
Harrison, Helen *WhAmArt 85*
Harrison, Helen 1929- *ConArt 83*
Harrison, Helen Amy 1943- *WhoAmA 80, –82, –84*
Harrison, Helen Mayer *WhoAmA 76, –78, –80, –82, –84*
Harrison, Henry *DcVicP 2, FolkA 86, NewYHSD*
Harrison, Henry d1923 *WhAmArt 85*
Harrison, Henry 1785?-1865? *BiDBrA*
Harrison, Henry G 1813-1895 *BiDAmAr, MacEA*
Harrison, Ian 1935- *ClaDrA*
Harrison, J *BiDBrA, DcVicP, –2*

WhoAmA 73, –76, –78, –80, –82, –84
Hartger, G J *AmArch* 70
Harth, Philipp 1887- *PhDcTCA* 77
Harth, Philipp 1887-1968 *OxTwCA*
Hartheimer, A S *AmArch* 70
Harthorne, Francis Joseph 1915- *AmArch* 70
Hartigan, Grace 1922- *BnEnAmA, ConArt* 77, –83,
 DcAmArt, DcCAA 71, –77, *DcCAr* 81,
 McGDA, OxTwCA, PhDcTCA 77,
 WhoAmA 73, –76, –78, –80, –82, –84, *WomArt,*
 WorArt[port]
Hartigan, Lynda Roscoe 1950- *WhoAmA* 80, –82, –84
Harting, G W 1877- *WhAmArt* 85
Harting, H *ArtsEM*
Harting, Marinus *NewYHSD*
Harting, Marinus d1861 *ArtsEM*
Harting, Peter 1799-1864 *FolkA* 86
Harting, Rial *NewYHSD*
Hartl, Leon *WhAmArt* 85
Hartl, Leon 1889- *DcCAA* 71, *WhoAmA* 73, –76,
 –78N, –80N, –82N, –84N
Hartl, Leon 1889-1973 *DcCAA* 77
Hartland, Henry Albert 1840-1893 *DcBrWA,*
 DcVicP 2
Hartley, Mrs. *DcBrECP, DcWomA*
Hartley, Alfred d1933 *ClaDrA*
Hartley, Alfred 1855-1933 *DcBrA* 1, *DcVicP, –2*
Hartley, Mrs. Alfred *DcVicP* 2
Hartley, Bernard 1745?-1834 *BiDBrA*
Hartley, E A *DcVicP* 2, *DcWomA*
Hartley, Elaine 1909- *WhAmArt* 85
Hartley, Florence *FolkA* 86, *WhAmArt* 85
Hartley, Harold W 1923- *AmArch* 70
Hartley, Harrison Smith 1888- *WhAmArt* 85
Hartley, J S 1845- *ArtsNiC*
Hartley, James Mitchell 1926- *AmArch* 70
Hartley, Joan 1892- *DcWomA, WhAmArt* 85
Hartley, Jonathan Scott 1845-1912 *WhAmArt* 85
Hartley, Joseph 1842- *WhAmArt* 85
Hartley, Marsden 1877-1943 *ArtsAmW* 1, –3,
 BnEnAmA, ConArt 77, *DcAmArt, DcCAA* 71,
 –77, *IlBEAAW, McGDA, OxTwCA,*
 WhAmArt 85
Hartley, Marsden Edmund 1877-1943 *PhDcTCA* 77
Hartley, Mary *DcWomA*
Hartley, Nora *DcWomA*
Hartley, Paul Jerome 1943- *WhoAmA* 78, –80, –82,
 –84
Hartley, Rachel 1884- *DcWomA, WhAmArt* 85
Hartley, Richard d1921 *DcBrA* 1, *DcVicP* 2
Hartley, Thomas *DcVicP, –2*
Hartley, Thomas R *WhAmArt* 85
Hartley, W Douglas 1921- *WhoAmA* 80, –82, –84
Hartley, William *ClaDrA, NewYHSD*
Hartman, A O *NewYHSD*
Hartman, Adam *NewYHSD*
Hartman, Adolph *NewYHSD*
Hartman, Barnard Wilson, Jr. 1922- *AmArch* 70
Hartman, Bertram *WhoAmA* 80N, –82N, –84N
Hartman, Bertram 1882-1960 *WhAmArt* 85
Hartman, C Bertram 1882-1960 *ArtsAmW* 1
Hartman, Carroll S *ArtsEM*
Hartman, Charles F *NewYHSD*
Hartman, Christian B *FolkA* 86
Hartman, Conrad Fried *NewYHSD*
Hartman, Daisy *WhAmArt* 85
Hartman, Ethel B *DcWomA*
Hartman, George 1928- *WhoAmA* 80, –82
Hartman, George A 1925- *AmArch* 70
Hartman, George E 1936- *ConArch*
Hartman, George E, Jr. 1936- *AmArch* 70
Hartman, H W *AmArch* 70
Hartman, Hazel 1900- *WhAmArt* 85
Hartman, J W *NewYHSD*
Hartman, John 1805?- *FolkA* 86
Hartman, Julius 1870-1922 *BiDAmAr*
Hartman, Martin *NewYHSD*
Hartman, Mauno 1930- *OxTwCA*
Hartman, Morton 1923- *AmArch* 70
Hartman, O F *AmArch* 70
Hartman, Peter *FolkA* 86
Hartman, Reber S *WhAmArt* 85
Hartman, Robert 1926- *DcCAA* 71, –77
Hartman, Robert Leroy 1926- *WhoAmA* 73, –76, –78,
 –80, –82, –84
Hartman, Rosella 1894- *WhAmArt* 85
Hartman, Sarah Ann 1807?- *FolkA* 86
Hartman, Sterling Reber 1901- *WhAmArt* 85
Hartman, Sydney K 1863-1929 *WhAmArt* 85
Hartman, Theodore 1822?- *NewYHSD*
Hartman, W H *AmArch* 70
Hartman, W J, Jr. *AmArch* 70
Hartmann, Anna Rosa *DcWomA*
Hartmann, Charles G *FolkA* 86
Hartmann, Christian *DcVicP* 2
Hartmann, Emilie Von *DcWomA*
Hartmann, Erich 1922- *ConPhot, ICPEnP* A
Hartmann, Georg Theo 1894- *WhoAmA* 76
Hartmann, Georg Theo 1894-1976 *WhAmArt* 85,
 WhoAmA 78N, –80N, –82N, –84N
Hartmann, Hans 1913- *WhoGrA* 82[port]

Hartmann, Herman *NewYHSD*
Hartmann, Ilka Maria 1942- *ICPEnP* A, *MacBEP*
Hartmann, Johann Joseph 1753-1830 *ClaDrA*
Hartmann, Karl 1818-1857 *DcVicP* 2
Hartmann, Lucy H *DcWomA*
Hartmann, Sadakichi 1867-1944 *MacBEP*
Hartmann, Sadakichi 1869-1944 *ArtsAmW* 2,
 WhAmArt 85
Hartmann, William Edward 1916- *AmArch* 70
Hartnell, Katherine Grant *ClaDrA, DcBrA* 1
Hartnell, Kathleen Grant *DcWomA*
Hartnell, Nathaniel *DcVicP* 2
Hartnell, Norman 1901- *WorFshn*
Hartnell, Norman 1902- *FairDF ENG*
Hartnett, Eva Valker 1895- *ArtsAmW* 1,
 WhAmArt 85
Hartnett, J J *AmArch* 70
Hartnett, John J 1940- *MarqDCG* 84
Hartog VanBanda, Lo 1916- *WorECom*
Hartrath, Joseph *NewYHSD*
Hartrath, Lucie *WhAmArt* 85
Hartrath, Lucie 1868-1962 *DcWomA*
Hartray, John Fleming 1928- *AmArch* 70
Hartrick, Archibald Standish 1864-1950 *ClaDrA,*
 DcBrA 1, *DcBrBI, DcVicP* 2
Hartrick, Archibald Standish 1865-1950 *DcBrWA*
Hartrick, Lilly *DcWomA*
Hartry, E *DcVicP* 2
Hartsell, Philip *ArtsEM*
Hartsell, William Newell, Jr. 1940- *AmArch* 70
Hartsfield, Robert James 1934- *AmArch* 70
Hartshorn, Charles P 1833-1880 *BiDAmAr*
Hartshorn, John *FolkA* 86
Hartshorn, John 1650-1734 *FolkA* 86
Hartshorn, Jonathan *FolkA* 86
Hartshorn, Jonathan 1773?-1803 *CabMA*
Hartshorn, Samuel 1725-1784 *FolkA* 86
Hartshorn, Stephen 1737- *FolkA* 86
Hartshorn, Willis E 1950- *WhoAmA* 82, –84
Hartshorne, Charles Henry 1802-1865 *DcBrWA*
Hartshorne, Harold *ArtsAmW* 3
Hartshorne, Howard Morton *WhAmArt* 85
Hartshorne, Lois *WhAmArt* 85
Hartsoe, Sylvanus *FolkA* 86
Hartson, Addie *ArtsEM*
Hartson, Walter C 1866- *WhAmArt* 85
Hartstern, Fred J 1903- *AmArch* 70
Hartswell, Philip H 1844?-1902 *ArtsEM*
Hartt, Cecil Laurence 1844-1930 *WorECar*
Hartt, Frederick 1914- *WhoAmA* 73, –76, –78, –80,
 –82, –84
Hartung *FolkA* 86
Hartung, F *IlBEAAW*
Hartung, Hans 1904- *ConArt* 83, *DcCAr* 81,
 McGDA, OxTwCA, PhDcTCA 77, *PrintW* 85,
 WhoArt 80, –82, –84, *WorArt[port]*
Hartung, Hans Ernst 1904- *ConArt* 77
Hartung, Hans Heinrich Ernst 1904- *ClaDrA*
Hartung, Heinrich 1851-1919 *ClaDrA*
Hartung, Hugo 1855-1932 *MacEA*
Hartung, Karl 1908- *McGDA*
Hartung, Karl 1908-1967 *OxTwCA, PhDcTCA* 77
Hartung, Peter *FolkA* 86
Hartung, Richard Lee 1937- *AmArch* 70
Hartwell, Alonzo *FolkA* 86
Hartwell, Alonzo 1805-1873 *EarABI, EarABI SUP,*
 NewYHSD
Hartwell, Arthur Lewis 1882- *WhAmArt* 85
Hartwell, Charles Leonard 1873-1951 *DcBrA* 1
Hartwell, Edith *WhAmArt* 85
Hartwell, Emily S *ArtsAmW* 3
Hartwell, G G *NewYHSD*
Hartwell, George G 1815-1901 *FolkA* 86
Hartwell, George Kenneth d1949 *WhoAmA* 78N,
 –80N, –82N, –84N
Hartwell, Helen A 1847- *DcWomA*
Hartwell, Henry W 1833-1919 *BiDAmAr*
Hartwell, Henry Walker 1833-1919 *MacEA*
Hartwell, Kenneth 1891-1949 *WhAmArt* 85
Hartwell, Marjorie *WhAmArt* 85
Hartwell, Nina Rosabel *ArtsAmW* 2, *DcWomA,*
 WhAmArt 85
Hartwell, Patricia Lochridge 1916- *WhoAmA* 76, –78,
 –80, –82, –84
Hartwell, Stephen A 1954- *MarqDCG* 84
Hartwell And Richardson *MacEA*
Hartwich, Herman 1853- *WhAmArt* 85
Hartwick, Bruce Miles 1919- *AmArch* 70
Hartwick, Gunther *NewYHSD*
Hartwick, T B *NewYHSD*
Hartwig, Cleo 1911- *McGDA, WhAmArt* 85,
 WhoAmA 73, –76, –78, –80, –82, –84
Hartwig, Edward 1909- *ConPhot, ICPEnP* A
Hartwig-Hood, Susan *MarqDCG* 84
Hartwigsen, Bruce 1931- *AmArch* 70
Hartz, Daniel *FolkA* 86
Hartz, Sophie 1805- *DcWomA*
Hartzel, John, Jr. *FolkA* 86
Hartzer, Karl Ferdinand *ArtsNiC*
Harumitsu *AntBDN* L
Harunobu 1725-1770 *McGDA*

Harunobu, Suzuki 1720?-1770 *OxArt*
Harushige *McGDA*
Haruta, Kyoichi 1931- *MarqDCG* 84
Harvard, William Bloxham 1911- *AmArch* 70
Harvel, Jerry Thomas 1941- *MarqDCG* 84
Harvey, A E *AmArch* 70
Harvey, A R, III *AmArch* 70
Harvey, Agnes *DcWomA*
Harvey, Alice 1894- *DcWomA*
Harvey, Alice 1905- *WorECar*
Harvey, Alice K 1951- *MarqDCG* 84
Harvey, Andre 1941- *WhoAmA* 80, –82, –84
Harvey, Annie E *DcWomA*
Harvey, Archibald *ArtsEM*
Harvey, Bill *FolkA* 86
Harvey, Catharine P *DcWomA*
Harvey, Charles *DcBrA* 1
Harvey, Charles Y 1869-1912 *WhAmArt* 85
Harvey, David Alan 1944- *ICPEnP* A
Harvey, Dermot 1941- *WhoAmA* 76, –78, –80, –82,
 –84
Harvey, Didy *DcCAr* 81
Harvey, Donald 1930- *PrintW* 83, –85, *WhoAmA* 76,
 –78, –80, –82, –84
Harvey, Donald E 1941- *DcCAr* 81
Harvey, Donald Gilbert 1947- *WhoAmA* 73, –76, –78,
 –80, –82, –84
Harvey, Douglas S *DcVicP* 2
Harvey, Doyle L 1915- *AmArch* 70
Harvey, E *DcVicP* 2
Harvey, Earl Miners 1918- *AmArch* 70
Harvey, Eli 1860- *WhAmArt* 85
Harvey, Eli 1860-1957 *ArtsAmW* 1, *IlBEAAW*
Harvey, Elisabeth *DcWomA*
Harvey, Elsie M 1893- *DcBrA* 1, *DcWomA*
Harvey, Frederick E *BiDBrA*
Harvey, G *DcVicP* 2, *OfPGCP* 86
Harvey, George 1800?-1878 *DcAmArt, IlBEAAW,*
 NewYHSD
Harvey, George 1801-1878 *BnEnAmA*
Harvey, George 1835?-1920? *NewYHSD* ,
 WhAmArt 85
Harvey, George 1846-1910 *DcBrA* 2
Harvey, George 1874-1962 *FolkA* 86
Harvey, Sir George 1806-1876 *ArtsNiC, ClaDrA,*
 DcBrWA, DcVicP, –2
Harvey, George L 1866-1923 *BiDAmAr*
Harvey, George W 1855- *WhAmArt* 85
Harvey, Gerald 1933- *IlBEAAW*
Harvey, Gertrude *DcBrA* 2
Harvey, H M *DcVicP* 2
Harvey, Harold C 1874-1941 *DcBrA* 1, *DcVicP* 2
Harvey, Harold LeRoy 1899- *WhAmArt* 85
Harvey, Henrietta *DcWomA*
Harvey, Herbert Johnson 1884-1928 *DcBrA* 1
Harvey, Isaac A *FolkA* 86
Harvey, J H *AmArch* 70
Harvey, J K *DcVicP* 2
Harvey, J S *DcBrECP*
Harvey, Jacob 1783-1867 *BiDBrA*
Harvey, Jacqueline 1927- *WhoAmA* 73, –76, –78, –80,
 –82, –84
Harvey, Jake 1948- *WhoArt* 80, –82, –84
Harvey, James *DcBrECP*
Harvey, James 1929-1965 *DcCAA* 71, –77
Harvey, James V d1965 *WhoAmA* 78N, –80N, –82N,
 –84N
Harvey, Jane *DcWomA*
Harvey, Jeanette P *DcWomA*
Harvey, John *BiDBrA, DcBrECP, MacEA*
Harvey, John Armstrong 1934- *AmArch* 70
Harvey, John Rabone *ClaDrA*
Harvey, John Rabone d1933 *DcBrA* 1
Harvey, John Rathbone d1933 *DcVicP* 2
Harvey, Joshua George 1937- *AmArch* 70
Harvey, K E *AmArch* 70
Harvey, Laura Cornell 1906- *WhAmArt* 85
Harvey, M T *FolkA* 86
Harvey, Michael Anthony *WhoArt* 82, –84
Harvey, Michael Anthony 1921- *WhoArt* 80
Harvey, Nelly *DcWomA*
Harvey, Pat *WhoArt* 80, –82, –84
Harvey, Paul *WhAmArt* 85
Harvey, Paul 1878-1948 *ArtsAmW* 2
Harvey, Peter R 1955- *MarqDCG* 84
Harvey, Priscilla *DcWomA*
Harvey, Raymond Kent 1906- *AmArch* 70
Harvey, Reginald Leonard 1897- *ClaDrA*
Harvey, Richard Dean 1940- *WhoAmA* 80, –82
Harvey, Robert 1868- *WhAmArt* 85
Harvey, Robert 1924- *DcCAA* 71, –77
Harvey, Robert Darnell 1919- *MarqDCG* 84
Harvey, Robert Martin 1924- *WhoAmA* 73, –76, –78,
 –80, –82, –84
Harvey, Sara Edith *WhAmArt* 85
Harvey, Sarah E 1834-1924 *DcWomA*
Harvey, Sarah E 1835-1924 *FolkA* 86
Harvey, Sarah Hope *DcWomA*
Harvey, Sydney *DcBrBI*
Harvey, Thomas *FolkA* 86

Harvey, V G *WhAmArt 85*
Harvey, W Craig 1882- *WhAmArt 85*
Harvey, William 1796-1866 *DcBrBI, DcBrWA, DcVicP 2*
Harvey, William 1798-1866 *ArtsNiC*
Harvey, William Andre 1941- *WhoAmA 78*
Harvey And Otis *EncASM*
Harvey-Bloom, J *DcBrA 2*
Harvey-Jones, Dorothy 1898- *ClaDrA, DcBrA 1, DcWomA*
Harveymore, A *DcVicP 2*
Harvie, Bettina *DcWomA*
Harvie, R *DcBrECP*
Harwood, Burt 1897-1924 *ArtsAmW 1*
Harwood, Burt S 1897-1924? *IlBEAAW, WhAmArt 85*
Harwood, Conrad *ArtsEM*
Harwood, Edith *DcWomA*
Harwood, Edward 1814- *DcVicP, -2*
Harwood, Elizabeth *WhAmArt 85*
Harwood, Elizabeth Case *DcWomA*
Harwood, H T *WhAmArt 85*
Harwood, Harriet Richards d1922 *ArtsAmW 3*
Harwood, Hattie Richards d1922 *ArtsAmW 3*
Harwood, Henry *DcVicP 2*
Harwood, J E *AmArch 70*
Harwood, J Taylor 1860-1940 *WhAmArt 85*
Harwood, James T 1860-1940 *ArtsAmW 1*
Harwood, James Taylor 1860-1940 *IlBEAAW*
Harwood, John *DcBrBI, DcSeaP*
Harwood, John Hammond 1904- *DcBrA 1, WhoArt 80, -82, -84*
Harwood, John James 1816-1872 *DcVicP, -2*
Harwood, June Beatrice 1933- *WhoAmA 76, -78, -80*
Harwood, Robert 1830- *DcVicP, -2*
Harwood, Robert Kent 1932- *AmArch 70*
Harwood, Sabra B 1895- *DcWomA, WhAmArt 85*
Harwood, William D, Jr. 1953- *MarqDCG 84*
Hasan B Husayn At-Tuluni 1432?-1517 *MacEA*
Hasbrook, K *ArtsEM, DcWomA*
Hasbrouck, DuBois Fenelon 1860- *WhAmArt 85*
Hasbrouck, Elsa *WhAmArt 85*
Hasbrouck, Wilbert Roland 1931- *AmArch 70*
Hase, Conrad Wilhelm 1818-1902 *MacEA, WhoArch*
Hasegawa, Akira 1940- *MarqDCG 84*
Hasegawa, Haruko 1895-1967 *DcWomA*
Hasegawa, Tony Seisuke 1941- *MarqDCG 84*
Haselar, Edwin *AntBDN G*
Haselden, W K 1872-1953 *WorECom*
Haselden, William Kerridge 1872-1953 *DcBrA 1, DcBrBI*
Haseler, Henry *DcBrWA*
Haseler, W *DcVicP 2*
Haseler, W H *DcNiCA*
Haselhuhn, Robert G 1906- *AmArch 70*
Haseltine, Charles Field 1840-1915 *NewYHSD , WhAmArt 85*
Haseltine, Elisabeth *DcWomA, WhAmArt 85*
Haseltine, Elizabeth Stanley 1811-1882 *DcWomA, NewYHSD*
Haseltine, Henry J *ArtsNiC*
Haseltine, Herbert 1877-1962 *WhAmArt 85, WhoAmA 80N, -82N, -84N*
Haseltine, J P *DcVicP 2*
Haseltine, James Henry 1833-1907 *NewYHSD , WhAmArt 85*
Haseltine, James Lewis 1924- *WhoAmA 73, -76, -78, -80, -82, -84*
Haseltine, Maury 1925- *AmArt, WhoAmA 73, -76, -78, -80, -82, -84*
Haseltine, William Stanley *ArtsNiC*
Haseltine, William Stanley 1835-1900 *DcAmArt, DcSeaP, NewYHSD , WhAmArt 85*
Haselton, Helen A *WhAmArt 85*
Hasen, Burt Stanly 1921- *PrintW 83, -85, WhoAmA 73, -76, -78, -80, -82, -84*
Hasen, Irwin 1918- *WorECom*
Hasenauer, Carl 1833-1894 *MacEA*
Hasenauer, Karl Von 1833-1894 *McGDA*
Hasenclever, F P 1810-1853 *ArtsNiC*
Hasenfus, Gary L 1939- *MarqDCG 84*
Hasenritter, C W d1878 *FolkA 86*
Hasenritter, Robert Hermann d1892 *FolkA 86*
Hashem, Erfan 1924- *AmArch 70*
Hashimoto, Gaho 1835-1908 *McGDA*
Hashimoto, Kansetsu 1883-1945 *McGDA*
Hashimoto, Mrs. Masahiko 1890- *ArtsAmW 3*
Hashimoto, Mrs. Michi 1890?- *DcWomA, WhAmArt 85*
Hashimoto, Michi Yosida 1890- *ArtsAmW 3*
Hashmi, Zarina *PrintW 85*
Hasior, Vladislav 1928- *PhDcTCA 77*
Haskell, Barbara 1946- *WhoAmA 76, -78, -80, -82, -84*
Haskell, Douglas 1899- *AmArch 70, WhoAmA 73, -76*
Haskell, Ernest 1876-1925 *ArtsAmW 1, GrAmP, IlBEAAW, WhAmArt 85*
Haskell, Frederick T d1935 *WhAmArt 85*
Haskell, Harry Garner, Jr. 1921- *WhoAmA 76, -78, -80, -82*

Haskell, Henry C *EncASM*
Haskell, Hiram Betts 1823-1873 *NewYHSD*
Haskell, Howard A 1913- *AmArch 70*
Haskell, Ida C 1861?-1932 *DcWomA, WhAmArt 85*
Haskell, John G 1832-1907 *BiDAmAr*
Haskell, Joseph Allen *ArtsEM*
Haskell, Joseph Allen 1808-1894 *NewYHSD*
Haskell, Lyman *NewYHSD*
Haskell, Thomas J *NewYHSD*
Haskell, William 1791- *CabMA*
Haskell, William C 1869-1933 *BiDAmAr*
Haskell, William H d1952 *WhoAmA 78N, -80N, -82N, -84N*
Haskell, William Homer 1875-1952 *WhAmArt 85*
Haskell, William Lincoln *WhAmArt 85*
Haskell Beecher *EncASM*
Haskew, J T *DcVicP 2*
Haskew, Walter William 1909- *AmArch 70*
Haskey, George 1903- *WhAmArt 85*
Haskin, Donald Marcus 1920- *WhoAmA 76, -78, -80, -82, -84*
Haskins, Albert Lewis, Jr. 1910- *AmArch 70*
Haskins, John Franklin 1919- *WhoAmA 78, -80, -82, -84*
Haskins, Sam 1926- *ConPhot, ICPEnP A*
Haslam, W D *DcVicP 2*
Hasledon, Ron 1944- *DcCAr 81*
Haslegrave, Adelaide L *DcVicP 2*
Haslehurst, Ernest William 1866-1949 *DcBrWA, DcVicP 2*
Haslehurst, Minette Tucker *ArtsAmW 3*
Haslehust, Ernest William 1866-1949 *DcBrA 1*
Haslam, Jane N 1934- *WhoAmA 73, -76, -78, -80, -82, -84*
Haslam, John 1808-1884 *AntBDN M, DcBrWA, DcVicP 2*
Haslam, John Arthur 1934- *WhoAmA 73, -76*
Hasler, William N 1865- *WhAmArt 85*
Haslett, Lillian E *ArtsEM, DcWomA*
Haslund, R H *AmArch 70*
Hasmer, H *DcVicP 2*
Haspel, E M *AmArch 70*
Hass, A T *AmArch 70*
Hass, Bernard *NewYHSD*
Hassall, Joan 1906- *DcBrA 1, IlsCB 1946, WhoArt 80, -82, -84, WhoGrA 62, -82[port]*
Hassall, John 1868- *ClaDrA*
Hassall, John 1868-1948 *AntBDN B, DcBrA 1, DcBrBI, DcVicP 2, WorECar*
Hassall, Richard *BiDBrA*
Hassam, Alfred *DcBrWA, DcVicP 2*
Hassam, Childe *OxTwCA*
Hassam, Childe 1859- *ClaDrA*
Hassam, Childe 1859-1935 *ArtsAmW 3, BnEnAmA, DcAmArt, PhDcTCA 77, WhAmArt 85*
Hassam, Frederick Childe 1859-1935 *GrAmP, IlBEAAW, McGDA*
Hassan, Fack 1914- *DcCAr 81*
Hassan, Fuad Suleiman 1907- *AmArch 70*
Hassan Al-Said, Shakir 1926- *DcCAr 81*
Hasse, Sella 1878?-1963 *DcWomA*
Hassel, William *DcBrECP*
Hasselbring, John *EncASM*
Hasselgren, Anna Catharina 1775-1841 *DcWomA*
Hassell, Edward *DcVicP*
Hassell, Edward d1852 *DcBrBI, DcBrWA, DcVicP 2*
Hassell, Hilary Clements *DcWomA*
Hassell, John 1767-1825 *DcBrBI, DcBrWA*
Hassellbusch, Louis 1863-1938? *WhAmArt 85*
Hasselman, Anna 1872?- *DcWomA, WhAmArt 85*
Hasselman, Jan *WhAmArt 85*
Hasselman, Peter M 1937- *AmArch 70*
Hasselriis, Else *ConICB, IlsCB 1744*
Hasselriis, Malthe M 1888- *WhAmArt 85*
Hasselunippe, Bjorn 1942- *MarqDCG 84*
Hassen, William *NewYHSD*
Hassenpflug, Robert Jacob *AmArch 70*
Hassid, Sami 1912- *AmArch 70*
Hassinger, Herman Adolph 1929- *AmArch 70*
Hasslacher, George *NewYHSD*
Hasslein, George Johann 1917- *AmArch 70*
Hassler, Sven *FolkA 86*
Hasslock, Charles *FolkA 86*
Hassner, Rune 1928- *ConPhot, ICPEnP A, MacBEP*
Hasson, David 1937- *AmArch 70*
Hasson, Sallie E *FolkA 86*
Hassouna, Fred 1918- *AmArch 70*
Hassrick, Peter H 1941- *WhoAmA 78, -80, -82, -84*
Hast, Etta *WhAmArt 85*
Haste, L B *WhAmArt 85*
Hasted, Michael 1945- *PrintW 83, -85*
Hastenteufel, Dieter 1939- *WhoAmA 84*
Hastie, Edward 1876-1947 *DcBrA 2*
Hastie, Grace H *ClaDrA, DcBrA 1, DcVicP, -2, DcWomA*
Hastie, Grace H 1855-1930 *DcBrWA*
Hastie, Reid 1916- *WhoAmA 73, -76, -78, -80, -82, -84*
Hastie, William 1755?-1832 *BiDBrA*

Hastings *NewYHSD*
Hastings, Bryce 1931- *AmArch 70*
Hastings, Constance S 1911- *WhAmArt 85*
Hastings, Daniel *NewYHSD*
Hastings, Daniel 1749- *FolkA 86*
Hastings, E W d1896 *FolkA 86*
Hastings, Edward *DcVicP 2*
Hastings, Ethel *DcVicP 2*
Hastings, George *DcVicP 2*
Hastings, Helen M *DcWomA, WhAmArt 85*
Hastings, Henry J 1931- *AmArch 70*
Hastings, James *NewYHSD*
Hastings, Jean Wells 1908- *AmArch 70*
Hastings, John 1901- *ClaDrA*
Hastings, Joseph d1785 *CabMA*
Hastings, Kate Gardiner *DcVicP 2, DcWomA*
Hastings, L Jane 1928- *AmArch 70*
Hastings, Louis Royer *WorFshn*
Hastings, M V *DcWomA*
Hastings, Marion Keith 1894- *ArtsAmW 2, DcWomA, WhAmArt 85*
Hastings, Matthew 1834-1919 *NewYHSD , WhAmArt 85*
Hastings, Michael Dean 1957- *MarqDCG 84*
Hastings, Paul Dean 1943- *AmArch 70*
Hastings, Robert Frank 1914- *AmArch 70*
Hastings, Sybil Hamilton 1890- *DcBrA 1, DcWomA*
Hastings, T Mitchell *WhAmArt 85*
Hastings, Thomas *DcBrWA, McGDA*
Hastings, Thomas 1860-1929 *BiDAmAr, McGDA, WhAmArt 85, WhoArch*
Hastings, Thomas N 1938- *MarqDCG 84*
Hastings, Mrs. Thomas Wood *WhAmArt 85*
Hastings, William Granville 1868?-1902 *WhAmArt 85*
Hastins, Edmund *DcBrWA*
Hastling, Annie E *DcVicP 2, DcWomA*
Hastrup, W *AmArch 70*
Haswell *DcBrBI*
Haswell, Anthony *WhoAmA 73*
Haswell, Mrs. Anthony *WhoAmA 73*
Haswell, Ernest Bruce 1889- *WhAmArt 85*
Haswell, Ernest Bruce 1889-1965 *WhoAmA 78N, -80N, -82N, -84N*
Haswell, George d1784 *BiDBrA*
Haswell, Hollee 1948- *WhoAmA 78, -80, -82, -84*
Haswell, John 1855-1925 *DcBrA 1, DcVicP 2*
Haswell, Leona Halderman *WhAmArt 85*
Haswell, Robert *ArtsAmW 1, NewYHSD*
Hatami, Marvin 1925- *AmArch 70*
Hatch, Clifford Franklin 1927- *AmArch 70*
Hatch, D E *AmArch 70*
Hatch, Edbury 1849-1935 *FolkA 86*
Hatch, Elisha *FolkA 86, NewYHSD*
Hatch, Emily Nichols *WhoAmA 80N, -82N, -84N*
Hatch, Emily Nichols 1871-1959 *DcWomA, WhAmArt 85*
Hatch, Ethel C *DcBrA 1, DcVicP 2, DcWomA*
Hatch, Ethel C 1870-1975 *DcBrA 2*
Hatch, George C 1911- *AmArch 70*
Hatch, George W 1805-1867 *NewYHSD*
Hatch, George W, Jr. *NewYHSD*
Hatch, John Davis 1907- *WhoAmA 73, -76, -78, -80, -82, -84*
Hatch, John W 1919- *WhoAmA 73, -76, -78, -80, -82, -84*
Hatch, L Robert 1930- *AmArch 70*
Hatch, Lionel Douglas 1949- *WhoArt 80, -82, -84*
Hatch, Lorenzo James 1857-1914 *WhAmArt 85*
Hatch, M E *DcWomA*
Hatch, Marshall 1918- *WhoAmA 80, -82, -84*
Hatch, Mrs. Marshall 1918- *WhoAmA 80, -82, -84*
Hatch, Mary 1935- *AmArt, WhoAmA 84*
Hatch, Mary Cummings *DcWomA*
Hatch, Minnie *DcWomA*
Hatch, P H *NewYHSD*
Hatch, Sara *FolkA 86*
Hatch, Stephen D 1839-1894 *BiDAmAr, MacEA*
Hatch, Tom J 1950- *DcCAr 81*
Hatch, W A S 1948- *WhoAmA 76, -78, -80, -82, -84*
Hatch, Warner D *NewYHSD*
Hatchard, Charles *BiDBrA*
Hatcher, Gilbert H 1924- *AfroAA*
Hatcher, James Arthur 1929- *AmArch 70*
Hatcher, Thurston Robert 1924- *AmArch 70*
Hatchett, Duayne 1925- *ConArt 77, DcCAA 71, -77, DcCAr 81, WhoAmA 73, -76, -78, -80, -82, -84*
Hatchett, J C *DcVicP 2*
Hatfield, Aaron *AntBDN N*
Hatfield, Dalzell 1893- *WhAmArt 85*
Hatfield, Dalzell 1893-1963 *ArtsAmW 2*
Hatfield, Dave *MarqDCG 84*
Hatfield, David Underhill 1940- *WhoAmA 73, -76, -78, -80, -82, -84*
Hatfield, Donald Gene 1932- *AmArt, WhoAmA 73, -76, -78, -80, -82, -84*
Hatfield, Eunice Camille 1911- *WhAmArt 85*
Hatfield, James Spear 1902- *AmArch 70*
Hatfield, Joseph *FolkA 86*
Hatfield, Joseph Henry 1863-1928 *WhAmArt 85*

Hatfield, Karl L 1886- *WhAmArt 85*
Hatfield, Karl Leroy 1886- *ArtsAmW 2*
Hatfield, Nina *WhAmArt 85*
Hatfield, Oliver Perry 1819-1891 *BiDAmAr*
Hatfield, R G 1815-1879 *BiDAmAr*
Hatfield, Samuel *CabMA*
Hatfield, Thomas F d1925 *WhAmArt 85*
Hatfield, W C *AmArch 70*
Hatgil, Paul 1921- *WhoAmA 73, -76, -78, -80, -82, -84*
Hathaway *NewYHSD*
Hathaway, Abby Watkins *ArtsEM, DcWomA*
Hathaway, C H *FolkA 86*
Hathaway, Calvin S d1974 *WhoAmA 76N, -78N, -80N, -82N, -84N*
Hathaway, Calvin Sutliff *WhoAmA 73*
Hathaway, Charles E *FolkA 86*
Hathaway, George M 1852?-1903 *WhAmArt 85*
Hathaway, Herbert M 1878-1944 *BiDAmAr*
Hathaway, Isaac Scott 1874- *AfroAA*
Hathaway, Isaiah *AfroAA*
Hathaway, James S *NewYHSD*
Hathaway, John W *WhAmArt 85*
Hathaway, John Wallace 1905- *WhoAmA 73, -76*
Hathaway, Joseph *NewYHSD*
Hathaway, Josephine Ames 1886- *WhAmArt 85*
Hathaway, Lovering d1949 *WhoAmA 78N, -80N, -82N, -84N*
Hathaway, Lovering 1898-1949 *WhAmArt 85*
Hathaway, Rufus 1770-1822 *AmFkP, BnEnAmA, FolkA 86, NewYHSD*
Hathaway, Walter Murphy 1939- *WhoAmA 76, -78, -80, -82, -84*
Hatherell, W *WhAmArt 85*
Hatherell, William 1855-1928 *AntBDN B, DcBrA 1, DcBrBI, DcBrWA, DcVicP 2*
Hatherty, Henry *NewYHSD*
Hatheway, H H *AmArch 70*
Hatheway, Rufus *FolkA 86*
Hathorne, George d1889 *BiDAmAr*
Hatke, Walter Joseph 1948- *WhoAmA 84*
Hatley, Olga *WhAmArt 85*
Hatley, Robert *AntBDN K*
Hatlo, James d1963 *WhoAmA 78N, -80N, -82N, -84N*
Hatlo, James 1897-1963 *ArtsAmW 3*
Hatlo, James 1898-1963 *WorECom*
Hatlo, Jimmy d1963 *WhAmArt 85*
Hatt, Doris Brabham 1890- *ClaDrA, DcBrA 1, DcWomA*
Hattan, Michael *NewYHSD*
Hatteberg, J K, Jr. *AmArch 70*
Hattersley, Charles *FolkA 86*
Hattersley, Martha Emma *DcWomA*
Hattersley, Ralph Marshall, Jr. 1921- *ICPEnP A, MacBEP*
Hattersley, William *EncASM*
Hattersley And Dickinson *EncASM*
Hatton, Brian 1887-1916 *DcBrA 1, DcBrBI, DcBrWA*
Hatton, Clara Anna 1901- *WhAmArt 85*
Hatton, Helen Howard *DcVicP 2, DcWomA*
Hatton, Helen Howard 1860- *DcBrBI*
Hatton, Helen Howard 1860?-1935 *ClaDrA*
Hatton, Leroy Alexander 1905- *AmArch 70*
Hatton, Richard George 1864-1926 *DcBrA 1*
Hatton, Richard George 1865-1926 *DcBrWA, DcVicP 2*
Hatton, Thomas *BiDBrA*
Hattorf, Mrs. Alvin *WhAmArt 85*
Hattorf, Alvin F 1899- *WhAmArt 85*
Hattrup, James Clinton 1957- *MarqDCG 84*
Hatts, Clifford Ronald 1921- *WhoArt 80, -82, -84*
Hatwell, Anthony 1931- *ClaDrA*
Hatzlerin, Clara *DcWomA*
Haubensack, Pierre 1935- *DcCAr 81*
Hauberg, John *WhoAmA 73*
Hauberg, Mrs. John *WhoAmA 73*
Hauberisser, G 1841-1922 *WhoArch*
Hauberrisser, Georg Von 1841-1922 *MacEA*
Haubisen, Christopher 1830-1913 *NewYHSD , WhAmArt 85*
Haubrich, Edward *WhAmArt 85*
Haubrock, Glenn Omer 1930- *AmArch 70*
Hauck, August Christian 1742-1801 *ClaDrA*
Hauck, Augusta *DcWomA*
Hauck, Edwin H 1906- *AmArch 70*
Hauck, John Maurice *DcBrECP*
Hauck, Lester W 1923- *AmArch 70*
Hauck, P H *AmArch 70*
Hauck, Philip Elias *DcBrECP*
Haucke, Frederick 1908- *WhAmArt 85*
Haudebourt, Antoinette Cecile Hortense 1784-1845 *ClaDrA*
Haudebourt-Lescot, Antoinette Cecile H 1784-1845 *DcWomA*
Haudebourt-Lescot, Antoinette-Cecile-H 1784-1845 *WomArt*
Hauduroy, S *BiDBrA*
Hauenstein, Eugenia *WhAmArt 85*
Hauenstein, Oskar 1883- *WhAmArt 85*

Hauet, Anna *DcWomA*
Hauf, Harold Dana 1905- *AmArch 70*
Haug, Donald Raymond 1925- *WhoAmA 73, -76, -78, -80, -82, -84*
Haugaard, Robert Duncan 1927- *AmArch 70*
Haugaard, William E 1889-1948 *BiDAmAr*
Haugaard, William E 1889-1949 *MacEA*
Hauge, Marie Gjellstad *ArtsAmW 3*
Hauge, Marie Octavia Nielsen 1864- *DcWomA*
Haugg, Louis *NewYHSD*
Haugh, George 1756-1827 *DcBrECP*
Haughey, James M 1914- *WhoAmA 80, -82, -84*
Haughey, James M 1915?- *IlBEAAW*
Haughey, Phillip 1914- *AmArch 70*
Haughton, Benjamin 1865-1924 *DcBrA 1, DcVicP 2*
Haughton, Marie *DcWomA*
Haughton, Marie L *WhAmArt 85*
Haughton, Moses 1772?-1848 *AntBDN J, ClaDrA, DcBrWA*
Haughton, Moses, Sr. 1734-1804 *DcBrECP*
Haughton, Wilfred H 1893- *WorECar*
Haughton, Wilfred James 1921- *ClaDrA, DcBrA 1, WhoArt 80, -82, -84*
Haughwout, J L *AmArch 70*
Haugseth, Anders John 1884- *ArtsAmW 3*
Haugseth, Andrew 1884- *ArtsAmW 3*
Haugseth, Andrew John 1884- *WhAmArt 85*
Haugseth, Gladys Browning *DcWomA*
Haukaness, Lars 1865- *WhAmArt 85*
Haukeland, Arnold 1920- *OxTwCA, PhDcTCA 77*
Haukins, Cornelius *WhAmArt 85*
Haukins, W W *FolkA 86*
Haulick, Christian J *NewYHSD*
Haulman, Donald James 1929- *AmArch 70*
Hauman, Doris 1897- *IlsCB 1946*
Hauman, George 1890- *IlsCB 1946*
Haumann, David Roger 1954- *MarqDCG 84*
Haun, Declan 1937- *ICPEnP A*
Haun, Robert Charles 1903- *WhAmArt 85*
Haupers, Clement 1900- *WhAmArt 85*
Haupers, Clement Bernard 1900-1982 *GrAmP*
Haupt, Charlotte 1898- *DcWomA, WhAmArt 85*
Haupt, Mrs. Enid *WhoAmA 73*
Haupt, Erik Guide 1891- *WhAmArt 85, WhoAmA 73, -76*
Haupt, Georg 1741-1784 *OxDecA*
Haupt, Robert Karl 1924- *AmArch 70*
Haupt, Shirley Eliason *WhoAmA 78, -80, -82, -84*
Haupt, Theodore G 1902- *WhAmArt 85*
Haupt, Theodore J *AfroAA*
Haupt, Winifred Hope 1891- *DcWomA, WhAmArt 85*
Hauptle, Frederick W *WhAmArt 85*
Hauptman, Susan Ann 1947- *WhoAmA 76, -78, -80*
Hauptmann, Susette 1811-1890 *DcWomA*
Hauptmann-Sommer, Eugenie 1865- *DcWomA*
Haure, Madame *DcWomA*
Haurn, Mrs. *DcWomA*
Haus-Rucker-Co *DcCAr 81*
Hauschka, Carola Spaeth d1948 *WhoAmA 78N, -80N, -82N, -84N*
Hauschka, Carola Spaeth 1883-1948 *DcWomA, WhAmArt 85*
Hausdorfer, Richard B *WhAmArt 85*
Hausel, Martin *FolkA 86*
Hausel, William *FolkA 86*
Hauseman, George *WhAmArt 85*
Hausen, Mana Van *DcWomA*
Hausenbuiller, Mrs. C E *WhAmArt 85*
Hauser, Alonzo 1909- *WhAmArt 85, WhoAmA 76, -78, -80, -82, -84*
Hauser, Erich 1930- *ConArt 77, -83, DcCAr 81, OxTwCA, PhDcTCA 77*
Hauser, Johann 1926- *DcCAr 81*
Hauser, John 1858?-1913 *IlBEAAW, WhAmArt 85*
Hauser, John 1859-1918 *ArtsAmW 1*
Hauser, Joseph *FolkA 86*
Hauser, Joseph S *WhAmArt 85*
Hauser, Josephine *WhAmArt 85*
Hauser, Louise *DcWomA*
Hauser, Reine I 1956- *WhoAmA 82, -84*
Hauser, Richard 1931- *WhoAmA 73, -76*
Hauser, Richard Allen 1947- *MarqDCG 84*
Hauser, Sophie 1872- *DcWomA*
Hausey, Robert Michael 1949- *WhoAmA 84*
Hausgen, Frederick *FolkA 86*
Haushalter, George M 1862- *WhAmArt 85*
Hauskens, Peter Bert 1919- *AmArch 70*
Hausler, Werner 1932- *AmArch 70*
Hausman, Allen B *FolkA 86*
Hausman, B 1799?- *FolkA 86*
Hausman, E C *NewYHSD*
Hausman, Ephrain 1813?-1901 *FolkA 86*
Hausman, Fred S 1921- *WhoAmA 73, -76, -78, -80, -82, -84*
Hausman, G *FolkA 86*
Hausman, Jacob, Jr. 1808- *FolkA 86*
Hausman, Jacob, Sr. 1788-1863 *FolkA 86*
Hausman, Jerome Joseph 1925- *WhoAmA 73, -76, -78, -80, -82, -84*
Hausman, Joel 1826?- *FolkA 86*

Hausman, Solomon 1794?-1866 *FolkA 86*
Hausman, Tilgham 1832-1917 *FolkA 86*
Hausmann, Eugene Robert 1932- *AmArch 70*
Hausmann, Frederic Karl *ArtsNiC*
Hausmann, George E *WhAmArt 85*
Hausmann, Lina *DcWomA*
Hausmann, Marianne Pisko *WhoAmA 78N, -80N, -82N, -84N*
Hausmann, Marianne Pisko 1880-1966? *DcWomA*
Hausmann, Paula *DcWomA*
Hausmann, Raoul 1886- *McGDA, PhDcTCA 77*
Hausmann, Raoul 1886-1971 *ConArt 77, -83, ConPhot, ICPEnP A, MacBEP, OxTwCA*
Hausmann-Hoppe, Hedwig 1865- *DcWomA*
Hausner, R O *AmArch 70*
Hausner, Rudolf 1914- *OxTwCA, PhDcTCA 77*
Hausrath, Joan W 1942- *WhoAmA 82, -84*
Haussard, Catherine *DcWomA*
Haussard, Elisabeth *DcWomA*
Hausselin, H *DcVicP 2*
Hausser, Robert 1924- *ConPhot, ICPEnP A, MacBEP*
Haussman, Baron Georges-Eugene 1809-1891 *DcD&D*
Haussmann, Georges-Eugene 1809-1891 *EncMA, MacEA*
Haussmann, Georges Eugene 1809-1891 *McGDA*
Haussmann, Baron Georges Eugene 1809-1891 *WhoArch*
Haussmann, Louise Josephine Rose *DcWomA*
Haussmann, William Max 1906- *AmArch 70*
Haussoullier, Guillaume 1818-1891 *ClaDrA*
Hauswirth, Frieda 1886- *ArtsAmW 1, DcWomA*
Haut, Claire *WhoAmA 76, -78, -80, -82, -84*
Haut, Marguerite Jacobe De *DcWomA*
Haute, Pauline D' *DcWomA*
Hauteville, Paul D *WhAmArt 85*
Hauth-Trachsel, Dora 1874- *DcWomA*
Hautier, Virginie Eugenie 1822-1909 *DcWomA*
Hautman, Joseph Louis 1903- *AmArch 70*
Hautot, Adele *DcWomA*
Hautot, Rachel Lucy Ludivine 1882- *DcWomA*
Hautrive, Mathilde Marguerite 1881-1963 *DcWomA*
Hauttmann, Minna 1840-1887 *DcWomA*
Hauze, Margt B *DcWomA*
Havard, James 1937- *DcCAr 81, PrintW 85*
Havard, James Pinkney 1937- *AmArt, WhoAmA 73, -76, -78*
Havard, Valerie 1878-1909 *DcWomA*
Havas, Edwin John 1929- *WhoAmA 76*
Havekost, Daniel John 1936- *AmArch 70*
Haveland, Joseph H *NewYHSD*
Havelka, George R *WhAmArt 85*
Havell, Alfred C d1928 *DcBrA 2*
Havell, Alfred Charles *DcVicP 2*
Havell, Amelia Jane 1825-1907 *DcWomA*
Havell, Charles Richard 1827-1892 *DcBrWA*
Havell, Charles Richards *DcVicP 2*
Havell, Edmund 1785-1864 *DcBrWA*
Havell, Edmund 1819-1894 *DcBrWA*
Havell, Edmund, Jr. 1819-1894 *DcVicP, -2*
Havell, Edwin *DcVicP 2*
Havell, H *DcVicP 2*
Havell, Henry Augustus *NewYHSD*
Havell, Lili Angelique Vilhelmine *DcWomA*
Havell, Marianne A *DcWomA*
Havell, Robert 1793-1878 *NewYHSD*
Havell, Robert, Jr. 1793-1878 *AntBDN B, GrBII[port]*
Havell, William 1782-1857 *DcBrWA, DcVicP 2, McGDA*
Havelock, Christine Mitchell 1924- *WhoAmA 73, -76, -78, -80, -82, -84*
Havelock, Helen *DcBrBI, DcWomA*
Haveman, James K 1905- *AmArch 70*
Haveman, Josepha 1931- *ICPEnP A, MacBEP*
Havemann, Margarete 1877- *DcWomA*
Havemeyer, Helen Mitchell 1900- *WhAmArt 85*
Havemeyer, Mrs. Henry O 1855-1929 *WhAmArt 85*
Haven, Joshua P *NewYHSD*
Haven, Parkman Balke 1858-1943 *BiDAmAr*
Havens, Belle *DcWomA, WhAmArt 85*
Havens, Charles I 1849-1916 *BiDAmAr*
Havens, Elizabeth Carroll 1944- *WhoAmA 73, -76*
Havens, George *FolkA 86*
Havens, James Dexter 1900-1960 *WhAmArt 85, WhoAmA 80N, -82N, -84N*
Havens, Jan 1948- *WhoAmA 82, -84*
Havens, Murry P *WhoAmA 78N, -80N, -82N, -84N*
Havens, Samuel *FolkA 86*
Haver, Ralph B 1915- *AmArch 70*
Haverfield, J T *DcVicP 2*
Haverland, Leroy Joe 1941- *MarqDCG 84*
Havermaet, Piet Van 1834-1897 *ClaDrA*
Haverman, Margareta 1693-1750? *DcWomA*
Haverman, Margareta 1720-1795? *ClaDrA*
Haverman-Birnie, C 1864- *DcWomA*
Havers, Alice 1850-1890 *DcBrBI*
Havers, Alice Mary 1850-1890 *ClaDrA, DcBrWA, DcVicP, -2, DcWomA*
Havers, Mandy 1953- *DcCAr 81*
Havers, Val *DcBrA 2, DcVicP 2*

PhDcTCA 77
Hayden, Hiram *FolkA 86*
Hayden, J *FolkA 86*
Hayden, J H *NewYHSD*
Hayden, Janice Marie 1954- *MarqDCG 84*
Hayden, John Blake 1929- *AmArch 70*
Hayden, Kitty L 1942- *AfroAA*
Hayden, Mary P *ArtsEM, DcWomA*
Hayden, Michael 1943- *WhoAmA 78*
Hayden, Palmer C 1893- *AfroAA*
Hayden, Palmer C 1893-1973 *WhoAmA 80N, -82N, -84N*
Hayden, Palmer Cole 1890-1973 *WhAmArt 85*
Hayden, R S *AmArch 70*
Hayden, Sara S *ArtsAmW 1, WhAmArt 85*
Hayden, Sara Shewell *ArtsAmW 3, DcWomA*
Hayden, W S *AmArch 70*
Hayden, William 1916- *AfroAA*
Hayden, William W *EncASM*
Hayder, Kadhiri 1932- *DcCAr 81*
Haydock, May S *WhAmArt 85*
Haydock, May S 1878- *DcWomA*
Haydon, Benjamin Robert 1786-1846 *ClaDrA, DcBrWA, DcVicP, -2, McGDA, OxArt*
Haydon, G H *DcBrBI*
Haydon, Harold 1909- *AmArt, WhoAmA 73, -76, -78, -80, -82, -84*
Haydon, Madeline *AfroAA*
Haydon, William *NewYHSD*
Haye, Corneille DeLa *McGDA*
Hayek, K Anthony 1942- *AmArch 70*
Hayek, Sascha *DcWomA*
Hayer, Marie Elisabeth d1699 *DcWomA*
Hayes, Arthur *DcVicP 2*
Hayes, Bartlett H, Jr. 1904- *WhAmArt 85*
Hayes, Bartlett Harding, Jr. 1904- *WhoAmA 73, -76, -78, -80, -82, -84*
Hayes, C R, Jr. *AmArch 70*
Hayes, Chester C *WhAmArt 85*
Hayes, Claude 1852-1922 *DcBrA 1, DcBrWA, DcVicP, -2*
Hayes, Colin Graham 1919- *WhoArt 80, -82, -84*
Hayes, Dannielle Beverley 1943- *MacBEP*
Hayes, David Romain 1928- *AmArch 70*
Hayes, David V 1931- *DcCAA 71, -77*
Hayes, David Vincent 1931- *WhoAmA 73, -76, -78, -80, -82, -84*
Hayes, Dorothy *AfroAA*
Hayes, E Irene *DcVicP 2*
Hayes, E Paul 1906- *AmArch 70*
Hayes, Earl Chester, Jr. 1925- *AmArch 70*
Hayes, Edith Caroline 1860- *DcBrA 1, DcVicP 2, DcWomA*
Hayes, Edward 1797-1864 *DcBrWA, DcVicP 2*
Hayes, Edwin *ArtsNiC*
Hayes, Edwin 1819-1904 *DcSeaP*
Hayes, Edwin 1820-1904 *DcBrA 1, DcBrWA, DcVicP, -2*
Hayes, Ethel 1892- *ArtsAmW 3*
Hayes, F J *AmArch 70*
Hayes, Frederick William 1848-1918 *DcBrA 1, DcBrBI, DcBrWA, DcVicP 2*
Hayes, G *DcSeaP*
Hayes, G Mark 1907- *WhAmArt 85*
Hayes, George *DcBrWA, DcVicP 2*
Hayes, George A *FolkA 86*
Hayes, George H *NewYHSD*
Hayes, Gerald 1940- *WhoAmA 84*
Hayes, Gertrude Ellen 1872-1956 *DcBrA 1, DcVicP 2, DcWomA*
Hayes, Gordon 1911- *AmArch 70*
Hayes, Henry *DcVicP 2*
Hayes, Henry Edgar *DcVicP 2*
Hayes, J A 1930- *MarqDCG 84*
Hayes, J M Kinney *WhAmArt 85*
Hayes, J P *AmArch 70*
Hayes, J Percy *DcVicP 2*
Hayes, J W *AmArch 70, DcVicP 2*
Hayes, James *NewYHSD*
Hayes, James E 1827?- *NewYHSD*
Hayes, James Henry *NewYHSD*
Hayes, John *DcVicP 2*
Hayes, John 1786-1866 *DcVicP, -2*
Hayes, John Francis 1932- *AmArch 70*
Hayes, John Freeman 1926- *AmArch 70*
Hayes, Katharine W 1889- *WhAmArt 85*
Hayes, Katharine Williams 1889- *DcWomA*
Hayes, Laura M 1927- *WhoAmA 76, -78, -80, -82, -84*
Hayes, Lee 1854- *ArtsAmW 2, WhAmArt 85*
Hayes, Louisa 1881- *WhAmArt 85*
Hayes, M *DcWomA*
Hayes, Marian 1905- *WhoAmA 73, -76*
Hayes, Mary *ConArch A*
Hayes, Matilda *DcWomA*
Hayes, Michael Angelo 1820-1877 *DcBrWA, DcVicP 2*
Hayes, Michael Etheldred 1934- *AmArch 70*
Hayes, N H, Jr. *AmArch 70*
Hayes, Oscar *AfroAA*
Hayes, Paul J *MarqDCG 84*

Hayes, R B, Jr. *AmArch 70*
Hayes, Randy 1944- *WhoAmA 84*
Hayes, Robert Ehmet 1933- *AmArch 70*
Hayes, Robert T 1915- *WhoAmA 73, -76, -78, -80, -82*
Hayes, Robert Wendall 1931- *AmArch 70*
Hayes, S J *DcVicP 2*
Hayes, Samuel H 1825?- *NewYHSD*
Hayes, Terence *DcCAr 81*
Hayes, Thomas 1910- *WhAmArt 85*
Hayes, Thomas Thurman, Jr. 1925- *AmArch 70*
Hayes, Tua *WhoAmA 73, -76, -78, -80, -82, -84*
Hayes, Vertis 1911- *AfroAA*
Hayes, W B *DcVicP 2*
Hayes, Warren H 1849-1899 *BiDAmAr*
Hayes, William *CabMA, DcBrWA*
Hayes, William Christopher d1963 *WhoAmA 78N, -80N, -82N, -84N*
Hayes, William H 1800-1828 *NewYHSD*
Hayes And McFarland *EncASM*
Hayes Brothers *FolkA 86*
Hayes-Miller, Kenneth *WhAmArt 85*
Hayet, Catilie *DcWomA*
Hayez, Francesco 1791-1882 *McGDA*
Hayez, Francisco 1792- *ArtsNiC*
Haygarth, Miss *DcBrWA*
Hayles, Jane C *DcWomA*
Haylett, Malcolm John 1923- *DcBrA 2, WhoArt 80, -82, -84*
Haylett, Ward H, Jr. 1922- *AmArch 70*
Hayley, William d1860 *BiDBrA*
Hayllar, Edith *DcVicP*
Hayllar, Edith 1860-1948 *DcVicP 2, DcWomA, WomArt*
Hayllar, James 1829- *ArtsNiC*
Hayllar, James 1829-1920 *ClaDrA, DcBrA 1, DcVicP, -2*
Hayllar, Jessica *DcVicP*
Hayllar, Jessica 1858-1940 *DcVicP 2, DcWomA, WomArt*
Hayllar, Kate *DcVicP 2, DcWomA*
Hayllar, Mary *DcVicP 2, DcWomA*
Haymaker, Susan I *DcWomA, WhAmArt 85*
Hayman, Francis 1708?-1776 *BkIE, DcBrECP, McGDA, OxArt*
Hayman, Laure *DcWomA*
Hayman Chaffey, Frederick William 1920- *ClaDrA, DcBrA 1*
Haymann, G *DcVicP 2*
Hayn, Walter *WhAmArt 85*
Hayne, Francis Bourn 1940- *AmArch 70*
Haynes, Adeline *DcVicP 2, DcWomA*
Haynes, Arthur S *DcVicP 2*
Haynes, Benjamin *EncASM*
Haynes, C Younglove *NewYHSD*
Haynes, Caroline Coventry *DcWomA, WhAmArt 85*
Haynes, D F *FolkA 86*
Haynes, Douglas H 1936- *WhoAmA 73, -76, -78, -80, -82, -84*
Haynes, Edward Travanyon *DcVicP 2*
Haynes, Edward Trevanyon *ClaDrA*
Haynes, Elsie Haddon *WhAmArt 85*
Haynes, Elsie Haddon 1881-1963 *ArtsAmW 2, DcWomA*
Haynes, Emily *DcWomA*
Haynes, F *FolkA 86*
Haynes, Francis G *NewYHSD*
Haynes, Frank Jay 1853-1921 *ICPEnP A, MacBEP, WhAmArt 85*
Haynes, Frederick *DcVicP 2*
Haynes, George E 1875-1932 *BiDAmAr*
Haynes, George Edward 1910- *WhoAmA 76, -78, -80, -82, -84*
Haynes, H *DcVicP 2*
Haynes, Irving Bogle 1927- *AmArch 70*
Haynes, Isobel Jessie 1871-1958 *DcWomA*
Haynes, J R *EncASM*
Haynes, Jack Durham 1931- *AmArch 70*
Haynes, Jack Ellis 1884-1962 *MacBEP*
Haynes, John *ClaDrA*
Haynes, John William *DcVicP, -2*
Haynes, Jonathan *AntBDN Q*
Haynes, Mack William, Jr. 1948- *MarqDCG 84*
Haynes, P E *AmArch 70*
Haynes, Perry 1870- *WhAmArt 85*
Haynes, R 1934- *WhoAmA 82, -84*
Haynes, Robert *IlsBYP*
Haynes, Stanley Foster 1922- *AmArch 70*
Haynes, William Brailsford 1926- *AmArch 70*
Haynes And Lawton *EncASM*
Haynes-William, John *DcVicP 2*
Haynes-Williams, John 1836-1908 *DcBrA 1*
Haynie, Hugh 1927- *WhoAmA 76, -78, -80, -82, -84*
Haynie, Hugh Smith 1927- *WorECar*
Haynie, Wilbur 1929- *AfroAA*
Haynie, William Elliott 1930- *AmArch 70*
Hayoit *DcBrECP*
Hays *DcBrECP*
Hays, Miss *DcWomA*
Hays, Aline Davis 1887- *DcWomA*
Hays, Austin 1869-1915 *WhAmArt 85*

Hays, Barton S 1826-1914 *NewYHSD , WhAmArt 85*
Hays, Beatrice *DcVicP 2*
Hays, Ethel 1892- *ArtsAmW 3*
Hays, George *FolkA 86*
Hays, George A 1854- *WhAmArt 85*
Hays, Gertrude V *WhAmArt 85*
Hays, Henry, Jr. *NewYHSD*
Hays, Henry, Sr. *NewYHSD*
Hays, J M *FolkA 86*
Hays, Joseph Gregory, Jr. 1925- *AmArch 70*
Hays, Philip Harrison 1932- *IlrAm G, -1880*
Hays, R Price 1923- *AmArch 70*
Hays, Robert *FolkA 86*
Hays, Ron 1945- *WhoAmA 80, -82*
Hays, Solomon *CabMA*
Hays, Willard Carl 1921- *MarqDCG 84*
Hays, William H *NewYHSD*
Hays, William J 1830-1875 *ArtsNiC*
Hays, William Jacob 1830-1875 *ArtsAmW 1, IlBEAAW, NewYHSD*
Hays, William Jacob, Jr. 1872-1934 *WhAmArt 85*
Hays, William Jacob, Sr. 1830-1875 *WhAmArt 85*
Hayse, Martha S *DcWomA, FolkA 86, NewYHSD*
Hayslett, Jack J 1928- *AmArch 70*
Hayslip, William L 1936- *AmArch 70*
Hayter, Angelo Cohen *DcVicP 2*
Hayter, Anne *DcWomA*
Hayter, Charles 1761-1835 *DcBrECP*
Hayter, Edith C *DcVicP 2*
Hayter, Sir George 1792-1871 *ArtsNiC, ClaDrA, DcVicP, -2, OxArt*
Hayter, John 1800-1891 *DcVicP, -2*
Hayter, Staley William 1901- *WhoAmA 76*
Hayter, Stanley William 1901- *ConArt 77, -83, DcBrA 1, McGDA, OxTwCA, PhDcTCA 77, WhoAmA 73, WhoArt 80, -82, -84, WorArt[port]*
Hayter, Thomas *AntBDN Q*
Haythe, Ethel Campbell 1888- *DcWomA, WhAmArt 85*
Haythorne, Margaret Curtis 1893- *DcBrA 1*
Haytley, Edward *DcBrECP*
Hayward *DcBrECP*
Hayward, Mrs. *DcWomA*
Hayward, Mrs. A F W *DcVicP 2*
Hayward, Abraham *CabMA, EncASM*
Hayward, Abraham 1692-1747 *BiDBrA*
Hayward, Albert *DcVicP 2*
Hayward, Alfred d1939 *WhAmArt 85*
Hayward, Alfred 1893- *ArtsAmW 3*
Hayward, Alfred Frederick William 1856- *ClaDrA, DcVicP 2*
Hayward, Alfred Frederick William 1856-1939 *DcBrA 1*
Hayward, Alfred Robert 1875- *ClaDrA*
Hayward, Alfred Robert 1875-1971 *DcBrA 1, DcVicP 2*
Hayward, Arthur 1889- *DcBrA 1*
Hayward, Beatrice Burt *DcWomA*
Hayward, Beatrice Burt 1893- *WhAmArt 85*
Hayward, Caroline *DcWomA*
Hayward, Charles E *EncASM*
Hayward, David *NewYHSD*
Hayward, Edith *DcWomA*
Hayward, Emily L *DcVicP 2, DcWomA*
Hayward, F Harold 1867- *WhAmArt 85*
Hayward, Frank Harold 1861-1945 *ArtsEM*
Hayward, George *NewYHSD*
Hayward, Gerald Sinclair 1845-1926 *WhAmArt 85*
Hayward, J M *DcVicP 2*
Hayward, James 1943- *WhoAmA 84*
Hayward, Jane 1918- *WhoAmA 76, -78, -80, -82, -84*
Hayward, Jane Mary 1825-1894 *DcVicP 2*
Hayward, John *CabMA*
Hayward, John B *NewYHSD*
Hayward, John Forrest 1916- *WhoArt 80, -82, -84*
Hayward, John Samuel 1778-1822 *DcBrWA*
Hayward, Joshua Henshaw 1797-1856 *NewYHSD*
Hayward, Lucy *DcWomA, WhAmArt 85*
Hayward, M *DcVicP 2*
Hayward, Mary *DcVicP 2, DcWomA*
Hayward, Mildred 1889- *DcWomA, WhAmArt 85*
Hayward, Nathan 1720-1794 *FolkA 86*
Hayward, Peter 1905- *WhoAmA 73, -76, -78, -80, -82, -84*
Hayward, Stanley 1930- *WorECar*
Hayward, Thomas Cotton *CabMA*
Hayward, Tony *DcCAr 81*
Hayward, Walter E *EncASM*
Hayward, William d1823? *BiDBrA*
Hayward, William 1740?-1782 *BiDBrA*
Hayward And Briggs *EncASM*
Hayward And Sweet *EncASM*
Hayward-Young, Eric 1908- *ClaDrA, DcBrA 1*
Haywood, Carolyn 1898- *WhAmArt 85*
Haywood, Charles Richard, Jr. 1940- *MarqDCG 84*
Haywood, G T *AfroAA*
Haywood, Henry D *ArtsEM*
Haywood, J M *DcWomA*

Haywood, John 1751- *BiDBrA*
Haywood, M *DcVicP 2*
Haywood, Mary Carolyn 1898- *DcWomA*
Haywood, Mrs. Mordan *DcVicP 2*
Haywood, N D *AmArch 70*
Haywood, S Grant *ArtsEM*
Haywood, Thomas *FolkA 86*
Haywood, Thomas W, Jr. 1921- *AmArch 70*
Haz, Nicholas 1883- *WhAmArt 85*
Hazard, Arthur Merton 1872-1930 *ArtsAmW 2,*
 WhAmArt 85
Hazard, Benjamin W 1940- *AfroAA*
Hazard, Charles-Francois 1758-1812 *IlDcG*
Hazard, Frank Arthur 1890- *AmArch 70*
Hazard, Grace *DcWomA, WhAmArt 85*
Hazard, J T *NewYHSD*
Hazard, Jim 1946- *WhoAmA 76, -78, -80, -82*
Hazard, Juliette *DcWomA*
Hazard, Marthe *DcWomA*
Hazard, Mary *DcWomA, FolkA 86*
Hazard, Robert Zenas *AmArch 70*
Hazard, W P *AmArch 70*
Hazard-Roux, Aglae-Eulalie 1841- *DcWomA*
Hazell, Beatrice 1864-1946 *DcWomA*
Hazell, Frank *WhoAmA 80N, -82N, -84N*
Hazell, Frank 1883-1957? *WhAmArt 85*
Hazelrig, Jane Brownlee 1937- *MarqDCG 84*
Hazeltine, Florence 1889- *DcWomA, WhAmArt 85*
Hazeltine, Herbert *WhAmArt 85*
Hazeltine, Nea *DcWomA*
Hazelton, I B 1875-1943 *WhAmArt 85*
Hazelton, J B *WhAmArt 85*
Hazelton, Mary Brewster *DcWomA, WhAmArt 85*
Hazelton, Paul Allan 1922- *AmArch 70*
Hazelton, Robert Stafford 1940- *MarqDCG 84*
Hazelwood, David 1932- *WhoArt 80, -82, -84*
Hazelwood, Ella *WhAmArt 85*
Hazelwood, Otis Lloyd 1906- *AmArch 70*
Hazen, Bessie E 1861-1946 *WhAmArt 85*
Hazen, Bessie Ella 1862-1946 *ArtsAmW 2, DcWomA*
Hazen, E M *DcWomA*
Hazen, Fannie Wilhelmina 1877- *ArtsAmW 2,*
 DcWomA, WhAmArt 85
Hazen, George Wilber 1914- *AmArch 70*
Hazen, Grace 1874- *DcWomA*
Hazen, Grace 1874-1940 *WhAmArt 85*
Hazen, I *NewYHSD*
Hazen, J *NewYHSD*
Hazen, Joseph H *WhoAmA 73, -76, -78, -80, -82,*
 -84
Hazen, Nathan Bruce 1897- *AmArch 70*
Hazenplug, Frank *WhAmArt 85*
Hazlehurst, Franklin Hamilton 1925- *WhoAmA 76,*
 -78, -80, -82, -84
Hazlehurst, Mary S L 1878- *DcWomA,*
 WhAmArt 85
Hazlehurst, Thomas *AntBDN J*
Hazlett *FolkA 86*
Hazlett, Lawrence 1911- *WhAmArt 85*
Hazlewood, Charles Robert 1926- *AmArch 70*
Hazlewood, Phoebe W 1885- *WhAmArt 85*
Hazlitt, Don *DcCAr 81*
Hazlitt, Don 1948- *WhoAmA 80, -82, -84*
Hazlitt, Don Robert 1948- *WhoAmA 76, -78*
Hazlitt, John 1767-1837 *DcBrECP, FolkA 86,*
 NewYHSD
Hazon DeSaint-Firmin, Jane D' 1874- *DcWomA*
Hazzard, Sara *DcWomA, WhAmArt 85*
Hazzard, Stephen B 1920- *AmArch 70*
Hazzon, Robert *PrintW 4*
Heacock, Rebecca M 1890- *DcWomA*
Head, Anna Maria *DcWomA*
Head, Arthur William 1861- *DcBrA 1, DcVicP 2*
Head, B G *DcVicP 2*
Head, C *AmArch 70*
Head, Cecil F 1906- *WhAmArt 85*
Head, Charles Franklin d1850 *DcBrWA*
Head, Donald Bruce 1933- *AmArch 70*
Head, Edith d1981 *ConDes*
Head, Edward Joseph 1863- *DcBrA 1, DcVicP 2*
Head, Mrs. Francis *WhAmArt 85*
Head, G P *AmArch 70*
Head, George Bruce 1931- *WhoAmA 73, -76, -78,*
 -80, -82, -84
Head, George Edwin 1921- *AmArch 70*
Head, Guy 1753-1800 *DcBrWA*
Head, Guy 1762-1800 *DcBrECP*
Head, J W *AmArch 70*
Head, Jesse *CabMA*
Head, Lydia *DcWomA*
Head, Robert William 1941- *WhoAmA 73, -76, -78,*
 -80, -82, -84
Head, Samuel *NewYHSD*
Head, T J *DcVicP 2*
Head, Tim 1946- *ConArt 77, -83, ConBrA 79[port],*
 DcCAr 81
Heade, C M *AmArch 70*
Heade, Martin J *ArtsNiC*
Heade, Martin Johnson 1819-1904 *ArtsAmW 1,*
 BnEnAmA, DcAmArt, DcSeaP, NewYHSD ,
 WhAmArt 85

Heade, William P *NewYHSD*
Headland, Margaret *DcVicP 2*
Headley, David Allen 1946- *WhoAmA 82, -84*
Headley, Joseph H *FolkA 86, NewYHSD*
Headley, Lorenzo 1860- *DcVicP 2*
Headley, Lorenzo Headley 1860- *DcBrA 1, DcBrWA*
Headley, Sherman Knight 1922- *WhoAmA 78, -80*
Headley, Somers G *FolkA 86*
Headley-Neave, Alice *WhoArt 82N*
Headley-Neave, Alice 1903- *WhoArt 80*
Headlund, Larry Matthew 1950- *MarqDCG 84*
Headman, Andrew *FolkA 86*
Headman, August G 1883-1925 *BiDAmAr*
Headman, Charles *FolkA 86*
Headman, John *FolkA 86*
Headman, Peter *FolkA 86*
Headrick, Charles Maxwell 1924- *AmArch 70*
Heaford, Vincent *NewYHSD*
Heal, Sir Ambrose 1872-1959 *DcD&D[port],*
 DcNiCA, OxDecA
Heal, John Christopher 1911- *WhoArt 80*
Heal & Sons Ltd *DcNiCA*
Heald, H Benjamin 1819-1888 *DcBrWA*
Heald, James *NewYHSD*
Heald, Louisa Mary *DcWomA*
Heald, Paul *DcCAr 81*
Heald, Sarah Thorp *DcWomA, WhAmArt 85*
Heald, William Leslie 1910- *AmArch 70*
Healer, George 1936- *WhoArt 80, -82, -84*
Healey, C E H *DcVicP 2*
Healey, Edward Hopkins 1925- *AmArch 70*
Healey, Emily *DcWomA*
Healey, G R *DcVicP 2*
Healey, Leonard Douglas 1894- *ClaDrA*
Healey, Mary *DcWomA*
Heals, John *NewYHSD*
Heals, Robert *NewYHSD*
Healy, Aaron Augustus 1850-1921 *WhAmArt 85*
Healy, Anne Laura 1939- *WhoAmA 78, -80, -82, -84*
Healy, Arthur K D 1902- *WhAmArt 85,*
 WhoAmA 73, -76, -78, -80, -82
Healy, Arthur K D 1902-1978 *WhoAmA 80N, -82N,*
 -84N
Healy, Deborah Ann *WhoAmA 80, -82, -84*
Healy, Frank D 1862- *WhAmArt 85*
Healy, G P A 1808- *ArtsNiC*
Healy, George Peter Alexander 1808-1904 *DcVicP 2*
Healy, George Peter Alexander 1813-1894 *BnEnAmA,*
 DcAmArt, McGDA, NewYHSD , WhAmArt 85
Healy, J P *NewYHSD*
Healy, Julia Schmitt 1947- *AmArt, WhoAmA 78,*
 -80, -82, -84
Healy, Laura *DcWomA, WhAmArt 85*
Healy, Marion Maxon 1890- *DcWomA,*
 WhAmArt 85
Healy, Michael 1873-1941 *DcBrA 2*
Healy, Nathaniel *FolkA 86*
Healy, Recompense *CabMA*
Healy, Theron *ArtsEM*
Healy, Thomas Cantwell 1820-1873 *NewYHSD*
Healy, W A *AmArch 70*
Healy, William Timothy Joseph 1901- *DcBrA 1*
Hean, Messrs. *BiDBrA*
Heaney, A T *DcWomA*
Heaney, Charles Edward 1897- *ArtsAmW 1, -3,*
 IlBEAAW, WhAmArt 85
Heaney, H C *AmArch 70*
Heany, David Cameron 1951- *WhoAmA 82, -84*
Heap, A M *DcWomA*
Heap, G F *AmArch 70*
Heap, George *NewYHSD*
Heap, Gwinn Harris 1817-1887 *ArtsAmW 1,*
 IlBEAAW, NewYHSD
Heap, Jane *DcWomA, WhAmArt 85*
Heap, Olga T 1897?-1981 *DcWomA*
Heap, R P *AmArch 70*
Heape, M *DcWomA*
Heaphy, Archibald C *DcVicP 2*
Heaphy, Charles 1820?-1881 *OxArt*
Heaphy, Charles 1821-1881 *DcBrWA*
Heaphy, Elizabeth *DcVicP, -2, DcWomA,*
 NewYHSD
Heaphy, G *DcVicP 2*
Heaphy, Mary Ann *DcWomA*
Heaphy, Theodosia *DcVicP 2, DcWomA*
Heaphy, Thomas d1873 *ArtsNiC*
Heaphy, Thomas 1775-1835 *DcBrWA*
Heaphy, Thomas Frank 1813-1873 *DcBrWA, DcVicP,*
 -2
Heaps, Chris *DcBrBI*
Heard *BiDAmAr*
Heard, Andrew Louis 1936- *AmArch 70*
Heard, B *DcVicP 2, DcWomA*
Heard, Edith V R *WhAmArt 85*
Heard, Joseph *DcVicP*
Heard, Joseph 1799-1859 *DcSeaP, DcVicP 2*
Heard, Nathaniel 1872- *DcBrA 1, DcVicP 2*
Hearlin *DcBrECP*
Hearn, Alfred *WhAmArt 85*
Hearn, D C *AmArch 70*
Hearn, George Arnold 1835-1913 *WhAmArt 85*

Hearn, Howell Reid, Jr. 1908- *AmArch 70*
Hearn, James Victor 1957- *MarqDCG 84*
Hearn, M F 1938- *WhoAmA 78, -80*
Hearn, M F, Jr. 1938- *WhoAmA 82, -84*
Hearn, Mary H *DcWomA, WhAmArt 85*
Hearn, R H *DcVicP 2*
Hearn, Richard *DcCAr 81*
Hearne, Thomas 1744-1817 *DcBrWA, McGDA,*
 OxArt
Hearsey, Hyder Young 1782-1840 *DcBrWA*
Hearsey, James P *NewYHSD*
Heartfield, John 1891- *WhoGrA 62*
Heartfield, John 1891-1968 *ConArt 77, -83, ConDes,*
 ConPhot, ICPEnP A, MacBEP, OxTwCA,
 PhDcTCA 77
Heartfield, Richard Cornish 1902- *AmArch 70*
Heartt, Harold *WhAmArt 85*
Heaslewood, Arthur *AntBDN Q*
Heasley, W D *AmArch 70*
Heaslip, Ann *DcWomA*
Heaslip, William 1898- *IlrAm C*
Heaslip, William 1898-1970 *IlrAm 1880*
Heaslit, William 1898- *WhAmArt 85*
Heath, Miss *DcWomA*
Heath, A H *DcVicP 2*
Heath, Adrian 1920- *ConBrA 79[port], DcBrA 1,*
 DcCAr 81, PhDcTCA 77
Heath, Alice *WhAmArt 85*
Heath, Arch B 1891-1945 *WhAmArt 85*
Heath, Carroll D 1880- *ArtsAmW 3*
Heath, Charles 1785-1848 *DcBrBI, DcBrWA,*
 DcVicP 2
Heath, David 1931- *ConPhot*
Heath, David C 1940- *WhoAmA 76, -78, -80, -82,*
 -84
Heath, David Martin 1931- *ICPEnP A, MacBEP,*
 WhoAmA 76, -78, -80, -82, -84
Heath, Don Reid 1925- *AmArch 70*
Heath, Donald Campbell 1893- *AmArch 70*
Heath, Edda Maxwell *WhAmArt 85*
Heath, Edda Maxwell 1875-1972 *ArtsAmW 2,*
 DcWomA
Heath, Effie *DcWomA*
Heath, Ella *WhAmArt 85*
Heath, Ellen *DcWomA*
Heath, Ernest Dudley *DcBrA 1, DcBrBI, DcVicP 2,*
 IlsCB 1744
Heath, Eugenia A 1843- *DcWomA*
Heath, Frank Gascoigne 1873-1936 *DcBrA 1,*
 DcVicP 2
Heath, Frank L *ArtsAmW 1*
Heath, Frank L 1857-1921 *ArtsAmW 3, IlBEAAW*
Heath, George 1900-1968 *WorECom*
Heath, Grace Comstock 1897- *DcWomA,*
 WhAmArt 85
Heath, Henry *DcBrBI*
Heath, Herbert Charles 1900- *AmArch 70*
Heath, Howard P 1879- *WhAmArt 85*
Heath, Irene 1906- *DcBrA 1*
Heath, Isobel Atterbury *WhoArt 80, -82, -84*
Heath, Isobel Atterbury 1908- *DcBrA 2*
Heath, James 1757-1834 *DcBrWA*
Heath, James William 1938- *MarqDCG 84*
Heath, Mrs. John *FolkA 86*
Heath, Lillian Josephine Dake 1864- *WhAmArt 85*
Heath, Lillian Josephine Drake 1864-1961 *ArtsAmW 2,*
 DcWomA
Heath, Lionel *DcBrA 2*
Heath, Louise *DcWomA*
Heath, Margaret A *DcBrA 1, DcVicP 2, DcWomA*
Heath, Nathaniel *CabMA*
Heath, Peter *DcCAr 81*
Heath, Philip *DcCAr 81*
Heath, Russell 1926- *WorECom*
Heath, S F *DcVicP 2*
Heath, Samuel *FolkA 86*
Heath, Susan 1798- *DcWomA, FolkA 86*
Heath, Thomas Edward *DcVicP 2*
Heath, Thomas Hastead *DcBrBI, DcVicP 2*
Heath, W *DcVicP 2*
Heath, W W *AmArch 70*
Heath, William *FolkA 86*
Heath, William 1795-1840 *DcBrBI, DcBrWA,*
 DcVicP 2
Heath, William Albert 1840-1911 *ArtsAmW 3*
Heath, William H *NewYHSD*
Heath, William H H *DcVicP 2*
Heathcote, Mrs. *DcVicP 2*
Heathcote, C *DcNiCA*
Heathcote, Charles Gilbert 1841- *DcBrWA*
Heathcote, Evelyn *DcVicP 2, DcWomA*
Heathcote, F *DcVicP 2*
Heathcote, John Moyer 1800-1890 *DcBrWA*
Heathcote, John Moyer 1834-1912 *DcBrWA*
Heathcote, M *DcVicP 2*
Heathcote, W C *DcVicP 2*
Heather, Charles *BiDBrA*
Heather, F T *DcBrWA*
Heather, John *DcBrECP*
Heather, Marjorie Kate *ClaDrA, WhoArt 80, -82,*
 -84

Heatherley, Thomas *DcVicP 2*
Heatherwell, W *DcVicP 2*
Heatley *DcBrECP*
Heatley, Mrs. *DcBrECP*
Heatly, Mrs. *DcWomA*
Heaton, A *DcVicP 2*
Heaton, Augustus G 1844-1930 *WhAmArt 85*
Heaton, C *AmArch 70*
Heaton, Charles M, Jr. 1840-1921 *NewYHSD* , *WhAmArt 85*
Heaton, Clement *DcBrA 2*
Heaton, Clement 1861-1940 *WhAmArt 85*
Heaton, E *DcBrWA*
Heaton, J E *AmArch 70*
Heaton, John *DcVicP 2*
Heaton, Maurice 1900- *IlDcG*, *WhAmArt 85*, *WhoAmA 73, -76, -78, -80, -82, -84*
Heaton, Monica *DcVicP 2*
Heaton, William Clifford 1938- *AmArch 70*
Heaton Cooper, William 1903- *PhDcTCA 77*
Heaven, Ethel R *DcWomA*, *WhAmArt 85*
Heaviside, John Smith 1812-1864 *DcBrBI*
Heaviside, Mary *DcWomA*
Heaviside, T *DcBrBI*
Heavyside, John Smith d1864 *DcVicP 2*
Hebald, Milton 1917- *DcCAA 71, -77*, *McGDA*, *PhDcTCA 77*
Hebald, Milton Elting 1917- *WhAmArt 85*, *WhoAmA 73, -76, -78, -80, -82, -84*
Hebbard, Henry *EncASM*
Hebbard, W S 1863-1930 *WhoArch*
Hebbard, Will Sterling 1863-1930 *BiDAmAr*
Hebbelinck, Marie Josephe *DcWomA*
Hebblethwaite, H Sydney *DcBrBI*
Hebebrand, Werner 1899-1966 *MacEA*
Heber, Carl A 1885-1956 *WhoAmA 80N, -82N, -84N*
Heber, Carl Augustus 1875-1956 *WhAmArt 85*
Heber, Charles G *WhAmArt 85*
Heber, Claudia *DcWomA*, *WhAmArt 85*
Heberer, Charles *WhAmArt 85*
Heberling, Glen Austin 1915- *WhoAmA 73, -76, -78, -80, -82, -84*
Hebert, Antoine-Auguste-Ernest 1817- *ArtsNiC*
Hebert, Antoine Auguste Ernest 1817-1908 *ClaDrA*, *McGDA*
Hebert, Helena *DcWomA*
Hebert, Julien 1917- *WhoAmA 73, -76, -78*
Hebert, Juliette Charlotte 1837- *DcWomA*
Hebert, Louis-Philippe 1850-1917 *McGDA*
Hebert, Marian 1899- *WhAmArt 85*
Hebert, Marian 1899-1960 *ArtsAmW 2*, *DcWomA*
Hebert-Stevens, Pauline *DcWomA*
Hebler, Herman 1911- *DcCAr 81*
Hebra, Anna De *DcWomA*
Hebrank, C H *AmArch 70*
Hebrard, A A *AntBDN C*, *DcNiCA*
Hebrard, Ernest 1866-1933 *MacEA*
Hebrard, Germaine 1889- *DcWomA*
Hechenthall, Louis *NewYHSD*
Hechle, Alexa Ann 1939- *WhoGrA 82[port]*
Hechle, Hilda *ClaDrA*, *DcBrA 1*, *DcWomA*
Hechler, Samuel *FolkA 86*
Hechstetter, John David *NewYHSD*
Hecht, Abslam *FolkA 86*
Hecht, Benjamin *NewYHSD*
Hecht, Caroline Genie 1954- *MarqDCG 84*
Hecht, Godfrey *WhoArt 82N*
Hecht, Godfrey 1902- *ClaDrA*, *DcBrA 1*, *WhoArt 80*
Hecht, H Hartman 1937- *WhoAmA 73, -76*
Hecht, Mary 1931- *WhoAmA 82, -84*
Hecht, Robert Gustav 1928- *AmArch 70*
Hecht, Victor D 1873- *WhAmArt 85*
Hecht, Zoltan d1968 *WhoAmA 78N, -80N, -82N, -84N*
Hecht, Zoltan 1890-1968 *WhAmArt 85*
Hechtel, George Thomas 1909- *AmArch 70*
Hechter, Charles 1886- *WhAmArt 85*
Hechter, Daniel 1938- *FairDF FRA*
Heck, E C *AmArch 70*
Heck, G H *AmArch 70*
Heck, Mike *MarqDCG 84*
Hecke, Jan VanDen 1620-1684 *McGDA*
Heckel, Catharina 1699-1741 *DcWomA*
Heckel, Erich 1883- *McGDA*, *OxArt*, *PhDcTCA 77*
Heckel, Erich 1883-1970 *ConArt 77, -83*, *OxTwCA*
Heckel, Vilem 1918-1970 *ICPEnP A*, *MacBEP*
Heckendorf, Franz 1888-1962 *McGDA*
Hecker, Caroline T *DcWomA*
Hecker, Frank J d1927 *WhAmArt 85*
Hecker, Jacob S *EncASM*
Hecker, Miles J 1950- *MarqDCG 84*
Hecker, Robert Daniel 1923- *AmArch 70*
Hecker, W F *AmArch 70*
Hecker, Zvi 1931- *ConArch*
Heckert, Fritz *DcNiCA*, *IlDcG*
Heckert, W C *AmArch 70*
Hecklinger, Guy Edwards *WhAmArt 85*
Heckman, Albert William 1893-1971 *WhAmArt 85*
Heckman, Norm 1947- *MarqDCG 84*
Heckmann, John H *FolkA 86*

Heckroth, Hein 1901-1970 *ConDes*
Heckscher, Morrison Harris 1940- *WhoAmA 78, -80, -82, -84*
Heckscher, William Sebastian 1904- *WhoAmA 76, -78, -80, -82, -84*
Hecksher, Lydia A *ArtsEM*, *DcWomA*
Hecky, L R *AmArch 70*
Hector, June *AfroAA*
Hector, W Cunningham *DcBrA 2*
Heda, Gerrit Willemsz *McGDA*
Heda, Willem Claesz 1593?-1682? *OxArt*
Heda, Willem Claesz 1594-1682? *McGDA*
Hedberg, Gregory Scott 1946- *WhoAmA 76, -78, -80, -82, -84*
Hedden, Geoffrey Mark 1928- *MarqDCG 84*
Hedden, Martha *FolkA 86*
Hedden-Sellman, Zelda *WhoAmA 73, -76, -78, -80, -82, -84*
Hedderwick, Mairi 1939- *IlsCB 1967*
Heddinger, Fred M 1917- *MarqDCG 84*
Hedean 1904- *WhAmArt 85*
Hedeen, E N *AmArch 70*
Hedge, Franklin 1830?- *NewYHSD*
Hedge, Frederic Henry 1805-1890 *EarABI*
Hedge, Gene 1928- *DcCAr 81*
Hedgeland, Charles *BiDBrA*
Hedgeland, John Pike *BiDBrA*
Hedgepath, Harry DeWitt 1921- *AmArch 70*
Hedger, F *DcVicP 2*
Hedger, William *BiDBrA*
Hedges, D A *AmArch 70*
Hedges, Janet 1955- *DcCAr 81*
Hedges, Joe *FolkA 86*
Hedges, Margaret Ricker 1906- *WhAmArt 85*
Hedges, Nick 1943- *ConPhot*, *ICPEnP A*
Hedges, Robert Danforth 1878- *WhAmArt 85*
Hedges, William W 1835?- *NewYHSD*
Hedian, Helena *WhAmArt 85*
Hedian, T *FolkA 86*
Hedicaugh, William *FolkA 86*
Hedin, Donald M *OfPGCP 86*
Hedin, Donald Monroe 1920- *WhoAmA 80, -82, -84*
Hedinger, Elise 1854- *DcWomA*
Hedinger, John H *NewYHSD*
Hedlander, R Lincoln 1898- *AmArch 70*
Hedley, Johnson d1914 *DcBrA 1*, *DcVicP 2*
Hedley, Joseph H *FolkA 86*, *NewYHSD*
Hedley, Ralph 1848-1913 *DcBrA 1*
Hedley, Ralph 1851-1913 *ClaDrA*, *DcVicP, -2*
Hedley, Ralph 1948- *DcCAr 81*
Hedley, William W, Jr. 1930- *AmArch 70*
Hedlund, R *AmArch 70*
Hedlund, Ronald Walter 1933- *AmArch 70*
Hedman, Teri Jo 1944- *WhoAmA 76, -78, -80, -82, -84*
Hedouin, Edmond 1819- *ArtsNiC*
Hedouin, Pierre Edmond Alexandre 1820-1889 *ClaDrA*
Hedrick, Mary S 1903- *ArtsAmW 3*
Hedrick, Robert William 1923- *AmArch 70*
Hedrick, Wally Bill 1928- *WhoAmA 76, -78, -80, -82, -84*
Hedrick, William Scott 1945- *MarqDCG 84*
Hedvig, Elisabeth Charlotte 1759-1818 *DcWomA*
Hee, Arthur J K 1919- *AmArch 70*
Hee, Hon-Chew 1906- *AmArt*, *WhoAmA 76, -78, -80, -82, -84*
Heebner, Ann *DcWomA*, *WhAmArt 85*
Heebner, David *FolkA 86*
Heebner, John *FolkA 86*
Heebner, Maria *FolkA 86*
Heebner, Susanna *DcWomA*, *FolkA 86*
Heebneren, Susanha 1797-1879? *FolkA 86*
Heed, J *NewYHSD*
Heed, J M *NewYHSD*
Heed, M J *NewYHSD*
Heeg, Mademoiselle *DcWomA*
Heel, Johann 1637-1709 *IlDcG*
Heel, Johannes 1637-1709 *IlDcG*
Heeley, Desmond 1931- *ConDes*
Heeling, John *FolkA 86*
Heely, Emma A *DcWomA*, *NewYHSD*
Heem, Cornelis De 1631-1695 *McGDA*, *OxArt*
Heem, Jan Davidsz De 1606-1684 *ClaDrA*
Heem, Jan Davidsz De 1606-1684? *McGDA*, *OxArt*
Heemer, Jack Eddie 1870- *AmArch 70*
Heemskerck, Egbert Van 1634?-1704 *McGDA*
Heemskerck, Jacoba Van 1876-1923 *DcWomA*
Heemskerck, Maerten Van 1498-1574 *McGDA*, *OxArt*
Heemskerck VanBeest, Jacob Edward 1828-1894 *DcSeaP*
Heemskerk, Egbert Van 1610-1680 *ClaDrA*
Heemskerk, Egbert Van, II d1744? *DcBrECP*
Heemskerk, Marten Jacobsz VanVeen 1498-1574 *ClaDrA*
Heemskerk, Willem Jacobsz Van 1613-1692 *IlDcG*, *OxDecA*
Heemskerk VanBaes, Jacoba 1876-1923 *PhDcTCA 77*
Heemstra, H C *AmArch 70*
Heer, Fridolin 1834-1910 *BiDAmAr*

Heer, Fridolin, Jr. 1864-1940 *BiDAmAr*
Heer, Margarethe De *DcWomA*
Heer, Marie Louise *DcWomA*
Heer Brothers *EncASM*
Heer-Schofield *EncASM*
Heeramaneck, Nasil M 1902-1971 *WhoAmA 80N, -82N, -84N*
Heeramaneck, Nasili M 1902-1971 *WhoAmA 78N*
Heerdt, Emma 1849- *DcWomA*
Heere, Anna De *DcWomA*
Heere, Lucas De 1534-1584 *McGDA*
Heere, Lukas De 1534-1584 *ClaDrA*
Heeremans, Thomas 1641?-1699? *McGDA*
Heeren, Minna 1823-1898 *DcWomA*
Heeren Brothers *EncASM*
Heerfordt, Anna Cathrine Christine 1839-1910 *DcWomA*
Heerfordt, Ida Marie Margrethe 1834-1887 *DcWomA*
Heerich, Erwin 1922- *ConArt 77, -83*, *DcCAr 81*, *OxTwCA*
Heerlein, W *FolkA 86*
Heerlein, Norbert 1891- *WhAmArt 85*
Heerman, Norbert Leo 1891- *ArtsAmW 3*
Heermann, Norbert Leo 1891- *ArtsAmW 3*
Heermans, Augustyn 1605?-1686 *NewYHSD*
Heerschop, Hendrik 1620?-1672? *McGDA*
Heerup, Henri 1907- *OxTwCA*
Heerup, Henry 1907- *PhDcTCA 77*
Heery, Clarence Wilmer 1904- *AmArch 70*
Heery, George Thomas 1927- *AmArch 70*
Hees, Gerrit Van d1670 *McGDA*
Heesch, Theodore Maynard 1936- *AmArch 70*
Heese, Olga F *DcWomA*
Heesen, Willem 1925- *DcCAr 81*, *IlDcG*
Heffelbower, Richard Everett 1932- *AmArch 70*
Heffer, Edward A *DcBrA*
Hefferman, John 1765- *CabMA*
Hefferman, William L *WhAmArt 85*
Heffernan, Paul Malcolm 1909- *AmArch 70*
Heffler, Max Gerald 1957- *MarqDCG 84*
Heffner *FolkA 86*
Heffner, Stephen Fleming 1944- *MarqDCG 84*
Hefley, Maurice 1909- *AmArch 70*
Hefley, William Earl 1957- *MarqDCG 84*
Heflin, Tom Pat 1934- *WhoAmA 73, -76, -78, -80, -82, -84*
Hefner, George 1806?-1878 *FolkA 86*
Hefner, Harry Simon 1911- *WhoAmA 76, -78, -80, -82, -84*
Heft, R *AmArch 70*
Hegarty, Anna Agnes 1906- *WhAmArt 85*
Hege, Ekeith 1932- *MarqDCG 84*
Hegedus, I I *AmArch 70*
Hegedus, Laszlo 1920- *ClaDrA*, *WhoArt 84*
Hegedusic, Krsto 1901- *PhDcTCA 77*
Hegedusic, Krsto 1901-1975 *OxTwCA*
Hegeman, George *NewYHSD*
Hegemann, Werner 1881-1936 *MacEA*
Hegenbarth, Josef 1884- *WhoGrA 62*
Hegenbarth, Josef 1884-1962 *PhDcTCA 77*
Heger, Anna *DcWomA*
Heger, Dirk Arnfred 1940- *MarqDCG 84*
Heger, Joseph 1835- *ArtsAmW 1*, *IlBEAAW*, *NewYHSD*
Heger, Louise 1842- *DcWomA*
Heger-Gasser, Eugenie 1866- *DcWomA*
Hegfeldt, Gunilla 1915- *DcCAr 81*
Hegg, Eric A 1868-1948 *ICPEnP A*, *MacBEP*
Hegg, Teresa *DcVicP 2*
Hegg, Teresa Maria 1829-1911 *DcWomA*
Hegler, John Jacob 1812-1856 *NewYHSD*
Heglund, R L *AmArch 70*
Hegner, Casper Forman 1909- *AmArch 70*
Hegomin, Anzola D Laird *AfroAA*
Hehnke, A A *AmArch 70*
Heiberg, Jean *WhoArt 82N*
Heiberg, Jean 1884- *PhDcTCA 77*, *WhoArt 80*
Heichert, Otto 1868- *ClaDrA*
Heid, Warren Braue 1924- *AmArch 70*
Heidbreder, George Allen 1910- *AmArch 70*
Heide, August F 1862-1943 *MacEA*
Heidel, Edith Hope 1871- *DcWomA*
Heidel, Edith Ogden *WhAmArt 85*
Heidel, Frederick 1915- *WhoAmA 73, -76, -78, -80, -82, -84*
Heidelberger, Hans Albert 1910- *AmArch 70*
Heidelberger, Richard John 1907- *AmArch 70*
Heidelhoff, Niklaus Wilhelm Von 1761-1839? *AntBDN E*
Heideloff, Karl Alexander Von 1789-1865 *MacEA*
Heideloff, Nicolaus I W Clemens Van 1761-1837 *OxDecA*
Heideman, George Warren 1923- *AmArch 70*
Heidemans, Henri P *NewYHSD*
Heider, Hans *McGDA*
Heider, Klaus 1936- *DcCAr 81*
Heidloff, R H *AmArch 70*
Heidrich, A Grant 1952- *MarqDCG 84*
Heidrich, K J *AmArch 70*
Heidrick, Madeleine *WhAmArt 85*
Heidt, Herbert F 1915- *AmArch 70*

Hellebrand, Nancy 1944- *ICPEnP A, MacBEP*
Hellebronth, Gizella 1881- *DcWomA*
Hellegas, Richard Alan 1940- *AmArch 70*
Hellem, Charles B *NewYHSD*
Hellemaa, Karen *WorFshn*
Hellemans, Jeanne Marie Josephine 1796-1837 *DcWomA*
Hellemont, Matheus Van 1622?-1680? *ClaDrA*
Hellemont, Mattheus Van *McGDA*
Hellenberg, Bernard *ArtsEM*
Hellenberg, Frederick *ArtsEM*
Hellenbroek, Anna Elisabeth *DcWomA*
Heller, Ben 1925- *WhoAmA 73, –76, –78, –80, –82, –84*
Heller, Bessie Peirce 1896- *ArtsAmW 2, DcWomA, WhAmArt 85*
Heller, Cecile Mathilde 1890-1920 *DcWomA*
Heller, Charles O 1936- *MarqDCG 84*
Heller, Dorothy *WhoAmA 73, –76, –78, –80, –82, –84*
Heller, Eugenie M *DcWomA, WhAmArt 85*
Heller, Goldie *WhoAmA 73, –76, –78, –80, –82, –84*
Heller, Helen West 1870-1955 *WhAmArt 85*
Heller, Helen West 1885-1955 *DcWomA*
Heller, Jules 1919- *PrintW 85, WhoAmA 73, –76, –78, –80, –82, –84*
Heller, Lawrence J *WhoAmA 73*
Heller, Leonard G 1893-1966 *ArtsAmW 3*
Heller, Maxwell d1963 *WhoAmA 80N, –82N, –84N*
Heller, Maxwell L d1963 *WhoAmA 78N*
Heller, Maxwell 1881-1963 *WhAmArt 85*
Heller, Reinhold August 1940- *WhoAmA 78, –80, –82, –84*
Heller, Robert 1906- *WhAmArt 85*
Heller, S M *AmArch 70*
Heller, T *DcWomA*
Heller, Mrs. T *NewYHSD*
Heller, Ursula 1948- *DcCAr 81*
Heller, W B *AmArch 70*
Heller-Ostersetzer, Hermine 1874-1909 *DcWomA*
Hellerman, Robert *NewYHSD*
Hellerova, Erika 1924- *DcCAr 81*
Hellesen, Hanne 1801-1844 *DcWomA*
Hellesvig, Dennis Darrell 1936- *AmArch 70*
Helleu, Paul Cesar 1859-1927 *ClaDrA, DcBrBI*
Hellge, George *NewYHSD*
Hellick, Ann 1822?- *FolkA 86*
Helliger, Bernhard 1915- *DcCAr 81*
Helling, G D *AmArch 70*
Hellman, Bertha Louise 1900- *WhAmArt 85*
Hellman, Harold Herbert 1925- *AmArch 70*
Hellmann, E *AmArch 70*
Hellmann, Raymond Maxwell 1923- *AmArch 70*
Hellmer, Edmund 1850-1935 *McGDA*
Hellmers, Charles E, Jr. 1858-1905 *BiDAmAr*
Hellmuth, George 1907- *MacEA*
Hellmuth, George F 1907- *ConArch*
Hellmuth, George Francis 1907- *AmArch 70*
Hellmuth Obata And Kassabaum *ConArch, MacEA*
Hellrath, E *ArtsNiC*
Hellstrand, Rolf Lennart 1951- *MarqDCG 84*
Hellyer, Jeff *DcCAr 81*
Helm, Augustus L *NewYHSD*
Helm, F Kirk 1916- *AmArch 70*
Helm, John F, Jr. 1900-1972 *WhAmArt 85, WhoAmA 78N, –80N, –82N, –84N*
Helm, Katherine *DcWomA, WhAmArt 85*
Helm, Margarethe *DcWomA*
Helm, Reginald *AfroAA*
Helm, W E *AmArch 70*
Helman, Phoebe *WhoAmA 73*
Helman, Phoebe 1929- *WhoAmA 76, –78, –80, –82, –84*
Helman, Robert 1910- *DcCAr 81*
Helman, W R *AmArch 70*
Helmbrecker, Dirk Theodor 1633-1696 *ClaDrA*
Helmbreker, Theodoor 1633-1696 *McGDA*
Helmcke, Magda *DcWomA*
Helme, Frank J 1869-1929 *BiDAmAr*
Helme, J Burn 1897- *WhAmArt 85*
Helmer, Charles *AntBDN K*
Helmer, Charles Hood 1906- *AmArch 70*
Helmer, Jean Cassels *IlsBYP*
Helmer-Petersen, Keld 1920- *ConPhot, MacBEP*
Helmers, John Howard 1914- *AmArch 70*
Helmers, Magdalena *DcWomA*
Helmes, B P *AmArch 70*
Helmhack, Abraham 1654-1724 *IlDcG*
Helmholtz, Hermann Ludwig Ferdinand Von 1821-1894 *ICPEnP, MacBEP*
Helmich, A *DcVicP 2*
Helmick, J Gustav 1864-1936 *WhAmArt 85*
Helmick, Alice *WhAmArt 85*
Helmick, Howard 1845-1907 *DcBrBI, WhAmArt 85*
Helmke, Vernon Lloyd 1931- *AmArch 70*
Helmle, George B 1884-1938 *BiDAmAr*
Helmle, George H d1928? *BiDAmAr*
Helmle, J Burns 1897-1945 *BiDAmAr*
Helmold, Adele M Von *DcWomA, WhAmArt 85*
Helmont *McGDA*
Helmont, Mattheus Van 1623-1679? *McGDA*
Helmore, Thomas *DcVicP 2*

Helms, Kenneth C 1903- *AmArch 70*
Helmschmied, Desiderius *OxDecA*
Helmschmied, Kolomon *OxDecA*
Helmschmied, Lorenz *OxDecA*
Helmuth, Jessie L 1892- *WhAmArt 85*
Helmuth, William Tod 1833-1902 *NewYHSD*
Helmuts, Inars 1934- *PrintW 83, –85*
Helok, C P 1893- *WhAmArt 85*
Helpern, David Paul 1938- *AmArch 70*
Helps, Francis *DcBrA 1*
Helps, Francis A *DcBrA 2*
Hels, Madame *DcWomA*
Helsdon, Maureen Constance *WhoArt 80, –82, –84*
Helser, George *MarqDCG 84*
Helser, Robert A 1914- *AmArch 70*
Helske, K W 1922- *AmArch 70*
Helst, Bartholomeus VanDer 1613-1670 *ClaDrA, McGDA, OxArt*
Helstrom, Bessie *WhAmArt 85*
Helt, Chester LeRoy 1936- *AmArch 70*
Helt, Francois Gabriel 1948- *MarqDCG 84*
Helt-Stocade, Nicolaes Van 1614-1669 *McGDA*
Helton, Rondald Bailey 1936- *AmArch 70*
Heluis, Louise *DcWomA*
Helweg, Hans H *IlsCB 1967*
Helweg, Hans H 1917- *IlsCB 1946*
Helwick, Lottie B 1911- *AmArch 70*
Helwig, Albert M 1891- *WhAmArt 85*
Helwig, Arthur Louis *WhoAmA 73, –76*
Helwig, Arthur Louis d1976 *WhoAmA 78N, –80N, –82N, –84N*
Helwig, Arthur Louis 1899- *ArtsAmW 3*
Helwig, Arthur Louis 1899-1976 *WhAmArt 85*
Hely, E R *DcVicP 2*
Helzer, Richard Brian 1943- *WhoAmA 78, –80, –82, –84*
Hem, Louise De 1866-1922 *DcWomA*
Hemberger, Armin B 1896- *WhAmArt 85*
Hemby, P C *AmArch 70*
Hemenway, Alice Spaulding 1866- *DcWomA, WhAmArt 85*
Hemenway, Asa *NewYHSD*
Hemenway, Asa 1810-1892 *FolkA 86*
Hemenway, Charles d1887 *NewYHSD*
Hemenway, Louise Jordan 1893- *DcWomA, WhAmArt 85*
Hemenway, M Estelle *ArtsEM, DcWomA*
Hemenway, Nancy 1920- *WhoAmA 73, –76, –78, –80, –82, –84*
Hemery, Francoise Eleonore *DcWomA*
Hemery, Louise Rosalie *DcWomA*
Hemery, Marguerite 1745- *DcWomA*
Hemery, Therese Eleonore 1753- *DcWomA*
Hemessen, Caterina Van 1528- *WomArt*
Hemessen, Catharina Van 1528-1587? *DcWomA*
Hemessen, Jan Sanders 1504-1566 *ClaDrA*
Hemessen, Jan Sanders Van *McGDA*
Hemessen, Jan Sanders Van 1500?-1575? *OxArt*
Hemeter, David Kinard 1929- *AmArch 70*
Hemill *EncASM*
Heming, Miss *DcWomA*
Heming, Mrs. *DcWomA*
Heming, Arthur 1870-1940 *ArtsAmW 1, WhAmArt 85*
Heming, Arthur Henry Howard 1870-1940 *IlBEAAW*
Heming, George *AntBDN Q*
Heming, Matilda *DcBrBI, DcWomA*
Heming, Thomas *AntBDN Q*
Hemington, Charlotte *DcWomA*
Hemingway, A *DcVicP 2*
Hemingway, F *AmArch 70*
Hemingway, Grace Hall 1872-1951 *DcWomA*
Hemingway, Hall 1872- *WhAmArt 85*
Hemmerdinger, William *OfPGCP 86*
Hemmerdinger, William John, III 1951- *WhoAmA 80, –82, –84*
Hemmerich, Hugo 1953- *MarqDCG 84*
Hemmick, Alice Barney *WhAmArt 85*
Hemming *EncASM*
Hemming, Miss *DcWomA*
Hemming, Edith C S *DcWomA*
Hemming, Fanny *DcVicP 2, DcWomA*
Hemming, H *NewYHSD*
Hemming, J Charles *ArtsEM*
Hemming, Richard *NewYHSD*
Hemming, W B *DcWomA*
Hemming, Mrs. W B *DcVicP 2*
Hemming And Crouffond *ArtsEM*
Hemmings, Edward C 1876-1924 *BiDAmAr*
Hemmings, Robert *WhAmArt 85*
Hemon, James *FolkA 86*
Hemony, Francis *OxDecA*
Hemony, Peter *OxDecA*
Hemp, Robert 1916- *FolkA 86*
Hemphill, Benjamin Franklin 1907- *AmArch 70*
Hemphill, Frank Dantzler 1924- *AmArch 70*
Hemphill, Herbert Waide 1929- *WhoAmA 76, –78, –80, –82*
Hemphill, Herbert Waide, Jr. 1929- *WhoAmA 84*
Hemphill, Jack 1926- *AmArch 70*

Hemphill, James Calvin, Jr. 1920- *AmArch 70*
Hemphill, Joseph *FolkA 86*
Hemphill, Joseph 1770-1842 *AntBDN M, DcNiCA*
Hemphill, Judge *FolkA 86*
Hemphill, Pamela 1927- *WhoAmA 76, –78, –80, –82, –84*
Hempler, Orval F 1915- *AmArt, WhoAmA 80, –82, –84*
Hempstead, J H *DcWomA*
Hempstead, Joseph L 1884- *WhAmArt 85*
Hempstead, Joshua 1678-1758 *FolkA 86*
Hempton, Paul Andrew Keates 1946- *WhoArt 80, –82, –84*
Hemsley, George Philip 1933- *WhoArt 82, –84*
Hemsley, Henry 1764?- *BiDBrA*
Hemsley, Walter Howard *DcVicP 2*
Hemsley, William 1819- *ArtsNiC, DcBrWA, DcVicP, –2*
Hemstead, Margaret J d1924? *DcWomA*
Hemsted, Margaret J d1924? *DcWomA*
Hemstegger, L G *ArtsAmW 3*
Hemy, Bernard Benedict *DcVicP*
Hemy, Bernard Benedict d1913 *DcVicP 2*
Hemy, Bernard Benedict 1855?-1913 *DcBrA 1, DcBrWA, DcSeaP*
Hemy, Charles Napier 1841-1917 *ClaDrA, DcBrA 1, DcBrBI, DcBrWA, DcSeaP, DcVicP, –2*
Hemy, M W *DcVicP 2*
Hemy, Thomas Marie Madawaska 1852-1937 *DcBrA 1, DcBrWA, DcSeaP, DcVicP, –2*
Hemy, W M *DcVicP 2*
Hen, Catharina De *DcWomA*
Henard, Charles *NewYHSD*
Henard, Eugene 1849-1923 *MacEA*
Henard, Eugenie *DcWomA*
Henault *DcBrECP*
Henault, Stephanie *DcWomA*
Hench, Robert Irving 1928- *AmArch 70*
Henck, Karl N 1960- *MarqDCG 84*
Henck, Sofie Ernestine 1822-1893 *DcWomA*
Hencke, Albert 1865-1936 *WhAmArt 85*
Henckel, Carl 1862- *IlBEAAW*
Henckel, George A *EncASM*
Hendershot, J L 1941- *WhoAmA 76, –78, –80, –82, –84*
Henderson, Miss *DcWomA*
Henderson, Mrs. *DcBrECP*
Henderson, A *DcVicP 2*
Henderson, A Elizabeth 1873- *DcWomA, WhAmArt 85*
Henderson, Aaron F *AfroAA*
Henderson, Abigail *DcWomA, NewYHSD*
Henderson, Alice *DcWomA*
Henderson, Andrew Graham 1882-1963 *DcBrA 1*
Henderson, Arnold Clayton 1938- *MacBEP*
Henderson, Arthur Edward 1870-1956 *ClaDrA, DcBrA 1, DcVicP 2*
Henderson, C *DcVicP 2*
Henderson, C C *AmArch 70*
Henderson, Charles Cooper 1803- *ClaDrA*
Henderson, Charles Cooper 1803-1877 *DcBrWA, DcVicP, –2*
Henderson, Cyria Allen 1896- *DcWomA*
Henderson, D *AntBDN M*
Henderson, D J *FolkA 86*
Henderson, David d1787? *BiDBrA*
Henderson, David English 1832-1887 *NewYHSD*
Henderson, David George 1918- *AmArch 70*
Henderson, David L 1947- *MarqDCG 84*
Henderson, Dion 1941- *AfroAA*
Henderson, Dorothy 1912- *WhAmArt 85*
Henderson, E *DcVicP 2*
Henderson, Earl Wallace, Jr. 1931- *AmArch 70*
Henderson, Elen 1906- *WorFshn*
Henderson, Elsie M 1880- *DcBrA 1*
Henderson, Elsie M 1880-1967 *DcBrA 2*
Henderson, Elsie Marian 1880- *DcWomA*
Henderson, Ernest M 1905- *WhAmArt 85*
Henderson, Eselean *AfroAA*
Henderson, Evelyn *ArtsAmW 2, WhAmArt 85*
Henderson, Frank K *FolkA 86*
Henderson, Gary A 1953- *MarqDCG 84*
Henderson, George, Jr. 1804?- *FolkA 86*
Henderson, Georgiana Jane *DcWomA*
Henderson, Gerard D'A *OxTwCA*
Henderson, H *DcVicP 2*
Henderson, H W *AmArch 70*
Henderson, Harry V K 1883- *WhAmArt 85*
Henderson, Harry V K 1883-1939 *BiDAmAr*
Henderson, Helen *DcWomA*
Henderson, Helen Weston 1874- *DcWomA*
Henderson, Howard Brost 1922- *AmArch 70*
Henderson, Irene *DcWomA*
Henderson, J *AntBDN M*
Henderson, Jack W 1931- *WhoAmA 76, –78, –80, –82, –84*
Henderson, James 1871-1951 *DcBrA 2, IlBEAAW*
Henderson, James Alan 1928- *AmArch 70*
Henderson, James Freeman 1927- *AmArch 70*
Henderson, Jeanie H Reid 1835-1921 *DcWomA, WhAmArt 85*

Henderson, John *FolkA 86*
Henderson, John d1786 *BiDBrA*
Henderson, John 1754-1845 *DcVicP 2*
Henderson, John 1761?-1800 *BiDBrA*
Henderson, John 1764-1843 *DcBrWA*
Henderson, John 1797-1878 *DcBrWA*
Henderson, John 1804-1862 *BiDBrA A*
Henderson, John 1813?-1844 *BiDBrA*
Henderson, John 1860-1924 *DcBrA 1, -2, DcVicP 2*
Henderson, John Drews 1933- *AmArch 70*
Henderson, John Morris *DcVicP 2*
Henderson, John R *ArtsAmW 3, IlBEAAW, WhAmArt 85*
Henderson, John Robert 1926- *AmArch 70*
Henderson, Joseph *FolkA 86*
Henderson, Joseph 1832- *ArtsNiC*
Henderson, Joseph 1832-1908 *ClaDrA, DcBrA 1, DcBrWA, DcVicP 2*
Henderson, Joseph Morris 1863-1936 *DcBrA 1, DcVicP 2*
Henderson, Keith 1883- *DcBrA 1, DcBrBI, IlsCB 1744, WhoArt 80*
Henderson, L R *DcWomA*
Henderson, LeGrand 1901-1965 *IlsCB 1744, -1946, -1957*
Henderson, Leroy *AfroAA*
Henderson, Leroy W *AfroAA*
Henderson, Leslie 1895- *WhAmArt 85*
Henderson, Lester Kierstead 1906- *WhoAmA 78, -80, -82, -84*
Henderson, Linda Dalrymple 1948- *WhoAmA 84*
Henderson, Lizzie *DcWomA*
Henderson, Margaret *DcWomA*
Henderson, Mark Richard 1949- *MarqDCG 84*
Henderson, Martha 1925- *AfroAA*
Henderson, Mike 1943- *WhoAmA 76, -78, -80, -82*
Henderson, Napoleon *AfroAA*
Henderson, Nigel *OxTwCA*
Henderson, Nigel 1917- *ConPhot, ICPEnP A*
Henderson, Philip Cristy 1930- *AmArch 70*
Henderson, Philip L 1911- *WhAmArt 85*
Henderson, R *DcVicP 2*
Henderson, Richard 1928- *AmArch 70*
Henderson, Robbin Legere 1942- *WhoAmA 84*
Henderson, Robert Donald 1946- *MarqDCG 84*
Henderson, Roy Manwaring 1930- *AmArch 70*
Henderson, Russel D 1898- *AmArch 70*
Henderson, Sheila Scott 1910- *DcBrA 1, WhoArt 80, -82, -84*
Henderson, Thomas 1811- *CabMA*
Henderson, Thomas C 1952- *MarqDCG 84*
Henderson, Thomas J, Jr. 1929- *AmArch 70*
Henderson, Thomas R 1951- *MarqDCG 84*
Henderson, Vernita *AfroAA*
Henderson, Victor 1939- *WhoAmA 78, -80, -82, -84*
Henderson, W L *AmArch 70*
Henderson, W S P *DcVicP, -2*
Henderson, William *DcVicP 2*
Henderson, William 1737?-1824 *BiDBrA*
Henderson, William 1943- *AfroAA*
Henderson, Mrs. William *DcVicP 2, DcWomA*
Henderson, William C 1932- *AmArch 70*
Henderson, William Penhallow 1877-1943 *ArtsAmW 1, IlBEAAW, WhAmArt 85*
Henderson, Z W *AmArch 70*
Henderson Allen *CabMA*
Hendil, Birgitte 1944- *WhoArt 80, -82, -84*
Hendler, Raymond 1923- *DcCAA 71, -77, WhoAmA 73, -76, -78, -80, -82, -84*
Hendley, Charles *NewYHSD*
Hendley, G E *DcVicP 2*
Hendley, John D *CabMA*
Hendley, John Walter 1826-1899 *NewYHSD*
Hendon, Owen William *AmArch 70*
Hendree, George D *CabMA*
Hendrick, C L *AmArch 70*
Hendrick, David *CabMA*
Hendrick, Joe *IlsBYP*
Hendrick, Lloyd Melville 1891- *AmArch 70*
Hendrick, William Thomas 1920- *AmArch 70*
Hendricks, Barkley Leonard 1945- *AfroAA*
Hendricks, Barkley Leonnard 1945- *WhoAmA 73, -76, -78, -80, -82, -84*
Hendricks, Bessie 1867-1929 *DcWomA, WhAmArt 85*
Hendricks, David Charles 1948- *WhoAmA 78, -80, -82, -84*
Hendricks, Donald Teves 1914- *WhoAmA 76, -78, -80, -82*
Hendricks, Edith F *WhAmArt 85*
Hendricks, Edward Lee 1952- *WhoAmA 84*
Hendricks, Emma Stockman 1869- *IlBEAAW, WhAmArt 85*
Hendricks, Emma Stockmon 1869- *ArtsAmW 2, DcWomA*
Hendricks, Geoffrey 1931- *ConArt 77, -83, WhoAmA 73, -76, -78, -80, -82, -84*
Hendricks, J L *AmArch 70*
Hendricks, J P *FolkA 86*
Hendricks, James 1938- *WhoAmA 73, -76, -78, -80, -82, -84*

Hendricks, Marie *ArtsEM, DcWomA*
Hendricks, R *WhAmArt 85*
Hendricksen, Ralph *WhAmArt 85*
Hendrickson, B E 1851- *BiDAmAr*
Hendrickson, David 1896- *ArtsAmW 3, IlrAm D, WhAmArt 85*
Hendrickson, David 1896-1973 *IlrAm 1880*
Hendrickson, Donald Edward 1928- *AmArch 70*
Hendrickson, Morris James, Jr. 1918- *AmArch 70*
Hendrickson, Peter 1936- *AmArch 70*
Hendrickson, Ronald William 1928- *AmArch 70*
Hendrickson, William Clair 1916- *AmArch 70*
Hendricus A Rijssel *McGDA*
Hendrie, E *DcWomA*
Hendrie, Herbert 1887-1946 *DcBrA 1*
Hendrie, Marion 1876-1968 *DcWomA*
Hendrie, Marion G *ArtsAmW 3, WhAmArt 85*
Hendrie, Robert *DcVicP 2*
Hendrie, Sarah *DcWomA*
Hendriks, Sara Frederika 1846-1925 *DcWomA*
Hendriks, Wybrand 1744-1831 *ClaDrA, OxArt*
Hendriquez DeCastro, Gabriel 1808- *ClaDrA*
Hendrix, Connie 1942- *WhoAmA 80, -82, -84*
Hendrix, J Louis *DcVicP 2*
Hendrix, T B *AmArch 70*
Hendry, Archibald Hunter *WhoArt 84N*
Hendry, Archibald Hunter 1890- *DcBrA 1, WhoArt 80, -82*
Hendry, George E *DcVicP 2*
Hendry, George E d1915 *DcBrA 2*
Hendry, Sydney *DcBrBI*
Hendry, W C, Jr. *AmArch 70*
Hendryx, R K *AmArch 70*
Hendryx, T K *AmArch 70*
Heneghan, George Edward, Jr. 1934- *AmArch 70*
Heneghan, Tom *ConArch A*
Henes, Donna 1945- *WhoAmA 84*
Heney, Miss *DcWomA*
Henfrey, Charles *DcBrBI*
Hengel, Raymond Joseph 1922- *AmArch 70*
Hengeler, Adolf 1863- *WorECar*
Hengels, Henry C 1876-1944? *BiDAmAr*
Henger, Wesley Joseph 1906- *AmArch 70*
Henghes, Heinz 1906-1975 *DcBrA 2*
Henis, William *FolkA 86*
Henisch, Heinz K 1922- *MacBEP*
Henius, L G 1879-1925 *WhAmArt 85*
Henius, Lillian Grace 1879-1925 *DcWomA*
Henk, Christopher 1821?-1905 *AntBDN M*
Henka, Bernard Albert 1888-1949 *ArtsAmW 3*
Henke, Bernard 1888- *WhAmArt 85*
Henke, Bernard Albert 1888-1949 *ArtsAmW 3*
Henkel, A Vandalaine *WhAmArt 85*
Henkel, Ambrose *FolkA 86*
Henkel, Ambrosius *EarABI*
Henkel, Anna Vandalaine *DcWomA*
Henkel, August 1880- *WhAmArt 85*
Henkel, Estella M 1889- *ArtsAmW 3*
Henkel, Kathe *DcWomA*
Henkel, Manfred 1936- *DcCAr 81*
Henkel, Solomon *EarABI*
Henkle, James Lee 1927- *WhoAmA 73, -76, -78, -80, -82, -84*
Henkley, Henry *DcVicP 2*
Henkora, Leo A 1893- *WhAmArt 85*
Henle, Fritz 1909- *ConPhot, ICPEnP A, MacBEP, WhoAmA 84*
Henley, A W *DcBrBI, DcVicP 2*
Henley, Bob *OfPGCP 86*
Henley, Carroll Juan 1931- *AmArch 70*
Henley, J *DcVicP 2*
Henley, Lionel Charles 1843-1893? *DcBrBI, DcVicP, -2*
Henley, W B *DcVicP 2*
Henley, Wayne *MarqDCG 84*
Henmi, R T *AmArch 70*
Henn, Edward *ArtsEM*
Henn, Rudolph *WhAmArt 85*
Henn, Ulrich 1925- *OxTwCA*
Hennah, Joseph Edward 1897- *DcBrA 1*
Henne, Daniel P *FolkA 86*
Henne, J S *FolkA 86*
Henne, Joseph K *FolkA 86*
Henneberg, Rudolf Friedrich 1826-1876 *ArtsNiC*
Henneberger, Dorothee *DcWomA*
Henneberger, Robert G 1921- *IlsBYP*
Henneberger, Roger G 1921- *IlsCB 1946*
Hennebique, Francois 1842-1921 *MacEA, WhoArch*
Hennebutte, Blanche *DcWomA*
Hennecart, Jan *McGDA*
Hennegan, Paul M *WhAmArt 85*
Hennegan, William H *EncASM*
Hennegan Bates *EncASM*
Hennekin, Paulus 1611?-1672 *McGDA*
Hennell, David *AntBDN Q*
Hennell, David 1712- *DcD&D*
Hennell, David 1767- *DcD&D*
Hennell, Robert *AntBDN Q, DcD&D*
Hennell, Robert d1811 *DcD&D*
Hennell, Samuel *AntBDN Q*
Hennell, Samuel -1837 *DcD&D*

Hennell, Thomas 1903-1945 *DcD&D*
Hennell, Thomas Barclay 1903-1945 *DcBrA 1*
Hennell, William *DcD&D*
Hennell Family *DcD&D*
Henneman, Nikolaas 1813-1875 *ICPEnP*
Henneman, Theresa *MarqDCG 84*
Henneman, Valentin 1861-1930 *WhAmArt 85*
Henneman, William C 1769-1856 *DcNiCA*
Hennenberger, Martin *NewYHSD*
Hennequart, Jehan *McGDA*
Hennequin, Jan *McGDA*
Hennequin, Philippe Auguste 1762-1833 *ClaDrA*
Henner, Jean-Jacques *ArtsNiC*
Henner, Jean Jacques 1829-1905 *ClaDrA, WhAmArt 85A*
Henner, Jean-Jacques 1829-1905 *McGDA*
Henners, H H *WhAmArt 85*
Hennes, Hubert 1907- *DcBrA 1, WhoArt 80, -82, -84*
Hennessey, Edward *AntBDN G*
Hennessey, Mary Erkenbrack *WhAmArt 85*
Hennessey, Tom *OfPGCP 86*
Hennessey, William John 1948- *WhoAmA 80, -82, -84*
Hennessy, Joseph Francis 1917- *AmArch 70*
Hennessy, Kevin Frank 1959- *MarqDCG 84*
Hennessy, Richard Martin 1928- *AmArch 70*
Hennessy, Stephen 1893- *ArtsAmW 3*
Hennessy, T F *AmArch 70*
Hennessy, William J 1839- *ArtsNiC*
Hennessy, William J 1839-1917 *WhAmArt 85*
Hennessy, William John 1839-1917 *DcBrBI, EarABI, EarABI SUP, NewYHSD*
Hennessy, William John 1839-1920 *ClaDrA*
Hennessy, William John 1839-1920? *DcBrA 1, DcVicP 2*
Hennesy, Dale 1926-1981 *ConDes*
Hennesy, Gerald Craft 1921- *WhoAmA 76, -78, -80, -82, -84*
Hennet, Jeanne *DcWomA*
Henniker, Annie L *DcVicP 2*
Henning, A *FolkA 86, NewYHSD*
Henning, Albin 1886-1943 *IlBEAAW, IlrAm C, -1880, WhAmArt 85*
Henning, Archibald Samuel *DcBrWA*
Henning, Archibald Samuel d1864 *DcBrBI*
Henning, Arthur Brandt 1910- *AmArch 70*
Henning, Christoph Daniel 1734-1795 *ClaDrA*
Henning, Edward B 1922- *WhoAmA 73*
Henning, Edward Burk 1922- *WhoAmA 76, -78, -80, -82, -84*
Henning, Henrietta Hunt 1893- *WhAmArt 85*
Henning, Henrietta Hunt 1898- *DcWomA*
Henning, Herman D A *FolkA 86*
Henning, K A *AmArch 70*
Henning, Ludwig H *WhAmArt 85*
Henning, Paul Harvey 1949- *WhoAmA 78, -80, -82*
Henning, Virginia 1881?-1962 *ArtsAmW 2, DcWomA*
Henning, William Edwin 1911- *WhAmArt 85*
Henninger, Joseph Morgan 1906- *WhAmArt 85*
Hennings, E Martin 1886-1956 *ArtsAmW 1, WhAmArt 85*
Hennings, Ernest Martin 1886-1956 *IlBEAAW*
Henningsen, Poul 1894-1967 *ConDes*
Hennis, John *FolkA 86*
Hennyei, Erzsi *DcWomA*
Henoch, Hanley *WhAmArt 85*
Henoch, S Stella *DcWomA, WhAmArt 85*
Henrard, Robert Arnold 1617-1676 *McGDA*
Henri, Adrian 1932- *WhoArt 80, -82, -84*
Henri, Florence 1893- *ConPhot, DcWomA, MacBEP*
Henri, Florence 1895- *ICPEnP*
Henri, Lucien *DcVicP 2*
Henri, Marjorie *DcWomA*
Henri, Pierre *NewYHSD*
Henri, Robert 1865-1929 *ArtsAmW 1, -2, BnEnAmA, ConArt 77, DcAmArt, IlBEAAW, McGDA, OxArt, OxTwCA, PhDcTCA 77, WhAmArt 85*
Henri, Mrs. Robert *WhAmArt 85*
Henrich, Biff 1953- *WhoAmA 84*
Henrich, Frederick William *ArtsEM*
Henrich, Gretchen Ellen 1957- *MarqDCG 84*
Henrich, Jean *WhAmArt 85*
Henrichsen, Susanna Dorothea *DcWomA*
Henrici, Karl 1842-1927 *MacEA*
Henrici, W C *AmArch 70*
Henricksen, Ralf Christian 1907- *WhoAmA 73, -76*
Henricksen, Ralf Christian 1907-1975 *WhoAmA 78N, -80N, -82N, -84N*
Henrickson, Paul Robert *WhoAmA 73, -76, -78, -80, -82, -84*
Henrie, John *FolkA 86*
Henriet, Marie 1837- *DcWomA*
Henriette, Genevieve *DcWomA*
Henriguz, Stephanie *AfroAA*
Henrill, Hermann *FolkA 86*
Henrion, F H K 1914- *ConDes, WhoGrA 62*
Henrion, F Henri K 1914- *WhoArt 80, -82, -84*
Henrion, Frederick Henri Kay 1914- *WhoGrA 82[port]*

Hereford, Edgar *DcBrA 2*
Hereford, Laura 1831-1870 *ArtsNiC, DcWomA*
Herendeen, Dennis Michael 1955- *MarqDCG 84*
Herendeen, John Charles 1931- *AmArch 70*
Herff, Charles Adelbert 1853-1943 *FolkA 86*
Herfield, Phyllis 1947- *PrintW 85, WhoAmA 82, -84*
Herfield, Phyllis Anne *WhoAmA 78, -80*
Herfindahl, Lloyd Manford 1922- *AmArt, WhoAmA 76, -78, -80, -82, WhoArt 80, -82, -84*
Herford, A Laura *DcVicP 2*
Herford, Laura 1831?-1870 *DcWomA*
Herford, Oliver 1863-1935 *WhAmArt 85, WorECar*
Herge *WorECom*
Hergenroder, Emilie d1925 *DcWomA, WhAmArt 85*
Herges, Clarence Lorenz 1919- *AmArch 70*
Hergesheimer, Ella Sophonisba d1943 *WhAmArt 85*
Hergesheimer, Ella Sophonisba 1873-1943 *DcWomA*
Herhan, Elisabeth G *DcWomA*
Herholdt, J D 1818-1902 *MacEA*
Herholdt, Johann Daniel 1818-1902 *McGDA*
Heric, John F 1942- *WhoAmA 73, -76, -78, -80, -82, -84*
Hering, John F *NewYHSD*
Hering 1785-1817 *FolkA 86*
Hering, Elsie *DcWomA*
Hering, Elsie Ward 1872-1923 *WhAmArt 85*
Hering, Emil 1872-1917 *WhAmArt 85*
Hering, Frederick 1799?-1869 *BiDBrA*
Hering, G E *DcWomA*
Hering, George E 1806-1879 *ArtsNiC*
Hering, George Edwards 1805-1879 *DcBrBI, DcBrWA, DcVicP, -2*
Hering, Mrs. George Edwards *DcVicP 2*
Hering, Harry d1967 *WhoAmA 78N, -80N, -82N, -84N*
Hering, Harry 1887-1967 *WhAmArt 85*
Hering, Henry d1949 *WhoAmA 78N, -80N, -82N, -84N*
Hering, Henry 1874-1949 *WhAmArt 85*
Hering, Loy 1485?-1554? *McGDA, OxArt*
Hering, Oswald C 1874-1941 *BiDAmAr*
Heriot, Miss *NewYHSD*
Heriot, George 1766-1844 *DcBrWA, DcVicP 2, NewYHSD*
Heriot, Joseph *AntBDN Q*
Heriot, Robertine *DcWomA*
Heritage, Robert 1927- *ConDes, DcD&D[port]*
Heritage, Thomas Price *AmArch 70*
Herkimer, Herman Gustave 1863- *ArtsAmW 1*
Herklots, Gerard Andreas *DcVicP 2*
Herkner, Frederich 1902- *WhoArt 80*
Herkomer, Bertha *DcVicP 2*
Herkomer, Herman G *DcBrA 2*
Herkomer, Herman G 1863- *DcVicP 2*
Herkomer, Herman Gustave 1862-1935 *WhAmArt 85*
Herkomer, Hubert 1849- *ArtsNiC*
Herkomer, Sir Hubert Von 1849-1914 *DcBrA 1, ClaDrA, DcBrBI, DcBrWA, DcVicP, -2, McGDA, OxArt*
Herkomer, Mrs. L *DcWomA, NewYHSD*
Herkomer, Lorenz 1815-1888 *NewYHSD*
Herkomer, Lorenz, Sr. d1887 *DcVicP 2*
Herl, C E *WhAmArt 85*
Herlac, Baroness *DcWomA*
Herland, Emma 1856-1947 *DcWomA*
Herlihy, Robert Anthony 1937- *AmArch 70*
Herlin, August *NewYHSD*
Herlin, August Joseph 1815-1900 *ClaDrA*
Herlin, Emil 1905-1943 *WhAmArt 85*
Herlin, Friedrich *OxArt*
Herlin, Friedrich 1435-1500? *ClaDrA, McGDA*
Herlinde *DcWomA*
Herline, Edward *NewYHSD*
Herlinger, Robert Alan 1939- *AmArch 70*
Herlow, Erik 1913- *ConDes*
Herlth, Robert Paul Fritz 1893-1962 *ConDes*
Herman, Mister *IlBEAAW*
Herman, A C *AmArch 70*
Herman, A F *AmArch 70*
Herman, Alan 1944- *PrintW 83, -85*
Herman, Alan David 1947- *WhoAmA 76, -78, -80, -82, -84*
Herman, Bernard 1935- *AmArch 70*
Herman, Brenetta *WhAmArt 85*
Herman, C *FolkA 86*
Herman, Frederick 1924- *AmArch 70*
Herman, Gabor *MarqDCG 84*
Herman, Harold *WhAmArt 85*
Herman, Hermine Von 1857- *DcWomA*
Herman, James Garson 1936- *AmArch 70*
Herman, John *FolkA 86*
Herman, John F *AmArch 70*
Herman, Josef 1911- *ConArt 77, ConBrA 79[port], DcBrA 1, PhDcTCA 77, WhoArt 80, -82, -84*
Herman, Joyce Elaine 1945- *WhoAmA 78, -80*
Herman, L M *AmArch 70*
Herman, Lenore 1901- *WhAmArt 85*
Herman, Leonora Owsley 1888- *WhAmArt 85*
Herman, Leonora Owsley 1893- *DcWomA*
Herman, Lloyd Eldred 1936- *WhoAmA 73, -76, -78, -80, -82, -84*

Herman, M *AmArch 70*
Herman, Mark E 1949- *MarqDCG 84*
Herman, R W *DcVicP 2*
Herman, Sali 1898- *OxTwCA, WhoArt 80, -82, -84*
Herman, Samuel J 1936- *IlDcG*
Herman, Stan 1932- *WorFshn*
Herman, Susan L 1942- *WhoAmA 78, -80*
Herman, Vic *WhoAmA 73, -76, -78, -80, -82, -84*
Herman, Vic 1919- *WhAmArt 85*
Hermandt, Ph *NewYHSD*
Hermann *WorECom*
Hermann, Amelie Maria *DcWomA*
Hermann, Antonius *DcWomA*
Hermann, Elisabeth 1756?-1806 *DcWomA*
Hermann, Ernst 1914- *OxTwCA*
Hermann, F A *EncASM*
Hermann, George d1943? *BiDAmAr*
Hermann, H *DcVicP 2*
Hermann, Jack Philip 1917- *AmArch 70*
Hermann, M L *WhoAmA 84*
Hermann, Max 1879- *WhAmArt 85*
Hermann, Theresia *DcWomA*
Hermann, William Frederick, Jr. 1929- *AmArch 70*
Hermannsthal, Amalie *DcWomA*
Hermanovski, Egil Paul *WhoAmA 76*
Hermans, Cecilia *DcWomA*
Hermans, Josephine 1895- *DcWomA*
Hermanson, Raymond T 1916- *AmArch 70*
Hermanson, Robert Dean 1938- *AmArch 70*
Hermansson, Jean 1938- *ICPEnP A*
Hermansthal, Theodora Von 1835- *DcWomA*
Hermant, Leon 1866-1936 *WhAmArt 85*
Herme, Daniel *FolkA 86*
Hermes *FairDF FRA, WorFshn*
Hermes, Gertrude *WhoArt 84N*
Hermes, Gertrude 1901- *WhoArt 80, -82*
Hermes, Gertrude Anna Bertha 1901- *DcBrA 1*
Hermes, Randy Joseph 1956- *MarqDCG 84*
Herminghaus, Ernst 1890- *ArtsAmW 3*
Hermle, Jorg 1936- *WhoGrA 82[port]*
Hermogenes *MacEA, McGDA*
Hermogenesz *OxArt*
Hermoni-Abraham, Shlomit 1891-1969 *DcWomA*
Hermstin, O *DcVicP 2*
Hern, Charles Edward 1848-1894 *DcVicP 2*
Hernandez, Alejo *McGDA*
Hernandez, Anthony 1947- *ICPEnP A, MacBEP*
Hernandez, Anthony Louis 1947- *WhoAmA 78, -80, -82, -84*
Hernandez, Daniel *OxTwCA*
Hernandez, Elena *DcWomA*
Hernandez, Feliciano 1936- *OxTwCA*
Hernandez, G *OxArt*
Hernandez, Gregorio *McGDA*
Hernandez, Jo Farb 1952- *WhoAmA 84*
Hernandez, Joanne Farb 1952- *WhoAmA 80, -82*
Hernandez, John A 1952- *AmArt*
Hernandez, Jose *OxTwCA*
Hernandez, Jose Job Samuel Robles 1949- *MarqDCG 84*
Hernandez, Maria Lagunes *WhoAmA 78, -80*
Hernandez, Mateo 1885-1949 *PhDcTCA 77*
Hernandez, Mateo 1888-1949 *OxTwCA*
Hernandez, Sam 1948- *WhoAmA 80, -82, -84*
Hernandez-Cruz, Luis *WhoAmA 73, -76, -78, -80, -82, -84*
Hernandez Mompo, Manuel 1927- *OxTwCA*
Hernandez Pijuan, Juan 1931- *OxTwCA*
Hernberg, Ernst *DcSeaP*
Herndl, Marie d1912 *DcWomA*
Herndl, Maris d1912 *WhAmArt 85*
Herndon, Lawrence 1883- *WhAmArt 85*
Herne, Charles Edward 1848-1894 *DcBrWA, DcVicP 2*
Hero, Peter Decourcy 1942- *WhoAmA 78, -80, -82, -84*
Herold, Christian Friedrich 1700-1779 *AntBDN M*
Herold, Don 1889- *WhAmArt 85*
Herold, Don 1889-1966 *ArtsAmW 1, WorECar*
Herold, Don G 1927- *WhoAmA 73, -76*
Herold, Donald G 1927- *WhoAmA 78, -80, -82*
Herold, J J 1866- *ArtsAmW 3*
Herold, Jacques 1910- *OxTwCA, PhDcTCA 77*
Herold, Johanna Maria Helena *DcWomA*
Herold, Katharine Porter Brown 1893- *DcWomA*
Herold, Marguerite *DcWomA*
Herold, Rudolph A 1870-1926 *BiDAmAr*
Herolz, R A, Jr. *AmArch 70*
Heron *MacEA*
Heron, Edith Harvey 1895- *ArtsAmW 2, DcWomA, WhAmArt 85*
Heron, Ethel *DcBrA 1, DcWomA*
Heron, Hilary *WhoArt 80N*
Heron, James *FolkA 86*
Heron, N *DcWomA*
Heron, Patrick 1920- *ConArt 77, -83, ConBrA 79[port], DcBrA 1, McGDA, OxTwCA, PhDcTCA 77, PrintW 83, -85, WhoArt 80, -82, -84, WorArt[port]*
Herond, L J *DcBrBI*

Herot, Christopher Frederick 1950- *MarqDCG 84*
Herouard, Mathilde Angeline *DcWomA*
Heroult, Mrs. *DcVicP 2*
Heroult, H *DcVicP 2*
Heroult, M *DcVicP 2*
Herp, Charles Adelbert 1853-1943 *FolkA 86*
Herp, Willem Van 1614-1677 *ClaDrA, McGDA*
Herpin, Mademoiselle *DcWomA*
Herpin, Leon 1841-1880 *ArtsNiC*
Herpin, Wayne Douglas 1944- *MarqDCG 84*
Herpin-Masseras, Marguerite d1888 *DcWomA*
Herpolsheimer, A *WhAmArt 85*
Herpp, Adolfine 1843- *DcWomA*
Herpst, Martha 1911- *WhAmArt 85*
Herpst, Martha Jane *WhoAmA 73, -76, -78, -80, -82, -84*
Herr, Anna *FolkA 86*
Herr, David *FolkA 86*
Herr, Elizabeth R *FolkA 86*
Herr, George *NewYHSD*
Herr, Henry *FolkA 86*
Herr, John *FolkA 86*
Herr, Laetitia Neff *WhAmArt 85*
Herr, Laetitia Neff 1881- *DcWomA*
Herr, Laurin I 1950- *MarqDCG 84*
Herr, Margaret *DcWomA, WhAmArt 85*
Herr, Michael 1591-1661 *ClaDrA*
Herr, Richard Joseph 1937- *WhoAmA 76, -78, -80, -82, -84*
Herrade Von Landsberg d1195 *DcWomA*
Herraez Gomez, Fernando 1948- *ConPhot, ICPEnP A*
Herraghty, George Edward 1949- *WhoArt 80*
Herran, Saturnino *OxTwCA*
Herran, Saturnino 1887-1918 *McGDA*
Herregouts, Hendrik 1633-1704 *McGDA*
Herrera, Alonso De 1579- *ClaDrA*
Herrera, Antonio *FolkA 86*
Herrera, Carmen 1915- *WhoAmA 76, -78, -80, -82, -84*
Herrera, Francisco, The Elder 1576?-1656 *McGDA, OxArt*
Herrera, Francisco, The Younger 1622-1685 *McGDA, OxArt*
Herrera, Francisco De 1622-1685 *ClaDrA*
Herrera, Isabel *DcWomA*
Herrera, Joe Hilario 1923- *IlBEAAW*
Herrera, Jose Inez *FolkA 86*
Herrera, Juan De 1530-1597 *MacEA, McGDA, OxArt, WhoArch*
Herrera, Miguel *FolkA 86*
Herrera, P P *AmArch 70*
Herrera, Raul Othon 1941- *WhoAmA 76, -78, -80, -82, -84*
Herrera, Velino 1902- *IlsCB 1744*
Herrera, Velino 1902-1973 *WhAmArt 85*
Herrera, Velino Shije 1902-1973 *IlBEAAW*
Herreras, E D *AmArch 70*
Herrero, Abelardo 1936- *WhoGrA 62*
Herreshoff, Louise 1876-1967 *DcWomA*
Herreshoff, Louise C *WhAmArt 85*
Herreter *FolkA 86*
Herrgard, Sighsten 1947- *WorFshn*
Herric, Prudence C 1897- *DcWomA*
Herrick, Edward B *WhAmArt 85*
Herrick, Ethel *DcWomA, WhAmArt 85*
Herrick, Frederick Charles 1887-1970 *DcBrA 1*
Herrick, Helen *WhoAmA 82*
Herrick, Henry W 1824-1906 *IlBEAAW, NewYHSD , WhAmArt 85*
Herrick, Henry Walker 1824-1906 *EarABI, EarABI SUP*
Herrick, Hugh M 1890- *WhAmArt 85*
Herrick, Hugh M 1890-1946 *ArtsAmW 2*
Herrick, Margaret Cox 1865- *ArtsAmW 1, DcWomA, WhAmArt 85*
Herrick, Oliver Leon 1923- *AmArch 70*
Herrick, Pru 1897- *WhAmArt 85*
Herrick, Prudence C 1897- *DcWomA*
Herrick, Robert A *FolkA 86*
Herrick, Robert Ross 1918- *AmArch 70*
Herrick, William F *EarABI SUP*
Herrick, William F d1906? *EarABI*
Herrick, William Francis 1826-1906 *NewYHSD*
Herrick, William Salter *DcVicP 2*
Herries, H *DcVicP 2*
Herries, H C *DcVicP 2*
Herriman, George 1880-1944 *WorECom*
Herrin, Bradley 1957- *MarqDCG 84*
Herrin, M H 1897- *WhAmArt 85*
Herrin, Rodney Keith 1939- *AmArch 70*
Herrin, William Weldon, Jr. 1938- *AmArch 70*
Herring, Mrs. *DcWomA, NewYHSD*
Herring, Benjamin d1871 *ClaDrA, DcBrBI*
Herring, Benjamin, Jr. 1830-1871 *DcVicP, -2*
Herring, Benjamin, Sr. 1806-1830 *DcVicP, -2*
Herring, Charles *DcVicP 2*
Herring, E L *DcBrWA*
Herring, Elsie T *WhAmArt 85*
Herring, Elsie Thomas *DcWomA*
Herring, Fern Lord 1895-1975 *ArtsAmW 3,*

Hester, L A *AmArch 70*
Hester, R B, Jr. *AmArch 70*
Hester, R Wallace *DcBrBI*
Hesthal, William 1908- *WhAmArt 85*
Heston, Jacob *NewYHSD*
Heston, Joan *WhoAmA 82, –84*
Hestrup, H J *AmArch 70*
Heter, Thomas Marion 1906- *AmArch 70*
Hetfield, E H *DcWomA*
Hetfield, Mrs. E H *NewYHSD*
Heth, Eva M A *DcWomA*
Hethcock, Edith E *WhAmArt 85*
Hetherington, Alfred H 1868- *WhAmArt 85*
Hetherington, Irene 1921- *DcBrA 1*
Hetherington, Ivystan *DcVicP 2*
Hetherington, Ivystan d1917 *DcBrA 2*
Hetherington, John Todd 1858-1936 *BiDAmAr*
Hetherington, T D d1934 *BiDAmAr*
Hetland, Audun 1920- *WhoGrA 62, –82[port]*
Hetrovo, Nicholas 1896-1959? *ArtsAmW 3*
Hetrovo, Nicolai 1896-1959? *ArtsAmW 3*
Hetsch, G F 1788-1864 *MacEA*
Hetz, John *MarqDCG 84*
Hetzel, George 1826-1899 *NewYHSD*
Hetzel, Lila B *DcWomA, WhAmArt 85*
Hetzell, George J *FolkA 86*
Heuck, Sigrid *IlsBYP*
Heude, Nicolas d1703 *DcBrECP*
Heudebert, Raymonde 1905- *ClaDrA*
Heuel, Robert *ArtsEM*
Heuel And Ullmer *ArtsEM*
Heuer, Christine *DcCAr 81*
Heuer, L S *AmArch 70*
Heuer, R E *AmArch 70*
Heuermann, Magda *WhoAmA 78N, –80N, –82N, –84N*
Heuermann, Magda 1868-1962? *DcWomA*
Heuermann, Magda 1868-1964? *WhAmArt 85*
Heugh, James *WhAmArt 85*
Heulan, J J *NewYHSD*
Heuling, Martha *FolkA 86*
Heulitt, G T *AmArch 70*
Heun, Arthur 1866-1946 *BiDAmAr*
Heuring, J B *AmArch 70*
Heurtault, Marie 1887- *DcWomA*
Heusch, Guilliam De 1638-1692 *ClaDrA*
Heusch, Jacob De 1657-1701 *ClaDrA*
Heusche, Henry *WhAmArt 85*
Heuser, Adeline *DcWomA*
Heuser, Alwine *DcWomA*
Heuser, Louise *DcWomA*
Heuseux, Lucette 1913- *DcBrA 1*
Heuss, F *DcVicP 2*
Heuss, M *DcVicP 2*
Heusser, Eleanore Elizabeth *WhoAmA 73, –76, –78, –80, –82, –84*
Heustis, Edna F *WhAmArt 85*
Heustis, Louise Lyons 1865?-1951 *DcWomA*
Heustis, Louise Lyons 1878- *WhAmArt 85*
Heuston, Frank Zell 1880- *WhAmArt 85*
Heuston, George Franklin 1906- *WhAmArt 85*
Heuston, George Z 1855-1939 *ArtsAmW 1*
Heusy, Charles W *WhAmArt 85*
Heuvelmans, Lucienne Antoinette 1881?- *DcWomA*
Heuze, Edmond Amedee 1884- *ClaDrA*
Heuze, Jehanne *DcWomA*
Heuze, Rosine Victorine *DcWomA*
Hevdicourt, F P D' *DcWomA*
Hevner, Alan Raymond 1950- *MarqDCG 84*
Heward, Efa Prudence 1896-1947 *DcWomA*
Heward, Harold Cornelius 1881- *DcBrA 2*
Heward, Howard Cornelius 1881-1973 *DcBrA 2*
Heward, Prudence *OxTwCA*
Hewart, Thomas 1767-1787 *DcBrECP*
Hewel, Johannes 1947- *DcCAr 81*
Hewell, Will *FolkA 86*
Hewerdine, Matthew Bede 1871-1909 *DcBrBI, DcBrWA*
Hewes, Clarence 1894-1970 *FolkA 86*
Hewes, Horace G *WhAmArt 85*
Hewes, Robert 1751-1830 *IlDcG*
Hewet, H W *EarABI, NewYHSD*
Hewetson, Edith *DcVicP 2*
Hewetson, Edward *DcBrBI, DcVicP 2*
Hewett, Ainslie *WhAmArt 85*
Hewett, I *NewYHSD*
Hewett, Isaac *FolkA 86*
Hewett, Mabel *DcVicP 2*
Hewett, Sir Prescott Gardiner 1812-1891 *DcBrWA, DcVicP 2*
Hewett, Sarah F *DcBrWA, DcVicP 2*
Hewett, Sir Thomas 1656-1726 *BiDBrA*
Hewings, E F *ArtsEM*
Hewins, Alfred J *DcVicP 2*
Hewins, Amasa *FolkA 86*
Hewins, Amasa 1795-1855 *NewYHSD*
Hewins, Philip 1806-1850 *FolkA 86, NewYHSD*
Hewins, Sara *DcWomA, NewYHSD*
Hewison, William 1925- *WhoAmA 80, –82, –84*
Hewit, Charles *FolkA 86*
Hewit, Forrest 1870-1956 *DcBrA 1, DcVicP 2*

Hewit, Mabel A 1903- *WhAmArt 85*
Hewitt *NewYHSD*
Hewitt, Miss *DcWomA*
Hewitt, Alice J *DcVicP 2*
Hewitt, Beatrice M *DcWomA*
Hewitt, Beatrice Pauline 1907- *DcBrA 1*
Hewitt, C H *DcWomA*
Hewitt, Carter Edmund *AmArch 70*
Hewitt, Clemence *DcWomA*
Hewitt, David M 1936- *AmArch 70*
Hewitt, Donald *WhAmArt 85*
Hewitt, Dudley Fergusson Barbour 1913- *WhAmArt 85*
Hewitt, Duncan Adams 1949- *WhoAmA 84*
Hewitt, Edward S *WhAmArt 85*
Hewitt, Edwin H 1874- *WhAmArt 85*
Hewitt, Edwin H 1874-1939 *BiDAmAr*
Hewitt, Eleanor Gurnee d1924 *WhAmArt 85*
Hewitt, Evelyn 1882- *ClaDrA, DcBrA 1, DcWomA*
Hewitt, Francis Ray 1936- *WhoAmA 73, –76, –78, –80, –82, –84*
Hewitt, Frederick F *NewYHSD*
Hewitt, Geoffrey 1930- *ClaDrA*
Hewitt, George d1944 *BiDAmAr*
Hewitt, George 1841-1916 *WhoArch*
Hewitt, George Watson 1841-1916 *BiDAmAr*
Hewitt, H *DcVicP 2*
Hewitt, H Harwood 1874-1926? *BiDAmAr*
Hewitt, Helen *DcWomA*
Hewitt, Henry George *DcBrA 2, DcVicP 2*
Hewitt, Herbert Edmund 1871-1945 *BiDAmAr*
Hewitt, Isaac *FolkA 86*
Hewitt, Jackson 1914- *DcSeaP*
Hewitt, Jean Clifford 1922- *WhoAmA 78, –80*
Hewitt, John *CabMA, DcBrBI*
Hewitt, John Marvin 1910- *AmArch 70*
Hewitt, Mark *AfroAA*
Hewitt, Sarah Cooper 1859-1930 *WhAmArt 85*
Hewitt, Sarah F *DcWomA*
Hewitt, William D 1848-1924 *BiDAmAr*
Hewitt, William Keesey 1817-1893 *NewYHSD*
Hewkley, Henry *DcVicP 2*
Hewkley, Marion Edith *DcBrA 1, DcWomA*
Hewland, Elise Dalton 1901- *ClaDrA, DcBrA 1, WhoArt 80*
Hewlett, A E M 1887- *DcWomA*
Hewlett, Arthur L *DcVicP 2*
Hewlett, Arthur T *WhAmArt 85*
Hewlett, C Russell 1872-1913 *WhAmArt 85*
Hewlett, J Monroe 1868-1941 *WhAmArt 85*
Hewlett, James d1829 *DcBrWA*
Hewlett, James 1789-1836 *DcBrWA*
Hewlett, James August 1921- *AmArch 70*
Hewlett, James Leroy 1939- *AmArch 70*
Hewlett, James M 1868-1941 *BiDAmAr*
Hewlett, Joseph M *WhAmArt 85*
Hewlett, Palmer A 1919- *AmArch 70*
Hewlett, T Y *AmArch 70*
Hewlett, Thomas Harry 1898- *AmArch 70*
Hewlings, Drew Walgrave 1915- *WhAmArt 85*
Hews, Abraham *FolkA 86*
Hews, Alpheus *CabMA*
Hewson, Miss *DcBrECP*
Hewson, John *OxDecA*
Hewson, John d1822 *FolkA 86*
Hewson, Marie Oliva *DcWomA*
Hewson, Martha N *FolkA 86*
Hewson, Paul Willingham 1948- *MacBEP*
Hewson, Stephen *DcBrECP*
Hewton, Otto *WhAmArt 85*
Hext, Elizabeth 1734?- *FolkA 86*
Hey, Cecily *WhoArt 82N*
Hey, Cicely 1896- *DcBrA 1, DcWomA, WhoArt 80*
Heyboer, Anton 1924- *PhDcTCA 77*
Heyburn, Gheretein *DcWomA*
Heyd, Conrad 1837-1912 *NewYHSD , WhAmArt 85*
Heyd, Varvara Hasselbalch 1920- *MacBEP*
Heyde, Charles L *NewYHSD*
Heyde, Charles Louis 1822-1892 *FolkA 86*
Heyde, Jan VanDer 1637-1712 *ClaDrA*
Heydecker, Richard Creagh 1933- *AmArch 70*
Heydel, Paul 1854- *ClaDrA*
Heydemann, Clara 1843- *DcWomA*
Heyden, August Jacob Theodor Von 1827- *ArtsNiC*
Heyden, Jacob VanDer 1573-1645 *ClaDrA, McGDA*
Heyden, Jan VanDer *McGDA*
Heyden, Jan VanDer 1637-1712 *ClaDrA, OxArt*
Heyden, Otto Johann Heinrich 1820- *ArtsNiC*
Heyden, Peter VanDer 1530?- *McGDA*
Heydendhall, C *DcVicP 2*
Heydenreich, Ludwig H 1903- *WhoArt 80, –82, –84*
Heyder, F O *AmArch 70*
Heydon, Mary *DcWomA*
Heydrich, Balzer 1762-1845 *FolkA 86*
Heydt, Edna 1903- *WhAmArt 85*
Heye, Frederick d1881 *FolkA 86*
Heyer, H 1876- *WhAmArt 85*
Heyer, Paul *ConArch A*
Heyer, William B 1896-1973 *WhAmArt 85*
Heyerdahl, Ruth Lovold 1894- *DcWomA, WhAmArt 85*

Heyermans, Marie *DcWomA*
Heygendorf, Caroline Von *DcWomA*
Heyl, Bernard Chapman *WhoAmA 78N, –80N, –82N, –84N*
Heyl, John Kleppinger 1906- *AmArch 70*
Heyl, Larry F 1954- *MarqDCG 84*
Heylan, Ana *DcWomA*
Heylbrouck, Michael 1635-1733 *ClaDrA*
Heyler, Mary P Ginther *WhAmArt 85*
Heyler, Mary Pemberton *DcWomA*
Heyliger, Joseph *NewYHSD*
Heylman, Warren Cummings 1923- *AmArch 70*
Heym, Nancy Porter 1931- *AmArch 70*
Heyman, Abigail 1942- *ConPhot, ICPEnP A*
Heyman, Charles *NewYHSD*
Heyman, David M *WhoAmA 73, –76, –78*
Heyman, Mrs. David M *WhoAmA 73, –76, –78*
Heyman, F B *FolkA 86*
Heyman, Ken 1930- *ICPEnP A, MacBEP*
Heyman, Lawrence 1932- *PrintW 83, –85*
Heyman, Lawrence Murray 1932- *WhoAmA 80, –82, –84*
Heyman, Octavie *DcWomA*
Heyman, Therese Thau *WhoAmA 80, –82, –84*
Heymann, Octavie *DcWomA*
Heymann, Siegfried 1933- *AmArch 70*
Heymans, Adriaan Josef 1839-1921 *ClaDrA*
Heyne, Johann Christopher *FolkA 86*
Heyneman, Anne 1909- *IlsCB 1946*
Heyneman, Anne 1910- *IlsCB 1744*
Heyneman, Julie H 1871-1943 *ArtsAmW 3*
Heynemann, Julia H 1871-1943 *ArtsAmW 3*
Heynertz, D G *DcSeaP*
Heyns, H E, II *AmArch 70*
Heysen, Sir Hans 1877-1968 *OxArt*
Heyser, Orwin *WhAmArt 85*
Heyser, W *FolkA 86*
Heysinger, Ernest W 1872- *WhAmArt 85*
Heysinger, Evelyn L *WhAmArt 85*
Heyward, B Henderson 1913- *AmArch 70*
Heyward, J T, Jr. *AmArch 70*
Heyward, Katherine Bayard *WhAmArt 85*
Heyward, Katherine Bayard 1886- *DcWomA*
Heywood, Brookes d1926 *DcBrA 2*
Heywood, George *NewYHSD*
Heywood, Herbert 1893- *ArtsAmW 3*
Heywood, J C 1941- *PrintW 83, –85, WhoAmA 80, –82, –84*
Heywood, J Carl 1941- *WhoAmA 76, –78*
Heywood, Manie *FolkA 86*
Heywood, Mona *WhAmArt 85*
Heywood, Tom *DcVicP 2*
Heyworth, Alfred 1926- *DcBrA 1, WhoArt 80, –82, –84*
Heyworth, Alfred 1926-1976 *DcBrA 2*
Heyworth, James Charles 1956- *WhoArt 84*
Heyworth, Richard 1862- *ClaDrA, DcBrA 1, DcVicP 2*
Hiaktake, Y *DcVicP 2*
Hiatt, Aletha M *WhAmArt 85*
Hiatt, Hugh Wilson 1910- *AmArch 70*
Hiatt, James *FolkA 86*
Hiatt, Margaret Smith 1910- *WhoAmA 82, –84*
Hiatt, Maurine *WhAmArt 85*
Hiatt, Maurine 1898- *ArtsAmW 2*
Hiatt, R D *AmArch 70*
Hibbard, A T 1886-1972 *WhAmArt 85*
Hibbard, Aldro Thompson 1886-1972 *WhoAmA 78N, –80N, –82N, –84N*
Hibbard, Don J *ConArch A*
Hibbard, Elisabeth Haseltine 1889?- *DcWomA*
Hibbard, Elisabeth Haseltine 1894- *WhAmArt 85*
Hibbard, Frederick Cleveland 1881- *WhAmArt 85*
Hibbard, George 1858-1928 *WhAmArt 85*
Hibbard, Howard 1928- *WhoAmA 76, –78, –80, –82, –84*
Hibbard, L H *AmArch 70*
Hibbard, Mary P *WhAmArt 85*
Hibbard Spencer Bartlett *EncASM*
Hibben, Helene 1882- *DcWomA, WhAmArt 85*
Hibben, Thomas 1893- *WhAmArt 85*
Hibbert, Miss *DcWomA*
Hibbert, Phyllis I 1903- *DcBrA 1, WhoArt 80*
Hibbitts, Beatrice *DcWomA*
Hibbs, Henry C 1882-1949 *BiDAmAr*
Hibbs, James Lacy 1905- *AmArch 70*
Hibbs, W Wyatt 1903- *AmArch 70*
Hibel, Edna *OfPGCP 86*
Hibel, Edna 1917- *AmArt, PrintW 83, –85, WhAmArt 85, WhoAmA 73, –76, –78, –80, –82, –84*
Hible, Robert Leslie 1936- *AmArch 70*
Hibler, B C *AmArch 70*
Hibner, K I *AmArch 70*
Hibon, Marianne *DcWomA*
Hichborne, Thomas *CabMA*
Hick, Allanson 1898- *ClaDrA, DcBrA 1*
Hickcox, T N *ArtsEM*
Hickcox, Thomas N *NewYHSD*
Hickel, Joseph 1736-1807 *ClaDrA*
Hickel, Karl Anton 1745-1798 *DcBrECP*

Hildebrand, Irene *DcWomA*
Hildebrand, June Mary Ann 1930- *WhoAmA 73, –76, –78, –80, –82, –84*
Hildebrand, Marshall Asbury, Jr. 1928- *AmArch 70*
Hildebrandt, Claire *DcWomA*
Hildebrandt, Cornelia Ellis *WhAmArt 85*
Hildebrandt, Cornelia Trumbull 1876- *DcWomA*
Hildebrandt, Daniel *WorECar*
Hildebrandt, E F *AmArch 70*
Hildebrandt, Edouard 1817-1869? *ArtsAmW 3*
Hildebrandt, Eduard 1817-1868 *ArtsNiC*
Hildebrandt, Ferdinand Theodor 1804-1874 *ArtsNiC, ClaDrA*
Hildebrandt, Howard Logan 1872-1958 *WhAmArt 85*
Hildebrandt, Howard Logan 1874-1958 *WhoAmA 80N*
Hildebrandt, Jean Luca Von 1668-1745 *WhoArch*
Hildebrandt, Johann Lucas Von 1668-1745 *MacEA, McGDA, OxArt*
Hildebrandt, Johann Lukas Von 1668-1745 *DcD&D*
Hildebrandt, Melvin Leroy 1934- *AmArch 70*
Hildebrandt, William Albert 1917- *AmArt, WhoAmA 73, –76, –78, –80, –82, –84*
Hildebrandt, William Albert, Jr. 1917- *WhAmArt 85*
Hildegard Of Bingen 1098-1179 *McGDA*
Hildegard Von Bingen 1098-1179 *DcWomA*
Hilder, Howard 1866-1935 *WhAmArt 85*
Hilder, P John *DcVicP 2*
Hilder, Richard *DcVicP*
Hilder, Richard H *DcVicP 2*
Hilder, Rowland 1905- *DcBrA 1, IlsCB 1744, WhoArt 80, –82, –84*
Hilderbrandt, Howard Logan 1874-1958 *WhoAmA 82N, –84N*
Hildinger, L G *AmArch 70*
Hilditch, George 1803-1857 *DcVicP, –2*
Hilditch, Richard H *DcVicP, –2*
Hildreth, Caroline *DcWomA*
Hildreth, Herbert L *FolkA 86*
Hildreth, Joseph Alan 1947- *WhoAmA 73, –76, –78, –80, –82, –84*
Hildreth, M D *AmArch 70*
Hildreth, Mrs. Richard *NewYHSD*
Hildreth, Susan W d1938? *DcWomA, WhAmArt 85*
Hildrew, Ken 1934- *ClaDrA*
Hildrith, Issac 1741?-1807 *MacEA*
Hiler, Hilaire d1966 *WhoAmA 78N, –80N, –82N, –84N*
Hiler, Hilaire 1898-1966 *ArtsAmW 2, DcWomA, WhAmArt 85*
Hiler, Pere *FolkA 86*
Hiles, Bartram 1872-1927 *DcBrA 1*
Hiles, Frederick John 1872-1927 *DcVicP 2*
Hiles, Frederick John Bartram 1872-1927 *DcBrWA*
Hiles, George *DcVicP 2*
Hiles, Henry Edward 1857- *DcBrA 1, DcVicP 2*
Hiley, Michael 1945- *MacBEP*
Hilfeling, Anna Maria 1714-1786 *DcWomA*
Hilfinger, Dean F 1912- *AmArch 70*
Hilgendorf, Fred C 1888- *WhAmArt 85*
Hilgenhurst, Charles George 1929- *AmArch 70*
Hilgers, Albert William 1907- *AmArch 70*
Hiliard, John 1945- *ConArt 83*
Hilken, Annie Kathleen 1902- *IlsCB 1946*
Hilker, Frederick *FolkA 86*
Hill, A *AmArch 70, EarABI, EarABI SUP, NewYHSD*
Hill, A C E *DcVicP 2*
Hill, A Neil 1926- *AmArch 70*
Hill, Abby Rhoda Williams 1861-1943 *DcWomA*
Hill, Abby Williams 1861- *IlBEAAW, WhAmArt 85*
Hill, Abby Williams 1861-1943 *ArtsAmW 1*
Hill, Adrian Keith Graham *WhoArt 80N*
Hill, Adrian Keith Graham 1895- *DcBrA 1*
Hill, Albert 1901- *WorECom*
Hill, Mrs. Albert J *DcWomA*
Hill, Alfred Dodge 1903- *AmArch 70*
Hill, Alice 1850?-1921? *DcWomA*
Hill, Alice Stewart *ArtsAmW 2*
Hill, Alice Stewart 1850?-1921? *IlBEAAW, WhAmArt 85*
Hill, Alva Leroy, Jr. 1920- *AmArch 70*
Hill, Amelia R *ArtsNiC*
Hill, Amelia Robertson *NewYHSD*
Hill, Amelia Robertson 1820-1904 *DcWomA*
Hill, Andrew Putnam *ArtsAmW 1*
Hill, Anna Wyers d1935 *WhAmArt 85*
Hill, Anne *DcWomA, NewYHSD*
Hill, Anthony 1930- *ConArt 77, –83, ConBrA 79[port], OxTwCA, PhDcTCA 77, WhoArt 80, –82, –84*
Hill, Arthur *DcBrWA, DcVicP, –2*
Hill, Arthur 1829?- *DcBrWA*
Hill, Arthur E 1860-1925 *BiDAmAr*
Hill, Arthur Turnbull 1868-1929 *WhAmArt 85*
Hill, Asa 1719-1809 *FolkA 86*
Hill, B C *AmArch 70*
Hill, Billie 1896?- *DcWomA*
Hill, Bryan Lee 1941- *MarqDCG 84*
Hill, C *DcWomA*
Hill, Miss C *NewYHSD*
Hill, C D, Jr. *AmArch 70*

Hill, Cad *FolkA 86*
Hill, Carl Frederick 1849-1911 *ClaDrA*
Hill, Carl Fredrik 1849-1911 *McGDA, OxArt, PhDcTCA 77*
Hill, Carrie L *DcWomA, WhAmArt 85*
Hill, Charles Christopher 1948- *PrintW 83, –85*
Hill, Charles Hamor d1863 *BiDBrA*
Hill, Clara 1870-1935 *DcWomA*
Hill, Clara P d1935 *WhAmArt 85*
Hill, Clarence Harrison, Jr. 1919- *AmArch 70*
Hill, Clifton Thompson 1902- *AfroAA*
Hill, Clinton *DcCAr 81*
Hill, Clinton J 1922- *AmArt, PrintW 85, WhoAmA 73, –76, –78, –80, –82, –84*
Hill, Clinton M 1873-1939 *BiDAmAr*
Hill, D H *DcVicP 2*
Hill, Dale Logan 1909- *WhoAmA 73, –76, –78, –80, –82, –84*
Hill, Daniel *AntBDN N*
Hill, Darrell *PrintW 85*
Hill, David *AfroAA, BiDBrA*
Hill, David Octavius 1802-1870 *ArtsNiC, DcBrBI, DcBrWA, DcVicP, –2, ICPEnP, MacBEP, OxDecA*
Hill, David Wyers *WhAmArt 85*
Hill, Dean E 1922- *AmArch 70*
Hill, Derek 1916- *DcBrA 1, WhoArt 80, –82, –84*
Hill, Diana d1844 *DcWomA*
Hill, Donald Allen 1938- *AmArch 70*
Hill, Dorothy Kent 1907- *WhoAmA 73, –76, –78, –80, –82, –84, WhoArt 80, –82, –84*
Hill, Douglas 1950- *MacBEP*
Hill, Draper 1935- *WhoAmA 76, –78, –80, –82, –84, WorECar*
Hill, Ed 1937- *WhoAmA 76, –78, –80, –82, –84*
Hill, Edith *DcWomA*
Hill, Edith L 1884- *DcWomA, WhAmArt 85*
Hill, Edward Rufus 1852- *ArtsAmW 1*
Hill, Edward Rufus 1852-1908 *IlBEAAW, WhAmArt 85*
Hill, Eleanor Caroline *DcWomA*
Hill, Ellen G *DcVicP 2, DcWomA*
Hill, Evelyn 1886-1974 *DcWomA*
Hill, Evelyn Corthell 1886- *ArtsAmW 1, IlBEAAW, WhAmArt 85*
Hill, F *DcVicP 2*
Hill, Fanny *DcVicP 2, DcWomA*
Hill, Frances 1801-1895 *DcWomA*
Hill, Francis 1842?- *NewYHSD*
Hill, Francis C *NewYHSD*
Hill, Frank 1881- *DcBrA 1*
Hill, Frank Hazel, Jr. 1920- *AmArch 70*
Hill, Gale A 1937- *AmArch 70*
Hill, George *FolkA 86*
Hill, George Snow d1969 *WhoAmA 78N, –80N, –82N, –84N*
Hill, George Snow 1898-1969 *WhAmArt 85*
Hill, George T *AfroAA*
Hill, George W 1815-1893 *NewYHSD*
Hill, Gertrude *WhAmArt 85*
Hill, Harriet 1790-1817 *FolkA 86*
Hill, Hector 1934-1963 *AfroAA*
Hill, Henry *FolkA 86*
Hill, Mrs. Henry *DcVicP 2*
Hill, Henry Lloyd 1927- *AmArch 70*
Hill, Henry W 1852-1924 *BiDAmAr*
Hill, Herbert H *EncASM*
Hill, Herbert Wilbur 1868- *WhAmArt 85*
Hill, Homer *WhoAmA 78N, –80N, –82N, –84N*
Hill, Homer d1968? *WhAmArt 85*
Hill, Hugh *AfroAA*
Hill, I *NewYHSD*
Hill, I W *NewYHSD*
Hill, Ida *DcWomA*
Hill, Ida 1868- *ArtsEM*
Hill, Isaac Preston 1819- *CabMA*
Hill, Ithuel 1769-1821 *FolkA 86*
Hill, J *DcBrECP, NewYHSD*
Hill, J Alan 1903- *DcBrA 2*
Hill, J B *DcVicP 2*
Hill, Mrs. J Gray *DcVicP 2*
Hill, J H *NewYHSD*
Hill, J Hollyer d1952 *DcBrA 2*
Hill, J Tweed *WhoAmA 76, –78, –80, –82, –84*
Hill, Jack Phillip 1929- *AmArch 70*
Hill, James *CabMA, DcVicP 2, NewYHSD*
Hill, James d1734 *BiDBrA*
Hill, James Berry 1945- *WhoAmA 80, –82, –84*
Hill, James G 1814-1913 *BiDAmAr*
Hill, James Jerome, II 1905- *WhAmArt 85*
Hill, James John 1811-1882 *DcVicP, –2*
Hill, James S *NewYHSD*
Hill, James Stevens 1854-1921 *ClaDrA, DcBrA 1, DcVicP 2*
Hill, Jeff *MarqDCG 84*
Hill, Jerome 1905- *WhoAmA 73, –76, –78N, –80N, –82N, –84N*
Hill, Jerry Edward 1938- *AmArch 70*
Hill, Jessie F *WhAmArt 85*
Hill, Jim 1944- *WhoAmA 73, –76, –78*
Hill, Joan *WhoAmA 73, –76, –78, –80, –82, –84*

Hill, Joan E *ArtsEM, DcWomA*
Hill, Jockey d1827 *DcBrWA*
Hill, John *AntBDN H, IlDcG*
Hill, John 1760-1850 *McGDA*
Hill, John 1770-1850 *DcAmArt, NewYHSD*
Hill, John 1905- *DcD&D[port]*
Hill, John, Family *DcAmArt*
Hill, John Alexander 1907- *WhoAmA 78, –80, –82, –84*
Hill, John Clyde 1918- *AmArch 70*
Hill, John Conner 1945- *WhoAmA 76, –78, –80, –82, –84*
Hill, John Henry *DcVicP 2*
Hill, John Henry 1839-1922 *ArtsAmW 2, DcAmArt, EarABI, EarABI SUP, IlBEAAW, NewYHSD, WhAmArt 85, WhoAmA 80N, –82N, –84N*
Hill, John Jay 1933- *AmArch 70*
Hill, John R 1840?- *NewYHSD*
Hill, John William 1812-1879 *BnEnAmA, DcAmArt, NewYHSD, WhoAmA 80N, –82N, –84N*
Hill, John William 1930- *AmArch 70*
Hill, Julia Faulkner 1888- *DcWomA, WhAmArt 85*
Hill, Justus *DcVicP 2*
Hill, Kate *DcVicP 2, DcWomA*
Hill, L L, Jr. *AmArch 70*
Hill, L M *DcVicP 2*
Hill, Lavina Baker *ArtsAmW 3*
Hill, Leonard Raven- *DcBrBI, DcVicP 2*
Hill, Levi L 1816-1865 *ICPEnP*
Hill, Louis W *WhAmArt 85*
Hill, Lovice 1793-1849 *FolkA 86*
Hill, M C, Jr. *AmArch 70*
Hill, Mabel B 1877- *WhAmArt 85*
Hill, Mabel Betsy 1877- *DcWomA*
Hill, Mamie *DcWomA*
Hill, Margaret E 1867- *WhAmArt 85*
Hill, Maria Susanah *DcWomA*
Hill, Marvin William 1915- *WhoAmA 73*
Hill, Mary *DcWomA*
Hill, Mary E d1913 *ArtsEM, DcWomA*
Hill, Matthew *AntBDN D*
Hill, Megan Lloyd 1942- *WhoAmA 73, –76, –78, –80, –82, –84*
Hill, Milton Baxter Ellis 1917- *AmArch 70*
Hill, N B *AmArch 70*
Hill, N H *AmArch 70*
Hill, Nathaniel *DcBrA 1, –2, DcVicP 2*
Hill, Nellie *DcWomA*
Hill, Nora *DcVicP 2*
Hill, Oliver 1887-1968 *DcBrA 1, DcD&D[port]*
Hill, Pamela E 1803-1860 *DcWomA*
Hill, Pamelia E 1803-1860 *NewYHSD*
Hill, Paul 1941- *ConPhot, ICPEnP A, MacBEP*
Hill, Pearl L 1884?- *DcWomA, WhAmArt 85*
Hill, Peter 1933- *WhoAmA 73, –76, –78, –80, –82, –84*
Hill, Philip Maurice 1892-1952 *DcBrA 1*
Hill, Phinehas 1778- *FolkA 86*
Hill, Polly Knipp 1900- *WhAmArt 85, WhoAmA 73, –76, –78, –80, –82, –84*
Hill, R *DcVicP 2*
Hill, R E *AmArch 70*
Hill, R Jerome 1878- *WhAmArt 85*
Hill, Raymond A *WhoArt 82N*
Hill, Raymond A 1916- *WhoArt 80*
Hill, Raymond Leroy 1891-1980 *ArtsAmW 3*
Hill, Reba Dickerson *AfroAA*
Hill, Richard Wayne 1950- *WhoAmA 78, –80, –82, –84*
Hill, Robert *DcBrECP*
Hill, Robert E, Sr. 1929- *MarqDCG 84*
Hill, Robert Jerome 1878- *ArtsAmW 2, IlBEAAW*
Hill, Robert John 1891- *WhAmArt 85*
Hill, Robert Wayne 1932- *AmArch 70*
Hill, Robert William 1932- *ClaDrA, WhoArt 82, –84*
Hill, Roger William 1931- *AmArch 70*
Hill, Ronald James 1933- *WhoArt 82, –84*
Hill, Ronald Kenneth 1930- *MarqDCG 84*
Hill, Roswell Stone 1861- *WhAmArt 85*
Hill, Rowland *DcBrBI, WhoArt 82N*
Hill, Rowland 1919- *DcBrA 1, WhoArt 80*
Hill, Rowland Henry 1873- *DcWomA*
Hill, Rowland Henry 1873-1952 *DcBrA 2, DcVicP 2*
Hill, S B *WhAmArt 85*
Hill, Samuel *DcBrECP, EarABI SUP, NewYHSD*
Hill, Samuel Prout 1820-1861 *DcSeaP*
Hill, Sara B *DcWomA*
Hill, Stephen G *NewYHSD*
Hill, Stephen G 1819?- *ArtsAmW 2*
Hill, Stuart 1943- *DcCAr 81*
Hill, Thomas *AntBDN M*
Hill, Thomas d1926 *DcBrA 1*
Hill, Thomas 1661-1734 *DcBrECP*
Hill, Thomas 1829- *ArtsNiC*
Hill, Thomas 1829-1908 *ArtsAmW 1, DcAmArt, EarABI, IlBEAAW, NewYHSD, WhAmArt 85*
Hill, Thomas 1852-1926 *DcVicP 2*
Hill, Tony 1907- *AfroAA*
Hill, Vernon 1887- *DcBrA 1, DcBrBI*
Hill, Vincent *DcBrA 2*
Hill, W *NewYHSD*

Hill, W B *AmArch 70*
Hill, W E *WhAmArt 85*
Hill, W F *AmArch 70*
Hill, W L *AmArch 70*
Hill, W R *DcVicP 2*
Hill, William d1820 *CabMA*
Hill, William Fitzgerald 1935- *AmArch 70*
Hill, William Mansfield 1925- *WhoAmA 78, -80, -82, -84*
Hill, William Robert *DcVicP 2*
Hill Henderson *CabMA*
Hill-Snowe, Lilly *DcVicP 2*
Hilla *DcWomA*
Hillard, E *FolkA 86*
Hillard, S *DcVicP 2*
Hillard, William H d1905 *WhAmArt 85*
Hillard, William Henry 1836-1905 *ArtsAmW 2*
Hillblom, Henrik 1863- *WhAmArt 85*
Hillblom, Ralph *WhAmArt 85*
Hillding, John Emil *WhoAmA 76, -78, -80*
Hilleary, James Francis 1924- *AmArch 70*
Hillebrand, Michael Henry 1943- *MarqDCG 84*
Hillegaert, Pauwels Van 1595-1640 *ClaDrA*
Hillegas, Jacob *FolkA 86*
Hillemacher, Eugene Ernest 1818-1887 *ClaDrA*
Hillemacher, Eugene-Ernest 1820- *ArtsNiC*
Hillen, Edward 1818?- *NewYHSD*
Hillen, J T E 1818?- *NewYHSD*
Hiller, Mrs. *DcWomA, NewYHSD*
Hiller, Anton 1893- *PhDcTCA 77*
Hiller, Betty R 1925- *WhoAmA 78, -80, -82, -84*
Hiller, C R *AmArch 70*
Hiller, Eugenie *DcWomA*
Hiller, H N *AmArch 70*
Hiller, Jan Stanley 1918- *DcBrA 1*
Hiller, Joe William 1929- *AmArch 70*
Hiller, Joseph, Jr. 1777-1795 *NewYHSD*
Hiller, Joseph, Sr. 1748-1814 *NewYHSD*
Hiller, Karol 1891-1939 *PhDcTCA 77*
Hiller, Lejaren A 1880- *WhAmArt 85*
Hiller, Leonore 1881- *DcWomA*
Hiller, Margareta 1695-1778 *DcWomA*
Hiller, Susan 1940- *ConBrA 79[port]*
Hillerich, Walter 1868-1939 *BiDAmAr*
Hillermann, Anna *DcWomA*
Hillern, Bertha Von *DcWomA*
Hillers, John K 1843-1925 *ICPEnP A, MacBEP, WhAmArt 85*
Hillery, Arthur M *WhAmArt 85*
Hilles, Carrie P *WhAmArt 85*
Hilles, D E, Jr. *AmArch 70*
Hilles, Florence Bayard 1865- *WhAmArt 85*
Hilles, Susan Morse 1905- *WhoAmA 73, -76, -78, -80, -82, -84*
Hillger, Samuel E 1861-1935 *BiDAmAr*
Hillhouse, David 1945- *WhoArt 82, -84*
Hillhouse, James Douglass, III 1928- *AmArch 70*
Hillhouse, May *OxTwCA*
Hilliard, Mrs. Clyde Stafford 1900-1937 *WhAmArt 85*
Hilliard, Constance *DcVicP 2, DcWomA*
Hilliard, F John 1886- *WhAmArt 85*
Hilliard, Henry *NewYHSD*
Hilliard, John *OxTwCA*
Hilliard, John 1945- *ConBrA 79[port], ConPhot, ICPEnP A*
Hilliard, John 1954- *ConArt 77*
Hilliard, John Edward 1926- *AmArch 70*
Hilliard, John Meredith 1924- *AmArch 70*
Hilliard, L *AmArch 70*
Hilliard, Laurence 1581?-1640 *AntBDN J*
Hilliard, Lawrence *DcVicP 2*
Hilliard, Nicholas 1547-1619 *AntBDN J, McGDA, OxArt*
Hilliard, Philip H *FolkA 86*
Hilliard, Robert *CabMA*
Hilliard, William Henry 1836- *ArtsNiC*
Hilliard, William Henry 1836-1905 *ArtsAmW 2, NewYHSD*
Hilliard, William Henry 1863-1905 *WhAmArt 85*
Hillier, H D *DcVicP 2*
Hillier, Harriet C *DcVicP 2*
Hillier, J R *AmArch 70*
Hillier, Mark Richard 1948- *MarqDCG 84*
Hillier, Tristram 1905- *ConBrA 79[port], OxTwCA, PhDcTCA 77*
Hillier, Tristram Paul *WhoArt 84N*
Hillier, Tristram Paul 1905- *DcBrA 1, McGDA, WhoArt 80, -82*
Hilligoss, Martha M 1928- *WhoAmA 78, -80, -82, -84*
Hillingford, Robert Alexander 1825-1904 *DcVicP 2*
Hillingford, Robert Alexander 1828- *ArtsNiC, DcBrA 1, DcVicP*
Hillingford, Robert Alexander 1828-1907 *ClaDrA*
Hillings, John d1894 *FolkA 86*
Hillis, Richard K 1936- *WhoAmA 76, -78, -80*
Hillyard, Carrie *DcWomA*
Hillman, Alex L d1968 *WhoAmA 78N, -80N, -82N, -84N*
Hillman, Anna G *WhAmArt 85*

Hillman, Arthur Stanley 1945- *WhoAmA 73, -76, -78, -80, -82, -84*
Hillman, Charles L 1859-1934 *BiDAmAr*
Hillman, Edward Lloyd 1953- *MarqDCG 84*
Hillman, J R *AmArch 70*
Hillman, J W *AmArch 70*
Hillman, Richard S *FolkA 86, NewYHSD*
Hillmann, Hans 1925- *WhoGrA 82[port]*
Hillmann, Hans Georg 1925- *ConDes, WhoGrA 62*
Hillringhaus, Adele *DcWomA*
Hills, Miss *DcWomA*
Hills, Mrs. *DcWomA*
Hills, A A d1930 *WhAmArt 85*
Hills, A Stephen *BiDAmAr*
Hills, Anna Althea 1882-1930 *ArtsAmW 1, DcWomA*
Hills, David *WhAmArt 85*
Hills, Dorothy *WhAmArt 85*
Hills, George Macdonald *DcVicP 2*
Hills, James Bertram 1888- *AmArch 70*
Hills, James H 1814?- *NewYHSD*
Hills, James W *ArtsEM*
Hills, Laura Coombs d1952 *WhoAmA 78N*
Hills, Laura Coombs 1859-1952 *DcWomA, WhAmArt 85*
Hills, Leo Himmelfarb 1914- *WhoAmA 82, -84*
Hills, Metta V 1873- *DcWomA, WhAmArt 85*
Hills, Patricia 1936- *WhoAmA 80, -82, -84*
Hills, Peter Faber 1925- *WhoArt 80, -82, -84*
Hills, R F *AmArch 70*
Hills, Ralph *WhAmArt 85*
Hills, Robert 1769-1844 *DcBrBI, DcBrWA, DcVicP 2*
Hills, Mrs. W *DcVicP 2*
Hills, W Noel *DcBrBI*
Hillsmith, Fannie 1911- *DcCAA 71, -77, WhoAmA 73, -76, -78, -80, -82, -84*
Hillstrom, E C *AmArch 70*
Hillyard, Caroline Learoyd *DcWomA*
Hillyard, Henry 1806?- *NewYHSD*
Hillyard, J *NewYHSD*
Hillyard, J W *DcVicP 2*
Hillyard, Richard Michael 1950- *MarqDCG 84*
Hillyer, Bernard H 1920- *AmArch 70*
Hillyer, Eva *DcWomA*
Hillyer, Henry L *ArtsEM, NewYHSD*
Hillyer, William d1782 *BiDBrA*
Hillyer, William, Jr. *FolkA 86, NewYHSD*
Hilmer, Herbert Frederick 1918- *AmArch 70*
Hilmers, Charlotte *DcWomA*
Hils, Laura Coombs d1952 *WhoAmA 80N, -82N, -84N*
Hilscher, Hubert 1924- *ConDes*
Hilson, Doug 1941- *DcCAr 81*
Hilson, Douglas 1941- *WhoAmA 78, -80, -82, -84*
Hiltmann, Jochen 1935- *OxTwCA, PhDcTCA 77*
Hilton, Aaron Swett 1819- *CabMA*
Hilton, Arthur Cyril 1897- *DcBrA 1*
Hilton, Eric G 1937- *WhoAmA 78, -80, -82*
Hilton, Henry *DcVicP 2*
Hilton, Howard K 1867-1909 *BiDAmAr*
Hilton, J TenE *WhAmArt 85*
Hilton, Joachim W 1910- *AmArch 70*
Hilton, John William 1904- *IlBEAAW, WhoAmA 73, -76, -78, -80*
Hilton, Joseph 1946- *WhoAmA 84*
Hilton, Marie E *DcVicP 2*
Hilton, Ned *WhAmArt 85*
Hilton, Robert *DcBrBI*
Hilton, Roger 1911- *DcBrA 1*
Hilton, Roger 1911-1975 *ConArt 77, -83, DcBrA 2, OxTwCA, PhDcTCA 77*
Hilton, Roy 1891- *NewYHSD*
Hilton, William *DcBrECP*
Hilton, William 1786-1839 *DcBrWA, DcVicP 2*
Hilton, William Hayes 1829-1909 *ArtsAmW 2*
Hilton, William Henry 1918- *AmArch 70*
Hilts, Alvin 1908- *WhoAmA 73, -76, -78, -80, -82, -84*
Hiltunen, Eila 1922- *OxTwCA*
Hilty, Bernardine *DcWomA*
Hilty, Thomas R 1941- *WhoAmA 80, -82, -84*
Him, George *ConDes*
Him, George 1900- *IlsCB 1744, -1957, WhoGrA 62, -82[port]*
Hime, Ainslie Barron *DcWomA*
Hime, Harry *DcVicP 2*
Himelfarb, Harvey 1941- *DcCAr 81*
Himelick, Lucy Emma 1896- *DcWomA*
Himes, Dennis Paul 1954- *MarqDCG 84*
Himes, Harold William 1919- *AmArch 70*
Himes, Richard Scholl 1917- *AmArch 70*
Himler, Mary Martha *WhAmArt 85*
Himler, Mary Martha 1889- *DcWomA*
Himler, Ronald 1937- *IlsBYP*
Himler, Ronald Norbert 1937- *IlsCB 1967, WhoAmA 78, -80, -82*
Himmel, Kalman Edward 1903- *WhAmArt 85*
Himmelberger, Ralph 1887- *WhAmArt 85*
Himmelfarb, John 1946- *PrintW 83, -85*

Himmelfarb, John David 1946- *AmArt, WhoAmA 76, -78, -80, -82, -84*
Himmelfarb, Samuel 1904- *WhAmArt 85*
Himmelsbach, Francesca *WhAmArt 85*
Himmelsbach, Francisca *DcWomA*
Himmelsbach, Paula *DcWomA, WhAmArt 85*
Himmes, Henriette *DcWomA*
Himona, Nicholas d1929 *DcBrA 1*
Himpel, Anthonis 1634- *ClaDrA*
Himpler, Francis G 1833-1916 *BiDAmAr*
Hinchcliff, W *DcVicP 2*
Hinchco, Benjamin *FolkA 86*
Hinchey, William J 1829-1893 *NewYHSD*
Hinchley, Edith Mary 1870- *DcBrA 1, DcVicP 2, DcWomA*
Hinchliff, C H *DcVicP 2*
Hinchliff, George Frederick 1894- *DcBrA 1*
Hinchliff, John 1915- *AmArch 70*
Hinchliff, John James d1875 *ArtsNiC*
Hinchliff, Woodbine K *DcBrA 2, DcVicP 2*
Hinchliffe, C H *DcVicP 2*
Hinchliffe, Richard George 1868-1942 *DcBrA 1, DcVicP 2*
Hinchman, John H *WhAmArt 85*
Hinchman, John Herbert 1884- *ArtsEM, WhAmArt 85*
Hinchman, John Herbert 1884-1948 *ArtsAmW 2*
Hinchman, Margaretta S d1955 *DcWomA, WhAmArt 85*
Hinchy, Theresa *WhAmArt 85*
Hinckle, Charles *NewYHSD*
Hinckle, Mrs. William H *DcWomA*
Hinckley *NewYHSD*
Hinckley, Albert Pope, Jr. 1934- *AmArch 70*
Hinckley, Cornelius T 1820?- *EarABI, NewYHSD*
Hinckley, F H *NewYHSD*
Hinckley, L C *AmArch 70*
Hinckley, Lawrence Bradford 1900- *WhAmArt 85*
Hinckley, Robert 1853-1941 *NewYHSD, WhAmArt 85*
Hinckley, Thomas Hewes 1813- *ArtsNiC*
Hinckley, Thomas Hewes 1813-1896 *ArtsAmW 1, DcAmArt, EarABI, IlBEAAW, NewYHSD*
Hinckman *NewYHSD*
Hincks, S C *DcVicP 2*
Hincks, William 1752-1797 *DcBrECP*
Hind, Arthur Mayger 1880-1957 *DcBrA 1*
Hind, Ellen Mary *DcVicP 2, DcWomA*
Hind, Frank *DcVicP 2*
Hind, Henry Youle 1823- *IlBEAAW*
Hind, James F *WhAmArt 85*
Hind, M A *DcVicP 2, DcWomA*
Hind, P *DcVicP 2, DcWomA*
Hind, William G R d1888 *ArtsAmW 1*
Hind, William George Richardson 1833-1888? *IlBEAAW*
Hinde, Mrs. B L *DcBrWA, DcVicP 2*
Hinde, Robert Reginald, Jr. 1924- *AmArch 70*
Hinder, Frank 1906- *DcCAr 81*
Hinder, Margel 1906- *DcCAr 81*
Hindes, Charles Austin 1942- *CenC[port]*
Hindes, Chuck 1942- *WhoAmA 84*
Hindes, John M *FolkA 86*
Hindle, Albert 1888- *DcBrA 1*
Hindle, William James d1884 *BiDBrA A*
Hindley, Godfrey C *DcBrA 2, DcBrBI, DcVicP 2*
Hindley, Helen M *DcVicP 2*
Hindman, Robyn *OfPGCP 86*
Hindmarsh, Mary 1817-1887 *DcWomA*
Hinds, Donald 1883- *WhAmArt 85*
Hinds, George Allen 1922- *AmArch 70*
Hinds, Isaac *AntBDN D*
Hinds, Patrick Swazo *WhoAmA 73*
Hinds, Paul *NewYHSD*
Hine, Charles 1827-1871 *NewYHSD*
Hine, Esther *DcVicP 2*
Hine, H G *ArtsNiC*
Hine, Harry 1845-1941 *DcBrA 1*
Hine, Mrs. Harry 1840-1926 *DcVicP 2*
Hine, Harry T 1845-1941 *DcBrWA, DcVicP 2*
Hine, Henry George 1811-1895 *DcBrBI, DcBrWA, DcVicP 2, IlBEAAW*
Hine, Lewis W 1874-1940 *ConPhot*
Hine, Lewis Wickes 1874-1940 *BnEnAmA, DcAmArt, ICPEnP, MacBEP*
Hine, Lewis Wickes 1879-1940 *WhAmArt 85*
Hine, Mary E *DcVicP 2*
Hine, Samuel P *NewYHSD*
Hine, T K *AmArch 70*
Hine, Victoria S d1926 *DcBrA 1*
Hine, Victoria Susanna *DcBrWA, DcWomA*
Hine, Mrs. W E *DcVicP 2*
Hine, William Egerton d1926 *DcBrA 1, DcBrWA, DcVicP 2*
Hine, Mrs. William Egerton *DcWomA*
Hines *FolkA 86*
Hines, Bob *IlsBYP*
Hines, Clifford Gentner, Jr. 1924- *AmArch 70*
Hines, Donald Henry 1924- *AmArch 70*
Hines, E Gene 1924- *AmArch 70*
Hines, Felrath 1918- *AfroAA*

Holbird, Isaac *AntBDN G*
Holbrook, Anna Stanley *DcWomA, WhAmArt 85*
Holbrook, Charles L *EncASM*
Holbrook, Elizabeth Bradford 1913- *WhoAmA 73, -76, -78, -80, -82, -84*
Holbrook, Emeline M *WhAmArt 85*
Holbrook, Emmeline M *DcWomA*
Holbrook, Harry R *EncASM*
Holbrook, Hollis Howard 1909- *WhAmArt 85, WhoAmA 73, -76, -78, -80, -82, -84*
Holbrook, John Richards 1908- *AmArch 70*
Holbrook, Peter Greene 1940- *WhoAmA 84*
Holbrook, Vivian Nicholas 1913- *WhAmArt 85, WhoAmA 73, -76, -78, -80, -82, -84*
Holbrook, W A 1849-1910 *BiDAmAr*
Holbrook And Simmons *EncASM*
Holbrook Whiting And Albee *EncASM*
Holbrooke, William *EncASM*
Holck, Cathalyutje-Willems VanDer d1651 *DcWomA*
Holck, Poul 1939- *WorECar*
Holcomb, Adele Mansfield 1930- *WhoAmA 78, -80, -82, -84*
Holcomb, Alice 1906- *WhoAmA 76*
Holcomb, Alice 1906-1977 *WhoAmA 78N, -80N, -82N, -84N*
Holcomb, Allen 1782-1860 *FolkA 86*
Holcomb, Charles Richard 1934- *AmArch 70*
Holcomb, Grant 1942- *WhoAmA 76, -78, -80*
Holcomb, J H *AmArch 70*
Holcomb, Mabel Crawford 1902- *WhAmArt 85*
Holcomb, Maurice S 1896- *ArtsAmW 3*
Holcomb, Sarah *FolkA 86*
Holcombe, Miss *DcWomA*
Holcombe, Blanche Keaton 1912- *WhoAmA 73, -76, -78N, -80N, -82N, -84N*
Holcombe, Eunice *DcWomA*
Holcombe, Fred M *WhAmArt 85*
Holcombe, Frederick Dudley 1925- *AmArch 70*
Holcombe, John Calvin 1934- *AmArch 70*
Holcombe, R Gordon, Jr. 1913- *WhoAmA 73, -76, -78, -80, -82, -84*
Hold, Abel *DcVicP 2*
Hold, Helene *DcWomA*
Holdaway, James 1927-1970 *WorECom*
Holdby *DcBrECP*
Holden, Albert William 1848-1932 *DcBrA 1, DcVicP 2*
Holden, Ann *NewYHSD*
Holden, Ann 1811?- *DcWomA*
Holden, Arthur Cort 1890- *AmArch 70*
Holden, Asa *CabMA*
Holden, Barry *PrintW 85*
Holden, C *DcVicP 2*
Holden, Charles 1875-1960 *MacEA, OxArt, WhoArch*
Holden, Sir Charles 1875-1960 *ConArch*
Holden, Charles Henry 1875-1960 *DcD&D[port]*
Holden, Clarence C *ArtsEM*
Holden, Cliff 1919- *DcBrA 1*
Holden, Clifford C *NewYHSD*
Holden, Cora Millet 1895-1938? *WhAmArt 85*
Holden, Cora Millet 1895-1939? *DcWomA*
Holden, Donald 1931- *WhoAmA 76, -78, -80, -82, -84*
Holden, E *DcVicP 2*
Holden, Edith 1871-1920 *DcWomA*
Holden, Effie 1867?- *DcWomA*
Holden, Eugene Patrick 1934- *AmArch 70*
Holden, Evelyn B d1920 *DcBrBI*
Holden, Evelyn B 1877?-1967? *DcWomA*
Holden, Frank H 1870-1937 *BiDAmAr*
Holden, H *FolkA 86*
Holden, Harold H *WhoArt 80N*
Holden, Harold Henry 1885- *DcBrA 1*
Holden, Henry *IlDcG*
Holden, J *DcVicP 2*
Holden, James Albert *ArtsAmW 2, WhAmArt 85*
Holden, James Julius 1934- *MarqDCG 84*
Holden, Jean Stansbury 1842?-1934 *DcWomA*
Holden, Jean Stansbury 1843?-1934 *ArtsEM*
Holden, Jesse *FolkA 86*
Holden, John H 1913- *WhoArt 80, -82, -84*
Holden, John J 1810?-1855 *NewYHSD*
Holden, Katharine 1717-1807 *FolkA 86*
Holden, Lansing C 1855-1930 *BiDAmAr*
Holden, Lephe Kingsley 1883?- *DcWomA*
Holden, Lephe Kingsley 1884- *WhAmArt 85*
Holden, Louisa Jane *DcVicP 2, DcWomA*
Holden, Luella M Stewart d1931 *DcWomA, WhAmArt 85*
Holden, Margaret *DcVicP 2, DcWomA*
Holden, Oliver *FolkA 86*
Holden, Oliver 1765-1844 *CabMA*
Holden, R J 1901- *WhAmArt 85*
Holden, Raymond James 1901- *WhoAmA 73, -76, -78, -80, -82, -84*
Holden, Ruth Egri *WhoAmA 84*
Holden, S *DcVicP 2*
Holden, Sarah B *DcWomA*
Holden, Sarah G *ArtsAmW 1, DcWomA*
Holden, Thomas *BiDBrA*

Holden, Violet Mary 1872?- *DcWomA*
Holden, Winifred 1869?- *DcWomA*
Holden And Jones *CabMA*
Holden-Jones, Margaret Talbot *WhoArt 80, -82, -84*
Holdensen, Peter *WhAmArt 85*
Holder, C Vincent d1916 *DcBrA 2*
Holder, Charles Albert 1925- *WhoAmA 73*
Holder, Charlotte *DcVicP 2*
Holder, Edward Henry *DcBrA 1, DcVicP, -2*
Holder, Edwin *DcVicP 2*
Holder, Geoffrey 1930- *AfroAA*
Holder, H W, Sr. *DcVicP 2*
Holder, Kenneth Allen 1936- *WhoAmA 76, -78, -80, -82, -84*
Holder, Louisa Jane *DcWomA*
Holder, Roscoe *AfroAA*
Holder, Tom 1940- *WhoAmA 76, -78, -80, -82, -84*
Holderness, Herbert Glynn *AmArch 70*
Holdich, W Whyte- *DcVicP 2*
Holding, Edgar Thomas 1870-1952 *DcBrA 1*
Holding, Edgar Thomas 1876- *ClaDrA*
Holding, Eileen *OxTwCA*
Holding, Frederick 1817-1874 *DcBrBI, DcBrWA*
Holding, Henry James G 1833-1872 *DcVicP 2*
Holding, Henry James G H 1833?-1872 *DcBrWA*
Holding, John *DcVicP 2*
Holding, Tim *DcCAr 81*
Holditch, J *DcBrECP*
Holdredge, Ransom G 1836-1899 *ArtsAmW 1*
Holdredge, Ransom Gillet 1836-1899 *IlBEAAW, WhAmArt 85*
Holdredge, W D *AmArch 70*
Holdship, Josiah *AntBDN M*
Holdship, Richard *AntBDN M*
Holdstein, Milo S 1910- *AmArch 70*
Holdsworth, Burt Conn 1932- *AmArch 70*
Holdsworth, Watson *WhAmArt 85*
Holdsworth, William Curtis *IlsBYP*
Holdt, Jacob 1947- *ICPEnP A, MacBEP*
Hole, Alice *DcVicP 2*
Hole, Quentin 1923- *IlsCB 1967*
Hole, William *McGDA*
Hole, William 1846-1917 *ClaDrA, DcBrBI*
Hole, William B 1846-1917 *DcBrA 1*
Hole, William Brassey 1846-1917 *DcVicP 2*
Holeman, Marguerite d1905 *DcWomA*
Holen, Norman Dean 1937- *WhoAmA 76, -78, -80, -82, -84*
Holene, Bjorg 1947- *DcCAr 81*
Holewinski, Peter John 1927- *AmArch 70*
Holflfand, Thomas R d1876 *ArtsNiC*
Holford, Lord 1907- *DcD&D[port]*
Holford, Sir William 1907- *EncMA*
Holford, Lord William Graham 1907-1975 *DcBrA 2, ConArch*
Holgate, Brian R 1937- *MarqDCG 84*
Holgate, E J *WhAmArt 85*
Holgate, Edwin *OxTwCA*
Holgate, Edwin Headley 1892- *DcCAr 81, IlBEAAW, WhoAmA 73, -76*
Holgate, Edwin Headley 1892-1977 *WhoAmA 78N, -80N, -82N, -84N*
Holgate, J *DcVicP 2*
Holgate, J F H *NewYHSD*
Holgate, Jeanne 1920- *WhoAmA 76, -78, -80, -82, -84*
Holgate, Margaret 1917- *WhoArt 80*
Holgate, T W *DcBrA 2*
Holgate, Thomas R 1936- *AmArch 70*
Holgate, Thomas W *DcVicP 2*
Holguin, Hector 1935- *MarqDCG 84*
Holguin, Melchor Perez 1660?-1724? *McGDA*
Holguin, Melchor Perez 1660?-1725? *OxArt*
Holian, Edith Regina *DcWomA*
Holiday, Gilbert 1879-1937 *DcBrBI*
Holiday, Gilbert Joseph 1879-1937 *DcBrA 1*
Holiday, H G *DcVicP 2*
Holiday, Henry 1839-1927 *DcBrA 1, DcVicP, -2*
Holiday, Henry James 1839-1927 *DcBrBI, DcBrWA*
Holiday, John *EncASM*
Holingsworth, Mary *FolkA 86*
Holister, Frederick Darnton 1927- *WhoArt 80, -82, -84*
Holl, E Alan 1930- *AmArch 70*
Holl, Edward d1824 *BiDBrA*
Holl, Elias 1573-1646 *MacEA, McGDA, WhoArch*
Holl, Elisabeth Christina *DcWomA*
Holl, Francis Montague 1845-1888 *DcBrBI, McGDA*
Holl, Francis Montague Frank 1845-1888 *DcBrWA*
Holl, Frank 1845- *ArtsNiC*
Holl, Frank 1845-1888 *DcVicP, -2*
Holl, Mrs. Frank *DcWomA*
Holl, Frank Montague 1845-1888 *ClaDrA*
Holl, Maria Katharina *DcWomA*
Holl, Mina 1836-1871 *DcWomA*
Holl, William 1807-1871 *ArtsNiC*
Holladay, Harlan H 1925- *WhoAmA 73, -76, -78, -80, -82, -84*
Holladay, Wilhelmina Cole *WhoAmA 82, -84*
Hollagan, J *DcBrECP*
Hollams, F Mabel *DcVicP 2, DcWomA*

Holland *DcNiCA*
Holland, Ada R *DcVicP 2, DcWomA*
Holland, Alwyn H 1861- *DcBrA 2*
Holland, Ayler Job, Jr. 1929- *AmArch 70*
Holland, B B *AmArch 70*
Holland, Brad 1943- *ConGrA 1[port], IlrAm 1880*
Holland, Brad 1944- *WhoGrA 82[port], WorECar*
Holland, Cecil Ernest 1923- *AmArch 70*
Holland, Charles *AfroAA, DcBrECP*
Holland, Charlotte F *DcVicP 2*
Holland, Christopher 1946- *DcCAr 81*
Holland, Daniel E 1918- *WhoAmA 73, -76, WorECar*
Holland, F *DcVicP 2*
Holland, F Raymond 1886-1934 *WhAmArt 85*
Holland, Francis P *NewYHSD*
Holland, Frank *DcBrBI*
Holland, G *DcVicP 2*
Holland, George *NewYHSD*
Holland, George H B 1901- *ClaDrA, WhoArt 80, -82, -84*
Holland, George Herbert Buckingham 1901- *DcBrA 1*
Holland, Georgina *DcWomA*
Holland, Gertrude *DcVicP 2*
Holland, H *AntBDN N*
Holland, Harry 1941- *DcCAr 81*
Holland, Harry Charles 1937- *WhoAmA 82, -84*
Holland, Henry *DcVicP 2*
Holland, Henry 1745-1806 *BiDBrA, DcD&D[port], MacEA, McGDA, OxArt, WhoArch*
Holland, Henry T *DcBrBI, DcVicP 2*
Holland, Hester *DcWomA*
Holland, J D *AmArch 70*
Holland, James *FolkA 86*
Holland, James 1799-1870 *DcVicP, -2*
Holland, James 1800-1870 *ArtsNiC, ClaDrA, DcBrWA, McGDA*
Holland, James 1905- *ConDes*
Holland, James Sylvester 1905- *DcBrA 1*
Holland, Janice d1962 *WhoAmA 78N, -80N, -82N, -84N*
Holland, Janice 1913-1962 *IlsBYP, IlsCB 1946, -1957, WhAmArt 85*
Holland, John *CabMA, ClaDrA, DcBrECP, DcBrWA, DcVicP, -2*
Holland, John 1830-1886 *DcBrWA*
Holland, John Edward 1932- *AmArch 70*
Holland, John Frederick *FolkA 86*
Holland, John J *BiDBrA*
Holland, John Joseph 1776?-1820 *NewYHSD*
Holland, Kerry Ryan 1956- *MarqDCG 84*
Holland, L G d1893 *DcVicP 2*
Holland, Lawrence Pegram 1914- *AmArch 70*
Holland, Lucy *DcWomA*
Holland, Mabel Constance Burnes 1885- *ClaDrA, DcBrA 1, DcWomA*
Holland, Major Leonard 1941- *AmArch 70*
Holland, Marie *WhAmArt 85*
Holland, Marie 1890- *DcWomA*
Holland, Sir Nathaniel Dance- 1735-1811 *DcBrWA*
Holland, Peter *DcBrWA*
Holland, Peter 1757-1812 *DcBrECP*
Holland, Philip *DcVicP 2*
Holland, Philip Sidney 1855-1891 *DcVicP, -2*
Holland, R A 1868- *WhAmArt 85*
Holland, Richard 1752-1827 *BiDBrA*
Holland, Samuel 1807?-1887 *DcBrWA, DcVicP 2*
Holland, Samuel 1835?-1895? *DcBrWA*
Holland, Sebastopol S *DcVicP 2*
Holland, Thomas *NewYHSD*
Holland, Thomas 1936- *DcCAA 77*
Holland, Thomas J B *DcVicP 2*
Holland, Thomas R 1816?- *NewYHSD*
Holland, Tom 1936- *AmArt, ConArt 77, -83, PrintW 83, -85, WhoAmA 73, -76, -78, -80, -82, -84*
Holland, Tom 1946- *DcCAr 81*
Holland, Vera Mary *WhoArt 80N*
Holland, W J *WhAmArt 85*
Holland, W L *AntBDN O*
Hollander, Mrs. Clifford *WhAmArt 85*
Hollander, George Fenton 1936- *AmArch 70*
Hollander, Gino F 1924- *WhoAmA 76, -78, -80, -82*
Hollander, Michael Frederic 1946- *MarqDCG 84*
Hollander, Ronald Lloyd 1932- *AmArch 70*
Hollandine, Princess Louise *DcWomA*
Hollands, S D *DcBrBI*
Hollar, W E *AmArch 70*
Hollar, Wenceslaus 1607-1677 *DcBrWA, McGDA*
Hollar, Wenzel 1607-1677 *OxArt*
Hollaway, Antony Lynn 1928- *WhoArt 80, -82, -84*
Holle, Henry Charles 1924- *AmArch 70*
Hollefreund, Matthias 1947- *DcCAr 81*
Hollegha, Wolfgang 1929- *DcCAr 81, OxTwCA, PhDcTCA 77*
Hollein, Hans 1934- *ConArch, ConDes, DcCAr 81*
Holleley, Douglas 1949- *MacBEP*
Holleman, Marguerite 1909 *DcWomA*
Hollen, John E *NewYHSD*
Hollen-Bolmgren, Donna 1935- *WhoAmA 80, -82, -84*
Hollenbach, Thomas Robert 1935- *AmArch 70*

Hollenbeck, Frank Bradbury 1932- *AmArch 70*
Hollender, James B 1946- *MarqDCG 84*
Hollenstein, Stephanie 1886- *DcWomA*
Holler, J *FolkA 86*
Holler, Steve 1947- *WhoAmA 76*
Hollerbach, Anna Margarethe *DcWomA*
Hollerbach, Serge 1923- *WhoAmA 73, -76, -78, -80, -82, -84*
Hollerith, Lucia Beverly 1891- *DcWomA, WhAmArt 85*
Hollett, Rolla Spry 1881- *DcWomA*
Holley, Lee 1933- *WorECar*
Holley, P H *AmArch 70*
Holley, Robert Maurice 1913- *WhAmArt 85*
Hollick, Kenneth Russell 1923- *WhoArt 80, -82, -84*
Holliday, Betty *WhoAmA 76, -78, -80, -82*
Holliday, Edward *DcVicP 2*
Holliday, F *DcBrBI*
Holliday, Jackson Riley 1922- *AmArch 70*
Holliday, James Bennett 1931- *AmArch 70*
Holliday, Judith 1938- *WhoAmA 78, -80, -82, -84*
Holliday, Lily *DcVicP 2, DcWomA*
Holliday, Rebecca Francis *WhAmArt 85*
Holliday, Robert *ArtsAmW 2*
Hollidge, J *DcVicP 2*
Hollidge, T *DcVicP 2*
Hollier, Harold S 1886- *ArtsAmW 3*
Hollier, Jean Francois d1845 *AntBDN J*
Hollier-Houber, Delide 1887- *DcWomA*
Hollies-Smith, Roland George 1910- *WhoArt 80, -82*
Hollifield, J A *AmArch 70*
Holliman, John 1704-1744? *FolkA 86*
Hollimon, C H *AmArch 70*
Holling, Clancy *IlsBYP*
Holling, Holling C *IlBEAAW*
Holling, Holling Clancy 1900- *IlsCB 1946, -1957*
Holling, Lucille Webster 1900- *IlsBYP, IlsCB 1946, -1957*
Hollingbery, Donald Ross 1924- *AmArch 70*
Hollingdale, Horatio R *DcVicP, -2*
Hollingdale, Richard *DcVicP, -2*
Hollinger *WhoAmA 73, -76, -78, -80*
Hollinger, Helen Wetherbee *WhoAmA 82, -84*
Hollinger, Lizzie *FolkA 86*
Hollings, G Seymour *DcVicP 2*
Hollingshead, M Mary 1897- *ArtsAmW 3*
Hollingshead, Mark A 1951- *MarqDCG 84*
Hollingshead, Mary 1897- *ArtsAmW 3*
Hollingsworth, Alice Claire 1907- *WhAmArt 85*
Hollingsworth, Alvin *IlsBYP*
Hollingsworth, Alvin C 1931- *AfroAA*
Hollingsworth, Alvin Carl 1930- *WhoAmA 73, -76, -78, -80, -82, -84*
Hollingsworth, F A *AmArch 70*
Hollingsworth, Fred P *AfroAA*
Hollingsworth, George 1813-1882 *NewYHSD*
Hollingsworth, Mary *FolkA 86*
Hollingsworth, Ruth *DcBrA 1, DcWomA*
Hollingsworth, Thomas *DcVicP 2*
Hollingsworth, William R, Jr. d1944 *WhAmArt 85*
Hollingworth, Keith William 1937- *ConArt 77, WhoAmA 78, -80, -82*
Hollins, Jack 1958- *MarqDCG 84*
Hollins, John 1798-1855 *DcBrWA, DcVicP, -2*
Hollins, William 1763-1843 *BiDBrA*
Hollinshead, Joseph 1894- *DcBrA 1*
Hollinshead, Mary Ann 1812?- *FolkA 86*
Hollis, Charles *BiDBrA*
Hollis, Charles J 1815?- *NewYHSD*
Hollis, Charles T *DcVicP 2*
Hollis, Donald R 1924- *AmArch 70*
Hollis, George 1793-1842 *DcBrWA*
Hollis, Gerald 1908- *DcBrA 1*
Hollis, J T *AmArch 70*
Hollis, R L *AmArch 70*
Hollis, Thomas 1818-1843 *DcBrWA, DcVicP 2*
Hollis, William Eugene 1927- *AmArch 70*
Hollister, Antoinette B 1873- *DcWomA, WhAmArt 85*
Hollister, Emily H 1908- *WhAmArt 85*
Hollister, J M *AmArch 70*
Hollister, Laura S *DcWomA, WhAmArt 85*
Hollister, Paul *WhoAmA 73, -76, -78, -80, -82, -84*
Hollister, Valerie 1939- *WhoAmA 73, -76, -78, -80, -82, -84*
Hollister, W R *FolkA 86*
Hollman, Charles E *WhAmArt 85*
Hollman, William Noble 1926- *AmArch 70*
Hollo, G C *AmArch 70*
Hollogan, J *DcBrECP*
Holloran, Robert Timothy 1919- *AmArch 70*
Hollow, Della *WhoArt 82N*
Hollow, Della 1922- *WhoArt 80*
Holloway, Arthur Thomas 1870- *DcBrA 1*
Holloway, Benjamin *BiDBrA*
Holloway, Charles 1859-1941 *WhAmArt 85*
Holloway, Charles Edward 1838-1897 *ClaDrA, DcBrWA, DcVicP, -2*
Holloway, D N *AmArch 70*
Holloway, David George 1934- *AmArch 70*
Holloway, Edgar 1914- *DcBrA 1, WhoArt 80, -82, -84*
Holloway, Edward Stratton d1939 *WhAmArt 85*
Holloway, Ernest A 1919- *DcBrA 1*
Holloway, George d1843 *DcVicP 2*
Holloway, H E *NewYHSD*
Holloway, H Maxson d1966 *WhoAmA 78N, -80N, -82N, -84N*
Holloway, Herbert *DcBrBI*
Holloway, Ida H *WhAmArt 85*
Holloway, Ida Holterhoff *DcWomA*
Holloway, Isabella *FolkA 86*
Holloway, J *DcVicP 2*
Holloway, J S *AmArch 70*
Holloway, L *DcVicP 2*
Holloway, L C, Jr. *AmArch 70*
Holloway, Michael Steven 1956- *MarqDCG 84*
Holloway, R L *AmArch 70*
Holloway, Robert Charles 1914- *DcBrA 1, WhoArt 80, -82, -84*
Holloway, Thomas 1749-1827 *DcBrECP*
Hollreiser, Len 1923- *WorECar*
Hollrock, George L *WhAmArt 85*
Hollstien, Jack Lowell 1925- *AmArch 70*
Hollway, Janet *DcWomA*
Holly, Ben *FolkA 86*
Holly, Henry Hudson 1834-1892 *BiDAmAr*
Holly, John Halm 1941- *MarqDCG 84*
Holly, W A *WhAmArt 85*
Holly, William *FolkA 86*
Hollyer, Christopher C *DcVicP 2*
Hollyer, Eva *DcVicP 2, DcWomA*
Hollyer, F *DcVicP 2*
Hollyer, Fred 1837-1933 *MacBEP*
Hollyer, Samuel 1826-1919 *NewYHSD, WhAmArt 85*
Hollywood, William *OfPGCP 86*
Holm, Alvin H, Jr. 1936- *AmArch 70*
Holm, Bill 1925- *WhoAmA 78, -80, -82, -84*
Holm, Florence French 1897- *WhAmArt 85*
Holm, George Carl 1924- *AmArch 70*
Holm, Gerda *DcWomA*
Holm, Hans Jorgen 1835-1916 *MacEA*
Holm, Milton W *WhoAmA 73, -76, -78, -80, -82, -84*
Holm, Milton W 1903- *WhAmArt 85*
Holm, Peter Christian 1823-1888 *DcSeaP*
Holm, Rosalie 1807-1873 *DcWomA*
Holm, Victor S 1876-1935 *WhAmArt 85*
Holm, Wallace 1917- *AmArch 70*
Holm-Moller, Olivia *DcWomA*
Holman, Abigail *ArtsAmW 2, WhAmArt 85*
Holman, Abigail 1876- *DcWomA*
Holman, Arthur 1926- *WhoAmA 73, -76, -78, -80, -82, -84*
Holman, Arthur S 1926- *AmArt*
Holman, Bill 1903- *WorECom*
Holman, Edwin Charles Pascoe *DcBrA 1*
Holman, Francis d1790 *DcBrECP, DcSeaP*
Holman, Frank 1865-1930 *WhAmArt 85*
Holman, Fred Hildreth 1936- *AmArch 70*
Holman, George Alfred *WhoArt 84N*
Holman, George Alfred 1911- *DcBrA 1, WhoArt 80, -82*
Holman, Irvin C 1925- *AmArch 70*
Holman, Jane S *ArtsEM, DcWomA*
Holman, John *FolkA 86*
Holman, Jonas W *FolkA 86, NewYHSD*
Holman, Levi *CabMA*
Holman, Louis A *WhAmArt 85*
Holman, Samuel *BiDAmAr*
Holman, Silas 1953- *WhoAmA 80, -82, -84*
Holman, Thomas S 1953- *WhoAmA 80, -82, -84*
Holman, William *WhAmArt 85*
Holman Hunt, William *DcVicP 2*
Holmans, William Clarence 1936- *AmArch 70*
Holmberg, Samuel 1885-1911 *ArtsAmW 3*
Holmboe, Henrik B *WhAmArt 85*
Holmbom, James William 1926- *WhoAmA 73, -76, -78, -80*
Holme, C Geoffrey *DcBrBI*
Holme, Charles Geoffrey 1887-1954 *DcBrA 2*
Holme, Dora *DcWomA*
Holme, John Francis 1868-1904 *ArtsAmW 2, IlBEAAW, WhAmArt 85*
Holme, John Frank 1868-1904 *ArtsAmW 2*
Holme, Lucy D *DcWomA, WhAmArt 85*
Holme, William *DcVicP 2*
Holmes, Miss *DcVicP 2*
Holmes, Allen E *FolkA 86*
Holmes, Andrew *DcCAr 81*
Holmes, Anna Maria *DcWomA, FolkA 86*
Holmes, B *DcVicP 2*
Holmes, Basil *DcVicP 2*
Holmes, Benjamin 1843-1912 *FolkA 86*
Holmes, Bettie *FolkA 86*
Holmes, Burton Harley 1914- *AmArch 70*
Holmes, Carole C 1937- *MarqDCG 84*
Holmes, Sir Charles John 1868- *ClaDrA*
Holmes, Sir Charles John 1868-1936 *DcBrA 1, DcBrWA, DcVicP 2*

Holmes, Mrs. Christian R *FolkA 86*
Holmes, D E 1938- *AmArch 70*
Holmes, David Bryan 1936- *WhoAmA 73, -76, -78, -80, -82, -84*
Holmes, David Valentine 1945- *WhoAmA 82, -84*
Holmes, E N *DcVicP 2*
Holmes, E W *NewYHSD*
Holmes, Eddie 1948- *AfroAA*
Holmes, Edith 1893-1973 *DcWomA*
Holmes, Edward *DcVicP, -2*
Holmes, Eleazer *FolkA 86*
Holmes, Elisha S *WhAmArt 85*
Holmes, Eliza J *ArtsEM, DcWomA*
Holmes, Ellen A *DcWomA, WhAmArt 85*
Holmes, Emily R *DcVicP 2*
Holmes, Emma Shaw *ArtsEM, DcWomA*
Holmes, Ethel G 1879- *WhAmArt 85*
Holmes, Ethel Greenough 1879- *DcWomA*
Holmes, F Mason *WhAmArt 85*
Holmes, F Mason 1858-1953 *ArtsAmW 1*
Holmes, Flora Virginia *FolkA 86*
Holmes, Frank Edward *MarqDCG 84*
Holmes, Frank Graham 1878- *WhAmArt 85*
Holmes, Frank Graham 1908- *WhAmArt 85*
Holmes, George *DcBrBI, DcBrWA*
Holmes, George Augustus *DcVicP*
Holmes, George Augustus d1911 *DcBrA 1, DcBrBI, DcVicP 2*
Holmes, George W 1812?- *NewYHSD*
Holmes, Gerald A *WhAmArt 85*
Holmes, Gerald A d1948 *BiDAmAr*
Holmes, H *DcVicP 2*
Holmes, Harriet Morton *ArtsAmW 2, DcWomA, WhAmArt 85*
Holmes, Harry Lloyd 1926- *AmArch 70*
Holmes, Henry 1832?- *NewYHSD*
Holmes, Henry 1906- *AfroAA*
Holmes, Mrs. Henry *DcWomA*
Holmes, Isaac *CabMA*
Holmes, Israel *EncASM*
Holmes, J D *NewYHSD*
Holmes, J L *AmArch 70*
Holmes, James 1777-1860 *AntBDN J, DcBrWA, DcVicP, -2*
Holmes, James, Jr. *DcVicP 2*
Holmes, Jane *DcWomA*
Holmes, Jess T 1939- *AmArch 70*
Holmes, John *AntBDN D*
Holmes, John 1695- *FolkA 86*
Holmes, K E *AmArch 70*
Holmes, Kate Clifton 1858-1925 *DcWomA*
Holmes, Kate Osgood d1925 *WhAmArt 85*
Holmes, Kenneth *WhoArt 80*
Holmes, Kenneth 1902- *DcBrA 1*
Holmes, L W *FolkA 86*
Holmes, Lothrop T 1824-1899 *FolkA 86*
Holmes, Madeline Rachel *DcWomA*
Holmes, Marcus 1877- *DcBrA 1*
Holmes, Margaret D Irish d1939 *WhAmArt 85*
Holmes, Marjorie Daingerfield *WhAmArt 85*
Holmes, Mary Adams 1910- *WhAmArt 85*
Holmes, Mary E 1900- *WhoAmA 73, -76, -78, -80, -82, -84*
Holmes, Mildred M 1897- *ArtsAmW 3*
Holmes, Morris *EncASM*
Holmes, Morris G 1862-1945 *BiDAmAr*
Holmes, Nathan 1664- *CabMA*
Holmes, Nathaniel, Jr. *NewYHSD*
Holmes, Nathaniel, Sr. *NewYHSD*
Holmes, Nicholas Hanson, Jr. 1924- *AmArch 70*
Holmes, Obediah *FolkA 86*
Holmes, Paul James 1896- *WhoAmA 73, -76, -78, -80, -82, -84*
Holmes, Paula Schatzman 1925- *AmArch 70*
Holmes, R M *AmArch 70*
Holmes, R Sheriton *DcBrWA, DcVicP 2*
Holmes, Ralph 1876- *ArtsAmW 1, WhAmArt 85*
Holmes, Ralph William 1876-1963 *ArtsAmW 3*
Holmes, Reginald 1934- *WhoAmA 73, -76, -78, -80*
Holmes, Rhoda *DcVicP 2, DcWomA, WhAmArt 85*
Holmes, Richard E 1934- *MarqDCG 84*
Holmes, Sir Richard Rivington 1835-1911 *DcBrA 2, DcBrWA*
Holmes, Sir Richard Rivington *DcVicP 2*
Holmes, Robert *CabMA, EncASM*
Holmes, Robert Frederick *EncASM*
Holmes, Rufus *CabMA*
Holmes, Ruth Atkinson *WhoAmA 73, -76, -78, -80, -82*
Holmes, Sarah *DcWomA*
Holmes, Sophia *DcVicP 2, DcWomA*
Holmes, Stuart 1884- *WhAmArt 85*
Holmes, Sue *DcWomA, WhAmArt 85*
Holmes, Thomas Reed, Jr. 1928- *AmArch 70*
Holmes, Victor *WhAmArt 85*
Holmes, W *DcVicP 2*
Holmes, W Grover *EncASM*
Holmes, Wendy 1946- *ICPEnP A, MacBEP, WhoAmA 84*
Holmes, William *AntBDN Q*

Holmes, William 1761?-1847 *BiDBrA*
Holmes, William 1816-1883 *EncASM*
Holmes, William 1855-1898 *BiDAmAr*
Holmes, William, Jr. *EncASM*
Holmes, William Henry 1846-1933 *ArtsAmW 1,*
IIBEAAW, WhAmArt 85
Holmes, William Whittaker 1943- *MarqDCG 84*
Holmes, Zacheus, Jr. 1839?- *NewYHSD*
Holmes And Edwards *EncASM*
Holmes And Roberts *CabMA*
Holmes And Tuttle *EncASM*
Holmes Booth And Haydens *EncASM*
Holmgaard, Simon Bergholt 1956- *MarqDCG 84*
Holmgren, H W *AmArch 70*
Holmgren, Martin 1921- *OxTwCA, PhDcTCA 77*
Holmgren, R John d1963 *WhoAmA 78N, -80N, -82N,*
-84N
Holmgren, R John 1897-1963 *IlrAm D, -1880,*
WhAmArt 85
Holmgren, Robert Everett 1946- *ICPEnP A,*
MacBEP
Holmlund, Jeannette 1825-1872 *DcWomA*
Holmlund, Josephine 1827-1905 *DcWomA*
Holmlund, Margaretha 1781-1821 *DcWomA*
Holmlund, Marvin N 1896- *ArtsAmW 2*
Holmquist, G W *AmArch 70*
Holmquist, Gosta 1926- *DcCAr 81*
Holmquist, W N *AmArch 70*
Holmstead, Marie H 1857-1911 *DcWomA*
Holmsted, Marie H 1857-1911 *DcWomA*
Holmstedt, Peter Lanz 1872?-1957 *ArtsAmW 3*
Holmstrom, Henry *WhAmArt 85*
Holmstrom, Tora 1880- *DcWomA*
Holmwood, Loren C *WhAmArt 85*
Holo, Selma Reuben 1943- *WhoAmA 78, -80*
Holonia, Delores E 1948- *MarqDCG 84*
Holoun, Harold Dean 1939- *WhoAmA 82, -84*
Holow, E J *WhAmArt 85*
Holowchak, E H *AmArch 70*
Holroyd, Lady *DcVicP 2*
Holroyd, Sir Charles 1861-1917 *DcBrA 1, ClaDrA,*
DcBrWA, DcVicP 2
Holroyd, Mrs. F F *DcVicP 2*
Holroyd, Fannie F d1924 *DcWomA*
Holroyd, Frank Lander 1937- *AmArch 70*
Holroyd, Harry James 1920- *AmArch 70*
Holroyd, Newman *DcBrA 2*
Holroyd, R E, Jr. *AmArch 70*
Holroyd, T *DcVicP 2*
Holsaple, Robert Duane 1926- *AmArch 70*
Holsch, Robert Fred 1952- *WhoAmA 82, -84*
Holscher, Knud 1930- *ConDes*
Holschuh, Fred 1902- *WhoAmA 76, -78, -80, -82,*
-84
Holschuh, George Frederick 1902- *WhAmArt 85*
Holsing, Hans C C 1893- *WhAmArt 85*
Holslag, Edward J 1870-1924 *ArtsEM*
Holslag, Edward J 1870-1925 *ArtsAmW 2,*
WhAmArt 85
Holsman, Elizabeth A Tuttle 1873- *ArtsAmW 3*
Holsman, Elizabeth Tuttle 1873- *DcWomA,*
WhAmArt 85
Holst, James Kenneth 1928- *AmArch 70*
Holst, Johannes 1880-1965 *DcSeaP*
Holst, Lauritz *DcVicP 2*
Holst, Richard Henry 1923- *AmArch 70*
Holst, Theodore M Von 1810-1844 *DcBrWA*
Holst, Theodore Von 1810-1844 *DcVicP 2*
Holste, Peter Caspar 1775?- *NewYHSD*
Holste, Thomas James 1943- *WhoAmA 78, -80, -82,*
-84
Holste, Tom 1943- *AmArt*
Holstein, Pieter 1937- *DcCAr 81*
Holsten, William George 1936- *MarqDCG 84*
Holswilder, Jan 1850-1890 *WorECar*
Holt, A H *DcVicP 2, DcWomA*
Holt, Anna B *DcWomA, WhAmArt 85*
Holt, Barbara R 1933- *AfroAA*
Holt, Charles *NewYHSD*
Holt, Charlotte Sinclair 1914- *WhoAmA 73, -76, -78,*
-80, -82, -84
Holt, Dorothy Morgianna 1909- *WhAmArt 85*
Holt, E F *DcVicP 2*
Holt, Mrs. E F *DcVicP 2*
Holt, Elias *FolkA 86*
Holt, Eric Stace 1944- *WhoArt 80*
Holt, Geoffrey *ArtsAmW 3, WhAmArt 85*
Holt, Gwynneth 1909- *DcBrA 1, WhoArt 80, -82,*
-84
Holt, Henry 1843-1922 *ArtsAmW 1*
Holt, Henry, Jr. 1889-1941 *WhAmArt 85*
Holt, Herbert Eman *DcBrA 1*
Holt, J *DcVicP 2*
Holt, Julia Samuel Travis 1897- *DcWomA,*
WhAmArt 85
Holt, Margaret McConnell 1909- *WhoAmA 78, -80,*
-82, -84
Holt, Martha A 1945- *WhoAmA 84*
Holt, Mary Ann *DcVicP 2, DcWomA*
Holt, Maud S 1866- *WhAmArt 85*
Holt, Maude S 1866- *DcWomA*

Holt, Nancy 1938- *ConArt 77, -83*
Holt, Nancy Louise 1938- *AmArt, WhoAmA 76, -78,*
-80, -82, -84
Holt, Naomi 1911- *WhAmArt 85*
Holt, Nicholas 1927- *AmArch 70*
Holt, Percy William *ArtsAmW 2, WhAmArt 85*
Holt, Percy William 1895?- *IIBEAAW*
Holt, Philetus Havens, III 1928- *AmArch 70*
Holt, Rufus Dailey 1919- *AmArch 70*
Holt, Samuel 1801- *NewYHSD*
Holt, Sara Barton *DcWomA*
Holt, Sherwood 1893- *AmArch 70*
Holt, Stephen *CabMA*
Holt, Thomas d1624 *BiDBrA*
Holt, Thyra 1890- *MacBEP*
Holt, W G *DcBrBI*
Holt, William Fuller *ArtsEM*
Holt, Winifred *DcWomA, WhAmArt 85*
Holte, A B *DcVicP 2*
Holte, Frank A *DcVicP 2*
Holten, Sofie 1858- *DcWomA*
Holten, Susette Cathrine 1863- *DcWomA*
Holterhoff, Ida *DcWomA, WhAmArt 85*
Holterhoff DeHarven, Alice *DcWomA*
Holtermann, Bernard Otto 1838-1885 *MacBEP*
Holthaus, Dick *WorFshn*
Holthouse, Michael H 1957- *MarqDCG 84*
Holtkamp, D C *AmArch 70*
Holtkamp, Loretta *DcWomA*
Holtmeier, Robert Louis 1912- *AmArch 70*
Holton, Alfred J S 1878-1936 *BiDAmAr*
Holton, Chancy *FolkA 86*
Holton, Curlee 1951- *WhoArt 82, -84*
Holton, Donald Allen 1950- *MarqDCG 84*
Holton, Frank Carey, Jr. 1930- *AmArch 70*
Holton, Grace *DcWomA, WhAmArt 85*
Holton, Henry *EarABI SUP, NewYHSD*
Holton, Leonard T 1900- *WhAmArt 85*
Holton, Leonard T 1906- *WhoAmA 73, -76, -78*
Holton, Thomas d1732 *CabMA*
Holton, William Coffen 1930- *MarqDCG 84*
Holty, Carl Robert 1900- *DcCAA 71, OxTwCA,*
WhoAmA 73
Holty, Carl Robert 1900-1973 *DcAmArt, DcCAA 77,*
WhAmArt 85, WhoAmA 76N, -78N, -80N, -82N,
-84N
Holtz, David Alan 1930- *AmArch 70*
Holtz, Itshak Jack 1925- *WhoAmA 76, -78, -80, -82,*
-84
Holtz, Marvin Ellis 1934- *AmArch 70*
Holtzapple, Arthur Robert 1932- *AmArch 70*
Holtze *NewYHSD*
Holtzman, C Thomas *AmArch 70*
Holtzman, Daniel Thomas 1961- *MarqDCG 84*
Holtzman, Harry 1912- *OxTwCA*
Holtzman, Irving 1897- *WhAmArt 85*
Holtzman, M *AmArch 70*
Holtzman, Michael Steven 1959- *MarqDCG 84*
Holtzmann, F *NewYHSD*
Holub, Leo M 1916- *ICPEnP A, MacBEP*
Holverson, John 1946- *WhoAmA 78, -80, -82, -84*
Holvey, Samuel Boyer 1935- *WhoAmA 73, -76, -78,*
-80, -82, -84
Holweck, Oskar 1924- *DcCAr 81*
Holwell, W *DcBrECP*
Holworthy, James 1781-1841 *DcBrWA*
Holy, Daniel *AntBDN N*
Holy And Parker *AntBDN N*
Holy And Wilkinson *AntBDN N*
Holy Mother Wisdom *FolkA 86*
Holyland, C J *NewYHSD*
Holynski, Marek 1947- *MarqDCG 84*
Holyoake, Rowland *DcBrA 1, DcVicP, -2*
Holyoake, William 1834-1894 *DcVicP, -2*
Holyoke, Edward Augustus, Jr. 1827- *NewYHSD*
Holyoke, Thomas G *WhAmArt 85*
Holyoke, Thomas Gannett 1866-1925? *BiDAmAr*
Holzbauer, Wilhelm 1930- *ConArch*
Holzbog, Thomas Jerald 1933- *AmArch 70*
Holzel, Adolf 1853-1934 *PhDcTCA 77*
Holzer, J A 1858- *WhAmArt 85*
Holzer, Jenny 1950- *WhoAmA 84*
Holzer, Julius *FolkA 86*
Holzhandler, Dora 1928- *DcCAr 81*
Holzhauer, Emil Eugen 1887- *WhAmArt 85*
Holzhauer, Ralph Newton 1921- *AmArch 70*
Holzhausen, Erna Von *DcWomA*
Holzhausen, Olga Von 1871- *DcWomA*
Holzhausen-Martiny, Margarete Von 1893- *DcWomA*
Holzhuber, Franz 1826-1898 *ArtsAmW 2*
Holzinger, R M *AmArch 70*
Holzl, Margareta Antonia *DcWomA*
Holzlhuber, Franz 1826-1898 *ArtsAmW 2*
Holzman, Malcolm 1940- *AmArch 70*
Holzman, Marek 1919-1982 *ICPEnP A*
Holzmann, Hans *McGDA*
Holzmeister, Clemens 1886- *ConArch, EncMA,*
MacEA
Holzner, Anton 1958- *DcCAr 81*
Holzwart, F A *NewYHSD*
Hom, E K *AmArch 70*

Hom, Jesper 1931- *MacBEP*
Homa, Ted Arthur 1911- *AmArch 70*
Homan *EncASM*
Homan, Charles Edwin 1932- *AmArch 70*
Homan, Frank d1880 *EncASM*
Homan, Gertrude *DcVicP 2, DcWomA*
Homan, Henry d1865 *EncASM*
Homan, Joseph T *EncASM*
Homan, Louis *EncASM*
Homan, Margaret *EncASM*
Homan, Samuel V *NewYHSD*
Homann, F K *AmArch 70*
Homans, Nancy 1861- *DcWomA*
Homans, Nannie *WhAmArt 85*
Homar, Lorenzo 1913- *WhoAmA 73, -76, -78, -80,*
-82, -84, WhoGrA 62
Homayounfar, Amir H 1927- *AmArch 70*
Home, Gordon *DcVicP 2*
Home, Gordon Cochrane 1878-1969 *DcBrA 1*
Home, Henry, Lord Kames 1696-1782 *OxArt*
Home, M A *DcWomA*
Home, Mrs. M A *NewYHSD*
Home, Robert 1752-1834 *DcBrECP, DcBrWA*
Home, Robert 1865- *ClaDrA, DcBrA 1, DcVicP 2*
Homer, Andrew *CabMA*
Homer, Eleazer B *WhAmArt 85*
Homer, Eleazer B 1864-1929 *BiDAmAr*
Homer, George E *EncASM*
Homer, Henrietta Maria 1808-1884 *DcWomA*
Homer, Henrietta Maria 1809-1884 *NewYHSD*
Homer, James *NewYHSD*
Homer, John 1727-1803? *FolkA 86*
Homer, Joseph J *EncASM*
Homer, R W *AmArch 70*
Homer, Ruth Wellington *DcWomA, WhAmArt 85*
Homer, William d1822 *FolkA 86*
Homer, William Innes 1929- *WhoAmA 73, -76, -78,*
-80, -82, -84
Homer, Winslow 1836- *ArtsNiC*
Homer, Winslow 1836-1910 *BnEnAmA, DcAmArt,*
DcSeaP, EarABI, EarABI SUP, McGDA,
NewYHSD, OxArt, WhAmArt 85
Homere, Stavros *DcBrBI*
Homes, Ronald Thomas John 1922- *WhoArt 80, -82,*
-84
Homeshaw, Arthur Howard 1933- *WhoArt 80, -82,*
-84
Homewood, Florence M *DcBrBI*
Homeyer, Konrad Von 1951- *DcCAr 81*
Homfray, J *DcVicP 2*
Homitzky, Peter 1942- *WhoAmA 76, -78, -80, -82,*
-84
Homlish, John Stephen 1907- *AmArch 70*
Hommel, Joseph M 1855- *ArtsEM*
Homola, R B *AmArch 70*
Homolka, Benno 1860-1925 *MacBEP*
Homolka, F *AmArch 70*
Hompson, Davi Det 1939- *WhoAmA 76, -78, -80, -82,*
-84
Homsey, George 1926- *AmArch 70*
Homsey, Samuel Eldon 1904- *AmArch 70,*
WhAmArt 85
Homsey, Victorine DuPont 1900- *AmArch 70*
Homsy, N A *AmArch 70*
Hona-Senft, Hedwig 1855- *DcWomA*
Honanie, Del *WhoAmA 76*
Honda, Kazuhisa 1948- *PrintW 85*
Honda, Kinkichiro 1850-1921 *WorECar*
Hondecoeter, Gijsbert Gillisz D' 1604-1653 *McGDA*
Hondecoeter, Gillis Claesz D' d1638 *McGDA*
Hondecoeter, Gillis D' d1638 *OxArt*
Hondecoeter, Gillis De d1638 *ClaDrA*
Hondecoeter, Gysbert D' 1604-1653 *OxArt*
Hondecoeter, Melchior D' 1636-1695 *McGDA, OxArt*
Hondecoeter, Melchior De 1636-1695 *ClaDrA*
Hondius, Abraham Danielsz 1625?-1695 *ClaDrA*
Hondius, Gerrit 1891-1970 *ArtsAmW 3,*
WhAmArt 85
Hondius, Gerritt 1891-1970 *ArtsAmW 3*
Hondius, Hendrik 1597?-1644? *ClaDrA*
Hondius, Jodocus 1563-1612 *AntBDN I*
Hone, David 1928- *WhoArt 80, -82, -84*
Hone, Evie S 1894-1955 *DcBrA 1, DcWomA*
Hone, Horace 1754-1825 *DcBrECP*
Hone, Horace 1756-1825 *AntBDN J*
Hone, John Camillus 1759-1836 *DcBrECP*
Hone, Nathanial 1831-1917 *ClaDrA*
Hone, Nathaniel d1917 *DcBrA 1*
Hone, Nathaniel 1718-1784 *AntBDN J, ClaDrA,*
DcBrECP, OxArt
Hone, Nathaniel 1831-1917 *DcBrA 2*
Hone, Nathaniel, II 1831-1917 *DcVicP 2*
Hone, Samuel 1726- *DcBrECP*
Honegger, Gottfried 1917- *ConArt 77, -83*
Honerbach, Margarete *DcWomA*
Honey, John *FolkA 86*
Honey, Winifred C *DcWomA*
Honeyman, John *DcVicP 2*
Honeyman, John 1831-1914 *DcBrA 2, MacEA*
Honeyman, Richard Kenneth 1947- *MarqDCG 84*
Honeyman, Robert B, Jr. *WhoAmA 73, -76, -78*

Hope Henderson, Eleanora 1917- WhoArt 80, -82, -84
Hope-Pinker, Henry Richard DcBrA 2
Hopeman FolkA 86
Hopewell, D C AmArch 70
Hopf, Annie Stebler 1861-1918 DcWomA
Hopf, Heike 1939- DcCAr 81
Hopf, Herbert H 1931- MarqDCG 84
Hopf, Peter S 1929- AmArch 70
Hopfgarten, August Ferdinand 1807- ArtsNiC
Hopfgarten, August Ferdinand 1807-1896 ClaDrA
Hopgood, Frank Robert Albert 1935- MarqDCG 84
Hopker, Thomas 1936- ConPhot
Hopkin, Robert 1832-1909 ArtsAmW 3,
 ArtsEM[port], NewYHSD , WhAmArt 85
Hopkin, Robert B 1854- ArtsEM
Hopkin, William G 1856?-1884 ArtsEM
Hopkin And Ralston ArtsEM
Hopkins, Miss DcVicP 2, DcWomA
Hopkins, Abner C 1903- AmArch 70
Hopkins, Alfred 1870-1941 BiDAmAr
Hopkins, Allen Crosby 1920- AmArch 70
Hopkins, Anna Mary WhAmArt 85
Hopkins, Arthur 1848-1930 DcBrA 1, DcBrBI,
 DcBrWA, DcVicP 2, IlBEAAW
Hopkins, Benjamin 1936- WhoAmA 78, -80, -82, -84
Hopkins, Budd 1931- ConArt 77, DcCAA 71, -77,
 PrintW 83, -85, WhoAmA 73, -76, -78, -80, -82,
 -84
Hopkins, Burtram Collver, II 1936- AmArch 70
Hopkins, C B 1882- WhAmArt 85
Hopkins, C E 1886- WhAmArt 85
Hopkins, Charles Benjamin 1882- ArtsAmW 1
Hopkins, Clyde 1946- DcCAr 81
Hopkins, Edna Bel Boies 1872?-1937? DcWomA
Hopkins, Edna Boies 1872-1937 WhAmArt 85
Hopkins, Edna Boies 1878-1935 ArtsEM
Hopkins, Mrs. Edward DcVicP 2
Hopkins, Elinor F 1901- WhAmArt 85
Hopkins, Eric Samuel 1926- ClaDrA
Hopkins, Everard 1860-1928 ClaDrA, DcBrA 1,
 DcBrBI, DcVicP 2
Hopkins, Frances Ann 1838-1918 DcWomA
Hopkins, Frances Ann 1838-1919 DcBrA 2
Hopkins, Frances Ann Beechey 1856-1918 IlBEAAW
Hopkins, Fritz DcBrBI
Hopkins, George E 1855- WhAmArt 85
Hopkins, George Edward 1855- ArtsAmW 3
Hopkins, Gerrard d1796 CabMA
Hopkins, Godfrey Thurston 1913- MacBEP
Hopkins, H P AmArch 70
Hopkins, Hannah H DcVicP 2, DcWomA
Hopkins, Henry Tyler 1928- WhoAmA 76, -78, -80,
 -82, -84
Hopkins, I NewYHSD
Hopkins, J Seth EncASM
Hopkins, James C 1873-1938 BiDAmAr
Hopkins, James Cleveland 1914- AmArch 70
Hopkins, James E NewYHSD
Hopkins, James Frederick 1869-1931 WhAmArt 85
Hopkins, James R 1877- WhAmArt 85
Hopkins, John FolkA 86
Hopkins, John Douglas d1869 BiDBrA
Hopkins, John Fornachon 1920- WhoAmA 73, -76
Hopkins, John G CabMA
Hopkins, John Henry 1792-1868 MacEA,
 NewYHSD
Hopkins, John Henry, Jr. 1820-1891 NewYHSD
Hopkins, Kendal Coles 1908- WhoAmA 73, -76, -78,
 -80, -82, -84
Hopkins, Kenneth R 1922- WhoAmA 78, -80, -82,
 -84
Hopkins, Lin 1886- ArtsAmW 1
Hopkins, Lucy M FolkA 86
Hopkins, M R DcVicP 2
Hopkins, M W NewYHSD
Hopkins, Marie A WhAmArt 85
Hopkins, Mark, Jr. 1851-1935 WhAmArt 85
Hopkins, Peter 1911- WhoAmA 73, -76, -78, -80, -82,
 -84, WhoArt 80, -82, -84
Hopkins, Richard Paynter 1929- AmArch 70
Hopkins, Roger BiDBrA
Hopkins, Ruth Joy 1891- ArtsAmW 1,
 WhAmArt 85, WhoAmA 73
Hopkins, Ruth Joy 1891-1973 DcWomA
Hopkins, Susan Miles d1853 DcWomA
Hopkins, Thurston 1913- ConPhot, ICPEnP A
Hopkins, Vaughan Albert 1947- MarqDCG 84
Hopkins, W DcBrECP, DcVicP 2
Hopkins, William H d1892 DcVicP, -2
Hopkins And Briele EncASM
Hopkinson, Anne E DcBrWA, DcVicP 2
Hopkinson, Anne Elizabeth DcWomA
Hopkinson, Charles d1962 WhoAmA 78N, -80N,
 -82N, -84N
Hopkinson, Charles 1869-1962 WhAmArt 85
Hopkinson, Francis 1737-1791 NewYHSD
Hopkinson, Glen Spencer 1946- WhoAmA 76, -78,
 -80, -82
Hopkinson, Harold 1918- IlBEAAW
Hopkinson, Harold I 1918- WhoAmA 76, -78, -80,
 -82, -84

Hopkinson, Robert DcBrECP
Hopkinson, Thomas 1905- MacBEP
Hopler, William C NewYHSD
Hopley, Charles DcVicP 2
Hopley, Edward W J 1816-1869 ArtsNiC
Hopley, Edward William John DcBrWA
Hopley, Edward William John 1816-1869 DcVicP, -2
Hopostad DcWomA
Hopp, George WhAmArt 85
Hoppe, E O 1878-1972 ConPhot
Hoppe, Emil Otto 1878-1972 ICPEnP, MacBEP
Hoppe, Erna DcWomA
Hoppe, Ernest O 1878- DcBrA 2
Hoppe, Hedwig DcWomA
Hoppe, Jenny DcWomA
Hoppe, Ketty DcWomA
Hoppe, Leslie F 1889- WhAmArt 85
Hoppe, Louis FolkA 86
Hoppenfeld, M AmArch 70
Hoppenhaupt DcWomA
Hoppenhaupt, Johann Christian d1785? OxDecA
Hoppenhaupt, Johann Michael 1709-1755? AntBDN G,
 OxDecA
Hopper, Annie 1904- FolkA 86
Hopper, Charles W DcVicP 2
Hopper, Cuthbert DcVicP 2
Hopper, D A, Jr. 1903- AmArch 70
Hopper, Edward 1882-1967 ArtsAmW 1, BnEnAmA,
 ConArt 77, -83, DcAmArt, DcCAA 71, -77,
 GrAmP, IlBEAAW, McGDA, OxArt, OxTwCA,
 PhDcTCA 77, WhAmArt 85, WhoAmA 78N,
 -80N, -82N, -84N, WorArt[port]
Hopper, F S AmArch 70
Hopper, Floyd D 1909- WhAmArt 85
Hopper, Frank J 1924- AmArt, WhoAmA 76, -78,
 -80, -82, -84
Hopper, Jo N d1968 WhoAmA 78N
Hopper, Jon d1968 WhoAmA 80N, -82N, -84N
Hopper, Josephine N d1968 WhAmArt 85
Hopper, Josephine Verstille 1883?-1968 DcWomA
Hopper, Justine WhAmArt 85
Hopper, Marianne Seward 1904- WhoAmA 76, -78,
 -80, -82, -84
Hopper, Pegge 1935- PrintW 83, -85
Hopper, Thomas 1776-1856 BiDBrA, DcD&D,
 MacEA
Hopperton, William d1853 BiDBrA
Hoppes, Lowell E 1913- WhoAmA 73, -76, -78, -80,
 -82, -84
Hoppin, Augustus 1828- ArtsNiC
Hoppin, Augustus 1828-1896 ArtsAmW 1, EarABI,
 EarABI SUP, IlBEAAW, NewYHSD ,
 WorECar
Hoppin, Courtland EarABI, EarABI SUP
Hoppin, Davis W 1771-1882 FolkA 86
Hoppin, Francis L V 1867-1941 MacEA
Hoppin, Francis V L 1867-1941 BiDAmAr
Hoppin, Helen I WhAmArt 85
Hoppin, Howard WhAmArt 85
Hoppin, Howard 1854-1940 BiDAmAr
Hoppin, Thomas B 1816- ArtsNiC
Hoppin, Thomas Frederick 1816-1872 NewYHSD
Hoppin, Tracy WhAmArt 85
Hoppner, John 1758-1810 DcBrECP, DcBrWA,
 McGDA, OxArt
Hoppner, Richard Belgrave 1786-1872 DcSeaP
Hopps, Charles NewYHSD
Hopps, David Vernon FolkA 86
Hopps, Nellie 1856-1956 DcWomA
Hopps, Walter WhoAmA 73, -76, -78, -80
Hoppus, Edward d1739 BiDBrA
Hopson, Henry DcBrECP
Hopson, William Fowler 1849-1935 WhAmArt 85
Hoptner, Richard 1921- AmArt, WhoAmA 76, -78,
 -80, -82, -84
Hopwell, Ruth Marjorie 1923- DcBrA 1
Hopwood, Henry Silkstone 1860-1914 DcBrA 1,
 DcBrWA, DcVicP 2
Hopwood, James 1752-1819 BkIE
Hopwood, Mrs. William NewYHSD
Horacek, Bohuslav 1933- DcCAr 81
Horacek, Rudolf 1915- DcCAr 81
Horack, Bertha M DcWomA
Horaku AntBDN L
Horan, J F AmArch 70
Horan, Steve 1940- PrintW 83, -85
Horch, David L 1956- MarqDCG 84
Horch, Louis L 1889-1979 WhoAmA 80N, -82N,
 -84N
Horchert, Joseph A 1874- WhAmArt 85
Hord, Donal d1966 WhoAmA 78N, -80N, -82N,
 -84N
Hord, Donal 1902- McGDA
Hord, Donal 1902-1966 IlBEAAW, WhAmArt 85
Hord, Jacob 1702-1758 FolkA 86
Hord, L T, Jr. AmArch 70
Horder, Margaret L'Anson IlsCB 1967
Horder, Margaret L'Anson 1911- IlsCB 1946
Horder, Nellie P 1885- ArtsAmW 1, DcWomA
Hordyk, Gerard 1899- WhAmArt 85
Hordyk, J G AmArch 70

Hore, Ethel DcWomA, WhAmArt 85
Hore, Jean DcWomA
Hore, Richard Peter Paul 1935- WhoArt 82, -84
Horeau, Hector 1801-1872 MacEA, McGDA
Horebout, Susanna 1503?-1545 DcWomA
Horeis, William 1945- ConPhot, ICPEnP A
Horeis, William Richard, Sr. 1945- WhoAmA 84
Horejc, Jaroslav 1886- IlDcG
Horelica, M C 1950- MarqDCG 84
Horenbolt, Susanna 1503?-1545 DcWomA
Horenbout, Susanna 1503?-1545 DcWomA
Horgan, Arthur J 1868-1912 BiDAmAr
Horgan, Jack 1943- MarqDCG 84
Horgan, Paul 1903- IlsCB 1744
Horgines, Merrouw 1846- DcWomA
Horgnies, Merrouw 1846- DcWomA
Horgos, William FolkA 86
Hori, Ichiro E 1879- WhAmArt 85
Horie, Mark Showph 1927- AmArch 70
Horiguchi, Sutemi 1895- ConArch, MacEA
Horii, H N AmArch 70
Horiot, Marceline DcWomA
Horiuchi, Masakazu 1911- PhDcTCA 77
Horiuchi, Paul 1906- DcCAA 71, -77, WhoAmA 73,
 -76, -78
Horky, Rosa DcWomA
Horlacher, Emma DcWomA
Horlbeck, E N AmArch 70
Horle, Angelika 1899-1923 DcWomA
Horle, Edith Louisa DcWomA, WhAmArt 85
Horley, Edward Francis 1901- AmArch 70
Horley, Ronald T 1904- DcBrA 1
Horlocker, Leta 1868-1951 DcWomA
Horlor, Edward C NewYHSD
Horlor, George W DcVicP, -2
Horlor, Henry P NewYHSD
Horlor, Joseph DcVicP, -2
Horman, Colin Drew 1945- MarqDCG 84
Horman-Fisher, Maud DcVicP 2
Hormann, Sophie Fessy DcWomA
Hormuth-Kallmorgen, Margarethe 1858-1916
 DcWomA
Horn, A NewYHSD
Horn, Axel 1913- WhAmArt 85
Horn, Benjamin Albert 1887- AmArch 70
Horn, Bruce 1946- WhoAmA 78, -80, -82, -84
Horn, Bruce William 1946- WhoAmA 76
Horn, Carol 1936- WorFshn
Horn, D H AmArch 70
Horn, Daniel Stephen FolkA 86
Horn, Frank Walton 1918- AmArch 70
Horn, Frederick Angus WhoArt 80N
Horn, Gerald DcCAr 81
Horn, Henry J NewYHSD
Horn, Howard F AmArch 70
Horn, Ivy DcWomA
Horn, J B DcVicP 2
Horn, John FolkA 86
Horn, Karl H MarqDCG 84
Horn, Maurice WorECar A
Horn, Milton 1901- WhAmArt 85
Horn, Milton 1906- WhoAmA 73, -76, -78, -80, -82,
 -84
Horn, Pierre WorECar A
Horn, R BiDBrA
Horn, R A AmArch 70
Horn, Rebecca 1944- ConArt 77, -83
Horn, Richard Campbell 1945- MarqDCG 84
Horn, Robert F WhAmArt 85
Horn, Robert Lawrence 1939- AmArch 70
Horn, Samuel FolkA 86
Horn, Stuart Alan 1945- WhoAmA 76, -78, -80, -82
Horn, Trader IlBEAAW
Horn, William BiDBrA
Horn-Zippelius, Dora 1876- DcWomA
Hornaday, J K WhAmArt 85
Hornaday, Richard Hoyt 1927- WhoAmA 76, -78,
 -80, -82, -84
Hornaday, William T FolkA 86
Hornak, Ian 1944- PrintW 83, -85
Hornak, Ian John 1944- WhoAmA 78, -80, -82, -84
Hornak, James Anthony 1932- AmArch 70
Hornbach, Charles Rittman 1932- AmArch 70
Hornbeck, James Sylvanus 1908- AmArch 70
Hornbein, Victor 1913- AmArch 70
Hornblower, Joseph C 1848-1908 BiDAmAr
Hornbostel, C AmArch 70
Hornbostel, Henry 1867-1961 MacEA
Hornbreaker, Henry FolkA 86
Hornbrook, A DcBrWA
Hornbrook, T L 1780-1850 DcVicP, -2
Hornbrook, Thomas Lyde 1780-1850 DcSeaP
Hornbuckle, Robert Garrett 1956- MarqDCG 84
Hornby, Mrs. DcWomA
Hornby, Gaulter CabMA
Hornby, Lester George 1882-1956 GrAmP,
 WhAmArt 85
Hornby, Squire T NewYHSD
Hornby, William CabMA
Hornby And Turner CabMA
Horncastle, Jane A DcVicP 2, DcWomA

Howard, *WhAmArt 85*
Howard, Frances *DcBrWA*
Howard, Francis 1874-1954 *DcBrA 1, DcBrBI, DcVicP 2*
Howard, Frank 1805-1866 *DcVicP 2*
Howard, Freeman *FolkA 86*
Howard, George 1843-1911 *DcVicP 2*
Howard, George, Earl Of Carlisle 1843-1911 *DcBrBI, DcVicP*
Howard, George Edwin, Jr. 1904- *AmArch 70*
Howard, George James, Earl Of Carlisle 1843-1911 *DcBrA 1*
Howard, H S, Jr. *AmArch 70*
Howard, H T *DcVicP 2*
Howard, H Wickham *DcVicP 2*
Howard, Harold C *WhAmArt 85*
Howard, Henry *DcVicP 2*
Howard, Henry 1769-1847 *DcBrECP, DcVicP 2*
Howard, Henry 1818-1884 *MacEA*
Howard, Henry Mowbray 1873- *WhAmArt 85*
Howard, Henry R d1895 *DcBrBI*
Howard, Hiram *EncASM*
Howard, Hugh 1675-1737 *BkIE*
Howard, Hugh 1676?-1738 *DcBrECP*
Howard, Hugh H 1860-1927 *WhAmArt 85*
Howard, Humbert L 1915- *AfroAA, WhoAmA 73, -76, -78, -80, -82, -84*
Howard, Ian George 1952- *WhoArt 84*
Howard, Isabella *DcWomA*
Howard, J *DcVicP 2, FolkA 86*
Howard, James Campbell 1906- *DcBrA 1, WhoArt 80, -82, -84*
Howard, James Henry 1949- *MarqDCG 84*
Howard, Jane B *WhAmArt 85*
Howard, Jemima Frances d1877 *DcWomA*
Howard, Jesse 1885-1983 *FolkA 86*
Howard, John 1912- *AfroAA*
Howard, John G 1864-1931 *BiDAmAr*
Howard, John Galen 1864-1931 *ArtsAmW 3, MacEA, McGDA*
Howard, John L 1902- *WhAmArt 85*
Howard, John Randolph 1915- *AmArch 70*
Howard, John Rowland Escott *DcBrA 1*
Howard, John William 1927- *MarqDCG 84*
Howard, Jonathan *FolkA 86*
Howard, Joseph *NewYHSD*
Howard, Joseph 1738-1810 *CabMA*
Howard, Josephine *DcWomA, WhAmArt 85*
Howard, Josiah W *NewYHSD*
Howard, Judson *NewYHSD*
Howard, Justin H *EarABI, EarABI SUP, NewYHSD*
Howard, K *DcVicP 2*
Howard, Ken 1932- *DcCAr 81, WhoArt 84*
Howard, Kenneth *AfroAA*
Howard, Kenneth 1932- *WhoArt 80, -82*
Howard, L W *AmArch 70*
Howard, Len R 1891- *WhAmArt 85, WhoAmA 73*
Howard, Lewis Edward 1909- *AmArch 70*
Howard, Lillian A *ArtsAmW 3*
Howard, Linda 1934- *DcCAr 81, PrintW 85, WhoAmA 78, -80, -82, -84*
Howard, Lizzie 1852- *DcWomA, WhAmArt 85*
Howard, Loretta 1904- *WhAmArt 85*
Howard, Lucile *DcWomA*
Howard, Lyle Price 1905- *AmArch 70*
Howard, Margaret Maitland 1898- *DcBrA 1, DcWomA, WhoArt 80, -82, -84*
Howard, Marion *DcVicP 2*
Howard, Marion 1883- *DcWomA, WhAmArt 85*
Howard, Marion 1886- *DcWomA, WhAmArt 85*
Howard, Mary *DcWomA*
Howard, Mary, Viscountess Andover 1716-1803 *DcBrWA*
Howard, Mary Ann Eliza 1822-1874 *FolkA 86*
Howard, Mary R Bradbury 1864- *ArtsAmW 2, DcWomA, WhAmArt 85*
Howard, Nellie *DcWomA*
Howard, Nellie Hopps *ArtsAmW 2*
Howard, Norman Douglas 1899-1955 *DcBrA 1*
Howard, O F 1888-1942 *WhAmArt 85*
Howard, Prentis Stafford 1931- *AmArch 70*
Howard, R E, Jr. *AmArch 70*
Howard, R G *AmArch 70*
Howard, Rebecca F *FolkA 86*
Howard, Rebecca F 1839- *DcWomA, NewYHSD*
Howard, Richard Foster 1902- *WhoAmA 73, -76, -78, -80*
Howard, Rob *IlsBYP*
Howard, Robert A 1922- *DcCAA 71, -77, WhoAmA 73, -76, -78, -80, -82, -84*
Howard, Mrs. Robert B *WhAmArt 85*
Howard, Robert Boardman 1896- *ArtsAmW 1, IIBEAAW, WhAmArt 85, WhoAmA 73, -76, -78, -80, -82*
Howard, Robert Boardman 1896-1983 *WhoAmA 84N*
Howard, Rose *ArtsAmW 3*
Howard, Rosine *ArtsAmW 3*
Howard, Ross H, Jr. 1935- *AmArch 70*
Howard, Sallie *DcWomA, WhAmArt 85*

Howard, Sarah T *DcWomA*
Howard, Seth *NewYHSD*
Howard, Stanley And Thomas *AntBDN N*
Howard, Stephen C *EncASM*
Howard, Stephen Colgate 1912- *WhAmArt 85*
Howard, Thomas *CabMA, FolkA 86*
Howard, Thomas, Earl Of Suffolk 1721-1783 *DcBrWA*
Howard, Vernon 1840-1902 *DcBrWA, DcVicP 2*
Howard, W C *AmArch 70*
Howard, W P, Jr. *AmArch 70*
Howard, Wallace E 1882- *WhAmArt 85*
Howard, William *DcVicP 2, FolkA 86*
Howard, William L 1938- *MarqDCG 84*
Howard, William Lester, Jr. 1923- *AmArch 70*
Howard And Cockshaw *EncASM*
Howard And Scherrieble *EncASM*
Howard-Johnson, Peter 1930- *AmArch 70*
Howard-Jones, Ray 1903- *DcBrA 1, WhoArt 80, -82, -84*
Howarth, Albany E 1872-1936 *DcBrA 1, DcVicP 2*
Howarth, Charles Wilfred 1893- *DcBrA 1, WhoArt 80, -82, -84*
Howarth, Constance M 1927- *WhoArt 80, -82, -84*
Howarth, F A *DcVicP 2*
Howarth, F M 1865-1908 *WhAmArt 85*
Howarth, F M 1870?-1908 *WorECom*
Howarth, Shirley Reiff 1944- *WhoAmA 78, -80, -82, -84*
Howat, John Keith 1937- *WhoAmA 73, -76, -78, -80, -82, -84*
Howbert, Alice *DcWomA*
Howd, Michael *ClaDrA*
Howd, Whitehead *CabMA*
Howdell, Thomas *NewYHSD*
Howden, D E *AmArch 70*
Howden, J L *AmArch 70*
Howe, Allen *WhAmArt 85*
Howe, Arthur Virgil d1925 *WhAmArt 85*
Howe, B A *DcVicP 2*
Howe, B D *NewYHSD*
Howe, C O, Jr. *AmArch 70*
Howe, Charles Kingsley d1916 *DcBrA 2*
Howe, F N *DcVicP 2*
Howe, Frank M 1849-1909 *BiDAmAr*
Howe, George *WhAmArt 85*
Howe, George 1886-1955 *ConArch, EncMA, MacEA, WhoArch*
Howe, George 1896-1941 *IlrAm D, -1880*
Howe, George B 1886-1955 *McGDA*
Howe, Gertrude Herrick 1902- *IlsCB 1946, WhAmArt 85*
Howe, Graham 1950- *ConPhot, DcCAr 81, ICPEnP A, MacBEP*
Howe, H *DcVicP 2*
Howe, H David, Jr. 1933- *AmArch 70*
Howe, Henry 1816-1893 *EarABI, EarABI SUP, NewYHSD*
Howe, J Raymond 1879- *WhAmArt 85*
Howe, J Theodore 1870- *WhAmArt 85*
Howe, James B *CabMA*
Howe, John *CabMA*
Howe, John Henry 1913- *AmArch 70*
Howe, Jonas Holland 1821-1898 *NewYHSD , WhAmArt 85*
Howe, Joseph C *NewYHSD*
Howe, Joseph P *NewYHSD*
Howe, Katharine M d1957 *WhAmArt 85*
Howe, Katherine L Mallet d1957 *WhoAmA 84N*
Howe, Katherine L Mallett d1957 *WhoAmA 80N, -82N*
Howe, Loftus d1760 *DcBrECP*
Howe, Louise *FolkA 86*
Howe, Nelson S 1935- *WhoAmA 73, -76, -78, -80, -82, -84*
Howe, Orville *NewYHSD*
Howe, Oscar 1915- *IIBEAAW, WhoAmA 73, -76, -78, -80, -82, -84*
Howe, Robert D 1957- *MarqDCG 84*
Howe, Robert Ellithorpe 1918- *AmArch 70*
Howe, Samuel *WhAmArt 85*
Howe, Spencer Kenneth 1955- *MarqDCG 84*
Howe, Susan Rosalind 1873- *DcWomA, WhAmArt 85*
Howe, Thomas Carr 1904- *WhoAmA 73, -76, -78, -80, -82*
Howe, Wallis E *WhAmArt 85*
Howe, William H 1846-1929 *WhAmArt 85*
Howe, William Henry 1846-1929 *ArtsEM*
Howe, Winifred 1880- *DcBrA 1, DcWomA*
Howe, Zadoc *EarABI, NewYHSD*
Howe And Alexander *CabMA*
Howell, A *AmArch 70*
Howell, Ada M *DcWomA*
Howell, Ada Mary *DcBrA 1*
Howell, Adelaide C *DcWomA*
Howell, Anne Huntington *DcWomA*
Howell, Carl E 1879-1930 *BiDAmAr*
Howell, Catherine M 1892- *DcWomA, WhAmArt 85*
Howell, Charles *WhAmArt 85*
Howell, Charles A *DcBrBI*
Howell, Claude *OfPGCP 86*

Howell, Claude Flynn 1915- *WhAmArt 85, WhoAmA 73, -76, -78, -80, -82, -84*
Howell, Constance E *DcVicP 2, DcWomA*
Howell, Douglass 1906- *WhoAmA 73, -76, -78, -80, -82, -84*
Howell, E Hilton *DcWomA*
Howell, Elias L *FolkA 86*
Howell, Elizabeth Ann 1932- *WhoAmA 73, -76, -78, -80, -82, -84*
Howell, Eugenie James 1883- *ArtsAmW 1*
Howell, F D, III *AmArch 70*
Howell, Felicie 1897-1968 *WhAmArt 85*
Howell, Felicie Waldo 1897-1968 *DcWomA*
Howell, Frank 1937- *WhoAmA 73, -76, -78, -80*
Howell, H W *AmArch 70*
Howell, Hannah Johnson 1905- *WhoAmA 73, -76, -78, -80, -82, -84*
Howell, Helen *DcWomA, WhAmArt 85*
Howell, J B *EarABI, NewYHSD*
Howell, James 1787?-1866 *BiDBrA*
Howell, James Harold 1937- *AmArch 70*
Howell, James M 1934- *AmArch 70*
Howell, James R 1929- *AmArch 70*
Howell, Joseph B *EarABI SUP, NewYHSD*
Howell, Josephine C *WhAmArt 85*
Howell, Killick And Partridge *EncMA*
Howell, Lucien *WhAmArt 85*
Howell, M D *AmArch 70*
Howell, Marie W 1931- *WhoAmA 73, -76, -78, -80*
Howell, P *NewYHSD*
Howell, Raymond 1927- *AfroAA, WhoAmA 73, -76, -78, -80*
Howell, Samuel *DcVicP 2*
Howell, Sophia H M *DcWomA*
Howell, Sydney *DcVicP 2*
Howell, Thomas E 1918- *AmArch 70*
Howell, W G *DcD&D*
Howell, William d1717 *CabMA*
Howell, William Calvin 1927- *AmArch 70*
Howell, William G 1922-1974 *ConArch*
Howell, William Gough *EncMA*
Howell, William L 1942- *AfroAA*
Howell & James *DcNiCA*
Howell Killick Partridge And Amis *ConArch, DcD&D*
Howells, Alice I d1938? *WhAmArt 85*
Howells, Alice Imogen d1937? *DcWomA*
Howells, Elinor Gertrude *DcWomA*
Howells, Gertrude Whitman 1865-1938? *WhAmArt 85*
Howells, Howard *DcVicP 2*
Howells, Ilka d1942 *WhAmArt 85*
Howells, J M *WhAmArt 85*
Howells, John Mead 1868-1959 *MacEA, McGDA, WhoArch*
Howells, Leonard T *DcVicP 2*
Howells, Mildred 1872- *DcWomA, WhAmArt 85*
Howells, O D *AmArch 70*
Howells, T C F *DcVicP 2*
Howells, William Dean 1837-1919 *WhAmArt 85*
Howerton, Penelope *DcWomA*
Howery, F A *AmArch 70*
Howes, Miss *DcWomA*
Howes, Alfred Loomis 1906- *WhAmArt 85*
Howes, Edgar Allan 1888- *DcBrA 1*
Howes, Edith M *DcWomA*
Howes, Edith M W *WhAmArt 85*
Howes, Edward Townsend *WhAmArt 85*
Howes, F *DcVicP 2*
Howes, John *DcBrECP*
Howes, Samuel P *NewYHSD*
Howes, T *DcVicP 2*
Howet, Marie 1897- *DcWomA*
Howett, John 1926- *WhoAmA 73, -76, -78, -80, -82, -84*
Howey, John R 1932- *AmArch 70*
Howey, John William 1873-1938 *DcBrA 1, DcVicP 2*
Howey, Robert L 1900- *DcBrA 1*
Howgate, William Arthur *DcVicP 2*
Howie, Robert Langford 1933- *WorECar*
Howitt, Anna Mary *DcVicP 2*
Howitt, Anna Mary 1824-1884 *DcWomA*
Howitt, John Newton 1885-1958 *WhAmArt 85, WhoAmA 80N, -82N, -84N*
Howitt, Samuel 1756-1822 *DcBrBI, DcBrWA*
Howitt, William Samuel 1765-1822 *ClaDrA*
Howk, Carleton Reynolds 1942- *MarqDCG 84*
Howland, Alfred C 1838- *ArtsNiC*
Howland, Alfred Cornelius 1838-1909 *ArtsAmW 2, EarABI, NewYHSD, WhAmArt 85*
Howland, Alfred R *NewYHSD*
Howland, Allen S *WhAmArt 85*
Howland, Anna Goodhart *WhAmArt 85*
Howland, Anna Goodhart 1871- *DcWomA*
Howland, B F *NewYHSD*
Howland, Charity *DcWomA, FolkA 86, NewYHSD*
Howland, E D *FolkA 86*
Howland, Edith 1949 *WhAmArt 85, WhoAmA 78N, -80N, -82N, -84N*
Howland, Edith 1863-1949 *DcWomA*
Howland, Edwin A d1876 *BiDAmAr*
Howland, Elizabeth H *WhAmArt 85*

Howland, Frank *NewYHSD*
Howland, French *NewYHSD*
Howland, Garth d1950 *WhoAmA 78N, –80N, –82N, –84N*
Howland, Garth 1887-1950 *WhAmArt 85*
Howland, George 1865-1928 *WhAmArt 85*
Howland, Georgiana *DcWomA, WhAmArt 85*
Howland, Isabella 1895- *WhAmArt 85*
Howland, Isabella 1895-1974 *DcWomA*
Howland, James *NewYHSD*
Howland, John *FolkA 86*
Howland, John Dare 1843-1914 *ArtsAmW 1, IlBEAAW, WhAmArt 85*
Howland, Joseph T *NewYHSD*
Howland, Lucinda *FolkA 86*
Howland, M C *AmArch 70*
Howland, Richard Hubbard 1910- *WhoAmA 73, –76, –78, –80, –82, –84*
Howland, Richard LeVan 1912- *AmArch 70*
Howland, Samuel *AntBDN Q*
Howland, William *NewYHSD*
Howland, William Chester 1927- *AmArch 70*
Howle, Jim *OfPGCP 86*
Howlett, Bartholomew 1767-1827 *DcBrWA*
Howlett, Carolyn Svrluga 1914- *WhAmArt 85, WhoAmA 73, –76, –78, –80, –82, –84*
Howlett, Dick *FolkA 86*
Howlett, Rosa *DcBrA 2*
Howley, Harriet Elizabeth d1860 *DcBrWA*
Howorth, George 1791?- *NewYHSD*
Howorth, John 1836?- *NewYHSD*
Howorth, Louise *WhAmArt 85*
Howorth, Nancy 1912- *WhoArt 80, –82, –84*
Howorth, Raymond 1914- *DcBrA 1*
Hows, John A 1832-1874 *ArtsNiC*
Hows, John Augustus 1832-1874 *EarABI, EarABI SUP, NewYHSD*
Howse, Charles *AntBDN D*
Howse, F *DcVicP 2*
Howse, Frederick D *DcVicP 2*
Howse, George d1860 *DcBrWA, DcVicP 2*
Howse, Henrietta Rose Chicheliana 1892- *WhoArt 80*
Howse, Henrietta Rose Chichelians *WhoArt 82N*
Howse, Kate *DcVicP 2*
Howson, Bernard *FolkA 86*
Howson, Cherry *WhoArt 82N*
Howson, Cherry 1912- *WhoArt 80*
Howson, John *FolkA 86*
Howson, Juliet *DcWomA*
Howson, Juliet H *DcWomA*
Howze, Albert Howell 1901- *AmArch 70*
Howze, James Dean 1930- *WhoAmA 73, –76, –78, –80, –82, –84*
Hoxie, E E *WhAmArt 85*
Hoxie, George Richmond 1907- *WhAmArt 85*
Hoxie, J C *BiDAmAr*
Hoxie, Jeffe Gene 1932- *AmArch 70*
Hoxie, Stansbury *NewYHSD*
Hoxie, Vinnie *DcWomA*
Hoxie, Vinnie Ream 1847-1914 *DcAmArt, IlBEAAW, WhAmArt 85, WomArt*
Hoy, Anne Tawes 1942- *WhoAmA 78, –80, –82*
Hoy, David *FolkA 86*
Hoyer, Arthur Vernon 1909- *AmArch 70*
Hoyer, Cornelius 1741-1804 *AntBDN J*
Hoyer, Edward *DcSeaP, DcVicP 2*
Hoyer, Ernest T H *WhAmArt 85*
Hoyer, F M 1863- *ArtsAmW 3*
Hoyer, Frans *WhAmArt 85*
Hoyer, Peter *DcSeaP*
Hoyer, W N *AmArch 70*
Hoyer VanBrakel, Louiza Aletta 1805- *DcWomA*
Hoyland, Hannah *DcWomA*
Hoyland, Henry G 1894-1948 *DcBrA 1*
Hoyland, John *AntBDN N*
Hoyland, John 1934- *ConArt 77, –83, ConBrA 79[port], DcCAr 81, OxTwCA, PhDcTCA 77, PrintW 83, –85*
Hoyland, Rosemary Jean 1929- *IlsCB 1946*
Hoyland, Thomas *AntBDN Q*
Hoyle, A E 1851-1931 *WhAmArt 85*
Hoyle, Annie Elizabeth 1851-1931 *DcWomA*
Hoyle, Ethel G 1883- *WhAmArt 85*
Hoyle, Raphael 1804-1838 *EarABI SUP, NewYHSD*
Hoyle, Walter 1922- *DcBrA 2, WhoArt 80, –82, –84*
Hoynck, C VanPapendrecht 1858- *DcBrBI*
Hoyningen-Huene, George 1900-1968 *ConPhot, ICPEnP, MacBEP*
Hoyningen-Huene, Baron George 1900-1968 *WorFshn*
Hoyoll, Philipp 1816- *DcVicP, –2*
Hoyrup, Paul 1909- *WhoGrA 62*
Hoyt, A G *NewYHSD*
Hoyt, Alice P *WhAmArt 85*
Hoyt, Andrew J 1847-1919 *WhAmArt 85*
Hoyt, C D *AmArch 70*
Hoyt, Dorothy 1909- *WhoAmA 73, –76, –78, –80, –82, –84*
Hoyt, E C *DcWomA*
Hoyt, Mrs. E C *NewYHSD*
Hoyt, Edith 1890?-1971 *DcWomA*

Hoyt, Edith 1894- *WhAmArt 85*
Hoyt, Edward A 1868-1936 *BiDAmAr*
Hoyt, Ellen 1933- *WhoAmA 84*
Hoyt, Esther *FolkA 86*
Hoyt, Fred Kitson 1910- *WhAmArt 85*
Hoyt, Hattie *ArtsEM, DcWomA*
Hoyt, Henry E *FolkA 86*
Hoyt, Henry E 1833?-1906 *NewYHSD , WhAmArt 85*
Hoyt, Henry M 1887-1920 *WhAmArt 85*
Hoyt, Mrs. Herbert H *ArtsEM, DcWomA*
Hoyt, Hettie *WhAmArt 85*
Hoyt, Margaret 1885-1943 *WhAmArt 85*
Hoyt, Margaret Howard Yeaton 1885- *DcWomA*
Hoyt, Mary Ann *FolkA 86*
Hoyt, Mary Huntoon 1896- *WhAmArt 85*
Hoyt, Merrill H 1881-1933 *BiDAmAr*
Hoyt, Purdy B 1829?- *NewYHSD*
Hoyt, Robert Ingle 1913- *AmArch 70*
Hoyt, Thaddeus *CabMA*
Hoyt, Thomas *FolkA 86, NewYHSD*
Hoyt, Thomas R, Jr. *FolkA 86, NewYHSD*
Hoyt, Vivian Church 1880- *DcWomA, WhAmArt 85*
Hoyt, Whitney F 1910- *WhoAmA 73, –76, –78, –80*
Hoyt, Whitney F 1910-1980 *WhoAmA 82N, –84N*
Hoyt, Whitney Ford 1910- *WhAmArt 85*
Hoyt, William H *NewYHSD*
Hoyt, William P *ArtsEM*
Hoyt, William S *NewYHSD*
Hoyt Babcock And Appleton *CabMA*
Hoyte, Lucy *DcVicP 2*
Hoyton, Edward Bouverie *WhoArt 80, –82, –84*
Hoyton, Inez Estella *ClaDrA, WhoArt 80, –82, –84*
Hozan *AntBDN L*
Hrdlicka, Alfred 1928- *ConArt 77, –83, OxTwCA, PhDcTCA 77*
Hrdlicka, Alfred 1929- *DcCAr 81*
Hrdy, Olinka *WhAmArt 85*
Hrdy, Olinka 1902- *WhoAmA 76, –78, –80*
Hritz, George Peter 1897- *AmArch 70*
Hrncyrz, Emma *DcWomA*
Hron, Imrich 1944- *DcCAr 81*
Hrovatic, Stane 1947- *DcCAr 81*
Hruska, George 1892- *WhAmArt 85*
Hryniewicz, Antonina *DcWomA*
Hryniewiecki, Jerzy 1908- *MacEA*
Hsi, Kang 1746-1816? *McGDA*
Hsi, P H *AmArch 70*
Hsi-An *McGDA*
Hsia, Ch'ang 1388-1470 *McGDA*
Hsia, Kuei *McGDA*
Hsiang, Mo-Lin *McGDA*
Hsiang, Sheng-Mo 1597-1658 *McGDA*
Hsiang, Yuan-Pien 1525-1590 *McGDA*
Hsiao, Chin 1935- *ConArt 77, WhoAmA 73, –76, –78, –80, –82, –84*
Hsiao, Mrs. Sidney C T *WhAmArt 85*
Hsiao, Sun Chien 1925- *AmArch 70*
Hsiao, Yun-Tsung 1596-1673 *McGDA*
Hsiao-T'un *McGDA*
Hsieh, Ho *McGDA*
Hsieh, T K *AmArch 70*
Hsing, Tz'u-Ching *DcWomA*
Hsing Teh-Hsin 1928- *OxTwCA*
Hsiung, Robert Yuan Chun 1935- *AmArch 70*
Hsu, Chung-Ming 1914- *WhoArt 80, –82, –84*
Hsu, Hsi d975 *McGDA*
Hsu, Ju-Tung 1945- *MarqDCG 84*
Hsu, Mei-Ling *MarqDCG 84*
Hsu, Pei-Hung 1896-1953 *McGDA*
Hsu, Tao-Ning *McGDA*
Hsu, Wei 1521-1593 *McGDA*
Hsu, Yu-Sheng 1938- *MarqDCG 84*
Hsuan-Te *McGDA*
Hsueh, T'ao *DcWomA*
Hsueh, Wu 1564?-1637 *DcWomA*
Hsueh-Ch'uang *McGDA*
Hu, Arthur Ta-Chuan 1958- *MarqDCG 84*
Hu, Cheng-Yen *McGDA*
Hu, Chi Chung 1927- *AmArt, WhoAmA 80, –82, –84*
Hu, Gilman Kee Mun 1930- *AmArch 70*
Hu, Juana DeLa *DcWomA*
Hu, Mary Lee *DcCAr 81*
Hu, Mary Lee 1943- *WhoAmA 78, –80, –82, –84*
Hu, Sandria 1946- *DcCAr 81*
Hua, Yen 1682-1765 *McGDA*
Huang, Chin 1942- *MarqDCG 84*
Huang, Ch'uan *McGDA*
Huang, Chun-Pi 1898- *WhoArt 84*
Huang, Kung-Wang 1269-1354 *McGDA, OxArt*
Huang, P'ing-Hung 1864-1955 *McGDA*
Huang, Sung-Cheng 1944- *MarqDCG 84*
Huang, Xiang 1903- *ICPEnP A*
Huard, Mademoiselle *DcWomA*
Huard, Charles 1875-1965 *WorECar*
Huard, Frans *DcVicP 2*
Huard, L d1874 *DcBrBI*
Huard, Louis *DcVicP 2*
Huard, Pierre d1857 *ClaDrA*
Huardel-Bly, George 1872- *ClaDrA*

Huarte DeMendicoa, Mariana *DcWomA*
Hubacek, William *WhAmArt 85*
Hubacek, William 1864-1958 *ArtsAmW 2*
Hubach, Carl Clark 1900- *AmArch 70*
Hubacher, Carl 1897- *MacEA*
Hubacher, Hermann 1885- *OxTwCA*
Huband, Henry Thomas 1902- *AmArch 70*
Hubard, Henri *DcVicP 2*
Hubard, William James *AntBDN O*
Hubard, William James 1807-1862 *BnEnAmA, DcAmArt, FolkA 86, NewYHSD*
Hubault, J *DcWomA*
Hubaux, Andre A J 1928- *MarqDCG 84*
Hubban, E A *DcWomA, FolkA 86*
Hubban, Miss E A *NewYHSD*
Hubbard *CabMA, FolkA 86*
Hubbard, Alice Cooper *WhAmArt 85*
Hubbard, B *DcVicP 2*
Hubbard, Bert C d1935 *BiDAmAr*
Hubbard, Bess Bigham 1896- *DcWomA, WhAmArt 85*
Hubbard, Bess Bingham 1896- *ArtsAmW 2*
Hubbard, C D 1876-1951 *WhAmArt 85*
Hubbard, Charles 1801-1876 *NewYHSD*
Hubbard, Charles Allen 1931- *AmArch 70*
Hubbard, Charles D d1951 *WhoAmA 78N, –80N, –82N, –84N*
Hubbard, Charles Joseph 1922- *AmArch 70*
Hubbard, David *NewYHSD*
Hubbard, Earl Wade 1924- *WhoAmA 73*
Hubbard, Elbert 1856-1915 *DcNiCA, MacEA*
Hubbard, Enoch *FolkA 86*
Hubbard, Eric Hesketh 1892-1957 *ClaDrA, DcBrA 1*
Hubbard, Florence Tuttle 1892- *DcWomA, WhAmArt 85*
Hubbard, Frank L *WhAmArt 85*
Hubbard, Frank McKinney 1868- *WhAmArt 85*
Hubbard, G A *DcVicP 2*
Hubbard, Helen *WhAmArt 85*
Hubbard, J *DcVicP 2*
Hubbard, Jean Paul *AfroAA*
Hubbard, John *FolkA 86*
Hubbard, John 1931- *ConArt 77, PrintW 83, –85, WhoAmA 78, –80, –82, –84*
Hubbard, John David 1924- *AmArch 70*
Hubbard, John T d1859 *ArtsEM*
Hubbard, Julia A *ArtsEM, DcWomA*
Hubbard, L M B *WhAmArt 85*
Hubbard, Marguerite *DcWomA, WhAmArt 85*
Hubbard, Marguerite 1894- *ArtsAmW 2*
Hubbard, Maria Cadman 1769- *FolkA 86*
Hubbard, Mary W 1871- *WhAmArt 85*
Hubbard, Mary Wilson 1871- *DcWomA*
Hubbard, Miles *CabMA*
Hubbard, Paul *FolkA 86*
Hubbard, Platt 1889-1946 *WhAmArt 85*
Hubbard, Richard *CabMA*
Hubbard, Richard A, II 1926- *MarqDCG 84*
Hubbard, Richard W *ArtsNiC*
Hubbard, Richard William 1816-1888 *NewYHSD*
Hubbard, Robert 1928- *WhoAmA 73, –76, –78, –80*
Hubbard, Robert Hamilton 1916- *WhoAmA 73, –76, –78, –80, –82, –84, WhoArt 80, –82, –84*
Hubbard, Samuel *FolkA 86*
Hubbard, Sidnee *WhAmArt 85*
Hubbard, T D *AmArch 70*
Hubbard, Tryphena Martague 1757- *FolkA 86*
Hubbard, W *DcVicP 2*
Hubbard, W W *AmArch 70*
Hubbard, Walter W 1893- *WhAmArt 85*
Hubbard, Whitney Myron 1875- *WhAmArt 85*
Hubbard, William J *NewYHSD*
Hubbard Girls *FolkA 86*
Hubbart, Samuel *FolkA 86*
Hubbell, B S, Jr. *AmArch 70*
Hubbell, Charles E *WhAmArt 85*
Hubbell, Henry Salem d1949 *WhoAmA 78N, –80N, –82N, –84N*
Hubbell, Henry Salem 1870-1949 *ArtsAmW 3, WhAmArt 85*
Hubbell, John *CabMA*
Hubbell, Katherine *WhAmArt 85*
Hubbell, Paul 1934- *MarqDCG 84*
Hubbell, Rose Strong *DcWomA, WhAmArt 85*
Hubbert, E L *DcWomA*
Hubbert, Lily Saxon 1878- *ArtsAmW 3*
Hubbold, Roger Jeffrey 1946- *MarqDCG 84*
Hubbs, W *FolkA 86*
Hubel, Robert W 1891-1944 *BiDAmAr*
Hubener, Georg *FolkA 86*
Hubenthal, James Henry 1934- *AmArch 70*
Hubenthal, Karl 1917- *WorECar*
Hubenthal, Karl Samuel 1917- *WhoAmA 73, –76, –78, –80, –82, –84*
Huber *NewYHSD*
Huber, Albert John 1920- *AmArch 70*
Huber, Barry Edward 1941- *MarqDCG 84*
Huber, Conrad *NewYHSD*
Huber, Damus *FolkA 86*
Huber, Gerald Arnold 1927- *AmArch 70*
Huber, H R 1936- *DcCAr 81*

Huber, Helen Ruth 1902- *WhAmArt 85*
Huber, Hermann 1888- *McGDA*
Huber, J *DcBrECP*
Huber, Jean Daniel 1754-1845 *ClaDrA*
Huber, Johann Rudolphe 1668-1748 *ClaDrA*
Huber, John 1807?- *FolkA 86*
Huber, Julius H 1852- *BiDAmAr*
Huber, K *EarABI*
Huber, Leo 1886- *WhAmArt 85*
Huber, Leon Charles 1858-1928 *ClaDrA*
Huber, Mathilde *DcWomA*
Huber, Max 1919- *ConDes*, *WhoGrA 62, -82[port]*
Huber, Mina *DcWomA*
Huber, Norman R 1947- *MarqDCG 84*
Huber, Paul E 1939- *MarqDCG 84*
Huber, Russell B 1926- *AmArch 70*
Huber, Stephan 1952- *DcCAr 81*
Huber, Therese 1864?-1911 *DcWomA*
Huber, Thomas F d1919 *BiDAmAr*
Huber, Timo 1944- *DcCAr 81*
Huber, Wolf 1490?-1553 *McGDA*, *OxArt*
Huber, Wolfgang 1490-1553 *McGDA*
Huberland, Joshua 1905- *AmArch 70*
Huberman, Jeffrey Allen 1942- *AmArch 70*
Hubert *NewYHSD*
Hubert, Saint d727 *McGDA*
Hubert, Anne M *WhoAmA 80, -82, -84*
Hubert, Arnold H *MarqDCG 84*
Hubert, August *WhAmArt 85*
Hubert, Auguste 1755-1798 *MacEA*
Hubert, Borys 1950- *DcCAr 81*
Hubert, Charles *NewYHSD*
Hubert, Edgar F *WhoAmA 80, -82, -84*
Hubert, Elisa *DcWomA*
Hubert, Ephraim *AmArch 70*
Hubert, Joseph *NewYHSD*
Hubert, Philip G 1830-1911 *BiDAmAr*
Hubert, Pomponne *DcWomA*
Hubert, R J *AmArch 70*
Hubert, Samuel Morton *BiDBrA*
Hubert, Sophie *DcWomA*
Hubert, Stephanie Louise *DcWomA*
Hubert, V *DcVicP 2*
Hubert-Lamalle, Jane 1868- *DcWomA*
Hubert-Robert, Marius 1885- *WhAmArt 85*
Huberti, Eduard Jules Joseph 1818-1880 *ClaDrA*
Hubiak, Metro 1926- *AmArch 70*
Hubinon, Victor 1924- *WorECom*
Hubler, Julius 1919- *WhoAmA 82, -84*
Hubley, Faith Elliot 1924- *ConGrA 1*
Hubley, John 1914-1977 *WorECar*
Hublier, Charlotte 1817- *DcWomA*
Hubmann, Hanns 1910- *ConPhot*
Hubner, Emma Gustavovna 1862- *DcWomA*
Hubner, Karl Wilhelm 1814-1879 *ArtsNiC*
Hubner, Louis d1769 *DcBrECP*
Hubner, Rudolf-Jules-Benno 1806-1882 *ArtsNiC*
Hubon, Henry 1790-1864 *CabMA*
Hubrecht, Amalda Bramine Louise 1855-1913 *DcWomA*
Hubrichs, Miss *DcBrECP*
Hubsch, Franzisca 1857- *DcWomA*
Hubsch, Heinrich 1795-1863 *MacEA*, *McGDA*, *WhoArch*
Hubschmann, Kurt *MacBEP*
Huchel, Frederick M 1947- *WhoAmA 78, -80, -82, -84*
Huchtenburg, Jan Van 1647-1733 *ClaDrA*
Huchtenburgh, Johan Van 1647-1733 *McGDA*
Huchthausen, David Richard *WhoAmA 78, -80, -82, -84*
Huchthausen, J T *AmArch 70*
Huchthausen, Walter J 1904-1945 *BiDAmAr*
Huck, Ferdinand *NewYHSD*
Huck, Robert E 1923-1961 *WhoAmA 80N, -82N, -84N*
Huckabee, Tommie Jack 1936- *AmArch 70*
Huckel, Christiana *WhAmArt 85*
Huckel, Samuel, Jr. 1858-1917 *BiDAmAr*
Hucker, Robert Edward 1916- *AmArch 70*
Hucklebridge, M *DcWomA*
Hucks, H M *DcVicP 2*
Huddell, William Henry 1847-1892 *WhAmArt 85*
Hudders, J S *FolkA 86*
Huddesford, George 1749-1809 *DcBrECP*
Huddle, N J *AmArch 70*
Huddle, Nannie Z *DcWomA*
Huddle, Nannie Z Carber *ArtsAmW 2*
Huddle, William Henry 1847-1892 *ArtsAmW 1, -2, IlBEAAW*
Huddleston, E T *AmArch 70*
Huddleston, John McKean 1927- *AmArch 70*
Huddleston, Norman Harper 1923- *AmArch 70*
Huddleston, Prentiss 1909- *AmArch 70*
Huddy, William M *NewYHSD*
Hude, Paula VanDer 1874- *DcWomA*
Hudelot, Anna 1879- *DcWomA*
Hudgings, James G 1944- *MarqDCG 84*
Hudgins, G E *AmArch 70*
Hudgins, Mary Margaret 1903- *WhAmArt 85*
Hudjon, J *DcVicP 2*

Hudland, Kenneth R 1954- *MarqDCG 84*
Hudler, Herbert, Jr. 1926- *AmArch 70*
Hudnut, Alexander M *WhAmArt 85*
Hudnut, Joseph *WhAmArt 85*
Hudnut, Joseph Fairman 1884-1968 *MacEA*
Hudon, Normand 1929- *WorECar*
Hudson *DcBrECP*
Hudson, Mrs. *DcBrECP*, *DcWomA*
Hudson, A E *AmArch 70*
Hudson, Albert Wilfred 1874- *DcVicP 2*
Hudson, Albert Wilfrid 1874- *DcBrA 1*
Hudson, Alfonzo 1927- *AfroAA*
Hudson, Allen Clark 1913- *AmArch 70*
Hudson, Anna Hope *DcBrA 2*, *WhAmArt 85*
Hudson, Anna Hope 1869-1957 *DcWomA*
Hudson, Annie E *DcWomA*
Hudson, Benjamin *DcVicP 2*
Hudson, Bill *AfroAA*
Hudson, Charles *AfroAA*, *DcVicP 2*
Hudson, Charles Bradford 1865-1938 *WhAmArt 85*
Hudson, Charles Bradford 1865-1939 *ArtsAmW 1*
Hudson, Charles W 1871-1943 *WhAmArt 85*
Hudson, Chauncey Frederick 1889- *AmArch 70*
Hudson, Donna Lee 1946- *MarqDCG 84*
Hudson, Edith F *WhAmArt 85*
Hudson, Edith H *DcVicP 2*
Hudson, Eleanor Erlund *WhoArt 80, -82, -84*
Hudson, Eleanor Erlund 1912- *DcBrA 1*
Hudson, Elmer F 1862-1932 *WhAmArt 85*
Hudson, Emma Little *ArtsEM*, *DcWomA*
Hudson, Eric d1932 *WhAmArt 85*
Hudson, F E, Jr. *AmArch 70*
Hudson, Frank D 1868-1941 *BiDAmAr*
Hudson, G H *EncASM*
Hudson, George Clyde 1925- *AmArch 70*
Hudson, Grace 1865-1937 *DcWomA*
Hudson, Grace Carpenter 1865-1937 *ArtsAmW 1, IlBEAAW*, *WhAmArt 85*
Hudson, Gwynedd M *DcBrA 2*, *DcBrBI*
Hudson, H G *EncASM*
Hudson, Henrietta 1862- *DcWomA*, *WhAmArt 85*
Hudson, Henry *DcVicP 2*
Hudson, Henry 1908- *AfroAA*
Hudson, Henry Bateman 1792?-1865 *BiDBrA*
Hudson, Henry John *DcVicP 2*
Hudson, Henry William, IV *MarqDCG 84*
Hudson, Ira 1876-1949 *FolkA 86*
Hudson, J *DcVicP 2*
Hudson, Jack H 1916- *AmArch 70*
Hudson, Jacqueline *WhoAmA 76, -78, -80, -82, -84*
Hudson, John *BiDBrA*
Hudson, John Bradley 1832-1903 *NewYHSD*, *WhAmArt 85*
Hudson, Jon Barlow 1945- *WhoAmA 82, -84*
Hudson, Josiah Bell *EncASM*
Hudson, Jules *NewYHSD*
Hudson, Julien *NewYHSD*
Hudson, Julien 1830- *AfroAA*
Hudson, Kenneth Eugene 1903- *WhAmArt 85, WhoAmA 73*
Hudson, Kenton Warne 1911- *WhAmArt 85*
Hudson, Mabel Ruth *WhAmArt 85*
Hudson, Martha *OfPGCP 86*
Hudson, Paul Grenville 1876-1960 *DcBrA 2*
Hudson, Ralph M 1907- *WhAmArt 85*
Hudson, Ralph Magee 1907- *WhoAmA 73, -76, -78, -80, -82, -84*
Hudson, Robert 1938- *BnEnAmA*, *CenC*, *DcCAr 81*
Hudson, Robert, Jr. d1884 *DcVicP 2*
Hudson, Robert H 1938- *DcCAA 71, -77*, *OxTwCA*, *WhoAmA 73, -76, -78, -80, -82, -84*
Hudson, Rose *AfroAA*
Hudson, Samuel Adams 1813- *NewYHSD*
Hudson, Samuel Adams 1813-1894 *FolkA 86*
Hudson, Thomas 1701-1779 *ClaDrA*, *DcBrECP*, *McGDA*, *OxArt*
Hudson, Thomas Roger Jackson 1929- *WhoArt 82, -84*
Hudson, William *DcVicP 2*
Hudson, William d1847 *DcBrWA*
Hudson, William, Jr. *FolkA 86*
Hudson, William, Jr. 1787- *NewYHSD*
Hudson, William Asa 1889- *AmArch 70*
Hudson, William Manchester 1916- *AmArch 70*
Hudson, Winnifred 1905- *WhoAmA 73, -76, -78*
Hudson, Yvonne 1924- *WhoArt 80, -82, -84*
Hudspeth, John B 1912- *AmArch 70*
Hudspeth, Robert Norman 1862- *WhAmArt 85*
Hudspeth, Rosalie 1882- *DcWomA*, *WhAmArt 85*
Hue, C B *DcVicP 2*
Hue, E *DcVicP 2*
Hue, Jean Francois 1751-1823 *ClaDrA*
Hue, Robert Raleigh De *AfroAA*
Hue, William Burnell *BiDBrA*
Hue DeBreval, Virginie *DcWomA*
Hueba, Barbara Maria *DcWomA*
Hueber, J M *AmArch 70*
Hueber, P J, Jr. *AmArch 70*
Huebl, Arthur Freiherr Von 1852-1932 *MacBEP*
Huebler, Douglas *OxTwCA*
Huebler, Douglas 1924- *ConArt 77, -83*, *DcCAr 81,*

WhoAmA 78, -80, -82, -84
Huebner, Abraham 1772-1818 *FolkA 86*
Huebner, Carl Wilhelm 1814-1879 *ClaDrA*
Huebner, Carol 1947- *MacBEP*
Huebner, George *FolkA 86*
Huebner, Henrich *FolkA 86*
Huebner, Louis Henry 1922- *AmArch 70*
Huebner, Nathan Daniel 1953- *MarqDCG 84*
Huebner, Richard Harris 1911- *WhAmArt 85*
Huebner, Susanna *FolkA 86*
Huebsch, Daniel A *WhAmArt 85*
Huebscher, Rene 1942- *MarqDCG 84*
Hueck, Edward *DcNiCA*
Hueffer, Catherine *DcWomA*
Hueffer, Catherine 1850-1927 *DcBrWA*
Hueffer, Mrs. Frank *DcVicP 2*
Huegli, Constance *DcWomA*
Hueholt, Raymond L 1920- *AmArch 70*
Huelsdonk, Robert A 1931- *MarqDCG 84*
Huelse, Carl *WhAmArt 85*
Huelsenbeck, Richard *OxTwCA*
Huelskoetter, Wayne R 1940- *MarqDCG 84*
Huemer, Christina Gertrude 1947- *WhoAmA 78, -80, -82, -84*
Huemer, Richard 1898- *WorECar*
Hueppelsheuser, Clyde Ross 1925- *AmArch 70*
Huerne, Prosper 1820- *BiDAmAr*
Huerta, Jean DeLa d1457? *McGDA*
Huerta, Juan DeLa *OxArt*
Huescar, Marianna, Duchess Of *DcWomA*
Huesmann, Louis Baldwin 1904- *AmArch 70*
Huessener *DcWomA*
Huessy, Gabrielle 1950- *DcCAr 81*
Huestis, Charles P *NewYHSD*
Huestis, Edna *DcWomA*
Huestis, Joseph W *WhAmArt 85*
Huet, Celeste *DcWomA*
Huet, Christophe d1759 *McGDA*, *OxDecA*
Huet, Ernestine *DcWomA*
Huet, Henri d1971 *ICPEnP A*
Huet, Jean Baptiste 1745-1811 *ClaDrA*
Huet, Jean-Baptiste-Marie 1745-1811 *McGDA*
Huet, Paul 1803-1869 *ClaDrA*
Huet, Paul 1804-1869 *ArtsNiC*
Hueter, James W 1925- *DcCAA 71, -77*
Hueter, James Warren 1925- *WhoAmA 73, -76, -78, -80, -82, -84*
Huett, Fred 1828-1912 *ArtsAmW 1*
Huettenrauch, Clarence 1934- *AmArch 70*
Hueva, Barbara Maria De 1733?-1772 *DcWomA*
Huey, Florence Greene 1872-1961 *DcWomA*, *WhAmArt 85*, *WhoAmA 80N, -82N, -84N*
Huey, J *CabMA*
Huf, Karl 1887-1937 *WhAmArt 85*
Hufbauer, Clyde 1911- *AmArch 70*
Hufeisen, John Laurence *AmArch 70*
Huff, A D *AmArch 70*
Huff, Celesta *DcWomA*, *FolkA 86*
Huff, Clarence Wright, Jr. 1900- *AmArch 70*
Huff, G *NewYHSD*
Huff, Howard Lee 1941- *WhoAmA 78, -80, -82, -84*
Huff, John Terrell 1919- *AmArch 70*
Huff, Laura Weaver 1930- *WhoAmA 82, -84*
Huff, William Gordon 1903- *WhAmArt 85*
Huffaker, Stanley Dwayne 1937- *AmArch 70*
Huffam, M *DcVicP 2*
Huffhines, B S *AmArch 70*
Huffington, John C 1864-1929 *WhAmArt 85*
Huffman, Barry G 1943- *FolkA 86*
Huffman, Cynthia *AfroAA*
Huffman, Frederick W *NewYHSD*
Huffman, Jenny *DcWomA*
Huffman, John Arthur 1932- *AmArch 70*
Huffman, Laton Alton 1843-1931 *ICPEnP A*
Huffman, Laton Alton 1854-1931 *MacBEP*
Huffman, Tom 1935- *AmArt*
Hufford, A C *AmArch 70*
Huffsmith, Dolly 1896- *ArtsAmW 3*, *DcWomA*
Huffstutter, Wayne E 1925- *AmArch 70*
Hufnagel, Hermine 1864-1897 *DcWomA*
Hufnagel, L C *AmArch 70*
Hufstedler, Mrs. E Virgil *ArtsAmW 3*
Hufty, Joseph *NewYHSD*
Hufty, Samuel *NewYHSD*
Hugard *DcVicP 2*
Hugart, Lina d1907 *DcWomA*
Huge, I F *FolkA 86*, *NewYHSD*
Huge, Jurgan Frederick 1809-1878 *AmFkP*, *DcSeaP*, *FolkA 86*
Huge, Jurgan Fredrich *FolkA 86*
Huge, Jurgan Friedrich *FolkA 86*
Hugenholtz, Arina 1851-1934 *DcWomA*
Huger, Emily H 1881-1946 *WhAmArt 85*
Huger, Emily Hamilton 1881-1946 *DcWomA*
Huger, Katherine M *WhAmArt 85*
Huger, Katherine Middleton *DcWomA*
Hugford, Ignazio 1703-1778 *DcBrECP*
Hugg, Louis Ryan, Jr. 1934- *AmArch 70*
Huggard, F E *AmArch 70*
Hugger, Gustave *WhAmArt 85*
Huggill, Henry Percy 1886-1957 *DcBrA 1*

Hulme, Frederick William 1816- *ArtsNiC*
Hulme, Frederick William 1816-1884 *ClaDrA, DcBrBI, DcBrWA, DcVicP, -2*
Hulme, Harold Emluh 1882- *ArtsAmW 3*
Hulme, James Sanford 1900- *WhAmArt 85*
Hulme, John J *NewYHSD*
Hulme, R W *EarABI SUP*
Hulme, Robert C *DcBrBI, DcVicP 2*
Hulme, T O *DcVicP 2*
Hulme, Ursula 1917- *WhoArt 80, -82, -84*
Hulme, W O *WhAmArt 85*
Hulmer, Eric Claus 1915- *WhoAmA 76, -78, -80, -82, -84*
Hulot, Caroline *DcWomA*
Hulsdonck, Jacob Van 1582-1647 *McGDA*
Hulse, C J *NewYHSD*
Hulse, Jesse *NewYHSD*
Hulse, Marion Jordan Gilmore *WhAmArt 85*
Hulse, Robert Harley 1915- *WhAmArt 85*
Hulseman, Edward *NewYHSD*
Hulsey, William Hansell 1901- *WhoAmA 73, -76, -78, -80, -82*
Hulsinger, George E *AfroAA*
Hulsizer, David W 1952- *MarqDCG 84*
Hulsman, Jan 1644- *McGDA*
Hulsman, Johann *ClaDrA*
Hulsmann, Valerie *DcWomA*
Hulst, Frans De 1610?-1661 *ClaDrA, McGDA*
Hulst, Pieter VanDer 1651-1727 *ClaDrA*
Hulstrop, T *DcBrBI*
Hulswit, Jan 1766-1822 *ClaDrA*
Hult, Harry *WhAmArt 85*
Hult, Hildur 1872-1904 *DcWomA*
Hultberg, Charles *WhAmArt 85*
Hultberg, John 1922- *DcCAA 71, -77, OxTwCA, PrintW 83, -85, WhoAmA 84*
Hultberg, John Phillip 1922- *PhDcTCA 77, WhoAmA 73, -76, -78, -80, -82*
Hulteen, Rubert J 1916- *WhAmArt 85*
Hultkin, Magnus *CabMA*
Hulton, Everard *DcVicP 2*
Hulton, John 1915- *WhoArt 80, -82, -84*
Hulton, William d1921 *DcBrA 1, DcVicP 2*
Hultz, Johann d1449 *McGDA*
Hultz, Johannes d1449 *MacEA*
Hulvey, Henry James 1921- *AmArch 70*
Humann, O Victor *WhAmArt 85*
Humayer, Erzsebet 1891- *DcWomA*
Humbeeck, Marie 1888-1969 *DcWomA*
Humber, Yvonne Twining 1907- *WhAmArt 85*
Humberdot, C S *DcWomA*
Humberstone, Frederick Patrick 1927- *AmArch 70*
Humbert, Adele *DcWomA, NewYHSD*
Humbert, Albert 1835-1886 *WorECar*
Humbert, Cecile *DcWomA*
Humbert, Ferdinand *ArtsNiC*
Humbert, Jacques-Fernand 1842- *ClaDrA*
Humbert-Bloume, Celina Marguerite 1884- *DcWomA*
Humbert-Vignot, Leonie 1878- *DcWomA*
Humble, Mrs. *DcWomA*
Humble, Catharine *DcWomA*
Humble, Catherine *DcBrECP*
Humble, Douglas *WhoAmA 78, -80, -82*
Humble, John *FolkA 86*
Humble, John 1944- *MacBEP*
Humblot, Emmeline 1816-1895 *DcWomA*
Humblot, Henriette *DcWomA*
Humblot, Robert 1907-1962 *OxTwCA, PhDcTCA 77*
Humblot-Buirette, Anna Jeanne Julie 1874- *DcWomA*
Humbrecht, Harry Joseph 1912- *AmArch 70*
Humbrecht, John Xavier 1954- *MarqDCG 84*
Hume, Amelia *DcWomA*
Hume, C M *DcWomA*
Hume, Edith *DcWomA*
Hume, Henry C *NewYHSD*
Hume, J Henry 1858-1881 *DcVicP, -2*
Hume, John *NewYHSD*
Hume, Joseph *FolkA 86*
Hume, Richard 1946- *MacBEP*
Hume, Robert *DcBrA 1, DcVicP, -2*
Hume, Sandy 1946- *ICPEnP A*
Hume, Sophia 1775?-1814 *DcWomA*
Hume, T *AmArch 70*
Hume, T H *DcVicP 2*
Hume, Mrs. T O *DcVicP, -2*
Hume, Thomas O *DcVicP, -2*
Hume, William H 1834-1899 *BiDAmAr*
Humes, Ralph H 1902- *WhoAmA 73, -76, -78, -80*
Humes, Ralph H 1902-1981 *WhoAmA 82N, -84N*
Humes, Ralph Hamilton 1902- *WhAmArt 85*
Humeston, Jay *CabMA*
Humfrey, Charles 1772-1848 *BiDBrA*
Humiston, Jay *CabMA*
Humiston And Stafford *CabMA*
Humleker, Ruth S 1922- *WhoAmA 76, -78, -80*
Hummel, Arthur Edward 1924- *AmArch 70*
Hummel, Charles Frederick 1925- *AmArch 70*
Hummel, Charles Frederick 1932- *WhoAmA 78, -80, -82, -84*
Hummel, Christiane Luise *DcWomA*
Hummel, Fred Ernest 1927- *AmArch 70*

Hummel, Frederick Charles 1884- *AmArch 70*
Hummel, Lisl *ConICB, IlsCB 1744*
Hummel, Marianne Von *DcWomA*
Hummel, R A *AmArch 70*
Hummel, Robert Alexander 1953- *MarqDCG 84*
Hummel, Susette *DcWomA*
Hummerston, Effie 1891- *DcBrA 1, DcWomA*
Hummert, George Thomas 1938- *MarqDCG 84*
Humphrey, Cath *DcWomA*
Humphrey, D R *AmArch 70*
Humphrey, David W 1872- *WhAmArt 85*
Humphrey, Don *WhAmArt 85*
Humphrey, Donald Gray 1920- *WhoAmA 73, -76, -78, -80, -82, -84*
Humphrey, Edward J *DcVicP 2*
Humphrey, Elizabeth B 1850?- *IlBEAAW, WhAmArt 85*
Humphrey, Elizabeth B 1850?-1890? *DcWomA*
Humphrey, F M *AmArch 70*
Humphrey, Florence *DcWomA, WhAmArt 85*
Humphrey, Florence T *DcWomA*
Humphrey, Francis S *WhAmArt 85*
Humphrey, Fred P *WhAmArt 85*
Humphrey, Harrison *FolkA 86*
Humphrey, Hiram *FolkA 86*
Humphrey, J H, Jr. *AmArch 70*
Humphrey, J R *AmArch 70*
Humphrey, Jack *OxTwCA*
Humphrey, Jack Weldon d1967 *WhoAmA 78N, -80N, -82N, -84N*
Humphrey, Jack Weldon 1901- *McGDA, WhoArt 80, -82, -84*
Humphrey, Josiah *ArtsEM, NewYHSD*
Humphrey, Judy Lucille 1949- *WhoAmA 84*
Humphrey, K Maude *DcBrBI*
Humphrey, Lizzie B 1850- *EarABI, EarABI SUP*
Humphrey, Mabel *WhAmArt 85*
Humphrey, Margo 1942- *AfroAA, DcCAr 81*
Humphrey, Maria Hyde *DcWomA, FolkA 86, NewYHSD*
Humphrey, Maud *WhAmArt 85*
Humphrey, Maud 1865?-1940 *DcWomA*
Humphrey, Nene 1947- *AmArt, WhoAmA 82, -84*
Humphrey, Ozias 1742-1810 *AntBDN J, ClaDrA, OxArt*
Humphrey, Ralph 1932- *DcCAA 71, -77, DcCAr 81, PrintW 83, -85, WhoAmA 78, -80, -82, -84*
Humphrey, S L 1941- *WhoAmA 76, -78, -80, -82, -84*
Humphrey, Walter Beach 1892- *WhAmArt 85*
Humphreys, A *CabMA*
Humphreys, Albert *WhAmArt 85*
Humphreys, Beatrice Jackson 1905- *WhAmArt 85*
Humphreys, Charles *NewYHSD*
Humphreys, David 1901- *WhAmArt 85*
Humphreys, David 1937- *ClaDrA, WhoArt 80, -82, -84*
Humphreys, Emma *DcWomA*
Humphreys, F W *DcVicP 2*
Humphreys, Francis 1815?- *NewYHSD*
Humphreys, George Alfred d1948 *DcBrA 1*
Humphreys, Graham 1945- *IlsCB 1967*
Humphreys, H Noel 1810-1879 *DcBrBI*
Humphreys, Henry 1773?- *DcBrWA*
Humphreys, Hugh R 1910- *AmArch 70*
Humphreys, Jane 1759?- *FolkA 86*
Humphreys, Jane K *DcVicP 2*
Humphreys, John Howard 1929- *WhoArt 82, -84*
Humphreys, John J 1860-1896 *BiDAmAr*
Humphreys, John Wharton 1896- *AmArch 70*
Humphreys, Malcolm 1894- *WhAmArt 85*
Humphreys, Maria Champney 1876-1906 *WhAmArt 85*
Humphreys, Marie 1876-1906 *DcWomA*
Humphreys, Mark 1925- *ClaDrA*
Humphreys, Marvin Gerald 1936- *AmArch 70*
Humphreys, Richard 1749-1832 *BnEnAmA*
Humphreys, S *FolkA 86*
Humphreys, Sallie Thomson *DcWomA, WhAmArt 85*
Humphreys-Johnstone, John *WhAmArt 85*
Humphries, A *DcBrBI*
Humphries, Charles Evans 1927- *AmArch 70*
Humphries, Charles Harry 1867- *WhAmArt 85*
Humphries, G C *NewYHSD*
Humphries, James Lamar, Jr. *AmArch 70*
Humphries, W *DcBrECP*
Humphris, William H 1880- *DcBrBI, DcVicP 2*
Humphriss, Charles Harry 1867- *WhAmArt 85*
Humphriss, Charles Harry 1867-1934? *IlBEAAW*
Humphry, C *DcVicP 2*
Humphry, K Maude *DcVicP 2*
Humphry, Ozias 1742-1810 *DcBrECP*
Humphrys *DcBrECP*
Humphrys, William 1794-1865 *NewYHSD*
Humpton, Mary Louise *WhoAmA 80*
Humsicker, Christian *FolkA 86*
Hunckel, George *NewYHSD*
Hunckel, Otto *NewYHSD*
Hundertwasser 1928- *OxTwCA, WhoArt 80, -82, -84, WorArt[port]*

Hundertwasser, Friedensreich 1928- *ConArt 77, -83*
Hundertwasser, Friedrich 1928- *ClaDrA*
Hundertwasser, Fritz 1928- *PhDcTCA 77*
Hundleby, A R 1923- *WhoArt 80, -82, -84*
Hundleigh, William T 1848-1916 *WhAmArt 85*
Hundley, David Holladay 1946- *WhoAmA 78, -80, -82, -84*
Hundley, Joe Henry *FolkA 86*
Hundley, Philip *DcVicP 2*
Hundley, S Philip 1940- *AmArch 70*
Hundreiser, Emil 1846-1911 *McGDA*
Hundrieser, Carl Edward 1927- *AmArch 70*
Hune, A G *DcBrECP*
Hune, J H C *NewYHSD*
Huneke, Ervin Coe 1920- *AmArch 70*
Huneker, Clio Hinton *WhAmArt 85*
Huneker, James Gibbons 1857-1921 *OxArt*
Hunes, A G *DcBrECP*
Hunfeld, Marie *DcWomA*
Hung-Jen *McGDA*
Hungate, Thomas Edwin 1935- *MarqDCG 84*
Hunger, Christoph Konrad *AntBDN M*
Hunger, Susanna Dorothea *DcWomA*
Hungerford, Charles Ellis 1903- *AmArch 70*
Hungerford, Constance Cain 1948- *WhoAmA 84*
Hungerford, Cyrus Cotton *WhoAmA 76, -78, -80*
Hungerford, Cyrus Cotton 1890?- *WorECar*
Hungerford, Lydia *ArtsEM, DcWomA*
Hungsberg, Lorin William 1948- *MarqDCG 84*
Hunicutt, William Gregory 1953- *MarqDCG 84*
Hunin, Alouis-Pierre-Paul 1808-1855 *ArtsNiC*
Hunipal, Frank R *WhAmArt 85*
Hunisak, John Michael 1944- *WhoAmA 78, -80, -82, -84*
Hunkler, Dennis Francis 1943- *WhoAmA 76, -78, -80, -82, -84*
Hunley, K J 1883- *WhAmArt 85*
Hunley, Katharine Jones 1883-1964 *ArtsAmW 2, DcWomA*
Hunn, Thomas H *DcBrWA, DcVicP 2*
Hunneman, William C *FolkA 86*
Hunnemann, Christopher William d1793 *DcBrECP*
Hunner, Isabella S 1903- *WhAmArt 85*
Hunnewell, Henry S 1851-1931 *BiDAmAr*
Hunnewell, Richard 1713-1788 *CabMA*
Hunnicutt, Jo *MarqDCG 84*
Hunnius, Carl Julius Ado 1842- *ArtsAmW 3*
Hunnius, Carl Julius Adolph 1842- *ArtsAmW 3*
Hunold, Walter *EncASM*
Hunsaker, Michael James 1947- *MarqDCG 84*
Hunsberger, I G *AmArch 70*
Hunsley, William *DcBrWA*
Hunster, Thomas Watson *AfroAA*
Hunt, Mrs. *ArtsEM, DcWomA*
Hunt, A *DcVicP 2*
Hunt, A W *WhAmArt 85*
Hunt, Abel *CabMA*
Hunt, Alfred *DcBrBI, DcVicP 2*
Hunt, Alfred William 1830-1896 *ClaDrA, DcBrWA, DcVicP, -2*
Hunt, Alfred William 1831- *ArtsNiC*
Hunt, Alice L *ArtsEM, DcWomA*
Hunt, Amy Henrietta *DcWomA*
Hunt, Andrew 1790-1861 *DcVicP 2*
Hunt, Andrew 1796-1861 *DcBrWA*
Hunt, Arthur Acland *DcBrWA, DcVicP 2*
Hunt, Arthur Hill 1874- *DcBrA 1*
Hunt, Ben *FolkA 86*
Hunt, Benjamin *CabMA*
Hunt, Bryan 1947- *ConArt 83, DcCAr 81, WhoAmA 80, -82, -84*
Hunt, Caleb *CabMA*
Hunt, Carolyn R 1941- *MarqDCG 84*
Hunt, Cecil Arthur 1873-1965 *DcBrA 1, DcBrWA, DcVicP 2*
Hunt, Charles 1803-1877 *ClaDrA, DcVicP, -2*
Hunt, Charles D 1840-1914 *NewYHSD, WhAmArt 85*
Hunt, Clifford *CabMA*
Hunt, Clyde DuV *DcVicP 2*
Hunt, Clyde DuVernet 1862-1941 *WhAmArt 85*
Hunt, Content 1791-1816 *FolkA 86*
Hunt, Courtenay 1917- *WhoAmA 78, -80, -82, -84*
Hunt, D W Lewis *FolkA 86*
Hunt, David Curtis 1935- *WhoAmA 76, -78, -80, -82, -84*
Hunt, Diane 1948- *PrintW 85*
Hunt, Dorothy H W *WhAmArt 85*
Hunt, Dwight Gordon 1927- *AmArch 70*
Hunt, E Aubrey 1855-1922 *DcBrA 1, DcSeaP, DcVicP 2, WhAmArt 85*
Hunt, Edgar 1876-1953 *DcBrA 1, DcVicP 2*
Hunt, Elisha *FolkA 86*
Hunt, Emily *DcVicP 2, DcWomA*
Hunt, Emma C W *DcVicP 2*
Hunt, Emma Charlotte Wesley Newenham *DcWomA*
Hunt, Emma Gates 1871- *WhAmArt 85*
Hunt, Esther 1885- *WhAmArt 85*
Hunt, Esther Anna 1885- *ArtsAmW 2*
Hunt, Esther Anna 1885-1951 *DcWomA*
Hunt, Eva E *DcVicP 2, DcWomA*

Hunt, F Marcia *WhAmArt 85*
Hunt, Francis d1753 *CabMA*
Hunt, Frank Bouldin 1915- *AmArch 70*
Hunt, George *DcVicP 2*
Hunt, George Henry *DcVicP 2*
Hunt, George J 1865- *EncASM*
Hunt, Gerard Leigh *DcVicP 2*
Hunt, H Harris, III 1961- *MarqDCG 84*
Hunt, Helen Dunlap *WhAmArt 85*
Hunt, Helen Zerbe 1905- *WhAmArt 85*
Hunt, Henry P *NewYHSD*
Hunt, Herbert S *DcVicP 2*
Hunt, J Osborne d1934? *BiDAmAr*
Hunt, J S *DcWomA*
Hunt, James M *AmArch 70*
Hunt, James M W 1855-1935 *WhAmArt 85*
Hunt, Jarvis 1859-1941 *BiDAmAr*
Hunt, Joan 1893- *DcWomA*
Hunt, John *FolkA 86*
Hunt, John W *NewYHSD*
Hunt, Joseph Rowland 1870-1924 *BiDAmAr*
Hunt, Julian Courtenay 1917- *WhoAmA 73, –76*
Hunt, Kari 1920- *WhoAmA 73, –76, –78, –80, –82*
Hunt, Lawrence Oren 1938- *AmArch 70*
Hunt, Leigh 1858-1937 *WhAmArt 85*
Hunt, Mrs. Leigh *DcWomA*
Hunt, Lydia *ArtsEM, DcWomA*
Hunt, Lynn 1878-1960 *WhoAmA 80N, –82N, –84N*
Hunt, Lynn Bogue d1960 *WhAmArt 85*
Hunt, Lynn Bogue 1878-1960 *IlrAm C, –1880*
Hunt, M Alcott 1898- *WhAmArt 85*
Hunt, M D *AmArch 70*
Hunt, Mabelle Alcott 1898- *DcWomA*
Hunt, Margaret L 1914- *WhAmArt 85*
Hunt, Maria *DcVicP 2, DcWomA*
Hunt, Marion Elizabeth *DcWomA*
Hunt, Mary Isabel *DcWomA, WhAmArt 85*
Hunt, Millson *DcVicP 2*
Hunt, Nellie G *ArtsEM, DcWomA*
Hunt, P C *WhAmArt 85*
Hunt, Peter 1870-1934 *FolkA 86*
Hunt, Rachel McMasters Miller 1892- *WhAmArt 85*
Hunt, Raymond 1947- *AfroAA*
Hunt, Reuben Harrison 1862-1937 *BiDAmAr*
Hunt, Richard 1935- *ConArt 83, DcAmArt, DcCAA 71, –77, PrintW 83, –85*
Hunt, Richard H 1862-1931 *BiDAmAr*
Hunt, Richard Howard 1925- *AfroAA*
Hunt, Richard Howard 1935- *AmArt, DcCAr 81, WhoAmA 73, –76, –78, –80, –82, –84*
Hunt, Richard M 1828- *ArtsNiC*
Hunt, Richard Morris 1827-1895 *BiDAmAr, DcD&D, EncAAr, MacEA, McGDA, OxArt, WhoArch*
Hunt, Richard Morris 1828-1895 *BnEnAmA*
Hunt, Robert 1807-1887 *MacBEP*
Hunt, Robert James 1921- *WhoAmA 73, –76, –78, –80, –82, –84*
Hunt, Rosamond Pier 1916- *WhAmArt 85*
Hunt, Samuel Valentine 1803-1893 *NewYHSD*
Hunt, Sumner P 1865-1938 *BiDAmAr*
Hunt, Sybil G *WhAmArt 85*
Hunt, T Greenwood *DcVicP 2*
Hunt, Thomas *WhAmArt 85*
Hunt, Thomas 1737-1818 *BiDBrA*
Hunt, Thomas 1854-1929 *ClaDrA, DcBrA 1, DcBrWA, DcVicP 2*
Hunt, Thomas Frederick 1791?-1831 *BiDBrA, MacEA*
Hunt, Thomas L *WhAmArt 85*
Hunt, Thomas L d1939 *ArtsAmW 1*
Hunt, Una Atherton 1876- *DcWomA*
Hunt, Una Clarke 1876- *WhAmArt 85*
Hunt, Violet 1856- *DcWomA*
Hunt, Virginia Lloyd 1888?-1977 *DcWomA*
Hunt, W *NewYHSD*
Hunt, Walter 1861- *ClaDrA, DcVicP*
Hunt, Walter 1861-1941 *DcBrA 1, DcVicP 2*
Hunt, Ward *CabMA*
Hunt, Wayne 1904- *IlBEAAW*
Hunt, Wayne Wolf Robe 1905-1977 *WhoAmA 78N, –80N, –82N, –84N*
Hunt, Will Harvey 1910- *WhAmArt 85*
Hunt, William *DcVicP 2, FolkA 86, NewYHSD*
Hunt, William Dudley, Jr. *ConArt A*
Hunt, William Dudley, Jr. 1922- *AmArch 70*
Hunt, William E *EncASM*
Hunt, William E 1873-1936 *BiDAmAr*
Hunt, William H Thurlow *DcVicP 2*
Hunt, William Henry 1790-1864 *ArtsNiC, ClaDrA, DcBrWA, DcVicP, –2, McGDA*
Hunt, William Holman 1827- *ArtsNiC*
Hunt, William Holman 1827-1910 *ClaDrA, DcBrA 1, DcBrBI, DcBrWA, DcVicP 2, McGDA, OxArt*
Hunt, William Holman 1827-1919 *DcVicP*
Hunt, William Howes 1806-1879 *DcBrWA, DcVicP 2*
Hunt, William Morris 1824-1879 *ArtsNiC, BnEnAmA, DcAmArt, McGDA, NewYHSD, WhAmArt 85*
Hunt, Yvonne Parks 1930- *AfroAA*
Hunt & Roskell *DcNiCA*
Hunten, Emil Johann 1827- *ArtsNiC*

Hunten, F *DcSeaP*
Hunter, A *DcVicP 2, NewYHSD*
Hunter, A R, Jr. *AmArch 70*
Hunter, Ada *DcVicP 2, DcWomA*
Hunter, Alexis *DcCAr 81*
Hunter, B M *AmArch 70*
Hunter, B R *AmArch 70*
Hunter, Blanche F *DcVicP 2, DcWomA*
Hunter, C A *AmArch 70*
Hunter, Carl John 1934- *AmArch 70*
Hunter, Clementine 1880?- *AfroAA*
Hunter, Clementine 1882?- *DcWomA*
Hunter, Clementine 1885- *FolkA 86*
Hunter, Colin 1841-1904 *ClaDrA, DcBrA 1, DcBrWA, DcVicP, –2*
Hunter, Colin 1842- *ArtsNiC*
Hunter, David Charles 1865-1926 *WhAmArt 85*
Hunter, Debora 1950- *ICPEnP A, MacBEP, WhoAmA 78, –80, –82, –84*
Hunter, Donald Edward 1927- *AmArch 70*
Hunter, Ebenezer M 1822?- *CabMA*
Hunter, Edgar Hayes 1914- *AmArch 70*
Hunter, Edmund Roger 1909- *WhoAmA 73, –76*
Hunter, Edward *WhAmArt 85*
Hunter, Elizabeth *DcVicP 2, DcWomA*
Hunter, Evangeline Deming *WhAmArt 85*
Hunter, F Jerome 1928- *AmArch 70*
Hunter, F Leo *WhAmArt 85*
Hunter, Frances Tipton 1896-1957 *DcWomA, IlrAm 1880*
Hunter, Frances Tipton 1896-1958? *WhAmArt 85*
Hunter, Francis Tipton *WhoAmA 80N, –82N, –84N*
Hunter, G Sherwood *DcVicP*
Hunter, G Sherwood d1920 *DcBrA 1*
Hunter, George *AntBDN Q*
Hunter, George Cameron 1912- *AmArch 70*
Hunter, George Leslie 1877-1931 *DcBrA 1*
Hunter, George Sherwood *DcVicP*
Hunter, Graham *WhoAmA 73, –76, –78, –80, –82, –84*
Hunter, Gregory Michael 1948- *MarqDCG 84*
Hunter, H Chadwick *WhAmArt 85*
Hunter, H H *AmArch 70*
Hunter, H T *AmArch 70*
Hunter, Harry Edward 1921- *AmArch 70*
Hunter, Herbert Alexander 1935- *MarqDCG 84*
Hunter, Ida Clark *DcWomA, WhAmArt 85*
Hunter, Iowa Roger 1897-1937 *DcWomA*
Hunter, Isabel *ArtsAmW 1, WhAmArt 85*
Hunter, Isabel 1878-1941 *DcWomA*
Hunter, J, Jr. *AmArch 70*
Hunter, J Young *WhAmArt 85*
Hunter, James *AntBDN F*
Hunter, James d1792 *DcBrWA*
Hunter, James 1755- *BiDBrA*
Hunter, James A *ArtsEM*
Hunter, James Graham 1901- *WhAmArt 85*
Hunter, James M 1908- *AmArch 70*
Hunter, James Riddick 1926- *AmArch 70*
Hunter, John *DcVicP 2*
Hunter, John H 1934- *WhoAmA 73, –76, –78, –80, –82, –84*
Hunter, John Kelso 1802-1873 *DcVicP 2*
Hunter, John Young 1874-1953 *ClaDrA*
Hunter, John Young 1874-1955 *DcBrA 1, DcBrBI, DcVicP 2*
Hunter, Mrs. John Young 1878-1936 *DcVicP 2*
Hunter, Joseph Leslie 1920- *AmArch 70*
Hunter, L W *WhAmArt 85*
Hunter, Leonard L 1905- *AmArch 70*
Hunter, Leonard Legrande, III 1940- *WhoAmA 76, –78, –80, –82, –84*
Hunter, Leslie 1879-1931 *DcBrBI*
Hunter, Lizbeth C 1868- *WhAmArt 85*
Hunter, Lizbeth Clifton 1868- *DcWomA*
Hunter, Margaret King 1919- *AmArch 70*
Hunter, Mary Anne 1752?- *DcBrECP, DcWomA*
Hunter, Mary Ethel 1878-1936 *DcBrA 1*
Hunter, Mary Ethel 1878-1936? *DcWomA*
Hunter, Mary M *WhAmArt 85*
Hunter, Mary Sutherland 1899- *DcBrA 1, DcWomA*
Hunter, Mary Young *DcBrBI*
Hunter, Mary Young 1878-1936 *DcWomA*
Hunter, Mason d1921 *DcBrA 1*
Hunter, Mason 1854-1921 *DcBrWA, DcVicP 2*
Hunter, Matthew *DcBrECP*
Hunter, Mel *OfPGCP 86*
Hunter, Mel 1927- *WhoAmA 76, –78, –80, –82, –84*
Hunter, Meridith 1927- *WhoAmA 80, –82, –84*
Hunter, Miriam Eileen 1929- *WhoAmA 78, –80, –82, –84*
Hunter, Nathaniel, Jr. 1939- *AfroAA*
Hunter, Paul Robinson 1906- *AmArch 70*
Hunter, Richard James 1922- *AmArch 70*
Hunter, Robert *DcBrECP*
Hunter, Robert Douglas 1928- *AmArt, WhoAmA 73, –76, –78, –80, –82, –84*
Hunter, Robert Howard 1929- *WhoAmA 73, –76, –78, –80, –82, –84*
Hunter, Ronnie *MarqDCG 84*
Hunter, Russell Vernon 1900-1955 *IlBEAAW, WhAmArt 85*

Hunter, Sam 1923- *WhoAmA 73, –76, –78, –80, –82, –84*
Hunter, Sara Katherine *WhAmArt 85*
Hunter, Sarah B *DcWomA*
Hunter, Stanley R 1939- *IlrAm 1880*
Hunter, Stephen W *DcVicP 2*
Hunter, Vincil F 1924- *AmArch 70*
Hunter, Vincil Francis, Sr. 1900- *AmArch 70*
Hunter, Warren *IlBEAAW, WhAmArt 85*
Hunter, William *AntBDN Q*
Hunter, William d1967 *DcBrA 1*
Hunter, William E N 1858-1947 *BiDAmAr*
Hunter, William Edgerton N 1868-1947 *ArtsEM*
Hunter, William Harold, Jr. 1904- *AmArch 70*
Hunter, William K 1933- *AmArch 70*
Hunter-Stiebel, Penelope *WhoAmA 78, –80, –82, –84*
Hunting, Asa *CabMA*
Hunting, Henry G *ArtsEM*
Huntingdon, Francis H *DcVicP 2*
Huntington, A Montgomery d1967 *WhoAmA 78N, –80N, –82N, –84N*
Huntington, Adelaide *DcWomA, WhAmArt 85*
Huntington, Alonzo St. George 1868-1941 *WhAmArt 85*
Huntington, Anna Hyatt 1876-1973 *WomArt*
Huntington, Anna V Hyatt d1973 *WhoAmA 76N, –78N, –80N, –82N, –84N*
Huntington, Anna V Hyatt 1876-1973 *WhAmArt 85*
Huntington, Anna Vaughn 1876-1973 *DcWomA*
Huntington, Anna Vaughn Hyatt 1876- *McGDA*
Huntington, Caleb 1749-1842 *FolkA 86*
Huntington, Charles *CabMA*
Huntington, Charles P 1874-1919 *BiDAmAr*
Huntington, Charles S *ArtsAmW 3*
Huntington, Clara 1878- *WhAmArt 85*
Huntington, Clara Leonora 1878-1965 *DcWomA*
Huntington, Daniel 1816- *ArtsNiC*
Huntington, Daniel 1816-1906 *BnEnAmA, DcAmArt, EarABI, McGDA, NewYHSD, WhAmArt 85*
Huntington, Daniel R 1871- *WhAmArt 85*
Huntington, Daniel Riggs 1871- *ArtsAmW 2*
Huntington, Daphne *WhoAmA 76, –78, –80*
Huntington, David *CabMA*
Huntington, Dyer *FolkA 86*
Huntington, Edwin 1829?- *FolkA 86*
Huntington, Eleazer *NewYHSD*
Huntington, Elizabeth Hamilton Thayer 1878- *DcWomA, WhAmArt 85*
Huntington, Ellen Bliss *DcWomA*
Huntington, F R *WhAmArt 85*
Huntington, Franklin B 1876-1947 *BiDAmAr*
Huntington, G *DcVicP 2*
Huntington, Henry Edwards d1927 *WhAmArt 85*
Huntington, J A *NewYHSD*
Huntington, J C *FolkA 86*
Huntington, J D *NewYHSD*
Huntington, Jim 1941- *WhoAmA 73, –76, –78, –80, –82, –84*
Huntington, Joel *CabMA*
Huntington, John 1705-1777 *FolkA 86*
Huntington, John W 1910- *WhoAmA 73, –76, –78, –80N, –82N, –84N*
Huntington, John W P *WhAmArt 85*
Huntington, John Willard 1910- *AmArch 70*
Huntington, Julie Swift *FolkA 86*
Huntington, Margaret Wendell 1867-1958 *DcWomA, WhAmArt 85, WhoAmA 80N, –82N, –84N*
Huntington, William H 1938- *MarqDCG 84*
Huntington, William Reed 1907- *AmArch 70*
Huntington, William Robert 1926- *AmArch 70*
Huntley, Miss *DcWomA*
Huntley, David C 1930- *WhoAmA 73, –76, –78, –80, –82, –84*
Huntley, Dennis 1929- *WhoArt 80, –82, –84*
Huntley, Georgina *DcWomA*
Huntley, Isabel 1877-1945 *DcWomA*
Huntley, Samantha Littlefield *WhAmArt 85*
Huntley, Samantha Littlefield 1865- *DcWomA*
Huntley, Victoria Ebbels Hutson 1900- *WhAmArt 85*
Huntley, Victoria Ebbels Hutson 1900-1971 *GrAmP*
Huntley, Victoria Hutson 1900-1971 *WhoAmA 78N, –80N, –82N, –84N*
Huntley, W *DcVicP 2*
Huntly, Nancy Weir 1890- *DcBrA 1, DcWomA*
Hunton, Charlotte *DcWomA*
Hunton, Edith *DcWomA*
Hunton, J H *AmArch 70*
Hunton, Tom Ricker 1933- *AmArch 70*
Huntoon, Mary 1896- *ArtsAmW 2, DcWomA, WhAmArt 85*
Hunts, Larry David 1934- *AmArch 70*
Huntsman, S Ralph 1896- *ArtsAmW 3*
Huntting, Marcy 1781- *FolkA 86*
Hunziker, Elise 1860- *DcWomA*
Hunziwer, Julie *DcWomA*
Huon-Dong-Ja *McGDA*
Huot, Robert 1935- *ConArt 77, DcCAA 71, –77, OxTwCA, WhoAmA 78, –80, –82, –84*
Hupendon, Ernest *FolkA 86*
Hupp, Frederick Duis 1938- *WhoAmA 73, –76, –78, –80, –82, –84*

Huppen, Hermann 1938- *WorECom*
Huppi, Alfonso 1935- *DcCAr 81*
Huquier, Gabriel 1695-1772 *ClaDrA*
Huquier, Jacques Gabriel 1725-1805 *DcBrECP*
Hurard, Adelaide *DcWomA*
Hurard, Celeste *DcWomA*
Hurd, Angela 1898- *WhAmArt 85*
Hurd, Angela M 1898- *DcWomA*
Hurd, Benjamin 1739-1781 *BnEnAmA*, *NewYHSD*
Hurd, Clement *IlsCB 1967*
Hurd, Clement 1908- *IlsCB 1744, -1946, -1957*
Hurd, Clyde *ArtsEM*
Hurd, E *NewYHSD*
Hurd, Earl 1880?-1950? *WorECar*
Hurd, Eleanor H *WhAmArt 85*
Hurd, Gildersleeve *NewYHSD*
Hurd, Gildersleeve 1791?-1859 *ArtsEM*
Hurd, J F *AmArch 70*
Hurd, Jacob *FolkA 86*
Hurd, Jacob 1676-1749 *CabMA*
Hurd, Jacob 1702-1758 *AntBDN Q*, *BnEnAmA*
Hurd, John *MarqDCG 84*
Hurd, Justin 1912- *WorECar*
Hurd, Justin G 1912- *WhoAmA 73, -76, -78, -80, -82*
Hurd, L Fred *WhAmArt 85*
Hurd, L P *IlBEAAW*
Hurd, Nathaniel 1729-1777 *AntBDN Q*, *BnEnAmA*, *NewYHSD*
Hurd, Nathaniel 1730-1777 *WorECar*
Hurd, Peter *OfPGCP 86*
Hurd, Peter 1904- *AmArt*, *ConICB*, *DcAmArt*, *IlBEAAW*, *IlsCB 1744*, *McGDA*, *WhAmArt 85*, *WhoAmA 73, -76, -78, -80N, -82, -84*
Hurd, Peter 1904-1984 *GrAmP*
Hurd, Mrs. Peter *WhAmArt 85*
Hurd, Rodney S *ArtsEM*
Hurd, Zorah 1940- *WhoAmA 76, -78, -80*
Hurd-Wood, J *DcVicP 2*
Hurdis, James Henry 1800-1857 *DcBrWA*
Hurdle, E H *DcVicP 2*
Hurdle, Levi *CabMA*
Hurdle, Robert Henry 1918- *DcBrA 1*, *WhoArt 80, -82, -84*
Hure, Marguerite Felicite 1896- *DcWomA*
Hureau, E, Madame *FolkA 86*
Hurel, Suzanne 1876-1956 *DcWomA*
Hurford, Charles William *WhoArt 80N*
Hurford, Miriam Story 1894- *DcWomA*, *WhAmArt 85*
Hurlbatt, Francis 1754?-1834 *BiDBrA*
Hurlbert, Josephine 1882- *DcWomA*
Hurlburt, Allen Freeman 1910-1983 *ConDes*
Hurlburt, Elizabeth *NewYHSD*
Hurlburt, Elizabeth 1838?- *DcWomA*
Hurlburt, Irving E *WhAmArt 85*
Hurlburt, Josephine 1882- *DcWomA*
Hurlburt, Mary Allis *WhAmArt 85*
Hurlbut, Mrs. *DcWomA*
Hurlbut, Elizabeth 1838?- *DcWomA*
Hurlbut, Gertrude d1909 *WhAmArt 85*
Hurlbut, Gertrude Rummel d1909 *DcWomA*
Hurlbut, Larry Joe 1939- *AmArch 70*
Hurlbutt, Roger *BiDBrA*
Hurlbutt, William *BiDBrA*
Hurleston, Richard d1780? *DcBrECP*
Hurley, Arnold J 1944- *AfroAA*
Hurley, Arnold James 1944- *WhoAmA 80*
Hurley, David Jeremiah 1930- *AmArch 70*
Hurley, Edward Timothy d1950 *WhoAmA 78N, -80N, -82N, -84N*
Hurley, Edward Timothy 1869-1950 *WhAmArt 85*
Hurley, Frank 1885-1962 *ICPEnP A*, *MacBEP*
Hurley, G W *AmArch 70*
Hurley, George *FolkA 86*
Hurley, Irene 1881-1925 *DcWomA*
Hurley, Irene Bishop 1881-1925 *WhAmArt 85*
Hurley, Kent *ConArch A*
Hurley, P J *AmArch 70*
Hurley, R M *AmArch 70*
Hurley, Wilson *OfPGCP 86*
Hurley, Wilson 1924- *IlBEAAW*, *WhoAmA 76, -78, -80, -82, -84*
Hurlimann, Ruth 1939- *IlsCB 1967*
Hurlstone, Mrs. *DcWomA*
Hurlstone, F B, Jr. *DcVicP 2*
Hurlstone, Frederick Yeates 1800-1869 *ArtsNiC*, *DcBrWA*
Hurlstone, Frederick Yeates 1801-1869 *DcVicP, -2*
Hurlstone, Jane d1858 *DcBrWA*, *DcVicP 2*
Hurlstone, Richard d1780? *DcBrECP*
Hurlstone, Robert William 1952- *WhoAmA 82, -84*
Hurly, John *EncASM*
Hurn, David 1934- *ConPhot*, *ICPEnP A*, *MacBEP*
Hurn, John Bruce 1926- *DcBrA 1*
Hurn, Peter Henry Charles 1942- *WhoArt 80, -82, -84*
Hurn, Richard Bruce 1948- *MarqDCG 84*
Hurrell, George 1904- *ICPEnP A*, *MacBEP*
Hurrig, Manfred 1937- *WhoGrA 82[port]*
Hurry, Agnes *DcVicP 2*, *DcWomA*
Hurry, Leslie 1909- *ClaDrA*, *DcBrA 1*

Hurry, Leslie 1909-1978 *OxTwCA*
Hurry, Lucy Washington *WhAmArt 85*
Hurry, Lucy Washington 1884- *DcWomA*
Hurry, Polly 1883-1963 *DcWomA*
Hursen, Sylvius *ArtsEM*
Hursh, Ronald E 1936- *MarqDCG 84*
Hursmans, Cornelis 1648-1727 *ClaDrA*
Hurson, Michael *DcCAr 81*
Hurson, Michael 1941- *WhoAmA 80, -82, -84*
Hurst, Aaron Henry 1762-1799 *BiDBrA*
Hurst, Arthur Henry 1934- *MarqDCG 84*
Hurst, Carol *DcWomA*
Hurst, Clara Scott 1889- *ArtsAmW 2*, *DcWomA*, *WhAmArt 85*
Hurst, Earl Oliver 1895- *WhAmArt 85*
Hurst, Earl Oliver 1895-1958 *IlrAm E, -1880*
Hurst, Hal 1865-1938 *DcBrA 1*, *DcVicP 2*
Hurst, Hal 1865-1938? *DcBrBI*
Hurst, John W 1905- *FolkA 86*
Hurst, L E 1883- *WhAmArt 85*
Hurst, Larry *DcCAr 81*
Hurst, Mary E *DcWomA*, *WhAmArt 85*
Hurst, Ralph *DcCAr 81*
Hurst, Ralph N 1918- *WhoAmA 73, -76, -78, -80, -82, -84*
Hurst, Rosebud *DcWomA*
Hurst, Sam T 1920- *AmArch 70*
Hurst, Sue Richards *DcWomA*, *WhAmArt 85*
Hurst, T W 1899- *FolkA 86*
Hurst, William 1787-1844 *BiDBrA*, *DcD&D*
Hurt, Fleming R 1904- *AmArch 70*
Hurt, James 1939- *MarqDCG 84*
Hurt, Louis B *DcVicP*
Hurt, Mrs. Louis B *DcVicP 2*
Hurt, Louis Bosworth 1856-1929 *DcBrA 1*, *DcVicP 2*
Hurt, Susanne M *WhoAmA 73, -76, -78, -80, -82, -84*
Hurtado, Angel 1927- *DcCAr 81*
Hurtado, Francisco 1669-1725 *McGDA*, *OxArt*
Hurtado Duhart, Rodolfo 1940- *WhoAmA 82, -84*
Hurtado Izquierdo, Francisco 1669-1725 *MacEA*
Hurten, C F 1818-1901 *AntBDN M*
Hurten, Charles Ferdinand 1818-1897 *DcNiCA*
Hurter, Ferdinand 1844-1898 *ICPEnP*, *MacBEP*
Hurter, Johann Heinrich 1734-1799 *DcBrECP*
Hurter, Marie 1852- *DcWomA*
Hurtig, Martin Russell 1929- *WhoAmA 73, -76, -78, -80, -82, -84*
Hurton, C F *DcVicP 2*
Hurtrel, Arsene Charles Narcisse 1817-1861 *ClaDrA*
Hurtt, Arthur R 1861- *WhAmArt 85*
Hurtt, Arthur R 1861-1938 *ArtsAmW 2*
Hurtubise, Mademoiselle *DcWomA*
Hurtubise, Jacques 1939- *ConArt 77*, *WhoAmA 73, -76, -78, -80, -82, -84*
Hurtubise, Jacques 1950- *WorECom*
Hurtuna, Josep Giralt 1913- *ClaDrA*, *WhoArt 80, -82, -84*
Hurum, Per 1910- *WhoArt 80, -82, -84*
Hurwitz, Sidney J 1932- *WhoAmA 76, -78, -80, -82, -84*
Hurwitz, Stephen A 1943- *MarqDCG 84*
Hurxthal, Isabel Hall *FolkA 86*
Husain, S V *AmArch 70*
Husband, Vicky 1940- *DcCAr 81*
Huse, John 1783-1827 *CabMA*
Huse, Marion 1896- *WhAmArt 85*
Huse, Marion 1896-1967 *DcWomA*
Huse, William *CabMA*
Huseby, Arleen *WhoAmA 73*
Husebye, Terry L 1945- *ICPEnP A*, *MacBEP*, *WhoAmA 84*
Husey, Agnes *DcWomA*
Husheer, John *WhAmArt 85*
Hushlak, Gerald 1945- *WhoAmA 84*
Hushlak, Gerald Marshall 1944- *WhoAmA 78*
Hushlak, Gerald Marshall 1945- *WhoAmA 80, -82*
Huskinsson, H *DcVicP 2*
Huskinsson, H L *DcVicP*
Huskinsson, L *DcVicP 2*
Huskisson, L *DcVicP 2*
Huskisson, Robert d1854 *DcVicP, -2*
Huslij, Jacob Otten 1753-1795 *McGDA*
Husly, J Otten 1738-1796 *MacEA*
Huson, R M 1899- *DcBrA 1*
Huson, Thomas 1844-1920 *DcBrA 1*, *DcBrWA*, *DcVicP, -2*
Huson, Mrs. Thomas *DcVicP 2*, *DcWomA*
Huson, W *DcBrECP*
Huss, W John 1942- *MacBEP*
Hussa, Theodore F, Jr. 1909- *WhAmArt 85*
Hussar, Laci 1903-1977 *WhAmArt 85*
Hussener, Auguste 1789-1877 *DcWomA*
Hussener, Elise 1809- *DcWomA*
Hussener, Julie *DcWomA*
Hussey, Agnes 1872- *DcWomA*, *DcWomA*
Hussey, Christopher 1936- *AmArch 70*
Hussey, E C *NewYHSD*
Hussey, Elijah *CabMA*
Hussey, Giles 1710-1788 *DcBrECP[port]*

Hussey, Grace *DcVicP 2*, *DcWomA*
Hussey, Henrietta 1819- *DcWomA*
Hussey, Henrietta 1819-1899 *DcBrWA*, *DcVicP 2*
Hussey, Henry James 1913- *DcBrA 1*, *WhoArt 80, -82, -84*
Hussey, J E *AmArch 70*
Hussey, John Denis 1928- *WhoArt 80, -82, -84*
Hussey, Mabel *DcWomA*
Hussey, Mabel De *WhAmArt 85*
Hussey, Philip 1713-1783 *DcBrECP*
Husson, Jeanne Elisabeth *DcWomA*
Husson, Leon Francis 1922- *AmArch 70*
Hustace, Maria 1803- *FolkA 86*
Hustad, D E *AmArch 70*
Hustead, Elvera C *WhAmArt 85*
Husted, Elvera C *ArtsAmW 2*
Husted, Mary Irving *WhAmArt 85*
Husted, Thomas C *NewYHSD*
Husted-Andersen, Adda *WhAmArt 85*, *WhoAmA 73*
Huston, Albert D *ArtsEM*
Huston, Bruce 1926- *AmArch 70*
Huston, C Aubrey 1857- *WhAmArt 85*
Huston, John I 1915- *WhoArt 80, -82, -84*
Huston, Paul James 1916- *AmArch 70*
Huston, Perry Clark 1933- *WhoAmA 80, -82, -84*
Huston, Ronald Lee 1937- *MarqDCG 84*
Huston, William *WhAmArt 85*
Huszar, Ilona 1865- *DcWomA*
Huszar, Vilmos 1884- *PhDcTCA 77*
Huszar, Vilmos 1884-1960 *OxTwCA*
Hutaf, August W 1879-1942 *WhAmArt 85*
Hutaff, John H *ArtsEM*
Hutawa, Julius *NewYHSD*
Hutchason, A R *AmArch 70*
Hutchason, R R *AmArch 70*
Hutchason, Willis Kenneth 1920- *AmArch 70*
Hutchcraft, Clinton Edward 1937- *AmArch 70*
Hutchcraft-Hill, Hattie 1847-1921 *DcWomA*
Hutchens *DcWomA*
Hutchens, Miss *ArtsEM*
Hutchens, Charles 1781?-1834 *BiDBrA*
Hutchens, Florence F *DcWomA*
Hutchens, Frank Townsend 1869-1937 *ArtsAmW 2*, *WhAmArt 85*
Hutcheson, Don 1940- *MarqDCG 84*
Hutcheson, Francis 1694-1747 *OxArt*
Hutcheson, John *BiDBrA*
Hutcheson, R C *AmArch 70*
Hutcheson, Tom 1922- *DcBrA 1*, *WhoArt 80, -82*
Hutcheson, Tom 1924- *WhoArt 84*
Hutcheson, W A, Jr. *AmArch 70*
Hutcheson, Walter d1910 *DcBrA 2*
Hutchings *NewYHSD*
Hutchings, A B 1828?- *NewYHSD*
Hutchings, Augusta Ladd Sweetland d1881 *ArtsAmW 3*
Hutchings, Elvira Sproat 1842-1917? *ArtsAmW 3*
Hutchings, Hilda Edith 1890- *DcBrA 1*, *DcWomA*
Hutchings, Ivan Brent 1948- *MarqDCG 84*
Hutchings, J *DcVicP 2*
Hutchings, John Bacon, Jr. 1859-1916 *BiDAmAr*
Hutchings, LaVere 1918- *WhoAmA 82, -84*
Hutchings, Sam C *AmArch 70*
Hutchings, Stephen B *NewYHSD*
Hutchings, W H *NewYHSD*
Hutchings, William E *NewYHSD*
Hutchins *NewYHSD*
Hutchins, Charles Bowman 1889- *ArtsAmW 2*, *WhAmArt 85*
Hutchins, Chester Eaton 1922- *AmArch 70*
Hutchins, Dana Wade 1954- *MarqDCG 84*
Hutchins, Emma *ArtsEM*, *DcWomA*
Hutchins, Franklin H 1871-1934 *BiDAmAr*
Hutchins, Frederic Loudon 1896- *WhAmArt 85*
Hutchins, John E 1891- *WhAmArt 85*
Hutchins, Lydia A *ArtsEM*
Hutchins, Mary Alice *AmArch 70*
Hutchins, Maude Phelps McVeigh *WhAmArt 85*, *WhoAmA 76, -78, -80*
Hutchins, Maude Phelps McVeigh 1889- *DcWomA*
Hutchins, Pat 1942- *IlsBYP*, *IlsCB 1967*
Hutchins, R A *AmArch 70*
Hutchins, Robert S 1907- *AmArch 70*
Hutchins, Sheldon F 1886- *ArtsAmW 3*
Hutchins, Sylvia *AfroAA*
Hutchins, Will 1878- *WhAmArt 85*
Hutchinson, Allen 1855- *WhAmArt 85*
Hutchinson, C K *AmArch 70*
Hutchinson, Charles L 1854-1924 *WhAmArt 85*
Hutchinson, Mrs. Charles L d1936 *WhAmArt 85*
Hutchinson, Claudia Jane 1949- *PrintW 83, -85*
Hutchinson, Constance Ethel *DcWomA*
Hutchinson, Cyrus *NewYHSD*
Hutchinson, E L *DcWomA*
Hutchinson, Ebenezer *FolkA 86*
Hutchinson, Edmund *BiDBrA*
Hutchinson, F J *DcVicP 2*
Hutchinson, G D *AmArch 70*
Hutchinson, George *DcVicP 2*
Hutchinson, George Alfred 1911- *AmArch 70*
Hutchinson, George W C *DcBrBI*, *DcVicP 2*

Hutchinson, Henry 1800-1831 *BiDBrA*
Hutchinson, Jane P *DcVicP 2*
Hutchinson, Janet L 1917- *WhoAmA 73, -76, -78, -80, -82, -84*
Hutchinson, Jessie *DcWomA*
Hutchinson, John *CabMA*
Hutchinson, John A *FolkA 86*
Hutchinson, John H 1838-1897 *EncASM*
Hutchinson, Louise *DcWomA*
Hutchinson, Marie *DcWomA*
Hutchinson, Mary E 1906-1970 *WhAmArt 85*
Hutchinson, Max 1925- *WhoAmA 73, -76, -78, -80, -82, -84*
Hutchinson, P *DcVicP 2*
Hutchinson, Peter 1930- *PrintW 83, -85*
Hutchinson, Peter Arthur 1930- *ConArt 77, WhoAmA 73, -76, -78, -80, -82, -84*
Hutchinson, Mrs. Richard Ernest *DcWomA*
Hutchinson, Robert *DcCAr 81, NewYHSD*
Hutchinson, Robert F 1912- *AmArch 70*
Hutchinson, Samuel *DcBrECP, DcBrWA*
Hutchinson, Thomas *CabMA*
Hutchinson, Thomas d1782 *CabMA*
Hutchinson, W Henry Florio *DcVicP 2*
Hutchinson, William *FolkA 86*
Hutchinson, William 1779?-1869 *BiDBrA*
Hutchinson, William M 1916- *IlsBYP, IlsCB 1957*
Hutchinson-Parrish, Annabelle *DcWomA*
Hutchison, Alexander Cowper 1838-1922 *MacEA*
Hutchison, D C 1869-1954 *IlBEAAW, WhAmArt 85*
Hutchison, David 1883- *WhAmArt 85*
Hutchison, Elizabeth S *WhoAmA 73, -76, -78, -80, -82, -84*
Hutchison, Ellen Wales 1868-1937 *DcWomA, WhAmArt 85*
Hutchison, F W 1871-1953 *WhAmArt 85*
Hutchison, Frank Ray 1919- *AmArch 70*
Hutchison, George Jackson 1896-1918 *DcBrA 1, -2*
Hutchison, Inez 1890- *DcWomA*
Hutchison, James 1751?-1801 *BiDBrA*
Hutchison, Jane Campbell *WhoAmA 84*
Hutchison, John *ArtsNiC*
Hutchison, John d1910 *DcBrA 1*
Hutchison, John 1833-1910 *DcVicP 2*
Hutchison, Joseph Shields 1912- *WhAmArt 85*
Hutchison, Marlin Douglas 1926- *AmArch 70*
Hutchison, Mary Elizabeth 1906-1970 *WhoAmA 78N, -80N, -82N, -84N*
Hutchison, Maud Gemmell *DcWomA*
Hutchison, Milburn Robert 1917- *WhoAmA 73*
Hutchison, Paula 1905- *IlsBYP, IlsCB 1946*
Hutchison, Robert *BiDBrA*
Hutchison, Robert Gemmell 1855-1936 *ClaDrA, DcBrA 1, DcVicP, -2*
Hutchison, Robert Gemmell 1860-1936 *DcBrWA*
Hutchison, Shand Campbell 1920- *ClaDrA*
Hutchison, Sidney Charles 1912- *WhoArt 80, -82, -84*
Hutchison, William George 1938- *MarqDCG 84*
Hutchison, Sir William Oliphant 1889- *ClaDrA*
Hutchison, Sir William Oliphant 1889-1970 *DcBrA 1*
Hutchman, James Frederick 1923- *AmArch 70*
Huten, Camille *DcWomA*
Hutenreith, L *NewYHSD*
Huter, Marie *DcWomA*
Huth, Abraham *FolkA 86*
Huth, Hans 1892- *WhoAmA 73, -76, -78*
Huth, Marta 1898- *DcWomA, WhoAmA 73, -76, -78, -80, -82*
Huth, Rosa 1815-1843 *DcWomA*
Hutin, Anne Auguste *DcWomA*
Hutlett, Maximilian 1933- *DcCAr 81*
Hutman, Richard Morris 1935- *AmArch 70*
Hutner, Laurence M, Jr. 1937- *AmArch 70*
Hutsaliuk, Lubo 1923- *WhoAmA 73, -76, -78, -80, -82, -84*
Hutson, Bill 1936- *AfroAA*
Hutson, Charles 1840-1935 *NewYHSD*
Hutson, Charles Woodward 1840-1935? *FolkA 86*
Hutson, Charles Woodward 1840-1936 *WhAmArt 85*
Hutson, Ethel 1872- *DcWomA, WhAmArt 85*
Hutson, Victoria *WhAmArt 85*
Hutt, C S *AmArch 70*
Hutt, Henry 1875- *WhAmArt 85*
Hutt, Henry 1875-1950 *IlrAm A, -1880*
Hutt, John *NewYHSD*
Huttbug, Charles E 1874- *WhAmArt 85*
Hutte, Axel 1951- *DcCAr 81*
Hutter, Barbara *DcWomA*
Hutter, David 1935- *DcCAr 81*
Hutter, E 1835-1886 *ClaDrA*
Hutter, Wolfgang 1928- *OxTwCA, PhDcTCA 77*
Huttinger, Peter 1953- *DcCAr 81, PrintW 83, -85*
Huttio, E W *WhAmArt 85*
Huttlinger, Maria Ursula *DcWomA*
Hutton, Addison 1834-1916 *BiDAmAr, MacEA*
Hutton, Alfred *DcVicP 2*
Hutton, Amy S *WhAmArt 85*
Hutton, Christopher *FolkA 86*
Hutton, Clarke *IlsCB 1967*
Hutton, Clarke 1898- *DcBrA 1, IlsCB 1744, -1946, -1957, WhoArt 80, -82, -84*

Hutton, Dorothy *WhoArt 80, -82, -84*
Hutton, Dorothy Wackerman 1898?- *DcWomA, WhAmArt 85*
Hutton, Dorothy Wackerman 1899- *WhoAmA 73, -76, -78, -80, -82, -84*
Hutton, Hugh McMillen 1897- *WhoAmA 73, -76*
Hutton, Hugh McMillen 1897-1976 *WhAmArt 85, WhoAmA 78N, -80N, -82N, -84N*
Hutton, Isaac 1767?-1855 *NewYHSD*
Hutton, John 1906- *DcBrA 2, IlDcG*
Hutton, Kurt 1893-1960 *ConPhot, ICPEnP A, MacBEP*
Hutton, Leonard *WhoAmA 73, -76, -78, -80, -82, -84*
Hutton, R *DcVicP 2*
Hutton, T G *DcVicP 2*
Hutton, Thomas S 1875?-1935 *DcBrA 1, DcVicP 2*
Hutton, Walter C Stritch *DcVicP 2*
Hutton, William *EncASM*
Hutton, William 1926- *WhoAmA 73, -76, -78, -80, -82, -84*
Hutton, William Rich 1826-1901 *ArtsAmW 1, -3, IlBEAAW, NewYHSD, WhAmArt 85*
Huttula, Richard C *DcBrBI, DcBrWA, DcVicP 2*
Hutty, Alfred 1877-1954 *WhAmArt 85*
Hutty, Alfred Heber 1877-1954 *GrAmP*
Hutty, Alfred Heber 1878- *ArtsEM, ClaDrA*
Hutty, Alfred Heber 1878-1954 *ArtsAmW 1*
Hutzel, Ingeborg 1948- *MarqDCG 84*
Huve, Jean-Jacques-Marie 1742-1808 *MacEA*
Huve, Jean Jacques Marie 1783-1852 *McGDA*
Huxford, Marie *DcWomA, WhAmArt 85*
Huxley, E L *AmArch 70*
Huxley, Marian *DcWomA*
Huxley, Minnie *ArtsEM, DcWomA*
Huxley, Nettie *DcVicP 2*
Huxley, Paul 1938- *ConArt 77, -83, ConBrA 79[port], DcCAr 81, OxTwCA, PhDcTCA 77*
Huxley-Jones, Thomas Bayliss 1908-1969 *DcBrA 1*
Huxtable, Ada Louise *WhoAmA 73, -76, -78, -80, -82, -84*
Huxtable, Diane Pierce *WhoAmA 82*
Huy, Jean De *OxArt*
Huybers, John *DcVicP 2*
Huyck, Laura Talmage *WhAmArt 85*
Huygens, Frederik-Lodewyh 1802-1887 *ClaDrA*
Huygens, Remmert William 1932- *AmArch 70*
Huygens, Susanna Louise 1714-1785 *DcWomA*
Huyghe, Rene 1906- *WhoArt 80, -82, -84*
Huyn, Paul *WhAmArt 85*
Huynh, Ut Cong 1951- *MacBEP*
Huyot, Jean Nicolas 1780-1840 *MacEA*
Huys, Frans 1522-1562 *McGDA*
Huysmans Of Mechlin *McGDA*
Huysmans, Cornelis 1648-1727 *McGDA*
Huysmans, Jan-Baptist 1654-1716 *McGDA*
Huysmans, Jan Baptiste 1826- *ClaDrA*
Huysmans, P J *ClaDrA*
Huyssen, Margareta *DcWomA*
Huysum *McGDA*
Huysum, Jan Van 1682-1749 *ClaDrA*
Huysum, Justus Van 1659-1716 *ClaDrA, OxArt*
Huysum, Justus Van 1684-1707 *ClaDrA*
Huysum, Maria Van *DcWomA*
Huysum, Michiel Van *ClaDrA*
Huzel, Leonie *DcWomA*
Huzjan, Zdenko *DcCAr 81*
Hvidt, Peter 1916- *DcD&D*
Hwang, Kyu-Baik 1932- *PrintW 85*
Hyacinthe, Kuller Baron 1936- *WhoAmA 80*
Hyams, William *DcBrA 2*
Hyath, Winfred S *WhAmArt 85*
Hyatt, Anna *DcWomA*
Hyatt, Anna Vaughan *WhAmArt 85*
Hyatt, Audella 1839?-1932 *DcWomA, WhAmArt 85*
Hyatt, Augustus *NewYHSD*
Hyatt, Cornelia *DcWomA*
Hyatt, Derek James 1931- *WhoArt 80, -82, -84*
Hyatt, Foster Highlands 1908- *AmArch 70*
Hyatt, Harriet Randolph *WhAmArt 85*
Hyatt, Harriet Randolph 1868-1960 *DcWomA*
Hyatt, Jacob *NewYHSD*
Hyatt, John *AntBDN Q*
Hyatt, W S *WhAmArt 85*
Hyatt, William W 1826?- *NewYHSD*
Hyatt, Winifred S 1891?-1959 *DcWomA*
Hyde *DcBrECP*
Hyde, A Leicester 1902- *AmArch 70*
Hyde, A M *AmArch 70*
Hyde, Alice Earle 1876?-1943 *DcWomA, WhAmArt 85*
Hyde, Andrew Cornwall 1941- *WhoAmA 73, -76, -78, -80*
Hyde, Annie *DcWomA*
Hyde, B B *AmArch 70*
Hyde, C S *AmArch 70*
Hyde, Della Mae Pascal 1895- *DcWomA*
Hyde, Edgar *DcBrBI*
Hyde, Edward *NewYHSD*
Hyde, Emily Griffin 1859-1919 *DcWomA,*

WhAmArt 85
Hyde, F *DcVicP 2*
Hyde, Frank *DcVicP 2*
Hyde, Guy N 1946- *MarqDCG 84*
Hyde, Hallie Champlin *DcWomA, WhAmArt 85*
Hyde, Harriet L *ArtsEM, DcWomA*
Hyde, Helen 1863-1919 *DcWomA*
Hyde, Helen 1868-1919 *ArtsAmW 1, WhAmArt 85*
Hyde, Henry *CabMA, NewYHSD*
Hyde, Henry James *DcBrWA, DcVicP 2*
Hyde, J F, Jr. *AmArch 70*
Hyde, J N *EarABI, EarABI SUP*
Hyde, James N *EncASM*
Hyde, John 1846-1927 *WhAmArt 85*
Hyde, John R 1941- *MarqDCG 84*
Hyde, Joseph *BiDAmAr*
Hyde, Josephine E 1885- *ArtsAmW 3, DcWomA*
Hyde, Laura *WhAmArt 85*
Hyde, Laurence 1914- *WhoAmA 73, -76, -78, -80, -82*
Hyde, Lora *DcWomA*
Hyde, Lucy *DcWomA*
Hyde, Marie A 1882- *DcWomA*
Hyde, Marie A H 1882- *ArtsAmW 2, WhAmArt 85*
Hyde, Mary *DcWomA*
Hyde, Mary Elizabeth *WhAmArt 85*
Hyde, Maxwell 1868-1946 *BiDAmAr*
Hyde, Nathaniel *CabMA*
Hyde, Pascal *WhAmArt 85*
Hyde, Philip 1921- *ICPEnP A, MacBEP*
Hyde, Raymond Newton 1863- *WhAmArt 85*
Hyde, Mrs. Richard *DcVicP 2*
Hyde, Richard F 1941- *MarqDCG 84*
Hyde, Russell Taber 1886- *WhAmArt 85*
Hyde, Scott 1926- *ConPhot, ICPEnP A, MacBEP, WhoAmA 84*
Hyde, Violet Buel *DcWomA, WhAmArt 85*
Hyde, W D *WhAmArt 85*
Hyde, Warren G *NewYHSD*
Hyde, William *DcVicP 2*
Hyde, William d1925 *DcBrA 2*
Hyde, William H 1858-1943 *WhAmArt 85*
Hyde, William Henry 1858- *DcBrBI*
Hyde, William Henry 1858-1943 *WorECar*
Hyde, Winfield Hadsell 1902- *AmArch 70*
Hyde And Goodrich *EncASM*
Hyde DeNeuville, Baroness *FolkA 86*
Hyde DeNeuville, Baroness Anne-M-H 1779?-1849 *NewYHSD*
Hyde DeNeuville, Anne Marguerite H 1749?-1849 *DcWomA*
Hyde-Pownall, George 1876-1932 *DcVicP 2*
Hydeman, Sid L 1895- *WhAmArt 85*
Hyer, Florine 1868- *ArtsAmW 3*
Hyer, Florine A 1868- *DcWomA*
Hyer, Robert Stewart 1860-1929 *ArtsAmW 3*
Hyett, John Edward d1936 *DcBrA 1*
Hyett, Will J 1876- *WhAmArt 85*
Hykes, Ethel Johnt *WhAmArt 85*
Hyks, Sterling Vance *AfroAA*
Hyland, Bruce Alexander 1943- *MarqDCG 84*
Hyland, Clayton Malcolm 1924- *AmArch 70*
Hyland, Clifford F 1911- *AmArch 70*
Hyland, Douglas K S 1949- *WhoAmA 82, -84*
Hyland, F T *AmArch 70*
Hyland, Flora *DcWomA*
Hyland, Fred *DcBrBI*
Hyland, Irving Litchfield 1896- *AmArch 70*
Hyle, N *NewYHSD*
Hylwa, W *AmArch 70*
Hyman, Hilda 1872- *DcWomA*
Hyman, Isabelle 1930- *WhoAmA 84*
Hyman, Linda 1940- *WhoAmA 82, -84*
Hyman, Martin Joseph 1938- *AmArch 70*
Hyman, Moses 1870- *WhAmArt 85*
Hyman, Timothy 1946- *DcCAr 81*
Hyman, Trina Schart *IlsCB 1967*
Hyman, Trina Schart 1939- *IlsBYP, IlsCB 1957*
Hymel, A C, Sr. *AmArch 70*
Hynckes, Raoul 1893- *PhDcTCA 77*
Hynd, Frederic Stuart 1905- *WhAmArt 85*
Hyneman, Herman N 1859-1907 *WhAmArt 85*
Hyneman, Juliet J *DcWomA, WhAmArt 85*
Hynes, Edith *WhAmArt 85*
Hynes, Gladys 1888-1958 *DcBrA 1, DcWomA*
Hynes, Mary Helen 1894- *WhAmArt 85*
Hynson, Nathan *CabMA*
Hyppolite, Hector *OxTwCA*
Hyppolite, Hector 1894-1948 *McGDA*
Hyre, Laurent DeLa 1606-1656 *ClaDrA*
Hysell, Robert M 1932- *AmArch 70*
Hysing, Hans 1678-1753 *DcBrECP*
Hysler, Minnie *DcWomA, WhAmArt 85*
Hyslop, Alfred John 1898- *WhAmArt 85, WhoAmA 73*
Hyslop, Francis Edwin 1909- *WhoAmA 73, -76, -78, -80, -82*
Hyslop, Theo B *DcVicP 2*
Hyson, Jean 1933- *WhoAmA 76, -78, -80, -82, -84*
Hyssong, C B *FolkA 86*
Hytche, Kezia *DcVicP 2, DcWomA*

Hyttlin, Elizabetha *DcWomA*
Hyzen, Leon 1910- *AmArch 70*
Hyzer, Arthur K *MarqDCG 84*

I

Iacopi, John Albert 1942- *AmArch 70*
Iacopino DaTradate *McGDA*
Iacurto, Francesco 1908- *WhoAmA 73, -76, -78, -80, -82, -84*
Iaia Of Cyzicus *DcWomA*
Iakimov, Anne Marie 1889- *DcWomA*
Iakunchikova-Veber, Maria Vasilievna 1870-1902 *DcWomA*
Iams, J Howard 1897- *WhAmArt 85*
Iams, Jack Louis 1929- *AmArch 70*
Iamucci, Ricardo *ArtsEM*
Ianiro, Abel 1919-1960 *WorECom*
Iankovitz, Marie Lucie De *DcWomA*
Iannaccone, Piero *WhAmArt 85*
Iannarella, Rodolfo F C 1942- *MarqDCG 84*
Iannelli, Alfonso 1888- *WhAmArt 85*
Iannelli, Alfonso 1888-1965 *ArtsAmW 2*
Iannetti, Pasquale Francesco Paolo 1940- *WhoAmA 78, -80, -82, -84*
Ianniello, Anthony Joseph 1931- *AmArch 70*
Iannitto, John Anthony, Jr. 1930- *AmArch 70*
Iannone, Dorothy 1933- *ConArt 77, -83, PrintW 85, WhoAmA 78, -80*
Iannone, Vincent Anthony 1927- *AmArch 70*
I'Anson, Charles *DcBrA 2, DcVicP 2*
I'Anson, Charles 1924- *DcBrA 1, WhoArt 80, -84*
I'Anson, Edward 1775-1853 *BiDBrA, McGDA*
I'Anson, Edward, Jr. 1812-1888 *MacEA*
I'Anson, F *DcVicP 2*
Ianuzzi, Mara *WhoAmA 80, -82*
Iardella, Andrew B *NewYHSD*
Iardella, Francisco 1793-1831 *NewYHSD*
Iardella, Giuseppe *NewYHSD*
Iaricci, A 1888- *WhAmArt 85*
Iazykova, Katarina Alexandrovna 1820-1896 *DcWomA*
Ibanez, Francisco 1935- *WorECar*
Ibarra, Jose De 1688-1756 *McGDA*
Ibarrola, Agustin *OxTwCA*
Ibbeson, Herbert G *DcVicP 2*
Ibbeson, Graham 1951- *DcCAr 81*
Ibbetson, Arvah J *NewYHSD*
Ibbetson, Denzil O 1775-1857 *DcBrWA*
Ibbetson, James B *DcSeaP*
Ibbetson, Sir John Thomas Selwin 1789- *DcBrWA*
Ibbetson, Julius Caesar 1759-1817 *DcBrECP, DcBrWA, McGDA, OxArt*
Ibbetson, Julius Caesar 1783-1825 *DcBrWA*
Ibbetson, Peter William 1909- *DcBrA 1*
Ibbotson, James *NewYHSD*
Ibels, Henri-Gabriel 1867-1936 *WorECar*
Ibels, Louise Catherine 1891- *DcWomA*
Ibelshauser, John *NewYHSD*
Iberg, Eva Von *DcWomA*
Ibia, Isabel De *DcWomA*
Ibling, Miriam 1895- *DcWomA, WhAmArt 85*
Iborra, Rosa Cabrera De *DcWomA*
Ibou, Paul 1939- *WhoGrA 82[port]*
Ibs, Ernst A 1935- *AmArch 70*
Icart, Louis *OfPGCP 86A*
Icart, Louis 1888-1950 *WhAmArt 85*
Icaza 1930- *WhoAmA 73, -76, -78*
Ichanson, Marie 1889- *DcWomA*
Ichenhauser, Natalie *DcVicP 2, DcWomA*
Ichimura, Tetsuya 1930- *ConPhot, ICPEnP A*
Ickes, Paul A 1895- *WhAmArt 85*
Ickovic, Paul 1944- *ICPEnP A, MacBEP*
Ictinus *McGDA, OxArt*
Ida, Shoichi 1941- *DcCAr 81, PrintW 83, -85, WhoAmA 78, -80*
Idaherma *WhoAmA 84*
Ide, Alice Steele *DcWomA, WhAmArt 85*

Ide, Mary 1790-1817 *FolkA 86*
Idell, G S *AmArch 70*
Iden, Sheldon 1933- *WhoAmA 73, -76, -78, -80, -82, -84*
Idsinga, Wilhelmina Geertruida Van 1788-1819 *DcWomA*
Iervolino, Joseph Anthony 1920- *WhoAmA 73, -76, -78*
Iervolino, Paula *WhoAmA 73, -76, -78*
Ifield, Henry *AntBDN M*
Ifold, Frederick *DcVicP 2*
Iftikhar, Ali 1955- *MarqDCG 84*
Igarashi, Takenobu 1944- *ConDes*
Igaz, R, Jr. *AmArch 70*
Iger, Samuel Maxwell 1903- *WorECom*
Ighina-Barbano, Mary 1865- *DcWomA*
Igleburger, Arnold Franklin 1912- *AmArch 70*
Iglehart, Robert L 1912- *WhoAmA 73, -76, -78, -80, -82, -84*
Iglesias Y Acevedo, Felicindo 1898- *OxTwCA*
Igloo, Alex T 1951- *WhoAmA 82*
Ignatius Loyola, Saint 1491-1556 *McGDA*
Ignatovich, Boris 1899-1976 *ConPhot, ICPEnP A*
Ignelzi, A J *AmArch 70*
Ignelzi, Michael Anthony 1929- *AmArch 70*
Igonet, Marie Madeleine *DcWomA*
Igonnet, Marie Madeleine *DcWomA*
Ih, Donna Muan-Lee 1935- *MarqDCG 84*
Ihara, Michio 1928- *WhoAmA 76, -78, -80, -82, -84*
Ihbe, G M *AmArch 70*
Ihle, John Livingston 1925- *WhoAmA 78, -80, -82, -84*
Ihlee, Rudolph *DcBrA 1, -2, DcCAr 81*
Ihlefeld, Henry 1859-1932 *WhAmArt 85*
Ihmsen, Charles *FolkA 86*
Ihrig, Clara Louise 1893- *DcWomA, WhAmArt 85*
Ihrig, D K *AmArch 70*
Iid, J W *AmArch 70*
Iida, Yoshikuni 1923- *DcCAr 81*
Iimura, Taka 1937- *ConArt 77, -83, WhoAmA 78, -80, -82, -84*
Ijkens, Catharina *DcWomA*
Ikard, Virginia 1871- *ArtsAmW 3*
Ikeda, Masuo 1934- *OxTwCA, PhDcTCA 77, WhoAmA 76, -78*
Ikeda, Shoen 1888-1917 *DcWomA*
Ikeda, Yoshiro 1947- *WhoAmA 82, -84*
Ikegawa, Shiro 1933- *WhoAmA 84*
Iken, Jonathan Alfred *DcBrWA*
Ikenoyama, G K *AmArch 70*
Ikkala, Outi 1935- *DcCAr 81*
Ikkan *AntBDN L, OxDecA*
Ikko *AntBDN L, ConPhot*
Ikko 1931- *ICPEnP A, MacBEP*
Ikkosai *AntBDN L*
Ikkwan *AntBDN L*
Iktinos *MacEA*
Ikuta, Kacho 1893- *DcWomA*
Il Cronaca 1457-1508 *WhoArch*
Ilarreta, Hersilia *DcCAr 81*
Iler, William *FolkA 86*
Iles, Marvin Stuart 1917- *AmArch 70*
Ilg, Frederick William, Jr. 1931- *AmArch 70*
Ilgen, R L *WhAmArt 85*
Iliewa, Dona 1880- *DcWomA*
Iliff, Cynthia *WhAmArt 85*
Iliff, Richard *FolkA 86*
Iligan, Ralph W 1894-1960 *WhAmArt 85, WhoAmA 80N, -82N, -84N*
Iliprandi, Giancarlo 1925- *ConDes, WhoGrA 82[port]*

Illava, Karl *WhAmArt 85*
Ille, Eduard 1823-1900 *WorECar*
Illescas Mirosa, Sixto 1903- *MacEA*
Illian, George 1894-1932 *WhAmArt 85*
Illidge, Thomas Henry 1799-1851 *DcVicP 2*
Illinger, Peter 1937- *DcCAr 81*
Illingworth, Adeline S *DcBrA 1*
Illingworth, Adeline S 1858- *DcWomA*
Illingworth, F W *DcBrBI*
Illingworth, Leslie Gilbert 1902- *DcBrA 2, WorECar*
Illingworth, S E *DcBrBI*
Illions, Marcus Charles *FolkA 86*
Illius *NewYHSD*
Illman, Charles T 1842?- *NewYHSD*
Illman, Edward 1833?- *NewYHSD*
Illman, George 1824?- *NewYHSD*
Illman, Henry *NewYHSD*
Illman, Thomas d1860? *NewYHSD*
Illman, William *NewYHSD*
Illsley, Samuel 1863-1946 *BiDAmAr*
Ilmanen, J W *AmArch 70*
Ilo, Mat *DcCAr 81*
Ilowitz, Theodora 1921- *WhoAmA 82, -84*
Ilsey, Frederick J 1855- *WhAmArt 85*
Ilsley, Velma Elizabeth 1918- *IlsBYP, IlsCB 1946*
Ilvonen, Jouko Arimo 1927- *AmArch 70*
Ilyin, Gleb A 1889-1968 *ArtsAmW 3*
Ilyin, Peter 1887- *WhAmArt 85*
Ilyin, Peter A 1887- *ArtsAmW 1*
Image, Jean *WorECar*
Image, Selwyn 1849-1930 *DcBrA 2, DcBrBI, DcNiCA*
Imai, Toshimitsu 1928- *OxTwCA, PhDcTCA 77*
Imana, Jorge Garron 1930- *WhoAmA 78, -80, -82, -84*
Imargiassi, Mario *DcBrBI*
Imbert, Anthony *NewYHSD*
Imbert, John Claude *NewYHSD*
Imbrey, Jai Alison 1952- *WhoAmA 80, -82*
Imbs, T J *AmArch 70*
Imel, A Blaine, Jr. 1921- *AmArch 70*
Imer, Berthe *DcWomA*
Imer, Edouard 1820?-1881 *ArtsNiC*
Imglessi, Marie 1880- *DcWomA*
Imgraben, Cacilie 1879- *DcWomA*
Imhof, August Erwin 1929- *AmArch 70*
Imhof, Joseph A 1871-1955 *IIBEAAW, WhAmArt 85*
Imhoff, Clare Dean 1924- *AmArch 70*
Imhoff, Joseph A 1871-1955 *ArtsAmW 1*
Imhoff, Margaretha *DcWomA*
Imhotep *MacEA*
Imiretinsky, Princess *DcWomA*
Imkamp, Wilhelm 1906- *OxTwCA*
Imlac, Miss *DcWomA*
Imlach, William Bertram *WhAmArt 85*
Imler, Edgar 1896- *WhAmArt 85*
Immaculata, Sister M *WhAmArt 85*
Immanuel, M *DcBrECP*
Immediate, C *AmArch 70*
Immel, Paul 1896- *WhAmArt 85*
Immel, Paul J 1896- *ArtsAmW 2*
Immen, Frederick William 1904- *AmArch 70*
Immen, Thomas Laurence 1911- *AmArch 70*
Immendorff, Jorg 1945- *DcCAr 81, PrintW 85*
Immerman, David 1911- *WhAmArt 85*
Immerwahr, Sara Anderson 1914- *WhoAmA 76, -78, -80*
Imming, G L *AmArch 70*
Imola, Innocenzo Da 1490?-1550? *McGDA*
Imparato, Francesco 1530?-1565 *ClaDrA*

Imperato, Mrs. Edmund *WhAmArt 85*
Impey, Lillian *DcWomA*
Impey, Lillian Cotton *WhAmArt 85*
Impiglia, Giancarlo 1940- *AmArt*, *PrintW 85*
Impson, Jacob *FolkA 86*
Imredy, Stephen A 1936- *MarqDCG 84*
Imregh, Agnes Elizabeth 1950- *MarqDCG 84*
Imretinski, Princess *DcWomA*
Imrey, Ferenc 1885- *WhAmArt 85*
Imrie, Archibald Brown 1900- *DcBrA 1*
Imrie, Herbert David *WhAmArt 85*
Imsweller, Henry *FolkA 86*
In-Jae *McGDA*
Inabet, Mike *FolkA 86*
Inada, Hitoshi 1937- *MarqDCG 84*
Inada, N *AmArch 70*
Inama-Sternegg, Franziska Von 1870- *DcWomA*
Incandela, Gerald 1952- *ICPEnP A*
Ince, Miss A C 1868- *DcBrA 2*
Ince, Charles 1875- *DcBrBI*
Ince, Charles Percy 1875-1952 *DcBrA 1*, *DcVicP 2*
Ince, Evelyn Grace 1886?-1941 *DcBrA 1*, *DcWomA*
Ince, Howard *DcVicP 2*
Ince, Ilhan 1958- *MarqDCG 84*
Ince, Joseph Murray 1806-1859 *DcBrBI*, *DcBrWA*,
 DcVicP, -2
Ince, William *AntBDN G*, *DcD&D*
Inchbald, Michael *WhoArt 80, -82, -84*
Inchbald, Michael 1920- *DcD&D[port]*
Inchbold, John William 1830-1888 *ClaDrA*, *DcBrWA*,
 DcVicP, -2
Inchbold, Stanley *DcBrWA*
Inchbold, Stanley 1856- *DcBrA 1*, *DcVicP 2*
Incledon, Marjorie M 1891- *ClaDrA*, *DcBrA 1*,
 DcWomA
Indaco, Jacopo DeDell *ClaDrA*
Indeck, Karen Joy 1951- *WhoAmA 78, -80, -82*
Inden, Hugo 1901- *WhAmArt 85*
Indermaur, J G *DcVicP 2*
Inderwick *NewYHSD*
Indiana, Robert 1928- *AmArt*, *BnEnAmA*,
 ConArt 77, -83, *DcAmArt*, *DcCAA 71, -77*,
 DcCAr 81, *OxTwCA*, *PhDcTCA 77*, *PrintW 83*,
 -85, *WhoAmA 73, -76, -78, -82, -84*,
 WorArt[port]
Indick, Janet 1932- *WhoAmA 82, -84*
Indiviglia, Salvatore Joseph 1919- *WhoAmA 73, -76,
 -78, -80, -82, -84*
Induno, Girolamo 1815- *ArtsNiC*
Ines, Eleonore Roberts 1934- *MacBEP*
Infantino, Carmine 1925- *WorECom*
Ing, Harold 1900- *ClaDrA*, *DcBrA 1*
Ingall, J Spence *DcVicP 2*
Ingall, J Spence d1936 *DcBrA 2*
Ingalls, C A *FolkA 86*
Ingalls, C S *AmArch 70*
Ingalls, Mrs. C T *WhAmArt 85*
Ingalls, Charles *NewYHSD*
Ingalls, Eileen Brodie 1903- *WhAmArt 85*
Ingalls, Eve *DcCAr 81*
Ingalls, Eve 1936- *WhoAmA 78, -80, -84*
Ingalls, Frank *WhAmArt 85*
Ingalls, Gardner 1800-1874 *NewYHSD*
Ingalls, Harry C 1876-1936 *BiDAmAr*
Ingalls, Walter 1805-1874 *FolkA 86*, *NewYHSD*
Ingalls, Wilbur Rosman 1923- *AmArch 70*
Ingber, Barbara 1932- *WhoAmA 76, -78, -80, -82,
 -84*
Ingeborg, Mrs. Hansell *WhAmArt 85*
Ingegno, L' *McGDA*
Ingell, Jonathan W *FolkA 86*
Ingels, Frank Lee 1866- *WhAmArt 85*
Ingels, Frank Lee 1886-1957 *ArtsAmW 2*
Ingels, Graham 1915- *WorECom*
Ingels, Kathleen Beverley 1882- *WhAmArt 85*
Ingels, Kathleen Beverly Robinson 1882-1958
 DcWomA
Ingemann, Lucie Marie 1792-1868 *DcWomA*
Ingen, Willem Van 1651?-1708 *ClaDrA*
Inger, Christian *NewYHSD*
Inger, Edmund *NewYHSD*
Inger, Egmont *NewYHSD*
Inger, J Fritz *FolkA 86*
Ingerfurth, Ulf 1948- *DcCAr 81*
Ingerle, Rudolph F 1879- *WhAmArt 85*
Ingersoll *NewYHSD*
Ingersoll, Anna Warren 1887- *DcWomA*,
 WhAmArt 85
Ingersoll, Calista *DcWomA*
Ingersoll, D William *ArtsEM*
Ingersoll, Emma Kipling Hess 1878- *DcWomA*,
 WhAmArt 85
Ingersoll, John 1788-1815 *FolkA 86*, *NewYHSD*
Ingersoll, John Gage 1815- *FolkA 86*
Ingersoll, John Gage 1815-1889 *NewYHSD*
Ingersoll, Randall E *NewYHSD*
Ingersoll, Susan Crook 1908- *WhAmArt 85*
Ingersoll, W King 1909- *WhAmArt 85*
Ingersoll, W S *FolkA 86*
Ingerton, R R *AmArch 70*
Inges, George Scott 1874- *DcVicP 2*

Ingham, C S *AmArch 70*
Ingham, Charles C 1796-1863 *ArtsNiC*
Ingham, Charles Cromwell 1796-1863 *BnEnAmA*,
 DcAmArt, *McGDA*, *NewYHSD*
Ingham, Charles Frederick 1879- *DcBrA 1*
Ingham, David 1800-1891? *FolkA 86*
Ingham, George Bryan 1936- *WhoArt 80, -82, -84*
Ingham, Thomas 1942- *AmArt*
Ingham, William *NewYHSD*
Ingham-Smith, Elizabeth *WhAmArt 85*
Ingham-Smith, Elizabeth Howell *DcWomA*
Ingle, Annie W *DcWomA*
Ingle, Eliza 1885- *DcWomA*, *WhAmArt 85*
Ingle, J F, Jr. *AmArch 70*
Ingle, J Lee *DcVicP 2*
Ingle, John S 1933- *WhoAmA 84*
Ingle, John Stuart 1933- *AmArt*
Ingle, Leura *DcVicP 2*
Ingle, Tom 1920- *WhoAmA 73*
Ingle, Tom 1920-1973 *WhoAmA 76N, -78N, -80N,
 -82N, -84N*
Ingledue, T E *AmArch 70*
Inglefield, E A *DcVicP 2*
Inglefield, Sir Edward Augustus 1820-1894 *DcBrWA*,
 DcSeaP
Inglefield, Sir Gilbert Samuel 1909- *WhoArt 80, -82,
 -84*
Ingleman, Richard 1777-1838 *BiDBrA*
Ingles, David N *DcBrA 1*
Ingles, Eric Ingeson 1896- *WhAmArt 85*
Ingles, George Scott 1874- *DcBrA 1*
Ingles, Jorge *OxArt*
Ingles, Thomas *FolkA 86*
Ingleson, Lewis 1932- *AmArch 70*
Inglis, Antoinette Clark 1880- *DcWomA*,
 WhAmArt 85
Inglis, Archie *DcBrBI*
Inglis, Curtis Lee, Jr. 1939- *AmArch 70*
Inglis, G *DcBrBI*
Inglis, Hester *DcWomA*
Inglis, J Johnston *DcBrA 2*
Inglis, J Johnstone *DcVicP 2*
Inglis, Jane *DcVicP*
Inglis, Jane d1916 *DcBrA 1*, *DcBrWA*, *DcVicP 2*,
 DcWomA
Inglis, Jean Winifred 1884- *DcBrA 1*, *DcWomA*
Inglis, John J 1867-1946 *WhAmArt 85*
Inglis, Lionel *DcBrBI*
Inglis, Thomas *CabMA*
Inglis, William T *WhAmArt 85*
Ingold, Dale D 1954- *MarqDCG 84*
Ingold, J T *WhAmArt 85*
Ingoldsby, C J *AmArch 70*
Ingolfsson, Gudmunder 1946- *ICPEnP A*
Ingpen, A W *DcVicP 2*
Ingraham, Elias 1805-1885 *DcNiCA*
Ingraham, Ellen M 1832-1917 *DcWomA*,
 NewYHSD, *WhAmArt 85*
Ingraham, Esther Price *WhoAmA 73, -76, -78, -80*
Ingraham, F T *WhAmArt 85*
Ingraham, George Hunt 1870- *WhAmArt 85*
Ingraham, John Douglas 1955- *WhoAmA 82, -84*
Ingraham, Katherine Ely 1900-1982 *WhAmArt 85*
Ingraham, Mary L *DcWomA*, *FolkA 86*,
 NewYHSD
Ingraham, Natalie *DcWomA*, *WhAmArt 85*
Ingraham, Peggy 1778-1818 *FolkA 86*
Ingraham, Thomas *NewYHSD*
Ingram, Alexander *CabMA*
Ingram, Archibald B *DcVicP 2*
Ingram, Archibald Bennett 1903- *DcBrA 1*
Ingram, C H *AmArch 70*
Ingram, E J *DcVicP 2*, *DcWomA*
Ingram, Edith 1921- *AfroAA*
Ingram, George L 1914- *AmArch 70*
Ingram, H d1860 *DcBrBI*
Ingram, J M, Sr. *AmArch 70*
Ingram, James Hardin 1935- *AmArch 70*
Ingram, James Maurice, Jr. 1931- *AmArch 70*
Ingram, Jeff Ray 1942- *MarqDCG 84*
Ingram, Jerry *OfPGCP 86*
Ingram, Jerry Cleman 1941- *WhoAmA 73, -76, -78,
 -80, -82, -84*
Ingram, Judith 1926- *WhoAmA 73, -76, -78, -80, -82,
 -84*
Ingram, Margaret K *DcVicP 2*, *DcWomA*
Ingram, R C *AmArch 70*
Ingram, R P *DcWomA*
Ingram, Veronica Marie *WhoAmA 78, -80*
Ingram, William *NewYHSD*
Ingram, William Ayerst 1855-1913 *DcBrA 1*,
 DcBrWA, *DcVicP, -2*
Ingram, Zell 1910- *AfroAA*
Ingrand, Max 1908- *IlDcG*
Ingres, Jean Auguste Dominique 1780-1867 *ClaDrA*,
 OxArt
Ingres, Jean-Auguste-Dominique 1780-1867 *McGDA*
Ingres, Jean-Dominique-Augustin 1781-1867 *ArtsNiC*
Ingres, Maurice *WhAmArt 85*
Ingulli, R F *AmArch 70*
Ingwersen, Samuel Emil 1927- *AmArch 70*

Inha, Into Konrad 1865-1930 *ICPEnP A*
Injalbert, Jean Antoine 1845-1933 *WhAmArt 85A*
Injalbert, Jean-Antonin *ArtsNiC*
Injeyan, Seta L 1946- *WhoAmA 82, -84*
Inlander, H 1925- *ClaDrA*
Inlander, Henry 1925- *DcBrA 2*, *DcCAr 81*
Inlender, Av *PrintW 85*
Inman, Bobby R *MarqDCG 84*
Inman, F Tempest *WhAmArt 85*
Inman, Henry 1801?-1846 *AntBDN J*, *BnEnAmA*,
 DcAmArt, *FolkA 86*, *IlBEAAW*, *McGDA*,
 NewYHSD
Inman, Henry 1802-1846 *ArtsNiC*
Inman, J O'Brien *ArtsNiC*
Inman, J T *EncASM*
Inman, John O'Brien 1828-1896 *ArtsAmW 2*,
 NewYHSD, *WhAmArt 85*
Inman, Marshall Nisbet *DcVicP 2*
Inman, Pauline Winchester 1904- *WhoAmA 73, -76,
 -78, -80, -82, -84*
Inman, Roy W *EncASM*
Inman, William Southcote 1798-1879 *BiDBrA*
Innes, Alice *DcVicP 2*, *DcWomA*
Innes, Charles *NewYHSD*
Innes, Henry P *DcVicP 2*
Innes, James Archibald *DcVicP 2*
Innes, James Dickson 1887-1914 *DcBrA 1*, *DcBrWA*,
 McGDA
Innes, John 1863-1941 *IlBEAAW*
Innes, John Dickson *OxTwCA*
Innes, John Dickson 1887-1914 *OxArt*
Innes, Robert *AntBDN Q*
Innes, William Henry 1905- *WhoArt 80, -82, -84*
Inness, George 1825- *ArtsNiC*
Inness, George 1825-1894 *ArtsAmW 1*, *BnEnAmA*,
 DcAmArt, *IlBEAAW*, *McGDA*, *NewYHSD*,
 OxArt, *WhAmArt 85*
Inness, George 1853?-1926 *IlBEAAW*
Inness, George, Jr. *ArtsNiC*
Inness, George, Jr. 1853-1926 *WhAmArt 85*
Inness, George, Jr. 1854-1926 *ArtsAmW 1*, *OxArt*
Innocenti, Ferdinand Edward 1912- *AmArch 70*
Inokuma, Guenichiro 1921- *WhoAmA 73, -76, -78,
 -80*
Inoue, Kazuko 1939- *WhoAmA 76, -78*
Inoue, Kazuko 1946- *WhoAmA 80, -82, -84*
Inoue, Yosuke 1931- *WorECar*
Insall, Donald W 1926- *WhoArt 84*
Insam, Ernst *DcCAr 81*
Inscho, C C *AmArch 70*
Insel, Paula 1903- *WhoAmA 73, -76, -78, -80, -82,
 -84*
Inserro, A F *AmArch 70*
Inshaw, David 1943- *ConBrA 79[port]*, *DcCAr 81*,
 OxTwCA
Inskip, John Henry d1947 *DcBrA 1*, *DcVicP, -2*
Inskipp, James 1790-1860 *DcBrWA*
Inskipp, James 1790-1868 *DcVicP, -2*
Inslee, Charles T *NewYHSD*
Inslee, Marguerite T 1891- *WhoAmA 73, -76, -78,
 -80, -82*
Inslee, Robert Ray 1910- *AmArch 70*
Inslee, William *NewYHSD*
Insley, Albert B 1842-1937 *WhAmArt 85*
Insley, Will 1929- *BnEnAmA*, *ConArt 77, -83*,
 DcCAA 71, -77, *DcCAr 81*, *OxTwCA*,
 WhoAmA 73, -76, -78, -80, -82, -84
Instone, Jeff 1941- *DcCAr 81*
Intingaro, J *AmArch 70*
Inukai, Kyohei *WhAmArt 85*
Inukai, Kyohei 1913- *AmArt*, *PrintW 83, -85*,
 WhoAmA 73, -76, -78, -80, -82, -84
Inumaki, Kenji 1943- *ConArt 77*
Inverarity, Robert Bruce 1909- *WhAmArt 85*,
 WhoAmA 73, -76, -78, -80, -82, -84
Inverarity, Wallace Duncan 1904- *WhAmArt 85*
Invernizzi, Prosper *WhAmArt 85*
Inwood, Charles Frederick 1798-1840 *OxArt*
Inwood, Charles Frederick 1799?-1840 *BiDBrA*
Inwood, Edward 1803?- *BiDBrA*
Inwood, Henry W 1794-1843 *MacEA*
Inwood, Henry William *McGDA*
Inwood, Henry William 1794-1843 *BiDBrA*, *DcD&D*,
 OxArt, *WhoArch*
Inwood, William *McGDA*
Inwood, William 1771?-1843 *BiDBrA*, *DcD&D*,
 MacEA, *OxArt*
Inzerillo, Gian DelValentino 1929- *WhoAmA 78*
Ioanowits, Paul 1859- *WhAmArt 85*
Iofan, Boris M 1891- *MacEA*
Iolas, Alexander *WhoAmA 78*
Iolas, Alexandre *WhoAmA 73, -76*
Iommi, Ennio 1926- *PhDcTCA 77*
Ionesco, Irena 1935- *ConPhot*, *ICPEnP A*
Ionesco, Nicolas 1919- *OxTwCA*
Ionescu, Grigore 1904- *MacEA*
Ionge, Ekaterina Feodorovna 1843-1913 *DcWomA*
Ions, John 1785?-1826 *BiDBrA*
Ions, Willoughby *WhAmArt 85*
Iordanov And Ovcharov *MacEA*
Iorgenson, Alexandra Petrovna 1869- *DcWomA*

Israel, L J *AmArch 70*
Israel, Marvin 1924- *WhoAmA 76, -78, -80, -82, -84*
Israel, Mel 1939- *AmArch 70*
Israel, Nathan 1895- *WhAmArt 85*
Israels, Charles H 1865-1911 *BiDAmAr*
Israels, Isaac 1865-1934 *OxArt, PhDcTCA 77*
Israels, Josef 1824- *ArtsNiC*
Israels, Josef 1824-1911 *McGDA*
Israels, Joseph 1824-1911 *ClaDrA*
Israels, Jozef 1824-1911 *OxArt*
Israelson, Harold G 1928- *MarqDCG 84*
Isroff, Lola K 1920- *FolkA 86*
Issan *AntBDN L*
Isser, Johanna Von 1802-1880 *DcWomA*
Isserstedt, Dorothea Carus *WhoAmA 73, -76, -78, -80, -82, -84*
Issigonis, Alec 1906- *ConDes*
Istrati, Alexander 1915- *OxTwCA*
Istrati, Alexandre 1915- *PhDcTCA 77*
Istvanffy, Gabriella *DcWomA*
Itabashi, Masao James 1932- *AmArch 70*
Italia, Angelo 1629-1700 *MacEA*
Italiano, Joan *WhoAmA 82, -84*
Italiano, Joan Nylen *WhoAmA 76, -78, -80*
Itami, Robert Mark 1952- *MarqDCG 84*
Itasse, Jeanne 1867- *DcWomA*
Itatani, Michiko 1948- *PrintW 85, WhoAmA 82, -84*
Itaya, Yoshio Ted 1932- *AmArch 70*
Itchkawich, David Michael 1937- *WhoAmA 73, -76, -78, -80, -82, -84*
Iterson, Olga Van *DcWomA*
Ith, Anna Margaretha Luise 1849- *DcWomA*
Ith, Emilie Sophie Margaritha 1846-1904 *DcWomA*
Ito, M Robert 1938- *MarqDCG 84*
Ito, Miyoko 1918- *AmArt, DcCAr 81*
Ito, Mohei 1898-1967 *WorFshn*
Ito, Shima 1937- *ConDes*
Ito, Shoha 1877-1968 *DcWomA*
Ito, Sumako *WorFshn*
Itoh, Kenji 1915- *WhoGrA 62, -82[port]*
Itsumin, Hokyudo *AntBDN L*
Ittan *AntBDN L*
Ittar, Stefano d1790 *MacEA*
Itten, Johannes 1888-1967 *OxTwCA, PhDcTCA 77*
Ittenbach, Franz 1813-1879 *ArtsNiC*
Itter, Diane 1946- *DcCAr 81*
Ittleson, Henry, Jr. 1900- *WhoAmA 73*
Ittleson, Henry, Jr. 1900-1973 *WhoAmA 76N, -78N, -80N, -82N, -84N*
Ittner, Harry Curtis 1925- *AmArch 70*
Ittner, William B 1864-1936 *BiDAmAr*
Ittner, William Butts 1899- *AmArch 70*
Iturbide, Graciela 1942- *ConPhot, ICPEnP A*
Itzenplitz, Countess Frida 1869-1921 *DcWomA*
Itzkowitz, Howard Frank 1942- *AmArch 70*
Iuca, Marie Marguerite 1943- *DcCAr 81*
Iuen, Richard R 1909- *AmArch 70*
Iungerich, Helene *WhAmArt 85*
Ivall, D J *DcVicP 2*
Ivanitsky, Oleg Nichol 1906- *AmArch 70*
Ivanoff, Eugene *WhAmArt 85*
Ivanoff, Eugene Samson 1898?-1954 *ArtsAmW 3*
Ivanov, Aleksandr Vasilyevich 1899-1959 *WorECar*
Ivanov, Alexander Andreevich 1806-1858 *McGDA*
Ivanov, Alexander Andreyevich 1806-1858 *OxArt*
Ivanov, Andrey 1772-1848 *OxArt*
Ivanov, I A 1779-1848 *IlDcG*
Ivanov, Vladimir 1926- *ICPEnP A*
Ivanov-Vano, Ivan Petrovich 1900- *WorECar*
Ivanova, Ksenia Vassilievna *DcWomA*
Ivanova, Maria Ivanovna 1760-1827 *DcWomA*
Ivanova, Vera Viktorovna *DcWomA*
Ivanova-Raievskaia, Maria Dmitrievna *DcWomA*
Ivanovics, Katalin 1817- *DcWomA*
Ivanovits, Katalin 1817- *DcWomA*
Ivanovsky, Elizabeth 1910- *IlsCB 1744*
Ivanowski, Sigismund De 1875-1944 *WhAmArt 85*
Ivel, Karl, Madame d1899 *DcWomA*
Ivelich, George 1936- *AmArch 70*
Iver, R H *DcVicP 2*
Iverd, Eugene 1893-1938? *WhAmArt 85*
Ivernois, Comtesse D' d1909 *DcWomA*
Iverny, Jacques *McGDA*
Iversen, Earl Harvey 1943- *WhoAmA 84*
Iversen, Gordon Edwin 1933- *AmArch 70*
Iversen, Helen *DcWomA*
Iversen, Herbert James 1928- *AmArch 70*
Iverson, Barry Lee 1956- *MacBEP*
Iverson, Donald E 1920- *AmArch 70*
Ives, Antoinette *DcWomA*
Ives, C B *ArtsNiC*
Ives, Chauncey *AntBDN D*
Ives, Chauncey And Lawson *AntBDN D*
Ives, Chauncey B *FolkA 86*
Ives, Chauncey Bradley 1810-1894 *BnEnAmA, DcAmArt, NewYHSD , WhAmArt 85*
Ives, Daisy N *ArtsEM, DcWomA*
Ives, Edward *NewYHSD*
Ives, Elaine Caroline 1922- *WhoAmA 76, -78, -80, -82, -84*

Ives, Elsie d1915 *WhAmArt 85*
Ives, Elsie Caron 1864-1915 *ArtsEM, DcWomA*
Ives, Frederic Eugene 1856-1937 *ICPEnP*
Ives, Frederick Eugene 1856-1937 *ICPEnP A, MacBEP*
Ives, Glen Palmer 1933- *WhoAmA 73*
Ives, H Douglas 1888-1945 *BiDAmAr*
Ives, Halsey Cooley 1847-1911 *WhAmArt 85*
Ives, Ira *FolkA 86*
Ives, J J *NewYHSD*
Ives, James Merritt 1824-1895 *McGDA, NewYHSD*
Ives, John Milton 1943- *MarqDCG 84*
Ives, Joseph *AntBDN D*
Ives, Joseph Christmas 1828-1868 *NewYHSD*
Ives, Julius *FolkA 86*
Ives, L T *NewYHSD*
Ives, Lewis Thomas 1833-1894 *ArtsEM*
Ives, Loyal Moss *NewYHSD*
Ives, Neil McDowell 1890-1946 *WhAmArt 85*
Ives, Norman S 1924-1978 *WhoAmA 78N, -80N, -82N, -84N*
Ives, Percy 1864-1928 *ArtsEM[port], WhAmArt 85*
Ives, Philip 1904- *AmArch 70*
Ives, S Martin 1899- *AmArch 70*
Ives, Sarah Noble 1864-1944 *ArtsEM, DcWomA*
Ivey, Edwin J, Jr. d1940 *BiDAmAr*
Ivey, Elizabeth Hall *WhAmArt 85*
Ivey, James Burnett 1925- *ConGrA 1[port], WhoAmA 73, -76, -78, -80, -82, -84, WorECar*
Ivey, Jim *ConGrA 1*
Ivey, John *ArtsAmW 2*
Ivey, Joseph *ArtsAmW 1*
Ivey, Marion Teresa *DcVicP 2*
Ivey, Marion Theresa *DcWomA*
Ivey, Robert Lee, Jr. 1942- *MarqDCG 84*
Ivey, Tim W 1942- *MarqDCG 84*
Ivimey, Julia B *DcWomA*
Ivinney, Faith E *WhAmArt 85*
Ivins, Florence *DcWomA*
Ivins, Florence W *WhAmArt 85*
Ivins, William M, Jr. 1881-1961 *WhAmArt 85, WhoAmA 80N, -82N, -84N*
Ivone, Arthur 1894- *WhAmArt 85*
Ivory, Alice E W *AfroAA*
Ivory, P V E *WhAmArt 85*
Ivory, Silas *CabMA*
Ivory, Thomas d1786 *BiDBrA*
Ivory, Thomas 1709-1779 *BiDBrA, MacEA*
Ivory, Thomas 1720?-1786 *DcD&D*
Ivory, Thomas 1732?-1786 *MacEA*
Ivory, William 1746-1801 *BiDBrA*
Ivory, William 1747?-1837 *BiDBrA*
Ivry, Fanny D' *DcWomA*
Ivy, Gregory Dowler 1904- *WhAmArt 85, WhoAmA 73, -76, -78, -80, -82, -84*
Ivy, Virginia Mason *FolkA 86*
Iwad d1428 *MacEA*
Iwamasa, Ken 1943- *WhoAmA 78, -80, -82, -84*
Iwamoto, Ralph Shigeto 1927- *WhoAmA 76, -78, -80, -82, -84*
Iwanaga, R R *AmArch 70*
Iwasaki, Chihiro *IlsCB 1967*
Iwata, A A *AmArch 70*
Iwatsu, Sunao John 1913- *AmArch 70*
Iwerks, Ubbe 1901-1971 *WorECar*
Iwersen, Marguerite 1897- *WhAmArt 85*
Iwill, Germaine *DcWomA*
Iwill, Marie Joseph Leon Clavel 1850-1923 *ClaDrA*
Iwill, Renee *DcWomA*
Iwonski, Carl G Von 1830-1922 *ArtsAmW 1, NewYHSD*
Iyama, Shigenori 1927- *AmArch 70*
Iyer, Mani 1936- *MarqDCG 84*
Izacyro 1930- *WhoAmA 73, -76, -78*
Izant, Herbert *DcVicP 2*
Izard, Anne *DcWomA*
Izard, Edith A *DcVicP 2, DcWomA*
Izard, Edwin *DcVicP 2*
Izard, Gertrude M *DcVicP 2, DcWomA*
Izard, Merle 1928- *WhoAmA 76*
Izart, Marie Antoinette *DcWomA*
Izis *MacBEP*
Izis 1911-1980 *ConPhot, ICPEnP*
Izor, Estelle Peele *DcWomA, WhAmArt 85*
Izquierdo, Elena *DcWomA*
Izquierdo, Maria 1906-1955 *McGDA*
Izquierdo, Mitzou *WorFshn*
Izuka, Kunio 1939- *WhoAmA 76, -78, -80, -82, -84*
Izumi, Kiyoshi 1921- *WhoAmA 76, -78, -80, -82, -84*
Izuno, Gene Takashi 1934- *AmArch 70*

J

J J 1932- *WhoAmA 82,*
−84
J S D *BkIE*
Jaako, Harry 1952- *MarqDCG 84*
Jaarsma, E H 1879- *DcWomA*
Jabal, Dhula Jehan Satyakama 1898- *WhAmArt 85*
Jablecki, Kasnia Boleslaw 1907- *WhAmArt 85*
Jablinske, Robert John 1936- *MarqDCG 84*
Jablonski, Joseph S 1898- *WhAmArt 85*
Jablonsky, Arthur Russell 1928- *AmArch 70*
Jaccaci, August Florian 1856-1930 *WhAmArt 85*
Jaccard, Christian 1939- *ConArt 77, −83, DcCAr 81*
Jaccard, D C *EncASM*
Jaccard, Mermod C, Jr. 1928- *AmArch 70*
Jachmann, Kurt M *WhoAmA 73, −76, −78, −80*
Jachna, Joseph D 1935- *ConPhot*
Jachna, Joseph David 1935- *ICPEnP A, MacBEP,*
WhoAmA 76, −78, −80, −82, −84
Jacho d1057 *McGDA*
Jack, Ella *WhAmArt 85*
Jack, Gavin Hamilton 1859-1938 *ArtsAmW 3*
Jack, George 1855-1932 *AntBDN A, DcNiCA*
Jack, Marion Elizabeth *DcWomA*
Jack, Martha Sharpe Forrester 1850?-1908 *DcWomA*
Jack, Patti *DcVicP 2*
Jack, Richard d1952 *WhoAmA 78N, −80N, −82N,*
−84N
Jack, Richard 1866-1952 *DcBrA 1, DcBrBI,*
DcVicP 2
Jack, W *DcSeaP*
Jacka, B G *AmArch 70*
Jackard, Jerald Wayne *WhoAmA 76, −78, −80, −82,*
−84
Jackels, R T *AmArch 70*
Jacker, B *DcVicP 2*
Jacker, Francis 1810?- *ArtsEM*
Jackley, F Dano 1900- *WhAmArt 85*
Jacklin, Bill 1943- *ConBrA 79[port], DcCAr 81*
Jackman, Florence F 1892- *DcBrA 1, DcWomA*
Jackman, Iris Rachel *ClaDrA, WhoArt 80, −82, −84*
Jackman, Kate *DcVicP 2*
Jackman, Oscar F *WhAmArt 85*
Jackman, P *DcVicP 2*
Jackman, Reva 1892- *DcWomA, WhAmArt 85*
Jackman, Theodore *WhAmArt 85*
Jackman, Theodore 1878-1940 *ArtsAmW 2*
Jackman, Mrs. Theodore *WhAmArt 85*
Jackman, William G *NewYHSD*
Jackovich, Anthony 1923- *WhoAmA 73, −76*
Jackowski, Andrzej 1947- *DcCAr 81*
Jacks, Ernest Eugene 1925- *AmArch 70*
Jacks, Thurmon E 1930- *AmArch 70*
Jackson *BiDBrA, NewYHSD*
Jackson, Miss *DcWomA*
Jackson, Mrs. *DcVicP 2*
Jackson, A B 1925- *WhoAmA 73, −76, −78, −80, −82,*
−84
Jackson, A E *AfroAA*
Jackson, A H *DcWomA*
Jackson, A W, Jr. *AmArch 70*
Jackson, Albert Edward 1873-1952 *DcBrA 1,*
DcVicP 2
Jackson, Alexander Young 1882- *McGDA,*
WhoAmA 73
Jackson, Alexander Young 1882-1974 *DcBrA 2,*
OxTwCA, WhoAmA 76N, −78N, −80N, −82N,
−84N
Jackson, Alexander Young 1882-1976 *IlBEAAW*
Jackson, Amos D *CabMA*
Jackson, Ann d1956 *WhoAmA 80N, −82N, −84N*
Jackson, Anne Wakely *FolkA 86*

Jackson, Annie Hurlburt *WhoAmA 80N, −82N, −84N*
Jackson, Annie Hurlburt 1877-1960? *DcWomA,*
WhAmArt 85
Jackson, Anthony *ConArch A*
Jackson, Arthur *DcBrECP, DcVicP 2*
Jackson, Arthur 1911- *DcBrA 1, PhDcTCA 77*
Jackson, Arthur C 1865-1941 *BiDAmAr*
Jackson, Ashley 1940- *WhoArt 80, −82, −84*
Jackson, B *AmArch 70*
Jackson, B Leslie 1866- *DcBrA 2*
Jackson, Beatrice 1905- *WhoAmA 73, −76*
Jackson, Betty Ruth 1927- *AmArch 70*
Jackson, Billy Morrow 1926- *WhoAmA 73, −76, −78,*
−80, −82, −84
Jackson, Burt *AfroAA*
Jackson, C A *FolkA 86*
Jackson, C D *WhAmArt 85*
Jackson, Caroline F *DcVicP 2*
Jackson, Cecilia *DcWomA*
Jackson, Charles *NewYHSD*
Jackson, Charles Akerman 1857- *WhAmArt 85*
Jackson, Charles D'Orville Pilkington 1887-1973
DcBrA 1
Jackson, Charles Elbert 1926- *AmArch 70*
Jackson, Charles Thomas 1805-1880 *EarABI,*
FolkA 86, NewYHSD
Jackson, Chevalier 1865- *WhAmArt 85*
Jackson, Clarence Thomas 1922- *AmArch 70*
Jackson, Clifford 1927- *AfroAA*
Jackson, Daryl 1937- *ConArch*
Jackson, David 1931- *ConArch*
Jackson, David E 1874- *ArtsAmW 3*
Jackson, Dennis Emerson 1878- *WhAmArt 85*
Jackson, Don 1944- *DcCAr 81*
Jackson, E *CabMA, DcVicP 2*
Jackson, E D *AmArch 70*
Jackson, E Jeaffreson *DcVicP 2*
Jackson, E L *AmArch 70*
Jackson, Edward 1923- *AmArch 70*
Jackson, Edwin W *NewYHSD*
Jackson, Elbert McGran *WhAmArt 85*
Jackson, Elbert McGran 1896- *IlrAm 1880*
Jackson, Ella F 1894- *DcWomA*
Jackson, Emily E *DcVicP 2, DcWomA*
Jackson, Emily F *DcVicP, −2, DcWomA*
Jackson, Emily Jane *DcWomA*
Jackson, Emily M *DcVicP 2*
Jackson, Emma *DcVicP 2*
Jackson, Ethel A *WhAmArt 85*
Jackson, Evelyn *DcVicP 2*
Jackson, Everett Gee 1900- *IlBEAAW,*
WhAmArt 85, WhoAmA 73, −76, −78, −80, −82,
−84
Jackson, F Ellis 1879-1950 *BiDAmAr*
Jackson, F W *AmArch 70, WhAmArt 85*
Jackson, Florine Teal *AfroAA*
Jackson, Foster Rhodes 1911- *AmArch 70*
Jackson, Francis Ernest 1872-1945 *DcBrA 1, DcBrBI,*
DcVicP 2
Jackson, Francis Ernest 1873-1945 *ClaDrA*
Jackson, Frank George 1831-1905 *ClaDrA*
Jackson, Frank H 1864- *WhAmArt 85*
Jackson, Frederick C *DcVicP 2*
Jackson, Frederick Ellis *WhAmArt 85*
Jackson, Frederick Hamilton 1848-1923 *DcBrA 1,*
DcBrBI, DcBrWA, DcVicP, −2
Jackson, Frederick William 1859-1918 *ClaDrA,*
DcBrA 1, DcBrWA, DcVicP, −2
Jackson, G *DcVicP 2*
Jackson, Genevieve Vaughan *IlsCB 1946*
Jackson, George *BiDBrA*

Jackson, George 1805?-1842 *BiDBrA*
Jackson, George Andrew, Jr. 1934- *AmArch 70*
Jackson, George William 1914- *DcBrA 1,*
WhoArt 80, −82, −84
Jackson, Gerald 1936- *AfroAA*
Jackson, Gordena Parker 1900- *WhAmArt 85*
Jackson, Granbery, Jr. 1906- *AmArch 70*
Jackson, H B *WhAmArt 85*
Jackson, H J 1938- *WhoArt 80, −82, −84*
Jackson, Harlan *AfroAA*
Jackson, Harlan Christopher 1918- *WhoAmA 73, −76*
Jackson, Harriett A E *DcWomA*
Jackson, Harry *AfroAA*
Jackson, Harry Andrew 1924- *AmArt, IlBEAAW,*
WhoAmA 73, −76, −78, −80, −82, −84
Jackson, Hazel Brill *WhoAmA 73, −76, −78, −80, −82,*
−84
Jackson, Hazel Brill 1894?- *DcWomA, WhAmArt 85*
Jackson, Hazel Drake *DcWomA*
Jackson, Helen d1911 *DcBrA 1, DcVicP 2,*
DcWomA
Jackson, Henry *FolkA 86, NewYHSD*
Jackson, Henry Alden d1952 *WhoAmA 78N, −80N,*
−82N, −84N
Jackson, Herb 1945- *AmArt, PrintW 83, −85,*
WhoAmA 73, −76, −78, −80, −82, −84
Jackson, Herbert P M *DcVicP 2*
Jackson, Hiram *AfroAA*
Jackson, Howard M 1906- *WhAmArt 85*
Jackson, Huson 1913- *AmArch 70*
Jackson, J *DcBrBI, FolkA 86, NewYHSD*
Jackson, J D *AfroAA, AmArch 70*
Jackson, Jack Comp 1917- *AmArch 70*
Jackson, James *AmArch 70, NewYHSD*
Jackson, James Eyre *DcVicP 2*
Jackson, James Grey *DcBrBI*
Jackson, James Howard 1943- *MarqDCG 84*
Jackson, Jay Paul 1905- *AfroAA*
Jackson, Jesse Short *ArtsAmW 3*
Jackson, Jessie Short *ArtsAmW 3*
Jackson, John *DcVicP 2*
Jackson, John 1602?-1663 *BiDBrA, MacEA*
Jackson, John 1778-1831 *DcBrWA, McGDA*
Jackson, John 1801-1848 *DcVicP 2*
Jackson, John 1938- *DcCAr 81*
Jackson, John Adams 1825-1879 *ArtsNiC, BnEnAmA,*
NewYHSD
Jackson, John Edwin *WhoAmA 78N, −80N, −82N,*
−84N
Jackson, John Edwin 1875-1950? *WhAmArt 85*
Jackson, John George 1798?-1852 *BiDBrA*
Jackson, John Hamilton *FolkA 86*
Jackson, John LeRoy 1905- *WhAmArt 85*
Jackson, John P *WhAmArt 85*
Jackson, John Richardson 1819-1877 *DcVicP 2*
Jackson, John Spencer *AfroAA*
Jackson, Joseph *FolkA 86*
Jackson, Joseph d1850 *NewYHSD*
Jackson, Joseph 1858-1922 *DcBrA 1, DcVicP 2*
Jackson, Joseph 1867- *WhAmArt 85*
Jackson, Mrs. Joseph *DcWomA, NewYHSD*
Jackson, Joseph H B *FolkA 86*
Jackson, Josephine L *DcWomA*
Jackson, Katherine *AfroAA*
Jackson, Kenneth E 1913- *AmArch 70*
Jackson, Kevin P 1942- *MarqDCG 84*
Jackson, L *DcVicP 2*
Jackson, L Quincy 1927- *AmArch 70*
Jackson, Lee 1909- *WhAmArt 85, WhoAmA 73,*
−76, −78, −80, −82, −84
Jackson, Lesley 1866-1958 *WhoAmA 80N, −82N,*

Jacopo Degli Avanzi *McGDA*
Jacopo DelCasentino 1300?-1358? *McGDA*
Jacopo DiCione *McGDA*
Jacopo DiFrancesco 1337?-1396 *McGDA*
Jacopo DiPaolo *McGDA*
Jacopo, Don *McGDA*
Jacopo, Gherardo Di *McGDA*
Jacopo DiGaspare, Giovanni Battista Di *McGDA*
Jacot, Monique 1934- *ICPEnP A*
Jacott, Henriette *DcWomA*
Jacovelli, Ettore *WhAmArt 85*
Jacovitti, Benito 1923- *WorECar, WorECom*
Jacqmain, Andre 1921- *MacEA*
Jacquand, Mademoiselle *DcWomA*
Jacquand, Claudius 1805-1878 *ArtsNiC*
Jacquard 1937- *WhoAmA 76, -78, -80, -82, -84*
Jacquard, Joseph Marie 1752-1834 *AntBDN P*
Jacquart, Lucie 1882- *DcWomA*
Jacque, Charles Emile 1813- *ArtsNiC*
Jacque, Charles Emile 1813-1894 *ClaDrA, McGDA*
Jacque, G H *DcBrBI*
Jacque, Marie Euphrosine *DcWomA*
Jacquelin, Marguerite *DcWomA*
Jacqueline-Hubert, Madeleine Suzanne 1883-
 DcWomA
Jacquemart, Henri Alfred 1824- *ArtsNiC*
Jacquemart, Henri-Alfred-Marie 1824-1896
 AntBDN C
Jacquemart, Henri-Alfred Marie 1824-1896 *DcNiCA*
Jacquemart, Jules Ferdinand 1837-1880 *ArtsNiC,*
 ClaDrA
Jacquemart, Nelie *ArtsNiC*
Jacquemart, Nelie Barbe Hyacinthe 1841-1912
 DcWomA
Jacquemin, Jeanne *DcWomA*
Jacquemin, Pierre 1935- *WhoAmA 73, -76, -78, -80,*
 -82, -84
Jacquemot, Blanche 1875- *DcWomA*
Jacques *ConGrA 1*
Jacques DeBesancon *McGDA*
Jacques, Emil 1874-1937 *ArtsAmW 2, WhAmArt 85*
Jacques, Faith *IlsBYP*
Jacques, Herbert 1857-1916 *BiDAmAr*
Jacques, Michael Louis 1945- *WhoAmA 76, -78, -80,*
 -82, -84
Jacques, R G *AmArch 70*
Jacques, Raphael 1882-1914 *ClaDrA*
Jacques, Raymond E 1937- *MarqDCG 84*
Jacques, Richard *CabMA*
Jacques, Robin *IlsCB 1967*
Jacques, Robin 1920- *IlsBYP, IlsCB 1946, -1957,*
 WhoArt 80, -82
Jacques, Russell Kenneth 1943- *WhoAmA 84*
Jacques, Stephen *CabMA*
Jacques-Mary, Marie 1868- *DcWomA*
Jacquesson DeLaChevreuse, Louis 1840- *ArtsNiC*
Jacquet, Adeline Jeanne *DcWomA*
Jacquet, Alain 1939- *ConArt 77, -83, DcCAr 81*
Jacquet, Alain George Frank 1939- *OxTwCA,*
 PhDcTCA 77
Jacquet, Cecilia *DcVicP 2, DcWomA*
Jacquet, Constance 1805- *DcWomA*
Jacquet, Gustave Jean 1846-1909 *ClaDrA*
Jacquet, Henriette *DcWomA*
Jacquet, Jean Gustave 1846- *ArtsNiC*
Jacquet, Marie Euphrosine *DcWomA*
Jacquet, Marie Zelie *DcWomA*
Jacquet DeGrenoble, Mathieu d1610 *McGDA*
Jacquette, William J 1933- *AmArch 70*
Jacquette, Yvonne 1934- *ConArt 77, DcCAr 81,*
 PrintW 85
Jacquette, Yvonne H 1934- *WhoAmA 84*
Jacquette, Yvonne Helene 1934- *PrintW 83,*
 WhoAmA 76, -78, -80, -82
Jacquier *DcBrA 1, DcWomA*
Jacquier, Elodie *DcWomA*
Jacquier, Fanny *DcWomA*
Jacquin, Alice 1879- *DcWomA*
Jacquinot, Louise Francoise *DcWomA*
Jacquinot, Valentine Therese *DcWomA*
Jacquotot, Marie Victoire *DcWomA*
Jacta, Lucie Alexandrine *DcWomA*
Jacta, Suzanne *DcWomA*
Jadelot, Sophie 1820- *DcWomA*
Jaderholm-Snellman, Greta Lisa 1894- *DcWomA*
Jadin, Emmanuel Charles *ArtsNiC*
Jadin, Louis Godefroy 1805-1882 *ArtsNiC, ClaDrA*
Jadlli, M D *AmArch 70*
Jadlli, Maxwell D 1929- *MarqDCG 84*
Jadot, Jean Nicolas 1710-1761 *MacEA*
Jadot, Maurice 1893- *WhoArt 80, -82, -84*
Jae 1947- *WhoAmA 84*
Jaech, Jeremy Andrew 1954- *MarqDCG 84*
Jaeckel, Christoph *FolkA 86*
Jaeckel, Gertrude *WhAmArt 85*
Jaeckel, Lotte 1889- *DcWomA*
Jaeckel, Willy 1888-1944 *PhDcTCA 77*
Jaediker, Max *WhAmArt 85*
Jaediker, Theodore *WhAmArt 85*
Jaeger *WorFshn*
Jaeger, Anna 1849- *DcWomA*

Jaeger, Arthur S *WhAmArt 85*
Jaeger, Brenda Kay 1950- *AmArt, WhoAmA 82, -84*
Jaeger, Charles H *WhAmArt 85*
Jaeger, George *WhAmArt 85*
Jaeger, Gustav 1808-1871 *ArtsNiC*
Jaeger, Martha 1867- *DcWomA*
Jaeger, Michael *FolkA 86*
Jaeger, Robert Thomas 1938- *AmArch 70*
Jaegers, Albert 1868-1925 *WhAmArt 85*
Jaegers, Augustine 1878- *DcWomA, WhAmArt 85*
Jaegglin, E A *FolkA 86*
Jaekel, Lotte 1889- *DcWomA*
Jaenichen, Hedwig *DcWomA*
Jaenisch, Hans 1907- *ClaDrA, OxTwCA,*
 PhDcTCA 77, WhoArt 80, -82, -84
Jaffe, Barbara 1942- *MacBEP*
Jaffe, Hans 1915- *WhoArt 80, -82, -84*
Jaffe, Harold 1922- *WhoArt 80, -82, -84*
Jaffe, Ira Sheldon 1943- *WhoAmA 78, -80*
Jaffe, Irma B *WhoAmA 73, -76, -78, -80, -82, -84*
Jaffe, Lois 1928- *WhoAmA 78, -80, -82, -84*
Jaffe, Nora 1928- *WhoAmA 78, -80, -82, -84*
Jaffe, Norman C 1932- *AmArch 70*
Jaffe, Shirley 1923- *DcCAr 81*
Jaffe, William B d1972 *WhoAmA 78N, -80N, -82N,*
 -84N
Jaffe, Mrs. William B *WhoAmA 73, -76,*
 -78, -80
Jaffee, Allan 1921- *WorECom*
Jaffee, Fern 1924- *AmArt*
Jaffee, N Jay 1921- *ICPEnP A, MacBEP*
Jaffray, Alexander 1677- *BiDBrA*
Jaffray, George *BiDBrA*
Jaffrey, James *BiDBrA*
Jagemann, Anna Von 1816-1905 *DcWomA*
Jagemann, Caroline *DcWomA*
Jagens, William 1818?- *NewYHSD*
Jager, Adeline 1809-1897 *DcWomA*
Jager, Charlotte Friederike 1823-1891 *DcWomA*
Jager, Gerard De d1679 *ClaDrA*
Jager, Gottfried 1937- *MacBEP*
Jager, Heinrich *IlDcG*
Jager, Joseph *FolkA 86*
Jagerspacher, Helene 1885- *DcWomA*
Jaggar, Margaret Leah 1907- *WhoArt 80, -82, -84*
Jagger, Benjamin *DcBrECP*
Jagger, Charles Sargeant 1885-1934 *DcBrA 1*
Jagger, David d1958 *DcBrA 1*
Jagger, Edith 1890?-1955 *DcBrA 2*
Jagger, Gillian 1930- *WhoAmA 73, -76, -78, -80, -82,*
 -84
Jagger, Wilson *DcVicP 2*
Jagman, Ed 1936- *WhoAmA 76, -78, -80, -82, -84*
Jagman, Edward 1936- *WhoAmA 73*
Jago, Ernest T *WhAmArt 85*
Jago, W C *AmArch 70*
Jagodic, Stane 1943- *WhoGrA 82[port]*
Jagow, Ellen T 1920- *WhoAmA 73, -76, -78, -80, -82*
Jaguaribe, Sergio 1932- *WhoGrA 62*
Jaguaribe, Sergio DeMagalhaes Gomes 1932-
 WorECar
Jaham, Marie De *DcWomA*
Jahelka, Robert George 1906- *AmArch 70*
Jahn, Adolph, Jr. *ArtsEM*
Jahn, Adolph, Sr. 1899?- *ArtsEM*
Jahn, C O *AmArch 70*
Jahn, Edward Currie 1929- *AmArch 70*
Jahn, Ernst *ArtsEM*
Jahn, Hannes 1934- *DcCAr 81*
Jahn, Helma Heynsen 1874-1925 *DcWomA*
Jahn, Helmut 1940- *ConArch*
Jahn, Louis d1911 *DcNiCA*
Jahr, T R *AmArch 70*
Jahraus, J L *NewYHSD*
Jahraus, Jacob 1838?- *NewYHSD*
Jahrig-Lohr, Mathilde 1870- *DcWomA*
Jaidinger, Judith 1941- *PrintW 83, -85*
Jaidinger, Judith C 1941- *WhoAmA 76, -78, -80, -82,*
 -84
Jain, Arun 1945- *MarqDCG 84*
Jain, Rajendra Kumar 1951- *MarqDCG 84*
Jain, Uttam C 1934- *ConArch*
Jais, Joanne *AntBDN K*
Jais, Lucie 1882- *DcWomA*
Jak *WorECar*
Jaka, G C *AmArch 70*
Jakimow, Anne Marie *DcWomA*
Jakob, John H *AmArch 70*
Jakobb, Christian Arpad 1880- *WhAmArt 85*
Jakobi, Ruth *DcWomA*
Jakobsen, Kathy 1952?- *FolkA 86*
Jakopic, Rihard 1869-1943 *PhDcTCA 77*
Jakstas, Alfred John 1916- *WhoAmA 76, -78, -80,*
 -82, -84
Jakubowski, Charles *IlsBYP*
Jakuchu d1800 *McGDA*
Jalabert, Charles Francois 1819- *ArtsNiC*
Jalabert, Marie *DcWomA*
Jalanivich, Manuel 1897- *WhAmArt 85*
Jalavisto, Mikko 1937- *OxTwCA*
Jalfon, A J *DcVicP 2*

Jalland, G H *DcBrBI*
Jama, Luise 1871- *DcWomA*
Jamacie, Louis *NewYHSD*
Jamar, Pauline *DcWomA*
Jamar, S Corinne 1873?- *DcWomA, WhAmArt 85*
Jambor, Louis 1884-1955? *WhAmArt 85*
Jameikis, Brone Aleksandra *WhoAmA 73, -76, -78,*
 -80, -82, -84
Jamerson, Robert Howard 1932- *AmArch 70*
James *DcBrECP, NewYHSD*
James, Miss 1759- *DcWomA*
James Of Saint George *McGDA*
James The Greater, Saint *McGDA*
James The Less, Saint *McGDA*
James, A C *AmArch 70, NewYHSD*
James, A Everette, Jr. 1938- *WhoAmA 82, -84*
James, A Gosset 1875-1950 *DcBrA 1*
James, A R *AmArch 70, NewYHSD*
James, Alexander 1890-1946 *WhAmArt 85*
James, Alfred *WorECom*
James, Alfred Everett 1908- *WhAmArt 85*
James, Alfred Percy *DcVicP 2*
James, Alice *DcBrA 1, DcWomA*
James, Alice Archer 1870-1955 *DcWomA*
James, Alice Archer Sewall 1870- *WhAmArt 85*
James, Allan Kendrick 1927- *AmArch 70*
James, Arthur C *DcVicP 2*
James, Arthur E *WhAmArt 85*
James, Austin 1885- *WhAmArt 85*
James, B, Jr. *AmArch 70*
James, Ben *AfroAA*
James, Bess 1897- *DcWomA*
James, Bess B 1897- *ArtsAmW 3, WhAmArt 85*
James, Bill 1943- *AmArt*
James, Bob *AfroAA*
James, Boyd *FolkA 86*
James, C *DcVicP 2*
James, C D *AmArch 70*
James, C H *AmArch 70*
James, C Shelton *MarqDCG 84*
James, Cary Amory 1935- *AmArch 70*
James, Catherine *AfroAA, WhoAmA 73, -76, -78,*
 -80, -82
James, Catti 1940- *WhoAmA 84*
James, Charles *WorFshn*
James, Charles 1906- *FairDF US*
James, Charles Holloway 1893-1953 *DcBrA 1*
James, Charles Stanfield *DcVicP 2*
James, Charlotte J *DcBrWA*
James, Christopher 1947- *ICPEnP A, MacBEP*
James, Christopher P 1947- *PrintW 85,*
 WhoAmA 78, -80, -82, -84
James, D C *FolkA 86*
James, David *DcSeaP, DcVicP, -2*
James, David F *MarqDCG 84*
James, Donald 1932- *WhoArt 84*
James, Dora *DcVicP 2*
James, E *WhAmArt 85*
James, E D'O *DcWomA*
James, Edgar Lee 1935- *AmArch 70*
James, Edith Augusta 1857-1898 *DcBrWA, DcVicP 2,*
 DcWomA
James, Edward d1798 *CabMA*
James, Elizabeth Campbell 1923- *DcBrA 1*
James, Esther M 1885- *WhAmArt 85*
James, Esther Morse 1885- *DcWomA*
James, Eva Gertrude 1871- *DcWomA, WhAmArt 85*
James, Evalyn Gertrude 1898- *DcWomA,*
 WhAmArt 85
James, Evelyn *DcWomA*
James, F E *DcVicP 2*
James, Faustina *DcWomA, WhAmArt 85*
James, Francis *DcVicP 2*
James, Francis Edward 1849-1920 *ClaDrA, DcBrA 1,*
 DcBrWA, DcVicP 2
James, Frank James *DcVicP 2*
James, Fred J 1865-1932? *BiDAmAr*
James, Frederic 1915- *WhoAmA 73, -76, -78, -80,*
 -82, -84
James, Frederick *AfroAA*
James, Frederick 1845-1907 *WhAmArt 85*
James, G *DcWomA*
James, G A *DcWomA*
James, G Watson, Jr. 1887- *WhAmArt 85*
James, Geoffrey 1942- *PrintW 85, WhoAmA 78, -80*
James, George d1795 *DcBrECP*
James, George W *CabMA*
James, Gilbert *DcBrA 2, DcBrBI, IlsCB 1744*
James, H Francis *WhAmArt 85*
James, H James *DcVicP 2*
James, Harold *IlsBYP*
James, Harry E *DcVicP 2*
James, Harry H 1868-1937 *BiDAmAr*
James, Henry *NewYHSD*
James, Mrs. Henry C *WhAmArt 85*
James, Herbert Norman 1918- *WhoArt 80, -82, -84*
James, Hywel Arthur 1944- *WhoArt 80, -82, -84*
James, Isaac *FolkA 86*
James, J *NewYHSD*
James, J Dearman *DcVicP 2*
James, Bishop J T 1786-1828 *DcBrBI*

James, James *New YHSD*
James, James Francis 1912- *AmArch 70*
James, Jerome Anthony 1934- *AmArch 70*
James, Jimmie 1894- *ArtsAmW 3*
James, John *CabMA, New YHSD*
James, John 1672?-1746 *BiDBrA, DcD&D, MacEA, OxArt, WhoArch*
James, John Wells 1873- *WhAmArt 85*
James, Josiah *BiDAmAr*
James, Kim 1928- *WhoArt 80, -82, -84*
James, Laura Gwenllian *DcWomA*
James, Linda *DcCAr 81*
James, Lionel *DcBrBI*
James, M *DcVicP 2, DcWomA*
James, M E *DcWomA*
James, Martin 1940- *MarqDCG 84*
James, Owen Mervyn 1934- *WhoArt 80, -82, -84*
James, P *DcVicP 2*
James, Philip N 1932- *MarqDCG 84*
James, R *DcVicP 2*
James, R D *AmArch 70*
James, R D, Jr. *AmArch 70*
James, R M *AmArch 70*
James, Rachel *FolkA 86*
James, Rachel Barlow 1924- *AmArch 70*
James, Rebecca 1891-1968 *DcWomA*
James, Rebecca Salsbury 1891-1968 *IlBEAAW, WhAmArt 85*
James, Rebecca Salsbury Strand 1891-1968 *ArtsAmW 2*
James, Richard S *DcVicP, -2*
James, Robert Shelton 1921- *AmArch 70*
James, Roy Harrison 1889- *WhAmArt 85*
James, Roy Walter 1896- *WhAmArt 85*
James, Roy Walter 1897- *ArtsAmW 2*
James, Ruth *FolkA 86*
James, S *DcVicP 2*
James, S C *New YHSD*
James, Samuel *CabMA*
James, Sandra *WhAmArt 85*
James, Sarah *DcBrWA*
James, Sarah H *FolkA 86*
James, Stanley Phillips 1917- *AmArch 70*
James, Stephen Harold 1930- *AmArch 70*
James, Suzanne Berthe *DcWomA*
James, Mrs. T M *WhAmArt 85*
James, Theodore *New YHSD*
James, Thomas K 1906- *WhoArt 80, -82*
James, Thomas M 1875-1942 *BiDAmAr*
James, Thomas R *FolkA 86*
James, Thomas Simmons *BiDAmAr*
James, Victor *WhAmArt 85*
James, W L *AmArch 70*
James, Sir Walter Charles *DcVicP 2*
James, Walter John 1869-1932 *DcBrA 1, DcVicP 2*
James, Webster *FolkA 86*
James, Will 1892-1942 *ArtsAmW 1, IlBEAAW, WhAmArt 85*
James, William *BiDBrA, DcBrECP, DcBrWA*
James, William 1882-1961 *WhAmArt 85*
James, William Clifford 1920- *AmArch 70*
James, Willis Ed 1921- *AmArch 70*
James, Wilmer *AfroAA*
James, Wyllis Eugene 1924- *AmArch 70*
Jameson, Anna 1794-1860 *DcWomA*
Jameson, Arthur E 1872- *WhAmArt 85*
Jameson, Cecil Stuart 1883- *DcBrA 1*
Jameson, David 1941- *MarqDCG 84*
Jameson, Demetrios George 1919- *WhoAmA 73, -76, -78, -80, -82, -84*
Jameson, Donald 1901- *WhAmArt 85*
Jameson, Frank d1968 *DcBrA 1*
Jameson, G *DcBrECP*
Jameson, Gabrielle-Robert 1864- *DcWomA*
Jameson, George 1590?-1644 *OxArt*
Jameson, Georgina *DcVicP 2*
Jameson, John E 1927- *AmArch 70*
Jameson, John William 1882-1939 *WhAmArt 85*
Jameson, Kenneth Ambrose 1913- *ClaDrA, DcBrA 1, WhoArt 80, -82, -84*
Jameson, Lillian E *WhAmArt 85*
Jameson, Margaret *DcBrBI*
Jameson, Middleton d1919 *DcVicP 2*
Jameson, Minor Story 1873- *WhAmArt 85*
Jameson, Norma Marion 1933- *WhoArt 80, -82, -84*
Jameson, Philip Alexander 1952- *WhoAmA 84*
Jameson, Rebecca *WhAmArt 85*
Jameson, Rosa *DcVicP 2, DcWomA*
Jameson, Samilla Love 1881- *DcWomA, WhAmArt 85*
Jameson, T *DcBrWA*
Jameson, W G *AmArch 70*
Jameson, William *DcVicP 2*
Jameson-Smith, Frank 1899- *DcBrA 1*
Jamesone, George 1588-1644 *McGDA*
Jamet, Helene Robert *DcWomA*
Jamet, Pauline 1822?- *DcWomA*
Jamieson, Agnes D *ArtsAmW 2, DcWomA, WhAmArt 85*
Jamieson, Alexander 1873-1937 *DcBrA 1, DcVicP 2*
Jamieson, Bernice 1898- *WhAmArt 85*

Jamieson, Bernice Evelyn 1898- *DcWomA*
Jamieson, Biddy *DcBrA 2, DcWomA*
Jamieson, Dorothea *DcWomA*
Jamieson, Ethel *DcWomA*
Jamieson, F E *DcBrA 1*
Jamieson, F E 1895?- *DcBrA 2*
Jamieson, James F 1867-1941 *BiDAmAr*
Jamieson, John S 1920- *WhoArt 80, -82*
Jamieson, Malcolm McGregor, Jr. *WhAmArt 85*
Jamieson, Mitchell 1915- *WhAmArt 85, WhoAmA 73, -76, -78, -80*
Jamieson, Percy D V *WhAmArt 85*
Jamieson, Robert Kirkland 1881-1950 *DcBrA 1*
Jamieson, Rosina *DcWomA*
Jamil, Basharat Ahmad 1944- *MarqDCG 84*
Jamilly, Victor 1927- *WhoArt 80, -82, -84*
Jamison, Mrs. Archer *DcVicP 2*
Jamison, Mrs. Arthur *DcVicP 2*
Jamison, Cecilia Viets 1837-1909 *DcWomA*
Jamison, Celia 1920- *WhAmArt 85*
Jamison, Chris Mark 1953- *MarqDCG 84*
Jamison, George Eugene 1922- *AmArch 70*
Jamison, George W d1868 *New YHSD*
Jamison, Henriette Lewis *DcWomA*
Jamison, Isabel *DcWomA*
Jamison, J S *FolkA 86*
Jamison, James Kenneth 1931- *WhoArt 80, -82, -84*
Jamison, James William 1924- *AmArch 70*
Jamison, John P *New YHSD*
Jamison, Margaret Conry 1917- *WhoAmA 76, -78*
Jamison, Philip *OfPGCP 86*
Jamison, Philip 1925- *DcCAr 81, WhoAmA 73, -76, -78, -80, -82, -84*
Jamison, Sarah *DcVicP 2*
Jamison, W W, II *AmArch 70*
Jammes, Andre *ICPEnP*
Jamnitzer, Abraham *McGDA*
Jamnitzer, Albrecht *McGDA*
Jamnitzer, Barthel *McGDA*
Jamnitzer, Christian *OxDecA*
Jamnitzer, Christoph 1563-1618 *OxDecA*
Jamnitzer, Hans *OxDecA*
Jamnitzer, Hans, II *McGDA*
Jamnitzer, Wenzel 1508-1585 *McGDA, OxDecA*
Jamnitzer, Wenzel, II *McGDA*
Jamois, Charlotte 1899- *DcWomA*
Jamont DeJoncreil, Clemence *DcWomA*
Jamot-Somon, Marie 1884- *DcWomA*
Jampol, Glenn D 1950- *WhoAmA 84*
Jampol, Richard Allen 1925- *AmArch 70*
Jamron, S *AmArch 70*
Janacek, Mirice *WhoArt 80, -82, -84*
Janak, Pavel 1882-1956 *MacEA*
Janas, Zbigniew Edmund 1922- *AmArch 70*
Janaszak, Helen 1909- *WhAmArt 85*
Janavs, J *AmArch 70*
Jancic, Djuro 1934- *OxTwCA*
Jancic, Olga 1929- *PhDcTCA 77*
Janco, Marcel 1895- *DcCAr 81, OxTwCA, PhDcTCA 77, WhoArt 80, -82, -84*
Janda, Hermine Von 1854-1925 *DcWomA*
Jandelle-Lienard, Alice 1888- *DcWomA*
Jandeni 1939- *WhoAmA 84*
Jandl, Henry Anthony 1910- *AmArch 70*
Jandron, Francoise 1857- *DcWomA*
Jane, Fred T 1870-1916 *DcBrBI*
Jane, Marie *DcWomA*
Janecek, Ota 1919- *WhoGrA 62, -82[port]*
Janelsins, Veronica 1910- *WhoAmA 76, -78, -80, -82, -84*
Janes, Alfred *DcCAr 81, FolkA 86*
Janes, Almarin *FolkA 86*
Janes, Elizabeth 1908- *WhAmArt 85*
Janes, Norman *WhoArt 82N*
Janes, Norman 1892- *ClaDrA, DcSeaP, WhoArt 80*
Janes, Norman Thomas 1892- *DcBrA 1*
Janes, Violeta *ClaDrA, WhoArt 80, -82, -84*
Janes, Violeta 1917- *DcBrA 1*
Janes, Walter *WhAmArt 85*
Janesch, Frank L 1932- *AmArch 70*
Janet *McGDA, OxArt*
Janet, Adele d1877 *DcWomA*
Janet, Gustave 1829- *DcBrBI*
Janet, Henry *New YHSD*
Janevin, M J 1883- *DcWomA*
Janey, Jacob *FolkA 86*
Jang, Harry 1919- *AmArch 70*
Jang, T G *AmArch 70*
Janicki, Hazel 1918- *WhoAmA 73, -76*
Janicki, Hazel 1918-1976 *WhoAmA 78N, -80N, -82N, -84N*
Janin, Louise *WhAmArt 85*
Janin, Louise 1892- *ArtsAmW 3*
Janin, Louise Sophie Jeanne 1781-1842 *DcWomA*
Janinet, Jean Francois 1752-1814 *McGDA*
Janinet, Sophie 1786?- *DcWomA*
Janini, Joaquim Pla 1879-1970 *ICPEnP A, MacBEP*
Janis, Eugenia Parry 1940- *MacBEP*
Janis, Sidney 1896- *WhoAmA 73, -76, -78, -80, -82, -84*

Janka, Martin Joseph 1926- *AmArch 70*
Jankowitz, Marie Lucie De 1778-1866 *DcWomA*
Jankowski, Conrad Chester 1933- *AmArch 70*
Jankowski, Gregory E 1959- *MarqDCG 84*
Jankowski, Joseph P 1916- *WhoAmA 73, -76, -78*
Jankowski, Joseph Paul 1916- *WhoArt 80, -82*
Jankowski, Thomas Edward 1934- *AmArch 70*
Janmot, Anne Francois Louis 1814-1892 *McGDA*
Jannasch, Adolf 1898- *WhoArt 80, -82, -84*
Jannelli, A J *AmArch 70*
Jannelli, Vincent 1882- *WhAmArt 85*
Jannet, Francois *ClaDrA*
Jannetides, T *AmArch 70*
Jannetti, Tony *PrintW 83*
Jannetti, Tony 1947- *PrintW 85*
Janney, Christopher Draper 1950- *WhoAmA 84*
Janni, Pino 1899- *WhAmArt 85*
Jannoch, Vera *DcVicP 2, DcWomA*
Jannock, Vera *DcWomA*
Jannot, Henri 1905- *OxTwCA*
Jannot-Pinet, Marie 1874- *DcWomA*
Janoge, Jeanne 1890- *DcWomA*
Janopoulos, Vasilios 1951- *PrintW 83, -85*
Janosch *IlsCB 1967*
Janosch 1931- *IlsBYP*
Janota-Bzowski Von, Elisabeth *WhoGrA 82[port]*
Janousek, Louis *WhAmArt 85*
Janousek, Louis 1856-1934 *ArtsAmW 2*
Janovska, Bronislava *DcWomA*
Janowitz, Joel 1945- *PrintW 83, -85*
Janowski, C *DcBrBI*
Janowski, Bela 1900- *WhAmArt 85, WhoAmA 73, -76, -78, -80*
Janowsky, Mrs. Bela *WhAmArt 85*
Janowsky, Clara Louise *DcWomA*
Jans, Christopher 1951- *MarqDCG 84*
Janschka, Fritz 1919- *WhoAmA 76, -78, -80, -82, -84*
Jansem, Jean *OfPGCP 86*
Jansem, Jean 1920- *OxTwCA*
Jansen, Angela 1929- *PrintW 85*
Jansen, Angela Bing 1929- *WhoAmA 78, -80, -82, -84*
Jansen, Arno 1938- *ConPhot, ICPEnP A, MacBEP*
Jansen, Bernd 1945- *DcCAr 81, MacBEP*
Jansen, Catherine S 1945- *MacBEP*
Jansen, Catherine Sandra 1945- *WhoAmA 78, -80, -82, -84*
Jansen, Emilie 1871- *DcWomA*
Jansen, Fifi *DcWomA*
Jansen, Frederick William *FolkA 86*
Jansen, Fritz *DcVicP 2*
Jansen, Gerhard 1636-1725 *ClaDrA*
Jansen, Han 1931- *DcCAr 81*
Jansen, Harry J *DcSeaP*
Jansen, Hendrick Willebrord 1855-1908 *DcSeaP*
Jansen, Lawrence Childs 1922- *AmArch 70*
Jansen, Leonard B 1955- *MarqDCG 84*
Jansen, Luise 1835-1912 *DcWomA*
Jansen, P J *DcVicP 2*
Jansen, Richard H *WhAmArt 85*
Jansen, Theodore *DcVicP 2*
Jansen, Wayne 1947- *MarqDCG 84*
Jansens, Cornelius *McGDA*
Janson *DcBrECP*
Janson, Agnes *WhoAmA 84*
Janson, Agnes 1911- *WhoAmA 82*
Janson, Andrew R 1900- *WhAmArt 85*
Janson, Anthony Fredrick 1943- *WhoAmA 78, -80, -82, -84*
Janson, Dorothy Plymouth *WhAmArt 85*
Janson, H W 1913- *WhAmArt 85*
Janson, Horst Woldemar 1913- *WhoAmA 73, -76, -78, -80, -82, WhoArt 80, -82, -84*
Janson, Horst Woldemar 1913-1982 *WhoAmA 84N*
Janson, Johannes 1729-1784 *ClaDrA*
Jansons, Juris 1931- *AmArch 70*
Janss, Edwin 1914- *DcCAr 81*
Janss, Edwin, Jr. *WhoAmA 73, -76, -78*
Janssen, A D *AmArch 70*
Janssen, Bernard *BiDBrA, MacEA*
Janssen, Hans *WhoAmA 78N, -80N, -82N, -84N*
Janssen, Herman Phillip 1932- *AmArch 70*
Janssen, Horst 1929- *ConArt 77, -83, DcCAr 81, OxTwCA, PhDcTCA 77*
Janssen, Marie Hermine 1876- *DcWomA*
Janssen, Peter Johann Theodor 1844- *ArtsNiC*
Janssen, Pierre Jules Cesar 1824-1923 *MacBEP*
Janssen, Ton 1948- *MarqDCG 84*
Janssen VanKeulen, Cornelis *McGDA*
Janssens, Abraham 1575?-1631 *McGDA*
Janssens, Abraham 1575?-1632 *ClaDrA, OxArt*
Janssens, Anna 1894- *DcWomA*
Janssens, Hieronymus 1624-1693 *McGDA*
Janssens, Victor Honore 1658-1736 *ClaDrA*
Janssens Elinga, Pieter d1682? *McGDA*
Jansson, Alfred 1863-1931 *ArtsAmW 2, WhAmArt 85*
Jansson, Arthur A 1890- *WhAmArt 85*
Jansson, Arthur August 1890- *IlBEAAW*

Jansson, Jan 1588-1664 *AntBDN I*
Jansson, John Phillip 1918- *AmArch 70*
Jansson, Lars 1926- *WorECom*
Jansson, Tove *IlsCB 1967*
Jansson, Tove 1914- *IlsCB 1957, WorECom*
Jansson-Blommer, Edla Gustava 1817-1908 *DcWomA*
Jansson-Hammarsten, Signe 1882- *DcWomA*
Janthur, Richard *OxTwCA*
Janus, Virginia *DcWomA*
Janusas, Ceslovas 1907- *WhoAmA 73, -76*
Janusey, William John *AmArch 70*
Janvier, Albert Wilson *NewYHSD*
Janvier, Antide 1751-1835 *OxDecA*
Janvier, Catherine A *DcWomA*
Janvier, Catherine Ann Drinker *WhAmArt 85*
Janvier, Francis DeHaes 1775?-1824 *NewYHSD*
Janvier, George Washington *FolkA 86*
Janvier, Hortense 1896- *DcWomA*
Janvier, John 1777-1850 *CabMA*
Janvier, Loise *AfroAA*
Janz, Robert 1932- *PrintW 83, -85*
Janzen, Loren Gene 1938- *WhoAmA 76, -78, -80, -82*
Japha, Minna 1828- *DcWomA*
Japp, Darsie Napier 1883-1973 *DcBrA 1*
Jappelli, Giuseppe 1783-1852 *MacEA, McGDA*
Japy, Frederic d1812 *DcNiCA*
Japy, Frederic 1749-1813 *AntBDN D*
Japy, Louis Aime *ArtsNiC*
Jaque, Louis 1919- *WhoAmA 76, -78, -80, -82, -84*
Jaquemar, Clara *DcWomA*
Jaquemet, Marguerite 1859- *DcWomA*
Jaquerio, Giacomo *McGDA*
Jaques, Bertha E *WhAmArt 85*
Jaques, Bertha E Clauson 1863- *ArtsAmW 2*
Jaques, Bertha Evelyn 1863-1941 *DcWomA*
Jaques, F L 1887- *WhAmArt 85*
Jaques, Faith Heather 1923- *IlsCB 1967*
Jaques, Francis Lee 1887- *IlsCB 1946*
Jaques, Francis Lee 1887-1969 *ArtsAmW 3*
Jaques, Jules *DcVicP 2*
Jaques, Julia *DcWomA*
Jaques, Norman Clifford 1922- *WhoArt 80, -82, -84*
Jaques, Stephen *CabMA*
Jaquet, Mademoiselle *DcWomA*
Jaquet, Adele 1828-1899 *DcWomA*
Jaquet, Alice 1916- *DcCAr 81*
Jaquet, Augustus *NewYHSD*
Jaquet, Lucy 1849-1893 *DcWomA*
Jaquish, Orin W 1886-1931 *WhAmArt 85*
Jaquotot, Marie Victoire 1772-1855 *DcWomA*
Jara, Andrew Paul 1924- *AmArch 70*
Jara, Raul 1923- *AmArch 70*
Jaramillo, Juanita 1949- *FolkA 86*
Jaramillo, Virginia 1939- *WhoAmA 73, -76, -78, -80, -82, -84*
Jaray, Tess 1937- *ConArt 77, ConBrA 79[port], DcCAr 81, PhDcTCA 77, WhoArt 80, -82, -84*
Jarazo, R J *AmArch 70*
Jarche, James 1890-1965 *ConPhot, ICPEnP A, MacBEP*
Jarchow, Gordon C 1927- *AmArch 70*
Jardalla, Joseph *FolkA 86*
Jardella *NewYHSD*
Jardet, Florence *WhAmArt 85*
Jardet, Florence M *DcWomA*
Jardin, Nicholas-Henri 1720?-1799? *WhoArch*
Jardin, Nicolas 1720-1799 *MacEA*
Jardine, David 1840-1892 *BiDAmAr*
Jardine, Donald Leroy 1926- *WhoAmA 76, -78, -80, -82, -84*
Jardine, Mrs. James *DcVicP 2, DcWomA*
Jardine, Joseph P *EarABI SUP, NewYHSD*
Jareckie, Stephen Barlow 1929- *MacBEP*
Jarema, Maria 1908-1958 *PhDcTCA 77*
Jarett, Alex S 1958- *MarqDCG 84*
Jarett, Irwin M 1930- *MarqDCG 84*
Jarett, Rhoda Ronnie 1930- *MarqDCG 84*
Jaretzki, Alfred, Jr. *WhoAmA 73*
Jaretzki, Mrs. Alfred, Jr. *WhoAmA 73*
Jarkowski, Stefania Agnes *WhoAmA 73, -76, -78, -80*
Jarman, Anne Nesta *WhoArt 80, -82, -84*
Jarman, Edward *BiDBrA*
Jarman, Henry T *DcVicP 2*
Jarman, Walton Maxey 1904- *WhoAmA 73, -76, -78, -80*
Jarman, Walton Maxey 1904-1980 *WhoAmA 82N, -84N*
Jarmul, Seymour 1920- *AmArch 70*
Jarnefelt, Eero Nikolai 1863- *ClaDrA*
Jarnuskiewicz, Jerzy 1919- *PhDcTCA 77*
Jaros, Paul A 1938- *AmArch 70*
Jaroslav 1944- *WhoAmA 80, -82*
Jaroszewicz, Mark T 1921- *AmArch 70*
Jarova, Alexandra Alexandrovna 1853- *DcWomA*
Jarovova, Alexandra Alexandrovna 1853- *DcWomA*
Jarrard, John D 1937- *AmArch 70*
Jarrat, Thomas *BiDBrA*
Jarratt, Mrs. *DcWomA*
Jarratt, W R *AmArch 70*
Jarrell, Adah *WhAmArt 85*

Jarrell, Jae *AfroAA*
Jarrell, Randall d1965 *WhoAmA 78N, -80N, -82N, -84N*
Jarrell, Wadsworth A *AfroAA*
Jarrett, Barbara Anne 1934- *WhoArt 80, -82, -84*
Jarrett, Charles D *WhAmArt 85*
Jarrett, Marcia Lane *DcWomA*
Jarrin, Elise Sophie *DcWomA*
Jarry DeMancy, Adele 1794-1854 *DcWomA*
Jarsaillon, Jeanne *DcWomA*
Jarvaise, James 1927- *DcCAA 71*
Jarvaise, James 1932- *DcCAA 77*
Jarvaise, James J 1931- *WhoAmA 73, -76, -78*
Jarvass, Jacob *NewYHSD*
Jarvis *DcBrECP*
Jarvis, Antonio J 1901- *AfroAA*
Jarvis, Charles *DcBrECP*
Jarvis, Charles Wesley 1812-1868 *NewYHSD*
Jarvis, Donald 1923- *WhoAmA 78, -80, -82, -84*
Jarvis, Donald Edward 1928- *AmArch 70*
Jarvis, George *DcVicP 2*
Jarvis, Gloria *WhoArt 80, -82, -84*
Jarvis, Harold Duane 1931- *AmArch 70*
Jarvis, Henry C 1867- *ClaDrA*
Jarvis, Henry C 1867-1955 *DcBrA 1, DcVicP 2*
Jarvis, Hubert 1882- *DcBrA 2*
Jarvis, James Donald 1929- *AmArch 70*
Jarvis, John Brent 1946- *WhoAmA 78, -80, -82, -84*
Jarvis, John Daniel 1905- *AmArch 70*
Jarvis, John Wesley 1780-1834 *AntBDN J*
Jarvis, John Wesley 1780-1840 *BnEnAmA, DcAmArt, EarABI, McGDA, NewYHSD*
Jarvis, Lucy 1927- *WhoAmA 78, -80, -82, -84*
Jarvis, Lucy M H *DcCAr 81*
Jarvis, Lucy Mary Hope 1896- *DcWomA*
Jarvis, M *DcWomA, EarABI*
Jarvis, Miss M *IlBEAAW*
Jarvis, Mary E *WhAmArt 85*
Jarvis, Matthew *DcVicP 2*
Jarvis, R B *AmArch 70*
Jarvis, Samuel *NewYHSD*
Jarvis, Thomas Lee 1948- *MarqDCG 84*
Jarvis, W Frederick *IlBEAAW, WhAmArt 85*
Jarvis, W Frederick 1868- *ArtsAmW 3*
Jarvis, W H *DcBrA 1*
Jarvis, William Howard 1903-1964 *DcBrA 2*
Jary, Lloyd Walker 1933- *AmArch 70*
Jarzombek, Stanley Joseph, Jr. 1955- *MarqDCG 84*
Jascha, Johann 1942- *DcCAr 81*
Jaser, Marie Marguerite Francoise *DcWomA*
Jasinki, D A *AmArch 70*
Jaskowiak, Edward 1930- *AmArch 70*
Jasoku *McGDA*
Jason *IlDcG*
Jasper, William *CabMA*
Jasson, Josephine *DcWomA*
Jastremsky, Julian K 1910- *AmArch 70*
Jaudon, Valerie 1945- *ConArt 83, PrintW 83, -85, WhoAmA 78, -80, -82, -84*
Jaudon, Valerie 1954- *DcCAr 81*
Jaume, Alexander Charles d1858 *NewYHSD*
Jaume, J *NewYHSD*
Jaunez, Lina *DcWomA*
Jauss, Anne Marie *IlsCB 1967*
Jauss, Anne Marie 1907- *IlsCB 1946, -1957, WhoAmA 73, -76, -78, -80, -82, -84*
Jaussely, Leon 1876-1933 *MacEA*
Jauvin, Aline *DcWomA*
Jauzion, Aline d1862 *DcWomA*
Jauzion, Jeanne 1851- *DcWomA*
Jauziou, Aline *DcWomA*
Java, Marie Amelie De *DcWomA*
Javacheff *WhoAmA 76, -78, -80*
Javitch, Ronald A 1935- *MarqDCG 84*
Javo, G N *AmArch 70*
Jawlensky, Alexei Von 1864-1941 *ConArt 77, OxTwCA, PhDcTCA 77*
Jawlensky, Alexey Von 1864-1941 *McGDA*
Jawlensky, Alexis Von 1864-1941 *OxArt*
Jaworska, Tamara *DcCAr 81, WhoAmA 78, -80, -82, -84*
Jaworskij, Stanislaw 1937- *ICPEnP A*
Jaxson *WhoAmA 82*
Jaxson 1932- *WhoAmA 80*
Jay, Bill 1940- *MacBEP, WhoAmA 78, -80, -82, -84*
Jay, C C *AmArch 70*
Jay, C E *AmArch 70*
Jay, Carrie *DcVicP 2, DcWomA*
Jay, Miss Cecil *DcBrA 2*
Jay, Cecil *DcWomA, WhAmArt 85*
Jay, Hamilton *DcVicP 2*
Jay, Henry *AntBDN K*
Jay, J A B *DcVicP 2*
Jay, J Isabella Lee *DcVicP 2*
Jay, J W *DcVicP 2*

Jay, Jane Isabella Lee *DcWomA*
Jay, Lynn Eugene 1927- *AmArch 70*
Jay, Mary *DcWomA, NewYHSD*
Jay, Norma Joyce *WhoAmA 82, -84*
Jay, Robert W *NewYHSD*
Jay, William 1792-1837 *BnEnAmA*
Jay, William 1793?-1837 *BiDBrA, MacEA*
Jay, William 1794- *BiDAmAr*
Jay, William Samuel *DcVicP*
Jay, William Samuel 1843-1933 *DcBrA 1, DcVicP 2*
Jayet, Clement 1731-1804 *AntBDN C*
Jayne, Charles *DcVicP 2*
Jayne, Mrs. Charles *DcVicP, -2*
Jayne, DeWitt Whistler 1911- *WhAmArt 85*
Jayne, Mary *DcWomA*
Jaynes, Elizabeth *DcWomA*
Jayson, Robert Francis 1932- *AmArch 70*
Jeager, Johannes 1832-1908 *ICPEnP A*
Jeakes, Joseph d1829? *DcBrWA*
Jeal, Lydia Jemima *DcWomA*
Jean Boulogne *McGDA*
Jean DeBeausse *McGDA*
Jean DeBoullogne *McGDA*
Jean De Bruges *McGDA, OxArt*
Jean DeCambrai d1438 *McGDA*
Jean DeChartres *McGDA*
Jean DeLiege *McGDA, OxArt*
Jean De Loup *MacEA*
Jean Des Champs *MacEA*
Jean D'Orbais *MacEA*
Jean, A *IlDcG*
Jean, Antoine 1690?- *ClaDrA*
Jean, Maria *DcWomA*
Jean, Philip 1755-1802 *AntBDN J, DcBrECP*
Jean DeMertens, Fernande *DcWomA*
Jean-Gilles, Joseph *DcCAr 81*
Jean-Louis, Don 1937- *WhoAmA 84*
Jeancon, Miss *DcWomA*
Jeanes, Ben Hanna 1923- *AmArch 70*
Jeanette, Helen *WhoAmA 76*
Jeanfil, Henri 1909- *WhAmArt 85*
Jeanneney, Paul 1861-1921 *DcNiCA*
Jeanneret 1896- *McGDA*
Jeanneret, Charles-Edouard *DcD&D, OxTwCA*
Jeanneret, Charles-Edouard 1887-1965 *DcNiCA*
Jeanneret, Charles Edouard 1887-1965 *WhoArch*
Jeanneret, Henry A *NewYHSD*
Jeanneret, Pierre *McGDA*
Jeanneret, Pierre 1896-1967 *MacEA*
Jeanneret, Ulysse *NewYHSD*
Jeanneret-Gris, Charles-Edouard *McGDA*
Jeannert, Emile 1813-1857 *AntBDN M*
Jeannest, Pierre Emile 1813-1857 *DcNiCA*
Jeannin, Georges *ArtsNiC*
Jeannin, Jean Baptiste 1792?-1863 *NewYHSD*
Jeannin, T B *NewYHSD*
Jeanron, Desiree Angeline *DcWomA*
Jeanron, Philippe-Auguste 1809- *ArtsNiC*
Jeanron, Philippe Auguste 1809-1877 *ClaDrA*
Jeans, John d1808 *BiDBrA*
Jeans, Thomas *BiDBrA*
Jeanson, Louise Esther J *DcWomA*
Jeanson, Marguerite Cecile Marie *DcWomA*
Jearrad, Robert William d1861 *BiDBrA*
Jeaurat, Etienne 1699-1789 *McGDA*
Jeauron, Philippe Auguste *DcVicP 2*
Jeayes, J *DcVicP 2*
Jebb, Kathleen Mary 1878- *DcBrA 1, DcWomA*
Jebe, Martha Caroline Tupsy *DcWomA*
Jechl, Isa 1873- *DcWomA*
Jeckyll, Thomas 1827-1881 *DcNiCA*
Ject-Key, David *WhoAmA 78N, -80N, -82N, -84N*
Ject-Key, Elsie *WhoAmA 73, -76, -78, -80, -82, -84*
Jee, David *DcBrWA*
Jeeves, Louie *DcVicP 2*
Jeff *WorECar*
Jeffcock, Charles Augustine Castleford 1872- *DcBrA 1, DcVicP 2*
Jeffcock, Robert Salisbury *DcBrA 2*
Jeffe, Huldah Cherry *WhoAmA 76, -78, -80, -82, -84*
Jefferies, J *DcVicP 2*
Jefferies, John Randolph 1934- *AmArch 70*
Jefferies, Kathleen Grant 1886- *DcBrA 1, DcWomA*
Jefferies, Wilfred Avalon 1907- *DcBrA 1*
Jeffers, A P *ArtsEM*
Jeffers, James T *FolkA 86*
Jeffers, Susan *IlsBYP*
Jeffers, Susan Jean 1942- *IlsCB 1967*
Jeffers, Wendy Jane 1948- *WhoAmA 78, -80, -82, -84*
Jefferson, Alan 1918- *ClaDrA, DcBrA 1, WhoArt 80, -82, -84*
Jefferson, Archie *AfroAA*
Jefferson, Bob 1943- *AfroAA*
Jefferson, Charles George 1831-1902 *DcBrWA, DcVicP 2*
Jefferson, Donzleigh Hendricks 1912- *AfroAA*
Jefferson, Henry Homer *AfroAA*
Jefferson, Janice 1948- *AfroAA*

Jefferson, John *DcBrWA*
Jefferson, John H 1926- *AfroAA*
Jefferson, Joseph 1774-1832 *NewYHSD*
Jefferson, Joseph 1804-1842 *NewYHSD*
Jefferson, Joseph 1829-1905 *NewYHSD*
Jefferson, Joseph, IV 1829-1905 *WhAmArt 85*
Jefferson, Louise E *AfroAA*
Jefferson, Mannie Holland *FolkA 86*
Jefferson, Orville *WhAmArt 85*
Jefferson, Peter Augustus 1928- *AmArch 70*
Jefferson, R E *AmArch 70*
Jefferson, Robert Louis 1929- *IlsBYP*
Jefferson, Thomas 1743-1826 *BnEnAmA, DcD&D, EncAAr, FolkA 86, MacEA, McGDA, OxArt, WhoArch*
Jefferson, Thomas 1745-1826 *BiDAmAr*
Jeffery, Anna *DcVicP 2*
Jeffery, Annie *DcWomA*
Jeffery, C *DcVicP 2*
Jeffery, Charlen *OfPGCP 86*
Jeffery, Charles Bartley 1910- *WhAmArt 85, WhoAmA 73, -76*
Jeffery, Emmanuel 1806-1874 *DcBrWA, DcVicP 2*
Jeffery, Jerry Quincy 1932- *AmArch 70*
Jeffery, Ralph 1920- *DcBrA 1*
Jefferys, Bertha *DcVicP 2*
Jefferys, Charles William d1951 *WhoAmA 78N, -80N, -82N, -84N*
Jefferys, Charles William 1869-1951 *IlBEAAW, WhAmArt 85*
Jefferys, James 1751-1784 *DcBrECP*
Jefferys, Thomas d1771 *AntBDN I*
Jefferys, Thomas R *NewYHSD*
Jefferys, William 1723?-1805 *DcBrECP*
Jeffords, J E *FolkA 86*
Jeffray, A Edgar *DcVicP 2*
Jeffray, James *BiDBrA, DcVicP 2*
Jeffray, Richard *DcVicP 2*
Jeffrays *NewYHSD*
Jeffrey, Benjamin *NewYHSD*
Jeffrey, Dwaynet 1939- *MarqDCG 84*
Jeffrey, E C *DcVicP 2*
Jeffrey, Edward *WhoArt 80N*
Jeffrey, Edward 1898- *ClaDrA, DcBrA 1*
Jeffrey, Elmore E 1877-1931 *BiDAmAr*
Jeffrey, Helen *DcWomA*
Jeffrey, James Hunter 1874- *DcBrA 1, DcVicP 2*
Jeffrey, Thomas *BiDBrA*
Jeffrey-Waddell, John 1876-1941 *DcBrA 1*
Jeffreys, Arthur Bishop 1892- *ArtsAmW 3*
Jeffreys, Edith Gwyn *DcWomA*
Jeffreys, Jean A *DcWomA*
Jeffreys, Lee *DcWomA*
Jeffreys, Lee 1901- *WhAmArt 85*
Jeffries, Alexander, Jr. 1937- *AmArch 70*
Jeffries, David *FolkA 86*
Jeffries, Deborah Hunt *FolkA 86*
Jeffries, L R *WhAmArt 85*
Jeffries, Lulu Zita *DcWomA*
Jeffries, N H *AmArch 70*
Jeffries, Neal Powell 1935- *MarqDCG 84*
Jeffries, Rosalind 1938- *AfroAA*
Jeffries, S L *AmArch 70*
Jeffries, Theodore *FolkA 86*
Jeffries, W L *AmArch 70*
Jeffries, W P *FolkA 86*
Jegart, Rudolph *WhAmArt 85*
Jegher, Christoffel 1596-1653? *McGDA*
Jehan De Paris *OxArt*
Jehan LeHome *McGDA*
Jehan, William 1946- *MarqDCG 84*
Jehle, William King 1923- *AmArch 70*
Jehn, John M *WhAmArt 85*
Jehn, Mrs. John M *DcWomA, WhAmArt 85*
Jehne, Linton *DcBrBI*
Jehu, John M *WhAmArt 85*
Jehu, Mrs. John M *WhAmArt 85*
Jekyll, Miss *DcVicP 2*
Jekyll, Gertrude *DcWomA*
Jekyll, Gertrude 1843-1932 *MacEA*
Jelenc, Marjan 1949- *DcCAr 81*
Jelenic, Bozidar 1924- *DcCAr 81*
Jelfe, Andrews d1759 *BiDBrA*
Jelgerhuis, Johannes 1770-1836 *ClaDrA*
Jelgersma, Tako 1702-1795 *ClaDrA*
Jeliff, John *DcNiCA*
Jeliff, John 1813-1893 *FolkA 86*
Jelinek, Ernestine 1884- *DcWomA*
Jelinek, Frances *WhAmArt 85*
Jelinek, Hans *WhoAmA 73, -76, -78, -80, -82, -84*
Jelinek, Hans 1910- *WhAmArt 85*
Jelinek, S *AmArch 70*
Jelinek, Vladimir 1934- *DcCAr 81*
Jelks, George Wiland 1935- *AmArch 70*
Jelks, J O *AmArch 70*
Jellet, K M *DcWomA*
Jellett, Mainie 1896-1943 *DcBrA 2*
Jellett, Mainie 1897-1944 *McGDA*
Jelley, James Valentine *DcBrA 1, DcVicP, -2*
Jellico, John Anthony 1914- *WhoAmA 73, -76, -78, -80, -82, -84*

Jellicoe, Nancy R 1939- *WhoAmA 82, -84*
Jellicoe, Colin 1942- *DcCAr 81, WhoArt 80, -82, -84*
Jellicoe, Geoffrey 1900- *MacEA*
Jellicoe, Sir Geoffrey *ConArch A*
Jellicoe, Sir Geoffrey 1900- *ConArch*
Jellicoe, Geoffrey Alan *WhoArt 80*
Jellicoe, Sir Geoffrey Alan *WhoArt 82, -84*
Jellicoe, John *DcBrBI*
Jellicoe, John F *DcVicP 2*
Jelliff, Horatio F 1844-1892 *BiDAmAr*
Jelliff, John 1813-1893 *CabMA*
Jelliffe, John H 1925- *AmArch 70*
Jellison, M R *AmArch 70*
Jelly, Thomas d1781 *BiDBrA*
Jelson, Carla Witte 1944- *MarqDCG 84*
Jemely, James *DcBrECP*
Jemison, Edward F 1932- *AmArch 70*
Jemison, W F 1922- *MarqDCG 84*
Jemmett-Browne, Mina *DcWomA*
Jemne, Elsa Laubach *WhAmArt 85*
Jemne, Elsa Laubach 1888- *IlsCB 1744*
Jemne, Elsa Laubach 1888-1974 *DcWomA*
Jemne, Elsa Lauback 1888- *ArtsAmW 3*
Jemric, Anton 1925- *AmArch 70*
Jen, Chih-Chen 1929- *AmArch 70*
Jen, Jen-Fa 1254-1327 *McGDA*
Jen, Pai-Nien 1840-1895 *McGDA*
Jenckes, Joseph 1602-1683 *NewYHSD*
Jencks, Eleanor *WhAmArt 85*
Jencks, Francis Haynes 1902- *AmArch 70*
Jencks, Penelope *WhoAmA 76, -78*
Jendritzko, Guido 1925- *DcCAr 81*
Jenings, Arthur Bates 1849-1927 *BiDAmAr*
Jenison, Emily *DcWomA*
Jenison, J *FolkA 86*
Jenkin, Mrs. M M *DcBrA 1*
Jenkin, Margaret *DcWomA*
Jenkin, Margaret M 1868-1949 *DcBrA 2*
Jenkin, William *DcVicP 2*
Jenkins, A *FolkA 86*
Jenkins, Albert Allan 1933- *AmArch 70*
Jenkins, Alfred W 1862-1932 *WhAmArt 85*
Jenkins, Anne *DcVicP 2, DcWomA*
Jenkins, Arthur Henry 1871- *DcBrA 1, DcVicP 2*
Jenkins, Barbara F *AfroAA*
Jenkins, Bill Gene 1948- *MarqDCG 84*
Jenkins, Blanche *DcVicP 2, DcWomA*
Jenkins, Burris d1966 *WhoAmA 78N, -80N, -82N, -84N*
Jenkins, Burris, Jr. 1897-1966 *WhAmArt 85*
Jenkins, C *DcWomA*
Jenkins, C K *AmArch 70*
Jenkins, C S *DcVicP 2*
Jenkins, C W *AmArch 70*
Jenkins, Charles *AfroAA*
Jenkins, Charles Waldo 1820?- *NewYHSD*
Jenkins, Clayton Evans 1898- *WhAmArt 85*
Jenkins, Cleo Harold 1892- *AmArch 70*
Jenkins, Constance *DcWomA*
Jenkins, Daniel S *NewYHSD*
Jenkins, David C *DcVicP 2*
Jenkins, Denzil 1927- *AmArch 70*
Jenkins, Donald John 1931- *WhoAmA 78, -80, -82, -84*
Jenkins, Edward *BiDBrA*
Jenkins, Edward Charles *AmArch 70*
Jenkins, Emily Vaughan *DcVicP 2, DcWomA*
Jenkins, Eveline A *WhoArt 80N*
Jenkins, F Lynn *WhAmArt 85*
Jenkins, Florian 1940- *AfroAA*
Jenkins, Francis A *NewYHSD*
Jenkins, George *ConDes*
Jenkins, George Washington Allston 1816-1907 *NewYHSD , WhAmArt 85*
Jenkins, Gordon H 1923- *AmArch 70*
Jenkins, Guy S *EncASM*
Jenkins, H *DcVicP 2, FolkA 86*
Jenkins, Haley Dodge *WhAmArt 85*
Jenkins, Hannah T d1927 *WhAmArt 85*
Jenkins, Hannah Tempest *ArtsAmW 2*
Jenkins, Hannah Tempest 1855?-1927 *DcWomA*
Jenkins, Harry *WhAmArt 85*
Jenkins, Harvey *NewYHSD*
Jenkins, Heinke *DcCAr 81*
Jenkins, Heinke 1937- *WhoArt 82, -84*
Jenkins, J *BiDBrA*
Jenkins, J S, Sr. *NewYHSD*
Jenkins, James 1924- *AmArch 70*
Jenkins, John *BiDBrA*
Jenkins, John 1798?- *DcBrWA*
Jenkins, John Eliot 1868- *ArtsAmW 2, WhAmArt 85*
Jenkins, Joseph *BiDAmAr, NewYHSD*
Jenkins, Joseph J 1811- *ArtsNiC*
Jenkins, Joseph John 1811-1885 *DcBrBI, DcBrWA, DcVicP, -2*
Jenkins, Julian Weldon 1932- *AmArch 70*
Jenkins, Kenneth W 1936- *MarqDCG 84*
Jenkins, Leonard Seweryn 1905- *WhAmArt 85*

Jenkins, Marian Brooks 1885-1944 *ArtsAmW 3*
Jenkins, Martha E d1923 *DcWomA, WhAmArt 85*
Jenkins, Mary *DcWomA*
Jenkins, Mary Anne K 1929- *WhoAmA 76, -78, -80, -82*
Jenkins, Mary Anne Keel 1929- *WhoAmA 84*
Jenkins, Mattie M 1867- *WhAmArt 85*
Jenkins, Mattie Maud 1867- *DcWomA*
Jenkins, Michael *CabMA*
Jenkins, Morris Troy 1923- *AmArch 70*
Jenkins, Nellie C *ArtsEM, DcWomA*
Jenkins, P O *NewYHSD*
Jenkins, Paul 1923- *AmArt, ConArt 77, DcAmArt, DcCAA 71, -77, OxTwCA, PrintW 83, -85, WhoAmA 73, -76, -78, -80, -82, -84, WorArt[port]*
Jenkins, Paul 1932- *ConArt 83*
Jenkins, Paul Ripley 1940- *WhoAmA 73*
Jenkins, Paul Ripley 1940-1974 *ConArt 77, WhoAmA 76N, -78N, -80N, -82N, -84N*
Jenkins, R G *AmArch 70*
Jenkins, Richard Bramlett 1936- *AmArch 70*
Jenkins, Roy Allen 1928- *AmArch 70*
Jenkins, Russell Willis, Jr. 1925- *AmArch 70*
Jenkins, Solomon *BiDAmAr*
Jenkins, Thomas 1722-1798 *DcBrECP*
Jenkins, Trevor Francis 1955- *MarqDCG 84*
Jenkins, Victorine B *DcWomA*
Jenkins, Violet Edgecombe *DcBrA 1, DcWomA*
Jenkins, W E *AmArch 70*
Jenkins, W Irving 1850-1916 *WhAmArt 85*
Jenkins, Waldo C *NewYHSD*
Jenkins, Wilfred *DcVicP, -2*
Jenkins, Will *DcBrBI, WhAmArt 85*
Jenkins, William *DcBrWA*
Jenkins, William 1760?-1836 *CabMA*
Jenkins, William 1763?-1844 *BiDBrA*
Jenkins, William Paul 1923- *PhDcTCA 77*
Jenkins, William Robert 1925- *AmArch 70*
Jenkins, William Wesley d1864 *BiDBrA*
Jenkins And Jenkins *EncASM*
Jenkinson, Charlotte *DcVicP 2*
Jenkinson, Edgar Townsley 1901- *AmArch 70*
Jenkinson, Geoffrey 1925- *DcBrA 1, WhoAmA 76, -78, -80, -82, -84, WhoArt 80, -82, -84*
Jenkinson, George W *NewYHSD*
Jenkinson, H L *AmArch 70*
Jenkinson, J *DcSeaP*
Jenkinson, Joseph *NewYHSD*
Jenks, Albert 1824-1901 *ArtsAmW 1, ArtsEM, NewYHSD , WhAmArt 85*
Jenks, B W *NewYHSD*
Jenks, Dea S *ArtsAmW 3, WhAmArt 85*
Jenks, Edward B *CabMA*
Jenks, George *MarqDCG 84*
Jenks, Jo 1903- *WhAmArt 85*
Jenks, Lewis E *EncASM*
Jenks, Phoebe 1849- *ArtsNiC*
Jenks, Phoebe A Pickering Hoyt 1847-1907 *DcWomA, WhAmArt 85*
Jenks, R R *AmArch 70*
Jenks, Samuel B *ArtsEM*
Jenks Peebles And Baldwin *ArtsEM*
Jenkyns, Caroline *DcBrWA*
Jenkyns, Chris 1924- *IlsBYP, IlsCB 1946*
Jenkyns, Richard 1782-1854 *DcBrWA*
Jennens, Luke *DcVicP 2*
Jennens, W *DcVicP 2*
Jennens & Bettridge *DcNiCA*
Jennens And Bettridge *AntBDN G*
Jenner, Augie *FolkA 86*
Jenner, Everett Hollis, Jr. 1930- *AmArch 70*
Jenner, G P *DcVicP 2*
Jenner, Hans, Jr. *FolkA 86*
Jenner, Hans, Sr. *FolkA 86*
Jenner, Isaac Walter 1836?- *DcVicP 2*
Jenner, Isaac Walter 1836-1901 *DcSeaP*
Jenner, John d1728 *BiDBrA*
Jenner, Stephen *DcBrBI*
Jenner, William *NewYHSD*
Jennerjahn, W P 1922- *WhoAmA 76, -78, -80, -82, -84*
Jennett, Norman Ethre 1877- *WhAmArt 85*
Jennett, Sean 1912- *WhoArt 80, -82, -84*
Jennewein, C Paul 1890- *WhoAmA 73, -76*
Jennewein, C Paul 1890-1978 *WhoAmA 78N, -80N, -82N, -84N*
Jennewein, Carl Paul 1890-1978 *WhAmArt 85*
Jennewein, G Peter 1931- *AmArch 70*
Jennewein, James Joseph 1929- *AmArch 70*
Jennewein, Paul 1890- *BnEnAmA*
Jenney, Edgar W 1869- *WhAmArt 85*
Jenney, N D *FolkA 86*
Jenney, Neil 1945- *ConArt 83, DcCAr 81*
Jenney, Samuel 1633?- *CabMA*
Jenney, William LeBaron 1832-1907 *BiDAmAr, EncAAr, EncMA, MacEA, WhoArch*
Jenney, William LeBaron 1837-1907 *McGDA*
Jenni, Eva 1952- *DcCAr 81*
Jennings *EncASM*

Johnson, C K *DcBrBI*
Johnson, C R *AmArch 70, DcVicP 2*
Johnson, C Raimond 1889- *AmArch 70*
Johnson, Carl H 1913- *AmArch 70*
Johnson, Carl O 1864- *ArtsEM*
Johnson, Carol *WhAmArt 85*
Johnson, Caroline R *ArtsAmW 2, WhAmArt 85*
Johnson, Carrie Rixford *ArtsAmW 2, WhAmArt 85*
Johnson, Carrie Rixford 1873?-1961 *DcWomA*
Johnson, Catherine *FolkA 86*
Johnson, Catherine C *WhAmArt 85*
Johnson, Catherine C 1883- *ArtsAmW 3*
Johnson, Cecil A *WhAmArt 85*
Johnson, Cecile Ryden *WhoAmA 73, -76, -78, -80, -82, -84*
Johnson, Charles E *NewYHSD*
Johnson, Charles Edward 1832-1913 *DcBrA 1, DcBrWA, DcVicP, -2*
Johnson, Charles F 1827?- *NewYHSD*
Johnson, Charles G 1902- *DcBrA 1, WhoArt 80, -82, -84*
Johnson, Charles M *FolkA 86, WhAmArt 85*
Johnson, Charles Marland 1932- *AmArch 70*
Johnson, Charles Norman 1923- *AmArch 70*
Johnson, Charles W, Jr. 1938- *WhoAmA 76, -78, -80, -82, -84*
Johnson, Charles William 1929- *AmArch 70*
Johnson, Charlotte *DcWomA*
Johnson, Charlotte B 1918- *WhoAmA 82*
Johnson, Charlotte Buel *WhoAmA 80*
Johnson, Charlotte Buel 1918- *WhoAmA 73, -76, -78*
Johnson, Cheryl Nan 1959- *MarqDCG 84*
Johnson, Clair E 1947- *MarqDCG 84*
Johnson, Clarence F 1931- *AmArch 70*
Johnson, Clarence R 1894- *WhAmArt 85*
Johnson, Cletus Merlin 1941- *WhoAmA 76, -78, -80, -82*
Johnson, Clifford Leo 1931- *WhoAmA 73, -76*
Johnson, Clifton 1865- *WhAmArt 85*
Johnson, Colin Trever 1942- *WhoArt 84*
Johnson, Content d1949 *DcWomA, WhAmArt 85, WhoAmA 78N, -80N, -82N, -84N*
Johnson, Cordelia 1871- *ArtsAmW 1, DcWomA, WhAmArt 85*
Johnson, Cornelius 1593?-1661? *AntBDN J*
Johnson, Cornelius 1593-1661 *McGDA, OxArt*
Johnson, Cornelius W 1905- *AfroAA*
Johnson, Crocket 1906-1976 *WhoAmA 82N, -84N*
Johnson, Crockett *WorECom*
Johnson, Crockett d1975 *IlsCB 1967*
Johnson, Crockett 1906- *WhoAmA 73, -76*
Johnson, Crockett 1906-1975 *IlsCB 1946, -1957*
Johnson, Crockett 1906-1976 *WhoAmA 78N, -80N*
Johnson, Cyrus 1848-1925 *DcBrA 1, DcBrBI, DcBrWA, DcVicP, -2*
Johnson, D E *AmArch 70*
Johnson, D P *FolkA 86*
Johnson, D V *AmArch 70*
Johnson, D W *AmArch 70*
Johnson, Dale Raymond 1933- *AmArch 70*
Johnson, Dana Doane 1914- *WhoAmA 76, -78, -80*
Johnson, Daniel LaRue 1938- *AfroAA, WhoAmA 73*
Johnson, Daniel Larue 1938- *WhoAmA 76, -78*
Johnson, David 1827- *ArtsNiC*
Johnson, David 1827-1908 *BnEnAmA, NewYHSD, WhAmArt 85*
Johnson, David E 1955- *MarqDCG 84*
Johnson, David G *NewYHSD*
Johnson, David R 1919- *AmArch 70*
Johnson, David Torvestad 1921- *AmArch 70*
Johnson, D'Elaine 1932- *AmArt*
Johnson, D'Elaine A *WhoAmA 82*
Johnson, D'Elaine A Herard *WhoAmA 84*
Johnson, Delbert *ArtsEM*
Johnson, Dennis L 1932- *AmArch 70*
Johnson, Diane Chalmers 1943- *WhoAmA 76, -78, -80, -82, -84*
Johnson, Don Carl 1923- *AmArch 70*
Johnson, Donald J *AmArch 70*
Johnson, Donald Leslie 1930- *AmArch 70*
Johnson, Donald Marvin 1947- *WhoAmA 78, -80, -82, -84*
Johnson, Donald Ray 1942- *WhoAmA 76, -78, -80, -82, -84*
Johnson, Donald Steele 1905- *AmArch 70*
Johnson, Donald Steele, Jr. 1937- *AmArch 70*
Johnson, Doris Miller 1909- *WhAmArt 85, WhoAmA 73, -76, -78, -80, -82, -84*
Johnson, Dorothy May 1912- *WhAmArt 85*
Johnson, Doug 1940- *IlrAm 1880*
Johnson, Douglas Walter 1946- *AmArt, WhoAmA 76, -78, -80, -82, -84*
Johnson, E A *AmArch 70, DcWomA*
Johnson, E G *AmArch 70*
Johnson, E H, Jr. *AmArch 70*
Johnson, E S *EncASM*
Johnson, E William 1932- *AmArch 70*
Johnson, Eastman 1824- *ArtsNiC*
Johnson, Eastman 1824-1906 *BnEnAmA, DcAmArt, McGDA, NewYHSD, WhAmArt 85*
Johnson, Eastwood *DcVicP 2*

Johnson, Ed Jordan 1936- *AmArch 70*
Johnson, Edmund *AntBDN G, CabMA*
Johnson, Edna B *OfPGCP 86*
Johnson, Edvard Arthur 1911- *WhoAmA 73, -76, -78, -80, -82, -84*
Johnson, Edward *NewYHSD*
Johnson, Edward d1672 *CabMA*
Johnson, Edward 1722-1799 *CabMA*
Johnson, Edward 1911- *WhAmArt 85*
Johnson, Edward C, Jr. 1937- *AmArch 70*
Johnson, Edward Killingworth 1825- *ArtsNiC*
Johnson, Edward Killingworth 1825-1896 *ClaDrA, DcBrWA*
Johnson, Edward Killingworth 1825-1923 *DcBrA 1, DcVicP, -2*
Johnson, Edward M 1909- *AmArch 70*
Johnson, Edwin Boyd 1904- *WhAmArt 85*
Johnson, Edyth A B 1880- *DcWomA, WhAmArt 85*
Johnson, Elena 1889-1939 *DcWomA*
Johnson, Elena Mix 1889- *WhAmArt 85*
Johnson, Ellen Hulda 1910- *WhoAmA 76, -78, -80, -82, -84*
Johnson, Emery *CabMA*
Johnson, Eric B 1949- *MacBEP*
Johnson, Ernest 1924- *WhoAmA 84*
Johnson, Ernest Borough 1867-1949 *DcBrA 1, DcVicP 2*
Johnson, Ernst Vern 1911- *AmArch 70*
Johnson, Ernst Verner 1937- *AmArch 70*
Johnson, Esther Borough *ClaDrA, DcBrA 1, DcWomA*
Johnson, Eugene H *AfroAA*
Johnson, Eugene Harper *IlsBYP, IlsCB 1946, -1957*
Johnson, Eugene Joseph 1937- *WhoAmA 76, -78, -80, -82, -84*
Johnson, Eunice *AfroAA*
Johnson, Eunice W *WorFshn*
Johnson, Evelyn Elizabeth 1909- *AfroAA*
Johnson, Everett *AfroAA*
Johnson, Evert Alfred 1929- *WhoAmA 73, -76, -78, -80, -82, -84*
Johnson, F *DcBrECP, WhAmArt 85*
Johnson, F C *AmArch 70*
Johnson, F E *AmArch 70*
Johnson, F V *DcWomA*
Johnson, Mrs. F V *DcVicP 2*
Johnson, Fanny *DcVicP 2, FolkA 86*
Johnson, Ferd 1905- *WorECom*
Johnson, Floyd E 1909- *WhAmArt 85*
Johnson, Floyd Elmer 1909- *AmArch 70*
Johnson, Folger *AmArch 70*
Johnson, Francis Norton 1878-1931 *WhAmArt 85*
Johnson, Frank D *ArtsEM*
Johnson, Mrs. Frank Edgar *WhAmArt 85*
Johnson, Frank Edward 1873-1934 *WhAmArt 85*
Johnson, Frank Tenney 1874-1939 *ArtsAmW 1, IlBEAAW, WhAmArt 85*
Johnson, Fred G 1892- *FolkA 86*
Johnson, Frederick Arthur 1916- *AmArch 70*
Johnson, Fridolf Lester 1905- *WhoAmA 76, -78, -80, -82, -84*
Johnson, Frost *NewYHSD*
Johnson, Frost 1835- *ArtsNiC*
Johnson, G A *ArtsAmW 3*
Johnson, G E *AmArch 70*
Johnson, G F Waldo *DcVicP 2*
Johnson, G H *AmArch 70*
Johnson, G L *AmArch 70*
Johnson, G Q *AmArch 70*
Johnson, G Robert *AmArch 70*
Johnson, G S *AmArch 70*
Johnson, Garrison *IlBEAAW*
Johnson, Gearold Robert 1940- *MarqDCG 84*
Johnson, George A *ArtsAmW 3*
Johnson, George H Ben 1888- *AfroAA, WhAmArt 85*
Johnson, George Thomas 1927- *AmArch 70*
Johnson, Gerard *OxArt*
Johnson, Gerard d1611 *OxArt*
Johnson, Gertrude 1911- *AfroAA*
Johnson, Gilbert A 1892- *AmArch 70*
Johnson, Gladys L *AfroAA*
Johnson, Gordon E 1920- *AmArch 70*
Johnson, Grace M 1882- *WhAmArt 85*
Johnson, Grace Mott *AfroAA*
Johnson, Grace Mott 1882- *DcWomA*
Johnson, Gregory 1955- *WhoAmA 84*
Johnson, Gunnard Clifford 1928- *AmArch 70*
Johnson, Guy 1740?-1788 *NewYHSD*
Johnson, H *DcWomA*
Johnson, Mrs. H *DcVicP 2*
Johnson, H S, Jr. *AmArch 70*
Johnson, H Ted 1926- *AmArch 70*
Johnson, H W *AmArch 70*
Johnson, Hamlin *FolkA 86, NewYHSD*
Johnson, Hannah 1770-1818 *FolkA 86*
Johnson, Harley Hovey 1918- *AmArch 70*
Johnson, Harold LeRoy 1909- *WhAmArt 85*
Johnson, Harold Wilbert 1920- *AmArch 70*
Johnson, Harrison Wall *WhAmArt 85*

Johnson, Harry *DcVicP*
Johnson, Harry F *EncASM*
Johnson, Harry John 1826-1884 *ClaDrA, DcBrWA, DcVicP, -2*
Johnson, Harry L *WhAmArt 85*
Johnson, Harvey W 1920?- *IlBEAAW*
Johnson, Harvey William 1921- *WhoAmA 76, -78, -80, -82, -84*
Johnson, Hazel *DcWomA, WhAmArt 85*
Johnson, Helen *DcWomA*
Johnson, Helen G *DcWomA*
Johnson, Helen Lessing 1865-1946 *DcWomA*
Johnson, Helen Lossing 1865-1946 *WhAmArt 85*
Johnson, Helen Mary *DcVicP 2, DcWomA*
Johnson, Helen Sewell *WhAmArt 85*
Johnson, Henry *ClaDrA, DcVicP 2, NewYHSD*
Johnson, Henry C, Jr. 1928- *AmArch 70*
Johnson, Henry Gustave 1923- *AmArch 70*
Johnson, Henry William 1935- *AmArch 70*
Johnson, Herbert *AfroAA*
Johnson, Herbert 1848-1906 *DcBrBI, DcVicP 2*
Johnson, Herbert 1878-1946 *ArtsAmW 3, WhAmArt 85, WorECar*
Johnson, Herbert Fisk 1901-1980 *WhoAmA 80N, -82N, -84N*
Johnson, Herbert Howard 1913- *AmArch 70*
Johnson, Hilary Martin 1929- *AmArch 70*
Johnson, Homer 1925- *WhoAmA 76, -78, -80, -82, -84*
Johnson, Horace C 1820- *ArtsNiC*
Johnson, Horace Chauncey 1820-1890 *NewYHSD*
Johnson, Howard 1934- *AmArch 70*
Johnson, Howard C 1913- *WhAmArt 85*
Johnson, Hugh B 1904- *AmArch 70*
Johnson, Ida 1852?-1931 *ArtsAmW 3*
Johnson, Ines *DcBrA 1, DcWomA*
Johnson, Ira Lee 1935- *AmArch 70*
Johnson, Irene Charlesworth 1888- *DcWomA, WhAmArt 85*
Johnson, Iris B *DcWomA*
Johnson, Isaac *FolkA 86*
Johnson, Isaac 1754-1835 *DcBrWA*
Johnson, Ivan Earl 1911- *WhoAmA 73, -76, -78, -80, -82, -84*
Johnson, J C *DcVicP 2*
Johnson, J E *NewYHSD*
Johnson, J F *AmArch 70*
Johnson, Mrs. J Lee, III 1923- *WhoAmA 73, -76*
Johnson, J Seward, Jr. 1930- *WhoAmA 84*
Johnson, J Stewart 1925- *WhoAmA 73, -76, -78, -80, -82, -84*
Johnson, Mrs. J T *WhAmArt 85*
Johnson, J Theodore 1902- *WhAmArt 85*
Johnson, J W *EncASM*
Johnson, James *AntBDN N, NewYHSD*
Johnson, James d1807 *BiDBrA*
Johnson, James 1803-1834 *DcBrWA*
Johnson, James A 1865-1939 *BiDAmAr*
Johnson, James A 1934- *AmArch 70*
Johnson, James Alan 1945- *WhoAmA 78, -80, -82, -84*
Johnson, James Boyd 1931- *AmArch 70*
Johnson, James E 1810-1858 *FolkA 86*
Johnson, James Edwin 1942- *WhoAmA 78, -80, -82, -84*
Johnson, James Henry 1932- *AmArch 70*
Johnson, James Herbert 1920- *AmArch 70*
Johnson, James Owen *AmArch 70*
Johnson, James Ralph 1922- *WhoAmA 76, -78, -80, -82, -84*
Johnson, James Ross, Jr. 1931- *AmArch 70*
Johnson, Jarred *FolkA 86*
Johnson, Jeanne 1940- *AfroAA*
Johnson, Jeanne Payne d1958 *WhoAmA 80N, -82N, -84N*
Johnson, Jeanne Payne 1887-1958 *DcWomA, WhAmArt 85*
Johnson, Jedediah 1759?-1821 *CabMA*
Johnson, Jeh Vincent 1931- *AmArch 70*
Johnson, Jerom *IlDcG*
Johnson, Jerome *AntBDN H*
Johnson, Jessamine Inglee 1874- *DcWomA, WhAmArt 85*
Johnson, Jimmie Lee 1941- *MarqDCG 84*
Johnson, Joanne Jackson 1943- *MacBEP*
Johnson, Joe Warren 1937- *AmArch 70*
Johnson, Joel 1721?-1799 *BiDBrA*
Johnson, Joel Bernard 1939- *AmArch 70*
Johnson, John *BiDBrA, CabMA, DcVicP 2, FolkA 86, NewYHSD, OxArt*
Johnson, John 1732-1814 *BiDBrA, MacEA*
Johnson, John 1769?-1846 *DcBrWA*
Johnson, John E *IlsCB 1967*
Johnson, John E 1929- *IlsBYP, IlsCB 1957*
Johnson, John Grover 1841-1917 *WhAmArt 85*
Johnson, John R *NewYHSD*
Johnson, Jonathan 1683?-1741 *CabMA*
Johnson, Jonathan Eastman 1824-1906 *EarABI, IlBEAAW, NewYHSD*
Johnson, Joseph *AfroAA, FolkA 86, WhAmArt 85*
Johnson, Joseph 1698- *FolkA 86*

Johnston, Eliza Griffin *ArtsAmW 3*
Johnston, F P *AmArch 70*
Johnston, Frances Benjamin 1864-1952 *ICPEnP, MacBEP, WhAmArt 85, WomArt*
Johnston, Francis 1760-1829 *DcD&D, MacEA, WhoArch*
Johnston, Francis Hans 1888-1948 *IlBEAAW*
Johnston, Frank *OxTwCA*
Johnston, Frank B 1904-1956 *ICPEnP A, MacBEP*
Johnston, Frederic 1890- *ArtsAmW 2, WhAmArt 85*
Johnston, Frederick *DcVicP 2*
Johnston, Frederick Charles 1916- *WhoArt 80, -82, -84*
Johnston, G A *AmArch 70*
Johnston, G E *AmArch 70*
Johnston, G N *AmArch 70*
Johnston, George Bonar 1933- *WhoArt 80, -82, -84*
Johnston, George Liddell 1817-1902 *DcBrWA, DcVicP 2*
Johnston, Sir Harry Hamilton *DcVicP 2*
Johnston, Sir Harry Hamilton 1858-1927 *ClaDrA, DcBrBI*
Johnston, Helen Head *MacBEP, WhoAmA 76, -78, -80, -82, -84*
Johnston, Henrietta *McGDA*
Johnston, Henrietta d1728 *FolkA 86*
Johnston, Henrietta d1728? *WomArt*
Johnston, Henrietta 1670?- *BnEnAmA*
Johnston, Henrietta 1670?-1728? *NewYHSD*
Johnston, Henrietta 1670?-1729? *DcWomA*
Johnston, Henrietta Deering 1728?- *DcAmArt*
Johnston, Henry *DcBrWA, DcVicP 2*
Johnston, Henry H *DcVicP 2*
Johnston, Henry Mortimer 1831-1920 *WhAmArt 85*
Johnston, Henry Wood 1939- *AmArch 70*
Johnston, J A *AmArch 70*
Johnston, J Dudley 1868-1955 *ICPEnP A, MacBEP*
Johnston, J H *EncASM*
Johnston, James Hugh 1933- *AmArch 70*
Johnston, Jessie E *ArtsEM, DcWomA*
Johnston, John *BiDBrA, FolkA 86*
Johnston, John 1753-1818 *NewYHSD*
Johnston, John Humphreys 1857-1941 *WhAmArt 85*
Johnston, John M *NewYHSD*
Johnston, John R *NewYHSD*
Johnston, Joshua *BnEnAmA, DcAmArt, FolkA 86, NewYHSD*
Johnston, Joshua 1765-1830 *AfroAA, WhoAmA 80N*
Johnston, Julia *WhAmArt 85*
Johnston, June Frazier 1927- *WhoAmA 84*
Johnston, L *FolkA 86*
Johnston, Louisa *ArtsEM, DcWomA*
Johnston, M *DcWomA*
Johnston, Miss M H *DcBrWA*
Johnston, Margaret Isabelle 1884- *ArtsAmW 3, DcWomA, WhAmArt 85*
Johnston, Margaret Kalb Broxton 1909- *WhAmArt 85*
Johnston, Mary *DcWomA*
Johnston, Mary Ann *DcWomA*
Johnston, Mary G 1872- *DcWomA, WhAmArt 85*
Johnston, Mary Virginia 1865-1948? *DcWomA*
Johnston, Mary Virginia DelCastillo *WhAmArt 85*
Johnston, Mary Virginia DelCastillo 1865- *ArtsAmW 2*
Johnston, Norman John 1918- *AmArch 70*
Johnston, P T 1842-1926? *DcWomA*
Johnston, Philip Mainwaring *DcVicP 2*
Johnston, Phillip M 1944- *WhoAmA 80, -82, -84*
Johnston, R S *AmArch 70*
Johnston, Randolph 1904- *WhAmArt 85*
Johnston, Ray 1936- *DcCAr 81*
Johnston, Reuben LeGrande 1850- *WhAmArt 85*
Johnston, Richard M 1942- *WhoAmA 73, -76, -78, -80, -82, -84*
Johnston, Robert *BiDBrA, DcBrA 1*
Johnston, Robert E 1885-1933 *WhAmArt 85*
Johnston, Robert Harold 1928- *WhoAmA 78, -80, -82, -84*
Johnston, Robert Porter 1924- *WhoAmA 76, -78, -80, -82, -84*
Johnston, Ruth 1864- *DcWomA, WhAmArt 85*
Johnston, Mrs. S H *WhAmArt 85*
Johnston, Sarah J F 1850- *DcWomA*
Johnston, Sarah J F 1850-1925 *WhAmArt 85*
Johnston, Scott 1903- *WhAmArt 85*
Johnston, Stella d1906 *DcWomA*
Johnston, Stephen Dow 1932- *AmArch 70*
Johnston, Thomas *FolkA 86*
Johnston, Thomas 1708?-1767 *BnEnAmA, NewYHSD*
Johnston, Thomas, Jr. 1731- *NewYHSD*
Johnston, Thomas Alix 1941- *AmArt, WhoAmA 78, -80, -82, -84*
Johnston, Thomas Henry, Jr. 1906- *AmArch 70*
Johnston, Thomas Murphy 1834-1869 *NewYHSD*
Johnston, Walt 1932- *IlBEAAW*
Johnston, Walter R *NewYHSD*
Johnston, William 1732-1772 *FolkA 86, NewYHSD*
Johnston, William Borthwick 1804-1868 *DcVicP 2*
Johnston, William Edgar 1946- *MarqDCG 84*
Johnston, William Edward 1917- *AfroAA,*

WhoAmA 76, -78, -80, -82
Johnston, William L *NewYHSD*
Johnston, William L 1811-1849 *MacEA*
Johnston, William M 1821-1907 *NewYHSD, WhAmArt 85*
Johnston, William M P *WhAmArt 85*
Johnston, William Medford 1941- *WhoAmA 78, -80, -82, -84*
Johnston, William Ralph 1936- *WhoAmA 76, -78, -80, -82, -84*
Johnston, Wilmer Atkinson, Jr. 1941- *AmArch 70*
Johnston, Winant 1890- *WhAmArt 85*
Johnston, Ynes 1920- *AmArt*
Johnston, Ynez *WhoAmA 73*
Johnston, Ynez 1920- *DcCAA 71, -77, WhoAmA 76, -78, -80, -82, -84*
Johnstone, Mrs. *DcWomA*
Johnstone, Alexander 1815-1891 *DcBrBI*
Johnstone, Allan *BiDBrA*
Johnstone, Anne *IlsBYP*
Johnstone, B Kenneth 1907- *AmArch 70, WhAmArt 85*
Johnstone, Couzens *DcWomA*
Johnstone, Mrs. Couzens *DcVicP 2*
Johnstone, Mrs. David *DcVicP 2*
Johnstone, Dorothy 1892- *DcBrA 2, DcWomA*
Johnstone, George Whitton 1849-1901 *DcBrA 1, DcBrWA, DcVicP, -2*
Johnstone, Harry Inge 1903- *AmArch 70*
Johnstone, Henry *DcVicP 2*
Johnstone, Henry J *DcVicP 2*
Johnstone, Henry James 1835-1907 *DcBrA 2*
Johnstone, J Nicholson *DcVicP 2*
Johnstone, Janet *IlsBYP*
Johnstone, John *BiDBrA*
Johnstone, John 1937- *WhoArt 84*
Johnstone, Mark *WhoAmA 82*
Johnstone, Mark 1953- *WhoAmA 84*
Johnstone, Mark David 1953- *MacBEP*
Johnstone, May *DcWomA*
Johnstone, Ralph Wilbur 1911- *WhAmArt 85*
Johnstone, Tully *MarqDCG 84*
Johnstone, Will B d1944 *WhAmArt 85*
Johnstone, William 1897- *DcBrA 1*
Johnstone, William Borthwick 1804-1868 *DcBrWA*
Johnt, Ethel 1904- *WhAmArt 85*
Joho, Vera 1895- *DcWomA*
Johonnot, Ralph H d1940 *ArtsAmW 3, WhAmArt 85*
Johst, Paul Spener *WhAmArt 85*
Joicey, Richard *DcCAr 81*
Joicey, Richard Raylton 1925- *ClaDrA, WhoArt 80, -82, -84*
Joigny, Juan De *McGDA*
Joiner, Charles *FolkA 86*
Joiner, Harvey 1852-1932 *WhAmArt 85*
Joiner, John Edgar 1932- *AmArch 70*
Joiner, John J *NewYHSD*
Joiner, Lemuel *AfroAA*
Joinet, M *BiDBrA*
Jokai, Rosa *DcWomA*
Jokinen, Leo 1947- *OxTwCA*
Jolden, Frieda Blanca Von 1878- *DcWomA*
Joli, Antonio 1700?-1777 *DcBrECP, McGDA*
Joli DeDipi, Antonio 1700?-1777 *DcSeaP*
Joliffe, Arnold H 1940- *WhoAmA 76, -78, -80, -82, -84*
Jolin, Einar 1890- *PhDcTCA 77*
Jolin, Ellen 1854-1939 *DcWomA*
Joline, Everett Stark 1927- *MarqDCG 84*
Joliot, Marguerite 1887- *DcWomA*
Jollain, Nicolas Rene 1732-1804 *ClaDrA*
Jollay, William Edward 1935- *AmArch 70*
Jolles, Arnold H 1940- *WhoAmA 76, -78, -80, -82, -84*
Jolley, Donal Clark 1933- *AmArt, WhoAmA 80, -82, -84*
Jolley, George B 1928- *WhoAmA 76, -78, -80*
Jolley, Geraldine H 1911- *WhoAmA 76, -78, -80, -82, -84*
Jolley, Jerry 1911- *WhoAmA 73, -76*
Jolley, Martin Gwilt- 1859- *DcVicP 2*
Jolley, Richard 1952- *DcCAr 81*
Jolli, Antonio 1700?-1777 *DcBrECP*
Jolliff, Grace *DcWomA*
Jolliffe, Eric 1907- *WorECar*
Jollivet, Pierre Jules 1794-1871 *ClaDrA*
Jolly, Blanchard Eugene 1926- *AmArch 70*
Jolly, Celine *DcWomA*
Jolly, D G *AmArch 70*
Jolly, Fanny C *DcBrWA, DcVicP 2, DcWomA*
Jolly, Michael 1953- *MarqDCG 84*
Jolly, Wade Lytton 1909- *WhAmArt 85*
Jolly, William *DcBrECP*
Joly, Aglae *DcWomA*
Joly, Alexis Victor, Madame *DcWomA*
Joly, David 1960- *MarqDCG 84*
Joly, Jeanne *DcWomA*
Joly, John 1857-1933 *ICPEnP*
Joly, Victorine *DcWomA*
Jomon *McGDA*
Jona, T K *AmArch 70*
Jonaitis, Aldona 1948- *WhoAmA 82, -84*

Jonas 1935- *DcCAr 81*
Jonas, Joan 1936- *ConArt 77, -83, DcCAr 81, PrintW 83, -85, WhoAmA 78, -80, -82, -84*
Jonas, LeRoy F 1897-1981 *WhAmArt 85*
Jonas, Louis Paul 1894- *WhAmArt 85*
Jonas, Margarethe J 1783-1858 *DcWomA*
Jonas, Martin 1924- *OxTwCA*
Jonas, Suzanne 1885-1928 *DcWomA*
Jonassen, James O 1940- *AmArch 70*
Jonathan B *McGDA*
Joncich, A J *AmArch 70*
Joncieres, Leonce J V De 1871- *ClaDrA*
Joncus, Stephen Joseph 1932- *AmArch 70*
Jonczyk, Leon 1934- *WhoArt 84*
Jones *DcBrBI, FolkA 86, NewYHSD*
Jones, Mrs. *DcVicP 2, DcWomA*
Jones, A *DcVicP 2*
Jones, A E *AmArch 70*
Jones, A H *EncASM*
Jones, A Howard *WhAmArt 85*
Jones, A L *NewYHSD*
Jones, A Quincy 1913- *AmArch 70*
Jones, A Quincy 1913-1979 *ConArch, MacEA*
Jones, A W *FolkA 86*
Jones, Abraham d1857 *CabMA*
Jones, Adaline W *DcWomA, WhAmArt 85*
Jones, Adolphe Robert 1806-1874 *DcVicP 2*
Jones, Adrian 1845-1938 *DcBrA 1, DcBrBI, DcVicP 2*
Jones, Agnes *DcVicP 2*
Jones, Agnes B 1868?-1940 *DcWomA*
Jones, Albertus E 1882-1957 *WhAmArt 85*
Jones, Albertus Eugene 1882-1957 *WhoAmA 80N, -82N, -84N*
Jones, Aldwyn Douglas 1910- *WhoArt 80, -82, -84*
Jones, Alfred 1819- *ArtsNiC*
Jones, Alfred 1819-1900 *NewYHSD, WhAmArt 85*
Jones, Alfred Garth *DcBrBI, DcVicP 2*
Jones, Allan Dudley 1915- *WhoAmA 76, -78, -80, -82*
Jones, Allan Dudley, Jr. 1915- *WhAmArt 85*
Jones, Allan L 1940- *DcCAr 81*
Jones, Allen *AfroAA*
Jones, Allen 1937- *ConArt 77, -83, ConBrA 79[port], DcCAr 81, OxTwCA, PhDcTCA 77, PrintW 83, -85, WhoArt 80, -82, -84, WorArt[port]*
Jones, Amalie *DcWomA*
Jones, Amy 1899- *DcWomA, WhAmArt 85, WhoAmA 73, -76, -78, -80, -82, -84*
Jones, Anna M *DcBrWA, DcVicP 2, DcWomA*
Jones, Annie Weaver *DcWomA, WhAmArt 85*
Jones, Anthony 1944- *WhoAmA 78, -80*
Jones, Anthony W *FolkA 86, NewYHSD*
Jones, Archie Joseph *AfroAA*
Jones, Aristine M P *WhAmArt 85*
Jones, Arne 1914- *OxTwCA, PhDcTCA 77*
Jones, Arthur *AfroAA*
Jones, Arthur 1945- *FolkA 86*
Jones, Arthur E W *WhAmArt 85*
Jones, Arthur Sidney 1875- *WhAmArt 85*
Jones, Arzie *AfroAA*
Jones, B *DcBrECP*
Jones, B F, Jr. *AmArch 70*
Jones, B K *AmArch 70*
Jones, B T, III 1929- *AmArch 70*
Jones, Barbara *AfroAA, DcBrA 2, WhoArt 80, -82N*
Jones, Barbara Nester 1923- *WhoAmA 76, -78, -80*
Jones, Barclay Gibbs 1925- *AmArch 70*
Jones, Bayard 1869- *WhAmArt 85*
Jones, Beatrice Ruth *AfroAA*
Jones, Ben 1942- *WhoAmA 78, -80, -82, -84*
Jones, Benjamin *NewYHSD*
Jones, Benjamin 1941- *AfroAA*
Jones, Benjamin Franklin 1942- *WhoAmA 73, -76*
Jones, Bernard Irvin 1933- *AmArch 70*
Jones, Beryl Bailey- *IlsCB 1946*
Jones, Betty Jo *AmArch 70*
Jones, Bill 1946- *DcCAr 81, WhoAmA 76, -78*
Jones, Brian *DcCAr 81*
Jones, C Agnes *DcWomA*
Jones, C E *AmArch 70*
Jones, C K *AmArch 70*
Jones, C R *AmArch 70*
Jones, Calvert Richard 1804-1877 *DcBrWA, DcVicP 2*
Jones, Calvin 1943- *MarqDCG 84*
Jones, Calvin B 1934- *WhoAmA 82, -84*
Jones, Carmita DeSolens *WhAmArt 85*
Jones, Carol Ann 1942- *IlsCB 1957*
Jones, Carrie E 1858- *DcWomA*
Jones, Carter R 1945- *WhoAmA 82, -84*
Jones, Catherine 1899- *WhAmArt 85*
Jones, Catherine Forbes *WhAmArt 85*
Jones, Cecil *AntBDN M*
Jones, Champion *DcVicP 2*
Jones, Charles 1836-1892 *ClaDrA, DcBrWA, DcVicP, -2*
Jones, Charles 1912- *WorECar*
Jones, Charles Dexter, III 1926- *WhoAmA 78*

Jordan, William 1884- DcBrA 1
Jordan, William B 1940- WhoAmA 78, -80, -82, -84
Jordan, William Lester 1937- AmArch 70
Jordani, David A 1948- MarqDCG 84
Jordi ConGrA 1
Jordy, William H ConArch A
Jorge Ingles McGDA
Jorge, Sergio 1937- ICPEnP A
Jorgensen, Christian 1859-1935 ArtsAmW 1
Jorgensen, Christian 1860-1935 IlBEAAW,
 WhAmArt 85
Jorgensen, Ejler Andreas Christoffer 1838-1876
 ArtsAmW 3
Jorgensen, Emil 1858-1942 MacEA
Jorgensen, Flemming 1934- WhoAmA 76, -78, -80,
 -82, -84
Jorgensen, IB 1935- WorFshn
Jorgensen, Jorgen 1871- WhAmArt 85
Jorgensen, L E AmArch 70
Jorgensen, Matt Lawrence 1905- AmArch 70
Jorgensen, Sandra 1934- AmArt, WhoAmA 76, -78,
 -80, -82, -84
Jorgensen, Thorvald 1867-1946 MacEA
Jorgenson FolkA 86
Jorgenson, Arne 1943- MarqDCG 84
Jorgenson, Dale Alfred 1926- WhoAmA 76, -78, -80,
 -82, -84
Jorgulesco, Jonel WhAmArt 85
Joris, Agnese 1850-1922 DcWomA
Joris, Leontine 1870-1962 DcWomA
Joris, Victor 1929- WorFshn
Jorn, Asger 1914- McGDA, WhoAmA 73
Jorn, Asger 1914-1973 ConArt 77, -83, OxTwCA,
 PhDcTCA 77, WhoAmA 76N, -78N, -80N, -82N,
 -84N, WorArt[port]
Jorns, Byron Charles 1898-1958 WhAmArt 85,
 WhoAmA 80N, -82N, -84N
Jory, S L AmArch 70
Joryu, Shownsai AntBDN L
Jose, Fernando 1937- WorFshn
Joseph, Master McGDA
Joseph Of Arimathea, Saint McGDA
Joseph, Saint McGDA
Joseph, Adelyn L 1895- DcWomA
Joseph, Alfred S, Jr. 1912- AmArch 70
Joseph, Amy ClaDrA
Joseph, Amy 1876-1961 DcBrA 1, DcWomA
Joseph, Antonio 1921- McGDA
Joseph, Carolina DcWomA
Joseph, Charles FolkA 86
Joseph, Cliff 1922- WhoAmA 76, -78, -80
Joseph, Cliff 1927- AfroAA
Joseph, Mrs. Delissa 1864-1940 DcVicP 2
Joseph, F B DcVicP 2
Joseph, George Francis 1764-1846 DcBrBI, DcBrECP,
 DcVicP 2
Joseph, Hope DcWomA
Joseph, J P AmArch 70
Joseph, Jasmin 1923- McGDA
Joseph, Joan A DcWomA
Joseph, Joan A 1895- WhAmArt 85
Joseph, John Louis 1955- MarqDCG 84
Joseph, Lily Delissa 1864-1940 DcBrA 1, DcWomA
Joseph, Lucy 1869- DcWomA
Joseph, Marguerite 1856-1905 DcWomA
Joseph, Mely 1886-1920 DcWomA
Joseph, Peter 1929- ConBrA 79[port], WhoArt 80,
 -82, -84
Joseph, Robert 1943- DcCAr 81
Joseph, Ronald 1910- AfroAA
Joseph, Samuel NewYHSD
Joseph, Seymour Ronald 1914- AmArch 70
Joseph, Stanford Raymond 1936- AmArch 70
Joseph, Sylvan Lehman, Jr. 1929- AmArch 70
Joseph, Theophilus AfroAA
Joseph, W F, Jr. AmArch 70
Josephi, I A WhAmArt 85
Josephine 1763-1814 DcWomA
Josephs, Joseph 1826-1893 FolkA 86
Josephs, Lemuel B C WhAmArt 85
Josephs, Samuel WhAmArt 85
Josephs, Walter W 1887- WhAmArt 85
Josephson, Ernst 1851-1906 McGDA, OxArt,
 PhDcTCA 77
Josephson, Kenneth 1932- ConPhot, DcCAr 81,
 ICPEnP A, MacBEP
Josephson, Kenneth Bradley 1932- WhoAmA 84
Josephy, Hetty DcBrA 1
Josetsu McGDA
Josey, H C AmArch 70
Joshi, Raghunath 1936- WhoGrA 82[port]
Joshua McGDA
Josi, Charles DcVicP, -2
Josic, Alexis 1921- ConArch, MacEA
Josimovich, George 1894- WhAmArt 85,
 WhoAmA 73, -76, -78, -80, -82, -84
Joskowicz, Alfredo 1937- WhoAmA 76, -78, -80
Joslin, Richard Smith 1932- AmArch 70
Joslyn, Adele WhAmArt 85
Joslyn, Florence Brown WhAmArt 85
Joslyn, Florence Brown 1881?-1954 ArtsAmW 3

Joso, Miyasaki AntBDN L
Josselin-Darde, Marguerite Louise DcWomA
Josselyn, Edgar A 1861-1943 BiDAmAr
Josselyn, Henry S 1845-1934 BiDAmAr
Josset, Lawrence Leon Louis 1910- DcBrA 1,
 WhoArt 80, -82, -84
Josset, Raoul 1900-1957 WhAmArt 85,
 WhoAmA 80N, -82N, -84N
Jost, Albert Henry 1910- AmArch 70
Jost, Ottilie E 1876?-1961 DcWomA
Josten, Peter WhoAmA 73
Josten, Mrs. Werner E WhoAmA 80, -73, -76, -78,
 -82
Josus WhoAmA 73
Jotter, Jacob FolkA 86
Jouanne-Hugonet, Marthe 1871- DcWomA
Jouanon, Mademoiselle DcWomA
Jouatte-Biva, Julienne DcWomA
Joubert, Andree DcWomA
Joubert, Gilles 1689-1775 OxDecA
Joubert, Leon ClaDrA
Joubert, Louise Adeone DcWomA
Jouclard, Adrienne Lucie 1881?-1972? DcWomA
Jouenne DcWomA
Jouet, Belinda Hearn d1935 DcWomA,
 WhAmArt 85
Jouett, Matthew Harris 1787-1827 BnEnAmA,
 DcAmArt, NewYHSD
Jouette, Madame DcWomA
Jouffroy, Francois 1806-1882 ArtsNiC
Jouffroy, Marthe De DcWomA
Jouffroy, Pierre DcBrECP
Joukhadar, Kristina 1952- WhoAmA 84
Joukhadar, Moumtaz 1940- WhoAmA 84
Joukhadar, Moumtaz A N 1940- WhoAmA 78, -80,
 -82
Joullin, Amedee 1862-1917 ArtsAmW 1, IlBEAAW,
 WhAmArt 85
Joullin, Lucile 1876-1924 ArtsAmW 1, DcWomA,
 IlBEAAW
Joullin, Lucille 1876-1924 WhAmArt 85
Jouqmart, W DcBrBI
Jourdain, Frantz 1847-1935 MacEA, McGDA
Jourdain, Frantz 1847-1937 WhoArch
Jourdan, Adolphe ArtsNiC
Jourdan, Alda 1889- ArtsAmW 3
Jourdan, F DcWomA
Jourdier-Chabas, Marie S DcWomA
Jourjon, Marie DcWomA
Journeaux, Adele DcWomA
Journeay, Helen 1893- WhAmArt 85
Journeay, Helen 1893-1942 DcWomA
Journet, Elise Marie Thomate d1866 DcWomA
Journey, Margaret MarqDCG 84
Journiac, Michel 1943- ConArt 77, -83, DcCAr 81
Jousse, Aline 1898- DcWomA
Jousserandot, Louise DcWomA
Jousset, Marie 1888- DcWomA
Joutz, L A AmArch 70
Jouve, Paul 1880- ClaDrA
Jouvenal, Jacques 1829-1905 NewYHSD ,
 WhAmArt 85
Jouvenet, Jean 1644-1711 OxArt
Jouvenet, Jean Baptiste 1644-1717 ClaDrA
Jouvenet, Jean-Baptiste 1644-1717 McGDA
Jouvenet, Marie Madeleine DcWomA
Jouvet-Magron, Dominique DcWomA
Jouvray, Madeleine DcWomA
Jouy, Adelina DcWomA
Jova, Henri Vatable 1919- AmArch 70
Jovanovic, Miloslav OxTwCA
Jove, Angel OxTwCA
Jovick, Anton 1896- WhoArt 80, -82, -84
Jovin, Aimee DcWomA
Jovin DesFayeres, Marie Louise Cornelie DcWomA
Jovine, Marcel 1921- WhoAmA 82, -84
Jowers, Alfred DcVicP 2
Jowett, Ann DcWomA
Jowett, Ellen 1874- DcBrA 2
Jowett, Percy Hague 1882-1955 DcBrA 1
Jowitt, John Alan 1904- DcBrA 1, WhoArt 80, -82,
 -84
Joy, Arthur 1808?-1838 DcBrWA, DcVicP 2
Joy, Caroline DcVicP 2, DcWomA, FolkA 86
Joy, Charles FolkA 86
Joy, George William 1844-1925 ClaDrA, DcBrA 1,
 DcVicP, -2
Joy, Jessey DcWomA
Joy, Jessie DcVicP 2
Joy, John Cantiloe DcVicP 2
Joy, John Cantiloe 1806-1866 DcBrWA, DcSeaP
Joy, Josephine 1860?- FolkA 86
Joy, Josephine Hiett 1869-1948 DcWomA
Joy, Kenneth I 1946- MarqDCG 84
Joy, M E DcVicP 2
Joy, Nancy Grahame 1920- WhoAmA 73, -76, -78,
 -80
Joy, R DcVicP 2
Joy, Robert WhAmArt 85
Joy, Sue 1903- WhAmArt 85
Joy, Thaddeus 1883-1942 BiDAmAr

Joy, Thomas Musgrove 1812-1866 ClaDrA, DcBrBI,
 DcVicP, -2
Joy, William 1803-1867 DcBrWA, DcSeaP, DcVicP,
 -2
Joy And Cantiloe DcVicP
Joya, Jose 1931- WhoArt 80, -82, -84
Joya, Mario Garcia 1938- ICPEnP A, MacBEP
Joyant, Jules Romain 1803-1854 ClaDrA
Joyard, Henriette DcWomA
Joyaux, Alain Georges 1950- WhoAmA 84
Joybert, Countess Charlotte 1851- DcWomA
Joyce, Annie G DcVicP 2
Joyce, Anthony Francis 1954- MarqDCG 84
Joyce, C R AmArch 70
Joyce, E W AmArch 70
Joyce, J David 1946- WhoAmA 84
Joyce, James BiDBrA, NewYHSD
Joyce, Marshall Woodside OfPGCP 86
Joyce, Marshall Woodside 1912- WhoAmA 76, -78,
 -80, -82, -84
Joyce, Mary DcVicP 2, DcWomA
Joyce, Paul DcCAr 81
Joyce, Paul 1940- ConPhot, ICPEnP A
Joyce, Robert F 1928- AmArch 70
Joyce, Thomas Grey 1930- AmArch 70
Joye, John 1790- NewYHSD
Joymer, Charles E AfroAA
Joyner, A Bruce 1933- AmArch 70
Joyner, Arista Arnold 1911- WhAmArt 85
Joyner, Charles FolkA 86
Joyner, Howard Warren 1900- WhAmArt 85,
 WhoAmA 73
Joyner, Jerry IlsBYP
Joyner, Lemuel M AfroAA
Joyner, M DcVicP 2
Joyner, Margaret Pearson DcWomA
Joynes, Henry 1684?-1754 BiDBrA
Jozens, J J AmArch 70
Jozon, Jeanne 1868-1946 DcWomA
Ju Peon McGDA
Ju, I-Hsiung 1923- WhoAmA 73, -76, -78, -80, -82,
 -84
Ju, Ix Hsiung 1923- AmArt
Juan Bautista DeToledo McGDA
Juan DeBadajoz McGDA
Juan DeColonia McGDA
Juan DeFlandes McGDA
Juan De Flandes d1519? OxArt
Juan De Juanes OxArt
Juan DeJuni 1507?-1577 OxArt
Juan DeSevilla Romero Y Escalante 1643-1695 ClaDrA
Juanes, Juan De 1523?-1579 McGDA
Juani, Juan De McGDA
Juarez, Claudio 1935- DcCAr 81
Juarez, Fernando 1929- AmArch 70
Juarez, Jose 1615?-1665? OxArt
Juarez, Jose 1615?-1690? McGDA
Juarez, Juan Rodriguez McGDA
Juarez, Luis McGDA
Juarez, Ramon Holguin 1930- AmArch 70
Juarez, Roberto 1952- PrintW 85, WhoAmA 84
Jubert, Cecile 1885- DcWomA
Jubin, Ernestine DcWomA
Juch, Ernst 1838-1909 WorECar
Jucker, Sita 1921- IlsBYP
Judah, Doris Minette 1887- DcWomA
Judah, Harriet Brandon 1808-1884 DcWomA
Judas Thaddeus, Saint McGDA
Judd, A M AmArch 70
Judd, David CabMA
Judd, DeForrest Hale 1916- WhoAmA 76, -78, -80,
 -82, -84
Judd, Don 1928- DcCAA 71, -77
Judd, Donald 1928- BnEnAmA, ConArt 77, -83,
 DcAmArt, DcCAr 81, McGDA, OxTwCA,
 PhDcTCA 77, PrintW 83, -85, WorArt
Judd, Donald Clarence 1928- AmArt, WhoAmA 73,
 -76, -78, -80, -82, -84
Judd, Frank Willson ArtsAmW 3
Judd, John DcBrECP
Judd, Neale M WhAmArt 85
Judd, Norman L FolkA 86
Judd, Thomas C 1952- MarqDCG 84
Judeich, Therese 1831?-1914 DcWomA
Judell, Anna WhAmArt 85
Judge, B AmArch 70
Judge, Mary Frances 1935- AmArt, WhoAmA 82,
 -84
Judia, B T 1880?- ArtsAmW 2
Judice, G A AmArch 70
Judkin, Thomas James 1788-1871 DcBrWA,
 DcVicP 2
Judkins, Eliza Maria 1809-1887 DcWomA,
 NewYHSD
Judkins, Elizabeth DcWomA, McGDA
Judkins, Sylvia WhoAmA 73, -76, -78, -80, -82, -84
Judson, Alice d1948 DcWomA, WhAmArt 85,
 WhoAmA 78N, -80N, -82N, -84N
Judson, Almira DcWomA, WhAmArt 85
Judson, Almira Austin ArtsAmW 2
Judson, C Chapel WhAmArt 85

Judson, C Chapel 1864-1946 *ArtsAmW 1*
Judson, Charles H *NewYHSD*
Judson, Jane Berry *WhAmArt 85*
Judson, Jeanette Alexander 1912- *AmArt*
Judson, Jeannette Alexander 1912- *WhoAmA 73, -76, -78, -80, -82, -84*
Judson, Minnie Lee 1865?-1938 *DcWomA, WhAmArt 85*
Judson, Oliver B *WhAmArt 85*
Judson, Sylvia 1897-1978 *DcWomA*
Judson, Sylvia Shaw 1897- *WhAmArt 85, WhoAmA 73, -76, -78*
Judson, Sylvia Shaw 1897-1978 *WhoAmA 80N, -82N, -84N*
Judson, William D 1939- *WhoAmA 82, -84*
Judson, William L 1842-1928 *WhAmArt 85*
Judson, William Lees 1842-1928 *ArtsAmW 1, IlBEAAW*
Jue, Spencer *AmArch 70*
Jue, Spencer 1931- *MarqDCG 84*
Juel, Jens 1745-1802 *McGDA, OxArt*
Juer, Frederick G 1950- *MarqDCG 84*
Juergens, Alfred 1866-1934? *WhAmArt 85*
Juergens, Charles 1875- *WhAmArt 85*
Juge-Laurens, Suzanne *DcWomA*
Jugelet, Jean Marie Auguste 1805-1875 *DcSeaP*
Jugyoku, Ruikosai *AntBDN L*
Juhasz, Joseph B *ConArch A*
Juhl, Finn 1912- *ConDes, DcD&D, McGDA*
Juillerat, Clotilde 1806-1905? *DcWomA*
Juillerat, Marie 1843- *DcWomA*
Juitt, David Neal *MarqDCG 84*
Jujol, Josep Maria 1879-1949 *ConArch*
Jujol I Gibert, Josep Maria 1879-1949 *MacEA*
Jukes, Benjamin *FolkA 86*
Jukes, Edith Elizabeth 1910- *DcBrA 1, WhoArt 80, -82, -84*
Jukes, Francis 1745-1812 *DcBrWA*
Jukes, John L 1900-1972 *WorECom*
Juleen, Lee D 1891- *ArtsAmW 3*
Jules *WorECom*
Jules, David 1808-1892 *OxDecA*
Jules, Mervin 1912- *McGDA, WhAmArt 85, WhoAmA 73, -76, -78, -80, -82, -84*
Juley, Peter A 1862-1937 *WhAmArt 85*
Julian, A J *AmArch 70*
Julian, Amelie *DcWomA*
Julian, Diane *MarqDCG 84*
Julian, Ernest Roderick Fluse 1872- *DcBrA 1, DcVicP 2*
Julian, George Hanson *BiDBrA*
Julian, Humphrey John d1850 *DcBrWA*
Julian, June 1947- *WhoAmA 82, -84*
Julian, Lazaro 1945- *WhoAmA 78, -80, -82, -84*
Julian, M *DcVicP 2*
Julian, Marvin 1894- *WhAmArt 85*
Julian, Paul Hull 1914- *WhAmArt 85*
Julian, Peter 1952- *PrintW 83, -85*
Julianelli, Mabel 1919- *WorFshn*
Julianis, Caterina De *DcWomA*
Juliard, Germaine *DcWomA*
Julien, Anne J F 1855- *DcWomA*
Julien, Elisabeth Charlotte 1850- *DcWomA*
Julien, Marie Pauline *DcWomA*
Julio, Pat T 1923- *WhoAmA 73, -76, -78, -80, -82, -84*
Juliot, Jacques, I d1562 *McGDA*
Juliot, Jacques, II *McGDA*
Juliot, Jacques, III *McGDA*
Julius, Leon 1906- *AmArch 70*
Julius, Oscar H 1886- *WhAmArt 85*
Julius, Ruth *DcCAr 81*
Julius, Victor 1882- *WhAmArt 85*
Jullian, Michel Claude 1945- *DcCAr 81*
Jullian, Philippe 1922- *IlsCB 1946*
Julliard, Mademoiselle *DcWomA*
Jullien, Cecile *DcWomA*
Julliott, Made 1887-1948 *DcWomA*
Julyan, Mary E *DcVicP 2*
Julyan, Mary E d1913 *DcWomA*
Julyot, Family *McGDA*
Juman, H *NewYHSD*
Jumel, Madeleine 1875- *DcWomA*
Jumiere-Gilgengrantz, Adele *DcWomA*
Jumonji, Bishin 1947- *ConPhot, ICPEnP A*
Jumont, Agathe *DcWomA*
Jumont, Anna *DcWomA*
Jump, Edward 1831?- *NewYHSD*
Jump, Edward 1831?-1883 *EarABI*
Jump, Edward 1838-1883 *ArtsAmW 1, IlBEAAW, WorECar*
Jump, Mary Victoria 1897- *DcBrA 1, DcWomA, WhoArt 80, -82, -84*
Jump, R *DcVicP 2*
Jumpello, Simon *NewYHSD*
Jumsai, Sumet 1939- *ConArch*
Juncker-Streit, Kathe 1858-1919 *DcWomA*
Junco, Pio *WhAmArt 85*
Juncosa, Joaquin 1631-1708 *ClaDrA*
Jundt, Gustave 1830-1884 *ArtsNiC*

June, Benjamin 1790?- *FolkA 86*
June, John *BkIE*
Juneau, Denis *OxTwCA*
Junes, C *DcVicP 2*
Jung, A Jac *WhAmArt 85*
Jung, Anastasia *WhoArt 80*
Jung, C Jac 1880- *WhAmArt 85*
Jung, Dieter 1941- *DcCAr 81*
Jung, Dora Elisabet 1906-1980 *ConDes*
Jung, Franz *OxTwCA*
Jung, Henry 1912- *AmArch 70*
Jung, Kwan Yee 1932- *AmArt, WhoAmA 76, -78, -80, -82, -84*
Jung, Max *WhAmArt 85*
Jung, R A *AmArch 70*
Jung, Tracey *DcCAr 81*
Jung, Yee Wah 1936- *WhoAmA 76, -78, -80, -82, -84*
Jung-Stilling, Elise Von 1829-1904 *DcWomA*
Junge, Carl Stephen 1880- *ArtsAmW 3, WhAmArt 85*
Jungerich, Helene *WhAmArt 85*
Jungk, Elfriede 1889- *DcWomA*
Jungkind, Walter 1923- *WhoGrA 82[port]*
Jungkurth, J W *FolkA 86*
Jungman, N W *DcVicP 2*
Jungman, Nico 1872-1935 *DcBrA 1, DcVicP 2*
Jungmann, Nico W 1873-1935 *DcBrBI*
Jungnickel, Gertrud 1870- *DcWomA*
Jungquist, Neva Gertrude d1930 *WhAmArt 85*
Jungwirth, I Gayas *WhoAmA 82, -84*
Jungwirth, Irene Gayas *WhoAmA 73, -76, -78, -80*
Jungwirth, Irene Gayas 1913- *WhAmArt 85*
Jungwirth, Joseph 1858?-1940 *ArtsEM*
Jungwirth, Leonard D d1964 *WhoAmA 78N, -80N, -82N, -84N*
Jungwirth, Leonard D 1903-1964 *WhAmArt 85*
Jungwirth, Maria 1894- *DcWomA*
Jungwirth, Martha 1940- *DcCAr 81*
Juni, Juan De 1506?-1577 *McGDA*
Junier, Allan G *AfroAA*
Juniere-Gilgengrantz, Adele *DcWomA*
Junius, Isaak *ClaDrA*
Junjel, Barthol *NewYHSD*
Junker, C Anthony 1937- *AmArch 70*
Junker, D J *AmArch 70*
Junker, Johann *McGDA*
Junker, Leo Helmholz 1882- *WhAmArt 85*
Junkin, James W, Jr. 1922- *AmArch 70*
Junkin, Marion Montague 1905- *WhoAmA 73, -76*
Junkin, Marion Montague 1905-1977 *WhAmArt 85, WhoAmA 78N, -80N, -82N, -84N*
Junno, Tapio 1940- *OxTwCA*
Juno *McGDA*
Juntenen, Charles Arthur 1904- *AmArch 70*
Jupo, Frank J 1904- *IlsCB 1946*
Jupp, Fannie Bartlet *ArtsEM*
Jupp, Fannie Bartlett *DcWomA*
Jupp, George Herbert 1869- *DcBrA 1, DcVicP 2*
Jupp, Richard 1728-1799 *BiDBrA*
Jupp, William d1788 *BiDBrA*
Jupp, William d1839 *BiDBrA*
Juppe, Ludwig 1465?-1538 *McGDA*
Juppin, Jean-Baptiste 1675-1729 *McGDA*
Jura, Tomasz 1943- *WhoGrA 82[port]*
Juracich, Stanley Richard 1920- *AmArch 70*
Jurak, Drago 1911- *DcCAr 81*
Juramy, Mademoiselle *DcWomA*
Jurecka, Cyril *WhoAmA 80N, -82N, -84N*
Jurecka, Cyril 1884-1960? *WhAmArt 85*
Jurenec, G G *AmArch 70*
Jurgen-Fischer, Klaus 1930- *OxTwCA, PhDcTCA 77*
Jurgens, Grethe 1899- *DcWomA*
Jurgensen, Fritz 1818-1863 *WorECar*
Jurgensen, Louis O 1863- *WhAmArt 85*
Jurgensen, Peter Harold 1956- *MarqDCG 84*
Jurgenssen, Birgit 1949- *DcCAr 81*
Jurgensson, Alexandra Petrovna 1869- *DcWomA*
Jurimy, Mademoiselle *DcWomA*
Jurkovic, Dusan 1868-1947 *MacEA*
Juros, James Emil 1938- *AmArch 70*
Jurow, Dennis 1934- *AmArch 70*
Jursevskis, Zigfrids 1910- *WhoAmA 82, -84*
Jury, Julius 1821- *DcVicP 2*
Juskelis, Romas 1946- *ICPEnP A*
Jusko, Jeno *WhAmArt 85*
Jusp *WorECar*
Jussim, Estelle 1927- *MacBEP*
Jussow, Heinrich Christoph 1754-1825 *MacEA*
Just, William *NewYHSD*
Juste, Antonio *McGDA*
Juste, Estelle 1894-1962 *DcWomA*
Juste, Giovanni, I *McGDA*
Juste, Jean *OxArt*
Juster, Howard H 1924- *AmArch 70*
Juster, S *AmArch 70*
Justesen, Kenneth Elwood 1921- *AmArch 70*
Justh *NewYHSD*
Justice, Alfred R *EncASM*
Justice, C C *AmArch 70*
Justice, Herbert M *EncASM*

Justice, Joseph *NewYHSD*
Justice, Martin *ArtsAmW 3, WhAmArt 85*
Justin, J Karl 1928- *AmArch 70*
Justinart, Berthe A *DcWomA*
Justis, Lyle 1892-1960 *IlrAm C, -1880*
Justis And Armiger *EncASM*
Justus Of Ghent *OxArt*
Justus Of Ghent 1430?-1476? *McGDA*
Justus, Elisabeth 1872- *DcWomA*
Justus, Roy B 1901- *WhAmArt 85*
Justus, Roy Braxton 1901- *WhoAmA 73, -76, -78, -80, -82*
Justus, Roy Braxton 1901-1983 *WhoAmA 84N*
Justyne, Percy William 1812-1883 *DcBrBI, DcBrWA, DcVicP 2*
Juszczyk, James 1943- *PrintW 83, -85*
Juszczyk, James Joseph 1943- *AmArt, WhoAmA 76, -78, -80, -82, -84*
Juszko, Jeno 1880-1954 *WhAmArt 85*
Juteau, Emma Cecile 1875- *DcWomA*
Jutsum, Henry 1816-1869 *ClaDrA, DcBrWA, DcVicP, -2*
Jutz, Julie Dorothea 1795-1852 *DcWomA*
Jutz-Rumelin, Dora 1883- *DcWomA*
Juvara, Filippo 1678-1736 *McGDA*
Juvarra, Filippo 1678-1736 *DcD&D, MacEA, OxArt, WhoArch*
Juvenel, Esther d1673? *DcWomA*
Juvenel, Paul 1579-1643 *ClaDrA*
Juvin, Juliette 1896- *DcWomA*
Jyring, Eino Arthur 1907- *AmArch 70*

K

K O S 1881- *ConICB*
K, J H L V *DcWomA*
Kaa, Jan VanDer 1813-1877 *ClaDrA*
Kaan, Emma *DcWomA*, *WhAmArt 85*
Kaasmann, C *AmArch 70*
Kaatz, James Frederick 1933- *AmArch 70*
Kaatz, Lynn *OfPGCP 86*
Kabak, Robert *WhoAmA 73*
Kabak, Robert 1930- *DcCAA 71, -77, WhoAmA 78, -80, -82, -84*
Kabat, Jules 1913- *AmArch 70*
Kabatnik, J J *AmArch 70*
Kabcenell, Dirk Alan 1953- *MarqDCG 84*
Kabel, Adriaan VanDer *DcSeaP*
Kabis, Leo Thomas 1905- *AmArch 70*
Kabo, Michael *MarqDCG 84*
Kabotie, Fred *FolkA 86*
Kabotie, Fred 1900- *IlBEAAW, WhAmArt 85, WhoAmA 76, -78, -80, -82, -84*
Kabush, N A *AmArch 70*
Kacer, Mania *DcWomA*
Kacere, John 1920- *DcCAA 71, -77*
Kacere, John C 1920- *AmArt, ConArt 77, WhoAmA 73, -78, -80, -82, -84*
Kachadoorian, Zubel 1924- *WhoAmA 73, -76, -78, -80, -82, -84*
Kachel, Harold Stanley 1928- *WhoAmA 78, -80, -82, -84*
Kachel, John 1809-1889 *FolkA 86*
Kachena, Nina 1898- *DcWomA*
Kachergis, George Joseph 1917- *WhoAmA 73*
Kachergis, George Joseph 1917-1974 *WhoAmA 76N, -78N, -80N, -82N, -84N*
Kachinsky, Alexander 1888-1958 *WhAmArt 85, WhoAmA 80N, -82N, -84N*
Kachler, T T *DcBrECP*
Kachura-Falileeva, Ekaterina Nikolaevna 1886- *DcWomA*
Kaclik, John Gabriel 1927- *AmArch 70*
Kacziany, Adrienne 1877- *DcWomA*
Kadar, Livia *DcWomA*
Kadesky, Janet Lee *WhoAmA 82*
Kadioglu, Mehmet N 1957- *MarqDCG 84*
Kadish, Norman Maurice 1916- *ClaDrA*
Kadish, Reuben 1913- *WhAmArt 85*
Kadishman, Menashe 1932- *DcCAr 81, PrintW 85*
Kaehrle, Gabriel *NewYHSD*
Kaelber, Carl F W, Jr. 1917- *AmArch 70*
Kaelber, William G 1886-1948 *BiDAmAr*
Kaeli, E F *AmArch 70*
Kaelin, Charles S 1858-1929 *WhAmArt 85*
Kaemmerer, Frederic Henri *ArtsNiC*
Kaemmerlen, R B *AmArch 70*
Kaemmerling, Harold Elroy 1930- *AmArch 70*
Kaendler, Johann Joachim 1706-1775 *McGDA, OxDecA*
Kaenel, Reginald Alfred 1929- *MarqDCG 84*
Kaep, Louis J 1903- *WhAmArt 85*
Kaep, Louis Joseph 1903- *WhoAmA 73, -76, -78, -80, -82, -84*
Kaercher, Amalie *DcWomA*
Kaergling-Pacher, Henriette 1821- *DcWomA*
Kaericher, John Conrad 1936- *WhoAmA 76, -78, -80, -82, -84*
Kaeselau, Charles Anton 1889- *WhAmArt 85*
Kaeser, Fritz 1910- *MacBEP*
Kaeser, William Frederick 1908- *WhAmArt 85*
Kaeser, William Vogt 1906- *AmArch 70, WhAmArt 85*
Kaessner, Donald L 1926- *AmArch 70*
Kaestle, John Anton 1932- *AmArch 70*

Kaestner, Kenneth Kimball 1923- *AmArch 70*
Kaestner, R C, Jr. *AmArch 70*
Kaeyer, Erik 1897-1948 *BiDAmAr*
Kaeyer, Richard Erik 1935- *AmArch 70*
Kafadar, Karen *MarqDCG 84*
Kaffka, Richard E 1921- *AmArch 70*
Kaffka, Warren Ellsworth 1927- *AmArch 70*
Kafka, Hugo 1843-1913 *BiDAmAr*
Kaftal, L *AmArch 70*
Kaftanoglu, Bilgin 1939- *MarqDCG 84*
Kagami, Kozo *IlDcG*
Kagan, Andrew Aaron 1947- *WhoAmA 82, -84*
Kagan, H *AmArch 70*
Kagan, Norman 1942- *MarqDCG 84*
Kagann, Theo *WhAmArt 85*
Kaganove, Joshua 1892- *WhAmArt 85*
Kagawa, Dean M 1954- *MarqDCG 84*
Kagawa, Shoso 1922- *AmArch 70*
Kagawa, W K *AmArch 70*
Kage, Manfred Paul 1935- *MacBEP*
Kage, Wilhelm 1889-1960 *ConDes*
Kagel, Marianne *DcWomA*
Kagel, Stephen Joseph *AmArch 70*
Kagen, Boris Timiochino 1908- *WhAmArt 85*
Kager, Erica Von 1890- *DcWomA*
Kager, Johan Mathias 1575-1634 *ClaDrA*
Kagermeier, James Howard 1935- *AmArch 70*
Kagetoshi *AntBDN L*
Kagle, Joseph L, Jr. 1932- *WhoAmA 80, -82, -84*
Kagy, Sheffield 1907- *WhAmArt 85*
Kagy, Sheffield Harold 1907- *WhoAmA 76, -78, -80, -82, -84*
Kaha, Arthur Lyon, Jr. 1939- *AmArch 70*
Kahan, Alexander *WhoAmA 78, -80, -82, -84*
Kahan, Leonard 1935- *WhoAmA 82, -84*
Kahan, Mitchell Douglas 1951- *WhoAmA 80, -82, -84*
Kahan, Sol B 1887- *WhAmArt 85*
Kahananui, Jonathan Kalama 1921- *AmArch 70*
Kahane, Anne 1924- *WhoAmA 73, -76, -78, -80, WhoArt 80*
Kahane, Melanie 1910- *WhoAmA 73, -76, -78, -80, -82, -84*
Kahill, Joseph B 1882-1957 *WhAmArt 85, WhoAmA 80N, -82N, -84N*
Kahill, Victor *WhAmArt 85*
Kahl, A W *AmArch 70*
Kahl, Elfrida *DcWomA*
Kahl, George F *NewYHSD*
Kahl, J M *AmArch 70*
Kahl, J Robert 1925- *AmArch 70*
Kahl, Virginia 1919- *IlsCB 1946, -1957*
Kahl, Virginia Caroline *IlsCB 1967*
Kahle, Anna Von 1853-1920 *DcWomA*
Kahle, Herman *WhAmArt 85*
Kahle, Julie *WhAmArt 85*
Kahle, Julie d1937 *DcWomA*
Kahle, Julie Von 1841- *DcWomA*
Kahle, Mathew S *FolkA 86*
Kahlenberg, Mary Hunt 1940- *WhoAmA 76, -78, -80, -82, -84*
Kahler, Carl 1855- *ArtsAmW 3, IlBEAAW, WhAmArt 85*
Kahler, D T *AmArch 70*
Kahler, Eugen 1882-1911 *OxTwCA*
Kahler, John *WhAmArt 85*
Kahler, Joseph A *ArtsAmW 3*
Kahler, Karl 1855- *ArtsAmW 3*
Kahler, Rose *AfroAA*
Kahles, C W *WhAmArt 85*
Kahles, Charles William 1878-1931 *WorECom*
Kahlich, Karl Hermann 1890- *WhAmArt 85*

Kahlo, Frida *OxTwCA*
Kahlo, Frida 1910-1954 *WomArt*
Kahlo DeRivera, Frida 1910-1954 *McGDA*
Kahn, A Michael 1917- *WhoAmA 78, -80, -82, -84*
Kahn, Albert 1869-1942 *BiDAmAr, BnEnAmA, EncAAr, EncMA, MacEA, McGDA, WhoArch*
Kahn, Annelies Ruth 1927- *WhoAmA 73, -76, -78, -80, -82, -84*
Kahn, Charles Howard 1926- *AmArch 70*
Kahn, E J *AmArch 70*
Kahn, Ely Jacques 1884- *WhAmArt 85*
Kahn, Ely Jacques 1884-1972 *MacEA*
Kahn, Erich *WhoArt 82N*
Kahn, Erich 1904- *WhoArt 80*
Kahn, Erika *PrintW 85*
Kahn, Franziska *DcWomA*
Kahn, Hans 1929- *AmArch 70*
Kahn, Helen Beling *WhAmArt 85*
Kahn, Herbert Louis 1921- *AmArch 70*
Kahn, Isaac 1882- *WhAmArt 85*
Kahn, Judith Pesmen 1920- *WhAmArt 85*
Kahn, Julia S 1875- *DcWomA, WhAmArt 85*
Kahn, Lawrence Isaac 1927- *AmArch 70*
Kahn, Louis 1885-1945 *BiDAmAr*
Kahn, Louis 1901- *DcD&D[port], McGDA*
Kahn, Louis I 1901- *EncMA*
Kahn, Louis I 1901-1974 *ConArch, MacEA*
Kahn, Louis Isadore 1901- *AmArch 70*
Kahn, Louis Isadore 1901-1974 *BnEnAmA, EncAAr*
Kahn, Louis Isadore 1902-1974 *WhoArch*
Kahn, Max 1903- *WhAmArt 85*
Kahn, Max 1904- *DcCAr 81, McGDA*
Kahn, Michael A 1917- *WhoAmA 76*
Kahn, Otto H 1867-1934 *WhAmArt 85*
Kahn, Peter 1921- *WhoAmA 73, -76, -78, -80, -82, -84*
Kahn, R W *AmArch 70*
Kahn, Ralph H 1920- *WhoAmA 73, -76, -78, -80, -82, -84*
Kahn, Roger Eugene 1930- *AmArch 70*
Kahn, Steve 1943- *DcCAr 81, ICPEnP A, MacBEP*
Kahn, Susan B 1924- *WhoAmA 73, -76, -78, -80, -82, -84*
Kahn, Wolf 1927- *DcCAA 71, -77, DcCAr 81, PrintW 83, -85, WhoAmA 73, -76, -78, -80, -82, -84*
Kahn DeChaumesnil, Louise *DcWomA*
Kahn-Schatzman, Cecile 1882- *DcWomA*
Kahnweiler, Daniel-Henri 1884-1976 *OxTwCA*
Kahrs, C R *AmArch 70*
Kaier, G J *AmArch 70*
Kaiffer, Frederick W *FolkA 86*
Kaigetsudo, Ando *McGDA*
Kaighn, M M *WhAmArt 85*
Kaighn, W A *AmArch 70*
Kaikei d1240? *McGDA*
Kain, Francis 1786?-1844 *NewYHSD*
Kain, James d1838 *NewYHSD*
Kainen, Jacob 1909- *DcAmArt, WhAmArt 85, WhoAmA 73, -76, -78, -80, -82, -84*
Kainer, Lene *DcWomA*
Kainlauri, Eino Olavi 1922- *AmArch 70*
Kainz, Luise 1902- *WhAmArt 85*
Kainz, Martin 1899- *WhAmArt 85*
Kairys, Louis Paul 1944- *MarqDCG 84*
Kaiser, August 1889- *WhAmArt 85*
Kaiser, Benjamin 1943- *WhoAmA 84*
Kaiser, C O *AmArch 70*
Kaiser, Charles 1893- *WhAmArt 85*
Kaiser, Charles James 1939- *WhoAmA 73, -76, -78, -80, -82, -84*

Kanner, Charles G 1930- *AmArch 70*
Kanno, Gertrude 1876-1937 *DcWomA*
Kanno, Gertrude Boyle 1876-1937 *WhAmArt 85*
Kanno, Gertrude Farquharson Boyle 1876-1937 *ArtsAmW 3*
Kano, Betty *DcCAr 81*
Kano, Mitsuo 1933- *PhDcTCA 77*
Kanoff, W H *FolkA 86*
Kanoldt, Alexander 1881-1939 *OxTwCA, PhDcTCA 77*
Kanovitch, A *WhAmArt 85*
Kanovitz, Howard 1929- *AmArt, ConArt 77, -83, DcCAA 77, DcCAr 81, PrintW 83, -85, WhoAmA 73, -76, -78, -80, -82, -84*
Kansy, Klaus 1945- *MarqDCG 84*
Kant, Immanuel 1724-1804 *OxArt*
Kantack, Walter W d1953 *WhoAmA 78N, -80N, -82N, -84N*
Kantack, Walter W 1889-1953 *WhAmArt 85*
Kantardzhiev, Petur 1893-1980 *MacEA*
Kantianis, Christopher Peter 1909- *AmArch 70*
Kantor, Bruce M 1957- *MarqDCG 84*
Kantor, Joseph 1904- *WhAmArt 85*
Kantor, Leonard *WhAmArt 85*
Kantor, M A *AmArch 70*
Kantor, Martha Rythor 1896- *DcWomA, WhAmArt 85*
Kantor, Morris 1896- *DcAmArt, DcCAA 71, WhoAmA 73*
Kantor, Morris 1896-1974 *BnEnAmA, DcCAA 77, WhAmArt 85, WhoAmA 76N, -78N, -80N, -82N, -84N*
Kantor, Tadeusz 1915- *ConArt 77, -83, ConDes, OxTwCA, PhDcTCA 77*
Kantor, Tim 1932- *ICPEnP A*
Kantz, Ralph Clayton 1916- *AmArch 70*
Kanzler, Henry *ArtsEM*
Kao *McGDA*
Kao, Ch'i-P'ei 1672-1732 *McGDA*
Kao, K'o-Kung 1248-1310 *McGDA*
Kao, Qifeng *ICPEnP A*
Kao, Ruth Lee *WhoAmA 78, -80, -82, -84*
Kape, William Jack *WhoArt 80, -82, -84*
Kapenekas, Theodore John 1920- *AmArch 70*
Kapff, Aline Von 1842- *DcWomA*
Kapitzki, Herbert W 1925- *ConDes, WhoGrA 82[port]*
Kaplan, Alice Manheim 1903- *WhoAmA 73, -76, -78, -80, -82*
Kaplan, Boche 1926- *IlsBYP, IlsCB 1967*
Kaplan, E *AmArch 70*
Kaplan, Gary Y 1937- *AmArch 70*
Kaplan, Harold 1910- *AmArch 70*
Kaplan, I H *AmArch 70*
Kaplan, Jacques 1922- *WhoAmA 73, -76, -78, -80, -82*
Kaplan, Jacques 1924- *FairDF US, WhoAmA 84*
Kaplan, Jerome Eugene *WhoAmA 76, -78, -80*
Kaplan, Jerome Eugene 1920- *WhoAmA 73, -82, -84*
Kaplan, Joseph 1900- *WhAmArt 85, WhoAmA 73, -76, -78*
Kaplan, Joseph 1900-1980 *WhoAmA 80N, -82N, -84N*
Kaplan, Julius David 1941- *WhoAmA 78, -80, -82, -84*
Kaplan, Leo 1912- *WhoAmA 80, -82, -84*
Kaplan, Leonard 1922- *WhoAmA 76, -78, -80, -82, -84*
Kaplan, Margorie *MarqDCG 84*
Kaplan, Marilyn *WhoAmA 76, -78*
Kaplan, Marilyn Flashenberg *WhoAmA 80, -82, -84*
Kaplan, Muriel Sheerr 1924- *WhoAmA 78*
Kaplan, Nat 1912- *WhAmArt 85*
Kaplan, Nolan Scott 1951- *MarqDCG 84*
Kaplan, Peter B 1939- *ICPEnP A*
Kaplan, R D *AmArch 70*
Kaplan, Rhoda B 1916- *WhoAmA 73, -76*
Kaplan, Richard Howe 1935- *AmArch 70*
Kaplan, Robert 1894- *AmArch 70*
Kaplan, Robert Irwin 1942- *AmArch 70*
Kaplan, Samuel 1890- *WhAmArt 85*
Kaplan, Sandra *PrintW 85*
Kaplan, Sandra 1943- *WhoAmA 84*
Kaplan, Stanley 1925- *WhoAmA 78, -80, -82, -84*
Kaplan, Walter 1927- *AmArch 70*
Kaplan, Ysabel DeWitte *DcWomA, WhAmArt 85*
Kaple, Art 1933- *AmArch 70*
Kaplinski, Buffalo 1943- *WhoAmA 73, -76, -78, -80, -82, -84*
Kaplinsky, Raphael Malcolm 1946- *MarqDCG 84*
Kaposkay, Victoria Von *DcWomA*
Kapousouz, Vasileos 1912- *WhAmArt 85*
Kapp, Christof *FolkA 86*
Kapp, Edmond X 1890- *WhoArt 80, -82, -84*
Kapp, Edmond Xavier 1890- *DcBrA 1, -2*
Kapp, Edmond Xavier 1890-1978 *DcBrBI*
Kapp, Helen *WhoArt 80, -82, -84N*
Kapp, Helen B 1901- *DcBrA 1*
Kappardaki, S *DcVicP 2*
Kappe, Raymond L 1927- *AmArch 70*
Kappel, Gottfried *FolkA 86*

Kappel, Philip 1901- *WhAmArt 85, WhoAmA 76, -78, -80*
Kappel, Philip 1901-1981 *WhoAmA 82N, -84N*
Kappel, R Rose 1908- *WhAmArt 85*
Kappel, R Rose 1910- *WhoAmA 78, -80, -82, -84*
Kappeler, M R *AmArch 70*
Kappeli, Robert 1900- *DcCAr 81*
Kappes, Alfred 1861-1943 *WhAmArt 85*
Kapple, W H *AmArch 70*
Kappler, Wolf-Dieter 1951- *MarqDCG 84*
Kapr, Albert 1918- *ConDes, WhoGrA 62, -82[port]*
Kaprov, Susan 1945- *PrintW 83, -85, WhoAmA 82*
Kaprov, Susan 1946- *WhoAmA 84*
Kaprov, Susan L 1945- *WhoAmA 80*
Kaprow, Alan 1927- *DcCAA 71, McGDA*
Kaprow, Allan 1927- *ConArt 77, -83, DcAmArt, DcCAA 77, OxTwCA, PhDcTCA 77, WhoAmA 73, -76, -78, WorArt*
Kaprow, J *AmArch 70*
Kaps, Andreas 1946- *DcCAr 81*
Kapsalis, Thomas Harry 1925- *WhoAmA 73, -76, -78, -80, -82, -84*
Kaptur, Hugh Michael 1931- *AmArch 70*
Kapup, Christoph *McGDA*
Kapus, Sergej *DcCAr 81*
Kapustin, Razel 1908- *WhAmArt 85*
Kaputa, William Vincent 1947- *MarqDCG 84*
Kar, Chintamoni 1915- *ClaDrA, DcBrA 1*
Karaberi, Marianthe *WhoAmA 73, -76*
Karagheusian, Mrs. Charles A *WhAmArt 85*
Karales, James H 1930- *ICPEnP A, MacBEP*
Karan, Donna 1948- *ConDes, WorFshn*
Karant, Barbara E 1952- *ICPEnP A, MacBEP*
Karash, Richard I 1946- *MarqDCG 84*
Karasick, Leland Irwin 1934- *AmArch 70*
Karasick, Mary K 1888- *DcWomA, WhAmArt 85*
Karasik, Myron Solomon 1950- *MarqDCG 84*
Karasz, Ilonka 1896- *DcWomA, IlsBYP, IlsCB 1946, WhAmArt 85*
Karasz, Mariska 1898-1960 *WhoAmA 80N, -82N, -84N*
Karawina, Erica *WhoAmA 73, -76, -78, -80, -82, -84*
Karawina, Erica 1904- *WhAmArt 85*
Karbiner, Edeline 1879- *DcWomA*
Karcher, Amalie *DcWomA*
Karcher, Hans *OxDecA*
Karcher, Nicolas *OxDecA*
Kardia, Carolyne 1951- *DcCAr 81*
Kardon, Dennis *PrintW 85*
Kardon, Janet *WhoAmA 78, -80, -82, -84*
Kardovskaia DellaVos, Olga Ludwigovna 1875?- *DcWomA*
Karel, Marian 1944- *DcCAr 81*
Karella, Marina *DcCAr 81*
Karene, Jacqueline *WorFshn*
Karesh, Ann Bamberger *WhoAmA 73, -76, -78*
Karfik, Vladimir 1901- *MacEA*
Karfiol, Bernard d1952 *WhoAmA 78N, -80N, -82N, -84N*
Karfiol, Bernard 1886-1952 *DcAmArt, DcCAA 71, -77, McGDA, OxTwCA, PhDcTCA 77, WhAmArt 85*
Karfunkel, David 1880- *WhAmArt 85*
Karfunkle, O *WhAmArt 85*
Karg, Georg *ClaDrA*
Karger, R M *AmArch 70*
Kargere, Raymond 1899- *WhAmArt 85*
Kargling-Pacher, Henriette *DcWomA*
Kari *WorECar*
Karidis, Chris Pete 1934- *AmArch 70*
Karies, Nikolaus *McGDA*
Karima, Medhat Mohamed 1949- *MarqDCG 84*
Karinskaia, Anna Nikolaevna 1871- *DcWomA*
Karl, Mabel Fairfax 1901- *WhAmArt 85*
Karl, Walter C *WhAmArt 85*
Karle, Robert Faukner 1937- *MarqDCG 84*
Karlen, Mark 1929- *AmArch 70*
Karlen, Peter H *WhoAmA 82, -84*
Karlin, D I *AmArch 70*
Karlin, Eugene 1918- *IlsBYP, IlsCB 1957, WhAmArt 85*
Karlin, I M *AmArch 70*
Karlowska, Stanislawa De 1876-1952 *DcBrA 1, DcWomA*
Karlsberger, Louis Frank 1901- *AmArch 70*
Karlsberger, R L *AmArch 70*
Karlsen, Anne-Marie 1952- *WhoAmA 82, -84*
Karlsson, Ewert 1918- *WhoGrA 82[port]*
Karlsson, Stig T 1930- *ICPEnP A*
Karlstrom, Karl V 1918- *MarqDCG 84*
Karlstrom, Paul Johnson 1941- *WhoAmA 78, -80, -82, -84*
Karmel, E M *EncASM*
Karmi, Dov 1905-1962 *ConArch, WhoArch*
Karmi, Ram 1931- *ConArch*
Karmin, Kurt Wright 1933- *AmArch 70*
Karn, Gloria Stoll 1923- *WhoAmA 73, -76, -78, -80, -82, -84*
Karner, Rosina Elisabeth *DcWomA*
Karnes, Karen 1920- *CenC*

Karnes, Karen 1925- *WhoAmA 80, -82, -84*
Karnik, Sister Mary Norbert 1885- *DcWomA*
Karniol, Eugene 1909- *WhoAmA 80, -82, -84*
Karniol, Hilda 1910- *WhoAmA 73, -76, -78, -80, -82, -84*
Karns, Mrs. Jack d1929 *DcWomA*
Karny, Fides 1886- *DcWomA*
Karolina Maria, Archduchess Of Austria *DcWomA*
Karoline Ferdinande Therese 1801-1832 *DcWomA*
Karoline Luise 1723-1783 *DcWomA*
Karoly, Andrew B 1893- *WhoAmA 73, -76*
Karoly, Andrew B 1895- *WhAmArt 85*
Karoly, Fredric *WhoAmA 73, -76*
Karow, Annie *WhAmArt 85*
Karow, Kenneth 1928- *MarqDCG 84*
Karp, Aaron S 1947- *WhoAmA 82, -84*
Karp, Eleanor 1930- *AmArch 70*
Karp, Ivan C 1926- *WhoAmA 73, -76, -78, -80, -82*
Karp, Leon d1951 *WhAmArt 85, WhoAmA 78N, -80N, -82N, -84N*
Karp, Mort 1926- *AmArch 70*
Karp, Richard Gordon 1933- *WhoAmA 76, -78, -80, -82, -84*
Karpel, Bernard 1911- *WhoAmA 76, -78, -80, -82*
Karpel, Eli 1916- *WhoAmA 76, -78, -80, -82, -84*
Karpeles, Andree 1885- *DcWomA*
Karpen, R *DcVicP 2*
Karpick, John 1884-1960 *WhoAmA 80N, -82N, -84N*
Karpick, John J 1883-1960 *WhAmArt 85*
Karpinski, Zbigniew 1906- *MacEA*
Karplus, Alan Kurt 1937- *MarqDCG 84*
Karplus, Gerhard Emanuel 1909- *AmArch 70*
Karpovsky, Mark G 1940- *MarqDCG 84*
Karpowicz, Terrence Edward 1948- *WhoAmA 84*
Karpp, Dollie *ArtsEM, DcWomA*
Karr, Elizabeth *DcWomA*
Karr, Russell A 1948- *MarqDCG 84*
Karras, Spiros John 1897- *ArtsAmW 2, WhAmArt 85*
Karsanow, Nikolaus *AmArch 70*
Karsay, Joseph L d1936 *WhAmArt 85*
Karsch, Joachim 1897-1945 *PhDcTCA 77*
Karsch, Johan 1945- *DcCAr 81*
Karsh, Arlene E *MarqDCG 84*
Karsh, Malak 1908- *ICPEnP A*
Karsh, Malak 1915- *MacBEP*
Karsh, Yousuf 1908- *ConPhot, ICPEnP, MacBEP, WhoAmA 73, -76, -78, -80, -82, -84*
Karshan, Donald H 1929- *WhoAmA 73*
Karsner, Clark 1916-1971 *FolkA 86*
Karson, Herman Morris 1921- *AmArch 70*
Karson, William George 1925- *AmArch 70*
Karst, Gary Gene 1936- *AmArch 70*
Karst, John 1836-1922 *NewYHSD, WhAmArt 85*
Karsten, Elisabet Charlotta 1789-1833? *DcWomA*
Karsten, Ludwig 1876-1926 *PhDcTCA 77*
Kart, Heino L 1930- *AmArch 70*
Karth, Thekla Crescentia *DcWomA*
Karthauserin, Margaretha *DcWomA*
Kartsch, Marie 1848- *DcWomA*
Karuth, Ethel *ClaDrA, DcWomA*
Karwelis, Donald C 1934- *PrintW 83, -85*
Karwelis, Donald Charles 1934- *AmArt, WhoAmA 76, -78, -80, -82, -84*
Karwoski, Richard C 1938- *PrintW 83, -85*
Karwoski, Richard Charles 1938- *AmArt, WhoAmA 76, -82, -84*
Karydas, Apostolos E 1938- *AmArch 70*
Kasak, Princess Marie *DcWomA*
Kasak, Nikolai *WhoAmA 80, -82, -84*
Kasak, Nikolai 1917- *WhoAmA 76, -78*
Kasak, Nikolas 1917- *WhoAmA 73*
Kasakov, Matvei Feodorovich 1733-1812 *McGDA*
Kasal, Richard Talley 1920- *AmArch 70*
Kasavan, J *AmArch 70*
Kasbarian, Yeghia 1896- *WhAmArt 85*
Kasch, Norman Arthur 1925- *AmArch 70*
Kaschanoff, Elisabet Charlotta *DcWomA*
Kaschauer, Jakob *McGDA*
Kasday, Leonard R *MarqDCG 84*
Kase, Paul G 1895- *WhAmArt 85*
Kasebier, Gertrude 1852-1934 *DcAmArt, ICPEnP, MacBEP, WomArt*
Kasebier, Gertrude Stanton 1852-1934 *BnEnAmA, WhAmArt 85*
Kaselau, Klaus 1938- *DcCAr 81*
Kasen, Michael George 1928- *AmArch 70*
Kashani, Hamid Reza 1955- *MarqDCG 84*
Kashani, Mir Massoud 1964- *MarqDCG 84*
Kashdin, Gladys S 1921- *WhoAmA 76, -78, -80*
Kashdin, Gladys Shafran 1921- *WhoAmA 82, -84*
Kashetsky, Herzl 1950- *DcCAr 81*
Kashiwagi, Isami 1925- *IlsBYP, IlsCB 1946*
Kasimer, Luigi 1881-1962 *ArtsAmW 1*
Kasimir-Hoernes, Tanna 1887- *DcWomA*
Kasindorf, S *AmArch 70*
Kaskey, Raymond John 1943- *WhoAmA 82, -84*
Kasle, Gertrude 1917- *WhoAmA 73, -76, -78, -80, -82, -84*
Kasling, Driftwood Charlie 1901- *FolkA 86*
Kasman, Murray Bernard 1926- *AmArch 70*

Kawamoto, Kihachiro 1924- *WorECar*
Kawamura, Gozo 1886- *WhAmArt 85*
Kawamura, Ishio 1943- *WorFshn*
Kawanabe, Gyosai 1831-1889 *WorECom*
Kawara 1933- *PhDcTCA 77*
Kawara, On 1933- *ConArt 77, -83, DcCAr 81, OxTwCA, WhoAmA 78*
Kawasaki, Ranko 1882-1918 *DcWomA*
Kawashima, Takeshi 1930- *WhoAmA 82, -84*
Kawden, Henry *NewYHSD*
Kawecki, C S *AmArch 70*
Kawecki, Jean Mary 1926- *WhoAmA 78, -80, -82, -84*
Kawecki, W *AmArch 70*
Kawerau, Johanna *DcWomA*
Kay, A *DcBrWA*
Kay, Archibald 1860-1935 *DcBrA 1, DcBrWA, DcVicP 2*
Kay, Dorothy 1886-1964 *DcWomA*
Kay, Edward A 1900?- *FolkA 86*
Kay, F E *AntBDN H*
Kay, Floyd Ferguson, Jr. 1927- *AmArch 70*
Kay, G Y *AmArch 70*
Kay, Gertrude Alice *WhAmArt 85*
Kay, Gertrude Alice 1884-1939 *ConICB, DcWomA*
Kay, Helena De *DcWomA*
Kay, J Illingworth *DcBrBI*
Kay, James 1858- *ClaDrA*
Kay, James 1858-1942 *DcBrA 1, DcBrWA, DcVicP 2*
Kay, John 1742-1826 *DcBrBI*
Kay, John 1742-1830 *DcBrWA*
Kay, Joseph *DcBrWA*
Kay, Joseph 1775-1847 *BiDBrA*
Kay, Katherine *DcWomA*
Kay, Nora *WhoArt 80, -82, -84*
Kay, Reed 1925- *WhoAmA 78, -80, -82, -84*
Kay, Richard *DcVicP 2*
Kay, Robert 1740-1818 *BiDBrA*
Kay, Ted Kwiatkowski 1929- *AmArch 70*
Kay, Violet MacNeish 1914- *ClaDrA, DcBrA 1*
Kay, Violet McNeish 1914-1971 *DcWomA*
Kay, Willem *McGDA*
Kay, William *NewYHSD*
Kay-Scott, Cyril 1879- *ArtsAmW 2, WhAmArt 85*
Kaya, Lawton Nobuo 1956- *MarqDCG 84*
Kaye, David H 1947- *DcCAr 81*
Kaye, David Haigh 1947- *WhoAmA 78, -80, -82, -84*
Kaye, Elizabeth Gutman 1887- *DcWomA, WhAmArt 85*
Kaye, George 1911- *WhoAmA 73, -76, -78, -80, -82, -84*
Kaye, J Graham *WhAmArt 85*
Kaye, Joseph *WhAmArt 85*
Kaye, Mildred Elaine 1929- *WhoAmA 82, -84*
Kaye, Samuel Harvey 1940- *AmArch 70*
Kayflick, Henry *NewYHSD*
Kaylor, Richard Lee *MarqDCG 84*
Kayn, Hilde d1950 *WhoAmA 78N, -80N, -82N, -84N*
Kayn, Hilde B 1903-1950 *WhAmArt 85*
Kayne, Mrs. Sigmond 1910- *WorFshn*
Kaynoot *McGDA*
Kays, Keith Sevier *AmArch 70*
Kayser *NewYHSD*
Kayser, Ebba 1846- *DcWomA*
Kayser, Jean 1840-1911 *DcNiCA*
Kayser, Klaus 1940- *MarqDCG 84*
Kayser, Louise Darmstaedter 1899- *ArtsAmW 3, DcWomA, WhAmArt 85*
Kayser, Stephen S 1900- *WhAmArt 85, WhoAmA 73, -76, -78*
Kayser, Thomas Arthur 1935- *WhoAmA 82, -84*
Kayser, Tilnan 1941- *DcCAr 81*
Kayserling, Karoline Charlotte Amalia *DcWomA*
Kayton, Myron 1934- *MarqDCG 84*
Kaz 1922- *WhoAmA 73, -76, -78, -80, -82, -84*
Kaz, Joyce Zickerman 1936-1979 *WhoAmA 80N, -82N, -84N*
Kaz, Nathaniel 1917- *McGDA, WhAmArt 85, WhoAmA 73, -76, -78, -80, -82, -84*
Kazacsay, Lujza 1872- *DcWomA*
Kazak, Princess Marie *DcWomA*
Kazakov, Matvei F 1738-1812 *MacEA*
Kazakov, Matvei Feodorovich 1733-1812 *DcD&D*
Kazan 1793-1841 *McGDA*
Kazan, Benjamin 1917- *MarqDCG 84*
Kazanowska, Maria d1898 *DcWomA*
Kazebier, Roy Albert *AmArch 70*
Kazimierski, Daniel 1949- *ICPEnP A, MacBEP*
Kaziun, Charles 1918?- *IlDcG*
Kazor, Virginia Ernst 1940- *WhoAmA 76, -78, -80, -82, -84*
Kazukawa, Suji *WhAmArt 85*
Keable, William *DcBrECP*
Keagy, Abraham, I 1786-1867 *FolkA 86*
Keagy, Abraham, II *FolkA 86*
Keagy, Ann *WorFshn*
Keagy, I *FolkA 86*
Keagy, John 1811-1890 *FolkA 86*
Keagy, Samuel 1837- *FolkA 86*

Keahbone, George Campbell *WhAmArt 85*
Keahey, Kirby Max 1934- *AmArch 70*
Kealing, Ruth Elizabeth 1890- *DcWomA, WhAmArt 85*
Keally, Francis d1978 *WhoAmA 80N, -82N, -84N*
Keally, Francis 1889- *AmArch 70, WhAmArt 85*
Kealy, Minrath *NewYHSD*
Kean, Carl Lewis *FolkA 86*
Kean, Edmund A 1893-1927 *WhAmArt 85*
Kean, Frederick A 1811?-1893 *FolkA 86*
Kean, Michael *AntBDN M*
Kean, Michael 1761-1823 *DcBrECP*
Keane, Bil 1922- *ConGrA 1[port], WhoAmA 73, -76, -78, -80, -82, -84*
Keane, Frank M 1876- *WhAmArt 85*
Keane, Gustave R 1914- *AmArch 70*
Keane, Lucina Mabel 1904- *WhoAmA 73, -76, -78, -80, -82, -84*
Keane, Theodore J 1880- *ArtsAmW 3, WhAmArt 85*
Keane, William 1922- *WorECar*
Keany, Brian James 1945- *WhoAmA 82, -84*
Kearfott, C B *AmArch 70*
Kearfott, Clarence Baker, Jr. 1917- *AmArch 70*
Kearfott, Robert 1890- *ArtsAmW 3*
Kearfott, Robert Ryland 1890- *WhAmArt 85*
Kearl, Stanley Brandon 1913- *DcCAA 71, -77, WhoAmA 73, -76, -78, -80, -82, -84*
Kearnan, Thomas *DcBrBI, DcBrWA, DcVicP 2*
Kearney, Francis 1785-1837 *NewYHSD*
Kearney, John 1924- *AmArt, WhoAmA 73, -76, -78, -80, -82, -84*
Kearney, Joseph 1939- *WhoArt 84*
Kearney, Patrick Neville 1919- *DcBrA 1*
Kearney, Richard George 1926- *AmArch 70*
Kearney, William Henry 1800-1858 *DcBrWA, DcVicP, -2*
Kearns, Celia *DcWomA*
Kearns, David Henry 1936- *AmArch 70*
Kearns, Garry John 1935- *AmArch 70*
Kearns, James 1924- *DcCAA 71, -77, DcCAr 81*
Kearns, James Joseph 1924- *WhoAmA 73, -76, -78, -80, -82, -84*
Kearns, Thomas Matthew 1931- *AmArch 70*
Kears, Mark *FolkA 86*
Kearse, Mrs. *DcBrECP*
Kearse, Mary *DcWomA*
Kearsley, Miss H *DcVicP*
Kearsley, Harriet *DcWomA*
Kearsley, Harriet d1881 *DcBrWA, DcVicP 2*
Kearsley, John 1684?-1772 *BiDAmAr*
Kearsley, Thomas 1773-1801? *DcBrECP*
Kearton, Cherry 1871-1940 *ICPEnP A, MacBEP*
Kearton, Richard 1862-1928 *MacBEP*
Keasbey, Henry T 1882- *WhAmArt 85*
Keasby, William P *WhAmArt 85*
Keasoner, Ronald B 1948- *MarqDCG 84*
Keast, M *AmArch 70*
Keast, Susette Schultz d1932 *WhAmArt 85*
Keast, Susette Schultz 1892-1932 *DcWomA*
Keast, William R Morton *WhAmArt 85*
Keate, George 1729-1797 *DcBrWA*
Keate, Georgiana Jane 1770-1850 *DcBrECP, DcWomA*
Keates, John Gareth 1915- *DcBrA 2, WhoArt 80, -82, -84*
Keating, Mrs. *DcVicP 2*
Keating, Andrew *DcCAr 81*
Keating, Charles *NewYHSD*
Keating, Edward *NewYHSD*
Keating, George *DcBrECP*
Keating, George 1762-1842 *McGDA*
Keating, John *WhoArt 80N*
Keating, John 1889- *ClaDrA, DcBrA 1*
Keating, Julia A *DcWomA*
Keating, Mary 1893-1953 *DcWomA*
Keating, Mary Aubrey 1898-1953 *ArtsAmW 2, WhAmArt 85*
Keating, Robert Paul 1930- *AmArch 70*
Keatinge, Elizabeth 1885- *ArtsAmW 3*
Keatinge, Mrs. R H *DcVicP 2*
Keaton, Russell 1910-1945 *WorECom*
Keats, C J *DcBrWA*
Keats, Ezra Jack *IlsCB 1967*
Keats, Ezra Jack 1916- *IlsBYP, IlsCB 1946, -1957, WhoAmA 76, -78, -80, -82, -84*
Keaveney, Sydney Starr 1939- *WhoAmA 80, -82, -84*
Keay, Harry 1914- *ClaDrA, DcBrA 1*
Keays, Verna *DcWomA*
Kebbell, William Francis Vere *DcBrA 1*
Keck *FolkA 86*
Keck, Anthony 1726-1797 *BiDBrA*
Keck, Charles *AfroAA*
Keck, Charles d1951 *WhoAmA 78N, -80N, -82N, -84N*
Keck, Charles 1875-1951 *WhAmArt 85*
Keck, George Fred 1895- *ConArch*
Keck, Josephine F 1860- *WhAmArt 85*
Keck, Josephine Frances 1860- *ArtsAmW 3*
Keck, Josephine Francis 1860- *ArtsAmW 3*
Keck, Robert Andrew 1938- *AmArch 70*
Keck, Sheldon Waugh 1910- *WhoAmA 73, -76, -78,

Keck, Susan *DcWomA*
Keck, Susan 1746-1835 *DcBrECP*
Keck, William 1908- *AmArch 70*
Keck And Keck *MacEA*
Keckley, John *CabMA*
Keddie, Kate M 1887- *DcWomA*
Kedo, Paul Nicholas 1949- *MarqDCG 84*
Kedzie, Ella M *ArtsEM*
Keeble, F G *AmArch 70*
Keeble, Henry Ashley *BiDBrA*
Keeble, William 1714?-1774 *DcBrECP*
Keebler, Julius *FolkA 86*
Keech, Robert John 1963- *MarqDCG 84*
Keef, John *NewYHSD*
Keefe, Charles S 1876-1946 *BiDAmAr*
Keefe, D A *AmArch 70*
Keefe, Dan *WhAmArt 85*
Keefe, James Wilber 1919- *AmArch 70*
Keefe, Katharine Lee 1941- *WhoAmA 78, -80*
Keefer, Elizabeth E *DcWomA*
Keefer, Elizabeth E 1899- *ArtsAmW 2, WhAmArt 85*
Keefer, Peter 1933- *PrintW 83, -85*
Keegan, Albert Frederick 1919- *AmArch 70*
Keegan, J E *AmArch 70*
Keegan, J T *AmArch 70*
Keegan, Marcia 1942- *ICPEnP A, MacBEP*
Keegan, Marie 1941- *FolkA 86*
Keel, Benjamin Hyman 1929- *AmArch 70*
Keel, W L *AmArch 70*
Keeler, Benjamin *FolkA 86*
Keeler, Mrs. Burton *WhAmArt 85*
Keeler, Charles B 1882- *WhAmArt 85*
Keeler, Charles Butler 1882- *ArtsAmW 1*
Keeler, David Boughton 1931- *WhoAmA 78, -80, -82, -84*
Keeler, George *CabMA*
Keeler, Grace *WhAmArt 85*
Keeler, Harold Emerson 1905- *WhAmArt 85*
Keeler, John, Jr. *NewYHSD*
Keeler, Julia Annette 1895- *ArtsAmW 2, DcWomA, WhAmArt 85*
Keeler, Katherine *DcWomA*
Keeler, Katherine Southwick *WhAmArt 85*
Keeler, Louis Bertrand Rolston 1882- *WhAmArt 85*
Keeler, Louise Mapes Bunnell *ArtsAmW 2, DcWomA*
Keeler, R Burton 1886- *WhAmArt 85*
Keeler, Warren Watson 1923- *AmArch 70*
Keeley, John 1849-1930 *DcBrA 1, DcBrWA, DcVicP 2*
Keeley, Mrs. Lester *WhAmArt 85*
Keeley, Patrick C 1816-1896 *BiDAmAr*
Keelhoff, Frans 1820-1893 *ClaDrA*
Keeling, Agnes *DcVicP 2, DcWomA*
Keeling, Cecil Frank 1912- *WhoGrA 62*
Keeling, E Bassett 1837-1886 *MacEA*
Keeling, G R *AmArch 70*
Keeling, Gertrude *DcVicP 2*
Keeling, Henry Cornelious 1923- *WhoAmA 73, -76, -78, -80, -82, -84*
Keeling, John C 1923- *AmArch 70*
Keeling, Michael 1750-1820 *DcBrECP*
Keeling, William *DcVicP 2*
Keeling, William Knight 1807-1886 *DcBrBI, DcBrWA, DcVicP 2*
Keelmann, Charles *NewYHSD*
Keely, Isaac H 1817-1891 *NewYHSD*
Keely, Patrick Charles 1816-1896 *MacEA*
Keen, Arthur *DcVicP 2*
Keen, G V *FolkA 86*
Keen, Helen Boyd *WhoAmA 73, -76, -78, -80, -82, -84*
Keen, Helen Boyd 1899- *DcWomA*
Keen, Palmyra M *FolkA 86*
Keen, Sarah *FolkA 86*
Keen, William C *NewYHSD*
Keena, James Trafton 1850-1924 *ArtsEM*
Keena, Janet Laybourn 1928- *WhoAmA 76, -78, -80, -82, -84*
Keena, John *FolkA 86*
Keenan, Armide Elizabeth 1910- *WhAmArt 85*
Keenan, John 1785?-1819? *DcBrECP*
Keenan, Mrs. John *DcWomA*
Keenan, John S *WhAmArt 85*
Keenan, L *DcWomA*
Keenan, Larry, Jr. 1943- *MacBEP*
Keenan, Mary Virginia 1831-1908 *DcWomA*
Keenan, Mary Winifred *WhAmArt 85*
Keenan, Peter 1896- *WhAmArt 85*
Keenan, W C, Jr. *AmArch 70*
Keenan, William 1810?- *NewYHSD*
Keenan, William Joseph, III 1922- *AmArch 70*
Keene, Mrs. A *DcBrWA*
Keene, Alfred *DcVicP 2*
Keene, Alfred John 1864-1930 *DcBrA 1, DcVicP 2*
Keene, Alfred John Jack 1864-1930 *DcBrWA*
Keene, Charles *AfroAA*
Keene, Charles 1823-1891 *AntBDN B, WorECar*
Keene, Charles B 1868-1931 *BiDAmAr*

Keene, Charles Samuel 1823-1891 ClaDrA, DcBrBI, DcBrWA, DcVicP, -2, McGDA, OxArt
Keene, David B 1957- MarqDCG 84
Keene, Elmer DcVicP 2
Keene, Henry 1726-1776 BiDBrA, DcD&D, MacEA, OxArt
Keene, Henry E DcVicP 2
Keene, J B DcVicP 2
Keene, Maxine M 1939- WhoAmA 73, -76
Keene, Millard Michael 1942- AmArch 70
Keene, Paul 1920- WhoAmA 73, -76, -78, -80, -82, -84
Keene, Paul F, Jr. 1920- AfroAA
Keene, Philip E 1906- AmArch 70
Keene, T R AmArch 70
Keene, Theodosius 1754?- BiDBrA
Keene, Thomas DcBrBI
Keene, William Caxton 1855-1910 DcBrA 1, DcBrWA, DcVicP 2
Keener, Anna E 1895- ArtsAmW 1
Keener, Anna Elizabeth 1895- DcWomA, WhAmArt 85, WhoAmA 73, -76, -78, -80, -82, -84
Keener, Henry FolkA 86
Keener, Jacob FolkA 86
Keener, John 1808?- FolkA 86
Keener, William Brown 1921- AmArch 70
Keeney, Allen Lloyd 1933- WhoAmA 80, -82, -84
Keeney, Anna WhAmArt 85
Keeney, Anna 1898- DcWomA
Keeney, B T AmArch 70
Keeney, Harold Stevens, Jr. 1921- AmArch 70
Keeney, R J AmArch 70
Keens, A W DcVicP 2
Keens, H L DcVicP 2
Keep, George FolkA 86
Keep, Helen Elizabeth 1868- WhAmArt 85
Keep, Helen Elizabeth 1868-1959 ArtsEM, DcWomA
Keep, Peter 1909- WhAmArt 85
Keep, Virginia DcWomA, WhAmArt 85
Keeper, Heinrich FolkA 86
Keeping, Charles William James IlsCB 1967
Keeping, Charles William James 1924- IlsBYP, IlsCB 1957
Keerinck, Alexandre 1600-1652 ClaDrA
Keerl, Bayat DcCAr 81
Kees, C F EncASM
Kees, Frederick 1852- BiDAmAr
Keesey, Anna L 1868-1938 DcWomA
Keesey, Walter Monckton 1887-1970 DcBrA 1
Keeson, A DcVicP 2
Keetman, Peter 1916- ICPEnP A, MacBEP
Kefauver, Nancy d1967 WhoAmA 78N, -80N, -82N, -84N
Kefer, A F, Jr. AmArch 70
Keffer, Frances 1881-1954 ArtsAmW 3, WhAmArt 85
Keffer, Frances Alice 1881-1954 DcWomA
Keffer, J L NewYHSD
Keffer, William FolkA 86
Kegel, Annie Robb DcWomA
Kegel, Fred Wolfe, Jr. 1922- AmArch 70
Kegg, George W 1884- WhAmArt 85
Kegg, George W 1884-1943 ArtsAmW 2
Kegg, Richard L 1935- MarqDCG 84
Keghel, Desire De 1839-1901 DcWomA
Kehaya, Dorothea 1925- MacBEP
Kehaya, Dorothy 1925- ICPEnP A
Kehde, Martha Elizabeth 1942- WhoAmA 78
Kehlmann, Robert 1942- DcCAr 81, WhoAmA 82, -84
Kehm, Anthony FolkA 86
Kehm, Bimel 1907- WhAmArt 85
Kehoe, R H AmArch 70
Kehr, John Leo, Jr. 1926- AmArch 70
Kehrer, F A WhAmArt 85
Kehres, Philip Carl 1917- AmArch 70
Kehrweider, Charles NewYHSD
Kehrweider, Otto NewYHSD
Kehrweider, William, Jr. NewYHSD
Kehrweider, William, Sr. 1795?- NewYHSD
Keibun 1779-1843 McGDA
Keich, Gideon 1923- WhoGrA 62, -82[port]
Keid, Andrew d1802 FolkA 86
Keifer, Louis FolkA 86
Keighley, Alexander 1861-1947 ConPhot, ICPEnP A, MacBEP
Keihl, Mabel C 1899- ArtsAmW 3
Keijser, Thomas De McGDA
Keil, Bernardo 1624-1687 McGDA
Keil, Fred C 1936- AmArch 70
Keil, Henry W ArtsEM
Keil, Louis O ArtsEM
Keil, Valentine NewYHSD
Keila, Louis WhAmArt 85
Keiley, Joseph T 1869-1914 ICPEnP A, MacBEP
Keilor, Bertha DcVicP 2
Keily, Jane B ArtsEM, DcWomA
Keim, George Henry, Jr. 1931- AmArch 70
Keim, John NewYHSD
Keim, T Beverly, Jr. 1884-1920 BiDAmAr

Keimer, Samuel 1688-1739 EarABI
Keinbusch, William Austin 1914- PhDcTCA 77
Keines, Simon NewYHSD
Keinley, Augustus NewYHSD
Keipner, William FolkA 86
Keir, Kenneth Mackenzie 1927- MarqDCG 84
Keirinckx, Alexander 1600-1652 McGDA
Keirns, Harry D MarqDCG 84
Keiser, Elisabeth 1866- DcWomA
Keiser, James Francis 1928- AmArch 70
Keiss, Daisy DcWomA
Keister, Howard Rucker, Jr. 1917- AmArch 70
Keister, L M AmArch 70
Keister, Roy C 1886- WhAmArt 85
Keister, Roy Chester 1886- WhoAmA 80, -82
Keister, Steve 1949- DcCAr 81, WhoAmA 84
Keith, Alexander DcVicP 2
Keith, Allan DcVicP 2
Keith, Belle Emerson 1865- DcWomA, WhAmArt 85
Keith, Castle 1863-1927 ArtsEM
Keith, Charles F FolkA 86
Keith, Charles W FolkA 86
Keith, David NewYHSD
Keith, David Graeme 1912- WhoAmA 73, -76
Keith, Denis 1932- AmArch 70
Keith, Dora 1856-1940 DcWomA
Keith, Dora Wheeler 1856-1940 WhAmArt 85
Keith, Elisha Boudinot 1892-1918 WhAmArt 85
Keith, Elizabeth 1887-1956 DcWomA
Keith, Elizabeth Emerson 1838-1882 ArtsAmW 3
Keith, Eros IlsBYP, IlsCB 1967
Keith, Eros 1942- WhoAmA 78, -80, -82, -84
Keith, G S AmArch 70
Keith, George A NewYHSD
Keith, James IlDcG, OxDecA
Keith, Mrs. L M DcVicP, -2
Keith, Lawrence Augustus Haltom 1892- WhAmArt 85
Keith, Letitia Margaret DcWomA
Keith, Lizzie Emerson 1838-1882 ArtsAmW 3
Keith, Margarethe 1942- DcCAr 81
Keith, Robert D MarqDCG 84
Keith, Susan Bacon 1889- DcWomA, WhAmArt 85
Keith, W Castle WhAmArt 85
Keith, Warren WhAmArt 85
Keith, William 1838-1911 ArtsAmW 1
Keith, William 1839-1911 DcAmArt, EarABI, EarABI SUP, IlBEAAW, McGDA, NewYHSD, WhAmArt 85
Keith, William 1929- AfroAA
Keithahn, Richard Edward 1933- AmArch 70
Keitz, Daniel McLeod 1960- MarqDCG 84
Kekoolani, George Hoololu, Jr. 1930- AmArch 70
Kekst, Keeva J 1932- AmArch 70
Kelch, N W AmArch 70
Kelchs McGDA
Kelder, Diane M 1934- WhoAmA 76, -78, -80, -82, -84
Kelder, Toon 1894- PhDcTCA 77
Keldermans, Rombout d1531 McGDA
Keldermans Family MacEA
Keleher, Thomas John 1930- AmArch 70
Kelemen, Pal 1894- WhAmArt 85, WhoAmA 73, -76, -78, -80, -82, -84
Kelen, Emery 1896- IlsCB 1744
Keleti, G Peter 1925- AmArch 70
Kelham, George W 1871-1936 BiDAmAr
Kelkar, Subhash Govind 1946- MarqDCG 84
Kell, D FolkA 86
Kell, Diane ConArch A
Kell, Ellen DcVicP 2
Kell, F W DcVicP 2
Kell, J S DcVicP 2
Kell, Lorna Beatrice 1914- DcBrA 1, WhoArt 80, -82, -84
Kell, Thomas DcVicP 2
Kell, Violet B DcWomA
Kell, W F DcVicP 2
Kellam, William E 1921- AmArch 70
Kellar, Shirley Lynn 1956- MarqDCG 84
Kellaye, Blanche DcWomA, WhAmArt 85
Kellehe, D D AmArch 70
Kelleher, Daniel Joseph 1930- WhoAmA 73, -76, -78, -80
Kelleher, J T AmArch 70
Kelleher, Maud E DcWomA
Kelleher, Maude E WhAmArt 85
Kelleher, Patrick Joseph 1917- WhoAmA 73, -76, -78, -80, -82, -84, WhoArt 80, -82, -84
Kellen, David VanDer 1827-1895 ClaDrA
Kellen, Hendrika Frederika VanDer 1846-1903 DcWomA
Kellen, Robert NewYHSD
Kellenberger, Fred J 1946- MarqDCG 84
Kellenyi, B A AmArch 70
Keller, Adam FolkA 86, NewYHSD
Keller, Andrea Miller 1942- WhoAmA 78, -80, -82
Keller, Arthur I 1866-1924 WhAmArt 85
Keller, Arthur I 1867-1924 ArtsAmW 1
Keller, Arthur Ignatius 1866?-1924 IlBEAAW, IlrAm 1880
Keller, Arthur Ignatius 1866-1925 IlrAm B
Keller, Arthur L DcBrBI
Keller, B DcVicP 2
Keller, Charles WhAmArt 85
Keller, Charles Frederick 1852-1928 WhAmArt 85
Keller, Claudia 1942- DcCAr 81
Keller, Clyde Leon 1872- ArtsAmW 2, IlBEAAW, WhAmArt 85
Keller, Collins Stevenson, Jr. 1921- AmArch 70
Keller, Conrad FolkA 86
Keller, Deane 1901- WhAmArt 85, WhoAmA 73, -76, -78, -80, -82, -84
Keller, Delphine Gabrielle 1836- DcWomA
Keller, Edgar WhAmArt 85
Keller, Edgar Martin 1868-1932 ArtsAmW 2, WhAmArt 85
Keller, Ella 1876- DcWomA
Keller, Elmer Albert 1937- AmArch 70
Keller, Ernst 1891- WhoGrA 62
Keller, Ernst 1891-1968 ConDes
Keller, Evelyn R DcWomA
Keller, Fanny H M DcWomA
Keller, Ferdinand 1842-1922 ClaDrA
Keller, Francis NewYHSD
Keller, Frank S 1951- WhoAmA 84
Keller, Georg 1568-1640 ClaDrA
Keller, George WhAmArt 85
Keller, George Antone 1908- WhAmArt 85
Keller, George Frederick ArtsAmW 2
Keller, George W 1842-1935 BiDAmAr
Keller, Henry G d1949 WhoAmA 78N, -80N, -82N, -84N
Keller, Henry George 1869-1949 ArtsAmW 3
Keller, Henry George 1870-1949 ArtsAmW 1, WhAmArt 85
Keller, J DcWomA
Keller, Mrs. J NewYHSD
Keller, James MarqDCG 84
Keller, Joan Theresa 1916- WhAmArt 85
Keller, Johann Heinrich 1692-1765 ClaDrA
Keller, John G WhAmArt 85
Keller, Kevin Neil 1955- MarqDCG 84
Keller, Magdalena 1793-1854 DcWomA
Keller, Marie DeForde DcWomA, WhAmArt 85
Keller, Mary Kenneth MarqDCG 84
Keller, Peter R 1940- MarqDCG 84
Keller, Philip 1956- MarqDCG 84
Keller, Ralph John 1926- AmArch 70
Keller, Richard 1944- MarqDCG 84
Keller, Robert Joseph 1930- AmArch 70
Keller, Stephane DcWomA
Keller, T F AmArch 70
Keller, Terrence 1947- DcCAr 81
Keller, W A AmArch 70
Keller, W L AmArch 70
Keller, Wallace NewYHSD
Keller, Walter Leonard 1918- AmArch 70
Keller, Walter S 1881-1918 BiDAmAr
Keller, William J NewYHSD
Keller & Guerin DcNiCA
Keller-Hermann, Marie 1868- DcWomA
Kellerhoven, Moritz 1758-1830 ClaDrA
Kellett, Edith 1877- DcWomA
Kellett, James Anthony 1930- AmArch 70
Kellett, Jane 1954- DcCAr 81
Kelley, Albert Sumter 1909- WhAmArt 85
Kelley, Annie Davisson d1933 DcWomA
Kelley, Arlanna WhAmArt 85
Kelley, Asahel A FolkA 86
Kelley, Chapman 1932- WhoAmA 73, -76, -78, -80, -82, -84
Kelley, Charles Harrison 1928- AmArch 70
Kelley, Charles Manford 1919- AmArch 70
Kelley, Donald Castell WhoAmA 78, -80, -82, -84
Kelley, Donald William 1939- WhoAmA 76, -78, -80, -82, -84
Kelley, E N AmArch 70
Kelley, Forrest M 1914- AmArch 70
Kelley, Gary Lee 1957- MarqDCG 84
Kelley, Gwendolyn Dunlevy DcWomA, WhAmArt 85
Kelley, H Roy 1893- AmArch 70
Kelley, Hannah Rusk WhAmArt 85
Kelley, Henry EncASM
Kelley, J R AmArch 70
Kelley, J Redding WhAmArt 85
Kelley, James T d1929 BiDAmAr
Kelley, John Gregory 1915- AmArch 70
Kelley, John S ArtsEM
Kelley, Joseph NewYHSD
Kelley, Lynn Scott 1919- AmArch 70
Kelley, May McClure DcWomA, WhAmArt 85
Kelley, O L AmArch 70
Kelley, Paul Eugene, Jr. 1947- MarqDCG 84
Kelley, Peter FolkA 86
Kelley, R L AmArch 70
Kelley, Ramon 1939- IlBEAAW, WhoAmA 73, -76, -78, -80, -82, -84
Kelley, Raymond Joseph 1932- AmArch 70
Kelley, Richard M 1921- AmArch 70
Kelley, Robert W 1920- ICPEnP A, MacBEP

Kelley, Roy C *AmArch 70*
Kelley, Samuel D 1848-1938 *BiDAmAr*
Kelley, Sue E *WhAmArt 85*
Kelley And McBean *EncASM*
Kellie, Ed *FolkA 86*
Kelling, H A *AmArch 70*
Kellinger, John A *NewYHSD*
Kellmer, Jack *EncASM*
Kellner, Anthony *FolkA 86*
Kellner, Charles H 1890- *WhAmArt 85*
Kellner, Dorothea 1875- *DcWomA*
Kellner, Hans *McGDA*
Kellner, Richard George 1943- *MarqDCG 84*
Kello, Esther 1571-1624 *DcWomA*
Kellogg, Alfred Galpin 1888-1935 *WhAmArt 85*
Kellogg, Alice D *DcWomA*
Kellogg, Anna P *DcWomA, WhAmArt 85*
Kellogg, Armand Wesley 1914- *AmArch 70*
Kellogg, Augustus G 1934- *AmArch 70*
Kellogg, Charles Edmund *NewYHSD*
Kellogg, D B *AmArch 70*
Kellogg, Daniel Wright 1807-1874 *NewYHSD*
Kellogg, E *ArtsEM, DcWomA*
Kellogg, Edmund Burke 1809-1872 *NewYHSD*
Kellogg, Edmund P 1879- *WhAmArt 85*
Kellogg, Elijah Chapman 1811-1881 *NewYHSD*
Kellogg, Elizabeth R *WhAmArt 85*
Kellogg, F R *AmArch 70*
Kellogg, Mrs. Francis Leonard *FolkA 86*
Kellogg, Harriet B *WhAmArt 85*
Kellogg, Harrietta B *DcWomA*
Kellogg, Mrs. Herbert Steele *WhAmArt 85*
Kellogg, Janet Reid 1894- *DcWomA, WhAmArt 85*
Kellogg, Jarvis Griggs 1805-1873 *NewYHSD*
Kellogg, Jean 1910- *WhAmArt 85*
Kellogg, Joseph Mitchell 1885- *ArtsAmW 2, WhAmArt 85*
Kellogg, Katherine L *DcWomA, WhAmArt 85*
Kellogg, Laura Elizabeth Gardner 1846-1886 *ArtsEM, DcWomA*
Kellogg, Martin *WhAmArt 85*
Kellogg, Mary Kilbourne 1814-1889 *DcWomA*
Kellogg, Maurice Dale 1919- *WhoAmA 76, -78, -80, -82, -84*
Kellogg, Miner Kilbourne 1814-1889 *NewYHSD*
Kellogg, Noah J *NewYHSD*
Kellogg, Norman Porter 1927- *AmArch 70*
Kellogg, Richard Edwin 1930- *AmArch 70*
Kellogg, Richard Eugene 1936- *AmArch 70*
Kellogg, Steven 1941- *IlsBYP*
Kellogg, Steven Castle 1941- *IlsCB 1967*
Kellogg, Mrs. T Steele *DcWomA*
Kellogg, Thomas M 1862-1935 *BiDAmAr*
Kellow, Kate *DcWomA*
Kellum, Frank 1865-1935 *FolkA 86*
Kellum, John 1807-1871 *BiDAmAr*
Kellum, John 1809-1871 *MacEA*
Kelly *FolkA 86*
Kelly, A J *AmArch 70*
Kelly, Alice M *DcWomA*
Kelly, Andrew Taylor 1894- *AfroAA*
Kelly, Angela Mary 1950- *MacBEP*
Kelly, Ann E *FolkA 86*
Kelly, Annie D d1933 *WhAmArt 85*
Kelly, Annie Davisson d1933 *DcWomA*
Kellie, Annie Elizabeth d1946 *DcBrA 1*
Kelly, Arleen P *WhoAmA 78, -80, -82, -84*
Kelly, Augustus *NewYHSD*
Kelly, Burnham 1912- *AmArch 70*
Kelly, Mrs. Charles *ArtsEM, DcWomA*
Kelly, Charles Edward 1902- *ClaDrA, WhoArt 80, -82*
Kelly, Clay 1874- *WhAmArt 85*
Kelly, Clyde Wetmore 1880-1927? *BiDAmAr*
Kelly, Deborah S *MarqDCG 84*
Kelly, Don Jay 1926- *AmArch 70*
Kelly, E Paul 1937- *AmArch 70*
Kelly, Edna 1890- *DcWomA, WhAmArt 85*
Kelly, Elisabeth 1825-1890 *DcWomA*
Kelly, Ellsworth 1923- *AmArt, BnEnAmA, ConArt 77, -83, DcAmArt, DcCAA 71, -77, DcCAA 81, McGDA, OxTwCA, PhDcTCA 77, PrintW 83, -85, WhoAmA 73, -76, -78, -80, -82, -84, WorArt[port]*
Kelly, Faustina James 1876- *DcWomA, WhAmArt 85*
Kelly, Felix 1916- *ConArt 77, DcBrA 1, WhoArt 80, -82, -84*
Kelly, Ferdinand Paul 1918- *AmArch 70*
Kelly, Francis *DcCAr 81*
Kelly, George T 1894- *AmArch 70*
Kelly, Sir Gerald 1879-1972 *PhDcTCA 77*
Kelly, Sir Gerald Festus 1879-1972 *DcBrA 1*
Kelly, Grace *DcWomA*
Kelly, Grace Veronica 1884- *DcWomA, WhAmArt 85*
Kelly, H *DcVicP 2*
Kelly, Hannah 1860- *DcWomA*
Kelly, Hannah R *WhAmArt 85*
Kelly, Harold Osman 1884-1955 *PhDcTCA 77*
Kelly, Helen *DcWomA*

Kelly, Herbert *WhAmArt 85*
Kelly, Hilda O'Farrill De *WorFshn*
Kelly, Isaac Perry 1925- *WhoAmA 76, -78, -80, -82, -84*
Kelly, J C *MarqDCG 84*
Kelly, J Frederick 1888-1947 *BiDAmAr*
Kelly, J Redding d1939 *WhAmArt 85*
Kelly, J Wallace *WhAmArt 85*
Kelly, James *FolkA 86, NewYHSD*
Kelly, James 1913- *DcCAA 71, -77, WhoAmA 73, -76, -78, -80, -82, -84*
Kelly, James Anthony *WhAmArt 85*
Kelly, James E 1855-1933 *WhAmArt 85*
Kelly, Joel Lee 1957- *MarqDCG 84*
Kelly, John *DcVicP 2, FolkA 86, OfPGCP 86*
Kelly, John F 1875-1940 *BiDAmAr*
Kelly, John Melville 1877- *ArtsAmW 2*
Kelly, John Melville 1879- *WhAmArt 85*
Kelly, John S *ArtsEM, WhAmArt 85*
Kelly, John Terence 1922- *AmArch 70*
Kelly, John William 1930- *AmArch 70*
Kelly, Joseph *NewYHSD*
Kelly, Judith Henriette 1826-1883 *DcWomA*
Kelly, Julia *DcWomA, WhAmArt 85*
Kelly, Lee 1932- *WhoAmA 73, -76, -78, -80, -82, -84*
Kelly, Leon 1901- *DcCAA 71, -77, WhAmArt 85, WhoAmA 73, -76, -78, -80, -82, -84*
Kelly, Loucile Jerome 1913- *WhAmArt 85*
Kelly, Louise *WhAmArt 85*
Kelly, Louise 1879- *DcWomA*
Kelly, Louise Minert 1879- *ArtsAmW 3*
Kelly, Lucy A *DcWomA*
Kelly, Margaret Elizabeth 1890- *DcWomA*
Kelly, Marie *DcWomA, WhAmArt 85*
Kelly, Mary *DcWomA*
Kelly, Mary 1941- *ConBrA 79[port], WhoAmA 84*
Kelly, Mary F *FolkA 86*
Kelly, Michael *NewYHSD*
Kelly, Minnie A *DcWomA*
Kelly, Myrle E 1891- *ArtsAmW 3*
Kelly, Norman E 1926- *AmArch 70*
Kelly, P S *AmArch 70*
Kelly, Mrs. Paul *WorFshn*
Kelly, Paul Gregory 1908- *WhAmArt 85*
Kelly, Richard Barrett Talbot 1896- *DcBrWA*
Kelly, Richard Barrett Talbot 1896-1971 *DcBrA 1*
Kelly, Robert B 1892-1932 *BiDAmAr*
Kelly, Robert George 1822-1910 *DcVicP 2*
Kelly, Robert George Talbot 1861-1934 *DcBrA 1, DcBrBI, DcBrWA, DcVicP 2*
Kelly, Robert Lester 1926- *AmArch 70*
Kelly, Robert Talbot 1861- *ClaDrA*
Kelly, S W *WhAmArt 85*
Kelly, Susan W 1855- *DcWomA*
Kelly, T J *NewYHSD*
Kelly, Thomas *NewYHSD*
Kelly, Thomas 1795?-1841? *NewYHSD*
Kelly, Thomas J, III 1947- *MacBEP*
Kelly, Thomas Meikle 1866- *ClaDrA*
Kelly, Tom *DcBrBI, DcVicP 2*
Kelly, W H *FolkA 86*
Kelly, W P, Jr. *AmArch 70*
Kelly, Walt 1913-1973 *IlsBYP, WorECom*
Kelly, Walter W 1941- *WhoAmA 73, -76, -78*
Kelly, William *BiDAmAr*
Kelly, William d1944 *DcBrA 1*
Kelly, William Andrew 1924- *AmArch 70*
Kelly, William Boulton 1928- *AmArch 70*
Kelly, William F *NewYHSD*
Kelly, William J 1838?- *NewYHSD*
Kelly, William Joseph 1943- *WhoAmA 78, -80, -82, -84*
Kelman, Benjamin 1887- *WhAmArt 85*
Kelman, Maureen 1952- *DcCAr 81*
Kelman, Ralph 1935- *AmArch 70*
Kelner, Hans *McGDA*
Kelp, Gunter Zamp 1941- *DcCAr 81*
Kelpe, Karl *WhAmArt 85*
Kelpe, Paul 1902- *WhoAmA 73, -76, -78, -80, -82, -84*
Kels, Hans, The Elder 1480?-1559 *McGDA*
Kels, Hans, The Younger 1507?-1566? *McGDA*
Kelsa, James *CabMA*
Kelsall, Charles 1782-1857 *BiDBrA*
Kelsey, C *NewYHSD*
Kelsey, C J *DcBrA 1*
Kelsey, Dorothy Storey 1893- *DcWomA*
Kelsey, Floyd Lamar, Jr. 1925- *AmArch 70*
Kelsey, Francis *DcBrECP*
Kelsey, Frank *ClaDrA, DcVicP 2*
Kelsey, John Field 1925- *AmArch 70*
Kelsey, John Warren 1937- *AmArch 70*
Kelsey, Muriel Chamberlain *WhAmArt 85*
Kelsey, Muriel Chamberlin *WhoAmA 73, -76, -78, -80, -82, -84*
Kelsey, Richard 1791-1856 *BiDBrA*
Kelsey, Richmond Irwin 1905- *WhAmArt 85*
Kelsey, Samuel *FolkA 86*
Kelso, Helen May 1890- *DcWomA, WhAmArt 85*
Kelso, John *AntBDN G, CabMA*
Kelso, R D *AmArch 70*

Kelso, Ruth Cromble *DcWomA, WhAmArt 85*
Kelson, James R 1888-1968 *FolkA 86*
Kelssen *McGDA*
Keltch, Jerry Lee 1932- *AmArch 70*
Kelter, William J *NewYHSD*
Kelton, Samuel *NewYHSD*
Kelz, Maria Barbara 1724-1798 *DcWomA*
Kemalettin 1870-1927 *MacEA*
Keman, Georges Antoine 1765-1830 *DcBrECP*
Kemb, Charles *NewYHSD*
Kemble, E W 1861-1933 *WhAmArt 85*
Kemble, Edward Windsor 1861- *DcBrBI*
Kemble, Edward Windsor 1861-1933 *ArtsAmW 1, IlBEAAW, IlrAm A, -1880*
Kemble, Edward Winsor 1861-1933 *WorECar*
Kemble, Richard 1932- *AmArt, WhoAmA 76, -78, -80, -82, -84*
Kemble, William *NewYHSD*
Kemeny, Gyorgy 1936- *ConDes*
Kemeny, John *WhAmArt 85*
Kemeny, Peter 1955- *MarqDCG 84*
Kemeny, Zoltan 1907-1965 *ConArt 77, -83, OxTwCA, PhDcTCA 77*
Kemeny, Zoltan 1908-1965 *McGDA*
Kemenyffy, Steven 1943- *WhoAmA 78, -80, -82, -84*
Kemenyffy, Susan B Hale 1941- *WhoAmA 78, -80, -82, -84*
Kemeryck, Colyn Van *McGDA*
Kemeys, Edward *ArtsNiC*
Kemeys, Edward 1843-1907 *DcAmArt, IlBEAAW, McGDA, WhAmArt 85*
Kemeys, Laura 1860?-1920? *DcWomA*
Kemeys, Laura S *WhAmArt 85*
Kemko, Josef 1887-1960 *OxTwCA*
Kemm, Robert *DcVicP, -2*
Kemmelmeyer, Frederick *FolkA 86, NewYHSD*
Kemmerer, Alfred G 1925- *AmArch 70*
Kemmon, Joseph *FolkA 86*
Kemner, B T 1929- *AmArch 70*
Kemoha 1914- *WhoAmA 73, -76, -78, -80*
Kemp, A *DcVicP 2, FolkA 86*
Kemp, Amy K P *DcVicP 2, DcWomA*
Kemp, D *FolkA 86*
Kemp, Mrs. Davidson *DcVicP 2*
Kemp, Eleanor Maria Hilda 1910- *DcBrA 1*
Kemp, Frederick *FolkA 86*
Kemp, George 1795-1844 *MacEA*
Kemp, George Meikle 1795-1844 *BiDBrA*
Kemp, George Steve 1948- *MarqDCG 84*
Kemp, Georgie W *DcVicP 2*
Kemp, Harris Atteridge 1912- *AmArch 70*
Kemp, J O *AmArch 70*
Kemp, John *DcBrWA, DcVicP 2*
Kemp, Kenneth *AfroAA*
Kemp, L *DcWomA*
Kemp, Nicolaes De 1574-1646 *ClaDrA*
Kemp, Oliver 1887-1934 *ArtsAmW 2, WhAmArt 85*
Kemp, Paul Zane 1928- *WhoAmA 73, -76, -78, -80, -82, -84*
Kemp, Percy *DcBrBI*
Kemp, R W *AmArch 70*
Kemp, Richard Jay, Jr. 1925- *AmArch 70*
Kemp, Robert Randolph 1954- *MarqDCG 84*
Kemp, Roger 1910- *McGDA*
Kemp, William *NewYHSD*
Kemp, William David 1912- *AmArch 70*
Kemp-Welch, Edith M *DcVicP 2*
Kemp-Welch, Edith M 1870-1941 *DcWomA*
Kemp-Welch, Lucy Elizabeth *ClaDrA*
Kemp-Welch, Lucy Elizabeth 1869-1958 *DcBrA 1, DcBrBI, DcVicP 2, DcWomA*
Kemp-Welch, Margaret d1968 *DcBrA 1, DcWomA*
Kempa, E F *AmArch 70*
Kempe, Fritz 1909- *ConPhot, ICPEnP A, MacBEP*
Kempe, Harriet *DcBrWA, DcVicP, -2, DcWomA*
Kempen, Wink Van 1948- *DcCAr 81*
Kempeneer, Pieter *McGDA*
Kemper, A L *WhAmArt 85*
Kemper, Alfred M 1933- *AmArch 70*
Kemper, Christopher *FolkA 86*
Kemper, Edward *FolkA 86*
Kemper, Henry W *NewYHSD*
Kemper, John Garner 1909- *WhAmArt 85, WhoAmA 73, -76, -78, -80, -82, -84*
Kemper, M D *AmArch 70*
Kemper, Ruby Webb *WhAmArt 85*
Kemper, Ruby Webb 1883- *DcWomA*
Kemper, Simon *FolkA 86*
Kempers, Mart 1924- *WhoGrA 62, -82[port]*
Kempf, Anna 1890- *DcWomA*
Kempf, F P 1886- *ArtsAmW 3*
Kempf, F P T *WhAmArt 85*
Kempf, Michel 1946- *MacBEP*
Kempf, Thomas M *WhAmArt 85*
Kempf, Thomas M 1895- *ArtsAmW 3*
Kempf, Tud 1886- *WhAmArt 85*
Kemplay, Charles H *DcVicP 2*
Kempner, Helen Hill 1938- *WhoAmA 80, -82, -84*
Kempsell, Jake 1940- *DcCAr 81*
Kempshall, Hubert Kim 1934- *WhoArt 80, -82, -84*
Kempshed, John *BiDBrA*

Kent, John Wellington 1920- *ConGrA 1[port]*
Kent, Leslie *WhoArt 82N*
Kent, Leslie 1890- *DcBrA 1, DcSeaP, WhoArt 80*
Kent, Leslie Harcourt 1890- *ClaDrA*
Kent, Lloyd Willington 1907- *AmArch 70*
Kent, M E *DcWomA*
Kent, Miss M E *NewYHSD*
Kent, Mable T *DcWomA*
Kent, Margaret Louise 1913- *WhAmArt 85*
Kent, Mary *WhoArt 80, -82*
Kent, Norman 1903-1972 *WhAmArt 85, WhoAmA 78N, -80N, -82N, -84N*
Kent, Rockwell 1882- *IlrAm D, McGDA*
Kent, Rockwell 1882-1971 *BnEnAmA, ConArt 77, -83, DcAmArt, DcCAA 71, -77, GrAmP, IlrAm 1880, IlsBYP, IlsCB 1744, OxTwCA, PhDcTCA 77, WhAmArt 85, WhoAmA 78N, -80N, -82N, -84N*
Kent, Stephen William 1931- *AmArch 70*
Kent, Thomas Frank 1944- *WhoAmA 76*
Kent, William *DcNiCA*
Kent, William 1684-1758 *ClaDrA*
Kent, William 1685?-1748 *BiDBrA, BkIE, DcBrECP, DcD&D[port], MacEA, OxArt, OxDecA, WhoArch*
Kent, William 1685?-1758 *McGDA*
Kent, William 1686?-1748 *AntBDN G*
Kent And Stanley *EncASM*
Kent-Biddlecombe, Jessica Doreen 1898- *ClaDrA*
Kentenber, John *AntBDN Q*
Kentish, P *DcBrECP*
Kentz, Joseph *FolkA 86*
Kenwell, Anna Maria *DcWomA*
Kenworthy, Esther *DcVicP 2, DcWomA*
Kenworthy, John Dalzell 1858-1954 *DcBrA 1, DcVicP 2*
Kenworthy, Jonathan 1943- *DcCAr 81*
Kenworthy, Vitilena *ArtsEM*
Kenyon, Ben Herrington 1923- *AmArch 70*
Kenyon, Colleen Frances 1951- *ICPEnP A, MacBEP, WhoAmA 80, -82, -84*
Kenyon, Douglas M 1942- *MacBEP*
Kenyon, E F *DcVicP 2*
Kenyon, George *DcVicP 2*
Kenyon, Henry R d1926 *WhAmArt 85*
Kenyon, Kathleen 1951- *ICPEnP A, MacBEP*
Kenyon, Leslie Harrison 1922- *AmArch 70*
Kenyon, Ley 1913- *WhoArt 80, -82, -84*
Kenyon, Norman 1901- *WhAmArt 85*
Kenyon, P S *AmArch 70*
Kenyon, Zula *ArtsAmW 3, WhAmArt 85*
Kenzan 1663-1743 *OxArt*
Kenzan 1664-1743 *McGDA*
Kenzan, Ogata 1663-1743 *OxDecA*
Kenzo 1939- *ConDes*
Kenzo 1945- *FairDF FRA[port]*
Keogh, Michael 1821?- *NewYHSD*
Keough, Patrick 1786-1863 *MacEA*
Keough, Robert Paul 1942- *MarqDCG 84*
Keough, W F, Jr. *AmArch 70*
Keown, C R *AmArch 70*
Kepalaite, Elena *WhoAmA 73, -76, -78, -80*
Kepalas *WhoAmA 73, -76, -78, -80, -82, -84*
Kepenek, Suat Mufahham 1925- *AmArch 70*
Kepes, Gyorgy 1906- *ConDes, ConPhot, DcCAA 71, -77, ICPEnP, MacBEP, McGDA, OxTwCA, WhoAmA 73, -76, -78, -80, -82, -84*
Kepes, Juliet *IlsCB 1967*
Kepes, Juliet 1919- *IlsCB 1946, -1957*
Kepets, Hugh 1946- *PrintW 83, -85*
Kepets, Hugh Michael 1946- *WhoAmA 73, -76, -78, -80, -82, -84*
Kephisdotus *McGDA*
Kepka, Vladimir 1925- *DcCAr 81*
Kepka, Zdenek 1930- *DcCAr 81*
Keplinger, Lona Miller *WhAmArt 85*
Keplinger, Lona Miller 1876-1956 *DcWomA*
Kepner, Absalom B *FolkA 86*
Kepner, Isaac *FolkA 86*
Kepner, Rita M 1944- *WhoAmA 82, -84*
Kepner, William *FolkA 86*
Keppel, William Coutts 1832-1894 *DcBrBI*
Keppie, Jessie *DcBrA 1*
Keppie, Jessie d1951 *DcWomA*
Keppie, John 1862-1945 *DcBrA 1*
Keppie, John 1863-1945 *MacEA*
Keppler, George 1856- *WhAmArt 85*
Keppler, Joseph 1837-1894 *WorECar*
Keppler, Udo J 1872-1956 *WorECar*
Keppler, Victor 1904- *ConPhot*
Keppler, Victor 1905- *ICPEnP*
Keppner, R H *AmArch 70*
Kepps, Alfred *ArtsAmW 1*
Ker, Balfour *WhAmArt 85*
Ker, Marie Sigsbee *WhAmArt 85*
Ker, Mary Ellen *DcWomA*
Ker, W A *DcVicP 2*
Ker, William B *WhAmArt 85*
Kerak, Jozef 1891-1945 *OxTwCA*
Kerbis, Gertrude Lempp 1926- *AmArch 70*
Kerby, John H 1858-1936 *BiDAmAr*

Kerby, Joseph 1857-1911 *ArtsAmW 1*
Kerby, Kate d1936 *WhAmArt 85*
Kerche, VanDer *NewYHSD*
Kerckhove, Antonia VanDen *DcWomA*
Kerckhove, Joseph VanDen 1667-1724 *ClaDrA*
Kerder, August *NewYHSD*
Kerelis, Albert J 1928- *AmArch 70*
Kerfoot, Margaret 1901- *WhAmArt 85, WhoAmA 73, -76*
Kerfoot, W H *AmArch 70*
Kerigan, Mrs. Ambrose, Jr. *WhAmArt 85*
Kerigan, Mildred Anderson Post 1892-1921 *DcWomA*
Kerkam, Earl d1965 *WhoAmA 78N, -80N, -82N, -84N*
Kerkam, Earl 1890-1965 *WhAmArt 85*
Kerkhove, Joseph VanDen 1667-1724 *ClaDrA*
Kerkhove, Louise VanDe 1860?- *DcWomA*
Kerkhove, Marie Louise VanDe 1831- *DcWomA*
Kerkovius, Ida 1879- *McGDA, PhDcTCA 77*
Kerkovius, Ida 1879-1970 *DcWomA*
Kerkovius, Ruth 1921- *WhoAmA 73, -76, -78, -80, -82*
Kerleroux, Jean-Marie 1936- *WhoGrA 82[port]*
Kerley, C R *AmArch 70*
Kerley, Thomas William 1923- *AmArch 70*
Kerlin, Laura L *WhAmArt 85*
Kerlin, Laura Lindsey *DcWomA*
Kerling, Anna E 1862-1920 *DcWomA*
Kerlow, Isaac Victor 1958- *MarqDCG 84*
Kermabon, Adelia Marie *DcWomA*
Kermacy, Martin Stephen 1915- *AmArch 70*
Kermadec, Eugene 1899- *OxTwCA*
Kermadec, Eugene De 1899- *PhDcTCA 77*
Kermarrec, Joel 1939- *DcCAr 81*
Kermes, Constantine John 1923- *WhoAmA 73, -76, -78, -80, -82, -84*
Kern, Arthur 1931- *WhoAmA 73, -76, -78, -80, -82, -84*
Kern, Benjamin Jordan 1818-1849 *IlBEAAW, NewYHSD*
Kern, Dennis M 1948- *MarqDCG 84*
Kern, Doreen 1931- *WhoArt 80, -82, -84*
Kern, Edward August *AmArch 70*
Kern, Edward M 1823-1863 *ArtsAmW 1*
Kern, Edward Meyer 1823-1863 *IlBEAAW, NewYHSD*
Kern, George *ArtsEM*
Kern, George Tilden 1921- *AmArch 70*
Kern, H G, Jr. *AmArch 70*
Kern, Hans F 1943- *MarqDCG 84*
Kern, John *NewYHSD*
Kern, Josephine M *WhAmArt 85*
Kern, Leonhard 1588-1662 *McGDA*
Kern, Michael 1580-1649 *McGDA*
Kern, Richard H 1821-1853 *ArtsAmW 1*
Kern, Richard Hovenden 1821-1853 *IlBEAAW, NewYHSD*
Kern-Lofftz, Marie *DcWomA*
Kernan, Catherine 1948- *PrintW 85*
Kernan, Joseph F 1878- *WhAmArt 85*
Kernan, Margot 1927- *ICPEnP A, MacBEP*
Kernan, Sean 1942- *ICPEnP A, MacBEP*
Kerner, Charles Henry 1923- *AmArch 70*
Kerner, Jerome 1935- *AmArch 70*
Kerner, Nancy *DcCAr 81*
Kerney *NewYHSD*
Kernkamp, Anny 1868- *ClaDrA, DcWomA*
Kernodle, Ruth *ArtsAmW 3, WhAmArt 85*
Kernoff, Harry 1900- *WhoArt 80, -82, -84*
Kernoff, Harry Aaron 1900- *DcBrA 1*
Kernot, Mrs. James H *DcVicP 2*
Kerns, Ed *DcCAr 81*
Kerns, Ed 1945- *WhoAmA 73, -76, -78, -80*
Kerns, Ed, Jr. 1945- *WhoAmA 82, -84*
Kerns, Fannie M *WhAmArt 85*
Kerns, Fannie M 1878-1968 *ArtsAmW 2, DcWomA*
Kerns, Maude I 1876- *WhAmArt 85*
Kerns, Maude Irvine 1876- *ArtsAmW 1, DcWomA*
Kerns, Miriam *DcVicP 2*
Kerns, William *FolkA 86*
Kernstock, Karoly 1873-1940 *McGDA*
Kernstok, Gina *DcWomA*
Kernweider, M *NewYHSD*
Keron, Caroline *DcWomA*
Kerr *DcBrECP*
Kerr, Miss *DcWomA*
Kerr, Adam Green *ArtsAmW 3*
Kerr, Arthur 1926-1979 *WhoAmA 80N, -82N, -84N*
Kerr, Berta Borgenicht 1943- *WhoAmA 73, -76, -78*
Kerr, Blanche Weyburn 1872- *WhAmArt 85*
Kerr, Blanche Weyburn 1872-1955 *DcWomA*
Kerr, Bobbie Gladys 1910- *WhAmArt 85*
Kerr, Charles Henry Malcolm 1858-1907 *DcBrA 1, DcBrBI, DcVicP 2*
Kerr, Mrs. Chester *WhAmArt 85*
Kerr, D Stewart 1910- *AmArch 70*
Kerr, E Coe 1914- *WhoAmA 73*
Kerr, E Coe 1914-1973 *WhoAmA 76N, -78N, -80N, -82N, -84N*
Kerr, Edward T 1862-1907 *WhAmArt 85*
Kerr, Elizabeth *DcWomA*

Kerr, Estelle Muriel 1879- *DcWomA*
Kerr, Francis Kenneth *AmArch 70*
Kerr, Frederick James 1853- *ClaDrA, DcBrA 1, DcBrWA, DcVicP*
Kerr, George Cochrane *DcBrA 1, DcSeaP, DcVicP, -2*
Kerr, George F *WhAmArt 85*
Kerr, Henry D, III *MarqDCG 84*
Kerr, Henry Wright 1857-1936 *DcBrA 1, DcBrBI, DcBrWA, DcVicP 2*
Kerr, Irene Waite 1873- *ArtsAmW 1, DcWomA, WhAmArt 85*
Kerr, J Patrick 1941- *AmArch 70*
Kerr, J W *NewYHSD*
Kerr, James *BiDAmAr, NewYHSD*
Kerr, James Archbald 1909- *AmArch 70*
Kerr, James Robert 1932- *AmArch 70*
Kerr, James Wilfrid 1897- *ArtsAmW 2, WhAmArt 85, WhoAmA 73, -76, -78, -80, -82, -84*
Kerr, Jerry Keen 1934- *AmArch 70*
Kerr, John Hoare 1931- *WhoAmA 73, -76, -78, -80*
Kerr, John T 1954- *MarqDCG 84*
Kerr, Kenneth A 1943- *WhoAmA 73, -76, -78*
Kerr, Leslie 1934- *WhoAmA 73, -76*
Kerr, Louisa *DcWomA*
Kerr, Lucy Whitney 1883?-1976 *DcWomA*
Kerr, Marcus H *ArtsEM*
Kerr, Margaret *DcVicP 2*
Kerr, Mary S 1888- *WhAmArt 85*
Kerr, Robert *NewYHSD*
Kerr, Robert 1823-1904 *DcVicP 2*
Kerr, Robert 1824-1904 *MacEA*
Kerr, Robert Scott *WhAmArt 85*
Kerr, Susan 1944- *WhoArt 80, -82, -84*
Kerr, T *DcVicP 2*
Kerr, William *BiDAmAr*
Kerr, William B *EncASM*
Kerr, William Edward 1936- *AmArch 70*
Kerr-Lawson, James 1864-1939 *DcBrBI*
Kerr-Lawson, James 1865-1939 *DcBrA 1, DcVicP 2*
Kerr-Nelson, Alice *DcWomA*
Kerremans, William *ArtsEM*
KerricK, Arthur T *WhAmArt 85*
Kerricx, Katrina Klara 1684-1762 *DcWomA*
Kerricx, Willem Ignatius 1682-1745 *ClaDrA*
Kerrigan, Mark Leo 1954- *MarqDCG 84*
Kerrigan, Maurie 1951- *WhoAmA 82, -84*
Kerrigan, William Joseph 1949- *MarqDCG 84*
Kerrisk, Michael Timothy 1961- *MarqDCG 84*
Kerry, William L *DcVicP 2*
Kerschbaumer, Anton 1885-1931 *McGDA*
Kersey, A M *DcVicP 2*
Kersey, Joseph 1909- *AfroAA*
Kersey, Pliny Earle 1850-1873 *ArtsAmW 3*
Kershaw, Agnes *DcVicP 2*
Kershaw, Frederick *NewYHSD*
Kershaw, J Franklin d1917 *DcBrA 2*
Kershaw, James M *NewYHSD*
Kershaw, Mary E *DcBrA 1, DcWomA*
Kershner, Frederick Vance 1904- *AmArch 70*
Kersill, William *AntBDN Q*
Kerslake, Kenneth Alvin 1930- *WhoAmA 73, -76, -78, -80, -82, -84*
Kerssenbroek, Gisela Von *DcWomA*
Kerstetter, Barbara Ann 1928- *WhoAmA 76, -78, -80, -82*
Kerstetter-Bailey, Barbara Ann 1928- *WhoAmA 84*
Kersting, Georg Friedrich 1785-1847 *OxArt*
Kerswill, J W Roy 1925- *AmArt, WhoAmA 73, -76, -78, -80, -82, -84*
Kerswill, Roy 1925- *IlBEAAW*
Kertell, George *FolkA 86*
Kertess, Klaus D 1940- *WhoAmA 73, -76, -78, -80, -82*
Kertesz, Andre 1894- *ConPhot, DcCAr 81, ICPEnP, MacBEP, PrintW 85, WhAmArt 85*
Kerth, Albert Lucien 1924- *AmArch 70*
Kervily, George LeSerrec De 1883- *ArtsAmW 2*
Kerwin, Mary Catherine 1902- *WhAmArt 85*
Kerwood, William 1779- *CabMA*
Kerxton, Jack Smith 1933- *AmArch 70*
Kerz, Leo 1912-1976 *ConDes*
Kerzeske, Ralph *WhAmArt 85*
Kerzie, Ted L *DcCAr 81*
Kerzie, Ted L 1943- *AmArt, WhoAmA 82, -84*
Keseru, Ilona 1933- *DcCAr 81*
Keske, Ronald William 1932- *AmArch 70*
Keskulla, Carolyn Windeler 1912- *WhAmArt 85, WhoAmA 73, -76*
Kesler, Clara E 1910- *WhAmArt 85*
Kesler, Frederick *NewYHSD*
Kesler, Michael d1794 *CabMA*
Kesnow, Joseph F 1919- *AmArch 70*
Kessanis, Nikos *OxTwCA*
Kessel, Dmitri 1902- *ConPhot, ICPEnP, MacBEP*
Kessel, Ferdinand Van 1648-1696 *ClaDrA, McGDA*
Kessel, Jan Van 1626-1679 *ClaDrA, OxArt*
Kessel, Jan Van, I 1626-1679 *McGDA*
Kessel, Jan Van, II 1654-1708 *McGDA*
Kessel, Jan Van, III 1641-1680 *ClaDrA*

Kimball, Yeffe 1914-1978 *WhoAmA 80N, -82N, -84N*
Kimball And Restaurick *EncASM*
Kimball And Sargent *CabMA*
Kimbel, Richard M 1865-1942 *WhAmArt 85*
Kimber, Hetty Donne *DcWomA*
Kimber, Miss S V M *DcBrA 1*
Kimberlin, Clarence W 1871-1935 *BiDAmAr*
Kimberly, Cara Draper 1876- *WhAmArt 85*
Kimberly, Cara Draper 1876-1961 *DcWomA*
Kimberly, Denison 1814-1863 *NewYHSD*
Kimberly, James H *NewYHSD*
Kimberly, Joseph A *NewYHSD*
Kimble, Colby *NewYHSD*
Kimble, Edward Arnold 1946- *MarqDCG 84*
Kimble, Evan F *IlDcG*
Kimble, G W *FolkA 86*
Kimble, James C 1926- *AmArch 70*
Kimble, Stephen C *EncASM*
Kimbrell, Leonard Buell 1922- *WhoAmA 80, -82, -84*
Kimbrough, Dodge *WhoAmA 73, -76, -78*
Kimbrough, Frank Richmond d1902 *ArtsAmW 3, WhAmArt 85*
Kimbrough, Sara Dodge *WhoAmA 82, -84*
Kimbrough, Sarah Dodge *WhoAmA 80*
Kimbrough, Verman 1902- *WhoAmA 73*
Kime, L Edward 1932- *AmArch 70*
Kimfel *AntBDN E*
Kimmel *FolkA 86*
Kimmel, Cary Allen 1943- *MarqDCG 84*
Kimmel, Christopher 1830?- *NewYHSD*
Kimmel, Frederick K *NewYHSD*
Kimmel, John D *NewYHSD*
Kimmel, Lu d1973 *WhAmArt 85*
Kimmel, Lu 1905-1973 *IlBEAAW*
Kimmel, P K *NewYHSD*
Kimmel-Cohn, Roberta 1937- *WhoAmA 76, -78, -80, -82, -84*
Kimmell, G F *AmArch 70*
Kimmell, Steven D 1938- *MarqDCG 84*
Kimmelman, Harold 1923- *WhoAmA 73, -76, -78, -80, -82, -84*
Kimmelman, Philip 1910- *AmArch 70*
Kimmich, Walter C 1941- *MarqDCG 84*
Kimmons, Leroy Sheldon 1924- *AmArch 70*
Kimpton, W *BiDBrA*
Kimura, Ihei 1901-1974 *ConPhot, ICPEnP A*
Kimura, Kazuo 1934- *ConDes*
Kimura, Riisaburo 1924- *WhoAmA 78, -80, -82, -84*
Kimura, Sueko M *WhoAmA 73, -76, -78, -80, -82, -84*
Kimura, Tsunehisa 1928- *WhoGrA 62*
Kimura, William Yusaburo 1920- *WhoAmA 73, -76, -78, -80, -82, -84*
Kinahan, Lady Coralie 1924- *WhoArt 80, -82, -84*
Kinais, Rudolph *WhAmArt 85*
Kincade, Arthur Warren 1896- *WhoAmA 76, -78, -80, -82, -84*
Kincaid, Alexander *AntBDN Q*
Kincaid, D Thomas 1930- *AmArch 70*
Kincaid, Hollis Whipple 1909- *AmArch 70*
Kinch, Helvig Agnete 1872- *DcWomA*
Kincheloe, John Arthur *AmArch 70*
Kind, Joshua B 1933- *WhoAmA 78, -80, -82, -84*
Kind, Phyllis *WhoAmA 73, -76, -78, -80, -82, -84*
Kind, S *EncASM*
Kindall, George *FolkA 86*
Kindberg, Agnes Marie 1906- *WhoArt 80, -82, -84*
Kinder, Joan 1916- *WhoArt 80, -82, -84*
Kinder, Maria List 1902- *WhAmArt 85*
Kinder, Milton Robert 1907- *WhAmArt 85*
Kinder, Wesley Carr 1921- *AmArch 70*
Kinderlen, Conrad *FolkA 86*
Kindermann, Helmmo 1947- *WhoAmA 78, -80, -82, -84*
Kindermann, Helmmo R 1947- *ICPEnP A, MacBEP*
Kindermans, Jean Baptiste 1822-1876 *ClaDrA*
Kindersley, David Guy Barnabas 1915- *WhoGrA 82[port]*
Kindersley, Fanny K *DcWomA*
Kindig, Robert William 1928- *AmArch 70*
Kindle, Millicent R 1949- *MarqDCG 84*
Kindleberger, D *WhAmArt 85*
Kindler, Alice 1892-1980 *DcWomA*
Kindler, Alice Riddle *WhAmArt 85*
Kindler, George *NewYHSD*
Kindlund, Anna Belle Wing 1876- *WhAmArt 85*
Kindlund, Anna Belle Wing 1876-1922 *DcWomA*
Kindon, Miss M E *DcBrA 1, DcVicP*
Kindon, Mary Evelina *DcBrWA, DcVicP 2, DcWomA*
Kindsvatterin, Anna Magdalena 1748?-1820 *DcWomA*
Kindt, Claire *DcWomA*
Kindt, Isabelle Catherine *DcWomA*
Kindt, Laurence 1805-1863 *DcWomA*
Kindt, Marie Adelaide 1804-1884? *DcWomA*
Kinert, Reed C 1912- *WhAmArt 85*
King, A G *AmArch 70*
King, Agnes Gardner *DcWomA*
King, Albert F 1854- *WhAmArt 85*
King, Alfred Faris, II 1941- *WhoAmA 80, -82*

King, Amy Bertha *DcWomA*
King, Andre *AfroAA*
King, Anne *DcWomA*
King, Ashbel 1747?-1806 *CabMA*
King, Bertha *DcVicP 2*
King, Beverly S 1879-1935 *BiDAmAr*
King, Bianca N *ArtsEM, DcWomA*
King, Blanche Tuing Elliot 1895-1975 *DcWomA*
King, Blanche V *DcWomA*
King, Brawley M 1916- *AmArch 70*
King, Brian 1942- *DcCAr 81*
King, Mrs. Brian 1935- *WorFshn*
King, Bruce Anthony 1934- *MacBEP*
King, C *WhAmArt 85*
King, C J *AmArch 70*
King, Cecil 1921- *DcCAr 81*
King, Cecil George Charles 1881-1942 *ClaDrA, DcBrA 1*
King, Charles *NewYHSD*
King, Charles Arthur 1907- *AmArch 70*
King, Charles B 1786-1862 *ArtsNiC*
King, Charles B 1869- *WhAmArt 85*
King, Charles Bird 1785-1862 *BnEnAmA, DcAmArt, FolkA 86, IlBEAAW, NewYHSD*
King, Charles Brady 1869-1957 *ArtsEM*
King, Charles Erwin 1919- *AmArch 70*
King, Charles Robert Baker *DcVicP 2*
King, Clement *WhAmArt 85*
King, Clinton 1901- *WhAmArt 85*
King, Clinton Blair 1901- *WhoAmA 76, -78*
King, Clinton Blair 1901-1979 *WhoAmA 80N, -82N, -84N*
King, Daisy Blanche 1875- *WhAmArt 85*
King, Daisy Blanche 1875-1947 *DcWomA*
King, Daniel *FolkA 86*
King, Daniel 1622?-1664? *DcBrWA*
King, Daniel 1828?-1888 *FolkA 86*
King, David *AntBDN Q*
King, David 1946- *DcCAr 81*
King, David F 1937- *DcCAr 81*
King, David H, Jr. 1849-1916 *WhAmArt 85*
King, Dorothy *DcBrA 1, WhoArt 80, -82, -84*
King, E Brownlow *DcVicP 2*
King, E Stanton *WhAmArt 85*
King, Edith Lawrence *DcWomA, WhAmArt 85*
King, Edith Louise Mary 1870-1962 *DcWomA*
King, Edward *DcBrA 1, DcVicP 2, WhAmArt 85*
King, Edward R *DcBrBI, DcVicP 2*
King, Edward S 1900- *WhoAmA 73, -76, -78, -80, -82, WhoArt 80, -82*
King, Edwin F *NewYHSD*
King, Edwin H 1914- *AmArch 70*
King, Elaine A 1947- *WhoAmA 78, -80, -82, -84*
King, Eleanor 1909- *WhAmArt 85, WhoAmA 84*
King, Elizabeth *DcBrA 1, DcWomA*
King, Elizabeth A 1855- *DcWomA, WhAmArt 85*
King, Elizabeth Thomson *DcVicP 2*
King, Elizabeth Thomson 1848-1914 *DcWomA*
King, Emily *DcWomA*
King, Emma *DcWomA*
King, Emma B 1858-1933 *DcWomA, WhAmArt 85*
King, Ernest 1916- *AmArch 70*
King, Ethel May *WhoAmA 73, -76, -78, -80, -82*
King, Ethel Slade *DcVicP 2, DcWomA*
King, Eugene Paul 1923- *AmArch 70*
King, F H *DcVicP 2*
King, F R *AmArch 70*
King, Fannie *DcWomA*
King, Fanny Mahon 1865- *DcWomA, WhAmArt 85*
King, Francis Scott 1850- *WhAmArt 85*
King, Frank d1969 *WhoAmA 78N, -80N, -82N, -84N*
King, Frank G W *DcVicP 2*
King, Frank O 1883-1969 *WhAmArt 85, WorECom*
King, Frank W S 1870-1940 *BiDAmAr*
King, Fred *DcVicP 2*
King, Frederic Leonard 1879-1947 *WhAmArt 85*
King, Frederick *NewYHSD*
King, Frederick Curtis 1900- *AmArch 70*
King, G L *AmArch 70*
King, George B *NewYHSD*
King, George Clinton 1854- *WhAmArt 85*
King, Gerald L 1919- *AmArch 70*
King, Gertrude *DcWomA, WhAmArt 85*
King, Gillis 1904- *WhAmArt 85*
King, Graham Peter 1930- *WhoArt 80, -82, -84*
King, Gunning 1859-1940 *DcBrBI*
King, Guy 1864-1925 *BiDAmAr*
King, Gwyneth 1910- *WhAmArt 85*
King, H B *DcVicP 2*
King, H M *AmArch 70*
King, H W *DcBrBI*
King, Hamilton d1952 *WhoAmA 78N, -80N, -82N, -84N*
King, Hamilton 1871-1952 *WhAmArt 85*
King, Mrs. Harry 1895- *WhAmArt 85*
King, Harry Abbott 1900- *AmArch 70*
King, Harry S 1925- *AmArch 70*
King, Haynes 1831-1904 *ClaDrA, DcBrA 1, DcBrWA, DcVicP, -2*

King, Hayward Ellis 1928- *WhoAmA 73, -76, -78, -80*
King, Helen A 1904- *WhAmArt 85*
King, Henri Umbaji *AfroAA*
King, Henri Umbaji 1923- *WhoAmA 76, -78, -80, -82*
King, Henry *DcVicP 2*
King, Henry John Yeend 1855-1924 *DcBrA 1, DcBrBI, DcBrWA, DcVicP 2*
King, Henry N 1839- *ArtsEM*
King, Herman *AfroAA*
King, Horace 1906- *WhAmArt 85*
King, Isaac B 1801-1870 *CabMA*
King, J *DcBrECP*
King, J Arthur *DcVicP 2*
King, J F *ArtsEM*
King, J Thomas 1950- *MarqDCG 84*
King, J W *DcVicP 2*
King, Jacob *CabMA*
King, James *BiDBrA*
King, James DeWitt 1941- *AfroAA*
King, James S *NewYHSD*
King, James S 1852-1925 *WhAmArt 85*
King, James W *NewYHSD*
King, Jane Spear 1906- *WhAmArt 85*
King, Jesse Marion 1875-1949 *DcVicP 2*
King, Jessie M 1875-1949 *DcWomA*
King, Jessie M 1876-1948 *AntBDN B*
King, Jessie Marion 1875-1949 *DcBrA 1, DcBrWA*
King, Jessie Marion 1876-1949 *DcBrBI*
King, Joe 1835-1913 *FolkA 86*
King, John *BiDBrA, NewYHSD*
King, John 1777-1835 *CabMA*
King, John 1788-1847 *DcVicP, -2*
King, John 1949- *DcCAr 81*
King, John Baragwanath 1864-1939 *DcBrA 1, DcVicP 2*
King, John Clancy 1927- *AmArch 70*
King, John Crookshanks 1806-1882 *BnEnAmA, McGDA, NewYHSD*
King, John Dillard 1928- *AmArch 70*
King, John Duncan 1789-1863 *DcBrWA, DcVicP, -2*
King, John F 1937- *AfroAA*
King, John Henry 1926- *AmArch 70*
King, John Lockwood *DcVicP 2*
King, John M 1897- *WhAmArt 85*
King, John W *DcVicP 2*
King, John William *NewYHSD*
King, John Yeend 1855-1924 *DcVicP*
King, Joseph *FolkA 86*
King, Joseph B *WhAmArt 85*
King, Joseph Bertram 1924- *AmArch 70*
King, Joseph Wallace 1912- *WhoAmA 73, -76, -78*
King, Josiah Brown *FolkA 86*
King, Josiah Brown 1831-1889 *NewYHSD*
King, Katherine *DcVicP 2*
King, Katherine 1844- *DcWomA*
King, Katherine M *DcWomA, WhAmArt 85*
King, L M *AmArch 70*
King, L W *AmArch 70*
King, Laura Morin 1868?-1913 *DcWomA*
King, Laurence Edward *WhoArt 84N*
King, Laurence Edward 1907- *WhoArt 80, -82*
King, Louise *DcWomA*
King, Louise H *WhAmArt 85*
King, Lulu *DcWomA*
King, Lydia B *DcVicP 2, DcWomA*
King, Lyndel Irene Saunders 1943- *WhoAmA 84*
King, M A *NewYHSD*
King, M E *WhAmArt 85*
King, Mabel DeBra *DcWomA*
King, Mabel Debra d1950 *WhoAmA 78N, -80N, -82N, -84N*
King, Mabel DeBra 1895-1950 *WhAmArt 85*
King, Margaret *DcBrECP, DcWomA*
King, Marion P 1894- *WhAmArt 85*
King, Marion Permelia 1894- *DcWomA*
King, Martha Ellen *FolkA 86*
King, Mary *FolkA 86*
King, Mary 1926- *WhoArt 82, -84*
King, Mary A *DcWomA, WhAmArt 85*
King, Mary Elizabeth 1818-1902 *ArtsEM, DcWomA*
King, Mary Elizabeth 1899- *DcWomA, WhAmArt 85*
King, Mary Louise 1907-1939 *WhAmArt 85*
King, Melville 1869-1946 *BiDAmAr*
King, Minnie 1877- *WhAmArt 85*
King, Minnie Clark 1877- *ArtsAmW 3*
King, Murry S d1925 *BiDAmAr*
King, Myron *NewYHSD*
King, Myron Lyzon 1921- *WhoAmA 76, -78, -80, -82, -84*
King, Nathaniel Phippen 1796?-1819 *CabMA*
King, Norman Michael 1933- *AmArch 70*
King, Oliver D *WhAmArt 85*
King, P J *AmArch 70*
King, Paul d1969 *WhoAmA 78N, -80N, -82N, -84N*
King, Paul 1867-1947 *WhAmArt 85*
King, Perry Mark 1931- *AmArch 70*
King, Philip 1934- *DcCAr 81, PhDcTCA 77*
King, Phillip 1934- *ConArt 77, -83, ConBrA 79[port], OxTwCA, WorArt[port]*

Column 1

Kirby, Joshua 1716-1774 *BkIE*
Kirby, K Sarah N 1903- *WhoArt 80, -82, -84*
Kirby, Kent 1934- *PrintW 83, -85*
Kirby, Kent Bruce 1934- *MacBEP, WhoAmA 76, -78, -80, -82, -84*
Kirby, Laverne Howe 1912- *AmArch 70*
Kirby, Michael 1949- *WhoArt 80, -82, -84*
Kirby, Peter 1928- *AmArch 70*
Kirby, Rollin 1875- *WhAmArt 85*
Kirby, Rollin 1875-1952 *WorECar*
Kirby, Ron 1936- *ConArch*
Kirby, Thomas 1824-1890 *AntBDN M*
Kirby, Thomas Ellis 1847-1924 *WhAmArt 85*
Kirby, U *DcWomA*
Kirby, Weymouth Wightman 1907- *AmArch 70*
Kirby, William d1771 *BiDBrA, DcBrWA*
Kirby, William Henry, Jr. 1923- *AmArch 70*
Kirby, William Moses, Jr. 1926- *AmArch 70*
Kirby Mowry *EncASM*
Kirchbach, Franck 1859-1912 *ClaDrA*
Kirchbaum, Joseph 1831?-1926 *NewYHSD, WhAmArt 85*
Kirchgasler, John Anthony 1923- *AmArch 70*
Kirchhoffer, Henry 1781-1860 *DcBrWA*
Kirchman, Milton Frederick 1910- *AmArch 70*
Kirchmayer, John 1860-1930 *WhAmArt 85*
Kirchner, Ernst Ludwig 1880-1938 *ConArt 77, -83, McGDA, OxArt[port], OxTwCA, PhDcTCA 77*
Kirchner, Eva Lucille 1901- *WhAmArt 85*
Kirchner, H William 1853- *BiDAmAr*
Kirchner, Helen Isabel Ottilie *WhAmArt 85*
Kirchner, Johann Gottlob *AntBDN M*
Kirchner, Sylvester J 1871-1895 *ArtsEM*
Kirchner, W *DcWomA*
Kirchner, Zdenek 1934- *DcCAr 81*
Kirchner-Moldenhauer, Dorothea 1884- *DcWomA*
Kirchoff, Merlin Ray 1931- *AmArch 70*
Kirchsberg, Ernestine Von 1857- *DcWomA*
Kirckman, Jacob 1710-1792 *AntBDN K*
Kirili, Alain 1946- *ConArt 83, DcCAr 81*
Kirishjian, Vahe *WhAmArt 85*
Kirk, Alexis *WorFshn*
Kirk, Arthur Nevill *WhAmArt 85*
Kirk, Ballard Harry Thurston 1929- *AmArch 70*
Kirk, C *DcVicP 2*
Kirk, Chadwick John 1936- *AmArch 70*
Kirk, Charles D *EncASM*
Kirk, Clarence E *EncASM*
Kirk, Donald William, Jr. 1921- *AmArch 70*
Kirk, Dorothy 1900- *WhAmArt 85*
Kirk, Douglas William 1949- *WhoArt 82, -84*
Kirk, Elisha *FolkA 86*
Kirk, Eliza 1812- *DcWomA*
Kirk, Elizabeth 1866- *DcWomA, WhAmArt 85*
Kirk, Eve 1900- *DcBrA 1*
Kirk, Eve 1900-1969 *DcBrA 2*
Kirk, Francis C *WhAmArt 85*
Kirk, Frank C d1963 *WhoAmA 78N, -80N, -82N, -84N*
Kirk, Frank C 1889-1963 *WhAmArt 85*
Kirk, Henry Child d1914 *EncASM*
Kirk, Henry Child, Jr. *EncASM*
Kirk, Jerome 1923- *WhoAmA 76, -78, -80, -82, -84*
Kirk, John 1823?-1862? *NewYHSD*
Kirk, Julia A *ArtsEM, DcWomA*
Kirk, Lydia C *WhAmArt 85*
Kirk, M B *DcWomA*
Kirk, Mrs. M B *ArtsEM*
Kirk, Maria L *WhAmArt 85*
Kirk, Maria Louise 1860?- *ConICB, DcWomA*
Kirk, Mark-Lee *ConDes*
Kirk, Mary Wallace *WhAmArt 85*
Kirk, Michael 1947- *WhoAmA 78, -80, -82, -84*
Kirk, Paul Hayden 1914- *AmArch 70*
Kirk, Richard Scott 1926- *AmArch 70*
Kirk, Robert Dyrel 1929- *AmArch 70*
Kirk, Samuel 1793-1872 *BnEnAmA, EncASM*
Kirk, Thomas 1765-1797 *BkIE, DcBrECP*
Kirk, Thomas Alan 1930- *AmArch 70*
Kirk, W B *AntBDN M*
Kirk, William 1749-1823 *BiDBrA*
Kirk And Matz *EncASM*
Kirk And Smith *EncASM*
Kirkaldy, D *DcVicP 2*
Kirkall, Elisha 1685-1742 *BkIE*
Kirkbride, E R 1891-1968 *WhAmArt 85*
Kirkbride, Earle R d1968 *WhoAmA 78N, -80N, -82N, -84N*
Kirkbride, Edward Earle 1936- *AmArch 70*
Kirkbride, Louise 1952- *MarqDCG 84*
Kirkbride, Mrs. Vernon 1894- *WhAmArt 85*
Kirkbride, Vernon Thomas *WhAmArt 85*
Kirkby *AntBDN N*
Kirkby, Paula Zolloto 1934- *WhoAmA 73*
Kirkby, Thomas *DcVicP 2, NewYHSD*
Kirkby, Thomas 1775-1847? *DcBrECP*
Kirkeby, Per 1938- *ConArt 77, -83*
Kirkgaard, L Maria *WhAmArt 85*
Kirkham, Charlotte Burt *WhAmArt 85*
Kirkham, Charlotte Burt 1856- *DcWomA*
Kirkham, Guy 1864-1935? *BiDAmAr*

Column 2

Kirkham, Ralph W *WhAmArt 85*
Kirkham, Reuben 1850-1886 *IlBEAAW*
Kirkham, Richard A 1850?-1930 *ArtsAmW 3*
Kirkham, Ruben 1850?-1886 *ArtsAmW 1*
Kirkham, Samuel R 1833?- *NewYHSD*
Kirkhum, Mrs. R N *WhAmArt 85*
Kirkland, F 1892-1942 *WhAmArt 85*
Kirkland, Forrest 1892-1942 *ArtsAmW 2, IlBEAAW*
Kirkland, India Underhill *DcWomA*
Kirkland, Sally *WorFshn*
Kirkland, Tom Brown 1910- *AmArch 70*
Kirkland, Vance H 1904- *WhAmArt 85*
Kirkland, Vance Hall 1904- *WhoAmA 73, -76, -78, -80, -82, -84*
Kirkland, Wallace W 1891-1979 *ICPEnP A, MacBEP*
Kirkley, Caroline *DcWomA*
Kirkley, S *DcWomA*
Kirkman, Augusta Josepha *DcWomA*
Kirkmann, Augusta Josepha *DcWomA*
Kirkpatrick *FolkA 86*
Kirkpatrick, Mrs. A B *WhAmArt 85*
Kirkpatrick, Alexander *FolkA 86*
Kirkpatrick, Amy *DcWomA*
Kirkpatrick, Andrew *FolkA 86*
Kirkpatrick, Cornwall E *FolkA 86*
Kirkpatrick, Diane 1933- *WhoAmA 82, -84*
Kirkpatrick, Donald M 1887- *WhAmArt 85*
Kirkpatrick, Ethel *DcBrA 1, DcVicP 2, DcWomA*
Kirkpatrick, Frank LeBrun 1853-1917 *WhAmArt 85*
Kirkpatrick, Harriet *DcWomA, WhAmArt 85*
Kirkpatrick, Ida Marion *DcBrA 1, DcVicP 2*
Kirkpatrick, Ida Marion 1866- *DcWomA*
Kirkpatrick, James *CabMA*
Kirkpatrick, Joseph *DcBrWA*
Kirkpatrick, Joseph 1872- *DcVicP 2*
Kirkpatrick, Joseph 1872-1930? *DcBrA 2*
Kirkpatrick, Kenneth Wayne 1927- *AmArch 70*
Kirkpatrick, Lily *DcVicP 2*
Kirkpatrick, Marianne Elizabeth 1831-1877 *DcWomA*
Kirkpatrick, Marion *DcWomA*
Kirkpatrick, Marion Powers *WhAmArt 85*
Kirkpatrick, Murray *FolkA 86*
Kirkpatrick, Norton 1889-1934 *BiDAmAr*
Kirkpatrick, Suzann Louise 1915- *WhoArt 80, -82, -84*
Kirkpatrick, W *DcVicP 2*
Kirkpatrick, W A 1880- *WhAmArt 85*
Kirkpatrick, Wallace *FolkA 86*
Kirkpatrick, William Sharp 1919- *AmArch 70*
Kirkshaw, Frederick d1913 *DcBrA 2*
Kirkup, James *AntBDN Q*
Kirkup, Mary A *DcWomA, WhAmArt 85*
Kirkup, Seymour Stocker 1788-1880 *DcBrWA, DcVicP 2*
Kirkwood, David Mather 1926- *AmArch 70*
Kirkwood, E K, Jr. *AmArch 70*
Kirkwood, James 1716-1781 *CabMA*
Kirkwood, Jerry 1928- *AmArch 70*
Kirkwood, John Sutherland 1947- *WhoArt 80, -82, -84*
Kirkwood, Larry Thomas 1943- *WhoAmA 76, -78, -80, -82, -84*
Kirkwood, Mary Burnette 1904- *WhoAmA 73, -76, -78, -80, -82, -84*
Kirley, Rollin *WhAmArt 85*
Kirley, T A *AmArch 70*
Kirlian, Semyon Davidovitch *MacBEP*
Kirlian, Valentina Chrisanfovna *MacBEP*
Kirmmse, Ralph Theodore 1924- *AmArch 70*
Kirmse, Marguerite 1885-1954 *ConICB, DcWomA, IlsBYP, IlsCB 1744, -1946, WhAmArt 85*
Kirn, Ann Minette 1910- *IlsCB 1957*
Kirn, Ronald E *MarqDCG 84*
Kirpal, Elsa *DcWomA, WhAmArt 85*
Kirsch, Agatha B 1879- *ArtsAmW 1, WhAmArt 85*
Kirsch, Agatha Beatrice 1879- *DcWomA*
Kirsch, Dwight, Jr. 1899- *ArtsAmW 3, WhAmArt 85*
Kirsch, Frederick Dwight 1899- *ArtsAmW 1*
Kirsch, Johanna 1856- *DcWomA*
Kirsch, Robert V 1923- *AmArch 70*
Kirsch, Steven Todd 1956- *MarqDCG 84*
Kirschbaum, Edward H, Jr. 1929- *AmArch 70*
Kirschbaum, Joseph, Sr. 1829-1926 *FolkA 86*
Kirschenbaum, Bernard *DcCAr 81*
Kirschenbaum, Bernard Edwin 1924- *WhoAmA 76, -78, -80, -82, -84*
Kirschenbaum, Jules 1930- *DcCAA 71, -77, WhoAmA 73, -76, -78, -80, -82, -84*
Kirschner, Julius *EncASM*
Kirschner, Marie Louise 1852- *DcWomA*
Kirshaw, Luke 1770?-1821 *BiDBrA*
Kirshner, Raphael 1876-1917 *WhAmArt 85*
Kirsop, Joseph Henry 1886- *DcBrA 1*
Kirst, John *FolkA 86*
Kirstein, Edith 1881-1926 *DcWomA*
Kirstein, Lincoln 1907- *WhoAmA 73, -76, -78, -80, -82*
Kirstein, Mrs. Lincoln *WhoAmA 73, -76, -78, -80, -82*
Kirstein, Lincoln Edward 1907- *WhAmArt 85*

Column 3

Kirstel, Richard *ConPhot, ICPEnP A*
Kirsten, Richard Charles 1920- *WhAmArt 85, WhoAmA 73, -76*
Kirsten-Daiensai, Richard Charles 1920- *WhoAmA 78, -80, -82, -84*
Kirtland, Elizabeth S 1876- *WhAmArt 85*
Kirtland, G *DcBrECP*
Kirtland, James *FolkA 86*
Kirven, Peyton Edward 1924- *AmArch 70*
Kirves, Dietmar 1941- *DcCAr 81*
Kirwan, Ernest 1928- *AmArch 70*
Kirwan, James R 1931- *MarqDCG 84*
Kirwan, William Bourke 1814?- *DcBrWA, DcVicP 2*
Kisch, Gloria 1941- *PrintW 83, -85, WhoAmA 73, -76, -78, -80, -82, -84*
Kiseleff, Margareta 1862-1924 *DcWomA*
Kiselewski, Joseph 1901- *WhAmArt 85, WhoAmA 73, -76, -78, -80, -82, -84*
Kiser, Arthur Francis, Jr. 1925- *AmArch 70*
Kiser, Virginia Lee 1884- *WhAmArt 85*
Kisfaludi-Strobl, Zsigmond 1884- *McGDA*
Kish, Maurice *WhoAmA 73, -76, -78, -80, -82, -84*
Kish, Maurice 1898- *WhAmArt 85*
Kishi, Arnold T 1949- *MarqDCG 84*
Kishimoto, Katsutomo 1931- *MarqDCG 84*
Kisielius, Albin Bruno 1927- *AmArch 70*
Kiskadden, Robert Morgan 1918- *WhoAmA 73, -76, -78, -80, -82, -84*
Kisko, Ardell Alvin 1919- *AmArch 70*
Kisling, Moise 1891-1953 *ClaDrA, McGDA, OxTwCA, PhDcTCA 77*
Kisner, Benedict *FolkA 86*
Kisner, Bernard 1909- *WhoAmA 76, -78*
Kisner, John A *FolkA 86*
Kisner, Steven M 1955- *MarqDCG 84*
Kiss, August Karl Eduard 1802-1865 *McGDA*
Kiss, Augustus 1802-1865 *ArtsNiC*
Kiss, Sarolta 1883- *DcWomA*
Kissack, R A 1878- *WhAmArt 85*
Kissam, Henry S 1860-1930 *BiDAmAr*
Kissel, Eleanor M 1891-1966 *ArtsAmW 1*
Kissel, Eleanora M 1891-1966 *ArtsAmW 2, DcWomA*
Kissel, Eleonora 1891-1966 *IlBEAAW, WhAmArt 85*
Kissel, Irene 1904- *WhAmArt 85*
Kissel, William Thorn, Jr. 1920- *WhoAmA 73, -76, -78, -80, -82, -84*
Kisseleva, Elena Andreevna 1878- *DcWomA*
Kisseliova, Elena Andreevna 1878- *DcWomA*
Kissell, Elwood Louis 1927- *MarqDCG 84*
Kissinger, George Edwin 1918- *AmArch 70*
Kissinger, Stewart Slayton 1905- *AmArch 70*
Kissner, Franklin H 1909- *WhoAmA 73*
Kiste, Adolph 1812- *DcVicP 2*
Kiste, J A *DcVicP 2*
Kistler, Daniel D 1928- *AmArch 70*
Kistner, T C *AmArch 70*
Kisui *AntBDN L*
Kisvarday, Tibor Istvan 1931- *AmArch 70*
Kitabjian, Hagop Artin 1932- *AmArch 70*
Kitai, Kazuo 1944- *ICPEnP A*
Kitaj, R B 1932- *ConArt 83, ConBrA 79[port], DcCAr 81, OxTwCA, PhDcTCA 77, PrintW 83, -85, WhoAmA 78, -80, -82, -84, WorArt[port]*
Kitaj, Ron B 1932- *ConArt 77*
Kitaj, Ronald 1932- *WhoAmA 73, -76*
Kitani, Chigusa 1890-1947 *DcWomA*
Kitao, T Kaori 1933- *WhoAmA 84*
Kitatsuji, Yoshihisa 1948- *ConArt 77, -83*
Kitchell, John *NewYHSD*
Kitchell, Peter A 1919- *AmArch 70*
Kitchen, Annie Louise 1871- *DcWomA, WhAmArt 85*
Kitchen, Benjamin W 1933- *AmArch 70*
Kitchen, Bert *DcCAr 81*
Kitchen, Denis 1946- *WorECom*
Kitchen, E M *DcVicP 2, DcWomA*
Kitchen, Miss E M *DcBrWA*
Kitchen, Henry 1793?-1822 *BiDBrA*
Kitchen, R S *AmArch 70*
Kitchen, T S *DcBrWA, DcVicP, -2*
Kitchen, Tella 1902- *FolkA 86*
Kitchen, Thomas 1718-1784 *AntBDN I*
Kitchener, Bessie Maud 1886- *DcWomA*
Kitchener, Ina Maria 1957- *MarqDCG 84*
Kitchin, Benjamin Spurgeon 1892- *AfroAA*
Kitchin, Roy 1926- *DcCAr 81*
Kitchiner, Robert Montague 1907- *DcBrA 1*
Kitching, Ian Macdonald 1958- *MarqDCG 84*
Kitchingman, John 1740?-1781 *DcBrECP*
Kite, Joseph Milner d1946 *DcBrA 1*
Kite, Robert Woodville 1926- *AmArch 70*
Kite, Roger *DcCAr 81*
Kitfield, Benjamin K, Jr. 1817- *CabMA*
Kitfield, Thomas Hooper 1818- *CabMA*
Kitner, Harold 1921- *WhoAmA 73, -76, -78, -80, -82, -84*
Kitsell, Thomas R *DcVicP 2*
Kitson, Anne Meredith 1855?-1937 *DcWomA, WhAmArt 85*
Kitson, Catherine M *DcVicP 2*

Kitson, Frederick Lee 1952- *MarqDCG 84*
Kitson, Henry H 1863-1947 *WhAmArt 85*
Kitson, Michael 1926- *WhoArt 82, -84*
Kitson, Nathan *FolkA 86*
Kitson, R H *DcBrA 1*
Kitson, Robert Hawthorn d1947 *DcBrA 2*
Kitson, Robert L *DcVicP 2*
Kitson, Samuel James 1884-1906 *WhAmArt 85*
Kitson, Theo Alice 1871?-1932 *DcWomA*
Kitson, Theo Alice Ruggles 1876-1932 *WhAmArt 85*
Kitt, Emma 1885-1953? *DcWomA*
Kitt, Emma 1885-1955? *WhAmArt 85*
Kitt, Katherine F 1876- *WhAmArt 85*
Kitt, Katherine Florence 1876- *ArtsAmW 2,*
 DcWomA
Kitta, George Edward 1953- *WhoAmA 78, -80, -82,*
 -84
Kittas, Elizabeth Boggs 1938- *AmArch 70*
Kittell, Nicholas Biddle 1822-1894 *FolkA 86,*
 NewYHSD
Kittelsen, Theodor 1857-1914 *WorECar*
Kittelson, John Henry 1930- *IlBEAAW,*
 WhoAmA 76, -78, -80
Kittinger, John *FolkA 86*
Kittinger, Peg Phillips 1896- *ArtsAmW 2*
Kittle, Nellie *FolkA 86*
Kittleman, J M *AmArch 70*
Kitton, Frederick George *DcBrWA, DcVicP 2*
Kitton, Frederick George 1856-1903 *DcBrBI*
Kitton, R *DcBrBI*
Kittredge, Kraemer 1905- *WhAmArt 85*
Kittredge, Nancy 1938- *AmArt, WhoAmA 82, -84*
Kittredge, Robert *WhAmArt 85*
Kitts, Barry Edward Lyndon 1943- *WhoArt 80, -82,*
 -84
Kitts, Jasmine DeLancey 1869- *ArtsAmW 2,*
 DcWomA, WhAmArt 85
Kitts, Jessie DeLancey 1869- *ArtsAmW 2*
Kitzel, Herbert 1928- *DcCAr 81*
Kitzinger, Ernst 1912- *WhoAmA 73, -76, -78, -80,*
 -82, -84
Kiva, Lloyd *WhoAmA 73, -76, -78, -80, -82, -84*
Kiverley d1789 *DcBrECP*
Kivetoruk *FolkA 86*
Kivett, Clarence 1905- *AmArch 70*
Kiyochika 1847-1915 *McGDA*
Kiyohara, Tama 1861-1939 *DcWomA*
Kiyohiro *McGDA*
Kiyokatsu *AntBDN L*
Kiyomasu I *McGDA*
Kiyomasu II 1706-1763 *McGDA*
Kiyomitsu 1735-1785 *McGDA*
Kiyonaga 1752-1815 *McGDA*
Kiyonaga, Torii 1752-1815 *OxArt*
Kiyonobu I 1664-1729 *McGDA*
Kiyonobu II 1702-1752 *McGDA*
Kiyooka, Roy *OxTwCA*
Kizer, Charlotte *WhAmArt 85*
Kizer, Charlotte Elizabeth *WhoAmA 73, -76*
Kjaerholm, Poul 1929-1980 *ConDes*
Kjargaard, John Ingvard 1902- *WhoAmA 73, -76, -78,*
 -80, -82, -84
Kjarval, Johannes Sveinsson 1885- *PhDcTCA 77*
Kjeldsen, Lana *WhAmArt 85*
Kjellberg, Agnes *DcWomA*
Kjerner, Esther 1873-1952 *DcWomA*
Klaauw, Jacques *McGDA*
Klaber, Eugene Henry 1883- *AmArch 70*
Klaber, John James 1884- *AmArch 70*
Klablena, Edward 1881-1933 *DcNiCA*
Klabunde, Charles *DcCAr 81*
Klabunde, Charles S 1935- *PrintW 83, -85*
Klabunde, Charles Spencer 1935- *WhoAmA 78, -80,*
 -82, -84
Klackner, Christian 1850-1916 *WhAmArt 85*
Klackner, John 1848-1916 *WhAmArt 85*
Klaebisch, Louis *NewYHSD*
Klaeson, A R, Jr. *AmArch 70*
Klaetke, Frank William 1930- *AmArch 70*
Klages, D *AmArch 70*
Klages, Frank F 1892- *WhAmArt 85*
Klagstad, Arnold Ness 1898- *WhAmArt 85*
Klagstad, August 1866- *WhAmArt 85*
Klammer, Mariska 1873- *DcWomA*
Klank, Conrad *EncASM*
Klank, F William *EncASM*
Klank, Frederick W *EncASM*
Klank, George H *EncASM*
Klank, George H, Jr. *EncASM*
Klank, Herbert *EncASM*
Klank, William *EncASM*
Klaphauer, Johann Georg *ClaDrA*
Klapheck, Konrad 1935- *ConArt 77, DcCAr 81,*
 OxTwCA, PhDcTCA 77, PrintW 83, -85
Klapheck, Konrad 1938- *ConArt 83*
Klapka, Jerome J 1888- *WhAmArt 85*
Klapp, J E *AmArch 70*
Klar, Francis Joseph *FolkA 86*
Klar, Mary Shepard 1882- *WhAmArt 85*
Klar, Walter Hughes 1882- *WhAmArt 85*
Klarin, Winifred Erlick 1912- *WhoAmA 73, -76, -78,*

 -80, -82, -84
Klarwein, Mati 1932- *PrintW 85*
Klas, Oehlin 1928- *MarqDCG 84*
Klasen, Peter 1935- *ConArt 77, DcCAr 81*
Klass, Friedrich Christian 1752-1827 *ClaDrA*
Klass, Maria *DcWomA*
Klassen, Cecil Frank 1918- *AmArch 70*
Klassen, John P 1888- *WhAmArt 85*
Klassen, Michael *MarqDCG 84*
Klassnik, Robin 1947- *ConArt 77*
Klasstorner, Samuel 1895- *WhAmArt 85*
Klattau, Laurin Von *McGDA*
Klauber, Alice 1871- *ArtsAmW 1, WhAmArt 85*
Klauber, Alice E 1871-1951 *DcWomA*
Klauder, Charles Z *WhAmArt 85*
Klauder, Charles Z 1872-1938 *BiDAmAr, MacEA*
Klauder, Charles Zeller, Jr. 1905- *AmArch 70*
Klauder, Elfrieda *WhAmArt 85*
Klauder, Jacob *NewYHSD*
Klauder, Mary *DcWomA, WhAmArt 85*
Klauke, Jurgen 1943- *DcCAr 81*
Klaus, Clarence Edward, Jr. 1937- *AmArch 70*
Klausmeyer, Thomas Henry 1921- *AmArch 70*
Klavans, Minnie 1915- *WhoAmA 73, -76, -78, -80,*
 -82, -84
Klaven, Marvin L 1931- *WhoAmA 76, -78, -80, -82,*
 -84
Klavins, Janis 1930- *ICPEnP A*
Klaw, Alonzo 1885- *WhAmArt 85*
Kleb, Oscar 1923- *AmArch 70*
Klebe, Elfreda D 1884- *DcWomA, WhAmArt 85*
Klebe, Gene 1905- *WhoAmA 82, -84*
Klebe, Gene 1907- *WhoAmA 73, -76, -78, -80*
Kleboe, Bernhardt *WhAmArt 85*
Kleckner, Susan 1941- *WhoAmA 82, -84*
Klee, Marguerite *DcWomA*
Klee, Paul 1879-1940 *ConArt 77, -83, McGDA,*
 OxArt[port], OxTwCA, PhDcTCA 77
Kleemann, Ron 1937- *AmArt, PrintW 83, -85,*
 WhoAmA 78, -80, -82, -84
Kleen, Anna Beata 1813-1894 *DcWomA*
Kleen, Thyra *DcWomA*
Kleen, Tyra *WhAmArt 85*
Klehl, J *FolkA 86*
Kleibacker, Charles *FairDF US*
Kleiber, Hans 1887-1967 *ArtsAmW 1, IlBEAAW,*
 WhAmArt 85
Kleidon, Dennis Arthur 1942- *WhoAmA 78, -80, -82,*
 -84
Kleihues, Josef Paul 1933- *ConArch*
Kleijne, David 1754-1805 *DcSeaP*
Kleiman, Alan 1938- *WhoAmA 76, -78, -80, -82, -84*
Kleiman, Joseph 1930- *AmArch 70*
Kleiminger, A F 1865- *WhAmArt 85*
Klein, A *DcVicP 2*
Klein, A John 1943- *MarqDCG 84*
Klein, Aart 1909- *ConPhot, ICPEnP A*
Klein, Albert Daniel 1932- *AmArch 70*
Klein, Albert F 1882-1935 *BiDAmAr*
Klein, Alexander 1879-1961 *MacEA*
Klein, Andrew *FolkA 86*
Klein, Anna 1883- *DcWomA*
Klein, Anne 1923-1974 *ConDes, FairDF US[port],*
 WorFshn
Klein, August *NewYHSD*
Klein, Auguste 1777?- *DcWomA*
Klein, Bart J 1958- *MarqDCG 84*
Klein, Beatrice T 1920- *WhoAmA 76, -78, -80, -82*
Klein, Benjamin *WhAmArt 85*
Klein, Calvin 1942- *WorFshn*
Klein, Calvin Richard 1942- *ConDes*
Klein, Carroll A 1894-1946 *BiDAmAr*
Klein, Catharina 1861-1929 *DcWomA*
Klein, Cecelia F 1938- *WhoAmA 78, -80, -82, -84*
Klein, Cesar 1876-1954 *McGDA, OxTwCA,*
 PhDcTCA 77
Klein, Doris 1918- *WhoAmA 73, -76, -78, -80, -82,*
 -84
Klein, Ellen Lee *WhoAmA 84*
Klein, Erwin B 1933-1974 *ICPEnP A*
Klein, Esther M 1907- *WhoAmA 73, -76, -78, -80,*
 -82, -84
Klein, Francis 1829?- *FolkA 86*
Klein, Frank 1915- *AmArch 70*
Klein, Frank Anthony 1890- *WhAmArt 85*
Klein, Fred Robert 1938- *AmArch 70*
Klein, Fredoline 1831?- *FolkA 86*
Klein, George Frederick, Jr. 1923- *AmArch 70*
Klein, Gerold Dale 1939- *AmArch 70*
Klein, Gwenda J 1949- *WhoAmA 84*
Klein, H J *AmArch 70*
Klein, H Peter 1923- *AmArch 70*
Klein, Henry *WhAmArt 85*
Klein, Henry 1920- *AmArch 70*
Klein, I 1897- *ConGrA 1, WhAmArt 85*
Klein, Irving Robert 1906- *AmArch 70*
Klein, Isidore 1897- *WorECar*
Klein, J *AmArch 70*
Klein, J Alan *WhAmArt 85*
Klein, J Arvid 1932- *AmArch 70*

Klein, J B *AmArch 70*
Klein, Jeanette *WhAmArt 85*
Klein, Johann Adam 1792-1875 *ArtsNiC*
Klein, John 1834?-1901 *FolkA 86*
Klein, Joseph Bernard 1907- *AmArch 70*
Klein, Kenneth August 1932- *AmArch 70*
Klein, Lawrence E 1942- *MarqDCG 84*
Klein, Lewis D 1923- *AmArch 70*
Klein, Lillie V O'Ryan *ArtsAmW 2, DcWomA,*
 WhAmArt 85
Klein, Louis Peace 1932- *WhoGrA 82[port]*
Klein, Lynn 1950- *WhoAmA 84*
Klein, Mabel S *DcWomA, WhAmArt 85*
Klein, Margaretha *DcWomA*
Klein, Mathias *FolkA 86*
Klein, Medard 1905- *WhoAmA 73, -76, -78, -80, -82,*
 -84
Klein, Medard P 1905- *WhAmArt 85*
Klein, Michael *WhAmArt 85*
Klein, Michael d1851 *FolkA 86*
Klein, Michael 1941- *MarqDCG 84*
Klein, Michael Eugene 1940- *WhoAmA 80, -82, -84*
Klein, Milton 1930- *AmArch 70*
Klein, N M *AmArch 70*
Klein, Nathan *WhAmArt 85*
Klein, Patricia Windrow *WhoAmA 78, -80, -82, -84*
Klein, Paul R 1946- *WhoAmA 80, -82, -84*
Klein, Peter H 1951- *MarqDCG 84*
Klein, Sandor C 1912- *WhoAmA 73, -76, -78, -80,*
 -82, -84
Klein, Sardi 1949- *MacBEP*
Klein, Serge 1914- *AmArch 70*
Klein, Simone Marie 1878- *DcWomA*
Klein, Stanley 1936- *MarqDCG 84*
Klein, Stanley H 1908- *AmArch 70*
Klein, Stephan Marc 1938- *AmArch 70*
Klein, Stephanie *DcWomA*
Klein, Vladimir 1950- *DcCAr 81*
Klein, William *WhAmArt 85*
Klein, William 1926- *DcCAr 81*
Klein, William 1928- *ConPhot, ICPEnP, -A,*
 MacBEP, OxTwCA
Klein, Yves 1928-1962 *ConArt 77, -83, McGDA,*
 OxTwCA, PhDcTCA 77, WorArt
Kleinbardt, Ernest 1874-1962 *WhAmArt 85*
Kleinbardt, Ernest 1875-1962 *WhoAmA 80N, -82N,*
 -84N
Kleinbardt, Marie *DcWomA*
Kleinbauer, W Eugene 1937- *WhoAmA 78, -80, -82,*
 -84
Kleinert, Hermine E 1880?-1943 *DcWomA,*
 WhAmArt 85
Kleinhans, Robert Burton 1907- *ClaDrA*
Kleinhofen, Henry *FolkA 86*
Kleinholz, Frank *DcCAr 81*
Kleinholz, Frank 1901- *AmArt, McGDA,*
 WhAmArt 85, WhoAmA 73, -76, -78, -80, -82,
 -84
Kleinknecht, Hermann 1943- *DcCAr 81*
Kleinman, Alyce Chaikin *WhoAmA 84*
Kleinman, Art 1949- *PrintW 83, -85*
Kleinman, Sue *WhoAmA 76, -80, -82, -84*
Kleinman, Sue 1917- *WhoAmA 73*
Kleinmann, Alice Adele *DcWomA*
Kleinofen, Henry *NewYHSD*
Kleinpeter, R R *AmArch 70*
Kleinrock, Sybil *PrintW 83, -85*
Kleins, Valts 1960- *ICPEnP A*
Kleinsasser, Allen J 1930- *AmArch 70*
Kleinschmidt, D B *AmArch 70*
Kleinschmidt, Florian Arthur 1897- *AmArch 70,*
 ArtsAmW 3
Kleinschmidt, Gisela 1926- *DcCAr 81*
Kleinschmidt, Peter 1923- *DcCAr 81*
Kleinschmidt, Robert Sere 1940- *AmArch 70*
Kleinsmith, Bruce John *WhoAmA 76, -78, -80, -82,*
 -84
Kleinsmith, Gene 1941- *WhoAmA 80, -82, -84*
Kleiser, Jeffrey Means 1954- *MarqDCG 84*
Kleiser, Lorentz 1879- *WhAmArt 85*
Kleiser, Lorentz 1879-1963 *ArtsAmW 2*
Kleist, Addie *DcWomA*
Kleist, Addie L *WhAmArt 85*
Kleist, Emma Von 1840-1892 *DcWomA*
Kleist, Michael Robert *MarqDCG 84*
Kleitch, Edith 1890-1950 *ArtsAmW 3*
Kleitch, Joseph 1885- *ArtsAmW 1*
Kleitch, Joseph 1885-1931 *ArtsAmW 3*
Kleitsch, Edna 1890-1950 *ArtsAmW 3*
Kleitsch, Joseph 1885- *ArtsAmW 1*
Kleitsch, Joseph 1885-1931 *ArtsAmW 3*
Kleitsch, Mrs. Joseph *WhAmArt 85*
Klekamp, B R *AmArch 70*
Klement, Vera 1929- *AmArt, DcCAr 81,*
 WhoAmA 76, -78, -80, -82, -84
Klements, C D *AmArch 70*
Klements, Walter Straton 1924- *AmArch 70*
Klemke, Werner 1917- *ConDes, WhoGrA 62*
Klemm, Germany 1900- *WhAmArt 85*
Klemm-Jager, Hedwig 1862- *DcWomA*
Klemmedson, R L *AmArch 70*

Kneeland, Samuel 1755-1828 *CabMA*
Kneeland, Stillman F *WhAmArt 85*
Kneeland And Adams *CabMA*
Kneen, E W 1866- *DcBrA 1, DcVicP 2*
Kneen, William 1862-1921 *DcBrA 1, DcVicP 2*
Kneer, William Clarke, Jr. 1925- *AmArch 70*
Kneeshaw, Cecilia Margaret 1883- *ClaDrA, DcBrA 1, DcWomA*
Kneipp, Caroline K 1807-1880 *DcWomA*
Kneipp, G *NewYHSD*
Kneisel, James Francis 1920- *AmArch 70*
Kneivih, Ot *NewYHSD*
Knell, Adolphus *DcBrWA, DcVicP 2*
Knell, J H *DcBrWA*
Knell, John Henry 1818?- *DcSeaP*
Knell, Lee Campbell 1926- *AmArch 70*
Knell, William Adolphus 1805-1875 *ClaDrA, DcBrWA, DcVicP, -2*
Knell, William Adolphus 1808?-1875 *DcSeaP*
Knell, William Callcott *DcBrWA, DcVicP, -2*
Knell, William Callcott 1830?-1876? *DcSeaP*
Kneller, Frank *WhoArt 80N*
Kneller, Frank 1914- *ClaDrA*
Kneller, Sir Godfrey 1646-1723 *ClaDrA, DcBrECP, McGDA*
Kneller, Sir Godfrey 1649?-1723 *OxArt*
Kneller, Johann Zacharias 1644-1702 *ClaDrA*
Knerr, Harold H 1883-1949 *WorECom*
Knerr, Harold Hering *WhAmArt 85*
Knerr, Sallie Frost 1914- *WhoAmA 73, -76, -78, -80, -82, -84*
Knewstub, W Holmes *DcVicP 2*
Knewstub, Walter John 1831-1906 *DcBrA 1, DcBrWA, DcVicP, -2*
Knez, Dejan 1961- *DcCAr 81*
Knibb, John *AntBDN D*
Knibb, Joseph 1640-1711 *AntBDN D, OxDecA*
Knibb, Samuel *OxDecA*
Knibbergen, Catharina Van *DcWomA*
Knibbergen, Francois Van 1597-1665? *McGDA*
Knickerbocker, Charles E *NewYHSD*
Knickerbocker, Helen *ArtsEM, DcWomA*
Knickerbocker, Irving S d1930 *WhAmArt 85*
Knief, Helen Jeanette 1909- *WhoAmA 82, -84*
Knief, Janet 1909- *WhoAmA 76, -78, -80*
Kniep, Frieda 1884- *DcWomA*
Knievel, Evel *OfPGCP 86*
Knifer, Julije *DcCAr 81*
Kniffin, Edgar Aldrich, Jr. *AmArch 70*
Kniffin, H R *WhAmArt 85*
Kniffin, Ralph Gus 1946- *WhoAmA 78, -80, -82, -84*
Knight, Miss *DcBrECP*
Knight, A W *AmArch 70*
Knight, Adah *DcVicP 2, DcWomA*
Knight, Adam d1931 *DcBrA 1, DcVicP 2*
Knight, Alfred E *DcVicP 2*
Knight, Anne 1946- *IlsCB 1967*
Knight, Arthur W *DcVicP 2*
Knight, Augusta *ArtsAmW 2*
Knight, Augusta d1938? *WhAmArt 85*
Knight, Augusta Henriette d1931 *DcWomA*
Knight, Avel De *AfroAA*
Knight, B Nathaniel 1942- *AfroAA*
Knight, Belinda D *FolkA 86*
Knight, Benjamin Thackston 1895-1977 *WorECar*
Knight, Bertram G *WhAmArt 85*
Knight, C *DcVicP 2*
Knight, C A *AmArch 70*
Knight, C J *DcVicP 2*
Knight, Charles *NewYHSD*
Knight, Charles 1743-1826 *McGDA*
Knight, Charles 1901- *DcBrA 1, WhoArt 80, -82, -84*
Knight, Charles, Sr. 1865-1948 *DcBrA 2*
Knight, Charles A *NewYHSD*
Knight, Charles Donald 1950- *MarqDCG 84*
Knight, Charles Frasuer 1932- *AmArch 70*
Knight, Charles Neil 1865- *DcBrA 1, DcVicP 2*
Knight, Charles Parsons 1829-1897 *ClaDrA, DcVicP, -2*
Knight, Charles Raleigh *DcBrBI*
Knight, Charles Robert 1874-1953 *IlsCB 1946, WhAmArt 85*
Knight, Christopher Allen 1950- *WhoAmA 80, -82, -84*
Knight, Clara 1861?- *DcBrA 1, DcWomA*
Knight, Clara 1861?-1899 *DcVicP 2*
Knight, Clayton 1891- *IlrAm D, WhAmArt 85*
Knight, Clayton 1891-1969 *IlrAm 1880, WorECom*
Knight, D Ridgway 1839-1924 *WhAmArt 85*
Knight, Daniel 1784?-1843 *BiDBrA*
Knight, Daniel Ridgway *ArtsNiC*
Knight, Daniel Ridgway 1839-1924 *ClaDrA*
Knight, Daniel Ridgway 1840-1924 *NewYHSD*
Knight, E H *AmArch 70*
Knight, Edward *NewYHSD*
Knight, Edward Loxton 1905- *ClaDrA, DcBrA 1*
Knight, Emily *FolkA 86*
Knight, Enoch 1771-1844 *CabMA*
Knight, Frank 1941- *DcCAr 81*
Knight, Frederic 1855-1930 *ArtsAmW 3*

Knight, Frederic 1898- *WhAmArt 85*
Knight, Frederic Charles 1898- *WhoAmA 73, -76, -78*
Knight, Frederic Charles 1898-1979 *WhoAmA 80N, -82N, -84N*
Knight, Frederic Hardwicke 1911- *MacBEP*
Knight, Frederick George *DcVicP 2*
Knight, G J *DcVicP 2*
Knight, George *DcSeaP, NewYHSD*
Knight, George Daniel, Jr. 1935- *AmArch 70*
Knight, Gwendolyn *AfroAA*
Knight, H *FolkA 86*
Knight, Harold 1874- *ClaDrA*
Knight, Harold 1874-1961 *DcBrA 1, DcVicP 2, OxArt*
Knight, Harold Clifford 1902- *AmArch 70*
Knight, Henry 1830?- *NewYHSD*
Knight, Henry Gally 1786-1846 *DcBrBI, DcBrWA*
Knight, Henry Hull *DcVicP 2*
Knight, Hilary *IlsCB 1967, WhoAmA 73, -76, -78, -80, -82, -84*
Knight, Hilary 1926- *IlsCB 1957*
Knight, Howard Besson 1897- *AmArch 70*
Knight, J G 1824-1892 *MacEA*
Knight, J Lee *NewYHSD*
Knight, J Louis *DcBrBI*
Knight, Jacob Jaskoviak 1938- *WhoAmA 78, -80, -82, -84*
Knight, James P *DcVicP 2*
Knight, John 1802?- *NewYHSD*
Knight, John 1945- *WhoAmA 82, -84*
Knight, John A 1825?- *NewYHSD*
Knight, John Baverstock 1788-1859 *DcBrWA, DcVicP 2*
Knight, John Buxton 1843-1908 *ClaDrA*
Knight, John Coleman 1918- *AmArch 70*
Knight, John Prescott 1803-1881 *ArtsNiC, ClaDrA, DcBrWA, DcVicP, -2*
Knight, Mrs. John Prescott *DcVicP 2*
Knight, John William Buxton 1842-1908 *DcBrA 1*
Knight, John William Buxton 1843-1908 *DcBrBI, DcBrWA, DcVicP, -2*
Knight, Joseph 1837-1909 *DcBrWA, DcVicP, -2*
Knight, Joseph 1838-1909 *DcBrA 1*
Knight, Joseph 1870- *DcBrA 1, DcVicP 2*
Knight, Joseph 1870-1950 *DcBrWA*
Knight, Judson R 1853-1899 *ArtsEM*
Knight, Julia *DcWomA*
Knight, Julia Murray 1889- *DcWomA*
Knight, K K *AmArch 70*
Knight, Katherine Sturges *WhAmArt 85*
Knight, Katherine Sturges 1890-1979 *IlrAm 1880*
Knight, L *FolkA 86*
Knight, Dame Laura 1877- *McGDA*
Knight, Laura 1877-1970 *ClaDrA, DcBrA 1, OxArt, OxTwCA*
Knight, Laura 1877-1971 *PhDcTCA 77*
Knight, Laura Arms 1877-1970 *DcWomA*
Knight, Lionel John 1901- *WhoArt 80*
Knight, Lois Atwood 1869-1899 *WhAmArt 85*
Knight, Louis Aston 1873- *WhAmArt 85*
Knight, Louis Aston 1873-1948 *ArtsAmW 3*
Knight, Mary *DcVicP 2, DcWomA*
Knight, Mary Ann 1776-1851 *DcWomA*
Knight, Maurice A *FolkA 86*
Knight, Paul *DcVicP 2*
Knight, R H *AmArch 70*
Knight, R P 1750-1824 *MacEA*
Knight, Richard 1623- *FolkA 86*
Knight, Richard, Jr. 1928- *AmArch 70*
Knight, Richard Payne 1750-1824 *DcBrWA, DcD&D, OxArt, OxDecA, WhoArch*
Knight, Robert 1921- *ConArt 77, DcCAr 81*
Knight, Robert 1944- *AfroAA*
Knight, Robert T 1827?- *NewYHSD*
Knight, S Dubois *ArtsAmW 3, ArtsEM*
Knight, Stephanas *FolkA 86*
Knight, T *NewYHSD*
Knight, T G *FolkA 86*
Knight, Tack 1895- *WhoAmA 76*
Knight, Tack 1895-1976 *WhoAmA 78N, -80N, -82N, -84N*
Knight, Thomas Allen 1934- *AmArch 70*
Knight, Thomas Lincoln, Jr. 1925- *WhoAmA 76, -78, -80*
Knight, Tom, Jr. 1925- *WhoAmA 82, -84*
Knight, Valentine *DcVicP 2*
Knight, W F *DcVicP 2*
Knight, W M *AmArch 70*
Knight, W S *DcVicP 2*
Knight, William *BiDBrA, DcVicP 2*
Knight, William d1832 *BiDBrA*
Knight, William 1871- *ClaDrA, DcBrA 1, DcVicP 2*
Knight, William Dewey, Jr. 1922- *AmArch 70*
Knight, William George d1938 *DcBrA 1, DcVicP 2*
Knight, William Henry 1823-1863 *ClaDrA, DcVicP, -2*
Knight, William Henry 1859- *DcBrA 1, DcVicP 2*
Knight, William Hutton 1938- *AmArch 70*
Knight, Wood Dewey 1923- *AmArch 70*
Knighton, Dorothea 1781- *DcWomA*

Knighton, Jack *AmArch 70*
Knighton, William C 1866-1938 *BiDAmAr*
Knighton-Hammond, Arthur Henry 1875-1970 *DcBrA 1*
Knights, Winifred Margaret 1899-1947 *DcBrA 1, DcWomA*
Knigin, Michael Jay 1942- *PrintW 83, -85, WhoAmA 73, -76, -78, -80, -82, -84*
Knigle, Gwendolyn *AfroAA*
Knijff, Wouter 1607?-1693? *McGDA*
Knille, Otto 1832- *ArtsNiC*
Kniller, Sir Godfrey 1649?-1723 *OxArt*
Knip, Henriette *DcWomA*
Knip, Henriette Gertrude 1783-1842 *DcWomA*
Knip, Pauline 1781-1851 *DcWomA*
Knipe, E Benson 1870- *WhAmArt 85*
Knipe, Eliza *DcWomA*
Knipe, Emilie 1870- *DcWomA*
Knipe, Helen *DcWomA, WhAmArt 85*
Knipe, Jacob *EncASM*
Knipers, W *FolkA 86, NewYHSD*
Knippa, E A *AmArch 70*
Knippers, Edward Cade, Jr. 1946- *WhoAmA 82, -84*
Knipscher, Gerard Allen 1935- *WhoAmA 76, -78, -80, -82, -84*
Knipschild, Robert 1927- *DcCAA 77, WhoAmA 73, -76, -78, -80, -82, -84*
Knirim, A D *FolkA 86*
Knirsch, Otto *NewYHSD*
Kniskern, John Poyer 1926- *AmArch 70*
Knittel, Anna 1841-1915 *DcWomA*
Knittel, D L 1935- *MarqDCG 84*
Kniveton, William *DcBrWA*
Knizak, Milan *OxTwCA*
Knizak, Milan 1940- *ConArt 77, -83*
Knobbs, Harry R 1902- *WhAmArt 85*
Knobelsdorff, Georg Wenceslaus 1699-1753 *McGDA*
Knobelsdorff, Georg Wenceslaus Von 1699-1753 *MacEA, OxArt*
Knobelsdorff, Georg Wenzeslaus Von 1699-1753 *WhoArch*
Knobelsdorff, George Wenceslas 1699-1753 *DcD&D*
Knobla, Bernard Herbert 1908- *AmArch 70*
Knoblauch, Eduard 1801-1865 *MacEA*
Knoble, Frank 1920- *AmArch 70*
Knobler, Lois Jean 1929- *WhoAmA 73, -76, -78, -80, -82, -84*
Knobler, Nathan 1926- *WhoAmA 73, -76, -78, -80, -82, -84*
Knobloch, Gertrud 1867- *DcWomA*
Knobloch, Isabelle S 1879- *DcWomA, WhAmArt 85*
Knoblock, *FolkA 86*
Knoblock, Herman *ArtsEM*
Knoblock, Joan 1917- *WhoArt 80, -82, -84*
Knoblock, Robert Conrad 1934- *AmArch 70*
Knoch, Leland McIntyre 1901- *WhAmArt 85*
Knoche, Lucille Morley 1899- *DcWomA*
Knochenmuss, Fanny Chase 1883-1962 *ArtsAmW 2*
Knodel, Gerhardt 1940- *DcCAr 81*
Knodle, Donald Harold 1920- *AmArch 70*
Knoebel, David 1949- *DcCAr 81*
Knoebel, David Jon 1949- *WhoAmA 84*
Knoebel, Jacob *FolkA 86*
Knoebel, Wolf 1940- *DcCAr 81*
Knoebel, Wolfgang 1940- *ConArt 77*
Knoechel, Hans *DcVicP 2*
Knoedel, Gerhardt 1940- *AmArt*
Knoedler, Cyriak *FolkA 86, NewYHSD*
Knoedler, Edmond L 1862-1933 *WhAmArt 85*
Knoedler, Roland F 1856-1932 *WhAmArt 85*
Knoesel, Erwin W H 1911- *AmArch 70*
Knoffel, J C 1686-1752 *WhArch*
Knoll, Florence 1917- *BnEnAmA, ConDes, DcD&D*
Knoll, Hans G 1914-1955 *BnEnAmA*
Knoll, Isabel A Giampietro *WhoAmA 84*
Knoll, Josepha *DcWomA*
Knoll, William *EncASM*
Knollenberg, Mrs. Bernhard *WhAmArt 85*
Knoller, Martin 1725-1804 *ClaDrA*
Knoller, Paco R 1950- *DcCAr 81*
Knollys, Courtenay Hugh 1918- *ClaDrA*
Knolton, David *CabMA*
Knoop, Dorothy Marie Anderson *DcWomA*
Knoop, Gitou 1902- *McGDA*
Knoop, Guitou *WhAmArt 85*
Knoop, Stuart Lawrence 1933- *AmArch 70*
Knopf, Alfred A *WhAmArt 85*
Knopf, Nellie A *WhAmArt 85*
Knopf, Nellie Augusta 1875-1962 *ArtsAmW 2, DcWomA*
Knopfle, Olga 1879-1961 *DcWomA*
Knopp, Gertrude M 1875- *DcBrA 1, DcWomA*
Knorr, Don Robert 1922- *AmArch 70*
Knorr, George *NewYHSD*
Knorr, Jeanne Boardman *WhoAmA 73, -76, -78, -80, -82, -84*
Knorr, Lester 1916- *WhoAmA 73, -76*
Knorre, Auguste *DcWomA*
Knorre, Johanna Louisa Dorothea 1766-1834 *DcWomA*
Knorth, Albert Stanley 1897- *AmArch 70*
Knost, Edward *FolkA 86*

Knostman, J W *AmArch 70*
Knothe, Alice *DcVicP 2*
Knothe, Richard John 1930- *AmArch 70*
Knott, Arthur Harold 1883- *ArtsAmW 2,*
WhAmArt 85
Knott, Charles Franklin 1911- *AmArch 70*
Knott, E *DcWomA*
Knott, Franklin Price 1854-1900 *ArtsAmW 1*
Knott, Franklin Price 1854-1930 *WhAmArt 85*
Knott, Gene 1883-1937 *WhAmArt 85*
Knott, John F *WhAmArt 85*
Knott, John Francis 1878-1963 *ArtsAmW 1,*
WorECar
Knott, Meredith Lee 1941- *MarqDCG 84*
Knott, Ralph 1878-1929 *DcD&D, McGDA*
Knott, Ralph N 1878-1929 *MacEA*
Knotter, Paul Steven 1952- *MacBEP*
Knotts, Howard Clayton 1922- *IlsCB 1967*
Knowland, R S *AmArch 70*
Knowland, Ralph Edward 1922- *AmArch 70*
Knowles, Alison 1933- *ConArt 77, -83, WhoAmA 78,*
-80, -82, -84
Knowles, Berenice *DcWomA*
Knowles, Billy C 1934- *AmArch 70*
Knowles, Christopher 1959- *DcCAr 81*
Knowles, Davidson *ClaDrA, DcBrBI, DcVicP, -2*
Knowles, Dorothy Elsie 1927- *WhoAmA 73, -76, -78,*
-80, -82
Knowles, Edward F 1929- *ConArch*
Knowles, Edward Frank 1929- *AmArch 70*
Knowles, Elizabeth A McG 1866-1928 *WhAmArt 85*
Knowles, Elizabeth A McGillivray 1866-1928
DcWomA
Knowles, F McGillvray 1860-1932 *WhAmArt 85*
Knowles, Florence M *WhAmArt 85*
Knowles, Frederick J 1874- *DcBrA 1, DcVicP 2*
Knowles, G *DcVicP 2*
Knowles, G T *DcVicP 2*
Knowles, George 1776?-1856 *BiDBrA*
Knowles, George Sheridan 1863-1931 *DcBrA 1,*
DcBrBI, DcBrWA, DcVicP, -2
Knowles, George T 1932- *AmArch 70*
Knowles, Harry P 1871-1944 *BiDAmAr*
Knowles, Mrs. Henry L *FolkA 86*
Knowles, Horace J *DcBrBI*
Knowles, Isaac W *DcNiCA, FolkA 86*
Knowles, J T, Jr. 1831-1908 *MacEA*
Knowles, J T, Sr. 1806-1884 *MacEA*
Knowles, James Thomas *DcVicP 2*
Knowles, Joe 1869-1942 *WhAmArt 85*
Knowles, Joseph 1869?-1942 *ArtsAmW 2*
Knowles, Joseph B d1891 *EncASM*
Knowles, Juliet *DcVicP 2*
Knowles, Leonora C E *DcWomA*
Knowles, Lila Caroline McGillivray 1886?- *DcWomA*
Knowles, Maida Doris Parlow French 1891- *DcWomA*
Knowles, Michael *DcCAr 81*
Knowles, Raymond Murrel 1924- *AmArch 70*
Knowles, Reginald Lionel *DcBrBI*
Knowles, Richard H 1934- *WhoAmA 73, -76, -78,*
-80, -82, -84
Knowles, Stephen M *EncASM*
Knowles, Thomas George 1928- *AmArch 70*
Knowles, W L *NewYHSD*
Knowles, W L And Co. *ArtsEM*
Knowles, Wilbur S 1857-1944 *BiDAmAr*
Knowles, Wilhelmina *DcWomA, WhAmArt 85*
Knowles, William Howard 1909- *AmArch 70*
Knowles, William L *ArtsEM*
Knowles, William Pitcairn *DcVicP 2*
Knowles, William W 1871-1944 *BiDAmAr*
Knowles And Harper *ArtsEM*
Knowles And Horton *ArtsEM*
Knowles And Ladd *EncASM*
Knowlton, Abraham 1756?-1797 *CabMA*
Knowlton, Alexander 1902- *AmArch 70*
Knowlton, Annie D *WhAmArt 85*
Knowlton, Bertha Mae *DcWomA*
Knowlton, Mrs. Daniel *WhAmArt 85*
Knowlton, Daniel Gibson 1922- *WhoAmA 73, -76, -78,*
-80, -82, -84
Knowlton, Ebenezer 1769-1810 *CabMA*
Knowlton, Grace Farrar 1932- *AmArt, WhoAmA 73,*
-76, -78, -80, -82, -84
Knowlton, Helen M *ArtsNiC*
Knowlton, Helen Mary 1832- *WhAmArt 85*
Knowlton, Helen Mary 1832-1918 *DcWomA,*
NewYHSD
Knowlton, J H *NewYHSD*
Knowlton, Jonathan 1937- *WhoAmA 73, -76, -78, -80,*
-82, -84
Knowlton, Mary F *DcWomA, WhAmArt 85*
Knowlton, Maud Briggs 1870-1956 *DcWomA,*
WhAmArt 85
Knowlton, Maude Briggs 1876-1956 *WhoAmA 80N,*
-82N, -84N
Knowlton, Monique 1937- *WhoAmA 78, -80, -82, -84*
Knowlton, Nathaniel 1761?- *CabMA*
Knowlton, Nathaniel, Sr. 1786-1859 *CabMA*
Knowlton, William 1805- *CabMA*
Knowlton, Willis Sargent 1808- *CabMA*

Knox, Archibald 1864-1931 *DcNiCA*
Knox, Archibald 1864-1933 *DcBrWA, DcVicP 2*
Knox, Arthur Howell 1880- *AmArch 70*
Knox, B D *DcVicP 2*
Knox, Clara Thomson 1882- *DcWomA,*
WhAmArt 85
Knox, Columbus *AfroAA*
Knox, Donald Ray 1949- *MarqDCG 84*
Knox, Edward *WhAmArt 85*
Knox, Elizabeth Ann 1944- *WhoAmA 76, -78, -80,*
-82
Knox, George 1922- *WhoAmA 73, -76, -78, -80, -82,*
-84
Knox, George James 1810-1897 *DcBrWA, DcVicP 2*
Knox, Grace M d1944 *WhAmArt 85*
Knox, Harry Cooke *WhoArt 80, -82, -84*
Knox, Harry Cooke 1905- *ClaDrA, DcBrA 1*
Knox, Helen Estelle *WhAmArt 85*
Knox, Helen Estelle 1890- *DcWomA*
Knox, Helen Tigner *AmArch 70*
Knox, James 1866- *WhAmArt 85*
Knox, James Thoburn 1927- *AmArch 70*
Knox, Jean *WhAmArt 85*
Knox, John 1778-1845 *DcVicP 2*
Knox, John 1936- *WhoArt 80, -82*
Knox, Joseph B *NewYHSD*
Knox, Julian F 1930- *AmArch 70*
Knox, Katharine McCook *WhoAmA 73, -76, -78, -80*
Knox, Katherine 1878-1965 *ArtsAmW 2, DcWomA*
Knox, Madeline 1890-1975 *DcBrA 2*
Knox, Malcolm Robinson 1911- *AmArch 70*
Knox, Margaret High 1950- *MarqDCG 84*
Knox, Nancy 1923- *WorFshn*
Knox, Robert Lewis 1924- *AmArch 70*
Knox, Seymour H 1898- *WhoAmA 73, -76, -78, -80,*
-82, -84
Knox, Simmie *AfroAA*
Knox, Susan Ricker *DcWomA, IlBEAAW,*
WhAmArt 85
Knox, T *DcVicP 2*
Knox, Thomas E *ArtsEM*
Knox, W C *FolkA 86*
Knox, W D *AmArch 70*
Knox, W P *NewYHSD*
Knudsen, Christian 1945- *WhoAmA 82, -84*
Knudsen, Knud 1832-1915 *ICPEnP A*
Knudsen, Marie Rasmine 1850-1890 *DcWomA*
Knudson, Donald W 1925- *AmArch 70*
Knudson, Helen Eliza *WhAmArt 85*
Knudson, K I *AmArch 70*
Knudson, Robert 1929- *IlBEAAW*
Knudson, Robert Leroy 1929- *WhoAmA 78, -80, -82,*
-84
Knuebel, John *WhAmArt 85*
Knutesen, Edwin B 1901- *WhAmArt 85*
Knuteson, Oscar *WhAmArt 85*
Knuth, R W *AmArch 70*
Knuth, Robert Craig 1930- *AmArch 70*
Knutsen, Knut 1903-1969 *ConArch, MacEA*
Knutsen, Lloyd Bernard *AmArch 70*
Knutson, Greta 1899- *DcCAr 81, DcWomA*
Kny, Frederick Engelbert *IlDcG*
Kny, Friedrich *DcNiCA*
Knyff, Alfred De *ArtsNiC*
Knyff, Alfred De 1819-1885 *ClaDrA*
Knyff, Jacob 1638-1681 *DcSeaP*
Knyff, Leonard 1650-1722 *DcBrECP*
Knyff, Wouter *McGDA*
Knyff, Wouter 1607-1693 *ClaDrA*
Ko, Anthony 1934- *WhoAmA 73, -76, -78, -80, -82,*
-84
Koanantakool, Hugh Thaweesak 1953- *MarqDCG 84*
Kobak, Evelyn *WhAmArt 85*
Kobashi, J *AmArch 70*
Kobayashi, Hideaki 1956- *MarqDCG 84*
Kobayashi, Katsumi Peter 1935- *WhoAmA 73, -76,*
-78, -80, -82, -84
Kobayashi, Kiyochika 1847-1915 *WorECom*
Kobayashi, N *AmArch 70*
Kobayashi, Naomi 1945- *DcCAr 81*
Kobayashi, Noboru 1926- *AmArch 70*
Kobayashi, Sandra Chantal 1958- *MarqDCG 84*
Kobayashi, Susumu 1939- *MarqDCG 84*
Kobayashi Okano, Clarice Miyako 1954-
MarqDCG 84
Kobbe, Gustave 1857-1918 *WhAmArt 85*
Kobbe, Helen Metcalfe *WhAmArt 85*
Kobbe, Herman *WhAmArt 85*
Kobbe, Marie Olga 1870- *DcWomA, WhAmArt 85*
Kobell, Anna 1794?-1847 *DcWomA*
Kobell, Ferdinand 1740-1799 *ClaDrA, McGDA*
Kobell, Hendrick 1751-1779 *DcSeaP*
Kobell, Hendrik 1751-1782? *DcBrECP*
Kobell, Jan, I 1756-1833 *ClaDrA*
Kobell, Wilhelm Von 1766-1853 *McGDA*
Kobenhaupt, Georg *McGDA*
Kober, Alfred John 1937- *WhoAmA 76, -78, -80, -82,*
-84
Kober, Charles McChesney 1923- *AmArch 70*
Kober, Dorota 1549-1622 *DcWomA*
Kober, Helene *DcWomA*

Kober, Leo 1878-1931 *WhAmArt 85*
Koberling, J R *AmArch 70*
Koberwein, Georg *DcVicP, -2*
Koberwein, Georgina *DcWomA*
Koberwein, Georgina F *DcVicP, -2*
Koberwein, Rosa *DcVicP, -2, DcWomA*
Kobes, Franziska 1803?- *DcWomA*
Kobilca, Ivana Johanna 1861-1926 *DcWomA*
Kobke, Christen 1810-1848 *OxArt*
Kobke, Christen Schjellerup 1810-1848 *McGDA*
Koblick, Freda *WhoAmA 73, -76, -78, -80, -82*
Koblik, W *AmArch 70*
Kobman, Clara H *WhAmArt 85*
Kobori Enshu *McGDA*
Kobro, Katarzyna 1898-1950 *OxTwCA,*
PhDcTCA 77
Kobro, Katarzyna 1898-1951 *DcWomA*
Kobsa, Calvin Kern 1927- *AmArch 70*
Kobuladze, Sergei 1909- *ClaDrA, WhoArt 80, -82,*
-84
Kobzdej, Alexander 1920- *OxTwCA, PhDcTCA 77*
Kocan, J H 1947- *ConArt 83*
Kocar, George 1948- *AmArt*
Koch *FolkA 86*
Koch, Ann Koenig *FolkA 86*
Koch, Armand D 1879-1932? *BiDAmAr*
Koch, Arthur P 1904- *WhAmArt 85*
Koch, Arthur Robert 1934- *WhoAmA 82, -84*
Koch, Bertha C d1975 *WhoAmA 76N*
Koch, Bertha Couch 1899-1975 *WhoAmA 78N, -80N,*
-82N, -84N
Koch, Berthe Couch 1899-1975 *ArtsAmW 2,*
DcWomA, WhAmArt 85
Koch, C *AmArch 70*
Koch, Carl 1912- *ConArch*
Koch, Charles Louis Phillip 1863- *WhAmArt 85*
Koch, Dieter 1954- *DcCAr 81*
Koch, E A *AmArch 70*
Koch, Edna *WhAmArt 85*
Koch, Edwin E 1915- *WhoAmA 76, -78, -80, -82, -84*
Koch, Elisa *DcWomA*
Koch, Gaetano 1849-1910 *MacEA, McGDA*
Koch, George *NewYHSD , WhAmArt 85*
Koch, George Joseph 1885-1951 *ArtsAmW 3*
Koch, Gerd 1929- *DcCAr 71, -77, WhoAmA 73,*
-76, -78, -80, -82, -84
Koch, Helen C 1892- *WhAmArt 85*
Koch, Helen C 1895- *DcWomA*
Koch, Helisena *DcWomA*
Koch, Henry G 1840- *BiDAmAr*
Koch, Irene Mabel 1929- *WhoAmA 73, -76*
Koch, Johanna 1866- *DcWomA*
Koch, John 1909- *ConArt 77, DcCAA 71, -77,*
WhAmArt 85, WhoAmA 73, -76, -78
Koch, John 1909-1978 *ConArt 83, WhoAmA 80N,*
-82N, -84N
Koch, Joseph Anton 1768-1839 *ArtsNiC, McGDA,*
OxArt
Koch, Karl F 1888- *ArtsAmW 3*
Koch, Lizette J 1909- *WhAmArt 85*
Koch, Lizette R 1899- *DcWomA*
Koch, Marie *DcWomA*
Koch, Miguel 1952- *MarqDCG 84*
Koch, P U *AmArch 70*
Koch, Peter 1900- *WhAmArt 85*
Koch, Phil 1948- *WhoAmA 80, -82*
Koch, Philip 1948- *WhoAmA 84*
Koch, Philip Frederick 1948- *AmArt*
Koch, Pyke 1901- *ConArt 77, -83, McGDA,*
PhDcTCA 77
Koch, R J *AmArch 70*
Koch, Ralph Richard 1928- *AmArch 70*
Koch, Richard *WhAmArt 85*
Koch, Richard 1889- *AmArch 70*
Koch, Robert 1918- *WhoAmA 73, -78, -80, -82, -84*
Koch, Samuel 1887- *FolkA 86, WhAmArt 85*
Koch, Theo John 1881- *WhAmArt 85*
Koch, Valentine *FolkA 86*
Koch, Virginia *WhoAmA 82, -84*
Koch, Virginia Greenleaf *WhoAmA 73, -76, -78, -80*
Koch, William *WhAmArt 85*
Koch, William Emery 1922- *WhoAmA 76, -78, -80,*
-82, -84
Koch-Amberg, Ilse 1869- *DcWomA*
Koch-Stetter, Dora *DcWomA*
Koch VonLangentreu, Friederike 1866- *DcWomA*
Kochanek, Doris 1957- *MarqDCG 84*
Kochendoerfer, N R *AmArch 70*
Kochenour, Richard Conway 1927- *AmArch 70*
Kocher, Alfred Lawrence 1885-1969 *MacEA*
Kocher, Norman E *AmArch 70*
Kocher, Robert Lee 1929- *WhoAmA 73, -76, -78, -80,*
-82, -84
Kocher, William Daniel, II *AmArch 70*
Kocher And Frey *MacEA*
Kocherscheidt, Kurt 1943- *DcCAr 81*
Kocherthaler, Mina *WhoAmA 73, -76, -78, -82, -84*
-84
Kochlin, Regina Emilie 1822- *DcWomA*
Kochmeister, Samuel *FolkA 86*
Kochmeister, Samuel 1887- *WhAmArt 85*

Kolb, Key 1933- *AmArch 70*
Kolb, Wilhelmine Von 1868- *DcWomA*
Kolba, Tamara *WhoAmA 78, -80*
Kolbe, Arno 1880-1942 *BiDAmAr*
Kolbe, Edward M, Jr. 1931- *AmArch 70*
Kolbe, Georg 1877-1947 *McGDA, OxArt, OxTwCA, PhDcTCA 77*
Kolbe, Ronald 1935- *AmArch 70*
Kolbeck, C G *AmArch 70*
Kolbert, Frank L 1948- *WhoAmA 78, -80, -82, -84*
Kolbo, Neal Byron 1925- *AmArch 70*
Kolbrook, Joseph Kenneth 1922- *AmArch 70*
Kolde, Frederick William *WhoAmA 80N, -82N, -84N*
Kolde, Frederick William 1870-1958? *WhAmArt 85*
Kolflat, A Frederick 1937- *AmArch 70*
Kolibal, Stanislav 1925- *ConArt 77, DcCAr 81*
Kolig, Anton 1886-1950 *OxTwCA*
Kolig, Cornelius 1942- *DcCAr 81*
Kolin, Sacha 1911- *WhoAmA 78, -80*
Kolin, Sacha 1911-1975 *WhoAmA 84N*
Kolin, Sacha 1911-1981 *WhoAmA 82N*
Kolisnyk, Peter 1934- *WhoAmA 84*
Kolker, Florence R *DcWomA, WhAmArt 85*
Kolko, Berenice 1905-1970 *ConPhot, ICPEnP A*
Kolle, Miss M *DcBrA 1*
Kollenbaum, Louise C *WhoAmA 80, -82*
Koller, Broucia 1867- *DcWomA*
Koller, E Leonard 1877- *WhAmArt 85*
Koller, Guillaume 1829- *ArtsNiC*
Koller, Johanna *DcWomA*
Koller, R *DcVicP 2*
Koller, Silvia *DcWomA*
Kolliker, Maria Euphrosyne *DcWomA*
Kolliker, William A 1905- *WhAmArt 85*
Kolliker, William Augustin 1905- *WhoAmA 73, -76, -78, -80, -82, -84*
Kolling, Ingeborg Marta *DcWomA*
Kollmer, Huber *NewYHSD*
Kollner *NewYHSD*
Kollner, August 1813- *FolkA 86*
Kollner, Augustus 1813- *NewYHSD*
Kollock, Mary 1832-1911 *WhAmArt 85*
Kollock, Mary 1840- *ArtsNiC*
Kollock, Mary 1840-1911 *DcWomA, NewYHSD*
Kollonitsch, Christian 1730-1802 *ClaDrA*
Kollwitz, Kaethe 1867-1945 *ConArt 77*
Kollwitz, Kathe 1867-1945 *DcWomA, McGDA, OxArt, OxTwCA, PhDcTCA 77, WomArt*
Kolman, Ronald 1932- *AmArch 70*
Kolmar, Elisabetha *DcWomA*
Kolodner, Nathan K 1950- *WhoAmA 76, -78, -80, -82, -84*
Kolodzie, Ronald *WorFshn*
Kolos-Vary, 1899- *ConArt 77*
Kolpin, Mugge *WorFshn*
Kolski, Gan 1899-1932 *WhAmArt 85*
Koltai, Ralph 1924- *ConDes*
Koltun, Frances Lang *WhoAmA 76, -78, -80, -82, -84*
Koluwsky, Herminias *NewYHSD*
Koluwsky, Herminias 1823?- *DcWomA*
Komar, Vitaly 1943- *WorArt[port]*
Komar And Melamid *WorArt[port]*
Komarin, Gary 1951- *PrintW 85*
Komarnitsky, Mrs. R S *WhAmArt 85*
Komaromi-Kacz, Sarolta *DcWomA*
Komatsu, A S *AmArch 70*
Komatsu, S Richard 1916- *AmArch 70*
Komisarow, Don *WhAmArt 85*
Komjati, Julius *DcBrA 1*
Komlosy, Irma 1850- *DcWomA*
Komoda, Kiyo *IlsCB 1967*
Komoda, Kiyo 1937- *IlsCB 1957*
Komodore, Bill 1932- *WhoAmA 73, -76, -78, -80, -82, -84*
Komor, Mathias 1909- *WhoAmA 73, -76, -78, -80, -82, -84*
Komorkoski, Raymond Paul 1922- *AmArch 70*
Komorowska, Wanda 1883- *DcWomA*
Komow, Ray 1958- *MarqDCG 84*
Komroff, Elinor M *DcWomA*
Koncevic, Charles Bruno 1909- *AmArch 70*
Konchalovsky, Pietr *OxTwCA*
Konczewska, Madame *DcWomA*
Kondner, Robert Louis, Jr. 1955- *MarqDCG 84*
Kondo, Hidezo 1908- *WorECar*
Kondrup, Cathinka Jenny Helene 1851- *DcWomA*
Konec, Alojz 1956- *DcCAr 81*
Konecsni, Gyorgy 1908- *WhoGrA 62*
Konek, Ida 1856- *DcWomA*
Koner, Sophie 1855- *DcWomA*
Konersman, Robert *WhAmArt 85*
Kong, Antony Kingyin 1953- *MarqDCG 84*
Kong, Sou-Jan *DcWomA*
Kong, Wein *DcSeaP*
Konger, Henry *NewYHSD*
Koni, Nicolaus 1911- *WhAmArt 85, WhoAmA 73, -76, -78, -80, -82, -84*
Konig, Anna Dorothea *DcWomA*
Konig, Caroline 1793-1823 *DcWomA*

Konig, Caroline Elisabeth 1799- *DcWomA*
Konig, Catherina *DcWomA*
Konig, Elisabeth 1785- *DcWomA*
Konig, Franz Niklaus 1765-1832 *ClaDrA*
Konig, Franziska *DcWomA*
Konig, Jeanne Francoise *DcWomA*
Konig, Julie 1791-1821 *DcWomA*
Konig, Julie 1839-1881 *DcWomA*
Konig, Leo Von 1871-1944 *McGDA*
Konig, Lily *DcWomA*
Konig, Margarethe Elisabeth *DcWomA*
Konig, Marie Albert 1866-1927 *DcWomA*
Konig, Mathilde 1863- *DcWomA*
Konig-Ingenheim, Marie 1849- *DcWomA*
Konig-Lorinser, Minna 1849-1893 *DcWomA*
Koniger, Gustel 1893- *DcWomA*
Konigsberg, Harvey 1940- *WhoAmA 76, -78, -80*
Konijnenburg, Willem A Van 1868-1943 *McGDA*
Konijnenburg, Willem Adriaan Van 1868-1944 *OxArt*
Konikoff, A *AmArch 70*
Koninck, Jacob, I 1616-1708 *ClaDrA*
Koninck, Philips 1619-1688 *McGDA, OxArt*
Koninck, Philips De 1619-1688 *ClaDrA*
Koninck, Salomon 1609-1656 *OxArt*
Koninck, Salomon 1656- *ClaDrA*
Koninck Family *OxArt*
Koning, Elizabeth Johanna 1816-1888 *DcWomA*
Koningh, Sophie De 1807-1870 *DcWomA*
Koningsbruggen, Rob Van 1948- *ConArt 77*
Konitz, Peter *DcCAr 81*
Kono, Takashi 1906- *WhoGrA 62, -82[port]*
Konody, Pauline Evelyn *DcBrA 1, DcWomA*
Konopka, Joseph 1932- *WhoAmA 73, -76, -78, -80, -82, -84*
Konrad VonSoest *McGDA*
Konrad, Adolf Ferdinand *WhoAmA 73, -76, -78, -80, -82, -84*
Konrad, Tony 1917- *WhoAmA 80, -82, -84*
Konrady, W J *AmArch 70*
Konraty, Lola 1900- *WhAmArt 85*
Konse, Margaretha Elisabeth *DcWomA*
Konstam, Gertrude A *DcVicP 2*
Konstantin, Frida 1884-1918 *DcWomA*
Konstantin-Hansen, Elise *DcWomA*
Konstantinidis, Aris *MacEA*
Konstantinidis, Aris 1913- *ConArch*
Konstantinov, Fyodor Denisovich 1910- *WhoGrA 62*
Konti, Isidore 1862-1938 *WhAmArt 85*
Kontoglou, Fotis 1896-1965 *OxTwCA*
Kontoglous, Fotis 1896-1965 *OxTwCA*
Kontturi, Arne John 1913- *AmArch 70*
Konuch, R L S *AmArch 70*
Konzal, Joseph 1905- *DcCAA 71, -77, DcCAr 81, WhoAmA 73, -76, -78, -80, -82, -84*
Koochagian, Armen Vahe 1924- *AmArch 70*
Koochin, Bill 1927- *DcCAr 81*
Koochin, William 1927- *WhoAmA 76, -78, -80, -82, -84*
Koogler, Jessie Marion *ArtsAmW 3*
Koogler, Marion *DcWomA*
Kooi, Willem Bartel VanDer 1768-1836 *ClaDrA*
Kooij, Theo 1933- *MarqDCG 84*
Kool, Catharina 1860- *DcWomA*
Kool, Willem Gillisz 1608?-1666 *McGDA*
Kool, Willem Gillisz 1608?-1666 *DcSeaP*
Koolman, Alex C *DcBrA 1*
Koonce, Norman Lamar 1932- *AmArch 70*
Koones, Charles *CabMA*
Kooning, Elaine De *WorArt*
Kooning, Willem De *OxTwCA, WorArt*
Kooning, Willem De 1904- *PhDcTCA 77*
Koons, Darell J 1924- *AmArt, WhoAmA 73, -76, -78, -80, -82, -84*
Koons, James *NewYHSD*
Koons, Kenneth H 1934- *AmArch 70*
Koontz, Fredrick Wayne 1922- *AmArch 70*
Koontz, John *FolkA 86*
Koonz *EncASM*
Koop, Mary *DcBrA 1, DcWomA*
Koopman, Augustus 1869-1914 *WhAmArt 85*
Koopman, Augustus B 1867-1914 *ArtsAmW 3*
Koopman, H J *AmArch 70*
Koopman, John R d1949 *WhoAmA 78N, -80N, -82N, -84N*
Koopman, John R 1881-1949 *WhAmArt 85*
Koorten, Joanna *DcWomA*
Kooten, Juffrouw Van *DcWomA*
Kootz, Daniel *ArtsEM*
Kootz, Samuel M 1898- *WhAmArt 85, WhoAmA 73, -76*
Kop, David VanDe 1937- *ConArt 77*
Kopac, Slavko 1913- *PrintW 85*
Kopcak, Adolph J 1895- *WhAmArt 85*
Kopecky, Oldrich 1923- *WhoGrA 62, -82[port]*
Kopecky, Thomas Jerry 1937- *AmArch 70*
Kopel, Harold 1915- *WhoAmA 80, -82, -84*
Kopelow, Sanford Leland 1935- *AmArch 70*
Kopenhaupt, Georg *McGDA*
Kopenhaver, Josephine Young 1908- *WhAmArt 85*
Koper, Frieda *DcWomA*
Kopetzky, Olga 1870- *DcWomA*

Kopietz, Edmund Martin 1900- *WhAmArt 85*
Koplin, Norma-Jean *WhoAmA 73, -76*
Koplowitz, Benjamin *WhoAmA 80N, -82N, -84N*
Koplowitz, Benjamin 1893-1958? *WhAmArt 85*
Kopman, Benjamin d1965 *WhoAmA 78N, -80N, -82N, -84N*
Kopman, Benjamin 1887-1965 *DcCAA 71, McGDA, WhAmArt 85*
Kopman, Benjamin 1897-1965 *DcCAA 77*
Kopman, Katharine H S 1870?-1950 *DcWomA*
Kopman, Katherine *WhAmArt 85*
Kopman, Yuli *DcWomA*
Kopmanis, Augusts A 1910- *WhoAmA 73, -76, -78, -80, -82*
Koponen, Vesa H J 1949- *MarqDCG 84*
Koposov, Gennadi 1938- *ConPhot, ICPEnP A*
Kopp, George 1570-1622 *ClaDrA*
Kopp, Mathilde 1836- *DcWomA*
Kopp, Countess Susanne Von *DcWomA*
Koppe, Richard 1916- *WhoAmA 73, -76, -78N, -80N, -82N, -84N*
Koppel, Charles *ArtsAmW 1, IlBEAAW, NewYHSD*
Koppel, Gerda 1875- *DcWomA*
Koppel, Henning 1918-1981 *ConDes*
Koppelman, Chaim 1920- *AmArt, DcCAA 71, -77, PrintW 83, -85, WhoAmA 73, -76, -78, -80, -82, -84*
Koppelman, Dorothy 1920- *WhoAmA 73, -76, -78, -80, -82, -84*
Koppenol, Elisabeth Frederika *DcWomA*
Koppers, Julia 1855- *DcWomA*
Koppes, Robert John 1928- *AmArch 70*
Koppes, Wayne Farland 1902- *AmArch 70*
Kopping, Karl 1848-1914 *DcNiCA, IlDcG*
Koppitz, Rudolf d1936 *ICPEnP A, MacBEP*
Kopple, D P *AmArch 70*
Kopricanec, Martin 1943- *DcCAr 81*
Kopriva, Sharon 1948- *AmArt, WhoAmA 82*
Kopriva, Sharon Ortman 1948- *WhoAmA 84*
Koprowski, Richard Carl 1926- *AmArch 70*
Kopschen, Barbara Helene *DcWomA*
Kopy, Adolph J *WhAmArt 85*
Kora *DcWomA*
Korach, Dean *WhAmArt 85*
Korach, Irvin 1915- *AmArch 70*
Koraichi, Rachid 1947- *DcCAr 81*
Koran, Arley Joseph 1928- *AmArch 70*
Koranyi, Baroness Anna Von 1870- *DcWomA*
Koraromi-Kacz, Sarolta *DcWomA*
Koras, George *WhoAmA 84*
Koras, George 1925- *WhoAmA 73, -76, -78, -80, -82*
Korb, Boske 1899-1925 *DcWomA*
Korb, Hermann 1656-1735 *WhoArch*
Korbel, Mario J 1882-1954 *WhAmArt 85*
Korbuly, Laszlo John 1935- *AmArch 70*
Korchinski, Dennis James 1945- *MarqDCG 84*
Korda, Augustine 1894- *ArtsAmW 3, WhAmArt 85*
Korda, Augustyn 1894- *ArtsAmW 3*
Korda, Augustyne 1894- *ArtsAmW 3*
Korda, Vincent *WhoAmA 80N, -82N, -84N*
Korda, Vincent 1897-1979 *ConDes*
Korder, Walter O R *WhAmArt 85*
Kordes, Eva 1866- *DcWomA*
Kordina, Brigitte 1944- *DcCAr 81*
Kordys, C J *AmArch 70*
Kordys, J R *AmArch 70*
Kordys, Joseph Ralph, Jr. 1933- *AmArch 70*
Korein, Jonathan David 1954- *MarqDCG 84*
Koren, Edward B 1935- *WhoAmA 76, -78, -80, -82, -84, WhoGrA 82[port], WorECar*
Korenic, Emil W 1926- *AmArch 70*
Koreschkov, Valeri 1941- *ICPEnP A*
Koreska, Jan 1944- *MarqDCG 84*
Korff, D H *AmArch 70*
Korff, Edwin Walter 1931- *AmArch 70*
Korff, Herman *NewYHSD*
Korff, Louis *NewYHSD*
Koriansky, Alexander 1884- *ArtsAmW 3*
Korin 1658-1716 *McGDA*
Korin, Ogata 1658-1716 *OxArt*
Koris, B A Z *AmArch 70*
Korjus, Veronica Maria Elisabeth *WhoAmA 73, -76, -78, -80, -82, -84*
Korman, Barbara 1938- *WhoAmA 76, -78, -80, -82, -84*
Korman, H *AmArch 70*
Korman, Harriet 1947- *DcCAr 81*
Korman, Harriet R 1947- *WhoAmA 73, -76, -78, -80, -82, -84*
Korman, N I 1916- *MarqDCG 84*
Korman, Wesley V 1920- *AmArch 70*
Kormendi, Andre 1905- *WhAmArt 85*
Kormendi, Elisabeth *WhAmArt 85*
Kormendi, Eugene 1889-1959 *WhAmArt 85, WhoAmA 80N, -82N, -84N*
Kormis, Fred J 1894- *DcBrA 1, WhoArt 84*
Kormis, Fred J 1896- *WhoArt 80*
Kormis, Fred J 1897- *WhoArt 82*
Korn, Arthur 1891-1978 *ConArch*
Korn, Elizabeth P *WhoAmA 73, -76, -78, -80, -82N,*

Kraemer, Alfred Achille 1906- *WhAmArt 85*
Kraemer, Charles *EncASM*
Kraemer, Elisabeth 1868- *DcWomA*
Kraemer, Mrs. Eric *WhAmArt 85*
Kraemer, Friedrich Wilhelm 1907- *ConArch, EncMA, MacEA*
Kraemer, Joseph L 1872-1938 *ArtsEM*
Kraemer, Peter *NewYHSD*
Kraetsch, George A 1884-1940 *BiDAmAr*
Kraetzer, Gustav *NewYHSD*
Krafe *FolkA 86*
Krafft, Anna Barbara 1764-1825 *WomArt*
Krafft, Barbara 1764-1825 *DcWomA*
Krafft, Carl R 1884- *WhAmArt 85*
Krafft, E W *AmArch 70*
Krafft, Elton *WhAmArt 85*
Krafft, Helene 1867- *DcWomA*
Krafft, Johann August 1798-1829 *McGDA*
Krafft, Johann Peter 1780-1856 *ClaDrA*
Krafft, Julie 1821- *DcWomA*
Krafft, Laurence, Madame *DcWomA*
Krafft, Marie 1812-1885 *DcWomA*
Krafft, Wilhelmina 1778-1828 *DcWomA*
Kraft, Adam 1455?-1509 *McGDA*
Kraft, Adam 1460?-1508? *OxArt*
Kraft, Alfred 1955- *DcCAr 81*
Kraft, Allison A 1900- *WhAmArt 85*
Kraft, Emma L *DcWomA*
Kraft, Lewis *NewYHSD*
Kraftmeier, Marta *DcVicP 2*
Krag, Lul Karen Marie 1878- *DcWomA*
Krager, C L *FolkA 86*
Kraguly, Radovan D 1935- *DcCAr 81*
Krahleng, Charles *NewYHSD*
Krahn, Fernando 1935- *IlsCB 1967, WhoGrA 82[port]*
Krahnass, Marie Gabrielle *DcWomA*
Krail, Charlotte *DcWomA*
Kraitsir *NewYHSD*
Krajcar, Edward Antone 1926- *AmArch 70*
Krajcberg, Franz 1921- *PhDcTCA 77*
Krajewski, William J 1941- *MarqDCG 84*
Krakauer, J A 1955- *MarqDCG 84*
Krakauer-Wolf, Grete 1890-1970 *DcWomA*
Krakel, Dean 1923- *WhoAmA 76, -78*
Krakow, Barbara L 1936- *WhoAmA 78, -80, -82, -84*
Krakow, Richard H, Sr. 1858-1935? *ArtsEM*
Kral, Kadharina *FolkA 86*
Kralik, Emil 1880-1946 *MacEA*
Kraljevic, Miroslav 1885-1913 *PhDcTCA 77*
Kramarsky, Mrs. Siegfried *WhoAmA 73*
Kramarsky, Mrs. Siegried *WhoAmA 76, -78, -80*
Krame, Lambert 1712-1790 *ClaDrA*
Kramer, Allen Robert 1920- *AmArch 70*
Kramer, Arnold 1944- *ICPEnP A, MacBEP*
Kramer, Baltasar d1813? *IlDcG*
Kramer, Burton 1932- *WhoAmA 76, -78, -80, -82, -84, WhoGrA 82[port]*
Kramer, Carveth Hilton 1943- *WhoAmA 80, -82*
Kramer, Charles *NewYHSD*
Kramer, Charles M *EncASM*
Kramer, Charles M 1935- *AmArch 70*
Kramer, Christian 1773-1858 *AntBDN H, DcNiCA*
Kramer, D D *AmArch 70*
Kramer, Dieter 1937- *DcCAr 81*
Kramer, Edward Adam 1866-1941 *WhAmArt 85*
Kramer, Edward Alan 1955- *MarqDCG 84*
Kramer, Edwin Robert 1923- *AmArch 70*
Kramer, Erwin *WhAmArt 85*
Kramer, George W 1847-1938 *BiDAmAr*
Kramer, Gerhardt 1909- *AmArch 70*
Kramer, Gertrude M *WhoAmA 82, -84*
Kramer, H J *AmArch 70*
Kramer, Harry 1925- *OxTwCA, PhDcTCA 77*
Kramer, Hilton 1928- *WhoAmA 73, -76, -78, -80, -82, -84*
Kramer, Hyman I 1927- *AmArch 70*
Kramer, J H *DcBrECP*
Kramer, Jack N 1923- *WhoAmA 73, -76, -78, -80, -82, -84*
Kramer, Jacob 1892-1962 *DcBrA 1*
Kramer, James *OfPGCP 86*
Kramer, James 1927- *WhoAmA 76, -78, -80, -82, -84*
Kramer, John Matthias *NewYHSD*
Kramer, Linda *AmArt*
Kramer, Marjorie Anne 1943- *WhoAmA 73, -76, -78, -80, -82, -84*
Kramer, Paul 1930- *WhoAmA 76, -78, -80, -82*
Kramer, Peter 1823-1907 *EarABI, EarABI SUP, NewYHSD , WhAmArt 85*
Kramer, Philip G, Jr. *ArtsEM*
Kramer, Piet 1881-1961 *WhoArch*
Kramer, Pieter Lodewijk 1881- *McGDA*
Kramer, Pieter Lodewijk 1881-1961 *MacEA*
Kramer, R G *AmArch 70*
Kramer, Reuben 1909- *WhoAmA 73, -76, -78, -80, -82, -84*
Kramer, Reuben Robert 1909- *WhAmArt 85*
Kramer, Robert 1930- *AmArch 70*
Kramer, W R *AmArch 70*
Kramer, William E *AmArch 70*

Kramer, William Puntenney 1904- *AmArch 70*
Kramer, William T C 1953- *MarqDCG 84*
Kramlich, John *FolkA 86*
Kramm, Gustavus *NewYHSD*
Kramolc, Theodore Maria 1922- *WhoAmA 73, -76, -78, -80, -82*
Kramp, William C *NewYHSD*
Kramrisch, Stella *WhoAmA 73, -76, -78, -80, -82, -84*
Kramskoi, Ivan Nikolayevich 1837-1887 *McGDA*
Krandievskaia, Nadezhda Vasilevna 1891- *DcWomA*
Krane, Susan 1954- *WhoAmA 82, -84*
Kraner, Florian G 1908- *WhoAmA 73, -76, -78, -80N, -82N, -84N*
Kranert, Lloyd H 1925- *AmArch 70*
Kraneskol, Mademoiselle *DcWomA*
Kranich, Joel H 1929- *AmArch 70*
Krank, Ronald 1936- *AmArch 70*
Kranking, Margaret Graham 1930- *WhoAmA 78, -80, -82, -84*
Krans, J *FolkA 86*
Krans, Olaf 1838-1916 *BnEnAmA, IlBEAAW, NewYHSD , WhAmArt 85*
Krans, Olof 1838-1916 *AmFkP[port], FolkA 86*
Kransz, Sigmund *WhAmArt 85*
Krantz, A Steven 1947- *MarqDCG 84*
Krantz, Jeffrey Isaac 1955- *MarqDCG 84*
Krantz, Les 1945- *WhoAmA 84*
Krantz, Thomas W 1945- *MarqDCG 84*
Kranz, Josef 1901-1968 *MacEA*
Kranz-Gerhard, Elisabeth 1870- *DcWomA*
Krasa, Edward Jan 1877- *WhAmArt 85*
Krashes, Barbara *WhoAmA 76, -78, -80, -82, -84*
Krasin, Kate 1943- *PrintW 83, -85*
Krasinska, Elise, Duchess 1820-1876 *DcWomA*
Kraslawsky, Walter P 1947- *MarqDCG 84*
Krasnegor, H A *AmArch 70*
Krasner, Lee *WhoAmA 73, -76, -78, -80*
Krasner, Lee 1908- *AmArt, ConArt 77, -83, DcAmArt, WhAmArt 85, WhoAmA 82, -84, WomArt*
Krasner, Lee 1908-1984 *WorArt[port]*
Krasner, Lee 1911- *DcCAA 71, -77, DcCAr 81, OxTwCA, PrintW 83*
Krasner, Lee 1911-1984 *PrintW 85*
Krasner, Oscar *WhoAmA 73, -76, -78, -80, -82*
Krasniansky, Bernardo 1951- *ConArt 77*
Krasnik, Antoinette *DcWomA*
Krasnoff, Howard Ourin 1924- *AmArch 70*
Krasnow, Peter *WhAmArt 85*
Krasnow, Peter 1886- *ArtsAmW 2*
Krasnushkina, Ekaterina Zakharovna 1858-1914? *DcWomA*
Kraszevska, Otolia 1859- *DcWomA*
Kraszna-Krausz, Andor 1904- *ICPEnP*
Krasznai, John Frank 1951- *MarqDCG 84*
Kratina, George *WhAmArt 85*
Kratina, Jos M 1872- *WhAmArt 85*
Kratina, K George 1910- *WhoAmA 73, -76, -78, -80, -82, -84*
Kratke, Marthe 1884- *DcWomA*
Kratochvil, Stephen 1876- *WhAmArt 85*
Kratt, William Joseph 1931- *AmArch 70*
Kratz, Edwin Garman 1906- *AmArch 70*
Kratz, H Frances 1893- *WhAmArt 85*
Kratz, Laura *DcWomA, WhAmArt 85*
Kratz, Lawrence John 1943- *MarqDCG 84*
Kratz, Mildred Sands *OfPGCP 86, WhoAmA 73, -76, -78, -80, -82, -84*
Kratz, Philip W *WhAmArt 85*
Kratzen, Joseph *FolkA 86*
Kraus, Adolph F 1850-1901 *WhAmArt 85*
Kraus, Bertha *WhAmArt 85*
Kraus, D *AmArch 70*
Kraus, Edwin J *AmArch 70*
Kraus, Georg-Melchior 1737-1806 *ClaDrA*
Kraus, Johanna Sibilla *DcWomA*
Kraus, John *FolkA 86*
Kraus, Michael J *AmArch 70*
Kraus, Philippe Joseph 1789-1864 *ClaDrA*
Kraus, Robert *IlsCB 1967*
Kraus, Robert 1925- *IlsCB 1957*
Kraus, Robert Mary 1920- *AmArch 70*
Kraus, Romuald 1891-1954 *WhAmArt 85*
Kraus, Zili *WhoAmA 82, -84*
Kraus And Jantzen *EncASM*
Kraus Kragel *EncASM*
Kraus McKeever And Adams *EncASM*
Krause, Alfred F 1930- *AmArch 70*
Krause, Charles Kenneth, Jr. 1932- *AmArch 70*
Krause, E G *AmArch 70*
Krause, Erik Hans 1899- *WhAmArt 85*
Krause, Francois 1705-1752 *ClaDrA*
Krause, Frederick John 1945- *MarqDCG 84*
Krause, George 1937- *ConPhot, DcCAr 81, ICPEnP A, MacBEP, WhoAmA 82, -84*
Krause, Glen Adolph 1914- *WhAmArt 85*
Krause, Henry 1820?- *NewYHSD*
Krause, Jakob 1531?-1585 *OxDecA*
Krause, Julius W 1867-1943 *BiDAmAr*
Krause, Kai 1957- *MarqDCG 84*

Krause, LaVerne Erickson 1924- *WhoAmA 73*
Krause, Laverne Erickson 1924- *WhoAmA 76, -78, -80, -82, -84*
Krause, Lina 1857- *DcWomA*
Krause, Lisbeth B *WhAmArt 85*
Krause, Lisbeth B 1880- *DcWomA*
Krause, Melvin Stanley, Jr. 1934- *AmArch 70*
Krause, Mici 1884- *DcWomA*
Krause, N E *AmArch 70*
Krause, Oscar *FolkA 86*
Krause, Paul Edward 1933- *AmArch 70*
Krause, Robert Joseph 1917- *AmArch 70*
Krause, Stephen R 1937- *MarqDCG 84*
Krause, Thomas *FolkA 86*
Krause, Wilhelm August Leopold Christian 1803-1864 *ArtsNiC, DcSeaP*
Krause, William O *FolkA 86*
Krauser, Joel 1936- *WhoAmA 73, -76, -78, -80, -82*
Kraushaar, Antoinette M *WhoAmA 73, -76, -78, -80, -82*
Kraushaar, Antoinette M 1902- *WhoAmA 84*
Kraushaar, Charles W 1854-1917 *WhAmArt 85*
Kraushaar, John F 1871-1946 *WhAmArt 85*
Krausnick, Johanna *DcWomA*
Krauss, Amy Eliza *DcBrA 1, DcWomA*
Krauss, Harold William *MarqDCG 84*
Krauss, Baroness Helene 1876- *DcWomA*
Krauss, Johannes 1770- *FolkA 86*
Krauss, Karl Frederick, Jr. 1923- *AmArch 70*
Krauss, Marianne Walpurgis 1765-1838 *DcWomA*
Krauss, Oscar *IlsBYP*
Krauss, Regina *FolkA 86*
Krauss, Richard I 1935- *AmArch 70*
Krauss, Rolf H 1930- *MacBEP*
Krauss, Rosalind E 1940- *WhoAmA 84*
Krauss, Stephen *NewYHSD*
Krauss-Pabst, Amalie 1805-1883 *DcWomA*
Krausse, R M *AmArch 70*
Krausz, Laszlo 1903- *WhoAmA 73, -76, -78*
Krausz, Laszlo 1903-1979 *WhoAmA 80N, -82N, -84N*
Krausz, Sigmund 1857- *WhAmArt 85*
Kraut, Irving *WhAmArt 85*
Kraut, M *AmArch 70*
Krauth, Charles Philip 1893- *ArtsAmW 2, WhAmArt 85*
Krauth, Harald 1923- *WhoAmA 84*
Krautheimer, Richard 1897- *WhoAmA 73*
Krauze, Andrzej 1947- *WhoGrA 82[port]*
Kravet, Daniel 1920- *AmArch 70*
Kravis, Janis 1935- *WhoAmA 78, -80, -82, -84*
Kravitz, Walter 1938- *WhoAmA 84*
Kravjansky, Mikulas 1928- *PrintW 83, -85*
Kravos, Marjan 1948- *DcCAr 81*
Krawiec, Harriet B 1894- *DcWomA, WhAmArt 85*
Krawiec, Walter 1889- *WhAmArt 85*
Kraxberger, Darrel Otto William 1940- *AmArch 70*
Kraykovic, Michel Alfred 1902- *WhAmArt 85*
Krebs, Adolph K *NewYHSD*
Krebs, Anna *DcWomA*
Krebs, Franz Werner 1927- *AmArch 70*
Krebs, Friedrich d1815 *FolkA 86*
Krebs, Hulda *DcWomA*
Krebs, Johanne Cathrine 1848-1924 *DcWomA*
Krebs, Patricia 1933- *WhoAmA 76, -78, -80, -82*
Krebs, Patsy 1940- *DcCAr 81*
Krebs, Philip, Jr. *FolkA 86*
Krebs, Philip, Sr. 1780?- *FolkA 86*
Krebs, Rockne 1938- *WhoAmA 73, -76, -78, -82, -84*
Kreca, Djordje 1934- *OxTwCA*
Krecker, Baird Philip 1929- *AmArch 70*
Kredel, Fritz *IlsCB 1967*
Kredel, Fritz 1900- *WhAmArt 85, WhoAmA 73, -76*
Kredel, Fritz 1900-1973 *IlsBYP, IlsCB 1744, -1946, -1957*
Kreeb, Karl R *MarqDCG 84*
Kreebel, Isaac *FolkA 86*
Kreefting, John *WhAmArt 85*
Kreeger, David Lloyd 1909- *WhoAmA 73, -76, -78, -80, -82, -84*
Kreeger, Marianne 1929- *WhoArt 80, -82, -84*
Kreel, John *NewYHSD*
Kregar, Igor 1956- *DcCAr 81*
Kregar, Stane 1905- *PhDcTCA 77*
Kregarman, Josephine 1910-1944 *WhAmArt 85*
Krehbiel, Mrs. Albert *WhAmArt 85*
Krehbiel, Albert H 1875-1945 *WhAmArt 85*
Krehbiel, Dulah Marie Evans *DcWomA*
Krehm, William P 1901- *WhAmArt 85*
Kreider, Albert M *FolkA 86*
Kreider, Maurice *FolkA 86*
Kreig, Raymond Arthur 1946- *MarqDCG 84*
Kreighoff, W G 1875-1930 *WhAmArt 85*
Kreilick, Marjorie E 1925- *WhoAmA 76, -78, -80, -82, -84*
Kreindler, Doris Barsky 1901- *WhoAmA 73*
Kreindler, Doris Barsky 1901-1974 *WhAmArt 85, WhoAmA 76N, -78N, -80N, -82N, -84N*
Kreis, Henry d1963 *WhoAmA 78N, -80N, -82N*
Kreis, Henry 1899-1963 *WhAmArt 85*
Kreis, Wilhelm 1873-1953 *MacEA*

L

L, E H *DcBrBI*
L, R *DcBrBI*
L A *NewYHSD*
Laabs, Hans 1915- *DcCAr 81*
Laak, Maria VanDer *DcWomA*
Laar, Pieter Van 1612?-1673? *ClaDrA*
Laar, Ulrike Charlotte Auguste 1824-1881 *DcWomA*
Laatsch, Gary 1956- *WhoAmA 84*
Labarber, J P *AmArch 70*
Labarchede, Dalila *DcWomA*
LaBarge, F G *AmArch 70*
Labarte, John B *NewYHSD*
Labarthe, Charlotte Augustine *DcWomA*
Labarthe, Helene Jeanne Marie 1861- *DcWomA*
Labarthe, J, Jr. *AmArch 70*
Labasque, Jean 1902- *ClaDrA*
LaBassetiere, Countess *DcWomA*
Labaste, John B *NewYHSD*
Labatut, Isador *NewYHSD*
Labatut, J *NewYHSD*
Labatut, Jean 1899- *AmArch 70, MacEA*
Labatut, Suzanne Marie Carmen 1889- *DcWomA*
Labatut, T *NewYHSD*
LaBau, David Nelson 1925- *AmArch 70*
Labaudt, Lucien 1880-1943 *ArtsAmW 1, DcCAA 71,*
 -77
Labaudt, Lucien Adolph 1880-1943 *WhAmArt 85*
LaBaume, Marie Berthe *DcWomA*
Labauvie, Dominique 1948- *DcCAr 81*
LaBaw, George W 1822-1896 *BiDAmAr*
Labbe, Aline *DcWomA*
Labbe, Claude Suzanne 1877- *DcWomA*
Labbe-Serveille, Blanche 1874- *DcWomA*
Labbe-Serville, Blanche 1874- *DcWomA*
LaBella, Sebastian Louis 1928- *AmArch 70*
LaBelle, E J *AmArch 70*
Labelye, Charles 1705-1781? *BiDBrA*
Labelye, Charles 1705-1781 *DcD&D*
Labenwolf, Pankraz 1492-1563 *McGDA*
Labenwolff, Pankraz 1492-1563 *OxArt*
Labesse, Jeanne Pauline *DcWomA*
Labeyril, Constant *FolkA 86*
Labhardt, Christoph d1695 *IlDcG*
Labhart, J M *FolkA 86*
LaBichardiere, Mademoiselle De *DcWomA*
Labiche, Walter Anthony 1924- *WhoAmA 78*
Labiche, Walter Anthony 1924-1979 *WhoAmA 80N,*
 -82N, -84N
Labie, A *AmArch 70*
Labille-Guiard, Adelaide 1749-1803 *DcWomA,*
 McGDA, WomArt
Labino, Dominick 1910- *AmArt, BnEnAmA, IlDcG,*
 OxDecA, WhoAmA 73, -76, -78, -80, -82, -84
Labisi, Paolo 1720?-1798? *MacEA*
Labisse, Felix 1905- *ClaDrA, ConArt 77,*
 PhDcTCA 77
Labitte, Eugene Leon 1858- *ClaDrA*
LaBlanchetee, Mathilde De *DcWomA*
Lable, Eliot *WhoAmA 84*
Labliere DesHayes, Victorine Antoinette *DcWomA*
Labo, Mario 1884-1961 *MacEA*
Labodda, Gerald Robert 1935- *AmArch 70*
Labois, Marie Mathilde Louise *DcWomA*
LaBoissiere, Jacqueline De *DcWomA*
LaBoiteaux, Mary Mitchell Hinchman d1946
 WhAmArt 85
Labom, Adolphe *NewYHSD*
LaBonne, Henriette Jussiaume *DcWomA*
Labonte, Anton Edward 1935- *MarqDCG 84*
Laborde, C A B *DcWomA, WhAmArt 85*
Laborey, Felicite *DcWomA*

Laborn, Adolphe *NewYHSD*
Labouisse, F M *AmArch 70*
Labouisse, Frederick T 1908-1936 *WhAmArt 85*
Labouisse, Samuel S 1879-1918 *BiDAmAr*
Labouret, Adele *DcWomA*
Labouret, Mathilde *DcWomA*
Laboureur, Jean Emile 1877-1943 *ClaDrA*
Labourier, J E *WhAmArt 85*
Labra, Jose Maria De *OxTwCA*
Labrie, Rose 1916- *FolkA 86, WhoAmA 73, -76,*
 -78, -80, -82, -84
Labriere, Alexandre-Louis De *BiDBrA*
Labro, Georges 1887- *MacEA*
Labrot, Syl 1929-1977 *ConPhot, ICPEnP A,*
 MacBEP
Labroue, Louise *DcWomA*
LaBroue DeSt. Avrit, Louise *DcWomA*
Labrousse, Jeanne A *DcWomA*
Labrouste, Henri 1801-1875 *DcD&D, EncMA,*
 MacEA, McGDA, WhoArch
Labrouste, Theodore 1799-1885 *MacEA*
LaBruce, F M *WhAmArt 85*
Labunska, Dorothea 1910- *WhAmArt 85*
Laby, Alexander *DcBrBI, DcVicP 2*
Lac, Ming 1948- *MarqDCG 84*
LaCanfora, Peter 1936- *MarqDCG 84*
Lacasse, Joseph 1894- *PhDcTCA 77*
Lacasse, Joseph 1894-1975 *OxTwCA*
Lacasse, Joseph-Fernand 1894-1975 *ConArt 77*
LaCava, Frank Anthony 1904- *AmArch 70*
LaCava, Gregory 1892-1949 *WorECar*
LaCave *DcBrECP*
LaCave, Peter *DcBrWA*
Lacaze-Dory, Louise J d1904 *DcWomA*
Lacazette, Amelie *DcWomA*
Lacazette, Sophie Clemence *DcWomA*
Lacepede, Amelie 1796-1860 *DcWomA*
Lacey, Bertha 1878-1943 *WhAmArt 85*
Lacey, Bertha J 1878-1943 *DcWomA*
Lacey, Bruce 1927- *ConArt 77, ConBrA 79[port],*
 OxTwCA, PhDcTCA 77
Lacey, Edward Hill 1892- *DcBrA 1*
Lacey, Enid H *DcBrA 2*
Lacey, George T 1907- *AmArch 70*
Lacey, Jessie P *WhAmArt 85*
Lacey, Jessie Pixley 1865- *DcWomA*
Lacey, Julia A Witherell 1833-1919 *ArtsEM,*
 DcWomA
Lacey, Margaret Schaff 1903- *WhAmArt 85*
Lacey, Mary Elliot 1923- *WhoArt 80, -82, -84*
Lacey, Neal, Jr. 1931- *AmArch 70*
Lacey, Robert P 1948- *MarqDCG 84*
Lacey, Thomas H *ArtsEM*
Lacey, W S *DcVicP 2*
Lacger, Louise Victoire De *DcWon A*
Lachaise, Mademoiselle *DcWomA*
LaChaise, Eugene A d1925 *WhAmArt 85*
Lachaise, Gaston 1882-1935 *BnEnAmA, ConArt 77,*
 DcAmArt, DcCAA 71, -77, McGDA, OxTwCA,
 PhDcTCA 77, WhAmArt 85
LaChance, Georges 1888- *WhAmArt 85*
LaChapelle, Georges De *McGDA*
Lachapelle, Joseph Robert 1943- *WhoAmA 82,*
 -84
Lachassaigne, Aimee *DcWomA*
Lachasse *FairDF ENG*
Lachaud, Emilie *DcWomA*
Lache, Albert R d1910 *WhAmArt 85*
Lachecki, Chester S 1925- *AmArch 70*
Lachenal, Edmond 1855-1930 *DcNiCA*
Lachenal, Raoul *DcNiCA*

Lachenmeyer, Paul N *WhAmArt 85*
Lacher *IlBEAAW*
Lacher, Gisella Loeffler 1900- *WhAmArt 85*
Lacher, Gisella Loeffler 1903- *IlsCB 1744*
Lacher, Johannes 1940- *WhoAmA 84*
Lachert, Bohdan 1900- *ConArch, MacEA*
Lachin, J M, Jr. *AmArch 70*
Lachman, Charles R *WhoAmA 73*
Lachman, Mrs. Charles R *WhoAmA 73*
Lachman, Harry 1886- *WhAmArt 85*
Lachmund, Fritz 1911- *MacBEP*
Lachtropius, Nicolaes *McGDA*
Lachtropius, Nicolas *ClaDrA*
Lack, Barbara Dacia *WhoArt 80, -82, -84*
Lack, Henry Martyn *WhoArt 82N*
Lack, Henry Martyn 1909- *DcBrA 1, WhoArt 80*
Lack, J *DcVicP 2*
Lack, Richard Frederick 1928- *WhoAmA 73, -76, -78,*
 -80, -82, -84
Lackens, John Wendell 1934- *AmArch 70*
Lackey, B H, Sr. *AmArch 70*
Lackey, Henry Evans, Jr. 1928- *AmArch 70*
Lackey, Lawrence 1914- *AmArch 70*
Lackey, R J *AmArch 70*
Lackey, Vinson 1889-1959 *ArtsAmW 3, IlBEAAW*
Lackey, Zeb Vance 1923- *AmArch 70*
Lackner, Herman H 1912- *AmArch 70*
Lackner, Suzanne O 1908- *WhoArt 80, -82, -84*
Lackowic, Ivan 1932- *OxTwCA*
Lacktman, Michael 1938- *WhoAmA 78, -80, -82, -84*
Laclau, J M Elisabeth 1853- *DcWomA*
Laclotte, Hyacinthe *NewYHSD*
Lacombe, Miss *DcWomA*
Lacombe, Laura *DcWomA*
Lacombe, M De *DcWomA*
Lacombe, Marguerite *DcWomA*
LaCorcia, Agnese *DcWomA*
Lacoste, Camille *DcWomA*
Lacoste, E J, III *AmArch 70*
Lacoste, Elisabeth Leonie 1821- *DcWomA*
Lacoste, H B *DcVicP 2*
Lacour, Peter *NewYHSD*
Lacourse, Lauren Richard 1948- *MarqDCG 84*
LaCourt VanDenVoort, Catherine A De d1754?
 DcWomA
Lacretelle, Jean Edouard 1817-1900 *DcVicP 2*
Lacretelle, Marie *DcWomA*
Lacroix, Clemence Caroline Catherine 1849-1925
 DcWomA
Lacroix, Flora Luisa *WhoAmA 84*
Lacroix, Francis Joseph 1775-1806 *CabMA*
LaCroix, G F De *DcSeaP*
Lacroix, Gabrielle d1894 *DcWomA*
Lacroix, Gaspard Jean 1820-1878 *ArtsNiC*
LaCroix, Jeanne *DcWomA*
Lacroix, Louise Renee 1890- *DcWomA*
Lacroix, Marie 1831-1907 *DcWomA*
Lacroix, Paul *NewYHSD*
Lacroix, Pauline Victorine Jeanne 1892- *DcWomA*
Lacroix, Richard 1939- *WhoAmA 73, -76, -78, -80,*
 -82, -84
LaCroix, Richard Philip 1941- *AmArch 70*
Lacroix, Roger *AntBDN G*
LaCroix, Ursule *DcWomA*
Lacroix, William 1846-1922 *ArtsEM*
Lacroix DePrechatain, Yvonne Pauline 1869-
 DcWomA
Lacroux, Marguerite 1898- *DcWomA*
Lactorius, Nicolaes *McGDA*
LaCueva Benavides Y Barradas, Mariana De *DcWomA*
Lacy, Bettie 1924- *WhoAmA 78, -80*

Lacy, Bill N 1933- *AmArch 70*
Lacy, D L *AmArch 70*
Lacy, Henry Frederic, Jr. 1932- *AmArch 70*
Lacy, James Oscar 1918- *AmArch 70*
Lacy, Joseph Newton 1905- *AmArch 70*
Lacy, L Verne 1893- *AmArch 70*
Lacy, Lucile Land 1901- *WhAmArt 85*
Lacy, P S *AmArch 70*
Lacy, Robert Eugene 1943- *WhoAmA 76, -78, -80, -82, -84*
Lacy, Suzanne 1945- *WhoAmA 78, -80, -82, -84*
Lacz, Stanley John 1938- *AmArch 70*
Lacza, Maria 1946- *DcCAr 81*
Lada *DcWomA*
Ladanyi, Emory 1902- *WhAmArt 85*
Ladau, E *AmArch 70*
Ladbrooke, Frederick *DcVicP 2*
Ladbrooke, Henry 1800-1870 *DcBrWA, DcVicP 2*
Ladbrooke, John Berney 1803-1879 *DcBrWA, DcVicP, -2*
Ladbrooke, Robert 1770-1842 *DcBrWA, DcVicP 2, McGDA*
Ladd, Anna Coleman 1878-1939 *DcWomA, WhAmArt 85*
Ladd, Anne 1746-1770 *DcBrECP, DcWomA*
Ladd, B F *NewYHSD*
Ladd, Mrs. B F *NewYHSD*
Ladd, Franklin Bacon 1815-1898 *NewYHSD*
Ladd, Fred *WorECar*
Ladd, James M *NewYHSD*
Ladd, John Arthur 1924- *AmArch 70*
Ladd, Laura D Stroud 1863-1943 *ArtsAmW 3, DcWomA, WhAmArt 85*
Ladd, Peter 1897- *WhAmArt 85*
Ladd, Thornton 1924- *AmArch 70*
Ladd, Westray 1863-1909 *BiDAmAr*
Ladds, Elizabeth 1837-1922 *DcWomA*
Ladell, Edward *ClaDrA, DcVicP*
Ladell, Edward 1821-1886 *DcVicP 2*
LaDell, Edwin 1914-1970 *DcBrA 1*
Ladell, Ellen *DcVicP, -2, DcWomA*
Laden, Frieda Savitz *WhoAmA 78, -80, -82, -84*
Ladendorf, Frank H *WhAmArt 85*
Ladenspelder, Johann 1511- *ClaDrA*
Lader, A S *DcBrBI*
Lader, Melvin Paul 1947- *WhoAmA 84*
Laderman, Fred 1927- *WorECar*
Laderman, Gabriel 1929- *AmArt, ConArt 77, DcCAA 77, WhoAmA 73, -76, -78, -80, -82, -84*
Ladeveze-Cauchois, Louise De 1860- *DcWomA*
Ladner, Jane Ellen 1944- *MarqDCG 84*
Ladner, R D *AmArch 70*
Ladner, Robert Charles 1944- *MarqDCG 84*
Ladovsky, Nikolai A 1881-1941 *MacEA*
Ladow, Jesse 1918- *WhoAmA 78, -80*
Ladow, Jesse Amos 1918- *WhoAmA 76*
LaDriere, L L *WhAmArt 85*
Ladue, John 1803?-1854 *ArtsEM*
LaDue, Leonard James 1927- *AmArch 70*
Laeck, Maria VanDer d1664? *DcWomA*
Laederich, Madame *DcWomA*
Laemen, Christoffel *McGDA*
Laemmle, Cheryl 1947- *PrintW 83, -85, WhoAmA 84*
Laer, Ferdinand Von *NewYHSD*
Laer, Pieter Van 1592?-1642 *McGDA, OxArt*
Laerka, Karl 1892-1981 *ICPEnP A*
Laermans, Eugene 1864-1940 *McGDA, OxTwCA, PhDcTCA 77*
Laermans, Eugene Jules Joseph 1864-1940 *ClaDrA*
Laessig, Robert 1920- *WhoAmA 73, -76, -78, -80, -82, -84*
Laessle, Albert 1877-1954 *WhAmArt 85*
Laessle, Margaret Smoot 1907- *WhAmArt 85*
Laessle, Mary P Middleton 1870- *DcWomA*
Laessle, Paul 1908- *WhAmArt 85*
Lafabrique, Nicolas 1649-1733 *McGDA*
Lafage, Raymond De 1650?-1684 *ClaDrA*
Lafair, Samuel *WhAmArt 85*
LaFarge, Bancel d1938 *WhAmArt 85*
LaFarge, Christopher Grant 1862-1938 *BiDAmAr, MacEA*
LaFarge, Julie *ArtsNiC*
LaFarge, John 1835-1910 *BnEnAmA, DcAmArt, EarABI, EarABI SUP, McGDA, NewYHSD, WhAmArt 85*
Lafarge, L B *AmArch 70*
LaFarge, Mabel Hooper 1875-1944 *DcWomA, WhAmArt 85*
LaFarge, Margaret Mason Perry d1925 *WhAmArt 85*
LaFarge, Oliver H P 1867-1936 *WhAmArt 85*
LaFarge, Thomas 1904-1943 *WhAmArt 85*
Lafarge-Charma, Georges, Madame *DcWomA*
LaFargue, Ambroisine Laure Gabrielle De *DcWomA*
LaFargue, Maria Margaretha 1743-1813 *DcWomA*
Lafargue, Pauline *DcWomA*
LaFargue, Paulus Constantin 1732-1782 *ClaDrA*
Lafaurie, Marie Anne *DcWomA*
LaFavor, Will *WhAmArt 85*
Lafaye, G E, Jr. *AmArch 70*
Lafaye, George E 1878-1939 *BiDAmAr*

Lafaye, Nell Murray 1937- *WhoAmA 73, -76, -78, -80, -82, -84*
Lafaye, Prosper 1806-1883 *DcVicP 2*
Lafaye, R S *AmArch 70*
Laferriere 1825?- *WorFshn*
LaFerriere, Mademoiselle De *DcWomA*
Lafever, Minard 1798-1854 *BiDAmAr, BnEnAmA, MacEA, McGDA, WhoArch*
Laffan, William J 1921- *AmArch 70*
Laffen, W W Mackey *ArtsEM*
Lafferty, Blanche C 1896- *WhAmArt 85*
Lafferty, James V 1860?- *MacEA*
Laffilee, Jeanne *DcWomA*
Laffin, W G *AmArch 70*
Laffon, Carmen 1934- *OxTwCA*
Laffont, Emilie 1881-1959 *DcWomA*
Laffont, Jean Pierre 1935- *ICPEnP A*
Lafitte, Antonia *DcWomA*
LaFizeliere-Ritti, Marthe De 1865- *DcWomA*
LaFlair, John *FolkA 86*
Laflare, Helen Louise *MarqDCG 84*
LaFlesche, Yosette *DcWomA*
Lafleur, Charles *FolkA 86*
LaFleur, Eugene Terry 1933- *AmArch 70*
LaFleur, James Kemble 1930- *MarqDCG 84*
LaFlotte, Mademoiselle De *DcWomA*
LaFollie, Yves Adolphe Marie De 1830-1896 *DcVicP 2*
Lafon, Dee J 1929- *WhoAmA 73, -76, -78, -80, -82, -84*
Lafon, Gertrude *DcWomA*
LaFon, Julia Anna 1919- *WhoAmA 76, -78, -80, -82, -84*
Lafon, Marie Meloe *DcWomA*
Lafon, Mary Virginia *FolkA 86*
Lafond, Charles Nicolas Rafael 1774-1835 *ClaDrA*
Lafond DeFenion, Aurore Etiennette *DcWomA*
Lafont, Caliste, Madame *DcWomA*
Lafont, Marie *DcWomA*
LaFontaine, Charles *WhAmArt 85*
LaFontaine, Henriette Sophie De *DcWomA*
LaFontaine, Rachel Adelaide 1845- *DcWomA*
Lafontaine, Rosalie De *DcWomA*
LaFontaine, Thomas Sherwood 1915- *DcBrA 1, WhoArt 80, -82, -84*
LaFontaine, Yvonne De *DcWomA*
LaFontaine-Saran, Marceline Emilie d1892 *DcWomA*
Laforcade, Roland 1925- *DcCAr 81*
LaForest, Pauline De 1849- *DcWomA*
Laforge, Marie 1865- *DcWomA*
Lafortune, Francois *WhoAmA 76, -78, -80*
Lafosse, Cecile Berthe *DcWomA*
Lafosse, Charles De 1636-1716 *McGDA*
LaFosse, Charles De 1636-1716 *OxArt*
Lafourcade, Henriette Marie *DcWomA*
Lafrance, Earnest Clyde 1943- *MarqDCG 84*
LaFrance, Marcus G 1937- *AmArch 70*
LaFrance, Mitchell 1882- *FolkA 86*
LaFreniere, Isabel Marcotte *WhoAmA 73*
Lafreniere, Isabel Marcotte *WhoAmA 76, -78*
Lafrensen, Nils *McGDA*
LaFresnaye, Roger De 1885-1925 *McGDA, OxTwCA, PhDcTCA 77*
LaFresnaye, Roger Noel Francois De 1885-1925 *ClaDrA*
Lafresnee-Bruneau, Aimee 1880- *DcWomA*
LaFuente, Maria Ignazia De *DcWomA*
Lagache, Mathilde 1814- *DcWomA*
Lagae, Jules 1862-1931 *McGDA*
Lagana, Filippo 1896- *WhAmArt 85*
Lagana, Giuseppe 1944- *WorECar*
Lagar, Celso 1891- *ClaDrA*
Lagar, Celso 1891-1966 *PhDcTCA 77*
Lagar, Hortense *DcWomA*
Lagarde, Angele De *DcWomA*
Lagarde, Pierre 1853-1910 *ClaDrA*
Lagarde-Brochot, Marie Jeanne 1888- *DcWomA*
Lagatinerie, Eugenie *DcWomA*
Lagatta, John d1976 *WhoAmA 78N, -80N, -82N, -84N*
Lagatta, John 1894- *IlrAm D, WorECar*
LaGatta, John 1894-1976 *WhAmArt 85*
LaGatta, John 1894-1977 *IlrAm 1880*
Lage, Julie VonDer 1841- *DcWomA*
Lage, Marie De d1869 *DcWomA*
Lagedrost, Hugh L 1923- *AmArch 70*
Lager, Fannie 1911- *WhoAmA 82, -84*
Lagerberg, Lucy De *DcWomA*
Lagercrantz, Ava De *WhAmArt 85*
Lagercrantz, Ava Hedvig Gustafva 1862- *DcWomA*
Lagerfeld, Karl 1930- *WorFshn*
Lagerfeld, Karl 1939- *FairDF FRA*
Lagerfeld, Karl Otto 1938- *ConDes*
Lagerholm, Wilhelmina 1826-1917 *DcWomA*
Lagerlof, Catharina Maria *DcWomA*
Lagerson, Rolf H 1925- *WhoGrA 62*
Laget, A *FolkA 86*
Lagier, Erica 1830- *DcWomA*
Lagier, Eugene 1817-1892 *ClaDrA*
Lagier, Marie Augustine 1841-1862 *DcWomA*
Laging, Duard Walter 1906- *WhoAmA 73, -76*
Lagneau, Suzanne 1890- *DcWomA*

Lagoda-Chischkina, Olga Antonovna 1850-1881 *DcWomA*
Lagoda-Schischkina, Olga Antonovna 1850-1881 *DcWomA*
Lagoderie, Marie 1864- *DcWomA*
Lagoor, Johan *McGDA*
Lagorio, Irene 1921- *PrintW 83, -85*
Lagorio, Irene R 1921- *WhoAmA 73, -76, -78, -80, -82, -84*
Lagorio, Marie 1893- *DcWomA*
Lagrange, Camille De *DcWomA*
Lagrenee, Jean Jacques 1739-1821 *ClaDrA*
Lagrenee, Louis Jean Francois 1725-1805 *ClaDrA*
Lagrenee, Louis-Jean-Francois, The Elder 1725-1805 *McGDA*
Lagrenee, Lucy 1873- *DcWomA*
Lagrone, Oliver *AfroAA*
Lagrone, R E *AfroAA*
Lagrost, Marguerite 1865- *DcWomA*
Lagroue, Harold Joseph, Jr. 1917- *AmArch 70*
Lagru, Dominique 1873-1960 *OxTwCA*
LaGuepiere, Pierre Louis Philippe De 1715?-1773 *MacEA*
Laguernela, Mariane Barbasan 1864-1924 *DcWomA*
Laguerre, Louis 1663-1721 *DcBrECP, OxArt*
Laguillermie, August Frederic *ArtsNiC*
Laguna, Lawrence 1919- *AmArch 70*
Laguna, Mariella 1935- *AmArt*
Laguna, Marielle *WhoAmA 82, -84*
Laguna, Muriel *WhoAmA 76, -78, -80*
Lagunas, Santiago *OxTwCA*
Lagunes, Maria *WhoAmA 73, -76, -78, -80, -82*
Lagurane, John *NewYHSD*
Lagurane, Peter *NewYHSD*
Lagurane, Santonio *NewYHSD*
Lagut, Irene 1893- *DcWomA*
Lagye, Victor *ArtsNiC*
Lagye, Victor 1825-1896 *ClaDrA*
Laha, Asoke K 1945- *MarqDCG 84*
Lahee, Arnold Warburton 1888- *WhAmArt 85*
Lahey, Marguerite Duprez 1880-1958 *WhoAmA 80N, -82N, -84N*
Lahey, Marguerite Dupuz 1890-1958 *WhAmArt 85*
Lahey, Richard 1893- *WhAmArt 85, WhoAmA 73, -76, -78*
Lahey, Richard 1893-1979 *WhoAmA 80N, -82N, -84N*
Lahey, Mrs. Richard *WhAmArt 85*
Lahey, Vida 1880-1968 *DcWomA*
LaHire, Laurent De 1606-1656 *ClaDrA, McGDA*
LaHire, Marie De 1878- *DcWomA*
Lahm, Renee D 1897-1945 *WhAmArt 85*
Lahm, Renee De 1897-1945 *DcWomA*
LaHotan, Robert L 1927- *WhoAmA 73, -76, -78, -80, -82, -84*
Lahr, Florence G 1898- *DcWomA, WhAmArt 85*
Lahr, J Stephen 1943- *WhoAmA 84*
Lahr, Leanna 1903- *WhAmArt 85*
Lahr, R W 1890- *WhAmArt 85*
Lahrs, Maria 1880-1917 *DcWomA*
LaHyre, Laurent De *McGDA*
LaHyre, Laurent De 1606-1656 *OxArt*
Lai, Gar Chew 1922- *AmArch 70*
Lai, Ming 1929- *OxTwCA*
Lai, Richard Tseng-Yu 1937- *AmArch 70*
Lai, Sung *DcSeaP*
Lai, Waihang 1939- *WhoAmA 73, -76, -78, -80, -82, -84*
Laible, Eugene *ArtsEM*
Laible Wright And Hopkin *ArtsEM*
Laiderman, Ralph Yale 1939- *AmArch 70*
Laidlaw, Cora M 1863- *ArtsAmW 3*
Laidlaw, H Giuseppe *DcVicP 2*
Laidlaw, James B 1822?-1854 *NewYHSD*
Laidlaw, Jennie L 1861- *DcWomA, WhAmArt 85*
Laidlaw, Nicol 1886- *DcBrA 1*
Laidlay, Lucy *DcVicP 2*
Laidlay, William James 1846-1912 *DcBrA 1, DcVicP, -2*
Laidler, Miss *DcVicP 2*
Laidler, Thomas *NewYHSD*
Laighton, Daniel 1764-1794 *CabMA*
Laighton, Deborah *FolkA 86*
Laillard, Jeanne 1897- *DcWomA*
Laimgruber, Monika 1946- *IlsCB 1967*
Lainberger, Simon *McGDA*
Laine, Alice 1885- *DcWomA*
Laine, Lenore *WhoAmA 73, -76, -78, -80*
Laine, Marie Theophile *DcWomA*
Lainee, Thomas 1686-1739 *MacEA*
Laing, Alan Kemp 1902- *AmArch 70*
Laing, Albert 1811-1886 *FolkA 86*
Laing, Annie R 1869-1946 *DcBrA 1*
Laing, Annie Rose 1869-1946 *DcWomA*
Laing, Bill 1944- *DcCAr 81*
Laing, David 1774-1856 *BiDBrA, DcD&D, WhoArch*
Laing, Florence *DcWomA*
Laing, Frank *DcBrA 1*
Laing, Frank 1862- *DcVicP 2*

Lambert, Sophie 1810- *DcWomA*
Lambert, Stewart Birtrum 1933- *AmArch 70*
Lambert, Terence Henry 1891- *DcBrA 1*
Lambert, Thomas *FolkA 86*
Lambert-Stieffel, Marie 1897- *DcWomA*
Lambert-Tristan, Baroness Louise De *DcWomA*
Lambert Y Martinez, Jose Valeriano *AmArch 70*
Lamberti, Niccolo DiPietro 1370?-1451 *McGDA*
Lamberti, Pietro DiNiccolo 1393?-1435 *McGDA*
Lamberti, Stefano 1485-1538 *McGDA*
Lambertin, Theo *DcCAr 81*
Lambeth, Michel 1923-1977 *ConPhot, ICPEnP A*
Lambeth, William H, Jr. *AmArch 70*
Lambinet, Emile 1810-1878 *ArtsNiC*
Lambinet, Emile Charles 1815-1877 *ClaDrA*
Lamblotte, Maria Elisabeth *DcWomA*
Lambo, Don *IlsBYP*
Lamboley, Lea-Louise 1883- *DcWomA*
Lamborghini, Raffaele Enea 1923- *AmArch 70*
Lamborne, Peter Spendelowe 1722-1774 *DcBrWA*
Lambourn, George 1900- *DcBrA 1*
Lambourne, Alfred 1850-1926 *ArtsAmW 1,*
 IIBEAAW, WhAmArt 85
Lambourne, Nigel 1919- *DcBrA 1, WhoArt 80, -82,*
 -84
Lambquin, Berthe *DcWomA*
Lambray, Maureen *ICPEnP A, MacBEP*
Lambright, Elizabeth *FolkA 86*
Lambright, Mrs. Menno *FolkA 86*
Lambright, Susan *FolkA 86*
Lambson, Hayden *OfPGCP 86*
Lambton, Mary *DcWomA*
Lamelas, David 1946- *ConArt 77, -83*
Lamell, Robert 1913- *WhoAmA 82, -84*
Lamell, Robert Charles 1913- *AmArch 70*
Lamen, Christoffel Jacob VanDer 1615?-1651?
 McGDA
Lamen, Christoffel Jacobsz VanDer 1615-1651 *ClaDrA*
Lamen, Erlen Mylo 1927- *AmArch 70*
LaMendola 1929- *WorFshn*
Lamerand, Ed *FolkA 86*
Lameras, Lazaros 1918- *WhoArt 80, -82, -84*
Lamerie, Paul 1688-1751 *OxDecA*
Lamerie, Paul De 1688-1757 *AntBDN Q*
Lamey, Charlotte Von *DcWomA*
Lamey, Richard *WhAmArt 85*
Lami, Eugene 1800-1890 *DcBrBI*
Lami, Eugene-Louis 1800-1890 *McGDA, OxArt*
Lami, Louis Eugene 1800- *ArtsNiC*
Lamielle, E *FolkA 86*
Lamiral, Henriette *DcWomA*
Lamiral-Gilles, Julie 1882- *DcWomA*
Lamis, Leroy 1925- *DcCAA 71, -77, WhoAmA 73,*
 -76, -78, -80, -82, -84
Lamison, Robert Miller 1918- *AmArch 70*
Lamith, Joseph *NewYHSD*
Lamkin, Charles Roberts 1913- *AmArch 70*
Lamkin, Robert Elliott 1928- *AmArch 70*
Lamm, B D *AmArch 70*
Lamm, George Barry 1935- *AmArch 70*
Lamm, Lora 1928- *WhoGrA 62, -82[port]*
Lamm, Placida d1692? *DcWomA*
Lamme, Adrienne *DcWomA*
Lamme, Arie Johannes 1812-1900 *ClaDrA*
Lamme, Cornelia *DcWomA*
Lamme, Placida d1692? *DcWomA*
Lammer, Vladimir 1930- *MacBEP*
Lammerhirt, Marianne Walpurgis *DcWomA*
Lammers, Herman C 1867- *WhAmArt 85*
Lammers, L *AmArch 70*
Lamming, Ken *DcCAr 81*
Lammini, Miss *DcVicP 2*
Lamoisse, Elizabeth *DcWomA*
Lamond, Miss *DcVicP 2*
LaMond, Stella Lodge 1893- *ArtsAmW 2, DcWomA,*
 WhAmArt 85
Lamond, W B d1924 *DcBrA 2*
Lamonica, James Albert 1946- *MarqDCG 84*
Lamonica, Robert De 1933- *PhDcTCA 77*
Lamont, Daniel Elihu 1912- *AmArch 70*
Lamont, Daniel G *NewYHSD*
Lamont, Elish 1800-1870 *DcBrBI, DcWomA*
Lamont, Frances *WhoAmA 73*
Lamont, Frances d1975 *WhoAmA 76N, -78N, -80N,*
 -82N, -84N
Lamont, Frances Kent d1975 *WhAmArt 85*
Lamont, Frances Kent 1899-1975 *DcWomA*
Lamont, Frederick *NewYHSD*
LaMont, James Charles 1924- *AmArch 70*
Lamont, John Charles 1894- *DcBrA 1*
Lamont, Thomas Reynolds 1826-1898 *DcBrBI,*
 DcBrWA, DcVicP, -2
LaMontagne, Walter E 1839-1915 *ArtsEM,*
 NewYHSD, WhAmArt 85
LaMontague, Walter E 1839-1915 *NewYHSD,*
 WhAmArt 85
LaMonte, Elish 1800-1870 *DcBrBI, DcWomA*
Lamor, Antony 1824?- *NewYHSD*
LaMore, Chet Harmon 1908- *WhAmArt 85,*
 WhoAmA 73, -76, -78, -80
LaMore, Chet Harmon 1908-1980 *WhoAmA 82N,*

-84N
Lamoreau, Lowell A d1922 *BiDAmAr*
LaMoriniere, Mademoiselle De *DcWomA*
Lamoriniere, Jean Pierre Francois 1828-1911 *ClaDrA*
Lamothe, J *DcWomA*
LaMotte, Bernard *WhAmArt 85*
Lamour, Jean d1719 *OxDecA*
Lamour, Jean 1698-1771 *McGDA*
Lamour, Jean-Baptiste 1698-1771 *OxDecA*
Lamoureux, Richard Joseph 1938- *AmArch 70*
Lamp, D L *AmArch 70*
Lamp, Johann Baptist *McGDA*
Lampe, Edith 1912- *WhAmArt 85*
Lampe, Elisabeth *DcWomA*
Lampe-Soholt, Inger 1920- *DcCAr 81*
Lampert, Dorrie *WhoAmA 76, -78, -80*
Lampert, Ellen 1948- *AmArt*
Lampert, Emma *WhAmArt 85*
Lampert, Emma Esther *DcWomA*
Lamphere, James A 1934- *AmArch 70*
Lamphere, Ralph *FolkA 86*
Lampi, Johann Baptist, The Elder 1751-1830 *McGDA*
Lamping, R D *AmArch 70*
Lampitoc, Rol Ponce *WhoAmA 82, -84*
Lampkin, R H 1866- *WhAmArt 85*
Lampl, Paul 1915- *AmArch 70*
Lamplough, Augustus Osborne 1877-1930 *DcBrA 1,*
 DcBrWA
Lampman, Helen Winifred 1898- *DcWomA*
Lamprecht, Gisela Helene Louise 1899- *DcWomA*
Lamprell, Benjamin A *CabMA*
Lampron, Joseph Felix 1912- *AmArch 70*
Lampson, David John 1940- *MacBEP*
Lamson, Amos 1769?-1821 *CabMA*
Lamson, Asa *FolkA 86*
Lamson, Benjamin *CabMA*
Lamson, Caleb 1697-1767 *FolkA 86*
Lamson, David *FolkA 86*
Lamson, Francis *CabMA*
Lamson, J *ArtsAmW 1*
Lamson, J 1825?- *IIBEAAW, NewYHSD*
Lamson, James *ArtsAmW 3*
Lamson, John 1732-1776 *FolkA 86*
Lamson, Joseph *NewYHSD*
Lamson, Joseph 1656-1722 *FolkA 86*
Lamson, Joseph 1731-1789 *FolkA 86*
Lamson, Joseph 1760-1808 *FolkA 86*
Lamson, Nathaniel 1693-1755 *FolkA 86*
Lamson, William *CabMA*
Lamsweerde, Eugene Van 1930- *ConArt 77*
LaMura, E L *AmArch 70*
LaMuro, Gennaro Thomas *AmArch 70*
Lamy, Aline 1862- *DcWomA*
Lamy, Ferdinand C *EncASM*
Lamy, Louise *DcWomA*
Lamy, Nelly *DcWomA*
Lan, Ying 1585-1660? *McGDA*
Lana DaModena, Lodovico 1597-1646 *ClaDrA*
Lanbender, Ruth E 1864- *WhAmArt 85*
Lanberg, Emely 1851- *DcWomA*
Lancaster, Mrs. *DcVicP 2*
Lancaster, Alfred Dobree d1909 *DcVicP 2*
Lancaster, Brian Christy 1931- *WhoArt 80*
Lancaster, Carl Herbert, Jr. 1913- *AmArch 70*
Lancaster, Charles R 1949- *MarqDCG 84*
Lancaster, E B *AmArch 70*
Lancaster, E M *AmArch 70*
Lancaster, Edward Purser 1911-1954 *DcBrA 1*
Lancaster, Elizabeth Greig 1889- *DcWomA,*
 WhAmArt 85
Lancaster, Eric 1911- *WhoGrA 62*
Lancaster, Hume d1850 *DcVicP, -2*
Lancaster, James Roydon, II 1954- *MarqDCG 84*
Lancaster, John *DcVicP 2*
Lancaster, John 1939- *MarqDCG 84*
Lancaster, Lilian *DcBrA 1, DcWomA*
Lancaster, Lois 1932- *DcCAr 81*
Lancaster, Lydia *FolkA 86*
Lancaster, Mark 1938- *ConArt 77, DcCAr 81,*
 WhoAmA 78, -80, -82, -84
Lancaster, N H *AmArch 70*
Lancaster, Osbert 1908- *DcBrA 1, IlsCB 1946,*
 PhDcTCA 77, WhoGrA 62
Lancaster, Sir Osbert 1908- *WhoGrA 82[port],*
 WorECar
Lancaster, Percy 1878-1951 *ClaDrA, DcBrA 1,*
 DcBrWA
Lancaster, W S *AmArch 70*
Lancats, Marie *DcWomA*
Lancbquin, Berthe *DcWomA*
Lance, Agnes *DcWomA*
Lance, E *DcVicP 2, DcWomA*
Lance, Elizabeth *WhAmArt 85*
Lance, Eveline *DcVicP 2, DcWomA*
Lance, George 1802-1864 *ArtsNiC, ClaDrA,*
 DcBrWA, DcVicP, -2
Lance, Marjorie 1900- *DcBrA 1*
Lance, Robert W 1928- *AmArch 70*
Lance, W B *DcVicP 2*
Lance, William *DcVicP 2*
Lance, Wilmot *DcVicP 2*

Lanceley, Colin 1938- *ConArt 77*
Lanceley, John 1938- *WhoArt 80, -82, -84*
Lancelin, John L d1822 *NewYHSD*
Lancelot, Dieudonne Auguste 1822-1894 *DcBrBI*
Lancelot-Croce, Marcelle Renee 1854- *DcWomA*
Lanceni, Michelangela *DcWomA*
Lanceroy, Eugene 1848-1886 *AntBDN C*
Lancetti, Pino *FairDF ITA*
Lancetti, Pino 1932- *ConDes, WorFshn*
Lancey, T *DcBrECP*
Lanchester, Mary *DcWomA*
Lanchester, Mary 1864- *ClaDrA, DcBrA 1*
Lanciani, Marcella *DcWomA*
Lancon, A *DcVicP 2*
Lancon, Auguste Andre 1836-1887 *DcBrBI*
Lancret, Nicolas 1690-1743 *ClaDrA, McGDA,*
 OxArt
Lancroft, George *BiDAmAr*
Lanctot, Mederic, Madame *DcWomA*
Land, Edwin Herbert 1909- *ICPEnP, MacBEP*
Land, Ernest Albert 1918- *WhoAmA 73, -76, -78, -80,*
 -82, -84
Land, H H, Jr. *AmArch 70*
Land, H H, Sr. *AmArch 70*
Land, Sarah Agnes Riley *WhoAmA 84*
Land-Weber, Ellen 1943- *ICPEnP A, MacBEP*
Land-Weber, Ellen E 1943- *WhoAmA 78, -80, -82,*
 -84
Landa, Rudolph John 1914- *AmArch 70*
Landacre, Paul d1963 *WhoAmA 78N, -80N, -82N,*
 -84N
Landacre, Paul Hambleton 1893-1963 *ArtsAmW 1,*
 GrAmP, WhAmArt 85
Landais, C J 1800-1883 *DcNiCA*
Landais, Marie Marguerite *DcWomA*
Landaker, H C *WhAmArt 85*
Landaker, Harold 1892?-1966 *ArtsAmW 3*
Landau, Dorothea *DcBrA 1*
Landau, Dorothea Natalie Sophia *DcWomA*
Landau, Felix 1924- *WhoAmA 73, -76, -78, -80, -82*
Landau, Jacob *IlsCB 1967*
Landau, Jacob 1917- *DcCAA 71, -77, IlsBYP,*
 IlsCB 1946, -1957, OxTwCA, PrintW 83, -85,
 WhoAmA 73, -76, -78, -80, -82, -84
Landau, Laureen 1939- *DcCAr 81*
Landau, Mitzi 1925- *WhoAmA 78, -80, -82, -84*
Landau, Myra *WhoAmA 82, -84*
Landau, Rom 1899- *WhoAmA 73*
Landau, Samuel David *WhoAmA 73, -76, -78, -80*
Landau, Sol 1919- *FolkA 86*
Landberg, K E *AmArch 70*
Landberg, Nils 1907- *IlDcG*
Lande, Willem Van 1610- *ClaDrA*
Landeau, Sandor L 1864- *WhAmArt 85*
Landeck, Armin 1905- *GrAmP, WhAmArt 85,*
 WhoAmA 73, -76, -78, -80, -82, -84
Landefeld, Frederick C *WhAmArt 85*
Landelle, Anais *DcWomA*
Landelle, Charles 1821- *ArtsNiC*
Landelle, Charles Zacharie 1812-1908 *ClaDrA*
Landells, Ebenezer 1808-1860 *DcBrBI, DcBrWA*
Landells, Robert Thomas 1833-1877 *DcBrBI,*
 DcBrWA, DcVicP, -2
Landels, Willy *WorFshn*
Landen, Edward *AfroAA*
Lander, Alice *DcVicP 2*
Lander, Benjamin 1842- *WhAmArt 85*
Lander, Edgar 1883- *DcBrBI*
Lander, Edgar Longley 1883- *DcBrA 1*
Lander, Helmut 1924- *DcCAr 81*
Lander, Henry Longley *DcVicP 2*
Lander, John St. Helier 1869-1944 *DcBrA 1*
Lander, Louisa 1826-1923 *DcWomA, NewYHSD,*
 WhAmArt 85
Lander, Mary E *DcVicP 2*
Lander, Reginald Montague 1913- *WhoArt 80, -82,*
 -84
Lander, William, II d1778 *CabMA*
Lander, Wills *DcVicP 2*
Landerer, Ferdinand 1746-1795 *ClaDrA*
Landerman, Urban Edward 1951- *MarqDCG 84*
Landers, Bertha *WhoAmA 78, -80, -82, -84*
Landers, Bertha 1911- *WhAmArt 85*
Landers, George M *EncASM*
Landers, Michael Frank 1951- *MarqDCG 84*
Landers And Smith *EncASM*
Landers Frary And Clark *EncASM*
Landerset, Blanche De 1860- *DcWomA*
Landerset, Teresa Maria *DcWomA*
Landes, Barbara *FolkA 86*
Landes, John *FolkA 86*
Landes, R P *AmArch 70*
Landes, Rudolph *FolkA 86*
Landesmann-Krail, Charlotte 1833-1885 *DcWomA*
Landfield, Ronald 1947- *ConArt 77*
Landfield, Ronnie 1947- *WhoAmA 78, -80, -82, -84*
Landi, Edoardo N *OxTwCA*
Landi, Gaetano *BiDBrA*
Landi, Rossane *DcWomA*
Landifeld, Ronnie 1947- *AmArt*
Landig, R M *AmArch 70*

Lapierre, Louis Emile 1820?- *ArtsNiC*
LaPierre, Thomas 1930- *WhoAmA 73, -76, -78, -80, -82, -84*
LaPietra, Ugo 1938- *ConArt 77, ConDes*
Lapin, Gregory Dean 1956- *MarqDCG 84*
Lapiner, Alan C 1933- *WhoAmA 73, -76, -78, -80, -82*
Laping, John Michael 1937- *AmArch 70*
Lapinski, Tadeusz 1928- *WhoAmA 76, -78, -80, -82, -84*
Lapis, Gaetano 1706-1758 *ClaDrA*
Lapito, Louis-Auguste 1805-1874 *ArtsNiC*
LaPlace, Cyrille 1793-1875 *ArtsAmW 1*
Laplace, Cyrille Pierre Theodore 1793-1875 *IlBEAAW, NewYHSD*
LaPlanche, Francois, De *McGDA*
LaPlanche, Raphael, De *McGDA*
LaPlanche, Sebastien Francois, De *McGDA*
LaPlant, Michele Mimi 1943- *PrintW 83*
LaPlant, Mimi 1943- *PrintW 85*
Laplantz, David 1944- *WhoAmA 76, -78, -80, -82*
LaPlantz, David 1944- *WhoAmA 84*
Laplantz, Shereen 1947- *WhoAmA 82*
LaPlantz, Shereen 1947- *WhoAmA 84*
Lapointe, C *DcWomA*
Lapointe, Eugene Joseph 1932- *MarqDCG 84*
Lapointe, Frank 1942- *DcCAr 81, PrintW 83, WhoAmA 78, -80, -82, -84*
LaPointe, Frank 1942- *PrintW 85*
Lapointe, Jeanne d1920 *DcWomA*
Lapointe, Marthe Marie d1890 *DcWomA*
Laporte, Mademoiselle *DcWomA*
LaPorte, Adele De *DcWomA*
Laporte, George Henry 1799-1873 *DcBrWA, DcVicP, -2*
Laporte, John 1761-1839 *DcBrWA*
Laporte, Mary Ann *DcVicP 2, DcWomA*
Laporte, Mary Anne *DcBrWA*
Laporte, Paul M 1904- *WhAmArt 85*
Laporte-Blairsy, F J *DcWomA*
Laposky, Ben Francis 1914- *WhoAmA 76, -78, -80, -82, -84*
Lapostelet, Charles 1824-1890 *ClaDrA*
Lapostolet, Charles *ArtsNiC*
Lapota, M *AmArch 70*
Lapoter, Adelaide Isabelle Antonine 1814-1880 *DcWomA*
Lapoujade, Robert 1921- *OxTwCA*
Lapow, Harry 1909- *MacBEP*
Lapow, Harry 1909-1983 *ICPEnP A*
Lapp, Christian *FolkA 86*
Lapp, Ferdinand *ArtsEM, FolkA 86*
Lapp, Henry 1822-1913 *FolkA 86*
Lapp, Lydia *FolkA 86*
Lappe, Alexander H *WhAmArt 85*
Lappen, David I 1956- *MarqDCG 84*
Lappley, C J *AmArch 70*
Lappo, Osmo 1927- *MacEA*
Laprade, Albert 1883-1978 *ConArch, MacEA*
LaPrade, Malcolm *WhAmArt 85*
Laprade, Pierre 1875-1931 *OxTwCA*
Laprade, Pierre 1875-1932 *ClaDrA, PhDcTCA 77*
Lapworth, William E *DcVicP 2*
Laquy, Willem Joseph 1738-1798 *ClaDrA*
Lara, Alberto 1949- *MarqDCG 84*
Lara, George *DcVicP*
Lara, Georgina *DcVicP 2*
Lara, Percy Leslie 1870- *DcBrA 1*
Laramey, R D *AmArch 70*
Laramore, Joseph Cornish, Jr. 1927- *AmArch 70*
Larason, R C *AmArch 70*
Larbalestier, P *DcVicP 2*
Larcada, Richard Kenneth 1935- *WhoAmA 73, -76, -78, -80, -82, -84*
Larche, Raoul F 1860-1912 *AntBDN A*
Larche, Raoul-Francois 1860-1912 *DcNiCA*
Larcher, Antoinette 1685- *DcWomA*
Larcher, Dorothy *ConDes*
Larcher, Jean 1947- *ConDes*
Larcher-Eyssegg *DcWomA*
Lardera, Berto 1911- *ConArt 77, -83, McGDA, OxTwCA, PhDcTCA 77, WhoArt 80, -82, -84*
Lardillon, Lucy d1904 *DcWomA*
Lardner, Jon Benton 1933- *AmArch 70*
Lareau, Glenn Coney 1928- *AmArch 70*
Lareau, R J *AmArch 70*
Laredo, Gary 1921- *AmArch 70*
Large, T C *AmArch 70*
Large, Virginia 1914- *IlBEAAW*
L'Argenta *McGDA*
Largesse, M D *WhoAmA 82*
Largilliere, Nicolas De 1654-1746 *McGDA*
Largilliere, Robert Joseph 1931- *MarqDCG 84*
Lari, Robert Joseph 1931- *MarqDCG 84*
LaRiar, Lawrence 1908- *WhAmArt 85*
Lariar, Lawrence 1908- *WhoAmA 73, -76, -78, -80, -82, -84*
Larible, Blanche *DcWomA*
Laricci, Beatrice *DcWomA*
Laridon, Louise 1868-1943 *DcWomA*
Larimer, Harry E *WhAmArt 85*

Larin, Alfredo 1925- *AmArch 70*
Larionoff, Michel 1881- *ClaDrA*
Larionov, Michael 1881-1964 *McGDA*
Larionov, Mikhail 1881-1964 *ConArt 77, -83, PhDcTCA 77*
Larionov, Mikhail Fedorovich 1882-1964 *OxTwCA*
Laris, F G *DcVicP 2*
Laris, Hermine *DcWomA*
Larius, Augusta *DcWomA*
LaRiva-Munoz, Maria Luisa *DcWomA*
Lariviere, Alice *DcWomA*
Lariviere, Charles Philippe Auguste De 1798-1876 *ClaDrA*
Lariviere, Jenny 1801-1885 *DcWomA*
Lark, Raymond 1939- *AfroAA, WhoAmA 73, -76, -78, -80, -82, -84*
Lark, Sylvia 1947- *WhoAmA 82, -84*
Lark, Tremayne *DcVicP 2*
Larke, R G *AmArch 70*
Larkin *FolkA 86*
Larkin, Alice *WhAmArt 85*
Larkin, Alice P *DcWomA*
Larkin, Anya 1945- *ConDes*
Larkin, Charles Henry *NewYHSD*
Larkin, Edward d1677 *CabMA*
Larkin, Edward, Jr. 1689-1751 *CabMA*
Larkin, Elisha *CabMA*
Larkin, Eugene 1921- *WhoAmA 73, -76, -78, -80, -82, -84*
Larkin, Mrs. Fred S 1884- *DcWomA*
Larkin, J F *AmArch 70*
Larkin, John *CabMA*
Larkin, John 1690-1720 *CabMA*
Larkin, John 1724-1798 *CabMA*
Larkin, John E, Jr. *WhoAmA 78, -80*
Larkin, John E, Jr. 1930- *WhoAmA 82, -84*
Larkin, Katherine B S *WhAmArt 85*
Larkin, Lawrence Iturbe 1957- *MarqDCG 84*
Larkin, Mayo I 1916- *AmArch 70*
Larkin, Michael Joseph 1925- *AmArch 70*
Larkin, Oliver 1896-1970 *WhoAmA 78N, -80N, -82N, -84N*
Larkin, Samuel 1701-1784 *CabMA*
Larkin, Thomas 1730-1799 *CabMA*
Larkin, William 1902- *WhoAmA 73*
Larkin, William 1902-1969 *WhoAmA 76N, -78N, -80N, -82N, -84N*
Larking, Louisa Margaret 1898- *DcBrA 1, DcWomA*
Larking, Patrick Lambert 1907- *DcBrA 1, WhoArt 80, -82, -84*
Larkins, F *DcVicP 2*
Larkins, William Martin 1901- *DcBrA 1*
Larmande, Leo J *NewYHSD*
Larmando, Leo J *NewYHSD*
Larmer, Oscar Vance 1924- *WhoAmA 78, -80, -82, -84*
Larmont, Eric 1943- *WhoArt 80, -82, -84*
Larned, Charles W 1850-1911 *WhAmArt 85*
Larned, Ellen Saulsbury 1840-1918 *DcWomA*
Larned, Ellen Saulsbury Lester 1840-1918 *ArtsEM*
Larned, Marguerite Y *WhAmArt 85*
Larned, Walter Cranston 1850-1914 *WhAmArt 85*
Larocca, Frank Luke 1931- *AmArch 70*
LaRocca, Ketty 1938- *ConArt 77*
Laroche *AntBDN F*
LaRoche, Edwin Bruce 1886-1944? *BiDAmAr*
Laroche, Guy 1923- *WorFshn*
LaRoche, Maria 1870- *DcWomA*
LaRochefoucauld, Countess Antoine De *DcWomA*
LaRochefoucault, Countess Antoine De *DcWomA*
Larock, Evrard 1865-1901 *ClaDrA*
Larocque, Eleanor Theodora *WhAmArt 85*
Larocque, William *MarqDCG 84*
Laroon, Marcel *OxArt*
Laroon, Marcel 1653-1702 *ClaDrA*
Laroon, Marcellus 1653-1772 *OxArt*
Laroon, Marcellus 1679-1772 *DcBrECP, OxArt*
Laroon, Marcellus, Jr. 1679-1774 *McGDA*
Laroque-Zo, Blanche Marie Adelaide *DcWomA*
LaRosa, Fernando 1943- *ICPEnP A, MacBEP*
LaRosa, Vincenzo 1871?-1925 *ArtsAmW 3*
LaRosee, Josephine Basselet 1784-1845 *DcWomA*
Larouche, Guy 1921- *FairDF FRA*
LaRoy, Wesley Evans 1923- *AmArch 70*
Larpin, Cecile Henriette 1840-1912 *DcWomA*
Larraga, Josefa Maria *DcWomA*
Larrain, Gilles Michel Leon 1938- *MacBEP*
Larratt, Richard David 1940- *MarqDCG 84*
Larraz, Julio F 1944- *WhoAmA 82, -84*
Larraz, Julio Fernandez 1944- *WhoAmA 76, -78, -80*
Larrecq, John M *IlsBYP*
Larrecq, John Maurice 1926- *IlsCB 1967*
Larrick, Thomas 1905- *AmArch 70*
Larrieu, Jean Claude 1943- *MacBEP*
Larrinaga, Juan B 1885- *ArtsAmW 2*
Larrinaga, Mario 1895- *ArtsAmW 2, WhoAmA 73, -76*
Larroque, Marie *DcWomA*
Larroque, Mathilde *DcWomA*
Larsen, A H *AmArch 70*
Larsen, Andreas R *WhAmArt 85*

Larsen, Arnold Lester 1925- *AmArch 70*
Larsen, B F 1882- *WhAmArt 85*
Larsen, Ben 1892- *ArtsAmW 3*
Larsen, Bent Franklin 1882-1970 *ArtsAmW 1, IlBEAAW*
Larsen, Bessie 1889- *ArtsAmW 3*
Larsen, Carl Christian 1853-1910 *DcBrBI*
Larsen, Carl Frederick Emmanuel 1823-1859 *DcSeaP*
Larsen, Charles Peter 1892- *WhAmArt 85*
Larsen, Christine *DcWomA*
Larsen, D Dane 1950- *WhoAmA 78, -80, -82, -84*
Larsen, Donald Ernest 1937- *AmArch 70*
Larsen, Emil J 1877- *IlDcG*
Larsen, Erik 1911- *WhoAmA 73, -76, -78, -80, -82, -84*
Larsen, George Christian 1920- *AmArch 70*
Larsen, Gerda 1894- *DcWomA*
Larsen, Gudrun *DcWomA*
Larsen, Jack Lenor 1927- *ConDes, DcD&D[port], WhoAmA 73, -76, -78, -80, -82, -84*
Larsen, Johannes 1867- *IlsCB 1946*
Larsen, John Christian *WhoAmA 80, -82, -84*
Larsen, John R *WhAmArt 85*
Larsen, Knud V 1930- *WorECom*
Larsen, Lisa 1925-1959 *ICPEnP A, MacBEP*
Larsen, Mae Sybil d1953 *ArtsAmW 3, DcWomA, WhAmArt 85*
Larsen, Mernet Ruth 1940- *WhoAmA 84*
Larsen, Mimi 1851- *DcWomA*
Larsen, Morten 1858-1930 *ArtsAmW 3*
Larsen, Niels Hjalmar 1885- *AmArch 70*
Larsen, Ole *WhoAmA 73, -76, -78, -80, -82, -84*
Larsen, Patrick Heffner 1945- *WhoAmA 78, -80, -82, -84*
Larsen, Ralph William 1920- *AmArch 70*
Larsen, Robert George 1932- *AmArch 70*
Larsen, Robert James *AmArch 70*
Larsen, Robert Wesley 1923- *WhoAmA 84*
Larsen, Susan C 1946- *WhoAmA 78, -80, -82, -84*
Larsen, Suzanne Kesteloo 1930- *IlsCB 1957*
Larsen, Terry R 1945- *MarqDCG 84*
Larsen, Wilhelm R *WhAmArt 85*
Larsen, Yvi *WorFshn*
Larsh, Theodora d1955 *DcWomA, WhAmArt 85*
Larson, Arvid G 1937- *MarqDCG 84*
Larson, Blaine 1937- *WhoAmA 76, -78, -80, -82, -84*
Larson, Brian Foix 1935- *AmArch 70*
Larson, C Theodore 1903- *AmArch 70*
Larson, C W *AmArch 70*
Larson, Dayl Andrew 1930- *AmArch 70*
Larson, Edward *PrintW 85*
Larson, Edward 1931- *FolkA 86*
Larson, Edwin 1898- *AmArch 70*
Larson, Edwin Laurin 1923- *AmArch 70*
Larson, Ernest *AmArch 70*
Larson, Frank E *WhAmArt 85*
Larson, Fred T 1868- *WhAmArt 85*
Larson, Gary Harold 1939- *AmArch 70*
Larson, George W *WhAmArt 85*
Larson, Godfrey E 1898-1945 *BiDAmAr*
Larson, J F *AmArch 70*
Larson, Jane 1922- *WhoAmA 78, -80, -82, -84*
Larson, Jeffrey Gordon 1954- *MarqDCG 84*
Larson, Jerome Morley 1935- *AmArch 70*
Larson, John Harry 1931- *AmArch 70*
Larson, Kay L 1946- *WhoAmA 80, -82, -84*
Larson, Larry Uno 1930- *AmArch 70*
Larson, M J *AmArch 70*
Larson, Nils Fredrick 1922- *AmArch 70*
Larson, Orland 1931- *WhoAmA 78, -80, -82, -84*
Larson, P M *AmArch 70*
Larson, Philip 1944- *PrintW 85*
Larson, Philip Seely 1944- *PrintW 83, WhoAmA 76, -78, -80, -82, -84*
Larson, Richard Charles 1943- *MarqDCG 84*
Larson, Roy Frank 1893- *AmArch 70*
Larson, Sidney 1923- *WhoAmA 73, -76, -78, -80, -82, -84*
Larson, Theresa Gail *WhoAmA 82, -84*
Larson, V A *AmArch 70*
Larson, Virginia *DcVicP 2*
Larson, W L *AmArch 70*
Larson, W N *AmArch 70*
Larson, William 1942- *ConPhot, ICPEnP A, MacBEP*
Larson, William G 1912- *WhoAmA 78, -80*
Larson, William G 1942- *WhoAmA 82, -84*
Larsonneur, Marie *DcWomA*
Larsson, Carl 1853-1919 *McGDA, OxArt*
Larsson, Ingrid 1898-1978 *DcWomA*
Larsson, Karin *DcWomA*
Larsson, Karl 1893-1967 *ArtsAmW 2*
Larsson, Marjorie Flack *WhAmArt 85*
Larsson, Martha Sofia 1887- *DcWomA, WhAmArt 85*
Larsson, Simeon Markus 1825-1864 *DcSeaP*
Larter, Josenia Elizabeth 1898- *WhAmArt 85*
Larter, Robert E *WhAmArt 85*
Lartigue, Jacques-Henri 1894- *ConPhot, ICPEnP*
Lartigue, Jacques Henri 1894- *MacBEP*
Larue, David Lee 1954- *MarqDCG 84*

Larue, Lise *DcWomA*
Larue, Marie Catherine *DcWomA*
LaRue, Myra 1850- *DcWomA*
LaRue, Philibert Benoit De 1718-1780 *ClaDrA*
LaRue, Robert Leonard 1925- *AmArch 70*
LaRue, Walt 1925?- *IlBEAAW*
Larum, Oscar *DcBrBI*
Larusdottir, Karolina 1944- *WhoArt 82, –84*
Lasala, Vito William 1929- *AmArch 70*
LaSalle, Charles 1893?-1958 *ArtsAmW 1*
LaSalle, Charles 1894-1958 *IlBEAAW*
Lasalle, Charles Louis 1894-1958 *IlrAm D*
LaSalle, Charles Louis 1894-1958 *IlrAm 1880,*
 WhAmArt 85
LaSalle, Eugene Carl 1917- *AmArch 70*
Lasalle, Philippe De 1723-1803 *OxDecA*
Lasansky, Leonardo 1946- *WhoAmA 82, –84*
Lasansky, Leonardo DaIowa 1946- *WhoAmA 76, –78,*
 –80
Lasansky, Mauricio 1914- *BnEnAmA, DcAmArt,*
 DcCAA 71, –77, McGDA, OxTwCA,
 WhAmArt 85, WhoAmA 73, WorArt[port]
Lasansky, Mauricio L *WhoAmA 82*
Lasansky, Mauricio L 1914- *PrintW 83, –85,*
 WhoAmA 76, –78, –80, –84
Lasar, Charles A C 1856-1936 *WhAmArt 85*
Lascari, Hilda Kristina 1885-1937 *DcWomA,*
 WhAmArt 85
Lascari, Salvatore 1884- *WhAmArt 85*
Lascaris, Pietro d1531 *McGDA*
Lascelles, Charles 1890- *DcBrA 1*
Lascelles, Frank d1934 *DcBrA 2*
Lascelles, Thomas W *DcVicP 2*
Lasch, E *DcVicP 2*
Lasch, Karl Johann 1822- *ArtsNiC*
Lasch, Pat 1944- *PrintW 83, –85, WhoAmA 78, –80,*
 –82, –84
Laschenski, Sigmund J 1891- *AmArch 70*
Laschkow, Andrej 1946- *ICPEnP A*
Lasdun, Denys 1914- *DcD&D[port]*
Lasdun, Sir Denys *WhoArt 80, –82, –84*
Lasdun, Sir Denys 1914- *ConArch*
Lasdun, Sir Denys Louis 1914- *WhoArch*
LaSecla Fried *EncASM*
Lasegue, Marie d1899 *DcWomA*
Lasell, David L 1954- *MarqDCG 84*
Lasell, Fen H *IlsCB 1967*
Lasell, Fen H 1929- *IlsCB 1957*
Laser, Robert Stephens 1926- *AmArch 70*
Lash, Kenneth 1918- *WhoAmA 76, –78, –80, –82, –84*
Lash, Lee *WhAmArt 85*
Lash, Lee 1864- *ArtsAmW 3*
Lash, William Stanley Mallory 1928- *AmArch 70*
Lashel *FolkA 86*
Lashell, L M *FolkA 86*
Lashin, Abraham Isaac 1926- *AmArch 70*
Lashley, James Edward *AmArch 70*
Lashmit, Luther 1899- *AmArch 70*
Lasibille, Madeleine 1879- *DcWomA*
Laske, Lyle F 1937- *WhoAmA 82, –84*
Laske-Kesselbauer, Elisabeth 1884- *DcWomA*
Lasker, Mrs. Albert D *WhoAmA 80, –73, –76, –78,*
 –82
Lasker, Cecile Mathilde *DcWomA*
Lasker, Joe *IlsCB 1967*
Lasker, Joe 1919- *IlsCB 1957, WhoAmA 82, –84*
Lasker, Joseph 1918- *WhoAmA 73, –76, –78, –80*
Lasker, Joseph L 1919- *WhAmArt 85*
Lasker, Joseph Leon 1919- *IlsBYP*
Lasker-Schuler, Else 1869?-1945 *DcWomA*
Laskey, Norman F *WhoAmA 73, –76, –78, –80,*
 –82
Laskey, Mrs. Norman F *WhoAmA 73, –76, –78,*
 –80, –82
Laskin, Bruce S 1956- *MarqDCG 84*
Laskin, Myron, Jr. 1930- *WhoAmA 76, –78, –80, –82,*
 –84
Laskoski, Pearl *FolkA 86*
Laskoski, Pearl 1886- *WhAmArt 85*
Laskoski, Pearl Doud 1886- *DcWomA*
Lasky, Benjamin 1734?-1778 *CabMA*
Lasky, Bessie 1890- *WhAmArt 85*
Lasky, Bessie 1890-1972 *ArtsAmW 2*
Lasky, Bessie Mona 1890-1972 *DcWomA*
Lasky, Thomas 1696?- *CabMA*
Laslett, Basil George Frederick 1903- *AmArch 70*
Laslett, William Lenox 1928- *AmArch 70*
Laslo, Patricia Louise 1930- *WhoAmA 73, –76, –78,*
 –80, –82, –84
Lasnier, Marthe Mathilde *DcWomA*
LaSonnette, Georges De *McGDA*
LaSonnette, Jean Michel *McGDA*
Lassam, Susie 1875- *ClaDrA, DcBrA 1, DcWomA*
Lassare, Catherine Helie *DcWomA*
Lassaw, Ibram 1913- *BnEnAmA, DcAmArt,*
 DcCAA 71, –77, DcCAr 81, McGDA, OxTwCA,
 PhDcTCA 77, WhAmArt 85, WhoAmA 73, –76,
 –78, –80, –82, –84, WorArt[port]
Lasseigne, C C *AmArch 70*
Lassell, Charles *WhAmArt 85*
Lassen, Ben d1968 *WhoAmA 78N, –80N, –82N,*

 –84N
Lassen, Kathe 1880- *DcWomA*
Lasseter, T M *AmArch 70*
Lassiter, Vernice 1927- *WhoAmA 73, –76, –78, –80,*
 –82
Lassnig, Maria *DcCAr 81*
Lasson, Oda *DcWomA*
Lassonde, Omer Thomas 1903- *WhAmArt 85*
Lassurance *WhoArch*
Lassurance, Pierre 1660-1724 *MacEA*
Lassus, Jean-Baptiste-Antoine 1807-1857 *MacEA*
Lassus, Jean Baptiste Antoine 1807-1857 *WhoArch*
Lasswell, Fred 1916- *WorECom*
Lastman, Claes Pietersz 1586?-1625 *ClaDrA*
Lastman, Pieter 1583-1633 *OxArt*
Lastman, Pieter Pietersz 1583-1633 *ClaDrA, McGDA*
Laston, Louise *DcWomA*
Lastra, Aldo P 1935- *AmArch 70*
Lastra, Luis 1930- *WhoAmA 73, –76, –78, –80*
Lasuchin, Michael 1923- *AmArt, PrintW 83, –85,*
 WhoAmA 76, –78, –80, –82, –84, WhoArt 80, –82,
 –84
Lasz, Philip *OfPGCP 86*
Laszlo, George 1891- *WhAmArt 85*
Laszlo, Philip Alexius De 1869-1937 *DcBrA 1*
Laszlo DeLombos, Philip Alexius De 1869- *ClaDrA*
Lataster, Ger 1920- *OxTwCA, PhDcTCA 77*
Latazar, France *DcWomA*
Latchford, Alice *DcBrA 2*
Latchford, Joan Clarence 1926- *MacBEP*
Latenser, Frank J 1890- *AmArch 70*
Latenser, William Banks 1926- *AmArch 70*
Latham, Angela 1896- *DcWomA*
Latham, Barbara 1896- *ArtsAmW 1, DcWomA,*
 IlBEAAW, IlsCB 1744, –1946, WhAmArt 85,
 WhoAmA 73, –76, –78, –80, –82, –84
Latham, Barbara Rose Aronofsky 1947- *MarqDCG 84*
Latham, Catherine Doris 1920- *WhoAmA 78, –80, –82*
Latham, Edward *CabMA*
Latham, Frances A *DcVicP 2*
Latham, Francis P *DcVicP 2*
Latham, George d1871 *BiDBrA*
Latham, Harold *DcBrA 1*
Latham, J *DcBrECP*
Latham, James 1696-1747 *DcBrECP*
Latham, John *AntBDN M, NewYHSD*
Latham, John 1805?- *BiDBrA*
Latham, John 1921- *ConArt 77, –83,*
 ConBrA 79[port]
Latham, Oliver Matthew 1828?- *DcBrWA*
Latham, O'Neill *WhAmArt 85*
Latham, Richard 1920- *McGDA*
Latham, William *DcBrWA*
LaThangue, Henry Herbert 1859-1929 *ClaDrA,*
 DcBrA 1, DcVicP, –2
Lathbury, Mrs. *DcBrBI, DcWomA*
Lathbury, Kathleen 1900- *WhoArt 80, –82, –84*
Lathbury, Mary A *DcWomA*
Lathe, Nama Aurelia 1881- *WhAmArt 85*
Lathe, Nama Aurelia 1881-1965 *DcWomA*
Lathouse, Mrs. W B *FolkA 86*
Lathrop, Betsy B *DcWomA, NewYHSD*
Lathrop, Betsy B 1812- *FolkA 86*
Lathrop, Charles *FolkA 86*
Lathrop, Churchill Pierce 1900- *WhoAmA 73, –76,*
 –78, –80, –82, –84
Lathrop, Clara W *WhAmArt 85*
Lathrop, Clara Wells *DcWomA*
Lathrop, Dorothy P 1891- *WhoAmA 73, –76, –78*
Lathrop, Dorothy Pulis *WhAmArt 85*
Lathrop, Dorothy Pulis 1891- *Cald 1938, ConICB,*
 DcWomA, IlsBYP, IlsCB 1744, –1946, –1957
Lathrop, Elinor 1899- *WhAmArt 85*
Lathrop, Elinor L *DcWomA*
Lathrop, Francis 1849- *ArtsNiC*
Lathrop, Francis 1849-1909 *WhAmArt 85*
Lathrop, Mrs. George A *ArtsEM, DcWomA*
Lathrop, Gertrude K 1896- *WhAmArt 85,*
 WhoAmA 73, –76, –78, –80, –82, –84
Lathrop, Gertrude Katherine 1896- *DcWomA*
Lathrop, Ida 1859-1937 *DcWomA*
Lathrop, Ida Pulis 1859-1937 *WhAmArt 85*
Lathrop, James S *FolkA 86*
Lathrop, John D *NewYHSD*
Lathrop, Loring 1770-1847 *FolkA 86*
Lathrop, May C *ArtsEM, DcWomA*
Lathrop, Patrick Moore 1928- *AmArch 70*
Lathrop, Thacher 1734-1806 *FolkA 86*
Lathrop, W L 1859-1938 *WhAmArt 85*
Latil, Eugenie 1808-1879 *DcWomA*
Latilla, Eugenio H 1800-1859 *DcVicP, –2*
Latilla, Eugenio Honorius 1808-1861 *NewYHSD*
Latilla, F Z *DcWomA*
Latimer, E E *AmArch 70*
Latimer, Glenna M 1898- *DcWomA*
Latimer, Glenna Montague *DcWomA*
Latimer, Glenna Montague 1898- *WhAmArt 85*
Latimer, Hubert *WorFshn*
Latimer, James M *NewYHSD*
Latimer, John Donald 1916- *AmArch 70*
Latimer, Lewis Howard 1848-1928 *AfroAA*

Latimer, Lorenzo Palmer 1857-1941 *ArtsAmW 1,*
 IlBEAAW, WhAmArt 85
Latimer, Louis R *AfroAA*
Latimer, R E *AmArch 70*
Latimer, Ralph R *ArtsEM*
Latimer, William T *NewYHSD*
Latizar, Ferdinand *NewYHSD*
Latner, Albert J *WhoAmA 73, –76*
Latoix, Gaspard *ArtsAmW 2, DcVicP 2,*
 IlBEAAW
Latorre, David Franklin 1937- *AmArch 70*
LaTouche, Gaston De 1854-1913 *ClaDrA*
Latouche, Louis *ArtsNiC*
Latour, Anna *DcWomA*
Latour, Arsene Lacarriere *NewYHSD*
LaTour, Charles A d1888 *ArtsEM*
LaTour, Georges De 1593-1652 *McGDA, OxArt*
Latour, Jan 1719-1782 *ClaDrA*
Latour, Marie Elizabeth *DcWomA*
LaTour, Maurice Quentin De 1704-1788 *ClaDrA,*
 DcBrECP
LaTour, Maurice-Quentin De 1704-1788 *McGDA*
LaTour, Maurice Quentin De 1704-1788 *OxArt*
Latourette, Henry *FolkA 86*
LaTourette, Henry 1832?-1892 *FolkA 86*
Latourette, John *FolkA 86*
Latourette, John 1793-1849 *FolkA 86*
Latourette, Sarah *FolkA 86*
LaTourette, Sarah 1822-1914 *FolkA 86*
Latrobe, Benjamin 1766-1820 *OxArt*
Latrobe, Benjamin H 1764-1820 *MacEA*
Latrobe, Benjamin Henry 1764-1820 *BiDAmAr,*
 BiDBrA, BnEnAmA, DcD&D, EncAAr,
 McGDA, NewYHSD , WhoArch
Latrobe, John Hazlehurst Boneval 1803-1891
 NewYHSD
Latrobe, Mary *DcWomA, NewYHSD*
Latronico, Giuseppe 1952- *DcCAr 81*
Latruffe-Colombe, Marie *DcWomA*
Latry, Anna 1840?- *DcWomA*
Latt, Hedda *DcWomA*
Latta, Graham 1906- *AmArch 70*
Latta, John N 1944- *MarqDCG 84*
Latta, William *CabMA*
Lattanzi, Luciano 1925- *OxTwCA, PhDcTCA 77*
Lattanzio DaRimini *McGDA*
Lattanzio, Concettina Josephine 1944- *MarqDCG 84*
Lattanzio, Frances 1949- *WhoAmA 82, –84*
Lattard, N A L *WhAmArt 85*
Latter, Jim *DcCAr 81*
Latter, Ruth *DcBrA 1, DcWomA*
Latter, Suzanne 1890- *DcWomA*
Latterman, Hermine, Freiin Von 1857- *DcWomA*
Lattimer, John *BiDBrA*
Lattimore, Eleanor Frances 1904- *IlsCB 1744, –1946,*
 –1957
Laty, Michael 1826-1848 *NewYHSD*
Latzarus, Edith M *DcVicP 2*
Latzke, Caroline *DcWomA, WhAmArt 85*
Lau, J *AmArch 70*
Lau, Olga Andrea Mathilde 1875- *DcWomA*
Lau, Yiu Chung 1958- *MarqDCG 84*
Laub, Albert F 1870-1921 *WhAmArt 85*
Laub-Novak, Karen 1937- *WhoAmA 76, –78, –80, –82,*
 –84
Laubenheimer, Rudolph *NewYHSD*
Lauber, A E *AmArch 70*
Lauber, Adolph *DcVicP 2*
Lauber, Felicitas 1679-1743 *DcWomA*
Lauber, Joseph 1855- *WhAmArt 85*
L'Aubiniere, C A *DcWomA*
Laubser, Maria Magdalena 1886-1973 *DcWomA*
Laubsser, Eric *OxTwCA*
Laubsser, Maggie *OxTwCA*
Lauchner, Aden Jesse 1932- *AmArch 70*
Lauck, Anthony Joseph 1908- *WhoAmA 73, –76, –78,*
 –80, –82, –84
Lauck, John *NewYHSD*
Laud, Henry S *NewYHSD*
Laudadio, A J, Jr. *AmArch 70*
Lauder, Agnes 1880- *DcBrA 1, DcWomA*
Lauder, Charles *NewYHSD*
Lauder, Charles James d1920 *DcBrA 1, DcVicP 2*
Lauder, Charles James 1841-1920 *DcBrA 2, DcBrWA*
Lauder, Isaac 1830?- *NewYHSD*
Lauder, James 1825?- *NewYHSD*
Lauder, James E 1812-1869 *ArtsNiC*
Lauder, James Eckford 1811-1869 *ClaDrA, DcVicP,*
 –2
Lauder, John *NewYHSD*
Lauder, John, Jr. *NewYHSD*
Lauder, Kenneth Scott 1918- *WhoArt 80*
Lauder, Robert Scott 1803-1869 *ArtsNiC, DcVicP, –2*
Lauder, Sir Thomas Dick 1784-1848 *DcBrBI*
Lauder, William *NewYHSD*
Lauderbach *NewYHSD*
Lauderdale, Ursula 1879- *ArtsAmW 2, –3*
Lauderdale, Ursula 1880?- *DcWomA, IlBEAAW,*
 WhAmArt 85
Laudermilk, Jerome Douglas 1893-1956 *ArtsAmW 2*
Lauderset, Teresa De *DcVicP 2*

Lawler, C Genevieve *WhAmArt 85*
Lawler, John L 1934- *AmArch 70*
Lawler, W J *AmArch 70*
Lawless, Billie 1950- *WhoAmA 84*
Lawless, Carl 1894- *WhAmArt 85*
Lawless, Matthew James 1837-1864 *ClaDrA, DcBrBI, DcBrWA, DcVicP, -2*
Lawlor, George W 1878- *WhAmArt 85*
Lawlor, Uniacke James *DcVicP 2*
Lawlor, W J *DcVicP 2*
Lawman, Jasper 1825- *ArtsNiC*
Lawman, Jasper Holman 1825-1906 *NewYHSD , WhAmArt 85*
Lawn, Michael Alan 1940- *AmArch 70*
Lawnin, Dorothy Ferguson 1896- *DcWomA, WhAmArt 85*
Lawrance, Bringhurst B *DcVicP 2*
Lawrance, T *DcVicP 2*
Lawranson, Thomas *DcBrECP*
Lawranson, William *DcBrECP*
Lawrence, Miss *DcWomA*
Lawrence Of Rome, Saint d258 *McGDA*
Lawrence, A A *NewYHSD*
Lawrence, A Nelson *ArtsEM*
Lawrence, Alfred Kingsley 1893- *DcBrA 1*
Lawrence, Alfred Kingsley 1893-1975 *DcBrA 2*
Lawrence, Aline Helen 1913- *AmArch 70*
Lawrence, Arnold 1916- *AmArch 70*
Lawrence, Arthur, Jr. 1925- *AmArch 70*
Lawrence, C A, Jr. *AmArch 70*
Lawrence, C O, Jr. *AmArch 70*
Lawrence, Carol *AfroAA*
Lawrence, Carolyn Elizabeth 1943- *MarqDCG 84*
Lawrence, Charles Arthur 1865- *WhAmArt 85*
Lawrence, Charles B *NewYHSD*
Lawrence, Charles Edmond 1927- *AmArch 70*
Lawrence, Daniel *CabMA*
Lawrence, David *FolkA 86*
Lawrence, David Herbert 1885-1930 *ArtsAmW 3*
Lawrence, David J 1937- *MarqDCG 84*
Lawrence, Edith *DcWomA*
Lawrence, Edith M *DcVicP 2*
Lawrence, Edith Mary 1890- *ClaDrA, DcBrA 1*
Lawrence, Edith Mary 1890-1973 *DcWomA*
Lawrence, Edna W 1898- *DcWomA, WhAmArt 85*
Lawrence, Edward *CabMA*
Lawrence, Eliza C d1903 *DcWomA*
Lawrence, Ellis Fuller 1879-1946 *MacEA*
Lawrence, Eugene 1934- *AmArch 70*
Lawrence, George *FolkA 86*
Lawrence, George 1758?-1802 *DcBrECP*
Lawrence, Georgina *DcVicP 2*
Lawrence, Harry Zachary 1905- *WhAmArt 85*
Lawrence, Helen Christopher *WhAmArt 85*
Lawrence, Helen Christopher 1895- *DcWomA*
Lawrence, Helen H 1878-1950? *WhAmArt 85*
Lawrence, Helen Humphreys *WhoAmA 78N, -80N, -82N, -84N*
Lawrence, Helen Humphreys 1878-1948? *DcWomA*
Lawrence, Henry *DcVicP 2, NewYHSD*
Lawrence, Herbert Myron 1852-1937 *ArtsAmW 3*
Lawrence, Howard Ray 1936- *WhoAmA 76, -78, -80, -82, -84*
Lawrence, J *DcVicP 2*
Lawrence, J, Jr. *AmArch 70*
Lawrence, J R *AmArch 70*
Lawrence, J W *AmArch 70*
Lawrence, Jack *WhoAmA 73*
Lawrence, Jacob *IlsBYP, IlsCB 1967*
Lawrence, Jacob 1917- *AfroAA, AmArt, BnEnAmA, DcAmArt, DcCAA 71, -77, McGDA, OxTwCA, PhDcTCA 77, PrintW 83, -85, WhAmArt 85, WhoAmA 73, -76, -78, -80, -82, -84, WorArt[port]*
Lawrence, James A 1910- *WhoAmA 76, -78, -80, -82, -84*
Lawrence, James L, Jr. 1930- *MarqDCG 84*
Lawrence, Jaye A 1939- *WhoAmA 76, -78, -80, -82, -84*
Lawrence, Jean Mitchell *DcWomA, WhAmArt 85*
Lawrence, John *CabMA, NewYHSD*
Lawrence, John 1933- *IlsCB 1967*
Lawrence, John C *DcVicP 2*
Lawrence, John Wallace 1924- *AmArch 70*
Lawrence, Josephine 1905- *WhAmArt 85*
Lawrence, Kathleen *WhAmArt 85*
Lawrence, L G *FolkA 86*
Lawrence, L L *AmArch 70*
Lawrence, Leonard E *DcVicP 2*
Lawrence, Les 1940- *WhoAmA 76, -78, -80, -82, -84*
Lawrence, Margery L *DcBrA 1, DcWomA*
Lawrence, Marion 1901- *WhAmArt 85, WhoAmA 73, -76, -78*
Lawrence, Marion Otis, Jr. 1927- *AmArch 70*
Lawrence, Martin 1899- *AmArch 70*
Lawrence, Mary *DcBrWA, DcWomA, WhAmArt 85*
Lawrence, Mary 1794-1830? *DcBrECP*
Lawrence, Mary C 1899- *DcWomA*
Lawrence, Mary Stickney *WhAmArt 85*
Lawrence, Melvin Richard 1930- *AmArch 70*

Lawrence, Mervyn 1868- *DcBrA 1*
Lawrence, Nellie *DcWomA*
Lawrence, Philip Archer, Jr. 1940- *AmArch 70*
Lawrence, R E *AmArch 70*
Lawrence, Robert Martin 1930- *AmArch 70*
Lawrence, Rod *OfPGCP 86*
Lawrence, Ruth 1890- *DcWomA, WhAmArt 85*
Lawrence, Samuel *CabMA, NewYHSD*
Lawrence, Sarah *DcWomA*
Lawrence, Sherman B *FolkA 86*
Lawrence, Sydney M 1865?-1940 *IlBEAAW, WhAmArt 85*
Lawrence, T Cromwell d1905 *WhAmArt 85*
Lawrence, Thomas *DcBrECP*
Lawrence, Sir Thomas 1769-1830 *BkIE, ClaDrA, DcBrECP, McGDA, OxArt*
Lawrence, W S *NewYHSD*
Lawrence, Warrington G 1861-1938 *BiDAmAr*
Lawrence, William Hurd 1866-1938 *WhAmArt 85*
Lawrence, William R 1829-1856 *EarABI*
Lawrence, William Roderick 1829-1856 *NewYHSD*
Lawrence-Wetherill, Maria 1892- *DcWomA, WhAmArt 85*
Lawrenson, Charlotte Mary 1883- *ClaDrA*
Lawrenson, Charlotte Mary Rose 1883- *DcBrA 1, DcWomA*
Lawrenson, Edward Louis 1868- *DcBrA 1, DcBrWA*
Lawrie, Alexander *FolkA 86*
Lawrie, Alexander 1828- *ArtsNiC*
Lawrie, Alexander 1828-1917 *NewYHSD , WhAmArt 85*
Lawrie, Anne 1904- *WhAmArt 85*
Lawrie, Archer 1902- *WhAmArt 85*
Lawrie, Harry d1935? *BiDAmAr*
Lawrie, Lee d1963 *WhoAmA 78N, -80N, -82N, -84N*
Lawrie, Lee 1877-1963 *BnEnAmA, DcAmArt, WhAmArt 85*
Lawrie, Mary B *WhAmArt 85*
Lawry, Mervin George 1929- *AmArch 70*
Laws, Kenneth Ivan 1950- *MarqDCG 84*
Laws, Tony 1935- *WhoArt 80, -82*
Lawser, Mary Louise *WhAmArt 85*
Lawson, Adelaide *DcWomA*
Lawson, Adelaide J *AfroAA*
Lawson, Adelaide J 1889- *WhAmArt 85*
Lawson, Alexander *DcVicP 2*
Lawson, Alexander 1773-1846 *NewYHSD*
Lawson, Allen 1923- *MarqDCG 84*
Lawson, Carol Antell 1946- *IlsCB 1967*
Lawson, Mrs. Cecil *DcVicP, -2*
Lawson, Cecil G 1851-1882 *ArtsNiC*
Lawson, Cecil Gordon 1851-1882 *ClaDrA, DcBrBI, DcBrWA, DcVicP, -2, McGDA*
Lawson, Clarence 1909- *AfroAA*
Lawson, Constance *DcBrWA*
Lawson, Constance B *DcWomA*
Lawson, David 1790?- *FolkA 86*
Lawson, David Arthur *DcVicP 2*
Lawson, David E 1937- *AmArch 70*
Lawson, David L 1948- *MarqDCG 84*
Lawson, David R *MarqDCG 84*
Lawson, E *DcVicP 2*
Lawson, Edith Grace *DcWomA*
Lawson, Edith M *DcVicP 2*
Lawson, Edward Pitt 1927- *WhoAmA 73, -76, -78, -80, -82, -84*
Lawson, Elizabeth R *DcWomA*
Lawson, Ernest *OxTwCA*
Lawson, Ernest 1873-1939 *ArtsAmW 1, -2, BnEnAmA, DcAmArt, DcCAA 71, -77, IlBEAAW, McGDA, PhDcTCA 77, WhAmArt 85*
Lawson, F Wilfrid *ArtsNiC*
Lawson, Francis Wilfred *ClaDrA*
Lawson, Francis Wilfred 1842-1935 *DcBrA 1, DcVicP, -2*
Lawson, Francis Wilfrid 1842-1935 *DcBrBI*
Lawson, Frederick 1888- *DcBrA 1*
Lawson, G *DcBrBI*
Lawson, George W 1940- *AmArch 70*
Lawson, Grace 1891- *DcWomA*
Lawson, H Raymond *WhAmArt 85*
Lawson, Mrs. Harry C *DcWomA*
Lawson, Helen E *DcWomA, NewYHSD*
Lawson, J L *DcSeaP*
Lawson, J P, Jr. *AmArch 70*
Lawson, Jess M *WhAmArt 85*
Lawson, John *CabMA, DcBrBI, DcVicP 2*
Lawson, John 1868-1909 *DcBrA 2, DcVicP 2*
Lawson, John 1869-1909 *DcBrA 1*
Lawson, Mrs. John Donald *WhAmArt 85*
Lawson, Katharine S 1885- *WhAmArt 85*
Lawson, Katharine Stewart 1885- *DcWomA*
Lawson, Lamonte 1953- *MarqDCG 84*
Lawson, Leonore Conde 1899- *DcWomA, WhAmArt 85*
Lawson, Lizzie *DcVicP 2*
Lawson, Lori L 1958- *MarqDCG 84*
Lawson, Louise d1900 *WhAmArt 85*
Lawson, M S *DcVicP 2*

Lawson, M Stace *DcWomA*
Lawson, Margaret *DcWomA, WhAmArt 85*
Lawson, Marie Abrams 1894-1956 *IlsCB 1946*
Lawson, Marion *DcVicP 2*
Lawson, Michael 1942- *DcCAr 81*
Lawson, Neal Howard 1927- *AmArch 70*
Lawson, Oliver *FolkA 86*
Lawson, Oscar A 1813-1854 *NewYHSD*
Lawson, Percival P 1815?- *NewYHSD*
Lawson, R A 1833-1902 *MacEA*
Lawson, Richard *CabMA*
Lawson, Richard Alan 1946- *MacBEP*
Lawson, Robert 1742?-1816 *DcBrWA*
Lawson, Robert 1892-1957 *Cald 1938, IlBEAAW, IlsBYP, IlsCB 1744, –1946, WhAmArt 85, WhoAmA 80N, –82N, –84N*
Lawson, Sonia 1934- *WhoArt 84*
Lawson, Thomas *NewYHSD*
Lawson, Thomas 1922- *WhoArt 80, –82, –84*
Lawson, Thomas 1951- *WhoAmA 84*
Lawson, Thomas B *FolkA 86*
Lawson, Thomas Bayley 1807-1888 *NewYHSD*
Lawson, Thomas George 1938- *AmArch 70*
Lawson, Victor Thomas 1951- *MarqDCG 84*
Lawson, William *DcVicP 2*
Lawson, William 1893- *ClaDrA*
Lawson, Mrs. William *DcVicP 2*
Lawson, Yvonne *AfroAA*
Lawson Dick, Winifred *WhoArt 80N*
Lawson-Peacey, Jess M 1885- *DcWomA, WhAmArt 85*
Lawton, Alice *WhAmArt 85*
Lawton, Almira C *DcWomA, WhAmArt 85*
Lawton, Betty *AfroAA*
Lawton, C *FolkA 86*
Lawton, Cuthbert *AntBDN M*
Lawton, Duane Eugene 1949- *MarqDCG 84*
Lawton, Florian Kenneth 1921- *WhoAmA 80, –82, –84*
Lawton, Francis *NewYHSD*
Lawton, George d1928 *BiDAmAr*
Lawton, Mrs. Harry C *WhAmArt 85*
Lawton, Herbert Thomas 1930- *AmArch 70*
Lawton, James L 1944- *WhoAmA 78, –80, –82, –84*
Lawton, R M *AmArch 70*
Lawton, Richard C *NewYHSD*
Lawton, Robert, Jr. *CabMA*
Lawyer, F D *AmArch 70*
Lawyer, James 1810?- *FolkA 86*
Lawyer, Jean 1909- *WhAmArt 85*
Lawyer, Steve A 1956- *MarqDCG 84*
Lax, David 1910- *WhAmArt 85, WhoAmA 73, –76, –78, –80, –82, –84*
Lax, Leo 1946- *MarqDCG 84*
Lax, Michael 1929- *ConDes*
Laxson, Ruth *WhoAmA 82, –84*
Laxson, Ruth 1924- *AmArt*
Laxton, William Robert 1776?- *BiDBrA*
Lay, A W *NewYHSD*
Lay, C W *AmArch 70*
Lay, Charles Downing 1877-1956 *WhAmArt 85*
Lay, Fred L 1836?- *NewYHSD*
Lay, Oliver Ingraham 1845- *ArtsNiC*
Lay, Patricia Anne 1941- *WhoAmA 76, –78, –80, –82, –84*
Lay, Tomas Gabor 1947- *WhoAmA 76*
Layard, Arthur *DcBrBI*
Laybourn-Jensen 1883- *WhAmArt 85*
Laybourne-Smith, Louis 1880-1965 *MacEA*
Laycock, Eliza *FolkA 86*
Laycock, Norman 1920- *DcBrA 1, WhoArt 80, –82, –84*
Laycox, Jack 1921- *WhoAmA 73, –76, –78*
Laycox, Jack 1924- *WhoAmA 80, –82, –84*
Layens, Mathieu De d1483 *McGDA*
Layer, Claudia 1881- *DcWomA*
Layer, R W *AmArch 70*
Layham, Julia Sherwood *ArtsAmW 2*
Laying, George W *WhAmArt 85*
Layman, E *NewYHSD*
Layman, Elizabeth *DcWomA, WhAmArt 85*
Layman, James H *NewYHSD*
Layman, Walter 1871- *WhAmArt 85*
Layman, William Naismith 1917- *AmArch 70*
Laymon, Cynthia J 1948- *WhoAmA 84*
Layne, Herschel Neal 1920- *AmArch 70*
Layne, Kay Ellen 1941- *AmArch 70*
Layng, Mabel *DcWomA*
Laynor, Harold Arthur 1922- *WhoAmA 80, –82, –84*
Laytin, Peter 1949- *MacBEP*
Layton, Mrs. E M *DcVicP 2*
Layton, Emmet 1905- *AmArch 70*
Layton, F W *DcVicP 2*
Layton, Gloria 1914- *WhoAmA 78N, –80N, –82N, –84N*
Layton, H B *DcVicP 2*
Layton, Louis Henry, III 1925- *AmArch 70*
Layton, Peter 1937- *DcCAr 81*
Layton, Richard 1929- *WhoAmA 73, –76, –78, –80, –82, –84*
Laz, D R *AmArch 70*

Leibl, Wilhelm 1844-1900 *McGDA, OxArt,*
 WhAmArt 85A
Leibo, Jacob *FolkA 86*
Leibovitz, Annie 1950- *ICPEnP A*
Leibowitz, D E *AmArch 70*
Leibowitz, Matthew 1918- *WhoGrA 62*
Leicester, Andrew John 1948- *WhoAmA 84*
Leicester, Emily *DcBrA 1, DcWomA*
Leicester, Sir John Fleming *DcBrWA*
Leich, Chester 1889- *ArtsAmW 3, WhAmArt 85*
Leich, Donald Richard 1953- *MarqDCG 84*
Leichman, Seymour 1933- *IlsBYP, WhoAmA 73, -76*
Leicht, Walter G 1920- *AmArch 70*
Leichtag, Lillian Helen 1904- *WhAmArt 85*
Leichterkost, Martin *NewYHSD*
Leichtweis, Louis 1824?- *NewYHSD*
Leick, J A *AmArch 70*
Leidenfrost, O E *AmArch 70*
Leidig, Peter *FolkA 86*
Leidy, Mrs. Carter d1933 *WhAmArt 85*
Leidy, John 1780?- *FolkA 86*
Leidy, Marjorie d1933 *DcWomA*
Leidy, William B *NewYHSD*
Leiendecker, Paul H *WhAmArt 85*
Leif, Florence 1913- *WhAmArt 85*
Leif, Suzanne B 1941- *MarqDCG 84*
Leifer, Neil 1942- *ICPEnP A*
Leiferman, Silvia W *WhoAmA 73, -76, -80, -82*
Leifeste, A A, Jr. *AmArch 70*
Leiftuchter, F B *WhAmArt 85*
Leigh, A W *WhAmArt 85*
Leigh, Clara Maria *DcVicP, -2, DcWomA*
Leigh, Conrad Heighton 1883- *DcBrA 1*
Leigh, David I 1933- *WhoAmA 73, -76*
Leigh, Esther L *WhAmArt 85*
Leigh, Frances Elizabeth *DcWomA*
Leigh, George Leonard 1857-1942 *DcBrA 1,*
 DcVicP 2
Leigh, H G *DcVicP 2*
Leigh, Harry E 1931- *WhoAmA 82, -84*
Leigh, Hazel *WhAmArt 85*
Leigh, Howard 1896- *WhAmArt 85*
Leigh, Jack David 1948- *WhoAmA 84*
Leigh, James Mathews 1808-1860 *DcBrWA*
Leigh, James Matthews 1808-1860 *DcVicP, -2*
Leigh, Jared d1769 *DcBrECP*
Leigh, John E *CabMA*
Leigh, Maud Boughton 1881?-1945 *DcWomA*
Leigh, Parry 1919- *WhoArt 82*
Leigh, Phillipa 1913- *DcBrA 2*
Leigh, Roger *DcVicP 2*
Leigh, Rose J *DcVicP 2*
Leigh, Mrs. William R *WhAmArt 85*
Leigh, William Robinson 1866-1955 *ArtsAmW 1,*
 IlBEAAW, WhAmArt 85
Leigh-Hunt, Gerard 1873-1945 *DcBrA 1*
Leigh-Pemberton, John 1911- *ClaDrA, DcBrA 1,*
 WhoArt 80, -82, -84
Leight, Edward *IlsBYP*
Leighton, Lady *DcWomA*
Leighton, Lord 1830-1896 *DcVicP, -2*
Leighton, A C d1965 *WhoAmA 78N, -80N, -82N,*
 -84N
Leighton, Alfred Crocker 1901- *DcBrA 1*
Leighton, Alfred Crocker 1901-1965 *DcBrA 2,*
 IlBEAAW
Leighton, Charles Blair *DcVicP, -2*
Leighton, Clare 1901- *ClaDrA, WhoAmA 73, -76,*
 -78, -80, -82, WhoArt 80, -82, -84
Leighton, Clare Veronica Hope *IlsCB 1967*
Leighton, Clare Veronica Hope 1899- *IlsCB 1946*
Leighton, Clare Veronica Hope 1900- *DcBrA 1*
Leighton, Clare Veronica Hope 1901- *GrAmP,*
 IlsBYP, IlsCB 1957
Leighton, Daniel 1764-1794 *CabMA*
Leighton, David S R 1928- *WhoAmA 73, -76, -78,*
 -80, -82, -84
Leighton, Edmund Blair 1853-1922 *ClaDrA, DcBrA 1,*
 DcBrBI, DcVicP, -2
Leighton, Elizabeth B *WhAmArt 85*
Leighton, Ezekiel 1657-1723 *FolkA 86*
Leighton, F E *AmArch 70*
Leighton, Lord Frederic 1830-1896 *DcBrBI, DcBrWA,*
 McGDA, OxArt
Leighton, Frederick 1830- *ArtsNiC*
Leighton, Lord Frederick 1830-1896 *AntBDN C,*
 ClaDrA
Leighton, George A *NewYHSD*
Leighton, Henry *IlDcG*
Leighton, John *DcVicP 2*
Leighton, John 1822-1912 *DcBrBI, DcVicP 2*
Leighton, John H *IlDcG*
Leighton, Jonathan 1715- *FolkA 86*
Leighton, Kathryn 1876-1952 *DcWomA*
Leighton, Kathryn W 1876-1952 *WhAmArt 85*
Leighton, Kathryn Woodman 1876-1952 *ArtsAmW 1,*
 IlBEAAW
Leighton, Lady Mary d1864 *DcBrWA*
Leighton, Melvin Edward 1928- *AmArch 70*
Leighton, Nicholas Winfield Scott d1898
 WhAmArt 85

Leighton, Richard 1686-1749 *FolkA 86*
Leighton, Sarah *DcVicP 2, DcWomA*
Leighton, Stanley 1837-1901 *DcBrA 1*
Leighton, Thomas 1786-1849 *DcNiCA*
Leighton, Thomas Charles 1913- *WhoAmA 73, -76,*
 -78
Leighton, Thomas Charles 1913-1976 *WhoAmA 80N,*
 -82N, -84N
Leighton, Thomas H 1776-1849 *IlDcG*
Leighton, William *IlDcG, OxDecA*
Leighton, William, Jr. *IlDcG*
Leighton Family *IlDcG*
Leighty, Benjamin *FolkA 86*
Leignes *DcBrECP*
Leijerzapf, Ingeborg Theresia 1946- *MacBEP*
Leijster, Judith Jansdr 1609-1660 *McGDA*
Leilah *WhoArt 84*
Leimdorf, Adele *DcWomA, WhAmArt 85*
Lein, Malcolm Emil 1913- *WhoAmA 73, -76, -78, -80,*
 -82, -84
Leinbach, C H *AmArch 70*
Leinberger, Hans *OxArt*
Leinberger, Hans 1480?-1535? *McGDA*
Leindorfer-Lubzer, Adele 1876- *WhAmArt 85*
Leinfellner, Heinz 1911- *McGDA, OxTwCA,*
 PhDcTCA 77
Leinonen, Edwin *EncASM*
Leinonen, Karl F 1866- *EncASM*
Leinroth, Robert G *WhAmArt 85*
Leinweber, Joseph William *AmArch 70*
Leiper, William 1839-1916 *DcBrA 1*
Leipsiger, Frederick I *ArtsEM*
Leipzeiger, Frederick I *ArtsEM*
Leipzig, Arthur 1918- *ConPhot, ICPEnP A,*
 MacBEP, WhoAmA 84
Leipzr-Pearce, H P *AmArch 70*
Leiris, J T De 1886- *DcWomA*
Leis, Malle 1940- *PrintW 83*
Leisenring, L Morris 1875- *WhAmArt 85*
Leisenring, Mathilde 1870?-1949 *DcWomA*
Leisenring, Mathilde Mueden *WhAmArt 85*
Leiser, Christian *NewYHSD*
Leisey, Peter 1803?- *FolkA 86*
Leisgen, Barbara *DcCAr 81*
Leisgen, Michael *DcCAr 81*
Leisher, William Rodger 1941- *WhoAmA 78, -80*
Leishman, Robert 1916- *ClaDrA, DcBrA 1,*
 WhoArt 80, -82, -84
Leisk, David Johnson 1906-1975 *IlsCB 1946, -1957,*
 WorECom
Leissler, Arnold 1939- *OxTwCA, PhDcTCA 77*
Leist, Fred *DcBrA 1, DcBrBI*
Leist, Frederick William 1878-1945 *DcBrA 2*
Leistikow, Walter 1865-1908 *McGDA*
Leistler, Carl *DcNiCA*
Leitch, Annie Mary *DcBrA 1, DcWomA*
Leitch, Hugh John 1920- *AmArch 70*
Leitch, Paul Douglas 1954- *MarqDCG 84*
Leitch, R, Jr. *DcVicP 2*
Leitch, R R *AmArch 70*
Leitch, Richard P *IlBEAAW*
Leitch, Richard Principal *DcBrBI, DcBrWA,*
 DcVicP 2
Leitch, Robert d1882 *DcBrWA*
Leitch, W L d1883 *ArtsNiC*
Leitch, William Leighton 1804-1883 *ClaDrA, DcBrBI,*
 DcBrWA, DcVicP, -2
Leitersdorf, Fini 1906- *WorFshn*
Leith, Gordon 1885-1965 *MacEA*
Leith, J W *DcWomA*
Leith, Jessie *WhAmArt 85*
Leith-Ross, Harry *WhoAmA 76N, -78N, -80N, -82N,*
 -84N
Leith-Ross, Harry 1886- *ArtsAmW 3, WhAmArt 85,*
 WhoAmA 73
Leithauser, Mark Alan 1950- *WhoAmA 84*
Leithauser, Richard William 1920- *AmArch 70*
Leitman, Norman 1933- *WhoAmA 73, -76, -78, -80,*
 -82, -84
Leitman, Samuel 1908- *WhoAmA 73, -76, -78, -80*
Leitman, Samuel 1908-1981 *WhoAmA 82N, -84N*
Leitner, Leander 1873- *WhAmArt 85*
Leitz *FolkA 86*
Leitz, Ernst 1843-1920 *ICPEnP*
Leitz, Ernst 1871-1956 *ICPEnP*
Leitz, J *FolkA 86*
Leitz, Louis *NewYHSD*
Leivers, William *DcBrECP*
Leizer, Matthew Robert 1910- *AmArch 70*
Leja, Michael Joseph 1951- *WhoAmA 78, -80, -82,*
 -84
Lejault, Anais *DcWomA*
LeJeune, Elizabeth *DcWomA*
Lejeune, Francois 1908- *WhoGrA 62, -82[port],*
 WorECar
LeJeune, Henry 1819-1904 *DcVicP 2*
LeJeune, Henry 1820- *ArtsNiC*
LeJeune, Henry L 1819-1904 *DcBrBI, DcVicP*
LeJeune, Henry L 1820-1904 *ClaDrA, DcBrWA*
LeJeune, James George 1910- *ClaDrA, DcBrA 1,*
 WhoArt 80, -82, -84

Lejeune, Josh *AntBDN Q*
Lejeune, Thomas *CabMA*
Lejmann, Anna 1860- *DcWomA*
Lejmann, Thea 1857- *DcWomA*
LeJolle, Sara Agatha *DcWomA*
LeJune, Elizabeth *DcWomA*
Lek, Hendrik 1903- *WhoArt 82, -84*
Lek, Karel 1929- *ClaDrA, WhoArt 80, -82, -84*
Lekakis, Michael 1907- *DcCAA 71, -77*
Lekakis, Michael Nicholas 1907- *WhoAmA 73, -76,*
 -78, -80, -82, -84
Lekberg, Barbara Hult 1925- *WhoAmA 73, -76, -78,*
 -80, -82, -84
Lekegian, Gabriel *DcVicP 2*
LeKeux, Henry 1787-1869 *ArtsNiC*
Leland, Miss *DcWomA, NewYHSD*
Leland, Clara Walsh *WhAmArt 85*
Leland, Clara Walsh 1869- *ArtsAmW 2, DcWomA*
Leland, Elizabeth 1905- *WhAmArt 85*
Leland, Francis I d1916 *WhAmArt 85*
Leland, Henry 1850-1877 *ArtsNiC*
Leland, Henry Perry 1828-1868 *EarABI*
Leland, Raymond Olaf 1926- *AmArch 70*
Leland, Whitney Edward 1945- *WhoAmA 73, -76,*
 -78, -80, -82, -84
LeLanne *NewYHSD*
LeLatrouwer, A *DcVicP 2*
LeLedier, Marie *DcWomA*
Leleu, Alexandre Felix 1871- *ClaDrA*
Leleu, Charlotte Moorhouse 1885- *DcWomA*
Leleu, Jean Francois 1729-1807 *AntBDN G*
Leleu, Jean-Francois 1729-1807 *OxDecA*
Leleux, Adolphe 1812- *ArtsNiC*
Leleux, Adolphe Pierre 1812-1891 *ClaDrA*
Leleux, Armand 1820- *ArtsNiC*
Leleux, Louise Emilie 1824-1885 *DcWomA*
Lelie, Adriaen De 1755-1820 *ClaDrA*
Lelienbergh, Cornelis *ClaDrA*
Lelienbergh, Cornelis 1626?-1676? *McGDA*
Lelievre, Mademoiselle *DcWomA*
Lella, Carl 1899- *WhAmArt 85*
Lelli, Ercole 1702-1766 *McGDA*
Leloir, Alexandre Louis 1843-1884 *ArtsNiC*
Leloir, Heloise *AntBDN E*
Leloir, Heloise Suzanne *DcWomA*
Leloir, Jean Baptiste Auguste 1809- *ArtsNiC*
Leloir, Maurice *ArtsNiC*
Leloir, Maurice 1853-1940 *ClaDrA*
Leloir, Suzanne 1890-1924 *DcWomA*
Lelong, Amelie *DcWomA*
Lelong, Lucien 1889-1958 *FairDF FRA, WorFshn*
Lelong, Rene *DcBrBI*
Lelorain, Marguerite 1882- *DcWomA*
LeLorrain *McGDA*
LeLorrain, Louis 1715-1759 *MacEA*
LeLorrain, Robert 1666-1743 *McGDA*
LeLouarn, Yvan 1915- *WhoGrA 62*
LeLouarn, Yvan 1915-1968 *WorECar*
LeLoup, Jean *McGDA*
Leluc, Pauline Juliette Adrienne 1864- *DcWomA*
Lely, Sir Peter 1618-1680 *ClaDrA, McGDA, OxArt*
Lem, Richard Douglas 1933- *WhoAmA 73, -76, -78,*
 -80, -82, -84
Lema, Lennard Franklin 1942- *MarqDCG 84*
Lemagny, Jean-Claude 1931- *MacBEP*
LeMair, H Willebeek 1889- *IlsCB 1744*
LeMair, H Willebeek 1889-1966 *DcBrBI*
LeMair, Henriette Willebeek *DcWomA*
Lemaire, Adele Etiennette *DcWomA*
Lemaire, Aline *DcWomA*
Lemaire, Camille *DcWomA*
Lemaire, Francois 1620-1688 *ClaDrA*
Lemaire, Gabrielle Bonnaz 1880- *DcWomA*
Lemaire, Hector *ArtsNiC*
Lemaire, Jean 1598-1659 *McGDA*
Lemaire, Madeleine Jeanne 1845?-1928 *DcWomA*
Lemaire, Marie Therese 1861- *DcWomA*
Lemaire, Philippe-Henri 1798-1880 *ArtsNiC*
Lemaire, Suzanne *DcWomA*
Lemaistre, Mademoiselle *DcWomA*
LeMaistre, Francis William Synge 1859- *DcBrA 1,*
 DcVicP 2
Lemaitre, Aline M d1907 *DcWomA*
LeMaitre, Angelique Marie Gabrielle *DcWomA*
Lemaitre, Claire M *DcWomA*
Lemaitre, Clara Anne *DcWomA*
Lemaitre, Eglantine *DcWomA*
Lemaitre, Jeanne Adele *DcWomA*
Lemaitre, Louise *DcWomA*
Lemaitre, Lucile *DcWomA*
Lemaitre, Marie *DcWomA*
Leman, Alicia J *DcVicP 2*
Leman, Henry *FolkA 86*
Leman, Johannes *FolkA 86*
Leman, John *FolkA 86*
Leman, Robert 1799-1863 *DcBrWA, DcVicP 2*
Lemann, E A *DcVicP 2*
Lemann, Miss E A *DcBrBI*
Lemar, Karen T 1952- *MarqDCG 84*
Lemarchand, Anne *DcWomA*
LeMarchant, John Gaspard 1766-1812 *DcBrWA*

Leverene, David F 1943- *MarqDCG 84*
Leverett, Miss *DcWomA*
Leverett, David 1938- *ConArt 77, -83, ConBrA 79[port], DcCAr 81*
Leverett, Elizabeth *FolkA 86*
Leverett, Sarah Sedwick *FolkA 86*
Leverett, William *CabMA*
Leverin, Katharina *DcWomA*
Levering, Albert 1869-1929 *WhAmArt 85, WorECar*
Levering, Robert K 1919- *WhoAmA 73, -76, -78, -80, -82, -84*
Levering, T W *FolkA 86*
Leverkuhne, Silke 1953- *DcCAr 81*
Leverson, R A *AmArch 70*
LeVert *NewYHSD*
Levert, Pierre E 1948- *MarqDCG 84*
Leverton, Thomas 1743-1824 *BiDBrA, DcD&D, MacEA, WhoArch*
Leverton, William *BiDBrA*
Leveson, A H *DcBrBI*
Leveson, Dorothy *DcVicP 2*
Leveson, Mary E *DcVicP 2*
Levesque, Camille *DcWomA*
Levesque, Gabrielle *DcWomA*
Levesque, Marie *DcWomA*
Levesque, Sophie *DcWomA*
Levesques, Marthe *DcWomA*
Levet, Louise 1888- *DcWomA*
Levett, Joel J *WhAmArt 85*
Levetus, Celia *DcBrBI*
Levetus, Celia A *DcWomA*
Levey, Aaron *WhAmArt 85*
Levey, Jeffrey King 1908- *WhAmArt 85*
Levey, Marc B 1938- *MacBEP*
Levey, Norman Jerome 1908- *AmArch 70*
Levi, Carlo *WhoAmA 76N, -78N, -80N, -82N, -84N*
Levi, Carlo 1902- *PhDcTCA 77*
Levi, Hans Leopold 1935- *ICPEnP A, MacBEP*
Levi, Isaac *NewYHSD*
Levi, Josef 1938- *DcCAA 71, -77, PrintW 83, -85, WhoAmA 73, -76, -78, -80, -82, -84*
Levi, Julian 1900- *DcCAA 71, -77, WhoAmA 73, -76, -78, -80, -82*
Levi, Julian 1900-1982 *WhoAmA 84N*
Levi, Julian Clarence 1874- *AmArch 70, WhAmArt 85*
Levi, Julian E 1900- *WhAmArt 85*
Levi, Julian Edwin 1900- *McGDA*
Levi, Rino 1901-1965 *ConArch, MacEA*
Levi, S J *EncASM*
Levi, Walter Edgar 1927- *AmArch 70*
Levi-Montalcini, Gino 1902-1974 *MacEA*
Levick, Irving *WhoAmA 73, -76, -78, -80, -82, -84*
Levick, Mrs. Irving *WhoAmA 73, -76, -78, -80, -82, -84*
Levick, Milnes 1887- *WhAmArt 85*
Levick, Richard *DcVicP 2*
Levick, Richard 1864-1917 *WhAmArt 85*
Levick, Ruby *DcBrA 2*
Levick, Ruby Winifred *DcWomA*
Levie, John E *FolkA 86, NewYHSD*
Levikow, John Russell 1930- *AmArch 70*
Levill, A, Jr. *FolkA 86*
Levin, A J *AmArch 70*
Levin, Abraham 1880-1957 *FolkA 86*
Levin, Alexander *WhAmArt 85*
Levin, Alexander B 1906- *WhAmArt 85*
Levin, Chris *WorFshn*
Levin, Eli 1938- *AmArt*
Levin, Gail 1948- *WhoAmA 78, -80, -82, -84*
Levin, Herman *WhAmArt 85*
Levin, Hugh Lauter 1951- *WhoAmA 82, -84*
Levin, J D *AmArch 70*
Levin, Jeanne 1901- *WhoAmA 73, -76, -78, -80, -82, -84*
Levin, Katherine *DcWomA*
Levin, Kim *WhoAmA 73, -76, -78, -80, -82, -84*
Levin, Morton D 1923- *WhoAmA 78, -80, -82, -84*
Levin, Phoebus *DcVicP, -2*
Levin, R R *AmArch 70*
Levin, Richard Donald 1926- *AmArch 70*
Levin, Victoria *DcVicP 2*
Levine *EncASM*
Levine, Arthur Morton 1931- *AmArch 70*
Levine, B R *AmArch 70*
Levine, Beth *WorFshn*
Levine, David *WhoAmA 82*
Levine, David 1910- *AmArch 70*
Levine, David 1926- *IlrAm 1880[port], IlsCB 1957, WhoAmA 76, -78, -80, -84, WhoGrA 82[port], WorArt, WorECar*
Levine, David Phillip 1910- *WhAmArt 85*
Levine, Emma Amos *AfroAA*
Levine, Ernest 1899- *AmArch 70*
Levine, Gilbert *WhAmArt 85*
Levine, H Gilbert *WhAmArt 85*
Levine, Herbert *WorFshn*
Levine, I *AmArch 70*
Levine, Jack 1915- *AmArt, BnEnAmA, ConArt 77, DcAmArt, DcCAA 71, -77, McGDA, OxTwCA,*

PhDcTCA 77, PrintW 83, -85, WhAmArt 85, WhoAmA 73, -76, -78, -80, -82, -84, WorArt[port]
Levine, Jay H *MarqDCG 84*
Levine, Jeffrey Sumner 1955- *MarqDCG 84*
Levine, Kenneth M 1950- *MarqDCG 84*
Levine, Les 1935- *AmArt, BnEnAmA, ConArt 77, -83, DcCAA 77, DcCAr 81, PrintW 85, WhoAmA 73, -76, -78, -80, -82, -84*
Levine, M L *AmArch 70*
Levine, Marilyn 1933- *ConArt 83*
Levine, Marilyn 1935- *AmArt, CenC[port]*
Levine, Marilyn Anne 1933- *ConArt 77*
Levine, Marilyn Anne 1935- *WhoAmA 73, -76, -78, -80, -82, -84*
Levine, Marion Lerner 1931- *WhoAmA 82, -84*
Levine, Martin 1945- *WhoAmA 78, -80, -82, -84*
Levine, Melinda 1947- *WhoAmA 82, -84*
Levine, Merilyn 1935- *DcCAr 81*
Levine, Michael 1952- *DcCAr 81*
Levine, Michael Grayson 1952- *MacBEP*
Levine, Morris L 1896- *WhAmArt 85*
Levine, Morton Z 1925- *AmArch 70*
LeVine, N N *AmArch 70*
LeVine, Newton 1929- *AmArch 70*
Levine, Reeva 1912- *WhoAmA 76, -78*
Levine, Reeva Miller 1912- *WhoAmA 73, -80, -82, -84*
Levine, Richard *AmArch 70*
Levine, Richard Sheldon 1952- *MarqDCG 84*
Levine, Robert H 1934- *AmArch 70*
Levine, Ruth Gikow *WhoAmA 78, -80*
Levine, S J *AmArch 70*
Levine, Saul 1915- *WhAmArt 85*
Levine, Seymour R 1906- *WhoAmA 73, -76, -78, -80, -82, -84*
Levine, Shepard 1922- *WhoAmA 73, -76, -78, -80, -82, -84*
Levinge, Sir Richard George Augustus 1811-1884 *DcBrWA, NewYHSD*
Levings, Mark M 1881- *ArtsAmW 2, WhAmArt 85*
Levinski, E *WhAmArt 85*
Levinson, Abraham F 1883-1946 *WhAmArt 85*
Levinson, Alma *DcWomA*
Levinson, C B *AmArch 70*
Levinson, David Joshua 1944- *MacBEP*
Levinson, Dorothy Ann 1934- *AmArch 70*
Levinson, Fred 1928- *WhoAmA 73, -76, -78*
Levinson, Mrs. Horace *WhAmArt 85*
Levinson, Joel 1938- *AmArch 70*
Levinson, Joel D *MacBEP, WhoAmA 84*
Levinson, Mimi 1940- *WhoAmA 82, -84*
Levinson, Mon *DcCAr 81*
Levinson, Mon 1926- *AmArt, ConArt 77, DcCAA 71, -77, WhoAmA 73, -76, -78, -80, -82, -84*
Levinson, Ruth *WhAmArt 85*
Levis, Juliette 1826?-1902 *DcWomA*
Levis, Max 1863- *DcBrBI*
Levison, Brigitte 1832-1916 *DcWomA*
Levison, Robert Henry 1915- *AmArch 70*
Levit, Herschel 1912- *WhAmArt 85, WhoAmA 73, -76, -78, -80, -82, -84*
Levitan, Benjamin W 1878-1941 *BiDAmAr*
Levitan, Isaac Ilyitch 1861-1900 *McGDA*
Levitan, Israel 1912- *DcCAA 71, -77, WhoAmA 73, -76, -78, -80*
Levitine, George 1916- *WhoAmA 73, -76, -78, -80, -82, -84*
Levitoff, Harold 1920- *AmArch 70*
Levitsky, Dmitri 1735?-1822 *McGDA*
Levitt, Abraham D 1920- *AmArch 70*
Levitt, Alfred 1894- *WhAmArt 85, WhoAmA 73, -76, -78, -80, -82, -84*
Levitt, Harold Warren 1921- *AmArch 70*
Levitt, Helen *DcCAr 81, MacBEP*
Levitt, Helen 1918- *ConPhot, ICPEnP, WhoAmA 84*
Levitt, Joel J 1875- *ArtsAmW 3*
Levitt, Joel J 1875-1937 *WhAmArt 85*
Levitt, L C *DcVicP 2*
Levitt And Gold *EncASM*
Levitz, Ebbitt A 1897- *WhAmArt 85*
Levly, Morris *NewYHSD*
Levol, Angelique *DcWomA*
Levone, Albert Jean 1895- *WhAmArt 85*
Levorsen, James Kingdon *AmArch 70*
Levow, Irving 1902- *WhAmArt 85*
Levy, A *AmArch 70*
Levy, A D *AmArch 70*
Levy, A G *AmArch 70*
Levy, Alexander Oscar 1881-1947 *WhAmArt 85*
Levy, Alice *DcWomA*
Levy, Amelie *DcWomA*
Levy, Andree 1892- *DcWomA*
Levy, Beatrice S 1892- *ArtsAmW 3, WhoAmA 73*
Levy, Beatrice S 1892-1974 *DcWomA, WhAmArt 85, WhoAmA 76N, -78N, -80N, -82N, -84N*
Levy, Bernard 1917- *WhoAmA 80, -82, -84*
Levy, Birdie M *DcWomA*
Levy, Clarisse 1896- *DcWomA*

Levy, David Corcos 1938- *WhoAmA 73, -76, -78, -80, -82, -84*
Levy, Don 1953- *MarqDCG 84*
Levy, E P *AmArch 70*
Levy, Edgar 1907- *WhAmArt 85*
Levy, Edward Abram 1925- *AmArch 70*
Levy, Emanuel 1900- *DcBrA 1*
Levy, Emile 1826- *ArtsNiC*
Levy, Emile 1826-1890 *ClaDrA*
Levy, Fanny 1854- *DcWomA*
Levy, Florence N d1947 *WhoAmA 78N, -80N, -82N, -84N*
Levy, Florence N 1870-1947 *WhAmArt 85*
Levy, G H *AmArch 70*
Levy, Harold 1940- *MarqDCG 84*
Levy, Harold Julian 1916- *AmArch 70*
Levy, Henri Leopold 1840- *ArtsNiC*
Levy, Henri Leopold 1840-1904 *ClaDrA*
Levy, Henry 1927- *AmArch 70*
Levy, Henry L 1868- *WhAmArt 85*
Levy, Herbert A *WhAmArt 85*
Levy, Herbert Sidney 1900- *AmArch 70*
Levy, Herbert W 1924- *AmArch 70*
Levy, Hilda *WhoAmA 73, -76, -78, -80, -82, -84*
Levy, Hilda P 1907- *WhAmArt 85*
Levy, Ida B *DcWomA*
Levy, Jane 1894- *DcWomA*
Levy, Jeanne *DcWomA*
Levy, John *NewYHSD*
Levy, Joseph, Jr. 1894- *AmArch 70*
Levy, Julia M *DcVicP 2*
Levy, Julien 1906- *WhoAmA 78, -80*
Levy, Julien 1906-1981 *WhoAmA 82N, -84N*
Levy, L *AmArch 70*
Levy, Laure 1866-1954 *DcWomA*
Levy, M A *AmArch 70*
Levy, Margaret 1899- *DcWomA*
Levy, Margaret Wasserman 1899- *WhoAmA 82, -84*
Levy, Margrethe 1881- *DcWomA*
Levy, Marguerite *DcWomA*
Levy, Mayra Phyllis 1955- *WhoAmA 78, -80*
Levy, Mervyn 1915- *DcBrA 1*
Levy, Michael Ray *MarqDCG 84*
Levy, Morris Leonard 1891- *AmArch 70*
Levy, Morton L, Jr. 1933- *AmArch 70*
Levy, Moses *NewYHSD*
Levy, Nat 1896- *ArtsAmW 2*
Levy, Netta *DcVicP 2*
Levy, Philip *WhAmArt 85*
Levy, Phyllis Houser 1927- *WhoAmA 82, -84*
Levy, Rudolf 1875-1944 *McGDA, PhDcTCA 77*
Levy, Rudolf 1875-1944? *OxTwCA*
Levy, S Dean 1942- *WhoAmA 80, -82, -84*
Levy, Samuel 1924- *AmArch 70*
Levy, Stuart D 1950- *WhoAmA 78, -80, -82*
Levy, Ted 1930- *AmArch 70*
Levy, Tibbie 1908- *WhoAmA 73, -76, -78, -80, -82, -84*
Levy, William Auerbach 1889- *WhAmArt 85*
Levy-Bloch, Laurence Rachel 1894- *DcWomA*
Levy-Dhurmer, Lucien 1865-1953 *ClaDrA*
Levy-Engelmann, Yvonne 1894- *DcWomA*
Levy-Lambert, Therese *DcWomA*
Levy-Salomon, Henriette 1866- *DcWomA*
Levyne, Sidney Alfred 1903- *WhAmArt 85*
Lew, A Y *AmArch 70*
Lew, Eileen *WhoAmA 80, -82, -84*
Lew, Eugene 1937- *AmArch 70*
Lew, Jefferey 1946- *PrintW 83, -85*
Lew, Thomas Kenton 1936- *AmArch 70*
Lew, Weyman 1935- *AmArt, PrintW 83, -85, WhoAmA 84*
Lew, Weyman Michael 1935- *WhoAmA 73, -76, -78, -80, -82*
Lew, William W 1941- *WhoAmA 80, -82*
Lewandowski, Edmund 1914- *McGDA*
Lewandowski, Edmund D 1914- *DcCAA 71, -77, WhAmArt 85, WhoAmA 73, -76, -78, -80, -82, -84*
Leward, Charles J *EncASM*
Lewcock, Ronald *ConArch A*
Lewczynski, Jerzy 1924- *ConPhot, ICPEnP A*
Leweke, Gizela *DcWomA*
Lewen, Si 1918- *WhoAmA 76, -78, -80, -82*
Lewenberg, N *WhAmArt 85*
Lewenstein, Eileen 1925- *WhoArt 80, -82, -84*
Lewerentz, Sigurd 1885- *EncMA*
Lewerentz, Sigurd 1885-1975 *ConArch, MacEA, WhoArch*
Lewers, Samuel *NewYHSD*
Lewi, Minna 1872- *DcWomA*
Lewicki, James 1917- *IlrAm F, WhoAmA 73, -76, -78, -80, -82, -84*
Lewicki, James 1917-1980 *IlrAm 1880*
Lewikoff, S J *DcWomA*
Lewin, Ann White 1939- *MarqDCG 84*
Lewin, Bernard *WhoAmA 73, -76, -78, -80, -82, -84*
Lewin, C L *FolkA 86, NewYHSD*
Lewin, Frederic George *DcBrBI*
Lewin, Frederic George d1933 *DcBrA 1*

Lewin, Immanuel H 1911- *AmArch 70*
Lewin, Isaac *FolkA 86*
Lewin, James M 1836-1877 *NewYHSD*
Lewin, John William *DcBrWA*
Lewin, Keith K *WhoArt 80*
Lewin, Keith Kerton 1931- *WhoAmA 76, -78,*
-80
Lewin, Milton J 1929-1979 *WhoAmA 84N*
Lewin, Robert L *WhoAmA 78, -80, -82*
Lewin, Mrs. Robert L *WhoAmA 78, -80,*
-82
Lewin, Stephen *DcVicP 2*
Lewin, Ted *IlsBYP*
Lewin, William d1795 *DcBrWA*
Lewine, Harris 1929- *AmGrD[port]*
Lewine, Milton J 1929-1979 *WhoAmA 80N, -82N*
Lewinhoff, Theodore *NewYHSD*
Lewis d1803 *DcBrECP*
Lewis, Miss *DcWomA*
Lewis, Mrs. *DcWomA*
Lewis, A *DcVicP 2*
Lewis, A N *FolkA 86*
Lewis, A Neville 1895-1972 *DcBrA 1*
Lewis, Abraham L 1907- *AmArch 70*
Lewis, Ada *WhAmArt 85*
Lewis, Alice *ArtsEM, DcWomA*
Lewis, Alice L 1873- *WhAmArt 85*
Lewis, Alice Loring 1872?- *DcWomA*
Lewis, Allen 1873-1957 *WhAmArt 85,*
WhoAmA 80N, -82N, -84N
Lewis, Alonzo Victor 1886-1946 *WhAmArt 85*
Lewis, Alonzo Victor 1891-1950 *ArtsAmW 2*
Lewis, Amelia C 1801?-1820 *DcWomA, NewYHSD*
Lewis, Anne *IlsBYP*
Lewis, Anne Madeline *DcBrA 1, DcVicP 2,*
DcWomA
Lewis, Archie Henry *WhAmArt 85*
Lewis, Arthur Allen 1873-1957 *GrAmP, IlsCB 1744,*
-1946
Lewis, Arthur James 1824-1901 *DcVicP, -2*
Lewis, Arthur James 1825-1901 *DcBrBI*
Lewis, Avery *DcVicP 2*
Lewis, Barbara Carstairs *AmArch 70*
Lewis, Barry Anthony 1948- *MacBEP*
Lewis, Benjamin Archibald *DcBrA 1*
Lewis, Bertram *WhAmArt 85*
Lewis, Betsey 1786-1818 *FolkA 86*
Lewis, Bob *WorECom*
Lewis, C B *AmArch 70*
Lewis, C E *NewYHSD*
Lewis, C H *DcVicP 2*
Lewis, C W Mansel *DcBrA 1, DcVicP 2*
Lewis, Carrington H 1912- *AmArch 70*
Lewis, Charles 1753-1794 *DcBrECP*
Lewis, Charles F 1942- *AmArch 70*
Lewis, Charles James 1830-1892 *DcBrWA, DcVicP,*
-2
Lewis, Charles Walter Edward 1916- *DcBrA 1,*
WhoArt 80, -82, -84
Lewis, Charlotte *DcWomA*
Lewis, Cynthia Gano 1950- *MacBEP*
Lewis, Cyril Arthur 1903- *WhAmArt 85*
Lewis, D J *AmArch 70*
Lewis, David *NewYHSD*
Lewis, David 1922- *AmArch 70, ConArch*
Lewis, David C 1867-1918 *BiDAmAr, MacEA*
Lewis, Dennis Reginald 1928- *WhoArt 80*
Lewis, Don 1935- *WhoAmA 76, -78, -80*
Lewis, Don S, Sr. 1919- *WhoAmA 76, -78, -80, -82,*
-84
Lewis, Donald Sykes, Jr. 1947- *WhoAmA 76, -78, -80,*
-82, -84
Lewis, Donna M 1945- *MarqDCG 84*
Lewis, Dorothy *DcWomA*
Lewis, Dorris Muriel *AmArch 70*
Lewis, Douglas 1938- *WhoAmA 73, -76, -78, -80, -82,*
-84
Lewis, E *DcWomA*
Lewis, E C *AmArch 70*
Lewis, Edmonia *ArtsNiC*
Lewis, Edmonia 1843?- *WhAmArt 85, WomArt*
Lewis, Edmonia 1843?-1909? *IlBEAAW*
Lewis, Edmonia 1845?- *AfroAA, DcAmArt*
Lewis, Edmonia 1845-1909? *DcWomA*
Lewis, Edmund Darch 1835-1910 *NewYHSD,*
WhAmArt 85
Lewis, Edward *NewYHSD*
Lewis, Edward C 1926- *AmArch 70*
Lewis, Edward D *NewYHSD*
Lewis, Edwin E *AfroAA*
Lewis, Edwin James, Jr. 1859-1937 *BiDAmAr*
Lewis, Edwin S *WhAmArt 85*
Lewis, Eleanor Parke *DcWomA*
Lewis, Elijah P *FolkA 86, NewYHSD*
Lewis, Elizabeth *WhoAmA 82, -84*
Lewis, Elizabeth 1908- *WhAmArt 85*
Lewis, Elizabeth H *WhAmArt 85*
Lewis, Elizabeth Matthew *WhoAmA 78, -80, -82, -84*
Lewis, Elizabeth N *WhAmArt 85*
Lewis, Elma Ina 1921- *WhoAmA 73, -76, -78, -80,*
-82, -84

Lewis, Erastus *FolkA 86*
Lewis, Esther *DcWomA*
Lewis, Eva *WhAmArt 85*
Lewis, Eva F *DcWomA*
Lewis, Eveleen *DcVicP 2*
Lewis, Evelyn C *DcWomA*
Lewis, F *DcBrBI*
Lewis, F C *DcVicP 2, WhAmArt 85*
Lewis, Flora 1903- *FolkA 86*
Lewis, Flora Carnell 1903- *AfroAA*
Lewis, Florence E *DcVicP 2*
Lewis, Florence E d1917 *DcWomA*
Lewis, Francoise 1943- *DcCAr 81*
Lewis, Frank E *FolkA 86*
Lewis, Frederick C 1813-1875 *ArtsNiC*
Lewis, Frederick Christian 1779-1856 *DcBrBI,*
DcBrWA, DcVicP, -2, McGDA
Lewis, Frederick Christian, Jr. 1813-1875 *DcVicP 2*
Lewis, G R *AmArch 70*
Lewis, Garth 1939- *DcCAr 81*
Lewis, Garth 1945- *ConBrA 79[port]*
Lewis, George *AmArch 70, CabMA*
Lewis, George 1943- *DcCAr 81*
Lewis, George Albert d1915 *WhAmArt 85*
Lewis, George Lennard 1826-1913 *DcBrA 1,*
DcBrWA, DcVicP, -2
Lewis, George M D 1891- *AmArch 70*
Lewis, George Robert 1782-1871 *DcBrBI, DcBrWA,*
DcVicP, -2
Lewis, George Sherman 1916- *AmArch 70*
Lewis, George Stephen 1908- *AmArch 70*
Lewis, George W *NewYHSD*
Lewis, Glen *OxTwCA*
Lewis, Glenn 1935- *DcCAr 81*
Lewis, Glenn Alun *WhoAmA 76, -78, -80, -82, -84*
Lewis, Golda *WhoAmA 73, -76, -78, -80, -82, -84*
Lewis, Gordon E 1930- *AmArch 70*
Lewis, Graceanina *DcWomA*
Lewis, Han *ArtsAmW 2, NewYHSD*
Lewis, Hanson Y 1939- *AmArch 70*
Lewis, Harry C *AfroAA*
Lewis, Harry Emerson 1892- *ArtsAmW 2,*
WhAmArt 85
Lewis, Harvey *FolkA 86*
Lewis, Helen Natalie 1946- *WhoAmA 80, -82, -84*
Lewis, Helen V 1879?- *WhAmArt 85*
Lewis, Helen Vaughan 1879- *DcWomA*
Lewis, Henry *FolkA 86*
Lewis, Henry 1819-1904 *IlBEAAW, NewYHSD,*
WhAmArt 85
Lewis, Henry Jackson 1847- *AfroAA*
Lewis, Herbert Taylor 1893- *WhAmArt 85*
Lewis, Herbert Taylor 1893-1962 *ArtsAmW 3*
Lewis, Howarth Lister, Jr. 1934- *AmArch 70*
Lewis, Howell 1853?-1935 *ArtsAmW 3*
Lewis, I B *NewYHSD*
Lewis, Ion 1858-1933 *BiDAmAr, MacEA*
Lewis, Ira *FolkA 86*
Lewis, Isaac *FolkA 86*
Lewis, J A *AmArch 70*
Lewis, J Q *AmArch 70*
Lewis, Jack Richard 1911- *AmArch 70*
Lewis, Jackson Pittman 1945- *WhoAmA 76, -78*
Lewis, James *CabMA*
Lewis, James 1751?-1820 *BiDBrA, MacEA*
Lewis, James E 1923- *AfroAA*
Lewis, James O 1931- *AmArch 70*
Lewis, James Otto 1799-1858 *ArtsEM, FolkA 86,*
IlBEAAW, NewYHSD
Lewis, James Trevor 1916- *AmArch 70*
Lewis, Jane Hamblin 1919- *AmArch 70*
Lewis, Jane M *DcWomA*
Lewis, Lady Jane M d1939 *DcBrWA, DcVicP 2*
Lewis, Janet *DcVicP 2*
Lewis, Jeanette Carick *DcWomA*
Lewis, Jeanette Maxfield 1894-1982 *ArtsAmW 3*
Lewis, Jeannette Maxfield *WhoAmA 73, -76*
Lewis, Jeannette Maxfield 1894-1982 *ArtsAmW 3,*
DcWomA
Lewis, Jeannette Maxfield 1896- *WhAmArt 85*
Lewis, Jeannette Mayfield 1894- *ArtsAmW 1*
Lewis, Jennie *WhAmArt 85*
Lewis, Jess *DcWomA*
Lewis, Jessica 1859?-1947 *DcWomA, WhAmArt 85*
Lewis, John *DcBrECP, DcVicP 2*
Lewis, John 1921- *WhoArt 80, -82, -84*
Lewis, John Chapman 1920- *WhoAmA 80, -82, -84*
Lewis, John Conard 1942- *WhoAmA 78, -80, -82, -84*
Lewis, John Frederick 1805-1876 *ArtsNiC, ClaDrA,*
DcBrBI, DcBrWA, DcVicP, -2, McGDA
Lewis, John Frederick 1860-1932 *WhAmArt 85*
Lewis, John Hardwicke 1840-1927 *DcVicP 2*
Lewis, John Hardwicke 1841-1927 *DcBrA 2*
Lewis, John Hardwicke 1842-1927 *DcBrWA*
Lewis, John R *ClaDrA*
Lewis, John R d1943? *DcBrA 1*
Lewis, John R 1949- *MarqDCG 84*
Lewis, John Smith *WhAmArt 85*
Lewis, John Wendall 1925- *AmArch 70*
Lewis, Joseph *NewYHSD*
Lewis, Joseph L *NewYHSD*

Lewis, Josephine *DcWomA*
Lewis, Josephine M *WhAmArt 85*
Lewis, Josephine Miles 1865- *DcWomA*
Lewis, Judith *DcBrECP, DcWomA*
Lewis, Kathleen Margaret 1911- *WhoArt 80, -82, -84*
Lewis, L *DcWomA, NewYHSD*
Lewis, L Howell 1853-1935 *WhAmArt 85*
Lewis, Lalla Walker 1912- *WhAmArt 85*
Lewis, Larry 1927- *AfroAA*
Lewis, Laura Blocker 1915- *WhAmArt 85*
Lewis, Laura C 1874- *WhAmArt 85*
Lewis, Laura Craven 1874- *DcWomA*
Lewis, Mrs. Lennard *DcVicP 2*
Lewis, Leonard *WorFshn*
Lewis, Linda C 1949- *MarqDCG 84*
Lewis, Louise 1927- *DcCAr 81*
Lewis, Louise G *WhAmArt 85*
Lewis, M *NewYHSD*
Lewis, M A *DcVicP 2, DcWomA*
Lewis, Mabel Terry d1957 *DcBrA 2*
Lewis, Madeleine *DcVicP 2*
Lewis, Marcia *WhoAmA 78, -80, -82, -84*
Lewis, Margaret Sarah 1907- *WhAmArt 85*
Lewis, Martin 1881-1962 *DcAmArt, GrAmP,*
WhAmArt 85
Lewis, Martin 1883-1962 *BnEnAmA, WhoAmA 80N,*
-82N, -84N
Lewis, Mary 1870- *DcWomA*
Lewis, Mary 1926- *WhoAmA 76, -78, -80, -82, -84*
Lewis, Mary Amanda 1872-1953 *ArtsAmW 3*
Lewis, Mary Amanda 1877-1953 *DcWomA*
Lewis, Mary Ann *DcWomA, NewYHSD*
Lewis, Mary Priestley 1870- *DcBrA 1*
Lewis, Matthew *NewYHSD*
Lewis, Maxwell 1910- *AmArch 70*
Lewis, Michael Frederick Paul 1925- *ClaDrA,*
DcBrA 1
Lewis, Michael H 1941- *WhoAmA 73, -76, -78, -80,*
-82, -84
Lewis, Minard 1812?- *ArtsAmW 1, IlBEAAW,*
NewYHSD
Lewis, Monty 1907- *WhAmArt 85*
Lewis, Morland 1903-1943 *DcBrA 1*
Lewis, Mortimer 1796-1879 *MacEA*
Lewis, Murphy A *AfroAA*
Lewis, Myron Eugene 1934- *AmArch 70*
Lewis, Nat Brush 1925- *WhoAmA 73, -76, -78, -80,*
-82, -84
Lewis, Norman 1909- *AfroAA, DcCAA 71, -77*
Lewis, Norman Wilfred *WhoAmA 73, -76, -78*
Lewis, Norman Wilfred d1979 *WhoAmA 80N, -82N,*
-84N
Lewis, Norman Wilfred 1909- *ConArt 77*
Lewis, O V *FolkA 86*
Lewis, Ollie *AfroAA*
Lewis, P F *AmArch 70*
Lewis, Patrick *FolkA 86*
Lewis, Mrs. Percy *AfroAA*
Lewis, Percy Wyndham 1882-1957 *DcBrA 1,*
OxTwCA
Lewis, Peter 1938- *MarqDCG 84*
Lewis, Philip 1913- *MarqDCG 84*
Lewis, Phillip Harold 1922- *WhoAmA 73, -76, -78,*
-80, -82, -84
Lewis, Phillips F 1892-1930 *WhAmArt 85*
Lewis, Phillips Frisbie 1892-1930 *ArtsAmW 3*
Lewis, R *DcVicP 2*
Lewis, R E *AmArch 70*
Lewis, R L *AmArch 70*
Lewis, Ralph Mansfield 1911- *WhAmArt 85*
Lewis, Richard *AfroAA*
Lewis, Richard Arnold 1930- *AmArch 70*
Lewis, Richard Jeffreys *DcVicP 2*
Lewis, Richard William 1933-1966 *IlsCB 1957*
Lewis, Robert 1940- *MacBEP*
Lewis, Robert H *AfroAA*
Lewis, Robert R 1952- *MarqDCG 84*
Lewis, Robert Thomas 1931- *MarqDCG 84*
Lewis, Roger Kutnow 1941- *AmArch 70*
Lewis, Ronald Walter 1945- *WhoAmA 78, -80, -82,*
-84
Lewis, Ross A 1902- *WhAmArt 85, WorECar*
Lewis, Rufus Duncan, Jr. 1922- *AmArch 70*
Lewis, Ruth 1905- *WhAmArt 85*
Lewis, S M *EncASM*
Lewis, Samella S *AfroAA*
Lewis, Samella Sanders 1924- *WhoAmA 73, -76,*
-80, -82, -84
Lewis, Samuel *NewYHSD*
Lewis, Schell d1975 *MacEA*
Lewis, Seth *FolkA 86*
Lewis, Shelton *DcBrWA, DcVicP 2*
Lewis, St. John 1866-1915 *WhAmArt 85*
Lewis, Stanley 1930- *WhoAmA 73, -76, -78, -80, -82,*
-84
Lewis, Stanley T 1927- *AmArch 70*
Lewis, Stella *DcWomA*
Lewis, Steven A 1947- *MacBEP*
Lewis, Sydney 1883- *DcBrA 1*
Lewis, Sylvia C *DcVicP 2, DcWomA*
Lewis, T C *AmArch 70*

Liddle, James W *NewYHSD*
Liddle, Nancy Hyatt 1931- *WhoAmA 76, –78, –80, –82, –84*
Lide, M J *AmArch 70*
Lidov, Arthur 1917- *IlrAm G, –1880*
Lidov, Arthur Herschel 1917- *WhAmArt 85, WhoAmA 76, –78, –80, –82, –84*
Lidow, Leza 1924- *AmArt*
Lidstone, Joseph *BiDBrA*
Lidz, Howard L 1931- *AmArch 70*
Lie, Gunnar Riber 1917- *AmArch 70*
Lie, Jonas 1880-1940 *ArtsAmW 3, BnEnAmA, DcAmArt, McGDA, PhDcTCA 77, WhAmArt 85*
Lieb, Hans Peter 1934- *AmArch 70*
Lieb, Leonard 1912- *WhoAmA 73, –76*
Lieb, Vered *DcCAr 81*
Lieb, Vered 1947- *WhoAmA 78, –80*
Liebelt, Linda George 1947- *WhoAmA 76*
Liebenau, Henry 1802?- *NewYHSD*
Liebenberg, J J *AmArch 70*
Lieber, France *WhoAmA 76, –78, –80, –82N, –84N*
Lieber, Thomas Alan 1949- *WhoAmA 82, –84*
Lieberenz, Robert LeVerne 1926- *AmArch 70*
Lieberfeld, L *AmArch 70*
Lieberman, Frances Beatrice 1911- *WhAmArt 85*
Lieberman, Frank Joseph 1910- *WhAmArt 85*
Lieberman, Harry 1876- *WhoAmA 78, –80, –82*
Lieberman, Harry 1876-1983 *WhoAmA 84N*
Lieberman, Harry 1877- *WhoAmA 73, –76*
Lieberman, Harry 1877?-1983 *FolkA 86*
Lieberman, Henry A 1952- *MarqDCG 84*
Lieberman, Laura Crowell 1952- *WhoAmA 80, 82, –84*
Lieberman, Louis 1915- *AmArch 70*
Lieberman, Louis 1944- *AmArt, PrintW 85, WhoAmA 80, –82, –84*
Lieberman, Meyer Frank 1923- *WhoAmA 73, –76, –78, –80, –82, –84*
Lieberman, Vickie 1952- *WhoAmA 80, –82, –84*
Lieberman, William S 1924- *WhoAmA 73, –76, –78, –80, –82, –84*
Liebermann, Max 1847-1935 *McGDA, OxArt, OxTwCA, PhDcTCA 77*
Liebersbach, William Augustus 1921- *AmArch 70*
Liebert, Carl 1903- *AmArch 70*
Liebes, Dorothy 1899- *McGDA*
Liebes, Dorothy 1899-1972 *DcD&D[port], WhoAmA 78N, –80N, –82N, –84N*
Liebes, Dorothy Wright 1899-1972 *WhAmArt 85*
Liebhardt, F *AmArch 70*
Liebhart *NewYHSD*
Liebich, Kathleen Chipman 1892- *DcWomA*
Liebig, Hans Joachim 1930- *AmArch 70*
Liebig, O E, Jr. *AmArch 70*
Liebing, Lotte Marianne 1891- *DcWomA*
Liebing, Ralph William 1935- *AmArch 70*
Liebler, Theodore August 1830-1890 *NewYHSD*
Liebling, Jerome 1924- *ConPhot, ICPEnP A, MacBEP, WhoAmA 84*
Liebman, Aline Meyer *WhAmArt 85*
Liebman, Harold M 1920- *AmArch 70*
Liebman, Norman M 1926- *AmArch 70*
Liebman, Oscar 1919- *IlsCB 1946*
Liebmann, Berthe 1868- *DcWomA*
Liebmann, Fred L 1909- *AmArch 70*
Liebner, O F *WhAmArt 85*
Liebold, Otto *ArtsEM*
Liebs *EncASM*
Liebscher, Gustave *WhAmArt 85*
Liechti, Andreas *OxDecA*
Liechti, Erhard *OxDecA*
Liechti, Hans Heinrich d1810 *OxDecA*
Liechti, Laurenz d1545 *OxDecA*
Liechti, Ulrich *OxDecA*
Liedet, Loyset *McGDA, OxArt*
Liedloff, James E 1905- *WhAmArt 85*
Lieftuchter, Felix B 1883- *WhAmArt 85*
Liege, Jean De *McGDA*
Liehala, Ulla 1948- *DcCAr 81*
Liehert, Stephen R d1945 *BiDAmAr*
Liello, John *WhAmArt 85*
Lienard, Sophie *DcWomA*
Lienau, Daniel Clifford 1943- *WhoAmA 78, –80, –82, –84*
Lienau, Detlef 1818-1887 *BiDAmAr, BnEnAmA, MacEA, McGDA*
Lienau, J August 1854-1906 *BiDAmAr*
Lieneck, P G *AmArch 70*
Lienemeyer, Gerhard *ConDes*
Lienemeyer, Gerhard 1936- *WhoGrA 82[port]*
Lienhard, Emilie *DcWomA*
Lienhard, R H *AmArch 70*
Lienhart, James L 1935- *WhoGrA 82[port]*
Liepina, Marta *DcWomA*
Liepke, Malcolm 1954- *IlrAm 1880*
Lier, Adolf 1826-1882 *ArtsNiC*
Lierd, Miss *DcWomA*
Lierman, Linda 1943- *MarqDCG 84*
Liermann, Frieda 1877- *DcWomA*

Liernur, Maria Elisabeth 1802- *ClaDrA, DcWomA*
Lierow, Anny 1879- *DcWomA*
Lies, Jozef Hendrik Hubert 1821-1865 *ClaDrA*
Liesse, Sophie Augustine *DcWomA*
Liessen, R *AntBDN K*
Liessner-Blomberg, Elena 1897- *DcWomA*
Lieth, Helmut H F 1925- *MarqDCG 84*
Lietz, F *AmArch 70*
Lietz, Mattie 1893- *DcWomA, WhAmArt 85*
Lieven, Karin 1899- *DcWomA*
Lievens, Jan 1607-1674 *McGDA, OxArt*
Lievens, Jan Andrees 1644- *ClaDrA*
Lievens, Johanis 1607-1674 *ClaDrA*
Liff, B J *AmArch 70*
Liff, O *AmArch 70*
Liff, Seymour Herbert 1923- *MarqDCG 84*
Lifraud, Suzanne 1892- *DcWomA*
Lifshay, Morris Abraham 1925- *AmArch 70*
Lifson, Benjamin M 1941- *MacBEP*
Liftin, Joan 1935- *ICPEnP A, MacBEP*
Lifvendahl, Robert *WhAmArt 85*
Ligamari, Tony 1952- *AmArt*
Ligare, David 1945- *AmArt, DcCAr 81, PrintW 83, –85*
Ligare, David H 1945- *WhoAmA 73, –76, –78, –80, –82, –84*
Ligari, Giovanni Pietro 1686-1752 *ClaDrA*
Ligari, Vittoria 1713- *DcWomA*
Ligario, Vittoria 1713- *DcWomA*
Liger, Isaac *AntBDN Q*
Ligeret, Antonie *DcWomA*
Ligeti, Kato *DcWomA*
Ligges, Wulf 1939- *MacBEP*
Ligget, Jane Stewart 1893- *DcWomA, WhAmArt 85*
Liggett, Henry T *WhAmArt 85*
Liggett, John, Jr. *WhAmArt 85*
Light, Alvin 1931- *DcCAr 81*
Light, Edward *AntBDN K*
Light, Herman Charles 1911- *AmArch 70*
Light, Kate *DcBrBI*
Light, Ken 1951- *ICPEnP A, MacBEP*
Light, Robert *MarqDCG 84*
Light, Ruth *WhAmArt 85*
Light, Susan K *ArtsEM, DcWomA*
Light, William *DcBrWA*
Lightbody, Robert *DcVicP 2*
Lighter, Clyde Wilhelm 1901- *AmArch 70*
Lightfoot, Elba 1910- *AfroAA*
Lightfoot, John Jackson 1795- *BiDBrA*
Lightfoot, Mrs. M *AntBDN O*
Lightfoot, M G *OxTwCA*
Lightfoot, Mary L 1898- *ArtsAmW 3*
Lightfoot, Maxwell Gordon 1886-1911 *DcBrA 1*
Lightfoot, Will Henry *AmArch 70*
Lightfoot, William Mallory *AmArch 70*
Lightner, Adam Mortimer *NewYHSD*
Lightoler, Timothy *BiDBrA*
Lightoler, Timothy d1779? *MacEA*
Lighton, Sir Christopher Robert *DcVicP 2*
Lighton, Gertrude G *WhAmArt 85*
Lighty, Benjamin *FolkA 86*
Ligler, George Todd 1949- *MarqDCG 84*
Ligne, Flore, Princess De *DcWomA*
Lignell, Lois 1911- *IlsCB 1946*
Lignereux, Martin-Eloy 1750?-1809 *OxDecA*
Ligo, Norman Lee 1937- *AmArch 70*
Ligon, C P 1901- *FolkA 86*
Ligon, C W *AmArch 70*
Ligorio, Pirro 1500?-1583 *OxArt*
Ligorio, Pirro 1513?-1583 *MacEA*
Ligozzi, Jacopo 1547?-1626 *McGDA*
Liguoro, Antonia Di *DcWomA*
Lihault, Augustus *CabMA*
Lijn, Liliane 1939- *ConArt 77, –83, ConBrA 79[port], WhoAmA 78, –80, –82, –84*
Likan, Gustav 1912- *WhoAmA 76, –78, –80, –82, –84*
Lilburne, T *DcWomA*
Lile, Greer H 1925- *MacBEP*
Lile, James T 1931- *AmArch 70*
Lile, T R, Jr. *AmArch 70*
Liles, Charles Johnson 1921- *AmArch 70*
Liles, R B *AmArch 70*
Liles, Raeford Bailey 1923- *WhoAmA 73, –76, –78, –80, –82, –84*
Lilienfield, Karl d1966 *WhoAmA 78N, –80N, –82N, –84N*
Lilienthal, Philip N, Jr. *WhoAmA 73, –76, –78*
Lilienthal, Mrs. Philip N, Jr. *WhoAmA 73, –76, –78*
Lilio, Andrea 1555-1610 *McGDA*
Liljegren, Frank 1930- *WhoAmA 73, –76, –78, –80, –82, –84*
Liljegren, Tom R 1935- *AmArch 70*
Liljestrom, Gus F 1882-1958 *ArtsAmW 3*
Liljestrom, Gustav F 1882-1958 *ArtsAmW 3*
Lillagore, Theodore W *FolkA 86*
Lillard, R A, Jr. *AmArch 70*
Lilley, Albert E V *DcBrA 1, DcVicP 2*
Lilley, Elizabeth A *DcVicP 2, DcWomA*
Lilley, Geoffrey Ivan 1930- *WhoArt 80, –82, –84*
Lilley, H *DcVicP 2*
Lilley, John *DcVicP 2*

Lilley, William 1894-1958 *DcBrA 1*
Lillford, Ralph 1932- *ClaDrA, WhoArt 80, –82, –84*
Lillie, Carleton Fenn, Jr. 1923- *AmArch 70*
Lillie, Charles T *DcBrBI, DcVicP 2*
Lillie, Denis Gascoigne *DcBrWA*
Lillie, Ella Fillmore 1887- *DcWomA, WhAmArt 85*
Lillie, John 1867- *WhAmArt 85*
Lillie, Robert *DcVicP 2*
Lillie, William Henry, Jr. 1917- *AmArch 70*
Lillienthal, Samuel 1897-1947 *BiDAmAr*
Lilliestrom, Per 1932- *OxTwCA*
Lillingston, G B P *DcVicP 2*
Lillingstone, Juliana *DcVicP 2*
Lillis, Ant *NewYHSD*
Lillis, D F *AmArch 70*
Lilljeqvist, Adele 1862-1927 *DcWomA*
Lillo, Christine De *DcWomA*
Lilly, Bruce 1956- *MarqDCG 84*
Lilly, Charles *IlsBYP*
Lilly, Edmund d1716 *DcBrECP*
Lilly, Emily Jane *FolkA 86*
Lilly, J J *WhAmArt 85*
Lilly, Joseph *AntBDN N*
Lilly, Mrs. Joseph *WhAmArt 85*
Lilly, Marjorie 1891- *DcBrA 2*
Lilly, William *CabMA*
Lillywhite, Raphael 1891-1958 *ArtsAmW 1, IlBEAAW, WhAmArt 85*
Lilyquist, Christine 1940- *WhoAmA 80, –82, –84*
Lim, Chong Keat 1930- *ConArch*
Lim, Gary Radford 1937- *AmArch 70*
Lim, John 1931- *PrintW 83, –85*
Lim, Kim 1936- *ConArt 77, ConBrA 79[port], DcCAr 81*
Lim, Wasim 1929- *WhoArt 82, –84*
Lim, William S W 1932- *ConArch*
Lima, Hely 1945- *DcCAr 81*
Lima, Vasco Machado DeAzevedo 1886?-1973 *WorECar*
Lima, Victor Meirelles De *ArtsNiC*
LiMarzi, Joseph *WhoAmA 76, –78, –80, –82, –84*
Limarzi, Joseph 1907- *WhAmArt 85*
Limbach, Christian *FolkA 86*
Limbach, Russell T 1904- *WhAmArt 85*
Limber, Trudy C *WhoAmA 78*
Limbert, David Edwin 1942- *MarqDCG 84*
Limborch, Hendrik Van 1681-1759 *ClaDrA*
Limborg, Thomas *WhAmArt 85*
Limbourg, Hermann *McGDA*
Limbourg, John Malouel *McGDA*
Limbourg, Paul *McGDA*
Limbrey, M D *DcVicP 2*
Limburg, Francis *NewYHSD*
Limburg, Pol De *OxArt*
Limerick, J Arthur *EncASM*
Limerick, J Arthur 1870-1931 *WhAmArt 85*
Liminge, Robert *BiDBrA*
Limmer, Emil 1854- *ClaDrA*
Limmroth, Manfred 1935?- *WorECar*
Limner, Luke *DcVicP 2*
Limoelan *NewYHSD*
Limon, Sylvan 1932- *AmArch 70*
Limone, Frank 1938- *WhoAmA 80, –82, –84*
Limont, Naomi 1929- *PrintW 83, –85*
Limont, Naomi Charles *WhoAmA 76, –78, –80, –82, –84*
Limosin, Leonard 1505?-1577? *ClaDrA*
Limouro, Raphael *WhAmArt 85*
Limouse, Jeanne *DcWomA*
Limouse, Roger 1894- *OxTwCA*
Limozin-Balas, Andree 1886- *DcWomA*
Lin, Clifton *DcVicP 2*
Lin, Hans *ClaDrA*
Lin, Hsueh *DcWomA*
Lin, James C 1942- *MarqDCG 84*
Lin, P C *AmArch 70*
Lin, Richard 1933- *ConArt 77, ConBrA 79[port], DcCAr 81, OxTwCA, PhDcTCA 77*
Lin, Richard Show Yu 1933- *WhoArt 80*
Lin, Siue *DcWomA*
Lin, T'ing-Kuei *McGDA*
Lin, Wen Chun 1926- *MarqDCG 84*
Lin, Xue *DcWomA*
Linard, Jacques 1600?-1645 *McGDA*
Linares, Isolda E 1954- *MarqDCG 84*
Linblad, Raymond John 1910- *AmArch 70*
Linch, William E 1895- *AmArch 70*
Linck, Walter 1903- *PhDcTCA 77*
Lincke, Erna 1899- *DcWomA*
Lincke, Alexander Of *McGDA*
Lincoln, Agnes Harrison 1870?-1953? *DcWomA*
Lincoln, Agnes Harrison 1870-1955? *WhAmArt 85*
Lincoln, Amos *CabMA*
Lincoln, Anna Maria Stanhope 1760-1834? *DcWomA*
Lincoln, Brooks M 1853-1898 *BiDAmAr*
Lincoln, Daniel H *FolkA 86*
Lincoln, Ebed 1748-1817 *CabMA*
Lincoln, Edwin Hale *MacBEP*
Lincoln, Elizabeth Neave 1876-1957 *DcWomA*
Lincoln, Eunice 1780-1852 *FolkA 86*
Lincoln, F Foster *WhAmArt 85*

Lincoln, Fred Clinton 1943- *WhoAmA 76, -78, -80*
Lincoln, Henry *NewYHSD*
Lincoln, James *FolkA 86*
Lincoln, James Sullivan 1811-1888 *NewYHSD*
Lincoln, Jedediah *CabMA*
Lincoln, Joseph Whiting 1859-1938 *FolkA 86*
Lincoln, L E *AmArch 70*
Lincoln, M H *AmArch 70*
Lincoln, Martha 1796?- *FolkA 86*
Lincoln, Richard Mather 1929- *WhoAmA 73, -76, -78, -80, -82, -84*
Lincoln, Thomas 1778-1851 *CabMA*
Lincoln, Walter Stephen, II 1932- *AmArch 70*
Lind, E R *AmArch 70*
Lind, Edmund G 1829-1909 *BiDAmAr*
Lind, Edward G 1884- *ArtsAmW 3, WhAmArt 85*
Lind, Frank C *WhAmArt 85*
Lind, Jennifer 1942- *AmArt*
Lind, John Howard 1932- *AmArch 70*
Lind, Kenneth N 1909- *AmArch 70*
Lind, Lewis *NewYHSD*
Lind, Ruby *DcWomA*
Lind, Victor 1940- *WhoAmA 73*
Lindahl, John C 1916- *AmArch 70*
Lindberg, Arthur H 1895- *WhAmArt 85*
Lindberg, Curtis N 1921- *AmArch 70*
Lindberg, P T *AmArch 70*
Lindberg, Stig 1916- *WhoGrA 62*
Lindberg, Stig 1916-1982 *ConDes*
Lindberg, T 1878- *WhAmArt 85*
Lindberg, Thorsten Harold Frederick 1878- *ArtsAmW 3*
Lindblad, Bertil Nathaniel 1913- *AmArch 70*
Lindblom, Hans L 1931- *MarqDCG 84*
Lindblom, Sivert *DcCAr 81*
Lindbloom, Eric *DcCAr 81*
Lindborg, Alice Whitten 1912- *WhAmArt 85*
Lindborg, Carl 1903- *WhAmArt 85*
Lindborg, Ingeborg A *WhAmArt 85*
Lindburg, William Harold 1932- *AmArch 70*
Linde, Carl A 1864-1945 *BiDAmAr*
Linde, Horst 1912- *ConArch*
Linde, Louise VanDer *DcWomA*
Linde, Ossip L *WhAmArt 85*
Linde, Philip N *AmArch 70*
Linde, Richard Montgomery 1926- *AmArch 70*
Linde, Richard Paul 1932- *AmArch 70*
Lindeberg, Carl *IlBEAAW*
Lindeberg, George Leanard 1894- *AmArch 70*
Lindegger, Albert 1904- *WhoGrA 62, -82[port]*
Lindegren, Amalia 1814-1891 *ClaDrA, DcWomA*
Lindegren, Yrjo 1900-1952 *MacEA*
Lindell, Lage 1920- *OxTwCA, PhDcTCA 77*
Lindem, C J *WhAmArt 85*
Lindeman, Carl *ArtsEM*
Lindeman, Clara Christina 1871-1960 *DcWomA*
Lindeman, Jack E 1932- *AmArch 70*
Lindeman, Laura E 1873-1967 *DcWomA*
Lindemann, Edna M *WhoAmA 76, -78, -80, -82, -84*
Lindemann, Hedwig 1872- *DcWomA*
Lindemere, Gladys 1887?- *DcWomA*
Linden, Carl T *WhAmArt 85*
Linden, Clara VanDer 1870- *DcWomA*
Linden, E V D *DcVicP 2*
Linden, Frank L *WhAmArt 85*
Linden, Fred *WhoAmA 73, -76*
Linden, G *DcVicP 2*
Linden, Louise VanDer 1844-1911 *DcWomA*
Linden, Richard Allen 1934- *AmArch 70*
Linden, Steve 1953- *DcCAr 81*
Lindenberg, Hedwig 1866- *DcWomA*
Lindenberg, Richard Evans 1947- *MarqDCG 84*
Lindenberger, Charles *CabMA*
Lindeneher, Edouard 1837- *ArtsNiC*
Lindenmeyr, Philip *NewYHSD*
Lindenmuth, Arlington N 1867- *WhAmArt 85*
Lindenmuth, Elisabeth B *DcWomA*
Lindenmuth, R L *WhAmArt 85*
Lindenmuth, Tod 1885-1976 *WhAmArt 85*
Lindenmuth, Mrs. Tod *WhAmArt 85*
Lindenschmit, Wilhelm 1829- *ArtsNiC*
Lindenthaler, Charles J *WhAmArt 85*
Linder, Alf 1944- *DcCAr 81*
Linder, C Bennett 1886- *WhAmArt 85*
Linder, Emilie 1797-1867 *DcWomA*
Linder, Henry 1854-1910 *WhAmArt 85*
Linder, P *DcVicP 2*
Linder, Roland Leonard 1893- *AmArch 70*
Linder, S B *WhAmArt 85*
Linder, Sophie 1838-1871 *DcWomA*
Linder, Stasia 1922- *WhoAmA 76, -78*
Linderman, Earl William 1931- *WhoAmA 80, -82, -84*
Linderman, Jacob *FolkA 86*
Linderman, Winnifred 1868- *DcWomA, WhAmArt 85*
Lindesay, Vane 1920- *WorECar A*
Lindestrom, Tekla 1856- *DcWomA*
Lindgren, Armas 1874-1929 *MacEA, WhoArch*
Lindgren, Arthur A 1917- *AmArch 70*
Lindgren, Bjorn Frank 1943- *WhoAmA 82, -84*

Lindgren, Carl Albert, Jr. 1910- *AmArch 70*
Lindgren, Charlotte 1931- *DcCAr 81, WhoAmA 73, -76, -78, -80, -82, -84*
Lindgren, Donald Harry 1923- *AmArch 70*
Lindgren, Earl Richard 1932- *AmArch 70*
Lindgren, Ernest Godfrey *AmArch 70*
Lindgren, Hilda 1833- *DcWomA*
Lindhardt, Dagmar B 1881- *ArtsAmW 2*
Lindheim, Ray 1884-1910 *WhAmArt 85*
Lindheim, Roslyn 1921- *AmArch 70*
Lindheimer, Maria Dorothea *DcWomA*
Lindholm, B *ArtsNiC*
Lindholm, E *AmArch 70*
Lindholm, Mark 1947- *MarqDCG 84*
Lindhout, William Pierce 1924- *AmArch 70*
Lindi 1904- *WhoGrA 82[port]*
Lindiakos, Louie G 1937- *AmArch 70*
Lindin, Carl 1869-1942 *WhAmArt 85*
Linding, Herman M 1880- *WhAmArt 85*
Linding, Lillian *WhAmArt 85*
Lindlan, James Farrell 1928- *AmArch 70*
Lindley, Blanche B *ArtsEM, DcWomA*
Lindley, Daniel Allen, Jr. 1933- *ICPEnP A, MacBEP*
Lindley, Gerrard 1950- *DcCAr 81*
Lindley, Kenneth Arthur 1928- *WhoArt 80, -82, -84*
Lindley, William 1739?-1818 *BiDBrA*
Lindlof, Edward Axel, Jr. 1943- *WhoAmA 76, -78, -80, -82*
Lindmark, Arne 1929- *WhoAmA 73, -76, -78, -80, -82, -84*
Lindmark, Winter *FolkA 86, NewYHSD*
Lindner, C M *AmArch 70*
Lindner, Carl Max, Jr. 1924- *AmArch 70*
Lindner, Doris 1896?- *DcNiCA*
Lindner, Doris L M *WhoArt 84N*
Lindner, Doris L M 1896- *DcBrA 1, DcWomA, WhoArt 80, -82*
Lindner, Ernest 1897- *WhoAmA 73, -76, -78, -80, -82, -84*
Lindner, G M *DcVicP 2*
Lindner, Gussie *DcVicP 2*
Lindner, James Alan *MarqDCG 84*
Lindner, Moffat Peter 1852-1949 *ClaDrA*
Lindner, Moffatt Peter 1852-1949 *DcBrWA*
Lindner, Norman *WhAmArt 85*
Lindner, Peter Moffat 1852-1949 *DcBrA 1, DcVicP, -2*
Lindner, Richard 1901- *BnEnAmA, ConArt 77, DcCAA 71, -77, McGDA, PhDcTCA 77, WhoAmA 73, -76, -78*
Lindner, Richard 1901-1978 *ConArt 83, DcAmArt, OxTwCA, PrintW 83, -85, WhAmArt 85, WhoAmA 80N, -82N, -84N, WorArt[port]*
Lindner-Latt, Hedda 1875- *DcWomA*
Lindneux, Robert Ottakar 1871-1970 *ArtsAmW 1*
Lindneux, Robert Ottokar 1871-1970 *IlBEAAW, WhAmArt 85*
Lindnig, Lillian *WhAmArt 85*
Lindnig, Lillian 1887- *DcWomA*
Lindo, F *DcBrECP*
Lindoe, David *DcBrECP*
Lindow, Christian 1945- *ConArt 77, -83*
Lindow, William Clay 1949- *MarqDCG 84*
Lindow, William Otto 1940- *AmArch 70*
Lindquist, Evan 1936- *PrintW 83, -85, WhoAmA 76, -78, -80, -82, -84*
Lindquist, Harold S 1887- *WhAmArt 85*
Lindquist, Mark 1949- *WhoAmA 80, -82, -84*
Lindquist, Therold S L 1932- *MacBEP*
Lindqvist, Selim A 1867-1939 *MacEA*
Lindroth, Linda 1946- *MacBEP, PrintW 83, WhoAmA 82, -84*
Lindroth, Linda Hammer 1946- *PrintW 85*
Lindsay, Lady *DcVicP*
Lindsay, Lady 1844-1912 *DcVicP 2*
Lindsay, A S *AmArch 70*
Lindsay, Alan 1918- *DcBrA 1*
Lindsay, Andrew Jackson d1895 *ArtsAmW 1*
Lindsay, Andrew Jackson 1820?-1895 *IlBEAAW, NewYHSD*
Lindsay, Anne *DcWomA*
Lindsay, C S *AmArch 70*
Lindsay, C T d1916 *DcBrA 2*
Lindsay, Caroline Blanche Elizabeth d1912 *DcWomA*
Lindsay, Sir Coutts 1824-1913 *DcBrA 1, DcBrWA, DcVicP, -2*
Lindsay, Sir Daryl *WhoArt 80N*
Lindsay, Sir Daryl 1889- *ClaDrA, OxArt*
Lindsay, Elizabeth *DcWomA*
Lindsay, Sir Ernest Daryl 1889- *DcBrA 1*
Lindsay, F B *AmArch 70*
Lindsay, G *DcBrBI*
Lindsay, H G *AmArch 70*
Lindsay, Henry A *WhAmArt 85*
Lindsay, Ian Gordon 1906-1966 *DcBrA 1*
Lindsay, J B *AmArch 70*
Lindsay, J C *AmArch 70*
Lindsay, Joan *DcWomA*
Lindsay, Joseph d1764 *CabMA*
Lindsay, Kenneth C 1919- *WhoAmA 73, -76, -78, -80, -82, -84*

Lindsay, Lilah Denton d1943 *ArtsAmW 3*
Lindsay, Sir Lionel 1874-1961 *OxArt*
Lindsay, Sir Lionel Arthur 1874-1961 *DcBrA 1*
Lindsay, Lizzie *DcWomA, NewYHSD*
Lindsay, Mrs. Lloyd *DcVicP 2*
Lindsay, M *DcWomA*
Lindsay, Marion Margaret Violet *DcWomA*
Lindsay, Norman 1879- *McGDA*
Lindsay, Norman 1879-1969 *OxArt*
Lindsay, Norman Alfred William 1879- *DcBrBI*
Lindsay, Norman Alfred William 1879-1969 *DcBrA 1*
Lindsay, Norman Alfred Williams 1879-1969 *WorECar*
Lindsay, Percy 1870-1953 *OxArt*
Lindsay, Robert d1836 *DcBrWA*
Lindsay, Ruby 1887-1919 *DcBrA 2, OxArt*
Lindsay, Ruby Lind 1887-1919 *DcWomA*
Lindsay, Ruth *DcVicP 2, DcWomA*
Lindsay, Ruth A 1888- *WhAmArt 85*
Lindsay, Ruth Andrews 1888- *ArtsAmW 2, DcWomA*
Lindsay, T C 1845-1907 *IlBEAAW*
Lindsay, Thomas 1793-1861 *DcBrWA, DcVicP, -2*
Lindsay, Thomas C *WhAmArt 85*
Lindsay, Thomas Corwin 1845-1907 *NewYHSD*
Lindsay, Thomas M *DcBrWA, DcVicP 2*
Lindsay, Violet d1937 *DcVicP 2*
Lindsay, William *FolkA 86, NewYHSD*
Lindsay Family *OxArt*
Lindsell, Leonard *DcBrBI*
Lindsey, Edward D 1841-1916 *BiDAmAr*
Lindsey, G M *AmArch 70*
Lindsey, J W, Jr. *AmArch 70*
Lindsey, Richard William 1904- *AfroAA*
Lindsey, Robert M 1916- *AmArch 70*
Lindsey, S Arthur *DcBrA 1*
Lindsey, Seymore S 1849-1927 *FolkA 86*
Lindsey, T W *AmArch 70*
Lindsley, Emily Earle 1858-1944 *DcWomA, WhAmArt 85*
Lindsley, Julia I C *WhAmArt 85*
Lindsley, Julia S C *DcWomA*
Lindson, John *CabMA*
Lindstrand, Vicke 1904- *IlDcG*
Lindstrand, Vicke 1904-1983 *ConDes*
Lindstrom, August *WhAmArt 85*
Lindstrom, Bengt 1925- *ConArt 77, -83, OxTwCA, PhDcTCA 77*
Lindstrom, C N *AmArch 70*
Lindstrom, Carl E *WhAmArt 85*
Lindstrom, Gaell 1919- *WhoAmA 73, -76, -78, -80, -82, -84*
Lindstrom, J *AmArch 70*
Lindt, John William 1845-1926 *MacBEP*
Lindtmayer, Daniel 1552-1607 *ClaDrA*
Lindy, James Herman 1937- *AmArch 70*
Linebarger, Tom Carl 1919- *AmArch 70*
Linehan, Thomas Edward 1943- *MarqDCG 84*
Linen, George 1802-1888 *NewYHSD*
Linen, John 1800?- *NewYHSD*
Lines, Augustus E 1823?- *NewYHSD*
Lines, C M 1862- *WhAmArt 85*
Lines, Henry Harris 1800-1889 *DcBrWA*
Lines, Henry Harris 1801-1889 *DcVicP, -2*
Lines, Mrs. M M *WhAmArt 85*
Lines, Mabel Mary d1935 *DcWomA*
Lines, Nellie Day *WhAmArt 85*
Lines, Samuel 1778-1863 *DcBrWA*
Lines, Samuel Restell 1804-1833 *DcBrWA*
Lines, Vincent Henry 1909-1968 *DcBrA 1*
Linet, Louise *DcWomA*
Linfert, Carl 1900- *WhoArt 80, -82, -84*
Linfoot, Benjamin S 1910- *AmArch 70*
Linford, Alan Carr 1926- *DcBrA 1*
Linford, Byron Leslie 1936- *AmArch 70*
Ling, Rita M 1922- *DcBrA 2*
Ling, Shui-Cheung Charles 1952- *MarqDCG 84*
Lingan, Penelope *ArtsAmW 2, DcWomA*
Lingan, Violetta D P d1938? *WhAmArt 85*
Lingan, Violette D P d1940? *DcWomA*
Lingard *FolkA 86*
Lingard, Henry *DcVicP 2*
Lingard, William *FolkA 86*
Lingee, Therese Eleonore *DcWomA*
Lingelbach, Johannes d1674 *ClaDrA*
Lingelbach, Johannes 1622-1674 *DcSeaP, McGDA*
Lingeman, J *DcVicP 2*
Lingen, Penelope *ArtsAmW 2, DcWomA, WhAmArt 85*
Linger, Helene Von 1856- *DcWomA*
Lingeri, Pietro 1894-1968 *MacEA*
Lingford, T J *DcVicP 2*
Lingham, G *DcVicP 2*
Lingwood, Edward J *DcVicP 2*
Lingwood, Emily *DcWomA*
Linhares, Philip E 1939- *WhoAmA 78, -80, -82, -84*
Linhart, Evzen 1898-1949 *MacEA*
Liniers, Louise De 1864- *DcWomA*
Lining, Thomas d1763 *CabMA*
Link, B Lillian *WhAmArt 85*
Link, B Lillian 1880- *DcWomA*
Link, C H Pete 1928- *MarqDCG 84*

Lockwood, Florence 1896-1963 *ArtsAmW 3*
Lockwood, Frances Isabelle *DcWomA*
Lockwood, Francis A 1913- *AmArch 70*
Lockwood, Frank 1865-1936 *BiDAmAr*
Lockwood, Sir Frank 1847-1897 *DcBrBI*
Lockwood, H A, Jr. *AmArch 70*
Lockwood, Helen M *DcWomA*
Lockwood, Henry Francis 1811-1878 *MacEA*
Lockwood, John Ward 1894-1963 *IlBEAAW, WhAmArt 85*
Lockwood, Joshua *NewYHSD*
Lockwood, Kenneth 1920- *ClaDrA*
Lockwood, Larry George 1936- *AmArch 70*
Lockwood, Lee 1932- *ICPEnP A*
Lockwood, Mary M *WhAmArt 85*
Lockwood, Mary Murray *DcWomA*
Lockwood, Rembrandt *NewYHSD*
Lockwood, Ward d1963 *WhoAmA 78N, -80N, -82N, -84N*
Lockwood, Ward 1894-1963 *ArtsAmW 1, -3, DcAmArt*
Lockwood, William *FolkA 86*
Lockwood, Wilton 1862-1914 *WhAmArt 85*
Lockyer, Florence A *DcVicP 2*
Lockyer, J M *DcVicP 2*
Lockyer, S B *DcVicP 2*
Locquist *NewYHSD*
Locraft, Matthew Elgas 1939- *AmArch 70*
Locsin, Leandro V 1928- *ConArch*
Lodato, Peter 1946- *DcCAr 81*
Lodberg, Agnes C L 1875- *WhAmArt 85*
Lodde, Alexia De *DcWomA*
Loddengaard, Rolf Gunnar 1903- *AmArch 70*
Lodder, Charles A *DcVicP 2*
Lodding, Kenneth N *MarqDCG 84*
Lodeman, Hilda *ArtsEM, DcWomA*
Loder, Erik 1933- *DcCAr 81*
Loder, James *DcVicP, -2*
Lodes, J B *AmArch 70*
Lodge, Edward Howitt *DcVicP 2*
Lodge, Florence F *DcVicP 2*
Lodge, George E 1860-1954 *DcBrA 1*
Lodge, George Edward *DcBrBI*
Lodge, George Edward 1860-1954 *DcVicP 2*
Lodge, Jean 1941- *DcCAr 81*
Lodge, John d1796 *BkIE*
Lodge, Reginald B *DcVicP 2*
Lodge, William 1649-1689 *ClaDrA*
Lodi, Giovanni DiDomenico Da *McGDA*
Lodoli, Carlo 1690-1761 *MacEA*
Lodolo, Sandro 1929- *WorECar*
Lods, Marcel 1891- *ConArch, EncMA*
Lodwick, Agnes *WhAmArt 85*
Loeb, Dorothy 1887- *DcWomA, WhAmArt 85*
Loeb, Ella *WhAmArt 85*
Loeb, Jeanette *DcCAr 81*
Loeb, John L *WhoAmA 73, -76, -78, -80*
Loeb, Mrs. John L *WhoAmA 73, -76, -78, -80*
Loeb, Judy 1931- *WhoAmA 82, -84*
Loeb, Louis 1866-1909 *DcBrBI, IlrAm 1880, WhAmArt 85*
Loeb, Sidney *WhAmArt 85*
Loeb-Lennich, Hedwig *DcWomA*
Loebach, Ferdinand Alois 1911- *AmArch 70*
Loebenstein, Alphons *WhoArt 80N*
Loeber, Louise Marie 1894- *DcWomA*
Loebig, George *FolkA 86*
Loebl, Florence Weinberg 1894- *DcWomA, WhAmArt 85*
Loebl, Jerrold 1899- *AmArch 70*
Loederer, Richard A 1894- *WhAmArt 85*
Loeff, Jacob Gerritsz *DcSeaP*
Loeffitz, Ludwig *ArtsNiC*
Loeffler, Carl Eugene 1946- *WhoAmA 78, -84*
Loeffler, Charles *NewYHSD*
Loeffler, Frederick Thomas 1917- *AmArch 70*
Loeffler, Gisella *WhAmArt 85*
Loeffler, Gisella 1900- *IlBEAAW*
Loeffler, Joseph Eugene 1924- *AmArch 70*
Loeffler, Ludwig 1819-1876 *DcBrBI*
Loeffler, Moritz d1935 *WhAmArt 85*
Loefftz, Ludwig 1845-1910 *WhAmArt 85A*
Loehle, Betty *AfroAA*
Loehle, Betty Barnes 1923- *WhoAmA 82, -84*
Loehle, Richard E 1923- *WhoAmA 84*
Loehr, Elizabeth *FolkA 86*
Loehr, Max 1903- *WhoAmA 73, -76, -78, -80, -82, -84*
Loekle, Charles *NewYHSD*
Loemans, Alexander F *IlBEAAW*
Loemans, Alexander F d1894 *ArtsAmW 2*
Loengard, John Borg 1934- *ICPEnP A, MacBEP*
Loennecker, Louisa *ArtsEM, DcWomA*
Loercher, Elsie A *WhAmArt 85*
Loercher, Everett R *FolkA 86*
Loercher, Ronald *FolkA 86*
Loerke, William Carl 1920- *WhoAmA 84*
Loesch *FolkA 86*
Loeser, Charles A 1864-1928 *WhAmArt 85*
Loeser, Elizabeth H *DcWomA, WhAmArt 85*
Loetz, J *DcNiCA*

Loew, Michael 1907- *DcCAA 71, -77, WhoAmA 73, -76, -78, -80, -82, -84*
Loewe, Margarete 1859- *DcWomA*
Loewenberg, Henry *NewYHSD*
Loewenberg, Israel Sidney 1892- *AmArch 70*
Loewenberg, James Rudolph 1934- *AmArch 70*
Loewenberg, Max 1889- *AmArch 70*
Loewenguth, Frederick M 1887- *WhAmArt 85*
Loewenheim, S Frederick 1870-1929 *WhAmArt 85*
Loewensberg, Verena 1912- *DcCAr 81*
Loewenstein, Aenny 1871- *DcWomA*
Loewenstein, Bernice *IlsBYP*
Loewenstein, Edward 1913- *AmArch 70*
Loewenthal, Baroness Anka *WhAmArt 85*
Loewer, Henry Peter 1934- *WhoAmA 78, -80, -82, -84*
Loewig, Roger 1930- *DcCAr 81*
Loewy, Mrs. George *WhAmArt 85*
Loewy, Raymond 1893- *DcD&D[port], McGDA*
Loewy, Raymond Fernand 1893- *ConDes*
Loffler, Charlotte Amalie 1794-1878 *DcWomA*
Loffler, Emma Auguste 1843- *DcWomA*
Lofgren, Charles *WhAmArt 85*
Lofgren, Clara Fredrika 1843-1923 *DcWomA*
Lofgren, I H *AmArch 70*
Lofgren, N P *WhAmArt 85*
Lofstrand, Kenneth Eugene 1933- *AmArch 70*
Lofstrom, E V *AmArch 70*
Loft, P *ArtsAmW 2, IlBEAAW, NewYHSD*
Lofthouse, Mrs. 1853-1885 *DcVicP 2*
Lofthouse, Hermione Thornton 1928- *WhoArt 80, -82, -84*
Lofthouse, Mary 1853-1885 *DcBrWA, DcWomA*
Lofthouse, Matthew E *AntBDN Q*
Lofthouse, S H S *DcVicP 2*
Lofthouse, Seth *AntBDN Q*
Loftin, R Bowen 1949- *MarqDCG 84*
Lofting, Hugh 1886-1947 *ConICB, IlsCB 1744, WhAmArt 85*
Loftus, Lady Anna *DcVicP 2, DcWomA*
Loftus, Cyril S 1910- *AmArch 70*
Loftus, James Edward 1908- *AmArch 70*
Lofving, Hjalmar Edvard 1896-1968 *WorECar*
Lofving, I E *AmArch 70*
Logan, A *FolkA 86*
Logan, C *NewYHSD*
Logan, Charlotte E 1900- *WhAmArt 85*
Logan, Clarice George 1909- *WhAmArt 85*
Logan, David *BiDBrA*
Logan, David George 1937- *WhoAmA 76, -78, -80, -82, -84*
Logan, Donn 1938- *AmArch 70*
Logan, Elizabeth D 1914- *WhAmArt 85*
Logan, Frank G 1852-1937 *WhAmArt 85*
Logan, Frederick M 1909- *WhAmArt 85*
Logan, Frederick Manning 1909- *WhoAmA 73, -76, -78, -80, -82, -84*
Logan, Gene Adams 1922- *WhoAmA 76, -78, -80, -82, -84*
Logan, Gladys Caroline *DcWomA*
Logan, Grace Redfield 1873- *DcWomA*
Logan, Herschel C 1901- *WhAmArt 85*
Logan, Ian 1939- *ConDes*
Logan, Jack Keith 1951- *MarqDCG 84*
Logan, James *FolkA 86, NewYHSD*
Logan, James Douglas 1929- *AmArch 70*
Logan, Juan Leon 1946- *WhoAmA 76, -78, -80, -82*
Logan, Juari *AfroAA*
Logan, Marjorie Sybilla *WhAmArt 85*
Logan, Martha 1863-1937 *DcWomA*
Logan, Maurice 1886- *WhoAmA 73, -76*
Logan, Maurice 1886-1977 *WhAmArt 85, WhoAmA 78N, -80N, -82N, -84N*
Logan, Maurice George 1886- *ArtsAmW 2*
Logan, Millie B *EncASM*
Logan, Patrick 1752?- *FolkA 86*
Logan, R F *DcVicP 2*
Logan, Robert Fulton 1899- *WhAmArt 85*
Logan, Robert Henry 1875-1942 *WhAmArt 85*
Logan, Samantha *WhAmArt 85*
Logan, Thayne Johnstone 1900- *AmArch 70*
Logan, Velma Kidd 1912- *WhAmArt 85*
Logan, W *AmArch 70*
Logar, Lojze 1944- *DcCAr 81*
Logasa, Charles 1883-1936 *WhAmArt 85*
Logemann, Jane Marie 1942- *WhoAmA 73, -76*
Logereau, Pauline *DcWomA*
Logerot, Louise *DcWomA*
Logerot, Pauline *DcWomA*
Loges, Herbert *WhAmArt 85*
Loggan, David 1633-1692 *OxArt*
Loggie, Helen A *WhoAmA 73, -76*
Loggie, Helen A d1976 *WhAmArt 85, WhoAmA 78N, -80N, -82N, -84N*
Loghades, Leonie De 1850- *DcWomA*
Loghem, J B Van 1881-1940 *MacEA*
Loghuer, Henry *NewYHSD*
Logsdail, Marian *DcVicP 2, DcWomA*
Logsdail, William 1859- *DcVicP*
Logsdail, William 1859-1944 *DcBrA 1, DcBrBI, DcVicP 2*

Logsdon, Margaret 1846- *DcWomA*
Logsdon, Vail E 1922- *AmArch 70*
Logue, Hollis Lyon, Jr. 1920- *AmArch 70*
Logue, John James 1810?- *NewYHSD*
Logue, Kate 1825?- *DcWomA, NewYHSD*
Loguen, Gerritt *AfroAA, FolkA 86*
Loh, John C F *AmArch 70*
Lohan, Dirk 1938- *AmArch 70*
Lohansen, Edna May S *DcWomA, WhAmArt 85*
Lohaus, Bernd *DcCAr 81*
Lohaus, Bernd 1940- *ConArt 77*
Loheac, Henry 1932- *AmArch 70*
Lohman, B K *AmArch 70*
Lohmann, Albert C *WhAmArt 85*
Lohmann, Erika 1900- *WhAmArt 85*
Lohmann, F D *WhAmArt 85*
Lohmuller, Joseph *WhAmArt 85*
Lohne, Solveig 1945- *DcCAr 81*
Lohr, Alfred *WhAmArt 85*
Lohr, Anna 1870-1955 *DcWomA*
Lohr, E E *AmArch 70*
Lohr, Kathryn Lavinia 1912- *WhAmArt 85*
Lohr, Mathilde *DcWomA*
Lohrer, Hanns 1912- *WhoGrA 62, -82[port]*
Lohrman, William *FolkA 86*
Lohrmann, Ernest *WhAmArt 85*
Lohse, Bernd 1911- *ICPEnP A, MacBEP*
Lohse, Richard P 1902- *PhDcTCA 77*
Lohse, Richard Paul 1902- *ConArt 77, -83, DcCAr 81, OxTwCA, WhoArt 80, -82, -84, WhoGrA 62*
Lohse, Willis R 1890- *WhAmArt 85*
Lohwag, Ernestine *DcWomA*
Lohwag, Frida *DcWomA*
Loir, Luigi 1845-1916 *ClaDrA*
Loir, Marie *DcWomA*
Loir, Marie Anne 1715?- *DcWomA*
Lois, George 1931- *ConDes*
Lois-Pennroze, L M *DcWomA*
Loiseau, Euan Emiel 1927- *AmArch 70*
Loiseau, Gustave 1865-1935 *PhDcTCA 77*
Loisier, M S *DcWomA*
Loison, Louise-Noela 1861- *DcWomA*
Loison, Pierre 1821- *ArtsNiC*
Lojewski, Steven Richard 1952- *MacBEP*
Lokajski, Eugeniusz 1909-1944 *ConPhot, ICPEnP A*
Loker, John 1938- *ConBrA 79[port], DcCAr 81*
Lokerson, Robert Clayton 1942- *MarqDCG 84*
Lokke, Marie *DcWomA, WhAmArt 85*
Lokke, S R *FolkA 86*
Lokuta, Donald Peter 1946- *ICPEnP A, MacBEP*
Lollo, V *EncASM*
Loloma, Charles 1921- *WhoAmA 76, -78, -80, -82, -84*
Lom, Josephine *WhoArt 80, -82, -84*
Lomahaftewa, Linda 1947- *WhoAmA 73, -76, -78, -80, -82, -84*
Lomas, J L *DcVicP 2*
Lomas, Jean Elizabeth 1926- *DcBrA 1*
Lomas, William *DcVicP 2*
Lomas Garza, Carmen 1948- *DcCAr 81*
Lomasney, Ethel M *WhAmArt 85*
Lomax, Arthur *DcVicP 2*
Lomax, Conrad Hope 1885- *DcBrA 1*
Lomax, J O'Bryen *DcVicP 2*
Lomax, Jerrold Ellsworth 1927- *AmArch 70*
Lomax, John Arthur 1857-1923 *DcBrA 1, DcVicP, -2*
Lomax, John Chadwick *DcVicP 2*
Lomax, L *DcVicP 2*
Lomazzo, Giovanni Paolo 1538-1600 *ClaDrA, McGDA, OxArt*
Lombard, Annette 1929- *WhoAmA 84*
Lombard, Caroline Marie *DcWomA*
Lombard, Catherine B 1810?- *DcWomA, NewYHSD*
Lombard, Cesarine 1792- *DcWomA*
Lombard, James 1865- *FolkA 86*
Lombard, Jeanne 1865- *DcWomA*
Lombard, Lambert 1505-1566 *OxArt*
Lombard, Lambert 1506?-1567? *McGDA*
Lombard, Rachel H *FolkA 86*
Lombard, Warren P 1855-1939 *WhAmArt 85*
Lombard, Warren Plimpton 1855-1939 *ArtsAmW 3, ArtsEM[port]*
Lombardi, Alfonso 1497-1537 *McGDA*
Lombardi, Antonio *McGDA*
Lombardi, Gina *PrintW 83, -85*
Lombardi, Michael William 1926- *AmArch 70*
Lombardi, Pietro *McGDA*
Lombardi, Tullio *McGDA*
Lombardini, Gaetano 1801-1869 *ArtsNiC*
Lombardino *McGDA*
Lombardo, Antonio d1516 *OxArt*
Lombardo, Antonio 1458?-1516? *McGDA*
Lombardo, Cristoforo *McGDA*
Lombardo, Emilio Vincent 1890- *ArtsAmW 3, WhAmArt 85*
Lombardo, Josef Vincent 1908- *WhAmArt 85, WhoAmA 73, -76, -78, -80, -82, -84*
Lombardo, Joseph C 1924- *AmArch 70*

Lombardo, Pietro 1433?-1515 *OxArt*
Lombardo, Pietro 1435?-1515 *McGDA, WhoArch*
Lombardo, Sante 1504?-1560? *McGDA*
Lombardo, Sergio 1939- *ConArt 77*
Lombardo, Tommaso *McGDA*
Lombardo, Tullio d1532 *OxArt*
Lombardo, Tullio 1455?-1532 *McGDA*
Lombardo Family *OxArt*
Lomberg, Jon 1948- *DcCAr 81*
LoMedico, Thomas 1904- *WhAmArt 85*
LoMedico, Thomas Gaetano 1904- *WhoAmA 73, -76, -78, -80, -82, -84*
Lomeo, Angelo 1921- *ICPEnP A*
Lomer, Lorna Gertrude *DcWomA*
Lomi *OxArt*
Lomi, Artemisia *McGDA*
Lomi, Orazio *McGDA*
Lomid, T *DcVicP 2*
Lominack, Thomas Jerry 1940- *AmArch 70*
Lomme, Janin *McGDA*
Lommis, Samuel d1814 *CabMA*
Lomnicka, Azdia Josephine *WhoArt 80*
Lomnicka, Azdis Josephine *WhoArt 82, -84*
Lomonosov, M V d1765 *IldcG*
Lonati, Nichola *NewYHSD*
Londerback, Walt *WhAmArt 85*
Londerseel, Assuerus Van 1572?-1635 *ClaDrA*
London, Alexander *WhoAmA 73, -76, -78, -80, -82, -84*
London, Barbara 1946- *WhoAmA 78, -80, -82, -84*
London, E L *AmArch 70*
London, Elca 1930- *WhoAmA 78, -80, -82, -84*
London, F Marsden, Jr. 1914- *AmArch 70*
London, Frank 1876-1945 *WhAmArt 85*
London, George d1714 *MacEA*
London, Hiram 1925- *AmArch 70*
London, Jacqueline Buffy 1954- *MarqDCG 84*
London, Jeff 1942- *WhoAmA 73, -76, -78, -80, -82*
London, Leonard 1902- *WhAmArt 85*
London, Peter 1939- *WhoAmA 80, -82, -84*
Londoner, A 1878- *WhAmArt 85*
Londoner, Amy 1878- *DcWomA*
Londonio, Francesco 1723-1783 *ClaDrA*
Londot, J M *OxTwCA*
Lone Wolf *ArtsAmW 1*
Lone Wolf 1882-1965? *IlBEAAW, WhAmArt 85*
Lonergan, James *NewYHSD*
Lonergan, John 1897-1969 *WhAmArt 85*
Loners, Harry *AmArch 70*
Lonette, Reisie Dominee 1924- *IlsBYP, IlsCB 1946, -1957*
Lonewolf, Joseph 1932- *WhoAmA 78, -80, -82*
Loney, Doris Howard 1902- *WhoAmA 73, -76, -78, -80, -82, -84*
Lonez, Ernestine DuC *DcWomA*
Long, A *DcVicP 2*
Long, Adelaide Husted *DcWomA, WhAmArt 85*
Long, Amelia *DcWomA*
Long, Art *OfPGCP 86*
Long, Arthur *NewYHSD*
Long, Beatrice Mary 1877- *DcWomA*
Long, Betty *WhAmArt 85*
Long, Birch Burdette 1878-1927 *WhAmArt 85*
Long, C *FolkA 86*
Long, C Chee 1942- *WhoAmA 73, -76, -78, -80, -82, -84N*
Long, Charles Raymond 1909- *WhAmArt 85*
Long, Chin-San 1890- *ICPEnP A*
Long, Christopher 1946- *MarqDCG 84*
Long, Clifford Allan 1931- *MarqDCG 84*
Long, Dale Harold 1922- *AmArch 70*
Long, David d1904? *FolkA 86*
Long, Donna *DcWomA*
Long, Dorothy *WhAmArt 85*
Long, E D *NewYHSD*
Long, E W *DcVicP 2*
Long, Edwin *ArtsNiC*
Long, Edwin 1829-1891 *ClaDrA, DcVicP, -2*
Long, Elizabeth Mary *DcWomA*
Long, Ellis B 1874- *WhAmArt 85*
Long, Emily L *DcVicP 2*
Long, Eulah Biggers *WhAmArt 85*
Long, F *BiDBrA*
Long, Fannie Louella 1898- *DcWomA, WhAmArt 85*
Long, Frances *DcWomA*
Long, Frank D 1864-1939 *BiDAmAr*
Long, Frank Weathers 1906- *AmArt, WhAmArt 85, WhoAmA 78, -80, -82, -84*
Long, Franklin B 1842-1913 *BiDAmAr*
Long, Frederic Almond 1906- *AmArch 70*
Long, Frederick *NewYHSD*
Long, Frederick A, Jr. 1931- *AmArch 70*
Long, George *FolkA 86*
Long, Glenn Alan 1939- *WhoAmA 76, -78, -80, -82*
Long, Gwen 1926- *WhoAmA 73*
Long, H *DcVicP 2*
Long, H F *FolkA 86*
Long, Harold Glenn 1938- *AmArch 70*
Long, Henry Sprott 1914- *AmArch 70*
Long, Hubert 1907- *WhoAmA 76, -78, -80, -82, -84*
Long, Ira M *ArtsEM*

Long, J H *FolkA 86*
Long, Jacob *FolkA 86*
Long, James B *FolkA 86*
Long, James L *FolkA 86*
Long, Jasper *FolkA 86*
Long, Jenny 1955- *WhoAmA 82*
Long, John *FolkA 86*
Long, John Kenneth 1924- *DcBrA 1*
Long, John Marshall 1928- *MarqDCG 84*
Long, John N *FolkA 86*
Long, John O *DcBrWA, DcVicP, -2*
Long, John S *FolkA 86*
Long, John St. John 1789-1834 *DcBrWA*
Long, Joseph Dahlgren, Jr. 1922- *AmArch 70*
Long, Kenneth Dean 1929- *AmArch 70*
Long, Lonnie Lee, Jr. 1940- *AmArch 70*
Long, Louis L d1925 *BiDAmAr*
Long, M A *FolkA 86*
Long, M E *DcBrWA*
Long, Marion 1882-1970 *DcWomA*
Long, Marion Lee 1898- *WhAmArt 85*
Long, Marshall B 1954- *MarqDCG 84*
Long, Mary 1789-1875 *DcWomA*
Long, Lady Mary 1789-1875 *DcVicP 2*
Long, Melchor d1774 *CabMA*
Long, Meredith J 1928- *WhoAmA 73, -76, -78, -80, -82, -84*
Long, Michael J *MarqDCG 84*
Long, Nat 1893- *DcBrA 2*
Long, Nicholas *FolkA 86*
Long, P Thomas *AmArch 70*
Long, P V *AmArch 70*
Long, R D 1884- *WhAmArt 85*
Long, Richard *OxTwCA*
Long, Richard 1945- *ConArt 83, ConBrA 79, DcCAr 81*
Long, Richard J 1945- *ConArt 77*
Long, Robert *OfPGCP 86*
Long, Robert C, Jr. 1810-1849 *BiDAmAr*
Long, Robert Carey 1770-1833 *BiDAmAr*
Long, Robert Cary 1810-1849 *MacEA*
Long, Robert Cary, Sr. 1770-1833 *BnEnAmA*
Long, Rose-Carol Washton 1938- *WhoAmA 84*
Long, Rose H *DcVicP 2*
Long, Rufus *FolkA 86*
Long, Samuel 1762-1794 *CabMA*
Long, Samuel P *NewYHSD*
Long, Sandra Tardo 1936- *WhoAmA 73, -76, -78, -80*
Long, Scott 1917- *ConGrA 1[port], WhoAmA 78, -80, -82, -84*
Long, Scott 1927- *WhoAmA 76*
Long, Stanley M 1892-1972 *ArtsAmW 1, IlBEAAW, WhAmArt 85, WhoAmA 78N, -80N, -82N, -84N*
Long, Susan B *MarqDCG 84*
Long, Sydney 1878-1955 *DcBrA 1*
Long, Ted *OfPGCP 86*
Long, Thomas *EncASM*
Long, W A *AmArch 70*
Long, Walter Kinscella 1904- *WhoAmA 73, -76, -78, -80, -82, -84*
Long, William *DcVicP, -2*
Longacre, Andrew 1831?- *NewYHSD*
Longacre, Breta *WhAmArt 85*
Longacre, James Barton 1794-1869 *NewYHSD*
Longacre, Lydia E d1951 *WhoAmA 78N, -80N, -82N, -84N*
Longacre, Lydia E 1870-1951 *WhAmArt 85*
Longacre, Lydia Eastwick 1870-1951 *DcWomA*
Longacre, Margaret Gruen 1910- *WhoAmA 73, -76*
Longacre, Margaret Gruen 1910-1976 *WhAmArt 85, WhoAmA 78N, -80N, -82N, -84N*
Longacre, Matthias Reiff 1836- *NewYHSD*
Longaker, Jon Dasu 1920- *WhoAmA 76, -78, -80, -82, -84*
Longanesi, Leo 1905-1957 *WorECar*
Longarzo, P J *AmArch 70*
Longastre *DcBrECP*
Longaxe *NewYHSD*
Longbotham, Charles Norman 1917- *DcBrA 1, WhoArt 80, -82, -84*
Longbottom, Robert I *DcVicP 2*
Longchamp, Catherine Julie 1806-1879 *DcWomA*
Longchamp, Henriette De *DcWomA*
Longcroft, Thomas *DcBrWA*
Longden, Alfred Appleby d1954 *ClaDrA*
Longden, William *AntBDN M*
Longe, M Antoine *CabMA*
Longe, William Verner 1857-1924 *DcBrA 2*
Longenecker, Peter 1821?- *FolkA 86*
Longfellow, Alexander W 1854-1934 *BiDAmAr*
Longfellow, Ernest W 1845- *ArtsNiC*
Longfellow, Ernest Wadsworth 1845-1921 *WhAmArt 85*
Longfellow, Mary King *WhAmArt 85*
Longfellow, Mary King 1852-1945 *DcWomA*
Longfellow, William Pitt Preble 1836-1913 *BiDAmAr, NewYHSD, WhAmArt 85*
Longfish, George Chester 1942- *WhoAmA 80*
Longhena, Baldassare 1596?-1682 *MacEA*
Longhena, Baldassare 1598-1682 *McGDA, OxArt,*

WhoArch
Longhi *OxArt*
Longhi, Alessandro 1733-1813 *ClaDrA, McGDA*
Longhi, Allesandro 1733-1813 *OxArt*
Longhi, Barbara 1552-1638? *DcWomA*
Longhi, Barbara 1552-1638 *WomArt*
Longhi, Luca *McGDA*
Longhi, Martino d1591 *McGDA*
Longhi, Martino 1602-1657 *McGDA*
Longhi, Onorio 1569-1619 *McGDA*
Longhi, Pietro 1702-1785 *McGDA, OxArt*
Longhi Family *MacEA*
Longhurst, F G *DcVicP 2*
Longhurst, Joseph 1874-1922 *DcBrA 2*
Longley, Miss *DcWomA*
Longley, Bernique *WhoAmA 73, -76, -78, -80, -82, -84*
Longley, Evelyn Louise 1921-1959 *WhoAmA 80N, -82N, -84N*
Longley, Stanislaus Soutten 1894-1966 *DcBrA 1*
Longman, Charlotte *DcVicP 2*
Longman, Eduardo 1952- *ICPEnP A*
Longman, Eleanor D *DcVicP 2, DcWomA*
Longman, Evelyn Beatrice 1874-1954 *DcWomA*
Longman, John B 1860- *WhAmArt 85*
Longman, Lester Duncan 1905- *WhoAmA 73, -76, -78, -80, -82, -84*
Longman, Louise *DcWomA*
Longman, Mary Evelyn Beatrice 1874- *WhAmArt 85*
Longman And Broderip *AntBDN K*
Longmire, Mrs. *DcWomA*
Longmire, R O *DcBrBI*
Longmire, W T *DcBrWA*
Longmire, W Taylor 1841-1914 *DcBrA 1*
Longmore, W S *DcVicP 2*
Longnecker, R K *AmArch 70*
Longo, D A *AmArch 70*
Longo, Martino *McGDA*
Longo, Robert 1953- *AmArt, PrintW 85*
Longo, Vincent 1923- *DcCAA 77, WhoAmA 73, -76, -78*
Longobardi, Nino, *DcCAr 81, PrintW 83, -85*
Longoni, Alberto 1921- *WhoGrA 62, -82[port]*
Longsdon, David *DcVicP 2*
Longshaw, Frank W *DcVicP 2*
Longshore, Willie F 1933- *AfroAA*
Longson, Tony 1948- *DcCAr 81*
Longstaff, Sir John 1862-1941 *DcBrA 1, DcVicP 2*
Longstaffe, Edgar *DcVicP 2*
Longstaffe, John 1622-1694 *BiDBrA*
Longstaffe, John Ronald 1934- *WhoAmA 73, -76, -78, -80, -82, -84*
Longstreet, Stephen 1907- *WhoAmA 73, -76, -78, -80, -82, -84*
Longstreth, Edward 1839-1905 *NewYHSD, WhAmArt 85*
Longstreth, Margaret *DcWomA, WhAmArt 85*
Longstreth, Thaddeus 1909- *AmArch 70*
Longsworth, Jennie *ArtsEM, DcWomA*
Longueil, Joseph De 1730-1792 *McGDA*
Longuelune, Zacharias 1669-1740 *WhoArch*
Longuelune, Zacharias 1669-1748 *MacEA*
Longuet, Alexandre Marie d1850? *ClaDrA*
Longuet, L M 1875- *DcWomA*
Longwood, James Clayton 1921- *AmArch 70*
Longworth, B W *DcWomA*
Longworth, Mrs. B W *WhAmArt 85*
Longworth, James *BiDBrA*
Longworth, Maria *DcWomA, FolkA 86*
Longworth, Montreville *NewYHSD*
Longyear, Esther *DcWomA*
Longyear, Ida *DcWomA, WhAmArt 85*
Longyear, William Llowyn 1899- *WhAmArt 85*
Lonidier, Fred Spencer 1942- *MacBEP, WhoAmA 76, -78, -80, -82, -84*
Lonsdale, Charles Kinsey 1925- *AmArch 70*
Lonsdale, James 1777-1839 *DcBrWA*
Lonsdale, R T *DcVicP, -2*
Loo, Charles Andre 1705-1765 *ClaDrA*
Loo, Sophie Adele Van 1827-1869 *DcWomA*
Loof, A *NewYHSD*
Loof, Jan 1940- *WorECom*
Looff, Charles I D d1918 *FolkA 86*
Look, H M *AmArch 70*
Look, James Henry 1912- *AmArch 70*
Look, Jim *FolkA 86*
Looke, T D *AmArch 70*
Looker, Silas *NewYHSD*
Lookey, Christian *CabMA*
Looman, Jos 1941- *WorECom*
Loomer, Gifford C 1916- *WhoAmA 73, -76, -78, -80*
Loomis, Amasa d1840 *FolkA 86*
Loomis, Andrew 1892- *WhAmArt 85*
Loomis, Arthur 1857-1934 *BiDAmAr*
Loomis, Caspar *NewYHSD*
Loomis, Charles A 1816-1893 *ArtsEM*
Loomis, Charles K, III 1940- *AmArch 70*
Loomis, Chester 1852-1924 *ArtsAmW 2, IlBEAAW, WhAmArt 85*
Loomis, D Jean *WhAmArt 85*
Loomis, D K *AmArch 70*

Lovett, George H 1824-1894 *NewYHSD*
Lovett, John D *NewYHSD*
Lovett, Keith 1937- *MarqDCG 84*
Lovett, Max Dowell 1912- *AmArch 70*
Lovett, Mildred 1880-1955 *DcWomA*
Lovett, Robert 1796?- *NewYHSD*
Lovett, Robert, Jr. 1817?- *NewYHSD*
Lovett, Robert K 1841?- *NewYHSD*
Lovett, Rodman 1809-1895 *FolkA 86*
Lovett, Thomas 1820?-1856 *NewYHSD*
Lovett, Wendell Harper 1922- *AmArch 70*
Lovett, William *FolkA 86*
Lovett, William 1773-1801 *NewYHSD*
Lovewell, R *DcSeaP*
Lovewell, Rominer 1853-1932 *WhAmArt 85*
Lovey, Allen d1907 *WhAmArt 85*
Lovi, Father Walter *BiDBrA*
Lovick, Annie Pescud 1882- *DcWomA,
WhAmArt 85*
Lovie, Henri *EarABI, EarABI SUP, NewYHSD*
Lovin, John d1679 *BiDBrA*
Loving, Alvin, Jr. 1935- *AfroAA*
Loving, F B *AmArch 70*
Loving, George Horace 1933- *AmArch 70*
Loving, Joseph *NewYHSD*
Loving, Michael Vincent *AfroAA*
Loving, Richard Maris 1924- *WhoAmA 80, -82, -84*
Loving, Sharon *AfroAA*
Lovins, Henry 1883- *WhAmArt 85*
Lovins, Henry 1883-1960? *ArtsAmW 2*
Lovis, C *NewYHSD*
Lovitt, Lilliam Nahmias 1948- *WhoAmA 82*
Lovko, Erik 1953- *DcCAr 81*
Lovmand, Christine Marie 1803-1872 *DcWomA*
Lovmand, Frederikke Elisabeth 1801-1885 *DcWomA*
Lovy, G T *AmArch 70*
Low *NewYHSD*
Low, Andrew *NewYHSD*
Low, Annie Rose *DcWomA*
Low, Bertha Lea 1848- *DcWomA, WhAmArt 85*
Low, Bet 1924- *WhoArt 84*
Low, Charles *DcBrA 1, DcVicP, -2*
Low, Charlotte E *DcVicP 2, DcWomA*
Low, D A *AmArch 70*
Low, Daniel *EncASM*
Low, David 1881-1963 *McGDA*
Low, Sir David 1891- *DcBrBI*
Low, Sir David 1891-1963 *DcBrA 1,
WhoGrA 62, WorECar*
Low, David Raymond 1959- *MarqDCG 84*
Low, Diana 1911- *DcBrA 1*
Low, Fritzi 1892- *DcWomA*
Low, Harry *DcBrBI*
Low, Jack 1903- *WhoArt 80, -82, -84*
Low, John *DcNiCA*
Low, John Gorham 1921- *AmArch 70*
Low, John J *EncASM*
Low, Joseph *IlsCB 1967*
Low, Joseph 1911- *IlsCB 1946, -1957, WhoAmA 73,
-76, -78, -80, -82, -84, WhoGrA 62*
Low, K *DcBrBI*
Low, Lawrence Gordon 1912- *WhAmArt 85*
Low, Lucy 1764?- *FolkA 86*
Low, Mary 1858-1946 *DcWomA*
Low, Mary Fairchild 1858-1946 *WhAmArt 85*
Low, Max 1899-1970 *FolkA 86*
Low, Minnie 1876- *WhAmArt 85*
Low, Minnie P 1876- *DcWomA*
Low, Sanford d1964 *WhoAmA 78N, -80N, -82N, -84N*
Low, Sanford Ballad Dole 1905-1964 *WhAmArt 85*
Low, Seth F *EncASM*
Low, Will H 1853- *ArtsNiC*
Low, Will H 1853-1932 *WhAmArt 85*
Low, William *FolkA 86*
Low Ball *EncASM*
Lowber, J B S *NewYHSD*
Lowcock, Charles Frederick *ClaDrA, DcBrA 1,
DcVicP, -2*
Lowcray, Rose 1889-1968 *DcWomA*
Lowden, Reed Carleton 1925- *AmArch 70*
Lowder, John *BiDBrA*
Lowdon, Elsie Motz *WhAmArt 85*
Lowdon, Elsie Motz 1883- *ArtsAmW 2, DcWomA*
Lowe, Miss *DcVicP 2*
Lowe, Alice *DcWomA*
Lowe, Alice Leszinska *WhAmArt 85*
Lowe, Arthur *DcVicP 2*
Lowe, C C, Jr. *AmArch 70*
Lowe, David Ming-Li 1932- *AmArch 70*
Lowe, Doreen *DcCAr 81*
Lowe, Edward *NewYHSD*
Lowe, Edward S *DcVicP 2*
Lowe, Ella *DcVicP 2*
Lowe, Elmo C 1876-1933 *BiDAmAr*
Lowe, Emily d1966 *WhoAmA 78N, -80N, -82N, -84N*
Lowe, F *NewYHSD*
Lowe, G E *DcVicP 2*
Lowe, George Theodore 1858- *ClaDrA*
Lowe, Harry 1922- *WhoAmA 73, -76, -78, -80, -82, -84*

Lowe, J *NewYHSD*
Lowe, J Michael 1942- *WhoAmA 73, -76, -78, -80,
-82, -84*
Lowe, James M 1908- *AmArch 70*
Lowe, Jeffrey 1952- *DcCAr 81*
Lowe, Joe Hing 1934- *WhoAmA 73, -76, -78, -80*
Lowe, John *NewYHSD*
Lowe, LeRoy C 1935- *AmArch 70*
Lowe, Marvin 1927- *PrintW 83, -85, WhoAmA 73,
-76, -78, -80, -82, -84*
Lowe, Mary C *DcVicP 2*
Lowe, Mary Elizabeth *WhAmArt 85*
Lowe, Mauritius d1793 *BkIE*
Lowe, Mauritius 1746-1793 *DcBrECP*
Lowe, Meta 1864- *DcWomA*
Lowe, Peter 1913- *WhAmArt 85*
Lowe, Peter 1938- *ConBrA 79[port], DcCAr 81*
Lowe, Robert *NewYHSD*
Lowe, Ron 1952- *MarqDCG 84*
Lowe, S L *DcVicP 2*
Lowe, S V *DcWomA*
Lowe, Samuel W *NewYHSD*
Lowe, Scott Alan *MarqDCG 84*
Lowe, Unni 1943- *DcCAr 81*
Lowe, Valerie Taylor 1950- *MarqDCG 84*
Lowe, W D *DcVicP 2*
Lowell, Benjamin F *EncASM*
Lowell, Edith Allen *WhAmArt 85*
Lowell, Frederick E 1873-1933 *WhAmArt 85*
Lowell, Guy 1870-1927 *BiDAmAr, MacEA*
Lowell, J C *DcWomA*
Lowell, Mrs. J C *ArtsEM*
Lowell, John Adams *NewYHSD*
Lowell, Lemuel L d1914 *WhAmArt 85*
Lowell, M H 1848-1927 *WhAmArt 85*
Lowell, Maurice J 1917- *AmArch 70*
Lowell, Nat 1880- *WhAmArt 85*
Lowell, Orson *DcBrBI*
Lowell, Orson 1871-1956 *WhAmArt 85*
Lowell, Orson Byron 1871-1956 *IlBEAAW,
IlrAm 1880, WhoAmA 80N, -82N, -84N,
WorECar*
Lowenberg, Richard 1946- *MarqDCG 84*
Lowenberg, Victor *NewYHSD*
Lowenbruck-Parmentier, Caroline 1846- *DcWomA*
Lowendal, Constance De *DcWomA*
Lowenfeld, Viktor 1903-1960 *WhoAmA 80N, -82N,
-84N*
Lowenfinck, Adam Friedrich Von 1714-1754
AntBDN M
Lowenfinck, Seraphia Maria Susanna M Von 1728-1805
DcWomA
Lowenfinken, Elisabeth *DcWomA*
Lowenfish, Joshua D 1904- *AmArch 70*
Lowenfish, M *AmArch 70*
Lowengrund, Margaret 1902-1957 *WhAmArt 85*
Lowengrund, Margaret 1905-1957 *WhoAmA 80N,
-82N, -84N*
Lowenich, Peter *DcNiCA*
Lowenstamm, Emma 1879- *DcWomA*
Lowenstein, Christian 1943- *DcCAr 81*
Lowenstein, Katharina d1885 *DcWomA*
Lowenstein, Loretta *WhAmArt 85*
Lowenstein, Loretto Christine 1876- *DcWomA*
Lowenstein, Maria L 1894-1982 *DcWomA*
Lowenstein, Milton D 1898- *AmArch 70*
Lowenthal, Anka Von 1853- *DcWomA*
Lowenthal, Bertha *DcBrA 1, DcVicP 2, DcWomA*
Lowenthal, E *DcVicP 2*
Lowenthal, Frank 1945- *MarqDCG 84*
Lowenthal, Milton *WhoAmA 73*
Lower, Alan 1932- *AmArch 70*
Lowery, Alexander *FolkA 86*
Lowery, Daniel *FolkA 86*
Lowes, J H *DcVicP 2*
Lowes, Sadie H 1870- *DcWomA, WhAmArt 85*
Lowinger, Thomas 1949- *MarqDCG 84*
Lowinsky, Simon L 1945- *WhoAmA 78, -80, -82, -84*
Lowinsky, Thomas Esmond 1892- *ClaDrA*
Lowinsky, Thomas Esmond 1892-1947 *DcBrA 1,
DcBrBI*
Lowmiller, William 1809-1879 *FolkA 86*
Lown, Lynn 1947- *ICPEnP A, MacBEP*
Lowndes, Alan 1921- *DcBrA 2, WhoArt 80, -82*
Lowndes, Anna *WhAmArt 85*
Lowndes, Jonathan *AntBDN D*
Lowndes, Mary *DcVicP 2, DcWomA*
Lownes, Anna *DcWomA*
Lownes, Caleb *NewYHSD*
Lowney, Bruce Stark 1937- *WhoAmA 73, -76, -78,
-80, -82, -84*
Lownie, Theodore Leonard 1936- *AmArch 70*
Lowrey, John d1796 *CabMA*
Lowrey, Mark Perrin 1926- *AmArch 70*
Lowrey, Robert Sidney 1925- *AmArch 70*
Lowrey, Rosalie 1893- *DcWomA, WhAmArt 85*
Lowrie, Agnes Potter *DcWomA*
Lowrie, Agnes Potter 1892- *WhAmArt 85*
Lowrie, Eleanor 1875- *ArtsAmW 3*
Lowrie, Marion *ArtsEM, DcWomA*

Lowry, Bates 1923- *WhoAmA 73, -76, -78, -80, -82,
-84*
Lowry, D E *AmArch 70*
Lowry, Edward Joseph 1914- *AmArch 70*
Lowry, Eleanor 1875- *ArtsAmW 3*
Lowry, Ellis Randolph 1928- *AmArch 70*
Lowry, Ethelwyn *WhAmArt 85*
Lowry, Eugene Isley *AmArch 70*
Lowry, Everett E 1870-1936 *WhAmArt 85*
Lowry, James Paul 1940- *AmArch 70*
Lowry, L S 1887-1976 *ConArt 83, PhDcTCA 77,
WorArt[port]*
Lowry, Laurence Stephen 1887- *DcBrA 1*
Lowry, Laurence Stephen 1887-1976 *ConArt 77,
DcBrA 2, OxTwCA*
Lowry, Lawrence Stephen 1887- *ClaDrA*
Lowry, Lawrence Stephen 1888-1976 *DcSeaP*
Lowry, Lydia P H *ArtsEM*
Lowry, Lydia P Hess *DcWomA, WhAmArt 85*
Lowry, Matilda *DcBrWA, DcVicP 2, DcWomA*
Lowry, Peter 1914- *DcBrA 1*
Lowry, R S, Jr. *AmArch 70*
Lowry, Strickland 1737?-1785? *DcBrECP*
Lowry, W B *FolkA 86*
Lowry, W McNeil 1913- *WhoAmA 73, -76*
Lowry, William S d1881 *ArtsEM*
Lowry, Willis Gentry 1908- *WhAmArt 85*
Lowry Brothers *FolkA 86*
Lowstadt, Emma 1855-1936 *DcWomA*
Lowstadt, Eva Matilda *DcWomA*
Lowther, Julia *DcWomA*
Lowy, A F *AmArch 70*
Lowy, J *AmArch 70*
Loxley, Mrs. Benjamin Rhees *WhAmArt 85*
Loxton-Knight, Edward 1905- *ClaDrA*
Loxton Knight, Edward 1905- *WhoArt 80, -82, -84*
Loxton Peacock, Clarisse 1926- *WhoArt 80, -82, -84*
Loy, John Sheridan 1930- *WhoAmA 73, -76, -78, -80,
-82, -84*
Loy, M *FolkA 86*
Loy, Ramon 1896- *AfroAA*
Loyau-Morance, Jeanne Marie Eugenie 1898-
DcWomA
Loyd, C *AmArch 70*
Loyd, L *DcWomA*
Loye, Edwin M 1895- *AmArch 70*
Loyer, Ernestine 1846- *DcWomA*
Loyer, Mathilde Augustine *DcWomA*
Loyet, David A 1938- *AmArch 70*
Loyless, J G *AmArch 70*
Lozano, Adrian 1921- *AmArch 70*
Lozowick, Louis 1892- *DcCAA 71, McGDA,
WhoAmA 73*
Lozowick, Louis 1892-1973 *ArtsAmW 3, DcAmArt,
DcCAA 77, GrAmP, WhAmArt 85,
WhoAmA 76N, -78N, -80N, -82N, -84N*
Lu, Chi *McGDA*
Lu, Chih 1495-1576 *McGDA*
Lu, T'an-Wei *McGDA*
Lu Chon Min 1933- *OxTwCA*
Luard, John 1790-1875 *DcBrWA*
Luard, John Dalbiac 1830-1860 *DcBrBI, DcBrWA,
DcVicP 2*
Luard, L *DcVicP 2*
Luard, Lowes Dalbiac 1872-1944 *DcBrA 1*
Luba *WorFshn*
Lubalin, Herb 1918- *WhoGrA 82[port]*
Lubalin, Herbert 1918- *WhoGrA 62*
Lubalin, Herbert Frederick 1918-1981 *ConDes*
Luban, Boris 1881- *WhAmArt 85*
Lubanska, Zofia *DcWomA*
Lubarda, Petar 1907- *OxTwCA, PhDcTCA 77*
Lubart, Henriette D'Arlin 1915- *WhoAmA 82, -84*
Lubbers, H *DcVicP 2*
Lubbers, Leland Eugene 1928- *WhoAmA 73, -76, -78,
-80, -82, -84*
Lubbers, Robert 1922- *WorECom*
Lubbers, T C *NewYHSD*
Lubbes, Maria 1847- *DcWomA*
Lubcke, Harry Raymond 1905- *MarqDCG 84*
Lubeck, G H *AmArch 70*
Lubell, Ellen 1950- *WhoAmA 80, -82, -84*
Lubell, Winifred Milius *IlsCB 1967*
Lubell, Winifred Milius 1914- *IlsCB 1946, -1957*
Lubelski, Jan Stanislaw 1922- *WhoArt 80, -82, -84*
Lubersac, Countess *DcWomA*
Lubetkin, Berthold 1901- *ConArch, DcD&D,
MacEA, McGDA, WhoArch*
Lubetz, L A *AmArch 70*
Lubicz-Nycz, Jan 1925- *AmArch 70*
Lubieniecki, Bogdan Theodor 1653- *ClaDrA*
Lubienska, Countess Amelie Hedwig Von 1852-
DcWomA
Lubin, Leonard B *IlsCB 1967*
Lubin, Morris A 1888- *WhAmArt 85*
Lubman, Ronald 1936- *MarqDCG 84*
Lubner, Martin Paul 1929- *WhoAmA 73, -76, -78,
-80*
Lubomirska, Princess Helene 1783-1876 *DcWomA*
Lubovsky, Maxim H *WhAmArt 85*
Lubrano, David G *MarqDCG 84*

Lubroth, J *AmArch 70*
Lubschez, Ben Judah 1881-1963 *MacBEP*
Luc, Frerc 1614-1685 *McGDA*
Luca DiTomme 1330?-1389? *McGDA*
Luca Fa Presto *McGDA*
Luca, Mark 1918- *WhoAmA 84*
Luca, Raymond J 1941- *MarqDCG 84*
Lucae, Richard 1829-1877 *MacEA*
Lucan, Margaret, Countess Of d1815 *DcBrWA*
Lucan, Countess Margaret Bingham 1740-1815?
 DcWomA
Lucano, Giovanni Battista Da d1539? *MacEA*
Lucas, Mrs. *DcWomA*
Lucas VanLeyden *McGDA*
Lucas VanLeyden 1494-1533 *OxArt[port]*
Lucas, A M *DcVicP 2*
Lucas, A P *DcVicP 2*
Lucas, Albert Durer *DcNiCA*
Lucas, Albert Durer 1828- *ClaDrA, DcVicP*
Lucas, Albert Durer 1828-1918 *DcVicP 2*
Lucas, Albert Durer 1828-1919 *DcBrA 1*
Lucas, Albert P 1862-1945 *WhAmArt 85*
Lucas, Alice Mary 1844-1939 *DcBrWA*
Lucas, Ann Rachel d1971 *DcBrWA*
Lucas, Antonie Gerrit 1922- *AmArch 70*
Lucas, Arthur *DcVicP 2*
Lucas, Arthur Charles, Jr. 1921- *AmArch 70*
Lucas, Bernard J *DcVicP 2*
Lucas, Blanche Wingert 1888- *DcWomA*
Lucas, C *DcVicP 2*
Lucas, Cecil Veronica *DcBrA 1*
Lucas, Charles C, Jr. 1939- *WhoAmA 73, -76, -78,
 -80, -82*
Lucas, Colin 1906- *ConArch, MacEA*
Lucas, Constance *DcBrWA*
Lucas, Daniel d1867 *AntBDN M, DcNiCA*
Lucas, David *AntBDN B*
Lucas, David 1802-1881 *McGDA*
Lucas, David 1948- *FolkA 86*
Lucas, Denis 1918- *DcBrA 2*
Lucas, E B *WhAmArt 85*
Lucas, E G Handel *DcVicP*
Lucas, Edward George Handel 1861-1936 *DcBrA 1,
 DcVicP 2*
Lucas, Emmett W 1928- *AfroAA*
Lucas, Eric 1911- *WhoArt 80, -82, -84*
Lucas, Essie Leone Leavey 1872?-1932 *DcWomA,
 WhAmArt 85*
Lucas, Evelyn *DcVicP 2, DcWomA*
Lucas, Florence *DcBrWA, DcVicP 2*
Lucas, Frank Edward 1934- *AmArch 70*
Lucas, George *DcVicP, -2*
Lucas, Hannah *DcVicP 2*
Lucas, Henry Frederick Lucas d1943 *DcBrA 1*
Lucas, Horatio Joseph 1839-1873 *ClaDrA, DcBrBI*
Lucas, J *NewYHSD*
Lucas, J Carrell *WhAmArt 85*
Lucas, J R *AmArch 70*
Lucas, Jay Harlan 1923- *AmArch 70*
Lucas, Jean *NewYHSD , WhAmArt 85*
Lucas, Jean Williams 1873- *DcWomA*
Lucas, Jeanie *DcVicP 2, DcWomA*
Lucas, John 1807-1874 *ArtsNiC, DcVicP, -2*
Lucas, John Robert 1754-1828 *IlDcG*
Lucas, John Seymour 1849-1923 *ClaDrA, DcBrA 1,
 DcBrBI, DcBrWA, DcVicP, -2*
Lucas, Mrs. John Seymour 1855-1921 *DcVicP 2*
Lucas, John Templeton 1836-1880 *DcBrBI, DcVicP,
 -2*
Lucas, Mrs. John Templeton *DcVicP 2*
Lucas, Lancaster *DcVicP 2*
Lucas, Leroy *AfroAA*
Lucas, Louise Antoinette *DcWomA*
Lucas, Marie Elizabeth 1855-1921 *DcBrA 1,
 DcWomA*
Lucas, Marie Ellen Segmont d1951 *DcBrA 2*
Lucas, Marjorie A 1911- *DcBrA 1, WhoArt 80, -82,
 -84*
Lucas, Martha Hobbs *FolkA 86*
Lucas, Mary *DcVicP 2, DcWomA*
Lucas, Matilda *DcBrWA*
Lucas, Matilda 1849-1943 *DcBrWA*
Lucas, May Lancaster *DcVicP 2, DcWomA*
Lucas, R David 1944- *MarqDCG 84*
Lucas, R W *DcWomA*
Lucas, Ralph W *DcVicP, -2*
Lucas, Ralph W 1796-1874 *DcBrWA*
Lucas, Mrs. Ralph W *DcVicP 2*
Lucas, Richard Cockle 1800-1883 *DcNiCA*
Lucas, Rosa *DcBrWA*
Lucas, S Bright *DcVicP 2*
Lucas, Samuel 1805-1870 *DcBrWA, DcVicP 2*
Lucas, Samuel 1840-1919 *DcBrWA*
Lucas, Stephen 1924- *DcBrA 1*
Lucas, Suzanne 1915- *ClaDrA, DcBrA 1,
 WhoArt 80, -82, -84*
Lucas, Sydney Seymour *DcBrBI*
Lucas, Thomas *FolkA 86*
Lucas, Thomas James, Jr. 1925- *AmArch 70*
Lucas, W M *AmArch 70*
Lucas, William 1762- *DcBrECP*

Lucas, William 1840-1895 *DcBrWA, DcVicP, -2*
Lucas, William B *NewYHSD*
Lucas, William James 1888- *ClaDrA*
Lucas-Robiquet, Marie Aimee 1864- *ClaDrA,
 DcWomA*
Lucas Y Padilla, Eugenio 1824-1870 *McGDA*
Lucassen, Reinier 1939- *ConArt 77,
 -83*
Lucca, Gaudencio 1954- *MarqDCG 84*
Luccardi, Vincenzo 1811-1876 *ArtsNiC*
Luccearini, Andrew *NewYHSD*
Luccearini, John *NewYHSD*
Lucchesi, Andrea Carlo 1860-1925 *DcBrA 1*
Lucchesi, Bruno 1926- *DcCAA 77, WhoAmA 73,
 -76, -78, -80, -82, -84*
Lucchesi, Edmund 1870-1964 *DcBrA 2*
Lucchesino, Il *OxArt*
Luce, Benjamin *FolkA 86*
Luce, C *WhAmArt 85*
Luce, Cal *WhAmArt 85*
Luce, Charles 1947- *PrintW 85*
Luce, Clarence Sumner 1852-1924 *MacEA*
Luce, J E, Jr. *WhAmArt 85*
Luce, Laura H 1845- *WhAmArt 85*
Luce, Laura Wilson 1845- *DcWomA*
Luce, Leonard E 1893- *WhAmArt 85*
Luce, Lois 1906- *WhAmArt 85*
Luce, Marie Huxford *DcWomA, WhAmArt 85*
Luce, Maximilien 1858-1941 *ClaDrA, McGDA,
 OxTwCA, PhDcTCA 77*
Luce, Molly 1896- *DcWomA, WhAmArt 85,
 WhoAmA 82, -84*
Luce, Olive Susanna *DcWomA*
Luce, Richard *OfPGCP 86*
Luce, Shubael H *FolkA 86*
Lucebert 1924- *PhDcTCA 77*
Luceck, G *NewYHSD*
Lucente, Samuel Anthony 1958- *MarqDCG 84*
Lucero, Juanita *FolkA 86*
Lucero, Michael 1953- *PrintW 83, -85,
 WhoAmA 82, -84*
Lucey, Jack 1929- *WhoAmA 80, -82, -84*
Luchian, Stefan 1868-1916 *OxTwCA, PhDcTCA 77*
Luchinger, Arnulf *ConArch A*
Luchs, Alison 1948- *WhoAmA 82, -84*
Luchtemeyer, Edward A 1887- *WhAmArt 85*
Lucia, Angelo Peter 1913- *AmArch 70*
Lucian Of Samosata *OxArt*
Luciani, Sebastiano *McGDA*
Luciano, Sebastiano 1485?-1547 *ClaDrA*
Lucidel *McGDA*
Lucie-Smith, John Edward McKenzie 1933-
 WhoArt 80
Lucier, Mary 1944- *WhoAmA 84*
Lucile 1864?-1935 *WorFshn*
Lucille d1937 *FairDF ENG*
Lucio 1929- *OxTwCA*
Lucioni, Louis J *WhAmArt 85*
Lucioni, Luigi 1900- *McGDA, WhAmArt 85,
 WhoAmA 73, -76, -78, -80, -82, -84*
Lucius, Florence G *WhAmArt 85*
Lucius, Florence Gertrude 1887?-1962 *DcWomA*
Luck, Robert 1921- *WhoAmA 73, -76, -78, -80, -82,
 -84*
Luckenbach, Carl Frederick 1935- *AmArch 70*
Luckenbach, O A *AmArch 70*
Luckenbach, Reuben O 1818-1880 *NewYHSD*
Luckett, T D *AmArch 70*
Luckett, William E *AfroAA*
Luckey, Mrs. *EncASM*
Luckey, B M d1916 *WhAmArt 85*
Luckhardt, Hans 1890-1954 *ConArch, EncMA,
 MacEA*
Luckhardt, Wassili 1889- *EncMA*
Luckhardt, Wassili 1889-1972 *ConArch, MacEA*
Luckhurst, Charles Alfred 1879- *AmArch 70*
Luckhurst, Nigel *DcCAr 81*
Luckman, Charles 1909- *AmArch 70*
Luckman, J M *AmArch 70*
Luckner, Kurt T 1945- *WhoAmA 76, -78, -80, -82,
 -84*
Luckx, Kerstiaen *McGDA*
Lucky, Eliza J *DcWomA*
Lucot, Alexandra 1890- *DcWomA*
Lucotte DeChampmont, Anne Alexandrine *DcWomA*
Lucquin, Henriquetta 1819-1866 *DcWomA*
Lucy, Anne *DcVicP 2*
Lucy, Charles 1692-1736? *DcBrECP*
Lucy, Charles 1804-1873 *ArtsNiC*
Lucy, Charles 1814-1873 *DcVicP, -2*
Lucy, Charles Hampden *DcVicP 2*
Lucy, Edward *BiDBrA*
Lucy, Edward Falkland d1908 *DcBrA 1, DcVicP 2*
Lucy, Gary *OfPGCP 86*
Lucy, Hubert A *DcVicP 2*
Lucy, James *BiDBrA*
Luczun, Robert 1946- *WhoAmA 80, -82, -84,
 WhoArt 80, -82, -84*
Ludbrook, Alberta *WhAmArt 85*
Ludby, Max 1858-1943 *DcBrA 1, DcBrWA, DcVicP,*

 -2
Ludders, Heinrich Paul 1826-1897 *DcSeaP*
Luddington, Mrs. *DcWomA*
Luddington, Leila *ClaDrA*
Ludekens, Fred *WhoAmA 73, -76, -78, -80, -82*
Ludekens, Fred 1900- *IlBEAAW, IlrAm E,
 WhAmArt 85*
Ludekens, Fred 1900-1982 *IlrAm 1880*
Ludeking, David *DcSeaP*
Luderitz, Poppe *DcWomA*
Luders, David 1710?-1759 *DcBrECP*
Luders, Jurgen Edward 1917- *AmArch 70*
Ludgin, Earle 1898- *WhoAmA 73, -76, -78, -80*
Ludgin, Earle 1898-1981 *WhoAmA 82N, -84N*
Ludick, Lodewijk Van 1629-1697? *McGDA*
Ludington, Julia *DcWomA*
Ludington, Katharine 1869- *DcWomA, WhAmArt 85*
Ludington, Wright S 1900- *WhoAmA 73, -76, -78,
 -80*
Ludins, Eugene 1904- *WhAmArt 85*
Ludins, Ryah *WhAmArt 85*
Ludius *McGDA*
Ludlam, Eugenie Shonnard 1936-1978 *WhoAmA 80N,
 -82N, -84N*
Ludlow, C A *NewYHSD*
Ludlow, D *AmArch 70*
Ludlow, Edward Hunter 1810-1884 *NewYHSD*
Ludlow, Fitz-Hugh *ArtsAmW 1*
Ludlow, Gabriel Augustus 1800-1838 *NewYHSD*
Ludlow, Gabriel R *FolkA 86*
Ludlow, Gulian 1764-1826 *NewYHSD*
Ludlow, Hal 1861- *DcBrA 1*
Ludlow, Henry Stephen 1861- *DcBrBI, DcVicP 2*
Ludlow, J L *WhAmArt 85*
Ludlow, Miss M S *DcBrA 1*
Ludlow, Mary Sophia *DcWomA*
Ludlow, Mike 1921- *IlrAm 1880*
Ludlow, S *DcBrBI*
Ludlow, Thomas W 1881-1929 *BiDAmAr*
Ludlow, W *DcVicP 2*
Ludman, Joan Hurwitz 1932- *WhoAmA 78, -80, -82,
 -84*
Ludmann, Paula 1869- *DcWomA*
Ludmer, Joyce Pellerano *WhoAmA 78, -80, -82, -84*
Ludolff, Margarete *DcWomA*
Ludorf, H F *AmArch 70*
Ludovice, Albert 1820-1894 *ClaDrA*
Ludovice, Joao Federico 1670-1750 *WhoArch*
Ludovice, Joao Frederico 1670-1752 *DcD&D,
 McGDA, OxArt*
Ludovici, Albert 1820-1894 *DcBrWA, DcVicP, -2*
Ludovici, Albert 1852- *ClaDrA*
Ludovici, Albert 1852-1932 *DcBrWA*
Ludovici, Albert, Jr. 1852-1932 *DcBrA 1, DcBrBI,
 DcVicP, -2*
Ludovici, Alice E 1872- *WhAmArt 85*
Ludovici, Alice Emilie 1872- *ArtsAmW 1*
Ludovici, Alice Emilie 1872-1957 *DcWomA*
Ludovici, Julius *ArtsAmW 1, WhAmArt 85*
Ludovici, Marguerite *DcWomA*
Ludovico, Albert, Jr. 1852-1932 *DcBrBI*
Ludre, Claire Pauline De *DcWomA*
Ludtke, Lawrence Monroe 1929- *WhoAmA 76, -78,
 -80, -82, -84*
Ludvigsen, Warren Lawrence 1940- *AmArch 70*
Ludwig II 1845-1886 *DcNiCA*
Ludwig, Alexis 1861- *WhAmArt 85*
Ludwig, Allan I 1933- *MacBEP, WhoAmA 80, -82,
 -84*
Ludwig, Amalia 1889- *DcWomA, WhAmArt 85*
Ludwig, Augusta 1834- *DcWomA*
Ludwig, Charles L *NewYHSD*
Ludwig, E *DcVicP 2*
Ludwig, Eva 1923- *WhoAmA 73, -76, -78, -80, -82,
 -84*
Ludwig, Frederick Frank 1932- *AmArch 70*
Ludwig, Helen *IlsBYP*
Ludwig, Henry *ArtsEM, NewYHSD*
Ludwig, Homer William, Jr. 1923- *AmArch 70*
Ludwig, J F 1670-1752 *OxArt*
Ludwig, James Christian Oberwetter 1933-
 AmArch 70
Ludwig, Johann Friedrich *McGDA*
Ludwig, Karel 1919-1977 *MacBEP*
Ludwig, Robert *ArtsEM*
Ludwig, Ronald S 1933- *AmArch 70*
Ludwig, W N *AmArch 70*
Ludwig, William *NewYHSD*
Ludwig, William Joseph 1941- *AmArch 70*
Ludwig-Kunz, Katie 1853- *DcWomA*
Ludwig Redlich *EncASM*
Luebkert, Alma *WhAmArt 85*
Lueckin, C *FolkA 86*
Luecking, Stephen Joseph 1948- *WhoAmA 82, -84*
Lueders, A D *AmArch 70*
Lueders, Jimmy C 1927- *WhoAmA 73, -76, -78, -80,
 -82, -84*
Luedtke, Charles William 1934- *AmArch 70*
Luedy, C A *AmArch 70*
Luehrsen, Hannes 1907- *AmArch 70*
Lueloff, Marjorie Kaltenback 1906- *WhAmArt 85*

Luepke, Gordon Maas 1913- *AmArch 70*
Lueppo-Cramer, Hinricus 1871-1943 *MacBEP*
Luer, Jack Richard 1935- *AmArch 70*
Luethje, Donald Herbert 1932- *AmArch 70*
Luey, J Min 1935- *AmArch 70*
Luff, George W *FolkA 86*
Luff, John *AntBDN Q*
Luff, John V *FolkA 86*
Luffman, Charles E 1909- *WhAmArt 85*
Luffman, John *NewYHSD*
Lufkin, Lee *DcWomA, WhAmArt 85*
Lufkin, Raymond H 1897- *IlsBYP, IlsCB 1744,*
 -1946
Lugano, Ines Somenzini *WhAmArt 85*
Lugano, Tommaso Da *McGDA*
Lugar, Robert 1773?-1855 *BiDBrA, MacEA*
Lugard, Charlotte E *DcWomA*
Lugenbush, Julius L *NewYHSD*
Luginbuehl, Bernhard 1929- *DcCAr 81*
Luginbuhl, Bernard 1929- *PhDcTCA 77*
Lugo, Michael Angel 1934- *AmArch 70*
Lugosch, J D, Jr. *AmArch 70*
Lugosch, Joseph D 1877-1942 *BiDAmAr*
Lugossy, Maria 1950- *DcCAr 81*
Lugsdin, John E 1945- *MarqDCG 84*
Lugton, Charles Royall 1923- *AmArch 70*
Luhn, Graham Barton 1937- *AmArch 70*
Luhukay, Joseph Felipus Peter 1946- *MarqDCG 84*
Luigi, Andrea Di 1470-1512? *ClaDrA*
Luiken, Jan *McGDA*
Luini, Bernardino 1480?-1532 *McGDA*
Luini, Bernardino 1485?-1532 *OxArt*
Luini, Costanzo 1886- *WhAmArt 85*
Luis, Rose E *AmArch 70*
Luise Henriette 1627-1667 *DcWomA*
Luise Hollandine, Princess *DcWomA*
Luisi, Jerry 1939- *WhoAmA 76, -78, -80, -82, -84*
Luisi, Nicholas 1894-1977 *WhAmArt 85*
Luitjens, Helen Anita *WhoAmA 76, -78, -80, -82,*
 -84
Luitwealer, Lillian *WhAmArt 85*
Luitwieler, Lillian *DcWomA*
Luja, Katharina Karolina *DcWomA*
Lujan, Maria T 1895- *FolkA 86*
Lukacs, William 1907- *AmArch 70*
Lukas, Dennis Brian 1947- *WhoAmA 78, -80, -82,*
 -84
Lukasiewicz, Ronald Joseph 1943- *WhoAmA 78, -80,*
 -82, -84
Lukaszewicz, George 1938- *AmArch 70*
Lukatch, Edward *FolkA 86*
Luke 1945- *WorFshn*
Luke, Saint *McGDA*
Luke, Alexandra *OxTwCA*
Luke, Alexandra 1901- *WhoAmA 78N, -80N, -82N,*
 -84N
Luke, Herbert K C 1930- *AmArch 70*
Luke, Jane Corbus 1881- *DcWomA*
Luke, John 1906- *DcBrA 1*
Luke, Kathryn Logan *WhAmArt 85*
Luke, William 1790- *FolkA 86, NewYHSD*
Lukeman, Augustus 1872-1935 *WhAmArt 85*
Luken, Timothy Philip 1945- *MarqDCG 84*
Lukens, Arthur Rolan 1924- *AmArch 70*
Lukens, Glen 1887-1967 *BnEnAmA, CenC[port]*
Lukens, Glen 1890- *WhAmArt 85*
Lukens, Isaiah 1779-1846 *DcNiCA*
Lukens, John Brockie 1916- *AmArch 70*
Lukens, Thomas *CabMA*
Luker, Miss *DcVicP 2, DcWomA*
Luker, A *DcVicP 2*
Luker, Gilham *DcVicP 2*
Luker, Louise H *DcWomA*
Luker, William *DcVicP, -2*
Luker, William 1867- *DcBrBI*
Luker, Mrs. William *DcVicP 2, DcWomA*
Luker, William, Jr. 1867- *ClaDrA, DcBrA 1,*
 DcVicP, -2
Lukin, Philip 1903- *WhoAmA 73, -76, -78, -80, -82*
Lukin, Sven 1934- *ConArt 77, -83, DcCAA 71, -77,*
 OxTwCA, WhoAmA 73, -76, -78, -80, -82, -84
Lukin, William *AntBDN Q*
Lukits, Theodore N *WhAmArt 85*
Lukits, Theodore Nicholas 1899- *ArtsAmW 2*
Lukolz, Philip *FolkA 86*
Lukosius, Richard Benedict 1918- *WhoAmA 73, -76,*
 -78, -80, -82, -84
Lukowsky, R L *AmArch 70*
Luks, George 1867-1933 *OxArt, PhDcTCA 77,*
 WhAmArt 85
Luks, George B 1866-1933 *DcAmArt*
Luks, George Benjamin 1867-1933 *BnEnAmA,*
 McGDA, OxTwCA, WorECar
Luksch-Makowsky, Elena 1878- *DcWomA*
Luksenas, Antanas 1948- *ICPEnP A*
Luksus, Tzaims 1932- *WorFshn*
Lull, Wendy W 1952- *MarqDCG 84*
Lum, B M *AmArch 70*
Lum, Bertha Boynton 1879-1954 *DcWomA,*
 WhAmArt 85
Lum, Bertha Boynton 1897-1954 *ArtsAmW 3*

Lum, C T *ArtsEM*
Lum, Charles M *NewYHSD*
Lum, Charles Mathieu 1830-1899 *ArtsEM[port]*
Lum, Peter Thomas 1949- *MarqDCG 84*
Lumas, Parker *NewYHSD*
Lumb, Maude *DcWomA*
Lumbard, Jean Ashmore *WhoAmA 80, -82, -84*
Lumbers, James Richard 1929- *WhoAmA 78, -80, -82,*
 -84
Lumby, Thomas *BiDBrA*
Lumby, William d1804 *BiDBrA*
Lumia, Ronald 1950- *MarqDCG 84*
Lumiere, Auguste 1862-1954 *ICPEnP, MacBEP*
Lumiere, Louis 1864-1948 *ICPEnP, MacBEP*
Luminais, Evariste-Vital 1818?- *ArtsNiC*
Luminais, Helene Vital *DcWomA*
Lumis, Harriet Eunice 1870-1953 *DcWomA*
Lumis, Harriet Randall 1870-1953 *WhAmArt 85*
Lumley, A Fairfax *DcVicP 2*
Lumley, Arthur 1837-1912 *DcBrBI, EarABI,*
 EarABI SUP, NewYHSD , WhAmArt 85
Lumley, Augustus Savile *DcBrBI, DcVicP, -2*
Lumley, George *DcBrECP*
Lumley, John 1654-1721 *BiDBrA*
Lummus, David *CabMA*
Lumpkins, William *AmArch 70*
Lumpkins, William Thomas, Jr. 1909- *WhAmArt 85*
Lumsden, A J H *AmArch 70*
Lumsden, Alan *DcCAr 81*
Lumsden, Anthony 1928- *ConArch, MacEA*
Lumsden, Ernest Stephen 1883-1948 *DcBrA 1*
Lumsden, Ernest Steven 1883- *ClaDrA*
Lumsden, Ian Gordon 1945- *WhoAmA 76, -78, -80,*
 -82, -84
Lumsden, R A *AmArch 70*
Lumsdon, Christine Marie d1937 *DcWomA*
Lumsdon, Christine Marie Voss d1937 *WhAmArt 85*
Luna 1910- *WhoAmA 76, -78, -80, -82, -84*
Luna, Maximo L 1896-1964 *FolkA 86*
Luna, T C *AmArch 70*
Lunari, Enzo 1937- *WorECar*
Lund, Belle Jenks 1879- *DcWomA, WhAmArt 85*
Lund, Charlotte *WhAmArt 85*
Lund, Christian G 1923- *MacBEP*
Lund, David 1925- *DcCAA 71, -77, WhoAmA 73,*
 -76, -78, -80, -82, -84
Lund, David Jeffrey 1955- *MarqDCG 84*
Lund, E K 1910?- *FolkA 86*
Lund, G W *AmArch 70*
Lund, Giuseppe 1951- *DcCAr 81*
Lund, Harold Marrat 1904- *WhAmArt 85*
Lund, James S 1943- *MarqDCG 84*
Lund, Jane *WhoAmA 76, -78, -80, -84*
Lund, Jane 1956- *WhoAmA 82*
Lund, Kjell 1927- *ConArch*
Lund, Niels Moeller 1863-1916 *DcBrA 1, DcBrWA*
Lund, Niels Moeller 1863-1916 *DcVicP 2*
Lund, Niels Moller 1863-1916 *ClaDrA*
Lund, P F *WhAmArt 85*
Lund, Ralph Orlow 1909- *AmArch 70*
Lund, Robert K 1920- *AmArch 70*
Lund, Theodore *NewYHSD*
Lundahl, Amelie Helga 1850-1914 *DcWomA*
Lundahl, Fanny 1853-1918 *DcWomA*
Lundahl, Frank A 1858- *WhAmArt 85*
Lundahl, Richard Louis 1929- *AmArch 70*
Lundberg, A F *WhAmArt 85*
Lundberg, Caroline *DcWomA*
Lundberg, Elmer A 1909- *AmArch 70*
Lundberg, Mrs. Godfrey *WhAmArt 85*
Lundberg, Gustaf 1695-1786 *ClaDrA, McGDA*
Lundberg, Olga Maria *DcWomA*
Lundberg, Robert Saunier 1916- *AmArch 70*
Lundbery, Peter *NewYHSD*
Lundblad, Glenn Everett 1928- *AmArch 70*
Lundborg, Florence *ArtsAmW 1*
Lundborg, Florence d1949 *WhoAmA 78N, -80N,*
 -82N, -84N
Lundborg, Florence 1871-1949 *ArtsAmW 3,*
 DcWomA
Lundborg, Florence 1880?-1949 *IlBEAAW,*
 WhAmArt 85
Lunde, David Arland 1938- *AmArch 70*
Lunde, Emily 1914- *FolkA 86*
Lunde, F M *AmArch 70*
Lunde, Karl Roy 1931- *WhoAmA 73, -76, -78, -80,*
 -82, -84
Lundean, Mrs. J Louis *WhAmArt 85*
Lundean, Louis 1896- *WhAmArt 85*
Lundeberg, Helen 1908- *DcCAA 71, -77,*
 WhoAmA 73, -76, -78, -80, -82, -84
Lundeen, Edgar Emmanuel 1898- *AmArch 70*
Lundeen, F V *FolkA 86*
Lundeen, George Wayne 1948- *WhoAmA 82, -84*
Lundeen, Thomas Curt 1927- *AmArch 70*
Lundegard, Loyal Gerald 1925- *FolkA 86*
Lundell, Linda *DcCAr 81*
Lunden, Samuel Eugene 1897- *AmArch 70*
Lundenberg, A I *AmArch 70*
Lundens, Gerrit 1622?-1677? *ClaDrA*
Lundens, Gerrit 1622-1683? *McGDA*

Lundgoot, R G *AmArch 70*
Lundgren, Carolina *DcWomA*
Lundgren, Egron 1816-1875 *ArtsNiC*
Lundgren, Egron Sellif 1815-1875 *DcBrWA,*
 DcVicP 2
Lundgren, Eric 1906- *WhAmArt 85*
Lundgren, Ernest O, Jr. *AmArch 70*
Lundgren, L R *AmArch 70*
Lundgren, Lea *DcWomA*
Lundgren, Leonard John 1918- *AmArch 70*
Lundgren, Martin 1871- *WhAmArt 85*
Lundgren, Roy E 1931- *AmArch 70*
Lundgren, Tyra 1897-1979 *DcWomA*
Lundgren, Tyra 1911- *IlDcG*
Lundh, Arthur 1923- *AmArch 70*
Lundh, Peter P 1865-1943 *ICPEnP A*
Lundie *NewYHSD*
Lundie, Edwin Hugh 1886- *AmArch 70*
Lundie, Edwin Hugh 1886-1972 *WhoAmA 76N, -78N,*
 -80N, -82N, -84N
Lundin, Earl H 1902- *AmArch 70*
Lundin, Emelia A 1884- *ArtsAmW 3, WhAmArt 85*
Lundin, Ingeborg 1921- *IlDcG*
Lundin, Norman K 1938- *AmArt, WhoAmA 82, -84*
Lundmark, Leon 1875- *ArtsAmW 2, WhAmArt 85*
Lundmark, Winter *FolkA 86*
Lundquist, C N 1930- *AmArch 70*
Lundquist, Einar 1901- *WhAmArt 85*
Lundquist, Evert 1904- *ConArt 77, -83, DcCAr 81,*
 WhoArt 80, -82, -84
Lundquist, Henry E 1920- *AmArch 70*
Lundquist, Oliver L 1916- *AmArch 70*
Lundquist-Blanch, Lucile *DcWomA*
Lundqvist, Evert 1904- *OxTwCA, PhDcTCA 77*
Lundsteen, Lilli Elisabeth Charlotte 1871- *DcWomA*
Lundstrom, Vilhelm 1893-1950 *OxArt*
Lundstrom, Wilhelm 1893-1950 *PhDcTCA 77*
Lundstrum, J E *AmArch 70*
Lundwall, Phillip Edward 1939- *AmArch 70*
Lundy, F *FolkA 86*
Lundy, G F, Jr. *AmArch 70*
Lundy, J B *AmArch 70*
Lundy, Victor 1923- *MacEA*
Lundy, Victor A 1921- *EncMA*
Lundy, Victor A 1923- *ConArch*
Lundy, Victor Alfred 1923- *AmArch 70*
Lundy, W *FolkA 86*
Lundy, W H *AmArch 70*
Luneau, Omer Joachim 1909- *WhAmArt 85*
Lunenschloss, Anton Clemens 1680?-1762 *McGDA*
Lung, Rowena Clement 1905- *WhAmArt 85*
Lunge, Jeffrey 1905- *WhoAmA 73, -76, -78, -80, -82*
Lungerich, Helene *WhAmArt 85*
Lunghi, Martino *McGDA*
Lunghi, Martino, The Elder d1591 *OxArt*
Lunghi, Martino, The Younger 1602-1657 *OxArt*
Lunghi, Onofrio 1569?-1619 *OxArt*
Lungkwitz, Carl Hermann Frederick 1813-1891*
 IlBEAAW
Lungkwitz, Herman 1813-1891 *ArtsAmW 1*
Lungkwitz, Hermann 1813-1891 *NewYHSD*
Lungren, Fernand 1859-1932 *WhAmArt 85*
Lungren, Fernand H 1857-1932 *ArtsAmW 1*
Lungren, Fernand Harvey 1859?-1932 *IlBEAAW*
Lunin, Lois F *MarqDCG 84*
Lunn, Agnes Cathinka Vilhelmine 1850- *DcWomA*
Lunn, David R 1947- *MarqDCG 84*
Lunn, Harry, Jr. 1933- *WhoAmA 76, -78, -80, -82,*
 -84
Lunn, Harry H, Jr. 1933- *MacBEP*
Lunn, William *FolkA 86*
Lunois, Alexandre 1863-1916 *ClaDrA*
Lunsford, John 1933- *WhoAmA 76, -78, -80, -82, -84*
Lunsford, Thomas Wesley 1932- *AmArch 70*
Lunt, Abraham 1683- *CabMA*
Lunt, George C *EncASM*
Lunt, J W *AmArch 70*
Lunt, Joshua *CabMA*
Lunt, Wilmot *DcBrBI*
Luntley, James *DcVicP 2*
Luntz, Irving 1929- *WhoAmA 73, -76, -78, -80, -82,*
 -84
Luntz, Viktor 1840-1903 *MacEA*
Luny, Thomas 1759-1837 *DcBrECP, DcBrWA,*
 DcSeaP
Luolie, Peter *NewYHSD*
Luongo, Aldo 1940- *PrintW 83, -85*
Luongo, V D *AmArch 70*
Luoni, Alfred Joseph 1914- *AmArch 70*
Luparello, Anthony Martin 1936- *AmArch 70*
Lupas, Ana 1940- *ConArt 77, -83*
Lupertz, Markus 1941- *DcCAr 81*
Lupfer, E A *WhAmArt 85*
Luplau, Marie Antoinette Henriette 1848-1925*
 DcWomA
Lupo, W A *AmArch 70*
Lupori, Peter John 1918- *WhoAmA 78, -80, -82, -84*
Lupot, Nicholas 1758-1824 *AntBDN K*
Luppen, Gerard Josef Adrian Van 1834-1891 *ClaDrA*
Lupper, Edward 1936- *WhoAmA 73, -76, -78, -80,*
 -82, -84

Lynch, Laura 1949- *FolkA 86*
Lynch, Lorena Babbitt *WhAmArt 85*
Lynch, Mary Ann Bruchac 1944- *MacBEP*
Lynch, Mary Britten 1932- *WhoAmA 84*
Lynch, Mary Britten 1934- *AmArt*
Lynch, Mary Britten 1938- *WhoAmA 78, -80, -82*
Lynch, R J *AmArch 70*
Lynch, Thomas F 1924- *AmArch 70*
Lynch, Tom 1950- *WhoAmA 82, -84*
Lynch, Virginia *WhAmArt 85*
Lynch, Virginia 1878- *DcWomA*
Lynd, J Norman 1878- *WhAmArt 85*
Lynd, J Norman 1878-1943 *WorECar*
Lynd, J S *AmArch 70*
Lynd, Katharine Leslie *DcWomA*
Lynd, Mattie *ArtsEM, DcWomA*
Lyndall, Isabel *WhAmArt 85*
Lynde, Stan 1931- *WhoAmA 76, -78, -80, -82, -84, WorECom*
Lyndon, Caleb *CabMA*
Lyndon, D *AmArch 70*
Lyndon, Donlyn 1936- *ConArch*
Lyndon, Herbert *DcBrA 1, DcBrWA, DcVicP, -2*
Lyndon, Maynard 1907- *AmArch 70*
Lynds, C 1936- *WhoAmA 84*
Lynds, Clyde William 1936- *WhoAmA 73, -76, -78, -80, -82*
Lyne, Amy *DcBrA 1*
Lyne, Charles Edward Michael 1912- *DcBrA 1, WhoArt 80, -82, -84*
Lyne, Esther *WhAmArt 85*
Lynen, Amedee Ernest 1852-1938 *McGDA*
Lynes, George Platt 1907-1955 *ConPhot, ICPEnP, MacBEP, WhAmArt 85*
Lynes, Russell 1910- *WhoAmA 73, -76, -78, -80, -82, -84*
Lynham, George *CabMA*
Lynker, Anna 1834- *DcWomA*
Lynn, Arie 1905- *AmArch 70*
Lynn, Charles *WhAmArt 85*
Lynn, Donald Scott 1945- *MarqDCG 84*
Lynn, Jack 1926- *MacEA*
Lynn, James, Jr. 1855-1924 *WhAmArt 85*
Lynn, John *DcSeaP, DcVicP 2*
Lynn, Katharine Evans Norcross 1875-1930 *DcWomA*
Lynn, Katherine Evans 1875-1930 *WhAmArt 85*
Lynn, Michael 1938- *AmArch 70*
Lynn, Roger Y 1941- *MarqDCG 84*
Lynn, Samuel Ferris d1876 *ArtsNiC*
Lynn, Timothy Francis 1958- *MarqDCG 84*
Lynn, William *NewYHSD*
Lynn, William H d1916 *DcBrA 2*
Lynn, William Henry 1829-1915 *DcBrWA*
Lynn-Jenkins, Frank 1870-1927 *DcBrA 1, WhAmArt 85*
Lynne, Danna 1957- *WhoAmA 80*
Lynnes, Allan R 1924- *AmArch 70*
Lynskey, James Edward 1918- *AmArch 70*
Lyon, Miss *DcWomA*
Lyon, A *DcVicP 2*
Lyon, Alfred *NewYHSD*
Lyon, Alfred B *WhAmArt 85*
Lyon, Bruce H 1948- *MarqDCG 84*
Lyon, C E *DcVicP 2*
Lyon, Charles E *DcVicP 2*
Lyon, Danny 1942- *ConPhot, ICPEnP A, MacBEP*
Lyon, David *DcBrECP*
Lyon, Douglas Harold 1934- *AmArch 70*
Lyon, E F *DcVicP 2*
Lyon, Edwin *NewYHSD*
Lyon, Fred William 1925- *AmArch 70*
Lyon, G A *AmArch 70*
Lyon, George Francis 1795-1832 *DcBrBI*
Lyon, George P *DcVicP 2*
Lyon, Harold Lloyd 1930- *WhoAmA 76, -78, -80, -82*
Lyon, Harriette A *WhAmArt 85*
Lyon, Hayes 1909- *WhAmArt 85*
Lyon, Hayes Paxton 1909- *WhoAmA 76, -78, -80, -82, -84*
Lyon, J B *NewYHSD*
Lyon, J H d1921 *DcBrA 2*
Lyon, James B *DcNiCA*
Lyon, Jeannette Agnew 1862- *DcWomA, WhAmArt 85*
Lyon, Jules *NewYHSD*
Lyon, L *DcWomA*
Lyon, Lucie d1893 *DcWomA*
Lyon, Lucy S *DcVicP 2*
Lyon, M W *NewYHSD*
Lyon, Maggie E *ArtsEM, DcWomA*
Lyon, Marie Victorine *DcWomA*
Lyon, Nicholas *WhAmArt 85*
Lyon, Raymond Wayne 1915- *AmArch 70*
Lyon, Richard *WhAmArt 85*
Lyon, Robert *WhoArt 80N*
Lyon, Robert 1894- *DcBrA 1*
Lyon, Rowland 1904- *WhAmArt 85*
Lyon, Sarah 1774-1843 *FolkA 86*
Lyon, Thomas Bonar 1873- *DcBrA 1*
Lyon, Virginia S *AmArch 70*
Lyon, W H *EncASM*

Lyoncourt, Baron De *DcVicP 2*
Lyonet, Pieter 1708-1789 *ClaDrA*
Lyons, Annie *DcWomA*
Lyons, Catharine *DcWomA*
Lyons, Charles Raymond 1925- *AmArch 70*
Lyons, David Matthew 1954- *MacBEP*
Lyons, E D 1905- *ConArch*
Lyons, Edward Douglas *EncMA*
Lyons, Eric 1912- *ConArch, DcD&D[port]*
Lyons, Eric 1912-1978 *MacEA*
Lyons, Eric Alfred 1912- *EncMA*
Lyons, F M *DcWomA*
Lyons, Helen M *DcWomA*
Lyons, Ian Raymond 1948- *WhoAmA 78, -80*
Lyons, J I *AmArch 70*
Lyons, Joan 1937- *ConPhot, ICPEnP A*
Lyons, Lisa 1950- *WhoAmA 78, -80, -82, -84*
Lyons, Matthew *WhAmArt 85*
Lyons, Michael 1943- *DcCAr 81*
Lyons, Nathan 1930- *ICPEnP, MacBEP*
Lyons, Robert A 1954- *MacBEP*
Lyons, S D *AmArch 70*
Lyons, Sidney S *NewYHSD*
Lyons, Thomas *DcVicP 2*
Lyons, Thomas Joseph 1907- *AmArch 70*
Lyons Israel And Ellis *EncMA*
Lyons Israel Ellis And Gray *ConArch*
Lyria, Hado 1940- *WhoArt 80, -82, -84*
Lys, Johann *McGDA*
Lyser, Edna Potwin 1880- *ArtsAmW 3*
Lysippus *McGDA, OxArt*
Lysistratus *OxArt*
Lysle, Anthony De *IlDcG*
Lystad, Elsa 1899- *DcWomA*
Lyster, Richard d1863 *DcVicP 2*
Lysun, Gregory 1924- *WhoAmA 73, -76, -78, -80, -82, -84*
Lytel, R E *AmArch 70*
Lytens, Gijsbrecht *McGDA*
Lytle *FolkA 86*
Lytle, G D *AmArch 70*
Lytle, Kathryn Odessa 1888-1976 *DcWomA*
Lytle, Richard 1935- *AmArt, DcCAA 71, -77, WhoAmA 73, -76, -78, -80, -82, -84*
Lytle, Robert Bruce, Jr. 1919- *AmArch 70*
Lyttelton, Elizabeth d1795 *DcWomA*
Lyttelton, Lady Elizabeth 1716-1795 *DcBrECP*
Lytton, Bart d1969 *WhoAmA 78N, -80N, -82N, -84N*
Lytton, Herman Leon 1934- *AmArch 70*
Lytton, Neville 1879- *ClaDrA*
Lytton, Neville Stephen 1879-1951 *DcBrA 1*

M

M J *NewYHSD*
M P J *NewYHSD*
Ma, Cheou-Tchen *DcWomA*
Ma, Ch'uan 1768?-1848? *DcWomA*
Ma, Fen *McGDA*
Ma, Ho-Chih *McGDA*
Ma, Kung-Hsien *McGDA*
Ma, Lin *McGDA*
Ma, Shou-Chen *DcWomA*
Ma, Yuan *McGDA, OxArt*
Ma-Pe-Wi *WhAmArt 85*
Maack, Albert Carl 1894- *AmArch 70*
Maack, George J *ArtsAmW 3*
Maartman, Elsa *DcWomA*
Maas *NewYHSD*
Maas, Arnold 1620?-1664 *ClaDrA*
Maas, Arnold 1909- *WhoAmA 78, -80, -82*
Maas, Charles E 1827?- *NewYHSD*
Maas, Dirk *McGDA*
Maas, Dirk 1659-1717 *ClaDrA*
Maas, Elaine H 1925- *AmArch 70*
Maas, George 1910- *WhAmArt 85*
Maas, Godfried *McGDA*
Maas, Henrik Pieter 1901- *AmArch 70*
Maas, Jacob 1800?- *NewYHSD*
Maas, Julie *IlsBYP*
Maas, Karen Lee 1958- *MarqDCG 84*
Maas, Michael 1931- *AmArch 70*
Maas, Nicolas 1632-1693 *ClaDrA*
Maas, Paul 1890-1962 *OxTwCA, PhDcTCA 77*
Maas, Raymond *WhAmArt 85*
Maas, William A *NewYHSD*
Maasen, Margaret 1907- *WhAmArt 85*
Maass, David *OfPGCP 86*
Maass, Richard Andrew 1946- *WhoAmA 76, -78, -80, -82, -84*
Maassen, R J *AmArch 70*
Mabe, Manabu 1910- *PhDcTCA 77*
Mabe, Manabu 1924- *DcCAr 81, McGDA, OxTwCA*
Maberley, William 1798?- *BiDBrA*
Mabie, Don Edward 1947- *WhoAmA 78, -80*
Mabie, George Harold 1892- *WhAmArt 85*
Mabie, Helen *WhAmArt 85*
Mabie, Lester W *WhAmArt 85*
Mabrassi, L *AntBDN C*
Mabrey, Leslie Bruce 1927- *AmArch 70*
Mabry, Jane *IlBEAAW, WhoAmA 76, -78, -80, -82, -84*
Mabry, Jerry H *MarqDCG 84*
Mabuse *McGDA, OxArt*
Mabuse, Angelica *DcWomA*
Mabuse, Anna *DcWomA*
Mabuse, Clorinda *DcWomA*
Mabuse, Jan De 1478?-1533 *ClaDrA*
Mabuse, Lucrezia *DcWomA*
Mac, Mary *FolkA 86*
Mac, Robert F *DcVicP 2*
MacAdam, Freda Churchwell 1907- *WhAmArt 85*
MacAdams, Cynthia 1939- *ICPEnP A, MacBEP*
MacAgy, Douglas Guernsey *WhoAmA 76N*
Macagy, Douglas Guernsey *WhoAmA 78N, -80N, -82N, -84N*
MacAgy, Douglas Guernsey 1913- *WhoAmA 73*
Macagy, Jermayne *WhoAmA 78N, -80N, -82N, -84N*
Macaire, Adrienne *DcWomA*
MacAlister, Paul 1901- *WhAmArt 85*
MacAlister, Paul Ritter 1901- *WhoAmA 73, -76, -78, -80, -82, -84*

Macallister, A D *DcVicP 2*
Macallum, Hamilton 1841-1896 *ClaDrA, DcVicP*
Macallum, Hamilton 1843- *ArtsNiC*
Macallum, John Thomas Hamilton 1841-1896 *DcBrWA, DcVicP 2*
MacAlpine, Samuel E 1892- *AfroAA*
MacAlpine, William *DcSeaP*
Macaluso, Edmond Roy 1959- *MarqDCG 84*
Macandrew, Ernest Henry 1877- *DcBrA 1*
Macaray, Lawrence 1921- *PrintW 83, -85*
Macaray, Lawrence Richard 1921- *AmArt, WhoAmA 73, -76, -78, -80, -82, -84*
Macardell, Cornelius Worcester 1888- *AmArch 70*
MacArdell, James 1729-1765 *McGDA*
Macarron, Ricardo 1926- *ClaDrA, WhoArt 80, -82, -84*
MacArthur, Blanche *DcBrWA*
MacArthur, Blanche F *DcVicP, -2*
MacArthur, Charles M *DcBrWA, DcVicP 2*
MacArthur, John 1755-1840 *DcBrWA*
Macarthur, Lindsay G *DcBrA 1, DcVicP 2*
MacArthur, Mary *DcBrWA, DcVicP 2*
MacArthur, Ronald Malcolm 1914- *WhoArt 84*
Macarthur-Onslow, Annette 1933- *IlsCB 1967*
Macarthy, J *NewYHSD*
Macartney, Carlile Henry Hayes 1842-1924 *DcBrA 1, DcVicP, -2*
Macartney, Catherine Naomi *DcWomA*
Macartney, Mervyn 1853-1932 *MacEA*
Macarty, Jessie *DcWomA*
Macaualy, David Alexander 1946- *WhoAmA 78*
Macaulay, David Alexander 1946- *IlsCB 1967, WhoAmA 80, -82, -84*
Macaulay, Kate *DcBrWA, DcVicP, -2, DcWomA*
Macaulay, Lorna Gertrude Lomer 1881- *DcWomA*
Macaulay, Thomas 1946- *DcCAr 81*
Macauley, Charles 1871-1934 *WorECar*
Macauley, Charles Raymond d1934 *WhAmArt 85*
Macauley, Ellen *DcWomA, WhAmArt 85*
Macauly, John *NewYHSD*
Macavoy, Edouard 1905- *OxTwCA*
Macaya, Luis Fernando 1888-1953 *WorECar*
MacBean, Clara Sophia 1841- *DcWomA*
MacBean, W Forbes *DcVicP 2*
Macbeth, Ann *DcBrBI*
Macbeth, Ann 1875-1948 *DcWomA*
Macbeth, James *ArtsNiC*
Macbeth, James 1847-1891 *DcBrBI, DcVicP, -2*
MacBeth, Jerome Russell 1933- *WhoAmA 73*
Macbeth, Jerome Russell 1933- *WhoAmA 76*
Macbeth, L *DcVicP 2*
Macbeth, Norman *ArtsNiC*
Macbeth, Norman 1821-1888 *DcVicP, -2*
Macbeth, R W 1848- *ArtsNiC*
Macbeth, Robert Walker 1848-1910 *ClaDrA, DcBrA 1, DcBrBI, DcBrWA, DcVicP, -2*
Macbeth, Robert Walker 1884-1940 *WhAmArt 85*
Macbeth, William 1851-1917 *WhAmArt 85*
Macbeth-Raeburn, Henry 1860-1947 *DcVicP 2*
Macbeth-Raeburn, Henry Raeburn 1860-1947 *DcBrA 1, DcBrBI*
MacBird, Rosemary 1921- *WhoAmA 84*
MacBird, Theodore Detarr 1906- *AmArch 70*
MacBrair, Archibald *NewYHSD*
Macbride, Alexander 1859-1955 *DcBrA 1*
MacBride, Alexander 1859-1955 *DcBrWA, DcVicP 2*
Macbride, John *DcBrWA*
MacBride, Maud Gonne 1866- *IlsCB 1744*
MacBride, Robert *OxTwCA*

Macbride, William *DcBrA 1*
MacBride, William *DcVicP 2*
Macbride, William d1913 *DcBrA 1*
Macbryde, Robert 1913-1966 *DcBrA 1*
MacBryde, Robert 1913-1966 *OxTwCA, PhDcTCA 77*
Macburney, James 1678-1744? *DcBrECP*
Macca, Lorita *FolkA 86*
Maccabe, Gladys *WhoArt 80, -82, -84*
Maccabe, Gladys 1918- *DcBrA 1*
Maccabe, Max 1917- *DcBrA 1, WhoArt 80, -82, -84*
Maccall, A St. John *DcBrA 1*
MacCallum, Andrew 1821-1902 *DcBrWA*
MacCallum, Andrew 1828- *ArtsNiC*
MacCallum, Bertha A *WhAmArt 85*
MacCallum, I C *AmArch 70*
MacCallum, Polly *DcCAr 81*
MacCameron, Robert Lea 1866-1912 *WhAmArt 85*
MacCannell, Earl E 1885- *ArtsAmW 3*
Maccari, Cesare 1840- *ArtsNiC*
Maccari, Mino 1898- *WhoGrA 62, WorECar*
MacCartan, Edward *WhAmArt 85*
Maccarthy, Clara d1906 *DcBrA 2*
MacCarthy, Susie L *DcWomA*
MacCartney, Catherine *WhAmArt 85*
MacChesney, Clara T 1860-1928 *WhAmArt 85*
MacChesney, Clara Taggart 1860-1928 *ArtsAmW 1, DcWomA*
Macchi, Charles L 1907- *AmArch 70*
Macchiavelli, Elisabetta *DcWomA*
Maccio, Romulo *OxTwCA*
Maccio, Romulo 1931- *McGDA, WhoGrA 62*
MacClain, George *IlsBYP*
Macclintock, Dorcas 1932- *WhoAmA 78, -80, -82*
MacClintock, Dorcas 1932- *WhoAmA 84*
MacClure, Colbert T A 1870-1912 *BiDAmAr*
Macco-Pool, Maria 1887- *DcWomA*
Maccoll, Dugald Sutherland 1859-1948 *DcBrA 1, OxArt*
MacColl, Dugald Sutherland 1859-1948 *DcVicP 2, McGDA, OxTwCA*
MacCollin, Edmond Morgan 1925- *AmArch 70*
Macconnel, Kim 1946- *PrintW 83, -85*
MacConnell, Kim 1946- *DcCAr 81*
MacConnell, Lillian G Clarke *WhAmArt 85*
MacConnell, S W *AmArch 70*
MacCord, Charles William 1852-1923 *WhAmArt 85*
MacCord, Mary N *WhAmArt 85*
MacCormick, Evelyn *WhAmArt 85*
MacCornack, Donald Amsden 1907- *AmArch 70*
MacCoy, Guy 1904- *WhAmArt 85*
MacCready, Paul B 1925- *DcCAr 81*
MacCubbin, Elizabeth *WhAmArt 85*
MacCuiston, Jacques 1906- *WhAmArt 85*
MacCulloch, Horatio 1805-1867 *ArtsNiC, DcVicP, -2*
MacCulloch, James *DcVicP*
Macculloch, James d1915 *DcBrA 1, DcBrWA*
MacCulloch, James d1915 *DcVicP 2*
MacDermott, Stewart Sinclair 1889- *WhAmArt 85*
MacDomel, Edward *WhAmArt 85*
Macdonald, A *DcVicP 2*
MacDonald, A *DcWomA*
Macdonald, Miss A *DcBrWA*
Macdonald, A K *DcBrBI*
MacDonald, Alastair James Henderson 1934- *ClaDrA, WhoArt 80, -82, -84*
Macdonald, Alexander 1839-1921 *DcBrA 2*
Macdonald, Alfred *DcVicP 2*

387

Top-center note fragment: –82N, –84N

Macintyre, Donald Edward 1900- DcBrA 1
MacIntyre, Dorothy Morrison 1909- WhAmArt 85
MacIntyre, Elisabeth 1916- IlsCB 1744
MacIntyre, Elizabeth 1916- IlsBYP, IlsCB 1946
MacIntyre, Emilie WhAmArt 85
Macioce, Andrew Joseph 1928- AmArch 70
Macioge, Frank A, Jr. 1938- AmArch 70
Macip, Dorotea d1609 DcWomA
Macip, Juan DeJuanes 1523?-1579 OxArt
Macip, Juan Vicente 1523?-1579 OxArt
Macip, Margarita Joanes d1613 DcWomA
Macip, Vicente d1550? OxArt
Macip Family OxArt
Macirone, Cecilia A DcVicP 2, DcWomA
Macirone, Emily DcBrWA, DcVicP, -2, DcWomA
Maciunas, George 1931-1978 ConArt 83,
 WhoAmA 80N, -82N, -84N
MacIver, Bessie Maud DcWomA
MacIver, Ian Tennant Morrison 1912- WhAmArt 85
MacIver, Loreen 1909- WhAmArt 85
MacIver, Loren 1909-
 BnEnAmA, DcCAA 71, -77,
 McGDA, OxTwCA,
 PhDcTCA 77, WhoAmA 73, -76,
 -78, -80, -82, -84,
 WorArt[port]
Mack, Mister NewYHSD
Mack, Alexander Watson 1896- ArtsAmW 3
Mack, C J AmArch 70
Mack, Charles Randall 1940- WhoAmA 78, -80, -82,
 -84
Mack, Clyde Frederick 1887- AmArch 70
Mack, David Keller 1941- AmArch 70
Mack, Ebenezer NewYHSD
Mack, Francis Asbury ArtsEM, DcWomA
Mack, Frank WhAmArt 85
Mack, Harry Francis 1907- WhAmArt 85
Mack, Heinz 1931- ConArt 77, -83, DcCAr 81,
 OxTwCA, PhDcTCA 77
Mack, Hilda Muriel 1895- DcBrA 1, DcWomA
Mack, J Harold 1927- AmArch 70
Mack, John AfroAA
Mack, Joseph L AfroAA
Mack, Leal 1892-1962 ArtsAmW 1, IlBEAAW
Mack, Ludwig Hirschfeld 1893-1965 OxTwCA
Mack, Mary Agnes 1899- DcWomA
Mack, Rodger Allen 1938- WhoAmA 73, -76, -78,
 -80, -82, -84
Mack, Stanley IlsBYP
Mack, Ulrich B 1934- MacBEP
Mack, Warren B 1896- WhAmArt 85
Mackall, McGill 1889- WhAmArt 85
MacKay FolkA 86
Mackay, Arthur Stewart 1909- DcBrA 1,
 WhoArt 80, -82, -84
Mackay, Barbara DcVicP 2
Mackay, Charles 1868- DcBrA 1, DcVicP 2
Mackay, D EarABI
Mackay, David ConArch A
Mackay, David 1933- ConArch
Mackay, David Wayne 1960- MarqDCG 84
MacKay, Donald A IlsBYP
Mackay, Donald Cameron 1906- WhoAmA 73, -76,
 -78, WhoArt 80, -82, -84
Mackay, Donald Cameron 1906-1979 WhoAmA 80N,
 -82N, -84N
Mackay, Father Edward DcVicP 2
Mackay, Edwin Murray 1869-1926 ArtsEM
Mackay, Edwin Murray 1869-1926 WhAmArt 85
MacKay, Helen Victoria 1897- DcBrA 1, DcWomA
Mackay, Hugh 1934- WhoAmA 76, -78, -80, -82
MacKay, Hugh 1934- WhoAmA 84
MacKay, Hugh 1936- WhoAmA 73
MacKay, Jean V 1909- WhAmArt 85
Mackay, Michael T MarqDCG 84
Mackay, N I AmArch 70
Mackay, Richard DcBrECP
Mackay, Steven A 1952- MarqDCG 84
MacKay, T DcBrWA
Mackay, T W DcVicP 2
Mackay, Wallis DcBrBI
MacKay, William A 1878-1939 WhAmArt 85
Mackay, William Darling 1844-1924 ClaDrA
Macke, August 1887-1914 McGDA, OxArt,
 OxTwCA, PhDcTCA 77
Macke, Harry J 1890- WhAmArt 85
Macke, Helmut 1891-1936 McGDA
MacKechnie, John DcCAr 81
Mackechnie, R G S DcBrA 1
Mackechnie, Robert G S d1975 DcBrA 2
Mackei, B Jessop DcVicP 2
Mackellar, Duncan 1849-1908 DcBrA 1,
 DcVicP 2
MacKellar, Duncan 1849-1908 DcBrWA
MacKendrick, Lilian
 WhoAmA 73, -76, -78,
 -80, -82, -84
Mackennal, Sir Bertram 1863-1931 DcBrA 1

Mackensen, Fritz OxTwCA
Mackensen, Fritz 1866-1953 McGDA
Mackensen, Marie DcWomA
MacKenzie FolkA 86
Mackenzie, Lady DcVicP 2
Mackenzie, Alexander George Robertson 1879-1963
 DcBrA 1
Mackenzie, Alexander Marshall 1848- DcVicP 2
Mackenzie, Alexander Marshall 1848-1933 DcBrA 1
MacKenzie, Alix 1922-1962 CenC
Mackenzie, C V 1889-1948 ClaDrA, DcBrA 1
MacKenzie, Carl 1905- FolkA 86
Mackenzie, Catherine 1896- ArtsAmW 3
Mackenzie, Charles DcBrECP
Mackenzie, David BiDBrA
Mackenzie, David 1942- WhoAmA 76, -78
Mackenzie, David, IV 1942- WhoAmA 80, -82, -84
Mackenzie, E DcVicP 2
MacKenzie, E NewYHSD
Mackenzie, Mrs. E Phillipe DcVicP 2
MacKenzie, Evelyn Harriet DcWomA
MacKenzie, Florence Bryant 1890- WhAmArt 85
Mackenzie, Florence Louise 1890- DcWomA
Mackenzie, Florence Louise Bryant 1890- ArtsAmW 2
Mackenzie, Frank J DcVicP 2
MacKenzie, Frank J 1867-1939 WhAmArt 85
Mackenzie, Frederick 1787-1854 DcBrBI, DcBrWA,
 DcVicP 2
MacKenzie, G A AmArch 70
MacKenzie, Garry 1921- IlsBYP, IlsCB 1946, -1957
Mackenzie, George DcVicP 2
Mackenzie, H A O DcVicP 2
MacKenzie, H B DcWomA
Mackenzie, Helen Margaret d1966 DcBrA 1,
 DcWomA
Mackenzie, Helen Winifred DcWomA
Mackenzie, Hugh M 1956- MarqDCG 84
MacKenzie, Hugh Seaforth 1928- WhoAmA 73
MacKenzie, Hugh Seaforth 1928- WhoAmA 76
Mackenzie, Hugh Seaforth 1929- WhoAmA 78, -80,
 -82
MacKenzie, Hugh Seaforth 1929- WhoAmA 84
Mackenzie, Isabella DcWomA
Mackenzie, Ivor 1880- DcBrA 1
MacKenzie, J B WhAmArt 85
Mackenzie, J M DcVicP 2
Mackenzie, Jane DcWomA
MacKenzie, Janet WhAmArt 85
Mackenzie, James Hamilton 1875-1926 DcBrA 1,
 DcBrWA, DcVicP 2
Mackenzie, James M DcVicP 2
Mackenzie, James Wilson DcVicP 2
MacKenzie, John D DcBrBI, DcVicP 2
Mackenzie, Keith WhoArt 84N
Mackenzie, Keith 1924- DcBrA 1, WhoArt 80, -82
Mackenzie, Kenneth DcVicP, -2
MacKenzie, Lucy 1952- ConArt 79[port]
Mackenzie, Lucy Elizabeth Babington DcWomA
Mackenzie, M H DcVicP 2
Mackenzie, Phyllis Edith 1911- WhoArt 80, -82, -84
MacKenzie, Roderick D 1865- WhAmArt 85
Mackenzie, S A Muir DcVicP 2
Mackenzie, W G d1925 DcBrA 1
MacKenzie, Warren 1924- CenC
Mackenzie, William G DcVicP 2
Mackenzie, William Macdonald d1856 BiDBrA
Mackenzie, Winifred Emily 1888- ClaDrA, DcBrA 1,
 DcWomA
Mackeon, Abraham B FolkA 86
Mackeown, Ida C d1952 WhoAmA 78N, -80N, -82N,
 -84N
MacKeown, Ida C 1885?-1952 DcWomA
Mackertich, Robin 1921- ClaDrA, WhoArt 84
Mackesey, Thomas William 1908- AmArch 70
Mackewan, Arthur DcBrBI
Mackey, Beatrice Howie DcWomA
Mackey, Eugene Joseph, III 1938- AmArch 70
Mackey, Haydn Reynolds 1883- DcBrA 1
Mackey, Howard Hamilton 1901- AfroAA,
 AmArch 70
Mackey, J DcVicP 2
Mackey, James NewYHSD
Mackey, James, Jr. NewYHSD
Mackey, Matthew NewYHSD
Mackey, R AmArch 70
Mackey, Spencer 1880-1958 WhAmArt 85
Mackey, William NewYHSD
Mackey, William Enro 1919- WhAmArt 85
Mackie, Annie DcVicP 2
Mackie, Bob WorFshn
Mackie, Charles H 1862-1920 ClaDrA, DcBrA 1
Mackie, Charles Hodge 1862-1920 DcBrBI, DcBrWA,
 DcVicP 2
Mackie, D C AmArch 70
MacKie, Frederick James, Jr. 1905- AmArch 70
Mackie, George 1920- DcBrA 1, WhoArt 80
Mackie, Kathleen Isabella 1899- DcBrA 1, DcWomA
Mackie, Matthew NewYHSD
Mackie, Peter Robert Macleod d1959 DcBrA 1
Mackie, Sheila Gertrude 1928- WhoArt 80
Mackie, T C Campbell DcBrA 1

Mackie, William BiDBrA
MacKillop, William WhAmArt 85
Mackin, Peter R 1948- MarqDCG 84
Mackinen, William Ferdinand AmArch 70
Mackinlay, Ian 1926- AmArch 70
Mackinlay, Thomas DcVicP 2
Mackinney, Herbert Wood 1881- DcBrA 1
MacKinnon, Archibald Angus d1918 WhAmArt 85
MacKinnon, Ella Cecelia 1887- WhAmArt 85
Mackinnon, Esther Blaikie DcBrA 1, DcWomA
MacKinnon, Luther Gillis, III 1937- AmArch 70
MacKinnon, Mary 1890- DcWomA, WhAmArt 85
MacKinnon, R D, Jr. AmArch 70
MacKinnon, Sine 1901- DcBrA 1
MacKinnon, W DcBrWA
MacKinnon-Pearson, Cecilia 1887?- DcWomA
MacKinstry, Elizabeth d1956 ConICB, IlsCB 1744
MacKinstry, Elizabeth 1879- WhAmArt 85
Mackintosh, Alexander 1861-1945 BiDAmAr
Mackintosh, Alexander Day 1912- AmArch 70
Mackintosh, Charles Rennie 1868-1928 AntBDN A,
 ConArch, DcBrA 1, DcD&D[port], DcNiCA,
 EncMA, MacEA, McGDA, OxArt, OxDecA,
 PhDcTCA 77, WhoArch
Mackintosh, Colin J d1910 DcBrA 2
Mackintosh, David McNabb, Jr. 1916- AmArch 70
Mackintosh, John 1931-1966 DcBrA 1
Mackintosh, Margaret DcVicP 2, DcWomA
Mackintosh, Margaret Macdonald DcBrA 1
Mackintosh, Miss S B NewYHSD
Mackintosh, Sarah B DcWomA
Mackintosh, Thomas BiDBrA
Mackley, George 1900- DcBrA 1
Macklin, Anderson AfroAA
Macklin, Anderson D 1933- WhoAmA 78, -80, -82,
 -84
Macklin, Edith 1871- DcWomA
Macklin, Harold d1947? BiDAmAr
Macklin, Lida Allen 1872- ArtsAmW 3
Macklin, Neal 1954- MarqDCG 84
Macklin, Thomas Eyre 1867-1943 DcBrA 1, DcBrBI,
 DcBrWA, DcVicP 2
Macklow, J NewYHSD
Mackmillion, Alexander CabMA
Mackmillion, Jonathan 1708-1739 CabMA
Mackmurdo, A H 1851-1942 MacEA
Mackmurdo, Arthur H 1851-1942 AntBDN A, OxArt,
 OxDecA
Mackmurdo, Arthur Heygate 1851-1942 AntBDN B,
 DcD&D, WhoArch
Mackmurdo, Arthur Heygate 1857-1942 DcNiCA
MacKnight, Arthur Alexander 1925- AmArch 70
MacKnight, Dodge 1860-1950 ArtsAmW 2
MacKnight, Dodge 1860-1950 WhAmArt 85
MacKnight, Nino 1908- WhAmArt 85
MacKnight, Ninon 1908- IlsBYP, IlsCB 1946
Mackosikwe 1862- FolkA 86
Mackreth, Harriet F S DcVicP 2, DcWomA
Mackreth, Robert DcVicP 2
Mackrow, Elsie M DcWomA
Macksoud, Alfred C 1919- AmArch 70
Mackubin, Florence 1861?-1918 DcWomA
Mackubin, Florence 1866-1918 WhAmArt 85
Mackubin, Kate DcWomA, WhAmArt 85
Mackwitz, William 1831-1919 NewYHSD ,
 WhAmArt 85
Mackworth, Audley DcVicP 2
Mackworth, T DcVicP 2
Macky, Constance L WhAmArt 85
Macky, Constance L 1883- ArtsAmW 2
Macky, D S AmArch 70
Macky, Eric Spencer 1880-1958 ArtsAmW 2
Macky, Spencer 1880-1958 WhoAmA 80N, -82N,
 -84N
Maclachlan, Donald L 1921- AmArch 70
Maclagan, Dorothea F 1895- DcBrA 1, DcWomA,
 WhoArt 80, -82, -84
Maclagan, Philip Douglas 1901- DcBrA 1
Maclagan, Philip Douglas 1901-1972 DcBrA 2
MacLagger, Richard Joseph 1947- WhoAmA 80, -82
MacLagger, Richard Joseph 1947- WhoAmA 84
Maclane, Jean d1964 WhoAmA 78N, -80N, -82N,
 -84N
MacLane, Jean 1878-1964 WhAmArt 85
MacLane, Myrtle Jean 1878-1964 DcWomA
Maclaren, A D, Jr. AmArch 70
Maclaren, Donald Graeme 1886-1917 DcBrA 1
Maclaren, Helen 1898- DcBrA 1, DcWomA
MacLaren, James M 1843-1890 MacEA
Maclaren, John Stewart 1860- DcBrA 1, DcVicP 2
MacLaren, Neil 1909- WhoArt 80
MacLaren, Neil 1909- WhoArt 82, -84
MacLaren, T ArtsAmW 1
MacLaren, T d1928 ArtsAmW 3
Maclaren, Thomas DcVicP 2
MacLaren, Thomas d1928 ArtsAmW 3, BiDAmAr
MacLaren, Walter DcVicP, -2
MacLaughlin, Donald Shaw 1876-1938 WhAmArt 85
Maclaughlin, Frances DcVicP 2
MacLaurin, W A AmArch 70
Maclay, David, Jr. 1946- WhoAmA 82, -84

Maclay, David S, Jr. 1946- MacBEP
Maclay, Margaret DcWomA
Maclean, Alexander 1867-1940 DcBrA 1, DcVicP 2
MacLean, Arthur WhoAmA 73
MacLean, Arthur WhoAmA 76, -78, -80, -82, -84
MacLean, Christina WhAmArt 85
MacLean, Christina 1853- ArtsAmW 2, DcWomA
MacLean, Hector DcVicP 2
MacLean, J Arthur WhAmArt 85
MacLean, Jean 1879-1952 DcWomA
MacLean, L A EarABI
MacLean, Marion DcWomA, WhAmArt 85
MacLean, Sara DcBrWA, DcVicP 2
MacLean, W J 1941- WhoArt 80, -82, -84
MacLean, William Lacy 1860-1940 WhAmArt 85
MacLean-Smith, Elizabeth 1916-
 WhoAmA 73, -76, -78,
 -80, -82, -84
MacLeary, Bonnie WhAmArt 85
MacLeary, Bonnie 1892- DcWomA
Macley, Miss DcWomA
MacLeay, Kenneth 1802-1878 ArtsNiC
Macleay, Kenneth 1802-1878 DcBrWA, DcVicP 2
Macleay, Macneil DcVicP 2
MacLeay, Rosanna 1887- DcWomA
MacLeish, Norman 1890- WhAmArt 85
MacLellan, Charles Archibald 1887- WhAmArt 85
Maclellan, Malcolm 1908- DcBrA 1
MacLennan, Eunice C 1890- WhAmArt 85
MacLennan, Eunice Cashion 1886-1966 ArtsAmW 1
MacLennan, Eunice Cashion 1888?-1966 DcWomA
MacLeod, Alexander 1888- ArtsAmW 1
MacLeod, Alexander Samuel 1888- WhAmArt 85
Macleod, Dolina WhoAmA 76
MacLeod, Flora 1907- DcBrA 1, WhoArt 80
MacLeod, Flora 1907- WhoArt 82, -84
MacLeod, Grace Roberts 1899- DcWomA
MacLeod, Jessie DcVicP, -2, DcWomA
MacLeod, John WhAmArt 85
Macleod, Louisa Elizabeth Garden 1857-1944
 ArtsAmW 2
Macleod, Margaret Henderson 1922- WhoArt 80, -82
Macleod, Pegi Nichol WhoAmA 78N, -80N, -82N,
 -84N
MacLeod, Pegi Nicol 1904-1949 IlBEAAW
MacLeod, Robert James 1888- WhAmArt 85
Macleod, William Douglas 1892- DcBrA 1
Macleod, Yan 1889-1978 WhoAmA 80N, -82N, -84N
MacLeod Robertson, Sheila 1927- DcSeaP
MacLeod-Thorp, Louise Elizabeth 1857-1944
 DcWomA
MacLeran, James FolkA 86
Maclin, Benoit NewYHSD
Maclin, Elaine AfroAA
Maclin, Elizabeth WhAmArt 85
Maclise, Daniel 1806-1870 ClaDrA, DcBrBI,
 DcBrWA, DcVicP, -2, OxArt
Maclise, Daniel 1811-1870 AntBDN B, ArtsNiC,
 McGDA
Maclure, Andrew DcBrBI, DcVicP 2
Maclure, Samuel 1860-1929 MacEA
Maclusky, Hector John 1923- DcBrA 1, WhoArt 80
MacLusky, Hector John 1923- WhoAmA 82,
 -84
MacMahon, Charles Hutchins, Jr. 1918- AmArch 70
MacManus, Henry 1810-1878 DcVicP, -2
Macmartin, John Rayment 1925- WhoArt 80, -82,
 -84
MacMaster, James DcVicP
MacMaster, James 1856-1913 DcVicP 2
MacMiadhachain, Padraig DcCAr 81
MacMiadhachain, Padraig 1929- ClaDrA,
 WhoArt 80, -82, -84
Macmichael, William 1784-1839 DcBrBI
MacMillan, Daniel Preston 1921- AmArch 70
MacMillan, Donald Roger 1932- AmArch 70
MacMillan, Francis W 1923- AmArch 70
MacMillan, Henry Jay 1908- WhAmArt 85
MacMillan, Joseph Ellsworth 1924- AmArch 70
MacMillan, Mary WhAmArt 85
MacMonnies, Alice DcWomA
MacMonnies, Frederick 1863-1937 BnEnAmA,
 IlBEAAW
Macmonnies, Frederick 1863-1937 OxArt
MacMonnies, Frederick W 1863-1937 WhAmArt 85
MacMonnies, Frederick William 1863-1937 DcAmArt,
 McGDA
MacMonnies, Marjorie Mae DcWomA
MacMonnies, Mary F DcWomA
MacMonnies, Mary Fairchild WhAmArt 85
MacMorris, Daniel 1893- WhAmArt 85
MacMullan, D D AmArch 70
MacMullen, Nellie C WhAmArt 85
MacMullen, Nelly C DcWomA
Macmurray, Elizabeth Hyde 1891- WhoArt 80, -82,
 -84
MacMurray, M WhAmArt 85
Macnab, Iain 1890-1967 DcBrA 1
Macnab, John DcVicP 2

MacNab, John S 1853- WhAmArt 85
MacNab, Marie d1911 DcWomA
Macnab, Peter d1900 DcBrBI, DcVicP, -2
MacNair, Frances DcWomA
Macnair, Herbert DcBrA 1
Macnair, J L Herbert DcVicP 2
Macnamara, F A DcVicP 2
MacNaughton, Mary Hunter WhAmArt 85
MacNaughton, Mary Hunter 1892- DcWomA
MacNeal, Frederic S WhAmArt 85
MacNee, Sir Daniel 1805-1882 ArtsNiC
Macnee, Sir Daniel 1806-1882 DcVicP, -2
Macnee, Robert Russell d1952 DcBrA 1, DcVicP 2
Macneil, A B AmArch 70
MacNeil, Carol 1871-1944 DcWomA
MacNeil, Carol Brooks 1871-1944 WhAmArt 85
Macneil, H DcBrBI
MacNeil, H A 1866-1947 WhAmArt 85
MacNeil, Hermon A 1866-1947 McGDA
MacNeil, Hermon Atkins 1866-1947 ArtsAmW 1,
 BnEnAmA, IlBEAAW
MacNeil, R L AmArch 70
MacNeille, Perry R 1872-1931 BiDAmAr
MacNeir, Andrew E 1828?- NewYHSD
MacNelly, Jeffrey Kenneth 1947-

 WhoAmA 73,
 -76, -78, -80, -82, -84
 WorECar
MacNichol, Joyce WhAmArt 85
Macnicol, Bessie 1869-1904 DcBrA 1
MacNicol, Bessie 1869-1904 DcVicP 2, DcWomA
Macnicol, Gregory Elton 1951- MarqDCG 84
MacNicol, Roy Vincent WhAmArt 85
MacNiven, D P DcVicP 2
MacNiven, John DcVicP 2
MacNutt, Glenn Gordon 1906-
 WhAmArt 85, WhoAmA 76, -78,
 -80, -82, -84
MacNutt, J Scott 1885- WhAmArt 85
Macomb, Alexander 1782-1841 ArtsEM
Macomb, Henry A 1845-1933 BiDAmAr
Macomber EncASM
Macomber, Allison 1916- WhoAmA 76, -78
Macomber, Allison 1916-1979 WhoAmA 80N, -82N,
 -84N
Macomber, Allison R 1916- WhAmArt 85
Macomber, Ann 1788-1862 FolkA 86
Macomber, Eva M DcWomA, WhAmArt 85
Macomber, Mary L 1861-1916 WhAmArt 85
Macomber, Mary Lizzie 1861-1916 DcWomA
Macomber, Stephen WhAmArt 85
Macomber, William NewYHSD
Macomber, William B 1921- WhoAmA 80, -82, -84
Macomber, William Kaluna WhAmArt 85
Macon, Robert James 1933- AmArch 70
Macougtry, James NewYHSD
MacPacke, Jose BiDBrA
Macphail, Ian S 1922- WhoArt 80, -82
MacPhail, Ian S 1922- WhoArt 84
Macpheadris, Archibald FolkA 86
MacPhearson, Mrs. M WhAmArt 85
MacPhee, James F d1936 WhAmArt 85
Macpherson, Alex DcBrA 1
MacPherson, Annie A H DcWomA
Macpherson, Barbara H DcVicP 2
MacPherson, Barbara H DcWomA
Macpherson, Craig Alan 1954- MarqDCG 84
Macpherson, Donald William 1914- AmArch 70
Macpherson, Douglas 1871- DcBrA 1, DcBrBI
Macpherson, Duncan Ian 1924- WorECar
MacPherson, E E FolkA 86
Macpherson, Fanny DcWomA
MacPherson, Frances L WhAmArt 85
Macpherson, George Gordon 1910- DcBrA 1
MacPherson, George Gordon 1910- WhoArt 80, -82,
 -84
Macpherson, Giuseppe 1726- DcBrECP
Macpherson, Hamish 1915- DcBrA 1, WhoArt 80,
 -82, -84
Macpherson, Ian David 1954- MarqDCG 84
MacPherson, Mrs. J Havard WhAmArt 85
MacPherson, J Howard WhAmArt 85
MacPherson, John DcBrWA
Macpherson, John DcVicP 2
MacPherson, John Havard 1894- WhAmArt 85
Macpherson, M DcBrWA
MacPherson, M E DcWomA
MacPherson, Mrs. M E ArtsEM
Macpherson, Margaret Campbell DcVicP 2
MacPherson, Margaret Campbell DcWomA
MacPherson, Marie WhAmArt 85
MacPherson, Marie 1879- DcWomA
MacPherson, Orison WhAmArt 85
MacPherson, Orison 1898-1966 IlrAm D, -1880
Macpherson, Robert 1811-1872 DcVicP 2
MacPherson, Robert 1811-1872 ICPEnP, MacBEP
MacPherson, Robert Allan 1920- AmArch 70

MacPherson, Willina DcWomA
MacQueen, James M 1859-1934 BiDAmAr
Macqueen, Jane Una DcBrA 1
MacQueen, Jane Una DcWomA
Macqueen, Kenneth 1897- DcBrA 1
Macquin, Ange Denis Meldensis 1756-1823 DcBrWA
MacQuoid, Percy T 1852-1925 DcBrA 1
Macquoid, Percy T 1852-1925 DcBrBI
MacQuoid, Percy T 1852-1925 DcVicP
MacQuoid, Percy Thomas 1852-1925 DcBrWA,
 DcVicP 2
Macquoid, Thomas Robert 1820-1912 DcBrA 1,
 DcBrBI
MacQuoid, Thomas Robert 1820-1912 DcVicP, -2
Macquoid, William A FolkA 86
MacRae, Mrs. Bruce WhAmArt 85
MacRae, Elmer L 1875-1953 WhAmArt 85
MacRae, Emma Fordyce WhoAmA 73
Macrae, Emma Fordyce WhoAmA 76
MacRae, Emma Fordyce 1887- WhAmArt 85
MacRae, Emma Fordyce 1887-1974 DcWomA
Macrae, James John 1921- AmArch 70
MacRae, John Sumter, III 1937- AmArch 70
Macrae, L C DcVicP 2
MacRae, Mary DcVicP 2
MacRae, Nell DcWomA
MacRae, Wendell Scott 1896-1980 ICPEnP A,
 MacBEP
Macready, Mrs. Edward DcWomA
MacReady, William H 1898-1956 WhAmArt 85
Macreery, John B 1917- AmArch 70
Macrino D'Alba 1494-1508 McGDA
MacRitchie, Alexina DcBrA 1, DcWomA
MacRory, Anna A DcVicP 2
Macrum, George H WhAmArt 85
Macs, Yan 1933- PrintW 85
Macsai, J AmArch 70
Macsoud, Nicolas S 1884- WhAmArt 85
Mactaggart, William 1835-1910 ClaDrA
MacTaggart, Sir William WhoArt 82N
MacTaggart, Sir William 1903-
 DcBrA 1, PhDcTCA 77,
 WhoArt 80
Mactarian, Ludwig WhAmArt 85
MacVeagh, Louise Thoron WhAmArt 85
MacVeal, R DcVicP 2
MacVicar, Annie DcWomA
Macvittie, Walter J 1952- MarqDCG 84
MacWeeney, Alen Brasil 1939- ICPEnP A, MacBEP
MacWhinnie, John Vincent 1945- WhoAmA 84
MacWhirter, Agnes E DcWomA
MacWhirter, Agnes E 1837- DcBrWA
MacWhirter, Agnes Eliza 1837- DcVicP 2
MacWhirter, Emma DcWomA
MacWhirter, John 1839- ArtsNiC
Macwhirter, John 1839-1911 DcBrA 1
MacWhirter, John 1839-1911 ClaDrA,
 DcBrBI, DcBrWA,
 DcVicP, -2
MacWhirter, John A 1839-1911 ArtsAmW 3
MacWhurter, Agnes E DcWomA
Macy FolkA 86
Macy, Alfonso 1928- AmArch 70
Macy, Augusta Arnold d1909 DcWomA
Macy, Mrs. Carleton WhAmArt 85
Macy, Fannie S DcWomA
Macy, Harriet 1883- DcWomA
Macy, Harriet P 1883- WhAmArt 85
Macy, Henry C 1821- BiDAmAr
Macy, Mayme A 1874-1895 DcWomA
Macy, Reuben NewYHSD
Macy, Reuben d1838 FolkA 86
Macy, Robert H FolkA 86
Macy, Rowland Hussey EncASM
Macy, W S ArtsNiC
Macy, William Starbuck 1853-1945 ArtsAmW 3,
 WhAmArt 85
Mad Carpentier FairDF FRA
Madan, Fred 1885- WhAmArt 85
Madan, Frederic C 1885- IlBEAAW
Madarassy, Erzsebet Von 1865-1915 DcWomA
Madaule, L NewYHSD
Maddalene, Herbert F 1928- AmArch 70
Madden, Anne 1932- ConArt 77, DcCAr 81
Madden, Betty I 1915- WhoAmA 73, -76, -78, -80,
 -82
Madden, Daryl John 1959- MarqDCG 84
Madden, Dennis William 1921- AmArch 70
Madden, Don 1927- IlsBYP
Madden, Edward NewYHSD
Madden, George Carroll 1910- AmArch 70
Madden, J M FolkA 86
Madden, Thomas J, Jr. 1920- AmArch 70
Madden, William V 1868-1921 BiDAmAr
Madden, Wyndham DcBrECP, DcVicP 2
Madden-Work, Betty I 1915- WhoAmA 84
Maddersteg, Michiel 1659-1709 DcSeaP
Maddhes, C FolkA 86
Maddigan, Isabelle Maeder 1880- DcWomA,
 WhAmArt 85
Maddison, John DcVicP 2

Maddock, Bruce Wayne 1938- *MarqDCG 84*
Maddock, George C *NewYHSD*
Maddock, John *FolkA 86*
Maddock, William A 1830?- *NewYHSD*
Maddocks, Peter 1929- *WorECar*
Maddov, Rance, Jr. *FolkA 86*
Maddox, Conroy 1912- *DcCAr 81*
Maddox, Edmond D *AmArch 70*
Maddox, George 1760-1843 *BiDBrA, DcBrWA, DcVicP 2*
Maddox, George Vaughan 1802-1864 *BiDBrA*
Maddox, J D *AmArch 70*
Maddox, Jerald Curtis 1933- *WhoAmA 76, -78, -80, -82, -84*
Maddox, Jerrold Warren 1932- *WhoAmA 76, -78, -80, -82, -84*
Maddox, Milton T 1924- *AmArch 70*
Maddox, Richard Leach 1816-1902 *ICPEnP, -A, MacBEP*
Maddox, Richard Willes *DcVicP 2*
Maddox, Ronald 1930- *WhoArt 80, -82, -84*
Maddox, Ronald A 1930- *ClaDrA*
Maddox, Terry Ladd 1956- *MarqDCG 84*
Maddox, Willis 1813-1853 *DcVicP 2*
Maddux, D C *AmArch 70*
Maddy, Malcolm Clark 1936- *MarqDCG 84*
Madeira, Clara N d1929 *DcWomA, WhAmArt 85*
Madeira, Daniel *NewYHSD*
Madeleine, Jeanne *DcWomA*
Madeley, Lucy *DcBrA 1, DcWomA*
Madell, Kenneth Steven 1949- *MarqDCG 84*
Maden, Sait 1932- *WhoGrA 82[port]*
Mader, John Robert 1936- *AmArch 70*
Mader, Louis 1842?-1892 *FolkA 86*
Maderna, Carlo 1556-1629 *OxArt*
Maderno, Carlo 1556-1629 *DcD&D, MacEA, McGDA, WhoArch*
Maderno, Stefano 1576-1636 *McGDA, OxArt*
Madeweiss, Hedwig 1856- *DcWomA*
Madeyski, Marie *DcWomA*
Madgwick, Clive 1934- *WhoArt 82, -84*
Madhloum, Tariq 1933- *DcCAr 81*
Madigan, Col 1921- *ConArch*
Madigan, Mary Jean Smith *WhoAmA 84*
Madigan, Mary Jean Smith 1941- *WhoAmA 76, -78, -80, -82*
Madigan, Richard Allen 1937- *WhoAmA 76, -78, -80, -82, -84*
Madigan, Rosemary 1926- *DcCAr 81*
Madigan, Thomas Joseph 1934- *AmArch 70*
Madill, Robert 1947- *MarqDCG 84*
Madin, P *AntBDN N*
Madison, B E *AmArch 70*
Madison, Robert Prince 1923- *AmArch 70*
Madison, Steve *IlsBYP*
Madlinger, George Joseph, Jr. 1927- *AmArch 70*
Madonia, Ann C *WhoAmA 84*
Madot, A E *DcVicP 2*
Madot, Adolphus M *DcVicP 2*
Madot, Adolphus M d1864 *DcBrBI*
Madou, Jean Baptiste 1796-1877 *ArtsNiC, ClaDrA*
Madox Brown, Ford *DcVicP 2*
Madrazo, Federico De 1815-1894 *OxArt*
Madrazo, Frederic Madrazo Y Kunt, Don *ArtsNiC*
Madrazo, Jose De 1781-1859 *OxArt*
Madrazo, Louis *ArtsNiC*
Madrazo, Ricardo *ArtsNiC*
Madrazo Y Agudo, Jose De 1781-1859 *McGDA*
Madrazo Y Kuntz, Federico De 1815-1894 *McGDA*
Madsen, Alfrida Vilhelmine Ludovica *DcWomA*
Madsen, Emil Milton 1930- *AmArch 70*
Madsen, Henrik, II 1929- *MarqDCG 84*
Madsen, L J *AmArch 70*
Madsen, Loren 1943- *DcCAr 81*
Madsen, Loren Wakefield 1943- *AmArt, WhoAmA 78, -80, -82, -84*
Madsen, Otto 1882- *ArtsAmW 3, WhAmArt 85*
Madsen, Russell E 1914- *AmArch 70*
Madsen, Sofie 1829-1856 *DcWomA*
Madsen, Steven R 1947- *AmArt*
Madsen, Viggo Holm 1925- *PrintW 83, -85, WhoAmA 73, -76, -78, -80, -82, -84*
Madson, John Andrew 1920- *AmArch 70*
Madson, Norman Edward 1921- *AmArch 70*
Madter, Richard C 1949- *MarqDCG 84*
Madura, Jack Joseph 1941- *WhoAmA 76, -78, -80, -82, -84*
Maduro, Jose N *WhAmArt 85*
Madzarac, Nada 1952- *DcCAr 81*
Maeck, Philippe 1927- *McGDA*
Maeda, Shinzo 1922- *ICPEnP A, MacBEP*
Maehara, Hiromu 1914- *WhoAmA 73, -76, -78, -80, -82*
Maekawa, Kunio 1905- *EncMA, MacEA, WhoArch*
Maella, Mariano Salvador De 1739-1819 *McGDA*
Maene, Edward 1852-1931 *WhAmArt 85*
Maental, Jacob 1763-1863 *FolkA 86*
Maentel, Jacob 1763?-1863 *AmFkP, BnEnAmA*
Maentel, Jacob 1763-1863 *BnEnAmA, NewYHSD*
Maer, Stephen 1933- *WhoArt 80, -82, -84*
Maercklein, Marion C *WhAmArt 85*

Maertz, Charles *FolkA 86*
Maes, Barent *McGDA*
Maes, Dirk 1659-1717 *McGDA*
Maes, Godfried 1649-1700 *McGDA*
Maes, H *DcVicP 2*
Maes, Jan Baptist Lodewyck 1794-1856 *ClaDrA*
Maes, Karel 1900- *OxTwCA, PhDcTCA 77*
Maes, Nicolaes 1634-1693 *McGDA, OxArt*
Maesch, F 1865- *WhAmArt 85*
Maestas, J D 1938- *MarqDCG 84*
Maestro Jacopo *McGDA*
Maestro, David 1927- *ICPEnP A, MacBEP*
Maestro, Giulio 1942- *IlsBYP*
Maestro, Giulio Marcello 1942- *IlsCB 1967, WhoAmA 78, -80, -82, -84*
Maether, Christiane 1941- *DcCAr 81*
Maeuser, O P *AmArch 70*
Mafai, Mario 1902-1965 *McGDA, OxTwCA, PhDcTCA 77*
Maffei, Francesco 1600?-1660 *McGDA, OxArt*
Maffeo DaVerona *McGDA*
Maffey *NewYHSD*
Maffia, Robert H 1956- *MarqDCG 84*
Maffia, Robert Henry 1956- *MarqDCG 84*
Maffioli, Albertino *McGDA*
Maffitt, Theodore Stuart, Jr. 1923- *AmArch 70*
Magafan, Ethel *WhoAmA 73, -76, -78, -80, -82, -84*
Magafan, Ethel 1916- *IlBEAAW, WhAmArt 85*
Magafan, Jenne *WhoAmA 78N, -80N, -82N, -84N*
Magafan, Jennie 1916?-1950? *WhAmArt 85*
Magalashvili, Ketevan Konstantinovna 1894-1973 *DcWomA*
Magalhaes, Aloisio Sergio 1927- *WhoGrA 62, -82[port]*
Magalhaes, Augusto 1945- *WorECar A*
Magali, Lara 1956- *WhoAmA 82, -84*
Magalski, Frank W 1940- *MarqDCG 84*
Maganza, Alessandro 1556-1630? *ClaDrA*
Maganza, Giovanni Battista 1510-1586 *McGDA*
Maganza, Giovanni Battista 1513?-1586 *ClaDrA*
Magar, Tony 1936- *AmArt*
Magargee, G Robert 1913- *AmArch 70*
Magaud, Dominique Antoine 1817- *ArtsNiC*
Magaud, Dominique Antoine Jean Baptiste 1817-1899 *ClaDrA*
Magaud, Marie *DcWomA*
Magaziner, Henry J 1911- *AmArch 70*
Magazzini, Gene 1914- *WhoAmA 73, -76, -78, -80, -82, -84*
Magdalen Master *McGDA*
Magde, Madeleine 1876- *DcWomA*
Magdelena *FolkA 86*
Magee, Alan 1947- *DcCAr 81*
Magee, Alan Arthur 1947- *WhoAmA 80, -82, -84*
Magee, Alderson *OfPGCP 86*
Magee, Alderson 1929- *WhoAmA 78, -80, -82, -84*
Magee, C W *AmArch 70*
Magee, George Eldridge 1933- *AmArch 70*
Magee, James C 1846-1924 *WhAmArt 85*
Magee, James Harold, Jr. 1929- *AmArch 70*
Magee, John L *EarABI, EarABI SUP, NewYHSD*
Magee, R L *AmArch 70*
Magee, Regina *WhAmArt 85*
Magee, Rena 1880- *DcWomA*
Magee, Rena Tucker Kohlman 1880- *WhAmArt 85*
Magee, Richard *NewYHSD*
Magee, Richard Fadler 1933- *AmArch 70*
Magenau, E F *AmArch 70*
Magenis, H *NewYHSD*
Magenta, Giovanni 1565-1635 *McGDA*
Magenta, Muriel 1932- *WhoAmA 80, -82, -84*
Mager, Charles Augustus 1878-1956 *WorECom*
Mager, Daniel *NewYHSD*
Mager, Frederick 1882- *ClaDrA*
Mager, Frederick W 1882- *DcBrA 1*
Mager, Gus 1878- *WhAmArt 85*
Magerfleisch, V R *AmArch 70*
Maggi, Ortensia *DcWomA*
Maggini, Giovanni Paolo 1580-1640 *AntBDN K*
Magginni, Joseph *NewYHSD*
Maggiolini, Giuseppe *OxDecA*
Maggiolini, Giuseppe 1738-1814 *AntBDN G*
Maggiora, Nevio 1930- *AmArch 70*
Maggiotto, Domenico Fedeli 1713-1794 *McGDA*
Maggiotto, Francesco 1750-1805 *McGDA*
Maggs, Arnaud 1926- *ConPhot, ICPEnP A, WhoAmA 84*
Maggs, John Charles 1819-1896 *DcVicP, -2*
Magidson, Iris 1942- *AmGrD[port]*
Magie, Gertrude 1862- *DcWomA, WhAmArt 85*
Magill, Alice 1907- *WhoAmA 80*
Magill, Arthur 1907- *WhoAmA 80*
Magill, Beatrice *WhAmArt 85*
Magill, L *DcVicP 2*
Magill, Margaret *DcWomA*
Magimel, E Cecile *DcWomA*
Maginnis, Charles D 1867-1955 *MacEA*
Magistretti, Vico 1920- *ConDes, DcD&D*
Magistro, Charles John 1941- *WhoAmA 80, -82, -84*
Magleby, Francis R 1928- *WhoAmA 73, -76, -78, -80*
Magleby, Frank 1928- *WhoAmA 82, -84*

Magliani, Francesca 1845- *DcWomA*
Magmenat-Thalmann, Nadia 1942- *MarqDCG 84*
Magnan, Oscar Gustav 1937- *WhoAmA 76, -78, -80, -82, -84*
Magnani, Carlo d1673 *MacEA*
Magnani, Dorotea *DcWomA*
Magnani, Nicostrato 1532-1611? *MacEA*
Magnani Family *MacEA*
Magnasco, Alessandro 1667-1749 *McGDA*
Magnasco, Allessandro 1667-1749 *OxArt*
Magnasco, Stefano 1635-1681? *McGDA*
Magne, Antoinette *DcWomA*
Magne, Auguste 1816-1885 *MacEA*
Magne, Hortense *DcWomA*
Magne, Lucien 1849-1916 *MacEA*
Magnelli, Alberto 1888- *McGDA, PhDcTCA 77*
Magnelli, Alberto 1888-1971 *ConArt 77, -83, OxTwCA*
Magner, Adelaide *DcWomA, WhAmArt 85*
Magner, David *NewYHSD*
Magner, Helen E *WhAmArt 85*
Magnes, Isidore *DcVicP 2*
Magney, Robert G 1926- *AmArch 70*
Magni, Cesare *McGDA*
Magni, Pietro 1816-1877 *ArtsNiC*
Magniac, Mrs. *DcVicP 2*
Magnier, Berthe Marie *DcWomA*
Magno, Pastor *WhAmArt 85*
Magnocavallo, Francesco Ottavio 1707-1789 *MacEA*
Magnolato, Cesco 1926- *DcCAr 81*
Magnus, Charles *NewYHSD*
Magnus, E *EncASM*
Magnus, Eduard 1799-1872 *ArtsNiC*
Magnus, Emma *DcVicP 2*
Magnus, Emma 1856- *DcWomA*
Magnus, Gunter Hugo 1933- *WhoGrA 82[port]*
Magnus, Leonard *NewYHSD*
Magnus, Rose *DcVicP 2*
Magnus, Rose 1859-1900 *DcWomA*
Magnuson, E Harry *AmArch 70*
Magnuson, Mrs. George *WhAmArt 85*
Magnussen, Christian Karl 1821-1896 *DcVicP 2*
Magnussen, Erik *EncASM*
Magnussen, Erik 1884- *WhAmArt 85*
Magnussen, Ingeburg 1855- *DcWomA*
Magnusson, Kristjan H 1903-1937 *WhAmArt 85*
Magnusson, Olafur 1889-1954 *ICPEnP A*
Magnusz, Hendrik 1639-1686? *OxDecA*
Magnusz, Hendriksz 1610-1674 *OxDecA*
Magny, Risso 1798-1850 *NewYHSD*
Magny, Xavier *NewYHSD*
MaGo *OfPGCP 86*
Magol, Rene Marguerite 1753-1793 *DcWomA*
Magonigle, Edith M 1877- *WhAmArt 85*
Magonigle, Edith Marion 1877- *DcWomA*
Magonigle, H VanBuren 1867-1935 *BiDAmAr, WhAmArt 85*
Magoon, H A *AmArch 70*
Magor, Liz *DcCAr 81*
Magor, M A *DcVicP 2*
Magor, William Laurence 1913- *DcBrA 1, WhoArt 80, -82, -84*
Magragh, George *NewYHSD*
Magrath, Edmund 1885- *WhAmArt 85*
Magrath, Richard *CabMA*
Magrath, William *ArtsNiC*
Magrath, William 1838- *WhAmArt 85*
Magrath, William 1838-1918 *DcVicP 2, EarABI, NewYHSD*
Magriel, Paul 1916- *WhoAmA 73, -76, -78, -80, -82, -84*
Magritte, Rene 1898-1967 *ClaDrA, ConArt 77, ConPhot, ICPEnP A, McGDA, OxArt, PhDcTCA 77, WorArt[port]*
Magritte, Rene-Francois-Ghislain 1898-1967 *OxTwCA*
Magro, Del *McGDA*
Magron, Dominique *DcWomA*
Magruder, Jean Bowman *WhoAmA 78, -80*
Magruder, John B, Jr. 1925- *AmArch 70*
Magruder, P K *AmArch 70*
Magruder, Robertson Bowie 1931- *MarqDCG 84*
Magsino, Frank 1937- *WorECom*
Magubane, Peter 1932- *ConPhot, ICPEnP A*
Magues, J *DcVicP 2*
Maguire, Adelaide Agnes 1852-1875 *DcWomA*
Maguire, Adelaide Agnes 1852-1876 *DcBrWA, DcVicP 2*
Maguire, Bertha *DcBrWA, DcVicP 2, DcWomA*
Maguire, Charles *WhoAmA 73, -76*
Maguire, David John 1958- *MarqDCG 84*
Maguire, Edith *WhAmArt 85*
Maguire, Eric 1923- *WhoGrA 62*
Maguire, Gerald Quentin, Jr. 1955- *MarqDCG 84*
Maguire, Helena J 1860-1909 *DcBrA 2, DcBrWA, DcVicP 2, DcWomA*
Maguire, Henry Calton 1790-1854 *DcVicP 2*
Maguire, Henry Pownall 1943- *WhoAmA 84*
Maguire, Keith Robert 1909- *AmArch 70*
Maguire, Mary M d1910 *DcWomA, NewYHSD, WhAmArt 85*
Maguire, Sidney Calton *DcVicP 2*

Maguire, Thomas Herbert 1821-1895 DcVicP, -2
Maguire, William 1943- MacBEP
Maguire, William Henry DcVicP 2
Maguolo, George John 1893- AmArch 70
Magy, Jules Eduard De 1827-1878 ClaDrA
Mah, Francis 1928- AmArch 70
Mah, Harry George 1958- MarqDCG 84
Mah, Peter 1946- WhoAmA 78, -80, -82
Mah, Sammy Tanwan 1960- MarqDCG 84
Mahaffey, Frederick J 1926- AmArch 70
Mahaffey, Merrill Dean 1937- WhoAmA 73, -76, -78,
 -80, -82, -84
Mahaffey, Noel 1944- DcCAr 81
Mahaffey, Noel A 1944- WhoAmA 73, -76
Mahaffie, Isabel Cooper 1892- DcWomA,
 WhAmArt 85
Mahajan, Sat 1944- MarqDCG 84
Mahal, L Kenneth 1921- AmArch 70
Mahan, Francis NewYHSD
Mahan, W T AmArch 70
Mahaney, G T AmArch 70
Maharan, D T AmArch 70
Mahavira McGDA
Mahdaoui, Neja DcCAr 81
Mahdavi, Rafael DcCAr 81
Maher, Christopher Brian 1952- MacBEP
Maher, E FolkA 86
Maher, Edward F 1865-1937 BiDAmAr
Maher, Edward John 1904- AmArch 70
Maher, Elizabeth B WhAmArt 85
Maher, Elizabeth Brooks DcWomA
Maher, J Thomas, III 1940- AmArch 70
Maher, Kate Heath ArtsAmW 3
Maher, Kate Heath 1861-1946 DcWomA
Maher, Michael Duane 1938- AmArch 70
Maher, Philip Brooks 1894- AmArch 70
Maher, Virginia DcWomA
Mahey, John A 1932- WhoAmA 73, -76, -78, -80,
 -82, -84
Mahier, Edith 1892- ArtsAmW 1, -3, DcWomA,
 IlBEAAW, WhAmArt 85
Mahier, Herminie DcWomA
Mahier, Lois WhAmArt 85
Mahieu, Mathilde DcWomA
Mahl, Max NewYHSD
Mahlau, Alfred 1894- ClaDrA
Mahle, Walter Stephen 1938- MarqDCG 84
Mahler, Elise 1856- DcWomA
Mahler, Emma 1861- DcWomA
Mahler, Harry B 1928- AmArch 70
Mahler, Henry DcBrA 1
Mahler, Marianne WhoArt 80, -82, -84N
Mahler, Melvin 1929- AmArch 70
Mahler, R 1877- WhAmArt 85
Mahler, Rebecca 1871?- DcWomA
Mahlke, Ernest D 1930- WhoAmA 78, -80, -82, -84
Mahlman, F H AmArch 70
Mahlmann, John James 1942- WhoAmA 78, -80, -82,
 -84
Mahlmeister, Susanne 1952- DcCAr 81
Mahlum, E K AmArch 70
Mahlum, J E AmArch 70
Mahmoud, Ben 1935- ConArt 77, WhoAmA 73, -76,
 -78, -80, -82, -84
Mahner, Luise 1799-1861 DcWomA
Mahnker, J R, Jr. AmArch 70
Mahomed, Emma DcWomA
Mahomed, H DcVicP 2
Mahomed, Mrs. J D K DcVicP 2
Mahon, Josephine 1881- DcWomA, WhAmArt 85
Mahoney, Charles 1903-1968 DcBrA 1
Mahoney, D J EncASM
Mahoney, Dorothy 1902- WhoArt 84
Mahoney, Dorothy Louise 1902- WhoArt 80, -82
Mahoney, Edward 1825-1895 MacEA
Mahoney, Frank P 1862-1916 DcBrA 2
Mahoney, Herbert E 1927- MarqDCG 84
Mahoney, J DcBrBI
Mahoney, James 1810?-1879 DcBrWA, DcVicP 2
Mahoney, James 1816-1879 ClaDrA, DcBrBI
Mahoney, James Owen 1907- WhAmArt 85,
 WhoAmA 73, -76, -78, -80, -82, -84
Mahoney, John H WhAmArt 85
Mahoney, L J AmArch 70
Mahoney, Michael R T 1935- WhoAmA 78, -80, -82,
 -84
Mahoney, R J AmArch 70
Mahoney, Thomas 1854-1923 MacEA
Mahony, Felix d1939 WhAmArt 85
Mahony, Leo Halpin 1931- AmArch 70
Mahood, Alexander Blount 1888- AmArch 70
Mahood, Alexander Blount, Jr. 1920- AmArch 70
Mahood, Annie W R WhAmArt 85
Mahood, Kenneth 1930- IlsCB 1967
Mahr, Mari DcCAr 81
Mahr, Mari 1941- ConPhot, ICPEnP A
Mahu, Cornelis 1613-1689 ClaDrA, McGDA
Mahu, Cornelisz 1613-1689 DcSeaP
Mahudez, Jeanne Louise Jacontot 1876- DcWomA
Mahurin, Guy M 1877-1942 BiDAmAr
Mahuys, Anna Cecilie Wilhelmine Jeanne J DcWomA

Mai, Thomas FolkA 86
Maiano, Benedetto Da OxArt
Maiano, Benedetto Da 1442?-1497 McGDA
Maiano, Giovanni Da 1438-1478 McGDA
Maiano, Giuliano Da 1432-1490 MacEA, McGDA
Maiben, Henry ArtsAmW 3
Maichel, Berthold 1952- DcCAr 81
Maidlow, Lance J 1949- MarqDCG 84
Maidment, T DcBrA 2
Maier, Annette Yates 1908- AmArch 70
Maier, Frank G 1932- AmArch 70
Maier, Hennes 1935- DcCAr 81
Maier, J NewYHSD
Maier, J, Jr. AmArch 70
Maier, Maryanne E WhoAmA 84
Maier, Peter 1952- DcCAr 81
Maier-Krieg, Eugene WhAmArt 85
Maignan, Albert ArtsNiC
Maignan, Albert Pierre Rene 1845-1908 ClaDrA
Maignen DeSte.-Marie, Jeanne 1896- DcWomA
Maigreau, Gabrielle DcWomA
Maiks, G DcVicP 2
Maile, Alfred DcVicP 2
Maillard, Madame DcWomA
Maillard, Jeanne Beatrix DcWomA
Maillardoz DeRue, Therese De DcWomA
Maillart, Diogene Ulysses Napoleon 1840-1926 ClaDrA
Maillart, Jeanne Beatrix DcWomA
Maillart, Jeanne Catherine 1782- DcWomA
Maillart, Robert 1872-1940 ConArch, DcD&D,
 EncMA, MacEA, McGDA, OxArt, WhoArch
Maillart-Marion, Suzanne Marie 1877- DcWomA
Maillet, Corinne Dupuis 1895- DcWomA
Maillet, Jacques Leonard 1827?- ArtsNiC
Maillier, Nicolas 1745?- MacEA
Maillol, Aristide 1861-1944 McGDA, OxArt,
 OxTwCA, PhDcTCA 77
Maillol, Aristide Joseph Bonaventure 1861-1944
 ClaDrA
Maillon, Louise DcWomA
Maillot, Jeanne Marie DcWomA
Maillot, Pauline d1897 DcWomA
Maillou, Jean Baptiste 1668-1753 MacEA
Mailly, Simon De McGDA
Mailman, Cynthia 1942- WhoAmA 76, -78, -80, -82,
 -84
Mails, Thomas E 1920?- IlBEAAW
Main, James CabMA
Main, William 1796-1876 NewYHSD
Main, William H FolkA 86
Main-Becret, Alice 1875- DcWomA
Mainardi, Patricia 1942- ConArt 77
Mainardi, Patricia M 1942- WhoAmA 73, -76, -78,
 -80, -82, -84
Mainardi, Sebastiano 1460?-1513 McGDA
Mainardi, Sebastiano DiBartolo 1455?-1515 OxArt
Mainbocher FairDF US
Mainbocher 1890- WorFshn
Mainbocher 1890-1976 ConDes
Maindron, Etienne-Hippolyte 1801-1884 ArtsNiC
Mainds, Allan Douglass 1881-1945 DcBrA 1
Maine, George DeL NewYHSD
Maine, Henry C WhAmArt 85
Maine, John DcCAr 81
Maine, Lulu H DcWomA
Maine, Tony 1941- MacBEP
Mainelli, Michael 1958- MarqDCG 84
Maineri, Gianfrancesco McGDA
Maingy, Miss DcBrWA, DcWomA
Mainiero, Mike 1959- MarqDCG 84
Mainini, Trovatore 1893- WhAmArt 85
Maino, Juan Bautista 1578-1649 McGDA
Mains, J R NewYHSD
Mains, J R 1833?- ArtsAmW 2
Mainssieux, Lucien 1885- ClaDrA
Mainssieux, Lucien 1885-1958 OxTwCA
Mainwaring, Boulton BiDBrA
Mainwaring, Geoffrey Richard 1912- ClaDrA
Mainwaring, Herbert J 1924- MarqDCG 84
Mainwaring, Mary DcWomA
Mainzer, Herbert R 1878-1925 BiDAmAr
Maio, Stephen T 1942- MarqDCG 84
Maione, Robert 1932- WhoAmA 76, -78, -80, -82,
 -84
Mair, Alexander 1559?-1620? ClaDrA
Mair, C H NewYHSD
Mair, George James John 1809?-1889 BiDBrA A
Mair, Kathleen DcWomA
Maire, Anna DcWomA
Maire, Valentine Emelie DcWomA
Maireau, Rose DcWomA
Mairs, Clara Gardner 1878-1963 DcWomA
Mairs, Clara Gardner 1879- WhAmArt 85
Maisel, Herbert 1930- MarqDCG 84
Maisel, Jay 1931- DcCAr 81, ICPEnP A, MacBEP
Maisey, Frederick Charles 1825-1892 DcBrWA
Maisey, Thomas 1787-1840 DcBrWA, DcVicP 2
Maisiat, Joanny ArtsNiC
Maison, Mary 1886- WhAmArt 85
Maison, Mary Edith 1886-1954 ArtsAmW 2,
 DcWomA

Maison, Rudolf 1854-1904 McGDA
Maistre, Leroy Leveson Laurent Joseph De 1894-1968
 DcBrA 1
Maistre, Roy De 1894-1968 OxTwCA, PhDcTCA 77
Maitani, Lorenzo 1270?-1330 MacEA
Maitani, Lorenzo 1275?-1330 McGDA, OxArt
Maitin, Irving Jacob 1924- AmArch 70
Maitin, Sam 1928- WhoAmA 82, -84
Maitin, Samuel 1928- WhoAmA 73, -76, -78, -80
Maitland, Alexander Fuller DcVicP 2
Maitland, Ann Emma DcBrA 1, DcWomA
Maitland, Antony Jasper IlsCB 1957
Maitland, Antony Jasper 1935- IlsBYP, IlsCB 1957
Maitland, J E DcVicP 2
Maitland, Paul Fordyce 1863-1909 DcBrA 1
Maitland, Paul Fordyce 1869-1909 DcVicP 2
Maitre Francois McGDA
Maitre, Angelique DcWomA
Maiwald, C R AmArch 70
Maiwoger, Gottfried DcCAr 81
Maiwurm, Donald Jay 1927- AmArch 70
Maiz-Del Toro F AmArch 70
Maize, Adam FolkA 86
Maizus, S AmArch 70
Majano McGDA
Majdrakoff, Ivan 1927- WhoAmA 73, -76, -78, -80,
 -82, -84
Majeau, E DcWomA
Majer, Barbara DcWomA
Majer, F, Jr. AmArch 70
Majers, A H AmArch 70
Majeski, Alexander John 1920- AmArch 70
Majeski, R B AmArch 70
Majeski, Thomas H 1933- WhoAmA 78, -80, -82, -84
Majewski, Robert Richard 1925- AmArch 70
Majo De, Willy Maks 1917- WhoGrA 82[port]
Major, Alfred Sarony d1929 WhAmArt 85
Major, Charles Smith, Jr. 1933- AmArch 70
Major, Charlotte DcVicP 2
Major, Charlotte Ruth 1893- DcWomA,
 WhAmArt 85
Major, Daniel 1815?- NewYHSD
Major, Ernest 1864- WhAmArt 85
Major, H K AmArch 70
Major, H L DcVicP 2
Major, Henry A DcVicP 2
Major, Henry B NewYHSD
Major, Isaac 1576?-1630 ClaDrA
Major, James Parsons 1818-1900 NewYHSD
Major, John NewYHSD
Major, Mrs. R H DcVicP 2
Major, Richard C NewYHSD
Major, Thomas 1720-1799 BkIE
Major, W DcVicP 2
Major, W Wreford DcVicP 2
Major, William Warner FolkA 86
Major, William Warner 1804-1854 ArtsAmW 1,
 IlBEAAW, NewYHSD
Majorelle, Louis 1859-1926 AntBDN A, DcNiCA
Majors, Beverly 1951- WorFshn
Majors, Robert J 1913- WhAmArt 85
Majors, William 1930- AfroAA
Mak, Kum Siew 1940- WhoArt 80, -82, -84
Makar, D G AmArch 70
Makarenko, Zachary Philipp 1900- WhoAmA 73, -76,
 -78, -80
Makarius, Robert Joseph, Jr. 1924- AmArch 70
Makarov, Alexandr 1936- ConPhot, ICPEnP A
Makarovic, Branko MarqDCG 84
Makart, Hans 1840-1884 ArtsNiC, McGDA, OxArt
Makay, Mayann 1948- DcCAr 81
Makay, Philomena 1840- DcWomA
Makeig-Jones, Daisy 1881-1945 DcNiCA, DcWomA
Makela, Marika 1947- DcCAr 81
Makela, Roy O 1924- AmArch 70
Makepeace, Eunice DcWomA
Makepeace, John 1939- WhoArt 80, -82, -84
Makhijani, Raju T 1950- MarqDCG 84
Maki, Fumihiko 1928- ConArch, MacEA
Maki, Robert 1938- DcCAr 81
Maki, Robert Richard 1938- WhoAmA 73, -76, -78,
 -80, -82, -84
Maki, Sheila 1932- PrintW 83, -85
Makielski, Bronislaw Alexander 1901- WhAmArt 85
Makielski, Leon A 1885- WhAmArt 85
Makielski, Stanislaw John 1893- WhAmArt 85
Makila, Otto 1904-1955 PhDcTCA 77
Makila, Otto Fredrik 1906-1955 OxTwCA
Makin, J R DcVicP 2
Makinen, John Jacob, Sr. 1890?-1942 FolkA 86
Makino, K WhAmArt 85
Makino, Y T AmArch 70
Makinson, Randell L ConArch A
Makinson, Trevor Owen 1926- DcBrA 1, WhoArt 80,
 -82, -84
Makler, Hope Welsh 1924- WhoAmA 73, -76, -78,
 -80, -82, -84
Maklouf, Raphael 1937- WhoArt 80, -82, -84
Mako, B 1890- ArtsAmW 2
Makos, Christopher E 1948- ICPEnP A, MacBEP
Makovecz, Imre 1935- ConArch

Makowski, Tadeusz 1882-1932 *PhDcTCA 77*
Makowski, Zbigniew 1930- *OxTwCA*, *PhDcTCA 77*
Makowsky, Elena *DcWomA*
Makowsky, Marina *DcWomA*
Makris, David P 1956- *MarqDCG 84*
Makron *McGDA*
Mal *WorECar*
Malachowski, Maria *DcWomA*
Malambre, John A *NewYHSD*
Malan, Solomon Caeser 1812-1894 *DcBrWA*
Malandrin, H *DcWomA*
Malapeau, E *DcVicP 2*
Malasits, E M *AmArch 70*
Malatesta, Sigismondo 1417-1468 *OxArt*
Malaval, Robert 1937- *ConArt 77*, *DcCAr 81*
Malbet, Aurelie-Leontine *DcWomA*
Malbet, Olivia Delphine *DcWomA*
Malbin, Lydia Winston *WhoAmA 73, -76, -78*
Malbone, Edward Greene 1777-1807 *AntBDN J*,
 BnEnAmA, *DcAmArt*, *McGDA*, *NewYHSD*
Malchair, John Baptiste 1731-1812 *DcBrWA*
Malchin, Karl Wilhelm Christian 1838- *ArtsNiC*
Malcles, Jean-Denis 1912- *ClaDrA*, *WhoArt 80, -82,*
 -84
Malcolm, Mrs. *FolkA 86*
Malcolm, Beatrice *DcVicP 2*
Malcolm, Ellen 1923- *WhoArt 80, -82, -84*
Malcolm, J *DcVicP 2*
Malcolm, J A, Jr. *AmArch 70*
Malcolm, James Peller 1767-1815 *DcBrBI*, *DcBrECP*,
 DcBrWA, *NewYHSD*
Malcolm, L *DcVicP 2*, *DcWomA*
Malcolm, Miller Day 1932- *AmArch 70*
Malcolm , Nadine Edith 1948- *MarqDCG 84*
Malcolm, O C *WhAmArt 85*
Malcolm, R *DcVicP 2*
Malcolm, Robert Broker 1929- *AmArch 70*
Malcolm, Thalia Wescott 1888- *WhAmArt 85*
Malcolm, Thalia Westcott Millett 1878- *DcWomA*
Malcolmson, R F *AmArch 70*
Malcolmson, Reginald Francis 1912- *MacEA*
Malcom, Thalia Westcott Millett 1878- *DcWomA*
Malcomb, William Earl 1938- *AmArch 70*
Malcomson, William G 1853-1937 *BiDAmAr*
Malcor, Marie Angelique Alexandrine 1823- *DcWomA*
Malczewski, Rafael 1892- *PhDcTCA 77*
Maldarelli, Lawrence *WhAmArt 85*
Maldarelli, Oronzio d1963 *WhoAmA 78N, -80N,*
 -82N, -84N
Maldarelli, Oronzio 1892- *McGDA*, *PhDcTCA 77*
Maldarelli, Oronzio 1892-1963 *DcCAA 71, -77,*
 WhAmArt 85
Malden, Sarah 1761?-1838 *DcWomA*
Maldjian, Vartavar B 1918- *WhoAmA 76, -78, -80,*
 -82, -84
Maldonado, Adal *MacBEP*
Maldonado, Alexander 1901- *FolkA 86*
Maldonado, Estuardo 1928- *DcCAr 81*
Maldonado, Tomas 1922- *ConDes*, *OxTwCA*,
 PhDcTCA 77
Maldre, Mati 1947- *ICPEnP A*, *MacBEP*,
 WhoAmA 76, -78, -80, -82, -84
Maldura, Cesare C 1853-1907 *WhAmArt 85*
Maldura, Lilla *DcWomA*
Male, Emile 1862-1954 *OxArt*
Maleady, James Nugent 1936- *AmArch 70*
Malek, R J *AmArch 70*
Malempre, Leo *DcVicP 2*
Malenchini, Matilde *DcWomA*
Malenda, James William 1946- *WhoAmA 82, -84*
Malenoir, Mary 1940- *WhoArt 84*
Maler, Leopoldo 1937- *ConArt 77*
Maler, Leopoldo Mario 1937- *ConArt 83*
Maler, Valentine 1540?-1603 *McGDA*
Malerbi, R J *AmArch 70*
Malerme, Isabelle *DcWomA*
Males, June *DcCAr 81*
Males, Miha 1903- *WhoArt 80, -82, -84*
Malesardi, Richard Thomas 1934- *AmArch 70*
Maleskircher, Gabriel *McGDA*
Malet, Guy 1900- *WhoArt 80, -82, -84*
Malet, Guy Seymour Warre 1900-1973 *DcBrA 1*
Malevich, Kasimir 1878-1935 *ConArt 77, -83,*
 EncMA, *MacEA*, *McGDA*, *OxArt*,
 PhDcTCA 77, *WhoArch*
Malevich, Kasimir Severinovich 1878-1935 *OxTwCA*
Maley Bussiere, Louise 1891- *DcWomA*
Malezieux, Caroline *DcWomA*
Malezieux, Laure *DcWomA*
Malfatti, Anita 1889-1964 *DcWomA*
Malfatti, Anita 1896- *McGDA*
Malfatti, Annita 1896-1964 *OxTwCA*
Malfatti, Faustina 1792-1837 *DcWomA*
Malfatti, Nino 1940- *DcCAr 81*
Malfilatre, Lucie 1871- *DcWomA*
Malfrait, Joseph 1937- *DcCAr 81*
Malfray, Charles 1887-1940 *OxTwCA*
Malgren, E C 1863-1921 *BiDAmAr*
Malharro, Martin *OxTwCA*
Malharro, Martin 1865-1911 *PhDcTCA 77*
Malherbe, Pauline Marie 1822- *DcWomA*

Malhy, Simon De *McGDA*
Mali, Christian Friedrich 1832-1906 *ClaDrA*
Malick, Donald *OfPGCP 86*
Malicoat, Philip Cecil 1908- *WhAmArt 85*,
 WhoAmA 73, -76, -78, -80
Malicoat, Philip Cecil 1908-1981 *WhoAmA 82N,*
 -84N
Malik, Latif A *AfroAA*
Malin, A W *AmArch 70*
Malin, L *AmArch 70*
Malin, Michael Charles 1950- *MarqDCG 84*
Malin, Suzi *DcCAr 81*
Malin, Walter *WorFshn*
Malina, Frank Joseph 1912- *OxTwCA*, *PhDcTCA 77,*
 WhoAmA 78, -80, -82
Malina, Frank Joseph 1912-1981 *WhoAmA 84N*
Malinger, Alan J 1940- *MarqDCG 84*
Malinoff, R *AmArch 70*
Malinowski, Jerome Joseph 1939- *WhoAmA 76, -78,*
 -80
Malins, Margery Helen *WhoArt 80, -82, -84*
Malinski, Irving *FolkA 86*
Malinski, John *WhAmArt 85*
Maliphant, George *DcBrWA*
Maliphant, George 1788?- *BiDBrA*
Maliphant, H *DcBrWA*
Maliphant, William 1862- *DcBrA 1*, *DcBrWA*,
 DcVicP 2
Maliquet, Claire 1884- *DcWomA*
Maliver, Emilie 1885- *DcWomA*
Malkasian, Gregor 1943- *WhoAmA 73, -76*
Malkin, Miss *DcVicP 2*
Malkin, A C *DcVicP 2*
Malkin, S *DcBrWA*
Malkind, Samuel Lewis 1896- *AmArch 70*
Mall, Robert Franklin 1922- *AmArch 70*
Mallaivre, Alice 1887- *DcWomA*
Mallalieu, Frank Arthur 1937- *AmArch 70*
Mallalieu, H d1973? *DcBrA 2*
Mallalieu, Harry Lee 1913- *AmArch 70*
Mallar, Gordon Cranton 1909- *AmArch 70*
Mallard, Lawrence Henry 1927- *AmArch 70*
Mallard, Louise 1900- *WhAmArt 85*
Mallard, Prudent 1809- *CabMA*
Mallary, Robert 1917- *DcCAA 71, -77*, *OxTwCA*,
 PhDcTCA 77, *WhoAmA 73, -76, -78, -80, -82,*
 -84
Mallavarapu, Louis T *MarqDCG 84*
Mallender, Peter *DcCAr 81*
Malleson, Kate *DcVicP 2*
Malleson, Katherine *DcVicP 2*
Mallet, F *NewYHSD*
Mallet, Harriette *DcVicP 2*, *DcWomA*
Mallet, Jean Baptiste 1759-1835 *ClaDrA*
Mallet, Roma 1905- *WhAmArt 85*
Mallet, Violet Sanders *WhoArt 80, -82*
Mallet-Stevens, Robert 1886-1945 *ConArch*, *EncMA,*
 MacEA, *McGDA*
Mallett, R W *DcBrBI*
Mallette-Proust, Alice 1869- *DcWomA*
Malling, Jenny *DcWomA*
Mallinson, Constance 1948- *WhoAmA 73, -76*
Mallison, Euphame C 1895- *WhAmArt 85*
Mallon, Claire *DcWomA*
Mallon, Fred *WhAmArt 85*
Mallon, Grace Elizabeth 1911- *WhAmArt 85*
Mallonee, Jo 1892- *DcWomA*, *WhAmArt 85*
Mallory, Howard *AfroAA*
Mallory, Larry Richard 1949- *WhoAmA 73, -76, -78,*
 -80, -82
Mallory, Margaret 1911- *WhoAmA 73, -76, -78, -80,*
 -82, -84
Mallory, Michael J *MarqDCG 84*
Mallory, Nina A *WhoAmA 78, -80, -82*
Mallory, Nina Ayala *WhoAmA 84*
Mallory, R G *AmArch 70*
Mallory, Richard P *EarABI SUP*, *NewYHSD*
Mallory, Robert *OxTwCA*
Mallory, Ronald 1935- *ConArt 77*, *DcCAA 71, -77,*
 DcCAr 81, *WhoAmA 73, -76, -78, -80, -82, -84*
Mallows, Charles Edward *DcVicP 2*
Mallozzi, A *AmArch 70*
Mallozzi, J P *AmArch 70*
Mally, George W *WhAmArt 85*
Malm, Gustav N 1869- *WhAmArt 85*
Malm, Gustav N 1869-1928 *ArtsAmW 3*
Malm, Leo 1878- *DcWomA*
Malman, Christina 1912-1958 *WhoAmA 80N, -82N,*
 -84N
Malmar, Ruth May 1891- *DcWomA*, *WhAmArt 85*
Malmberg, Hans 1927-1977 *ConPhot*, *ICPEnP A*
Malmore, John *NewYHSD*
Malmquist, Leonard Valdemar 1935- *AmArch 70*
Malmquist, Olof Carl *WhAmArt 85*
Malmquist, Olof Carl, Jr. 1927- *AmArch 70*
Malmros, Robert W 1917- *AmArch 70*
Malmsten, Carl 1888-1972 *ConDes*, *MacEA*
Malnati, Jeanne 1893- *DcWomA*
Malnstrom, Thyra Ester Ellinor 1875-1928 *DcWomA*
Malo, Edward Joseph 1919- *AmArch 70*
Malo, Gertrude *DcWomA*

Malo, P H *AmArch 70*
Malo, Teri 1954- *WhoAmA 84*
Malo, Vincent 1600?-1650? *ClaDrA*
Malo, Vincent 1600?-1670? *McGDA*
Maloba, Gregory 1922- *OxTwCA*
Malone, A H *AmArch 70*
Malone, Betty *OfPGCP 86*
Malone, Blondelle *WhAmArt 85*
Malone, Blondelle 1877- *DcWomA*
Malone, Blondelle Octavia Edwards 1879-1951
 ArtsAmW 3
Malone, E C *AmArch 70*
Malone, G R *AmArch 70*
Malone, James H *AfroAA*
Malone, James William 1943- *WhoAmA 73, -76, -78,*
 -80
Malone, John A 1926- *AmArch 70*
Malone, Laetitia *DcWomA*
Malone, Laetitia Neff Herr 1881- *WhAmArt 85*
Malone, Lee H B 1913- *WhoAmA 73, -76, -78, -80,*
 -82, -84
Malone, Marianne *DcWomA*
Malone, May *WhAmArt 85*
Malone, May Stanhope *DcWomA*
Malone, Mildred *FolkA 86*
Malone, Robert James 1892- *WhAmArt 85*
Malone, Robert R 1933- *AmArt*, *WhoAmA 73, -76,*
 -78, -80, -82, -84
Malone, Rosamund *WhAmArt 85*
Malone, W T *AmArch 70*
Maloney, J W *AmArch 70*
Maloney, Joe 1949- *ICPEnP A*, *MacBEP*
Maloney, Louise B *WhAmArt 85*
Maloney, Louise Burdette 1887- *DcWomA*
Maloney, Raymond C 1938- *MarqDCG 84*
Maloney, Robert Thomas 1919- *AmArch 70*
Maloney, William M 1815?- *NewYHSD*
Maloof, Louis N 1935- *AmArch 70*
Maloof, Sam 1916- *BnEnAmA*
Malosso, Il *McGDA*
Malott, C J *AmArch 70*
Malouel, Jean *McGDA*
Malouel, Jean d1419 *OxArt*
Malpas, T *BiDBrA*
Malpass, Michael Allen 1946- *WhoAmA 84*
Malraux, Andre 1901- *McGDA*
Malraux, Andre 1901-1976 *WhoAmA 78N, -80N,*
 -82N, -84N
Malraux, Georges Andre 1901-1976 *OxTwCA*
Malroy, D Florence *DcVicP 2*
Malsby, Robert J 1917- *AmArch 70*
Malsch, Ellen L *WhoAmA 73, -76, -78, -80, -82, -84*
Malsis, Mademoiselle *DcWomA*
Malta, Vincent 1922- *WhoAmA 78, -80, -82, -84*
Maltby, Chapman *EncASM*
Maltby, Hazel Farrow *WhoAmA 76, -78, -80, -82,*
 -84
Maltby, John *DcCAr 81*
Maltby, Kathleen *DcBrA 1*
Maltby Stevens *EncASM*
Maltby Stevens And Curtiss *EncASM*
Maltese, Fanny Jane 1849-1926 *DcBrWA*, *DcWomA*
Maltherr, Maria Dorothea *DcWomA*
Malthert, Marie *DcWomA*
Malthouse, Eric 1914- *DcBrA 1*, *WhoArt 80, -82,*
 -84
Malton, James d1803 *BiDBrA*, *BkIE*
Malton, James 1766?-1803 *DcBrWA*
Malton, Thomas 1726-1801 *BiDBrA*
Malton, Thomas 1726-1808 *DcBrWA*
Malton, Thomas 1748-1804 *BiDBrA*, *DcBrWA*
Malton, Thomas, Jr. 1748-1804 *McGDA*
Mal'tsev, Akim *IlDcG*
Mal'tsev, I S *IlDcG*
Mal'tsev, S Ivan *IlDcG*
Mal'tsev, Vasilii *IlDcG*
Maltwood, Katharine E d1961 *DcBrA 2*
Maltwood, Katherine Emma 1878-1961 *DcWomA*
Maltz, Edwin 1931- *AmArch 70*
Maltz, N J *AmArch 70*
Maltzman, Stanley 1921- *PrintW 83, -85,*
 WhoAmA 73, -76, -78, -80, -82, -84
Malus, Alex *NewYHSD*
Malvaney, E B *AmArch 70*
Malvaney, E L *AmArch 70*
Malvasia, Carlo, Conte 1616-1693 *OxArt*
Malvern, Corinne *IlsBYP*
Malvern, Corinne d1956 *WhAmArt 85,*
 WhoAmA 80N, -82N, -84N
Malvito, Tommaso *McGDA*
Maly, Vaclav *WhAmArt 85*
Malyshev, Vasili 1900- *ConPhot*, *ICPEnP A*
Mambour, Auguste 1896-1958 *OxTwCA*
Mamet-Patin, Maria Louise 1873- *DcWomA*
Mamigonian, Vahan 1902- *WhAmArt 85*
Maminger, A *DcVicP 2*
Mammen, Jeanne 1890?-1976? *DcWomA*
Mamm, Mathias 1803-1893 *FolkA 86*
Mamola, Ross Rosario 1930- *AmArch 70*
Mamon, Marie Rose *DcWomA*

Mannebach, Lewis *FolkA 86*
Mannen, Paul William 1906- *WhAmArt 85, WhoAmA 73, -76*
Manners, George Phillips 1789?-1866 *BiDBrA*
Manners, Mrs. Henry *DcVicP 2*
Manners, Norman Egmont 1905- *DcBrA 1*
Manners, William *DcBrA 1, DcBrWA, DcVicP 2*
Mannes, Leopold D 1899-1964 *MacBEP*
Mannes, Leopold Damrosch 1899-1964 *ICPEnP*
Mannfeld, Conrad *DcVicP 2*
Mannheim, Eunice 1862-1910 *DcWomA*
Mannheim, Jean 1863- *WhAmArt 85*
Mannheim, Jean 1863-1945 *ArtsAmW 1*
Mannheimer, Charlotte 1866-1934 *DcWomA*
Manni, Giannicola DiPaolo 1460?-1544 *McGDA*
Mannin, James d1779 *DcBrECP, DcBrWA*
Mannin, Mrs. M d1864 *DcVicP 2*
Mannin, Mary A 1800-1864 *DcWomA*
Manning *FolkA 86*
Manning, Caleb d1810? *CabMA*
Manning, Charles H 1813?- *CabMA*
Manning, Daniel A 1825- *CabMA*
Manning, E B *EncASM*
Manning, E P *EncASM*
Manning, Eleanor 1884-1973 *MacEA*
Manning, Eliza F *DcVicP 2*
Manning, Frederick 1758-1806? *FolkA 86*
Manning, H F *AmArch 70*
Manning, H Rosalie *WhAmArt 85*
Manning, Harry J 1877-1933 *BiDAmAr*
Manning, Hilda Scudder *WhoAmA 82, -84*
Manning, Jack 1920- *ICPEnP A*
Manning, Jo 1923- *WhoAmA 73, -76, -78, -80, -82, -84*
Manning, John *FolkA 86*
Manning, John H *NewYHSD*
Manning, John H 1820?- *EarABI, EarABI SUP*
Manning, Josiah 1725-1806 *FolkA 86*
Manning, M R *DcVicP 2*
Manning, Marion Dale *AmArch 70*
Manning, Michael P *DcVicP 2*
Manning, Pierre *NewYHSD*
Manning, R H *DcVicP 2*
Manning, Reg 1905- *WhAmArt 85, WhoAmA 73, -76, -78, -80, -82, -84*
Manning, Reginald 1905- *WorECar*
Manning, Rockwell 1760-1806 *FolkA 86*
Manning, Rosalie H *DcWomA*
Manning, Russell 1929- *WorECom*
Manning, Samuel *FolkA 86*
Manning, Sondra Sides 1950- *MarqDCG 84*
Manning, Thaddeus *EncASM*
Manning, Thomas *CabMA*
Manning, Ula Lee 1897- *AmArch 70*
Manning, Virginia 1907- *WhAmArt 85*
Manning, William Reynolds 1902- *AmArch 70*
Manning, William Westley 1868-1954 *DcBrA 1, DcBrWA, DcVicP 2*
Manning, Wray *WhAmArt 85*
Manning Bowman *EncASM*
Mannini, Giacomo Antonio 1646-1732 *ClaDrA*
Mannino, Thomas Joseph 1934- *AmArch 70*
Manno DiBandino *McGDA*
Manno DiSebastiano Sbarri *McGDA*
Mannozi, Giovanni 1592-1636 *ClaDrA*
Mannozzi, Giovanni 1592-1636 *McGDA*
Mannstein Von, Coordt 1937- *WhoGrA 82[port]*
Mannucci, Edgardo 1904- *OxTwCA, PhDcTCA 77*
Manny, Carter Hugh, Jr. 1918- *AmArch 70*
Mano, Kiyoshi 1921- *AmArch 70*
Manocchi, Giuseppe *BiDBrA*
Manoir, Irving K 1891- *ArtsAmW 2, WhAmArt 85*
Manolo 1872-1945 *PhDcTCA 77*
Manon, Estelle *DcWomA*
Manon, Estelle Ream 1884- *ArtsAmW 3, WhAmArt 85*
Manon Buteux, Marie Barbe *DcWomA*
Manoog, John M *NewYHSD*
Manoogian, Richard Jacob 1922- *AmArch 70*
Manor, Florence 1881- *WhAmArt 85*
Manor, Florence M 1881- *DcWomA*
Manor, Irving 1891- *WhAmArt 85*
Manor, Irving K 1891- *ArtsAmW 2*
Manos, Constantine *MacBEP*
Manos, Constantine 1934- *ConPhot, ICPEnP A*
Manos, Peter Nicholas 1932- *AmArch 70*
Manos, R N *AmArch 70*
Manos, Theodore 1956- *MarqDCG 84*
Manos, William Arthur 1954- *MarqDCG 84*
Manousos, Steven Peter 1960- *MarqDCG 84*
Manouvrier, Jules *NewYHSD*
Manrique, Jorge Alberto 1936- *WhoAmA 76, -78, -80, -82*
Manross *FolkA 86*
Mansan, Mrs. *NewYHSD*
Mansaram, P 1934- *WhoAmA 80, -82, -84*
Mansaram, Panchal 1934- *WhoAmA 76, -78*
Mansard, Jeanne *DcWomA*
Mansart, Francois 1598-1666 *DcD&D, MacEA, McGDA, WhoArch*
Mansart, Francois 1598-1667 *OxArt*

Mansart, Jules Hardouin 1646-1708 *DcD&D*
Mansart, Jules-Hardouin 1646-1708 *McGDA*
Mansart, Jules Hardouin 1646-1708 *OxArt*
Mansart DeSagonne, Jacques Hardouin 1703-1758 *MacEA*
Mansel, Miss *DcBrBI*
Mansell, Mrs. *DcWomA*
Mansell, Sir Robert 1573-1656 *IlDcG, AntBDN H*
Mansell, T Norman 1904- *AmArch 70*
Manser, Percy L 1886- *ArtsAmW 3*
Mansergh, Heywood Pettingill 1933- *AmArch 70*
Mansfeld, Al 1912- *ConArch*
Mansfeld, Alfred 1912- *MacEA, WhoArch*
Mansfeld, Joseph George 1764-1817 *ClaDrA*
Mansfield, Benjamin Bream *CabMA*
Mansfield, Blanche *DcWomA*
Mansfield, Blanche McManus 1870- *WhAmArt 85*
Mansfield, George *BiDBrA*
Mansfield, James Carroll 1896- *WhAmArt 85*
Mansfield, John 1601-1674 *AntBDN Q*
Mansfield, Louise B *WhAmArt 85*
Mansfield, Louise Buckingham 1876- *DcWomA*
Mansfield, Richard Harvey 1888- *WhAmArt 85*
Mansfield, Robert Adams 1942- *WhoAmA 82, -84*
Manship, John Paul 1927- *WhoAmA 73, -76, -78, -80, -82, -84*
Manship, Paul 1885-1966 *BnEnAmA, DcAmArt, DcCAA 71, -77, OxTwCA, PhDcTCA 77, WhAmArt 85, WhoAmA 78N, -80N, -82N, -84N*
Manship, Paul Howard 1885-1966 *McGDA*
Manske, Walter Paul 1894- *AmArch 70*
Manskirch, Franz Joseph 1768-1830 *DcBrECP*
Manskirch, Franz Joseph 1770-1827 *DcBrWA*
Manso, Leo 1914- *DcCAA 71, -77, McGDA, WhoAmA 73, -76, -78, -80, -82, -84*
Manso Y Chaves, Barnarda d1821 *DcWomA*
Manson, Elmer John 1913- *AmArch 70*
Manson, George 1850-1876 *ArtsNiC, ClaDrA, DcBrWA, DcVicP 2*
Manson, Harold *WhAmArt 85*
Manson, J B *OxTwCA*
Manson, James Bolivar 1879-1945 *DcBrA 1*
Manson, Lewis P 1911- *AmArch 70*
Mansueti, Giovanni *McGDA*
Mansur *McGDA*
Mansur, D F *AmArch 70*
Mansur, Wilfrid A d1931 *BiDAmAr*
Mansure, Charles 1832?- *NewYHSD*
Mansure, John J 1834?- *NewYHSD*
Mansure, Robert *NewYHSD*
Mansuy, Suzanne Lucie 1874- *DcWomA*
Mansuy-Dotin, Lucie *DcWomA*
Manta, Joao Abel 1928- *WhoGrA 62, -82[port]*
Mante, Harald 1936- *ConPhot, ICPEnP A*
Mante, Louis-Amedee 1826-1913 *MacBEP*
Mante, Perina d1745? *DcWomA*
Mantegazza, Antonio d1489? *McGDA*
Mantegazza, Cristoforo d1482 *McGDA*
Mantegna, Andrea 1431-1506 *ClaDrA, McGDA, OxArt*
Mantel, Jacob *FolkA 86*
Mantel, James Edward 1927- *AmArch 70*
Mantel, Maurice 1914- *AmArch 70*
Mantell, Ann *WhAmArt 85*
Mantell, James *FolkA 86*
Mantell, Thomas *FolkA 86*
Mantenais, Elisabeth Dominique *DcWomA*
Manteola, Flora 1936- *ConArch*
Manter, Alice A 1857-1919 *DcWomA*
Manthey, E W *AmArch 70*
Mantilla, Pedro Pablo 1910- *AmArch 70*
Mantius, Marie 1872- *DcWomA*
Mantle, Glenn Wallace 1922- *AmArch 70*
Mantle, Mickey W 1949- *MarqDCG 84*
Manton, Elizabeth *DcVicP 2*
Manton, G Grenville d1932 *DcBrA 1, DcVicP 2*
Manton, G Grenville 1855-1932 *DcBrBI*
Manton, Grenville *DcVicP*
Manton, Jock 1906- *WhoAmA 73, -76, -78, -80, -82, -84*
Manton, John 1752-1834 *AntBDN F*
Manton, Joseph 1766-1835 *AntBDN F, OxDecA*
Mantovani, Rosina *DcWomA*
Mantovano *McGDA*
Mantuana, Diana *DcWomA*
Mantz, Werner 1901- *ConPhot*
Mantz, Werner 1901-1983 *ICPEnP*
Manuel *DcBrECP*
Manuel, Boccini 1890- *WhAmArt 85*
Manuel, Donaldo 1890- *ArtsAmW 3*
Manuel, Dorothy Holt *WhAmArt 85*
Manuel, Hans Rudolf 1525?-1572 *ClaDrA*
Manuel, J Wright T d1899 *DcBrBI*
Manuel, Margaret *WhAmArt 85*
Manuel, Mildred Beamish 1899- *DcWomA*
Manuel, Niklaus *ClaDrA, OxArt*
Manuel, Victor *OxTwCA*
Manuel-Deutsch, Nikolaus 1484?-1530 *McGDA*
Manuela, Marie DeRoche-Chouart-Mortemart 1847-1933 *DcWomA*
Manuella, Frank R *WhoAmA 76, -78, -80, -82, -84*

Manuilov, Giorgi 1897- *WhAmArt 85*
Manus, Connie Sandage *WhoAmA 80, -82, -84*
Manutius, Aldus 1449-1515 *OxDecA*
Manville, Clara *ArtsEM, DcWomA*
Manville, Ella Viola Grainger 1889-1979 *DcWomA, WhoAmA 80N, -82N, -84N*
Manville, Elsie 1922- *PrintW 85, WhoAmA 73, -76, -78, -80, -82, -84*
Manwaring, G R *DcVicP 2*
Manwaring, Michael 1942- *ConDes*
Manwaring, Robert *AntBDN G*
Manwell, Tom 1941- *MarqDCG 84*
Many, Alexis B 1879- *DcWomA*
Many, Alexis B 1879-1937 *WhAmArt 85*
Many, Alexis B 1879-1938 *ArtsAmW 2*
Manyard, Adolph Best *WhAmArt 85*
Manzanares, Luisa 1864-1949 *FolkA 86*
Manzavrakos, Michael *PrintW 85*
Manzi, Angelo *WhAmArt 85*
Manzi, Riccardo 1913- *WhoGrA 62*
Manzo, Anthony Joseph *WhoAmA 76, -78, -80, -82, -84*
Manzo, Anthony Joseph 1928- *AmArt*
Manzolini, Anna Morandi 1716-1774 *DcWomA*
Manzon, Jean 1915- *ICPEnP A*
Manzoni, Claudia Felicita d1703 *DcWomA*
Manzoni, Marie Louise 1855-1919 *DcWomA*
Manzoni, Piero 1933-1963 *ConArt 77, -83, OxTwCA, PhDcTCA 77*
Manzoni, Teresa *DcWomA*
Manzu, Giacomo 1908- *ConArt 77, -83, McGDA, OxArt, OxTwCA, PhDcTCA 77, WhoArt 80, -82, -84, WorArt[port]*
Manzu, Pio 1939-1969 *ConDes*
Manzuoli, Tommaso D'Antonio 1532?-1571 *McGDA*
Manzur, David *OxTwCA*
Mao I *McGDA*
Mao, Sung *McGDA*
Mapel, Ida Bigler *DcWomA, WhAmArt 85*
Mapes, Doris Williamson 1920- *WhoAmA 73, -76, -78, -80, -82, -84*
Mapes, James Jay 1806-1866 *NewYHSD*
Mapes, Philip M 1934- *AmArch 70*
Maphis, John M *FolkA 86*
Maples, Anna B C *WhAmArt 85*
Maples, C F *AmArch 70*
Maples, Horace Calvin 1922- *AmArch 70*
Maples, Thomas 1803?- *NewYHSD*
Maplesden, Gwendoline E *DcWomA, WhAmArt 85*
Maplestone, Florence E *DcBrWA, DcWomA*
Maplestone, Florence Elizabeth *DcVicP 2*
Maplestone, Henry 1819-1884 *DcBrWA, DcVicP 2*
Mapother, Dillon H *NewYHSD*
Mapp, F T *FolkA 86*
Mapp, John *DcCAr 81*
Mapp, John Ernest 1926- *ClaDrA, WhoArt 80, -82, -84*
Mappes, H *FolkA 86*
Mappin, John Newton *EncASM*
Mappin And Webb *EncASM*
Mappin Brothers *EncASM*
Mapping, Helen *DcBrWA, DcVicP 2*
Mapplethorpe, Robert 1946- *AmArt, ConPhot, ICPEnP A, MacBEP, PrintW 85, WhoAmA 82, -84*
Mapplethorpe, Robert 1947- *DcCAr 81, PrintW 83*
Maqhubela, Louis *OxTwCA*
Maquarre, D *WhAmArt 85*
Mar, Earl Of *BiDBrA*
Mar, J W *AmArch 70*
Mara, Pol 1920- *ConArt 77, OxTwCA, PhDcTCA 77*
Mara, Tim 1948- *DcCAr 81*
Maracsko, Gabriella 1949- *DcCAr 81*
Maradiaga, Ralph 1934- *WhoAmA 76, -78, -80, -82, -84*
Maraffi, Luigi 1891- *WhAmArt 85*
Maragliano, Anton Maria 1664-1739 *McGDA*
Maragliotti, Vincent *WhAmArt 85*
Maragliotti, Vincent 1888-1978 *WhoAmA 80N, -82N, -84N*
Maraini, Adelaide 1843- *DcWomA*
Marais *WhoAmA 73, -76, -78, -80, -82, -84, WhoArt 80, -82, -84*
Marais, Sophie 1797-1847 *DcWomA*
Marak, K J *AmArch 70*
Marak, Louis Bernard 1942- *WhoAmA 76, -78, -80, -82, -84*
Maran, Anuica 1918- *OxTwCA*
Maran, Mary Jane Green *FolkA 86*
Marandel, J Patrice 1944- *WhoAmA 76, -78, -80*
Marandon DeMontyel, Nelly *DcWomA*
Marangoni, Margherita *DcWomA*
Maranhao, Pericles 1924-1961 *WorECar*
Marans, Moissaye 1902- *WhoAmA 73, -76*
Marans, Moissaye 1902-1977 *WhAmArt 85, WhoAmA 78N, -80N, -82N, -84N*
Marantz, Irving 1912-1972 *WhoAmA 78N, -80N, -82N, -84N*
Maras *NewYHSD*

Marasco, Rose 1948- *WhoAmA 84*
Maratta, Carlo 1625-1713 *McGDA, OxArt*
Maratta, Hardesty Gillmore 1864-1924 *ArtsAmW 2, WhAmArt 85*
Maratta, M Faustina 1680-1745? *DcWomA*
Maratti, Carlo 1625-1713 *ClaDrA, OxArt*
Maratti, M Faustina 1680-1745? *DcWomA*
Marazzi, William C P 1947- *WhoAmA 76, -78, -80, -82, -84*
Marbe-Fries, Milly 1876- *DcWomA*
Marbeau, Philippe 1807-1861 *ClaDrA*
Marbel Jr. *WorFshn*
Marber, Romek 1925- *WhoGrA 82[port]*
Marberger, A Aladar 1947- *WhoAmA 78, -80, -82, -84*
Marble, Edward H 1920- *AmArch 70*
Marble, John 1764-1844 *FolkA 86*
Marble, John Nelson 1855-1918 *ArtsAmW 2, WhAmArt 85*
Marble, Joseph 1726-1805 *FolkA 86*
Marblo *DcCAr 81*
Marboutin, Germaine 1899- *DcWomA*
Marburg, C F *AmArch 70*
Marc, Andre 1887-1932 *DcNiCA*
Marc, Fanny 1858-1937 *DcWomA*
Marc, Franz 1880-1916 *ConArt 83, McGDA, OxArt, OxTwCA, PhDcTCA 77*
Marc, Jean-Auguste 1818- *ArtsNiC*
Marc-Bonnehee, Louise Mathilde 1836?-1900 *DcWomA*
Marc-Bonnemee, Louise Mathilde 1836?-1900 *DcWomA*
Marca-Relli, Conrad 1913- *AmArt, BnEnAmA, ConArt 77, -83, DcAmArt, DcCAA 71, -77, McGDA, OxTwCA, PhDcTCA 77, PrintW 83, -85, WhoAmA 73, -76, -78, -80, -82, -84, WorArt[port]*
Marcacci, Henri 1925- *DcCAr 81*
Marcadet, Jeanne 1893- *DcWomA*
Marcantonio Raimondi *McGDA, OxArt*
Marcantonio, Richard C 1930- *AmArch 70*
Marceau-Desgraviers, Marie Jeanne Louise *DcWomA*
Marcel *EncASM*
Marcel 1946- *PrintW 83, -85*
Marcel, Adele *DcWomA*
Marcel, Edwards-Renee 1899- *DcWomA*
Marcelle, Vito *NewYHSD*
Marcelli, Michael Philip 1925- *AmArch 70*
Marcellin, Jean-Esprit 1822?-1884 *ArtsNiC*
Marcellino, F C *AmArch 70*
Marcello *DcWomA*
Marcellus, John *FolkA 86*
Marceron-Maille, Jeanne 1871- *DcWomA*
Marcet, E M *AmArch 70*
Marcey, William *NewYHSD*
March, A *AmArch 70*
March, Carl *WhAmArt 85*
March, Dillon Taylor 1923- *AmArch 70*
March, Edward *DcVicP 2*
March, Elsie *DcBrA 1, DcWomA*
March, Emma *DcWomA, WhAmArt 85*
March, Esteban d1660 *ClaDrA*
March, Giovanni *NewYHSD*
March, J H d1847 *FolkA 86*
March, Jones *CabMA*
March, Otto 1845-1913 *MacEA*
March, Virginia Stephens *AmArch 70*
March, W H *AmArch 70*
March, Werner 1894-1976 *MacEA*
Marchais DesGentils, Jules *NewYHSD*
Marchal, Andree-Oda 1886- *DcWomA*
Marchal, Charles Francois 1825-1877 *ClaDrA*
Marchal, Charles Francois 1828?-1877 *ArtsNiC*
Marchal, Leonide *DcWomA*
Marchand, A *DcWomA*
Marchand, Aline *DcWomA*
Marchand, Andre 1907- *ClaDrA, McGDA, OxTwCA*
Marchand, Andre 1910- *PhDcTCA 77*
Marchand, Andree 1935- *DcCAr 81*
Marchand, Cecile *DcWomA*
Marchand, David *NewYHSD*
Marchand, Gabrielle 1755?- *DcWomA*
Marchand, Jean 1882-1941 *OxTwCA*
Marchand, Jean Hippolyte 1883-1940 *ClaDrA*
Marchand, Jean Omer 1872-1936 *MacEA*
Marchand, John N 1875-1921 *ArtsAmW 1*
Marchand, John Norval 1875-1921 *IIBEAAW, WhAmArt 85*
Marchand, Jules *NewYHSD*
Marchand, Paul 1870- *WhAmArt 85*
Marchant, Edward D *FolkA 86*
Marchant, Edward Dalton 1806-1887 *NewYHSD*
Marchant, G W *NewYHSD*
Marchant, H G *DcWomA*
Marchant, Henry A 1839?- *NewYHSD*
Marchant, Jean M *MarqDCG 84*
Marchant, Padma 1943- *MarqDCG 84*
Marchbanks, G H, Jr. *AmArch 70*
Marchbanks, Hal *WhAmArt 85*
Marche, Adolfo Jose 1936- *AmArch 70*

Marchegiani, Elio 1929- *ConArt 77*
Marcher, James *FolkA 86*
Marchesani, Alfred Richard 1933- *AmArch 70*
Marcheschi, Cork 1945- *WhoAmA 76, -78, -80, -82, -84*
Marcheschi, Louis Cork 1945- *ConArt 77*
Marchese, Lamar Vincent 1943- *WhoAmA 76, -78, -80*
Marchese, N J *AmArch 70*
Marchese, Patricia Davis 1943- *WhoAmA 76, -78, -80, -82, -84*
Marchesi, Girolamo 1471?-1540? *McGDA*
Marchesi, Pompeo 1790-1858 *ArtsNiC*
Marchesi, Salvatore *ArtsNiC*
Marchetti, Elena *DcWomA*
Marchetti, Peter Leonard 1935- *AmArch 70*
Marchi, Agostino De' *McGDA*
Marchi, Giuseppe d1808 *DcBrECP*
Marchi, Virgilio 1895-1960 *ConDes, MacEA*
Marchino, Frederick *NewYHSD*
Marchinville, Mademoiselle De *DcWomA*
Marchinville, Lucile 1759-1780 *DcWomA*
Marchioni, Elisabetta *DcWomA*
Marchionni, Carlo 1702-1786 *MacEA*
Marchisotto, Linda A *WhoAmA 78, -80, -82, -84*
Marcia *DcWomA*
Marcile, Stanley 1907- *FolkA 86*
Marcillat, Guglielmo DiPietro De 1470?-1529 *McGDA*
Marcinowska-Brykner, Eugenia 1892- *DcWomA*
Marck, Caroline Van *DcWomA*
Marcke, Julie Palmyre Van 1801-1875 *DcWomA*
Marcke DeLummen, Emile Van 1827-1890 *ClaDrA*
Marcke DeLummen, Marie Van *DcWomA*
Marcks, Edward Russell 1907- *AmArch 70*
Marcks, Gerhard 1889- *McGDA, OxArt, OxTwCA, PhDcTCA 77, WhoGrA 62*
Marco DaSiena 1525?-1587? *McGDA*
Marco Dell'Avogaro *McGDA*
Marco D'Oggiono 1475-1530 *McGDA*
Marcol, Eugenie Josephine Charlotte De *DcWomA*
Marcolini, Count Camillo 1739-1814 *AntBDN M*
Marcon, Lucien *NewYHSD*
Marconi, Enrico 1792-1863 *MacEA*
Marconi, Giovanni Battista *MacEA*
Marconi, Leandro 1763-1837 *MacEA*
Marconi, Leandro Jan 1834-1919 *MacEA*
Marconi, Leonard 1836-1899 *MacEA*
Marconi, Rocco *McGDA*
Marconi, Wladyslaw 1848-1915 *MacEA*
Marconi Family *MacEA*
Marcotte, Leon *CabMA*
Marcotte, Marie Antoinette 1869- *DcWomA*
Marcou, Jules 1824-1898 *IIBEAAW*
Marcou, Lucien *NewYHSD*
Marcoussis 1883-1941 *OxTwCA*
Marcoussis, Alice *DcWomA*
Marcoussis, Louis 1878-1941 *McGDA*
Marcoussis, Louis 1883-1941 *PhDcTCA 77*
Marcoussis, Louis Casimir Ladislas M 1883-1941 *ClaDrA*
Marcoux, George E 1896-1946 *WhAmArt 85*
Marcoux, Joseph 1894- *AmArch 70*
Marcovigi, Clementina 1863-1887 *DcWomA*
Marcu, Duiliu 1885-1966 *MacEA*
Marcu, M *AmArch 70*
Marcum, Watts Marks, Jr. 1934- *AmArch 70*
Marcus Vitruvius Pollio *McGDA*
Marcus, Aaron 1943- *MarqDCG 84*
Marcus, Angelo P 1942- *WhoAmA 82*
Marcus, Angelo P 1944- *WhoAmA 84*
Marcus, Betty 1923- *WhoAmA 76, -78*
Marcus, Edward S 1910- *WhoAmA 73, -76*
Marcus, Edward S 1910-1972 *WhoAmA 80N, -82N, -84N*
Marcus, Edward S 1910-1977 *WhoAmA 78N*
Marcus, Edwin *WhAmArt 85*
Marcus, Elisa *DcWomA*
Marcus, Elli 1899-1977 *ICPEnP A, MacBEP, WhAmArt 85*
Marcus, I *EncASM*
Marcus, Irving E 1929- *WhoAmA 73, -76, -78, -80, -82, -84*
Marcus, Jerry 1924- *ConGrA 1[port], WorECar*
Marcus, Kaete Ephraim 1892-1970 *DcWomA*
Marcus, Lynne S 1944- *MarqDCG 84*
Marcus, Marcia 1928- *DcCAA 71, -77, PrintW 83, -85, WhoAmA 73, -76, -78, -80, -82, -84*
Marcus, Nathan 1914- *WhAmArt 85*
Marcus, Peter 1889-1934 *WhAmArt 85*
Marcus, Rachel *DcWomA*
Marcus, Stanley 1905- *WhoAmA 73, -76, -78, -80, -82, -84, WorFshn*
Marcus, Susan 1946- *MarqDCG 84*
Marcus, Zola 1915- *WhAmArt 85*
Marcuvitz, Andrew 1949- *MarqDCG 84*
Marcy, Frederick I 1838-1896 *EncASM*
Marcy, J J *FolkA 86*
Marczinowski, Antje 1939- *DcCAr 81*
Marczuk, Michael 1929- *AmArch 70*
Marczynski, Adam 1908- *PhDcTCA 77*

Mardall, C S 1909- *ConArch*
Mardel-Ferreira, Elizabeth Gilchrist 1931- *WhoArt 84*
Mardell, Charles *BiDBrA*
Marden, Brice 1938- *AmArt, ConArt 77, -83, DcAmArt, DcCAA 77, DcCAr 81, PrintW 83, -85, WhoAmA 73, -76, -78, -80, -82, -84*
Marden, J *FolkA 86*
Marden, Luis 1913- *ICPEnP A*
Marden, Richard A 1960- *MarqDCG 84*
Marder, Dorie *WhoAmA 73, -76, -78, -80, -82, -84*
Marder, W S *AmArch 70*
Mardersteig, Giovanni 1892- *WhoGrA 62*
Mardersteig, Giovanni 1892-1977 *ConDes*
Mardirosian, A H *AmArch 70*
Mardon, Allan 1931- *IlrAm 1880*
Mardrus, Lucie *DcWomA*
Mare *NewYHSD*
Mare, Andre 1885-1932 *ClaDrA*
Mare, John 1739?- *NewYHSD*
Mare, John 1739?-1795? *DcAmArt*
Marean, Willis A 1853-1939 *BiDAmAr*
Marec, Victor 1862-1920 *ClaDrA*
Marechal, Cecile *DcWomA*
Marechal, Charles-Laurent 1800?- *ArtsNiC*
Marechal, Helene 1863- *DcWomA*
Marechal, Marguerite *DcWomA*
Marechal, Olympe *DcWomA*
Marechal, Talon, Madame *DcWomA*
Marees, Hans Von 1837-1887 *McGDA*
Marein, Mahala *FolkA 86*
Marek *DcBrA 1, WhoArt 80, -82, -84*
Marek, Jerzy 1925- *WhoArt 80, -82, -84*
Marelli, Andrea *ClaDrA*
Maremont, Arnold H 1904- *WhoAmA 73, -76, -78*
Maremont, Arnold H 1904-1978 *WhoAmA 80N, -82N, -84N*
Marengi, Joseph Alexander 1953- *MarqDCG 84*
Mares, E J *DcVicP 2*
Mares, Henry *DcVicP 2*
Marescalchi, Pietro Dei 1520?-1589 *McGDA*
Marescalco, Il *McGDA*
Mareschal, Olympe *DcWomA*
Mareschal, Pauline *DcWomA*
Marest, Julie *DcWomA*
Marevna 1892- *DcWomA*
Marey, Etienne Jules 1830-1904 *ICPEnP*
Marey, Etienne-Jules 1830-1904 *MacBEP*
Marfaing, Andre 1925- *PhDcTCA 77*
Marfleet, John Allen 1926- *AmArch 70*
Marford, Wladimir 1814-1827 *FolkA 86, NewYHSD*
Margah, Katherine 1868-1950 *DcWomA*
Margah, Katherine Conely 1868-1950 *ArtsEM*
Marganne 1865- *DcWomA*
Margantin, Marie Leonie 1869- *DcWomA*
Margaret Of Antioch, Saint *McGDA*
Margaretha *DcWomA, FolkA 86*
Margaretten, Frederick M *FolkA 86*
Margarito Of Arezzo *OxArt*
Margaritone D'Arezzo *McGDA*
Margat, Marie M *DcWomA*
Marge *WhAmArt 85*
Margerie *DcCAr 81*
Margerum, R R *AmArch 70*
Margerum, Roger Williams 1930- *AmArch 70*
Margeson, Gilbert Tucker *WhAmArt 85*
Margetson, Helen Howard 1860- *DcBrA 1, DcBrWA, DcWomA*
Margetson, Hester 1890-1965 *DcWomA*
Margetson, Mrs. W H 1860- *DcVicP 2*
Margetson, William Henry 1861-1940 *ClaDrA, DcBrA 1, DcBrBI, DcBrWA, DcVicP 2*
Margetts, Mrs. *DcWomA*
Margetts, Ada *DcVicP 2, DcWomA*
Margetts, Mary d1886 *DcBrWA, DcVicP 2, DcWomA*
Marggraff, Ida 1851- *DcWomA*
Margitson, Maria *DcVicP 2*
Margitson, Marie *DcWomA*
Margni, Semaje 1941- *AfroAA*
Margo, Boris 1902- *DcCAA 71, -77, WhAmArt 85, WhoAmA 73, -76, -78, -80, -82, -84*
Margo, Jeannette *WhAmArt 85*
Margolf, David Glenn 1930- *AmArch 70*
Margolies, Ethel Polacheck 1907- *WhoAmA 73, -76, -78, -80, -82, -84*
Margolies, John 1940- *ICPEnP A, MacBEP, WhoAmA 76, -78, -80, -82*
Margolies, John Samuel 1940- *WhoAmA 73*
Margolies, S L 1897- *WhAmArt 85*
Margolis, David 1911- *WhAmArt 85, WhoAmA 82, -84*
Margolis, Edward Morris 1934- *AmArch 70*
Margolis, J H *AmArch 70*
Margolis, Joseph 1896- *AmArch 70*
Margolis, Nathan 1908- *WhAmArt 85*
Margolis, Richard 1943- *ConPhot, ICPEnP A, MacBEP*
Margolis, Richard M 1943- *WhoAmA 82, -84*
Margon, Lester 1892- *WhAmArt 85*
Margot, Antoinette 1843-1925 *DcWomA*
Margot, Augustus P *NewYHSD*

Margoulies, Berta 1907- *WhAmArt 85,*
 WhoAmA 78, −80, −82, −84
Margraf, John Irwin 1938- *AmArch 70*
Margraff, Francis *NewYHSD*
Margrie, Victor 1929- *WhoArt 80, −82, −84*
Margritte, Rene 1898-1967 *ConArt 83*
Marguerita *WorECar*
Marguerite, Archduchess Of Austria 1480-1530
 DcWomA
Margules, Dehirsh d1965 *WhoAmA 78N, −80N,*
 −82N, −84N
Margules, DeHirsh 1899-1965 *WhAmArt 85*
Margules, Gabriele Ella 1927- *WhoAmA 76, −78, −80,*
 −82, −84
Margulies, Herman 1922- *WhoAmA 84*
Margulies, Isidore 1921- *WhoAmA 76, −78, −80, −82,*
 −84
Margulies, James *WhAmArt 85*
Margulies, Joseph 1896- *WhAmArt 85,*
 WhoAmA 73, −76, −78, −80, −82, −84
Margulies, Pauline 1895- *DcWomA, WhAmArt 85*
Margulis, Martha 1928- *WhoAmA 82, −84*
Margulis, Martha Boyer 1938- *AmArt*
Mari *WhoAmA 76, −78, −80, −82, −84*
Mari, Enzo 1932- *ConArt 77, ConDes, OxTwCA,*
 PhDcTCA 77
Mari, Valere De 1886- *ArtsAmW 2*
Mari, Valerie De 1886- *ArtsAmW 2, WhAmArt 85*
Mari, Valerius De 1886- *ArtsAmW 2*
Maria *DcBrWA*
Maria 1900- *McGDA*
Maria Anna, Archduchess Of Austria 1738-1789
 DcWomA
Maria Antonia Walpurgis 1724-1780 *DcWomA*
Maria Carolina, Charlotte 1752-1814 *DcWomA*
Maria Christina 1742-1798 *DcWomA*
Maria Cristina DeBourbon, Queen Of Spain 1806-1878
 DcWomA
Maria Elisabeth Amalia *DcWomA*
Maria Fedorovna 1759-1828 *DcWomA*
Maria Francisca DeAsis DeBourbon 1783-1834
 DcWomA
Maria Isabella Of Bourbon *DcWomA*
Maria Luisa DeBourbon, Queen Of Spain 1662-1689
 DcWomA
Maria Maddalena De'Pazzi *DcWomA*
Maria Speranda *DcWomA*
Maria Teodora *DcWomA*
Maria Theresa, Empress Of Austria 1717-1780
 DcWomA
Marian *WhoArt 80, −82*
Marian, Maria *DcWomA*
Mariana *IlsCB 1946, −1957, −1967*
Mariana, Mademoiselle *DcWomA*
Marianetti, Louise E 1916- *WhAmArt 85*
Mariani, Camillo 1565?-1611 *McGDA*
Mariani, Elio 1943- *ConArt 77*
Mariani, Theodore Frank 1931- *AmArch 70*
Mariani, Umberto 1936- *ConArt 77*
Mariani, Virginia 1824-1898 *DcWomA*
Marianne 1941- *AmArt, WhoAmA 82, −84*
Mariano, Agnolo DiCosimo Di *McGDA*
Mariano, Anne 1934- *WhoAmA 73, −76*
Mariano, Kristine 1939- *WhoAmA 76, −78, −80, −82,*
 −84
Marichal, Peter *DcVicP 2*
Maricot, Zoe Amelie *DcWomA*
Marie Alexandrine 1849-1922 *DcWomA*
Marie Anna Of Prussia *DcWomA*
Marie Caroline Ferdinande L DeBourbon *DcWomA*
Marie Christine Caroline D'Orleans 1813-1839
 DcWomA
Marie De Sainte-Catherine *DcWomA*
Marie DeChantal *DcWomA*
Marie DeL'Assumption *DcWomA*
Marie DeMedici *DcWomA*
Marie Leszczynska, Queen Of France 1703-1768
 DcWomA
Marie Louise, Empress Of France 1791-1847 *DcWomA*
Marie Louise Alexandrine Caroline 1845-1905
 DcWomA
Marie, Queen Of Romania 1875-1938 *DcWomA*
Marie, Adrien Emmanuel 1848-1891 *ClaDrA*
Marie, Adrien-Emmanuel 1848-1891 *DcBrBI*
Marie, Louise *DcWomA*
Marie, Louise Sophie *DcWomA*
Marie-Antoinette, Archduchess Of Austria 1755-1793
 DcWomA
Marie-De-L'Incarnation, Mere 1599-1672 *DcWomA*
Marie-Teresa 1877- *DcWomA, WhAmArt 85*
Marielle, Adele *DcWomA*
Marien, Marcel 1920- *ConArt 77*
Mariendal, Anne 1948- *DcCAr 81*
Marieschi, Jacopo DiPaolo 1711-1791 *McGDA*
Marieschi, Michele Giovanni 1710-1743 *McGDA*
Mariette, Pierre Jean 1694-1774 *McGDA*
Marigny, Marquis De 1727-1781 *MacEA*
Marigny, Anne Marguerite H Rouille *DcWomA*
Marigny, Eulalie 1800?-1868 *DcWomA*
Marigny, Louise d1868? *DcWomA*
Mariinsky, Harry 1909- *WhAmArt 85*

Marijac *WorECom*
Maril, Herman 1908- *AmArt, WhAmArt 85,*
 WhoAmA 73, −76, −78, −80, −82, −84
Maril, Lee 1895- *WhAmArt 85*
Marilhat, Prosper 1810-1847 *ArtsNiC*
Marilhat, Prosper Georges Antoine 1811-1847 *ClaDrA*
Marillier, Clement Pierre 1740-1808 *BkIE*
Marillier, Clement-Pierre 1740-1808 *McGDA*
Marimekko *FairDF FIN*
Marin, Augusto 1921- *WhoAmA 76, −78, −80, −82,*
 −84, WhoGrA 62
Marin, Berthe *DcWomA*
Marin, Enrique 1935- *DcCAr 81*
Marin, John 1870-1953 *BnEnAmA, ConArt 83,*
 DcAmArt, DcCAA 71, −77, GrAmP, IlBEAAW,
 McGDA, OxArt, OxTwCA, PhDcTCA 77,
 WhAmArt 85, WhoAmA 78N, −80N, −82N, −84N
Marin, John 1872-1953 *ArtsAmW 2*
Marin, Kathryn Garrison 1936- *WhoAmA 73, −76,*
 −78
Marinaccio, Paul Joseph 1937- *MarqDCG 84*
Marinali, Orazio 1643-1720 *McGDA*
Marinari, Gaetano *DcBrECP*
Marinaro, J *AmArch 70*
Marinaro, Robert Anthony 1952- *MarqDCG 84*
Marinc, Joze 1954- *DcCAr 81*
Marinelli, Eva *WhoAmA 73*
Marinetti, Antonio 1710?-1796 *McGDA*
Marinetti, Emilio Filippo Tommaso 1876-1944
 McGDA
Marinetti, Filippo Tommaso 1876-1944 *OxArt,*
 OxTwCA
Marini, Daniele 1946- *MarqDCG 84*
Marini, Giulia *DcWomA*
Marini, Marino *WhoArt 82N*
Marini, Marino 1901- *ConArt 77, DcCAr 81,*
 McGDA, PhDcTCA 77, WhoArt 80
Marini, Marino 1901-1966 *OxArt*
Marini, Marino 1901-1980 *ConArt 83, OxTwCA,*
 PrintW 85, WorArt[port]
Marinier, Jeanne Alice *DcWomA*
Marinitch, Cosima Antonowitch d1870 *DcWomA*
Marinitsch, Christian De 1868- *ClaDrA*
Marinkelle, Maria Adriana 1764-1794? *DcWomA*
Marinko, George J 1908- *WhAmArt 85*
Marinkovic, Anna 1882- *DcWomA*
Marinkovic, Miroslav 1928- *OxTwCA*
Marino, Albert Joseph 1899- *WhoAmA 73, −76, −78*
Marino, Albert Joseph 1899-1975 *WhoAmA 80N,*
 −82N, −84N
Marino, Anthony Louis 1944- *MarqDCG 84*
Marino, Anthony Robert 1937- *AmArch 70*
Marino, Dorothy Bronson 1912- *IlsCB 1946, −1957*
Marino, Frank 1942- *WhoAmA 82, −84*
Marino, Louis J 1934- *AmArch 70*
Marino-Merlo, Joseph 1906-1956 *WhAmArt 85,*
 WhoAmA 80N, −82N, −84N
Marinoni-Gramizzi, Ida *DcWomA*
Marinot, Maurice 1882-1960 *DcNiCA, IlDcG*
Marinsky, Harry 1909- *WhoAmA 76, −78, −80, −82,*
 −84
Marinus VanReymerswaele d1567? *OxArt*
Marinus, Ferdinand Joseph Bernard 1808-1890 *ClaDrA*
Mario, Alessandro E *NewYHSD*
Marion, Edward *FolkA 86*
Marion, Ida *DcWomA*
Marion, Ida Dougherty 1878- *WhAmArt 85*
Marion, John Baptist 1928- *AmArch 70*
Marion, Markham *WhAmArt 85*
Marioni, Luigi J 1903- *AmArch 70*
Marioni, Paul 1941- *DcCAr 81, WhoAmA 84*
Marioni, Tom 1937- *ConArt 83, PrintW 83, −85,*
 WhoAmA 76, −78, −80, −82, −84
Mariotto Albertinelli *McGDA*
Mariotto DiNardo 1394?-1424? *McGDA*
Maris, Alyse Tyson 1895- *DcWomA, WhAmArt 85*
Maris, Jacob 1837-1899 *McGDA, OxArt*
Maris, Jacob Henricus 1837-1899 *ClaDrA*
Maris, Jacques *ArtsNiC*
Maris, Matthew 1839-1917 *McGDA*
Maris, Matthias *ArtsNiC*
Maris, Matthias 1839-1917 *OxArt*
Maris, Matthijs 1839-1917 *ClaDrA, OxArt*
Maris, Thijs 1839-1917 *OxArt*
Maris, Valdi S 1919- *WhoAmA 73, −76*
Maris, Willem 1844-1910 *ClaDrA, McGDA, OxArt*
Maris Family *OxArt*
Mariscal, Javier 1950- *ConDes*
Marisol 1930- *ConArt 77, −83, DcCAA 71, −77,*
 McGDA, OxTwCA, PhDcTCA 77, WomArt,
 WorArt[port]
Marisol Escobar 1930- *BnEnAmA, PrintW 85*
Marisol, Escobar 1930- *PrintW 83, WhoAmA 73,*
 −76, −78, −80, −82, −84
Mariston, E *AntBDN C*
Maritain, Genevieve *DcWomA*
Maritz, R E, Jr. *AmArch 70*
Marius, Gerarda Hermina 1854-1919 *DcWomA*
Marius DeMaria *DcVicP 2*
Marjolin, Cornelia *DcWomA*
Marjot, Ernst 1827-1898 *WhAmArt 85*

Mark, Saint *McGDA*
Mark, Adolf DeRoy 1929- *AmArch 70*
Mark, Bendor 1912- *WhAmArt 85, WhoAmA 73,*
 −76, −78, −80, −82, −84
Mark, David M 1947- *MarqDCG 84*
Mark, E W *DcVicP 2*
Mark, Enid 1932- *WhoAmA 76, −78, −80, −82, −84*
Mark, George Washington d1879 *NewYHSD*
Mark, George Washington 1795-1879 *FolkA 86*
Mark, George Zenon 1929- *AmArch 70*
Mark, James *NewYHSD*
Mark, Johanna *DcWomA*
Mark, Joseph Gate 1932- *AmArch 70*
Mark, Louis 1867-1942 *WhAmArt 85*
Mark, Marilyn *WhoAmA 80, −82, −84*
Mark, Marilyn 1930- *WhoAmA 76, −78*
Mark, Mary Ellen *DcCAr 81, MacBEP*
Mark, Mary Ellen 1940- *ConPhot, ICPEnP A,*
 WhoAmA 84
Mark, Matthew W *FolkA 86*
Mark, Phyllis *AmArt, WhoAmA 73, −76, −78, −80,*
 −82, −84
Markam, Wolfe 1892- *AmArch 70*
Markel, Kathryn E 1946- *WhoAmA 78, −80, −82, −84*
Markelbach, Alexandre 1824-1906 *ClaDrA*
Markelin, Antero *ConArch A*
Markelius, Sven 1889- *EncMA, McGDA, OxArt*
Markelius, Sven 1889-1972 *ConArch, WhoArch*
Markelius, Sven Gottfrid 1889-1972 *MacEA*
Markelius, Sven Gottfried 1889- *DcD&D*
Markell, Isabella Banks 1891- *WhoAmA 73, −76, −78,*
 −80, −82, −84
Markell, Isabella Banks 1896- *DcWomA,*
 WhAmArt 85
Marker, Mariska Pugsley *AmArt, WhoAmA 76, −78,*
 −80, −82, −84
Marker, Ralph E 1925- *WhoAmA 76, −78, −80, −82,*
 −84
Marker, Thomas Morrison 1901- *WhAmArt 85*
Markert, Herman *FolkA 86*
Markes, Albert Ernest 1865-1901 *DcBrA 1, DcBrWA,*
 DcVicP 2
Markeson, E P *WhAmArt 85*
Markevich, Boris Anisimovich 1925- *WhoGrA 62*
Markham, Charles C 1837-1907 *WhAmArt 85*
Markham, Charles Cole 1837-1907 *NewYHSD*
Markham, Charlotte *DcWomA*
Markham, Charlotte 1892- *WhAmArt 85*
Markham, Fred Lewis 1902- *AmArch 70*
Markham, J F *AmArch 70*
Markham, Joy Pratt *WhAmArt 85*
Markham, Kyra 1891- *WhAmArt 85*
Markham, Kyra 1891-1967 *DcWomA*
Markham, Marion *WhAmArt 85*
Markham, Marion Esther 1875- *DcWomA*
Markham, Markwick *AntBDN D*
Markham, Michael *DcCAr 81*
Markham, Michael Adrian 1921- *DcBrA 1*
Markham, Philip K 1926- *AmArch 70*
Markham, R *DcBrECP*
Markham, William 1796-1852 *DcBrWA*
Markiewicz, Aleksander 1918- *AmArch 70*
Markiewicz, Herbert Otto 1900- *DcBrA 1*
Markino, Yoshio 1874- *DcBrA 1*
Markland, James *NewYHSD*
Markland, Sadie d1899 *DcWomA*
Markland, William *AntBDN N*
Markle, Alvan, Jr. 1889- *WhAmArt 85*
Markle, Jack M 1939- *WhoAmA 76, −78, −80, −82,*
 −84
Markle, Robert *OxTwCA*
Markle, Robert 1936- *DcCAr 81, PrintW 83, −85*
Markle, Sam 1933- *WhoAmA 76, −78, −80, −82, −84*
Marklen, H *DcBrBI*
Markley, C A *AmArch 70*
Markley, James C *FolkA 86*
Markley, Robert Charles 1937- *AmArch 70*
Markley, William E 1930- *AmArch 70*
Markman, Ronald 1931- *DcCAA 71, −77,*
 WhoAmA 78, −80, −82, −84
Markman, Sidney David 1911- *WhoAmA 78, −80, −82,*
 −84
Marko, Katalin 1831-1865 *DcWomA*
Markoe, Francis, Jr. *NewYHSD*
Markoe, Francis Hartman 1884- *WhAmArt 85*
Markoe, S Bendelari *WhAmArt 85*
Markous, Louis *McGDA*
Markovich, Radmilo Antonije 1929- *AmArch 70*
Markow, Jack 1905- *WhAmArt 85, WhoAmA 73,*
 −76, −78, −80, −82, WorECar
Markow, Jack 1905-1983 *WhoAmA 84N*
Markowitz, B *AmArch 70*
Markowitz, Herman 1922- *MarqDCG 84*
Markowski, Eugene David 1931- *WhoAmA 76, −78,*
 −80, −82, −84
Markowski, Susan Elizabeth 1960- *MarqDCG 84*
Markoya, Louis John 1951- *MarqDCG 84*
Marks *NewYHSD*
Marks, A H *FolkA 86*
Marks, A J *DcBrBI*
Marks, A M *AmArch 70*

Marks, Aleksandar 1922- *WorECar*
Marks, Anne *DcVicP 2*
Marks, B *AmArch 70*
Marks, Barnett Samuel 1827- *DcVicP*
Marks, Barnett Samuel 1827-1916 *DcBrA 1,*
DcVicP 2
Marks, Cedric H *WhoAmA 73, -76, -78, -80,*
-82, -84
Marks, Mrs. Cedric H *WhoAmA 73, -76, -78,*
-80, -82, -84
Marks, Charles E *WhAmArt 85*
Marks, Claude 1915- *WhoAmA 76, -78, -80, -82, -84,*
WhoArt 80, -82, -84
Marks, Edmund *DcVicP 2*
Marks, Edward 1902- *AmArch 70*
Marks, Eldon Dean 1934- *AmArch 70*
Marks, Florence *DcVicP 2*
Marks, George *DcBrA 1, DcVicP, -2*
Marks, George B 1923- *IlBEAAW, WhoAmA 76,*
-78, -80, -82
Marks, George B 1923-1983 *WhoAmA 84N*
Marks, Gilbert *AntBDN A*
Marks, Mrs. H S *DcVicP 2*
Marks, Henry Stacy 1829- *ArtsNiC*
Marks, Henry Stacy 1829-1898 *ClaDrA, DcBrBI,*
DcBrWA, DcNiCA, DcVicP, -2
Marks, Irving Philip 1911- *AmArch 70*
Marks, Isaac 1859- *WhAmArt 85*
Marks, J *BiDBrA*
Marks, J G *DcVicP 2*
Marks, Laura Anne Celia 1954- *WhoArt 84*
Marks, Mrs. Laurence M *WhoAmA 73*
Marks, Lewis *DcBrBI*
Marks, Lucie E *DcWomA*
Marks, Montague *WhAmArt 85*
Marks, P J *AmArch 70*
Marks, Peggie 1914- *WhoArt 80, -82, -84*
Marks, Peter A 1948- *MarqDCG 84*
Marks, Raymond Otto 1907- *AmArch 70*
Marks, Roberta B 1936- *CenC*
Marks, Roberta Barbara 1936- *AmArt, WhoAmA 82,*
-84
Marks, Royal S 1927- *WhoAmA 84*
Marks, Royal S 1929- *WhoAmA 73, -76, -78, -80,*
-82
Marks, Rudenko *WorFshn*
Marks, Stanley *WhoAmA 73*
Marks, Stanley Albert 1927- *WhoAmA 76, -78*
Marks, Stella 1889- *DcWomA*
Marks, Stella Lewis 1889- *DcBrA 1*
Marks, Stella Lewis 1892- *WhAmArt 85*
Marks, William d1906 *WhAmArt 85*
Markson, Jerome 1929- *ConArch*
Markus, Erzsi 1888- *DcWomA*
Markus, Henry A *WhoAmA 78N*
Markus, Mrs. Henry A *WhoAmA 80*
Markus, Henry A *WhoAmA 80N, -82N, -84N*
Markus, Mrs. Henry A *WhoAmA 73, -76, -78*
Markusen, Thomas Roy 1940- *WhoAmA 78, -80, -82,*
-84
Markwart, Peter *OxDecA*
Markwart, Simon *OxDecA*
Marlais, John Louis 1926- *AmArch 70*
Marlatt, H Irving d1929 *ArtsAmW 1, IlBEAAW*
Marlatt, H Irving 186-?-1929 *WhAmArt 85*
Marlborough, George, Duke Of 1766-1840 *DcBrWA*
Marlchamm, Charlotte *WhAmArt 85*
Marle, Cornelia Van *DcWomA*
Marle, Eva Van *DcWomA*
Marlef, Claude 1864- *DcWomA*
Marlelliere, Laure 1886- *DcWomA*
Marlen, Cornelia Van *DcWomA*
Marlen, William *CabMA*
Marlet, Jean Henri 1771-1847 *ClaDrA*
Marlett, Eliza Ann *FolkA 86*
Marlett, Wilson *WhAmArt 85*
Marlette, Douglas N 1949- *WorECar*
Marletto, Carlos Joseph 1909- *WhAmArt 85*
Marley, J J *AmArch 70*
Marley, Mary Ann 1820- *FolkA 86*
Marlie Lepicie, Renee Elisabeth *DcWomA*
Marlier, B J *AmArch 70*
Marlin, Hilda *WhAmArt 85*
Marlin, Hilda VanStockum 1908- *WhoAmA 73, -76*
Marlin, James, Sr. *CabMA*
Marlin, Molly 1865- *DcWomA*
Marling, J *AmArch 70*
Marling, Jacob 1774-1833 *NewYHSD*
Marling, Mrs. Jacob *NewYHSD*
Marling, James H 1857-1895 *BiDAmAr*
Marlitt, Richard J 1909- *AmArch 70*
Marlo, Albert J 1923- *AmArch 70*
Marlo, M *AmArch 70*
Marlor, Clark Strang 1922- *WhoAmA 76, -78, -80,*
-82, -84
Marlow, Francis S 1888-1932 *BiDAmAr*
Marlow, Henry 1838-1911 *WhAmArt 85*
Marlow, Lucy Clare Drake *ArtsAmW 3*
Marlow, Lucy Drake *WhAmArt 85*
Marlow, Lucy Drake 1890- *DcWomA*
Marlow, Rusty *FolkA 86*

Marlow, William 1740-1813 *DcBrECP, DcBrWA,*
McGDA, OxArt
Marlowe, Florence *DcVicP 2*
Marlowe, W *AmArch 70*
Marmanik, Frank J *WhAmArt 85*
Marmet, Leon *WhAmArt 85*
Marmion, Simon d1489 *OxArt*
Marmion, Simon 1420?-1489 *McGDA*
Marmitta, Francesco d1505 *McGDA*
Marmocchini Cortesi, Giovanna *DcWomA*
Marmon, Harvey Victor, Jr. 1925- *AmArch 70*
Marmonnier, Angele *DcWomA*
Marmorstein, Elmer 1930- *AmArch 70*
Marmottant, Louise 1881- *DcWomA*
Marner, David 1910- *AmArch 70*
Marney, Davide Charles 1956- *MarqDCG 84*
Marny, Paul *ClaDrA*
Marny, Paul 1829-1914 *DcBrA 1, DcBrWA,*
DcVicP 2
Marochetti, Baron Carlo 1805-1867 *McGDA*
Marochetti, Baron Carlo 1805-1868 *DcNiCA*
Marochetti, Baron Charles 1805-1868 *ArtsNiC*
Maroicic, Anka Von *DcWomA*
Marokvia, Artur *IlsCB 1967*
Marokvia, Artur 1909- *IlsBYP, IlsCB 1946, -1957*
Marolda, Emilio *DcVicP 2*
Marolf, Leo Albert 1926- *AmArch 70*
Maron, Theresa Concordia *DcWomA*
Maron-Mengs, Therese Concordia 1725-1808 *WomArt*
Marone, Roberto 1479-1539 *McGDA*
Maroney, James H, Jr. 1943- *WhoAmA 80, -82, -84*
Maroniez, Georges Philibert 1865- *ClaDrA*
Maroon, Fred 1924- *ICPEnP A*
Marot, Daniel 1661-1720 *AntBDN G*
Marot, Daniel 1661-1752 *MacEA*
Marot, Daniel 1662?-1752 *DcD&D*
Marot, Daniel 1663-1752 *OxArt, OxDecA, WhoArch*
Marot, Francois 1666-1719 *ClaDrA*
Marot, Jean 1619-1679 *OxArt*
Marot, Samuel 1835?- *NewYHSD*
Marot Family *OxArt*
Maroto, Esteban 1942- *ConGrA 1, WorECom*
Marotta, Tom 1943- *ICPEnP A, MacBEP*
Marovic, Anka 1815-1859? *DcWomA*
Marovich, Anka 1815-1859? *DcWomA*
Marowska, Lika 1889- *DcWomA*
Marozzi, Eli Raphael 1913- *WhoAmA 73, -76, -78,*
-80, -82, -84
Marple, Charles F *WhAmArt 85*
Marple, Mary *WhAmArt 85*
Marple, William L 1827-1910 *ArtsAmW 1,*
IlBEAAW, WhAmArt 85
Marple, William Lewis 1827-1910 *ArtsAmW 3*
Marples, George 1869-1939 *DcBrA 1, DcVicP 2*
Marquam, Edward *CabMA*
Marquand, Frederick *EncASM*
Marquand, Isaac *EncASM*
Marquand, John 1723?-1810 *BiDBrA*
Marquand, Josiah P *EncASM*
Marquand And Paulding *EncASM*
Marquand Harriman *EncASM*
Marquand Paulding And Penfield *EncASM*
Marquart, Gail Eugene 1917- *AmArch 70*
Marquet, Albert 1875-1947 *McGDA, OxTwCA,*
PhDcTCA 77
Marquet, Louise Mathilde *DcWomA*
Marquet, Pierre Albert 1875-1947 *ClaDrA*
Marquet, Pierre-Albert 1875-1947 *OxArt*
Marquez, J A *AmArch 70*
Marquezane, Juanita 1868- *DcWomA*
Marquis, Alexander 1811-1884 *NewYHSD*
Marquis, Dorothea Tomlinson *DcWomA*
Marquis, James Richard d1885 *DcVicP 2*
Marquis, James Richard 1885?- *DcSeaP*
Marquis, Richard 1945- *AmArt*
Marquis, Robert B 1928- *AmArch 70*
Marquis, Mrs. Tomlinson *WhAmArt 85*
Marr, C, Jr. *AmArch 70*
Marr, C B *AmArch 70*
Marr, C J *AmArch 70*
Marr, Carl *WhAmArt 85*
Marr, Danny Joseph 1953- *MarqDCG 84*
Marr, J W Hamilton *DcVicP 2*
Marr, Mrs. J W Hamilton *DcVicP 2*
Marr, John *FolkA 86*
Marr, Joseph Heinrick Ludwig 1807-1871 *ClaDrA*
Marr, Kate T *DcWomA*
Marr, Leslie 1922- *ClaDrA, DcBrA 2, WhoArt 80,*
-82, -84
Marr, Octavia E T 1891- *DcWomA*
Marr, Owen K 1861-1933 *WhAmArt 85*
Marr, Richard H 1886-1946 *BiDAmAr*
Marr, Sophie d1901 *DcWomA*
Marr, Thomas *WhAmArt 85*
Marr, Thomas S 1866-1935? *BiDAmAr*
Marr, W Allen 1948- *MarqDCG 84*
Marra, James Vincent 1910- *AmArch 70*
Marrable, Mrs. d1916 *DcVicP 2*
Marrable, Edith *DcBrWA, DcVicP 2, DcWomA*
Marrable, Madeline Frances d1916 *DcBrA 1,*
DcBrWA

Marrable, Madeline Frances 1835?-1916 *DcWomA*
Marras, John *NewYHSD*
Marrel Freres *DcNiCA*
Marrias *NewYHSD*
Marriner, William 1880?-1914 *WorECom*
Marriner, William F *WhAmArt 85*
Marriott, Alvin Tolman 1902- *WhoArt 80, -82*
Marriott, Bett Kniseley *AmArch 70*
Marriott, Ernest 1882-1918 *DcBrA 1*
Marriott, Frank Pickford 1876- *DcBrA 1*
Marriott, Fred M 1805-1884 *ArtsAmW 1*
Marriott, Frederick *AntBDN A*
Marriott, Frederick 1860-1941 *ClaDrA, DcBrA 1,*
DcVicP 2
Marriott, James *BkIE*
Marriott, Pat *IlsCB 1967*
Marriott, Pat 1920- *IlsCB 1957*
Marriott, William Allen 1942- *WhoAmA 78, -80, -82,*
-84
Marris, Robert 1750-1827 *DcBrECP, DcBrWA*
Marro, Raymond M, Jr. 1941- *AmArch 70*
Marrolim, S *NewYHSD*
Marron, Donald B 1934- *WhoAmA 78, -80, -82, -84*
Marron, Eugenie Marie 1901- *WhAmArt 85*
Marron, Marie Anne Carrelet De 1725-1778 *DcWomA*
Marrott, Ted *FolkA 86*
Marrow, Deborah 1948- *WhoAmA 80*
Marrow, James Henry 1941- *WhoAmA 84*
Marrozzini, Luigi 1933- *WhoAmA 73, -76, -78, -80*
Marrs, Mrs. *DcVicP 2, DcWomA*
Marrs, Ralph Edward 1935- *AmArch 70*
Marryat, Francis Samuel 1826-1855 *EarABI SUP,*
IlBEAAW, NewYHSD
Marryat, Frederick 1792-1848 *DcBrBI, DcBrWA*
Marryat, Samuel Francis 1826-1855 *ArtsAmW 1*
Mars 1849-1912 *DcBrBI*
Mars Borghese *McGDA*
Mars, Ethel 1876-1956 *DcWomA*
Mars, Ethel 1876-1956? *WhAmArt 85*
Mars, Irma Bratton 1901- *WhAmArt 85*
Mars, Reginald Degge 1901- *WhAmArt 85*
Mars, Witold T *IlsCB 1967*
Mars, Witold Tadeusz 1908- *IlsBYP, IlsCB 1946,*
-1957
Marsac, Harvey *NewYHSD*
Marsal, Edouard Antoine 1845- *ClaDrA*
Marsaud, Marie Meloe *DcWomA*
Marschall, Adelheid *DcWomA*
Marschall, Frederick *WhAmArt 85*
Marschall, Nicola 1829-1917 *NewYHSD,*
WhAmArt 85
Marschall, Richard 1949- *WorECar A*
Marschner, Arthur 1884-1950 *ArtsEM*
Marschner, Arthur A 1884- *WhAmArt 85*
Marsden, Barbara d1789? *DcWomA*
Marsden, Edith Frances *DcWomA*
Marsden, Edith Frances 1880- *DcWomA*
Marsden, Ruth Gladys *WhAmArt 85*
Marsden, Ruth Gladys 1898- *DcWomA*
Marsden, Simon 1948- *ICPEnP A*
Marsden, Simon Nevile Lewellyn 1948- *MacBEP*
Marsden, Theodore *EarABI SUP, NewYHSD*
Marsellos, F A *AmArch 70*
Marseus VanSchrieck, Otto *McGDA*
Marsh, Miss *DcWomA*
Marsh, A E *DcWomA*
Marsh, Alice Randall *ArtsEM, DcWomA,*
WhAmArt 85
Marsh, Alphonso Howard 1938- *MarqDCG 84*
Marsh, Ann 1717-1796 *FolkA 86*
Marsh, Anne Steele 1901- *WhAmArt 85,*
WhoAmA 73, -76, -78, -80, -82, -84
Marsh, Annie *NewYHSD*
Marsh, Annie 1836?- *DcWomA*
Marsh, Mrs. Arthur *DcVicP 2*
Marsh, Arthur H 1842-1909 *DcVicP*
Marsh, Arthur Hardwick 1842-1909 *DcBrWA,*
DcVicP 2
Marsh, Arthur Hardwicke 1842-1909 *DcBrA 1*
Marsh, Augustus L C 1865-1942 *BiDAmAr*
Marsh, Charles *CabMA*
Marsh, Charles Edward *DcVicP 2*
Marsh, Charles F *DcVicP 2*
Marsh, Charles H 1885- *WhAmArt 85*
Marsh, Charles Howard 1885-1956 *ArtsAmW 2*
Marsh, Christopher Alan 1956- *MarqDCG 84*
Marsh, David Foster 1926- *WhoAmA 78, -80, -82,*
-84
Marsh, David M 1922- *AmArch 70*
Marsh, Emily F *DcVicP 2*
Marsh, Eva Emmeline Louisa *DcBrA 1, DcWomA*
Marsh, Florence d1936 *WhAmArt 85*
Marsh, Fred Dana 1872-1961 *WhAmArt 85,*
WhoAmA 80N, -82N, -84N
Marsh, Frederick C 1878-1939 *BiDAmAr*
Marsh, George *NewYHSD*
Marsh, Harold D 1889- *WhAmArt 85*
Marsh, Harold Dickson 1889- *ArtsAmW 2*
Marsh, Helen *ArtsEM, DcWomA*
Marsh, Henry *EarABI, NewYHSD*
Marsh, J *DcVicP 2, DcWomA, FolkA 86*

Marsh, J E *WhAmArt 85*
Marsh, James 1946- *WhoGrA 82[port]*
Marsh, James R *DcNiCA*
Marsh, Jean 1910- *WhAmArt 85*
Marsh, John *NewYHSD*
Marsh, Mrs. John Bigelow *FolkA 86*
Marsh, Joseph *FolkA 86*
Marsh, Joseph Y *NewYHSD*
Marsh, Kermit Bertram 1934- *AmArch 70*
Marsh, Lucile Patterson 1890- *ArtsAmW 3,*
DcWomA, IlrAm 1880, WhAmArt 85
Marsh, M R *AmArch 70*
Marsh, Martha R *ArtsEM, DcWomA*
Marsh, Mary Ann *DcWomA*
Marsh, Mary E *ArtsAmW 2, DcWomA,*
WhAmArt 85
Marsh, N W *AmArch 70*
Marsh, Norman *WhAmArt 85*
Marsh, Reginald 1898-1954 *BnEnAmA, DcAmArt,*
DcCAA 71, -77, GrAmP, IlsBYP, IlsCB 1946,
McGDA, OxTwCA, PhDcTCA 77,
WhAmArt 85, WhoAmA 78N, -80N, -82N, -84N,
WorArt[port]
Marsh, Robert 1768- *DcBrECP*
Marsh, Sam *WhAmArt 85*
Marsh, Samuel *BiDBrA, CabMA*
Marsh, Susan R *WhAmArt 85*
Marsh, Thomas 1934- *WhoAmA 73, -76, -78, -80,*
-82, -84
Marsh, William *DcSeaP, FolkA 86, NewYHSD*
Marsh, William J d1926 *BiDAmAr*
Marsh, William R 1810?- *NewYHSD*
Marsh Jones & Cribb *DcNiCA*
Marshak, Ira Cotler 1904- *AmArch 70*
Marshal, Alexander *DcBrWA*
Marshall *NewYHSD*
Marshall, Abner *FolkA 86*
Marshall, Albert M *EncASM*
Marshall, Alice Lord 1895- *WhoAmA 73*
Marshall, Anne 1943- *DcCAr 81*
Marshall, Benjamin 1767-1835 *DcBrECP, McGDA,*
OxArt
Marshall, Benjamin H 1874-1945 *BiDAmAr*
Marshall, Benjamin Marshall 1768-1835 *DcBrBI*
Marshall, Brian Roberts 1935- *WhoArt 80*
Marshall, Bruce 1929- *WhoAmA 78, -80, -82, -84*
Marshall, C *DcVicP 2*
Marshall, C A *DcBrBI*
Marshall, C B *AmArch 70*
Marshall, C H *AmArch 70*
Marshall, C W *AmArch 70*
Marshall, Carolyn *OfPGCP 86*
Marshall, Charles *DcBrWA*
Marshall, Charles 1806- *ArtsNiC*
Marshall, Charles 1806-1890 *DcBrWA, DcVicP, -2*
Marshall, Charles, Jr. *DcVicP 2*
Marshall, Charles Edward *DcBrA 1, DcVicP, -2*
Marshall, Mrs. Charles H *DcWomA, WhAmArt 85*
Marshall, Charles Leroy 1905- *AmArch 70*
Marshall, Clark S *WhAmArt 85*
Marshall, Clemency Christian Sinclair 1900- *ClaDrA,*
DcBrA 1
Marshall, Clifton James 1919- *AmArch 70*
Marshall, Constance Kay *IlsCB 1967*
Marshall, Constance Kay 1918- *IlsBYP, IlsCB 1946*
Marshall, D *DcVicP 2*
Marshall, Daniel *IlsBYP*
Marshall, David George 1936- *FolkA 86*
Marshall, Donald Leroy 1929- *AmArch 70*
Marshall, Dunbar *WhoArt 84*
Marshall, Edmund 1938-1979 *WhoAmA 80N, -82N,*
-84N
Marshall, Edward *AfroAA*
Marshall, Edward 1578-1675 *OxArt*
Marshall, Edward 1598?-1675 *BiDBrA*
Marshall, Edward N *WhAmArt 85*
Marshall, Edward W *FolkA 86*
Marshall, Elijah D *NewYHSD*
Marshall, Emily *DcWomA, FolkA 86, NewYHSD*
Marshall, F *DcVicP 2*
Marshall, F J *DcVicP 2*
Marshall, Francis *WhoArt 80, -82, -84*
Marshall, Francis 1946- *DcCAr 81*
Marshall, Frank 1943- *AfroAA*
Marshall, Frank H 1866- *WhAmArt 85*
Marshall, Frank Howard 1866-1934 *ArtsAmW 2*
Marshall, Frank W 1866-1930 *WhAmArt 85*
Marshall, Frederic *WhAmArt 85*
Marshall, George A 1944- *MarqDCG 84*
Marshall, Harold Edward 1899- *AfroAA*
Marshall, Henry *AfroAA*
Marshall, Henry J *DcVicP 2*
Marshall, Henry Rutgers 1852-1927 *BiDAmAr*
Marshall, Herbert Menzies 1841-1913 *ClaDrA,*
DcBrA 1, DcBrWA, DcVicP, -2
Marshall, Hugh Key 1916- *AmArch 70*
Marshall, Inez 1907-1984 *FolkA 86*
Marshall, Isabelle C *DcWomA, WhAmArt 85*
Marshall, J D *AmArch 70, DcVicP 2*
Marshall, J Fitz 1859- *DcVicP*
Marshall, J Fitz 1859-1932 *DcBrA 1, DcVicP 2*

Marshall, J Miller *DcBrA 1, DcVicP 2*
Marshall, J W *AmArch 70*
Marshall, James Duard 1914- *WhAmArt 85,*
WhoAmA 78, -80, -82, -84
Marshall, James Edward 1942- *IlsCB 1967*
Marshall, James Omer 1920- *AmArch 70*
Marshall, James Ross 1939- *MarqDCG 84*
Marshall, James Rush 1851-1927 *BiDAmAr*
Marshall, John *DcVicP, -2, WhoArt 80, -82, -84*
Marshall, John d1755 *CabMA*
Marshall, John d1820 *CabMA*
Marshall, John 1664-1732 *FolkA 86*
Marshall, John Carl 1936- *WhoAmA 73, -76, -78,*
-80, -82, -84
Marshall, Joseph R, Jr. 1956- *MarqDCG 84*
Marshall, Joshua 1629-1678 *MacEA, OxArt*
Marshall, Kerry 1942- *WhoAmA 76, -78, -80*
Marshall, MacLean 1912- *WhAmArt 85*
Marshall, Mara 1926- *WhoAmA 76, -78, -80, -82,*
-84
Marshall, Margaret Jane 1895- *DcWomA,*
WhAmArt 85
Marshall, Mark V *AntBDN M*
Marshall, Mary *ArtsAmW 3*
Marshall, Mary E *WhAmArt 85*
Marshall, Matthew *NewYHSD*
Marshall, May Chiswell 1874- *DcWomA,*
WhAmArt 85
Marshall, Michael Gurney 1939- *AmArch 70*
Marshall, Mortimer Mercer, Jr. 1929- *AmArch 70*
Marshall, Nathaniel *CabMA*
Marshall, Oscar Thomas, III 1931- *AmArch 70*
Marshall, Peter Paul *DcNiCA*
Marshall, Peter Paul 1830-1900 *DcVicP, -2*
Marshall, Philippa *DcVicP 2*
Marshall, R *AmArch 70, DcVicP 2*
Marshall, R C *AmArch 70*
Marshall, Rachel *DcWomA, WhAmArt 85*
Marshall, Ralph 1923- *WhoAmA 82, -84*
Marshall, Randall S 1933- *AmArch 70*
Marshall, Richard Donald 1947- *WhoAmA 78, -80,*
-82, -84
Marshall, Robert Angelo Kittermaster 1849- *ArtsNiC*
Marshall, Robert Angelo Kittermaster 1849-1923?*
DcBrWA
Marshall, Robert Leroy 1944- *WhoAmA 78, -80, -82,*
-84
Marshall, Robert William 1921- *AmArch 70*
Marshall, Roberto Angelo Kittermaster 1849-*
DcBrA 1, DcVicP
Marshall, Roberto Angelo Kittermaster 1849-1923?*
DcVicP 2
Marshall, Rose *DcVicP, -2, DcWomA*
Marshall, S R *AmArch 70*
Marshall, Samuel Meeker 1927- *AmArch 70*
Marshall, T F *AmArch 70*
Marshall, Tad A 1955- *MarqDCG 84*
Marshall, Thomas Falcon 1818-1878 *ClaDrA,*
DcBrWA, DcVicP, -2
Marshall, Thomas Mervyn Bouchier *DcVicP 2*
Marshall, Thomas W 1850-1874 *ArtsNiC*
Marshall, W M *AmArch 70*
Marshall, W S *AmArch 70*
Marshall, Wilhelmina *DcVicP 2*
Marshall, William *FolkA 86, McGDA*
Marshall, William d1793? *BiDBrA*
Marshall, William, Jr. 1925- *AmArch 70*
Marshall, William C d1929 *WhAmArt 85*
Marshall, William C 1813- *ArtsNiC*
Marshall, William E *DcBrWA*
Marshall, William Edgar 1837- *WhAmArt 85*
Marshall, William Edgar 1837-1906 *NewYHSD*
Marshall, William Elstob *DcVicP 2*
Marshall, William Henry *AmArch 70*
Marshall, Winifred *DcWomA*
Marshall Malagola, Dunbar 1918- *WhoArt 80, -82,*
-84
Marshall-Wells *EncASM*
Marsham, Miss *DcVicP 2, DcWomA*
Marshman, J *DcBrBI, DcVicP 2*
Marsicano, Nicholas 1914- *DcCAA 71, -77,*
WhoAmA 73, -76, -78, -80, -82, -84
Marsiglia, Gherlando 1792-1850 *NewYHSD*
Marsiglia, M *NewYHSD*
Marsilii, Mario Joseph 1919- *AmArch 70*
Marsland, Thomas Anthony 1937- *MarqDCG 84*
Marson, Bernard A 1931- *AmArch 70*
Marson, Thomas E *DcVicP 2*
Marsteller, A *FolkA 86*
Marsteller, Thomas 1812?- *FolkA 86*
Marsteller, William A 1914- *WhoAmA 73, -76, -78,*
-80, -82, -84
Marston, F H *AmArch 70*
Marston, F R W *DcVicP 2*
Marston, Freda 1895-1949 *DcBrA 1, DcWomA*
Marston, Hunter S 1951- *MarqDCG 84*
Marston, J B *NewYHSD*
Marston, James B *FolkA 86*
Marston, Keith Palmer 1914- *AmArch 70*
Marston, Mabel G *DcVicP 2, DcWomA*
Marston, Reginald St. Clair 1886-1943 *DcBrA 1*

Marston, Richard 1842-1917 *WhAmArt 85*
Marston, Sylvanus B 1883-1946 *BiDAmAr*
Marston, W W *FolkA 86*
Marston, William Moulton 1893-1947 *WorECom*
Marstrand, Julie 1882- *DcWomA*
Marstrand, William Nicolas 1810-1873 *ArtsNiC*
Marsui, R H 1941- *MarqDCG 84*
Marsuzi, Maria Elisa *DcWomA*
Mart, Frank Griffiths *DcVicP 2*
Marta, Anna Maria *FolkA 86*
Marteen, W *FolkA 86*
Martel, Therese *DcWomA*
Martel DeJanville, Countess *DcWomA*
Martell, Barbara Bentley *WhoAmA 73, -76, -78, -80,*
-82, -84
Martell, Carroll 1912- *AmArch 70*
Martell, Isaac *DcBrECP*
Martelli, Paul F *ArtsEM*
Martelli And Giardini *ArtsEM*
Marten *NewYHSD*
Marten, Christine Walters 1896- *DcWomA,*
WhAmArt 85
Marten, Elliot H *DcBrWA, DcVicP 2*
Marten, John *DcBrWA*
Marten, John, II *DcBrBI*
Marten, Richard *FolkA 86*
Marten, W J *DcVicP 2*
Martenne, Therese De 1885- *DcWomA*
Martens, G *FolkA 86, NewYHSD*
Martens, Henry *DcBrBI*
Martens, Henry d1860 *DcBrWA, DcVicP, -2*
Martens, Henry Ernest 1919- *AmArch 70*
Martens, John W *NewYHSD*
Martens, Luise Henriette Von 1828-1897 *DcWomA*
Martens, R E *AmArch 70*
Martenson, Eugene Glenn 1924- *AmArch 70*
Marter, Joan 1946- *WhoAmA 84*
Marter, Joan M 1946- *WhoAmA 78, -80, -82*
Marter, John *NewYHSD*
Martha *DcWomA*
Martha Of Bethany, Saint *McGDA*
Marthaller, Duwayne *MarqDCG 84*
Marthinsen, T *EncASM*
Martich-Severi, Icilio 1920- *DcCAr 81*
Martienssen, Rex 1905-1942 *ConArch*
Martigne, Alice De *DcWomA*
Martignoni, Anna 1820-1873 *DcWomA*
Martin *FolkA 86*
Martin, Mademoiselle *DcWomA*
Martin Of Toledo *McGDA*
Martin Of Tours, Saint 315?- *McGDA*
Martin, A *ArtsEM*
Martin, A C 1835-1879 *BiDAmAr*
Martin, A P *AmArch 70*
Martin, Adam E *FolkA 86*
Martin, Adele *DcWomA*
Martin, Adolphe Alexandre *MacBEP*
Martin, Adrian Neilson 1928- *AmArch 70*
Martin, Agnes 1912- *ConArt 77, -83, DcAmArt,*
DcCAA 77, DcCAr 81, WomArt, WorArt[port]
Martin, Agnes 1921- *BnEnAmA*
Martin, Agnes Bernice 1912- *AmArt, WhoAmA 76,*
-78, -80, -82, -84
Martin, Agnes Fulton 1904- *DcBrA 1*
Martin, Albert Carey 1913- *AmArch 70*
Martin, Albert Rankin 1901- *AmArch 70*
Martin, Alexander Toedt 1931- *WhoAmA 78, -80,*
-82, -84
Martin, Alexandrine *DcWomA*
Martin, Alfred James *AfroAA*
Martin, Alice *DcWomA*
Martin, Alice Ethel *WhAmArt 85*
Martin, Allyn C 1918- *AmArch 70*
Martin, Ambrose *DcBrWA, DcVicP 2*
Martin, Angelique Marie *NewYHSD*
Martin, Ann *WhAmArt 85*
Martin, Annie D *DcWomA*
Martin, Anson A *DcVicP, -2*
Martin, Anthony 1937- *DcCAr 81*
Martin, Antoinette 1876- *DcWomA*
Martin, Arthur Edmund d1932 *DcBrA 2*
Martin, Arthur Ronald 1904- *DcBrA 2, WhoArt 84*
Martin, B K *AmArch 70*
Martin, B W *AmArch 70*
Martin, Barry 1943- *ConBrA 79[port], DcCAr 81*
Martin, Basil E 1903- *WhAmArt 85*
Martin, Beatrice 1876- *ClaDrA*
Martin, Beatrix 1876- *DcBrA 1, DcWomA*
Martin, Benjamin 1704-1782 *AntBDN D*
Martin, Bernard *OfPGCP 86*
Martin, Bernard Murray 1935- *WhoAmA 73, -76, -78,*
-80, -82, -84
Martin, Bernice Fenwick 1912- *WhoAmA 73, -76, -78,*
-80, -82, -84
Martin, Bill *DcCAr 81*
Martin, Bill 1943- *AmArt*
Martin, Boyd G 1901- *AmArch 70*
Martin, Briton 1899- *AmArch 70*
Martin, C H *AmArch 70, DcVicP 2*
Martin, C J *DcSeaP*
Martin, Carl *DcCAr 81*

Martin, Carl William 1931- *AmArch 70*
Martin, Caroline *DcWomA*
Martin, Caroline Louise 1903- *WhAmArt 85*
Martin, Cecil A 1917- *AmArch 70*
Martin, Celeste *DcWomA*
Martin, Charles *DcBrBI, DcNiCA, ICPEnP A, NewYHSD*
Martin, Charles 1820-1906 *DcVicP, -2, NewYHSD , WhAmArt 85*
Martin, Charles E 1910- *WhAmArt 85, WhoAmA 73, -76, -78, -80, -82, -84*
Martin, Charles Edward 1910- *WorECar*
Martin, Charles J *WhAmArt 85*
Martin, Charles Lee 1924- *AmArch 70*
Martin, Charles Wayne 1932- *MarqDCG 84*
Martin, Christine 1895- *DcWomA, WhAmArt 85*
Martin, Clarence A 1862-1944 *BiDAmAr*
Martin, Clarence Lee 1923- *AmArch 70*
Martin, D W *DcVicP 2*
Martin, Daniel Webster 1915- *AmArch 70*
Martin, David *DcVicP 2, NewYHSD*
Martin, David 1737-1797 *DcBrECP*
Martin, David Brownson 1927- *AmArch 70*
Martin, David Edward 1933- *AmArch 70*
Martin, David McLeod 1922- *DcBrA 1, WhoArt 80, -82, -84*
Martin, David Stone 1913- *IlrAm F, -1880, IlsBYP, IlsCB 1946, WhAmArt 85, WhoGrA 62*
Martin, David Stone 1916- *WhoGrA 82[port]*
Martin, Denise B 1940- *WhoAmA 82, -84*
Martin, Derek 1923- *AmArch 70*
Martin, Doak 1917- *AmArch 70*
Martin, Don 1920- *FolkA 86*
Martin, Don 1931- *WorECar*
Martin, Don E 1928- *AmArch 70*
Martin, Doris-Marie Constable 1941- *WhoAmA 78, -80, -82, -84*
Martin, Dorothy Burt 1882- *ClaDrA*
Martin, Dorothy Burt 1882-1949 *DcWomA*
Martin, Dorothy Freeborn 1886- *DcBrA 1, DcWomA*
Martin, Dorothy Freeman *WhAmArt 85*
Martin, Doug 1947- *WhoAmA 82, -84*
Martin, Douglas Jerome 1949- *MarqDCG 84*
Martin, E *NewYHSD*
Martin, E G *FolkA 86*
Martin, E Hall *NewYHSD*
Martin, E Hall 1818-1851 *ArtsAmW 2*
Martin, E L *AmArch 70*
Martin, E O *NewYHSD*
Martin, E W *AmArch 70*
Martin, Earl 1893- *AmArch 70*
Martin, Easoin J *WhAmArt 85*
Martin, Eddie Owens 1908- *FolkA 86*
Martin, Edgar Everett 1898-1960 *WorECom*
Martin, Edith E 1875- *DcBrA 1, DcVicP 2, DcWomA*
Martin, Edna M 1896- *DcWomA, WhAmArt 85*
Martin, Edward *DcVicP 2*
Martin, Edward B K *ArtsEM*
Martin, Edwin *DcNiCA*
Martin, Edwin D 1908- *AmArch 70*
Martin, Eleonore 1803- *DcWomA*
Martin, Elias 1739-1818 *DcBrECP, DcBrWA, OxArt*
Martin, Eliza *DcVicP 2*
Martin, Emile Elisabeth Pauline *DcWomA*
Martin, Emma *DcWomA*
Martin, Emma E *FolkA 86*
Martin, Emma May 1865-1956 *DcWomA*
Martin, Emmet G 1889-1937 *BiDAmAr*
Martin, Emmie Emilie *DcWomA*
Martin, Ernest F *NewYHSD*
Martin, Ethel 1873- *ClaDrA, DcBrA 1, DcVicP 2, DcWomA*
Martin, Etienne Philippe 1858-1945 *ClaDrA*
Martin, F Lestar 1936- *AmArch 70*
Martin, Ferdinand *NewYHSD*
Martin, Fletcher 1904- *DcCAA 71, -77, IlBEAAW, McGDA, WhAmArt 85, WhoAmA 73, -76, -78*
Martin, Fletcher 1904-1979 *WhoAmA 80N, -82N, -84N*
Martin, Florence *DcVicP 2*
Martin, Floyd Thornton *WhAmArt 85*
Martin, Francis Patrick 1883-1966 *DcBrA 1*
Martin, Francis Thomas Beckett 1904- *WhAmArt 85*
Martin, Frank Graeme 1914- *DcBrA 1, WhoArt 80, -82, -84*
Martin, Frank H 1863-1917 *BiDAmAr*
Martin, Frank Vernon 1921- *DcBrA 1*
Martin, Fred 1927- *DcCAA 71, -77*
Martin, Fred Fretz 1903- *AmArch 70*
Martin, Fred Thomas 1927- *PrintW 85, WhoAmA 73, -76, -78, -80, -82, -84*
Martin, Frederick C *WhAmArt 85*
Martin, G W 1913- *WhoAmA 73, -76, -78, -80, -82, -84*
Martin, Gail Wycoff 1913- *WhAmArt 85*
Martin, George Keith 1910- *WhAmArt 85*
Martin, George Marshall, Jr. 1926- *AmArch 70*
Martin, George Mathew *DcVicP 2*
Martin, George Whitefield 1771-1810 *CabMA*
Martin, Grace S *DcWomA, WhAmArt 85*

Martin, H D *DcVicP 2*
Martin, H M *AmArch 70*
Martin, Harry W 1924- *AmArch 70*
Martin, Henri Jean Guillaume 1860-1943 *McGDA*
Martin, Henry *DcBrWA, DcVicP, -2*
Martin, Henry 1840?-1908 *DcBrA 2*
Martin, Henry 1925- *WorECar*
Martin, Henry Harrison *DcVicP, -2*
Martin, Holly Lee 1950- *MarqDCG 84*
Martin, Homer D *ArtsNiC*
Martin, Homer Dodge 1836-1897 *BnEnAmA, DcAmArt, EarABI, McGDA, NewYHSD , WhAmArt 85*
Martin, Ionis B 1936- *AfroAA*
Martin, Irma *DcWomA*
Martin, J *DcVicP 2, FolkA 86*
Martin, J A *NewYHSD*
Martin, J H *ArtsAmW 2, WhAmArt 85*
Martin, J W *DcVicP 2*
Martin, James *CabMA, FolkA 86, NewYHSD*
Martin, Jane 1943- *DcCAr 81, WhoAmA 82, -84*
Martin, Jean Baptiste 1659-1735 *ClaDrA*
Martin, Jeanne 1775?-1788 *DcWomA*
Martin, Jo G 1886- *ArtsAmW 3*
Martin, John *FolkA 86*
Martin, John 1789-1854 *ClaDrA, DcBrBI, DcBrWA, DcNiCA, DcVicP, -2, McGDA, OxArt*
Martin, John A Lee *ArtsAmW 1, NewYHSD*
Martin, John B 1857-1938? *WhAmArt 85*
Martin, John Blennerhassett 1797-1857 *NewYHSD*
Martin, John Breckenridge 1857- *ArtsAmW 1, -2*
Martin, John Breckinridge 1857- *IlBEAAW*
Martin, John F *DcVicP 2, FolkA 86*
Martin, John Frederick 1745-1808 *DcBrWA*
Martin, John Gibson 1922- *AmArch 70*
Martin, John H *DcVicP 2*
Martin, John L *FolkA 86*
Martin, Jonathan 1782-1838 *DcBrBI*
Martin, Jonathan Mad 1782-1838 *DcBrWA*
Martin, Joseph *MarqDCG 84*
Martin, Josiah 1843-1916 *MacBEP*
Martin, Juliet *DcWomA, NewYHSD*
Martin, Keith 1910- *WhoAmA 73, -76, -78*
Martin, Keith Morrow 1911- *WhAmArt 85, WhoAmA 73, -76, -78, -80, -82*
Martin, Keith Morrow 1911-1983 *WhoAmA 84N*
Martin, Kenneth 1905- *ConArt 77, -83, ConBrA 79[port], DcBrA 1, DcCAr 81, McGDA, OxTwCA, PrintW 83, -85, WhoArt 80, -82, -84*
Martin, Kenneth 1929- *PhDcTCA 77*
Martin, Kennith 1928- *AmArch 70*
Martin, Kirk *WhAmArt 85*
Martin, Kirk 1906- *IlBEAAW*
Martin, Knox 1923- *DcCAA 71, -77, WhoAmA 73, -76, -78, -80, -82, -84*
Martin, L *DcVicP 2*
Martin, Langton 1913- *WhoAmA 73, -76, -78, -80, -82*
Martin, Larry K *OfPGCP 86*
Martin, Larry Kenneth 1939- *AmArt, WhoAmA 82, -84*
Martin, Laure *DcWomA*
Martin, Laurin H 1875- *WhAmArt 85*
Martin, Lawrence M *MarqDCG 84*
Martin, Leonard George 1949- *MarqDCG 84*
Martin, Leonie *DcWomA*
Martin, Leslie 1908- *MacEA*
Martin, Sir Leslie 1908- *ConArch, DcD&D[port], McGDA*
Martin, Lester Reavis 1950- *MarqDCG 84*
Martin, Lester W d1934 *WhAmArt 85*
Martin, Lilly *DcWomA, NewYHSD*
Martin, Linda *ConArch A*
Martin, Lloyd Pierre 1928- *AmArch 70*
Martin, Locket Brooks 1913- *AmArch 70*
Martin, Lorenzo D *ArtsEM*
Martin, Loretta Marsh 1933- *WhoAmA 76, -78, -80, -82, -84*
Martin, Louisa Catherine *DcWomA*
Martin, Lucille Caiar 1918- *WhoAmA 73, -76, -78, -80, -82, -84*
Martin, Lucy *FolkA 86*
Martin, Mabel L I *WhoArt 80N*
Martin, Mabel L I 1887- *DcBrA 1, DcWomA*
Martin, Margaret *WhAmArt 85*
Martin, Margaret M 1940- *WhoAmA 76, -78, -80, -82, -84*
Martin, Marguerite 1897- *DcWomA*
Martin, Maria 1796-1863 *DcWomA, NewYHSD*
Martin, Marianne Winter *WhoAmA 78, -80, -82, -84*
Martin, Mrs. Marshall B *WhAmArt 85*
Martin, Marvin B 1907- *WhAmArt 85*
Martin, Mary 1907- *McGDA, PhDcTCA 77*
Martin, Mary 1907-1969 *ConArt 77, OxTwCA*
Martin, Mary Adela 1907- *DcWomA*
Martin, Mary Adela 1907-1969 *DcBrA 2*
Martin, Mary D *DcVicP 2, DcWomA*
Martin, Mary Finch 1916- *WhoAmA 78, -80, -82, -84*
Martin, Max *DcBrA 2*

Martin, Menny Eusobio 1930- *WorECom*
Martin, Merrill John 1926- *AmArch 70*
Martin, Mildred Smith 1900- *WhAmArt 85*
Martin, Milton Foy 1914- *AmArch 70*
Martin, Moses *FolkA 86*
Martin, Nabby 1775-1864 *FolkA 86*
Martin, Nellie *DcWomA*
Martin, Noel 1922- *WhoGrA 62, -82[port]*
Martin, O Raymond 1924- *AmArch 70*
Martin, P *DcBrECP, DcVicP 2*
Martin, Paul 1864-1944 *ICPEnP A, MacBEP*
Martin, Paul 1883- *WhAmArt 85*
Martin, Paul 1917- *MarqDCG 84*
Martin, Paul 1948- *DcCAr 81*
Martin, Pearl S *AfroAA*
Martin, Peter Douglas 1943- *MarqDCG 84*
Martin, Philip *AfroAA*
Martin, Pierre Denis 1663?-1742 *ClaDrA*
Martin, Pierre Noel 1920- *WhoArt 80, -82, -84*
Martin, R *DcVicP 2*
Martin, R L *AmArch 70*
Martin, R T *DcVicP 2*
Martin, Raymond C, Jr. 1934- *AmArch 70*
Martin, Raymonde 1887- *DcWomA*
Martin, Rene *IlsBYP*
Martin, Richard 1946- *WhoAmA 76, -78, -80, -82, -84*
Martin, Richard Edward 1931- *AmArch 70*
Martin, Robert *FolkA 86, NewYHSD , WhAmArt 85*
Martin, Robert 1888- *WhAmArt 85*
Martin, Robert B 1915- *AmArch 70*
Martin, Robert Edward 1928- *AmArch 70*
Martin, Robert Russell 1918- *WhoArt 80, -82, -84*
Martin, Robert Stephen 1957- *MarqDCG 84*
Martin, Robert Stevens 1925- *AmArch 70*
Martin, Robert T 1917- *AmArch 70*
Martin, Robert Wallace *DcNiCA*
Martin, Roger 1925- *WhoAmA 73, -76, -78, -80, -82, -84*
Martin, Ron 1943- *ConArt 77, -83, DcCAr 81, WhoAmA 76, -78, -80, -82, -84*
Martin, Ronald Arthur 1904- *ClaDrA, WhoArt 80, -82*
Martin, Rosa Plant *DcBrA 2*
Martin, Rose Breyer 1910- *WhoAmA 78, -80*
Martin, S E *AmArch 70*
Martin, Sam Lee 1951- *MarqDCG 84*
Martin, Sara B 1957- *MarqDCG 84*
Martin, Solomon *NewYHSD*
Martin, Stanley Edward 1938- *AmArch 70*
Martin, Stefan *IlsCB 1967*
Martin, Stefan 1936- *IlsBYP, IlsCB 1957, PrintW 83, -85, WhoAmA 84*
Martin, Stephen I *ArtsEM*
Martin, Steven William 1958- *MarqDCG 84*
Martin, Stuart Timothy 1937- *AmArch 70*
Martin, Sue Pettey 1896- *ArtsAmW 2, DcWomA, WhAmArt 85*
Martin, Sylvester *DcBrWA, DcVicP 2*
Martin, T *DcVicP 2*
Martin, Theodore Edward 1939- *MarqDCG 84*
Martin, Thomas *CabMA, NewYHSD*
Martin, Thomas 1943- *WhoAmA 78, -80, -82, -84*
Martin, Thomas Mower 1838-1934 *IlBEAAW*
Martin, Thomas Mower 1839-1934 *ArtsAmW 1*
Martin, Timothy Stuart 1908- *WhoArt 80, -82, -84*
Martin, Vicente 1911- *McGDA*
Martin, W A *AmArch 70*
Martin, W A, Jr. *AmArch 70*
Martin, W C *AmArch 70*
Martin, W K *AmArch 70*
Martin, W N 1951- *MarqDCG 84*
Martin, W R *DcVicP 2*
Martin, Walter *DcNiCA, WhAmArt 85*
Martin, Wayne 1905- *WhAmArt 85*
Martin, Wesley Porter 1918- *AmArch 70*
Martin, William *CabMA, FolkA 86*
Martin, William 1752-1831? *DcBrECP*
Martin, William 1772-1851 *DcBrWA*
Martin, William A K 1817-1867 *NewYHSD*
Martin, William Alison *DcBrA 2*
Martin, William Barriss, II 1923- *WhoAmA 76, -78, -80*
Martin, William Clyde 1924- *AmArch 70*
Martin, William D *NewYHSD*
Martin, William Henry 1943- *WhoAmA 73, -76, -78, -80*
Martin, William J 1934- *AmArch 70*
Martin, William LaVerne 1920- *AmArch 70*
Martin, Y F *DcVicP 2*
Martin Brothers *AntBDN M*
Martin-Buchere, Clementine d1873 *DcWomA*
Martin DeCampo, Victoria *DcWomA*
Martin-Didier-Pape *McGDA*
Martin-Gourdault, Marie 1881- *DcWomA*
Martin-Harvey, Hester *DcWomA*
Martin-Laurel, Eugenie *DcWomA*
Martin-Nichols, Peggy *DcWomA*
Martin-Nichols, Pegus *WhAmArt 85*
Martin-Pregniard, Clotilde 1885- *DcWomA*

Martina, Piero *OxTwCA*
Martincek, Martin 1913- *ConPhot, ICPEnP A,*
 MacBEP
Martindale, John D 1909- *AmArch 70*
Martindale, Lucy *ArtsEM, DcWomA*
Martindale, Percy Henry 1869-1943 *DcBrA 1*
Martine, P *DcBrECP*
Martineau, Mrs. Basil *DcVicP 2*
Martineau, Clara *DcWomA*
Martineau, Edith 1842-1909 *DcBrA 1, DcBrWA,*
 DcVicP, -2, DcWomA
Martineau, Ellen Carol 1957- *MarqDCG 84*
Martineau, Gertrude *DcBrWA, DcVicP, -2,*
 DcWomA
Martineau, Lucienne 1890- *DcWomA*
Martineau, Robert B 1826-1869 *ArtsNiC*
Martineau, Robert Braithwaite 1826-1869 *ClaDrA,*
 DcBrWA, DcVicP, -2
Martineau DesChesnez, Helene *DcWomA*
Martinell Brunet, Cesar 1888-1973 *MacEA*
Martinelli, Domenico 1650-1718 *MacEA*
Martinelli, Ezio 1913- *DcCAA 71, -77,*
 WhAmArt 85, WhoAmA 73, -76, -78, -80, -82N,
 -84N
Martinelli, James C 1928- *AmArch 70*
Martinengo, Anna Margaretha 1630?-1721? *DcWomA*
Martinengo, Maria *DcWomA*
Martinet, Achille-Louis 1806- *ArtsNiC*
Martinet, Angelique 1731?-1780? *DcWomA*
Martinet, L A *DcWomA*
Martinet, Marguerite 1876- *DcWomA*
Martinet, Marie Elisabeth *DcWomA*
Martinet, Marie Therese 1731?- *DcWomA*
Martinet, Marjorie D 1886- *WhAmArt 85,*
 WhoAmA 73, -76, -78, -80
Martinet, Marjorie D 1886-1981 *WhoAmA 82N,*
 -84N
Martinet, Marjorie Dorsey 1886- *ArtsAmW 2*
Martinet, Marjorie D'orsi 1886- *ArtsAmW 2*
Martinet, Marjorie D'Orsi 1886- *DcWomA*
Martinet, Michael Francis 1956- *MarqDCG 84*
Martinetti, A *DcVicP 2*
Martinetti, Maria 1864- *DcWomA*
Martinez, Alfonso *McGDA*
Martinez, Alfred 1944- *WhoAmA 84*
Martinez, Alfredo Ramos 1872-1946 *ArtsAmW 2*
Martinez, Alfredo Ramos 1873-1946 *WhAmArt 85*
Martinez, Alonso d1668 *McGDA*
Martinez, Angelina Delgado *FolkA 86*
Martinez, Antonio 1638-1690 *ClaDrA*
Martinez, Apolonio *FolkA 86*
Martinez, Arturo *OxTwCA*
Martinez, Crescencio d1918 *ArtsAmW 3, IlBEAAW*
Martinez, Crescencio *FolkA 86*
Martinez, Eluid Levi 1944- *FolkA 86*
Martinez, Ernesto Pedregon 1926- *WhoAmA 76, -78,*
 -80, -82, -84
Martinez, Francesco 1718-1777 *MacEA*
Martinez, Hector Arteche *WhoAmA 84*
Martinez, John *IlsBYP*
Martinez, Juan *DcCAr 81*
Martinez, Julian 1879-1943 *WhAmArt 85*
Martinez, Julian 1897-1943 *ArtsAmW 3*
Martinez, Julian 1897-1943? *IlBEAAW*
Martinez, Katharine 1950- *WhoAmA 82*
Martinez, Lino *WorFshn*
Martinez, Maria 1884- *CenC*
Martinez, Maria 1887- *WomArt*
Martinez, Maria Montoya 1881?- *IlBEAAW*
Martinez, Mariano Emilio 1928- *AmArch 70*
Martinez, Marie Montoya 1881- *WhAmArt 85*
Martinez, Pearl *DcWomA*
Martinez, Pete 1894- *ArtsAmW 1, IlBEAAW*
Martinez, Romeo E 1912- *ICPEnP*
Martinez, Sebastian 1602-1667 *ClaDrA*
Martinez, Xavier 1869-1943 *IlBEAAW,*
 WhAmArt 85
Martinez, Xavier 1874-1943 *ArtsAmW 1*
Martinez Aledo, Luisa J *DcWomA*
Martinez DeHoyos, Ricardo 1918- *McGDA*
Martinez DePedro, Linda 1946- *FolkA 86*
Martinez-Maresma, Sara *WhoAmA 73, -76, -78, -80,*
 -82
Martinez-Roig, William 1933- *AmArch 70*
Martini *NewYHSD*
Martini, Arturo 1889-1947 *McGDA, OxTwCA,*
 PhDcTCA 77
Martini, Costanza *DcWomA*
Martini, Emilie Christiane Henriette 1797-1876
 DcWomA
Martini, Gebhard 1953- *DcCAr 81*
Martini, H E 1888- *WhAmArt 85*
Martini, Peter *MarqDCG 84*
Martini, Pietro *NewYHSD*
Martini, Simone *McGDA*
Martinic, Anka 1887- *DcWomA*
Martinie, Berthe *DcWomA*
Martino DaUdine *McGDA*
Martino DiBartolommeo DiBiagio d1434? *McGDA*
Martino, Mrs. *DcVicP, -2*
Martino, Anna 1829- *DcWomA*

Martino, Antonio *AfroAA*
Martino, Antonio P 1902- *WhoAmA 73, -76, -78, -80,*
 -82, -84
Martino, Antonio Pietro 1902- *WhAmArt 85*
Martino, Babette *WhoAmA 82, -84*
Martino, David Lee 1941- *AmArch 70*
Martino, Del Don *DcVicP 2*
Martino, Edmund 1915- *WhoAmA 78, -80, -82, -84*
Martino, Edoardo De 1838-1912 *DcSeaP*
Martino, Edward De 1838-1912 *DcVicP 2*
Martino, Eva E *WhoAmA 73, -76, -78, -80, -82, -84*
Martino, Frank d1941 *WhAmArt 85*
Martino, Giovanni *AfroAA*
Martino, Giovanni 1908- *WhAmArt 85,*
 WhoAmA 73, -76, -78, -80, -82, -84
Martino, Giovanni Di *McGDA*
Martino, Marie *AfroAA*
Martino, Michel 1889- *WhAmArt 85*
Martino, Nina F *WhoAmA 84*
Martins *EarABI SUP*
Martins, Aldemir 1922- *McGDA, PhDcTCA 77*
Martins, Clelio Ferrer 1942- *MarqDCG 84*
Martins, Jaime V 1920- *AmArch 70*
Martins, Maria *McGDA*
Martins, Maria 1900- *PhDcTCA 77*
Martins, Maria 1900-1959 *OxTwCA*
Martinsen, Ivar Richard 1922- *WhoAmA 73, -76, -78,*
 -80, -82, -84
Martinsen, Mona *WhAmArt 85*
Martinsen, Mona 1884- *DcWomA*
Martinskis, A *AmArch 70*
Martinsons, Gustavs Mierius 1926- *AmArch 70*
Martinuzzi, Napoleone *DcNiCA, IlDcG*
Martiny, Philip 1858-1927 *WhAmArt 85*
Martling, W L, Jr. *AmArch 70*
Martmer, William P 1939- *WhoAmA 73, -76, -78,*
 -80, -82
Marton, Pier 1950- *WhoAmA 84*
Marton, Tutzi 1936- *WhoAmA 84*
Marton, William Lamb 1928- *AmArch 70*
Martone, Michael 1941- *ICPEnP A, MacBEP,*
 WhoAmA 84
Martone, William Robert 1945- *WhoAmA 76, -78,*
 -80, -82, -84
Martorell, Bernardo *OxArt*
Martorell, Bernardo d1452? *McGDA*
Martorell, Joan 1833-1906 *MacEA*
Martorell-Bohigas-Mackay *ConArch*
Martorell Codina, Josep 1925- *ConArch*
Martsen, Jan, The Younger 1609?-1647? *McGDA*
Martsolf, Louis Glaser 1922- *AmArch 70*
Martss, Jan *ClaDrA*
Martucci, Richard J 1952- *MarqDCG 84*
Martucci, William Conrad 1914- *AmArch 70*
Marty, Benjamin *NewYHSD*
Marty, Emil F 1868-1926 *ArtsEM*
Marty, Henriette *DcWomA*
Martyl 1918- *WhAmArt 85, WhoAmA 73, -76, -78,*
 -80, -82, -84
Martyn, Dora *DcVicP 2*
Martyn, Ethel King *DcBrA 1, DcVicP 2*
Martyn, Ethel King 1863- *DcWomA*
Martyn, Greville *DcVicP 2*
Martyn, R K *AmArch 70*
Martyniuk, Osyp 1931- *AmArch 70*
Martynowicz, Makgorzata 1951- *DcCAr 81*
Martyr, J Greville *DcVicP 2*
Martyr, Thomas 1777?-1852 *BiDBrA*
Martz *FolkA 86*
Martz, Karl 1912- *WhoAmA 76, -78, -80, -82, -84*
Martz, Lawrence Stannard *AmArch 70*
Martz, Richard James 1944- *MarqDCG 84*
Marucelli, Germana 1906- *FairDF ITA*
Maruhn, Friede *DcWomA*
Marulis, Athan 1889- *ArtsAmW 3*
Marullo, Carmelo D 1931- *AmArch 70*
Marus, B R *AmArch 70*
Maruscelli, Paolo 1596-1649 *MacEA*
Marusic, Zivko 1945- *DcCAr 81*
Marusis, Athan 1889- *ArtsAmW 3, WhAmArt 85*
Marussig, Piero 1879-1937 *OxTwCA, PhDcTCA 77*
Marut, Charles *DcCAr 81*
Maruyama, Okyo 1733-1795 *OxArt*
Marval, Jacqueline 1866-1932 *ClaDrA, DcWomA*
Marvel, Gordon S 1903- *AmArch 70*
Marvel, Orin Edward 1940- *MarqDCG 84*
Marvel, Thomas Stahl 1935- *AmArch 70*
Marvell, Thomas 1913- *AmArch 70*
Marville, Charles 1816-1879 *ICPEnP*
Marville, Charles 1816-1880? *MacBEP*
Marville, Jean De *McGDA, OxArt*
Marvin, Alden Stewart 1901- *AmArch 70*
Marvin, C *NewYHSD*
Marvin, E *ArtsEM, DcWomA*
Marvin, F H *WhAmArt 85*
Marvin, Fay *FolkA 86*
Marvin, J L *NewYHSD*
Marvin, Joseph *BiDBrA*
Marvin, Keith Allen 1903- *AmArch 70*
Marvin, Philip J *DcVicP 2*

Marvin, R *AmArch 70*
Marvuglia, Giuseppe Venanzio 1729-1814 *MacEA*
Marvy, Louis 1815-1850 *ClaDrA*
Marwan 1934- *DcCAr 81*
Marwede, Richard L 1884- *WhAmArt 85*
Marwood, Lucy *DcWomA*
Marx, Enid 1902- *ConDes*
Marx, Enid C D 1902- *WhoArt 80, -82, -84*
Marx, Enid Crystal Dorothy 1902- *DcBrA 2*
Marx, Evelyn *WhoAmA 84*
Marx, Falko 1941- *DcCAr 81*
Marx, John *FolkA 86*
Marx, Joseph *NewYHSD*
Marx, Maia Joan 1925- *AmArch 70*
Marx, Michel Andre 1926- *AmArch 70*
Marx, Nicki D 1943- *AmArt, WhoAmA 76, -78, -80,*
 -82, -84
Marx, R J *AmArch 70*
Marx, Robert Ernst 1925- *WhoAmA 73, -76, -78, -80,*
 -82, -84
Marx, Roberto Burle 1909- *McGDA, WhoArch*
Marx-Elluin, Gabrielle 1872- *DcWomA*
Marx-Kruse, Margarethe 1897- *DcWomA*
Mary Albertine 1851-1917 *DcWomA*
Mary Gregory *DcNiCA*
Mary Laureen 1893- *DcWomA, WhAmArt 85*
Mary Magdalen, Saint *McGDA*
Mary Of Bethany, Saint *McGDA*
Mary, Princess 1723-1772 *DcWomA*
Mary, Princess Of Denmark *DcWomA*
Mary, Anne Marie 1882- *DcWomA*
Mary, Josephine *DcWomA*
Mary, Marthe *DcWomA*
Mary, Noemie *DcWomA*
Mary-Bisiaux, Reine 1846-1929 *DcWomA*
Mary-George, Marie Georgette *DcWomA*
Maryan 1927- *DcCAA 71, -77, PhDcTCA 77*
Maryan, Hazel Sinaiko 1905- *WhAmArt 85*
Maryan, Maryan S 1927- *OxTwCA, WhoAmA 73,*
 -76
Maryan, Maryan S 1927-1977 *WhoAmA 78N, -80N,*
 -82N, -84N
Marye, Philip T 1872-1935 *BiDAmAr*
Maryon, L Edith C *DcWomA*
Marzal DeSax, Andres *McGDA, OxArt*
Marzano, Albert 1919- *WhoAmA 73, -76, -78, -80,*
 -82, -84
Marzaroli, Cristoforo 1837-1871 *ArtsNiC*
Marzec, Alfred S 1923- *AmArch 70*
Marzella, Joseph V 1921- *AmArch 70*
Marziale, Marco *McGDA*
Marzio, Peter Cort 1943- *WhoAmA 80, -82, -84*
Marzolf, Emma *ArtsEM, DcWomA*
Marzollo, Claudio 1938- *WhoAmA 78, -80, -82, -84*
Marzolo, Leo Aurelio 1887- *WhAmArt 85*
Marzot, Livio 1934- *ConArt 77*
Masaccio 1401-1428 *McGDA*
Masaccio, Tommaso Giovanni DiMone 1401-1428
 OxArt
Masachika *AntBDN L*
Masaka *AntBDN L*
Masakatsu 1839-1899 *AntBDN L*
Masakatu *AntBDN L*
Masamune, Goro Nyudo 1264-1343 *OxDecA*
Masanao *AntBDN L, OxDecA*
Masanao 1815-1890 *AntBDN L*
Masani, Shakuntala *IlsCB 1946*
Masanobu 1434-1530 *McGDA*
Masanobu 1686-1764 *McGDA*
Masanobu 1761-1816 *McGDA*
Masanobu, Adachi *AntBDN L*
Masaoka, Kenzo 1898- *WorECar*
Masarie, Fred Emil 1927- *AmArch 70*
Masatsugu, Kaigyokusai *OxDecA*
Masayoshi 1819-1865 *AntBDN L*
Masayuki, Hoshunsai *AntBDN L*
Masbergh, Kenneth *WorFshn*
Mascall, Christopher Mark 1846-1933 *DcBrA 1,*
 DcVicP 2
Mascarella, J L *AmArch 70*
Mascarino, Ottaviano 1536-1606 *McGDA*
Mascaro, Cristiano 1944- *ICPEnP A*
Mascherini, Marcello 1906- *McGDA, PhDcTCA 77*
Mascherino, Ottaviano *McGDA*
Mascherino, Ottaviano 1536-1606 *MacEA*
Maschmeyer Richards *EncASM*
Masciarelli, Anthony D 1939- *AmArch 70*
Masclet, Daniel 1892-1969 *ConPhot, ICPEnP A*
Mascolo, A J *AmArch 70*
Masdeu, Horacio T 1939- *AfroAA*
Mase, Carolyn C *WhAmArt 85*
Mase, Carolyn Campbell *DcWomA*
Masegne, Jacobello d1409 *McGDA*
Masegne, Paolo DiJacobello Dalle *McGDA*
Masegne, Pierpaolo Dalle d1403 *McGDA*
Maseline, Madame *DcWomA*
Maseline, Michael 1947- *MarqDCG 84*
Maser, Edward Andrew 1923- *WhoAmA 73, -76, -78,*
 -80, -82, -84
Maser, Jacob *FolkA 86*
Masereel, Frans 1889- *McGDA, OxArt*

Masereel, Frans 1889-1972 *ConArt 83, PhDcTCA 77, WorArt[port]*
Masereel, Frans-Laurent 1889- *WhoGrA 62*
Masey, Francis *DcVicP 2*
Masey, J D *AmArch 70*
Masheck, Joseph Daniel 1942- *WhoAmA 78, -80, -82, -84*
Mashkov, Ilya *OxTwCA*
Masi, Oliviero 1949- *PrintW 85*
Masic, Slobodan 1939- *WhoGrA 82[port]*
Masiello, Frank Ralph, Jr. 1925- *AmArch 70*
Masini, Girolamo 1840- *ArtsNiC*
Masini, Lara-Vinca *ConArch A*
Masip *DcWomA*
Masip, Juan Vicente, The Elder 1495?-1550? *McGDA*
Masip, Juan Vicente, The Younger *McGDA*
Maskall, Eliza *DcWomA*
Maskall, Mary *DcWomA*
Maskell, Christopher Mark 1846-1933 *DcBrA 2*
Maskeny, Michael Delano 1951- *MarqDCG 84*
Maski, J *WhAmArt 85*
Maslan, Leon 1913- *AmArch 70*
Maslauski, W *AmArch 70*
Maslen, John R 1931- *AmArch 70*
Masley, Alexander Simeon 1903- *WhAmArt 85*
Maslow, H A *AmArch 70*
Maso DaSan Friano *McGDA*
Maso Di Banco *McGDA, OxArt*
Maso DiBartolommeo 1406-1457 *McGDA*
Maso Finiguerra *McGDA*
Maso I Valenti, Rafael 1888-1935 *MacEA*
Masolino 1383-1447? *McGDA*
Masolino Da Panicale 1383?-1447? *OxArt*
Mason *FolkA 86*
Mason Limner *McGDA*
Mason, Mrs. *DcWomA*
Mason, Abigail *FolkA 86*
Mason, Abraham John 1794- *DcBrBI, EarABI, EarABI SUP, NewYHSD*
Mason, Alden 1919- *AmArt*
Mason, Alden C 1919- *WhoAmA 73, -76, -78, -80, -82, -84*
Mason, Alfred William 1848-1933 *DcBrA 1, DcVicP 2*
Mason, Alice F 1895- *WhAmArt 85*
Mason, Alice F 1895-1966? *DcWomA*
Mason, Alice Frances 1895- *WhoAmA 73, -76, -78, -80N, -82N, -84N*
Mason, Alice Trumbull *DcCAr 81*
Mason, Alice Trumbull 1904- *DcCAA 71*
Mason, Alice Trumbull 1904-1971 *DcCAA 77, WhAmArt 85, WhoAmA 78N, -80N, -82N, -84N*
Mason, Alva *NewYHSD*
Mason, Arnold Henry 1885-1963 *DcBrA 1*
Mason, Asa *NewYHSD*
Mason, Bateson 1910- *ClaDrA, DcBrA 1*
Mason, Benjamin Franklin 1804-1871 *FolkA 86, NewYHSD*
Mason, Benjamin Lincoln 1940- *WhoAmA 80, -82, -84*
Mason, Bette *WhoAmA 73, -76, -78, -80, -82, -84*
Mason, Blossom *DcVicP 2, DcWomA*
Mason, C D 1830-1915 *NewYHSD , WhAmArt 85*
Mason, C E *AmArch 70*
Mason, Charles *NewYHSD*
Mason, Charles James *DcNiCA*
Mason, David *CabMA, DcVicP 2, FolkA 86*
Mason, David 1758- *NewYHSD*
Mason, David H *NewYHSD*
Mason, Donald Edward 1931- *AmArch 70*
Mason, Dora Belle Eaton 1896- *ArtsAmW 3*
Mason, Doris Belle Eaton 1896- *ArtsAmW 3, DcWomA, WhAmArt 85*
Mason, E F *DcVicP 2*
Mason, E R *AmArch 70*
Mason, Edith *DcVicP 2*
Mason, Edith M *DcVicP 2*
Mason, Edith Mary *DcWomA*
Mason, Effie *AfroAA*
Mason, Eleanor *DcVicP 2*
Mason, Elizabeth 1880- *ArtsAmW 1*
Mason, Elizabeth 1880-1953 *DcWomA*
Mason, Emily Florence 1870- *DcBrA 1, DcVicP 2, DcWomA*
Mason, Eric 1921- *ClaDrA*
Mason, Ernold A *DcVicP 2*
Mason, Ernold E *DcBrBI*
Mason, Evelyn *DcWomA*
Mason, Francis Scarlett, Jr. 1921- *WhoAmA 80, -82, -84*
Mason, Frank H 1876-1965 *DcBrA 1*
Mason, Frank Henry 1876-1965 *DcBrBI, DcBrWA, DcSeaP, DcVicP 2*
Mason, Frank Herbert 1921- *WhoAmA 73, -76, -78, -80, -82, -84*
Mason, Fred *DcBrBI*
Mason, G Finch d1915 *DcBrA 1*
Mason, George *BiDBrA*
Mason, George d1773 *NewYHSD*

Mason, George C, Jr. 1850-1924 *MacEA*
Mason, George C, Sr. 1820-1894 *MacEA*
Mason, George Champlin 1820-1894 *BiDAmAr, NewYHSD*
Mason, George Champlin, Jr. 1849-1924 *BiDAmAr*
Mason, George DeWitt 1856-1948 *BiDAmAr*
Mason, George Dewitt 1856-1948 *MacEA*
Mason, George Finch 1850-1915 *DcBrBI, DcBrWA, DcVicP 2*
Mason, George Frederick *IlsCB 1967*
Mason, George Frederick 1904- *IlsCB 1946, -1957*
Mason, George H d1872 *ArtsNiC*
Mason, George Hemming 1818-1872 *DcBrWA, DcVicP, -2*
Mason, George Miles *DcNiCA*
Mason, Georgine *WhAmArt 85*
Mason, Gertrude *DcWomA*
Mason, Gilbert 1913-1972 *DcBrA 1*
Mason, Mrs. H *DcVicP 2*
Mason, Harold 1937- *WhoAmA 84*
Mason, Harold Dean 1937- *WhoAmA 78, -80, -82*
Mason, Harry Leslie, Jr. 1939- *AmArch 70*
Mason, Harry Louis 1935- *MarqDCG 84*
Mason, Helen H *AfroAA*
Mason, Inez *AfroAA*
Mason, J *FolkA 86*
Mason, James L *NewYHSD*
Mason, Mrs. Jeremiah *FolkA 86*
Mason, John *BiDBrA, EncASM, WhAmArt 85, WhoArt 82N*
Mason, John 1868- *WhAmArt 85*
Mason, John 1901- *WhoArt 80*
Mason, John 1927- *CenC, ConArt 83, WhoAmA 73, -76, -78, -80, -82, -84*
Mason, John W *NewYHSD*
Mason, John W 1814-1866 *FolkA 86*
Mason, Jonathan, Jr. *FolkA 86*
Mason, Jonathan, Jr. 1795-1884 *NewYHSD*
Mason, Joseph H 1935- *AmArch 70*
Mason, Joseph R 1808-1842 *NewYHSD*
Mason, Josephine *DcBrA 2, DcWomA, WhAmArt 85*
Mason, Judith *OxTwCA*
Mason, Kathleen *DcWomA, WhAmArt 85*
Mason, Larkin *FolkA 86*
Mason, Lauris Lapidos 1931- *WhoAmA 76, -78, -80, -82, -84*
Mason, Lawrence Henry 1937- *AmArch 70*
Mason, Les 1924- *WhoGrA 82[port]*
Mason, Louisa Blake 1852-1908 *DcWomA*
Mason, M *DcWomA*
Mason, M Morton *DcVicP 2*
Mason, M Watts *DcVicP 2*
Mason, Marvin 1940- *FolkA 86*
Mason, Mary *DcVicP 2, DcWomA*
Mason, Mary S Winfield d1934 *WhAmArt 85*
Mason, Mary Stoddert Winfield 1850?-1934 *DcWomA*
Mason, Mary Stuard Townsend 1886- *DcWomA, WhAmArt 85*
Mason, Maud M 1867-1956 *WhAmArt 85*
Mason, Maud Mary 1867-1956 *DcWomA*
Mason, Maude *ArtsEM, DcWomA*
Mason, Maude M 1867-1956 *WhoAmA 80N, -84N*
Mason, Michael 1935- *DcCAr 81*
Mason, Michael L 1895- *WhAmArt 85*
Mason, Miles 1752-1822 *DcNiCA*
Mason, Miles B *DcVicP 2*
Mason, Novem M 1942- *WhoAmA 84*
Mason, Olive *WhAmArt 85*
Mason, Philip Ward *AmArch 70*
Mason, Phillip H *MarqDCG 84*
Mason, Phillip Lindsay 1939- *AfroAA, WhoAmA 78, -80, -82, -84*
Mason, R H *DcVicP 2*
Mason, Ralph *CabMA*
Mason, Richard *NewYHSD*
Mason, Robert 1946- *ConBrA 79[port], DcCAr 81*
Mason, Robert Lindsay 1874- *WhAmArt 85*
Mason, Robert W 1923- *DcBrA 1*
Mason, Roger *CabMA*
Mason, Roy Martell 1886- *ArtsAmW 1*
Mason, Roy Martell 1886-1972 *WhAmArt 85, WhoAmA 78N, -80N, -82N, -84N*
Mason, S *DcVicP 2*
Mason, Samuel *CabMA, NewYHSD*
Mason, Sanford 1798?-1862? *NewYHSD*
Mason, W 1769?-1822? *DcBrWA*
Mason, W G *DcBrBI*
Mason, W H *DcVicP*
Mason, Walter G *NewYHSD*
Mason, William *BiDBrA, DcNiCA, EarABI, EarABI SUP, FolkA 86, NewYHSD*
Mason, William 1724-1797 *DcBrECP*
Mason, William 1810-1896 *MacEA*
Mason, William 1810-1897 *BiDAmAr*
Mason, William 1906- *DcCAr 81*
Mason, William A *FolkA 86*
Mason, William Albert 1855-1923 *WhAmArt 85*
Mason, William Clifford 1929- *WhoAmA 76, -78, -80, -82, -84*

Mason, William G *NewYHSD*
Mason, William Henry *DcVicP 2*
Mason, William Sanford *FolkA 86*
Mason, William Sanford 1824-1864 *NewYHSD*
Masonobu, Okumura 1691-1768 *OxArt*
Maspero, Pierre Antoine d1822 *NewYHSD*
Maspons, Eric 1938- *AmArch 70*
Masqueray, Emanuel L 1861-1917 *BiDAmAr*
Masquerier, John James 1778-1855 *DcBrECP, DcVicP 2*
Masraff, Anthony George 1937- *MarqDCG 84*
Mass, Charles *NewYHSD*
Mass, Godfrey *NewYHSD*
Mass, Gotfried *NewYHSD*
Mass, Helene 1871- *DcWomA*
Mass, Jacob *NewYHSD*
Mass, L W *AmArch 70*
Massa, August Martin 1927- *AmArch 70*
Massa, Frederick 1909- *WhAmArt 85*
Massabo, Justin *NewYHSD*
Massaguer, Conrado 1889- *WhAmArt 85*
Massai, Elisa *WorFshn*
Massaloff, Nicolas 1846- *ArtsNiC*
Massar, Ivan 1924- *ICPEnP A, MacBEP*
Massara, Carl C 1937- *AmArch 70*
Massard, Anne *DcWomA*
Massard, Eleonore Sophie *DcWomA*
Massard, Leo *DcCAr 81*
Massard, Louise *DcWomA*
Massard, Victor *NewYHSD*
Massari, Giorgio 1687-1766 *MacEA*
Massari, Luigia 1810- *DcWomA*
Massaro, Karen Thuesen 1944- *WhoAmA 78, -80, -82, -84*
Massaro, Victor *NewYHSD*
Masse, Berthe Eugenie *DcWomA*
Masse, Dorothee *DcWomA*
Masse, Georges Severe 1918- *WhoAmA 73, -76*
Masse, Jean Baptiste 1687-1767 *ClaDrA*
Massee, Clarissa D *WhAmArt 85*
Massee, Clarissa Davenport *DcWomA*
Massen, Charles 1931- *AmArch 70*
Massena, Gabriel d1945 *BiDAmAr*
Massenburg, Eugenia C 1869- *ArtsAmW 3, DcWomA*
Massenburgh, Eugenia C 1869- *ArtsAmW 3*
Massenet, Julie *DcWomA*
Masseras, Marguerite *DcWomA*
Masseria, Francisco J J C *OfPGCP 86*
Masset, Ernest *DcVicP 2*
Massett, J W *NewYHSD*
Massey *FolkA 86*
Massey, Albert 1837?- *NewYHSD*
Massey, Augustus *NewYHSD*
Massey, Billy Jess 1922- *AmArch 70*
Massey, Charles Wesley, Jr. 1942- *WhoAmA 78, -80, -82, -84*
Massey, Edward *BiDBrA*
Massey, Frederick *DcVicP 2*
Massey, Gertrude 1868-1957 *DcBrA 1, DcVicP 2, DcWomA*
Massey, Henry Gibbs 1860-1934 *DcBrA 1, DcVicP 2*
Massey, James Kendall 1953- *MarqDCG 84*
Massey, John 1931- *AmGrD[port], ConDes*
Massey, John 1950- *DcCAr 81*
Massey, John Vincent 1931- *WhoGrA 82[port]*
Massey, Joseph *NewYHSD*
Massey, Joseph d1921 *DcBrA 1*
Massey, Joseph 1850-1921 *DcVicP 2*
Massey, Marie L *DcWomA, NewYHSD*
Massey, Marilyn 1932- *FolkA 86*
Massey, Robert Joseph 1921- *WhoAmA 73, -76, -78, -80, -82, -84*
Massey, William B *FolkA 86*
Massias, Henriette Marie *DcWomA*
Massie, Diane Redfield *IlsCB 1967*
Massie, Diane Redfield 1930- *IlsCB 1957*
Massie, James d1816 *BiDBrA*
Massie, Julia M 1875- *WhAmArt 85*
Massie, Julie M *DcWomA*
Massie, Lorna 1938- *WhoAmA 84*
Massie, Martha Willis 1894- *DcWomA, WhAmArt 85*
Massier, Clement *DcNiCA*
Massilot, L *FolkA 86*
Massimo, Cavaliere *McGDA*
Massin 1925- *ConDes*
Massin, Eugene Max 1920- *WhoAmA 73, -76, -78, -80, -82, -84*
Massin, Juliette *DcWomA*
Massio, Gentile DiNiccolo DiG Di *McGDA*
Massiot, Gamaliel d1781 *DcBrA 1*
Massip, Marguerite 1841-1927 *DcWomA*
Massironi, Manfredo *OxTwCA*
Masslenson, T W G *NewYHSD*
Massman, John A 1909- *AmArch 70*
Massolien, Anna 1848- *DcWomA*
Masson, Alexandrine *DcWomA*
Masson, Andre 1896- *ConArt 77, -83, McGDA, OxArt, OxTwCA, PhDcTCA 77, PrintW 83,*

-82, -84

Mattin, Stephen Arthur 1952- *MarqDCG 84*
Mattingly 1934- *WhoAmA 84*
Mattingly, David B 1956- *ConGrA 1*
Mattingly, Edward 1915- *AmArch 70*
Mattingly, Eliza Ann *FolkA 86*
Mattingly, John Miller 1907- *AmArch 70*
Mattingly, M L *WhAmArt 85*
Mattingly, Marie Louise 1849- *DcWomA*
Mattio, Christy 1903- *WhAmArt 85*
Mattison, Donald M 1905-1975 *WhAmArt 85*
Mattison, Donald Magnus 1905- *WhoAmA 73*
Mattison, Donald Magnus 1905-1975 *WhoAmA 76N*
Mattison, Donald Mangus 1905-1975 *WhoAmA 78N, -80N, -82N, -84N*
Mattison, John D *ArtsEM*
Mattison, W L *AmArch 70*
Mattner, Jakob 1946- *DcCAr 81*
Mattocks, John *CabMA*
Mattocks, Muriel *ArtsAmW 2, DcWomA, WhAmArt 85*
Mattocks, Samuel *CabMA*
Matton, Ida 1863- *DcWomA*
Mattoni, Andreas Vincenz Peter 1779-1864 *IlDcG*
Mattox, Charles 1910- *WhoAmA 76, -78, -80*
Mattox, Charles Porter 1910- *WhAmArt 85*
Mattox, Robert F 1938- *AmArch 70*
Mattson, George Arthur *AmArch 70*
Mattson, Henry 1887-1971 *WhoAmA 78N, -80N, -82N, -84N*
Mattson, Henry E 1887-1971 *WhAmArt 85*
Mattson, Henry Elis 1887- *McGDA*
Mattson, J I *AmArch 70*
Matuisieulx, Mathilde De 1879- *DcWomA*
Matulay, Laszlo 1912- *IlsBYP, IlsCB 1946*
Matulka, F *WhAmArt 85*
Matulka, Jan 1890- *DcCAA 71, IlBEAAW, IlsCB 1744, OxTwCA*
Matulka, Jan 1890-1972 *DcCAA 77, GrAmP, WhAmArt 85, WhoAmA 78N, -80N, -82N, -84N*
Matus, James J 1933- *MarqDCG 84*
Matyr, Marietta Osborn DeLa *DcWomA*
Matz, Otto H 1830-1919 *BiDAmAr*
Matzal, L C 1890- *WhAmArt 85*
Matzelle, John Felix, Jr. 1935- *AmArch 70*
Matzen, Friede 1832- *DcWomA*
Matzen, Herman *FolkA 86*
Matzen, Herman 1861-1938 *ArtsEM*
Matzen, Herman N 1861-1938 *WhAmArt 85*
Matzen, Herman Nicolai 1861-1938 *IlBEAAW*
Matzinger, Philip F 1860-1942 *WhAmArt 85*
Matzinger, Philip Frederick 1860-1942 *ArtsAmW 2*
Matzke, Albert 1882- *WhAmArt 85*
Matzke, Frank J 1922- *AmArch 70*
Matzkes, F W *WhAmArt 85*
Matzkin, Donald Robert 1940- *AmArch 70*
Matzkin, Meyer 1880- *WhAmArt 85*
Matzner, Gerald 1943- *DcCAr 81*
Mau, Hui-Chi 1922- *WhoAmA 76, -78, -80, -82, -84*
Mau, M O *AmArch 70*
Maubert, Madame *DcWomA*
Maubert, James 1666-1746 *DcBrECP*
Mauboules, Jean *DcCAr 81*
Maubuisson, Louise Hollandine *DcWomA*
Mauch, Carl 1854-1913 *WhAmArt 85*
Mauch, F A *WhAmArt 85*
Mauch, Max d1864 *NewYHSD*
Mauch, Max 1864-1905 *WhAmArt 85*
Mauch, Paul G 1914- *AmArch 70*
Mauck, Robert James 1950- *MarqDCG 84*
Maucourt, Charles d1768 *DcBrECP*
Maucourt, Claudius d1768 *DcBrECP*
Maud, Princess Of Wales *DcWomA*
Maud, W T 1865-1903 *DcBrA 1, DcBrBI, DcVicP 2*
Maude, Alice C 1879- *DcBrA 1, DcWomA*
Maude, John *NewYHSD*
Mauder, Bruno 1877-1948 *IlDcG*
Maudsley, Sutcliffe *NewYHSD*
Mauduit, Leonie *DcWomA*
Mauduit, Louise Marie Jeanne *DcWomA*
Mauerl, Anton Wilhelm 1672-1737 *IlDcG*
Maufe, Sir Edward Brantwood 1883- *DcBrA 1*
Maufe, Sir Edward Brantwood 1883-1974 *DcBrA 2*
Maufe, Edward Brantwood 1883-1974 *MacEA*
Maufils DeSaint-Louis, Marie Madeleine 1670?-1702 *DcWomA*
Maufra, Maxime Emile Louis 1861-1918 *ClaDrA*
Maugein, Marguerite Therese 1736-1787? *DcWomA*
Maugeins, Marguerite Therese 1736-1787? *DcWomA*
Maugendre-Domergue, Odette 1884- *DcWomA*
Maugham, J *DcVicP 2*
Maughan, Miss *DcVicP 2*
Maughan, J E *DcWomA*
Maughan, James Humphrey Morland 1817-1853 *DcBrWA, DcVicP 2*
Maughelli, Mary L 1935- *WhoAmA 76, -78, -80, -82, -84*
Maugin, Marguerite Therese 1736-1787? *DcWomA*
Mauk, R Gale 1934- *AmArch 70*
Maul, James H 1927- *AmArch 70*
Maul, Marie 1840- *DcWomA*

Maulbertsch, Franz Anton 1724-1796 *McGDA*
Mauldin, Bill 1921- *WhoAmA 73, -76, -78, -80, -82, -84*
Mauldin, L R *AmArch 70*
Mauldin, William Henry 1921- *WorECar*
Maule, Henry *DcVicP 2*
Maule, James *DcVicP, -2*
Maule, Tallie Burton 1917- *AmArch 70*
Maulevrier *NewYHSD*
Maull, C *DcVicP 2*
Maull, Margaret Howell 1897- *DcWomA, WhAmArt 85*
Maulmont, Laurence De 1887- *DcWomA*
Maulpertsch, Franz Anton 1724-1796 *OxArt*
Mault, William Herbert 1947- *WhoAmA 80*
Maund, Arthur 1722?-1803 *BiDBrA*
Maund, George C *DcBrWA, DcVicP 2*
Maund, Miss S *DcBrBI*
Maundrell, Charles Gilder 1860- *DcBrA 1, DcVicP 2*
Mauney, Richard Eugene 1930- *AmArch 70*
Maunoir, Esther Herminie 1796-1843 *DcWomA*
Maunsbach, George Eric *WhoAmA 78N, -80N, -82N, -84N*
Maunsbach, George Eric 1890- *WhAmArt 85*
Maunsbach, Olin C *WhAmArt 85*
Maunsell, Geraldine 1896- *DcBrA 1, DcWomA*
Maupeou, Caroline, Vicomtesse De *DcWomA*
Mauperche, Henri 1602-1686 *ClaDrA, McGDA*
Maur, W C *DcVicP 2*
Mauran, John Lawrence 1866-1933 *BiDAmAr*
Maurepas, Marie De *DcWomA*
Maurer *FolkA 86*
Maurer, Alfred 1868-1932 *PhDcTCA 77*
Maurer, Alfred H 1868-1932 *OxTwCA, WhAmArt 85*
Maurer, Alfred Henry 1868-1932 *BnEnAmA, DcAmArt, McGDA*
Maurer, Charles G 1844-1931 *WhAmArt 85*
Maurer, Christoph 1558-1614 *ClaDrA*
Maurer, Dora 1937- *DcCAr 81*
Maurer, E J, Jr. *AmArch 70*
Maurer, Evan Maclyn 1944- *WhoAmA 73, -76, -78, -80, -82, -84*
Maurer, Harold V *AmArch 70*
Maurer, Johannes 1784-1856 *FolkA 86*
Maurer, John 1804- *FolkA 86*
Maurer, Laurie M *AmArch 70*
Maurer, Louis 1832-1932 *ArtsAmW 1, FolkA 86, IlBEAAW, NewYHSD, WhAmArt 85*
Maurer, Neil 1941- *ICPEnP A, MacBEP*
Maurer, Neil Douglas 1941- *WhoAmA 84*
Maurer, S *AmArch 70*
Maurer, Sascha 1897-1961 *WhoAmA 80N, -82N, -84N*
Maurer, Sascha A 1897-1961 *WhAmArt 85*
Maurer, Werner *IlsBYP*
Maurer, Werner 1933- *WhoGrA 82[port]*
Maurer, William Robert 1937- *AmArch 70*
Maureta, Gabriel *ArtsNiC*
Mauri, Albert Ross 1932- *AmArch 70*
Mauri, Fabio 1926- *ConArt 77, -83*
Mauri, Giuseppe Attilio *MarqDCG 84*
Maurice 1830-1902 *DcWomA*
Maurice Of Agaunum, Saint *McGDA*
Maurice, Alfred Paul 1921- *WhoAmA 73, -76, -78, -80, -82, -84*
Maurice, E Ingersoll 1901- *WhoAmA 82, -84*
Maurice, Elanor Ingersoll 1904- *AmArt*
Maurice, Robert Weldon 1925- *AmArch 70*
Mauritz *DcBrECP*
Mauro, Gary 1944- *AmArt*
Mauro, Michael P 1949- *MarqDCG 84*
Mauroner, Fabio 1884- *WhAmArt 85*
Maurovic, Andrija 1901- *WorECom*
Maurus, Henriette 1854- *DcWomA*
Maury, Cornelia Field *WhAmArt 85*
Maury, Cornelia Field 1866- *DcWomA*
Maury, Edward *NewYHSD*
Maury, Louisa M *WhAmArt 85*
Maury, Mason d1912? *BiDAmAr*
Maus, Philip d1880 *FolkA 86*
Maus, Ray D 1932- *MarqDCG 84*
Mauser, B F *AmArch 70*
Mauser, Frank *EncASM*
Mauser, Jacob *FolkA 86*
Maussion, Charles 1923- *DcCAr 81*
Maussion, Elise DuPont De *DcWomA*
Maust, Adele *DcWomA*
Maust, Adele VanGunten *WhAmArt 85*
Maust, Henry *WhAmArt 85*
Mautner *EncASM*
Mauvais, A *NewYHSD*
Mauve, Antoine 1838-1888 *OxArt*
Mauve, Anton *ArtsNiC*
Mauve, Anton 1838-1888 *ClaDrA, McGDA*
Mauzaisse, Jean Baptiste 1784-1844 *ClaDrA*
Mauzey, Merritt 1897- *WhoAmA 73*
Mauzey, Merritt 1897?-1975 *IlBEAAW*
Mauzey, Merritt 1898- *ArtsAmW 1, IlsBYP, IlsCB 1946*

Mauzey, Merritt 1898-1973 *ArtsAmW 3*
Mauzey, Merritt 1898-1975 *WhAmArt 85*
Maver, Thomas Watt 1938- *MarqDCG 84*
Maverick, Aaron Howell 1809-1846 *NewYHSD*
Maverick, Andrew 1782-1826 *NewYHSD*
Maverick, Andrew Rushton 1809?-1835? *NewYHSD*
Maverick, Ann 1810?-1863 *DcWomA, EarABI, EarABI SUP, NewYHSD*
Maverick, Brewster 1830?-1898 *NewYHSD*
Maverick, Catharine 1811-1887 *NewYHSD*
Maverick, Catherine 1811-1887 *DcWomA*
Maverick, Emily 1803-1850 *DcWomA, NewYHSD*
Maverick, Lucy *DcWomA*
Maverick, Lucy Madison *ArtsAmW 3, WhAmArt 85*
Maverick, Maria Ann 1805-1832 *DcWomA, NewYHSD*
Maverick, Octavia 1814-1882 *DcWomA, NewYHSD*
Maverick, Peter 1780- *EarABI*
Maverick, Peter 1780-1831 *NewYHSD*
Maverick, Peter 1780-1871 *DcAmArt*
Maverick, Peter, Jr. 1809-1845 *NewYHSD*
Maverick, Peter Rushton 1755-1811 *NewYHSD*
Maverick, Rena *DcWomA*
Maverick, Samuel 1789-1845 *NewYHSD*
Maverick, Samuel R 1812-1839 *NewYHSD*
Maverick, W *NewYHSD*
Mavian, Salpi Miriam 1908- *WhoAmA 73, -76, -78, -80, -82, -84*
Mavigliano, George Jerome 1941- *WhoAmA 84*
Mavignier, Almir 1925- *ConDes, OxTwCA*
Mavignier, Almir DaSilva 1925- *PhDcTCA 77*
Mavrina, Tatjana Alexeyevna 1902- *WhoGrA 62*
Mavro, Mania 1889- *DcWomA*
Mavrogordato, Alexander J *DcVicP 2*
Mavrogordato, Alexander James *DcBrA 2*
Mavroudis, Demetrios 1937- *WhoAmA 78, -80, -82, -84*
Maw, John C 1930- *AmArch 70*
Maw, John Hornby *DcVicP 2*
Maw & Co. *DcNiCA*
Mawatee *FolkA 86*
Mawbrye, E *DcBrECP*
Mawdsley, Henry 1878- *DcBrA 1*
Mawdsley, Richard *DcCAr 81*
Mawdsley, Richard W 1945- *WhoAmA 76, -78, -80*
Mawe, Annie L *DcVicP 2*
Mawe, G *DcVicP 2*
Mawicke, Tran *WhAmArt 85*
Mawicke, Tran 1911- *WhoAmA 73, -76, -78, -80, -82, -84*
Mawley, Edward d1826 *BiDBrA*
Mawley, George 1838-1873 *DcBrWA, DcVicP, -2*
Mawn, Lawrence Edward 1902- *AmArch 70*
Mawson, Elizabeth Cameron *DcVicP*
Mawson, Elizabeth Cameron 1849-1939 *DcBrA 1, DcVicP 2, DcWomA*
Mawson, James 1939- *AmArch 70*
Mawson, Karl Henry 1953- *MarqDCG 84*
Mawson, Thomas Hayton 1861-1933 *MacEA*
Mawyer, David A 1954- *MarqDCG 84*
Max, Gabriel 1840- *ArtsNiC*
Max, Gabriel Cornelius 1840-1915 *ClaDrA*
Max, John 1936- *ICPEnP A*
Max, Lope 1943- *WhoAmA 84*
Max, Peter *IlsBYP*
Max, Peter 1937- *AmArt, PrintW 83, -85, WhoAmA 73, -76, -78, -80, -82, -84*
Max, William Edward 1936- *AmArch 70*
Max-Ehrler, Louise 1850- *DcWomA*
Max-Helle, Yvonne 1877- *DcWomA*
Maxey, Betty *IlsBYP*
Maxey, Dale 1927- *IlsCB 1957*
Maxey, Holderread 1907- *WhAmArt 85*
Maxey, Katherine *DcWomA, WhAmArt 85*
Maxey, Levi *FolkA 86*
Maxey, William Walter, Jr. 1919- *AmArch 70*
Maxfield, David Briggs 1906- *AmArch 70*
Maxfield, J E *WhAmArt 85*
Maxfield, James E, Jr. 1848- *ArtsEM*
Maxfield, Roberta Masur 1952- *WhoAmA 82, -84*
Maxfield And Eaton *ArtsEM*
Maxie, Paul *DcVicP 2*
Maxim, David 1945- *DcCAr 81*
Maxim, Nancy E *ArtsEM, DcWomA*
Maximos, Mrs. *DcVicP 2*
Maxon, Charles *NewYHSD*
Maxon, Edith 1883- *DcWomA, WhAmArt 85*
Maxon, John 1916- *WhoAmA 73, -76*
Maxon, John 1916-1977 *WhoAmA 78N, -80N, -82N, -84N*
Maxon, Rex 1892-1973 *WorECom*
Maxse, Mrs. *DcVicP 2*
Maxson, Holly 1952- *MacBEP*
Maxwell *DcWomA*
Maxwell, Ann *FolkA 86*
Maxwell, Ben W 1912- *AmArch 70*
Maxwell, Coralee DeLong 1878- *DcWomA, WhAmArt 85*
Maxwell, Donald 1877-1936 *DcBrA 1, DcBrBI, DcSeaP*

Maxwell, Edward 1867-1923 *MacEA*
Maxwell, George 1768-1789 *DcBrECP*
Maxwell, Guida B *WhAmArt 85*
Maxwell, Guida B 1896- *DcWomA*
Maxwell, H C *DcVicP 2*
Maxwell, H J *WhAmArt 85*
Maxwell, Hamilton 1830-1923 *DcBrA 1, DcBrWA, DcVicP 2*
Maxwell, J *FolkA 86*
Maxwell, James Clerk 1831-1879 *ICPEnP, MacBEP*
Maxwell, John *DcCAr 81, WhoAmA 80, -82, -84*
Maxwell, John 1905-1962 *DcBrA 1*
Maxwell, John 1909- *WhoAmA 76, -78*
Maxwell, John Alan 1904- *WhAmArt 85*
Maxwell, John Franklin 1936- *MarqDCG 84*
Maxwell, John R 1909- *WhoAmA 73*
Maxwell, Sir John Stirling 1866-1956 *DcBrWA*
Maxwell, Kathleen C *ArtsEM, DcWomA*
Maxwell, Laura 1877-1967 *ArtsAmW 1*
Maxwell, Laura M 1877-1967 *DcWomA*
Maxwell, Letitia *DcWomA*
Maxwell, Murvan Morris 1910- *AmArch 70*
Maxwell, Paul 1925- *PrintW 83, -85*
Maxwell, R *DcVicP 2*
Maxwell, Robert *ConArch A*
Maxwell, Robert Edwin 1929- *WhoAmA 76, -78, -80, -82, -84*
Maxwell, Vera 1904- *FairDF US[port], WorFshn*
Maxwell, W S 1874-1952 *MacEA*
Maxwell, William *FolkA 86*
Maxwell, William 1934- *AfroAA*
Maxwell, William C 1941- *AmArt, PrintW 83, -85, WhoAmA 78, -80, -82, -84*
May, A S *DcVicP 2, DcWomA*
May, A W *DcVicP 2*
May, Alfred *DcVicP 2*
May, Allan F 1923- *AmArch 70*
May, Anais Marie *DcWomA*
May, Angele *DcWomA*
May, Arthur Dampier *DcVicP, -2*
May, Arthur Powell *DcBrWA, DcVicP, -2*
May, Beulah 1883- *WhAmArt 85*
May, Beulah 1883-1959 *ArtsAmW 3, DcWomA*
May, Caroline *DcWomA, NewYHSD*
May, Charles *DcBrECP*
May, Charles 1847-1932 *DcBrBI*
May, Charles C 1883- *WhAmArt 85*
May, Charles C 1883-1937 *BiDAmAr*
May, Charles F *BiDAmAr*
May, Christiana Brix 1876-1954 *DcBrA 1, DcWomA*
May, Daniel Striger 1942- *WhoAmA 82, -84*
May, E M *DcBrBI*
May, E M 1913- *WhoAmA 73*
May, Edward *NewYHSD*
May, Edward Harrison *ArtsNiC*
May, Edward Harrison 1824-1887 *EarABI, NewYHSD*
May, Edward John 1853-1941 *MacEA*
May, Edwin 1824-1880 *BiDAmAr*
May, Ernst 1886- *EncMA*
May, Ernst 1886-1970 *ConArch, MacEA*
May, Florence Land *WhAmArt 85*
May, Florence Lister Land *DcWomA*
May, Mrs. Frank *DcVicP 2*
May, Frank T *EncASM*
May, Frederick 1891- *DcBrA 2*
May, George H *DcBrWA*
May, George W *NewYHSD*
May, Gertrude Brooke *DcVicP 2, DcWomA*
May, Mrs. Gisborne *DcVicP 2*
May, Gwendolen Marie 1903- *DcBrA 1, WhoArt 80, -82, -84*
May, H *DcVicP 2*
May, H Goulton *DcVicP 2*
May, Hayden Barkley 1935- *AmArch 70*
May, Henrietta Mabel 1884-1971 *DcWomA*
May, Howard d1941? *BiDAmAr*
May, Hugh 1621-1684 *DcBrA, MacEA*
May, Hugh 1622-1684 *DcD&D, OxArt, WhoArch*
May, James *DcVicP 2*
May, John 1792-1859 *CabMA*
May, John Edwin 1921- *AmArch 70*
May, Kate *DcVicP 2*
May, Lelia M *ArtsEM, DcWomA*
May, Lester N 1923- *AmArch 70*
May, Lewis Victor, Jr. 1927- *IlsCB 1946*
May, M Stannard *WhAmArt 85*
May, Margaret S *DcWomA, WhAmArt 85*
May, Margery *DcVicP 2*
May, Maria B *DcWomA, NewYHSD*
May, Michael *NewYHSD*
May, Morton David 1914- *WhoAmA 73, -76, -78, -80, -82, -84*
May, Ole 1873-1920? *WorECar*
May, Phil 1864-1903 *OxArt*
May, Philip 1864-1903 *McGDA*
May, Philip William 1864-1903 *AntBDN B, DcBrA 1, DcBrBI, DcBrWA, DcVicP 2, IlBEAAW, WorECar*
May, R *DcVicP 2*
May, Richard Harold 1923- *AmArch 70*

May, Roy 1930- *FolkA 86*
May, Sibyl Huntington 1734- *FolkA 86*
May, Sibyl Huntington 1743?- *DcWomA*
May, Sophie Maria Von *DcWomA*
May, Thomas 1860-1927 *ArtsEM, WhAmArt 85*
May, W *AmArch 70*
May, W Holmes *DcBrWA*
May, William 1831-1896 *DcBrBI, DcBrWA, DcVicP, -2*
May, William Charles 1853-1931 *DcBrA 1, DcVicP 2*
May, William Edward 1899- *WhoArt 80, -82, -84*
May, William H *NewYHSD*
May, William Holmes *DcVicP 2*
May, William L 1913- *WhoAmA 73, -76, -78, -80, -82, -84*
May-Hulsmann, Valerie 1883- *DcWomA*
May-Tinel, Maria Germaine 1880- *DcWomA*
Mayakovskaya, Lyudmila *DcWomA*
Mayall, Eliza McClellen *FolkA 86*
Mayall, Eliza McLellan 1822- *DcWomA, NewYHSD*
Mayall, John Jabez Edwin 1810-1901 *ICPEnP, -A, MacBEP*
Mayan, Theophile Henri 1860- *ClaDrA*
Mayans Y Pastor, Josefa *DcWomA*
Maybank, Joseph 1930- *AmArch 70*
Maybank, Thomas *DcBrBI*
Maybe, Emmeline *NewYHSD*
Maybe, Emmeline 1812?- *DcWomA*
Maybeck, Bernard 1862-1957 *ConArch, EncAAr, McGDA, WhoArch*
Maybeck, Bernard R 1862-1957 *MacEA*
Maybeck, Bernard Ralph 1862-1957 *BnEnAmA, EncMA*
Maybee, Eli D *WhAmArt 85*
Maybelle, Claude S 1872- *ArtsAmW 2, WhAmArt 85*
Mayberry, James 1841?- *NewYHSD*
Maybery, Edgar James 1887- *DcBrA 1*
Maybin, R H *AmArch 70*
Maybury, Thomas *FolkA 86*
Maycall, John 1842?- *NewYHSD*
Maydell, Anna, Baroness Von 1861- *DcWomA*
Maydell, Eveline, Baroness Von 1890- *DcWomA*
Mayden, John Clark 1951- *MacBEP*
Maye, H *DcBrBI*
Maye, Henry Thomas *DcVicP 2*
Mayekawa, Kunio 1905- *ConArch*
Mayen, Paul 1918- *WhoAmA 73, -76, -78, -80, -82, -84*
Mayer, Mrs. *DcVicP 2*
Mayer, A *DcVicP 2*
Mayer, A E *WhAmArt 85*
Mayer, Albert 1897- *AmArch 70*
Mayer, Albert 1897-1981 *MacEA*
Mayer, Annette Phipps *ArtsEM, DcWomA*
Mayer, Anthony Frederick 1941- *AmArch 70*
Mayer, Arminius d1847 *DcVicP 2*
Mayer, Bela 1888- *WhAmArt 85*
Mayer, Bena *WhAmArt 85*
Mayer, Bena Frank 1900- *WhoAmA 73, -76, -78, -80, -82, -84*
Mayer, C W *NewYHSD*
Mayer, Casper 1871-1931 *WhAmArt 85*
Mayer, Charlotte 1929- *WhoArt 84*
Mayer, Constance 1775?-1821 *DcWomA*
Mayer, Constant 1829-1911 *NewYHSD, WhAmArt 85*
Mayer, Constant 1831- *ArtsNiC*
Mayer, E H *EarABI*
Mayer, Eduard 1812- *ArtsNiC*
Mayer, Edward A 1889- *WhAmArt 85*
Mayer, Edward Albert 1942- *WhoAmA 82, -84*
Mayer, Etienne-Francois-Auguste 1805- *ArtsNiC*
Mayer, Evelyn S *ArtsAmW 3*
Mayer, F B *AmArch 70*
Mayer, Ferdinand 1817?- *NewYHSD*
Mayer, Francis Blackwell 1827-1899 *NewYHSD, WhAmArt 85*
Mayer, Frank B 1827- *ArtsNiC*
Mayer, Frank Blackwell 1827-1899 *IlBEAAW*
Mayer, Fred A 1904- *WhAmArt 85*
Mayer, Grace *ICPEnP*
Mayer, Grace M *WhAmArt 85, WhoAmA 73, -76, -78, -80, -82, -84*
Mayer, Henrik Martin 1908- *WhAmArt 85*
Mayer, Henry *FolkA 86*
Mayer, Henry 1868- *DcBrBI*
Mayer, Henry 1868-1953 *WhAmArt 85*
Mayer, Henry 1868-1954 *WorECar*
Mayer, Herbert Paul 1924- *AmArch 70*
Mayer, James *FolkA 86*
Mayer, Jane Smith 1883- *WhAmArt 85*
Mayer, Jessie Hull 1910- *WhAmArt 85*
Mayer, Joseph *EncASM, NewYHSD*
Mayer, Joseph F *FolkA 86*
Mayer, Jules 1911- *WhAmArt 85*
Mayer, Julius *NewYHSD*
Mayer, Karl 1810-1876 *ArtsNiC*
Mayer, Leonard 1929- *AmArch 70*

Mayer, Liezen *ArtsNiC*
Mayer, Louis 1869- *WhAmArt 85*
Mayer, Louis 1869-1969 *ArtsAmW 2*
Mayer, Luigi *DcBrBI*
Mayer, Marie *DcWomA*
Mayer, Marie Francoise C LaMartiniere 1775-1821 *ClaDrA*
Mayer, Marie Francoise Constance 1775-1821 *WomArt*
Mayer, Marshall 1952- *MacBEP*
Mayer, Martin 1931- *DcCAr 81*
Mayer, Mercer 1943- *IlsBYP, IlsCB 1967*
Mayer, Michael 1932- *DcCAr 81*
Mayer, Michael Leo 1952- *MarqDCG 84*
Mayer, Milton *WhAmArt 85*
Mayer, Peter Bela 1888- *WhAmArt 85*
Mayer, Philip *FolkA 86*
Mayer, R J *AmArch 70*
Mayer, Ralph 1895- *WhAmArt 85, WhoAmA 73, -76, -78*
Mayer, Ralph 1895-1979 *WhoAmA 80N, -82N, -84N*
Mayer, Ralph J 1952- *MarqDCG 84*
Mayer, Robert Bloom 1910- *WhoAmA 73*
Mayer, Rosemary 1943- *WhoAmA 78, -80, -82, -84*
Mayer, S *AmArch 70*
Mayer, Sheldon 1917- *WorECom*
Mayer, Sondra 1933- *WhoAmA 80, -82, -84*
Mayer, Susan Martin 1931- *WhoAmA 76, -78, -80, -82, -84*
Mayer, William *DcCAr 81*
Mayer, William G *WhAmArt 85*
Mayer Lamartiniere, Marie-F-Constance 1778-1821 *McGDA*
Mayer-Marton, George 1897- *ClaDrA*
Mayers, Andrew *NewYHSD*
Mayers, Ian Richard 1945- *MarqDCG 84*
Mayers, John J 1906- *WhoAmA 73, -76, -78*
Mayers, W S *FolkA 86*
Mayerson, Anna 1906- *ClaDrA, WhoArt 80, -82, -84*
Mayerson, Eric James 1952- *MarqDCG 84*
Mayerson, John H *WhAmArt 85*
Mayes, Elaine 1938- *ConPhot, ICPEnP A, MacBEP, WhoAmA 80, -82, -84*
Mayes, Gordon *AfroAA*
Mayes, H Harrison 1898- *FolkA 86*
Mayes, John Arthur 1926- *AmArch 70*
Mayes, Marietta Betty 1939- *AfroAA*
Mayes, Reginald Harry Duncan 1900- *WhoArt 80, -82, -84*
Mayes, Steven Lee 1939- *WhoAmA 78, -80, -82, -84*
Mayes, W Philip 1907- *WhoArt 80, -82, -84*
Mayes, William Edward 1861-1952 *DcBrA 1, DcVicP 2*
Mayfield, Henry Davis, Jr. 1913- *AmArch 70*
Mayfield, L H *AmArch 70*
Mayfield, R B 1869-1936 *WhAmArt 85*
Mayger, Arthur C d1948 *BiDAmAr*
Mayger, Chris Henry 1918- *WhoArt 80, -82, -84*
Mayhall, Dorothy A 1925- *WhoAmA 73, -76, -78*
Mayhall, Temple Bland 1900- *AmArch 70*
Mayhew *ArtsEM*
Mayhew, Bob *FolkA 86*
Mayhew, Edgar DeNoailles 1913- *WhoAmA 73, -76, -78, -80, -82, -84*
Mayhew, Elza *WhoAmA 76, -78, -80, -82, -84*
Mayhew, Frederick W *FolkA 86*
Mayhew, G W *DcVicP 2*
Mayhew, James Gray 1771-1845 *BiDBrA*
Mayhew, John d1811 *AntBDN G*
Mayhew, M H *FolkA 86*
Mayhew, Nathaniel *FolkA 86*
Mayhew, Nell Brooker *WhAmArt 85*
Mayhew, Nell Danely Brooker 1876-1940 *ArtsAmW 2, DcWomA*
Mayhew, Richard 1924- *AfroAA, DcCAA 71, -77, WhoAmA 73, -76, -78*
Mayhew, Richard 1934- *WhoAmA 80, -82, -84*
Mayhew, William C *NewYHSD*
Maylard, John Burnham 1898- *AmArch 70*
Maylord, James *DcVicP 2*
Maymont, Paul 1926- *MacEA*
Maynard, Miss *DcWomA*
Maynard, A E *FolkA 86*
Maynard, Anthony 1937- *WhoArt 80, -82*
Maynard, C L *AmArch 70*
Maynard, Carl Victor 1932- *AmArch 70*
Maynard, Charles, Viscount d1824 *DcBrWA*
Maynard, George W *ArtsNiC*
Maynard, George W 1843-1923 *WhAmArt 85*
Maynard, Guy *WhAmArt 85*
Maynard, Harold B 1866-1941 *WhAmArt 85*
Maynard, Harold Milton *WhAmArt 85*
Maynard, Harriette *DcVicP 2*
Maynard, Kenneth Douglas 1931- *AmArch 70*
Maynard, Richard Field 1875- *WhAmArt 85*
Maynard, Richard G 1940- *MarqDCG 84*
Maynard, Thomas 1752-1812? *DcBrECP*
Maynard, Valerie 1937- *WhoAmA 76, -78, -80*
Maynard, Valerie J *AfroAA*
Maynard, William 1921- *WhoAmA 76, -78, -80, -82, -84*

Mayne, Arthur Jocelyn 1837?-1893 *DcVicP 2*
Mayne, Clare Mary *DcWomA*
Mayne, Earl Leslie 1929- *AmArch 70*
Mayne, Roger 1929- *ConPhot, DcCAr 81,
ICPEnP A*
Mayne, W L *AmArch 70*
Maynell, John 1894-1970 *DcBrA 1*
Maynicke, Emma *DcWomA*
Maynicke, Robert D 1849-1913 *BiDAmAr*
Mayno, Juan Bautista *McGDA*
Mayno, Juan Bautista 1578-1649 *OxArt*
Maynors, Katherine *DcWomA*
Mayo, A *DcWomA*
Mayo, Arthur *EncASM*
Mayo, Benjamin *EncASM*
Mayo, Charles S *FolkA 86*
Mayo, Clarence, Jr. *AfroAA*
Mayo, Eileen *WhoArt 80, -82, -84*
Mayo, Ernest 1865-1946 *BiDAmAr*
Mayo, Frank Veach 1891- *AmArch 70*
Mayo, J E *NewYHSD*
Mayo, John B *EncASM*
Mayo, John S *MarqDCG 84*
Mayo, Joseph B *EncASM*
Mayo, L D *AmArch 70*
Mayo, M *DcVicP 2*
Mayo, M G *AmArch 70*
Mayo, Margaret Ellen 1944- *WhoAmA 80, -84*
Mayo, Marti 1945- *WhoAmA 80, -82, -84*
Mayo, Reba 1895- *WhAmArt 85*
Mayo, Reba Harkey 1895- *DcWomA*
Mayo, Robert *FolkA 86*
Mayo, Robert Bowers 1933- *WhoAmA 82, -84*
Mayo, S B *AmArch 70*
Mayo, S I *DcWomA*
Mayo, Mrs. S I *ArtsAmW 3*
Mayo, Samuel *EncASM*
Mayo, Stephen 1937- *AfroAA*
Mayo, William G *EncASM*
Mayor, A Hyatt 1901-1980 *WhoAmA 80N, -82N,
-84N*
Mayor, Alpheus Hyatt 1901- *WhAmArt 85,
WhoAmA 76, -78*
Mayor, Barnaby d1774 *DcBrECP*
Mayor, Hannah *DcWomA*
Mayor, Hannah 1871- *DcBrA 1, DcVicP 2*
Mayor, Harriet *DcWomA*
Mayor, Harriet Hyatt Randolph 1868- *WhAmArt 85*
Mayor, Louise *DcWomA*
Mayor, Robin 1937- *DcCAr 81*
Mayor, William Frederick 1865-1916 *DcBrA 1,
DcVicP 2*
Mayor, William Frederick 1866-1916 *DcBrWA*
Mayorga, Gabriel Humberto 1911- *WhoAmA 73, -76,
-78, -80, -82, -84*
Mayotte, Bernard Joseph 1923- *AmArch 70*
Mayotte, R E *AmArch 70*
Mayr, Christian 1805?-1851 *EarABI, EarABI SUP,
NewYHSD*
Mayr, Susanna *DcWomA*
Mayr VonBaldegg, Mathilde R DeWeck 1870-
DcWomA
Mayreder, Rose 1858- *DcWomA*
Mayreder Brothers *MacEA*
Mayrena, Jeanne Clemence *DcWomA*
Mayrhofer, Johann Nepomuk 1764-1832 *ClaDrA*
Mayrs, David Blair 1935- *WhoAmA 84*
Mays, Buddy 1943- *ICPEnP A*
Mays, Douglas Lionel 1900- *ClaDrA, DcBrA 1,
WhoArt 80, -82, -84*
Mays, Lewis Victor, Jr. *IlsCB 1967*
Mays, Lewis Victor, Jr. 1927- *IlsBYP, IlsCB 1957*
Mays, Paul 1887-1961 *WhAmArt 85*
Mays, Paul Kirtland 1887-1961 *ArtsAmW 1,
IlBEAAW, WhoAmA 80N, -82N, -84N*
Mays, R Ralph 1936- *AmArch 70*
Mays, Victor 1927- *WhoAmA 78, -80, -82, -84*
Mays, William Clayton, Jr. *AmArch 70*
Mayson, S *DcBrBI*
Maytham, Thomas Northrup 1931- *WhoAmA 73, -76,
-78, -80, -82, -84*
Mayton, Keith *DcCAr 81*
Maywood, C G *ArtsEM*
Mazarin, John *NewYHSD*
Mazaud-Sabatier, Leonie 1872- *DcWomA*
Maze, Paul Lucien 1887- *DcBrA 2*
Maze, R R *AmArch 70*
Mazeau, Caroline Leonie Jeanne *DcWomA*
Mazel, Denise 1892- *DcWomA*
Mazeline, Jehanne *DcWomA*
Mazell, Peter d1792? *BkIE*
Mazeppa, Jan 1645-1700 *DcNiCA*
Mazer, Jacob *FolkA 86*
Mazer, Richard Running 1926- *AmArch 70*
Mazerolle, Alexis Joseph 1826-1889 *ClaDrA*
Mazerolles, Philippe De d1480? *OxArt*
Mazerolles, Philippe De 1420?-1479 *McGDA*
Mazeski, Walter Adolph 1909- *WhAmArt 85*
Mazieres, Marquise DeTraysseix *WhAmArt 85*
Mazilier, Carmen 1891- *DcWomA*
Mazio, Gertrude Greenblatt 1915- *WhAmArt 85*

Mazliah, Gilbert 1942- *DcCAr 81*
Mazo, Juan Bautista Martinez Del 1612?-1667 *OxArt*
Mazo, Juan Bautista Martinez Del 1614?-1667
McGDA
Mazonowicz, Douglas *PrintW 83, -85*
Mazot, Angeline *DcWomA*
Mazur, Frank 1910- *FolkA 86*
Mazur, Jacob *FolkA 86*
Mazur, Michael 1935- *ConArt 77, PrintW 83, -85,
WhoAmA 76, -78, -80, -82, -84*
Mazur, Michael B 1935- *AmArt, DcCAA 71, -77,
WhoAmA 73, -76*
Mazur, Wladyslaw 1874- *WhAmArt 85*
Mazurkewicz, James Edward *EncASM*
Mazurowski, Thomas Joseph 1943- *MarqDCG 84*
Mazursky, Alan David 1955- *MarqDCG 84*
Mazyck, Isaac *NewYHSD*
Mazza, Giuseppe 1653-1741 *McGDA*
Mazzalupo, Vincent Frank 1934- *AmArch 70*
Mazzanovich, L 1872- *WhAmArt 85*
Mazzara *NewYHSD*
Mazzara, Francis *NewYHSD*
Mazze, Irving *WhoAmA 84*
Mazzeo, Natale *WhAmArt 85*
Mazzinghi, Pietro *DcSeaP*
Mazzocca, Gus 1940- *WhoAmA 78, -80, -82, -84*
Mazzola, Filippo 1460?-1505 *McGDA*
Mazzola, Francesco *McGDA*
Mazzola, Girolamo Francesco Maria 1503-1540
ClaDrA
Mazzola, Paolo *IlDcG*
Mazzola Bedoli, Girolamo 1500?-1569 *McGDA*
Mazzolino, Ludovico *McGDA*
Mazzone, Domenico 1927- *WhoAmA 73, -76, -78,
-80, -82, -84*
Mazzoni, A *DcVicP 2*
Mazzoni, Angiolo 1894-1979 *MacEA*
Mazzoni, Guido d1518 *McGDA*
Mazzoni, Isabella *DcWomA*
Mazzoni, Pellegrina *DcWomA*
Mazzoni, Sebastiano 1611?-1678 *McGDA*
Mazzotta, R *AmArch 70*
Mazzucchelli, Louis J 1956- *MarqDCG 84*
Mazzucchelli, Pier Francesco 1571-1626 *McGDA*
Mazzuchetti, Alessandro 1824-1894 *MacEA*
Mazzuoli, Giuseppe, The Elder 1644-1725 *McGDA*
McAbee, John W *NewYHSD*
McAdam, Walter 1866-1935 *DcBrA 1, DcVicP 2*
McAdams, A C *AmArch 70*
McAdams, Gladys Wilson *WhAmArt 85*
McAdams, Howard Douglas 1934- *AmArch 70*
McAdams, James E 1918- *AmArch 70*
McAdams, Kelly R 1929- *AmArch 70*
McAdoo, Annie Florence Violet *DcBrA 1*
McAdoo, Benjamin F, Jr. 1920- *AmArch 70*
McAdoo, Carol Westbrook 1937- *WhoAmA 82, -84*
McAdoo, Donald Eldridge 1929- *WhoAmA 76, -78,
-80, -82, -84*
McAdoo, Violet *ClaDrA*
McAfee, C F *AmArch 70*
McAfee, Charles Warner 1941- *MarqDCG 84*
McAfee, H E *AmArch 70*
McAfee, Ila 1897- *ArtsAmW 3*
McAfee, Ila 1900- *WhAmArt 85*
McAfee, Ila Mae 1897- *DcWomA, IlBEAAW*
McAfee, Mara 1934-1984 *IlrAm 1880*
McAleavey, F L *AmArch 70*
McAlister, R F *WhAmArt 85*
McAlister, W A *AmArch 70*
McAlister Sisters *DcWomA*
M'Call, William *DcVicP 2*
McAllister, Abel Franklin 1906- *WhAmArt 85*
McAllister, C J *AmArch 70*
McAllister, E P *ArtsAmW 2, WhAmArt 85*
McAllister, Edward Braden 1930- *AmArch 70*
McAllister, Ethel Louise 1898- *WhAmArt 85*
McAllister, James C *NewYHSD*
McAllister, John *NewYHSD*
McAllister, John A 1896-1925 *DcBrWA*
McAllister, Louis Erhardt 1897- *AmArch 70*
McAllister, Stewart Pierce 1936- *AmArch 70*
McAllister, V Jane 1912- *WhAmArt 85*
McAllister-Kelly *WhoAmA 73, -76, -78, -80, -82*
McAlpin, David H *WhoAmA 73*
McAlpine, Charles F, Jr. 1923- *AmArch 70*
McAlpine, Gordon A 1921- *MarqDCG 84*
McAlpine, Helen Emmeline *DcWomA*
McAlpine, J E *AfroAA*
McAndrew, Dennis Anthony 1945- *WhoAmA 82, -84*
McAndrew, John 1904- *WhoAmA 73, -76*
McAndrews, John Joseph 1928- *AmArch 70*
McAninch, Beth 1918- *WhoAmA 73, -76, -78, -80,
-82, -84*
McAnney, John *FolkA 86*
McArdle, Harry Arthur 1836-1908 *NewYHSD ,
WhAmArt 85*
McArdle, Henry Arthur 1836-1908 *ArtsAmW 1, -2,
IlBEAAW*
McArdle, James *NewYHSD*
McArdle, Jay *WhAmArt 85*
McArthur, Miss *DcWomA*

McArthur, A 1795?-1860? *DcBrWA*
McArthur, A F *DcWomA*
McArthur, Anson James 1924- *AmArch 70*
McArthur, Bettie 1865- *ArtsAmW 3, DcWomA*
McArthur, Betty *WhAmArt 85*
McArthur, Betty 1865- *ArtsAmW 3*
McArthur, Carolyn *WhAmArt 85*
McArthur, D W *MarqDCG 84*
McArthur, Frank Poole *AmArch 70*
McArthur, Grace 1898- *FolkA 86*
McArthur, J A, Jr. *AmArch 70*
McArthur, John, Jr. 1823-1890 *BiDAmAr, MacEA*
McArthur, Leon *WhAmArt 85*
McArthur, Mary Ann *DcWomA*
McArthur, Paul Harrison, Jr. 1932- *AmArch 70*
McArthur, Thomas William Herbert 1915- *WhoArt 84*
McArthur, W J *AmArch 70*
M'Carthy, Edward *NewYHSD*
McAuley, Cory L *DcWomA*
McAuley, John K 1865- *WhAmArt 85*
McAuley, Mary E *WhAmArt 85*
McAuley, Patsy *OfPGCP 86*
McAuliffe, Charles Michael 1924- *AmArch 70*
McAuliffe, J *FolkA 86, NewYHSD*
McAuliffe, James J 1848-1921 *WhAmArt 85*
McAuliffe, John Herbert, Jr. 1916- *AmArch 70*
McAuliffe, T J *WhAmArt 85*
McAuslan, Helen *WhAmArt 85*
McAvity, E Dorothy 1885?-1958 *DcWomA*
McAvoy, Eileen Mary 1953- *MarqDCG 84*
McAvoy, Thomas Dowell 1905-1966 *ICPEnP A,
MacBEP*
McBain, Raphael C 1938- *MarqDCG 84*
McBean, Angus 1904- *ConPhot, ICPEnP A*
McBean, Angus Rowland 1904- *MacBEP*
McBean, M E *DcVicP 2*
McBean, Thomas *BiDAmAr*
McBerty, Roger Baker 1937- *AmArch 70*
McBey, James 1883-1959 *DcBrA 1, McGDA,
WhAmArt 85*
McBey, James 1884-1959 *WhoAmA 80N, -82N,
-84N*
McBride, Adah 1892- *FolkA 86*
McBride, Clifford 1901- *WhAmArt 85*
McBride, Clifford 1901-1951 *WorECom*
McBride, E 1889- *WhAmArt 85*
McBride, Eva Ackley 1861- *ArtsAmW 2,
WhAmArt 85*
McBride, Eva Ackley 1861-1928 *DcWomA*
McBride, Henry d1962 *WhoAmA 78N, -80N, -82N,
-84N*
McBride, Henry 1867-1962 *WhAmArt 85*
McBride, James 1785?-1845 *BiDBrA*
McBride, James Joseph 1923- *WhoAmA 73, -76, -78,
-80*
McBride, Peter Campbell 1947- *MarqDCG 84*
McBride, Robert E 1933- *AmArch 70*
McBride, Walter Henry 1905- *WhAmArt 85,
WhoAmA 73, -76*
McBride, Will 1931- *ConPhot, ICPEnP A*
McBride, William 1942- *AfroAA*
McBroom, Louise G *WhAmArt 85*
McBryde, Bolton 1910- *AmArch 70*
McBryde, Ellen D *WhAmArt 85*
McBryde, Sarah Elva 1942- *WhoAmA 78, -80, -82,
-84*
McBurney, James Edwin 1868- *WhAmArt 85*
McBurney, James Edwin 1868-1955 *ArtsAmW 2*
McCabe, Cynthia Jaffee 1943- *WhoAmA 76, -78, -80,
-82, -84*
McCabe, Daniel H 1956- *MarqDCG 84*
McCabe, E *NewYHSD*
McCabe, James *AntBDN D*
McCabe, Junius D *WhAmArt 85*
McCabe, Lawrence 1924- *WhoAmA 76, -78, -80*
McCabe, Maureen M *WhoAmA 78, -80, -82, -84*
McCabe, Michael Wendell 1949- *MarqDCG 84*
McCabe, Thomas *CabMA*
McCafferty, Charles Terrence 1934- *AmArch 70*
McCafferty, Henry *NewYHSD*
McCafferty, Jay 1948- *DcCAr 81, PrintW 83, -85*
McCafferty, Jay David 1948- *AmArt, WhoAmA 76,
-78, -80, -82, -84*
McCaffery, Janet *IlsBYP*
McCaffery, Janet 1936- *IlsCB 1967*
McCagg, Edith *WhAmArt 85*
McCagg, Edward King, II 1935- *AmArch 70*
McCague, Lydia Scott 1870- *ArtsAmW 2, DcWomA,
WhAmArt 85*
McCahill, Agnes McGuire *DcWomA, WhAmArt 85*
McCahill, Mary C *WhAmArt 85*
McCaig, Flora T *WhAmArt 85*
McCaig, Flora Thomas 1856-1933 *ArtsAmW 3,
DcWomA*
McCaleb, Russell Haeber 1930- *AmArch 70*
McCall, Alice Howe 1882- *ArtsAmW 3*
McCall, Ann 1941- *WhoAmA 84*
McCall, Anthony 1946- *ConArt 77, WhoAmA 78,
-80, -82, -84*
McCall, Arthur *OfPGCP 86*
McCall, Charles Cooper 1947- *MarqDCG 84*

McCall, Charles James 1907- *DcBrA 1, WhoArt 80, -82, -84*
McCall, Eva Struthers *WhAmArt 85*
McCall, Gertrude S *DcVicP 2*
McCall, Howard Earl 1923- *AmArch 70*
McCall, J D, Jr. *AmArch 70*
McCall, K A *AmArch 70*
McCall, L R, Jr. *AmArch 70*
McCall, Mary A *DcWomA, WhAmArt 85*
McCall, Michael 1947- *MarqDCG 84*
McCall, Philena 1783-1822 *FolkA 86*
McCall, Robert Theodore 1919- *IlBEAAW, IlrAm F, -1880, WhoAmA 78, -80, -82, -84*
McCall, Sylvia H *ArtsEM*
McCall, Virginia Armitage 1908- *WhAmArt 85*
McCall, Wayne 1942- *MacBEP*
McCall, William Francis, Jr. 1916- *AmArch 70*
McCall, William Reaves 1930- *AmArch 70*
McCall, William Sherwood *WhAmArt 85*
McCalla, Irish *OfPGCP 86*
McCallebb, Howard *AfroAA*
McCallister, William O 1945- *MarqDCG 84*
McCallum, A *DcWomA*
McCallum, Andrew 1821-1902 *DcVicP, -2*
McCallum, Angus 1911- *AmArch 70*
McCallum, Corrie 1914- *WhoAmA 73, -76, -78, -80, -82, -84*
McCallum, Mrs. Donald 1885?- *DcWomA*
McCallum, Gilbert *NewYHSD*
McCallum, L M *AmArch 70*
McCallum, R H 1902- *WhAmArt 85*
McCallum, R N *AmArch 70*
McCallum, Stewart Leroy 1928- *AmArch 70*
McCalmont, Ethel E *DcVicP 2, DcWomA*
McCalmont, H B *DcVicP 2*
McCammish, Douglas Willis 1944- *MarqDCG 84*
McCan, J Ferdinand 1869- *WhAmArt 85*
McCan, James Ferdinand 1869-1925 *ArtsAmW 2*
McCance, Agnes *DcWomA*
McCance, William 1894- *DcBrA 1*
McCandless, B J *AmArch 70*
McCandless, D, Jr. *AmArch 70*
McCandless, J *AmArch 70*
McCandless, Madeline 1885?- *DcWomA*
McCandlish, Edward G 1887-1946 *WhAmArt 85*
McCandlish, Mary *DcWomA*
McCandlish, William *BiDBrA*
McCane, Mallory 1943- *WhoAmA 82, -84*
McCann, Miss *DcWomA*
McCann, Cecile Nelken *WhoAmA 76, -78, -80, -82, -84*
McCann, George *FolkA 86*
McCann, Gerald 1916- *IlsBYP, IlsCB 1946*
McCann, H D G *NewYHSD*
McCann, Henry G 1808?- *NewYHSD*
McCann, J *NewYHSD*
McCann, James Ferdinand 1869-1925 *ArtsAmW 2*
McCann, John A *ArtsEM*
McCann, John Buckley 1956- *MarqDCG 84*
McCann, Margery *DcWomA*
McCann, Mary A *DcWomA, NewYHSD*
McCann, Minna *WhAmArt 85*
McCann, R V *AmArch 70*
McCann, Rebecca *DcWomA*
McCann, Robert John 1953- *MarqDCG 84*
McCann, Thomas Edward *MarqDCG 84*
McCann, William *NewYHSD*
McCanna, Clare *WhAmArt 85*
McCannel, Mrs. Malcolm A 1915- *WhoAmA 73, -76, -78, -80, -82, -84*
McCannell, Otway 1883- *ClaDrA*
McCannell, Ursula *DcCAr 81*
McCannell, Ursula Vivian 1923- *DcBrA 1, WhoArt 80, -82*
McCannell, W Otway 1883-1969 *DcBrA 1*
McCannon, Dindga *AfroAA*
McCardell, Claire 1905-1958 *ConDes, WorFshn*
McCardell, Claire 1906-1958 *FairDF US*
McCarron, Edward Michael 1936- *AmArch 70*
McCarron, J J, III *AmArch 70*
McCarron, Richard V 1935- *AmArch 70*
McCarry, Ralph E 1900?- *FolkA 86*
McCart, Betty Moses *WhoAmA 78, -80, -82*
McCartan, Edward 1879-1947 *WhAmArt 85*
McCartan, James A 1938- *AmArch 70*
McCarter, Henry 1865-1943 *IlrAm 1880*
McCarter, Henry 1866-1942 *WhAmArt 85*
McCarter, Henry Bainbridge 1864-1942 *ArtsAmW 3*
McCarter, Keith 1936- *WhoArt 84*
McCarter, Michael G 1952- *MarqDCG 84*
McCarter, William *NewYHSD*
McCartey, Jessie *DcWomA*
McCartheyn, Mary Elizabeth Maxwell 1814-1893 *NewYHSD*
McCarthy *NewYHSD*
McCarthy, Claire Lindley *WhAmArt 85*
McCarthy, Clarence J 1887-1953 *WhAmArt 85*
McCarthy, D J *AmArch 70*
McCarthy, D Michael *OfPGCP 86*

McCarthy, Dan d1905 *WhAmArt 85*
McCarthy, Denis 1935- *WhoAmA 73, -76, -78, -80, -82, -84*
McCarthy, Doris *DcCAr 81*
McCarthy, Doris Jean 1910- *WhoAmA 73, -76, -78, -80, -82, -84*
McCarthy, Elizabeth White *WhAmArt 85*
McCarthy, Elizabeth White 1891- *DcWomA*
McCarthy, Fabian Hayes 1932- *AmArch 70*
McCarthy, Frank C *OfPGCP 86*
McCarthy, Frank C 1924- *AmArt, IlBEAAW, IlrAm G, -1880, WhoAmA 76, -78, -80*
McCarthy, Frank William 1892- *AmArch 70*
McCarthy, Fred 1918- *WorECar*
McCarthy, Helen K d1927 *WhAmArt 85*
McCarthy, Helen Kiner 1884-1927 *DcWomA*
McCarthy, Ivie *DcWomA*
McCarthy, Jack *MarqDCG 84*
McCarthy, John O'Toole 1843-1923 *WhAmArt 85*
McCarthy, Justin 1891-1977 *FolkA 86*
McCarthy, Justin 1892- *WhoAmA 76, -78N, -80N, -82N, -84N*
McCarthy, M A *DcWomA*
McCarthy, Marie *WorFshn*
McCarthy, Mary A C 1847- *DcWomA*
McCarthy, Michael Anthony 1934- *AmArch 70*
McCarthy, Rick 1941- *PrintW 83, -85*
McCarthy, Robert Neil 1927- *AmArch 70*
McCarthy Brothers *FolkA 86*
McCartin, Jan 1909- *WhoAmA 73, -76*
McCartin, William Francis 1905- *WhoAmA 73, -76, -78, -80, -82, -84*
McCartney, Edith 1897- *WhAmArt 85*
McCartney, Edith 1897?-1981 *DcWomA*
McCartney, Henry *NewYHSD*
McCartney, John Edward 1938- *AmArch 70*
McCartney, Linda Louise 1942- *MacBEP*
McCartney, Marion C *DcWomA*
McCartney, Mary Elizabeth Maxwell 1814-1893 *DcWomA*
McCartney, Napoleon *NewYHSD*
McCarty, Alexander E *NewYHSD*
McCarty, Bruce 1920- *AmArch 70*
McCarty, Daniel *NewYHSD*
McCarty, Don Carl 1938- *AmArch 70*
McCarty, Dow Washington 1931- *AmArch 70*
McCarty, Edward *NewYHSD*
McCarty, G J *AmArch 70*
McCarty, H L *AmArch 70*
McCarty, J J *NewYHSD*
McCarty, James 1820?- *NewYHSD*
McCarty, Lea Franklin 1905- *IlBEAAW*
McCarty, Lorraine Chambers *WhoAmA 80, -82, -84*
McCarty, Lorraine Chambers 1920- *WhoAmA 76, -78*
McCarty, Paul James *AmArch 70*
McCarty, R H *AmArch 70*
McCarty, R H, Jr. *AmArch 70*
McCarty, Shirley Carolyn 1934- *MarqDCG 84*
McCarty, W A *AmArch 70*
McCarty, W W *DcVicP 2*
McCaslin, John Wallace 1932- *MarqDCG 84*
McCaslin, Louise 1896- *ArtsAmW 3*
McCaslin, Walter Wright 1924- *WhoAmA 78, -80, -82, -84N*
McCathern, W W, Jr. *AmArch 70*
McCaughey, John W 1936- *MarqDCG 84*
McCaul, Earles Louis 1944- *MarqDCG 84*
McCaul, G J *DcVicP 2*
McCaul, Meta W *DcVicP 2*
McCauley, C H *AmArch 70*
McCauley, Gardiner Rae 1933- *WhoAmA 78, -80, -82, -84*
McCausland, Charlotte Katherine *DcVicP 2*
McCausland, Elizabeth d1965 *WhoAmA 78N, -80N, -82N, -84N*
McCausland, Elizabeth 1899-1965 *WhAmArt 85*
McCay, Winsor 1869-1934 *WorECar, WorECom*
McCay, Winsor Zenic d1934 *WhAmArt 85*
McCay, Winsor Zenic 1869?-1934 *ConGrA 1*
McChesney, Andrew *FolkA 86*
McChesney, Clifton 1929- *AmArt, WhoAmA 76, -78, -80, -82, -84*
McChesney, Mary Fuller *WhoAmA 78, -80, -82, -84*
McChesney, Robert P 1913- *DcCAA 71, -77*
McChesney, Robert Pearson 1913- *WhoAmA 73, -76, -78, -80, -82, -84*
McChesney, Samuel D d1926 *EncASM*
McChesney, William F *EncASM*
McChesney, William J *NewYHSD*
McCheyne, Alistair *WhoArt 84N*
McCheyne, Alistair 1918- *WhoArt 80, -82*
McCheyne, Alistair Walker 1918- *DcBrA 1*
McCheyne, John Robert Murray 1911- *DcBrA 1*
McChristy, Quentin L 1921- *WhoAmA 73, -76, -78, -80, -82, -84*
McClain *NewYHSD*
McClain, F M *WhAmArt 85*
McClain, Francis *NewYHSD*
McClain, G B *FolkA 86*

McClain, George M 1877- *ArtsAmW 3*
McClain, Helen Charleton 1884?- *DcWomA*
McClain, Helen Charleton 1887- *WhAmArt 85*
McClain, Malcolm 1933- *CenC*
McClain, Matthew 1956- *WhoAmA 80, -82, -84*
McClain, Robert Earl 1912- *AmArch 70*
McClaire, G A 1897- *WhAmArt 85*
McClaire, Gerald Armstrong 1897- *ArtsAmW 3*
McClamroch, W C *AmArch 70*
McClanahan, John D *WhoAmA 82, -84*
McClanahan, John D 1938- *WhoAmA 80*
McClanahan, John Dean 1938- *WhoAmA 78*
McClanahan, William J 1907- *WhoAmA 76, -78, -80*
McClean, Avis L *WhAmArt 85*
McClean, Clara *DcWomA*
McClean, Clara 1889- *WhAmArt 85*
McClean, J A *NewYHSD*
McClean, John *NewYHSD*
McClean, John d1768 *DcBrWA*
McClean, Roberta Fisk 1882- *DcWomA, WhAmArt 85*
McCleary, Bee L *WhAmArt 85*
McCleary, Lawrence Emmet 1938- *MarqDCG 84*
McCleary, Mary Fielding 1951- *DcCAr 81, WhoAmA 80, -82, -84*
McCleary, Nelson 1888- *WhAmArt 85*
McCleary, T H *AmArch 70*
McCleary, William James 1930- *AmArch 70*
McCleen, Kathleen *DcWomA*
McCleery, Robert C *DcVicP 2*
McClees, Douglas *WhAmArt 85*
McCleland, ArtsEM
McCleland, Thomas *NewYHSD*
McClellan, Cyranus Bolliva 1827?- *ArtsAmW 2*
McClellan, Douglas Eugene 1921- *DcCAA 71, -77, WhoAmA 78, -80, -82, -84*
McClellan, George Robert 1916- *AmArch 70*
McClellan, Harold Lee 1920- *AmArch 70*
McClellan, J *FolkA 86*
McClellan, James *CabMA*
McClellan, John Ward 1908- *WhAmArt 85*
McClellan, Mary 1860-1929 *DcWomA, WhAmArt 85*
McClellan, Ollie *AfroAA*
McClellan, R R *AmArch 70*
McClellan, Robert John 1906- *WhoAmA 73, -76*
McClellan Brothers *FolkA 86*
McClelland *NewYHSD*
McClelland, David *NewYHSD*
McClelland, Hugh 1912- *WorECom*
McClelland, James *OfPGCP 86*
McClelland, Jeanne C *WhoAmA 73, -76, -78, -80, -82, -84*
McClelland, John *OfPGCP 86*
McClelland, John 1919- *IlrAm G, -1880*
McClelland, R F *AmArch 70*
McClelland, Rachel P *WhAmArt 85*
McClenahan, Myrl A 1891-1940 *BiDAmAr*
McClendon, Maxine 1931- *WhoAmA 78, -80, -82, -84*
McClenney, Cheryl Ilene 1948- *WhoAmA 82, -84*
McCleskey, J W, Jr. *AmArch 70*
McCleuen, David *NewYHSD*
McCleuen, James *NewYHSD*
McCline, R G *AmArch 70*
McClintic, Fred F 1948- *MarqDCG 84*
McClintock, Clyde Edmond 1929- *AmArch 70*
McClintock, G *AmArch 70*
McClintock, Lucy *WhAmArt 85*
McClintock, Mary Howard 1888- *DcWomA*
McClintock, William F 1946- *MarqDCG 84*
McClory, Peter *NewYHSD*
McCloskey, Mrs. A B *WhAmArt 85*
McCloskey, Alberta 1863-1911 *DcWomA*
McCloskey, Alberta Binford 1863-1911 *ArtsAmW 3*
McCloskey, Eunice Lon Coske 1904- *WhoAmA 73*
McCloskey, Eunice Loncoske 1904- *WhoAmA 76, -78, -80*
McCloskey, Forrest Glenn 1932- *AmArch 70*
McCloskey, John Robert 1914- *WhAmArt 85*
McCloskey, Martha Linwood 1899- *DcWomA, WhAmArt 85*
McCloskey, Nelson W 1925- *AmArch 70*
McCloskey, Robert *IlsCB 1967*
McCloskey, Robert 1914- *WhoAmA 73, -76, -78, -80, -82, -84*
McCloskey, Robert 1914-1969 *Cald 1938, IlsBYP, IlsCB 1744, -1946, -1957*
McCloskey, William J *WhAmArt 85*
McCloskey, William J 1859-1941 *ArtsAmW 3*
McCloskey, William John 1859-1941 *ArtsAmW 3*
McCloskey, William Joseph 1859-1941 *ArtsAmW 3*
McClosky, A Binford *DcVicP 2*
McCloud, Carrol *AfroAA*
McCloud, Emma *DcWomA*
McCloy, Mrs. E L *DcBrWA*
McCloy, Samuel 1831-1904 *DcBrA 2, DcBrWA, DcVicP 2*
McCloy, William Ashby *WhAmArt 85*
McCloy, William Ashby 1913- *WhoAmA 73, -76, -78,*

McMurdie, Gertrude Demain *DcWomA*
McMurdo, James T d1955 *ArtsAmW 2*
McMurdo, K *DcWomA*
McMurray, G *AmArch 70*
McMurray, Howard Lambright 1917- *AmArch 70*
McMurrich, Miss *DcWomA*
McMurry, Benjamin F, Jr. *AmArch 70*
McMurry, Leonard 1913- *IlBEAAW*
McMurtie, William Birch 1816-1872 *NewYHSD*
McMurtrie, Edith *WhoAmA 78N, −80N, −82N, −84N*
McMurtrie, Edith 1883-1950? *WhAmArt 85*
McMurtrie, Edith 1883-1953? *DcWomA*
McMurtrie, James, Jr. *NewYHSD*
McMurtrie, William Birch 1816-1872 *ArtsAmW 1, IlBEAAW*
McMurtry, Edward Hoyse 1912- *AmArch 70*
McMurtry, John 1812-1890 *BiDAmAr*
McMurty, Edward A *WhAmArt 85*
McNab, Allan 1901- *DcBrA 1, WhoAmA 73, −76*
McNab, Richard *NewYHSD*
McNab, Robert Allan 1865- *DcBrWA, DcVicP 2*
McNab, Theo 1940- *DcCAr 81*
McNabb, Marcena Coffman *FolkA 86*
McNabb, Richard *NewYHSD*
McNabb, William Ross 1938- *WhoAmA 76, −78, −80, −82*
McNair *NewYHSD*
McNair, William 1867- *WhAmArt 85*
McNall, John *FolkA 86*
McNall, Ralph I, Jr. 1948- *MarqDCG 84*
McNally, Irvine *DcVicP 2*
McNally, Sheila John 1932- *WhoAmA 76, −78, −80, −82, −84*
McNamara, Mrs. A L *WhAmArt 85*
McNamara, Mrs. A M *WhAmArt 85*
McNamara, John Francis 1931- *AmArch 70*
McNamara, John Joseph 1897- *AmArch 70*
McNamara, John Stephen 1950- *WhoAmA 84*
McNamara, Lena Brooke 1891- *DcWomA, WhAmArt 85*
McNamara, Mary E *WhAmArt 85*
McNamara, Mary Jo 1950- *WhoAmA 78, −80, −82, −84*
McNamara, Nettie *ArtsEM, DcWomA*
McNamara, Raymond Edmund 1923- *WhoAmA 73, −76, −78, −80*
McNamara, William Patrick, Jr. 1946- *WhoAmA 84*
McNamee, Cecil William 1932- *AmArch 70*
McNamee, Dorothy Swinburne *WhAmArt 85*
McNamee, Dorothy Swinburne 1880- *DcWomA*
McNary, Oscar L 1944- *WhoAmA 78, −80, −82, −84*
McNaught, Harry *IlsBYP*
McNaughton *NewYHSD*
McNaughton, Belle *ArtsEM, DcWomA*
McNaughton, Donald *NewYHSD*
McNaughton, Eugene Eean 1931- *AmArch 70*
McNaughton, Robert *FolkA 86*
McNay, Marion 1883-1950 *DcWomA*
McNay, Marion Koogler 1883-1950 *ArtsAmW 3*
McNeall, Mrs. James Hector *WhAmArt 85*
McNear, Everett C 1904- *WhAmArt 85, WhoAmA 73, −76, −78, −80, −82, −84*
McNease, Tom 1946- *MacBEP*
McNeeley, Gary *AfroAA*
McNeely, James DuBois 1933- *AmArch 70*
McNeely, Perry 1886- *ArtsAmW 1, WhAmArt 85*
McNeely, Stephen 1909- *WhAmArt 85*
McNeil, Ambrose 1840?- *ArtsEM*
McNeil, George 1906- *BnEnAmA*
McNeil, George 1908- *DcCAA 71, −77, OxTwCA, PrintW 85*
McNeil, George J 1908- *WhoAmA 73, −76, −78, −80, −82, −84*
McNeil, George Joseph 1909- *WhAmArt 85*
McNeil, H C *AmArch 70*
McNeil, James *AfroAA*
McNeil, M C, Jr. *AmArch 70*
McNeil, William 1935- *AfroAA*
McNeil, William James *AmArch 70*
McNeilance, Sandra *DcCAr 81*
McNeill, Dorothy *DcWomA*
McNeill, H Bynum 1929- *MarqDCG 84*
McNeill, Hugh 1910- *WorECom*
McNeill, Lloyd G 1935- *AfroAA*
McNeill, Mary 1913- *WhoArt 80, −82, −84*
McNeill, Michael Francis 1944- *MarqDCG 84*
McNeill, Stanley F *WhAmArt 85*
McNeillie, David John 1950- *MarqDCG 84*
McNeilly, I J, Jr. *AmArch 70*
McNett, Elizabeth Vardell 1896- *DcWomA, WhoAmA 73*
McNett, F N *AmArch 70*
McNett, William Brown d1968 *WhoAmA 78N, −80N, −82N, −84N*
McNett, William Brown 1896-1968 *WhAmArt 85*
McNevin, J *EarABI, EarABI SUP*
McNevin, John *NewYHSD*
McNichol, D E *FolkA 86*
McNickle, J D *AmArch 70*
McNickle, Thomas Glen 1944- *WhoAmA 84*

McNicoll, Helen *DcBrA 2*
McNicoll, Helen Galloway 1879-1915 *DcWomA*
McNider, Alexander *NewYHSD*
McNitt, Miriam D 1916- *WhoAmA 76, −78*
McNiven, Thomas William Ogilvie *DcVicP 2*
McNiven, Thomas William Ogilvie d1870? *DcBrWA*
McNulby, Lucile *DcWomA*
McNulty, Agnes *DcWomA, WhAmArt 85*
McNulty, Agnes Tait *WhAmArt 85*
McNulty, Ann *DcWomA*
McNulty, Carrell Stewart, Jr. 1924- *AmArch 70*
McNulty, Frederick Charles 1919- *AmArch 70*
McNulty, James F *ArtsEM*
McNulty, Kneeland 1921- *WhoAmA 76, −78, −80, −82, −84*
McNulty, P M *NewYHSD*
McNulty, Thomas Frederick 1919- *AmArch 70*
McNulty, Mrs. William *WhAmArt 85*
McNulty, William Charles d1963 *WhoAmA 78N, −80N, −82N, −84N*
McNulty, William Charles 1884-1963 *ArtsAmW 3, WhAmArt 85*
McNutt, Bryan 1942- *FolkA 86*
McNutt, M James H 1922- *AmArch 70*
McNutt, N *DcWomA*
McPake, John 1943- *WhoArt 84*
McParlin, Eleanor Beall *WhAmArt 85*
McPeak, William *WhAmArt 85*
McPhail, David Michael 1940- *IlsCB 1967*
McPhail, Rodger *OfPGCP 86*
McPharlin, Paul d1948 *WhoAmA 78N, −80N, −82N, −84N*
McPharlin, Paul 1903-1948 *WhAmArt 85*
McPhearson, J *DcVicP 2*
McPhee, Angus J *ArtsEM*
McPheeters, Edwin Keith 1924- *AmArch 70*
McPheeters, Eugene Quentin 1924- *AmArch 70*
McPheeters, William N *OfPGCP 86*
McPherson, Bruce Rice 1951- *WhoAmA 80, −82, −84*
McPherson, J C *WhAmArt 85*
McPherson, John *NewYHSD*
McPherson, John R *MarqDCG 84*
McPherson, Larry E 1943- *ICPEnP A, MacBEP, WhoAmA 82, −84*
McPherson, Mrs. M E *ArtsEM, DcWomA*
McPherson, Murdoch 1841-1915 *DcSeaP*
McPherson, Ralph Harrison 1909- *AmArch 70*
McPherson, Robert A 1812?- *NewYHSD*
McPherson, Robert Earl 1933- *MarqDCG 84*
McPherson, Sarah 1894-1978 *DcWomA*
McPherson, W J *NewYHSD*
McPherson, William 1905- *DcBrA 1*
McPhirson, J R *DcVicP 2*
McPhisk *DcBrECP*
McQuade, Walter *WhAmArt 85*
McQuade, Walter 1922- *AmArch 70*
McQuaid, Jim 1946- *ICPEnP A, MacBEP*
McQuaid, Mary C 1886- *WhAmArt 85*
McQuaid, Mary Cameron 1886- *DcWomA*
McQuaide, Lee F *WhAmArt 85*
McQuate, Henry *FolkA 86*
McQuay, William *NewYHSD*
McQuay, William Kenneth 1945- *MarqDCG 84*
McQueen, Rosalie *DcWomA*
McQuesten, Fannie M *ArtsEM, DcWomA*
McQueston, Fannie M *ArtsEM, DcWomA*
McQuillan, Frances *WhoAmA 82, −84*
McQuillan, Frances C *WhoAmA 80*
McQuillan, Frances C 1910- *WhoAmA 73, −76, −78*
McQuillen, James *FolkA 86*
McQuinn, Robert *WhAmArt 85*
McQuoid, S *DcBrECP*
McQuoid, Thomas Robert 1820-1912 *DcBrWA*
McRae, Angus Andre 1931- *AmArch 70*
McRae, Gretchen 1893-1978 *DcWomA*
McRae, John C *NewYHSD*
McRae, Nellie C *ArtsEM, DcWomA*
McRae, Stephen D 1942- *MarqDCG 84*
McReynolds, Charles Bertram 1916- *AmArch 70*
McReynolds, Cliff 1933- *WhoAmA 76, −78, −80, −82, −84*
McReynolds, Donald Clayton 1925- *AmArch 70*
McReynolds, Joe Cliff 1933- *AmArt*
McReynolds, Kirk *WhoAmA 84*
McReynolds, Kirk Seymour *WhoAmA 78, −80, −82*
McRickard, James P 1872- *WhAmArt 85*
McRonald, Joel Alfred 1936- *AmArch 70*
McShan, Daniel Lee 1943- *MarqDCG 84*
McShane, J L *ArtsEM*
McSheehy, Cornelia Marie 1947- *WhoAmA 78, −80, −82, −84*
McSheffery, Charles Joseph, Jr. 1924- *AmArch 70*
McShine, Kynaston Leigh 1935- *WhoAmA 78, −80, −82, −84*
McSloy, David C 1941- *MarqDCG 84*
McSnyder, William *WhAmArt 85*
McSorley, Jack Ward 1937- *AmArch 70*
McSpedden, John Larry 1937- *AmArch 70*
McSween, Michael B 1948- *MarqDCG 84*
McSweeney, Angus McDonald 1900- *AmArch 70*

McSweeney, W A *AmArch 70*
McSweenye, Sean 1935- *DcCAr 81*
McSwiney, Eugene Joseph 1866- *DcBrA 1, DcVicP 2*
McTaggart, William 1835-1910 *DcBrA 1, DcBrBI, DcBrWA, DcSeaP, DcVicP, McGDA*
McTaggart, Sir William 1835-1910 *DcVicP 2*
McTavish, Miss *DcWomA*
McTighe, Anne *DcWomA, WhAmArt 85*
McTwigan, Michael 1948- *WhoAmA 80, −82, −84*
McVay, Robert Eury 1931- *AmArch 70*
McVay, Wayne M 1905- *AmArch 70*
McVeigh, Blanche *WhAmArt 85*
McVeigh, Blanche 1895-1970 *ArtsAmW 3, DcWomA*
McVeigh, Miriam Temperance *WhoAmA 73, −76, −78, −80, −82, −84*
McVeigh, Roberta Leber *WhoAmA 78, −80, −82, −84*
McVey, K *DcWomA*
McVey, Leroy V 1898- *WhAmArt 85*
McVey, Leza 1907- *WhoAmA 73, −76, −78, −80, −82, −84*
McVey, Leza S 1907- *WhAmArt 85*
McVey, William M 1905- *WhAmArt 85, WhoAmA 73, −76, −78, −80, −82, −84*
McVickar, Harry Whitney *WhAmArt 85*
McVicker, Charles Taggart 1930- *WhoAmA 80, −82, −84*
McVicker, J Jay *WhAmArt 85*
McVicker, J Jay 1911- *WhoAmA 73, −76, −78, −80, −82, −84*
McVicker, J R, Jr. *AmArch 70*
McWaters, Kenneth 1939- *AmArch 70*
McWhannell, Richard *DcCAr 81*
McWhinney, Harold 1908- *WhAmArt 85*
McWhinnie, Harold James 1929- *WhoAmA 73, −76, −78, −80, −82, −84*
McWhorter, Elsie Jean 1932- *WhoAmA 73, −76, −78, −80, −82, −84*
McWilliam, F E 1909- *ConArt 83, ConBrA 79[port], McGDA, PhDcTCA 77, WhoArt 80, −82, −84*
McWilliam, Frederick Edward 1909- *ConArt 77, DcBrA 1*
McWilliam, Robert *BiDBrA*
McWilliams, Alden 1916- *WorECom*
McWilliams, C E *AmArch 70*
McWilliams, Conrad Allen 1939- *AmArch 70*
McWilliams, Elizabeth *DcWomA, WhAmArt 85*
M'Donald, John B 1829- *ArtsNiC*
M'Dougall, John *NewYHSD*
M'Dowell, William H *NewYHSD*
Mea, Sabine d1904 *DcWomA*
Meacham, Dennis Jay 1941- *AmArch 70*
Meacham, James K 1930- *AmArch 70*
Meacham, L H *AmArch 70*
Mead, Dr. *FolkA 86*
Mead, Miss *DcBrECP*
Mead, Abraham *FolkA 86*
Mead, Alice *WhAmArt 85*
Mead, Ben Carlton 1902- *IlBEAAW, WhAmArt 85*
Mead, Dorothy d1975 *DcBrA 2*
Mead, Earl 1871-1936 *BiDAmAr*
Mead, Elinor Gertrude 1837-1910 *DcWomA, NewYHSD, WhAmArt 85*
Mead, Franklin Bush, III 1936- *AmArch 70*
Mead, Henry E 1832?- *NewYHSD*
Mead, Hope *DcWomA*
Mead, Howard *MarqDCG 84*
Mead, J P *EncASM*
Mead, John 1787-1824 *CabMA*
Mead, John Clement 1798-1839 *BiDBrA*
Mead, John O d1867? *EncASM*
Mead, Katherine Harper 1929- *WhoAmA 80, −82, −84N*
Mead, Larkin Goldsmith 1835-1910 *BnEnAmA, DcAmArt, EarABI SUP, NewYHSD, WhAmArt 85*
Mead, Marion Grace *DcBrA 2*
Mead, Mary P *DcVicP 2, DcWomA*
Mead, Mrs. Nelson *WhAmArt 85*
Mead, Paul Edward 1910- *WhAmArt 85*
Mead, Ray *OxTwCA*
Mead, Roderick Fletcher 1900- *WhAmArt 85*
Mead, Rose *DcVicP 2*
Mead, Rose 1868-1946 *DcBrA 2*
Mead, Samuel W *BiDAmAr*
Mead, T *DcVicP 2*
Mead, W C *AmArch 70*
Mead, William *FolkA 86*
Mead, William Rutherford 1846-1928 *BiDAmAr, EncAAr, MacEA, WhAmArt 85, WhoArch*
Mead And Robbins *EncASM*
Mead-Lopez, Beatriz *WhoAmA 82, −84*
Meade, Arthur *DcBrA 1*
Meade, Arthur 1863-1948? *DcVicP 2*
Meade, Francis 1814?- *NewYHSD*
Meade, Frank B 1867-1947 *BiDAmAr*
Meade, Herbert George Philip 1847-1868 *DcBrWA*
Meade, Larkin G 1835- *ArtsNiC*
Meade, Lucy Emma d1918 *DcBrWA*
Meade, S *FolkA 86*
Meader, Jonathan 1943- *AmArt, PrintW 83, −85*
Meader, Jonathan Grant *WhoAmA 82, −84*

Meader, Jonathan Grant 1943- *WhoAmA 78, –80*
Meaders, Aire *FolkA 86*
Meaders, Caspard *FolkA 86*
Meaders, Cheever 1887-1976 *FolkA 86*
Meaders, Lanier *FolkA 86*
Meadmore, Clement 1929- *ConArt 77*
Meadmore, Clement L 1929- *WhoAmA 73, –76, –78, –80, –82, –84*
Meadows, Algur H 1899- *WhoAmA 73, –76, –78*
Meadows, Algur H 1899-1980 *WhoAmA 80N, –82N, –84N*
Meadows, Arthur Joseph 1843-1907 *DcBrA 1, DcBrWA, DcSeaP, DcVicP, –2*
Meadows, Bernard 1915- *ConArt 83, ConBrA 79[port], DcBrA 1, McGDA, OxTwCA, PhDcTCA 77, WhoArt 80, –82, –84, WorArt*
Meadows, Christian 1814?- *NewYHSD*
Meadows, Cora Dell 1868-1946 *DcWomA*
Meadows, Daniel 1952- *MacBEP*
Meadows, Dell *WhAmArt 85*
Meadows, Dell 1868-1946 *ArtsAmW 2*
Meadows, Edwin *DcBrA 1*
Meadows, Edwin L *DcVicP, –2*
Meadows, Gordon Arthur 1868- *DcBrA 1, DcVicP 2*
Meadows, Grant Worth, Jr. 1951- *MarqDCG 84*
Meadows, J M *DcVicP 2*
Meadows, James 1828-1888 *DcSeaP, DcVicP*
Meadows, James, Sr. 1798-1864 *DcVicP 2*
Meadows, James Edwin *DcVicP*
Meadows, James Edwin 1828-1888 *DcVicP 2*
Meadows, John 1732?-1791 *BiDBrA*
Meadows, Joseph Kenny 1790-1874 *ClaDrA, DcBrBI, DcBrWA, DcVicP 2*
Meadows, K *DcVicP 2*
Meadows, P B 1938- *WhoAmA 84*
Meadows, R M *NewYHSD*
Meadows, Robert Mitchel *McGDA*
Meadows, Rufus Watson 1908- *AmArch 70*
Meadows, William *DcVicP 2*
Meagher, Donald *MarqDCG 84*
Meagher, James Leonard, Jr. 1923- *AmArch 70*
Meagher, M T *WhAmArt 85*
Meagher, P E *BiDAmAr*
Meagher, Richard L 1909- *AmArch 70*
Meaher, J W *FolkA 86*
Meakin, C W *AmArch 70*
Meakin, James *DcNiCA*
Meakin, L H 1850?-1917 *WhAmArt 85*
Meakin, Louis Henry 1850?-1917 *IlBEAAW*
Meakin, Louis Henry 1853-1917 *ArtsAmW 1*
Meakin, M L *DcWomA*
Meakin, Mary L *DcVicP 2*
Meakin, S *DcNiCA*
Mealing, E T *AmArch 70*
Mealy *FolkA 86*
Mealy, Charles A *EncASM*
Mealy, Edward H *EncASM*
Mealy, John W *EncASM*
Meance, Miss *DcWomA, NewYHSD*
Meance, Peter I *NewYHSD*
Meance, Peter J *NewYHSD*
Meaney, W F *AmArch 70*
Meano, Peter A *CabMA*
Means, Charles W *WhAmArt 85*
Means, Elliott *IlsBYP, WhoAmA 78N, –80N, –82N, –84N*
Means, Elliott 1905-1962 *WhAmArt 85*
Means, Elliott Anderson 1905-1962 *IlBEAAW*
Means, George Calvin, Jr. 1920- *AmArch 70*
Means, Glenn *WhAmArt 85*
Means, Mary Maud 1848- *ArtsAmW 2, DcWomA, WhAmArt 85*
Mear, Frederick *FolkA 86*
Mear, Stephen 1752?-1827 *BiDBrA*
Mear, William *BiDBrA*
Meares, Gerald A 1911- *DcBrA 1*
Meares, John 1756?-1809 *NewYHSD*
Meares, Lorran Robles 1947- *MacBEP*
Mearns, A *DcVicP 2*
Mearns, David William 1955- *MarqDCG 84*
Mearns, Fanny *DcVicP 2, DcWomA*
Mearns, Lois *DcVicP 2*
Mearns, Lois M *DcWomA*
Mears, Catharine *DcWomA, NewYHSD*
Mears, Sir Frank Charles 1880-1953 *DcBrA 1*
Mears, G *DcVicP*
Mears, George *DcSeaP, DcVicP 2*
Mears, H S, Jr. *AmArch 70*
Mears, Helen F 1876-1916 *WhAmArt 85*
Mears, Helen Farnsworth 1871-1916 *DcWomA*
Mears, Henrietta Dunn *WhAmArt 85*
Mears, Henrietta Dunn 1877- *DcWomA*
Mears, Margaret Mary *DcWomA*
Mears, Warren 1828?-1845 *CabMA*
Mears, William E 1868-1945 *WhAmArt 85*
Mears, William G 1959- *MarqDCG 84*
Mease, J *DcBrECP*
Measey, Michael *IlDcG*
Measham, Henry 1844- *DcVicP*
Measham, Henry 1844-1922 *DcBrA 1, DcBrWA, DcVicP 2*

Measom, William F *DcVicP 2*
Measom, William Frederick 1875- *DcBrA 1*
Meason, W *DcVicP 2*
Measor, W *DcBrBI, DcVicP 2*
Measor, W B M *DcVicP 2*
Meates, Marion *DcWomA*
Meathe, Philip J 1926- *AmArch 70*
Meatyard, Ralph Eugene 1925-1972 *ConPhot, ICPEnP, MacBEP*
Mebane, Mike 1908- *AmArch 70*
Mebes, Paul 1872-1938 *MacEA*
Mecarino, Domenico *ClaDrA*
Mecaskey, R *AmArch 70*
Meccarino *McGDA*
Mecham, William 1853-1902 *WorECar*
Mechau *NewYHSD*
Mechau, Frank 1904-1946 *McGDA*
Mechau, Frank Albert, Jr. 1903?-1946 *IlBEAAW, WhAmArt 85*
Mechau, Jakob Wilhelm 1745-1808 *ClaDrA, McGDA*
Mechelen, Keynoogh Van *McGDA*
Mechesi *NewYHSD*
Mechin, Clarice *DcWomA*
Mechin, Louise *DcWomA*
Mechkuev, Anton 1920- *WhoGrA 82[port]*
Mechle-Grossman, Hedwig *DcWomA*
Mechlin, Cornelia Stout 1847-1920 *DcWomA*
Mechlin, Leila *WhoAmA 78N, –80N, –82N, –84N*
Mechlin, Leila 1874-1950? *WhAmArt 85*
Meckel, Christoph 1935- *DcCAr 81*
Meckel, J S *FolkA 86*
Meckel, Max *NewYHSD*
Meckenem, Israel d1503? *ClaDrA*
Meckenem, Israel Van 1450?-1503 *McGDA*
Meckenem, Israhel Von *OxArt*
Meckenen, Ida Van *DcWomA*
Mecklem, Austin Merrill d1951 *WhoAmA 78N, –80N, –82N, –84N*
Mecklem, Austin Merrill 1894-1951 *WhAmArt 85*
Mecklem, Marianne *WhAmArt 85*
Mecklenburg, Virginia McCord 1946- *WhoAmA 84*
Meckler, J I *AmArch 70*
Meckuev, Anton 1920- *WhoGrA 62*
Meconi, Patrick 1925- *AmArch 70*
Mecord, Henry E *NewYHSD*
Meda, Caroline *DcWomA*
Medairy, Alexander R *NewYHSD*
Medairy, Charles E 1834?- *NewYHSD*
Medairy, John 1798?- *NewYHSD*
Medalen, Don Gordon 1938- *AmArch 70*
Medalla, David 1942- *ConArt 77*
Medard, Mademoiselle *DcWomA*
Medard, Virginie *DcWomA*
Medary, Amie Hampton 1903- *WhAmArt 85*
Medary, Milton B 1874-1929 *BiDAmAr*
Meday, H Augusta *DcWomA, WhAmArt 85*
Medcaff, William *CabMA*
Medcalfe, M L *AmArch 70*
Medcraft, Richard Arthur *AmArch 70*
Medd, H A N 1892-1977 *MacEA*
Meddala, David 1942- *ConArt 83*
Meddledeth, A F *WhAmArt 85*
Medearis, Roger 1920- *WhoAmA 73, –76, –78, –80, –82, –84*
Medel, Cecilia Ocampo 1951- *MarqDCG 84*
Medelli, Antonio *FolkA 86*
Medellin, Octavio 1908- *WhAmArt 85*
Meder, Ferdinand 1857-1922 *WhAmArt 85*
Medici, Clement, VII *OxArt*
Medici, Clemente *DcBrECP*
Medici, Cosimo 1389-1464 *OxArt*
Medici, Cosimo, I 1519-1574 *OxArt*
Medici, Cosmo *NewYHSD*
Medici, Giovanni 1475-1521 *OxArt*
Medici, Giovanni De' 1567-1621 *MacEA*
Medici, Giovanni DiBicci De' 1360-1429 *OxArt*
Medici, Giulio 1478-1534 *OxArt*
Medici, Lorenzo, The Magnificent 1449-1492 *OxArt*
Medici, Lorenzo DiPierfrancesco 1463-1503 *OxArt*
Medici, Marie De 1573-1642 *DcWomA*
Medici, Piero 1416-1469 *OxArt*
Medici Family *OxArt*
Medicine Flower, Grace 1938- *WhoAmA 78, –80, –82, –84*
Medina, Ada 1948- *WhoAmA 84*
Medina, John, II 1686?-1764 *DcBrECP*
Medina, John, III 1720-1796 *DcBrECP*
Medina, Sir John Baptist 1660-1710 *BkIE*
Medina, Sir John Baptist De 1659?-1710 *DcBrECP[port]*
Medina, Theresa S 1953- *MarqDCG 84*
Medina-Guzman, Pedro 1915- *DcCAr 81*
Medinger, Jacob d1930? *FolkA 86*
Medinger, William *FolkA 86*
Mediz-Pelikan, Emilie 1861-1908 *DcWomA*
Medland, J G *DcWomA*
Medland, James *BiDBrA*
Medland, John *DcVicP 2*
Medland, Thomas *DcBrWA*
Medland, Thomas Gallagher 1909- *AmArch 70*
Medlar, Clara *DcWomA*

Medley, Edward 1838-1910 *MacEA*
Medley, Robert 1905- *ConBrA 79[port], DcBrA 1, OxTwCA, PhDcTCA 77*
Medley, Samuel 1769-1857 *DcBrECP, DcBrWA*
Medlycott, Sir Hubert J 1841- *DcVicP*
Medlycott, Sir Hubert J 1841-1920 *DcVicP 2*
Medlycott, Sir Hubert James 1841-1920 *DcBrA 1, DcBrWA*
Medoff, Eve *WhoAmA 76, –78, –80, –82, –84*
Medrano, Roberto Covarrubias 1956- *MarqDCG 84*
Medrich, Libby E *WhoAmA 73, –76, –78, –80, –82, –84*
Medula, Andrea 1522-1563 *ClaDrA*
Meduna, Giovanni Battista 1810-1880 *MacEA*
Medunetsky, Kasimir *OxTwCA*
Meduniezky, Kasimir 1899- *McGDA*
Medve, Andras 1941- *DcCAr 81*
Medwin, Leslie *DcVicP 2*
Medworth, Frank Charles *ClaDrA*
Medworth, Frank Charles 1892- *DcBrA 1*
Medworth, Frank Charles 1892-1947 *DcBrA 2*
Medworth, Joseph 1754?-1827 *BiDBrA*
Mee, Miss *DcWomA*
Mee, Anne 1771?-1851 *DcWomA*
Mee, Anne Foldstone 1771?-1851 *WomArt*
Mee, Arthur Patrick 1802-1868 *BiDBrA*
Mee, Mrs. Joseph 1770?-1851 *AntBDN J*
Mee, Margaret *OfPGCP 86*
Meech, G *FolkA 86*
Meed, I M *FolkA 86*
Meeder, Philip d1913 *WhAmArt 85*
Meeds, Hollyday S *WhAmArt 85*
Meegan, Beatrice *DcWomA*
Meegan, Blanche VanC *DcWomA*
Meegan, Walter *DcVicP 2*
Meehan, Daniel Thomas 1935- *AmArch 70*
Meehan, James Aloysius, Jr. 1923- *AmArch 70*
Meehan, Joseph *NewYHSD*
Meehan, William Dale 1930- *WhoAmA 73, –76, –78, –80, –82, –84*
Meehan, William Russell 1922- *AmArch 70*
Meek, A J 1941- *MacBEP, WhoAmA 80, –82, –84*
Meek, Donald R 1925- *AmArch 70*
Meek, Harold L 1930- *AmArch 70*
Meek, J William, III 1950- *WhoAmA 76, –78, –80, –82, –84*
Meek, Mrs. M A *DcVicP 2*
Meek, Richard A 1923- *ICPEnP A, MacBEP*
Meeker, Barbara Miller 1930- *AmArt, WhoAmA 73, –76, –78, –80, –82, –84*
Meeker, D O, Jr. *AmArch 70*
Meeker, Dean Jackson 1920- *DcCAA 71, –77, WhoAmA 73, –76, –78, –80, –82, –84*
Meeker, Joseph Rusling 1827-1889 *ArtsAmW 2*
Meeker, Joseph Rusling 1827-1889? *IlBEAAW, NewYHSD*
Meeker, Mabel Aurelia *WhAmArt 85*
Meeks, Constance A *ArtsAmW 2, DcWomA, WhAmArt 85*
Meeks, Edward *BnEnAmA*
Meeks, J R *NewYHSD*
Meeks, John *CabMA*
Meeks, Joseph *CabMA, DcD&D, DcNiCA*
Meeks, Joseph 1771-1868 *BnEnAmA*
Meeks, Josiah 1815?- *FolkA 86*
Meeks, Leon 1940- *AfroAA*
Meeks, Marion Littleton 1923- *MarqDCG 84*
Meeks, Renelda *AfroAA*
Meel, Jan 1599-1663 *ClaDrA*
Meel, Raul 1941- *PrintW 83, –85*
Meem, John G d1908 *BiDAmAr*
Meem, John Gaw 1894- *AmArch 70*
Meen, Margaret *DcBrWA, DcWomA*
Meer, Barend VanDer 1659?- *ClaDrA*
Meer, Barent VanDer 1659-1702 *McGDA*
Meer, Catharina VanDer *DcWomA*
Meer, Jan VanDer 1628-1691? *ClaDrA*
Meer, Jan VanDer 1632?-1675 *ClaDrA*
Meer, Jan VanDer 1655?-1705 *ClaDrA*
Meer, Jan VanDer, II 1628-1691 *McGDA*
Meer, Jan VanDer, III 1656-1705 *McGDA*
Meer, John *FolkA 86*
Meer, John, Jr. *NewYHSD*
Meer, John, Sr. *NewYHSD*
Meer, Y *AmArch 70*
Meerbach *NewYHSD*
Meerbach, Philip *NewYHSD*
Meere, Catheline Del *DcWomA*
Meere, Charles 1890-1961 *DcBrA 2*
Meerhout, Johan d1667 *McGDA*
Meers, Mrs. *DcVicP 2*
Meers, Charlotte *DcWomA*
Meert, Joseph John Paul 1905- *WhAmArt 85*
Meert, Pieter 1619-1669 *McGDA*
Meerten, A B Van d1852 *DcWomA*
Mees, Charles Edward Kenneth 1882-1960 *ICPEnP, MacBEP*
Meese, L A *AmArch 70*
Meeser, Lillian B *WhAmArt 85*
Meeser, Lillian Burk 1864-1942 *DcWomA*

Mellis, Isaac *NewYHSD*
Mellish, Ida *DcWomA*
Mellish, Thomas *DcBrECP, DcSeaP*
Mello, W J, Jr. *AmArch 70*
Mellon, Andrew William 1855-1937 *WhAmArt 85*
Mellon, Campbell A 1876-1955 *DcBrA 1*
Mellon, Eleanor M 1894- *WhAmArt 85*
Mellon, Eleanor M 1894-1980 *DcWomA*
Mellon, James 1941- *WhoAmA 73, -76, -78, -80, -82, -84*
Mellon, Paul 1907- *WhoAmA 73, -76, -78, -80, -82, -84*
Mellor, David 1930- *ConDes, DcD&D[port]*
Mellor, Everett Watson 1878-1965 *DcVicP 2*
Mellor, George *NewYHSD*
Mellor, George Edward 1928- *WhoAmA 73, -76, -78, -80, -82, -84*
Mellor, Jack 1945- *MarqDCG 84*
Mellor, Sir John Paget 1862-1929 *DcBrBI*
Mellor, Pamela *WhoArt 80, -82, -84*
Mellor, Tom 1914- *MacEA*
Mellor, Walter 1880-1940 *BiDAmAr*
Mellor, William 1851-1931 *DcBrA 1, DcVicP, -2*
Mellor-Gill, Margaret Webster 1901- *WhAmArt 85*
Mellow, Cynthia Stan *WhoAmA 84*
Mellow, James R 1926- *WhoAmA 73*
Melloy, Colin Robert 1950- *MarqDCG 84*
Melnick, Edward 1949- *MarqDCG 84*
Melnick, Philip Albert 1935- *ICPEnP A, MacBEP*
Melniker, Albert 1910- *AmArch 70*
Melnikov, Konstantin 1890-1974 *MacEA*
Melody, Walter Howard 1928- *AmArch 70*
Melogan, Alexander *NewYHSD*
Melois, Bernard 1939- *DcCAr 81*
Melone, A C *AmArch 70*
Meloni, Altobello *McGDA*
Meloni, Marco *McGDA*
Meloni, Michael Anthony 1919- *AmArch 70*
Melor, Margaret *WhAmArt 85*
Melort, Andries 1779-1849 *IlDcG*
Melort, S J *IlDcG*
Melosh, Mildred E 1901- *WhAmArt 85*
Melotti, Fausto 1901- *ConArt 77, -83*
Melozzo Da Forli 1438-1494 *McGDA, OxArt*
Melrose, Andrew 1836-1901 *ArtsAmW 1*
Melrose, Andrew W 1836-1901 *IlBEAAW, NewYHSD , WhAmArt 85*
Melrose, Kenneth *NewYHSD*
Melter, Carl *AfroAA*
Meltmar, Wray Bruce 1936- *AmArch 70*
Melton, Catharine Parker *DcWomA*
Melton, Catherine Parker *WhAmArt 85*
Melton, Howard Ivy, Jr. 1934- *AmArch 70*
Melton, Mrs. Jesse J *ArtsAmW 3, WhAmArt 85*
Melton, Ronald Benjamin 1955- *MarqDCG 84*
Meltsner, Paul R 1905- *WhAmArt 85*
Meltzer, Anna E 1896- *WhAmArt 85, WhoAmA 73, -76, -78*
Meltzer, Anna Elkan 1896-1974 *DcWomA*
Meltzer, Arthur 1893- *WhAmArt 85, WhoAmA 73, -76, -78, -80, -82, -84*
Meltzer, Mrs. Arthur *WhAmArt 85*
Meltzer, Charlotte *WhAmArt 85*
Meltzer, Doris 1908- *WhAmArt 85, WhoAmA 73, -76, -78*
Meltzer, George J 1921- *AmArch 70*
Meltzer, Gerald Barnett 1941- *AmArch 70*
Meltzer, Marvin Herman *AmArch 70*
Meltzer, Paulette *DcWomA*
Meltzer, Robert Hiram 1921- *WhoAmA 78, -80, -82, -84*
Meltzoff, Stanley *OfPGCP 86*
Meltzoff, Stanley 1917- *IlrAm F, -1880*
Melvill, Antonia *WhAmArt 85*
Melvill, Antonia 1875- *DcWomA*
Melvill, Antonia Miether 1875- *ArtsAmW 2*
Melville, Alexander *DcVicP, -2*
Melville, Mrs. Alexander *DcVicP, -2*
Melville, Arthur 1855-1904 *DcBrA 1, DcVicP, -2*
Melville, Arthur 1858-1904 *ClaDrA, DcBrBI, DcBrWA*
Melville, Clare Gladys 1897- *DcWomA*
Melville, Eliza Anne *DcWomA*
Melville, Frank 1832-1917 *WhAmArt 85*
Melville, Grevis Whitaker 1904- *WhoAmA 73, -76, -78, -80, -82, -84*
Melville, Harden S *DcVicP*
Melville, Harden Sidney *DcBrBI, DcBrWA, DcVicP 2*
Melville, Henry *DcBrWA, DcVicP 2*
Melville, John 1902- *DcBrA 1*
Melville, Marguerite Louise 1912- *WhAmArt 85*
Melville, Pattie *DcVicP 2*
Melville, W *DcVicP 2*
Melvin, Grace Wilson *WhoAmA 73, -76*
Melvin, Grace Wilson d1977 *DcWomA, WhoAmA 78N, -80N, -82N, -84N*
Melvin, Hattie G *DcWomA*
Melvin, James *MacEA*
Melvin, Robert Edward *AmArch 70*

Melvin, Ronald McKnight 1927- *WhoAmA 82, -84*
Melzer, Theodore *ArtsEM*
Melzer, Wilhelmine 1868- *DcWomA*
Melzer, William *WhAmArt 85*
Melzi, Francesco 1493-1570? *McGDA*
Melzian, Harley 1911- *WhAmArt 85*
Memery, James P 1940- *MarqDCG 84*
Memhardt, Johann Gregor d1678 *MacEA*
Memin *NewYHSD*
Memling, Hans d1494 *DcSeaP*
Memling, Hans 1430?-1494 *ClaDrA, OxArt*
Memling, Hans 1435?-1494 *McGDA*
M'Emlyn, Miss *DcVicP 2*
Memmi, Lippo *McGDA, OxArt*
Memoli, Frank 1913- *AmArch 70*
Mena, Juan Pascual De 1707-1784 *McGDA*
Mena, Pedro De 1628-1688 *McGDA, OxArt*
Mena Y Bitoria, Andrea 1654-1734 *DcWomA*
Mena Y Bitoria, Claudia 1655-1702 *DcWomA*
Menaboni, Athos Rudolfo 1895- *WhoAmA 78, -80*
Menabuoi, Giusto Di Giovanni De d1393 *ClaDrA*
Menage, Bessie Marble 1877- *DcWomA, WhAmArt 85*
Menageot, Francois Guillaume 1744-1816 *ClaDrA*
Menager, Pierre 1893- *ArtsAmW 2*
Menapace, John 1927- *ICPEnP A, MacBEP*
Menard, Anne Marie *DcWomA*
Menard, Edmond 1942- *FolkA 86*
Menard, Emile 1862-1930 *WhAmArt 85A*
Menard, Louise *DcWomA*
Menard, Marie Auguste Emile Rene 1862-1930 *ClaDrA*
Menard, Marie-Auguste-Emile-Rene 1862-1930 *McGDA*
Menard, R N *AmArch 70*
Menarola, Crestano d1640? *ClaDrA*
Menassade, Emilie *DcWomA*
Menault, Marie Mathilde *DcWomA*
Mench, E *FolkA 86*
Menchaca, Juan 1910- *WhoAmA 76, -78, -80*
Menchilli, George G *NewYHSD*
Mencie, M *DcVicP 2*
Menconi, Frank G 1884-1928 *WhAmArt 85*
Menconi, Raffaello E 1877-1942 *WhAmArt 85*
Menconi, Ralph Joseph 1915-1972 *WhoAmA 78N, -80N, -82N, -84N*
Mendel, B, Jr. *AmArch 70*
Mendel, Edward *NewYHSD*
Mendel, Renee 1908- *WhoArt 80, -82, -84*
Mendell, Mark Robert 1939- *AmArch 70*
Mendell, Pierre 1929- *WhoGrA 82[port]*
Mendelowitz, Daniel Marcus 1905- *WhAmArt 85, WhoAmA 73, -76, -78, -80*
Mendelowitz, Daniel Marcus 1905-1980 *WhoAmA 82N, -84N*
Mendelsohn, Eric 1887-1953 *ConArch, DcD&D[port], MacEA, McGDA*
Mendelsohn, Erich 1887-1953 *EncMA, OxArt, WhoArch*
Mendelsohn, Henriette 1856- *DcWomA*
Mendelson, Haim 1923- *AmArt, WhoAmA 78, -80, -82, -84*
Mendelson, Marc 1915- *McGDA, OxTwCA, PhDcTCA 77*
Mendelson, Moses 1907- *AmArch 70*
Mendelssohn, Henriette 1856- *DcWomA*
Mendelssohn, Maria 1861-1928 *DcWomA*
Mendenhall, Mrs. Earl *WhAmArt 85*
Mendenhall, Emma *WhAmArt 85*
Mendenhall, Emma 1873- *ArtsAmW 3, DcWomA*
Mendenhall, Gertrude Emma 1913- *WhAmArt 85*
Mendenhall, J Z *NewYHSD*
Mendenhall, Jack 1937- *AmArt, WhoAmA 76, -78, -80, -82, -84*
Mendenhall, Sarah *DcWomA*
Mendes, Barbara 1948- *AmArt, WhoAmA 82, -84*
Mendes DaRocha, Paulo 1928- *ConArch*
Mendez, Leopoldo *OxTwCA*
Mendez, Leopoldo 1902- *McGDA, WhoGrA 62*
Mendez, Manuel *WorFshn*
Mendez, Manuel Ponce 1923- *AmArch 70*
Mendham, Edith *DcVicP 2*
Mendham, Robert *DcVicP 2*
Mendlick, Julie *DcWomA*
Mendoza, Antonio *DcCAr 81*
Mendoza, Antonio 1941- *ICPEnP A, MacBEP*
Mendoza, Antonio G 1941- *WhoAmA 84*
Mendoza, Catalina De 1542-1602 *DcWomA*
Mendoza, David C 1944- *WhoAmA 78, -80*
Mendoza, Esteban *DcCAr 81*
Mendoza, June *WhoArt 82, -84*
Mends, George Pechell d1872? *DcBrWA*
Mene, Pierre-Jules d1879 *ArtsNiC*
Mene, Pierre-Jules 1810-1859 *DcNiCA*
Mene, Pierre Jules 1810-1879 *AntBDN C*
Meneeley, Edward 1927- *ConArt 77, WhoAmA 78, -80, -82, -84*
Meneely, Andrew *FolkA 86*
Menefee, Edward Frost 1934- *AmArch 70*
Menefee, L A, Jr. *AmArch 70*
Menegon, Serifo John 1924- *AmArch 70*

Menelaws, Adam d1831 *BiDBrA*
Menen, Barbara Martha *WhoAmA 82*
Menendez, Anna 1714- *DcWomA*
Menendez, Arthur Middleton 1876- *WhAmArt 85*
Menendez, Clara 1712-1734 *DcWomA*
Menendez, F J *AmArch 70*
Menescardi, Giustino *McGDA*
Menetrier, Eric 1958- *DcCAr 81*
Meng, John 1734-1754? *NewYHSD*
Meng, Wendy 1944- *WhoAmA 76, -78, -80, -82, -84*
Menganti, Alessandro 1531-1594 *McGDA*
Mengardi, Giovan Battista 1738-1796 *McGDA*
Mengarini, Fausta Vittoria 1893- *WhAmArt 85*
Mengarini, Fausta Vittoria 1893-1952 *DcWomA*
Mengel, R G *AmArch 70*
Mengen, Theodore *FolkA 86*
Menger, Edward 1832?- *NewYHSD*
Menger, John L, Jr. 1922- *AmArch 70*
Menges, Adam *FolkA 86*
Menges, John Henry 1931- *AmArch 70*
Mengold, Esther 1877-1954 *DcWomA*
Mengoni, Giuseppe 1829-1877 *MacEA, McGDA*
Mengoni, Guiseppe 1829-1877 *WhoArch*
Mengs, Anna Maria 1751-1795? *DcWomA*
Mengs, Anton Raffael 1728-1779 *OxArt*
Mengs, Anton Raphael 1728-1779 *McGDA*
Mengs, Juliane Charlotte 1728-1789? *DcWomA*
Mengs, Theresa Concordia 1725-1808? *DcWomA*
Mengyan, Andras 1945- *DcCAr 81*
Menhart, Oldrich 1897- *WhoGrA 62*
Menichino DelBrizio *McGDA*
Menihan, John Conway 1908- *WhoAmA 73, -76, -78, -80, -82, -84*
Meninger, E *FolkA 86*
Meninsky, Bernard 1891-1950 *DcBrA 1, OxTwCA*
Menk, Elizabeth Regina 1950- *WhoAmA 76*
Menk, Hazel *DcWomA*
Menk, Louis 1908- *AmArch 70*
Menk, Mrs. Oswen W *WhAmArt 85*
Menke, Eric F 1901- *AmArch 70*
Menker, Samuel 1820?- *NewYHSD*
Menkes, Sigmund 1896- *DcCAA 71, -77, WhoAmA 73, -76, -78, -80, -82, -84*
Menkes, Sigmund Joseph 1896- *WhAmArt 85*
Menn, Barthelemy 1815-1893 *McGDA*
Menn, Dorothea 1725-1789 *DcWomA*
Mennen, I A *AmArch 70*
Mennessier, Auguste Dominique 1803-1890 *ClaDrA*
Mennie, Florence *WhAmArt 85*
Mennie, John George 1911- *WhoArt 80, -82, -84*
Menon, Marie *DcWomA*
Menpes, Mortimer 1860-1938 *ClaDrA, DcBrBI, DcVicP, -2*
Menpes, Mortimer L 1860-1938 *DcBrA 1*
Mensch, Irwin *FolkA 86*
Mense, Carlo 1889-1965 *OxTwCA, PhDcTCA 77*
Mense, Karl 1889- *McGDA*
Menser, David 1830?- *FolkA 86*
Menses, Jan 1933- *WhoAmA 73, -76, -78, -80, -82, -84*
Menshausen, Helene 1858-1904 *DcWomA*
Menshausen-Labriola, Frieda 1861- *DcWomA*
Mensing, Elisabeth 1857- *DcWomA*
Mente, Charles 1857-1933 *WhAmArt 85*
Mentel, Lillian A 1882- *DcWomA, WhAmArt 85*
Mentelle, Ward, Sr. *FolkA 86*
Mentgen, Ronald Paul 1934- *AmArch 70*
Menthe, Melissa 1948- *WhoAmA 78, -80, -82, -84*
Mention, Robert Carlos *AmArch 70*
Mentley, David E 1951- *MarqDCG 84*
Mentlikowski, Donald Richard 1932- *MarqDCG 84*
Menton, Frans 1550?-1615 *ClaDrA*
Menton, Mary Theresa *ArtsAmW 3*
Menton, Mary Theresa 1857- *DcWomA*
Mentula, Perttu 1936- *ConDes*
Menzel, Adolf 1815-1905 *OxArt*
Menzel, Adolf-Frederic-Erdmann 1815- *ArtsNiC*
Menzel, Adolf Friedrich Erdmann 1815-1905 *ClaDrA*
Menzel, Adolf Von 1815-1905 *McGDA*
Menzel, Adolph Von 1815-1905 *WorECar*
Menzel, Adolphus *NewYHSD*
Menzel, Antonia *DcWomA*
Menzel, Charles 1822?- *NewYHSD*
Menzel, Gustavus A *NewYHSD*
Menzel, Herman 1904- *WhAmArt 85*
Menzel, Herman G *NewYHSD*
Menzel, Johann Sigismund 1744-1810 *IlDcG*
Menzel, Julie 1863- *DcWomA*
Menzel, Luise 1854- *DcWomA*
Menzel, William *NewYHSD*
Menzies, Gordon William 1950- *WhoArt 80, -82, -84*
Menzies, Henry Hardinge 1928- *AmArch 70*
Menzies, John *DcBrA 2, DcVicP 2*
Menzies, Maria *DcVicP 2, DcWomA*
Menzies, William A *DcVicP 2*
Menzies, William Cameron 1896-1957 *ConDes*
Menzies-Jones, Llewelyn Frederick 1889- *ClaDrA, DcBrA 1*
Menzler, Wilhelm 1846- *ClaDrA*
Menzler-Peyton, Bertha *WhAmArt 85*

Menzler-Peyton, Bertha Sophia 1871?-1947 *DcWomA*
Menzler-Peyton, Bertha Sophia 1874-1947 *ArtsAmW 2*
Meo DaSiena *McGDA*
Meo, Gaetano *DcVicP 2*
Meo, Yvonne Cole *AfroAA*
Meores, George *NewYHSD*
Mequignon, Peter 1769-1826 *DcBrECP*
Meranda, C A *AmArch 70*
Merbity, Marguerite *DcWomA*
Merbitz, Marguerite *DcWomA*
Mercadante, Lorenzo *McGDA*
Mercade, Benito *ArtsNiC*
Mercanti, Gabriele d1646 *DcWomA*
Mercator, Gerhard 1512-1594 *AntBDN I*
Mercer, Douglas A 1955- *MarqDCG 84*
Mercer, Edward Stanley 1889- *DcBrA 1*
Mercer, Eleanor 1871- *DcWomA*
Mercer, Fletcher J 1861-1922 *DcBrA 1, DcVicP 2*
Mercer, Frederick *DcBrA 1, DcVicP 2*
Mercer, Geneva 1889- *DcWomA, WhAmArt 85*
Mercer, Henry C *FolkA 86*
Mercer, Henry Chapman 1856-1930 *CenC, WhAmArt 85*
Mercer, John Douglas 1945- *MacBEP, WhoAmA 78, -80*
Mercer, Joyce 1896-1965 *DcWomA*
Mercer, Max George 1903- *AmArch 70*
Mercer, W R *AmArch 70*
Mercer, Wayne D 1958- *MarqDCG 84*
Mercer, William *FolkA 86*
Mercer, William 1773-1850 *NewYHSD*
Mercer, William Robert, Jr. *WhAmArt 85*
Mercere, Blanche 1883- *DcWomA*
Mercereau, Alexandre 1884- *OxTwCA*
Merchant, A, Jr. *AmArch 70*
Merchant, Biddle *NewYHSD*
Merchant, Francis Osmond 1908- *AmArch 70*
Merchant, George W *NewYHSD*
Merchant, Henry *ClaDrA*
Merchant, Henry F *DcBrA 1*
Merchant, Pat 1928- *WhoAmA 76, -78, -80, -82*
Merchant, Richard *FolkA 86*
Merchant, S *FolkA 86*
Mercie, Marius Antonin 1845-1916 *WhAmArt 85A*
Mercie, Marius-Jean-Antoine *ArtsNiC*
Mercie, Marius Jean Antonin 1845-1916 *ClaDrA, McGDA*
Mercier, Charles 1834-1893? *DcVicP 2*
Mercier, Charlotte d1762 *DcWomA*
Mercier, Charlotte 1738-1762 *DcBrECP*
Mercier, Dorothy *DcBrECP, DcWomA*
Mercier, Elise *DcWomA*
Mercier, Emile Alfred 1901- *WorECar*
Mercier, Hyacinthe *DcWomA*
Mercier, Louise *DcWomA*
Mercier, Monique 1934- *PrintW 83, -85, WhoAmA 78, -80*
Mercier, Philip 1689?-1760 *DcBrECP*
Mercier, Philippe 1689-1760 *McGDA*
Mercier, Ruth *DcVicP 2, DcWomA*
Merck, C *FolkA 86*
Merck, Charles *ArtsAmW 2*
Merckelbach, Pieter 1633?-1673 *ClaDrA*
Mercord, G Brice 1936- *AmArch 70*
Mercurio, Philip Joseph 1958- *MarqDCG 84*
Merdinger, I M *AmArch 70*
Mere, Catherine DeLa *DcWomA*
Meredith, Alice Adkins 1905- *WhAmArt 85*
Meredith, David d1809 *ArtsEM*
Meredith, Dorothy L 1906- *WhAmArt 85*
Meredith, Dorothy Laverne 1906- *WhoAmA 73, -76, -78, -80, -82, -84*
Meredith, George 1762- *BiDBrA*
Meredith, James *BiDBrA*
Meredith, John *OxTwCA*
Meredith, John 1933- *ConArt 77, -83, DcCAr 81, WhoAmA 73, -76, -78, -80, -82, -84*
Meredith, Louisa Ann 1812-1895 *DcWomA*
Meredith, Michael d1865 *BiDBrA*
Meredith, Norman *WhoArt 80, -82, -84*
Meredith, Sophie *DcWomA*
Meredith, Sophie D'Ouseley *DcBrA 1*
Meredith, William 1851- *DcVicP 2*
Meredith Williams, Gertrude Alice *DcWomA*
Meredith Williams, Gertrude Alice d1934 *DcBrA 1*
Meredyth, William 1851- *DcBrWA, DcVicP 2*
Merenoff, Barry Nelson 1936- *AmArch 70*
Merey, Carl A 1908- *WhAmArt 85*
Merfeld, Gerald Lydon 1936- *WhoAmA 76, -78, -80, -82, -84*
Merfield, Bertha *DcWomA*
Merguerian, Arshag 1926- *AmArch 70*
Merhar, Richard John 1934- *AmArch 70*
Meri, Elisabeth *DcWomA*
Merian, Dorothea Maria Henrietta *DcWomA*
Merian, Johanna Maria Helena *DcWomA*
Merian, L H 1881- *WhAmArt 85*
Merian, Maria Sibilla 1647-1717 *OxArt*
Merian, Maria Sibylla 1647-1717 *DcWomA, WomArt*
Merian, Mathaus 1593-1650 *OxArt*

Merian, Matthaeus, The Elder 1593-1650 *McGDA*
Merian, Matthaus 1593-1650 *ClaDrA*
Meric, T S *AmArch 70*
Merickel, Mark L 1948- *MarqDCG 84*
Merida, Carlos 1891- *DcCAr 81, IlsBYP, IlsCB 1946, OxTwCA, WhoAmA 73, -76, -78, -80, WhoGrA 62*
Merida, Carlos 1893- *McGDA*
Merideth, T R *AmArch 70*
Meridith, Isaac Watt 1878- *WhAmArt 85*
Merienne, Nancy 1792-1860 *DcWomA*
Merieux, Luce-Marie 1897- *DcWomA*
Merifield, J *DcVicP 2*
Merifield, T *DcVicP 2*
Merignan, A *DcVicP 2*
Merimee, Anna M d1852 *DcWomA*
Merine, A *ArtsEM, NewYHSD*
Merine, J C *NewYHSD*
Merington, Ruth *DcWomA, WhAmArt 85*
Merino, Ignacio 1818-1876 *McGDA*
Merinsky, S *NewYHSD*
Merisio, Pepi 1931- *ConPhot, ICPEnP A*
Merithew, G R *AmArch 70*
Merivale, John Herman 1799-1844 *DcBrWA*
Meriwether, Hugh Mathew 1899- *AmArch 70*
Merkel, Georg 1881- *OxTwCA*
Merkel, Jayne 1942- *WhoAmA 76, -78, -80, -82, -84*
Merkel, Karl Henry 1916- *AmArch 70*
Merkel, Otto *WhAmArt 85*
Merkelbach, Ben 1901-1961 *MacEA*
Merkelbach, Reinhold *DcNiCA*
Merkelbach & Wick *DcNiCA*
Merkenich, Paul *ArtsEM*
Merker, Albert Seewald 1927- *AmArch 70*
Merkin, Henry 1914- *AmArch 70*
Merkin, Richard 1938- *ConArt 77, -83*
Merkin, Richard Marshall 1938- *PrintW 83, -85, WhoAmA 73, -76, -78, -80, -82, -84*
Merkle, Alexander 1816?- *FolkA 86*
Merkle, Augustus *NewYHSD*
Merkle, James *FolkA 86*
Merkling, Erica *IlsBYP*
Merle, Georges *ArtsNiC*
Merle, Hugues d1881 *ArtsNiC*
Merlen, Constance 1650-1706 *DcWomA*
Merlen, Constance Van 1609-1655 *DcWomA*
Merlen, Susanne Marie 1652-1706 *DcWomA*
Merletti, Alejandro 1860-1943 *ICPEnP A*
Merlier, Franz De 1873- *WhAmArt 85*
Merlin, Burton A 1935- *AmArch 70*
Merlin, C E P *DcVicP 2*
Merlin, Henry Beaufoy 1830-1873 *MacBEP*
Merlin, Josephus *AntBDN K*
Merlin, Maurice *WhAmArt 85*
Merlini, Cecilia *DcWomA*
Merlini, G *NewYHSD*
Merliss, William Sidney 1922- *AmArch 70*
Merlo, Edward Charles 1931- *AmArch 70*
Mermet, Cesarine *DcWomA*
Mermet, Jeanne Antoinette *DcWomA*
Mermilliod, Charles *NewYHSD*
Mermillod, A d1900 *ArtsAmW 3*
Mermin, Mildred *WhoAmA 73, -76, -78, -80, -82, -84*
Mermin, Mildred Shire 1907- *WhAmArt 85*
Mermod, A S *EncASM*
Mermod, Marie-Claire 1937- *DcCAr 81*
Mermod Jaccard And King *EncASM*
Mero, J A *AmArch 70*
Mero, Lee 1885- *WhAmArt 85*
Meroni, E A *AmArch 70*
Merre, Johanna H 1867- *DcWomA*
Merrel, Peter d1787 *FolkA 86*
Merrell, B S *NewYHSD*
Merrell, Ernest Earl, Jr. 1922- *AmArch 70*
Merrell, J M *NewYHSD*
Merrels, Mrs. Gray Price 1884- *WhAmArt 85*
Merrels, Mrs. Gray Price Crowley 1884- *DcWomA*
Merrett, Susan *DcWomA, FolkA 86, NewYHSD*
Merriam, Andrew G 1941- *AmArch 70*
Merriam, Ann Page *DcWomA, NewYHSD*
Merriam, Chloe E *ArtsEM, DcWomA*
Merriam, Irma S *WhAmArt 85*
Merriam, Irma S d1924? *ArtsAmW 3*
Merriam, James A *ArtsEM*
Merriam, James Arthur 1878?-1951 *ArtsAmW 3*
Merriam, John *FolkA 86*
Merriam, John F 1909- *WhoAmA 73*
Merriam, L M *DcWomA*
Merriam, Lawrence T *FolkA 86*
Merriam, Marie Suzanne 1942- *MarqDCG 84*
Merriam, Ruth 1909- *WhoAmA 73, -76, -78, -80*
Merriam, W H *AmArch 70*
Merrick, Arthur T *WhAmArt 85*
Merrick, Emily M *DcVicP 2*
Merrick, Emily M 1842- *DcWomA*
Merrick, James Kirk 1905- *WhAmArt 85, WhoAmA 73, -76, -78, -80, -82, -84*
Merrick, John C 1925- *AmArch 70*
Merrick, Joseph E *WhAmArt 85*
Merrick, Lulu 1878-1931 *WhAmArt 85*

Merrick, Richard L 1903- *WhAmArt 85*
Merrick, William Marshall 1833- *IlBEAAW, WhAmArt 85*
Merridan, Ann Page *FolkA 86*
Merrifield *FolkA 86*
Merrifield, Mrs. *DcVicP 2*
Merrifield, Leonard Stanford 1880-1943 *DcBrA 1*
Merrifield, Rube *WhAmArt 85*
Merriken, Francis M *NewYHSD*
Merriken, James *CabMA*
Merril, George Boardman 1848- *FolkA 86*
Merrild, Knud 1894- *ArtsAmW 1*
Merrild, Knud 1894-1954 *IlBEAAW, WhAmArt 85*
Merrilees, May S *WhAmArt 85*
Merrill, Alonzo *NewYHSD*
Merrill, Arthur 1885-1973 *ArtsAmW 1, -2*
Merrill, Calvin *FolkA 86*
Merrill, David Kenneth 1935- *WhoAmA 73, -76, -78, -80, -82, -84*
Merrill, Douglas Maynard 1922- *AmArch 70*
Merrill, Earl *FolkA 86*
Merrill, Edward Atkinson *AmArch 70*
Merrill, Edwin *FolkA 86*
Merrill, Edwin H *FolkA 86*
Merrill, F C *NewYHSD*
Merrill, Ford *FolkA 86*
Merrill, Frank Thayer 1848- *EarABI SUP, WhAmArt 85*
Merrill, Gardner B *NewYHSD*
Merrill, George E 1870-1933 *BiDAmAr*
Merrill, Henry E *FolkA 86*
Merrill, Henry W *FolkA 86*
Merrill, Hiram Campbell 1866- *WhAmArt 85*
Merrill, J C *AmArch 70*
Merrill, J M *EncASM*
Merrill, J O, Jr. *AmArch 70*
Merrill, John 1896-1975 *ConArch*
Merrill, John O *McGDA*
Merrill, John O 1896- *WhoArch*
Merrill, John O 1896-1975 *MacEA*
Merrill, John Ogden 1896- *AmArch 70*
Merrill, John P *NewYHSD*
Merrill, Joseph *WhAmArt 85*
Merrill, Joseph P *FolkA 86*
Merrill, Katherine *WhAmArt 85*
Merrill, Katherine 1876- *DcWomA*
Merrill, Lucile A *DcWomA*
Merrill, M W *NewYHSD*
Merrill, Mary A White *DcWomA*
Merrill, Minnie 1860?- *DcWomA*
Merrill, Moses 1798- *CabMA*
Merrill, Nelle *WhAmArt 85*
Merrill, R S *WhAmArt 85*
Merrill, Ross M 1943- *WhoAmA 78, -80, -82, -84*
Merrill, S C *DcWomA*
Merrill, Sailor *FolkA 86*
Merrill, Sarah *DcWomA, FolkA 86, NewYHSD*
Merrill, Stanley Stevens 1895- *AmArch 70*
Merrill, Susie B *ArtsEM, DcWomA*
Merrill, William Dean 1915- *AmArch 70*
Merrill, William Dickey 1909- *AmArch 70*
Merrill Brothers *EncASM*
Merriman *EncASM*
Merriman, Mrs. Dwight *ArtsEM*
Merriman, Helen 1844- *DcWomA*
Merriman, Helen Bigelow 1844-1933 *WhAmArt 85*
Merriman, Lizzie *ArtsEM, DcWomA*
Merriman, Patti *DcWomA*
Merrimen, Ives *FolkA 86*
Merrin, Edward H *WhoAmA 80, -82, -84*
Merriott, Jack 1901- *ClaDrA, DcBrA 1*
Merriott, Jack 1901-1968 *DcBrA 2*
Merritt, Anna Lea 1844- *ClaDrA*
Merritt, Anna Massey 1844-1930 *DcWomA*
Merritt, Anna Massey Lea 1844-1930 *DcBrA 1*
Merritt, Anna W Lea 1844-1930 *WhAmArt 85*
Merritt, C M *DcWomA*
Merritt, Catherine Rodman *DcWomA*
Merritt, E *FolkA 86, NewYHSD*
Merritt, E L *DcWomA*
Merritt, F R *DcBrBI*
Merritt, Francis Sumner 1913- *WhoAmA 73, -76, -78, -80, -82, -84*
Merritt, Gordon Reive 1933- *AmArch 70*
Merritt, Henry 1822-1877 *DcVicP 2*
Merritt, Mrs. Henry 1844- *DcVicP*
Merritt, Mrs. Henry 1844-1930 *DcVicP 2*
Merritt, Ingeborg Johnson 1888- *ArtsAmW 2, WhAmArt 85*
Merritt, Louisa P *DcWomA, WhAmArt 85*
Merritt, Susan 1826-1879 *DcWomA, FolkA 86*
Merritt, Thomas Light d1870 *DcBrWA, DcVicP 2*
Merritt, Warren Chase 1897- *ArtsAmW 2, WhAmArt 85*
Merritt, William Dennis Billy *FolkA 86*
Merritt, William J *DcVicP 2*
Merriweather, Robert *AfroAA*
Merriwether, C R *AmArch 70*
Merry, Elizabeth *DcWomA*
Merry, Godfrey *DcVicP 2*
Merry, James Lee 1936- *AmArch 70*

Merry, Jessie Electa 1883-1975 *DcWomA*
Merry, Mabel Jane 1888-1974 *DcWomA*
Merry, Tom *WorECar*
Merry, Tom 1852-1902 *DcBrBI*
Merry And Pelton *EncASM*
Merrylees, Annie R *DcWomA*
Mersereau, Paul 1868- *WhAmArt 85*
Mersfelder, Jules 1865-1937 *ArtsAmW 1*
Mersfelder, Jules R *WhAmArt 85*
Mersfelder, Lou *ArtsAmW 2, DcWomA, WhAmArt 85*
Mershon, C F *AmArch 70*
Mersion, Madeleine De *DcWomA*
Merson, Luc-Olivier *ArtsNiC*
Merson, Luc Olivier 1846-1920 *ClaDrA, McGDA, WhAmArt 85A*
Merten, Elise 1847- *DcWomA*
Merten, John William 1898- *WhAmArt 85*
Mertens, Fernande De *DcWomA*
Mertens, Francis William 1911- *WhAmArt 85*
Mertens, Stella 1896- *DcWomA*
Mertin, Roger 1942- *ConPhot, ICPEnP A, MacBEP, WhoAmA 80, -82, -84*
Mertler, Rudolph *WhAmArt 85*
Merton, Christine 1925- *DcCAr 81*
Merton, John Ralph 1913- *DcBrA 1, WhoArt 80, -82, -84*
Merton, Owen 1887- *DcBrA 2*
Merton, Owen 1887-1930 *WhAmArt 85*
Mertz, Albert 1920- *OxTwCA, PhDcTCA 77*
Mertz, Edward 1945- *MarqDCG 84*
Mertz, Jordan Gary 1935- *AmArch 70*
Mertz, Susanne 1946- *MacBEP*
Merving, Christopher *NewYHSD*
Mervyn, Sonia *ClaDrA, DcBrA 1, WhoArt 80N*
Merwin, Antoinette DeForest Parsons 1861- *DcWomA*
Merwin, Antoinette DeForrest 1861- *WhAmArt 85*
Merwin, Antoinette DeForrest Parsons 1861- *ArtsAmW 2*
Merwin, Bennett *EncASM*
Merwin, Decie 1894- *IlsBYP, IlsCB 1946*
Merwin, Frank Otis 1914- *AmArch 70*
Merwin, Lester Noble 1929- *AmArch 70*
Merwin, Sarah *DcWomA*
Merwin-Wilson *EncASM*
Mery, Eugenie *DcWomA*
Meryman, Hope d1975 *WhoAmA 76N, -78N, -80N, -82N, -84N*
Meryman, Richard S 1882- *WhAmArt 85*
Meryon, Charles 1821-1868 *ArtsNiC, McGDA*
Merz, Gerhard 1947- *DcCAr 81*
Merz, J G *AmArch 70*
Merz, Jacob *FolkA 86*
Merz, Mario 1925- *ConArt 77, -83, DcCAr 81*
Merz, Marisa *ConArt 83*
Merz, Merzbau *OxTwCA*
Mesa, Juan De 1586-1627 *McGDA*
Mesaros, Ron 1942- *WhoAmA 76, -78*
Mesaros, Ronald Malcolm 1942- *MacBEP*
Mesch, Borg 1870-1956 *ICPEnP A*
Mesches, Arnold 1923- *AmArt, WhoAmA 73, -76, -78, -80, -82, -84*
Mesdag, Gesina 1851- *DcWomA*
Mesdag, Hendrik-Willem *ArtsNiC*
Mesdag, Hendrik Willem 1831-1915 *ClaDrA, DcSeaP, McGDA, OxArt*
Mesdag, Sina 1834-1909 *DcWomA*
Mesdens, Catherine *DcWomA*
Mesens, E L T 1903-1971 *ConArt 83, OxTwCA, PhDcTCA 77*
Mesens, Edouard Leon Theodore 1903-1971 *ConArt 77*
Mesens, Jeanne Hendrix *DcWomA*
Mesereau, William H 1862-1933 *BiDAmAr*
Meserole, Vera Stromsted 1927- *WhoAmA 76, -78, -80, -82, -84*
Meserole, W Harrison 1893- *WhAmArt 85*
Meseroll, D C *DcWomA*
Meseroll, Mrs. D C *ArtsEM*
Mesghali, Farshid 1943- *WhoGrA 82[port]*
Mesham, Isabel Beatrice *WhoArt 80N*
Mesham, Isabel Beatrice 1896- *ClaDrA, DcBrA 1, DcWomA*
Mesibov, Hubert Bernard 1916- *WhAmArt 85*
Mesibov, Hugh 1916- *DcCAA 71, -77, WhoAmA 73, -76, -78, -80, -82, -84*
Mesic, Julian C 1889- *ArtsAmW 2, DcWomA, WhAmArt 85*
Mesick *EncASM*
Mesick, C *FolkA 86*
Mesick, J I *AmArch 70*
Mesier, Edward S *NewYHSD*
Mesier, Peter *NewYHSD*
Mesker, G L *FolkA 86*
Mesker, J B *FolkA 86*
Meskin, Morton 1916- *WorECom*
Mesnik, Robert F 1942- *MarqDCG 84*
Mesnil, Marie *DcWomA*
Mesples, Paul Eugene 1849- *ClaDrA*
Mesrell, D C *DcWomA*
Mesrell, Mrs. D C *ArtsEM*
Mesrobian, Ralfe 1920- *AmArch 70*

Mess, Evelynne Charlene 1903- *WhAmArt 85*
Mess, G B *AmArch 70*
Mess, George Jo d1962 *WhoAmA 78N, -80N, -82N, -84N*
Mess, George Jo 1898-1962 *GrAmP, WhAmArt 85*
Mess, Gordon Benjamin 1900-1959 *WhAmArt 85, WhoAmA 80N, -82N, -84N*
Messageot, Lucile *DcWomA*
Messager, Anette 1943- *DcCAr 81*
Messager, Annette 1943- *ConArt 77, -83*
Messagier, Jean 1920- *OxTwCA, PhDcTCA 77*
Messagier, Jean Felicien Emile 1920- *ConArt 77*
Messeguer, Villoro Benito 1930- *WhoAmA 73, -76, -78, -80, -82*
Messeguer, Villoro Benito 1930-1982 *WhoAmA 84N*
Messel, Adolf 1853-1909 *WhoArch*
Messel, Alfred 1853-1909 *EncMA, McGDA, OxArt*
Messelet, Jean 1898- *WhoArt 80, -82, -84*
Messenger, Charles *FolkA 86*
Messenger, Ivan 1895- *ArtsAmW 2, IlBEAAW*
Messensee, Jurgen 1936- *DcCAr 81*
Messent, Charles 1911- *ClaDrA, DcBrA 1, WhoArt 80, -82*
Messer, Brenda Ruth 1948- *WhoAmA 78*
Messer, Edmund C 1842-1919 *WhAmArt 85*
Messer, Jeanette d1917 *WhAmArt 85*
Messer, M Jeanette 1850?-1917 *DcWomA*
Messer, Thomas M 1920- *WhoAmA 73, -76, -78, -80, -82, -84*
Messerschmidt, Franz Xaver 1736-1783 *McGDA*
Messerschmidt, H C *AmArch 70*
Messerschmitt, Charles *WhAmArt 85*
Messersmith, E J, Jr. *AmArch 70*
Messersmith, Fred Lawrence 1924- *WhoAmA 73, -76, -78, -80, -82, -84*
Messersmith, Robert Charles 1925- *AmArch 70*
Messick, Ben 1901- *WhoAmA 73, -76, -78, -80, -82, -84*
Messick, Benjamin Newton 1901- *WhAmArt 85*
Messick, Dale 1906- *WhoAmA 76, -78, -80, -82, -84, WorECom*
Messick, Turner B *WhAmArt 85*
Messier, R A *AmArch 70*
Messieri, Anna Teresa *DcWomA*
Messin, Charles 1620-1649? *ClaDrA*
Messina, A P *AmArch 70*
Messina, Frank Jon 1927- *AmArch 70*
Messina, John 1940- *ICPEnP A, MacBEP*
Messina, Joseph *WhAmArt 85*
Messina, Joseph R 1904- *WhoAmA 84*
Messina, Salvatore 1916- *PhDcTCA 77*
Messineo, Joseph Humbert 1900- *AmArch 70*
Messing, John 1756- *DcBrECP*
Messinger, Henry, II d1681 *CabMA*
Messinger, Marion Gettelson 1908- *WhAmArt 85*
Messkirch, Master Of *McGDA*
Messmer, J *AmArch 70*
Messmer, Otto 1894- *WorECar*
Messmer, R F *AmArch 70*
Messner, Alfred John 1909- *WhAmArt 85*
Messner, Elizabeth *FolkA 86*
Messner, Elmer R *WhAmArt 85*
Messner, John Robert 1930- *AmArch 70*
Messo, Dominick *NewYHSD*
Mestchersky, Boris *WhAmArt 85*
Mestler, Ludwig 1891- *WhAmArt 85*
Meston, Emily *DcWomA*
Meston, Stanley Clark 1910- *AmArch 70*
Mestral D'Aruffens, Marie Pierrette A *DcWomA*
Mestres I Esplugas, Josep Oriol 1815-1895 *MacEA*
Mestres I Ono, Apel.les 1854-1936 *WorECar*
Mestrovic, Ivan 1883-1962 *ConArt 77, -83, DcCAA 71, -77, McGDA, OxTwCA, PhDcTCA 77*
Mestrovic, Ivan 1884-1962 *WhoAmA 80N, -82N, -84N*
Mestrovie, Mathilde Von 1843- *DcWomA*
Meszenyi, Charles K 1931- *MarqDCG 84*
Metalak, Lubos 1934- *DcCAr 81*
Metcalf, Arthur Charles 1908- *AmArch 70*
Metcalf, Augusta Isabella Corson 1881-1971 *ArtsAmW 2, DcWomA*
Metcalf, Conger A 1914- *WhoAmA 82, -84*
Metcalf, E Belle *DcWomA*
Metcalf, Edward *FolkA 86*
Metcalf, Edwin 1848- *WhAmArt 85*
Metcalf, Eliab 1785-1834 *BnEnAmA, McGDA, NewYHSD*
Metcalf, Helen *DcWomA*
Metcalf, Helen F *WhAmArt 85*
Metcalf, James 1925- *DcCAA 71, -77, PhDcTCA 77, WhoAmA 73, -76*
Metcalf, John *NewYHSD*
Metcalf, Joseph 1765-1849 *CabMA*
Metcalf, Louise *DcWomA*
Metcalf, Luther 1756-1838 *CabMA*
Metcalf, Marie S *WhAmArt 85*
Metcalf, Robert C 1923- *AmArch 70*
Metcalf, Robert M 1902- *WhoAmA 73, -76*
Metcalf, Robert Marion 1902- *WhAmArt 85*
Metcalf, Savil d1737 *FolkA 86*

Metcalf, Willard L 1858-1925 *WhAmArt 85*
Metcalf, Willard Leroy 1853-1925 *BnEnAmA*
Metcalf, Willard Leroy 1858-1925 *ArtsAmW 1, DcAmArt, IlBEAAW*
Metcalf, William Henry, Jr. 1928- *AmArch 70*
Metcalfe, Anne *DcVicP 2*
Metcalfe, Augusta Isabella Corson 1881-1971 *DcWomA*
Metcalfe, Eric William *WhoAmA 84*
Metcalfe, Gerald F *DcVicP 2*
Metcalfe, Gerald Fenwick *DcBrBI*
Metcalfe, Helen *DcWomA*
Metcalfe, Howard Arlington 1893- *WhAmArt 85*
Metcalfe, Kathleen Isabella *DcWomA*
Metcalfe, Louis R *WhAmArt 85*
Metcalfe, N W *WhAmArt 85*
Metcalfe, Percy 1895-1970 *DcBrA 1*
Metcalfe, W *DcVicP 2*
Metchnikoff, Olga *DcWomA*
Metein-Gilliard, Valentine 1891- *DcWomA*
Metelli, Orneore 1872-1938 *OxTwCA*
Meteyard, Sidney 1868-1947 *ClaDrA, DcVicP*
Meteyard, Sidney Harold 1868-1947 *DcBrA 1, DcBrBI, DcBrWA, DcVicP 2*
Meteyard, Thomas B 1865-1928 *WhAmArt 85*
Meteyard, Tom B 1865- *DcBrBI*
Metezeau, Clement, II d1652 *WhoArch*
Metezeau, Louis 1572?-1615 *WhoArch*
Metezeau, Marie *DcWomA*
Metezeau Family *MacEA*
Metford, Samuel 1810-1896 *NewYHSD*
Metheney, John *CabMA*
Metheny, John Renwick 1881- *WhAmArt 85*
Metheny, Sarah Fontaine 1886- *WhAmArt 85*
Metheun, Cathcart W *DcVicP 2*
Methey, Andre 1871-1921 *DcNiCA*
Methfossel, Herman 1873-1912 *WhAmArt 85*
Methorst, A S *DcWomA*
Methuen, Lord 1886- *ClaDrA, DcBrA 1*
Methuen, Lord 1886-1974 *DcBrA 2*
Methven, H Wallace 1875- *WhAmArt 85*
Metivet, Marie *DcWomA*
Metlay, Harry 1907-1955 *WhAmArt 85*
Metlikovic, Matej 1956- *DcCAr 81*
Metour, Eugene d1929 *WhAmArt 85*
Metoyen, Madame *DcWomA*
Metrana, Anna *DcWomA*
Metrodorus *McGDA*
Metson, Graham *DcCAr 81*
Metson, Graham 1934- *WhoAmA 78, -80, -82, -84*
Metsovaara, Marjatta 1927- *ConDes*
Metsu, Gabriel 1629-1667 *ClaDrA, McGDA, OxArt*
Metsu, Jacquemijntje Garniers *DcWomA*
Metsurs, Jacquemijntje Garniers *DcWomA*
Metsys *OxArt*
Metsys, Cornelis 1508?-1550? *McGDA*
Metsys, Jan 1509?-1575 *McGDA*
Metsys, Quentin 1466-1530 *McGDA*
Mettais, Charles-Joseph *DcBrBI*
Mettan, Charles d1897 *BiDAmAr*
Mettegang, Florentine 1865- *DcWomA*
Mettel, Hans 1902-1966 *PhDcTCA 77*
Mettel, Hans 1903- *DcCAr 81*
Mettenleiter, Johann Jakob 1750-1825 *ClaDrA*
Mettenleiter, Johann Michael 1765-1853 *ClaDrA*
Metters, Larry 1932- *AmArch 70*
Mettlen, Franke Wyman 1880- *ArtsAmW 2, WhAmArt 85*
Mettlin, Franke Wyman 1880- *DcWomA*
Metyko, Michael Joseph 1945- *WhoAmA 78, -80, -82, -84*
Metz, A F *NewYHSD*
Metz, Carl A 1892- *AmArch 70*
Metz, Caroline *BkIE*
Metz, Caroline M *DcWomA*
Metz, Conrad 1755-1827 *BkIE*
Metz, Conrad Martin 1749-1827 *DcBrECP*
Metz, Conrad Martin 1755-1827 *DcBrWA*
Metz, Frank Robert 1925- *AmArt, WhoAmA 73, -76, -78, -80, -82, -84*
Metz, Friederike *DcWomA*
Metz, Gerry Michael 1943- *WhoAmA 76, -78, -80, -82, -84*
Metz, Gertrud 1746- *DcWomA*
Metz, Gertrud 1746-1793? *DcBrECP*
Metz, Jeanne *DcWomA*
Metz, Johann Martin 1717-1790? *DcBrECP*
Metz, L *FolkA 86*
Metz, Louise 1865- *DcWomA*
Metz, R A *AmArch 70*
Metz, S *DcBrECP*
Metzei, Leslie *OxTwCA*
Metzger, George B *ArtsEM*
Metzger, Caroline *DcWomA*
Metzger, Evelyn Borchard 1911- *WhoAmA 76, -78, -80, -82, -84*
Metzger, F *FolkA 86*
Metzger, Gustav 1926- *ConArt 77, -83, OxTwCA*
Metzger, Henry G, Jr. 1940- *AmArch 70*
Metzger, R E *AmArch 70*
Metzger, Robert Paul *WhoAmA 78, -80, -82, -84*

Meynard, Jean-Claude 1951- *DcCAr 81*
Meynell, Francis Meredith Wilfrid 1891-1975 *ConDes*
Meynell, Sir Francis Meredith Wilfrid 1891-1975 *WhoGrA 62*
Meynell, Louis 1868- *WhAmArt 85*
Meyner, Walter 1867- *WhAmArt 85*
Meyniac, M R *DcWomA*
Meyniac, Mrs. M R *NewYHSD*
Meynier, Charles 1768-1832 *ArtsNiC*
Meynier, Jules Joseph *ArtsNiC*
Meynier, Zoe 1805- *DcWomA*
Meyr *NewYHSD*
Meyre *NewYHSD*
Meyrick, Arthur *DcBrA 1, DcVicP 2*
Meyrick, Myra *DcVicP 2, DcWomA*
Meyrick, Richard *NewYHSD*
Meyrowitz, Jenny 1866- *DcWomA*
Meyrueis, Patrick L 1946- *MarqDCG 84*
Meysenberg, Virginia C *ArtsAmW 3*
Meysenburg, Virginia C *ArtsAmW 3*
Meysick, Mary Ann *FolkA 86*
Meytens, Marten *McGDA*
Meyvis, Alme Leon 1877- *WhAmArt 85*
Meyvis, Frederick William *WhAmArt 85*
Meywick, Miss *DcVicP 2*
Meza, Guillermo 1917- *McGDA*
Meza, Ronald Raphael 1929- *AmArch 70*
Mezan, Robert W 1927- *AmArch 70*
Mezarra, Francis *NewYHSD*
Mezerova, Juliana 1893- *DcWomA*
Mezey, Phiz 1925- *MacBEP*
Mezger, Caroline 1787-1843 *DcWomA*
Mezger, Gerda *DcWomA*
Mezieres, Jean-Claude 1938- *WorECom*
Mezzara, Angelica d1868 *NewYHSD*
Mezzara, Angelique d1868 *DcWomA*
Mezzara, Clementine *DcWomA*
Mezzara, Florence *DcWomA*
Mezzara, Francis *NewYHSD*
Mezzera, M *NewYHSD*
Mezzera, Rosa 1791-1826 *DcWomA*
Mezzerer, Peter *NewYHSD*
Mezzerer, Peter 1825?- *ArtsAmW 1*
M'Farlan, Thomas *NewYHSD*
M'Gahey *NewYHSD*
M'Gee, John L *NewYHSD*
M'Ginnis *NewYHSD*
Mi, Fei 1051-1107 *OxArt*
Mi, Fu 1051-1107 *McGDA*
Mi, Yu-Jen 1086-1165 *McGDA*
Miao, John 1946- *MarqDCG 84*
Miaskiewicz, Richard F 1923- *MarqDCG 84*
Miau, A *WhAmArt 85*
Micale, Albert *WhoAmA 76, -78, -80, -82, -84*
Micas, Nathalie d1889 *DcWomA*
Micchis, Maria *DcWomA*
Michael *FairDF ENG*
Michael Of Canterbury *McGDA*
Michael, A C *DcBrBI*
Michael, Mrs. D D *WhAmArt 85*
Michael, Enos 1824?-1890 *FolkA 86*
Michael, Frederick Howard *DcVicP 2*
Michael, Gary 1937- *AmArt, WhoAmA 78, -80, -82, -84*
Michael, Gary Linn 1934- *AmArch 70*
Michael, George 1926- *MarqDCG 84*
Michael, George Revell, Jr. 1931- *AmArch 70*
Michael, J B *DcBrBI*
Michael, John 1928- *AmArch 70*
Michael, L H *DcBrBI, DcVicP 2*
Michael, Linda Harris 1936- *AmArch 70*
Michael, Mary Elizabeth *DcWomA*
Michael, Natalie *DcWomA*
Michael, Philip *FolkA 86*
Michael, Richard Dale 1935- *AmArch 70*
Michael, W A *DcVicP 2*
Michaelangelo Buonarroti 1475-1564 *DcD&D*
Michaeledes *DcCAr 81*
Michaelian, C S *AmArch 70*
Michaelis, Alice 1875- *DcWomA*
Michaelis, M U *AmArch 70*
Michaels *FolkA 86*
Michaels, Barbara L 1935- *MacBEP*
Michaels, Glen 1927- *WhoAmA 73, -76, -78, -80, -82, -84*
Michaels, Lawrence Allan 1931- *AmArch 70*
Michaels, Leonard 1919- *AmArch 70*
Michaels, Rebecca *WhoAmA 80*
Michaels-Paque, Joan *AmArt, WhoAmA 80, -82, -84*
Michaelson, Assur *DcVicP 2*
Michaelson, Assur 1870- *DcBrA 2*
Michalik, Chester 1935- *DcCAr 81, ICPEnP A, MacBEP*
Michalitschke, Emma 1864-1925 *DcWomA*
Michallon, Achille Etna 1796-1822 *ClaDrA*
Michallon, Achille-Etna 1796-1822 *McGDA*
Michalov, Ann 1904- *WhAmArt 85*
Michalove, Carla Maria 1951- *WhoAmA 78*
Michals, Duane 1932- *ConPhot, ICPEnP, MacBEP, PrintW 85, WhoAmA 76, -78, -80, -82, -84*

Michals, John *DcCAr 81*
Michalski, Joseph Edward 1927- *AmArch 70*
Michau, Theobald 1676-1765 *ClaDrA, McGDA*
Michaud, Leonie 1873- *DcWomA*
Michault, Pauline *DcWomA*
Michaut, Therese Herminie *DcWomA*
Michaux, Henri 1899- *ConArt 77, -83, DcCAr 81, OxTwCA, PhDcTCA 77, WorArt[port]*
Michaux, Laurence *DcWomA*
Michaux, Ronald Robert 1944- *WhoAmA 76, -78, -80, -82, -84*
Micheaux, Oscar *AfroAA*
Michejda, Albert Maurycy 1939- *AmArch 70*
Michel, Mademoiselle *DcWomA*
Michel, Adele *DcWomA*
Michel, Claude *McGDA*
Michel, Clemence Caroline Catherine *DcWomA*
Michel, Ella Bergmann *DcWomA*
Michel, Emile Francois 1818-1909 *ClaDrA*
Michel, Ernest-Barthelemy *ArtsNiC*
Michel, Ernest Barthelemy 1833-1902 *ClaDrA*
Michel, Eugene *DcNiCA*
Michel, Fanny *DcWomA*
Michel, Georges 1763-1843 *McGDA, OxArt*
Michel, Hans 1920- *WhoGrA 62, -82[port]*
Michel, Henri-Francois-Victor 1846-1925 *OxDecA*
Michel, Kenneth A 1903- *AmArch 70*
Michel, Marius *OxDecA*
Michel, Robert 1721-1786 *McGDA*
Michel + Kieser *WhoGrA 62*
Michel-Ange *McGDA*
Michel-Brandt, Martha 1879- *DcWomA*
Michela, Costanzo 1689-1754 *MacEA*
Michelangelo 1475-1564 *ClaDrA, MacEA*
Michelangelo Buonarroti 1475-1564 *McGDA, OxArt[port], WhoArch*
Michelangelo Delle Battaglie *McGDA*
Michelangelo Of The Midway *FolkA 86*
Michelau, Anna 1872- *DcWomA*
Michele DaFirenze *McGDA*
Michele DaVerona *McGDA*
Michele DiMatteo *McGDA*
Michele Giambono *McGDA*
Michelena, Arturo 1863-1898 *McGDA*
Michelet, A *WhoArt 84*
Micheli, Julio 1937- *WhoAmA 73, -76, -78, -80, -82, -84*
Micheli, Parrasio 1516?-1578 *McGDA*
Michelin, Francis *NewYHSD*
Michelin, M J *DcVicP 2*
Michelino DaBesozzo *McGDA*
Michelino, Domenico *McGDA*
Michell, Chester Lee 1940- *AmArch 70*
Michell, John *BiDBrA*
Michelozzo 1396-1472 *McGDA*
Michelozzo Di Bartolomeo 1396-1472 *MacEA*
Michelozzo DiBartolommeo 1396-1472 *WhoArch*
Michelozzo, Michelozzi 1396-1472 *OxArt*
Michels, Eileen Manning 1926- *WhoAmA 84*
Michelsen, Anton 1809- *EncASM*
Michelsen, Hans 1789-1859 *McGDA*
Michelson, Annette *WhoAmA 73, -76, -80*
Michelson, Dorothy 1906- *WhAmArt 85*
Michelson, Eric Gustavus *WhAmArt 85*
Michelson, Valerius Leo 1916- *AmArch 70*
Michelson-Bagley, Henrietta *WhoAmA 76, -78, -80, -82*
Michelucci, Giovanni 1891- *ConArch, EncMA*
Michener, Edward C 1913- *AmArch 70*
Michetti, Francesco Paolo 1851-1929 *ICPEnP A, MacBEP, McGDA*
Michetti, Nicola 1675?-1758 *MacEA*
Michie, Anne *DcWomA*
Michie, David Alan Redpath 1928- *DcBrA 1, WhoArt 80, -82, -84*
Michie, J *DcVicP 2*
Michie, James Coutts 1861-1919 *DcBrA 1, DcVicP, -2*
Michie, John D *DcVicP 2*
Michie, M Coutts- *DcVicP 2*
Michieli, Andrea 1539-1615? *McGDA*
Michiels, J J *AmArch 70*
Michis, Maria *DcWomA*
Michitsch, Robert Frank 1931- *AmArch 70*
Michnick, David 1893- *WhAmArt 85*
Michod, Susan A *DcCAr 81*
Michod, Susan A 1945- *AmArt, WhoAmA 76, -78, -80, -82, -84*
Micholls, A *DcVicP 2*
Michon, Clemence *DcWomA*
Michon, Inez *DcWomA*
Micia *FairDF ITA*
Mick, E N *AmArch 70*
Mickelsen, William Frands 1896- *AmArch 70*
Mickens, Charles *AfroAA*
Mickens, Charles 1940- *MarqDCG 84*
Mickey, Julius 1832-1916 *FolkA 86*
Mickle, Samuel *CabMA*
Micklethwaite, J T 1843-1906 *MacEA*
Micklewright, A E *AmArch 70*
Micklewright, R C *AmArch 70*

Micklewright, Robert 1923- *IlsCB 1967*
Micklewright, Robert Flavell 1923- *DcBrA 1, WhoArt 80, -82, -84*
Micks, J Rumsey 1886- *WhAmArt 85*
Mickwitz, Camilla 1937- *WorECar*
Micocci, Guiseppe *DcVicP 2*
Micoleau, Tyler *IlsBYP*
Micon *McGDA*
Micuda, Constantin V *AmArch 70*
Micus, Eduard 1925- *OxTwCA, PhDcTCA 77*
Midani, Akram 1927- *WhoAmA 82, -84*
Middaugh, Robert Burton 1935- *AmArt, DcCAr 81, WhoAmA 76, -78, -80, -82, -84*
Midderigh, Jean Jacques 1877- *ClaDrA*
Middlebrook, David 1944- *CenC[port], DcCAr 81*
Middlebrook, David A 1944- *WhoAmA 80, -82, -84*
Middlecoat, George Keith DeBlois 1896- *DcBrA 1*
Middleditch, Edward 1923- *ConBrA 79[port], DcBrA 1, McGDA, OxTwCA, PhDcTCA 77*
Middlehurst, Fred 1918- *DcBrA 1*
MiddleKamp *FolkA 86*
Middlekauf, C B *AmArch 70*
Middleman, Raoul F 1935- *WhoAmA 76, -78, -80, -82, -84*
Middleton, A B, III *AmArch 70*
Middleton, Arthur *AfroAA*
Middleton, Arthur Wesley 1931- *AmArch 70*
Middleton, Charles 1756- *BiDBrA*
Middleton, Sir Charles 1799-1867 *BiDBrA*
Middleton, Daniel Anthony 1959- *MarqDCG 84*
Middleton, David V 1922- *WhoAmA 73, -76*
Middleton, Dora *DcWomA*
Middleton, Elijah C *NewYHSD*
Middleton, Fanny *DcBrWA, DcVicP 2, DcWomA*
Middleton, George *NewYHSD*
Middleton, H W *AmArch 70*
Middleton, Harold Joe, Jr. 1938- *AmArch 70*
Middleton, Horace *DcBrA 2*
Middleton, J T *DcVicP 2*
Middleton, James Charles 1894- *DcBrA 1*
Middleton, James Godsell *DcVicP, -2*
Middleton, James Raeburn 1855- *DcBrA 1, DcVicP 2*
Middleton, John 1827-1856 *DcBrWA*
Middleton, John 1828-1856 *ClaDrA, DcVicP, -2*
Middleton, John Izard 1785-1849 *NewYHSD*
Middleton, Katherine *DcVicP 2*
Middleton, Keith Edward 1916- *AmArch 70*
Middleton, Mary E *DcVicP 2, DcWomA*
Middleton, Mary P *DcWomA, WhAmArt 85*
Middleton, Max *DcCAr 81*
Middleton, Michael Humfrey 1917- *WhoArt 80, -82, -84*
Middleton, Ralph *FolkA 86*
Middleton, Robert Evans 1921- *AmArch 70*
Middleton, Roland Gilbert 1927- *AmArch 70*
Middleton, Sallie *OfPGCP 86*
Middleton, Samuel M 1927- *AfroAA*
Middleton, Samuel Thomas, Jr. 1927- *AmArch 70*
Middleton, Selina M *DcWomA*
Middleton, Stanley *WhAmArt 85*
Middleton, Thomas 1797-1863 *NewYHSD*
Middleton, Thomas Eugene 1959- *MarqDCG 84*
Middleton, William *AntBDN Q*
Middleton, William 1730-1815 *BiDBrA*
Midener, Walter 1912- *WhoAmA 73, -76, -78, -80, -82, -84*
Midforth, Charles Henry *DcVicP 2*
Midgette, Willard Franklin 1937- *ConArt 77, WhoAmA 73, -76, -78*
Midgette, Willard Franklin 1937-1978 *WhoAmA 80N, -82N, -84N*
Midgley, J H *DcVicP 2*
Midgley, Waldo 1888- *ArtsAmW 3*
Midgley, William d1933 *DcBrA 1, DcVicP 2*
Midgley, William Peter 1937- *AmArch 70*
Midjo, Christian M S *WhAmArt 85*
Midkiff, Lula *FolkA 86*
Midkiff, Mary Louisa Givens *FolkA 86*
Midorikawa, Yoichi 1915- *ConPhot, ICPEnP A*
Midwood, W H *DcVicP, -2*
Midy, Louise Aline *DcWomA*
Midyette, Eugene Barton 1925- *AmArch 70*
Mieczkowski, Ed 1929- *DcCAr 81*
Mieczkowski, Edwin 1929- *WhoAmA 73, -76, -78, -80, -82, -84*
Miedinger, Gerard 1912- *WhoGrA 82[port]*
Mieg, Peter 1906- *WhoArt 80, -82, -84*
Miel, Jan *ClaDrA*
Miel, Jan 1599-1664? *McGDA*
Mielatz, C F William 1864-1919 *WhAmArt 85*
Mielatz, Charles Frederick William 1860?-1919 *GrAmP*
Mields, Rune 1935- *DcCAr 81*
Miele, A R *AmArch 70*
Miele, Jean Gerald 1938- *AmArch 70*
Mielich, Hans *McGDA*
Mielke, Lee Charles 1908- *AmArch 70*
Mielle, Elisabeth Helene *DcWomA*
Mielziner, Jo 1901- *McGDA, WhoAmA 73, -76*

Millard, E DcVicP 2
Millard, Ed A 1954- MarqDCG 84
Millard, Elizabeth B WhAmArt 85
Millard, Elizabeth Boynton DcWomA
Millard, Fred DcVicP
Millard, Fred 1857- DcBrA 1, DcVicP 2
Millard, Gail E 1931- MarqDCG 84
Millard, Hattie E ArtsEM, DcWomA
Millard, Jack DcBrA 2
Millard, James CabMA
Millard, Jennie Bellows 1850?- DcWomA
Millard, John FolkA 86
Millard, M Arturo 1952- MarqDCG 84
Millard, Patrick Ferguson 1902- DcBrA 1
Millard, Thomas, Jr. 1803-1870 FolkA 86
Millard, Tom FolkA 86
Millard, W John, Jr. 1927- AmArch 70
Millard, Walter J N DcVicP 2
Millard, William CabMA
Millares, Manolo 1926-1972 ConArt 77, -83,
 WorArt[port]
Millares, Manuel 1926-1972 OxTwCA, PhDcTCA 77
Millbourn, M Vaughn 1893- WhAmArt 85
Mille, Yvonne DcWomA
Millea, Tom DcCAr 81
Millea, Tom 1944- ICPEnP A, MacBEP,
 WhoAmA 84
Milleken NewYHSD
Millenson, Donald H 1925- MarqDCG 84
Miller EarABI SUP
Miller, A NewYHSD
Miller, A H AmArch 70
Miller, Aaron AfroAA
Miller, Abraham FolkA 86
Miller, Alec 1879- DcBrA 1
Miller, Alex Abraham 1924- AmArch 70
Miller, Alexander G DcVicP 2
Miller, Alfred J 1810-1874 ArtsNiC
Miller, Alfred Jacob 1810-1874 ArtsAmW 1,
 DcAmArt, IIBEAAW, McGDA, NewYHSD
Miller, Algernon 1945- AfroAA
Miller, Alice DcVicP 2, DcWomA
Miller, Ambrose 1812-1891? FolkA 86
Miller, Andrew FolkA 86
Miller, Anna G FolkA 86
Miller, Anna H 1863- WhAmArt 85
Miller, Anna Hazzard 1863- ArtsAmW 2, DcWomA
Miller, Anna Mari FolkA 86
Miller, Anna Viola 1900- FolkA 86
Miller, Anne D FolkA 86
Miller, Anne Louisa 1906- FolkA 86
Miller, Archibald Elliot Haswell 1887- DcBrA 1
Miller, Athanasias FolkA 86
Miller, August FolkA 86
Miller, B FolkA 86
Miller, B C FolkA 86
Miller, Barbara Darlene WhoAmA 73, -76, -78, -80,
 -82, -84
Miller, Barse 1904-1973 WhAmArt 85
Miller, Barse 1924-1973 WhoAmA 78N, -80N, -82N,
 -84N
Miller, Beatrix WorFshn
Miller, Benjamin 1877- WhAmArt 85
Miller, Benjamin 1934- AfroAA
Miller, Bob 1951- MarqDCG 84
Miller, Boyd Kinghay AmArch 70
Miller, Brenda WhoAmA 84
Miller, Brian Charles 1947- MacBEP
Miller, Burr 1904-1958 WhAmArt 85,
 WhoAmA 80N, -82N, -84N
Miller, C A, Jr. AmArch 70
Miller, C C AmArch 70
Miller, C G 1800?- NewYHSD
Miller, C H A DcWomA
Miller, C Howard 1920- AmArch 70
Miller, Callix Edwin, Jr. 1924- AmArch 70
Miller, Callix Edwin, Sr. 1897- AmArch 70
Miller, Catherine Melanie d1828 DcWomA
Miller, Celia J DcWomA
Miller, Charles NewYHSD
Miller, Charles 1820?- NewYHSD
Miller, Charles C 1831- BiDAmAr
Miller, Charles F NewYHSD
Miller, Charles H 1842- ArtsNiC
Miller, Charles H 1842-1922 WhAmArt 85
Miller, Charles Henry 1842-1922 NewYHSD
Miller, Charles Keith DcSeaP
Miller, Charles S DcVicP 2
Miller, Chris J 1951- MarqDCG 84
Miller, Christian FolkA 86
Miller, Clive Beverley 1938- WhoArt 80, -82, -84
Miller, Clive Beverly 1938- ClaDrA
Miller, Clyde P 1899- WhAmArt 85
Miller, Cora E DcWomA, WhAmArt 85
Miller, Courtney WhAmArt 85
Miller, D H AmArch 70
Miller, D Roy 1891- WhAmArt 85
Miller, Daniel Dawson 1928- WhoAmA 73, -76, -78,
 -80, -82, -84
Miller, David FolkA 86
Miller, David 1718-1789 FolkA 86
Miller, David 1926- AmArch 70

Miller, David 1948- WhoAmA 80, -82, -84
Miller, David E 1929- AmArch 70
Miller, David Haskel 1950- MarqDCG 84
Miller, Mrs. David J L FolkA 86
Miller, David Stuart 1948- WhoAmA 78
Miller, David T 1931- WhoArt 80, -82, -84
Miller, Delle d1932 ArtsAmW 2, DcWomA,
 WhAmArt 85
Miller, Dolly 1927- WhoAmA 78, -80, -82, -84
Miller, Dolores Uhrich 1931- AmArch 70
Miller, Don 1923- AfroAA
Miller, Donald 1934- WhoAmA 73, -76, -78, -80, -82,
 -84
Miller, Donald Carlos 1926- AmArch 70
Miller, Donald Richard 1925- AmArt, WhoAmA 73,
 -76, -78, -80, -82, -84
Miller, Donna 1885- DcWomA, WhAmArt 85
Miller, Doris Louise WhAmArt 85
Miller, Dorothy Canning WhAmArt 85,
 WhoAmA 73, -76, -78, -80, -82, -84
Miller, Dorothy McTaggart WhAmArt 85
Miller, Dwight Earl 1929- AmArch 70
Miller, E G DcWomA
Miller, E J DcVicP 2
Miller, E O AmArch 70
Miller, Earl B 1930- AfroAA, WhoAmA 84
Miller, Earle 1907- WhAmArt 85
Miller, Edgar 1899- WhAmArt 85
Miller, Edith Luella 1889- ArtsAmW 3, DcWomA
Miller, Edith Maude ArtsAmW 2, DcWomA,
 WhAmArt 85
Miller, Edna Anita 1920- IlsCB 1957
Miller, Edward NewYHSD
Miller, Edward A NewYHSD
Miller, Edward Charles 1906- AmArch 70
Miller, Edward J WhAmArt 85
Miller, Edwin N FolkA 86
Miller, Eleazer Hutchinson 1831-1921 NewYHSD ,
 WhAmArt 85
Miller, Eliza Armstead FolkA 86
Miller, Elizabeth DcWomA
Miller, Ellen WhAmArt 85
Miller, Emil NewYHSD
Miller, Emma D WhAmArt 85
Miller, Eva Hamlin AfroAA
Miller, Eva-Hamlin WhoAmA 73, -76, -78, -80
Miller, Evylena 1888-1966 DcWomA
Miller, Evylena Nunn 1888- WhAmArt 85
Miller, Evylena Nunn 1888-1966 ArtsAmW 1
Miller, Ewing Harry AmArch 70
Miller, F DcBrBI
Miller, F D AmArch 70
Miller, F E AmArch 70
Miller, F W WhAmArt 85
Miller, Fanny FolkA 86
Miller, Florence M WhAmArt 85
Miller, Frances 1893- DcWomA
Miller, Frances St. Clair PrintW 85
Miller, Frances T 1893- WhAmArt 85
Miller, Francis 1885-1930 WhAmArt 85
Miller, Frank 1898-1949 WorECom
Miller, Frank 1925- WorECar
Miller, Frank H WhAmArt 85
Miller, Fred, Jr. 1912- WhAmArt 85
Miller, Frederick DcVicP 2
Miller, Frederick A EncASM
Miller, G G AmArch 70
Miller, G H AmArch 70
Miller, Mrs. G Macculloch WhoAmA 73,
 -76, -78, -80, -82
Miller, Gabriel 1823?- FolkA 86
Miller, George DcVicP 2, NewYHSD
Miller, George 1944- WhoAmA 76, -78, -80,
 -84
Miller, George A FolkA 86
Miller, George B DcBrWA
Miller, George Charles 1894- WhAmArt 85
Miller, George H 1844?- NewYHSD
Miller, George M d1819 NewYHSD
Miller, George W DcVicP 2
Miller, George Washington 1904- WhAmArt 85
Miller, Gerhard C F OfPGCP 86
Miller, Godfrey 1893- McGDA
Miller, Godfrey 1893-1964 OxTwCA
Miller, Gottfried NewYHSD
Miller, Grambs IlsBYP
Miller, Gustaf 1940- AmArt
Miller, Guy WhoAmA 80, -82, -84
Miller, Guy 1909- AfroAA
Miller, H E AmArch 70
Miller, H McRae 1895- WhoAmA 73, -76, -78
Miller, Hammond NewYHSD
Miller, Harold George WhoAmA 73, -76
Miller, Harold James 1929- AmArch 70
Miller, Harriette G 1892- DcWomA, WhAmArt 85
Miller, Harrison DcBrA 2, DcVicP 2
Miller, Harry Vye 1907- WhoArt 80, -82, -84
Miller, Helen Adele Lerch WhAmArt 85
Miller, Helen Pendleton 1888-1957 DcWomA,
 WhAmArt 85, WhoAmA 80N, -82N, -84N

Miller, Helen Welsh DcWomA
Miller, Helena W d1929 DcWomA
Miller, Helena Welsh d1929 WhAmArt 85
Miller, Henrietta DcVicP 2, DcWomA
Miller, Henry ArtsAmW 2, FolkA 86, NewYHSD
Miller, Henry d1924 WhAmArt 85
Miller, Mrs. Henry DcWomA
Miller, Henry Arthur 1897- WhAmArt 85
Miller, Henry Forster 1916- AmArch 70
Miller, Hester DcWomA, WhAmArt 85
Miller, Hilary 1919- DcBrA 1
Miller, Hilda T DcBrA 1
Miller, Hilda T 1876-1939 DcWomA
Miller, Howard FolkA 86
Miller, Hubert Stauffer, Jr. 1936- AmArch 70
Miller, I AmArch 70
Miller, Inge Morath WhoAmA 78, -80, -82, -84
Miller, Iris Andrews 1881- WhAmArt 85
Miller, Iris Marie Andrews 1881- DcWomA
Miller, Irvin Melvin 1938- MarqDCG 84
Miller, Isaac NewYHSD
Miller, Isabelle Lazarus 1907- WhAmArt 85
Miller, J DcVicP 2, FolkA 86, NewYHSD
Miller, J A AmArch 70
Miller, J Arthur 1933- AmArch 70
Miller, J Brough 1933- WhoAmA 84
Miller, J C NewYHSD
Miller, J D AmArch 70
Miller, J E AmArch 70
Miller, J H AmArch 70, DcBrBI
Miller, J Nina DcBrA 1, DcWomA
Miller, J R AmArch 70
Miller, Jack Steven AmArch 70
Miller, Jacob FolkA 86
Miller, Jacob Maurice 1937- MarqDCG 84
Miller, Jamer d1947 DcBrA 1
Miller, James CabMA, DcBrECP, DcBrWA
Miller, James 1893- DcBrA 1, WhoArt 80, -82, -84
Miller, James 1944- FolkA 86
Miller, James Alexander 1931- AmArch 70
Miller, James Donaldson 1939- AmArch 70
Miller, James E 1940- MarqDCG 84
Miller, James Harold 1919- AmArch 70
Miller, James Kenneth 1942- AmArch 70
Miller, James R d1946 BiDAmAr
Miller, Jan WhoAmA 76, -78, -80, -82, -84
Miller, Jane DcWomA, WhAmArt 85
Miller, Jean Johnston 1918- WhoAmA 78, -80, -82,
 -84
Miller, Jessie M WhAmArt 85
Miller, Joan Vita 1946- WhoAmA 78, -80, -82, -84
Miller, Joaquin MarqDCG 84
Miller, John BiDBrA, CabMA, DcCAr 81,
 DcVicP 2, FolkA 86, NewYHSD
Miller, John 1713-1763 CabMA
Miller, John 1715?-1790? DcBrWA
Miller, John 1715?-1792 DcBrECP
Miller, John 1911- ClaDrA, DcBrA 1
Miller, John 1911-1975 DcBrA 2
Miller, John A 1863-1932 BiDAmAr
Miller, John Douglas DcVicP 2
Miller, John Edward WhAmArt 85
Miller, John F FolkA 86
Miller, John F 1936- AmArch 70
Miller, John F, Jr. FolkA 86
Miller, John Franklin 1940- WhoAmA 82, -84
Miller, John Frederick DcBrECP, DcBrWA
Miller, John G FolkA 86
Miller, John Keith 1934- AmArch 70
Miller, John Milton 1910- AmArch 70
Miller, John Paul EncASM
Miller, John Paul 1918- WhoAmA 76, -78, -80, -82,
 -84
Miller, John R WhAmArt 85
Miller, John Reichard 1929- AmArch 70
Miller, John Zollinger 1867- WhAmArt 85
Miller, Joseph FolkA 86, NewYHSD
Miller, Joseph 1918- AmArch 70
Miller, Joseph Maxwell 1877-1933 WhAmArt 85
Miller, Josephine Anne DcWomA
Miller, Josephine Haswell 1890- DcBrA 1, DcWomA
Miller, Josephine Haswell 1890-1975 DcBrA 2
Miller, Juanita AfroAA
Miller, Julia Booker 1940- AfroAA
Miller, Juliet Scott 1898- WhAmArt 85
Miller, Julius Anton 1906-1953 WhAmArt 85
Miller, K C AmArch 70
Miller, K G AmArch 70
Miller, Kate Reno 1870?-1929 DcWomA
Miller, Kate Reno 1874-1929 WhAmArt 85
Miller, Katherine Sproat 1829-1905 DcWomA
Miller, Katherine Sproat Trowbridge 1829-1905
 ArtsEM
Miller, Kathleen Helen 1904- DcBrA 1
Miller, Kathryn OfPGCP 86
Miller, Kathryn 1935- PrintW 83, -85
Miller, Katie FolkA 86
Miller, Keith Phillip 1942- AmArch 70
Miller, Kenneth Alfred 1915- WhoArt 80, -82, -84
Miller, Kenneth Hayes 1876-1952 BnEnAmA,
 DcAmArt, GrAmP, McGDA, PhDcTCA 77,

WhAmArt 85, WhoAmA 78N, –80N, –82N, –84N
Miller, Kenneth Hayes 1878-1952 *DcCAA 71, –77, OxTwCA*
Miller, Kenneth Neils 1911- *WhAmArt 85*
Miller, Kenneth Russell 1926- *AmArch 70*
Miller, Kenneth VanLeer 1930- *AmArch 70*
Miller, L A *AmArch 70*
Miller, L B *AmArch 70*
Miller, L S *AmArch 70*
Miller, Larry *AfroAA*
Miller, Laurence Glenn 1948- *ICPEnP A, MacBEP, WhoAmA 85*
Miller, Laurence Spurlock, Sr. 1900- *AmArch 70*
Miller, Lee *WhAmArt 85*
Miller, Lee 1906-1977 *ICPEnP A, MacBEP*
Miller, Lee Anne *WhoAmA 78*
Miller, Leigh Don 1925- *AmArch 70*
Miller, Leon Gordon 1917- *WhoAmA 73, –76, –78, –80*
Miller, Leroy Benjamin 1931- *AmArch 70*
Miller, Leslie W 1848-1931 *WhAmArt 85*
Miller, Levi M S *FolkA 86*
Miller, Lewis 1795-1882 *NewYHSD*
Miller, Lewis 1796-1882 *AmFkP[port], FolkA 86*
Miller, Lilian May d1943 *WhAmArt 85*
Miller, Lilian May 1895-1943 *ArtsAmW 3, DcWomA*
Miller, Lillian Dunn *WhoAmA 80, –82, –84*
Miller, Lillian L *ArtsEM, DcWomA*
Miller, Lindsay *DcCAr 81*
Miller, Lola Sleeth *DcWomA*
Miller, Lola Sleeth 1866- *WhAmArt 85*
Miller, Loren Roberta *DcWomA*
Miller, Lou *DcWomA*
Miller, Louisa F *DcWomA, FolkA 86, NewYHSD*
Miller, Lydia Ann *FolkA 86*
Miller, Lynn 1906- *FolkA 86*
Miller, M *FolkA 86*
Miller, M E, Jr. *AmArch 70*
Miller, M Loveland *DcCAr 81*
Miller, M Luther *AmArch 70*
Miller, Margaret L *DcWomA*
Miller, Marguerite C 1895- *WhAmArt 85*
Miller, Marguerite Cuttino 1895- *DcWomA*
Miller, Maria 1813-1875 *DcWomA*
Miller, Mariann 1932- *WhoAmA 76, –78, –80, –82*
Miller, Marie Clark 1892?- *DcWomA*
Miller, Marie Clark 1894- *ArtsAmW 1*
Miller, Mariema *WhAmArt 85*
Miller, Marilyn Jean 1925- *IlsCB 1957*
Miller, Marion *WhAmArt 85*
Miller, Mark Kendall 1955- *MarqDCG 84*
Miller, Marmaduke 1900- *DcBrA 1*
Miller, Martin 1865-1929? *BiDAmAr*
Miller, Mary *DcVicP 2, DcWomA, FolkA 86*
Miller, Mary 1770?- *FolkA 86*
Miller, Mary G *WhAmArt 85*
Miller, Maud Alvera 1883- *DcWomA*
Miller, Maude Alvera 1883- *ArtsAmW 2, WhAmArt 85*
Miller, Maurice Leon 1933- *AmArch 70*
Miller, Maxmilion 1823?- *FolkA 86*
Miller, Melissa Wren 1951- *WhoAmA 84*
Miller, Melvin O, Jr. 1937- *AmArt, WhoAmA 82, –84*
Miller, Merl 1942- *MarqDCG 84*
Miller, Mildred Bunting 1892- *ArtsAmW 1, DcWomA, WhAmArt 85*
Miller, Minerva Butler *FolkA 86*
Miller, Minnie M *DcWomA, WhAmArt 85*
Miller, Mitchell *IlsBYP, IlsCB 1967, WhoAmA 73*
Miller, Murile *WhAmArt 85*
Miller, Myra 1882-1961 *ArtsAmW 2, DcWomA*
Miller, Nancy 1927- *WhoAmA 73, –76, –78, –80, –82*
Miller, Nancy Tokar 1941- *WhoAmA 76, –78, –80, –82, –84*
Miller, Mrs. Nathaniel *FolkA 86*
Miller, Neil Allen 1945- *MacBEP*
Miller, Nelson T 1937- *AmArch 70*
Miller, Noble W 1889- *AmArch 70*
Miller, Nory *ConArch A*
Miller, Oscar 1867- *WhAmArt 85*
Miller, Oxley 1855-1909 *ArtsAmW 3*
Miller, P Compton, Jr. 1910- *AmArch 70*
Miller, Mrs. P H *DcVicP 2*
Miller, Paul D *AmGrD[port]*
Miller, Peter *NewYHSD*
Miller, Peter 1765-1810 *CabMA*
Miller, Philip 1898- *WhAmArt 85*
Miller, Philip Homan *DcVicP*
Miller, Philip Homan d1928 *DcBrA 1, DcVicP 2*
Miller, Polly *FolkA 86*
Miller, R Bruce 1925- *AmArch 70*
Miller, R C *AmArch 70*
Miller, R M *AmArch 70*
Miller, R S *AmArch 70*
Miller, Mrs. Ralph C, Jr. *WhAmArt 85*
Miller, Ralph Davison 1858-1945 *ArtsAmW 1, –3, IlBEAAW, WhAmArt 85*
Miller, Ralph Rillman 1915- *WhoAmA 73*
Miller, Ralph Vernon 1928- *AmArch 70*
Miller, Ralph Willett 1762-1799 *DcBrWA*

Miller, Ray William 1939- *AmArch 70*
Miller, Rebekah D *WhAmArt 85*
Miller, Reuben 1924- *AmArch 70*
Miller, Richard *WhAmArt 85*
Miller, Richard d1789 *DcBrECP*
Miller, Richard 1925- *AmArch 70*
Miller, Richard 1930- *DcCAA 77*
Miller, Richard C *MarqDCG 84*
Miller, Richard E 1875-1943 *WhAmArt 85*
Miller, Richard Emil 1875-1943 *ArtsAmW 2*
Miller, Richard K 1922- *DcCAA 71*
Miller, Richard Kendall 1946- *MarqDCG 84*
Miller, Richard Kidwell 1930- *AmArt, PrintW 83, –85, WhoAmA 73, –76, –78, –80, –82, –84*
Miller, Richard McDermott 1922- *AmArt, DcCAA 77, WhoAmA 73, –76, –78, –80, –82, –84*
Miller, Richard Paul 1925- *AmArch 70*
Miller, Robbins Huntington 1904- *AmArch 70*
Miller, Robert *NewYHSD*
Miller, Robert 1832?- *FolkA 86*
Miller, Robert 1937- *PrintW 83, –85*
Miller, Robert A 1943- *MarqDCG 84*
Miller, Robert A Darrah 1905- *WhAmArt 85*
Miller, Robert Carl 1931- *AmArch 70*
Miller, Robert Darwin 1929- *AmArch 70*
Miller, Robert Derald 1951- *MarqDCG 84*
Miller, Robert George 1930- *AmArch 70*
Miller, Robert Milton 1931- *AmArch 70*
Miller, Robert Peter 1939- *WhoAmA 76, –78, –80, –82, –84*
Miller, Robert Thomas Clark 1917- *AmArch 70*
Miller, Robert Watt 1898- *WhoAmA 82*
Miller, Mrs. Robert Watt 1898- *WhoAmA 73, –76, –78, –80, –84*
Miller, Rose Kellogg 1890- *ArtsAmW 3*
Miller, Rosina Barbara *DcWomA*
Miller, Ross Maurice 1954- *MarqDCG 84*
Miller, Roston H 1934- *AmArch 70*
Miller, Roy *WhAmArt 85*
Miller, Ruth Blanchard 1904- *WhAmArt 85*
Miller, S *AmArch 70*
Miller, S M *AmArch 70*
Miller, Mrs. S N *FolkA 86*
Miller, Samuel Clifford 1930- *WhoAmA 73, –76, –78, –80, –82, –84*
Miller, Sanderson 1716-1780 *BiDBrA*
Miller, Sanderson 1717-1780 *DcD&D, MacEA, OxArt, WhoArch*
Miller, Sarah *FolkA 86*
Miller, Sarah Alice *DcVicP 2*
Miller, Sarah Ann *FolkA 86*
Miller, Shane 1907- *IlsCB 1957*
Miller, Sidney Trowbridge 1929- *AmArch 70*
Miller, Solomon *FolkA 86*
Miller, Sophia *DcWomA*
Miller, Stephen *CabMA*
Miller, Stephen 1951- *DcCAr 81*
Miller, Stephen P 1947- *MarqDCG 84*
Miller, Steven W 1940- *AmArch 70*
Miller, Susan Barse d1935 *DcWomA, WhAmArt 85*
Miller, Susie *FolkA 86*
Miller, Suzanne *WhAmArt 85*
Miller, Sydney Leon 1901- *WorECom*
Miller, T Harrison *DcVicP 2*
Miller, T S *AmArch 70*
Miller, Theodore H 1823?- *FolkA 86*
Miller, Thomas, Jr. *NewYHSD*
Miller, Thomas Francis 1863-1939 *BiDAmAr*
Miller, Tobias *FolkA 86*
Miller, Tom Polk 1914- *AmArch 70*
Miller, Vel 1936- *WhoAmA 76, –78, –80*
Miller, Viola 1890- *DcWomA, WhAmArt 85*
Miller, Virgil George 1939- *AmArch 70*
Miller, W *DcVicP 2*
Miller, W E *AmArch 70*
Miller, Mrs. W E *DcVicP 2*
Miller, W H *AmArch 70, DcBrWA, DcVicP 2*
Miller, W K *AmArch 70*
Miller, Walter A 1928- *AmArch 70*
Miller, Walter James, Jr. 1920- *AmArch 70*
Miller, Wayne 1911- *ICPEnP A*
Miller, William *CabMA, NewYHSD*
Miller, William 1740?-1810? *DcBrECP*
Miller, William 1796-1882 *DcBrWA, DcVicP 2*
Miller, William 1835?-1907 *NewYHSD*
Miller, William 1850-1923 *WhAmArt 85*
Miller, William B *WhAmArt 85*
Miller, William C 1858-1927 *WhAmArt 85*
Miller, William David 1909- *AmArch 70*
Miller, William E *DcBrA 1, DcVicP*
Miller, William Edwards *DcBrBI, DcVicP 2*
Miller, William Frederick 1834-1918 *DcBrBI*
Miller, William Frederick 1932- *AmArch 70*
Miller, William G *DcVicP 2*
Miller, William H 1820?- *NewYHSD*
Miller, William Henry d1921? *BiDAmAr*
Miller, William Henry 1854-1928 *WhAmArt 85*
Miller, William J *EncASM, NewYHSD*
Miller, William J 183-?-1907 *WhAmArt 85*
Miller, William Jerome 1923- *AmArch 70*

Miller, William M *NewYHSD*
Miller, William Ongley 1883- *DcBrA 1*
Miller, William Rickarby 1818-1893 *ArtsAmW 3, EarABI, EarABI SUP, NewYHSD, WhAmArt 85*
Miller, Mrs. William Snyder *FolkA 86*
Miller Family *DcBrECP*
Millerd And Tilley *CabMA*
Milles, Carl 1875-1955 *McGDA, OxArt, PhDcTCA 77, WhAmArt 85*
Milles, Carl Wilhelm Emil 1875-1955 *BnEnAmA*
Milles, Charles *AfroAA*
Milles, Olga *DcWomA*
Milles, Ruth Anna Maria 1873-1941 *DcWomA*
Milleson, Hollis E *WhAmArt 85*
Milleson, Royal H 1849- *WhAmArt 85*
Milleson, Royal Hill 1849- *ArtsAmW 3*
Millet, Aime 1816?- *ArtsNiC*
Millet, Claire Henriette *DcWomA*
Millet, Clarence 1897-1959 *WhAmArt 85, WhoAmA 80N, –82N, –84N*
Millet, Francis D 1846- *ArtsNiC*
Millet, Francis Davis 1846-1912 *BnEnAmA, IlBEAAW, IlrAm 1880, WhAmArt 85*
Millet, Francois *ClaDrA*
Millet, Geraldine B 1853?-1945 *DcWomA*
Millet, Geraldine R *WhAmArt 85*
Millet, Jean-Francois 1642-1679 *McGDA*
Millet, Jean Francois 1642-1679 *OxArt*
Millet, Jean Francois 1666-1732 *OxArt*
Millet, Jean-Francois 1814-1875 *ArtsNiC, McGDA*
Millet, Jean Francois 1814-1875 *ClaDrA, IlBEAAW, OxArt*
Millet, Louis J d1923 *WhAmArt 85*
Millet, Richard Collamore 1929- *AmArch 70*
Millett, Benjamin R *CabMA*
Millett, Caroline Dunlop 1939- *WhoAmA 82, –84*
Millett, E W *AmArch 70*
Millett, Francis David 1846-1912 *DcBrA 1, DcVicP, –2*
Millett, G Van 1864- *WhAmArt 85*
Millett, Norman Charles 1920- *AmArch 70*
Millett, Robert Hall 1923- *AmArch 70*
Millett, Thalia W *WhAmArt 85*
Millett, Thalia Westcott *DcWomA*
Millette, Conrad Paul 1919- *AmArch 70*
Millette, Rosemary *OfPGCP 86*
Milley, Michael *MarqDCG 84*
Millhouse, Charles A 1907- *AmArch 70*
Millhouser, Harry L *WhAmArt 85*
Milliard, Charles *FolkA 86*
Milliard, James *FolkA 86*
Milliard, Thomas *FolkA 86*
Milliard, Thomas, Jr. *FolkA 86*
Millichap, G T *DcVicP 2*
Millichip, Paul 1929- *ClaDrA*
Millidge, Eliza 1819-1856 *DcWomA*
Millie, Elena Gonzalez *WhoAmA 84*
Millier, Arthur 1893- *ArtsAmW 1, –2, WhAmArt 85*
Milliet, Louise *DcWomA*
Milligan, Carina Eaglesfield 1890- *AmArch 70*
Milligan, Elizabeth *DcWomA, NewYHSD*
Milligan, Frances Jane Grierson 1919- *ClaDrA, DcBrA 1*
Milligan, Gladys 1892- *ArtsAmW 3, DcWomA, WhAmArt 85*
Milligan, Joan Arnold 1925- *WhoAmA 82, –84*
Milligan, John *AmGrD[port]*
Millikan, Rhoda Houghton 1838-1903 *DcWomA, NewYHSD, WhAmArt 85*
Milliken, A E *AmArch 70*
Milliken, Alexander Fabbri 1947- *WhoAmA 78, –80, –82, –84*
Milliken, Barry 1945- *MarqDCG 84*
Milliken, Cooper 1918- *AmArch 70*
Milliken, George *NewYHSD*
Milliken, Gibbs 1935- *AmArt, WhoAmA 73, –76, –78, –80, –82, –84*
Milliken, Henry O 1884-1945 *BiDAmAr*
Milliken, Mary A Bybee *DcWomA*
Milliken, Richard Alfred 1767-1815 *DcBrWA*
Milliken, Robert *FolkA 86*
Milliken, Robert McIntosh 1907- *WhAmArt 85*
Milliken, Thomas *FolkA 86*
Milliken, William M 1889-1978 *WhoAmA 80N, –82N, –84N*
Millin, D J *AmArch 70*
Millings, Samuel *AfroAA*
Millington *FolkA 86*
Millington, A R *AmArch 70*
Millington, James Heath 1799-1872 *DcVicP, –2*
Millington, Mary A *DcWomA*
Millington, Terence *DcCAr 81*
Millington, Thomas Charles *NewYHSD*
Millis, Charlotte 1906- *WhAmArt 85*
Millis, David B 1942- *MarqDCG 84*
Millis, H R *AmArch 70*
Millkey, H C *AmArch 70*
Millman, Edward 1907-1964 *DcCAA 71, –77,*

Minker, Gustave, Sr. 1866- *WhAmArt 85*
Minkhoff, Gerald 1937- *DcCAr 81*
Minkimer, Frederick *FolkA 86*
Minkkinen, Arno Rafael 1945- *ConPhot, ICPEnP A, MacBEP*
Minkler, Arthur Fiske 1916- *AmArch 70*
Minkler, Arthur Robert 1937- *AmArch 70*
Minko 1735-1816 *AntBDN L*
Minks, Wilfried 1930- *ConDes*
Minn, Fanny M *DcVicP 2*
Minna, Anna Maria *DcWomA*
Minna, Wilhelmina Frances Allen 1898- *WhAmArt 85*
Minne, Georg 1866-1941 *OxTwCA, PhDcTCA 77*
Minne, Georges 1866-1941 *McGDA*
Minnegerode, Cuthbert Powell d1951 *WhoAmA 78N, –80N, –82N, –84N*
Minner, Rosetta Dotson *AfroAA*
Minnerly, Leander Hewitt 1936- *AmArch 70*
Minnhaar, Gretchen 1935- *AmArch 70*
Minnick, Esther Tress *WhoAmA 73, –76, –78, –80, –82, –84*
Minnier, Harry R 1928- *MarqDCG 84*
Minnigerode, Marietta *DcWomA*
Minnis, Ted W 1922- *AmArch 70*
Minns, B E *DcBrBI*
Minnucci, Gaetanno 1896- *MacEA*
Mino Da Fiesole 1430?-1484 *OxArt*
Mino DaFiesole 1429-1484 *McGDA*
Mino DelReame *McGDA*
Mino, Yukata 1941- *WhoAmA 78*
Mino, Yutaka 1941- *WhoAmA 80, –82, –84*
Minoggio-Roussel, Ysabel 1865- *DcWomA*
Minor, Anne 1864- *DcWomA*
Minor, Anne Rogers 1864- *WhAmArt 85*
Minor, Carter *AmArch 70*
Minor, Edna Valentine 1878- *WhAmArt 85*
Minor, Edward Carr 1904- *AmArch 70*
Minor, Kenneth Orrin 1938- *AmArch 70*
Minor, L E *DcWomA*
Minor, Robert 1884-1952 *WorECar*
Minor, Robert C 1840- *ArtsNiC*
Minor, Robert Crannell 1839-1904 *NewYHSD, WhAmArt 85*
Minor, Robert Crannell, Jr. *WhAmArt 85*
Minorello, Orsola *DcWomA*
Minos *WhoGrA 62*
Minot *NewYHSD*
Minot, Blanche *DcWomA*
Minot, Edward *DcVicP 2*
Minot, Edwin *DcVicP 2*
Minot, Martin *CabMA*
Minot, R E *AmArch 70*
Minott *NewYHSD*
Minott, Joseph Otis d1909 *WhAmArt 85*
Minotti, Aldo Arthur *AmArch 70*
Mins, C *DcVicP 2*
Minshall *FolkA 86*
Minshall, M W *DcVicP 2*
Minshul, Captain *DcBrECP*
Minshull, R T *DcVicP, –2*
Minsky, Richard 1947- *WhoAmA 84*
Minsky, Samuel *CabMA*
Minster, Norman Edgar 1922- *AmArch 70*
Minsuaki *AntBDN L*
Mintchine, Isaac 1900-1941 *OxTwCA*
Minter, A *IlDcG*
Minter, S R *AmArch 70*
Mintich, Mary Ringelberg *WhoAmA 73, –76, –78, –80, –82, –84*
Mintie, David Stuart 1948- *MarqDCG 84*
Mintle, Ronald Gale 1947- *MarqDCG 84*
Minton, Francis John 1917-1957 *DcBrA 1*
Minton, Herbert 1793-1858 *DcNiCA*
Minton, J F *DcWomA*
Minton, J G *AmArch 70*
Minton, John *NewYHSD*
Minton, John 1917-1957 *PhDcTCA 77*
Minton, Thomas *DcNiCA*
Minton, Thomas 1765-1836 *AntBDN M*
Minton, W D *FolkA 86*
Mintorn, Miss *DcWomA*
M'Intosh, John 1771-1822 *CabMA*
M'Intosh And Foulds *CabMA*
Mintrop, Theodor 1814-1870 *ArtsNiC*
Mintz, Baron 1926- *WhoAmA 80, –82, –84*
Mintz, Daniel Gordon 1948- *MarqDCG 84*
Mintz, Ezra 1932- *MarqDCG 84*
Mintz, Harry 1909- *PrintW 83, –85, WhoAmA 73, –76, –78, –80, –82, –84*
Mintz, Harry S 1907- *WhAmArt 85*
Mintz, M M *AmArch 70*
Mintz, S E *AmArch 70*
Mintz, Saul Aaron 1931- *AmArch 70*
Minujin, Marta *OxTwCA*
Minutillo, Richard G *WhoAmA 78, –80*
Minzenmayer, D *AmArch 70*
Mioen, Aimee Bellarmina 1810-1883 *DcWomA*
Mion, Pierre Riccardo 1931- *WhoAmA 78, –80, –82, –84*
Miorelli, John Thomas 1933- *AmArch 70*

Miotke, Anne E 1943- *WhoAmA 76, –78, –80, –82, –84*
Miotti, Alvise 1553-1599 *IlDcG*
Miotti, Antonio *IlDcG*
Miotti, Bastian 1543-1594 *IlDcG*
Miotti, Daniele 1618-1673 *IlDcG*
Miotti, Peregrin *IlDcG*
Miotti Family *IlDcG*
Miotto, Albert Hugo 1936- *AmArch 70*
Miotto, Antonio *IlDcG*
Miotto-Muret, Luciana *ConArch A*
Mique, Richard 1728-1794 *MacEA*
Mir, Carmen *WorFshn*
Mir Y Trinxet, Joaquin 1873-1941 *McGDA*
Mirabal, Miguel Enrique 1946- *WhoAmA 76, –78, –80*
Mirabel, Eva *WhAmArt 85*
Mirabel, Vicente 1918-1945 *IIBEAA W*
Mirabel, Vincent 1918-1945 *WhAmArt 85*
Miracle, Hazel 1915- *FolkA 86*
Miralda, Antoni 1942- *ConArt 77, –83, WhoAmA 78, –80, –82*
Miralles, Adolfo Enrique 1932- *AmArch 70*
Miram, Lucie *DcWomA*
Miramon, M DeLaBouillerie, Comtesse De *DcWomA*
Miranda, Fernando 1842- *WhAmArt 85*
Miranda, Jaume C 1950- *MarqDCG 84*
Mirandola, Lucrezia Quistelli Della *DcWomA*
Mirano, Virgil Marcus 1937- *WhoAmA 76, –78, –80, –82, –84*
Mirbel, Lisinka Aimee Zoe De 1796-1849 *McGDA*
Mirbel, Lizinska Aimee Zoe 1796-1849 *DcWomA*
Mirenda, W M *AmArch 70*
Miret, Adelina *DcWomA*
Miretto, Niccolo 1375-1450 *McGDA*
Mirick, Benjamin *CabMA*
Mirick, Edward 1704-1765 *CabMA*
Mirick, Henry Dustin 1905- *AmArch 70*
Mirkil, Elise Maclay *WhAmArt 85*
Mirko 1910- *McGDA, OxTwCA, PhDcTCA 77*
Mirko 1910-1969 *WorArt*
Mirko 1934- *WhoAmA 76, –78, –80, –82, –84*
Mirkovszky, Gizella 1862- *DcWomA*
Mirlada, Antoni 1942- *WhoAmA 84*
Mirman, Jane Madeleine *DcWomA*
Miro, Joan *WhoArt 84N*
Miro, Joan 1893- *ClaDrA, ConArt 77, –83, DcCAr 81, McGDA, OxArt, OxTwCA, PhDcTCA 77, PrintW 83, WhoArt 80, –82, WhoGrA 62*
Miro, Joan 1893-1983 *PrintW 85, WorArt[port]*
Miro-Montilla, Antonio 1937- *AmArch 70*
Mirou, Antoine 1570-1653 *McGDA*
Mirou, Antoine 1588?-1661? *ClaDrA*
Miroude, Marie Julie *DcWomA*
Mirsoni, Ottavio 1921- *WorFshn*
Mirus, Lina 1838-1878 *DcWomA*
Mirvault, Cesarine Henriette *DcWomA*
Mirvish, David 1944- *WhoAmA 73, –76, –78, –80, –82*
Mirza, J W *AmArch 70*
Misani, Marco 1949- *MacBEP*
Misch, Allene K 1928- *WhoAmA 78, –80, –82, –84*
Misch, Otto *FolkA 86*
Mischke, Charles R 1927- *MarqDCG 84*
Mise, R C 1885- *WhAmArt 85*
Misel, Harry Earle, Jr. 1935- *AmArch 70*
Miserachs, Xavier 1937- *ICPEnP A*
Miserendino, Vincenzo 1876-1943 *WhAmArt 85*
Miseroole, Emilie Louise Marie *DcWomA*
Mish, Charlotte 1903- *WhAmArt 85*
Mishler, Clark 1948- *MacBEP*
Miskiel, Richard Andrew 1937- *AmArch 70*
Miskimen, Earl Douglas 1933- *AmArch 70*
Miskin, Lionel 1924- *DcBrA 2*
Misler Brothers *FolkA 86*
Misner, Donald Hogan 1934- *AmArch 70*
Misner, James I 1948- *MarqDCG 84*
Misner, Jean L *AmArch 70*
Misner, Marion *ArtsEM, DcWomA*
Misonne, Leonard 1870-1943 *ICPEnP A, MacBEP*
Misrach, Richard 1949- *ConPhot, DcCAr 81, ICPEnP A, PrintW 83, –85*
Misrach, Richard Laurence 1949- *MacBEP, WhoAmA 80, –82, –84*
Miss, Mary 1944- *ConArt 77, DcCAr 81, WhoAmA 73, –76, –78, –80, –82, –84*
Missaglia, Antonio d1496 *OxDecA*
Missaglia, Negroni DaEllo Detto *OxDecA*
Missaglia, Pietro d1429? *OxDecA*
Missaglia, Tomaso d1452 *OxDecA*
Missal, Joshua M 1915- *WhoAmA 80, –82, –84*
Missal, Mrs. Joshua M 1923- *WhoAmA 80*
Missal, Pegge 1923- *WhoAmA 82, –84*
Missal, Stephen J 1948- *WhoAmA 82, –84*
Misserole, Emilie Louise Marie *DcWomA*
Missoni, Ottavio 1921- *ConDes*
Missoni, Rosita *WorFshn*
Missoni, Rosita 1931- *ConDes*
Mist, James Underhill *AntBDN M*
Mistele, A W, Jr. *AmArch 70*

Misthopoluos, E *AmArch 70*
Mistry, F R *AmArch 70*
Mitan, A *DcVicP 2*
Mitan, Samuel 1786-1843 *DcVicP 2*
Mitarachi, Paul Jean 1921- *AmArch 70*
Mitch, H T *AmArch 70*
Mitcham, Georgia Whitman 1910- *WhoAmA 76, –78, –80*
Mitcham, Raymond 1932- *AmArch 70*
Mitchel, George Brian 1940- *AmArch 70*
Mitchel, Sophie *DcWomA*
Mitchell, Miss *DcWomA*
Mitchell, Aggie *ArtsEM, DcWomA*
Mitchell, Agnes *DcWomA, NewYHSD*
Mitchell, Alfred *DcVicP 2, IIBEAA W*
Mitchell, Alfred R 1888- *ArtsAmW 1*
Mitchell, Alfred R 1888?-1972 *IIBEAA W, WhAmArt 85, WhoAmA 80N, –82N, –84N*
Mitchell, Almira *FolkA 86*
Mitchell, Arnold Bidlake *DcVicP 2*
Mitchell, Arthur 1864- *WhAmArt 85*
Mitchell, Arthur 1889- *IIBEAA W, WhAmArt 85*
Mitchell, Arthur Croft 1872- *DcBrA 1, DcVicP 2*
Mitchell, Arthur R 1889- *ArtsAmW 1*
Mitchell, Arthur Roy 1889- *ArtsAmW 2*
Mitchell, Benjamin T 1816-1880 *NewYHSD*
Mitchell, Beresford Strickland 1921- *WhoAmA 78, –80*
Mitchell, Bruce Handiside d1963 *WhoAmA 78N, –80N, –82N, –84N*
Mitchell, Bruce Handiside 1908-1963 *WhAmArt 85*
Mitchell, Bruce Kirk 1933- *WhoAmA 73, –76*
Mitchell, C L d1918 *DcBrA 2*
Mitchell, Catherine *FolkA 86*
Mitchell, Charles 1912- *WhoArt 80*
Mitchell, Charles D 1885- *WhAmArt 85*
Mitchell, Charles Davis 1887-1940 *IlrAm B, –1880*
Mitchell, Charles E *AfroAA*
Mitchell, Charles J *ArtsEM*
Mitchell, Charles William *DcVicP, –2*
Mitchell, Chuck *OfPGCP 86*
Mitchell, Clifford 1925- *AfroAA, WhoAmA 73, –76, –78, –80, –82, –84*
Mitchell, Corrine *AfroAA*
Mitchell, Dana Covington, Jr. 1918- *WhoAmA 73, –76, –78, –80, –82, –84*
Mitchell, David R 1960- *MarqDCG 84*
Mitchell, Denis 1912- *DcBrA 2*
Mitchell, Donald 1922- *WhoAmA 76, –78, –80, –82, –84*
Mitchell, Dow Penrose 1915- *WhoAmA 76, –78, –80*
Mitchell, E *DcVicP 2, NewYHSD*
Mitchell, Ehrman B 1924- *ConArch, MacEA*
Mitchell, Ehrman Burkman, Jr. 1924- *AmArch 70*
Mitchell, Eleanor *DcWomA*
Mitchell, Eleanor 1907- *WhoAmA 73, –76, –78, –80, –82, –84*
Mitchell, Eleanor B 1872- *ArtsAmW 2, DcWomA, WhAmArt 85*
Mitchell, Elizabeth Harcourt 1833- *DcBrWA, DcWomA*
Mitchell, Elizabeth Roseberry *FolkA 86*
Mitchell, Elmira *WhAmArt 85*
Mitchell, Emily *DcVicP 2*
Mitchell, Enid *WhoArt 82*
Mitchell, Enid G D *WhoArt 80, –84*
Mitchell, Ernest Gabriel 1859- *DcBrA 1, DcVicP 2*
Mitchell, Eva B 1872- *WhAmArt 85*
Mitchell, Eveline Marie *DcWomA*
Mitchell, Evelyn *AfroAA*
Mitchell, Evelyn G *DcWomA*
Mitchell, Frances *WhAmArt 85*
Mitchell, Francis N *NewYHSD*
Mitchell, Frank *NewYHSD*
Mitchell, Fred 1923- *DcCAA 71, –77, WhoAmA 73, –76, –78, –80, –82, –84*
Mitchell, Frederick James 1902- *DcBrA 1*
Mitchell, Frelon William, Jr. 1926- *AmArch 70*
Mitchell, G B 1872-1966 *WhAmArt 85*
Mitchell, George 1820?- *NewYHSD*
Mitchell, George Bertrand 1872?-1966 *IIBEAA W*
Mitchell, George Harold 1880- *WhAmArt 85*
Mitchell, Giles C *AmArch 70*
Mitchell, Gladys Vinson 1894- *ArtsAmW 2, DcWomA, WhAmArt 85*
Mitchell, Glen 1894-1972 *WhAmArt 85, WhoAmA 78N, –80N, –82N, –84N*
Mitchell, Gordon G 1943- *MarqDCG 84*
Mitchell, Gordon Kinlay 1952- *WhoArt 82, –84*
Mitchell, Guernsey d1921 *WhAmArt 85*
Mitchell, H R *FolkA 86*
Mitchell, Harold D 1854- *BiDAmAr*
Mitchell, Harold Dee 1924- *AmArch 70*
Mitchell, Harriet Morgan *WhAmArt 85*
Mitchell, Harry C *WhAmArt 85*
Mitchell, Harvey 1801?-1864? *NewYHSD*
Mitchell, Hendrick E *AfroAA*
Mitchell, Henry *NewYHSD*
Mitchell, Henry 1915- *WhoAmA 73, –76, –78, –80*
Mitchell, Henry 1915-1980 *WhoAmA 82N, –84N*

Mitchell, Henry Raymond, Jr. 1918- AmArch 70
Mitchell, Hutton DcBrBI
Mitchell, I W DcWomA
Mitchell, Ida DcWomA
Mitchell, J NewYHSD
Mitchell, J Edgar 1871-1922 DcBrA 1, DcBrWA, DcVicP 2
Mitchell, J F AmArch 70
Mitchell, J L AmArch 70
Mitchell, J S AntBDN O
Mitchell, J T AmArch 70
Mitchell, James FolkA 86
Mitchell, James Anastasiou 1907- AmArch 70
Mitchell, James B DcVicP 2
Mitchell, Mrs. James B DcVicP 2, DcWomA
Mitchell, James E 1926- WhoAmA 73, -76, -78, -80, -82, -84
Mitchell, James Gordon Bennett 1909- AmArch 70
Mitchell, James Leo 1935- AmArch 70
Mitchell, James Marcus, Sr. 1921- AfroAA
Mitchell, James Murray 1892- WhAmArt 85
Mitchell, James Thompson 1929- AmArch 70
Mitchell, Jay Winston 1937- AmArch 70
Mitchell, Jeffrey Malcolm 1940- WhoAmA 78, -80
Mitchell, Joan 1926- AmArt, BnEnAmA, ConArt 77, -83, DcAmArt, DcCAA 71, -77, DcCAr 81, OxTwCA, PhDcTCA 77, PrintW 85, WhoAmA 73, -76, -78, -80, -82, -84, WomArt, WorArt[port]
Mitchell, Joan Elizabeth WhoAmA 78, -80, -82, -84
Mitchell, John 1811-1866 NewYHSD
Mitchell, John 1838-1926 DcBrWA
Mitchell, John 1937- WhoArt 80, -82, -84
Mitchell, John Ames 1845-1918 WhAmArt 85, WorECar
Mitchell, John Blair 1921- WhoAmA 73, -76, -78, -80, -82, -84
Mitchell, John Campbell 1862-1922 ClaDrA
Mitchell, John Campbell 1865-1922 DcBrA 1, DcVicP 2
Mitchell, John F 1816- BiDAmAr
Mitchell, John Magill, Jr. 1922- AmArch 70
Mitchell, Judith 1793-1837 NewYHSD
Mitchell, Julio 1942- ICPEnP A
Mitchell, Katherine 1944- WhoAmA 84
Mitchell, Kenneth M 1926- AmArch 70
Mitchell, Larry Dell 1938- MarqDCG 84
Mitchell, Laura M D WhAmArt 85
Mitchell, Laura M D 1883- ArtsAmW 1
Mitchell, Laura M D 1883-1965 DcWomA
Mitchell, Leonard Victor ClaDrA, WhoArt 80, -82
Mitchell, M D DcVicP 2, DcWomA
Mitchell, M L DcVicP 2
Mitchell, M V FolkA 86
Mitchell, Mabel Kriebel 1897- ArtsAmW 3
Mitchell, Madison FolkA 86
Mitchell, Maggie d1953 DcBrA 1, DcWomA
Mitchell, Margaret DcWomA
Mitchell, Margaretta K 1935- ICPEnP A, MacBEP, WhoAmA 82, -84
Mitchell, Margaretta K 1936- PrintW 83, -85
Mitchell, Marian 1840-1885 DcWomA, NewYHSD
Mitchell, Marianne DcWomA
Mitchell, Marjorie Chambers 1884- DcWomA
Mitchell, Mark Brendan 1934- AmArch 70
Mitchell, Mary AntBDN M, DcBrA 2
Mitchell, Mary 1907- WhAmArt 85
Mitchell, Mary E DcWomA
Mitchell, Michael d1750 DcBrECP
Mitchell, Michael 1943- ConPhot, ICPEnP A
Mitchell, Michael John 1943- WhoAmA 84
Mitchell, Mina NewYHSD
Mitchell, Minnie B Hall 1863- ArtsAmW 1, DcWomA
Mitchell, Neil Reid 1858-1934 WhAmArt 85
Mitchell, O Jack 1931- AmArch 70
Mitchell, Odessa WhAmArt 85
Mitchell, Percy DcVicP 2
Mitchell, Peter McDowall 1879- DcBrA 1
Mitchell, Peter Todd 1929- WhoAmA 73, -76, -78, -80, -82, -84
Mitchell, Philip 1814-1896 DcBrWA, DcVicP 2
Mitchell, Phoebe DcWomA, FolkA 86, NewYHSD
Mitchell, R 1942- WhoAmA 82, -84
Mitchell, Ralph Milton 1906- AmArch 70
Mitchell, Richard Allan 1918- AmArch 70
Mitchell, Richard Dillard 1933- AmArch 70
Mitchell, Richard Theodore 1927- AmArch 70
Mitchell, Robert BiDBrA, FolkA 86, MacEA
Mitchell, Robert Ellis 1942- WhoAmA 76, -78, -80
Mitchell, Robert James WhoArt 84N
Mitchell, Robert James 1930- WhoArt 80, -82
Mitchell, Robert S 1821-1883 BiDAmAr
Mitchell, Ronald Andrew 1931- AmArch 70
Mitchell, Ronald Edward, Jr. 1940- AmArch 70
Mitchell, S M WhoArt 80, -82, -84
Mitchell, Sara Edwards Hardy 1920- AfroAA
Mitchell, Sara Patterson DcWomA
Mitchell, Sara Patterson Snowden WhAmArt 85
Mitchell, Sophie WhAmArt 85
Mitchell, Stanley Lee 1931- AmArch 70

Mitchell, Thomas DcBrWA, FolkA 86
Mitchell, Thomas 1735-1790 DcBrECP, DcSeaP
Mitchell, Thomas John 1875- IlBEAAW, WhAmArt 85
Mitchell, Thomas W WhoAmA 78N, -80N, -82N, -84N
Mitchell, Tom DcVicP 2
Mitchell, Vernell FolkA 86
Mitchell, Vyvyan 1879- DcBrA 1
Mitchell, W A AmArch 70
Mitchell, Wallace 1911- DcCAA 71, -77, WhAmArt 85, WhoAmA 73, -76, -78
Mitchell, Wallace 1911-1977 WhoAmA 80N, -82N, -84N
Mitchell, Walter Homer 1927- AmArch 70
Mitchell, William AntBDN N, FolkA 86, MarqDCG 84
Mitchell, William Alton d1803 FolkA 86
Mitchell, William Frederick 1845?-1914 DcBrWA, DcSeaP, DcVicP 2
Mitchell, William George 1925- WhoArt 80, -82
Mitchell, William J NewYHSD
Mitchell, William Mansfield d1910 DcBrA 2
Mitchell & Rammelsberg DcNiCA
Mitchell And Pool EncASM
Mitchell/Giurgola MacEA
Mitchill, Neil R WhAmArt 85
Mitelberg, Louis 1919- WhoGrA 62, -82[port], WorECar
Mitelli, Giuseppe Maria 1634-1718 ClaDrA
Mitford, Bertram Osbaldeston 1777-1842 DcBrWA
Mitford-Barberton, Ivan WhoArt 80N
Mitford-Barberton, Ivan 1896- DcBrA 1
Mithun, Omer L 1918- AmArch 70
Mitius, Louis 1842-1911 WhAmArt 85
Mitra, Gopal C 1928- WhoAmA 78, -80, -82, -84
Mitscha, Max E 1923- AmArch 70
Mitscherlich, Frieda 1880- DcWomA
Mitschke, A H AmArch 70
Mitschke, Thomas N 1928- AmArch 70
Mitsuhashi, Chikako 1941- WorECar
Mitsuhashi, Yoko IlsBYP
Mitsuhiro, Ohara OxDecA
Mitsuhiro, Ohara 1810-1875 AntBDN L
Mitsuhisa DcWomA
Mitsui, Eiichi IlsBYP, IlsCB 1957
Mitsunaga McGDA
Mitsunobu d1521 McGDA
Mitsuoki 1617-1691 McGDA
Mitsuuchi DcCAr 81
Mittelbusher, E H AmArch 70
Mittell, Sybilla DcWomA, WhAmArt 85
Mittelman, Phillip S MarqDCG 84
Mittendorf, Sarah WhoAmA 82
Mittendorf, Sarah Yorke WhoAmA 80
Mitterhausen, W H AmArch 70
Mittleman, Ann 1898- DcWomA, WhoAmA 73, -76, -78
Mittleman, S W AmArch 70
Mittlestadt, Jennie 1877-1948 DcWomA
Mitton, A E DcWomA
Mitts, Harold Arthur 1902- WhAmArt 85
Mitzka, Ernst DcCAr 81
Mitzou FairDF SPA, WorFshn
Mitzscherling, Gustave 1823?- NewYHSD
Miura, T AmArch 70
Miwa AntBDN L
Mix, Edward T 1831-1890 BiDAmAr, MacEA
Mix, Elena 1889-1939 DcWomA, WhAmArt 85
Mix, Florence 1881-1922 DcWomA, WhAmArt 85
Mix, Garry I d1892 EncASM
Mix, James EncASM
Mix, James, Jr. EncASM
Mix, Lucius C NewYHSD
Mix, Walter Joseph 1928- WhoAmA 78, -80, -82, -84
Mix Y Escalante, Elena DcWomA
Mixter, Felicie DcWomA, WhAmArt 85
Miyachi, Harry Toshiyuki 1934- AmArch 70
Miyake, Issey 1939- ConDes
Miyamoto, Clarence Takashi 1932- AmArch 70
Miyamoto, Kaname 1891- WhAmArt 85
Miyamoto, Wayne A 1947- PrintW 83, -85
Miyamoto, Wayne Akira 1947- WhoAmA 78, -80, -82, -84
Miyao, Shigeo 1902- WorECar
Miyasaki, George 1935- PrintW 83, -85
Miyasaki, George Joji 1935- WhoAmA 73, -76, -78, -80, -82, -84
Miyashita, Tad 1922- WhoAmA 73, -76, -78, -80, -82
Miyashita, Tad 1922-1979 WhoAmA 84N
Miyatake, Toyo 1895-1979 ICPEnP A, MacBEP
Miyazaki, Schiro 1910- WhAmArt 85
Mize, Mahulda FolkA 86
Mizen, Frederic Kimball 1888-1964? IlBEAAW
Mizen, Frederic Kimball 1888-1964 WhAmArt 85
Mizen, Frederic Kimball 1888-1965 ArtsAmW 1, IlrAm D, -1880
Mizner, Addison 1872-1933 BiDAmAr, MacEA
Mizrakjian, Artin 1891- WhAmArt 85
Mizuki, Shigeru 1924- WorECom
Mizumura, Kazue IlsBYP, IlsCB 1957, -1967

Mizuno, S WhAmArt 85
Mizushima, Shinji 1939- WorECom
M'Kay, William D ArtsNiC
M'Kenzie, J NewYHSD
Mlakar, Simon 1954- DcCAr 81
Mlodozeniec, Jan 1929- WhoGrA 82[port]
Mlodozeniec, Jan Lukasz 1929- ConDes, WhoGrA 62
Mnesicles McGDA, OxArt
Mnesikles MacEA
Mniszech, Helene DcWomA
Mniszech, Jozefa Amelia DcWomA
Mniszech, Countess Maria Josefa DcWomA
Mniszek, Countess Maria Josefa DcWomA
Mo, Shih-Lung McGDA
Mo-Ni-Tien McGDA
Moale, John 1731-1798 NewYHSD
Moazed, David C 1954- MarqDCG 84
Moberg, Claus R 1908- AmArch 70
Moberly, Alfred DcBrA 1, DcVicP 2
Moberly, Mrs. H G DcVicP 2
Moberly, Mariquita Jenny 1855- ClaDrA, DcBrA 1, DcWomA
Mobley, Curtis Dale 1947- MarqDCG 84
Mobley, George 1935- ICPEnP A
Mobley, Robert Eugene 1922- AmArch 70
Mobley, Robert Wilson 1938- AmArch 70
Mobley, Sam L AmArch 70
Mocatta, D DcVicP 2
Mocatta, David 1806-1882 WhoArch
Mocatta, L DcVicP 2
Mocatta, Maria DcVicP 2
Mocatta, Rebecca DcVicP 2
Mocetto, Girolamo 1458?-1531? ClaDrA, McGDA
Moch, G A 1891- WhAmArt 85
Mocharniuk, Nicholas 1917- WhAmArt 85
Mochi, Francesco 1580-1654 McGDA
Mochi, Ugo 1889- WhoAmA 73, -76
Mochi, Ugo 1890-1977 WhAmArt 85
Mochi, Ugo 1894-1977 WhoAmA 78N, -80N, -82N, -84N
Mochizuki, Betty Ayako WhoAmA 73, -76, -78, -80
Mochizuki, Hiroshi 1952- MarqDCG 84
Mochon, Clinton 1924- AmArch 70
Mochon, Donald 1916- WhoAmA 73, -76, -78N, -80N, -82N, -84N
Mocine, Emily Rutherford DcWomA
Mocine, Emily Rutherford 1884- WhAmArt 85
Mocine, Ralph F WhAmArt 85
Mocine, Ralph Fullerton ArtsAmW 2
Mock, G AmArch 70
Mock, George Andrew WhoAmA 80N, -82N, -84N
Mock, George Andrew 1886-1958? WhAmArt 85
Mock, George E 1937- MarqDCG 84
Mock, Gladys WhAmArt 85, WhoAmA 73, -76
Mock, Gladys 1891?- DcWomA
Mock, James Benjamin 1942- MarqDCG 84
Mock, John Reginald 1934- AmArch 70
Mock, K D AmArch 70
Mock, R J AmArch 70
Mock, Richard Basil PrintW 85
Mock, Richard Basil 1944- WhoAmA 76, -78, -84
Mockers, Michel M 1922- WhoAmA 78, -80
Mockford, Stuart Benedict 1914- AmArch 70
Mockhaney, Lillian Ruth DcWomA
Mockler, Geraldine DcWomA
Mockridge, Gertrude Ellen DcBrA 1
Mocniak, George IlsBYP
Mocquart, Jeanne Marie Louise DcWomA
Mocquet, Amelie Jeanne DcWomA
Mocsanyi, Paul WhoAmA 73, -76
Modanino McGDA
Mode, Amy 1823?- FolkA 86
Mode, Carol A 1943- WhoAmA 84
Modeen, Mary K 1953- PrintW 85
Model, Elisabeth D AmArt, WhoAmA 76, -78, -80, -82, -84
Model, Hans 1908- DcCAr 81
Model, Lisette d1983 MacBEP
Model, Lisette 1906- ConPhot
Model, Lisette 1906-1983 ICPEnP
Modell, Elisabeth 1820-1865 DcWomA
Modell, Frank B 1917- WorECar
Modena, Barnaba Da McGDA
Modena, Tommaso Da McGDA
Modenese, Beppe 1928- WorFshn
Modersohn, Otto OxTwCA
Modersohn, Otto 1865-1943 McGDA
Modersohn-Becker, Paula 1876-1907 DcWomA, McGDA, OxTwCA, WomArt
Modigliani, Amedeo 1884-1920 ClaDrA, McGDA, OxArt, OxTwCA, PhDcTCA 77
Modigliani, Corinna Stella DcWomA
Modin, W J AmArch 70
Modjeska, Felicie M 1869- WhAmArt 85
Modjeska, Marylka 1893- WhAmArt 85
Modjeska, Marylka H 1893- ArtsAmW 2, DcWomA
Modl, Natalie 1850- DcWomA
Modney, Nancy Jean 1954- MarqDCG 84
Modotti, Tina 1896-1942 ConPhot, ICPEnP, MacBEP

Modra, T B 1873-1930 *WhAmArt 85*
Modra, Theodore B 1873-1930 *ArtsAmW 2*
Modrakowska, Eleanor 1879- *WhAmArt 85*
Modrakowska, Eleanor 1879-1955? *DcWomA*
Modrall, Augustus William, Jr. 1930- *AmArch 70*
Moe, George Eugene *WhAmArt 85*
Moe, Henry Allen 1894- *WhoAmA 73, -76*
Moe, Henry Allen 1894-1975 *WhoAmA 78N, -80N, -82N, -84N*
Moe, Louis Maria Niels Peder Halling 1859- *ConICB, IlsCB 1744*
Moe, R S, Jr. *AmArch 70*
Moe, Richard D 1928- *WhoAmA 78, -80, -82, -84*
Moe, Stanley Allen 1914- *AmArch 70*
Moe, W C *AmArch 70*
Moeckel, Henry Theodore, Jr. 1918- *AmArch 70*
Moeckel, William George 1913- *AmArch 70*
Moed, Leon 1931- *AmArch 70*
Moehl, Karl J 1925- *WhoAmA 82, -84*
Moejaert, Nicolaes Cornelisz 1592?-1655 *McGDA*
Moelk, Jacob J 1942- *MarqDCG 84*
Moeller, Charles *NewYHSD*
Moeller, D H *AmArch 70*
Moeller, Elizabeth Anne 1906- *WhAmArt 85*
Moeller, Gustave 1881-1931 *WhAmArt 85*
Moeller, Harry J *OfPGCP 86*
Moeller, Henry Nicholas 1883- *WhAmArt 85*
Moeller, Henry W *WhAmArt 85*
Moeller, Leo 1867- *WhAmArt 85*
Moeller, Louis 1855-1930 *DcAmArt, WhAmArt 85*
Moeller, Robert Charles, III 1938- *WhoAmA 73, -76, -78, -80, -82, -84*
Moeller, Selma 1880- *WhAmArt 85*
Moeller, Selma M D 1880- *DcWomA*
Moeller, Timothy George 1951- *MarqDCG 84*
Moellering, Harold 1942- *MarqDCG 84*
Moellman, Charles Frederick 1844-1902 *ArtsAmW 3*
Moen, Ella C 1901- *WhAmArt 85*
Moerenhout, Jacques Antoine 1796?-1879 *ArtsAmW 1*
Moers, Anna De *DcWomA*
Moers, Denny R *MacBEP*
Moerschel, Chiara *WhoAmA 76, -78, -80, -82, -84*
Moes, Wally 1856-1918 *DcWomA*
Moeschlin, Elsa *DcWomA*
Moeschlin, Elsa 1879- *ConICB*
Moeschlin-Hammar, Elsa 1879- *IlsCB 1744*
Moesman, Johannes Hendrikus 1909- *ConArt 77*
Moessell, Julius 1872- *WhAmArt 85*
Moessner, Roger Karl 1934- *AmArch 70*
Moffat, Alexander 1943- *DcCAr 81*
Moffat, Arthur Elwell *DcVicP 2*
Moffat, Curtis 1887-1949 *ICPEnP A, WhAmArt 85*
Moffat, Curtis E 1887-1949 *MacBEP*
Moffat, James 1775-1815 *DcBrWA*
Moffat, John *BiDBrA*
Moffat, John 1819-1894 *MacBEP*
Moffat, K M *DcWomA*
Moffat, Steven Pearsall *MarqDCG 84*
Moffat, William Lambie 1808-1882 *BiDBrA*
Moffatt, A *WhAmArt 85*
Moffatt, Adah Terrell 1880- *DcWomA*
Moffatt, Addie *DcWomA*
Moffatt, Anthea *DcCAr 81*
Moffatt, G E *AmArch 70*
Moffatt, William B 1812-1887 *MacEA*
Moffet, Thomas *NewYHSD*
Moffett, Alfred Wallace 1923- *AmArch 70*
Moffett, Anita *WhAmArt 85*
Moffett, Dorothy *DcWomA*
Moffett, Dorothy Gregory *WhAmArt 85*
Moffett, Frank Cardwell 1931- *AmArch 70*
Moffett, Mary Elvish Mantz 1863?-1940 *DcWomA, WhAmArt 85*
Moffett, Ross E *WhoAmA 78N, -80N, -82N, -84N*
Moffett, Ross E 1888- *WhAmArt 85*
Moffit, Jere Adel 1932- *AmArch 70*
Moffitt, Clare 1885- *AmArch 70*
Moffitt, G M *AmArch 70*
Moffitt, G Trevor 1936- *DcCAr 81*
Moffitt, J B *AmArch 70*
Moffitt, John Francis 1940- *WhoAmA 76, -78, -80, -82, -84*
Moffitt, John M 1837-1887 *NewYHSD*
Moffitt, Michael David 1939- *MarqDCG 84*
Moffly, Samuel *FolkA 86*
Mofsie, Louis *IlsBYP*
Mogalli, Teresa *DcWomA*
Mogavero, Michael James *WhoAmA 84*
Mogelin, Else 1889- *DcWomA*
Mogensen, Arnold C 1918- *AmArch 70*
Mogensen, Borge Vestergard 1914-1972 *ConDes*
Mogensen, I *AmArch 70*
Mogensen, Jorgen 1922- *WorECar*
Mogensen, Mogens 1920- *AmArch 70*
Mogensen, Paul 1941- *PrintW 83, -85, WhoAmA 78, -80, -82, -84*
Moger, H H, Jr. *AmArch 70*
Moger, Richard Robert 1932- *AmArch 70*
Mogford, Henry *DcBrWA, DcVicP 2*
Mogford, John 1821-1885 *DcBrWA, DcVicP, -2*
Mogford, Thomas 1800-1868 *DcVicP, -2*

Mogford, Thomas 1809-1868 *DcBrWA*
Moggridge, Helen *WhoArt 80, -82, -84*
Mogin, Ksenija 1955- *DcCAr 81*
Moglia, Luigi *WhoAmA 76, -78, -80, -82, -84*
Moglia, Luigi 1899- *WhoAmA 73*
Moglia, Ugo William 1906- *WhoArt 84*
Mognat, Rose *DcWomA*
Mogridge, C J, Jr. *AmArch 70*
Mogul, Susan Roberta 1949- *MacBEP*
Mohamed, Ethel Wright 1906- *FolkA 86*
Mohassess, Ardeshir 1938- *WhoGrA 82[port], WorECar*
Mohedano, Antonio 1560-1625 *ClaDrA*
Mohitz, Philippe 1941- *PrintW*
Mohler, Anny *DcWomA, FolkA 86*
Mohler, David Charles 1946- *MarqDCG 84*
Mohling, Fred H 1894- *ArtsAmW 2*
Mohlte, John Alfred 1865- *WhAmArt 85*
Mohn, Cheri 1936- *WhoAmA 73, -76, -78, -80, -82, -84*
Mohn, Gottlob Samuel 1789-1825 *DcNiCA, IlDcG*
Mohn, N Edward *WhAmArt 85*
Mohn, Samuel 1762-1815 *DcNiCA, IlDcG*
Mohn, Sigvard M 1891- *WhAmArt 85*
Mohner-Langhamer, Wilma *OfPGCP 86*
Moholy, Lucia *ConPhot, MacBEP*
Moholy, Lucia 1900?- *ICPEnP A*
Moholy-Nagy, Laszlo 1895-1946 *ConArt 77, -83, ConDes, ConPhot, ICPEnP, MacBEP, MacEA, McGDA, OxArt, OxDecA, OxTwCA, PhDcTCA 77, WhAmArt 85*
Moholy-Nagy, Lazlo 1895-1946 *DcCAA 71, -77*
Mohor, Charlotte 1868- *DcWomA, WhAmArt 85*
Mohr, Jean 1925- *ICPEnP A*
Mohr, Joronn *DcWomA*
Mohr, Manfred 1938- *DcCAr 81*
Mohr, Nicholasa *AfroAA*
Mohr, Olga 1905- *WhAmArt 85*
Mohr, Pauline Catherine 1948- *WhoAmA 78, -80, -82, -84*
Mohr-Piepenhagen, Charlotte Von 1828-1902 *DcWomA*
Mohring, Bruno 1863-1929 *MacEA*
Mohrmann, John Henry 1857-1916 *DcSeaP, WhAmArt 85*
Mohrt, Francoise *WorFshn*
Moigniez, Jules 1835-1894 *AntBDN C, DcNiCA*
Moilan, Otto E *WhAmArt 85*
Moilliet, Louis 1880-1962 *OxTwCA, PhDcTCA 77*
Moillon, Louise 1609?-1696 *McGDA*
Moillon, Louise 1610-1696 *DcWomA, WomArt*
Moinot, Maria Eugenie *DcWomA*
Moir, Alfred 1924- *WhoAmA 73, -76, -78, -80, -82, -84*
Moir, Ellen *DcVicP 2*
Moir, Lily Maitland *DcWomA*
Moir, Lydia 1847-1941 *DcWomA*
Moir, Robert B 1917- *WhAmArt 85*
Moira, Gerald Edward 1867-1959 *ClaDrA, DcBrA 1, DcBrBI, DcBrWA, DcVicP 2*
Moirand, Emilie *DcWomA*
Moire, Thomas *NewYHSD*
Moisand, Maurice *DcVicP 2*
Moise, Alice Leigh 1905- *WhAmArt 85*
Moise, B C, Jr. *AmArch 70*
Moise, Charles W *NewYHSD*
Moise, Theodore Sydney 1806-1883 *NewYHSD*
Moise, William Sidney 1922- *WhoAmA 76, -78, -80, -82, -84*
Moiseiwitsch, Tanya 1914- *ConDes*
Moises, W G *AmArch 70*
Moisset, Marthe *DcWomA*
Moisson-Desroches, Elise *DcWomA*
Moist, T R *AmArch 70*
Moitte, Elisabeth Melanie *DcWomA*
Moitte, Jean-Guillaume 1746-1810 *McGDA*
Moitte, Rose Angelique *DcWomA*
Moiturier, Antoine *OxArt*
Moiturier, Antoine Le *McGDA*
Mojesky, Raymond 1929- *AmArch 70*
Mok, E *AmArch 70*
Mokreys, John *WhAmArt 85*
Mokry-Meszaros, Deszo 1881-1970 *OxTwCA*
Mokuan, Reien d1345? *McGDA*
Mokubei 1767-1833 *McGDA*
Mol, Leo 1915- *WhoAmA 73, -76, -78*
Mol, Pieter Van 1599-1650 *ClaDrA, McGDA*
Mola, Gasparo 1580-1640 *McGDA*
Mola, Pier Francesco 1612-1666 *McGDA, OxArt*
Molander, Joel Lance 1936- *AmArch 70*
Molander, John B 1928- *AmArch 70*
Molanus, Matheus d1645 *McGDA*
Molard, Ida *DcWomA*
Molari, Gabriele Pier 1943- *MarqDCG 84*
Molarsky, Abram 1883- *WhAmArt 85*
Molarsky, Maurice d1950 *WhoAmA 78N, -80N, -82N, -84N*
Molarsky, Maurice 1885-1950 *WhAmArt 85*
Molarsky, Sarah Shreve 1879- *DcWomA, WhAmArt 85*
Molaskey, John Dewey 1864?-1938 *ArtsEM*

Mold, C Allen 1905- *DcBrA 1*
Moldovan, Anton Gabriel 1944- *MarqDCG 84*
Moldrem, Stuart 1925- *WorECar*
Moldroski, Al R 1928- *WhoAmA 73, -76, -78, -80, -82, -84*
Moldstad, Harold Alphonse, Jr. 1934- *AmArch 70*
Moldura, Lilla *DcWomA*
Mole, Clara *DcVicP 2*
Mole, Hilma 1901- *WhAmArt 85*
Mole, John Henry 1814-1886 *DcBrWA, DcVicP, -2*
Mole, William *FolkA 86*
Molella, Patricia Ann 1940- *WhoAmA 82, -84*
Molen, R L *AmArch 70*
Molenaer, Claes 1630?-1676 *McGDA*
Molenaer, Cornelis 1540?-1589? *ClaDrA*
Molenaer, Jan Miense 1610?-1668 *ClaDrA, McGDA, OxArt*
Molenaer, Judith *DcWomA*
Molenaer, Nicolaes 1630?-1676 *ClaDrA*
Molenaer, Pieter *DcWomA*
Molenkamp, Nicolaas Ferdinand 1920- *WhoArt 80, -82, -84*
Moles, C W *AmArch 70*
Moles, Pedro Pascual 1741-1797 *McGDA*
Molfessis, Iasson 1924- *PhDcTCA 77*
Moli *McGDA*
Moliere, Ambroise Marguerite *DcWomA*
Molijn, Pieter 1595-1661 *McGDA*
Molin, Brita 1919- *WhoAmA 73, -76*
Molin, C Gunnar *WhAmArt 85*
Molin, Carl Hjalmar Valentin 1868- *ClaDrA*
Molin, Hans Anders *DcCAr 81*
Molina, Antonio J 1928- *WhoAmA 73, -76, -78, -80, -82*
Molina, J E *AmArch 70*
Molina, Valentino *WhAmArt 85*
Molina Campos, Florencio 1891- *ArtsAmW 2*
Molinari, Antonio 1665-1727 *McGDA*
Molinari, Eduardo 1937- *AmArch 70*
Molinari, Guido 1933- *ConArt 77, -83, DcCAr 81, OxTwCA, PhDcTCA 77, WhoAmA 73, -76, -78, -80, -82, -84*
Molinary, A 1847-1915 *WhAmArt 85*
Molinary, Marie *DcWomA*
Molinary, Marie Seebold 1876- *WhAmArt 85*
Molind, A 1898- *WhAmArt 85*
Moline, Bob *OfPGCP 86*
Moline, Ronald Leslie 1937- *AmArch 70*
Moline I Muns, Manuel 1833-1901 *WorECar*
Molineux, E *DcVicP 2*
Molineux, M *DcVicP 2*
Molini, Raffael 1814?- *NewYHSD*
Molinier, Pierre 1900- *ConArt 77, DcCAr 81*
Molinier, Pierre 1900-1976 *ConArt 83*
Molino, Walter 1915- *WorECom*
Molinos, Auguste Isidore 1795-1850 *MacEA*
Molinos, Maurice 1743-1831 *MacEA*
Molitor, Countess *DcWomA*
Molitor, Bernard d1819 *OxDecA*
Molitor, John 1872-1928 *BiDAmAr*
Molitor, Mary C 1957- *MarqDCG 84*
Moll, Aage 1877- *WhAmArt 85*
Moll, Benjamin Franklin *FolkA 86*
Moll, David *FolkA 86*
Moll, Franklin B *FolkA 86*
Moll, Henry *FolkA 86*
Moll, Herman d1732 *AntBDN I*
Moll, Margarete 1884- *DcWomA*
Moll, Oskar 1875-1947 *McGDA, OxTwCA, PhDcTCA 77*
Moll, Verdin Atlee 1923- *AmArch 70*
Mollard, Amelie Marie Caroline *DcWomA*
Mollea, J F *DcVicP 2*
Mollenhauer, Frank 1907- *WhAmArt 85*
Molleno *FolkA 86*
Moller, Agnes *DcWomA*
Moller, Bjarne Kristian 1923- *WhoGrA 62, -82[port]*
Moller, C F 1898- *MacEA, WhoArch*
Moller, Catharine Marie 1744-1811 *DcWomA*
Moller, Charles *NewYHSD*
Moller, Clara *DcWomA*
Moller, Elisabeth *DcWomA*
Moller, F *DcVicP 2*
Moller, Georg 1784-1852 *MacEA*
Moller, Hans 1905- *DcCAA 71, -77, WhAmArt 85, WhoAmA 73, -76, -78, -80, -82, -84*
Moller, Ingegard 1928- *DcCAr 81*
Moller, Jacob A *EncASM*
Moller, Jeanette *DcWomA*
Moller, Olaf 1903- *WhAmArt 85*
Moller, Olivia Holm 1875- *DcWomA*
Moller, Rasmine Caroline 1827-1883 *DcWomA*
Moller, Robert *WhAmArt 85*
Moller, Sarah Isabel Towle *DcWomA*
Mollet, Armand Claude 1670?-1742 *WhoArch*
Mollet Family *MacEA*
Mollett, Michael M 1946- *WhoAmA 80, -82, -84*
Mollhausen, Heinrich Baldouin 1825-1905 *ArtsAmW 1*
Mollhausen, Heinrich Balduin 1825-1905 *IlBEAAW, NewYHSD*
Mollica, Peter 1941- *DcCAr 81*

Montagna, Benedetto *McGDA*
Montagnana, Jacopo Da 1440?-1499? *McGDA*
Montagne, Agricol Louis 1879-1960 *ClaDrA*
Montagny, Etienne 1816- *ArtsNiC*
Montagu, Elizabeth *DcWomA*
Montagu, Ellen *DcVicP 2*
Montagu, H Irving *DcBrBI*
Montagu, John, Duke Of 1690-1749 *BiDBrA*
Montagu, Richard *CabMA*
Montague, Mrs. *DcVicP 2, DcWomA*
Montague, Alfred *DcSeaP, DcVicP*
Montague, Alfred 1832-1883 *DcVicP 2*
Montague, Alice L *DcVicP 2, DcWomA*
Montague, Arthur *DcVicP 2*
Montague, Clifford *DcBrWA, DcVicP 2*
Montague, Ellen *DcVicP 2*
Montague, Enos *ArtsEM*
Montague, Fannie S *DcWomA, WhAmArt 85*
Montague, Frank C 1924- *AmArch 70*
Montague, H *DcVicP 2*
Montague, H Irving *DcVicP 2*
Montague, Hariotte Lee Taliaferro *WhAmArt 85*
Montague, Harriotte Lee Taliaferro *DcWomA*
Montague, James Herbert 1922- *AmArch 70*
Montague, James L 1906- *WhoAmA 73, -76, -78, -80, -82, -84*
Montague, Lilian Amy 1868- *DcWomA, WhAmArt 85*
Montague, Ruth DuBarry *WhoAmA 73*
Montague, Ruth Dubarry *WhoAmA 76, -78, -80, -82, -84*
Montague, Walter *ArtsEM*
Montague, Ward *WhAmArt 85*
Montaign, Emile De *ArtsEM*
Montaigne, Walter *ArtsEM*
Montaigne, William John d1902 *DcVicP, -2*
Montaigu, Emile De *ArtsEM*
Montaine, Richard Elliott 1933- *AmArch 70*
Montalant, Julius O *NewYHSD*
Montalba, A R *DcVicP 2*
Montalba, Anthony *DcVicP 2*
Montalba, Clara *ArtsNiC*
Montalba, Clara 1840-1929 *DcWomA*
Montalba, Clara 1842-1929 *ClaDrA, DcBrA 1, DcBrWA, DcVicP, -2*
Montalba, Ellen *DcBrA 1, DcBrWA, DcVicP, -2, DcWomA*
Montalba, Henrietta *DcBrWA*
Montalba, Henrietta Skerret 1856-1893 *DcWomA*
Montalba, Hilda d1919 *DcBrA 1, DcBrWA, DcVicP, -2, DcWomA*
Montalba, R *DcVicP 2*
Montalboddi, Ida *DcWomA*
Montalboddi, Raffaelo *ArtsAmW 2, WhAmArt 85*
Montalto, James Jeremiah 1924- *AmArch 70*
Montambeau, Bruce L *MarqDCG 84*
Montana, Bob 1920- *WhoAmA 73*
Montana, Bob 1920-1975 *WhoAmA 76N, -78N, -80N, -82N, -84N, WorECom*
Montana, Claude 1949- *ConDes*
Montana, Francesco 1911- *AmArch 70*
Montana, Pietro *WhoAmA 73, -76, -78*
Montana, Pietro d1978 *WhoAmA 80N, -82N, -84N*
Montana, Pietro 1890- *WhAmArt 85*
Montanee, Roger 1916- *ClaDrA, WhoArt 80, -82, -84*
Montanes, Juan Martinez 1568-1649 *McGDA, OxArt*
Montano D'Arezzo *McGDA*
Montano, Giovanni Battista 1534-1621 *MacEA*
Montano, Linda 1942- *AmArt, WhoAmA 84*
Montant, Pierre 1941- *DcCAr 81*
Montaran, Baroness *DcWomA*
Montardier *DcSeaP*
Montbard, G 1841-1905 *DcBrBI*
Montbard, Georges *DcVicP 2*
Montbertrand, Adele Josephine Genevieve *DcWomA*
Montcastle, Clara H *DcWomA*
Montcharmont, Madame *DcWomA*
Montchenu-Lavirotte, Jane Daniela De *DcWomA*
Monte, James K *WhoAmA 73*
Monte-Dotegny, Margareta *DcWomA*
Montealegre, Jorge 1952- *DcCAr 81*
Montefeltro, Counts Of *OxArt*
Montefeltro, Federigo 1422- *OxArt*
Montefiore 1932- *OxTwCA*
Montefiore, E B Stanley *DcVicP 2*
Montefiore, Edward Brice Stanley *DcBrBI*
Montefiore, Edward Levy 1820-1894 *ClaDrA*
Montefiore Micholls, Ada d1933 *DcBrA 1, DcWomA*
Montegut, Jeanne De *DcWomA*
Monteiro DeCarvalho, Joanna Ignacia *DcWomA*
Monteith, Jack Keightley 1922- *AmArch 70*
Montelupo, Baccio 1469-1535? *McGDA*
Montelupo, Raffaele Da 1505?-1566 *McGDA*
Monten, Heinrich Maria Dietrich 1799-1843 *ClaDrA*
Montenard, Frederic 1849-1926 *ClaDrA*
Montenegro, Enrique E 1917- *WhoAmA 73, -76, -78, -80*
Montenegro, Roberto 1885- *McGDA*
Montequin, Francois-Auguste De *WhoAmA 76, -78, -80*
Montereau *McGDA*

Montero, Luis 1826-1869 *McGDA*
Monteux, Yvonne 1897- *DcWomA*
Monteverde, Giulio 1836?- *ArtsNiC*
Monteverde, Giulio 1837-1917 *McGDA*
Montezin, Pierre Eugene 1874-1946 *ClaDrA*
Montfaucon, Bernard De 1665-1741 *McGDA*
Montferrand, August Ricard 1786-1856 *WhoArch*
Montferrand, August Ricard De 1786-1858 *McGDA*
Montferrand, Auguste Ricard De 1786-1858 *MacEA*
Montford *FolkA 86*
Montford, Marian Alice 1882- *DcBrA 1, DcWomA*
Montford, Paul Raphael 1868-1938 *DcBrA 1*
Montfort, H *DcVicP 2*
Montfort DeMarguerie, V De *DcWomA*
Montgiraud, Rose *DcWomA*
Montgomerie, Norah Mary 1913- *IlsCB 1946, -1957*
Montgomery *NewYHSD*
Montgomery, Alfred 1857-1922 *ArtsAmW 2, WhAmArt 85*
Montgomery, Carrie E 1878- *WhAmArt 85*
Montgomery, Carrie Ellen 1878- *DcWomA*
Montgomery, Carrie L 1865- *WhAmArt 85*
Montgomery, Carrie Lewis 1865- *DcWomA*
Montgomery, Charles Franklin 1910- *WhoAmA 73, -76*
Montgomery, Charles Franklin 1910-1978 *WhoAmA 78N, -80N, -82N, -84N*
Montgomery, Claude 1912- *WhoAmA 76, -78, -80, -82, -84*
Montgomery, Claude W 1912- *WhAmArt 85*
Montgomery, E A 1857-1922 *ArtsAmW 2*
Montgomery, E J 1933- *WhoAmA 80, -82, -84*
Montgomery, Eloise *WhAmArt 85*
Montgomery, Eugene Alexander 1905- *WhAmArt 85*
Montgomery, Evangeline J 1933- *AfroAA*
Montgomery, Fon Joseph 1920- *AmArch 70*
Montgomery, Gene Ladd 1932- *AmArch 70*
Montgomery, George A *EncASM*
Montgomery, Horace Clifford 1915- *AmArch 70*
Montgomery, J *DcVicP 2*
Montgomery, James *EncASM*
Montgomery, James A *EncASM*
Montgomery, James Alexander 1928- *WhoArt 84*
Montgomery, John *BiDBrA*
Montgomery, John Malhiot 1934- *AmArch 70*
Montgomery, Kenneth Rubbert 1931- *AmArch 70*
Montgomery, Lorin A D 1904- *WhAmArt 85*
Montgomery, Lorraine S *AfroAA*
Montgomery, M *DcWomA*
Montgomery, Mary L *ArtsEM, DcWomA*
Montgomery, Newcomb T 1907- *AmArch 70*
Montgomery, Ralph Earle 1933- *AmArch 70*
Montgomery, Richard M *WhAmArt 85*
Montgomery, Robert E M *DcVicP 2*
Montgomery, Robert Hale 1955- *MarqDCG 84*
Montgomery, Roger 1925- *AmArch 70*
Montgomery, Ronald Oliver 1935- *AmArch 70*
Montgomery, V A *DcVicP 2*
Montgomery, Miss V A *DcBrWA*
Montgomery, W H *WhAmArt 85*
Montgomery, W J *AmArch 70*
Montgomery, William *FolkA 86*
Montgomery, William M *FolkA 86*
Montgomery Brothers *EncASM*
Monthan, Doris Born 1924- *WhoAmA 80, -82*
Monthan, Guy 1925- *WhoAmA 76, -78, -80, -82, -84*
Montholon-Galtie, Elisa De *DcWomA*
Monti, Eleonora 1727-1767? *DcWomA*
Monti, Gaetano *DcNiCA*
Monti, Paolo 1908-1982 *ICPEnP A*
Monti, Rafaelle 1818-1881 *DcNiCA*
Monticciolo, Joseph Domenick 1937- *AmArch 70*
Monticelli, Adolphe 1824-1886 *McGDA*
Monticelli, Adolphe Joseph Thomas 1824-1886 *ClaDrA*
Montier, John *BiDBrA*
Montierth, G M *AmArch 70*
Montigny, Jenny 1875- *DcWomA*
Montigny, Louise De *DcWomA*
Montigny-Giguere, E Louise 1878- *DcWomA*
Montilla, Federico Victor 1934- *AmArch 70*
Montillon, Eugene D 1883- *AmArch 70*
Montiner, Erna *DcWomA*
Montion, Jeanne *DcWomA*
Montizambert, Beatrice 1874- *DcWomA*
Montizambert, Beatrice B 1874- *WhAmArt 85*
Montizon, Flore *DcWomA*
Montizon, Therese Justine *DcWomA*
Montlack, Edith *WhoAmA 73, -76, -78, -80, -82, -84*
Montminy, Elizabeth Tracy *WhAmArt 85*
Montminy, Tracy *WhoAmA 80, -82, -84*
Montminy, Tracy 1911- *AmArt*
Montmorency, Frederick 1929- *AmArch 70*
Montmorency, Lily De *DcVicP 2*
Montmorency, Miles Fletcher De 1893- *ClaDrA*
Montmorency, Sir Miles Fletcher De 1893- *DcBrA 1*
Montorfano, Giovanni Donato *McGDA*
Montorsoli, Giovanni Angelo 1507?-1563 *McGDA*
Montoya, Alfredo d1913 *ArtsAmW 3, IlBEAAW*
Montoya, Alfredo d1915? *WhAmArt 85*
Montoya, Fred F 1937- *AmArch 70*
Montoya, Geronima Cruz 1915- *IlBEAAW,*

WhAmArt 85, WhoAmA 73, -76, -78, -80, -82
Montoya, Gustavo 1905- *WhoAmA 84*
Montoya, Patricia *FolkA 86*
Montpellier, Albertine *DcWomA*
Montpellier, Eugenie *DcWomA*
Montpensier, Antoine P D'O, Duc De 1775-1807 *NewYHSD*
Montpreville, Cyrille 1819?- *NewYHSD*
Montpreville, Cyrus De 1819?- *NewYHSD*
Montresor, Beni *IlsCB 1967*
Montresor, Beni 1926- *IlsBYP, IlsCB 1957*
Montresor, John 1736-1799 *ArtsEM*
Montreuil, Benoit 1958- *MarqDCG 84*
Montreuil, Eudes De *MacEA*
Montreuil, Eudes De d1287 *McGDA*
Montreuil, Pierre De *MacEA, McGDA*
Montreuil, Pierre De d1267 *OxArt*
Montreville, Cyrille 1819?- *NewYHSD*
Montreville, Cyrus De 1819?- *NewYHSD*
Montrichard, Raymond Desmus 1887- *ArtsAmW 2, WhAmArt 85*
Montrose, R F *DcVicP 2*
Montross, N E 1849-1932 *WhAmArt 85*
Montserrat, Tomas 1873-1944 *MacBEP*
Montule, Edouard De *NewYHSD*
Montuori, Eugenio 1907- *McGDA, WhoArch*
Monty, Augustus *ArtsEM*
Montz, A S *AmArch 70*
Monvel, Louis-Maurice Boutet De *ArtsNiC*
Monvoisin, Domenica d1881 *DcWomA*
Monvoisin, Eleonore *DcWomA*
Monvoisin, Pierre Raymond Jacques 1794-1870 *ClaDrA*
Monza, Louis 1897-1984 *FolkA 86*
Mooberry, F M *AmArch 70*
Moodie, Agnes Dunbar *DcWomA*
Moodie, Donald 1892-1963 *DcBrA 1*
Moodie, George *MacBEP*
Moodie, Susanna 1803-1885 *DcWomA*
Moody, A R *AmArch 70*
Moody, B E *AmArch 70*
Moody, Benjamin d1781 *CabMA*
Moody, Catherine Olive 1920- *WhoArt 82, -84*
Moody, David William *NewYHSD*
Moody, Edward G *DcVicP 2*
Moody, Edwin *ArtsAmW 1, IlBEAAW, NewYHSD*
Moody, Elizabeth Chambers 1944- *WhoAmA 76, -78, -80, -82, -84*
Moody, Enoch, Jr. 1754-1804 *CabMA*
Moody, Ezra d1793 *CabMA*
Moody, Fannie 1861- *DcBrA 1, DcBrBI, DcVicP, -2, DcWomA*
Moody, Fanny 1861- *ClaDrA*
Moody, Frances J *WhAmArt 85*
Moody, Francis Wollaston 1824-1886 *DcVicP, -2*
Moody, Helen Wills *WhAmArt 85*
Moody, James *CabMA*
Moody, John 1759-1793 *CabMA*
Moody, John 1884- *DcBrBI*
Moody, John Charles 1884-1962 *DcBrA 1*
Moody, John E *NewYHSD*
Moody, Mary *DcVicP 2, DcWomA*
Moody, Matthew, Jr. *CabMA*
Moody, Michael David 1946- *WhoArt 80, -82, -84*
Moody, Oliver d1775 *CabMA*
Moody, Oliver, III d1786 *CabMA*
Moody, Oliver, Jr. d1776 *CabMA*
Moody, Ronald 1910- *DcBrA 1, WhoArt 80, -82, -84*
Moody, Ronald C 1900- *AfroAA*
Moody, Samuel Broadly d1923 *ArtsEM*
Moody, T B *DcWomA*
Moody, Ted 1947- *AfroAA*
Moody, Victor Hume 1896- *DcBrA 1, WhoArt 80, -82, -84*
Moody, W L *AmArch 70*
Mooers, J H *DcWomA*
Mooers, Mrs. J H *ArtsEM*
Mooers, Jacob B *FolkA 86, NewYHSD*
Mooleysar, Willem *IlDcG*
Moon *DcBrECP*
Moon, Alan George Tennant 1914- *DcBrA 1*
Moon, Anne Douglas *WhAmArt 85*
Moon, C T *DcVicP, -2*
Moon, Carl d1948 *WhoAmA 78N, -80N, -82N, -84N*
Moon, Carl 1878-1948 *ArtsAmW 1*
Moon, Carl 1879-1948 *ConICB, IlBEAAW, IlsCB 1744, WhAmArt 85*
Moon, George Christopher 1951- *MarqDCG 84*
Moon, Grace d1947 *ArtsAmW 2, DcWomA*
Moon, Henry George 1857-1905 *DcBrA 1, DcVicP 2*
Moon, Jeremy 1934-1973 *ConArt 77, -83, PhDcTCA 77*
Moon, Jim 1928- *AmArt, WhoAmA 82, -84*
Moon, Laurence Russell 1912- *AmArch 70*
Moon, Marc 1923- *WhoAmA 76, -78, -80, -82, -84*
Moon, Michael 1937- *ConArt 77, ConBrA 79[port]*
Moon, Richard Albert 1919- *AmArch 70*
Moon, Robert 1801?-1887 *FolkA 86*
Moon, Samuel 1805-1860 *NewYHSD*

Moore, Sarah Wool 1846- *DcWomA*
Moore, Scott Martin 1949- *WhoAmA 82, –84*
Moore, Sidney *DcVicP, –2*
Moore, Sophie *FolkA 86*
Moore, Susan Catherine *DcWomA*
Moore, Sydney Hart 1919- *AmArch 70*
Moore, T L *AmArch 70*
Moore, Tara *OfPGCP 86*
Moore, Temple 1856-1920 *MacEA*
Moore, Theo 1879- *DcBrA 1, DcWomA*
Moore, Theodore John, Jr. 1921- *AmArch 70*
Moore, Thomas *AntBDN Q, MarqDCG 84,
 NewYHSD*
Moore, Thomas Cooper 1827-1901 *DcBrWA,
 DcVicP 2*
Moore, Thomas Edmond 1947- *MarqDCG 84*
Moore, Thomas H *EncASM*
Moore, Thomas Sturge 1870-1944 *DcBrA 2, DcBrBI*
Moore, Tom James 1892- *ArtsAmW 1, IlBEAAW,
 WhAmArt 85*
Moore, W *DcVicP 2*
Moore, Walter Curham 1912- *AmArch 70*
Moore, Wayland *OfPGCP 86*
Moore, Wayland 1935- *PrintW 83, –85*
Moore, Wilbert 1938- *AfroAA*
Moore, William *NewYHSD*
Moore, William 1790-1851 *DcBrWA, DcVicP, –2,
 NewYHSD*
Moore, William 1817-1909 *DcBrWA*
Moore, William, Jr. *CabMA, FolkA 86*
Moore, William, Jr. 1817-1909 *DcVicP, –2*
Moore, William Banton 1919- *AmArch 70*
Moore, William Carroll 1934- *AmArch 70*
Moore, William J *DcVicP 2*
Moore, William Oliver 1935- *AmArch 70*
Moore, William Stanley 1914- *WhoArt 80, –82, –84*
Moore And Hofman *EncASM*
Moore And Leding *EncASM*
Moore Brothers *EncASM*
Moore-Park, Carton 1877-1956 *DcBrA 1*
Moore-Park, Carton 1879- *WhAmArt 85*
Moorehead, Leedell 1927- *AfroAA*
Moorehead, R L *EncASM*
Moorehead, Scipio *NewYHSD*
Moorehouse-Lelen, Charlotte *WhAmArt 85*
Moorer, V D, Jr. *AmArch 70*
Moores, Richard Arnold 1909- *WorECar*
Moorhead, Richard Alan 1940- *AmArch 70*
Moorhead, Scipio *AfroAA, FolkA 86*
Moorhouse, Adelina Blanche 1885- *DcBrA 1,
 DcWomA*
Moorhouse, Charlotte *DcWomA*
Moorhouse, George Mortram 1882- *DcBrA 1*
Moorhouse, Major Lee *WhAmArt 85*
Moorman, Frank Severing 1901- *AmArch 70*
Moormann, Howard Marvin 1936- *AmArch 70*
Moos, Max Von 1903- *ConArt 77*
Moos, Walter A 1926- *WhoAmA 73, –76, –78, –80,
 –82, –84*
Moosbrugger, Caspar 1656-1723 *MacEA, WhoArch*
Moose, Philip Anthony 1921- *WhoAmA 73, –76, –78,
 –80, –82, –84*
Moose, Talmadge Bowers 1933- *WhoAmA 76, –78,
 –80, –82, –84*
Mooser, William 1834-1896 *BiDAmAr*
Moossy, L E *AmArch 70*
Mootz *FolkA 86*
Mooy, Cornelisz Pietersz 1656-1693 *DcSeaP*
Mooy, Jaap 1915- *OxTwCA, PhDcTCA 77*
Mooy, Jan 1776-1847 *DcSeaP*
Mooz, R Peter 1940- *WhoAmA 76, –78, –80, –82, –84*
Mopope, Stephen 1898- *IlBEAAW*
Mopope, Steven 1898- *WhAmArt 85*
Mopope, Steven 1898-1974 *ArtsAmW 3*
Mopp, Maximilian *McGDA*
Mopp, Maximilian 1885- *WhAmArt 85*
Moquin, Richard Attilio 1934- *AmArt, WhoAmA 73,
 –76, –78, –80, –82, –84*
Mor, Anthonis 1517?-1577? *McGDA*
Mor, Antonis 1519-1578? *ClaDrA*
Mor, Therese Von 1871- *DcWomA*
Mor VanDashorst, Anthonis 1517?-1577? *OxArt*
Mora, Domingo d1911 *WhAmArt 85*
Mora, Enrique DeLa *McGDA*
Mora, F Luis 1874-1940 *McGDA, WhAmArt 85*
Mora, Francis Luis 1874-1940 *ArtsAmW 1,
 IlBEAAW*
Mora, Francisco *WhoAmA 76, –78, –80, –82*
Mora, Jo 1876- *WhAmArt 85*
Mora, Jose De 1642-1724 *McGDA, OxArt*
Mora, Joseph Jacinto 1876-1947 *ArtsAmW 1,
 IlBEAAW*
Mora Y Palomar, Enrique DeLa 1907- *McGDA*
Morado, Chavez Jose *WhoAmA 76, –78, –80*
Morado, Chavez Jose 1909- *WhoAmA 73*
Morahan, Eugene 1869- *WhAmArt 85*
Morales, Armando 1927- *DcCAr 81, McGDA,
 OxTwCA, PhDcTCA 77, PrintW 85,
 WhoAmA 73, –76, –78, –80, –82, –84*
Morales, Elsa *DcCAr 81*
Morales, Luis De d1586 *OxArt*

Morales, Luis De 1510?-1586 *McGDA*
Morales, Luisa *DcWomA*
Morales-Serrano, Efrer 1928- *AmArch 70*
Moralis, Yannis 1916- *OxTwCA, PhDcTCA 77*
Moran, Mr. *NewYHSD*
Moran, Allen C 1871- *WhAmArt 85*
Moran, Amanda Estill 1810- *FolkA 86*
Moran, Arthur O, Jr. 1924- *AmArch 70*
Moran, C *NewYHSD*
Moran, Clarence Edward *AmArch 70*
Moran, Connie *IlsBYP*
Moran, Denis Dominique 1957- *MarqDCG 84*
Moran, Earl 1893- *ArtsAmW 3, WhAmArt 85*
Moran, Edward 1829- *ArtsNiC*
Moran, Edward 1829-1901 *ArtsAmW 1, DcSeaP,
 EarABI, IlBEAAW, NewYHSD, WhAmArt 85*
Moran, Edward 1901- *WhAmArt 85*
Moran, Edward Percy 1862-1935 *WhAmArt 85*
Moran, Eliza Curtis *WhAmArt 85*
Moran, Emily Kelley *DcWomA*
Moran, Frances A Desnoyers *ArtsEM, DcWomA*
Moran, Frank 1877-1967 *FolkA 86*
Moran, H Marcus *WhAmArt 85*
Moran, Horace *WhAmArt 85*
Moran, J *NewYHSD*
Moran, J P *AmArch 70*
Moran, John *DcBrECP, NewYHSD*
Moran, John 1831-1903 *WhAmArt 85*
Moran, John P d1901 *DcVicP 2*
Moran, Leon 1864-1941 *WhAmArt 85*
Moran, Lottie E *DcWomA*
Moran, Margaret Jane Ballentine 1840-1910 *DcWomA*
Moran, Marie *WhAmArt 85*
Moran, Mary Eulalie *DcWomA*
Moran, Mary Nimmo 1842-1899 *ArtsAmW 2,
 DcAmArt, DcWomA, WhAmArt 85, WomArt*
Moran, Michael Joseph 1934- *AmArch 70*
Moran, Paul Kenneth, Jr. 1936- *AmArch 70*
Moran, Paul Nimmo d1907 *WhAmArt 85*
Moran, Paul Nimmo 1864-1907 *ArtsAmW 2*
Moran, Peter 1841-1914 *IlBEAAW, NewYHSD,
 WhAmArt 85*
Moran, Peter 1842- *ArtsNiC*
Moran, Peter 1842-1914 *ArtsAmW 1*
Moran, R P *AmArch 70*
Moran, Thomas 1837- *ArtsNiC*
Moran, Thomas 1837-1926 *ArtsAmW 1, DcAmArt,
 DcSeaP, EarABI, EarABI SUP, IlBEAAW,
 McGDA, NewYHSD, WhAmArt 85*
Morand, Daniel Jean 1943- *MarqDCG 84*
Morand, Pierre *DcVicP 2*
Morandi, Anna *DcWomA*
Morandi, Antonio DiBernardino *McGDA*
Morandi, Francesco d1604? *McGDA*
Morandi, Giorgio 1890-1964 *ConArt 77, –83,
 McGDA, OxArt, OxTwCA, PhDcTCA 77,
 WorArt[port]*
Morandi, L R *AmArch 70*
Morandi, Riccardo 1902- *ConArch, MacEA*
Morandini, Francesco *McGDA*
Morando, Paolo *McGDA*
Morang, Alfred 1901-1958 *WhAmArt 85*
Morang, Alfred Gwynne *WhoAmA 80N, –82N, –84N*
Morang, Alfred Gwynne 1901-1958 *IlBEAAW*
Morang, Dorothy 1906- *IlBEAAW, WhAmArt 85*
Morange, Edward A *WhAmArt 85*
Morange, Etienne *NewYHSD*
Moranges, Etienne *NewYHSD*
Morani, Salvatore *WhAmArt 85*
Morant, Charles Harbord *DcVicP 2*
Morant, George *DcCAr 81*
Moranzone, Jacopo *McGDA*
Moras, Ferdinand 1821- *WhAmArt 85*
Moras, Ferdinand 1821-1908 *NewYHSD*
Morath, Inge 1923- *ConPhot, ICPEnP A, MacBEP,
 WhoAmA 82, –84*
Morath, Inge 1924- *WhoAmA 78, –80*
Morawaska, Madame *DcWomA*
Morazzone, Il *McGDA*
Morbach, Susanna *DcWomA*
Morbelli, Angelo 1853-1919 *ClaDrA*
Morbito, Joseph Francis 1907- *AmArch 70*
Morby, Kate *DcVicP 2, DcWomA*
Morby, Walter *DcVicP 2*
Morchen, Horace *DcBrBI*
Morchoisne, Jean-Claude 1944- *WhoGrA 82[port]*
Morchower, Neil 1936- *AmArch 70*
Morcom, J Herbert 1871- *DcBrA 2*
Morcos, Maher N 1946- *WhoAmA 82, –84*
Mordaunt, Sir Charles d1823 *DcBrWA*
Mordaunt, F 1801- *DcVicP 2*
Mordaunt, Lady Marianne 1778-1842 *DcBrWA*
Mordecai, Joseph 1851- *DcBrA 1, DcVicP 2*
Mordecai, Joseph 1860- *DcVicP*
Morden, Robert d1703 *AntBDN I*
Mordillo, Guillermo 1932- *WorECar*
Mordillo, Guillermo 1933- *WorECom*
Mordkin, Ida 1884- *DcWomA*
Mordt, Gustav Adolph 1826-1856 *ClaDrA*
Mordue, Truda 1909- *ClaDrA, DcBrA 1,
 WhoArt 80, –82, –84*

Mordvinoff, Nicolas 1911- *WhoAmA 73*
Mordvinoff, Nicolas 1911-1973 *Cald 1938, IlsBYP,
 IlsCB 1744, –1946, –1957, WhoAmA 76N, –78N,
 –80N, –82N, –84N*
More, Anne Gabrielle 1769-1845 *DcWomA*
More, D H *AmArch 70*
More, Hermon d1968 *WhoAmA 78N, –80N, –82N,
 –84N*
More, Hermon 1887-1968 *WhAmArt 85*
More, Jacob 1740?-1793 *DcBrECP, DcBrWA*
More, Mary *DcWomA*
More, Octavie *DcWomA*
More, Samuel *FolkA 86*
More, Thomas *FolkA 86, NewYHSD*
Moreau, Madame *DcWomA*
Moreau, Mademoiselle *DcWomA*
Moreau, Adrien *ArtsNiC*
Moreau, Aimee 1926- *DcCAr 81*
Moreau, Angelique *DcWomA*
Moreau, Anna M *DcWomA*
Moreau, Camille 1840-1897 *DcWomA*
Moreau, Edward Robert 1913- *WhAmArt 85*
Moreau, Fanny *DcWomA*
Moreau, Gustave *ArtsNiC*
Moreau, Gustave 1826-1898 *ClaDrA, McGDA,
 OxArt, OxTwCA, PhDcTCA 77*
Moreau, Jean Michel 1741-1814 *BkIE, ClaDrA,
 McGDA*
Moreau, Jean Michel, LeJeune 1741-1814 *OxArt*
Moreau, Karl Von 1758-1840 *MacEA*
Moreau, Louis Gabriel 1739-1805 *OxArt*
Moreau, Louis-Gabriel, The Elder 1740-1806 *McGDA*
Moreau, Luc Albert 1882-1948 *ClaDrA,
 PhDcTCA 77*
Moreau, Luc-Albert 1882-1948 *McGDA, OxTwCA*
Moreau, Marie Eugenie *DcWomA*
Moreau, Mathurin 1824- *ArtsNiC*
Moreau, Mathurin-Auguste *ArtsNiC*
Moreau-Desproux, Pierre-Louis *MacEA*
Moreau DeTours, Georges 1848-1901 *ClaDrA*
Moreau-Ficatier, Rosa *DcWomA*
Moreau Le Jeune 1741-1814 *BkIE*
Moreau-Nelaton, Adolphe Etienne Auguste 1859-1927
 ClaDrA
Moreau-Vauthier, Augustin Jean *ArtsNiC*
Moreda, Armando *WhAmArt 85*
Moreel, Lievine d1510 *DcWomA*
Moreelse, Paulus 1571-1638 *ClaDrA, McGDA,
 OxArt*
Morehead, James Caddall, Jr. 1913- *AmArch 70*
Morehouse, Levi *CabMA*
Morehouse, P M *FolkA 86*
Morehouse, Richard Southwick 1921- *AmArch 70*
Morehouse, Vesta D *WhAmArt 85*
Morehouse, William Paul 1929- *AmArt,
 WhoAmA 78, –80, –82, –84*
Morein, J Augustus 1810?- *NewYHSD*
Moreing, Charles d1885 *BiDBrA A*
Moreira, Carlos 1936- *ICPEnP A*
Moreira, Jorge 1904- *MacEA*
Moreira, Jorge Machado 1904- *ConArch, McGDA,
 OxArt*
Morel *NewYHSD*
Morel, Carlos 1813-1894 *McGDA*
Morel, Casparus Johannes 1798-1861 *DcSeaP*
Morel, Charles 1861-1908 *DcBrBI*
Morel, Etienne *OxArt*
Morel, Flore Louise *DcWomA*
Morel, Hugues *McGDA*
Morel, Jacques *McGDA*
Morel, Jacques d1459 *OxArt*
Morel, Jean-Marie 1728-1810 *MacEA*
Morel, May *WhAmArt 85*
Morel, Perrin *OxArt*
Morel, Vera *WhAmArt 85*
Morel-Fatio, Antonie Leon 1810-1877 *ClaDrA*
Morel-Retz, Louis-Pierre 1825-1899 *WorECar*
Morelan, Jim D 1938- *AmArch 70*
Moreland, A *DcBrBI*
Moreland, Augustus *NewYHSD*
Moreland, Francis A 1836-1927 *WhAmArt 85*
Moreland, Thomas Clifford 1935- *AmArch 70*
Moreley, James *NewYHSD*
Morell, D'Arcy *DcVicP 2*
Morell, James L 1933- *MarqDCG 84*
Morell, L *DcVicP 2*
Morell, T J *ArtsEM*
Morelle, John P *DcVicP 2*
Morellet, Francois 1926- *ConArt 77, –83, DcCAr 81,
 OxTwCA*
Morelli, A *DcWomA*
Morelli, Alessio *IlDcG*
Morelli, Cosimo 1732-1812 *MacEA*
Morelli, Domenico 1826- *ArtsNiC*
Morelli, Giovanni 1816-1891 *OxArt*
Morelli, Mariano *DcVicP 2*
Moreni, Mattia *OxTwCA*
Moreni, Mattia 1920- *PhDcTCA 77*
Moreno, Jose 1936- *WorFshn*
Moreno, Luis Guevara *OxTwCA*
Moreno, Maria 1933- *OxTwCA*

Moreno, Maria Eugenia *WorFshn*
Moreno, Orduna Nicolas 1936- *WhoAmA 84*
Moreno, Rafael 1887-1955 *OxTwCA*
Moreno, S *AmArch 70*
Morenus, Richard Thomas *AmArch 70*
Mores, S *NewYHSD*
Moresby, Miss *DcBrECP*
Moreton, Alice Bertha 1901- *DcBrA 1*
Moreton, Russell 1929- *WhoAmA 73, -76, -78, -80, -82*
Moretti, Cristoforo *McGDA*
Moretti, Gaetano 1860-1930 *MacEA*
Moretti, Giuseppe d1772 *McGDA*
Moretti, Giuseppe 1859-1935 *WhAmArt 85*
Moretti, Irene 1835- *DcWomA*
Moretti, Lucien Philippe *DcCAr 81*
Moretti, Luigi 1907-1973 *MacEA*
Moretti, Peter M 1935- *MarqDCG 84*
Moretto, Emma *DcWomA*
Moretto, Quintilia 1572?-1671? *DcWomA*
Moretto DaBrescia 1498-1554 *McGDA*
Moretto DaBrescia, Alessandro Bonvicino 1498?-1554 *OxArt*
Morety, Andre *DcSeaP*
Morewood, George *NewYHSD*
Morey, Anna 1857?-1925 *DcWomA*
Morey, Anna Riordan 1857-1925 *ArtsAmW 1*
Morey, Arthur Warren, Jr. 1921- *AmArch 70*
Morey, Bertha Graves 1881- *DcWomA, WhAmArt 85*
Morey, Charles Rufus 1877- *WhAmArt 85*
Morey, Charlotte *FolkA 86*
Morey, Clayton Phelps 1928- *AmArch 70*
Morey, Craig H 1952- *ICPEnP A, MacBEP*
Morey, Edward *NewYHSD*
Morey, Loren S *ArtsEM*
Morey, Mathieu Prosper 1805-1886 *MacEA*
Morey, Norman 1901- *WhAmArt 85*
Morez, Mary *WhoAmA 73, -76, -78*
Morgan *FolkA 86*
Morgan, Miss *DcBrECP*
Morgan, A W *NewYHSD*
Morgan, Adelaide Baker *DcWomA, WhAmArt 85*
Morgan, Alan Edgar 1922- *AmArch 70*
Morgan, Alexander C 1849- *WhAmArt 85*
Morgan, Alexander Perry, Jr. 1924- *AmArch 70*
Morgan, Alfred *ClaDrA, DcBrA 1, DcVicP, -2*
Morgan, Alfred George *DcVicP 2*
Morgan, Alfred Kedington 1868-1928 *DcBrA 1, DcBrWA, DcVicP 2*
Morgan, Alice *DcWomA*
Morgan, Alice Mary *DcWomA*
Morgan, Annie Laurie *DcWomA*
Morgan, Annie Stephenson *WhAmArt 85*
Morgan, Arthur C 1904- *WhAmArt 85, WhoAmA 73, -76, -78, -80, -82, -84*
Morgan, Arthur H *EncASM*
Morgan, Ava *IlsBYP*
Morgan, Barbara 1900- *ConPhot, ICPEnP, PrintW 83, -85, WhAmArt 85, WomArt*
Morgan, Barbara Brooks 1900- *MacBEP, WhoAmA 73, -76, -78, -80, -82, -84*
Morgan, Benjamin, Jr. 1805- *CabMA*
Morgan, Benjamin B *ArtsEM*
Morgan, Blanche 1912- *WhAmArt 85*
Morgan, C G *DcWomA*
Morgan, Charles *DcVicP 2*
Morgan, Charles H 1902- *WhoAmA 73, -76, -78, -80, -82*
Morgan, Charles L 1890- *ArtsAmW 2, WhAmArt 85*
Morgan, Charles R, Jr. 1931- *AmArch 70*
Morgan, Charles W *DcVicP 2, FolkA 86*
Morgan, Charlotte Elizabeth Bodwell *ArtsAmW 2, DcWomA, WhAmArt 85*
Morgan, Christopher Clark 1933- *AmArch 70*
Morgan, Christopher Lloyd 1944- *MarqDCG 84*
Morgan, Constance *WhAmArt 85*
Morgan, D *FolkA 86*
Morgan, Dane David 1912- *AmArch 70*
Morgan, Darlene 1943- *WhoAmA 73, -76, -78, -80, -82, -84*
Morgan, David *FolkA 86*
Morgan, David H 1986- *AmArch 70*
Morgan, David P *NewYHSD*
Morgan, Dayton *ArtsEM*
Morgan, Don R 1931- *AmArch 70*
Morgan, Dorothy *WhAmArt 85*
Morgan, Douglas *CabMA*
Morgan, E G *AmArch 70*
Morgan, E P *DcVicP 2*
Morgan, Edith F *DcWomA*
Morgan, Edwin Ernest 1881- *DcBrA 1*
Morgan, Emily L 1871- *DcWomA*
Morgan, Emmylou 1891-1932 *DcWomA, WhAmArt 85*
Morgan, Ernest *WhAmArt 85*
Morgan, Eugene Leslie 1887- *AmArch 70*
Morgan, Evelyn *DcWomA*
Morgan, Evelyn De 1855-1919 *ClaDrA*
Morgan, F L *AmArch 70*

Morgan, Fanny *DcWomA*
Morgan, Frances Mallory *WhAmArt 85, WhoAmA 73, -76, -78, -80, -82, -84*
Morgan, Frank James 1916- *WhoAmA 78*
Morgan, Frank Somerville *DcVicP 2*
Morgan, Franklin Townsend 1883- *WhAmArt 85*
Morgan, Frederick 1856-1927 *ClaDrA, DcBrA 1, DcBrBI, DcVicP, -2*
Morgan, Mrs. Frederick *DcVicP, -2*
Morgan, G C *AmArch 70*
Morgan, George T *WhAmArt 85*
Morgan, Georgia Weston 1875-1953? *DcWomA*
Morgan, Georgia Weston 1875-1955? *WhAmArt 85*
Morgan, Gertrude *AfroAA*
Morgan, Sister Gertrude 1900-1980 *FolkA 86*
Morgan, Gertrude Ellen *DcWomA*
Morgan, Gladys B 1899- *DcWomA, WhAmArt 85, WhoAmA 73, -76, -78, -80*
Morgan, Gladys B 1899-1981 *WhoAmA 82N, -84N*
Morgan, Glynn 1926- *DcCAr 81*
Morgan, Griffith 1819?- *NewYHSD*
Morgan, Gwenda 1908- *DcBrA 1, WhoAmA 80, -82, -84*
Morgan, H *DcVicP 2*
Morgan, H J *DcSeaP*
Morgan, Harry S 1914- *AmArch 70*
Morgan, Helen *DcWomA, WhAmArt 85*
Morgan, Helen Bosart 1902- *WhAmArt 85, WhoAmA 73, -76, -78, -80, -82, -84*
Morgan, Henry *DcBrWA, DcVicP 2*
Morgan, Henry J *WhAmArt 85*
Morgan, Herbert A 1857-1917 *WhAmArt 85*
Morgan, Isaac 1871-1913 *WhAmArt 85*
Morgan, J A *ArtsEM*
Morgan, J O, Jr. *AmArch 70*
Morgan, J Pierpont 1837-1913 *WhAmArt 85*
Morgan, J S *AmArch 70*
Morgan, J T *EncASM*
Morgan, Jack Hubert 1920- *AmArch 70*
Morgan, Jacqui 1939- *ConGrA 1[port]*
Morgan, Jacqui 1941- *WhoGrA 82[port]*
Morgan, James *BiDBrA, FolkA 86*
Morgan, James, Jr. *FolkA 86*
Morgan, James A 1926- *AmArch 70*
Morgan, James Davies *BiDBrA*
Morgan, James Davies 1934- *AmArch 70*
Morgan, James Sherrod 1936- *WhoAmA 76, -78, -80, -82, -84*
Morgan, Jane 1832-1899 *DcVicP 2, DcWomA*
Morgan, Jay L *ArtsEM*
Morgan, Jean Scrimgeour 1868-1938 *ArtsAmW 3*
Morgan, Jeff *DcCAr 81*
Morgan, Jim *AmArt*
Morgan, John 1813- *CabMA*
Morgan, John 1823-1886 *DcVicP, -2*
Morgan, John B, Jr. *NewYHSD*
Morgan, John Cabot 1939- *AmArch 70*
Morgan, John Hill 1875-1945 *WhAmArt 85*
Morgan, John Peter 1929- *AmArch 70*
Morgan, John Thomas 1926- *AmArch 70*
Morgan, Joseph Marsters 1817- *CabMA*
Morgan, Julia 1872-1957 *MacEA, WomArt*
Morgan, Junius Spencer d1932 *WhAmArt 85*
Morgan, Kate *DcVicP 2*
Morgan, L *AmArch 70*
Morgan, Liliane *WhoAmA 84*
Morgan, Louis M 1814-1852 *NewYHSD*
Morgan, Lucy Calista 1889- *WhAmArt 85, WhoAmA 73, -76*
Morgan, Lynn Thomas 1889- *DcWomA, WhAmArt 85*
Morgan, M *WhAmArt 85*
Morgan, M DeNeale *WhAmArt 85*
Morgan, M L *DcVicP 2*
Morgan, Maggie J *DcWomA*
Morgan, Maritza Leskovar 1921- *WhoAmA 73, -76, -78, -80, -82, -84*
Morgan, Mary *DcWomA, FolkA 86*
Morgan, Mary A 1880- *ArtsAmW 3*
Morgan, Mary DeNeale 1868-1948 *ArtsAmW 1, DcWomA*
Morgan, Mary E T *DcVicP 2*
Morgan, Mary Vernon *DcBrA 1, DcVicP 2*
Morgan, Matt *FolkA 86*
Morgan, Matt Somerville 1836-1890 *DcBrBI*
Morgan, Matthew 1839-1890 *WhAmArt 85, WorECar*
Morgan, Matthew 1840- *ArtsNiC*
Morgan, Matthew Somerville 1839-1890 *DcVicP 2, EarABI SUP*
Morgan, Maud Cabot 1903- *WhAmArt 85*
Morgan, Melford Channing 1921- *AmArch 70*
Morgan, Michael Brewster 1953- *MarqDCG 84*
Morgan, Molly S 1955- *MarqDCG 84*
Morgan, Morgan, Jr. *EncASM*
Morgan, Myra Jean 1938- *WhoAmA 76, -78, -80, -82, -84*
Morgan, Norma Gloria *WhoAmA 73, -76, -78, -80, -82, -84*
Morgan, Norma Gloria 1928- *AfroAA*
Morgan, Norma Townsend 1918- *WhAmArt 85*

Morgan, Octavius 1850-1922 *BiDAmAr*
Morgan, Owen B *DcVicP 2*
Morgan, Patrick 1904- *WhAmArt 85*
Morgan, Peter James 1939- *MarqDCG 84*
Morgan, Randall 1920- *WhoAmA 73, -76*
Morgan, Reid A 1931- *AmArch 70*
Morgan, Richard Loyd 1939- *MarqDCG 84*
Morgan, Robert 1921- *ClaDrA*
Morgan, Robert 1922- *WhoArt 80, -82, -84*
Morgan, Robert Coolidge 1943- *WhoAmA 80, -82, -84*
Morgan, Robert Edward 1929- *AmArch 70*
Morgan, Robert F 1929- *IlBEAAW*
Morgan, Ronald 1936- *WhoAmA 80, -82, -84*
Morgan, Roy 1928- *IlsBYP, IlsCB 1946*
Morgan, S *DcVicP 2*
Morgan, S Louisa *DcVicP 2*
Morgan, Sherley Warner 1892- *AmArch 70*
Morgan, Sybil Andrews *WhoAmA 82, -84*
Morgan, T H *DcVicP 2*
Morgan, Tarquato *NewYHSD*
Morgan, Theo J 1872-1947 *ArtsAmW 3*
Morgan, Theodora *WhoAmA 78, -80, -82, -84*
Morgan, Theodore J 1872-1947 *ArtsAmW 3*
Morgan, Theophilous John 1872- *WhAmArt 85*
Morgan, Theophilus J 1872-1947 *ArtsAmW 3*
Morgan, Thomas *FolkA 86*
Morgan, Thomas H 1857-1940 *BiDAmAr*
Morgan, Thomas W *NewYHSD*
Morgan, Wallace d1948 *WhAmArt 85, WhoAmA 78N, -80N, -82N, -84N*
Morgan, Wallace 1873-1948 *IlrAm B, -1880, WorECar*
Morgan, Walter Jenks 1847-1924 *DcBrA 1, DcBrBI, DcVicP, -2*
Morgan, Warren Dean 1939- *WhoAmA 78*
Morgan, Wendell R, Jr. 1940- *AmArch 70*
Morgan, William *NewYHSD*
Morgan, William 1814-1896 *BiDAmAr*
Morgan, William 1826- *ArtsNiC*
Morgan, William 1826-1900 *NewYHSD, WhAmArt 85*
Morgan, William 1930- *ConArch, MacEA*
Morgan, William 1944- *WhoAmA 76, -78, -80, -82, -84*
Morgan, William Evan Charles 1903- *DcBrA 1*
Morgan, William Frend De 1839-1917 *AntBDN A, DcNiCA, McGDA*
Morgan, William H *FolkA 86*
Morgan, William James *DcVicP 2*
Morgan, William Newton 1930- *AmArch 70*
Morgan, William P *EarABI, NewYHSD*
Morgan, William S *FolkA 86*
Morgan And Sanders *AntBDN G*
Morgan-Jones, David Sylvanus *WhoArt 82N*
Morgan-Jones, David Sylvanus 1900- *WhoArt 80*
Morgand, Cecile *DcWomA*
Morganelli, Daniel 1917- *AmArch 70*
Morganstern, James 1936- *WhoAmA 84*
Morgen, Kate *DcVicP 2*
Morgenlander, Ella Kramer 1931- *WhoAmA 82, -84*
Morgenroth, Joseph G 1886- *WhAmArt 85*
Morgenstern, Andreas *McGDA*
Morgenstern, David M 1923- *AmArch 70*
Morgenstern, Harvey *MarqDCG 84*
Morgenthaler, Charles Albert 1893- *WhAmArt 85*
Morgenthaler, Ernst 1887-1962 *OxTwCA, PhDcTCA 77*
Morgereth, Frank 1899- *WhAmArt 85*
Morghen, Raffaele 1758-1833 *McGDA*
Morgner, Wilhelm 1891-1917 *McGDA, OxTwCA, PhDcTCA 77*
Morgret, Paul 1911- *AmArch 70*
Morgridge, Howard H 1919- *AmArch 70*
Morhart, Adam 1819?- *NewYHSD*
Morhous, Gwen Carl 1914- *AmArch 70*
Mori, A Y *AmArch 70*
Mori, Camilo 1896- *PhDcTCA 77*
Mori, Hanae *FairDF JAP, WorFshn*
Mori, Hanae 1926- *ConDes*
Mori, Yasuji 1925- *WorECar*
Moria, Blanche Adele 1859-1927 *DcWomA*
Moriarty, Albert P *NewYHSD*
Moriarty, John J *NewYHSD*
Moriarty, R E *AmArch 70*
Morice, A A *DcVicP 2, DcWomA*
Morice, Miss A A *DcBrWA*
Morien, Catharina *DcWomA*
Morier, David 1705?-1770 *DcBrECP*
Mories, Fred G *WhAmArt 85*
Morigi, Roger 1907- *WhoAmA 80, -82*
Morikage *McGDA*
Morillas, Cecilia *DcWomA*
Morimoto, Hiromitsu 1942- *ICPEnP A, MacBEP*
Morin, Alexander C *NewYHSD*
Morin, Anthony C *NewYHSD*
Morin, Donald G 1936- *MarqDCG 84*
Morin, Edmond 1824-1882 *ClaDrA, DcVicP 2*
Morin, Edward *DcVicP 2*
Morin, Edward 1824-1882 *DcBrBI*

Mosman, William d1771 *DcBrECP*
Mosnier, Jean-Laurent 1743-1808 *DcBrECP*
Moss, Alvin *FolkA 86*
Moss, Betty Anne Lipper 1921- *AmArch 70*
Moss, Charles *WhAmArt 85*
Moss, Charles Albert, Jr. 1929- *AmArch 70*
Moss, Charles E *WhAmArt 85*
Moss, Charles Eugene 1860-1901 *ArtsAmW 1*
Moss, Colin William 1914- *DcBrA 1*
Moss, Donald 1920- *ConGrA 1[port]*
Moss, Donald Laurie 1917- *AmArch 70*
Moss, Edward *NewYHSD*
Moss, Ella A 1844- *ArtsNiC, DcWomA*
Moss, Emma Lee 1916- *FolkA 86*
Moss, Frank 1838- *WhAmArt 85*
Moss, Frank 1838-1905? *NewYHSD*
Moss, Frederick *FolkA 86*
Moss, Gary *OfPGCP 86*
Moss, Gary William 1946- *WhoAmA 82, -84*
Moss, Henry William *DcBrA 1, DcVicP 2*
Moss, Hugh 1904- *WhoArt 80, -82, -84*
Moss, Irene *WhoAmA 73, -76, -78, -80, -82, -84*
Moss, Jacqueline *WhoAmA 82, -84*
Moss, Joe 1933- *PrintW 83, -85, WhoAmA 73, -76, -78, -80, -82, -84*
Moss, Joel C *WhoAmA 73, -76, -78, -80, -82, -84*
Moss, John H B *DcVicP 2*
Moss, Karen Canner 1944- *WhoAmA 80, -82, -84*
Moss, Leland Mark 1917- *AmArch 70*
Moss, Lottie Wilson *AfroAA*
Moss, Margaret 1814?- *FolkA 86*
Moss, Marlow 1890-1958 *DcBrA 2, DcWomA*
Moss, Milton *WhoAmA 73, -76, -78, -80, -82, -84*
Moss, Morrie Alfred 1907- *WhoAmA 73, -76, -78*
Moss, P Buckley *OfPGCP 86*
Moss, Phoebe Anna *DcWomA*
Moss, Randy Hays 1953- *MarqDCG 84*
Moss, Reuben *ArtsEM*
Moss, Sidney Dennant 1884-1946 *DcBrA 1, -2*
Moss, T W *AmArch 70*
Moss, William 1754- *BiDBrA*
Mossberg *EncASM*
Mossberg, Andrew Eric 1962- *MarqDCG 84*
Mosscher, Jacob De *ClaDrA*
Mosse, Frederick Hurd 1890- *AmArch 70*
Mosselman, Paul d1467 *McGDA*
Mosser, John 1811?- *FolkA 86*
Mosser, Veronica *FolkA 86*
Mosses, W J *DcVicP 2*
Mosset, Olivier 1944- *ConArt 77, -83*
Mossman, David 1825-1901 *DcBrWA, DcVicP 2*
Mossman, W H *DcVicP 2*
Most, Herbert J 1932- *MarqDCG 84*
Mostaert, Gillis 1534?-1598 *ClaDrA*
Mostaert, Jan 1475?-1556? *McGDA, OxArt*
Mostbock, Karl 1921- *DcCAr 81*
Mosteller, Johannes *FolkA 86*
Mosticker-Lavergne, Helene *DcWomA*
Mostyn, Ida *DcWomA*
Mostyn, Marjorie 1893- *DcBrA 1, DcWomA*
Mostyn, Tom 1864-1930 *DcBrA 1*
Mostyn, Tom E 1864-1930 *DcVicP 2*
Mota, Anisio Oscar Da 1891-1969 *WorECar*
Mote, Alden 1840-1917 *NewYHSD, WhAmArt 85*
Mote, Gary Ralph 1929- *AmArch 70*
Mote, George William 1832-1909 *DcBrA 1, DcBrWA, DcVicP, -2*
Mote, J H *DcVicP 2*
Mote, Marcus *FolkA 86*
Mote, Marcus 1817-1898 *NewYHSD, WhAmArt 85*
Mote, W H, Jr. *DcVicP 2*
Mothans, Alfred *DcVicP 2*
Motherwell, Robert 1915- *AmArt, ConArt 77, -83, DcAmArt, DcCAA 71, -77, DcCAr 81, McGDA, OxArt, OxTwCA, PhDcTCA 77, PrintW 83, -85, WhAmArt 85, WhoAmA 73, -76, -78, -80, -82, -84, WorArt[port]*
Motherwell, Robert Burns, III 1915- *BnEnAmA*
Mothon, Philip 1949- *MarqDCG 84*
Moti, Kaiko 1921- *PrintW 83, -85*
Motjuoadi, Andrew *OxTwCA*
Motley, Archibald J, Jr. 1891- *AfroAA*
Motley, Archibald John, Jr. 1891- *WhAmArt 85*
Motley, Eleanor W 1847- *DcWomA, WhAmArt 85*
Motley, Kenneth Leighton 1929- *AmArch 70*
Motley, Robert E *WhAmArt 85*
Motonaga, Sadamasa *OxTwCA*
Motonobu 1476-1559 *McGDA*
Motorojescu, Mariora *OxTwCA*
Mott, Mrs. *DcWomA*
Mott, Alice M *DcWomA*
Mott, B H *NewYHSD*
Mott, Dewitt C *FolkA 86*
Mott, Edwin *DcVicP 2*
Mott, J *DcVicP 2*
Mott, J C *AntBDN K*
Mott, J N *DcVicP 2*
Mott, John Kneeland 1937- *AmArch 70*
Mott, Laura *DcVicP 2*
Mott, R S *DcVicP 2*
Mott, Ralph Oliver 1903- *AmArch 70*

Mott-Smith, Harold M *WhAmArt 85*
Mott-Smith, John 1930- *ICPEnP A*
Mott-Smith, May d1952 *WhoAmA 78N, -80N, -82N, -84N*
Mott-Smith, May 1879-1952 *ArtsAmW 2, DcWomA, WhAmArt 85*
Motta, Flavio *ConArch A*
Motta, Raffaellino *McGDA*
Motte, Andrew d1730 *BkIE*
Motter, Dean Roger 1953- *WhoAmA 78, -80, -82*
Motter, Laurence Joseph 1904- *AmArch 70*
Motter, M A *AmArch 70*
Mottet, Jeanie Gallup 1864-1934 *DcWomA*
Mottet, Yvonne *OxTwCA*
Mottett, Jeanie Gallup d1934 *WhAmArt 85*
Mottez, Madame *DcWomA*
Mottez, Victor Louis 1809-1897 *ClaDrA*
Motti, Agostino *McGDA*
Motti, Cristoforo *McGDA*
Motti, Jacopo *McGDA*
Motto, Joseph C 1892- *WhAmArt 85*
Mottram, A *DcVicP 2*
Mottram, C *NewYHSD*
Mottram, Charles Sim *ClaDrA, DcBrA 1, DcBrWA, DcVicP, -2*
Mottram, J M *DcVicP 2*
Motts, Alicia Sundt *WhAmArt 85*
Moty, Eleanor 1945- *DcCAr 81*
Motz, Grace Leslie 1911- *WhAmArt 85*
Motz, Ray Estep *WhAmArt 85*
Motz, Mrs. Ray Estep 1875-1930 *DcWomA, WhAmArt 85*
Motz-Lowdon, Elsie *DcWomA, WhAmArt 85*
Mouchel, Marie Berthe *DcWomA*
Moucheron, Frederic De 1633-1686 *ClaDrA*
Moucheron, Frederik De 1633-1686 *McGDA*
Moucheron, Isaac De 1667-1744 *ClaDrA, McGDA*
Mouchet, Francois Nicolas 1750-1814 *ClaDrA*
Mouchette, Berthe *DcWomA*
Mouchot, Louis *ArtsNiC*
Moudrux, Mademoiselle *DcWomA*
Moufarrege, Nicolas A 1947- *WhoAmA 84*
Mougel, Max 1895- *WhAmArt 85*
Mouilleraux, Nathalie *DcWomA*
Mouillet, Marie Christine 1802-1885 *DcWomA*
Mould, J B *NewYHSD*
Mould, J W *DcVicP 2*
Mould, Jacob Wray 1825-1884 *BiDAmAr*
Mould, Jacob Wrey 1825-1886 *MacEA*
Mould, Lola Frowde 1908- *WhoAmA 73, -76, -78, -80*
Mould, Ruth Greene 1894- *DcWomA, WhAmArt 85*
Moule, Henry 1825-1904 *DcBrWA*
Moule, Henry Joseph *DcBrWA*
Moule, T W *AmArch 70*
Moule, Thomas *AntBDN I*
Moule, Thomas 1785-1851 *DcBrWA*
Mouledous, Richard Calvin 1930- *AmArch 70*
Moules, George Frederick 1918- *ClaDrA, DcBrA 1*
Moulignon, Henri Antoine Leopold De 1821-1897 *ClaDrA*
Moulin *DcBrBI*
Moulin, Hippolyte *ArtsNiC*
Moulin, Leopoldine *DcWomA*
Moulis, Frank John 1931- *AmArch 70*
Moulson, Deborah *DcWomA, NewYHSD*
Moulthrop, Edward *DcCAr 81*
Moulthrop, Edward Allen 1916- *AmArch 70*
Moulthrop, Major 1805- *FolkA 86*
Moulthrop, Reuben 1763-1814 *BnEnAmA, DcAmArt, FolkA 86, NewYHSD*
Moulting, George *DcVicP 2*
Moulton, Alex 1920- *ConDes*
Moulton, Claxton B *WhAmArt 85*
Moulton, Ebenezer 1768-1824 *AntBDN Q*
Moulton, Frank 1847- *WhAmArt 85*
Moulton, John 1669-1740 *FolkA 86*
Moulton, Jonathan 1726-1787 *CabMA*
Moulton, Katherine *WhAmArt 85*
Moulton, May *ArtsEM, DcWomA*
Moulton, Minerva *DcWomA*
Moulton, Rosalind Kimball 1941- *ICPEnP A, MacBEP, WhoAmA 78, -80, -82, -84*
Moulton, Sarah A *ArtsEM, DcWomA*
Moulton, Sue 1873- *DcWomA*
Moulton, Sue Buckingham 1873- *WhAmArt 85*
Moulton, Susan Gene 1944- *WhoAmA 78, -80, -82, -84*
Moulton, Walter 1929- *AmArch 70*
Moulton, William Carl 1921- *AmArch 70*
Moulton Brothers *FolkA 86*
Moultons, Abel 1784-1840? *BnEnAmA*
Moultons, Ebenezer 1768-1824 *BnEnAmA*
Moultons, Enoch 1780-1815 *BnEnAmA*
Moultons, Joseph 1694-1756 *BnEnAmA*
Moultons, Joseph 1744-1816 *BnEnAmA*
Moultons, Joseph 1814-1903 *BnEnAmA*
Moultons, William 1720-1793? *BnEnAmA*
Moultons, William 1772-1861 *BnEnAmA*
Moultray, J Douglas *DcVicP 2*
Mounce, Howard Wendell 1934- *AmArch 70*

Mouncey, William 1852-1901 *DcBrA 1, DcVicP 2*
Moundford, Arnold G 1873-1942 *ArtsAmW 2*
Mounfield, William Pratt 1915- *AmArch 70*
Mounicq, Jean 1931- *MacBEP*
Mounier, Louis 1852- *WhAmArt 85*
Mounier, Therese *DcWomA*
Mounsey, R K *DcVicP 2*
Mount, Cati 1903- *WhAmArt 85*
Mount, Charles Merrill 1928- *WhoAmA 73, -76, -78*
Mount, Evalina 1837-1920 *DcWomA*
Mount, Henry Smith 1802-1841 *NewYHSD*
Mount, James Donald 1924- *AmArch 70*
Mount, Marshall Ward 1927- *WhoAmA 78, -80, -82, -84*
Mount, Paul 1922- *WhoArt 84*
Mount, Pauline Ward *WhoAmA 78*
Mount, Richard *AntBDN I*
Mount, Rita *DcWomA*
Mount, Shepard 1804-1868 *ArtsNiC*
Mount, Shepard Alonzo 1804-1868 *NewYHSD*
Mount, Ward *WhAmArt 85, WhoAmA 73, -76, -80, -82, -84*
Mount, William S 1806-1868 *ArtsNiC*
Mount, William Sidney 1807-1868 *ArtsAmW 1, BnEnAmA, DcAmArt, McGDA, NewYHSD*
Mountague, James 1776?-1853 *BiDBrA*
Mountague, William 1773-1843 *BiDBrA*
Mountain, Charles 1743?-1805 *BiDBrA*
Mountain, Charles 1773?-1839 *BiDBrA*
Mountain, Kate A P *DcWomA*
Mountain, William *DcVicP 2*
Mountcastle, Clara H *DcWomA*
Mountcastle, Eliza *DcWomA*
Mountford *FolkA 86*
Mountford, Arthur Roy 1935- *AmArch 70*
Mountford, Edward William 1855-1908 *WhoArch*
Mountford, Ernest Chesmer 1844-1922 *DcBrA 1, DcVicP 2*
Mountford, S *AmArch 70*
Mountfort *FolkA 86*
Mountfort, Arnold 1873- *WhAmArt 85*
Mountfort, Arnold G 1873-1942 *ArtsAmW 2*
Mountfort, B W 1824-1898 *MacEA*
Mountfort, Julia Ann 1888?- *DcWomA, WhAmArt 85*
Mounts, Aaron *FolkA 86*
Mounts, L L *AmArch 70*
Mounts, Larry Lee *AmArch 70*
Mountz, Aaron 1873-1949 *FolkA 86*
Mouque, A *DcVicP 2*
Mourant, E *DcVicP 2*
Mouraud, Tania 1942- *ConArt 77, -83*
Moure, Nancy Dustin Wall 1943- *WhoAmA 76, -78, -80, -82, -84*
Mourgue, Olivier 1939- *ConDes*
Mourian, J *DcWomA*
Mourier, Madame *DcWomA*
Mouring, John Lynwood, Jr. 1931- *AmArch 70*
Mouron, Adolphe *McGDA*
Mourot, Hubert 1943- *DcCAr 81*
Mouse *DcBrBI*
Mousseau, Thomas Earl, Jr. 1951- *MarqDCG 84*
Mousseaux, Marie Amicie *DcWomA*
Moussu, Therese Alix *DcWomA*
Moutet, Celestine *DcWomA*
Mouton, Marguerite *DcWomA*
Mouton, P J *AmArch 70*
Mouton, Palma *DcWomA*
Moutoussamy, J W *AmArch 70*
Moutte, Jean Joseph Marie Alphonse 1840-1913 *ClaDrA*
Mouzoff, A *WhAmArt 85*
Movalli, Charles Joseph 1945- *WhoAmA 78, -80, -82, -84*
Movius, Mary L *ArtsEM, DcWomA*
Mow, Raymond 1932- *AmArch 70*
Mowat, Grace Helen 1875-1964 *DcWomA*
Mowat, H J *WhAmArt 85*
Mowat, Harold James 1879-1949 *IlrAm B, -1880*
Mowbray, H Siddons 1858-1928 *WhAmArt 85*
Mowbray, Henry Siddons 1858-1928 *ArtsAmW 2*
Mowbray, Henry Siddons 1917- *AmArch 70*
Mowbray-Clarke, John Frederick 1869- *WhAmArt 85*
Mower, Blanche J *ArtsEM, DcWomA*
Mower, Lowell Kendall, Jr. 1932- *AmArch 70*
Mower, Martin 1870- *WhAmArt 85*
Mowery, Michael E 1923- *AmArch 70*
Mowitz, Joachim 1944- *MarqDCG 84*
Mowris, Mrs. C C *WhAmArt 85*
Mowry *FolkA 86*
Mowry, James Raymond 1926- *AmArch 70*
Mowry, Phillip Charles 1932- *AmArch 70*
Mowry, William Harvey, Jr. 1935- *MarqDCG 84*
Mowson, J *DcBrECP*
Mowson, F d1808? *BkIE*
Moxey, Keith Patricio Fleming 1943- *WhoAmA 78, -80, -82, -84*
Moxley, Raymond 1923- *WhoArt 80, -82, -84*
Moxom, Jack 1913- *WhAmArt 85*
Moxon, Elizabeth *DcBrWA*
Moxon, Jenner *DcBrWA*

Moxon, John *DcBrWA*, *DcVicP 2*
Moxson, John *BiDBrA*
Moy d1750? *DcBrECP*
Moy, May 1913- *WhoAmA 76*, *−78*, *−80*, *−82*, *−84*
Moy, Phillip 1955- *MarqDCG 84*
Moy, Russell Gordon 1928- *AmArch 70*
Moy, Seong 1921- *DcCAA 71*, *−77*, *IlsBYP*, *IlsCB 1957*, *McGDA*, *WhoAmA 73*, *−76*, *−78*, *−80*, *−82*, *−84*
Moya, Hidalgo 1920- *ConArch*, *WhoArt 80*
Moya, Hidalgo 1926- *WhoArch*
Moya, John Hidalgo 1920- *McGDA*
Moya, Pedro De 1610-1674 *McGDA*
Moyaert, Claes *McGDA*
Moyall, James *FolkA 86*
Moyano, Louis A 1907- *ClaDrA*
Moye, Ernest, Madame *DcWomA*
Moyer, David Perry 1921- *AmArch 70*
Moyer, Frederic Derr 1937- *AmArch 70*
Moyer, Jennie J *DcWomA*, *WhAmArt 85*
Moyer, Martin *FolkA 86*
Moyer, Miriam Finsterwald 1909- *WhAmArt 85*
Moyer, Philip Franklin 1924- *AmArch 70*
Moyer, Roy 1921- *DcCAA 71*, *−77*, *WhoAmA 73*, *−76*, *−78*, *−80*, *−82*, *−84*
Moyer, Virginia *DcWomA*, *WhAmArt 85*
Moyers, William 1916- *IlBEAAW*, *IlsBYP*, *IlsCB 1946*, *WhoAmA 76*, *−78*, *−80*, *−82*, *−84*
Moyerstein *NewYHSD*
Moyerstein, Benjamin *NewYHSD*
Moyes, F *DcVicP 2*
Moyes, Peter M A 1916- *AmArch 70*
Moylan, Lloyd 1893- *ArtsAmW 1*, *IlBEAAW*, *WhAmArt 85*
Moyle, Eldred Finch 1902- *AmArch 70*
Moyle, John *BiDBrA*
Moynahan, Elizabeth 1925- *AmArch 70*
Moynahan, John S *ArtsEM*
Moynan, R T 1856-1906 *DcBrA 1*
Moynan, Richard Thomas 1856-1906 *DcBrA 2*, *DcVicP 2*
Moynihan, Dennis Patrick 1960- *MarqDCG 84*
Moynihan, Frederick 1843-1910 *WhAmArt 85*
Moynihan, H S 1902- *WhAmArt 85*
Moynihan, Rodrigo 1910- *ConBrA 79[port]*, *DcBrA 1*, *DcCAr 81*, *OxTwCA*, *PhDcTCA 77*, *WhoArt 80*, *−82*, *−84*
Moynihan, Ursula 1912- *DcBrA 1*
Moyreau, Jean 1690-1762 *McGDA*
Moyse, Arthur 1914- *WhoArt 80*, *−82*, *−84*
Moyser, James 1693?-1753 *BiDBrA*
Moyser, John 1660?-1738 *BiDBrA*
Moyssen, Xavier 1924- *WhoAmA 76*, *−78*, *−80*, *−82*
Mozart, Anton 1573-1625 *ClaDrA*
Mozier, Joseph 1812-1870 *ArtsNiC*, *DcAmArt*, *NewYHSD*
Mozin, Charles Louis 1806-1862 *ClaDrA*
Mozin, Melanie *DcWomA*
Mozley, Anita Ventura 1928- *MacBEP*, *WhoAmA 78*, *−80*, *−82*, *−84*
Mozley, Charles *IlsCB 1967*
Mozley, Charles 1914- *IlsCB 1957*
Mozley, Charles 1915- *WhoGrA 62*
Mozley, Loren Norman 1905- *IlBEAAW*, *WhAmArt 85*
Mraz, Franjo 1910- *OxTwCA*
Mroczynski, Claus 1941- *MacBEP*
Mroszczak, Marcin 1950- *ConDes*
Mroszczak, Jozef 1910- *WhoGrA 62*
Mroszczak, Jozef 1910-1975 *ConDes*
Mroszczak, Marcin Jan 1950- *WhoGrA 82[port]*
Mroz, Daniel 1917- *WhoGrA 62*, *−82[port]*, *WorECar*
Mrozek, E G *AmArch 70*
Mruk, W 1895-1942 *WhAmArt 85*
Mruk, Walter 1883-1942 *IlBEAAW*
Mruk, Walter E 1895-1942 *ArtsAmW 2*
Mruk, Walter F 1928- *MarqDCG 84*
Mruk, Wladyslaw E 1895-1942 *ArtsAmW 2*
M'Taggart, William *ArtsNiC*
Mu, Ch'i *OxArt*
Mu-Ch'i *McGDA*
Mucate, George *BiDAmAr*
Mucchetti, Stephen A 1942- *MarqDCG 84*
Mucchi, Gabriele *OxTwCA*
Mucchi, Gabriele 1899- *DcCAr 81*
Mucchi-Wiegmann, Jenny *DcWomA*
Mucci, Nina *DcWomA*
Mucci, Ronald 1945- *MarqDCG 84*
Muccioli, Anna Maria 1922- *AmArt*, *WhoAmA 76*, *−78*, *−80*, *−82*, *−84*
Mucha, Alphonse 1860-1931 *DcNiCA*
Mucha, Alphonse 1860-1933 *AntBDN A*
Mucha, Alphonse 1860-1939 *ClaDrA*, *OxTwCA*, *PhDcTCA 77*
Mucha, Alphonse Maria 1860-1939 *WhAmArt 85*
Mucha, Alphonse Marie 1860-1939 *ICPEnP A*, *MacBEP*
Muche, Georg 1895- *OxTwCA*, *PhDcTCA 77*
Muche, George 1895- *DcCAr 81*

Muchison, Loren Ross 1936- *MarqDCG 84*
Muchlen, Thomas *NewYHSD*
Muchnic, Suzanne *WhoAmA 80*, *−82*, *−84*
Muchow, Charlotte Irene *MarqDCG 84*
Muchow, William C 1922- *AmArch 70*, *ConArch*
Muck, Joseph *AfroAA*
Muck, Rosa 1761-1797? *DcWomA*
Mucke, Heinrich Karl Anton 1806- *ArtsNiC*
Muckenfuss, Michael 1774-1808 *CabMA*
Muckley, Arthur Fairfax *DcVicP 2*
Muckley, Louis Fairfax *ClaDrA*, *DcBrBI*
Muckley, Louis Fairfax- *DcVicP 2*
Muckley, William *DcNiCA*
Muckley, William Jabez 1837-1905 *DcBrA 1*, *DcBrWA*, *DcVicP*, *−2*
Mudano, Frank Robert 1928- *AmArch 70*
Muddell, J Edward 1891- *AmArch 70*
Mudford, Grant 1944- *ConPhot*, *ICPEnP A*, *MacBEP*
Mudford, Grant Leighton 1944- *WhoAmA 84*
Mudge *DcBrECP*
Mudge, Alfred *DcVicP 2*
Mudge, Edmund Webster, Jr. 1904- *WhoAmA 73*, *−76*, *−78*, *−80*, *−82*, *−84*
Mudge, Joseph B *NewYHSD*
Mudge, Thomas 1717-1794 *AntBDN D*
Mudge, Zachariah *ArtsAmW 1*
Mudge, Zachariah Atwell 1813-1888 *NewYHSD*
Mudgett, Lucille 1911- *WhAmArt 85*
Mudgett, Marcia *WhAmArt 85*
Mudrinich, Peter Josef 1946- *MarqDCG 84*
Mueck-Cary *EncASM*
Mueden, Mathilde *DcWomA*, *WhAmArt 85*
Muehl, Otto 1925- *ConArt 77*, *−83*
Muehlen, Bernis VonZur 1942- *ICPEnP A*, *MacBEP*
Muehlen, Peter VonZur 1939- *MacBEP*
Muehlenbeck, Herbert P 1886- *ArtsAmW 3*
Muehlenhoff, Heinrich *FolkA 86*
Muehsam, Gerd *WhoAmA 78*
Muehsam, Gerd 1913-1979 *WhoAmA 80N*, *−82N*, *−84N*
Muelich, Hans 1516-1573 *McGDA*
Mueller *NewYHSD*
Mueller, Alexander 1872-1935 *ArtsAmW 2*, *WhAmArt 85*
Mueller, Alfred 1853-1896 *BiDAmAr*
Mueller, Amy Bianca 1956- *MarqDCG 84*
Mueller, Anton 1934- *AmArch 70*
Mueller, Arthur 1912- *AmArch 70*
Mueller, Augustus Max Johannes 1847- *WhAmArt 85*
Mueller, Carl *WhAmArt 85*
Mueller, Earl George 1914- *WhoAmA 73*, *−76*, *−78*, *−80*, *−82*
Mueller, Ethel F *WhAmArt 85*
Mueller, Frederick *NewYHSD*
Mueller, Frederick G 1873-1947 *BiDAmAr*
Mueller, Gary D 1950- *MarqDCG 84*
Mueller, Gerhardt *NewYHSD*
Mueller, Gustave A 1874-1937 *BiDAmAr*
Mueller, Hans Alexander *WhAmArt 85*
Mueller, Hans Alexander 1888- *IlsBYP*, *IlsCB 1946*
Mueller, Henrietta Waters 1915- *WhoAmA 73*, *−76*, *−78*, *−80*, *−82*, *−84*
Mueller, Herman Oscar 1878- *WhAmArt 85*
Mueller, Isabel *WorFshn*
Mueller, Jan 1922-1958 *ConArt 77*, *−83*
Mueller, Johanna *WhAmArt 85*
Mueller, John *NewYHSD*
Mueller, John Charles 1889- *WhAmArt 85*
Mueller, John Jacob d1781 *NewYHSD*
Mueller, John U *ArtsEM*
Mueller, Lola Pace 1889- *ArtsAmW 2*, *WhAmArt 85*
Mueller, Lola Pace 1889-1949 *DcWomA*
Mueller, Louis F 1886- *WhAmArt 85*
Mueller, M Gerardine *WhoAmA 73*, *−76*, *−78*, *−80*, *−82*, *−84*
Mueller, Max 1901- *DcBrA 2*
Mueller, Michael J 1893-1931 *ArtsAmW 2*, *IlBEAAW*, *WhAmArt 85*
Mueller, Otto *McGDA*
Mueller, Paul L *WhAmArt 85*
Mueller, Robert F 1922- *AmArch 70*
Mueller, Rose *ArtsEM*, *DcWomA*
Mueller, Rudolph 1859-1929 *FolkA 86*
Mueller, Rudolph C *WhAmArt 85*
Mueller, Stephen Konrad 1956- *MarqDCG 84*
Mueller, Trude 1913- *WhoAmA 76*, *−78*, *−80*, *−82*, *−84*
Mueller, Vincent G *AmArch 70*
Mueller-Brittnau, Willy 1938- *ConArt 77*
Mueller-Munk, Peter *EncASM*
Mueller-Munk, Peter 1904- *WhAmArt 85*
Muench, Agnes Lilienberg 1897- *ArtsAmW 2*, *DcWomA*, *WhAmArt 85*
Muench, Charles A 1937- *MarqDCG 84*
Muench, David 1936- *ICPEnP A*
Muench, David Josef 1936- *MacBEP*
Muench, John 1914- *WhoAmA 73*, *−76*, *−78*, *−80*, *−82*, *−84*
Muench, John D 1914- *WhAmArt 85*
Muench, Julian Rhodes 1905- *WhAmArt 85*

Muench, Karl C *FolkA 86*
Muenchen, Al 1917- *IlrAm F*
Muenchen, Al 1917-1975 *IlrAm 1880*
Muendel, George F 1871- *WhAmArt 85*
Muenier, Jules Alexis *ClaDrA*
Muensenmayer, Jacob *FolkA 86*
Muensterberger, Helene Coler 1921- *WhoAmA 73*
Muensterberger, Werner *WhoAmA 73*, *−76*, *−78*, *−80*, *−82*, *−84*
Mues, A William 1877-1946 *WhAmArt 85*
Mueschke, H Jay 1939- *AmArch 70*
Muesse, Allen R 1946- *MarqDCG 84*
Muffoletto, Robert 1947- *MacBEP*
Mugasis, Alexander Peter 1925- *AmArch 70*
Mugford, William *NewYHSD*
Mugler, Thierry 1946- *ConDes*
Mugnaini, Joseph Anthony 1912- *WhoAmA 73*, *−76*
Mugnier, George Francois 1857?-1938 *MacBEP*
Muhammad B Al-Husayn *MacEA*
Muhammad B Atsiz *MacEA*
Muhammad B Mahmud Al-Isfahani *MacEA*
Muheim, J *DcVicP 2*
Muhl, Roger 1929- *PrintW 85*
Muhlbacher, Joe 1876-1955 *FolkA 86*
Muhlberger, Richard Charles 1938- *WhoAmA 78*, *−80*, *−82*, *−84*
Muhlen, Marianne Von 1874- *DcWomA*
Muhlenberg, Frederick Augustus 1887- *AmArch 70*
Muhlenfeld, Otto 1871-1907 *WhAmArt 85*
Muhlenfeldt, Louisa S *DcVicP 2*, *DcWomA*
Muhlenhaupt, Kurt 1921- *DcCAr 81*
Muhlert, Christopher Layton 1933- *WhoAmA 84*
Muhlert, Jan Keene 1942- *WhoAmA 76*, *−78*, *−80*, *−82*, *−84*
Muhlhofer, Elizabeth *WhAmArt 85*
Muhlhofer, Elizabeth 1877-1950 *DcWomA*
Muhlstock, Louis 1904- *DcCAr 81*, *WhoAmA 73*, *−76*, *−78*, *−80*, *−82*
Muhlthaler, Helene *DcWomA*
Muhovic, Joze 1954- *DcCAr 81*
Muhr, Gotthard *DcCAr 81*
Muhr, Philip 1860-1916 *WhAmArt 85*
Muhrman, H 1854- *WhAmArt 85*
Muhrman, Henry *DcVicP 2*
Muidbled, Helene *DcWomA*
Muinonen, Kirsti 1943- *DcCAr 81*
Muir, Agnes *DcVicP 2*
Muir, Anne Davidson *DcBrA 1*
Muir, Anne Davidson 1875-1951 *DcWomA*
Muir, David *DcVicP 2*
Muir, Edla 1906- *AmArch 70*
Muir, Emily Lansingh *WhoAmA 73*, *−76*, *−78*, *−80*, *−82*, *−84*
Muir, H *DcVicP 2*
Muir, Helen *ArtsEM*, *DcWomA*
Muir, Henrietta *DcWomA*
Muir, Jane 1929- *WhoArt 80*, *−82*, *−84*
Muir, Jean *FairDF ENG[port]*, *WorFshn*
Muir, Jean 1933- *ConDes*
Muir, Jessie *DcVicP 2*
Muir, John 1815-1892 *FolkA 86*
Muir, Lynn J 1928- *AmArch 70*
Muir, Robert 1808?- *FolkA 86*
Muir, Robert George 1932- *AmArch 70*
Muir, Thomas 1810?- *FolkA 86*
Muir, Thomas Minton B *MacBEP*
Muir, W Temple *DcVicP 2*
Muir, Wardrop Openshaw 1878-1927 *MacBEP*
Muir, William 1818-1888 *FolkA 86*
Muir, William Horace d1965 *WhoAmA 78N*, *−80N*, *−82N*, *−84N*
Muirhead, Charles *DcVicP 2*
Muirhead, David Thomson 1867-1930 *DcBrA 1*, *DcBrWA*, *DcVicP 2*
Muirhead, John 1863-1927 *DcBrA 1*, *DcBrWA*, *DcVicP 2*
Muirhead, Kate Campbell *DcBrA 2*
Muirhead, L *DcVicP 2*
Muizule, Malda 1937- *PrintW 83*, *−85*
Muje, H D *FolkA 86*
Mujica, Francisco *MacEA*
Muk, George *FolkA 86*
Mukhina, Vera Ignatievna 1889-1953 *DcWomA*
Mukoyama, K *ArtsAmW 2*, *WhAmArt 85*
Mulard, Henriette Clementine *DcWomA*
Mularz, Theodore L 1933- *AmArch 70*
Mulas, Ugo 1928- *DcCAr 81*
Mulas, Ugo 1928-1973 *ConPhot*, *ICPEnP*
Mulcahy, Freda *WhoAmA 73*, *−76*, *−78*
Mulcahy, Jeremiah Hodges d1889 *DcBrWA*, *DcVicP 2*
Mulcahy, Kathleen *DcCAr 81*
Mulcahy, Kathleen 1950- *WhoAmA 80*, *−82*, *−84*
Muldawer, Paul 1932- *AmArch 70*
Mulder, C *DcWomA*
Muler, Christian *FolkA 86*
Muler, Hector B *NewYHSD*
Mulertt, Carel Eugene 1869- *WhAmArt 85*
Mulford, Mrs. Hunter P *WhAmArt 85*
Mulford, John H *EncASM*
Mulford, Laura L 1894- *DcWomA*

Murillo, Gerardo *McGDA*
Murin *NewYHSD*
Muringer, Caspar *NewYHSD*
Murison, Neil *DcCAr 81*
Murison, Neil 1930- *WhoArt 80, -82, -84*
Murk, Martin R *OfPGCP 86*
Murnig, Guido Anthony *AmArch 70*
Murovich, Ralph J 1935- *AmArch 70*
Murphey, Edith Blaisdell *WhAmArt 85*
Murphey, J A *AmArch 70*
Murphey, Mimi 1912- *WhAmArt 85*
Murphey, Virginia A *DcWomA, WhAmArt 85*
Murphy *DcBrECP*
Murphy, Miss *DcBrECP*
Murphy, A W *AmArch 70*
Murphy, Ada C *WhAmArt 85*
Murphy, Ada Clifford *DcWomA*
Murphy, Adis C *ArtsEM*
Murphy, Alice 1871-1909 *DcWomA*
Murphy, Alice Harold *WhAmArt 85*
Murphy, Alice Harold 1896-1966 *DcWomA*
Murphy, Anna *DcWomA*
Murphy, Arthur Richard 1908- *AmArch 70*
Murphy, Blanche *DcWomA*
Murphy, Brian P *MarqDCG 84*
Murphy, C F *AmArch 70*
Murphy, C F, Jr. *AmArch 70*
Murphy, C W *AmArch 70*
Murphy, Caroline Boles *WhAmArt 85*
Murphy, Catherine 1946- *ConArt 83*
Murphy, Catherine E 1946- *WhoAmA 73, -76, -78, -80, -82, -84*
Murphy, Cecil Tremayne *DcWomA*
Murphy, Charles *FolkA 86*
Murphy, Charles Crawford 1936- *AmArch 70*
Murphy, Chester Glenn 1907- *WhoAmA 73, -76, -78, -80, -82, -84*
Murphy, Christopher, Jr. 1902- *WhAmArt 85*
Murphy, D X 1854-1933 *MacEA*
Murphy, David Bruce 1937- *AmArch 70*
Murphy, Dennis Brownell 1755?-1842 *DcBrWA*
Murphy, Dennis Xavier 1854-1933 *BiDAmAr*
Murphy, Don Gregory 1937- *AmArch 70*
Murphy, Douglas Smith *AmArch 70*
Murphy, Dudley C 1940- *WhoAmA 82, -84*
Murphy, Edward H *NewYHSD*
Murphy, Edward Henry 1796?-1841 *DcVicP 2*
Murphy, Elizabeth *ConArch A*
Murphy, Ella *WhAmArt 85*
Murphy, Emma J *WhAmArt 85*
Murphy, Esther *DcWomA*
Murphy, Esther Longyear McGraw *ArtsEM*
Murphy, Eugene John 1934- *AmArch 70*
Murphy, Eugenie Muelhauser *WhoAmA 73, -76*
Murphy, Florence *DcWomA*
Murphy, Frank C *OfPGCP 86*
Murphy, George *FolkA 86*
Murphy, Gerald 1888-1964 *DcAmArt, WhAmArt 85*
Murphy, Gertrude Burgess 1899- *WhAmArt 85*
Murphy, Gladys Wilkins 1907- *WhAmArt 85, WhoAmA 73, -76, -78, -80, -82, -84*
Murphy, H B *AmArch 70*
Murphy, Harriet Anderson 1851-1935 *DcWomA, WhAmArt 85*
Murphy, Harry 1880- *WhAmArt 85*
Murphy, Harry Daniels 1880- *ArtsAmW 2*
Murphy, Hass 1950- *WhoAmA 76, -78, -80, -82, -84*
Murphy, Helen Johnson 1933- *AmArch 70*
Murphy, Henry Cruse, Jr. 1886-1931 *WhAmArt 85*
Murphy, Henry David 1909- *WhAmArt 85*
Murphy, Herbert A 1911- *WhoAmA 73, -76, -78, -80, -82, -84*
Murphy, Hermann Dudley 1867-1945 *IlBEAAW, WhAmArt 85*
Murphy, J B, Jr. *AmArch 70*
Murphy, J Francis 1853-1921 *BnEnAmA, DcAmArt, WhAmArt 85*
Murphy, Mrs. J Francis *WhAmArt 85*
Murphy, J J *AmArch 70*
Murphy, Jack *DcCAr 81*
Murphy, James *CabMA, NewYHSD*
Murphy, James Cavanagh 1760-1814 *DcBrWA*
Murphy, James Cornelius 1864-1935 *BiDAmAr*
Murphy, James Edward 1891-1965 *WorECom*
Murphy, James Edward, Jr. 1891- *ArtsAmW 2*
Murphy, James Leonidas, Jr. 1916- *AmArch 70*
Murphy, John A *NewYHSD*
Murphy, John B *NewYHSD*
Murphy, John Cullen 1919- *WorECom*
Murphy, John Howard 1955- *MarqDCG 84*
Murphy, John J A *WhAmArt 85*
Murphy, John M *NewYHSD*
Murphy, John R *NewYHSD*
Murphy, John Ross 1827-1892 *DcBrWA, DcVicP 2*
Murphy, John Thomas 1913- *AmArch 70*
Murphy, Joseph Anthony 1894- *AmArch 70*
Murphy, Joseph Denis 1907- *AmArch 70*
Murphy, Joseph E *NewYHSD*
Murphy, L M *WhAmArt 85*
Murphy, Lawrence M *ArtsAmW 2*
Murphy, Leo 1906- *WhAmArt 85*

Murphy, Lucile Desbouillons *WhAmArt 85*
Murphy, M J, Jr. *AmArch 70*
Murphy, M J, Sr. *AmArch 70*
Murphy, Marjorie C *WhAmArt 85*
Murphy, Michael *NewYHSD*
Murphy, Michael 1867- *WhAmArt 85*
Murphy, Mildred V 1907- *WhAmArt 85*
Murphy, Minnie B 1863-1952 *DcWomA*
Murphy, Minnie B Hall 1863- *WhAmArt 85*
Murphy, Minnie B Hall Perry 1863- *ArtsAmW 2*
Murphy, Minnie Lois 1901- *WhAmArt 85*
Murphy, Myles 1927- *ConBrA 79[port]*
Murphy, Nelly Littlehale 1867- *WhAmArt 85*
Murphy, Nelly Littlehale Umbstaetter 1867-1941 *DcWomA*
Murphy, P L *AmArch 70*
Murphy, Peter *NewYHSD*
Murphy, R B *AmArch 70*
Murphy, Richard *FolkA 86*
Murphy, Robert L 1927- *AmArch 70*
Murphy, Robert Lyle 1914- *AmArch 70*
Murphy, Robert Stephen 1933- *AmArch 70*
Murphy, Rowley Walter 1891- *WhoAmA 73*
Murphy, Rowley Walter 1891-1975 *WhAmArt 85, WhoAmA 76N, -78N, -80N, -82N, -84N*
Murphy, Roy Dale 1927- *AmArch 70*
Murphy, S J *DcVicP 2*
Murphy, Seamus 1907- *DcBrA 1, WhoArt 80, -82, -84*
Murphy, Sean Patrick 1958- *MarqDCG 84*
Murphy, Susan 1950- *WhoAmA 84*
Murphy, Thomas J *NewYHSD*
Murphy, Thomas Joseph 1881- *DcBrA 1*
Murphy, Vahey *DcWomA*
Murphy, W *FolkA 86*
Murphy, William *NewYHSD*
Murphy, William Charles 1939- *MarqDCG 84*
Murphy, William Cook 1936- *AmArch 70*
Murphy, William D 1834- *NewYHSD , WhAmArt 85*
Murr, Lewis 1812?- *FolkA 86*
Murray, Albert 1906- *WhoAmA 73, -76, -78, -80, -82, -84*
Murray, Albert Edward 1849-1924 *DcBrA 1, -2*
Murray, Albert K 1906- *WhAmArt 85*
Murray, Alexander *ArtsEM*
Murray, Alexander 1888- *WhAmArt 85*
Murray, Alexander Henry Hallam 1854- *ClaDrA*
Murray, Alexander Henry Hallam 1854-1934 *DcBrA 1, DcVicP 2*
Murray, Amelia Matilda 1795-1884 *DcBrWA*
Murray, Anne *DcWomA*
Murray, Archibald *DcBrA 1*
Murray, C S *DcVicP 2*
Murray, Charles 1894-1954 *DcBrA 1*
Murray, Charles Fairfax 1849-1919 *ClaDrA, DcBrA 1, DcBrWA, DcVicP, -2*
Murray, Charles Gotschall 1909- *AmArch 70*
Murray, Charles Oliver 1842-1923 *DcBrA 1*
Murray, Charles Oliver 1842-1924 *DcBrBI*
Murray, Charles Parker 1938- *AmArch 70*
Murray, D J, III *AmArch 70*
Murray, Daniel McClure 1944- *MarqDCG 84*
Murray, David *DcBrECP*
Murray, David 1849- *ArtsNiC*
Murray, Sir David 1849-1933 *DcBrA 1, ClaDrA, DcBrBI, DcBrWA, DcVicP, -2*
Murray, David George 1919- *AmArch 70*
Murray, Donald 1940- *WhoArt 80, -82, -84*
Murray, Donald Howard 1920- *AmArch 70*
Murray, E *DcVicP 2*
Murray, E O *AmArch 70*
Murray, Lady Edith *DcVicP 2*
Murray, Elenor *DcWomA, FolkA 86, NewYHSD*
Murray, Eliza *DcWomA, FolkA 86, NewYHSD*
Murray, Eliza Dundas *DcVicP 2*
Murray, Elizabeth d1882 *ArtsNiC*
Murray, Elizabeth 1815-1882 *DcBrWA, DcWomA*
Murray, Elizabeth 1940- *AmArt, ConArt 83, PrintW 83, -85, WhoAmA 76, -78, -80, -82, -84*
Murray, Elizabeth Emily *DcVicP 2, DcWomA*
Murray, Elizabeth Heaphy 1815-1882 *NewYHSD*
Murray, Elwin George 1918- *AmArch 70*
Murray, Emily, Lady Oswald 1800-1896 *DcBrWA*
Murray, Ethel *DcVicP 2*
Murray, Faith Cornish 1897- *DcWomA, WhAmArt 85*
Murray, Florence E *DcVicP 2*
Murray, Floretta May *WhoAmA 73, -76, -78, -80, -82, -84*
Murray, Frank *DcVicP, -2*
Murray, Frank Waldo 1884-1956 *WhoAmA 80N, -82N, -84N*
Murray, Frederick S 1894-1973 *ArtsAmW 1*
Murray, George *AfroAA, BiDBrA, DcBrBI, DcVicP 2*
Murray, George d1822 *NewYHSD*
Murray, George 1875-1933 *DcBrA 1, DcVicP 2*
Murray, George E 1920- *AmArch 70*
Murray, George J *NewYHSD*
Murray, Grace H 1872-1944 *DcWomA,*

WhAmArt 85
Murray, H *DcVicP 2*
Murray, H C *AmArch 70*
Murray, Harold Paul 1900- *WhAmArt 85*
Murray, Mrs. Henry John 1815-1882 *DcVicP, -2*
Murray, Hester Miller 1903- *WhAmArt 85*
Murray, Ian Stewart 1951- *WhoAmA 84*
Murray, J G *DcBrA 2*
Murray, J L *AmArch 70*
Murray, James *NewYHSD*
Murray, James d1634 *BiDBrA*
Murray, James Marshall, III 1933- *AmArch 70*
Murray, Joan 1927- *ICPEnP A, MacBEP, WhoAmA 78, -80, -82, -84*
Murray, John *NewYHSD*
Murray, John 1783-1861 *CabMA*
Murray, John 1804- *CabMA*
Murray, John Michael 1931- *WhoAmA 73, -76, -78, -80, -82, -84*
Murray, John Reid 1861-1906 *DcBrA 1, -2, DcVicP 2*
Murray, John Robert 1774-1851 *NewYHSD*
Murray, Judith 1941- *WhoAmA 80, -82, -84*
Murray, Keith 1893- *DcNiCA, IlDcG*
Murray, L L *AmArch 70*
Murray, Lee Cloyd 1923- *AmArch 70*
Murray, Maria *DcVicP 2*
Murray, Martha *DcWomA*
Murray, Martin Joseph 1908- *WhAmArt 85*
Murray, Mary *DcBrA 1, DcWomA, NewYHSD*
Murray, Nina *DcWomA*
Murray, Ossie 1938- *IlsCB 1967*
Murray, Paul Joseph 1932- *AmArch 70*
Murray, Philip *MarqDCG 84*
Murray, R *DcBrECP*
Murray, Ralph V 1897- *ArtsAmW 3*
Murray, Richard Deibel 1921- *WhoAmA 73, -76, -78, -80, -82, -84*
Murray, Richard McCann 1920- *AmArch 70*
Murray, Richard Newton 1942- *WhoAmA 80, -82, -84*
Murray, Robert 1936- *ConArt 77, -83, DcCAA 71, -77, OxTwCA, WhoAmA 73, -76, -78, -80, -82, -84*
Murray, Robert James 1939- *AmArch 70*
Murray, Robert Peter 1937- *AmArch 70*
Murray, Samuel A 1869?-1941 *DcAmArt*
Murray, Samuel A 1870-1941 *WhAmArt 85*
Murray, Stuart 1926- *ConArch*
Murray, Thomas 1663-1735 *DcBrECP*
Murray, W *DcBrECP*
Murray, W Bazett *DcBrBI, DcVicP 2*
Murray, W Hay *DcVicP 2*
Murray, W L *AmArch 70*
Murray, Waldo *WhAmArt 85*
Murray, William *FolkA 86*
Murray, William Colman 1899- *WhoAmA 73, -76, -78*
Murray, William Colman 1899-1977 *WhoAmA 80N, -82N, -84N*
Murray, William Grant 1877-1950 *ClaDrA, DcBrA 1, DcVicP 2*
Murray, William J d1943 *WhAmArt 85*
Murray, William Maurice 1922- *AmArch 70*
Murray, William Staite *DcBrA 1*
Murray, William Staite 1881- *McGDA*
Murray, William Staite 1881-1962 *DcNiCA*
Murray Dixon, Henry Edward Otto 1885-1917 *DcBrA 1*
Murraygreen, Ryan 1947- *WhoAmA 78, -80, -82*
Murrell, Claire *DcBrBI*
Murrell, R C *AmArch 70*
Murrell, Sara *AfroAA*
Murrell, Thomas Grenalds 1929- *AmArch 70*
Murrer, Anna Barbara 1688-1721 *DcWomA*
Murrey, J M, Jr. *AmArch 70*
Murrin, Robert Joseph 1923- *AmArch 70*
Murry, Jerre 1904- *WhAmArt 85*
Murry, Richard Arthur Crossthwaite 1902- *DcBrA 1, WhoArt 80, -82, -84*
Murry, T *NewYHSD*
Murtaugh, Gerald *MarqDCG 84*
Murtaugh, J R *AmArch 70*
Murtfeldt, Amalie 1822?-1888 *DcWomA*
Murtic, Edo 1921- *DcCAr 81, OxTwCA, PhDcTCA 77, WhoGrA 62*
Murton, Clarence C 1901- *WhAmArt 85*
Murty, Frank *NewYHSD*
Musashi *McGDA*
Muscarelli, Susannah Fauntleroy Quarles *DcWomA*
Muscatelli, Dominic F 1940- *MarqDCG 84*
Musch, Max Adam 1903- *AmArch 70*
Muschamp, F Sydney *DcVicP*
Muschamp, F Sydney d1929 *DcBrA 1, DcVicP 2*
Muschamp, Francis *McGDA*
Muschenheim, Carl Arthur 1933- *AmArch 70*
Muschenheim, William 1902- *AmArch 70*
Muse, Aaron *NewYHSD*
Muse, Isaac Lane 1906- *WhAmArt 85*
Muse, John Edward 1950- *MarqDCG 84*
Musemeche, Robert Joe 1938- *AmArch 70*

Musgrave, Lady *DcWomA*
Musgrave, Miss *DcVicP 2*
Musgrave, Arthur Franklin 1878-1969 *ArtsAmW 3*
Musgrave, Arthur Franklin 1880-1970 *ArtsAmW 1*
Musgrave, Arthur Franklyn 1876- *WhAmArt 85*
Musgrave, Barbara 1937- *WhoArt 80, -82, -84*
Musgrave, Edith 1887- *DcWomA, WhAmArt 85*
Musgrave, G A *DcVicP 2*
Musgrave, Harry *DcVicP 2*
Musgrave, Helen Greene 1890- *DcWomA, WhAmArt 85*
Musgrave, Isabella *DcWomA*
Musgrave, Mary Ann *DcWomA*
Musgrave, Shirley H 1935- *WhoAmA 73, -76, -78, -80, -82, -84*
Musgrave, Thomas M *DcVicP, -2*
Musgrave, William *DcVicP 2*
Musgrave-Wood, John 1915- *WorECar*
Musgrove, A J *WhoAmA 78N, -80N, -82N, -84N*
Musgrove, Alexander 1882-1952 *DcBrA 2*
Musgrove, E M *AmArch 70*
Musgrove, Louis 1893- *WhAmArt 85*
Musgrove, Stephen Ward 1949- *WhoAmA 78, -80, -82, -84*
Musho, Theodore John 1932- *AmArch 70*
Musi, Agostino De 1490?-1540? *McGDA*
Musial, Joseph 1905- *WorECom*
Music, Antonio 1909- *McGDA*
Music, Zoran 1909- *DcCAr 81*
Music, Zoran Antonio 1909- *ConArt 77, PhDcTCA 77, WhoArt 80, -82, -84*
Musick, Archie L 1902- *WhAmArt 85, WhoAmA 76, -78*
Musick, Clayton Crews 1919- *AmArch 70*
Musick, George Meredith 1892- *AmArch 70*
Musick, James Roger 1903- *AmArch 70*
Musick, Pat 1926- *AmArt, WhoAmA 80, -82, -84*
Musick, W E 1896- *WhAmArt 85*
Musin, Auguste Henri 1852- *DcSeaP*
Musin, Francois *ArtsNiC*
Musin, Francois Etienne 1826-1888 *DcSeaP*
Musker, Rachel Joan 1928- *WhoArt 84*
Muskett, Alice J *DcWomA*
Musmeci, Sergio 1926-1981 *MacEA*
Musolino, Anthony Frank 1926- *AmArch 70*
Muspratt, Aimee *DcBrA 2*
Muspratt, Alicia Frances *ClaDrA*
Muspratt, Alicia Frances 1902- *DcBrA 2*
Muspratt, R F L *DcVicP 2*
Muss, Charles 1779-1824 *DcNiCA*
Muss-Arnolt, Gustav 1858-1927 *WhAmArt 85*
Mussawir, Donald Victor 1931- *AmArch 70*
Musscher, Michael Van 1645-1705 *ClaDrA*
Musscher, Michiel Van 1645-1705 *McGDA*
Musselman, Darwin B 1916- *WhoAmA 73, -76, -78, -80, -82, -84*
Musselman, M Emma 1880- *DcWomA, WhAmArt 85*
Musselman, Samuel B 1799-1871 *FolkA 86*
Musselman-Carr, M V 1880- *WhAmArt 85*
Musselman-Carr, Myra V 1880- *DcWomA*
Musser, B J 1885- *WhAmArt 85*
Musser, Everett Wilson 1931- *AmArch 70*
Musser, Tharon 1925- *ConDes*
Mussett, Charles 1927- *DcCAr 81*
Mussey, I Osgood 1818?- *NewYHSD*
Mussey, J Osgood 1818?- *NewYHSD*
Mussill, W *AntBDN M*
Mussini, Cesare 1808- *ArtsNiC*
Mussini, Luigi 1813- *ArtsNiC*
Mussini-Franchi, Luisa 1864?- *DcWomA*
Mussini-Piaggio, Luigia 1830-1865 *DcWomA*
Mussino, Attilio 1878-1954 *IlsBYP, WorECar*
Mussman, Laurel Anderson 1925- *AmArch 70*
Musso, Angelo *AmArch 70*
Musson, Noverre 1910- *AmArch 70*
Mustchin, Jill 1939- *DcCAr 81*
Muster, Miki 1925- *WorECom*
Musto, Frederick *DcVicP 2*
Musurus, P *DcVicP 2*
Muszalski, James Robert 1939- *MarqDCG 84*
Muszynska, Teresa 1937- *ConArt 77*
Muszynski, Leszek Tadeusz 1923- *ClaDrA, DcBrA 1, WhoArt 80, -82, -84*
Muszynski, Tadeusz Znicz- 1921- *WhoArt 80, -82, -84*
Mutalier, Jean 1947- *WhoGrA 82[port]*
Mutch, George Kirkton 1877- *DcBrA 1*
Mutchler, Robert C 1933- *AmArch 70*
Muteau, J *DcWomA*
Mutel, Alexandrine *DcWomA*
Mutel, Louise Hermine 1811-1881 *DcWomA*
Muter, Marie Mela 1873?-1967 *DcWomA*
Muter, Marie Mela 1886- *ClaDrA*
Muth, Alice Lolita 1887- *WhAmArt 85*
Muth, Alice Lolita Helen 1887- *DcWomA*
Muth, Gustave 1891- *AmArch 70*
Muth, John Haverstick 1907- *WhAmArt 85*
Muth, Marcia 1919- *FolkA 86*
Muthesius, Hermann 1861-1927 *EncMA, MacEA, McGDA*

Muths, Thomas Brown 1931- *AmArch 70*
Mutrie, Annie F *ArtsNiC*
Mutrie, Annie Feray 1826-1893 *ClaDrA, DcVicP, -2, DcWomA*
Mutrie, Martha D *ArtsNiC*
Mutrie, Martha Darlay 1824-1885 *ClaDrA*
Mutrie, Martha Darley 1824-1885 *DcVicP, -2, DcWomA*
Mutrux, Louis *WhAmArt 85*
Mutrux, Robert Henri 1909- *AmArch 70*
Mutter, R J *AmArch 70*
Mutti, Augustus d1873? *ArtsEM*
Mutton, Hilda *ArtsAmW 3, DcWomA, WhAmArt 85*
Muttoni, Clorinda *DcWomA*
Muttoni, Francesco 1669-1747 *MacEA*
Muttoni, Pietro 1603-1678 *McGDA*
Mutunayagam, N Brito 1943- *MarqDCG 84*
Mutzel, Gustav 1839-1893 *IlBEAAW*
Mutzer, Frederich *IlDcG*
Mutzer, Gottlieb *IlDcG*
Muxart, Jaume *OxTwCA*
Muybridge, Eadweard *DcNiCA*
Muybridge, Eadweard 1830-1904 *BnEnAmA, DcAmArt, ICPEnP, MacBEP, WhAmArt 85*
Muys, Cornelia 1745- *DcWomA*
Muys, Nicolaes 1740-1808 *ClaDrA*
Muysson, Hertha 1898- *DcWomA*
Muzaune, Suzanne 1876- *DcWomA*
Muziano, Girolamo 1528-1592 *McGDA, OxArt*
Muzio, Giovanni 1893- *MacEA*
Muzzy, C B *NewYHSD*
My, Hieronymus VanDer 1687-1761 *ClaDrA*
Myall, H A *DcVicP 2*
Mycock, Mike 1936- *DcCAr 81*
Mydans, Carl *MacBEP*
Mydans, Carl 1907- *ConPhot, ICPEnP*
Myer *NewYHSD*
Myer, Felix *NewYHSD*
Myer, George Val 1883-1959 *DcBrA 2*
Myer, H Ed *NewYHSD*
Myer, Henry *NewYHSD*
Myer, Henry 1837-1881 *BiDAmAr*
Myer, Hyam 1904- *DcBrA 1*
Myer, I *FolkA 86*
Myer, John Randolph 1927- *AmArch 70*
Myer, Marie Shields *DcWomA, WhAmArt 85*
Myer, P *FolkA 86*
Myer, Peter Livingston 1934- *WhoAmA 73, -76, -78, -80, -82, -84*
Myerling, Fred C 1940- *MarqDCG 84*
Myers *NewYHSD*
Myers, Anna M 1858- *DcWomA*
Myers, Annie M 1858- *WhAmArt 85*
Myers, Barton 1934- *ConArch*
Myers, Bernice *IlsBYP*
Myers, Bill G 1933- *MarqDCG 84*
Myers, C Stowe 1906- *WhoAmA 73, -76, -78, -80, -82, -84*
Myers, C Stowe Daniel 1906- *WhAmArt 85*
Myers, Carole Ann 1934- *WhoAmA 82, -84*
Myers, Charles D *FolkA 86*
Myers, Clarence T 1892- *AmArch 70*
Myers, D D *AmArch 70*
Myers, Daniel L *FolkA 86*
Myers, Datus E *WhAmArt 85*
Myers, Datus E 1879-1960 *ArtsAmW 2*
Myers, David C 1873-1935 *BiDAmAr*
Myers, David J *WhAmArt 85*
Myers, Denys Peter 1916- *WhoAmA 73, -76, -78, -80*
Myers, Donald Glenn 1938- *AmArch 70*
Myers, E J *AmArch 70*
Myers, E W *FolkA 86*
Myers, Elijah E 1831-1909 *ArtsEM*
Myers, Elijah E 1832-1909 *BiDAmAr, MacEA*
Myers, Elizabeth 1828-1917 *FolkA 86*
Myers, Emmet E 1868-1937 *WhAmArt 85*
Myers, Ethel 1881-1960 *DcWomA*
Myers, Ethel H Klink 1881-1960 *WhAmArt 85*
Myers, Ethel K 1881-1960 *WhoAmA 80N, -82N, -84N*
Myers, Florence *WhAmArt 85*
Myers, Forrest Warden 1941- *WhoAmA 73, -76, -78, -80, -82, -84*
Myers, Frances 1936- *PrintW 83, -85, WhoAmA 73, -76, -78, -80, -82, -84*
Myers, Frank Harmon 1899-1956 *ArtsAmW 1, -3, IlBEAAW, WhAmArt 85, WhoAmA 80N, -82N, -84N*
Myers, Fred A 1937- *WhoAmA 73, -76, -78, -80, -82, -84*
Myers, G *DcVicP 2*
Myers, George Hewitt 1865-1957 *WhoAmA 80N, -82N, -84N*
Myers, George Milton 1929- *AmArch 70*
Myers, Gerald D 1935- *AmArch 70*
Myers, Hannah *DcBrA 2*
Myers, Irwin *WhAmArt 85*
Myers, J A *AmArch 70*
Myers, Jack Fredrick 1927- *WhoAmA 78, -80, -82, -84*

Myers, James *FolkA 86*
Myers, Jennie C 1861-1934 *WhAmArt 85*
Myers, Jennie Chace 1861-1934 *DcWomA*
Myers, Jerome *OxTwCA*
Myers, Jerome 1867-1940 *BnEnAmA, DcAmArt, GrAmP, McGDA, WhAmArt 85*
Myers, Jerome 1867-1941 *PhDcTCA 77*
Myers, Joan 1944- *ICPEnP A, MacBEP*
Myers, Joel P 1934- *IlDcG*
Myers, Joel Philip 1934- *WhoAmA 76, -78, -80, -82, -84*
Myers, John *DcVicP 2*
Myers, John 1895- *WhoAmA 73*
Myers, John B *WhoAmA 73, -76, -78, -80*
Myers, John Kenneth 1910- *AmArch 70*
Myers, John Matthew 1923- *AmArch 70*
Myers, John Walter 1933- *AmArch 70*
Myers, Joyce Stillman *PrintW 83, -85*
Myers, Legh 1916- *WhoAmA 73, -76, -78, -80, -82, -84*
Myers, Lloyd B 1892-1955? *WhAmArt 85*
Myers, Lloyd Burton 1892-1954? *ArtsAmW 2*
Myers, Malcolm Haynie 1917- *WhoAmA 73, -76, -78, -80, -82, -84*
Myers, Mark Richard 1945- *DcSeaP, WhoArt 80, -82, -84*
Myers, Martin 1951- *DcCAr 81, WhoAmA 84*
Myers, Mary *FolkA 86*
Myers, Mary Rosalie Prestmen *FolkA 86*
Myers, Mary Shepherd Lukens 1878- *DcWomA, WhAmArt 85*
Myers, Myer 1723-1795 *AntBDN Q, BnEnAmA, McGDA, OxDecA*
Myers, O Irwin 1888- *ArtsAmW 3, WhAmArt 85*
Myers, R E *AmArch 70*
Myers, Ralph E 1917- *AmArch 70*
Myers, Randolph Peter 1941- *AmArch 70*
Myers, Richard Lewis 1937- *WhoAmA 78, -80, -82, -84*
Myers, Robert Harold 1928- *AmArch 70*
Myers, Robert L 1940- *MarqDCG 84*
Myers, Robert Luther 1926- *AmArch 70*
Myers, Russell 1938- *WorECom*
Myers, Russell C 1927- *AmArch 70*
Myers, S F *EncASM*
Myers, Sadie S *WhAmArt 85*
Myers, Sidney Jay *AmArch 70*
Myers, Stanley Lawrence 1923- *AmArch 70*
Myers, Texie 1900- *WhAmArt 85*
Myers, Virginia Anne 1927- *WhoAmA 76, -78, -80, -82, -84*
Myers, W *NewYHSD*
Myers, Ware 1913- *MarqDCG 84*
Myers, Wayne P 1919- *AmArch 70*
Myers, Willard 1887- *WhAmArt 85*
Myers, William Barksdale *EarABI SUP, NewYHSD*
Myers, William H 1815- *ArtsAmW 3*
Myers, William Henry 1815- *IlBEAAW, NewYHSD*
Myerscough-Walker 1912- *WhoArt 80, -82*
Myerscough-Walker 1913- *WhoArt 84*
Myerson, M *WhAmArt 85*
Myford, James C 1940- *WhoAmA 84*
Mygatt, Emily Tyers *DcWomA, WhAmArt 85*
Mygatt, Hiram 1795-1831 *FolkA 86*
Mygatt, Nellie B 1861?-1936 *DcWomA, WhAmArt 85*
Mygatt, Robertson K d1919 *WhAmArt 85*
Myhr, Dean Andrew 1930- *WhoAmA 73, -76*
Myin, Maria Jacoba 1769-1849 *DcWomA*
Mykkanen, Martti August 1926- *WhoGrA 62, -82[port]*
Myklebust, Arvid 1945- *MarqDCG 84*
Mykolyk, Ismay Mary 1926- *AmArch 70*
Mykrantz, Elizabeth S *WhAmArt 85*
Mylander, Mathilde M *WhAmArt 85*
Myler, Marshall *WhAmArt 85*
Myles, Glenn *AfroAA*
Myles, Milton *AfroAA*
Myles, Morton 1929- *WorFshn*
Mylius, Andrew 1935- *DcCAr 81*
Myll, Henry d1886 *ArtsEM*
Mylne, H *DcVicP 2*
Mylne, John d1621 *BiDBrA*
Mylne, John d1657 *BiDBrA*
Mylne, Robert *DcVicP 2*
Mylne, Robert 1633-1710 *BiDBrA*
Mylne, Robert 1733-1811 *BiDBrA*
Mylne, Robert 1734-1811 *DcD&D[port], McGDA, WhoArch*
Mylne, Robert, Family *MacEA*
Mylne, Mrs. Robert Williams *DcVicP 2*
Mylne, Thomas d1763 *BiDBrA*
Mylne, William 1734-1790 *BiDBrA*
Mylne, William Chadwell 1781-1863 *BiDBrA*
Mylne, William M d1903 *ArtsEM*
Myn, Agatha VanDer *DcWomA*
Myn, Cornelia VanDer 1710-1772 *DcWomA*
Myn, Frans VanDer 1719-1783 *ClaDrA*

Myn, Herman VanDer *McGDA*
Myn, Herman VanDer 1684-1741? *ClaDrA*
Mynarts, H *NewYHSD*
Mynatt, Gordon H 1912- *AmArch 70*
Mynerts, W E *NewYHSD*
Mynott, Derek 1926- *WhoArt 80*
Mynott, Derek G 1926- *ClaDrA, WhoArt 82, -84*
Mynott, Gerald Philip 1957- *WhoArt 80, -82, -84*
Mynott, John Burnell 1931- *ClaDrA*
Mynott, Lawrence 1954- *WhoArt 80, -82, -84*
Mynott, Patricia 1927- *WhoArt 80, -82, -84*
Mynssen, Julie 1873- *DcWomA*
Myochin *OxDecA*
Myrander *DcBrA 1*
Myrbach, F *WhAmArt 85*
Myrbach-Rheinfeld, Baroness Lily 1852- *DcWomA*
Myrer, Angele 1896-1970 *WhAmArt 85*
Myrer, Angele E 1896-1970 *DcWomA*
Myric, Nancy 1789?- *FolkA 86*
Myrick, Elizabeth *WhAmArt 85*
Myrick, Frank W *WhAmArt 85*
Myrick, Fredrick *FolkA 86*
Myrick, James Richard 1958- *MarqDCG 84*
Myrick, Katherine S *WhoAmA 78N, -80N, -82N, -84N*
Myrick, Katherine S d1950? *WhAmArt 85*
Myrick, Katherine Smith d1948? *DcWomA*
Myrick, Margaret Wilson *ArtsAmW 3*
Myrick, Roberta Neal Miller 1866-1947 *ArtsAmW 3*
Myrick, Ruth Kealing *WhAmArt 85*
Myrick Roller And Holbrook *EncASM*
Myrninerest *DcWomA*
Myrold, Clarence Werner 1925- *AmArch 70*
Myron *McGDA, OxArt*
Myron, Robert 1928- *WhoAmA 80, -82, -84*
Myrus, Carl Steere *AmArch 70*
Myslive, Frank Richard 1908- *WhAmArt 85*
Mytens *McGDA*
Mytens, Daniel 1590?-1648? *OxArt*
Mytens, Jan 1614-1670 *ClaDrA*
Myzel, S *AmArch 70*

N

N E Thing Co 1936- *DcCAr 81*
Naanes, Ted *MarqDCG 84*
Naar, Harry I 1946- *WhoAmA 84*
Naber, George *FolkA 86*
Nabers, Grace A *DcWomA*
Nachemja-Bunton, Richard E 1951- *MarqDCG 84*
Nachmann, Frieda 1871- *DcWomA*
Nacht, Daniel Joseph 1915- *AmArch 70*
Nachtegall, James Bernard 1929- *AmArch 70*
Nachtigal, Emma 1875- *DcWomA*
Nachtigal, Maria 1869- *DcWomA*
Nachtrieb, Michael Strieby 1835-1916 *NewYHSD* ,
 WhAmArt 85
Nachtwey, James 1948- *ICPEnP A*
Nacimiento, Cecilia Del *DcWomA*
Nacknouck, James D 1950- *MarqDCG 84*
Naczinski, Rufin Roman 1925- *AmArch 70*
Nadaillac, Comtesse De *DcWomA*
Nadal, Marcelle 1897-1961 *DcWomA*
Nadal, Therese 1898- *DcWomA*
Nadalini 1927- *WhoAmA 73, –76, –78, –80, –82, –84*
Nadamoto, Tadahito 1927- *WhoGrA 82[port]*
Nadar *WorECar*
Nadar 1820-1910 *ICPEnP, MacBEP*
Nadar, Paul 1856-1939 *ICPEnP A, MacBEP*
Nadeau, Luis R 1951- *MacBEP*
Nadeau, Wingfield L *ArtsEM*
Nadejen, T *WhAmArt 85*
Nadejen, Theodore *ConICB, IlsCB 1744*
Nadel, H N *AmArch 70*
Nadell, Abram *AmArch 70*
Nadelman, Elie 1882-1946 *BnEnAmA, CenC,
 ConArt 77, DcAmArt, DcCAA 71, –77,
 McGDA, OxTwCA, PhDcTCA 77*
Nadelman, Elie 1885-1946 *WhAmArt 85*
Naden, D M *AmArch 70*
Nadherney, E V *WhAmArt 85*
Nadin, Mihai 1925- *MarqDCG 84*
Nadler, Berta 1853- *DcWomA*
Nadler, Emma Auguszta 1852- *DcWomA*
Nadler, Harry 1930- *WhoAmA 76, –78, –80, –82, –84*
Nadler, Ida 1859- *DcWomA*
Nadler, Istvan 1938- *DcCAr 81*
Nadler, Morton 1921- *MarqDCG 84*
Nadler, R *AmArch 70*
Nadler, Robert *IlsBYP*
Nadolski, Stephanie L 1945- *AmArt*
Nadolski, Stephanie Lucille 1945- *WhoAmA 84*
Naef, Robert William *AmArch 70*
Naef, Weston J 1942- *MacBEP*
Naegele, Charles Frederick 1857-1944 *WhAmArt 85*
Naegele, F Harold 1903- *AmArch 70*
Naegeli, Betty 1854- *DcWomA*
Naegelin, Charles *FolkA 86*
Naegely, Henry *DcVicP 2*
Naegle, Dale William 1928- *AmArch 70*
Naegle, Stephen Howard 1938- *WhoAmA 76, –78, –80*
Naegle, Stephen Howard 1938-1981 *WhoAmA 82N, –84N*
Naesby, Bent 1934- *MacBEP*
Naetzker, Julian W 1927- *AmArch 70*
Naeve, Milo M 1931- *WhoAmA 73, –76, –78, –80, –82, –84*
Naftel, Isabel *DcVicP 2, DcWomA*
Naftel, Isobel *DcBrWA*
Naftel, Maud 1856-1890 *DcBrBI, DcBrWA, DcWomA*
Naftel, Maude 1856-1890 *DcVicP, –2*
Naftel, Mrs. P J *DcVicP, –2*
Naftel, Paul J *ArtsNiC*

Naftel, Paul Jacob 1817-1891 *ClaDrA, DcBrWA, DcVicP, –2*
Naftulin, Rose *WhoAmA 82, –84*
Naftulin, Rose 1925- *AmArt*
Nag, Shanta Devi 1893- *DcWomA*
Nagahara, Shisui 1864-1930 *WorECar*
Nagai, Kazumasa 1929- *ConDes, WhoGrA 62, –82[port]*
Nagano, Paul Tatsumi 1938- *WhoAmA 73, –76, –78, –80, –82, –84*
Nagano, Shozo *WhoAmA 73, –76, –78, –80, –82, –84*
Nagarajan, T S 1932- *ConPhot, ICPEnP A*
Nagasawa, Hidetoshi 1940- *ConArt 77, –83*
Nagashima, Shinji 1937- *WorECom*
Nagatani, Patrick August 1945- *ICPEnP A, MacBEP*
Nagatomo, Keisuke 1939- *WhoGrA 82[port]*
Nagel, Brigitta 1877- *DcWomA*
Nagel, Chester Emil 1911- *AmArch 70*
Nagel, Elizabeth *DcWomA*
Nagel, Eva M *WhAmArt 85*
Nagel, Eva M 1880- *DcWomA*
Nagel, Helene *DcWomA*
Nagel, Herman F 1876- *WhAmArt 85*
Nagel, Jerome Kaub 1923- *AmArch 70*
Nagel, John William 1942- *MacBEP*
Nagel, Louis 1817?- *NewYHSD*
Nagel, Nellie Foster 1873-1955 *DcWomA, WhAmArt 85*
Nagel, Peter *ConArt 77*
Nagel, Peter 1941- *ConArt 83, DcCAr 81*
Nagel, Peter 1942- *OxTwCA*
Nagel, Philip *FolkA 86*
Nagel, Stina d1969 *WhoAmA 78N, –80N, –82N, –84N*
Nagelvoort, Betty 1909- *WhAmArt 85*
Nagengast, William Joseph 1934- *AmArt, WhoAmA 82, –84*
Nager, Arthur 1949- *MacBEP*
Nagesh, Aragam Ramarao 1952- *MarqDCG 84*
Naggar, A *AmArch 70*
Nagin, Dan *EncASM*
Nagle *NewYHSD*
Nagle, E D *AmArch 70*
Nagle, Edward John, Jr. 1941- *MarqDCG 84*
Nagle, Edward P 1893- *WhAmArt 85*
Nagle, Fred *WhAmArt 85*
Nagle, James F *FolkA 86*
Nagle, James Frederick 1833?- *NewYHSD*
Nagle, James Lee 1937- *AmArch 70*
Nagle, Ron 1939- *CenC[port], DcCAr 81*
Nagler, Edith 1890- *WhAmArt 85*
Nagler, Edith Kroger *WhoAmA 73, –76, –78, –80, –82, –84*
Nagler, Edith Kroger 1890- *DcWomA*
Nagler, Fred *WhoAmA 73, –76, –78, –80, –82, –84*
Nagler, Fred 1891- *WhAmArt 85*
Nagler, O *AmArch 70*
Nagrani, Shyam K 1948- *MarqDCG 84*
Naguchi, Louise *DcCAr 81*
Naguy, Mary Jane *FolkA 86*
Nagy, Al *IlsBYP*
Nagy, Denes 1929- *MarqDCG 84*
Nagy, Dennis Alan 1944- *MarqDCG 84*
Nagy, Frank 1897- *WhAmArt 85*
Nagy, H S *AmArch 70*
Nagy, James Joseph, Jr. 1930- *AmArch 70*
Nagy-Kriesch, Laura *DcWomA*
Nagy VonKonoly, Marianne *DcWomA*
Naha, Raymond *WhoAmA 73*
Naha, Raymond d1975 *WhoAmA 76N, –78N, –80N, –82N, –84N*

Naha, Raymond 1933-1976 *IlBEAAW*
Nahl, Arthur *NewYHSD*
Nahl, Charles Christian 1818-1878 *ArtsAmW 1,
 DcAmArt, EarABI, EarABI SUP, IlBEAAW,
 NewYHSD , WhAmArt 85*
Nahl, H W Arthur 1820-1881 *ArtsAmW 1*
Nahl, H W Arthur 1820-1887 *EarABI, EarABI SUP*
Nahl, Hugo Wilhelm 1820-1889 *DcAmArt*
Nahl, Hugo Wilhelm Arthur 1820-1889 *NewYHSD ,
 WhAmArt 85*
Nahl, Hugo Wilhelm Arthur 1833-1889 *IlBEAAW*
Nahl, Johann August 1710-1785 *OxDecA*
Nahl, Perham W 1869-1935 *WhAmArt 85*
Nahl, Perham Wilhelm 1869-1935 *ArtsAmW 1*
Nahl, Virgil 1876-1930 *WhAmArt 85*
Nahl, Virgil Theodore 1876-1930 *ArtsAmW 1, –3*
Nahmias, Lillian 1948- *WhoAmA 80*
Nahory, William Francis 1926- *AmArch 70*
Nahrgang, Donald Thomas 1926- *AmArch 70*
Nahser, Clifford Albert 1927- *AmArch 70*
Nahuys, Cecile Dorothea 1800-1866 *DcWomA*
Naidorf, Louis Murray 1928- *AmArch 70*
Naigeon, Clemence *DcWomA*
Naigeon, Jean Claude 1753-1832 *ClaDrA*
Nail, Ginny Martin 1952- *WhoAmA 80*
Nailor, Miss *DcWomA*
Nailor, Gerald A 1917- *IlsCB 1744*
Nailor, Gerald A 1917-1952 *IlBEAAW*
Nailor, Gerald Lloyde d1952 *WhoAmA 78N, –80N, –82N, –84N*
Nailor, Gerald Lloyde 1917-1952 *WhAmArt 85*
Naiman, Adeline *MarqDCG 84*
Naiman, Lee *WhoAmA 80, –82, –84*
Naiman, Lee E *WhoAmA 78*
Naimaster, John Lynch *WhoArt 82N*
Naimaster, John Lynch 1905- *WhoArt 80*
Naintre, E De *DcWomA*
Nairn, Mr. *DcBrBI*
Nairn, Mrs. *DcWomA, NewYHSD*
Nairn, Anne Langley *DcVicP 2*
Nairn, Annie Langley *DcWomA*
Nairn, Cecilia Margaret 1791-1857 *DcVicP 2, DcWomA*
Nairn, George 1799-1850 *DcVicP 2*
Nairn, James M 1859-1904 *DcBrA 1, DcVicP 2*
Nairn, James McLachlan 1859-1904 *OxArt*
Nairn, Janet *ConArch A*
Naish, J *DcVicP 2*
Naish, John *DcBrWA*
Naish, John 1771- *DcBrECP*
Naish, John George 1824- *ArtsNiC*
Naish, John George 1824-1905 *DcVicP, –2*
Naish, William d1800 *DcBrWA*
Naissant, Claude 1801-1879 *MacEA*
Naitoh, Masatoshi 1938- *ConPhot, ICPEnP A*
Nakache, Margaret 1932- *WhoAmA 80*
Nakache-Lynch, Margaret 1932- *WhoAmA 82, –84*
Nakagawa, H *WhAmArt 85*
Nakagawa, Masaaki 1943- *ICPEnP A, MacBEP*
Nakamizo, Fugi 1889-1950? *WhAmArt 85*
Nakamizo, Fuji *WhoAmA 78N, –80N, –82N, –84N*
Nakamura, Fusetsu 1868-1943 *WorECar*
Nakamura, Kanzi 1887-1932 *WhAmArt 85*
Nakamura, Kazuo *OxTwCA*
Nakamura, Kazuo 1926- *McGDA, WhoAmA 73, –76, –78, –80, –82, –84*
Nakamura, Makoto 1926- *ConDes*
Nakamura, Masaya 1926- *ConPhot, ICPEnP A*
Nakamura, N *AmArch 70*
Nakashima, George 1905- *BnEnAmA*
Nakashima, Thomas Vincent 1941- *PrintW 83, –85*

Nakata, Clifford S 1929- *AmArch 70*
Nakata, H M *AmArch 70*
Nakatani, Carlos 1934- *WhoAmA 78, -80*
Nakatani, Chiyoko *IlsBYP*
Nakatani, Chiyoko 1930- *IlsCB 1967*
Nakatani, Satoru 1931- *AmArch 70*
Nakayama, M K *AmArch 70*
Nakazato, Hitoshi 1936- *PrintW 83, -85, WhoAmA 78, -80, -82, -84*
Nakazawa, Y *AmArch 70*
Nake, Frieder *OxTwCA*
Nakian, Reuben 1897- *AmArt, BnEnAmA, CenC, DcAmArt, DcCAA 71, -77, McGDA, OxTwCA, PhDcTCA 77, WhAmArt 85, WhoAmA 73, -76, -78, -80, -82, -84, WorArt[port]*
Nakken, W C *ArtsNiC*
Nako, Countess Berta 1820-1882 *DcWomA*
Nakpil, J F *AmArch 70*
Nakrosis, J D *AmArch 70*
Nalder, James H *DcVicP, -2*
Nalder, Nan 1938- *WhoAmA 76, -78, -80*
Naldini, Paolo 1619-1691 *McGDA*
Nalecz, Halima *ClaDrA*
Nalecz, Halima 1917- *WhoArt 80, -82, -84*
Nall, Gus *AfroAA*
Nall, Stephen Owen 1934- *AmArch 70*
Nallard, Louis 1918- *OxTwCA*
Nalley, Donald Francis 1933- *AmArch 70*
Nam, Cheong *DcSeaP*
Nama, George Allen 1939- *WhoAmA 73, -76, -78, -80, -82, -84*
Namias, Rodolfo 1867-1938 *MacBEP*
Namingha, Dan 1950- *WhoAmA 78, -82, -84*
Namkung, Johsel 1919- *MacBEP*
Namuth, Hans 1915- *ConPhot, ICPEnP A, MacBEP, WhoAmA 73, -76, -78, -80, -82, -84*
Nan, Ning 1936- *MarqDCG 84*
Nanbu, Shotaro 1918-1976 *WorECar*
Nancarrow, Robert Edward 1925- *AmArch 70*
Nance, Robert M *DcVicP 2*
Nance, Robert Morton *DcBrBI*
Nancy, Claire *DcWomA*
Nando 1912- *DcCAr 81*
Nankivel, Claudine *IlsBYP*
Nankivell, Edith *WhAmArt 85*
Nankivell, Frank A 1869- *WhAmArt 85*
Nankivell, Frank Arthur 1869- *ArtsAmW 2, DcBrBI*
Nankivell, Frank Arthur 1869-1959 *WorECar*
Nankivell, Helen L *DcVicP 2*
Nankivelli, Frank Arthur 1869- *ArtsAmW 2*
Nankwell, Fred *WhAmArt 85*
Nanni D'Antonio DiBanco 1384?-1421 *McGDA*
Nanni Di Banco 1385?-1421 *OxArt*
Nanni DiBaccio Bigio d1568? *McGDA*
Nanni DiBartolo d1451? *McGDA*
Nanni, Giovanni *McGDA*
Nannichi, Tsuneo 1929- *MarqDCG 84*
Nanninga, Jaap 1904-1962 *OxTwCA, PhDcTCA 77*
Nannoni, Barb *DcWomA*
Nannucci, Maurizio 1939- *ConArt 77, -83*
Nanon, Louis *NewYHSD*
Nanos, P C *AmArch 70*
Nanteuil *EarABI SUP*
Nanteuil, Celestin 1813-1873 *ArtsNiC*
Nanteuil, Robert 1623?-1678 *AntBDN B, McGDA, OxArt*
Nanteuil-Leboeuf, Celestin Francois 1813-1873 *ClaDrA*
Nantion, J *FolkA 86*
Nants, J Stanley, Jr. 1919- *AmArch 70*
Naonobu 1607-1650 *McGDA*
Naoum-Aranson, Madame *DcWomA*
Napier, Charles Goddard 1889- *ClaDrA, DcBrA 1, WhoArt 80*
Napier, Sir Charles James 1782-1853 *DcBrWA*
Napier, Eva *DcVicP 2, DcWomA*
Napier, George *NewYHSD*
Napier, George Alexander 1827?-1869 *DcSeaP*
Napier, J Macvicar *DcVicP 2*
Napier, James H *EncASM*
Napier, John 1944- *ConDes*
Napier, John J *DcVicP*
Napier, John James *DcVicP 2*
Napier, Lady Mary Margaret *DcBrWA*
Napier, Robert Jon 1934- *AmArch 70*
Napier, Sir William Francis Patrick 1785-1860 *DcVicP 2*
Napier-Bliss *EncASM*
Napier Of Magdala, Lady *DcVicP 2*
Napoleon, Charlotte *DcWomA*
Napoli, James 1907- *WhAmArt 85*
Napolitano, Giovanni *WhAmArt 85*
Napolitano, Pasquale G *WhAmArt 85*
Naponic, Anthony 1954- *PrintW 83, -85*
Nappelbaum, Mikhail Salomonovitch 1869-1958 *ICPEnP A*
Nappenbach, Henry 1862-1931 *ArtsAmW 1, IIBEAAW, WhAmArt 85*
Napper, Harry *DcVicP 2*
Napper, John 1916- *DcBrA 1, WhoArt 80, -82, -84*
Nappi, Anthony Thomas 1906- *AmArch 70*
Nappier, Connie, Jr. 1923- *AmArch 70*

Narahara, Ikko 1931- *ConPhot*
Naramore, Floyd A 1879- *AmArch 70*
Naranjo, Frank 1953- *MarqDCG 84*
Naranjo, Michael Alfred 1944- *AmArt, WhoAmA 76, -78, -80, -82, -84*
Naranjo, Rogelio 1937- *WhoAmA 76, -80*
Naray, Aurel *WhAmArt 85*
Narbeth, William Arthur 1893- *DcBrA 1*
Narbonne, Eugene 1885- *ClaDrA*
Narcisi, L J *AmArch 70*
Nardi, Angelo 1584-1665 *ClaDrA*
Nardi, Hedwig Augusta Paulina 1885- *DcWomA*
Nardi, Ugo 1946- *DcCAr 81*
Nardin, Concetta 1939- *WhoAmA 80, -82*
Nardin, Mario 1940- *WhoAmA 73, -76, -78, -80, -82, -84*
Nardini, Peter Anthony 1947- *WhoArt 80*
Nardone, Vincent Joseph 1937- *WhoAmA 78, -80, -82, -84*
Narducci, Enrica *DcWomA*
Narducci, Leo *WorFshn*
Nares, Edward 1762?-1841 *DcBrWA*
Nargeot, Clara Agathe 1829- *DcWomA*
Nargis, James Jackson 1906- *AmArch 70*
Naril, C *DcVicP 2*
Naril, O *DcVicP 2*
Narin, David 1243-1293 *OxDecA*
Narine, James *NewYHSD*
Narischkine, Natalia Nikolaevna 1850?-1920? *DcWomA*
Narjot, Ernest 1826-1898 *ArtsAmW 1*
Narjot, Ernest E 1827-1898 *WhAmArt 85*
Narjot, Ernest Etienne DeFrancheville 1827?-1898 *IIBEAAW, NewYHSD*
Narkiewicz, Paul 1937- *PrintW 83, -85*
Narotzky, Norman 1928- *PrintW 83, -85*
Narotzky, Norman David 1928- *WhoAmA 73, -76, -78, -80, -82, -84*
Narovec, G *AmArch 70*
Narraway, William Edward *WhoArt 82N*
Narraway, William Edward 1915- *ClaDrA, DcBrA 1*
Narraway, William Edward 1917- *WhoArt 80*
Narrows, Parker Alfred 1919- *AmArch 70*
Narus, Marta Maria Margareta 1937- *WhoAmA 78, -80, -82*
Narveson, Mark Alan 1959- *MarqDCG 84*
Naryshkina, Natalia Nikolaevna 1850?-1920? *DcWomA*
Nas Li Hanum, Princess 1857- *DcWomA*
Naschen, Doria *DcBrBI*
Nase, John *FolkA 86*
Naser, Frederick 1786-1860 *CabMA*
Nasgaard, Roald 1941- *WhoAmA 80, -82, -84*
Nash, A Douglas d1940 *IlDcG*
Nash, Albert C 1826-1890 *BiDAmAr*
Nash, Alice Louise 1915- *WhoAmA 80, -82, -84*
Nash, Anne Taylor 1884- *DcWomA, WhAmArt 85*
Nash, Arthur 1916- *WhoArt 80, -82, -84*
Nash, Arthur J 1849-1934 *IlDcG*
Nash, Charles Richard 1920- *AmArch 70*
Nash, Claude Alfred 1924- *AmArch 70*
Nash, David 1945- *DcCAr 81*
Nash, E *FolkA 86*
Nash, Edgar S *WhAmArt 85*
Nash, Edward 1778-1821 *DcBrWA*
Nash, Elizabeth F *DcWomA*
Nash, F M *FolkA 86*
Nash, Federick 1782-1856 *DcBrWA*
Nash, Flora *WhAmArt 85*
Nash, Fred D *WhAmArt 85*
Nash, Frederick 1782-1856 *DcBrBI, DcVicP, -2*
Nash, Frederick C 1876?-1939 *ArtsEM*
Nash, G *FolkA 86*
Nash, Graham William 1942- *MacBEP*
Nash, H *FolkA 86*
Nash, H Mary 1951- *FolkA 86*
Nash, Harold Siegrist 1894- *WhAmArt 85*
Nash, Isabel *DcWomA, WhAmArt 85*
Nash, J A *AmArch 70*
Nash, J F *NewYHSD*
Nash, Mrs. J N *DcVicP 2*
Nash, J O *DcVicP 2*
Nash, John 1752-1835 *BiDBrA, DcD&D[port], EncMA, McGDA, OxArt, WhoArch*
Nash, John 1752-1837 *MacEA*
Nash, John 1893- *McGDA, OxArt, PhDcTCA 77*
Nash, John 1893-1977 *ConArt 83, DcBrBI*
Nash, John Northcote *WhoArt 80N*
Nash, John Northcote 1893- *DcBrA 1*
Nash, John Northcote 1893-1977 *OxTwCA*
Nash, Jorgen 1920- *DcCAr 81*
Nash, Joseph d1922 *DcBrWA*
Nash, Joseph 1664-1740 *FolkA 86*
Nash, Joseph 1808-1878 *ClaDrA, DcBrBI, DcVicP, -2*
Nash, Joseph 1809-1878 *DcBrWA*
Nash, Joseph 1812-1878 *ArtsNiC*
Nash, Joseph, Jr. *DcVicP*
Nash, Joseph, Jr. d1922 *DcBrA 1, DcBrBI, DcVicP 2*
Nash, Joseph Pfanner 1900-1955? *WhAmArt 85*

Nash, Katherine *OxTwCA*
Nash, Katherine 1910- *WhAmArt 85*
Nash, Katherine E *WhoAmA 73, -76, -78, -80, -82, -84*
Nash, Kathleen *DcBrA 1, DcWomA*
Nash, Leslie *IlDcG*
Nash, Louisa *ArtsAmW 3*
Nash, Manley K *WhAmArt 85*
Nash, Marguerite L *DcWomA*
Nash, Mary 1951- *AmArt, WhoAmA 84*
Nash, Mary Harriet 1951- *WhoAmA 82*
Nash, Matilda *FolkA 86*
Nash, Mildred Archer *WhAmArt 85*
Nash, Nina *DcWomA*
Nash, Paul *MacBEP*
Nash, Paul 1889-1946 *ClaDrA, ConArt 77, -83, ConPhot, DcBrA 1, DcBrBI, ICPEnP A, McGDA, OxArt, OxTwCA, PhDcTCA 77*
Nash, Percy Cuthbert *ArtsEM*
Nash, R H *NewYHSD*
Nash, Ray 1905- *WhAmArt 85, WhoAmA 73, -76, -80, -82*
Nash, Ray 1905-1982 *WhoAmA 84N*
Nash, Robert Johnson 1929- *AmArch 70*
Nash, Sarah E *WhAmArt 85*
Nash, Stephen 1951- *DcCAr 81*
Nash, Steven Alan 1944- *WhoAmA 76, -78, -80, -82, -84*
Nash, Teixera *AfroAA*
Nash, Thomas *DcBrBI*
Nash, Thomas 1891- *DcBrA 1*
Nash, Thomas L 1861-1926 *BiDAmAr*
Nash, Tom 1931- *WhoArt 80, -82, -84*
Nash, Veronica F 1927- *WhoAmA 78, -80, -82, -84*
Nash, Wallis 1837-1926 *ArtsAmW 3*
Nash, Willard Ayer 1898-1943 *ArtsAmW 1, -3, IIBEAAW, WhAmArt 85*
Nash, William Elton 1914- *AmArch 70*
Nash, William Thomas *BiDBrA*
Nash And Ertz *ArtsEM*
Nasher, Patsy R 1928- *WhoAmA 80, -82, -84*
Nasisse, Andy S 1946- *WhoAmA 84*
Nasmith, Robert d1793 *BiDBrA*
Nasmyth, Alexander 1758-1840 *BiDBrA, DcBrBI, DcBrECP, DcBrWA, DcVicP 2, OxArt*
Nasmyth, Anne 1798- *DcBrWA*
Nasmyth, Anne G 1798- *DcVicP 2*
Nasmyth, Anne Gibson 1798- *DcWomA*
Nasmyth, Barbara 1790- *DcBrWA, DcVicP 2, DcWomA*
Nasmyth, Charlotte 1804- *DcBrWA, DcVicP 2, DcWomA*
Nasmyth, Elizabeth 1793- *DcBrWA, DcVicP 2*
Nasmyth, Elizabeth Wemyss 1793- *DcWomA*
Nasmyth, Jane 1778- *DcBrWA*
Nasmyth, Jane 1788- *DcVicP 2*
Nasmyth, Jane 1788-1866? *DcWomA*
Nasmyth, Margaret 1791- *DcBrWA, DcVicP 2, DcWomA*
Nasmyth, Patrick 1786-1831 *DcVicP*
Nasmyth, Patrick 1787-1831 *DcBrWA, DcVicP 2, McGDA, OxArt*
Nasmyth-Langlands, George *DcBrA 1*
Nason, Anna L *WhAmArt 85*
Nason, Anna L 1890- *DcWomA*
Nason, Daniel W *ArtsAmW 1*
Nason, Daniel W 1825?- *IIBEAAW, NewYHSD*
Nason, Gertrude *WhoAmA 78N, -80N, -82N, -84N*
Nason, Gertrude 1890-1968? *WhAmArt 85*
Nason, Gertrude 1890-1978? *DcWomA*
Nason, J R *AmArch 70*
Nason, L M *WhAmArt 85*
Nason, Thomas W 1889-1971 *WhAmArt 85, WhoAmA 78N, -80N, -82N, -84N*
Nason, Thomas Willoughby 1889-1971 *GrAmP*
Nasoni, Niccolo d1773 *OxArt*
Nasoni, Nicolau 1691-1773 *WhoArch*
Nassau-Hadamar, Ernestine, Princess Von *DcWomA*
Nasser, Jacques 1952- *MarqDCG 84*
Nassif, Joseph Lee 1933- *AmArch 70*
Nast, Conde 1874-1942 *WorFshn*
Nast, Cyril *WhAmArt 85*
Nast, J 1840-1902 *DcBrBI*
Nast, Jean-Nepomuc-Herman 1754-1817 *DcNiCA*
Nast, Thomas 1840- *ArtsNiC*
Nast, Thomas 1840-1902 *ConGrA 1[port], EarABI, EarABI SUP, IIBEAAW, IlrAm 1880, McGDA, NewYHSD , WhAmArt 85, WorECar*
Nast, Thomas, Jr. *WhAmArt 85*
Nast, William E 1901- *AmArch 70*
Nasu, Mitsuru 1943- *MarqDCG 84*
Nasu, Ryosuke 1913- *WorECar*
Nasuti, Armand John 1926- *AmArch 70*
Nat *WhAmArt 85*
Natale, Charles Joseph 1933- *MarqDCG 84*
Natale, Maddalena 1657- *DcWomA*
Natali, Enrico 1933- *ICPEnP A, MacBEP*
Natali, Giovanni Battista *McGDA*
Natali, Maddalena 1657- *DcWomA*
Natchev, Zdravko *ConArch A*

Nathan, Adelaide A Burnett *DcVicP 2*
Nathan, Annette M *DcVicP 2*
Nathan, Doris B *AmArch 70*
Nathan, Estelle *DcVicP 2*
Nathan, Fanny *DcVicP 2*
Nathan, G *AmArch 70*
Nathan, Helmuth Max 1901- *WhoAmA 78*
Nathan, Helmuth Max 1901-1979 *WhoAmA 80N, −82N, −84N*
Nathan, Isadore *ArtsEM*
Nathan, Janet 1939- *DcCAr 81*
Nathan, Lewis 1954- *MarqDCG 84*
Nathan, Meyer Oscar 1891- *AmArch 70*
Nathan, Pamela D'Avigdor 1905- *DcBrA 1*
Nathan, T M *AmArch 70*
Nathan-Garamond, Jacques 1910- *WhoGrA 62*
Nathan-Garamond, Jacques Lucien 1910- *WhoGrA 82[port]*
Nathaniel, Inez 1911- *FolkA 86*
Nathanielsen, Bertha 1869- *DcWomA*
Nathans, Gwendolyn *DcWomA, WhAmArt 85*
Nathans, Joseph *NewYHSD*
Nathans, Rhoda R 1940- *WhoAmA 76, −78, −80, −82, −84*
Nathanson, A *AmArch 70*
Nathe, Amalia Philippine *DcWomA*
Nathe, Christoph 1753-1808 *ClaDrA*
Nathe, Gerald A *MarqDCG 84*
Nathusius, Susanne Von 1850- *DcWomA*
Natkin, Robert 1930- *AmArt, ConArt 77, DcCAA 71, −77, DcCAr 81, PrintW 83, −85, WhoAmA 73, −76, −78, −80, −82, −84*
Natoire, Charles Joseph 1700-1777 *ClaDrA, McGDA*
Natoire, Jeanne d1776 *DcWomA*
Natsuki *AntBDN L*
Natsuo 1829-1898 *AntBDN L*
Natt, Joseph S *NewYHSD*
Natt, Phebe D *WhAmArt 85*
Natt, Phebe Davis *DcWomA*
Natt, Thomas J *NewYHSD*
Nattali, Margaret *DcWomA*
Nattes, John Claude 1765?-1822 *DcBrBI, DcBrWA*
Natti, Camilla *DcWomA*
Nattier, Jean Marc 1685-1766 *ClaDrA*
Nattier, Jean-Marc 1685-1766 *OxArt*
Nattier, Jean-Marc, The Younger 1683-1766 *McGDA*
Nattier, Marie 1655?-1703 *DcWomA*
Nattress, George *DcVicP 2*
Natus, Charles *ArtsEM*
Natus, John, Jr. *ArtsEM*
Natus, John, Sr. *ArtsEM*
Natzler, Gertrud d1971 *WhoAmA 76N, −78N, −80N, −82N, −84N*
Natzler, Gertrud 1908- *McGDA*
Natzler, Gertrud 1908-1971 *CenC[port], WhAmArt 85*
Natzler, Gertrud Amon 1908-1971 *BnEnAmA*
Natzler, Otto 1908- *BnEnAmA, CenC[port], McGDA, WhAmArt 85, WhoAmA 73, −76, −78, −80, −82, −84*
Natzmer, Von *DcWomA*
Natzmer, Cheryl Lynn 1947- *WhoAmA 80, −82, −84*
Nau, Carl A 1890-1944 *BiDAmAr*
Nau, Carl W *ArtsAmW 2, WhAmArt 85*
Naude, Burgert 1928- *MarqDCG 84*
Naude, Hugo *OxTwCA*
Naudet, Caroline 1775-1839 *DcWomA*
Naudet, Thomas Charles 1778-1810 *ClaDrA*
Naudin, Bernard 1876-1940 *ClaDrA*
Naudin, Bernard 1876-1946 *WorECar*
Naudin, Bernard Etienne Hubert *DcCAr 81*
Nauen, Heinrich 1880-1941 *McGDA, PhDcTCA 77*
Nauen, Maria 1880- *DcWomA*
Naughn, Martha Agry *FolkA 86*
Naughten, Elizabeth *DcVicP 2, DcWomA*
Naughton, James W 1840-1898 *BiDAmAr*
Naughton, John Joseph 1957- *MarqDCG 84*
Naugis, Genevieve 1746-1802 *DcWomA*
Naugle, James d1924 *FolkA 86*
Nault, A G *AmArch 70*
Nault, Norman Dollard 1901- *AmArch 70*
Nauman, Bruce 1941- *AmArt, BnEnAmA, ConArt 77, −83, DcAmArt, DcCAA 77, DcCAr 81, OxTwCA, PrintW 83, −85, WhoAmA 78, −80, −82, −84*
Nauman, F R 1892- *WhAmArt 85*
Nauman, Paul Macon 1959- *MarqDCG 84*
Naumann, Charlotte 1880?- *DcWomA*
Naumann, Cora Gerhard 1782-1827 *DcWomA*
Naumann, Friedrich Gotthard 1750-1821 *ClaDrA*
Naumburg, Master *McGDA*
Naumburg, Nettie Goldsmith d1930 *WhAmArt 85*
Naumer, Helmuth 1907- *WhAmArt 85, WhoAmA 73, −76, −78, −80, −82, −84*
Nauta, Donald Hendrick 1923- *AmArch 70*
Navaretta, Cynthia *WhoAmA 80, −82, −84*
Navarra, Toby *IlsBYP*
Navarre, Bisynthe *NewYHSD*
Navarre, Genevieve 1737-1795 *DcWomA*
Navarre, Henri 1885- *IlDcG*
Navarre, Henri 1889- *DcNiCA*

Navarrete, Juan Fernandez De 1526?-1579 *OxArt*
Navarro, Maria Ignacia *DcWomA*
Navarro, Miguel 1945- *DcCAr 81*
Navarro, Osvaldo 1893-1965 *WorECar*
Navarro, Pascal 1923- *OxTwCA*
Navarro, Rafael 1940- *ConPhot, ICPEnP A, MacBEP*
Navarro, Rosalia *DcWomA*
Navarro, Victor Manuel 1947- *MarqDCG 84*
Navas, Elizabeth S 1895- *WhoAmA 73, −76, −78, −80N, −82N, −84N*
Nave, Royston 1876- *WhAmArt 85*
Nave, Royston 1876-1931? *ArtsAmW 2*
Navez, Francois 1787-1869 *McGDA*
Navez, Francois Joseph 1787-1869 *ArtsNiC, ClaDrA*
Naviasky, Philip 1894- *DcBrA 1*
Navigato, Rocco D *WhAmArt 85*
Navone, Edoardo *DcVicP 2*
Navrat, Den 1942- *WhoAmA 78, −80, −82, −84*
Navratil, Amy *WhoAmA 82, −84*
Navratil, Amy R 1950- *WhoAmA 78, −80*
Navy, H S *AmArch 70*
Nawara, Jim 1945- *PrintW 85, WhoAmA 82, −84*
Nawara, Lucille Procter 1941- *WhoAmA 82, −84*
Nawrocki, Thomas Dennis 1942- *WhoAmA 76, −78, −80, −82, −84*
Nay, E W 1902-1968 *ConArt 83*
Nay, Ernst Wilhelm 1902-1968 *ConArt 77, McGDA, OxTwCA, PhDcTCA 77, WorArt[port]*
Nay, H R *AmArch 70*
Nay, Mary Spencer 1913- *WhoAmA 73, −76, −78, −80, −82, −84*
Naya, Carlo d1873 *ICPEnP A, MacBEP*
Naykki, Pertti 1943- *MarqDCG 84*
Nayler, Maria Elisabeth *DcWomA*
Naylor, Miss *DcWomA*
Naylor, Alice *WhAmArt 85*
Naylor, Alice Stephenson *WhoAmA 73, −76, −78, −80*
Naylor, Bruce Fountain 1954- *MarqDCG 84*
Naylor, Charles J *NewYHSD*
Naylor, Clifford 1953- *WhoArt 80*
Naylor, Colin *ConArch A*
Naylor, E M *EarABI SUP*
Naylor, Francis Ives 1892- *DcBrA 1*
Naylor, Georgiana *DcWomA*
Naylor, Henry L *NewYHSD*
Naylor, J P *AmArch 70*
Naylor, John Geoffrey 1928- *WhoAmA 73, −76, −78, −80, −82, −84*
Naylor, Marie J *DcVicP 2, DcWomA*
Naylor, Martin 1944- *ConArt 77, ConBrA 79[port], DcCAr 81*
Naylor, Penelope 1941- *IlsBYP*
Naylor, Robert 1910- *WorECom*
Naylor, T *DcBrECP*
Naylor, Thomas *DcBrWA*
Naylor, Thomas P 1938- *MarqDCG 84*
Naylor, William Henry d1773 *BiDAmAr*
Naylor, William Rigby *NewYHSD*
Naylor, William Rigby d1773 *BiDBrA*
Nazarenko, Bonnie Coe 1933- *WhoAmA 73, −76, −78, −80, −82, −84*
Nazari, Maria Giacomina *DcWomA*
Nazzari, Bartolomeo 1699-1758 *McGDA*
Nazzari, Nazario 1724-1793? *McGDA*
Ndiaye, Iba 1928- *DcCAr 81*
Neafie, Edith S 1884- *DcWomA, WhAmArt 85*
Neagle *NewYHSD*
Neagle, E *DcWomA*
Neagle, Miss E *NewYHSD*
Neagle, James 1769?-1822 *NewYHSD*
Neagle, John 1796-1865 *BnEnAmA, DcAmArt, IIBEAAW, McGDA, NewYHSD*
Neagle, John 1799-1865 *ArtsNiC, DcVicP 2*
Neagle, John B 1796?-1866 *NewYHSD*
Neagle, Lewis 1837?- *NewYHSD*
Neagoe, Anna 1894- *DcWomA*
Neagu, Paul 1938- *ConArt 77, −83, ConBrA 79[port], DcCAr 81, OxTwCA, WhoArt 80, −82, −84*
Neal, Miss *DcWomA*
Neal, Mr. *FolkA 86*
Neal, Allan H 1893- *AmArch 70*
Neal, Ann Parker *WhoAmA 82, −84*
Neal, Avon 1922- *WhoAmA 73, −76, −78, −80, −82, −84*
Neal, Cecil *AfroAA*
Neal, David 1837- *ArtsNiC*
Neal, David Dalhoff 1838-1915 *ArtsAmW 1, IIBEAAW, NewYHSD, WhAmArt 85*
Neal, Donald Lee 1948- *MacBEP*
Neal, E F *AmArch 70*
Neal, E W *AmArch 70*
Neal, Elizabeth *DcWomA*
Neal, Frank *AfroAA*
Neal, Frank Wingfield 1955- *WhoAmA 84*
Neal, George *AfroAA*
Neal, George E 1906-1938 *AfroAA*
Neal, Grace Pruden 1876- *DcWomA, WhAmArt 85*
Neal, Harold 1930- *AfroAA*
Neal, Harold Milton 1916- *AmArch 70*

Neal, James *CabMA*
Neal, James 1918- *DcBrA 1, WhoArt 80, −82, −84*
Neal, James Austin 1935- *AmArch 70*
Neal, James Dennis *AmArch 70*
Neal, Jerry 1938- *AmArch 70*
Neal, John 1793-1876 *BnEnAmA, NewYHSD*
Neal, Joseph B *FolkA 86*
Neal, Lucinda *DcWomA, NewYHSD*
Neal, Mary Alley *DcWomA, WhAmArt 85*
Neal, R S *AmArch 70*
Neal, Reginald 1909- *DcCAA 71, −77*
Neal, Reginald H 1909- *WhAmArt 85, WhoAmA 73, −76, −78, −80, −82, −84*
Neal, Robert L 1916- *AfroAA*
Neal, Sue Rose *WhAmArt 85*
Neal, William *NewYHSD*
Neale, Miss *DcWomA*
Neale, Adam *DcBrBI*
Neale, Charles *NewYHSD*
Neale, Edward *DcBrBI, DcVicP 2*
Neale, Edward J *DcVicP 2*
Neale, Edwin A 1907- *AmArch 70*
Neale, Emily Campbell d1896 *ArtsEM, DcWomA*
Neale, George Hall 1863-1940 *DcBrA 1, DcVicP 2*
Neale, J *DcVicP 2*
Neale, James *DcNiCA*
Neale, John *NewYHSD*
Neale, John Preston 1780-1847 *DcBrBI, DcBrWA, DcVicP, −2*
Neale, Marguerite *DcWomA*
Neale, Marguerite B *WhAmArt 85*
Neale, Maud Hall *DcBrA 1, DcWomA*
Neale, Samuel 1758-1824 *DcBrWA*
Neale, Sidnee Hubbard *WhAmArt 85*
Neale, Sterling L 1910- *AmArch 70*
Neale, Thomas 1826?- *NewYHSD*
Neale, William d1822 *BiDBrA*
Neall, Margaret Acton *WhAmArt 85*
Neals, Otto 1930- *WhoAmA 78, −80, −82, −84*
Neals, Otto 1931- *AfroAA*
Nealy, Charles *AfroAA*
Neandross, Leif *WhAmArt 85*
Neandross, Sigurd 1869-1958 *WhoAmA 80N, −82N, −84N*
Neandross, Sigurd 1871-1958 *WhAmArt 85*
Nearing, Howard H 1927- *AmArch 70*
Neasom, Norman 1915- *WhoArt 82, −84*
Neatby, Edward Mossforth 1888-1949 *ClaDrA, DcBrA 1*
Neatby, William James *DcBrA 2*
Neatby, William James 1860-1910 *AntBDN A, ClaDrA*
Neave, Alice Headley *WhoArt 80*
Neave, Alice Headley 1903- *DcBrA 1*
Neave, David 1773-1841 *BiDBrA*
Neave, David S *DcBrA 2*
Neave, Henry J *DcBrA 2*
Neave, Sir Richard Digby 1793-1868 *DcVicP 2*
Neb, T H *AmArch 70*
Nebbia, Cesare 1536?-1614? *McGDA*
Nebel, Berthold *WhoAmA 78N, −80N, −82N, −84N*
Nebel, Berthold 1889-1964 *WhAmArt 85*
Nebel, Carl *NewYHSD*
Nebel, Gustave *IlsBYP*
Nebel, Kay Heinrich 1888-1953 *DcWomA*
Nebel, Otto 1892- *PhDcTCA 77*
Nebelong, J H 1817-1872 *MacEA*
Nebergall, Erik 1952- *MarqDCG 84*
Nebot, Balthasar *ClaDrA, DcBrECP*
Nechak, David *DcCAr 81*
Nechdoma, Antonin 1867-1928 *BiDAmAr*
Nechis, Barbara *WhoAmA 76, −78*
Nechis, Barbara 1937- *WhoAmA 80, −82, −84*
Nechvatal, Joseph *PrintW 85*
Neck, Jan Van 1635-1714 *ClaDrA*
Neck, Johan Van 1635-1714 *McGDA*
Necker, Herbert Ferdinand 1922- *AmArch 70*
Ned *AfroAA, FolkA 86, NewYHSD*
Neddeau, Donald Frederick Price 1913- *WhoAmA 73, −76, −78, −80, −82, −84*
Nedeham, James d1544 *MacEA*
Nederhoff, Dale Alvin 1930- *AmArch 70*
Nedo, M F 1926- *WhoGrA 82[port]*
Nedo, Mion Ferrario 1926- *WhoGrA 62*
Nedved, Elizabeth 1897-1969 *DcWomA*
Nedved, Elizabeth Kimball 1897- *WhAmArt 85*
Nedved, R J *AmArch 70*
Nedwill, Rose 1882- *ArtsAmW 1, DcWomA, WhAmArt 85*
Nee, Marguerite *DcWomA*
Neebe, Louis Alexander 1873- *WhAmArt 85*
Neebe, Minnie Harms 1873- *ArtsAmW 3, DcWomA, WhAmArt 85*
Need, Henry 1816?-1875 *DcBrWA*
Needham, Lieutenant Colonel *DcVicP 2*
Needham, A C 1872- *WhAmArt 85*
Needham, Charles Austin 1844-1923 *ArtsAmW 3, WhAmArt 85*
Needham, D *NewYHSD*
Needham, Daniel *CabMA*
Needham, E *DcBrECP*

Needham, Eleanor *DcWomA*
Needham, Frances 1850-1927 *ArtsEM, DcWomA*
Needham, Fred Walter 1922- *AmArch 70*
Needham, J 1755-1787 *CabMA*
Needham, Jasper 1707?-1794 *CabMA*
Needham, Jonathan *DcVicP 2*
Needham, Joseph *DcBrWA*
Needham, Joseph G *DcVicP 2*
Needham, Oscar N *ArtsEM*
Needham, Otis N *ArtsEM*
Needham, Ray C 1893- *WhAmArt 85*
Needham, Thomas 1729?-1787 *CabMA*
Needham, Thomas, Jr. 1755?- *CabMA*
Needhams, Mercy *FolkA 86*
Needles, John *DcNiCA*
Needles, John 1786-1878 *CabMA*
Needlman, Joel G 1935- *WhoAmA 80, -82, -84*
Needlman, Phyllis L 1938- *WhoAmA 80, -82, -84*
Neef, Eudoxie De *DcWomA*
Neeffs, Pieter 1578?-1656? *ClaDrA*
Neeffs, Pieter 1620-1676? *ClaDrA*
Neeffs, Pieter, The Elder 1578?-1661? *OxArt*
Neeffs, Pieter, The Younger 1620-1675 *OxArt*
Neefs, Peter, I 1578-1659? *McGDA*
Neefs, Peter, II 1620-1675? *McGDA*
Neegaard, A *DcWomA*
Neel, Alice 1900- *DcAmArt, DcCAr 81, PrintW 83, WhoAmA 73, -76, -78, -80, -82, -84, WomArt, WorArt[port]*
Neel, Alice 1900-1984 *PrintW 85, WhAmArt 85*
Neel, Birdie M *WhAmArt 85*
Neel, Frank 1874-1933 *WhAmArt 85*
Neel, John Irwin 1924- *AmArch 70*
Neel, Paul Robert 1933- *AmArch 70*
Neel, William Henry 1939- *AmArch 70*
Neeland, Minnie I D *ArtsEM, DcWomA*
Neeld, C E 1895- *WhAmArt 85*
Neeley, O *NewYHSD*
Neelon, Susan *OfPGCP 86*
Neels, Marc 1922- *WorECom*
Neelsen, Elisabeth 1870- *DcWomA*
Neely, Anne Abercrombie *WhAmArt 85*
Neely, C *NewYHSD*
Neely, Henry *FolkA 86*
Neely, N *FolkA 86*
Neely, Robert Walther 1915- *WhAmArt 85*
Neer, Aart VanDer 1603-1677 *ClaDrA*
Neer, Adriana VanDer *DcWomA*
Neer, Aert VanDer 1603?-1677 *McGDA, OxArt*
Neer, Casper Samuel 1920- *AmArch 70*
Neer, Eglon Hendrick VanDer 1634-1703 *ClaDrA*
Neer, Eglon Hendrik VanDer 1634?-1703 *McGDA*
Neer, Eglon VanDer 1634-1703 *OxArt*
Neer, Jan VanDer 1638-1665 *OxArt*
Neer, Marie *DcWomA*
Neergaard, Hermania Sigvardine 1799-1875 *DcWomA*
Neering, John V *MarqDCG 84*
Nees, Albert H 1929- *AmArch 70*
Nees, Lawrence 1949- *WhoAmA 84*
Nees VonEsenbeck, Elise 1842-1921 *DcWomA*
Neesz, Johannes 1775-1867 *FolkA 86*
Neeve, Miss *DcWomA*
Neevil, Opal *WhAmArt 85*
Nefertiti *AfroAA*
Neff, Christian *FolkA 86*
Neff, Earl J 1902- *WhAmArt 85*
Neff, Edith 1943- *WhoAmA 78, -80, -82, -84*
Neff, Elizabeth *FolkA 86*
Neff, George W 1907- *AmArch 70*
Neff, J E *AmArch 70*
Neff, John A 1926- *WhoAmA 73, -76, -78, -80, -82, -84*
Neff, John Hallmark 1944- *WhoAmA 80, -82, -84*
Neff, Joseph d1969 *WhoAmA 78N, -80N, -82N, -84N*
Neff, Timoleon Charles De 1807-1877 *ArtsNiC*
Neff, Wallace 1895- *AmArch 70, ConArch*
Neffensperger, J D *FolkA 86, NewYHSD*
Nefflen, P *NewYHSD*
Neffson, Robert 1949- *WhoAmA 84*
Neghle, William *NewYHSD*
Negin, Michael 1942- *MarqDCG 84*
Negre, Charles 1820-1879 *MacBEP, OxDecA*
Negre, Charles 1820-1880 *ICPEnP*
Negre, Nicolas Claes Van d1664? *ClaDrA*
Negrepont *DcCAr 81*
Negret, Edgar 1920- *ConArt 77, -83, OxTwCA*
Negret Duenas, Edgar 1920- *PhDcTCA 77*
Negreti, Jacopo *McGDA*
Negretti, Jacomo *OxArt*
Negretti, Jacopo *OxArt*
Negri, Ilio 1926- *WhoGrA 62*
Negri, Mario 1916- *McGDA*
Negri, Nina *WhoArt 80, -82, -84*
Negri, Pier Martire 1601?-1661 *ClaDrA*
Negri, Rocco *IlsBYP*
Negri, Rocco A 1932- *IlsCB 1967*
Negri, Rocco Antonio 1932- *WhoAmA 78, -80, -82, -84*
Negro, Teresa *DcWomA*
Negro DiSanfront, Ercole 1541-1622 *MacEA*

Negroli, Barini Detti *OxDecA*
Negroli, Filippo 1531-1551 *OxDecA*
Negroli, Giovanni Paolo 1525-1561 *OxDecA*
Negroni *OxDecA*
Negueloua, Francisca *WhAmArt 85*
Negus, Caroline 1814-1867 *DcWomA, NewYHSD*
Negus, Joel *NewYHSD*
Negus, Joseph d1823 *NewYHSD*
Negus, Nathan *FolkA 86*
Negus, Nathan 1801-1825 *NewYHSD*
Negus, Richard Colley 1948- *MarqDCG 84*
Negvesky, Richard Landon 1955- *MarqDCG 84*
Neher, Dora 1879- *DcWomA*
Neher, Fred 1903- *WhAmArt 85, WhoAmA 73, -76, -78, -80, -82, -84*
Neher, Rudolf Ludwig Caspar 1897-1962 *ConDes*
Nehlig, Victor 1830- *ArtsNiC*
Nehlig, Victor 1830-1909 *EarABI, EarABI SUP, IlBEAAW, NewYHSD , WhAmArt 85*
Nehou, Louis-Lucas *IlDcG*
Nehou, Richard-Lucas De d1675 *IlDcG*
Nehrebecki, Wladyslaw 1923- *WorECar*
Neider, Gustave *NewYHSD*
Neidhardt, Carl Richard 1921- *WhoAmA 78, -80, -82, -84*
Neidigh, Pansy Mills 1907- *WhAmArt 85*
Neidlinger, Katharina *DcWomA*
Neifahrer, Ludwig *McGDA*
Neiffer, Jacob *FolkA 86*
Neighors, Michael A 1948- *MarqDCG 84*
Neijna, Barbara 1937- *WhoAmA 78, -80*
Neikaios *IlDcG*
Neikais *IlDcG*
Neikrug, Marjorie *MacBEP, WhoAmA 73, -76, -78, -80, -82, -84*
Neil, H *DcBrBI, DcBrWA*
Neil, W F *AmArch 70*
Neiland, Brendan 1941- *ConArt 77, ConBrA 79[port]*
Neild, Elias *CabMA*
Neiley, R G *AmArch 70*
Neill, Ben E 1914- *WhoAmA 82, -84*
Neill, Frances Isabel 1871- *DcWomA*
Neill, Francis Isabel 1871- *WhAmArt 85*
Neill, George R 1944- *MarqDCG 84*
Neill, Harvey Gordon *NewYHSD*
Neill, Jane Anderson 1911- *WhAmArt 85*
Neill, Joe 1944- *PrintW 83, -85, WhoAmA 84*
Neill, John 1781-1837 *BiDBrA*
Neill, John R *WhAmArt 85*
Neill, Richard *NewYHSD*
Neill, Sidney Kay 1914- *AmArch 70*
Neill, Stewart Edward 1940- *WhoAmA 80, -82*
Neill, T E *EncASM*
Neill, T Joseph 1944- *WhoAmA 73, -76*
Neillot, Louis 1898- *ClaDrA*
Neilsen, Kay 1886- *ArtsAmW 2*
Neilsen, M P *WhAmArt 85*
Neilson, Charles P *ArtsAmW 2*
Neilson, E *DcVicP 2*
Neilson, Harry B *DcBrBI*
Neilson, Hugh M 1918- *AmArch 70*
Neilson, J *NewYHSD*
Neilson, J Crawford 1816-1900 *BiDAmAr*
Neilson, Katharine B 1902- *WhoAmA 73, -76*
Neilson, Katharine B 1902-1977 *WhoAmA 78N*
Neilson, Katherine B 1902-1977 *WhoAmA 80N, -82N, -84N*
Neilson, M *DcWomA*
Neilson, Raymond P R d1964 *WhoAmA 78N, -80N, -82N, -84N*
Neilson, Raymond P R 1881-1964 *WhAmArt 85*
Neilson, Samuel *BiDBrA*
Neilson, Thomas Raymond 1886- *ArtsAmW 3*
Neilson-Gray, Norah *DcWomA*
Neilson-Gray, Norah 1882-1931 *DcBrA 1*
Neiman, James *FolkA 86*
Neiman, LeRoy *DcCAr 81*
Neiman, Leroy *OfPGCP 86*
Neiman, LeRoy 1926- *PrintW 85, WhoAmA 73*
Neiman, Leroy 1926- *PrintW 83, WhoAmA 76, -78, -80, -82*
Neiman, LeRoy 1927- *AmArt*
Neiman, Leroy 1927- *WhoAmA 84*
Neimanas, Joyce 1944- *ICPEnP A, MacBEP*
Neimeyer, John H *NewYHSD*
Neipce, Janine 1921- *MacBEP*
Neisser, Jacob *FolkA 86*
Neiswander, Arlyn Claud 1926- *AmArch 70*
Neiter, Gabrielle *DcWomA*
Neithardt, Mathis *McGDA*
Neivert, M J *AmArch 70*
Neizvestny, Ernst 1925- *ConArt 77, -83*
Neizvestny, Ernst 1926- *WorArt[port]*
Nejad, Mehmed D 1923- *OxTwCA*
Nejberg, Johanne *DcWomA*
Nekhom, Marc 1931- *MarqDCG 84*
Nel-Cougny, Marie Edmee 1864- *DcWomA*
Nelan, Charles 1854-1904 *WhAmArt 85, WorECar*
Nelaton, Camille *DcWomA*
Nelder, A *NewYHSD*

Nele, E R 1932- *OxTwCA*
Nelke, Dora Kaufman 1889- *DcWomA, WhAmArt 85*
Nell, Antonia *DcWomA, WhAmArt 85*
Nell, Dwain Russell 1953- *MarqDCG 84*
Nell, William *WhAmArt 85*
Nellens, Roger 1937- *OxTwCA, WhoArt 80, -82, -84*
Nelli, Ottaviano DiMartino *McGDA*
Nelli, Plautilla 1523-1588? *DcWomA*
Nellis, David L 1934- *WhoAmA 80, -82, -84*
Nellis, Jennifred Gene *WhoAmA 82, -84*
Nellis, Saunders K G *NewYHSD*
Nellius, Martinus *McGDA*
Nellius, Martinus N *ClaDrA*
Nelly, George *WhAmArt 85*
Nelly, Johanna Cornelia Hermana *DcWomA*
Nelme, Anthony *AntBDN Q*
Nelms, Clack Campbell, Jr. 1933- *AmArch 70*
Nelsen, Arlene 1950- *MarqDCG 84*
Nelsen, I A *AmArch 70*
Nelsen, L J *AmArch 70*
Nelsen, S E *AmArch 70*
Nelsen, Victor B 1930- *AmArch 70*
Nelson *NewYHSD*
Nelson 1921- *AmArch 70*
Nelson, Miss *NewYHSD*
Nelson, Mr. *FolkA 86*
Nelson, Mrs. *NewYHSD*
Nelson, A *DcBrECP*
Nelson, A E *AmArch 70*
Nelson, A J *AmArch 70*
Nelson, A W, Jr. *AmArch 70*
Nelson, Albert W *WhAmArt 85*
Nelson, Amy Margaret *DcWomA*
Nelson, Ardine *DcCAr 81*
Nelson, Arthur Eugene 1923- *AmArch 70*
Nelson, Auldin Henry 1923- *AmArch 70*
Nelson, B T, Jr. *AmArch 70*
Nelson, Belle E *DcWomA*
Nelson, Bruce 1888- *ArtsAmW 1, WhAmArt 85*
Nelson, Cal *FolkA 86*
Nelson, Carey Boone *WhoAmA 73, -76, -78, -80, -82, -84*
Nelson, Carl Gustaf 1898- *WhAmArt 85*
Nelson, Cecil D, Jr. *AfroAA*
Nelson, Charles Andrew 1926- *AmArch 70*
Nelson, Clara K *DcWomA, WhAmArt 85*
Nelson, Mrs. D *DcVicP 2*
Nelson, D Earle 1902- *WhAmArt 85*
Nelson, Dale Allen 1926- *AmArch 70*
Nelson, David *MarqDCG 84*
Nelson, David E 1945- *MarqDCG 84*
Nelson, David Lee 1939- *AmArch 70*
Nelson, Don E 1926- *AmArch 70*
Nelson, Don Jerome 1930- *MarqDCG 84*
Nelson, Dona Rae 1947- *WhoAmA 82, -84*
Nelson, Donald C G 1924- *AmArch 70*
Nelson, Donald Richard 1927- *WhoAmA 73, -76*
Nelson, Donald S 1907- *AmArch 70*
Nelson, Edmund Hugh 1910- *DcBrA 1*
Nelson, Edward 1905- *FolkA 86*
Nelson, Edward D d1871 *NewYHSD*
Nelson, Edward Humphrey 1918- *AmArch 70*
Nelson, Ernest O *WhAmArt 85*
Nelson, G *AmArch 70*
Nelson, G Patrick *WhAmArt 85*
Nelson, George 1908- *BnEnAmA, ConArch, ConDes, DcD&D, EncMA, McGDA*
Nelson, George Laurence 1887- *WhoAmA 73, -76*
Nelson, George Laurence 1887-1978 *WhAmArt 85, WhoAmA 78N, -80N, -82N, -84N*
Nelson, Gertrude *WhAmArt 85*
Nelson, Gertrude Wiser *DcWomA, WhAmArt 85*
Nelson, Hans Peter 1908- *WhAmArt 85*
Nelson, Harold 1871- *DcBrA 1*
Nelson, Harold 1871-1946 *DcBrA 2*
Nelson, Harold Edward Hughes 1871- *DcBrBI, DcVicP 2*
Nelson, Harry William 1908- *WhoAmA 73, -76, -78, -80, -82, -84*
Nelson, Homer S *WhAmArt 85*
Nelson, J T *AmArch 70*
Nelson, Jack D 1929- *WhoAmA 76, -78, -80, -82, -84*
Nelson, James L *FolkA 86*
Nelson, James Richard 1938- *AmArch 70*
Nelson, Jane Gray 1928- *WhoAmA 76, -78, -80, -82, -84*
Nelson, John P 1940- *MarqDCG 84*
Nelson, Jon Allen 1936- *WhoAmA 78, -80, -82, -84*
Nelson, Jon Alvin 1945- *MarqDCG 84*
Nelson, Joseph Bernard 1929- *AmArch 70*
Nelson, Julie A 1953- *MarqDCG 84*
Nelson, K E *AmArch 70*
Nelson, K W *AmArch 70*
Nelson, Katherine *WhAmArt 85*
Nelson, Katherine Boyd 1897- *DcBrA 1, DcWomA*
Nelson, Kyler *MarqDCG 84*
Nelson, L A *AmArch 70*
Nelson, Lee J 1952- *MarqDCG 84*
Nelson, Leonard 1912- *WhoAmA 73, -76, -78, -80, -82, -84*

Neumann, Max 1949- *DcCAr 81*
Neumann, Roy Covert 1921- *AmArch 70*
Neumann, S K *AmArch 70*
Neumann, Seth C 1950- *MarqDCG 84*
Neumann, Vera 1910- *WorFshn*
Neumann, William A 1924- *WhoAmA 78, -80, -82, -84*
Neumann-Pitschpatsch, Brigitte *DcWomA*
Neumans, Alphonse *DcVicP 2*
Neumark, Anne 1906- *WhAmArt 85*
Neumayer, D A *AmArch 70*
Neumegen, Florence *DcWomA*
Neumegen, Florence A *DcVicP 2*
Neumeister, Alexander 1941- *ConDes*
Neumengen, Florence *DcWomA*
Neumeyer, Alfred 1901-1973 *WhAmArt 85, WhoAmA 78N, -80N, -82N, -84N*
Neumuller, Else 1875- *DcWomA*
Neumuller, Emma Mathilda Paulina *DcWomA*
Neunaber *NewYHSD*
Neunaber, C E *AmArch 70*
Neuner, A A *AmArch 70*
Neupert, Charles *NewYHSD*
Neurath, Marie 1898- *WhoArt 80, -82, -84*
Neurath, Otto 1882-1945 *ConDes*
Neusacher, Margaret 1872- *DcWomA*
Neuschatz, Perry M 1930- *AmArch 70*
Neuser, L A W 1837-1902 *NewYHSD , WhAmArt 85*
Neustadt, Barbara 1922- *WhoAmA 73, -76, -78, -80, -82*
Neustadter, Edward L 1928- *WhoAmA 73, -76, -78, -80, -82*
Neustein, A S *DcVicP 2*
Neustein, Joshua 1940- *AmArt, ConArt 77, -83, DcCAr 81, WhoAmA 78, -80, -82, -84*
Neususs, Floris M 1937- *ConPhot, ICPEnP A*
Neususs, Floris M 1939- *DcCAr 81*
Neususs, Floris Michael 1937- *MacBEP*
Neuswanger, Carl Edward 1941- *AmArch 70*
Neutra, Dion 1926- *AmArch 70*
Neutra, Josephine *DcWomA*
Neutra, Richard 1892- *McGDA*
Neutra, Richard 1892-1970 *DcD&D, MacEA, WhoAmA 78N, -80N, -82N, -84N*
Neutra, Richard J 1892-1970 *BnEnAmA, ConArch*
Neutra, Richard Josef 1892-1970 *WhoArch*
Neutra, Richard Joseph 1892- *EncMA*
Neutra, Richard Joseph 1892-1970 *EncAAr, WhAmArt 85*
Neuve, Mademoiselle *DcWomA*
Neuveu, Mademoiselle *DcWomA*
Neuville *NewYHSD*
Neuville, Baroness H De *DcWomA*
Neuville, Alphonse De 1836- *ArtsNiC*
Neuville, Alphonse Marie De 1835-1885 *ClaDrA*
Neuwirth, Morris 1912- *WhAmArt 85*
Neuwirth, Rosa 1883- *DcWomA*
Nevara, R E *AmArch 70*
Nevatia, Ramkant *MarqDCG 84*
Nevay, James *DcBrECP*
Neve, A Aug *DcVicP 2*
Neve, Frans De 1606-1681? *McGDA*
Neve, Margaret *DcCAr 81*
Neve, William West *DcVicP 2*
Nevel, Frederick 1838-1923 *FolkA 86*
Nevel, Robert B *ConArch A*
Nevell, Thomas G 1910- *WhoAmA 73*
Nevell, Thomas George William 1910- *WhAmArt 85*
Nevelson, Louise 1899- *ConArt 77, DcAmArt, DcWomA, WhAmArt 85, WomArt, WorArt[port]*
Nevelson, Louise 1900- *AmArt, BnEnAmA, CenC, ConArt 83[port], DcCAA 71, -77, DcCAr 81, McGDA, OxTwCA, PhDcTCA 77, PrintW 83, -85, WhoAmA 73, -76, -78, -80, -82, -84*
Nevelson, Mike 1922- *DcCAA 71, -77, WhoAmA 73, -76, -78, -80, -82, -84*
Neyers, Jacques *DcWomA*
Nevers, Roderick *NewYHSD*
Nevetz *WhoArt 80, -82, -84*
Neveu, Mademoiselle *DcWomA*
Neveu, Mathys 1647-1721 *ClaDrA*
Neveu, Olympe *DcWomA*
Nevia *WhoAmA 82, -84, WhoArt 84*
Nevia 1943- *AmArt*
Neville, Charlotte *DcWomA*
Neville, Edgar N *NewYHSD*
Neville, Frank Hulett 1935- *AmArch 70*
Neville, H F *AmArch 70*
Neville, Henry 1796-1857 *CabMA*
Neville, J *AntBDN O*
Neville, James *CabMA, NewYHSD*
Neville, Jane 1949- *WhoArt 80, -82, -84*
Neville, Joshua 1768-1840 *CabMA*
Neville, Katherine Young 1876- *DcWomA, WhAmArt 85*
Neville, Mary *DcWomA, WhAmArt 85*
Neville, R E *AmArch 70*
Neville, Ralf *WhAmArt 85*
Nevin, Blanche *ArtsNiC*

Nevin, Blanche 1838?-1925 *DcWomA, WhAmArt 85*
Nevin, John Denison 1880- *WhAmArt 85*
Nevin, Joseph F 1947- *MarqDCG 84*
Nevin, Josephine Welles d1929 *DcWomA, WhAmArt 85*
Nevins, Blanche 1838?-1925 *DcWomA*
Nevins, W Probyn- *DcVicP 2*
Nevinson, Christopher Richard Wynne 1889-1946 *ConArt 77, DcBrA 1, McGDA, OxArt, OxTwCA, PhDcTCA 77*
Nevis, Robert *BiDBrA*
Nevitt, Richard Barrington 1936- *WhoAmA 78, -80, -82, -84*
Nevius, Benjamin C *EncASM*
Nevius, John *DcVicP 2*
New, E *DcVicP 2*
New, E H *WhAmArt 85*
New, Edmund Hart 1871-1931 *DcBrWA, DcVicP 2*
New, Edmund Hort 1871-1931 *AntBDN B, DcBrA 1, DcBrBI*
New, George 1894-1963 *WhAmArt 85*
New, James 1692-1781 *FolkA 86*
New, James 1751-1835 *FolkA 86*
New, John 1722- *FolkA 86*
New, Lloyd H 1916- *WhoAmA 73, -76, -78, -80, -82, -84*
New, Vincent Arthur 1906- *WhoArt 80, -82, -84*
Newall, Mildred Tilton *DcWomA, WhAmArt 85*
Newall, Walter *BiDBrA*
Newark, Roland Stephen 1938- *AmArch 70*
Newark, Wilbur L *WhAmArt 85*
Newberg, Alan 1943- *WhoAmA 76*
Newberry, Clare Turlay d1970 *IlsCB 1967*
Newberry, Clare Turlay 1903-1970 *IlsCB 1744, -1946, WhAmArt 85, WhoAmA 78N, -80N, -82N, -84N*
Newberry, Frances *FolkA 86*
Newberry, Francis H 1855-1946 *DcBrWA*
Newberry, George H 1857-1935 *WhAmArt 85*
Newberry, John S d1964 *WhoAmA 78N, -80N, -82N, -84N*
Newberry, John Strong 1822-1892 *ArtsAmW 1, IlBEAAW, NewYHSD*
Newberry, Merwin Royce 1930- *AmArch 70*
Newberry, Truman Leo, Jr. 1933- *AmArch 70*
Newberry, William *DcBrWA*
Newberry, Winifred Mabel *DcWomA*
Newbery, Edward *NewYHSD*
Newbery, Evan Robert Garrood 1904- *DcBrA 1*
Newbery, Francis H 1855-1946 *DcBrA 1, DcVicP 2*
Newbery, Maud *DcVicP 2*
Newbery, Rose *DcWomA, NewYHSD*
Newbill, Al 1921- *DcCAA 71, -77, WhoAmA 78, -80, -82, -84*
Newbill, Al James 1921- *WhoAmA 73*
Newbill, Michael Bryan 1940- *AmArch 70*
Newbold, Annie *DcVicP 2*
Newbolt, Sir Francis George 1863-1940 *DcBrA 1, DcVicP 2*
Newbolt, J *DcVicP 2*
Newbould, Frank 1887- *DcBrA 2*
Newbould, William *AntBDN N*
Newbrook, Dana M 1938- *AmArch 70*
Newbury, Bertram 1913- *WhoArt 80, -82, -84*
Newbury, Edward Arnold 1910- *AmArch 70*
Newby, Alfred T *DcVicP 2*
Newby, C A *AmArch 70*
Newby, Ruby Warren 1886- *ArtsAmW 2, DcWomA, WhAmArt 85*
Newcastle, Lena May *DcWomA, WhAmArt 85*
Newcomb *FolkA 86*
Newcomb, Barbara 1936- *WhoArt 80*
Newcomb, D *NewYHSD*
Newcomb, Edwin Eldwood 1895- *AmArch 70*
Newcomb, Florence A 1881?-1943 *DcWomA, WhAmArt 85*
Newcomb, Levi 1822-1898 *BiDAmAr*
Newcomb, Lucinda *ArtsEM, DcWomA*
Newcomb, Maria Guise 1865- *DcWomA*
Newcomb, Marie Guise *WhAmArt 85*
Newcomb, Mary 1922- *WhoArt 80, -82, -84*
Newcombe, Bertha *DcBrBI, DcVicP 2, DcWomA*
Newcombe, Frederick Clive 1847-1894 *DcBrWA, DcVicP, -2*
Newcombe, George W 1799-1845 *NewYHSD*
Newcombe, Samuel Prout *DcBrWA*
Newcombe, Warren 1894- *ArtsAmW 1, WhAmArt 85*
Newcombe, William 1907- *ClaDrA*
Newcombe Pottery *DcNiCA*
Newcomber, John B 1867-1931 *BiDAmAr*
Newcomen, Olive *DcVicP 2*
Newcomer, C Edgar 1910- *AmArch 70*
Newcomer, Florence E *DcWomA, WhAmArt 85*
Newcomer, Paul Edward 1934- *AmArch 70*
Newcommer, Abraham *NewYHSD*
Newcourt, Richard d1679 *BiDBrA*
Newdegate, Miss *DcWomA*
Newdegate, Barbara Maria *DcWomA*
Newdelman, Barry Lee 1938- *AmArch 70*
Newdigate, Sir Roger 1719-1806 *BiDBrA*
Newell, Charless A *DcBrWA*
Newell, Clifton 1900- *WhAmArt 85*

Newell, Crosby *IlsBYP*
Newell, G Glenn 1870-1947 *WhAmArt 85*
Newell, G N *FolkA 86*
Newell, G W *FolkA 86*
Newell, George Glenn 1870-1947 *ArtsAmW 1, -3, ArtsEM*
Newell, Gordon *WhAmArt 85*
Newell, Hermon 1774-1833 *FolkA 86*
Newell, Hugh *ArtsNiC*
Newell, Hugh 1830- *DcVicP 2, WhAmArt 85*
Newell, Hugh 1830-1915 *NewYHSD*
Newell, Isaac d1873 *FolkA 86*
Newell, J A *AmArch 70*
Newell, J P *NewYHSD*
Newell, James Michael 1900- *WhAmArt 85*
Newell, Jonathan *CabMA*
Newell, Mary Helen *ArtsEM, DcWomA*
Newell, Peter 1862-1924 *WorECar*
Newell, Peter Sheaf 1862-1924 *IlrAm 1880*
Newell, Peter Sheaf Hersey 1862-1924 *WhAmArt 85*
Newell, Robert Hassell 1778-1852 *DcBrBI, DcBrWA*
Newell, Roger Henry 1942- *AmArch 70*
Newell, S *DcWomA*
Newenham, Frederick 1807-1859 *DcVicP, -2*
Newenham, Kate *DcWomA*
Newenham, Robert O'Callaghan 1770-1849 *DcBrWA, DcVicP 2*
Newer, Thesis *WhoAmA 73, -76, -78, -80, -82, -84*
Newey, Harry Foster 1858-1933 *DcBrA 1, DcBrWA, DcVicP 2*
Newey, Isaac 1810?-1861 *BiDBrA*
Newhall, Adelaide 1884-1960 *DcWomA*
Newhall, Adelaide May 1884-1960 *WhAmArt 85, WhoAmA 80N, -82N, -84N*
Newhall, Beaumont *DcCAr 81*
Newhall, Beaumont 1908- *ICPEnP, MacBEP, WhoAmA 73, -76, -78, -80, -82, -84*
Newhall, Donald Victor 1890- *WhAmArt 85*
Newhall, Elizabeth 1909- *WhAmArt 85*
Newhall, Fred Clinton *EncASM*
Newhall, G V *WhAmArt 85*
Newhall, Harriot B 1874- *DcWomA, WhAmArt 85*
Newhall, John Bailey 1806-1849 *NewYHSD*
Newhall, Kate W *DcWomA*
Newhall, Louis Chapell 1869-1925 *BiDAmAr*
Newhall, Nancy 1908-1974 *MacBEP*
Newhall, Robert Eugene 1919- *AmArch 70*
Newhall, Stephen Cyrus d1885 *EncASM*
Newhall, William Frederick *EncASM*
Newham *BiDBrA*
Newhouse, Bertram Maurice 1888- *WhoAmA 73, -76, -78, -80, -82*
Newhouse, Bertram Maurice 1888-1982 *WhoAmA 84N*
Newhouse, C B *DcBrBI*
Newhouse, Charles B *DcBrWA, DcVicP 2*
Newhouse, Clyde Mortimer 1920- *WhoAmA 78, -80, -82, -84*
Newhouse, Henry *WhAmArt 85*
Newhouse, Mortimer Alfred 1850-1928 *WhAmArt 85*
Newick, John 1919- *WhoArt 80, -82, -84*
Newill, Mary J *DcBrBI*
Newill, Mary J 1860-1947 *DcBrA 1, DcVicP 2, DcWomA*
Newkirk, Haywood Homan 1933- *AmArch 70*
Newkirk, Newton *WhAmArt 85*
Newland, Anne 1913- *DcBrA 1, WhoArt 80, -82, -84*
Newland, James Earl 1929- *MarqDCG 84*
Newlin, Archie *DcWomA, WhAmArt 85*
Newlin, John North 1911- *WhAmArt 85*
Newlin, Sara *DcWomA*
Newlin, Sara Julia *WhAmArt 85*
Newlove, Victor Melvin 1941- *AmArch 70*
Newman, Miss *DcWomA*
Newman, A G *NewYHSD*
Newman, Allen George 1875-1940 *WhAmArt 85*
Newman, Ann Anderson 1944- *MarqDCG 84*
Newman, Anna Mary d1930 *DcWomA, WhAmArt 85*
Newman, Anthony 1950- *MarqDCG 84*
Newman, Arnold 1918- *ConPhot, DcCAr 81, ICPEnP, MacBEP, WhoAmA 73, -76, -78, -80, -82, -84*
Newman, Azadia *WhAmArt 85*
Newman, B *NewYHSD*
Newman, Barnett 1905- *McGDA*
Newman, Barnett 1905-1970 *BnEnAmA, ConArt 77, -83, DcAmArt, DcCAA 71, -77, OxTwCA, PhDcTCA 77, WhAmArt 85, WhoAmA 78N, -80N, -82N, -84N, WorArt[port]*
Newman, Bartas P *NewYHSD*
Newman, Benjamin *CabMA, FolkA 86*
Newman, Benjamin T 1859- *WhAmArt 85*
Newman, Beryl 1906- *WhoArt 82, -84*
Newman, C E 1922- *AmArch 70*
Newman, Carl *WhAmArt 85*
Newman, Catherine M *DcVicP 2, DcWomA*
Newman, Christopher 1943- *WhoAmA 73, -76*
Newman, Clara G 1870- *DcWomA, WhAmArt 85*
Newman, Donald *PrintW 83, -85*

Nicola DiFilotesio *McGDA*
Nicola DiMaestro Antonio *McGDA*
Nicola Pisano *McGDA*
Nicola, Giovanni Di *McGDA*
Nicolai Kirche *McGDA*
Nicolai, A T *NewYHSD*
Nicolai, C A *WhAmArt 85*
Nicolaides, Kimon 1892-1938 *WhAmArt 85*
Nicolais, Harold John *AmArch 70*
Nicolais, R A *AmArch 70*
Nicolao Fiorentino *McGDA*
Nicolas d1973 *IlsCB 1967*
Nicolas 1911-1973 *IlsBYP*, *IlsCB 1946, –1957*
Nicolas DeVerdun *McGDA*
Nicolas Frances *McGDA*
Nicolas Of Verdun *OxArt*, *OxDecA*
Nicolas, Magdeleine *DcWomA*
Nicolas, Marie Josephine 1845- *DcWomA*
Nicolas, Nicole *DcCAr 81*
Nicolas, Xavier 1952- *MarqDCG 84*
Nicolau Y Parody, Teresa *DcWomA*
Nicolaus *McGDA*
Nicolaus VonLeyden *McGDA*
Nicolay, Helen 1866- *WhAmArt 85*
Nicolay, Helen 1866-1954 *DcWomA*
Nicole, Nicolas 1702-1784 *MacEA*
Nicole, Pierre d1784 *NewYHSD*
Nicolet, Fina *DcWomA*
Nicolet, Gabriel d1921 *DcBrA 1*
Nicolet, Theophile *WhAmArt 85*
Nicoletti, Manfredi G 1930- *MacEA*
Nicoletto Rosex DaModena *McGDA*
Nicolie, Paul Emile 1828-1894 *ClaDrA*
Nicoll, Archibald Frank 1886-1953 *OxArt*
Nicoll, Gordon 1888-1959 *DcBrA 1*
Nicoll, J C 1845- *ArtsNiC*
Nicoll, J C 1846-1918 *WhAmArt 85*
Nicoll, James Craig 1846-1918 *ArtsAmW 3*
Nicolls, Joseph *BkIE*
Nicolo, Marie Alice *DcWomA*
Nicolosi, Joseph 1893-1961 *WhAmArt 85,*
WhoAmA 80N, –82N, –84N
Nicolotti, Vanna 1929- *ConArt 77*
Nicols, Audley Dean *IIBEAAW*
Nicolson, Benedict *WhoArt 80N*
Nicolson, Edith Reynaud 1896- *DcWomA,*
WhAmArt 85
Nicolson, John 1891-1951 *ClaDrA*, *DcBrA 1*
Nicolson, John P *DcVicP 2*
Nicolson, Winifred Ursula *DcWomA*
Nicomb *FolkA 86*
Nicord, Caroline *DcWomA*
Nicotera, Marco Antonio *ClaDrA*
Nicoud, Henry E *NewYHSD*
Nicz-Borowiak, Maria 1896-1944 *DcWomA*
Niebuhr, Richard C 1902- *AmArch 70*
Niedecken, George Mann 1878- *WhAmArt 85*
Niedelson, Martin Sheldon 1932- *AmArch 70*
Niederer And Moore *EncASM*
Niederhausern, Sophie Von 1856-1926 *DcWomA*
Niederman, T A *AmArch 70*
Niedermayer, Johann Joseph *AntBDN M*
Niego, Sol 1939- *AmArch 70*
Niehaus, Charles H 1855-1935 *WhAmArt 85*
Niehaus, Charles Henry 1855-1935 *BnEnAmA,*
DcAmArt, *McGDA*
Niehaus, W L *AmArch 70*
Niehoff, Lester John 1920- *AmArch 70*
Niehus, Gustave A 1872-1945? *BiDAmAr*
Niel, Gabrielle Marie 1840?- *DcWomA*
Nieland, Brendon *DcCAr 81*
Nielsen, Amaldus Clarin 1838- *ClaDrA*
Nielsen, Amaldus Clarin 1838-1900 *DcSeaP*
Nielsen, Anne Marie Carl 1863- *DcWomA*
Nielsen, Anne Marie Frederikke *DcWomA*
Nielsen, Benson Adolph 1936- *AmArch 70*
Nielsen, Bent Rosenkilde 1904- *WhoArt 80, –82, –84*
Nielsen, Donald Edward 1937- *AmArch 70*
Nielsen, Ejner E D 1899- *AmArch 70*
Nielsen, H, Jr. *AmArch 70*
Nielsen, Holger 1883- *ArtsAmW 3*
Nielsen, Ida Marie Juliane *DcWomA*
Nielsen, Jack L 1934- *AmArch 70*
Nielsen, Julius 1910- *AmArch 70*
Nielsen, Kay 1886- *ConICB*, *IlsCB 1744*
Nielsen, Kay 1886-1957 *DcBrA 2*, *DcBrBI*
Nielsen, Nina I M 1940- *WhoAmA 80, –82, –84*
Nielsen, Oluf Norman 1925- *AmArch 70*
Nielsen, Palle 1920- *DcCAr 81*
Nielsen, Peter *WhAmArt 85*
Nielsen, Riener Carl 1915- *AmArch 70*
Nielsen, Roger P *MarqDCG 84*
Nielsen, Stuart 1947- *WhoAmA 76, –78*
Nielsen, Victor H 1905- *AmArch 70*
Nielson, Charles P *ArtsAmW 2*
Nielson, Harry A 1881- *ArtsAmW 3*, *WhAmArt 85*
Nielson, John 1881-1954 *WhAmArt 85*
Nielssen, Clementine *DcWomA*
Nieman, LeRoy 1926- *WhoAmA 73*
Niemann, Bernard John, Jr. 1937- *MarqDCG 84*
Niemann, Edmund E *WhoAmA 73, –76, –78, –80, –82,*
–84

Niemann, Edmund E 1909- *WhAmArt 85*
Niemann, Edmund John 1813-1876 *ArtsNiC, ClaDrA,*
DcBrWA, *DcSeaP*, *DcVicP, –2*
Niemann, Edward H *DcVicP, –2*
Niemann, H O *AmArch 70*
Niemeyer, Arnold Matthew 1913- *WhoAmA 73, –76,*
–78, –80, –82, –84
Niemeyer, Dale Frederick 1933- *AmArch 70*
Niemeyer, John H 1839- *ArtsNiC*
Niemeyer, John H 1839-1932 *WhAmArt 85*
Niemeyer, John Henry 1839-1932 *NewYHSD*
Niemeyer, Oscar 1907- *ConArch, DcD&D[port],*
EncMA, *MacEA*, *McGDA*, *WhoArch*
Niemeyer, Yael 1943- *DcCAr 81*
Niemeyer Soares Filho, Oscar 1907- *OxArt*
Nienhaus, D L *AmArch 70*
Niepce, Janine 1921- *ICPEnP A*
Niepce, Joseph Nicephore 1765-1833 *ICPEnP,*
MacBEP
Niepce DeSaint-Victor, Claude Felix Abel 1805-1870
ICPEnP
Niepce DeSt.-Victor, Abel 1805-1870 *MacBEP*
Niepold, Frank 1890- *WhAmArt 85*
Nierensee, John R 1831-1885 *BiDAmAr*
Nierhoff, Ansgar 1941- *ConArt 77, DcCAr 81*
Nieriker, Ernest, Madame 1840-1879 *NewYHSD*
Nieriker, May *DcWomA*
Nierman, Dennis Edward 1942- *MarqDCG 84*
Nierman, Leonardo 1932- *PrintW 83, –85*
Nierman, Leonardo M 1932- *WhoAmA 73, –76, –78,*
–80, –82, –84
Niese, Henry Ernst 1924- *WhoAmA 73, –76, –78, –80,*
–82, –84
Niestle, Jean Bloe 1884-1942 *McGDA*
Nieto, Grace 1899- *DcWomA*
Nieto, John W 1936- *WhoAmA 84*
Nieucasteel, Nicolas *McGDA*
Nieulandt, Adriaen Van 1587-1658 *McGDA*
Nieulandt, Constantia *DcWomA*
Nieulandt, Maria *DcWomA*
Nieulandt, Willem Van 1582?-1635? *ClaDrA*
Nieulandt, Willem Van 1584?-1636? *McGDA*
Nieulant, Willem Van 1582?-1635? *ClaDrA*
Nieuwenhuis, Celeste Withers *DcWomA,*
WhAmArt 85
Nieuwenhuis, Cesar Domela *McGDA*
Nieuwerhuys, E *DcVicP 2*
Nieva, Francisco *OxTwCA*
Nievergelt, Jurg 1938- *MarqDCG 84*
Nifflin, P *NewYHSD*
Nigetti, Matteo 1580?-1649 *MacEA*
Nigg, Joseph 1782-1863 *ClaDrA*
Niggli, Walter 1908- *WhoGrA 82[port]*
Nightingale, Agnes *DcBrWA*
Nightingale, Charles T 1878- *ConICB*
Nightingale, Frederick C *DcBrWA, DcVicP, –2*
Nightingale, Mrs. L C *DcVicP 2*
Nightingale, Leonard Charles *DcBrWA, DcVicP 2*
Nightingale, Robert *DcBrWA*
Nightingale, Robert 1815-1895 *DcVicP, –2*
Nigris, Julie *DcWomA*
Nigro, Jan 1920- *DcCAr 81*
Nigro, Mario 1917- *ConArt 77, –83, DcCAr 81*
Nigrosh, Israel 1911- *AmArch 70*
Nigrosh, Leon Isaac 1940- *WhoAmA 73, –76, –78, –80,*
–82, –84
Nihell, A *DcWomA*
Nihill, A *DcWomA*
Niizuma, Minoru 1930- *AmArt, ConArt 77, –83,*
WhoAmA 73, –76, –78, –80, –82, –84
Nike Of Paeonius *McGDA*
Nikias *McGDA*
Nikifor 1895?-1968 *OxTwCA*
Nikirk, Frank Martin 1949- *MarqDCG 84*
Nikkel, David Norman 1957- *MarqDCG 84*
Nikkelen, Jacoba Maria Van 1690?- *DcWomA*
Nikkila, Seppo Ilmari 1949- *MarqDCG 84*
Nikko *McGDA*
Nikolaki, Z P *WhAmArt 85*
Nikolaus Gerhaert VonLeyden *McGDA*
Nikoleski, Vlase 1958- *DcCAr 81*
Nikolskaia, Vera Nikolaievna 1890-1964 *DcWomA*
Nikos 1930- *ClaDrA, OxTwCA, PhDcTCA 77*
Nikosthenes *McGDA*
Niland, Deborah 1951- *IlsCB 1967*
Niland, Kilmeny 1951- *IlsCB 1967*
Niles, E R *AmArch 70*
Niles, Emory Hamilton, Jr. 1928- *AmArch 70*
Niles, Helen *DcWomA*
Niles, Helen J *WhAmArt 85*
Niles, Jane *FolkA 86*
Niles, Leland Henry 1890- *AmArch 70*
Niles, Melinda *FolkA 86*
Niles, Robert C 1944- *MarqDCG 84*
Niles, Rosamond *WhoAmA 80N, –82N, –84N*
Niles, Rosamond 1881-1959? *DcWomA*
Niles, Rosamond 1881-1960? *WhAmArt 85*
Niles, William J *WhAmArt 85*
Nilis, Pierre *NewYHSD*
Nill, Martha 1859- *DcWomA*

Nill, Mary *WhAmArt 85*
Nilles, Jack Mathias 1932- *MarqDCG 84*
Nillett, W *DcVicP 2*
Nils, Udo 1937- *DcCAr 81*
Nilsen, Eivind W *AmArch 70*
Nilson, Barbara 1758-1821? *DcWomA*
Nilson, Catharina Christina Johanna 1791- *DcWomA*
Nilson, Karl-Gustaf 1942- *DcCAr 81*
Nilson, Rosina Barbara 1691?-1763 *DcWomA*
Nilson, Rosina Catharina 1755-1785 *DcWomA*
Nilson, Susanna Christina Johanna 1786- *DcWomA*
Nilsson, Anita 1942- *DcCAr 81*
Nilsson, Barbro 1899- *ConDes*
Nilsson, Gladys 1940- *AmArt, DcCAr 81,*
WhoAmA 84
Nilsson, John B 1937- *MarqDCG 84*
Nilsson, Lennart 1922- *ConPhot, ICPEnP, MacBEP*
Nilsson, Pal-Nils 1929- *ConPhot, ICPEnP A*
Nilsson, Tora *DcWomA*
Nilsson, Vera 1888-1979 *DcWomA*
Nimbs, Areuna B *DcWomA, NewYHSD*
Nimciv, Miroslav Daniel 1910- *AmArch 70*
Nimmo, Louise 1899-1959 *DcWomA*
Nimmo, Louise Everett 1899- *ArtsAmW 1,*
WhAmArt 85
Nimmo, Mary *DcWomA*
Nimmons, George C 1865-1947 *BiDAmAr*
Nimo *WhAmArt 85*
Nimptsch, Uli 1897- *DcBrA 1*
Nims, Mrs. *ArtsEM, DcWomA*
Nims, Jeremiah d1842 *NewYHSD*
Nims, Mary Altha *DcWomA, FolkA 86,*
NewYHSD
Nims, Norman G 1879-1935 *BiDAmAr*
Nims, Theodore S *NewYHSD*
Nims-Gern, Marguerite *DcWomA*
Ninas, Jane *WhAmArt 85*
Ninas, Paul 1903- *WhAmArt 85*
Nind, Jean 1930- *WhoAmA 78, –80, –82, –84*
Nineham, Henry 1793-1874 *DcVicP 2*
Niner, Rod E 1953- *MarqDCG 84*
Ninham, Henry 1793-1874 *DcBrBI, DcBrWA*
Ninham, W *DcBrECP*
Ninker, Herbert Walker 1925- *AmArch 70*
Ninnes, Bernard 1899-1971 *DcBrA 1*
Nino Pisano d1368? *McGDA*
Nino, Alex N 1940- *WorECom*
Nino, Robert Victor, Jr. 1956- *MarqDCG 84*
Ninomiya, Eiji 1917- *AmArch 70*
Ninon 1908- *IlsBYP, IlsCB 1946*
Ninsei *McGDA*
Niobid, Painter *McGDA*
Nipon, Albert *WorFshn*
Nipon, Pearl *WorFshn*
Nipp, Robert *OfPGCP 86*
Nipper, Anne E 1955- *PrintW 85*
Nirvanno, Comet 1940- *WhoAmA 76, –78, –80, –82*
Nisa, Mademoiselle *DcWomA*
Nisbet, Mrs. C Becheler 1902- *WhAmArt 85*
Nisbet, David 1790-1853 *BiDBrA*
Nisbet, Ethel *DcWomA*
Nisbet, Frances E *DcVicP 2*
Nisbet, H *DcVicP 2*
Nisbet, Hume 1849-1923 *DcBrBI*
Nisbet, J *DcBrECP*
Nisbet, James d1781 *BiDBrA*
Nisbet, M H *ClaDrA, DcWomA*
Nisbet, Mrs. M H *DcVicP, –2*
Nisbet, Margaret D 1863-1935 *DcBrWA, DcVicP 2*
Nisbet, Noel Laura *DcWomA*
Nisbet, Noel Laura 1887- *IlsCB 1744*
Nisbet, Noel Laura 1887-1956 *DcBrA 1*
Nisbet, P A 1948- *AmArt*
Nisbet, Pollok Sinclair 1848-1922 *DcBrA 1, DcVicP,*
–2
Nisbet, Robert *BiDBrA*
Nisbet, Robert Buchan 1857-1942 *DcBrA 1,*
DcBrWA, DcVicP, –2
Nisbet, Robert H 1879-1961 *WhAmArt 85,*
WhoAmA 80N, –82N, –84N
Nisbeth, Frederick Clyde, Sr. 1911- *AmArch 70*
Nisbett, Ethel C *DcVicP 2, DcWomA*
Nisbett, J S *DcVicP 2*
Nisbett, M *DcVicP 2*
Nisbett, Pollock Sinclair 1848-1922 *DcBrWA*
Nisbit, Tom 1909- *DcBrA 2*
Nisen, William George 1951- *MarqDCG 84*
Nisenson, Samuel *IlsBYP*
Nishi, Noriko *WorFshn*
Nishida, Thomas Tadayuki 1909- *AmArch 70*
Nishihara, Seiichi 1946- *MarqDCG 84*
Nishii, K *ArtsAmW 3*
Nishimoto, Kenneth Masao 1907- *AmArch 70*
Nishimoto, Yoshio 1933- *AmArch 70*
Nishimura, Arlene Akiko 1932- *AmArch 70*
Nishizawa Flores, Luis 1918- *WhoAmA 84*
Nisita, Carlo Antonio 1895- *WhAmArt 85*
Nispel, Donald L 1931- *AmArch 70*
Niss, Robert Sharples 1949- *WhoAmA 76, –78, –80,*
–82
Nissen, Brian *PrintW 85*

Nissen, Charles *FolkA 86*
Nissen, Irvin Bernard 1935- *MarqDCG 84*
Nisson-Sommersted, Julie *DcWomA*
Nistri *DcBrECP*
Nistri, Anna *DcWomA*
Niswonger, Ilse V 1900- *WhAmArt 85*
Niten 1584-1645 *McGDA*
Nithardt, Mathis *McGDA*
Nitsch, Hermann 1938- *ConArt 77, –83*
Nitsche, Arik 1908- *WhAmArt 85*
Nitsche, Erik 1908- *WhoGrA 62, –82[port]*
Nitschke, Charles Albert 1928- *AmArch 70*
Nittis, Giuseppe De 1846-1884 *ArtsNiC, ClaDrA, McGDA*
Nitz, Thomas L 1941- *WhoAmA 78, –80*
Nitzsche, Elsa Koenig d1952 *WhoAmA 78N, –80N, –82N, –84N*
Nitzsche, Elsa Koenig 1880-1952 *DcWomA, WhAmArt 85*
Nivelet *FolkA 86*
Niven, David P M *DcVicP 2*
Niven, Frank R 1888- *WhAmArt 85*
Niven, Margaret Graeme 1906- *DcBrA 1, WhoArt 80, –82, –84*
Niven, William d1921 *DcBrA 1*
Niven, William 1846-1921 *DcBrA 2*
Nivet-Fontaubert, Amelie *DcWomA*
Nivinski, Iganti Ignatievitch 1881- *ClaDrA*
Nivison, Josephine *DcWomA*
Nivola, Claire *IlsBYP*
Nivola, Constantino 1911- *BnEnAmA, ConArt 83, DcCAA 71, –77, OxTwCA, PhDcTCA 77, WhoAmA 73, –76, –78, –80, –82, –84*
Nivola, Costantino 1911- *DcCAr 81*
Nivoulies, Marie *DcWomA*
Nix, George C 1939- *MarqDCG 84*
Nix, Patricia *WhoAmA 82, –84*
Nix, William Edward 1928- *AmArch 70*
Nixon, Mrs. *DcVicP 2, DcWomA*
Nixon, Charles L *NewYHSD*
Nixon, D *NewYHSD*
Nixon, Floyd S *WhAmArt 85*
Nixon, Floyd Sherman 1890- *ArtsEM*
Nixon, Bishop Francis Russell 1803-1879 *DcBrWA*
Nixon, J F *DcVicP 2*
Nixon, J Forbes *DcBrBI*
Nixon, James 1741?-1812 *AntBDN J, DcBrECP*
Nixon, James Henry *DcBrBI*
Nixon, James Henry 1808-1850? *DcVicP, –2*
Nixon, James M *NewYHSD*
Nixon, Janette T *ArtsEM, DcWomA*
Nixon, Job 1891-1938 *DcBrA 1*
Nixon, John d1818 *DcBrECP*
Nixon, John 1750?-1818 *DcBrBI, DcBrWA*
Nixon, John B *NewYHSD*
Nixon, Kathleen 1895- *DcWomA*
Nixon, Marian *DcVicP 2*
Nixon, Minna *DcVicP 2*
Nixon, N H *FolkA 86*
Nixon, Netta *DcWomA, WhAmArt 85*
Nixon, Nicholas 1947- *ConPhot, DcCAr 81, ICPEnP A*
Nixon, Robert 1750-1837 *DcBrECP*
Nixon, Robert 1759-1837 *DcBrWA*
Nixon, Robert Feake *BiDBrA*
Nixon, Robert James 1930- *AmArch 70*
Nixon, T *NewYHSD*
Nixon, T E *AmArch 70*
Nixon, William d1824 *BiDBrA*
Nixon, William 1810?-1848 *BiDBrA*
Nixon, William Charles 1813?-1878 *DcVicP 2*
Nixon, William D *AfroAA, WhAmArt 85*
Nizel, Robert Nathan 1938- *AmArch 70*
Nizzoli, Marcello 1887-1968 *MacEA*
Nizzoli, Marcello 1887-1969 *ConDes*
Nizzoli, Marcello 1895- *EncMA, McGDA, WhoGrA 62*
Njaroge Tawa *AfroAA*
Noa, Florence 1941- *WhoAmA 82, –84*
Noa, Jessie *DcVicP 2*
Noack, Helene *DcWomA*
Noack, James Clinton 1939- *AmArch 70*
Noailles, Comtesse De *DcWomA*
Noailles, Anna Elisabeth 1876-1933 *DcWomA*
Noakes, Charles G *DcVicP 2*
Noakes, Edward Henry 1916- *AmArch 70*
Noakes, James *DcVicP 2*
Noakes, Michael 1933- *ClaDrA, WhoArt 80, –82, –84*
Noami 1397-1471 *McGDA*
Noar, Eva *DcBrA 1, DcWomA*
Noback, Gustave Joseph 1890- *WhAmArt 85*
Nobas, Rosendo *ArtsNiC*
Nobbe, Walter 1941- *DcCAr 81*
Nobbs, Percy Erskine 1875-1964 *MacEA*
Nobel, Berthold *WhAmArt 85*
Nobel, John Sargeant 1848-1896 *ClaDrA*
Nobile, Peter Von 1774-1854 *McGDA*
Nobili, Elena 1833-1900 *DcWomA*
Nobili, Louise *WhoAmA 78, –80, –82, –84*
Nobili, Rosa *DcWomA*

Noble, Miss *DcWomA, NewYHSD*
Noble, Adeline M *DcWomA*
Noble, Mrs. Belden *WhAmArt 85*
Noble, Carl E *WhAmArt 85*
Noble, Charles F 1833?- *EarABI SUP, NewYHSD*
Noble, Charlotte M *DcVicP, –2, DcWomA*
Noble, Christopher 1949- *DcCAr 81*
Noble, Clarke *FolkA 86*
Noble, Dora 1922- *WhoArt 82, –84*
Noble, Edwin *DcVicP 2*
Noble, F W *DcVicP 2*
Noble, Florence K *DcVicP 2*
Noble, G J L *DcVicP 2*
Noble, George *FolkA 86*
Noble, Helen 1922- *AmArt, WhoAmA 82, –84*
Noble, Ida Chandler 1865- *DcWomA*
Noble, Ida S 1865- *WhAmArt 85*
Noble, James *DcBrA 1*
Noble, James d1875 *BiDBrA*
Noble, James 1797-1879 *DcVicP, –2*
Noble, James 1919- *WhoArt 82, –84*
Noble, James Campbell 1846-1913 *DcBrA 1, DcVicP, –2*
Noble, Joe 1894- *WorECar*
Noble, John 1874-1934 *ArtsAmW 1, –2, IlBEAAW*
Noble, John 1874-1935 *WhAmArt 85*
Noble, John A 1913- *WhoAmA 76, –78, –80, –82*
Noble, John A 1913-1983 *WhoAmA 84N*
Noble, John Edwin 1876- *ClaDrA, DcBrA 1, DcBrBI*
Noble, John Rushton 1927- *ClaDrA, WhoArt 80*
Noble, John Sargent 1848-1896 *DcVicP, –2*
Noble, Joseph Veach 1920- *WhoAmA 73, –76, –78, –80, –82, –84*
Noble, Mamie Jones *WhAmArt 85*
Noble, Mamie Jones 1875- *ArtsAmW 1, DcWomA*
Noble, Marion *DcVicP 2*
Noble, Mathew *CabMA*
Noble, Matthew 1818-1876 *ArtsNiC*
Noble, May *WhAmArt 85*
Noble, May 1878-1966 *DcWomA*
Noble, Morton *WhAmArt 85*
Noble, Morton W 1922- *AmArch 70*
Noble, R *DcVicP 2*
Noble, R P *DcBrWA, DcVicP, –2*
Noble, R S *DcVicP 2*
Noble, Robert 1857-1917 *DcBrA 1, DcVicP, –2*
Noble, Robert Heysham *DcVicP, –2*
Noble, Robert Warren 1904- *AmArch 70*
Noble, Thomas Satterwhite 1835-1907 *NewYHSD, WhAmArt 85*
Noble, W Clark 1858-1938 *WhAmArt 85*
Noble, Wilfred McNeill, Jr. 1933- *AmArch 70*
Noble, William Bonneau 1780-1831 *DcBrWA*
Noble-Ives, Sarah *WhAmArt 85*
Noble-Pijeaud, Claire Julienne *DcWomA*
Nobler, B G *AmArch 70*
Noblet, Madame Du *DcBrECP*
Noblet, Mary *DcWomA*
Noblett, Dell *CabMA*
Noblett, Henry John 1812- *DcBrWA, DcVicP 2*
Noblin, C W *AmArch 70*
Nobuharu *McGDA*
Nobuzane 1176-1265 *McGDA*
Nocella, Anthony C 1903- *AmArch 70*
Nochlin, Linda 1931- *WhoAmA 73, –76, –78, –80, –82, –84*
Noci, Arturo *WhAmArt 85*
Nock, Henry 1741-1804 *AntBDN F*
Nock, Samuel *AntBDN F*
Nock, Samuel 1903- *AmArch 70*
Nocka, Paul Frank 1904- *AmArch 70*
Nockolds, Roy Anthony 1911- *DcBrA 2*
Nocq, Marie Victorine *DcWomA*
Nocquet, Paul-Ange 1877-1906 *WhAmArt 85*
Nocret, Jean 1615-1672 *McGDA*
Noda, Tetsuya 1940- *ConArt 77, DcCAr 81*
Nodder, Frederick Polydore d1800? *DcBrWA*
Nodder, Richard Polydore *DcBrECP, DcBrWA*
Node, Marie Louise *DcWomA*
Nodel, Sol 1912- *WhoAmA 73, –76*
Nodel, Sol 1912-1976 *WhoAmA 78N, –80N, –82N, –84N*
Nodine, Alexander *FolkA 86*
Nodine, Jane Allen 1954- *WhoAmA 82, –84*
Noe, Amedee Charles Henri De, Viscomte 1819-1879 *ClaDrA*
Noe, Amedee De *McGDA*
Noe, Amedee De 1819-1879 *WorECar*
Noe, Jerry Lee 1940- *WhoAmA 76, –78, –80, –82, –84*
Noe, Leon Joseph 1942- *AmArch 70*
Noe, Luis Felipe *OxTwCA*
Noe, R K *AmArch 70*
Noe, Samuel V, Jr. 1933- *AmArch 70*
Noecker, J Harold 1912- *WhAmArt 85*
Noefer, Werner 1937- *ConArt 77*
Noel, Alexandre Jean 1752-1834 *McGDA*
Noel, Alexis Nicolas 1792-1871 *ClaDrA*
Noel, Amelia *DcBrWA, DcWomA*
Noel, Edme-Antony-Paul *ArtsNiC*
Noel, Ellen *DcWomA*

Noel, F *DcWomA*
Noel, F S *AmArch 70*
Noel, Frank E 1905-1966 *MacBEP*
Noel, Frederick R *AfroAA*
Noel, Georges 1924- *PhDcTCA 77, WhoAmA 78, –80, –82, –84*
Noel, Helen Jeanette 1912- *WhAmArt 85*
Noel, John Bates 1870-1927 *DcBrA 2*
Noel, Jules Achille 1815-1881 *ClaDrA, DcSeaP*
Noel, Julie Anne Marie 1812-1843 *DcWomA*
Noel, Laure *AntBDN E, DcWomA*
Noel, Louisa *DcWomA*
Noel, M P *FolkA 86*
Noel, Martin 1888-1963 *MacEA*
Noel, Mary Cathrine *DcWomA*
Noel, Susan D 1941- *MarqDCG 84*
Noelker, Harold Edwin 1924- *AmArch 70*
Noelle *NewYHSD*
Noelle, Frederick *NewYHSD*
Noelle, Gebrueder *EncASM*
Noerdinger, Jean Joseph 1895- *WhAmArt 85*
Noerdlinger, Janau Nau 1942- *WhoAmA 82, –84*
Noetzel, C E *AmArch 70*
Noeuveglise, Marie *DcWomA*
Nofer, Robert Ervin 1933- *AmArch 70*
Nofer, Werner 1937- *OxTwCA*
Noffsinger, James Philip 1925- *AmArch 70*
Noftsger, B Gaylord *AmArch 70*
Nofziger, Ed 1913- *WhAmArt 85*
Noga, Francois R E 1892- *WhAmArt 85*
Nogari, Giuseppe 1700?-1763 *McGDA*
Nogaro, Marie Therese *DcWomA*
Noggle, Anne *DcCAr 81*
Noggle, Anne 1922- *ICPEnP A, MacBEP, WhoAmA 76, –78, –80, –82, –84*
Noguchi, Isamu 1904- *AmArt, BnEnAmA, CenC, ConArt 77, –83, DcAmArt, DcCAA 71, –77, DcCAr 81, McGDA, OxArt, OxTwCA, PhDcTCA 77, WhAmArt 85, WhoAmA 73, –76, –78, –80, –82, –84, WorArt[port]*
Noguchi, Shohin Chika 1847-1917 *DcWomA*
Noguchi, Yataro 1899- *WhoArt 80, –82, –84*
Nogues I Cases, Xavier 1873-1941 *WorECar*
Noh, Nora *WorFshn*
Noh, Yong Deok 1953- *MarqDCG 84*
Noheimer, Mathias John 1909- *WhAmArt 85*
Nohowel, M Dressler 1888- *WhAmArt 85*
Nohowel, Margaret Dressler 1888- *DcWomA*
Nohren, Johanna *DcWomA*
Noireserre, Marie Therese *DcWomA*
Noiresterres, Marie Therese *DcWomA*
Noireterre, Marie Therese *DcWomA*
Noisette, William S *AfroAA*
Nojima, Yasuzo 1889-1964 *ICPEnP*
Nolan, Charles E, Jr. 1930- *AmArch 70*
Nolan, Daniel J 1862-1920 *WhAmArt 85*
Nolan, Diane Agnes 1939- *MarqDCG 84*
Nolan, Harry A *WhAmArt 85*
Nolan, Helen Esperance *DcWomA, WhAmArt 85*
Nolan, Humphrey 1897- *AmArch 70*
Nolan, John Francis 1924- *MarqDCG 84*
Nolan, Keith 1948- *MarqDCG 84*
Nolan, Lawrence Eugene 1948- *MarqDCG 84*
Nolan, Margaret Patterson *WhoAmA 82, –84*
Nolan, R A *AmArch 70*
Nolan, Sidney 1917- *ConArt 77, –83, McGDA, OxArt, OxTwCA, PhDcTCA 77*
Nolan, Sidney Robert 1917- *DcBrA 1, DcCAr 81, WhoArt 80, WorArt[port]*
Nolan, Stephen 1907- *AmArch 70*
Nolan, T J, Jr. *AmArch 70*
Nolan, Thomas 1857-1926 *BiDAmAr*
Nolan, U M *AmArch 70*
Nolan, Warren John 1923- *AmArch 70*
Noland, Iveson Batchelor, III 1938- *AmArch 70*
Noland, Kenneth 1924- *BnEnAmA, CenC[port], ConArt 83, DcAmArt, DcCAA 71, –77, DcCAr 81, McGDA, OxTwCA, PhDcTCA 77, PrintW 85, WhoAmA 73, –76, –78, –80, –82, –84, WorArt[port]*
Noland, Kenneth C 1924- *AmArt, ConArt 77*
Noland, Kenneth C 1927- *WhoArt 80*
Noland, William 1954- *WhoAmA 84*
Nold, Eugenie Helene *DcWomA*
Nolde, Emil 1867-1956 *ConArt 77, –83, McGDA, OxArt, OxTwCA, PhDcTCA 77*
Nolde, Emile 1867-1956 *WorArt[port]*
Nole, Andre Colyns De *McGDA*
Nole, Guillaume Colyns De *McGDA*
Nole, Jacob Colyns De *McGDA*
Nole, Jacob De d1601 *McGDA*
Nole, John Colyns De *McGDA*
Nole, Robert Colyns De *McGDA*
Nole, Willem Colyns De *McGDA*
Nolen, Henry S *NewYHSD*
Nolen, J A, Jr. *AmArch 70*
Nolet, Henriette *DcWomA*
Nolf, John Thomas 1872-1955? *WhAmArt 85*
Nolken, Franz 1884-1918 *McGDA*
Noll *FolkA 86*
Noll, Arthur Howard 1855- *WhAmArt 85*

North, L *FolkA 86*
North, Lemuel 1786-1845 *FolkA 86*
North, Linus 1794-1846 *FolkA 86*
North, Lois 1908- *WhAmArt 85*
North, Lucinda *FolkA 86*
North, Lucy E *DcVicP 2*
North, Marianne 1830-1890 *DcVicP 2, DcWomA*
North, Mary *DcWomA, NewYHSD*
North, Mercy *FolkA 86*
North, Noah *NewYHSD*
North, Noah 1809-1880 *AmFkP, FolkA 86*
North, Paula *DcCAr 81*
North, R P *DcVicP 2*
North, Robert *WhAmArt 85*
North, Roger 1653?-1734 *BiDBrA*
North, Seth *FolkA 86*
North, Silas *FolkA 86*
North, Simeon *FolkA 86*
North, Simeon 1765-1825 *AntBDN F*
North, Stephen 1767- *FolkA 86*
North, W B *AmArch 70*
North, William B *NewYHSD*
Northam, Caroline A 1872- *DcWomA, WhAmArt 85*
Northam, Thomas Edwin 1936- *MarqDCG 84*
Northampton, Countess *DcWomA*
Northcote, Hannah *AntBDN Q*
Northcote, Henry *NewYHSD*
Northcote, James 1746-1831 *ClaDrA, DcBrBI, DcBrECP, McGDA, OxArt*
Northcote, James 1822-1904 *NewYHSD , WhAmArt 85*
Northcote, Stafford M 1869- *WhAmArt 85*
Northcott, Nathaniel *DcBrECP*
Northen, O E, Jr. *AmArch 70*
Northerman, George *NewYHSD*
Northern, J E *AmArch 70*
Northrip, Elma 1876- *DcBrA 1, DcWomA*
Northey, William, Jr. *FolkA 86*
Northey, William Brooke d1897? *DcBrWA*
Northington, Allen Merrill 1918- *AmArch 70*
Northington, Clara Beard 1882- *ArtsAmW 3, DcWomA*
Northrop, John Willard 1934- *MarqDCG 84*
Northrop, A F *DcWomA*
Northrop, P H *AmArch 70*
Northrop, Rodolphus E *FolkA 86*
Northrup, Charles Vandercar 1909- *AmArch 70*
Northrup, L L *ArtsEM*
Northrup, Rebecca S *ArtsEM, DcWomA*
Northup, L N *AmArch 70*
Northup, William C d1942? *BiDAmAr*
Northwood, Harry *AntBDN H*
Northwood, John 1836-1902 *IlDcG*
Northwood, John 1837-1902 *DcNiCA*
Northwood, John, II 1870-1960 *IlDcG*
Northwood, John, Sr. 1836-1902 *AntBDN H*
Northwood, Joseph *IlDcG*
Northwood, Richard Alfred 1850-1926 *MacBEP*
Norton, Alice E *DcWomA*
Norton, Ann *WhoAmA 73, -76, -78, -80*
Norton, Ann Eliza *FolkA 86*
Norton, Ann W d1982 *WhoAmA 82N, -84N*
Norton, Arthur William *DcVicP 2*
Norton, Benjamin Cam *DcVicP, -2*
Norton, Charles *BiDBrA*
Norton, Charles D 1871-1923 *WhAmArt 85*
Norton, Charles Eliot 1827-1908 *WhAmArt 85*
Norton, Charles Martin *AmArch 70*
Norton, Charles W *WhAmArt 85*
Norton, Charles Wardlow 1843-1901 *ArtsEM*
Norton, Charles Wardlow 1848-1901 *DcSeaP*
Norton, Charles William 1870-1946 *DcBrA 1, DcVicP 2*
Norton, Christopher d1780? *BkIE*
Norton, Christopher d1799 *DcBrECP*
Norton, Clara Mamie *DcWomA*
Norton, Clara Mamre *WhAmArt 85*
Norton, D A *DcWomA*
Norton, David K 1947- *MarqDCG 84*
Norton, Dora M *WhAmArt 85*
Norton, Dora Miriam *DcWomA*
Norton, E *FolkA 86*
Norton, Eardley *AntBDN D*
Norton, Eardley B *DcBrBI*
Norton, Edward *FolkA 86*
Norton, Effie C Y *DcWomA*
Norton, Elizabeth 1887- *ArtsAmW 1, DcWomA, WhAmArt 85*
Norton, Ethel *WhAmArt 85*
Norton, Ezra *FolkA 86*
Norton, F M *DcVicP 2*
Norton, Florence Edith 1879- *DcWomA, WhAmArt 85*
Norton, Fred *MarqDCG 84*
Norton, George 1641-1696 *CabMA*
Norton, Georgie Leighton d1923 *WhAmArt 85*
Norton, Gilbertine C *WhAmArt 85*
Norton, Grace Greenwood *WhAmArt 85*
Norton, H *DcVicP 2*
Norton, Helen G 1882- *WhAmArt 85*
Norton, Helen Gaylord 1882- *ArtsAmW 1*

Norton, Helen Gaylord 1882-1965 *DcWomA*
Norton, J *FolkA 86*
Norton, J Arthur 1925- *AmArch 70*
Norton, Jack M 1958- *MarqDCG 84*
Norton, Jacob *CabMA*
Norton, James *WhAmArt 85*
Norton, James Edwin 1933- *AmArch 70*
Norton, John *AntBDN M, DcNiCA, FolkA 86*
Norton, John A 1948- *MarqDCG 84*
Norton, John Warner 1876-1934 *ArtsAmW 1, WhAmArt 85*
Norton, Julius *FolkA 86*
Norton, Kenneth Berkley 1890- *AmArch 70*
Norton, Louis Doyle 1867- *WhAmArt 85*
Norton, Louise Doyle 1867- *DcWomA*
Norton, Lucy King *DcWomA, NewYHSD*
Norton, Luman *FolkA 86*
Norton, Luman P *FolkA 86*
Norton, M Gene 1935- *AmArch 70*
Norton, Mary Joyce *WhoAmA 76, -78, -80, -82, -84*
Norton, Milton *ArtsEM*
Norton, Paul Foote 1917- *WhoAmA 73, -76, -78, -80, -82, -84*
Norton, Peter John 1913- *ClaDrA*
Norton, Philip Charles 1929- *AmArch 70*
Norton, R D *DcBrA 2*
Norton, Richard Allan 1932- *AmArch 70*
Norton, Rob Roy, Jr. 1948- *WhoAmA 76, -78*
Norton, Mrs. Ralph Hubbard 1881-1947 *WhAmArt 85*
Norton, S Mary d1922 *DcWomA, WhAmArt 85*
Norton, Samuel *FolkA 86*
Norton, Sarah *DcVicP 2*
Norton, Theodore Frederick 1901- *AmArch 70*
Norton, Thomas A 1922- *AmArch 70*
Norton, Val *DcBrBI*
Norton, W H *AmArch 70, NewYHSD*
Norton, Walter Harold *WhAmArt 85*
Norton, Wilfred 1880- *ClaDrA*
Norton, William *CabMA*
Norton, William E *ArtsNiC*
Norton, William E 1843-1916 *WhAmArt 85*
Norton, William Edward 1843-1916 *DcSeaP*
Norton, Zachariah *FolkA 86*
Norval, R B *AmArch 70*
Norvell, Patsy 1942- *WhoAmA 78, -80, -82, -84*
Norwicz, F J *AmArch 70*
Norwood, Arthur Harding *DcVicP 2*
Norwood, E E *AmArch 70*
Norwood, Malcolm Mark 1928- *WhoAmA 73, -76, -78, -80, -82, -84*
Norwood, Tony *AfroAA*
Nosenchuk, Martin 1927- *AmArch 70*
Noskowiak, Sonya 1900-1975 *ConPhot, ICPEnP A, MacBEP*
Nosoff, Frank 1919- *WhoAmA 76, -78, -80, -82, -84*
Nosow, H *AmArch 70*
Noss, David Scott 1959- *MarqDCG 84*
Nossal, Audrey Jean 1929- *WhoAmA 76, -78, -80*
Nost, John d1729 *OxArt*
Nost, John Van, The Elder d1729 *McGDA*
Nost, John Van, The Younger d1787 *McGDA*
Nost, William *EncASM*
Nostitz-Jackowska, Maria *DcWomA*
Nostrand, Robert Dwight 1929- *AmArch 70*
Nosworthy, Ann Louise 1929- *WhoArt 80, -82, -84*
Nosworthy, Florence England 1872-1936 *WhAmArt 85*
Nosworthy, Florence Pearl England 1872?-1936 *DcWomA*
Nosworthy, Matthew 1750-1831 *BiDBrA*
Notaire, Joseph Dessaux *NewYHSD*
Notarbartolo, Albert *WhoAmA 80, -82, -84*
Notarbartolo, Albert 1934- *WhoAmA 73, -76, -78*
Notaro, Anthony 1915- *WhoAmA 73, -76, -78, -80, -82, -84*
Notaro, Anthony 1956- *MarqDCG 84*
Notartomaso, P F *AmArch 70*
Noter, Annette De 1803- *DcWomA*
Noter, Josephine De 1805- *DcWomA*
Noter, Pierre Francois 1779-1843 *ClaDrA*
Noterman, Emmanuel 1808-1863 *ClaDrA*
Notestine, J W *AmArch 70*
Notestine, Tom W 1919- *WhoAmA 82, -84*
Noth, E F *AmArch 70*
Nothelfer, Gabriele 1945- *DcCAr 81*
Nothelfer, Helmut 1945- *DcCAr 81*
Nothhelfer, Gabriele 1945- *ConPhot, ICPEnP A, MacBEP*
Nothhelfer, Helmut 1945- *ConPhot, ICPEnP A, MacBEP*
Nothmann, Gerhard Adolf 1921- *MarqDCG 84*
Nothnagel, Johann Andreas Benjamin 1729-1804 *ClaDrA*
Notke, Bernt 1440?-1509 *McGDA*
Notkin, Richard T 1948- *WhoAmA 80, -82, -84*
Notley, David P, Jr. 1955- *MarqDCG 84*
Notman, Howard 1881- *WhAmArt 85*
Notman, John 1810-1865 *BiDAmAr, BnEnAmA, MacEA, McGDA*
Notman, William 1826-1891 *ICPEnP*
Notman, William McFarlane 1826-1891 *MacBEP*
Nott, Charles *NewYHSD*

Nott, Isabel C Pyke- *DcVicP 2*
Nott, James S Pyke- *DcVicP 2*
Nott, Thomas J *NewYHSD*
Nott, Zebedee *FolkA 86*
Notte, Mademoiselle *DcWomA*
Nottebohm, Jenny *DcWomA*
Notter, George M, Jr. 1933- *AmArch 70*
Nottidge, Caroline *DcWomA*
Nottingham, E *DcVicP 2*
Nottingham, Luther *FolkA 86*
Nottingham, Mary Elizabeth 1907-1956 *WhAmArt 85*
Nottingham, Robert A *DcBrWA*
Nottingham, Robert A, Jr. *DcVicP 2*
Nottingham, Walter 1930- *BnEnAmA*
Nottingham-Monnier, Maud 1876- *WhAmArt 85*
Notz, Ernest Herrmann 1906- *AmArch 70*
Nouailher, Sophie *DcWomA*
Noufflard, Berthe 1886- *DcWomA*
Nouri, Guy 1952- *MarqDCG 84*
Nourse, Caroline *DcWomA*
Nourse, Elizabeth 1859-1938 *DcWomA, WhAmArt 85*
Nourse, Mary Madeline 1870-1959 *DcWomA*
Nourse, Rebecca Wister *DcWomA*
Nouveau, Henri 1901- *PhDcTCA 77*
Novack, Frank T 1940- *WhoAmA 82, -84*
Novak, Adolph 1912- *AmArch 70*
Novak, Barbara *WhoAmA 73, -76, -78, -80, -82, -84*
Novak, Bretislav, Jr. 1952- *DcCAr 81*
Novak, Bretislav, Sr. 1913- *DcCAr 81*
Novak, Charles, Jr. 1924- *AmArch 70*
Novak, Frantisek 1942- *DcCAr 81*
Novak, G A *AmArch 70*
Novak, Giora 1934- *DcCAr 81*
Novak, Irene 1894- *DcWomA*
Novak, Louis 1903- *WhAmArt 85*
Novak, Martin 1956- *MarqDCG 84*
Novani, Cossado *WhAmArt 85*
Novani, Guillo 1889- *WhAmArt 85*
Novaresi, Elmo John 1925- *AmArch 70*
Novate, Bernardino Da *McGDA*
Novelle, Frederick *NewYHSD*
Novelli, Enrico 1876-1943 *WorECar*
Novelli, Gastone 1925- *PhDcTCA 77*
Novelli, Gastone 1925-1968 *ConArt 77, -83, OxTwCA*
Novelli, James *WhAmArt 85*
Novelli, Pietro 1603-1647 *McGDA*
Novelli, Pietro Antonio 1729-1804 *McGDA*
Novelli, R 1879- *WhAmArt 85*
Novelli, Rosalia 1628- *DcWomA*
Novello, E A *DcVicP 2*
Novello, Emma A *DcWomA*
Novello, Giuseppe 1897- *WhoGrA 62, WorECar*
November, David 1938- *AmGrD[port]*
Novendstern, Ronald 1949- *MarqDCG 84*
Noverraz, Henri 1915- *DcCAr 81*
Noverre, Ellen *DcWomA*
Novick, David Aaron 1938- *AmArch 70*
Novik, Jennie *FolkA 86*
Novikovs, N *AmArch 70*
Novinski, Lyle Frank 1932- *WhoAmA 73, -76, -78, -80, -82, -84*
Novoa, Gustavo 1941- *PrintW 83, -85*
Novosielski, Michael 1750-1795 *BiDBrA*
Novotnak, James Frank 1955- *MarqDCG 84*
Novotny, Elmer Ladislaw 1909- *AmArt, WhAmArt 85, WhoAmA 73, -76, -78, -80, -82, -84*
Novotny, Fritz 1903- *WhoArt 80, -82, -84*
Novotny, Otakar 1880-1959 *MacEA*
Novra, Carl H *ArtsEM*
Novra, Henry *DcVicP 2*
Novros, David 1941- *DcCAA 77, WhoAmA 78, -80, -82, -84*
Nowack, Wayne K 1923- *DcCAA 71, -77*
Nowack, Wayne Kenyon 1923- *WhoAmA 78, -80, -82, -84*
Nowak, E E *AmArch 70*
Nowak, Krysia Danuta 1948- *WhoArt 80, -82, -84*
Nowak, Leo 1907- *WhoAmA 80, -82, -84*
Nowell, Annie C *DcWomA*
Nowell, Arthur T 1861-1940 *DcVicP*
Nowell, Arthur Trevethin 1862-1940 *ClaDrA, DcBrA 1*
Nowell, Arthur Trevithan 1862-1940 *DcVicP 2*
Nowell, B F, Jr. *AmArch 70*
Nowell, Effie Alexander *DcWomA, WhAmArt 85*
Nowell, Frank H 1864-1950 *MacBEP*
Nowell, V H *AmArch 70*
Nowell, William Calmady d1883 *DcBrWA*
Nowell, William Calmody 1806?-1883 *DcSeaP*
Nowicki, Matthew 1910-1949 *EncMA*
Nowicki, Matthew 1910-1950 *McGDA*
Nowicki, Matthew 1910-1951 *ConArch, MacEA*
Nowicki, Nicholas Joseph, Jr. 1937- *AmArch 70*
Nowlan, Carlotta d1929 *ClaDrA, DcBrA 1, DcVicP 2, DcWomA*
Nowlan, Frank 1835?-1919 *DcBrA 1, DcBrWA, DcVicP, -2*
Nowlan, Margaret *FolkA 86*

Nowlan, Pauline *DcWomA*
Nowlan, Philip 1888-1940 *WorECom*
Nowlan, Wayne White 1941- *AmArch 70*
Nowosielski, Jerzy 1923- *OxTwCA, PhDcTCA 77*
Nowottny, Vincent 1854-1908 *WhAmArt 85*
Nowysz, William 1937- *AmArch 70*
Nowytski, Sviatoslav 1934- *WhoAmA 84*
Nowytski, Sviatoslav 1935- *WhoAmA 76, -78, -80, -82*
Noxon, Betty Lane *WhAmArt 85*
Noxon, Grace P *DcWomA, WhAmArt 85*
Noy, R *DcWomA*
Noy, Mrs. R *DcVicP 2*
Noyce, E *DcBrWA*
Noyer, Philippe 1917- *PrintW 83, -85*
Noyer, Philippe Henri 1917- *ClaDrA*
Noyes, Abigail Parker *FolkA 86*
Noyes, Bertha *WhAmArt 85*
Noyes, Bertha 1876-1966 *DcWomA*
Noyes, Diana H *WhoAmA 84*
Noyes, Diane *WhoAmA 80*
Noyes, Dora *DcBrA 1, DcVicP, -2, DcWomA*
Noyes, Edwin 1824?- *CabMA*
Noyes, Eliot 1910- *AmArch 70, EncMA, McGDA, WhoAmA 73, -76*
Noyes, Eliot 1910-1977 *ConArch, MacEA, WhoAmA 78N, -80N, -82N, -84N*
Noyes, Eliot Fette 1910-1977 *ConDes*
Noyes, Emily *DcWomA*
Noyes, Enoch 1743-1808 *FolkA 86*
Noyes, Ethel *WhAmArt 85*
Noyes, Ethel J R C *DcWomA*
Noyes, F A *NewYHSD*
Noyes, Francis *CabMA*
Noyes, George L *WhAmArt 85*
Noyes, George Loftus 1864-1951? *ArtsAmW 2*
Noyes, Helen Haskell d1940 *WhAmArt 85*
Noyes, Henriette 1890- *DcWomA, WhAmArt 85*
Noyes, Henry *DcBrWA*
Noyes, Henry James *DcVicP 2*
Noyes, Herbert MacArthur, Jr. 1926- *AmArch 70*
Noyes, Holton *EncASM*
Noyes, Ida T Smith 1853-1912 *DcWomA*
Noyes, Isaac 1737-1800 *CabMA*
Noyes, John Humphrey *EncASM*
Noyes, Mary *DcVicP 2*
Noyes, Morillo *FolkA 86*
Noyes, Paul 1740-1810 *FolkA 86*
Noyes, Phoebe G *DcWomA*
Noyes, Pierrepont *EncASM*
Noyes, Robert 1780?-1843 *DcBrWA*
Noyes, Samuel S *CabMA*
Noyes, Sandy 1941- *ICPEnP A, MacBEP, WhoAmA 84*
Noyes, Theodora *DcVicP 2*
Noyes Brothers *EncASM*
Noyes-Lewis, Tom *DcVicP 2*
Nozal, Alexandre 1852-1929 *ClaDrA*
Nozkowski, Tom *DcCAr 81*
Ntiro, Sam J *AfroAA*
Nuala 1896- *WhoAmA 73, -76, -78, -80, -82*
Nubel, Basil *WhoArt 82N*
Nubel, Basil 1923- *WhoArt 80*
Nuderscher, Frank 1880-1959 *WhAmArt 85*
Nuderscher, Frank Bernard 1880-1959 *WhoAmA 80N, -82N, -84N*
Nuechterlein, John George *FolkA 86*
Nuechterlein, W F *AmArch 70*
Nuetzel, Hans Henry 1921- *AmArch 70*
Nugent, A W 1891-1975 *WhAmArt 85*
Nugent, Arthur William 1891- *WhoAmA 73*
Nugent, Arthur William 1891-1975 *WhoAmA 76N, -78N, -80N, -82N, -84N*
Nugent, Bob 1947- *DcCAr 81, PrintW 85*
Nugent, Bob L 1947- *WhoAmA 82, -84*
Nugent, John Cullen 1921- *WhoAmA 78, -80, -82, -84*
Nugent, Marie 1844- *DcWomA*
Nugent, Marie Anne Alexandrine *DcWomA*
Nugent, Meredith 1860-1937 *ArtsAmW 2, WhAmArt 85*
Nugent, Richard Bruce *AfroAA*
Nuhfer, Olive Harriette 1907- *WhAmArt 85*
Nuhn, K M *AmArch 70*
Nuhn, Marjorie Ann 1898- *ArtsAmW 3, DcWomA, WhAmArt 85*
Nuitz, A *DcVicP 2*
Nuitz, Benjamin D *EncASM*
Nuki 1919- *WhoAmA 80, -82, -84*
Nuki 1929- *WhoAmA 76, -78*
Nulf, Frank Allen 1931- *WhoAmA 73, -76, -78, -80, -82, -84*
Nulty, Lawrence Frederick 1921- *AmArch 70*
Numan, Benjamin *NewYHSD*
Numkena, Lewis, Jr. 1927- *IlBEAAW*
Numyer, Frederick *NewYHSD*
Nunamaker, K R *WhAmArt 85*
Nunan, Philip Alan Widdrington 1925- *WhoArt 80, -82, -84*
Nune *DcBrECP*
Nunes, Abraham I *NewYHSD*

Nunes, J B *NewYHSD*
Nunes, Thomasia d1644 *DcWomA*
Nunez, Bonita Wa Wa Calachaw 1888-1972? *DcWomA*
Nunez, Guillermo *OxTwCA*
Nunez, Guillermo Victor 1928- *AmArch 70*
Nunez, Juan *McGDA*
Nunez DelPrado, Marina 1910- *OxTwCA*
Nungester, Mildred Bernice 1912- *WhAmArt 85*
Nunn, Evylena *DcWomA*
Nunn, Evylena 1888- *WhAmArt 85*
Nunn, Frederic *WhoAmA 80N, -82N, -84N*
Nunn, Frederic 1879-1960? *WhAmArt 85*
Nunn, J R *AmArch 70*
Nunn, J W *DcVicP 2*
Nunn, James H 1926- *AmArch 70*
Nunn, S *AmArch 70*
Nunn, Stayton, Jr. 1924- *AmArch 70*
Nuno, Benito 1899- *WhAmArt 85*
Nupok, Florence *WhAmArt 85*
Nur, A S Ali 1906- *ClaDrA*
Nura *WhAmArt 85*
Nura 1899-1950 *IlsBYP, IlsCB 1946*
Nuria, Pompeia 1931- *WorECar*
Nurick, Irving 1894-1963 *IlrAm D, -1880*
Nurick, Irving 1896- *WhAmArt 85*
Nurmesniemi, Antti 1927- *ConDes*
Nurmesniemi, Vuokko 1930- *WorFshn*
Nurmi, Sulho Alexander 1907- *AmArch 70*
Nurnberg, Walter 1907- *MacBEP*
Nurre, Joseph *FolkA 86*
Nursey, Claude Lorraine 1820-1873 *DcSeaP, DcVicP, -2*
Nursey, Perry *DcBrECP, DcBrWA*
Nursia, Saint 480-547? *McGDA*
Nusbaum, Esther Commons 1907- *WhAmArt 85, WhoAmA 76*
Nusbaum, J R *AmArch 70*
Nuse, Ellen Guthrie *WhAmArt 85*
Nuse, Oliver William 1914- *WhAmArt 85, WhoAmA 82, -84*
Nuse, Roy Cleveland 1885- *WhAmArt 85*
Nushawg, Michael Allan 1944- *WhoAmA 82, -84*
Nussbaum, Seymour 1941- *AmArch 70*
Nussbaum And Hunold *EncASM*
Nussbaumer, Paul Edmund *IlsCB 1967*
Nussbaumer, Paul Edmund 1934- *IlsCB 1957*
Nusser, Christian *FolkA 86*
Nute, Cherrie *OfPGCP 86*
Nute, Jennie Evelyn *DcWomA, WhAmArt 85*
Nute, Louisa A *ArtsEM, DcWomA*
Nuti, Giulia 1800?-1861 *DcWomA*
Nutt, Elizabeth Styring 1870-1946 *DcWomA*
Nutt, James Tureman 1938- *AmArt*
Nutt, Jim 1938- *ConArt 83, DcCAr 81, WhoAmA 84*
Nutt, John *CabMA*
Nuttall, Harold 1896- *DcBrA 1, WhoArt 80, -82, -84*
Nuttall, Thomas 1786-1859 *ArtsAmW 2, NewYHSD*
Nutter, J *DcVicP 2*
Nutter, Katherine M *DcVicP 2, DcWomA*
Nutter, Matthew Ellis 1795-1862 *DcBrWA, DcVicP 2*
Nutter, Roy Sterling, Jr. 1944- *MarqDCG 84*
Nutter, Tommy 1943- *WorFshn*
Nutter, William Henry 1821-1872 *DcBrWA, DcVicP 2*
Nutting, Benjamin F d1887 *NewYHSD*
Nutting, Benjamin F 1813-1873 *FolkA 86*
Nutting, Calvin, Sr. *FolkA 86*
Nutting, Chester d1976? *FolkA 86*
Nutting, Emily *DcWomA, NewYHSD*
Nutting, Joseph G *CabMA*
Nutting, Myron Chester 1890- *ArtsAmW 3, WhAmArt 85*
Nutting, Ruth F *DcWomA, WhAmArt 85*
Nutting, Wallace 1861- *WhAmArt 85*
Nutting, Wallace 1861-1941 *ICPEnP A, MacBEP*
Nuttman, I W Isaac d1872 *FolkA 86*
Nutty, Alfred Heber *ArtsEM*
Nutzle, Futzie 1942- *AmArt, WhoAmA 76, -78, -80, -82, -84*
Nuvolone, Carlo Francesco 1608-1661 *McGDA*
Nuyttens, J P 1885- *WhAmArt 85*
Nuzi, Allegretto 1315?-1373 *McGDA*
Nyberg, Donald Duane 1925- *AmArch 70*
Nyberg, Helle 1942- *DcCAr 81*
Nyblom, Olga Maria 1872- *DcWomA*
Nyden, John A 1878-1932 *BiDAmAr*
Nye, Alfred *FolkA 86*
Nye, Beatrice *DcWomA, WhAmArt 85*
Nye, D E *AmArch 70*
Nye, E *NewYHSD*
Nye, Edgar 1879-1943 *WhAmArt 85*
Nye, Elmer L 1888- *WhAmArt 85*
Nye, Elmer Lesly 1888- *ArtsAmW 2*
Nye, George F *DcVicP 2*
Nye, Herbert *DcBrBI*
Nye, Lucy 1799- *FolkA 86*
Nye, Mary Hathaway *DcWomA*

Nye, Myra *WhAmArt 85*
Nye, Myra 1875-1955 *ArtsAmW 2, DcWomA*
Nye, Robert T *WhAmArt 85*
Nye, William *FolkA 86*
Nyeste, James Joseph 1943- *FolkA 86*
Nyfeler, John Vernon 1935- *AmArch 70*
Nygard, Alfred F *ArtsEM*
Nygard Marty And Mildner *ArtsEM*
Nygren, John Fergus 1940- *WhoAmA 78, -80, -82, -84*
Nyholm, Arvid Frederick 1866-1927 *WhAmArt 85*
Nyholm, Greta *WhAmArt 85*
Nykvist, Ralph 1944- *ConPhot, ICPEnP A*
Nyl-Frosch, Marie 1857-1914 *DcWomA*
Nyland, H T *AmArch 70*
Nylund, Peter Y 1947- *MarqDCG 84*
Nyman, Gunnel 1909-1948 *IlDcG*
Nyman, Ingrid Vang 1916- *IlsBYP, IlsCB 1946*
Nyme, Joseph Samuel 1908- *WhAmArt 85*
Nymegen, Barbara Van *DcWomA*
Nymegen, Dionys Van 1705-1789 *ClaDrA*
Nymegen, Gerard Van 1735-1808 *ClaDrA*
Nymegen, Suzanna Catherina Van d1801 *DcWomA*
Nypoort, Justus VanDen 1625?-1692? *ClaDrA*
Nyquist, Earl B 1888- *WhAmArt 85*
Nyren, Carl 1917- *MacEA*
Nyrop, Martin 1849-1921 *MacEA, WhoArch*
Nyrop, Martin 1849-1923 *McGDA*
Nys, O A 1884- *WhAmArt 85*
Nystad, Gerda 1926?- *WorECar*
Nystrom, Carl Gustaf 1856-1917 *MacEA*
Nystrom, Martin Rudolph 1943- *AmArch 70*
Nystrom, P E *AmArch 70*
Nystrom-Stoopendaal, Jenny 1854?-1946 *DcWomA*
Nystuen, Courtney W 1937- *AmArch 70*

O

O A WorECar
O Donohue, Teige Martain 1942- WhoAmA 82
O Donohue, Teige Ros 1942- WhoAmA 84
Oakden AntBDN P
Oakely, Frank F NewYHSD
Oakes, A DcVicP 2
Oakes, Mrs. A T ArtsAmW 3,
 DcWomA, NewYHSD
Oakes, Edward Everett 1891- WhAmArt 85
Oakes, Frederick G DcVicP 2
Oakes, H F DcVicP 2
Oakes, J A AmArch 70
Oakes, John Warren 1941- WhoAmA 76, -78, -80,
 -82, -84
Oakes, John Wright 1820-1887 ClaDrA, DcBrBI,
 DcBrWA, DcVicP, -2
Oakes, John Wright 1822- ArtsNiC
Oakes, Katie L ArtsEM, DcWomA
Oakes, M 1826?- ArtsAmW 1
Oakes, Marcia DcWomA, WhAmArt 85
Oakes, R T AmArch 70
Oakes, T DcWomA
Oakes, W L 1876-1934 WhAmArt 85
Oakes, William Larry 1944- WhoAmA 80, -82, -84
Oakeshott, George J DcVicP 2
Oakeshott, Walter Fraser 1903- WhoArt 80
Oakeshott, Sir Walter Fraser 1903- WhoArt 82, -84
Oakey, Alexander F d1916 BiDAmAr
Oakey, Maria DcWomA, WhAmArt 85
Oakey, Maria R 1847- ArtsNiC
Oakford, Ellen DcWomA
Oakford, John FolkA 86
Oakland, C AmArch 70
Oakland, Frederic MarqDCG 84
Oakley, Mrs. DcVicP 2
Oakley, A DcVicP 2
Oakley, Agnes DcWomA
Oakley, Agnes d1866 DcBrWA, DcVicP 2
Oakley, Alfred James 1880-1959 DcBrA 1
Oakley, Arthur WhAmArt 85
Oakley, B DcVicP 2
Oakley, David Scott 1928- AmArch 70
Oakley, Edward BiDBrA, NewYHSD
Oakley, George 1793-1869 NewYHSD
Oakley, George C WhAmArt 85
Oakley, Georgina DcWomA, NewYHSD
Oakley, Graham 1929- IlsCB 1967
Oakley, Helen DcWomA
Oakley, Hester DcWomA
Oakley, Isabel DcVicP, -2, DcWomA
Oakley, Juliana DcWomA, NewYHSD
Oakley, Louisa DcWomA
Oakley, Maria L DcBrWA, DcVicP 2, DcWomA
Oakley, Octavius 1800-1867 DcBrWA, DcVicP, -2,
 NewYHSD
Oakley, Philip DcBrWA
Oakley, Russell 1947- MarqDCG 84
Oakley, Thornton 1881- ConICB, IlsCB 1744
Oakley, Thornton 1881-1953 WhAmArt 85
Oakley, Thornton 1881-1955 IlrAm B, -1880
Oakley, Violet 1874-1960 WhAmArt 85,
 WhoAmA 80N, -82N, -84N
Oakley, Violet 1874-1961 DcWomA, IlrAm 1880,
 WomArt
Oakley, William Harold DcBrBI, DcVicP 2
Oakman, Arthur W 1910- WhAmArt 85
Oakman, George Payne 1922- AmArch 70
Oaks NewYHSD
Oas, Joel R 1948- DcCAr 81
Oaten, Barbara A 1899- DcBrA 1, DcWomA

Oates, Bennett 1928- WhoArt 80, -82, -84
Oates, Christine Tate 1913- WhoArt 80, -82, -84
Oates, John d1831 BiDBrA
Oates, Mark 1750?- DcBrECP
Oates, William Robert 1943- MarqDCG 84
Oatley, Sir George Herbert 1863-1950 DcBrA 1
Obalska, Marie 1851- DcWomA
O'Banion, Nance 1949- AmArt, WhoAmA 84
Obata, Chiura WhAmArt 85
Obata, Chiura 1885- ArtsAmW 1, -3
Obata, Gyo 1923- AmArch 70, ConArch, MacEA
Obbard, C DcVicP 2, DcWomA
Obbard, Catherine DcWomA
Obe FolkA 86, NewYHSD
O'Beil, Hedy WhoAmA 84
Obel, Nils 1937- PrintW 83
Obelitz, Anna Cathrine Christine DcWomA
Oben, James George 1779?-1819? DcBrWA
Obendorf, Donald L 1930- MarqDCG 84
Obeno NewYHSD
Ober, Deborah Lyn 1961- MarqDCG 84
Ober, J Foster 1840-1896 BiDAmAr
Oberdick, W A AmArch 70
Oberg, Folke WhAmArt 85
Oberg, H A AmArch 70
Oberg, Kenneth Ivan 1931- AmArch 70
Oberhand, Robert 1953- MarqDCG 84
Oberhardt, William 1882-1958 IlBEAAW, IlrAm C,
 -1880, WhAmArt 85, WhoAmA 80N, -82N,
 -84N
Oberholser, Jacob FolkA 86
Oberholtzer, A FolkA 86
Oberhuber, Konrad J 1935- WhoAmA 73, -76, -78,
 -80, -82, -84
Oberhuber, Oswald 1931- DcCAr 81
Oberkampf, Mademoiselle DcWomA
Oberkampf, Christophe-Philippe d1815 OxDecA
Oberlaender, Gustave 1867-1936 WhAmArt 85
Oberlander, Adolf 1845-1923 WorECom
Oberlander, B E AmArch 70
Oberlin, Mathilde DcWomA
Oberly, Henry 1805?-1874 FolkA 86
Obermayer, Rosa DcWomA
Oberndorfer, Therese DcWomA
Obernetter, Johann Baptist 1840-1887 MacBEP
Oberson, Gideon 1942- WorFshn
Obertauffer, Helen WhAmArt 85
Oberteuffer, George 1878-1940 WhAmArt 85
Oberteuffer, H A 1878-1962 DcWomA
Oberteuffer, Henriette Amiard 1878-1962
 WhAmArt 85
Oberteuffer, Karl 1908- WhAmArt 85
Oberwarth, C Julian 1900- AmArch 70
Oberwarth, Leo L 1872-1939 BiDAmAr
Obidos, Josefa De DcWomA
Obin, Philome 1891- McGDA
Oblak, Amalie 1813-1860 DcWomA
Obler, Geri 1942- WhoAmA 84
Obligado, Lilian Isabel IlsCB 1967
Obligado, Lilian Isabel 1931- IlsCB 1957
Oblinski, Rafal 1943- AmArt
Obourn, G E AmArch 70
O'Boyle, Michael NewYHSD
O'Brady 1901- OxTwCA
O'Brady, Gertrude 1904- FolkA 86
Obrant, Susan IlsBYP
Obreen, Elisabeth DcWomA
Obregon, Alejandro 1920- DcCAr 81, McGDA,
 OxTwCA
Obrenau, Victorine VanDan DcWomA

O'Brien DcBrECP
O'Brien, Alf 1912- DcCAr 81
O'Brien, Arthur L 1876-1924 BiDAmAr
O'Brien, Catherine C WhAmArt 85
O'Brien, Christopher W NewYHSD
O'Brien, Daniel NewYHSD
O'Brien, Daniel J WhAmArt 85
O'Brien, G J, Jr. 1925- AmArch 70
O'Brien, G L AmArch 70
O'Brien, J H d1917 DcBrA 2
O'Brien, James NewYHSD
O'Brien, Joan 1940- WhoAmA 73, -76
O'Brien, John 1834-1904 NewYHSD , WhAmArt 85
O'Brien, John Larkin, Jr. 1925- AmArch 70
O'Brien, John Melvin, Jr. AmArch 70
O'Brien, John W NewYHSD
O'Brien, John Williams FolkA 86
O'Brien, Katharine DcWomA
O'Brien, Kitty 1910- DcBrA 1
OBrien, Kitty Wilmer 1910- WhoArt 80, -82,
 -84
O'Brien, Lucius Richard 1832-1899 IlBEAAW,
 McGDA
O'Brien, Marjorie WhoAmA 78, -80
O'Brien, Martin NewYHSD
O'Brien, Matthew 1871-1926 BiDAmAr
O'Brien, Michael 1950- ICPEnP A, MacBEP
O'Brien, Michael Edward 1854-1936 ArtsAmW 3,
 WhAmArt 85
O'Brien, Michael J 1956- MarqDCG 84
O'Brien, Nell Pomeroy WhAmArt 85
O'Brien, Nell Pomeroy 1899-1966 DcWomA
O'Brien, Robert NewYHSD
O'Brien, Robert John 1939- WhoArt 80, -84
O'Brien, Robert Stephen 1956- MarqDCG 84
O'Brien, Smith ArtsAmW 2, WhAmArt 85
O'Brien, T DcVicP 2
O'Brien, Timothy 1929- ConDes
O'Brien, William MarqDCG 84
O'Brien, William Dermod 1865- ClaDrA
O'Brien, William Dermod 1865-1945 DcBrA 1,
 DcVicP 2
O'Brien, William Lee, Jr. 1939- AmArch 70
O'Brien, William Vincent 1902- WhoAmA 78, -80N,
 -82N, -84N
Obrig, Clara d1930 DcWomA, WhAmArt 85
O'Brine, T DcVicP 2
Obrisset, John OxDecA
Obrist, Hermann 1862-1927 MacEA
Obrist, Hermann 1863-1927 McGDA, PhDcTCA 77
Obryon, Charles Austin 1910- AmArch 70
Obst, Emily Virginia AmArch 70
Obst, Harold Anthony 1917- AmArch 70
O'Byrne, Rose DcWomA
Ocacio, L A AmArch 70
O'Cain, William Henry 1913- AmArch 70
O'Callaghan, Lucius DcBrA 1
O'Callahan, C C 1890- WhAmArt 85
O'Callahan, Kevin B 1902- WhAmArt 85
O'Campo, Miguel OxTwCA
Ocampo, Miguel 1922- PhDcTCA 77, WhoAmA 76,
 -78, -80, -82, -84
Occhiali, Gaspare Dagli McGDA
Occioni, Lucilla Marzolo DcWomA
OCeallachain, Diarmuid 1915- WhoArt 80, -82, -84
Ocejo 1928- WhoAmA 73, -76, -78, -80, -82
Ocepek, Lou 1942- WhoAmA 84
Ocheretyanny, Semyon Mickael 1940- MarqDCG 84
Ochi, Hiro 1942- MarqDCG 84
Ochikubo, Tetsuo 1923- WhoAmA 73, -76
Ochikubo, Tetsuo 1923-1975 WhoAmA 78N, -80N,

Oliphant, Francis Wilson 1818-1859 *DcVicP 2*
Oliphant, Laurence 1829-1888 *DcBrBI*
Oliphant, Patrick 1935- *WhoAmA 80, -82, -84,*
WorECar
Oliphant, Patrick Bruce 1935- *WhoAmA 76, -78*
Oliphant, William F 1892-1933 *BiDAmAr*
Olis, Jan 1610?-1676 *McGDA*
Olis, Marcel *WhAmArt 85*
Olitski, Jules 1922- *AmArt, BnEnAmA, CenC,*
ConArt 77, -83, DcAmArt, DcCAA 71, -77,
DcCAr 81, McGDA, OxTwCA, PhDcTCA 77,
WhoAmA 73, -76, -78, -80, -82, -84,
WorArt[port]
Oliva, Alexandre-Joseph 1824?- *ArtsNiC*
Oliva, Angel, Jr. 1935- *AmArch 70*
Oliva, Ladislav 1933- *DcCAr 81, IlDcG*
Oliva, Lawrence Michael 1956- *MarqDCG 84*
Oliva, Mencia DeLa *DcWomA*
Olive, Florence *DcWomA*
Olive, Frank 1929- *WorFshn*
Olive, Howard Keith, Sr. 1921- *AmArch 70*
Olive, T *DcBrECP*
Olive, T P *DcWomA*
Oliveira, Matteus Vicente De 1710-1786 *WhoArch*
Oliveira, Nathan 1928- *BnEnAmA, ConArt 83,*
DcCAA 71, -77, DcCAr 81, McGDA, OxTwCA,
PhDcTCA 77, PrintW 85, WhoAmA 78, -80,
-82, -84
Oliveira, V'lou 1951- *WhoAmA 78,*
-80
Oliveira Bernardes, Michaela Arcangela R 1740-1815
DcWomA
Oliver *EncASM*
Oliver, Miss *DcVicP 2, DcWomA*
Oliver, A *DcVicP 2*
Oliver, Andre *FairDF FRA*
Oliver, Andre 1932- *WorFshn*
Oliver, Annie *DcWomA, WhAmArt 85*
Oliver, Archer James 1774-1842 *DcBrECP, DcVicP 2*
Oliver, Bobbie 1945- *DcCAr 81*
Oliver, C F *DcVicP 2*
Oliver, C H *AmArch 70*
Oliver, C K *FolkA 86*
Oliver, C N *DcWomA*
Oliver, Mrs. C N *DcVicP 2*
Oliver, Charles William 1911- *DcBrA 1, WhoArt 80,*
-82, -84
Oliver, Constance 1891- *DcBrA 1, DcWomA*
Oliver, D *FolkA 86*
Oliver, Dorothy Welch 1899- *WhAmArt 85*
Oliver, Edith *DcBrA 1*
Oliver, Edith Kemble *DcWomA, WhAmArt 85*
Oliver, Elisabeth Paxton 1894- *DcWomA,*
WhAmArt 85
Oliver, Ellis A *WhAmArt 85*
Oliver, Emma Sophia 1819-1885 *DcBrWA, DcWomA,*
NewYHSD
Oliver, F *DcVicP 2*
Oliver, Fred *WhAmArt 85*
Oliver, Frederick W 1876- *WhAmArt 85*
Oliver, G W, Jr. *AmArch 70*
Oliver, George *NewYHSD*
Oliver, Gilbert Lee 1933- *AmArch 70*
Oliver, Henry 1836?- *NewYHSD*
Oliver, Henry, Jr. *WhoAmA 73*
Oliver, Isaac *DcVicP 2*
Oliver, Isaac 1556?-1617 *AntBDN J, ClaDrA*
Oliver, Isaac 1565?-1617 *McGDA*
Oliver, Isaac 1568?-1617 *OxArt*
Oliver, Jean Nutting *WhAmArt 85*
Oliver, Jean Nutting d1946 *DcWomA*
Oliver, John 1616?-1701 *BiDBrA, ClaDrA*
Oliver, John 1807?- *NewYHSD*
Oliver, John A *FolkA 86*
Oliver, John Thomas, Jr. 1926- *AmArch 70*
Oliver, Joseph Kurtz *ArtsAmW 3*
Oliver, Ken 1948- *DcCAr 81*
Oliver, Kenneth Herbert 1923- *DcBrA 1, WhoArt 80,*
-82, -84
Oliver, L *NewYHSD*
Oliver, L Blanche *ArtsEM, DcWomA*
Oliver, L Dow 1936- *AmArch 70*
Oliver, L L *AmArch 70*
Oliver, Lee Percy, Jr. 1925- *AmArch 70*
Oliver, Leslie Allen 1877-1942 *BiDAmAr*
Oliver, Louis Arthur 1912- *AmArch 70*
Oliver, Louise 1912- *WhAmArt 85*
Oliver, Lyn *AfroAA*
Oliver, Madge 1875- *DcWomA*
Oliver, Madge 1875-1924 *DcBrA 1, DcVicP 2*
Oliver, Myron Angelo 1891- *ArtsAmW 2,*
WhAmArt 85
Oliver, Peter 1594?-1647 *AntBDN J, ClaDrA,*
McGDA
Oliver, R S, Jr. *AmArch 70*
Oliver, Richard Bruce 1942- *WhoAmA 78, -80, -82,*
-84
Oliver, Robert Dudley 1883-1899 *DcVicP, -2*
Oliver, Robin *NewYHSD*
Oliver, Samuel P *DcBrBI*
Oliver, T *DcVicP 2*

Oliver, T Clark d1893 *WhAmArt 85*
Oliver, Thomas 1791-1857 *BiDBrA*
Oliver, Thomas 1792-1858 *DcVicP 2*
Oliver, Travis Tipton 1929- *AmArch 70*
Oliver, W F *AmArch 70*
Oliver, W Redivivus *DcVicP 2*
Oliver, William *DcVicP 2, NewYHSD*
Oliver, William 1804-1853 *DcBrWA, DcVicP, -2*
Oliver, Mrs. William 1819-1885 *DcVicP, -2*
Oliveras Gensana, Camil 1840-1898 *MacEA*
Oliverson, Mary 1946- *MarqDCG 84*
Olivie, Leon *ArtsNiC*
Olivie, Leon 1833-1901 *ClaDrA*
Olivier, Albert Gilbert, Jr. 1923- *AmArch 70*
Olivier, Anna *DcWomA*
Olivier, Brice 1933- *DcCAr 81*
Olivier, Emma Louise *DcWomA*
Olivier, Ferdinand Von 1785-1841 *McGDA*
Olivier, Herbert Arnould 1861-1952 *DcBrA 1,*
DcVicP 2
Olivier, Josephine *DcWomA*
Olivier, Marie Therese *DcWomA*
Olivier, Mathilde *DcWomA*
Olivier, Michel-Barthelemy 1712-1784 *DcBrECP*
Olivier, Raymond 1942- *MarqDCG 84*
Olivieri, Claudio 1934- *ConArt 77, -83*
Olivieri, Maffeo 1484-1534? *McGDA*
Olivieri, Pharaonne Marie Madeleine *DcWomA*
Oliviero, Cammilla 1844- *DcWomA*
Olivola, Donald J 1921- *AmArch 70*
Olivotto, Germano 1935-1972 *ConArt 77*
Olkinetzky, Sam 1919- *WhoAmA 73, -76, -78, -80,*
-82, -84
Ollenburg, R V *AmArch 70*
Ollendon, Madame De *DcWomA*
Ollenroth, Jenny *DcWomA*
Ollerhead, R Damon 1939- *MarqDCG 84*
Ollers, Edvin 1888-1960 *IlDcG*
Olley, John *BiDBrA*
Ollinger, William VonPhul 1931- *AmArch 70*
Ollington, Robin 1929- *ClaDrA*
Ollinger, Michel-Barthelemy 1712-1784 *DcBrECP*
Ollivier, Michel Barthelemy 1712-1784 *McGDA*
Ollivier, Nadine *DcWomA*
Ollman, Arthur 1947- *DcCAr 81, ICPEnP A,*
MacBEP
Ollman, Arthur L 1947- *WhoAmA 80, -82, -84*
Ollrogge, H A *AmArch 70*
Olmade, Rodolphe, Madame *DcWomA*
Olmer, Henry d1950 *WhoAmA 78N, -80N, -82N,*
-84N
Olmer, Henry 1887-1950 *WhAmArt 85*
Olmes, Mildred Young 1906- *WhAmArt 85*
Olmstead *CabMA*
Olmstead, Frederick Law 1822-1903 *DcD&D,*
WhAmArt 85
Olmstead, Harold L *WhAmArt 85*
Olmstead, J L *DcWomA*
Olmstead, John A *NewYHSD*
Olmstead, Vincent H *WhAmArt 85*
Olmsted, Anna Wetherill *WhAmArt 85*
Olmsted, Frederick Law 1822-1903 *BnEnAmA,*
EncAAr, MacEA, McGDA, WhoArch
Olmsted, Harold S *WhAmArt 85*
Olmsted, M B *WhAmArt 85*
Olmsted, Pat *WhoAmA 73*
Olmsted, R H *AmArch 70*
Olmsted, Suzanne M 1956- *WhoAmA 84*
Olney, Daniel *AfroAA*
Olney, Daniel Gillette 1909- *WhAmArt 85*
Oloffson, Werner Olaf 1905- *WhoAmA 78, -80, -82,*
-84
Olofsson, Pierre 1921- *PhDcTCA 77*
Olpin, Lawrence Dee 1904- *AmArch 70*
Olpin, Robert Spencer 1940- *WhoAmA 76, -78, -80,*
-82, -84
Olrik, Dagmar 1860- *DcWomA*
Olsavsky, James Stephen 1929- *AmArch 70*
Olsen, Arthur *MarqDCG 84*
Olsen, Arthur Kershaw 1927- *AmArch 70*
Olsen, Bjarne Carl 1913- *AmArch 70*
Olsen, Carl 1893- *WhAmArt 85*
Olsen, Carl Julius Emil 1818-1878 *DcSeaP*
Olsen, Chris E H 1880- *WhAmArt 85*
Olsen, Don 1910- *WhoAmA 73, -76*
Olsen, Donal Alan 1922- *AmArch 70*
Olsen, Donald E 1919- *AmArch 70*
Olsen, Donald Keith 1931- *AmArch 70*
Olsen, Ernest Moran 1910- *WhoAmA 78, -80, -82,*
-84
Olsen, F *AmArch 70*
Olsen, Frederick L 1938- *WhoAmA 73, -76, -78, -80,*
-82, -84
Olsen, Harry Emil 1887- *WhAmArt 85*
Olsen, Herb 1905- *WhoAmA 73*
Olsen, Herb 1905-1973 *WhoAmA 76N, -78N, -80N,*
-82N, -84N
Olsen, Herbert Gale 1934- *MarqDCG 84*
Olsen, Ib Spang *IlsCB 1967*
Olsen, Ib Spang 1921- *IlsCB 1957*
Olsen, Iver George 1918- *AmArch 70*

Olsen, Jack Edmond 1929- *AmArch 70*
Olsen, John 1928- *McGDA, OxTwCA*
Olsen, L E, Jr. *AmArch 70*
Olsen, Lennart 1925- *ICPEnP A*
Olsen, Mrs. Niels *WorFshn*
Olsen, Norman D 1937- *AmArch 70*
Olsen, Norman H 1918- *AmArch 70*
Olsen, Sharon A 1940- *WhoAmA 84*
Olsen, Teckla 1889- *ArtsAmW 3, DcWomA*
Olshan, Bernard 1921- *WhoAmA 82, -84*
Olshanska, Stephanie 1900- *WhAmArt 85*
Olshausen-Schonberger, Kathe 1881- *DcWomA*
Olson *FolkA 86*
Olson, Albert Byron 1885-1940 *ArtsAmW 1, -3,*
WhAmArt 85
Olson, Benjamin Franklin 1888- *AmArch 70*
Olson, Bettye Johnson 1923- *WhoAmA 82, -84*
Olson, Callie Williams *ArtsAmW 2*
Olson, Carl G T 1875- *WhAmArt 85*
Olson, Charles L, Jr. 1960- *MarqDCG 84*
Olson, Chris 1905- *WhAmArt 85*
Olson, Clarence LaVern 1923- *AmArch 70*
Olson, David Myron 1938- *MarqDCG 84*
Olson, Donald Sanford 1933- *AmArch 70*
Olson, Doris *DcWomA*
Olson, Douglas John 1934- *WhoAmA 78, -80, -82,*
-84
Olson, Edward William 1913- *AmArch 70*
Olson, Erik 1901- *McGDA*
Olson, Eugene A 1920- *AmArch 70*
Olson, Florence *WhAmArt 85*
Olson, Gary Spangler 1946- *WhoAmA 76, -78, -80*
Olson, Gustaf Lennart Eugen 1925- *MacBEP*
Olson, H H *AmArch 70*
Olson, Harold John 1917- *AmArch 70*
Olson, Henry 1902- *WhAmArt 85*
Olson, Herbert Maurice 1929- *AmArch 70*
Olson, Herbert Vincent 1905- *WhAmArt 85*
Olson, Hugo Einar 1903- *AmArch 70*
Olson, J Olaf 1894- *ArtsAmW 2, IlBEAAW,*
WhAmArt 85
Olson, J Oliver *WhAmArt 85*
Olson, John Minter 1929- *AmArch 70*
Olson, Joseph Olaf *WhoAmA 76, -78, -80, -82, -84*
Olson, Joseph Oliver *ArtsAmW 3*
Olson, Judy M 1944- *MarqDCG 84*
Olson, Merle 1910- *IlBEAAW*
Olson, Oliver William 1914- *AmArch 70*
Olson, P H, Sr. *AmArch 70*
Olson, Phyllis Verzelle *AmArch 70*
Olson, Raymond Irving 1902- *AmArch 70*
Olson, Richard W 1938- *WhoAmA 78, -80, -82, -84*
Olson, Robert A *OfPGCP 86*
Olson, Robert Howard 1928- *AmArch 70*
Olson, Robert Thorwald 1927- *AmArch 70*
Olson, Roger Merwin 1922- *AmArch 70*
Olson, Ruth *WhAmArt 85*
Olson, Sigurd J *WhAmArt 85*
Olson, Thor A 1953- *MarqDCG 84*
Olson, Walter William 1947- *MarqDCG 84*
Olson, Wayne Alsworth 1927- *AmArch 70*
Olsson, Axel Elias 1857- *WhAmArt 85*
Olsson, H A, Jr. *AmArch 70*
Olsson, Julius *WhAmArt 85*
Olsson, Julius 1864-1942 *DcBrA 1, DcSeaP, DcVicP,*
-2
Olsson, Tommy *DcCAr 81*
Olstad, Einar Hanson 1876- *ArtsAmW 1, IlBEAAW,*
WhAmArt 85
Olstowski, Franciszek 1901- *WhAmArt 85*
Olten, Carol 1942- *WhoAmA 73, -76*
Oltmann, H *AmArch 70*
Olugebefola, Ademola *IlsBYP, WhoAmA 78, -80,*
-82, -84
Olugebefola, Ademola 1941- *AfroAA, AmArt*
Olver, Charles E, Jr. 1936- *AmArch 70*
Olver, Kate Elizabeth d1960 *DcBrA 1, DcWomA*
Olving, Gerhard 1931- *AmArch 70*
Olworth, C W *FolkA 86*
Olympias *DcWomA*
Olyphant, Donald 1896- *WhAmArt 85*
Omahen, John Clayton 1957- *MarqDCG 84*
O'Mahoney, Florence *DcVicP 2*
O'Malley, J M *WhAmArt 85*
O'Malley, James *NewYHSD*
O'Malley, James 1816?-1888 *DcVicP 2*
O'Malley, John 1919- *AmArch 70*
O'Malley, K K *AmArch 70*
O'Malley, Mary Holmes *WhAmArt 85*
O'Malley, Noel David 1938- *AmArch 70*
O'Malley, Mrs. Peter Diarmiud *WhoArt 80, -82, -84*
O'Malley, Power *WhAmArt 85*
O'Malley, Power 1870-1946 *ArtsAmW 2*
Oman, Charles 1901- *WhoArt 80, -82*
Oman, Edwin 1905- *WhAmArt 85*
Oman, F *AmArch 70*
Oman, G F *AmArch 70*
Oman, James *NewYHSD*
Oman, Julia Trevelyan 1930- *WhoArt 80, -82, -84*
Oman, Samuel Solon 1877-1943 *BiDAmAr*

Orcutt, Ina *ArtsEM, DcWomA*
Orcutt, Philip Dana 1901- *AmArch 70*
Orcutt, Stephen *FolkA 86*
Orcutt, Walter *FolkA 86*
Orczy, Baroness Emma 1865-1947 *DcWomA*
Orczy, Baroness Emmuska 1865- *DcVicP 2*
Ord, Mrs. *DcWomA*
Ord, Edward O C 1818-1883 *ArtsAmW 3*
Ord, Edward O C, Jr. 1858-1923 *ArtsAmW 3*
Ord, G W *DcBrBI*
Ord, Joseph Biays 1805-1865 *NewYHSD*
Ord, P *NewYHSD*
Ordbrown, Joyce 1894- *DcWomA*
Orde, Cuthbert Julian 1888- *DcBrA 1*
Orde, Gertrude Cederstrom 1901- *WhAmArt 85*
Order, Trudy 1944- *WhoAmA 76, -78, -80, -82, -84*
Orderson, T E *DcWomA*
Ording, Jan 1952- *DcCAr 81*
Ordish, Rowland M 1824-1886 *MacEA*
Ordonez, Bartolome d1520 *McGDA, OxArt*
Ordonez, Efren 1927- *WhoAmA 73, -76, -78, -80*
Ordonez, Luisina *WhAmArt 85*
Ordorica, Hilda Trull 1908- *WhoAmA 73*
Ordway, Albert O 1920- *AmArch 70*
Ordway, Alfred *ArtsNiC, FolkA 86*
Ordway, Alfred T 1819-1897 *NewYHSD ,
WhAmArt 85*
Ordway, Frances Hunt Troop 1860-1933 *DcWomA,
WhAmArt 85*
Ordway, Henry *CabMA*
O'Rear, Lucinda 1823-1852 *DcWomA*
O'Rear, Ronald L 1947- *MarqDCG 84*
Oredson, Vincent Leroy 1923- *AmArch 70*
Orefice, A F *AmArch 70*
O'Regan, C *NewYHSD*
O'Regan, James *NewYHSD*
Orehek, Don 1928- *ConGrA 1[port], WorECar*
O'Reilly, A F *ArtsEM, DcWomA*
O'Reilly, Faith 1938- *WhoArt 80, -82, -84*
O'Reilly, John Gerard 1953- *MarqDCG 84*
O'Reilly, Joseph d1893 *DcVicP 2*
O'Reilly, Montague Frederick d1888 *DcBrWA*
O'Reilly, Montague Frederick 1822-1888 *DcBrBI*
O'Reilly, Patrick *NewYHSD*
O'Reilly, Thomas Robert 1926- *AmArch 70*
Orellana, Gaston 1933- *OxTwCA*
Oremen, Edward Lee 1938- *AmArch 70*
Orensanz, Angel L 1941- *WhoAmA 84*
Orenstein, Gloria Feman 1938- *WhoAmA 76, -78, -80, -82, -84*
Orentlicher, John 1943- *WhoAmA 80, -82, -84*
Orentlicherman, Isaac Henry 1895- *WhAmArt 85*
Oreskovic, Jvka 1885- *DcWomA*
Orford, H W *DcBrBI*
Organ, Bryan 1935- *ConArt 77, ConBrA 79[port],
WhoArt 80, -82, -84*
Organ, Marjorie 1886- *WhAmArt 85*
Organ, Marjorie 1886-1930 *DcWomA*
Organ, Robert 1933- *WhoArt 84*
Orgeval, Claire D' *DcWomA*
Orgill, Marvin A 1933- *AmArch 70*
Orgill, T L *AmArch 70*
Orient, Josef 1677-1747 *ClaDrA*
Oringdulph, R E *AmArch 70*
Oriolo, Giovanni Da d1474? *ClaDrA*
Orizonte *McGDA*
Orkin, Fredrick Kent 1943- *MarqDCG 84*
Orkin, Ruth *WhoAmA 73, -76, -78, -80, -82*
Orkin, Ruth 1921- *ConPhot, ICPEnP A, MacBEP,
WhoAmA 84*
Orland, Edith *DcWomA*
Orland, Ted 1941- *MacBEP*
Orland, Ted N *WhoAmA 82, -84*
Orlandi, Deodato *McGDA*
Orlando, Dominic 1917- *AmArch 70*
Orlando, Frank Paul 1925- *AmArch 70*
Orlando, Joe 1927- *WorECom*
Orleans, Antoine Philippe D' *NewYHSD*
Orleans, Princess Blanche D' 1857- *DcWomA*
Orleans, F W *AmArch 70*
Orleans, Girard D' d1361 *OxArt*
Orleans, Jean D' *OxArt*
Orleans, Louis Charles D' *NewYHSD*
Orleans, Princess Marie Amelie F H D' 1865-1909
DcWomA
Orleans, Princess Marie D' *DcWomA*
Orleman, Elsie Maria 1881- *WhAmArt 85*
Orleman, Louise *DcWomA*
Orley, Bernaert Van 1490?-1541 *OxArt*
Orley, Bernard Van 1492?-1542 *McGDA*
Orley, Jan Van 1665-1735 *ClaDrA, McGDA*
Orley, Richard Van 1663-1732 *ClaDrA*
Orliac, Elise 1825?-1886? *DcWomA*
Orlick, Ralph Clarence 1953- *MarqDCG 84*
Orlik, Emil 1870-1932 *McGDA*
Orling, Anne *WhoAmA 78, -80, -82, -84*
Orloff, Chana 1888-1968 *DcWomA, OxTwCA,
PhDcTCA 77*
Orloff, Gregory 1890- *WhAmArt 85*
Orloff, Joseph Carl 1945- *MarqDCG 84*
Orloff, Lillian 1908-1957 *WhAmArt 85*

Orloff, Lily d1957 *WhoAmA 80N, -82N, -84N*
Orlov, Dimitry Stakhiyevich 1883-1946 *WorECar*
Orlov, M F *IlDcG*
Orlove, Mark 1950- *MacBEP*
Orlowski, Aleksander 1777-1832 *WorECar*
Ormand, Maria *DcWomA*
Ormani, Maria *DcWomA*
Ormbreck, Harlan Kermit 1936- *AmArch 70*
Orme, Albert *FolkA 86*
Orme, Daniel 1766-1832 *DcBrWA*
Orme, Daniel 1767-1832? *DcBrECP*
Orme, Edward 1774- *DcBrBI, DcBrWA*
Orme, Ernest *DcBrBI*
Orme, Lydia Gardner d1963 *WhAmArt 85,
WhoAmA 78N, -80N, -82N, -84N*
Orme, Philibert DeL' *OxArt*
Orme, William *DcBrBI, DcBrECP, DcBrWA*
Ormea, Willem 1673- *McGDA*
Ormerod, George *DcBrBI*
Ormerod, Stanley Horton *WhoArt 84N*
Ormerod, Stanley Horton 1918- *ClaDrA, DcBrA 1,
WhoArt 80, -82*
Ormes, Eleanor R 1865?-1938 *ArtsAmW 3*
Ormes, Mrs. Manly D 1865?- *DcWomA, IIBEAAW,
WhAmArt 85*
Ormeston, John *CabMA*
Ormond, M Georgia *DcWomA, WhAmArt 85*
Ormond, Waverly Chapman 1922- *AmArch 70*
Ormonde, Leonard *DcBrA 1, DcVicP 2*
Orms *FolkA 86*
Ormsbee, Caleb, Jr. 1752- *BiDAmAr*
Ormsbee, Mary Catherine 1854?-1947 *DcWomA,
WhAmArt 85*
Ormsby, Charles Cramer 1936- *AmArch 70*
Ormsby, Orrin 1766- *CabMA*
Ormsby, Robert *NewYHSD*
Ormsby, V *DcVicP 2*
Ormsby, Waterman Lilly 1809-1883 *NewYHSD*
Ormston, H E *AmArch 70*
Orne *CabMA*
Ornitz, Don 1920- *ICPEnP A*
Ornoff, Nathan *WhAmArt 85*
Ornstein, Jacob Arthur 1907- *WhAmArt 85*
Ornstein, Jeffrey A 1941- *AmArch 70*
Ornstein, Judith 1951- *DcCAr 81*
Orofino, John Joseph 1936- *AmArch 70*
Oron, Zvi 1888-1980 *ICPEnP A*
O'Rooke, Michael *NewYHSD*
Oropesa, Mariana DeSilva, Condesa De *DcWomA*
O'Rorke, Edward Brian 1901- *DcBrA 1*
O'Rorke, Edward Brian 1901-1974 *DcBrA 2*
O'Rourke, Andrew P 1894-1935 *WhAmArt 85*
O'Rourke, Donald Joseph 1930- *AmArch 70*
O'Rourke, Jeremiah 1833-1915 *BiDAmAr*
O'Rourke, W M *AmArch 70*
Orovida *DcBrA 1, DcWomA*
Orovida, Camille Pissaro 1893- *ClaDrA*
Orozco, Alfredo 1933- *DcCAr 81*
Orozco, Jose Clemente 1883-1949 *ConArt 77, -83,
McGDA, OxArt, OxTwCA, PhDcTCA 77*
Orozco Romero, Carlos 1898- *McGDA*
Orpen, Bea *WhoArt 82N*
Orpen, Bea 1913- *DcBrA 1, WhoArt 80*
Orpen, Richard Francis Caulfield 1863-1938 *DcBrA 1,
DcVicP 2*
Orpen, Sir William *OxTwCA*
Orpen, Sir William 1878-1931 *DcBrBI, PhDcTCA 77*
Orpen, Sir William Newenham Montague 1878-1931
DcBrA 1, ClaDrA, DcVicP 2, McGDA, OxArt
Orpheus, V *DcVicP 2*
Orphoot, Burnett Napier Henderson 1880-1964
DcBrA 1
Orput, Alden E 1931- *AmArch 70*
Orput, R A *AmArch 70*
Orr *NewYHSD*
Orr, Alfred Everitt 1886- *ArtsAmW 2, DcBrA 1,
WhAmArt 85*
Orr, Anona Christina 1947- *WhoAmA 76*
Orr, Arthur 1938- *WhoAmA 84*
Orr, Arthur Anselm 1868-1949 *DcBrA 2*
Orr, Carey *WhAmArt 85*
Orr, Carey 1890-1967 *WorECar*
Orr, Chris 1943- *OxTwCA*
Orr, Dick Robert 1929- *AmArch 70*
Orr, Eleanor Mason 1902- *WhAmArt 85*
Orr, Elliot 1904- *WhAmArt 85, WhoAmA 73, -76,
-78, -80, -82, -84*
Orr, Emily Louise *DcWomA*
Orr, Eric *PrintW 83, -85*
Orr, Eric 1939- *DcCAr 81*
Orr, Forrest 1895- *WhAmArt 85*
Orr, Frances 1880- *WhAmArt 85*
Orr, Frances Morris 1880- *DcWomA*
Orr, Frank Howard, III 1932- *AmArch 70*
Orr, G F *WhAmArt 85*
Orr, George *FolkA 86*
Orr, Georgianna 1946- *FolkA 86*
Orr, Gerald Porter 1938- *AmArch 70*
Orr, Gordon Dickson, Jr. 1926- *AmArch 70*
Orr, Hector *NewYHSD*

Orr, Mrs. J B *WhAmArt 85*
Orr, J Edward *WhAmArt 85*
Orr, J N J *DcVicP 2*
Orr, Jack R *AmArch 70*
Orr, James Ritchie, II 1940- *AmArch 70*
Orr, Joel Nathaniel 1947- *MarqDCG 84*
Orr, John *CabMA*
Orr, John William 1815-1887 *EarABI SUP,
NewYHSD*
Orr, Joseph Charles 1949- *WhoAmA 84*
Orr, Louis 1879-1961 *WhAmArt 85*
Orr, M M *AmArch 70*
Orr, Margaret R *WhAmArt 85*
Orr, Martha *WhAmArt 85*
Orr, Monro Scott 1874- *DcBrA 1, DcBrBI,
DcVicP 2*
Orr, Munro Scott 1874- *IlsCB 1744*
Orr, Nathaniel 1822- *NewYHSD*
Orr, Otis *WhAmArt 85*
Orr, Patrick William 1865- *DcVicP 2*
Orr, Ralph Edward 1953- *MarqDCG 84*
Orr, Ralph R 1891- *AmArch 70*
Orr, Richard *FolkA 86*
Orr, Steven Kendall 1950- *MarqDCG 84*
Orr, Stewart 1872-1944 *DcBrBI*
Orr, Stewart 1872-1945? *DcBrA 1, DcVicP 2*
Orr, The 1939- *DcCAr 81*
Orr, Veronica Marie 1945- *WhoAmA 78, -80*
Orr, William A *IlsBYP*
Orr-Cahall, Anona Christina 1947- *WhoAmA 78, -80,
-82, -84*
Orred, Sophia *DcWomA*
Orrente, Pedro 1570?-1645 *McGDA*
Orrick, John Riggs 1923- *AmArch 70*
Orrick-Semmes, A Gertrude *DcWomA,
WhAmArt 85*
Orridge, Caroline E *DcVicP 2*
Orridge, John *BiDBrA*
Orrinsmith, Lucy *DcWomA*
Orrock, James 1829-1913 *DcBrA 1, DcBrBI,
DcVicP, -2*
Orrock, James 1829-1919 *DcBrWA*
Orry-Kelly 1897-1964 *ConDes*
Orsetti, Alexander *ArtsEM*
Orsi, Lelio 1511-1587 *McGDA, OxArt*
Orsibal, Madame *DcWomA*
Orsini *WhoAmA 73, -78, -80*
Orsini 1912- *WhoAmA 76, -82, -84*
Orsini, Donna Theresa DiCassine d1778 *DcWomA*
Orsini, Giustina *DcWomA*
Orsolini, Giacomo *MacEA*
Orsolini, Giovanni, II d1597 *MacEA*
Orsolini, Giovanni Battista d1646 *MacEA*
Orsolini, Taddeo *MacEA*
Orsolini, Tommaso 1587-1675 *MacEA*
Orsolini Family *MacEA*
Orsollini, Theodore *NewYHSD*
Ortega, Ben *FolkA 86*
Ortega, Benjamin 1923- *FolkA 86*
Ortega, David 1917- *FolkA 86*
Ortega, Henry Christopher 1940- *AmArch 70*
Ortega, Jose 1921- *PrintW 83, -85*
Ortega, Jose Benito 1858?-1941 *FolkA 86*
Ortega, Jose Ramon 1828-1904 *FolkA 86*
Ortega, Nicacio 1875-1964 *FolkA 86*
Ortega, Robert James 1954- *FolkA 86*
Ortega Munoz, Godofredo 1905- *OxTwCA*
Ortelius, Abraham 1527-1598 *AntBDN I*
Ortes, Baroness Elmine D' *DcWomA*
Ortgies, John 1836-1908 *WhAmArt 85*
Ortgies, Vida 1858- *DcWomA*
Orth, Adam *FolkA 86*
Orth, G *AmArch 70*
Orth, J W 1889- *WhAmArt 85*
Orth, Marie Adelheid *DcWomA*
Orthmann, Albert Hugo 1907- *AmArch 70*
Orthwein, William Coe 1924- *MarqDCG 84*
Ortiz, Rafael Montanez 1934- *WhoAmA 80, -82, -84*
Ortiz, Ralph 1934- *ConArt 77, WhoAmA 73, -76,
-78*
Ortiz Echague, Jose *MacBEP*
Ortiz-Echague, Jose 1886-1980 *ConPhot, ICPEnP*
Ortiz Macedo, Luis 1933- *WhoAmA 76, -78, -80, -82*
Ortiz Monasterio, Pablo 1952- *ConPhot, ICPEnP A*
Ortiz Valiente, Manuel *OxTwCA*
Ortlieb, Evelyn *DcCAr 81*
Ortlieb, Robert Eugene 1925- *WhoAmA 76, -78, -80,
-82, -84*
Ortlip, Aileen *WhAmArt 85*
Ortlip, Aimee E 1888- *DcWomA, WhAmArt 85*
Ortlip, H Willard 1886- *WhAmArt 85*
Ortlip, Paul Daniel 1926- *WhoAmA 73, -76, -78, -80,
-82, -84*
Ortman, George 1926- *DcCAA 71, -77, OxTwCA*
Ortman, George Earl 1926- *WhoAmA 73, -76, -78,
-80, -82, -84*
Ortman, George Earle 1926- *PhDcTCA 77*
Ortmanns, Auguste *DcVicP 2*
Ortmayer, Constance 1902- *WhAmArt 85,
WhoAmA 73, -76, -78, -80, -82, -84*
Ortner, Laurids *DcCAr 81*

O'Sullivan, Timothy H 1840-1882 *BnEnAmA, DcAmArt, MacBEP, WhAmArt 85*
O'Sullivan, Timothy Henry 1840-1882 *ICPEnP*
Osumi, Paul S, Jr. 1937- *AmArch 70*
Osvaldo *WorECar*
Osver, Arthur 1912- *DcCAA 71, -77, DcCAr 81, McGDA, WhAmArt 85, WhoAmA 73, -76, -78, -80, -82, -84*
Osver, Mrs. Arthur *WhAmArt 85*
Oswald, Mrs. *DcWomA*
Oswald, Adrian 1908- *WhoArt 80, -82, -84*
Oswald, Emilie L *ArtsAmW 2, DcWomA*
Oswald, Frank *DcVicP 2*
Oswald, Frederick Charles 1875- *WhAmArt 85*
Oswald, Fritz 1878- *ClaDrA*
Oswald, John Clyde *WhAmArt 85*
Oswald, John H *DcBrWA, DcVicP 2*
Oswald, Kalman *WhAmArt 85*
Oswald, Warren Henry 1898- *AmArch 70*
Oswalt, Charles Clifford 1939- *MarqDCG 84*
Oswieczynski, Stanislaus Arthur 1915- *WhAmArt 85*
Osyczka, Bohdan Danny *WhoAmA 76, -78, -80, -82, -84*
Osze, Andrew 1909- *PrintW 83, -85*
Osze, Andrew E 1909- *WhoAmA 76, -78, -80, -82, -84*
Ota, Jack Kiyoshi 1911- *AmArch 70*
Ota, Thomas T 1930- *MarqDCG 84*
Otaka, Masato 1923- *ConArch*
O'Tama-Chiovara *DcWomA*
Otani, Sachio 1924- *ConArch*
Otawa, Toru 1952- *MarqDCG 84*
Oteiza Embil, Jorge De 1908- *PhDcTCA 77*
Otero, Alejandro 1921- *McGDA, OxTwCA*
Otfinowski, Danuta 1953- *MacBEP*
Otis, Alferez Don Jose Antonio *FolkA 86*
Otis, Amy *DcWomA, WhAmArt 85*
Otis, Bass 1784-1861 *McGDA, NewYHSD*
Otis, C H *WhAmArt 85*
Otis, C W *BiDAmAr*
Otis, Daniel *FolkA 86*
Otis, Elisha Graves 1811-1861 *MacEA*
Otis, Elizabeth *DcWomA, WhAmArt 85*
Otis, Erwin James, Jr. 1917- *AmArch 70*
Otis, Fessenden Nott 1825-1900 *ArtsAmW 1, IlBEAAW, NewYHSD , WhAmArt 85*
Otis, Fred *FolkA 86*
Otis, George Demont 1877- *ArtsAmW 1*
Otis, George Demont 1877-1962 *ArtsAmW 2*
Otis, George Demont 1879- *WhAmArt 85*
Otis, Isaac *CabMA*
Otis, James, Jr. 1931- *AmArch 70*
Otis, John *CabMA*
Otis, Lewis W *NewYHSD*
Otis, Marion *WhAmArt 85*
Otis, Mercy *FolkA 86*
Otis, Minnie V *ArtsAmW 3*
Otis, Samuel Davis 1889- *WhAmArt 85*
Otis, Samuel Shackford 1891- *AmArch 70*
Otis, William A 1855-1929 *BiDAmAr*
Otley, Barbara Kathleen 1918- *WhoArt 80, -82, -84*
Otley, Charles Bethell 1792-1867 *DcBrWA*
Otnes, Fred 1925- *IlBEAAW, IlrAm F, -1880*
Otnes, Fred 1926- *WhoGrA 82[port]*
Otoman *AntBDN L*
O'Toole, Cathal Brendan 1903- *WhAmArt 85*
O'Toole, James St. Laurence 1895- *WhoAmA 78, -80, -82, -84*
O'Toole, Lawrence J *NewYHSD*
Ott, Miss *DcWomA*
Ott, Augustus Louis, III 1928- *AmArch 70*
Ott, C *FolkA 86*
Ott, G L *AmArch 70*
Ott, Jerry 1947- *PrintW 83, -85, WhoAmA 84*
Ott, Jerry Duane 1947- *WhoAmA 76, -78, -80, -82*
Ott, Manfred 1933- *DcCAr 81*
Ott, Peterpaul 1895- *WhAmArt 85*
Ott, Philip *NewYHSD*
Ott, Ralph C *WhAmArt 85*
Ott, Robert William 1934- *WhoAmA 84*
Ott, Wendell Lorenz 1942- *WhoAmA 78, -80, -82, -84*
Ott & Brewer *DcNiCA*
Ott-Hirzel, Suzette *DcWomA*
Otte, Hans 1926- *DcCAr 81*
Otte, William L 1871- *ArtsAmW 2*
Otten, Mitzi 1888- *WhAmArt 85*
Ottenheimer, Henry A 1868-1919 *BiDAmAr*
Ottenheimer, John 1933- *AmArch 70*
Otter, T J *NewYHSD*
Otter, Thomas P *IlBEAAW, NewYHSD*
Ottesen, Ellen *DcWomA*
Ottewell, Benjamin John *DcBrA 1*
Ottewell, Benjamin John d1937 *DcBrA 2, DcBrWA, DcVicP 2*
Ottiano, John William 1926- *WhoAmA 73, -76, -78, -80, -82, -84*
Ottignon, William A 1823- *CabMA*
Ottinger, George M 1833-1917 *WhAmArt 85*
Ottinger, George Martin 1833-1917 *ArtsAmW 1*
Ottinger, George Morton 1833-1917 *IlBEAAW*

Ottini, Felice d1697 *ClaDrA*
Ottley, Albert E *ArtsEM*
Ottley, Emily *DcBrWA, DcVicP 2*
Ottley, George Oswald 1872?-1939 *ArtsEM*
Ottley, Oswald S *ArtsEM*
Ottley, William Young 1771-1836 *ClaDrA, DcBrECP, DcBrWA*
Ottman *FolkA 86*
Otto, Catherine K 1947- *WhoAmA 84*
Otto, Frei 1925- *ConArch, EncMA, MacEA, WhoArch*
Otto, Johann Henrich *FolkA 86*
Otto, Johanna 1839-1914 *DcWomA*
Otto, Mary Rita 1958- *MarqDCG 84*
Otto, Raymond Frank 1930- *AmArch 70*
Otto, Teo 1904-1968 *ConDes*
Otto, Waldemar 1929- *DcCAr 81*
Otto, Wilhelm *FolkA 86*
Otto, William *NewYHSD*
Otton, J Hare *FolkA 86*
Ottoni, Lorenzo 1648-1736 *McGDA*
Ottoson, Lars B 1931- *MarqDCG 84*
Otway, J *DcVicP 2*
Otzen, Charlotte 1879- *DcWomA*
Otzen, Johannes 1839-1911 *MacEA*
Ouborg, Piet 1893-1956 *OxTwCA, PhDcTCA 77*
Ouborg, Pieter *DcCAr 81*
Oubre, Hayward L *AfroAA*
Oubre, Hayward Louis *WhoAmA 76, -78, -80, -82, -84*
Oubre, James Paul 1929- *AmArch 70*
Ouchterlony, Miss *DcWomA*
Oud, J J P 1890-1963 *ConArch, MacEA*
Oud, Jacobus Johannes Pieter 1890-1963 *DcD&D, EncMA, McGDA, OxArt, WhoArch*
Ouda, Ethel Annetta 1908- *WhAmArt 85*
Oudens, Gerald Francis 1934- *AmArch 70*
Oudenaerde, Robert Van *ClaDrA*
Ouderra, Pierre Jan VanDer 1841-1915 *ClaDrA*
Oudet, Marie Augustine Clementine *DcWomA*
Oudin, Dorothy Savage 1898- *DcWomA, WhAmArt 85*
Oudine, Eugene-Andre 1810- *ArtsNiC*
Oudinot, Achille Francois 1820- *ArtsNiC*
Oudot, Georges 1928- *OxTwCA*
Oudot, Roland 1897- *ClaDrA, McGDA, OxTwCA, PhDcTCA 77*
Oudoyer-Paulin, Marthe 1883- *DcWomA*
Oudry, Jacques Charles 1720-1778 *ClaDrA*
Oudry, Jean Baptiste 1686-1755 *ClaDrA*
Oudry, Jean-Baptiste 1686-1755 *McGDA, OxArt, OxDecA*
Oudry, Marie Marguerite d1780 *DcWomA*
Ouellet, Joseph-Pierre 1871-1959 *MacEA*
Ought, William 1753-1778 *DcBrECP*
Ouless, Catherine 1879- *DcBrA 1, DcWomA*
Ouless, Philip J 1817-1885 *DcVicP 2*
Ouless, Philip John 1817-1885 *DcSeaP*
Ouless, Walter William 1848- *ArtsNiC*
Ouless, Walter William 1848-1933 *ClaDrA, DcBrA 1, DcVicP, -2*
Oulett, Jesse J *DcVicP 2*
Oulman, Judson *WorFshn*
Oumar, Madiha *DcCAr 81*
Ourdan, Joseph James Prosper 1803-1874 *NewYHSD*
Ourdan, Joseph Prosper 1828-1881 *NewYHSD*
Ouren, Karl 1882-1943 *WhAmArt 85*
Ourlac, Jean Nicolas 1789-1821 *NewYHSD*
Ourvantzoff, Miguel 1897- *ClaDrA*
Oury, Germaine 1889- *DcWomA*
Ouseley, Sir William Gore 1797-1866 *DcBrWA*
Ousey, Harry 1915- *ClaDrA*
Oussey, Buckley 1851-1889 *DcVicP 2*
Outcalt, R F *AmArch 70*
Outcault, John Filer 1927- *AmArch 70*
Outcault, R F 1863-1928 *ConGrA 1[port]*
Outcault, Richard F 1863-1928 *WhAmArt 85*
Outcault, Richard Felton 1863-1928 *WorECom*
Outerbridge, Paul, Jr. 1896-1958 *ConPhot, ICPEnP, WhAmArt 85*
Outerbridge, Paul, Jr. 1896-1959 *MacBEP*
Outhouse, Cora A *ArtsEM, DcWomA*
Outhwaite, Ida 1889-1961 *DcWomA*
Outin, Pierre 1840-1899 *ClaDrA*
Outlaw, Simon *AfroAA*
Outterbridge, James *AfroAA*
Outterbridge, John Wilfred 1933- *AfroAA, WhoAmA 78, -80, -82, -84*
Ouvrie, Pierre Justin 1810- *ArtsNiC*
Ouwater, Albert Van *McGDA, OxArt*
Ouwater, Isaak 1750-1793 *ClaDrA, OxArt*
Ouwerkerk, Timotheus Wilhelmus 1845-1910 *ClaDrA*
Ouzounian, Jack V *AmArch 70*
Ovcharov, Georgi Radev 1889-1953 *MacEA*
Ovenden, F W *DcSeaP, DcVicP 2*
Ovenden, Graham 1943- *ConBra 79[port], DcCAr 81*
Ovenholt, Abraham *FolkA 86*
Ovens, Jurriaen 1623-1678 *McGDA*
Over, Charles *BiDBrA*

Overath, George Nicholas, Jr. 1910- *AmArch 70*
Overbaugh, Abram W *WhAmArt 85*
Overbeck, Clarence Edward 1896- *AmArch 70*
Overbeck, Elizabeth Gray 1875-1936 *WhAmArt 85*
Overbeck, Friedrich 1789-1869 *ArtsNiC, OxArt*
Overbeck, Hannah Borger d1931 *WhAmArt 85*
Overbeck, Hermine *DcWomA*
Overbeck, Johann Friedrich 1789-1869 *ClaDrA, McGDA*
Overbeck, Margaret *WhAmArt 85*
Overbeck, Margaret d1911 *DcWomA*
Overbeck, Mary Frances 1878-1956 *DcWomA, WhAmArt 85*
Overbeck-Schenk, Gerta 1898-1979 *DcWomA*
Overbek, Julie 1788-1816 *DcWomA*
Overbury, L *DcVicP 2, DcWomA*
Overbury, Mary A 1860-1932 *DcWomA*
Overby, Marion *WhAmArt 85*
Overend, William Heysham 1851-1898 *DcBrWA, DcVicP, -2*
Overend, William Heysman 1851-1898 *DcBrBI*
Overgard, William Thomas 1926- *WorECom*
Overhardt, William *WhAmArt 85*
Overholt, Henry O 1813?- *FolkA 86*
Overland, Carlton Edward 1942- *WhoAmA 76, -78, -80, -82, -84*
Overland, Cora 1882- *WhAmArt 85*
Overland, Cora Burus 1882- *DcWomA*
Overmire, Edwin P 1864-1905 *BiDAmAr*
Overmire, P C *AmArch 70*
Overnell, T J *DcBrBI*
Overr, Carl *AfroAA*
Overstreet, Joseph 1934- *AfroAA*
Overstreet, N W *AmArch 70*
Overstreet, R K *AmArch 70*
Overstreet, Thomas *CabMA*
Overton, Katherine *WhAmArt 85*
Overton, L O *AmArch 70*
Overton, Nan *WhAmArt 85*
Overton, Nathan *FolkA 86*
Overton, Thomas Collins *BiDBrA*
Overturf, H J *AmArch 70*
Overweg, Lily *DcVicP 2*
Oviate, Anna P *WhAmArt 85*
Oviate, Anna P 1863-1930 *DcWomA*
Oviatt, Anna P 1863-1930 *DcWomA*
Oviatt And Warner *EncASM*
Ovick, Jack Lloyd *AmArch 70*
Ovresat, Raymond Charles 1926- *AmArch 70*
Ovryn, Benjamin S 1892- *WhAmArt 85*
Owen, A A *DcWomA*
Owen, A C *DcVicP 2*
Owen, Belle C *ArtsEM, DcWomA*
Owen, Bernard 1886- *DcBrA 1*
Owen, Bertha *DcWomA*
Owen, Bill *OfPGCP 86*
Owen, Bill 1942- *IlBEAAW, WhoAmA 76, -78, -80, -82, -84*
Owen, C H *DcWomA*
Owen, Mrs. Charles H *WhAmArt 85*
Owen, Charles Kent *WhAmArt 85*
Owen, Clara B *WhAmArt 85*
Owen, Courtney Briscoe 1934- *MarqDCG 84*
Owen, David Dale 1807-1860 *NewYHSD*
Owen, E *ArtsEM, DcWomA*
Owen, Edward Pryce 1788-1863 *DcBrBI, DcBrWA, DcVicP 2*
Owen, Ella W *ArtsEM, DcWomA*
Owen, Esther S D 1843-1927 *DcWomA, WhAmArt 85*
Owen, Fiona *DcCAr 81*
Owen, Frank 1939- *WhoAmA 78, -80, -82, -84*
Owen, Frederick 1869-1959 *WhoAmA 80N, -82N, -84N*
Owen, G Scott 1943- *MarqDCG 84*
Owen, George *NewYHSD*
Owen, George d1917 *DcNiCA*
Owen, George, Jr. *NewYHSD*
Owen, George Elmslie 1899-1964 *DcBrA 1*
Owen, George O *DcBrA 1*
Owen, Gladys 1889- *DcWomA*
Owen, Griffith *NewYHSD*
Owen, J B *FolkA 86*
Owen, Jacob 1778-1870 *BiDBrA*
Owen, James *DcBrA 1, DcVicP 2*
Owen, James Percival 1927- *AmArch 70*
Owen, John *DcCAr 81*
Owen, John 1836?-1895 *ArtsEM*
Owen, John D, Jr. 1921- *AmArch 70*
Owen, M W *FolkA 86*
Owen, Michael G, Jr. 1915- *WhAmArt 85*
Owen, Narcissa *DcWomA*
Owen, Narcissa Chisholm 1831-1911 *ArtsAmW 3*
Owen, Richard *NewYHSD*
Owen, Robert Emmett 1878-1957 *WhAmArt 85*
Owen, Russell Hartley 1957- *MarqDCG 84*
Owen, Samuel 1768-1857 *DcBrBI, DcBrECP, DcBrWA, DcSeaP*
Owen, Thomas Ellis 1804-1862 *BiDBrA*
Owen, Will 1869-1957 *DcBrA 1, DcBrBI*
Owen, William 1769-1825 *DcBrECP*

Owen, William B, Jr. *WhAmArt 85*
Owen Brothers *AntBDN P*
Owens *NewYHSD*
Owens, Al Curtis 1933- *WhoAmA 76, -78, -80*
Owens, B F *AmArch 70*
Owens, Bill 1938- *ConPhot, ICPEnP A*
Owens, Bob 1953- *DcCAr 81*
Owens, Charles H 1880-1958 *ArtsAmW 1*
Owens, Frank *FolkA 86*
Owens, Gail 1939- *IlsCB 1967*
Owens, George, Jr. *NewYHSD*
Owens, Griffith *NewYHSD*
Owens, Gwendolyn Jane 1954- *WhoAmA 80, -82, -84*
Owens, J B *DcNiCA, FolkA 86*
Owens, L L *WhAmArt 85*
Owens, Leroy F 1923- *AmArch 70*
Owens, Mary 1935- *WhoAmA 78, -80, -82, -84*
Owens, Maude Irwin 1900- *AfroAA*
Owens, Michael J *IlDcG*
Owens, R Judge 1924- *AmArch 70*
Owens, Mrs. R W *WhAmArt 85*
Owens, Robert G 1932- *AmArch 70*
Owens, S L *AmArch 70*
Owens, Tennys Bowers 1940- *WhoAmA 78, -80, -82, -84*
Owens, Timothy Ralph 1946- *WhoAmA 76*
Owens, W G, Jr. *AmArch 70*
Owens, Wallace, Jr. *WhoAmA 80, -82, -84*
Owens, William Elmo 1938- *MacBEP*
Owens, Winifred 1911- *WhoAmA 73*
Owensby, R L, Jr. *AmArch 70*
Owings, Edna M *DcWomA, WhAmArt 85*
Owings, Margaret Wentworth 1913- *WhoAmA 76, -78, -80*
Owings, N A *AmArch 70*
Owings, Nathaniel 1903- *ConArch, WhoArch*
Owings, Nathaniel A *McGDA*
Owings, Nathaniel A 1903- *MacEA*
Owings, Thomas Bond *WhAmArt 85*
Owings, Vonna *DcWomA*
Owler, Martha Tracy 1853-1916 *WhAmArt 85*
Owles, Alfred 1898- *ArtsAmW 2, WhAmArt 85*
Owles, Fred George 1925- *AmArch 70*
Owlsey, David Thomas 1929- *WhoAmA 78*
Ownby, Thomas *FolkA 86*
Owsley, Charles H 1846-1935 *BiDAmAr*
Owsley, David Thomas 1929- *WhoAmA 73, -76, -80, -82, -84*
Owsley, Leonora *WhAmArt 85*
Owsley, Willie 1897- *FolkA 86*
Owtram, Robert L *DcVicP 2*
Owyang, Judith Francine 1940- *WhoAmA 73, -76, -78*
Oxenbury, Helen 1938- *IlsBYP, IlsCB 1967*
Oxenbury, Thomas Bernard 1904- *WhoArt 80, -82, -84*
Oxenfeld, John Robert 1927- *AmArch 70*
Oxholm, Charlotte 1846- *DcWomA*
Oxley, Howard W, Jr. 1936- *AmArch 70*
Oxley, Joseph 1813?- *FolkA 86*
Oxley, Ursula 1918- *WhoArt 80, -82, -84*
Oxman, Katja 1942- *PrintW 85*
Oxman, Mark 1940- *WhoAmA 82, -84*
Oxtoby, David Jowett Greaves 1938- *WhoArt 80, -82, -84*
Oyakawa, Stephen Noboru 1921- *AmArch 70*
Oyarzo, J R *AmArch 70*
Oyen, Dorine Van 1887- *DcWomA*
Oyler, Judith Audrey Allenby *DcBrA 2, WhoArt 80, -82, -84*
Oyon, Madame *DcWomA*
Oyston, George *DcVicP 2*
Oyston, George Dean *DcBrA 2*
Ozanne, Jeanne Francoise 1735-1795 *DcWomA*
Ozanne, Marie Elisabeth *DcWomA*
Ozanne, Marie Jeanne 1736-1786 *DcWomA*
Ozanne, Nicolas-Marie 1728-1811 *DcSeaP*
Ozanne, Pierre 1737-1813 *ClaDrA, DcSeaP, NewYHSD*
Ozanne-Cederlund, Frederique 1880?-1966 *DcWomA*
Ozenfant, Amedee d1966 *WhoAmA 78N, -80N, -82N, -84N*
Ozenfant, Amedee 1886-1966 *ClaDrA, ConArt 83, MacEA, McGDA, OxArt, OxTwCA, PhDcTCA 77, WorArt*
Ozenfant, Amedee J 1886-1966 *ConArt 77, WhAmArt 85*
Ozereko, Frank 1948- *WhoAmA 80*
Ozier, Ken 1905- *WhAmArt 85*
Ozmun, Mrs. Donald *WhAmArt 85*
Ozonoff, Ida 1904- *WhoAmA 76, -78, -80, -82, -84*

P

469

Pantazi, Spiros George *AmArch 70*
Pantel, D *AmArch 70*
Pantell, Richard 1951- *AmArt*
Pantell, Richard Keith 1951- *WhoAmA 84*
Panteo, Matteo 1492-1502 *McGDA*
Panteon DeLosReyes, Leon *McGDA*
Pantin, Mademoiselle *DcWomA*
Pantin, Simon *AntBDN Q, OxDecA*
Panting, John 1940-1974 *ConArt 77*
Pantoja DeLaCruz, Juan 1553-1608 *McGDA*
Panton, Alexander *DcVicP, -2*
Panton, Alice Julie *DcWomA*
Panton, Henry *NewYHSD*
Panton, Verner 1926- *ConDes*
Panu, Zottu L 1924- *AmArch 70*
Panusch, Rosa *DcWomA*
Panushka, D H *AmArch 70*
Panzacchi, Maria Elena 1658?-1737 *DcWomA*
Panzachia, Maria Elena 1658?-1737 *DcWomA*
Panzel, Marie *DcWomA*
Panzica, A J *AmArch 70*
Panzucchi, Maria Elena 1658?-1737 *DcWomA*
Pao, John 1930- *MarqDCG 84*
Paoletti, Antonio Silvio *DcVicP 2*
Paolinelli, F *AmArch 70*
Paolini, Ameris M 1945- *ConPhot, ICPEnP A*
Paolini, Giulio 1940- *ConArt 77, -83,*
 PrintW 85
Paolini, R P *AmArch 70*
Paolino, Fra 1490?-1547 *McGDA*
Paolo DiGiovanni *McGDA*
Paolo DiStefano Badaloni *McGDA*
Paolo Romano *McGDA*
Paolo Veneziano *McGDA*
Paolo, C S 1882- *WhAmArt 85*
Paolo, Jacopo Di *McGDA*
Paolozzi, Eduardo 1924- *ConArt 77, -83,*
 ConBrA 79, DcBrA 1, DcCAr 81, McGDA,
 OxTwCA, PhDcTCA 77, WorArt[port]
Paolozzi, Eduardo Luigi 1924- *WhoArt 84*
Paone, Peter 1936- *AmArt, DcCAA 71, -77,*
 WhoAmA 73, -76, -78, -80, -82, -84
Papachristou, Tician 1928- *AmArch 70*
Papadakis, John 1922- *AmArch 70*
Papadatos, Steven Peter 1941- *AmArch 70*
Papadopulos, Patroklos J 1910- *AmArch 70*
Papageorge, Tod 1940- *ConPhot, DcCAr 81,*
 ICPEnP A, MacBEP, WhoAmA 76, -78, -80,
 -82, -84
Papanek, Victor 1925- *ConDes*
Paparella, A *AmArch 70*
Papart, Max 1911- *PrintW 83, -85*
Papas, William *IlsCB 1967*
Papas, William 1927- *IlsCB 1957*
Papashvily, George 1898- *WhoAmA 73, -76*
Papashvily, George 1898-1978 *WhoAmA 78N, -80N,*
 -82N, -84N
Papasian, Jack d1957 *WhoAmA 80N, -82N, -84N*
Papasian, Jack Charles 1878-1957 *WhAmArt 85*
Papavoine, Angelique *DcWomA*
Papavoine, Julia 1759- *DcWomA*
Pape, Abraham De 1621?-1666 *McGDA*
Pape, Alice d1911 *DcWomA*
Pape, Alice Monroe d1911 *WhAmArt 85*
Pape, Eduard Friedrich 1817- *ArtsNiC*
Pape, Eric 1870- *ConICB*
Pape, Eric 1870-1938 *WhAmArt 85*
Pape, Frank Cheyne *DcBrBI*
Pape, George K *WhAmArt 85*
Pape, Gretchen Anna 1866?-1947 *DcWomA,*
 WhAmArt 85
Pape, Hans 1894- *ArtsAmW 1*
Pape, Martin Didier *McGDA*
Papendiek, Charles Edward d1835 *BiDBrA*
Papesh, Alexander Anthony 1928- *AmArch 70*
Papety, Dominique Louis 1815-1849 *ClaDrA*
Papier, Bruce L 1940- *MarqDCG 84*
Papillon, David 1581-1659 *BiDBrA*
Papillon, Jean Michel 1698-1776 *McGDA*
Papillon, Marie Anne *DcWomA*
Papin, Jeannette 1761-1835 *DcWomA*
Papin, Joseph 1825-1862 *IlsBYP*
Papio, Iso 1925- *WhoAmA 76, -78, -80, -82, -84*
Papova, Vera *DcWomA*
Papp, Gabor 1918- *WhoGrA 62, -82[port]*
Papp, Jozefa 1835?-1858 *DcWomA*
Papp, Laszlo G 1929- *AmArch 70*
Pappafava, Beatrice *DcWomA*
Pappas, George 1929- *WhoAmA 78, -80, -82, -84*
Pappas, James G 1937- *AfroAA*
Pappas, John Gus 1926- *AmArch 70*
Pappas, John L 1898- *WhAmArt 85*
Pappas, Marilyn 1931- *WhoAmA 73, -76, -78, -80,*
 -82, -84
Pappas, Nicholas Anthony 1927- *AmArch 70*
Pappas, Steve Volane 1929- *AmArch 70*
Pappas, T P *AmArch 70*
Pappassimot, Eliane *DcWomA*
Pappel, Edda *DcWomA*

Pappenberg, Henry *FolkA 86*
Pappos *MacEA*
Papprill, Henry *NewYHSD*
Paprocki, Thomas 1901-1973 *WorECar*
Paps 1882-1965 *OxTwCA*
Papsdorf, Frederick 1887- *WhAmArt 85*
Papworth, C *DcVicP 2*
Papworth, F *DcVicP 2*
Papworth, John B 1775-1847 *MacEA*
Papworth, John Buonarotti 1775-1847 *BiDBrA,*
 DcBrBI, DcBrWA, DcD&D[port], McGDA,
 OxArt, WhoArch
Paque *DcBrBI*
Paquet, Anthony C 1814-1882 *NewYHSD*
Paquet-Steinhausen, Marie Henriette 1887- *DcWomA*
Paquier *AntBDN M*
Paquin *FairDF FRA, WorFshn*
Parachek, Ralph Edward *AmArch 70*
Parada, Esther 1938- *ICPEnP A, MacBEP*
Paradis, Roger 1944- *MarqDCG 84*
Paradise, John 1783-1833 *NewYHSD*
Paradise, John Wesley 1809-1862 *NewYHSD*
Paradise, Phil 1905- *WhoAmA 73, -76, -78, -80, -82,*
 -84
Paradise, Phil Herschel 1905- *WhAmArt 85*
Paradise, Philip Herschel 1905- *IlBEAAW*
Paraf-Javal, Therese *DcWomA*
Paralta, Francisco *DcVicP 2*
Paramino, John F 1888- *WhAmArt 85*
Parasole, Geronima *DcWomA*
Parasole, Isabella *DcWomA*
Paravano, Dino *OfPGCP 86*
Paravey, Miss *DcWomA*
Paravey, Marie A H *DcVicP 2*
Paravicini, Lizette 1889- *DcWomA, WhAmArt 85*
Parbury, Kathleen Ophir Theodora 1901- *DcBrA 1,*
 WhoArt 80, -82, -84
Parcehian, Duffy *WhoAmA 80, -82*
Parcell, L Evans *WhAmArt 85*
Parcell, Malcolm Stephens 1896- *WhAmArt 85*
Parczewska, Rosa 1799-1852 *DcWomA*
Parde, Phineas *NewYHSD*
Pardee, Alice S *AmArch 70*
Pardee, Kassandra 1947- *DcCAr 81*
Pardee, S C *AmArch 70*
Pardee, William Hearne 1946- *WhoAmA 84*
Pardi, Justin A d1951 *WhoAmA 78N, -80N, -82N,*
 -84N
Pardi, Justin Anthony 1898-1951 *WhAmArt 85*
Pardington, Joyce Elizabeth 1939- *WhoAmA 76, -78,*
 -80
Pardington, Ralph Arthur 1938- *WhoAmA 76, -78,*
 -80, -82, -84
Pardo, Ambroise *NewYHSD*
Pardoe, John *NewYHSD*
Pardoe, Thomas 1770- *AntBDN M*
Pardoe, Thomas 1770-1823 *DcNiCA*
Pardon, Earl B 1926- *WhoAmA 73, -76, -78, -80, -82,*
 -84
Pardue, Oscar Ward 1930- *AmArch 70*
Pardue, R B, Jr. *AmArch 70*
Pardue, Sherman 1929- *AmArch 70*
Pare, David 1911- *DcBrA 1*
Paredes, Diogenes *OxTwCA*
Paredes, Jose M 1912- *WhAmArt 85*
Paredes, Juan De d1738 *ClaDrA*
Paredes, Limon Mariano 1912- *WhoAmA 76, -78,*
 -80
Paredes, Limon Mariano 1912-1979 *WhoAmA 82N,*
 -84N
Paredes Jardiel, Jose *OxTwCA*
Parell, Sarah *FolkA 86*
Parella, Albert Lucian 1909- *WhoAmA 76, -78, -80,*
 -82, -84
Parent, Mademoiselle *DcWomA*
Parent, Claude 1923- *MacEA*
Parent, James Lawrence 1927- *AmArch 70*
Parent, Richard Earl 1950- *MarqDCG 84*
Parent Desbarres, Paule Marie Alice *DcWomA*
Parenti-Duclos, Irene 1754- *DcWomA*
Parentino, Bernardo 1437-1531 *McGDA*
Parentz, Ernest *NewYHSD*
Parenzuela, C M *AfroAA*
Paret Y Alcazar, Luis 1746-1799 *McGDA*
Parete, Eliodoro *FolkA 86*
Parette, Coelma *DcWomA*
Parezo, H *AmArch 70*
Parfait, Leonie Eugene Noel *DcWomA*
Parfenoff, Michael S 1926- *WhoAmA 78, -80, -82,*
 -84
Parfet, R T *AmArch 70*
Parfet, Robert 1952- *MarqDCG 84*
Parfitt, Albert E 1863-1926 *BiDAmAr*
Parfitt, Henry D d1888 *BiDAmAr*
Parfitt, M Kevin 1952- *MarqDCG 84*
Parge, Earl William 1926- *AmArch 70*
Pargeter, Philip *DcNiCA*
Pargeter, Philip 1826-1906 *IlDcG*
Pargh, Edith A 1953- *MarqDCG 84*
Parham, Alonzo *AfroAA*
Parham, Frederick Duncan 1893- *AmArch 70*

Parham, Hilton L, Jr. 1930- *AfroAA*
Parham, William, Jr. d1666 *FolkA 86*
Parigi, Alfonso 1606-1656 *MacEA*
Parigi, Giulio 1571-1635 *MacEA*
Paripovic, Nesa 1944- *DcCAr 81*
Paris, Miss *DcVicP 2*
Paris, A *AmArch 70*
Paris, Camille *ArtsNiC*
Paris, Delphina *FolkA 86*
Paris, Dorothy 1899- *WhoAmA 73, -76*
Paris, Erzsi Elisabeth 1887- *DcWomA*
Paris, Francois Edmond 1806-1893 *ArtsAmW 1*
Paris, Harold 1925- *McGDA, PhDcTCA 77*
Paris, Harold P 1925- *DcCAA 71, -77, OxTwCA*
Paris, Harold Persico 1925- *BnEnAmA,*
 WhoAmA 73, -76, -78
Paris, Harold Persico 1925-1979 *WhoAmA 80N,*
 -82N, -84N
Paris, Irving 1933- *AmArch 70*
Paris, James Keith 1939- *AmArch 70*
Paris, Jean De *McGDA*
Paris, Jeanne C *WhoAmA 73, -76, -78, -80, -82, -84*
Paris, Jehanne *DcWomA*
Paris, Kay 1930- *WhoAmA 82, -84*
Paris, Lucille M 1928- *WhoAmA 73, -76, -78, -80,*
 -82, -84
Paris, Matthew *McGDA*
Paris, Matthew 1200?-1259 *OxArt*
Paris, Pierre Adrien 1745-1819 *MacEA*
Paris, T C *DcVicP 2*
Paris, Walter *DcBrWA, DcVicP, -2*
Paris, Walter 1842-1906 *ArtsAmW 1, -3, IlBEAAW,*
 WhAmArt 85
Paris, William Francklyn *WhAmArt 85*
Paris-Persenet, Catherine Esther *DcWomA*
Parise, Charles John 1919- *AmArch 70*
Parisen, Mister *NewYHSD*
Parisen, J *NewYHSD*
Parisen, Otto 1723-1811 *NewYHSD*
Parisen, Philip d1822 *NewYHSD*
Parisen, William D 1800-1832 *NewYHSD*
Parish, Mrs. A Hutchinson *WhAmArt 85*
Parish, Annabelle Hutchinson *ArtsAmW 2,*
 DcWomA
Parish, Archie Gale 1898- *AmArch 70*
Parish, Benjamin *CabMA*
Parish, Betty Waldo 1910- *WhAmArt 85,*
 WhoAmA 73, -76, -78, -80, -82, -84
Parish, Charles Louis 1830?-1902 *IlBEAAW*
Parish, David Alexander 1941- *WhoArt 80*
Parish, Donald Gale 1928- *AmArch 70*
Parish, Hiram Maxwell 1924- *AmArch 70*
Parish, Jean E *WhoAmA 73, -76, -78, -80*
Parish, Norman *AfroAA*
Parish, Tom *PrintW 85*
Parish, W D *WhAmArt 85*
Parish, Wainwright 1867-1941 *BiDAmAr*
Parish-Watson, M d1941 *WhAmArt 85*
Parisi, Ico 1916- *ConArt 77, ConDes, DcCAr 81*
Parisien *NewYHSD*
Parizek, Jaro 1934- *WhoAmA 80, -82, -84*
Parizot, Lily 1876- *DcWomA*
Parjeaux *NewYHSD*
Park, A *NewYHSD*
Park, Alistair 1930- *WhoArt 80, -82, -84*
Park, Asa d1827 *NewYHSD*
Park, Barry M 1946- *MarqDCG 84*
Park, Carton Moore 1877-1956 *DcBrBI*
Park, Darragh *DcCAr 81*
Park, David 1911- *WhAmArt 85*
Park, David 1911-1960 *BnEnAmA, ConArt 77, -83,*
 DcAmArt, DcCAA 71, -77, McGDA,
 PhDcTCA 77
Park, Dirk E *DcCAr 81*
Park, Donald Gene 1927- *AmArch 70*
Park, Edward Chin 1918- *AmArch 70*
Park, Edwin Avery 1891- *WhAmArt 85*
Park, G H *DcVicP 2*
Park, Geoffrey M 1955- *MarqDCG 84*
Park, Gerald Allan 1932- *AmArch 70*
Park, Hazel A Hanes 1887- *ArtsAmW 1, DcWomA*
Park, Helen Graham *AmArch 70*
Park, Henry 1816-1871 *DcVicP 2*
Park, Holly *WorFshn*
Park, James *FolkA 86*
Park, James Chalmers 1858- *DcBrA 1, DcBrWA,*
 DcVicP 2
Park, John d1919 *DcBrA 1*
Park, John 1731?-1806? *FolkA 86*
Park, John 1761-1811 *FolkA 86*
Park, John Anthony 1880-1962 *DcBrA 1*
Park, Ki Suh 1932- *AmArch 70*
Park, L W *NewYHSD*
Park, Linton 1826- *NewYHSD*
Park, Linton 1826?-1906 *FolkA 86*
Park, Madeleine F 1891-1960 *WhAmArt 85,*
 WhoAmA 80N, -82N, -84N
Park, Madeleine Fish 1891-1960 *DcWomA*
Park, Malcolm S 1905- *WhAmArt 85*
Park, Margo *AfroAA*

Park, Marian E *ArtsEM*
Park, R *DcWomA*
Park, Richard Henry 1832- *WhAmArt 85*
Park, Richard Henry 1832-1890? *NewYHSD*
Park, S *NewYHSD*
Park, Stuart 1862-1933 *DcBrA 1, DcVicP, -2*
Park, Thomas *FolkA 86*
Park, Thomas 1745-1806 *FolkA 86*
Park, William *NewYHSD*
Park, William 1705-1788 *FolkA 86*
Park, William 1763-1795 *FolkA 86*
Park, William 1779?-1854? *FolkA 86*
Parke, Benjamin *DcBrECP*
Parke, Henry 1790?-1845 *DcSeaP*
Parke, Henry 1792?-1835 *BiDBrA, DcBrWA*
Parke, Jessie Burns 1889- *DcWomA, WhAmArt 85*
Parke, Joseph R *ArtsEM*
Parke, Lucinda N *DcWomA*
Parke, Mary *DcWomA, FolkA 86, NewYHSD*
Parke, Nathan G 1941- *MarqDCG 84*
Parke, Nathaniel Ross 1904- *WhAmArt 85*
Parke, R *DcVicP 2*
Parke, Sara Cornelia 1861-1937 *ArtsAmW 3*
Parke, Sarah Cornelia 1861-1937 *ArtsAmW 3*
Parke, Walter Simpson 1909- *WhoAmA 73, -76, -78, -80, -82, -84*
Parker, Mister 1822?- *NewYHSD*
Parker, A *NewYHSD*
Parker, A B *DcWomA*
Parker, A M *DcVicP 2*
Parker, Abraham *AfroAA*
Parker, Agnes Miller *WhoArt 80, -82*
Parker, Agnes Miller 1895- *DcBrA 1, DcWomA*
Parker, Al 1906- *WhoAmA 82*
Parker, Alba D *CabMA*
Parker, Alfred 1906- *IlrAm 1880, WhAmArt 85, WhoAmA 73, -76, -78, -80, -84*
Parker, Alfred Browning 1916- *AmArch 70*
Parker, Alfred Charles 1906- *IlrAm E*
Parker, Ann 1934- *ICPEnP A, MacBEP, WhoAmA 73, -76, -78, -80, -82, -84*
Parker, Anna B *WhAmArt 85*
Parker, Barry 1867-1941 *WhoArch*
Parker, Barry 1867-1947 *MacEA*
Parker, Benjamin Stiger 1899- *AmArch 70*
Parker, Bill 1924- *WhoAmA 73, -76, -78, -80, -82*
Parker, Brant 1920- *WorECom*
Parker, Burr 1915- *FolkA 86*
Parker, C M, Sr. *AmArch 70*
Parker, C R *NewYHSD*
Parker, C W And Son *ArtsEM*
Parker, C Y *AmArch 70*
Parker, Caroline Maude *ClaDrA*
Parker, Carolyn Johnson 1942- *WhoAmA 84*
Parker, Charles *EncASM*
Parker, Charles 1799-1881 *BiDBrA, MacEA*
Parker, Charles A *ArtsEM*
Parker, Charles E d1889 *BiDAmAr*
Parker, Charles H 1795?-1819 *NewYHSD*
Parker, Charles Pomeroy 1929- *AmArch 70*
Parker, Charles S 1870-1930 *WhAmArt 85*
Parker, Charles Stewart d1942 *WhAmArt 85*
Parker, Charles W *ArtsEM, FolkA 86*
Parker, Charlie *FolkA 86*
Parker, Chester A 1925- *AmArch 70*
Parker, Clarinda 1811?- *FolkA 86*
Parker, Clark *FolkA 86*
Parker, Constance-Anne 1921- *DcBrA 1, WhoArt 80, -82, -84*
Parker, Cora *ArtsAmW 2, DcWomA, WhAmArt 85*
Parker, Cushman 1881- *WhAmArt 85*
Parker, D *AmArch 70*
Parker, Dana 1891-1933 *WhAmArt 85*
Parker, Donald Burns *AmArch 70*
Parker, Edgar 1840- *ArtsNiC, NewYHSD*
Parker, Edgar 1925- *IlsCB 1957*
Parker, Edmund *EncASM*
Parker, Edythe Stoddard *DcWomA, WhAmArt 85*
Parker, Elizabeth 1916- *WhAmArt 85*
Parker, Elizabeth Rose *ClaDrA, DcBrA 1, DcWomA*
Parker, Ellen Grace *DcVicP, -2, DcWomA*
Parker, Ellis *FolkA 86*
Parker, Emma Alice *DcWomA*
Parker, Emma Alice 1876- *WhAmArt 85*
Parker, Ernest Lee *WhAmArt 85*
Parker, Ethel N *DcWomA*
Parker, F *DcVicP 2*
Parker, Frances *DcWomA*
Parker, Francis Fulton 1917- *AmArch 70*
Parker, Frank F *WhAmArt 85*
Parker, Frank R *ArtsEM*
Parker, Fred R 1938- *MacBEP*
Parker, Frederick *DcVicP, -2*
Parker, Frederick H A *DcBrA 1, DcVicP 2*
Parker, Frederick H A 1881-1904 *DcVicP*
Parker, G *CabMA*
Parker, George d1868 *NewYHSD*
Parker, George Waller d1957 *WhoAmA 80N, -82N, -84N*

Parker, George Waller 1888-1957 *WhAmArt 85*
Parker, Gladys *WhAmArt 85*
Parker, Gladys 1905?-1966 *WorECar*
Parker, Grace *FolkA 86*
Parker, Harold 1873-1962 *DcBrA 1, DcVicP 2*
Parker, Harold Wilson *WhoArt 84N*
Parker, Harold Wilson 1896- *DcBrA 1, WhoArt 80, -82*
Parker, Harry F *ArtsEM*
Parker, Harry Hanley 1869-1917 *WhAmArt 85*
Parker, Harry L 1952- *MarqDCG 84*
Parker, Harry S, III 1939- *WhoAmA 73, -76, -78, -80, -82, -84*
Parker, Helen Stockton *WhAmArt 85*
Parker, Henry H *DcVicP*
Parker, Henry H 1858-1930 *DcBrA 1, DcBrWA, DcVicP 2*
Parker, Henry Perlee 1795-1873 *DcVicP, -2*
Parker, Henry Perlee Smuggler 1795-1873 *DcBrWA*
Parker, Herbert 1908- *ClaDrA, WhoArt 80, -82, -84*
Parker, Howard Charles 1929- *AmArch 70*
Parker, Hugh G, Jr. 1934- *AmArch 70*
Parker, J B *DcVicP 2*
Parker, J C *DcVicP 2*
Parker, J Harleston 1873-1930 *BiDAmAr*
Parker, J Whiteman 1945- *PrintW 83, -85*
Parker, James 1933- *WhoAmA 73, -76, -78, -80, -82, -84*
Parker, James Adrian *AmArch 70*
Parker, James K *WhAmArt 85*
Parker, James K 1880?-1963 *IlBEAAW, WhAmArt 85*
Parker, James Varner 1925- *WhoAmA 73, -76, -78, -80, -82, -84*
Parker, Jamieson 1895-1939 *BiDAmAr*
Parker, Jamieson Kirkwood 1895-1939 *MacEA*
Parker, Jennie C H *DcWomA*
Parker, Jessie Cecilia 1891- *DcWomA*
Parker, Jessie D *DcWomA*
Parker, John *AntBDN Q, DcBrECP, FolkA 86*
Parker, John 1730?-1765? *DcBrECP*
Parker, John 1798-1860 *DcBrWA*
Parker, John 1839-1915 *ClaDrA, DcBrA 1, DcBrWA, DcVicP, -2*
Parker, John, Jr. *NewYHSD*
Parker, John A 1827- *ArtsNiC*
Parker, John Adams 1827- *WhAmArt 85*
Parker, John Adams, Jr. 1827?-1905? *NewYHSD*
Parker, John Clay 1907- *WhAmArt 85*
Parker, John E *EncASM, WhAmArt 85*
Parker, John F 1884- *WhAmArt 85*
Parker, John W 1862-1930 *WhAmArt 85*
Parker, John William 1922- *WhoAmA 76, -78, -80, -82*
Parker, Joseph *NewYHSD*
Parker, Julius G *ArtsEM*
Parker, Katharine Susanna Oster 1876- *DcWomA*
Parker, Kay Peterson 1901- *IlsCB 1946*
Parker, Kenneth Wayne 1939- *AmArch 70*
Parker, Kingsley *PrintW 85*
Parker, L S *AmArch 70*
Parker, Lawton S 1868- *ArtsEM*
Parker, Lawton S 1868-1954 *WhAmArt 85*
Parker, Leland Allen 1925- *AmArch 70*
Parker, Leroy *AfroAA*
Parker, Lester Shepard 1860-1925 *WhAmArt 85*
Parker, Life, Jr. *FolkA 86*
Parker, Life, Jr. 1822- *NewYHSD*
Parker, Lilian G 1880- *DcBrA 1*
Parker, Lilian G Wells 1880- *DcWomA*
Parker, Lillian M *WhAmArt 85*
Parker, Lloyd *FolkA 86*
Parker, Louise *DcVicP 2*
Parker, M S *NewYHSD*
Parker, Marcellus H 1831-1902 *BiDAmAr*
Parker, Margaret R *WhAmArt 85*
Parker, Marie A *DcWomA*
Parker, Mary *DcBrWA*
Parker, Mary Elizabeth 1881- *DcWomA, WhAmArt 85*
Parker, Matthew *NewYHSD*
Parker, Medad d1781 *CabMA*
Parker, Morris Buford 1924- *AmArch 70*
Parker, Nancy Winslow 1930- *IlsBYP, IlsCB 1967, WhoAmA 78, -80, -82, -84*
Parker, Nancy Wynne 1908- *WhAmArt 85*
Parker, Nathaniel 1802- *FolkA 86, NewYHSD*
Parker, Mrs. Neilson R *WhAmArt 85*
Parker, Nevillia *DcVicP 2*
Parker, Olivia 1941- *ConPhot, ICPEnP A, MacBEP, PrintW 83, -85, WhoAmA 80, -82, -84*
Parker, Paul 1905- *WhAmArt 85*
Parker, Phillips 1896-1935 *WhAmArt 85*
Parker, Phoebe *DcVicP 2*
Parker, R A *AmArch 70*
Parker, R H *DcVicP 2*
Parker, R O *AmArch 70*
Parker, Ray 1922- *WhoAmA 82, -84*
Parker, Raymond 1922- *BnEnAmA, DcCAA 71, -77, McGDA, OxTwCA, PhDcTCA 77, WhoAmA 73, -76, -78, -80*

Parker, Richard Henry 1881-1930 *ClaDrA, DcBrA 1*
Parker, Robert *DcBrWA*
Parker, Mrs. Robert Allerton 1898-1974 *WorFshn*
Parker, Robert Andrew *IlsBYP*
Parker, Robert Andrew 1927- *DcCAA 71, -77, IlrAm 1880, IlsCB 1967, WhoAmA 73, -76, -78, -80, -82, -84*
Parker, Robert Louis 1934- *AmArch 70*
Parker, Ron S *OfPGCP 86*
Parker, Ronald Lee 1937- *AmArch 70*
Parker, Roy Danford 1882- *WhoAmA 73, -76*
Parker, S *DcWomA, FolkA 86*
Parker, Sally *FolkA 86*
Parker, Samuel d1771 *CabMA*
Parker, Samuel Murray 1936- *WhoAmA 76, -78, -80, -82, -84*
Parker, Silas 1748?-1832 *CabMA*
Parker, Southey *CabMA*
Parker, Stephen Hills d1925 *WhAmArt 85*
Parker, Susanna *DcWomA*
Parker, Sybil C *DcVicP 2*
Parker, Sybil C 1860- *DcWomA*
Parker, T *DcVicP 2, DcWomA*
Parker, T H *AmArch 70*
Parker, Temperance *FolkA 86*
Parker, Thomas *ArtsEM, BiDBrA*
Parker, Thomas d1967 *WhoAmA 78N, -80N, -82N, -84N*
Parker, Thomas H 1801- *NewYHSD*
Parker, Thomas L 1927- *AmArch 70*
Parker, Thomas M *CabMA*
Parker, V *DcVicP 2*
Parker, Virginia 1897- *DcWomA, WhAmArt 85*
Parker, W *DcBrECP*
Parker, Mrs. W L *WhAmArt 85*
Parker, W M *AmArch 70*
Parker, W S *NewYHSD*
Parker, Walter F 1914- *WhoArt 80, -82, -84*
Parker, Warren *AfroAA*
Parker, Wentworth 1890- *WhAmArt 85*
Parker, Will 1944- *WhoAmA 80, -82, -84*
Parker, William *AntBDN H, BiDBrA, IlDcG*
Parker, William 1748-1842 *CabMA*
Parker, William David 1939- *MarqDCG 84*
Parker, William Gordon 1875- *ArtsAmW 2, WhAmArt 85*
Parker, William H *BiDAmAr*
Parker, Wilma Joan 1941- *WhoAmA 82, -84*
Parker, Zulma *DcWomA*
Parker And Casper *EncASM*
Parker And Unwin *MacEA*
Parkes, Alexander 1813-1890 *ICPEnP*
Parkes, C *DcWomA*
Parkes, David 1763-1833 *DcBrBI, DcBrWA*
Parkes, I *AmArch 70*
Parkes, James 1794-1828 *DcBrWA*
Parkes, John 1804-1832 *DcBrWA*
Parkes, S *DcVicP 2*
Parkes, W *NewYHSD*
Parkes, William Theodore d1908 *DcBrWA*
Parkes, William Theodore d1908? *DcVicP 2*
Parkhill, Mary *DcWomA*
Parkhouse, Stanley *WhAmArt 85*
Parkhurst, Anita 1892- *DcWomA, WhAmArt 85*
Parkhurst, Anna M *WhAmArt 85*
Parkhurst, Burleigh *WhAmArt 85*
Parkhurst, C E 1885- *WhAmArt 85*
Parkhurst, Charles 1913- *WhoAmA 73, -76, -78, -80, -82, -84*
Parkhurst, Daniel S *NewYHSD*
Parkhurst, Henry Landon 1867-1921 *WhAmArt 85*
Parkhurst, Howard Moor 1910- *AmArch 70*
Parkhurst, Thomas Shrewsbery 1853-1923 *WhAmArt 85*
Parkhurst, Thomas Shrewsbury 1853-1923 *ArtsAmW 2*
Parkin, John B 1911-1975 *ConArch*
Parkin, John Burnet 1911- *AmArch 70*
Parkin, John C 1922- *ConArch*
Parkin, Michael Robert 1931- *WhoArt 80, -82, -84*
Parkin, Richard *CabMA*
Parkin, Trevor *WhoArt 80, -82*
Parkins, Sir J *NewYHSD*
Parkins, Warren E 1907- *AmArch 70*
Parkinson, Miss *DcWomA*
Parkinson, A M *DcWomA*
Parkinson, Amelia *DcVicP 2, DcWomA*
Parkinson, Donald B *WhAmArt 85*
Parkinson, Donald B 1895-1945 *BiDAmAr*
Parkinson, Elizabeth Bliss 1907- *WhoAmA 73, -76, -78, -80, -82, -84*
Parkinson, Gerald 1926- *WhoArt 80, -82, -84*
Parkinson, Grace Wells *WhAmArt 85*
Parkinson, Helen B *WhAmArt 85*
Parkinson, Ida J *ArtsEM, DcWomA*
Parkinson, John *DcWomA*
Parkinson, John 1861-1935 *BiDAmAr*
Parkinson, John W *DcVicP 2*
Parkinson, Joseph T 1783-1855 *BiDBrA*
Parkinson, Leslie Ernest 1903- *DcBrA 1*
Parkinson, Norman 1913- *ConPhot, ICPEnP A*

Parkinson, Richard *NewYHSD*
Parkinson, Sydney 1745?-1771 *DcBrWA*
Parkinson, Thomas *BkIE*
Parkinson, Thomas 1744-1789? *DcBrECP*
Parkinson, William *DcBrBI*, *DcVicP 2*
Parkinson, William Edward 1871-1927 *DcBrA 1*,
 DcVicP 2
Parkinson, William H *DcVicP 2*
Parkinson, William Jensen 1899- *ArtsAmW 2*,
 IlBEAAW, *WhAmArt 85*
Parkisen *NewYHSD*
Parkman, Abigail Lloyd *FolkA 86*
Parkman, Alfred Edward 1852- *DcBrWA*, *DcVicP 2*
Parkman, Ernest 1856-1921 *DcVicP 2*
Parkman, Henry Spurrier 1814-1864 *DcVicP 2*
Parkman, Polly *WhAmArt 85*
Parkman, William 1685-1776 *CabMA*
Parks, Alonzo *NewYHSD*
Parks, Asa *NewYHSD*
Parks, B J *AmArch 70*
Parks, Billie *WhAmArt 85*
Parks, Carey James *MarqDCG 84*
Parks, Charles Cropper 1922- *WhoAmA 73*, *–76*, *–78*,
 –80, *–82*, *–84*
Parks, Christopher *AfroAA*
Parks, Christopher Cropper 1949- *WhoAmA 73*, *–76*,
 –78
Parks, Donald Bayliss 1912- *AmArch 70*
Parks, Eric Vernon 1948- *WhoAmA 73*, *–76*, *–78*
Parks, Eva Allen 1846-1932 *DcWomA*
Parks, Everett Ely 1901- *AmArch 70*
Parks, Frederick *NewYHSD*
Parks, G W *EncASM*
Parks, George W *EncASM*
Parks, Gordon 1912- *AfroAA*, *AmArt*, *ConPhot*,
 ICPEnP, *MacBEP*
Parks, J *FolkA 86*, *NewYHSD*
Parks, J W *ArtsEM*
Parks, James Dallas 1907- *AfroAA*, *WhoAmA 76*,
 –78, *–80*, *–82*, *–84*
Parks, James L 1932- *AmArch 70*
Parks, John 1952- *DcCAr 81*
Parks, Kate *DcBrA 1*
Parks, Louise Adele 1945- *AfroAA*
Parks, Lucille G 1924- *AfroAA*
Parks, Mrs. M E *ArtsEM*
Parks, R A *AmArch 70*
Parks, Ralph Henry 1906- *AmArch 70*
Parks, Richard *NewYHSD*
Parks, Robert Griffin 1924- *AmArch 70*
Parks, Robert Owen 1916- *WhAmArt 85*
Parks, Russell Dean 1934- *AmArch 70*
Parks, Samuel Augustus 1822-1877 *NewYHSD*
Parks, Samuel Dallas *AfroAA*
Parks, Walter John, III 1932- *AmArch 70*
Parks, Wendell Burton 1902- *AmArch 70*
Parks, William C *EncASM*
Parks, Winfield 1932-1977 *ICPEnP A*
Parkyn, John Herbert 1864- *DcBrA 1*, *DcVicP 2*
Parkyn, Maud *DcWomA*
Parkyn, William Samuel 1875-1949 *DcBrA 1*,
 DcVicP 2
Parkyns, George Isham 1749?-1820? *DcBrWA*,
 NewYHSD
Parkyns, Sir Thomas 1662-1741 *BiDBrA*
Parlaghy Brochfeld, Vilma Von 1863-1924? *DcWomA*
Parlby, James *DcBrWA*, *DcVicP 2*
Parlby, S *DcBrWA*
Parler, Heinrich *McGDA*
Parler, Heinrich 1300?- *MacEA*
Parler, Henrich *OxArt*
Parler, Janco 1383- *MacEA*
Parler, Johannes *McGDA*, *OxArt*
Parler, John d1406? *MacEA*
Parler, M L, Jr. *AmArch 70*
Parler, Michael *MacEA*
Parler, Nicolas d1397? *MacEA*
Parler, Peter *McGDA*
Parler, Peter 1330?-1399 *MacEA*, *McGDA*, *OxArt*
Parler, Wenceslaus 1360?-1404 *MacEA*
Parler, Wolfgangus *MacEA*
Parler Family *MacEA*, *OxArt*
Parli, R L *AmArch 70*
Parlin, Florence W *WhAmArt 85*
Parmater, John Quincy 1941- *MarqDCG 84*
Parmelee, Charles N 1805?- *NewYHSD*
Parmelee, Dean 1888- *AmArch 70*
Parmelee, Elmer Eugene 1839-1861 *NewYHSD*
Parmelee, Martin E 1852-1944? *BiDAmAr*
Parmelee, Mathilde 1909- *WhAmArt 85*
Parmelee, Olive Miriam Buchholz 1913- *WhAmArt 85*
Parmely, Irene E *DcWomA*
Parmenter, Helen Caroline 1873?-1915 *DcWomA*
Parmenter, N H *FolkA 86*
Parmentier, Amelie 1852- *DcWomA*
Parmentier, Celine *DcWomA*
Parmentier, Eugenie *DcWomA*
Parmentier, Fernand 1865-1915 *BiDAmAr*
Parmentier, Jacques 1658-1730 *DcBrECP*
Parmentier, Luisa Von *ArtsNiC*
Parmentier, Luise *DcWomA*

Parmentier, Maria Von 1844?-1879 *DcWomA*
Parmiggiani, Claudio 1943- *ConArt 77*, *–83*
Parmigianino 1503-1541 *McGDA*
Parmigianino, Francesco Mazzola 1503-1540 *OxArt*
Parmigiano, Fabrizio Andrea 1555-1600? *ClaDrA*
Parminter, G *DcVicP 2*
Parnall, Peter *IlsCB 1967*, *OfPGCP 86*
Parnall, Peter 1936- *IlsBYP*, *IlsCB 1957*,
 WhoAmA 78, *–80*, *–82*, *–84*
Parnell, Mrs. A *DcVicP 2*
Parnell, A M *DcVicP 2*
Parnell, Charles Octavius d1866? *MacEA*
Parnell, Edith *DcWomA*
Parnell, Eileen *WhAmArt 85*
Parnell, G *DcWomA*
Parnell, R *DcBrBI*
Parnell-Bailey, Eva *WhoArt 80*, *–82*, *–84*
Parniawski, Michael Anthony 1958- *MarqDCG 84*
Parnis, Mollie *WorFshn*
Parnis, Mollie 1905- *FairDF US*
Parnum, Edward J 1901- *WhAmArt 85*
Parnum, Edward Joseph 1901- *AmArch 70*
Parodi, Domenico 1668-1740 *McGDA*
Parodi, Filippo 1630-1702 *McGDA*
Parodi, Rene 1914- *DcCAr 81*
Parow, Emmy Dorothea *DcWomA*
Parr, A H *DcVicP 2*
Parr, Agnes R *DcWomA*
Parr, David *FolkA 86*
Parr, Elisha *FolkA 86*
Parr, Helen 1887-1970 *DcWomA*
Parr, Jack *FolkA 86*
Parr, James L *FolkA 86*
Parr, John *CabMA*
Parr, Margaret *FolkA 86*
Parr, Martin 1952- *ConPhot*, *ICPEnP A*, *MacBEP*
Parr, Mike 1945- *ConArt 83*
Parr, Russell C 1895- *WhAmArt 85*
Parr, Sam *DcVicP 2*
Parr, Walter W *AmArch 70*
Parr, William Gustavus 1911- *AmArch 70*
Parr, William Irving 1906- *AmArch 70*
Parra, Carmen 1944- *WhoAmA 84*
Parra, Luis Javier 1958- *MarqDCG 84*
Parra, Thomas 1937- *WhoAmA 76*, *–78*, *–80*, *–82*
Parran, Rosine *DcWomA*
Parratt, Marthe *DcWomA*
Parrette, Allen C 1908- *AmArch 70*
Parrhasios *McGDA*
Parrhasius *OxArt*
Parri Spinelli 1387-1453 *McGDA*
Parrino, George 1942- *WhoAmA 80*, *–82*, *–84*
Parris, Alexander 1780-1852 *BiDAmAr*, *BnEnAmA*,
 MacEA, *McGDA*
Parris, Edmund Thomas 1793-1873 *ClaDrA*, *DcBrBI*,
 DcBrWA, *DcVicP*, *–2*
Parris, Fred P 1906- *AmArch 70*
Parris, Mary Ann *DcVicP 2*, *DcWomA*
Parris, Nina Gumpert 1927- *WhoAmA 84*
Parrisen *NewYHSD*
Parrisen, J *NewYHSD*
Parrish, Anne *NewYHSD*
Parrish, Anne 1888-1957 *IlsBYP*, *IlsCB 1744*, *–1946*
Parrish, Anne L Willcox 1850?- *WhAmArt 85*
Parrish, Anne Lodge *ArtsAmW 1*, *DcWomA*
Parrish, Anne Lodge d1904? *ArtsAmW 3*
Parrish, Anne Lodge 1850?- *IlBEAAW*
Parrish, Charles Louis d1902 *ArtsAmW 1*
Parrish, Charles Louis 1830?-1902 *IlBEAAW*,
 NewYHSD, *WhAmArt 85*
Parrish, Clara 1861-1925 *DcWomA*
Parrish, Clara Weaver d1925 *WhAmArt 85*
Parrish, David Buchanan 1939- *WhoAmA 73*, *–76*,
 –78, *–80*, *–82*, *–84*
Parrish, Ernest Jackson 1934- *AmArch 70*
Parrish, F J *AmArch 70*
Parrish, Grace *WhAmArt 85*
Parrish, Jean 1911- *WhoAmA 82*, *–84*
Parrish, Jean 1920?- *IlBEAAW*
Parrish, John David 1919- *AmArch 70*
Parrish, Joseph 1905- *WorECar*
Parrish, K J *AmArch 70*
Parrish, Mary E *WhAmArt 85*
Parrish, Maxfield d1966 *WhoAmA 78N*, *–80N*, *–82N*,
 –84N
Parrish, Maxfield 1870-1966 *ArtsAmW 1*, *ConICB*,
 DcBrBI, *IlrAm B*, *–1880*, *IlsBYP*, *IlsCB 1744*,
 OfPGCP 86A, *WhAmArt 85*
Parrish, Maxfield Frederick 1870-1966 *BnEnAmA*,
 IlBEAAW, *McGDA*, *WorECar*
Parrish, Samuel Longstreth 1849-1932 *WhAmArt 85*
Parrish, Stephen 1846-1938 *WhAmArt 85*
Parrish, Thomas 1837- *ArtsAmW 1*
Parrish, Thomas 1837-1899 *IlBEAAW*,
 WhAmArt 85
Parrish, Thomas Clark 1837-1899 *ArtsAmW 3*
Parrish, Thomas Clarkson 1837-1899 *ArtsAmW 3*
Parrish, William E 1929- *AmArch 70*
Parrish, Williamina *WhAmArt 85*
Parrisien *NewYHSD*
Parrocel, Charles 1688-1752 *ClaDrA*, *McGDA*

Parrocel, Jeanne Francoise Pallas 1734-1829 *DcWomA*
Parrocel, Joseph 1646-1704 *ClaDrA*
Parrocel, Joseph-Francois, The Elder 1646-1704
 McGDA
Parrocel, Marie 1743?-1824 *DcWomA*
Parrocel, Therese 1745-1835 *DcWomA*
Parron, Rose De *DcWomA*
Parrot, Amandine De *DcWomA*
Parrot, Philippe *ArtsNiC*
Parrott, Charles Elliott 1936- *AmArch 70*
Parrott, David LeRoy 1917- *AmArch 70*
Parrott, Denis William 1931- *WhoArt 80*, *–82*, *–84*
Parrott, H *DcVicP 2*
Parrott, Pamela Gray 1952- *MarqDCG 84*
Parrott, Robert C 1934- *AmArch 70*
Parrott, Samuel 1797-1876 *DcBrWA*, *DcVicP 2*
Parrott, William 1813-1869 *DcBrWA*, *DcVicP*, *–2*
Parrott, William Samuel 1844-1915 *ArtsAmW 1*,
 IlBEAAW, *WhAmArt 85*
Parry, A *DcVicP 2*
Parry, C *DcVicP 2*
Parry, Carles James 1824-1894 *DcBrWA*
Parry, Caroline Keturah 1885- *ArtsAmW 3*
Parry, Charles James *DcBrWA*
Parry, Charles James 1824-1894 *DcVicP 2*
Parry, David Henry *DcBrWA*
Parry, David Henry 1793-1826 *DcBrWA*, *DcVicP 2*
Parry, E Gambier *DcVicP 2*
Parry, Eliza 1823- *FolkA 86*
Parry, Ellwood Comly, III 1941- *WhoAmA 78*, *–80*,
 –82, *–84*
Parry, F *AfroAA*
Parry, James 1805?-1871 *DcBrBI*, *DcBrWA*,
 DcVicP 2
Parry, John *DcVicP 2*
Parry, John 1812-1865? *DcBrBI*
Parry, K F *AmArch 70*
Parry, Leigh 1919- *WhoArt 84*
Parry, Linda 1943- *MacBEP*
Parry, Marian 1924- *PrintW 83*, *–85*, *WhoAmA 78*,
 –80, *–82*, *–84*
Parry, Pamela Jeffcott 1948- *WhoAmA 80*, *–82*, *–84*
Parry, Richard 1936- *WhoArt 80*, *–82*, *–84*
Parry, Roger 1905- *ICPEnP A*
Parry, Sheila Harwood 1924- *ClaDrA*, *WhoArt 80*,
 –82, *–84*
Parry, Thomas Gambier 1816-1888 *DcBrWA*,
 DcVicP 2
Parry, William 1742-1791 *DcBrECP*
Pars, Anne *DcBrECP*
Pars, Henry 1734-1806 *DcBrWA*
Pars, William 1742?-1782 *DcBrECP*, *DcBrWA*,
 McGDA
Parsell, Abraham 1792- *FolkA 86*, *NewYHSD*
Parsell, Florence 1892- *WhAmArt 85*
Parsell, John H *NewYHSD*
Parsell, Richard Leroy 1932- *AmArch 70*
Parshall, DeWitt 1864-1956 *ArtsAmW 1*, *IlBEAAW*,
 WhAmArt 85
Parshall, Dewitt 1864-1956 *WhoAmA 80N*, *–82N*,
 –84N
Parshall, Douglas Ewell *WhAmArt 85*
Parshall, Douglass Ewell 1899- *ArtsAmW 1*,
 IlBEAAW, *WhoAmA 73*, *–76*, *–78*, *–80*, *–82*
Parslow, Evalyn Ashley 1867- *ArtsAmW 2*,
 DcWomA
Parson, George *WhAmArt 85*
Parson, Lydia *DcWomA*, *WhAmArt 85*
Parsons *NewYHSD*
Parsons, Miss *DcVicP 2*
Parsons, A A *DcWomA*
Parsons, Mrs. A A *ArtsEM*
Parsons, A D *FolkA 86*
Parsons, Alfred 1830-1920 *WhAmArt 85*
Parsons, Alfred 1847-1920 *ClaDrA*, *DcBrBI*, *DcVicP*
Parsons, Alfred William 1847-1920 *DcBrA 1*,
 DcBrWA, *DcVicP 2*
Parsons, Antoinette DeForest *DcWomA*,
 WhAmArt 85
Parsons, Arthur Jeffrey 1856-1915 *WhAmArt 85*
Parsons, Arthur Wilde 1854-1931 *DcBrA 1*,
 DcBrWA, *DcVicP 2*
Parsons, Audrey Buller *WhAmArt 85*
Parsons, Barbara 1910- *WhAmArt 85*
Parsons, Beatrice *ClaDrA*
Parsons, Beatrice E *DcVicP*
Parsons, Beatrice E 1870-1955 *DcBrA 1*, *DcVicP 2*,
 DcWomA
Parsons, Betty Bierne *WhoAmA 73*, *–76*, *–78*, *–80*,
 –82
Parsons, Betty Bierne 1900-1982 *WhoAmA 84N*
Parsons, Charles 1821- *ArtsNiC*
Parsons, Charles 1821-1910 *ArtsAmW 1*, *EarABI*,
 EarABI SUP, *FolkA 86*, *NewYHSD*,
 WhAmArt 85
Parsons, Charles H 1821-1910 *IlBEAAW*
Parsons, Charles Herbert 1930- *AmArch 70*
Parsons, Charles Richard 1844-1920? *WhAmArt 85*
Parsons, Daniel *NewYHSD*
Parsons, David *NewYHSD*
Parsons, David Goode 1911- *WhAmArt 85*,

WhoAmA 78, −80, −82, −84
Parsons, E *DcVicP 2*
Parsons, E L *AmArch 70*
Parsons, Edith Baretta Stevens 1878-1956
WhAmArt 85
Parsons, Edith Barretto 1878-1956 *DcWomA,*
WhoAmA 80N, −82N, −84N
Parsons, Edmund *CabMA*
Parsons, Edward Roy *WhAmArt 85*
Parsons, Edward Shier 1907- *AmArch 70*
Parsons, Eli *FolkA 86*
Parsons, Ernestine d1967 *WhoAmA 78N, −80N,*
−82N, −84N
Parsons, Ernestine 1884-1967 *ArtsAmW 1, −3,*
DcWomA, IlBEAAW, WhAmArt 85
Parsons, Ethel M *WhAmArt 85*
Parsons, Evans J *ArtsEM*
Parsons, Francis d1804 *DcBrECP*
Parsons, Frank Alvah 1866-1930 *WhAmArt 85*
Parsons, Mrs. G *DcVicP 2*
Parsons, G M *AmArch 70*
Parsons, George F 1844- *ArtsAmW 2, WhAmArt 85*
Parsons, Gwendolene Frances Joy 1913- *ClaDrA*
Parsons, H *DcVicP 2*
Parsons, Herbert *DcVicP 2*
Parsons, Isabella Hunner 1903- *WhAmArt 85*
Parsons, J V R *DcVicP 2*
Parsons, J W 1859-1937 *DcBrA 1*
Parsons, James Herbert 1831-1905 *NewYHSD ,*
WhAmArt 85
Parsons, Jenme C *ArtsEM*
Parsons, John *AntBDN N, CabMA*
Parsons, John Fitch 1775- *CabMA*
Parsons, John R 1826?-1909 *DcVicP 2*
Parsons, John W 1859-1937 *DcVicP 2*
Parsons, Kitty *WhAmArt 85, WhoAmA 73, −76*
Parsons, Laura B *ArtsAmW 3*
Parsons, Laura Starr 1915- *WhAmArt 85*
Parsons, Lelia *ArtsEM, DcWomA*
Parsons, Letitia Margaret *DcVicP, −2, DcWomA*
Parsons, Lloyd Halman 1893-1968 *WhAmArt 85*
Parsons, Lloyd Holman d1968 *WhoAmA 78N, −80N,*
−82N, −84N
Parsons, Margaret H *DcWomA, WhAmArt 85*
Parsons, Marian Randall 1878-1953 *ArtsAmW 3*
Parsons, Mary Elizabeth 1859-1947 *DcWomA*
Parsons, Maud *DcWomA*
Parsons, Maude B *ArtsAmW 3, WhAmArt 85*
Parsons, Merribell Maddux *WhoAmA 78, −80, −82,*
−84
Parsons, Orin Sheldon 1866-1943 *ArtsAmW 1*
Parsons, Orrin Sheldon 1866-1943 *IlBEAAW,*
WhAmArt 85
Parsons, Phillip N *WhAmArt 85*
Parsons, Polly *FolkA 86*
Parsons, R D *AmArch 70*
Parsons, S F *DcWomA*
Parsons, T *DcBrECP*
Parsons, Theodosius *CabMA*
Parsons, Theophilus 1876- *WhAmArt 85*
Parsons, Virginia *IlsBYP*
Parsons, Walter Edward 1890- *WhAmArt 85*
Parsons, Wayman Francis 1903- *AmArch 70*
Parsons, William 1615-1702 *CabMA*
Parsons, William 1735-1795 *DcBrECP*
Parsons, William 1796-1857 *BiDBrA*
Parsons, William E 1872-1939 *BiDAmAr*
Parsons-Irwin, Maureen 1935- *WhoArt 80*
Partch, J F *AmArch 70*
Partch, Virgil Franklin, II 1916- *WhoAmA 73, −76,*
−78, −80, −82, −84, WorECar
Partch, Virgil Franklin, II 1916-1984 *ConGrA 1*
Partee, McCullough 1900- *WhAmArt 85*
Partenheimer, Jurgen *PrintW 85*
Partin, Robert 1927- *WhoAmA 73, −76, −78, −80, −82,*
−84
Parting, Florence *DcVicP 2*
Partington, Gertrude *DcWomA, WhAmArt 85*
Partington, J H E 1843- *DcVicP*
Partington, J H E 1843-1899 *ArtsAmW 1*
Partington, John H E 1843-1899 *DcBrWA, DcVicP 2*
Partington, Richard Langtry 1868-1919 *WhAmArt 85*
Partington, Richard Langtry 1868-1929 *ArtsAmW 2*
Parton, Arthur 1842- *ArtsNiC*
Parton, Arthur 1842-1914 *WhAmArt 85*
Parton, Ernest 1845- *ArtsNiC, WhAmArt 85*
Parton, Ernest 1845-1933 *DcBrA 1, DcVicP, −2*
Parton, Henry Woodbridge 1858-1933 *WhAmArt 85*
Parton, Hulda *DcWomA, WhAmArt 85*
Parton, Nike 1922- *WhoAmA 73, −76, −78, −80, −82,*
−84
Parton, Ralf 1932- *WhoAmA 78, −80, −82, −84*
Partos, Emeric Imre 1905-1975 *WorFshn*
Partridge, Ann St. John d1936 *DcBrA 1, DcWomA*
Partridge, Annie St. John d1936 *DcVicP 2*
Partridge, Bernard 1861-1945 *McGDA*
Partridge, Sir Bernard 1861- *ClaDrA*
Partridge, Sir Bernard 1861-1945 *AntBDN B,*
DcBrA 1,
WorECar
Partridge, Charlotte *DcWomA*

Partridge, Charlotte P *DcVicP 2*
Partridge, Charlotte Russell *WhAmArt 85*
Partridge, David 1919- *ConArt 77, −83*
Partridge, David Gerry 1919- *WhoAmA 76, −78, −80,*
−82, −84
Partridge, Dora *DcWomA*
Partridge, Ellen *DcVicP 2, DcWomA*
Partridge, Esther E 1875- *ArtsAmW 3*
Partridge, G *AmArch 70*
Partridge, G Roy 1888- *ArtsAmW 2*
Partridge, Imogene *WhAmArt 85*
Partridge, Imogene 1883-1976 *ArtsAmW 2*
Partridge, J *DcBrECP*
Partridge, Sir J Bernard 1861-1945 *DcBrBI*
Partridge, John 1790-1872 *DcBrWA, DcVicP, −2*
Partridge, John Arthur 1929- *WhoArt 80, −82, −84*
Partridge, Sir John Bernard 1861-1945 *DcBrWA,*
DcVicP 2
Partridge, Joseph *NewYHSD*
Partridge, Lawrence Scott 1928- *AmArch 70*
Partridge, Mary Elizabeth 1910- *WhAmArt 85*
Partridge, Nehemiah *NewYHSD*
Partridge, Philip Tallman 1906- *AmArch 70*
Partridge, Roi 1888- *ArtsAmW 1, −2, WhoAmA 76,*
−78, −80, −82, −84
Partridge, Roi 1888-1984 *GrAmP, WhAmArt 85*
Partridge, Rondal 1917- *ICPEnP A, MacBEP*
Partridge, Sara *ArtsEM, DcWomA*
Partridge, W H 1858- *WhAmArt 85*
Partridge, William K *ArtsEM*
Partridge, William Ordway 1861-1930 *BnEnAmA,*
WhAmArt 85
Partz, Feliz 1945- *WhoAmA 84*
Parys, Louise Van 1852-1910? *DcWomA*
Parys, Stephanie Van *DcWomA*
Parys-Driesten, Marie Fernande 1874- *DcWomA*
Pasanella, Giovanni 1931- *AmArch 70, ConArch*
Pasanen, Robert I 1924- *FolkA 86*
Pasavant, Frederick Joseph 1887-1919 *WhAmArt 85*
Pascal, Anne Marie 1898- *DcWomA*
Pascal, David *WhoAmA 73, −76, −78, −80, −82, −84*
Pascal, David 1918- *IlsCB 1957*
Pascal, Jean Louis 1837-1920 *MacEA, McGDA*
Pascal, Jeanne B 1891- *DcWomA*
Pascal, Leopold 1900- *DcBrA 2*
Pascal, Lucy *DcWomA*
Pascal, Marianne *DcWomA*
Pascal, Susanne 1914- *OxTwCA*
Pascali, Pino 1935-1968 *ConArt 77, −83, OxTwCA,*
PhDcTCA 77
Pascalis, Louise 1893- *DcWomA*
Pascau-Vignal, Camille M L *DcWomA*
Pasch, Ulrica Frederika 1735-1796 *DcWomA*
Paschal, Caraker Denham 1920- *AmArch 70*
Paschal, Frances *FolkA 86*
Paschal, Richard Lloyd 1931- *AmArch 70*
Paschall, Bill Holland 1926- *AmArch 70*
Paschall, Jo Anne 1949- *WhoAmA 80, −82, −84*
Paschke, Ed 1939- *ConArt 83, DcCAr 81,*
WhoAmA 76
Paschke, Edward 1939- *PrintW 83, −85*
Paschke, Edward F 1939- *AmArt, WhoAmA 78, −80,*
−82, −84
Paschoud, Lucile 1860- *DcWomA*
Paschoud, Marie 1859- *DcWomA*
Pascin, Hermine *DcWomA*
Pascin, Jules *WorECar*
Pascin, Jules 1885-1930 *OxTwCA, PhDcTCA 77,*
WhAmArt 85
Pascin, Julius 1885-1930 *McGDA*
Pascin, Julius Pinkas 1885-1930 *ClaDrA*
Pasco, Richard A *ArtsEM*
Pascoe, Ernest 1922- *DcBrA 1, WhoArt 80, −82, −84*
Pascoe, James *ArtsEM*
Pascoe, Jane 1955- *WhoArt 84*
Pascoe, Joseph *BiDBrA*
Pascoe, Richard A *ArtsEM*
Pascoe, William *DcVicP, −2, WhAmArt 85*
Pascoli, Luigia d1885? *DcWomA*
Pascoli Angeli, Marianna 1790-1846 *DcWomA*
Pascual, Manolo 1902- *WhoAmA 76, −78, −80, −82,*
−84
Pascual Abad Y Frances, Isabel 1836- *DcWomA*
Pascucci, M *AmArch 70*
Pascuccio D'Antonio, Donato Di *McGDA*
Pascullis, V R *AmArch 70*
Paseman, William Gerhard 1954- *MarqDCG 84*
Paseur, Charles Herbert 1925- *AmArch 70*
Pash, Florence *DcVicP 2, DcWomA*
Pash, George Harrison 1936- *AmArch 70*
Paschchenko, Mstislav 1901-1958 *WorECar*
Pashgian, Helen *DcCAr 81*
Pashley, Alfred F 1856-1932 *BiDAmAr*
Pashpatel, Leo *FolkA 86*
Pasilis, Felix 1922- *DcCAA 71, −77, WhoAmA 73,*
−76
Pasinelli, Lorenzo 1629-1700 *ClaDrA*
Pasini, Alberto *ArtsNiC*
Pasini, Alberto 1826-1899 *ClaDrA*
Pasinski, Irene 1923- *WhoAmA 80, −82, −84*
Pasiteles *McGDA, OxArt*

Pask, N E *AmArch 70*
Paskell, William Frederick d1951 *WhAmArt 85*
Pasker, Arthur Eugene 1933- *AmArch 70*
Paski, Bernard Francis 1913- *AmArch 70*
Pasley, Florence Sabine *DcWomA*
Pasley, M *DcVicP 2*
Pasley, Nancy A Sabine *DcVicP 2*
Pasman *FolkA 86*
Pasman, Frances *FolkA 86*
Pasmore, Mrs. *DcWomA*
Pasmore, Daniel, Jr. *DcVicP, −2*
Pasmore, Daniel, Sr. *DcVicP, −2*
Pasmore, Edwin John Victor 1908- *DcBrA 1,*
OxTwCA
Pasmore, Emily *DcVicP 2, DcWomA*
Pasmore, F G, Jr. *DcVicP 2*
Pasmore, John *DcVicP, −2*
Pasmore, John F *ClaDrA, DcVicP, −2*
Pasmore, Mrs. John F *DcVicP, −2*
Pasmore, Victor 1908- *ClaDrA, ConArt 77, −83,*
ConBrA 79[port], DcCAr 81, McGDA, OxArt,
PhDcTCA 77, PrintW 83, −85, WhoArt 80, −82,
−84, WorArt[port]
Pasmore, Wendy 1915- *DcBrA 1, WhoArt 80, −82,*
−84
Pasold, Ferman Joseph 1932- *AmArch 70*
Pasqualino Veneto *McGDA*
Pasquarosa, Marcelli 1896-1973 *DcWomA*
Pasque, Amelie *DcWomA*
Pasquelle, Frances M L *WhAmArt 85*
Pasquetti, Fortunato *McGDA*
Pasquier, C A *DcBrBI*
Pasquier, E J *DcBrWA*
Pasquier, Isabelle *DcWomA*
Pasquier, J Abbott *DcBrBI, DcBrWA*
Pasquier, James Abbott *DcVicP 2*
Pasquiou-Quivoron, Marie Antonine *DcWomA*
Pasquoil, Robert D 1881-1927 *DcBrA 1*
Pass, Derek Percy 1929- *WhoArt 80, −82, −84*
Pass, Donald James 1930- *WhoArt 82, −84*
Pass, James *FolkA 86*
Passacantando, Stelio 1927- *WorECar*
Passafaro, Henry Gregory 1922- *AmArch 70*
Passailaigue, Mary F *WhAmArt 85*
Passalacqua, David 1936- *IlrAm 1880*
Passall *DcBrECP*
Passamonti, Serafina *DcWomA*
Passanesi, Sebastian Joseph 1911- *AmArch 70*
Passante, Bartolommeo 1614-1656 *McGDA*
Passanti, Mario 1901-1975 *MacEA*
Passantino, George Christopher *WhoAmA 80, −82,*
−84
Passantino, Richard Joseph 1934- *AmArch 70*
Passarelli, R E *AmArch 70*
Passarotti, Bartolomeo 1529-1592 *ClaDrA, OxArt*
Passarotti, Bartolommeo 1529-1592 *McGDA*
Passavant, Johann David 1787-1861 *ClaDrA*
Passe, Crispin De 1564?-1637 *ClaDrA*
Passe, Crispin VanDe *OxArt*
Passe, Crispin VanDe d1637 *OxArt*
Passe, Crispin VanDe, The Elder 1565?-1637 *McGDA*
Passe, Magdalena VanDe *OxArt*
Passe, Magdalena VanDe 1600?-1638 *DcWomA*
Passe, Simon VanDe 1595?-1647 *OxArt*
Passe, Willem VanDe 1598?-1637? *OxArt*
Passerat-Laplace, Berthe *DcWomA*
Passeri, Giovanni Battista 1610?-1679 *McGDA,*
OxArt
Passeri, Giuseppe 1654-1714 *McGDA*
Passey, Charles Henry *DcVicP 2*
Passignano, Domenico 1560?-1636 *McGDA*
Passimore, Deborah G 1850- *DcWomA*
Passingham, Leila A *DcVicP 2*
Passini, Ludwig 1832- *ArtsNiC*
Passini, Rita 1883- *DcWomA*
Passmore, Deborah G 1850- *DcWomA*
Passmore, John Richard 1904- *McGDA*
Passmore, Thomas *FolkA 86*
Passmore, William H *ArtsEM*
Passo, Naia Avis 1955- *MarqDCG 84*
Passonneau, Joseph Russell 1921- *AmArch 70*
Passons, C L, Jr. *AmArch 70*
Passow, Cord *OxTwCA*
Passuntino, Peter 1936- *PrintW 83, −85*
Passuntino, Peter Zaccaria 1936- *DcCAr 81,*
WhoAmA 73, −76, −78, −80, −82, −84
Passy, Catherine 1833- *DcWomA*
Passy, Marc-Albert *AmGrD[port]*
Pasternacki, Vetold H 1897- *ArtsEM*
Pasternacki, Vetold Henry 1896- *WhAmArt 85*
Pasternak, A *MacEA*
Pasternak, Leonid 1862-1945 *OxArt, PhDcTCA 77*
Pasternak, Maurice 1946- *DcCAr 81*
Pasteur, Madame *DcWomA*
Pasteur, Marthe *DcWomA*
Pasti, Matteo DiAndrea De' 1410?-1468? *McGDA*
Pastor, James *FolkA 86*
Pastor, Nicholas Steve 1930- *AmArch 70*
Pastoret, Adelaide *DcWomA*
Pastura *McGDA*
Pasture, Rogelet DeLa *McGDA*

Pastureau, Madame DcWomA
Pastus, Matteo DiAndrea De' McGDA
Paszkovska, Weronika 1766?-1842 DcWomA
Pataky, Etelka Adele 1898- DcWomA
Pataky, Sara 1892- DcWomA
Pataky, Tibor WhAmArt 85
Patalano, Enrico DcVicP 2
Patalano, Frank Paul 1914- WhAmArt 85
Patanazzi, Alfonso McGDA
Patanazzi, Antonio McGDA
Patanazzi, Francesco McGDA
Patanazzi, Vincenzo McGDA
Patania, G F B NewYHSD
Pataud, Flore-Desiree DcWomA
Pataud, Henriette DcWomA
Patch, Harriet N DcWomA
Patch, John BiDBrA
Patch, Peggie WhoAmA 78, -80, -82, -84
Patch, Roger Whiting AmArch 70
Patch, Samuel, Jr. NewYHSD
Patch, Thomas 1725-1782 DcBrECP, OxArt
Patchett, Daniel Claude 1947- WhoAmA 76, -78, -80
Patchin, Calista Halsey DcWomA
Pate, C J AmArch 70
Pate, Felix Laure d1854 DcWomA
Pate, Lee 1952- WhoAmA 78, -80
Pate, Milton Eugene 1931- AmArch 70
Pate, Olin Hubert 1926- AmArch 70
Pate, P E AmArch 70
Pate, William NewYHSD
Pate-Desormes 1788- DcWomA
Patee, Francis ArtsEM
Patek, Joseph L WhAmArt 85
Patel, Atul Chimanlal 1943- MarqDCG 84
Patel, Bhupendra Ambalal 1949- MarqDCG 84
Patel, Pierre 1605?-1676 ClaDrA
Patel, Pierre, The Elder 1620?-1676 McGDA
Patel, Pierre, The Elder 1620?-1676? OxArt
Patel, Pierre-Antoine 1648-1708 OxArt
Patel, Pierre-Antoine, The Younger 1648-1707
 McGDA
Patella, Luca 1934- ConArt 77
Pateman, Kim WhoAmA 82, -84
Patenier, H OxArt
Patenier, Joachim OxArt
Pater, Jean Baptiste Joseph 1695-1736 ClaDrA
Pater, Jean-Baptiste-Joseph 1695-1736 McGDA,
 OxArt
Pater, Walter Horatio 1839-1894 OxArt
Paternosto, Cesar Pedro 1931- WhoAmA 73, -76, -78,
 -80, -82, -84
Paterson, Alexander Nisbet 1862-1947 DcBrA 1,
 DcBrWA, DcVicP 2
Paterson, Anthony R 1934- WhoAmA 76, -78, -80,
 -82, -84
Paterson, Caroline DcVicP 2, DcWomA
Paterson, David BiDBrA
Paterson, Diane 1946- IlsCB 1967
Paterson, Eglington Margaret DcVicP 2, DcWomA
Paterson, Emily Murray 1855-1934 DcBrA 1,
 DcBrWA, DcVicP 2, DcWomA
Paterson, Ethel M DcWomA
Paterson, Ethel Susan Graham DcWomA
Paterson, G W Lennox 1915- DcBrA 1, WhoArt 80,
 -82
Paterson, George d1789 BiDBrA
Paterson, George M DcVicP 2
Paterson, Grace WhAmArt 85
Paterson, Hamish C 1890-1955 DcBrA 2
Paterson, Helen DcWomA
Paterson, James d1838 BiDBrA
Paterson, James 1854-1932 DcBrA 1, DcBrWA,
 DcVicP, -2
Paterson, John d1832 BiDBrA
Paterson, Kathleen Nealey 1911- AmArch 70
Paterson, Maggie DcWomA
Paterson, Margaret WhAmArt 85
Paterson, Mary Viola 1899- DcBrA 1, DcWomA,
 WhoArt 80, -82
Paterson, Michael Hugh Orr 1927- WhoArt 80, -82,
 -84
Paterson, Norman Irving 1929- AmArch 70
Paterson, R W AmArch 70
Paterson, Robert 1790?-1846 BiDBrA
Paterson, Ronald FairDF ENG
Paterson, Samuel 1788?- BiDBrA
Paterson, Stirling DcVicP 2
Paterson, W DcVicP 2
Paterson, W Richard DcVicP 2
Paterson, Wallace A 1923- WhoArt 80
Paterson, Zama Vanessa Helder WhAmArt 85
Paterson Wallace, A 1923- WhoArt 82, -84
Pates, Daniel R AmArch 70
Patete, Carmen James 1907- AmArch 70
Patete, Eliodoro FolkA 86
Patey, Andrew d1834 BiDBrA
Patey, Ethel J DcVicP 2
Patience, John Thomas 1774?-1843 BiDBrA
Patience, Joseph 1739?-1797 BiDBrA
Patience, Joseph 1767?-1825 BiDBrA
Patigan, Haig 1876- WhAmArt 85

Patin, Charlotte Catherine 1660?- DcWomA
Patin, Fabian Arnold 1943- AmArch 70
Patin, Gabrielle Caroline 1666- DcWomA
Patina, Charlotte Catherine 1660?- DcWomA
Patina, Gabrielle Caroline 1666- DcWomA
Patinier, Joachim OxArt
Patinir, Joachim OxArt
Patinir, Joachim 1485-1524 McGDA
Patino, Vittoria DcWomA
Patiosville, Beatniks DcCAr 81
Patissou, Jacques 1880-1925 ClaDrA
Patit-Pain, Elisabeth DcWomA
Patki, Bhai Balkrishna Gopal 1925- WhoGrA 62
Patlen, Maurice Joseph 1902- AmArch 70
Patmore, Bertha G DcBrA 1, DcVicP, -2, DcWomA
Patney, Peter FolkA 86
Patnode, J Scott 1945- WhoAmA 76, -78, -80, -82,
 -84
Paton, A R NewYHSD
Paton, Amelia DcWomA
Paton, Bella DcWomA
Paton, David d1882 BiDBrA
Paton, David 1801-1882 MacEA
Paton, Frances Mary Richmond 1920- WhoArt 80,
 -82, -84
Paton, Frank 1856-1909 DcBrA 1, DcBrBI,
 DcBrWA, DcVicP, -2
Paton, Hugh 1853-1927 ClaDrA, DcBrA 1,
 DcVicP 2
Paton, J B DcWomA
Paton, Jacqueline DcWomA
Paton, Jane Elizabeth IlsCB 1967
Paton, Jane Elizabeth 1934- IlsBYP, IlsCB 1957
Paton, Sir Joseph Noel 1821-1901 ClaDrA, DcBrBI,
 DcBrWA, DcVicP, -2
Paton, Sir Noel 1821- ArtsNiC
Paton, Richard 1717-1791 DcBrECP, DcSeaP
Paton, Ronald Noel DcVicP 2
Paton, Waller H ArtsNiC
Paton, Waller Hugh 1828-1895 DcBrWA, DcVicP, -2
Paton, Walter Hugh 1828-1895 ClaDrA, DcBrBI
Paton, William Agnew 1848-1918 WhAmArt 85
Patou d1936 WorFshn
Patou, Jean 1887-1936 FairDF FRA
Patoun DcBrECP
Patri, Piero Nicole 1929- AmArch 70
Patric, Ruth McPherson 1897- DcWomA
Patrick, Saint 389?-461? McGDA
Patrick, A L AmArch 70
Patrick, Alan K 1942- WhoAmA 78, -80, -82, -84
Patrick, Charles William 1937- WhoAmA 80, -82,
 -84
Patrick, Darryl L 1936- WhoAmA 80, -82, -84
Patrick, Genie H 1938- WhoAmA 73, -76, -78
Patrick, Genie Hudson 1938- WhoAmA 80, -82, -84
Patrick, J McIntosh 1907- WhoArt 80, -82, -84
Patrick, J Rutherford DcVicP 2
Patrick, James H 1911-1944 WhAmArt 85
Patrick, James McIntosh 1907- DcBrA 1
Patrick, Jeremiah AntBDN F
Patrick, John Douglas 1863-1937 ArtsAmW 2,
 WhAmArt 85
Patrick, Joseph Alexander 1938- WhoAmA 73, -76,
 -78, -80, -82, -84
Patrick, Marion 1940- WhoArt 80, -82, -84
Patrick, Martha A DcWomA
Patrick, R A, Jr. AmArch 70
Patrick, Ransom R 1906-1971 WhoAmA 78N, -80N,
 -82N, -84N
Patrick, Vernon 1943- DcCAr 81
Patrick, William Arthur 1919- AmArch 70
Patricola, Philip WhAmArt 85
Patride, Marvin 1912- FolkA 86
Patridge, Charles S 1950- MarqDCG 84
Patrix, Michel 1917- ClaDrA
Patrizio, A J AmArch 70
Patrois, Isidore ArtsNiC
Patron, Therese Agnes DcWomA
Patry, Edward 1856-1940 ClaDrA, DcBrA 1,
 DcVicP, -2
Patry, Josephine Antoinette 1880?- DcWomA
Patte, Lucie DcWomA
Patte, Pierre 1723-1814 MacEA
Patteau, Mademoiselle d1874? DcWomA
Pattee, Elmer Ellsworth WhAmArt 85
Pattee, Elsie Dodge 1876- DcWomA, WhAmArt 85
Pattee, Francis ArtsEM
Pattee, Francis William 1928- AmArch 70
Pattee, Gertrude L DcWomA
Pattee, Rowena 1935- WhoAmA 76, -78, -80, -82,
 -84
Patteface, William CabMA
Patten, Miss DcWomA
Patten, Alfred Fowler 1829- ArtsNiC
Patten, Alfred Fowler 1829-1888 ClaDrA, DcVicP, -2
Patten, David John 1938- WhoAmA 78, -80, -82, -84
Patten, Edmund DcVicP 2
Patten, Frances M E WhAmArt 85
Patten, George 1801-1865 ClaDrA, DcBrWA,
 DcVicP, -2
Patten, George 1802-1865 ArtsNiC

Patten, Grace M DcWomA
Patten, Katharine 1866- ArtsAmW 3
Patten, L M AmArch 70
Patten, Leonard DcBrBI, DcVicP 2
Patten, Matthew CabMA
Patten, P C FolkA 86
Patten, Roger William 1932- AmArch 70
Patten, Sarah E WhAmArt 85
Patten, William DcBrBI
Patten, William 1865-1936 WhAmArt 85
Patten, William, Jr. d1843 DcVicP 2
Patten, Zebulon S NewYHSD
Patterson FolkA 86
Patterson, Ambrose 1877- WhAmArt 85
Patterson, Ambrose 1877-1967 ArtsAmW 2
Patterson, Angelica Schuyler 1864- WhAmArt 85
Patterson, Angelica Schuyler 1864-1952 DcWomA
Patterson, Anna Moore DcWomA, WhAmArt 85
Patterson, Bruce 1950- ICPEnP A, MacBEP
Patterson, C R 1878- WhAmArt 85
Patterson, Catherine DcWomA
Patterson, Catherine P DcVicP 2, DcWomA
Patterson, Charles Robert 1875-1958 WhoAmA 80N,
 -82N, -84N
Patterson, Charles Robert 1878-1958 DcSeaP
Patterson, Charles W 1870-1938 WhAmArt 85
Patterson, Clayton 1948- PrintW 85
Patterson, Clyde Alexander, Jr. 1923- AmArch 70
Patterson, Curtis Ray 1944- WhoAmA 78, -80, -82,
 -84
Patterson, David ArtsEM
Patterson, Edward P NewYHSD
Patterson, Frank Plunkett 1909- AmArch 70
Patterson, Freeman W 1937- MacBEP
Patterson, G DcVicP 2
Patterson, George Malcolm 1873- DcBrA 1
Patterson, George W Patrick WhoAmA 73, -76, -78,
 -80
Patterson, George Warren 1929- MarqDCG 84
Patterson, Gertrude Hough 1882- DcWomA,
 WhAmArt 85
Patterson, Girvan L 1945- MarqDCG 84
Patterson, Gordon ConArch A
Patterson, H DcVicP 2, NewYHSD
Patterson, H A, Jr. AmArch 70
Patterson, H M 1856-1928 BiDAmAr
Patterson, Henry Stuart 1874- WhAmArt 85
Patterson, Howard Ashman 1891- ArtsAmW 2,
 WhAmArt 85
Patterson, I M DcWomA
Patterson, J AmArch 70, FolkA 86
Patterson, J D AmArch 70
Patterson, J Malcolm DcBrBI
Patterson, James M 1935- AmArch 70
Patterson, James S 1832-1916 NewYHSD ,
 WhAmArt 85
Patterson, John Franklin 1950- MarqDCG 84
Patterson, John LaRue, Jr. 1941- AmArch 70
Patterson, Joseph NewYHSD
Patterson, Joseph Julian 1894- AmArch 70
Patterson, Lucile 1890- IlrAm 1880
Patterson, M A AmArch 70
Patterson, Margaret d1950 WhAmArt 85
Patterson, Margaret Jordan 1868?-1950 DcWomA
Patterson, Marion L 1909- WhAmArt 85
Patterson, Marion L 1933- MacBEP
Patterson, Martha ArtsAmW 2, DcWomA,
 WhAmArt 85
Patterson, Marvin Roberds 1905- AmArch 70
Patterson, Mary Ann Tanner FolkA 86
Patterson, Mary Frances 1872- WhAmArt 85
Patterson, Milford Haugh 1910- AmArch 70
Patterson, Minnie AfroAA
Patterson, Moles CabMA
Patterson, N H AmArch 70
Patterson, Nellie DcWomA, WhAmArt 85
Patterson, Norman William 1917- AmArch 70
Patterson, Patricia 1941- WhoAmA 78, -80, -82, -84
Patterson, Patty 1909- WhAmArt 85, WhoAmA 73
Patterson, Philip Carhart 1924- AmArch 70
Patterson, Rebecca Burd Peale DcWomA,
 WhAmArt 85
Patterson, Robert WhAmArt 85
Patterson, Robert 1895- WorECar
Patterson, Robert 1898- IlrAm D
Patterson, Robert 1898-1981 IlrAm 1880
Patterson, Robert Albert 1927- AmArch 70
Patterson, Roger L 1928- AmArch 70
Patterson, Russell 1894- WorECom
Patterson, Russell 1896- IlrAm C, WhAmArt 85
Patterson, Russell 1896-1977 IlrAm 1880
Patterson, Samuel 1765- DcBrECP
Patterson, Shirley 1923- WhoAmA 84
Patterson, Shirley Abbott 1923- WhoAmA 82
Patterson, Stirling DcVicP 2
Patterson, Thomas 1781?- FolkA 86
Patterson, Viola 1898- ArtsAmW 1, -3, DcWomA,
 WhAmArt 85
Patterson, William BiDBrA, CabMA
Patterson, William 1820?- NewYHSD
Patterson, William F 1915- AmArch 70

Patterson, William Joseph 1941- *PrintW 83, –85,* *WhoAmA 76, –78, –80, –82, –84*
Patterson, William Whitfield 1914- *WhAmArt 85*
Patterson Sisters *FolkA 86*
Patteson, R L *AmArch 70*
Patti, P *NewYHSD*
Patti, Tom *WhoAmA 80, –82, –84*
Pattillo, C E, III *AmArch 70*
Pattirson, Marylka H *DcWomA*
Pattison, A M Gould *WhAmArt 85*
Pattison, Abbott 1916- *DcCAA 71, –77,* *WhoAmA 73, –76, –78, –80, –82, –84*
Pattison, Anne R *DcVicP 2*
Pattison, Carl *DcVicP 2*
Pattison, Carrie A 1877- *DcWomA, WhAmArt 85*
Pattison, Charles T *DcVicP 2*
Pattison, Edgar L 1872- *DcBrA 1, DcVicP 2*
Pattison, Edward d1787 *FolkA 86*
Pattison, Edward, Jr. d1809 *FolkA 86*
Pattison, Helen *DcWomA*
Pattison, J *DcVicP 2*
Pattison, James William 1844-1915 *WhAmArt 85*
Pattison, Luther *FolkA 86*
Pattison, Robert J 1838-1903 *NewYHSD ,* *WhAmArt 85*
Pattison, Robert Maynicke 1923- *AmArch 70*
Pattison, Robert T *DcVicP 2*
Pattison, Samuel *FolkA 86*
Pattison, Shubael 1764-1828 *FolkA 86*
Pattison, Mrs. Sidney *WhAmArt 85*
Pattison, Thomas William 1894- *DcBrA 1*
Pattison, W R S *DcVicP 2*
Pattison, William *FolkA 86*
Patton, Alice Corson *WhAmArt 85*
Patton, Alice Vincent Corson d1915 *DcWomA*
Patton, Bessie E *ArtsEM, DcWomA*
Patton, C D *AmArch 70*
Patton, D L *AmArch 70*
Patton, D V *AmArch 70*
Patton, David *MarqDCG 84*
Patton, E C *AmArch 70*
Patton, J P *DcWomA*
Patton, Katharine *WhAmArt 85*
Patton, Katharine Maxey d1941 *DcWomA*
Patton, Katherine *AfroAA*
Patton, Katherine Maxey *WhAmArt 85*
Patton, Mrs. M C *WhAmArt 85*
Patton, Marion *WhAmArt 85*
Patton, Melissa F 1957- *MarqDCG 84*
Patton, Mort R 1919- *AmArch 70*
Patton, Normand S 1852-1915 *BiDAmAr*
Patton, Robert Bruce 1926- *AmArch 70*
Patton, Roy Edwin 1878- *WhAmArt 85*
Patton, Sharon F *AfroAA*
Patton, Sharon Frances *WhoAmA 84*
Patton, Sidney Emmons 1923- *AmArch 70*
Patton, Thomas Edward 1954- *MacBEP*
Patton, W E *AmArch 70*
Patton, Walker Lee 1930- *AmArch 70*
Patton, William 1824?- *NewYHSD*
Pattullo, Mary Frances *DcWomA*
Patty, R Bruce 1935- *AmArch 70*
Patty, William A 1889-1961 *WhoAmA 80N, –82N,* *–84N*
Patty, William Arthur 1884-1961 *ArtsAmW 3*
Patty, William Arthur 1889-1961 *WhAmArt 85*
Paty, James d1779 *BiDBrA*
Paty, Thomas 1712?-1789 *MacEA*
Paty, Thomas 1713?-1789 *BiDBrA*
Paty, William 1758-1800 *BiDBrA*
Patzer, William J 1936- *MarqDCG 84*
Patzig, Edna *DcWomA*
Patzke, Christian 1948- *DcCAr 81*
Patzki, Luise *DcWomA*
Patzschke, Lena *DcWomA*
Pau Gallet, Caroline *DcWomA*
Paudiss, Christoph 1618?-1666? *ClaDrA*
Pauditz, Christoph 1618?-1666? *ClaDrA*
Paufve, Reynold E 1894- *AmArch 70*
Paukulis, Visvaldis 1934- *AmArch 70*
Paul *WhAmArt 85*
Paul Frederic-W, Duke Of Wurttemberg 1797-1860 *NewYHSD*
Paul, Saint *McGDA*
Paul, A L *DcVicP 2*
Paul, A V *AmArch 70*
Paul, Andrew G *WhAmArt 85*
Paul, Art 1925- *ConDes*
Paul, Arthur 1925- *WhoAmA 80, –82, –84,* *WhoGrA 82[port]*
Paul, Bernard 1737-1820 *DcBrECP*
Paul, Bernard H 1907- *WhoAmA 73, –76, –78, –80*
Paul, Bernard Henry 1907- *WhAmArt 85*
Paul, Boris Dupont 1901- *WhoAmA 78N, –80N,* *–82N, –84N*
Paul, Brian Lauren 1939- *AmArch 70*
Paul, Bruno 1874- *WhoGrA 62*
Paul, Bruno 1874-1968 *MacEA, WorECar*
Paul, Charles R 1888-1945? *WhAmArt 85*
Paul, Clara *DcVicP 2*
Paul, Danielle *MarqDCG 84*

Paul, David J 1937- *AmArch 70*
Paul, Edward Milton, Jr. 1920- *AmArch 70*
Paul, Edwin H 1926- *AmArch 70*
Paul, Emily Letitia 1866-1917 *DcWomA*
Paul, Eugene 1830?- *NewYHSD*
Paul, Eugene R *MarqDCG 84*
Paul, Evelyn *DcBrBI*
Paul, Florence *DcVicP 2*
Paul, Fred 1875- *DcBrA 1*
Paul, Gabriel 1781-1845 *BiDAmAr*
Paul, Gen *WhAmArt 85*
Paul, Greg 1950- *WhoAmA 80, –82, –84*
Paul, J-B *DcVicP 2*
Paul, J G *DcVicP 2*
Paul, J W S *FolkA 86, NewYHSD*
Paul, James *IlsBYP*
Paul, James Richard 1920- *AmArch 70*
Paul, Jeremiah *FolkA 86*
Paul, Jeremiah, Jr. d1820 *NewYHSD*
Paul, Joanna *DcCAr 81*
Paul, John *FolkA 86, NewYHSD*
Paul, John, Jr. *FolkA 86*
Paul, Sir John Dean 1802-1868 *DcBrBI, DcBrWA,* *DcVicP 2*
Paul, John Francis 1947- *MarqDCG 84*
Paul, Joseph 1804-1887 *DcVicP 2*
Paul, Joseph Andrew 1941- *AmArch 70*
Paul, Judith 1777-1851 *FolkA 86*
Paul, Ken 1938- *WhoAmA 76, –78, –80, –82, –84*
Paul, Leonard 1953- *DcCAr 81*
Paul, Maclean *DcVicP 2*
Paul, P D *AmArch 70*
Paul, Paul 1865-1937 *DcBrA 1, DcVicP 2*
Paul, Peter *DcVicP 2*
Paul, Robert *DcVicP, –2*
Paul, Robert Boyd *DcVicP, –2*
Paul, Robert Stephen 1929- *AmArch 70*
Paul, Rowland d1850 *BiDBrA*
Paul, S S *AmArch 70*
Paul, Samuel *FolkA 86*
Paul, Samuel 1912- *AmArch 70*
Paul, Suzanne 1945- *WhoAmA 82, –84*
Paul, T L *AmArch 70*
Paul, W S *DcWomA*
Paul, Mrs. W S *ArtsEM*
Paul, William D, Jr. 1934- *WhoAmA 73, –76, –78,* *–80, –82, –84*
Paul, William H, Jr. 1880- *WhAmArt 85*
Paul-Baudry, Cecile *DcWomA*
Paula Filho, Wilson Padua 1946- *MarqDCG 84*
Paulding, John 1883-1935 *WhAmArt 85*
Paulding, Richard A *NewYHSD*
Paulding, Walter Coburn 1916- *AmArch 70*
Paulemile-Pissarro 1884- *ClaDrA*
Paules, G E *AmArch 70*
Paules, Granville Edward, III 1937- *MarqDCG 84*
Paulet *DcWomA*
Paulette *FairDF FRA*
Paulette, Madame *WorFshn*
Pauley, Floyd 1909-1935 *WhAmArt 85*
Pauley, Myron E 1915- *AmArch 70*
Pauli, Corinne *WhAmArt 85*
Pauli, Hanna 1864-1940 *DcWomA*
Pauli, W R *AmArch 70*
Paulic, Theresia 1887- *DcWomA*
Paulin, Clementine *DcWomA*
Paulin, Elise *WhAmArt 85*
Paulin, George Henry 1888-1962 *DcBrA 1*
Paulin, Richard Calkins 1928- *WhoAmA 73, –76, –78,* *–80, –82, –84*
Paulin, Richard John 1931- *AmArch 70*
Paulin, Telford *WhAmArt 85*
Paulin, Thomas *NewYHSD*
Pauling *NewYHSD*
Paulinier, Athenais *DcWomA*
Paull, Edith C *DcVicP 2, DcWomA*
Paull, Grace *WhAmArt 85*
Paull, Grace A 1898- *DcWomA, IlsCB 1744, –1946*
Paull, Michael L 1935- *MarqDCG 84*
Paull, Roland W *DcVicP 2*
Paulley, David Gordon 1931- *WhoAmA 76, –78*
Paulli, Augusta Dorothea Henriette C 1843- *DcWomA*
Paullin, Ethel M Parsons *WhAmArt 85*
Paullin, Telford 1885-1933 *WhAmArt 85*
Paulsen, Bent Arne 1926- *AmArch 70*
Paulsen, Brian Oliver 1941- *WhoAmA 76, –78, –80,* *–82, –84*
Paulsen, Donald Pascoe 1926- *AmArch 70*
Paulsen, Esther Erika 1896- *ArtsAmW 3*
Paulsen, Serenus Glen 1917- *AmArch 70*
Paulsen, Valdemar Hendrick 1904- *AmArch 70*
Paulson, Alan 1938- *WhoAmA 76, –78*
Paulson, Anna *DcVicP, –2*
Paulson, Anna Mansfield *DcWomA*
Paulson, C Robert 1923- *MarqDCG 84*
Paulson, F *AmArch 70*
Paulson, John 1852-1897 *BiDAmAr*
Paulson, Kermit Magnus 1914- *AmArch 70*
Paulson, Richard V *MarqDCG 84*
Paulucci, Enrico 1901- *PhDcTCA 77*
Paulus Silentiarus *McGDA*

Paulus, Christoph Daniel 1848- *ArtsAmW 2*
Paulus, Christopher Daniel 1848- *ArtsAmW 2,* *WhAmArt 85*
Paulus, Eugene H 1891- *AmArch 70*
Paulus, Francis Petrus 1862-1933 *ArtsEM,* *WhAmArt 85*
Paulus, Gertrude *DcWomA*
Paulus, J D, Jr. *AmArch 70*
Pauly, Charlotte E 1886- *DcWomA*
Pauly, Horatius 1644-1686? *ClaDrA*
Pauly, Samuel Johannes 1766- *OxDecA*
Paulze, Marie Anne *DcWomA*
Paungarten, Emmy 1874- *DcWomA*
Pauquet, A *AntBDN E*
Pauquette, Hippolyte Louis Emile 1797- *DcBrBI*
Paur, Tom R 1938- *MarqDCG 84*
Paus, Herbert 1880-1946 *IlrAm C, –1880,* *WhAmArt 85*
Pausanias *McGDA, OxArt*
Pausas, Francisco *WhAmArt 85*
Pausch, Eduard Ludwig Albert 1850- *WhAmArt 85*
Pausias *McGDA*
Pausias Of Sicyon *OxArt*
Pausinger, Fanny Von 1828- *DcWomA*
Pauthonnier-Selim, Honorine d1880 *DcWomA*
Pautrot, Ferdinand *AntBDN C*
Pauvert, Louise Marie Hortense 1870-1950 *DcWomA*
Pauw, Julie De d1863 *DcWomA*
Pauweis, William F 1830- *ArtsNiC*
Paval, Philip Kran 1890- *WhAmArt 85*
Paval, Philip Kran 1899- *ArtsAmW 2*
Pavelic, Julija 1920- *WhoGrA 62*
Paver, Dan *AmArch 70*
Pavey, Don *WhoArt 80, –82, –84*
Pavia, Anthony Michael 1907- *AmArch 70*
Pavia, Phillip 1912- *PhDcTCA 77*
Pavia, Raymond Francis 1931- *AmArch 70*
Pavic, Milan 1914- *MacBEP*
Pavicic, Mark Joseph 1952- *MarqDCG 84*
Pavid, Marie Louise 1817-1880? *DcWomA*
Paviere, Sydney Herbert 1891-1971 *DcBrA 1*
Pavillon, Charles d1772 *DcBrECP*
Paviot, Cecile *DcWomA*
Pavlidis, Theodosios 1934- *MarqDCG 84*
Pavlos, George Paul 1899- *AmArch 70*
Pavlovic, Nick 1941- *MarqDCG 84*
Pavlovich, Edward 1915- *WhAmArt 85*
Pavlovich, Paul Branibor 1932- *AmArch 70*
Pavon, Jose M *WhAmArt 85*
Pavone, Giorgio *WorFshn*
Pavy, Eugene *DcVicP 2*
Pavy, Philip *DcVicP 2*
Pawla, Frederick Alexander 1877- *WhAmArt 85*
Pawla, Frederick Alexander 1877-1964 *ArtsAmW 2*
Pawlan, Harold S 1915- *AmArch 70*
Pawle, F C *DcVicP 2*
Pawley, C H *AmArch 70*
Pawley, F A *AmArch 70*
Pawley, James *DcVicP 2*
Pawley, James, Sr. *NewYHSD*
Pawlik, Paul J 1946- *MarqDCG 84*
Pawlina, Michal 1956- *MarqDCG 84*
Pawling, Mrs. *DcWomA*
Pawlowski, Andrzej 1925- *ConDes*
Pawlowski, Edwin T 1930- *AmArch 70*
Pawlowsky, Anthony Patrick 1929- *AmArch 70*
Pawsey, Miss *DcWomA*
Paxon, Edgar Samuel 1852-1919 *WhAmArt 85*
Paxson, Edgar Samuel 1852-1919 *ArtsAmW 1,* *IIBEAAW*
Paxson, Ethel 1885- *DcWomA*
Paxson, Ethel 1885-1982 *WhAmArt 85*
Paxson, Martha K D 1875- *WhAmArt 85*
Paxson, Stella *ArtsAmW 3*
Paxton, Eliza *DcWomA, FolkA 86, NewYHSD*
Paxton, Elizabeth *DcWomA*
Paxton, Elizabeth Okie *WhAmArt 85*
Paxton, James Alfred 1934- *AmArch 70*
Paxton, John d1780 *BkIE, DcBrECP*
Paxton, Joseph 1803-1865 *DcD&D, EncMA,* *MacEA*
Paxton, Sir Joseph 1801-1865 *DcNiCA, WhoArch*
Paxton, Sir Joseph 1803-1865 *McGDA, OxArt*
Paxton, K G *AmArch 70*
Paxton, Lynne Adair 1936- *AmArch 70*
Paxton, Robert B M *DcBrBI*
Paxton, W A *WhAmArt 85*
Paxton, William A *ArtsAmW 3*
Paxton, William M 1869-1941 *DcAmArt,* *WhAmArt 85*
Payant, Felix 1891- *WhAmArt 85*
Paye, Eliza Anne *DcWomA*
Paye, Richard Morton d1821? *DcBrECP*
Paye And Baker *EncASM*
Payen, Cecile E *WhAmArt 85*
Payer, Ernst 1904- *AmArch 70*
Payette, Thomas Martin 1932- *AmArch 70*
Paymal-Amouroux, Blanche *DcWomA*
Payment, Richard C *ArtsEM*
Payn, Omer, Madame *DcWomA*
Payne, A C *FolkA 86*

Pearl, Sarah Wood *DcWomA*, *NewYHSD*
Pearl, William Inskeep 1921- *AmArch 70*
Pearlman, Charlotte Frank 1925- *WhoAmA 80, –82*
Pearlman, Etta S 1930- *WhoAmA 78, –80, –82, –84*
Pearlman, Etta S 1939- *WhoAmA 76*
Pearlman, George Gerson 1929- *AmArch 70*
Pearlman, Henry 1895- *WhoAmA 73*
Pearlman, Henry 1895-1974 *WhoAmA 76N, –78N, –80N, –82N, –84N*
Pearlman, Jerry K *MarqDCG 84*
Pearlman, Philip 1933- *AmArch 70*
Pearlstein, Philip 1924- *AmArt, BnEnAmA, ConArt 77, –83, DcAmArt, DcCAA 71, –77, DcCAr 81, OxTwCA, PhDcTCA 77, PrintW 83, –85, WhoAmA 73, –76, –78, –80, –82, –84, WorArt[port]*
Pearlstein, Seymour 1923- *WhoAmA 78, –80, –82, –84*
Pearlstine, Maynard *AmArch 70*
Pearman, Katharine K 1893-1961 *DcWomA, WhAmArt 85, WhoAmA 80N, –82N, –84N*
Pearman, Sara Jane 1940- *WhoAmA 78, –80, –82, –84*
Pearn, W *DcSeaP*
Pears, Augusta *DcVicP 2*
Pears, Charles 1873- *IlsCB 1744*
Pears, Charles 1873-1958 *ClaDrA, DcBrA 1, DcBrBI, DcSeaP, DcVicP 2*
Pears, James 1740?-1804 *BiDBrA*
Pears, Tanneke *FolkA 86*
Pearsall, Mrs. A B *WhAmArt 85*
Pearsall, Henry W *DcVicP, –2*
Pearse, Alfred d1933 *DcBrA 1, –2, DcVicP 2*
Pearse, Alfred 1854?-1933 *DcBrBI*
Pearse, F Mabelle *DcVicP 2*
Pearse, Frances Mabelle *DcWomA*
Pearse, Frederica Vincentia *DcWomA*
Pearse, Norah *DcBrA 1*
Pearse, Susan B *ConICB, DcBrBI*
Pearse, Susan Beatrice *IlsCB 1744*
Pearse, Susan Beatrice 1878- *DcWomA*
Pearsen, J *FolkA 86*
Pearson *DcVicP 2*
Pearson, Miss *DcWomA*
Pearson, A E, Jr. *AmArch 70*
Pearson, Albert R 1911- *WhAmArt 85*
Pearson, Alice Kent *DcWomA*
Pearson, Anton 1892- *ArtsAmW 2*
Pearson, Blanche A *DcVicP 2*
Pearson, C Robert 1949- *MarqDCG 84*
Pearson, Mrs. Charles *DcVicP 2*
Pearson, Charles Almond, Jr. 1914- *AmArch 70*
Pearson, Charles Lloyd 1931- *AmArch 70*
Pearson, Charles Theodore 1905- *AmArch 70*
Pearson, Chris 1950- *DcCAr 81*
Pearson, Clifton 1948- *WhoAmA 76, –78, –80, –82, –84*
Pearson, Clyde Collins 1904- *AmArch 70*
Pearson, Clyde Collins, Jr. 1938- *AmArch 70*
Pearson, Colin *DcCAr 81*
Pearson, Cornelius 1805-1891 *DcVicP, –2*
Pearson, Cornelius 1809-1891 *DcBrWA*
Pearson, D *AmArch 70*
Pearson, David John 1946- *MarqDCG 84*
Pearson, Edwin 1889- *ArtsAmW 1, WhAmArt 85*
Pearson, Eglington Margaret d1823 *DcWomA*
Pearson, Eglinton Margaret d1823 *DcBrWA*
Pearson, Eleanor Weare *DcWomA, WhAmArt 85*
Pearson, Eugene David 1929- *MarqDCG 84*
Pearson, Flora M *DcWomA*
Pearson, G H *AmArch 70*
Pearson, George T 1849-1920 *BiDAmAr*
Pearson, H G *DcBrA 2*
Pearson, H J S *DcVicP 2*
Pearson, Harry *NewYHSD*
Pearson, Harry John d1933 *DcBrA 1*
Pearson, Harry John 1872-1933 *DcVicP 2*
Pearson, Henry 1914- *ConArt 77*
Pearson, Henry C 1914- *WhoAmA 73, –76, –78, –80, –82, –84*
Pearson, Henry Charles 1914- *DcCAA 71, –77*
Pearson, Hugh A *FolkA 86*
Pearson, Isaac *AntBDN D*
Pearson, J *DcBrWA*
Pearson, J L 1817-1897 *MacEA*
Pearson, James *FolkA 86*
Pearson, James d1805 *DcBrWA*
Pearson, James E 1939- *WhoArt 80, –82, –84*
Pearson, James Eugene 1939- *WhoAmA 73, –76, –78, –80, –82, –84*
Pearson, Jane Mumford *DcWomA, WhAmArt 85*
Pearson, Jeremiah 1699-1768 *CabMA*
Pearson, John *DcVicP 2*
Pearson, John 1777-1813 *DcBrWA*
Pearson, John 1940- *ConArt 77, DcCAr 81, WhoAmA 73, –76, –78, –80, –82, –84*
Pearson, John Andrew 1867-1940 *MacEA*
Pearson, John Loughborough 1817-1897 *McGDA, WhoArch*
Pearson, John Loughborough 1817-1898 *OxArt*
Pearson, Joseph *NewYHSD*
Pearson, Joseph O d1917 *WhAmArt 85*

Pearson, Joseph T, Jr. d1951 *WhoAmA 78N, –80N, –82N, –84N*
Pearson, Joseph Thurman, Jr. 1876-1951 *WhAmArt 85*
Pearson, Juli *AfroAA*
Pearson, Kathleen Margaret 1898-1961 *DcBrA 1, DcWomA*
Pearson, L P *AmArch 70*
Pearson, Lawrence E 1900- *WhAmArt 85*
Pearson, Lionel 1879-1953 *MacEA*
Pearson, Louis O 1925- *WhoAmA 73, –76, –78, –80*
Pearson, Marguerite S 1898-1978 *WhAmArt 85*
Pearson, Marguerite Stuber *WhoAmA 73, –76, –78*
Pearson, Marguerite Stuber 1898-1978 *DcWomA*
Pearson, Mary A *DcWomA*
Pearson, Mary Martha 1799-1871 *DcWomA*
Pearson, Mathew *DcBrBI*
Pearson, Nils Anton 1892- *WhAmArt 85*
Pearson, Paul Martin 1939- *AmArch 70*
Pearson, Ralph M 1883-1958 *ArtsAmW 1, –2, WhAmArt 85, WhoAmA 80N, –82N, –84N*
Pearson, Richard *AntBDN N*
Pearson, Richard Cory 1929- *AmArch 70*
Pearson, Richard Wyman, Jr. 1929- *AmArch 70*
Pearson, Robert *DcVicP 2*
Pearson, Robert d1891 *NewYHSD*
Pearson, Robert Gene 1948- *MarqDCG 84*
Pearson, Ronald Hayes *DcCAr 81*
Pearson, W H *DcBrA 1, DcBrWA*
Pearson, Walter Buckley 1878- *DcBrA 1*
Pearson, William *AntBDN Q, DcBrBI, DcBrECP, DcBrWA, NewYHSD*
Pearson, William Marvin 1924- *AmArch 70*
Peart, Caroline *WhAmArt 85*
Peart, Caroline Brinton 1870-1963 *DcWomA*
Peart, D A *AmArch 70*
Peart, Henry, Jr. *DcBrECP*
Peart, Jerry Linn 1948- *AmArt, WhoAmA 76, –78, –80, –82, –84*
Pease, Alanzo *FolkA 86*
Pease, Alonzo *ArtsEM, NewYHSD*
Pease, Benjamin F 1822- *NewYHSD*
Pease, C W *NewYHSD*
Pease, Claude Edward 1874-1952 *DcVicP 2*
Pease, D M *AmArch 70*
Pease, David G 1932- *WhoAmA 73, –76, –78, –80, –82, –84*
Pease, E R E *DcVicP 2, DcWomA*
Pease, Fred I *WhAmArt 85*
Pease, H A *FolkA 86*
Pease, Harry E *NewYHSD*
Pease, Henry *NewYHSD*
Pease, James Norman, Jr. 1921- *AmArch 70*
Pease, John *FolkA 86*
Pease, John, Jr. 1654-1734 *CabMA*
Pease, Joseph Ives 1809-1883 *NewYHSD*
Pease, Lucius C 1869-1963 *ArtsAmW 1*
Pease, Lucius Curtis 1869-1963 *ArtsAmW 3, IlBEAAW, WorECar*
Pease, Lute 1869-1963 *WhAmArt 85*
Pease, Nell 1883- *WhAmArt 85*
Pease, Nell Christmas McMillan 1873-1958 *ArtsAmW 3*
Pease, Nell Christmas McMullin 1873-1958 *ArtsAmW 3*
Pease, Nell Christmas McMullin 1883- *IlBEAAW*
Pease, Nell Christmas McMullin 1883-1958 *DcWomA*
Pease, R G *AmArch 70*
Pease, Richard H 1813-1869 *NewYHSD*
Pease, Roland Folsom 1921- *WhoAmA 84*
Pease, Roland Folsom, Jr. 1921- *WhoAmA 73, –76, –78, –80, –82*
Peasley, A M *NewYHSD*
Peasley, Horatio N 1853- *WhAmArt 85*
Peaston, William *AntBDN Q*
Peat *NewYHSD*
Peat, Miss *NewYHSD*
Peat, M *DcWomA*
Peat, Thomas *DcBrECP*
Peate, Enid M M 1883- *DcBrA 1, DcWomA*
Peavler, Bill Eugene 1923- *AmArch 70*
Pebbles, Francis Marion 1839-1928 *ArtsAmW 1*
Pebbles, Frank Marion 1839-1928 *NewYHSD, WhAmArt 85*
Pebeahsy, Charles *FolkA 86*
Pebeashy, Charles *FolkA 86*
Pebeyre, Marie De *DcWomA*
Pecchenino, J Ronald 1932- *WhoAmA 84*
Pecchioli, Anna *DcWomA*
Peche, Dagobert 1887-1923 *DcNiCA*
Peche, Dale C 1928- *WhoAmA 73, –76, –78, –80, –82, –84*
Pechota, W *AmArch 70*
Pechstein, Max 1881-1955 *ConArt 77, –83, McGDA, OxArt, OxTwCA, PhDcTCA 77*
Pechy, Kynga *DcWomA*
Peck *FolkA 86*
Peck, Almyrah 1806-1861 *FolkA 86*
Peck, Anita Walbridge 1882- *WhAmArt 85*
Peck, Ann J 1792-1865 *FolkA 86*
Peck, Anna Gladys 1884- *DcWomA, WhAmArt 85*

Peck, Anne Merriman 1884- *ArtsAmW 3, DcWomA, IlsCB 1744, –1946, WhAmArt 85*
Peck, Asahel *FolkA 86*
Peck, Augustus 1906- *WhAmArt 85*
Peck, Benjamin 1749?-1838 *CabMA*
Peck, Charles *FolkA 86*
Peck, Charles 1827-1900 *ArtsAmW 3*
Peck, Christopher R 1953- *MarqDCG 84*
Peck, Clara Elsene *ConICB*
Peck, Clara Elsene 1883- *IlrAm B, –1880, WhAmArt 85*
Peck, Clara Elsene Williams 1883- *DcWomA*
Peck, D C *AmArch 70*
Peck, David *FolkA 86*
Peck, Don Owen 1938- *AmArch 70*
Peck, E W, Jr. *AmArch 70*
Peck, Edith Hogen 1884- *DcWomA, WhAmArt 85*
Peck, Edward d1970 *WhoAmA 78N, –80N, –82N, –84N*
Peck, Elisha *FolkA 86*
Peck, Esther *DcWomA, WhAmArt 85*
Peck, Gary Edward 1934- *AmArch 70*
Peck, George H 1817-1900 *BiDAmAr*
Peck, Glenna *WhAmArt 85*
Peck, Grace Brownell 1861-1931 *DcWomA, WhAmArt 85*
Peck, Graham 1914- *WhAmArt 85*
Peck, Helen M *ArtsEM, DcWomA*
Peck, Henry J 1880- *WhAmArt 85*
Peck, Henry Jarvis 1880- *IlBEAAW*
Peck, Henry Jarvis 1880-1964 *IlrAm 1880*
Peck, Jabez *FolkA 86*
Peck, James 1783-1812 *CabMA*
Peck, James Edward 1907- *WhAmArt 85, WhoAmA 73, –76, –78, –80, –82, –84*
Peck, James Ware 1925- *AmArch 70*
Peck, John *NewYHSD*
Peck, John D 1923- *AmArch 70*
Peck, Joseph A 1874- *WhAmArt 85*
Peck, Judith 1930- *WhoAmA 78, –80, –82, –84*
Peck, Julia *DcWomA*
Peck, Julia E *WhAmArt 85*
Peck, Lee Barnes 1942- *WhoAmA 76, –78, –80, –82, –84*
Peck, M L *DcWomA*
Peck, Natalie 1886- *DcWomA, WhAmArt 85*
Peck, Nathaniel *FolkA 86, NewYHSD*
Peck, Oliver *FolkA 86*
Peck, Orin 1860-1921 *IlBEAAW*
Peck, Orrin 1860-1921 *ArtsAmW 1, WhAmArt 85*
Peck, R H *AmArch 70*
Peck, Robert *DcVicP 2*
Peck, Russell Ralph 1909- *AmArch 70*
Peck, Sandra *AfroAA*
Peck, Seth *FolkA 86*
Peck, Sheldon *NewYHSD*
Peck, Sheldon 1797-1868 *AmFkP[port], FolkA 86*
Peck, Stephen Rogers 1912- *WhAmArt 85, WhoAmA 76, –78, –80, –82, –84*
Peck, Verna Johnston 1889- *DcWomA*
Peck, William Henry 1932- *WhoAmA 76, –78, –80, –82, –84*
Peckard, William *NewYHSD*
Pecker, Alec Maurice 1893- *DcBrA 1*
Peckham, A H, Jr. *AmArch 70*
Peckham, Deacon Robert 1785-1877 *FolkA 86*
Peckham, Isaac *CabMA*
Peckham, Kate *DcWomA*
Peckham, Lewis 1788-1822 *NewYHSD*
Peckham, Louis 1788-1822 *NewYHSD*
Peckham, Mary C 1861- *DcWomA, WhAmArt 85*
Peckham, Nicholas 1940- *WhoAmA 76, –78, –80, –82, –84*
Peckham, R F *DcVicP 2*
Peckham, Reuben *CabMA*
Peckham, Robert 1785-1877 *NewYHSD*
Peckham, Rose F *DcWomA*
Peckham, T *DcBrWA*
Peckham, William Davis, Jr. 1935- *AmArch 70*
Peckham, William F *NewYHSD*
Peckitt, T *DcVicP 2*
Peckolick, Alan 1940- *WhoGrA 82[port]*
Peckover, Richard *AntBDN D*
Peckwell, Henry W 1854- *WhAmArt 85*
Pecore, Albert Edison, Jr. 1925- *AmArch 70*
Pecori, Domenico 1480?-1527 *McGDA*
Pecorini, Margaret B 1879- *WhAmArt 85*
Pecorini, Countess Margaret Bucknell 1879- *DcWomA*
Pecqueur, Henriette *DcWomA*
Pecsok, John G 1930- *AmArch 70*
Pedder, Beatrice Stella 1875- *DcBrA 1, DcWomA*
Pedder, John 1850-1929 *ClaDrA, DcBrA 1, DcVicP, –2*
Peddie, Archibald 1917- *ClaDrA, DcBrA 1*
Peddie, James Dick *DcBrA 2*
Peddie, Jon G 1938- *MarqDCG 84*
Peddle, Caroline *DcWomA*
Peddle, Caroline C *WhAmArt 85*
Peddle, Eugene Francis 1925- *AmArch 70*
Peddle, Juliet Alice 1899- *AmArch 70*
Peden, Joseph *FolkA 86*

Pelly, Nicola 1948- *WorFshn*
Pelly, Rosalind *ClaDrA*
Pelouse, Leon Germain *ArtsNiC*
Pelouse, Leon Germain 1838-1891 *ClaDrA*
Pels, Albert 1910- *AmArt, WhAmArt 85, WhoAmA 73, -76, -78, -80, -82, -84*
Peltier, Olive *WhAmArt 85*
Peltier, Therese *DcWomA*
Pelton, Agnes 1881- *WhAmArt 85*
Pelton, Agnes 1881-1961 *ArtsAmW 1, -3, DcWomA*
Pelton, Emily *FolkA 86*
Pelton, Greg D 1961- *MarqDCG 84*
Pelton, Henry C 1868-1935 *BiDAmAr*
Pelton, Oliver 1798-1882 *NewYHSD*
Pelton, S K *DcWomA*
Pelton Brothers *EncASM*
Peluffo, Marta *OxTwCA*
Pelz, Paul J 1841-1918 *BiDAmAr*
Pelzer, Mildred *WhAmArt 85*
Pelzi, Robert d1931 *WhAmArt 85*
Pember, A *DcVicP 2*
Pember, Ada Humphrey 1859- *DcWomA, WhAmArt 85*
Pember, Winifred *DcVicP 2*
Pemberton, Anita LeRoy *DcWomA, WhAmArt 85*
Pemberton, Howard 1950- *DcCAr 81*
Pemberton, Ida Hrubesky 1890-1951 *DcWomA*
Pemberton, John P 1873-1914 *WhAmArt 85*
Pemberton, Muriel 1908- *DcCAr 81*
Pemberton, Muriel A 1909- *DcBrA 1*
Pemberton, Muriel Alice 1909- *ClaDrA, WhoArt 82, -84*
Pemberton, Samuel *AntBDN Q*
Pemberton, Sophia T *DcVicP 2*
Pemberton, Sophie 1869-1959 *DcWomA*
Pemberton, Mrs. Wykeham Leigh *DcVicP 2*
Pemberton And Mitchell *AntBDN N*
Pemberton-Longman, Joanne 1918- *DcBrA 1*
Pembroke, Earl Of 1689?-1750 *MacEA*
Pembroke, Earl Of 1693-1751 *WhoArch*
Pembrook, Theodore Kenyon 1865-1917 *WhAmArt 85*
Pemel, J *DcVicP, -2*
Pemell, J *DcBrWA, DcVicP, -2*
Pen, Rudolph 1918- *WhoAmA 73, -76, -78, -80, -82, -84*
Pen, Rudolph T 1918- *WhAmArt 85*
Pen-Symons, Mary Denise Nym 1923- *DcBrA 1*
Pena, Alberto 1900- *AfroAA*
Pena, Amado Maurilio, Jr. 1943- *AmArt, WhoAmA 76, -78, -80, -82, -84*
Pena, Tonita *WhoAmA 78N, -80N, -82N, -84N*
Pena, Tonita 1895-1949 *ArtsAmW 3, IlBEAAW, WhAmArt 85*
Pena, Tonita Vigil 1895-1949 *DcWomA*
Pena, William Merriweather 1919- *AmArch 70*
Pena Ganghegui, Luis 1926- *ConArch*
Penabert, F *NewYHSD*
Penalba 1918- *McGDA*
Penalba, Alicia 1913- *ConArt 77, -83, DcCAr 81*
Penalba, Alicia 1918- *OxTwCA, PhDcTCA 77*
Penalba, Rodrigo 1908- *DcCAr 81*
Penalva, Jordi *ConGrA 1*
Penavere, Eugenie 1790?-1842 *DcWomA*
Penavere, Henriette *DcWomA*
Pencak, John Joseph, IV *MarqDCG 84*
Pence, C E *AmArch 70*
Pence, John Gerald 1936- *WhoAmA 80, -82, -84*
Pence, Mark L 1926- *AmArch 70*
Pence, Nina Lorraine 1925- *AmArch 70*
Penchaud, Michel Robert 1772-1832 *MacEA*
Penck, A R 1939- *ConArt 77, -83, DcCAr 81, PrintW 83, -85*
Pencz, Georg 1500?-1550 *McGDA, OxArt*
Pencz, Georges *ClaDrA*
Penczner, Paul Joseph 1916- *WhoAmA 73, -76, -78, -80, -82, -84*
Pendergast *NewYHSD*
Pendergast, Molly Dennett 1908- *WhAmArt 85*
Pendergast, W W *FolkA 86*
Pendergraft, Craig Alan 1950- *MarqDCG 84*
Pendergraft, Norman Elveis 1934- *WhoAmA 78, -80, -82, -84*
Pendergrast, J *EarABI*
Pendergrast, M J *AmArch 70*
Pendle, Alexy 1943- *IlsCB 1967*
Pendleton, Andrew Lewis 1922- *AmArch 70*
Pendleton, Constance *WhAmArt 85*
Pendleton, John B 1798-1866 *NewYHSD*
Pendleton, Mary Caroline *WhoAmA 76, -78, -80, -82, -84*
Pendleton, W L Marcy 1865- *WhAmArt 85*
Pendleton, Warren F 1921- *AmArch 70*
Pendleton, William *NewYHSD*
Pendleton, William H *ArtsEM*
Pendleton, William S 1795-1879 *NewYHSD*
Pendley, C M, Jr. *AmArch 70*
Pendrell, William *WhAmArt 85*
Pene, Marie *DcWomA*
Pene DuBois, Guy 1884-1958 *DcAmArt*
Pene DuBois, William *IlsCB 1967*
Penecke-Buxbaum, Ida 1896- *DcWomA*

Penelon, Henri 1827-1885 *ArtsAmW 1, IlBEAAW, NewYHSD*
Penfield *FolkA 86, NewYHSD*
Penfield, Annie *ArtsEM, DcWomA*
Penfield, E E *AmArch 70*
Penfield, Edward 1866-1925 *BnEnAmA, IlBEAAW, IlrAm A, -1880, WhAmArt 85*
Penfield, Florence Bentz 1895- *DcWomA, WhAmArt 85*
Penfield, George W *WhAmArt 85*
Penfield, Josiah *EncASM*
Penfold, Catherine S *DcWomA*
Penfold, Frank C *DcVicP 2, WhAmArt 85*
Penfold, William *NewYHSD*
Pengeot, George J *WhAmArt 85*
Penguilly L'Haridon, Octave 1811-1870 *DcBrBI*
Penhall, H M d1913 *WhAmArt 85*
Penhallow, Benjamin H *NewYHSD*
Penic, Dujam *WhAmArt 85*
Penicaud, Jean, I *McGDA*
Penicaud, Jean, II *McGDA*
Penicaud, Jean, III *McGDA*
Penicaud, Leonard d1543? *McGDA*
Penicaud, Nardon d1543? *McGDA*
Penicaud, Pierre d1590? *McGDA*
Penicke, Clara 1818-1899 *DcWomA*
Penigaud, Germaine *DcWomA*
Peniston, John 1779?-1848 *BiDBrA*
Penkoff, Ronald Peter 1932- *WhoAmA 73, -76, -78, -80, -82, -84*
Penley, Aaron Edwin 1806-1870 *ArtsNiC*
Penley, Aaron Edwin 1807-1870 *DcBrWA, DcVicP, -2*
Penley, Claude *DcBrWA*
Penley, Edwin A *DcVicP, -2*
Penley, Edwin Aaron 1794- *DcBrWA*
Penley, Edwin Aaron 1807-1870 *ClaDrA*
Penley, William Henry Sawley 1794- *DcBrWA*
Penman, Edith d1929 *WhAmArt 85*
Penman, Edith 1860-1929 *DcWomA*
Penman, Serena 1949- *DcCAr 81*
Penmork *NewYHSD*
Penn, Audrey 1897- *DcBrA 2*
Penn, Irving 1917- *AmArt, BnEnAmA, ConPhot, ICPEnP, MacBEP, WhoAmA 76, -78, -80, -82, -84*
Penn, Mrs. Irving 1911- *WorFshn*
Penn, Jennie 1868- *DcWomA, WhAmArt 85*
Penn, Robert C 1925- *AmArch 70*
Penn, Stephen *DcBrWA*
Penn, Stuart Reavis 1928- *AmArch 70*
Penn, Thomas *FolkA 86*
Penn, William Charles 1877-1968 *DcBrA 1*
Penna, A Gerry 1932- *MarqDCG 84*
Pennacchi, Girolamo *McGDA*
Pennacchi, Pier Maria 1464-1515? *McGDA*
Penne, Charles Olivier De *ArtsNiC*
Penne, Charles Olivier De 1831-1897 *ClaDrA*
Pennel, Marmaduke *BiDBrA*
Pennell, Elizabeth Robins d1936 *WhAmArt 85*
Pennell, Eugene H *DcVicP 2*
Pennell, George *FolkA 86*
Pennell, Helen J *DcWomA*
Pennell, Joseph *AntBDN B*
Pennell, Joseph 1857-1926 *ArtsAmW 3, DcAmArt, GrAmP, McGDA*
Pennell, Joseph 1858-1926 *DcBrA 1*
Pennell, Joseph 1860-1926 *DcBrBI, IlrAm A, -1880, WhAmArt 85*
Pennell, Michael *FolkA 86*
Pennes, Jean 1894- *WorECar*
Pennes, Jean Jacques Charles 1894- *WhoGrA 62*
Pennethorne, James 1801-1871 *MacEA*
Pennethorne, Sir James 1801- *ArtsNiC*
Pennethorne, Sir James 1801-1871 *BiDBrA A, OxArt, WhoArch*
Penney, Bruce Barton 1929- *AmArt, WhoAmA 73, -76, -78, -80, -82, -84*
Penney, Charles Rand 1923- *WhoAmA 73, -76, -78, -80, -82, -84*
Penney, H E *AmArch 70*
Penney, Jacqueline 1930- *WhoAmA 84*
Penney, James 1910- *DcCAA 71, -77, WhAmArt 85, WhoAmA 73, -76, -78, -80, -82*
Penney, James 1910-1982 *WhoAmA 84N*
Penney, Mrs. James *WhAmArt 85*
Penney, L P *NewYHSD*
Penney, Richard James 1927- *AmArch 70*
Penney, Victor E 1909- *WhoArt 80, -82, -84*
Penni, Francesco 1488?-1528? *OxArt*
Penni, Giovan Francesco 1488?-1528? *McGDA*
Penni, Luca 1500-1556 *ClaDrA*
Penniall, Arthur *DcVicP 2*
Pennie, Michael 1936- *ConArt 77*
Penniman, E Louise *WhAmArt 85*
Penniman, H A F 1882- *WhAmArt 85*
Penniman, Helen Alison 1882- *DcWomA*
Penniman, John *FolkA 86*
Penniman, John 1817?-1850 *NewYHSD*
Penniman, John Ritto *FolkA 86*
Penniman, John Ritto 1783- *EarABI, NewYHSD*

Penniman, Leonora Naylor 1884- *ArtsAmW 1, DcWomA, WhAmArt 85*
Penning, David C 1931- *MarqDCG 84*
Penning, Nicolas Lodewijk 1764?-1818 *DcSeaP*
Penning, Tomas 1905- *WhAmArt 85*
Pennington, Annie D *DcWomA*
Pennington, Hall P 1889-1942 *BiDAmAr*
Pennington, Harper 1854- *DcBrBI, DcVicP 2*
Pennington, Harper 1855-1920 *WhAmArt 85*
Pennington, James *AntBDN M*
Pennington, John *CabMA*
Pennington, John 1773-1841 *DcBrECP*
Pennington, Josias d1929 *BiDAmAr*
Pennington, Mary Anne 1943- *WhoAmA 84*
Pennington, Ruth Esther 1905- *WhAmArt 85*
Pennington, S *DcVicP 2*
Pennington, S A, Jr. *AmArch 70*
Pennington, T Maurice 1923- *AfroAA*
Penniston, L E *AmArch 70*
Pennoyer, A Sheldon 1888- *ArtsAmW 1*
Pennoyer, A Sheldon 1888-1957 *WhoAmA 80N, -82N, -84N*
Pennoyer, Albert Sheldon 1888-1957 *WhAmArt 85*
Pennuto, James William 1936- *WhoAmA 78, -80, -82, -84*
Penny, Aubrey John Robert 1917- *WhoAmA 73, -76, -78, -80, -82, -84*
Penny, Carlton P 1896- *WhAmArt 85*
Penny, Charles H *NewYHSD*
Penny, Donald Charles 1935- *WhoAmA 82, -84*
Penny, Edward 1714-1791 *DcBrECP, NewYHSD*
Penny, G *DcVicP 2*
Penny, J S *DcBrECP*
Penny, Mary Frances *ArtsEM, DcWomA*
Penny, William Daniel 1834-1924 *DcVicP 2*
Pennypacker, James S 1951- *WhoAmA 84*
Penon, Adrienne *DcWomA*
Penow, Rjurik 1937- *ICPEnP A*
Penrice, John *BiDBrA*
Penrod, Mabel Allen 1889- *WhAmArt 85*
Penrod, Mable Allen 1889- *DcWomA*
Penrod, Viola D *WhAmArt 85*
Penrose, Francis Cranmer 1817-1903 *DcVicP 2*
Penrose, George *AntBDN H*
Penrose, Helen Stowe *WhAmArt 85*
Penrose, James Doyle 1862-1932 *DcBrA 1, DcVicP 2*
Penrose, Sir Roland 1900- *DcCAr 81*
Penrose, Sir Roland Algernon 1900- *DcBrA 1*
Penrose, Thomas 1743-1779 *DcBrWA*
Penrose, William *AntBDN H*
Penry, Neil 1934- *AmArch 70*
Pensaben, Fra Marco 1486-1531 *McGDA*
Pensak, Lois Bronstein 1950- *MarqDCG 84*
Penson, Frederick T *DcBrWA, DcVicP 2*
Penson, James 1814-1907 *DcBrWA, DcVicP 2*
Penson, R Kyrke 1815-1886 *DcVicP*
Penson, Richard Kyrke 1805-1886 *DcBrWA, DcVicP 2*
Penson, T M *DcVicP 2*
Penson, Thomas *BiDBrA*
Penson, Thomas d1824 *BiDBrA*
Pensotti, Celeste *DcWomA*
Penstone, Constance 1865-1928 *DcWomA*
Penstone, Edward *DcBrWA, DcVicP, -2*
Penstone, John Jewel *ClaDrA*
Penstone, John Jewell *DcVicP 2*
Pent, Rose Marie d1954 *DcWomA, WhAmArt 85*
Pentak, Stephen 1951- *WhoAmA 84*
Penteado, Fabio 1929- *ConArch*
Pentecost, A R, Jr. *AmArch 70*
Pentelovitch, Robert Alan 1955- *WhoAmA 82, -84*
Pentenrieder, Erhard 1830-1875 *ArtsAmW 1*
Pentland, J Howard *DcBrA 2*
Penton, David James 1952- *MarqDCG 84*
Pentreath, R T *DcVicP, -2*
Penttila, Timo 1931- *ConArch*
Pentz, Donald Robert 1940- *WhoAmA 84*
Pentz, E S *AmArch 70*
Penwork *NewYHSD*
Peny, Jeanne *DcWomA*
Penz, Arthur Carl, Jr. 1921- *AmArch 70*
Peoples, Augusta H 1896- *DcWomA, WhAmArt 85*
Peoples, James William 1942- *AmArch 70*
Pepe, Gerard 1945- *MarqDCG 84*
Pepe, Marie Sophie Huper 1922- *WhoAmA 80, -82, -84*
Peper, Meta A 1887- *DcWomA, WhAmArt 85*
Pepi, Franklin Marconi Vincent 1926- *AmArch 70*
Pepijn, Catherina *DcWomA*
Pepin, Arthur Lambert 1900- *AmArch 70*
Pepin, Clementine Antoinette *DcWomA*
Pepin, Edward L 1927- *AmArch 70*
Pepin, Paul S 1944- *MarqDCG 84*
Pepinsky, Bernard 1894- *AmArch 70*
Pepite *NewYHSD*
Peploe, Denis Frederic Neal 1914- *DcBrA 1*
Peploe, Denis Frederic Neil 1914- *WhoArt 80, -82, -84*
Peploe, Fitzgerald Cornwall 1861-1906 *WhAmArt 85*
Peploe, S J *OxTwCA*
Peploe, S J 1871-1935 *PhDcTCA 77*

Peploe, Samuel John 1871-1935 *ClaDrA, DcBrA 1, DcVicP 2*
Peppard, Lorena 1864-1939? *WhAmArt 85*
Peppard, Lorena 1864-1940? *DcWomA*
Peppe, Rodney 1934- *IlsCB 1967*
Pepper, Beverly 1924- *ConArt 77, -83, DcCAr 81, PrintW 85, WhoAmA 73, -76, -78, -80, -82, -84*
Pepper, Charles Hovey d1950 *WhoAmA 78N, -80N, -82N, -84N*
Pepper, Charles Hovey 1864-1950 *WhAmArt 85*
Pepper, Edward *NewYHSD*
Pepper, George W, Jr. 1895-1949 *BiDAmAr*
Pepper, Heyward Myers 1918- *AmArch 70*
Pepper, James Thomas *AmArch 70*
Pepper, Kathleen *DcWomA*
Pepper, Kathleen Daly *WhoAmA 82, -84*
Pepper, Mary *DcWomA, NewYHSD*
Pepper, Platt 1837-1907 *WhAmArt 85*
Pepper, Stephen Coburn 1891- *WhAmArt 85*
Pepper, William *BiDBrA*
Peppercorn, Alfred Douglas 1847-1924 *DcBrWA*
Peppercorn, Arthur Douglas 1847-1924 *DcBrA 1, DcVicP 2*
Peppercorn, Arthur Douglas 1847-1926 *ClaDrA, DcVicP*
Pepperrell, William *FolkA 86*
Peppi, Cenni Di *OxArt*
Peppler, Charles S 1960- *MarqDCG 84*
Peppmuller, Elise 1866- *DcWomA*
Peppmuller, Marie 1875- *DcWomA*
Pepyn, Catherina 1619-1688 *DcWomA*
Pepyn, Marten 1575?-1642 *ClaDrA*
Pepys, Elizabeth 1640-1669 *DcWomA*
Pepys, Rhoda Gertrude 1914- *WhoArt 80, -82, -84*
Pepys, Sandra Lynn 1942- *WhoArt 80, -82, -84*
Pequin, Charles 1879- *McGDA*
Pequin, Charles Etienne 1879- *ClaDrA*
Pera, Isabella 1945- *WhoAmA 80, -82, -84*
Peragallo, C Colombe *DcWomA*
Perahim, Jules 1914- *WhoGrA 62*
Peral, Jeanne *WorFshn*
Peralli *NewYHSD*
Peralta, Juana De *DcWomA*
Peralta, Richard Carl 1949- *MarqDCG 84*
Perantoni, J F *AmArch 70*
Perard, Victor S 1867-1957 *WhoAmA 80N, -82N, -84N*
Perard, Victor Seman 1870-1957 *WhAmArt 85*
Perard, Victor Semon 1870- *IlsCB 1744*
Perata, Albert A 1923- *AmArch 70*
Peratee, Sebastian *NewYHSD*
Perates, J W 1895-1970 *FolkA 86*
Perazzo, F J *AmArch 70*
Perbandt, Lina Von 1836- *DcWomA*
Percel, Madame De *DcWomA, NewYHSD*
Percel, E *FolkA 86*
Percell, John *NewYHSD*
Percellis *OxArt*
Perceval, Don 1908- *IlsBYP, IlsCB 1946*
Perceval, Don Louis 1908- *IIBEAAW*
Perceval, John 1923- *OxTwCA*
Perch, John Dennis *WhAmArt 85*
Percheron, Marie Antoinette Pauline *DcWomA*
Percier, Charles 1764-1838 *DcD&D, DcNiCA, MacEA, McGDA, OxArt, OxDecA, WhoArch*
Percier & Fontaine *DcNiCA*
Percier And Fontaine *MacEA*
Percival, Bessie *DcVicP 2, DcWomA*
Percival, Charles 1756-1840 *DcBrECP*
Percival, D C *EncASM*
Percival, Edwin 1793- *NewYHSD*
Percival, H *DcBrWA, DcVicP 2*
Percival, Harold Stanley 1868-1914 *DcBrA 2*
Percival, Henry 1810?- *NewYHSD*
Percival, Olive *ArtsAmW 3, DcWomA, WhAmArt 85*
Percival, Sir Thomas *IIDcG*
Percival, William *BiDBrA*
Percy, Lady Agnes d1856 *DcBrWA*
Percy, Amy Dora *DcVicP 2, DcWomA*
Percy, Ann Buchanan 1940- *WhoAmA 84*
Percy, E *DcWomA*
Percy, Edward Thomas *BiDBrA*
Percy, Lady Elizabeth Susan d1847 *DcBrWA*
Percy, Emily *DcBrWA, DcVicP 2*
Percy, F A *EarABI SUP*
Percy, George W 1847-1900 *BiDAmAr*
Percy, George Washington 1847-1900 *MacEA*
Percy, H L, Jr. *AmArch 70*
Percy, Herbert S *DcVicP 2*
Percy, Isabel Clark 1882-1976 *ArtsAmW 3*
Percy, Isabelle Clark *WhAmArt 85*
Percy, Isabelle Clark 1882- *ArtsAmW 1*
Percy, Isabelle Clark 1882-1976 *ArtsAmW 3, DcWomA*
Percy, J *BiDBrA*
Percy, J C *DcVicP 2*
Percy, Lilian Snow *DcVicP 2*
Percy, Sidney Richard 1821-1886 *DcVicP, -2*
Percy, Sydney Richard 1821?-1886 *ClaDrA*
Percy, William 1820-1903 *DcVicP, -2*

Perczel, Margit 1883- *DcWomA*
Perdew, Charles H 1874-1963 *FolkA 86*
Perdreau, Pauline *DcWomA*
Perdriat, Helene Marie Marguerite 1894- *DcWomA*
Perdriollat, Ninette *DcWomA*
Perdrion, Aline *DcWomA*
Perdue, W K 1884- *WhAmArt 85*
Pere Joan DeVallfogona d1445 *McGDA*
Pere, Henry William, Jr. 1928- *AmArch 70*
Pereda, Antonio *ClaDrA*
Pereda, Antonio De 1599-1669 *ClaDrA*
Pereda, Antonio De 1608?-1678 *OxArt*
Pereda, Eugene F 1909- *MarqDCG 84*
Pereda, Raimondo *ArtsNiC*
Pereda Y Salgado, Antonio 1608-1678 *McGDA*
Peregoy, Charles E *NewYHSD*
Perehudoff, Dorothy Elsie *WhoAmA 82*
Perehudoff, William W 1919- *WhoAmA 76, -78, -80, -82, -84*
Pereira, Arthur Lee 1931- *AmArch 70*
Pereira, Ferdinand *DcVicP 2*
Pereira, H *AmArch 70*
Pereira, I Rice 1901-1971 *DcCAA 71, -77, OxTwCA, WhoAmA 78N, -80N, -82N, -84N*
Pereira, I Rice 1907-1971 *DcAmArt, PhDcTCA 77, WorArt*
Pereira, Irene Rice 1907- *McGDA*
Pereira, Irene Rice 1907-1971 *BnEnAmA, ConArt 77, WhAmArt 85*
Pereira, John M *ArtsEM*
Pereira, Manuel d1683 *OxArt*
Pereira, Rice 1907-1971 *WomArt*
Pereira, William L 1909- *AmArch 70, ConArch*
Perelle, Adam 1640-1695 *OxArt*
Perelle, Gabriel 1603?-1677 *ClaDrA, OxArt*
Perelli, Achille 1822-1891 *NewYHSD*
Perelli, Cesar *NewYHSD*
Perelli, Lida *DcWomA*
Perelman, Carl 1924- *AmArch 70*
Perelman, Luis 1942- *DcCAr 81*
Perelman, Sidney Joseph 1904-1979 *WorECar*
Pereny, Andrew 1908- *WhAmArt 85*
Pereny, Madeleine S 1896- *DcWomA*
Pereny, Madeline S 1896- *WhAmArt 85*
Perera, Gino Lorenzo 1872- *WhAmArt 85*
Peress, Gilles 1946- *ConPhot*
Peressutti, Enrico 1908-1973 *ConArch*
Peresutti, Enrico 1908- *WhoArch*
Peret, Marcelle 1898- *WhAmArt 85*
Peretti, Achille d1923 *WhAmArt 85*
Peretti, Elsa 1940- *WorFshn*
Peretz-Brutzkus, Walli 1884- *DcWomA*
Pereyra, Manuel 1588-1683 *McGDA*
Perez, A, Jr. *AmArch 70*
Perez, August, III 1933- *AmArch 70*
Perez, Daniel Torres *ConGrA 1*
Perez, Jess Fuentes 1936- *AmArch 70*
Perez, Mike *FolkA 86*
Perez, Nissan 1946- *MacBEP*
Perez, Pedro *McGDA*
Perez, Sara 1902- *AmArch 70*
Perez, Vincent 1938- *AmArt, WhoAmA 76, -78, -80, -82, -84*
Perez Caballero, Angela *DcWomA*
Perez DeAlesio, Matteo 1547?-1600? *McGDA*
Perez-Marchand, Rafael A 1923- *AmArch 70*
Perez Palacios, Augusto 1909- *MacEA*
Perez Villalta, Guillermo 1948- *DcCAr 81*
Pereznieto, Castro Fernando 1938- *WhoAmA 82, -84*
Pereznieto, Fernando 1938- *DcCAr 81*
Perfetti, Elena 1828- *DcWomA*
Perfido, L P *AmArch 70*
Perfilieff, Vladimir 1895- *WhAmArt 85*
Pergault, Dominique 1729-1808 *ClaDrA*
Pergaut, Dominique 1729-1808 *ClaDrA*
Perhacs, Les 1940- *DcCAr 81*
Perham, Roy Gates 1916- *WhoAmA 73, -76, -78, -80, -82, -84*
Peri, Laszlo 1889- *OxTwCA*
Perich Escala, Jaime 1941- *WorECar*
Pericles *WorECar*
Pericoli, Niccolo *McGDA*
Pericoli, Tullio 1936- *WhoGrA 82[port], WorECar*
Perigal, Arthur d1884 *ArtsNiC*
Perigal, Arthur 1816-1884 *ClaDrA, DcBrWA, DcVicP*
Perigal, Arthur, Jr. 1816-1884 *DcVicP 2*
Perigaux, Madame *DcWomA*
Perignon, Alexis 1806-1882 *ArtsNiC*
Perignon, Caroline Louise Emma *DcWomA*
Perignon, Marie Eve Alexandrine *DcWomA*
Perilli, Achille 1927- *ConArt 77, -83, DcCAr 81, OxTwCA, PhDcTCA 77*
Perillo, Gregory *IIBEAAW, OfPGCP 86*
Perin, Bradford *WhAmArt 85*
Perine, Eva *WhAmArt 85*
Perine, Eva G 1854?-1938 *DcWomA*
Perine, George Edward 1837-1885 *NewYHSD*
Perine, Robert Heath 1922- *WhoAmA 76, -78, -80, -82, -84*
Perine, T B *NewYHSD*

Pering, Cornelius *FolkA 86*
Pering, Cornelius 1806-1881 *NewYHSD*
Perini, Maria-Grazia 1943- *WorECar A*
Perini, Maxine Walker 1911- *WhAmArt 85*
Perino DelVaga *McGDA*
Perinor, Mister *NewYHSD*
Perisse *DcCAr 81*
Perken, Stella Louise *DcWomA*
Perkes, Muriel Kathleen 1898- *DcBrA 1, DcWomA*
Perkin, Isabelle L *DcVicP 2*
Perkins, Miss *DcWomA, NewYHSD*
Perkins, A Alan 1915- *WhoAmA 78, -80, -82, -84*
Perkins, A R *AmArch 70*
Perkins, Abraham 1768-1839 *NewYHSD*
Perkins, Alexander Graves *WhAmArt 85*
Perkins, Angela L 1948- *AfroAA*
Perkins, Ann 1915- *WhoAmA 73, -76, -78, -80, -82, -84*
Perkins, Arthur E *DcVicP 2*
Perkins, Charles C 1823- *ArtsNiC*
Perkins, Charles C 1823-1886 *ClaDrA*
Perkins, Charles Callahan 1823-1886 *NewYHSD*
Perkins, Clarence 1906- *FolkA 86*
Perkins, Clarence James 1935- *WhoAmA 80, -82, -84*
Perkins, Constance M 1913- *WhoAmA 78, -80, -82, -84*
Perkins, D A *AmArch 70*
Perkins, D E *AmArch 70*
Perkins, D R *AmArch 70*
Perkins, David Layne 1925- *AmArch 70*
Perkins, Dwight H 1867-1941 *BiDAmAr*
Perkins, Edna L 1907- *WhAmArt 85*
Perkins, Elijah 1757?-1841 *CabMA*
Perkins, Elizabeth Taylor Brawner *FolkA 86*
Perkins, Elizabeth Welles d1928 *DcWomA*
Perkins, Emily R *DcWomA, WhAmArt 85*
Perkins, Eugene Ellis 1942- *MarqDCG 84*
Perkins, Fred M, Jr. 1938- *AmArch 70*
Perkins, Frederick Stanton 1832-1899 *NewYHSD, WhAmArt 85*
Perkins, Frederick W 1866-1928 *BiDAmAr*
Perkins, G Holmes 1904- *AmArch 70, WhoAmA 73, -76, -78, -80, -82, -84*
Perkins, George *DcVicP 2*
Perkins, Granville 1830-1895 *EarABI, EarABI SUP, IIBEAAW, NewYHSD, WhAmArt 85*
Perkins, H N, Jr. *AmArch 70*
Perkins, Harley 1883- *WhAmArt 85*
Perkins, Henry 1803- *NewYHSD*
Perkins, Horace, Jr. *NewYHSD*
Perkins, Horace Tidd *FolkA 86*
Perkins, J *DcVicP 2*
Perkins, J A *AmArch 70*
Perkins, J R *NewYHSD*
Perkins, Jacob 1766-1849 *NewYHSD*
Perkins, John U 1875- *WhAmArt 85*
Perkins, Joseph *NewYHSD*
Perkins, Joseph 1788-1842 *NewYHSD*
Perkins, Joseph Russell 1925- *AmArch 70*
Perkins, Katherine L *ArtsAmW 2, DcWomA*
Perkins, Katherine Lindsay *WhAmArt 85*
Perkins, Lawrence B 1907- *ConArch, MacEA*
Perkins, Lawrence Bradford 1907- *AmArch 70*
Perkins, Lee *NewYHSD*
Perkins, Louella *DcWomA*
Perkins, Lucy *DcWomA*
Perkins, Lucy 1865-1937 *DcWomA*
Perkins, Lucy Fitch 1865-1937 *ConICB, WhAmArt 85*
Perkins, Ma *FolkA 86*
Perkins, Mabel H 1880- *WhoAmA 73*
Perkins, Mabel H 1880-1974 *WhoAmA 76N*
Perkins, Mable H 1880-1974 *WhoAmA 78N, -80N, -82N, -84N*
Perkins, Marion 1908-1961 *WhoAmA 80N, -82N, -84N*
Perkins, Marion M 1908-1961 *AfroAA*
Perkins, Mary Smyth 1874?-1931 *DcWomA*
Perkins, Mary Smyth 1875-1931 *WhAmArt 85*
Perkins, Morris Richard 1925- *AmArch 70*
Perkins, Nathaniel 1803-1847 *NewYHSD*
Perkins, Pa *FolkA 86*
Perkins, Parker *WhAmArt 85*
Perkins, Percy Harold, Jr. 1905- *AmArch 70*
Perkins, Philip R d1968 *WhoAmA 78N, -80N, -82N, -84N*
Perkins, Prudence *DcWomA, FolkA 86*
Perkins, R A *AmArch 70*
Perkins, Robert Eugene 1931- *WhoAmA 73, -76, -78, -80, -82, -84*
Perkins, Ruth Hunter 1911- *FolkA 86*
Perkins, S C *AmArch 70*
Perkins, S Lee *NewYHSD*
Perkins, Samuel *FolkA 86*
Perkins, Sarah 1771-1831 *DcWomA, FolkA 86*
Perkins, Sarah S *DcWomA, WhAmArt 85*
Perkins, Stella Mary 1891?- *DcWomA, WhAmArt 85*
Perkins, Susan E H d1929 *WhAmArt 85*
Perkins, T D *AmArch 70*

Persse, K M 1899- *DcWomA*
Persson, Sigurd 1914- *ConDes*
Persuis, Eugenie *DcWomA*
Persuy, Michel Jean 1946- *MarqDCG 84*
Pertegaz, Manuel *FairDF SPA*, *WorFshn*
Pertrand, Clara *DcWomA*
Perttula, Norman Keith 1927- *AmArch 70*
Pertue, Marie *DcWomA*
Pertz, Anna J *DcVicP 2*
Pertz, Stuart K 1936- *AmArch 70*
Peruani, Joseph *NewYHSD*
Perugia, Andre *WorFshn*
Perugini, Mrs. C E *ArtsNiC*
Perugini, Charles Edward *ArtsNiC*
Perugini, Charles Edward 1839-1918 *ClaDrA*,
 DcBrA 1, *DcVicP, -2*
Perugini, Mrs. Charles Edward 1839-1929 *DcVicP, -2*
Perugini, Kate 1839-1929 *DcBrA 1*, *DcWomA*
Perugini, Katherine Elizabeth Macready 1838-1929
 DcBrWA
Perugino 1450?-1523 *McGDA*
Perugino, Il 1446?-1523 *ClaDrA*
Perugino, Pietro Vannucci 1445?-1523 *OxArt*
Perul, Madame De *DcWomA*,
 NewYHSD
Perutz, Otto 1847-1922 *ICPEnP*, *MacBEP*
Peruzzi, Baldassare 1481-1536 *McGDA*, *OxArt*,
 WhoArch
Peruzzi, Baldassarre 1481-1536 *MacEA*
Pervault, Ida Marie 1874- *DcWomA*, *WhAmArt 85*
Pesaro, Simone Da *McGDA*
Pesce, Gaetano 1939- *ConDes*
Peschel, Carl Gottlob 1798-1879 *ClaDrA*
Peschel, H W *AmArch 70*
Peschel, Helene 1859- *DcWomA*
Pescheret, Leon R 1892-1961 *WhAmArt 85*
Pescheret, Leon Rene 1892-1961 *ArtsAmW 3*,
 IlBEAAW
Pesellino, Francesco 1422?-1457 *McGDA*
Pesellino, Francesco DiStefano 1422?-1457 *OxArt*
Pesello, Giuliano 1367-1446 *McGDA*
Pesenti, Domenico 1852?- *ArtsNiC*
Peskett, Eric Harry 1914- *DcBrA 1*, *WhoArt 80, -82,
 -84*
Peslouan, Marthe De *DcWomA*
Pesne, Antoine 1683-1757 *McGDA*
Pesne, Henriette 1720?-1790? *DcWomA*
Pesner, Carole Manishin 1937- *WhoAmA 76, -78, -80,
 -82, -84*
Pesonen, Heikki Matti Juhani 1934- *MarqDCG 84*
Pessel, Esther 1903- *WhAmArt 85*
Pessina, G D *DcVicP 2*
Pessou, Louis *NewYHSD*
Pestel', Vera Efimovna 1888-1952 *DcWomA*
Pestivien, Jehan De 1380?-1463 *McGDA*
Pestka, Charles M 1941- *MarqDCG 84*
Petardi, Anne-Marie 1956- *DcCAr 81*
Petek, Poko d1972 *IlBEAAW*
Petel, Georg *AntBDN C*
Petel, George 1590?-1633 *McGDA*
Peter Nolasco, Saint 1189?-1256? *McGDA*
Peter, Saint *McGDA*
Peter, Amalie Von *DcWomA*
Peter, Baldur 1929- *AmArch 70*
Peter, Charlotte *WorFshn*
Peter, Edward 1780-1862 *DcBrWA*
Peter, Friedrich Gunther 1933- *WhoAmA 78, -80, -82,
 -84*
Peter, George *WhoAmA 76, -78, -80, -82, -84*
Peter, George 1860-1943 *WhAmArt 85*
Peter, H P *FolkA 86*
Peter, John Edward 1934- *AmArch 70*
Peter, Norman Anthony 1932- *AmArch 70*
Peter, Reuben 1821?- *FolkA 86*
Peter, Robert Charles 1888- *DcBrA 1*, *WhoArt 80*
Peter, Victor 1840-1918 *AntBDN C*
Peter, W G, Jr. *AmArch 70*
Peter, Walter G 1868-1945? *BiDAmAr*
Peter-Reininghaus, Maria 1883- *DcWomA*
Peterdi, Gabor 1915- *BnEnAmA*, *DcAmArt*,
 DcCAA 71, -77, *McGDA*, *WhAmArt 85*,
 WorArt[port]
Peterdi, Gabor F 1915- *PrintW 83, -85*,
 WhoAmA 73, -76, -78, -80, -82, -84
Peterhans, Walter 1897-1960 *ConPhot*, *ICPEnP*
Peterhans, William G *ArtsEM*
Peterich, Paul 1864-1937 *McGDA*
Peteris, Viktor R 1932- *AmArch 70*
Peterman, Casper 1780?- *FolkA 86*
Peterman, Daniel 1809-1857 *FolkA 86*
Peterman, Jack Maurice 1931- *AmArch 70*
Petermann, Hedwig 1877- *DcWomA*
Peters, Miss *DcWomA*
Peters, Albert Edward 1865?-1939 *ArtsEM[port]*
Peters, Anna 1843- *ArtsNiC*
Peters, Anna 1843-1926 *DcWomA*
Peters, Anna Robb 1907- *AmArch 70*
Peters, Bernard E 1893- *WhAmArt 85*
Peters, Betty *WhAmArt 85*
Peters, C *FolkA 86*, *NewYHSD*
Peters, C H 1847-1932 *MacEA*

Peters, C Merriman *WhAmArt 85*
Peters, C W *DcBrBI*
Peters, Carl W 1897- *WhoAmA 73, -76, -78, -80*
Peters, Carl W 1897-1980 *WhoAmA 82N, -84N*
Peters, Carl William 1897- *WhAmArt 85*
Peters, Charles F *WhAmArt 85*
Peters, Charles Rollo 1862-1928 *ArtsAmW 1*,
 WhAmArt 85
Peters, Charles Rollo 1862-1928? *IlBEAAW*
Peters, Charles Rollo, III 1892-1967 *ArtsAmW 2*
Peters, Christian *FolkA 86*
Peters, Clara *DcWomA*
Peters, Constance *WhAmArt 85*
Peters, Constance Evans *ArtsAmW 1*
Peters, D E *AmArch 70*
Peters, David L 1934- *MarqDCG 84*
Peters, Dewitt Clinton 1865- *WhAmArt 85*
Peters, Diane 1940- *WhoAmA 80, -82, -84*
Peters, Edith Macausland *DcWomA*, *WhAmArt 85*
Peters, Francis C 1902-1977 *WhoAmA 78N, -80N,
 -82N, -84N*
Peters, Frans Johannes 1945- *MarqDCG 84*
Peters, G W *WhAmArt 85*
Peters, George Louis 1935- *AmArch 70*
Peters, Gerald James 1923- *AmArch 70*
Peters, Hela 1885- *DcWomA*
Peters, Herbert 1925- *DcCAr 81*
Peters, J *FolkA 86*, *NewYHSD*
Peters, J, Sr. *NewYHSD*
Peters, John E *NewYHSD*
Peters, Joseph *FolkA 86*
Peters, Joy Ballard *AfroAA*
Peters, K A *AmArch 70*
Peters, Kenneth *AmArch 70*
Peters, Larry Dean 1938- *WhoAmA 78, -80, -82, -84*
Peters, Leslie H 1916?- *IlBEAAW*
Peters, Louis W d1924 *WhAmArt 85*
Peters, Luther d1921 *BiDAmAr*
Peters, Maryella *WhAmArt 85*
Peters, Matthew William 1741?-1814 *DcBrECP*
Peters, Matthew William 1742-1814 *OxArt*
Peters, Mike 1943- *WorECar*
Peters, Paul E 1948- *MarqDCG 84*
Peters, Pietronella 1848-1924 *DcWomA*
Peters, Richard C *ConArch A*
Peters, Richard Carl 1928- *AmArch 70*
Peters, Richard Walter 1930- *AmArch 70*
Peters, Robert Lee 1920- *AmArch 70*
Peters, Rollo *WhAmArt 85*
Peters, Miss S A *NewYHSD*
Peters, Sara *DcWomA*
Peters, Scott *FolkA 86*
Peters, Theodore James 1926- *AmArch 70*
Peters, W T *NewYHSD*
Peters, William *DcBrA 2*, *DcVicP 2*, *NewYHSD*
Peters, William Thompson, Jr. 1828- *NewYHSD*
Peters, William Wesley 1912- *AmArch 70*
Peters-Baurer, Pauline *DcWomA*
Petersen, Anders 1944- *ConPhot*, *ICPEnP A*,
 MacBEP
Petersen, Anna Sofie 1845-1910 *DcWomA*
Petersen, Asmus 1928- *DcCAr 81*
Petersen, Barbara Ann 1951- *MarqDCG 84*
Petersen, C G *AmArch 70*
Petersen, Carl 1874-1924 *MacEA*
Petersen, Carl August 1929- *AmArch 70*
Petersen, Carl Olof 1881-1939 *WorECar*
Petersen, Carsten 1776- *CabMA*
Petersen, Chip 1954- *MarqDCG 84*
Petersen, Christian 1885- *WhAmArt 85*
Petersen, David A 1948- *MarqDCG 84*
Petersen, Duane Melvin 1932- *AmArch 70*
Petersen, Eilif 1852-1928 *ClaDrA*
Petersen, Einar C 1885- *ArtsAmW 3*
Petersen, Einer 1885- *ArtsAmW 3*
Petersen, Eugen H 1892- *WhAmArt 85*
Petersen, Fanny 1861- *DcWomA*
Petersen, Heinrich Andreas Sophus 1834-1916 *DcSeaP*
Petersen, Jacob 1774-1854 *DcSeaP*
Petersen, John E C 1839-1874 *ArtsNiC*
Petersen, John Peter 1926- *MarqDCG 84*
Petersen, K Helmer 1947- *ICPEnP A*
Petersen, Lorenz 1803-1870 *DcSeaP*
Petersen, Martin 1870- *WhAmArt 85*
Petersen, Nielsine Caroline 1851-1916 *DcWomA*
Petersen, Robert 1945- *PrintW 83, -85*
Petersen, Robert Storm 1882-1949 *WorECar*
Petersen, Roland Conrad 1926- *DcCAA 71, -77*,
 WhoAmA 73, -76, -78, -80, -82, -84
Petersen, Terje 1952- *MarqDCG 84*
Petersen, Timothy *MarqDCG 84*
Petersen, Vilhelm 1830-1913 *MacEA*
Petersen, Will 1928- *WhoAmA 78, -80, -82, -84*
Petersham, Maud 1889-1971 *ConICB*, *IlsBYP*,
 IlsCB 1744, -1946, -1957
Petersham, Maud And Miska *Cald 1938*
Petersham, Maud Feller 1889- *WhoAmA 73, -76*
Petersham, Maud Fuller d1971 *IlsCB 1967*
Petersham, Maud Fuller 1889- *DcWomA*,
 WhAmArt 85
Petersham, Miska 1888-1959 *WhAmArt 85*,

WhoAmA 80N, -82N, -84N
Petersham, Miska 1889-1960 *ConICB*, *IlsBYP*,
 IlsCB 1744, -1946
Petershime, Mrs. Samuel *FolkA 86*
Peterson, A E S 1908- *WhoAmA 73, -76, -78, -80,
 -82, -84*
Peterson, A H M *NewYHSD*
Peterson, A L *FolkA 86*
Peterson, A V *AmArch 70*
Peterson, Abraham *AntBDN Q*
Peterson, Amelia *ArtsEM*, *DcWomA*
Peterson, Audrey Mount 1914- *WhoAmA 76*
Peterson, Barbara 1940- *AfroAA*
Peterson, Betty Ferguson 1917- *IlsCB 1957*
Peterson, C *NewYHSD*
Peterson, C O *AmArch 70*
Peterson, C W *AmArch 70*
Peterson, Charles A 1930- *AmArch 70*
Peterson, Charles Dean *AmArch 70*
Peterson, Charles E 1906- *AmArch 70*
Peterson, Charles Peter 1956- *MarqDCG 84*
Peterson, Chester G 1922- *WhoAmA 76, -78, -80,
 -82*
Peterson, David Winfield 1913- *WhoAmA 82, -84*
Peterson, Don *DcCAr 81*
Peterson, Donald Stanley 1932- *AmArch 70*
Peterson, Edwin John 1907- *AmArch 70*
Peterson, Elna Charlotte 1916-1937 *WhAmArt 85*
Peterson, Elsa Kirpal 1891- *DcWomA*, *WhAmArt 85*
Peterson, Eric A *WhAmArt 85*
Peterson, Frederick R 1808-1885 *BiDAmAr*
Peterson, G L *AmArch 70*
Peterson, G R *AmArch 70*
Peterson, Gene Stuart 1928- *AmArch 70*
Peterson, George *FolkA 86*
Peterson, Gerhard C 1907- *AmArch 70*
Peterson, Giles Gordon 1939- *MarqDCG 84*
Peterson, H *NewYHSD*
Peterson, Harold Patrick 1935- *WhoAmA 78, -80,
 -82, -84*
Peterson, Helen *DcWomA*
Peterson, Hulda Hook *DcWomA*
Peterson, Ida Eldora 1875- *DcWomA*
Peterson, J B *AmArch 70*
Peterson, J E *AmArch 70*
Peterson, J R *AmArch 70*
Peterson, J Soren, Jr. 1932- *AmArch 70*
Peterson, Jane *WhoAmA 78N, -80N, -82N, -84N*
Peterson, Jane 1876-1965 *DcWomA*, *WhAmArt 85*
Peterson, Jesse Julius, Jr. 1936- *AmArch 70*
Peterson, John Douglas 1939- *WhoAmA 73, -76, -78,
 -80, -82, -84*
Peterson, John Ellis 1930- *AmArch 70*
Peterson, John Marsilje 1935- *AmArch 70*
Peterson, John Norman 1923- *AmArch 70*
Peterson, John P d1949 *WhoAmA 78N, -80N, -82N,
 -84N*
Peterson, Jon 1945- *DcCAr 81*
Peterson, Kay 1902- *WhAmArt 85*
Peterson, Keith Leonard 1930- *AmArch 70*
Peterson, Kenneth Herbert 1924- *AmArch 70*
Peterson, L H *AmArch 70*
Peterson, L R *AmArch 70*
Peterson, L S *EncASM*
Peterson, Larry D 1935- *AmArt*, *WhoAmA 73, -76,
 -78, -80, -82, -84*
Peterson, Leroy *MarqDCG 84*
Peterson, Lillian Isabel *DcWomA*
Peterson, Lily Blanche *DcWomA*, *WhAmArt 85*
Peterson, Margaret 1903- *WhAmArt 85*
Peterson, Marvin Lauritz 1939- *AmArch 70*
Peterson, Michael P 1954- *MarqDCG 84*
Peterson, Millie *ArtsEM*, *DcWomA*
Peterson, Niss C *NewYHSD*
Peterson, Oscar B 1887- *FolkA 86*
Peterson, Perry 1908-1958 *IlrAm E, -1880*,
 WhoAmA 80N, -82N, -84N
Peterson, Peter Charles 1934- *WhoArt 82, -84*
Petrinson, Petrina *FolkA 86*
Peterson, R A *AmArch 70*
Peterson, R D *AmArch 70*
Peterson, R H *AmArch 70*
Peterson, Richard Allen 1923- *AmArch 70*
Peterson, Richard Michael 1936- *AmArch 70*
Peterson, Richard Vincent 1922- *AmArch 70*
Peterson, Robert Baard 1943- *WhoAmA 73, -76*
Peterson, Robert Claude 1932- *AmArch 70*
Peterson, Robert Edward Lee 1917- *AmArch 70*
Peterson, Robert Wayne 1939- *AmArch 70*
Peterson, Roger Tory *OfPGCP 86*
Peterson, Roger Tory 1908- *AmArt*, *WhAmArt 85*,
 WhoAmA 76, -78, -80, -82, -84
Peterson, Roy 1936- *WorECar*
Peterson, Russell Edmond 1938- *AmArch 70*
Peterson, Russell Francis *IlsCB 1957*
Peterson, Samuel Randolph 1929- *AmArch 70*
Peterson, Susan Harnly 1925- *WhoAmA 82, -84*
Peterson, Thalia Gouma *WhoAmA 78, -80*
Peterson, Vivian K *DcWomA*, *WhAmArt 85*
Peterson, W D *AmArch 70*
Peterson, Warren A 1928- *AmArch 70*

Peterzano, Simone *McGDA*
Petetin, Sidonia *ArtsAmW 2, DcWomA*
Petheo, Bela 1934- *PrintW 83, -85*
Petheo, Bela Francis 1934- *WhoAmA 73, -76, -78, -80, -82, -84*
Pether, Abraham 1756-1812 *DcBrECP*
Pether, Henry 1828-1865 *DcVicP, -2*
Pether, Sebastian 1790-1844 *DcVicP, -2*
Pether, William 1731-1795? *McGDA*
Pether, William 1738?-1821 *DcBrECP*
Petherbridge, Albert George 1882- *DcBrA 1*
Petherbridge, Deanna 1939- *WhoArt 80, -82*
Petherick, Edith M *DcVicP 2*
Petherick, Horace William 1839-1919 *DcBrA 1, DcBrBI, DcVicP 2*
Petherick, Rosa C *DcBrBI*
Petherick, Rosa C d1931 *DcBrA 2*
Pethybridge, J Ley *DcBrBI, DcVicP 2*
Peti, Maria *DcWomA*
Peticolas, Arthur Brown *ArtsAmW 3*
Peticolas, Arthur Edward 1820?- *NewYHSD*
Peticolas, Edward F 1793-1853? *IlBEAAW, NewYHSD*
Peticolas, Jane Pitfield Braddick 1791-1852 *DcWomA, NewYHSD*
Peticolas, Philippe Abraham 1760-1841 *NewYHSD*
Peticolas, Theodore V 1797- *NewYHSD*
Peticov, Antonio 1946- *PrintW 83, -85*
Petie, Haris 1915- *IlsBYP*
Petiet, Marie *DcWomA*
Petigru, Caroline 1819- *DcWomA, NewYHSD*
Petigru, Caroline 1819-1893 *WhAmArt 85*
Petiot, Flore Thereze *DcWomA*
Petit, C A *BiDBrA*
Petit, Celine Marie Louise *DcWomA*
Petit, Dale 1898- *ArtsAmW 3*
Petit, Jacob *AntBDN M*
Petit, Jacob & Mardochee *DcNiCA*
Petit, John Louis 1801-1868 *DcBrBI, DcBrWA*
Petit, Marie Charlotte *DcWomA*
Petit, Pierre 1832- *ICPEnP A, MacBEP*
Petit, Rosalie *DcWomA*
Petit, Solange *DcWomA*
Petit, Thomas J *DcCAr 81*
Petit-Jean, Marie Antoinette 1795-1831 *DcWomA*
Petit-Radel, Louis Francois 1740-1818 *MacEA*
Petiteau *DcWomA*
Petitjean, Edmond Marie 1844-1925 *ClaDrA*
Petitjean, Jeanne 1838- *DcWomA*
Petitot, Jean 1607-1691 *AntBDN J*
Petitot, Jean, The Elder 1607-1691 *McGDA*
Petitot DiLione, Ennemondo Alessandro 1727-1801 *MacEA*
Petitpas, Eugenie Marie *DcWomA*
Petlin, Irving 1934- *ConArt 83, DcCAA 77, DcCAr 81, WhoAmA 78, -80, -82, -84*
Petna, George 1833?- *FolkA 86*
Peto, Gladys Emma 1890- *DcBrA 2*
Peto, Gladys Emma 1891-1977 *DcBrBI*
Peto, Harold 1854-1933 *WhoArch*
Peto, John Frederick 1854-1907 *BnEnAmA, DcAmArt, McGDA, OxArt, WhAmArt 85*
Peto, Michael James 1928- *WhoArt 80, -82, -84*
Peto, Morton K *DcVicP 2*
Petow, Edward T 1877- *WhAmArt 85*
Petraglia, Roger F *AmArch 70*
Petraschek, Helene *DcWomA*
Petrasco, Gheorghe 1872-1949 *PhDcTCA 77*
Petrash, Robert W 1935- *AmArch 70*
Petrauskas, Vyto V 1930- *AmArch 70*
Petrazio, Edward Glenn 1921- *AmArch 70*
Petre, Elisabeth *DcWomA*
Petre, F W 1847-1918 *MacEA*
Petrella, Concezio 1921- *AmArch 70*
Petrella, Joyce P *MarqDCG 84*
Petremont, Clarice M d1949 *WhoAmA 78N, -80N, -82N, -84N*
Petremont, Clarice Marie d1949 *DcWomA, WhAmArt 85*
Petrescu, Aurel 1897-1948 *WorECar*
Petri, B I *AmArch 70*
Petri, Frederick Richard 1824-1857 *IlBEAAW*
Petri, Giovanni 1935- *AmArch 70*
Petri, Heinrich 1834-1871 *ArtsNiC*
Petri, Petrus d1291 *McGDA*
Petri, Richard 1824-1857 *ArtsAmW 1, NewYHSD*
Petric, Aloisia Maria 1807-1858 *DcWomA*
Petricic, Dusan 1946- *WhoGrA 82[port]*
Petrick, Wolfgang 1939- *ConArt 77, DcCAr 81*
Petrides, Heidrun 1944- *IlsCB 1957*
Petrides, M D *AmArch 70*
Petrie *FolkA 86*
Petrie, Elizabeth C *DcVicP 2, DcWomA*
Petrie, F D *AmArch 70*
Petrie, Ferdinand Ralph 1925- *WhoAmA 73, -76, -78, -80, -82, -84*
Petrie, George 1789-1866 *DcBrBI*
Petrie, George 1790-1866 *DcBrWA, DcVicP 2*
Petrie, Graham 1859- *ClaDrA*
Petrie, Graham 1859-1940 *DcBrA 1, DcBrWA*
Petrie, Henry 1768-1842 *DcBrBI, DcBrWA*

Petrie, John *FolkA 86*
Petrie, Mary Anne *DcBrWA, DcWomA*
Petrie, R G *ArtsEM*
Petrie, S Graham 1859-1940 *DcVicP 2*
Petrie, Sylvia 1931- *PrintW 83, -85*
Petrie, Sylvia Spencer 1931- *WhoAmA 76, -78, -80, -82, -84*
Petrilli, Alfred J 1928- *AmArch 70*
Petrilli, C J *AmArch 70*
Petrina, Carlotta 1901- *WhAmArt 85*
Petrina, John 1893-1935 *WhAmArt 85*
Petro, Joseph, Jr. 1932- *WhoAmA 73, -76, -78, -80, -82, -84*
Petrochuk, Konstantin 1947- *WhoAmA 76, -78, -80*
Petroff, Gilmer 1913- *WhAmArt 85, WhoAmA 73, -76*
Petroff, Serge P 1913- *AmArch 70*
Petrofsky, P P, Sr. *AmArch 70*
Petrone, August Mario 1927- *AmArch 70*
Petroni, Ginevra *DcWomA*
Petroni, Sister Giovanna *DcWomA*
Petros, Marie Louise 1862-1898 *DcWomA*
Petrot, Marie Louise 1862-1898 *DcWomA*
Petrov, Dimitre 1919- *PrintW 83, -85*
Petrovic, Jelisaveta 1895- *DcWomA*
Petrovic, Milan V 1893- *WhAmArt 85*
Petrovic, Nadezda 1873-1915 *PhDcTCA 77*
Petrovic, Nadezda 1874-1915 *DcWomA*
Petrovic, Zora 1894- *DcWomA*
Petrovits, Milan 1892- *WhAmArt 85*
Petrovits, N Paul *ArtsAmW 3*
Petrovits, Stephen *MarqDCG 84*
Petruccelli, Antonio 1907- *WhAmArt 85*
Petrucci, Carlo Alberto *WhAmArt 85*
Petrucci, Ferdinand Anthony *AmArch 70*
Petrus A Merica *McGDA*
Petrus-Blanc, J *DcWomA*
Petrusov, Georgii 1903-1971 *ConPhot, ICPEnP A*
Petry, Henry 1816?- *FolkA 86*
Petry, Liese 1952- *DcCAr 81*
Petry, Marguerite 1897- *DcWomA*
Petry, Peter 1809?- *FolkA 86*
Petry, Victor 1903- *WhAmArt 85*
Petryl, August *WhAmArt 85*
Petschacher, Olga *DcWomA*
Petschnigg, Hubert *McGDA*
Petschnigg, Hubert 1913- *McGDA*
Pett, Helen Bailey 1908- *WhAmArt 85*
Pett, John *NewYHSD*
Pett, Norman *DcBrBI*
Pettafor, Charles R *ClaDrA, DcVicP, -2*
Pette, John Phelps *WhAmArt 85*
Pettenkofen, Auguste 1823- *ArtsNiC*
Petter, Henry Adolph, II 1916- *AmArch 70*
Pettersen, Eleanore Kendall 1916- *AmArch 70*
Pettersen, Sverre 1884-1959 *IlDcG*
Petterson, Hilda *DcWomA*
Petterson, J P *EncASM*
Petterson, John P 1884-1949 *WhAmArt 85*
Petterson, Ness C *NewYHSD*
Pettersson, Signe Madeleine 1895-1982 *DcWomA*
Pettet, Ralph Edward 1930- *AmArch 70*
Pettet, William 1942- *ConArt 77, DcCAA 77, WhoAmA 76, -78, -80, -82, -84*
Pettette, Mrs. C S *ArtsEM, DcWomA*
Petteway, James Elliott 1926- *AmArch 70*
Pettibone, Abraham *FolkA 86*
Pettibone, Daniel *NewYHSD*
Pettibone, John Wolcott 1942- *WhoAmA 76, -78, -80, -82, -84*
Pettibone, Richard *OxTwCA*
Pettibone, Richard H 1938- *WhoAmA 78, -80, -82, -84*
Petticord, G W, Jr. *AmArch 70*
Pettie, Henry *FolkA 86*
Pettie, John 1839- *ArtsNiC*
Pettie, John 1839-1893 *DcBrBI, DcBrWA, DcVicP, -2, McGDA, OxArt*
Pettie, Marion *DcVicP 2*
Pettingell, Frank Noble 1848-1883 *DcBrWA*
Pettingell, Lillian Annin 1871- *WhAmArt 85*
Pettingell, Robert Clyde, Jr. *WhAmArt 85*
Pettingill, Lillian Annin 1871- *ArtsAmW 3, DcWomA*
Pettis *NewYHSD*
Pettit, Della *ArtsEM*
Pettit, Edwin Alfred 1840-1912 *DcBrWA*
Pettit, Evelyn M 1870- *DcWomA, WhAmArt 85*
Pettit, George W *WhAmArt 85*
Pettit, Grace *WhAmArt 85*
Pettit, Heil Charles 1918- *AmArch 70*
Pettit, Pattie *DcBrWA*
Pettit, W E *AmArch 70*
Pettit, William B 1838-1910 *BiDAmAr*
Pettitt, Alfred *DcVicP, -2*
Pettitt, Charles *ClaDrA, DcVicP, -2*
Pettitt, Mrs. E A *DcVicP 2*
Pettitt, Edwin Alfred 1840-1912 *ClaDrA, DcBrA 1, DcVicP, -2*
Pettitt, George *DcVicP, -2*

Pettitt, Jay S, Jr. 1926- *AmArch 70*
Pettitt, Jenny *DcVicP 2, DcWomA*
Pettitt, Joseph Paul d1882 *DcVicP, -2*
Pettitt, P *DcVicP 2*
Pettitt, Pattie *DcWomA*
Pettitt, Wilfred Stanley 1904- *ClaDrA, DcBrA 1*
Pettittson, C J *DcVicP 2*
Petton, R *DcBrECP*
Pettoruti, Emilio 1892-1971 *OxTwCA, PhDcTCA 77*
Pettoruti, Emilio 1893- *OxArt*
Pettoruti, Emilio 1894- *McGDA*
Pettrich, Ferdinand Friedrich August 1798-1872 *IlBEAAW, NewYHSD*
Pettrich, Frederick August Ferdinand 1798-1872 *NewYHSD*
Petts, John 1914- *DcBrA 1, WhoArt 80, -82, -84*
Pettus, Jane Messick 1908- *WhoAmA 82, -84*
Petty, Bruce Leslie 1929- *WhoGrA 62, WorECar*
Petty, Gary Don 1950- *MarqDCG 84*
Petty, George *WhAmArt 85*
Petty, H W *AmArch 70*
Petty, Jessie W *WhAmArt 85*
Petty, John L, Jr. 1939- *WhoAmA 76, -78, -80*
Petty, Mary 1899-1976 *DcWomA, WorECar*
Petty, Vernon E 1956- *MarqDCG 84*
Petty, W R *DcVicP 2*
Petty, Walter Frazier 1902- *AmArch 70*
Petty, Sir William 1623-1687 *AntBDN I*
Pettys, Linden Church 1927- *AmArch 70*
Petua, Jeanne 1881- *DcWomA*
Petua, Leonie 1883- *DcWomA*
Petyko, Luiza 1896-1931 *DcWomA*
Petzel, Rosa 1831- *DcWomA*
Petzl, Joseph 1803-1871 *ClaDrA*
Petzold, Adolph *WhAmArt 85*
Petzolt, Hans 1551-1633 *McGDA*
Petzsch, Helmut Franz Gunther 1920- *WhoArt 80, -82, -84*
Petzval, Josef Max 1807-1891 *ICPEnP, MacBEP*
Peuckert, Edward A *DcVicP 2*
Peugeot, George I 1869- *WhAmArt 85*
Peugniez, Pauline 1890- *ClaDrA, DcWomA*
Peven, Michael D 1949- *ICPEnP A, MacBEP*
Peverelli, Cesare 1922- *PhDcTCA 77*
Pevsner, Antoine 1886-1962 *ConArt 77, -83, McGDA, OxArt, OxTwCA, PhDcTCA 77, WorArt[port]*
Pevsner, Sir Nikolaus *WhoArt 84N*
Pevsner, Sir Nikolaus 1902- *WhoArt 80, -82*
Pew, George *CabMA*
Pew, Gertrude L 1876- *DcWomA, WhAmArt 85*
Pew, James *NewYHSD*
Pewtress, John B *FolkA 86*
Pexton, Mackley F 1952- *MarqDCG 84*
Peynet, Raymond 1908- *WhoGrA 62, -82[port], WorECar*
Peynot, Amelie Henriette *DcWomA*
Peyrau, A *FolkA 86*
Peyraud, Elizabeth K *WhAmArt 85*
Peyraud, Elizabeth Krysher *DcWomA*
Peyraud, Frank C 1858- *WhAmArt 85*
Peyraud, Frank Charles 1858-1948 *ArtsAmW 3*
Peyre, Antoine Francois 1739-1823 *McGDA*
Peyre, Antoine-Marie 1770-1843 *McGDA*
Peyre, Jeanne *DcWomA*
Peyre, Marie-Joseph 1730-1788 *McGDA*
Peyre Family *MacEA*
Peyrissac, Jean 1895- *McGDA*
Peyrol-Bonheur, Juliette *DcWomA*
Peyron, Jean Francois Pierre 1744-1814 *ClaDrA*
Peyronnet, Dominique 1872-1943 *OxTwCA*
Peyronnet, Dominique Paul 1872-1943 *McGDA*
Peyson, Pierre Frederic 1807-1877 *ClaDrA*
Peytel, Adrienne *DcWomA*
Peyton, A *DcBrBI*
Peyton, Alfred Conway 1875-1936 *WhAmArt 85*
Peyton, Ann Douglas Moon 1891- *WhAmArt 85*
Peyton, Ann Moon 1891- *DcWomA*
Peyton, Bertha *DcWomA*
Peyton, Bertha Menzler *WhoAmA 78N, -80N, -82N, -84N*
Peyton, Bertha S D Menzler 1871-1950? *WhAmArt 85*
Peytowe Family *IlDcG*
Pez, Aime 1808-1849 *ClaDrA*
Pezare, Walter John 1911- *DcBrA 1*
Pezenik, R I *AmArch 70*
Pezet, Mrs. A Washington *WhAmArt 85*
Pezold, Friederike 1945- *DcCAr 81*
Pezzati, Peter *WhAmArt 85*
Pezzati, Pietro 1902- *WhoAmA 73, -76, -78, -80, -82, -84*
Pezzi, Maria *WorFshn*
Pezzo, Lucio Del *OxTwCA*
Pfachler, Emil H *DcVicP 2*
Pfaendtner, Walter J 1921- *AmArch 70*
Pfaff, Judy *DcCAr 81*
Pfaff, Judy 1946- *PrintW 85*
Pfaff, Margarete 1863- *DcWomA*
Pfaff, Mario P 1914- *AmArch 70*
Pfaffenbach, Ida *DcWomA*
Pfaffinger, Michaela 1863- *DcWomA*
Pfahl, Charles Alton, III 1946- *WhoAmA 73, -82, -84*

Pfahl, Charles Anton, III 1946- *WhoAmA 76, −78, −80*
Pfahl, John 1939- *ConPhot, DcCAr 81, ICPEnP A, MacBEP, PrintW 83, −85*
Pfahler, George Karl 1926- *ConArt 77, PhDcTCA 77*
Pfahler, Karl Georg 1926- *OxTwCA*
Pfaller, Mark A 1921- *AmArch 70*
Pfaller, Mark F 1892- *AmArch 70*
Pfaltzgraf, R *WhAmArt 85*
Pfanenstiel, Walter Joseph 1937- *AmArch 70*
Pfarr, Paul 1938- *DcCAr 81*
Pfau, Gustavus 1800?- *NewYHSD*
Pfeffer, C J *AmArch 70*
Pfeffer, F *NewYHSD*
Pfeffer, Gerald *MarqDCG 84*
Pfefferer, Marie 1845?- *DcWomA*
Pfefferle, F W *AmArch 70*
Pfeifer, Bodo 1936- *WhoAmA 73, −76, −78*
Pfeifer, Clara Maria *DcWomA, WhAmArt 85*
Pfeifer, Herman 1874-1931 *IlrAm 1880*
Pfeifer, Herman 1879-1931 *WhAmArt 85*
Pfeifer, Marcuse 1936- *WhoAmA 78, −80, −82, −84*
Pfeifer, Marcuse Lucile 1936- *MacBEP*
Pfeiffen, Justus *WhAmArt 85*
Pfeiffer *NewYHSD*
Pfeiffer, A M *NewYHSD*
Pfeiffer, Albert, Jr. 1935- *AmArch 70*
Pfeiffer, Amalie *DcWomA*
Pfeiffer, Carl 1838-1888 *BiDAmAr*
Pfeiffer, Daniel Jacob 1929- *AmArch 70*
Pfeiffer, Emily 1827-1890 *DcWomA*
Pfeiffer, Francois Joseph 1778-1835 *ClaDrA*
Pfeiffer, Frank A *ArtsEM*
Pfeiffer, Fritz 1889-1960 *WhAmArt 85, WhoAmA 80N, −82N, −84N*
Pfeiffer, Heinrich H *WhoAmA 80N, −82N, −84N*
Pfeiffer, Heinrich H 1874-1960? *WhAmArt 85*
Pfeiffer, Hope *DcWomA*
Pfeiffer, Hope Voorhees 1891-1970? *WhAmArt 85*
Pfeiffer, J Emily *DcVicP 2*
Pfeiffer, J H *DcSeaP*
Pfeiffer, Jacob *NewYHSD*
Pfeiffer, Norman Henry 1940- *AmArch 70*
Pfeiffer, Philip 1860-1925 *BiDAmAr*
Pfeiffer, Reuben John 1901- *AmArch 70*
Pfeiffer, W H *EncASM*
Pfeiffer, Werner 1937- *AmArt*
Pfeiffer, Werner Bernhard 1937- *WhoGrA 82[port]*
Pfeiffer-Korth, Gertrud 1875- *DcWomA*
Pfeil, Charles O 1871-1927 *BiDAmAr*
Pfeil, G H *WhAmArt 85*
Pfeninger, Martin, Sr. d1782 *CabMA*
Pfenninger, Elisabeth 1772-1847? *DcWomA*
Pfenninger, Jacob *NewYHSD*
Pferd, William, III 1922- *MarqDCG 84*
Pfetsch, Carl P 1817-1898 *NewYHSD , WhAmArt 85*
Pfeufer, Carl 1910- *WorECom*
Pfeuffer, Helmut 1933- *DcCAr 81*
Pfingsten, Clara Ella 1891- *DcWomA, WhAmArt 85*
Pfister, Elisabetha *DcWomA*
Pfister, Elsa *DcWomA*
Pfister, Harold Francis 1947- *WhoAmA 84*
Pfister, Jean Jacques d1949 *WhoAmA 78N, −80N, −82N, −84N*
Pfister, Jean Jacques 1878-1949 *WhAmArt 85*
Pfitner, Amalie 1808?-1843? *DcWomA*
Pflager, Dorothy Holloway 1900- *WhAmArt 85*
Pflagger, Henry *FolkA 86*
Pflauder, Rosina *DcWomA*
Pflaum, Nance *DcBrA 1, DcWomA*
Pflaumer, Paul Gottlieb, II 1907- *WhAmArt 85*
Pfleghar, Frank P *EncASM*
Pfliger, Terry 1947- *DcCAr 81*
Pflueger, John Milton 1937- *AmArch 70*
Pflueger, Milton T 1907- *AmArch 70*
Pflueger, Timothy L 1892-1946 *BiDAmAr*
Pfluger, E J *AmArch 70*
Pfluger, J D *AmArch 70*
Pfohl, Karel 1826-1894 *IlDcG*
Pfohl, L H *AmArch 70*
Pfohl, Roswell E 1895- *AmArch 70*
Pfohl, William F *WhAmArt 85*
Pforr, Franz 1788-1812 *McGDA, OxArt*
Pfosi, Peter *DcCAr 81*
Pfriem, Bernard 1916- *DcCAA 71, −77, WhoAmA 73, −76, −78, −80, −82, −84*
Pfriem, Bernard A 1914- *WhAmArt 85*
Pfrundt, Anna Maria 1642-1713 *DcWomA*
Pfuhl, Johannes 1846- *ArtsNiC*
Pfuller, Minna 1824-1907 *DcWomA*
Pfund, Roger 1943- *DcCAr 81, WhoGrA 82[port]*
Pfyffer VonAltishofen, Mathilde Marie 1871- *DcWomA*
Phaeidias *McGDA*
Phaidimos *McGDA*
Phair, Ruth 1898- *ArtsAmW 3*
Phalipon, Louise *DcWomA*
Pham, Luong Hai 1956- *MarqDCG 84*
Pharaon, Jeanne *DcWomA*

Phares, Frank *WhAmArt 85*
Phares, Mary Anne *FolkA 86*
Pharmakidis, Panayiotis Demetrius 1931- *AmArch 70*
Pharo, John Paul 1925- *AmArch 70*
Pharr, Walter Nelson 1906- *WhoAmA 73, −76, −78, −80*
Pharr, Mrs. Walter Nelson 1923- *WhoAmA 73, −76, −78, −80*
Pheidias *MacEA, McGDA*
Phelan, Andrew L 1943- *WhoAmA 84*
Phelan, Andrew L 1945- *WhoAmA 82*
Phelan, Charles T 1840- *NewYHSD*
Phelan, Ellen Denise 1943- *WhoAmA 84*
Phelan, Harold L 1881- *WhAmArt 85*
Phelan, J Gerald 1893- *AmArch 70*
Phelan, Joseph *IlsBYP*
Phelan, Linn Lovejoy 1906- *WhAmArt 85, WhoAmA 73, −76, −78, −80, −82, −84*
Phelen, James *FolkA 86*
Phelips, Emily Bancroft 1869- *DcWomA, WhAmArt 85*
Phelps, Adele C *WhAmArt 85*
Phelps, Albert Charles 1873-1937 *BiDAmAr*
Phelps, Carl *OfPGCP 86*
Phelps, Dorothy *WhAmArt 85*
Phelps, E *NewYHSD*
Phelps, Edith Catlin 1875-1961 *ArtsAmW 1, DcWomA, WhAmArt 85, WhoAmA 80N, −82N, −84N*
Phelps, Elijah 1761-1842 *FolkA 86*
Phelps, Eliza Henriette *DcWomA*
Phelps, H G *FolkA 86*
Phelps, Helen Watson 1859?-1944 *DcWomA*
Phelps, Helen Watson 1864-1944 *WhAmArt 85*
Phelps, Marie Louise *ArtsEM, DcWomA*
Phelps, Mary C 1833?-1899 *ArtsEM, DcWomA*
Phelps, Millicent *DcVicP 2*
Phelps, Nan Dee *WhoAmA 73, −76, −78, −80, −82, −84*
Phelps, Nan Dee 1904- *AmArt*
Phelps, Nathaniel 1721-1789 *FolkA 86*
Phelps, R, Jr. *AmArch 70*
Phelps, Richard 1710?-1785 *DcBrECP*
Phelps, Robert 1806-1890 *DcBrWA*
Phelps, Rosemarie Beck *WhoAmA 78, −80, −84*
Phelps, Sophia Throop 1875- *DcWomA, WhAmArt 85*
Phelps, Timothy 1702-1756 *CabMA*
Phelps, Timothy, Jr. 1725?-1784 *CabMA*
Phelps, W *AntBDN O*
Phelps, W Hal 1908- *AmArch 70*
Phelps, W P *ArtsNiC*
Phelps, W P 1848- *WhAmArt 85*
Phelps, William Abner 1929- *AmArch 70*
Phelps And Cary *EncASM*
Pheney, Richard *DcVicP 2*
Phenix, John Russell 1926- *AmArch 70*
Phenix, V D *AmArch 70*
Phenstein, W A *FolkA 86*
Phidias *McGDA, OxArt*
Philander, Guillaume 1505- *MacEA*
Philbin, Clara *DcWomA, WhAmArt 85*
Philbrick, Allen Erskine 1879- *WhAmArt 85*
Philbrick, Jane W 1911- *WhAmArt 85*
Philbrick, Margaret Elder 1914- *WhAmArt 85, WhoAmA 73, −76, −78, −80, −82, −84*
Philbrick, Mary *DcWomA, WhAmArt 85*
Philbrick, Otis 1888- *WhoAmA 73*
Philbrick, Otis 1888-1973 *WhAmArt 85, WhoAmA 76N, −78N, −80N, −82N, −84N*
Philbrick, Stacey *IlBEAAW*
Phile, Thomas *EncASM*
Philibert DeL'Orme *McGDA*
Philibert, T H, Jr. *AmArch 70*
Philip Neri, Saint 1515-1595 *McGDA*
Philip Of Burgundy *McGDA*
Philip, Saint *McGDA*
Philip, Constance B *DcVicP, −2, DcWomA*
Philip, Frederick William 1814-1841 *NewYHSD*
Philip, Genevieve Albertine *DcWomA*
Philip, James Henry 1946- *MarqDCG 84*
Philip, Lotte Brand 1910- *WhoAmA 80, 82, −84*
Philip, William H *NewYHSD*
Philipault, Julie 1780-1834 *DcWomA*
Philipon, Mademoiselle *DcWomA*
Philipon, Charles 1806-1862 *WorECar*
Philipp, Johanna Dorothea *DcWomA*
Philipp, K B *AmArch 70*
Philipp, Mrs. M Bernard *WhAmArt 85*
Philipp, Robert 1895- *WhoAmA 73, −76, −78, −80*
Philipp, Robert 1895-1981 *WhAmArt 85, WhoAmA 82N, −84N*
Philipp, Werner 1897-1982 *ArtsAmW 3*
Philippa Dona *DcWomA*
Philippain, Marie Elisabeth Ernestine *DcWomA*
Philippar-Quinet, Jeanne Charlotte *DcWomA*
Philippi, R C *AmArch 70*
Philippon, Augustine *DcWomA*
Philippoteaux, Felix-Emmanuel-Henri 1815- *ArtsNiC*
Philippoteaux, Henri Felix Emmanuel 1815-1884 *ClaDrA*

Philippoteaux, Paul Dominick 1846- *NewYHSD*
Philippovich, Hanna Von 1890- *DcWomA*
Philippson, Madame *DcWomA*
Philippson, Clara *DcWomA*
Philippson, Franz, Madame *DcWomA*
Philips *NewYHSD*
Philips, Anna Elisabeth 1758?- *DcWomA*
Philips, Charles 1708-1747 *DcBrECP*
Philips, Chester Hoen 1915- *AmArch 70*
Philips, Emily *WhAmArt 85*
Philips, J *AmArch 70*
Philips, John *DcBrBI*
Philips, Katherine Elisabeth *DcWomA*
Philips, Katherine Elizabeth *WhAmArt 85*
Philips, Margaretha Elisabeth *DcWomA*
Philips, Marie *DcWomA*
Philips, Nathaniel George 1795-1831 *DcBrBI, DcBrWA*
Philips, Richard 1681?-1741 *DcBrECP*
Philips, Solomon Alexander 1822-1909 *FolkA 86*
Philipse, Margaret G *WhAmArt 85*
Philipse, Margaret Gouverneur *DcWomA*
Philipse, Mary 1730-1825 *DcWomA, NewYHSD*
Philipsen, Sally Nikolaj 1879- *DcWomA*
Philipson, Robin 1916- *OxTwCA, PhDcTCA 77, WhoArt 80, −82*
Philipson, Sir Robin 1916- *WhoArt 84*
Philipson, Robin J 1916- *DcBrA 1*
Philipson, Steven H 1957- *MarqDCG 84*
Phillene, Ferdinand J *NewYHSD*
Philles *FolkA 86*
Phillian, Harry Edgar 1914- *AmArch 70*
Philliban, Patrick James 1933- *MarqDCG 84*
Phillibrowne, Thomas *NewYHSD*
Phillimore, Lady *DcVicP 2*
Phillimore, B J *DcVicP 2*
Phillimore, C *DcBrECP*
Phillimore, G *DcVicP 2*
Phillimore, Reginald 1855- *DcBrA 1*
Phillimore, Reginald P 1855- *DcVicP 2*
Phillip, Albert 1915- *DcBrA 1, WhoArt 80, −82, −84*
Phillip, Colin Bent 1855-1932 *DcBrA 1, DcBrWA, DcVicP, −2*
Phillip, H *AmArch 70*
Phillip, John 1817-1867 *ArtsNiC, ClaDrA, DcVicP, −2, OxArt*
Phillip, John Spanish 1817-1867 *DcBrWA*
Phillips, John 1892- *AfroAA*
Phillipp, J P *DcVicP 2*
Phillipps, Henry G Peter 1933- *AmArch 70*
Phillips *EncASM, NewYHSD*
Phillips, Mrs. *NewYHSD*
Phillips, A M *DcVicP 2*
Phillips, Abraham *WhAmArt 85*
Phillips, Agda *WhAmArt 85*
Phillips, Alan 1922- *WorFshn*
Phillips, Alfred *DcVicP 2*
Phillips, Alice Jane 1947- *WhoAmA 84*
Phillips, Alvin Turtel *AfroAA*
Phillips, Ambrose 1707?-1737 *BiDBrA*
Phillips, Amelia Mary *DcWomA*
Phillips, Ammi 1787?-1865 *NewYHSD*
Phillips, Ammi 1788-1865 *AmFkP, BnEnAmA, DcAmArt, FolkA 86*
Phillips, Anne-Catherine *DcCAr 81*
Phillips, Arthur *DcVicP 2*
Phillips, Aubrey 1920- *WhoArt 82, −84*
Phillips, Aubrey R 1920- *DcBrA 1*
Phillips, Benjamin R *NewYHSD*
Phillips, Bert Greer 1868-1956 *ArtsAmW 1, IlBEAAW, WhAmArt 85*
Phillips, Bertrand D 1938- *AfroAA, WhoAmA 76, −78, −80, −82, −84*
Phillips, Blackburne *DcVicP 2*
Phillips, Bonnie 1942- *WhoAmA 78, −80, −82, −84*
Phillips, C Edward 1939- *AmArch 70*
Phillips, Caroline A *ArtsEM, DcWomA*
Phillips, Caroline King *DcWomA, WhAmArt 85*
Phillips, Charles *NewYHSD*
Phillips, Charles Bannerman 1848-1931 *DcBrA 1, DcVicP 2*
Phillips, Charles C *NewYHSD*
Phillips, Charles Gustav Louis 1863-1944 *DcBrWA, DcVicP 2*
Phillips, Charles Gustave Louis 1863- *ClaDrA*
Phillips, Claire Donner 1887- *WhAmArt 85*
Phillips, Claire Dooner 1887- *ArtsAmW 1, DcWomA, IlBEAAW*
Phillips, Clarence Coles 1880-1927 *WhAmArt 85, WorECar*
Phillips, Clarence William 1919- *AmArch 70*
Phillips, Coles 1880-1927 *IlrAm B, −1880*
Phillips, Corley Melvin 1954- *MarqDCG 84*
Phillips, D F *AmArch 70*
Phillips, Deborah Joan 1953- *MarqDCG 84*
Phillips, Delos *ArtsEM*
Phillips, Dick 1933- *WhoAmA 82, −84*
Phillips, Donald John 1930- *AmArch 70*
Phillips, Donald L 1937- *MarqDCG 84*
Phillips, Donna-Lee 1941- *WhoAmA 78, −80, −82*
Phillips, Doris 1921- *WhoArt 82, −84*

Pierie, William *DcBrECP, NewYHSD*
Pierik, P G *AmArch 70*
Pieris, Justin *OxTwCA*
Pierluca 1926- *PhDcTCA 77*
Piermarini, Giuseppe 1734-1808 *MacEA, McGDA*
Piero D'Antonio Dei *McGDA*
Piero D'Arrigo Tedesco *McGDA*
Piero Dei Franceschi 1410-1492 *OxArt*
Piero Della Francesca 1410?-1492 *McGDA, OxArt*
Piero Di Cosimo 1462-1521 *McGDA*
Piero Di Cosimo 1462?-1521? *OxArt*
Piero DiGiovanni *McGDA*
Piero, Dimitri 1933- *WorFshn*
Pieron, Gustave Louis Marie 1824-1864 *ClaDrA*
Pierotti, John *WhoAmA 73, –76, –78, –80, –82, –84*
Pierotti, John 1911- *WorECar*
Pierotti, Ray 1932- *WhoAmA 84*
Pierpont, Miss *AntBDN E*
Pierpont, Clarence S *WhAmArt 85*
Pierpont De, Benoit 1937- *WhoGrA 82[port]*
Pierre DeMontereau *McGDA*
Pierre, Caroline *DcWomA*
Pierre, Dieudonne 1807-1838 *ClaDrA*
Pierre, E D *AmArch 70*
Pierre, F J *FolkA 86*
Pierre, Francois *AntBDN H*
Pierre, Gustave Rene 1875- *ClaDrA*
Pierre, Jean Baptiste Marie 1713-1789 *ClaDrA*
Pierre, Mathilde Henriette Juliette M *DcWomA*
Pierre, Philip Leo *AfroAA*
Pierre-Noel, Lois Jones 1905- *WhoAmA 73*
Pierre-Noel, Lois Mailou Jones *AfroAA*
Pierre-Noel, Vergniaud 1910- *WhoAmA 76, –78, –80, –82, –84*
Pierredou, Francoise Jacqueline Louise *DcWomA*
Pierrepont, C Constance *DcBrWA, DcVicP 2, DcWomA*
Pierret, Esther *DcWomA*
Pierret, Gabrielle *DcWomA*
Pierret, Victor-Athanase 1806-1893 *DcNiCA*
Pierrie, William *NewYHSD*
Pierron, Blanche Pauline Virginie *DcWomA*
Pierron, Gerald Paul 1934- *AmArch 70*
Pierron, John 1934- *WhoAmA 76*
Piers, Elizabeth *DcWomA*
Piers, John Leslie 1922- *AmArch 70*
Pierson, Alden 1874-1921 *WhAmArt 85*
Pierson, Andrew *FolkA 86*
Pierson, Blanche Adeline *DcWomA*
Pierson, Elizabeth G *WhAmArt 85*
Pierson, J A *DcWomA*
Pierson, Mrs. J A *ArtsEM*
Pierson, John *FolkA 86*
Pierson, John C *WhAmArt 85*
Pierson, Mrs. John C *WhAmArt 85*
Pierson, Lucius S *ArtsEM*
Pierson, Lydia Jane *DcWomA*
Pierson, Martha *FolkA 86*
Pierson, N *WhAmArt 85*
Pierson, Paul R B *NewYHSD*
Pierson, Paul Sanford, Jr. 1928- *AmArch 70*
Pierson, R D *AmArch 70*
Pierson, Rosalind 1954- *WhoArt 84*
Pierson, Rosalind Elizabeth 1954- *WhoArt 80, –82*
Pierson, Sarah *DcWomA, NewYHSD*
Pierson, Susan E *DcWomA, WhAmArt 85*
Pierson, W, Jr. *AmArch 70*
Piet, Frans 1905- *WorECom*
Piet, John Frances 1946- *WhoAmA 82, –84*
Pieter, Toert 1856- *ClaDrA*
Pieters, Geertje *DcWomA*
Pieters, Jan 1667?-1727 *DcBrECP*
Pietersen, Jacqueline *DcBrA 2*
Pietersz, Aert 1550?-1612 *ClaDrA*
Pietersz, Bertus 1869-1938 *WhAmArt 85*
Pietersz, Gerrit *McGDA*
Pietersz, John C *WhAmArt 85*
Pietierre, P *ArtsAmW 3*
Pietila, Reima 1923- *ConArch, MacEA*
Pietra, Lucrezia *DcWomA*
Pietra, Angelo 1836-1876 *ArtsNiC*
Pietrasanta, Angelo 1836-1876 *ArtsNiC*
Pietrasanta, Jacopo Da d1495? *MacEA*
Pietre, Henri 1725?-1790? *MacEA*
Pietre, Nanine *DcWomA*
Pietro DaBarga *McGDA*
Pietro DaCortona *McGDA*
Pietro DiDomenico 1457-1533? *McGDA*
Pietro DiDomenico DaMontepulciano *McGDA*
Pietro DiGiovanni DiAmbrogio 1410-1449 *McGDA*
Pietro, Cartaino DiSciarrino 1886-1918 *WhAmArt 85*
Pietro, Cecco Di *McGDA*
Pietro, Giovanni Di *McGDA*
Pietro, Niccolo Di *McGDA*
Pietro, Mrs. S C *WhAmArt 85*
Pietro D'Angelo, Jacopo Di *OxArt*
Pietrodangelo, Donato A 1950- *MacBEP*
Pietrolungo, Herman George 1921- *AmArch 70*
Pietsch, Heinz Dieter 1944- *DcCAr 81*
Pietsch, Theodore W 1868-1930 *BiDAmAr*
Pietz, Adam 1873- *WhAmArt 85*

Pifer, William *FolkA 86*
Piffard, Harold H *DcBrBI, DcVicP 2*
Piffard, Jeanne 1892- *DcWomA*
Piffarerio, Paolo 1924- *WorECar*
Piffete, Pietro 1700?-1777 *AntBDN G*
Piffetti, Pietro 1700-1777 *OxDecA*
Pigage, Nicolas De 1723-1796 *MacEA*
Pigal *NewYHSD*
Pigal, Edme Jean 1798-1872 *ClaDrA*
Pigalle *NewYHSD*
Pigalle, Jean-Baptiste 1714-1785 *McGDA, OxArt*
Pigalle, Madeleine Elisabeth 1751-1827 *DcWomA*
Pigatt, Anderson J 1928- *AfroAA*
Pigault, C *DcWomA*
Pigault, Marie Celestine *DcWomA*
Pigeon, Laure 1882-1965 *DcWomA*
Piggot, Robert 1795-1887 *NewYHSD*
Piggott, Arabella Elizabeth *DcWomA*
Piggott, John *DcVicP 2*
Pigott, Charles *DcBrWA, DcVicP 2*
Pigott, Miss *DcWomA*
Pigott, Frank E *WhAmArt 85*
Pigott, Marjorie *WhoAmA 76, –78, –80, –82, –84*
Pigott, R E *AmArch 70*
Pigott, W H 1810?-1901 *DcBrWA, DcVicP 2*
Pigozzi, Raymond A 1928- *AmArch 70*
Piguet, Robert 1901-1953 *WorFshn*
Pijanowski, Eugene 1938- *DcCAr 81*
Pijanowski, Eugene M 1938- *WhoAmA 78, –80, –82, –84*
Pijanowski, Hiroko Sato 1942- *DcCAr 81, WhoAmA 78*
Pijeaud, Claire Julienne *DcWomA*
Pijnacker, Adam 1622?-1673 *McGDA*
Pijnas, Jacob Symonsz d1648? *McGDA*
Pijnas, Jan 1583?-1631 *McGDA*
Pijuan, Hernandez 1931- *ConArt 77*
Pike, A G *DcVicP 2, DcWomA*
Pike, Alice *DcWomA*
Pike, Charles J *WhAmArt 85*
Pike, Clement E *DcVicP 2*
Pike, Gordon B 1865-1925 *BiDAmAr*
Pike, Harriet A *WhAmArt 85*
Pike, John 1911- *IlrAm E, WhAmArt 85, WhoAmA 73, –76, –78, –80*
Pike, John 1911-1979 *IlrAm 1880, WhoAmA 82N, –84N*
Pike, Joseph *DcVicP 2, NewYHSD*
Pike, Joseph 1883- *ClaDrA, DcBrA 1*
Pike, Leonard 1887- *ClaDrA*
Pike, Leonard 1887-1959 *DcBrA 1*
Pike, Lloyd LeRaine 1892- *AmArch 70*
Pike, Mary H *DcWomA*
Pike, N H *DcVicP 2*
Pike, Olive *DcBrA 1, DcWomA*
Pike, Oliver Gregory 1877-1963 *MacBEP*
Pike, S *EarABI, NewYHSD*
Pike, Sidney *DcBrA 1, DcBrWA, DcVicP, –2*
Pike, W H 1846- *DcBrA 2, DcVicP*
Pike, W H 1846-1908 *DcBrBI*
Pike, William Henry 1846-1908 *DcBrWA, DcVicP 2*
Pikionis, D A 1887-1968 *MacEA*
Pikionis, Dimitris A 1887-1968 *ConArch*
Pilafian, Suren 1910- *AmArch 70*
Piland, Robert Stanley, Jr. 1932- *AmArch 70*
Piland, Vollie Mathis 1927- *AmArch 70*
Pilar, Ricardo De d1700 *McGDA*
Pilavin, Selma F 1908- *WhoAmA 76, –78, –80, –82, –84*
Pilawski, Wieslaw 1916- *ClaDrA, DcBrA 1*
Pilbrow, Edward *NewYHSD*
Pilchard, J *DcVicP 2*
Pilcher, Cecil Westland 1870-1943 *DcBrA 1*
Pilcher, Charles Westland 1870-1943 *DcVicP 2*
Pilcher, J V *EncASM*
Pilcher, Lewis F 1871-1941 *BiDAmAr, MacEA*
Pilcher, Thomas Dodson 1908- *DcBrA 1*
Pildas, Ave Earl 1939- *MacBEP*
Pile, Albert Thomas *WhoArt 82N*
Pile, Albert Thomas 1882- *DcBrA 1, WhoArt 80*
Pile, John *FolkA 86*
Pilet, Berthe *DcWomA*
Pilgram, Anton 1455?-1515 *MacEA*
Pilgram, Anton 1460?-1515 *McGDA*
Pilgram, Regina Katharina *DcWomA*
Pilgram, Sophie *DcWomA*
Pilgrim, Dianne H 1941- *WhoAmA 80, –82, –84*
Pilgrim, Herbert Francis 1915- *ClaDrA*
Pilgrim, James *NewYHSD*
Pilgrim, James F 1941- *WhoAmA 76, –78, –80, –82, –84*
Pilie, J *NewYHSD*
Pilkington, Adam d1856 *FolkA 86*
Pilkington, Adam 1810-1856 *NewYHSD*
Pilkington, E E *AmArch 70*

Pilkington, F M M *DcVicP 2*
Pilkington, F T 1832-1898 *MacEA*
Pilkington, Flora *DcBrA 1, DcWomA*
Pilkington, H *DcVicP, –2*
Pilkington, James E *NewYHSD*
Pilkington, Margaret 1891-1974 *DcWomA*
Pilkington, Maud E *DcWomA*
Pilkington, Redmond William 1789-1844 *BiDBrA*
Pilkington, Richard Godfrey 1918- *WhoArt 80, –82, –84*
Pilkington, Robert W 1765-1834 *DcBrBI, DcBrWA*
Pilkington, Ruth Jane 1924- *WhoArt 82, –84*
Pilkington, Sydney d1905 *DcBrA 2*
Pilkington, Thomas 1862- *DcVicP 2*
Pilkington, William 1758-1848 *BiDBrA, MacEA*
Pilkington Brothers *IlDcG*
Pilkinton, Thomas 1862- *DcBrWA*
Pill, Martha *DcVicP 2*
Pillars, Charles Adrian 1870-1937 *WhAmArt 85*
Pillars, Murray De *AfroAA*
Pillaut, Claire *DcWomA*
Pillaut, Rosalie *DcWomA*
Pille, Henri *ArtsNiC*
Pille, William *DcVicP 2*
Pilleau, F Startin *DcVicP 2*
Pilleau, G *DcVicP 2*
Pilleau, H E *DcVicP 2*
Pilleau, Henry 1813-1899 *DcBrWA, DcVicP, –2*
Pilleau, Henry 1815-1899 *ClaDrA*
Pillement, Adele *DcWomA*
Pillement, Anne *DcWomA*
Pillement, Jean 1728-1805 *ClaDrA*
Pillement, Jean Baptiste 1727-1808 *OxArt*
Pillement, Jean-Baptiste 1727-1808 *OxDecA*
Pillement, Jean-Baptiste 1728-1808 *DcBrECP, McGDA*
Pillement, Jean Baptiste 1728-1808 *DcSeaP*
Pillemont, Jean *AntBDN M*
Pillert, Edward Joseph 1928- *AmArch 70*
Pillet, Edgard 1912- *OxTwCA, PhDcTCA 77*
Pillet, Michel Louis 1926- *WhoAmA 80, –82, –84*
Pilley, Vivien 1907- *WhoArt 80, –82*
Pillhofer, Josef 1921- *OxTwCA*
Pillin, Polia 1905- *WhAmArt 85*
Pillin, Polia 1909- *WhoAmA 78, –80, –82, –84*
Pilliner, C A *FolkA 86, NewYHSD*
Pilliner, Frederick J *NewYHSD*
Pilling, Keith *DcCAr 81*
Pillini, Marguerite *DcWomA*
Pillitz, Hedwig Esther *DcBrA 1*
Pillner, George *NewYHSD*
Pillorge, George John 1937- *AmArch 70*
Pillot, C *DcWomA*
Pillow, George *NewYHSD*
Pillow, Lorna Mary Carol *WhoArt 80, –82, –84*
Pillsbury, Arthur L 1869-1925 *BiDAmAr*
Pillsbury, C F *AmArch 70*
Pillsbury, Charles Francis, Jr. 1899- *AmArch 70*
Pillsbury, Mary *DcWomA*
Pillsbury, Tom G 1915?- *IlBEAAW*
Pilo, Carl Gustaf 1711-1793 *McGDA, OxArt*
Pilolla, N A, Jr. *AmArch 70*
Pilon 1850- *DcWomA*
Pilon, E Agathe *DcWomA*
Pilon, Germain 1530?-1590 *McGDA*
Pilon, Germain 1537-1590 *OxArt*
Pilotelle, Georges *DcBrBI*
Piloto, Il *McGDA*
Piloty, Carl 1826-1886 *WhAmArt 85A*
Piloty, Carl Theodor Von 1826- *ArtsNiC*
Piloty, Karl 1826-1886 *OxArt*
Piloty, Karl Von 1826-1886 *McGDA*
Pils, Isidore Alexandre Augustin 1813-1875 *ArtsNiC, ClaDrA*
Pils, Robert Bruce 1925- *AmArch 70*
Pilsbury, Elizabeth *DcVicP 2, DcWomA*
Pilsbury, Emma J *DcWomA, WhAmArt 85*
Pilsbury, Harry Clifford 1870- *DcBrA 1, DcBrWA, DcVicP 2*
Pilsbury, Wilmot 1840-1908 *DcBrA 1, DcBrWA, DcVicP, –2*
Pilsen, Frans 1700-1784 *ClaDrA*
Pilsk, Adele Inez 1937- *WhoAmA 78, –80, –82, –84*
Pilvelis, Algirdas 1944- *ICPEnP A*
Pilz, Vincenz 1819- *ArtsNiC*
Pim, William Paul 1885- *WhAmArt 85*
Pimat, P Mignon *FolkA 86, NewYHSD*
Pimenov, Yurii *OxTwCA*
Pimenta Cardote, Ignacia *DcWomA*
Pimentel, David Delbert 1943- *WhoAmA 80, –82, –84*
Pimentel, F *AmArch 70*
Pimley, Samuel *AntBDN N*
Pimlott, E Philip *DcBrBI, DcVicP 2*
Pimlott, John 1905- *DcBrA 1*
Pimlott, Philip *DcBrA 1*
Pimm, Arthur 1921- *AmArch 70*
Pimm, John *CabMA*
Pimm, Joseph Frank 1900- *ClaDrA, DcBrA 1*
Pimm, William Edwin *DcVicP 2*
Pimper, Jeffrey E 1946- *MarqDCG 84*
Pin, Armande *DcWomA*

Pina, Evelio Oscar 1928- *AmArch 70*
Pinacci, Eleonora *DcWomA*
Pinard-Viteau, Isabelle *DcWomA*
Pinardi, Enrico Vittorio 1934- *WhoAmA 73, –76, –78, –80, –82, –84*
Pinart, Robert 1927- *DcCAr 81*
Pinat, Madeleine *DcWomA*
Pinault, Louis C 1889- *AmArch 70*
Pincas, Julius 1885-1930 *WorECar*
Pinch, John 1770?-1827 *BiDBrA, MacEA*
Pinch, John, Jr. d1849 *BiDBrA*
Pinchas, Julius *OxTwCA*
Pinchbeck, Christopher 1670-1732 *AntBDN D*
Pinchbeck, Peter *DcCAr 81*
Pinchbeck, Peter 1940- *AmArt*
Pinchbeck, Peter G 1940- *WhoAmA 82, –84*
Pinches, John Robert 1885- *DcBrA 1*
Pinchon, Jean-Pierre 1871-1953 *WorECom*
Pinckard, Nathaniel *FolkA 86*
Pinckney, John Adams, Jr. 1936- *AmArch 70*
Pinckney, Stanley 1940- *AfroAA, WhoAmA 78, –80, –82, –84*
Pincott, W H *DcVicP 2*
Pincour, Marie 1876-1971 *DcWomA*
Pincovitz, H A *WhAmArt 85*
Pincus, David N *WhoAmA 84*
Pincus, Harriet *IlsBYP, IlsCB 1967*
Pincus, Robert L 1953- *WhoAmA 84*
Pincus-Witten, Robert A 1935- *WhoAmA 73, –76, –78, –80, –82, –84*
Pindell, Howardena *DcCAr 81*
Pindell, Howardena 1943- *AfroAA, ConArt 77*
Pindell, Howardena Doreen 1943- *WhoAmA 73, –76, –78, –80, –82, –84*
Pinder, John Michael 1948- *WhoArt 80, –82, –84*
Pinder Bourne & Co. *DcNiCA*
Pine, Diana *WhoArt 82, –84*
Pine, Diana 1915- *WhoArt 80*
Pine, Geri 1914- *WhAmArt 85*
Pine, J *DcWomA*
Pine, James *NewYHSD*
Pine, John 1690-1756 *BkIE, McGDA*
Pine, Robert Edge *FolkA 86*
Pine, Robert Edge 1730?-1788 *BnEnAmA, DcAmArt, DcBrECP, NewYHSD*
Pine, Robert Edge 1742-1788 *ClaDrA*
Pine, S H *AmArch 70*
Pine, Simon d1772 *DcBrECP*
Pine, Theodore E 1828-1905 *NewYHSD, WhAmArt 85*
Pineau, Jean-Baptiste d1694 *OxArt, OxDecA*
Pineau, Nicholas 1684-1754 *McGDA*
Pineau, Nicholas *AntBDN G*
Pineau, Nicolas 1684-1754 *MacEA, OxArt, OxDecA*
Pineda, Marianna 1925- *DcCAA 71, –77, WhoAmA 73, –76, –78, –82, –84*
Pinegar, W L *AmArch 70*
Pinel, Anna *DcWomA*
Pineles, Cipe 1908- *WhAmArt 85*
Pineles, Cipe 1910- *ConDes*
Pinell, Broucia *DcWomA*
Pinelli, Antonia *DcWomA*
Pines, Ned L 1905- *WhoAmA 73, –76, –78, –80, –82, –84*
Pines DeMerbity, Marguerite *DcWomA*
Pines DeMerbitz, Marguerite *DcWomA*
Pingenet, Cleopha Dosithee *DcWomA*
Pingo, Henry *DcBrECP*
Pingree, E A *DcWomA*
Pingusson, Georges Henri 1894- *MacEA*
Pinhey, Mrs. Robert Spottiswoode d1931 *DcWomA, WhAmArt 85*
Pini, Wendy 1951- *ConGrA 1[port]*
Pink, Harry *WhAmArt 85*
Pink, Marilyn Overman *WhoAmA 80, –82, –84*
Pink, Paul Markus 1933- *AmArch 70*
Pinka, E J *AmArch 70*
Pinkel, Sheila 1941- *MacBEP*
Pinkel, Sheila Mae 1941- *WhoAmA 82, –84*
Pinkerton, Clayton 1931- *ConArt 77, WhoAmA 73, –76, –78, –80, –82, –84*
Pinkerton, E J *EarABI, NewYHSD*
Pinkerton, Harriet Jane 1852-1936 *DcWomA*
Pinkerton, Robert Short 1915- *AmArch 70*
Pinkerton, W E *DcVicP 2*
Pinkey, Helen Louise *WhoAmA 73*
Pinkham, Marjorie Stafford 1909- *WhAmArt 85*
Pinkney, Edward J *NewYHSD*
Pinkney, Helen Louise *WhoAmA 76, –78, –80, –82, –84*
Pinkney, Jerry *IlsCB 1967*
Pinkney, Jerry 1939- *AfroAA, IlrAm 1880, IlsCB 1957*
Pinkney, Samuel J *NewYHSD*
Pinkowski, Emily Joan *WhoAmA 73, –76, –78, –80*
Pinks, G A *WhoArt 80N*
Pinks, Miss G A 1890- *DcBrA 1*
Pinks, Gladys A 1890- *DcWomA*
Pinkston, Margaret Evelyn 1923- *AmArch 70*
Pinkwart, Gertrud 1883- *DcWomA*
Pinnell, Vesta Paige, Jr. 1944- *MacBEP*

Pinnell, Virgil A 1923- *AmArch 70*
Pinner, Erna 1893- *DcWomA*
Pinner, Philip 1910- *WhAmArt 85*
Pinney, Clifford Jene 1946- *MarqDCG 84*
Pinney, Eunice 1770-1849 *AmFkP, DcAmArt, DcWomA, WomArt*
Pinney, Eunice Griswold 1770-1849 *BnEnAmA, NewYHSD*
Pinney, Eunice Griswold Holcombe 1770-1849 *FolkA 86*
Pinney, Gould *FolkA 86*
Pinney, N J *AmArch 70*
Pinney, Olga Geneva *DcWomA*
Pinniger, Abigail 1715-1919 *FolkA 86*
Pinnington, Jane 1896?- *ArtsAmW 2, DcWomA*
Pino, Marco Dal *McGDA*
Pinoff, Marie Elisabeth 1853- *DcWomA*
Pinoli, Signor A *NewYHSD*
Pinoni, Edward A 1932- *AmArch 70*
Pinot, Jeanne B *DcWomA*
Pinschewer, Julius 1883-1961 *WorECar*
Pinsker, J Marcus 1906- *AmArch 70*
Pinsky, Alfred 1921- *WhoAmA 73, –76, –78, –80, –82*
Pinsky, Alfred 1924- *DcCAr 81*
Pinsley, A *DcVicP 2*
Pinson, Isabelle *DcWomA*
Pinson, Nicolas 1640- *ClaDrA*
Pinson, Solomon M *WhAmArt 85*
Pinsonault, L *FolkA 86*
Pint, Joseph *NewYHSD*
Pinter, Ferenc 1931- *WhoGrA 82[port]*
Pinti Zambrini, Enedina 1884- *DcWomA*
Pintner, Dora *WhAmArt 85*
Pinto, Angelo 1908- *WhAmArt 85*
Pinto, Angelo Raphael 1908- *WhoAmA 76, –78, –80, –82, –84*
Pinto, Biagio 1911- *WhAmArt 85, WhoAmA 76, –78, –80, –82, –84*
Pinto, Hilton Silveira 1942- *MarqDCG 84*
Pinto, J J DeSouza *DcVicP 2*
Pinto, James 1907- *WhoAmA 73, –76, –78, –80, –82, –84*
Pinto, Jody 1942- *AmArt, WhoAmA 80, –82, –84*
Pinto, Ralph *IlsBYP*
Pinto, Salvatore 1905- *WhAmArt 85*
Pinto, Ziraldo Alves 1932- *WorECar*
Pinto-Sezzi, Ida *DcWomA*
Pintoff, Ernest 1931- *WorECar*
Pintori, Giovanni 1912- *ConDes, WhoGrA 62*
Pintoricchio, Bernardino DiBetto 1454?-1513 *OxArt*
Pinturicchio, Il 1454?-1513 *McGDA*
Pinturicchio, Bernardino DiBetto 1454?-1513 *OxArt*
Pinwell, George John 1842-1875 *AntBDN B, ArtsNiC, ClaDrA, DcBrBI, DcBrWA, DcVicP, –2, McGDA*
Pinzarrone, Paul 1951- *AmArt, WhoAmA 78, –80, –82, –84*
Pinzarrone, Paul Frank 1951- *WhoAmA 76*
Pio, A *DcVicP 2*
Pio, Angelo Gabriello 1690-1770 *McGDA*
Pioch, A C *AmArch 70*
Piola, Domenico 1627-1703 *ClaDrA*
Piola, Domenico 1627-1708 *McGDA*
Piola, Margherita *DcWomA*
Piola, Maria *DcWomA*
Piola, Pellegro 1617-1640 *McGDA*
Piombo, Fra Guglielmo Del *McGDA*
Piombo, Sebastiano *ClaDrA*
Piombo, Sebastiano Del *McGDA*
Piore, E R 1908- *MarqDCG 84*
Piot, Jeanne Adele *DcWomA*
Piot, Rene 1869-1934 *ClaDrA*
Piotrkowczykowna, Agnes *DcWomA*
Piotrowska, Irena Glebocka 1904- *WhAmArt 85*
Piotrowski, Antoine 1853-1924 *DcBrBI*
Piotti, Vittorio 1935- *WhoArt 84*
Piotti-Pirola, Caterina 1800- *DcWomA*
Pious, Robert Savon 1908- *AfroAA*
Pipart, Gerard *FairDF FRA*
Pipart, Gerard 1933- *WorFshn*
Piper, Charles B 1951- *MarqDCG 84*
Piper, Elizabeth *ClaDrA, DcBrA 1, DcVicP 2, DcWomA*
Piper, Fredrik Magnus 1746-1824 *MacEA*
Piper, George H *WhAmArt 85*
Piper, Herbert William *DcVicP, –2*
Piper, James Dickinson 1912- *AmArch 70*
Piper, Jane 1916- *WhoAmA 82, –84*
Piper, John 1903- *ClaDrA, ConArt 77, –83, ConBrA 79[port], DcBrA 1, DcCAr 81, McGDA, OxArt, PhDcTCA 77, WhoArt 80, –82, –84, WorArt[port]*
Piper, John C *FolkA 86*
Piper, John Egerton Christmas 1903- *OxTwCA*
Piper, L A *DcWomA*
Piper, Natt 1886- *ArtsAmW 2, WhAmArt 85*
Piper, Robert Johnston 1926- *AmArch 70*
Piper, Rose *AfroAA*
Piper, Timothy Sheldon 1957- *MarqDCG 84*
Piper, Tom 1942- *DcCAr 81*
Piper, Van D *WhAmArt 85*

Piper, William W 1827?-1886 *MacEA*
Pipka, Stephen 1916- *AmArch 70*
Pipon, Steve George, Jr. 1933- *AmArch 70*
Pippenger, Robert 1912- *WhAmArt 85*
Pippet, Gabriel Joseph 1880- *IlsCB 1744*
Pippin, Horace 1888-1946 *AfroAA, AmFkP[port], DcAmArt, FolkA 86, WhAmArt 85*
Pippin, Horace 1888-1947 *OxTwCA*
Pippin, Paul W T 1912- *AmArch 70*
Pippin, Wayne Gordon 1920- *AmArch 70*
Pipping, Augusta 1829-1919 *DcWomA*
Pique, H E *AmArch 70*
Piquenard, Alfred H d1876 *BiDAmAr*
Piquenard, Alfred H 1826?-1876 *MacEA*
Piquer, Jose 1806-1871 *McGDA*
Piquet, M S *WhAmArt 85*
Piquet, Robert 1901-1953 *FairDF FRA*
Piramowicz, Sophie *DcWomA*
Pirandello, Fausto 1899- *PhDcTCA 77*
Piranesi, Francesco 1758-1810 *MacEA*
Piranesi, Giovanni Battista 1720-1778 *AntBDN G, DcD&D, MacEA, McGDA, OxArt, WhoArch*
Piranesi, Laura 1755?-1785 *DcWomA*
Pirie, Sir George 1863-1946 *DcBrA 1, DcVicP 2*
Pirih Hup, Dusan 1952- *DcCAr 81*
Pirkis *DcBrBI*
Pirkl, James Joseph 1930- *WhoAmA 76, –78, –80, –82, –84*
Pirnot, Thomas L 1943- *MarqDCG 84*
Piron, Valerie d1909 *DcWomA*
Pirosmanashvili, Niko 1863-1918 *OxTwCA*
Pirotte, Julia 1911- *ICPEnP A*
Pirotte, Pete Michael 1918- *AmArch 70*
Pirrie, Kenneth *WorFshn*
Pirroli *NewYHSD*
Pirrson, James W *NewYHSD*
Pirscher, C W *AmArch 70*
Pirson, Elmer 1888- *WhAmArt 85*
Pirsson, J Emily *WhAmArt 85*
Pirsson, James W 1833-1888 *BiDAmAr*
Pisa, Bonanno Da *McGDA*
Pisanello *OxDecA*
Pisanello 1395?-1455? *OxArt*
Pisanello, Antonio 1395?-1455? *McGDA*
Pisani, C *NewYHSD*
Pisani, F *NewYHSD*
Pisani, Francis 1931- *AmArch 70*
Pisani, Gianni 1935- *ConArt 77*
Pisani, Joseph 1938- *WhoAmA 76, –78, –80, –82, –84*
Pisani, Livia *DcWomA*
Pisani, Vettor 1935- *ConArt 83*
Pisano, Andrea *McGDA*
Pisano, Andrea 1290?-1348 *OxArt*
Pisano, Antonio *McGDA*
Pisano, Antonio 1395?-1455? *OxArt, OxDecA*
Pisano, Gilio *McGDA*
Pisano, Giovanni *McGDA, OxArt*
Pisano, Giovanni 1248?-1314? *MacEA*
Pisano, Giunta 1202?-1258 *McGDA*
Pisano, Nicola *McGDA, OxArt*
Pisano, Nicola 1225?-1280? *MacEA*
Pisano, Nino *McGDA*
Pisano, Nino d1368? *OxArt*
Pisano, Ronald George 1948- *WhoAmA 78, –80, –82, –84*
Pisano Family *MacEA*
Piscanec, Elda 1897- *DcWomA*
Piscatory, Adelaide Louise 1765-1843 *DcWomA*
Pischon, Marie 1856- *DcWomA*
Piscioneri, Robert Joseph 1932- *AmArch 70*
Pisciotta, Joseph Michael 1924- *AmArch 70*
Pisciotta, Lucian 1889- *AmArch 70*
Pise, Lewis *NewYHSD*
Pishbourne *NewYHSD*
Pisis, Filippo De 1896-1956 *McGDA, PhDcTCA 77*
Pisis, Filippo Tibertelli De 1896-1956 *OxTwCA*
Piskoti, James 1944- *WhoAmA 80, –82, –84*
Pissarro, Camille 1830-1903 *McGDA, OxArt*
Pissarro, Esther 1871-1951 *DcWomA*
Pissarro, Lucien 1863- *ClaDrA*
Pissarro, Lucien 1863-1944 *DcBrA 1, DcBrBI, DcVicP 2, IlsCB 1744, –1946, McGDA, OxArt, OxTwCA, PhDcTCA 77*
Pissarro, Orovida Camille 1893-1968 *DcBrA 1, DcWomA, OxTwCA*
Pissis, Albert 1852-1914 *MacEA*
Pissis, Emile M 1854- *ArtsAmW 3*
Pissus, Alfred d1914 *BiDAmAr*
Pistey, Joseph, Jr. *WhAmArt 85*
Pistler, Brown *AmArch 70*
Pistler, Willard Charles, Jr. 1927- *AmArch 70*
Pistoia, Fra Paolino Da *McGDA*
Pistoletto, Michelangelo 1933- *ConArt 77, –83, DcCAr 81, OxTwCA, PhDcTCA 77, PrintW 83, –85, WorArt[port]*
Pistor, Willi 1935- *DcCAr 81*
Pistrucci, Benedetto 1784-1855 *OxDecA*
Pistrucci, Elena 1822-1886 *DcWomA*
Pistrucci, Maria Elisa 1824-1881 *DcWomA*
Pistrui, William Martin 1926- *AmArch 70*

Pitati, De *OxArt*
Pitati, Bonifazio De' *McGDA*
Pitcairn, Constance *DcVicP 2, DcWomA*
Pitcairn-Knowles, Andrew 1871-1956 *MacBEP*
Pitcher, John *OfPGCP 86*
Pitcher, John Charles 1949- *WhoAmA 76, –78, –80, –82, –84*
Pitcher, N Sotheby *DcBrA 1*
Pitcher, Samuel H *WhAmArt 85*
Pitcher, W H *DcVicP 2*
Pitcher, William John Charles 1858-1925 *DcBrA 1, DcBrWA, DcVicP 2*
Pitchforth, Roland Vivian 1895- *ClaDrA, ConBrA 79[port], DcBrA 1, WhoArt 80, –82*
Pitchforth, Roland Vivien *WhoArt 84N*
Pite, Arthur Beresford 1861-1934 *DcBrA 2, MacEA, WhoArch*
Pitet, Elisa Honorine *DcWomA*
Pitfield, Florence Beatrice *DcWomA, WhAmArt 85*
Pitfield, Thomas Baron 1903- *ClaDrA, DcBrA 1, WhoArt 80, –82, –84*
Pitkanen, Matti A 1930- *ICPEnP A, MacBEP*
Pitkin, Anna Denio d1929 *ArtsEM, DcWomA*
Pitkin, Caroline W 1858- *DcWomA, WhAmArt 85*
Pitkin, E Josephine *DcWomA*
Pitkin, Elisha *IlDcG*
Pitkin, Elizabeth *FolkA 86*
Pitkin, Horace Edward *EncASM*
Pitkin, John Owen *EncASM*
Pitkin, Josephine *WhAmArt 85*
Pitkin, Richard *FolkA 86*
Pitkin, Walter *EncASM*
Pitkin, William *IlDcG*
Pitkin, William Leonard *EncASM*
Pitman, Agnes 1850-1946 *DcWomA*
Pitman, Benn d1910 *FolkA 86*
Pitman, Edith H *DcVicP 2*
Pitman, Elizabeth S *WhAmArt 85*
Pitman, Harriette Rice *WhAmArt 85*
Pitman, J W *AmArch 70*
Pitman, Janetta *DcVicP*
Pitman, Janetta 1850?-1910? *DcBrWA, DcWomA*
Pitman, Janetta R A 1850?-1910? *DcVicP 2*
Pitman, John d1800 *CabMA*
Pitman, John, Jr. *CabMA*
Pitman, Mark 1779?- *CabMA*
Pitman, Mark, Jr. 1814?-1859? *CabMA*
Pitman, Mary 1758-1841 *FolkA 86*
Pitman, Primrose Vera *DcBrA 1, WhoArt 80, –82, –84*
Pitman, Rosie M M *DcBrBI, DcVicP 2, DcWomA*
Pitman, Sarah Bennard *DcWomA*
Pitman, Sophia L *WhAmArt 85*
Pitman, Theodore B 1892-1956 *IlBEAAW, WhAmArt 85*
Pitman, Thomas *NewYHSD*
Pitman, Thomas 1853-1911 *WhAmArt 85*
Pitocchetto, Il *McGDA*
Pitolet, Anna Marguerite *DcWomA*
Pitolet, Fanny Jeanne *DcWomA*
Piton, Thomas *CabMA*
Piton Guitel, Flore d1940 *DcWomA*
Pitsala *DcBrECP*
Pitseolak 1908?- *WhoGrA 82[port]*
Pitseolak, Ashoona 1908?- *WhoGrA 82[port]*
Pitt, Miss *DcWomA, NewYHSD*
Pitt, Douglas Fox- d1923 *DcVicP 2*
Pitt, Douglas Fox- 1864-1922 *DcBrWA*
Pitt, Miss E K *DcBrA 1*
Pitt, E K *DcWomA*
Pitt, Elizabeth Francis *DcWomA*
Pitt, G *AmArch 70*
Pitt, J Lunn *DcBrA 1*
Pitt, John 1706?-1787 *BiDBrA*
Pitt, Joseph B *NewYHSD*
Pitt, Stanley John 1925- *WorECom*
Pitt, Suzan *WhoAmA 84*
Pitt, Thomas, Baron Camelford 1737-1793 *BiDBrA*
Pitt, Thomas Henry *DcVicP, –2*
Pitt, W *DcWomA*
Pitt, William *DcBrWA, DcVicP, –2*
Pitt, William 1855-1918 *MacEA*
Pittack, W A *AmArch 70*
Pittaluga, Antonio *DcSeaP*
Pittam, Judson Wright 1923- *AmArch 70*
Pittar, I J *DcVicP, –2*
Pittar, J F Barry 1880-1948 *DcBrA 1, DcBrWA*
Pittard, Charles William *DcBrA 1, DcVicP, –2*
Pittaro, Charles *DcVicP 2*
Pittas, Michael *MarqDCG 84*
Pittatore, Michel Angelo *DcVicP 2*
Pittee, David C 1818?- *CabMA*
Pitteloud, Jose 1952- *DcCAr 81*
Pitteri, Marco Alvise 1702-1786 *McGDA*
Pittfield, William *NewYHSD*
Pittis, Henry *NewYHSD*
Pittis, Thomas 1807?- *NewYHSD*
Pittman, Hobson 1899-1972 *WhAmArt 85*
Pittman, Hobson 1900-1972 *DcCAA 71, WhoAmA 78N, –80N, –82N, –84N*
Pittman, Hobson L 1900- *DcCAA 71*

Pittman, Hobson L 1900-1972 *DcCAA 77*
Pittman, J W *FolkA 86*
Pittman, James Roland, Jr. 1922- *AmArch 70*
Pittman, John 1948- *DcCAr 81*
Pittman, John G 1942- *MarqDCG 84*
Pittman, Jon H 1956- *MarqDCG 84*
Pittman, Kathryn 1915-1979 *WhoAmA 80N, –82N, –84N*
Pittman, Kitty Butner 1914- *WhAmArt 85*
Pittman, Osmund 1874- *ClaDrA*
Pittman, Osmund 1874-1958 *DcBrA 1, DcVicP 2*
Pittman, Oswald 1874-1958 *DcBrBI*
Pittner, F J *NewYHSD*
Pitton, Donald Albert 1922- *AmArch 70*
Pittoni, Gasparina *DcWomA*
Pittoni, Giovanni Battista 1687-1767 *McGDA, OxArt*
Pittore, Carlo 1943- *WhoAmA 84*
Pittoud, Josephine Louisa De *DcWomA*
Pitts, Mrs. *DcVicP 2, DcWomA*
Pitts, Betty J 1940- *AfroAA*
Pitts, C I *AmArch 70*
Pitts, Fred L 1842- *WhAmArt 85*
Pitts, Frederick *DcVicP 2*
Pitts, Henry S *WhAmArt 85*
Pitts, Kate 1896- *DcWomA, WhAmArt 85*
Pitts, Lendall *WhAmArt 85*
Pitts, Lendall 1875-1938 *ArtsAmW 2, ArtsEM*
Pitts, Mrs. Lindell *DcWomA*
Pitts, Marcus W *DcVicP 2*
Pitts, Mary *DcWomA*
Pitts, Richard G 1940- *WhoAmA 84*
Pitts, Terence Randolph 1950- *MacBEP*
Pitts, Thomas *AntBDN Q*
Pitts, William *AntBDN Q*
Pittuck, Douglas Frederick 1911- *DcBrA 1*
Pittwood, Ann 1895- *ArtsAmW 3*
Pitxot, Antonio 1934- *DcCAr 81*
Pitz, Henry Clarence d1976 *IlsCB 1967*
Pitz, Henry Clarence 1895- *ConICB, IlrAm E, IlsBYP, IlsCB 1744, –1946, –1957, WhoAmA 73, –76*
Pitz, Henry Clarence 1895-1976 *IlrAm 1880, WhAmArt 85, WhoAmA 78N, –80N, –82N, –84N*
Pitz, Molly Wood 1913- *WhAmArt 85, WhoAmA 73, –76, –78*
Pitzig, Edna *WhAmArt 85*
Pitzinger, Joe A, Jr. 1922- *AmArch 70*
Pitzl, Gerald R 1933- *MarqDCG 84*
Piussi-Campbell, Judy *IlsBYP*
Pivar, Gary M 1956- *MarqDCG 84*
Piven, Peter Anthony 1939- *AmArch 70*
Pixell, Maria *DcBrBI, DcBrECP, DcBrWA, DcWomA*
Pixley, Emma Catharine O'Reilly 1836- *ArtsAmW 3*
Pizer, Perri Dee 1958- *WhoAmA 84*
Pizer, Stephen Murray 1941- *MarqDCG 84*
Pizey, Gordon 1949- *MarqDCG 84*
Pizitz, Silvia *WhoAmA 78, –80, –82, –84*
Pizza, Richard *MarqDCG 84*
Pizzala, Francesco d1769 *DcBrECP*
Pizzat, Joseph 1926- *WhoAmA 80, –82, –84*
Pizzati, Salvatore 1954- *MarqDCG 84*
Pizzella, Edmund 1868-1941 *ArtsAmW 2*
Pizzella, Edmundo 1868-1941 *ArtsAmW 2*
Pizzica, Stephen V 1939- *MarqDCG 84*
Pizzinato, Armando 1910- *DcCAr 81, McGDA, OxTwCA, PhDcTCA 77*
Pizzini, Robert Allen 1930- *AmArch 70*
Pizzoli, Maria Oriana Galli *DcWomA*
Pizzolo, Niccolo 1421?-1453 *McGDA*
Pizzuti, Michele 1882- *WhAmArt 85*
Pla Janini, Joaquim 1879-1970 *ConPhot*
Pla Janini, Joaquin 1879-1970 *ICPEnP A*
Pla-Narbona, Jose 1928- *WhoGrA 82[port]*
Place, Bradley Eugene 1920- *WhoAmA 76, –78, –80, –82, –84*
Place, Francis 1647-1728 *DcBrWA, OxArt*
Place, George *AntBDN J*
Place, Graham *WhAmArt 85*
Place, Henri 1820?- *ArtsNiC*
Place, Lew 1913- *AmArch 70*
Place, Rosa *DcVicP 2, DcWomA*
Place, Vera Clark 1890- *DcWomA, WhAmArt 85*
Place-Fontaine, Madame *DcWomA*
Placek, J W *AmArch 70*
Plachek, James W 1893-1948 *BiDAmAr*
Plachy, Sylvia 1943- *ICPEnP A, MacBEP*
Plack, William L 1854-1944 *BiDAmAr*
Plackman, Carl 1943- *ConBrA 79[port], DcCAr 81*
Placzek, Adolf Kurt 1913- *WhoAmA 78, –80, –82, –84*
Placzek, Floyd *DcCAr 81*
Plagemann, Anna Catherina *DcWomA*
Plagens, Peter 1941- *WhoAmA 73, –76, –78, –80, –82, –84*
Plain, Bartholomew *NewYHSD*
Plainemaison, Leonie Marie *DcWomA*
Plaisance, Claytus Joseph, Jr. 1932- *AmArch 70*
Plaiss, L E *AmArch 70*
Plaisted, F A *FolkA 86*
Plaisted, T J *FolkA 86*

Plaisted, Zelpha M *DcWomA, WhAmArt 85*
Plaistridge, Philip *WhAmArt 85*
Plamondon, Antoine 1804-1895 *OxArt*
Plamondon, Antoine Sebastien 1804-1895 *McGDA*
Plamondon, Marius Gerald 1919- *WhoAmA 73, –76, –78, –80*
Plamondon, Peter M *WhoAmA 84*
Planasdura, E 1921- *ClaDrA, WhoArt 80, –82, –84*
Planck, Emma 1837-1923 *DcWomA*
Planckner, Lonny Von 1863- *DcWomA*
Planet, Marie Maxime *DcWomA*
Plangini, Luisa 1790?- *DcWomA*
Plank, Esther Rae *WhAmArt 85*
Plank, G Wolfe *WhAmArt 85*
Plank, George *DcBrBI*
Plank, J L *FolkA 86*
Plank, Keith Emerson 1922- *AmArch 70*
Plank, Kenneth Robert 1907- *AmArch 70*
Plank, Samuel 1821-1900 *FolkA 86*
Planka, H M *AmArch 70*
Planken, VanDen *McGDA*
Planson, Andre 1898- *OxTwCA*
Plant, Olive *WhAmArt 85*
Plant, S *WhAmArt 85*
Plant, Vincent *DcCAr 81*
Plant-Hollins, H *DcVicP 2*
Plante, Ada May 1875-1950 *DcWomA*
Plante, George 1914- *WhoArt 80*
Plante, Helene *DcWomA*
Plantery, Gian Giacomo 1680-1756 *MacEA*
Plantin, Christophe 1520?-1589 *OxDecA*
Plantou, Anthony, Madame *NewYHSD*
Plantou, Julia 1778-1853 *DcWomA*
Plaschke, Paul A 1880- *WhAmArt 85*
Plasencia, Peter P *IlsBYP*
Plashke, Paul Albert 1880-1954 *WorECar*
Plaskett, Joseph F 1918- *DcCAr 81*
Plass, A F *DcVicP 2*
Plassan, Antoine Emile *ArtsNiC*
Plasschaert, Richard W *OfPGCP 86*
Plassman, Ernest d1877 *ArtsNiC*
Plassmann, Ernst 1823-1877 *NewYHSD*
Plaster, Alice Marie *WhoAmA 82, –84*
Plaster, Alice Marie 1955- *AmArt*
Plastow, A B *DcVicP 2*
Plastow, C B *DcVicP 2*
Plate, Anna 1871- *DcWomA*
Plate, Jeffrey *DcCAr 81*
Plate, Walter 1925- *WhoAmA 73*
Plate, Walter 1925-1972 *WhoAmA 76N, –78N, –80N, –82N, –84N*
Plateau, Joseph Antoine Ferdinand 1801-1883 *MacBEP*
Plateau, Joseph-Antoine-Ferdinand 1801-1883 *WorECar*
Platel, Peter *AntBDN Q*
Platel, Pierre *AntBDN Q, OxDecA*
Platen, C *NewYHSD*
Plater-Zyberk, Josaphat *AmArch 70*
Plath, Iona 1907- *WhoAmA 73, –76, –78, –80, –82, –84*
Plath, Karl *WhAmArt 85*
Platina, Giovanni Maria d1500 *McGDA*
Platner, Warren 1919- *AmArch 70, ConDes*
Plato, Alice 1889- *DcWomA*
Platt *BiDBrA*
Platt, Mrs. *NewYHSD*
Platt, A E *DcWomA*
Platt, Alethea Hill 1861-1932 *DcWomA, WhAmArt 85*
Platt, Annie *DcWomA*
Platt, Augustus *FolkA 86*
Platt, Mrs. Charles *FolkA 86*
Platt, Charles Adams 1861-1933 *BiDAmAr, BnEnAmA, MacEA, McGDA, WhAmArt 85*
Platt, Charles Adams 1932- *AmArch 70*
Platt, Charles H, Jr. *WhAmArt 85*
Platt, Eleanor *WhoAmA 76N, –78N, –80N, –82N, –84N*
Platt, Eleanor 1910- *WhAmArt 85, WhoAmA 73*
Platt, Elizabeth *DcWomA*
Platt, Elsie H *ArtsEM, DcWomA*
Platt, Emily *DcVicP 2, DcWomA*
Platt, Eric Warhurst 1915- *DcBrA 1, WhoArt 80, –82, –84*
Platt, Geoffrey 1905- *AmArch 70*
Platt, George *NewYHSD*
Platt, George 1700-1743 *BiDBrA*
Platt, George W 1839-1899 *ArtsAmW 1, IlBEAAW, NewYHSD, WhAmArt 85*
Platt, H *NewYHSD*
Platt, Harold *WhAmArt 85*
Platt, Henry *DcVicP, –2*
Platt, J B *WhAmArt 85*
Platt, J T *AmArch 70*
Platt, J W *AmArch 70*
Platt, James C d1882 *NewYHSD*
Platt, John d1730 *BiDBrA*
Platt, John 1728-1810 *BiDBrA*
Platt, John Edgar 1886- *ClaDrA, DcBrA 1*
Platt, John Edgar 1886-1967 *DcBrA 2*
Platt, John Gerald *WhoArt 82N*

Platt, John Gerald 1892- *DcBrA 1*, *WhoArt 80*
Platt, Mrs. Joseph S *ArtsEM*
Platt, Juliette P *DcWomA*
Platt, Kalvin J 1931- *AmArch 70*
Platt, Livingston *WhAmArt 85*
Platt, Lloyd Easton 1934- *AmArch 70*
Platt, Lydia *FolkA 86*
Platt, Marie Starbuck *DcWomA*
Platt, Martha A *DcWomA*, *WhAmArt 85*
Platt, Mary Cheney 1893- *DcWomA*, *WhAmArt 85*
Platt, Michael 1914- *DcBrA 1*, *WhoArt 80*, *-82*, *-84*
Platt, R J *AmArch 70*
Platt, Samuel *DcVicP 2*
Platt, Sidney S 1916- *AmArch 70*
Platt, Stella 1913- *ClaDrA*, *DcBrA 1*, *WhoArt 80*, *-82*, *-84*
Platt, William 1775- *DcBrECP*
Platt, William 1897- *AmArch 70*
Platt Family *MacEA*
Plattemontagne *DcSeaP*
Plattenberg, Mathieu Van 1608?-1660 *DcSeaP*
Plattenberger *FolkA 86*, *NewYHSD*
Plattner, Karl 1919- *McGDA*
Plattner, Maria *DcWomA*
Plattner, Phyllis 1940- *PrintW 85*
Platus, Libby *WhoAmA 76*, *-78*, *-80*, *-82*, *-84*
Platzer, Johann Georg 1704-1761 *ClaDrA*
Plau, Eleanor Walls 1878- *ArtsAmW 3*
Plauche, Leda Hincks 1887- *WhAmArt 85*
Plauen, E O *WorECom*
Plauger, David J 1954- *MarqDCG 84*
Plault, Mathilde *DcWomA*
Plaut, James S 1912- *WhoAmA 73*, *-76*, *-78*, *-80*, *-82*, *-84*
Plaut, U *AmArch 70*
Plautilla *DcWomA*
Plautilla Bricci *DcWomA*
Plavcan, Catharine Burns 1906- *WhAmArt 85*
Plavcan, Joseph Michael *WhoAmA 76*, *-78*, *-80*, *-82*
Plavcan, Joseph Michael d1981 *WhoAmA 84N*
Plavcan, Joseph Michael 1908- *WhAmArt 85*
Plaw, Eleanor Walls 1878- *ArtsAmW 3*
Plaw, John 1745?-1820 *BiDBrA*, *MacEA*
Player, F DePonte *DcVicP*, *-2*
Player, John *AntBDN K*
Player, Samuel Joseph 1931- *AmArch 70*
Player, William H *DcVicP*, *-2*
Playfair, James 1755-1794 *BiDBrA*, *MacEA*
Playfair, James Charles *DcVicP 2*
Playfair, W H 1790-1857 *MacEA*
Playfair, William Henry 1780-1857 *DcBrWA*
Playfair, William Henry 1789-1857 *McGDA*, *WhoArch*
Playfair, William Henry 1790-1857 *BiDBrA*
Playter, S M *AmArch 70*
Plaza, Julio *OxTwCA*
Plazzotta, Enzo Mario *WhoArt 84N*
Plazzotta, Enzo Mario 1921- *WhoArt 80*, *-82*
Pleadwell, Amy Margaret *WhAmArt 85*
Pleadwell, Amy Margaret 1875- *DcWomA*
Plear, Scott Edward 1952- *WhoAmA 82*, *-84*
Pleasant, L M *AmArch 70*
Pleasants, Albert C *NewYHSD*
Pleasants, Frederick R 1906- *WhoAmA 73*, *-76*, *-78*, *-80N*, *-82N*, *-84N*
Plecker, D A *NewYHSD*
Plecnik, Joze 1872-1957 *MacEA*
Plee, Augustine Gabrielle *DcWomA*
Pleger, Richard Henry 1908- *AmArch 70*
Plehn, Alice *DcWomA*
Plehn, Rose 1865- *DcWomA*
Pleijsier, Ary 1809-1879 *DcSeaP*
Pleimling, Winifred 1899- *DcWomA*
Pleimling, Winnifred 1899- *WhAmArt 85*
Plein, Charles M d1920 *ArtsAmW 3*, *WhAmArt 85*
Pleiss, Michael Andrew 1953- *MarqDCG 84*
Pleissner, Ogden *OfPGCP 86*
Pleissner, Ogden M 1905-1983 *WhAmArt 85*
Pleissner, Ogden Minton 1905- *IlBEAAW*, *WhoAmA 73*, *-76*, *-78*, *-80*, *-82*
Pleissner, Ogden Minton 1905-1983 *WhoAmA 84N*
Plemenitas, Karel 1954- *DcCAr 81*
Plender, Donald James 1932- *WhoArt 80*, *-82*
Plenderleith, Thomas Donald 1921- *DcBrA 1*
Plenert, J W *AmArch 70*
Plenk, Elisabeth 1889- *DcWomA*
Plepel, Joseph K 1921- *AmArch 70*
Pleshko, Peter 1936- *MarqDCG 84*
Plessi, Fabrizio 1940- *ConArt 77*
Pletcher, Gerry *WhoAmA 73*, *-76*, *-78*, *-80*, *-82*, *-84*
Pletka, Paul 1946- *AmArt*, *WhoAmA 82*, *-84*
Pletsch, George 1850-1919 *ArtsEM*
Pletscher, Josephine Marie *WhoAmA 80*, *-82*, *-84*
Plettenberg, R E *AmArch 70*
Pleus, F C *AmArch 70*
Pleuthner, Walter Karl 1885- *WhAmArt 85*
Pleva, W F *AmArch 70*
Plevins, Joseph *BiDBrA*
Plews, Helen M *DcVicP 2*
Pleydenwurff, Hans d1471 *OxArt*
Pleydenwurff, Hans 1420?-1472 *McGDA*

Pleydenwurff, Wilhelm d1494 *McGDA*
Plhak, R L *AmArch 70*
Plicator, Frank *NewYHSD*
Plichta, Fred *FolkA 86*
Plimer, Andrew 1763-1837 *AntBDN J*
Plimer, John d1761? *DcBrECP*
Plimer, Nathaniel 1751-1787 *AntBDN J*
Plimmer, John d1761? *DcBrECP*
Plimpton, Constance E *DcVicP*, *-2*, *DcWomA*
Plimpton, Cordelia Bushnell 1830-1886 *DcWomA*
Plimpton, Fannie E *DcWomA*
Plimpton, G R *DcVicP 2*
Plimpton, Herbert Wheatley 1928- *WhoAmA 80*, *-82*
Plimpton, Russell A 1891- *WhoAmA 73*, *-76*
Plimpton, William E *WhAmArt 85*
Plimsoll, Fanny G *WhAmArt 85*
Plimsoll, Fanny Grace *DcWomA*
Pline, James Leonard 1931- *MarqDCG 84*
Plinval, Zoe De *DcWomA*
Pliny The Elder 023?-079 *OxArt*
Pliny The Elder 024-079 *McGDA*
Pliskova, Nadezda 1934- *DcCAr 81*
Pliszka, F J *AmArch 70*
Plitt, Lyle A 1942- *MarqDCG 84*
Pliva, Otto 1946- *DcCAr 81*
Plocher, Jacob J d1820 *NewYHSD*
Plochmann, Carolyn Gassan 1926- *WhoAmA 73*, *-76*, *-78*, *-80*, *-82*, *-84*
Plockhorst, Bernhard 1825- *ArtsNiC*
Plockross-Irminger, Ingeborg 1872- *DcWomA*
Plog, Olga 1899- *DcWomA*
Ploger, Benjamin John 1908- *WhAmArt 85*
Plomdeur, Simone 1897- *DcWomA*
Plommer, Anna 1836-1890 *DcWomA*
Plonsey, Robert 1925- *MarqDCG 84*
Plontke, Anna 1890?-1930 *DcWomA*
Ploos vanAmstel, Sarah *DcWomA*
Plossu, Bernard 1945- *AmArt*, *ConPhot*, *ICPEnP A*, *MacBEP*, *WhoAmA 84*
Ploszezynski, N *DcVicP 2*
Plotkin, Edna *WhAmArt 85*
Plotkin, Linda 1938- *PrintW 83*, *-85*
Plotkin, Peter *ArtsAmW 3*
Plotner, Rosa *DcWomA*
Plotner, Rosa Hooper *ArtsAmW 2*
Plourde, Ben 1896-1963 *FolkA 86*
Plous, Phyllis *WhoAmA 82*, *-84*
Plous, Phyllis 1925- *WhoAmA 76*, *-78*, *-80*
Plowden, David 1932- *ConPhot*, *ICPEnP A*, *MacBEP*
Plowden, Edith R *DcVicP 2*
Plowden, Trevor Chichele *DcBrWA*, *DcVicP 2*
Plowman, Chris 1952- *DcCAr 81*
Plowman, Elise *DcWomA*
Plowman, George T 1869-1932 *WhAmArt 85*
Plowman, George Taylor 1869-1932 *ArtsAmW 2*
Plowman, John 1773?-1843 *BiDBrA*
Plowman, Thomas 1805?-1828 *BiDBrA*
Pluckebaum, Meta 1876- *DcWomA*
Pluijm, Carel VanDer 1625-1672 *McGDA*
Plum, R B *DcVicP 2*
Plum, Seth *FolkA 86*
Plumb *NewYHSD*
Plumb, Ebenezer, Jr. *CabMA*
Plumb, George *MacEA*
Plumb, H G 1847-1930 *WhAmArt 85*
Plumb, Harriot Kirby *DcWomA*
Plumb, James Douglas 1941- *WhoAmA 80*, *-82*, *-84*
Plumb, John 1927- *ConArt 79[port]*, *DcCAr 81*, *PhDcTCA 77*
Plumb, Robert *FolkA 86*
Plumb, Seth *FolkA 86*
Plumb, W P *AmArch 70*
Plumb, William Lansing *ConDes*
Plumbe, John, Jr. 1809-1857 *ICPEnP*, *MacBEP*
Plumer, Harrison Lorenzo 1814- *NewYHSD*
Plumer, Jacob P *NewYHSD*
Plumer, Nan D *DcWomA*, *WhAmArt 85*
Plumery, Armande *DcWomA*
Plumet, Charles 1861-1928 *MacEA*
Plummer, Adrian *NewYHSD*
Plummer, Arrie Elizabeth 1884- *DcWomA*, *WhAmArt 85*
Plummer, Charles F 1879-1939 *BiDAmAr*
Plummer, Edward *FolkA 86*, *NewYHSD*
Plummer, Edwin *NewYHSD*
Plummer, Edwin 1820-1880 *FolkA 86*
Plummer, Elmer 1910- *WhAmArt 85*
Plummer, Ethel d1936 *WhAmArt 85*
Plummer, Ethel McClellan 1888-1936 *DcWomA*
Plummer, Ethel M'Clellan 1888- *WhAmArt 85*
Plummer, H L *DcVicP 2*
Plummer, Harrison *FolkA 86*
Plummer, Herschell Willford 1919- *AmArch 70*
Plummer, John H 1919- *WhoAmA 73*, *-76*, *-78*, *-80*
Plummer, R *FolkA 86*, *NewYHSD*
Plummer, W Kirtman *IlsBYP*
Plummer, William *AntBDN Q*, *FolkA 86*, *NewYHSD*
Plump, Berta 1853- *DcWomA*
Plumpton, A W *DcVicP 2*

Plunder, Franz *WhAmArt 85*
Plunguian, Gina d1962 *WhoAmA 78N*, *-80N*, *-82N*, *-84N*
Plunkett, Brian Charles 1950- *MarqDCG 84*
Plunkett, Edward Milton 1922- *WhoAmA 76*, *-78*, *-80*, *-82*
Plunkett, Henry P 1900- *AmArch 70*
Plunkett, Herbert Connely 1928- *AmArch 70*
Plunkett, James Gardner 1933- *AmArch 70*
Plunkett, Robert Brantley 1911- *AmArch 70*
Plunkett, Walter 1902- *ConDes*
Plussa, Jerry S 1919- *AmArch 70*
Plyer, William A 1939- *AmArch 70*
Plymouth, Henry Windsor, Earl Of 1768-1843 *DcBrWA*
Plympton, Calvin *CabMA*
Plympton, D Delia 1874- *DcWomA*
Plympton, D Della *WhAmArt 85*
Pneuman, Mildred Y 1899- *WhoAmA 73*, *-76*, *-78*, *-80*
Pneuman, Mildred Young 1899- *ArtsAmW 2*, *DcWomA*, *WhAmArt 85*
Pniewski, Joseph R 1920- *AmArch 70*
Po, Teresa Del 1649-1713 *DcWomA*
Po, Vittoria Del *DcWomA*
Po-Tsu-Nu *WhAmArt 85*, *WhoAmA 78*, *-80*
Poage, Waller Staples, III 1936- *AmArch 70*
Poalk, George *CabMA*
Poate, R *DcVicP 2*
Poats, Mrs. William W *ArtsEM*, *DcWomA*
Poccard DeSaintilau, Blanche *DcWomA*
Pocci, Franz Von 1803-1876 *WorECar*
Pocci, Countess Maria Elisabeth 1835- *DcWomA*
Pocci, Countess Xaveria Amalia Franziska 1778-1849 *DcWomA*
Pocetti, Bernardino 1548-1612 *McGDA*
Pochhammer, Elisabeth *DcWomA*
Pochon-Emery, Francoise 1930- *WhoGrA 82[port]*
Pochron, Stanley Edward 1930- *AmArch 70*
Pocivavsek, Matjaz 1955- *DcCAr 81*
Pockels, C *DcVicP 2*
Pocklington, F C *DcVicP 2*
Pocock, A *DcVicP 2*
Pocock, Alfred Lyndhurst 1881- *ClaDrA*, *DcBrA 1*
Pocock, Alfred Lyndhurst 1881-1962 *DcBrA 2*
Pocock, Anna *DcWomA*
Pocock, Anna 1882- *ClaDrA*
Pocock, E *DcBrBI*
Pocock, Geoffrey Buckingham 1879- *ClaDrA*, *DcBrA 1*
Pocock, Geoffrey Buckingham 1879-1960 *DcBrA 2*
Pocock, H *DcVicP 2*
Pocock, Henry Childe 1854-1934 *DcBrA 1*, *DcBrWA*, *DcVicP 2*
Pocock, Hilda Joyce 1882- *DcWomA*
Pocock, Innes *DcVicP 2*
Pocock, Isaac 1782-1835 *DcBrWA*
Pocock, J *DcVicP 2*
Pocock, Julia *DcBrWA*, *DcWomA*
Pocock, Lexden Lewis 1850-1919 *DcBrA 1*, *DcBrWA*, *DcVicP*, *-2*
Pocock, Lilian J *DcWomA*
Pocock, Lilian Josephine *ClaDrA*
Pocock, Margaret *DcWomA*
Pocock, Nicholas 1740-1821 *DcBrWA*, *DcSeaP*
Pocock, Nicholas 1741-1821 *DcBrECP*
Pocock, Philip 1954- *ICPEnP A*
Pocock, William Fuller 1779-1849 *BiDBrA*, *DcBrWA*, *DcD&D[port]*
Pocock, William Innes 1783-1836 *DcBrWA*, *DcSeaP*
Pococke, E *DcBrWA*
Pococke, K D *AmArch 70*
Podchernikoff, A 1886-1931 *ArtsAmW 1*
Podchernikoff, Alexis 1912- *WhAmArt 85*
Podchernikoff, Alexis M 1886-1933? *ArtsAmW 3*
Podd, Stanley C 1904- *AmArch 70*
Poddar, Jugal B 1957- *MarqDCG 84*
Poddard, J *DcVicP 2*
Podesta, Stephen *NewYHSD*
Podesto, W D *AmArch 70*
Podgornik, Tomo 1949- *DcCAr 81*
Podhorsky, John *FolkA 86*
Podietz, Eric S 1953- *MarqDCG 84*
Podlecki, Mary Kay 1948- *MarqDCG 84*
Podolsky, Henry W *WhAmArt 85*
Poduska, John William, Sr. *MarqDCG 84*
Poduska, T F 1925- *WhoAmA 76*, *-78*, *-80*, *-82*, *-84*
Podvinecz, Erzsebet 1894- *DcWomA*
Poe, Albert Donald 1925- *AmArch 70*
Poe, Elisabeth Ellicott 1886?-1947 *DcWomA*
Poe, Elisabeth Ellicott 1888- *WhAmArt 85*
Poe, Hugh M 1902- *WhAmArt 85*
Poe, Lucy A *DcWomA*, *WhAmArt 85*
Poe, Thomas *CabMA*
Poe, William 1914- *FolkA 86*
Poehler, G F *AmArch 70*
Poehler, John *WhAmArt 85*
Poehlmann, Charlotte 1860?-1920 *DcWomA*
Poehlmann, Joanna 1932- *WhoAmA 84*
Poel, Egbert Lievensz VanDer 1621-1664 *McGDA*
Poel, Egbert VanDer 1621-1664 *ClaDrA*

Poelaert, Joseph 1817-1879 *MacEA, McGDA*
Poelart, Joseph 1817-1879 *WhoArch*
Poelenburg, Cornelis Van 1586-1667 *ClaDrA, OxArt*
Poelenburgh, Cornelis Van 1586?-1667 *McGDA*
Poeller, Dina 1926- *WhoAmA 76*
Poelzig, Hans 1869-1936 *ConArch, DcD&D, EncMA, MacEA, McGDA, OxArt, WhoArch*
Poerbus, Pieter Jansz *McGDA*
Poethig, Fred Francis 1917- *AmArch 70*
Poetting, Countess Adrienne 1856- *DcWomA*
Poetz, John C d1929 *BiDAmAr*
Poffinbarger, Paul *WhAmArt 85*
Pogacnik, Marko *DcCAr 81*
Pogany, Margit 1879?-1964 *DcWomA*
Pogany, Miklos *PrintW 85*
Pogany, William Andrew 1882- *DcBrBI*
Pogany, William Andrew 1882-1955 *ArtsAmW 2, IlrAm 1880, IlsBYP, WhAmArt 85*
Pogany, Willy 1882-1955 *ConICB, IlsCB 1744*
Poggi, Antonio *DcBrECP*
Poggi, Giuseppe 1811-1901 *MacEA*
Poggi, Robert A 1943- *MarqDCG 84*
Poggianti, Roy Peter 1927- *AmArch 70*
Poggini, Domenico 1520-1590 *McGDA*
Poggioli, Caterina 1828?-1861 *DcWomA*
Poggioli, Elena *DcWomA*
Pogliani, Maria Antoinette *DcWomA*
Pogliano, Michael F 1940- *AmArch 70*
Pogmire, Alexander *BiDBrA*
Pogson, Annie L *ArtsAmW 2, DcWomA, WhAmArt 85*
Pogue, E L *AmArch 70*
Pogue, Stephanie E 1944- *AfroAA*
Pogue, Stephanie Elaine 1944- *WhoAmA 78, -80, -82*
Pogzeba, Wolfgang 1936- *IlBEAAW*
Pogzeba, Wolfgang H 1936- *WhoAmA 80, -82, -84*
Pohl, Edward *NewYHSD*
Pohl, Grete *DcWomA*
Pohl, Hugo D 1878- *ArtsEM*
Pohl, Hugo David 1878-1960 *ArtsAmW 2, IlBEAAW, WhAmArt 85, WhoAmA 80N, -82N, -84N*
Pohl, Joseph *FolkA 86*
Pohl, LaVera Ann 1901- *WhAmArt 85*
Pohl, Louis G 1915- *WhoAmA 73, -76, -78*
Pohl, Lydia D *WhAmArt 85*
Pohl, Marianne 1930- *DcCAr 81*
Pohl, Marie *DcWomA*
Pohl, Minette T *WhAmArt 85*
Pohl, Ulli 1935- *OxTwCA*
Pohl-Stein, Hilde 1886-1922 *DcWomA*
Pohle, Carla 1883- *DcWomA*
Pohlman, Gustavus A *EncASM*
Pohlmann, Charlotte *DcVicP 2, DcWomA*
Pohlmeyer, M W *AmArch 70*
Pohlschroder, Eleonore 1861-1922 *DcWomA*
Poignand, David *CabMA*
Poiker, Thomas Karl 1938- *MarqDCG 84*
Poillon, Clara Louise 1851-1936 *WhAmArt 85*
Poillon, Mrs. Cornelius *DcWomA*
Poincy, A *NewYHSD*
Poincy, Paul 1833-1909 *NewYHSD , WhAmArt 85*
Poindexter, Elinor Fuller *WhoAmA 73, -76, -78, -80, -82, -84*
Poindexter, James Thomas 1832-1891 *NewYHSD*
Poindexter, Vernon Stephensen 1918- *AfroAA*
Poindexter, William F d1908 *BiDAmAr*
Poinet, Josephine Louise Marguerite *DcWomA*
Poingdestre, Charles H d1905 *DcBrA 1, DcVicP, -2*
Poingdestre, W W *DcVicP 2*
Poinier, Arthur Best 1911- *WhoAmA 76, -78, -80, -82, -84*
Poinsot, Eudoxie *DcWomA*
Point, Father Nicholas 1799-1868 *NewYHSD*
Point, Nicolas 1799-1868 *ArtsAmW 1*
Point, Father Nicolas 1799-1868 *IlBEAAW*
Pointel, J B *NewYHSD*
Pointelin, Auguste-Emmanuel *ArtsNiC*
Pointelin, Auguste Emmanuel 1839-1933 *ClaDrA*
Pointer, Augusta L 1898- *DcWomA, WhAmArt 85*
Pointer, G Henry *DcVicP 2*
Pointer, John Richard 1921- *AmArch 70*
Pointer, R M *DcVicP 2*
Pointer And Childres *CabMA*
Poire, Emmanuel 1859-1909 *WorECar*
Poire, Marguerite *DcWomA*
Poiret, Paul d1944 *ClaDrA*
Poiret, Paul 1880-1944 *FairDF FRA, WorFshn*
Poirier, Anne 1942- *ConArt 77, -83, DcCAr 81*
Poirier, Patrick 1942- *ConArt 77, -83, DcCAr 81*
Poirier, Simon-Philippe *OxDecA*
Poirier-McConnell, Edmonde 1940- *DcCAr 81*
Poirson, Solange *DcWomA*
Poirson, V A *DcBrBI*
Poissant, Adele *DcWomA*
Poisson, Jean Antoinette *DcWomA*
Poisson, Julien *NewYHSD*
Poisson, Marie Leonide *DcWomA*
Poitevin, Alphonse Louis 1819-1882 *ICPEnP, MacBEP*
Poitevin, Eleonore Alice *DcWomA*
Poitevin, Esther Rosina *DcWomA*

Poitevin, Marie-Irma *DcWomA*
Poitevin, Marie Louise d1909 *DcWomA*
Poitier, Charles d1797 *DcBrECP*
Poitier, Jacqueline 1937- *MacBEP*
Poittevin, Eugene Le 1806-1870 *ArtsNiC*
Poitvin, J *DcBrECP*
Poivet, Raymond 1910- *WorECom*
Poivret, Jean-Luc 1950- *DcCAr 81*
Poix, Hugh De *DcBrA 1*
Pojar, Bretislav 1923- *WorECar*
Pojezny, Fred, Jr. 1920- *AmArch 70*
Pojman, Victor 1927- *AmArch 70*
Pokorny, Jan Hird 1914- *AmArch 70*
Pokorny, Joseph, Jr. 1935- *AmArch 70*
Pokrandt, Thomas Frank 1932- *AmArch 70*
Pol DeLimbourg *McGDA*
Pol, Santiago 1946- *WhoGrA 82[port]*
Polachek, Herbert Bruce 1932- *AmArch 70*
Polaha, Steven *FolkA 86*
Polaine, Horace George William 1910- *ClaDrA*
Polak, D *AmArch 70*
Polak, Richard 1870-1957 *ICPEnP A, MacBEP*
Polan, Lincoln M 1909- *WhoAmA 73, -76, -78, -80, -82, -84*
Polan, Nancy Moore *WhoAmA 73, -76, -78, -80, -82, -84*
Poland, Lawrence *WhAmArt 85*
Poland, W A 1852-1935 *BiDAmAr*
Poland, William Carey 1846-1929 *WhAmArt 85*
Polangin, Abba Isa 1938- *AmArch 70*
Polart, Marie Henriette *DcWomA*
Polasek, Albin 1879- *WhAmArt 85*
Polasek, Ruth *DcWomA*
Polcari, Stephen 1945- *WhoAmA 82, -84*
Poldeman, William F *NewYHSD*
Pole, T G *DcVicP 2*
Polehalt, Emily *DcVicP 2*
Polelonema, Otis 1902- *IlBEAAW, WhAmArt 85*
Polenova, Elena Dmitrievna 1850-1898 *DcWomA*
Poleo, Hector *OxTwCA*
Poleo, Hector 1918- *DcCAr 81, McGDA*
Polesello, Rogelio 1939- *OxTwCA, PhDcTCA 77*
Polesello, Rogeliu 1939- *DcCAr 81*
Poleskie, Stephen Francis 1938- *WhoAmA 73, -76, -78, -80, -82, -84*
Poleskie, Steve 1938- *PrintW 83, -85*
Polevitzky, I B *AmArch 70*
Polevitzky, Igor Boris 1911- *McGDA*
Polgreen, John *IlsBYP, WhAmArt 85*
Polhemus, John *EncASM*
Polhemus, John Thomas 1929- *MarqDCG 84*
Polhemus, Neil William 1951- *MarqDCG 84*
Polhemus And Strong *EncASM*
Poli, Flavio 1900- *IlDcG*
Poli, Kenneth 1921- *MacBEP*
Poli-Marchetti, Alice *DcWomA*
Poliack, Richard Samuel *AmArch 70*
Poliakoff *DcCAr 81*
Poliakoff, Serge 1900?-1969 *WorArt[port]*
Poliakoff, Serge 1906- *McGDA*
Poliakoff, Serge 1906-1969 *ConArt 77, -83, OxTwCA, PhDcTCA 77*
Polidori, Gianni 1923- *ConDes*
Polidoro DaCaravaggio 1490-1543 *McGDA*
Polidoro DaCaravaggio 1500?-1543 *OxArt*
Polidoro DaLanciano 1514-1565 *McGDA*
Polier, August Lewis 1922- *AmArch 70*
Polieri, Jacques 1928- *MarqDCG 84*
Polillo, Lawrence Philip 1928- *AmArch 70*
Polimenakos, Carmon 1939- *WhoAmA 76, -78*
Poling, Clark V *WhoAmA 84*
Polis, Michael Philip 1943- *MarqDCG 84*
Polish, Nathaniel 1962- *MarqDCG 84*
Poliszczuk, Orest Stephan 1942- *WhoAmA 82, -84*
Politi, Leo *IlsCB 1967*
Politi, Leo 1908- *Cald 1938, IlBEAAW, IlsBYP, IlsCB 1744, -1946, -1957, WhAmArt 85*
Politinsky, F Augusta *WhoAmA 73, -76*
Polito, S d1814 *DcNiCA*
Politzer, John Robert 1931- *AmArch 70*
Polivnick, Norton 1918- *AmArch 70*
Polk, Benjamin Kauffman 1916- *AmArch 70*
Polk, Charles Peale *FolkA 86*
Polk, Charles Peale 1767-1822 *AntBDN O, BnEnAmA, NewYHSD*
Polk, Frank 1909- *IlBEAAW*
Polk, Frank Fredrick 1908- *WhoAmA 76, -78, -80, -82, -84*
Polk, Mary Alys 1902- *WhAmArt 85*
Polk, Paul Ronald 1950- *MarqDCG 84*
Polk, Prentice H 1898- *ICPEnP A, MacBEP*
Polk, W M *AmArch 70*
Polk, Willis 1867-1924 *MacEA*
Polk, Willis Jefferson 1867-1924 *BiDAmAr, EncMA*
Polke, Sigmar 1941- *ConArt 77, -83, DcCAr 81*
Polkes, Alan H 1931- *WhoAmA 78N, -80N, -82N, -84N*
Polkinghorn, George 1898- *ArtsAmW 2, WhAmArt 85*
Polkinghorn, James B 1934- *AmArch 70*

Polkovnikov, Vladimir 1906- *WorECar*
Polky, Olaf H *WhAmArt 85*
Pollack, Barbara Lynn 1945- *MarqDCG 84*
Pollack, Bary William 1944- *MarqDCG 84*
Pollack, H A *AmArch 70*
Pollack, Jackson 1912-1956 *ConArt 83*
Pollack, Jan d1519 *McGDA*
Pollack, Louis 1921-1970 *WhoAmA 78N, -80N, -82N, -84N*
Pollack, Max 1886-1970 *ArtsAmW 2*
Pollack, Michael 1773-1855 *McGDA, WhoArch*
Pollack, Peter 1909-1978 *ICPEnP, MacBEP*
Pollack, Peter 1911- *WhoAmA 73, -76, -78*
Pollack, Peter 1911-1978 *WhoAmA 80N, -82N, -84N*
Pollack, Reginald 1924- *DcCAA 71, -77*
Pollack, Reginald M 1924- *IlsCB 1957*
Pollack, Reginald Murray *IlsCB 1967*
Pollack, Reginald Murray 1924- *WhoAmA 73, -76, -78, -80, -82, -84*
Pollack, S S *AmArch 70*
Pollack, Virginia Morris *WhoAmA 78N, -80N, -82N, -84N*
Pollaiuolo, Antonio 1432?-1498 *OxArt*
Pollaiuolo, Antonio Del 1431?-1498 *McGDA*
Pollaiuolo, Piero 1441?-1496? *OxArt*
Pollaiuolo, Piero Del 1443?-1496? *McGDA*
Pollaiuolo, Simone Del *McGDA*
Pollak, Augusto *WhAmArt 85*
Pollak, Jerry Leslie 1929- *AmArch 70*
Pollak, Max 1886- *WhAmArt 85*
Pollak, Max 1886-1970 *ArtsAmW 2*
Pollak, Pauline *DcWomA*
Pollak, Theresa 1899- *DcWomA, WhAmArt 85, WhoAmA 73, -76, -78, -80, -82, -84*
Pollak, Virginia *DcWomA*
Polland, Donald Jack 1932- *WhoAmA 76, -78, -80, -82, -84*
Pollard, A Read *DcVicP 2*
Pollard, A W *FolkA 86*
Pollard, Alice Esther *DcWomA, WhAmArt 85*
Pollard, C H *AmArch 70*
Pollard, C J *NewYHSD*
Pollard, Calvin 1797-1850 *NewYHSD*
Pollard, Donald 1924- *IlDcG*
Pollard, Donald Pence 1924- *WhoAmA 73, -76, -78, -80, -82, -84*
Pollard, F *DcVicP 2*
Pollard, Henry *NewYHSD*
Pollard, Mrs. Henry *WhAmArt 85*
Pollard, Henry G *NewYHSD*
Pollard, James *BiDBrA*
Pollard, James 1792-1867 *DcBrWA, DcVicP, -2*
Pollard, John 1802-1885 *NewYHSD*
Pollard, Kattern *DcVicP 2*
Pollard, Luke *FolkA 86, NewYHSD*
Pollard, Remira *DcVicP 2*
Pollard, Robert 1755-1838 *DcBrECP, DcBrWA*
Pollard, S G *DcVicP, -2*
Pollard, William *NewYHSD*
Pollaro, Paul *WhoAmA 73, -76, -78, -80, -82, -84*
Pollastrini, Enrico 1817-1876 *ArtsNiC*
Pollatz, W *AmArch 70*
Pollen, Arthur Joseph Lawrence 1899- *DcBrA 2*
Pollen, Daphne 1904- *DcBrA 2*
Pollen, John Hungerford 1820-1902 *DcBrWA, DcVicP 2*
Pollentine, Alfred *DcVicP, -2*
Pollentine, R J *DcVicP, -2*
Pollentine, W H *DcVicP, -2*
Pollet, Mademoiselle 1843- *DcWomA*
Pollet, Joseph 1897-1979 *WhAmArt 85*
Pollet, Joseph 1898-1979 *WhoAmA 80N, -82N, -84N*
Pollexfen, J *DcVicP 2*
Polley, Frederick *WhoAmA 80N, -82N, -84N*
Polley, Frederick 1875-1958? *WhAmArt 85*
Pollia, Joseph P 1893-1954 *WhAmArt 85*
Pollini, Gino *McGDA*
Pollini, Gino 1903- *ConArch, EncMA, MacEA, McGDA*
Pollitt, Albert *DcBrA 2, DcBrWA, DcVicP 2*
Pollitt, C W *AmArch 70*
Pollitt, Evan 1913- *AmArch 70*
Pollitt, Jerome Jordan 1934- *WhoAmA 80, -82, -84*
Pollitzer, Anita L *WhAmArt 85*
Pollitzer, Luise 1875- *DcWomA*
Pollitzer, Sigmund 1913- *DcCAr 81*
Pollock, A M *ArtsAmW 3*
Pollock, Alice *WorFshn*
Pollock, Beatrice M *DcVicP 2*
Pollock, Bruce Walter 1951- *WhoAmA 84*
Pollock, Charles Cecil 1902- *WhAmArt 85*
Pollock, Courtenay Edward Maxwell 1877-1943 *ClaDrA, DcBrA 1*
Pollock, Courtnay *WhAmArt 85*
Pollock, Elsie *WorFshn*
Pollock, Sir Frederick 1815-1874 *DcVicP 2*
Pollock, Sir Frederick Montague- 1815-1874 *DcBrWA*
Pollock, George F 1928- *WhoArt 80, -82, -84*
Pollock, Helen 1945- *WhoArt 80, -82, -84*
Pollock, Jackson 1912-1956 *BnEnAmA, ConArt 77, DcAmArt, DcCAA 71, -77, McGDA, OxArt,*

OxTwCA, PhDcTCA 77, WhAmArt 85,
WhoAmA 78N, −80N, −82N, −84N, WorArt[port]
Pollock, James Arlin d1949 WhoAmA 78N, −80N,
−82N, −84N
Pollock, James Arlin 1898-1949 WhAmArt 85
Pollock, Mabel Clare Hillyer 1884- DcWomA,
WhAmArt 85
Pollock, Maurice DcVicP 2
Pollock, Merlin F 1905- WhoAmA 73, −76, −78, −80,
−82, −84
Pollock, Sir Montague Frederick Montagu- 1864-1938
DcBrWA
Pollock, N E AmArch 70
Pollock, Samuel FolkA 86
Pollock, Sarah E FolkA 86
Pollock, Thomas NewYHSD
Pollok, Merlin 1905- WhAmArt 85
Polniaszek, Ronald Edward 1936- AmArch 70
Polonceau, Blanche 1846-1914 DcWomA
Polonsky, Arthur 1925- WhoAmA 73, −76, −78, −80,
−82, −84
Polonyi, John WhAmArt 85
Polos, Theodore C 1902- WhAmArt 85
Poloukhine, Olga PrintW 85
Polousky, Julie 1908- WhAmArt 85
Polowetski, C Ezekiel 1884- WhAmArt 85
Polowetski, Charles Ezekiel 1884- ArtsAmW 2
Polseno, Jo IlsBYP
Polseno, Joe OfPGCP 86
Polshek, James Stewart 1930- AmArch 70, ConArch,
MacEA
Polsky, Cynthia 1939- WhoAmA 73, −76, −78, −80,
−82, −84
Polsky, Donald Perry 1928- AmArch 70
Polster, Dora 1884- DcWomA
Polster, Joanne F 1930- WhoAmA 80, −82, −84
Polston, Morris V 1942- MarqDCG 84
Polter NewYHSD
Polter, E DcVicP 2
Polter, Samuel NewYHSD
Polujan, Romuald Karol 1924- AmArch 70
Polunin, Elizabeth 1887- DcBrA 1, DcWomA
Polunin, Vladimir 1880-1957 DcBrA 1
Polwarth, Lady Amabel 1751-1833 DcWomA
Polychrone, Demetrios Aremistos 1920- AmArch 70
Polycleitus McGDA
Polycletus Of Argos OxArt
Polycletus Of Sikyon OxArt
Polyclitus OxArt
Polyclitus Of Argos OxArt
Polyclitus Of Sikyon OxArt
Polydorides, Nicos D 1946- MarqDCG 84
Polydorus McGDA
Polyeuctus McGDA
Polygnotos McGDA
Polygnotus Of Thasos OxArt
Polykleitos d350BC MacEA
Polymedes McGDA
Polzer, Joseph 1929- WhoAmA 76, −78, −80, −82, −84
Pomarance, Cavaliere Delle McGDA
Pomarancio 1517?-1596? McGDA
Pomarancio, Il OxArt
Pomarede, Edwards NewYHSD
Pomarede, Leon 1807?-1892 IlBEAAW, NewYHSD
Pomarede, Leon D 1807-1892 FolkA 86
Pomaret, Gabrielle De DcWomA
Pombo, Eduardo 1929- MarqDCG 84
Pomedello, Giovanni Maria 1478-1537? ClaDrA
Pomerance, Fay 1912- DcBrA 1, WhoArt 80, −82,
−84
Pomerance, Leon 1907- WhoAmA 73
Pomerance, Ralph 1907- AmArch 70
Pomerantz, Louis 1919- WhoAmA 78, −80, −82, −84
Pomeranzewa, Raissa Ivanovna DcWomA
Pomeroy, Charles FolkA 86
Pomeroy, Elise Lower 1882-1971 DcWomA
Pomeroy, Ellen M DcWomA
Pomeroy, Elsie Lower WhAmArt 85
Pomeroy, Elsie Lower 1882- ArtsAmW 2
Pomeroy, Florence W 1889- DcWomA,
WhAmArt 85
Pomeroy, Frederick William 1856-1924 DcBrA 1
Pomeroy, Gerald Charles 1927- AmArch 70
Pomeroy, Grace V d1906 DcWomA, WhAmArt 85
Pomeroy, James Calwell, Jr. 1945- WhoAmA 78, −80,
−82, −84
Pomeroy, Laura Skeel 1833-1911 DcWomA,
NewYHSD , WhAmArt 85
Pomeroy, Leason Frederick, III 1937- AmArch 70
Pomeroy, Lee Harris 1932- AmArch 70
Pomeroy, Lucinda FolkA 86
Pomeroy, Mary Agnes DcWomA, WhAmArt 85
Pomeroy, Noah FolkA 86
Pomey-Ballue, Therese DcWomA
Pommayrac NewYHSD
Pommer, Julius 1895?-1945 ArtsAmW 2
Pommer, Mildred Newell 1893- ArtsAmW 1,
DcWomA, WhAmArt 85
Pommer, Richard 1930- WhoAmA 82, −84
Pommers, Indulis 1946- MarqDCG 84

Pommier-Zaborowska, Gilberte Helene 1889-
DcWomA
Pomodoro, Arnaldo 1926- ConArt 77, −83, OxTwCA,
PhDcTCA 77, WorArt[port]
Pomodoro, Gio 1930- ConArt 77, −83, OxTwCA,
PhDcTCA 77, WorArt
Pompadour, Jeanne A Poisson, Marquise De 1721-1764
DcWomA
Pompe, Antoine 1873-1980 MacEA
Pompe, Gerrit DcSeaP
Pompei, Alessandro 1705-1772 MacEA
Pompei, Roger Louis 1934- AmArch 70
Pompeio, Vincenzo IlDcG
Pompey, L W FolkA 86
Pompili, Lucian Octavius 1942- CenC
Pompon, Francois 1855-1923 OxTwCA
Pompon, Francois 1855-1933 AntBDN C
Pomroy, Lucinda FolkA 86
Ponc, Joan 1927- ConArt 77, OxTwCA
Poncarali Maggi, Ortensia, Contessa 1730?- DcWomA
Ponce, Marguerite DcWomA
Ponce DeLeon, Fidelio 1895- McGDA
Ponce DeLeon, Michael 1922- AmArt, DcCAA 71,
−77, PrintW 83, −85, WhoAmA 73, −76, −78, −80,
−82, −84
Poncelet, Georges OxTwCA
Poncet-Matrat, Pauline DcWomA
Ponchon, Anthony 1820?- NewYHSD
Poncia, Antonio 1793?- NewYHSD
Poncy, Alfred Vevier De DcVicP, −2
Pond, Allen B 1858-1929 BiDAmAr
Pond, Allen Bartlit WhAmArt 85
Pond, Arthur 1700?-1758 DcBrECP
Pond, Arthur 1705-1758 BkIE, ClaDrA
Pond, Burton FolkA 86
Pond, Charles ArtsEM
Pond, Clayton 1941- AmArt, ConArt 77,
DcCAA 71, −77, PrintW 85, WhoAmA 73, −76,
−78, −80, −82, −84
Pond, Dana d1962 WhAmArt 85, WhoAmA 78N,
−80N, −82N, −84N
Pond, David F NewYHSD
Pond, Edward 1929- ConDes
Pond, Edward L FolkA 86
Pond, Emma McHenry WhAmArt 85
Pond, Florence A DcWomA
Pond, George D WhAmArt 85
Pond, Harold Woodford 1897- WhAmArt 85
Pond, Irving K 1857-1939 BiDAmAr
Pond, Mabel E Dickinson WhAmArt 85
Pond, Theodore Hanford 1873-1933 WhAmArt 85
Pond, Willi Baze d1947 WhoAmA 78N, −80N, −82N,
−84N
Pond, Willi Baze 1896-1947 WhAmArt 85
Ponder, James R DcVicP 2
Ponder, Larry Neal 1940- AmArch 70
Poninska, Helena 1791-1834 DcWomA
Ponnelle, Jean-Pierre 1932- ConDes
Ponnet, Charles WhAmArt 85
Ponninger, Caroline 1845- DcWomA
Pons DeL'Herault, Herminie DcWomA
Pons DeL'Herault, Pauline DcWomA
Ponsen, Tunis 1891- WhAmArt 85
Ponsford, John 1790?-1870 DcVicP 2
Ponsford, K E AmArch 70
Ponson, Luc Raphael 1835-1904 ClaDrA
Ponson DuTerrail, Marguerite DcWomA
Ponsonby, Gerald DcVicP 2
Ponsor, Dale Wayne 1935- AmArch 70
Ponsot, Claude F 1927- WhoAmA 82, −84
Pont, Charles Ernest 1898- WhAmArt 85
Pont, J DcBrBI
Pont-Jest, Renee De d1902 DcWomA
Ponte, Da OxArt
Ponte, Francesco Da McGDA
Ponte, Giovanni Dal McGDA
Pontelli, Baccio 1450-1492 MacEA
Pontelli, Baccio 1450?-1492? McGDA
Pontelli, M L De NewYHSD
Ponten, Julia 1880- DcWomA
Ponthie, F L AmArch 70
Ponti, Carlo ICPEnP, MacBEP
Ponti, Gio 1891- DcD&D[port], EncMA, McGDA
Ponti, Gio 1891-1979 ConArch, ConDes, MacEA
Ponti, Gio 1897- WhoArch
Pontin, George ClaDrA, DcBrA 1, DcVicP 2
Ponting, Herbert George 1871-1935 MacBEP
Pontius, Paul 1603-1648 McGDA
Ponton, Alexander BiDBrA
Ponton, Mungo 1801-1880 ICPEnP, MacBEP
Pontormo 1494-1557? McGDA
Pontormo, Jacopo Carucci 1494-1557 OxArt
Ponzio, Flaminio 1559?-1613 MacEA
Ponzio, Flaminio 1560-1613 McGDA, OxArt
Poock, Fritz 1877-1944? ArtsAmW 2
Poock, Fritz 1877-1944? ArtsAmW 2
Pook, Fritz 1877-1944? ArtsAmW 2
Pook, Gerrard Stewart 1926- AmArch 70
Pooke, Marion Louise DcWomA, WhAmArt 85
Pool, B EncASM
Pool, Eugenia Pope ArtsAmW 3, DcWomA

Pool, John Lidbury BiDBrA
Pool, Juriaen 1665?-1745 ClaDrA
Pool, Nelda Lee WhoAmA 80
Pool, Nelda Lee 1941- WhoAmA 78
Pool, O J AmArch 70
Pool, Rachel DcWomA
Pool, Sam W 1939- AmArch 70
Pool, William Anthony, Jr. 1931- AmArch 70
Poole EncASM
Poole, Abram 1882-1961 WhoAmA 80N, −82N, −84N
Poole, Abram 1883-1961 WhAmArt 85
Poole, Bert 1853-1939? WhAmArt 85
Poole, Burnell 1884-1933 WhAmArt 85
Poole, Christopher DcVicP, −2
Poole, Colin MacGarvey 1954- MacBEP
Poole, Earl L 1891-1972 WhAmArt 85
Poole, Earl Lincoln 1891-1972 WhoAmA 78N, −80N,
−82N, −84N
Poole, Eugene Alonzo 1841- WhAmArt 85
Poole, Eugene Alonzo 1841-1912 ArtsAmW 2
Poole, Flora ArtsEM, DcWomA
Poole, Frank Burton, Jr. 1923- AmArch 70
Poole, Frederic Victor 1865-1936 WhAmArt 85
Poole, Frederick Victor DcVicP 2
Poole, G T DcBrBI
Poole, George Temple 1856-1934 MacEA
Poole, H Nelson 1885- ArtsAmW 1
Poole, Henry 1785?-1857 BiDBrA
Poole, Henry 1873-1928 DcBrA 1
Poole, Horatio Nelson 1883- WhAmArt 85
Poole, J L AmArch 70
Poole, James AntBDN D
Poole, James 1804-1886 DcVicP, −2
Poole, John WhAmArt 85
Poole, Leslie Donald 1942- WhoAmA 84
Poole, Lester Brooks 1914- AmArch 70
Poole, Monica 1921- DcBrA 1, WhoArt 80, −82, −84
Poole, Paul Falconer 1807-1879 ClaDrA, DcBrWA,
DcVicP, −2
Poole, Paul Falconer 1818-1879 ArtsNiC
Poole, Richard Elliott 1931- WhoAmA 76, −78, −80,
−82, −84
Poole, Samuel 1870- DcBrA 1, DcVicP 2
Poole, Thomas E 1860-1919 BiDAmAr
Poole, W E AmArch 70
Poole, W F AmArch 70
Poole, William DcBrBI, DcVicP 2, WorFshn
Poole, William Ellenburg 1929- AmArch 70
Poole, William H 1830?- NewYHSD
Poole And Roche EncASM
Pooley, A NewYHSD
Pooley, Roy Medora, Jr. 1920- AmArch 70
Pooley, Thomas 1646-1723? DcBrECP
Poons, Larry 1937- AmArt, BnEnAmA, CenC[port],
ConArt 77, −83, DcCAA 71, −77, DcCAr 81,
McGDA, OxTwCA, PhDcTCA 77,
WhoAmA 73, −76, −78, −80, −82, −84, WorArt
Poons, Lawrence 1937- PrintW 85
Poor, Alfred Easton WhAmArt 85
Poor, Alfred Easton 1899- AmArch 70
Poor, Anne 1918- WhoAmA 73, −76, −78, −80, −82,
−84
Poor, Charles H WhAmArt 85
Poor, Henry Varnum 1888- McGDA
Poor, Henry Varnum 1888-1970 ArtsAmW 1,
BnEnAmA, DcAmArt, DcCAA 71, −77,
IlBEAAW, WhAmArt 85, WhoAmA 78N, −80N,
−82N, −84N
Poor, Henry Varnum 1888-1971 CenC
Poor, Henry Warren 1863- WhAmArt 85
Poor, John 1812?- CabMA
Poor, Jonathan D FolkA 86, NewYHSD
Poor, Robert John 1931- WhoAmA 73, −76, −78, −80,
−82, −84
Poor, Samuel d1727 CabMA
Poore, Henry R 1859-1940 ArtsAmW 1,
WhAmArt 85
Poore, Henry Rankin 1859-1940 IlBEAAW
Poorter, Bastiaan De 1813-1880 ClaDrA
Poorter, Willem De 1608-1648? ClaDrA, McGDA
Poost, Maximillian 1922- AmArch 70
Pop Chalee 1908- IlBEAAW
Pope FolkA 86
Pope, Mrs. DcWomA, FolkA 86, NewYHSD
Pope, Alexander 1680-1744 DcBrECP
Pope, Alexander 1763-1835 DcBrECP
Pope, Alexander 1829-1924 DcAmArt
Pope, Alexander 1849-1924 BnEnAmA,
WhAmArt 85
Pope, Mrs. Alexander d1838 DcVicP, −2
Pope, Alvin AfroAA
Pope, Annemarie Henle WhoAmA 73, −76, −78, −80,
−82, −84
Pope, Arthur WhAmArt 85
Pope, Arthur Edward DcVicP 2
Pope, C, Jr. AmArch 70
Pope, Celestine Johnston 1911- AfroAA
Pope, Charles St. George 1904- AmArch 70
Pope, Clara Maria 1750?-1838 DcWomA
Pope, Clara Maria 1768?-1838 DcBrWA
Pope, Collett S WhAmArt 85

Portmann, Frieda Bertha Anne *WhoAmA 73, –76, –78*
Portner, Alex *WhoArt 82, –84*
Portner, Alexander Manrico *WhoArt 80*
Portner, Alexander Manrico 1920- *ClaDrA*
Portner, Edward 1835?- *NewYHSD*
Portner, Lawrence J *MarqDCG 84*
Portnoff, Alexander d1949 *WhoAmA 78N, –80N, –82N, –84N*
Portnoff, Alexander 1887-1949 *WhAmArt 85*
Portnoy, Harry Philip 1922- *AmArch 70*
Portnoy, Theodora Preiss *WhoAmA 80, –82, –84*
Porto Alegre, Manuel DeAraujo 1806-1879 *McGDA*
Portocarrero, Rene 1912- *McGDA*
Portoghesi, Paolo 1931- *ConArch*
Portois, Peter 1812-1900 *MacEA*
Portois, Pierre *BiDAmAr*
Portor, Fairfield 1907-1975 *WhoAmA 82N*
Portsmouth, Delia 1939- *WhoArt 80, –82, –84*
Portsmouth, Percy Herbert 1874-1953 *DcBrA 1*
Portuese, Vincent, Jr. 1917- *AmArch 70*
Portway, Douglas *OxTwCA*
Portway, Douglas 1922- *ConArt 77, ConBrA 79[port], DcCAr 81*
Portway, Douglas Owen 1922- *WhoArt 80, –82, –84*
Portway, Patrick *MarqDCG 84*
Portwood, Charles Sterling 1942- *MarqDCG 84*
Portwood, George d1742 *BiDBrA*
Portzline, Elizabeth *FolkA 86*
Portzline, Francis 1771- *FolkA 86*
Porumbescu, Nicolae 1919- *MacEA*
Posada, Jose Guadalupe *OxTwCA*
Posada, Jose Guadalupe 1851-1913 *McGDA*
Posada, Juan Guadalupe 1852-1913 *OxArt*
Posavec, Tereza *OxTwCA*
Poschacher, Maria Louise 1886- *DcWomA*
Poschinger, Benedikt Von *IlDcG*
Poschinger, Ferdinand Benedikt Von 1867-1921 *IlDcG*
Poschinger, Ferdinand Von 1815-1867 *IlDcG*
Posdamer, Jeffrey L 1943- *MarqDCG 84*
Posegate, David Robert *MarqDCG 84*
Poseler, Frank Edward 1920- *AmArch 70*
Posen, Stephen 1939- *ConArt 77, –83, DcCAA 77, DcCAr 81, WhoAmA 73, –76, –78, –80, –82, –84*
Posener, Julius *ConArch A*
Poses, Jack I 1899- *WhoAmA 73, –76, –78, –80, –82, –84*
Poses, Mrs. Jack I *WhoAmA 73, –76*
Poses, Mrs. Jack I 1908- *WhoAmA 78, –80, –82, –84*
Posey, Ernest Noel 1937- *WhoAmA 76, –78, –80, –82, –84*
Posey, Leslie Thomas 1900- *WhAmArt 85, WhoAmA 73, –76, –78, –80, –82, –84*
Posey, R K *AmArch 70*
Posi, Paolo 1708-1776 *MacEA*
Poskus, E A J *AmArch 70*
Posluszny, Stephen Douglas 1959- *MarqDCG 84*
Posnik, Yakoslev *OxArt*
Posner, Donald 1931- *WhoAmA 73, –76, –78, –80, –82, –84*
Posner, F *AmArch 70*
Posner, J *EncASM*
Posner, Judith L 1941- *WhoAmA 76, –78, –80, –82, –84*
Posner, Richard 1948- *DcCAr 81*
Posner, Richard Perry 1948- *WhoAmA 78, –80*
Posnett, David Wilson 1942- *WhoArt 80, –82, –84*
Posniak, Lawrence Ellis 1945- *MarqDCG 84*
Posselwhite, George W 1822?- *NewYHSD*
Possoz, Milly 1892- *DcWomA*
Post, Miss *DcWomA*
Post, Anne B *WhoAmA 76, –78, –80, –82, –84*
Post, Bruce 1885-1927 *BiDAmAr*
Post, Carl A 1931- *AmArch 70*
Post, Charles Johnson 1873- *WhAmArt 85*
Post, Cornelia S *DcWomA*
Post, David Edward 1926- *AmArch 70*
Post, Edward C *NewYHSD*
Post, Edward Everett 1911- *AmArch 70*
Post, Edwin V 1953- *MarqDCG 84*
Post, Edwina M *DcWomA, WhAmArt 85*
Post, Frans 1612?-1680 *McGDA, OxArt*
Post, G Allen 1938- *MarqDCG 84*
Post, George 1906- *WhoAmA 73, –76, –78, –80, –82, –84*
Post, George B 1837-1913 *McGDA*
Post, George Booth 1906- *WhAmArt 85*
Post, George Browne 1837-1913 *BiDAmAr, EncAAr, MacEA, WhoArch*
Post, Kristina Von 1835-1917 *DcWomA*
Post, Marion 1910- *WhoAmA 84*
Post, Mary *DcWomA*
Post, May Audubon d1929 *DcWomA, WhAmArt 85*
Post, Mildred Anderson 1892-1921 *WhAmArt 85*
Post, Nellie A *ArtsEM, DcWomA*
Post, Philip 1923- *AmArch 70*
Post, Pieter 1608-1669 *MacEA, WhoArch*
Post, Pieter Jansz 1608-1669 *McGDA*
Post, Raymond George, Jr. 1939- *AmArch 70*
Post, W Merritt 1856-1935 *WhAmArt 85*
Post, William Stone 1866-1940 *BiDAmAr*

Post Wolcott, Marion 1910- *ConPhot*
Postempska, Agnese *DcWomA*
Postgate, Margaret J *WhAmArt 85*
Posthumus Meyjes, C B 1858-1922 *MacEA*
Postiglione, Corey *DcCAr 81*
Postiglione, Corey M 1943- *WhoAmA 78, –80, –82, –84*
Postil, S *AmArch 70*
Postin, Robert William 1921- *AmArch 70*
Postle, Joy 1896- *ArtsAmW 3*
Postle, Robert Clarence 1934- *AmArch 70*
Postlethwaite, Elinor 1866- *DcBrA 1, DcVicP 2, DcWomA*
Postlethwaite, Mary Emily *DcWomA*
Poston, David 1948- *DcCAr 81*
Poston, Robert M 1942- *MarqDCG 84*
Postregna, A M *AmArch 70*
Pot, Heindrick Gerritsz 1585-1657 *ClaDrA*
Pot, Hendrick Gerritsz 1585?-1657 *McGDA*
Pot, Hendrik Gerritsz 1585?-1657 *OxArt*
Potain, Nicolas Marie 1713-1796 *MacEA*
Potamkin, Meyer P 1909- *WhoAmA 73, –76*
Potchett, Caroline H *DcVicP, –2, DcWomA*
Potchett, Emily *DcVicP, –2, DcWomA*
Poteat, Ida I 1856- *WhAmArt 85*
Poteet, Bruce C 1936- *AmArch 70*
Potel, Denise Louise Estelle 1803- *DcWomA*
Potel, Michael John 1948- *MarqDCG 84*
Potemont, Adolphe Theodore Jules Martial 1828-1883 *ClaDrA*
Poterin DuMotel, Charlotte *DcWomA*
Pothoven, Hendrick 1725-1795 *ClaDrA*
Poticha, Otto Paul 1934- *AmArch 70*
Potie, Albain 1830-1863 *DcWomA*
Potier, T *DcBrECP*
Potocka, Beata *DcWomA*
Potocka, Countess Jozefa Amelia d1798 *DcWomA*
Potoff, Reeva *DcCAr 81*
Potok, Anna Maximilian 1907- *WorFshn*
Potron DeLaMarliere, Rita *DcWomA*
Pott, Charles L *DcBrBI, DcVicP 2*
Pott, Constance M *DcBrA 1*
Pott, Constance Mary 1862- *DcWomA*
Pott, L J 1837- *ArtsNiC*
Pott, Laslett John 1837-1898 *DcVicP, –2*
Pott, Richard Moncrieff 1895- *AmArch 70*
Potten, Miss *DcVicP 2, DcWomA*
Potten, Christopher *DcVicP 2*
Pottenger, Zeb *WhAmArt 85*
Potter, A L *ArtsAmW 3*
Potter, Agnes Squire 1892- *DcWomA, WhAmArt 85*
Potter, Anne W *DcWomA, WhAmArt 85*
Potter, Arthur *DcVicP 2*
Potter, B *DcWomA*
Potter, Beatrix 1866-1943 *DcBrA 1, DcWomA*
Potter, Bertha *WhAmArt 85*
Potter, Bertha Herbert 1895- *DcWomA*
Potter, Bessie *WhAmArt 85*
Potter, Bessie Onahotema *DcWomA*
Potter, C L, Jr. *AmArch 70*
Potter, Charles *DcVicP, –2*
Potter, Charles 1878- *DcBrA 1*
Potter, Clare *FairDF US, WorFshn*
Potter, Crowell *NewYHSD*
Potter, D D, Jr. *AmArch 70*
Potter, D W *AmArch 70*
Potter, Daniel *CabMA*
Potter, David S *MarqDCG 84*
Potter, Don Howard 1926- *AmArch 70*
Potter, Donald 1902- *WhoArt 80, –82, –84*
Potter, Edna *ConICB*
Potter, Edna E *WhAmArt 85*
Potter, Edward C 1857-1923 *WhAmArt 85*
Potter, Edward Clark 1800-1826 *NewYHSD*
Potter, Edward Palmer 1893- *AmArch 70*
Potter, Edward T 1831-1904 *MacEA*
Potter, Edward Tuckerman *McGDA*
Potter, Edward Tuckerman d1904 *BiDAmAr*
Potter, Edward Tuckerman 1831- *NewYHSD*
Potter, Ellis J 1890- *AmArch 70*
Potter, Emily *DcVicP 2*
Potter, Frank 1885- *DcBrA 1*
Potter, Frank Hayden *WhoArt 80, –82N*
Potter, Frank Hayden 1896- *DcBrA 1*
Potter, Frank Huddlestone 1845-1887 *ClaDrA, DcVicP, –2, McGDA*
Potter, Gertrude *DcWomA*
Potter, Gertrude B *WhAmArt 85*
Potter, Gordon M 1928- *AmArch 70*
Potter, Grafton Whipple, Jr. 1929- *AmArch 70*
Potter, Gwen 1904- *DcBrA 1*
Potter, H S 1873- *WhAmArt 85*
Potter, Harry Spafford 1870- *ArtsEM*
Potter, Helen Beatrix 1866-1943 *DcVicP 2*
Potter, Helen Beatrix 1866-1946 *DcBrBI, DcBrWA*
Potter, Henry *NewYHSD*
Potter, Horace E 1873- *WhAmArt 85*
Potter, Jack 1927- *IlrAm G, –1880*
Potter, James Thompson 1928- *AmArch 70*
Potter, Joan Terese *WhoAmA 76*
Potter, John *BiDBrA*

Potter, John B 1864- *ArtsEM*
Potter, John W 1926- *MarqDCG 84*
Potter, Joseph d1768 *CabMA*
Potter, Joseph 1756?-1842 *BiDBrA*
Potter, Kenneth 1926- *WhoAmA 73, –76, –78, –80, –82, –84*
Potter, Larry *AfroAA*
Potter, Lillian Brown 1892- *WhAmArt 85*
Potter, Louis McClellan 1873-1912 *ArtsAmW 2, WhAmArt 85*
Potter, Lucy 1778-1864 *FolkA 86*
Potter, M Helen *WhAmArt 85*
Potter, Martha J 1864- *WhAmArt 85*
Potter, Martha Julia 1864- *DcWomA*
Potter, Mary 1900- *ConBrA 79[port], DcBrA 1, WhoArt 80, –82*
Potter, Mary Knight *DcWomA, WhAmArt 85*
Potter, Mathilde 1880- *DcWomA, WhAmArt 85*
Potter, Michael Currie 1950- *MarqDCG 84*
Potter, Muriel Melbourne 1903- *WhAmArt 85*
Potter, Nathan D 1893-1934 *WhAmArt 85*
Potter, Paulus 1625-1654 *ClaDrA, OxArt*
Potter, Paulus Pietersz 1625-1654 *McGDA*
Potter, Pearl *DcWomA*
Potter, Percy C *DcVicP 2*
Potter, Phillips *CabMA*
Potter, Pieter Symonsz 1597?-1652 *ClaDrA, McGDA*
Potter, R H *DcVicP 2*
Potter, Raymond *DcBrBI*
Potter, Richard Montgomery 1923- *AmArch 70*
Potter, Richard Treat 1935- *AmArch 70*
Potter, Robert 1795?-1854 *BiDBrA*
Potter, Robert P 1904- *AmArch 70*
Potter, Rose *DcWomA, WhAmArt 85*
Potter, Ross Thomas 1936- *AmArch 70*
Potter, Ruth Morton 1896- *WhAmArt 85*
Potter, Samuel *NewYHSD*
Potter, Stephen Johnson 1906- *AmArch 70*
Potter, Sydney *DcVicP 2*
Potter, Taylor McWilliams 1927- *AmArch 70*
Potter, Ted 1933- *WhoAmA 73, –76, –78, –80, –82, –84*
Potter, Tennant *DcVicP 2*
Potter, Thomas Irving, Jr. 1916- *AmArch 70*
Potter, Ursula Yeaworth *WhAmArt 85*
Potter, V G *WhAmArt 85*
Potter, W A 1845-1915 *FolkA 86*
Potter, W C *NewYHSD*
Potter, W G *AmArch 70*
Potter, Wallace Marshall, Jr. 1943- *MarqDCG 84*
Potter, Walter B *DcVicP 2*
Potter, William A 1842-1909 *MacEA*
Potter, William Appleton *McGDA*
Potter, William Appleton 1842-1909 *BnEnAmA*
Potter, William C 1842-1909 *BiDAmAr*
Potter, William J d1964 *WhoAmA 78N, –80N, –82N, –84N*
Potter, William J 1883-1964 *ArtsAmW 1, IlBEAAW, WhAmArt 85*
Potter, Wilson 1868-1936 *BiDAmAr*
Potter, Zenas L 1886-1958 *ArtsAmW 2*
Potters, Barbara *IlDcG*
Potterveld, Burton Lee 1908- *WhAmArt 85*
Potthast, Edward H 1857-1927 *WhAmArt 85*
Potthast, Edward Henry 1857-1927 *ArtsAmW 1, –3, IlBEAAW, IlrAm 1880*
Pottier, Constance *DcWomA*
Pottier, Esther *DcWomA*
Pottier, Marie *DcWomA*
Pottier & Stymus *DcNiCA*
Potting, Countess Adrienne 1856- *DcWomA*
Pottinger, H *DcVicP 2*
Pottinger, Zeb *WhAmArt 85*
Pottman Brothers *FolkA 86*
Potts, Abram *FolkA 86*
Potts, Christopher *FolkA 86*
Potts, Don 1936- *DcCAr 81, WhoAmA 73, –76, –78, –80, –82, –84*
Potts, George B *DcVicP, –2*
Potts, Gertrude Early *ArtsEM, DcWomA*
Potts, Jackie *MarqDCG 84*
Potts, John Joseph 1844-1933 *DcBrA 1, DcBrWA, DcVicP 2*
Potts, Marian 1917- *AmArch 70*
Potts, Thurman Ira 1921- *AmArch 70*
Potts, W Sherman 1876-1930 *WhAmArt 85*
Potts, William Stephens 1802-1852 *NewYHSD*
Potuijl, H *McGDA*
Potvin, Alfred Raoul 1942- *MarqDCG 84*
Potvin, Daniel 1946- *WhoAmA 76, –78, –80*
Potvin, Lora Remington 1880- *ArtsAmW 3*
Potwine, John 1698-1792 *AntBDN Q*
Potworowski, Peter 1898- *DcBrA 1*
Potworowski, Pjotr 1898-1960 *PhDcTCA 77*
Pou, Pedro F 1930- *AmArch 70*
Poucher, Edward A *WhAmArt 85*
Poucher, Elizabeth Morris *WhAmArt 85, WhoAmA 73, –76, –78, –80, –82, –84*
Poucher, Emily Rollinson *WhAmArt 85*
Poucher, W A 1891- *MacBEP*

Prentice, Andrew N *DcVicP 2*
Prentice, David 1943- *PrintW 83, –85*
Prentice, David Ramage 1943- *WhoAmA 73, –76, –78, –80, –82, –84*
Prentice, George W *NewYHSD*
Prentice, John 1920- *WorECom*
Prentice, John R *DcVicP 2*
Prentice, Kate 1845-1911 *DcBrA 1, DcBrWA, DcVicP 2, DcWomA*
Prentice, N F *AmArch 70*
Prentice, Oliver *CabMA*
Prentice, Sydney C *ArtsAmW 3*
Prentice, T Merrill, Jr. 1930- *AmArch 70*
Prentice, Thomas C 1958- *MarqDCG 84*
Prentice, Thurlow Merrill 1898- *AmArch 70*
Prentis, Edmund Astley 1856-1929 *WhAmArt 85*
Prentis, Edward 1797-1854 *DcBrBI, DcVicP, –2*
Prentiss, Addison *NewYHSD*
Prentiss, Grace Leonie *DcWomA*
Prentiss, Nathaniel Smith *NewYHSD*
Prentiss, Sarah J 1823-1877 *DcWomA, NewYHSD*
Pres, Francois M T Des *AfroAA*
Presant, Sally Crosby 1956- *MarqDCG 84*
Presas, Leopoldo 1915- *OxTwCA*
Presbrey, D A *AmArch 70*
Preschez, Catherine *DcWomA*
Prescott, A C *AmArch 70*
Prescott, C Trevor *DcVicP 2*
Prescott, Charles Barrow Clarke 1870-1932 *DcBrA 1, DcVicP 2*
Prescott, Douglass Gordan 1912- *AmArch 70*
Prescott, H P *DcVicP 2*
Prescott, Katharine T Hooper *WhAmArt 85*
Prescott, Katherine T *DcWomA*
Prescott, Kenneth Wade 1920- *WhoAmA 76, –78, –80, –82, –84*
Prescott, Martha Abbott 1773?- *FolkA 86*
Prescott, Plumer 1833-1881 *NewYHSD*
Prescott, Preston L 1898- *WhAmArt 85*
Prescott, R J *AmArch 70*
Prescott, W H *AmArch 70*
Prescott, William Linzee 1917- *WhAmArt 85*
Prescott-Davies, Norman 1862-1915 *DcBrBI*
Preskar, Edward William 1928- *AmArch 70*
Presnal, William Boleslaw 1910- *WhAmArt 85*
Press, Henry 1844-1920 *DcSeaP*
Press, J, Jr. *AmArch 70*
Press, Nancy Neumann 1940- *WhoAmA 78, –80, –82*
Press, Robert 1928- *AmArch 70*
Press, Zal 1951- *MarqDCG 84*
Pressel, David C 1947- *MarqDCG 84*
Presser, Josef d1967 *WhoAmA 78N, –80N, –82N, –84N*
Presser, Josef 1907-1967 *WhAmArt 85*
Pressler, Fred Walker 1914- *AmArch 70*
Pressler, Gene *WhAmArt 85*
Pressley, Daniel 1918- *AfroAA*
Pressley, Daniel 1918-1971 *FolkA 86*
Pressly, Nancy Lee 1941- *WhoAmA 84*
Pressly, T A, Jr. *AmArch 70*
Pressly, William Laurens, Jr. 1944- *WhoAmA 80, –82, –84*
Pressma, Conrad J 1944- *ICPEnP A, MacBEP*
Pressman, Meihel *FolkA 86*
Pressoir, Esther *WhAmArt 85*
Prestel, Maria Katharina 1747-1794 *DcWomA*
Prestel, Theophilus 1739-1808 *ClaDrA*
Prestel, Ursula Magdalena 1777-1845 *DcWomA*
Prestini, James 1908- *ConDes, McGDA, WhAmArt 85*
Prestini, James Libero 1908- *WhoAmA 73, –76, –78, –80, –82, –84*
Prestinien, Jehan De *McGDA*
Preston, A C *DcVicP 2*
Preston, Alice Bolam 1888-1958 *DcWomA*
Preston, Alice Bolam 1889- *IlsCB 1744*
Preston, Alice Bolam 1889-1958 *WhAmArt 85, WhoAmA 80N, –82N, –84N*
Preston, Alice M *DcWomA, WhAmArt 85*
Preston, Alice Roberts *WhAmArt 85*
Preston, Arnett Carl 1934- *AmArch 70*
Preston, Blanche *WhAmArt 85*
Preston, David 1948- *DcCAr 81*
Preston, Frank Loring *WhAmArt 85*
Preston, George Nelson 1938- *WhoAmA 82, –84*
Preston, Goddard 1928- *WhoArt 82*
Preston, H J *DcWomA*
Preston, Mrs. H J *DcVicP 2*
Preston, Harriet Brown 1892-1961 *DcWomA, WhoAmA 80N, –82N, –84N*
Preston, J A *AmArch 70*
Preston, James 1941- *MarqDCG 84*
Preston, James M 1874-1962 *WhAmArt 85, WhoAmA 80N, –82N, –84N*
Preston, James Moore 1873-1962 *IlrAm C, –1880*
Preston, Jasper N 1832- *BiDAmAr*
Preston, Jessie Goodwin 1880- *DcWomA, WhAmArt 85*
Preston, Jonathan 1801-1888 *BiDAmAr*
Preston, Josephine *DcVicP 2*
Preston, Lawrence d1960 *DcBrA 1*

Preston, Malcolm H 1919- *WhoAmA 73, –76, –78, –80, –82, –84*
Preston, Margaret 1883-1963 *OxArt*
Preston, Margaret 1893-1963 *OxTwCA*
Preston, Margaret Rose 1875-1963 *DcWomA*
Preston, Mary Wilson 1873- *WhAmArt 85*
Preston, May Watkins 1873-1949 *DcWomA*
Preston, May Wilson 1873-1949 *IlrAm C, –1880*
Preston, N A *DcWomA*
Preston, R *DcVicP 2*
Preston, Thomas *DcVicP 2*
Preston, W *DcSeaP*
Preston, W E *AmArch 70*
Preston, William G *WhAmArt 85*
Preston, William G 1844-1910 *BiDAmAr*
Preston Goddard 1928- *WhoArt 84*
Prestopino, Gregorio 1907- *DcCAA 71, –77, McGDA, WhAmArt 85, WhoAmA 73, –76, –78, –80, –82, –84*
Prestridge, James A, Jr. 1918- *AmArch 70*
Preszler, Arlie Delmar 1934- *AmArch 70*
Preszler, Donald Lee 1926- *AmArch 70*
Prete Genovese *McGDA*
Prete Genovese, Il *OxArt*
Preti, Mattia 1613-1699 *McGDA, OxArt*
Preti, Pier Paolo 1940- *MacBEP*
Pretlove, David *NewYHSD*
Pretot, Elise *DcWomA*
Pretsch, John Edward 1925- *WhoAmA 73, –76, –78, –80, –82, –84*
Pretsch, Paul 1808-1873 *ICPEnP, MacBEP*
Pretsell, Peter 1942- *WhoArt 80, –82, –84*
Pretty, Edward 1792-1865 *DcBrWA, DcVicP 2*
Pretyman, William *WhAmArt 85*
Pretzinger, A, II *AmArch 70*
Pretzinger, F A *AmArch 70*
Preu, John D 1913- *WhAmArt 85*
Preuschen, Hermione Von 1854-1918 *DcWomA*
Preuschen-Telmann, Hermione Von 1854-1918 *DcWomA*
Preuss, Charles d1853? *ArtsAmW 1*
Preuss, Charles 1803-1854 *ArtsAmW 3, IlBEAAW, NewYHSD*
Preuss, Peter *MarqDCG 84*
Preuss, Roger *OfPGCP 86, WhoAmA 73*
Preuss, Roger 1922- *AmArt, PrintW 83, –85, WhoAmA 76, –78, –80, –82, –84*
Preusser, Nelly 1889- *DcWomA*
Preusser, Robert Ormerod 1919- *WhAmArt 85, WhoAmA 73, –76, –78, –80, –82, –84*
Preussler, Christian *IlDcG*
Preussler, Georg *IlDcG*
Preussler, Karl Christian *IlDcG*
Preussler, Wolfgang *IlDcG*
Preussler Family *IlDcG*
Preval, Christiane De 1876- *DcWomA*
Preval, E *AntBDN E*
Preval, Juanita *WhAmArt 85*
Prevett, Avis Ann 1937- *AmArch 70*
Previati, Gaetano 1852-1920 *OxTwCA, PhDcTCA 77*
Previtali, Andrea *McGDA*
Prevost, Madame *DcWomA*
Prevost, Jan *McGDA*
Prevost, Pierre 1764-1823 *ClaDrA*
Prevost, Victor 1820- *NewYHSD*
Prevost, William S *NewYHSD*
Prevost-Duval, Rose Julie 1786-1847 *DcWomA*
Prevost-Roqueplan, Camille *DcWomA*
Prevot, M J *WhAmArt 85*
Prevot, Maria *DcWomA*
Prewett, William *AntBDN J*
Preyer, David C 1862-1913 *WhAmArt 85*
Preyer, Emilie 1849-1930 *DcWomA*
Preyer, Johann Wilhelm 1803- *ArtsNiC*
Preyer, Louise 1805-1834 *DcWomA*
Prezament, Joseph 1923- *WhoAmA 73, –76, –78, –80*
Preziose, Richard Jacques 1920- *AmArch 70*
Preziosi, Donald A 1941- *WhoAmA 84*
Prezzi, Wilma M *WhoAmA 78N, –80N, –82N, –84N*
Prezzi, Wilma Maria 1915-1964? *WhAmArt 85*
Pribble, Easton 1917- *WhoAmA 73, –76, –78, –80, –82, –84*
Prica, Zlatko 1916- *OxTwCA, PhDcTCA 77*
Price, Abial *FolkA 86*
Price, Albert 1931- *FolkA 86*
Price, Alice *DcVicP 2*
Price, Alice Hendee 1889- *DcWomA*
Price, Anna G *WhAmArt 85*
Price, Annabella *DcWomA*
Price, Anne Kirkendall 1922- *WhoAmA 76, –78, –80, –82, –84*
Price, Barbara Gillette 1938- *WhoAmA 80, –82, –84*
Price, Bem 1883-1940 *BiDAmAr*
Price, Beryl 1910- *AmArch 70*
Price, Blackwood *DcVicP 2*
Price, Bruce 1843-1903 *BiDAmAr*
Price, Bruce 1845-1903 *MacEA, McGDA*
Price, C K, Jr. *AmArch 70*
Price, Caroline Mary *DcWomA*
Price, Cedric 1934- *ConArch*
Price, Charles Douglas 1906- *WhAmArt 85*

Price, Charles Matlack *WhAmArt 85*
Price, Chester B d1962 *WhoAmA 78N, –80N, –82N, –84N*
Price, Chester B 1885-1962 *WhAmArt 85*
Price, Christine *IlsCB 1967*
Price, Christine Hilda 1928- *IlsCB 1946, –1957*
Price, Clayton S 1874-1950 *DcCAA 71, –77, IlBEAAW, PhDcTCA 77, WhAmArt 85, WhoAmA 78N, –80N, –82N, –84N*
Price, Clayton S 1875-1950 *ArtsAmW 1*
Price, Dennis Lynn 1950- *MarqDCG 84*
Price, E Jessop *WhoArt 80, –82, –84*
Price, E Jessop 1902- *DcBrA 1*
Price, E V *AmArch 70*
Price, Ebenezer 1728-1788 *FolkA 86*
Price, Edith Ballinger 1897- *DcWomA, WhAmArt 85*
Price, Edward *DcBrBI, DcBrWA, DcVicP 2*
Price, Edward Allen, Jr. 1947- *MarqDCG 84*
Price, Eleanore *WhAmArt 85*
Price, Ephraim S d1839 *CabMA*
Price, Esther Prabel 1904- *WhAmArt 85*
Price, Eugenia 1865-1923 *ArtsAmW 1, –3, DcWomA, WhAmArt 85*
Price, Francis 1704?-1753 *BiDBrA*
Price, Frank C *WhAmArt 85*
Price, Frank Corbyn *DcVicP*
Price, Frank Corbyn 1862- *DcBrA 1, DcVicP 2*
Price, Mrs. Frank Corbyn *DcVicP 2*
Price, Frederic Newlin d1963 *WhoAmA 78N, –80N, –82N, –84N*
Price, Frederic Newlin 1884-1963 *WhAmArt 85*
Price, Frederick G *DcVicP 2*
Price, G *FolkA 86*
Price, G R, Jr. *AmArch 70*
Price, Garret 1896- *ArtsAmW 3*
Price, Garrett *WhAmArt 85*
Price, Garrett 1896- *ArtsAmW 3, IlrAm D, IlsBYP, IlsCB 1957*
Price, Garrett 1896-1979 *IlrAm 1880, WorECar*
Price, Garrett 1897-1979 *WhoAmA 80N, –82N, –84N*
Price, George 1826- *NewYHSD*
Price, George 1901- *WhAmArt 85, WhoAmA 73, –76, –78, –80, –82, –84, WorECar*
Price, Grace *DcVicP 2, DcWomA*
Price, Gray *WhAmArt 85*
Price, Gwynne C *DcWomA, WhAmArt 85*
Price, Harold 1912- *IlsBYP, IlsCB 1946*
Price, Hattie Longstreet 1891- *ConICB, DcWomA, IlsCB 1744*
Price, Helen F 1893- *DcWomA, WhAmArt 85*
Price, Henry *WhAmArt 85*
Price, Henry Brooks 1872-1936 *BiDAmAr*
Price, Henry M *EncASM*
Price, Herbert 1930- *MarqDCG 84*
Price, Irene Roberta 1900- *WhAmArt 85*
Price, James *ClaDrA, DcBrWA, DcVicP, –2*
Price, James 1860-1935 *BiDAmAr*
Price, Jane R *DcWomA*
Price, Jane Wilder *FolkA 86*
Price, Janis 1833- *FolkA 86*
Price, Joan Webster 1931- *MarqDCG 84, WhoAmA 82, –84*
Price, Joe 1935- *PrintW 83, –85, WhoAmA 82, –84*
Price, John *EncASM, NewYHSD*
Price, John d1736 *BiDBrA*
Price, Joseph *CabMA*
Price, Julius Mendes d1924 *ClaDrA, DcBrA 1, DcBrBI*
Price, Julius Mendes 1857-1924 *DcVicP 2, IlBEAAW*
Price, Ken 1935- *PrintW 83, –85*
Price, Kenneth 1935- *AmArt, BnEnAmA, CenC[port], ConArt 77, –83, DcCAA 71, –77, DcCAr 81, OxTwCA, WhoAmA 73, –76, –78, –80, –82, –84*
Price, Kenneth Thomas 1898- *AmArch 70*
Price, Leslie 1915- *ClaDrA, DcBrA 1*
Price, Leslie 1945- *AfroAA*
Price, Leslie Kenneth *WhoAmA 78, –80, –82, –84*
Price, Lida S *DcWomA*
Price, Lida Sarah *ArtsAmW 3, WhAmArt 85*
Price, Luxor *ConICB*
Price, Lydia Jemina *DcWomA*
Price, M Elizabeth *WhAmArt 85*
Price, M Elizabeth 1875-1960 *DcWomA*
Price, Margaret 1888-1978? *DcWomA*
Price, Margaret E *WhoAmA 76N, –78N, –80N, –82N, –84N*
Price, Margaret Evans 1888- *IlsCB 1744, WhAmArt 85*
Price, Mary *WhAmArt 85*
Price, Mary Roberts Ball *DcWomA, WhAmArt 85*
Price, Mary S *DcWomA*
Price, Mathilde Juliane Engeline 1849- *DcWomA*
Price, May A *DcWomA*
Price, Michael Benjamin 1940- *WhoAmA 76, –78, –80, –82, –84*
Price, Minnie 1877-1957 *ArtsAmW 1, DcWomA, WhoAmA 80N, –82N, –84N*
Price, Minor Carr 1907- *AmArch 70*
Price, Nell Gwenllian *DcWomA*

Puech, Denis 1854-1942 *McGDA*
Puech, Eugenie Caroline *DcWomA*
Puech, Yvonne *DcWomA*
Puerari, Emma *DcWomA*
Pueyrredon, Prilidiano 1823-1870 *McGDA*
Pufahl, John K 1942- *WhoAmA 78, -80, -82, -84*
Puget, Francois 1651-1707 *McGDA*
Puget, Pierre 1620-1694 *DcSeaP, McGDA, OxArt*
Puggaard, Bolette Catharine Frederikke 1798-1847
 DcWomA
Pugh, C J *DcBrECP*
Pugh, Charles J d1815 *DcBrWA*
Pugh, Clifton 1924- *DcCAr 81*
Pugh, D A *AmArch 70*
Pugh, Dow *FolkA 86*
Pugh, Edward d1813 *DcBrWA*
Pugh, Effie *WhAmArt 85*
Pugh, Elizabeth Worthington *WhAmArt 85*
Pugh, Grace Huntley 1912- *WhoAmA 80, -82, -84*
Pugh, Herbert d1788? *DcBrECP*
Pugh, Herbert d1788 *DcBrWA*
Pugh, Loranzo *FolkA 86*
Pugh, Mabel *ConICB, WhAmArt 85*
Pugh, Mabel 1891- *DcWomA*
Pugh, Warren Rutley 1920- *AmArch 70*
Pugh, William *AntBDN Q*
Pughe, Buddig Anwylini 1857- *DcBrA 1, DcVicP 2,*
 DcWomA
Pughe, J S 1870-1909 *WorECar*
Pughsley, Ralphine *AfroAA*
Pugin, Auguste-Charles 1762-1832 *OxArt*
Pugin, Augustus Charles 1762-1832 *DcBrBI,*
 DcD&D[port]
Pugin, Augustus Charles 1768-1832 *MacEA*
Pugin, Augustus Charles 1769-1832 *BiDBrA*
Pugin, Augustus Charles De 1762-1832 *DcBrWA*
Pugin, Augustus Northmore Welby 1812-1852 *DcBrBI,*
 DcBrWA
Pugin, Augustus Welby 1812-1852 *AntBDN M,*
 BiDBrA A
Pugin, Augustus Welby Northmore 1812-1852
 DcD&D[port], MacEA, McGDA, OxArt,
 OxDecA, WhoArch
Pugin, Augustus Wellby Northwood 1812-1852
 DcNiCA
Pugin, Augustus Wilby Northwore 1812-1852
 AntBDN G
Pugin, Edward W 1834- *ArtsNiC*
Pugin, Edward Welby 1834-1875 *MacEA, WhoArch*
Pugin, Eric *WorFshn*
Pugin, Peter Paul *DcVicP 2*
Puglia, Niccolo *McGDA*
Pugliane, Cosimo d1618 *MacEA*
Pugliano, Frederick 1929- *AmArch 70*
Pugliese, Anthony 1907- *WhAmArt 85*
Pugni, Louis *NewYHSD*
Pugsley, J L *AmArch 70*
Puhn, Franklin 1925- *WhoArt 80, -82, -84*
Puhn, Sophie 1864- *DcWomA*
Puia, Florika *OxTwCA*
Puiforcat, Jean 1879-1945 *DcNiCA*
Puig, Augusto 1929- *PhDcTCA 77*
Puig Boada, Isidro 1891- *MacEA*
Puig I Cadafalch, Josep 1867-1956 *ConArch*
Puig I Cadafalch, Josep 1867-1957 *MacEA*
Puig Rosado, Fernando 1931- *WhoGrA 82[port]*
Puigaudeau, Clotilde 1869- *DcWomA*
Puisha, J *AmArch 70*
Puisoye, Marie *DcWomA*
Pujdak, J L *AmArch 70*
Pujol, Adrienne Marie Louise *DcWomA*
Pujol, Alexandre Denis Abel De 1787-1861 *ClaDrA*
Pujol, Antonio *OxTwCA*
Pujol, Antonio 1914- *McGDA*
Pujol, Elliott 1943- *WhoAmA 80, -82, -84*
Puk, Richard Frank 1945- *MarqDCG 84*
Pulaski, J Irvin *FolkA 86*
Pulaski, Rolly Herman 1934- *AmArch 70*
Pulcher, Theresa S *ArtsEM, DcWomA*
Pulcifer, Francis 1771-1823 *CabMA*
Pulcifer, James *CabMA*
Pulcifer And Frothingham *CabMA*
Pulfrey, Dorothy Ling 1901- *WhAmArt 85*
Pulgram, William L 1921- *AmArch 70*
Pulham, Maria *DcWomA*
Pulham, Peter Rose 1910-1956 *DcBrA 1*
Pulido, Guillermo Aguilar 1920- *WhoAmA 78, -80*
Puligo, Domenico 1492-1527 *McGDA*
Pulitzer, Joseph, Jr. 1913- *WhoAmA 73, -76, -78,*
 -80
Pulitzer, Mrs. Joseph, Jr. *WhoAmA 76, -78, -80*
Pulitzer, Lilly *WorFshn*
Pulitzer, Lilly 1932- *FairDF US*
Pull, Georges *DcNiCA*
Pullan, L *AmArch 70*
Pullan, Margaret Ida Elizabeth 1907- *ClaDrA,*
 WhoArt 80, -82, -84
Pullar, Robert A 1924- *AmArch 70*
Pullen, T W *DcVicP 2*
Puller, John Anthony *DcVicP, -2*
Pulley, Charles Madison 1916- *AmArch 70*

Pulley, Mary *AfroAA*
Pulliam, James Graham 1925- *AmArch 70*
Pullin, Edgar *DcBrA 1*
Pullinen, Laila 1933- *OxTwCA*
Pulling, Phyllis Mary 1892-1951 *DcBrA 1, DcWomA*
Pullinger, Herbert 1878- *WhAmArt 85*
Pullinger, R C *AmArch 70*
Pullins, John 1953- *MarqDCG 84*
Pullman, Margaret McDonald d1892 *DcWomA*
Pulos, Arthur J 1917- *ConDes*
Pulos, Arthur Jon 1917- *WhoAmA 76, -78, -80, -82,*
 -84
Puls, Barry R 1952- *MarqDCG 84*
Pulsford, Charles 1912- *ClaDrA, DcBrA 1,*
 WhoArt 80, -82, -84
Pulsifer, Israel Eliot 1774?-1809 *CabMA*
Pulsifer, J D *WhAmArt 85*
Pulsifer, Walter Hall, Jr. 1915- *AmArch 70*
Pulver, Burdette M, Jr. 1927- *AmArch 70*
Pulvermacher, Anna *DcVicP 2, DcWomA*
Pulzone, Scipione 1550?-1598 *McGDA*
Puma, Fernando 1915- *WhAmArt 85*
Pummill, Robert *OfPGCP*
Pumpelly, Margarita *DcWomA*
Punchatz, Don Ivan 1936- *IlrAm 1880*
Punderson, E M *NewYHSD*
Punderson, Hannah 1776-1821 *DcWomA, FolkA 86*
Punderson, Lemuel S *NewYHSD*
Punderson, Prudence 1758-1784 *FolkA 86*
Punderson, Prudence Geer 1735-1822 *FolkA 86*
Puni, Ivan 1894-1956 *McGDA*
Puni, Ivan Albertovich *OxTwCA*
Punin, Nikolai Nikolaevich 1888-1953 *OxTwCA*
Punit, Michael 1946- *DcCAr 81*
Punita, Madame *DcWomA*
Puokka, Jaakko Ilmari 1915- *WhoArt 80, -82, -84*
Pura, William Paul 1948- *WhoAmA 82, -84*
Purcell, Ann 1941- *WhoAmA 80, -82, -84*
Purcell, E *EarABI, EarABI SUP*
Purcell, Edward *DcBrWA*
Purcell, Edward B *NewYHSD*
Purcell, Edward B, Jr. *NewYHSD*
Purcell, Eleanor *FolkA 86*
Purcell, Hazel *WhAmArt 85*
Purcell, Henry *CabMA, NewYHSD*
Purcell, James d1856 *MacEA*
Purcell, James Aderton 1927- *AmArch 70*
Purcell, John Wallace 1901- *WhAmArt 85*
Purcell, Mrs. M C *DcVicP 2*
Purcell, Mark Thomas 1903- *AmArch 70*
Purcell, Norah *DcWomA*
Purcell, P V *DcVicP 2*
Purcell, Rosamond Wolff 1942- *ConPhot, ICPEnP A*
Purcell, Rosanna *DcWomA, NewYHSD*
Purcell, W R, Jr. 1939- *MarqDCG 84*
Purcell, William G 1880- *McGDA*
Purcell, William Gray 1880-1964 *BnEnAmA*
Purcell, William Gray 1880-1965 *MacEA*
Purcell And Elmslie *BnEnAmA, MacEA*
Purchas, Thomas J *DcVicP 2*
Purchase, Alfred *DcVicP 2*
Purchasem, Mark *FolkA 86*
Purday, Sarah T *DcVicP 2*
Purdey, James 1784-1863 *AntBDN F*
Purdey, James, Jr. 1828-1909 *AntBDN F*
Purdie, Evelyn 1858-1943 *DcWomA, WhAmArt 85*
Purdin, William A *NewYHSD*
Purdo, Nick *FolkA 86*
Purdock, Glenn David 1948- *MarqDCG 84*
Purdon, George 1759- *DcBrECP*
Purdy, Albert J 1835?-1909 *NewYHSD,*
 WhAmArt 85
Purdy, Bernice 1940- *DcCAr 81*
Purdy, C *FolkA 86*
Purdy, Charlie *FolkA 86*
Purdy, Donald R 1924- *WhoAmA 73, -84*
Purdy, E *AmArch 70*
Purdy, Earl *WhAmArt 85*
Purdy, Fitzhugh *FolkA 86*
Purdy, George Donald, Jr. 1939- *MarqDCG 84*
Purdy, Gordon B *FolkA 86*
Purdy, Henry Carl 1937- *WhoAmA 84*
Purdy, John T *MarqDCG 84*
Purdy, Maud H 1873?- *DcWomA*
Purdy, Maud H 1874- *WhAmArt 85*
Purdy, Richard Charles 1929- *AmArch 70*
Purdy, Robert Cleaver *WhAmArt 85*
Purdy, Solomon *FolkA 86*
Purdy, Susan Gold 1939- *IlsCB 1957*
Purdy, W Frank 1865-1943 *WhAmArt 85*
Purdy, William H 1943- *MarqDCG 84*
Purefoy, Heslope 1884- *WhAmArt 85*
Purgau, Maximiliana *DcWomA*
Purgold, Louise 1782-1848 *DcWomA*
Purhonen, Arne Raymond 1915- *AmArch 70*
Purifoy, Noah 1917- *AfroAA*
Purina, Teiksma 1953- *ICPEnP A*
Puringer, Milla 1874- *DcWomA*
Purinton, Beulah 1802- *FolkA 86*

Purinton, Mark Alton 1953- *MarqDCG 84*
Purintum, Abigail *FolkA 86*
Purkis, A B *DcVicP 2*
Purnell, Edward J *AfroAA*
Purnell, John 1954- *WhoArt 80, -82, -84*
Purnhagen, Tom Gordon 1934- *MarqDCG 84*
Purrington, Caleb B *FolkA 86*
Purrington, Caleb P *NewYHSD*
Purrington, Henry J 1825- *FolkA 86, NewYHSD,*
 WhAmArt 85
Purrington, J *NewYHSD*
Purrmann, Hans 1880-1966 *OxTwCA, PhDcTCA 77*
Purrmann, Hans 1890-1966 *McGDA*
Purse, George *AntBDN Q*
Purse, Reginald d1915 *DcBrA 2*
Purse, W W 1797-1858 *CabMA*
Pursel, Louis William 1907- *AmArch 70*
Pursell, Daniel *FolkA 86*
Pursell, Henry D *NewYHSD*
Pursell, Isaac 1853-1910 *BiDAmAr*
Pursell, Joe Thomas 1920- *AmArch 70*
Pursell, John *FolkA 86*
Pursell, Weimer *IlsBYP*
Purser, Charles 1802?- *BiDBrA*
Purser, Keith Kaye 1955- *MarqDCG 84*
Purser, Mary May 1914- *WhAmArt 85*
Purser, Sarah 1849-1943 *DcBrA 2*
Purser, Sarah H d1943 *DcBrA 1*
Purser, Sarah H 1848-1943 *DcVicP 2, DcWomA*
Purser, Stuart R 1907- *WhAmArt 85*
Purser, Stuart Robert 1907- *WhoAmA 76, -78, -80,*
 -82, -84
Purser, William 1790?-1852? *DcBrBI, DcBrWA*
Purser, William, Jr. 1790?- *BiDBrA*
Pursifull, Ross Walters 1920- *AmArch 70*
Purssell, Marie Louise *DcWomA, WhAmArt 85*
Purtle, Carol Jean 1939- *WhoAmA 84*
Purton, Cecil P *DcVicP 2*
Purucker, Ervin Frederick 1925- *AmArch 70*
Purves, Austin 1900- *WhoAmA 73*
Purves, Austin, Jr. 1900- *WhAmArt 85*
Purves, C J *DcVicP 2, DcWomA*
Purves, John W *FolkA 86*
Purviance, Cora Louise 1904- *WhAmArt 85*
Purviance, Florence V *AfroAA*
Purvis, Fanny *DcWomA*
Purvis, John Rennie 1950- *MarqDCG 84*
Purvis, R Murray *WhAmArt 85*
Purvis, T G *DcSeaP*
Purvis, Tom 1889-1959 *ConDes*
Purvis, William G *WhAmArt 85*
Purvis, Winifred Percy *DcWomA*
Pury, Marie Amelie Mathilde De 1850- *DcWomA*
Puryear, Martin 1941- *AmArt, PrintW 85,*
 WhoAmA 78, -80, -82
Puschkin, Jeanne *DcWomA*
Pusey, Mavis *WhoAmA 76, -78, -80, -82, -84*
Pusey, Mavis 1931- *AfroAA*
Pushman, Horsep T 1877-1966 *ArtsAmW 2*
Pushman, Hovsep d1966 *WhoAmA 78N, -80N, -82N,*
 -84N
Pushman, Hovsep 1877-1966 *WhAmArt 85*
Pushman, Hovsep T 1877-1966 *ArtsAmW 2*
Pusinelli, Doris *DcBrA 1*
Pusinelli, Doris d1976 *DcBrA 2*
Puskar, J M *AmArch 70*
Puskar, Robert 1923- *AmArch 70*
Pusterla, Attilio 1862-1941 *WhAmArt 85*
Puteo, Borgino De *McGDA*
Puterski, Robert 1951- *MarqDCG 84*
Puthuff, Hanson 1875-1972 *WhAmArt 85*
Puthuff, Hanson Duvall 1875- *ArtsAmW 1*
Puthuff, Hanson Duvall 1875-1972 *IlBEAAW*
Putman, Andree *ConDes*
Putman, Brenda d1975 *WhoAmA 82N, -84N*
Putman, Donald 1927- *IlBEAAW*
Putman, Stephen Howard 1941- *MarqDCG 84*
Putnam *ArtsEM, DcWomA*
Putnam, Arion *WhAmArt 85*
Putnam, Arthur 1873-1930 *IlBEAAW, WhAmArt 85*
Putnam, B G *AmArch 70*
Putnam, Betsy *FolkA 86*
Putnam, Brenda d1975 *WhoAmA 76N, -78N, -80N*
Putnam, Brenda 1890-1975 *DcWomA, WhAmArt 85*
Putnam, Charlotte Ann 1906- *WhAmArt 85*
Putnam, David A 1816?-1840 *NewYHSD*
Putnam, Edmund 1800?- *NewYHSD*
Putnam, Elizabeth *WhAmArt 85*
Putnam, Elizabeth D *DcWomA*
Putnam, George *FolkA 86*
Putnam, George Patrick 1925- *MarqDCG 84*
Putnam, George W 1812?- *NewYHSD*
Putnam, Mrs. John B 1903- *WhoAmA 80, -73, -76,*
 -78, -82, -84
Putnam, Joseph *CabMA*
Putnam, Keith O 1932- *AmArch 70*
Putnam, L J *DcWomA*
Putnam, Marion *DcWomA, WhAmArt 85*
Putnam, Marion Walton *WhoAmA 78, -80, -82, -84*
Putnam, Mary *DcWomA*
Putnam, N B *FolkA 86*

Putnam, Nathaniel d1800 *CabMA*
Putnam, Palmer Heaton 1923- *AmArch 70*
Putnam, Ruthey 1768?- *FolkA 86*
Putnam, Sarah Goold *DcWomA*
Putnam, Stephen G 1852- *WhAmArt 85*
Putnam, Wallace 1899- *WhoAmA 73, –76, –78, –80*
Putnam, Wallace B 1899- *WhAmArt 85*
Putnam, William E d1947? *BiDAmAr*
Putnam And Low *EncASM*
Putney, David Y 1949- *MarqDCG 84*
Putney, Henry *FolkA 86*
Putrih, Bostjan 1947- *DcCAr 81*
Putt, Hilda *DcVicP 2*
Puttcamp, Robert Raymond 1931- *MarqDCG 84*
Putter, Pieter De 1600?-1659 *McGDA*
Putterman, Florence 1927- *PrintW 85*
Putterman, Florence Grace 1927- *WhoAmA 73, –76, –78, –80, –82, –84*
Putterman, Jaydie 1945- *MacBEP*
Putty, Paul Gowan, Jr. 1924- *AmArch 70*
Putz, Leo 1869- *ClaDrA*
Putzki, Kate *DcWomA*
Putzki, Paul A 1858-1936 *WhAmArt 85*
Puvis DeChavannes, Pierre 1824- *ArtsNiC*
Puvis DeChavannes, Pierre 1824-1898 *McGDA, OxArt, WhAmArt 85A*
Puvis DeChavannes, Pierre C 1824-1898 *ClaDrA*
Puvrez, Henri 1893- *PhDcTCA 77*
Puvrez, Henri 1893-1971 *OxTwCA*
Puwelle, Arnold *FolkA 86*
Puy, Jean 1876-1959 *ClaDrA*
Puy, Jean 1876-1960 *McGDA, OxTwCA, PhDcTCA 77*
Puyl, Gerard 1750-1824 *ClaDrA*
Puyo, Charles 1857-1933 *ICPEnP A, MacBEP*
Puyplat, Marie Alice *DcWomA*
Puyroche, Elise 1828-1895 *DcWomA*
Puzio, Henry Anthony 1927- *AmArch 70*
Puzzanghera, Paul Joseph 1956- *MarqDCG 84*
Puzzovio, Dalila *OxTwCA*
Py, A B, Jr. *AmArch 70*
Pyatt, George *FolkA 86*
Pyatt, J G *FolkA 86*
Pybourne, Thomas 1708-1734? *DcBrECP*
Pyburg, Elizabeth *DcWomA*
Pyburn, Don *AfroAA*
Pybus, H *DcVicP 2*
Pybus, W *DcVicP 2*
Pycock, George 1749?-1799 *BiDBrA*
Pye, A *DcVicP 2*
Pye, Charles Eugene 1930- *AmArch 70*
Pye, Fred 1882- *WhAmArt 85*
Pye, John 1746- *DcBrECP*
Pye, John 1782-1874 *ArtsNiC*
Pye, Thomas 1756- *DcBrECP*
Pye, William *DcBrWA, DcVicP 2*
Pye, William 1938- *ConArt 77, ConBrA 79[port], DcCAr 81, WhoArt 80, –82, –84*
Pyfer, William *FolkA 86*
Pyk, Jan *IlsBYP*
Pyk, Madeleine *DcCAr 81*
Pyke, John *AntBDN D*
Pyke, Mary *DcVicP 2*
Pyke-Nott, Evelyn *DcWomA*
Pyke-Nott, Isabel C *DcWomA*
Pylada, Y Rita 1889- *DcWomA*
Pyle, Arnold *WhAmArt 85*
Pyle, C E *AmArch 70*
Pyle, Clifford C 1894- *WhAmArt 85*
Pyle, Clifford Colton 1894- *ArtsAmW 2*
Pyle, David Keith 1926- *AmArch 70*
Pyle, Ellen B T 1881-1936 *WhAmArt 85*
Pyle, Ellen Bernard Thompson 1876-1936 *DcWomA, IlrAm 1880*
Pyle, Howard 1853-1911 *AntBDN B, ClaDrA, DcBrBI, IlBEAAW, IlrAm A, –1880, IlsBYP, WhAmArt 85*
Pyle, John J 1906- *AmArch 70*
Pyle, John W *FolkA 86*
Pyle, Katharine d1939? *WhAmArt 85*
Pyle, Katharine 1863-1938 *DcWomA*
Pyle, Margery Kathleen 1903- *WhAmArt 85*
Pyle, Robert *DcBrECP*
Pyle, W C *AmArch 70*
Pyle, Walter, Jr. 1906- *WhAmArt 85*
Pyle, William Scott d1938 *WhAmArt 85*
Pyles, Minnie Louise *DcWomA*
Pyles, Virgil E 1891- *WhAmArt 85*
Pylyshenko, Wolodymyr *WhoAmA 82, –84*
Pylyshenko, Wolodymyr Walter *WhoAmA 76, –78, –80*
Pym, T *DcBrBI*
Pynacker, Adam *McGDA*
Pynacker, Adam 1622-1673 *ClaDrA, OxArt*
Pynaker, Adam 1622-1673 *ClaDrA*
Pynas, Jacob Symonsz *McGDA*
Pynas, Jan *McGDA*
Pynas, Jan 1583?-1631 *OxArt*
Pyne, Annie C *DcVicP 2, DcWomA*
Pyne, Benjamin *AntBDN Q*
Pyne, Charles *DcVicP*

Pyne, Charles 1842- *DcBrWA, DcVicP 2*
Pyne, Charles Claude 1802-1878 *DcBrBI, DcBrWA, DcVicP, –2*
Pyne, Doris Grace 1910- *WhoArt 82, –84*
Pyne, Eva E *DcVicP 2, DcWomA*
Pyne, George 1800-1884 *DcBrBI, DcBrWA, DcVicP, –2*
Pyne, George Clinton, Jr. 1914- *AmArch 70*
Pyne, James B 1800-1870 *ArtsNiC*
Pyne, James Baker 1800-1870 *DcBrWA, DcSeaP, DcVicP, –2*
Pyne, Mable Mandeville 1903-1969 *IlsCB 1744, –1946*
Pyne, R L *NewYHSD*
Pyne, R Lorrdine *WhAmArt 85*
Pyne, R S *NewYHSD*
Pyne, Thomas 1843-1935 *DcBrA 1, DcBrWA, DcVicP, –2*
Pyne, W B *DcVicP 2*
Pyne, William Henry 1769-1843 *DcBrBI, DcBrWA*
Pyros, Nicholas Jonathan 1928- *AmArch 70*
Pyskacek, Donald Joseph 1932- *AmArch 70*
Pythagoras *McGDA, OxArt*
Pytheos d330BC *MacEA*
Pythius *OxArt*
Pytka, Stephen M 1947- *MarqDCG 84*
Pytlak, Leonard 1910- *WhAmArt 85*
Pyzdrowski, Stanley S 1916- *AmArch 70*
Pyzdrowski, T M *AmArch 70*

Q

Qadri, Sohan 1932- *OxTwCA*
Qian, Jinghua *ICPEnP A*
Qin, Lang *DcWomA*
Qiu, Shi *DcWomA*
Qua, Sees *DcSeaP*
Quackenboss, Leonard C d1924 *BiDAmAr*
Quackenbush, Ethel *DcWomA*
Quackenbush, Ethel H *WhAmArt 85*
Quackenbush, Grace M *DcWomA, WhAmArt 85*
Quackenbush, John Joseph 1917- *AmArch 70*
Quackenbush, Robert Mead *IlsCB 1967*
Quackenbush, Robert Mead 1929- *IlsBYP, IlsCB 1957*
Quackinbush, Laurence *CabMA*
Quadal, Martin Ferdinand 1736-1808 *DcBrECP*
Quadal, Martin Ferdinand 1736-1811 *ClaDrA*
Quade, Julius *FolkA 86*
Quadrel, Richard William 1959- *MarqDCG 84*
Quaghebeur, Marie Aimee 1890- *DcWomA*
Quagliaroli, John Anthony 1938- *MarqDCG 84*
Quagliata, Narcissus 1923- *DcCAr 81*
Quaglio, Agnes 1822-1854 *DcWomA*
Quaglio, Domenico 1786-1837 *ClaDrA*
Quaglio, Lorenzo 1793-1869 *ClaDrA*
Quaglio Family *MacEA*
Quaintance, Helen Yocum *DcWomA*
Qualley, Lena *DcWomA, WhAmArt 85*
Qualls, George Wyckoff 1923- *AmArch 70*
Qualters, Robert *DcCAr 81*
Quam, Will George *AmArch 70*
Quan, Alfred S *AmArch 70*
Quanbeck, Robert M *AmArch 70*
Quanchi, Leo 1892- *WhAmArt 85, WhoAmA 73*
Quandt, Elizabeth 1922- *WhoAmA 76, -78, -80, -82, -84*
Quandt, Russell Jerome 1919-1970 *WhoAmA 78N, -80N, -82N, -84N*
Quann, Leonard Wood 1916- *AmArch 70*
Quant, Mary 1934- *ConDes, FairDF ENG[port], WorFshn*
Quantin, Ernestine 1820- *DcWomA*
Quantock, John *AntBDN Q*
Quantrill, Malcolm *ConArch A*
Quaranta, Saverio Anthony 1924- *AmArch 70*
Quare, Daniel 1648?-1724 *OxDecA*
Quare, Daniel 1649-1724 *AntBDN D*
Quarenghi, Giacomo 1744-1817 *DcD&D, MacEA, McGDA, OxArt, WhoArch*
Quaresma, D F *AmArch 70*
Quarini, Mario Ludovico 1736-1800? *MacEA*
Quarles, Susannah Fauntleroy *DcWomA*
Quarmby, George F 1883-1957 *DcBrA 1*
Quarnstrom, Carl Gustav 1810-1867 *ArtsNiC*
Quaroni, Ludovico 1911- *ConArch, MacEA*
Quarre, Ferdinand *NewYHSD*
Quarre, Frederick *NewYHSD*
Quarry, Regina Catharina 1762?-1818? *DcWomA*
Quartana, Mark Steven 1956- *MarqDCG 84*
Quartley, Arthur 1839- *ArtsNiC*
Quartley, Arthur 1839-1886 *NewYHSD, WhAmArt 85*
Quartley, Frederick William 1808-1874 *NewYHSD*
Quarton, Enguerrand *McGDA*
Quatremaine, G William 1858-1930 *DcVicP 2*
Quast, Anna *DcWomA*
Quast, Pieter Jansz 1605?-1647 *McGDA*
Quast, Pieter Jansz 1606-1647 *ClaDrA, OxArt*
Quat, Helen S 1918- *WhoAmA 73, -76, -78, -80, -82, -84*
Quat, Judith Gutman 1903- *WhAmArt 85*
Quatremain, G William 1858-1930 *DcBrWA*

Quatremere DeQuincy, Antoine C 1755-1849 *MacEA*
Quatrepomme, Isabelle *DcWomA*
Quattrocchi, Edmondo d1966 *WhAmArt 85, WhoAmA 78N, -80N, -82N, -84N*
Quaw, John C *NewYHSD*
Quay, John Richard 1923- *AmArch 70*
Quayle, Charles 1866-1940 *BiDAmAr*
Quaytman, Harvey 1937- *AmArt, ConArt 77, DcCAA 77, DcCAr 81, WhoAmA 73, -76, -78, -80, -82, -84*
Queau, Philippe 1952- *MarqDCG 84*
Queborne, Crispyn VanDen 1604-1652 *ClaDrA*
Queborne, Daniel VanDen 1560?-1618? *McGDA*
Queby, John *NewYHSD*
Quedenfeldt, Anna 1868- *DcWomA*
Quedlinburg, Agnes *DcWomA*
Queen, James 1824-1877? *NewYHSD*
Queen, John H *BiDAmAr*
Queen, S O *AmArch 70*
Queensberry, Marchioness Of *DcWomA*
Queensberry, Catherine, Duchess Of 1701-1776 *DcBrECP*
Quellin, Arnold, The Younger 1653-1686 *OxArt*
Quellin, Artus, II 1625-1700 *OxArt*
Quellin, Artus, III 1653-1686 *OxArt*
Quellin, Artus, The Elder 1609-1668 *OxArt*
Quellin, Jean Erasmus 1634?-1715 *ClaDrA*
Quellinus, Artus, The Elder 1609-1668 *McGDA, OxArt*
Quellinus, Erasmus 1607-1678 *McGDA*
Quellinus, Jan Erasmus 1634-1715 *McGDA*
Quelvee, Francois Albert 1884- *ClaDrA*
Queneau, Jean-Marie *DcCAr 81*
Quennel, Marjorie 1883- *ClaDrA*
Quennell, Charles Henry Bourne 1872-1935 *DcBrBI*
Quennell, Marjorie 1883- *DcBrA 1, DcWomA*
Quenneville, Earl Armand 1928- *AmArch 70*
Quentin, Robert Charles 1924- *AmArch 70*
Queor, William B d1981 *FolkA 86*
Querangal, Y De *DcVicP 2*
Quercia, Jacopo Della 1374?-1438 *McGDA, OxArt*
Quercia, Priamo Della *McGDA*
Querfurt, August 1696-1761 *ClaDrA*
Querini-Stampalia, Maria d1849 *DcWomA*
Queriolo, Steven Michael 1959- *MarqDCG 84*
Queroy, Maria *DcWomA*
Querubini, Caterina *DcWomA*
Quervelle, Anthony *CabMA*
Querville, Anthony *AntBDN G, DcNiCA*
Quesenberg, William 1822-1888 *ArtsAmW 3*
Quesenburg, William 1822-1888 *ArtsAmW 3*
Quesenbury, William 1822-1888 *NewYHSD*
Quesnay, Alexandre-Marie 1755-1820 *NewYHSD*
Quesnel, Augustin 1595-1661 *ClaDrA*
Quesnel, E *AntBDN C*
Quesnel, Francois 1543-1619 *ClaDrA, OxArt*
Quesnel, Pierre d1547? *OxArt*
Quesnel, Theonie Jouanna *DcWomA*
Quesnoy *McGDA*
Quest, Charles F 1904- *WhAmArt 85*
Quest, Charles Francis 1904- *WhoAmA 73, -76, -78, -80, -82, -84*
Quest, Dorothy 1909- *WhAmArt 85, WhoAmA 73, -76, -78, -80, -82, -84*
Quest, E Eloise *WhAmArt 85*
Quest, Francis *FolkA 86*
Quested, George R *DcBrBI, DcVicP 2*
Questel, Charles Auguste 1807-1888 *MacEA*
Questiers, Catharina 1631-1669 *DcWomA*
Questroy, Elisabeth *DcWomA*
Quevillon, E H d1909 *DcWomA*

Quezada Calderon, Abel 1920- *WorECar*
Quick, Birney MacNabb 1912- *WhoAmA 73*
Quick, Birney Macnabb 1912- *WhoAmA 76, -78, -80, -82, -84*
Quick, Edith P *DcVicP 2*
Quick, H B *NewYHSD*
Quick, H Lansing 1870-1945 *BiDAmAr*
Quick, Herb 1925- *MacBEP*
Quick, Isaac *NewYHSD*
Quick, Israel *NewYHSD*
Quick, Richard *DcVicP 2*
Quick, Sarah V B *FolkA 86*
Quick, William *NewYHSD*
Quick-To-See, Jaune *PrintW 85*
Quidor, George W 1817?- *NewYHSD*
Quidor, John 1801-1881 *BnEnAmA, DcAmArt, FolkA 86, McGDA, NewYHSD*
Quigg, Paul Conklin 1931- *AmArch 70*
Quigley, Arthur Grainger d1945 *DcBrA 1*
Quigley, D *DcBrECP*
Quigley, E B 1895- *ArtsAmW 1*
Quigley, Edward B 1895- *IlBEAAW, WhAmArt 85*
Quigley, Ellen Louise *WhAmArt 85*
Quigley, J *BiDAmAr*
Quigley, J C *AmArch 70*
Quigley, Michael Allen 1950- *WhoAmA 78, -80, -82, -84*
Quigley, S *FolkA 86*
Quijada, Robert 1935- *PrintW 85*
Quiles, Manuel 1908- *FolkA 86*
Quillen, Nate 1839-1908 *FolkA 86*
Quiller, Stephen Frederick 1946- *AmArt, WhoAmA 82, -84*
Quilliam, J *NewYHSD*
Quilter, Harry 1851-1907 *DcVicP 2*
Quimby, Fred 1886-1965 *WorECar*
Quimby, Fred G 1863-1923 *WhAmArt 85*
Quimby, John *CabMA*
Quimby, Moses *CabMA*
Quin, Carmelo Arden *OxTwCA*
Quinan, Henry B 1876- *WhAmArt 85*
Quinan, Henry Brewerton 1876- *ArtsAmW 2*
Quinan, Henry R *WhAmArt 85*
Quinaux, Joseph 1822-1895 *ClaDrA*
Quinby, Frank Haviland 1868-1932 *BiDAmAr*
Quinby, Josephine *DcWomA*
Quinby, Sarah A 1822- *FolkA 86*
Quincke, Julie *DcWomA*
Quinckhardt, Jan Maurits 1688-1772 *ClaDrA*
Quinckhardt, Julius 1736-1776 *ClaDrA*
Quincy, C B *WhAmArt 85*
Quincy, Caroline *FolkA 86*
Quincy, Edmund 1903- *WhAmArt 85*
Quincy, Henrietta S *DcWomA*
Quincy, Mary Perkins *FolkA 86*
Quiner, Joanna 1796?-1873? *DcWomA*
Quiner, Joanna 1801-1873 *NewYHSD*
Quinetus, Gillis *McGDA*
Quinier, Adele *DcWomA*
Quinlan, Charles William 1930- *AmArch 70*
Quinlan, Timothy Joseph 1921- *AmArch 70*
Quinlan, Will J 1877- *ArtsAmW 3, WhAmArt 85*
Quinlan, William Sherman 1932- *AmArch 70*
Quinlivan, John D 1921- *AmArch 70*
Quinn, Anne Kirby *DcWomA, WhAmArt 85*
Quinn, Aysha 1945- *WhoAmA 84*
Quinn, Brian Grant 1950- *WhoAmA 76, -78, -80, -82, -84*
Quinn, C F *FolkA 86*
Quinn, Christine Annette 1952- *MarqDCG 84*
Quinn, Don A *AmArch 70*

Quinn, E H *FolkA 86*
Quinn, Edmond T 1868-1929 *WhAmArt 85*
Quinn, Fred P 1932- *AmArch 70*
Quinn, Gus G, Jr. 1937- *AmArch 70*
Quinn, Henrietta Reist 1918- *WhoAmA 73, –76, –78, –80, –82, –84*
Quinn, J C *FolkA 86*
Quinn, James Peter 1871-1951 *DcBrA 1*
Quinn, James Toms 1931- *AmArch 70*
Quinn, John *FolkA 86*
Quinn, John 1870-1924 *WhAmArt 85*
Quinn, John C *WhAmArt 85*
Quinn, K E *AmArch 70*
Quinn, Noel Joseph 1915- *WhoAmA 73, –76, –78, –80, –82, –84*
Quinn, Patrick James 1931- *AmArch 70*
Quinn, Raymond John 1938- *WhoAmA 78, –80*
Quinn, Rene Robert d1934 *DcBrA 2*
Quinn, Richard Walter 1936- *AmArch 70*
Quinn, Robert Hayes d1962 *WhoAmA 78N, –80N, –82N, –84N*
Quinn, Robert Hayes 1902-1962 *WhAmArt 85*
Quinn, Sandi 1941- *WhoAmA 78, –80*
Quinn, Thomas *OfPGCP 86*
Quinn, Vincent Paul 1911- *WhAmArt 85*
Quinn, William 1929- *AmArt, PrintW 83, –85, WhoAmA 78, –80, –82, –84*
Quinnell, Cecil Watson 1868-1932 *DcBrA 1, DcVicP 2*
Quino *WorECom*
Quinones, Pablo R *AmArch 70*
Quinquand, Anna 1890- *DcWomA*
Quinsac, Annie-Paule 1945- *WhoAmA 76, –78, –80, –82, –84*
Quinsac, Charles *DcVicP 2*
Quint, Louis H *NewYHSD*
Quintana, Ben 1923-1944 *IIBEAAW*
Quintana, Joe A *IIBEAAW*
Quintana, Nicolas Jose 1925- *AmArch 70*
Quintanilla, Isabel 1938- *ConArt 77, OxTwCA*
Quintanilla, Luis 1895- *IlsBYP, IlsCB 1946, WhAmArt 85*
Quintard, Lucien Charles Justin 1849-1905 *ClaDrA*
Quintart, Angele E 1880- *DcWomA*
Quintas, Ted S 1933- *AmArch 70*
Quinte, Lothar 1923- *OxTwCA, PhDcTCA 77*
Quinteros Gomez, Adolfo 1927- *WhoGrA 82[port]*
Quintin, D S *NewYHSD*
Quintman, Myron 1904- *WhAmArt 85*
Quinton *NewYHSD*
Quinton, Alfred Robert *ClaDrA, DcVicP, –2*
Quinton, Alfred Robert 1853- *DcBrA 1, DcBrBI, DcBrWA*
Quinton, Cornelia Bentley *DcWomA*
Quinton, Cornelia Bentley Sage 1876-1936 *ArtsAmW 1*
Quinton, Marcelle *DcCAr 81*
Quinton, Mrs. W W *WhAmArt 85*
Quirarte, Jacinto 1931- *WhoAmA 78, –80, –82, –84*
Quirizio DaMurano *McGDA*
Quirk, Francis Joseph 1907- *WhoAmA 73*
Quirk, Francis Joseph 1907-1974 *WhAmArt 85, WhoAmA 76N, –78N, –80N, –82N, –84N*
Quirk, Thomas Charles, Jr. 1922- *WhoAmA 73, –76, –78, –80, –82, –84*
Quiros, Juan Gomez *OxTwCA*
Quiros, Lorenzo 1717-1789 *ClaDrA*
Quirot *NewYHSD*
Quirt, Walter 1902- *McGDA*
Quirt, Walter 1902-1968 *DcCAA 71, –77, WhoAmA 78N, –80N, –82N, –84N*
Quirt, Walter W 1902- *IIBEAAW*
Quirt, Walter W 1902-1968 *WhAmArt 85*
Quisgard, Liz Whitney 1929- *DcCAA 71, –77, WhoAmA 73, –76, –78, –80, –84*
Quispe Ttito, Diego *McGDA*
Quist, Hans 1922- *WorECar*
Quistelli DellaMirandola, Lucrezia *DcWomA*
Quistgaard, Johan Waldemar DeRehling d1962 *WhoAmA 78N, –80N, –82N, –84N*
Quistgaard, Johann Waldemar DeRehling 1877-1962 *WhAmArt 85*
Quiter, Catharina Elisabeth 1697-1737 *DcWomA*
Quiter, Hermann Heinrich d1731 *DcBrECP*
Quitrel, Lisa *DcWomA*
Quittelier, Albert Eugene 1910- *AmArch 70*
Quitter, Catharina Elisabeth 1697-1737 *DcWomA*
Quittner, Olga 1895-1918 *DcWomA*
Quiz *DcBrBI*
Quizet, Alphonse 1885-1955 *PhDcTCA 77*
Quizet, Alphonse Leon 1885-1955 *ClaDrA*
Quost, Suzanne *DcWomA*
Qvale, R C *AmArch 70*
Qvist, Gerda 1883- *DcWomA*

R

R A *BkIE*
R, N *DcBrBI*
R, W *DcBrECP*
Raab, Ada Dennett d1950 *DcWomA*, *WhAmArt 85*, *WhoAmA 78N, –80N, –82N, –84N*
Raab, Doris 1851- *DcWomA*
Raab, Ferdinand *NewYHSD*
Raab, Francis 1813?- *NewYHSD*
Raab, Frederic Joseph 1952- *MarqDCG 84*
Raab, Fritz 1925- *WorECom*
Raab, George *DcCAr 81*
Raab, George 1866-1943 *WhAmArt 85*
Raab, Martin David 1932- *AmArch 70*
Raabe, Alfred 1872-1913 *WhAmArt 85*
Raabe, Erna 1882- *DcWomA*
Raabe, Joseph 1780-1849 *ArtsNiC*
Raabe, Margarete 1863- *DcWomA*
Raach, Richard 1906- *WhoAmA 80, –82*
Raad, George K 1924- *AmArch 70*
Raad, T O *AmArch 70*
Raaholt, Lennart 1947- *WorFshn*
Raasch, Ronald Adler 1939- *AmArch 70*
Rab, Paul 1898-1933 *WorECar*
Rabago, Andres 1947- *WorECar*
Rabanne, Paco *WorFshn*
Rabanne, Paco 1934- *ConDes*, *FairDF FRA*
Rabascall, Joan 1935- *ConArt 77*
Rabb, Irving W *WhoAmA 73, –76, –78, –80, –82, –84*
Rabb, Mrs. Irving W *WhoAmA 73, –76, –78, –80, –82, –84*
Rabbeth, James, Jr. 1824-1858? *NewYHSD*
Rabbit, William E 1946- *WhoAmA 84*
Rabe, Alida Kristine 1825-1870 *DcWomA*
Rabe, Benjamin John *AmArch 70*
Rabe, Sharman *MarqDCG 84*
Rabeneck, Andrew *ConArch A*
Rabeuf, Hippolyte *DcVicP 2*
Rabier, Benjamin Armand 1869-1939 *WorECar*
Rabillon, Leonce 1814-1886 *NewYHSD*
Rabin, Bernard 1916- *WhoAmA 73, –76, –78*
Rabin, Oskar Yakovlevich 1928- *OxTwCA*
Rabindran, K George 1935- *MarqDCG 84*
Rabineau, Eli 1914- *AmArch 70*
Rabineau, Francis *NewYHSD*
Rabinek, George 1929- *AmArch 70*
Rabino, Saul 1892- *ArtsAmW 2*, *WhAmArt 85*
Rabinoffsky, Isaac Irwin *FolkA 86*
Rabinov, Irwin 1898-1980 *FolkA 86*
Rabinovich, Raquel 1929- *WhoAmA 73, –76, –78, –80, –82, –84*
Rabinovich, Rhea Sanders *WhoAmA 82, –84*
Rabinovitch, Mendel 1941- *ICPEnP A*
Rabinovitch, William A 1936- *PrintW 83, –85*
Rabinovitch, William Avrum 1936- *WhoAmA 73, –76, –78, –80, –82, –84*
Rabinovitch, Harold 1915- *WhAmArt 85*
Rabinowitch, David 1943- *AmArt*, *ConArt 77*, *DcCAr 81*, *WhoAmA 76, –78, –80, –82, –84*
Rabinowitch, Royden Leslie 1943- *WhoAmA 76, –78, –80, –82, –84*
Rabinowitz, Numa *WhAmArt 85*
Rabirius *MacEA*
Rabkin, Leo 1919- *DcCAA 71, –77, WhoAmA 73, –76, –78, –80, –82, –84*
Rabold, W A *AmArch 70*
Rabon, William James, Jr. 1931- *AmArch 70*
Raborg, Benjamin 1871-1918 *ArtsAmW 1*, *IlBEAAW*, *WhAmArt 85*

Rabouille, Emilie 1884- *DcWomA*
Rabow, Rose *WhoAmA 76, –78*
Raboy, Emanuel 1914-1967 *WorECom*
Raboy, Mac 1914- *WhAmArt 85*
Rabuske, Theodore *EarABI*
Rabuski, Theodore *NewYHSD*
Rabut, Paul 1914- *IlBEAAW*, *IlrAm E*, *WhAmArt 85*, *WhoAmA 73, –76, –78, –80*
Rabut, Paul 1914-1983 *IlrAm 1880*
Rabuteaux, Isabelle *DcWomA*
Rabuzin, Ivan 1919- *OxTwCA*
Racchini, Peter Louis 1924- *AmArch 70*
Raccuglia, Joseph Victor *AmArch 70*
Race, Ernest 1913-1964 *ConDes*
Race, Ernest 1915-1964 *DcD&D[port]*
Race, Robert Oscar 1925- *AmArch 70*
Rachamova, Iecaterina *DcWomA*
Rachel, Madame *DcVicP 2*
Rachel, Vaughan 1933- *ICPEnP A*, *MacBEP*, *WhoAmA 76, –78, –80*
Rachelski, Florian W *WhoAmA 73, –76, –78*
Rachmanow, Nikalaj 1932- *ICPEnP A*
Rachmiel, Jean 1871- *WhAmArt 85*
Rachtoes, Matene 1905- *WhAmArt 85*
Racim, Mohammed 1896- *ClaDrA*
Racine, Albert 1907- *IlBEAAW*, *WhAmArt 85*
Racine, Albert Batiste 1907- *WhoAmA 78, –80*
Racine, Robert 1956- *DcCAr 81*
Raciti, Cherie 1942- *WhoAmA 76, –78, –80, –82, –84*
Rackett, Thomas 1757-1841 *DcBrWA*
Rackham, Arthur 1867-1937 *AntBDN B*
Rackham, Arthur 1867-1939 *ClaDrA*, *ConICB*, *DcBrA 1*, *DcBrBI*, *DcBrWA*, *DcVicP, –2*, *McGDA*
Rackham, Edith *DcBrWA*
Rackham, Edyth 1867- *DcWomA*
Rackham, W Leslie 1864-1944 *DcBrA 1*, *DcVicP 2*
Rackley, Mildred 1906- *WhAmArt 85*
Rackow, Leo *WhAmArt 85*
Rackus, George 1927- *WhoAmA 84*
Rackwitz, G A *AntBDN K*
Racz, Andre 1916- *DcCAA 71, –77*, *WhAmArt 85*, *WhoAmA 73, –76, –78, –80, –82, –84*
Raczkiewicz, George 1947- *MarqDCG 84*
Radbourne, William H 1838-1914 *NewYHSD*, *WhAmArt 85*
Radcliff, Anna *DcVicP 2*
Radcliff, Charles 1777?-1807 *NewYHSD*
Radcliffe, Radcliffe W *DcVicP, –2*
Radcliffe, T B *NewYHSD*
Radcliffe, Charles Walter 1817-1903 *ClaDrA*, *DcBrBI*, *DcBrWA*, *DcVicP, –2*
Radcliffe, Edward 1810-1863 *ArtsNiC*
Radclyffe, William, Jr. 1813-1846 *DcVicP 2*
Radden, Thomas M *NewYHSD*
Radecki, Martin John 1948- *WhoAmA 80, –82, –84*
Radegonde, Saint 519?-587 *McGDA*
Radeke, Eliza Green 1855-1931 *WhAmArt 85*
Radell, Robert Roy *AmArch 70*
Rademaker, Abraham 1675-1735 *ClaDrA*
Rademaker, Gerrit 1672-1711 *ClaDrA*
Radenkovitch, Yovan 1903- *WhAmArt 85*
Rader, E *AmArch 70*
Rader, Elaine Myers 1902- *WhAmArt 85*
Rader, H D *AmArch 70*
Rader, Isaac 1906- *WhAmArt 85*
Rader, M *AmArch 70*
Rader, Marcia A 1894-1937 *DcWomA*, *WhAmArt 85*
Rader, Paul Wilbur 1913- *AmArch 70*
Raders, Luise Van *DcWomA*
Raderscheidt, Anton 1892-1970 *PhDcTCA 77*

Rades, William L 1943- *WhoAmA 84*
Radetsky, Jack 1948- *DcCAr 81*
Radey, F H, Jr. *AmArch 70*
Radey, Frank Herbert 1896- *AmArch 70*
Radford, Mrs. Colin *WhAmArt 85*
Radford, Edward 1831- *ArtsNiC*
Radford, Edward 1831-1920 *DcBrA 1*, *DcBrWA*, *DcVicP, –2*
Radford, J Russell 1904- *AmArch 70*
Radford, James *DcVicP, –2*
Radford, Paul 1957- *DcCAr 81*
Radford, Robert, III 1947- *MarqDCG 84*
Radford, W H *AmArch 70*
Radford, Zilpha 1885- *ArtsAmW 3*
Radfore, P M *FolkA 86*
Radice, Anne-Imelda Marino 1948- *WhoAmA 80, –82, –84*
Radice, Mario 1898- *ConArt 83*
Radice, Mario 1900- *ConArt 77*, *OxTwCA*, *PhDcTCA 77*
Radilovic, Julio 1928- *WorECom*
Radimsky, Venzel 1867- *ClaDrA*
Radin, Dan 1929- *WhoAmA 73, –76, –78, –80, –82, –84*
Raditz, Lazar 1887- *WhAmArt 85*
Raditz, Violetta C *WhAmArt 85*
Raditz, Violetta Constance *DcWomA*
Radivojevic, Ljubisa Bosko 1954- *MarqDCG 84*
Radley, William J *ArtsEM*
Radloff, Celeste Pauline 1930- *WhoArt 84*
Radmanic, Franjo *OxTwCA*
Radnay, Elizabeth *DcWomA*
Rado, Ilona *DcWomA*
Rado, Ladislav Leland 1909- *AmArch 70*, *McGDA*
Radoczy, Albert 1914- *WhoAmA 73, –76, –78, –80, –82, –84*
Radojicic, Mirko 1948- *DcCAr 81*
Radosavljevic, Svetislav M 1920- *MarqDCG 84*
Radoslovich, Michael L 1902- *AmArch 70*
Radotinsky, J W *AmArch 70*
Radou, Anne Marie Elisa *DcWomA*
Radovich, Donald 1932- *WhoAmA 82, –84*
Radovska-Borgna, Baroness Annetta *DcWomA*
Radowska-Borgna, Baroness Annetta *DcWomA*
Radtke, Robert Lee 1952- *MarqDCG 84*
Radu, Dan 1929- *WhoGrA 82[port]*
Radue, Josephine Watt Lee 1910- *WhAmArt 85*
Radulovic, Savo 1911- *WhoAmA 73, –76, –78, –80, –82, –84*
Rady, Elsa 1943- *WhoAmA 84*
Radycki, J Diane 1946- *WhoAmA 82, –84*
Radziwill, Franz 1895- *McGDA*, *PhDcTCA 77*
Radziwill, Marie Eleonore 1671-1756 *DcWomA*
Rae, Alison *DcWomA*
Rae, Cecil W *DcVicP 2*
Rae, Edwin C 1911- *WhoAmA 73, –76, –78*
Rae, Frank B *WhAmArt 85*
Rae, Henrietta *DcWomA*
Rae, Henrietta 1859-1928 *DcBrA 1*
Rae, Henrietta R *DcVicP, –2*
Rae, Iso *DcVicP 2*, *DcWomA*
Rae, John *AfroAA*
Rae, John 1882- *WhAmArt 85*
Rae, John 1882-1963 *IlBEAAW*, *IlsCB 1744*
Rae, John 1931- *WhoArt 80, –82, –84*
Rae, Mary *DcVicP 2*
Rae, William T *EncASM*
Rae-Ong *McGDA*
Raeburn, Agnes 1872-1955 *DcWomA*
Raeburn, Agnes Middleton d1955 *DcBrA 1*, *DcBrWA*

Raeburn, Sir Henry 1756-1823 *DcBrECP, McGDA, OxArt*
Raeburn, Kenneth Alexander 1942- *WhoArt 80, –82, –84*
Raeburn, Robert R 1819-1888 *BiDBrA*
Raedecker, John 1885-1956 *OxArt*
Raeder, Frederick W 1832- *BiDAmAr*
Raeder, George B 1934- *AmArch 70*
Raeder, Hartman *FolkA 86*
Raeder, Sebastian *FolkA 86*
Raemaekers, Louis 1869-1956 *WorECar*
Raemakers, Louis 1869-1956 *DcBrBI*
Raemich, Ruth 1893- *WhAmArt 85*
Raemisch, Ruth 1893- *DcWomA*
Raemisch, Waldemar 1888-1955 *WhAmArt 85*
Raemsch, Henry Arthur 1929- *AmArch 70*
Raemy, Leocadie 1829-1906 *DcWomA*
Raen, Isaac *NewYHSD*
Raes, Marguerite *DcWomA*
Raetz, Markus 1941- *ConArt 77, –83, DcCAr 81*
Raetze, G W *AmArch 70*
Raeuber, F W *AmArch 70*
Rafaelli, Lucia *WorFshn*
Rafat, Emilie L A *DcWomA*
Raff, Helene 1865- *DcWomA*
Raffael, Joseph 1933- *AmArt, ConArt 77, –83, DcCAA 71, –77, PrintW 83, –85, WhoAmA 73, –76, –78, –80, –82, –84*
Raffael, Judith K *WhoAmA 82, –84*
Raffael, Judith K 1937- *WhoAmA 78, –80*
Raffaelli, Gino *WhAmArt 85*
Raffaelli, Jean Francois 1850-1924 *ClaDrA, WhAmArt 85A*
Raffaelli, Jean-Francois 1850-1924 *McGDA*
Raffaelli, Leo Peter 1912- *AmArch 70*
Raffaellino DaColle *McGDA*
Raffaellino DaReggio 1550-1578 *McGDA*
Raffaellino DelColle 1490?-1566 *McGDA*
Raffaellino DelGarbo 1466?-1527? *McGDA*
Raffaello DaBrescia, Fra *McGDA*
Raffaello De'Carli *McGDA*
Raffel, Alvin R 1905- *WhAmArt 85*
Raffel, Alvin Robert 1905- *AmArt, WhoAmA 73, –76, –78, –80, –82, –84*
Raffel, Charles *DcVicP 2*
Rafferty, G E *AmArch 70*
Rafferty, R J *AmArch 70*
Raffet, Auguste 1804-1860 *ClaDrA, WorECar*
Raffet, Denis-Auguste-Marie 1804-1860 *ArtsNiC, McGDA*
Raffet, Denis Auguste Marie 1804-1860 *DcBrBI*
Raffield, John *BiDBrA*
Raffler, Max *OxTwCA*
Raffo, Steve 1912- *WhoAmA 82, –84*
Rafols Casamada, Alberto 1923- *OxTwCA*
Rafsky, Jessica C 1924- *WhoAmA 73, –76, –78, –80, –82, –84*
Rafter, H *DcBrBI, DcVicP 2*
Ragan, Connie Seabourn 1951- *WhoAmA 84*
Ragan, Mrs. Henry *WhAmArt 85*
Ragan, Leslie Darrell 1897- *WhAmArt 85*
Ragan, Nannie *DcWomA*
Ragazzini, Enzo 1934- *ConPhot, ICPEnP A*
Ragg, Isabel Mary 1901- *DcBrA 1*
Ragg, R E 1922- *DcBrA 1*
Raggi, Ercole Antonio 1624-1686 *McGDA*
Raggi, Giovanni 1712-1794? *McGDA*
Raggi, Pietro Paolo 1646?-1724 *McGDA*
Raggi, Richard August 1924- *AmArch 70*
Raggin, E *DcVicP 2*
Raggio, Guiseppe *DcVicP 2*
Raggio, Olga *WhoAmA 78, –80*
Raggio, Olga 1926- *WhoAmA 82, –84*
Raghuwanshi, Pravin M 1945- *MarqDCG 84*
Raginsky, Nina *DcCAr 81, WhoAmA 84*
Ragland, Bob 1938- *WhoAmA 76, –78, –80, –82, –84*
Ragland, Jack Whitney 1938- *AmArt, WhoAmA 73, –76, –78, –80, –82, –84*
Ragland, Phillda *AfroAA*
Ragless, Max 1901- *ClaDrA*
Raglow, Rick Alan 1954- *MarqDCG 84*
Ragnars, Bergljot 1944- *DcCAr 81*
Ragnes, Andrew Philip 1942- *MarqDCG 84*
Ragnoni, Barbara *DcWomA*
Ragnoni-Cratognini, Francesca 1850- *DcWomA*
Ragnoni-Gratognini, Francesca 1850- *DcWomA*
Ragoczy, Laura Johanne Wilhelmine 1880- *DcWomA*
Ragold, E M *AmArch 70*
Ragon, Adolphe d1924 *DcBrA 1, DcVicP, –2*
Ragsdale, Delbert Leon 1936- *AmArch 70*
Ragsdell, Kenneth M *MarqDCG 84*
Rague, John Francis *BiDAmAr*
Rague, John Francis 1799-1877 *MacEA*
Raguib, Hakim *AfroAA*
Ragusa, Signor *NewYHSD*
Ragusa, Eleonora *DcWomA*
Ragusa, Isa 1926- *WhoAmA 84*
Raguzzini, Filippo 1680?-1771 *MacEA*
Rahbula, Mabel *DcWomA*
Rahe, Charles T *DcVicP 2*
Rahikainen, Tua 1944- *WorFshn*

Rahill, Margaret Fish 1919- *WhoAmA 78, –80, –82, –84*
Rahimi, Bahman 1960- *MarqDCG 84*
Rahja, Virginia Helga 1921- *WhoAmA 73, –76, –78, –80, –82, –84*
Rahl, Charles 1812-1865 *ArtsNiC*
Rahl, Karl 1770-1843 *ClaDrA*
Rahman, Abdul *AfroAA*
Rahmeier, Frederick d185-? *FolkA 86*
Rahming, Norris 1886-1959 *WhAmArt 85, WhoAmA 80N, –82N, –84N*
Rahn, A Donald *WhAmArt 85*
Rahn, E C *AmArch 70*
Rahn, Irving *WhAmArt 85*
Rahnis, David J 1938- *MarqDCG 84*
Rahr, Frederic H 1904- *WhoAmA 73, –76*
Rahtjen, Fitzhugh *ArtsAmW 2, WhAmArt 85*
Rahv, N S *AmArch 70*
Rai, Vinay 1949- *MarqDCG 84*
Raible, Alton Robert *IlsCB 1967*
Raible, Alton Robert 1918- *IlsBYP, IlsCB 1957*
Raibolini, Francesco *McGDA*
Raiboloni, Francesco *OxArt*
Raidel, Dorion 1892-1977 *FolkA 86*
Raider, David Howard 1939- *AmArch 70*
Raidl, Ida 1894- *DcWomA*
Raige, Emilie *DcWomA*
Raigersfeld, Jeffrey, Baron De 1770?-1844 *DcSeaP*
Raigersfield, Jeffrey 1770?-1844 *DcBrECP*
Raiguel, William C 1876-1941 *BiDAmAr*
Raiken, Leo *WhAmArt 85*
Raikes, Arlen Dean 1930- *AmArch 70*
Railla, Joseph J 1934- *AmArch 70*
Railton, F J *DcVicP, –2*
Railton, Fanny *DcBrBI*
Railton, Herbert 1857-1910 *DcBrA 1, DcBrBI*
Railton, Herbert 1858-1910 *ClaDrA*
Railton, William d1877 *DcVicP 2*
Railton, William A 1801?-1877 *BiDBrA*
Raimbach, Abraham 1776-1843 *DcBrBI*
Raimbach, David Wilkie 1820-1895 *DcBrWA, DcVicP 2*
Raimbach, Emma Harriet 1810-1882? *DcVicP 2, DcWomA*
Raimbault, Louise *DcWomA*
Raimist, Robert 1923- *AmArch 70*
Raimond *EncASM*
Raimond, Rosalie *DcWomA*
Raimond-Dityvon, Claude 1937- *ConPhot, ICPEnP A*
Raimondi *DcWomA*
Raimondi, John Richard 1948- *WhoAmA 82, –84*
Raimondi, Marcantonio 1480?-1534 *McGDA*
Raimondi, Marcantonio 1480?-1534? *OxArt*
Raimondi-Velli, Theresa De *DcWomA*
Raimonte, Harry Anthony 1922- *AmArch 70*
Rain, Charles 1911- *WhoAmA 73, –76, –78, –80*
Rain, Isaac *NewYHSD*
Rainaldi, Carlo 1611-1691 *McGDA, OxArt, WhoArch*
Rainaldi, Girolamo *OxArt*
Rainaldi, Girolamo 1570-1655 *MacEA, McGDA*
Rainaldo *MacEA*
Rainaud, Louise Emma *DcWomA*
Rainbird, Victor Noble 1888- *ClaDrA*
Rainbird, Victor Noble 1888-1936 *DcBrA 1*
Rainbow, W C *DcVicP 2*
Raincock, Sophia *DcVicP 2*
Raincourt, Paul, Madame *DcWomA*
Raine, Earle Thomas 1911- *WhAmArt 85*
Raine, Sarah Lamar 1940- *WhoArt 84*
Rainer, Arnulf 1924- *DcCAr 81, PrintW 85*
Rainer, Arnulf 1929- *ConArt 77, –83, OxTwCA, PhDcTCA 77*
Rainer, Florian 1927- *DcCAr 81*
Rainer, Roland 1910- *ConArch, EncMA, MacEA*
Raineri DiUgolino *McGDA*
Rainerieus Of Pisa, Saint *McGDA*
Raines, Gary K 1944- *MarqDCG 84*
Raines, Minnie *WhAmArt 85*
Rainey, Catherine S *ArtsEM, DcWomA*
Rainey, Clifford 1948- *DcCAr 81*
Rainey, Edward *BiDBrA*
Rainey, Francis Tristram 1910- *DcBrA 1*
Rainey, Froelich Gladstone 1907- *WhoAmA 73, –76, –78*
Rainey, H William 1852-1936 *DcBrWA, DcVicP 2*
Rainey, John Crews 1934- *AmArch 70*
Rainey, John Watts 1948- *WhoAmA 76, –78, –80*
Rainey, Robert E L 1914- *WhAmArt 85*
Rainey, Robert Lee *MarqDCG 84*
Rainey, William 1852- *ClaDrA*
Rainey, William 1852-1936 *DcBrA 1, DcBrBI, DcVicP*
Rainford, E *DcVicP 2*
Rainger, Gus *DcVicP 2*
Rainger, William Augustus *DcVicP 2*
Rains, Harry S *EncASM*
Rains, Malcolm 1947- *DcCAr 81*
Rainsford, Miss *DcWomA, NewYHSD*
Rainville, Paul d1952 *WhoAmA 78N, –80N, –82N, –84N*

Rairden, Anthony W 1944- *MarqDCG 84*
Rairden, Eugene Paul, II 1936- *AmArch 70*
Raisbeck, J J *WhAmArt 85*
Raiser, Jacob *FolkA 86*
Rajan, Periasamy Karivaratha 1942- *MarqDCG 84*
Rajaram, Navaratna S 1943- *MarqDCG 84*
Rajecka, Anna 1760?-1832 *DcWomA*
Rajkovic, Budimir *OxTwCA*
Rajlich, Tomas 1940- *ConArt 77, –83*
Rajner, Gabriella 1877- *DcWomA*
Rajon, A *DcVicP 2*
Rajon, Paul-Adolphe *ArtsNiC*
Rajon, Paul Adolphe 1843?-1888 *ClaDrA*
Rajzik, Jaroslav 1940- *ConPhot, ICPEnP A, MacBEP*
Rakatansky, Ira 1919- *AmArch 70*
Rakauskas, Romualdas 1941- *ConPhot, ICPEnP A, MacBEP*
Rake, William A 1931- *AmArch 70*
Rakeman, Carl 1878- *WhAmArt 85*
Raker, Daniel *MarqDCG 84*
Rakestraw, Joseph *FolkA 86*
Rakocy, William 1924- *AmArt, WhoAmA 73, –76, –78, –80, –82, –84*
Rakoczi, Basil Ivan 1908- *DcBrA 2, WhoArt 80, –82*
Rakosi-Geonczy, Iolna 1886- *DcWomA*
Rakovan, Lawrence F 1939- *PrintW 83, –85*
Rakovan, Lawrence Francis 1939- *WhoAmA 76, –78, –80, –82, –84*
Raleigh, Charles Sidney 1830-1925 *DcSeaP, FolkA 86, WhAmArt 85*
Raleigh, Henry 1880- *WhAmArt 85*
Raleigh, Henry Patrick 1880- *ArtsAmW 3*
Raleigh, Henry Patrick 1880-1944 *IlrAm B, –1880*
Raleigh, Henry Patrick 1931- *WhoAmA 76, –78, –80, –82, –84*
Raley, Joseph Oscar, Jr. 1923- *AmArch 70*
Raley, R L *AmArch 70*
Raley, Robert L 1924- *WhoAmA 78, –80, –80, –82, –84*
Raley, Mrs. Robert L *WhoAmA 78,*
Ralfe, Mrs. E *DcVicP 2*
Rall, Mrs. *WhAmArt 85*
Rall, Herman George 1921- *AmArch 70*
Rall, Rainer G 1942- *MarqDCG 84*
Ralli, H *DcVicP 2*
Ralli, Theoddore Jacques 1852-1909 *ClaDrA*
Rallier DuBaty, Louise Marie *DcWomA*
Rallis, W H *AmArch 70*
Ralls, F Gene 1923- *AmArch 70*
Ralph, Benjamin *DcBrECP*
Ralph, Bryan 1937- *AmArch 70*
Ralph, G E *AmArch 70*
Ralph, George Keith 1752-1798? *DcBrECP*
Ralph, John d1801 *CabMA*
Ralph, John A *NewYHSD*
Ralph, Lester 1877-1927 *WhAmArt 85*
Ralph, Richard *DcBrECP*
Ralph, W *NewYHSD*
Ralph, William S 1901- *AmArch 70*
Ralph And Silberg *CabMA*
Ralphs, John *BiDBrA*
Ralston, Alexander *ArtsEM*
Ralston, George Washington 1819-1843 *NewYHSD*
Ralston, J K 1896- *ArtsAmW 1, WhAmArt 85, WhoAmA 73*
Ralston, James Kenneth 1896- *IlBEAAW, WhoAmA 76, –78, –80, –82, –84*
Ralston, John McL *DcBrBI*
Ralston, Louis d1928 *WhAmArt 85*
Ralston, Robert *NewYHSD*
Ralston, Robert S *AmArch 70*
Ralston, William d1911 *DcBrA 2*
Ralston, William 1848-1911 *DcBrBI, DcVicP 2*
Ram, Jane A *DcVicP 2*
Ram, Jane Adye *DcWomA*
Ramage, John 1746-1802 *McGDA*
Ramage, John 1748?-1802 *BnEnAmA, NewYHSD*
Ramah, Henri-Francois 1887-1947 *OxTwCA*
Ramakrishna, Kamesh 1952- *MarqDCG 84*
Ramanauskas, Dalia Irena 1936- *WhoAmA 76, –78, –80, –82, –84*
Ramapriyan, H K 1943- *MarqDCG 84*
Ramauge, Roberto 1890- *ClaDrA*
Rambal, Mina 1840- *DcWomA*
Ramberg, Christina 1946- *AmArt, DcCAr 81, WhoAmA 73, –76, –78, –80, –82, –84*
Ramberg, Donald Albert 1919- *AmArch 70*
Ramberg, Johann Heinrich 1763-1840 *BkIE, ClaDrA, DcBrBI, DcBrECP, McGDA, WorECar*
Ramberg, Lucy Dodd d1929 *DcWomA, WhAmArt 85*
Ramberg, Walter Dodd 1932- *AmArch 70*
Rambissoon, Sonnylal 1926- *WhoArt 80, –82, –84*
Ramble, Fred *DcBrBI*
Rambo, James I 1923- *WhoAmA 73, –76*
Rambosson, A Yvanhoe, Madame *DcWomA*
Rambow, Gunter 1938- *WhoGrA 82[port]*
Rambusch, Agnes *DcWomA*
Rambusch, Frode C W 1860-1924 *WhAmArt 85*
Rameau, Charlotte Louise *DcWomA*

Ramee, Daniel 1806-1887 *MacEA*
Ramee, John Jacques 1764-1842 *BiDAmAr*
Ramee, Joseph Jacques 1764-1842 *BnEnAmA,*
MacEA, NewYHSD
Rameijer, Jaap Willem 1945- *MarqDCG 84*
Ramenghi, Bartolommeo *McGDA*
Rames, Stanley Dodson 1923- *WhoAmA 82, -84*
Ramesh, Bhashyam 1955- *MarqDCG 84*
Ramey, George *WhAmArt 85*
Ramey, Uel Clifton 1918- *AmArch 70*
Ramie, C W *DcVicP 2*
Ramie, Marian *DcVicP 2*
Ramirez, Daniel 1941- *DcCAr 81*
Ramirez, Daniel P 1941- *AmArt*
Ramirez, Eduardo Villamizar 1923- *WhoAmA 73, -76*
Ramirez, Gabriel 1938- *WhoAmA 76, -78*
Ramirez, Joel Tito 1923- *WhoAmA 76, -78, -80, -82,*
-84
Ramirez, Martin 1885-1960 *FolkA 86*
Ramirez, R O 1936- *AmArch 70*
Ramirez Vazquez, Pedro 1919- *ConArch,*
WhoAmA 78
Ramirez-Vazquez, Pedro 1919- *WhoAmA 80, -82*
Ramirez Villamizar, Eduardo 1923- *OxTwCA*
Ramis, Julio 1910- *WhoArt 80*
Ramke, Henry H 1936- *AmArch 70*
Rammel, William Gregory 1898- *AmArch 70*
Rammelt-Burger, Kate 1877- *DcWomA*
Ramming, W J *AmArch 70*
Ramon *IlBEAAW*
Ramon, Adolpho *WhAmArt 85*
Ramos, Antonio Casimir 1926- *AmArch 70*
Ramos, Chris Peter 1925- *AmArch 70*
Ramos, D M *AmArch 70*
Ramos, Gloria Diana *AmArch 70*
Ramos, L *AmArch 70*
Ramos, Mel 1935- *ConArt 77, -83, DcCAA 71, -77,*
OxTwCA, PrintW 83, -85
Ramos, Melvin John 1935- *AmArt, WhoAmA 73,*
-76, -78, -80, -82, -84
Ramos Blanco, Teodoro *AfroAA*
Ramos Martinez, Alfredo 1872-1946 *McGDA*
Ramos-Prida, Fernando 1937- *WhoAmA 76, -78, -80*
Ramosa, Edival 1940- *ConArt 77*
Ramp, A H *AmArch 70*
Rampling, Clark d1875 *BiDBrA*
Rampling, R E d1909 *DcBrA 2*
Rampling, Reginald d1909 *DcBrWA*
Rampulla, Phillip V 1930- *AmArch 70*
Rams, Dieter 1932- *ConDes*
Ramsauer, Joseph Francis 1943- *WhoAmA 78, -80,*
-82, -84
Ramsay, A *DcWomA*
Ramsay, Alexander 1777?-1847 *BiDBrA*
Ramsay, Allan 1713-1784 *DcBrECP[port], McGDA,*
OxArt
Ramsay, David *NewYHSD*
Ramsay, David 1869- *ClaDrA, DcBrA 1, DcBrWA,*
DcVicP 2
Ramsay, Eleanor *DcVicP 2*
Ramsay, F L *DcVicP 2*
Ramsay, Hallie *DcWomA*
Ramsay, James d1800 *BiDBrA*
Ramsay, James 1786-1854 *DcVicP, -2*
Ramsay, John Erwin 1915- *AmArch 70*
Ramsay, Milne 1847-1915 *WhAmArt 85*
Ramsay, R I *AmArch 70*
Ramsay, Lady Victoria P Helena Elizabeth 1886-1974
DcBrA 2
Ramsay, Lady Victoria Patricia Helena E 1886-
DcBrA 1
Ramsay, Lady Victoria Patricia Helena E 1886-1974
DcWomA
Ramsaye, Fern Forester 1889-1931 *DcWomA,*
WhAmArt 85
Ramsdell, Anne *DcWomA*
Ramsdell, Fred Winthrop 1865-1915 *WhAmArt 85*
Ramsdell, Katherine *WhAmArt 85*
Ramsdell, Katherine D *DcWomA*
Ramsdell, M Louise *WhAmArt 85*
Ramsden, Eric 1927- *WhoArt 80, -82, -84*
Ramsden, Omar 1873-1939 *DcBrA 2*
Ramsden, Thomas *DcVicP 2*
Ramses, Akhenaten V *AfroAA*
Ramseur, Mary D *WhAmArt 85*
Ramsey, Alice *DcWomA*
Ramsey, Barnett *FolkA 86*
Ramsey, Charles E d1913 *BiDAmAr*
Ramsey, Charles F *WhAmArt 85*
Ramsey, David *AntBDN D*
Ramsey, Edith 1889- *DcWomA, WhAmArt 85*
Ramsey, G *DcSeaP*
Ramsey, G L *AmArch 70*
Ramsey, George S *DcVicP 2*
Ramsey, Harold Joseph 1924- *AmArch 70*
Ramsey, J *DcVicP 2*
Ramsey, Joseph *FolkA 86*
Ramsey, Lewis A 1873- *WhAmArt 85*
Ramsey, Lewis A 1873-1941 *IlBEAAW*
Ramsey, Lewis A 1875-1941 *ArtsAmW 1*
Ramsey, Lucy C *DcWomA*

Ramsey, Margaret *FolkA 86*
Ramsey, Milne *ArtsNiC*
Ramsey, N *DcWomA*
Ramsey, Rachel *NewYHSD*
Ramsey, Rachel 1832?- *DcWomA*
Ramsey, T *DcBrECP*
Ramsey, W R *AmArch 70*
Ramsey, William *FolkA 86*
Ramseyer, Andre 1914- *PhDcTCA 77*
Ramshaw, Wendy 1939- *DcCAr 81*
Ramshaw, William *BiDBrA*
Ramsing, Lilli Elisabeth Charlotte *DcWomA*
Ramstead, Edward Oliver, Jr. 1930- *WhoAmA 76, -78,*
-80, -82
Ramstedt, Nils Walter, Jr. 1947- *WhoAmA 80, -82*
Ramus, Charles Frederick 1902- *WhAmArt 85*
Ramus, Michael *WhAmArt 85*
Ran-Gok *McGDA*
Rana, Carlo Amedeo 1714-1804 *MacEA*
Ranadive, Joan Settle 1949- *WhoAmA 82*
Ranalli, Daniel 1946- *MacBEP, PrintW 83, -85,*
WhoAmA 78, -80, -82, -84
Ranallo, F A *AmArch 70*
Ranaweera, Munidasa Padmasiri 1942- *MarqDCG 84*
Ranc, Jean 1674-1735 *ClaDrA, McGDA*
Ranch, Mildred *WhAmArt 85*
Rancillac, Bernard 1931- *PhDcTCA 77*
Ranck, D K *AmArch 70*
Rancon, Victor *NewYHSD*
Rancorn, N C, Jr. *AmArch 70*
Rand, Archie 1949- *AmArt, PrintW 83, -85,*
WhoAmA 80, -82, -84
Rand, E M *DcWomA*
Rand, Ebenezer 1688-1743 *CabMA*
Rand, Ellen G Emmet 1876-1941 *WhAmArt 85*
Rand, Ellen Gertrude 1875-1941 *DcWomA*
Rand, F *NewYHSD*
Rand, Harry 1947- *WhoAmA 80, -82, -84*
Rand, Helen 1895- *DcWomA, WhAmArt 85*
Rand, Henry A 1886- *WhAmArt 85*
Rand, J *DcVicP 2, FolkA 86*
Rand, Jacob 1778-1840 *CabMA*
Rand, John Goffe 1801-1873 *NewYHSD*
Rand, Margaret A 1868-1930 *WhAmArt 85*
Rand, Margaret Arnold 1868-1930 *DcWomA*
Rand, Noyes Patrick 1927- *AmArch 70*
Rand, Paul 1914- *ConDes, IlsCB 1946, -1957,*
McGDA, WhAmArt 85, WhoAmA 73, -76, -78,
-80, -82, -84, WhoGrA 62, -82[port]
Rand, Archie 1949- *PrintW 83*
Rand, Steven Jay *WhoAmA 84*
Rand, Thomas d1786 *CabMA*
Rand, Willard Doane 1914- *AmArch 70*
Rand And Crane *EncASM*
Randahl, E Scott *EncASM*
Randahl, Julius Olaf 1880-1972 *EncASM*
Randahl, Julius Olaf, Jr. *EncASM*
Randal, Charles *DcVicP 2*
Randal, Frank *DcBrWA, DcVicP 2*
Randall, A G *WhAmArt 85*
Randall, A M *FolkA 86*
Randall, Amey 1780-1845 *FolkA 86*
Randall, Amos Willard 1909- *AmArch 70*
Randall, Asa Grant 1869- *WhAmArt 85*
Randall, Byron 1918- *WhAmArt 85*
Randall, C Ray *EncASM*
Randall, Charles E *CabMA*
Randall, Charles Harry 1926- *AmArch 70*
Randall, Christine *IlsBYP*
Randall, Corydon Chandler *ArtsEM*
Randall, D Ernest 1877- *ArtsAmW 2, WhAmArt 85*
Randall, Mrs. Darley *WhAmArt 85*
Randall, Eleanor Elizabeth *WhAmArt 85*
Randall, Emma F Leavitt *DcWomA, WhAmArt 85*
Randall, F L *AmArch 70*
Randall, George *NewYHSD*
Randall, George Archibald 1887- *WhAmArt 85*
Randall, George Archibald 1887-1941 *ArtsAmW 2*
Randall, H M *AmArch 70*
Randall, Harriet *DcWomA*
Randall, Herbert Eugene 1936- *MacBEP*
Randall, Ida A *ArtsAmW 3*
Randall, J D *AmArch 70*
Randall, J Parke 1927- *AmArch 70*
Randall, James *FolkA 86, WhAmArt 85*
Randall, James 1778?-1820 *BiDBrA*
Randall, James 1782- *DcBrWA*
Randall, Jane Spillman *FolkA 86*
Randall, Jessie Louise *DcWomA*
Randall, John *DcVicP 2*
Randall, John d1910 *AntBDN M*
Randall, L C *WhAmArt 85*
Randall, Lilian M C 1931- *WhoAmA 82, -84*
Randall, Maurice *DcSeaP*
Randall, Paul A 1879-1933 *WhAmArt 85*
Randall, Paula 1895- *WhoAmA 73, -76, -78, -80,*
-82, -84
Randall, R R, Jr. *AmArch 70*
Randall, Richard Harding, Jr. 1926- *WhoAmA 76,*
-78, -80, -82, -84
Randall, Richard J *DcVicP 2*

Randall, Ruth Hunie 1896- *DcWomA, WhAmArt 85,*
WhoAmA 73, -76, -78, -80, -82, -84
Randall, Ruth Hunie 1898- *CenC*
Randall, Sarah Ann 1815?- *FolkA 86*
Randall, T Henry 1862-1905 *BiDAmAr*
Randall, Theodore A 1914- *WhoAmA 73, -76, -78,*
-80, -82, -84
Randall, Theodore Amossa 1914- *WhAmArt 85*
Randall, Thomas Martin *AntBDN M*
Randall, Thomas Martin 1786-1859 *DcNiCA*
Randall And Fairchild *EncASM*
Randazzo, Frank 1899- *AmArch 70*
Randel, Elias, Jr. *NewYHSD*
Randel, Lucille Marie-Berthe 1908- *WhoAmA 76*
Randel, Martin *FolkA 86*
Randell, Abraham R *NewYHSD*
Randell, Elias, Jr. *NewYHSD*
Randell, James *DcVicP 2*
Randell, Martha *FolkA 86*
Randell, Richard K 1929- *DcCAA 71, -77,*
WhoAmA 73, -76, -78, -80
Randerson, Glenda 1949- *DcCAr 81*
Randle, Charles *DcBrWA*
Randle, Florence *DcVicP 2*
Randle, James Gilbert 1937- *AmArch 70*
Randle, William *CabMA*
Randlett, Mamie Randall *ArtsAmW 3*
Randlett, Mary Willis 1924- *WhoAmA 80, -82, -84*
Randolph, B F *BiDAmAr*
Randolph, Benjamin *CabMA, OxDecA*
Randolph, Benjamin d1792 *AntBDN G*
Randolph, Benjamin 1737?-1791 *BnEnAmA*
Randolph, Edmund *DcVicP 2*
Randolph, Edward Washburn *NewYHSD*
Randolph, Elizabeth *DcWomA*
Randolph, Gladys Conrad *WhoAmA 73, -76*
Randolph, Grace *DcWomA*
Randolph, Grace Fitz *WhAmArt 85*
Randolph, Innes 1837-1887 *NewYHSD*
Randolph, James T *FolkA 86*
Randolph, James Thompson 1817-1874 *NewYHSD*
Randolph, Joseph Fitz *NewYHSD*
Randolph, Lee F 1880- *ArtsAmW 1, WhAmArt 85*
Randolph, Lynn Moore 1938- *WhoAmA 84*
Randolph, Mary *DcWomA, WhAmArt 85*
Rands, Sarah E *DcVicP 2*
Ranes, Chris *WhoAmA 78, -80, -82, -84*
Raney, J K *AmArch 70*
Raney, Suzanne Bryant d1967 *WhoAmA 78N, -80N,*
-82N, -84N
Raney, Vincent Gerard 1905- *AmArch 70*
Ranft, Thomas 1945- *DcCAr 81*
Rang-Babut, Louise 1806-1884 *DcWomA*
Range, Thomas *AfroAA*
Rangel, Jose Arthur 1960- *MarqDCG 84*
Ranger, Miss *DcVicP 2*
Ranger, Dee Bruce 1937- *MarqDCG 84*
Ranger, Edmund *CabMA*
Ranger, Henry W 1858-1916 *WhAmArt 85*
Ranger, Henry Ward 1858-1916 *BnEnAmA,*
DcAmArt, McGDA
Ranger, William 1800?-1863 *BiDBrA*
Ranieri DiUgolino *McGDA*
Ranieri Of Pisa, Saint d1160 *McGDA*
Rank, Johannes 1763-1828 *CabMA*
Rank, John Peter *FolkA 86*
Rank, John Peter, Sr. 1765-1851 *CabMA*
Rank, Peter *CabMA, FolkA 86*
Rankaitis, Susan Anne 1949- *ICPEnP A, MacBEP,*
WhoAmA 82, -84
Ranken, William B E *WhAmArt 85*
Ranken, William Bruce Ellis 1881- *ClaDrA*
Ranken, William Bruce Ellis 1881-1941 *DcBrA 1*
Rankin, A Scott *DcVicP 2*
Rankin, Andrew Scott 1868- *DcBrBI*
Rankin, Arabella Louisa 1871- *DcBrA 1, DcBrBI,*
DcWomA
Rankin, C S *AmArch 70*
Rankin, Don 1942- *WhoAmA 73, -76, -78, -80, -82,*
-84
Rankin, Dorothy Taylor *WhAmArt 85*
Rankin, Ellen Houser 1863- *WhAmArt 85*
Rankin, F A *AmArch 70*
Rankin, Grace *ArtsEM, DcWomA*
Rankin, Helen Houser 1853- *DcWomA*
Rankin, Mary *DcVicP 2*
Rankin, Mary Kirk 1897- *ArtsAmW 1, DcWomA*
Rankin, Myra Warner 1884- *ArtsAmW 1, DcWomA,*
WhAmArt 85
Rankin, Samuel *CabMA*
Rankin, Stella 1915- *WhoArt 80, -82, -84*
Rankine, George William Terry 1927- *AmArch 70*
Rankine, V V *WhoAmA 73, -76, -78, -80, -82, -84*
Rankley, Alfred 1819-1872 *ClaDrA, DcVicP, -2*
Rankley, Alfred 1820-1873 *ArtsNiC*
Rann, Vollian Burr 1897-1956 *WhAmArt 85,*
WhoAmA 80N, -82N, -84N
Rannells, J *AmArch 70*
Rannells, Will 1892- *WhAmArt 85*
Ranney, E H *DcWomA*
Ranney, Mrs. E H *ArtsEM*

Ranney, Edward 1942- *ICPEnP A, MacBEP*
Ranney, Glen Allison 1896-1959 *WhAmArt 85, WhoAmA 80N, -82N, -84N*
Ranney, William 1813-1857 *ArtsAmW 1*
Ranney, William Tylee 1813-1857 *BnEnAmA, DcAmArt, IIBEAAW, NewYHSD*
Ranninger, Conrad *FolkA 86*
Rannit, Aleksis 1914- *WhoAmA 73, -76, -78*
Rannus, A W *WhAmArt 85*
Ranon, John F 1928- *AmArch 70*
Ransom, Alexander *NewYHSD*
Ransom, Caroline L Ormes 1838-1910 *DcWomA, NewYHSD, WhAmArt 85*
Ransom, Fletcher C *WhAmArt 85*
Ransom, Frank 1874- *DcBrA 1*
Ransom, George *DcVicP 2*
Ransom, Harry S 1924- *AmArch 70*
Ransom, Henry Cleveland, Jr. 1942- *AmArt, WhoAmA 78, -80, -82, -84*
Ransom, K *DcWomA*
Ransom, King Rhodes 1903- *AmArch 70*
Ransom, Leon Andrew 1929- *AmArch 70*
Ransom, Louis Liscolm 1831-1926? *WhAmArt 85*
Ransom, Louis Liscolm 1831-1927? *NewYHSD*
Ransom, Ralph 1874- *WhAmArt 85*
Ransom, William A 1856-1919 *WhAmArt 85*
Ransome, Ernest L 1844-1917 *McGDA*
Ransome, Ernest Leslie 1844-1917 *MacEA*
Ranson, Nancy Sussman *WhoAmA 73, -76*
Ranson, Nancy Sussman 1905- *WhoAmA 78, -80, -82, -84*
Ranson, Nancy Sussmann 1905- *WhAmArt 85*
Ranson, Paul 1864-1909 *PhDcTCA 77*
Ransonnet, Elisa *DcWomA*
Ransonnette, Charles *ArtsAmW 1*
Ransy-Putzeys, Felicie 1853- *DcWomA*
Ranta, A C *AmArch 70*
Rantanen, Ulla 1938- *DcCAr 81, OxTwCA*
Rantei *AntBDN L*
Rantoul, Augustus Neal 1864-1934 *BiDAmAr*
Rantoul, Talbot Neal 1946- *ICPEnP A, MacBEP*
Ranuio, Roger Frank 1927- *AmArch 70*
Ranvaud, Thea *DcWomA*
Ranvier, Victor Joseph *ArtsNiC*
Ranvier-Chartier, Lucie 1867-1932 *DcWomA*
Ranwell, W *DcVicP 2*
Rao, Lakshmi K 1942- *MarqDCG 84*
Rao, Sathish Srinivas 1953- *MarqDCG 84*
Rao, Sukalata 1886-1969 *DcWomA*
Raoul, Louis *NewYHSD*
Raoul, Margaret Lente 1892- *DcWomA, WhAmArt 85*
Raout, Antoinette M *DcWomA*
Raoux, Jean 1677-1734 *ClaDrA, DcBrECP, McGDA*
Rapaport, Marjorie O'Brien *WhoAmA 78, -80*
Rapela, Enrique 1911- *WorECom*
Raper, Anne *DcVicP 2*
Raper, B W *NewYHSD*
Raper, Benjamin *AntBDN F*
Raper, Edna *WhAmArt 85*
Raper, Millie *FolkA 86*
Rapetti, John 1862-1936 *WhAmArt 85*
Raphael 1483-1520 *MacEA, McGDA, OxArt[port], WhoArch*
Raphael DeCaponnibus *McGDA*
Raphael DeFlorentia *McGDA*
Raphael, Mrs. Arthur *DcVicP 2*
Raphael, Frances 1913- *WhAmArt 85*
Raphael, Joe 1869-1950 *ArtsAmW 3*
Raphael, Joseph 1872- *WhAmArt 85*
Raphael, Joseph 1872-1950 *ArtsAmW 1*
Raphael, Joseph M 1869-1950 *ArtsAmW 3*
Raphael, Mary F *DcWomA*
Raphael, Samuel *WhAmArt 85*
Raphael, Steven M *MarqDCG 84*
Raphael, W *DcVicP 2*
Raphaelino *McGDA*
Raphaello, Santi 1483-1520 *ClaDrA*
Rapier, Robert Edward 1923- *AmArch 70*
Rapier, Rowen W, Jr. 1937- *AmArch 70*
Rapin, Aimee 1869- *DcWomA*
Rapin, Alexandre *ArtsNiC*
Rapin, Alexandre 1839-1889 *ClaDrA*
Rapoport, Sonya *AmArt, DcCAr 81, WhoAmA 82, -84*
Rapotec, Stanislaus 1912- *McGDA*
Rapp, Ebba *WhAmArt 85, WhoAmA 76, -78, -80*
Rapp, Edgar Lee 1937- *AmArch 70*
Rapp, Ernest David 1918- *AmArch 70*
Rapp, G W *AmArch 70*
Rapp, George *WhAmArt 85*
Rapp, George L 1878-1941 *BiDAmAr*
Rapp, Helmut 1949- *MarqDCG 84*
Rapp, I H *BiDAmAr*
Rapp, J R *AmArch 70*
Rapp, Lois *WhoAmA 73, -76, -78, -80, -82, -84*
Rapp, Lois 1907- *WhAmArt 85*
Rapp, M G *AmArch 70*
Rapp, R R, Jr. *AmArch 70*
Rapp, Raymond Rudolf, Jr. 1920- *AmArch 70*
Rapp, S Z *AmArch 70*

Rapp, W *AmArch 70*
Rapp, W L *AmArch 70*
Rapp And Rapp *MacEA*
Rappaport, Maurice I *WhAmArt 85*
Rappaport, Susan *MarqDCG 84*
Rappard, Clara Von 1862-1912 *DcWomA*
Rappe, Mary *DcWomA, FolkA 86, NewYHSD*
Rappe, W A *AmArch 70*
Rappin, Adrian 1934- *WhoAmA 73, -76, -78, -80, -82, -84*
Rappleye, Eva d1955? *WhAmArt 85*
Rapson, Ralph 1914- *ConArch, MacEA*
Rapson, Ralph Earl 1914- *McGDA*
Rapson, Ralph R 1914- *AmArch 70*
Rasario, Ada *WhAmArt 85*
Rasch, Lady 1891- *WhoArt 80, -82, -84*
Rasch, Anthony *OxDecA*
Raschdorff, Julius 1823-1914 *MacEA*
Rasche, J David 1929- *AmArch 70*
Raschen, Carl Martin 1882- *WhAmArt 85*
Raschen, Henry 1854?-1937? *IIBEAAW, WhAmArt 85*
Raschen, Henry 1856-1937 *ArtsAmW 1, -2*
Rasco, Bertis Crawford 1934- *AmArch 70*
Rascoe, Stephen Thomas 1924- *WhoAmA 73, -76, -78, -80, -82, -84*
Rascovich, Roberto Benjamine 1857-1905 *WhAmArt 85*
Rase, Marie Alexandrine d1887 *DcWomA*
Rase, Wolf Dieter 1944- *MarqDCG 84*
Rasell, Robert *DcBrWA, DcVicP 2*
Raseman, Richard E 1855-1944 *BiDAmAr*
Raseman, Richard Perrien 1896- *AmArch 70*
Raser, John H *FolkA 86*
Rasey, Rose *ArtsEM, DcWomA*
Rash, Nancy 1940- *WhoAmA 84*
Rash, Paul Jones, Jr. 1932- *AmArch 70*
Rash, Robert Louis 1937- *AmArch 70*
Rashleigh, Peter 1746-1836 *DcBrWA*
Rasic, Janko I 1938- *AmArch 70*
Rasic, Milan 1931- *OxTwCA*
Rasinelli, Robert *DcVicP 2*
Raskai, Slava E Von 1877-1906 *DcWomA*
Raskaj, Slava E Von 1877-1906 *DcWomA*
Raskin, Ellen *IlsCB 1967, WhoAmA 80, -82, -84*
Raskin, Ellen 1928- *IlsBYP, IlsCB 1957*
Raskin, Eugene 1909- *AmArch 70*
Raskin, Joseph 1897- *WhAmArt 85*
Raskin, Saul 1878- *WhAmArt 85*
Raskind, Philis *WhoAmA 80, -82, -84*
Raskins, Ellen *WhoAmA 78*
Rasko, Maximilian A 1884-1961 *WhoAmA 80N, -82N, -84N*
Rasko, Maxmilian Aurel Reinitz 1883-1961 *WhAmArt 85*
Rasmusen, Henry Neil 1909- *WhAmArt 85*
Rasmusen, Anton Jesse 1942- *WhoAmA 78, -80, -82, -84*
Rasmussen, Bertrand 1890- *WhAmArt 85*
Rasmussen, Charles *FolkA 86*
Rasmussen, Charles Ray 1926- *AmArch 70*
Rasmussen, D E *AmArch 70*
Rasmussen, Erik 1943- *DcCAr 81*
Rasmussen, Frede Kristine *DcWomA*
Rasmussen, Gerda *DcWomA*
Rasmussen, H *AmArch 70*
Rasmussen, J d1895 *FolkA 86*
Rasmussen, Keith Eric 1942- *WhoAmA 78, -80, -82, -84*
Rasmussen, Larry Neil 1935- *AmArch 70*
Rasmussen, Lloyd Ashley 1904- *AmArch 70*
Rasmussen, Nils *FolkA 86, NewYHSD*
Rasmussen, P *AmArch 70*
Rasmussen, R E *AmArch 70*
Rasmussen, Robert Norman *WhoAmA 76, -78, -80, -82, -84*
Rasmussen, Steen Eiler 1898- *WhoArt 80, -82, -84*
Rasmussen, Victor Wilhelm 1909-1978 *MacBEP*
Rasmusson, Robert Wesley 1923- *AmArch 70*
Raspall, Manuel J 1877-1937 *MacEA*
Rasque, G M *AmArch 70*
Rassano, C *DcVicP 2*
Rassau, J H *NewYHSD*
Rasse, Pauline, Baroness De 1796-1848 *DcWomA*
Rassenfosse, Andrew Louis Armand 1862-1934 *ClaDrA*
Rasset, Jean *McGDA*
Rassiner, Edgar A 1891-1930 *BiDAmAr*
Rassinier, P F *AmArch 70*
Rassweiler, H *FolkA 86*
Rassweiler, Philip 1822?- *FolkA 86*
Rasto 1943- *WhoAmA 84*
Rastrelli, Bartolomeo 1700-1771 *WhoArch*
Rastrelli, Bartolomeo Carlo 1670-1744 *McGDA*
Rastrelli, Bartolomeo Francesco 1700-1771 *OxArt*
Rastrelli, Bartolommeo 1700?-1771 *MacEA*
Rastrelli, Bartolommeo Francesco 1700-1771 *McGDA*
Rastrelli, Count Bartolommeo Francesco 1700?-1770 *DcD&D*
Rastrom, Antoinette *DcWomA*
Rastrum, Margaretta 1611- *DcWomA*
Raszenski, Alexandre *NewYHSD*

Raszewski, Alexandre *NewYHSD*
Raszler, Karoly 1925- *DcCAr 81*
Ratajczak, Robin *MarqDCG 84*
Ratcliff, Carter 1941- *WhoAmA 76, -78, -80, -82, -84*
Ratcliff, John 1914- *ClaDrA, WhoArt 80, -82, -84*
Ratcliff, Robert Williams 1913- *AmArch 70*
Ratcliffe, D B *AmArch 70*
Ratcliffe, M T *FolkA 86*
Ratcliffe, William *OxTwCA*
Ratcliffe, William Whitehead 1870-1955 *DcBrA 1*
Rateau, Armand-Albert 1882-1938 *DcNiCA*
Ratellier, Francis *NewYHSD*
Ratgeb, Jorg 1480-1526 *OxArt*
Rath, Anna 1883- *DcWomA*
Rath, B *DcVicP 2*
Rath, Henriette 1772?-1856 *DcWomA*
Rath, Hildegard *WhoAmA 84*
Rath, Hildegard 1909- *WhoAmA 73, -76, -78, -80, -82*
Rathbone, Augusta Payne 1897- *ArtsAmW 1, DcWomA*
Rathbone, Mrs. Charles H, Jr. *WhAmArt 85*
Rathbone, Charles Horace, Jr. 1902-1936 *WhAmArt 85*
Rathbone, Edith K *WhAmArt 85*
Rathbone, Harold S *DcVicP 2*
Rathbone, John 1750?-1807 *DcBrECP, DcBrWA*
Rathbone, Mary *DcWomA*
Rathbone, Perry Townsend 1911- *WhAmArt 85, WhoAmA 73, -76, -78, -80, -82, -84, WhoArt 80, -82*
Rathbone, Richard Adams 1902- *WhAmArt 85*
Rathbone, Thomas *BiDBrA*
Rathbun, D B *AmArch 70*
Rathbun, D R *AmArch 70, NewYHSD*
Rathbun, David Leigh 1943- *MacBEP*
Rathbun, Harlan Edwin 1911- *AmArch 70*
Rathbun, Helen R *DcWomA, WhAmArt 85*
Rathbun, Richard 1852-1918 *WhAmArt 85*
Rathbun, Seward Humet 1886- *WhAmArt 85*
Rathbun, William Jay 1931- *WhoAmA 84*
Rather, Elizabeth D 1940- *MarqDCG 84*
Rather, Hugh Henry 1916- *AmArch 70*
Rather, Louis Herbert, Jr. 1930- *AmArch 70*
Rathert, A B *AmArch 70*
Rathjens, William 1842-1882 *DcVicP 2*
Rathle, Henri 1911- *WhoAmA 82, -84*
Rathmell, Thomas *DcCAr 81*
Rathmell, Thomas Roland 1912- *WhoArt 80, -82, -84*
Rathousky, Jiri 1924- *WhoGrA 62, -82[port]*
Ratia, Armi *WorFshn*
Ratkai, George 1907- *WhAmArt 85, WhoAmA 73, -76, -78, -80, -82, -84*
Ratkai, Helen 1914- *WhAmArt 85*
Ratliff, Blanche Cooley 1896- *ArtsAmW 1, WhAmArt 85*
Ratliff, Blanche Marshall Cooley 1896- *DcWomA*
Ratliff, C L *AmArch 70*
Ratliff, J *AntBDN P*
Ratliff, James Edwin 1935- *AmArch 70*
Ratner, David M 1922- *WhoAmA 80, -82, -84*
Ratner, Max 1916- *AmArch 70*
Rattan, Shashi Kapoor 1953- *MarqDCG 84*
Rattenbury, F M 1867-1935 *MacEA*
Rattenbury, John 1928- *AmArch 70*
Ratterman, W G *WhAmArt 85*
Ratti, Gino A 1882-1937 *WhAmArt 85*
Ratti, Julie *DcWomA*
Rattner, Abraham 1895- *BnEnAmA, ConArt 77, DcAmArt, DcCAA 71, -77, McGDA, PhDcTCA 77, WhoAmA 73, -76*
Rattner, Abraham 1895-1978 *PrintW 83, -85, WhAmArt 85, WhoAmA 78N, -80N, -82N, -84N, WorArt[port]*
Rattray, A Wellwood 1849-1902 *DcBrA 1*
Rattray, Alexander Wellwood 1849-1902 *DcBrWA, DcVicP 2*
Rattray, Annie L *DcWomA*
Rattray, Matthew 1796-1872 *FolkA 86*
Rattray, Wellwood 1849-1902 *DcVicP*
Rattray-Haupt, Diana 1947- *DcCAr 81*
Ratych, E *AmArch 70*
Ratzenberger, Katharine M *WhoAmA 82*
Ratzenberger, Katharine 1950- *WhoAmA 78, -80*
Ratzka, Arthur L *WhoAmA 80N, -82N, -84N*
Ratzka, Arthur L 1869- *WhAmArt 85*
Ratzker, Max *WhAmArt 85*
Rau, Emil 1858- *ClaDrA*
Rau, Jacob 1821?- *NewYHSD*
Rau, V B *WhAmArt 85*
Rau, William 1874- *WhAmArt 85*
Rau, William H 1855-1920 *MacBEP, WhAmArt 85*
Rau-Mohn, Hede *DcWomA*
Rauch, Charles 1791-1857 *ClaDrA*
Rauch, Christian Daniel 1777-1857 *OxArt*
Rauch, Elisaeet *FolkA 86*
Rauch, Hans-Georg 1939- *WorECar*
Rauch, Hans-George 1939- *WhoGrA 82[port]*
Rauch, Johann Christian 1777-1857 *McGDA*
Rauch, John 1930- *ConArch*

Rauch, John Alexander 1891- *AmArch 70*
Rauch, John G 1890- *WhoAmA 73, -76, -78*
Rauch, John G 1890-1976 *WhoAmA 80N, -82N, -84N*
Rauch, John K, Jr. 1930- *AmArch 70*
Rauch, M *FolkA 86*
Rauch, Michael *AntBDN K*
Rauch, Thomas *AntBDN K*
Rauch, William *NewYHSD*
Raucher, Hava 1944- *PrintW 83, -85, WhoAmA 84*
Rauchfuss, Marie *DcWomA, WhAmArt 85*
Raudnitz, Albert *DcVicP 2*
Raught, John Willard 1857-1931 *WhAmArt 85*
Rauh, Caspar Walter 1912- *DcCAr 81*
Rauh, Fritz 1920- *WhoAmA 73, -76*
Rauh, W *DcVicP 2*
Rauhauser, Warren C 1918- *MacBEP*
Raul, Harry Lewis *WhAmArt 85*
Raul, Josephine Gesner *WhAmArt 85*
Raul, Minnie Louise Briggs d1955 *WhAmArt 85*
Raul, Minnie Louise Briggs 1890-1955 *DcWomA, WhAmArt 85*
Raul Esparza S 1923- *WhoAmA 76, -78*
Raulin, E *DcWomA*
Raulin, G *DcWomA*
Raulston, Marion Churchill 1883-1955 *ArtsAmW 2*
Raulston, Marion Churchill 1886-1955 *DcWomA, WhAmArt 85*
Rault, Jean-Claude Lucien Guy 1937- *MarqDCG 84*
Rauma, John Gunnar 1926- *AmArch 70*
Raup, Samuel Stephen 1923- *AmArch 70*
Rausch, J *AmArch 70*
Rausch, Stella Jane 1871?- *DcWomA*
Rausch, Stella Jane 1876- *WhAmArt 85*
Rauschenbach, Elisabetha 1784-1851 *DcWomA*
Rauschenbach, R R *AmArch 70*
Rauschenberg, Robert 1925- *AmArt, BnEnAmA, CenC, ConArt 77, -83, DcAmArt, DcCAA 71, -77, DcCAr 81, ICPEnP A, McGDA, OxArt, OxTwCA, PhDcTCA 77, PrintW 83, -85, WhoAmA 73, -76, -78, -80, -82, -84, WorArt[port]*
Rauschnabel, W F *ArtsAmW 2, WhAmArt 85*
Rauschner, Henry *NewYHSD*
Rauschner, John Christian 1760- *NewYHSD*
Rauser, Gabriel 1803?- *FolkA 86*
Rausher, Gabriel *FolkA 86*
Rautbord, Dorothy H 1906- *WhoAmA 78, -80, -82, -84*
Rautert, Tim 1941- *DcCAr 81*
Rautianen, Harri Juhani 1945- *MarqDCG 84*
Ravagli, Angelino 1891- *ArtsAmW 2*
Ravalli, Antonio 1811-1884 *ArtsAmW 1*
Ravanesi, Bill 1947- *MacBEP*
Ravazzi, Romea 1870- *DcWomA*
Rave, Georgia 1936- *WhoAmA 76, -78, -80, -82, -84*
Rave-Faensen, Maria Theresa 1903- *DcCAr 81*
Raveau, Emilie 1785?-1830? *DcWomA*
Raveel, Roger 1921- *ConArt 77, OxTwCA*
Ravel, Dana B 1943- *WhoAmA 78*
Ravel, Edouard John E 1847-1920 *ClaDrA*
Ravel, Marie *DcWomA*
Ravell, Henry *WhAmArt 85*
Ravelle, Barbara Jo *ICPEnP A*
Ravelli, Father *NewYHSD*
Raven, Arlene 1944- *WhoAmA 76, -78, -80, -82, -84*
Raven, Francis Harvey 1928- *MarqDCG 84*
Raven, J S *ArtsNiC*
Raven, Jane A *DcVicP 2*
Raven, John Samuel 1829-1877 *ClaDrA, DcBrWA, DcVicP, -2*
Raven, Thomas *ClaDrA*
Raven, Thomas 1795?-1868 *DcBrWA*
Raven-Hill, Leonard *DcVicP 2*
Raven-Hill, Leonard 1867-1942 *DcBrA 1, DcBrBI, WorECar*
Raveneau, Rose *DcWomA*
Ravenel, Pamela Vinton 1888- *WhAmArt 85*
Ravenel, Pamela Vinton Brown 1888- *DcWomA*
Ravenel, William DeChastignier 1859-1933 *WhAmArt 85*
Ravenet, Simon-Francois 1706-1774 *OxDecA*
Ravenet, Simon-Francois 1749?-1814? *OxDecA*
Ravenez, Henriette Alice *DcWomA*
Ravenez, Marie Louise *DcWomA*
Ravenhill, Anna *DcVicP 2*
Ravenhill, Margaret F *DcVicP 2*
Ravenhorst, Henry Louis 1913- *AmArch 70*
Ravenold, Bruce *WhAmArt 85*
Ravenscroft, Edward Abbott, Jr. 1934- *AmArch 70*
Ravenscroft, Ellen *WhoAmA 78N, -80N, -82N, -84N*
Ravenscroft, Ellen 1876-1949 *WhAmArt 85*
Ravenscroft, Ellen 1885-1949 *DcWomA*
Ravenscroft, George 1618-1681 *AntBDN H, DcD&D, OxDecA*
Ravenscroft, George 1632-1683 *IlDcG*
Ravenscroft, P *DcVicP 2*
Ravenshaw, Edith L *DcVicP 2*
Ravenswaay, Adriana Van 1816-1872 *DcWomA*
Ravensway, Jan Van 1789-1869 *ClaDrA*
Ravensway, Jan Van 1815-1849 *ClaDrA*

Ravenzwaay, Adriana Van 1816-1872 *DcWomA*
Ravera, James 1870- *WhoAmA 85, -82, -84*
Raverat, Gwen 1885-1957 *DcBrBI*
Raverat, Gwendolen Mary 1885-1957 *DcBrA 1, DcWomA, IlsBYP, IlsCB 1744, -1946*
Raves, Elisa *DcWomA*
Raveson, Sherman Harold *WhoAmA 73*
Raveson, Sherman Harold d1974 *WhoAmA 76N, -78N, -80N, -82N, -84N*
Raveson, Sherman Harold 1907-1974 *WhAmArt 85*
Ravesteijn, Hubert Van 1638-1691 *McGDA*
Ravesteijn, Jan Anthonisz Van 1572?-1657 *McGDA*
Ravesteyn, Anthony Van 1580?-1669 *ClaDrA*
Ravesteyn, Arnold Van 1615-1690 *ClaDrA*
Ravesteyn, Hubert Van 1638-1692? *ClaDrA*
Ravesteyn, Jan Anthonisz Van 1570-1657 *ClaDrA, OxArt*
Ravielli, Anthony *IlsCB 1967*
Ravielli, Anthony 1916- *IlsCB 1946, -1957*
Ravier, Auguste Francois 1814-1895 *ClaDrA*
Ravier, Jeanne 1865- *DcWomA*
Ravilious, Eric 1903-1942 *IlDcG, McGDA*
Ravilious, Eric William 1903-1942 *DcBrA 1*
Ravlin, Grace 1873?-1956 *DcWomA*
Ravlin, Grace 1885- *WhAmArt 85*
Ravlin, Grace 1885-1956 *ArtsAmW 2, IlBEAAW*
Ravn-Hansen, Louise *DcWomA*
Ravy, Jean *McGDA*
Ravy, Jean d1344 *OxArt*
Raw, Jacob *NewYHSD*
Rawdon, Blaine Neahr 1923- *AmArch 70*
Rawdon, Freeman 1801?-1859 *NewYHSD*
Rawdon, Henry M *NewYHSD*
Rawdon, J Dawson *DcVicP 2*
Rawdon, Ralph *NewYHSD*
Rawdon-Hastings, Francis 1754-1826 *NewYHSD*
Rawle, John S *DcVicP*
Rawle, John Samuel *DcBrWA, DcVicP 2*
Rawle, Samuel 1771-1860 *DcBrBI, DcBrWA*
Rawle, Valentine *AntBDN N*
Rawlence, Frederick A *DcVicP 2*
Rawles, Charles S *ArtsAmW 3*
Rawlings, Ada *DcVicP 2*
Rawlings, Alfred 1855- *DcBrA 1*
Rawlings, Alfred 1855-1939 *DcBrBI, DcBrWA, DcVicP 2*
Rawlings, Clarence H 1900- *AmArch 70*
Rawlings, Frank H 1924- *AfroAA*
Rawlings, Henry *NewYHSD*
Rawlings, J *AmArch 70, DcVicP 2*
Rawlings, James Scott 1922- *AmArch 70*
Rawlings, John W 1912- *ICPEnP A*
Rawlings, Sophia *DcWomA*
Rawlings, W *DcVicP 2*
Rawlins, Darsie 1912- *DcBrA 1, WhoArt 80, -82, -84*
Rawlins, E S *DcVicP 2*
Rawlins, Ethel Louise 1880?- *DcBrA 1, DcWomA*
Rawlins, H A *AmArch 70*
Rawlins, Janet 1931- *WhoArt 80, -82, -84*
Rawlins, Lara *ArtsAmW 3*
Rawlins, Mark Grover 1949- *MarqDCG 84*
Rawlins, Monica Octavie 1903- *DcBrA 1*
Rawlins, Thomas *BiDBrA*
Rawlins, Thomas d1646? *BiDBrA*
Rawlins, Thomas J *DcBrBI, DcBrWA*
Rawlinson, Charles 1729-1786 *BiDBrA*
Rawlinson, Elaine 1911- *WhAmArt 85*
Rawlinson, Eliza *DcBrWA*
Rawlinson, George 1734?-1823 *BiDBrA*
Rawlinson, James 1768?-1848 *DcBrECP*
Rawlinson, James 1769-1848 *DcBrWA*
Rawlinson, Jonlane Frederick 1940- *WhoAmA 76, -78, -80, -82, -84*
Rawlinson, William Thomas 1912- *WhoArt 80, -82, -84*
Rawls, Eugene Lawrence, Jr. 1928- *AmArch 70*
Rawls, James *WhAmArt 85*
Rawnsley, Brenda Mary 1916- *WhoArt 80*
Rawnsley, Edith *DcVicP 2, DcWomA*
Rawschnor *NewYHSD*
Rawski, Conrad Henry 1914- *WhoAmA 73*
Rawson, Albert Leighton 1829-1902 *NewYHSD, WhAmArt 85*
Rawson, Carl W 1884- *WhAmArt 85*
Rawson, E M *NewYHSD*
Rawson, Eleanor *DcWomA, FolkA 86, NewYHSD*
Rawson, Grindall 1719-1803 *CabMA*
Rawson, Harry D 1873-1934 *BiDAmAr*
Rawson, Joseph d1835 *CabMA*
Rawsthorne, J W *WhAmArt 85*
Rawstorne, Edward *DcVicP 2, NewYHSD*
Rawstorne, Edwin *NewYHSD*
Rawstorne, John 1761?-1832 *BiDBrA*
Rawstorne, Walker d1867 *BiDBrA*
Ray *WhoArt 80, -82, -84*
Ray, Alice *WhAmArt 85*
Ray, B E *AmArch 70*
Ray, Christopher T 1937- *WhoAmA 80, -82, -84*
Ray, Clary 1865- *WhAmArt 85*
Ray, Deborah *WhoAmA 82, -84*

Ray, Deborah 1940- *IlsBYP, WhoAmA 78, -80*
Ray, Edith 1905- *ClaDrA, DcBrA 1, WhoArt 80, -82, -84*
Ray, Emilie *DcWomA*
Ray, Georgette *DcWomA*
Ray, Gertrude 1921- *AfroAA*
Ray, Gypsy Patricia 1949- *MacBEP*
Ray, H C *AmArch 70*
Ray, James Milton 1930- *AmArch 70*
Ray, Jim 1924- *WhoAmA 76, -78, -80, -82, -84*
Ray, John 1815- *DcVicP 2*
Ray, John Franklin 1937- *AmArch 70*
Ray, Joseph Johnson *IlBEAAW*
Ray, Karen *DcCAr 81*
Ray, M B, III *AmArch 70*
Ray, Man 1890- *BnEnAmA, McGDA*
Ray, Man 1890-1976 *ICPEnP, PhDcTCA 77, WhAmArt 85, WorArt[port]*
Ray, Man 1890-1977 *DcAmArt*
Ray, Noemie *DcWomA*
Ray, R T *AmArch 70*
Ray, Ralph 1920-1952 *IlsBYP, IlsCB 1946*
Ray, Richard Archibald 1884-1968 *DcBrA 1*
Ray, Robert 1924- *WhoAmA 73, -76, -80, -82, -84*
Ray, Robert Arthur 1934- *WhoAmA 76, -78*
Ray, Robert Donald 1924- *IlBEAAW, WhoAmA 78*
Ray, Robert Lee 1934- *AmArch 70*
Ray, Ruth 1919- *WhoAmA 73, -76*
Ray, Ruth 1919-1977 *WhoAmA 78N, -80N, -82N, -84N*
Ray, Silvey Jackson 1891- *WhAmArt 85*
Ray, Silvey Jackson 1891-1970 *WorECar*
Ray, Stuart Alexander 1916- *DcBrA 1*
Ray, Tom *MarqDCG 84*
Ray, W David *DcVicP 2*
Ray-Jones, Raymond 1886-1942 *DcBrA 1*
Ray-Jones, Tony 1941-1972 *ConPhot, ICPEnP A, MacBEP*
Raybon, Phares Henderson 1914- *WhoAmA 76, -78*
Rayburn, A K *AmArch 70*
Rayburn, Bryan B 1931- *WhoAmA 76, -78*
Rayburn, Dale 1942- *WhoAmA 80, -82, -84*
Raycroft, Jessie *DcWomA*
Raydon, Alexander R *WhoAmA 73, -76, -78, -80, -82, -84*
Rayen, James Wilson 1935- *WhoAmA 73, -76, -78, -80, -82, -84*
Rayfield *AfroAA*
Rayleigh, Lord 1842-1919 *ICPEnP*
Rayment, Robert *DcVicP 2*
Rayment, Thomas *AntBDN D*
Raymond *EncASM*
Raymond, A *AmArch 70*
Raymond, Alex 1909-1956 *WorECom*
Raymond, Alexander 1909-1956 *WhoAmA 80N, -82N, -84N*
Raymond, Alexander Gillespie 1909-1956 *WhAmArt 85*
Raymond, Alice *DcWomA*
Raymond, Antonin 1888-1976 *ConArch, MacEA, WhoArch*
Raymond, Antonin 1889- *McGDA*
Raymond, Benjamin 1768- *CabMA*
Raymond, Edith *WhAmArt 85*
Raymond, Edmund *FolkA 86*
Raymond, Eleanor 1887- *AmArch 70*
Raymond, Elizabeth 1904- *WhAmArt 85*
Raymond, Flora Andersen *WhAmArt 85*
Raymond, Frank Willoughby 1881- *WhAmArt 85*
Raymond, George H *NewYHSD*
Raymond, Grace *DcWomA*
Raymond, Grace Russell 1876- *ArtsAmW 2, DcWomA, WhAmArt 85*
Raymond, J *FolkA 86*
Raymond, James S *FolkA 86*
Raymond, Jean Arnaud 1742-1811 *MacEA, McGDA*
Raymond, John d1784 *DcBrECP*
Raymond, Julie E *DcWomA, WhAmArt 85*
Raymond, Kate Cordon 1888- *ArtsAmW 3*
Raymond, Katharine T *DcWomA*
Raymond, Kathryn Tileston *WhAmArt 85*
Raymond, L Evelyn 1908- *WhAmArt 85*
Raymond, Larry Thomas 1940- *AmArch 70*
Raymond, Lilo 1922- *ConPhot, ICPEnP A, MacBEP, PrintW 83, -85, WhoAmA 80, -82, -84*
Raymond, Norman LeRoy 1913- *AmArch 70*
Raymond, Robert J 1930- *AmArch 70*
Raymond, W *AmArch 70*
Raymond, William *CabMA*
Raymond, William Asa 1819-1853 *ArtsEM*
Raymono, Antonin A *WhAmArt 85*
Raymundo, Francisco V 1897- *WhAmArt 85*
Raynaud, Claude 1918- *WorECar*
Raynaud, Jean-Pierre 1939- *ConArt 77, -83*
Raynaud, Jean Pierre 1939- *PhDcTCA 77*
Raynaud, Louis 1905- *WhAmArt 85*
Rayne, Edward 1922- *WorFshn*
Rayner, Ada 1901- *WhAmArt 85, WhoAmA 76, -78, -80, -82, -84*
Rayner, Donald Lewis *WhoArt 80N*
Rayner, Donald Lewis 1907- *ClaDrA, DcBrA 1*

Rayner, Frances *DcBrWA, DcVicP 2, DcWomA*
Rayner, Gordon *DcCAr 81, OxTwCA*
Rayner, Gordon 1935- *PrintW 83, -85, WhoAmA 80, -82, -84*
Rayner, James *CabMA*
Rayner, Louise J 1829-1924 *DcBrA 1, DcVicP, DcWomA*
Rayner, Louise J 1832-1924 *DcBrWA, DcVicP 2*
Rayner, Margaret *DcBrWA, DcVicP 2, DcWomA*
Rayner, Mary Yoma *IlsCB 1967*
Rayner, Nancy *DcVicP 2*
Rayner, Nancy 1827-1855 *DcBrWA, DcWomA*
Rayner, Prebble 1886- *DcBrA 1*
Rayner, Richard M *DcBrWA, DcVicP 2*
Rayner, Robert *DcBrECP*
Rayner, Robert J *NewYHSD*
Rayner, Rosa *DcVicP 2, DcWomA*
Rayner, Rose *DcBrWA, DcVicP 2*
Rayner, Samuel d1874 *ClaDrA*
Rayner, Mrs. Samuel *DcWomA*
Rayner, Samuel A *DcVicP*
Rayner, Samuel A d1874 *DcBrBI, DcBrWA, DcVicP 2*
Rayner, Thomas *DcBrECP*
Rayner, Thomas W *NewYHSD*
Raynerius Of Pisa, Saint *McGDA*
Raynes, John *IlsBYP*
Raynes, Joseph F 1876- *WhAmArt 85*
Raynes, Sidney 1907- *WhAmArt 85*
Rayness, Gerard 1898-1946 *WhAmArt 85*
Rayness, Velma Wallace 1896- *DcWomA, WhAmArt 85*
Raynolds, Randolph 1928- *AmArch 70*
Raynor, Ben *FolkA 86*
Raynor, E Webster *WhAmArt 85*
Raynor, Grace Horton 1884- *DcWomA, WhAmArt 85*
Raynor, Louis B 1917- *CenC*
Raynor, Trevor Samuel 1929- *WhoArt 84*
Rayns, Sheila 1923- *DcBrA 1*
Raynsford, Solomon *CabMA*
Rayo, Omar *OxTwCA*
Raysac, B Esther De *DcWomA*
Rayska, Julia 1817?-1908 *DcWomA*
Rayski, Ferdinand 1806-1890 *McGDA*
Raysman, Richard *MarqDCG 84*
Raysse, Martial 1936- *ConArt 77, -83, DcCAr 81, OxTwCA, PhDcTCA 77, WorArt[port]*
Razalle, Emma *DcWomA*
Razalle, Tess S *DcWomA*
Raze, E *DcVicP 2*
Razelle, Tess S *DcWomA*
Razzi, Angelica *DcWomA*
Re, Giovanna Maria Dal *DcWomA*
Re, Leonardo 1942- *MarqDCG 84*
Re David, Rosettina 1884- *DcWomA*
Rea, Cecil William 1861-1935 *DcBrA 1, DcVicP 2*
Rea, Constance *DcBrA 1, DcWomA*
Rea, Daniel, Jr. 1743- *NewYHSD*
Rea, Dorothy *WhAmArt 85*
Rea, Gardner 1892-1966 *WorECar*
Rea, James Edward 1910- *WhAmArt 85*
Rea, John 1916- *AmArch 70*
Rea, John L 1882- *WhAmArt 85*
Rea, Lewis Edward 1868- *ArtsAmW 1*
Rea, Pauline DeVol 1893- *WhAmArt 85*
Rea, Pauline Hamill DeVol 1893-1974 *DcWomA*
Rea, Samuel 1855-1929 *WhAmArt 85*
Reaburn, Maude Lightfoot *DcWomA*
Read *FolkA 86, NewYHSD*
Read, Miss *DcWomA*
Read, Mrs. *DcWomA*
Read, Adele VonHelmold *DcWomA, WhAmArt 85*
Read, Alexander 1752- *DcBrECP*
Read, Arthur Rigden 1879- *DcBrA 1*
Read, Caroline *DcWomA*
Read, Catherine 1723-1778 *DcWomA*
Read, Charles Carter *DcVicP 2*
Read, Dave 1938- *WhoAmA 82, -84*
Read, David Charles 1790-1851 *DcBrWA, DcVicP 2*
Read, Donald F *EarABI SUP, NewYHSD*
Read, Donald Lee 1924- *AmArch 70*
Read, E J 1862- *WhAmArt 85*
Read, E S *AmArch 70*
Read, Edward H *DcVicP 2*
Read, Edward Henry Handley 1870- *DcBrBI*
Read, Edwin Alfred 1918- *WhoArt 80, -82, -84*
Read, Edwin Morton 1894- *AmArch 70*
Read, F W *WhAmArt 85*
Read, Frank E 1862- *ArtsAmW 3, WhAmArt 85*
Read, G A *DcVicP 2*
Read, George *NewYHSD*
Read, H Hope *DcBrBI*
Read, H P *AmArch 70*
Read, Harold Hope *DcBrA 1*
Read, Helen Appleton 1887- *WhoAmA 73*
Read, Helen Appleton 1887-1974 *WhoAmA 76N, -78N, -80N, -82N, -84N*
Read, Helen M *ArtsEM, DcWomA*
Read, Henry *DcVicP 2*
Read, Henry 1851-1935 *ArtsAmW 1, WhAmArt 85*

Read, Herbert *DcVicP 2*
Read, Sir Herbert 1893-1968 *McGDA, OxTwCA*
Read, Herbert Sidney 1908- *DcBrA 1*
Read, J *DcVicP 2*
Read, James A *EarABI SUP*
Read, James Alexander *NewYHSD*
Read, James B 1803?- *ArtsEM, NewYHSD*
Read, Jane *AntBDN O, NewYHSD*
Read, John *CabMA, DcBrECP, NewYHSD*
Read, Katherine 1723-1778 *DcBrECP*
Read, Mary *DcWomA*
Read, Matthias 1669-1747 *DcBrECP*
Read, Nicholas 1841?- *NewYHSD*
Read, Paul Daniel 1927- *AmArch 70*
Read, Samuel 1815-1883 *DcBrBI, DcBrWA, DcVicP, -2*
Read, Samuel 1816-1883 *ClaDrA*
Read, Simon 1949- *DcCAr 81*
Read, Thomas *BiDBrA, FolkA 86*
Read, Thomas Buchanan 1822-1872 *ArtsNiC, DcAmArt, DcVicP 2, IlBEAAW, NewYHSD*
Read, William *DcBrECP*
Read, William 1607-1679 *NewYHSD*
Reade, Brian Edmund 1913- *WhoArt 80, -82, -84*
Reade, Luke *FolkA 86*
Reade, Roma 1877-1958 *ArtsAmW 1, DcWomA, WhAmArt 85, WhoAmA 80N, -82N, -84N*
Reader, George W 1820?- *NewYHSD*
Reader, Michael 1942- *WhoArt 80, -82*
Reader, Samuel J *NewYHSD*
Reader, Tomas A *MarqDCG 84*
Reading, Alice *WhAmArt 85*
Reading, Alice Matilda 1858-1939 *DcWomA*
Reading, C R *DcVicP 2, DcWomA*
Reading, Mrs. E C *DcVicP 2*
Reading, J, Sr. *DcVicP 2*
Reading, Sarah *DcWomA*
Reading, William *NewYHSD*
Readio, Wilfred A 1895-1961 *WhAmArt 85, WhoAmA 80N, -82N, -84N*
Readmond, Jeremiah *CabMA*
Readshaw, Emily S *DcVicP 2*
Ready *NewYHSD*
Ready, A *DcVicP 2*
Ready, H J *DcVicP 2*
Ready, William James Durant 1823-1873 *DcBrWA, DcSeaP, DcVicP 2*
Reagan, James Earl 1915- *AmArch 70*
Real, Sue 1950- *DcCAr 81*
Real DelSarte, Marie Magdeleine d1928 *DcWomA*
Reale, Nicholas Albert 1922- *WhoAmA 78, -80, -82, -84*
Realier Dumas, Maurice 1860-1928 *ClaDrA*
Ream, Bruce Charles 1937- *AmArch 70*
Ream, Carducius P 1836?-1917 *WhAmArt 85*
Ream, Carducius Plantagenet 1836?-1917 *NewYHSD*
Ream, J Hubert 1932- *AmArch 70*
Ream, James Terrill 1929- *AmArch 70*
Ream, Scott W 1952- *MarqDCG 84*
Ream, Vinnie *ArtsNiC, WhAmArt 85*
Ream, Vinnie 1847-1914 *DcAmArt, DcWomA*
Reamer, Maude *WhAmArt 85*
Reames, L E *AmArch 70*
Reaney, Thomas A 1916- *IlBEAAW*
Reardon, Bernard Charles 1934- *MarqDCG 84*
Reardon, M A 1912- *WhAmArt 85*
Reardon, Mary A *WhoAmA 73, -76, -78, -80, -82, -84*
Reardon, Susan P 1953- *MarqDCG 84*
Reardon, William Mark 1931- *AmArch 70*
Rease, William H 1818?- *NewYHSD*
Reaser, Wilbur 1860-1942 *WhAmArt 85*
Reaser, Wilbur Aaron 1860- *ArtsAmW 1*
Reason, Florence *DcBrBI, DcBrWA, DcVicP 2, DcWomA*
Reason, Henry J *NewYHSD*
Reason, Patrick 1817-1852 *WhoAmA 80N, -82N, -84N*
Reason, Patrick Henry 1817- *NewYHSD*
Reason, Patrick Henry 1817-1850 *AfroAA*
Reason, Philip H *NewYHSD*
Reason, Robert G *DcVicP 2*
Reasoner, Mrs. A E *FolkA 86*
Reasoner, Edward Alan 1931- *AmArch 70*
Reasoner, Gladys *DcWomA*
Reasoner, Gladys Thayer 1886- *WhAmArt 85*
Reasoner, Grace Dredge 1895- *DcWomA*
Reaugh, Charles Franklin 1860-1945 *IlBEAAW*
Reaugh, F 1860-1945 *WhAmArt 85*
Reaugh, Frank 1860-1945 *ArtsAmW 1*
Reaves, Angela Westwater 1942- *WhoAmA 73*
Reaves, G F 1927- *AmArch 70*
Reavis, Esma Jacobs 1900- *WhAmArt 85*
Reay, Charles *FolkA 86*
Reay, D P *AmArch 70*
Reay, David, Jr. *EncASM*
Reay, John *DcVicP 2*
Reay, Martine R 1871- *WhAmArt 85*
Reay, Sylvia 1916- *AmArch 70*
Rebajes, Francisco 1907- *WhAmArt 85*
Rebane, George *MarqDCG 84*

Rebay, Hilla d1967 *WhoAmA 78N, -80N, -82N, -84N*
Rebay, Hilla 1890-1967 *DcWomA, WhAmArt 85*
Rebbeck, Lester J, Jr. 1929- *PrintW 83, -85*
Rebbeck, Lester James, Jr. 1929- *AmArt, WhoAmA 76, -78, -80, -82, -84*
Rebbot, Olivier 1949-1981 *ICPEnP A*
Rebecca, Biagio 1735-1808 *DcBrECP*
Rebecca, John Biagio d1847 *BiDBrA*
Rebechini, Guido *WhAmArt 85*
Rebeck, Steven Augustus 1891- *WhAmArt 85, WhoAmA 73, -76, -78*
Rebel, Eleonore Sophie 1790- *DcWomA*
Reber, Alfred A *WhAmArt 85*
Reber, J M *AmArch 70*
Reber, John Slatington Carver 1857-1938 *FolkA 86*
Reber, L O *ArtsEM*
Reber, Mick 1942- *WhoAmA 78, -80, -82, -84*
Rebert, Jo Liefeld 1915- *WhoAmA 73, -76, -78*
Rebety, Victor *NewYHSD*
Rebeyrol, C, Madame *DcWomA*
Rebeyrolle, Paul *ConArt 77*
Rebeyrolle, Paul 1926- *ConArt 83, OxTwCA, PhDcTCA 77, PrintW 83, -85*
Rebichon, Emile *NewYHSD*
Rebichon, Theodorus *NewYHSD*
Rebisso, Louis T 1837-1899 *NewYHSD, WhAmArt 85*
Rebole, Henry *NewYHSD*
Reboli, Joseph John 1945- *WhoAmA 73, -76, -78, -80, -82*
Reboul, Marie Therese *DcWomA*
Reboux, Caroline 1837-1927 *FairDF FRA, WorFshn*
Rebuffi, Giorgio 1928- *WorECom*
Rebull, Santiago 1829-1902 *McGDA*
Reca, Kenneth J *MarqDCG 84*
Recalcati, Antonio 1938- *PhDcTCA 77*
Recamador, Giovanni *McGDA*
Recamier, Gabrielle 1883- *DcWomA*
Recanati, Dina *WhoAmA 78, -80, -82, -84*
Recca, J George 1899- *WhAmArt 85*
Recchia, Richard *WhoAmA 73, -76, -78, -80, -82*
Recchia, Richard d1983 *WhoAmA 84N*
Recchia, Richard H 1885- *WhAmArt 85*
Recchia, Mrs. Richard H *WhAmArt 85*
Recchini, Teresa d1780? *DcWomA*
Recco, Elena *DcWomA*
Recco, Giuseppe 1634-1695 *McGDA*
Rechberg, Countess Hippolyte 1811-1895 *DcWomA*
Rechberger, Franz 1771-1841 *ClaDrA*
Rechiman, Rose E *MarqDCG 84*
Rechter, Yacov 1924- *ConArch*
Rechtern, Countess Friederike 1787- *DcWomA*
Reck, Caroline *DcWomA*
Reck, Hermine Von 1833-1906 *DcWomA*
Reckendorf, J Angelika 1893- *WhAmArt 85*
Reckhard, Gardner Arnold 1858-1908 *WhAmArt 85*
Reckitt, Francis William d1932 *DcBrA 1*
Reckitt, Francis William 1859?-1932 *DcVicP 2*
Reckitt, Rachel *DcBrA 2*
Reckless, Stanley L 1892- *WhAmArt 85*
Reckless, Stanley Lawrence 1892- *ArtsAmW 2*
Reckling, Genevieve *AmArt, PrintW 85*
Reckmeyer, William George 1937- *AmArch 70*
Recknagel, John H, Jr. 1870- *WhAmArt 85*
Reclam, Friedrich 1734-1774 *ClaDrA*
Recoley, Julius *NewYHSD*
Recordon, Suzanne 1881- *DcWomA*
Rector, Anne *WhAmArt 85*
Rector, Henry *BiDAmAr*
Rector, I C *AmArch 70*
Red, David Douglass 1913- *AmArch 70*
Red, Harold Doak *ArtsAmW 3*
Red Star, Kevin *WhoAmA 82, -84*
Red Star, Kevin 1943- *AmArt*
Red Star, Kevin F 1943- *WhoAmA 80*
Red Star, Kevin Francis 1943- *WhoAmA 76, -78*
Reda, John F *AmArch 70*
Redbird *WhoAmA 76, -78, -80*
Redd, Lura 1891- *ArtsAmW 3*
Redd, Richard James 1931- *WhoAmA 76, -78, -80, -82, -84*
Redd Ekks 1937- *WhoAmA 76, -78, -80, -82, -84*
Reddall, John W *EncASM*
Reddemann, A O *AmArch 70*
Redden, Alvie Edward 1915- *WhoAmA 73, -76*
Redden, James O *AmArch 70*
Redden, John Stokes 1902- *AmArch 70*
Redden, Robert R *OfPGCP 86*
Reddick, John David, Jr. 1923- *AmArch 70*
Reddick, Larry *AfroAA*
Reddick, Otta M *ArtsEM*
Reddick, Peter 1924- *WhoArt 80, -82, -84*
Reddie, Arthur W L *DcVicP 2*
Redding *NewYHSD*
Redding, Mister *NewYHSD*
Redding, J Y *WhAmArt 85*
Redding, Kelly J *WhAmArt 85*
Redding, Steve *WhoAmA 78, -80*
Redding, Vernon d1940? *BiDAmAr*
Redding, William *NewYHSD*

Reddington, Charles Leonard 1929- *WhoAmA 76, -78, -80, -82, -84*
Reddington, George M 1905- *WhAmArt 85*
Redditt, W L *AmArch 70*
Reddix, Roscoe C 1933- *AfroAA*
Reddix, Roscoe Chester 1933- *WhoAmA 76, -78, -80, -82, -84*
Reddy, Krishna N 1925- *AmArt, WhoAmA 78, -80, -82, -84*
Reddy, Paul Roscoe 1917- *AmArch 70*
Redein, Alex S 1912- *WhoAmA 82, -84*
Redeker, Peter 1942- *DcCAr 81*
Redell, Raymond *WhAmArt 85*
Redelsheimer, Franziska 1873-1913 *DcWomA*
Redelsperger, Louise *DcWomA*
Reder, Bernard d1963 *WhoAmA 78N, -80N, -82N, -84N*
Reder, Bernard 1897- *PhDcTCA 77*
Reder, Bernard 1897-1963 *DcCAA 71, -77, McGDA, OxTwCA, WorArt[port]*
Rederer, Franz 1899- *WhAmArt 85*
Rederer, Franz 1899-1965 *ArtsAmW 2*
Rederus, S F 1854- *WhAmArt 85*
Redett, B M 1885- *WhAmArt 85*
Redfarn, W B *DcVicP 2*
Redfarn, William Beales *DcBrBI, DcBrWA*
Redfern *WorFshn*
Redfern, Charles Poynter *FairDF FRA*
Redfern, Howard Vernon 1924- *AmArch 70*
Redfern, Richard *DcVicP 2*
Redfield, Alfred C *WhAmArt 85*
Redfield, Edward W d1965 *WhoAmA 78N, -80N, -82N, -84N*
Redfield, Edward W 1869-1965 *WhAmArt 85*
Redfield, Edward Willis 1869-1965 *DcAmArt*
Redfield, Grace Chapman *DcWomA, WhAmArt 85*
Redfield, Heloise Guillou 1883- *DcWomA, WhAmArt 85*
Redfield, Mary Banister 1883- *DcWomA, WhAmArt 85*
Redfield, William D *NewYHSD*
Redfield And Rice *EncASM*
Redfoot, Dale E *AmArch 70*
Redford, George *DcVicP 2*
Redgate, A W *DcVicP, -2*
Redgate, L A *AmArch 70*
Redgate, William Edward 1932- *AmArch 70*
Redgrave, Evelyn Leslie *DcBrWA, DcVicP, -2, DcWomA*
Redgrave, Felicity 1920- *WhoAmA 84*
Redgrave, Frances M *DcVicP, -2, DcWomA*
Redgrave, Gilbert Richard *DcBrWA, DcVicP, -2*
Redgrave, J Fraser *DcVicP 2*
Redgrave, John *BiDBrA*
Redgrave, Richard 1804- *ArtsNiC*
Redgrave, Richard 1804-1888 *ClaDrA, DcBrBI, DcBrWA, DcVicP, -2*
Redgrave, Mrs. Richard *DcVicP 2*
Redhead, H *AntBDN O*
Redhead, R B *AmArch 70*
Redi, Giovanna *DcWomA*
Redi, Tommaso 1665-1726 *ClaDrA*
Redick, John *FolkA 86*
Redick, Milton D 1932- *MarqDCG 84*
Redin, Carl *WhAmArt 85*
Redin, Carl 1892-1944 *ArtsAmW 3*
Redin, Henry *CabMA*
Redin, William H *NewYHSD*
Reding, W *NewYHSD*
Redinger, Walter F 1940- *ConArt 77, DcCAr 81*
Redinger, Walter Fred 1942- *WhoAmA 76, -78, -80, -82, -84*
Redka, Eugenia *WhAmArt 85*
Redkin, Mark 1908- *ICPEnP A*
Redlich, A Alec *EncASM*
Redlich, Wilhelmine 1869- *DcWomA*
Redman, Harry Newton 1869- *WhAmArt 85*
Redman, Henry d1528 *MacEA, OxArt*
Redman, Joseph Hodgson d1914 *WhAmArt 85*
Redman, Richard *FolkA 86*
Redman, Thomas *FolkA 86*
Redman, Thomas, I *OxArt*
Redman, William H 1833?- *NewYHSD*
Redmayne, Mrs. Nessy J *DcVicP 2*
Redmayne, Robert 1826?- *NewYHSD*
Redmon, Lucinda *DcWomA*
Redmond, Andrew d1791 *CabMA*
Redmond, Frieda Voelter *WhAmArt 85*
Redmond, Frieda Weller 1857- *DcWomA*
Redmond, Granville 1871- *DcWomA*
Redmond, Granville 1871-1935 *ArtsAmW 1*
Redmond, Gregory F 1957- *MarqDCG 84*
Redmond, James McKay *WhAmArt 85*
Redmond, John J *WhAmArt 85*
Redmond, Lydia *DcWomA, WhAmArt 85*
Redmond, Margaret *WhAmArt 85*
Redmond, Margaret 1867-1948 *DcWomA*
Redmond, Sibley H *ArtsEM*
Redmond, Thomas 1745?-1785 *DcBrECP*
Redmore, E K 1860?-1939 *DcVicP 2*
Redmore, Henry 1820-1887 *DcSeaP, DcVicP, -2*

Rednick, Herman 1902- *WhAmArt 85*
Redon, Georges 1869-1943 *DcBrBI*
Redon, Odilon 1840-1916 *ClaDrA, McGDA, OxArt, PhDcTCA 77*
Redondo, Nestor 1928- *WorECom*
Redoute, Henri Joseph 1766-1852 *ClaDrA*
Redoute, Marie Louise Aldelaide 1792-1822 *DcWomA*
Redoute, Pierre Joseph 1759-1840 *ClaDrA*
Redpath, Anne 1895-1965 *ClaDrA, DcBrA 1, DcWomA, OxTwCA, PhDcTCA 77*
Redpath, Barbara 1924- *WhoArt 80, -82, -84*
Redrup, Sidney *DcVicP 2*
Redstone, Louis Gordon 1903- *AmArch 70, WhoAmA 78, -80, -82, -84*
Redstone, S *AmArch 70*
Redwood, Allen C 1844-1922 *ArtsAmW 1, IlBEAAW, WhAmArt 85*
Redwood, Allen Carter 1834-1922 *IlrAm 1880*
Redwood, Junius 1917- *AfroAA*
Redworth, William Josiah 1873- *DcBrA 1, DcVicP 2*
Ree, Anita 1885-1933 *DcWomA*
Ree, Max Emil *WhAmArt 85*
Reeb, J E *AmArch 70*
Reece, Dora *WhAmArt 85*
Reece, Jane 1868-1961 *MacBEP*
Reece, John Dee 1927- *AmArch 70*
Reece, Mark *OfPGCP 86*
Reece, Maynard *OfPGCP 86, WhoAmA 76*
Reece, Maynard 1920- *WhoAmA 78, -80, -82, -84*
Reece, R C *AmArch 70*
Reed *DcBrECP, NewYHSD*
Reed, Miss *DcWomA*
Reed, Abner *FolkA 86*
Reed, Abner 1771-1866 *NewYHSD*
Reed, Anna Vaughn *DcWomA*
Reed, Benjamin 1780?-1853 *BiDBrA*
Reed, Bertha M *WhAmArt 85*
Reed, Bob Harold 1924- *AmArch 70*
Reed, Burton I *WhAmArt 85*
Reed, C T *DcVicP 2*
Reed, C W *DcBrBI*
Reed, Carl N 1949- *MarqDCG 84*
Reed, Charles A d1911 *BiDAmAr*
Reed, Charles Harmon 1912- *AmArch 70*
Reed, Chester A *WhAmArt 85*
Reed, Clayton Earl 1924- *AmArch 70*
Reed, Daniel T *CabMA*
Reed, David 1951- *DcCAr 81*
Reed, David Fredrick 1946- *WhoAmA 76, -78, -80, -82, -84*
Reed, Doel 1894- *ArtsAmW 1, -3, GrAmP, IlBEAAW, WhAmArt 85, WhoAmA 73, -76, -78, -80, -82, -84*
Reed, Dolly Hartwell 1803- *FolkA 86*
Reed, Don Ashley 1914- *AmArch 70*
Reed, Donald Stenson 1897- *AmArch 70*
Reed, Dorothy H *DcWomA*
Reed, E *DcBrECP*
Reed, Earl H 1863-1931 *WhAmArt 85*
Reed, Earl Meusel 1894- *ArtsAmW 2*
Reed, Earl Meusel 1895- *IlBEAAW, WhAmArt 85*
Reed, Ed *WhAmArt 85*
Reed, Edward *DcVicP 2*
Reed, Edward Barcalo 1924- *AmArch 70*
Reed, Edward Tennyson *DcVicP 2*
Reed, Edward Tennyson 1860-1933 *DcBrA 2, DcBrBI*
Reed, Edwin O 1824?- *NewYHSD*
Reed, Eleanor 1913- *WhAmArt 85*
Reed, Erastus R *NewYHSD*
Reed, Ernest 1924-1985 *FolkA 86*
Reed, Esther Silber 1900- *WhAmArt 85*
Reed, Ethel 1876- *DcBrBI, DcWomA*
Reed, F H, Jr. *AmArch 70*
Reed, F N, Jr. *AmArch 70*
Reed, Fishe P *NewYHSD*
Reed, Florence Robie 1915- *WhAmArt 85*
Reed, George Francis *AmArch 70*
Reed, George W *ArtsEM*
Reed, Georgia Lee Blaz 1947- *WhoAmA 80*
Reed, Geraldine B *DcWomA*
Reed, Grace Adelaide 1874- *DcWomA, WhAmArt 85*
Reed, Grace Corbett *WhAmArt 85*
Reed, H E *AmArch 70*
Reed, Hal 1921- *WhoAmA 73, -76, -78, -80, -82, -84*
Reed, Harold 1937- *WhoAmA 73, -76, -78, -80, -82, -84*
Reed, Helen *ArtsNiC, DcWomA*
Reed, Helen A *WhAmArt 85*
Reed, Helen C *DcWomA, WhAmArt 85*
Reed, Henry *BnEnAmA*
Reed, Henry Good *EncASM*
Reed, I L *DcWomA*
Reed, I N *DcWomA*
Reed, Mrs. I N *ArtsEM*
Reed, Izah B *NewYHSD*
Reed, J *DcVicP 2*
Reed, J A *AmArch 70*
Reed, J H *EarABI SUP*
Reed, Jack Chandler 1930- *MarqDCG 84*
Reed, James Reuben 1920- *AfroAA*

Reed, Jerry 1949- *AfroAA*
Reed, Jesse Floyd 1920- *WhoAmA 76, -78, -80, -82, -84*
Reed, John *NewYHSD*
Reed, John B *NewYHSD*
Reed, John Benjamin, Jr. 1926- *AmArch 70*
Reed, John S *NewYHSD*
Reed, Jon *MarqDCG 84*
Reed, Joseph Charles 1822-1877 *DcBrWA, DcVicP, -2*
Reed, Joyce Hagerbaumer *OfPGCP 86*
Reed, Kate *DcVicP 2, DcWomA*
Reed, Kate D *FolkA 86*
Reed, Kenneth *FolkA 86*
Reed, Lillian R *DcWomA, WhAmArt 85*
Reed, Luke *FolkA 86*
Reed, Lyman Sims 1930- *AmArch 70*
Reed, M G *AmArch 70*
Reed, Margaret W 1892-1983 *WhAmArt 85*
Reed, Marjorie 1915- *IlBEAAW*
Reed, Mary *DcVicP 2, DcWomA*
Reed, Mary 1870?- *DcWomA*
Reed, Mary Taylor *DcWomA, WhAmArt 85*
Reed, Melton *ArtsEM*
Reed, Michael Arthur 1947- *WhoAmA 78, -80, -82, -84*
Reed, Myra 1905- *WhAmArt 85*
Reed, Olga Geneva 1873- *DcWomA*
Reed, P *FolkA 86, NewYHSD*
Reed, Paul Allen 1919- *WhoAmA 73, -76, -78, -80, -82, -84*
Reed, Peter Fishe 1817-1887 *ArtsAmW 3, NewYHSD*
Reed, Philip G 1908- *IlsBYP, IlsCB 1744, -1957*
Reed, Polly *FolkA 86*
Reed, R A *AmArch 70*
Reed, R F *AmArch 70*
Reed, Raymond Deryl 1930- *AmArch 70*
Reed, Reuben Law *FolkA 86*
Reed, Richard Crandall 1928- *AmArch 70*
Reed, Robert W 1950- *MarqDCG 84*
Reed, Roger Vernon 1935- *AmArch 70*
Reed, Roland 1864-1934 *MacBEP*
Reed, Samuel *NewYHSD*
Reed, Stanley 1908- *DcBrA 1, WhoArt 80, -82, -84*
Reed, Thomas Adam 1923- *AmArch 70*
Reed, V R *FolkA 86*
Reed, Veronica *IlsBYP, IlsCB 1946*
Reed, Violet Laura Caroline *DcWomA*
Reed, W T *DcVicP 2*
Reed, Walt Arnold 1917- *WhoAmA 76, -78, -80, -82, -84*
Reed, Walter D d1933 *BiDAmAr*
Reed, Walter H 1925- *AmArch 70*
Reed, William *AntBDN Q*
Reed, William 1922- *AmArch 70*
Reed, William A *FolkA 86*
Reed, William Ryder 1933- *AmArch 70*
Reed, William Vernon 1907- *AmArch 70*
Reed And Barton *BnEnAmA, EncASM*
Reed And Crane *ArtsEM*
Reed And Stem *MacEA*
Reeder, Alexander *NewYHSD*
Reeder, Arthur *MacBEP*
Reeder, Benjamin F 1834?- *NewYHSD*
Reeder, Charles E 1948- *MarqDCG 84*
Reeder, Dickson 1913- *WhAmArt 85*
Reeder, Flora Blanc Maclean 1888- *DcWomA*
Reeder, Flora MacLean 1887- *WhAmArt 85*
Reeder, Henry Sutherland, Jr. 1939- *AmArch 70*
Reeder, J H *NewYHSD*
Reeder, Lydia Morrow 1885- *DcWomA, WhAmArt 85*
Reeder, Walter Edwin 1893- *ArtsAmW 3*
Reedu, Clarence M *WhAmArt 85*
Reedy, Leonard 1899-1956 *ArtsAmW 1*
Reedy, Leonard Howard 1899-1956 *ArtsAmW 3, IlBEAAW, WhAmArt 85*
Reekers, H *DcVicP 2*
Reen, Charles 1827?- *NewYHSD*
Reen, Patrick Murty 1954- *MarqDCG 84*
Reents, Henry A 1892- *WhAmArt 85*
Reep, Edward Arnold 1918- *AmArt, WhoAmA 73, -76, -78, -80, -82, -84*
Reep, Richard Thomas, Sr. 1933- *AmArch 70*
Rees, A Ivan 1936- *MarqDCG 84*
Rees, Adya Van 1876-1959 *DcWomA*
Rees, Edward d1793 *CabMA*
Rees, F *DcBrBI*
Rees, Gladys Mary *DcWomA, WhoArt 80, -82, -84*
Rees, Gladys Mary 1898- *DcBrA 1*
Rees, John *DcVicP, -2*
Rees, Joseph F 1946- *WhoAmA 76, -78*
Rees, Mrs. Lewis *DcWomA, NewYHSD*
Rees, Lloyd 1895- *DcCAr 81*
Rees, Lonnie 1910- *WhAmArt 85*
Rees, M R *DcVicP 2, DcWomA*
Rees, Sir Richard Lodowick E Montagu 1900-1970 *DcBrA 1*
Rees, Rosalie L 1897- *DcWomA, WhAmArt 85*
Rees Jones, Stephen 1909- *WhoArt 84*

Reese, Bernard Frank 1914- *AmArch 70*
Reese, Charles Chandler 1862-1936 *WhAmArt 85*
Reese, Donald Carroll 1935- *AmArch 70*
Reese, Emily Shaw *WhAmArt 85*
Reese, Frank L 1934- *AmArch 70*
Reese, Henry Ernest 1933- *AmArch 70*
Reese, John W 1919- *AmArch 70*
Reese, Johnny Maclin 1936- *AmArch 70*
Reese, Katherine L *MacBEP*
Reese, Pearl Hardaway *WhoAmA 78, -80, -82, -84*
Reese, Susannah S *FolkA 86*
Reese, Thomas Ford 1943- *WhoAmA 76, -78, -80, -82, -84*
Reese, W R *WhAmArt 85*
Reese, Walter O *WhAmArt 85*
Reese, Walter Oswald 1889- *ArtsAmW 3*
Reese, William Foster 1938- *WhoAmA 76, -78, -80, -82, -84*
Reeser, Lillian 1876- *ArtsAmW 2, DcWomA, WhAmArt 85*
Reeser, Robert D 1931- *WhoAmA 82, -84*
Reeve, Miss *DcVicP 2*
Reeve, A *DcBrBI*
Reeve, A W *DcVicP 2*
Reeve, Alice *DcVicP 2*
Reeve, Herbert 1870- *DcBrA 1*
Reeve, Hope *DcVicP 2*
Reeve, J *DcVicP 2*
Reeve, James 1939- *OxTwCA*
Reeve, James Key *WhoAmA 84*
Reeve, James Key 1925- *WhoAmA 80, -82*
Reeve, John Sebastian 1943- *WhoAmA 73*
Reeve, Joseph H *FolkA 86*
Reeve, Lawrence Lowell 1912- *AmArch 70*
Reeve, Marion Jose 1926- *WhoArt 80, -82, -84*
Reeve, Myrtle A *WhAmArt 85*
Reeve, R G *DcVicP 2*
Reeve, Russell 1895- *ClaDrA*
Reeve, Russell Sidney 1895-1970 *DcBrA 1*
Reeve-Fowkes, Amy Constance 1886- *DcBrA 1, DcWomA*
Reeve-Fowkes, Arthur Fred 1881- *DcBrA 1*
Reeves, Anita Louis 1953- *MarqDCG 84*
Reeves, B *FolkA 86*
Reeves, Benjamin *WhoAmA 73*
Reeves, Mrs. Benjamin *WhoAmA 73*
Reeves, Burgess J 1848-1936 *BiDAmAr*
Reeves, Cathy *AfroAA*
Reeves, David Louis 1913- *WhoArt 80, -82*
Reeves, E *DcVicP 2*
Reeves, E B *DcVicP 2*
Reeves, E S *AmArch 70*
Reeves, Edward *BiDBrA*
Reeves, Frank Blair 1922- *AmArch 70*
Reeves, George H *DcVicP 2*
Reeves, Glenn Curtis 1941- *AmArch 70*
Reeves, H Alban 1869-1916 *BiDAmAr*
Reeves, J Mason 1898-1973 *WhoAmA 78N, -80N, -82N, -84N*
Reeves, J Mason, Jr. 1898- *WhoAmA 73*
Reeves, J Mason, Jr. 1898-1973 *WhoAmA 76N*
Reeves, James Franklin 1946- *WhoAmA 76, -78, -80, -82, -84*
Reeves, John Alexander 1938- *MacBEP, WhoAmA 78, -80, -82, -84*
Reeves, Joseph Mason, Jr. 1898-1973 *ArtsAmW 2, WhAmArt 85*
Reeves, Keith 1947- *DcCAr 81*
Reeves, Louise *DcWomA*
Reeves, Mary *DcVicP 2, DcWomA*
Reeves, Maude Cooper 1873- *DcWomA*
Reeves, Philip Thomas Langford 1931- *WhoArt 80, -82, -84*
Reeves, R, Jr. *AmArch 70*
Reeves, R B, Jr. *AmArch 70*
Reeves, Robert Roy, Jr. 1914- *AmArch 70*
Reeves, Ruth 1892- *WhAmArt 85*
Reeves, Ruth 1892-1966 *McGDA*
Reeves, W H *NewYHSD*
Reeves, Walter Henry *WhAmArt 85*
Reeves, William Benton 1925- *AmArch 70*
Reeves And Browne *EncASM*
Reeves And Sillcocks *EncASM*
Reevs, George M 1864-1930 *WhAmArt 85*
Reevs, J Graham *WhAmArt 85*
Reff, Theodore 1930- *WhoAmA 80, -82, -84*
Refregier, Anton 1905- *BnEnAMA, McGDA, WhAmArt 85, WhoAmA 73, -76, -78, -80*
Refregier, Anton 1905-1979 *WhoAmA 82N, -84N, WorArt*
Regalado, Manuel Rivera 1886- *ArtsAmW 2*
Regamey, Felix Elie 1844-1907 *ArtsAmW 1, DcBrBI, IlBEAAW*
Regamey, Guillaume Urbain 1837-1875 *ClaDrA*
Regan, John Daniel 1928- *AmArch 70*
Regan, John Joseph 1896- *AmArch 70*
Regan, T P, Jr. *AmArch 70*
Regat, Jean Jacques 1945- *WhoAmA 76, -78*
Regat, Jean-Jacques Albert 1945- *WhoAmA 80, -82, -84*
Regat, Mary E 1943- *WhoAmA 73, -76, -78, -80, -82,*

-84
Rege, Henriette De 1849- *DcWomA*
Regemorter, Ignatius Josephus Van 1785-1873 *ClaDrA*
Regensburg, Sophy 1885-1974 *FolkA 86*
Regensburg, Sophy P 1885- *WhoAmA 73*
Regensburg, Sophy P 1885-1974 *DcWomA, WhoAmA 76N, -78N, -80N, -82N, -84N*
Regensteiner, Else 1906- *WhoAmA 76, -78, -80, -82, -84*
Regensteiner, Else F 1906- *WhoAmA 73*
Regent, Irwin Alan 1934- *AmArch 70*
Regeon, Anne Rose Hermance Julienne G *DcWomA*
Reger, Lawrence L 1939- *WhoAmA 80, -82, -84*
Regester, Charlotte *WhoAmA 78N, -80N, -82N, -84N*
Regester, Charlotte d1964? *WhAmArt 85*
Regester, Charlotte 1883-1962? *DcWomA*
Reggi, Theresa *DcWomA*
Reggiani, Mauro 1897- *OxTwCA, PhDcTCA 77*
Reghi, Ralph 1914- *FolkA 86*
Regier, Willis 1919- *AmArch 70*
Regina, Valentine G *DcWomA*
Reginato, D D *AmArch 70*
Reginato, Peter 1945- *AmArt, ConArt 77, WhoAmA 73, -76, -78, -80, -82, -84*
Regis, Emma 1854- *DcWomA*
Register, Emmasita *DcWomA, WhAmArt 85*
Register, Philippe DeMontauzan 1921- *AmArch 70*
Regnard, Marie *DcWomA*
Regnault De Cormont *MacEA*
Regnault, Alexandre-Georges-Henri 1843-1871 *ArtsNiC, McGDA*
Regnault, Genevieve *DcWomA*
Regnault, Guillaume *OxArt*
Regnault, Guillaume 1450?-1533? *McGDA*
Regnault, Henri Alexandre Georges 1843-1871 *ClaDrA, DcBrBI*
Regnault, Henri-Victor 1810-1878 *ICPEnP A, MacBEP*
Regnault, Jean Baptiste 1754-1829 *ClaDrA*
Regnault, Jean-Baptiste 1754-1829 *McGDA*
Regner, J A *AmArch 70*
Regnier, Angelica *DcWomA*
Regnier, Anna *DcWomA*
Regnier, Clorinda *DcWomA*
Regnier, Elise *DcWomA*
Regnier, Lucrezia *DcWomA*
Regnier, Michel 1931- *WorECom*
Regnier, Nicolas 1590?-1667 *McGDA*
Regnier, Victoria 1824- *DcWomA*
Regnvall, A Kendrick 1936- *AmArch 70*
Regny, Jane *FairDF FRA*
Rego Monteiro, Vicente Do *OxTwCA*
Regoyos Y Valdes, Dario De 1857-1913 *McGDA*
Regschek, Kurt 1923- *DcCAr 81*
Regteren Altena, Maria E Van *DcWomA*
Regters, Tiebout 1710-1768 *ClaDrA*
Rehag, Lawrence J 1913- *WhAmArt 85*
Rehar, Igor *DcCAr 81*
Rehberg, Caroline *DcWomA*
Rehberger, Gustav 1910- *IlrAm F, WhoAmA 73, -76, -78, -80, -82, -84*
Rehbock, Lillian Fitch 1907- *WhAmArt 85*
Rehder, Larry E 1943- *MarqDCG 84*
Rehfous, Albert 1860- *ClaDrA*
Rehkopf, Frederick A 1938- *AmArch 70*
Rehl, George Jurij 1927- *AmArch 70*
Rehling, Zelda *DcWomA, WhAmArt 85*
Rehm, Marie *DcWomA*
Rehm, Marie Jeanne 1854-1930 *DcWomA*
Rehm, Victorine 1862- *DcWomA*
Rehm, Wilhelmine *WhAmArt 85*
Rehm, Wilhelmine 1899-1967 *DcWomA*
Rehmus, Michael H *MarqDCG 84*
Rehn, F M R *WhAmArt 85*
Rehn, Frank Knox M 1848-1914 *WhAmArt 85*
Rehn, Henry C *ArtsEM*
Rehn, Isaac *NewYHSD*
Rehn, Jean Eric 1717-1793 *McGDA*
Rehn, John *NewYHSD*
Rehn, Michael *IlsBYP*
Rehse, George Washington 1868-1930? *WorECar*
Rehsener, Maria 1840?-1917 *DcWomA*
Reiach, Alan 1910- *DcBrA 1, WhoArt 80, -82, -84*
Reiback, Earl M 1938- *WhoAmA 73, -76*
Reiback, Earl M 1943- *WhoAmA 78, -80, -82, -84*
Reibel, Bertram 1901- *WhAmArt 85, WhoAmA 73, -76, -78, -80, -82, -84*
Reiber, Cora Sarah 1884- *DcWomA, WhAmArt 85*
Reiber, Richard Henry 1912- *WhAmArt 85*
Reibling, Fred A *ArtsEM*
Reibling-Lewis *EncASM*
Reibnitz, Alexandra Von 1857- *DcWomA*
Reibsamen, Piercy K 1928- *AmArch 70*
Reich, Caroline 1807- *DcWomA*
Reich, Don 1931- *DcCAr 81, WhoAmA 80, -82, -84*
Reich, Elizabeth *FolkA 86*
Reich, George 1937- *AmArch 70*
Reich, Haskell A 1926- *MarqDCG 84*
Reich, Jacques 1852-1923 *WhAmArt 85*
Reich, Jean Heyl *WhAmArt 85*

Reich, Jerry R 1936- *AmArch 70*
Reich, Johann Mathias 1768-1833 *NewYHSD*
Reich, John *EarABI*
Reich, John 1768-1833 *NewYHSD*
Reich, Nathaniel E *WhoAmA 73, -76, -78, -80, -82, -84*
Reich, Sheldon 1931- *WhoAmA 78, -80, -82, -84*
Reich, Steve 1936- *PrintW 83, -85*
Reich, Stuart Herbert 1934- *AmArch 70*
Reich, Tibor 1916- *WhoArt 80, -82, -84*
Reichard, Daniel *FolkA 86*
Reichard, Gustave 1843-1917 *WhAmArt 85*
Reichard, H F *AmArch 70*
Reichard, Raul G 1908- *AmArch 70*
Reichard, Stephen Brantley 1949- *WhoAmA 80, -82, -84*
Reichardt, Ferdinand *NewYHSD*
Reichardt, Helene 1853- *DcWomA*
Reichardt, John *NewYHSD*
Reichardt, Otto *EncASM*
Reichardt, Walter Louis 1908- *AmArch 70*
Reichart, Donald 1912- *WhAmArt 85*
Reichart, Joseph Francis *WhAmArt 85*
Reiche, F *NewYHSD*
Reiche, J F *EarABI, EarABI SUP, NewYHSD*
Reichek, Elaine 1943- *WhoAmA 82, -84*
Reichek, Jesse 1916- *DcCAA 71, -77, WhoAmA 73, -76, -78, -80, -82, -84*
Reichel, D J *AmArch 70*
Reichel, Hans *McGDA*
Reichel, Hans 1892-1958 *PhDcTCA 77*
Reichel, Louise *DcWomA*
Reichel, Valesca 1833- *DcWomA*
Reichel, William Cornelius 1824-1876 *NewYHSD*
Reichelt, Augusta Wilhelmine 1840-1907 *DcWomA*
Reichenbach, Sophie Ludovika *DcWomA*
Reichenberg-Smith *EncASM*
Reichenberger, Peter 1945- *DcCAr 81*
Reichert, A J *AmArch 70*
Reichert, Clifford F 1891-1930 *BiDAmAr*
Reichert, Donald Karl 1932- *WhoAmA 73, -76, -78, -80, -82, -84*
Reichert, Donald O 1912- *WhoAmA 73, -76, -78, -80, -82*
Reichert, E L *AmArch 70*
Reichert, H *FolkA 86*
Reichert, Janina 1895- *DcWomA*
Reichert, Josua 1937- *PhDcTCA 77*
Reichert, Robert George 1921- *AmArch 70*
Reichert-Facilides, Otto E 1925- *AmArch 70*
Reichle, Hans 1570-1642 *McGDA*
Reichlin-Meldegg, Baroness Adolfine 1839-1907 *DcWomA*
Reichman, Fred 1925- *WhoAmA 73, -76, -78, -80, -82, -84*
Reichman, Gerson *WhoAmA 73*
Reichmann, Georg Friedrich 1798-1853 *ClaDrA*
Reichmann, Josephine L 1864-1939 *WhAmArt 85*
Reichmann, Josephine Lemos 1864-1938 *DcWomA*
Reichmann, Josephine Lemos 1864-1939? *ArtsAmW 3*
Reichmann, Pnina *DcCAr 81*
Reichmann, Vilem 1908- *MacBEP*
Reichmann, Wanda *DcWomA*
Reichter, Frederick *FolkA 86*
Reick, William A *WhAmArt 85*
Reid *NewYHSD*
Reid, A *DcWomA*
Reid, A D *FolkA 86*
Reid, A D, Jr. *AmArch 70*
Reid, Agnes L 1902- *DcBrA 1*
Reid, Albert Turner 1873-1955 *ArtsAmW 1, WhAmArt 85, WorECar*
Reid, Alfred Damian 1899- *AmArch 70*
Reid, Andrew 1831-1902 *DcBrWA*
Reid, Archibald D *ArtsNiC*
Reid, Archibald David 1844-1908 *DcBrA 1, DcBrWA, DcVicP, -2*
Reid, Aurelia Wheeler *WhAmArt 85*
Reid, Aurelia Wheeler 1876-1969 *ArtsAmW 2, DcWomA*
Reid, Bill *IlsBYP*
Reid, C Cregor *WhAmArt 85*
Reid, Charles 1936- *WhoAmA 78, -80*
Reid, Charles 1937- *WhoAmA 82, -84*
Reid, Dan Terry *AfroAA*
Reid, Donald A *AfroAA*
Reid, Donald Redevers 1902- *AfroAA*
Reid, Dorothy 1944- *DcCAr 81*
Reid, E C *DcWomA*
Reid, Mrs. E C *ArtsEM*
Reid, Edith A *WhAmArt 85*
Reid, Edith M *DcVicP 2, DcWomA*
Reid, Elspeth Margaret Georgina 1930- *WhoArt 84*
Reid, Estelle Ray *DcWomA, WhAmArt 85*
Reid, Flora M *DcVicP*
Reid, Flora Macdonald *DcBrA 1, DcBrWA, DcVicP 2, DcWomA*
Reid, Florence Sims 1891- *DcWomA*
Reid, G *FolkA 86*
Reid, George *ArtsNiC*
Reid, Sir George 1841-1913 *DcBrA 1, ClaDrA,*

Reiss, Lee *WhoAmA 73, −76*
Reiss, Lionel S 1894- *WhAmArt 85, WhoAmA 82, −84*
Reiss, Louis H 1873- *WhAmArt 85*
Reiss, Paul 1929- *AmArch 70*
Reiss, Peter *DcCAr 81*
Reiss, Roland 1929- *AmArch 70*
Reiss, William *FolkA 86*
Reiss, Winold *AfroAA*
Reissberger, Karl *DcCAr 81*
Reissert, Wilhelmine *DcWomA*
Reissner, Martin A *NewYHSD*
Reist, Johannes *FolkA 86*
Reister, Floyd M 1921- *AmArch 70*
Reister, Werner 1943- *DcCAr 81*
Reisz, Frank *WhAmArt 85*
Reiter, Barthelemy d1622 *ClaDrA*
Reiter, Freda Leibovitz 1919- *WhAmArt 85*
Reiter, John Richard 1938- *AmArch 70*
Reiter, Melvin 1925- *AmArch 70*
Reiter, Nicholas *FolkA 86*
Reiter, P W *AmArch 70*
Reith, James *AntBDN D*
Reitlinger, Gerald Roberts 1900- *DcBrA 1*
Reitman, Joseph *NewYHSD*
Reitter, Doris *DcCAr 81*
Reitz, Donald L 1929- *CenC[port]*
Reitz, Isaac Jones 1863-1949 *FolkA 86*
Reitzel, Marques E 1896- *WhAmArt 85*
Reitzel, Marques E 1896-1963 *ArtsAmW 2*
Reitzenstein, Reinhard 1949- *WhoAmA 76, −78, −80, −82, −84*
Reizes, Kenneth J 1935- *AmArch 70*
Rejchan, Stanislas *DcBrBI*
Rejlander, Oscar Gustav 1817-1875 *MacBEP*
Rejlander, Oscar Gustave 1813-1875 *DcVicP 2, ICPEnP*
Relf, Clyde Eugenia *WhAmArt 85*
Relin, Marie *DcWomA*
Relinde *DcWomA*
Relis, Rochelle R *WhoAmA 73, −76*
Relis, Sandy 1931- *WhoAmA 76, −78, −80*
Relyea, Charles M 1863-1932 *WhAmArt 85*
Remahl, Frederick 1901- *WhAmArt 85*
Remaury, Leontine *DcWomA*
Rembert, Catharine Philip 1905- *WhAmArt 85*
Rembert, Virginia Pitts 1921- *WhoAmA 76, −78, −80, −82, −84*
Rembrandt Harmensz VanRijn 1606-1669 *McGDA, OxArt*
Rembrandt, Harmensz Van 1606-1669 *ClaDrA*
Rembski, Stanislav *WhoAmA 73, −76, −78, −80, −82, −84*
Rembski, Stanislav 1896- *WhAmArt 85*
Remde, F *DcVicP 2*
Remecke, Adolphe *NewYHSD*
Remeneye, Edward *NewYHSD*
Remenick, Seymour 1923- *WhoAmA 73, −76, −78, −80, −82, −84*
Remeta, Daniel 1925- *AmArch 70*
Remey, Henry *FolkA 86*
Remfry, David 1942- *DcCAr 81, WhoArt 80, −82, −84*
Remi Of Reims, Saint 440?-535? *McGDA*
Remi, Georges 1907- *WorECom*
Remick, C R *AmArch 70*
Remick, Christian 1726- *NewYHSD*
Remington, Deborah 1930- *DcCAA 71, −77*
Remington, Deborah 1935- *ConArt 77*
Remington, Deborah Williams 1930- *WhoAmA 73*
Remington, Deborah Williams 1935- *AmArt, WhoAmA 76, −78, −80, −82, −84*
Remington, Edith Liesee *WhAmArt 85*
Remington, Eliphalet, Jr. 1793-1861 *AntBDN F*
Remington, Elizabeth 1825-1917 *NewYHSD*
Remington, Elizabeth H 1825-1917 *WhAmArt 85*
Remington, Elizabeth H 1827?-1917 *DcWomA*
Remington, Frederic 1861-1909 *ArtsAmW 1, ClaDrA, DcAmArt, IlBEAAW, McGDA*
Remington, Frederic Sackrider 1861-1909 *IlrAm A, −1880, WhAmArt 85*
Remington, Frederick 1861-1909 *BnEnAmA, DcNiCA*
Remington, John H 1930- *AmArch 70*
Remington, M *DcWomA*
Remington, Mrs. M *ArtsEM*
Remington, Mary 1793-1820 *FolkA 86*
Remington, Mary 1910- *DcBrA 1, WhoArt 80, −82, −84*
Remington, Polly *FolkA 86*
Remington, S J *IlBEAAW*
Remington, Schuyler *WhAmArt 85*
Reminick, Harry 1913- *WhAmArt 85*
Remlinger, Joseph J 1909- *WhAmArt 85*
Remmele, P F *AmArch 70*
Remmey, Charles H *NewYHSD*
Remmey, Henry I *FolkA 86*
Remmey, Henry, II *FolkA 86*
Remmey, Henry, III *FolkA 86*
Remmey, Johannes, I *FolkA 86*
Remmey, John, I *FolkA 86*
Remmey, John, II *FolkA 86*

Remmey, John, III *FolkA 86*
Remmey, Joseph Henry *FolkA 86*
Remmey, Paul B *WhoAmA 80N, −82N, −84N*
Remmey, Paul Baker 1903-1958? *WhAmArt 85*
Remmey, R C *FolkA 86*
Remmick, Joseph *FolkA 86*
Remmlein, Jules *WhAmArt 85*
Remney, Henry, I *FolkA 86*
Remney, Henry, II *FolkA 86*
Remney, Henry, III *FolkA 86*
Remney, John, I *FolkA 86*
Remney, John, II *FolkA 86*
Remney, John, III *FolkA 86*
Remney, Joseph Henry *FolkA 86*
Remney, Richard Clinton *FolkA 86*
Remond, Cecile *DcWomA*
Remond, Jean Charles Joseph 1795-1875 *ClaDrA*
Remotti, Remo 1924- *DcCAr 81*
Remouit, L *NewYHSD*
Rempe, Edward Theodore 1906- *AmArch 70*
Rempelakis, Emmanuel John 1925- *AmArch 70*
Rempp, F J *AmArch 70*
Remquit, Carl *WhAmArt 85*
Remsdyke *DcBrECP*
Remsen, Helen Q 1897- *DcWomA, WhAmArt 85*
Remsen, Ira M *WhAmArt 85*
Remsen, John Everett, II 1939- *WhoAmA 76, −78, −80, −82, −84*
Remshard, Dorothea *DcWomA*
Remshard, Eleonora Katharina 1704-1767 *DcWomA*
Remsing, Gary 1946- *AmArt, WhoAmA 73, −76, −78, −80, −82, −84*
Remus, P D *AmArch 70*
Remus, Peter *NewYHSD*
Remy Of Reims, Saint *McGDA*
Remy, James *FolkA 86*
Remy, Marie 1829-1915 *DcWomA*
Remy, Virginie *DcWomA*
Ren, Chuck *OfPGCP 86*
Renacco, Nello 1915- *MacEA*
Renaldi, Francesco 1755- *DcBrECP*
Renaldo, James Anthony 1936- *AmArch 70*
Renard, Adele Valerie *DcWomA*
Renard, B A Gudin, Madame d1900 *DcWomA*
Renard, Bruno 1781-1861 *MacEA*
Renard, Camille *DcWomA*
Renard, Edward *DcVicP 2*
Renard, Emile 1850-1930 *ClaDrA*
Renard, Flavie Clementine 1856- *DcWomA*
Renard, Lucie Gabrielle *DcWomA*
Renard, Marie Jeanne *DcWomA*
Renard, Marie Louise *DcWomA*
Renard, Mary *DcWomA*
Renard DeBuzelet, Marguerite Adrienne *DcWomA*
Renau, Josep 1907-1982 *ICPEnP A*
Renaud *NewYHSD*
Renaud, Mademoiselle *DcWomA*
Renaud, A P *AmArch 70*
Renaud, Denise *DcWomA*
Renaud, Elisabeth Marie Victorine Zoe *DcWomA*
Renaud, Fredric John 1933- *AmArch 70*
Renaud, G *DcBrBI*
Renaud, Georges Elisabeth *DcWomA*
Renaud, Marie Honore 1797-1856 *DcWomA*
Renaudin, Madame *DcWomA*
Renaudin, Rosalie *DcWomA*
Renault, Antoine *NewYHSD*
Renault, Emma *DcWomA*
Renault, Giorgio *WhAmArt 85*
Renault, Honorine *DcWomA*
Renault, John Francis *NewYHSD*
Renault, Luigi P *DcSeaP*
Renault, Michele *DcSeaP*
Rench, Polly *DcWomA*
Rencz, Andrew Nicholas 1952- *MarqDCG 84*
Rendahl, William B 1940- *MarqDCG 84*
Rendall, Arthur D *DcVicP 2*
Rendall, Bessie *DcVicP 2*
Rendell, Joseph Frederick Percy 1872-1955 *DcBrA 1, DcVicP 2*
Rendle, Arthur E d1917 *DcBrA 2*
Rendle, John *BiDBrA*
Rendle, John Morgan 1889-1952 *DcBrA 1*
Rendon, A J *AmArch 70*
Rendon, Enrique 1923- *FolkA 86*
Rendon, Maria *OxTwCA*
Rene *DcBrBI*
Renefer, Jean Constant Raymond 1879-1957 *ClaDrA*
Renehan, Ann H *AmArch 70*
Reneson, Chet *OfPGCP 86*
Renesse, Constantin Adrien 1626-1680 *ClaDrA*
Renfro, Donald William 1931- *AmArch 70*
Renfro, M W *AmArch 70*
Renfroe, Bruce A 1917- *AmArch 70*
Renger-Patzsch, Albert 1897-1966 *ConPhot, ICPEnP, MacBEP*
Rengetsu 1791-1875 *DcWomA*
Rengifo, Cesar *OxTwCA*
Reni, Guido 1575-1642 *ClaDrA, McGDA, OxArt*
Renick, Charles Cooley 1925- *WhoAmA 76, −78, −80, −82, −84*

Renie, Andre Marie 1789-1853 *MacEA*
Renier Of Huy *McGDA, OxDecA*
Renier, Alix 1859-1887 *DcWomA*
Renier, Joseph Emile d1966 *WhoAmA 78N, −80N, −82N, −84N*
Renier, Joseph Emilie 1887-1966 *WhAmArt 85*
Renieri, Niccolo *McGDA*
Reniers, Peter *NewYHSD*
Renilde *DcWomA*
Renison, William *DcBrA 1*
Renk, Merry 1921- *WhoAmA 73, −76, −78, −80, −82, −84*
Rennard, James Edwin 1933- *AmArch 70*
Renneke, David Richard 1940- *MarqDCG 84*
Renneker, Fred, Jr. 1908- *AmArch 70*
Rennell, J W 1876- *WhAmArt 85*
Rennell, Joseph *DcBrBI*
Rennell, Thomas 1718-1788 *DcBrECP*
Rennels, F M 1942- *WhoAmA 73*
Rennels, F Merritt 1942- *WhoAmA 80, −82*
Rennels, Frederic M 1942- *WhoAmA 76, −78*
Renner, Eric 1941- *AmArt, MacBEP, WhoAmA 78, −80, −82, −84*
Renner, George *FolkA 86*
Renner, Jon A 1931- *AmArch 70*
Renner, Otto 1881- *WhAmArt 85*
Renner, Otto Hermann 1881- *ArtsAmW 2*
Renner, P *FolkA 86*
Rennertz, Karl Manfred 1952- *DcCAr 81*
Rennick, Dan 1905- *WhoAmA 76, −78, −80, −82, −84*
Rennie, Helen *WhoAmA 73, −76, −78, −80, −82, −84*
Rennie, Helen Sewell *WhAmArt 85*
Rennie, John 1761-1821 *BiDBrA, DcD&D[port], MacEA, McGDA, WhoArch*
Rennie, Mark Edmund 1949- *MacBEP*
Rennie, R W *AmArch 70*
Renninger, Conrad *FolkA 86*
Renninger, Johannes, Jr. *FolkA 86*
Renninger, John *FolkA 86*
Renninger, John, Jr. *FolkA 86*
Renninger, Katharine Steele 1925- *WhoAmA 82, −84*
Renninger, Paul *WhAmArt 85*
Renninger, Wendell *FolkA 86*
Renninger, Wilmer Brunner 1909-1935 *WhAmArt 85*
Renny, M *DcVicP 2*
Renny, William *BiDBrA*
Reno, John 1940- *AmArch 70*
Reno, R D *AmArch 70*
Renoir, Alexander *NewYHSD*
Renoir, Pierre Auguste 1841-1919 *ClaDrA, OxArt[port]*
Renoir, Pierre-Auguste 1841-1919 *DcNiCA, McGDA, PhDcTCA 77*
Renommee *EncASM*
Renou, Louise Antoinette 1754- *DcWomA*
Renou, Marguerite Adelaide *DcWomA*
Renouard, Charles Paul 1845-1924 *DcBrBI*
Renouard, G *WhAmArt 85*
Renouf, Mrs. *DcVicP 2, DcWomA*
Renouf, Edda 1943- *AmArt, ConArt 77, −83, DcCAr 81, PrintW 83, −85, WhoAmA 78, −80, −82, −84*
Renouf, Edward 1906- *WhoAmA 82, −84*
Renouf, Edward M *FolkA 86*
Renouf, Edward Pechmann 1906- *AmArt, WhoAmA 73, −76, −78, −80*
Renoux, Andre 1939- *DcCAr 81*
Renoux, M *DcVicP 2*
Renoz, Mademoiselle *DcWomA*
Renqvist, Torsten 1924- *OxTwCA, PhDcTCA 77*
Rensch, Roslyn *WhoAmA 76, −78, −80, −82, −84*
Renshaw, Alice *DcVicP 2*
Renshaw, C M *AmArch 70*
Renshaw, Ellen *DcWomA*
Renshaw, Thomas *CabMA, FolkA 86*
Renshawe, J H *WhAmArt 85*
Renshawe, John H 1852-1934 *ArtsAmW 2*
Rensie, Florine 1883- *DcWomA, WhAmArt 85*
Rensie, Willis *ConGrA 1, WorECom*
Renta, Oscar DeLa 1932- *WorFshn*
Rentier, Louise Adeline *DcWomA*
Rentinck, Arnold 1712-1774 *ClaDrA*
Rentmeester, Co 1936- *ICPEnP A, MacBEP*
Rentmeesters, Stephen Joseph 1957- *MarqDCG 84*
Renton, Andrew 1917- *ConArch*
Renton, Joan 1935- *WhoArt 80, −82, −84*
Renton, John *DcVicP 2*
Renton, John 1774-1841? *DcBrBI, DcBrWA*
Renton, Lizzie *DcVicP 2*
Rentoul, Ida *DcWomA*
Rentscher, J G *AmArch 70*
Rentschler, Fred *WhAmArt 85*
Rentschler, Sarah Yorke 1950- *WhoAmA 80, −82, −84*
Rentz Brothers *EncASM*
Renwick, Edward A 1860-1941 *BiDAmAr*
Renwick, Frank Forster 1877-1943 *MacBEP*
Renwick, Gladys W 1905- *AfroAA*
Renwick, Howard Crosby *WhAmArt 85*
Renwick, James 1792-1863 *NewYHSD , OxArt*
Renwick, James 1818-1895 *BiDAmAr, BnEnAmA, DcD&D, MacEA, McGDA, WhoArch*

Renwick, James, Jr. 1818-1895 *EncAAr*
Renwick, William W 1864-1933 *BiDAmAr*
Renwick, William Whetten 1864-1933 *WhAmArt 85*
Renz, Anna Maria 1866- *DcWomA*
Renz, Belle *DcWomA*
Renz, Maria Philippina *DcWomA*
Renzetti, Aurelius *WhAmArt 85*
Reol, Marie Marguerite 1880- *DcWomA*
Reopel, Joyce 1933- *WhoAmA 73*
Reopel, Joyce 1938- *WhoAmA 76, -78, -80, -82, -84*
Reparata, Saint *McGDA*
Repelaer VanDriel, C 1880- *DcWomA*
Repelius, Betsy Johanna Elisabeth 1848-1921 *DcWomA*
Repentigny, Rodolphe De *OxTwCA*
Repin, Ilya 1844-1930 *OxArt, PhDcTCA 77*
Repin, Ilya Efimovich 1844-1930 *McGDA*
Replinger, Dot 1924- *WhoAmA 78, -80, -82, -84*
Reppenhagen, C W *AmArch 70*
Reppert *FolkA 86*
Repton, George Stanley *OxArt, OxDecA*
Repton, George Stanley d1858 *DcBrWA*
Repton, George Stanley 1786-1858 *BiDBrA, MacEA*
Repton, Humphrey 1752-1818 *DcBrWA, McGDA*
Repton, Humphry 1752-1818 *DcBrBl, DcD&D, MacEA, OxArt, OxDecA, WhoArch*
Repton, John Adey *OxArt, OxDecA*
Repton, John Adey 1775-1860 *BiDBrA, DcBrBl, DcBrWA, MacEA*
Repton And Repton *MacEA*
Repulles I Vargas, Enrique 1845-1922 *MacEA*
Repult, Frank Clifton, Jr. 1928- *AmArch 70*
Requa, Richard S 1880-1941? *BiDAmAr*
Requicha, Aristides Adelino Gvalberto 1939- *MarqDCG 84*
Requichot, Bernard 1929-1961 *PhDcTCA 77*
Requillart, Bruno 1947- *ConPhot, ICPEnP A*
Resch, Elisabeth *DcWomA*
Reschke, J B *AmArch 70*
Resek, Kate Frances *WhoAmA 78, -80, -82, -84*
Resende Carvalho, Flavio De *OxTwCA*
Reside, William *CabMA*
Resika, Paul 1928- *DcCAA 71, -77, WhoAmA 73, -76, -78, -80, -82, -84*
Resler, George Earl 1882- *WhAmArt 85*
Resmann, Francesco *DcSeaP*
Resnick, Louis 1916- *AmArch 70*
Resnick, Marcia 1950- *ConPhot, DcCAr 81, ICPEnP A*
Resnick, Marcia Aylene 1950- *WhoAmA 76, -78, -80, -82, -84*
Resnick, Milton 1917- *BnEnAmA, DcCAA 71, -77, McGDA, OxTwCA, PhDcTCA 77, WhoAmA 73, -76, -78, -80, -82, -84*
Resnick, S *AmArch 70*
Ressel, Maria 1877- *DcWomA*
Resser, William W 1860-1941 *FolkA 86*
Ressinger, Paul M *WhAmArt 85*
Ressler, Perry 1932- *AmArch 70*
Ressler, Rudolph 1822?- *FolkA 86*
Ressler, Sanford Paul 1956- *MarqDCG 84*
Ressler, Susan Rebecca 1949- *ICPEnP A, MacBEP*
Restein, Edmund B 1837-1891 *NewYHSD*
Restein, Edmund P 1837-1891 *NewYHSD*
Restein, Ludwig 1838?- *NewYHSD*
Restifo, Joseph David 1926- *AmArch 70*
Restivo, Mary Ann *WorFshn*
Restout, Anne Catherine 1733- *DcWomA*
Restout, Jean 1692-1768 *ClaDrA*
Restout, Jean, The Younger 1692-1768 *McGDA*
Restout, Marie Madeleine 1655?-1729? *DcWomA*
Restout, Pauline Elisa *DcWomA*
Ret, Etienne 1900- *WhAmArt 85*
Retailleau, Yvonne *DcWomA*
Retfalvi, Sandor 1940- *DcCAr 81*
Reth, Alfred 1884-1966 *OxTwCA, PhDcTCA 77*
Rethel, Alfred 1816-1859 *ArtsNiC, ClaDrA, McGDA, OxArt*
Rethel, Else *DcWomA*
Rethi, Lili 1894- *DcWomA, IlsBYP, WhAmArt 85*
Reti, Damigella 1584- *DcWomA*
Retor, Mademoiselle *DcWomA*
Rettberg, G C *AmArch 70*
Retti, Damigella 1584- *DcWomA*
Retti, Leonardo *McGDA*
Rettich, Klara 1860-1916 *DcWomA*
Rettick, Otta M *ArtsEM*
Rettig, Carolina *DcWomA*
Rettig, John 1860?-1932 *IlBEAAW, WhAmArt 85*
Rettig, Mrs. John d1919 *WhAmArt 85*
Rettig, Martin *WhAmArt 85*
Rettig, Ted *DcCAr 81*
Rettinger, A *CabMA*
Rettstatt, Harold Edward 1938- *AmArch 70*
Rety, Zsuzsa 1899- *DcWomA*
Retz, Philip 1902- *WhAmArt 85*
Retzer, Howard Earl 1925- *WhoAmA 78, -80, -82, -84*
Retzler, H P *AmArch 70*
Retzsch, Frederick August Moritz 1779-1857 *NewYHSD*
Retzsch, Friedrich August Moritz 1779-1857 *OxArt*

Reuchle, Hans *McGDA*
Reul, Alexander 1874-1937 *WhAmArt 85*
Reumaux, Amelie *DcWomA*
Reusch, Erich 1925- *ConArt 77, -83, DcCAr 81*
Reusch, Friedrich *ArtsNiC*
Reusch, Helen *DcWomA, WhAmArt 85*
Reusch, Helga Ring 1865-1944 *DcWomA*
Reusens, Robert 1909-1981 *ConPhot, ICPEnP A*
Reuss, Albert *WhoArt 80N*
Reuss, Albert 1889-1975 *DcBrA 2*
Reuss, Princess Elisabeth Henriette 1824-1861 *DcWomA*
Reuss, Rae Roy 1928- *AmArch 70*
Reusser, Susanna 1848-1907 *DcWomA*
Reussner, Robert *NewYHSD*
Reusswig, William 1902- *IlBEAAW, IlrAm D, WhAmArt 85*
Reusswig, William 1902-1978 *IlrAm 1880*
Reuter, Elisabeth 1853-1903 *DcWomA*
Reuter, Erich F 1911- *DcCAr 81, WhoArt 80, -82, -84*
Reuter, F H *AmArch 70*
Reuter, Hans Peter 1942- *ConArt 83, DcCAr 81*
Reuter, John 1953- *ICPEnP A, MacBEP*
Reuter, Laurel J 1943- *WhoAmA 76, -78, -80, -82, -84*
Reuter, Maria 1929- *DcCAr 81*
Reuter-Christansen, Ursula *DcCAr 81*
Reuterdahl, Henry 1870-1925 *DcSeaP*
Reuterdahl, Henry 1871-1925 *IlrAm A, -1880, WhAmArt 85*
Reutershan, Quentin Lewis 1924- *AmArch 70*
Reutersward, Carl Frederik 1934- *OxTwCA*
Reutersward, Carl-Fredrik 1934- *PhDcTCA 77*
Reuther, Gertrud Elisabeth 1788-1845 *DcWomA*
Reuther, Richard G 1859-1913 *ArtsEM*
Reutlinger, J L *AmArch 70*
Rev, Miklos 1906- *ICPEnP A*
Reva, James 1940- *WorFshn*
Reveillon, Juliette *DcWomA*
Revel, John Daniel 1884-1967 *DcBrA 1*
Revel, Joseph *AntBDN D*
Revel, Lucy Elizabeth Babington 1887-1961 *DcBrA 1, DcWomA*
Reveley, Henry Willey 1788-1875 *MacEA*
Reveley, Willey 1760-1799 *BiDBrA, DcBrWA*
Revell, Viljo 1910- *EncMA*
Revell, Viljo 1910-1964 *ConArch, DcD&D, MacEA*
Revels, Frederick W 1869-1937 *BiDAmAr*
Revenaugh, Aurelius O 1840- *ArtsEM*
Revenaugh And McCurdy *ArtsEM*
Reventlow, Countess Franziska 1871-1918 *DcWomA*
Reventlow, Countess Louise Sybille 1783-1848 *DcWomA*
Reverchon, Louise *DcWomA*
Revere, C H *NewYHSD*
Revere, Joseph Warren 1812-1880 *ArtsAmW 1, IlBEAAW, NewYHSD*
Revere, Paul 1735-1818 *AntBDN Q, BnEnAmA, DcAmArt, DcD&D[port], DcNiCA, EarABI, McGDA, NewYHSD, OxDecA, WorECar*
Revere, Paul, Sr. 1702-1754 *AntBDN Q*
Reverend, J *NewYHSD*
Reverend, M M *WhAmArt 85*
Reverend, T *NewYHSD*
Reveron, Armando 1889-1954 *McGDA, PhDcTCA 77*
Reveron, Armando 1889-1956 *OxTwCA*
Revest, Cornelie Louise 1795-1856 *DcWomA*
Revesz, Gyorgyike 1877- *DcWomA*
Revesz, Tamas 1946- *ICPEnP A*
Revett, Nicholas 1720-1804 *BiDBrA, DcBrWA, MacEA, OxArt, WhoArch*
Reviere *NewYHSD*
Revill, W H *DcVicP 2*
Reville *WorFshn*
Reville, H Whittaker *DcVicP 2*
Revillon *WorFshn*
Revillon, Marie *DcWomA*
Revington, George D, III *WhoAmA 73, -76, -78, -80N, -82N, -84N*
Revington, Mrs. George D, III *WhoAmA 80, -82*
Revington-Burdick, Betty, III *WhoAmA 84*
Revness, Ellis G 1927- *AmArch 70*
Revold, Axel 1887-1962 *PhDcTCA 77*
Revon, Louise *DcWomA*
Revor, Remy 1914- *WhoAmA 73, -76, -78, -80, -82, -84*
Rew, Charles Henry *DcVicP 2*
Rew, E *DcVicP 2*
Rewald, John 1912- *WhAmArt 85, WhoAmA 73, -76, -78, -80, -82, -84, WhoArt 80, -82, -84*
Rewell, Viljo 1910-1964 *WhoArch*
Rex, John L 1909- *AmArch 70*
Rexach, Alberto *WhAmArt 85*
Rexach, Juan *McGDA*
Rexford, Blanch *ArtsEM, DcWomA*
Rexrode, James *FolkA 86*
Rexroth, Mrs. Andre 1902- *WhAmArt 85*
Rexroth, Nancy *DcCAr 81*

Rexroth, Nancy 1946- *ConPhot*
Rexroth, Nancy Louise 1946- *ICPEnP A, MacBEP, WhoAmA 80, -82, -84*
Rey *DcBrECP*
Rey, Amelie Charlotte Marie *DcWomA*
Rey, Claire *DcWomA*
Rey, Elisabeth *DcWomA*
Rey, H A d1977 *IlsCB 1967*
Rey, H A 1898- *WhAmArt 85, WhoAmA 73, -76, -78, -80*
Rey, H A 1898-1977 *WhoAmA 82N, -84N*
Rey, Hans Augusto 1898- *IlsCB 1744, -1946, -1957*
Rey, Jacques Joseph 1820- *NewYHSD*
Rey, Jacques Joseph 1820-1899? *ArtsAmW 1*
Rey, Loris *DcBrA 1*
Rey, Rita *DcWomA*
Rey-Berling, Estelle Andre *DcWomA*
Reyam, David 1864-1943 *WhAmArt 85*
Reyburn, William F *WhAmArt 85*
Reychan, Stanislas 1897- *DcBrA 1, WhoArt 80, -82, -84*
Reye, H *DcVicP 2*
Reyerman, Anna M *DcWomA*
Reygers, Johannes Hubertus 1767-1849 *DcSeaP*
Reyher, Max 1862- *FolkA 86*
Reylander-Bohme, Ottilie 1882-1965 *DcWomA*
Reymann, Teodoro *DcVicP 2*
Reymerswaele, Van *OxArt*
Reymerswaele, Marinus Van 1490?-1567? *McGDA*
Reymeyer, Frederick *FolkA 86*
Reymond, Eugenie 1853- *DcWomA*
Reymond, Jean Marc 1951- *DcCAr 81*
Reymond, Pierre 1513?-1584? *McGDA*
Reymond, Pierre, I *McGDA*
Reymond-Suffren, Nanette 1895- *DcWomA*
Reyn, Jan VanDe 1610-1678 *ClaDrA*
Reyna, Marilyn De *IlsBYP*
Reynal, Jeanne 1903- *DcCAA 71, -77, WhoAmA 73, -76, -78, -80, -82, -84, WomArt*
Reynard, Carolyn Cole 1934- *WhoAmA 73, -76, -78, -80, -82, -84*
Reynard, Flora *DcWomA*
Reynard, Grant 1887-1967 *WhAmArt 85*
Reynard, Grant T d1967 *WhoAmA 78N, -80N, -82N, -84N*
Reynard, Grant T 1887-1968 *ArtsAmW 1*
Reynard, Grant Tyson 1887- *IlrAm C*
Reynard, Grant Tyson 1887-1968 *ArtsAmW 3, GrAmP, IlrAm 1880*
Reynard, Ian David 1942- *WhoArt 80*
Reynaud, Alain *WorFshn*
Reynaud, Emile 1844-1918 *WorECar*
Reynaud, Francois 1909- *ClaDrA*
Reyneau, Betsy 1888-1964 *DcWomA*
Reyneau, Betsy Graves *AfroAA*
Reyneau, Mrs. Paul O *WhAmArt 85*
Reynel, Jacob *CabMA*
Reynel, John *CabMA*
Reynell, Gladys 1881-1956 *DcWomA*
Reynell, John *FolkA 86*
Reynell, Thomas *DcBrECP*
Reyner, Christopher *DcBrECP*
Reynerson, June 1891- *DcWomA*
Reynes, Mrs. Joseph 1805- *DcWomA, NewYHSD*
Reynolds *DcBrECP, FolkA 86*
Reynolds, Alan 1926- *ConBrA 79[port]*
Reynolds, Alan 1947- *DcCAr 81*
Reynolds, Alan Munro 1926- *DcBrA 1*
Reynolds, Alfred *AntBDN M*
Reynolds, Alice *WhAmArt 85*
Reynolds, Alice M *ArtsAmW 2, DcWomA, WhAmArt 85*
Reynolds, Apollonia *DcVicP 2, DcWomA*
Reynolds, Basil 1916- *WorECom*
Reynolds, Bernard Robert 1915- *DcBrA 1, WhoArt 80, -82, -84*
Reynolds, C Jeannie *DcBrA 2*
Reynolds, Carita *AfroAA*
Reynolds, Carl Wellington 1952- *MarqDCG 84*
Reynolds, Catherine 1782?-1864 *DcWomA, NewYHSD*
Reynolds, Charles Barton 1935- *ICPEnP A, MacBEP*
Reynolds, Clara *DcVicP 2*
Reynolds, Clara P *ArtsAmW 3*
Reynolds, Clara W 1899- *DcWomA, WhAmArt 85*
Reynolds, David William, II 1941- *AmArch 70*
Reynolds, Douglas Wolcott 1913- *WhAmArt 85*
Reynolds, Edith *DcWomA, WhAmArt 85*
Reynolds, Elizabeth *DcWomA, WhAmArt 85*
Reynolds, Emanuel *NewYHSD*
Reynolds, Ernest G *DcBrBl*
Reynolds, Esau 1725-1778 *BiDBrA*
Reynolds, Fanny *DcWomA*
Reynolds, Frances *DcWomA, WhAmArt 85*
Reynolds, Frances 1729-1807 *DcBrECP, DcWomA*
Reynolds, Frank d1895 *DcVicP 2*
Reynolds, Frank 1876- *ClaDrA, IlsCB 1744*
Reynolds, Frank 1876-1953 *DcBrA 1, DcBrBl, DcBrWA, WorECar*
Reynolds, Frederick 1882- *WhAmArt 85*
Reynolds, Frederick George 1828-1921 *ClaDrA,*

DcBrA 1, DcBrWA, DcVicP, –2
Reynolds, G S *DcVicP 2*
Reynolds, Mrs. G S *DcVicP 2*
Reynolds, George *ArtsAmW 2, WhAmArt 85*
Reynolds, Graham 1914- *WhoArt 80, –82, –84*
Reynolds, H *DcBrBI*
Reynolds, Harold Francis 1903- *AmArch 70*
Reynolds, Harry Reuben 1898- *ArtsAmW 1, WhAmArt 85, WhoAmA 73*
Reynolds, Helen Baker 1896- *WhAmArt 85*
Reynolds, Ivan Moody 1907- *AmArch 70*
Reynolds, J *DcVicP 2*
Reynolds, J H *DcBrBI*
Reynolds, J W *FolkA 86*
Reynolds, James *OfPGCP 86*
Reynolds, James E 1926- *IlBEAAW*
Reynolds, James Elwood 1926- *WhoAmA 76, –78, –80, –82, –84*
Reynolds, John *NewYHSD*
Reynolds, John C 1929- *AmArch 70*
Reynolds, John Patrick 1909-1935 *DcBrA 2*
Reynolds, John Ronald 1938- *AmArch 70*
Reynolds, Jonathan *CabMA*
Reynolds, Jos *DcWomA*
Reynolds, Joseph B 1912- *AmArch 70*
Reynolds, Joseph G, Jr. 1886- *WhAmArt 85*
Reynolds, Joseph Gardiner 1886- *WhoAmA 73, –76, –78, –80*
Reynolds, Sir Joshua 1723-1792 *ClaDrA, DcBrECP[port], McGDA, OxArt*
Reynolds, Joshua W *NewYHSD*
Reynolds, Larry 1912- *WorECar*
Reynolds, Lilian Mary *DcWomA*
Reynolds, Lloyd J *WhAmArt 85*
Reynolds, Lloyd J 1902-1978 *WhoAmA 80N, –82N, –84N*
Reynolds, Lydia Barlett *FolkA 86*
Reynolds, M D *AmArch 70*
Reynolds, M E *DcVicP 2*
Reynolds, Mabel *WhoArt 80, –82, –84*
Reynolds, Marcus T 1870-1937 *BiDAmAr*
Reynolds, Margaret *DcWomA*
Reynolds, Mary Catherine 1958- *MarqDCG 84*
Reynolds, May E *WhAmArt 85*
Reynolds, Minor Garland, Jr. 1935- *AmArch 70*
Reynolds, Nancy DuPont 1919- *WhoAmA 73, –76, –78, –80*
Reynolds, Nancy Dupont 1919- *WhoAmA 84*
Reynolds, O B *DcBrA 2*
Reynolds, Oakley *WhAmArt 85*
Reynolds, Mrs. P *FolkA 86*
Reynolds, Patricia *DcCAr 81*
Reynolds, Patricia Ellen 1934- *WhoAmA 84*
Reynolds, Percy T *DcBrBI*
Reynolds, R *DcVicP 2*
Reynolds, Ralph William 1905- *WhAmArt 85, WhoAmA 73, –76, –78, –80, –82, –84*
Reynolds, Reginald Francis d1936 *DcBrA 1*
Reynolds, Richard 1827-1918 *NewYHSD , WhAmArt 85*
Reynolds, Richard 1913- *WhoAmA 73, –76, –78, –80, –82, –84*
Reynolds, Robert 1936- *WhoAmA 78, –80, –82, –84*
Reynolds, Robert F 1818?- *NewYHSD*
Reynolds, Robert Kary 1937- *AmArch 70*
Reynolds, Ruth Evelyn Millicent 1915- *WhoArt 80, –82, –84*
Reynolds, Samuel William *DcBrWA*
Reynolds, Samuel William 1773-1835 *BiDBrA, DcBrECP, DcBrWA, McGDA*
Reynolds, Samuel William, Jr. 1794-1872 *DcVicP 2*
Reynolds, T Lillian *DcWomA*
Reynolds, Thomas *BiDBrA, NewYHSD*
Reynolds, Valrae 1944- *WhoAmA 78, –80, –82, –84*
Reynolds, Virginia 1866- *WhAmArt 85*
Reynolds, Virginia 1866-1903 *DcWomA*
Reynolds, W *DcVicP 2*
Reynolds, W J *FolkA 86*
Reynolds, W N *AmArch 70*
Reynolds, Wade *AmArt, WhoAmA 82, –84*
Reynolds, Walter *DcVicP, –2*
Reynolds, Walter E 1924- *MarqDCG 84*
Reynolds, Warwick *DcBrBI, DcBrWA, DcVicP 2*
Reynolds, Warwick 1880-1926 *DcBrA 1, DcBrBI, DcBrWA*
Reynolds, Wellington Jarard 1869- *WhAmArt 85*
Reynolds, William DuPree 1939- *AmArch 70*
Reynolds, Mrs. William H *WhAmArt 85*
Reynolds-Stephens, Sir William Ernest 1862-1943 *DcBrA 1, DcVicP 2*
Reyntiens, Nicholas Patrick 1925- *WhoArt 80, –82, –84*
Reyntjens, Henrich Engelbert 1817-1859 *ClaDrA*
Reys, Jenny Augustine 1798- *DcWomA*
Reyschoot, Petrus Johannes Van 1702-1772 *DcBrECP*
Reysschoot, Anna Maria Van 1758-1850 *DcWomA*
Rezac, Henry 1872-1951 *ArtsAmW 2*
Rezia, Felice A *DcVicP 2*
Rezinor, John *FolkA 86*
Reznicek, Edward Joe 1936- *AmArch 70*
Reznicek, Ferdinand Von 1868-1909 *WorECar*

Rezny, James B 1871-1945 *BiDAmAr*
Rezvani, Serge 1928- *OxTwCA, PhDcTCA 77*
Rezza, Martin Dominick 1935- *AmArch 70*
Rhaye, Yves *DcCAr 81*
Rhea, Robert *CabMA*
Rhead, Annie *DcWomA*
Rhead, Charlotte *DcNiCA*
Rhead, F A *DcBrBI*
Rhead, Frederick Alfred 1856-1929 *DcNiCA*
Rhead, Frederick Hurten *WhAmArt 85*
Rhead, Frederick Hurten 1880-1942 *CenC, DcNiCA*
Rhead, G W *DcNiCA*
Rhead, George W *WhAmArt 85*
Rhead, George Wooliscroft 1855-1920 *DcBrBI, DcVicP 2*
Rhead, George Woolliscroft d1920 *DcBrA 1*
Rhead, George Woolliscroft 1855-1920 *ClaDrA*
Rhead, Lois Whitcomb 1897- *DcWomA, WhAmArt 85*
Rhead, Louis 1857-1926 *WhAmArt 85*
Rheal, Ronda 1891-1945? *WhAmArt 85*
Rheal, Ronda 1891-1947? *DcWomA*
Rheam, Henry Meynell 1859-1920 *ClaDrA, DcBrA 2, DcBrWA, DcVicP 2*
Rheaume, Alton V 1911- *AmArch 70*
Rhedey, Claudina *DcWomA*
Rhee, Jongmyung 1953- *MarqDCG 84*
Rheem, Royal Alexander 1883- *WhAmArt 85*
Rheen, Theodorus Justinus *ClaDrA*
Rhees, N *IlBEAAW*
Rhein, Fritz 1873- *ClaDrA*
Rhein, R V W 1892- *WhAmArt 85*
Rheinhardt, Enoch W *FolkA 86*
Rhenae *FolkA 86*
Rhett, Antoinette 1884- *WhAmArt 85*
Rhett, Antoinette Francesca 1884- *DcWomA*
Rhett, Hannah McC 1871- *WhAmArt 85*
Rhett, Hannah McCord 1871- *DcWomA*
Rhijn, Rembrandt Van *McGDA*
Rhind, C *NewYHSD*
Rhind, David 1808-1883 *MacEA*
Rhind, Ethel Mary d1952 *DcBrA 2*
Rhind, J Massey 1860-1936 *WhAmArt 85*
Rhind, John Massey 1860?-1936 *IlBEAAW*
Rhind, John Massey 1860-1936 *DcBrA 1*
Rhind, T Duncan *DcBrA 2*
Rhind, William Birnie d1933 *DcBrA 1*
Rhinedesbacher *NewYHSD*
Rhinehart, Donald Weaver 1926- *AmArch 70*
Rhinelander, W H *NewYHSD*
Rhines, George V 1875-1938 *BiDAmAr*
Rho, Pietro Da *McGDA*
Rhoades, Geoffrey H *WhoArt 82N*
Rhoades, Geoffrey H 1898- *DcBrA 1, WhoArt 80*
Rhoades, Helen N d1938 *DcWomA*
Rhoades, John Harsen d1906 *WhAmArt 85*
Rhoades, K N *WhAmArt 85*
Rhoades, Katharine Nash 1885-1965 *DcWomA*
Rhoades, Katherine 1895-1938 *DcWomA*
Rhoades, Nathaniel A 1810?- *CabMA*
Rhoades, William H *NewYHSD*
Rhoads, Eugenia Eckford 1901- *WhoAmA 73, –76, –78, –80*
Rhoads, Harry Davis 1893- *WhAmArt 85*
Rhoads, Jessie Dubose 1900-1972 *FolkA 86*
Rhoads, John Samuel 1930- *AmArch 70*
Rhoads, Katherine 1895-1938? *WhAmArt 85*
Rhoads, William *NewYHSD*
Rhoda, George Franklin 1915- *AmArch 70*
Rhode, Henry *FolkA 86*
Rhoden, Irene *DcCAr 81*
Rhoden, John 1918- *AfroAA*
Rhoden, John W 1918- *WhoAmA 73, –76, –78, –80, –82, –84*
Rhodes, Charles Ward d1905 *WhAmArt 85*
Rhodes, Collin *FolkA 86*
Rhodes, Curtis A 1939- *WhoAmA 82, –84*
Rhodes, D *FolkA 86*
Rhodes, Daniel 1838-1901 *FolkA 86*
Rhodes, Daniel 1911- *BnEnAmA, CenC, WhAmArt 85*
Rhodes, Edgar 1941- *MarqDCG 84*
Rhodes, Ethel VanLinschoten 1882- *WhAmArt 85*
Rhodes, F R *DcVicP 2*
Rhodes, G E *AmArch 70*
Rhodes, George F *NewYHSD*
Rhodes, H *DcVicP 2, DcWomA*
Rhodes, H Douglas *DcVicP 2*
Rhodes, Helen N d1938 *ArtsAmW 1, WhAmArt 85*
Rhodes, Helen Neilson 1875-1938 *ArtsAmW 3*
Rhodes, Henry d1846 *BiDBrA*
Rhodes, Henry J *DcVicP 2*
Rhodes, James Melvin 1938- *WhoAmA 78, –80, –82, –84*
Rhodes, John *DcVicP 2*
Rhodes, John Nicholas 1809-1842 *DcBrWA, DcVicP 2*
Rhodes, John W *AfroAA*
Rhodes, Joseph 1782-1854 *DcBrWA*
Rhodes, Lynda 1945- *MarqDCG 84*
Rhodes, Marion 1907- *DcBrA 1, WhoArt 80, –82,*

–84
Rhodes, Michael Laurence 1949- *MarqDCG 84*
Rhodes, Naomi 1899- *WhAmArt 85*
Rhodes, Reilly Patrick 1941- *WhoAmA 73, –76, –78, –80, –82, –84*
Rhodes, Richard Kay 1938- *AmArch 70*
Rhodes, Richard Ritenour 1918- *AmArch 70*
Rhodes, T *FolkA 86*
Rhodes, Willard Conrad 1930- *AmArch 70*
Rhodes, William *BiDBrA*
Rhodes, William H *NewYHSD*
Rhodes, Zandra 1940- *ConDes, WorFshn*
Rhodes, Zandra 1942- *FairDF ENG[port]*
Rhoecus *OxArt*
Rhoikos Of Samos d540BC *MacEA*
Rhomberg, Hanno 1820-1869 *ArtsNiC*
Rhomberg, Joseph Anton 1786-1855 *ClaDrA*
Rhome, Lily Blanche Peterson *WhAmArt 85*
Rhome, Lily Blanche Peterson 1874- *DcWomA*
Rhumaux, Emilie *DcWomA*
Rhymus, Detlef 1945- *DcCAr 81*
Rhyne, Charles Sylvanus 1932- *WhoAmA 78, –80, –82, –84*
Rhyne, James R 1942- *MarqDCG 84*
Rhyne, V Thomas 1942- *MarqDCG 84*
Rhys, Oliver *DcVicP, –2*
Ri, Sampei *McGDA*
Riaboff, B *AmArch 70*
Riabushinsky, Nikolai Pavlovich 1876-1951 *OxTwCA*
Rial, John *NewYHSD*
Rialland, Charlotte 1880- *DcWomA*
Rialto, Luisa *DcWomA*
Riangina, Serafima Vasilievna 1891-1955 *DcWomA*
Riano, Diego d1534 *OxArt*
Riario, Francesco *DcBrECP*
Rib, David Gady *AmArch 70*
Rib, David Gady 1942- *AmArch 70*
Riba, Paul 1912-1977 *WhAmArt 85*
Riba, Paul F 1912- *WhoAmA 73, –76*
Riba, Paul F 1912-1977 *WhoAmA 78N, –80N, –82N, –84N*
Ribak, Louis 1902- *WhAmArt 85, WhoAmA 76, –78, –80*
Ribak, Louis 1902-1980 *WhoAmA 82N, –84N*
Ribak, Louis Leon 1903?- *IlBEAAW*
Ribalta, Francisco 1555?-1628 *McGDA*
Ribalta, Francisco 1565-1628 *OxArt*
Ribalta, Juan 1596?-1628 *McGDA*
Ribault, Mademoiselle *DcWomA*
Ribault, Athalie 1781- *DcWomA*
Ribault, Julie 1789- *DcWomA*
Ribaut, Marguerite Charlotte *DcWomA*
Ribbans, Albert Charles 1903-1967 *DcBrA 2*
Ribbans, William Parkes d1871 *BiDBrA*
Ribbing, Sofia Amalia 1835-1894 *DcWomA*
Ribblesdale, Baron Thomas *DcVicP 2*
Ribbons, Ian *IlsCB 1967*
Ribbons, Ian 1924- *IlsBYP, IlsCB 1946, –1957*
Ribcowsky, Dey De *ArtsAmW 3*
Ribcowsky, Dey De 1880- *WhAmArt 85*
Ribe, Marie *DcWomA*
Ribeiro, Juliette De *DcWomA*
Ribera, Carlos Louis 1812- *ArtsNiC*
Ribera, Jose De 1591-1652 *OxArt*
Ribera, Josef 1588-1656 *ClaDrA*
Ribera, Jusepe De 1591-1652 *McGDA, OxArt*
Ribera, Pedro De 1683?-1742 *OxArt, WhoArch*
Ribera, Pierre 1867- *ClaDrA*
Rible, Ulysses Floyd 1904- *AmArch 70*
Riboni, Giacinto *NewYHSD*
Ribot, Louise Aimee *DcWomA*
Ribot, Theodule 1823-1891 *McGDA*
Ribot, Theodule Augustin 1823-1891 *ClaDrA*
Riboud, Barbara Chase *AfroAA*
Riboud, Marc 1923- *ConPhot, ICPEnP, MacBEP*
Ribson, E J *AmArch 70*
Ricalton, William *FolkA 86*
Ricarby, George *NewYHSD*
Ricard, Gustave 1824-1873 *ArtsNiC*
Ricard, Louis Gustave 1823-1873 *ClaDrA, McGDA*
Ricardo, Clifford *WhoAmA 76, –78, –80*
Ricardo, Mrs. R J *NewYHSD*
Ricauti, T J *BiDBrA*
Ricchi, Clena *DcWomA*
Ricchini, Francesco Maria 1583-1658 *McGDA*
Ricchino, Francesco 1518?-1568? *ClaDrA*
Ricchino, Francesco Maria 1583-1658 *MacEA*
Ricci, A *OxArt*
Ricci, Antonio 1927- *MarqDCG 84*
Ricci, Camillo 1580-1618 *ClaDrA*
Ricci, F *OxArt*
Ricci, Fray Juan Andres 1600-1681 *McGDA*
Ricci, H *DcVicP 2*
Ricci, J *OxArt*
Ricci, Jerri *WhoAmA 73, –76, –78, –80, –82, –84*
Ricci, Leonardo 1918- *ConArch, MacEA*
Ricci, Lucia *DcWomA*
Ricci, Marco 1676-1729 *ClaDrA, DcSeaP, OxArt*
Ricci, Marco 1676-1730? *DcBrECP*
Ricci, Marco 1676-1730 *McGDA*
Ricci, Nina 1883-1970 *FairDF FRA[port], WorFshn*

Ricci, Sebastian 1659-1734 *ClaDrA*
Ricci, Sebastiano 1659-1734 *DcBrECP, McGDA, OxArt*
Ricci, Stefano 1765-1837 *McGDA*
Ricci, Tiberiu 1913-1979 *MacEA*
Ricci, Ulysses 1888-1960 *WhoAmA 80N, -82N, -84N*
Ricci, Ulysses Anthony 1888-1960 *WhAmArt 85*
Ricci DeGuevara, Francisco *McGDA*
Ricciardelli, Gabriello *DcBrECP*
Ricciardi, Cesare A 1892- *WhAmArt 85*
Ricciardi, Mirella 1933- *ConPhot, ICPEnP A*
Ricciardi, Robert Hugh 1935- *AmArch 70*
Ricciarelli, Daniele *McGDA*
Riccio *McGDA*
Riccio DaVerona *McGDA*
Riccio, Il 1470-1532 *OxArt*
Riccio, A M *AmArch 70*
Riccio, Andrea Briosco 1470-1532 *OxArt*
Riccio, Cecilia Del *DcWomA*
Riccio, Domenico Del *McGDA*
Riccio, Felice Del *McGDA*
Riccio, Henry Americo 1921- *AmArch 70*
Riccitelli, D 1881- *WhAmArt 85*
Ricciuti, Italo William 1906- *AmArch 70*
Ricciuti, Paul J 1935- *AmArch 70*
Rice *DcBrBI*
Rice, A G *AmArch 70*
Rice, Aaron Adger 1925- *AmArch 70*
Rice, Anne Estelle 1879- *WhAmArt 85*
Rice, Anne Estelle 1879-1959 *DcWomA*
Rice, Anthony Hopkins 1948- *WhoAmA 76, -78, -80, -82, -84*
Rice, Arthur Wallace 1869-1938 *BiDAmAr*
Rice, Barbara Menen *WhoAmA 82, -84*
Rice, Bernard *EncASM*
Rice, Bernard 1900- *DcCAr 81, WhoArt 80, -82, -84*
Rice, Bernard Charles 1900- *ClaDrA*
Rice, Burton *WhAmArt 85*
Rice, Calvin L *NewYHSD*
Rice, Charles H *WhAmArt 85*
Rice, Clayton Jefferson, III 1955- *MarqDCG 84*
Rice, Dan 1926- *DcCAA 71, -77, WhoAmA 73, -76, -78*
Rice, Dorothy *WhAmArt 85*
Rice, E A *NewYHSD*
Rice, E Garrett *DcBrA 2*
Rice, Elizabeth 1913- *IlsBYP*
Rice, Emery *FolkA 86, NewYHSD*
Rice, Emma Deuel *DcWomA*
Rice, Emma Duel *WhAmArt 85*
Rice, Ernest S *FolkA 86*
Rice, Ettie L *DcWomA*
Rice, Eve Hart 1951- *IlsCB 1967*
Rice, F B *AmArch 70*
Rice, F E *AmArch 70*
Rice, Franklin Albert 1906- *WhAmArt 85*
Rice, Frederick A *DcVicP 2*
Rice, H R *AmArch 70*
Rice, Harold Randolph 1912- *WhAmArt 85, WhoAmA 73, -76, -78, -80, -82, -84*
Rice, Harris & Sons *DcNiCA*
Rice, Henry W *WhAmArt 85*
Rice, J S *AmArch 70*
Rice, Jack B 1934- *MarqDCG 84*
Rice, James *EncASM*
Rice, James R 1824- *NewYHSD*
Rice, James Watson 1917- *AmArch 70*
Rice, James William, Jr. 1934- *WhoAmA 78, -80, -82*
Rice, Jenny *DcWomA*
Rice, John E *NewYHSD*
Rice, John J *ArtsEM*
Rice, Joseph R *NewYHSD*
Rice, Joseph T *EncASM*
Rice, Julia Hall *DcWomA*
Rice, Kathryn Clark 1910- *WhAmArt 85*
Rice, Laura Gwenllian *DcWomA*
Rice, Leland 1940- *ConPhot, DcCAr 81*
Rice, Leland David 1940- *ICPEnP A, MacBEP*
Rice, Lillian J 1888-1938 *BiDAmAr*
Rice, Lucy Wilson 1874- *ArtsAmW 2, DcWomA, WhAmArt 85*
Rice, M Robert *WhoAmA 80, -82, -84*
Rice, Maegeane Ruble 1911- *WhAmArt 85*
Rice, Marguerite Smith 1897- *DcWomA, WhAmArt 85*
Rice, Mervyn A *WhAmArt 85*
Rice, Myra M *WhAmArt 85*
Rice, N P *AmArch 70*
Rice, Nan 1890-1955 *DcWomA, WhAmArt 85*
Rice, Nancy Newman *WhoAmA 84*
Rice, Norman Lewis 1905- *WhAmArt 85, WhoAmA 73, -76, -78, -80, -82, -84*
Rice, Norman N 1903- *AmArch 70*
Rice, O O *AmArch 70*
Rice, Oran Winthrop 1871-1931 *BiDAmAr*
Rice, Philip Somerset 1944- *WhoAmA 73, -76, -78*
Rice, Prosper *FolkA 86*
Rice, R *FolkA 86*
Rice, Richard Austin 1846-1925 *WhAmArt 85*

Rice, Richard Lawrence 1925- *AmArch 70*
Rice, Richard Lee 1919- *AmArch 70*
Rice, Richard N 1931- *AmArch 70*
Rice, Robert *NewYHSD*
Rice, Sandra 1949- *FolkA 86*
Rice, Shelley Enid 1950- *WhoAmA 78, -80, -82, -84*
Rice, Susanne C *DcWomA, WhAmArt 85*
Rice, W W *NewYHSD*
Rice, William *NewYHSD*
Rice, William 1734?-1789 *BiDBrA*
Rice, William 1773-1847 *FolkA 86*
Rice, William C 1875-1928 *WhAmArt 85*
Rice, William M J 1854-1922 *WhAmArt 85*
Rice, William Maxwell 1917- *AmArch 70*
Rice, William S 1873-1963 *WhAmArt 85*
Rice, William Seltzer 1873- *ArtsAmW 2, IlBEAAW*
Rice-Keller, Inez d1928 *DcWomA, WhAmArt 85*
Rice-Meyerowitz, Jenny *WhAmArt 85*
Rich *FolkA 86*
Rich, A H *NewYHSD*
Rich, Alfred William 1856-1921 *ClaDrA, DcBrA 1, DcBrWA, DcVicP 2*
Rich, Anthony *DcBrBI, DcVicP 2*
Rich, Charles A *ArtsEM*
Rich, Charles Alonzo 1855-1943 *BiDAmAr, MacEA*
Rich, Daniel Catton 1904- *WhoAmA 73, -76*
Rich, Daniel Catton 1904-1976 *WhoAmA 78N, -80N, -82N, -84N*
Rich, David Tenneson 1929- *AmArch 70*
Rich, E *DcBrBI*
Rich, Frances L 1910- *WhAmArt 85, WhoAmA 73, -76, -78, -80, -82, -84*
Rich, Frederick W *DcVicP 2*
Rich, Garry Lorence 1943- *WhoAmA 73, -76, -78, -80, -82, -84*
Rich, George *WhAmArt 85*
Rich, H B *AmArch 70*
Rich, Harvey J *NewYHSD*
Rich, Howard Leonard 1905- *AmArch 70*
Rich, James *FolkA 86*
Rich, James Rogers 1847-1910 *WhAmArt 85*
Rich, James William 1918- *AmArch 70*
Rich, Joe Lynn 1924- *AmArch 70*
Rich, John *FolkA 86*
Rich, John 1786-1871 *FolkA 86*
Rich, John Hubbard d1955? *WhAmArt 85*
Rich, John Hubbard 1876- *ArtsAmW 1*
Rich, Katharina *WhoAmA 80*
Rich, Katharina 1937- *WhoAmA 82*
Rich, Kenneth E 1943- *MarqDCG 84*
Rich, Lorimer 1891- *AmArch 70*
Rich, Lorimer 1892-1978 *WhoAmA 80N, -82N, -84N*
Rich, Merrill Shackleton 1916- *AmArch 70*
Rich, Obadiah 1809-1888 *BnEnAmA*
Rich, P F *AmArch 70*
Rich, R L *WhAmArt 85*
Rich, Sheldon *FolkA 86*
Rich, Waldo Leon 1853-1930 *WhAmArt 85*
Rich, William George *DcVicP 2*
Rich-Perlow, Katharina 1937- *WhoAmA 84*
Richard, Alexandre Louis Marie Theodore 1782-1859 *ClaDrA*
Richard, Augustine Francoise 1829-1857 *DcWomA*
Richard, Betti 1916- *WhoAmA 73, -76, -78, -80, -82*
Richard, Bruce Nugent *AfroAA*
Richard, Charlotte Josephine 1791- *DcWomA*
Richard, Christine *DcWomA*
Richard, George Mairet 1923- *WhoAmA 76, -78, -80*
Richard, Helene *DcWomA*
Richard, Henri *WhAmArt 85*
Richard, Hortense 1847- *DcWomA*
Richard, Hortense 1860- *DcWomA*
Richard, J *FolkA 86*
Richard, Jack 1922- *WhoAmA 76, -78, -80, -82, -84*
Richard, Jacob 1883- *WhAmArt 85*
Richard, John H 1807?- *NewYHSD*
Richard, Louis 1869-1940 *WhAmArt 85*
Richard, Louise Aurelie *DcWomA*
Richard, Marie Louise 1874- *DcWomA*
Richard, Melanie *DcWomA*
Richard, Octavie *DcWomA*
Richard, Paul 1939- *WhoAmA 73, -76, -78, -80, -82, -84*
Richard, R *DcVicP 2*
Richard, Richard Valerion 1915- *AmArch 70*
Richard, Stephen *NewYHSD*
Richard, Suzanne 1896- *DcWomA*
Richard, William D 1909- *AfroAA*
Richard And Dike *CabMA*
Richard-Bascoules, Jeanne 1892- *DcWomA*
Richard-Bouffe, Pauline 1837- *DcWomA*
Richard-Chaponet, Marie Eugenie 1867- *DcWomA*
Richard-Dumazeau, Marguerite 1892- *DcWomA*
Richard-Fogg, Mark E 1949- *MarqDCG 84*
Richard-Gallois, Madame *DcWomA*
Richard-Hennecart, Francine 1881- *DcWomA*
Richard Sheppard, Robson *NewYHSD*
Richard-Sordoillet, Marguerite 1872- *DcWomA*
Richard-Sordouillet, Marguerite 1872- *DcWomA*
Richard-Troncy, Laura Anning 1867-1950 *DcWomA*
Richard-Vergne, Jeanne 1871- *DcWomA*

Richardby, James 1776?-1846 *BiDBrA*
Richardi, J V *AmArch 70*
Richardin, Madame *DcWomA*
Richards *DcBrECP, FolkA 86*
Richards, Mademoiselle *DcWomA*
Richards, A A *AmArch 70*
Richards, Aimee G *DcVicP 2*
Richards, Albert 1888- *DcBrA 1*
Richards, Albert 1919-1945 *DcBrA 1*
Richards, Albert F 1859-1944 *DcBrA 1, DcVicP 2*
Richards, Alice S *DcVicP 2*
Richards, Anna *DcVicP 2*
Richards, Anna M 1870- *WhAmArt 85*
Richards, Anna Mary 1870-1952 *DcWomA*
Richards, Benjamin *NewYHSD*
Richards, Bill 1936- *WhoAmA 76, -78, -80, -82, -84*
Richards, Bill 1944- *WhoAmA 84*
Richards, Burr 1917- *AmArch 70*
Richards, Carrie *DcWomA*
Richards, Ceri 1903- *McGDA*
Richards, Ceri 1903-1971 *ConArt 77, OxTwCA, PhDcTCA 77, WorArt[port]*
Richards, Ceri Geraldus 1903-1971 *DcBrA 1*
Richards, Charles *DcVicP, -2*
Richards, Charles Alfred 1940- *AmArch 70*
Richards, Charles K *WhAmArt 85*
Richards, Charles Russell 1865-1936 *WhAmArt 85*
Richards, Clarence E 1865-1921 *BiDAmAr*
Richards, David 1828-1897 *NewYHSD*
Richards, David 1829-1897 *WhAmArt 85*
Richards, David Taliesin 1932- *AmArch 70*
Richards, Donald Frederick 1929- *AmArch 70*
Richards, Donald James 1926- *AmArch 70*
Richards, E M *WhAmArt 85*
Richards, E Margaret 1918- *WhoArt 80, -82, -84*
Richards, Earl G 1926- *AmArch 70*
Richards, Edward *AntBDN Q, CabMA, DcBrECP*
Richards, Elizabeth *FolkA 86*
Richards, Ella E *DcWomA, WhAmArt 85*
Richards, Emma *DcWomA*
Richards, Emma Gaggiotti 1825-1912 *DcVicP 2*
Richards, Ernest V 1859-1915 *BiDAmAr*
Richards, Eugene 1944- *ICPEnP A, MacBEP, WhoAmA 80, -82, -84*
Richards, Eva *WorFshn*
Richards, F DeBerg 1822-1903 *ArtsAmW 3*
Richards, Fanny *DcVicP 2*
Richards, Frances 1903- *DcBrA 1, OxTwCA, WhoArt 80, -82, -84*
Richards, Frank *DcBrA 1, DcBrBI, DcVicP 2*
Richards, Frank Pierson 1852-1929 *FolkA 86*
Richards, Frederick Charles 1878-1932 *DcBrWA*
Richards, Frederick Charles 1887-1932 *DcBrA 1*
Richards, Frederick DeBourg 1822-1903 *IlBEAAW, NewYHSD , WhAmArt 85*
Richards, Frederick T 1864-1921 *WhAmArt 85, WorECar*
Richards, Frenchie *AfroAA*
Richards, G E *DcBrBI*
Richards, George *BiDBrA, DcVicP 2*
Richards, George M 1880- *WhAmArt 85*
Richards, George Mather 1880- *IlsCB 1744*
Richards, Gertrude Lundborg *WhAmArt 85*
Richards, Glenora 1909- *WhoAmA 84*
Richards, H *AmArch 70, DcVicP 2*
Richards, Harriet R d1932 *WhAmArt 85*
Richards, Harriet Roosevelt *DcWomA*
Richards, Helena *DcVicP 2*
Richards, Henry *DcVicP 2*
Richards, Ian Lindsay 1932- *ClaDrA*
Richards, Ida *DcWomA*
Richards, J *DcBrECP, DcVicP 2*
Richards, J G *AmArch 70*
Richards, J G, IV *AmArch 70*
Richards, J R *NewYHSD*
Richards, James d1902? *BiDAmAr*
Richards, James D 1954- *MarqDCG 84*
Richards, Jeanne Herron *WhoAmA 73, -76, -78, -80, -82, -84*
Richards, John *WhAmArt 85*
Richards, John 1690-1778 *BiDBrA*
Richards, John 1806-1834 *CabMA*
Richards, John 1831-1889 *FolkA 86, NewYHSD*
Richards, John H *NewYHSD*
Richards, John H 1807?- *NewYHSD*
Richards, John Inigo 1720?-1810 *DcBrWA*
Richards, John Inigo 1731-1810 *DcBrECP*
Richards, John Noble 1904- *AmArch 70*
Richards, John Paul *IlsBYP*
Richards, Joseph Edward 1921- *WhoAmA 80, -82, -84*
Richards, Karl Frederick 1920- *WhoAmA 73, -76, -78, -80, -82, -84*
Richards, Larry *ConArch A*
Richards, Larry George 1942- *MarqDCG 84*
Richards, Lee 1932- *WhoAmA 76, -78, -80*
Richards, Lee Green 1878-1950 *ArtsAmW 1*
Richards, Lee Greene 1878-1950 *IlBEAAW, WhAmArt 85*
Richards, Letitia *DcWomA*
Richards, Lisle Frederick 1909- *AmArch 70*

Richards, Lucy Currier DcWomA, WhAmArt 85
Richards, Margaret A ArtsEM, DcWomA
Richards, Meredith Martin 1941- MarqDCG 84
Richards, Myra R 1882-1934 WhAmArt 85
Richards, Myra Reynolds 1882-1934 DcWomA
Richards, N NewYHSD
Richards, Orren C 1842- ArtsNiC
Richards, Patricia 1935- WhoArt 80, -82, -84
Richards, Richard Peter 1840-1877 DcBrWA,
 DcVicP 2
Richards, S B AmArch 70
Richards, Samuel G 1853-1893 ArtsAmW 3
Richards, Seymour AmArch 70
Richards, T DcVicP 2
Richards, T Addison 1820- ArtsNiC
Richards, Tally WhoAmA 78, -80, -82, -84
Richards, Thomas BiDAmAr
Richards, Thomas Addison 1820-1900 EarABI,
 NewYHSD , WhAmArt 85
Richards, Thomas W NewYHSD
Richards, Thomas W 1937- MarqDCG 84
Richards, W DcBrWA, DcVicP 2
Richards, W G AmArch 70
Richards, W S DcVicP 2
Richards, Walter D 1907- IlrAm E
Richards, Walter DuBois 1907- IlrAm 1880,
 WhAmArt 85
Richards, Walter Dubois 1907-
 WhoAmA 76, -78, -80, -82,
 -84
Richards, Westley AntBDN F
Richards, William BiDBrA
Richards, William 1871-1945 BiDAmAr
Richards, William Phillip 1858-1925 BiDAmAr
Richards, William T 1833- ArtsNiC
Richards, William Trost DcBrWA, DcVicP 2
Richards, William Trost 1833-1905 ArtsAmW 3,
 BnEnAmA, DcAmArt, EarABI, NewYHSD ,
 WhAmArt 85
Richardson FolkA 86
Richardson, Mrs. DcWomA
Richardson, Mrs. A M DcWomA,
 WhAmArt 85
Richardson, Agnes 1885-1951 DcWomA
Richardson, Agnes E DcVicP 2
Richardson, Albert E 1880-1964 MacEA
Richardson, Sir Albert Edward 1880-1964 DcBrA 1
Richardson, Alice DcBrECP
Richardson, Ambrose Madison 1917- AmArch 70
Richardson, Andrew 1799-1876 NewYHSD
Richardson, Arthur IlDcG
Richardson, Arthur 1865-1928 DcBrA 1, DcBrWA,
 DcVicP 2
Richardson, Ben AfroAA
Richardson, Benjamin AntBDN H, DcNiCA
Richardson, Benjamin 1835-1926 NewYHSD
Richardson, Benjamin, I IlDcG
Richardson, Benjamin, III IlDcG
Richardson, Benjamin J 1835-1926 WhAmArt 85
Richardson, Brenda 1942- WhoAmA 76, -78, -80, -82,
 -84
Richardson, Caroline DcWomA
Richardson, Catherine Priestly 1900- WhAmArt 85
Richardson, Charles DcBrBI, DcVicP
Richardson, Charles 1829-1908 DcBrA 1, DcBrBI,
 DcBrWA, DcVicP 2
Richardson, Mrs. Charles DcVicP 2, DcWomA
Richardson, Charles E DcVicP 2
Richardson, Charles J 1809-1871 MacEA
Richardson, Charles James 1806-1871 DcBrBI,
 DcBrWA, DcVicP 2
Richardson, Charles M 1943- MarqDCG 84
Richardson, Charles Verne 1922- AmArch 70
Richardson, Christopher Columbus d1826 CabMA
Richardson, Clara Virginia 1855- WhAmArt 85
Richardson, Clara Virginia 1855-1933 DcWomA
Richardson, Constance 1905- WhoAmA 73, -76, -78,
 -80, -82, -84
Richardson, Constance Coleman 1905- WhAmArt 85
Richardson, D W AmArch 70
Richardson, Daniel DcBrECP
Richardson, David L 1934- AmArch 70
Richardson, David L 1949- MarqDCG 84
Richardson, David Lafayette 1937- AmArch 70
Richardson, Donald Wayne 1926- AmArch 70
Richardson, E A DcWomA
Richardson, E R AmArch 70
Richardson, Earl 1912-1935 WhAmArt 85
Richardson, Earle Wilton 1913-1935 AfroAA
Richardson, Ebenezer CabMA
Richardson, Ed ArtsAmW 3
Richardson, Ed 1927- AfroAA
Richardson, Edgar P 1902-1985 WhAmArt 85
Richardson, Edgar Preston 1902- WhoAmA 73, -76,
 -78, -80, -82, -84
Richardson, Edith 1867- DcBrA 1, DcVicP 2,
 DcWomA
Richardson, Edmond Thompson 1919- AmArch 70
Richardson, Edward 1810-1874 DcVicP
Richardson, Edward, Jr. 1824-1858 FolkA 86

Richardson, Edward M ArtsAmW 3
Richardson, Edward M 1810-1874 DcBrWA,
 DcVicP 2
Richardson, Eileen WorFshn
Richardson, Elisha CabMA
Richardson, Ellen DcVicP 2
Richardson, Emma DcWomA
Richardson, Eri Horner 1909- AmArch 70
Richardson, Esdaile DcVicP 2
Richardson, Esther Ruble 1895- DcWomA,
 WhAmArt 85
Richardson, Mrs. Evans T ArtsEM, DcWomA
Richardson, F W DcVicP 2
Richardson, Florence Wood WhAmArt 85
Richardson, Francis AntBDN Q
Richardson, Francis 1681-1729 AntBDN Q,
 BnEnAmA
Richardson, Francis 1705?-1782 BnEnAmA
Richardson, Francis B FolkA 86
Richardson, Francis H 1859-1934 WhAmArt 85
Richardson, Frank, Jr. 1950- WhoAmA 76, -78, -80,
 -82, -84
Richardson, Frederic Stuart 1855-1934 DcBrA 1,
 DcVicP, -2
Richardson, Frederick NewYHSD
Richardson, Frederick 1862- ConICB
Richardson, Frederick 1862-1937 WhAmArt 85
Richardson, Frederick Stuart 1855-1934 DcBrWA
Richardson, Frederick William 1924- MarqDCG 84
Richardson, G C DcVicP 2
Richardson, Geoffrey Philip 1928- WhoArt 80, -82,
 -84
Richardson, George AntBDN M, FolkA 86,
 NewYHSD
Richardson, George d1813? BiDBrA, MacEA
Richardson, George 1740?-1813? DcBrWA
Richardson, George 1808-1840 DcBrWA, DcVicP, -2
Richardson, George Luther 1894- AmArch 70
Richardson, Gerard 1910- WhoAmA 73
Richardson, Gretchen WhoAmA 73, -76, -78, -80,
 -82, -84
Richardson, H H 1838-1886 MacEA
Richardson, Harold B WhAmArt 85
Richardson, Harry L DcVicP 2
Richardson, Harry Linley 1878-1947 DcBrA 1
Richardson, Harry S AfroAA
Richardson, Henry NewYHSD
Richardson, Henry Burdon DcVicP
Richardson, Henry Burdon 1811-1874 DcBrBI,
 DcBrWA, DcVicP 2
Richardson, Henry C WhAmArt 85
Richardson, Henry Gethin IlDcG
Richardson, Henry Hobson 1836-1886 BnEnAmA
Richardson, Henry Hobson 1838-1886 BiDAmAr,
 DcD&D, EncAAr, EncMA, McGDA, OxArt,
 WhoArch
Richardson, Hugh 1898- AmArch 70
Richardson, J DcBrWA
Richardson, J F NewYHSD
Richardson, J T DcVicP 2
Richardson, James B WhAmArt 85
Richardson, James H NewYHSD
Richardson, James Lewis 1927- WhoAmA 76, -78,
 -80N, -82N, -84N
Richardson, John FolkA 86
Richardson, John 1774-1865? BiDBrA
Richardson, John Adkins 1929- WhoAmA 82, -84
Richardson, John Frederick 1906- WhAmArt 85
Richardson, John Frederick 1912- WhoArt 80, -82,
 -84
Richardson, John Isaac 1836-1913 DcBrA 1,
 DcBrWA, DcVicP 2
Richardson, John J 1836-1913 ClaDrA, DcVicP
Richardson, John Newton 1837-1902 BiDAmAr
Richardson, John Vinson 1949- MarqDCG 84
Richardson, Jonathan IlDcG
Richardson, Jonathan 1665-1745 ClaDrA, OxArt
Richardson, Jonathan, Jr. 1694-1771 DcBrECP
Richardson, Jonathan, Sr. 1665?-1745 DcBrECP
Richardson, Joseph 1711-1784 AntBDN Q,
 BnEnAmA
Richardson, Joseph, Jr. 1752-1831 AntBDN Q,
 BnEnAmA
Richardson, Joseph Kent DcBrA 1
Richardson, Joseph Priestley 1913- AmArch 70
Richardson, Judith Heidler 1942- WhoAmA 73
Richardson, Kathleen R 1900- DcBrA 1
Richardson, Kenneth Eugene 1909- AmArch 70
Richardson, L C NewYHSD
Richardson, L D AmArch 70
Richardson, Louis H WhAmArt 85
Richardson, Maggie DcWomA
Richardson, Marcella ArtsEM, DcWomA
Richardson, Margaret DcWomA
Richardson, Margaret F WhAmArt 85
Richardson, Margaret Foster 1881- DcWomA
Richardson, Maria ArtsEM, DcWomA
Richardson, Marion 1877- DcWomA, WhAmArt 85
Richardson, Mary 1848-1931 DcWomA
Richardson, Mary Curtis 1848-1931 ArtsAmW 1,
 WhAmArt 85

Richardson, Mary N 1859- WhAmArt 85
Richardson, Mary Nettie Neal 1859-1937 DcWomA
Richardson, Murlin Keith 1923- AmArch 70
Richardson, Nathaniel 1754-1827 AntBDN Q,
 BnEnAmA
Richardson, Phyllis A 1941- WhoAmA 76, -78
Richardson, R FolkA 86
Richardson, R Esdaile DcVicP 2
Richardson, R W, Jr. AmArch 70
Richardson, Rachel M 1896-1941 WhAmArt 85
Richardson, Rachel Madeley 1896-1941 DcWomA
Richardson, Ralph J DcBrBI, DcVicP 2
Richardson, Richard AntBDN Q, NewYHSD
Richardson, Robert L 1935- MarqDCG 84
Richardson, Roland 1944- PrintW 83, -85
Richardson, Rome K 1877- WhAmArt 85
Richardson, S NewYHSD
Richardson, S E AmArch 70
Richardson, S H AmArch 70
Richardson, Sam 1934- AmArt, DcCAA 77,
 DcCAr 81, WhoAmA 73, -76, -78, -80, -82, -84
Richardson, Mrs. Samuel NewYHSD
Richardson, Sarah WhAmArt 85
Richardson, Stephen W CabMA
Richardson, T M ArtsNiC, NewYHSD
Richardson, Theodore J 1855-1914 ArtsAmW 2,
 WhAmArt 85
Richardson, Theodore Scott WhAmArt 85
Richardson, Thomas FolkA 86
Richardson, Thomas Miles 1784-1848 DcBrBI,
 DcBrWA
Richardson, Thomas Miles 1813-1890 DcBrWA
Richardson, Thomas Miles, Jr. 1813-1890 ClaDrA,
 DcBrBI, DcVicP, -2
Richardson, Thomas Miles, Sr. 1784-1848 DcVicP, -2
Richardson, V A 1880- WhAmArt 85
Richardson, Volney Allan 1880- ArtsAmW 2
Richardson, W H IlDcG
Richardson, Walter John 1926- AmArch 70
Richardson, Warren Robert AmArch 70
Richardson, Will WorFshn
Richardson, William DcBrWA, DcVicP, -2,
 FolkA 86
Richardson, William Alan, Jr. 1930- AmArch 70
Richardson, William Alma 1929- AmArch 70
Richardson, William C 1854-1935 BiDAmAr
Richardson, William Cummings 1854-1935 MacEA
Richardson, William David, Jr. 1937- AmArch 70
Richardson, William Dudley 1862-1929 DcBrA 1
Richardson, William H AfroAA
Richardson, William Haden IlDcG
Richardson, William Ralph 1930- AmArch 70
Richardson, William S 1873-1931 BiDAmAr
Richardson, Z B DcWomA
Richardt, Ferdinand Joachim 1819-1895 IlBEAAW,
 NewYHSD
Richardt, Joachim Ferdinand 1819-1895 ArtsAmW 1
Richarson, J V DcVicP 2
Richarson, R DcVicP 2
Richart, Emma Belle DcWomA
Richarz, Hermann F 1937- MarqDCG 84
Richbell, Thomas DcBrECP, DcBrWA
Richberg, Alexander AfroAA
Riche, Adele 1791-1878 DcWomA
Richenburg, Robert B 1917- DcCAA 71, -77
Richenburg, Robert Bartlett 1917- WhoAmA 73, -76,
 -78, -80, -82, -84
Richer, Donny WorFshn
Richer, Madeleine Marie 1668?-1708 DcWomA
Richerson, Michael E 1950- MarqDCG 84
Richert, Charles Henry 1880- WhAmArt 85
Richert, Renee 1894- DcWomA
Richert, Robert OfPGCP 86
Richert, Roger Raymond 1935- AmArch 70
Riches NewYHSD
Richet, Leon ArtsNiC
Richey, Clemence DcWomA
Richey, G T AmArch 70
Richey, Oakley E 1902- WhAmArt 85
Richey, Robert Lee 1923- AmArch 70
Richez, Jacques 1918- WhoGrA 62, -82[port]
Richie, G R AmArch 70
Richie, Harold AfroAA
Richier, Gerard 1534-1601 McGDA
Richier, Germaine 1904-1959 ConArt 77, -83,
 McGDA, OxTwCA, PhDcTCA 77, WomArt,
 WorArt[port]
Richier, Jacob 1585?-1640? McGDA
Richier, Jean 1581-1624 McGDA
Richier, Ligier 1500?-1567? McGDA
Richier, Ligier 1500?-1567 OxArt
Richino, Francesco Maria McGDA
Richir, Herman Jean Joseph 1866- ClaDrA
Richman, Harry Bernard 1922- AmArch 70
Richman, Marvin J AmArch 70
Richman, Robert M 1914- WhoAmA 73, -76, -78, -80,
 -82, -84
Richmond, A D FolkA 86
Richmond, Agnes M WhAmArt 85
Richmond, Agnes M 1870?-1964 DcWomA
Richmond, Almond WhAmArt 85

Richmond, C, Jr. *AmArch 70*
Richmond, Catherine B *AfroAA*
Richmond, Donald Edward 1929- *WhoArt 80, -82, -84*
Richmond, Dorothy Kate 1861-1935 *OxArt*
Richmond, Douglas Arthur Robert *WhoArt 82N*
Richmond, Douglas Arthur Robert *WhoArt 80*
Richmond, Evelyn K 1872- *ArtsAmW 2, DcWomA, WhAmArt 85*
Richmond, Evelyn N *WhAmArt 85*
Richmond, Frederick W 1923- *WhoAmA 73, -76, -78, -80, -82*
Richmond, Gaylord D 1903- *WhAmArt 85*
Richmond, George 1809- *ArtsNiC*
Richmond, George 1809-1896 *ClaDrA, DcBrWA, DcVicP, -2, McGDA, OxArt*
Richmond, George S *EncASM*
Richmond, Henry Glen 1937- *AmArch 70*
Richmond, Isidor 1893- *AmArch 70*
Richmond, James C *DcVicP 2*
Richmond, James Crowe 1822-1898 *OxArt*
Richmond, Jim 1939- *PrintW 85*
Richmond, John *BiDBrA*
Richmond, Julia *DcVicP 2, DcWomA*
Richmond, Lawrence 1909- *WhoAmA 73, -76, -78, -80*
Richmond, Lawrence 1909-1978 *WhoAmA 80N, -82N, -84N*
Richmond, Leonard *IlBEAAW*
Richmond, Leonard d1965 *ArtsAmW 3, DcBrA 1*
Richmond, Oliffe *WhoArt 80N*
Richmond, R C 1867- *WhAmArt 85*
Richmond, R E *AmArch 70*
Richmond, Rebekah *WhoAmA 84*
Richmond, Ronald R 1933- *AmArch 70*
Richmond, S S *AmArch 70*
Richmond, Thomas 1771-1837 *AntBDN J*
Richmond, Thomas 1802-1874 *DcBrWA*
Richmond, Thomas, Jr. 1802-1874 *DcVicP, -2*
Richmond, Thomas Robert 1930- *AmArch 70*
Richmond, William Blake 1842-1874 *ClaDrA*
Richmond, Sir William Blake 1842-1921 *DcBrA 1, DcVicP, -2*
Richmonde *CabMA*
Richomme, Celeste 1839- *DcWomA*
Richomme, Jules 1818- *ArtsNiC*
Richter *EncASM*
Richter, Abner A 1873-1925? *BiDAmAr*
Richter, Adrian Ludwig 1803-1884 *ArtsNiC, ClaDrA, McGDA, OxArt*
Richter, Aimee *DcWomA*
Richter, Albert B 1845-1898 *ArtsAmW 1, IlBEAAW*
Richter, Alexander 1904- *AmArch 70*
Richter, C E *AmArch 70*
Richter, Caroline *DcWomA*
Richter, Charles Henry, Jr. 1922- *AmArch 70*
Richter, E J *FolkA 86*
Richter, Emil H *WhAmArt 85*
Richter, Erica 1869- *DcWomA*
Richter, Etha 1883- *DcWomA*
Richter, George A *WhAmArt 85*
Richter, George Martin 1875-1942 *WhAmArt 85*
Richter, Gerd 1932- *OxTwCA, PhDcTCA 77*
Richter, Gerhard 1932- *ConArt 77, -83, DcCAr 81, PrintW 85*
Richter, Giesela Marie Augusta 1882-1972 *WhAmArt 85*
Richter, Gisela Marie Augusta 1882- *WhoArt 80, -82, -84*
Richter, Gisela Marie Augusta 1882-1972 *WhoAmA 78N, -80N, -82N, -84N*
Richter, Gustav 1822?-1884 *ArtsNiC*
Richter, H *DcVicP 2*
Richter, Hank 1928- *WhoAmA 78, -80, -82, -84*
Richter, Hans 1888-1976 *ConArt 77, -83, OxTwCA, PhDcTCA 77, WhoAmA 78N, -80N, -82N, -84N, WorECar*
Richter, Harry Edward 1931- *MarqDCG 84*
Richter, Heinrich 1920- *DcCAr 81, PhDcTCA 77*
Richter, Helene *DcWomA*
Richter, Henrietta S *DcWomA*
Richter, Henry J 1772-1857 *BkIE*
Richter, Henry James 1772-1857 *DcBrWA, DcVicP 2*
Richter, Henry L 1870- *ArtsAmW 1*
Richter, Henry L 1871- *WhAmArt 85*
Richter, Henry Leopold 1870-1960 *ArtsAmW 3*
Richter, Herbert Davis 1874-1955 *DcBrA 1, DcBrWA, DcVicP 2*
Richter, Irma Anne *DcBrA 1*
Richter, Irma Anne 1876-1956 *DcWomA*
Richter, Johan 1665-1745 *McGDA*
Richter, Johanna Juliana Friederike *DcWomA*
Richter, Julius 1876- *WhAmArt 85*
Richter, Lillian *AfroAA*
Richter, Lillian 1915- *WhAmArt 85*
Richter, Louise C 1918- *WhAmArt 85*
Richter, M *DcVicP 2*
Richter, Mischa 1910- *WhAmArt 85*
Richter, Mischa 1912- *WorECar*
Richter, Richard *NewYHSD*
Richter, Roger William 1933- *AmArch 70*

Richter, Therese Caroline 1777-1865 *DcWomA*
Richter, Uli 1926- *WorFshn*
Richter, Vjenceslav 1917- *PhDcTCA 77*
Richter, W S *AmArch 70*
Richter, Willibald *DcBrBI*
Richter, Wilmer Siegfried 1891- *WhAmArt 85*
Richter-Johnsen, Friedrich-Wilhelm 1912- *WorECom*
Rick, Robert Gordon 1915- *AmArch 70*
Rickard, Bruce 1929- *ConArch*
Rickard, Gino 1961- *DcCAr 81*
Rickard, Jack 1922- *WorECar*
Rickard, Marjorie Rey 1893-1968 *ArtsAmW 2, DcWomA*
Rickard, Stephen 1917- *DcBrA 1, WhoArt 80, -82, -84*
Rickards, Edwin A 1872-1920 *DcBrBI*
Rickards, R *DcBrECP*
Rickards, T W *DcVicP 2*
Rickatson, Octavius *DcVicP, -2*
Rickenbacher, Paul 1907- *DcCAr 81*
Rickenback, Robert 1923- *AmArch 70*
Rickenbaker, Thomas Carlisle 1928- *AmArch 70*
Ricker, F J *AmArch 70*
Ricker, Grace *WhAmArt 85*
Ricker, Henry *CabMA*
Ricker, Lorin Max 1952- *MarqDCG 84*
Ricker, N C 1843-1924 *MacEA*
Ricker, Nathan C 1843-1924 *BiDAmAr*
Ricker, William Edward 1915- *AmArch 70*
Rickerby, Arthur 1921-1972 *ICPEnP A, MacBEP*
Rickerby, Eliza Greenup *DcWomA*
Rickert, J *NewYHSD*
Rickert, R A *AmArch 70*
Ricket, Jacob *FolkA 86*
Ricket, Thomas *NewYHSD*
Ricketson *EncASM*
Ricketson, Walton 1839- *WhAmArt 85*
Ricketson, Walton 1839-1923 *NewYHSD*
Ricketts *FolkA 86*
Ricketts, Agnes Fairlie *WhAmArt 85*
Ricketts, C *DcVicP 2*
Ricketts, Charles 1866-1931 *AntBDN A, -B, -C, ClaDrA, DcBrA 1, McGDA, OxArt, OxDecA, PhDcTCA 77*
Ricketts, Charles DeSousy 1866-1931 *DcBrBI, DcBrWA, DcVicP 2*
Ricketts, Charles Robert *DcBrBI, DcSeaP, DcVicP 2*
Ricketts, John *BiDBrA*
Ricketts, William C *DcVicP 2*
Rickey, Carrie Deborah 1952- *WhoAmA 80, -82*
Rickey, George 1907- *AmArt, BnEnAmA, ConArt 83, DcAmArt, DcCAA 71, -77, OxTwCA, PhDcTCA 77*
Rickey, George W 1907- *WhoAmA 73, -76, -78, -80, -82, -84*
Rickey, George Warren 1907- *ConArt 77, DcCAr 81, WhAmArt 85, WorArt[port]*
Rickey, Kenneth Charles 1914- *AmArch 70*
Rickly, Jessie Beard 1895- *WhAmArt 85*
Rickman, Philip 1891- *DcBrA 1, WhoArt 80, -82, -84*
Rickman, Thomas 1776-1841 *BiDBrA, DcBrWA, DcD&D, MacEA, McGDA, OxArt*
Rickner, Louis *NewYHSD*
Ricks, Donus W 1933- *AmArch 70*
Ricks, James *DcVicP 2*
Ricks, Percy 1923- *AfroAA*
Ricks, Roy L 1930- *AmArch 70*
Rickson, Gary A 1942- *AfroAA*
Rico, Andreas *McGDA*
Rico, Dan 1912- *WhAmArt 85*
Rico, Martin 1835-1908 *OxArt*
Rico Y Ortega, Martin 1833-1908 *ClaDrA*
Ricois, Octavie *DcWomA*
Ricord, Patrice 1947- *WhoGrA 82[port]*
Ricozzi, A *DcVicP 2*
Ridabock, Ray 1904- *WhoAmA 73*
Ridabock, Ray 1904-1970 *WhAmArt 85, WhoAmA 76N, -78N, -80N, -82N, -84N*
Ridcocks, E F *DcBrBI*
Riddel, James d1928 *ClaDrA*
Riddel, James 1857-1928 *DcBrA 1, DcVicP 2*
Riddel, John *DcBrWA*
Riddell, Annette Irwin *WhAmArt 85*
Riddell, Annie *DcWomA, WhAmArt 85*
Riddell, Bruce 1944- *DcCAr 81*
Riddell, Lady Buchanan *DcVicP 2*
Riddell, J A *AmArch 70*
Riddell, R A *DcBrECP*
Riddell, Robert Andrew *DcBrBI, DcBrWA*
Riddell, Thomas *BiDBrA*
Riddell, Wdem *DcVicP 2*
Riddell, William Wallace 1877- *WhAmArt 85*
Riddell, William Wallace 1877-1948 *ArtsAmW 2*
Ridder, Arthur *WhAmArt 85*
Ridder, Willem De *OxTwCA*
Ridderbosch, Jeanne Francoise 1754-1837 *DcWomA*
Riddet, Michael James *OfPGCP 86*
Riddett, Leonard Charles *DcVicP 2*
Riddick, George P, III 1948- *MarqDCG 84*

Riddle, Alice *DcWomA*
Riddle, Alice 1892- *WhAmArt 85*
Riddle, C W *WhAmArt 85*
Riddle, G D *AmArch 70*
Riddle, H J *AmArch 70*
Riddle, Hannah *FolkA 86*
Riddle, Harry Earle, Jr. 1929- *AmArch 70*
Riddle, Herbert H 1875-1939 *BiDAmAr*
Riddle, Hugh Joseph 1912- *DcBrA 1, WhoArt 80*
Riddle, John *DcBrA 2*
Riddle, John T 1933- *AfroAA*
Riddle, John Thomas, Jr. 1933- *WhoAmA 80, -82, -84*
Riddle, L M *AmArch 70*
Riddle, Mary Althea *WhAmArt 85*
Riddle, Mary M 1876- *DcWomA, WhAmArt 85*
Riddle, Morton 1909- *FolkA 86*
Riddle, Mrs. Theodate P d1946 *BiDAmAr*
Riddle, Theodate Pope 1868-1946 *MacEA*
Riddle, W D *AmArch 70*
Riddle, William L 1936- *AmArch 70*
Riddle, William R *NewYHSD*
Riddles, Leonard 1910- *IlBEAAW*
Riddlesbarger, Sara K 1869- *ArtsAmW 3, DcWomA*
Ride, T *DcBrECP*
Ride, William *BiDBrA*
Rideau DuSal, Henriette *DcWomA*
Rideau-Paulet, Marie Thelika 1853- *DcWomA*
Ridel, Louis Marie Joseph 1866- *ClaDrA*
Ridelstein, Maria Elisabeth Von 1884- *DcWomA*
Ridelstein, Maria Von 1885-1970 *ArtsAmW 3*
Ridenour, William Clyde 1923- *AmArch 70*
Rideout, Alice 1874?- *DcWomA*
Rideout, Philip H *DcBrA 1, DcVicP 2*
Rider *BiDBrA*
Rider, Alan Hamilton 1931- *AmArch 70*
Rider, Alexander *NewYHSD*
Rider, Arthur Grover 1886- *ArtsAmW 2, WhAmArt 85*
Rider, Charles Joseph 1880- *ArtsAmW 2, WhAmArt 85*
Rider, Donald Charles 1924- *AmArch 70*
Rider, Elijah *CabMA*
Rider, H *DcVicP 2*
Rider, Henry Orne 1860- *WhAmArt 85*
Rider, John *DcBrWA, DcVicP 2*
Rider, Lydia 1755- *FolkA 86*
Rider, Michael Allan 1946- *WhoAmA 80, -82*
Rider, Myra Bell Chamberlain 1839?- *ArtsEM, DcWomA*
Rider, Peter *FolkA 86*
Rider, Richard *BiDBrA*
Rider, Urban *DcVicP 2*
Rider, William *DcBrWA, DcVicP 2*
Rider, Wini *WorFshn*
Ridgely, Frances Summers 1892- *DcWomA, WhAmArt 85*
Ridgeway, Bindsall *FolkA 86*
Ridgeway, Caroline *FolkA 86*
Ridgeway, E *DcVicP 2*
Ridgeway, Ebenezer *CabMA*
Ridgeway, Ellen *DcWomA*
Ridgewell, William Leigh 1881-1937 *DcBrA 2*
Ridgway, James Clay 1932- *AmArch 70*
Ridgway, Job *DcNiCA*
Ridgway, John *DcNiCA*
Ridgway, Mary O *DcWomA*
Ridgway, Peggi 1942- *WhoAmA 84*
Ridgway, Samuel d1773 *CabMA*
Ridgway, W *NewYHSD*
Ridgway, William *DcNiCA*
Ridinger, Georg *McGDA*
Ridinger, Johann Elias 1698-1767 *McGDA*
Ridings, James Leonard 1937- *MarqDCG 84*
Ridley, Annie *DcVicP 2, DcWomA*
Ridley, B *DcBrBI*
Ridley, Edward 1883- *DcBrA 1*
Ridley, Essex *NewYHSD*
Ridley, Gregory D 1925- *AmArt*
Ridley, Gregory D, Jr. 1925- *AfroAA, WhoAmA 76, -78, -80, -82, -84*
Ridley, J T *AmArch 70*
Ridley, Mary *FolkA 86*
Ridley, Mathew White 1837-1888 *DcBrBI*
Ridley, Matthew White 1837-1888 *DcVicP, -2*
Ridley, Susan *DcWomA*
Ridley, W *DcVicP 2*
Ridlon, James A 1934- *WhoAmA 73, -76, -78, -80, -82, -84*
Ridolfi, Carlo 1594-1658 *OxArt*
Ridolfi, Mario 1904- *MacEA*
Ridosh, James J 1947- *MarqDCG 84*
Ridout, F J, Jr. *AmArch 70*
Ridyard, J M *AmArch 70*
Rie, Luci 1902- *McGDA*
Rie, Marguerite Van *DcWomA*
Riebe, A W *AmArch 70*
Riebel, G L *AmArch 70*
Rieben, John R *AmGrD[port]*
Rieben, John Robert 1935- *WhoGrA 82[port]*
Riebenstein, F *DcBrECP*
Rieber, Winifred 1872- *ArtsAmW 1*

Rieber, Winifred Smith 1872-1963 DcWomA
Riebesehl, Heinrich 1938- ConPhot, DcCAr 81, ICPEnP A, MacBEP
Rieck, Hellmuth DcCAr 81
Riecke, George 1848- WhAmArt 85
Ried, Benedikt 1454-1534 MacEA
Ried, Elisa DcWomA
Riedel, A FolkA 86
Riedel, Anton Henrich 1763-1809? ClaDrA
Riedel, August 1800- ArtsNiC
Riedel, August Heinrich 1799-1883 ClaDrA
Riedel, Claus Josef 1925- IlDcG
Riedel, Franz Anton 1786-1844 IlDcG
Riedel, Johanna 1854- DcWomA
Riedel, Josef IlDcG
Riedel, Josef 1816-1894 IlDcG
Riedel, Manfred Hansjoachim 1928- AmArch 70
Riedel, Maria Theresia 1720?-1792? DcWomA
Riedel, Mathilde DcWomA
Riedel, Willy Christian 1919- AmArch 70
Riedel Family IlDcG
Riedinger, Georg 1568-1616? McGDA
Riedl, Alois 1935- DcCAr 81
Riedl, Fritz 1923- OxTwCA
Riedy, Lorene M 1900- WhAmArt 85
Rief, Lynne Ann 1957- MarqDCG 84
Rief, Mark J 1956- MarqDCG 84
Riefenstahl, Leni 1902- ConPhot, ICPEnP A, MacBEP
Rieff, Christian FolkA 86
Rieff, Joseph BiDAmAr
Riefstahl, Rudolf Meyer 1880-1936 WhAmArt 85
Riefstahl, Wilhelm Ludwig Friedrich 1827- ArtsNiC
Riegel, L A AmArch 70
Riegel, Michael Byron 1946- WhoAmA 78, -80, -82, -84
Riegel, Simon 1807?- FolkA 86
Riegen, Nicolaas 1827-1889 DcSeaP
Rieger, Clara DcWomA
Rieger, Jenny DcWomA
Rieger, Maria DcWomA
Rieger, Michael L 1950- MarqDCG 84
Riegger, Harold Eaton 1913- CenC, WhAmArt 85
Riehl, George John DeBaptist 1900- AmArch 70
Riehl, Helene Christine 1850- DcWomA
Riek, Bob H 1934- AmArch 70
Riekarts, Frederick NewYHSD
Rieker, Albert George 1889-1959 WhAmArt 85, WhoAmA 80N, -82N, -84N
Riemann, George FolkA 86
Riemenschneider, Tilman 1460?-1531 McGDA
Riemer, Herbert W 1927- AmArch 70
Riemerschmid, Richard 1868-1957 DcNiCA, EncMA, MacEA, McGDA
Rieniets, James Henry 1937- AmArch 70
Rienzi, Anthony Thomas 1920- AmArch 70
Rieppel, Ludwig 1861-1960 WhAmArt 85, WhoAmA 80N, -82N, -84N
Riera, Maria DcWomA
Ries, Gerta WhAmArt 85
Ries, Henry 1917- ICPEnP A
Ries, James R 1934- MarqDCG 84
Ries, Martin 1926- AmArt, WhoAmA 73, -76, -78, -80, -82, -84
Ries, Teresa Feodorovna 1874?- DcWomA
Riesen, Carl H 1915- AmArch 70
Riesenberg, Sidney H 1885- ArtsAmW 1, IlBEAAW, WhAmArt 85
Riesener, Jean Henri 1734-1806 AntBDN G, McGDA
Riesener, Jean-Henri 1734-1806 DcD&D, OxDecA
Riesener, Louis-Antoine-Leon 1808-1878 ArtsNiC
Riesener, Louis Antoine Leon 1808-1878 ClaDrA
Riesener, Rosalie DcWomA
Riesenfeld, Richard F 1944- MarqDCG 84
Rieser, Dolf Eric WhoArt 84N
Rieser, Dolf Eric 1898- WhoArt 80, -82
Riesland, Alana Kathleen Cordy-Collins WhoAmA 78, -80
Riess, Lore WhoAmA 73, -76, -78, -80, -82, -84
Riess, Wilhelm 1856-1919 ArtsAmW 2
Riess, William 1856-1919 WhAmArt 85
Riess, William J 1856-1919 ArtsAmW 2
Riess, William L 1956- MarqDCG 84
Rietdorf, Vernon Joseph 1926- AmArch 70
Riethain, Dorothea Von DcWomA
Riethmuller, Aloise D DcWomA
Rietow, Robert G 1937- AmArch 70
Rietschel, Ernst Friedrich August 1804-1861 McGDA
Rietschof, Hendrik 1687-1746 DcSeaP
Rietschoof, Jan Claes 1652-1719 ClaDrA
Rietschoof, Jan Claesz 1652?-1719 DcSeaP
Rietveld, Albert 1884-1964 WhoArch
Rietveld, Gerrit 1888-1964 ConArch, DcD&D[port], MacEA, OxDecA
Rietveld, Gerrit Thomas 1888- EncMA
Rietveld, Gerrit Thomas 1888-1964 McGDA
Rietveld, Gerrit Thomas 1888-1965 OxArt
Rietz, John Jacob 1905- AmArch 70
Rieu, Alicia Del DcWomA

Riezler, Anna 1798?-1829 DcWomA
Rife, Dwight W 1896- ArtsAmW 2
Rife, Peter FolkA 86
Rifenburgh, Richard P MarqDCG 84
Rifer DeCourcelles, Pauline DcWomA
Riffinburg, William NewYHSD
Riffle, Elba Louisa 1905- WhAmArt 85
Riffle, Mark 1955- DcCAr 81
Riffle, Martha Jane FolkA 86
Rifka, Judy PrintW 85
Rifkin, Harold WhoAmA 73, -76, -78
Rifkin, Mrs. Harold WhoAmA 73, -76, -78
Rifkind, Robert Gore 1928- WhoAmA 78, -80, -82, -84
Rigali, G NewYHSD
Rigaud, Denise DcWomA
Rigaud, Elizabeth Anne 1776-1852 DcBrECP
Rigaud, Emilie DcWomA
Rigaud, Hyacinthe 1659-1743 McGDA
Rigaud, Hyacinthe Francois Honore 1659-1743 ClaDrA
Rigaud, John Francis 1742-1810 DcBrECP
Rigaud, Marguerite DcWomA
Rigaud, Pierre Gaston 1874- ClaDrA
Rigaud, Stephen Francis Dutilh 1777-1861 DcBrECP, DcBrWA, DcVicP 2
Rigaud Y Ros, Hyacinthe 1649-1743 OxArt
Rigby FolkA 86
Rigby, Mrs. DcVicP 2
Rigby, Cuthbert 1850-1935 DcBrA 1, DcBrWA, DcVicP, -2
Rigby, F A DcWomA
Rigby, F G WhAmArt 85
Rigby, Gwendolyn AfroAA
Rigby, Harroke B WhAmArt 85
Rigby, Ida Katherine 1944- WhoAmA 78, -80, -82, -84
Rigby, Joseph P WhAmArt 85
Rigby, Paul Crispin 1924- WorECar
Rigby, T FolkA 86
Rigbye, Harriette DcVicP 2
Rigeaud, Pauline DcWomA
Rigel, Maria Magdalena FolkA 86
Riger, Robert 1924- IlBEAAW, IlrAm F, -1880
Rigg, Alfred DcVicP 2
Rigg, Arthur H DcVicP 2
Rigg, E G AmArch 70
Rigg, Ernest H DcVicP 2
Rigg, Ernest Higgins DcBrA 1
Rigg, Jane DcVicP 2
Rigg, Margaret AfroAA
Rigg, Margaret Ruth 1929- WhoAmA 76, -78, -80, -82, -84
Rigg, Mary Ann DcWomA
Riggall, Louise B d1918 DcWomA
Riggi, Vincent S 1935- AmArch 70
Riggio, Joseph S 1915- AmArch 70
Riggs, Colin Edward 1960- MarqDCG 84
Riggs, George Henry, Jr. 1904- AmArch 70
Riggs, Katherine G DcWomA
Riggs, Lutah Maria AmArch 70
Riggs, Mary Kathryn 1935- WhoAmA 80, -82, -84
Riggs, Robert 1896- IlrAm E
Riggs, Robert 1896-1970 GrAmP, IlrAm 1880, WhAmArt 85, WhoAmA 78N, -80N, -82N, -84N
Riggs, Robert Edward 1901- AmArch 70
Riggs, Wesley FolkA 86
Righter, Alice DcWomA
Righter, Alice L ArtsAmW 2, WhAmArt 85
Righter, Mary ArtsAmW 2
Righter, Mary L WhAmArt 85
Rightmeyer, J E FolkA 86
Rightmier, L A AmArch 70
Rigney, Francis J 1882- WhAmArt 85
Rigney, Frederick John 1910- AmArch 70
Rignot-Dubaux, Marie Madeleine 1857-1887 DcWomA
Rigny, Chevalier De DcBrECP
Rigolo, Arthur Emil 1909- AmArch 70
Rigor DaEva, A H AmArch 70
Rigotti, Annibale 1870-1968 MacEA
Rigoulot, Helene WhAmArt 85
Rigsby, Clarence S d1926 WhAmArt 85
Rigsby, Harold OfPGCP 86
Rigsby, John David 1934- WhoAmA 73, -76, -78, -80, -82, -84
Riha, Donald Frank 1940- AmArch 70
Riha, Paul James 1938- MarqDCG 84
Rihbany, Carin Elias 1905- AmArch 70
Riherd, H B AmArch 70
Riis, Anna M WhAmArt 85
Riis, Jacob A 1849-1914 DcAmArt, ICPEnP
Riis, Jacob August 1849-1914 MacBEP, WhAmArt 85
Riise, John 1885-1978 ICPEnP A
Riishede, Jan 1940- DcCAr 81
Rij-Rousseau, Jeanne 1870-1956 DcWomA, OxTwCA
Rijberg, Elizabeth DcWomA
Rijck, Cornelia De DcWomA
Rijck, Cornelia De 1656- McGDA
Rijck, Pieter Cornelisz Van 1568- McGDA
Rijckaert McGDA
Rijn ClaDrA

Rijn, Rembrandt Van McGDA
Rijngraf, Abraham McGDA
Rijutine, Elisa DcWomA
Rijvers, Wim DcCAr 81
Rike, Z AmArch 70
Rikimaru, Yuki 1927- AmArch 70
Rikkers, Willem 1812- ClaDrA
Riland FolkA 86
Riley DcBrECP, FolkA 86
Riley, Agnes WhAmArt 85
Riley, Anita B 1928- AfroAA
Riley, Art 1911- WhoAmA 73, -76, -78, -80, -82, -84
Riley, B D AmArch 70
Riley, Barbra Bayne 1949- WhoAmA 82, -84
Riley, Bernard Joseph 1915- WhoAmA 78, -80, -82, -84
Riley, Betsy Anne 1952- MarqDCG 84
Riley, Bridget 1931- ConArt 77, -83, ConBrA 79[port], DcCAr 81, McGDA, PhDcTCA 77, PrintW 83, WhoArt 80, -82, -84, WorArt[port]
Riley, Bridget 1931-1984 PrintW 85
Riley, Bridget Louise 1931- OxTwCA
Riley, C Ford OfPGCP 86
Riley, C W AmArch 70
Riley, Chapin WhoAmA 73, -76, -78, -80, -82
Riley, Charles Anderson 1910- AmArch 70
Riley, Donald R 1947- MarqDCG 84
Riley, Dorothy Gertrude DcWomA
Riley, Frank E WhAmArt 85
Riley, Frank H 1894- WhAmArt 85
Riley, Frank W 1922- ClaDrA
Riley, Garada Clark 1894- WhAmArt 85
Riley, George William 1927- AmArch 70
Riley, Gerald Lee 1961- MarqDCG 84
Riley, Gerald Patrick 1941- WhoAmA 73, -76, -78, -80, -82
Riley, Harry Arthur 1895- DcBrA 1
Riley, Herbert E 1914- AmArch 70
Riley, James Cooper, Jr. 1935- AmArch 70
Riley, Jennie Little 1867- DcWomA
Riley, Jeremiah H NewYHSD
Riley, John AntBDN M, NewYHSD
Riley, John 1646-1691 OxArt
Riley, John 1751-1804 CabMA
Riley, John H EncASM
Riley, John Leon 1933- AmArch 70
Riley, Ken 1919- IlrAm F, -1880
Riley, Kenneth Pauling 1919- IlBEAAW
Riley, Marguerite WhAmArt 85
Riley, Mary G d1939 WhAmArt 85
Riley, Mary G 1883-1939 DcWomA, IlBEAAW
Riley, Maude Kemper 1902- WhAmArt 85
Riley, Neville William 1930- MarqDCG 84
Riley, Nicholas F 1900-1944 IlrAm E, -1880, WhAmArt 85
Riley, O B, III AmArch 70
Riley, O M AmArch 70
Riley, R B AmArch 70
Riley, Raymond Francis 1947- MarqDCG 84
Riley, Reginald WhoArt 82N
Riley, Reginald 1895- DcBrA 1, WhoArt 80
Riley, Richard AntBDN M
Riley, Robert WorFshn
Riley, Roy John 1903- WhoAmA 73, -76, -78, -80, -82
Riley, Samuel CabMA
Riley, Samuel S ArtsEM
Riley, Thomas ClaDrA, DcVicP, -2
Riley, W DcVicP 2
Riley, W A AmArch 70
Riley, William Edward 1852-1937 DcBrA 1
Riley-Land, Sarah 1947- WhoAmA 84
Rilke-Westhoff, Clara 1878-1954 DcWomA
Rillos, Alfred Carlos 1934- MarqDCG 84
Rimanczy, A W WhAmArt 85
Rimbaud, Marie Henriette 1882-1968 DcWomA
Rimbault, Anna DcWomA
Rimbault, John Stephen AntBDN D
Rimbert, Rene 1896- OxTwCA
Rimbert, Sylvie J 1927- MarqDCG 84
Rimby, W B FolkA 86
Rimer, Charles Edward 1927- AmArch 70
Rimer, Louisa Serena DcVicP, -2, DcWomA
Rimer, William DcBrBI, DcVicP 2
Riminaldi, Orazio 1598-1631? McGDA
Rimington, Mrs. Alexander DcVicP 2
Rimington, Alexander Wallace 1854?-1918 DcBrA 1, DcBrWA, DcVicP 2
Rimington, Evelyn Jane DcBrA 1, DcBrWA, DcWomA
Rimmel, E P Grebe WhoAmA 73
Rimmer, Alfred 1829-1893 DcBrBI
Rimmer, Caroline Hunt 1851- WhAmArt 85
Rimmer, Caroline Hunt 1851-1918 DcWomA
Rimmer, David McLellan 1942- WhoAmA 76, -78, -80, -82
Rimmer, William 1816-1879 AntBDN C, BnEnAmA, DcAmArt, McGDA, NewYHSD , OxArt, WhAmArt 85
Rimmer, William 1821-1879 ArtsNiC

Rimprecht, Johann Baptist 1801-1877 *NewYHSD*
Rimprecht, John 1801-1877 *NewYHSD*
Rin, Laure *DcWomA*
Rinaldi, Antonio 1709?-1794 *WhoArch*
Rinaldi, Arnold Stanley 1925- *AmArch 70*
Rinaldi, J A *AmArch 70*
Rinaldo Mantovano *McGDA*
Rinaman, W K *AmArch 70*
Rinard, Clarence Adam 1909- *AmArch 70*
Rinck, A D *NewYHSD*
Rinck, Helene 1885- *DcWomA*
Rincon, Fernando Del *McGDA*
Rinderer, A D *AmArch 70*
Rindge, John 1759?-1801 *CabMA*
Rindge, Warren Lester 1891- *AmArch 70*
Rindge, William K 1898-1935 *BiDAmAr*
Rindisbacher, Peter 1806-1834 *ArtsAmW 2,*
 IlBEAAW, NewYHSD
Rindlaub, Mrs. M Bruce Douglas *ArtsAmW 2,*
 DcWomA,
 WhAmArt 85
Rindskopf, Alex C *WhAmArt 85*
Rindy, Dell Nichelson 1889-1962 *WhAmArt 85*
Rine, B E *AmArch 70*
Rinehart, Marion Jack, Jr. 1934- *AmArch 70*
Rinehart, Michael 1934- *WhoAmA 78, -80, -82, -84*
Rinehart, William Henry 1825-1874 *ArtsNiC,*
 BnEnAmA, DcAmArt, McGDA, NewYHSD
Rinehart, William Henry 1835-1874 *OxArt*
Rinehart, William Russell 1929- *AmArch 70*
Riner, Florence *WhAmArt 85*
Rines, Frank M 1892- *WhAmArt 85*
Ring, A J, III *AmArch 70*
Ring, Alice Blair *WhAmArt 85*
Ring, Alice Blair 1869-1947 *ArtsAmW 2, DcWomA*
Ring, Asta *DcWomA*
Ring, David *NewYHSD*
Ring, Der 1925- *EncMA*
Ring, Edward A *WhoAmA 80, -82, -84*
Ring, Edward Alfred *WhoAmA 73, -76, -78*
Ring, Elizabeth C *WhAmArt 85*
Ring, Gardner Manning 1924- *AmArch 70*
Ring, Helga *DcWomA*
Ring, J F *AmArch 70*
Ring, Ludger Tom 1496-1547 *McGDA*
Ring, Pieter De 1615?-1660 *McGDA*
Ring, S *AmArch 70*
Ring, William E 1949- *MarqDCG 84*
Ringe, Charlotta Sophia 1739- *DcWomA*
Ringel, Hortense Jeanne *DcWomA*
Ringeling, Hendrick 1812-1874 *ClaDrA*
Ringelke, H *WhAmArt 85*
Ringer, Peter 1829?- *FolkA 86*
Ringgli, Gotthard 1575-1635 *ClaDrA*
Ringgold, Cadwalader 1802-1867 *NewYHSD*
Ringgold, Faith 1934- *AfroAA, ConArt 77,*
 DcAmArt, WhoAmA 76, -78, -80, -82, -84
Ringi, Kjell Arne Soerensen 1939- *IlsBYP*
Ringier, Julie Therese *DcWomA*
Ringius, Carl d1950 *WhoAmA 78N, -80N, -82N,*
 -84N
Ringius, Carl 1879-1950 *WhAmArt 85*
Ringius, Lisa *WhAmArt 85*
Ringle, Bryant *AfroAA*
Ringler, Josef Jakob 1730-1799 *AntBDN M*
Ringlin, Elisabeth 1727-1768 *DcWomA*
Ringling, John d1936 *WhAmArt 85*
Ringling, Mrs. John d1929 *WhAmArt 85*
Ringness, Charles 1946- *DcCAr 81*
Ringness, Charles Obert 1946- *WhoAmA 84*
Ringwalt, Katherine H *WhAmArt 85*
Rinhart, George R 1944- *WhoAmA 78, -80*
Rink, Frederick Davis 1908- *AmArch 70*
Rink, John J *NewYHSD*
Rinke, Klaus *OxTwCA*
Rinke, Klaus 1939- *ConArt 77, -83, DcCAr 81*
Rinker, H T *AmArch 70*
Rinn, David Frederic 1937- *AmArch 70*
Rinn, Reed H 1952- *MarqDCG 84*
Rintoul, William *DcBrECP, DcBrWA*
Rinzivillo, Joseph C 1926- *AmArch 70*
Rio, Sebastian Richard 1912- *AmArch 70*
Riofrio, Eduardo Kingman *OxTwCA*
Riollet, Marie Catherine 1755-1788 *DcWomA*
Rion, Hanna 1875-1924 *DcWomA, WhAmArt 85*
Riopelle, Jean-Paul 1922- *DcCAr 81, PhDcTCA 77*
Riopelle, Jean-Paul 1923- *ConArt 77, -83, McGDA,*
 OxTwCA, PrintW 83, -85, WhoArt 80,
 WorArt[port]
Riordan, Anna *DcWomA*
Riordan, G C *WhAmArt 85*
Riordan, Roger d1904 *WhAmArt 85*
Rios *NewYHSD*
Rios, Mademoiselle *DcWomA*
Rios, John Fidel 1918- *WhAmArt 85*
Rios, Susan 1950- *PrintW 85*
Riot, Mademoiselle *DcWomA*
Riou, Edouard 1833-1900 *ClaDrA, DcBrBI*
Riou, Stephen 1720-1780 *BiDBrA*
Rioux, Gilles N C 1928- *AmArch 70*
Rip 1873-1925? *DcBrBI*

Ripa, Cesare *McGDA*
Ripa DeRoveredo, Yvonne 1882- *DcWomA*
Ripley, A Lassell 1896-1969 *WhAmArt 85*
Ripley, Alden Lassell d1969 *WhoAmA 78N, -80N,*
 -82N, -84N
Ripley, Clinton 1849-1922 *BiDAmAr*
Ripley, Hubert G 1869-1942 *BiDAmAr*
Ripley, Lucy Fairfield d1948? *DcWomA*
Ripley, Lucy P *WhAmArt 85*
Ripley, R R *DcBrWA, DcVicP 2*
Ripley, Robert *WhoAmA 78N, -80N, -82N, -84N*
Ripley, Robert d1950? *WhAmArt 85*
Ripley, Robert LeRoy 1893-1949 *WorECar*
Ripley, Thomas 1683?-1758 *BiDBrA, MacEA,*
 OxArt
Ripley, Thomas Emerson 1865- *ArtsAmW 2,*
 WhAmArt 85
Ripnen, Kenneth Henry 1909- *AmArch 70*
Rippa, J R *AmArch 70*
Rippel, M 1930- *WhoAmA 82, -84*
Ripper, Charles 1864- *DcBrA 1, DcVicP 2*
Ripper, Charles L 1929- *IlsBYP, IlsCB 1946, -1957*
Ripper, Chuck *OfPGCP 86*
Ripperdan, Edwin H 1923- *AmArch 70*
Rippeteau, Darrel Downing 1917- *AmArch 70*
Rippeteau, Hallie Crane *ArtsAmW 3, DcWomA*
Rippey, Clayton 1923- *WhoAmA 73, -76, -78, -80,*
 -82, -84
Rippingille, Edward Villiers 1798-1859 *ClaDrA,*
 DcBrWA, DcVicP, -2
Rippingille, T *DcVicP 2*
Rippl-Ronai, Jozsef 1861-1930 *McGDA*
Rippmann, Lore 1887- *DcWomA*
Rippon, E Fay 1930- *AmArch 70*
Rippon, Peter 1930- *DcCAr 81*
Rippon, Ruth Margaret 1927- *WhoAmA 76, -78, -80,*
 -82, -84
Rippon, Tom Michael 1954- *WhoAmA 76, -78*
Ripps, Rodney *WhoAmA 78, -80, -82, -84*
Ripps, Rodney 1950- *DcCAr 81, PrintW 83, -85*
Rippy, Mark Alan 1958- *MarqDCG 84*
Ripszam, Henrik 1889- *ClaDrA, DcBrA 1*
Riquier, Aimee *DcWomA*
Ris, Gunter Ferdinand *DcCAr 81*
Ris, Gunter Ferdinand 1928- *PhDcTCA 77*
Risbeck, Philip Edward 1939- *WhoAmA 84*
Rischgitz, Alice *DcVicP 2*
Rischgitz, Alice 1856-1936 *DcWomA*
Rischgitz, Edward 1828-1909 *DcBrBI, DcNiCA*
Rischgitz, Mary *DcVicP 2, DcWomA*
Rischia, Raul Joseph 1923- *AmArch 70*
Risdon, Richard P *NewYHSD*
Rise, John Ernest 1954- *WhoAmA 82, -84*
Riseling, Robert Lowell 1941- *WhoAmA 76, -78, -80,*
 -82, -84
Risely *FolkA 86*
Riseman, William 1910- *WhAmArt 85*
Risen Burgh, Bernard Van d1767? *OxDecA*
Risen Burgh, Bernhard Van 1700?-1765? *DcD&D*
Risenbourgh, Bernard Van d1767? *OxDecA*
Risenburgh, Bernard, II, Van d1767? *McGDA*
Risheberger, Jack W 1922- *AmArch 70*
Rishel, Gerald Edward 1932- *AmArch 70*
Rishel, Joseph John, Jr. 1940- *WhoAmA 76, -78, -80,*
 -82, -84
Rishell, Robert 1925?- *IlBEAAW*
Rishell, Robert Clifford 1917- *WhoAmA 76, -78*
Rishell, Robert Clifford 1917-1976 *WhoAmA 80N,*
 -82N, -84N
Risher, Anna Priscilla 1875- *ArtsAmW 2, DcWomA,*
 WhAmArt 85
Rising, Dorothy Milne 1895- *ArtsAmW 1, DcWomA,*
 WhAmArt 85, WhoAmA 73, -76, -78, -80, -82,
 -84
Rising, Eric C 1892- *AmArch 70*
Rising, John 1753-1817 *DcBrECP*
Rising, Lester *FolkA 86*
Risk, Cornelia De *DcWomA*
Riskula, Helge 1951- *DcCAr 81*
Risler, Emma *DcWomA*
Risler, Helene *DcWomA*
Risler-Puerari, Emma Jeannette 1836- *DcWomA*
Risley, Miss *DcWomA*
Risley, Charles *FolkA 86*
Risley, Charles E *FolkA 86*
Risley, Donald Manley 1924- *AmArch 70*
Risley, George L *FolkA 86*
Risley, H S *NewYHSD*
Risley, John Hollister 1919- *WhoAmA 73, -76, -78,*
 -80, -82, -84
Risley, Russell 1842-1927 *FolkA 86*
Risley, Sidney *FolkA 86*
Risley, W L *AmArch 70*
Risling, Jay *WhAmArt 85*
Risom, Jens 1916- *BnEnAmA, ConDes*
Risque, Caroline Everett 1886- *DcWomA,*
 WhAmArt 85
Risquet, Van *DcBrECP*
Riss, Jeanne 1887- *DcWomA*
Riss, Murray 1940- *ICPEnP A, MacBEP,*

WhoAmA 76, -78, -80, -82, -84
Riss, Pauline *DcWomA*
Rissanen, Juho 1873-1950 *PhDcTCA 77*
Rissanen, Juho Vilho 1873-1950 *OxTwCA*
Risser, Arthur C 1907- *AmArch 70*
Risser, J Hemley *WhAmArt 85*
Risser, James K 1947- *WhoAmA 84*
Risser, L D *FolkA 86*
Rissik, Albert W M *DcBrA 1*
Rissman, Marshall William 1923- *AmArch 70*
Rissman, Maurice B 1894-1942 *BiDAmAr*
Risso, Charles *NewYHSD*
Rissone, Paolo *DcCAr 81*
Rist, Louis G 1888-1959 *WhAmArt 85,*
 WhoAmA 80N, -82N, -84N
Rist, Minna 1809-1849 *DcWomA*
Ristori, Tito *DcNiCA*
Ristoro, Fra 1225?-1283? *MacEA*
Ristow, Linda Sue 1947- *MarqDCG 84*
Ristvedt-Handerek, Milly 1942- *DcCAr 81*
Rita, Isabel Maria d1735? *DcWomA*
Ritch, John Warren 1822- *BiDAmAr*
Ritch-Weimar, Christophe *ClaDrA*
Ritchey, Dahlen Klahre 1910- *AmArch 70*
Ritchie, Miss *DcWomA*
Ritchie, Alexander 1863- *WhAmArt 85*
Ritchie, Alexander H 1822- *ArtsNiC*
Ritchie, Alexander Hay 1822-1895 *McGDA,*
 NewYHSD , WhAmArt 85
Ritchie, Alick P F *DcBrBI*
Ritchie, Andrew, Jr. 1782-1862 *NewYHSD*
Ritchie, Andrew C 1907- *WhAmArt 85,*
 WhoAmA 73, -76, -78
Ritchie, Andrew C 1907-1978 *WhoAmA 80N, -82N,*
 -84N
Ritchie, Ann 1934- *WhoAmA 80, -82, -84*
Ritchie, C E *DcBrA 2*
Ritchie, Charles E *DcVicP 2*
Ritchie, David Archibald Hugh 1914- *ClaDrA*
Ritchie, Donald 1912- *AmArch 70*
Ritchie, Eleanora *DcVicP 2*
Ritchie, J C *AmArch 70*
Ritchie, Jane *DcCAr 81*
Ritchie, John *DcVicP, -2*
Ritchie, John M *NewYHSD*
Ritchie, Lucy *DcWomA*
Ritchie, Mary D Bladen *DcWomA, WhAmArt 85*
Ritchie, Robert *DcVicP 2*
Ritchie, Trekkie 1902- *DcBrA 1, IlsBYP,*
 IlsCB 1946
Ritchie, William 1941- *WhoAmA 78, -80, -82, -84*
Ritchie, William A 1867-1931 *BiDAmAr*
Ritchings, Joan Drew 1916- *WhoAmA 80*
Rite, Isabel Maria d1735? *DcWomA*
Riter, Carl Frederick 1915- *WhAmArt 85*
Rithet, Elizabeth Jane 1853-1952 *DcWomA*
Ritins, Ilmars 1937- *MarqDCG 84*
Ritman, Louis d1963 *WhoAmA 78N, -80N, -82N,*
 -84N
Ritman, Louis 1889-1963 *WhAmArt 85*
Ritman, Maurice 1906- *WhAmArt 85*
Ritoit, Berthe Marie *DcWomA*
Ritschel, William d1949 *WhoAmA 78N, -80N, -82N,*
 -84N
Ritschel, William 1864-1949 *ArtsAmW 1, -3,*
 IlBEAAW, WhAmArt 85
Ritschl, Otto 1885- *OxTwCA, PhDcTCA 77*
Ritsema, Coba 1876-1961 *DcWomA*
Ritsema, Coba 1876-1962 *OxArt*
Ritsema, Jacoba 1876-1962 *OxArt*
Ritso, John *DcBrWA*
Ritson, Claire 1907- *DcBrA 1*
Ritson, J *DcVicP 2*
Ritsuo 1637-1747 *OxDecA*
Ritsuo 1663-1747 *AntBDN L*
Ritt, William 1902-1972 *WorECom*
Rittase, Roger M *WhAmArt 85*
Rittenberg, Henry R 1879- *WhAmArt 85*
Rittenberry, James Floyd 1913- *AmArch 70*
Rittenhouse, David 1732-1796 *AntBDN D, OxDecA*
Rittenhouse, W F *AmArch 70*
Ritter, Alice Bickley *WhAmArt 85*
Ritter, Alonzo W 1898- *WhAmArt 85*
Ritter, Anne G 1868- *WhAmArt 85*
Ritter, Anne Gregory 1868-1929 *ArtsAmW 1*
Ritter, Anne Lawrence Gregory 1868-1929
 ArtsAmW 3
Ritter, Anne Louise Lawrence 1868-1929 *DcWomA*
Ritter, Betty J 1922- *AmArch 70*
Ritter, Charles *CabMA*
Ritter, Charles H *WhAmArt 85*
Ritter, Charlotte 1873- *DcWomA*
Ritter, Chris 1908- *WhAmArt 85*
Ritter, Mrs. Chris *WhAmArt 85*
Ritter, Daniel 1746-1828 *FolkA 86*
Ritter, Emma 1878- *DcWomA*
Ritter, Florent *FolkA 86*
Ritter, George Julius 1933- *AmArch 70*
Ritter, Gerald Anthony 1938- *AmArch 70*

Robert De Luzarches *MacEA*
Robert, Mademoiselle *DcWomA*
Robert Of Beverly d1284 *McGDA*
Robert Of Molesme, Saint 1024?-1110 *McGDA*
Robert, Alexander *NewYHSD*
Robert, Alexandre Nestor Nicolas 1817-1890 *ClaDrA*
Robert, Berthe *DcWomA*
Robert, C *DcWomA*
Robert, Mrs. C E *WhAmArt 85*
Robert, Caroline *DcVicP 2*
Robert, Fanny 1795-1872 *DcWomA*
Robert, Francois Paul 1946- *WhoGrA 82[port]*
Robert, Helena Josephine *DcWomA*
Robert, Henriette Felicitas *DcWomA*
Robert, Henry Flood, Jr. 1943- *WhoAmA 78, -80, -82, -84*
Robert, Hubert 1733-1808 *ClaDrA, MacEA, McGDA, OxArt*
Robert, Julie *DcWomA*
Robert, L W, Jr. *AmArch 70*
Robert, Leo-Paul *ArtsNiC*
Robert, Leopold Louis 1794-1835 *ClaDrA*
Robert, Leopold-Louis 1794-1835 *McGDA*
Robert, Lou J 1928- *MarqDCG 84*
Robert, Louise 1941- *DcCAr 81*
Robert, Lulu *DcWomA*
Robert, M *DcVicP 2*
Robert, Margueritte *DcWomA*
Robert, Marie *DcWomA*
Robert, Mathilde *DcWomA*
Robert, Nicolas 1614-1685 *ClaDrA*
Robert, Richard Caswell 1913- *AmArch 70*
Robert, Therese 1895- *DcWomA*
Robert-Fleury, Joseph-Nicolas 1797- *ArtsNiC*
Robert-Fleury, Joseph Nicolas 1797-1890 *ClaDrA*
Robert-Fleury, Joseph-Nicolas 1797-1890 *McGDA*
Robert-Fleury, Tony *ArtsNiC*
Robert Fleury, Tony 1837-1912 *ClaDrA*
Robert-Fleury, Tony 1837-1912 *WhAmArt 85A*
Robert-Houdin, Eglantine *DcWomA*
Roberta Of Venice 1920- *WorFshn*
Roberth, Minna Elisabeth 1851-1920 *DcWomA*
Roberti, Ercole De' 1450?-1496 *McGDA, OxArt*
Roberti, Romolo 1896- *WhAmArt 85*
Roberto, Joseph John 1908- *AmArch 70*
Roberto, Luigi *DcSeaP*
Roberto, Marcello d1965 *ConArch*
Roberto, Marcelo 1908-1956? *McGDA*
Roberto, Marcio *MacEA*
Roberto, Mauricio 1921- *McGDA*
Roberto, Milton d1955 *ConArch*
Roberto, Milton 1914-1953 *McGDA*
Roberto Brothers *MacEA*
Roberton, Alfred J *DcVicP 2*
Roberts *FolkA 86*
Roberts, Miss *DcWomA*
Roberts, Mrs. *DcVicP 2*
Roberts, A *DcVicP 2*
Roberts, A E *AmArch 70*
Roberts, A L *DcWomA*
Roberts, Aaron 1758-1831 *CabMA*
Roberts, Adam *NewYHSD*
Roberts, Alan M 1959- *MarqDCG 84*
Roberts, Alice *DcBrECP*
Roberts, Alice M *DcWomA*
Roberts, Alice Mumford *WhAmArt 85*
Roberts, Alice T 1876-1955 *DcWomA, WhAmArt 85*
Roberts, Allen *NewYHSD*
Roberts, Mrs. Alton True *WhAmArt 85*
Roberts, Annie *DcVicP 2, DcWomA*
Roberts, Beatrice *DcWomA*
Roberts, Benjamin *DcVicP, -2*
Roberts, Bill 1914-1978 *WhoAmA 80N, -82N, -84N*
Roberts, Bishop *FolkA 86*
Roberts, Bishop d1739 *NewYHSD*
Roberts, Blanche Gilroy 1871- *DcWomA, WhAmArt 85*
Roberts, Bruce Elliott *WhoAmA 82, -84*
Roberts, Bruce Stuart 1930- *ICPEnP A, MacBEP*
Roberts, C *AmArch 70*
Roberts, C A *AmArch 70*
Roberts, C F *AmArch 70, DcBrECP*
Roberts, Candace 1785-1806 *FolkA 86*
Roberts, Mrs. Chandler *DcVicP 2, DcWomA*
Roberts, Charles *FolkA 86*
Roberts, Charles J Cramer 1834-1895 *DcBrBI*
Roberts, Charles J Cramer- 1834-1895 *DcBrWA*
Roberts, Clyde Harry 1923- *WhoAmA 73, -76, -78, -80, -82, -84*
Roberts, Colette 1910- *WhoAmA 73, -76, -78, -80N, -82N, -84N*
Roberts, Cornelia Howard *ArtsEM, DcWomA*
Roberts, Cyril 1871-1949 *DcBrA 1, DcVicP 2*
Roberts, David *FolkA 86*
Roberts, David 1796-1864 *ArtsNiC, DcBrBI, DcBrWA, DcVicP, -2, McGDA, OxArt*
Roberts, Dean 1899- *DcWomA, WhAmArt 85*
Roberts, Della *OfPGCP 86*
Roberts, Donald 1923- *WhoAmA 78, -80, -82, -84*
Roberts, Donald H *AfroAA*
Roberts, Donna *MarqDCG 84*

Roberts, Dora *DcWomA*
Roberts, Doreen *IlsCB 1967*
Roberts, Doreen 1922- *IlsCB 1957*
Roberts, Dorothy *DcBrA 2*
Roberts, Dorothy Freeborn *DcWomA*
Roberts, E *DcVicP 2*
Roberts, E A *AmArch 70*
Roberts, E M *EncASM*
Roberts, Eben Ezra 1867-1943 *BiDAmAr*
Roberts, Ebenezer L 1824-1890 *BiDAmAr*
Roberts, Edith A 1887- *DcWomA, WhAmArt 85*
Roberts, Edith Lucile *DcWomA*
Roberts, Edward J 1797-1865 *ArtsNiC*
Roberts, Edwin *DcBrBI, DcVicP*
Roberts, Edwin Thomas 1840-1917 *DcVicP 2*
Roberts, Elizabeth *WhAmArt 85*
Roberts, Elizabeth W 1871-1927 *WhAmArt 85*
Roberts, Elizabeth Wentworth 1871-1927 *DcWomA*
Roberts, Ella A 1866-1930 *DcWomA*
Roberts, Ellis William 1860-1930 *DcBrA 1, DcVicP 2*
Roberts, Elmer Clifford 1896- *AmArch 70*
Roberts, Elsie *DcVicP 2, DcWomA*
Roberts, Ephriam A *ArtsEM*
Roberts, Mrs. Etienne *DcVicP 2*
Roberts, Eugene David 1926- *AmArch 70*
Roberts, Evan Elijah 1922- *AmArch 70*
Roberts, F A *DcVicP 2*
Roberts, F M *DcVicP 2*
Roberts, F Stewart 1913- *AmArch 70*
Roberts, F W B *DcVicP 2*
Roberts, Francis E 1928- *AmArch 70*
Roberts, Franklin C 1937- *MarqDCG 84*
Roberts, Frederick *DcVicP 2*
Roberts, G *DcVicP 2, DcWomA*
Roberts, George S *FolkA 86*
Roberts, George W *WhAmArt 85*
Roberts, Georgina Wootan 1891- *ArtsAmW 3*
Roberts, Georgina Wooton 1891- *WhAmArt 85*
Roberts, Gertrude *DcWomA*
Roberts, Gilroy 1905- *WhoAmA 73, -76, -78, -80, -82, -84*
Roberts, Gladys Gregory *WhoArt 80, -82, -84*
Roberts, Goodridge *OxTwCA*
Roberts, Goodridge 1904- *WhoAmA 73, -76, -80*
Roberts, Grace *DcWomA*
Roberts, H J *AmArch 70*
Roberts, H K *NewYHSD*
Roberts, H Larpent *DcVicP*
Roberts, H Larpent d1890? *DcVicP 2*
Roberts, H M *AmArch 70*
Roberts, Helen *DcWomA, WhAmArt 85*
Roberts, Helene Emylou 1931- *WhoAmA 78, -80, -82, -84*
Roberts, Helm Bruce 1931- *AmArch 70*
Roberts, Henry d1790? *BkIE*
Roberts, Henry 1802-1876 *McGDA*
Roberts, Henry 1803-1876 *BiDBrA, MacEA*
Roberts, Henry Benjamin 1832-1915 *ClaDrA, DcBrA 1, DcBrBI, DcBrWA, DcVicP, -2*
Roberts, Henry L 1915- *AmArch 70*
Roberts, Henry Larpent 1830?-1890? *DcBrWA*
Roberts, Henry William *DcVicP 2*
Roberts, Herbert H *DcVicP 2*
Roberts, Mrs. Herbert S *WhAmArt 85*
Roberts, Hermine Matilda 1892- *ArtsAmW 2, DcWomA, WhAmArt 85*
Roberts, Hosea 1768-1815 *FolkA 86*
Roberts, Howard 1843- *ArtsNiC*
Roberts, Howard 1843-1900 *DcAmArt, WhAmArt 85*
Roberts, Hugh 1867-1928 *BiDAmAr*
Roberts, I *DcBrBI*
Roberts, I H *NewYHSD*
Roberts, J H *DcBrBI, NewYHSD*
Roberts, J H, Jr. *AmArch 70*
Roberts, J T *AmArch 70*
Roberts, Jack 1894- *IlsCB 1744*
Roberts, Jack 1920- *IIBEAAW*
Roberts, Jacob *AntBDN N*
Roberts, James *BkIE, DcVicP 2, NewYHSD*
Roberts, James 1753-1809? *DcBrECP*
Roberts, James H *ArtsEM*
Roberts, Jay Goodliff 1923- *AmArch 70*
Roberts, Jenifer *DcCAr 81*
Roberts, Jessie Macy *WhAmArt 85*
Roberts, Jewel Mack *AmArch 70*
Roberts, Joe Ben *AmArch 70*
Roberts, John *BiDBrA*
Roberts, John 1768-1803 *NewYHSD*
Roberts, John Lewis *DcVicP 2*
Roberts, John M *FolkA 86*
Roberts, John Taylor 1878- *WhAmArt 85*
Roberts, John Vivian 1923- *DcBrA 1, WhoArt 80, -82, -84*
Roberts, Jonathan *FolkA 86*
Roberts, Joseph *FolkA 86*
Roberts, Joseph Baylor 1902- *ICPEnP A*
Roberts, Josephine Seaman *WhAmArt 85*
Roberts, Katherine M *DcVicP 2*
Roberts, Lancelot d1950 *DcBrA 1*
Roberts, Lavinia *DcVicP 2*
Roberts, Leland Boyd 1932- *AmArch 70*

Roberts, Linda *OfPGCP 86*
Roberts, Louisa *DcVicP 2*
Roberts, Louise Smith 1887?-1936 *DcWomA, WhAmArt 85*
Roberts, Lucille D *AfroAA, WhoAmA 73, -76, -78, -80, -82, -84*
Roberts, M E *WhAmArt 85*
Roberts, Manuel S *FolkA 86*
Roberts, Marcus Rees 1951- *DcCAr 81*
Roberts, Margaret Lee 1911- *WhAmArt 85*
Roberts, Marguerite Hazel *WhoArt 80, -82, -84*
Roberts, Marguerite Hazel 1927- *ClaDrA*
Roberts, Marie C *DcWomA, WhAmArt 85*
Roberts, Marion *DcVicP 2*
Roberts, Mark Dennis 1943- *MacBEP*
Roberts, Martha 1919- *ICPEnP A*
Roberts, Martin 1950- *MacBEP*
Roberts, Marvin S *NewYHSD*
Roberts, Marvin S 1813-1872 *FolkA 86*
Roberts, Mary d1761 *DcWomA, NewYHSD*
Roberts, Mary R *WhAmArt 85*
Roberts, Maurine Hiatt *ArtsAmW 2*
Roberts, Maurine Hiatt 1898- *WhAmArt 85*
Roberts, Milnora *WhAmArt 85*
Roberts, Morton d1964 *WhoAmA 78N, -80N, -82N, -84N*
Roberts, Morton 1927-1964 *IlrAm F, -1880*
Roberts, Mrs. Nat *WhAmArt 85*
Roberts, Nathan B *NewYHSD*
Roberts, Nellie H *DcWomA*
Roberts, Mrs. Nelson L *ArtsEM, DcWomA*
Roberts, Norman L 1896- *WhAmArt 85*
Roberts, Paul 1948- *DcCAr 81*
Roberts, Percival R 1935- *WhoAmA 76, -78, -80, -82, -84*
Roberts, Phyllis Kathleen 1916- *ClaDrA, DcBrA 1, WhoArt 80, -82, -84*
Roberts, Priscilla Warren 1916- *WhoAmA 73, -76, -78, -80, -82, -84*
Roberts, R *AmArch 70*
Roberts, R E *ArtsEM*
Roberts, R R *DcVicP 2*
Roberts, Rachel 1908- *DcBrA 1*
Roberts, Sir Randal Howland *DcVicP 2*
Roberts, Reynold Marvin 1928- *AmArch 70*
Roberts, Richard 1925- *WhoAmA 82, -84*
Roberts, Robert *DcVicP 2*
Roberts, Robert 1821?- *NewYHSD*
Roberts, Roland Douglas, Jr. 1937- *AmArch 70*
Roberts, S *CabMA, DcVicP 2*
Roberts, Samuel *AntBDN N, -Q, CabMA*
Roberts, Samuel 1757- *DcBrECP*
Roberts, Samuel, Jr. *AntBDN Q*
Roberts, Sarah Pickens *WhAmArt 85*
Roberts, Selina M 1948- *MacBEP*
Roberts, Solomon *AfroAA*
Roberts, Spencer *WhAmArt 85*
Roberts, Stewart Allan 1922- *AmArch 70*
Roberts, Sydney A 1900- *WhAmArt 85*
Roberts, Thomas 1748-1778 *DcBrECP*
Roberts, Thomas 1820- *ArtsNiC*
Roberts, Thomas 1909- *WhoAmA 73, -76, -78*
Roberts, Thomas E 1820-1901 *DcVicP*
Roberts, Thomas Edward 1820-1901 *DcBrWA, DcVicP 2*
Roberts, Thomas Sautelle 1760?-1826 *DcBrWA*
Roberts, Thomas Sautelle 1764-1826 *DcBrECP*
Roberts, Thomas William 1856-1931 *McGDA*
Roberts, Tom 1856-1931 *DcBrA 1, DcVicP 2, OxArt, PhDcTCA 77*
Roberts, Tom 1908- *WhoAmA 82, -84*
Roberts, Tom 1909- *WhoAmA 80*
Roberts, Tommy *WorFshn*
Roberts, Tommy, Jr. 1927- *AmArch 70*
Roberts, V T, Jr. *AmArch 70*
Roberts, Violet K 1880-1958? *WhAmArt 85*
Roberts, Violet Kent *WhoAmA 80N, -82N, -84N*
Roberts, Violet Kent 1880-1956? *DcWomA*
Roberts, W *DcVicP 2, EarABI, EarABI SUP, NewYHSD*
Roberts, W C *AmArch 70*
Roberts, W F, Jr. *AmArch 70*
Roberts, W J Edward 1925- *AmArch 70*
Roberts, W L *AmArch 70*
Roberts, W S *AmArch 70*
Roberts, W T B *DcVicP 2*
Roberts, Walter Dewey, Jr. 1927- *AmArch 70*
Roberts, Walter James 1907- *ClaDrA, DcBrA 1, WhoArt 80, -82, -84*
Roberts, Walter L *AfroAA*
Roberts, Will *WhoArt 80, -82, -84*
Roberts, William *BiDBrA, FolkA 86*
Roberts, William 1811?- *NewYHSD*
Roberts, William 1829?- *NewYHSD*
Roberts, William 1895- *ConBrA 79, DcCAr 81, PhDcTCA 77*
Roberts, William 1895-1980 *OxTwCA*
Roberts, William Edward 1941- *WhoAmA 78, -80, -82, -84*
Roberts, William Goodridge 1904- *McGDA, WhoAmA 78*

Roberts, William Griffith 1921- *WhoAmA 76, -78, -80, -82*
Roberts, William H 1906- *AmArch 70*
Roberts, William J *NewYHSD*
Roberts, William Patrick 1895- *DcBrA 1, McGDA*
Roberts, Winifred Russell *DcBrA 2, DcVicP 2*
Roberts-Jones, Ivor 1913- *WhoArt 80, -82, -84*
Roberts-Jones, Ivor 1916- *DcBrA 1*
Robertshaw, A C 1928- *AmArch 70*
Robertson *ArtsEM*
Robertson, Miss *DcWomA*
Robertson, Mrs. *DcWomA*
Robertson, Alexander *NewYHSD*
Robertson, Alexander 1772-1841 *NewYHSD*
Robertson, Alexander 1916- *WhoArt 80, -82, -84*
Robertson, Alfred J *DcVicP 2*
Robertson, Anderson Bain 1929- *WhoArt 84*
Robertson, Andrew 1777-1845 *AntBDN J*
Robertson, Anna Mary *DcWomA, FolkA 86*
Robertson, Archibald 1745?-1813 *DcBrWA, NewYHSD*
Robertson, Archibald 1765-1835 *NewYHSD*
Robertson, Mrs. Archibald *NewYHSD*
Robertson, Arthur *DcBrA 2*
Robertson, Arthur 1850- *DcVicP 2*
Robertson, B *AmArch 70*
Robertson, Barbara Janette 1945- *WhoArt 80, -82, -84*
Robertson, Bryan *WhoAmA 73*
Robertson, C Dale 1952- *MarqDCG 84*
Robertson, C Kay *DcVicP 2*
Robertson, Cecile *DcWomA*
Robertson, Charles 1760-1821 *AntBDN J, DcBrWA*
Robertson, Charles 1844-1891 *ClaDrA, DcBrWA, DcVicP, -2*
Robertson, Charles J 1934- *WhoAmA 76, -78, -80, -82, -84*
Robertson, Christina *DcWomA*
Robertson, Clementina 1795-1853? *DcWomA*
Robertson, D Hall 1918- *WhoAmA 73, -76, -78, -80, -82*
Robertson, D M *AmArch 70*
Robertson, Daniel *BiDBrA*
Robertson, David d1925 *DcBrA 1*
Robertson, David D *ArtsEM*
Robertson, David M *DcVicP 2*
Robertson, David T 1880- *DcBrA 1*
Robertson, Donald J 1933- *AfroAA*
Robertson, Donald Mitchel 1922- *AmArch 70*
Robertson, Eleanor A *DcWomA*
Robertson, Eliza *DcWomA*
Robertson, Elizabeth *DcWomA*
Robertson, Eric Harald Macbeth 1887-1941 *DcBrA 1*
Robertson, Eric J Forbes *DcVicP 2*
Robertson, Ethel Burt 1872- *DcWomA, WhAmArt 85*
Robertson, Fred E 1878- *WhAmArt 85*
Robertson, George *AntBDN M*
Robertson, George 1748-1788 *DcBrWA*
Robertson, George 1749-1788 *DcBrECP*
Robertson, George 1776-1833 *DcBrWA*
Robertson, George Edward 1864- *DcBrA 1, DcBrBI, DcVicP 2*
Robertson, George J *FolkA 86, NewYHSD*
Robertson, Gertrude Mary *DcWomA*
Robertson, Giles Henry 1913- *WhoArt 80, -82, -84*
Robertson, H O *WhAmArt 85*
Robertson, Henrietta J *DcWomA*
Robertson, Henry *DcVicP 2*
Robertson, Henry M *ArtsEM*
Robertson, Henry Robert 1839-1921 *ClaDrA, DcBrA 1, DcBrBI, DcBrWA, DcVicP, -2*
Robertson, Sir Howard 1888-1963 *ConArch*
Robertson, Sir Howard Morley 1888-1963 *DcBrA 1*
Robertson, Howard Morley 1888-1963 *MacEA*
Robertson, Hugh Cornwall 1844-1908 *CenC, DcNiCA*
Robertson, J Milton 1890- *WhAmArt 85*
Robertson, J R *DcVicP 2*
Robertson, J W *AmArch 70*
Robertson, James *BiDBrA, DcBrBI, FolkA 86, ICPEnP, MacBEP*
Robertson, James Drunken *DcBrWA*
Robertson, Jane Porter *ArtsAmW 2, DcWomA, WhAmArt 85*
Robertson, Janet 1880- *ClaDrA*
Robertson, Janet Elspeth 1896- *ClaDrA*
Robertson, Janet S 1880- *DcBrA 1, DcWomA*
Robertson, Jaquelin 1933- *ConArch*
Robertson, Jaquelin Taylor 1933- *AmArch 70*
Robertson, Joan E 1942- *WhoArt 80, -82, -84*
Robertson, Joan Elizabeth 1942- *WhoAmA 78*
Robertson, John *AntBDN Q, BiDBrA, FolkA 86, NewYHSD*
Robertson, John Ewart 1820-1879 *DcVicP 2, NewYHSD*
Robertson, John Roy *NewYHSD*
Robertson, John Tazewell 1905- *WhAmArt 85*
Robertson, Sir Johnston Forbes- 1853-1937 *DcVicP 2*
Robertson, Joseph *FolkA 86*
Robertson, Kay *DcVicP 2*
Robertson, L Roy *DcVicP 2*

Robertson, M Clark 1955- *ConDes*
Robertson, Madeleine Nixon 1912- *WhAmArt 85*
Robertson, May Marshall *DcWomA*
Robertson, Michael Ralli 1915- *DcBrA 1*
Robertson, Mittie Newton 1893- *WhAmArt 85*
Robertson, Nancy Elizabeth *WhoAmA 78, -80, -82, -84*
Robertson, Paul Chandler 1902-1961 *WhAmArt 85, WhoAmA 80N, -82N, -84N*
Robertson, Percy 1868-1934 *DcVicP 2*
Robertson, Percy 1869-1934 *DcBrA 1, DcBrWA*
Robertson, Persis W 1896- *WhAmArt 85*
Robertson, Persis Weaver 1896- *DcWomA*
Robertson, R H 1849-1919 *MacEA*
Robertson, Ralph F *WhAmArt 85*
Robertson, Rhodes 1886- *AmArch 70, WhAmArt 85*
Robertson, Richard Ross 1914- *DcBrA 1, WhoArt 80, -82, -84*
Robertson, Robert Cowan 1863-1910 *DcBrA 1, DcVicP 2*
Robertson, Robert Currie *DcBrA 1*
Robertson, Robert H 1849-1919 *BiDAmAr*
Robertson, S *DcVicP 2*
Robertson, Sarah M d1948 *WhoAmA 78N, -80N, -82N, -84N*
Robertson, Sarah Margaret 1891-1948 *DcWomA*
Robertson, Seonaid Mairi *WhoArt 82, -84*
Robertson, Seonaid Mairi 1912- *WhoArt 80*
Robertson, Sheila Macleod *WhoArt 82*
Robertson, Sheila Macleod 1927- *DcBrA 1, WhoArt 80, -84*
Robertson, Susanne 1856-1922 *DcWomA*
Robertson, Thomas *NewYHSD*
Robertson, Thomas Arthur 1911- *WhAmArt 85*
Robertson, Tom 1850-1947 *DcBrA 1, DcVicP 2*
Robertson, Victor J *DcVicP 2*
Robertson, W *BiDBrA, DcBrECP*
Robertson, W, Jr. *AmArch 70*
Robertson, W S *DcVicP 2*
Robertson, Walford Graham 1867-1948 *ClaDrA, DcBrA 1, DcBrBI*
Robertson, Walford Graham- 1867-1948 *DcVicP 2*
Robertson, Walter 1750?-1802 *NewYHSD*
Robertson, Wayland H d1935 *BiDAmAr*
Robertson, William *BiDBrA, NewYHSD*
Robertson, William d1856 *DcBrWA*
Robertson, William 1786?-1841 *BiDBrA*
Robertson, William 1864-1929 *WhAmArt 85*
Robertson, William A *DcSeaP, FolkA 86*
Robertson, William R *NewYHSD*
Robertz, Wayne Eliot 1953- *MarqDCG 84*
Robeson *EncASM*
Robeson, Edna Amelia 1887- *DcWomA, WhAmArt 85*
Robeson, James Lee 1905- *AmArch 70*
Robetta, Cristofano 1462- *McGDA*
Robichaud, Michel 1939- *WorFshn*
Robida, Albert 1848-1926 *WorECar*
Robida-Boucher, Emilie 1882- *DcWomA*
Robie, Jean-Baptiste 1821- *ArtsNiC*
Robie, Jean Baptiste 1821-1910 *ClaDrA*
Robie, Lee C 1956- *MarqDCG 84*
Robilant, Filippo Nicolis Di 1723-1783 *MacEA*
Robilliard, Samuel *CabMA*
Robillot, Marthe Blanche 1856- *DcWomA*
Robilotti, Leonard John 1928- *AmArch 70*
Robin, Augustus *NewYHSD*
Robin, Edward *NewYHSD*
Robin, Eline *DcWomA*
Robin, Fanny 1888- *DcWomA, WhAmArt 85*
Robin, Louise Adelaide *DcWomA*
Robineau, Adelaide d1929 *WhAmArt 85*
Robineau, Adelaide Alsop 1865-1929 *CenC*
Robineau, Auguste *DcBrECP*
Robineau, Charles Jean *DcBrECP*
Robineau, Claire *DcWomA*
Robineau, Francis *NewYHSD*
Robins, Mrs. A *DcVicP 2*
Robins, B *DcVicP 2*
Robins, Corinne 1934- *WhoAmA 76, -78, -80, -82, -84*
Robins, D E *DcVicP 2*
Robins, Gertrude M *DcVicP 2*
Robins, Greenway d1853 *BiDBrA*
Robins, H *DcSeaP, DcVicP 2*
Robins, Hugo *WhAmArt 85*
Robins, Ida S *DcVicP 2*
Robins, Ida Southwell *DcWomA*
Robins, J E *DcVicP 2*
Robins, John *AntBDN M, -Q*
Robins, John L *NewYHSD*
Robins, Louisa W 1898- *WhAmArt 85*
Robins, Louisa W 1898-1962 *DcWomA*
Robins, Luke *NewYHSD*
Robins, Mabel Louisa *DcWomA*
Robins, Mary Ellis 1860- *WhAmArt 85*
Robins, Mary Ellis 1860-1949 *DcWomA*
Robins, Matthew *DcVicP 2*
Robins, Susan P B 1849- *DcWomA, WhAmArt 85*
Robins, Thomas 1745-1806 *DcBrWA*
Robins, Thomas Sewell 1809?-1880 *DcSeaP*

Robins, Thomas Sewell 1814-1880 *DcBrWA, DcVicP, -2*
Robins, William Palmer 1882-1959 *DcBrA 1*
Robins & Randall *DcNiCA*
Robinson *BiDBrA, FolkA 86*
Robinson, A *DcWomA*
Robinson, A *DcWomA*
Robinson, Mrs. A A *ArtsEM*
Robinson, A C, III *AmArch 70*
Robinson, A N, Jr. *AmArch 70*
Robinson, A S *AmArch 70*
Robinson, Abby 1947- *MacBEP*
Robinson, Adah Matilda 1882- *ArtsAmW 1, DcWomA, WhAmArt 85*
Robinson, Adah Matilda 1882-1962 *ArtsAmW 3*
Robinson, Agnes Agatha *ClaDrA*
Robinson, Alan Marshall 1915- *DcBrA 1*
Robinson, Albert Henry 1881-1956 *McGDA*
Robinson, Alexander Charles 1867- *WhAmArt 85*
Robinson, Alfred 1806-1895 *ArtsAmW 1, IlBEAAW, NewYHSD*
Robinson, Alice *DcWomA, WhAmArt 85*
Robinson, Alonzo Clark 1876- *WhAmArt 85*
Robinson, Amy R *WhAmArt 85*
Robinson, Ann *WhAmArt 85*
Robinson, Ann 1813?- *FolkA 86*
Robinson, Anne Marjorie 1858-1924 *DcBrWA*
Robinson, Annie *DcWomA*
Robinson, Annie Louisa *DcVicP, -2*
Robinson, Anson *FolkA 86*
Robinson, Archibald *DcBrECP*
Robinson, Arthur *DcVicP 2*
Robinson, Arthur P *DcVicP 2*
Robinson, Basil William 1912- *WhoArt 80, -82, -84*
Robinson, Bay *WhoArt 80, -82, -84N*
Robinson, Miss Bay 1898- *DcBrA 2*
Robinson, Beverley 1886- *AmArch 70*
Robinson, Boardman d1952 *WhoAmA 78N, -80N, -82N, -84N*
Robinson, Boardman 1876- *DcCAA 71*
Robinson, Boardman 1876-1952 *ArtsAmW 1, BnEnAmA, DcCAA 77, IlBEAAW, IlsCB 1744, McGDA, WhAmArt 85, WorECar*
Robinson, Boardman 1876-1962 *DcAmArt*
Robinson, Boardman Michael 1876-1952 *ArtsAmW 3*
Robinson, Bruce Edward 1956- *MarqDCG 84*
Robinson, C *DcVicP 2*
Robinson, C d1881 *DcBrBI*
Robinson, C And Co. *ArtsEM*
Robinson, C David 1936- *WhoAmA 76, -78, -80, -82, -84*
Robinson, Carrie B 1867- *WhAmArt 85*
Robinson, Cervin 1928- *MacBEP*
Robinson, Charles *ArtsEM*
Robinson, Charles 1870-1937 *AntBDN B, DcBrA 1, DcBrBI, DcVicP 2*
Robinson, Charles 1931- *IlsBYP, IlsCB 1967*
Robinson, Charles Aral 1905- *AfroAA*
Robinson, Charles Dorman 1847-1933 *IlBEAAW, WhAmArt 85*
Robinson, Charles Dormon 1847-1933 *ArtsAmW 1*
Robinson, Charles F *ClaDrA, DcBrA 1, DcBrWA, DcVicP, -2*
Robinson, Charles H 1862- *WhAmArt 85*
Robinson, Charles Hoxey 1862-1945 *ArtsAmW 2*
Robinson, Charles K 1935- *WhoAmA 78, -80, -82*
Robinson, Charles M 1867-1932? *BiDAmAr*
Robinson, Charles Neely 1915- *AmArch 70*
Robinson, Charles W *WhAmArt 85*
Robinson, Charlotte *ArtsEM, DcWomA, WhoAmA 78, -80*
Robinson, Charlotte 1924- *PrintW 83, -85, WhoAmA 82, -84*
Robinson, Chris 1951- *WhoAmA 84*
Robinson, Clarence Clayton 1901- *AmArch 70*
Robinson, Constance *DcWomA*
Robinson, Courtney E 1926- *AmArch 70*
Robinson, David 1886- *WhAmArt 85*
Robinson, David 1936- *ConPhot, ICPEnP A, MacBEP*
Robinson, Delia Mary *ArtsAmW 3, WhAmArt 85*
Robinson, Dent *WhAmArt 85*
Robinson, Major Douglas F d1937 *DcBrA 2*
Robinson, Douglas F 1864-1929 *ClaDrA, DcVicP 2*
Robinson, E *AntBDN Q, DcVicP 2*
Robinson, E F *AmArch 70*
Robinson, E John *OfPGCP 86*
Robinson, E Julia *DcVicP 2, DcWomA*
Robinson, Edith *DcWomA*
Robinson, Edward *DcVicP 2*
Robinson, Edward 1858-1931 *WhAmArt 85*
Robinson, Edward W *DcVicP*
Robinson, Edward W 1824-1883 *DcBrWA, DcVicP 2*
Robinson, Elizabeth Bradbury 1832-1897 *DcWomA*
Robinson, F DeLancey 1872-1939 *BiDAmAr*
Robinson, Faith *FolkA 86*
Robinson, Florence V 1874-1937 *WhAmArt 85*
Robinson, Florence Vincent 1864?-1937 *DcWomA*
Robinson, Francis 1830-1886 *DcVicP 2*

Rochard, Simon Jacques 1788-1872 *AntBDN J*
Rochas, Marcel d1955 *FairDF FRA*
Rochas, Ramon *FolkA 86*
Rochat, Alexandre 1895- *DcCAr 81*
Rochat, Louise *DcWomA*
Rochdale, A *DcVicP 2*
Roche, Mrs. *DcWomA*
Roche, Alexander Ignatius 1861-1921 *DcBrA 1,*
DcVicP 2
Roche, David *NewYHSD*
Roche, Eamonn Kevin 1922- *AmArch 70*
Roche, F M *AmArch 70*
Roche, Hyman 1910- *AmArch 70*
Roche, Jeanne *DcWomA*
Roche, Jenny *DcWomA*
Roche, Jim 1943- *WhoAmA 73, –76*
Roche, Juliette 1884- *DcWomA*
Roche, Kevin 1922- *BnEnAmA, ConArch, MacEA*
Roche, Laurence 1944- *WhoArt 80, –82, –84*
Roche, Leo Joseph 1888- *WhAmArt 85*
Roche, M Paul 1888- *WhAmArt 85*
Roche, Marthe De 1884- *DcWomA*
Roche, Martin *McGDA*
Roche, Martin 1853-1927 *BiDAmAr, MacEA*
Roche, Martin 1855-1925 *WhoArch*
Roche, Martin 1855-1927 *McGDA*
Roche, Peter DeLa *BiDBrA*
Roche, Philip *AntBDN H*
Roche, Pierre 1855-1922 *DcNiCA*
Roche, Robert 1921- *WhoAmA 80, –82, –84*
Roche, Samson Towgood 1759-1847 *AntBDN J*
Roche, Thomas S *DcVicP 2*
Roche, W *AntBDN C*
Roche And Dinkeloo *MacEA*
Rochebrune, Octave Guillaume De 1824-1900 *ClaDrA*
Rochefort, Countess Of *DcVicP 2*
Rochegrosse, Georges Antoine 1859-1938 *ClaDrA*
Rochelle, Eugene 1876-1914 *WhAmArt 85*
Rochelle, Russell Briscoe 1954- *MarqDCG 84*
Rochereau, Victorine Antoinette *DcWomA*
Rochette, Josephine *DcWomA*
Rochette, Roland 1887- *FolkA 86*
Rochlin, Fred 1923- *AmArch 70*
Rochling, Karl 1855-1920 *ClaDrA*
Rochon, Julius *NewYHSD*
Rochon, Louise *WhAmArt 85*
Rochon, Marie Louise *DcWomA*
Rochussen, Charles 1824-1894 *ClaDrA*
Rock, Helen Frazer d1932 *DcBrA 1, DcWomA*
Rockburne, Dorothea *ConArt 77, –83,*
DcCAr 81, WhoAmA 73, –76, –78, –80,
–82, –84
Rocke, Basil 1904- *DcBrA 2*
Rockefeller, David 1915- *WhoAmA 73, –76, –78, –80,*
–82, –84
Rockefeller, Mrs. David *WhoAmA 73, –76, –78, –80,*
–82, –84
Rockefeller, John Davison, III 1906- *WhoAmA 73,*
–76, –78
Rockefeller, John Davison, III 1906-1978*
WhoAmA 80N, –82N, –84N
Rockefeller, Mrs. Laurance S *WhoAmA 73,*
–76, –78, –80, –82, –84
Rockefeller, Nelson Aldrich 1908- *WhoAmA 73,*
–76, –78, –80N, –82N,
–84N
Rockefeller, Winthrop *WhoAmA 76N, –78N, –80N,*
–82N, –84N
Rockefeller, Winthrop 1912- *WhoAmA 73*
Rockefeller, Mrs. Winthrop *WhoAmA 73*
Rocker, Fermin 1907- *IlsCB 1957*
Rocker, Nicholas *NewYHSD*
Rockey, Abraham B 1799- *NewYHSD*
Rockey, Paul Thomas 1894- *AmArch 70*
Rocklin, Raymond 1922- *DcCAA 71, –77,*
PhDcTCA 77, WhoAmA 73, –76, –78, –80, –82,
–84
Rockline, Vera Schlezinger 1896-1934 *DcWomA*
Rockman, David Lee 1935- *AmArch 70*
Rockmore, M Gladys *WhAmArt 85*
Rockmore, Noel *WhoAmA 76, –78, –80, –82*
Rockmore, Noel 1928- *WhoAmA 73*
Rockrise, George Thomas 1916- *AmArch 70*
Rockrise, Thomas S d1936 *BiDAmAr*
Rockwell, Anna *DcWomA*
Rockwell, Anne *IlsCB 1967*
Rockwell, Anne 1934- *IlsBYP*
Rockwell, Augustus *NewYHSD*
Rockwell, B L, Jr. *AmArch 70*
Rockwell, Bertha 1874- *ArtsAmW 2, DcWomA,*
WhAmArt 85
Rockwell, Cleveland 1837-1907 *ArtsAmW 1,*
IlBEAAW, WhAmArt 85
Rockwell, Edwin Amasa 1846-1919 *WhAmArt 85*
Rockwell, Elizabeth A *ArtsAmW 3, DcWomA*
Rockwell, Etta Maia Reubell 1874- *ArtsAmW 3,*
DcWomA
Rockwell, Evelyn Enola 1887- *DcWomA,*
WhAmArt 85
Rockwell, Frederick 1917- *WhAmArt 85*

Rockwell, Fritz *WhAmArt 85*
Rockwell, Gail *IlsBYP*
Rockwell, Gary R 1948- *MarqDCG 84*
Rockwell, Harlow *IlsBYP, IlsCB 1967*
Rockwell, Harry Phillips Davis 1926- *AmArch 70*
Rockwell, Horace 1811-1877 *NewYHSD*
Rockwell, Jennie *ArtsEM, DcWomA*
Rockwell, Lucy Twyman *WhAmArt 85*
Rockwell, Matthew Laflin 1915- *AmArch 70*
Rockwell, Maxwell Warren 1876-1911 *WhAmArt 85*
Rockwell, Norman *OfPGCP 86*
Rockwell, Norman 1894- *IlrAm C, IlsBYP,*
IlsCB 1744, WhoAmA 73, –76, –78, WhoGrA 62
Rockwell, Norman 1894-1978 *IlrAm 1880[port],*
PrintW 83, –85, WhoAmA 80N, –82N, –84N
Rockwell, Norman Percevel 1894- *IlBEAAW*
Rockwell, Norman Percevel 1894-1978 *WhAmArt 85,*
WorECar
Rockwell, Peter Barstow 1936- *WhoAmA 76, –78, –80,*
–82
Rockwell, R A *DcWomA*
Rockwell, Rena Victoria 1890- *DcWomA,*
WhAmArt 85
Rockwell, Robert Goode 1922- *MarqDCG 84*
Rockwell, Robert H 1886- *WhAmArt 85*
Rockwell, Selden 1909- *WhoAmA 73*
Rockwell, Thomas H *CabMA*
Rockwell, W H *FolkA 86*
Rockwell, Warren *CabMA*
Rocle, Margaret 1897- *WhAmArt 85*
Rocle, Margaret K 1897- *ArtsAmW 2*
Rocle, Margaret King 1897- *DcWomA*
Rocle, Marius R 1897- *WhAmArt 85*
Rocle, Marius Romain 1897- *ArtsAmW 2*
Rocquain DeCurtemblay, Aline *DcWomA*
Rod, Bruce John 1947- *WhoAmA 80, –82, –84*
Roda 1926- *WhoAmA 76, –78, –80, –82, –84*
Roda, Fernand 1951- *DcCAr 81*
Rodakowski, Henri 1823- *ArtsNiC*
Rodan, Don 1950- *WhoAmA 82, –84*
Rodari, Bernardino *McGDA*
Rodari, Donato *McGDA*
Rodari, Giacomo *McGDA*
Rodari, Giovanni *McGDA*
Rodari, Tomaso *McGDA*
Rodbard, Betty *WhoAmA 80, –82, –84*
Rodchenko, Aleksandr 1891-1956 *PhDcTCA 77,*
WorArt[port]
Rodchenko, Aleksandr Mikhailovich 1891-1956*
OxTwCA
Rodchenko, Alexander 1891-1956 *ICPEnP, McGDA*
Rodchenko, Alexander Mihailovich 1891-1956 *MacBEP*
Rodchenko, Alexandr 1891-1956 *ConArt 83, ConPhot*
Rodchenko, Alexandr Mikhailovitch 1891-1956*
ConArt 77
Rodda, P M *AmArch 70*
Rodden, H *NewYHSD*
Roddy, Edith Jeannette *WhoAmA 80N, –82N, –84N*
Roddy, Edith Jeannette d1959? *DcWomA*
Roddy, Edith Jeannette d1960? *WhAmArt 85*
Rode, Christian Bernhard 1727-1797 *McGDA*
Rode, Cora 1898- *ArtsAmW 3*
Rode, Eugenie C *DcWomA*
Rode, Ingeborg Marta 1865-1932 *DcWomA*
Rode, John Alfred 1920- *AmArch 70*
Rode, Meredith Eagon 1938- *WhoAmA 78*
Rode, Meredith Eagon 1938- *WhoAmA 80, –82, –84*
Rode, Niels 1742?-1794 *ClaDrA*
Rodeck, Melita 1914- *AmArch 70*
Roden, Mary *DcBrWA*
Roden, W Frederick *DcBrWA*
Roden, William Thomas 1817-1892 *DcVicP 2*
Roden Brothers *EncASM*
Rodenbach, Aimee Bellarmina *DcWomA*
Roderer, Caroline Friederike Von *DcWomA*
Roderick, C E D *WhAmArt 85*
Roderick, Harry T *WhAmArt 85*
Roderick, James Donald 1935- *MarqDCG 84*
Roderick, John M 1878- *WhAmArt 85*
Roderick, L Z *WhAmArt 85*
Roderick, Lulu Zita *DcWomA*
Rodet, Madame *DcWomA*
Rodet, Anne Charlotte Claudine *DcWomA*
Rodetsky, M D *AmArch 70*
Rodewald, Fred C *IlBEAAW*
Rodger, George 1908- *ConPhot, ICPEnP, MacBEP*
Rodgers *FolkA 86, NewYHSD*
Rodgers, Fitz William *CabMA*
Rodgers, George Ray 1927- *AmArch 70*
Rodgers, Herbert *AfroAA*
Rodgers, Isabel Frances 1890- *DcWomA,*
WhAmArt 85
Rodgers, Jack A 1938- *WhoAmA 78, –80, –82, –84*
Rodgers, John B 1905- *AmArch 70*
Rodgers, Joseph *AntBDN N, DcVicP 2, EncASM*
Rodgers, Joshua *NewYHSD*
Rodgers, M C *WhAmArt 85*
Rodgers, Maria Sanchez *WhAmArt 85*
Rodgers, Marjorie 1894- *DcBrA 1, DcWomA*
Rodgers, Richard Perrier Channing 1950-*
MarqDCG 84

Rodgers, Robert B 1925- *AmArch 70*
Rodgers, Robert Perry 1895-1934 *BiDAmAr*
Rodgers, Shannon *WorFshn*
Rodgers, Stuart Demory 1919- *AmArch 70*
Rodgers, T K *AmArch 70*
Rodhe, Lennart 1916- *OxTwCA, PhDcTCA 77*
Rodia, Simon 1879-1965 *FolkA 86, MacEA*
Rodiana, Onorata d1452 *DcWomA*
Rodier, G L *AmArch 70*
Rodigue, Marie *DcWomA*
Rodin, Auguste 1840-1917 *AntBDN C, DcNiCA,*
McGDA, OxArt, PhDcTCA 77, WhAmArt 85A
Rodin, Barry H 1942- *MarqDCG 84*
Rodina, K Michaloff *WhAmArt 85*
Rodker, Judith 1910- *WhoArt 80, –82, –84*
Rodman, Cary S 1869-1911 *BiDAmAr*
Rodman, H Purcell *WhAmArt 85*
Rodman, Harry Eugene 1913- *AmArch 70*
Rodman, Mrs. J *WorFshn*
Rodman, Ruth M 1928- *WhoAmA 78, –80, –82, –84*
Rodman, Selden 1909- *WhoAmA 73, –76, –78, –80,*
–82, –84
Rodmell, G Hudson 1896- *DcSeaP*
Rodmell, Harry Hudson 1896- *ClaDrA, DcBrA 1,*
WhoArt 80, –82, –84
Rodmell, Ilsa 1898- *DcBrA 2*
Rodney, Steven R 1956- *MarqDCG 84*
Rodon, Rachel *DcWomA*
Rodrigue, George *OfPGCP 86*
Rodrigue, George G 1944- *WhoAmA 76, –78, –80, –82*
Rodrigue, Michael Antoine 1950- *MarqDCG 84*
Rodrigues, Antonio Carlos 1944- *ICPEnP A*
Rodrigues, Augusto 1913- *WorECar*
Rodrigues, Glauco 1929- *WhoGrA 62*
Rodrigues, Sebastiao 1929- *WhoGrA 62, –82[port]*
Rodrigues, Vilmar Silva 1931- *WorECar*
Rodrigues-Ferreira, Paulo 1911- *WhoGrA 62*
Rodriguez, Alfred C *ArtsAmW 1*
Rodriguez, Alonso d1513 *McGDA*
Rodriguez, Edward Lawrence 1933- *AmArch 70*
Rodriguez, Emilio D 1937- *WorECom*
Rodriguez, Geno 1940- *WhoAmA 80, –82, –84*
Rodriguez, Ida *ConArch A*
Rodriguez, J P *AmArch 70*
Rodriguez, Joe Bastida 1949- *WhoAmA 76, –78, –80*
Rodriguez, Jorge Jose 1939- *AmArch 70*
Rodriguez, Jose Miguel *FolkA 86*
Rodriguez, Lorenzo 1704-1774 *McGDA, WhoArch*
Rodriguez, Oscar 1943- *WhoAmA 76, –78, –80, –82,*
–84
Rodriguez, Pedro *FairDF SPA, WorFshn*
Rodriguez, Pedro A 1936- *WhoAmA 82, –84*
Rodriguez, R A *AmArch 70*
Rodriguez, Ralph 1924- *AmArch 70*
Rodriguez, Ralph Noel 1952- *WhoAmA 78*
Rodriguez, Ventura 1717-1785 *McGDA, OxArt,*
WhoArch
Rodriguez, Verneda *WhoAmA 78, –80*
Rodriguez Ayuso, Emilio 1845-1891 *MacEA*
Rodriguez Castelao, Daniel 1886-1950 *WorECar*
Rodriguez DeToro, Luisa *DcWomA*
Rodriguez-Diaz, Cuauhtemoc 1943- *MarqDCG 84*
Rodriguez Juarez, Juan 1675-1728 *McGDA*
Rodriguez-Leon, Ana M *WhoAmA 8?*
Rodriguez Lozano, Manuel *OxTwCA*
Rodriguez Lozano, Manuel 1896- *McGDA*
Rodriguez Luna, Antonio *WhoAmA 76, –78, –80*
Rodriguez Luna, Antonio 1910- *WhoAmA 73*
Rodriguez-Morales, Luis Manuel 1925- *WhoAmA 76,*
–78, –80
Rodriguez Roque, Oswaldo 1949- *WhoAmA 82*
Rodriguez-Sero, Juna Antonio 1942- *MarqDCG 84*
Rodriguez Tizon, Ventura 1717-1785 *MacEA*
Rodway *NewYHSD*
Rodway, Eric 1914- *DcBrA 1, WhoArt 80*
Rodway, Florence 1881- *DcWomA*
Roe, Clarence *DcVicP*
Roe, Clarence d1909 *DcBrA 1, DcVicP 2*
Roe, Fred 1864-1947 *DcBrBI*
Roe, Frederic 1864-1947 *DcVicP 2*
Roe, Frederic Gordon 1894- *WhoArt 80, –82, –84*
Roe, Frederick 1864-1947 *DcBrA 1, DcBrWA,*
DcVicP
Roe, Harold Richard 1930- *AmArch 70*
Roe, Henrietta A *DcVicP 2*
Roe, John *DcBrBI, DcBrWA*
Roe, Julia *DcWomA*
Roe, Nicholas *NewYHSD*
Roe, Richard Manleverer *DcVicP 2*
Roe, Mrs. Robert *WhAmArt 85*
Roe, Robert Ernest *DcBrWA, DcVicP 2*
Roe, Robert Henry 1793-1880 *DcBrWA, DcVicP, –2*
Roe, W J *DcVicP 2*
Roe, Walter Herbert *DcVicP, –2*
Roe, William *DcBrWA*
Roebel, George *FolkA 86*
Roebling, John Augustus 1806-1869 *MacEA, McGDA*
Roebling, Mary G 1905- *WhoAmA 73, –76, –78, –80,*
–82, –84
Roebling, Washington Augustus 1837-1926 *MacEA*
Roeckenschuss, Christian 1933- *DcCAr 81*

Roecker, H Leon *WhAmArt 85*
Roeder, Conrad d1877 *FolkA 86*
Roeder, Elsa 1883?-1914 *DcWomA*
Roeder, Elsa 1885-1914 *WhAmArt 85*
Roeder, Emy 1890- *PhDcTCA 77*
Roeder, Emy 1890-1971 *DcWomA*
Roeder, John 1877-1964 *ArtsAmW 3, FolkA 86*
Roeder, Judith E R *AmArch 70*
Roeder, Lawrence Frank 1935- *AmArch 70*
Roeder And Kiersky *EncASM*
Roederstein, Ottilie Wilhelmine 1859- *DcWomA*
Roedig, Johannes Christianus 1751-1802 *ClaDrA*
Roediger, Richard Merrill 1933- *AmArch 70*
Roeding, Frances 1910- *WhAmArt 85*
Roeger, Jack Lewis 1925- *AmArch 70*
Roehl, William Hamilton 1928- *AmArch 70*
Roehlk, Ernst *WhAmArt 85*
Roehn, A *DcVicP 2*
Roehner, Wilhelm *NewYHSD*
Roehr, Peter 1944-1968 *ConArt 77, -83*
Roehrich, P *WhAmArt 85*
Roel, J S *AmArch 70*
Roelas, Juan De 1558?-1625 *McGDA*
Roelas, Juan DeLas 1558?-1625 *OxArt*
Roelfsema, Alberta *DcWomA*
Roelly, Josephine Claire *DcWomA*
Roelofs, Mrs. Richard, Jr. *WhoAmA 73*
Roelofs, Willem 1822-1897 *ClaDrA*
Roelofsz, Robert Edward 1935- *AmArch 70*
Roeloss, W *DcVicP 2*
Roemer, Chester E 1921- *AmArch 70*
Roemhild, Amelie *DcWomA*
Roen, Irma *WhAmArt 85*
Roentgen, Abraham 1711-1793 *AntBDN G, OxDecA*
Roentgen, David d1807 *OxDecA*
Roentgen, David 1743-1807 *AntBDN G, DcD&D, McGDA*
Roentgen, Georg *OxDecA*
Roentgen, Wilhelm Conrad 1845-1923 *ICPEnP A, MacBEP*
Roepel, Coenraet 1678-1748 *ClaDrA*
Roerich, Konstantin 1874-1947 *ArtsAmW 2*
Roerich, Nicholas 1874-1947 *ArtsAmW 2, PhDcTCA 77*
Roerich, Nicholas Konstantin 1874-1947 *IlBEAAW*
Roes, Anna Eliza *FolkA 86*
Roesch, Kurt 1905- *DcCAA 71, -77, WhAmArt 85, WhoAmA 73, -76, -78, -80, -82, -84*
Roeschlaub, Robert S 1843-1923 *BiDAmAr*
Roesen, Severin *DcAmArt, FolkA 86*
Roesen, Severin 1848-1871 *BnEnAmA, NewYHSD*
Roesler, Norbert Leonhard Hugo 1901- *WhoAmA 73, -76, -78, -80, -82, -84*
Roessler, Clarence Arthur 1917- *AmArch 70*
Roessler, Pauline *DcWomA*
Roessling, Adolf Henry 1912- *AmArch 70*
Roessner, Roland Gommel 1911- *AmArch 70*
Roestraeten, Pieter Van 1630?-1700 *ClaDrA*
Roestraten, Pieter Gerritsz Van 1630?-1698 *McGDA*
Roestraten, Pieter Van 1630?-1700 *ClaDrA*
Roeters, Catharina Julia *DcWomA*
Roeth, Esther *WhAmArt 85*
Roethe, L H 1860- *ArtsAmW 1*
Roetling, Paul Gordon 1933- *MarqDCG 84*
Roetter, Paulus 1806-1894 *IlBEAAW, NewYHSD*
Roettger, David Allen 1934- *AmArch 70*
Roettger, Richard Earl 1932- *AmArch 70*
Roever, J M *IlsBYP*
Roever, Joan Marilyn 1935- *WhoAmA 78, -80, -82, -84*
Roey Van, Leon 1921- *WhoGrA 82[port]*
Roff *FolkA 86*
Roff, Amos B *FolkA 86*
Roffe, Alfred F *DcVicP 2*
Roffe, F *DcBrBI*
Roffe, William John *DcVicP, -2*
Roffey, Maureen 1936- *IlsCB 1967*
Roflow, Richard *OfPGCP 86*
Rogala, Irene Salvatore 1928- *AmArch 70*
Rogall, Wilhelmine *WhAmArt 85*
Rogalski, Walter 1923- *DcCAA 71, -77, WhoAmA 73, -76, -78, -80, -82, -84*
Rogatewier, B A *DcVicP 2*
Rogatnick, Abraham *ConArch A*
Rogeard, Madame *DcWomA*
Roger VonHelmarshausen *McGDA*
Roger, Louis 1874-1953 *ClaDrA*
Roger, Marie Blanche 1873- *DcWomA*
Roger, Rosa Marie 1898- *DcWomA*
Roger, Suzanne 1899?- *DcWomA*
Rogerius Of Melfi *McGDA*
Rogers *NewYHSD*
Rogers, Miss *DcWomA*
Rogers, Mrs. *DcWomA*
Rogers, A Edith *WhAmArt 85*
Rogers, A H *WhAmArt 85*
Rogers, A L, Jr. *AmArch 70*
Rogers, Adele 1861- *WhAmArt 85*
Rogers, Adele Shrenk 1861- *DcWomA*
Rogers, Annette Perkins 1841-1920 *DcWomA, WhAmArt 85*

Rogers, Archibald C 1917- *ConArch*
Rogers, Archibald Coleman 1917- *AmArch 70*
Rogers, Arthur Jensen 1936- *AmArch 70*
Rogers, Arthur Lee *DcVicP 2*
Rogers, Asa, Jr. *EncASM*
Rogers, B *DcBrWA*
Rogers, Barbara *AfroAA*
Rogers, Barbara Joan 1937- *WhoAmA 78, -80, -82, -84*
Rogers, Barksdale *WhAmArt 85*
Rogers, Bernard Holcomb 1932- *AmArch 70*
Rogers, Bob Carlton 1930- *AmArch 70*
Rogers, Brenda 1940- *AfroAA*
Rogers, Bruce *FolkA 86*
Rogers, Bruce 1870-1957 *OxDecA, WhoAmA 80N, -82N, -84N*
Rogers, C A *ArtsAmW 1*
Rogers, Carol *IlsBYP*
Rogers, Cephas B *EncASM*
Rogers, Charles *NewYHSD*
Rogers, Charles 1840?-1913 *WhAmArt 85*
Rogers, Charles A 1840?- *IlBEAAW, NewYHSD*
Rogers, Charles A 1848- *ArtsAmW 3*
Rogers, Charles B 1911- *WhAmArt 85, WhoAmA 73, -76, -78, -80, -82, -84*
Rogers, Charles D *OfPGCP 86*
Rogers, Charles D 1935- *AfroAA*
Rogers, Charles Edward 1932- *AmArch 70*
Rogers, Charles Eugene 1935- *AmArch 70*
Rogers, Charles H *ArtsAmW 1*
Rogers, Claude *WhoArt 80, -82N*
Rogers, Claude 1907- *PhDcTCA 77*
Rogers, Claude 1907-1979 *OxTwCA*
Rogers, Claude Maurice 1907- *DcBrA 1*
Rogers, D *NewYHSD*
Rogers, David *NewYHSD*
Rogers, David C *EncASM*
Rogers, David Peers 1929- *AmArch 70*
Rogers, Derek 1910- *DcBrA 1*
Rogers, E E *DcWomA*
Rogers, E F *DcVicP 2*
Rogers, E Q *AmArch 70*
Rogers, Ebenezer *CabMA*
Rogers, Edward *NewYHSD*
Rogers, Edward James 1872- *DcBrA 1, DcVicP 2*
Rogers, Eleanor Gale *ArtsAmW 2, DcWomA, WhAmArt 85*
Rogers, Elizabeth A *DcWomA*
Rogers, Elnora D *WhAmArt 85*
Rogers, Eric 1902- *DcBrA 1*
Rogers, Ernesto 1909-1969 *WhoArch*
Rogers, Ernesto N 1909- *EncMA*
Rogers, Ernesto Nathan 1909- *McGDA*
Rogers, Ernesto Nathan 1909-1969 *ConArch*
Rogers, F B *EncASM*
Rogers, Florence M *DcWomA*
Rogers, Frances *WhAmArt 85*
Rogers, Frances Elizabeth 1886- *DcWomA*
Rogers, Francis Day 1912- *AmArch 70*
Rogers, Frank Whiting 1854- *ArtsNiC*
Rogers, Frank Willson *EncASM*
Rogers, Franklin W *WhAmArt 85*
Rogers, Frederick *DcBrA 2*
Rogers, G R *AmArch 70*
Rogers, Gene *FolkA 86*
Rogers, George *AntBDN M, DcBrWA*
Rogers, George d1815 *DcNiCA*
Rogers, George 1718-1792 *DcBrECP*
Rogers, George 1930- *AfroAA*
Rogers, George B 1869-1945 *BiDAmAr*
Rogers, George E *EncASM*
Rogers, George H *EncASM, FolkA 86, NewYHSD*
Rogers, Gertrude 1896- *DcWomA, FolkA 86*
Rogers, Gilbert H *EncASM*
Rogers, Gina J *DcVicP 2*
Rogers, Gordon Patrick 1936- *AmArch 70*
Rogers, Grace *DcBrA 1, DcWomA*
Rogers, Grace Evelyn 1894- *DcBrA 1, DcWomA*
Rogers, Gretchen W *DcWomA, WhAmArt 85*
Rogers, H *DcVicP 2*
Rogers, H B *AmArch 70*
Rogers, H O *EncASM*
Rogers, Hamilton E 1857-1920 *BiDAmAr*
Rogers, Henry *EncASM*
Rogers, Henry W *NewYHSD*
Rogers, Henry Warren 1831-1919 *BiDAmAr*
Rogers, Henry Whittingham 1824-1855 *NewYHSD*
Rogers, Isaiah 1800-1869 *BiDAmAr, BnEnAmA, MacEA, McGDA*
Rogers, J *DcVicP 2, EncASM*
Rogers, J B *AmArch 70*
Rogers, J L *AmArch 70*
Rogers, James *AntBDN M, FolkA 86*
Rogers, James B *WhoAmA 73, -76*
Rogers, James Edward 1838-1896 *DcBrBI, DcBrWA, DcVicP, -2*
Rogers, James Gamble 1867-1947 *BiDAmAr, MacEA*
Rogers, James Gamble, II 1901- *AmArch 70*
Rogers, Jane 1896- *DcWomA, WhAmArt 85*
Rogers, Jane Masters *DcVicP, -2, DcWomA*

Rogers, John *AntBDN M, -N, ArtsNiC, FolkA 86*
Rogers, John d1816 *DcNiCA*
Rogers, John 1807?- *FolkA 86*
Rogers, John 1808?-1888? *NewYHSD*
Rogers, John 1829-1904 *BnEnAmA, DcAmArt, McGDA, NewYHSD, OxArt, WhAmArt 85*
Rogers, John 1906- *WhAmArt 85, WhoAmA 73, -76, -78, -80, -82, -84*
Rogers, John A 1870-1934 *WhAmArt 85*
Rogers, John Arthur 1870-1934 *BiDAmAr*
Rogers, John B 1922- *AmArch 70*
Rogers, John Davis, Jr. 1935- *AmArch 70*
Rogers, John George 1886-1967 *DcBrA 1*
Rogers, John H 1921- *WhoAmA 73, -76, -78, -80, -82, -84*
Rogers, Joseph Sheppard 1943- *WhoArt 84*
Rogers, Joseph Shepperd *WhoAmA 82, -84*
Rogers, Juanita *FolkA 86*
Rogers, Kate *DcVicP 2, DcWomA*
Rogers, Kate J *ArtsEM, DcWomA*
Rogers, Katherine M 1908- *WhAmArt 85*
Rogers, Kenneth Rolland 1922- *AmArch 70*
Rogers, Lanssat *WhAmArt 85*
Rogers, Leo M 1902- *WhoAmA 73, -76, -78, -80, -82, -84*
Rogers, Leora Corrin 1897- *DcWomA*
Rogers, Leore Corrin 1897- *WhAmArt 85*
Rogers, Leslie *AfroAA*
Rogers, Lincoln 1878-1944 *BiDAmAr*
Rogers, Louise DeGignilliet *DcWomA, WhAmArt 85*
Rogers, M *DcVicP 2, DcWomA*
Rogers, M J *DcVicP 2*
Rogers, Margaret *WhAmArt 85*
Rogers, Margaret Esther 1872-1961 *ArtsAmW 1, DcWomA, WhAmArt 85*
Rogers, Margaret Esther 1873-1961 *WhoAmA 80N, -82N, -84N*
Rogers, Mark 1848-1933 *DcBrA 2*
Rogers, Mary 1882-1920 *DcWomA, WhAmArt 85*
Rogers, Mary G *WhAmArt 85*
Rogers, Meyric Reynold 1893-1972 *WhAmArt 85, WhoAmA 78N, -80N, -82N, -84N*
Rogers, Michael G 1805?-1832 *NewYHSD*
Rogers, Millard Buxton 1912- *WhoAmA 84*
Rogers, Millard Foster, Jr. 1932- *WhoAmA 73, -76, -78, -80, -82, -84*
Rogers, Miriam 1900- *WhoAmA 76, -78, -80*
Rogers, Nathaniel *FolkA 86*
Rogers, Nathaniel 1788-1844 *NewYHSD*
Rogers, Nathaniel Burton *EncASM*
Rogers, O A *WhAmArt 85*
Rogers, Otto Donald 1935- *WhoAmA 73, -76, -78, -80, -82, -84*
Rogers, P J *WhoAmA 84*
Rogers, P J 1925- *WhoAmA 73, -76, -78, -80, -82*
Rogers, P J 1936- *AmArt*
Rogers, Palmer D 1881-1933 *BiDAmAr*
Rogers, Peter Wilfrid 1933- *WhoAmA 73, -76, -78, -80, -82, -84*
Rogers, Philip Hutchings 1786?-1853 *DcVicP, -2*
Rogers, Pliny 1882-1930 *BiDAmAr*
Rogers, Ralph *NewYHSD*
Rogers, Randolph 1825?- *ArtsNiC*
Rogers, Randolph 1825-1892 *ArtsEM, BnEnAmA, DcAmArt, IlBEAAW, McGDA, NewYHSD, WhAmArt 85*
Rogers, Rebecca *DcWomA*
Rogers, Richard 1933- *ConArch*
Rogers, Mrs. Richard *WhAmArt 85*
Rogers, Richard Boone 1905- *AmArch 70*
Rogers, Richard George 1933- *WhoArt 84*
Rogers, Robert *NewYHSD*
Rogers, Robert B 1907- *WhAmArt 85*
Rogers, Robert Stockton *WhoAmA 80N, -82N, -84N*
Rogers, Robert Stockton 1896-1960? *WhAmArt 85*
Rogers, Ronald Alexander 1934- *AmArch 70*
Rogers, Roy D *WhAmArt 85*
Rogers, S D *WhAmArt 85*
Rogers, Sarah *DcWomA, NewYHSD*
Rogers, Sarah 1735-1811 *FolkA 86*
Rogers, Simeon *EncASM*
Rogers, Simeon L *EncASM*
Rogers, Stanley R H d1961 *DcBrA 1*
Rogers, Steven P 1943- *MarqDCG 84*
Rogers, Thomas 1744?- *BiDBrA*
Rogers, Thomas Melvin 1920- *AmArch 70*
Rogers, Trevor Warren 1907- *AmArch 70*
Rogers, W A *DcBrBI*
Rogers, W A 1854-1931 *WhAmArt 85*
Rogers, W H *FolkA 86*
Rogers, W P *DcVicP 2*
Rogers, Wilbur F *EncASM*
Rogers, Will 1950- *DcCAr 81*
Rogers, William *FolkA 86, McGDA, OxArt*
Rogers, William 1865-1952 *FolkA 86*
Rogers, William, Jr. d1896 *EncASM*
Rogers, William A *EncASM*
Rogers, William Allen 1854-1931 *ArtsAmW 1, IlBEAAW, IlrAm 1880, WorECar*
Rogers, William G *EncASM*
Rogers, William H *EncASM*

Rogers, William Harry 1825-1873 *DcBrBI*
Rogers, William Hazen d1873 *EncASM*
Rogers, William Henry d1896 *EncASM*
Rogers, William P *DcBrWA*, *DcVicP 2*
Rogers, William Stewart 1906- *AmArch 70*
Rogers And Brittin *EncASM*
Rogers And Cole *EncASM*
Rogers And Hamilton *EncASM*
Rogers And Mead *EncASM*
Rogers And Spurr *EncASM*
Rogers Brothers *EncASM*
Rogers Lunt And Bowlen *EncASM*
Rogers Smith *EncASM*
Rogers Wendt And Wilkinson *EncASM*
Rogerson, John 1837-1925 *FolkA 86*
Rogert, Alene *WhAmArt 85*
Roget, John Lewis *DcVicP 2*
Rogge, Cornelius 1932- *ConArt 77*
Rogge, Emy 1866- *DcWomA*
Rogge, Lisel 1869- *DcWomA*
Roggenbach, D R *AmArch 70*
Roggenhofer, Ludwig 1937- *MarqDCG 84*
Roghman, Geertruyt d1658? *DcWomA*
Roghman, Magdalena *DcWomA*
Roghman, Roeland 1597-1686 *ClaDrA*
Roghman, Roelant 1597?-1686? *McGDA*
Rogier *McGDA*
Rogier, Jean M *DcVicP 2*
Rogier-Robert, Marie Alice *DcWomA*
Rogisse, Leonie Antoinette *DcWomA*
Rogister, Marie-Louise Von *DcCAr 81*
Rogman, Geertruyt d1658? *DcWomA*
Rognstad, J P *AmArch 70*
Rogovin, Howard Sand 1927- *WhoAmA 73, –76, –78, –80*
Rogovin, Mark 1946- *WhoAmA 78, –80, –82, –84*
Rogovin, Milton 1909- *ConPhot, ICPEnP A, WhoAmA 84*
Rogues, Lucie Eugenie *DcWomA*
Rogus, Robert Casimir 1933- *AmArch 70*
Roh, C Chase *MarqDCG 84*
Rohan-Soubise, Princess Charlotte G E De *DcWomA*
Rohault DeFleury Family *MacEA*
Rohde, Gilbert *WhAmArt 85*
Rohde, Gilbert 1894-1944 *BnEnAmA*
Rohde, Peggy Ann 1911- *WhAmArt 85*
Rohde, William F *NewYHSD*
Rohden, Marianne Von 1785-1866 *DcWomA*
Rohden, T *DcVicP 2*
Rohdenburg, Theodor Karl 1914- *AmArch 70*
Rohkohl, Fritz Carl 1931- *AmArch 70*
Rohl, Maria Christiana 1801-1875 *DcWomA*
Rohl-Smith, Carl *WhAmArt 85*
Rohland, Caroline Speare 1885- *DcWomA, WhAmArt 85*
Rohland, Caroline Speare 1885-1965 *ArtsAmW 3*
Rohland, H Paul *WhAmArt 85*
Rohland, H Paul 1884-1949 *ArtsAmW 3*
Rohland, Paul *WhoAmA 78N, –80N, –82N, –84N*
Rohland, Paul 1884-1953 *IlBEAAW, WhAmArt 85*
Rohlfing, Christian 1916- *WhoAmA 73, –76, –78, –80, –82, –84*
Rohlfing, Frederick *FolkA 86*
Rohlfs, Charles 1853-1936 *WhAmArt 85*
Rohlfs, Christian 1849-1938 *McGDA, OxArt, OxTwCA, PhDcTCA 77*
Rohloff, Wolfgang 1939- *DcCAr 81*
Rohm, Robert 1934- *BnEnAmA, ConArt 77, DcCAA 71, –77, WhoAmA 73, –76, –78, –80, –82, –84*
Rohn, Ray 1888-1935 *WhAmArt 85*
Rohner, Mister *NewYHSD*
Rohner, Georges 1913- *OxTwCA*
Rohnstock, J Henry 1879- *WhAmArt 85*
Rohonyi, Charles 1906- *WhoGrA 62*
Rohr, Rene 1944- *MarqDCG 84*
Rohrbach, Charles 1892- *WhAmArt 85*
Rohrbach, Henry J *EncASM*
Rohrbaugh, Charles Henry 1917- *AmArch 70*
Rohrer, J *AmArch 70*
Rohrer, Lina 1866- *DcWomA*
Rohrer, P *FolkA 86*
Rohrer, Walter Wayne 1930- *AmArch 70*
Rohrer, Warren 1927- *WhoAmA 76, –78, –80, –82, –84*
Rohrheimer, Louis *WhAmArt 85*
Rohrig, Fritz 1878- *WhAmArt 85*
Rohrig, Walter 1893-1945 *ConDes*
Rohrs, Marie 1820- *DcWomA*
Rohrwasser, Laura Amanda 1856- *DcWomA*
Rohse, Otto Friedrich Gustav 1925- *WhoGrA 62, –82[port]*
Rohte, Hermine *DcWomA*
Rohwer, Herbert Edward, Sr. 1918- *AmArch 70*
Rohwer, W D *AmArch 70*
Roine, J E *WhAmArt 85*
Roiter, Fulvio 1926- *ConPhot, ICPEnP A*
Roitz, Charles D *ICPEnP A, MacBEP*
Rojankovsky, Feodor Stepanovich d1970 *IlsCB 1967*
Rojankovsky, Feodor Stepanovich 1891- *Cald 1938, IlsBYP, IlsCB 1744, –1946, –1957*

Rojankovsky, Feodor Stepanovich 1891-1970 *WhoAmA 78N, –80N, –82N, –84N*
Rojas, Carlos *OxTwCA*
Rojas, Cleto *DcCAr 81*
Rojas, Cristobal 1858-1890 *McGDA*
Rojas Roca, Roberto 1943- *MarqDCG 84*
Rojc, Melitta 1878-1924 *DcWomA*
Rojc, Nasta 1883- *DcWomA*
Rojko, Melvin A 1926- *AmArch 70*
Rojo, Vicente *OxTwCA*
Rojo, Vicente 1932- *WhoAmA 73, –76, –78, –80, –82, –84*
Rojtman, Marc B *WhoAmA 82*
Rojtman, Mrs. Marc B *WhoAmA 73, –76, –78, –80*
Rokicki, R S *AmArch 70*
Rokita, David George 1952- *MarqDCG 84*
Roko *DcWomA*
Rokos, Demetrius K L 1941- *MarqDCG 84*
Rola, A *AmArch 70*
Rolader, William Washington 1856-1922 *FolkA 86*
Roland, Arthur *AfroAA*
Roland, Arthur 1935- *WhoAmA 76, –78, –80*
Roland, Conrad *WhAmArt 85*
Roland, Craig Williamson 1935- *AmArch 70*
Roland, Edward 1911- *WhAmArt 85*
Roland, Frederick S 1938- *AmArch 70*
Roland, Henry M 1907- *WhoArt 80, –82, –84*
Roland, Jay 1904-1960 *WhAmArt 85*
Roland, Jay 1905-1960 *WhoAmA 80N, –82N, –84N*
Roland, Mrs. Jay *WhAmArt 85*
Roland, John *NewYHSD*
Roland, Lorinda 1938- *WhoAmA 76*
Roland, Philippe-Laurent 1746-1816 *McGDA*
Roland, Ruth *DcCAr 81*
Roland, Seth, Jr. 1947- *MarqDCG 84*
Roland DeLaPlatiere, Marie Jeanne 1754-1793 *DcWomA*
Roland DeLaPorte, Henri Horace 1724?-1793 *McGDA*
Rolando, Paolo Emilio 1884- *WhAmArt 85*
Rolando, Virginia Moorhead 1898- *DcWomA, WhAmArt 85*
Roldan, Francisca *DcWomA*
Roldan, Luisa 1656-1704 *DcWomA, WomArt*
Roldan, Maria *DcWomA*
Roldan, Pedro 1624?-1700? *McGDA*
Roldan, Pedro 1624-1700 *OxArt*
Roldana, La *McGDA*
Rolez, Marie Emilie 1896- *DcWomA*
Rolf, Emma *DcWomA, NewYHSD*
Rolf, Margot 1940- *DcCAr 81*
Rolfe, Mrs. A F *DcVicP 2*
Rolfe, Alexander F *DcBrWA, DcVicP, –2*
Rolfe, Ebenezer 1818- *CabMA*
Rolfe, Edmond 1877-1917 *ArtsEM*
Rolfe, Edmund *DcVicP 2*
Rolfe, Edmund 1877-1917 *WhAmArt 85*
Rolfe, Emma *DcWomA, NewYHSD*
Rolfe, F *DcVicP 2*
Rolfe, Frederick d1913 *DcVicP 2*
Rolfe, H L *ArtsNiC*
Rolfe, Henry Leonidas *DcVicP, –2*
Rolfe, John *NewYHSD*
Rolfe, John A 1799-1862 *NewYHSD*
Rolfe, Julia L *DcVicP 2*
Rolfe, Mary *WhAmArt 85*
Rolfe, William Edward *BiDBrA*
Rolfsen, Alf *WhoArt 82N*
Rolfsen, Alf 1895- *OxArt, PhDcTCA 77, WhoArt 80*
Rolfsen, Kari 1938- *DcCAr 81*
Rolin-Jacquemyns, Madame *DcWomA*
Rolin-Jaequemyns, Madame *DcWomA*
Roline, Lester Elmer 1920- *AmArch 70*
Roling, Marte 1939- *WhoGrA 82[port]*
Roll *DcVicP 2*
Roll, Alfred-Philippe *ArtsNiC*
Roll, Alfred Philippe 1846-1919 *ClaDrA*
Roll, Jean 1921- *DcCAr 81*
Roll, Robert Edward 1927- *AmArch 70*
Rollason, Benjamin Howard 1921- *AmArch 70*
Rollaston, W A *DcVicP 2*
Rolle, Miss *DcWomA*
Rolle, A H O 1875- *WhAmArt 85*
Rolle, Albert *NewYHSD*
Rolle, Marie 1865- *DcWomA*
Roller, Albert Frederick 1891- *AmArch 70*
Roller, E R *AmArch 70*
Roller, George Conrad 1856- *DcBrA 1, DcVicP 2*
Roller, George R *DcVicP 2*
Roller, George R 1858- *DcBrBI*
Roller, Janet Worsham *WhAmArt 85*
Roller, K *WhAmArt 85*
Roller, Marion Bender *WhoAmA 73, –76, –78, –80, –82, –84*
Roller, Nettie Huxley *DcVicP 2*
Roller, Russell Kenneth 1938- *WhoAmA 82, –84*
Rolleston, Benjamin Howard *sic*
Rolleston, Lucy *DcVicP 2*
Rolleston, William Anthony 1903- *AmArch 70*
Rollet, Citizeness *DcWomA*

Rollet, Louis Rene Lucien, Madame *DcWomA*
Rollett, Herbert 1872-1932 *DcBrA 1*
Rollett, I Kathleen 1898- *DcBrA 1, DcWomA*
Rolli, Anna 1810?- *DcWomA*
Rollin, Kate C *DcWomA*
Rollin, Marie *DcWomA*
Rolling Mountain Thunder, Chief *FolkA 86*
Rollings, A Sydney 1880- *WhAmArt 85*
Rollings, Lucy *FolkA 86*
Rollins, Bernard *AfroAA*
Rollins, Carl Purington 1880- *WhAmArt 85*
Rollins, George W S *FolkA 86*
Rollins, Helen A Jordan 1893- *WhAmArt 85*
Rollins, Helen Jordan 1893- *ArtsAmW 1, DcWomA*
Rollins, Henry C 1937- *AfroAA*
Rollins, Jo Lutz 1896- *AmArt, WhoAmA 76, –78, –80, –82, –84*
Rollins, John Wenlock d1940 *DcBrA 1*
Rollins, Josephine *DcWomA, WhAmArt 85*
Rollins, Oney *AfroAA*
Rollins, Rich *DcCAr 81*
Rollins, Warren E 1861-1962 *ArtsAmW 1*
Rollins, Warren Eliphalet 1861-1962 *IlBEAAW, WhAmArt 85*
Rollinson, Charles *WhAmArt 85*
Rollinson, Charles 1793?-1833 *NewYHSD*
Rollinson, S O *NewYHSD*
Rollinson, Sunderland *DcVicP 2*
Rollinson, Sunderland 1872- *ClaDrA, DcBrBI*
Rollinson, Sunderland 1882- *DcBrA 1*
Rollinson, William 1762-1842 *NewYHSD*
Rollman-Shay, Charlotte 1947- *WhoAmA 78, –80, –82, –84*
Rollman-Shay, Ed 1947- *WhoAmA 78, –80, –82, –84*
Rollo, Mrs. *DcWomA*
Rollo, Herman *AfroAA*
Rollo, Jo 1904- *WhAmArt 85*
Rollot, Berthe *DcWomA*
Rollot, Eugenie *DcWomA*
Rolls, Elizabeth Harcourt *DcWomA*
Rolls, Elizabeth Mary *DcWomA*
Rolls, Florence *DcVicP 2*
Rolls, M S *DcVicP 2*
Rolls, Patty *DcWomA*
Rolly, Ronald Joseph 1937- *WhoAmA 76, –78, –80, –82, –84*
Roloff, John 1947- *AmArt, DcCAr 81*
Roloff, John Scott 1947- *WhoAmA 76, –78, –80, –82, –84*
Roloff, Louis *NewYHSD*
Roloff, R B *AmArch 70*
Roloson, Robert James 1927- *AmArch 70*
Rolph, D M *AmArch 70*
Rolph, John A 1799-1862 *NewYHSD*
Rolph, Richard Norman 1949- *MarqDCG 84*
Rolshoven, Julius 1858-1930 *IlBEAAW, WhAmArt 85*
Rolshoven, Julius C 1858-1930 *ArtsAmW 1, ArtsEM[port]*
Rolt, Charles *DcBrBI, DcVicP, –2*
Rolt, Vivian 1874-1933 *DcBrA 1, DcBrWA, DcVicP 2*
Roma, Spiridione 1735?-1787 *DcBrECP*
Romagnesi, Madame *DcWomA*
Romagnoni, Giuseppe 1930-1964 *OxTwCA, PhDcTCA 77*
Romain, Le *McGDA*
Romaine-Walker, Winefride *DcBrA 1*
Roman, Alexius *CabMA*
Roman, Amelie *WhAmArt 85*
Roman, D E *AmArch 70*
Roman, D F *FolkA 86*
Roman, George Anthony 1937- *AmArch 70*
Roman, Jon Richard 1950- *MarqDCG 84*
Roman, Kathe 1871- *DcWomA*
Roman, Nicholas M 1920- *AmArch 70*
Roman, Shirley *WhoAmA 76, –78, –80, –82, –84*
Romanach, Leopoldo *WhAmArt 85*
Romanach, M J *AmArch 70*
Romance, Adele *DcWomA*
Romanelli, Carlo *WhAmArt 85*
Romanelli, Carlo 1872- *ArtsEM*
Romanelli, Frank 1909- *WhAmArt 85*
Romanelli, Giovanni Francesco 1610?-1662 *McGDA, OxArt*
Romanelli, P *ArtsNiC*
Romanet, Ernest Victor 1876- *ClaDrA*
Romani, Juana 1869-1924 *ClaDrA, DcWomA*
Romani, Romolo *OxTwCA*
Romanini, Fanny *DcWomA*
Romanino, Girolamo 1484?-1566 *McGDA*
Romanne, Valentine, Madame *DcWomA*
Romano, Clare 1922- *PrintW 83, –85*
Romano, Clare Camille *WhoAmA 73, –76, –78, –80, –82, –84*
Romano, Emanuel Glicen 1897- *WhoAmA 73, –76, –78, –80, –82, –84*
Romano, Emanuel Glicen 1901- *WhAmArt 85*
Romano, Gian Cristoforo 1470?-1512 *McGDA*
Romano, Giulio 1499-1546 *McGDA*
Romano, Jaime 1942- *WhoAmA 73, –76, –78, –80,*

Roper, A F *DcVicP 2*
Roper, Cecil B *DcVicP 2*
Roper, David Ridall 1774?-1855 *MacEA*
Roper, David Riddall 1774?-1855 *BiDBrA*
Roper, Edward 1857-1891 *IlBEAAW*
Roper, Frank *DcCAr 81*
Roper, Frank 1914- *DcBrA 1*
Roper, Geoffrey John 1942- *WhoArt 80, -82, -84*
Roper, Mrs. George *WhAmArt 85*
Roper, J F *AmArch 70*
Roper, M Secor 1886- *DcWomA, WhAmArt 85*
Roper, Murray J 1910- *WhAmArt 85*
Roper, Paul *MarqDCG 84*
Roper, Richard *DcBrECP*
Roper, Robert *BiDBrA*
Roper, William E 1942- *MarqDCG 84*
Ropes, Andrew M 1830-1913 *WhAmArt 85*
Ropes, George *NewYHSD*
Ropes, George 1788- *FolkA 86*
Ropes, George 1788-1819 *DcSeaP, NewYHSD*
Ropes, George H 1868-1937 *BiDAmAr*
Ropes, George L *ArtsEM*
Ropes, Joseph 1812-1885 *NewYHSD*
Ropes, Phebe *WhAmArt 85*
Ropp, Hubert 1894- *WhAmArt 85*
Ropp, Roy M 1888- *ArtsAmW 2, WhAmArt 85*
Rops, Felicien 1833-1898 *McGDA, OxArt, WorECar*
Rops, Felicien Joseph Victor 1833-1898 *ClaDrA*
Roque Gaimeiro, Rachel 1889- *DcWomA*
Roque Gameiro, Helena 1889- *DcWomA*
Roque Gameiro, Mamia 1897- *DcWomA*
Roquen, August *NewYHSD*
Roqueplan, Camille-Joseph-Etienne 1800-1855 *McGDA*
Roqueplan, Camille Joseph Etienne 1803-1855 *ClaDrA*
Roqueplan, Joseph-Etienne-Camille 1802-1855 *ArtsNiC*
Roques, Anna Charlotte *DcWomA*
Roquette, Mansion *AfroAA*
Rorer, Margareta *DcWomA*
Rorex, Evelyn 1931- *AmArch 70*
Rorex, Robert Albright 1935- *WhoAmA 84*
Rorheimer, Louis 1872-1939 *WhAmArt 85*
Roriczer Family *MacEA*
Rorimer, James J *WhoAmA 78N, -80N, -82N, -84N*
Rorimer, James J 1905-1968? *WhAmArt 85*
Rorimer, Louis 1872-1939 *WhAmArt 85*
Roritzer, Konrad d1475 *McGDA*
Roritzer, Mathaus d1492? *OxArt*
Roritzer Family *OxArt*
Rorke, E *DcVicP 2*
Rorke, Edward A 1856-1905 *WhAmArt 85*
Rorman, Maynard William, Jr. 1928- *AmArch 70*
Rorphuro, Julius J *ArtsAmW 1*
Rorphuro, Julius J 1861?-1928 *ArtsAmW 3*
Rorty, Marion *DcWomA*
Ros, Baroness De *DcWomA*
Rosa DaTivoli *McGDA*
Rosa, Anella De *DcWomA*
Rosa, Anna Sofia De *DcWomA*
Rosa, Clarence Henry 1912- *AmArch 70*
Rosa, Francis J *MarqDCG 84*
Rosa, Frank Yates, Jr. 1930- *AmArch 70*
Rosa, Guido 1890- *WhAmArt 85*
Rosa, Julio L 1951- *MarqDCG 84*
Rosa, Lawrence 1892- *WhAmArt 85*
Rosa, Luisa Maria *DcWomA*
Rosa, Salvator 1615-1673 *ClaDrA, McGDA, OxArt*
Rosabel, Cecilia *DcWomA*
Rosai, Ottone 1895-1957 *McGDA, OxTwCA, PhDcTCA 77*
Rosaies, E O *WhAmArt 85*
Rosalbin DeBuncey, Marie Abraham *DcWomA*
Rosales, Eduardo d1873 *ArtsNiC*
Rosales, Eduardo 1836-1873 *McGDA*
Rosales Y Martinez, Eduardo 1836-1873 *OxArt*
Rosamond, William Irby 1912- *AmArch 70*
Rosand, David 1938- *WhoAmA 80, -82, -84*
Rosane, Richard Clarence 1929- *AmArch 70*
Rosanova, Olga *DcWomA*
Rosanovick, Maria Vorobeva *DcWomA*
Rosapina, Francesco 1762-1841 *ClaDrA*
Rosarius *DcVicP 2*
Rosarius, R Brett *DcWomA*
Rosas, Mel 1950- *WhoAmA 82, -84*
Rosati, James 1912- *BnEnAmA, DcCAA 71, -77, OxTwCA, PhDcTCA 77, WhoAmA 73, -76, -78, -80, -82, -84*
Rosatti, Ector F *WhAmArt 85*
Rosbach, Elias 1700-1765 *IlDcG*
Roscamp, Katharina 1875- *DcWomA*
Roscher, Franz 1928- *WorECom*
Roscoe, Henry Enfield 1833-1915 *MacBEP*
Roscoe, S G W *DcBrA 1, DcVicP*
Roscoe, S G William 1852-1922? *DcVicP 2*
Roscoe, S G Williams 1852- *DcBrWA*
Rose *EncASM*
Rose, Mrs. *FolkA 86*
Rose, A W *AmArch 70*
Rose, Adelaide E *DcWomA, WhAmArt 85*
Rose, Alison Helen 1900- *DcBrA 1*

Rose, Arthur *AfroAA*
Rose, Arthur 1921- *WhoAmA 73, -76*
Rose, Augustus Foster 1873-1946 *WhAmArt 85*
Rose, Barbara E 1937- *WhoAmA 78, -80, -82*
Rose, Ben 1916-1980 *ICPEnP A*
Rose, Bernd 1942- *DcCAr 81*
Rose, Bernice Berend *WhoAmA 78, -80*
Rose, Billy 1906-1966 *WhoAmA 78N, -80N, -82N, -84N*
Rose, Byron Stewart *AmArch 70*
Rose, Carl *WhAmArt 85*
Rose, Carl 1903-1971 *WorECar*
Rose, Daniel *WhAmArt 85*
Rose, David 1910- *WhoAmA 80, -82, -84*
Rose, Diana Cecilia 1921- *WhoArt 80, -82, -84*
Rose, Dorothy *WhoAmA 73, -76*
Rose, Ed *WhAmArt 85*
Rose, Elihu *NewYHSD*
Rose, Elizabeth Agnes *DcWomA, WhAmArt 85*
Rose, Emmi d1920 *DcWomA*
Rose, Ethel Boardman *WhAmArt 85*
Rose, Ethel Boardman 1871-1946 *ArtsAmW 2, DcWomA*
Rose, Sir Francis Cyril 1909- *DcBrA 1*
Rose, Francis John 1907- *AmArch 70*
Rose, George David 1939- *MarqDCG 84*
Rose, George Herbert 1882-1955 *DcBrA 1*
Rose, George L 1861- *WhAmArt 85*
Rose, George P *NewYHSD*
Rose, George W *ArtsEM*
Rose, Gerald *IlsCB 1967*
Rose, Gerald 1935- *IlsBYP, IlsCB 1957*
Rose, Gerard De 1921- *ClaDrA*
Rose, Guy 1867-1925 *ArtsAmW 1, IlBEAAW, WhAmArt 85*
Rose, H Ethel *DcBrWA, DcVicP, -2, DcWomA*
Rose, H Randolph *DcBrWA, DcVicP, -2*
Rose, Hanna Toby *WhoAmA 73, -76*
Rose, Hanna Toby 1909-1976 *WhoAmA 78N, -80N, -82N, -84N*
Rose, Harold Cleagland 1920- *AmArch 70*
Rose, Helen *WorFshn*
Rose, Henry *BiDBrA*
Rose, Herman 1909- *McGDA, WhoAmA 73, -76, -78, -80, -82, -84*
Rose, Iver 1899-1972 *WhAmArt 85, WhoAmA 78N, -80N, -82N, -84N*
Rose, Jack Gloster 1933- *AmArch 70*
Rose, Jack Manley *WhAmArt 85*
Rose, James 1731?-1796 *BiDBrA*
Rose, James F 1938- *MarqDCG 84*
Rose, James L 1943- *MarqDCG 84*
Rose, John *NewYHSD*
Rose, John 1760?-1841 *AntBDN M*
Rose, John 1772?-1841 *DcNiCA*
Rose, Kate 1948- *DcCAr 81*
Rose, Leatrice *WhoAmA 78, -80, -82, -84*
Rose, Leize *WhAmArt 85*
Rose, LeRoy 1927- *AmArch 70*
Rose, Mary Anne 1949- *WhoAmA 78, -80, -82, -84*
Rose, Minnie *ArtsEM, DcWomA*
Rose, Muriel 1923- *ClaDrA, DcBrA 1, WhoArt 80, -82, -84*
Rose, Noble Eugene 1929- *AmArch 70*
Rose, P P *AmArch 70*
Rose, Peter 1943- *ConArch*
Rose, Peter Henry 1935- *WhoAmA 73, -76, -78, -80, -82, -84*
Rose, Philip 1791?- *FolkA 86*
Rose, R W *AmArch 70*
Rose, Richard H *DcBrWA, DcVicP 2*
Rose, Richard Warren 1924- *AmArch 70*
Rose, Robert R 1946- *MarqDCG 84*
Rose, Robert Traill 1863- *DcBrA 1, DcBrBI, DcVicP 2*
Rose, Robert Traill 1863-1942 *DcBrA 2*
Rose, Roslyn 1929- *WhoAmA 78, -80, -82, -84*
Rose, Ruth Starr 1887-1965 *DcWomA*
Rose, Samuel 1941- *WhoAmA 76, -78, -80, -82, -84*
Rose, Starr 1887- *WhAmArt 85*
Rose, Stephanie 1943- *WhoAmA 84*
Rose, Susan Penelope *DcWomA*
Rose, Thomas *DcNiCA*
Rose, Thomas Albert *DcCAr 81*
Rose, Thomas Albert 1942- *WhoAmA 73, -76, -78, -80, -82, -84*
Rose, Thomas Leslie 1867-1935 *BiDAmAr*
Rose, Timothy G 1944- *WhoAmA 78, -80*
Rose, William *DcCAr 81*
Rose, William Allen, Jr. 1938- *AmArch 70*
Rose, William F d1864 *DcNiCA*
Rose, William F 1909- *WhAmArt 85*
Rose, William Henry Harrison 1839-1913 *FolkA 86*
Rose, William S 1810-1873 *DcVicP, -2*
Rose, William S, Jr. *ArtsEM*
Rose, William S, Sr. 1846?-1938 *ArtsEM*
Rose-Grabow, Martha 1860- *DcWomA*
Rose-Pulham, Peter 1910-1956 *ICPEnP A*
Roseberg, Carl Andersson 1916- *WhoAmA 73, -76, -78, -80, -82, -84*
Roseblade, William 1882- *DcBrA 1*
Rosebrook, Rod 1900- *FolkA 86*

Rosebush, Judson George 1947- *MarqDCG 84*
Rosee *DcWomA*
Rosekrans, Adolph Spreckels 1930- *AmArch 70*
Roseland, Harry 1866-1950 *WhAmArt 85*
Roseland, Harry Herman d1950 *WhoAmA 78N, -80N, -82N, -84N*
Rosello, Francisco *DcVicP 2*
Roseman, Bill 1891- *FolkA 86*
Roseman, Stanley 1945- *WhoAmA 82, -84, WhoArt 82, -84*
Roseman, Susan Carol 1950- *WhoAmA 82, -84*
Rosembert-Couder, Jeanne 1874- *DcWomA*
Rosemond, Mademoiselle Carreaux De d1788 *DcWomA*
Rosemont, Mademoiselle Carreaux De d1788 *DcWomA*
Rosen, Alan 1925- *AmArch 70*
Rosen, Alfred Joseph 1913- *AmArch 70*
Rosen, Ann B 1948- *MacBEP*
Rosen, Anton S 1859-1928 *MacEA*
Rosen, Beverly Doris *WhoAmA 76, -78, -80, -82, -84*
Rosen, Charles d1950 *WhoAmA 78N, -80N, -82N, -84N*
Rosen, Charles 1878-1950 *WhAmArt 85*
Rosen, David 1880-1960 *WhoAmA 80N, -82N, -84N*
Rosen, Mrs. Eduard *WhAmArt 85*
Rosen, Edward Marshall 1930- *MarqDCG 84*
Rosen, Ernest T *WhAmArt 85*
Rosen, Esther Yovits 1916- *WhAmArt 85*
Rosen, Fredric Alan 1941- *AmArch 70*
Rosen, George, Count Von *ArtsNiC*
Rosen, Gerald Irving 1934- *AmArch 70*
Rosen, Hy 1923- *ConGrA 1[port], WhoAmA 73, -76, -78, -80, -82, -84*
Rosen, Hyman J 1923- *WorECar*
Rosen, Ismond 1924- *WhoArt 80, -82, -84*
Rosen, Israel 1911- *WhoAmA 73, -76, -78, -80, -82, -84*
Rosen, James Mahlon 1933- *AmArt, WhoAmA 76, -78, -80, -82, -84*
Rosen, Jeanie 1954- *AmArt*
Rosen, Joan Fischman *WhoAmA 80, -82, -84*
Rosen, Kay *DcCAr 81*
Rosen, Lloyd Jerome 1931- *AmArch 70*
Rosen, Michael Blair 1941- *AmArch 70*
Rosen, Michael Lee 1935- *AmArch 70*
Rosen, Moses *ArtsEM*
Rosen, N N *AmArch 70*
Rosen, Richard L 1935- *AmArch 70*
Rosen, Robert 1943- *MarqDCG 84*
Rosen, Sandy 1944- *DcCAr 81*
Rosen-Queralt, Jann 1951- *WhoAmA 78, -80*
Rosenau, Helen *WhoArt 80, -82, -84*
Rosenauer, M *AmArch 70*
Rosenbach, Luise 1849- *DcWomA*
Rosenbach, Ulrike 1943- *ConArt 83, DcCAr 81*
Rosenbauer, W Wallace 1900- *WhAmArt 85*
Rosenbaum, Allen *WhoAmA 82, -84*
Rosenbaum, Caroline 1896- *DcWomA, WhAmArt 85*
Rosenbaum, Charles Jay 1936- *AmArch 70*
Rosenbaum, David Howell 1908- *WhAmArt 85*
Rosenbaum, David Howell, Jr. 1908- *IlBEAAW*
Rosenbaum, Evelyn Eller *WhoAmA 82, -84*
Rosenbaum, J W *EncASM*
Rosenbaum, Jerrold Stephen 1943- *MarqDCG 84*
Rosenbaum, Philip J 1950- *MarqDCG 84*
Rosenbaum, Roy Ivan 1936- *AmArch 70*
Rosenberg, A F *AmArch 70*
Rosenberg, Alex Jacob 1919- *WhoAmA 78, -80, -82, -84*
Rosenberg, Avis Lang 1944- *WhoAmA 82*
Rosenberg, Barry Howard 1946- *MarqDCG 84*
Rosenberg, Bernard 1938- *WhoAmA 78, -80, -82, -84*
Rosenberg, Carl Christian 1745-1844 *OxDecA*
Rosenberg, Carole Halsband 1936- *WhoAmA 78, -80, -82, -84*
Rosenberg, Charles *DcBrWA*
Rosenberg, Charles 1745?-1844 *AntBDN O*
Rosenberg, Charles, Jr. *DcVicP 2*
Rosenberg, Charles G *NewYHSD*
Rosenberg, Charles Michael 1945- *WhoAmA 76, -78, -80*
Rosenberg, Else *DcWomA*
Rosenberg, Ethel Jenner *DcBrWA, DcWomA*
Rosenberg, Eugene *ConArch A*
Rosenberg, Eugene 1907- *ConArch, MacEA*
Rosenberg, Mrs. F *DcVicP 2*
Rosenberg, Frances Elizabeth Louisa *DcVicP 2*
Rosenberg, Frances Elizabeth Louisa 1822-1873 *DcBrWA*
Rosenberg, Frances Elizabeth Louise *DcWomA*
Rosenberg, George Frederick 1825-1869 *DcBrWA*
Rosenberg, George Frederick 1825-1870 *DcVicP 2*
Rosenberg, H B *DcVicP 2, DcWomA*
Rosenberg, H M 1858- *WhAmArt 85*
Rosenberg, Harold 1906- *WhoAmA 73, -76, -78*
Rosenberg, Harold 1906-1978 *WhoAmA 80N, -82N, -84N*
Rosenberg, Hymen 1904- *AmArch 70*
Rosenberg, Isaac 1890-1918 *DcBrA 2*
Rosenberg, Jakob 1893- *WhAmArt 85, WhoAmA 73,*

-76, -78, -80, -82
Rosenberg, Jakob 1893-1980 *WhoAmA 84N*
Rosenberg, James N 1874- *WhAmArt 85*
Rosenberg, Jeanne C *DcWomA*
Rosenberg, L C *AmArch 70*
Rosenberg, Louis Conrad 1890- *ArtsAmW 2, MacEA, WhAmArt 85, WhoAmA 73, -76*
Rosenberg, Louis Conrad 1890-1983 *GrAmP*
Rosenberg, M L *AmArch 70*
Rosenberg, Manuel 1897- *WhAmArt 85*
Rosenberg, Mary *DcVicP 2*
Rosenberg, Mary Ann *DcBrWA*
Rosenberg, Mary Elizabeth *DcWomA*
Rosenberg, Mordecai *WhAmArt 85*
Rosenberg, Nelson Chidecker 1908- *WhAmArt 85*
Rosenberg, Rosa *WhAmArt 85*
Rosenberg, Saemy *WhoAmA 78N, -80N, -82N, -84N*
Rosenberg, Samuel 1896-1972 *WhAmArt 85, WhoAmA 78N, -80N, -82N, -84N*
Rosenberg, Samuel M 1893- *WhAmArt 85*
Rosenberg, T *DcVicP 2*
Rosenberg, Thomas Elliot 1790-1835 *DcBrWA*
Rosenberg, Victor L 1944- *MarqDCG 84*
Rosenberg, William Frederick *DcBrWA*
Rosenberg, Yetta 1905- *WhAmArt 85*
Rosenblatt, Adolph 1933- *WhoAmA 73, -76, -78, -80, -82, -84*
Rosenblatt, Alice *WhAmArt 85*
Rosenblatt, Arthur I 1931- *AmArch 70*
Rosenblatt, Suzanne Maris 1937- *WhoAmA 76, -78, -80, -82, -84*
Rosenbloom, Andrew Russell 1951- *MarqDCG 84*
Rosenbloom, Charles J *WhoAmA 73*
Rosenblum, Arthur Gordon 1928- *AmArch 70*
Rosenblum, Jay 1933- *ConArt 77, PrintW 83, -85, WhoAmA 73, -76, -78, -80, -82, -84*
Rosenblum, Jeffrey Marc 1944- *AmArch 70*
Rosenblum, Richard *IlsBYP*
Rosenblum, Richard 1941- *AmArt*
Rosenblum, Richard Stephen 1940- *WhoAmA 82, -84*
Rosenblum, Robert 1927- *WhoAmA 73, -76, -78, -80, -82, -84*
Rosenblum, Sadie Skoletsky 1899- *WhoAmA 73, -76, -78, -80, -82, -84*
Rosenblum, Walter 1919- *ConPhot, ICPEnP A, MacBEP*
Rosenborg, Ralph M 1910- *WhAmArt 85*
Rosenborg, Ralph M 1913- *DcCAA 71, -77, WhoAmA 73, -76, -78, -80, -82, -84*
Rosendahl, Carl *MarqDCG 84*
Rosendahl, Gertrude *WhAmArt 85*
Rosendale, Harriet *WhoAmA 73, -76*
Rosendorn, Francis *EncASM*
Rosene, R A *AmArch 70*
Rosener, Hilda Frank *DcWomA*
Rosener, Hilda-Frank *WhAmArt 85*
Rosenfeld, Arthur H 1905- *AmArch 70*
Rosenfeld, Azriel 1931- *MarqDCG 84*
Rosenfeld, Boris 1900- *AmArch 70*
Rosenfeld, Edward 1906- *WhAmArt 85*
Rosenfeld, Max 1915- *AmArch 70*
Rosenfeld, Norman 1933- *AmArch 70*
Rosenfeld, Paul 1890-1946 *WhAmArt 85*
Rosenfeld, Richard Joel 1940- *WhoAmA 78, -80, -82, -84*
Rosenfeld, Samuel L 1931- *WhoAmA 80, -82, -84*
Rosenfield, Hugo 1885-1932 *WhAmArt 85*
Rosenfield, Isadore 1893- *AmArch 70*
Rosenfield, John M 1924- *WhoAmA 82, -84*
Rosenfield, Lester 1886- *WhAmArt 85*
Rosenfield, Rachel 1951- *MacBEP*
Rosenfield, Zachary 1925- *AmArch 70*
Rosengren, Herbert 1908- *WhAmArt 85*
Rosenhan, Alvin Kirk 1940- *MarqDCG 84*
Rosenheim, Alfred Paist 1859-1943 *BiDAmAr*
Rosenhouse, Irwin 1924- *WhoAmA 84*
Rosenhouse, Irwin 1929- *PrintW 83, -85*
Rosenhouse, Irwin Jacob 1924- *WhoAmA 73, -76, -78, -80, -82*
Rosenkranz, Clarence C *WhAmArt 85*
Rosenmeyer, B J *WhAmArt 85*
Rosenquist, Fingal *WhAmArt 85*
Rosenquist, James 1933- *AmArt, BnEnAmA, ConArt 77, -83, DcAmArt, DcCAA 71, -77, DcCAr 81, McGDA, OxTwCA, PhDcTCA 77, PrintW 83, -85, WhoAmA 78, -80, -82, -84, WorArt[port]*
Rosenquit, Bernard 1923- *WhoAmA 73, -76, -78, -80, -82, -84*
Rosenshine, Annette 1880- *DcWomA*
Rosenson, Olga Lea 1892- *DcWomA, WhAmArt 85*
Rosenstein, A *WhAmArt 85*
Rosenstein, Arthur 1890- *AmArch 70*
Rosenstein, Nettie *WorFshn*
Rosenstock, Ronald 1943- *MacBEP*
Rosental, Nicholas R *DcVicP 2*
Rosenthal, Mrs. Alan H *WhoAmA 73, -76, -78, -80, -82*
Rosenthal, Albert 1863-1939 *WhAmArt 85*
Rosenthal, Bernard 1914- *DcCAA 71, -77, OxTwCA,*

WhoAmA 76
Rosenthal, Bernard J 1914- *WhAmArt 85, WhoAmA 73*
Rosenthal, D R *AmArch 70*
Rosenthal, David *MarqDCG 84*
Rosenthal, David d1949 *WhoAmA 78N, -80N, -82N, -84N*
Rosenthal, David 1876-1949 *WhAmArt 85*
Rosenthal, Deborah Maly 1950- *WhoAmA 82, -84*
Rosenthal, Doris *McGDA, WhAmArt 85, WhoAmA 78N, -80N, -82N, -84N*
Rosenthal, Doris d1971 *ArtsAmW 1, DcWomA*
Rosenthal, Doris 1895?-1971 *IIBEAAW*
Rosenthal, Earl Edgar 1921- *WhoAmA 84*
Rosenthal, F R *AmArch 70*
Rosenthal, Gertrude 1903- *WhoAmA 73, -76, -78, -80, -82, -84*
Rosenthal, Gertrude 1906- *WhAmArt 85*
Rosenthal, Gloria M 1928- *AmArt, WhoAmA 76, -78, -80, -82, -84*
Rosenthal, Jean 1912-1969 *ConDes*
Rosenthal, Joe 1911- *ICPEnP A*
Rosenthal, John W 1928- *WhoAmA 78, -80, -82, -84*
Rosenthal, Joseph J 1911- *MacBEP*
Rosenthal, Judith-Ann Saks *WhoAmA 80, -82, -84*
Rosenthal, L *AmArch 70*
Rosenthal, Leon 1914- *AmArch 70*
Rosenthal, Louis Chatel 1888- *WhAmArt 85*
Rosenthal, Louis N *NewYHSD*
Rosenthal, Mark L 1945- *WhoAmA 84*
Rosenthal, Martin 1899- *WhAmArt 85*
Rosenthal, Max 1833-1918 *NewYHSD , WhAmArt 85*
Rosenthal, Michael 1888-1942 *WhAmArt 85*
Rosenthal, Mildred 1890- *ArtsAmW 2, DcWomA, WhAmArt 85*
Rosenthal, Morris *NewYHSD*
Rosenthal, Myron Martin 1930- *MarqDCG 84*
Rosenthal, Philip *DcNiCA, EncASM*
Rosenthal, Rachel 1926- *AmArt, WhoAmA 76, -78, -80, -82, -84*
Rosenthal, Rena *WhAmArt 85*
Rosenthal, Richard Lee 1954- *MarqDCG 84*
Rosenthal, Richard Phillips 1926- *AmArch 70*
Rosenthal, Robert Allen 1932- *AmArch 70*
Rosenthal, S *AmArch 70, DcVicP 2*
Rosenthal, Seymour 1921- *WhoAmA 80, -82, -84*
Rosenthal, Seymour Joseph 1921- *WhoAmA 73, -76, -78*
Rosenthal, Simon *NewYHSD*
Rosenthal, Sophie *WhAmArt 85*
Rosenthal, Stephen 1935- *WhoAmA 73, -76, -78, -80, -82, -84*
Rosenthal, Toby E *ArtsNiC*
Rosenthal, Toby E 1848-1917 *ArtsAmW 1, WhAmArt 85*
Rosenthal, Tony 1914- *WhoAmA 78, -80, -82, -84*
Rosenthal-Hatschek, Marie 1871- *DcWomA*
Rosenvold, Richard Charles 1930- *AmArch 70*
Rosenwald, Barbara K *WhoAmA 84*
Rosenwald, Barbara K 1924- *WhoAmA 73, -76, -78*
Rosenwald, Barbara K 1944- *WhoAmA 80, -82*
Rosenwald, Carol 1900- *WhoAmA 80, -82, -84*
Rosenwald, Lessing Julius 1891- *WhoAmA 73, -76, -78*
Rosenwald, Lessing Julius 1891-1979 *WhoAmA 80N, -82N, -84N*
Rosenwey, Paul *WhAmArt 85*
Rosenwinkel, Howard Arthur 1929- *AmArch 70*
Rosenzweig, Daphne Lange 1941- *WhoAmA 76, -78, -80, -82, -84*
Rosenzweig, Phyllis D 1943- *WhoAmA 78, -80, -82, -84*
Rosenzweig-Windisch, Nanette *DcWomA*
Roser, Ce *WhoAmA 80, -82, -84*
Roser, Maud *FairDF FRA*
Rosestone, Douglas *MarqDCG 84*
Roseto, Giacomo *McGDA*
Rosetsu 1755-1799 *McGDA*
Rosett And Mulford *CabMA*
Roseumen, Richard *FolkA 86*
Rosey, Alexander P 1890- *WhAmArt 85*
Rosher, Mrs. G B *DcVicP 2*
Rosi, John E *CabMA*
Rosich, Daniel 1943- *MarqDCG 84*
Rosie, Paul 1910- *WhoGrA 82[port]*
Rosienkiewicz, Martin *NewYHSD*
Rosier, Amedee *ArtsNiC*
Rosier, Jean Guillaume 1858-1931 *ClaDrA*
Rosier, Joseph *FolkA 86*
Rosier, Robert *CabMA*
Rosin, Harry *WhoAmA 73*
Rosin, Harry d1973 *WhoAmA 76N, -78N, -80N, -82N, -84N*
Rosin, Harry 1897-1973 *WhAmArt 85*
Rosin, T L 1886- *WhAmArt 85*
Roskell, Nicholas R *DcVicP 2*
Roskill, Mark Wentworth 1933- *WhoAmA 73, -76, -78, -80, -82, -84*
Roskot, Kamil 1886-1945 *MacEA*
Roskruge, Francis John 1871- *DcBrA 2*

Roslansky, R D *AmArch 70*
Rosler, Martha Rose 1943- *WhoAmA 76, -78, -80, -82, -84*
Rosler, Paula 1875- *DcWomA*
Roslin, Alexander 1718-1793 *OxArt*
Roslin, Alexandre 1718-1793 *ClaDrA*
Roslin, Alexandre-Charles 1718-1793 *McGDA*
Roslin, Emma Adele d1883 *DcWomA*
Roslin, Marie Suzanne *DcWomA*
Roslyn *EncASM*
Roslyn, Louis Frederick 1878- *DcBrA 1*
Rosmer, Leo 1905- *WhAmArt 85*
Rosner, Charles 1894-1975? *DcSeaP*
Rosner, Charles 1894-1975 *WhAmArt 85*
Rosofsky, Seymour *DcCAr 81*
Rosofsky, Seymour 1924- *WhoAmA 73, -76, -78, -80, -82X, -84N*
Rosol, John 1911- *WhAmArt 85*
Rosoman, Leonard 1913- *ConBrA 79[port], DcBrA 1, WhoArt 80, -82, -84, WhoGrA 82[port]*
Ross, Miss *DcWomA, NewYHSD*
Ross, Mister *NewYHSD*
Ross, Mrs. *NewYHSD*
Ross, A H *DcVicP 2*
Ross, Abby F Bell *FolkA 86*
Ross, Adele *WhAmArt 85*
Ross, Al 1911- *WorECar*
Ross, Alastair Robertson 1941- *WhoArt 80, -82, -84*
Ross, Albert S 1897- *AmArch 70*
Ross, Alex 1909- *IlrAm F, -1880, WhAmArt 85*
Ross, Alexander 1908- *WhoAmA 73, -76, -78, -80, -82, -84*
Ross, Alfred *ArtsNiC*
Ross, Alvin 1920- *WhoAmA 73*
Ross, Alvin 1920-1975 *WhoAmA 76N, -78N, -80N, -82N, -84N*
Ross, Annie F *DcWomA*
Ross, B Brook *WhoAmA 82, -84*
Ross, Barbara Ellis 1909- *WhAmArt 85*
Ross, Beatrice Brook *WhoAmA 76, -78, -80*
Ross, Boyce Dew 1934- *AmArch 70*
Ross, Budd 1923- *AmArch 70*
Ross, C Chandler d1952 *WhAmArt 85, WhoAmA 78N, -80N, -82N, -84N*
Ross, Calvin *FolkA 86*
Ross, Caroline *DcWomA*
Ross, Charles *BiDBrA, NewYHSD*
Ross, Charles 1722-1806 *BiDBrA*
Ross, Charles 1937- *ConArt 77, -83, DcCAA 71, -77, DcCAr 81, PrintW 85, WhoAmA 73, -76, -78, -80, -82, -84*
Ross, Charles B 1878-1933 *WhAmArt 85*
Ross, Charles Gregory 1949- *MarqDCG 84*
Ross, Charles H *DcBrBI*
Ross, Christina Paterson 1843-1906 *DcBrWA, DcVicP 2, DcWomA*
Ross, Christine Paterson *DcVicP*
Ross, Clare Romano *IlsCB 1967*
Ross, Clare Romano 1922- *IlsCB 1957*
Ross, Clifford 1952- *WhoAmA 84*
Ross, Colin William 1914- *DcBrA 1*
Ross, Conrad H 1931- *WhoAmA 80, -82, -84*
Ross, Conrad Harold 1931- *WhoAmA 73, -76, -78*
Ross, Cyril Joshua 1891- *DcBrA 1*
Ross, D R *ArtsEM*
Ross, D T *AmArch 70*
Ross, David *AfroAA*
Ross, David Anthony 1949- *WhoAmA 76, -78, -80, -82, -84*
Ross, David B 1940- *AmArch 70*
Ross, David P, Jr. 1908- *WhAmArt 85*
Ross, Denman W 1853-1935 *WhAmArt 85*
Ross, Donald Olds 1913- *AmArch 70*
Ross, Douglas Allan 1937- *WhoAmA 78, -80, -82, -84*
Ross, E C *DcWomA*
Ross, E Robert *OfPGCP 86*
Ross, Edward Joseph 1934- *AmArch 70*
Ross, Eleanor M *DcWomA*
Ross, Eliza *DcWomA*
Ross, Elizabeth *DcWomA*
Ross, Ernest 1927- *AmArch 70*
Ross, Eva *WhAmArt 85*
Ross, F *DcWomA*
Ross, F J *AmArch 70*
Ross, F W L 1792-1860 *DcBrWA*
Ross, Fred 1927- *WhoAmA 76, -78, -80, -82, -84*
Ross, Fred Joseph 1927- *DcCAr 81*
Ross, Frederick Webb *WhAmArt 85*
Ross, George *DcBrECP*
Ross, George Allen 1878-1946 *MacEA*
Ross, George Gates 1814-1856 *NewYHSD*
Ross, George Stephen *MarqDCG 84*
Ross, Gloria F 1923- *WhoAmA 80, -82, -84*
Ross, Gordon 1873-1946 *ArtsAmW 3, WhAmArt 85*
Ross, H M *ArtsEM*
Ross, Hamilton 1933- *AmArch 70*
Ross, Harry Dick 1899- *ArtsAmW 3*
Ross, Harrydick 1899- *ArtsAmW 3*
Ross, Helene *DcWomA*

Rouvier, Noemie 1832?-1888 *DcWomA*
Rouvroy, Marie Von 1826-1893 *DcWomA*
Rouw, Henry 1775-1834? *DcBrECP*
Roux, Alexander *FolkA 86*
Roux, Alexander 1813-1886 *BnEnAmA*
Roux, Anne Marie 1898- *DcWomA*
Roux, Emile *ClaDrA*
Roux, Francis *NewYHSD*
Roux, Francois Geoffroi 1811-1882 *DcSeaP*
Roux, Frederic 1805-1870 *DcSeaP*
Roux, Joseph 1725-1793? *DcSeaP*
Roux, Joseph Ange Antoine 1765-1835 *DcSeaP*
Roux, Louis 1817-1903 *DcSeaP*
Roux, Marie *DcWomA*
Roux, Mathieu Antoine 1799-1872 *DcSeaP*
Roux, Theodore Linton *AmArch 70*
Roux, Ursula *DcSeaP*
Roux-Spitz, Michel 1888-1957 *ConArch*, *McGDA*
Rouyon, Adele 1870- *WhAmArt 85*
Rouzie, A W *AmArch 70*
Rova, William M 1933- *AmArch 70*
Rovaldi Stroppa, Giulia d1918 *DcWomA*
Rovelstad, Trygve A *WhoAmA 73, -76*
Rover, Henry *NewYHSD*
Rover, Valeska 1849-1931 *DcWomA*
Rovere, E J *AmArch 70*
Rovere, Giovanni Mauro Della 1575?-1640 *McGDA*
Roversi, Luigi 1860-1927 *WhAmArt 85*
Rovetti, Paul F 1939- *WhoAmA 78, -80, -82, -84*
Rovezzano, Da *McGDA*
Rovira, Pedro *WorFshn*
Rovisi, Leopoldina 1755- *DcWomA*
Rovray, Fanny Galland De *DcWomA*
Rovtar, L S *AmArch 70*
Row, Alvin A, Jr. 1929- *AmArch 70*
Row, George Daniel *CabMA*
Row, Robert Benison 1907- *AmArch 70*
Rowan, Alexander *ClaDrA*, *DcVicP 2*
Rowan, C Patrick 1937- *WhoAmA 78*
Rowan, David Paul 1950- *WhoArt 82, -84*
Rowan, Dennis Michael 1938- *WhoAmA 73, -76, -78, -80, -82, -84*
Rowan, Edward Beatty d1946 *WhoAmA 78N, -80N, -82N, -84N*
Rowan, Edward Beatty 1898-1946 *WhAmArt 85*
Rowan, Evadne Harris *WhoArt 80, -82, -84*
Rowan, Frances Physioc *WhoAmA 73, -76, -78, -80, -82, -84*
Rowan, George Miles *WhAmArt 85*
Rowan, Herman 1923- *WhoAmA 73, -76, -78, -80, -82, -84*
Rowan, Jan C 1924- *AmArch 70*
Rowan, Marian Ellis 1847-1922 *DcWomA*
Rowan, Patrick 1937- *WhoAmA 80, -82, -84*
Rowan, R N *AmArch 70*
Rowan, William G *DcVicP 2*
Rowan And Wilcox *EncASM*
Rowand, Phyllis *IlsBYP*, *IlsCB 1946*
Rowand, William *NewYHSD*
Rowat, James *DcVicP 2*
Rowbotham, Charles *DcBrA 2*, *DcBrWA*, *DcVicP, -2*
Rowbotham, Claude *DcBrA 1*, *DcBrWA*
Rowbotham, E *DcVicP 2*
Rowbotham, Leeson *DcBrA 1*
Rowbotham, Thomas Charles Leeson 1823-1875 *DcBrWA*, *DcVicP, -2*
Rowbotham, Thomas L 1823-1875 *ArtsNiC*
Rowbotham, Thomas Leeson Scarse 1783-1853 *DcBrWA*
Rowden, Jessie *DcVicP 2*
Rowden, Thomas d1926 *DcBrA 2*
Rowden, Thomas 1842-1926 *DcBrWA*, *DcVicP 2*
Rowe, Miss *DcWomA*
Rowe, A M *DcVicP 2*
Rowe, Abram 1807?- *CabMA*
Rowe, C J *AmArch 70*
Rowe, C V *AmArch 70*
Rowe, Carrie A *ArtsEM*, *DcWomA*
Rowe, Charles Alfred 1934- *WhoAmA 76, -78, -80, -82, -84*
Rowe, Clarence 1878-1930 *WhAmArt 85*
Rowe, Clarence Herbert 1878-1930 *IIBEAAW*
Rowe, Corinne d1965 *WhoAmA 78N, -80N, -82N, -84N*
Rowe, Corinne Finsterwald 1894-1965 *DcWomA*
Rowe, Drake William 1938- *AmArch 70*
Rowe, Duane Barr 1923- *AmArch 70*
Rowe, E Arthur d1922 *DcBrA 1*, *DcBrWA*, *DcVicP*
Rowe, E R *NewYHSD*
Rowe, Edith D'Oyley *DcVicP 2*, *DcWomA*
Rowe, Elizabeth *DcWomA*
Rowe, Elsie Hugo *DcBrA 1*, *DcWomA*
Rowe, Ernest Arthur 1863-1922 *DcVicP 2*
Rowe, Frances Ely *WhAmArt 85*
Rowe, George 1797-1864 *DcBrWA*, *DcVicP*
Rowe, George James d1883 *DcBrWA*, *DcVicP, -2*
Rowe, George W *CabMA*
Rowe, Gertrude *DcVicP 2*
Rowe, Guy d1969 *WhoAmA 78N, -80N, -82N, -84N*
Rowe, Guy 1894-1969 *WhAmArt 85*

Rowe, Mrs. Guy *WhAmArt 85*
Rowe, H Dean 1934- *AmArch 70*
Rowe, H L d1913 *BiDAmAr*
Rowe, Hayward Standish 1938- *AmArch 70*
Rowe, Heather Maureen 1953- *MarqDCG 84*
Rowe, Helen Wright 1910- *WhAmArt 85*
Rowe, Henry 1787-1859 *BiDBrA*
Rowe, Isaac *BiDBrA*
Rowe, J Staples 1856-1905 *WhAmArt 85*
Rowe, Joseph *BiDBrA*
Rowe, Joseph E 1927- *MarqDCG 84*
Rowe, L Earle 1882-1937 *WhAmArt 85*
Rowe, L K *FolkA 86*, *NewYHSD*
Rowe, Lynn Cawfield 1925- *AmArch 70*
Rowe, M L Arrington d1932 *DcWomA*
Rowe, Mrs. M L Arrington d1932 *WhAmArt 85*
Rowe, Mabel *WhAmArt 85*
Rowe, Nellie Mae 1900- *FolkA 86*
Rowe, Reginald M 1920- *WhoAmA 73, -76, -78, -80, -82, -84*
Rowe, Robert Bryan 1925- *AmArch 70*
Rowe, Ron Gene 1932- *AmArch 70*
Rowe, Sidney Grant 1861-1928 *DcBrA 1*, *DcVicP, -2*
Rowe, Susan *DcWomA*
Rowe, Tom Trythall 1856- *DcVicP, -2*
Rowe, W H *AmArch 70*
Rowe, William, Jr. *DcVicP 2*
Rowe, William B 1910-1955 *WhAmArt 85*
Rowe, William Henry 1946- *ICPEnP A*, *MacBEP*
Rowe, William J Monkhouse *DcVicP 2*
Rowe, Willie Lucille Reed 1914- *WhAmArt 85*
Rowell, D *AmArch 70*
Rowell, Fanny Taylor 1865-1928 *DcWomA*, *WhAmArt 85*
Rowell, Galen 1940- *ICPEnP A*
Rowell, Louis 1873-1928 *WhAmArt 85*
Rowell, Margit *WhoAmA 82, -84*
Rowell, Margit 1937- *WhoAmA 76, -78, -80*
Rowell, Samuel *FolkA 86*
Rowell, Samuel 1815- *NewYHSD*
Rowen, George Miles *WhAmArt 85*
Rowland, A M *DcWomA*
Rowland, Benjamin, Jr. 1904-1972 *WhAmArt 85*, *WhoAmA 78N, -80N, -82N, -84N*
Rowland, Dan L 1922- *AmArch 70*
Rowland, E Bruce 1948- *MarqDCG 84*
Rowland, Earl *WhAmArt 85*
Rowland, Edith *DcBrA 1*, *DcWomA*
Rowland, Edward B *WhAmArt 85*
Rowland, Elden Hart 1915- *WhoAmA 73, -76, -78, -80, -82*
Rowland, Elden Hart 1915-1982 *WhoAmA 84N*
Rowland, Elizabeth *FolkA 86*
Rowland, Henrietta *DcWomA*
Rowland, Henry *NewYHSD*
Rowland, Hugh Wilson 1921- *AmArch 70*
Rowland, J N *AmArch 70*
Rowland, James S *NewYHSD*
Rowland, John T 1872-1945 *BiDAmAr*
Rowland, Mary Adele 1915- *WhoAmA 82, -84*
Rowland, Nancy *AfroAA*
Rowland, Ralph *DcBrBI*
Rowland, Ralph Thomas 1920- *AmArch 70*
Rowland, Ruby *WhAmArt 85*
Rowland, Samuel d1845? *BiDBrA*
Rowland, Susan 1940- *DcCAr 81*
Rowland, Thomas *BiDBrA*
Rowland, W *DcBrA 1*, *DcBrWA*
Rowland, W E *WhAmArt 85*
Rowlands, Constance Ethel 1891- *DcWomA*
Rowlands, E M *AmArch 70*
Rowlands, Martyn 1923- *ConDes*
Rowlands, Tom 1926- *WhoAmA 73, -76*
Rowlandson, George Derville 1861- *DcBrBI*
Rowlandson, Thomas 1756-1827 *AntBDN B*, *BkIE*, *ClaDrA*, *DcBrBI*, *DcBrWA*, *OxArt*, *WorECom*
Rowlandson, Thomas 1757?-1827 *McGDA*
Rowles, W L *AmArch 70*
Rowlett, G *DcVicP 2*
Rowlett, John Miles 1914- *AmArch 70*
Rowley *EncASM*
Rowley, Charles Bacon *AmArch 70*
Rowley, E *DcVicP 2*
Rowley, E S *DcVicP, -2*
Rowley, Mrs. Edward R *WhAmArt 85*
Rowley, Elizabeth *DcVicP, -2*, *DcWomA*
Rowley, Mrs. Francis *DcVicP 2*
Rowley, H *DcVicP 2*
Rowley, Hugh *DcVicP 2*
Rowley, Hugh 1833-1908 *DcBrBI*
Rowley, Jacob *FolkA 86*
Rowley, James Spencer 1917- *AmArch 70*
Rowley, Jean 1920- *ClaDrA*
Rowley, John S 1923- *AmArch 70*
Rowley, Philander *FolkA 86*
Rowley, R *FolkA 86*
Rowley, Reuben *NewYHSD*
Rowling, Eileen Marjorie 1906- *DcBrA 1*
Rowlstone, F *DcVicP 2*
Rowney, Margaret 1908- *WhoArt 80, -82, -84*
Rowntree, Diana *ConArch A*

Rowntree, Kenneth 1915- *ClaDrA*, *DcBrA 1*
Rowse, J B *NewYHSD*
Rowse, Samuel *NewYHSD*
Rowse, Samuel W *ArtsNiC*
Rowse, Samuel Worcester 1822-1901 *EarABI*, *EarABI SUP*, *NewYHSD* , *WhAmArt 85*
Rowsell, T Norman *DcVicP 2*
Rowson, Hugh Thomas 1946- *WhoArt 82, -84*
Rowson, Jim *MarqDCG 84*
Rowson, John *BiDBrA*
Rowstorne, Edwin *DcVicP 2*
Roxby, C W *DcVicP 2*
Rox, Henry 1899- *WhAmArt 85*
Roxborough, Alexander *NewYHSD*
Roxborough, William 1829?- *NewYHSD*
Roxby, C W *DcVicP 2*
Roy, A J *AmArch 70*
Roy, Eugene Armand *DcVicP 2*
Roy, Geoffrey Grenfell 1947- *MarqDCG 84*
Roy, Hippolyte 1763-1829 *FairDF FRA*, *WorFshn*
Roy, Jacqueline 1898- *DcWomA*
Roy, Jeanne Francoise 1837-1899 *DcWomA*
Roy, Laurent Charles 1900- *AmArch 70*
Roy, M J Antoine *ArtsEM*
Roy, Marie *DcWomA*
Roy, McCoy Hancock 1926- *MarqDCG 84*
Roy, Pierre 1880-1950 *ClaDrA*, *McGDA*, *OxTwCA*, *PhDcTCA 77*
Roy, Robert Edward 1919- *AmArch 70*
Royal, Elizabeth *DcBrWA*
Royal, Elizabeth L *DcVicP 2*
Royal, Henry Duval 1948- *MarqDCG 84*
Royannez, Jeanne *DcWomA*
Royannez DeValcourt, Adele *DcWomA*
Roybal, Alfonso 1895-1955 *ArtsAmW 3*
Roybal, Maria Luisa Delgado *FolkA 86*
Roybal, Martin 1860- *FolkA 86*
Roybal, Tonita Cruz *WhAmArt 85*
Roybet, Ferdinand 1840-1920 *ClaDrA*
Royce, Elizabeth Randolph *WhAmArt 85*
Royce, Jenny *FolkA 86*
Royce, John D, Jr. *AmArch 70*
Royce, R R *AmArch 70*
Royce, Richard Benjamin 1941- *WhoAmA 76, -78*
Royce, Woodford 1902- *WhAmArt 85*
Royco, Emil 1908- *AmArch 70*
Royds, Mabel A 1874-1941 *DcWomA*
Roye, Jozef VanDe 1861- *ClaDrA*
Roye, Paladine *OfPGCP 86*
Royen, Anna Maria Van 1800-1870 *DcWomA*
Royer *WorFshn*
Royer, A *FolkA 86*
Royer, Henri Paul 1869- *ClaDrA*
Royer, Jacob S 1883- *WhAmArt 85, -85*
Royer, John *FolkA 86*
Royer, Pierre Alexandre *DcBrECP*
Royer, Robert Woodrow 1916- *AmArch 70*
Royer-Forge, Germaine 1897- *DcWomA*
Royla, Bonnie *DcWomA*, *WhAmArt 85*
Royle, C *DcBrBI*
Royle, Herbert *DcBrA 1*
Royle, Herbert 1870-1958 *DcVicP 2*
Royle, Stanley 1888-1961 *DcBrA 1*
Royle, Thomas *BiDBrA*
Roymerswaelen, Marinus Claesz *McGDA*
Roys, Mary G *ArtsEM*, *DcWomA*
Roysher, Hudson 1911- *WhAmArt 85*, *WhoAmA 73, -76, -78, -80, -82, -84*
Rozaire, Arthur D 1879-1922 *ArtsAmW 2*
Rozanova, Olga Vladimirovna 1886-1918 *DcWomA*, *OxTwCA*
Rozanski, Evely 1947- *MarqDCG 84*
Rozas, Linda De *DcWomA*
Rozee, Mademoiselle 1632-1682 *DcWomA*
Rozehnal, Bedrich 1902- *MacEA*
Rozema, Hal *OfPGCP 86*
Rozenfeld, Henrique 1958- *MarqDCG 84*
Rozentouler, Victor 1949- *MarqDCG 84*
Rozet, Fanny 1881- *DcWomA*
Rozier, Dominique Hubert 1840-1901 *ClaDrA*
Rozier, Marie Josephine *DcWomA*
Rozman, Edward Frank 1931- *AmArch 70*
Rozman, Joseph 1944- *AmArt*, *PrintW 83, -85*
Rozman, Joseph John 1944- *WhoAmA 76, -78, -80, -82, -84*
Roznoy, Richard L 1947- *MarqDCG 84*
Rozsypal, Ivo 1942- *DcCAr 81*
Rozumalski, Ted 1931- *ICPEnP A*, *MacBEP*
Rozycki, Walter J 1909- *AmArch 70*
Rozzi 1921- *WhoAmA 76, -78, -80, -82, -84*
Rshevskaia, Antonina Leonardovna 1861- *DcWomA*
Ruano, Robert Theodore 1921- *AmArch 70*
Rubano, Robert 1946- *MarqDCG 84*
Rubbi *DcBrECP*
Rubbigliard, Vincenzo *DcBrECP*
Rubczak, Marie *DcWomA*
Rubel, C Adrian 1904-1978 *WhoAmA 78N, -80N, -82N, -84N*
Rubel, George Kenneth 1901- *AmArch 70*
Rubello, David Jerome 1935- *WhoAmA 82, -84*
Rubempre, Marie Cozette De *DcWomA*
Ruben, Albert 1918- *WhoAmA 84*

Ryan, Adrian 1920- *ClaDrA, DcBrA 1, WhoArt 80, –82, –84*
Ryan, Alonza Bailey 1921- *AmArch 70*
Ryan, Angela *WhAmArt 85*
Ryan, Anne 1889-1954 *DcWomA, WhAmArt 85, WomArt*
Ryan, Arlette 1892- *DcWomA*
Ryan, Charles J *DcBrWA, DcVicP 2*
Ryan, Charles James 1865-1949 *ArtsAmW 3*
Ryan, Charles Richard 1932- *AmArch 70*
Ryan, Claude *DcVicP 2*
Ryan, Daniel Lee 1941- *MarqDCG 84*
Ryan, David Michael 1939- *WhoAmA 80, –82, –84*
Ryan, David Rogers 1941- *MarqDCG 84*
Ryan, Douglas *WhAmArt 85*
Ryan, Edward *WhAmArt 85*
Ryan, Edward John 1927- *AmArch 70*
Ryan, Elizabeth Theresa *WhoAmA 84*
Ryan, F *DcVicP 2*
Ryan, F L *DcWomA*
Ryan, Francis *DcBrECP*
Ryan, Gabrielle C 1942- *MarqDCG 84*
Ryan, Grover E 1934- *AmArch 70*
Ryan, H *DcVicP 2*
Ryan, H Calvin *WhAmArt 85*
Ryan, H S *DcVicP 2*
Ryan, J L *AmArch 70*
Ryan, James L *NewYHSD*
Ryan, John *NewYHSD*
Ryan, John Gerald Christopher 1921- *IlsCB 1967, WhoArt 80, –82, –84*
Ryan, John William, Jr. 1930- *AmArch 70*
Ryan, June *WhoArt 80, –82, –84*
Ryan, June 1925- *ClaDrA*
Ryan, Kathleen 1900- *DcBrA 1*
Ryan, Kathryn White *WhAmArt 85*
Ryan, Mazie Theresa 1879-1946 *CenC*
Ryan, Milton A 1904- *AmArch 70*
Ryan, Paul A 1907- *AmArch 70*
Ryan, Roger Neville 1934- *AmArch 70*
Ryan, Ronald Thomas 1941- *AmArch 70*
Ryan, Sally 1916- *WhAmArt 85*
Ryan, T E *DcVicP 2*
Ryan, T F *AmArch 70*
Ryan, Thomas P 1952- *MarqDCG 84*
Ryan, Tom *OfPGCP 86*
Ryan, Tom 1922- *IlBEAAW*
Ryan, Tom K 1926- *WorECom*
Ryan, Vivian Desmond 1893-1950 *DcBrA 2*
Ryan, W H *AmArch 70*
Ryan, W J *AmArch 70*
Ryan, William Fortune *WhAmArt 85*
Ryan, William Lawrence *WhAmArt 85*
Ryan, William Redmond *ArtsAmW 2, NewYHSD*
Ryback, Issachar 1897-1934 *OxArt, OxTwCA*
Ryberg, Elizabeth *DcWomA*
Rybka, Steven 1956- *AmArt*
Rychman, John *CabMA*
Rychter, Bronislava 1868- *DcWomA*
Ryck, Cornelia De *McGDA*
Ryck, Cornelia De 1656- *DcWomA*
Ryck, John De *DcBrECP*
Ryck, Katharina *DcWomA*
Ryck, Pieter Cornelisz Van *McGDA*
Ryck, Pieter Cornelisz Van 1568-1635? *ClaDrA*
Ryckaert, David, I 1560-1607 *ClaDrA*
Ryckaert, David, II 1596-1642 *ClaDrA*
Ryckaert, David, III 1612-1661 *McGDA*
Ryckaert, Marten 1587-1631 *McGDA*
Ryckere, Bernard 1535?-1590 *ClaDrA*
Ryckhals, Francois 1600?-1647 *McGDA*
Ryckkals, Frans 1600-1647 *ClaDrA*
Rydberg, Gerda *DcWomA*
Rydeen, James Edward 1937- *AmArch 70*
Rydeen, Lloyd B *WhAmArt 85*
Ryden, Fleming 1869- *WhAmArt 85*
Ryden, Henning 1869-1939 *WhAmArt 85*
Ryden, Kenneth Glenn 1945- *WhoAmA 78, –80, –82, –84*
Ryder, Albert P 1847-1917 *WhAmArt 85*
Ryder, Albert Pinkham 1847-1917 *BnEnAmA, DcAmArt, DcSeaP, IlBEAAW, McGDA, OxArt*
Ryder, Alfred Hubbard 1914- *AmArch 70*
Ryder, Chauncey F 1868-1949 *WhAmArt 85*
Ryder, Chauncey Foster d1949 *WhoAmA 78N, –80N, –82N, –84N*
Ryder, Chauncey Foster 1868-1949 *ArtsAmW 1*
Ryder, David *FolkA 86*
Ryder, Donald Porter 1926- *AmArch 70*
Ryder, Emily *DcBrWA*
Ryder, Emily S *DcVicP 2*
Ryder, Eve 1896- *DcWomA*
Ryder, Frances Elizabeth 1886- *DcWomA*
Ryder, George 1887- *DcBrA 1*
Ryder, Harriet E *DcVicP 2*
Ryder, Henry Orne 1860- *WhAmArt 85*
Ryder, J F *NewYHSD*
Ryder, Jane G *DcWomA, WhAmArt 85*
Ryder, Mahler B 1937- *AfroAA*
Ryder, Mahler Bessinger 1937- *WhoAmA 78, –80, –82, –84*

Ryder, Margaret Elaine 1908- *ClaDrA, DcBrA 1, WhoArt 80, –82, –84*
Ryder, Marilla *WhAmArt 85*
Ryder, Mary Veronica *DcWomA*
Ryder, Paul R 1950- *MarqDCG 84*
Ryder, Platt Powell 1821-1896 *NewYHSD , WhAmArt 85*
Ryder, R R *AmArch 70*
Ryder, Richard d1683 *BiDBrA*
Ryder, Stephen Wilson 1938- *MarqDCG 84*
Ryder, Thomas 1746-1810 *DcBrECP*
Ryder, W F *DcWomA*
Ryder, Mrs. W F *ArtsEM*
Ryder, Worth 1884- *WhAmArt 85*
Ryder, Worth 1884-1960 *ArtsAmW 1*
Ryding, Caroline Mathilde 1780- *DcWomA*
Rydzewski, Norbert Anthony 1931- *AmArch 70*
Rye, Marguerite Van *DcWomA*
Rye, T 1811?- *DcWomA*
Ryepin *OxArt*
Ryerson, Luther L *NewYHSD*
Ryerson, Margery A *WhoAmA 80*
Ryerson, Margery A 1886- *WhoAmA 82, –84*
Ryerson, Margery Austen *WhoAmA 73, –76, –78*
Ryerson, Margery Austen 1886- *DcWomA, WhAmArt 85*
Ryerson, Martin Antoine 1856-1932 *WhAmArt 85*
Ryerson, Mary d1936 *DcWomA*
Ryerson, Mary McIlvaine d1936 *WhAmArt 85*
Ryk, Cornelia De 1656- *DcWomA*
Ryke, Katharina De *DcWomA*
Ryker, Edward *NewYHSD*
Rykiel, Sonia *FairDF FRA[port]*
Rykiel, Sonia 1930- *ConDes, WorFshn*
Rykwert, Joseph *ConArch A*
Ryland, Miss *DcWomA*
Ryland, Adolfine Mary 1903- *DcBrA 1*
Ryland, C J 1892- *ArtsAmW 3*
Ryland, Henry 1856-1924 *ClaDrA, DcBrA 1, DcBrBI, DcBrWA, DcVicP, –2*
Ryland, Irene *ClaDrA, DcBrA 1, DcWomA*
Ryland, Mrs. L H *WhAmArt 85*
Ryland, Mark *NewYHSD*
Ryland, Robert Knight d1951 *WhoAmA 78N, –80N, –82N, –84N*
Ryland, Robert Knight 1873-1951 *WhAmArt 85*
Ryland, William *AntBDN N, DcVicP 2*
Ryland, William Wynne 1732-1783 *DcBrWA*
Ryland, William Wynne 1738-1783 *BkIE*
Rylands, J *DcSeaP*
Ryle, Arthur Johnston 1857-1915 *DcBrA 1, DcVicP, –2*
Ryley, Charles 1752?-1798 *BkIE*
Ryley, Charles Reuben 1752?-1798 *DcBrECP, DcBrWA*
Ryley, Jane *DcVicP 2*
Ryman, C M *WhAmArt 85*
Ryman, Robert 1930- *AmArt, ConArt 77, –83, DcAmArt, DcCAA 77, DcCAr 81, PrintW 85, WhoAmA 73, –76, –78, –80, –82, –84*
Rymer, C W *DcVicP 2*
Rymer, Chadwick Francis *DcVicP 2*
Rymer, J W *DcVicP 2*
Rymer, William C *ArtsAmW 3*
Rymsdyk, Andreas Van 1754-1786 *DcBrECP*
Rymsdyk, Andrew d1786 *DcBrWA*
Ryn, Rembrandt Van *McGDA*
Rynasko, L A 1957- *MarqDCG 84*
Rynd, Charles E 1945- *MacBEP*
Rynd, Edith *DcVicP 2, DcWomA*
Rynders, Frederick Leopold *AmArch 70*
Ryon, James P *WhAmArt 85*
Ryon, L J *AmArch 70*
Ryott, W *DcVicP 2*
Ryozen *McGDA*
Rypel, S A *AmArch 70*
Rypsam, Fred W 1880-1969 *ArtsEM*
Rypsam, Russell *WhAmArt 85*
Rysbrack, Gerard 1696-1773 *DcBrECP*
Rysbrack, John Michael 1694-1770 *McGDA, OxArt*
Rysbrack, Pieter 1655-1729 *ClaDrA*
Rysbrack, Pieter Andreas 1684?-1748 *DcBrECP*
Rysbraeck, Pieter 1655-1729 *McGDA*
Rysdale, Anne 1920- *AmArch 70*
Rysiewski, Richard Raymond 1945- *MarqDCG 84*
Rysner, Sheldon *AmGrD[port]*
Rysselberghe, Theo Van 1862-1926 *McGDA, OxTwCA, PhDcTCA 77*
Rysselberghe, Theodore 1862-1926 *ClaDrA*
Rystedt, Bengt 1937- *MarqDCG 84*
Rysz, Frederick Mathew 1945- *MarqDCG 84*
Ryther, Martha *WhAmArt 85*
Ryther, Martha 1896-1981 *DcWomA*
Ryther, Mary *ArtsEM, DcWomA*
Ryujo, Yamazaki *DcWomA*
Ryukei *AntBDN L*
Ryumkin, Yakov 1913- *ICPEnP A*
Ryves, Thomas d1788 *DcBrECP*

S

S, C L *DcBrBI*
S, M H *DcBrBI*
Saabye, Harold Paulsen 1926- *AmArch 70*
Saad, Edward T 1923- *AmArch 70*
Saadie *AfroAA*
Saagmolen, Martinus 1620-1669 *ClaDrA*
Saakow, Alexander 1941- *ICPEnP A*
Saalbach, C F *AmArch 70*
Saalburg, Allen Russel 1899- *WhoAmA 76, –78, –80, –82, –84*
Saalburg, Allen Russell 1899- *ArtsAmW 2, WhAmArt 85*
Saalburg, Leslie 1897-1974 *IlrAm 1880*
Saalfeld, Alan *MarqDCG 84*
Saalfield, Agnes G 1942- *WhoAmA 80, –82*
Saalmueler, Peter *FolkA 86*
Saar, Betye 1926- *AfroAA, DcCAr 81, WhoAmA 73, –76, –78, –80, –82, –84*
Saar, Edward Harold 1928- *AmArch 70*
Saar, Lee R 1954- *MarqDCG 84*
Saari, Peter 1951- *DcCAr 81*
Saari, Peter H 1951- *WhoAmA 78, –80, –82, –84*
Saarinen, Eero 1910-1960 *DcNiCA*
Saarinen, Eero 1910-1961 *BnEnAmA, ConArch, ConDes, DcD&D[port], EncAAr, EncMA, MacEA, McGDA, OxArt, WhoAmA 78N, –80N, –82N, –84N, WhoArch*
Saarinen, Eliel 1873- *WhAmArt 85*
Saarinen, Eliel 1873-1950 *BnEnAmA, ConArch, DcD&D, EncAAr, EncMA, MacEA, McGDA, OxArt, WhoArch*
Saarinen, Lilian *WhAmArt 85*
Saarinen, Lilian 1912- *WhoAmA 76, –78, –80, –82, –84*
Saarinen, Loja *WhAmArt 85*
Saart, Albert *EncASM*
Saart, Herman *EncASM*
Saart, William H *EncASM*
Saart Brothers *EncASM*
Saathoff, Billy *OfPGCP 86*
Saba, Rintaro *WhAmArt 85*
Sabaroff, Bernard J 1919- *AmArch 70*
Sabat, Hermenegildo 1933- *WhoGrA 82[port]*
Sabatella, Joseph John 1931- *WhoAmA 78, –80, –82, –84*
Sabatier, Aglae Appoline *DcWomA*
Sabatier, Josefa *DcWomA*
Sabatini, Andrea 1484?-1530 *McGDA*
Sabatini, Marina *DcWomA*
Sabatini, Raphael 1898- *WhAmArt 85, WhoAmA 73, –76, –78, –80, –82, –84*
Sabatino, John Simon 1928- *AmArch 70*
Sabattier, Louis Remy *DcBrBI*
Sabaud, Caroline 1833-1868 *DcWomA*
Sabaud, Nina *DcWomA*
Sabelis, Huibert 1942- *PrintW 83, –85, WhoAmA 76, –78, –80, –82, –84, WhoArt 80, –82, –84*
Sabella, Paolo Enrique 1958- *MarqDCG 84*
Saber, Clifford 1914- *WhAmArt 85*
Sabin, M Cordelia *DcWomA*
Sabin, Mark 1936- *FolkA 86, PrintW 83, –85*
Sabin, Peter S 1932- *AmArch 70*
Sabin, Sarah Smith 1799-1847 *FolkA 86*
Sabine, Julia 1905- *WhoAmA 73, –76, –78, –80*
Sabine, Wallace Clement 1868-1919 *MacEA*
Sable, Lawrence W *WhAmArt 85*
Sables, Thomas *FolkA 86*
Sablow, Rhoda Lillian *WhoAmA 76, –78, –80, –82, –84*
Sabo, Betty 1928- *IlBEAAW*
Sabo, Betty Jean 1928- *WhoAmA 76, –78, –80, –82,*

–84
Sabo, Irving 1920- *WhoAmA 82, –84*
Sabo, Ladis 1870-1953 *FolkA 86*
Sabo, Michael J 1931- *AmArch 70*
Sabogal, Jose 1888-1956 *McGDA, OxTwCA*
Sabolchy, Elmer Peter 1922- *AmArch 70*
Sabran, Comtesse De *DcWomA*
Sabri, Atta 1913- *DcCAr 81*
Sabri, Mahmoud 1927- *DcCAr 81*
Sabsovitch, L M *MacEA*
Sabuda, Jerry David 1954- *MarqDCG 84*
Sac, Ollet 1900- *WhAmArt 85*
Sacca, Filippo Da *McGDA*
Sacca, Paolo d1537 *McGDA*
Sacca, Tommaso d1517 *McGDA*
Saccaro, Giovanni 1913- *WhAmArt 85*
Sacchetti, Giacinta *DcWomA*
Sacchetti, Giovanni Battista 1700-1764 *MacEA, OxArt*
Sacchi, Andrea 1599-1661 *ClaDrA, McGDA, OxArt*
Sacchi, Carlo 1616-1706 *ClaDrA*
Sacchi, Giovanni Antonio De' *McGDA*
Sacchi, Pier Francesco 1485-1528 *McGDA*
Sacco, J *AmArch 70*
Sacconi, Giuseppe 1854-1905 *MacEA*
Sacconi, Giuseppe 1855-1905 *WhoArch*
Sacerdote, Jenny *WorFshn*
Sacerdote, Rosy 1872- *DcWomA*
Sacharoff, Olga 1889- *DcWomA*
Sacharov, Adrian Dmitrievich *McGDA*
Sacharova, Olga 1889- *DcWomA*
Sache, F *DcVicP 2*
Sacheverell, John *NewYHSD*
Sachinis, Nicos 1924- *PhDcTCA 77*
Sachs, A M *WhoAmA 73, –76, –78, –80, –82, –84*
Sachs, Ada R *DcWomA*
Sachs, Bernard *NewYHSD*
Sachs, Carl I 1896- *WhAmArt 85*
Sachs, Clara 1862-1921 *DcWomA*
Sachs, Frederick *NewYHSD*
Sachs, Gloria *WorFshn*
Sachs, James H 1907-1971 *WhoAmA 78N, –80N, –82N, –84N*
Sachs, Johanna *DcWomA*
Sachs, Joseph 1887- *ArtsAmW 3, WhAmArt 85*
Sachs, Lambert *NewYHSD*
Sachs, Melvin Hugh 1931- *AmArch 70*
Sachs, Paul J d1965 *WhoAmA 78N, –80N, –82N, –84N*
Sachs, Paul Joseph 1878-1965 *WhAmArt 85*
Sachs, Samuel, II 1935- *WhoAmA 73, –76, –78, –80, –82, –84*
Sachs, Stuart Harold 1947- *MarqDCG 84*
Sachs, William J *DcBrBI*
Sachs, William Robert 1933- *AmArch 70*
Sachse, August *NewYHSD*
Sachse, Edward 1804-1873 *NewYHSD*
Sachse, Edward J *DcVicP 2*
Sachse, Emma F *WhAmArt 85*
Sachse, Janice R 1908- *WhoAmA 73, –76, –78, –80, –82, –84*
Sachse, Jochen *DcSeaP*
Sachse, John Henry David *NewYHSD*
Sachse, Theodore 1815?- *NewYHSD*
Sachse, William *NewYHSD*
Sachse-Schubert, Marta 1890- *DcWomA*
Sachsen-Teschen, Erzherzogin Maria C 1742-1798 *DcWomA*
Sachsenheim, Klara Adelheid *DcWomA*
Sachson, B David 1931- *AmArch 70*
Sack, Bertha *WhoArt 80, –82, –84*

Sack, Manfred *ConArch A*
Sack, Michael Philip 1953- *DcCAr 81*
Sackenheim, Rolf 1921- *DcCAr 81*
Sacker, Amy M 1876- *DcWomA, WhAmArt 85*
Sacket, Harriot *FolkA 86*
Sacket, Laura Frances 1907- *WhAmArt 85*
Sackett *EncASM*
Sackett, Alfred M *FolkA 86*
Sackett, Clara E *WhAmArt 85*
Sackett, Clara Elizabeth *DcWomA*
Sackett, David A *FolkA 86*
Sackett, Edith S *DcWomA, WhAmArt 85*
Sackett, Ester *FolkA 86*
Sackett, Esther *DcWomA, NewYHSD*
Sackett, Isaac *CabMA*
Sackett, Richard R 1909- *WhAmArt 85*
Sacklarian, Stephen 1899- *WhoAmA 78, –80, –82, –84*
Sackrider, Jean A *DcWomA*
Sacks, Beverly *WhoAmA 80, –82, –84*
Sacks, Charles Henry 1900- *AmArch 70*
Sacks, Joseph 1887- *ArtsAmW 3, WhAmArt 85*
Sacks, Ray *WhoAmA 80, –82, –84*
Sacks, Walter Thomas 1901- *WhAmArt 85*
Sacksteder, Aloys 1911- *WhAmArt 85*
Sacksteder, John Dennis 1926- *AmArch 70*
Saco, Amalia *DcWomA*
Sacre, Marie Clara *DcWomA*
Sacret, Elsie May Cecilia *DcWomA*
Sacriste, Eduardo 1905- *MacEA*
Sadao, Shoji 1927- *AmArch 70*
Sadar Breznik, Marjeta 1950- *DcCAr 81*
Sadd, Henry S *NewYHSD*
Saddington, Tom 1952- *DcCAr 81*
Saddler, Lewis *FolkA 86*
Sadeghi, Ali Akbar 1937- *WhoGrA 82[port]*
Sadek, George 1928- *WhoAmA 73, –76, –78, –80, –82, –84*
Sadeler, Aegidius 1570-1629 *ClaDrA*
Sadeler, Aegidius, II 1575-1629 *McGDA*
Sadeler, Daniel *OxDecA*
Sadeler, Emmanuel *OxDecA*
Sader, Kuldip S 1949- *MarqDCG 84*
Sadhal, Kuldip S 1949- *MarqDCG 84*
Sadik, Marvin Sherwood 1932- *WhoAmA 76, –78, –80, –82, –84*
Sadler, Allan Elwood 1935- *AmArch 70*
Sadler, F H *EncASM*
Sadler, Fernande 1869- *DcWomA*
Sadler, Geoffrey M *ClaDrA*
Sadler, George *DcVicP 2*
Sadler, Guy Albert 1933- *AmArch 70*
Sadler, H G *AmArch 70*
Sadler, James Henry 1925- *AmArch 70*
Sadler, John 1720- *AntBDN M*
Sadler, Kate *DcBrWA, DcVicP, –2, DcWomA*
Sadler, M H *AmArch 70*
Sadler, Richard Gordon James 1927- *MacBEP*
Sadler, Robert 1909- *DcBrA 1*
Sadler, Rufus 1816?- *NewYHSD*
Sadler, Rupert 1816?- *NewYHSD*
Sadler, Thomas *DcVicP 2*
Sadler, Walter Dendy 1854-1923 *ClaDrA, DcBrA 1, DcVicP, –2*
Sadler, William *DcVicP 2*
Sadler, William d1788? *DcBrECP*
Sadley, Wojciech 1932- *ConArt 77*
Sadolin, Mana 1898- *DcWomA*
Sadow, Sue 1896- *DcWomA*
Sadowski, Daniel 1950- *MarqDCG 84*
Sadri, Frederick Farid 1923- *AmArch 70*
Sadtler, C Herbert d1899 *EncASM*

Saito, Tsutomu Gregory 1922- *AmArch 70*
Saito, Yoshishige 1904- *ConArt 77, –83, OxTwCA, PhDcTCA 77*
Sajtinac, Borislav 1943- *WorECar*
Sakai, Kazuya *OxTwCA*
Sakai, Kazuya 1927- *WhoAmA 76, –78, –80, –82*
Sakai, N *AmArch 70*
Sakai, Toshio 1940- *MacBEP*
Sakakura, Junzo 1901-1969 *ConArch*
Sakakura, Junzo 1904- *McGDA*
Sakakura, Junzo 1904-1968 *MacEA*
Sakakura, Junzo 1904-1974 *WhoArch*
Sakamoto, Fusawo 1931- *AmArch 70*
Sakaoka, Yasue 1933- *WhoAmA 73, –76, –78*
Sakashita, Kiyoshi 1933- *ConDes*
Sakellar, N G *AmArch 70*
Sakier, George 1897- *WhAmArt 85*
Sako, Roy H 1927- *AmArch 70*
Sakrison, G Edward 1898- *AmArch 70*
Saks, Arnold 1931- *AmGrD[port], WhoGrA 82[port]*
Saks, Judith-Ann 1943- *WhoAmA 80, –82, –84*
Sakuyama, Shunji 1940- *WhoAmA 84*
Sal, Jack 1954- *WhoAmA 80, –82, –84*
Sala, Dominique *IlDcG*
Sala, George Augustus Henry 1828-1896 *DcBrBI*
Sala, Jean 1895- *IlDcG*
Sala, Jeanne 1899- *DcWomA, WhAmArt 85*
Sala, John *FolkA 86*
Sala, Jorge *WhoAmA 84*
Sala, Jose Escano *AmArch 70*
Sala, Juan 1867-1918 *ClaDrA*
Salabert, Firmin *DcVicP 2*
Salabes, George Spear, Jr. 1940- *AmArch 70*
Saladini, Achille d1895 *ClaDrA*
Saladino, John F 1939- *ConDes*
Salai 1480-1524 *McGDA*
Salaman, Christopher 1939- *WhoArt 80, –82, –84*
Salaman, Julia *DcWomA*
Salaman, Kate *DcWomA*
Salaman, Mrs. M *DcBrA 1*
Salaman, Michael Jonathan 1911- *DcBrA 2, WhoArt 80, –82, –84*
Salamanca, Manuel *OxTwCA*
Salamon, Miriam 1937- *DcCAr 81*
Salamon, Nicholas John 1942- *MarqDCG 84*
Salamone, Gladys L *WhoAmA 73, –76, –78, –80, –82, –84*
Salamoun, Jiri 1935- *WhoGrA 82[port]*
Salamun, Andraz 1947- *DcCAr 81*
Salanson, Eugenie *DcVicP 2*
Salanson, Eugenie Marie *DcWomA*
Salazar, Alejandro *FolkA 86*
Salazar, Andres 1938- *WhoGrA 82[port]*
Salazar, David 1901- *FolkA 86*
Salazar, Francisco *NewYHSD*
Salazar, Jose De *NewYHSD*
Salazar, Juan 1934- *WhoAmA 73, –76, –78, –80, –82, –84*
Salazar, Leo G 1933- *FolkA 86*
Salazar, Maria 1893- *ArtsAmW 2*
Salazar Simpson, Sylvia 1939- *DcCAr 81*
Salbitani, Roberto 1945- *MacBEP*
Salcedo, Bernardo 1941- *ConArt 77*
Salchow, R W *AmArch 70*
Salden, Helmut 1910- *WhoGrA 62, –82[port]*
Salditt, P F *AmArch 70*
Saldivar, Jaime 1923- *WhoAmA 73, –76, –78*
Saldun, Charles S 1916- *AmArch 70*
Sale, Isobel Morton- *IlsCB 1946*
Sale, John Morton- *IlsCB 1946*
Sale, Thomas W 1951- *MarqDCG 84*
Salem, Albert Richard 1823- *AmArch 70*
Salemme, Antonio 1892- *McGDA, WhAmArt 85, WhoAmA 76, –78, –80, –82, –84*
Salemme, Attilio 1911-1955 *DcCAA 71, –77, McGDA*
Salemme, Lucia 1919- *WhoAmA 73, –76, –78, –80, –82, –84*
Salemme, Martha 1912- *WhoAmA 73, –76, –78, –80, –82, –84*
Salentin, Hubert 1822- *ArtsNiC*
Salerni, Guerino 1905- *AmArch 70*
Salerno, Charles 1916- *WhAmArt 85, WhoAmA 73, –76, –78, –80, –82, –84*
Salerno, Daniel Nick 1930- *AmArch 70*
Salerno, Joseph 1914- *AmArch 70*
Salerno, Steve 1958- *AmArt*
Salerno, Vincent 1893- *WhAmArt 85*
Salesin, David H 1961- *MarqDCG 84*
Salete, Eduardo 1952- *MarqDCG 84*
Saletta, C A *AmArch 70*
Salgado, Sebastiao 1944- *ICPEnP A*
Salgado, Susana *OxTwCA*
Salganik, Jassa 1887-1937 *WhAmArt 85*
Salghetti-Drioli, Angelica 1817-1853 *DcWomA*
Saliba, Antonello De *McGDA*
Saliceti, Jeane 1873-1950 *DcWomA*
Salieres, Sylvain d1920 *WhAmArt 85*
Salimbeni, Ventura 1567?-1613 *McGDA*
Salimbeni DaSanseverino, Jacopo d1427 *McGDA*

Salimbeni DaSanseverino, Lorenzo 1374?-1420 *McGDA*
Salinas, Baruj 1935- *WhoAmA 73, –76, –78, –80, –82, –84*
Salinas, Baruj 1938- *DcCAr 81, PrintW 83, –85*
Salinas, Porfirio 1910- *IlBEAAW*
Saline, Marvin Harold 1927- *AmArch 70*
Saling, Henry 1901- *WhAmArt 85*
Saling, Paul E 1876-1936 *WhAmArt 85*
Salinger, Flora *DcWomA, WhAmArt 85*
Salinger, Joan A 1951- *MacBEP*
Salini, Tommaso 1575-1625 *McGDA*
Salisbury, A W 1879-1933 *WhAmArt 85*
Salisbury, Allen Booth 1927- *AmArch 70*
Salisbury, Alta 1879-1933 *DcWomA*
Salisbury, Benjamin *CabMA*
Salisbury, C B *NewYHSD*
Salisbury, Cornelius 1882-1970 *ArtsAmW 3, IlBEAAW, WhAmArt 85*
Salisbury, Dorothy *WhAmArt 85*
Salisbury, Eve 1914- *WhAmArt 85*
Salisbury, Francis Owen 1874-1962 *DcVicP 2*
Salisbury, Frank O 1874-1962 *ClaDrA, DcBrA 1*
Salisbury, H A *AmArch 70*
Salisbury, Henry *FolkA 86*
Salisbury, J *DcBrECP, FolkA 86*
Salisbury, James *BiDBrA*
Salisbury, John Larmon 1926- *AmArch 70*
Salisbury, Laura Walker *DcWomA, WhAmArt 85*
Salisbury, Lee H 1888- *WhAmArt 85*
Salisbury, Mary *FolkA 86*
Salisbury, Michael *AmGrD[port]*
Salisbury, Paul 1903?- *WhAmArt 85*
Salisbury, Paul 1903?-1973 *IlBEAAW*
Salisbury, Paul George 1935- *AmArch 70*
Salisbury, Rose Howard 1887-1975 *ArtsAmW 3*
Salisbury, Rosine Howard 1887-1975 *ArtsAmW 3, DcWomA, IlBEAAW, WhAmArt 85*
Salisbury, W W *AmArch 70*
Saliske, Helen V 1909- *WhAmArt 85*
Salk, Arthur Phillip 1925- *AmArch 70*
Salk, Norton Elliot 1927- *AmArch 70*
Salkeld, Cecil Ffrench 1908- *ClaDrA, DcBrA 1*
Salkeld, John *AntBDN Q*
Salkin, L E *AmArch 70*
Salko, Samuel 1888- *WhAmArt 85*
Salkovits, Zoltan Ostffy 1917- *WhoGrA 62*
Salkowitz, Abraham Harold 1908- *AmArch 70*
Salla, Salvatore 1903- *WhAmArt 85, WhoAmA 76, –78, –80, –82, –84*
Sallaert, Antoine 1590?-1657? *ClaDrA*
Sallaert, Antoon 1590?-1657 *McGDA*
Sallaway, J Pamela 1947- *MarqDCG 84*
Salle, Countess Charlotte DeLa *DcWomA*
Salle, David 1952- *AmArt, PrintW 83, –85, WhoAmA 82, –84*
Sallee, Charles L, Jr. 1913- *AfroAA*
Salles-Wagner, Adelaide 1825-1890 *DcWomA*
Salley, Craig Homer 1938- *AmArch 70*
Salley, Eleanor King 1909- *WhAmArt 85*
Sallick, Lucy Ellen 1937- *WhoAmA 82, –84*
Sallinen, Tyko 1879-1951 *OxArt*
Sallinen, Tyko 1879-1955 *PhDcTCA 77*
Sallinen, Tyko Konstantin 1879- *ClaDrA*
Sallinen, Tyko Konstantin 1879-1955 *OxTwCA*
Sallitt, Lily *DcVicP 2*
Sallon, Ralph 1899- *WorECar*
Salm, Adriaen Van 1660?-1720 *DcSeaP*
Salm, Roelof Van 1688-1765 *DcSeaP*
Salm-Reifferscheid, Johanna 1780-1857 *DcWomA*
Salman, Gerardo 1929- *AmArch 70*
Salmeggia, Il *McGDA*
Salmeggia, Chiara *DcWomA*
Salmeggia, Elisabetta *DcWomA*
Salmi, Raymond C *AmArch 70*
Salmig, Paul E *WhAmArt 85*
Salminen, Carl Roger 1939- *AmArch 70*
Salmoiraghi, Frank 1942- *WhoAmA 73, –76, –78*
Salmon, Balliol 1868-1953 *DcBrA 1*
Salmon, Bradford *FolkA 86*
Salmon, Christine F 1916- *AmArch 70*
Salmon, Donna 1935- *ConGrA 1[port]*
Salmon, Donna Elaine 1935- *WhoAmA 78, –80, –82*
Salmon, E *DcVicP 2*
Salmon, F Cuthbert 1915- *AmArch 70*
Salmon, Helen R *DcVicP 2, DcWomA*
Salmon, J *DcSeaP, DcVicP 2, NewYHSD*
Salmon, J E *DcVicP 2*
Salmon, J F *DcVicP 2*
Salmon, J M Balliol 1868-1953 *DcBrBI*
Salmon, James 1874-1924 *MacEA*
Salmon, James Marchbank 1916- *ClaDrA, DcBrA 1*
Salmon, John Cuthbert 1844-1917 *DcBrA 1, DcBrWA, DcVicP, –2*
Salmon, John Francis 1814?-1875? *DcBrWA*
Salmon, Larry 1945- *WhoAmA 73, –76, –78, –80, –82, –84*
Salmon, Lionel E *WhAmArt 85*
Salmon, Mary 1670?-1760 *DcWomA*
Salmon, Raymond M 1931- *ConGrA 1[port]*
Salmon, Raymond Merle 1931- *WhoAmA 78, –80, –82, –84*

Salmon, Robert 1763-1821 *BiDBrA*
Salmon, Robert 1775?-1842? *McGDA, NewYHSD*
Salmon, Robert 1775?-1844? *BnEnAmA*
Salmon, Robert 1775?-1845? *DcSeaP*
Salmon, Robert 1775?-1848? *DcAmArt*
Salmon, Ronald E 1943- *MarqDCG 84*
Salmon, Thomas Graham 1910- *WhoArt 80, –82, –84*
Salmon, W R D *DcVicP 2*
Salmon, William 1703?-1779 *BiDBrA*
Salmon And Gillespie *MacEA*
Salmona, Rogelio 1929- *ConArch, MacEA*
Salmond, Gwendolen d1958 *DcWomA*
Salmond, Ronald 1912- *WhoArt 82, –84*
Salmson, Hugo *ArtsNiC*
Salmson, Hugo Frederik 1844-1894 *ClaDrA*
Salo, Gasparo Da 1542-1612 *AntBDN K*
Salo, Pietro Da *McGDA*
Saloff, Michael *DcCAr 81*
Salogga, Frederick William 1908- *AmArch 70*
Salogga, Michael Joseph 1958- *MarqDCG 84*
Salokorpi, Asko *ConArch A*
Salomans, F *DcVicP 2*
Salomans, M *DcVicP 2*
Salome, Emile 1833-1881 *ClaDrA*
Salomon, Anne Elodie *DcWomA*
Salomon, Bernard 1506?-1561? *ClaDrA, OxDecA*
Salomon, Erich 1886-1944? *ConPhot*
Salomon, Erich 1886-1944 *ICPEnP, MacBEP*
Salomon, Lawrence 1940- *WhoAmA 78, –80, –82, –84*
Salomon, William 1823?- *NewYHSD*
Salomoni, Tito 1928- *PrintW 83, –85*
Salomons, Edward d1906 *DcVicP 2*
Salomons, J R *DcVicP 2*
Salomonsky, Henry Louis 1939- *AmArch 70*
Salpeter, Robert 1935- *WhoGrA 82[port]*
Salsberg, I *AmArch 70*
Salsbury, Edith Colgate 1907- *WhAmArt 85*
Salsbury, Robert *DcVicP 2*
Salsman, Byron Dale *AmArch 70*
Salt, Henry 1780-1827 *DcBrBI, DcBrWA*
Salt, John 1937- *ConArt 77, DcCAr 81, OxTwCA, WhoAmA 78, –80, –82, –84*
Salt, Ralph d1846 *AntBDN M*
Salt, Ralph 1782-1846 *DcNiCA*
Salt, S A *DcVicP 2*
Salter, Mrs. *DcVicP 2, DcWomA*
Salter, Ann Elizabeth *FolkA 86, NewYHSD*
Salter, Anne G *DcBrWA, DcVicP 2, DcWomA*
Salter, Ben S 1878-1919 *FolkA 86*
Salter, Elizabeth Ann *DcWomA*
Salter, Emily K *DcBrWA*
Salter, George d1967 *WhoAmA 78N, –80N, –82N, –84N*
Salter, George 1897-1967 *ConDes*
Salter, J *DcVicP 2*
Salter, John Randall 1898- *WhoAmA 73, –76, –78*
Salter, John Randall 1898-1978 *WhoAmA 80N, –82N, –84N*
Salter, John William *DcBrWA*
Salter, Mrs. M F *DcVicP 2*
Salter, Richard *MarqDCG 84*
Salter, Richard Mackintire 1940- *WhoAmA 76, –78, –80, –82, –84*
Salter, Stefan 1907- *WhAmArt 85*
Salter, William 1804-1875 *ArtsNiC, DcVicP, –2*
Salter, William Philip *DcVicP 2*
Salters, F O *DcWomA*
Saltfleet, Frank d1937 *DcBrA 1*
Saltfleet, Frank 1860-1937 *DcVicP 2*
Saltin, Alexandra Theodora *DcWomA*
Saltmarche, Kenneth Charles 1920- *WhoAmA 73, –76, –78, –80, –82, –84*
Saltmer, Florence A *DcVicP, –2, DcWomA*
Salto, Kamma 1890- *DcWomA*
Saltonstall, Elizabeth 1900- *WhAmArt 85, WhoAmA 73, –76, –78, –80, –82, –84*
Saltonstall, J W 1873- *DcBrA 1, DcVicP 2*
Salts, Guy Gerald 1942- *AmArch 70*
Saltus, J Sanford 1853-1922 *WhAmArt 85*
Saltus, Seymour 1907- *AmArch 70*
Saltz, Billy D 1930- *AmArch 70*
Saltz, Jerome 1951- *DcCAr 81, PrintW 85*
Saltzman, E *AmArch 70*
Saltzman, Marvin 1931- *WhoAmA 76, –78, –80, –82, –84*
Saltzman, Mary P E 1878- *WhAmArt 85*
Saltzman, Mary Peyton Eskridge 1878- *DcWomA*
Saltzman, William *ClaDrA*
Saltzman, William 1916- *WhAmArt 85, WhoAmA 73, –76, –78, –80, –82, –84, WhoArt 80, –82, –84*
Saltzmann, Anna *DcWomA*
Saltzmann, Carl 1847-1923 *DcSeaP*
Saltzmann, John C *NewYHSD*
Salvador, Leonard *AmArch 70*
Salvador Carmona, Anna Maria *DcWomA*
Salvador Carmona, Luis 1708-1767 *McGDA*
Salvanh, Antoine 1478?-1552 *McGDA*
Salvat, Francois Martin 1892- *ClaDrA*

Salvati, D *AmArch 70*
Salvati, Jon R 1956- *MarqDCG 84*
Salvatore, Victor d1965 *WhoAmA 78N, –80N, –82N, –84N*
Salvatore, Victor 1885-1965 *WhAmArt 85*
Salvemini, Mauro 1948- *MarqDCG 84*
Salvendy, Frieda 1887- *DcWomA*
Salvi, Giovanni Battista *McGDA*
Salvi, Nicola 1697-1751 *MacEA, McGDA, WhoArch*
Salviati, Antonio *DcNiCA, IlDcG*
Salviati, Francesco 1510-1563 *McGDA*
Salviati, Francesco De'Rossi 1510-1553 *OxArt*
Salvignac, Jean *NewYHSD*
Salvin, Miss *DcVicP 2*
Salvin, Anthony 1799-1881 *BiDBrA A, MacEA, McGDA, WhoArch*
Salvini, Roberto 1912- *WhoArt 80, –82, –84*
Salvioni, Rosalba Maria *DcWomA*
Salvisberg, O R 1882-1940 *ConArch*
Salvisberg, Otto R 1882-1940 *MacEA*
Salvotti-Fratnik, Anna De d1834? *DcWomA*
Salway, Joseph *BiDBrA*
Salwen, Ellen 1947- *MacBEP*
Saly, Jacques-Francois-Joseph 1717-1776 *McGDA*
Salz, Helen 1883- *WhAmArt 85*
Salz, Helen Arnstein 1883- *ArtsAmW 2*
Salz, Helen Arnstein 1883-1978 *DcWomA*
Salzberg, Helen 1923- *FolkA 86*
Salzbrenner, Albert *ArtsAmW 2, WhAmArt 85*
Salzillo, Francisco 1707-1783 *McGDA*
Salzillo Y Alcaraz, Ines *DcWomA*
Salzman, A *AmArch 70*
Salzman, Arthur George 1929- *AmArch 70*
Salzman, Hal 1955- *MarqDCG 84*
Salzman, Rick 1943- *WhoAmA 76, –78*
Salzman, Roy M 1933- *MarqDCG 84*
Salzman, Stanley 1924- *AmArch 70*
Salzmann, Auguste 1824- *MacBEP*
Salzmann, Auguste 1824-1872 *ICPEnP*
Salzmann, Laurence 1944- *ICPEnP A, MacBEP*
Sam, F *AmArch 70*
Samachini, Orazio 1532-1577 *ClaDrA*
Samaha, Fouad Sleiman 1924- *AmArch 70*
Samaniego, E J *AmArch 70*
Samant, Mohan B 1926- *OxTwCA*
Samaras, Lucas 1936- *AmArt, BnEnAmA, ConArt 77, –83, ConPhot, DcCAA 71, –77, DcCAr 81, ICPEnP A, MacBEP, OxTwCA, PhDcTCA 77, PrintW 83, –85, WhoAmA 73, –76, –78, –80, –82, –84*
Samarchi, Hashem 1934- *DcCAr 81*
Samarina, Iecaterina 1854- *DcWomA*
Samaris, P *AmArch 70*
Sambach, Caspar Franz 1715-1795 *McGDA*
Sambach, Franz Gaspard 1715-1795 *ClaDrA*
Sambell, Philip 1798-1874 *BiDBrA*
Sambin, Hugues 1515?-1601? *OxDecA*
Sambin, Hugues 1515?-1602? *McGDA, OxArt*
Sambin, Hugues 1520-1600? *MacEA*
Sambolec, Duba 1949- *DcCAr 81*
Sambonet, Roberto 1924- *ConDes*
Sambourne, Edward Linley 1844-1910 *AntBDN B, DcBrA 1, DcBrBI, DcVicP, –2*
Sambourne, Edward Linley 1845-1910 *WorECar*
Sambourne, Linley 1844-1910 *ClaDrA*
Sambourne, Maud *DcBrBI*
Sambroke DeRockstro, J *DcVicP 2*
Sambugnac, Alexander 1888- *WhAmArt 85*
Samburg, Grace *WhoAmA 76, –78, –80, –82, –84*
Samerjan, George E 1915- *WhAmArt 85, WhoAmA 73, –76, –78, –80, –82, –84*
Samet, William *FolkA 86*
Samford, Mauryce Stacy 1922- *AmArch 70*
Samimi, Mehrdad 1939- *AmArch 70*
Sammallahti, Pentti Ilmari 1950- *MacBEP*
Sammann, Detlef *ArtsAmW 2, WhAmArt 85*
Sammaren, Detlef *ArtsAmW 2*
Sammartano, Nicholas Fred 1920- *AmArch 70*
Sammel, Carrie E *WhAmArt 85*
Sammet, E R *WhAmArt 85*
Sammichele 1484-1559 *OxArt*
Sammon, J C *DcVicP 2*
Sammons, Burl Raymond 1926- *AmArch 70*
Sammons, Frederick Harrington Cruikshank 1838-1917 *WhAmArt 85*
Sammons, Hester *DcWomA*
Samona, Giuseppe 1898- *ConArch, MacEA*
Samore, Samuel Eli 1953- *MacBEP*
Samouri, Claude *NewYHSD*
Sampe, Astrid *WhoArt 80, –82, –84*
Sampe, Astrid 1909- *DcD&D*
Sampel, William *AntBDN Q*
Samperi, Elena *DcCAr 81*
Samperton, John Stanley 1923- *AmArch 70*
Sampier, Budgeon *FolkA 86*
Sampieri, John Matthew 1929- *AmArch 70*
Sample, B R *AmArch 70*
Sample, John Edward 1941- *MarqDCG 84*
Sample, Nathaniel W 1918- *AmArch 70*
Sample, Patricia Marie 1949- *MacBEP*
Sample, Paul 1896- *WhoAmA 73*

Sample, Paul 1896-1974 *WhoAmA 76N, –78N, –80N, –82N, –84N*
Sample, Paul Starrett 1896- *ArtsAmW 1, McGDA*
Sample, Paul Starrett 1896-1974 *IlBEAAW, WhAmArt 85*
Sampler, Marian *AfroAA*
Sampliner, Paul *WhoAmA 82*
Sampliner, Mrs. Paul *WhoAmA 82*
Sampliner, Paul H *WhoAmA 73, –76, –78, –80*
Sampliner, Mrs. Paul H *WhoAmA 80, –73, –76, –78*
Sampson, Alden 1853- *WhAmArt 85*
Sampson, Aylwin Arthur 1926- *WhoArt 80, –82, –84*
Sampson, C A L 1825-1881 *FolkA 86*
Sampson, Claude DeWitt 1908- *AmArch 70*
Sampson, Deborah *FolkA 86*
Sampson, Emma Speed *WhAmArt 85*
Sampson, Emma Steer *DcWomA*
Sampson, Frank 1928- *WhoAmA 80, –82, –84*
Sampson, George *BiDBrA*
Sampson, Helene 1894- *DcWomA*
Sampson, Herbert *DcVicP 2*
Sampson, James Henry *DcVicP, –2*
Sampson, Jeanne *DcWomA*
Sampson, John *NewYHSD*
Sampson, John H 1896- *WhAmArt 85*
Sampson, L *DcVicP 2*
Sampson, Peter Frederick 1949- *MarqDCG 84*
Sampson, S Andrea 1891- *ArtsAmW 3*
Sampson, Thomas *DcVicP, –2*
Sampson, William *CabMA*
Sams, James H 1872-1935 *BiDAmAr*
Samson, Denis Roger *AmArch 70*
Samson, Edme *AntBDN M, DcNiCA*
Samstag, Gordon 1906- *WhAmArt 85, WhoAmA 73, –76, –78, –80, –82, –84*
Samton, P *AmArch 70*
Samuel, Christian Haywood 1919- *AmArch 70*
Samuel, George d1823? *DcBrECP*
Samuel, George d1823 *DcBrWA*
Samuel, Helene 1894- *WhAmArt 85*
Samuel, Juliette *DcWomA*
Samuel, Matilda S 1860- *DcWomA*
Samuel, Richard d1787 *DcBrECP*
Samuel, Roger D 1929- *AmArch 70*
Samuel, W M G 1815-1902 *FolkA 86*
Samuel, William M G 1815-1902 *IlBEAAW, WhAmArt 85*
Samuels, Arthur, Jr. 1934- *WorFshn*
Samuels, Burton Lewis 1933- *AmArch 70*
Samuels, Danny 1947- *DcCAr 81*
Samuels, Edward George 1941- *WhoAmA 80, –82, –84*
Samuels, Gerald 1927- *WhoAmA 76, –78, –80, –82, –84*
Samuels, H S *DcWomA*
Samuels, Harold 1917- *WhoAmA 76, –78, –80, –82, –84*
Samuels, John Stockwell, III 1933- *WhoAmA 78, –80, –82, –84*
Samuels, Peggy 1922- *WhoAmA 76, –78, –80, –82, –84*
Samuels, W G M *NewYHSD*
Samuels, W G M 1815-1902 *ArtsAmW 2*
Samuels, W S M *FolkA 86*
Samuelson, Fred Binder 1925- *WhoAmA 73, –76, –78, –80, –82, –84*
Samuelson, Lawrence Allen 1938- *AmArch 70*
Samwell, Augusta *DcWomA*
Samwell, William 1628-1676 *BiDBrA, MacEA*
Samworth, Joanna *DcVicP 2, DcWomA*
Samworth, Joanna 1830?- *DcBrWA*
Samyn *NewYHSD*
San Daniele, Pellegrino Da *McGDA*
San Gimignano, Vincenzo Da *McGDA*
San Giovanni, Giovanni Da *McGDA*
San Giovanni, R L *AmArch 70*
San Michel, Giuseppe *DcBrECP*
San Miguel, R R *AmArch 70*
San Soucie, Patricia Molm 1931- *WhoAmA 82, –84*
San Torpe, Master Of *McGDA*
Sanabria, P N *AmArch 70*
Sanabria, Robert 1931- *WhoAmA 82, –84*
Sanbach, Herman *FolkA 86*
Sanborn, Alan Tilden 1936- *AmArch 70*
Sanborn, C T *WhAmArt 85*
Sanborn, Caroline V 1843?-1934 *DcWomA, WhAmArt 85*
Sanborn, Dana J 1859-1932 *BiDAmAr*
Sanborn, Earl Edward 1890-1937 *WhAmArt 85*
Sanborn, Herbert J 1907- *WhoAmA 73, –76, –78, –80, –82, –84*
Sanborn, Herbert James 1907- *WhAmArt 85*
Sanborn, Julia Crawford *ArtsEM, DcWomA*
Sanborn, Margaret J *DcWomA*
Sanborn, Percy A 1849-1929 *WhAmArt 85*
Sanborn, Reuben *CabMA*
Sanborn Hermanos *EncASM*
Sancan, J *NewYHSD*
Sancha, Carlos 1920- *DcBrA 1, WhoArt 82, –84*
Sancha, R P 1920- *WhoArt 80*
Sancha, Tom Luis 1947- *MarqDCG 84*

Sanchez, Adrian *McGDA*
Sanchez, Beatrice Rivas 1941- *WhoAmA 84*
Sanchez, Carlos 1908- *IlsCB 1744*
Sanchez, Carol Lee 1934- *WhoAmA 76, –78, –80*
Sanchez, Emilio 1921- *WhoAmA 73, –76, –78*
Sanchez, Fernando *WorFshn*
Sanchez, Jesualda *DcWomA*
Sanchez, Louis Edward 1938- *MarqDCG 84*
Sanchez, Mario 1908- *FolkA 86*
Sanchez, Mary Lowe 1914- *WhoAmA 80, –82, –84*
Sanchez, Raul Esparza *WhoAmA 76, –78*
Sanchez, Thorvald 1933- *WhoAmA 76, –78, –80, –82, –84*
Sanchez-Camus, Patricio Ernesto 1930- *AmArch 70*
Sanchez Coello, Alonso 1531?-1588 *McGDA, OxArt*
Sanchez Coello, Isabel 1564-1612 *DcWomA*
Sanchez Cotan, Juan 1561-1627 *McGDA, OxArt*
Sanchez DeCastro, Juan *McGDA*
Sanchez-DelValle, Carmina 1959- *MarqDCG 84*
Sanchez-Flores, Jorge Guillermo 1952- *MarqDCG 84*
Sanchez M, Carlos 1908- *ConICB*
Sanchez Y Tapia, Lino *IlBEAAW*
Sancho, Raymond Charles 1929- *AmArch 70*
Sancroft, D A *DcVicP 2*
Sanctis, Erminia 1840- *DcWomA*
Sand, Alice L *WhAmArt 85*
Sand, Aurore Dudevant 1866-1961 *DcWomA*
Sand, George 1804-1876 *DcWomA*
Sand, Henry A L *WhAmArt 85*
Sand, John F *NewYHSD*
Sand, Maurice 1823-1889 *ClaDrA*
Sand, Maurice 1825?- *ArtsNiC*
Sand, Michael 1940- *MarqDCG 84*
Sand-Danse, Louise *DcWomA*
Sand VanDe, Michael 1945- *WhoGrA 82[port]*
Sandall, James *DcCAr 81*
Sandback, Fred 1943- *ConArt 77, –83, DcCAA 77, DcCAr 81, PrintW 83, –85*
Sandback, Frederick Lane 1943- *WhoAmA 76, –78, –80, –82, –84*
Sandberg, Agnes *DcWomA*
Sandberg, Hannah 1904- *WhoAmA 78, –80, –82, –84*
Sandberg, Lasse E M 1924- *IlsBYP, IlsCB 1957*
Sandberg, Lasse Erik Mathias *IlsCB 1967*
Sandberg, Robert Young 1922- *AmArch 70*
Sandberg, Willem 1897- *WhoArt 80, –82, –84, WhoGrA 62*
Sandberg, Willem Jacob Henri Berend 1897-1984 *ConDes*
Sandbert, Willem 1897- *WhoGrA 82[port]*
Sandby, Paul 1725?-1809 *BkIE, DcBrWA, McGDA, OxArt*
Sandby, Paul 1730-1809 *DcBrECP*
Sandby, Thomas 1721-1798 *BiDBrA, DcBrWA, McGDA, OxArt*
Sandby, Thomas Paul d1832 *DcBrECP, DcBrWA*
Sande, Rhoda *WhoAmA 78, –80, –82, –84*
Sande, Theodore Anton 1933- *AmArch 70*
Sande-Bakhuysen, Gerardina *DcWomA*
Sande-Lacoste, Carel Eliza VanDer 1860-1894 *DcWomA*
Sandecki, Albert Edward 1935- *WhoAmA 73, –76, –78, –80, –82*
Sandefer, Lucile Gilbert *ArtsAmW 3*
Sandefur, John Courtney 1893- *ArtsAmW 2, WhAmArt 85*
Sandefur, Pentard William, Jr. 1931- *AmArch 70*
Sandell, Scott 1953- *PrintW 85*
Sandels, Gosta 1887-1919 *PhDcTCA 77*
Sandels, Karl 1906- *ConPhot, ICPEnP A*
Sandeman, Mrs. B *DcVicP 2*
Sanden, Arthur G 1893- *ArtsAmW 3*
Sanden, John Howard 1935- *WhoAmA 82, –84*
Sandenbergh, John Wessels 1915- *AmArch 70*
Sandenbergh, Roberta Bocian 1939- *AmArch 70*
Sander, A H 1892- *IlBEAAW*
Sander, Mrs. A H 1892- *DcWomA*
Sander, August 1876-1964 *ConPhot, ICPEnP, MacBEP*
Sander, Dennis Jay 1941- *WhoAmA 76, –78, –80*
Sander, Hans K 1925- *AmArch 70*
Sander, Helmut Steve 1912- *AmArch 70*
Sander, Ludwig 1906- *DcCAA 71, WhoAmA 73*
Sander, Ludwig 1906-1975 *DcCAA 77, WhoAmA 76N, –78N, –80N, –82N, –84N*
Sander, Tom *OfPGCP 86*
Sander-Plump, Agnes 1888-1980 *DcWomA*
Sandercock, Henry Ardmore *DcBrBI, DcVicP 2*
Sanders *NewYHSD*
Sanders, Miss *DcWomA*
Sanders, Mrs. *DcVicP 2*
Sanders, Mrs. A H 1892- *ArtsAmW 3, DcWomA*
Sanders, Adam Achod 1889- *WhAmArt 85*
Sanders, Albertina *DcWomA*
Sanders, Andrew *NewYHSD*
Sanders, Andrew Dominick 1918- *WhoAmA 73, –76, –78, –80, –82, –84*
Sanders, Anna 1791-1860 *FolkA 86*
Sanders, Bernard 1904- *WhAmArt 85*
Sanders, Bertha D *DcWomA, WhAmArt 85*

Sanders, Catharina *DcWomA*
Sanders, Charles W 1921- *MacBEP*
Sanders, Charles W 1924- *AmArch 70*
Sanders, Christina *DcWomA*
Sanders, Christopher Cavania 1905- *DcBrA 1, WhoArt 80, -82, -84*
Sanders, Daniel *FolkA 86*
Sanders, David Lewis 1935- *AmArch 70*
Sanders, Dean Harris 1914- *AmArch 70*
Sanders, Donald Gilbert 1919- *AmArch 70*
Sanders, Ellen *DcVicP 2*
Sanders, F *NewYHSD*
Sanders, H *DcVicP 2*
Sanders, H L *AmArch 70*
Sanders, H M *WhAmArt 85*
Sanders, Har 1929- *ConArt 77*
Sanders, Harris A 1927- *AmArch 70*
Sanders, Helen Fitzgerald *ArtsAmW 3, WhAmArt 85*
Sanders, Henry *WhoArt 84N*
Sanders, Henry 1918- *DcBrA 2, WhoArt 80, -82*
Sanders, Herbert 1909- *CenC*
Sanders, Herbert Harvey 1909- *WhAmArt 85, WhoAmA 80, -82, -84*
Sanders, Isaac *WhAmArt 85*
Sanders, Jerry 1933- *AmArch 70*
Sanders, John *FolkA 86*
Sanders, John 1750-1825 *DcBrWA*
Sanders, John 1768-1826 *BiDBrA*
Sanders, John, Jr. 1750-1825 *DcBrECP*
Sanders, John, Sr. *DcBrECP*
Sanders, John Arnold 1801?- *DcBrWA*
Sanders, John Mac 1935- *AmArch 70*
Sanders, Joop A 1922- *WhoAmA 73, -76, -78, -80, -82, -84*
Sanders, Joseph *AntBDN Q*
Sanders, Margery Beverly 1891- *ClaDrA, DcBrA 1, DcWomA*
Sanders, Mariane *DcVicP 2*
Sanders, Michael Joseph *MarqDCG 84*
Sanders, Nancy *FolkA 86*
Sanders, Norman 1927- *ICPEnP A, MacBEP*
Sanders, Otis Edward 1925- *AmArch 70*
Sanders, Rhea 1923- *WhoAmA 82, -84*
Sanders, Roy Dean, Jr. 1922- *AmArch 70*
Sanders, S Kent *WhAmArt 85*
Sanders, Samella *AfroAA*
Sanders, T H *DcVicP 2*
Sanders, T Hale *DcBrWA, DcVicP 2*
Sanders, Thomas Graham 1932- *AmArch 70*
Sanders, Violet *WhoArt 84N*
Sanders, Violet 1904- *WhoArt 80, -82*
Sanders, Violet E C 1904- *DcBrA 1*
Sanders, W *DcBrWA, DcVicP 2*
Sanders, W C *NewYHSD*
Sanders, Walter 1897- *ICPEnP A*
Sanders, Walter B 1906- *AmArch 70*
Sanders, Walter G *DcBrA 1, DcVicP, -2*
Sanders, William Brownell 1854-1929 *WhAmArt 85*
Sanders, William Willard 1933- *WorECar*
Sanders-Turner, Carolyn *OfPGCP 86*
Sanderson *NewYHSD*
Sanderson, Arthur *DcNiCA*
Sanderson, Bill 1913- *WhAmArt 85*
Sanderson, C J 1949- *WhoArt 80, -82, -84*
Sanderson, Charles Howard 1925- *WhoAmA 78, -80, -82, -84*
Sanderson, Charles Wesley 1835-1905 *WhAmArt 85*
Sanderson, Charles Wesley 1838- *ArtsNiC*
Sanderson, Charles Wesley 1838-1905 *NewYHSD*
Sanderson, Elijah 1751-1825 *AntBDN G, DcNiCA*
Sanderson, Elijah 1752-1825 *CabMA*
Sanderson, Francis *FolkA 86*
Sanderson, George *NewYHSD*
Sanderson, George H 1928- *MarqDCG 84*
Sanderson, H *DcBrBI*
Sanderson, Henrietta 1909- *WhAmArt 85*
Sanderson, Henry 1808-1880 *NewYHSD*
Sanderson, Ivan T 1911-1973 *IlsCB 1744, -1946*
Sanderson, Jacob *DcNiCA*
Sanderson, Jacob 1758?-1810 *CabMA*
Sanderson, James 1791?-1835 *BiDBrA*
Sanderson, James Wright d1813 *BiDBrA*
Sanderson, John *DcVicP 2*
Sanderson, John d1774 *BiDBrA, MacEA*
Sanderson, John 1794-1857? *CabMA*
Sanderson, Joseph d1747 *BiDBrA*
Sanderson, Julia J *DcVicP 2*
Sanderson, Raymond Phillips 1908- *WhAmArt 85, WhoAmA 76, -78, -80, -82*
Sanderson, Robert 1608-1693 *AntBDN Q, BnEnAmA*
Sanderson, Robert Wright 1920- *WhoAmA 76, -78*
Sanderson, Ruth L 1951- *IlsCB 1967*
Sanderson, S M *DcVicP 2*
Sanderson, Warren 1931- *WhoAmA 84*
Sanderson, William 1905- *IlBEAAW, WhAmArt 85*
Sanderson-Wells, John Sanderson 1872-1955 *DcBrA 1, DcVicP 2*
Sandeson, William Seymour 1913- *WhoAmA 76, -78, -80, -82, -84*
Sandfield, M M *AmArch 70*

Sandford, Christopher 1902- *WhoArt 80, -82*
Sandford, D R, Jr. *AmArch 70*
Sandford, D R, Sr. *AmArch 70*
Sandford, George *BiDBrA*
Sandford, Joseph E *WhAmArt 85*
Sandford, M T *AmArch 70*
Sandford, Peter Peregrine *FolkA 86*
Sandgren, Ernest Nelson 1917- *WhoAmA 73, -76, -78, -80, -82, -84*
Sandground, Mark Bernard, Sr. 1932- *WhoAmA 73, -76, -78, -80, -82, -84*
Sandham, Henry 1842-1912 *WhAmArt 85*
Sandham, J Henry 1842-1910 *ArtsAmW 1*
Sandham, J Henry 1842-1912 *IlBEAAW*
Sandham, R C A *WhAmArt 85*
Sandheim, Amy *DcBrBI*
Sandheim, May *DcBrBI*
Sandholt, Marie 1872- *DcWomA*
Sandidge, William Trevilian 1920- *AmArch 70*
Sandifer, Dan P 1927- *AmArch 70*
Sandig, Armin 1929- *DcCAr 81, PhDcTCA 77*
Sandig, H *AmArch 70*
Sandilands, George Sommerville 1889-1961 *DcBrA 1*
Sandin, Joan *IlsBYP*
Sandin, Joan 1942- *IlsCB 1967*
Sandland Capron *EncASM*
Sandlass, H L *AmArch 70*
Sandle, Michael 1936- *ConArt 77, -83, ConBrA 79[port], DcCAr 81*
Sandler, Barbara 1943- *WhoAmA 76, -78, -80, -82, -84*
Sandler, Irving Harry 1925- *WhoAmA 73, -76, -78, -80, -82, -84*
Sandler, Pat 1929- *WorFshn*
Sandlin, E L *AmArch 70*
Sandman, Jo 1931- *WhoAmA 84*
Sandman, R E *AmArch 70*
Sandmeyer, Jacques *NewYHSD*
Sandness, Lynn Bradford 1951- *WhoAmA 82*
Sando, F J *AmArch 70*
Sandol, Maynard 1930- *DcCAA 71, -77, WhoAmA 73, -76, -78, -80, -82, -84*
Sandona, Matteo 1883- *ArtsAmW 1, WhAmArt 85*
Sandor *WhAmArt 85*
Sandor, Josephine 1914- *WhoAmA 82, -84*
Sandor, Josephine Beardsley *WhoAmA 76*
Sandor, Kata *DcWomA*
Sandor, Laszlo Ernest 1926- *AmArch 70*
Sandor, Mathias 1857-1920 *ArtsAmW 1, -3, IlBEAAW, WhAmArt 85*
Sandormirskaja, Beatrice 1894- *DcWomA*
Sandoval, Fernan Euclides 1947- *MarqDCG 84*
Sandow, Franz 1910- *WhAmArt 85*
Sandoz, Edouard 1918- *IlsBYP, IlsCB 1946*
Sandoz, Gerard *DcNiCA*
Sandquist, Gary Marlin 1936- *MarqDCG 84*
Sandquist, Oliver 1905- *AmArch 70*
Sandrart, Auguste Von, Madame *DcWomA*
Sandrart, Esther Barbara 1651- *DcWomA*
Sandrart, Jan 1588-1679? *ClaDrA*
Sandrart, Joachim 1606-1688 *ClaDrA*
Sandrart, Joachim Von 1606-1688 *McGDA, OxArt*
Sandrart, Susanna Maria Von 1658-1716 *DcWomA*
Sandrart, Susanne Marie Von 1707-1769 *DcWomA*
Sandreczki, Otto *WhAmArt 85*
Sandrock, Brian 1925- *ConArch*
Sands, Master *NewYHSD*
Sands, A *DcVicP 2*
Sands, Alfred R *NewYHSD*
Sands, Anna M *WhAmArt 85*
Sands, Anna M 1860- *DcWomA*
Sands, Charles Douglas 1935- *AmArch 70*
Sands, David Henry 1935- *AmArch 70*
Sands, Edward E 1910- *AmArch 70*
Sands, Ethel *WhAmArt 85*
Sands, Ethel 1873-1962 *DcBrA 1, DcWomA*
Sands, Frederick 1916- *WhoArt 80, -82, -84*
Sands, Gertrude Louis 1899- *ArtsAmW 2, DcWomA, WhAmArt 85*
Sands, Henry H *DcVicP 2*
Sands, Herman Edward 1937- *AmArch 70*
Sands, J *DcBrBI*
Sands, James *BiDBrA*
Sands, John *NewYHSD*
Sands, Richard *NewYHSD*
Sands, Richard Martin 1960- *MarqDCG 84*
Sands, William d1751 *BiDBrA*
Sandstedt, Julius Siegfried 1908- *AmArch 70*
Sandstrom, George F *IlsBYP*
Sandstrom, L E, Jr. *AmArch 70*
Sandstrom, Marita *IlsBYP*
Sandstrom, Paul Wesley 1924- *AmArch 70*
Sandusky, William 1813-1846 *ArtsAmW 1*
Sandusky, William H 1813-1846 *IlBEAAW*
Sandusky, William H 1813-1849 *FolkA 86*
Sandweiss, Marni 1954- *MacBEP*
Sandweiss, Martha Ann 1954- *WhoAmA 80, -82, -84*
Sandwith, Noelle *WhoArt 80, -82, -84*
Sandy, A C *DcBrBI*
Sandy, Donald, Jr. 1933- *AmArch 70*
Sandy, Percy T *WhAmArt 85*

Sandy, Percy Tsisete 1918- *IlBEAAW*
Sandys, Anthony 1806-1883 *DcBrWA, DcVicP 2*
Sandys, Anthony Frederick Augustus 1829-1904 *DcBrWA, DcVicP 2, McGDA*
Sandys, E *DcVicP 2*
Sandys, Edwin *NewYHSD*
Sandys, Emma 1834-1877 *DcWomA*
Sandys, Francis *BiDBrA*
Sandys, Francis d1815 *MacEA*
Sandys, Frederick 1829-1904 *DcVicP*
Sandys, Frederick 1832-1904 *AntBDN B, ClaDrA, DcBrA 1*
Sandys, Frederick Augustus 1832-1904 *DcBrBI*
Sandys, Frederick K 1832- *ArtsNiC*
Sandys, S *DcVicP 2*
Sandzen, Birger 1871-1954 *WhAmArt 85*
Sandzen, Margaret 1909- *WhAmArt 85*
Sandzen, Sven Birger 1871-1954 *ArtsAmW 1, -2, IlBEAAW*
Sanejouand, Jean-Michel 1934- *ConArt 77, -83*
Sanell, Louis *WhAmArt 85*
Sanetel, R L *AmArch 70*
Sanfelice, Ferdinando 1675-1750 *MacEA*
Sanford *NewYHSD*
Sanford, Arthur Carol 1905- *AmArch 70*
Sanford, B C *AmArch 70*
Sanford, Carl Charles 1910- *AmArch 70*
Sanford, Edward Field, Jr. 1887- *WhAmArt 85*
Sanford, G P *NewYHSD*
Sanford, George T *NewYHSD*
Sanford, Henry Howarton 1907- *AmArch 70*
Sanford, Isaac *FolkA 86, NewYHSD*
Sanford, Isobel Burgess 1911- *WhAmArt 85*
Sanford, J *NewYHSD*
Sanford, John *CabMA*
Sanford, John Williams, Jr. 1917- *WhAmArt 85*
Sanford, Joseph D *EncASM*
Sanford, Lockwood 1817?- *NewYHSD*
Sanford, M M *FolkA 86, NewYHSD*
Sanford, Marion 1902- *WhAmArt 85*
Sanford, Mary *DcWomA*
Sanford, R D *FolkA 86*
Sanford, Roy 1914- *WhoArt 80, -82*
Sanford, S Ellen *DcBrA 1, DcVicP 2, DcWomA*
Sanford, Samuel *CabMA*
Sanford, Sheila *WhoArt 80, -82*
Sanford, Sheila 1922- *WhoArt 84*
Sanford, Thomas *FolkA 86*
Sanford, Walter *AfroAA*
Sanford, Zachariah *CabMA*
Sanford And Nelson *CabMA*
Sang, Andreas Friedrich *IlDcG*
Sang, Frederick J *DcVicP 2*
Sang, Jacob *AntBDN B, OxDecA*
Sang, Jacob d1783 *IlDcG*
Sang, Johann Heinrich Balthasar *IlDcG*
Sangallo, Antonio Da, The Elder 1455-1534 *OxArt, WhoArch*
Sangallo, Antonio Da, The Elder 1455?-1535 *McGDA*
Sangallo, Antonio Da, The Younger 1483-1546 *McGDA, OxArt*
Sangallo, Antonio Da, The Younger 1485-1546 *WhoArch*
Sangallo, Francesco Da 1494-1576 *McGDA*
Sangallo, Giuliano Da 1443?-1516 *OxArt*
Sangallo, Giuliano Da 1445?-1516 *McGDA, WhoArch*
Sangallo Family *MacEA, OxArt*
Sanger, Anthony *NewYHSD*
Sanger, Grace H H C 1881- *WhAmArt 85*
Sanger, Grace H H Cochrane 1881- *DcWomA*
Sanger, Henry L *NewYHSD*
Sanger, I J 1899- *WhAmArt 85*
Sanger, John *DcBrECP*
Sanger, Stephen S *CabMA*
Sanger, Wendolin *NewYHSD*
Sanger, William 1888?- *WhAmArt 85*
Sangernebo, Alexander 1856-1930 *WhAmArt 85*
Sangernebo, Emma Eyles *WhAmArt 85*
Sangernebo, Emma Eyles 1877- *DcWomA*
Sanghvi, Chetan V 1956- *MarqDCG 84*
Sangiamo, Albert *WhoAmA 76, -78, -80, -82, -84*
Sangine, Robert *AmArch 70*
Sangree, Paul Clausen 1930- *AmArch 70*
Sangree, Theodora 1901- *WhAmArt 85*
Sangster, Samuel 1804-1872 *ArtsNiC*
Sangsue, Andre 1931- *DcCAr 81*
Sanguinetti, Eugene F 1917- *WhoAmA 73, -76, -78, -80, -82, -84*
Sanguinetti, Francesco d1870 *ArtsNiC*
Sanguinetti, Teresa Bertelli *DcWomA*
Sanguszko, Kunegunde *DcWomA*
Sani, A *DcVicP 2*
Sankar, C S 1950- *MarqDCG 84*
Sankey, Mrs. Clifford H *WhAmArt 85*
Sanko, Alexander *AmArch 70*
Sankova, Galina 1904- *ICPEnP A*
Sankowsky, Itzhak 1908- *WhAmArt 85, WhoAmA 76, -78, -80, -82, -84*
Sanlorenzo *WorFshn*
Sanmarti, Maria *DcWomA*

Sanmicheli, Michele 1484?-1559 MacEA, McGDA, WhoArch
Sanner, Albert Edward 1920- AmArch 70
Sannom, Charlotte Amalie 1846-1923 DcWomA
Sano Di Pietro 1406-1481 McGDA, OxArt
Sanoff, Henry 1934- AmArch 70
Sanon, John A 1860-1929 WhAmArt 85
Sanraku 1559-1635 McGDA
Sansam, Edith DcWomA
Sansay, Madame NewYHSD
Sansom, E DcSeaP
Sansom, Joseph NewYHSD
Sansom, L Charles DcVicP 2
Sansom, Nellie DcBrBI
Sansom, Thomas AntBDN N
Sanson, Justin-Chrysostome ArtsNiC
Sanson, Stella DcWomA
Sansosti, Alexander Tobio 1913- AmArch 70
Sansovino, Il 1486-1570 McGDA
Sansovino, Andrea d1529 OxArt
Sansovino, Andrea 1460-1529 McGDA
Sansovino, Francesco 1521-1586 OxArt
Sansovino, Jacopo 1486-1570 MacEA, WhoArch
Sansovino, Jacopo Tatti 1486?-1570 OxArt
Sansum, Edith DcWomA
Sant, George DcVicP, -2
Sant, H R DcVicP 2
Sant, James 1820- ArtsNiC
Sant, James 1820-1916 ClaDrA, DcBrA 1, DcBrWA, DcVicP, -2
Santa Cruz, Maria Anna DcWomA
Santa Eulalia, Alexis WhAmArt 85
Santa Maria, Andres De OxTwCA
Santa Maria, Andres De 1860-1945 McGDA
Santachiara, Carlo 1937- WorECar
Santacroce, Daniel Patrick 1929- AmArch 70
Santacroce, Francesco Da McGDA
Santacroce, Girolamo Da 1503-1556 McGDA
Santafede, Francesco 1519- ClaDrA
Santamaria, Joseph William 1939- AmArch 70
Santamaria Y Sedano, Marceliano 1866- ClaDrA
Sant'Angelo, Giorgio 1939- ConDes
Sant'Angelo, Giorgio Di 1936- WorFshn
Santarelli, Emilio 1801- ArtsNiC
Santayana, George 1863-1952 OxArt
Santee, Franklin ArtsEM
Santee, Miner ArtsEM
Santee, Ross 1889- ArtsAmW 1
Santee, Ross 1889-1965 IlBEAAW, WhAmArt 85
Santel, Augusta 1852-1935 DcWomA
Santel, Augusta 1876- DcWomA
Santel, Henriette 1874- DcWomA
Sant'Elia, Antonio 1880-1916 EncMA, WhoArch
Sant'Elia, Antonio 1888-1916 MacEA, McGDA, OxArt
Santella NewYHSD
Santello NewYHSD
Santer, Miner ArtsEM
Santer, W DcVicP 2
Santerre, Jean Baptiste 1651-1717 ClaDrA
Santerre, Jean-Baptiste 1651-1717 McGDA, OxArt
Santesson, Ninnan Gertrud Paulina 1891- DcWomA
Santi DiTito 1536-1603 MacEA, McGDA
Santi, Andriolo McGDA
Santi, Andriolo DiPagano d1375? McGDA
Santi, Carolina DcWomA
Santi, Giovanni d1494 McGDA
Santi, Giovanni 1431?-1494 OxArt
Santi, Giovanni De McGDA
Santi, Giovanni De d1392 McGDA
Santi, Raffaello ClaDrA, McGDA
Santiago, Helene 1910- WhoAmA 73, -76
Santiago, Miguel De 1625?-1706 McGDA
Santiago Avendano, Fileman 1958- DcCAr 81
Santillo, Frank William 1924- AmArch 70
Santini, Imelda 1857- DcWomA
Santini Aichel, Jan Blazej 1677-1723 MacEA
Santley, Edith DcVicP 2
Santlofer, Jonathan 1946- WhoAmA 78, -80, -82, -84
Santo, Harold Paul 1947- MarqDCG 84
Santo, L W AmArch 70
Santo, Pasquale 1893- WhAmArt 85
Santo, Patsy 1893- FolkA 86
Santo Spirito, Florence McGDA
Santocono, G AmArch 70
Santomaso, Giuseppe 1907- McGDA, OxTwCA, PhDcTCA 77
Santomaso, Guiseppe 1907- WorArt[port]
Santora, Mark 1957- MarqDCG 84
Santore, Charles 1935- IlrAm 1880
Santoro, Leonard John 1932- AmArch 70
Santos, Jesse F 1928- WorECom
Santos, Malang 1928- WorECom
Santos, Richard Thomas 1940- AmArch 70
Santos DeCarvalho, Eugenio Dos 1711-1760 MacEA, McGDA
Santvoort, Dirck Dircksz 1610?-1680 OxArt
Santvoort, Dirck Dircksz Van 1610?-1680 McGDA
Sanvitale, Countess Giuseppina 1800-1848 DcWomA

Sanz, C R AmArch 70
Sanz, Eduardo OxTwCA
Sanz, Ines Mercedes DcWomA
Sanz-Pastor Fz DePierola, Consuelo WhoArt 80, -82, -84
Sanzio, Raffaello McGDA
Sapack, Robert Andrew 1937- AmArch 70
Saphire, Lawrence M 1931- WhoAmA 78, -80, -82, -84
Sapieha, Princess Anna 1774-1859 DcWomA
Sapieha, Anna De 1798-1864 DcWomA
Sapieha, Christine IlsBYP
Sapien, Darryl Rudolph 1950- WhoAmA 78, -80, -82, -84
Sapir, Gerry 1954- MarqDCG 84
Sapolsky, T AmArch 70
Saporta, I E AmArch 70
Sapozhnikova, Nadezhda DcWomA
Sapozhnikova, Vera DcWomA
Sapp, Kitt George 1887- WhAmArt 85
Sapp, Michael Norwood 1946- MarqDCG 84
Sapp, Ronald J 1935- AmArch 70
Sappenfield, Charles Madison 1930- AmArch 70
Sapper, Richard 1932- ConDes
Sapper, S David 1939- MarqDCG 84
Sapper, William FolkA 86
Saputo, Albert Joseph AmArch 70
Saracchi Family McGDA
Saraceni, Carlo 1580?-1620 McGDA
Saraceni, Carlo 1585-1620 ClaDrA, OxArt
Sarachi, Giovanni Ambrogio 1550- McGDA
Sarachi, Michele McGDA
Sarachi, Simone 1548- McGDA
Sarachi, Stefano d1595 McGDA
Sarah FolkA 86
Saraiya, Rohit R 1945- MarqDCG 84
Sarason, Henry 1896-1979 WhoAmA 80N, -82N, -84N
Sarauw, Laura Oline Adolphine 1853-1912 DcWomA
Sarazin, Jacques McGDA
Sarazin, L DcWomA
Sarazin, Mrs. L NewYHSD
Sarazin DeBelmont, Louise Josephine 1790-1871? DcWomA
Sardeau, Helene d1968 WhoAmA 78N, -80N, -82N, -84N
Sardeau, Helene 1899-1968 WhAmArt 85
Sardeau, Helene 1899-1969 DcWomA
Sardelic, Ante 1947- WhoAmA 84
Sardent, Marie Genevieve DcWomA
Sardi, Giuseppe 1621?-1699 MacEA
Sardi, Giuseppe 1680?-1753 McGDA
Sardi, Teresa 1795-1833 DcWomA
Sardina, Adolfo 1933- WorFshn
Sardisco, Frank Vincent 1930- WhoAmA 76
Sardsam, Miss DcWomA
Sare, Hilda Mary 1879- DcBrA 1, DcWomA
Saree, Gunter 1940-1973 ConArt 77
Saret, Alan 1944- ConArt 77, -83, DcCAA 77, DcCAr 81, PrintW 85
Saret, Alan 1944- WhoAmA 78, -80, -82, -84
Saretzky, Gary D 1946- MacBEP
Sarff, Walter 1905- WhoAmA 73, -76, -78, -80, -82, -84
Sarff, Walter Smith 1905- WhAmArt 85
Sarg, Mary 1911- WhAmArt 85
Sarg, Tony 1880- DcBrBI
Sarg, Tony 1880-1942 ConICB, WhAmArt 85
Sarg, Tony 1882-1942 IlrAm C, -1880, WorECar
Sargant, Francis William 1870-1960 DcBrA 1
Sargant, Mary DcWomA
Sargeant, Clara McClean 1889- DcWomA, WhAmArt 85
Sargeant, Geneve Rixford 1868- ArtsAmW 1, WhAmArt 85
Sargeant, Geneve Rixford 1868-1957 DcWomA
Sargeant, H DcSeaP
Sargeant, John DcVicP 2
Sargeant, Minnie R DcWomA
Sargeant, William C AmArch 70
Sargent FolkA 86
Sargent, Anita W 1876- DcWomA, WhAmArt 85
Sargent, Ben 1948- WorECar
Sargent, Christiana Keadie Swan 1777-1867 DcWomA, NewYHSD
Sargent, Donald Kenneth 1904- AmArch 70
Sargent, Emily DcWomA
Sargent, Florence Mary 1857- WhAmArt 85
Sargent, Frederick d1899 DcBrWA, DcVicP 2
Sargent, G F DcBrBI, DcBrWA
Sargent, H d1796? DcBrECP
Sargent, H Garton DcVicP 2
Sargent, Henry 1770-1845 BnEnAmA, DcAmArt, NewYHSD
Sargent, Mrs. I T NewYHSD
Sargent, Irene d1932 WhAmArt 85
Sargent, J McNeil WhoAmA 82, -84
Sargent, J McNeil 1924- PrintW 83, -85
Sargent, Jabez CabMA
Sargent, John 1910- DcBrA 1, WhoArt 80
Sargent, John B FolkA 86

Sargent, John S 1856- ArtsNiC
Sargent, John S 1856-1925 WhAmArt 85
Sargent, John Singer 1856-1925 ArtsAmW 3, BnEnAmA, ClaDrA, DcAmArt, DcBrA 1, DcBrBI, DcBrWA, DcVicP, -2, McGDA, OxArt, PhDcTCA 77
Sargent, Lloyd L 1881-1934 ArtsAmW 3
Sargent, Louis Augustus 1881- DcBrA 1
Sargent, M 1892- WhAmArt 85
Sargent, Margaret Holland WhoAmA 73, -76, -78, -80
Sargent, Margaret Holland 1927- AmArt, WhoAmA 82, -84
Sargent, Margarett W 1892-1978 DcWomA
Sargent, Mary F 1875- WhAmArt 85
Sargent, Mary Forward 1875-1963 DcWomA
Sargent, Paul Turner 1880- ArtsAmW 2, WhAmArt 85
Sargent, Richard WhAmArt 85
Sargent, Richard 1911- IlrAm E
Sargent, Richard 1911-1978 IlrAm 1880
Sargent, Richard 1932- WhoAmA 76, -78, -80, -82, -84
Sargent, Robert Edward 1933- IlsCB 1957
Sargent, Rosa 1867- DcWomA
Sargent, Solomon, III CabMA
Sargent, W K DcWomA
Sargent, Waldo DcBrBI
Sargent, Walter 1868-1927 WhAmArt 85
Sargent, Warren Gooch 1918- AmArch 70
Sargent, William AntBDN D
Sargent, Winthrop CabMA
Sargisson, Ralph M DcBrBI
Sargon II, Of Assyria 722BC-705BC IlDcG
Sari AntBDN L, IlsBYP, IlsCB 1946
Saridakis, E G AmArch 70
Sarille, C G AmArch 70
Saris, Anthony 1924- IlrAm G, -1880, WhoGrA 82[port]
Sarisky, Michael A 1906- WhAmArt 85
Sarjeant, G R DcVicP 2
Sarjent, Emily DcVicP 2
Sarjent, Francis James 1780?-1812 DcBrWA
Sarjent, G R DcBrWA
Sarka, Charles Nicholas 1879-1960 WorECar
Sarka, Charles Nicolas 1879- WhAmArt 85
Sarka, Charles Nicolas 1879-1960 IlrAm A, -1880
Sarkadi, Leo 1879-1947 WhAmArt 85
Sarkany, Geysa, Jr. 1933- AmArch 70
Sarkis 1909- WhoAmA 73, -76
Sarkis 1909-1977 WhoAmA 78N, -80N, -82N, -84N
Sarkis 1938- ConArt 77, -83
Sarkisian, Paul 1928- AmArt, ConArt 83, DcCAr 81, WhoAmA 76, -78, -80, -82, -84
Sarkisian, Sarkis 1909-1977 WhAmArt 85
Sarkissian, Berge 1941- MarqDCG 84
Sarkissian, Haig A 1960- MarqDCG 84
Sarle, Sister C H FolkA 86
Sarli, Fausto 1927- WorFshn
Sarluis, Leonard 1874-1949 ClaDrA
Sarmi, Ferdinando FairDF US
Sarmiento, Teresa DcWomA
Sarmiento, Wenceslao Alfonso 1922- AmArch 70
Sarno, Dick 1904- ICPEnP A
Sarnoff, Arthur 1912- AmArt, WhAmArt 85
Sarnoff, Arthur Saron 1912- WhoAmA 73, -76, -78, -80, -82, -84
Sarnoff, Lolo 1916- AmArt, WhoAmA 73, -76, -78, -80, -82, -84
Sarnoff, Robert W 1918- WhoAmA 73, -76, -78
Saroff, Leonard 1927- AmArch 70
Sarony, Hector NewYHSD
Sarony, Napoleon 1821-1896 ICPEnP A, MacBEP, NewYHSD, WhAmArt 85
Sarony, Olivier Francois Xavier 1820-1879 MacBEP
Sarony-Lambert, N WhAmArt 85
Sarp, Gerda Ploug 1881- DcWomA
Sarpaneva, Timo 1926- ConDes, IlDcG
Sarrazin, Mademoiselle DcWomA
Sarrazin, Jacques 1588-1660 OxArt
Sarrazin, Jacques 1592-1660 McGDA
Sarre, Carmen G 1895- DcWomA, WhAmArt 85
Sarrocchi, Tito 1825?- ArtsNiC
Sarsony, Robert 1938- PrintW 83, -85, WhoAmA 73, -76, -78, -80, -82, -84
Sartain, Emily d1927 WhAmArt 85
Sartain, Emily 1841- ArtsNiC
Sartain, Emily 1841-1927 DcAmArt, DcWomA
Sartain, Harriet WhAmArt 85
Sartain, Harriet 1873- DcWomA
Sartain, Henry 1833?-1895 DcAmArt
Sartain, Henry 1833-1895? NewYHSD
Sartain, John 1808- ArtsNiC
Sartain, John 1808-1897 DcAmArt, McGDA, NewYHSD, WhAmArt 85
Sartain, John, Family DcAmArt
Sartain, Samuel 1830-1906 DcAmArt, NewYHSD, WhAmArt 85
Sartain, William 1843- ArtsNiC
Sartain, William 1843-1924 DcAmArt, WhAmArt 85
Sartelle, Mildred E DcWomA, WhAmArt 85

Scanes, Ernest William 1909- WhAmArt 85
Scanes, Maude DcWomA
Scanferla, Maria Domenica 1729-1763 DcWomA
Scanga, Italo 1932- AmArt, ConArt 77, –83,
 DcCAr 81, PrintW 83, –85, WhoAmA 73, –76,
 –78, –80, –82, –84
Scanlan, Robert 1908- ClaDrA
Scanlan, Robert Richard DcBrWA
Scanlan, Robert Richard d1876 DcVicP, –2
Scanlin, Jennifer 1953- MarqDCG 84
Scanlon, Marcia PrintW 83, –85
Scannabecchi, Dalmasio McGDA
Scannabecchi, Teresa DcWomA
Scannell, Edith M S DcBrA 1, DcVicP, –2,
 DcWomA
Scannell, Edith S DcBrBI
Scannell, Robert H 1894- AmArch 70
Scapicchi, Erminio WhAmArt 85
Scapitta, Giovanni Battista 1653-1715 MacEA
Scappa, Miss DcVicP 2, DcWomA
Scappa, E C DcVicP 2
Scappa, G A DcBrWA, DcVicP, –2
Scapre-Pierret, Jeanne DcWomA
Scaramuzza, Francesco ArtsNiC
Scaravaglione, Concetta 1900- McGDA
Scaravaglione, Concetta Maria WhoAmA 73
Scaravaglione, Concetta Maria d1975 WhoAmA 76N,
 –78N, –80N, –82N, –84N
Scaravaglione, Concetta Maria 1900- WhAmArt 85
Scarborough, Alonzo 1878-1943 WhAmArt 85
Scarborough, John NewYHSD
Scarborough, John d1696 BiDBrA
Scarborough, W W AmArch 70
Scarborough, William Harrison 1812-1871
 NewYHSD
Scarbro, W B AmArch 70
Scarbrough, Cleve Knox, Jr. 1939- WhoAmA 73, –76,
 –78, –80, –82, –84
Scarbrough, Lewis Arthur 1926- AmArch 70
Scarbrough, W H AmArch 70
Scardina, Joseph Thomas 1944- MarqDCG 84
Scarfaglia, Lucrezia DcWomA
Scarfe, Gerald 1936- WorECar
Scarfe, Laurence WhoArt 80, –82, –84
Scarfe, Laurence 1914- DcBrA 1
Scarfe, Laurence 1916- WhoGrA 82[port]
Scarff, Thomas S 1942- AmArt
Scarfone, Lee S 1931- AmArch 70
Scaringi, Carlo 1936- WorECar A
Scarlet, James DcBrECP
Scarlett, Rolph WhAmArt 85
Scarlett, Samuel 1775?- NewYHSD
Scarpa, Carlo 1902-1978 MacEA
Scarpa, Carlo 1906- EncMA
Scarpa, Carlo 1906-1978 ConArch, ConDes
Scarpa, Tobia 1935- ConDes
Scarpelli, Filiberto 1870-1933 WorECar
Scarpitta, G Salvatore Cartiano 1887-1948
 WhAmArt 85
Scarpitta, Salvatore 1919- ConArt 83, DcCAA 71,
 –77, DcCAr 81, WhoAmA 73, –76, –78, –80, –82,
 –84
Scarr, Laura 1871?-1936 DcWomA, WhAmArt 85
Scarry, Richard IlsCB 1967
Scarry, Richard 1919- IlsCB 1957
Scarsell, Jessie E DcWomA
Scarsella, Ippolito 1551-1620 OxArt
Scarselli, Maria Catarina DcWomA
Scarsellino, Ippolito 1551-1620 OxArt
Scarsellino, Lo 1551-1620 McGDA
Scartezini, Vanda R T 1947- MarqDCG 84
Scarth, John DcBrWA
Scarth, Lorraine Alice 1909- WhAmArt 85
Scattergood, David NewYHSD
Scavullo, Francesco 1929- ICPEnP A, MacBEP
Scavuzzo, J AmArch 70
Scawen, Peter Raymond 1940- MarqDCG 84
Scearce, Joe Leland 1930- AmArch 70
Scepens, Elisabeth DcWomA
Schaaf, Anton 1869- WhAmArt 85
Schaaf, Henry FolkA 86
Schaaf, Larry John 1947- MacBEP
Schaaf, Norbert John 1925- AmArch 70
Schaak, J S C DcBrECP
Schaal, Solange 1899- ClaDrA, DcWomA
Schaap, H W J 1867- DcWomA
Schaardt, William Thomas 1914- AmArch 70
Schaare, Harry J 1922- IlBEAAW
Schaats, Bartholomew 1683-1758 AntBDN Q
Schab, Margo Pollins 1945- WhoAmA 78, –80, –82,
 –84
Schabacker, Betty B 1925- WhoAmA 73
Schabacker, Betty Barchet 1925- WhoAmA 76, –78,
 –80, –82, –84
Schabelitz, R F 1884- WhAmArt 85
Schabelitz, Rudolph F 1887-1959 WorECar
Schaberg, Laura 1866- DcWomA
Schablin, Margaretha DcWomA
Schachner, Erwin IlsBYP
Schachner, Therese 1869- DcWomA
Schacht, Emil 1854-1926 BiDAmAr, MacEA

Schacht, Louise WhAmArt 85
Schachter, Bruce J 1946- MarqDCG 84
Schachter, Justine Ranson 1927- WhoAmA 73, –76,
 –78, –80, –82, –84
Schachtman, Frederic Samuel 1924- AmArch 70
Schack, Franziska 1788- DcWomA
Schack, Mario Lawrence 1929- AmArch 70
Schacter, Murray L EncASM
Schactman, Barry Robert 1930- WhoAmA 78, –80,
 –82, –84
Schad, Christian 1894- ConArt 77
Schad, Christian 1894-1982 ConArt 83, ConPhot,
 ICPEnP A
Schade, Charles Argow 1910- AmArch 70
Schade, E K AmArch 70
Schade, George Donald 1899- AmArch 70
Schade, Harry M EncASM
Schade, Harvey M EncASM
Schade, Henry EncASM
Schade, Torsten G 1948- DcCAr 81
Schadler, H C AmArch 70
Schadow, Friedrich Wilhelm 1789-1862 ArtsNiC
Schadow, Gottfried 1764-1850 McGDA, WorECar
Schadow, Johann Gottfried 1764-1850 OxArt
Schadow, Wilhelm 1788-1862 ClaDrA
Schadow, Wilhelm Von 1788-1862 McGDA
Schadt, Thomas E, Sr. 1919- AmArch 70
Schaef, Catharina DcWomA
Schaefels, Hendrik Frans 1827-1904 ClaDrA
Schaefels, Lucas 1824-1885 ClaDrA
Schaefer FolkA 86
Schaefer, A Ted 1949- MarqDCG 84
Schaefer, Anne 1888- DcWomA
Schaefer, Anthony NewYHSD
Schaefer, Carl OxTwCA
Schaefer, Carl 1903- DcCAr 81
Schaefer, Carl Fellman 1903- McGDA, WhoAmA 73,
 –76, –78, –80, –82, –84, WhoArt 80, –82, –84
Schaefer, Elisabeth 1949- DcCAr 81
Schaefer, Gail 1938- WhoAmA 82, –84
Schaefer, Hans 1875- WhAmArt 85
Schaefer, Harry 1875-1944 ArtsAmW 3
Schaefer, Henri Bella WhoAmA 73, –76
Schaefer, John Paul 1934- MacBEP
Schaefer, Josephine Marie 1910- WhAmArt 85
Schaefer, Kenneth Miller 1917- AmArch 70
Schaefer, Maria 1854- DcWomA
Schaefer, Martha W DcWomA, WhAmArt 85
Schaefer, Mathilde 1909- IlBEAAW, WhAmArt 85
Schaefer, R E AmArch 70
Schaefer, Richard Paul 1924- AmArch 70
Schaefer, Robert Jules 1925- AmArch 70
Schaefer, Robert M 1931- AmArch 70
Schaefer, Robert Stephen 1934- MarqDCG 84
Schaefer, Rockwell B 1901- WhAmArt 85
Schaefer, Ronald H 1939- WhoAmA 76, –78, –80, –82,
 –84
Schaefer, Scott Jay 1948- WhoAmA 82, –84
Schaefer, William David MarqDCG 84
Schaefer, William G WhAmArt 85
Schaefer-Ast, Albert 1890-1951 WorECar
Schaeffer NewYHSD
Schaeffer, Augusta d1924 DcWomA
Schaeffer, Bertha M DcWomA
Schaeffer, Frederick Ferdinand 1839?-1917?
 ArtsAmW 3
Schaeffer, Mrs. H S WhoArt 80, –82, –84
Schaeffer, Henry FolkA 86
Schaeffer, John Herbert 1917- AmArch 70
Schaeffer, John Simon NewYHSD , WhAmArt 85
Schaeffer, Kate WhoAmA 82, –84
Schaeffer, Martha Jane 1948- WhoAmA 82, –84
Schaeffer, Mead 1898- IlrAm D, IlsCB 1744,
 WhAmArt 85
Schaeffer, Mead 1898-1980 IlrAm 1880
Schaeffer, Otto Hans 1942- DcCAr 81
Schaeffer, R A AmArch 70
Schaeffer, Rudolph 1886- WhAmArt 85
Schaeffer, Rudolph Frederick 1886- WhoAmA 73
Schaeffer, William FolkA 86
Schaeffer VonWienwald, Augusta 1862- DcWomA
Schaeffler, Elizabeth 1907- WhAmArt 85
Schaeffler, Lizbeth 1907- WhoAmA 73
Schaeffner, Andrew FolkA 86
Schaening, Donald Norman 1932- AmArch 70
Schaep, Henri Adolphe 1826-1870 ClaDrA, DcSeaP
Schaepkens, Theodor 1810-1883 ClaDrA
Schaeppi, Sophie DcWomA
Schaer-Krause, Ida 1877- DcWomA
Schaerdel, Marie Jenny DcWomA
Schaerff, Charles NewYHSD
Schaerff, J W NewYHSD
Schaettle, Louis d1917 WhAmArt 85
Schaettler FolkA 86
Schaetzel, May Conly DcWomA
Schaevitz, S AmArch 70
Schaewen, Deidi Von 1941- ICPEnP A, MacBEP
Schaezlein, Robert d1932? EncASM
Schaezlein, Robert Frederick d1960 EncASM
Schaezlein, Robert Frederick, Jr. EncASM
Schaezlein And Burridge EncASM

Schafer, A F AmArch 70
Schafer, Alice Pauline 1899- WhoAmA 73, –76, –78,
 –80
Schafer, Alice Pauline 1899-1980 DcWomA,
 WhoAmA 82N, –84N
Schafer, Curtis Clingan 1926- AmArch 70
Schafer, Edward A, Jr. 1939- MarqDCG 84
Schafer, Frederick F 1841-1917 ArtsAmW 1
Schafer, Frederick Ferdinand 1839?-1917?
 ArtsAmW 3
Schafer, Frederick Ferdinand 1841- IlBEAAW
Schafer, Frederick Ferdinand 1841-1917 WhAmArt 85
Schafer, George L 1895- WhAmArt 85
Schafer, Gertrud 1880- DcWomA
Schafer, Gilbert Pierson 1897- AmArch 70
Schafer, Henry DcVicP
Schafer, Henry d1900? DcVicP 2
Schafer, Henry Thomas ClaDrA, DcBrA 1, DcVicP,
 –2
Schafer, Howard Frederick 1932- AmArch 70
Schafer, Irene S WhAmArt 85
Schafer, John J ArtsEM
Schafer, Karl 1844-1908 WhoArch
Schafer, Maria DcWomA
Schafer, Theresia DcWomA
Schaffenberger, Kurt 1920- WorECom
Schaffer, Amelie DcWomA
Schaffer, George Alexander 1914- AmArch 70
Schaffer, Henry ArtsEM
Schaffer, L Dorr ArtsAmW 2, WhAmArt 85
Schaffer, Magdalene Margrethe DcWomA
Schaffer, Marea FolkA 86
Schaffer, Martin Bennett 1931- AmArch 70
Schaffer, Myer 1912- WhAmArt 85
Schaffer, Pop 1880-1964 FolkA 86
Schaffer, Rose WhoAmA 73, –76, –78, –80, –82, –84
Schaffer, Sophie DcWomA
Schaffert, Charles FolkA 86
Schaffner, Dexter L FolkA 86
Schaffner, J Luray WhoAmA 76, –78, –80, –82, –84
Schaffner, Jacob 1478?-1549? OxArt
Schaffner, Martin 1478?-1546? ClaDrA
Schaffner, Martin 1480?- McGDA
Schaffner, Ruth S WhoAmA 78, –80, –82, –84
Schaffrath, Ludwig 1924- DcCAr 81
Schafran, J AmArch 70
Schagen, John Peter 1914- AmArch 70
Schahovskoy, Princess Mary DcWomA
Schaible, Ernst Lennox 1913- AmArch 70
Schalander, F W DcVicP 2
Schalch, Jan Jacob 1723-1789 DcBrECP
Schalcke, Cornelis Symonsz VanDer 1611-1671
 McGDA
Schalcken, Godfried 1643-1706 ClaDrA
Schalcken, Marie DcWomA
Schaldach, William J 1896- WhAmArt 85
Schaldach, William Joseph 1896- ArtsAmW 3,
 IlBEAAW
Schalk, Ada VanDer 1883- DcWomA
Schalk, Edgar DcWomA
Schalk, Josefine 1850- DcWomA
Schalk, L AmArch 70
Schalken, Godfried 1643-1703 OxArt
Schalken, Gotfried Cornelisz 1643-1706 McGDA
Schalken, Marie DcWomA
Schall, F P 1877- WhAmArt 85
Schall, Marie DcWomA
Schallan, Joseph B 1949- MarqDCG 84
Schallan, Linda Kristine 1952- MarqDCG 84
Schaller, Therese De 1858-1908 DcWomA
Schaller-Harlin, Kate 1877- DcWomA
Schaller-Mouillot, Charlotte DcWomA
Schallhas, Carl Philipp 1767-1797 ClaDrA
Schallinger, Max 1902-1955 WhAmArt 85
Schamberg, Morton 1881-1918 McGDA
Schamberg, Morton L 1881-1918 WhAmArt 85
Schamberg, Morton Livingston 1881-1918 DcAmArt
Schamberg, Morton Livingston 1881-1918 BnEnAmA
Schamberg, Morton Livingstone 1881-1918 OxTwCA,
 PhDcTCA 77
Schamesohn, Eduardo 1924- AmArch 70
Schampheleer, Edmond De ArtsNiC
Schampheleer, Edmond De 1824-1899 ClaDrA
Schang, Frederick, Jr. 1893- WhoAmA 73, –76, –78,
 –80, –82
Schanker, Louis 1903- DcCAA 71, –77,
 WhAmArt 85, WhoAmA 73, –76, –78, –80
Schanker, Louis 1903-1981 WhoAmA 82N, –84N
Schantz, David G 1941- MarqDCG 84
Schantz, Emma Von DcWomA
Schantz, Joseph FolkA 86
Schanz, Elizabeth WhAmArt 85
Schanzenbacher, Nellie WhAmArt 85
Schaper, Dorothea 1897- DcWomA
Schaper, Johann 1621-1670 IlDcG, OxDecA
Schapiro, Cecil WhAmArt 85
Schapiro, Meyer 1904- WhoAmA 73, –76, –78, –80,
 –82, –84
Schapiro, Miriam 1923- AmArt, ConArt 77, –83,
 DcCAA 71, –77, DcCAr 81, OxTwCA,
 PrintW 83, –85, WhoAmA 73, –76, –78, –80, –82,

Schiaffino, Gualtiero 1943- *WorECar*
Schiaminossi, Raffaello 1529-1622 *ClaDrA*
Schiani, Evangelista *DcWomA*
Schiano, Evangelista *DcWomA*
Schiaparelli, Elsa 1890-1973 *FairDF FRA[port]*,
 WorFshn
Schiavo, Paolo *McGDA*
Schiavone, Andrea *ClaDrA*
 , Andrea 1522?-1563? *McGDA*
Schiavone, Andrea Meldolla 1522-1564 *OxArt*
Schiavone, Giorgio 1433?-1504 *McGDA*
Schiavoni, Michele *McGDA*
Schick, Eleanor *IlsCB 1967*
Schick, Eleanor 1942- *IlsCB 1957*
Schick, Elma H *WhAmArt 85*
Schick, F A *AmArch 70*
Schick, Fred G 1893- *WhAmArt 85*
Schick, Gottlieb 1776-1812 *McGDA*
Schick, Joel 1945- *IlsCB 1967*
Schick, P *DcVicP 2*
Schick, Paul Raymond 1888- *WhAmArt 85*
Schick, Seraphia Maria Susanna Magdalena *DcWomA*
Schickedanz, L D *AmArch 70*
Schickel, William 1850-1907 *BiDAmAr*
Schickele, Hans G R 1914- *AmArch 70*
Schickler, Leonard 1933- *AmArch 70*
Schickli, Edward Jacob, Jr. 1928- *AmArch 70*
Schicko, Franz 1951- *DcCAr 81*
Schidlowski, Joseph C 1939- *AmArch 70*
Schiebold, Hans 1938- *WhoAmA 82, -84*
Schiedes, Petrus Paulus 1813-1876 *DcSeaP*
Schiefer, Henry *NewYHSD*
Schiefer, Johannes *WhoAmA 80N, -82N, -84N*
Schieferdecker, Ivan E 1935- *WhoAmA 76, -78, -80,*
 -82, -84
Schieffer *NewYHSD*
Schieffer, Herman *NewYHSD*
Schieffer, Paul *NewYHSD*
Schiel, Mary *ArtsEM, DcWomA*
Schielderup, Leys Georgia Elise 1856-1933 *DcWomA*
Schiele, Egon 1890-1918 *McGDA, OxTwCA,*
 PhDcTCA 77
Schiele, Moik 1938- *DcCAr 81*
Schier, Helwig, Jr. *WhAmArt 85*
Schierer, Joseph Philip 1912- *AmArch 70*
Schierfberk, Helena Sofia 1862- *ClaDrA*
Schierfberk, Helene Sofia *DcWomA*
Schierholz, Karoline 1831- *DcWomA*
Schiertz, Franz Wilhelm 1813-1887 *DcSeaP*
Schietinger, James Frederick 1946- *WhoAmA 76, -78,*
 -80, -82, -84
Schievelbein, Friedrich Anton Hermann 1817-1867
 ArtsNiC
Schiewe, E A *AmArch 70*
Schifano, Mario *OxTwCA*
Schifano, Mario 1934- *ConArt 77, -83,*
 PhDcTCA 77
Schiff, Charles Harrington 1927- *AmArch 70*
Schiff, Fredi 1915- *WhAmArt 85*
Schiff, Gert K A 1926- *WhoAmA 84*
Schiff, Jean 1929- *WhoAmA 76, -78, -80, -82, -84*
Schiff, Jeanne Henriette *DcWomA*
Schiff, Jeffrey Allen 1952- *WhoAmA 82, -84*
Schiff, John Charles *AmArch 70*
Schiff, Lonny *WhoAmA 73, -76, -78, -80, -82,*
 -84
Schiff, Mathias 1862-1886 *ClaDrA*
Schiffer *DcBrECP*
Schiffer, Ethel Bennet 1879- *DcWomA*
Schiffer, Ethel Bennett 1879- *WhAmArt 85*
Schiffer, Hubert *DcNiCA*
Schiffer, J J *AmArch 70*
Schifferl, Lou *FolkA 86*
Schiffman, Warren Louis 1937- *AmArch 70*
Schiffner, Fritz 1910- *WhoArt 80, -82, -84*
Schiffrin, Herbert *DcCAr 81*
Schijnvoet, Cornelia *DcWomA*
Schilcher, Anton Von 1795-1827 *ClaDrA*
Schilcock, Charles *NewYHSD*
Schild, Charlotte Rebekka 1734- *DcWomA*
Schild, Julia *DcWomA*
Schild, Maria Helena Florentina 1745-1827 *DcWomA*
Schildhauer, Mrs. Henry d1927? *ArtsAmW 3*
Schildknecht, Edmund Gustav 1899- *WhAmArt 85*
Schildknecht, Ruth Stebbins *WhAmArt 85*
Schiler, Marc Eugene 1951- *MarqDCG 84*
Schill, Alice E *WhAmArt 85*
Schill, Lore *DcWomA*
Schill, Robert James 1939- *AmArch 70*
Schille, Alice d1955 *WhAmArt 85*
Schille, Alice 1869-1955 *DcWomA*
Schille, Alice O 1869-1955 *ArtsAmW 3*
Schiller, A R *AmArch 70*
Schiller, Arthur Adam 1910- *AmArch 70*
Schiller, Beatrice *WhoAmA 73, -76, -78, -80, -82,*
 -84
Schiller, Christophine *DcWomA*
Schiller, D A *AmArch 70*
Schiller, Frederick *ArtsEM*
Schiller, Gottfried *NewYHSD*
Schiller, H Carl *DcVicP 2*

Schiller, Ida 1856- *DcWomA*
Schiller, Valentine John 1912- *AmArch 70*
Schillig, Josephine 1846- *DcWomA*
Schilling, Alexander *WhAmArt 85*
Schilling, Arthur O 1882- *WhAmArt 85*
Schilling, Betty *IlsBYP*
Schilling, Clotilde 1856- *DcWomA*
Schilling, J L *AmArch 70*
Schilling, Johannes 1828- *ArtsNiC*
Schilling, Johannes 1828-1910 *McGDA*
Schilling, Karoline 1801-1840 *DcWomA*
Schilling, O A *AmArch 70*
Schilling, Robert William 1918- *AmArch 70*
Schilling, W H *AmArch 70*
Schillinger, Charles Frederick 1908- *AmArch 70*
Schilperoort, A B *DcWomA*
Schilsky, Eric 1898-1974 *DcBrA 1*
Schilsky, Mrs. Eric *WhoArt 80, -82, -84*
Schimansky, Donya Dobrila *WhoAmA 78, -80, -82,*
 -84
Schimeneck, William G 1932- *AmArch 70*
Schimenti, Michael 1915- *AmArch 70*
Schimmel, Heidrun 1941- *DcCAr 81*
Schimmel, Norbert 1904- *WhoAmA 73, -76, -78, -80*
Schimmel, Wilhelm 1817-1890 *BnEnAmA, FolkA 86*
Schimmel, William *DcNiCA*
Schimmel, William Berry 1906- *IlBEAAW,*
 WhoAmA 73, -76, -78, -80
Schimmenti, Ludwig *ArtsEM*
Schimonsky, Stanislas *IlBEAAW, NewYHSD*
Schimonsky, Stanislas W Y *ArtsAmW 1*
Schimper, William *EncASM*
Schimpf, Paul Henry 1959- *MarqDCG 84*
Schinasi, Leon 1890-1930 *WhAmArt 85*
Schindelman, Joseph *IlsCB 1967*
Schindelman, Joseph 1923- *IlsBYP, IlsCB 1957*
Schindler, Anna Margareta 1893-1929 *DcWomA*
Schindler, Caspar *IlDcG*
Schindler, Elsa 1880- *DcWomA, WhAmArt 85*
Schindler, Georg *IlDcG*
Schindler, Howard Yser 1934- *AmArch 70*
Schindler, J F *AmArch 70*
Schindler, R M 1887-1953 *MacEA, WhoAmA 78N,*
 -80N, -82N, -84N
Schindler, Rosina Elisabeth *DcWomA*
Schindler, Rudolf M 1887-1953 *WhoArch*
Schindler, Rudolph 1887-1953 *ConArch*
Schindler, Rudolph M 1887-1953 *EncMA*
Schindler, Rudolph Michael 1887-1953 *BnEnAmA*
Schindler, Wolfgang *IlDcG*
Schinhofen, Raymond John 1934- *AmArch 70*
Schinkel, Karl Friedrich 1781-1841 *ArtsNiC,*
 DcD&D[port], DcNiCA, EncMA, MacEA,
 OxArt, WhoArch
Schinkel, Karl Friedrich Von 1781-1841 *McGDA*
Schinnerl, Susi *DcWomA*
Schinotti, C A *NewYHSD*
Schinotti, E *NewYHSD*
Schinzel, Karl 1886-1951 *MacBEP*
Schioldborg, Frida 1885-1926 *DcWomA*
Schioler, Ole Torben 1927- *AmArch 70*
Schiottz-Jensen, Ida Marie Juliane 1861-1932
 DcWomA
Schipanski, August *ArtsEM*
Schipper, Gerritt 1775-1830? *NewYHSD*
Schipper, Jacob *FolkA 86*
Schipper, Merle Solway *WhoAmA 84*
Schippers, Willem Theodoor 1942- *PhDcTCA 77*
Schippers, Willem Theodor 1942- *OxTwCA*
Schipporeit, G D *AmArch 70*
Schira, Cynthia 1934- *WhoAmA 84*
Schira, Cynthia Jones 1934- *WhoAmA 78, -80, -82*
Schirm, David H 1945- *WhoAmA 84*
Schirm, Jerome N *EncASM*
Schirmacher, M Dora *DcVicP 2*
Schirmer, Audrey *DcCAr 81*
Schirmer, Guillaume 1804-1866 *ArtsNiC*
Schirmer, Henry William 1922- *AmArch 70*
Schirmer, Johann Wilhelm 1807-1863 *ClaDrA*
Schirmer, Robert F 1887-1946 *BiDAmAr*
Schirren, Ferdinand 1872-1944 *OxTwCA*
Schiwetz, Edward M 1898- *ArtsAmW 1, -2,*
 IlBEAAW, WhAmArt 85
Schjelderup, Gerik *WhoArt 80, -82, -84*
Schjelderup, Lejs *DcWomA*
Schjerfbeck, H *DcVicP 2*
Schjerfbeck, Helena Sofia 1862-1947 *DcWomA*
Schjerfbeck, Helene 1862-1946 *OxArt, OxTwCA,*
 PhDcTCA 77
Schlabach, Barbara *WhAmArt 85*
Schlacks, Henry John 1868-1938 *BiDAmAr*
Schladermundt, Herman T 1863-1937 *WhAmArt 85*
Schladermundt, Peter 1907- *AmArch 70*
Schladitz, Ernest 1862- *WhAmArt 85*
Schlaebitz, William Donald 1924- *AmArch 70*
Schlaff, Herman 1884- *WhAmArt 85*
Schlaffer, Lisa 1907- *WhAmArt 85*
Schlafhorst, Marie 1865-1925 *DcWomA*
Schlag, Felix Oskar 1891- *WhAmArt 85*
Schlager *NewYHSD*
Schlager, Wilhelm 1907- *DcCAr 81*

Schlageter, Robert William 1925- *WhoAmA 73, 76,*
 -78, -80, -82, -84
Schlaikjer, Jes 1897- *WhoAmA 76, -78, -80, -82*
Schlaikjer, Jes 1897-1982 *WhoAmA 84N*
Schlaikjer, Jes Wilhelm 1897- *ArtsAmW 2,*
 WhAmArt 85, WhoAmA 73, -76
Schlaikjer, Jes William 1897- *ArtsAmW 2*
Schlam, Murray J 1911- *WhoAmA 76, -78, -80, -82,*
 -84
Schlangenhausen, Emma 1882- *DcWomA*
Schlanger, Ben 1904- *AmArch 70*
Schlanger, Jeff 1937- *CenC, WhoAmA 78, -80, -82,*
 -84
Schlapp, Charles W L 1895- *WhAmArt 85*
Schlapper, Fee 1927- *MacBEP*
Schlater, Katherine *WhAmArt 85*
Schlatter, Louise 1825-1880 *DcWomA*
Schlaun, Johann Conrad 1695-1773 *OxArt, WhoArch*
Schlazer, Michael 1910- *WhAmArt 85*
Schlecht, Richard 1936- *WhoAmA 73, -76*
Schlee, Nicholaevna Sanina 1904- *WorFshn*
Schleeh, Hans Martin 1928- *WhoAmA 84*
Schleeter, Howard Behling 1903- *IlBEAAW,*
 WhAmArt 85
Schlegel, David J 1956- *MarqDCG 84*
Schlegel, Don Paul 1926- *AmArch 70*
Schlegel, Eugenie *DcWomA*
Schlegel, Fridolin *NewYHSD*
Schlegel, Friedrich Von 1772-1829 *McGDA*
Schlegel, Wayne L *AmArch 70*
Schlegell, Gustav Von 1877- *WhAmArt 85*
Schlegell, Martha Von 1861- *DcWomA*
Schleger, Hans *ClaDrA, WhoGrA 62*
Schleger, Hans 1898-1976 *ConDes*
Schleh, Anna 1833-1879 *DcWomA*
Schleich, August 1814-1865 *ClaDrA*
Schleich, Charles F *NewYHSD*
Schleich, Eduard 1812-1874 *ArtsNiC, McGDA*
Schleicher, Lloyd G 1928- *AmArch 70*
Schleicher, S D *AmArch 70*
Schleiden, Angelika *DcWomA*
Schleiger, R R *AmArch 70*
Schlein, Charles 1900- *WhAmArt 85*
Schleiss-Simandl, Emilie 1880- *DcWomA*
Schleman, S *AmArch 70*
Schlemm, Betty Lou 1934- *WhoAmA 73, -76, -78,*
 -80, -82, -84
Schlemmer, F Louis 1893- *WhAmArt 85*
Schlemmer, Oscar 1888-1943 *OxDecA*
Schlemmer, Oskar 1888-1943 *ConArt 77, -83,*
 McGDA, OxArt, OxTwCA, PhDcTCA 77
Schlemowitz, Abram 1911- *DcCAA 71, -77,*
 WhoAmA 73, -76, -78, -80, -82, -84
Schlenker, Kathinka *DcWomA*
Schlereth, Hans 1897- *WhAmArt 85*
Schlesinger, Frank 1925- *AmArch 70, ConArch*
Schlesinger, Henri Guillaume *ArtsNiC*
Schlesinger, Leon 1884-1949 *WorECar*
Schlesinger, Louis 1874- *WhAmArt 85*
Schlessinger, Alfred R *WhAmArt 85*
Schlessinger, Peter M 1946- *ICPEnP A, MacBEP*
Schleuning, Jon Richen 1937- *AmArch 70*
Schleusner, Thea 1879- *DcWomA*
Schley, Evander Duer 1941- *WhoAmA 73, -76, -78,*
 -80, -82, -84
Schley, George 1795-1846 *NewYHSD*
Schley, M G d1941 *WhAmArt 85*
Schley, Mathilde G 1874- *DcWomA*
Schley, P G *AmArch 70*
Schlezinger, Vera *DcWomA*
Schlicher, Clement Reinhart 1902- *AmArch 70*
Schlicher, Karl Theodore 1905- *WhoAmA 73, -76,*
 -78, -80, -82, -84
Schlichten, Johann Franz VonDer 1725-1795 *ClaDrA*
Schlichter, Rudolf 1890-1955 *PhDcTCA 77*
Schlichting, Gordon A 1913- *AmArch 70*
Schlichting, H C *WhAmArt 85*
Schlichting, Wilhelmine d1888 *DcWomA*
Schlick, E Ray 1926- *AmArch 70*
Schlick, J J *AmArch 70*
Schlickum, Charles, Sr. d1869 *ArtsEM*
Schlicting, Alan Walter 1941- *AmArch 70*
Schlieben, Caroline Von *DcWomA*
Schliefer, Stafford Lerrig 1939- *WhoAmA 76, -78,*
 -80, -82, -84
Schliemann, Heinrich 1822-1890 *McGDA*
Schlientz, Randall Harry 1934- *AmArch 70*
Schlink, Terrance Joseph 1938- *AmArch 70*
Schlitt, John Joseph, Jr. 1932- *AmArch 70*
Schlittgen, Hermann 1859-1930 *ClaDrA, WorECar*
Schloesser, Carl Bernhard 1832-1914 *DcBrBI,*
 DcVicP 2
Schloesser, Karl *ArtsNiC*
Schloesser, Maud *DcVicP 2*
Schloezer, Louise *DcWomA*
Schlosberg, Carl Martin 1936- *WhoAmA 76, -78, -80,*
 -82, -84
Schloss, Arleen P 1943- *WhoAmA 78, -80, -82, -84*
Schloss, Edith *WhoAmA 73, -76, -78, -80, -82, -84*
Schlosser, Joseph Leo 1925- *AmArch 70*
Schlossman, John Isaac 1931- *AmArch 70*

Schlossman, Norman Joseph 1901- *AmArch 70*
Schlott, A A, Jr. *AmArch 70*
Schlotter, Eberhard 1884- *PhDcTCA 77*
Schlotter, Eberhard 1921- *DcCAr 81*
Schlotterlein, F W *AmArch 70*
Schlozer, Caroline Friederike Von 1753-1808 *DcWomA*
Schlueter, J P *AmArch 70*
Schlueter, Lydia Bicky 1890- *ArtsAmW 3, DcWomA*
Schlumberg, Cecile Elisabeth *DcWomA*
Schlumberger, Jean 1907- *WorFshn*
Schlumberger, Suzanne *DcWomA*
Schlump, John Otto 1933- *WhoAmA 78, -80, -82, -84*
Schlup, Elaine Smitha 1930- *WhoAmA 76, -78, -80*
Schlup, Elisabeth 1860- *DcWomA*
Schlusselberg, Daniel 1955- *MarqDCG 84*
Schluter, Andreas 1659?-1714 *MacEA*
Schluter, Andreas 1660?-1714 *McGDA, WhoArch*
Schluter, Andreas 1662-1714 *OxArt*
Schmack, Emilie *DcWomA*
Schmack, Emily *DcVicP 2*
Schmalcalder, C *OxDecA*
Schmalenbach, Fritz 1909- *WhoArt 80, -82, -84*
Schmall, Samuel 1931- *AmArch 70*
Schmaltz, Roy Edgar 1937- *WhoAmA 82, -84*
Schmaltz, Roy Edward 1924- *AmArch 70*
Schmalz, Arthur E *WhAmArt 85*
Schmalz, Carl 1926- *WhoAmA 73, -76, -78, -80*
Schmalz, Carl, Jr. 1926- *AmArt, WhoAmA 82, -84*
Schmalz, Herbert Gustave 1856- *DcVicP, -2*
Schmalz, Herbert Gustave 1856-1935 *DcBrA 1*
Schmalzigaug, Jules 1882-1917 *OxTwCA*
Schmand, J Phillip 1871-1942 *WhAmArt 85*
Schmandt, Charles Kenneth 1932- *AmArch 70*
Schmandt-Besserat, Denise 1933- *WhoAmA 76, -78, -80, -82, -84*
Schmauss, Peter *WhAmArt 85*
Schmautz, Harry 1923- *AmArch 70*
Schmeck, John *FolkA 86*
Schmeckebier, Laurence E 1906- *WhAmArt 85, WhoAmA 73, -76, -78, -80, -82, -84*
Schmedtgen, William H 1862-1936 *WhAmArt 85*
Schmedtgen, William Herman 1862-1936 *ArtsAmW 3*
Schmeer, M H, Jr. *AmArch 70*
Schmeidler, Blanche J *WhoAmA 76N, -78N, -80N, -82N, -84N*
Schmeidler, Blanche J 1915- *WhoAmA 73*
Schmerfeld, Johanna Elisabeth Von 1749-1803 *DcWomA*
Schmerl, Robert H 1909- *AmArch 70*
Schmerling, Pauline Von *DcWomA*
Schmertz, Mildred F *ConArch A*
Schmertz, Mildred Floyd *AmArch 70*
Schmertz, Robert W 1898- *AmArch 70*
Schmettau, Joachim 1937- *DcCAr 81*
Schmetterling, Christiane Josefa 1796-1840 *DcWomA*
Schmetterling, Elisabeth Barbara 1804- *DcWomA*
Schmict, Robert D *MarqDCG 84*
Schmid, Alfred A 1920- *WhoArt 80*
Schmid, Charlotte 1932- *WhoGrA 82[port]*
Schmid, Edith *WorFshn*
Schmid, Elsa 1897- *DcWomA, WhAmArt 85*
Schmid, Fritz 1898- *WhoArt 80, -82, -84*
Schmid, Georg 1928- *WhoGrA 82[port]*
Schmid, Julie Dorothea *DcWomA*
Schmid, Matthias 1835-1923 *ClaDrA*
Schmid, Mattias *ArtsNiC*
Schmid, Max 1921- *WhoGrA 82[port]*
Schmid, Richard Alan 1934- *WhoAmA 73, -76, -78, -80, -82, -84*
Schmid, Richard Gustave 1863-1937 *BiDAmAr*
Schmid Esler, Annemarie 1937- *DcCAr 81*
Schmid-Goringer, Rosa 1868- *DcWomA*
Schmidlin, Emil Achilles 1906- *AmArch 70*
Schmidt *NewYHSD*
Schmidt, Agnes C *DcWomA*
Schmidt, Albert Felix *WhAmArt 85*
Schmidt, Albert H 1883-1957 *ArtsAmW 2, IIBEAAW*
Schmidt, Albert H 1885-1957 *WhAmArt 85*
Schmidt, Alfred 1939- *AmArch 70*
Schmidt, Allan Henry 1935- *MarqDCG 84*
Schmidt, Alwin 1900- *WhAmArt 85*
Schmidt, Alwin E 1900- *IIBEAAW*
Schmidt, Amalie August *FolkA 86*
Schmidt, Anna Marie 1872- *FolkA 86*
Schmidt, Arnold Alfred 1930- *WhoAmA 73, -76, -78, -80, -82, -84*
Schmidt, Arthur O A 1909- *AmArch 70*
Schmidt, August *NewYHSD*
Schmidt, Augusta *DcWomA*
Schmidt, B E 1922- *AmArch 70*
Schmidt, Benjamin J 1884-1968 *FolkA 86*
Schmidt, Carl *WhAmArt 85*
Schmidt, Carl 1909- *WhAmArt 85*
Schmidt, Carl Arthur 1890- *WhAmArt 85*
Schmidt, Charles 1939- *WhoAmA 80, -82, -84*
Schmidt, Clarence 1897- *FolkA 86, MacEA*
Schmidt, Curt *WhAmArt 85*
Schmidt, Dennis *OfPGCP 86*
Schmidt, Douglas W 1942- *ConDes*
Schmidt, E *EncASM*

Schmidt, E H *AmArch 70*
Schmidt, Eberhard Winter 1902- *WhAmArt 85*
Schmidt, Edward Allan- *DcVicP 2*
Schmidt, Edward William 1946- *WhoAmA 84*
Schmidt, Elisabeth 1862- *DcWomA*
Schmidt, Elisabeth 1882- *DcWomA*
Schmidt, Erwin Carl 1902- *AmArch 70*
Schmidt, Felix *WhAmArt 85*
Schmidt, Felix G *WhAmArt 85*
Schmidt, Frank *FolkA 86*
Schmidt, Frank George, Jr. 1933- *AmArch 70*
Schmidt, Frederick *NewYHSD*
Schmidt, Frederick 1826?- *NewYHSD*
Schmidt, Frederick Lee 1937- *WhoAmA 73, -76, -78, -80, -82, -84*
Schmidt, Frederick Louis 1922- *WhoAmA 82, -84*
Schmidt, Friedrich 1825-1891 *WhoArch*
Schmidt, Friedrich Von 1825-1891 *McGDA*
Schmidt, Georg Friedrich 1712-1775 *ClaDrA, McGDA*
Schmidt, George Adam 1791-1844 *ClaDrA*
Schmidt, H W *AmArch 70*
Schmidt, Hans 1893-1972 *MacEA*
Schmidt, Hans Wolfgang *IlDcG*
Schmidt, Harold Von 1893- *IlrAm E*
Schmidt, Harvey 1929- *IlrAm G, -1880*
Schmidt, Harvey Lester 1929- *WhoAmA 76, -78, -80, -82*
Schmidt, Henry William 1935- *AmArch 70*
Schmidt, Hermine 1873- *DcWomA*
Schmidt, Herminone *DcWomA*
Schmidt, J *AmArch 70*
Schmidt, Jay *OfPGCP 86*
Schmidt, John Louis 1931- *AmArch 70*
Schmidt, Julius 1923- *ConArt 77, -83, DcCAA 71, -77, DcCAr 81, WhoAmA 73, -76, -78, -80, -82, -84*
Schmidt, Karl 1890-1962 *ArtsAmW 2, WhAmArt 85*
Schmidt, Katherine 1898- *WhAmArt 85, WhoAmA 73, -76, -78*
Schmidt, Katherine 1898-1978 *DcWomA, WhoAmA 80N, -82N, -84N*
Schmidt, Louise 1855-1924 *DcWomA*
Schmidt, Louise 1874- *DcWomA*
Schmidt, M B *AmArch 70*
Schmidt, Manfred 1913- *WorECom*
Schmidt, Margaret *DcWomA*
Schmidt, Margaret R 1899- *DcBrA 1, DcWomA*
Schmidt, Martin Johann 1718-1801 *McGDA*
Schmidt, Mary Morris 1926- *WhoAmA 78, -80, -82, -84*
Schmidt, Matjaz 1948- *DcCAr 81*
Schmidt, Max 1818- *ArtsNiC*
Schmidt, Michael 1945- *ConPhot, ICPEnP A, MacBEP*
Schmidt, Minna Moscherosch 1866- *WhAmArt 85*
Schmidt, Oscar F *WhAmArt 85*
Schmidt, Oscar Frederick 1892-1957 *IlrAm D, -1880*
Schmidt, Otto d1940 *ArtsAmW 2, WhAmArt 85*
Schmidt, Peter *FolkA 86*
Schmidt, Peter 1795-1838 *FolkA 86*
Schmidt, Peter 1822-1867 *NewYHSD*
Schmidt, Peter 1931- *ConArt 77, DcCAr 81*
Schmidt, R E *AmArch 70*
Schmidt, Randall Bernard 1942- *WhoAmA 73, -76, -78, -80, -82, -84*
Schmidt, Richard Ernest 1865-1958 *MacEA*
Schmidt, Richard Karl 1934- *AmArch 70*
Schmidt, Richard O 1923- *AmArch 70*
Schmidt, Ronald Hans 1938- *AmArch 70*
Schmidt, S G *AmArch 70*
Schmidt, Solomon 1806?- *NewYHSD*
Schmidt, Stephen 1925- *WhoAmA 73, -76, -78, -80, -82, -84*
Schmidt, Theodor B W 1869- *ArtsAmW 3*
Schmidt, Theodore B W *WhAmArt 85*
Schmidt, Thomas H 1930- *AmArch 70*
Schmidt, Tore 1946- *MarqDCG 84*
Schmidt, W B *WhAmArt 85*
Schmidt, W W *AmArch 70*
Schmidt, Winston A 1918- *AmArch 70*
Schmidt Garden And Martin *MacEA*
Schmidt-Rottluff, Karl 1884- *McGDA, OxArt*
Schmidt-Rottluff, Karl 1884-1976 *ConArt 77, -83, OxTwCA*
Schmidtke, John Calvin 1928- *AmArch 70*
Schmidtova, Natalia 1895- *OxTwCA*
Schmidts, C R *AmArch 70*
Schmidts, Clara *ArtsEM, DcWomA*
Schmiedeberg-Blume, Else Von 1876- *DcWomA*
Schmiedeke, Denis Charles 1929- *AmArch 70*
Schmiedel, John Albert 1938- *AmArch 70*
Schmierer, Martha *DcWomA*
Schmieth, Bertha 1860- *DcWomA*
Schmit, Tomas 1943- *ConArt 77, DcCAr 81*
Schmitt, Adam *FolkA 86*
Schmitt, Albert F 1873- *WhAmArt 85*
Schmitt, Ambrose *FolkA 86*
Schmitt, Carl 1889- *WhAmArt 85*
Schmitt, Carl John, Jr. 1925- *AmArch 70*
Schmitt, Ernest George 1956- *MarqDCG 84*

Schmitt, Eugene Charles 1938- *AmArch 70*
Schmitt, Georgette *DcWomA*
Schmitt, Guido Philipp 1834-1922 *DcVicP 2*
Schmitt, Henry 1860-1921 *WhAmArt 85*
Schmitt, J D J *AmArch 70*
Schmitt, Julius *NewYHSD*
Schmitt, Marilyn Low 1939- *WhoAmA 78, -80, -82, -84*
Schmitt, Noemie *DcWomA*
Schmitt, Paul A 1893- *ArtsAmW 2, WhAmArt 85*
Schmitt, Robert *DcCAr 81*
Schmitt, Sylvester John 1905- *AmArch 70*
Schmitt-Schenkh, Maria 1837- *DcWomA*
Schmitter, Paul Frederick 1934- *AmArch 70*
Schmitthenner, Paul 1884-1972 *MacEA*
Schmitz, Bruno 1858-1916 *McGDA*
Schmitz, Carl Ludwig d1967 *WhoAmA 78N, -80N, -82N, -84N*
Schmitz, Carl Ludwig 1900-1967 *WhAmArt 85*
Schmitz, Elizabeth T *WhAmArt 85*
Schmitz, Gail 1936- *FolkA 86*
Schmitz, Henry *ArtsEM*
Schmitz, M S *NewYHSD*
Schmitz, Paul Joseph 1925- *AmArch 70*
Schmitz, Paul M 1939- *MarqDCG 84*
Schmitz, Peter David 1935- *AmArch 70*
Schmitz, Wolfgang 1934- *DcCAr 81*
Schmitz And Crongeyer *ArtsEM*
Schmitz Moore *EncASM*
Schmohl, Fred C 1847-1922 *WhAmArt 85*
Schmolle, Stella 1908-1975 *DcBrA 2*
Schmoller, Hans 1916- *ConDes, WhoArt 82, WhoGrA 62, -82[port]*
Schmoller, Hans Peter 1916- *WhoArt 80*
Schmolze, Karl Heinrich 1823-1861 *NewYHSD*
Schmuck, Emilie *DcWomA*
Schmuckal, Janet Bell *WhoAmA 82*
Schmuckal, Janet Bell 1948- *WhoAmA 80, -84*
Schmucker, Sam L *WhAmArt 85*
Schmutz, Rodolphus 1670-1715? *DcBrECP*
Schmutzer, Ferd *WhAmArt 85*
Schmutzhart, Berthold Josef 1928- *WhoAmA 73, -76, -78, -80, -82, -84*
Schmutzhart, Slaithong Chengtrakul 1934- *WhoAmA 78, -80, -82, -84*
Schmutzler, Leopold 1864- *ClaDrA*
Schmuzer Family *MacEA*
Schnabel, Day N 1905- *PhDcTCA 77*
Schnabel, Edward *NewYHSD*
Schnabel, Julian 1951- *AmArt, ConArt 83, DcCAr 81, PrintW 85*
Schnabel, Marie *DcVicP 2*
Schnackenberg, Roy 1934- *WhoAmA 73, -76, -78, -80, -82, -84*
Schnaittacher, Sylvain 1874-1926 *BiDAmAr*
Schnakenberg, Henry 1892- *DcCAA 71*
Schnakenberg, Henry 1892-1970 *DcCAA 77, WhoAmA 78N, -80N, -82N, -84N*
Schnakenberg, Henry Ernest 1892-1970 *WhAmArt 85*
Schnall, Judson Eugene 1909- *AmArch 70*
Schnaple, Frederick A 1872?-1948 *ArtsEM*
Schnarr, D *NewYHSD*
Schnars-Alquist, Carl Wilhelm Hugo 1855-1936? *DcSeaP*
Schnebbelie, Jacob Christopher 1760-1792 *DcBrWA*
Schnebbelie, Robert Blemmel d1849 *DcBrWA*
Schnebblie, Robert Blemmel d1849 *DcBrBI*
Schneck, Russell C 1958- *MarqDCG 84*
Schnedl, Edwin Floyd 1924- *AmArch 70*
Schnedl, Richard Burke 1926- *AmArch 70*
Schnee, Hermann 1840-1926 *ClaDrA*
Schnee, Joseph F 1792-1838 *FolkA 86*
Schnee, William *FolkA 86*
Schneebaum, Tobias 1921- *AmArt, WhoAmA 73, -76, -78, -80, -82*
Schneeberger, J *WhAmArt 85*
Schneeberger, Nelson Charles 1923- *AmArch 70*
Schneeman, George *PrintW 83, -85*
Schneemann, Carolee *PrintW 85*
Schneemann, Carolee 1939- *ConArt 77, WhoAmA 78, -80, -82, -84*
Schneid, Otto 1900- *ClaDrA*
Schneider, Amable Louis 1824-1884 *ClaDrA*
Schneider, Arthur *WhAmArt 85*
Schneider, Arthur E 1866-1942 *WhAmArt 85*
Schneider, B J *AmArch 70*
Schneider, Charles 1881-1962 *DcNiCA, IlDcG*
Schneider, Charles B 1821?- *NewYHSD*
Schneider, Charles S 1874-1932 *BiDAmAr*
Schneider, Christian *FolkA 86*
Schneider, Christian Gottfried 1710-1773 *IlDcG*
Schneider, Clara M *WhAmArt 85*
Schneider, Ed J 1946- *MarqDCG 84*
Schneider, Elsbeth 1904- *WhAmArt 85*
Schneider, Ernest *IlDcG*
Schneider, Eva *DcWomA*
Schneider, F P *AmArch 70*
Schneider, Felicie 1831-1888 *DcWomA*
Schneider, G F *AmArch 70*
Schneider, George Gustav 1904- *AmArch 70*
Schneider, George W 1876- *WhAmArt 85*

Schopfer, Hans ClaDrA
Schopin, M DcVicP 2
Schopke, Philipp 1921- DcCAr 81
Schorer, Maria DcWomA
Schorgl, Thomas Barry 1950- WhoAmA 78, -80, -82
Schork, Joseph Carl WhAmArt 85
Schorn, Carl 1803-1850 ClaDrA
Schorn, Charles 1803-1850 ArtsNiC
Schornack, David Thomas 1955- MarqDCG 84
Schorr, Esther WhAmArt 85
Schorr, Justin 1928- WhoAmA 73, -76, -78, -80, -82, -84
Schorr, S AmArch 70
Schorre, Charles 1925- DcCAr 81, MacBEP, WhoAmA 76, -82, -84
Schossberger, Baroness Klara 1893- DcWomA
Schot, L DcWomA
Schotanus, J John, Jr. 1911- AmArch 70
Schotanus, Petrus McGDA
Schotel, Christina Petronella 1818-1854 DcWomA
Schotel, Johannes Christiaan 1787-1838 DcSeaP
Schotel, P T DcVicP 2
Schotel, Petrus Jan 1808-1865 ClaDrA
Schotel, Petrus Johannes 1808-1865 DcSeaP
Schott, Arthur 1813-1875 ArtsAmW 1, IlBEAAW, NewYHSD
Schott, Cecil DcVicP 2
Schott, Creszentia DcWomA
Schott, Friedrich Otto 1851-1935 MacBEP
Schott, Ignatius d1882? ArtsEM
Schott, Joseph John 1922- WhoAmA 73, -76
Schottland, M 1935- WhoAmA 80, -82, -84
Schottlander, Bernard 1924- ConArt 77
Schotz, Benno 1891- DcBrA 1, WhoArt 80, -82, -84
Schoubroeck, Pieter 1570-1607 ClaDrA, McGDA
Schouler, Willard C 1852- ArtsAmW 2, WhAmArt 85
Schouler, William 1852- ArtsAmW 2
Schoultz, Emma Von DcWomA
Schoultz, Johan Tietrich 1754?-1807 DcSeaP
Schouman, Aert 1710-1792 ClaDrA, IlDcG, OxArt
Schouman, Isaak 1801?- ClaDrA
Schouman, Martinus 1770-1838 DcSeaP
Schoyer, Raphael NewYHSD
Schrack, Catharine 1801?- FolkA 86
Schrack, Gunther Friedemann MarqDCG 84
Schrack, Joseph FolkA 86
Schrack, Joseph Earl WhoAmA 73
Schrack, Joseph Earl d1973 WhoAmA 76N, -78N, -80N, -82N, -84N
Schrack, Joseph Earl 1890-1973 WhAmArt 85
Schrader NewYHSD
Schrader, Bertha 1845-1920 DcWomA
Schrader, Dorothy A V WhAmArt 85
Schrader, Gustave 1900- WhAmArt 85
Schrader, H FolkA 86
Schrader, Julius 1815- ArtsNiC
Schrader, Theodore NewYHSD
Schrader, W D, Jr. AmArch 70
Schrag, Douglas Lee 1956- MarqDCG 84
Schrag, Karl 1912- BnEnAmA, DcCAA 71, -77, McGDA, PhDcTCA 77, WhAmArt 85, WhoAmA 73, -76, -78, -80, -82, -84
Schrag, Martha 1870-1957 DcWomA
Schrager, Victor 1950- ICPEnP A, MacBEP
Schram, Abraham John 1891- WhAmArt 85
Schramm, Butch FolkA 86
Schramm, James Siegmund 1904- WhoAmA 73, -76, -78, -80, -82, -84
Schramm, Speck FolkA 86
Schramm, Ulrik 1912- IlsCB 1957
Schrand, Eugene Frank 1907- AmArch 70
Schrang, Edmund John 1907- AmArch 70
Schranil, Yoshiko 1937- AmArt
Schranz, Anton 1769-1839 DcSeaP
Schranz, John 1794-1882 DcSeaP
Schranz, Norbert 1951- MarqDCG 84
Schrap, W J FolkA 86
Schreaunch DcSeaP
Schrech, Horst 1885- IlBEAAW
Schreck, Horst 1885- ArtsAmW 1, WhAmArt 85
Schreck, Michael H WhoAmA 80, -82, -84
Schreck, Michael Henry WhoAmA 73, -76, -78
Schreck, Richard Franklin 1924- AmArch 70
Schreckengost, Don 1911- WhAmArt 85
Schreckengost, Viktor 1906- CenC, WhAmArt 85, WhoAmA 73, -76, -80, -82, -84
Schreder, Marianne 1871- DcWomA
Schreffler, Henry 1814-1881 FolkA 86
Schreffler, Isaac 1826?- FolkA 86
Schreffler, Samuel 1804?- FolkA 86
Schrefl, Anna Edle Von 1768- DcWomA
Schreib, Werner 1925- OxTwCA, PhDcTCA 77
Schreiber, Anna Schilling 1877- DcWomA
Schreiber, Charlotte Mount Brock 1834-1922 DcWomA
Schreiber, Edward 1943- MarqDCG 84
Schreiber, Eileen Sher WhoAmA 73, -76, -78, -80, -82, -84
Schreiber, Eugene Augustus 1924- AmArch 70
Schreiber, Gaby WhoArt 80, -82, -84

Schreiber, George L WhAmArt 85
Schreiber, Georges 1904- IlBEAAW, IlsBYP, IlsCB 1946, WhoAmA 73, -76
Schreiber, Georges 1904-1977 GrAmP, PrintW 83, -85, WhAmArt 85, WhoAmA 78N, -80N, -82N, -84N
Schreiber, Hans Joachim 1937- DcCAr 81
Schreiber, Isabel 1902- WhAmArt 85
Schreiber, John 1872-1919 WhAmArt 85
Schreiber, Martin 1923- WhoAmA 73, -76, -78, -80, -82, -84
Schreiber, Milton J EncASM
Schreiber, Richard Henry 1926- AmArch 70
Schreiber, S O AmArch 70
Schreiber DeGrahl, Hannah 1864- DcWomA
Schreier, E P AmArch 70
Schreier, Michael George 1949- MacBEP
Schreiner, Martin AntBDN D
Schreiner, Peter 1853-1936 BiDAmAr
Schreiner, T DcWomA
Schreiner, Mrs. T NewYHSD
Schreiter, George Carl 1924- AmArch 70
Schreiter, Johannes 1930- DcCAr 81
Schreiter, Rick 1936- IlsBYP, IlsCB 1957
Schreiver, George August WhoAmA 76
Schreiver, George August d1977 WhoAmA 78N, -80N, -82N, -84N
Schrero, Ruth Lieberman WhoAmA 82, -84
Schreuder, Andrew B 1828- EncASM
Schrevelius, Elisabeth DcWomA
Schreyer, Adolf 1828-1899 ClaDrA
Schreyer, Adolphe 1828- ArtsNiC
Schreyer, Claudius 1864- WhAmArt 85
Schreyer, Greta L 1923- WhoAmA 73, -76, -78, -80, -82, -84
Schreyvogel, Charles 1861-1912 ArtsAmW 1, DcAmArt, IlBEAAW, WhAmArt 85
Schrieber, E WhAmArt 85
Schrieber, John FolkA 86
Schrieck, Otto Marcellis Van 1619?-1678 McGDA
Schrier And Protze EncASM
Schrim, David 1945- DcCAr 81
Schrimpf, Georg 1889-1938 McGDA, OxTwCA
Schrimpf, Georg 1898-1938 PhDcTCA 77
Schrimpf, Maria DcWomA
Schriver, Jacob 1816-1896 FolkA 86
Schriver, John FolkA 86
Schrock, Mrs. Sam FolkA 86
Schrock, Susan FolkA 86
Schroder, Anna Dorothea DcWomA
Schroder, Arnold ArtsAmW 2, WhAmArt 85
Schroder, Burnos Leslie 1915- AmArch 70
Schroder, C C IlDcG
Schroder, Charles WhAmArt 85
Schroder, Dora 1851-1873 DcWomA
Schroder, F L 1950- DcCAr 81
Schroder, Georg Engelhard 1684-1750 DcBrECP
Schroder, H DcBrECP
Schroder, Hubert DcBrA 1, DcVicP 2
Schroder, Lina DcWomA
Schroder, Liska 1834- DcWomA
Schroder, Louise DcWomA
Schroder, Walter G DcVicP 2
Schroder-Sonnenstern, Friedrich 1892- OxTwCA
Schrodter, Adolf 1805-1875 ClaDrA, WorECar
Schrodter, Alwine 1820-1892 DcWomA
Schroeder, C NewYHSD
Schroeder, Carl 1817-1895 FolkA 86
Schroeder, Charlotte D 1893- DcWomA, WhAmArt 85
Schroeder, David R NewYHSD
Schroeder, Douglas Fredrick 1935- AmArch 70
Schroeder, Eric WhoAmA 76N, -78N, -80N, -82N, -84N
Schroeder, Eric 1904- WhAmArt 85, WhoAmA 73
Schroeder, Fran E 1908- AmArch 70
Schroeder, George Eugene 1865-1934 ArtsAmW 2
Schroeder, Grayson Louis 1922- AmArch 70
Schroeder, H A, Jr. AmArch 70
Schroeder, Harold F, Jr. 1926- AmArch 70
Schroeder, Howard Charles 1918- AmArch 70
Schroeder, John NewYHSD
Schroeder, Joseph F 1925- AmArch 70
Schroeder, Larry Joe 1929- AmArch 70
Schroeder, Leonard John 1929- AmArch 70
Schroeder, Minna d1931 DcWomA
Schroeder, Tom 1885-1976 FolkA 86
Schroeder, Wayne Harold 1944- MarqDCG 84
Schroeder-Sonnenstern, Friedrich 1892- PhDcTCA 77
Schroedter, Adolf 1805-1875 ArtsNiC
Schroer, Sabina 1946- DcCAr 81
Schroester, Adeline DcVicP 2, DcWomA
Schroeter, Carolina Von 1803- DcWomA
Schroff, Alfred Hermann 1863-1939 ArtsAmW 2, WhAmArt 85
Schrom, Archie Mark 1911- WhAmArt 85
Schrontz FolkA 86
Schropfer, R W 1921- AmArch 70
Schrorer, Hans Friedrich ClaDrA
Schroter, Corona Elise Wilhelmine 1751-1802 DcWomA

Schroter, Marianne Von DcWomA
Schroth, Daniel FolkA 86
Schroth, Dorothy L 1906- WhAmArt 85
Schroth, Marcella 1899- DcWomA, WhAmArt 85
Schrottky, Edwin ArtsEM
Schrowang, Augustus Richard, Jr. 1928- AmArch 70
Schroyer, Robert McClelland 1907- WhoAmA 73, -76
Schruben, John H 1926- AmArch 70
Schruder, James AntBDN Q
Schruers, Edwin Judson 1913- AmArch 70
Schrum FolkA 86
Schrup, John Edmund 1937- WhoAmA 73, -76
Schrut, Sherry 1928- WhoAmA 78, -80, -82, -84
Schuback, Elisabeth DcWomA
Schubart, H, Jr. AmArch 70
Schuberg, Clara 1862- DcWomA
Schubert, Bess DcWomA
Schubert, Carl Wenzel 1898- AmArch 70
Schubert, Christa 1934- MarqDCG 84
Schubert, Edita 1947- DcCAr 81
Schubert, Gary E 1944- MarqDCG 84
Schubert, Hans-Gottfried 1936- DcCAr 81
Schubert, John G 1838-1909 FolkA 86
Schubert, Peter 1929- DcCAr 81
Schubert, W C AmArch 70
Schubert, William ArtsEM
Schuberth, Emilio FairDF ITA
Schubiger, Leon 1936- DcCAr 81
Schubin, Mark Isaac 1950- MarqDCG 84
Schubler, Johann Jakob 1689-1741 AntBDN G
Schuch, Karl 1846-1903 McGDA
Schuchard, Carl 1827-1883 ArtsAmW 1, IlBEAAW, NewYHSD
Schuchard, Oliver A 1944- MacBEP
Schuchlin, Hans 1469-1503 McGDA
Schuchmann, Henry FolkA 86
Schuck, F Francis 1927- AmArch 70
Schucker, Charles 1908- DcCAA 71, -77, WhAmArt 85, WhoAmA 73, -76, -78, -80, -82, -84
Schucker, James IlsBYP, WhAmArt 85
Schucker, James W 1903- IlrAm D, -1880
Schuckman, George NewYHSD
Schuckman, William NewYHSD
Schueler, Jon 1916- DcCAA 71, -77
Schueler, Jon R 1916- WhoAmA 73, -76, -78, -80, -82, -84
Schueller, Frederick ArtsEM
Schuenemann, Mary B 1898- DcWomA, WhAmArt 85
Schuermans, Jan DcBrECP
Schuett, G A D AmArch 70
Schuette, Kurt Paul 1917- AmArch 70
Schuetz, Richard Joseph 1933- AmArch 70
Schuffenecker, Emile OxTwCA
Schuffert, John H 1919- WorECar
Schuh, Gotthard 1897-1969 ConPhot, ICPEnP A
Schuhle, H W AmArch 70
Schuhmacher, Meta DcWomA
Schuhmacher, Thomas DcSeaP
Schuhmann, G Raymond 1945- MarqDCG 84
Schuitema, Paul 1897-1973 ConDes
Schulak, B L AmArch 70
Schule, Christian 1764-1816 McGDA
Schule, Clifford H IlsBYP, IlsCB 1946
Schule, Donald Kenneth 1938- WhoAmA 82, -84
Schulein, Julius W 1881- WhAmArt 85
Schulein, Suzanne 1883- DcWomA
Schulenberg, Adele 1883- DcWomA, WhAmArt 85
Schuler, Anne WhAmArt 85
Schuler, Eric WhAmArt 85
Schuler, H J WhAmArt 85
Schuler, Hans 1874- WhAmArt 85
Schuler, Horst 1952- DcCAr 81
Schuler, Jules Theophile 1821-1878 ClaDrA
Schuler, Melvin Albert 1924- WhoAmA 78, -80, -82, -84
Schulhof, Rudolph B WhoAmA 73, -76, -78, -80, -82
Schulhof, Mrs. Rudolph B WhoAmA 73, -76, -78, -80, -82
Schulhof, S Edith DcVicP 2
Schulhoff, Marjory WhAmArt 85
Schulhoff, William 1898-1943 WhAmArt 85
Schulke, Flip 1930- ICPEnP A, MacBEP
Schulke, P AmArch 70
Schull, Della F WhAmArt 85
Schuller, Betty 1860-1904 DcWomA
Schuller, Grete WhoAmA 73, -76, -78, -80, -82, -84
Schuller, Grete d1984 DcWomA
Schuller, Jack Valentine 1912- WhAmArt 85
Schuller, Johann Valentin d1812? FolkA 86
Schuller, John D NewYHSD
Schuller, Nancy Shelby 1942- WhoAmA 82, -84
Schulman, A G 1881-1935 WhAmArt 85
Schulman, Abraham Gustav 1881-1935 ArtsAmW 2
Schulman, Elliott E 1940- MarqDCG 84
Schulman, Jack A 1952- MarqDCG 84
Schulman, Jacob 1915- WhoAmA 73, -76, -78, -80, -82, -84
Schulman, M AfroAA

Schwanfelder, Charles Henry 1774-1837 *DcBrECP*
Schwanhard, Katharina 1701- *DcWomA*
Schwanhard, Marie d1658 *DcWomA*
Schwanhard, Sophie d1657 *DcWomA*
Schwanhard, Susanna d1669 *DcWomA*
Schwanhardt, Georg d1676 *IlDcG*
Schwanhardt, Georg 1601-1667 *AntBDN H, IlDcG, OxDecA*
Schwanhardt, Heinrich *OxDecA*
Schwanhardt, Heinrich d1693 *IlDcG*
Schwanhardt, Maria *IlDcG*
Schwanhardt, Sophia *IlDcG*
Schwanhardt, Susanna *IlDcG*
Schwankovsky, Frederic John, Jr. 1885- *ArtsAmW 2*
Schwankovsky, Frederick John DeSt. Vrain 1885-1974 *WhAmArt 85*
Schwantaler, Ludwig 1802-1848 *McGDA*
Schwanthaler, Ludwig d1848 *DcNiCA*
Schwanzer, Carl 1918-1975 *WhoArch*
Schwarbreck, Samuel Dukinfield *DcBrWA*
Schwarcz, Dorothea *DcWomA, WhAmArt 85*
Schwarcz, June Theresa 1918- *WhoAmA 80, -82, -84*
Schwarcz, June Therese 1918- *WhoAmA 73, -76, -78*
Schwarm, Wesley A *WhAmArt 85*
Schwartz *DcBrECP, FolkA 86*
Schwartz, Adrienne Claire *WhoAmA 82, -84*
Schwartz, Alfred 1833- *ClaDrA*
Schwartz, Alfred W *WhAmArt 85*
Schwartz, Alvin Howard 1916- *WhAmArt 85*
Schwartz, Andrew 1867-1942 *WhAmArt 85*
Schwartz, Anna Maria *DcWomA*
Schwartz, Arthur Warren 1934- *AmArch 70*
Schwartz, Aubrey E 1928- *WhoAmA 73, -76, -78, -80, -82, -84*
Schwartz, Barbara *DcCAr 81*
Schwartz, Barbara Ann 1948- *PrintW 83, -85, WhoAmA 76, -78, -80, -82, -84*
Schwartz, Barbara J 1947- *WhoAmA 73*
Schwartz, Bella *WhoAmA 82, -84*
Schwartz, Buky 1932- *DcCAr 81*
Schwartz, C *AmArch 70, NewYHSD*
Schwartz, Carl E 1935- *AmArt, WhoAmA 73, -76, -78, -80, -82, -84*
Schwartz, Catherine *DcWomA*
Schwartz, Christian *NewYHSD*
Schwartz, Christoph 1545?-1597 *McGDA*
Schwartz, Dan 1943- *MarqDCG 84*
Schwartz, Daniel 1929- *IlrAm G, -1880, WhoGrA 82[port]*
Schwartz, Daniel Bennet 1929- *WhoAmA 76*
Schwartz, Daniel Erlund 1925- *MarqDCG 84*
Schwartz, Davis Francis 1879-1969 *ArtsAmW 1*
Schwartz, Dorothea *DcWomA*
Schwartz, Elizabeth *DcWomA, WhAmArt 85*
Schwartz, Ellen Judith 1949- *WhoAmA 80, -82, -84*
Schwartz, Elsa 1888- *DcWomA*
Schwartz, Esther *DcWomA*
Schwartz, Eugene M 1927- *WhoAmA 73, -76, -78, -80, -82, -84*
Schwartz, Frederick *NewYHSD*
Schwartz, George 1935- *DcCAr 81*
Schwartz, Henry 1927- *WhoAmA 73, -76, -78, -80, -82, -84*
Schwartz, Ira 1922- *AmGrD[port]*
Schwartz, Irving Donn 1927- *AmArch 70*
Schwartz, Ise 1942- *DcCAr 81*
Schwartz, J C *AmArch 70*
Schwartz, J Charles *WhAmArt 85*
Schwartz, Jacob T 1930- *MarqDCG 84*
Schwartz, Julius 1915- *WorECom*
Schwartz, Kenneth Emery 1925- *AmArch 70*
Schwartz, Lester O *WhAmArt 85*
Schwartz, Lewis I *AmArch 70*
Schwartz, Lillian 1927- *WhoAmA 82, -84*
Schwartz, Lillian Feldman 1927- *MarqDCG 84*
Schwartz, M D *AmArch 70*
Schwartz, M M *AmArch 70*
Schwartz, Manfred 1909-1970 *DcCAA 71, -77, WhAmArt 85, WhoAmA 78N, -80N, -82N, -84N*
Schwartz, Marjorie Watson 1905- *WhAmArt 85*
Schwartz, Mark Coffey 1956- *ICPEnP A, MacBEP*
Schwartz, Martin *AmArch 70*
Schwartz, Martin 1928- *AmArch 70*
Schwartz, Marvin D 1926- *WhoAmA 73, -76, -78, -80, -82, -84*
Schwartz, Marvin Irwin 1934- *AmArch 70*
Schwartz, Michael 1810?-1904 *FolkA 86*
Schwartz, Milton Meyer 1925- *AmArch 70*
Schwartz, Mrs. Morris *ArtsAmW 3, DcWomA*
Schwartz, Noel F 1929- *MarqDCG 84*
Schwartz, Peter *FolkA 86*
Schwartz, R E *AmArch 70*
Schwartz, Raymond F 1927- *AmArch 70*
Schwartz, Robert E *AmArch 70*
Schwartz, Robert Thomas 1940- *MarqDCG 84*
Schwartz, Rudolph d1912 *WhAmArt 85*
Schwartz, Rudolph 1899- *WhAmArt 85*
Schwartz, Sadie *DcWomA*
Schwartz, Sadie O *WhAmArt 85*
Schwartz, Samuel 1681-1737 *IlDcG*
Schwartz, Sing-Si 1954- *WhoAmA 76, -78, -80, -82, -84*

Schwartz, Therese *WhoAmA 73, -76, -78, -80, -82, -84*
Schwartz, Therese 1927- *ConArt 77*
Schwartz, William S *WhoAmA 76, -78, -80*
Schwartz, William S 1896-1977 *WhAmArt 85*
Schwartz, William Samuel 1896- *ArtsAmW 3, WhoAmA 73*
Schwartzbaum, Paul Martin 1946- *WhoAmA 76, -78, -80*
Schwartzburger, C 1850- *WhAmArt 85*
Schwartzchild, Monroe M d1932 *WhAmArt 85*
Schwartze, Georgine Elisabeth 1854- *DcWomA*
Schwartze, Johan Georg 1814?-1874 *NewYHSD*
Schwartze, Theresa *DcVicP 2*
Schwartze, Therese 1852-1918 *ClaDrA, DcWomA*
Schwartzenbach, Jacob 1763-1805 *DcSeaP*
Schwartzkopf, Earl C 1888- *WhAmArt 85*
Schwartzkopf, Mimi *DcWomA*
Schwartzman, Alan 1923- *AmArch 70*
Schwartzman, Arnold Martin 1936- *WhoArt 84*
Schwartzman, Daniel 1908- *AmArch 70*
Schwartzman, Daniel 1909-1977 *WhoAmA 78N, -80N, -82N, -84N*
Schwarz, Albert *ArtsNiC*
Schwarz, Amy *WhAmArt 85*
Schwarz, Arthur Frederick 1909- *AmArch 70*
Schwarz, Elizabeth *DcWomA, WhAmArt 85*
Schwarz, Else *DcWomA*
Schwarz, Felix Conrad 1906- *WhAmArt 85, WhoAmA 73, -76, -78, -80, -82, -84*
Schwarz, Frank 1894-1951 *WhAmArt 85*
Schwarz, Frank Henry d1951 *WhoAmA 78N, -80N, -82N, -84N*
Schwarz, Frank Henry 1894-1951 *ArtsAmW 2*
Schwarz, Franz J 1845-1930 *WhAmArt 85*
Schwarz, G J *AmArch 70*
Schwarz, Gladys *WhoAmA 76, -78*
Schwarz, Hans 1492?- *McGDA*
Schwarz, Hans 1922- *WhoArt 84*
Schwarz, Heinrich 1894- *WhoAmA 73*
Schwarz, Heinrich 1894-1974 *WhAmArt 85, WhoAmA 76N, -78N, -80N, -82N, -84N*
Schwarz, Joseph Edmund 1929- *WhoAmA 76*
Schwarz, Kurt 1916- *WhoGrA 62, -82[port]*
Schwarz, Kurt L 1909- *WhoAmA 78, -80, -82, -84*
Schwarz, Myrtle Cooper *WhAmArt 85*
Schwarz, Myrtle Cooper 1900- *WhoAmA 73, -76, -78, -80, -82, -84*
Schwarz, Olly *DcWomA*
Schwarz, Rudolf 1897-1961 *ConArch, EncMA, MacEA*
Schwarz, S L *WhAmArt 85*
Schwarz, William Tefft 1888- *WhAmArt 85*
Schwarzbauer, Renata 1944- *DcCAr 81*
Schwarzburg, Nathaniel 1896- *WhAmArt 85*
Schwarzchild, Karl 1873-1916 *ICPEnP*
Schwarzenbach, Peter A 1872- *WhAmArt 85*
Schwarzenberg, Johanna Elisabeth *DcWomA*
Schwarzenberg, Pauline Charlotte Iris 1774-1810 *DcWomA*
Schwarzer, Franz *FolkA 86*
Schwarzinger, Veronika 1953- *DcCAr 81*
Schwarzkogler, Rudolf 1940-1969 *ConArt 77*
Schwarzmann, Herman J 1843-1891 *BiDAmAr*
Schwarzmann, Hermann J 1846-1891 *MacEA*
Schwarzott, Maximilian M *WhAmArt 85*
Schwarzschild, Karl 1873-1916 *MacBEP*
Schwebel, Carl Dana 1935- *AmArch 70*
Schwebel, Celia 1903- *WhAmArt 85*
Schwebel, Lewis *NewYHSD*
Schwebel, Lewis, Jr. *NewYHSD*
Schwebel, Renata Manasse 1930- *AmArt, WhoAmA 82, -84*
Schwechten, Franz 1841-1924 *MacEA, WhoArch*
Schwedler, William A 1942- *WhoAmA 76, -78, -82*
Schwedler, William A 1942-1982 *WhoAmA 84N*
Schwedler, Wm A 1942- *WhoAmA 80*
Schweickardt, A *WhAmArt 85*
Schweickardt, Katharina Wilhelmina *DcWomA*
Schweickart, Lowell Gray 1907- *AmArch 70*
Schweickhardt, Hendrik Willem 1746-1797 *DcBrECP*
Schweig, Aimee Gladstone 1897- *DcWomA, WhAmArt 85*
Schweigardt, Frederick William 1885- *WhAmArt 85*
Schweiger, Hans *DcVicP 2*
Schweikart, John 1870-1954 *FolkA 86*
Schweikert, Thomas Charles 1945- *MarqDCG 84*
Schweikher, Paul 1903- *AmArch 70, ConArch, McGDA*
Schweinfurt, John George *FolkA 86*
Schweinfurth, A C 1864-1900 *MacEA*
Schweinfurth, Charles F 1858-1919 *BiDAmAr*
Schweinfurth, Charles Frederick 1856-1919 *MacEA*
Schweinfurth, Eva Margarethe 1878- *DcWomA*
Schweinfurth, G *DcVicP 2*
Schweinfurth, Julius A 1858-1931 *BiDAmAr*
Schweinitz, Rudolf 1839- *ArtsNiC*
Schweinsburg, Roland Arthur 1898- *WhAmArt 85*
Schweiss, Hans 1924- *WhoGrA 62, -82[port]*
Schweiss, Ruth Keller *WhoAmA 76, -78, -80, -82, -84*

Schweitzer *EncASM*
Schweitzer, Daniel K 1946- *MacBEP*
Schweitzer, F J *AmArch 70*
Schweitzer, Gertrude *WhAmArt 85, WhoAmA 73, -76, -78, -80, -82, -84*
Schweitzer, Heinrich 1871- *MacEA*
Schweitzer, M R 1911- *WhoAmA 73, -76, -78, -80, -82, -84*
Schweitzer, Moy J 1872- *WhAmArt 85*
Schweitzer, Richard H, Jr. 1940- *MarqDCG 84*
Schweitzer, Udo 1943- *MarqDCG 84*
Schweizer, Helmut 1946- *DcCAr 81*
Schweizer, J Otto 1863-1955 *WhAmArt 85*
Schweizer, Mark, Jr. *AmArch 70*
Schweizer, Nils M 1925- *AmArch 70*
Schweizer, O E 1890-1966 *MacEA*
Schweizer, Paul Douglas 1946- *WhoAmA 78, -80, -82, -84*
Schwendau, Mark Steven 1954- *MarqDCG 84*
Schweninger, Ann Rozzelle 1951- *WhoAmA 82, -84*
Schweninger, Bruce Merrill 1919- *AmArch 70*
Schweninger, Karl 1818-1887 *ClaDrA*
Schweninger, Rosa 1849- *DcWomA*
Schwenk, Johanna 1890- *DcWomA*
Schwenkmeyer, C H *AmArch 70*
Schwenn, D B *AmArch 70*
Schwentker, Hazel F 1894- *ArtsAmW 2, DcWomA*
Schwerd, D *AmArch 70*
Schwerdgeburth, Charlotte Amalia 1795-1831 *DcWomA*
Schwerin, Amelie Ulrika Sofia Von 1819-1897 *DcWomA*
Schwerin, Ricarda 1912- *ICPEnP A*
Schwertfeger, Ellen Newman 1918- *WhAmArt 85*
Schwerzler, Urban G 1904- *AmArch 70*
Schwetz-Lehmann, Ida 1883- *DcWomA*
Schwidder, Ernst Carl 1931- *WhoAmA 76, -78, -80, -82, -84*
Schwieder, Arthur I 1884- *WhAmArt 85*
Schwieger, C Robert 1936- *WhoAmA 76, -78, -80, -82, -84*
Schwieger, Christopher Robert 1936- *WhoAmA 73*
Schwiering, Conrad 1916- *IIBEAAW, PrintW 85, WhoAmA 76, -78, -80, -82, -84*
Schwill, William V 1864- *WhAmArt 85*
Schwimmer, Eva 1901- *DcCAr 81*
Schwind, Ernestine *DcWomA*
Schwind, Moritz Ludwig 1804-1871 *ArtsNiC*
Schwind, Moritz Von 1804-1871 *McGDA, OxArt, WorECar*
Schwindel, Rosina Elisabeth *DcWomA*
Schwindt, Joseph Thomas, Jr. 1938- *AmArch 70*
Schwindt, Robert *NewYHSD*
Schwing, C E *AmArch 70*
Schwinger, Hermann 1610-1683 *AntBDN H*
Schwinger, Hermann 1640-1683 *IlDcG*
Schwinger, Sylvia *WhoAmA 78, -80, -82*
Schwinn, Barbara E 1907- *IlrAm E, -1880, WhAmArt 85*
Schwinn, Robert James 1930- *AmArch 70*
Schwitter, Fridolin *NewYHSD*
Schwitter, George *NewYHSD*
Schwitter, Joseph *NewYHSD*
Schwitters, Kurt 1887-1948 *ConArt 77, -83, MacEA, McGDA, OxArt, OxTwCA, PhDcTCA 77*
Schwob, Antoinette *FolkA 86*
Schwob, Claire 1948- *MacBEP*
Schwob, Pierre R 1946- *MarqDCG 84*
Schwode, Andrea *NewYHSD*
Schye, Mildred Ruth 1901- *WhAmArt 85*
Schyfer, Martha *FolkA 86*
Schyndel, Anna Van *DcWomA*
Schynvoet, Cornelia *DcWomA*
Sciacero, James R 1945- *MarqDCG 84*
Scialdone, J J *AmArch 70*
Scialoja, Toti 1914- *OxTwCA, PhDcTCA 77*
Scianna, Ferdinando 1943- *ICPEnP A, MacBEP*
Sciarpelloni, Lorenzo *McGDA*
Sciarrino, Cartaino *WhAmArt 85*
Scibelli, L A *AmArch 70*
Scibetta, Angelo Charles 1904- *WhAmArt 85*
Scifoni, Anatolio *ArtsNiC*
Scime, Giuliana 1939- *MacBEP*
Scipione 1904-1933 *McGDA, OxTwCA*
Scipione Di Guido *McGDA*
Scipione, Gino Bonichi 1904-1933 *PhDcTCA 77*
Scipione, L Charles 1920- *AmArch 70*
Scjenck, Amalie *DcWomA*
Sclater, E *DcVicP 2*
Sclater-Booth, Miss *DcVicP 2*
Scobell, A Margaretta *DcWomA*
Scobie, Gavin 1940- *DcCAr 81*
Scofield, Cary P 1951- *MarqDCG 84*
Scofield, E A *FolkA 86*
Scofield, Edna *WhAmArt 85*
Scofield, Edna M *ArtsAmW 2, DcWomA*
Scofield, Edward Kamp 1928- *AmArch 70*
Scofield, F P *EncASM*
Scofield, Levi T 1842-1917 *BiDAmAr*
Scofield, William B 1864-1930 *WhAmArt 85*

–80, –82, –84
Seckinger, Harold Eugene *AmArch 70*
Seckler, A J, Jr. *AmArch 70*
Seckler, Dorothy Gees 1910- *WhoAmA 73, –76, –78, –80, –82, –84*
Seckner, C M *FolkA 86*
Seco DeCaceres, Florentina *DcWomA*
Secor, David Pell 1824-1909 *NewYHSD , WhAmArt 85*
Secor, Robert Wesley 1931- *AmArch 70*
Secord, S A *DcWomA*
Secunda, Arthur 1927- *PrintW 83, –85, WhoAmA 73, –76, –78, –80, –82, –84*
Sedberry, Bond Robert, Jr. 1921- *AmArch 70*
Sedcole, Herbert Edward 1864- *DcBrA 1*
Sedding, A E *DcBrBI*
Sedding, Edmund H *DcVicP 2*
Sedding, John D 1838-1891 *MacEA*
Sedding, John Dando 1838-1891 *WhoArch*
Seddon, Fanny *DcVicP 2*
Seddon, George *DcNiCA*
Seddon, George 1727-1801 *AntBDN G*
Seddon, J P 1827-1906 *MacEA*
Seddon, John Pollard 1825-1906 *DcNiCA*
Seddon, John Pollard 1827-1906 *DcVicP 2, McGDA*
Seddon, M *DcVicP 2*
Seddon, Richard Harding *WhoArt 80, –82, –84*
Seddon, Richard Harding 1915- *ClaDrA, DcBrA 1*
Seddon, Thomas *DcNiCA*
Seddon, Thomas 1821-1856 *DcBrWA*
Seddon, Thomas B 1821-1856 *DcVicP, –2*
Sedelmayer, Joseph Anton 1797- *ClaDrA*
Sedelmayr, Eleonora Katharina *DcWomA*
Sedelmayr, Sabina 1700?-1775 *DcWomA*
Seder, Alan Grantham 1925- *AmArch 70*
Sederboom *McGDA*
Seders, Francine Lavinal 1932- *WhoAmA 73, –76, –78, –80, –82, –84*
Sedgefield, Isabel M *DcVicP 2*
Sedgewick, J M *WhAmArt 85*
Sedgewick, Thomas James 1928- *AmArch 70*
Sedgley, Peter 1930- *ConArt 77, –83, ConBrA 79[port], DcCAr 81, PhDcTCA 77*
Sedgwick, Emma Sophia *DcWomA*
Sedgwick, Francis Minturn 1904-1967 *IlBEAAW*
Sedgwick, Henry Renwick 1881-1946 *BiDAmAr*
Sedgwick, Mrs. John *DcVicP, –2*
Sedgwick, Susan *FolkA 86*
Sedgwick, Susan Anne Livingston 1789?-1867 *DcWomA*
Sedgwick, Susan Anne Livingston Ridley 1789?-1867 *NewYHSD*
Sedille, Paul 1836-1900 *MacEA, McGDA*
Sedillot, Anna *DcWomA*
Sediva, Emanuela 1880- *DcWomA*
Sedlack, Paul Dean 1956- *MarqDCG 84*
Sedlecka, Irena 1928- *WhoArt 84*
Sedletzky, Marcel Eugen 1923- *AmArch 70*
Sedlis, G *AmArch 70*
Sedlmaier, Thekla Crescentia *DcWomA*
Sedoff, G S 1831?-1886 *ClaDrA*
Sedor, L *AmArch 70*
Sedworth, Miss *DcWomA*
See, Ella E *DcWomA, WhAmArt 85*
See, Imogene 1848-1940 *ArtsAmW 2, DcWomA*
See, J J *AmArch 70*
See, Jack Fletcher, Jr. 1935- *AmArch 70*
See, Mathilde *ClaDrA*
See, Mathilde d1935 *DcWomA*
See, Milton 1854-1920 *BiDAmAr*
See, Salvator *NewYHSD*
See, William Edward 1918- *WhoGrA 62*
Seebach, V W *AmArch 70*
Seebeck, Walter 1919- *FolkA 86*
Seeber, Joseph G 1941- *MarqDCG 84*
Seeberger, Pauline Bridge 1897- *ArtsAmW 2, WhAmArt 85*
Seeberger, Pauline Bridge 1897-1976 *DcWomA*
Seebold, Marie M *WhAmArt 85*
Seebold, Marie Madeleine 1876- *DcWomA*
Seebold, Phillip *FolkA 86*
Seebold, W E 1833-1921 *WhAmArt 85*
Seeck, Marie 1861- *DcWomA*
Seed, Brian 1929- *ICPEnP A, MacBEP*
Seed, Suzanne 1940- *ICPEnP A, MacBEP*
Seed, Suzanne Liddell 1940- *WhoAmA 82, –84*
Seeds, Elise *WhAmArt 85*
Seeff, Norman 1939- *MacBEP*
Seeger, Jacob *EncASM*
Seeger, Karl Ludwig 1808-1866 *ClaDrA*
Seegmiller, Janette *ArtsEM, DcWomA*
Seegmiller, Wilhelmina 1856?-1913 *DcWomA*
Seegmuller, Wilhelmina 1856-1913 *WhAmArt 85*
Seehaus, Paul Adolf 1891-1919 *McGDA, PhDcTCA 77*
Seehausen, R F *AmArch 70*
Seekatz, Johann Conrad 1711-1768 *McGDA*
Seel, Adolf 1829- *ArtsNiC*
Seel, Adolf 1829-1907 *ClaDrA*
Seeler, Edgar V 1867-1929 *BiDAmAr*
Seeler, O F *AmArch 70*

Seeley, B F *ArtsEM*
Seeley, E L *DcVicP 2*
Seeley, Miss E L *DcBrBI*
Seeley, Florence *DcWomA*
Seeley, George 1880-1955 *ICPEnP A, MacBEP*
Seeley, J 1946- *MacBEP*
Seeley, R *DcVicP 2*
Seelig, B J *AmArch 70*
Seelig, Moritz J 1809- *FolkA 86*
Seelig, Warren 1946- *DcCAr 81*
Seely, Florence *WhAmArt 85*
Seely, Michael J 1946- *MarqDCG 84*
Seely, Walter Frederick 1886- *ArtsAmW 2, WhAmArt 85*
Seeman, Enoch 1694?-1745? *DcBrECP*
Seeman, Mrs. Erwin W *WhAmArt 85*
Seeman, Helene Zucker 1950- *WhoAmA 78, –80, –82, –84*
Seeman, Isaac d1751 *DcBrECP*
Seemann, Dora 1858-1923 *DcWomA*
Seepol, A *AmArch 70*
Seerey-Lester, John *OfPGCP 86*
Seery, John *WhoAmA 73, –76, –78*
Seery, John 1941- *ConArt 77*
Seewald, John *FolkA 86*
Seewald, Margaret 1899- *ArtsAmW 2, DcWomA, WhAmArt 85*
Seff, Manuel *WhoAmA 73*
Seff, Mrs. Manuel *WhoAmA 73*
Seffel, E A, Jr. *IlBEAAW*
Seffrin, Nickolaus 1931- *DcCAr 81*
Sefran, Gorazd 1945- *DcCAr 81*
Sefton, Anne Harriet *DcWomA*
Segal, Arthur d1944 *DcBrA 1*
Segal, Arthur 1875-1944 *DcBrA 2*
Segal, David 1940- *WhoAmA 84*
Segal, Dorothy 1900- *WhAmArt 85*
Segal, George 1924- *AmArt, BnEnAmA, ConArt 77, –83, DcAmArt, DcCAA 71, –77, DcCAr 81, McGDA, OxTwCA, PhDcTCA 77, PrintW 83, –85, WhoAmA 73, –76, –78, –80, –82, –84, WorArt[port]*
Segal, Hyman 1914- *ClaDrA, DcBrA 1, WhoArt 80, –82, –84*
Segal, Jacques H 1905- *WhAmArt 85*
Segal, Jacques Hendall 1905- *AmArch 70*
Segal, Patrick 1947- *ICPEnP A, MacBEP*
Segal, Ruth *WhAmArt 85*
Segal, Tama 1949- *WhoAmA 84*
Segal, Walter 1907- *ConArch, MacEA*
Segala, Francesco d1593? *McGDA*
Segala, Giovanni 1663-1720 *McGDA*
Segall, Julius G 1860-1925 *WhAmArt 85*
Segall, Lasar 1890-1957 *ClaDrA, OxArt*
Segall, Lasar 1891-1957 *McGDA, OxTwCA, PhDcTCA 77*
Segalla, Livio J 1921- *AmArch 70*
Segalove, Ilene Judy 1950- *WhoAmA 76, –78, –80, –82, –84*
Segan, Kenneth Akiba 1950- *AmArt, WhoAmA 82*
Segan, Kenneth Akiva 1950- *WhoAmA 84*
Segantini, Giovanni 1858-1899 *ClaDrA, McGDA, OxArt*
Segar, Elzie Crisler 1894-1938 *WorECom*
Segar, Joseph d1740 *CabMA*
Segar, William S 1823-1887 *NewYHSD*
Segar Pugh, Robert 1883- *DcBrA 1*
Segawa, Yasuo 1932- *IlsBYP*
Sege, Alexandre *ArtsNiC*
Segel, Sheldon 1928- *AmArch 70*
Seger, Anna d1566? *DcWomA*
Segers, Hercules *McGDA*
Segers, Hercules Pietersz 1589?-1635? *OxArt*
Segerstrale, Johanna Wilhelmina *DcWomA*
Segesman, John F 1899- *ArtsAmW 3*
Segesser, Marguerite VonBrunegg 1843-1910 *DcWomA*
Segger, Martin Joseph 1946- *WhoAmA 76, –78, –80, –82, –84*
Segher, Anna d1566? *DcWomA*
Seghers, Anna d1566? *DcWomA*
Seghers, Cornelius Johannes Adrianus 1814-1875 *ClaDrA*
Seghers, D P *AmArch 70*
Seghers, Daniel 1590-1661 *ClaDrA, McGDA, OxArt*
Seghers, Francois 1849- *ClaDrA*
Seghers, Gerard 1591-1651 *OxArt*
Seghers, Gerardo *McGDA*
Seghers, Hercules 1589?-1638? *McGDA*
Seghers, Hercules Pietersz 1589?-1635? *OxArt*
Segina, Victor John 1927- *AmArch 70*
Segna Di Bonaventura *McGDA*
Segonzac, Andre Dunoyer De *PhDcTCA 77*
Segonzac, Andre Dunoyer De 1884- *McGDA*
Segraves, Warren Dennis 1924- *AmArch 70*
Segrest, Robert *ConArch A*
Segreti, Anthony John 1935- *AmArch 70*
Segui, Antonio 1934- *DcCAr 81, PhDcTCA 77*
Seguier, Margaret 1829- *DcWomA*
Seguier, William 1771-1843 *DcBrECP*
Seguin, C *DcWomA*

Seguin, Marc 1786-1875 *MacEA*
Segur, Eleanor Corinne 1923- *WhoAmA 80, –82, –84*
Segura, Perry 1929- *AmArch 70*
Seguso, Armand *WhAmArt 85*
Segy, Ladislas 1904- *WhAmArt 85, WhoAmA 73, –76, –78, –80, –82, –84*
Seheult, Francois Leonard 1771-1840 *MacEA*
Sehgal, Vipin C 1947- *MarqDCG 84*
Sehlstedt, Elias 1808-1874 *DcSeaP*
Sehon, Adeliza Drake d1902 *DcWomA*
Sehon, John *MarqDCG 84*
Sehres, Lawrence M 1932- *AmArch 70*
Sehring, Adolf *OfPGCP 86*
Sehring, Adolf 1930- *AmArt, PrintW 83, –85, WhoAmA 82, –84*
Seibel, Fred O d1968 *WhoAmA 78N, –80N, –82N, –84N*
Seibel, Fred O 1886-1968 *WhAmArt 85*
Seibel, Frederick Otto 1886-1969 *WorECar*
Seibel, Phyllis Ganders 1928- *AmArch 70*
Seiberling, Dorothy Buckler Lethbridge 1922- *WhoAmA 73*
Seiberling, Gertrude Penfield 1866-1946 *WhAmArt 85*
Seibert *NewYHSD*
Seibert, Alvah Frederick 1934- *AmArch 70*
Seibert, E J *AmArch 70*
Seibert, Edward *NewYHSD*
Seibert, Henry *FolkA 86, NewYHSD*
Seibert, Henry Eugene *AmArch 70*
Seibert, Jacob *NewYHSD*
Seibert, John, Jr. *FolkA 86*
Seibert, John, Sr. 1796-1854 *FolkA 86*
Seibert, Lee V 1908- *AmArch 70*
Seibert, Owen 1828?- *FolkA 86*
Seiberth, Peter 1821- *FolkA 86*
Seibert, William Henry 1917- *AmArch 70*
Seibold, Macmillan *WhAmArt 85*
Seid, Eva 1950- *MacBEP*
Seide, Charles 1915- *WhoAmA 73, –76, –78, –80*
Seide, Charles 1915-1980 *WhoAmA 82N, –84N*
Seide, Paul A 1949- *WhoAmA 82, –84*
Seidel, Alexander Carl-Victor 1897- *WhoAmA 78*
Seidel, Alexander Carl-Victor 1897-1979 *WhoAmA 80N, –82N, –84N*
Seidel, Charles Frederick *NewYHSD*
Seidel, Craig Howard 1961- *MarqDCG 84*
Seidel, Emory P 1881- *WhAmArt 85*
Seidel, Frederick *NewYHSD*
Seidel, Julie 1791- *DcWomA*
Seidel, W W *AmArch 70*
Seidelin, Ingeborg 1872-1914 *DcWomA*
Seiden, A *AmArch 70*
Seiden, Arthur *WhoAmA 80, –82, –84*
Seiden, Regina *DcWomA*
Seidenberg, Henry *CabMA*
Seidenberg, Janet *WhAmArt 85*
Seidenberg, Jean 1930- *WhoAmA 73, –76*
Seidenberg, Roderick *WhAmArt 85*
Seideneck, Catherine 1886-1967 *DcWomA*
Seideneck, Catherine Comstock 1885-1967 *ArtsAmW 3*
Seideneck, George J 1885- *WhAmArt 85*
Seideneck, George Joseph 1885-1972 *ArtsAmW 2*
Seidenspinner, John 1831?- *FolkA 86*
Seidensticker, Robert Beach 1957- *MarqDCG 84*
Seidl, Claire 1951- *WhoAmA 80, –82, –84*
Seidl, Gabriel 1848-1913 *WhoArch*
Seidl, Gabriel Von 1848-1913 *MacEA*
Seidler, Doris *WhoAmA 73, –76, –78, –80, –82, –84*
Seidler, Harry *ConArch A*
Seidler, Harry 1923- *ConArch, EncMA, MacEA, WhoArch*
Seidler, Louise Caroline Sophie 1786-1866 *DcWomA*
Seidler, Migdonio 1928- *AmArch 70*
Seidler, Sheldon *AmGrD[port]*
Seidlitz, Nelly Von 1870- *DcWomA*
Seidman, Aaron 1937- *MarqDCG 84*
Seidman, S *AmArch 70*
Seidner, Peter P 1931- *AmArch 70*
Seielstad, Benjamin Goodwin 1886- *ArtsAmW 3, WhAmArt 85*
Seifert, Andrew 1820?-1900 *FolkA 86*
Seifert, Annie 1863-1913 *DcWomA*
Seifert, D W *AmArch 70*
Seifert, Dora 1861- *DcWomA*
Seifert, Emanuel 1830?- *FolkA 86*
Seifert, Emanuela 1852-1910 *DcWomA*
Seifert, F *NewYHSD*
Seifert, Grete *DcWomA*
Seifert, Henry 1823?-1905 *FolkA 86*
Seifert, Henry 1824-1911 *NewYHSD , WhAmArt 85*
Seifert, Ivan 1926- *ConArch*
Seifert, Paul A 1840-1921 *AmFkP, FolkA 86*
Seifert, Robin 1910- *ConArch*
Seifert, W J 1921- *AmArch 70*
Seiferth, Solis 1895- *AmArch 70*
Seiffert, Karl Friedrich 1809- *ArtsNiC*
Seigel, Walter 1932- *AmArch 70*
Seigfreid, James Ray 1934- *AmArch 70*
Seigle, Ralph Cornell 1912- *WhAmArt 85*
Seignac, Guillaume *ClaDrA*

Seigneur, Linda 1950- *MarqDCG 84*
Seignobosc, Francoise 1900-1961 *IlsBYP*, *IlsCB 1744*, *-1946, -1957*
Seignouret, Francois *AntBDN G, DcNiCA*
Seignouret, Francois 1768- *CabMA*
Seigrist, Henry 1788-1860 *FolkA 86*
Seiko 1837-1913 *DcWomA*
Seile, Simeon B *NewYHSD*
Seiler, Frederick *NewYHSD*
Seiler, H *FolkA 86*
Seiler, S A *AmArch 70*
Seilhean, Renee 1897- *DcWomA*
Sein, Mangul *DcVicP 2*
Seinsheim, August Carl 1789-1869 *ClaDrA*
Seip *FolkA 86*
Seip, Gertrud 1887- *DcWomA*
Seipel, Herbert Theodore 1912- *AmArch 70*
Seiple, Stan C, Jr. 1927- *AmArch 70*
Seipp, Alice *WhAmArt 85*
Seipp, Alice 1889- *DcWomA*
Seippel, Sophie Vera *DcWomA*
Seisenegger, Jacob 1505-1567 *OxArt*
Seisser, Martin B 1845- *ArtsNiC*
Seitanakis, Peter John 1936- *AmArch 70*
Seither, Anne Barber *DcWomA, WhAmArt 85*
Seitoku, Norio 1947- *MarqDCG 84*
Seitz, A *AmArch 70*
Seitz, Charles B 1832?- *ArtsEM*
Seitz, Charles M 1930- *AmArch 70*
Seitz, Gustav 1906- *PhDcTCA 77*
Seitz, H F *AmArch 70*
Seitz, John *NewYHSD*
Seitz, Otto 1846-1912 *ClaDrA*
Seitz, Patricia *IlsBYP*
Seitz, Peter 1931- *MarqDCG 84*
Seitz, Roger Michael 1937- *AmArch 70*
Seitz, William Chapin 1914- *WhoAmA 73*
Seitz, William Chapin 1914-1974 *WhoAmA 76N, -78N, -80N, -82N, -84N*
Seitz-Zeller, Justine 1856- *DcWomA*
Seiwert, Franz-Wilhelm 1894-1933 *PhDcTCA 77*
Seixas, David G *FolkA 86*
Seiyodo *AntBDN L*
Sejourne, Bernard 1947- *AfroAA*
Sekaer, Peter 1901-1950 *MacBEP*
Sekalski, Jozef 1904- *DcBrA 1*
Sekanina, Jaroslav *WhAmArt 85*
Sekers *WorFshn*
Seki, Naoyasu 1949- *MarqDCG 84*
Sekido, Yoshida 1894- *ArtsAmW 2, DcWomA, WhAmArt 85*
Sekimachi, Kay 1926- *BnEnAmA, DcCAr 81, WhoAmA 78, -80, -82, -84*
Sekine, Nobuo 1942- *ConArt 77, -83, PhDcTCA 77*
Sekishu *AntBDN L*
Sekler, Eduard F *ConArch A*
Sekoto, C *AfroAA*
Sekoto, Gerard *OxTwCA*
Sekula, Allan *WhoAmA 76, -78*
Sekulic, Ivan 1947- *DcCAr 81*
Sel, B *NewYHSD*
Sel, John B d1832 *NewYHSD*
Selb, Josef 1784-1832 *ClaDrA*
Selb, Orpheus Victor W *DcVicP 2*
Selbing, John 1908- *IlDcG*
Selby, Cleland *FolkA 86*
Selby, Edward *FolkA 86*
Selby, Emma Margaret *DcBrA 1, DcWomA*
Selby, F *NewYHSD*
Selby, M *DcWomA*
Selby, Prideaux John 1788-1867 *DcBrBI, DcBrWA, DcVicP 2*
Selby, Robert Irwin 1943- *AmArch 70*
Selby, Roger Lowell 1933- *WhoAmA 80, -82*
Selby, T *DcVicP 2*
Selchow, Roger Hoffman 1911- *WhoAmA 78, -80, -82, -84*
Seld, Baroness Berta De 1860- *DcWomA*
Selden, Dixie 1870-1935 *DcWomA*
Selden, Dixie 1871-1936 *WhAmArt 85*
Selden, Henry Bill 1886-1934 *WhAmArt 85*
Selden, Theodore E 1930- *AmArch 70*
Selders, Allan Hunt 1926- *AmArch 70*
Seldis, Henry J 1925- *WhoAmA 73, -76*
Seldis, Henry J 1925-1978 *WhoAmA 78N, -80N, -82N, -84N*
Seldon, Isaac *CabMA*
Seldon, Reeda 1905- *WhAmArt 85*
Seldron, Elizabeth *DcWomA*
Seletz, Emil 1909- *WhoAmA 78, -80, -82, -84*
Seley, Jason 1919- *BnEnAmA, DcCAA 71, -77, DcCAr 81, McGDA, PhDcTCA 77, WhoAmA 73, -76, -78, -80, -82*
Seley, Jason 1919-1983 *WhoAmA 84N*
Self, Bob 1946- *FolkA 86*
Self, Clarence Ron 1936- *AmArch 70*
Self, Colin 1941- *ConArt 77, -83*
Self, Howrhu *AfroAA*
Self, Robert Eugene 1936- *AmArch 70*
Selfridge, Reynolds L 1898- *WhAmArt 85*
Selig, C E *AmArch 70*

Selig, J Daniel 1938- *WhoAmA 78, -80, -82, -84*
Selig, Manfred *WhoAmA 73, -76, -78, -80, -82, -84*
Selig, Mrs. Manfred *WhoAmA 73, -76, -78, -80, -82, -84*
Selig, Martin *WhoAmA 73*
Selig, Sylvie *IlsBYP*
Selig, Sylvia 1942- *IlsCB 1967*
Seliger, Charles 1926- *DcCAA 71, -77, WhoAmA 73, -76, -78, -80, -82, -84*
Seligman, Alfred L 1864-1912 *WhAmArt 85*
Seligman, Charles 1893-1978 *WhoAmA 80N, -82N, -84N*
Seligman, Emma *DcWomA*
Seligman, Thomas Knowles 1944- *WhoAmA 78, -80, -82, -84*
Seligmann, Arnold 1870-1932 *WhAmArt 85*
Seligmann, Herbert J 1891- *WhoAmA 78, -80, -82, -84*
Seligmann, Kurt 1900-1961 *PhDcTCA 77, WhAmArt 85*
Seligmann, Kurt 1900-1962 *ClaDrA, ConArt 77, DcCAA 71, -77, OxTwCA, WhoAmA 78N, -80N, -82N, -84N*
Seligmann, Werner 1930- *AmArch 70, ConArch*
Seligson, Leon 1914- *AmArch 70*
Seligson, Theodore H 1930- *AmArch 70*
Selim, Honorine *DcWomA*
Selim, Jewed 1914- *ClaDrA*
Selincart, Henriette *DcWomA*
Selinger, Emily H McGary *WhAmArt 85*
Selinger, Emily Harris 1854- *DcWomA*
Selinger, Jean Paul 1850-1909 *WhAmArt 85*
Sell, Charles *DcVicP 2*
Sell, Christian 1831-1883 *ArtsNiC*
Sella, Alvin Conrad 1919- *WhoAmA 73, -76, -78, -80*
Sella, Alvin Conrad 1924- *WhoAmA 82, -84*
Sella, Giuseppe Venanzio 1823-1876 *MacBEP*
Sellaio, Jacopo Del 1442-1493 *McGDA*
Sellar, Charles A *DcBrA 1*
Sellar, Charles A d1926 *DcBrWA, DcVicP 2*
Sellars, Gene Clayton 1927- *AmArch 70*
Sellars, James 1843-1888 *MacEA*
Sellars, William *CabMA*
Selleck, Margaret *WhoAmA 80N, -82N, -84N*
Selleck, Margaret 1892-1960? *WhAmArt 85*
Selleck, Margaret Hall 1892-1961? *DcWomA*
Selleck, Rhoda *DcWomA*
Sellen, Enos *EncASM*
Sellen, Osman *EncASM*
Sellens, David Allen 1953- *MarqDCG 84*
Seller, James *FolkA 86*
Seller, John *AntBDN I*
Sellers, Anna 1824-1905 *DcWomA*
Sellers, Charles Coleman 1903- *WhoAmA 73, -76, -78, -80*
Sellers, D W *AmArch 70*
Sellers, George Escol 1808-1899 *FolkA 86, NewYHSD*
Sellers, Gregory J 1947- *MarqDCG 84*
Sellers, Horace W 1857-1933 *BiDAmAr*
Sellers, J H 1861-1954 *MacEA*
Sellers, James Henry 1861-1954 *DcBrA 2*
Sellers, John Lewis 1934- *WhoAmA 78, -80, -82, -84*
Sellers, Mary 1869- *DcWomA, WhAmArt 85*
Sellers, Minnie 1869- *WhAmArt 85*
Sellers, Rorick Anthony 1948- *MarqDCG 84*
Sellers, William Freeman 1929- *WhoAmA 73, -76, -78, -80, -82, -84*
Sellery, Bruce Morley 1922- *AmArch 70*
Selles, Malvin M 1904- *AmArch 70*
Sellew *EncASM*
Sellew, Francis B 1913- *AmArch 70*
Sellew, R W *AmArch 70*
Sellick, Rhoda *DcWomA*
Sellier, Charles Auguste d1882 *ArtsNiC*
Sellier, Charles Francois 1830-1882 *ClaDrA*
Sellier, Sophie *DcWomA*
Sellier, William E 1924- *AmArch 70*
Sellin, David 1930- *WhoAmA 78, -80, -82, -84*
Sellinger, G M *AmArch 70*
Sellon, William *DcVicP 2*
Sellors, Roy 1913- *AmArch 70*
Sells, C H *IlBEAAW*
Sells, V P *DcVicP, -2*
Sellstedt, Lars Gustaf 1819- *ArtsNiC*
Sellstedt, Lars Gustaf 1819-1911 *NewYHSD , WhAmArt 85*
Selma, Georgij *ConPhot*
Selmair, Claire 1886-1935 *DcWomA*
Selman, William *FolkA 86*
Selmersheim, Tony 1872- *MacEA*
Selmersheim-Desgrange, Jeanne 1879-1958 *DcWomA*
Selmy, Eugene Benjamin 1874- *ClaDrA*
Selonke, Irene A *WhoAmA 78, -80*
Selonke, Irene A d1981 *WhoAmA 82N, -84N*
Selonke, Irene A 1910- *WhoAmA 73, -76*
Selous, Dorothea Medley *DcBrA 1, DcWomA*
Selous, Henry Courtney 1803-1890 *DcBrBI, DcBrWA*
Selous, Henry Courtney 1811-1890 *ClaDrA, DcVicP, -2*

Selous, J *DcVicP 2*
Selser, Christopher 1950- *WhoAmA 82, -84*
Seltz, J R *AmArch 70*
Seltz-Petrash, Ann Elizabeth 1950- *MarqDCG 84*
Seltzer, Andreas 1943- *DcCAr 81*
Seltzer, Christian *FolkA 86*
Seltzer, Gilbert L 1914- *AmArch 70*
Seltzer, Herbert Richard 1925- *MarqDCG 84*
Seltzer, Howard Stephen 1928- *AmArch 70*
Seltzer, Isadore 1930- *IlrAm 1880*
Seltzer, Joanne *PrintW 85*
Seltzer, Joanne Lynn 1946- *WhoAmA 84*
Seltzer, Johannes 1774-1845 *CabMA*
Seltzer, John *FolkA 86*
Seltzer, John 1774-1845 *CabMA*
Seltzer, Olaf C *OfPGCP 86*
Seltzer, Olaf Carl 1877-1957 *ArtsAmW 1, IlBEAAW, WhAmArt 85*
Seltzer, Phyllis 1928- *PrintW 83, -85, WhoAmA 76, -78, -80, -82, -84*
Selva, Giovanni Antonio 1751-1819 *MacEA, McGDA*
Selvage, Helen A Coe *WhAmArt 85*
Selvig, Forrest Hall 1924- *WhoAmA 73, -76, -78, -80, -82, -84*
Selvin, Nancy 1943- *DcCAr 81, WhoAmA 82, -84*
Selway, John 1938- *DcCAr 81*
Selwin *DcBrWA, NewYHSD*
Selwitz, Ruth F *WhoAmA 80, -82, -84*
Selwitz, Ruth F 1933- *WhoAmA 78*
Selwyn, George Augustus 1719-1791 *DcBrWA*
Selz, Peter H 1919- *WhoAmA 73, -76, -78, -80, -82, -84*
Selzer, Christian 1749-1831 *CabMA, FolkA 86*
Selzer, Dale Edwin 1933- *AmArch 70*
Selzer, Frank E, Jr. *ArtsEM*
Selzer, Frank E, Sr. *ArtsEM*
Selzer, Gerhard Adalbert 1930- *AmArch 70*
Selzer, John *FolkA 86*
Selzer, L J, Jr. *AmArch 70*
Selzer, Louis *ArtsEM*
Sem *WorECar*
Sem 1863-1934 *ClaDrA, DcBrBI*
Semak, Michael 1934- *ConPhot, WhoAmA 76, -78, -80, -82, -84*
Semak, Michael William 1934- *ICPEnP A, MacBEP*
Semancik, Donald John 1931- *AmArch 70*
Semans, James Hustead 1910- *WhoAmA 73, -76, -78, -80, -82, -84*
Sembach, A *DcVicP 2*
Sembat, Georgette *DcWomA*
Semchishen, Orest M 1932- *WhoAmA 84*
Semchuk, Sandra Ann 1948- *MacBEP*
Seme, Joe *OfPGCP 86*
Semerau, George *MarqDCG 84*
Semino, Andrea 1525?-1595? *McGDA*
Seminoff, George 1927- *AmArch 70*
Semitekol, John Anthony 1918- *AmArch 70*
Semmel, Joan 1932- *ConArt 77, WhoAmA 76, -78, -80, -82, -84*
Semmence, John Oswald 1930- *WhoArt 80, -82, -84*
Semmes, A Gertrude O *WhAmArt 85*
Semon, John d1917 *WhAmArt 85*
Semore, Charles *AntBDN Q*
Sempe, Jean Jacques 1932- *WhoGrA 82[port]*
Sempe, Jean-Jacques 1932- *WorECar*
Semper, Gottfried 1803-1879 *DcNiCA, EncMA, MacEA, McGDA, WhoArch*
Semper, Gottfried 1804-1879 *ArtsNiC*
Sempere, Eusebio 1924- *OxTwCA*
Semple, Joseph *DcSeaP*
Sen, Ranjan 1941- *DcCAr 81*
Sena, Antonio 1941- *WhoArt 80*
Senat, Prosper L 1852-1925 *WhAmArt 85*
Senat, Prosper Louis 1852-1925 *ArtsAmW 2*
Senave, Jacques Albert 1758-1829 *ClaDrA*
Senbergs, Jan 1939- *DcCAr 81*
Sence, Leonard *NewYHSD*
Sendak, Maurice *IlsCB 1967*
Sendak, Maurice 1928- *IlrAm 1880, IlsBYP, IlsCB 1946, -1957, WhoGrA 82[port]*
Sendak, Maurice Bernard 1928- *WhoAmA 76, -78, -80, -82, -84*
Sendorf, Reinhardt *NewYHSD*
Sene, Jean-Baptiste-Claude 1748-1803 *OxDecA*
Seneca *EncASM*
Senecal, Ralph L 1883- *WhAmArt 85*
Senechal, Alexandre 1767- *DcBrECP*
Senefeld, Claude Leslie 1914- *AmArch 70*
Senefelder, Alois 1771-1834 *McGDA, OxDecA*
Senefelder, Aloys 1771-1834 *OxArt*
Senell, Martin Anthony 1936- *AmArch 70*
Senesey, Nicholas Joseph 1913- *AmArch 70*
Senevas DeCroix-Mesnil, Baroness Julie *DcWomA*
Senex, John *AntBDN I*
Senff, Karoline *DcWomA*
Senft, Nadin 1932- *WhoAmA 84*
Senftleber, Frederick Arthur 1927- *AmArch 70*
Seng, Regina Katharina 1756-1786 *DcWomA*
Senga *DcVicP 2*
Sengl, Peter 1945- *DcCAr 81*
Sengtacke, Bobby *AfroAA*

Sengteller, Alexander 1813?- *NewYHSD*
Senia, Al Michael 1951- *MarqDCG 84*
Senior, Bryan 1935- *DcCAr 81*, *WhoArt 80*, *-82*, *-84*
Senior, C F *FolkA 86*, *NewYHSD*
Senior, Dorothy Elizabeth *WhoAmA 73*, *-76*, *-78*, *-80*, *-82*
Senior, E N *DcVicP 2*
Senior, Mark 1864-1927 *ClaDrA*, *DcBrA 1*, *DcVicP 2*
Senior, Oliver 1880- *ClaDrA*, *DcBrA 1*
Senlis, Seraphine De *DcWomA*
Senlis, Seraphine De 1864-1934 *WomArt*
Senmut *MacEA*
Senn *DcBrECP*
Senn, Emil *WhAmArt 85*
Senn, Herold H 1932- *MarqDCG 84*
Senn, Paul 1901-1953 *ConPhot*, *ICPEnP A*
Sennema, David C 1934- *WhoAmA 76*, *-78*, *-80*, *-82*, *-84*
Sennep *WorECar*
Sennep, Jean 1894- *WhoGrA 62*
Sennett, John T *NewYHSD*
Sennhauser, John *WhoAmA 73*, *-76*
Sennhauser, John d1978 *WhoAmA 78N*, *-80N*, *-82N*, *-84N*
Sennhauser, John 1907- *DcCAA 71*, *-77*
Sennhauser, Robert 1940- *MacBEP*
Sens, William Of *OxArt*
Sens, William De *McGDA*
Senseman, Ronald Sylvester 1912- *AmArch 70*
Sensemann, Susan 1949- *WhoAmA 76*
Senseney, George E 1874-1943 *WhAmArt 85*
Sentell, G D *AmArch 70*
Senter, L, Jr. *AmArch 70*
Senteri, Florio *WhAmArt 85*
Senties, T *DcVicP, -2*
Senyard, Corley Price, Jr. 1956- *MarqDCG 84*
Senyard, George d1924 *WhAmArt 85*
Seoane, Luis 1910- *OxTwCA*, *PhDcTCA 77*, *WhoGrA 62*
Seow, E J *ConArch A*
Sepelak, George R 1949- *MarqDCG 84*
Sepeshy, Zelton 1898- *ArtsAmW 2*
Sepeshy, Zoltan 1898- *McGDA*, *WhAmArt 85*
Sepeshy, Zoltan L 1898- *ArtsAmW 2*, *WhoAmA 73*, *-76*
Sephton, George Harcourt *DcVicP 2*
Sephton, Henry 1686?-1756 *BiDBrA*
Sephyel, Professor *DcVicP 2*
Seplowin, Charles Joseph 1945- *WhoAmA 76*, *-78*, *-80*, *-82*, *-84*
Sepo, Severo 1895- *ClaDrA*
Sepolina, Josephine *DcWomA*
Seppa, Heikki 1927- *DcCAr 81*
Seppa, Heikki Markus 1927- *WhoAmA 78*, *-80*, *-82*, *-84*
Seppanen, J *AmArch 70*
Seppo 1753?-1824 *DcWomA*
Sepyo, James 1933- *PrintW 83*, *-85*, *WhoAmA 82*, *-84*
Sequeira, Domingos Antonio De 1768-1837 *McGDA*, *OxArt*
Sequin, Carlo *MarqDCG 84*
Sera, J *NewYHSD*
Serabian, Capril 1927- *AmArch 70*
Seracuse, Jerome M 1933- *AmArch 70*
Serafino Serafini 1320?-1384 *McGDA*
Serafinowicz, Leokadia 1915- *ConDes*
Seraphin, Joseph Anthony 1945- *WhoAmA 78*
Seraphin, Sanctus *AntBDN K*
Seraphine 1864-1934 *OxTwCA*, *PhDcTCA 77*
Seraphine 1864-1942 *McGDA*
Seraphine DeSenlis 1864-1934 *OxTwCA*
Seraphine DeSenlis 1864-1942 *McGDA*
Serbaroli, Hector 1886- *ArtsAmW 2*, *WhAmArt 85*
Serber, D *AmArch 70*
Serebriakoff, Alexandre 1907- *IlsCB 1744*
Serebriakova, Zinaida 1884-1967 *DcWomA*
Seredy, Kate *WhoAmA 73*
Seredy, Kate 1899?-1975 *IlsCB 1744*, *-1946*
Seregni, Vincenzo 1509?-1594 *MacEA*
Sereni, Paola Soria *WhoAmA 76*
Serff, Abraham 1791-1876 *FolkA 86*
Serge 1901- *ClaDrA*
Sergeant, Edgar 1878- *WhAmArt 85*
Sergeant, Tacie N *WhAmArt 85*
Sergel, Johan Tobias 1740-1814 *McGDA*, *OxArt*
Sergent, Lucien Pierre 1849-1904 *ClaDrA*
Sergent-Marceau, Marie Jeanne Louise F S *DcWomA*
Serger, Frederick B d1965 *WhoAmA 78N*, *-80N*, *-82N*, *-84N*
Serger, Frederick B 1889-1965 *WhAmArt 85*
Serger, Helen 1901- *WhoAmA 73*, *-76*, *-78*, *-80*, *-82*, *-84*
Sergio, Mario Joseph 1910- *AmArch 70*
Serisawa, Ikuo *WhoAmA 73*, *-76*, *-78*, *-80*, *-82*, *-84*
Serisawa, Sueo 1910- *DcCAA 71*, *-77*, *WhAmArt 85*, *WhoAmA 73*, *-76*, *-78*, *-80*, *-82*, *-84*
Serjeantson, Thomas *BiDBrA*

Serl, Jon 1894- *FolkA 86*
Serle, Dora 1875-1968 *DcWomA*
Serle, H *DcVicP 2*, *DcWomA*
Serlin, Arnold Frank 1939- *AmArch 70*
Serlio, Sebastiano 1475-1554 *DcD&D*, *McGDA*, *WhoArch*
Serlio, Sebastiano 1475-1555 *MacEA*
Serlio, Sebastiano 1475-1564 *OxArt*
Sermaise-Perillard, Louise 1880- *DcWomA*
Sermenzan, Elmine *DcWomA*
Sermezy, Clemence Sophie *DcWomA*
Sermoneta, Girolamo Da *McGDA*
Serniak, Regina *WhoAmA 78*, *-80*, *-82*, *-84*
Sernin Of Toulouse, Saint *McGDA*
Serodine, Giovanni 1594?-1631 *McGDA*
Seron, Levon 1905- *AmArch 70*
Seron, Stephanie *DcWomA*
Seroni, Marie *DcWomA*
Serota, Kip Warren 1934- *AmArch 70*
Seroux D'Agincourt, Jean 1730-1814 *McGDA*
Serov, Valentin *OxTwCA*
Serov, Valentin A 1865-1911 *McGDA*
Serpa, Ivan *OxTwCA*
Serpa, Ivan 1923- *McGDA*
Serpan, Iaroslav *WhoArt 80N*
Serpan, Jaroslav 1922- *PhDcTCA 77*
Serpell, Susan 1875-1913 *DcWomA*
Serpell, Susan Watkins 1875-1913 *WhAmArt 85*
Serpotta, Giacomo 1656-1732 *McGDA*
Serpotta, Giuseppe 1653-1719 *McGDA*
Serpotta, Procopio 1679-1755 *McGDA*
Serra, Angela d1814 *DcWomA*
Serra, Daniel 1914- *WhAmArt 85*
Serra, E M *AmArch 70*
Serra, Jaime *McGDA*
Serra, Jaime d1399? *OxArt*
Serra, Juan *McGDA*
Serra, Pedro d1409? *OxArt*
Serra, Pedro 1343?-1405? *McGDA*
Serra, Richard 1938- *DcCAA 77*
Serra, Richard 1939- *AmArt*, *BnEnAmA*, *ConArt 77*, *-83*, *DcAmArt*, *DcCAr 81*, *OxTwCA*, *PrintW 83*, *-85*, *WhoAmA 73*, *-76*, *-78*, *-80*, *-82*, *-84*
Serra, Rudy 1948- *WhoAmA 76*, *-78*, *-80*, *-82*, *-84*
Serra-Badue, Daniel 1914- *PrintW 83*, *-85*, *WhoAmA 73*, *-76*, *-78*, *-80*, *-82*, *-84*
Serra-Badue, Daniel F 1914- *WhoArt 80*, *-82*, *-84*
Serra Guell, Eudaldo 1911- *PhDcTCA 77*
Serrano, Juan *OxTwCA*
Serrano, Pablo 1910- *ConArt 77*, *-83*, *OxTwCA*, *PhDcTCA 77*
Serrano Y Bartolome, Joaquina *DcWomA*
Serrao, Luella Varney 1865- *WhAmArt 85*
Serrao, Luella Varney 1865-1935? *DcWomA*
Serrell, Henry P K *NewYHSD*
Serrell, Ottilie *WhAmArt 85*
Serres, Dominic 1722-1793 *BkIE*, *DcBrECP*, *DcBrWA*
Serres, Dominic, The Elder 1722-1793 *DcSeaP*
Serres, Dominic, The Younger 1761?-1804? *DcSeaP*
Serres, Dominic M *DcBrWA*
Serres, Dominic M 1761?- *DcBrECP*
Serres, John Thomas 1759-1825 *DcBrECP*, *DcBrWA*, *DcSeaP*
Serres, Olivia 1772-1834 *DcBrECP*, *DcWomA*
Serres, S *DcWomA*
Serret, Marie Ernestine *DcWomA*
Serrier 1929- *PrintW 85*
Serritelli, Giovani *DcSeaP*
Serrur, Henry Auguste Calixte Cesar 1794-1865 *ClaDrA*
Serrurier-Bovy, Gustave 1858-1910 *AntBDN A*, *MacEA*
Serruys, Yvonne 1874- *DcWomA*
Sert, J L *AmArch 70*
Sert, Jose Luis 1902- *EncMA*, *McGDA*
Sert, Josep Lluis 1902- *ConArch*, *MacEA*, *WhoArch*
Sert Y Badia, Jose Maria 1874-1945 *McGDA*
Sert Y Badia, Jose Maria 1876-1945 *PhDcTCA 77*
Serth, Arthur M Sertich 1898- *WhAmArt 85*
Serusier, Louis Paul Henri 1863-1927 *ClaDrA*
Serusier, Paul 1863-1927 *OxTwCA*, *PhDcTCA 77*
Serusier, Paul 1864-1927 *McGDA*
Servaes, Albert 1883- *McGDA*, *OxArt*
Servaes, Albert 1883-1966 *OxTwCA*, *PhDcTCA 77*
Servais, Raoul 1928- *WorECar*
Servandoni, Giovanni Niccolo 1695-1766 *BiDBrA*, *McGDA*
Servandoni, Giovanni Nicolano Geronimo 1695-1766 *MacEA*
Servandoni, Giovanni Nicolo 1695-1766 *WhoArch*
Servandoni, Jean-Nicolas 1695-1766 *OxArt*
Servandoni, Jean Nicolas 1695-1766 *OxDecA*
Servandoni, Niccolo 1695-1766 *DcBrECP*
Servant, J *DcBrECP*
Servello, Joe *IlsCB 1967*
Serven, Lydia Maria 1898- *DcWomA*
Serven, Lydis M *WhAmArt 85*
Server, J William 1882- *WhAmArt 85*
Service, Michael Joseph 1924- *AmArch 70*

Servieres, Eugenie Marguerite Honoree L 1786- *DcWomA*
Servin, Amedee Elie 1829-1885 *ClaDrA*
Servoisier, Zenobie Honorine 1821- *DcWomA*
Servolini, Luigi *WhoArt 84N*
Servolini, Luigi 1906- *WhoArt 80*, *-82*
Servranckx, Victor 1897- *McGDA*
Servranckx, Victor 1897-1965 *OxTwCA*, *PhDcTCA 77*
Serwazi, Albert B 1905- *WhAmArt 85*, *WhoAmA 76*, *-78*, *-80*, *-82*, *-84*
Serz, John 1810?- *NewYHSD*
Sesboue, Suzanne Marie 1894-1927 *DcWomA*
Seslar Zaloznik, Vera 1950- *DcCAr 81*
Sesma, Raymundo 1954- *PrintW 85*
Sessai *AntBDN L*
Sessford, Rosalie M *DcWomA*
Sesshu, Toyo 1420-1506 *McGDA*
Sessinghaus, E J *AmArch 70*
Sessions, Annamay 1855?-1947 *DcWomA*
Sessions, Annamay Orton 1855-1947 *WhAmArt 85*
Sessions, H A 1935- *AmArch 70*
Sessions, Irone Hancock *DcWomA*
Sessions, James Milton 1882-1962 *WhAmArt 85*
Sessler, Alfred d1963 *WhoAmA 78N*, *-80N*, *-82N*, *-84N*
Sessler, Alfred A 1909-1963 *WhAmArt 85*
Sessler, Stanley Sascha 1903- *WhoAmA 73*
Sessler, Stanley Sascha 1905- *WhAmArt 85*
Sesson 1504-1589? *McGDA*
Sesto, Cesare Da 1477-1523 *McGDA*
Setaro, J Arthur 1922- *AmArch 70*
Setch, Terry *DcCAr 81*
Setch, Terry 1936- *WhoArt 80*, *-82*, *-84*
Setchel, Elizabeth *DcVicP 2*
Setchel, Sarah 1803-1894 *DcBrWA*, *DcVicP 2*
Setchel, Sarah 1813?-1894 *DcVicP*
Setchell, Sarah 1813?-1894 *DcWomA*
Setchell, Stanley Stuart 1901- *AmArch 70*
Seth, Gertrude *DcWomA*
Seth, Laurel 1953- *WhoAmA 84*
Seth-Landis, Laurel 1953- *WhoAmA 80*, *-82*
Setliff, W Wade 1931- *AmArch 70*
Setlock, Stanley J 1939- *MarqDCG 84*
Seton, Charles C *DcVicP, -2*
Seton, Ernest Thompson 1860- *DcBrBI*
Seton, Ernest Thompson 1860-1946 *ArtsAmW 1*, *DcBrA 1*, *DcVicP 2*, *IlBEAAW*, *IlsCB 1744*, *WhAmArt 85*
Seton, John Thomas 1738?- *DcBrECP*
Seton, Katherine *DcWomA*
Seton-Tait, Adela *DcWomA*
Settani, Pino *DcCAr 81*
Settanni, Joseph Andrew 1954- *MarqDCG 84*
Settanni, Luigi 1908- *WhAmArt 85*
Settecase, P K *AmArch 70*
Settegast, Josef 1813- *ArtsNiC*
Settele, Theodora *WhAmArt 85*
Setterberg, Carl *WhAmArt 85*
Setterberg, Carl 1897- *ArtsAmW 3*
Setterberg, Carl Georg *WhoAmA 73*, *-76*, *-78*, *-80*
Setterberg, Carl Georg 1897- *WhoAmA 82*, *-84N*
Setterington, John *DcBrECP*
Setterington, Rosalie *DcWomA*
Settignano, Da *McGDA*
Settle, Alison *WorFshn*
Settle, William Frederick 1821-1897 *DcBrWA*, *DcSeaP*, *DcVicP 2*
Settlemyre, Julius Lee, Jr. 1916- *WhAmArt 85*
Setton, Toby *WorFshn*
Setty *NewYHSD*
Setzer, Jacob 1819-1892 *FolkA 86*
Seubert, Lester George 1919- *AmArch 70*
Seudtner, Alexander *FolkA 86*
Seuphor, Michel 1901- *ConArt 77*, *-83*, *OxTwCA*, *PhDcTCA 77*, *WhoArt 80*, *-82*, *-84*
Seurat, Georges 1859-1891 *McGDA*, *OxArt*, *PhDcTCA 77*
Seurat, Georges Pierre 1859-1891 *ClaDrA*
Seusenhofer, Hans 1470-1555 *OxDecA*
Seusenhofer, Jorg 1500?-1580 *OxDecA*
Seusenhofer, Konrad 1450?-1517 *OxDecA*
Seuss, Dr. *IlsCB 1967*, *WorECar*
Seuss, Dr. 1904- *IlsCB 1946*, *-1957*
Seuter, Bartholomaus 1678-1754 *AntBDN M*
Seuter, Bartolomaus 1678-1754 *IldcG*
Seuter, John *FolkA 86*
Seutter, Carl V 1867-1937? *BiDAmAr*
Seven, Group Of *OxArt*
Seven-Seven, Twins 1944?- *OxTwCA*
Seventy, Sylvia 1947- *DcCAr 81*
Sever, Jiri 1904-1968 *MacBEP*
Severance, Benjamin J *NewYHSD*
Severance, Clare M 1887-1955? *WhAmArt 85*
Severance, Clare M 1887-1956? *WhoAmA 85*
Severance, H Craig 1879-1941 *BiDAmAr*
Severance, John L 1863-1936 *WhAmArt 85*
Severance, Julia Gridley 1877- *ArtsAmW 3*, *DcWomA*, *WhAmArt 85*
Severence, Benjamin J *FolkA 86*
Severin, A A *WhAmArt 85*

Severin, Charles 1808?- *NewYHSD*
Severin, John Powers 1921- *WorECom*
Severin, Mark *WhoArt 80*
Severin, Mark 1906- *ClaDrA, IlsBYP, IlsCB 1946, WhoGrA 62*
Severin, Mark F 1906- *WhoGrA 82[port]*
Severin, Michael Louis 1931- *AmArch 70*
Severin, R W *AmArch 70*
Severinghaus, J Walter 1905- *AmArch 70*
Severini, Gino 1883-1966 *ClaDrA, ConArt 77, -83, McGDA, OxArt, OxTwCA, PhDcTCA 77*
Severino, D Alexander 1914- *WhoAmA 73*
Severino, Dominick Alexander 1914- *WhoAmA 76, -78, -80, -82*
Severino, Joseph Peter, Jr. 1927- *AmArch 70*
Severn, Ann Mary *DcVicP 2, DcWomA*
Severn, Ann Mary, Lady Newton 1832-1866 *DcBrWA*
Severn, Arthur 1842-1931 *ClaDrA, DcVicP*
Severn, Benjamin *DcBrECP*
Severn, Joseph 1793-1879 *DcBrWA, DcVicP, -2*
Severn, Joseph Arthur Palliser 1842-1931 *DcBrA 1, DcBrBI, DcBrWA, DcVicP 2*
Severn, Mary *DcVicP, -2*
Severn, Walker 1830-1904 *DcBrA 1*
Severn, Walter 1830-1904 *DcBrA 2, DcBrBI, DcBrWA, DcVicP, -2*
Severns, John Edward 1926- *AmArch 70*
Severo, Joseph P 1944- *MarqDCG 84*
Severson, Douglas G 1951- *MacBEP*
Severson, William Conrad 1924- *WhoAmA 82, -84*
Severud, Gordon M 1909- *AmArch 70*
Severus And Celer *MacEA*
Severyn, Charles 1808?- *NewYHSD*
Sevic, William 1898- *AmArch 70*
Sevigny, Maurice Joseph, II 1943- *WhoAmA 80, -82, -84*
Sevilla, Jack 1931- *AmArch 70*
Seville, F N *AntBDN O*
Sevrin, Jeanne *DcWomA*
Sevy, Barbara Snetsinger 1926- *WhoAmA 78, -80, -82, -84*
Sewall, Alice *DcWomA*
Sewall, Alice Archer *WhAmArt 85*
Sewall, Blanche Harding 1889- *ArtsAmW 2, DcWomA, WhAmArt 85*
Sewall, Harriet *FolkA 86*
Sewall, Harriot *DcWomA*
Sewall, Howard S 1899- *WhAmArt 85*
Sewall, Howard Stoyell 1899- *ArtsAmW 2*
Sewall, Marcia Osgood 1935- *IlsCB 1967*
Seward *FolkA 86*
Seward, Coy Avon 1884-1939 *ArtsAmW 1, IlBEAAW, WhAmArt 85*
Seward, Edith Jessie *DcWomA*
Seward, Edwin *DcVicP 2*
Seward, Edwin 1853-1924 *DcBrA 1*
Seward, Mrs. Edwin *DcVicP 2*
Seward, Henry Hake 1778?-1848 *BiDBrA*
Seward, James 1832?- *NewYHSD*
Seward, Prudence *IlsBYP*
Seward, Prudence Eaton 1926- *DcBrA 1, IlsCB 1967, WhoArt 80, -82*
Seward, William *FolkA 86*
Sewards, Michele Bourque 1944- *WhoAmA 76, -78, -80*
Sewell, Alice *WhAmArt 85*
Sewell, Amos 1901- *IlBEAAW, IlrAm E, WhAmArt 85*
Sewell, Amos 1901-1983 *IlrAm 1880*
Sewell, Annie L *DcWomA*
Sewell, Darrel L 1939- *WhoAmA 84*
Sewell, Edith G *DcWomA, WhAmArt 85*
Sewell, Ellen Mary 1813-1905 *DcBrBI, DcBrWA*
Sewell, Eugene Michon 1933- *AmArch 70*
Sewell, G H *DcVicP 2*
Sewell, H *NewYHSD*
Sewell, Harriet *NewYHSD*
Sewell, Harriot *DcWomA*
Sewell, Helen *AfroAA*
Sewell, Helen Moore 1896-1957 *ConICB, DcWomA, IlsCB 1744, -1946, WhAmArt 85*
Sewell, Helen Moore 1897-1957 *WhoAmA 80N, -82N, -84N*
Sewell, Jack Vincent 1923- *WhoAmA 73, -76, -78, -80, -82, -84*
Sewell, John 1926- *WhoGrA 62*
Sewell, Lydia Amanda Brewster 1859-1926 *DcWomA, WhAmArt 85*
Sewell, M M *DcWomA, WhAmArt 85*
Sewell, Richard George 1942- *WhoAmA 84*
Sewell, Robert V V 1860-1924 *WhAmArt 85*
Sewter, Albert Charles 1912- *WhoArt 80, -82, -84*
Sexauer, Donald Richard *WhoAmA 73, -76, -78, -80, -82*
Sextie, William A *DcVicP 2*
Sexton, E S 1880-1948 *WhAmArt 85*
Sexton, Emily Stryker d1948 *WhoAmA 78N, -80N, -82N, -84N*
Sexton, Emily Stryker 1880-1948 *DcWomA*
Sexton, Frederick Lester 1889- *ArtsAmW 2, WhAmArt 85*

Sexton, John 1953- *ICPEnP A, MacBEP, WhoAmA 82, -84*
Sexton, Leo Lloyd 1912- *WhAmArt 85*
Sexton, Leo Lloyd, Jr. 1912- *WhoAmA 73*
Sexton, Robert Ellis 1927- *AmArch 70*
Sexton, Samuel H *NewYHSD*
Sexton, William *NewYHSD*
Seybert, Abraham *FolkA 86*
Seybold, Carl F *FolkA 86*
Seybold, Henry *NewYHSD*
Seyd, Eileen *ClaDrA, WhoArt 80, -82, -84*
Seyd, Eileen 1907- *DcBrA 1*
Seyda, Maria 1900- *DcBrA 1*
Seydel, Victor L A *WhAmArt 85*
Seydelmann, Apollonie 1767?-1840 *DcWomA*
Seydl, Zdenek 1916- *WhoGrA 62*
Seyfang, Robert Frederick 1936- *AmArch 70*
Seyfer, Hans d1509 *McGDA*
Seyfer, William H *EncASM*
Seyfert, Richard Leopold 1915-1979 *WhoAmA 84N*
Seyfert, Theodore H *WhAmArt 85*
Seyffarth, Agnes *DcBrWA, DcWomA*
Seyffarth, Louisa *DcBrWA, DcVicP, -2, DcWomA*
Seyffer, Kent D 1936- *AmArch 70*
Seyffert, Helen *DcWomA*
Seyffert, Helen F *WhAmArt 85*
Seyffert, Leopold 1887-1956 *ArtsAmW 1, WhAmArt 85*
Seyffert, Richard Leopold 1915- *WhoAmA 76, -78, -80*
Seyffert, Richard Leopold 1915-1979 *WhoAmA 82N*
Seyfort, Aimee 1905- *WhAmArt 85*
Seyfried, John Louis 1930- *WhoAmA 73, -76, -78*
Seyfried, Wilhelmine 1785-1847 *DcWomA*
Seyle, Robert Harley 1937- *WhoAmA 76, -78, -80, -82, -84*
Seyler, David W *WhoAmA 73, -76, -78, -80, -82, -84*
Seyler, David Warren 1917- *WhAmArt 85*
Seyler, Julius *WhAmArt 85*
Seymour *FolkA 86*
Seymour, Mrs. *DcVicP, -2*
Seymour, Catryna TenEyck *WhoAmA 73, -78, -80*
Seymour, Celia Burnham 1869?- *DcWomA*
Seymour, Celia Burnham 1869-1958 *ArtsAmW 3*
Seymour, Cella B 1872- *WhAmArt 85*
Seymour, Charles, Jr. 1912- *WhoAmA 73, -76*
Seymour, Charles, Jr. 1912-1977 *WhoAmA 78N, -80N, -82N, -84N*
Seymour, David *ConPhot*
Seymour, David 1911-1956 *ICPEnP, MacBEP*
Seymour, E G *EncASM*
Seymour, Edward d1757 *DcBrECP*
Seymour, Emily Anne *DcWomA*
Seymour, G E *DcWomA*
Seymour, George L *DcBrBI, DcVicP 2*
Seymour, George R *FolkA 86*
Seymour, H S *AmArch 70*
Seymour, Handley, Madame *WorFshn*
Seymour, Hariette Anne 1830- *DcBrWA*
Seymour, Harriette Anne 1830- *DcVicP 2, DcWomA*
Seymour, Henry T *WhAmArt 85*
Seymour, Isabelle D *WhAmArt 85*
Seymour, Israel *FolkA 86*
Seymour, J O *NewYHSD*
Seymour, J Sidney *DcVicP 2*
Seymour, James 1702?-1752 *DcBrECP*
Seymour, Jane Fortescue *DcWomA*
Seymour, John *AntBDN G, BnEnAmA, CabMA, FolkA 86, OxDecA*
Seymour, John 1738-1818 *DcD&D*
Seymour, John B *NewYHSD*
Seymour, John F *NewYHSD*
Seymour, Joseph *EncASM*
Seymour, Joseph 1815- *EncASM*
Seymour, Joseph H *EarABI SUP, NewYHSD*
Seymour, Kate *DcBrWA, DcWomA*
Seymour, Kenneth R 1953- *MarqDCG 84*
Seymour, Major *FolkA 86*
Seymour, Nathaniel *FolkA 86*
Seymour, Oliver D *EncASM*
Seymour, Orson H *FolkA 86*
Seymour, Prentiss M 1938- *AmArch 70*
Seymour, Rachel 1937- *WhoAmA 78, -80, -82*
Seymour, Ralph Fletcher 1876- *WhAmArt 85*
Seymour, Ralph Fletcher 1876-1966 *ArtsAmW 2*
Seymour, Ralph Russell *WhAmArt 85*
Seymour, Robert 1798-1836 *DcBrBI*
Seymour, Robert George 1836-1885 *DcBrWA*
Seymour, Russell 1897- *AmArch 70*
Seymour, Samuel *FolkA 86*
Seymour, Samuel 1775?- *IlBEAAW, NewYHSD*
Seymour, Samuel 1797-1823 *ArtsAmW 1*
Seymour, T D *DcVicP 2*
Seymour, Thomas *CabMA, OxDecA*
Seymour, Thomas 1771-1848 *BnEnAmA*
Seymour, Walter *DcVicP 2*
Seymour, Walter J *FolkA 86*
Seymour And Hollister *EncASM*
Seymour-Damer, Anne *DcWomA*
Seyms, Katherine *WhAmArt 85*
Seynour, Jean Parrish *WhoAmA 82*

Seyppel, Ferdinand *NewYHSD*
Seyranian, A R *AmArch 70*
Seyssaud, Rene 1867-1952 *ClaDrA*
Seyter, Vittoria *DcWomA*
Sezauer, Donald Richard *WhoAmA 84*
Sfarti, Adrian 1951- *MarqDCG 84*
Sferrino, Vincent John 1930- *MarqDCG 84*
Sforza, Francesco *OxArt*
Sforza, Lodovico *OxArt*
Sgouros, Thomas 1927- *IlrAm 1880*
Sgrilli, Roberto 1899- *WorECar*
Sgro, A J *AmArch 70*
Sha, Fei d1950 *ICPEnP A*
Shackelford, Bud 1918- *WhoAmA 82, -84*
Shackelford, John Edward 1926- *AmArch 70*
Shackelford, Katharine Buzzell *WhAmArt 85*
Shackelford, Shelby 1899- *WhAmArt 85, WhoAmA 73, -76, -78, -80, -82, -84*
Shackelton, William 1872-1933 *DcBrA 1*
Shackelford, W S *NewYHSD*
Shackleton, Charles d1920 *WhAmArt 85*
Shackleton, Edwin Rockingham, Jr. *AmArch 70*
Shackleton, John d1767 *DcBrECP*
Shackleton, Keith *OfPGCP 86*
Shackleton, Keith 1923- *DcSeaP*
Shackleton, Keith Hope 1923- *ClaDrA, DcBrA 2, WhoArt 80, -82, -84*
Shackleton, William 1872-1933 *DcBrBI, DcBrWA, DcVicP, -2*
Shacknove, Reta *WhoAmA 73, -76*
Shacter, Burton Barry 1937- *AmArch 70*
Shadbolt, Jack *OxTwCA*
Shadbolt, Jack 1909- *PhDcTCA 77*
Shadbolt, Jack Leonard 1909- *ConArt 77, DcCAr 81, IlBEAAW, McGDA, WhoAmA 73, -76, -78, -80, -82, -84*
Shaddle, Alice 1928- *WhoAmA 78, -80, -82, -84*
Shade, J *FolkA 86*
Shade, James William Ball 1926- *AmArch 70*
Shade, P *FolkA 86*
Shade, Willoughby 1820- *FolkA 86*
Shadid, Henry Norman 1924- *AmArch 70*
Shadrach, Jean H *WhoAmA 73, -76, -78, -80, -82, -84*
Shadrach, Jean H 1926- *AmArt*
Shaefer, William G *WhAmArt 85*
Shafer, Burr d1965 *WhoAmA 78N, -80N, -82N, -84N*
Shafer, Claude 1878- *WhAmArt 85*
Shafer, Ella M *ArtsEM, DcWomA*
Shafer, G Edward 1937- *AmArch 70*
Shafer, J *FolkA 86*
Shafer, L A 1866-1940 *WhAmArt 85*
Shafer, Marguerite *DcWomA*
Shafer, Marguerite Neuhauser 1888-1976 *WhoAmA 78N, -80N, -82N, -84N*
Shafer, Orie Thomas 1951- *DcCAr 81*
Shafer, Samuel C *FolkA 86, NewYHSD*
Shafer, Simon P *ArtsEM*
Shaffer *NewYHSD*
Shaffer, Carl 1904- *WhAmArt 85*
Shaffer, Donald Lee 1936- *AmArch 70*
Shaffer, Donald Martin 1935- *AmArch 70*
Shaffer, Elmer 1929- *AmArch 70*
Shaffer, Henry *NewYHSD*
Shaffer, Herbert Roger 1926- *AmArch 70*
Shaffer, J Robert 1915- *AmArch 70*
Shaffer, John *NewYHSD*
Shaffer, Lucy K 1885- *DcWomA, WhAmArt 85*
Shaffer, Milton Z 1925- *AmArch 70*
Shaffer, Richard 1947- *PrintW 83, -85, WhoAmA 82, -84*
Shaffer, Richard Forrest 1947- *WhoAmA 80*
Shaffner, Jacob *FolkA 86*
Shaffran, Jascha 1891-1955? *WhAmArt 85*
Shafran, Joan Karen 1947- *MarqDCG 84*
Shafteberg, Lewis *NewYHSD*
Shaftel, Stanley Jerome 1924- *AmArch 70*
Shagarn, Mrs. Robert *WhAmArt 85*
Shagin, Ivan 1904- *ICPEnP A*
Shah, Govind 1950- *MarqDCG 84*
Shah, Kiran K 1953- *MarqDCG 84*
Shah, Lalit C 1940- *MarqDCG 84*
Shah, Nirmal M 1949- *MarqDCG 84*
Shah, Vijay A 1953- *MarqDCG 84*
Shah, Vikram R *MarqDCG 84*
Shahly, Jehan 1928- *WhoAmA 76, -78, -80, -82, -84*
Shahn, Ben d1969 *IlsCB 1967*
Shahn, Ben 1898-1969 *BnEnAmA, ConArt 77, -83, ConPhot, DcAmArt, DcCAA 77, ICPEnP A, IlsCB 1957, MacBEP, McGDA, OxArt, OxTwCA, PhDcTCA 77, PrintW 83, -85, WhAmArt 85, WhoAmA 73, -76, -80N, -82N, -84N, WhoGrA 62, WorArt[port]*
Shaikhet, Arkadi 1898-1959 *ICPEnP A*
Shaikhet, Arkadii 1898-1959 *ConPhot*
Shain, Kenneth Stephen 1952- *MarqDCG 84*
Shainess, Clara 1898- *DcWomA, WhAmArt 85*
Shakespear, Dorothy 1886- *DcBrA 1*
Shakespear, Dorothy 1886-1973 *DcWomA*
Shakespear, George *BiDBrA*

Shakespear, Raul 1947- *ConDes, WhoGrA 82[port]*
Shakespear, Ronald 1941- *ConDes, WhoGrA 82[port]*
Shakespeare, Marjorie Kathleen 1899- *DcBrA 1, DcWomA*
Shaknis, Alfred Charles 1908- *AmArch 70*
Shalat, Herbert 1924- *AmArch 70*
Shalders, George 1825-1873 *ArtsNiC*
Shalders, George 1826-1873 *ClaDrA, DcBrWA, DcVicP, -2*
Shaler, Frederick 1880-1916 *WhAmArt 85*
Shalit, Mitzi 1923- *WhoAmA 78, -80, -82, -84*
Shalk, Jacob *FolkA 86*
Shalk, Jacob d1864 *FolkA 86*
Shalk, John *FolkA 86*
Shalkop, Robert Leroy 1922- *WhoAmA 76, -78, -80, -82, -84*
Shallenberger, Martin C 1912- *WhAmArt 85*
Shallenberger, Peter *FolkA 86*
Shallus, Francis 1774-1821 *NewYHSD*
Shalom VonSafed 1885?- *OxTwCA*
Shaman, Sanford Sivitz 1946- *WhoAmA 78, -80, -82, -84*
Shamask, Ronaldus 1945- *ConDes*
Shambaugh, Bertha M Horack 1871-1953 *DcWomA*
Shamblin, Barbara 1951- *MacBEP*
Shamey, Michael 1931- *AmArch 70*
Shamp, D *FolkA 86*
Shamrock, J A *AmArch 70*
Shanagher, D J *AmArch 70*
Shanahan, Ray P 1892-1935 *WhAmArt 85*
Shanayda, M *AmArch 70*
Shand, Christine R *DcVicP 2*
Shand, Helen *WhAmArt 85*
Shands, Anne T *DcWomA, WhAmArt 85*
Shands, Franklin McKenzie *AfroAA*
Shane, Francis Allison 1933- *AmArch 70*
Shane, Frederick E 1906- *WhoAmA 73, -76, -78, -80, -82, -84*
Shane, Frederick Emanuel 1906- *WhAmArt 85*
Shane, Herbert Thomas 1921- *AmArch 70*
Shane, James Barry 1932- *AmArch 70*
Shane, Mildred Dora 1898- *WhAmArt 85*
Shane, Rose M *DcWomA, WhAmArt 85*
Shane, W H, Jr. *AmArch 70*
Shaner, David 1934- *CenC[port], WhoAmA 80, -82, -84*
Shanes, Helen Berry *WhAmArt 85*
Shanfield, Zelda *DcWomA, WhAmArt 85*
Shangraw, Clarence Frank 1935- *WhoAmA 76, -78, -80, -82, -84*
Shangraw, Sylvia Chen 1937- *WhoAmA 76, -78, -80N, -82N, -84N*
Shanika, Leo *OfPGCP 86*
Shank, H *FolkA 86*
Shank, Isadore 1902- *AmArch 70*
Shank, M *FolkA 86*
Shank, Rosella *DcWomA*
Shank, W *FolkA 86*
Shank, William *FolkA 86*
Shanks *NewYHSD*
Shanks, Bruce McKinley 1908- *WhoAmA 73, -76, -78, -80, WorECar*
Shanks, C A *AmArch 70*
Shanks, Emiliia Yakovlevna 1857-1900? *DcWomA*
Shanks, Maria Gore 1875- *DcWomA*
Shanks, Maria Xakovlevna 1866-1900? *DcWomA*
Shanks, Robert Patterson 1938- *AmArch 70*
Shanks, William Somerville 1864-1951 *DcBrA 1, DcVicP 2*
Shanley, B M, Jr. *EncASM*
Shanley, F B *AmArch 70*
Shannan, A McF d1915 *DcBrA 1*
Shannon, Aileen Phillips 1888- *ArtsAmW 2, DcWomA, WhAmArt 85*
Shannon, Charles 1863-1937 *PhDcTCA 77*
Shannon, Charles 1914- *WhoAmA 84*
Shannon, Charles Eugene 1914- *WhAmArt 85*
Shannon, Charles Haslewood 1863-1937 *DcBrA 1, DcVicP, -2, McGDA*
Shannon, Charles Haslewood 1865-1937 *ClaDrA*
Shannon, Charles Hazelwood 1863-1937 *DcBrBI, DcBrWA, OxArt*
Shannon, Charles Hazlewood 1863-1937 *OxTwCA*
Shannon, G L *AmArch 70*
Shannon, George W *FolkA 86*
Shannon, Howard Johnson 1876- *WhAmArt 85*
Shannon, J B *AmArch 70*
Shannon, J J 1862-1923 *WhAmArt 85*
Shannon, Sir James Jebusa 1862-1923 *DcBrA 1, DcVicP, -2*
Shannon, Joseph *WhoAmA 73, -76*
Shannon, Lorene Lamar 1933- *AmArch 70*
Shannon, Martha A *WhAmArt 85*
Shannon, Martha A 1842- *DcWomA*
Shannon, Patric 1920- *WhoAmA 73*
Shannon, R H *AmArch 70*
Shannon, Robert McDonald 1917- *AmArch 70*
Shannon, W *NewYHSD*
Shannon, Mrs. William *WhAmArt 85*
Shannon, William Ray, Jr. 1922- *AmArch 70*

Shannonhouse, Sandra Lynne 1947- *WhoAmA 78*
Shannonhouse, Sandra Lynne Riddell 1947- *WhoAmA 80, -82, -84*
Shany, Ronit 1950- *MacBEP*
Shao, Po Hu 1920- *AmArch 70*
Shapero, Esther Geller *WhoAmA 78, -80, -82, -84*
Shapiro, A M *AmArch 70*
Shapiro, Abraham 1926- *AmArch 70*
Shapiro, Adrian Michael 1950- *WhoAmA 84*
Shapiro, B *AmArch 70*
Shapiro, Babe 1937- *WhoAmA 73, -76, -78, -80, -82, -84*
Shapiro, Benjamin 1898- *AmArch 70*
Shapiro, Daisy Viertel 1892- *WhoAmA 73, -76, -78, -80, -82, -84*
Shapiro, Daniel 1920- *WhAmArt 85*
Shapiro, David 1916- *AmArt, WhoAmA 76, -78, -80, -82, -84*
Shapiro, David 1944- *AmArt, PrintW 83, -85, WhoAmA 73, -76, -78, -80, -82, -84*
Shapiro, Dee *AmArt*
Shapiro, Dee 1936- *PrintW 85, WhoAmA 82, -84*
Shapiro, Frank D 1914- *WhAmArt 85, WhoAmA 78, -80, -82*
Shapiro, I D *AmArch 70*
Shapiro, Irving 1927- *WhoAmA 73, -76, -78, -80, -82, -84*
Shapiro, J *AmArch 70*
Shapiro, Janice 1908- *WhAmArt 85*
Shapiro, Joel 1941- *ConArt 77, -83, DcCAr 81, PrintW 83, -85, WhoAmA 73, -76, -78, -80, -82, -84*
Shapiro, Joel Elias 1941- *AmArt*
Shapiro, Lili 1896- *WhAmArt 85*
Shapiro, Pauline 1920-1972 *FolkA 86*
Shapiro-Lieb, Vered *WhoAmA 78, -80*
Shapland, Mrs. A F Terrell *DcVicP 2*
Shapland, Ellen *DcWomA*
Shapland, John d1929 *DcBrA 1, DcVicP 2*
Shapleigh, A F *EncASM*
Shapleigh, F H 1842- *ArtsNiC*
Shapleigh, Frank Henry 1842-1906 *ArtsAmW 1, IlBEAAW, WhAmArt 85*
Shapley, *FolkA 86*
Shapley, A Foster *DcBrA 1, DcWomA*
Shapley, Fern Rusk 1890- *WhoAmA 73, -76, -78, -80, -82*
Shapley, John *WhoAmA 73, -76*
Shapley, John 1890- *WhoAmA 78*
Shapley, John 1890-1969 *WhoAmA 84N*
Shapley, John 1890-1978 *WhoAmA 80N, -82N*
Shappley, A, Jr. *AmArch 70*
Shapps, Harvey Roy 1937- *AmArch 70*
Shapshak, Rene *WhoAmA 73, -76, -78, -80, -82, -84*
Shapshak, Rene 1899- *WhoAmA 80, -82, -84*
Sharadin, Henry William 1872- *WhAmArt 85*
Sharady, H M *WhAmArt 85*
Sharaff, Irene 1910- *ConDes*
Sharaku *McGDA*
Sharaku d1801 *OxArt*
Shard, J C *AmArch 70*
Share, Henry Pruett 1853-1905 *WhAmArt 85*
Sharer, William E *IlBEAAW*
Sharf, Frederic Alan 1934- *WhoAmA 78, -80, -82*
Sharfman, N 1947- *MarqDCG 84*
Sharir, David 1938- *PrintW 83, -85*
Sharits, Paul Jeffrey 1943- *WhoAmA 76, -78, -80, -82, -84*
Shark, Herman R 1946- *WhoAmA 78, -80, -82*
Sharland, E W *DcBrA 2*
Sharland, L A *DcVicP 2*
Sharma, Lakshmipati *MarqDCG 84*
Sharman, Florence M 1876- *WhAmArt 85*
Sharman, Grace Evelyn *DcWomA*
Sharman, John *BiDBrA, WhAmArt 85*
Sharon, Arieh *ConArch A*
Sharon, Arieh 1902- *ConArch*
Sharon, Aryeh 1900- *WhoArch*
Sharon, Aryeh 1902- *MacEA*
Sharon, David *MarqDCG 84*
Sharon, Dov 1954- *MarqDCG 84*
Sharon, Mary B 1891-1961 *WhoAmA 80N, -82N, -84N*
Sharon, Mary Bruce 1877?-1961 *DcWomA*
Sharova, Alexandra Alexandrovna *DcWomA*
Sharp, Miss *DcVicP 2*
Sharp, Mister *NewYHSD*
Sharp, A C, Jr. *AmArch 70*
Sharp, Mrs. A E *WhAmArt 85*
Sharp, Anne 1943- *AmArt, PrintW 85, WhoAmA 78, -80, -82, -84*
Sharp, Arnold Haigh 1891- *DcBrA 1*
Sharp, Arthur William 1902- *DcVicP 2*
Sharp, Bennis *WhAmArt 85*
Sharp, C B *AmArch 70*
Sharp, Charles *FolkA 86*
Sharp, Dale O 1956- *MarqDCG 84*
Sharp, Dennis *ConArch A*
Sharp, Dorothea 1874-1955 *DcBrA 1, DcVicP 2, DcWomA*
Sharp, Edward *DcVicP 2*

Sharp, Edwin V *NewYHSD*
Sharp, Eliza Mary 1829- *DcWomA, NewYHSD*
Sharp, George B *EncASM*
Sharp, George Henry 1834- *NewYHSD*
Sharp, Harold 1919- *WhoAmA 73, -76, -78, -80, -82, -84*
Sharp, Harris Perry 1919- *AmArch 70*
Sharp, Hill 1907- *WhAmArt 85*
Sharp, J Stanley 1914- *AmArch 70*
Sharp, James *NewYHSD*
Sharp, James Clement 1818-1897 *NewYHSD*
Sharp, John O Robert *WhAmArt 85*
Sharp, Joseph H 1859-1953 *WhAmArt 85*
Sharp, Joseph Henry 1859-1934 *ClaDrA*
Sharp, Joseph Henry 1859-1953 *ArtsAmW 1, IlBEAAW*
Sharp, L R 1865- *WhAmArt 85*
Sharp, Lewis Inman 1941- *WhoAmA 82, -84*
Sharp, Louis Hovey 1875-1946 *ArtsAmW 2, IlBEAAW, WhAmArt 85*
Sharp, M A *DcVicP 2*
Sharp, M S *AmArch 70*
Sharp, Marion Leale *WhAmArt 85, WhoAmA 73, -76*
Sharp, Marion Leale 1875?-1979 *DcWomA*
Sharp, Martin 1942- *DcCAr 81*
Sharp, Michael William d1804 *DcBrWA*
Sharp, Miles *WhoArt 82N*
Sharp, Miles 1897- *ClaDrA, WhoArt 80*
Sharp, Miles Balmford 1897- *DcBrA 1*
Sharp, Minnie Lee *WhAmArt 85*
Sharp, Philip Thomas 1831- *NewYHSD*
Sharp, Richard Giles 1920- *AmArch 70*
Sharp, Richard Hey 1793?-1853 *BiDBrA*
Sharp, Robert *AntBDN Q*
Sharp, Robert James 1948- *MarqDCG 84*
Sharp, Robert John 1913- *AmArch 70*
Sharp, Samuel 1808-1874 *BiDBrA*
Sharp, Theodora *WhAmArt 85*
Sharp, Vincent 1937- *ICPEnP A*
Sharp, William *EncASM*
Sharp, William 1749-1824 *McGDA*
Sharp, William 1800?-1900 *ArtsAmW 2*
Sharp, William 1802?- *NewYHSD*
Sharp, William 1900- *IlsBYP, IlsCB 1744, -1946*
Sharp, William 1900-1961 *WhAmArt 85, WhoAmA 80N, -82N, -84N*
Sharp, William 1900-1965 *McGDA*
Sharp, William A 1864-1944 *ArtsAmW 2*
Sharp, William Alexander 1864-1944 *WhAmArt 85*
Sharp, William Comely 1822-1897 *NewYHSD*
Sharp, Willoughby 1936- *WhoAmA 76, -78, -80, -82, -84*
Sharpe, Blair 1954- *WhoAmA 82, -84*
Sharpe, C N *FolkA 86*
Sharpe, Caroline *DcWomA, IlsBYP*
Sharpe, Charles *DcBrWA*
Sharpe, Charles Kirkpatrick 1781-1851 *DcBrBI, DcBrWA*
Sharpe, Charles W d1876? *NewYHSD*
Sharpe, Charles William d1955 *DcBrA 1*
Sharpe, Charlotte d1849 *DcVicP 2, DcWomA*
Sharpe, Charlotte 1794?-1849 *DcBrWA*
Sharpe, Cornelius N d1828 *NewYHSD*
Sharpe, David Flemming 1944- *PrintW 83, -85, WhoAmA 78, -80, -82, -84*
Sharpe, Donald George 1936- *AmArch 70*
Sharpe, E *DcVicP 2*
Sharpe, E A *DcVicP 2*
Sharpe, Edmund 1809-1877 *DcVicP 2*
Sharpe, Eliza 1795?-1874 *DcBrWA, DcVicP 2, DcWomA*
Sharpe, F *DcVicP 2*
Sharpe, Frank 1942- *AfroAA*
Sharpe, G W *DcVicP 2*
Sharpe, H Percy *WhAmArt 85*
Sharpe, J B *DcVicP 2*
Sharpe, J C *DcVicP 2*
Sharpe, J F *DcBrWA, DcVicP 2*
Sharpe, Jim 1936- *IlrAm 1880*
Sharpe, John *DcBrWA*
Sharpe, Julia Graydon d1938? *DcWomA, WhAmArt 85*
Sharpe, Louisa 1798-1843 *DcBrWA, DcVicP 2, DcWomA*
Sharpe, Mary *DcVicP 2*
Sharpe, Mary Anne 1802-1867 *DcBrWA, DcVicP 2, DcWomA*
Sharpe, Mathilde 1830-1915 *DcWomA*
Sharpe, Matthew E 1902- *WhAmArt 85*
Sharpe, Richard 1930- *AmArch 70*
Sharpe, Ron 1943- *MarqDCG 84*
Sharpe, Thomas *DcNiCA*
Sharpe, William *DcVicP 2*
Sharpe Family *DcVicP, -2*
Sharpin, Eleanor Annie *DcWomA*
Sharpland, Mrs. A F Terrell *DcVicP 2*
Sharpland, Ellen *DcWomA*
Sharples, Elen T *FolkA 86*
Sharples, Ellen 1769-1849 *DcWomA*

Shechtman, George Henoch 1941- *WhoAmA* 78, –80, –82, –84
Sheckell, T O *ArtsAmW* 2, *WhAmArt* 85
Sheckell, Thomas O 1884-1943 *MacBEP*
Sheckels, Glenn d1939 *ArtsAmW* 3
Shecker, Herman *NewYHSD*
Shecter, Ben *IlsCB* 1967
Shecter, Ben 1935- *IlsCB* 1957
Shecter, Mark 1943- *WhoAmA* 78, –80, –82, –84
Shecter, Pearl S 1910- *WhoAmA* 73, –76, –78, –80, –82, –84
Shed, Charles D 1818-1893 *ArtsAmW* 1
Shedletsky, Stuart 1944- *PrintW* 83, –85
Shedwick, John *NewYHSD*
Shedy, Roy T d1931 *WhAmArt* 85
Shee, Sir Martin Archer 1769-1850 *DcBrECP[port]*, *OxArt*
Shee, Sir Martin Archer- 1769-1850 *DcVicP* 2
Shee, Peter d1767 *DcBrECP*
Sheehan, A F *AmArch* 70
Sheehan, Charles A *DcVicP* 2
Sheehan, Evelyn 1919- *WhoAmA* 76, –78, –80, –82, –84
Sheehan, Paul Brenden 1925- *AmArch* 70
Sheehe, Lillian Carolyn 1915- *AmArt*, *WhoAmA* 73, –76, –78, –80, –82, –84
Sheehy, Frank Thomas 1931- *AmArch* 70
Sheehy, Patrick Evan 1940- *AmArch* 70
Sheeler, Charles 1883-1965 *ArtsAmW* 2, *BnEnAmA*, *ConPhot*, *DcAmArt*, *DcCAA* 71, –77, *GrAmP*, *ICPEnP*, *MacBEP*, *McGDA*, *WhAmArt* 85, *WhoAmA* 78N, –80N, –82N, –84N
Sheeler, Charles R 1883-1965 *ConArt* 77, –83, *OxTwCA*
Sheeler, Charles R, Jr. 1883-1965 *PhDcTCA* 77
Sheels *DcBrECP*
Sheerer, Mary G *WhAmArt* 85
Sheerer, Mary Given 1865-1954 *CenC*, *DcWomA*
Sheeres, C W *DcBrBI*
Sheerin, Jerry 1933- *WhoAmA* 82, –84
Sheers, William *DcBrECP*
Sheet, E Allan 1898-1948 *BiDAmAr*
Sheets, Cree *WhAmArt* 85
Sheets, Frank M *FolkA* 86
Sheets, John *NewYHSD*
Sheets, Joseph Brian 1951- *MarqDCG* 84
Sheets, Millard 1907- *DcCAA* 71, –77
Sheets, Millard Owen 1907- *AmArt*, *IlBEAAW*, *McGDA*, *WhAmArt* 85, *WhoAmA* 73, –76, –78, –80, –82, –84
Sheets, Nan 1885-1976 *ArtsAmW* 3
Sheets, Nan 1889- *ArtsAmW* 1, *WhAmArt* 85
Sheets, Nan Jane *WhoAmA* 73, –76
Sheets, Nan Jane 1885?- *DcWomA*, *IlBEAAW*
Sheets, Raymond *EncASM*
Sheets, William C 1872-1945 *BiDAmAr*
Sheets, Willie A *WhAmArt* 85
Sheetz, Francis Bond, Jr. 1920- *AmArch* 70
Shefchik, Thomas Joseph, Jr. 1920- *AmArch* 70
Shefelman, T W *AmArch* 70
Sheffer, Glen C d1948 *WhoAmA* 78N, –80N
Sheffer, Glen C 1881-1948 *WhAmArt* 85
Sheffer, Glenn C d1948 *WhoAmA* 82N, –84N
Sheffer, LaFayette Miles 1925- *AmArch* 70
Sheffers, Peter Winthrop d1949 *WhoAmA* 78N, –80N, –82N, –84N
Sheffers, Peter Winthrop 1893-1949 *ArtsAmW* 2, *WhAmArt* 85
Sheffield, David Gareth 1933- *AmArch* 70
Sheffield, Elizabeth 1770?- *FolkA* 86
Sheffield, George 1839-1892 *DcBrWA*, *DcVicP* 2
Sheffield, Gloria Angela 1879- *DcWomA*, *WhAmArt* 85
Sheffield, Isaac 1798-1845 *BnEnAmA*, *DcAmArt*, *FolkA* 86, *NewYHSD*
Sheffield, Margaret A *DcVicP* 2, *DcWomA*
Sheffield, Mary *DcWomA*
Sheffield, Mary J *DcVicP* 2
Sheffield, T Percy *DcVicP* 2
Sheffler, Isreal 1826?- *FolkA* 86
Shegogue, Alfred M *NewYHSD*
Shegogue, James Hamilton 1806-1872 *NewYHSD*
Sheil, Edward 1834-1869 *DcBrBI*, *DcVicP* 2
Shein, Joseph 1937- *AmArch* 70
Sheinfeld, L L *AmArch* 70
Sheingate, Bertram P 1946- *MarqDCG* 84
Sheinman, Susan 1944- *WorFshn*
Sheinwald, B S *AmArch* 70
Sheirr, Olga 1931- *WhoAmA* 84
Shekerjian, Haig *IlsBYP*
Shekerjian, Regina *IlsBYP*
Shekhtel, Fedor 1859-1926 *MacEA*
Shelby, Edwin, III 1918- *AmArch* 70
Shelby, George Cass 1878-1975 *FolkA* 86
Shelden, C G *WhAmArt* 85
Shelden, M A *DcWomA*
Sheldon *DcBrECP*, *FolkA* 86
Sheldon, A N *AmArch* 70
Sheldon, Alfred *DcVicP* 2
Sheldon, Arabella Stebbens *FolkA* 86
Sheldon, Charles M *DcBrBI*

Sheldon, Charles Mills 1866-1928 *WhAmArt* 85
Sheldon, F L *FolkA* 86
Sheldon, George Crosby 1934- *AmArch* 70
Sheldon, George William 1843-1914 *WhAmArt* 85
Sheldon, Jonathan *CabMA*
Sheldon, Joshua *NewYHSD*
Sheldon, Lucy *FolkA* 86
Sheldon, Lucy 1788-1889 *DcWomA*, *NewYHSD*
Sheldon, Marshall H *WhAmArt* 85
Sheldon, Mary A 1859-1912 *WhAmArt* 85
Sheldon, Nellie *DcWomA*
Sheldon, Olga 1897- *WhoAmA* 73
Sheldon, Olga N 1897- *WhoAmA* 76, –78, –80, –82
Sheldon, Pearl *DcBrA* 2
Sheldon, R V A *WhAmArt* 85
Sheldon, Rufus d1917 *WhAmArt* 85
Sheldon, Walter G *WhAmArt* 85
Sheldon, Walter G 1856-1931 *BiDAmAr*
Sheldon, William Henry 1840-1912 *NewYHSD*
Sheldon And Feltman *EncASM*
Sheldon-Williams, Inglis *DcBrA* 1
Sheldon-Williams, Inglis 1870-1940 *DcBrA* 2, *IlBEAAW*
Sheldrake, J *DcBrECP*
Sheldrick, Albert William 1911- *WhoArt* 80, –82, –84
Sheley, Robert N 1902- *AmArch* 70
Shelgren, O W *AmArch* 70
Shelgren, O W, Jr. *AmArch* 70
Shelite, L G *FolkA* 86
Shell, Frank Lawrence 1920- *AmArch* 70
Shell, Irving W *WhoAmA* 73, –76, –80, –82
Shell, Mrs. Irving W *WhoAmA* 73, –76, –80, –82
Shellabarger, Fred David 1918- *AmArch* 70
Shelley *DcNiCA*
Shelley, Arthur 1841-1902 *DcBrWA*, *DcVicP* 2
Shelley, Bill M 1952- *MarqDCG* 84
Shelley, Fay *WhAmArt* 85
Shelley, Frank *DcVicP* 2
Shelley, Frederick 1865- *DcBrA* 1, *DcVicP* 2
Shelley, Henry *DcVicP* 2
Shelley, J Richard 1923- *AmArch* 70
Shelley, John William 1838-1870 *DcBrWA*
Shelley, Mary 1950- *FolkA* 86
Shelley, Lady Percy Florence *DcWomA*
Shelley, Samuel 1750?-1808 *AntBDN* J
Shelley, Samuel 1750-1808? *DcBrWA*
Shellshear, Alicia J *DcVicP* 2
Shelly, Arthur 1841-1902 *DcBrA* 1, *DcVicP*, –2
Shelmire, Overton 1930- *AmArch* 70
Shelov, S M *AmArch* 70
Shelp, Robert Harold 1926- *AmArch* 70
Shelton, Alphonse Joseph 1905- *WhAmArt* 85
Shelton, Bill J 1925- *AmArch* 70
Shelton, Christopher 1933- *AfroAA*
Shelton, D C *AmArch* 70
Shelton, Donald Bertram 1932- *AmArch* 70
Shelton, Frederick Davis 1910-1943 *WhAmArt* 85
Shelton, George F *WhAmArt* 85
Shelton, Gilbert 1940- *WorECom*
Shelton, Gilbert Key 1940- *WhoAmA* 78, –80
Shelton, Harold 1913- *DcBrA* 1
Shelton, J H *AmArch* 70
Shelton, J M *AmArch* 70
Shelton, M Kent 1923- *AmArch* 70
Shelton, Michael *AfroAA*
Shelton, Peter T 1951- *WhoAmA* 82, –84
Shelton, Robert Lee 1939- *WhoAmA* 76, –78, –80, –82, –84
Shelton, Sidney *DcVicP* 2
Shelton, Theophilus d1717 *BiDBrA*
Shelton, W H 1840-1932 *WhAmArt* 85
Shemesh, Lorraine R 1949- *WhoAmA* 82, –84
Shemtov, Igael 1952- *ConPhot*, *ICPEnP* A
Shemtov, Rqael 1952- *MacBEP*
Shen, Chou 1427-1509 *McGDA*, *OxArt*
Shen, Ch'uan *McGDA*
Shen, Hsin-Yu *McGDA*
Shen, Nan-P'ing *McGDA*
Shen, Shih-T'ien *McGDA*
Shen, Tzu-Fan *McGDA*
Shen, Yangmin 1955- *MarqDCG* 84
Sheng, Mou *McGDA*
Sheng, Shao Fang 1918- *WhoAmA* 73, –76, –78, –80, –82
Shenk, Frederick Rentschler 1900- *AmArch* 70
Shenkel, William *FolkA* 86
Shenolikar, Ashok Kumar 1939- *MarqDCG* 84
Shenstone, William 1714-1763 *MacEA*
Shenton, Edward 1895- *IlrAm* E, *IlsBYP*, *IlsCB* 1744, –1946, –
Shenton, Edward 1895-1977 *IlrAm* 1880
Sheon, Aaron 1937- *WhoAmA* 78, –80, –82, –84
Sheoris, John Vasilios 1927- *AmArch* 70
Shepard, Augustus D, Jr. *WhAmArt* 85
Shepard, C E *WhAmArt* 85

Shepard, Chester d1902 *EncASM*
Shepard, Chester Burdelle d1921 *EncASM*
Shepard, Clare *ArtsAmW* 2, *DcWomA*, *WhAmArt* 85
Shepard, Daniel *FolkA* 86
Shepard, Daniel M *NewYHSD*
Shepard, Edward *CabMA*
Shepard, Effie *WhAmArt* 85
Shepard, Elihu H *FolkA* 86
Shepard, Elsie *WhAmArt* 85
Shepard, Ernest Howard d1976 *IlsCB* 1967
Shepard, Ernest Howard 1879- *ConICB*, *DcBrA* 1, *IlsBYP*, *IlsCB* 1744, –1946, –1957
Shepard, Ernest Howard 1879-1976 *DcBrA* 2, *DcBrBI*, *DcVicP* 2
Shepard, Florence Eleanor *DcWomA*
Shepard, George *FolkA* 86
Shepard, Mrs. H D *DcVicP* 2
Shepard, H E, Jr. *AmArch* 70
Shepard, Isabel Benson 1908- *WhAmArt* 85
Shepard, Joseph, Jr. *FolkA* 86
Shepard, Lemuel d1825 *CabMA*
Shepard, Lemuel S *CabMA*
Shepard, Lewis Albert 1945- *WhoAmA* 78, –80, –82, –84
Shepard, Llewlyn *EncASM*
Shepard, Mary Eleanor *IlsCB* 1967
Shepard, Mary Eleanor 1909- *IlsBYP*, *IlsCB* 1946, –1957
Shepard, Mary N *WhAmArt* 85
Shepard, Ralph *WhAmArt* 85
Shepard, S L *AmArch* 70
Shepard, Walter Dorman 1920- *AmArch* 70
Shepard, William E 1866-1948 *ArtsAmW* 1
Shepard And Cook *CabMA*
Shepard And Rice *EncASM*
Shephard, Clarence 1869- *WhAmArt* 85
Shephard, Elizabeth Hammond *WhAmArt* 85
Shephard, Eric A *DcVicP* 2
Shephard, Henry Dunkin *DcBrWA*, *DcVicP*, –2
Shephard, Joseph *AntBDN* N
Shephard, Minnie *ArtsAmW* 3, *WhAmArt* 85
Shephard, Rupert 1909- *DcBrA* 1, *WhoArt* 80, –82, –84
Shepheard, George 1770-1842 *DcBrBI*, *DcBrWA*, *DcVicP*, –2
Shepheard, George Wallwyn 1804-1852 *DcBrWA*
Shepheard, George Walwyn 1804-1852 *DcVicP*, –2
Shepheard, Lewis Henry *DcBrWA*, *DcVicP* 2
Shepheard, Sir Peter 1913- *WhoArt* 82, –84
Shepheard, Peter Faulkner 1913- *MacEA*, *WhoArt* 80
Shepheart, Frederick *NewYHSD*
Shepherd *FolkA* 86
Shepherd, Miss *DcWomA*, *FolkA* 86
Shepherd, Beth 1949- *MacBEP*
Shepherd, Bill 1943- *AmArt*
Shepherd, Carol Ruth 1922- *MacBEP*
Shepherd, Charles 1844-1924 *WhAmArt* 85
Shepherd, Chester George 1894- *WhAmArt* 85
Shepherd, David 1931- *WhoArt* 80, –82, –84
Shepherd, Don 1930- *WhoAmA* 82, –84
Shepherd, Dorothy G 1916- *WhoAmA* 73, –76, –78
Shepherd, E *DcBrBI*
Shepherd, Edward d1747 *BiDBrA*, *MacEA*
Shepherd, Eric Andres d1937 *DcBrA* 1
Shepherd, F H Newton *DcBrBI*
Shepherd, F H S d1948 *DcBrA* 1
Shepherd, F H S 1877-1948 *DcBrA* 2
Shepherd, Fanny *DcVicP* 2, *DcWomA*
Shepherd, Fitch *NewYHSD*
Shepherd, Frederick *DcBrWA*
Shepherd, G E *DcBrBI*
Shepherd, G S *NewYHSD*
Shepherd, George *WhAmArt* 85
Shepherd, George 1782?-1830? *DcBrBI*, *DcBrWA*
Shepherd, George B *WhAmArt* 85
Shepherd, George M 1823?- *NewYHSD*
Shepherd, George Sidney d1858 *DcVicP*, –2
Shepherd, George Sidney d1861 *DcBrWA*
Shepherd, J Clinton 1888- *ArtsAmW* 3, *IlBEAAW*, *WhAmArt* 85
Shepherd, Jacob *FolkA* 86
Shepherd, James Affleck 1867-1931? *DcBrBI*
Shepherd, James Affleck 1867-1946 *IlsCB* 1744
Shepherd, Jessie Curtis *DcWomA*, *EarABI* SUP
Shepherd, John Chiene 1896- *MacEA*
Shepherd, John S 1892-1933 *BiDAmAr*
Shepherd, Juliana Charlotte d1898 *DcWomA*
Shepherd, Julianna Charlotte *DcVicP* 2
Shepherd, N C *NewYHSD*
Shepherd, Nellie 1877-1920 *ArtsAmW* 2, *DcWomA*
Shepherd, Nina *DcWomA*
Shepherd, Reginald 1924- *WhoAmA* 84
Shepherd, Richard *BiDBrA*
Shepherd, Robert *FolkA* 86
Shepherd, S *DcVicP* 2
Shepherd, S Horne 1909- *ClaDrA*, *DcBrA* 1, *WhoArt* 80, –82, –84
Shepherd, Samuel Godfrey 1902- *AmArch* 70
Shepherd, Sarah d1814 *DcWomA*

Shepherd, Scott 1892- *DcBrA 1*
Shepherd, Stanley Raymond 1906- *DcBrA 1*
Shepherd, T L *AmArch 70*
Shepherd, Thomas Griffin 1931- *AmArch 70*
Shepherd, Thomas Hosmer d1840 *DcBrWA*
Shepherd, Thomas Hosmer 1792-1864 *DcVicP, -2*
Shepherd, Thomas Hosmer 1817?-1842? *DcBrBI*
Shepherd, Thomas S *NewYHSD*
Shepherd, Valentine Claude *DcBrWA*
Shepherd, Vincent 1750?-1812 *BiDBrA*
Shepherd, Violet Edgecombe *DcWomA*
Shepherd, W A *DcVicP 2*
Shepherd, William Fritz 1943- *WhoArt 84*
Shepherd, William James Affleck 1867-1946 *DcBrA 1,*
 DcVicP 2, WorECar
Shepler, Dwight 1905- *WhAmArt 85, WhoAmA 73,*
 -76, -78N, -80N, -82N, -84N
Shepley, Annie Barrows *DcWomA, WhAmArt 85*
Shepley, Clifford *WhoArt 84N*
Shepley, Clifford 1908- *WhoArt 80, -82*
Shepley, Edward *AntBDN D*
Shepley, George F 1860-1903 *McGDA*
Shepley, George Foster 1860-1903 *BiDAmAr, MacEA*
Shepley, Hugh 1928- *AmArch 70*
Shepley Rutan And Coolidge *MacEA*
Shepp, Alan 1935- *WhoAmA 84*
Sheppard, Miss *DcWomA*
Sheppard, Adrian *ConArch A*
Sheppard, Albert Edward 1910- *AmArch 70*
Sheppard, Benjamin *DcBrA 1*
Sheppard, Carl Dunkle 1916- *WhoAmA 73, -76, -78,*
 -80, -82, -84
Sheppard, Charlotte Lillian d1925 *DcBrA 1,*
 DcVicP 2, DcWomA
Sheppard, Donald Arthur 1948- *MarqDCG 84*
Sheppard, Edward *NewYHSD*
Sheppard, Edwin W *NewYHSD*
Sheppard, Ella *DcWomA*
Sheppard, Ella W *WhAmArt 85*
Sheppard, Emma *DcWomA*
Sheppard, Eugenia *WorFshn*
Sheppard, Faith Tresidder *DcBrA 1, WhoArt 82, -84*
Sheppard, Faith Tresidder 1920- *WhoArt 80*
Sheppard, Herbert C *DcVicP 2*
Sheppard, J Warren 1882- *WhAmArt 85*
Sheppard, John Craig 1913- *WhoAmA 73, -76, -78*
Sheppard, John Craig 1913-1978 *WhoAmA 80N,*
 -82N, -84N
Sheppard, Joseph Sherly 1930- *WhoAmA 73, -76, -78,*
 -80, -82, -84
Sheppard, Liz 1933- *WhoArt 80, -82, -84*
Sheppard, Luvon 1940- *WhoAmA 76, -78, -80*
Sheppard, M R *DcVicP 2*
Sheppard, Mary 1889- *DcWomA*
Sheppard, Maurice Raymond 1947- *WhoArt 80, -82,*
 -84
Sheppard, Nancy *DcWomA*
Sheppard, Nina Akamu *WhoAmA 82, -84*
Sheppard, Oliver d1941 *DcBrA 1*
Sheppard, Oliver 1864-1941 *DcBrA 2*
Sheppard, Philip 1838-1895 *DcBrWA, DcVicP 2*
Sheppard, R *DcBrA 2*
Sheppard, R H *FolkA 86*
Sheppard, Raymond *DcBrBI*
Sheppard, Raymond 1913- *ClaDrA, IlsCB 1946*
Sheppard, Raymond 1913-1958 *DcBrA 1*
Sheppard, Richard *ConArch A*
Sheppard, Richard 1910- *DcD&D*
Sheppard, Richard H *NewYHSD , WhoArt 84N*
Sheppard, Richard H 1910- *DcBrA 1, WhoArt 80,*
 -82
Sheppard, Richard Herbert 1910- *EncMA*
Sheppard, Richard W 1910- *MacEA*
Sheppard, Samuel Edward 1882-1948 *MacBEP*
Sheppard, Samuel Roger 1919- *AmArch 70*
Sheppard, Sarah *DcWomA*
Sheppard, W *DcBrBI*
Sheppard, Warren 1858-1937 *WhAmArt 85*
Sheppard, William H C 1871- *WhAmArt 85*
Sheppard, William L 1833-1912 *EarABI,*
 EarABI SUP
Sheppard, William Ludlow 1833-1912 *NewYHSD*
Sheppard, William Ludwell 1833-1912 *IlBEAAW,*
 WhAmArt 85
Sheppard And Robson *MacEA*
Sheppard Robson *ConArch*
Shepperson, Claude Allin 1867-1921 *DcBrA 1,*
 DcBrBI, DcBrWA, DcVicP 2
Shepperson, Patricia 1929- *DcCAr 81*
Shepperson, Patricia Ann 1929- *WhoArt 82, -84*
Sher, Elizabeth 1943- *WhoAmA 84*
Sher, M *AmArch 70*
Sher-Gil, Amrita 1913-1941 *OxTwCA*
Sher-Gill, Amitra 1913-1941 *WomArt*
Sheraden, W A *AmArch 70*
Sherard, DeWit-VanDyke *DcCAr 81*
Sheraton, J Ritson *DcVicP 2*
Sheraton, T *DcVicP 2*
Sheraton, Thomas 1751-1806 *AntBDN G, DcD&D,*
 McGDA, OxDecA
Sherbell, Rhoda *AmArt, WhoAmA 73, -76, -78, -80,*

Sherborn, Charles William 1831-1912 *DcBrA 1*
Sherborn, G F *DcVicP 2*
Sherburn, Thomas d1806 *CabMA*
Shere, Charles Everett 1935- *WhoAmA 78, -80, -82,*
 -84
Sherer, John *NewYHSD*
Sherer, Joseph John 1920- *AmArch 70*
Sherer, Renslow Parker 1888- *WhAmArt 85*
Sherer, Stephen Doyle 1951- *MarqDCG 84*
Sherer, William Joseph 1920- *AmArch 70*
Sheres, C *AmArch 70*
Sheridan, Mrs. *DcWomA*
Sheridan, Clare *WhAmArt 85*
Sheridan, Clare Consuelo 1885-1970 *DcBrA 1,*
 DcWomA
Sheridan, Francis James 1931- *AmArch 70*
Sheridan, Frank J, Jr. *WhAmArt 85*
Sheridan, Fredrick Englert 1926- *AmArch 70*
Sheridan, Harry *DcVicP 2*
Sheridan, Helen Adler *WhoAmA 80, -82, -84*
Sheridan, Helen Adler 1937- *WhoAmA 78*
Sheridan, J 1764-1790 *DcBrECP*
Sheridan, John E *WhAmArt 85*
Sheridan, John E 1880-1948 *IlrAm C, -1880*
Sheridan, John J *CabMA*
Sheridan, Joseph Marsh 1897- *ArtsAmW 2,*
 WhAmArt 85
Sheridan, Kittie L *DcWomA*
Sheridan, Mark 1884- *WhAmArt 85*
Sheridan, Max *WhAmArt 85*
Sheridan, Sonia Landy 1925- *ICPEnP A, MacBEP,*
 WhoAmA 80, -82, -84
Sheridan, Thomas Brown 1929- *MarqDCG 84*
Sherie, Ernest F *DcBrBI*
Sheriff, Charles E *ArtsEM*
Sheriff, Daisy *WhAmArt 85*
Sheriff, Paul 1903-1965 *ConDes*
Sherin, Ray 1926- *IlsCB 1957*
Sheringham, George 1884-1937 *DcBrA 1, DcBrBI,*
 DcBrWA
Sherinyan, Elizabeth 1877-1947 *WhAmArt 85*
Sherker, Michael Z 1936- *WhoAmA 76, -78*
Sherley, C *DcVicP 2*
Sherling, J *DcVicP 2*
Sherlock *NewYHSD*
Sherlock, A Marjorie 1897-1973 *DcBrA 1, DcWomA*
Sherlock, John, Jr. *BiDBrA*
Sherlock, John A *DcVicP 2*
Sherlock, Max 1925- *DcCAr 81*
Sherlock, William 1738?- *DcBrECP*
Sherlock, William 1738?-1806? *BkIE*
Sherlock, William P 1780?-1820? *DcBrBI*
Sherlock, William P 1780?-1821? *DcBrWA*
Sherman, Albert John 1882- *DcBrA 2*
Sherman, Beatrix *WhAmArt 85*
Sherman, C H *WhAmArt 85*
Sherman, Charles W 1923- *AmArch 70*
Sherman, Christopher S 1957- *MarqDCG 84*
Sherman, Cindy *ICPEnP A*
Sherman, Cindy 1954- *AmArt*
Sherman, Claire Richter 1930- *WhoAmA 76, -78, -80,*
 -82, -84
Sherman, Clifford C 1878-1920 *WhAmArt 85*
Sherman, Edith Freeman *DcWomA*
Sherman, Edith Freeman 1876- *WhAmArt 85*
Sherman, Edward Walter 1955- *MarqDCG 84*
Sherman, Edwin Allen 1829-1914 *NewYHSD ,*
 WhAmArt 85
Sherman, Effim H 1889- *WhAmArt 85*
Sherman, Elizabeth Evelyn 1896- *ArtsAmW 2,*
 DcWomA
Sherman, Ella *DcWomA*
Sherman, Ella Bennett *WhAmArt 85*
Sherman, Emmons F *EncASM*
Sherman, Florence Taylor Kushner 1911-*
 WhAmArt 85
Sherman, Frederic Fairchild 1874-1940 *WhAmArt 85*
Sherman, Gail *DcWomA, WhAmArt 85*
Sherman, George Charles 1936- *AmArch 70*
Sherman, George E 1810?- *NewYHSD*
Sherman, Harlan E 1926- *AmArch 70*
Sherman, Henry K 1870-1946 *WhAmArt 85*
Sherman, Heyman *WhAmArt 85*
Sherman, Howard Charles 1908- *AmArch 70*
Sherman, Ira D 1950- *WhoAmA 84*
Sherman, Irving Josef 1917- *WhAmArt 85*
Sherman, J W *AmArch 70*
Sherman, Jacob 1820?- *FolkA 86*
Sherman, Jesse T *FolkA 86*
Sherman, Jessie *WhAmArt 85*
Sherman, John *FolkA 86*
Sherman, John 1896- *ArtsAmW 1, WhAmArt 85*
Sherman, John H *NewYHSD*
Sherman, John K 1898- *WhAmArt 85,*
 WhoAmA 78N, -80N, -82N, -84N
Sherman, Julia Munson 1875- *WhAmArt 85*
Sherman, Lenore 1920- *WhoAmA 73, -76, -78, -80,*
 -82, -84

Sherman, Lenore Walton 1920- *IlBEAAW*
Sherman, Lucy McFarland *FolkA 86*
Sherman, Lucy McFarland 1838-1878 *DcWomA,*
 NewYHSD
Sherman, M L *FolkA 86*
Sherman, M Tony 1910- *AmArch 70*
Sherman, Martha E Coleman 1875- *DcWomA,*
 WhAmArt 85
Sherman, N N *AmArch 70*
Sherman, Nicholas S *ArtsEM*
Sherman, P A *DcWomA*
Sherman, Mrs. P A *NewYHSD*
Sherman, Philip Todd 1903- *AmArch 70*
Sherman, R *AmArch 70*
Sherman, Robert Burton 1920- *AmArch 70*
Sherman, Robert S 1938- *AmArch 70*
Sherman, Sarai *WhoAmA 73, -76, -78, -80, -82, -84*
Sherman, Stanley Morton 1922- *AmArch 70*
Sherman, Stowell B 1886- *WhAmArt 85*
Sherman, Theodore David 1935- *AmArch 70*
Sherman, Theresa 1916- *IlsBYP, IlsCB 1946*
Sherman, Winnie Borne 1902- *WhoAmA 73, -76*
Sherman, Z Charlotte 1924- *PrintW 83, -85,*
 WhoAmA 76, -78, -80, -82, -84
Shermoe, Raymond Ferdinand 1922- *WhoAmA 76*
Shermund, Barbara *WhAmArt 85*
Shermund, Barbara 1910?-1978 *WorECar*
Sherr, Ronald Norman 1952- *WhoAmA 82, -84*
Sherr, Solomon 1918- *MarqDCG 84*
Sherrard, Mrs. *DcWomA*
Sherrard, Florence E *DcVicP 2*
Sherrat, Charles 1770-1792? *DcBrECP*
Sherratt, Margt J *DcWomA*
Sherratt, Obadiah *AntBDN M, DcNiCA*
Sherrer, Jean-Louis *FairDF FRA*
Sherrer, Sabrina Doney 1857-1930 *ArtsAmW 2,*
 DcWomA
Sherrick, David *FolkA 86*
Sherrif *DcBrECP*
Sherriff *DcBrECP*
Sherriff, Annie *DcVicP 2*
Sherriff, G Vincent *DcVicP 2*
Sherriffs, Robert Stewart 1907-1961 *WorECar*
Sherril, Laura *FolkA 86*
Sherrill, Charles H 1867-1936 *WhAmArt 85*
Sherrill, Edgar B *WhAmArt 85*
Sherrill, James Nelson 1925- *AmArch 70*
Sherrill, Marvin Leroy 1925- *AmArch 70*
Sherrin, Daniel *DcBrA 1, DcVicP, -2*
Sherrin, John 1819-1896 *DcBrWA, DcVicP, -2*
Sherrod, Philip 1935- *DcCAr 81*
Sherrod, Philip Lawrence 1935- *AmArt, PrintW 83,*
 -85, WhoAmA 76, -78, -80, -82, -84
Sherry, Joseph A 1936- *AmArch 70*
Sherry, William Grant 1914- *AmArt, WhoAmA 73,*
 -76, -78, -80, -82, -84
Shervud, Vladimir 1832-1897 *OxArt*
Sherwill, George *DcBrBI*
Sherwin, Daniel *DcBrWA*
Sherwin, Frank 1896- *ClaDrA, DcBrA 1,*
 WhoArt 80, -82, -84
Sherwin, John H 1834- *NewYHSD*
Sherwin, John Keyes 1751-1790 *BkIE*
Sherwin, John Keyse 1751-1790 *DcBrECP, DcBrWA*
Sherwin, Kate *DcVicP 2*
Sherwin, Thomas *NewYHSD*
Sherwin, William 1645?-1711? *McGDA*
Sherwood, A *NewYHSD*
Sherwood, A 1932- *WhoAmA 73, -76, -78, -80, -82,*
 -84
Sherwood, Anna K K d1931 *DcWomA,*
 WhAmArt 85
Sherwood, Bette *WhoAmA 73*
Sherwood, Betty *WhoAmA 76*
Sherwood, Coleman Hobart 1897- *AmArch 70*
Sherwood, H A *WhAmArt 85*
Sherwood, Henry *NewYHSD*
Sherwood, Henry J *NewYHSD*
Sherwood, J P *NewYHSD*
Sherwood, Leona *WhoAmA 82, -84*
Sherwood, Mary Clare 1868-1943 *DcWomA,*
 WhAmArt 85
Sherwood, Nelson B *CabMA*
Sherwood, P B *AmArch 70*
Sherwood, Richard E 1928- *WhoAmA 76, -78, -80,*
 -82, -84
Sherwood, Rosina *DcWomA*
Sherwood, Rosina Emmet d1948 *WhoAmA 78N,*
 -80N, -82N, -84N
Sherwood, Rosina Emmet 1854-1948 *WhAmArt 85*
Sherwood, Ruth d1953 *WhAmArt 85*
Sherwood, Ruth 1889-1953 *DcWomA*
Sherwood, Sherry *WhoAmA 80N, -82N, -84N*
Sherwood, Sherry 1902-1958? *WhAmArt 85*
Sherwood, Thomas *CabMA*
Sherwood, Thorne 1910- *AmArch 70*
Sherwood, Vladimir 1832-1897 *OxArt*
Sherwood, Walter J 1865- *WhAmArt 85*
Sherwood, William 1875-1951 *WhAmArt 85*
Sherwood, William Anderson d1951 *WhoAmA 78N,*
 -80N, -82N, -84N

Shoemaker, Jonathan d1793 *CabMA*
Shoemaker, Lowell Thomas 1935- *AmArch 70*
Shoemaker, Morrell McKenzie, Jr. 1923- *AmArch 70*
Shoemaker, Peter *CabMA*
Shoemaker, Peter 1920- *WhoAmA 73, -76, -78, -80, -82, -84*
Shoemaker, Thomas Frederick 1919- *AmArch 70*
Shoemaker, Vaughn 1902- *WhoAmA 73, -76, -78, -80, -82, -84, WorECar*
Shoemaker, Vaughn Richard 1902- *WhAmArt 85*
Shoemaker Pickering *EncASM*
Shoenberger, C E *AmArch 70*
Shoener, John *FolkA 86*
Shoenfelt, Joseph Franklin d1968 *WhoAmA 78N, -80N, -82N, -84N*
Shoenfelt, Joseph Franklin 1918-1968 *WhAmArt 85*
Shoenhut *FolkA 86*
Shoesmith, Kenneth Denton 1890-1939 *DcBrA 1*
Shoesmith, Kenneth Denton 1896-1939 *DcSeaP*
Shoga *McGDA*
Shohaku 1730-1781 *McGDA*
Shohin *DcWomA*
Shoji, Sadao 1937- *WorECar*
Shokado, Shojo 1584-1639 *McGDA*
Shokei *McGDA*
Shokler, Harry 1896- *WhAmArt 85, WhoAmA 73, -76, -78, -80, -82N, -84N*
Shokler, Morris *WhAmArt 85*
Shoko *AntBDN L*
Sholar, Willard Covington, Jr. 1930- *AmArch 70*
Sholder, David 1904- *AmArch 70*
Sholl, Anna McClure 1868?-1956 *DcWomA, WhAmArt 85*
Sholler, Thomas Howard 1928- *AmArch 70*
Shomalt, Albert 1950- *DcCAr 81*
Shomate, E M *AmArch 70*
Shon, Mila *WorFshn*
Shonborn, Lewis J *WhAmArt 85*
Shone-Jones, Ernest 1899- *DcBrA 1*
Shonnard, Eugenie F 1886- *WhAmArt 85, WhoAmA 73, -76*
Shonnard, Eugenie Frederica 1886- *ArtsAmW 1, IIBEAAW*
Shonnard, Eugenie Frederica 1886-1978 *DcWomA*
Shontz, Janet *WhAmArt 85*
Shook, Georg 1932- *WhoAmA 76, -78, -80*
Shook, Georg 1934- *AmArt, WhoAmA 82, -84*
Shook, George E 1932- *WhoAmA 73*
Shook, M Melissa 1939- *ICPEnP A, MacBEP*
Shoolbred, James *DcNiCA*
Shoop, P L *AmArch 70*
Shoop, P L, Jr. *AmArch 70*
Shoosmith, A G 1888-1974 *MacEA*
Shoosmith, Thurston Laidlaw 1865-1933 *ClaDrA, DcBrA 1, DcBrWA, DcVicP 2*
Shooter, Tom 1941- *WhoAmA 76, -78, -80, -82, -84*
Shope, Henry B 1862-1929 *WhAmArt 85*
Shope, Irvin 1900- *WhoAmA 76*
Shope, Irvin 1900-1977 *WhAmArt 85, WhoAmA 78N, -80N, -82N, -84N*
Shope, Irvin Shorty 1900- *IIBEAAW*
Shope, R A *AmArch 70*
Shope, Richard Irvin 1940- *AmArch 70*
Shopen, Kenneth d1967 *WhoAmA 78N, -80N, -82N, -84N*
Shopen, Kenneth 1902-1967 *WhAmArt 85*
Shopsin, W C *AmArch 70*
Shor, Bernice Abramowitz 1945- *WhoAmA 76, -78, -80, -82, -84*
Shoran *DcWomA*
Shorb, Adam A *FolkA 86*
Shorb, Adam L *FolkA 86*
Shorb, D L *DcWomA*
Shorb, Mrs. D L *ArtsAmW 2*
Shorb, J, Jr. *FolkA 86*
Shore, Mrs. *DcWomA*
Shore, Agatha Catherine 1878- *ClaDrA, DcWomA*
Shore, B E *DcVicP 2*
Shore, Clover Virginia 1906- *WhoAmA 73, -76*
Shore, Frederick William John *DcVicP 2*
Shore, Henrietta M *ArtsAmW 2*
Shore, Henrietta M d1963 *WhAmArt 85*
Shore, Henrietta Mary 1880-1963 *DcWomA*
Shore, Henry Noel *DcBrWA*
Shore, Henry W *DcVicP 2*
Shore, Jack 1922- *WhoArt 82, -84*
Shore, Mary 1912- *WhoAmA 73, -76, -78, -80, -82, -84*
Shore, Richard Paul 1943- *WhoAmA 73, -76, -78*
Shore, Robert 1924- *IlrAm G, -1880, IlsBYP, IlsCB 1957*
Shore, Mrs. Robert *ArtsEM, DcWomA*
Shore, Robert S d1931 *DcBrA 1, -2, DcVicP 2*
Shore, Stephen 1947- *ConPhot, DcCAr 81, ICPEnP A, MacBEP, WhoAmA 84*
Shores, Franklin 1942- *WhoAmA 73, -76, -78, -80, -82, -84*
Shorett, L J *AmArch 70*
Shorey, George H d1944 *WhAmArt 85*
Shorey, Mary F Jones 1865?-1944 *DcWomA, WhAmArt 85*

Shorey, Maude Kennish 1882- *ArtsAmW 3*
Shorney, Margo Kay 1930- *WhoAmA 84*
Shorr, Bernard 1918- *AmArch 70*
Shorr, Harriet 1939- *PrintW 85*
Shorr, Kenneth Cooper 1952- *MacBEP*
Short, Dan *OfPGCP 86*
Short, David B 1953- *MarqDCG 84*
Short, F J *DcVicP 2*
Short, Sir Frank 1857-1945 *DcBrA 1, ClaDrA, DcVicP 2*
Short, Frederick Golden *DcBrA 2, DcVicP, -2*
Short, Gordon Kenneth 1952- *MarqDCG 84*
Short, Jessie Francis *WhAmArt 85*
Short, John *CabMA*
Short, Joseph 1771-1819 *AntBDN G, CabMA*
Short, Joseph Harold 1911- *AmArch 70*
Short, Lillie 1900- *FolkA 86*
Short, Obadiah 1803-1886 *DcVicP 2*
Short, Obediah 1803-1886 *DcBrWA*
Short, Percy *DcVicP 2*
Short, Richard 1841-1916 *DcBrA 1, DcVicP, -2*
Short, Sam Boykin, Jr. 1927- *AmArch 70*
Short, Sewell 1735-1773 *CabMA*
Short, Stephen 1807- *CabMA*
Short, W E *AmArch 70*
Short, W J *DcVicP 2*
Short, William d1753 *CabMA*
Short, William d1921 *DcBrA 2*
Short, William Hosley 1924- *AmArch 70*
Shortall, Leonard *IlsBYP, IlsCB 1946, -1957*
Shortall, Leonard W *IlsCB 1967*
Shorter, Edward S 1900- *WhAmArt 85*
Shorter, Edward Swift 1902- *WhoAmA 73, -76, -78, -80, -82, -84*
Shortess, J *BiDBrA*
Shorthose & Co. *DcNiCA*
Shorthose & Heath *DcNiCA*
Shorthouse, Arthur Charles 1870-1953 *DcBrA 1, DcVicP 2*
Shorthouse, Stella H *DcVicP 2*
Shortland, Dorothy Frances 1908- *WhoArt 80, -82, -84*
Shortt, L R *AmArch 70*
Shortwell, Frederic Valpey 1907-1929 *WhAmArt 85*
Shostack, Christine M 1951- *MarqDCG 84*
Shostak, Ed 1941- *ConArt 77*
Shostak, Edwin Bennett 1941- *WhoAmA 73, -76, -78, -80, -82, -84*
Shostrom, Nell *DcWomA*
Shotten, J *DcVicP 2*
Shotton, James *DcVicP 2*
Shotwell *FolkA 86*
Shotwell, H C *NewYHSD*
Shotwell, Helen Harvey 1908- *WhAmArt 85, WhoAmA 73*
Shotwell, Henry Titus 1916- *AmArch 70*
Shotwell, Margaret *WhAmArt 85*
Shoubridge, W *DcBrBI, DcVicP 2*
Shoubridge, Mrs. W *DcVicP 2*
Shoubridge, William *BiDBrA, DcVicP 2*
Shoulberg, Harry 1903- *WhAmArt 85, WhoAmA 73, -76, -78, -80, -82, -84*
Shoumate, Belford Washington Wren 1903- *AmArch 70*
Shoumatoff, Elizabeth 1888-1980 *DcWomA*
Shoup, J T, Jr. *AmArch 70*
Shoup, Richard G *MarqDCG 84*
Shourdes, Harry 1871-1920 *FolkA 86*
Shourds, George Washington *NewYHSD*
Shourds, Harry M *FolkA 86*
Shourds, Harry V 1861-1920 *FolkA 86*
Shourds, John *NewYHSD*
Shouse, Helen Bigoney 1911- *WhAmArt 85*
Shouse, Nicholas *FolkA 86*
Shout *BiDBrA*
Shout, Benjamin *BiDBrA*
Shout, John 1738-1781 *BiDBrA*
Shout, Matthew 1774-1817 *BiDBrA*
Shout, Robert 1702?-1774 *BiDBrA*
Shout, Robert 1734-1797 *BiDBrA*
Shout, Robert Howard *DcVicP 2*
Shout, William 1678- *BiDBrA*
Shout, William 1750?-1826 *BiDBrA*
Shove, John J *FolkA 86*
Shove, Theophilus *CabMA*
Shoven, Hazel Brayton 1884- *ArtsAmW 2, DcWomA, WhAmArt 85*
Shover, Edna Mann *WhAmArt 85*
Shover, Edna Mann 1885- *DcWomA*
Shover, Lucy M *WhAmArt 85*
Shovers, E *DcVicP 2*
Show, Mrs. S VanD *WhAmArt 85*
Showe, Lou Ellen *DcWomA, WhAmArt 85*
Showell, Kenneth 1939- *PrintW 83, 85*
Showell, Kenneth L 1939- *WhoAmA 73, -76, -78, -80, -82, -84*
Shpak, Dale John 1957- *MarqDCG 84*
Shpak-Benua, Maria Viktorovna 1870-1891 *DcWomA*
Shrader, Alfred *NewYHSD*
Shrader, E Roscoe 1879-1960 *WhAmArt 85*
Shrader, Edwin Roscoe 1879-1960 *ArtsAmW 1,*

IIBEAAW
Shrady, Frederick 1907- *WhoAmA 84*
Shrady, Frederick C 1907- *WhoAmA 76, -78, -80, -82*
Shrady, Henry M 1871-1922 *WhAmArt 85*
Shrady, Henry Merwin 1871-1922 *IIBEAAW*
Shramm, Paul H 1867- *WhAmArt 85*
Shrank, William *NewYHSD*
Shrapnel, N H S *DcVicP 2*
Shrapnell, E S *DcVicP 2*
Shreeve, John 1823?- *NewYHSD*
Shreeve, Thomas *CabMA*
Shreeves, John 1823?- *NewYHSD*
Shreffler, Henry *FolkA 86*
Shreffler, Samuel 1804?- *FolkA 86*
Shrem, V J *AmArch 70*
Shreve, Benjamin *EncASM*
Shreve, George C d1893 *EncASM*
Shreve, George R *EncASM*
Shreve, Richard *EncASM*
Shreve, Richard H 1877-1946 *BiDAmAr, McGDA*
Shreve, Richmond Harold 1877-1946 *MacEA*
Shreve, Robert Joseph 1937- *AmArch 70*
Shreve, Samuel S *EncASM*
Shreve, Timothy N 1954- *MarqDCG 84*
Shreve Crump And Low *EncASM*
Shreve Lamb And Harmon *MacEA*
Shreve Treat And Eacret *EncASM*
Shrier, Stefan 1942- *MarqDCG 84*
Shrigley, Arthur 1875-1938 *BiDAmAr*
Shrimpton, Ada M *DcVicP 2*
Shrimpton, Ada Matilda 1858-1925 *DcWomA*
Shring, Margaret S *DcVicP 2*
Shriro, Gloria 1930- *WhoAmA 76*
Shriver, D S *AmArch 70*
Shriver, Henry Vannier 1927- *AmArch 70*
Shrock, John Granville 1910- *WhAmArt 85*
Shropshire, C C *AmArch 70*
Shropshire, George E *WhAmArt 85*
Shrubsole, W G d1889 *DcVicP 2*
Shrum, R M *AmArch 70*
Shryock, Burnett Henry, Sr. 1904-1971 *WhAmArt 85, WhoAmA 78N, -80N, -82N, -84N*
Shryock, Gideon 1802-1880 *BiDAmAr, BnEnAmA, MacEA*
Shryock, John Carter *WhAmArt 85*
Shryock, Lucy W *WhAmArt 85*
Shryock, Mathias 1780-1883? *BiDAmAr*
Shtainmetz, Leon *IlsCB 1967*
Shteir, J *AmArch 70*
Shu, Stanley Kou-Chih 1934- *AmArch 70*
Shubert, Casper 1825-1901 *FolkA 86*
Shubert, Katherine Schmidt *WhoAmA 78, -80*
Shubin, Fedot 1740-1805 *OxArt*
Shubin, Morris Jack 1920- *WhoAmA 76, -78, -80, -82, -84*
Shubrook, Emma L *DcVicP 2*
Shubrook, Emma Louise *DcWomA*
Shubrook, Laura A *DcVicP 2, DcWomA*
Shubrook, Minnie J *DcVicP, -2*
Shubrook, Minnie Jane 1867- *DcWomA*
Shubun *McGDA*
Shuck, Kenneth Menaugh 1921- *WhoAmA 73, -76, -78, -80, -82, -84*
Shuckard, Frederick P *ClaDrA, DcBrA 1, DcVicP, -2*
Shudi, Burkat *AntBDN K*
Shuebrook, Ron 1943- *WhoAmA 82, -84*
Shuell, Ray 1951- *DcCAr 81*
Shuff, Lily *WhoAmA 73, -76, -78, -80, -82, -84*
Shuff, Lily 1906- *WhAmArt 85*
Shuflin, F H *AmArch 70*
Shugetsu, Tokan *McGDA*
Shugg, Richard *NewYHSD*
Shui, Chien-T'ung *DcCAr 81*
Shuiemina, Vera *DcWomA*
Shuja B Qasim Al-Isfahani *MacEA*
Shukman, Solomon 1927- *PrintW 85*
Shukotoff, Alice Zelma 1911- *WhAmArt 85*
Shukri, Akram 1910- *DcCAr 81*
Shuldham, E B *DcVicP 2*
Shuler, F William 1924- *AmArch 70*
Shuler, Paul Edwin 1936- *AmArch 70*
Shuler, Thomas H, Jr. 1949- *MacBEP, WhoAmA 80, -82, -84*
Shulevitz, Uri *IlsCB 1967*
Shulevitz, Uri 1935- *IlsBYP, IlsCB 1957*
Shulgold, William *WhAmArt 85*
Shulkin, Anatol *AfroAA*
Shulkin, Anatol 1899-1961 *WhAmArt 85*
Shulkin, Anatol 1901-1961 *WhoAmA 80N, -82N, -84N*
Shull, Carl Edwin 1912- *WhoAmA 78, -80, -82, -84*
Shull, Delia F *WhAmArt 85*
Shull, Della *DcWomA*
Shull, J Marion 1872-1950? *WhAmArt 85*
Shull, James Marion *WhoAmA 78N, -80N, -82N, -84N*
Shulman, Joseph L *WhoAmA 73, -76*
Shulman, Leon 1936- *WhoAmA 73, -76*
Shulman, Morris *WhAmArt 85*

Siegen, Ludwig Von 1609-1680? *McGDA*
Sieger, Marie *DcWomA*
Sieger, Nicholas F 1910- *WhAmArt 85*
Sieger, Victor 1843?-1905 *ClaDrA*
Siegert, August 1820-1883 *ArtsNiC*
Siegfried, Edwin 1889-1955 *ArtsAmW 3*
Siegfried, Samuel *FolkA 86*
Siegl, Helen 1924- *IlsCB 1957*
Siegl, Theodor *WhoAmA 76*
Siegl, Theodor d1976 *WhoAmA 78N, -80N, -82N, -84N*
Siegle, J W *AmArch 70*
Siegler *NewYHSD*
Siegler, G J *AmArch 70*
Siegler, Maurice 1896- *WhAmArt 85*
Siegler, N *AmArch 70*
Siegmann, Naomi Rita 1933- *WhoAmA 82, -84*
Siegnars, Charles *NewYHSD*
Siegriest, Louis 1899- *ArtsAmW 1*
Siegriest, Louis B 1899- *WhAmArt 85*
Siegriest, Lundy 1925- *WhoAmA 73, -76, -78, -80, -82, -84*
Sielaff, Bruce Whitney 1933- *AmArch 70*
Sielaff, M A *AmArch 70*
Sielke, Leo, Jr. 1880-1930 *WhAmArt 85*
Siemering, Leopold Rudolf 1835-1905 *McGDA*
Siemiradsky, Henri 1843- *ArtsNiC*
Siems, Alice Lettig 1897- *WhAmArt 85*
Siems, Alice Letting 1897- *DcWomA*
Siems, Lester Eugene, Jr. *AmArch 70*
Siemsen, Frederick *WhAmArt 85*
Sienkiewicz, Ernest Reynold 1925- *AmArch 70*
Sierks, John F 1914- *AmArch 70*
Siess, M W *AmArch 70*
Sietz, Lewis *NewYHSD*
Sietze, Helene 1843-1913 *DcWomA*
Sieurac, Francois Joseph Juste 1781-1832 *ClaDrA*
Sievan, Maurice 1898- *WhAmArt 85, WhoAmA 73, -76, -78, -80, -82*
Sievan, Maurice 1898-1981 *WhoAmA 84N*
Sieve, Michael *OfPGCP 86*
Sieveking, Elisabeth 1825-1894 *DcWomA*
Sieveking, Louise *DcWomA*
Sieveking, Monika 1944- *DcCAr 81*
Sieverding, Katharina 1941- *DcCAr 81*
Sieverding, Katharina 1944- *ConArt 83*
Sievers, Ed 1932- *ICPEnP A, MacBEP*
Sievers, Edward Earl 1950- *MarqDCG 84*
Sievers, Elisabeth Benedicta Von 1773-1799 *DcWomA*
Sievers, Frederick William 1872- *WhAmArt 85*
Sievers, Lucille Scott *WhAmArt 85*
Sievert, Emilie I *WhAmArt 85*
Sievert, Katharina *DcWomA*
Sievre, Martin *WorECar*
Siewert, Clara 1862- *DcWomA*
Siewert, Gerdt Marian 1920- *DcCAr 81*
Siewert, Melvin F 1913- *AmArch 70*
Sifontes, Orval E 1932- *AmArch 70*
Siftar, Vladimir 1943- *MarqDCG 84*
Sigal, William Francis 1926- *AmArch 70*
Sigalon, Alexandre Francois Xavier 1787-1837 *McGDA*
Sigalon, Xavier 1787-1837 *ClaDrA*
Sigel, Barry Chaim 1943- *WhoAmA 73, -76, -78, -80, -82*
Sigel, Emil *NewYHSD*
Sigfusson, Benedict 1927- *AmArch 70*
Sigg, Fred George 1934- *AmArch 70*
Sigg, Martha 1871- *DcWomA*
Sigismondo, Gallina *DcWomA*
Sigismund, Violet M *WhoAmA 73, -76, -80, -82, -84*
Sigle, John David 1941- *AmArch 70*
Sigler, Clarence Grant 1897-1959 *FolkA 86*
Sigler, Hollis *DcCAr 81*
Sigler, Hollis 1946- *PrintW 83, -85*
Sigler, Jack 1925- *FolkA 86*
Siglin, Jennie 1849- *DcWomA*
Sigman, T L *AmArch 70*
Sigmon, William Hill 1924- *AmArch 70*
Sigmund, Benjamin D *DcBrA 1, DcBrWA, DcVicP, -2*
Sigmund, Louis Bernardine 1887- *DcWomA*
Signac, Paul 1863-1935 *ClaDrA, McGDA, OxArt, PhDcTCA 77*
Signature, Cynthia *WhoAmA 84*
Signature, Cynthia 1948- *WhoAmA 82*
Signol, Emile 1804- *ArtsNiC*
Signol, Emile 1804-1892 *ClaDrA*
Signor, Charles Gary 1939- *AmArch 70*
Signorelli, Francesco d1559 *McGDA*
Signorelli, Luca 1441?-1523 *McGDA, OxArt*
Signoret-Ledieu, Lucie 1858?-1904 *DcWomA*
Signori, Carlo 1906- *PhDcTCA 77*
Signori, Carlo Sergio 1906- *DcCAr 81*
Signorielli, Anthony 1912- *AmArch 70*
Signorini, Telemaco 1835-1901 *ClaDrA*
Sigoloff, Violet Bruce *WhoAmA 76, -78*
Sigrin, Michael E 1944- *WhoAmA 78, -80*
Sigrist, Kurt 1943- *DcCAr 81*
Sigsbee, Mary Ellen *DcWomA*

Sigstedt, Thorsten 1884- *WhAmArt 85*
Sigsway, Charles Stephen 1933- *AmArch 70*
Sigurdson, John T 1929- *AmArch 70*
Sigurta, Luigi *DcBrECP*
Sigwald, Thomas *CabMA*
Sihvonen, Oli 1921- *WhoAmA 73, -76, -78, -80, -82, -84*
Siikamaki, Arvo 1943- *OxTwCA*
Sika, Jutta 1877- *DcWomA*
Sikes, Bessie *FolkA 86*
Sikes, C R, Jr. *AmArch 70*
Sikes, Dale R 1951- *MarqDCG 84*
Sikes, E *FolkA 86*
Sikes, Victory 1649-1708 *CabMA*
Sikli, Eva B *MarqDCG 84*
Sikolya, Zsolt 1944- *MarqDCG 84*
Sikora, Tomasz 1948- *ICPEnP A*
Sikora, Zdzislaw R 1952- *WhoAmA 84*
Silage, Dennis Alex 1946- *MarqDCG 84*
Silanion *McGDA*
Silas *ConGrA 1, WorECom*
Silas, Ellis 1883- *DcBrA 1*
Silas, Ellis 1883-1971 *DcSeaP*
Silas, Lillian *DcWomA*
Silber, Esther *WhAmArt 85*
Silber, Maurice 1922- *WhoAmA 76, -78, -80, -82, -84*
Silber, Zavel *WhoAmA 76, -78, -80*
Silberfeld, Kay 1934- *WhoAmA 78, -80, -82*
Silberg, Nicholas d1801 *CabMA*
Silberger, Manuel G *WhAmArt 85*
Silberman, Arthur 1929- *WhoAmA 78, -80, -82, -84*
Silberman, Sarah G 1909- *WhAmArt 85*
Silberstein, A L *EncASM*
Silberstein, Muriel Rosoff *WhoAmA 73, -76*
Silberstein Hecht *EncASM*
Silberstein LaPorte *EncASM*
Silberstein-Storfer, Muriel Rosoff *WhoAmA 78, -80, -82, -84*
Silbert, Bailey Saiger 1934- *AmArch 70*
Silbert, Ben 1893- *WhAmArt 85*
Silburn, A *DcVicP 2*
Silcock, Sara Lesley 1947- *IlsCB 1967*
Silcox, Emily 1832?- *FolkA 86*
Silcox, T R *AmArch 70*
Silei, Luisa 1825-1898 *DcWomA*
Sileika, Jonas 1883- *WhAmArt 85*
Sileikis, Michael Justin 1893- *WhAmArt 85*
Siler, Todd 1953- *DcCAr 81, WhoAmA 84*
Silfverberg, Ida 1834-1899 *DcWomA*
Silfwersparre, Sophie 1783-1815 *DcWomA*
Silhouette, Etienne De 1709-1767 *AntBDN O*
Siligato, Carlo *WhAmArt 85*
Silins, Janis 1896- *WhoAmA 73, -76, -78, -80, -82, -84*
Silk, George 1916- *ConPhot, ICPEnP A, MacBEP*
Silk, Robert *AntBDN N*
Silke, Lucy S *DcWomA, WhAmArt 85*
Silkotch, Mary Ellen 1911- *WhAmArt 85, WhoAmA 73, -76, -78, -80, -82, -84*
Silks, Donald Kirk 1912- *WhAmArt 85*
Sill, Ebenezer Enoch 1822- *NewYHSD*
Sill, Emilie *DcWomA*
Sill, Howard *WhAmArt 85*
Sill, Howard 1865-1927 *BiDAmAr*
Sill, John N 1914- *AmArch 70*
Sill, Joseph 1801-1854 *NewYHSD*
Sill, Robert A 1895- *ArtsAmW 3*
Sill, Thomas *CabMA*
Sillavan, George *DcVicP 2*
Sillcox, Luise M *WhAmArt 85*
Sillem, Charles *DcVicP 2*
Sillemans, Experiens 1611-1653 *DcSeaP*
Sillen, Herman Gustaf 1857-1908 *ClaDrA*
Sillen, Herman Gustave Af 1857-1908 *DcSeaP*
Sillett, Emma *DcBrWA, DcWomA*
Sillett, James 1764-1840 *DcBrECP, DcBrWA, DcVicP 2*
Silletto, C B *AmArch 70*
Sillince, William A 1906- *ClaDrA*
Sillince, William Augustus 1906-1974 *DcBrA 1*
Silling, Cyrus Edgar *AmArch 70*
Sillman, Norman H 1921- *DcBrA 1, WhoArt 80, -82, -84*
Sillner, Manfred 1937- *DcCAr 81*
Silloway, Joseph *CabMA*
Silloway, Samuel *FolkA 86*
Silloway, Thomas W 1828-1910 *BiDAmAr*
Sills, Leonard H 1935- *AmArch 70*
Sills, R L *AmArch 70*
Sills, Thomas 1914- *AfroAA*
Sills, Thomas Albert 1914- *WhoAmA 73, -76, -78, -80, -82, -84*
Sillue, Francisco *DcCAr 81*
Silman, Richard Campbell 1928- *AmArch 70*
Silo, Adam 1674-1766 *DcSeaP*
Siloe, Diego De 1495?-1563 *MacEA, McGDA, OxArt, WhoArch*
Siloe, Gil De *OxArt*
Siloe, Gil De d1501? *McGDA*
Silsbe, Sarah 1738?- *FolkA 86*

Silsbee, J Lyman 1845-1913 *MacEA*
Silsbee, James Lyman 1845-1913 *BiDAmAr*
Silsbee, Martha 1858-1929? *DcWomA, WhAmArt 85*
Silsbee, Nathaniel, Jr. 1805?- *CabMA*
Silsbee, Sarah 1738?- *FolkA 86*
Silsbury, George M *NewYHSD*
Silsby, Clifford 1896- *WhAmArt 85*
Silsby, Clifford F 1896- *ArtsAmW 2*
Silsby, Wilson 1883-1952 *ArtsAmW 2, WhAmArt 85*
Silva, Andre Soares Da 1730-1769 *WhoArch*
Silva, Francis A 1835- *ArtsNiC*
Silva, Francis Augustus 1835-1886 *DcSeaP, NewYHSD, WhAmArt 85*
Silva, Maria Vieira Da *PhDcTCA 77*
Silva, S M *AmArch 70*
Silva, William Posey d1948 *WhoAmA 78N, -80N, -82N, -84N*
Silva, William Posey 1859-1948 *ArtsAmW 1, -3, WhAmArt 85*
Silva Bazan Y Arcos Meneses DeS, Mariana 1750-1784 *DcWomA*
Silva Da, Vitor 1932- *WhoGrA 82[port]*
Silvani, Gherardo 1579-1675 *MacEA, McGDA*
Silveira, Belle *DcWomA, WhAmArt 85*
Silveira, Joseph N *NewYHSD*
Silver, Alice L *WhAmArt 85*
Silver, Arthur 1924- *AmArch 70*
Silver, Larry Arnold 1947- *WhoAmA 84*
Silver, Michael *WhAmArt 85*
Silver, Nathan *ConArch A*
Silver, Nathan 1936- *AmArch 70*
Silver, Pat 1922- *WhoAmA 78, -80, -82, -84*
Silver, Paul 1937- *AmArch 70*
Silver, Rawley A *WhoAmA 80, -82, -84*
Silver, Rose 1902- *WhAmArt 85*
Silver, S M *AmArch 70*
Silver, Stephen R *MarqDCG 84*
Silver, Thomas C 1942- *WhoAmA 78, -80, -82, -84*
Silverberg, E Myer 1876- *WhAmArt 85*
Silverberg, Ellen Ruth 1947- *WhoAmA 78, -80, -82, -84*
Silverburg, Ellen Ruth 1947- *WhoAmA 76*
Silvercruys, Susanne d1973 *WhoAmA 82N, -84N*
Silvercruys, Suzanne *DcWomA, WhoAmA 73*
Silvercruys, Suzanne d1973 *WhoAmA 76N, -78N, -80N*
Silvercruys, Suzanne 1898-1973 *WhAmArt 85*
Silverman, A *AmArch 70*
Silverman, Adolph *WhAmArt 85*
Silverman, Barry G 1952- *MarqDCG 84*
Silverman, Burt 1928- *IlrAm 1880*
Silverman, Burton Philip 1928- *AmArt, IlsBYP, IlsCB 1957, WhoAmA 73, -76, -78, -80, -82, -84*
Silverman, David Frederick 1948- *WhoAmA 76, -78*
Silverman, H *AmArch 70*
Silverman, J L *AmArch 70*
Silverman, Jerry *WorFshn*
Silverman, Mel d1966 *WhoAmA 78N, -80N, -82N, -84N*
Silverman, Melvin Frank 1931-1966 *IlsBYP, IlsCB 1957*
Silverman, Miles Mittenthal 1910- *WhAmArt 85*
Silverman, R *AmArch 70*
Silverman, Richard *MarqDCG 84*
Silverman, Ronald H *WhoAmA 73, -76, -78, -80*
Silverman, Ronald H 1926- *WhoAmA 82, -84*
Silverman, S *AmArch 70*
Silverman, Sherley C 1909- *WhoAmA 76, -78, -80, -82, -84*
Silvern, Leonard Charles 1919- *MarqDCG 84*
Silvernail, James Martin 1942- *MarqDCG 84*
Silvers, A H *AmArch 70*
Silvers, Herbert 1906- *WhAmArt 85*
Silverstein, Edward Benjamin 1909- *AmArch 70*
Silverstone, Marilyn 1929- *ICPEnP A*
Silverstone, O I *AmArch 70*
Silverthorn, James Harold 1934- *AmArch 70*
Silverthorne, Jeffrey Kim 1946- *ICPEnP A, MacBEP*
Silvertooth, Dennis Carl 1957- *WhoAmA 82, -84*
Silvester *FolkA 86*
Silvester, H H *DcVicP 2*
Silvester, Peter P 1935- *MarqDCG 84*
Silvestre, Madame *DcWomA*
Silvestre, Israel 1621-1691 *McGDA, OxArt*
Silvestre, Louis, The Elder 1669-1740 *McGDA*
Silvestre, Louis, The Younger 1675-1760 *McGDA*
Silvestre, Marie Catherine 1680-1743 *DcWomA*
Silvestre, Marie Maximilienne 1708-1797 *DcWomA*
Silvestre, R *DcWomA*
Silvestre, Suzanne Elisabeth 1694-1738? *DcWomA*
Silvestri, Ester *DcWomA*
Silvestri, H N *AmArch 70*
Silvette, Brooks 1906- *WhAmArt 85*
Silvette, David 1909- *WhAmArt 85*
Silvette, Ellis M 1876- *WhAmArt 85*
Silvette, Marcia *WhAmArt 85*
Silvia, Judith Heidler Richardson 1942- *WhoAmA 76, -78, -80*
Silvia, Rafael *FolkA 86*
Silvis, Caroline *DcWomA, WhAmArt 85*
Silvis, Margaret 1875- *WhAmArt 85*

Skeysert, Clara De *DcWomA*
Skiagraphos *McGDA*
Skidmore, E V *AmArch 70*
Skidmore, Francis *DcNiCA*
Skidmore, Harriet *DcVicP 2*
Skidmore, Lewis Palmer 1877-1955 *WhAmArt 85*
Skidmore, Louis 1897- *EncMA*
Skidmore, Louis 1897-1962 *ConArch, DcD&D, EncAAr, MacEA, McGDA*
Skidmore, Thornton D 1884- *WhAmArt 85*
Skidmore Owings And Merrill
 ConArch, DcD&D, EncAAr, EncMA, WhoArch
Skidmore Owings Merrill *MacEA*
Skilbeck, Clement O *DcVicP 2*
Skiles, Charles d1969 *WhoAmA 78N, -80N, -82N, -84N*
Skill, F John d1881 *ArtsNiC*
Skill, Frederick John 1824-1881 *DcBrBI, DcBrWA, DcVicP, -2*
Skillen, W E *DcWomA*
Skillett, S D *DcVicP 2*
Skillin, James *CabMA*
Skillin, John 1746-1800 *CabMA, FolkA 86, NewYHSD*
Skillin, Samuel d1816 *NewYHSD*
Skillin, Samuel 1742-1816 *CabMA*
Skillin, Samuel 1742?-1830 *FolkA 86*
Skillin, Simeon *NewYHSD*
Skillin, Simeon 1716-1778 *BnEnAmA, NewYHSD*
Skillin, Simeon, III 1766-1830 *CabMA, FolkA 86, NewYHSD*
Skillin, Simeon, Jr. 1756?-1806 *NewYHSD*
Skillin, Simeon 1757-1806 *CabMA, FolkA 86*
Skillin, Simeon, Sr. 1716-1778 *CabMA, FolkA 86*
Skillin Family *CabMA*
Skilling, Chauncey F 1868-1945 *BiDAmAr*
Skilling, John *FolkA 86*
Skilling, Samuel *FolkA 86*
Skilling, Simeon, Jr. *FolkA 86*
Skilling, Simeon, Sr. *FolkA 86*
Skillings Family *CabMA*
Skillington, G *DcVicP 2*
Skillington, Nancy *WhoArt 80, -82, -84*
Skillman, Robert *CabMA*
Skillyngton, Robert *McGDA*
Skilton, Charles Philip 1921- *WhoArt 80, -82, -84*
Skilton, John Davis, Jr. 1909- *WhAmArt 85*
Skinas, John Constantine d1966 *WhoAmA 78N, -80N, -82N, -84N*
Skinner, Augustus *CabMA*
Skinner, B A, Jr. *AmArch 70*
Skinner, Carl T d1944 *BiDAmAr*
Skinner, Charles *MarqDCG 84*
Skinner, Charles Everett *WhAmArt 85*
Skinner, Charlotte B 1879- *ArtsAmW 1, DcWomA, IIBEAAW, WhAmArt 85*
Skinner, Clara *WhoAmA 73, -76*
Skinner, Dewitt A 1880- *WhAmArt 85*
Skinner, Edward *FolkA 86*
Skinner, Edward F *DcBrBI, DcVicP 2*
Skinner, Elsa Kells *WhoAmA 73, -76, -78, -80, -82, -84*
Skinner, Frances Johnson 1902- *WhAmArt 85*
Skinner, Frank 1896- *DcBrA 1*
Skinner, H F C *DcBrBI*
Skinner, Mrs. I G M 1890- *DcBrA 1, DcWomA*
Skinner, James Lister, Jr. 1913- *AmArch 70*
Skinner, Jesse R 1863-1946 *DcWomA*
Skinner, Jessie R *WhAmArt 85*
Skinner, John *FolkA 86*
Skinner, John Llewellyn 1893- *AmArch 70*
Skinner, John R M *NewYHSD*
Skinner, L B *WhAmArt 85*
Skinner, L R *DcWomA*
Skinner, M *DcWomA*
Skinner, Mary Colle *WhAmArt 85*
Skinner, Mary Dart 1859- *ArtsAmW 1, DcWomA*
Skinner, Orin Ensign 1892- *WhAmArt 85, WhoAmA 73, -76, -78, -80, -82, -84*
Skinner, R H *AmArch 70*
Skinner, Rachel *WhAmArt 85*
Skinner, Rachel L 1893-1981 *DcWomA*
Skinner, T O *AmArch 70*
Skinner, Thomas C 1888-1955 *WhAmArt 85*
Skinner, V M *DcVicP 2, DcWomA*
Skinner, W Hammond *FolkA 86*
Skinner, William *NewYHSD*
Skinner, William 1700-1780 *BiDBrA*
Skippe, John 1741-1811 *DcBrWA*
Skipworth *NewYHSD*
Skipworth, Arthur Henry *DcVicP 2*
Skipworth, Frank Markham *ClaDrA, DcVicP*
Skipworth, Frank Markham 1854-1929 *DcBrA 1, DcVicP 2*
Skirka, Peter *OfPGCP 86*
Skirmunt, Helena 1827-1874 *DcWomA*
Skirving, Archibald 1749-1819 *DcBrECP*
Skirving, John *IIBEAAW, NewYHSD*

Skislewicz, A *AmArch 70*
Skjorten, Einar 1933- *MarqDCG 84*
Sklar, Dorothy *WhAmArt 85, WhoAmA 73, -76, -78, -80, -82, -84*
Sklar, George d1968 *WhoAmA 78N, -80N, -82N, -84N*
Sklar, George 1905-1968 *WhAmArt 85*
Sklar, Isaac 1933- *AmArch 70*
Sklar-Weinstein, Arlene 1931- *WhoAmA 73, -76, -78, -80, -82, -84*
Sklarek, Norma Merrick 1928- *AmArch 70*
Sklarek, R *AmArch 70*
Skleney, Ronald J 1955- *MarqDCG 84*
Skodik, Antonin C 1870- *WhAmArt 85*
Skoff, Gail 1949- *ConPhot, ICPEnP A, MacBEP*
Skoff, Gail Lynn *WhoAmA 84*
Skoglund, Sandra Louise 1946- *WhoAmA 82, -84*
Skoglund, Sandy 1946- *ICPEnP A*
Skoglund, Wilhelmine *DcWomA*
Skok, David *MarqDCG 84*
Skold, Kenneth L 1925- *AmArch 70*
Skold, Otte 1894-1958 *PhDcTCA 77*
Skold, Ottel 1894- *ClaDrA*
Skoler, L *AmArch 70*
Skolfield, Raymond White 1909- *WhAmArt 85*
Skolle, John 1903- *WhAmArt 85, WhoAmA 76, -78, -80*
Skolnick, Arnold 1937- *WhoAmA 76, -78, -80*
Skonvere, Harold *WhAmArt 85*
Skoog, Karl F 1878-1933 *WhAmArt 85*
Skoogfors, Olaf d1975 *WhoAmA 76N, -78N, -80N, -82N, -84N*
Skop, Michael 1932- *WhoAmA 73, -76*
Skopas *MacEA*
Skorchev, Rumen 1932- *WhoGrA 82[port]*
Skorza Dynasty *OxArt*
Skotnes, Cecil Edwin Frans 1926- *OxTwCA*
Skottowe, Charles 1793- *DcVicP 2*
Skou, Sigurd d1929 *WhAmArt 85*
Skouger, Martha Gilbert 1885- *DcWomA*
Skougor, Martha Gilbert 1885- *WhAmArt 85*
Skovgaard, Peter Christian 1817-1876 *ArtsNiC*
Skovgaard, Susette Cathrine *DcWomA*
Skowronski, Victor Joseph 1949- *MarqDCG 84*
Skrainka, Blanche *WhAmArt 85*
Skrebneski, Victor 1929- *ICPEnP A*
Skredswig, Christian Eriksen 1854-1924 *ClaDrA*
Skreisoska, Katharina *DcWomA*
Skrip, Richard Joseph 1937- *AmArch 70*
Skruch, Norman John 1934- *AmArch 70*
Skrzypek, Josef 1946- *MarqDCG 84*
Skubic, Leroy Frederick 1908- *AmArch 70*
Skubin, Iris 1954- *DcCAr 81*
Skuce, Thomas Louis 1886-1951 *WorECar*
Skulason, Thorvaldur 1906- *OxTwCA, PhDcTCA 77*
Skulme, Marta 1890- *DcWomA*
Skumavc, Marjan 1947- *DcCAr 81*
Skupas, Anthony J *WhAmArt 85*
Skurjeni, Mato *OxTwCA*
Skurry, E *DcWomA*
Sky, Alison 1946- *WhoAmA 82, -84*
Skyllas, Drossos P 1912-1973 *FolkA 86*
Skynear 1941- *AmArt*
Slaatto, Nils 1923- *ConArch*
Slabbaert, Karel 1619?-1654 *ClaDrA, McGDA*
Slaby, Henry Robert 1906- *AmArch 70*
Slack, Abraham 1811?- *NewYHSD*
Slack, Abram 1811?- *NewYHSD*
Slack, D E 1946- *WhoAmA 80*
Slack, Dee 1946- *WhoAmA 73, -76, -78*
Slack, Emma Patton *WhAmArt 85*
Slack, Erle B 1892- *ArtsAmW 3*
Slack, George R H *FolkA 86*
Slack, Gilbert McLeod 1923- *AmArch 70*
Slack, John *DcBrECP*
Slack, L W *AmArch 70*
Slack, M E *DcVicP 2*
Slack, Robert M 1842?- *NewYHSD*
Slack, Thomas Burgoyne 1954- *MarqDCG 84*
Slack, Willard Eugene 1937- *MarqDCG 84*
Slack, William J *NewYHSD*
Slackman, Chas B 1934- *WhoGrA 82[port]*
Slade, Adam *DcBrA 1*
Slade, C Arnold 1882- *WhAmArt 85*
Slade, Cora L d1938? *WhAmArt 85*
Slade, D E *AmArch 70*
Slade, Emily *DcWomA, WhAmArt 85*
Slade, Frank 1875- *DcBrA 1*
Slade, J Morgan 1852-1882 *MacEA*
Slade, John *FolkA 86*
Slade, Lionel John Charles 1924- *DcBrA 1*
Slade, Margaret Louise 1949- *AfroAA*
Slade, Roy 1933- *WhoAmA 73, -76, -78, -80, -82, -84, WhoArt 80, -82, -84*
Slade, S V *NewYHSD*
Slade, W J *DcSeaP*
Slader, Alfred *DcBrBI*
Slader, Samuel Ernest *DcVicP 2*
Slafter, Alonzo 1801-1864 *NewYHSD*
Slafter, Theodore S *WhAmArt 85*
Slager, Corry 1883- *DcWomA*

Slager, J R *AmArch 70*
Slager, Jeannette 1881- *DcWomA*
Slager-Van, Gilse *DcWomA*
Slager-Velsen, Suze *DcWomA*
Slagle, F L *AmArch 70*
Slak, Joze 1951- *DcCAr 81*
Slama, Murray Alfred 1925- *AmArch 70*
Slaney, John *NewYHSD*
Slaney, Noel 1915- *DcBrA 1, WhoArt 84*
Slapar, Nejc 1945- *DcCAr 81*
Slate, Joseph Frank 1928- *WhoAmA 73, -76, -78, -80, -82, -84*
Slater *DcBrECP, NewYHSD*
Slater, Alfred *FolkA 86*
Slater, C H *DcVicP 2*
Slater, Edward D 1901- *AmArch 70*
Slater, Edwin C 1884- *WhAmArt 85*
Slater, Ella *DcWomA*
Slater, Frank d1965 *WhoAmA 78N, -80N, -82N, -84N*
Slater, Gary Lee 1947- *WhoAmA 78, -80, -82, -84*
Slater, Henrietta Vane 1815-1866 *DcWomA*
Slater, J Atwood *DcVicP 2*
Slater, J T *DcVicP 2*
Slater, John *ArtsEM, BiDBrA*
Slater, John F *DcVicP*
Slater, John Falconar 1857-1937 *DcBrA 1, DcVicP 2*
Slater, John Falconer 1857-1937 *DcSeaP*
Slater, Joseph 1750-1805? *DcBrECP*
Slater, Josiah d1847 *DcBrWA*
Slater, Mitchell Alexander 1959- *MarqDCG 84*
Slater, R F *AmArch 70*
Slater, Richard Haskell 1920- *AmArch 70*
Slater, Roderick B 1930- *AmArch 70*
Slater, S M *AmArch 70, NewYHSD*
Slater, T M *AmArch 70*
Slater, Van 1937- *AfroAA*
Slater, Van E 1937- *WhoAmA 76, -78, -80, -82, -84*
Slater, Walter J 1845-1923 *DcBrA 1*
Slater, Walter James *DcVicP*
Slater, Walter James 1845-1923 *DcVicP 2*
Slater, William *DcVicP 2*
Slater, William 1794-1867 *AntBDN M*
Slatin, Peter 1954- *DcCAr 81*
Slatin, Yeffe Kimball 1914-1978 *WhoAmA 80N, -82N, -84N*
Slatkes, Leonard J 1930- *WhoAmA 82, -84*
Slatkes, Leonard Joseph 1930- *WhoAmA 76, -78, -80*
Slatkin, Charles E 1908-1977 *WhoAmA 78N, -80N, -82N, -84N*
Slatkin, Wendy 1950- *WhoAmA 82, -84*
Slaton, Edgar Bale 1917- *AmArch 70*
Slattery *NewYHSD*
Slattery, Bill 1929- *WhoGrA 62*
Slattery, Michael *NewYHSD*
Slattery, Rosemary 1927- *WhoArt 80, -82, -84*
Slatton, Billy Eugene *AmArch 70*
Slatton, Ray Douglas 1950- *MarqDCG 84*
Slaughter, Hazel 1888-1979 *DcWomA*
Slaughter, Hazel Burnham 1888-1979 *WhoAmA 80N, -82N, -84N*
Slaughter, Mrs. John B 1858-1947 *ArtsAmW 3*
Slaughter, Lurline Eddy 1919- *WhoAmA 73, -76, -78, -80, -82, -84*
Slaughter, Mary *DcWomA*
Slaughter, Phillip Howard 1948- *MarqDCG 84*
Slaughter, Robert K *NewYHSD*
Slaughter, Stephen 1697-1765 *DcBrECP*
Slaughton, Mrs. *NewYHSD*
Slave Of Thomas Fleet *AfroAA*
Slavec, Darko 1951- *DcCAr 81*
Slavich, George Raymond 1925- *AmArch 70*
Slavin, Arlene 1942- *PrintW 83, -85, WhoAmA 76, -78, -80, -82, -84*
Slavin, C B *AmArch 70*
Slavin, John Daniel 1907- *WhAmArt 85*
Slavin, Neal 1941- *ConPhot, ICPEnP A, MacBEP, WhoAmA 78, -80, -82, -84*
Slavit, Ann L 1948- *WhoAmA 78, -80*
Slavona, Maria 1865-1931 *DcWomA*
Slavsky, Frank 1919- *AmArch 70*
Slawinski, Joseph *WhoArt 84N*
Slawinski, Joseph 1905- *WhoAmA 78, -80, -82, -84, WhoArt 80, -82*
Slay, Ralph Ernest 1915- *AmArch 70*
Slaybough, Charles *FolkA 86*
Slaybough, Josiah 1825?- *FolkA 86*
Slaybough, Samuel 1819?- *FolkA 86*
Slaybough, William *FolkA 86*
Slaymaker, Elizabeth *DcWomA, WhAmArt 85*
Slaymaker, Martha *AmArt, PrintW 83, -85, WhoAmA 82, -84*
Slayton, Joel *MarqDCG 84*
Slayton, Ronald Alfred 1910- *WhAmArt 85*
Sleap, Joseph Axe 1808-1859 *DcBrWA, DcVicP 2*
Sleath, Gabriel *AntBDN Q*
Sleator, James Sinton *ClaDrA*
Sleator, James Sinton d1950 *DcBrA 1*
Sledd, Donald Robert 1935- *AmArch 70*
Slee, John B 1875-1947 *BiDAmAr*
Slee, Mary *ClaDrA*

Smart, Mary-Leigh 1917- *WhoAmA 73, −76, −78, −80, −82, −84*
Smart, R *DcVicP 2*
Smart, R Borlase 1881-1947 *DcBrA 1*
Smart, Richard Kendall 1924- *AmArch 70*
Smart, Richard Lloyd 1944- *MarqDCG 84*
Smart, Samuel 1754-1787? *DcBrECP*
Smart, T *DcVicP, −2*
Smart, Wini 1932- *WhoAmA 76, −78, −80, −82, −84*
Smartley, H *DcVicP 2*
Smay, Joe Edgar 1898- *AmArch 70*
Smeallie, E R *AmArch 70*
Smeasters *DcBrECP*
Smeaton, John 1724-1792 *MacEA*
Smedley, Geoffrey 1927- *DcCAr 81, WhoAmA 82, −84*
Smedley, Gordon Owen 1925- *WhoArt 80, −82, −84*
Smedley, Walter D 1862-1939 *BiDAmAr*
Smedley, Will Larymore *WhoAmA 80N, −82N, −84N*
Smedley, Will Larymore 1871-1958? *WhAmArt 85*
Smedley, William T 1858-1920 *WhAmArt 85*
Smedley, William Thomas 1858-1920 *ArtsAmW 1, IlBEAAW, IlrAm A, −1880*
Smee, David Charles 1937- *IlsCB 1967*
Smeeton, A Williams *DcVicP 2*
Smeeton, J *DcVicP 2*
Smekens, Jan Cornell 1922- *AmArch 70*
Smellie, Robert *IlBEAAW*
Smellie, Robert d1908? *ArtsAmW 2*
Smelow, Boris 1951- *ICPEnP A*
Smeltzer, Sterling *WhAmArt 85*
Smeraldi, John D 1868?-1947 *ArtsAmW 3, WhAmArt 85*
Smerdel, Damir 1945- *DcCAr 81*
Smerdu, Mojca 1951- *DcCAr 81*
Smertz, Robert *WhAmArt 85*
Smet, Gustave De 1877-1943 *McGDA, OxArt, OxTwCA, PhDcTCA 77*
Smet, Pierre-Jean 1801-1873 *ArtsAmW 1*
Smet, Father Pierre-Jean De 1801-1873 *NewYHSD*
Smeth, Hendrick 1865- *ClaDrA*
Smetham, James 1821-1889 *ClaDrA, DcBrWA, DcVicP, −2*
Smeyers, Gillis 1635-1710 *McGDA*
Smiadecki, Franciszek *AntBDN J*
Smibert, John 1688-1751 *BnEnAmA, DcAmArt, DcBrECP, FolkA 86, McGDA, NewYHSD, OxArt*
Smibert, Nathaniel 1735-1756 *NewYHSD*
Smidt, Agnes 1874- *DcWomA*
Smidth, Anna 1861- *DcWomA*
Smies, Jacob 1764-1833 *WorECar*
Smigocki, Stephen Vincent 1942- *WhoAmA 78, −80, −82, −84*
Smigrod, Claudia Merin 1949- *MacBEP*
Smiley, H K *FolkA 86*
Smiley, Helen A 1896- *WhAmArt 85*
Smiley, Lavinia 1919- *IlsCB 1946*
Smiley, Ralph Jack 1916- *WhoAmA 73*
Smiley, Saul Charles 1918- *AmArch 70*
Smilkstein, Harry 1911- *ConGrA 1[port]*
Smillie, George F 1854- *WhAmArt 85*
Smillie, George H 1840- *ArtsNiC*
Smillie, George H 1840-1921 *WhAmArt 85*
Smillie, George Henry 1840-1921 *ArtsAmW 1, EarABI, IlBEAAW, NewYHSD*
Smillie, Helen Sheldon 1854-1926 *DcWomA*
Smillie, Helen Sheldon Jacobs 1854-1926 *WhAmArt 85*
Smillie, James 1807- *ArtsNiC*
Smillie, James 1807-1885 *NewYHSD*
Smillie, James D 1833- *ArtsNiC*
Smillie, James David 1833-1909 *ArtsAmW 1, EarABI, IlBEAAW, NewYHSD, WhAmArt 85*
Smillie, William Cumming 1813-1908 *NewYHSD*
Smirke *NewYHSD*
Smirke, Dorothy *DcVicP 2, DcWomA*
Smirke, Mary 1779-1853 *DcBrWA, DcWomA*
Smirke, Robert 1752-1845 *BkIE, DcBrBI*
Smirke, Robert 1753-1845 *DcBrECP*
Smirke, Robert 1780-1867 *MacEA*
Smirke, Sir Robert 1780-1867 *ArtsNiC, BiDBrA*
Smirke, Sir Robert 1781-1867 *DcD&D, McGDA, OxArt, WhoArch*
Smirke, Sydney 1797-1877 *BiDBrA A*
Smirke, Sydney 1798-1877 *ArtsNiC, MacEA, OxArt, WhoArch*
Smisek, Joseph John 1916- *AmArch 70*
Smit, Aernout 1641-1710 *DcSeaP*
Smit, Derk 1889- *WhAmArt 85*
Smit, Joseph 1836-1929 *GrBII[port]*
Smith *FolkA 86*
Smith 1747?-1834? *NewYHSD*
Smith, Messrs. *NewYHSD*
Smith, Miss *DcVicP 2, DcWomA*
Smith, Mister *NewYHSD*
Smith, Mrs. *FolkA 86*
Smith, A *DcVicP 2, DcWomA, FolkA 86*
Smith, Miss A *NewYHSD*
Smith, A B *DcVicP 2*
Smith, A C *NewYHSD*

Smith, A Cary 1837- *ArtsNiC*
Smith, A E *FolkA 86*
Smith, A F *FolkA 86*
Smith, A J *AmArch 70*
Smith, A Knight *WhAmArt 85*
Smith, A L *AmArch 70*
Smith, A T *AmArch 70, DcBrBI*
Smith, A V *FolkA 86*
Smith, Adam *BkIE*
Smith, Adams 1760?-1789 *CabMA*
Smith, Adelaine d1907 *DcWomA, WhAmArt 85*
Smith, Adolphe *ICPEnP*
Smith, Adolphus 1828?- *NewYHSD*
Smith, Adrian W 1860-1892 *BiDAmAr*
Smith, Al 1902- *WorECom*
Smith, Alan Edwin 1931- *AmArch 70*
Smith, Alanson *CabMA*
Smith, Albert 1805-1870 *NewYHSD*
Smith, Albert 1902- *WhoAmA 76, −78, −80, −82, −84*
Smith, Albert Alexander 1896- *WhAmArt 85*
Smith, Albert Alexander 1896-1940 *AfroAA*
Smith, Albert C *DcVicP 2*
Smith, Albert D *DcVicP 2*
Smith, Albert Delmont d1962 *WhoAmA 78N, −80N, −82N, −84N*
Smith, Albert Delmont 1886-1962 *WhAmArt 85*
Smith, Albert E *WhAmArt 85, WhoAmA 76, −78, −80, −82, −84*
Smith, Alden Clyde 1926- *AmArch 70*
Smith, Alexander *FolkA 86*
Smith, Alexander B *ArtsEM*
Smith, Alexander C 1875-1922 *DcBrWA*
Smith, Alexander Monro 1860-1933 *DcBrA 1*
Smith, Alexander Munro 1860-1933 *DcVicP 2*
Smith, Alexis 1949- *WhoAmA 76, −78, −80, −82, −84*
Smith, Alfred *DcVicP 2, IlDcG*
Smith, Alfred 1841-1898 *BiDAmAr*
Smith, Alfred 1853- *ClaDrA*
Smith, Mrs. Alfred *DcVicP 2*
Smith, Alfred Aloysius 1854?-1927 *IlBEAAW, WhAmArt 85*
Smith, Alfred E 1863-1955 *WhAmArt 85*
Smith, Alfred H *WhAmArt 85*
Smith, Alfred J *AfroAA*
Smith, Alfred James, Jr. 1948- *WhoAmA 78, −80*
Smith, Alfred Newland 1812-1876 *DcBrWA*
Smith, Alice *DcWomA*
Smith, Alice J *DcWomA, WhAmArt 85*
Smith, Alice R Huger 1876- *WhAmArt 85*
Smith, Alice Ravenel Huger 1876-1945? *DcWomA*
Smith, Allen, Jr. 1810-1890 *ArtsEM, NewYHSD*
Smith, Alvin *IlsCB 1967*
Smith, Alvin 1933- *AfroAA, IlsBYP, IlsCB 1957, WhoAmA 73, −76, −78*
Smith, Alvin J *ArtsEM*
Smith, Amanda Banks 1846-1924 *DcWomA, WhAmArt 85*
Smith, Amos F d1833 *CabMA*
Smith, Andre *WhAmArt 85*
Smith, Andre 1880-1959 *WhoAmA 80N, −82N, −84N*
Smith, Andrew C 1857-1913 *BiDAmAr*
Smith, Anita M 1893- *WhAmArt 85*
Smith, Anita Miller 1893- *DcWomA*
Smith, Anna Leigh *DcVicP 2*
Smith, Anna P *ArtsEM, DcWomA*
Smith, Anne d1886 *DcWomA*
Smith, Anne Edwards *DcWomA*
Smith, Anne Fry 1890- *DcWomA, WhAmArt 85*
Smith, Annie *ArtsAmW 2, DcVicP 2, DcWomA, WhAmArt 85*
Smith, Annie H Raeburn *DcWomA, WhAmArt 85*
Smith, Archibald Carey 1837-1911 *NewYHSD*
Smith, Archibald Cary 1837-1911 *WhAmArt 85*
Smith, Arenzo 1939- *AfroAA*
Smith, Arthur *DcVicP 2*
Smith, Arthur 1923- *AfroAA*
Smith, Arthur Anshel 1943- *MarqDCG 84*
Smith, Arthur B *WhAmArt 85*
Smith, Arthur Calvin 1932- *AmArch 70*
Smith, Arthur F *EncASM*
Smith, Arthur Hall 1929- *WhoAmA 73, −76, −78, −80, −82, −84*
Smith, Arthur Reginald *ClaDrA*
Smith, Arthur Reginald 1871-1934 *DcBrA 1, DcVicP 2*
Smith, Arthur Reginald 1872-1934 *DcBrBI, DcBrWA*
Smith, Arthur Riddick 1922- *AmArch 70*
Smith, Asa E *FolkA 86*
Smith, Asa Hartung 1909- *AmArch 70*
Smith, Aurelius *FolkA 86*
Smith, B G *AmArch 70*
Smith, B J 1931- *WhoAmA 78, −80, −82, −84*
Smith, Barbara Baldwin *WhAmArt 85*
Smith, Barbara Leigh *DcBrWA, DcVicP 2*
Smith, Barbara Leigh 1827-1891 *DcWomA*
Smith, Barbara Neff 1908-1977 *WhoAmA 78N, −80N, −82N, −84N*
Smith, Barbara Turner 1931- *WhoAmA 78, −80, −82, −84*
Smith, Belle Earle *ArtsEM*
Smith, Belle Patterson *DcWomA, WhAmArt 85*

Smith, Ben 1870-1942 *FolkA 86*
Smith, Ben 1941- *WhoAmA 76, −78, −80, −82*
Smith, Benjamin *AntBDN Q*
Smith, Benjamin, Jr. 1791-1850 *DcNiCA*
Smith, Benjamin, Sr. d1823 *DcNiCA*
Smith, Benjamin Dalton 1931- *AmArch 70*
Smith, Benjamin F 1830-1927 *WhAmArt 85*
Smith, Benjamin Franklin 1830-1927 *NewYHSD*
Smith, Benjamin Lane 1906- *AmArch 70*
Smith, Bernard E *DcVicP 2*
Smith, Berta A *ArtsEM, DcWomA*
Smith, Bertha *WhAmArt 85*
Smith, Bertram *WhoAmA 82*
Smith, Mrs. Bertram *WhoAmA 73, −76, −78, −80, −84*
Smith, Bessy N W *DcVicP 2*
Smith, Betty Maud *DcWomA*
Smith, Beuford *AfroAA*
Smith, Beuford 1939- *ICPEnP A*
Smith, Bill D 1939- *AmArch 70*
Smith, Blanche E *ArtsEM, DcWomA*
Smith, Bloomfield *NewYHSD*
Smith, Bodrell Joer'dan 1931- *AmArch 70*
Smith, Bowen Bancroft 1869-1932 *BiDAmAr*
Smith, Bradford *MarqDCG 84*
Smith, Bradford Leaman 1940- *WhoAmA 76, −78, −80, −82*
Smith, Bradley 1910- *ICPEnP A*
Smith, Brantley *WhAmArt 85*
Smith, Bruce Harry 1923- *AmArch 70*
Smith, Bryan H 1958- *MarqDCG 84*
Smith, Burtt Russell 1929- *AmArch 70*
Smith, Buse T *AfroAA*
Smith, C *DcVicP 2*
Smith, Mrs. C *WhAmArt 85*
Smith, C A, II *AmArch 70*
Smith, C C *AmArch 70*
Smith, C Christopher *DcVicP 2*
Smith, C D, Jr. *AmArch 70*
Smith, C Dowton *DcVicP, −2*
Smith, C F, Jr. *AmArch 70*
Smith, C H 1810?- *DcWomA*
Smith, C J *WhAmArt 85*
Smith, C M *AmArch 70, DcVicP 2*
Smith, C M, Jr. *AmArch 70*
Smith, C R *EncASM, WhoAmA 73*
Smith, C Ray *ConArch A*
Smith, C Ray 1929- *AmArch 70*
Smith, C W *FolkA 86*
Smith, Mrs. C W *WhAmArt 85*
Smith, C Welby *DcVicP 2*
Smith, C Wendell 1908- *AmArch 70*
Smith, C William *DcVicP 2*
Smith, Caby Carroll 1931- *MarqDCG 84*
Smith, Caleb, Jr. 1785- *CabMA*
Smith, Calvin Rae 1850-1918 *WhAmArt 85*
Smith, Camille 1892- *ArtsAmW 2*
Smith, Campbell L *DcVicP 2*
Smith, Carl *WhAmArt 85*
Smith, Carl 1859-1917 *ClaDrA*
Smith, Carl R 1931- *AfroAA*
Smith, Carl Rohl d1900 *WhAmArt 85*
Smith, Mrs. Carlton A *DcVicP 2*
Smith, Carlton Alfred 1853-1946 *DcBrA 1, DcBrWA, DcVicP, −2*
Smith, Caroline *DcVicP, −2, DcWomA*
Smith, Carrie M *DcWomA*
Smith, Cassius *FolkA 86*
Smith, Catherine 1874- *ClaDrA, DcBrA 1, DcVicP 2, DcWomA*
Smith, Catherine N *NewYHSD*
Smith, Catherine N 1785?- *DcWomA*
Smith, Catherine W Matthew-Clarke *DcBrWA*
Smith, Cecelia 1900- *WhAmArt 85*
Smith, Cecil A 1910- *IlBEAAW, WhAmArt 85*
Smith, Cecil Alden 1910- *WhoAmA 78, −80, −82, −84*
Smith, Celeste M *AfroAA*
Smith, Chadwell *DcVicP 2*
Smith, Charles *ArtsEM, DcBrA 1, DcVicP, −2, NewYHSD*
Smith, Charles 1750-1824 *DcBrECP*
Smith, Charles 1893- *WhoAmA 73, −76, −78, −80*
Smith, Charles A *CabMA*
Smith, Charles Benson 1926- *AmArch 70*
Smith, Charles C *NewYHSD*
Smith, Charles E 1943- *MarqDCG 84*
Smith, Charles Everett 1930- *AmArch 70*
Smith, Charles H *NewYHSD*
Smith, Charles Hamilton 1776-1859 *DcBrBI, DcBrWA*
Smith, Charles Harriott 1792-1864 *BiDBrA*
Smith, Charles John 1803-1838 *DcBrBI, DcBrWA*
Smith, Charles L 1812?- *IlBEAAW, NewYHSD*
Smith, Charles L A *AfroAA*
Smith, Charles L A 1871-1937 *ArtsAmW 2, WhAmArt 85*
Smith, Charles Loraine 1751-1835 *DcBrECP, DcBrWA*
Smith, Charles Moore *WhAmArt 85*
Smith, Charles Rayford 1928- *AmArch 70*
Smith, Charles S *DcVicP 2*

Smith, Charles S 1790?- *BiDBrA*
Smith, Charles Timothy 1897- *WhAmArt 85*
Smith, Charles W *NewYHSD*
Smith, Charles W 1822?- *NewYHSD*
Smith, Charles William 1893- *WhAmArt 85*
Smith, Charlotte *FolkA 86*
Smith, Charlotte Elizabeth *DcBrA 1, DcWomA*
Smith, Chloethiel Woodard 1910- *AmArch 70, MacEA*
Smith, Chris *FolkA 86*
Smith, Clarence W 1933- *AmArch 70*
Smith, Clayton B 1899- *WhAmArt 85*
Smith, Clemie C *ArtsAmW 3, DcWomA, WhAmArt 85*
Smith, Clifford *DcWomA*
Smith, Clifford S *DcVicP 2*
Smith, Coke *DcVicP 2*
Smith, Cole 1926- *AmArch 70*
Smith, Colin Louis Melville 1933- *AmArch 70*
Smith, Colvin 1793-1875 *ArtsNiC*
Smith, Colvin 1795-1875 *DcVicP, -2*
Smith, Connie U *MarqDCG 84*
Smith, Constance *DcVicP, -2*
Smith, Constance E *DcWomA*
Smith, Constance I *DcWomA*
Smith, Craig Dudley 1939- *AmArch 70*
Smith, Mrs. Creagh *DcWomA, NewYHSD*
Smith, Creig Ruskin 1949- *MarqDCG 84*
Smith, Curtis Wager *WhAmArt 85*
Smith, Cyril Kinsella, Jr. 1925- *AmArch 70*
Smith, D C *AmArch 70*
Smith, D G *DcCAr 81*
Smith, D H *AmArch 70*
Smith, D R *NewYHSD*
Smith, D S *AmArch 70*
Smith, D W *DcSeaP*
Smith, Dale D 1942- *AmArch 70*
Smith, Dan 1865-1934 *ArtsAmW 1, IlBEAAW, IlrAm A, -1880, WhAmArt 85*
Smith, Dan Evans 1905- *WhAmArt 85*
Smith, Dan J *WhAmArt 85*
Smith, Dana *FolkA 86*
Smith, Daniel *AntBDN Q, NewYHSD*
Smith, Daniel Newland 1791?-1839 *DcBrWA*
Smith, Daniel S *FolkA 86*
Smith, Daniel T *NewYHSD*
Smith, Daniel W *NewYHSD*
Smith, Darrell Dean 1933- *AmArch 70*
Smith, Darrell Lyle 1935- *AmArch 70*
Smith, David *CabMA, NewYHSD*
Smith, David *NewYHSD*
Smith, David d1845? *BiDBrA*
Smith, David 1906-1965 *BnEnAmA, CenC, ConArt 77, -83, DcAmArt, DcCAA 71, -77, McGDA, OxArt, OxTwCA, PhDcTCA 77, WhAmArt 85, WhoAmA 78N, -80N, -82N, -84N, WorArt[port]*
Smith, Mrs. David *WhAmArt 85*
Smith, David H *FolkA 86*
Smith, David H 1844-1904 *ArtsAmW 1, NewYHSD, WhAmArt 85*
Smith, David Henry 1947- *WhoArt 80, -82, -84*
Smith, David Lee 1940- *AmArch 70*
Smith, David Lester 1940- *AmArch 70*
Smith, David Loeffler 1928- *WhoAmA 73, -76, -78, -80, -82, -84*
Smith, David Murray 1865-1952 *DcBrA 1, DcVicP 2*
Smith, David T 1920- *DcBrA 2*
Smith, David V *NewYHSD*
Smith, David W 1934- *MarqDCG 84*
Smith, Dean Lance 1943- *MarqDCG 84*
Smith, DeCost 1864-1939 *ArtsAmW 1, IlBEAAW, WhAmArt 85*
Smith, Delbert Ray 1931- *AmArch 70*
Smith, Dinah Maxwell 1941- *WhoAmA 82, -84*
Smith, Dolph 1933- *WhoAmA 73, -76, -78, -80, -82, -84*
Smith, Dolphus *AfroAA*
Smith, Donald *MarqDCG 84*
Smith, Donald C 1929- *AmArch 70*
Smith, Donald C 1935- *WhoAmA 78, -80, -82*
Smith, Donald Eugene 1935- *WhoAmA 78, -80*
Smith, Donald Hall 1912- *AmArch 70*
Smith, Donald Leo 1934- *AmArch 70*
Smith, Donald Lloyd 1935- *AmArch 70*
Smith, Donald Powers 1908- *AmArch 70*
Smith, Donald Thomas 1927- *AmArch 70*
Smith, Donald William 1930- *AmArch 70*
Smith, Dora F *DcWomA*
Smith, Dorman H 1892-1956 *WhAmArt 85, WorECar*
Smith, Dorman Henry 1892-1956 *ArtsAmW 1*
Smith, Dorothy Alden 1918- *WhAmArt 85*
Smith, Douglas Clark 1932- *AmArch 70*
Smith, Douglas Cole 1925- *AmArch 70*
Smith, Douglas Herbert 1926- *AmArch 70*
Smith, Dudley Tyler *AmArch 70*
Smith, Duncan 1877-1934 *WhAmArt 85*
Smith, Dwight E 1951- *MarqDCG 84*
Smith, E *DcVicP 2*
Smith, E A 1896- *FolkA 86*

Smith, E Bert *ArtsAmW 2, WhAmArt 85*
Smith, E Boyd 1860-1943 *ConICB*
Smith, E C *AmArch 70*
Smith, E Cleave *DcBrWA*
Smith, E D *DcWomA*
Smith, E E *AmArch 70*
Smith, E Galusha 1849- *WhAmArt 85*
Smith, E H *AmArch 70*
Smith, E H H *EncASM*
Smith, E J *AmArch 70*
Smith, E L *AmArch 70*
Smith, E May *DcWomA*
Smith, E P *NewYHSD*
Smith, E S *AfroAA, DcWomA*
Smith, Mrs. E S *DcVicP 2*
Smith, E Toulmin *DcVicP 2*
Smith, E V *DcWomA*
Smith, E W *AmArch 70*
Smith, Earl Baldwin 1888- *WhAmArt 85*
Smith, Ebenezer *CabMA*
Smith, Eberle Minard 1905- *AmArch 70*
Smith, Eddy 1896-1957 *McGDA*
Smith, Edgar Carlyle, Jr. 1939- *AmArch 70*
Smith, Edith *DcWomA*
Smith, Edith Agnes 1867- *DcWomA*
Smith, Edith Heckstall *DcVicP 2*
Smith, Edith Paul *DcWomA*
Smith, Edith T *WhAmArt 85*
Smith, Edmund *MarqDCG 84*
Smith, Edmund Reuel 1829-1911 *NewYHSD*
Smith, Edmund Revel 1829-1911 *WhAmArt 85*
Smith, Edna Kenderdine 1879- *DcWomA*
Smith, Edna Wybrant *DcWomA, WhAmArt 85*
Smith, Edward *AntBDN Q, DcBrECP, DcVicP 2, NewYHSD*
Smith, Edward 1820-1893 *DcBrWA*
Smith, Edward Blount d1899 *DcVicP, -2*
Smith, Edward Gregory 1880-1961 *WhAmArt 85*
Smith, Edward Herndon 1891- *WhAmArt 85*
Smith, Edward John 1895- *AmArch 70*
Smith, Edward John Milton 1922- *WhoArt 80, -82, -84*
Smith, Edward R 1854-1921 *WhAmArt 85*
Smith, Edwin 1912-1971 *ConPhot, ICPEnP A, MacBEP*
Smith, Mrs. Edwin A *DcWomA*
Smith, Edwin B *EncASM, FolkA 86, NewYHSD*
Smith, Edwin Dalton 1800- *DcBrBI*
Smith, Edwin James 1899- *ArtsAmW 2, WhAmArt 85*
Smith, Edwin M *ArtsEM*
Smith, Egbert *ArtsEM*
Smith, Eileen A 1899- *WhAmArt 85*
Smith, Eldad *FolkA 86*
Smith, Eliakim 1735-1775 *CabMA*
Smith, Elihu B *CabMA*
Smith, Elinor Bellingham 1906- *DcCAr 81*
Smith, Elisabeth Hall *DcWomA*
Smith, Eliza *DcWomA*
Smith, Eliza A *DcVicP 2, DcWomA*
Smith, Eliza Lloyd 1872- *DcWomA, WhAmArt 85*
Smith, Elizabeth *WhAmArt 85*
Smith, Elizabeth Jean 1930- *WhoAmA 78, -80, -82, -84*
Smith, Ella B *DcWomA, WhAmArt 85*
Smith, Ellingwood 1805- *DcWomA*
Smith, Elliott 1796-1841 *CabMA*
Smith, Elma *WhAmArt 85*
Smith, Elmer Boyd 1860-1943 *ArtsAmW 2, IlBEAAW, WhAmArt 85*
Smith, Emily *DcVicP 2*
Smith, Emily Guthrie 1909- *AmArt, WhAmArt 85, WhoAmA 73, -76, -78, -80, -82, -84*
Smith, Emma *ArtsEM, DcWomA*
Smith, Emma 1783- *DcBrWA, DcWomA*
Smith, Emma J *WhAmArt 85*
Smith, Emma J McGrew 1849-1947 *DcWomA*
Smith, Eric *AfroAA*
Smith, Eric Wilburn, Jr. 1916- *AmArch 70*
Smith, Erik *WhoArt 82N*
Smith, Erik 1914- *DcBrA 1, WhoArt 80*
Smith, Erik 1914-1973 *DcBrA 2*
Smith, Ernest *DcVicP 2*
Smith, Ernest Browning 1866-1951 *ArtsAmW 2, WhAmArt 85*
Smith, Ernest John 1919- *WhoAmA 76, -78, -80, -82, -84*
Smith, Ernest Oren 1892- *AmArch 70*
Smith, Ernest R 1924- *WhoGrA 82[port]*
Smith, Erwin E 1888-1947 *IlBEAAW, WhAmArt 85*
Smith, Esther *DcWomA*
Smith, Esther L *DcWomA*
Smith, Ethel Amelia *WhAmArt 85*
Smith, Ethel M *WhAmArt 85*
Smith, Eugene Leslie *ArtsAmW 3*
Smith, Eugene Russell 1934- *AmArch 70*
Smith, Eugene T 1927- *AmArch 70*
Smith, Eunice Hatfield 1911- *WhAmArt 85*
Smith, Eva Augusta *DcWomA*
Smith, Eva F *DcWomA, WhAmArt 85*
Smith, F Carl 1868- *ArtsAmW 1*

Smith, F Denner *DcVicP 2*
Smith, F Drexel 1874- *WhAmArt 85*
Smith, F E D *FolkA 86*
Smith, F F *AmArch 70*
Smith, F F, Jr. *AmArch 70*
Smith, Mrs. F G *DcVicP 2*
Smith, F H *AmArch 70*
Smith, F Hargreaves *DcVicP 2*
Smith, F Hopkinson 1838- *ArtsNiC*
Smith, F M Bell- *DcVicP 2*
Smith, F Marshall 1915- *AmArch 70*
Smith, F Olin 1910- *AmArch 70*
Smith, F Patterson 1870-1932? *BiDAmAr*
Smith, F R *DcVicP 2*
Smith, F S *DcVicP 2*
Smith, F Stanley *WhAmArt 85*
Smith, F Vernon H, Jr. 1929- *AmArch 70*
Smith, Fleming Wood, Jr. 1936- *AmArch 70*
Smith, Florence *DcWomA*
Smith, Florence Sprague 1888- *WhAmArt 85*
Smith, Frances A *DcWomA*
Smith, Frances Kathleen 1913- *WhoAmA 80, -82, -84*
Smith, Frances S *DcWomA, WhAmArt 85*
Smith, Francis *DcBrECP*
Smith, Francis 1672-1738 *BiDBrA, MacEA*
Smith, Francis 1705?-1779? *DcBrWA*
Smith, Francis, Of Warwick 1672-1738 *OxArt*
Smith, Francis Berkeley 1868-1931 *WhAmArt 85*
Smith, Francis Drexel 1874- *ArtsAmW 1*
Smith, Francis Drexel 1874-1956 *ArtsAmW 3, IlBEAAW*
Smith, Francis Hopkinson 1838-1915 *ArtsAmW 1, NewYHSD, WhAmArt 85*
Smith, Francis Joseph 1925- *AmArch 70*
Smith, Francis Palmer 1886- *AmArch 70*
Smith, Mrs. Francis S *WhAmArt 85*
Smith, Frank Anthony 1939- *DcCAr 81, WhoAmA 73, -76, -78, -80, -82, -84*
Smith, Frank C 1921- *MarqDCG 84*
Smith, Frank E 1935- *AfroAA*
Smith, Frank H *EncASM*
Smith, Frank Hill 1841- *ArtsNiC*
Smith, Frank Hill 1841-1904 *WhAmArt 85*
Smith, Frank Lorraine 1936- *AmArch 70*
Smith, Frank Vining 1879-1967 *DcSeaP, WhAmArt 85*
Smith, Frank W 1848-1904 *EncASM*
Smith, Franklin *EncASM*
Smith, Franklin Delano 1933- *MarqDCG 84*
Smith, Fred *FolkA 86*
Smith, Fred 1886-1975 *FolkA 86*
Smith, Fred H *DcVicP 2*
Smith, Fred L 1862-1941 *BiDAmAr*
Smith, Frederic Augustus d1852 *NewYHSD*
Smith, Frederica J *DcVicP 2, DcWomA*
Smith, Frederick *DcVicP 2, NewYHSD*
Smith, Frederick 1807?- *NewYHSD*
Smith, Frederick B *NewYHSD*
Smith, Frederick Carl 1868-1955 *WhAmArt 85*
Smith, Frederick Henry *DcBrWA*
Smith, Frederick L *EncASM*
Smith, Frederick Richard 1876- *ClaDrA, DcBrA 1*
Smith, Frederick Sydney 1888- *DcBrA 1*
Smith, Frederick W 1885- *WhAmArt 85*
Smith, Frog *FolkA 86*
Smith, G *DcBrWA*
Smith, G A C 1834-1886 *BiDAmAr*
Smith, G E Kidder 1913- *AmArch 70, MacBEP*
Smith, G F *DcVicP 2*
Smith, G G *NewYHSD*
Smith, G H *DcVicP 2*
Smith, G J *DcVicP 2*
Smith, G L *AmArch 70*
Smith, G N *AmArch 70*
Smith, G R *DcVicP 2*
Smith, G S *DcWomA*
Smith, G W *DcBrWA*
Smith, Gabell *DcBrA 1, DcWomA*
Smith, Gar 1946- *DcCAr 81*
Smith, Garden Grant 1860-1913 *DcBrWA, DcVicP 2*
Smith, Garold D, Jr. 1936- *AmArch 70*
Smith, Gary Douglas 1948- *PrintW 83, -85, WhoAmA 82, -84*
Smith, Gary M 1944- *WhoAmA 73*
Smith, Gaylord *AfroAA*
Smith, Gean 1851-1928 *ArtsAmW 1, IlBEAAW, WhAmArt 85*
Smith, Gene Davidson 1923- *AmArch 70*
Smith, Geoffrey Kyle 1947- *MarqDCG 84*
Smith, George *AntBDN G, -Q, CabMA, DcNiCA, FolkA 86, NewYHSD, OxDecA*
Smith, George 1714-1776 *ClaDrA, DcBrWA*
Smith, George 1763?-1802? *DcBrECP*
Smith, George 1783-1869 *BiDBrA, MacEA*
Smith, George 1829- *ArtsNiC*
Smith, George 1829-1901 *DcVicP, -2*
Smith, George 1844?- *FolkA 86*
Smith, George 1870- *ClaDrA*
Smith, George 1870-1934 *DcBrA 1, DcVicP 2*
Smith, George 1941- *AfroAA*
Smith, George Ann 1921- *WhAmArt 85*

Smith, George Armfield *DcVicP 2*
Smith, George Daughtry 1928- *AmArch 70*
Smith, George Dick 1910- *AmArch 70*
Smith, George E *DcVicP 2*
Smith, George Elias *CabMA*
Smith, George F *NewYHSD*
Smith, George Fearn 1835-1926 *DcBrA 1, DcVicP 2*
Smith, George Fearn 1840-1926 *DcBrWA*
Smith, George G *DcVicP 2*
Smith, George Girdler 1795-1878 *NewYHSD*
Smith, George H 1805?- *BiDBrA*
Smith, George M 1821?- *FolkA 86*
Smith, George Melville *WhAmArt 85*
Smith, George N *ArtsAmW 3, WhAmArt 85*
Smith, George Robert, Jr. 1889- *WhAmArt 85*
Smith, George Stanislaus 1889- *AmArch 70*
Smith, George Tanner 1920- *AmArch 70*
Smith, George W *EncASM*
Smith, George W 1879-1930 *BiDAmAr*
Smith, George W 1941- *WhoAmA 73, -76, -78*
Smith, George Walter Vincent d1923 *WhAmArt 85*
Smith, George Washington 1876-1930 *MacEA*
Smith, George Washington 1879-1930 *ArtsAmW 2, WhAmArt 85*
Smith, George William 1922- *AmArch 70*
Smith, George Worthington 1835-1917 *DcBrA 1*
Smith, Georgine *WhAmArt 85*
Smith, Georgine Wetherell *DcWomA*
Smith, Gertrude 1869-1962 *DcWomA*
Smith, Gertrude Binney 1873?-1932 *DcWomA, WhAmArt 85*
Smith, Gertrude Roberts 1869- *WhAmArt 85*
Smith, Gil *FolkA 86*
Smith, Gladys K 1888- *DcWomA, WhAmArt 85*
Smith, Gladys Nelson *WhAmArt 85*
Smith, Gladys Nelson 1888- *ArtsAmW 3*
Smith, Gladys Nelson 1890- *DcWomA*
Smith, Gord 1937- *WhoAmA 73, -76, -78, -80, -82*
Smith, Gordon *OxTwCA*
Smith, Gordon 1919- *WhoAmA 73, -76, -78, -80, -82, -84*
Smith, Gordon A *EncASM*
Smith, Gordon A 1919- *DcCAr 81*
Smith, Gordon Mackintosh 1906- *WhoAmA 73, -76, -78*
Smith, Gordon Mackintosh 1906-1979 *WhoAmA 80N, -82N, -84N*
Smith, Grace Cossington 1892- *DcWomA, OxTwCA*
Smith, Grace Crossington 1892- *DcCAr 81*
Smith, Grace P *WhAmArt 85*
Smith, Graham 1942- *WhoAmA 84*
Smith, Mrs. Graham *DcVicP 2, DcWomA*
Smith, Graham Monro 1947- *MarqDCG 84*
Smith, Grainger 1892- *DcBrA 1*
Smith, Gregor M *DcCAr 81*
Smith, Gregor M 1944- *WhoArt 82, -84*
Smith, Gregory *WhAmArt 85, WhoAmA 80N, -82N, -84N*
Smith, Griffin 1930- *WhoAmA 76, -78, -80, -82, -84*
Smith, Guy *WhAmArt 85*
Smith, Gwendolen *DcWomA*
Smith, H A Hammond *AfroAA*
Smith, H Anthony 1939- *AmArch 70*
Smith, H C *FolkA 86*
Smith, H Clarendon *DcWomA*
Smith, Mrs. H Clarendon *DcVicP 2*
Smith, H E *WhAmArt 85*
Smith, H G *AmArch 70, DcVicP, -2*
Smith, H J *DcVicP 2*
Smith, H K *AmArch 70*
Smith, H P, Jr. *AmArch 70*
Smith, H S *FolkA 86*
Smith, H T, Jr. *AmArch 70*
Smith, H W *AmArch 70*
Smith, Hamilton Pike 1925- *AmArch 70*
Smith, Hannah *DcWomA*
Smith, Hannah 1797-1867 *DcBrWA, DcVicP 2*
Smith, Hannah Elizabeth *DcWomA*
Smith, Harriet E *WhAmArt 85*
Smith, Harriet F 1873-1935 *WhAmArt 85*
Smith, Harriet Frances 1873-1935 *DcWomA*
Smith, Harry *ArtsEM, DcVicP 2*
Smith, Harry Baker 1926- *AmArch 70*
Smith, Harry F *DcVicP 2*
Smith, Harry Knox 1879- *WhAmArt 85*
Smith, Harry Lee 1906- *AmArch 70*
Smith, Harry William 1937- *WhoAmA 84*
Smith, Harvey Barton 1897- *AmArch 70*
Smith, Hassel W, Jr. *WhoAmA 84*
Smith, Hassel W, Jr. 1915- *DcCAA 71, -77, WhoAmA 73, -76, -78, -80, -82*
Smith, Hassel Wendell, Jr. 1915- *WhAmArt 85*
Smith, Helen Francis *DcWomA*
Smith, Helen Henrietta *AfroAA*
Smith, Helen Leon 1894- *WhAmArt 85*
Smith, Helen Leona 1894- *DcWomA*
Smith, Helen M 1917- *WhoAmA 73, -76, -78, -80, -82, -84*
Smith, Helen Shelton *DcWomA, WhAmArt 85*
Smith, Helen Stafford 1871- *ArtsAmW 1, DcWomA*
Smith, Helena *DcWomA*

Smith, Helena Wood *DcWomA, WhAmArt 85*
Smith, Helene 1867?- *DcWomA*
Smith, Helene F *WhAmArt 85*
Smith, Hely Augustus Morton 1862-1941 *DcBrA 1, DcBrWA, DcVicP 2*
Smith, Henry *DcBrECP, FolkA 86, IlDcG, NewYHSD*
Smith, Henry A *WhAmArt 85*
Smith, Henry E *FolkA 86*
Smith, Henry Few *NewYHSD*
Smith, Henry Holmes 1909- *ConPhot, ICPEnP A, MacBEP, WhoAmA 73, -76, -78, -80, -82, -84*
Smith, Henry Howard 1927- *AmArch 70*
Smith, Henry Lawson 1894- *DcBrA 1*
Smith, Henry Leon, Jr. 1925- *AmArch 70*
Smith, Henry M *FolkA 86*
Smith, Henry Pember 1854-1907 *WhAmArt 85*
Smith, Henry S *NewYHSD*
Smith, Henry Smith *DcVicP, -2*
Smith, Henry T 1866-1947 *WhAmArt 85*
Smith, Henry W *NewYHSD*
Smith, Herbert Leary, Jr. 1923- *AmArch 70*
Smith, Herbert Livingston, III 1920- *AmArch 70*
Smith, Herbert Luther 1809-1869 *DcBrWA, DcVicP 2*
Smith, Herbert Luther 1811-1870 *DcVicP*
Smith, Herbert Tyson 1883- *DcBrA 1*
Smith, Hezekiah *FolkA 86*
Smith, Hezekiah Wright 1828- *NewYHSD*
Smith, Holmes 1863-1938? *WhAmArt 85*
Smith, Holmes 1863-1943 *ArtsAmW 3*
Smith, Homer Jackson 1902- *AmArch 70*
Smith, Hope *DcWomA*
Smith, Hope 1879- *DcWomA, WhAmArt 85*
Smith, Horace 1808-1893 *AntBDN F*
Smith, Houghton Cranford *WhAmArt 85*
Smith, Houghton Cranford 1887- *ArtsAmW 3*
Smith, Howard 1885-1970 *ArtsAmW 2*
Smith, Howard 1928- *AfroAA*
Smith, Howard Daniel 1932- *AmArch 70*
Smith, Howard E 1885- *WhAmArt 85*
Smith, Howard Everett 1885-1970 *IlrAm 1880*
Smith, Howard Heuer *AmArch 70*
Smith, Howard Patterson 1935- *AmArch 70*
Smith, Howard Ross 1910- *WhoAmA 73, -76, -78, -80N, -82N, -84N*
Smith, Howard Wesley 1929- *MarqDCG 84*
Smith, Howland *FolkA 86*
Smith, Hugh Bellingham *DcVicP 2*
Smith, Hugh Bellingham 1866-1922 *DcBrWA*
Smith, Hughie Lee *AfroAA*
Smith, I B *NewYHSD*
Smith, I R *FolkA 86*
Smith, Ian H 1928- *AmArch 70*
Smith, Ian McKenzie 1935- *WhoArt 80, -82, -84*
Smith, Ira *CabMA, WhAmArt 85*
Smith, Ira J *WhAmArt 85*
Smith, Irwin Elwood 1893- *ArtsAmW 2, WhAmArt 85*
Smith, Isaac *FolkA 86*
Smith, Isabel E d1938 *ArtsAmW 1*
Smith, Isabel E 1843?-1937 *DcWomA*
Smith, Isabel E 1843-1938 *WhAmArt 85*
Smith, Isabella *DcWomA*
Smith, Ishmael 1886- *WhAmArt 85*
Smith, Ivan Huron 1907- *AmArch 70*
Smith, Ivor 1926- *MacEA*
Smith, J *BkIE, DcBrBI, DcVicP 2, DcWomA, WhAmArt 85*
Smith, Mrs. J *NewYHSD*
Smith, J Andre 1880-1959 *WhAmArt 85*
Smith, J B *AmArch 70*
Smith, J B 1908- *WhoAmA 73*
Smith, J Bell *DcVicP, -2*
Smith, J C *FolkA 86*
Smith, J Clifford C *DcVicP 2*
Smith, J D *AmArch 70*
Smith, J E *DcWomA*
Smith, J F *WhAmArt 85*
Smith, J Frederick 1917- *ICPEnP A, MacBEP*
Smith, J H 1861-1941 *ArtsAmW 1*
Smith, J Howard *WhAmArt 85*
Smith, J J *AmArch 70*
Smith, J Kent *FolkA 86*
Smith, J L *AmArch 70*
Smith, J M *AmArch 70*
Smith, J Moyr *DcBrBI, DcNiCA, DcVicP 2*
Smith, J P *DcVicP 2*
Smith, J S *DcVicP 2*
Smith, J W *AmArch 70, FolkA 86*
Smith, Jack 1928- *ConArt 77, ConBrA 79[port], DcBrA 1, DcCAr 81, McGDA, OxTwCA, PhDcTCA 77*
Smith, Jack Carrington 1908- *ClaDrA*
Smith, Jack Martin *ConDes*
Smith, Jack W 1873-1949 *WhAmArt 85*
Smith, Jack Wells 1931- *AmArch 70*
Smith, Jack Wilkinson 1873-1949 *ArtsAmW 3, IlBEAAW*
Smith, Jack Wilkinson 1874-1949 *ArtsAmW 1*
Smith, Jacob *DcBrWA*

Smith, Jacob, Jr. *NewYHSD*
Smith, Jacob Getlar 1898-1958 *WhAmArt 85, WhoAmA 80N, -82N, -84N*
Smith, James *AntBDN Q, BiDBrA, DcBrECP, NewYHSD*
Smith, James 1645?-1731 *BiDBrA, MacEA*
Smith, James 1734-1807 *BiDBrA*
Smith, James 1753- *FolkA 86*
Smith, James 1779-1862 *BiDBrA*
Smith, James 1782-1867 *BiDBrA*
Smith, James Bennett H *DcVicP, -2*
Smith, James Burrell *ClaDrA, DcVicP, -2*
Smith, James Burrell 1822-1897 *DcBrBI, DcBrWA*
Smith, James Calvert *WhAmArt 85*
Smith, James E *NewYHSD*
Smith, James Edgar 1922- *AmArch 70*
Smith, James Haywood 1911- *AmArch 70*
Smith, James Joseph 1931- *AmArch 70*
Smith, James Kellum 1893-1963 *MacEA*
Smith, James MacLaren *DcVicP 2*
Smith, James Michael 1949- *AmArt*
Smith, James Morton 1919- *WhoAmA 78, -80, -82, -84*
Smith, James P 1803?-1888 *NewYHSD*
Smith, James Russell 1927- *AmArch 70*
Smith, James Whittet *DcVicP, -2*
Smith, James William *NewYHSD*
Smith, James William Garrett *DcVicP, -2*
Smith, Jane 1956- *WhoAmA 80, -82*
Smith, Jane B *DcWomA*
Smith, Jane Sophia Collingwood *DcBrWA*
Smith, Jane Stewart *DcBrWA*
Smith, Janet *AfroAA*
Smith, Jaquelin Taliaferro 1908- *WhAmArt 85*
Smith, Jaune Quick-To-See 1940- *AmArt*
Smith, Jeremiah Francis 1809?- *CabMA*
Smith, Jerome H 1861-1941 *WorECar*
Smith, Jerome Howard 1861?-1941 *IlBEAAW, WhAmArt 85*
Smith, Jerome Irving 1910- *WhoAmA 73*
Smith, Jesse 1819?- *AntBDN M*
Smith, Jessie 1910- *AfroAA*
Smith, Jessie Sherwood 1885- *WhAmArt 85*
Smith, Jessie Wilcox d1935 *DcBrBI*
Smith, Jessie Wilcox 1863-1935 *IlrAm A*
Smith, Jessie Willcox *WomArt A*
Smith, Jessie Willcox 1863-1935 *ConICB, DcWomA, IlrAm 1880, WhAmArt 85, WomArt*
Smith, Jo-An 1933- *WhoAmA 76, -78, -80, -82, -84*
Smith, Joe *OfPGCP 86*
Smith, Joe Michael 1949- *MarqDCG 84*
Smith, John *AfroAA, AntBDN I, BiDBrA, CabMA, DcBrECP, DcBrWA, DcVicP 2, FolkA 86, NewYHSD*
Smith, John 1652?-1742 *ClaDrA, McGDA*
Smith, John 1748?-1815 *BiDBrA*
Smith, John 1749-1831 *McGDA, OxArt*
Smith, John 1781-1852 *BiDBrA*
Smith, John 1782-1864 *BiDBrA*
Smith, John 1794?- *FolkA 86*
Smith, John 1841-1917 *DcBrA 1, DcVicP 2*
Smith, John, Jr. *NewYHSD*
Smith, John A *NewYHSD*
Smith, John B *NewYHSD*
Smith, John Bertie 1908- *WhAmArt 85, WhoAmA 76, -78*
Smith, John Bodwell 1820?-1847 *CabMA*
Smith, John Brandon *DcVicP*
Smith, John Brandon 1848-1884 *DcVicP 2*
Smith, John Bruce 1915- *AmArch 70*
Smith, Mrs. John C *WhAmArt 85*
Smith, John Calvin *NewYHSD*
Smith, Mrs. John Calvin *DcWomA, NewYHSD*
Smith, John E *FolkA 86, WhAmArt 85*
Smith, John F *NewYHSD*
Smith, John Francis *ArtsAmW 2, WhAmArt 85*
Smith, John Francis 1888- *DcBrA 1*
Smith, John Guthrie Spence 1880-1951 *DcBrA 1*
Smith, John H *FolkA 86*
Smith, John Henry *DcVicP, -2*
Smith, John Henry 1879- *AfroAA*
Smith, John Ivor 1927- *WhoAmA 76, -78, -80, -82, -84*
Smith, John Knox 1932- *AmArch 70*
Smith, John L *NewYHSD*
Smith, John Lockhart *NewYHSD*
Smith, John Raphael 1752-1812 *DcBrECP, DcBrWA, McGDA, OxArt*
Smith, John Rowson *FolkA 86*
Smith, John Rowson 1810-1864 *IlBEAAW, NewYHSD*
Smith, John Rubens 1775-1849 *DcBrWA, NewYHSD*
Smith, John Thomas 1766-1833 *DcBrBI, DcBrWA*
Smith, John Warwick 1749-1831 *DcBrWA*
Smith, Joline Butler *DcWomA, WhAmArt 85*
Smith, Jordan L 1926- *AmArch 70*
Smith, Joseph *CabMA, FolkA 86*
Smith, Joseph 1802?- *AntBDN M*
Smith, Joseph 1936- *WhoAmA 80*
Smith, Joseph A *CabMA*

Smith, Joseph A 1936- *WhoAmA 73, −82, −84*
Smith, Joseph Anthony 1936- *WhoAmA 76, −78*
Smith, Joseph B 1798-1876 *DcSeaP, FolkA 86, NewYHSD*
Smith, Joseph C *FolkA 86*
Smith, Joseph Clarendon 1778-1810 *DcBrBI, DcBrWA*
Smith, Joseph Edward 1946- *MarqDCG 84*
Smith, Joseph Lindon 1863- *WhAmArt 85*
Smith, Joseph Newton, III 1925- *AmArch 70*
Smith, Josephine *WhAmArt 85*
Smith, Judith *FolkA 86*
Smith, Judson d1962 *WhoAmA 78N, −80N, −82N, −84N*
Smith, Judson DeJonge 1880-1962 *ArtsEM, WhAmArt 85*
Smith, Julia Cecilia *DcVicP 2*
Smith, Julia O *DcWomA*
Smith, Justin V 1903- *WhoAmA 73, −76, −78, −80N, −82N, −84N*
Smith, Kate A *DcWomA*
Smith, Kate Alice *DcVicP 2, DcWomA*
Smith, Kate Stanley *DcWomA*
Smith, Katharine Adams *DcWomA*
Smith, Katharine Conley 1895- *ArtsAmW 3*
Smith, Katharine English 1899- *ArtsAmW 2, DcWomA, WhAmArt 85*
Smith, Katherine 1945- *WhoAmA 84*
Smith, Katherine Adams *WhAmArt 85*
Smith, Katherine Conely *ArtsEM*
Smith, Keith 1938- *ConPhot*
Smith, Keith A 1938- *ICPEnP A, MacBEP, WhoAmA 78, −80, −82, −84*
Smith, Ken *MarqDCG 84*
Smith, Kenneth Alan 1913- *AmArch 70*
Smith, Kenneth Alexander 1905- *AmArch 70*
Smith, Kent Alvin 1943- *WhoAmA 76, −78, −80, −82, −84*
Smith, Kent Richard 1959- *MarqDCG 84*
Smith, Kimber 1922- *DcCAr 81, PhDcTCA 77*
Smith, Kit Bellinger *WhAmArt 85*
Smith, L *DcVicP 2*
Smith, L D, Jr. *AmArch 70*
Smith, Mrs. L Graham *DcVicP 2*
Smith, L L *AmArch 70*
Smith, L L, Jr. *AmArch 70*
Smith, L P *EncASM*
Smith, Landon Edwards 1903- *AmArch 70*
Smith, Larry E 1942- *MarqDCG 84*
Smith, Lawrence B *EncASM*
Smith, Lawrence B C 1953- *MarqDCG 84*
Smith, Lawrence Beall *WhAmArt 85*
Smith, Lawrence Beall 1909- *IlsBYP, IlsCB 1957, WhoAmA 76, −78, −80, −82, −84*
Smith, Lawrence Fidwor 1926- *AmArch 70*
Smith, Lawrence Harold 1933- *AmArch 70*
Smith, Lawrence Lattin 1915- *AmArch 70*
Smith, Lawrence M C 1902- *WhoAmA 73, −76*
Smith, Lawrence M C 1902-1975 *WhoAmA 78N, −80N, −82N, −84N*
Smith, Lawson Wentworth 1947- *WhoAmA 78, −80, −82, −84*
Smith, Lee *IlsCB 1957*
Smith, Lee N, III 1950- *AmArt*
Smith, Lee Potter 1919- *AmArch 70*
Smith, Leland Stuart, Jr. 1924- *AmArch 70*
Smith, Leo Illesley Gibbons 1919- *WhoArt 80, −82, −84*
Smith, Leon Keith 1928- *AmArch 70*
Smith, Leon P 1906- *WhAmArt 85*
Smith, Leon Polk *DcCAr 81*
Smith, Leon Polk 1906- *DcCAA 71, −77, OxTwCA, WhoAmA 73, −76, −78, −80, −82, −84*
Smith, Leslie 1948- *DcCAr 81*
Smith, Lester Wickham 1909- *AmArch 70*
Smith, Letita Crapo 1862-1921 *ArtsEM*
Smith, Letta Crapo 1862-1921 *DcWomA, WhAmArt 85*
Smith, Leverett L *WhAmArt 85*
Smith, Leyland C 1910- *WhAmArt 85*
Smith, Lillian 1882-1971 *DcWomA*
Smith, Lillian B *ArtsAmW 2, DcWomA, WhAmArt 85*
Smith, Lillian W *IlBEAAW*
Smith, Lillian Wilhelm 1882-1971 *ArtsAmW 2*
Smith, Lindsay d1915 *DcBrA 2*
Smith, Linn 1917- *AmArch 70*
Smith, Linus Burr 1899- *AmArch 70, ArtsAmW 2, WhAmArt 85*
Smith, LoAnn 1772-1799 *FolkA 86*
Smith, Lochlan *NewYHSD*
Smith, Mrs. Louis *WhoAmA 73, −76*
Smith, Louise J 1873-1928 *WhAmArt 85*
Smith, Louise Jordan 1868-1928 *DcWomA*
Smith, Lowell Ellsworth 1924- *WhoAmA 84*
Smith, Lowell Kent 1937- *MarqDCG 84*
Smith, Lucian E *WhAmArt 85*
Smith, Lucy Bentley *DcVicP 2, DcWomA*
Smith, Lura Gertrude 1875- *DcWomA*
Smith, Luther 1950- *ICPEnP A, MacBEP*
Smith, Luther A 1950- *WhoAmA 82, −84*

Smith, Lydia Dunham *DcWomA, WhAmArt 85*
Smith, Lyle Benson 1934- *MarqDCG 84*
Smith, Lyman *WhAmArt 85*
Smith, Lyn Wall 1909- *WhoAmA 78*
Smith, Lyn Wall 1909-1979 *WhoAmA 80N, −82N, −84N*
Smith, M *DcVicP 2, DcWomA*
Smith, M, Jr. *AmArch 70*
Smith, M A *DcWomA*
Smith, M B *DcWomA*
Smith, M E *AmArch 70, WhAmArt 85*
Smith, M H *AmArch 70*
Smith, M H, Jr. *AmArch 70*
Smith, M Lavina Olin 1878- *ArtsAmW 3*
Smith, M Lavinia Olin 1878- *DcWomA*
Smith, Mabel Beatrice *DcWomA, WhAmArt 85*
Smith, Macon Strother 1919- *AmArch 70*
Smith, Madeleine *DcWomA*
Smith, Malcolm Earl 1922- *AmArch 70*
Smith, Marcella 1887- *WhAmArt 85*
Smith, Marcella Claudia Heber 1887-1963 *DcBrA 1, DcWomA*
Smith, Margaret *DcWomA*
Smith, Margaret E *DcWomA*
Smith, Margaret L 1910- *WhAmArt 85*
Smith, Margarette W *FolkA 86*
Smith, Margery Hoffman 1888- *ArtsAmW 2, WhAmArt 85*
Smith, Margery Hoffmann 1888- *DcWomA*
Smith, Maria *DcWomA*
Smith, Marie *WhAmArt 85*
Smith, Marie Vaughan 1892- *ArtsAmW 3, DcWomA*
Smith, Marietta Riggs *ArtsAmW 2*
Smith, Marietta Riggs 1852-1890 *DcWomA*
Smith, Marion Jocelyn 1928- *AmArch 70*
Smith, Marion Patience 1883- *DcWomA*
Smith, Mark Lane 1950- *MarqDCG 84*
Smith, Marrow Stuart 1889- *DcWomA*
Smith, Mrs. Marrow Stuart *WhAmArt 85*
Smith, Marshall D *WhAmArt 85*
Smith, Martha *DcWomA*
Smith, Martha Swale 1872-1950 *FolkA 86*
Smith, Marvin Pentz 1910- *AfroAA*
Smith, Mary 1842-1878 *DcWomA, NewYHSD*
Smith, Mary A *DcWomA, NewYHSD*
Smith, Mary Ann *FolkA 86*
Smith, Mary Caroline Wooley *FolkA 86*
Smith, Mary E *AfroAA*
Smith, Mary Priscilla Wilson *NewYHSD*
Smith, Mary Priscilla Wilson d1874 *DcWomA*
Smith, Mary S *DcWomA*
Smith, Mary W *WhoArt 80, −82, −84*
Smith, Mary W 1904- *DcBrA 2*
Smith, Maryan *DcWomA*
Smith, Mrs. Mason *DcWomA, WhAmArt 85*
Smith, Matilda *DcWomA*
Smith, Matthew 1879-1959 *McGDA*
Smith, Sir Matthew 1879- *ClaDrA*
Smith, Sir Matthew 1879-1959 *PhDcTCA 77*
Smith, Sir Matthew Arnold Bracy 1879-1959 *DcBrA 1, OxArt, OxTwCA*
Smith, Maurice Randolph 1918- *AmArch 70*
Smith, May *DcWomA*
Smith, May Aimee 1891- *DcWomA*
Smith, May Mott *WhAmArt 85*
Smith, Melvin Howard 1930- *AmArch 70*
Smith, Michael A 1942- *ICPEnP A, MacBEP, WhoAmA 84*
Smith, Michael P 1937- *ICPEnP A, MacBEP*
Smith, Mildred R *WhAmArt 85*
Smith, Miles 1920?- *FolkA 86*
Smith, Miller *DcBrA 1, DcVicP 2*
Smith, Minna Walker 1883- *DcWomA, WhAmArt 85*
Smith, Minor *FolkA 86*
Smith, Miriam Tindall *WhAmArt 85*
Smith, Moishe 1929- *PrintW 83, −85, WhoAmA 73, −76, −78, −80, −82, −84*
Smith, Moore *WhAmArt 85*
Smith, Moreland Griffith 1906- *AmArch 70*
Smith, Morgan Sparks *AfroAA*
Smith, Mortimer L 1840-1896 *ArtsEM, BiDAmAr*
Smith, Murcie *AfroAA*
Smith, Muriel Constance *WhoArt 80, −82, −84*
Smith, Muriel Constance 1903- *DcBrA 1*
Smith, Mrs. Myron Davis *DcWomA*
Smith, Myrtis 1887- *DcWomA, WhAmArt 85*
Smith, Myrtle Holm 1875- *DcWomA, WhAmArt 85*
Smith, N *AmArch 70, DcBrWA*
Smith, N B *AmArch 70*
Smith, Nan S 1952- *AmArt, WhoAmA 82, −84*
Smith, Nancy *DcWomA*
Smith, Nathaniel *AntBDN N, DcBrWA*
Smith, Ned *IlsBYP*
Smith, Neill 1928- *AmArch 70*
Smith, Neville d1916 *DcBrA 2*
Smith, Noel *DcVicP 2*
Smith, Norman *FolkA 86*
Smith, Norman 1910- *ClaDrA, DcBrA 1, WhoArt 80, −82, −84*
Smith, Olga Marie 1866-1930 *DcWomA*

Smith, Olive Wheeler *DcVicP 2*
Smith, Olive Wheeler *DcWomA*
Smith, Oliver 1896- *WhoAmA 73, −76, −78, −80*
Smith, Oliver 1918- *ConDes*
Smith, Oliver Claude *DcBrWA*
Smith, Oliver Harold, Jr. 1909- *AmArch 70*
Smith, Oliver Phelps 1867-1953 *WhAmArt 85*
Smith, Owen E *WhAmArt 85*
Smith, Owen Franklin 1917- *AmArch 70*
Smith, P *DcVicP 2, DcWomA*
Smith, P C *NewYHSD*
Smith, P H *FolkA 86*
Smith, Pamela Colman 1877?-1950? *DcWomA*
Smith, Pamela Colman 1878- *WhAmArt 85*
Smith, Patrick Knox 1907- *WhAmArt 85*
Smith, Paul 1907- *WhAmArt 85*
Smith, Paul H 1894- *WhAmArt 85*
Smith, Paul J 1931- *WhoAmA 73, −76, −78, −80, −82, −84*
Smith, Paul K 1893- *WhoAmA 73*
Smith, Paul Kauvar 1893- *ArtsAmW 2, IlBEAAW, WhAmArt 85*
Smith, Paul Roland 1916- *WhoAmA 73, −76, −78, −80, −82, −84*
Smith, Paul Williamson 1886- *WhAmArt 85*
Smith, Mrs. Percy *DcVicP 2*
Smith, Percy John Delf 1882-1948 *DcBrA 1, DcBrBI*
Smith, Perry Coke 1899- *AmArch 70*
Smith, Peter Harmon 1943- *MarqDCG 84*
Smith, Peter William 1920- *WhoArt 80, −82, −84*
Smith, Phil W *DcBrA 2*
Smith, Philip Henry 1924- *WhoArt 80, −82, −84*
Smith, Phillip D *MarqDCG 84*
Smith, Phillip Oliver 1934- *AmArch 70*
Smith, Phillippe G 1934- *AfroAA*
Smith, Phillips W 1937- *MarqDCG 84*
Smith, Porter Jackson 1928- *AmArch 70*
Smith, Purchase 1774-1828 *CabMA*
Smith, R *FolkA 86*
Smith, R A *AmArch 70*
Smith, R Beatrice L *DcVicP 2*
Smith, Mrs. R Catterson *DcVicP 2, DcWomA*
Smith, R Chipchase- *DcVicP 2*
Smith, R D *AmArch 70*
Smith, R G *AmArch 70*
Smith, R H *AmArch 70*
Smith, R Harmer 1906- *WhoAmA 73, −76, −78, −80*
Smith, R J *DcWomA*
Smith, R K *NewYHSD*
Smith, R L *AmArch 70*
Smith, R P *NewYHSD*
Smith, R S *AmArch 70*
Smith, Rachel *FolkA 86*
Smith, Rae *NewYHSD*
Smith, Ragnar 1930- *AmArch 70*
Smith, Ralph *AfroAA*
Smith, Ralph Alexander 1929- *WhoAmA 73, −76, −78, −80, −82, −84*
Smith, Ralph Eden *AmArch 70*
Smith, Ralph Waldo 1877- *ArtsAmW 1*
Smith, Ray Twitchell *WhAmArt 85*
Smith, Ray Winfield 1897- *WhoAmA 73, −76, −78*
Smith, Raymond F 1901- *AmArch 70*
Smith, Rebecca *FolkA 86*
Smith, Reginald 1870?-1926 *DcBrA 1, DcVicP 2*
Smith, Rich L 1938- *MarqDCG 84*
Smith, Richard *EncASM*
Smith, Richard d1857 *CabMA*
Smith, Richard 1931- *ConArt 77, −83, ConBrA 79[port], DcCAr 81, McGDA, OxTwCA, PhDcTCA 77, PrintW 83, −85*
Smith, Richard Eugene 1952- *MarqDCG 84*
Smith, Richard L 1926- *AmArch 70*
Smith, Richard Scott 1912- *AmArch 70*
Smith, Richard Sharp 1852-1924 *BiDAmAr*
Smith, Richard Somers 1813-1877 *NewYHSD*
Smith, Rick 1955- *MarqDCG 84*
Smith, Robert *NewYHSD*
Smith, Robert 1722?-1777 *BnEnAmA, MacEA*
Smith, Robert 1787-1873 *DcBrWA, MacEA*
Smith, Robert 1792-1882 *DcBrWA*
Smith, Robert, Jr. *BiDBrA*
Smith, Robert Alan 1923- *WhoAmA 73, −76, −78, −80, −82, −84*
Smith, Robert B *NewYHSD*
Smith, Robert C 1912- *WhoAmA 73*
Smith, Robert C 1912-1975 *WhoAmA 76N, −78N, −80N, −82N, −84N*
Smith, Robert Calhoun 1925- *AmArch 70*
Smith, Robert Catterson *DcBrBI, DcVicP 2*
Smith, Robert Charles 1926- *WhoAmA 80, −82, −84*
Smith, Robert Converse 1924- *AmArch 70*
Smith, Robert Eugene 1930- *MarqDCG 84*
Smith, Robert Gray 1942- *WhoAmA 76, WorECar*
Smith, Robert Harmer 1906- *WhAmArt 85*
Smith, Robert Henry *DcBrA 1*
Smith, Robert Jackson 1914- *AmArch 70*
Smith, Robert James 1923- *AmArch 70*
Smith, Robert Judson, II 1944- *MarqDCG 84*
Smith, Robert Lewis 1940- *WhoAmA 76, −78, −80, −82, −84*

Smith, Robert M *WhAmArt 85*
Smith, Robert Marion 1927- *AmArch 70*
Smith, Robert Milton 1925- *AmArch 70*
Smith, Robert Neil 1936- *AmArch 70*
Smith, Robert Press 1953- *MarqDCG 84*
Smith, Robert S 1722?-1777 *BiDAmAr*
Smith, Robert Sidney 1877-1935 *WorECom*
Smith, Robert Skilleter 1862-1943 *BiDAmAr*
Smith, Robin Artine 1903- *WhAmArt 85*
Smith, Ronald Dean 1935- *AmArch 70*
Smith, Ronald LeNoell 1934- *AmArch 70*
Smith, Rosa *DcVicP 2*
Smith, Rosa M *DcVicP 2, DcWomA*
Smith, Rosamond L *WhAmArt 85*
Smith, Rosamond Lombard *DcWomA*
Smith, Ross Ransom Williams 1941- *WhoAmA 78, –80, –82*
Smith, Roswell *CabMA*
Smith, Roswell T *FolkA 86, NewYHSD*
Smith, Royal Brewster *FolkA 86*
Smith, Ruby *DcWomA*
Smith, Rupert 1954- *PrintW 83, –85*
Smith, Russell 1812-1896 *ArtsAmW 1, NewYHSD*
Smith, Russell 1812-1898 *ArtsAmW 85*
Smith, Russell Train 1905- *WhAmArt 85*
Smith, Ruth Reininghaus *WhoAmA 84*
Smith, S *AmArch 70, DcWomA*
Smith, S A *AfroAA*
Smith, S G *DcVicP 2*
Smith, S M *AmArch 70*
Smith, S Theobald *DcVicP 2*
Smith, Sally *FolkA 86*
Smith, Sam 1918- *WhoAmA 73, –76, –78, –80, –82, –84*
Smith, Sampson 1813-1878 *DcNiCA*
Smith, Samuel *BiDBrA, CabMA, FolkA 86*
Smith, Samuel 1786?- *NewYHSD*
Smith, Samuel 1888- *DcBrA 1*
Smith, Samuel, Jr. d1812 *NewYHSD*
Smith, Samuel Mountjoy *DcVicP, –2*
Smith, Samuel P *NewYHSD*
Smith, Sara J *DcWomA*
Smith, Sarah *FolkA 86, WhAmArt 85*
Smith, Sarah Burrell *DcVicP 2, DcWomA*
Smith, Sarah Douglas *FolkA 86*
Smith, Sarah E *ArtsEM, DcWomA*
Smith, Sarah J *WhAmArt 85*
Smith, Sarah K *WhAmArt 85*
Smith, Sarah Katharine *DcWomA*
Smith, Sarah R *WhAmArt 85*
Smith, Sharon Jean 1951- *MacBEP*
Smith, Sherman *WhAmArt 85*
Smith, Sherri 1943- *WhoAmA 84*
Smith, Sherry 1943- *WhoAmA 78, –80, –82*
Smith, Sherwood 1925- *AmArch 70*
Smith, Sherwood Alan 1920- *AmArch 70*
Smith, Shirlann *WhoAmA 73, –76, –78, –80, –82*
Smith, Shirley Ann *WhoAmA 84*
Smith, Sibley 1908- *WhAmArt 85*
Smith, Sidney 1877-1935 *WhAmArt 85*
Smith, Sidney 1912- *DcBrA 2*
Smith, Sidney L 1845- *EarABI*
Smith, Sidney Lawton *WhAmArt 85*
Smith, Sidney Paul 1904- *IIBEAAW, WhAmArt 85*
Smith, Sidney Scott 1930- *AmArch 70*
Smith, Simon *DcCAr 81*
Smith, Sophia *DcWomA*
Smith, Sophia Stevens *FolkA 86*
Smith, St. John 1910- *AmArch 70*
Smith, Stanley *WhoArt 82N*
Smith, Stanley 1893- *DcBrA 1, WhoArt 80*
Smith, Stanley Albert *DcBrA 1*
Smith, Stanley Monroe 1917- *AmArch 70*
Smith, Stanley Swinford 1928- *AmArch 70*
Smith, Stephen *DcVicP 2*
Smith, Stephen Catterson 1806-1872 *DcVicP, –2*
Smith, Stephen Catterson 1849-1912 *DcBrA 1, DcVicP, –2*
Smith, Mrs. Stephen Catterson *DcWomA*
Smith, Stephen Clinton 1949- *MarqDCG 84*
Smith, Steve P, Jr. 1943- *MarqDCG 84*
Smith, Steven Cole 1952- *MarqDCG 84*
Smith, Mrs. Stowell LeCain *WhAmArt 85*
Smith, Stuart *DcVicP 2*
Smith, Sukey Jarvis 1773-1809 *FolkA 86*
Smith, Susan 1783-1853 *FolkA 86*
Smith, Susan Carlton 1923- *WhoAmA 78, –80, –82, –84*
Smith, Susan E *DcWomA, WhAmArt 85*
Smith, Susanne F *DcWomA, WhAmArt 85*
Smith, Suzanne *WhAmArt 85*
Smith, Sydney *DcVicP 2, WhAmArt 85*
Smith, Sydney Ure 1887-1949 *DcBrA 2*
Smith, T *FolkA 86*
Smith, T B *DcVicP 2*
Smith, T C *AmArch 70*
Smith, T E *AmArch 70*
Smith, T H *AmArch 70*
Smith, T J *NewYHSD*
Smith, T L *DcVicP 2*
Smith, T L 1835- *ArtsNiC*

Smith, T M *NewYHSD*
Smith, T S *DcVicP 2*
Smith, T W *DcVicP 2, DcWomA*
Smith, Thelma Degoede 1915- *WhoAmA 76, –78, –80, –82, –84*
Smith, Thomas *BnEnAmA, DcAmArt, DcBrWA, FolkA 86, McGDA, NewYHSD*
Smith, Thomas d1767 *DcBrECP, DcBrWA*
Smith, Thomas 1678-1742 *EarABI*
Smith, Thomas 1785-1857 *BiDBrA*
Smith, Thomas 1799-1875 *BiDBrA*
Smith, Thomas A *NewYHSD*
Smith, Thomas Anthony 1926- *AmArch 70*
Smith, Thomas Baker, Jr. *AmArch 70*
Smith, Thomas C *DcBrBI, FolkA 86*
Smith, Thomas Gerard 1922- *AmArch 70*
Smith, Thomas H *FolkA 86, NewYHSD*
Smith, Thomas Herbert 1877- *WhAmArt 85*
Smith, Thomas Lochlan 1835-1884 *NewYHSD*
Smith, Thomas Moore *DcBrA 1*
Smith, Thomas Reynolds 1839-1910 *DcBrA 2*
Smith, Thomas Richard 1945- *MarqDCG 84*
Smith, Thomas Tayler *DcVicP 2*
Smith, Thomas Wilson 1909- *AmArch 70*
Smith, Tom *DcVicP 2, MarqDCG 84*
Smith, Tony 1912- *BnEnAmA, ConArt 77, DcAmArt, DcCAA 77, DcCAr 81, McGDA, OxTwCA, PhDcTCA 77, WhoAmA 73, –76, –78, –80, –82, –84*
Smith, Tony 1912-1980 *ConArt 83, WorArt[port]*
Smith, Tryphena Goldsbury 1801-1836 *DcWomA, FolkA 86, NewYHSD*
Smith, Tucker *OfPGCP 86*
Smith, Twigg 1882- *WhAmArt 85*
Smith, V *AmArch 70*
Smith, V F *AmArch 70*
Smith, V L, Jr. *AmArch 70*
Smith, V S *AmArch 70*
Smith, Vera Crichton *DcWomA*
Smith, Vernon B 1894- *WhAmArt 85*
Smith, Vernon C 1933- *AmArch 70*
Smith, Victor Joachim 1929- *WhoAmA 78, –80, –82, –84*
Smith, Vincent D 1929- *AmArt, WhoAmA 78, –80, –82, –84*
Smith, Vincent DaCosta 1929- *AfroAA*
Smith, Violet Thompson 1882- *DcWomA, WhAmArt 85*
Smith, Virgil Raymond 1938- *AmArch 70*
Smith, Virginia Bland *FolkA 86*
Smith, Virginia Jeffrey *WhAmArt 85*
Smith, Von *NewYHSD*
Smith, W *AmArch 70, DcVicP 2, FolkA 86, NewYHSD*
Smith, Mrs. W *DcVicP 2*
Smith, W A *AmArch 70, DcVicP 2, FolkA 86*
Smith, W A 1753-1793? *DcBrECP*
Smith, W Armfield *DcVicP, –2*
Smith, W C *AmArch 70*
Smith, W Caldwell 1931- *AmArch 70*
Smith, W D *EncASM*
Smith, W Don *AmArch 70*
Smith, W Eugene 1918-1978 *ConPhot, ICPEnP, MacBEP, WhAmArt 85*
Smith, W Eugene 1919- *BnEnAmA*
Smith, W G *AmArch 70, DcBrBI*
Smith, W Harding C 1848-1922 *DcBrA 1, DcVicP*
Smith, W Harry d1951 *WhoAmA 78N, –80N, –82N, –84N*
Smith, W Harry 1875-1951 *WhAmArt 85*
Smith, W Linford 1869- *WhAmArt 85*
Smith, W Prior *DcBrWA, DcVicP 2*
Smith, W T *DcVicP 2*
Smith, W Thomas *DcVicP 2*
Smith, W T Russell 1812-1896 *EarABI SUP*
Smith, W Thomas *DcVicP 2*
Smith, W Thomas 1862- *DcBrBI*
Smith, Wallace Herndon 1901- *WhAmArt 85*
Smith, Walt Allen 1910-1971 *WhoAmA 78N, –80N, –82N, –84N*
Smith, Walter Alison 1924- *AmArch 70*
Smith, Walter Granville 1870-1938 *WhAmArt 85*
Smith, Walter Gray, Jr. 1941- *AmArch 70*
Smith, Walter Keeble, Jr. 1900- *AmArch 70*
Smith, Walter W *AfroAA*
Smith, Walter W 1884?- *WhAmArt 85*
Smith, Warren Huntington 1925- *AmArch 70*
Smith, Warren Lee 1911- *AmArch 70*
Smith, Weaks Gardner 1922- *AmArch 70*
Smith, Wells *DcVicP 2*
Smith, Whitney R 1911- *ConArch*
Smith, Whitney Rowland 1911- *AmArch 70*
Smith, Mrs. Wilbur *WhAmArt 85*
Smith, Wilfred Joseph 1932- *AmArch 70*
Smith, Will *FolkA 86*
Smith, Willi 1948- *WorFshn*
Smith, William *AntBDN N, ArtsEM, BiDBrA, CabMA, DcNiCA, DcVicP, –2, FolkA 86, IlDcG, NewYHSD*
Smith, William d1786 *BiDBrA*
Smith, William 1661-1724 *BiDBrA, OxArt*
Smith, William 1705-1747 *BiDBrA*

Smith, William 1707-1764 *DcBrECP*
Smith, William 1811?- *NewYHSD*
Smith, William 1842?- *FolkA 86*
Smith, William Arthur 1918- *IlBEAAW, IlrAm F, –1880, IlsBYP, IlsCB 1744, –1946, WhAmArt 85, WhoAmA 73, –76, –78, –80, –82, –84*
Smith, William Bailey 1914- *AmArch 70*
Smith, William Bassett- *DcVicP 2*
Smith, William Branston 1930- *WhoArt 80, –82, –84*
Smith, William Brooke *WhAmArt 85*
Smith, William C *NewYHSD*
Smith, William Collingwood 1815-1887 *DcBrWA, DcSeaP, DcVicP, –2*
Smith, William D *EncASM*
Smith, William D 1800?- *NewYHSD*
Smith, William Deane 1932- *AmArch 70*
Smith, William E *NewYHSD*
Smith, William E 1913- *AfroAA*
Smith, William Good *NewYHSD*
Smith, William H *DcVicP, –2, WhAmArt 85*
Smith, William H Seth- *DcVicP 2*
Smith, William Harding Collingwood 1848-1922 *DcBrWA, DcVicP 2*
Smith, William Harold 1900- *WhAmArt 85*
Smith, William J *DcVicP 2*
Smith, William Kern 1914- *AmArch 70*
Smith, William L *AfroAA*
Smith, Mrs. William Mason *WhAmArt 85*
Smith, William O *NewYHSD*
Smith, William Paul, Jr. 1922- *AmArch 70*
Smith, William R *NewYHSD*
Smith, William Ronald *OxTwCA*
Smith, William Russell *ArtsNiC*
Smith, William S *FolkA 86*
Smith, William S 1821- *NewYHSD*
Smith, William Thompson Russell 1812-1896? *IlBEAAW, NewYHSD*
Smith, William W *AfroAA, FolkA 86*
Smith, Willoughby *FolkA 86*
Smith, Wilson L 1878-1931 *BiDAmAr*
Smith, Winifred *ArtsEM, DcBrBI, DcWomA*
Smith, Wuanita 1866-1959 *DcWomA, WhAmArt 85*
Smith, Xanthus R 1838-1929 *DcSeaP*
Smith, Xanthus Russell 1839-1929 *IlBEAAW, NewYHSD , WhAmArt 85*
Smith, Zay 1902- *AmArch 70*
Smith, Zenobia *AfroAA*
Smith And Feltman *EncASM*
Smith And Mayo *EncASM*
Smith And Selzer *ArtsEM*
Smith And Smith *EncASM*
Smith-Dorrien, Mary L H *DcWomA*
Smith-Gordon, Nannette 1934- *WhoAmA 78*
Smith-Hald, Frithjof 1846-1903 *ClaDrA*
Smith Of Chichester, George 1714-1776 *DcBrECP*
Smith Patterson *EncASM*
Smith-Wildstein, Nannette 1934- *WhoAmA 76*
Smitham, David 1952- *DcCAr 81*
Smithard, G S d1919 *DcBrA 2*
Smithburn, Florence Bartley *WhAmArt 85*
Smither, Edward Murray 1937- *WhoAmA 76, –78, –80, –82, –84*
Smither, James d1797 *BnEnAmA, NewYHSD*
Smither, James 1741- *EarABI*
Smither, James, Jr. *NewYHSD*
Smitherman, G Scott 1921- *AmArch 70*
Smithers, Charles L 1942- *MarqDCG 84*
Smithers, Collier *DcVicP 2*
Smithers, H *DcVicP 2*
Smithers, Herbert H *WhAmArt 85*
Smithett, Agnes L *DcVicP 2*
Smithfield, Ulrich *FolkA 86*
Smithgall, James Jay 1930- *AmArch 70*
Smithingham, George *FolkA 86*
Smithmeyer, J L 1832-1908 *BiDAmAr*
Smithmeyer, John L 1832-1908 *MacEA*
Smithmeyer And Pelz *MacEA*
Smithmyer, Bernard Anthony 1955- *MarqDCG 84*
Smithson, Alison *McGDA*
Smithson, Alison 1928- *ConArch, DcD&D, EncMA, MacEA*
Smithson, Alison Margaret 1928- *WhoArch*
Smithson, John d1643 *OxArt*
Smithson, Peter *McGDA*
Smithson, Peter 1923- *ConArch, DcD&D, EncMA, MacEA*
Smithson, Peter Denham 1923- *WhoArch*
Smithson, Robert 1536?-1614 *OxArt*
Smithson, Robert 1938- *BnEnAmA, DcCAA 71*
Smithson, Robert 1938-1972 *OxTwCA*
Smithson, Robert 1938-1973 *ConArt 77, –83, DcAmArt, DcCAA 77, WorArt[port]*
Smithson, Robert I 1938- *WhoAmA 73*
Smithson, Robert I 1938-1974 *WhoAmA 76N, –78N, –80N, –82N, –84N*
Smithyes, Arthur W *DcVicP 2*
Smits, Eugene 1826-1912 *ClaDrA*
Smits, Gaspar 1635?-1707? *ClaDrA*
Smits, Jakob 1855-1928 *McGDA, OxArt*
Smits, Jakob 1856-1928 *OxTwCA, PhDcTCA 77*

Smits, Patrick Norval 1953- *MarqDCG 84*
Smitz, M *NewYHSD*
Smizer, F, Jr. *AmArch 70*
Smock, Sue M *AfroAA*
Smok, Jan 1921- *MacBEP*
Smokova-Vachova, Vera 1940- *ConPhot, ICPEnP A*
Smoky, Lois 1907- *IlBEAAW, WhAmArt 85*
Smolak, Stanley 1900?- *FolkA 86*
Smolan, Rick 1949- *ICPEnP A*
Smolen, Francis 1900- *WhAmArt 85*
Smolen, Victor 1925- *AmArch 70*
Smoliansky, Gunnar 1933- *ICPEnP A*
Smolin, Michael 1938- *MarqDCG 84*
Smolin, Nat d1950 *WhoAmA 78N, -80N, -82N, -84N*
Smolin, Nat 1890-1950 *WhAmArt 85*
Smongeski, Joseph L 1914- *WhAmArt 85*
Smongeski, Joseph Leon 1914- *WhoAmA 76, -78, -80, -82, -84*
Smoot, Margaret 1907- *WhAmArt 85*
Smoote, Jim S *AfroAA*
Smotrich, David Isadore 1933- *AmArch 70*
Smout, Lucas, The Younger 1671-1713 *DcSeaP*
Smrckova, Ludvika 1908- *DcCAr 81*
Smul, Ethel Lubell 1896?- *DcWomA*
Smul, Ethel Lubell 1897- *WhAmArt 85, WhoAmA 73, -76*
Smulders, Aivic 1940- *ICPEnP A*
Smulian, S *AmArch 70*
Smull, Neil Harrison 1922- *AmArch 70*
Smull, William 1921- *AmArch 70*
Smullyan, Robert *WhAmArt 85*
Smutny, Joseph S 1855-1903 *WhAmArt 85*
Smyly, R R, Jr. *AmArch 70*
Smyrl, Bill M *AmArch 70*
Smyser, Hugh F 1943- *MarqDCG 84*
Smytere, Anna De 1520?-1566? *DcWomA*
Smyters, Anna De 1520?-1566? *DcWomA*
Smyth, Albert *EncASM*
Smyth, C *DcVicP 2*
Smyth, Charles Piazzi 1812-1900 *MacBEP*
Smyth, Coke *DcVicP 2*
Smyth, Craig Hugh 1915- *WhoAmA 73, -76, -78, -80, -82, -84*
Smyth, David Richard 1943- *DcCAr 81, WhoAmA 78, -80, -82, -84*
Smyth, Dorothy Carleton *DcBrA 1, DcBrBI, DcWomA*
Smyth, Ed 1916- *WhoAmA 78, -80, -82, -84*
Smyth, Edmund R 1902- *WhAmArt 85*
Smyth, Edward *DcVicP 2*
Smyth, Emily R *DcVicP 2, DcWomA*
Smyth, Eugene Leslie 1857-1932 *ArtsAmW 3, IlBEAAW*
Smyth, Frederick Coke 1800?- *DcBrWA*
Smyth, Grace Allan, Jr. 1907- *WhAmArt 85*
Smyth, H *DcVicP 2*
Smyth, J G, Jr. *AmArch 70*
Smyth, Joel *FolkA 86*
Smyth, John *WhoArch*
Smyth, M *FolkA 86*
Smyth, Margaret *DcWomA*
Smyth, Margarita 1873- *DcWomA*
Smyth, Montague 1863-1965 *DcBrA 1*
Smyth, N B *AmArch 70*
Smyth, Ned 1948- *DcCAr 81, PrintW 83, -85*
Smyth, Nora *DcWomA, WhAmArt 85*
Smyth, Olive Carleton 1882- *DcBrA 1, DcWomA*
Smyth, S Gordon 1891- *WhAmArt 85*
Smyth, Thomas *DcVicP 2*
Smyth, W d1837 *DcBrWA*
Smyth, Walter Montague 1863-1965 *DcVicP 2*
Smyth, William d1877 *DcBrWA, NewYHSD*
Smyth, William Henry 1788-1865 *DcSeaP*
Smythe, D *DcVicP 2*
Smythe, David Richard 1943- *WhoAmA 73, -76*
Smythe, Edward Robert 1810-1899 *DcVicP, -2*
Smythe, Emily R *DcWomA*
Smythe, Emma *DcWomA*
Smythe, Ernest *DcBrBI*
Smythe, Eugene Leslie 1857-1932 *WhAmArt 85*
Smythe, Francis Sydney 1900-1949 *MacBEP*
Smythe, Leslie E B *DcVicP 2*
Smythe, Lionel Percy *WhAmArt 85*
Smythe, Lionel Percy 1839-1918 *ClaDrA, DcBrA 1, DcBrBI, DcBrWA, DcVicP, -2*
Smythe, Margarita Pumpelly 1873- *WhAmArt 85*
Smythe, Minnie *ClaDrA*
Smythe, Minnie d1955 *DcBrA 1, DcVicP 2, DcWomA*
Smythe, Richard 1863- *DcBrA 1, DcVicP 2*
Smythe, Robert L *NewYHSD*
Smythe, Thomas 1825-1906 *DcBrA 1*
Smythe, Thomas 1825-1907 *DcVicP, -2*
Smythe, Willard Grayson 1906- *WhAmArt 85*
Smythe, William 1800-1877 *ArtsAmW 1*
Smythson, John d1634 *BiDBrA, McGDA, WhoArch*
Smythson, John d1643 *OxArt*
Smythson, Marcus H *DcVicP 2*
Smitz, Robert d1614 *McGDA*
Smythson, Robert 1535-1614 *DcD&D, MacEA*

Smythson, Robert 1536?-1614 *OxArt, WhoArch*
Snabille, Maria Geertruida *DcWomA*
Snaer, Jonathan *NewYHSD*
Snaer, Seymour *WhAmArt 85*
Snaith, William 1908- *McGDA*
Snape, Martin *DcBrA 1, DcVicP, -2*
Snape, William H *DcVicP 2*
Snapp, Frank *WhAmArt 85*
Snapp, R L *AmArch 70*
Snapp, Warren P 1948- *MarqDCG 84*
Snard, Mrs. T G *DcVicP 2*
Snarr, Mildred Ann *WhAmArt 85*
Snaveley, John *FolkA 86*
Snayers, Pieter 1592-1666? *McGDA*
Snead, E M *AmArch 70*
Snead, J D, Jr. *AmArch 70*
Snead, Louise W *WhAmArt 85*
Snead, Louise Willis *DcWomA*
Snedaker, R Lloyd 1905- *AmArch 70*
Snedecor, Charles E 1875-1917 *WhAmArt 85*
Snedeker, Virginia 1909- *WhAmArt 85*
Sneden, Arthur Durant 1874-1942 *BiDAmAr*
Sneden, Eleanor Antoinette 1876- *DcWomA, WhAmArt 85*
Sneed, James *AfroAA*
Sneed, Patricia M 1922- *WhoAmA 73, -76, -78, -80, -82, -84*
Sneis, Frans *McGDA*
Snelgrove, Gordon William *WhoAmA 78N, -80N, -82N, -84N*
Snelgrove, Walter 1924- *DcCAA 71, -77*
Snelgrove, Walter H 1924- *WhoAmA 73, -76, -78*
Snell, Carroll C 1893- *WhAmArt 85*
Snell, Charles K *FolkA 86*
Snell, Florence Frances 1850?-1946 *DcWomA*
Snell, Florence Francis 1850-1946 *WhAmArt 85*
Snell, G *DcVicP 2*
Snell, George 1820-1893 *BiDAmAr*
Snell, Henry B 1858-1943 *WhAmArt 85*
Snell, James Herbert 1861-1935 *DcBrA 1, DcVicP, -2*
Snell, John L *FolkA 86*
Snell, Lulu *DcWomA*
Snell, Lulu M *WhAmArt 85*
Snell, Mary *DcVicP 2*
Snell, Olive *DcWomA*
Snell, P *NewYHSD*
Snell, Walter Scott 1915- *AmArch 70*
Snell, William R *NewYHSD*
Snell, Zulma M *DcWomA, WhAmArt 85*
Snellinck, Jan 1549-1638 *McGDA*
Snelling, John 1914- *WhoAmA 80, -82, -84*
Snelling, Lilian 1879?- *DcWomA*
Snelling, Richard Jackson 1896- *AmArch 70*
Snellings, Richard Temple 1915- *AmArch 70*
Snelson, Kenneth 1927- *BnEnAmA, ConArt 77, -83, DcCAA 71, -77, DcCAr 81, OxTwCA, WorArt*
Snelson, Kenneth D 1927- *WhoAmA 73, -76, -78, -80, -82, -84*
Snepp, Hazel *WhAmArt 85*
Sneyd, Eleanor F *DcWomA*
Sneyd, John 1766-1835 *DcBrBI*
Sneyd, Sarah M *DcVicP 2*
Sneyd, Walter 1809-1888 *DcBrBI*
Sneyers, Leon 1877-1949 *MacEA*
Snibbe, Richard Wilson 1916- *AmArch 70*
Snider, George *NewYHSD*
Snider, J *FolkA 86*
Snider, Lillian Bohl 1893?-1955? *WhAmArt 85*
Snider, Lillian Bohl 1893?-1956? *DcWomA*
Snider, Louise Bohl 1893-1955? *ArtsAmW 3*
Snider, Marguerite *WhAmArt 85*
Snider, Robert C 1924- *MacBEP*
Snider, Samuel 1820?- *FolkA 86*
Snidow, Gordon *OfPGCP 86*
Snidow, Gordon 1936- *IlBEAAW*
Snidow, Gordon E 1936- *AmArt, WhoAmA 76, -78, -80, -82, -84*
Sniff, John E *WhAmArt 85*
Snipes, Alfred Haywood 1909- *AmArch 70*
Snoddy, M F *AmArch 70*
Snoden, David d1747 *CabMA*
Snodgrass, Davis J *WhAmArt 85*
Snodgrass, Jeanne Owens 1927- *WhoAmA 73, -76, -78, -80, -82, -84*
Snodgrass, R L *AmArch 70*
Snook, C J, Jr. *AmArch 70*
Snook, Harry 1944- *DcCAr 81*
Snook, John Butler 1815-1901 *MacEA*
Snook, Jonathan B 1815-1901 *BiDAmAr*
Snook, Kevin Lee 1952- *MarqDCG 84*
Snook, Samuel B 1857-1915 *BiDAmAr*
Snoswell, W T *DcVicP 2*
Snow, Beverly Anne 1943- *MarqDCG 84*
Snow, Carmel White 1887-1961 *WorFshn*
Snow, Charles H *WhAmArt 85*
Snow, Cynthia Reeves 1907- *AmArt, WhoAmA 76, -78, -80, -82, -84*
Snow, E E *ArtsAmW 2, WhAmArt 85*
Snow, Eben H 1870-1945 *WhAmArt 85*
Snow, Edith Huntington *WhAmArt 85*
Snow, Edward Taylor 1844-1913 *WhAmArt 85*

Snow, Helena *DcVicP 2, DcWomA*
Snow, J W *DcBrBI, DcBrWA*
Snow, Jenny Emily *DcWomA, NewYHSD*
Snow, Jenny Emily 1835?- *FolkA 86*
Snow, John 1911- *WhoAmA 73, -76, -78, -80, -82, -84*
Snow, Laura E *DcWomA, WhAmArt 85*
Snow, Lee Erlin 1924- *WhoAmA 76, -78, -80, -82, -84*
Snow, Martin *FolkA 86*
Snow, Mary R B 1908- *WhAmArt 85*
Snow, Michael 1929- *ConArt 77, -83, ConPhot, ICPEnP A, OxTwCA, WhoAmA 73, -76, -78, -80, -82, -84*
Snow, Peter 1927- *DcCAr 81*
Snow, Richard B 1905- *AmArch 70*
Snow, Robert K d1936 *WhAmArt 85*
Snow, Vivian Douglas 1927- *WhoAmA 76, -78, -80*
Snow, W A *FolkA 86*
Snow, William R *DcBrWA*
Snow-Davis *WhAmArt 85*
Snow-Davis, Jessie *DcWomA*
Snowden, Alice B *AfroAA*
Snowden, Chester Dixon 1900- *WhAmArt 85*
Snowden, Elsie Brooke 1887- *DcWomA, WhAmArt 85*
Snowden, George Holburn 1902- *WhAmArt 85*
Snowden, Hilda Mary 1910- *WhoArt 80, -82, -84*
Snowden, Jedidiah d1797 *CabMA*
Snowden, Sylvia *AfroAA*
Snowden, William Etsel, Jr. 1904- *WhAmArt 85*
Snowdon 1930- *ConPhot*
Snowdon, Earl Of 1930- *WorFshn*
Snowdon, Lord 1930- *ICPEnP A, MacBEP*
Snowdon, Margaret Kemplay *DcBrA 1*
Snowdon, Sam Tinsley, Jr. 1926- *AmArch 70*
Snowman, Isaac 1874- *DcBrBI, DcVicP 2*
Snudgrass, William *CabMA*
Snyder, Amanda 1894- *ArtsAmW 3*
Snyder, Annie F *DcWomA, WhAmArt 85*
Snyder, Barry 1929- *WhoAmA 76, -78, -80*
Snyder, C B *WhAmArt 85*
Snyder, C F *WhAmArt 85*
Snyder, Carl Wayne 1953- *MarqDCG 84*
Snyder, Clarence W 1873- *WhAmArt 85*
Snyder, Clifford *WhAmArt 85*
Snyder, Corydon Granger 1879- *WhAmArt 85*
Snyder, Dan 1948- *WhoAmA 82, -84*
Snyder, Daniel *FolkA 86*
Snyder, Daniel Ardellas 1933- *AmArch 70*
Snyder, David Frank 1927- *AmArch 70*
Snyder, Edwin V *EncASM*
Snyder, G N *AmArch 70*
Snyder, George *NewYHSD*
Snyder, George 1820?- *NewYHSD*
Snyder, H C *AmArch 70*
Snyder, Henry *FolkA 86*
Snyder, Henry M *NewYHSD*
Snyder, Henry W *NewYHSD*
Snyder, Isaac 1827?- *FolkA 86*
Snyder, J Rowland 1902- *AmArch 70*
Snyder, Jacob 1825?-1892? *FolkA 86*
Snyder, James Wilberg *WhoAmA 76*
Snyder, James Wilbert *WhoAmA 73, -78, -80, -82*
Snyder, Jerome *IlsCB 1967*
Snyder, Jerome 1916- *IlsBYP, IlsCB 1957, WhAmArt 85, WhoGrA 62*
Snyder, Jerome 1916-1976 *ConDes*
Snyder, Joan 1940- *ConArt 77, PrintW 85, WhoAmA 73, -76, -78, -80, -82, -84*
Snyder, Joel 1940- *ICPEnP A*
Snyder, Joel B 1936- *MarqDCG 84*
Snyder, Joel Dudley, III 1943- *MarqDCG 84*
Snyder, John *FolkA 86*
Snyder, John, Jr. *FolkA 86*
Snyder, Kim Lawrence 1942- *WhoAmA 78, -80, -82, -84*
Snyder, M Elizabeth *DcWomA*
Snyder, Mary *FolkA 86*
Snyder, Patricia Stegman *WhoAmA 78, -80, -82*
Snyder, Philip *FolkA 86, NewYHSD*
Snyder, Richard George 1913- *AmArch 70*
Snyder, Robert *NewYHSD*
Snyder, Robert Harter 1918- *AmArch 70*
Snyder, Ruth *WhoAmA 82, -84*
Snyder, Ruth 1922- *WhoAmA 80*
Snyder, Samuel *FolkA 86*
Snyder, Seymour 1897- *WhAmArt 85, WhoAmA 73, -76, -78*
Snyder, Sidney Eugene 1931- *AmArch 70*
Snyder, Stanley Clayton 1917- *AmArch 70*
Snyder, Toni Goessler 1942- *WhoAmA 78, -80, -82*
Snyder, W H *ArtsEM*
Snyder, W L *IlBEAAW*
Snyder, Wahl John 1910- *AmArch 70*
Snyder, Wayne John 1937- *AmArch 70*
Snyder, William B 1926- *WhoAmA 76, -78, -80, -82, -84*
Snyder, William Henry 1829-1910 *NewYHSD, WhAmArt 85*
Snyders, Frans 1579?-1657 *ClaDrA, McGDA, OxArt*

Spence, Geraldine 1931- *IlsCB 1957*
Spence, Harry 1860-1928 *DcBrA 1, DcVicP 2*
Spence, Henry *BiDAmAr, DcVicP 2*
Spence, J M *AmArch 70*
Spence, James A, Jr. 1930- *AmArch 70*
Spence, James Alexander 1899- *AmArch 70*
Spence, John *DcCAr 81*
Spence, Karrol K 1932- *AmArch 70*
Spence, Melvin Merritt *AmArch 70*
Spence, Percy F S 1868-1933 *DcBrBI*
Spence, R W, Jr. *AmArch 70*
Spence, Robert 1870- *DcBrBI*
Spence, Robert 1871- *DcBrWA*
Spence, Robert 1871-1964 *ClaDrA, DcBrA 1, DcVicP 2*
Spence, Robert 1925- *WhoAmA 76, -78, -80, -82, -84*
Spence, Robert Woodard 1921- *AmArch 70*
Spence, Samuel Burton 1919- *AmArch 70*
Spence, T Everard *ClaDrA, WhoAmA 80, -82, -84*
Spence, Thomas Ralph *DcVicP 2*
Spence, Thomas Ralph 1855?- *ClaDrA*
Spence, William 1806?-1883 *BiDBrA A*
Spence Gaven *EncASM*
Spencelayh, Charles 1865- *ClaDrA*
Spencelayh, Charles 1865-1958 *DcBrA 1, DcBrWA, DcVicP 2*
Spencelayh, Vernon 1891- *DcBrA 1*
Spenceley, J Winfred *WhAmArt 85*
Spencer *DcBrECP*
Spencer 1909- *WhoAmA 73, -76*
Spencer, Mrs. *DcBrECP*
Spencer, Abiel d1878 *CabMA*
Spencer, Ann Hunt 1914- *WhAmArt 85*
Spencer, Asa 1805?- *NewYHSD*
Spencer, Asa, Jr. *NewYHSD*
Spencer, Augustus 1860-1924 *DcBrA 1, DcVicP 2*
Spencer, Benjamin R *NewYHSD*
Spencer, Bertha Augusta *WhAmArt 85*
Spencer, Blanche *DcVicP 2*
Spencer, C B *AmArch 70*
Spencer, C Neame *DcVicP 2*
Spencer, Celia *DcWomA*
Spencer, Charles Neame *DcBrA 1*
Spencer, Charles Samuel 1920- *WhoArt 80, -82, -84*
Spencer, Christopher M 1833-1922 *AntBDN F*
Spencer, Clara Barton *WhAmArt 85*
Spencer, Clyde H 1942- *MarqDCG 84*
Spencer, Daniel *CabMA*
Spencer, Diana *DcWomA*
Spencer, Lady Diana *DcWomA*
Spencer, Edna Isbester 1883- *DcWomA, WhAmArt 85*
Spencer, Eldridge Ted 1893- *AmArch 70*
Spencer, Eleanor Patterson *WhoAmA 73, -76, -78, -80, -82*
Spencer, Elizabeth C *WhAmArt 85*
Spencer, Ella D *AfroAA*
Spencer, Frank B *WhAmArt 85*
Spencer, Fred *DcVicP 2*
Spencer, Frederick B *FolkA 86*
Spencer, Frederick R 1805-1875 *ArtsNiC*
Spencer, Frederick R 1806-1875 *NewYHSD*
Spencer, Frederick W *ArtsEM*
Spencer, G P *NewYHSD*
Spencer, George *AfroAA*
Spencer, Gervase d1763 *AntBDN J*
Spencer, Gilbert 1892- *DcBrA 1, OxArt*
Spencer, Gilbert 1892-1979 *OxTwCA*
Spencer, Gordon R 1925- *MarqDCG 84*
Spencer, Guy Raymond 1878- *WhAmArt 85*
Spencer, Guy Raymond 1878-1945 *ArtsAmW 2*
Spencer, H S *AmArch 70*
Spencer, Harold Edwin 1920- *WhoAmA 78, -80, -82, -84*
Spencer, Harry *DcVicP 2*
Spencer, Harry L *FolkA 86*
Spencer, Henry Cecil 1903- *WhAmArt 85*
Spencer, Herbert 1924- *ConDes, WhoGrA 62, -82[port]*
Spencer, Herman *FolkA 86*
Spencer, Howard Bonnell *WhAmArt 85*
Spencer, Howard Dalee 1950- *WhoAmA 80, -82, -84*
Spencer, Hugh 1887- *WhoAmA 73, -76*
Spencer, Hugh 1887-1975 *WhAmArt 85, WhoAmA 78N, -80N, -82N, -84N*
Spencer, Irene *OfPGCP 86*
Spencer, Irvin B *WhAmArt 85*
Spencer, J B *AmArch 70*
Spencer, J C *NewYHSD*
Spencer, J G *AmArch 70*
Spencer, J W 1934- *AmArch 70*
Spencer, James 1828-1861 *FolkA 86*
Spencer, Jarrard 1650?-1712 *CabMA*
Spencer, Jarrard, Jr. 1684-1754 *CabMA*
Spencer, Jean 1904- *WhAmArt 85*
Spencer, Jean 1942- *ConBrA 79[port], DcCAr 81*
Spencer, Jim-Edd 1905- *WhAmArt 85*
Spencer, Job B 1829- *NewYHSD*
Spencer, Job B 1829-1899 *ArtsEM*
Spencer, John 1904- *WhoArt 80, -82, -84*
Spencer, John R 1923- *WhoAmA 73, -76, -78, -80, -82, -84*

Spencer, John S *DcVicP 2*
Spencer, Joseph *WhAmArt 85*
Spencer, Joseph B *NewYHSD*
Spencer, Julia Selden *WhAmArt 85*
Spencer, Kevin *ConArch A*
Spencer, Countess Lavinia 1762-1831 *DcWomA*
Spencer, Leontine G d1964 *WhoAmA 78N, -80N, -82N, -84N*
Spencer, Leontine G 1882-1964 *DcWomA, WhAmArt 85*
Spencer, Lilly Martin 1822-1902 *DcAmArt, DcWomA, WhAmArt 85, WomArt*
Spencer, Lily Martin 1822-1902 *NewYHSD*
Spencer, Lonnie 1939- *FolkA 86*
Spencer, Lorene 1923- *WhoAmA 76*
Spencer, Lyman Potter 1840-1915 *NewYHSD*
Spencer, Lynda *MarqDCG 84*
Spencer, Margaret F 1882- *WhAmArt 85*
Spencer, Margaret Fulton 1882- *ArtsAmW 2, DcWomA*
Spencer, Margaret K *DcWomA, WhAmArt 85*
Spencer, Mary *DcWomA, WhAmArt 85*
Spencer, Mary 1835-1923 *DcWomA, NewYHSD, WhAmArt 85*
Spencer, Mary J 1900- *WhAmArt 85*
Spencer, Meade A 1896- *WhAmArt 85*
Spencer, Niles *OxTwCA*
Spencer, Niles 1893-1952 *BnEnAmA, DcAmArt, DcCAA 71, -77, McGDA, PhDcTCA 77, WhAmArt 85, WhoAmA 78N, -80N, -82N, -84N*
Spencer, Noel Woodward 1900- *DcBrA 1, WhoArt 80, -82, -84*
Spencer, Obadiah, Jr. 1666-1741 *CabMA*
Spencer, Pamela Mary 1924- *WhoArt 80, -82, -84*
Spencer, Patricia 1943- *DcCAr 81*
Spencer, Platt Roger 1800-1864 *FolkA 86*
Spencer, R B *DcVicP, -2*
Spencer, R E *AmArch 70*
Spencer, Ralph Donald 1927- *AmArch 70*
Spencer, Raymond M *WhAmArt 85*
Spencer, Richard B *DcSeaP*
Spencer, Robert 1879-1931 *ArtsAmW 1, WhAmArt 85*
Spencer, Selina *DcWomA, NewYHSD*
Spencer, Stanley 1891-1959 *ConArt 77, -83, McGDA, OxTwCA, PhDcTCA 77*
Spencer, Sir Stanley 1891-1959 *DcBrA 1, OxArt, WorArt[port]*
Spencer, Sir Stanley 1892-1959 *ClaDrA*
Spencer, Terence 1918- *ICPEnP A, MacBEP*
Spencer, Thomas *DcBrECP*
Spencer, Thomas d1687 *CabMA*
Spencer, W B *DcSeaP*
Spencer, W Clyde 1874-1915 *WhAmArt 85*
Spencer, W H *NewYHSD*
Spencer, Walter Baldwin 1860-1929 *MacBEP*
Spencer, William *NewYHSD*
Spencer, William d1745 *CabMA*
Spencer, William 1829?- *FolkA 86*
Spencer, William A 1952- *MarqDCG 84*
Spencer Bower, Olivia 1905- *DcCAr 81*
Spencer-Stanhope, John Roddam 1829-1908 *DcVicP 2*
Spender, Mrs. *DcVicP 2, DcWomA*
Spender, C *DcVicP 2*
Spender, Humphrey 1910- *ConPhot, ICPEnP A*
Spender, John Humphrey 1910- *DcBrA 1, WhoArt 80, -82, -84*
Spendi, Irena 1951- *DcCAr 81*
Spendlove, Gerald Hugh 1929- *WhoArt 80, -82, -84*
Spengler, Marie Salome d1726 *DcWomA*
Spenko, Tanja 1956- *DcCAr 81*
Spenlove, Francis Raymond 1897- *DcBrA 1*
Spenlove, Frank Spenlove 1864-1933 *DcVicP*
Spenlove, Frank Spenlove 1868-1933 *DcVicP 2*
Spenlove, John Francis Spenlove-1866-1933 *DcBrWA*
Spenlove-Spenlove, Frank 1868-1933 *DcBrA 1*
Spenner, E E *WhAmArt 85*
Spens, Nathaniel 1838-1916 *ArtsAmW 1, IlBEAAW, WhAmArt 85*
Spenser, Daniel *CabMA*
Spenst, Albert Aubrey 1930- *AmArch 70*
Spera, Joseph James 1904- *AmArch 70*
Spera, Michele 1937- *WhoGrA 82[port]*
Sperakis, Nicholas George 1943- *WhoAmA 73, -76, -78, -80, -82, -84*
Sperandio Savelli Of Mantua *McGDA*
Speranza, Giovanni 1480-1532 *McGDA*
Speranza, Vittoria *DcWomA*
Sperl, Robert H 1927- *AmArch 70*
Sperling, Abraham 1920- *AmArch 70*
Sperling, Catharina *DcWomA*
Sperling, George J *WhAmArt 85*
Sperling, J W *DcVicP 2*
Sperling, Louis *FolkA 86*
Spero, M J *WhAmArt 85*
Spero, Nancy 1926- *ConArt 77, -83, DcCAr 81, WhoAmA 76, -78, -80, -82, -84*
Speroni, John L *NewYHSD*
Sperr, O A *AmArch 70*

Sperring, John *BiDBrA*
Sperry, Armstrong W 1897- *IlsCB 1744, -1946*
Sperry, Edward Peck *WhAmArt 85*
Sperry, John *FolkA 86*
Sperry, Joseph Evans 1854-1930 *BiDAmAr*
Sperry, Keith 1888- *WhAmArt 85*
Sperry, Robert 1927- *WhoAmA 76, -78, -80, -82, -84*
Sperry, Theodore S 1822- *NewYHSD*
Spertini, Giovanni *ArtsNiC*
Speyer, A James *WhAmArt 85, WhoAmA 73, -76, -78, -80, -82, -84*
Speyer, Friederich *FolkA 86*
Speyer, Georg Frederick *FolkA 86*
Speyer, Georg Friederich *FolkA 86*
Speyer, Georg Friedrich *FolkA 86*
Speyer, Nora *WhoAmA 76, -78, -80*
Sphinters, Annette *DcWomA*
Spicer, Catherine 1893-1929 *DcWomA*
Spicer, Charles *DcVicP 2*
Spicer, Etta M *ArtsEM, DcWomA*
Spicer, Henry 1743-1804 *AntBDN J*
Spicer, J *DcWomA*
Spicer, Jean Uhl 1935- *WhoAmA 82, -84*
Spicer, Lloyd N F 1905- *AmArch 70*
Spicer, M A *DcWomA*
Spicer, Stanley 1911- *AmArch 70*
Spicer-Simpson, Theodore 1871-1959 *WhoAmA 80N, -82N, -84N*
Spicer-Simson, Margaret 1874- *DcWomA*
Spicer-Simson, Margaret Schmidt 1874- *WhAmArt 85*
Spicer-Simson, Theodore 1871-1959 *WhAmArt 85*
Spickett, Ronald John 1926- *WhoAmA 73, -76, -78, -80, -82*
Spickett, Ronald John, Sr. 1926- *WhoAmA 84*
Spicre, Pierre d1478 *McGDA*
Spicuzza, Francesco J 1883-1962 *WhAmArt 85*
Spidell, Enid Jean 1905- *WhAmArt 85, WhoAmA 73*
Spiegel, Charles, Jr. d1905 *WhAmArt 85*
Spiegel, Doris 1907- *WhAmArt 85*
Spiegel, Dorothy A 1904- *WhAmArt 85*
Spiegel, Flore Von *DcWomA*
Spiegel, Henny *DcWomA*
Spiegel, Isaac, Jr. *FolkA 86*
Spiegel, Isaac, Sr. *FolkA 86*
Spiegel, John *FolkA 86*
Spiegel, Laurie 1945- *MarqDCG 84*
Spiegel, Sam 1904- *WhoAmA 73, -76, -78, -80, -82, -84*
Spiegel, Siegmund 1919- *AmArch 70*
Spiegel, Ted *ICPEnP A*
Spiegel, Theodore Richard 1934- *MacBEP*
Spiegelhalter *AntBDN N*
Spiegelman, Lon Howard 1941- *WhoAmA 82, -84*
Spiegle, Charles 1831?- *NewYHSD*
Spiegle, Dan 1920- *WorECom*
Spiegle, Frederick M 1863-1942 *WhAmArt 85*
Spielberger, Morris *WhAmArt 85*
Spieler, George *NewYHSD*
Spieler, Marie 1845-1913 *DcWomA*
Spieler, William F *NewYHSD*
Spielman, Howard A 1946- *MarqDCG 84*
Spielmann, Lucretia *WhAmArt 85*
Spielmann, Nina *DcWomA*
Spier, Ben *EncASM*
Spier, Peter 1927- *IlsBYP, IlsCB 1946, -1957*
Spier, Peter Edward *IlsCB 1967*
Spier, Peter Edward 1927- *WhoAmA 76, -78, -80, -82, -84*
Spier And Forsheim *EncASM*
Spierer, William McK 1913- *WhAmArt 85*
Spierincx, Frans 1551-1630 *McGDA*
Spiering, Louis C 1874-1912 *BiDAmAr*
Spierling, Hubert 1925- *DcCAr 81*
Spiers, Benjamin Walter *DcBrWA, DcVicP, -2*
Spiers, Bessie J *DcBrWA, DcVicP 2, DcWomA*
Spiers, Charlotte H *DcBrA 1, DcBrWA, DcVicP, -2, DcWomA*
Spiers, E J *DcVicP 2*
Spiers, Harry 1869- *WhAmArt 85*
Spiers, James *CabMA*
Spiers, Richard N 1873-1936 *WhAmArt 85*
Spiers, Richard Phene 1838-1916 *DcBrWA, DcVicP 2, MacEA*
Spiers, Tomas Hoskins, Jr. 1929- *AmArch 70*
Spiers & Son *DcNiCA*
Spies, Harry John 1915- *AmArch 70*
Spiess, Amalie 1793-1830 *DcWomA*
Spiess, C F *AmArch 70*
Spiessl, Ludwig 1931- *AmArch 70*
Spiezle, F B *AmArch 70*
Spike, John Thomas 1951- *WhoAmA 82, -84*
Spilberg, Adriana 1650?- *DcWomA*
Spilberg, Johann 1619-1690 *ClaDrA*
Spilhaus, Nita 1878-1967 *DcWomA*
Spilimberg, Irene Di 1540-1560 *WomArt*
Spilimbergo, Irene Di 1540?-1561? *DcWomA*
Spilimbergo, Lino Enea 1896-1964 *PhDcTCA 77*
Spilimbergo, Lino Eneas 1896-1964 *McGDA, OxTwCA*

Sprout, William Bradford, Jr. 1900- *AmArch 70*
Sprowls, R M *AmArch 70*
Spruance, Benton d1967 *WhoAmA 78N, –82N, –84N*
Spruance, Benton 1904-1967 *DcCAA 71, –77*
Spruance, Benton M 1904-1967 *WhAmArt 85*
Spruance, Benton Murdoch 1904-1967 *GrAmP, McGDA*
Spruance, Helen 1887?- *DcWomA*
Spruce, Edward Caldwell 1865?-1925 *DcBrA 2*
Spruce, Everett 1908- *DcCAA 71, –77, PhDcTCA 77*
Spruce, Everett Franklin 1907- *WhAmArt 85*
Spruce, Everett Franklin 1908- *IlBEAAW, McGDA, WhoAmA 73, –76, –78, –80, –82, –84*
Spruell, Mollye *AfroAA*
Sprunck, Marian L *WhAmArt 85*
Sprunger, Arthur L 1897- *WhAmArt 85*
Sprunger, Elmer 1915?- *IlBEAAW*
Sprunk, Robert Godfrey 1862-1912 *ArtsEM, WhAmArt 85*
Spruor, John *NewYHSD*
Sprute, Gerald Joseph 1933- *AmArch 70*
Spruyt, E Lee 1931- *WhoAmA 73, –76, –78, –80, –82, –84*
Spruyt, Philippe Lambert Joseph 1727-1801 *ClaDrA*
Spry, Charles V 1914-1942 *WhAmArt 85*
Spry, Robert J *ArtsEM*
Spry, William *DcBrWA, DcVicP, –2*
Spuance, Benton d1967 *WhoAmA 80N*
Spuhler, Anna Gustavine 1872- *DcWomA*
Spuler-Krebs, Anna 1876-1933 *DcWomA*
Spurgeon, Miss *DcWomA*
Spurgeon, Joseph E 1903- *WhAmArt 85*
Spurgeon, Sarah 1903- *WhAmArt 85, WhoAmA 73, –76, –78, –80, –82, –84*
Spurgin, James Lindsay *ArtsEM*
Spurgin, John Edwin 1932- *WhoAmA 78, –80, –82, –84*
Spuris, Egons 1931- *ConPhot, ICPEnP A*
Spurling, Alys *DcVicP 2*
Spurling, Celia *DcVicP 2*
Spurling, Everett Gordon, Jr. 1923- *AmArch 70*
Spurling, Jack 1871-1933 *DcBrA 1, DcVicP 2*
Spurling, Norine M 1930- *WhoAmA 80, –82, –84*
Spurlock, William Henry, II 1945- *WhoAmA 76, –78, –80, –82, –84*
Spurr, Eliza W 1794-1819 *FolkA 86*
Spurr, George W *EncASM*
Spurr, Gertrude E *DcVicP 2*
Spurr, Gertrude E 1858-1941 *DcWomA*
Spurr, Polly 1785-1805 *FolkA 86*
Spurrier, Mabel *WhoArt 84N*
Spurrier, Mabel 1880- *WhoArt 80, –82*
Spurrier, Mabel Annie 1880- *DcBrA 1, DcWomA*
Spurrier, Raymond 1920- *WhoArt 82, –84*
Spurrier, Steven 1878-1961 *ClaDrA, DcBrA 1, DcBrBI*
Spurrier, W R *DcBrBI*
Sput, Murray 1923- *AmArch 70*
Spy *WorECar*
Spybuck, E L *FolkA 86*
Spyropoulos, Jannis 1912- *OxTwCA*
Squadra, John 1932- *AmArt, WhoAmA 76, –78, –80, –82, –84*
Squarcione, Francesco 1394-1468? *OxArt*
Squarcione, Francesco 1397?-1468 *McGDA*
Squeri, H J *AmArch 70*
Squier, Donald Gordon 1895- *WhAmArt 85*
Squier, Ephraim George 1821-1888 *EarABI SUP*
Squier, Frank *WhAmArt 85*
Squier, Jack 1927- *DcCAA 71, –77, McGDA*
Squier, Jack Leslie 1927- *WhoAmA 73, –76, –78, –80, –82, –84*
Squier, Jerry *AfroAA*
Squiers, David Ellicott 1918- *WhAmArt 85*
Squilla, John Robert 1951- *MarqDCG 84*
Squire, Alice 1840-1935 *DcBrWA*
Squire, Alice 1840-1936 *DcBrA 1, DcVicP, –2, DcWomA*
Squire, Allan Taft *WhoAmA 78N, –80N, –82N, –84N*
Squire, Allan Taft 1904-1950? *WhAmArt 85*
Squire, Dorothea 1901- *WhAmArt 85*
Squire, Emma *DcVicP, –2, DcWomA*
Squire, Eunice *WhAmArt 85*
Squire, Eunice Clay *DcWomA*
Squire, Harold 1881- *DcBrA 1*
Squire, Hattie *DcWomA*
Squire, Helen *DcVicP 2*
Squire, John *DcBrWA, DcVicP, –2*
Squire, Maud Hunt 1873-1955? *DcWomA*
Squire, Maude H 1873-1955? *WhAmArt 85*
Squire, Richard 1700-1786 *BiDBrA*
Squire, William Cassius 1934- *AmArch 70*
Squires, Ansel *FolkA 86*
Squires, C Clyde 1883-1970 *ArtsAmW 3, IlBEAAW, WhAmArt 85*
Squires, Clyde 1883-1970 *ArtsAmW 3*
Squires, Frank C 1877-1934 *BiDAmAr*
Squires, Fred *FolkA 86*
Squires, Gerald Leopold 1937- *WhoAmA 73, –76, –78, –80, –82, –84*

Squires, H *DcVicP, –2*
Squires, Harry 1850-1928 *ArtsAmW 1*
Squires, Henry 1850-1928 *IlBEAAW, WhAmArt 85*
Squires, Lawrence 1887-1928 *ArtsAmW 1, IlBEAAW, WhAmArt 85*
Squires, Norma-Jean *WhoAmA 73, –76, –78, –80, –82, –84*
Squires, S A *NewYHSD*
Squires, Warren 1886-1938 *ArtsAmW 1*
Squirhill, Charles *BiDBrA*
Squirrell, Leonard Russell *WhoArt 82N*
Squirrell, Leonard Russell 1893- *DcBrA 1, WhoArt 80*
Squirrell, Martin 1926-1950 *DcBrA 2*
Sragow, Ellen *WhoAmA 80, –82, –84*
Srbinovic, Mladen 1925- *PhDcTCA 77*
Sreenivasalu, K 1923- *OxTwCA*
Srieve, A R *DcVicP 2*
Srihari, Sargur 1950- *MarqDCG 84*
Srinivasan, N 1942- *MarqDCG 84*
Srivastava, Narendra Nath 1931- *WhoGrA 82[port]*
Srnka, Milan Emil 1933- *AmArch 70*
Sroufe, Susan E *ArtsAmW 3*
Staab, William Dupont 1906- *AmArch 70*
Staakman, Ray 1941- *ConArt 77*
Staal, Arthur 1907- *McGDA*
Staal, Gustave 1817-1882 *ClaDrA*
Staal, J F 1879-1940 *MacEA*
Staal, Jan Frederik 1879-1940 *McGDA*
Staats, Florence 1940- *AfroAA*
Staats, Gertrud 1859- *DcWomA*
Staats, J W *AmArch 70*
Staats, Paul Stanley 1929- *AmArch 70*
Staats, Teresa 1896- *DcWomA, WhAmArt 85*
Staats, Teressa Simpson 1894- *AfroAA*
Stabb, Charles *DcBrA 2*
Stabb, Mrs. H Sparke *DcVicP 2*
Stabell, Waldemar Christian 1913- *WhoArt 80, –82, –84*
Stable *DcBrECP*
Stable, Fanny *DcVicP 2, DcWomA*
Stable, Harold K *DcVicP 2*
Stabler, Arthur Lea 1925- *AmArch 70*
Stabler, G *FolkA 86*
Stabler, Phoebe d1955 *DcBrA 1, DcWomA*
Stables *DcBrECP*
Stables, T G *DcVicP 2*
Stables, T J *DcWomA*
Staccioli, Mauro 1937- *ConArt 77*
Stacey, Miss *DcWomA*
Stacey, Anna Lee d1943 *ArtsAmW 2, WhAmArt 85*
Stacey, Anna Lee 1871-1943 *DcWomA*
Stacey, Dorothy Layman 1904- *WhAmArt 85*
Stacey, Edward Wesley 1949- *MacBEP*
Stacey, H E *DcVicP 2*
Stacey, J George 1863- *WhAmArt 85*
Stacey, John F 1859- *WhAmArt 85*
Stacey, John Franklin 1859-1941 *ArtsAmW 2*
Stacey, Lynn 1903- *WhAmArt 85*
Stacey, R J *AmArch 70*
Stacey, Walter S 1846-1929 *ClaDrA, DcBrA 1, DcBrBI, DcBrWA, DcVicP, –2*
Stachelberg, Charles G *WhoAmA 82N, –84N*
Stachelberg, Mrs. Charles G *WhoAmA 73, –76, –78, –80*
Stachurski, Marian 1931- *WhoGrA 62*
Stachurski, S W *AmArch 70*
Stack, Charles J *WhAmArt 85*
Stack, Frank Huntington 1937- *WhoAmA 76, –78, –80, –82, –84*
Stack, Gael Z 1941- *WhoAmA 78, –80, –82, –84*
Stack, John B 1858-1932 *BiDAmAr*
Stack, Michael 1941- *WhoAmA 84*
Stacke, E G *DcVicP 2*
Stackelberg, Sophie Von 1774-1828 *DcWomA*
Stacker, Antoine *NewYHSD*
Stackhouse, David *CabMA*
Stackhouse, J *DcBrECP*
Stackhouse, Robert 1942- *DcCAr 81, PrintW 85*
Stackhouse, Stacy *CabMA*
Stackpole, Alice *DcWomA, WhAmArt 85*
Stackpole, Patrick M *NewYHSD*
Stackpole, Peter 1913- *ICPEnP A, MacBEP*
Stackpole, Ralph 1885- *ArtsAmW 1, PhDcTCA 77, WhAmArt 85*
Stackpoole, Mary Constance *DcVicP 2*
Stacks, Leon 1928- *WhoAmA 73*
Stacks, William Leon 1928- *WhoAmA 76, –78, –80, –82, –84*
Stacquet, N *ArtsNiC*
Stacy, Donald L 1925- *PrintW 83, –85, WhoAmA 76, –78, –80, –82, –84*
Stacy, George *FolkA 86*
Stacy, H E d1915 *DcBrA 2*
Stacy, J Donald 1932- *AmArch 70*
Stacy, John Russell 1919- *WhoAmA 82, –84*
Stacy, William d1919 *WhAmArt 85*
Stacy-Judd, R B *AmArch 70*
Stacy-Judd, Robert 1884-1975 *MacEA*
Stacy-Marks, Ronald 1912- *WhoArt 80, –82, –84*
Stadden, Warren C 1922- *AmArch 70*

Stade, H *DcVicP 2, DcWomA*
Stadeker, Claire Leo 1886-1911 *WhAmArt 85*
Stadel, Anna Rosina Magdalena 1782-1845 *DcWomA*
Stadelman, Henryette Leech 1891- *DcWomA, WhAmArt 85*
Stading, Evelina 1803-1829 *DcWomA*
Stadler, Al 1914- *WhAmArt 85*
Stadler, Albert 1923- *WhoAmA 73, –76, –78, –80, –82, –84*
Stadler, Allan Edward 1942- *AmArch 70*
Stadler, Crescentia 1828- *DcWomA*
Stadler, J F *AmArch 70*
Stadler, Louise 1864- *DcWomA*
Stadler, Toni 1888- *DcCAr 81, McGDA, PhDcTCA 77*
Stadsvold, Byron Dean 1938- *AmArch 70*
Stadsvold, Cy V 1932- *AmArch 70*
Stadter, Frank *ArtsAmW 3*
Stadtfeld *NewYHSD*
Stadtherr, Angela 1899- *DcWomA*
Staeck, Klaus 1938- *ConArt 77, –83, ConDes*
Staehle, Albert 1899- *WhAmArt 85*
Staehli, Alfred M 1929- *AmArch 70*
Stael *NewYHSD*
Stael, Nicholas De 1914-1955 *PhDcTCA 77*
Stael, Nicolas De *WorArt*
Stael, Nicolas De 1914-1955 *McGDA, OxTwCA*
Staempfli, George W 1910- *WhoAmA 73, –76, –78, –80, –82, –84*
Staets, Hendrik *DcSeaP*
Staff, Jessie A *WhAmArt 85*
Staff, John 1751?-1833 *BiDBrA*
Staffel, Bertha *FolkA 86*
Staffel, Doris 1921- *WhoAmA 82, –84*
Staffel, Rudolf Harry 1911- *WhoAmA 78, –80, –82, –84*
Staffel, Rudolph 1911- *CenC*
Stafford, B E D *WhAmArt 85*
Stafford, Beatrice *AfroAA*
Stafford, Clara B 1868- *WhAmArt 85*
Stafford, Cora Elder *ArtsAmW 3*
Stafford, Donald Charles 1924- *AmArch 70*
Stafford, Gordon 1905- *AmArch 70*
Stafford, H M *FolkA 86*
Stafford, Helen T *DcWomA*
Stafford, John E 1916- *AmArch 70*
Stafford, John M *NewYHSD*
Stafford, John Phillips 1851-1899 *DcBrBI, DcVicP 2*
Stafford, Lulu C *ArtsEM, DcWomA*
Stafford, Marjorie *WhAmArt 85*
Stafford, Mary 1895- *DcWomA, WhAmArt 85*
Stafford, Nellie T *DcWomA*
Stafford, P S *WhAmArt 85*
Stafford, Paul 1918- *WhoArt 82, –84*
Stafford, Samuel *CabMA*
Stafford, T W *DcVicP 2*
Stafford, Theodore *CabMA*
Stafford, Thomas Andrew 1939- *AmArch 70*
Stage, Bertha 1890- *DcWomA*
Stage, John Lewis 1925- *ICPEnP A*
Stageberg, J E *AmArch 70*
Stager, Emil *NewYHSD*
Stager, Henry F 1820?-1888 *FolkA 86*
Stagg, Clarence Alfred 1902- *WhAmArt 85*
Stagg, Jessie d1958 *WhoAmA 80N, –82N, –84N*
Stagg, Jessie A 1891-1958 *DcWomA, WhAmArt 85*
Stagg, Richard Thomas 1935- *AmArch 70*
Stagg, William d1928 *DcBrA 1*
Staggs, C A *AmArch 70*
Staggs, John F 1938- *MarqDCG 84*
Stagi, Lorenzo 1455?-1506 *McGDA*
Stagi, Pietro *NewYHSD*
Stagi, Stagio 1496?-1563 *McGDA*
Stagliano, Francis Michael 1938- *AmArch 70*
Stahl, Ben *IlsCB 1967*
Stahl, Ben 1910- *WhAmArt 85, WhoAmA 73, –76, –78, –80, –82, –84*
Stahl, Benjamin Albert 1910- *IlrAm E, –1880, IlsBYP, IlsCB 1957*
Stahl, Benjamin F 1932- *IlrAm 1880*
Stahl, Charles *FolkA 86*
Stahl, Charles Fredric 1931- *AmArch 70*
Stahl, E M *AmArch 70*
Stahl, Frederick Arthur 1930- *AmArch 70*
Stahl, H A *AmArch 70*
Stahl, Isaac *FolkA 86*
Stahl, J L *AmArch 70*
Stahl, James *FolkA 86*
Stahl, Marie Louise *ArtsAmW 3, DcWomA, WhAmArt 85*
Stahl, R H *AmArch 70*
Stahl, Richard Payton 1914- *AmArch 70*
Stahl, Thomas Harmon 1931- *AmArch 70*
Stahl, William Henry, Jr. 1951- *MarqDCG 84*
Stahl-Nyberg, Birgit 1928- *DcCAr 81*
Stahley, Joseph 1900?- *IlBEAAW, WhAmArt 85*
Stahly, Francois 1911- *PhDcTCA 77*
Stahm, Miles E 1936- *AmArch 70*
Stahr, Fred C 1878-1946 *WhAmArt 85*

Stannard, Alexander Molyneux 1885- *DcBrA 1*
Stannard, Alfred 1806-1889 *DcBrWA, DcSeaP, DcVicP, -2*
Stannard, Alfred George 1828-1885 *DcVicP, -2*
Stannard, Alfred George 1828-1895 *DcBrWA*
Stannard, Mrs. Alfred George *DcWomA*
Stannard, Eloise Harriet *DcBrWA, DcVicP, -2*
Stannard, Eloise Harriet 1828-1915 *DcBrA 1, DcWomA*
Stannard, Emily *DcBrWA*
Stannard, Emily 1803-1885 *ClaDrA, DcBrWA, DcVicP, -2*
Stannard, Emily 1803-1888? *DcWomA*
Stannard, Emily 1827-1894 *DcWomA*
Stannard, Emily 1875-1907 *DcVicP 2, DcWomA*
Stannard, Emily, III 1875-1907 *DcBrWA*
Stannard, Eva *WhAmArt 85*
Stannard, Henry d1920 *DcBrA 1*
Stannard, Henry 1844-1920 *DcVicP 2*
Stannard, Henry John 1844-1920 *DcBrBI*
Stannard, Henry John Sylvester 1870-1951 *ClaDrA, DcBrA 1, DcBrWA, DcVicP 2*
Stannard, Ivy 1881-1968 *DcVicP 2, DcWomA*
Stannard, John 1794-1882 *DcVicP 2*
Stannard, Joseph 1797-1830 *ClaDrA, DcBrWA, DcSeaP*
Stannard, Joseph, Jr. 1795-1850 *BiDBrA*
Stannard, Joseph, Sr. 1771-1855 *BiDBrA*
Stannard, Lilian *DcBrA 1*
Stannard, Lilian 1877-1944 *DcVicP 2, DcWomA*
Stannard, Lilian 1884-1938 *ClaDrA*
Stannard, Lilian 1884-1944 *DcBrBI, DcBrWA*
Stannard, Theresa *DcBrWA*
Stannard, Theresa Sylvester 1898- *DcBrA 1*
Stannard, Theresa Sylvester 1898-1947 *DcVicP 2, DcWomA*
Stannard, William John *DcVicP 2*
Stanney, John *DcBrECP*
Stanniford, Jeremiah d1832 *CabMA*
Stannus, Anthony Carey *DcBrA 1, DcBrBI, DcBrWA, DcVicP, -2*
Stannus, Caroline *DcVicP 2*
Stannus, Hugh Hutton 1840-1908 *DcBrA 1, DcBrWA, DcVicP 2*
Stanny, Janusz 1932- *WhoGrA 82[port]*
Stansberry, Jennie M *ArtsEM*
Stansbury, A Jack 1928- *AmArch 70*
Stansbury, Arthur J 1781-1845? *NewYHSD*
Stansfield, Miss *DcWomA*
Stansfield, F W *NewYHSD*
Stansfield, Jack Charles 1920- *AmArch 70*
Stansfield, John Heber 1878-1953 *ArtsAmW 1, IIBEAAW, WhAmArt 85*
Stansfield, Lyle Howard 1910- *AmArch 70*
Stansfield, Manfred D 1928- *MarqDCG 84*
Stanson, George C 1885- *ArtsAmW 1, WhAmArt 85*
Stanson, George Curtin 1885- *IIBEAAW*
Stanton *BiDBrA*
Stanton, C W *AmArch 70*
Stanton, Charles *NewYHSD*
Stanton, Charley *BiDBrA*
Stanton, Clark 1832-1894 *ClaDrA*
Stanton, Edward 1681?-1734 *BiDBrA*
Stanton, Edward, Of Holborn 1681-1734 *OxArt*
Stanton, Elizabeth *DcVicP 2*
Stanton, Elizabeth Cady 1894- *DcWomA, WhAmArt 85*
Stanton, Emily Rose *DcWomA*
Stanton, F *AmArch 70*
Stanton, Frank 1890- *AmArch 70*
Stanton, G Clark *DcVicP 2*
Stanton, G Clark 1822-1894 *DcBrBI, DcBrWA*
Stanton, Gideon Townsend 1885- *WhAmArt 85*
Stanton, Grace Harper 1872- *DcWomA, WhAmArt 85*
Stanton, Sir Herbert E Pelham Hughes- 1870-1937 *DcBrWA*
Stanton, Horace Hughes 1843-1914 *DcBrBI*
Stanton, J E *AmArch 70*
Stanton, John *WhAmArt 85*
Stanton, John A 1860- *ArtsAmW 1*
Stanton, John Aloysius 1857-1929 *ArtsAmW 3*
Stanton, John Joseph 1894- *AmArch 70*
Stanton, Louise Parsons *WhAmArt 85*
Stanton, Lucy Mary 1875-1931 *ArtsAmW 2*
Stanton, Lucy May 1875-1931 *ArtsAmW 2, DcWomA, WhAmArt 85*
Stanton, Martha Zelt 1930- *WhoAmA 73*
Stanton, Nathaniel Palmer *FolkA 86*
Stanton, Phineas, Jr. 1817-1867 *NewYHSD*
Stanton, Richard D 1935- *MarqDCG 84*
Stanton, Robert 1900- *AmArch 70*
Stanton, Rose Emily 1838-1908 *DcBrA 1, DcVicP 2, DcWomA*
Stanton, Samuel M 1858-1946 *BiDAmAr*
Stanton, Samuel Ward 1870-1912 *WhAmArt 85*
Stanton, Sandys *DcVicP 2*
Stanton, Sarah *DcVicP 2*
Stanton, Thomas 1610-1674 *BiDBrA*
Stanton, Thomas, Of Holborn 1610-1674 *OxArt*
Stanton, Walter Judson 1927- *AmArch 70*

Stanton, William 1639-1705 *MacEA*
Stanton, William, Of Holborn 1639-1705 *OxArt*
Stantons, The, Of Holborn *OxArt*
Stanuga, Ted *PrintW 85*
Stanulis, Gabriel 1915- *DcCAr 81*
Stanwood, A *FolkA 86, NewYHSD*
Stanwood, Ebenezer, Jr. 1747?- *CabMA*
Stanwood, Gertrude *DcWomA, WhAmArt 85*
Stanwood, Samuel *CabMA*
Stanzione, Massimo 1585-1656 *McGDA*
Stanzioni, Massimo 1585-1656 *ClaDrA*
Stapen, Nancy 1950- *WhoAmA 84*
Stapert, Elisabeth Johanna *DcWomA*
Stapert, R M *AmArch 70*
Stapfer, Elise *DcWomA*
Stapfer, Luise 1792-1861 *DcWomA*
Staple, J *DcVicP 2*
Stapleaux, Louiza Schavije *DcWomA*
Stapleford, Thomas *CabMA*
Staples, Charles Richard 1940- *AmArch 70*
Staples, Clayton Henri 1892- *ArtsAmW 1, WhAmArt 85*
Staples, Edna Fisher Stout *WhAmArt 85*
Staples, Edna Fisher Stout 1871- *DcWomA*
Staples, Elizabeth B 1947- *MarqDCG 84*
Staples, Frank A 1900- *WhAmArt 85*
Staples, Hannah *FolkA 86*
Staples, John *CabMA*
Staples, John C *DcVicP 2*
Staples, Mrs. John C 1839- *DcVicP, -2*
Staples, Mary Ellen *DcWomA*
Staples, Mary Ellen 1839- *DcBrWA*
Staples, Sir Robert Ponsonby 1853-1943 *DcBrA 1, ClaDrA, DcBrBI, DcVicP, -2*
Staples, Roy Harvard d1958 *WhoAmA 80N, -82N, -84N*
Staples, Roy Harvard 1905-1958 *WhAmArt 85*
Staples, Samuel d1860 *BiDBrA*
Staples, Waity *FolkA 86*
Stapleton, C P *AmArch 70*
Stapleton, Mrs. George *DcVicP 2, DcWomA*
Stapleton, John J 1940- *MarqDCG 84*
Stapleton, Joseph F 1921- *WhoAmA 78, -80, -82, -84*
Stapleton, Michael d1801 *MacEA*
Stapleton, P V *AmArch 70*
Stapleton, W *DcVicP 2*
Stapley, M 1872- *WhAmArt 85*
Stapp, Ray Leroy 1913- *WhoAmA 73, -76, -78, -80, -82, -84*
Stapp, William F 1945- *WhoAmA 78, -80, -82, -84*
Stapples, E S *DcWomA, WhAmArt 85*
Staprans, Raimonds 1926- *WhoAmA 73, -76, -78, -80, -82, -84*
Stapylton, H E E *DcVicP 2*
Star, Jeffrey L 1953- *MarqDCG 84*
Starbird, Mary Ann *NewYHSD*
Starbird, Mary Ann 1830?- *DcWomA*
Starbuck, Ellen *DcWomA, WhAmArt 85*
Starbuck, M *FolkA 86*
Starbuck, Robert Francis 1913- *AmArch 70*
Starcke, Helmut *OxTwCA*
Stareishinski, Asen 1936- *WhoGrA 82[port]*
Starin, Arthur N *WhAmArt 85*
Starin, H S *AmArch 70*
Stark, Mrs. A J *DcVicP 2*
Stark, Arthur James 1831-1902 *DcBrA 1, DcBrWA, DcVicP, -2*
Stark, Bruce Gunsten 1933- *WhoAmA 76, -78, -80, -82, -84*
Stark, Charles Henry, III 1935- *AmArch 70*
Stark, Charles Henry, Jr. 1903- *AmArch 70*
Stark, Christian Jane *DcWomA*
Stark, D H *AmArch 70*
Stark, D Kent 1941- *AmArch 70*
Stark, Elizabeth *FolkA 86*
Stark, F M *DcVicP 2*
Stark, Flora M *DcVicP 2*
Stark, Forrest F 1903- *WhAmArt 85*
Stark, George King 1923- *WhoAmA 73, -76, -78, -80, -82, -84*
Stark, Gerald Franklin 1927- *AmArch 70*
Stark, J Norman 1929- *AmArch 70*
Stark, Jack Gage d1950 *WhoAmA 78N, -80N, -82N, -84N*
Stark, Jack Gage 1882-1950 *ArtsAmW 1, -3, WhAmArt 85*
Stark, James 1794-1859 *DcBrWA, DcVicP, -2, McGDA, OxArt*
Stark, Mrs. James *DcWomA*
Stark, James Arthur *DcBrA 1, DcVicP 2*
Stark, Jeffrey 1944- *FolkA 86*
Stark, John 1948- *MarqDCG 84*
Stark, Larry 1941- *PrintW 85*
Stark, Loyd Duane 1941- *AmArch 70*
Stark, Margaret 1915- *WhAmArt 85*
Stark, Marietta 1865- *DcWomA*
Stark, Marjorie Jean 1914- *WhoArt 80, -82, -84*
Stark, Mary E 1826-1909 *FolkA 86*
Stark, Melville F 1903- *WhoAmA 73, -76, -78, -80, -82, -84*
Stark, Melville F 1904- *WhAmArt 85*

Stark, Otto 1859-1926 *WhAmArt 85*
Stark, Paul M 1923- *AmArch 70*
Stark, R L *AmArch 70*
Stark, Robert 1853-1931 *DcBrA 1*
Stark, Ron 1944- *ICPEnP A, MacBEP, WhoAmA 76, -78, -80, -82*
Stark, Ronald C 1944- *WhoAmA 73*
Stark, Rose Isabella *DcBrA 1, DcVicP 2, DcWomA*
Stark, Roy Harry 1925- *AmArch 70*
Stark, Royaden Francis 1921- *AmArch 70*
Stark, Shirley 1927- *WhoAmA 76, -78, -84*
Stark, Terez 1856- *DcWomA*
Stark, Thomas H *MarqDCG 84*
Stark, Tillie Gabaldon 1910- *FolkA 86*
Stark, William 1770-1813 *BiDBrA, MacEA*
Starke, E C *AmArch 70*
Starke, Marie Wilhelmine 1860-1912 *DcWomA*
Starke, Michael Jay 1951- *MarqDCG 84*
Starkenborgh, J N, Baron Tjarda Van 1822-1895 *NewYHSD*
Starkenborgh, William T Van *NewYHSD*
Starkey *FolkA 86, NewYHSD*
Starkey, Estella Frances *DcWomA*
Starkey, James *NewYHSD*
Starkey, Jo-Anita 1895- *ArtsAmW 2, DcWomA, IIBEAAW, WhAmArt 85*
Starkey, John Denbigh 1946- *MarqDCG 84*
Starkey, William *CabMA*
Starkey, William Henry *DcVicP 2*
Starkie, Edyth *DcVicP 2, DcWomA*
Starkman, Maxwell 1921- *AmArch 70*
Starkovich, Robert L 1929- *AmArch 70*
Starks, Chloe Lesley 1866- *DcWomA, WhAmArt 85*
Starks, Elliott Roland 1922- *WhoAmA 73, -76, -78, -80, -82*
Starks, L F *AmArch 70*
Starks, Myron Eugene 1922- *AmArch 70*
Starkweather, J M *DcWomA, FolkA 86*
Starkweather, Miss J M *NewYHSD*
Starkweather, Merritt Howard 1891- *AmArch 70*
Starkweather, N G *BiDAmAr*
Starkweather, William d1969 *WhoAmA 78N, -80N, -82N, -84N*
Starkweather, William 1879-1969 *WhAmArt 85*
Starkweather-Nelson, Cynthia Louise 1950- *WhoAmA 84*
Starling, Albert *DcBrA 1, DcVicP, -2*
Starling, Marion A *DcVicP 2, DcWomA*
Starling, S S *DcWomA*
Starmer, Walter Percival *DcBrA 1*
Starnes, Earl Maxwell 1926- *AmArch 70*
Starnes, Jon Harris 1939- *AmArch 70*
Starnes, Lawrence David 1924- *AmArch 70*
Starnina, Gherardo d1413? *McGDA*
Staron, J M *AmArch 70*
Starov, Ivan Yegorovich 1743-1808 *McGDA*
Starowieyski, Franciszek 1930- *ConDes, WhoGrA 62, -82[port]*
Starr *NewYHSD*
Starr, B E *AmArch 70*
Starr, Edward L 1934- *AmArch 70*
Starr, Eliza *FolkA 86*
Starr, Eliza Allen 1824-1901 *DcWomA, NewYHSD, WhAmArt 85*
Starr, F *FolkA 86*
Starr, G L *AmArch 70*
Starr, Ida M H 1859- *DcWomA, WhAmArt 85*
Starr, Ivy Edmondson 1909- *WhAmArt 85*
Starr, Jack Glaser 1929- *AmArch 70*
Starr, Jonathan *CabMA*
Starr, Katharine Payne 1869- *ArtsAmW 2, DcWomA, WhAmArt 85*
Starr, L S *CabMA*
Starr, Leonard 1925- *WorECom*
Starr, Lorraine Webster 1887- *DcWomA, WhAmArt 85*
Starr, Louis *WhAmArt 85*
Starr, Louisa *DcVicP*
Starr, Louisa 1845-1909 *ClaDrA, DcVicP 2, DcWomA*
Starr, Mary H *DcWomA*
Starr, Maxwell B 1901- *WhAmArt 85*
Starr, N B *ArtsEM, NewYHSD*
Starr, Nellie S 1869- *ArtsAmW 3*
Starr, Norton 1936- *MarqDCG 84*
Starr, Polly *WhAmArt 85*
Starr, Richard Robert 1926- *AmArch 70*
Starr, Ron 1947- *MacBEP*
Starr, Sidney 1857-1925 *DcBrA 1, DcVicP, -2, WhAmArt 85*
Starr, Sydney 1857-1925 *DcBrBI*
Starr, Theodore B *EncASM*
Starr, Wilbur Dupas 1927- *AmArch 70*
Starr, William *NewYHSD*
Starr, William W *ArtsEM*
Starratt, C C *AmArch 70*
Starratt, K P *AmArch 70*
Starrett, Goldwyn 1876-1918 *BiDAmAr*
Starrett, Virginia Frances 1901-1931 *WhAmArt 85*
Starrett, William K *WhAmArt 85*
Starrs, Mildred *WhoAmA 73, -76, -78, -80, -82, -84*

Stars, William Kenneth 1921- *WhoAmA 76, –78, –80, –82, –84*
Start, C H *AmArch 70*
Startup, Peter 1921- *DcBrA 1*
Staruch, M Herbert 1941- *AmArch 70*
Starup, Edward *NewYHSD*
Stary, Oldrich 1884-1971 *MacEA*
Stasack, Edward Armen 1929- *WhoAmA 73, –76, –78, –80, –82, –84*
Staschus-Floess, Paula 1878- *DcWomA*
Stasik, Andrew 1932- *DcCAA 71, –77*
Stasik, Andrew J 1932- *WhoAmA 73, –76, –78, –80, –82, –84*
Stasiowski, Frank A 1948- *MarqDCG 84*
Stasov, Vasili Petrovich 1769-1848 *MacEA, McGDA*
Staszko, Edward Vincent 1921- *AmArch 70*
State, Charles *WhAmArt 85*
Staten, Douglas *AfroAA*
Staten, George Cowden, Jr. 1931- *AmArch 70*
Staten, J P *AmArch 70*
States, Adam *FolkA 86*
States, Ichabod *FolkA 86*
States, Mignon 1883- *DcWomA*
States, Mignon Trickey 1883- *ArtsAmW 3*
States, Peter *FolkA 86*
States, Randall 1955- *MacBEP*
States, William *FolkA 86*
Statfeld, Moritz *NewYHSD*
Statham, Henry Heathcote 1839-1924 *DcVicP 2*
Stathes, S Thomas 1912- *AmArch 70*
Statler, George *FolkA 86*
Statman, Jay B *WhoAmA 73, –76, –78, –80, –82, –84*
Statsinger, Evelyn 1927- *DcCAr 81*
Stattler, George *NewYHSD*
Stattmuller, Pater Beda 1699-1770 *McGDA*
Staub, Augustus Joseph 1937- *AmArch 70*
Staub, Cecilia 1886- *DcWomA*
Staub, G M *AmArch 70*
Staub, John F 1892- *AmArch 70*
Staub, John F 1892-1981 *MacEA*
Staub, Martin 1956- *DcCAr 81*
Staubel, William *WhAmArt 85*
Staubmann, Maria d1856 *DcWomA*
Stauch, Alfred 1836?- *NewYHSD*
Stauch, David, Jr. 1807-1879 *FolkA 86*
Stauch, David, Sr. d1839 *FolkA 86*
Stauch, Edward 1830?- *NewYHSD*
Staudacher, Hans *DcCAr 81*
Stauder, A E *AmArch 70*
Staudhammer, John *MarqDCG 84*
Staudinger, Karl 1905- *WhoGrA 62, –82[port]*
Staudinger, Luise 1879- *DcWomA*
Staudt, Simon *FolkA 86*
Stauff, Edward Lawrence 1958- *MarqDCG 84*
Stauffacher, Jack Werner 1920- *WhoGrA 82[port]*
Stauffer *DcCAr 81*
Stauffer, Edna Pennypacker 1887-1956 *DcWomA, WhAmArt 85, WhoAmA 80N, –82N, –84N*
Stauffer, Howard Boyer 1941- *MarqDCG 84*
Stauffer, Jacob *FolkA 86*
Stauffer, Jacob 1808-1880 *NewYHSD*
Stauffer, Mary Ann *FolkA 86*
Stauffer, R *FolkA 86*
Stauffer, Randolph Jay 1935- *AmArch 70*
Stauffer, Richard L 1932- *WhoAmA 80, –82, –84*
Staughton *NewYHSD*
Staughton, Anna *DcWomA*
Staunton *NewYHSD*
Staunton, W F, Jr. *AmArch 70*
Stauris, Rinaldo De' *McGDA*
Stautner, John P 1957- *MarqDCG 84*
Stautz, Carl Henry 1909- *AmArch 70*
Stauvers, Feliks 1926- *WhoArt 80, –82, –84*
Stavans, Isaac 1931- *WhoAmA 84*
Staveley, Christopher 1727?-1801 *BiDBrA*
Staveley, Christopher 1759-1827 *BiDBrA*
Staveley, Edward d1837 *BiDBrA*
Staveley, W *DcBrECP*
Stavely, Christopher 1759-1827 *BiDBrA*
Staven, Leland Carroll 1933- *WhoAmA 76, –78, –80, –82, –84*
Stavenitz, Alexander Raoul 1901-1960 *WhAmArt 85, WhoAmA 80N*
Stavenitz, Alexander Raqul 1901-1960 *WhoAmA 82N, –84N*
Staveren, Jan Adriensz Van 1625?-1668 *ClaDrA*
Staveren, Johan Adriaaensz Van 1620?-1668? *McGDA*
Stavropoulos *WorFshn*
Stavropoulos, George *FairDF US*
Stawicki, Ron Michael *MarqDCG 84*
Staynes, Percy Angelo 1875- *DcBrBI*
Staynes, Percy Angelo 1875-1953 *DcBrA 1, DcVicP 2*
Staytcho, Ellena 1884- *DcWomA*
Stayton, Janet 1939- *PrintW 83, 85, WhoAmA 80, –82, –84*
Stazewski, Henryk 1894- *ConArt 77, –83, OxTwCA, PhDcTCA 77, WhoArt 80, –82, –84*
Stazione, Peter *DcCAr 81*
Stea, Cesare 1893-1960 *WhAmArt 85, WhoAmA 80N, –82N, –84N*

Stead, Frederick 1863- *DcBrA 1, DcVicP, –2*
Stead, John *BiDBrA*
Stead, May *DcWomA*
Stead, Rexford Arthur 1923- *WhoAmA 76, –78, –80, –82, –84*
Stead, Robert 1856-1943 *BiDAmAr*
Stead, Thomas 1775?-1850 *BiDBrA*
Steadman, David Wilton 1936- *WhoAmA 76, –78, –80, –82, –84*
Steadman, J T *DcVicP 2*
Steadman, Marcia Hunt *DcWomA, WhAmArt 85*
Steadman, Ralph 1936- *WorECar*
Steadman, Ralph Idris 1936- *WhoGrA 82[port]*
Steadman, William Earl 1921- *WhoAmA 73, –76*
Steadwell, Gertrude Anna 1909- *AfroAA*
Steag, Jacob *NewYHSD*
Steane, Isaac J *EncASM*
Steane, Isaac J, Jr. *EncASM*
Steane Son And Hall *EncASM*
Stearns *FolkA 86*
Stearns, D W *AmArch 70*
Stearns, E *FolkA 86*
Stearns, Frederic Wainwright 1903- *WhAmArt 85*
Stearns, Mrs. G Douglas *DcWomA, WhAmArt 85*
Stearns, George R 1862-1938 *BiDAmAr*
Stearns, John Goddard 1843-1917 *BiDAmAr*
Stearns, John Goddard, Jr. 1843-1917 *MacEA*
Stearns, Junius Brutus 1810-1885 *IlBEAAW, NewYHSD, WhAmArt 85*
Stearns, Martha G *WhAmArt 85*
Stearns, Mary Ann H *DcWomA, FolkA 86, NewYHSD*
Stearns, Neilson *WhAmArt 85*
Stearns, Nellie 1855- *DcWomA*
Stearns, Robert 1947- *WhoAmA 82, –84*
Stearns, Robert Clayton 1928- *AmArch 70*
Stearns, Robert L *WhAmArt 85*
Stearns, Robert L 1871?-1939 *ArtsEM*
Stearns, Stanley *OfPGCP 86*
Stearns, Thomas Robert 1936- *WhoAmA 82, –84*
Stearns, William *FolkA 86, NewYHSD*
Steavenson, C H *DcBrWA, DcVicP 2*
Steavenson, C Herbert *DcBrBI*
Stebbing, Mrs. G *DcVicP 2*
Stebbing, John Noel, Jr. 1906- *WhAmArt 85*
Stebbing, Peter 1914- *WhoArt 80, –82, –84*
Stebbins, Carlos *NewYHSD*
Stebbins, Caroline *FolkA 86*
Stebbins, Emma *ArtsNiC*
Stebbins, Emma 1815-1882 *DcAmArt, DcWomA, NewYHSD, WomArt*
Stebbins, Ezra 1760-1819 *FolkA 86*
Stebbins, Richard Gregory 1932- *AmArch 70*
Stebbins, Roland Stewart 1883-1974 *WhAmArt 85*
Stebbins, Mrs. T E *WhAmArt 85*
Stebbins, Theodore Ellis, Jr. 1938- *WhoAmA 73, –76, –78, –80, –82, –84*
Stebbins, Wyman F *FolkA 86*
Stebel-Rudin, Elise 1864- *DcWomA*
Steber, T P *AmArch 70*
Stebinger, T B *AmArch 70*
Stebler, Annie *DcWomA*
Stebley, Gene L 1948- *MarqDCG 84*
Stecha, Pavel 1944- *ConPhot, ICPEnP A, MacBEP*
Stecher, Pernette *DcWomA*
Stecher, William Frederick 1864- *WhAmArt 85*
Stechow, Gertrud 1858- *DcWomA*
Stechow, Olaf 1927- *AmArch 70*
Stechow, Wolfgang 1896- *WhoAmA 73*
Stechow, Wolfgang 1896-1975 *WhAmArt 85, WhoAmA 76N, –78N, –80N, –82N, –84N*
Stechschulte, R F *AmArch 70*
Steck, Alden L 1904- *WhAmArt 85*
Steck, William Lloyd 1937- *AmArch 70*
Steckel, Anita *PrintW 85, WhoAmA 78, –84*
Steckel, Harriet Jeanne *WhoAmA 82, –84*
Stecker, R L *AmArch 70*
Steckler, Stuart Jay 1931- *WhoAmA 82, –84*
Steckling, Adri *WorFshn*
Steczynski, John Myron 1936- *WhoAmA 73, –76, –78, –80, –82, –84*
Stedman *FolkA 86*
Stedman, Absalom And Seymour, Frederick *FolkA 86*
Stedman, Esther *ArtsAmW 3, DcWomA, WhAmArt 85*
Stedman, James *BiDBrA*
Stedman, Jeannette 1880-1924 *DcWomA, WhAmArt 85*
Stedman, M *AmArch 70*
Stedman, Margaret Weir 1882- *DcWomA, WhAmArt 85*
Stedman, Myrtle Kelly 1908- *WhAmArt 85*
Stedman, W *DcVicP 2*
Stedman, Wilfred Henry d1950 *WhoAmA 78N, –80N, –82N, –84N*
Stedman, Wilfred Henry 1892-1950 *ArtsAmW 2, WhAmArt 85*
Stedman, William E *ArtsEM*
Steed, J E *AmArch 70*
Steedman, Amy *DcVicP 2, DcWomA*

Steedman, Charles *DcVicP, –2*
Steedman, Louisa Blake *DcWomA*
Steegmuller, Beatrice Stein d1961 *WhoAmA 80N, –82N, –84N*
Steel, Alfred B *NewYHSD*
Steel, Dorothy 1927- *WhoArt 80*
Steel, Edwin 1805-1871 *AntBDN M*
Steel, George Hammond 1900-1960 *DcBrA 1*
Steel, James W 1799-1879 *NewYHSD*
Steel, John *OfPGCP 86*
Steel, John 1825?- *NewYHSD*
Steel, John Sydney 1863- *DcBrA 1*
Steel, John Sydney 1863-1900 *DcVicP 2*
Steel, Kenneth 1906- *DcBrA 1*
Steel, Larry Eugene 1937- *AmArch 70*
Steel, Philip S 1934- *AmArch 70*
Steel, Rhys *WhAmArt 85*
Steel, Rhys Caparn *WhoAmA 78, –80, –82, –84*
Steel, Robert Howard 1928- *MarqDCG 84*
Steel, Russell *WhoAmA 76*
Steel, Sophie B *DcWomA, WhAmArt 85*
Steel, Thomas *BiDBrA*
Steel, Thomas 1771?-1850 *AntBDN M*
Steel, Thomas, Jr. *AntBDN M*
Steel, Virginia Oberlin 1950- *WhoAmA 80, –82, –84*
Steel-Brussel *EncASM*
Steele, Mister *NewYHSD*
Steele, A *DcWomA*
Steele, Mrs. A *NewYHSD*
Steele, Adeline *DcVicP 2*
Steele, Albert W 1862- *WhAmArt 85*
Steele, Albert Wilbur 1862-1925 *ArtsAmW 2*
Steele, Allan Cushman 1903- *AmArch 70*
Steele, Benjamin Charles 1917- *WhoAmA 76, –78, –80, –82, –84*
Steele, Bess *ArtsAmW 3*
Steele, Brandt 1870- *ArtsEM*
Steele, Brandt Theodore 1870- *WhAmArt 85*
Steele, C B *DcWomA*
Steele, C E, Jr. *AmArch 70*
Steele, Christopher 1733-1767 *DcBrECP*
Steele, Daniel *NewYHSD*
Steele, Mrs. Daniel *DcWomA, NewYHSD*
Steele, Emily 1939- *WhoAmA 78, –80, –82*
Steele, Frederic Dorr 1873-1944 *IlrAm A, –1880, WhAmArt 85*
Steele, George W 1798-1842 *BiDAmAr*
Steele, Gourlay 1819-1894 *DcBrBI*
Steele, Helen McKay *DcWomA, WhAmArt 85*
Steele, Horace *FolkA 86*
Steele, Ivy 1908- *WhoAmA 73, –76*
Steele, Ivy N 1908- *WhAmArt 85*
Steele, J S *DcVicP 2*
Steele, Jane *DcBrWA, DcWomA*
Steele, Jeffrey 1931- *ClaDrA, ConArt 77, –83, DcCAr 81*
Steele, Jeffrey M 1951- *MarqDCG 84*
Steele, Juliette 1909- *WhAmArt 85*
Steele, Lisa 1947- *WhoAmA 78, –80, –82, –84*
Steele, M T *AmArch 70*
Steele, Margaret *DcWomA*
Steele, Margaret 1872- *WhAmArt 85*
Steele, Marian Williams 1916- *WhAmArt 85*
Steele, Mark Wellington 1941- *AmArch 70*
Steele, Mary E *DcVicP 2*
Steele, Sandra 1938- *IlBEAAW*
Steele, Susan F 1834- *DcWomA*
Steele, T C 1847-1926 *WhAmArt 85*
Steele, T L *AmArch 70*
Steele, Thomas 1772-1850 *DcNiCA*
Steele, Thomas Sedgwick 1845-1903 *WhAmArt 85*
Steele, Viola *DcWomA, WhAmArt 85*
Steele, W A *AmArch 70*
Steele, Wallace Stanley 1925- *AmArch 70*
Steele, Willard Karl 1910- *WhAmArt 85*
Steele, William L 1875-1949 *BiDAmAr*
Steele, William LaBarthe, Jr. 1907- *AmArch 70*
Steele, William Porter 1817-1864 *NewYHSD*
Steele, Zulma 1881- *DcWomA*
Steele, Zulma 1881-1979 *WhAmArt 85*
Steele-Perkins, Chris 1947- *ConPhot, ICPEnP A*
Steele-Perkins, Christopher 1947- *MacBEP*
Steelink, Willem 1856-1928 *ClaDrA*
Steell, David George 1856-1930 *DcBrA 1, DcVicP 2*
Steell, Gourlay *ArtsNiC*
Steell, Gourlay 1819-1894 *DcVicP, –2*
Steell, Sir John 1804- *ArtsNiC*
Steelman, Edgar Jones, Jr. 1928- *AmArch 70*
Steels, John 1825?- *NewYHSD*
Steely, W T *AmArch 70*
Steen, Annie *DcVicP 2*
Steen, Carol J 1943- *WhoAmA 84*
Steen, Jan 1626?-1679 *OxArt*
Steen, Jan Havicksz 1625?-1679 *McGDA*
Steen, Jan Havicksz 1626-1679 *ClaDrA*
Steen, Ronald Earl 1940- *WhoAmA 78, –80, –82*
Steen-Hertel, Elna Sophie Cathrine 1872- *DcWomA*
Steenbak-Knap, Else Christine 1884- *DcWomA*
Steenbakkers, Hub Martin 1955- *MarqDCG 84*
Steene, William d1965 *WhoAmA 78N, –80N, –82N, –84N*

Steene, William 1888-1965 *WhAmArt 85*
Steenhof, Norman 1920- *AmArch 70*
Steenks, Gerard L *WhAmArt 85*
Steenrod, Margaret *WhAmArt 85*
Steenwijck, Harmen Evertsz Van 1612-1656? *McGDA*
Steenwijck, Hendrik Van, I 1550?-1603 *McGDA*
Steenwijck, Hendrik Van, II 1580?-1649 *McGDA*
Steenwinckel, Hans Van 1545-1601 *WhoArch*
Steenwinckel, Hans Van, The Younger 1587-1639
 WhoArch
Steenwinckel, Lourens Van *WhoArch*
Steenwinkel, Hans 1545?-1601 *McGDA*
Steenwinkel, Hans, II 1587-1639 *McGDA*
Steenwinkel, Lourens *McGDA*
Steenwyck, Abraham 1640?-1698 *ClaDrA*
Steenwyck, Hendrick Van, The Elder 1550?-1600?
 OxArt
Steenwyck, Hendrick Van, The Younger 1580-1650?
 OxArt
Steenwyck, Hendrik Van 1550?-1603 *ClaDrA*
Steenwyck, Hendrik Van 1580?-1649 *ClaDrA*
Steenwyck, Herman 1612-1662? *ClaDrA*
Steenwyck, Susanna Van *DcWomA*
Steeper, John *NewYHSD*
Steeple, C A *DcWomA*
Steeple, Georgiana *DcVicP 2*
Steeple, John d1887 *ClaDrA, DcBrBI, DcBrWA,
 DcVicP, -2*
Steer, Fanny *DcVicP 2*
Steer, Henry Reynolds 1858-1928 *ClaDrA, DcBrA 1,
 DcBrWA, DcVicP, -2*
Steer, James d1759 *BiDBrA*
Steer, P *DcVicP 2*
Steer, Philip *OxArt*
Steer, Philip Wilson 1860-1942 *ClaDrA, DcBrA 1,
 DcBrBI, DcBrWA, DcVicP, -2, McGDA,
 OxArt, PhDcTCA 77*
Steer, Philip Wilson 1890-1942 *OxTwCA*
Steere, Arnold 1792-1832 *FolkA 86, NewYHSD*
Steere, Lora Woodhead 1888- *DcWomA,
 WhAmArt 85*
Steers, A *DcVicP 2*
Steers, Arnold 1792-1832 *NewYHSD*
Steers, Fanny d1861 *DcBrWA, DcVicP, -2,
 DcWomA*
Steers, L May *ArtsEM, DcWomA*
Steers, Mary *DcWomA*
Steers, Thomas d1750 *BiDBrA*
Stees, Hubert Sheldon 1889- *AmArch 70*
Stees, Sevilla L *DcWomA, WhAmArt 85*
Steese, Edward 1902- *AmArch 70*
Steever, Andrew D 1941- *AmArch 70*
Steever, Edgar Zell, IV 1915- *WhoAmA 76*
Steeves, Ann E 1960- *MarqDCG 84*
Stefan, Ross 1934- *IlBEAAW, WhoAmA 76, -78,
 -80, -82, -84*
Stefanelli, Joe 1921- *WhoAmA 80, -82, -84*
Stefanelli, Joseph 1921- *DcCAA 71, -77*
Stefanelli, Joseph J 1921- *WhoAmA 73, -76, -78*
Stefani, Fossano Da *ClaDrA*
Stefano Da Verona 1375-1438? *McGDA*
Stefano Da Zevio 1375?-1438? *OxArt*
Stefano Di Giovanni *McGDA*
Stefano Di Giovanni Da Verona 1375?-1438? *OxArt*
Stefano Fiorentino *McGDA*
Stefano, Francesco Di *McGDA*
Stefanotti, Robert Alan 1947- *WhoAmA 80, -82, -84*
Stefanotty, Robert Alan 1947- *WhoAmA 73, -76, -78*
Stefanowicz, John E 1942- *MarqDCG 84*
Stefansson, Kristin Jonsdottir 1888- *DcWomA*
Stefany, John Edgar 1931- *AmArch 70*
Steffan, Edward *NewYHSD*
Steffan, Eugene *NewYHSD*
Steffeck, Karl Constantin Heinrich 1818- *ArtsNiC*
Steffelaar, Nico *DcVicP 2*
Steffen, Bernard Joseph 1907- *WhAmArt 85*
Steffen, Kenneth James 1928- *AmArch 70*
Steffen, R O *AmArch 70*
Steffen, Randy *OfPGCP 86*
Steffen, Randy 1915?- *IlBEAAW*
Steffens, J H *AmArch 70*
Steffens, L J *AmArch 70*
Steffens, Louise Eugenie 1841-1865 *DcWomA*
Steffensen, Signe 1881-1935 *DcWomA*
Steffian, Edwin Theodore 1899- *AmArch 70*
Steffian, Peter 1936- *AmArch 70*
Steffler, Alva W 1934- *WhoAmA 78, -80, -82, -84*
Steffy, Bill 1933- *AmArt*
Stefoniak, Edward Thomas 1935- *AmArch 70*
Steg, J L *WhoAmA 73, -76, -78, -80, -82, -84*
Steg, J L 1922- *DcCAA 71, -77*
Stegagnini, L *FolkA 86*
Stegagnini, Louis *NewYHSD*
Stegall, Irma Matthews 1888- *ArtsAmW 1,
 DcWomA, WhAmArt 85*
Stegall, James Park 1942- *WhoAmA 73, -76, -78*
Stegall, Joel E, Jr. 1925- *AmArch 70*
Stege, Wallace T *WhAmArt 85*
Stegeman, Charles 1924- *WhoAmA 73, -76, -78, -80,
 -82, -84*
Steger, Hans-Ulrich 1923- *WhoGrA 62, -82[port]*

Steger, Milly 1881- *DcWomA*
Stegman, H Herbert 1904- *AmArch 70*
Stegman, Patricia 1929- *WhoAmA 76, -78, -80, -82,
 -84*
Stegmann, Povl 1888-1944 *MacEA*
Stegmayer, Mathilde 1873- *DcWomA*
Stegmiller, G J *AmArch 70*
Stegnani, Louis *NewYHSD*
Stegner, Le Edward 1926- *AmArch 70*
Stegner, Nicholas 1882- *WhAmArt 85*
Stehl, Edward Richard 1844-1919 *WhAmArt 85*
Stehlin, Caroline *DcWomA, WhAmArt 85*
Stehling, J A *AmArch 70*
Stehlinger, Emily *DcWomA*
Steichen, Eduard Jean 1879-1973 *WhAmArt 85*
Steichen, Edward 1879-1973 *ConPhot, DcAmArt,
 ICPEnP[port], MacBEP, PrintW 85, WorFshn*
Steichen, Edward 1879-1979 *WhoAmA 80N, -82N,
 -84N*
Steichen, Edward Jean 1879-1973 *BnEnAmA*
Steidel, Paul J 1908- *AmArch 70*
Steider, Doris 1924- *AmArt, IlBEAAW,
 WhoAmA 73, -76, -80, -82, -84*
Steier, W *FolkA 86*
Steig, Joseph *WhAmArt 85*
Steig, Laura *FolkA 86*
Steig, William *WhAmArt 85*
Steig, William 1907- *IlsCB 1967, WhoAmA 73, -76,
 -78, -80, -82, -84, WhoGrA 82[port], WorECar*
Steig, William H 1907- *IlsBYP*
Steiger, Frederic *WhoAmA 76, -78, -80, -82, -84,
 WhoArt 80, -82, -84*
Steiger, Frederic 1899- *ClaDrA*
Steiger, Harwood 1900- *WhAmArt 85*
Steiger, Marie Louise 1872- *DcWomA*
Steiger, Rudolf 1900- *MacEA*
Steiger-Meister, Carla 1951- *ICPEnP A, MacBEP*
Steigman, Margot *WhoAmA 78, -80, -82, -84*
Steigner, Adelaide *WhAmArt 85*
Steil, Henry *DcVicP 2*
Stein *NewYHSD*
Stein, A *NewYHSD*
Stein, A L, Jr. *AmArch 70*
Stein, Aaron 1835-1900 *ArtsAmW 1*
Stein, Annie 1879- *WhAmArt 85*
Stein, Annie 1889- *DcWomA*
Stein, August Ludwig 1732-1814 *ClaDrA*
Stein, B *WhAmArt 85*
Stein, Benjamin Charles, Jr. 1922- *AmArch 70*
Stein, Charles *NewYHSD*
Stein, Charlotte Von 1742-1827 *DcWomA*
Stein, Claire A 1923- *WhoAmA 78, -80, -82, -84*
Stein, Clarence S *AmArch 70*
Stein, Clarence S 1882-1975 *EncAAr*
Stein, Clarence S 1883-1975 *MacEA*
Stein, Donna Michele 1942- *WhoAmA 80, -82, -84*
Stein, Enrique 1843-1919 *WorECar*
Stein, Ethel *DcCAr 81*
Stein, Evaleen *DcWomA*
Stein, Fred 1909-1967 *ICPEnP A*
Stein, Fritz Henry 1932- *WhoAmA 76, -78, -80, -82,
 -84*
Stein, George Edward 1920- *AmArch 70*
Stein, Gertrude 1874-1946 *WhAmArt 85*
Stein, Harve *WhAmArt 85*
Stein, Harve 1904- *IlsBYP, IlsCB 1946,
 WhoAmA 73, -76, -78, -80, -82, -84*
Stein, Harvey 1941- *ICPEnP A, MacBEP*
Stein, Irene 1895- *DcWomA*
Stein, Israel Herman 1929- *AmArch 70*
Stein, J *AmArch 70*
Stein, J S *AmArch 70*
Stein, Jacob *NewYHSD*
Stein, Janet A *WhAmArt 85*
Stein, Joel 1926- *ConArt 77, OxTwCA*
Stein, John Oliver 1921- *AmArch 70*
Stein, Joseph 1921- *AmArch 70*
Stein, Judith Ellen 1943- *WhoAmA 82, -84*
Stein, L I *AmArch 70*
Stein, Lester M 1930- *AmArch 70*
Stein, Lillie *DcVicP 2*
Stein, Ludwig K 1938- *WhoAmA 82, -84*
Stein, Ludwig Karl 1938- *WhoAmA 76*
Stein, Maurice Jay 1898- *WhoAmA 73, -76*
Stein, Modest *WhAmArt 85*
Stein, Richard G 1916- *MacEA*
Stein, Richard George 1916- *AmArch 70*
Stein, Robert *DcVicP 2*
Stein, Roger Breed 1932- *WhoAmA 76, -78, -80, -82,
 -84*
Stein, Ronald 1930- *DcCAA 71, -77*
Stein, Ronald Jay 1930- *WhoAmA 73, -76, -78, -80,
 -82, -84*
Stein, S M *AmArch 70*
Stein, Soloman *FolkA 86*
Stein, Walter 1924- *WhoAmA 73, -76, -78, -80, -82,
 -84*
Stein, Wilhelmine Von *DcWomA*
Stein, William Howard 1933- *AmArch 70*
Stein Callenfels, Johanna Wilhelmine Van 1831-
 DcWomA

Stein-Ranke, Marie 1873- *DcWomA*
Steinacker, H *EncASM*
Steinau, E Allan 1926- *AmArch 70*
Steinbach, Erwin Von d1318 *McGDA*
Steinbach, Henry *FolkA 86*
Steinbach, Sabina Von *DcWomA*
Steinback, I L *DcWomA*
Steinbaugh, Donald F 1906- *AmArch 70*
Steinbaugh, Robert Lin 1954- *MarqDCG 84*
Steinbaum, Bernice 1941- *WhoAmA 82, -84*
Steinbeigle, Raymond Lloyd 1929- *AmArch 70*
Steinberg, A D *AmArch 70*
Steinberg, Andrew David *MarqDCG 84*
Steinberg, Carl *AfroAA*
Steinberg, Claire James 1942- *MacBEP*
Steinberg, David Michael *IlsBYP*
Steinberg, E P *AmArch 70*
Steinberg, George *WhAmArt 85*
Steinberg, Goodwin B 1922- *AmArch 70*
Steinberg, Herbert Aaron 1929- *MarqDCG 84*
Steinberg, Isador N 1900- *WhAmArt 85,
 WhoAmA 73, -76*
Steinberg, Leo 1920- *WhoAmA 80, -82, -84*
Steinberg, Mrs. Milton 1910-1970 *WhoAmA 80N,
 -78N, -82N, -84N*
Steinberg, Nathaniel P 1895- *WhAmArt 85*
Steinberg, Saul 1914- *AmArt, ConArt 77, -83,
 DcAmArt, DcCAA 71, -77, McGDA, OxTwCA,
 PhDcTCA 77, WhAmArt 85, WhoAmA 78, -80,
 -82, -84, WhoGrA 62, WorArt[port], WorECar*
Steinberg, Vladimirovitch Jakob 1880-1942 *ICPEnP A*
Steinberger, Samuel *FolkA 86*
Steinbomer, Dorothy H 1912- *WhoAmA 73*
Steinbruck, Eduard 1802- *ArtsNiC*
Steinbruck, Elisabeth *DcWomA*
Steinbrueck, L H *AmArch 70*
Steinbrueck, Victor 1911- *AmArch 70*
Steindl, E 1839-1902 *WhoArch*
Steinecke, Henry F *NewYHSD*
Steineger, Agnes *DcWomA*
Steinegger, Henry 1831?- *ArtsAmW 1, IlBEAAW,
 NewYHSD*
Steinegger-Caderas, Elfriede 1942- *DcCAr 81*
Steiner, Agnes 1845-1925 *DcWomA*
Steiner, Alberto 1913- *WhoGrA 62*
Steiner, Alberto 1913-1974 *ConDes*
Steiner, Alexander 1899- *AmArch 70*
Steiner, Alice Fanny 1888- *DcWomA*
Steiner, Anna Barbara 1768-1854 *DcWomA*
Steiner, Antonie 1866- *DcWomA*
Steiner, Barbara *DcWomA*
Steiner, Bruce Alan 1955- *MarqDCG 84*
Steiner, David *FolkA 86*
Steiner, Donna Jean 1960- *MarqDCG 84*
Steiner, Emmanuel 1778-1831 *ClaDrA*
Steiner, Heinrich 1906- *WhoGrA 62*
Steiner, Heiri 1906- *WhoArt 80, -82, -84,
 WhoGrA 82[port]*
Steiner, Henry 1934- *ConDes, WhoGrA 82[port]*
Steiner, Julia Bourne *WhoAmA 78*
Steiner, Julie 1878- *DcWomA*
Steiner, Lilly 1884- *DcWomA*
Steiner, Michael 1945- *CenC, DcCAA 77, OxTwCA,
 WhoAmA 73, -76, -78, -80, -82, -84*
Steiner, Paul *WhoAmA 76, -78, -80, -82, -84*
Steiner, Ralph 1899- *BnEnAmA, ConPhot,
 DcCAr 81, ICPEnP, MacBEP, WhAmArt 85*
Steiner, Rudolf 1861-1925 *MacEA*
Steiner, Thomas *FolkA 86*
Steiner-Prag, Hugo 1880-1945 *WhAmArt 85*
Steiner-Prag, Paula 1880- *DcWomA*
Steinert, Daniel J 1932- *AmArch 70*
Steinert, Otto 1915-1978 *ConPhot, ICPEnP,
 MacBEP*
Steinfels, Melville P 1910- *WhAmArt 85,
 WhoAmA 73, -76, -78, -80, -82, -84*
Steinforth, Peter 1923- *DcCAr 81*
Steinhagen, Christofer Friderich Carl *FolkA 86*
Steinhardt, Alice 1950- *MacBEP, WhoAmA 84*
Steinhardt, H M *AmArch 70*
Steinhardt, Henry 1920- *AmArch 70*
Steinhardt, Jakob *OxTwCA*
Steinhardt, Jakob 1887- *McGDA*
Steinhart, Arden C 1906- *AmArch 70*
Steinharter, Walter Louis 1925- *AmArch 70*
Steinhaus, Frederick Campbell 1904- *AmArch 70*
Steinhausen, Marie Henriette *DcWomA*
Steinhauser, Judith H 1941- *MacBEP*
Steinhauser, Pauline Marie Luise 1810-1866 *DcWomA*
Steinheil, Carl August Von 1801-1870 *ICPEnP,
 MacBEP*
Steinheil, Hugo Adolf 1832-1893 *MacBEP*
Steinheil, Hugo Adolph 1832-1893 *ICPEnP*
Steinheil, Louis-Charles-Auguste 1814- *ArtsNiC*
Steinhilber, Walter *WhAmArt 85*
Steinhiler, Martin 1833-1920 *FolkA 86*
Steinhill Brothers *FolkA 86*
Steinhoff, Monika 1941- *AmArt*
Steinhorn, Morris H 1917- *AmArch 70*
Steinhouse, Tobie *WhoAmA 73, -76, -78, -80, -82,*

Sterchi, Eda Elisabeth 1885- *ArtsAmW 2, DcWomA*
Sterenberg, Abraham Petrovitch 1894-1978 *ICPEnP A*
Sterenberg, Abram 1894-1978 *ConPhot*
Sterhan, Elisabeth *DcWomA*
Sterk, Robert Joseph 1935- *AmArch 70*
Sterlacci, Thomas Bruno 1952- *MarqDCG 84*
Sterling *NewYHSD*
Sterling, Antoinette *DcWomA, WhAmArt 85*
Sterling, Dave 1887?-1971 *ArtsAmW 1*
Sterling, E C *DcVicP 2*
Sterling, Frances *DcVicP 2*
Sterling, Helen *DcVicP 2*
Sterling, James Elias 1908- *WhAmArt 85*
Sterling, Joseph 1936- *ICPEnP A, MacBEP*
Sterling, Lew Milton 1879- *ArtsAmW 3*
Sterling, Lewis Milton 1879- *ArtsAmW 3*
Sterling, Lindsey 1876-1931 *DcWomA*
Sterling, Lindsey Morris *WhAmArt 85*
Sterling, Mrs. Lindsey Morris 1876-1931 *WhAmArt 85*
Sterling, Mary E *DcWomA, FolkA 86, NewYHSD*
Sterling, Noah *FolkA 86*
Sterling, Regina M *ArtsEM, DcWomA*
Sterling, Robert, Jr. 1933- *AmArch 70*
Sterling, Ruth *DcWomA, WhAmArt 85*
Sterling, Will 1870-1962 *FolkA 86*
Sterlingworth, Angelina *FolkA 86*
Stermer, Dugald *AmGrD[port]*
Stermer, Dugald Robert 1936- *WhoAmA 80, -82, -84*
Stern, Arthur Lewis 1911- *WhoAmA 73, -76, -78, -80, -82, -84*
Stern, Mrs. Arthur Lewis 1913- *WhoAmA 80, -73, -76, -78, -82, -84*
Stern, Bert 1929- *ConPhot, ICPEnP A*
Stern, Caroline 1893?- *DcWomA, WhAmArt 85*
Stern, D E *AmArch 70*
Stern, Eliahu 1948- *MarqDCG 84*
Stern, Emma 1878-1970 *DcWomA*
Stern, Ethel Louise 1880- *WhAmArt 85*
Stern, Frances Lynn 1949- *MarqDCG 84*
Stern, George I *AmArch 70*
Stern, Gerd 1928- *DcCAA 71, -77*
Stern, Gerd Jacob 1928- *WhoAmA 78*
Stern, Gerson *NewYHSD*
Stern, H Peter *WhoAmA 73, -76, -78, -80, -82, -84*
Stern, Harold Phillip 1922- *WhoAmA 73, -76*
Stern, Harold Phillip 1922-1977 *WhoAmA 78N, -80N, -82N, -84N*
Stern, Irene Monat 1932- *WhoAmA 76, -78, -80, -82, -84*
Stern, Irma *OxTwCA*
Stern, Irma 1894-1966 *DcWomA, OxArt*
Stern, Jan Peter 1926- *WhoAmA 73, -76, -78, -80, -82, -84*
Stern, Jane 1946- *MacBEP*
Stern, Jean 1946- *WhoAmA 76, -78, -80, -82, -84*
Stern, Jonasz 1904- *PhDcTCA 77*
Stern, L S *AmArch 70*
Stern, Leon 1867-1931 *BiDAmAr*
Stern, Leonard B 1938- *WhoAmA 78*
Stern, Louis *EncASM*
Stern, Louis 1945- *WhoAmA 76, -78, -80, -82, -84*
Stern, Louise S 1901- *WhAmArt 85*
Stern, Lucia 1900- *WhAmArt 85*
Stern, M, Jr. *AmArch 70*
Stern, Marcus *DcVicP 2*
Stern, Marguerite Louise Delphine 1866- *DcWomA*
Stern, Marie Simchow 1909- *IlsCB 1744*
Stern, Mildred B *DcWomA, WhAmArt 85*
Stern, Raffaele 1774-1820 *McGDA*
Stern, Raffaello 1774-1820 *MacEA*
Stern, Robert A M 1939- *ConArch*
Stern, Rosa 1868- *DcWomA*
Stern, S *FolkA 86*
Stern, Sam Tilden 1909- *WhAmArt 85*
Stern, Shayne 1932- *MarqDCG 84*
Stern, Simon 1943- *IlsCB 1967*
Stern, Sol J *WhAmArt 85*
Stern, Sophie T *DcVicP 2*
Stern, Steven M 1948- *MarqDCG 84*
Stern, Veronica 1717-1801 *DcWomA*
Sternau, Sigmund *EncASM*
Sternbach, Paul 1919- *AmArch 70*
Sternberg, Eugene David 1915- *AmArch 70*
Sternberg, F C *AmArch 70*
Sternberg, Harry 1904- *DcCAA 71, -77, McGDA, WhAmArt 85, WhoAmA 73, -76, -78, -80, -82, -84*
Sternberg, Mrs. L B *WhAmArt 85*
Sternberg, Robert E Von 1939- *MacBEP*
Sternberg, William *FolkA 86*
Sternberger, Marcel 1899-1956 *ICPEnP A*
Sterndale, O J *DcVicP 2*
Sterndale-Bennett, Honor 1886- *DcBrA 1*
Sterndale-Bennett, Honor 1886-1975 *DcWomA*
Sterne, Dahli 1895- *AmArt*
Sterne, Dahli 1901- *WhoAmA 73, -76, -78, -80, -82, -84*
Sterne, Hedda 1916- *DcCAA 71, -77, OxTwCA, WhoAmA 73, -76, -78, -80, -82, -84*
Sterne, Maurice 1877- *ClaDrA*
Sterne, Maurice 1877-1957 *ArtsAmW 1*

Sterne, Maurice 1878?-1957 *BnEnAmA, DcAmArt, DcCAA 71, -77, IlBEAAW, McGDA, PhDcTCA 77, WhAmArt 85, WhoAmA 80N, -82N, -84N*
Sterner, Albert 1863-1946 *WhAmArt 85, WorECar*
Sterner, Albert E 1863-1946 *IlrAm A, -1880*
Sterner, Albert Edward 1863-1946 *DcBrBI, GrAmP*
Sterner, Frederick J 1876-1931 *BiDAmAr*
Sterner, Harold 1895- *WhAmArt 85*
Sternfeld, Edith A 1898- *ArtsAmW 2, WhAmArt 85*
Sternfeld, Harry *WhAmArt 85*
Sternfeld, Harry 1888- *AmArch 70*
Sternfeld, Joel Peter 1944- *ICPEnP A, MacBEP*
Sternfels, Edna *WhAmArt 85*
Sternfield, Edith A 1898- *ArtsAmW 2, DcWomA*
Sternhagen, Gertrude F 1890?-1976 *DcWomA*
Sterns, E *FolkA 86*
Sterrett, Cliff d1964 *WhoAmA 78N, -80N, -82N, -84N*
Sterrett, Cliff 1883-1964 *WhAmArt 85, WorECom*
Sterrett, Virginia Frances 1900- *ConICB*
Sterry, Ida S *DcVicP 2*
Sterry, John Ashby- *DcVicP 2*
Sterry, Thomas N *NewYHSD*
Stertz, G N *AmArch 70*
Stetcher, Karl 1831-1924 *ArtsAmW 3, NewYHSD, WhAmArt 85*
Steth, Raymond *AfroAA*
Stetler, J L *AmArch 70*
Stetser, Carol Linda 1948- *MacBEP*
Stetser, Dana George 1921- *AmArch 70*
Stetson, Charles Walter 1858-1911 *WhAmArt 85*
Stetson, Daniel Everett 1956- *WhoAmA 82, -84*
Stetson, Donald Warren 1924- *AmArch 70*
Stetson, John 1915- *AmArch 70*
Stetson, Katharine Beecher 1885-1979 *WhAmArt 85*
Stetson, Katherine Beecher 1885- *ArtsAmW 2, DcWomA*
Stetter, Dora 1881- *DcWomA*
Stetter, Lina 1869- *DcWomA*
Stetter, Lydia J *DcWomA*
Stettheimer, Florine 1871-1944 *DcWomA, WomArt*
Stettheimer, Florine 1871-1948 *DcAmArt, WhAmArt 85*
Stettinius, Samuel Enedy 1768-1815 *FolkA 86*
Stettinius, Samuel Enredy 1768-1815 *NewYHSD*
Stettinius, Wallace 1933- *MarqDCG 84*
Stettler, Marie Louise *DcWomA*
Stettler, Martha 1870- *DcWomA*
Stettler, Michael 1913- *WhoArt 80, -82, -84*
Stettner, Louis 1922- *ConPhot, WhoAmA 84*
Stettner, Louis J 1922- *ICPEnP A*
Stettner, Louis J 1924- *MacBEP*
Steuart *DcBrWA*
Steuart, Alice M Gow- *DcVicP 2*
Steuart, Charles *DcBrECP*
Steuart, Elizabeth Howard *WhAmArt 85*
Steuart, Emily Nourse 1893- *DcWomA, WhAmArt 85*
Steuart, George 1730?-1806 *BiDBrA, MacEA*
Steuart, LeConte 1891- *WhAmArt 85*
Steuart, M Louisa *DcWomA, WhAmArt 85*
Steuart, Sarah R *DcWomA, WhAmArt 85*
Steuben, Charles August, Baron De 1788-1856 *ClaDrA*
Steuben, Baroness Eleonore Anne 1788-1869 *DcWomA*
Steuer, Caroline *DcWomA*
Steuernagel, Hermann 1867- *ArtsAmW 3*
Steuerwald, Robert Warren 1923- *AmArch 70*
Steurnagle, Andrew *FolkA 86*
Steuver, Celia M *DcWomA, WhAmArt 85*
Stevanov, Zoran 1945- *WhoAmA 76, -78, -80, -82, -84*
Steven, Francis Simpson *WhAmArt 85*
Steven, S S *FolkA 86*
Stevens *FolkA 86, NewYHSD*
Stevens, Albert *DcBrA 1, DcBrWA, DcVicP, -2*
Stevens, Mrs. Albert *DcVicP 2*
Stevens, Alexander *BiDBrA*
Stevens, Alexander 1730?-1796 *BiDBrA*
Stevens, Alfred *FolkA 86*
Stevens, Alfred 1817-1875 *AntBDN C, DcVicP, McGDA*
Stevens, Alfred 1818-1875 *OxArt*
Stevens, Alfred 1823-1906 *ClaDrA, McGDA*
Stevens, Alfred 1828- *ArtsNiC*
Stevens, Alfred A *EncASM*
Stevens, Alfred-Emile-Leopold-Victor 1823-1906 *OxArt*
Stevens, Alfred G 1817-1875 *ArtsNiC*
Stevens, Alfred George 1817-1875 *DcBrWA, DcVicP 2*
Stevens, Alfred George 1818-1875 *DcNiCA*
Stevens, Almira E 1861?-1946 *DcWomA, WhAmArt 85*
Stevens, Ambrose *NewYHSD*
Stevens, Amelia *DcWomA, NewYHSD*
Stevens, Angelina V *WhAmArt 85*
Stevens, Arthur Dennis 1930- *AmArch 70*
Stevens, Augusta *FolkA 86*
Stevens, Beatrice 1876- *ConICB, WhAmArt 85*
Stevens, Burt Vincent 1910- *AmArch 70*

Stevens, C W *FolkA 86*
Stevens, Charles J 1822?- *NewYHSD*
Stevens, Charles K 1877-1934 *WhAmArt 85*
Stevens, Clara Hatch 1854- *DcWomA, WhAmArt 85*
Stevens, Craig 1947- *MacBEP*
Stevens, D E *AmArch 70*
Stevens, Daniel *NewYHSD*
Stevens, David E *AfroAA*
Stevens, Donald E 1935- *AmArch 70*
Stevens, Donald Meade 1947- *MarqDCG 84*
Stevens, Donald Philip 1915- *AmArch 70*
Stevens, Dorothy 1888?- *DcWomA, WhAmArt 85*
Stevens, Dwight Elton 1904- *WhAmArt 85*
Stevens, E *AmArch 70*
Stevens, E A *FolkA 86*
Stevens, E W, Jr. *AmArch 70*
Stevens, Edith *WhAmArt 85*
Stevens, Edith Barretto *DcWomA*
Stevens, Edith Briscoe 1896-1931 *DcWomA, WhAmArt 85*
Stevens, Edward 1744?-1775 *BiDBrA*
Stevens, Edward Dalton 1878-1939 *WhAmArt 85*
Stevens, Edward F 1860-1946 *BiDAmAr*
Stevens, Edward John, Jr. 1923- *WhAmArt 85, WhoAmA 73, -76, -78, -80, -82, -84*
Stevens, Elisabeth Goss 1929- *WhoAmA 73, -76, -78, -80, -82, -84*
Stevens, Elizabeth T *WhAmArt 85*
Stevens, Ellen Jane *DcWomA*
Stevens, Elsie 1917- *WhoArt 80, -82, -84*
Stevens, Ernest 1872-1938 *ArtsAmW 3*
Stevens, Esther 1885- *ArtsAmW 2, DcWomA, WhAmArt 85*
Stevens, Frances Simpson 1890?- *DcWomA*
Stevens, Francis 1781-1823 *DcBrWA*
Stevens, Frederick *DcVicP 2*
Stevens, Frederick William 1848-1900 *MacEA*
Stevens, G J *AmArch 70*
Stevens, Geoffrey Howard 1899- *DcBrA 1*
Stevens, George *DcVicP, -2, FolkA 86*
Stevens, George 1815?- *NewYHSD*
Stevens, George Alexander 1901- *ClaDrA*
Stevens, George W *NewYHSD*
Stevens, George W 1866-1926 *WhAmArt 85*
Stevens, Mrs. H Hoyt *DcWomA*
Stevens, Harvey A *FolkA 86*
Stevens, Helen B 1878- *ArtsAmW 2, DcWomA, WhAmArt 85*
Stevens, Henry 1611-1690 *FolkA 86*
Stevens, Henry Bryan 1908- *AmArch 70*
Stevens, Hollis Jack, Jr. 1934- *AmArch 70*
Stevens, J H *AmArch 70*
Stevens, J P *AmArch 70*
Stevens, Jacquie 1949- *WhoAmA 84*
Stevens, Johannes d1722 *DcBrECP*
Stevens, John *BiDBrA, CabMA, FolkA 86*
Stevens, John d1745 *CabMA*
Stevens, John d1857 *BiDBrA*
Stevens, John 1793-1868 *ArtsNiC, DcVicP, -2*
Stevens, John 1819-1879 *IlBEAAW, NewYHSD*
Stevens, John 1935- *AfroAA*
Stevens, John, I 1646-1736 *FolkA 86*
Stevens, John, II 1702-1778 *FolkA 86*
Stevens, John, Jr. *FolkA 86*
Stevens, John Calvin 1855- *WhAmArt 85*
Stevens, John Calvin 1855-1940 *BiDAmAr, MacEA*
Stevens, John Calvin 1908- *AmArch 70*
Stevens, John Rheinhardt 1919- *WhoAmA 76*
Stevens, Joseph 1819- *ArtsNiC*
Stevens, Joseph Herbert 1847- *DcBrA 1, DcVicP 2*
Stevens, Joseph P *FolkA 86*
Stevens, Joyce Smith *AmArch 70*
Stevens, Justin d1771 *DcBrECP*
Stevens, Kate *DcVicP 2*
Stevens, Kelly Haygood *WhAmArt 85*
Stevens, Kelly Haygood 1896- *ArtsAmW 2, IlBEAAW*
Stevens, Lawrence Tenney 1896- *IlBEAAW, WhoAmA 73*
Stevens, Lawrence Tenney 1896-1972 *ArtsAmW 2, WhAmArt 85, WhoAmA 76N*
Stevens, Lawrence Tenny 1896-1972 *WhoAmA 78N, -80N, -82N, -84N*
Stevens, Lizzie *ArtsEM, DcWomA*
Stevens, Louisa Bancroft 1872- *WhAmArt 85*
Stevens, Louise Bancroft 1872- *DcWomA*
Stevens, Lucy Beatrice 1876- *IlsCB 1744*
Stevens, Lucy Beatrice 1876-1947 *DcWomA*
Stevens, Luman S *ArtsEM*
Stevens, Luther *NewYHSD*
Stevens, Lyman 1923- *AmArch 70*
Stevens, M L *DcWomA*
Stevens, Marian *WhAmArt 85*
Stevens, Marian 1885-1974 *DcWomA*
Stevens, Marjorie 1902- *WhoAmA 76, -78, -80, -82, -84*
Stevens, Mary *DcBrWA, DcWomA*
Stevens, Mary 1924- *WhoAmA 80*
Stevens, Mary E 1920-1966 *IlsBYP, IlsCB 1946, -1957*
Stevens, May 1924- *ConArt 77, WhoAmA 73, -76,*

Stewart, Pythias NewYHSD
Stewart, R DcVicP 2
Stewart, Regina WhoAmA 82, -84
Stewart, Robert B WhAmArt 85
Stewart, Robert Gordon 1931- WhoAmA 76, -78, -80, -82, -84
Stewart, Robert Murray 1924- MarqDCG 84
Stewart, Robert W WhAmArt 85
Stewart, Robert Welton 1937- AmArch 70
Stewart, Robert Wright DcBrA 1
Stewart, Rosanna M DcWomA
Stewart, S NewYHSD
Stewart, S DeB WhAmArt 85
Stewart, Samuel CabMA
Stewart, Sarah B DcWomA
Stewart, Sarah Bartram WhAmArt 85
Stewart, Mrs. T J WhAmArt 85
Stewart, Thomas 1766-1801? DcBrECP
Stewart, Virginia FolkA 86
Stewart, W C AmArch 70
Stewart, William AfroAA, FolkA 86
Stewart, William 1886- ClaDrA
Stewart, William 1938- ConArt 77, WhoAmA 78, -80, -82, -84
Stewart, William Addison 1918- AmArch 70
Stewart, William Branks 1898- WhAmArt 85
Stewart, Mrs. William D WhAmArt 85
Stewart, William H NewYHSD
Stewart, William M FolkA 86
Stewart, William W 1865- WhAmArt 85
Stewart, William Ward 1934- AmArch 70
Stewart, Worth ArtsAmW 2, WhAmArt 85
Stewel, Gustav NewYHSD
Steyert, Auguste 1830-1904 DcBrBI
Steyn, Stella 1907- DcBrA 1, WhoArt 80, -82, -84
Stezaker, John 1949- ConArt 77, -83, ConBrA 79[port]
Stiattesi, Prudentia Palmira 1618?- DcWomA
Stibbs, Thomas d1759 BiDBrA
Stibor, Miloslav 1927- MacBEP
Stice, G L AmArch 70
Stich, G FolkA 86
Stichel, Dorte DcWomA
Stichler, Charles B 1940- MarqDCG 84
Stick, Frank WhAmArt 85
Stickel, F G AmArch 70
Stickel, Thomas R 1941- MarqDCG 84
Stickel, William Henry 1917- AmArch 70
Stickells, Robert d1620 BiDBrA
Sticker, Robert Edward 1922- WhoAmA 76, -78, -80, -82, -84
Stickle, R W AmArch 70
Stickler, Mary Royer 1814-1890 FolkA 86
Stickley, Gustave 1858-1942 WhAmArt 85
Stickney, C D AmArch 70
Stickney, Frederick W 1853-1918 BiDAmAr
Stickney, Jacob CabMA
Stickney, Lela Mabel 1872- WhAmArt 85
Stickney, Lucy May DcWomA, WhAmArt 85
Stickney, Margaret DcWomA
Stickney, Mary West DcWomA, WhAmArt 85
Stickney, Mehetable FolkA 86
Stickney, Mehitabel NewYHSD
Stickney, Samuel 1795?- CabMA
Stickney, Sarah d1872 DcWomA
Stickrod, Randall L 1944- MarqDCG 84
Stickroth, Harry I d1922 WhAmArt 85
Sticks, A J DcVicP 2
Sticks, George Blackie 1843-1938 DcBrA 1, DcBrWA, DcVicP 2
Sticks, George Edward DcBrA 1, DcVicP 2
Sticks, Harry d1938 DcBrA 1, DcBrWA, DcVicP 2
Sticks, William DcVicP 2
Sticotti, Marie Michelle DcWomA
Stidham, Edward AfroAA
Stidolph NewYHSD
Stidun, James NewYHSD
Stiebel, Augustus NewYHSD
Stiebel, Eric 1911- WhoAmA 76, -78, -80, -82, -84
Stiebel, Gerald Gustave 1944- WhoAmA 76, -78, -80, -82, -84
Stiebel, Penelope Hunter WhoAmA 78, -80, -84
Stiebel, Victor 1907- FairDF ENG
Stieber, Conrad Harold 1931- AmArch 70
Stiebig, John FolkA 86
Stiefel, Marie 1879- DcWomA
Stieff, Charles C EncASM
Stieff-Orth EncASM
Stieffel, Hermann 1826-1882 IlBEAAW, NewYHSD
Stieffel, Hermann 1826-1886 ArtsAmW 1
Stiegel, Baron Henry Wilhelm 1729-1785 FolkA 86
Stiegel, Henry William 1729-1785 AntBDN H, BnEnAmA, IlDcG, OxDecA
Stiegelmeyer, Norman Earl 1937- WhoAmA 78, -80, -82, -84
Stieger, Jacqueline 1936- WhoArt 80, -82, -84
Stiegler, Robert William 1938- ICPEnP A, MacBEP, WhoAmA 84
Stieglitz, Alfred PhDcTCA 77
Stieglitz, Alfred 1864-1946 BnEnAmA, ConPhot, DcAmArt, ICPEnP, MacBEP, McGDA,

OxTwCA, WhAmArt 85
Stiene, Frank J 1939- AmArch 70
Stiepevich, V G WhAmArt 85
Stierle, Max M ArtsEM
Stierlin, Margaret Emily 1891?- DcWomA, WhAmArt 85
Stiernschantz, Beda Maria 1867-1910 DcWomA
Stiernstedt, Sophie Louise 1845-1927 DcWomA
Stierwalt, Moses FolkA 86
Stievater, Richard John 1941- AmArch 70
Stievater, Robert H 1931- AmArch 70
Stiff, J FolkA 86
Stiff, Roy L 1905- AmArch 70
Stiffe, C E DcVicP 2
Stiffe, John Gilbee DcVicP 2
Stiffler, David Lawrence 1922- AmArch 70
Stiffler, Iva Haverstock 1887- DcWomA
Stifft, M NewYHSD
Stifter, Adalbert 1805-1885 OxArt
Stigand, Helen M DcBrWA, DcVicP 2, DcWomA
Stiggins, Hill 1922- AmArch 70
Stigzelius DeCock, Julia DcWomA
Stiha, Vladin 1910?- IlBEAAW
Stika, William Alfred 1929- AmArch 70
Stikeman, Annie DcVicP 2, DcWomA
Stiko, Per 1923- AmArch 70
Stiles, Florence Ward AmArch 70
Stiles, Helen WhoAmA 84
Stiles, Jack Leroy 1932- AmArch 70
Stiles, Jeremiah 1771-1826 FolkA 86, NewYHSD
Stiles, John R ArtsEM
Stiles, M L AmArch 70
Stiles, Patti WhAmArt 85
Stiles, Samuel FolkA 86
Stiles, Samuel 1796-1861 NewYHSD
Stiles, Susan Piece FolkA 86
Stiles, William M NewYHSD
Stilinovic, Mladen 1947- DcCAr 81
Stilke, Ada 1865-1911 DcWomA
Stilke, Hermann Anton 1803-1860 ClaDrA
Stilke, Hermine 1804-1869 DcWomA
Still, Clyfford 1904- BnEnAmA, ConArt 77, DcAmArt, DcCAA 71, -77, DcCAr 81, McGDA, PhDcTCA 77, WhoAmA 73, -76, -78, -80
Still, Clyfford 1904-1980 ConArt 83, OxTwCA, WhAmArt 85, WorArt[port]
Still, Clyfford 1904-1981 WhoAmA 82N, -84N
Still, Joseph AfroAA
Still, Roy WhAmArt 85
Stiller, J M AmArch 70
Stillman, Amelia Esther 1834-1902 DcWomA
Stillman, Ary 1891- WhAmArt 85
Stillman, Ary 1891-1967 ArtsAmW 3
Stillman, Damie 1933- WhoAmA 84
Stillman, E Clark 1907- WhoAmA 73, -76, -78, -80, -82, -84
Stillman, Effie DcWomA, WhAmArt 85
Stillman, Emma DcWomA
Stillman, George 1921- AmArt, WhoAmA 80, -82, -84
Stillman, George K 1821?- NewYHSD
Stillman, John 1920- ConArch
Stillman, John Cecil EncMA
Stillman, Lena DcWomA
Stillman, Leo 1903- AmArch 70
Stillman, Lisa d1946 WhAmArt 85
Stillman, Lisa R DcVicP 2, DcWomA
Stillman, Maria 1844- DcBrWA
Stillman, Marie DcWomA, WhAmArt 85
Stillman, Marie 1844-1927 ClaDrA
Stillman, Marie Spartali 1844-1927 DcWomA
Stillman, Mrs. William J 1844-1927 DcVicP, -2
Stillman, William James 1828-1901 NewYHSD, WhAmArt 85
Stillman And Eastwick-Field ConArch, EncMA
Stillman-Myers, Joyce 1943- WhoAmA 84
Stillson, Blanche WhAmArt 85
Stillwagon, G B NewYHSD
Stillwaugh, D M AmArch 70
Stillwel, Sarah S DcWomA
Stillwell, E G AmArch 70
Stillwell, Earle Albert 1936- AmArch 70
Stillwell, Ida FolkA 86
Stillwell, James Dean 1937- AmArch 70
Stillwell, John E 1853-1930 WhAmArt 85
Stillwell, Sarah S WhAmArt 85
Stilson, Ethel M WhAmArt 85
Stilson, William W ArtsEM
Stilwell, Alison 1917- IlsCB 1946
Stilwell, J, Jr. DcVicP 2
Stilwell, R L AmArch 70
Stilwell, V E, Jr. AmArch 70
Stilwell, Wilber Moore 1908- WhoAmA 73
Stilwell, Wilber Moore 1908-1974 WhoAmA 76N
Stilwell, Wilbur Moore 1908-1974 WhAmArt 85, WhoAmA 78N, -80N, -82N, -84N
Stilwell-Weber, Sarah S 1878-1939 IlrAm A
Stilwell Weber, Sarah S 1878-1939 IlrAm 1880
Stimets, Adelaide N DcWomA, WhAmArt 85
Stimmel, George 1880-1964 WhAmArt 85

Stimmel, S FolkA 86
Stimmel, William Edwin 1923- AmArch 70
Stimmer, Tobias 1539-1584 ClaDrA, McGDA, OxArt
Stimmer Family OxArt
Stimming, Pauline 1836- DcWomA
Stimp FolkA 86
Stimpson, Helen Townsend 1886- DcWomA, WhAmArt 85
Stimpson, James H EncASM
Stimson, Anna K 1892- WhAmArt 85
Stimson, Anna Katharine 1892- DcWomA
Stimson, John Ward 1850-1930 ArtsAmW 2, WhAmArt 85
Stimson, Joseph E 1870-1952 ArtsAmW 3
Stinchfield, Estelle 1878- WhAmArt 85
Stinchfield, Estelle 1878-1945 ArtsAmW 2, DcWomA
Stinde, Sophie 1853- DcWomA
Stine, Robert Walter AmArch 70
Stinemetz, Morgan WhAmArt 85
Stiner, Louis NewYHSD
Stinessen, Siggen 1942- MacBEP
Stinger, Samuel 1801?-1879 FolkA 86
Stingfield, Clarence 1903- FolkA 86
Stinski, Gerald Paul 1929- WhoAmA 73, -76, -78, -80, -82
Stinsmuehlen, Susan Dodds 1948- WhoAmA 84
Stinson, Charles A WhAmArt 85
Stinson, Donald R AfroAA
Stinson, Gorrell Robert 1904- AmArch 70
Stinson, Harry 1898- WhAmArt 85
Stinson, Henry FolkA 86
Stinson, J Whitla WhAmArt 85
Stinson, Lucile 1888-1981 DcWomA
Stinson, Lucile S 1898- ArtsAmW 2
Stinson, Nolan Lawrence, Jr. 1922- AmArch 70
Stinson, Robert A 1927- AmArch 70
Stinson, William H NewYHSD
Stinton, James 1856-1954 DcNiCA
Stipe, William S 1916- WhoAmA 73, -76, -78, -80, -82, -84
Stippich, Glenn Robert 1924- AmArch 70
Stirling NewYHSD
Stirling, Dave 1889- WhAmArt 85
Stirling, David MacEA
Stirling, Glen WhAmArt 85
Stirling, James EncMA
Stirling, James 1926- ConArch, DcD&D[port], MacEA, WhoArch
Stirling, John 1820-1871 DcVicP, -2
Stirling, Lance 1928- WhoGrA 62
Stirling, Lindsey Morris DcWomA
Stirling, Louis West 1928- AmArch 70
Stirling, Nina DcVicP 2, DcWomA
Stirling, William DcVicP 2
Stirling, William 1772-1838 BiDBrA
Stirling, William Arthur NewYHSD
Stirling And Gowan EncMA, MacEA
Stirnaman, Marilou 1907- WhAmArt 85
Stirnweis, Shannon 1931- IlrAm 1880, IlsBYP
Stirrett, Wylie 1915- WhAmArt 85
Stirton, Malcolm Roderick 1909- AmArch 70
Stitcher And Clemmens CabMA
Stites, Claribel DcWomA
Stites, John Randolph WhAmArt 85
Stites, John Randolph 1836- NewYHSD
Stites, Raymond Somers 1899- WhoAmA 73
Stites, Raymond Somers 1899-1974 WhAmArt 85, WhoAmA 76N
Stites, Raymond Sommers 1899-1974 WhoAmA 78N, -80N, -82N, -84N
Stitt, Alexander 1937- WhoGrA 62
Stitt, Herbert D 1880- ArtsAmW 3
Stitt, Hobart 1880- IlBEAAW
Stitt, Hobart D 1880- WhAmArt 85
Stitt, Susan 1942- WhoAmA 76, -78, -80, -82, -84
Stivers, Don OfPGCP 86
Stivers, Harley Ennis 1891- WhAmArt 85
Stivers, John FolkA 86
Stivour, Sarah FolkA 86
Stix, Marguerite 1907-1975 WorFshn
Stizelberger, Jacob, Sr. FolkA 86
Stizelberger, William FolkA 86
Stjernschantz, Beda Maria DcWomA
Stjernstedts, S, Madame DcVicP 2
Stluka, Frederick P 1960- MarqDCG 84
Sto WorECar
Stoakes, Charles BiDBrA
Stoaks, Caroline 1892- DcWomA
Stobart, Adela 1885?-1950 DcBrA 1, DcWomA
Stobart, John 1929- DcBrA 2, DcSeaP, WhoArt 80, -82, -84
Stobart, Ralph IlsBYP
Stobbaerts, Jan 1838-1894? ClaDrA
Stobbs, William IlsCB 1967
Stobbs, William 1914- IlsBYP, IlsCB 1946, -1957
Stober, John FolkA 86
Stobie, Charles S 1845-1931 ArtsAmW 1, IlBEAAW, WhAmArt 85
Stobwasser, Christian Friedrich DcNiCA
Stobwasser Und Sohn DcNiCA

Stone, Ellen J *DcWomA, WhAmArt 85*
Stone, Erika 1924- *ICPEnP A, MacBEP*
Stone, Esther *DcWomA*
Stone, Esther F *WhAmArt 85*
Stone, Fern *DcWomA*
Stone, Francis 1775-1834 *BiDBrA*
Stone, Frank 1800-1859 *ArtsNiC, DcBrBI, DcBrWA, DcVicP, -2*
Stone, Frank F 1860-1939 *WhAmArt 85*
Stone, Fred *OfPGCP 86*
Stone, Fred 1835?- *NewYHSD*
Stone, G E N *AmArch 70*
Stone, George *FolkA 86*
Stone, George 1811?- *NewYHSD*
Stone, George H *WhAmArt 85*
Stone, George J 1860-1932 *WhAmArt 85*
Stone, George M 1858- *WhAmArt 85*
Stone, George Melville 1858-1931 *ArtsAmW 2*
Stone, Gerald Eugene 1929- *AmArch 70*
Stone, Gilbert L 1940-1984 *IlrAm 1880*
Stone, Gillman *CabMA*
Stone, Gwen 1913- *WhoAmA 78, -80, -82, -84*
Stone, H B *AmArch 70*
Stone, H Mulready *DcBrA 2*
Stone, H W *AmArch 70*
Stone, Hal *ConGrA 1*
Stone, Hannah *FolkA 86*
Stone, Helen 1903- *WhAmArt 85*
Stone, Helen 1904- *IlsBYP, IlsCB 1744, -1946, -1957*
Stone, Helen Loasley *WhAmArt 85*
Stone, Henry *DcVicP 2, NewYHSD*
Stone, Henry William 1919- *AmArch 70*
Stone, Herbert Marshall 1936- *AmArch 70*
Stone, Horatio 1808-1875 *BnEnAmA, NewYHSD*
Stone, Horatio 1810-1875 *ArtsNiC*
Stone, Isaac *CabMA*
Stone, Iva Goldhamer 1917- *WhAmArt 85*
Stone, Ivan Lial 1927- *AmArch 70*
Stone, J M 1841- *ArtsNiC*
Stone, Jeffrey Ingram 1945- *WhoAmA 82, -84*
Stone, Jeremy 1957- *WhoAmA 84*
Stone, Jim 1947- *MacBEP, WhoAmA 80, -82, -84*
Stone, John *DcBrECP*
Stone, John 1620-1667 *BiDBrA*
Stone, John Benjamin 1836-1914 *ICPEnP A, MacBEP*
Stone, John Christopher 1923- *WhoAmA 80, -82, -84*
Stone, John Lewis, Jr. 1937- *WhoAmA 73, -76, -78, -80, -82*
Stone, Julia *DcWomA, WhAmArt 85*
Stone, Leona *WhAmArt 85*
Stone, Lewis Collins *WhAmArt 85*
Stone, Louis K 1902- *WhAmArt 85*
Stone, M Bainbridge *WhAmArt 85*
Stone, M L *DcWomA*
Stone, M Lee 1937- *WhoAmA 82, -84*
Stone, Madeline Masters d1932 *WhAmArt 85*
Stone, Madeline Masters 1877-1932 *DcWomA*
Stone, Marcus *ArtsNiC*
Stone, Marcus 1840-1921 *DcBrA 1, DcBrBI, DcBrWA, DcVicP, -2*
Stone, Marcus C 1840-1921 *ClaDrA*
Stone, Margaret *NewYHSD*
Stone, Margaret 1815?- *DcWomA*
Stone, Margaret Anthony 1910- *WhAmArt 85*
Stone, Marianna *DcWomA, WhAmArt 85*
Stone, Marie W d1920 *DcWomA, WhAmArt 85*
Stone, Mary *DcWomA*
Stone, Mary A *DcWomA*
Stone, Mary L *DcWomA*
Stone, Mary Mulready *DcWomA*
Stone, Mary Young *DcWomA*
Stone, Maysie *WhAmArt 85*
Stone, Michael 1945- *MacBEP*
Stone, Mildred B *WhAmArt 85*
Stone, N *FolkA 86, NewYHSD*
Stone, Nicholas 1583-1647 *OxArt*
Stone, Nicholas 1587-1647 *BiDBrA, MacEA, McGDA*
Stone, Orrin F *WhAmArt 85*
Stone, Pauline *WhAmArt 85*
Stone, Raymond Norman 1953- *MarqDCG 84*
Stone, Reynolds 1909- *WhoGrA 62*
Stone, Reynolds 1909-1979 *ConDes*
Stone, Robert *FolkA 86*
Stone, Robert D *MarqDCG 84*
Stone, Robert Dunlop 1905- *AmArch 70*
Stone, Robert Faires 1925- *AmArch 70*
Stone, Ruby 1900- *WhAmArt 85*
Stone, Sam, Jr. 1868-1933? *BiDAmAr*
Stone, Samuel 1760- *CabMA*
Stone, Sarah *DcWomA, FolkA 86*
Stone, Seymour Millais 1877- *WhAmArt 85*
Stone, Sidney Mason *BiDAmAr*
Stone, Mrs. Smith *DcWomA*
Stone, Stanford Byron 1906- *WhAmArt 85*
Stone, Sylvia *WhoAmA 73, -76, -78, -80, -82, -84*
Stone, Sylvia 1928- *DcCAA 77, DcCAr 81*
Stone, Thomas *CabMA*
Stone, Todd 1951- *PrintW 83, -85*

Stone, Vera *WhAmArt 85*
Stone, Vernon Francis 1920- *AmArch 70*
Stone, Viola Pratt 1872-1958 *ArtsAmW 2, DcWomA, WhAmArt 85*
Stone, W Henry *DcVicP 2*
Stone, Walter King 1875- *WhAmArt 85*
Stone, Willard 1916- *IlBEAAW, WhoAmA 76, -78, -80, -82, -84*
Stone, William *CabMA, DcVicP 2*
Stone, William Addison 1902- *AmArch 70*
Stone, William Ellsworth 1895- *WhAmArt 85*
Stone, William F, Jr. *OfPGCP 86*
Stone, William Fusselbaugh, Jr. 1890- *AmArch 70*
Stone, William J 1798-1865 *NewYHSD*
Stone, William Oliver 1830-1875 *ArtsNiC, NewYHSD*
Stone And Alexander *CabMA*
Stonebarger, Virginia 1926- *WhoAmA 73, -76, -78, -80, -82, -84*
Stoneham, John 1929- *WhoAmA 78, -80, -82, -84*
Stonehill, George 1888-1943 *WhAmArt 85*
Stonehill, John Jay 1933- *AmArch 70*
Stonehill, Mary d1951 *WhoAmA 78N, -80N, -82N, -84N*
Stonehill, Mary 1900-1951 *WhAmArt 85*
Stonehouse, Charles *DcVicP, -2*
Stonelake, Frank P *DcBrA 1*
Stoneman, Daniel Lee 1951- *MarqDCG 84*
Stoner, A R *AmArch 70*
Stoner, Albert *FolkA 86*
Stoner, Elmer *AfroAA*
Stoner, Harry 1880- *WhAmArt 85*
Stoner, Henry *FolkA 86*
Stoner, John Lawrence 1906- *WhAmArt 85*
Stoner, Joyce Hill 1946- *WhoAmA 78, -80, -82, -84*
Stoner, Olive *AfroAA, WhAmArt 85*
Stones, Angela 1914- *WhoArt 80, -82, -84*
Stones, Christopher John Assheton- 1947- *WhoArt 82, -84*
Stones, Emily R *DcBrA 1, DcVicP 2, DcWomA*
Stones, Margaret Alison 1942- *WhoAmA 78, -80, -82, -84*
Stones, Thomas Fiendley 1920- *WhoArt 80, -82, -84*
Stoney, Charles B *DcVicP, -2*
Stoney, Eleanor E *WhAmArt 85*
Stoney, T Butler *DcVicP 2*
Stoney, Thomas Butler *DcBrBI*
Stonhouse, Charles *DcBrBI*
Stonier, Lucille Holderness 1886- *ArtsAmW 1, WhAmArt 85*
Stonier, Lucille Holderness 1890- *DcWomA*
Stonington, Nancy Taylor *OfPGCP 86*
Stonorov, Oscar 1905- *McGDA*
Stonorov, Oscar 1905-1970 *ConArch*
Stonorov, Oskar 1905- *WhAmArt 85*
Stonorov, Oskar 1905-1970 *MacEA*
Stoop, Dirck 1610?-1686? *DcSeaP*
Stoop, Dirck 1618?-1686 *McGDA*
Stoop, Dirk 1618?-1681 *ClaDrA*
Stoop, Maerten 1620?-1647 *McGDA*
Stoop, Maerton 1620?-1647 *ClaDrA*
Stoop, Marianna VanDer *DcWomA*
Stoop, Willem VanDer *DcSeaP*
Stoopendaal, Jenny *DcWomA*
Stoopendall, G *WhAmArt 85*
Stoopenkoff, Lavr Alexis 1931- *AmArch 70*
Stoops, Herbert d1948 *WhoAmA 78N, -80N, -82N, -84N*
Stoops, Herbert Morton 1887?-1948 *IlBEAAW, WhAmArt 85*
Stoops, Herbert Morton 1888-1948 *ArtsAmW 1, IlrAm D, -1880*
Stoops, Jack Donald 1914- *WhoAmA 73, -76*
Stoops, William Lee 1925- *AmArch 70*
Stooter, Cornelisz Leonardsz 1620-1655 *DcSeaP*
Stop *WorECar*
Stoper, Frank *NewYHSD*
Stopford, Robert Lowe 1813-1898 *DcBrBI, DcBrWA, DcVicP 2*
Stopford, William Henry 1842-1890 *DcBrWA, DcVicP 2*
Stopp, Marianna VanDer *DcWomA*
Stoppel, R T *AmArch 70*
Stoppelaer, Charles *DcBrECP*
Stoppelaer, Herbert d1772 *DcBrECP*
Stoppelaer, Michael *DcBrECP*
Stoppino, Giotto 1926- *ConDes*
Storch, Anna Friederike 1815-1898 *DcWomA*
Storch, Max H *EncASM*
Storck, Abraham 1635?-1710? *ClaDrA*
Storck, Abraham 1644-1710 *DcSeaP*
Storck, Abraham Jansz 1644-1704? *McGDA*
Storck, Cecilia 1879- *DcWomA*
Storck, Jacobus *ClaDrA*
Storck, Jacobus 1641-1693? *DcSeaP*
Storck, W B *DcVicP 2*
Store, Coquerel & Legros D'Anisy *DcNiCA*
Storelli, Felix-Marie-Ferdinand 1778-1854 *ArtsNiC*
Storelli, Felix Marie Ferdinand 1778-1854 *IlBEAAW*
Storer, Mrs. Bellamy *FolkA 86*
Storer, Catherine *DcWomA, NewYHSD*

Storer, Charles *WhAmArt 85*
Storer, Florence *DcWomA, WhAmArt 85*
Storer, Frances Nell 1917- *WhoAmA 80, -82, -84*
Storer, Henry Sargant 1797-1837 *DcBrBI, DcBrWA*
Storer, Inez 1933- *PrintW 85*
Storer, Inez Mary 1933- *WhoAmA 78, -80, -82, -84*
Storer, James Sargant 1771-1853 *DcBrBI, DcBrWA*
Storer, Louisa *DcVicP 2, DcWomA*
Storer, Maria 1849-1932 *DcWomA*
Storer, Maria Longworth *AntBDN M*
Storey *FolkA 86*
Storey, Ellsworth P 1879-1960 *MacEA*
Storey, George Adolphus 1834- *ArtsNiC*
Storey, George Adolphus 1834-1919 *ClaDrA, DcBrA 1, DcBrBI, DcBrWA, DcVicP, -2*
Storey, George Bernard *AmArch 70*
Storey, Harold 1888-1965 *DcBrA 1*
Storey, Isabelle B 1933- *WhoAmA 76*
Storey, J *DcBrECP*
Storey, John 1827?-1877? *DcVicP 2*
Storey, John 1828-1888 *DcBrWA*
Storey, Ross Barron 1940- *IlrAm G, -1880*
Storey, Terence 1923- *WhoArt 80, -82, -84*
Storey, Terence Lionel 1923- *DcSeaP*
Storey, Warren 1924- *DcBrA 1, WhoArt 80, -82, -84*
Storey, William *CabMA*
Storie, Harold *FolkA 86*
Storioni, Lorenzo *AntBDN K*
Stork, Daniel F 1945- *MarqDCG 84*
Stork, E L *FolkA 86*
Stork, Lisl 1888- *DcWomA, WhAmArt 85*
Stork-Kruyff, A M 1870- *DcWomA*
Storm, Alfrida Anna 1896- *ArtsAmW 1, DcWomA*
Storm, Anna Alfrida 1896- *WhAmArt 85*
Storm, G F *NewYHSD*
Storm, George 1830-1913 *NewYHSD, WhAmArt 85*
Storm, Greenup Moorsom 1901- *DcBrA 1*
Storm, Howard 1946- *WhoAmA 73, -76, -78, -80, -82, -84*
Storm, J P *AmArch 70*
Storm, Larue *WhoAmA 73, -76, -78, -80, -82, -84*
Storm, Mark 1911- *WhoAmA 76, -78, -80, -82, -84*
Storm, William George 1826-1892 *MacEA*
Storment, K D *AmArch 70*
Stormo, Paul John 1936- *MarqDCG 84*
Stormoen, Gene Allen 1931- *AmArch 70*
Stormont, Howard Gull *DcBrWA, DcVicP 2*
Stormont, Mrs. Howard Gull *DcVicP 2*
Storms, Christian S *NewYHSD*
Storms, John *NewYHSD*
Storni, Alfredo 1881-1966 *WorECar*
Storr, Milton *DcVicP 2*
Storr, Paul 1771-1844 *AntBDN Q, DcD&D, DcNiCA, OxDecA*
Storrer, Bradley Ray 1930- *AmArch 70*
Storrs, Frances Hudson *DcWomA, WhAmArt 85*
Storrs, G D, Jr. *AmArch 70*
Storrs, John 1885-1956 *BnEnAmA, DcAmArt, WhAmArt 85, WhoAmA 78N, -80N, -82N, -84N*
Storrs, John Bradley 1885-1956 *PhDcTCA 77*
Storrs, Lewis Austin 1903- *AmArch 70*
Storrs, W A *AmArch 70*
Storstein, Aage 1900- *ClaDrA, WhoArt 80, -82, -84*
Stort, Eva 1855-1936 *DcWomA*
Stortenbecker, Nikolaus 1940- *DcCAr 81, OxTwCA*
Stortenbeker, P *DcVicP 2*
Story *NewYHSD*
Story, Benjamin d1927 *WhAmArt 85*
Story, Blanche *DcVicP 2, DcWomA*
Story, George H 1835- *ArtsNiC*
Story, George H 1835-1923 *WhAmArt 85*
Story, George Henry 1835-1923 *NewYHSD*
Story, Howard T 1914- *AmArch 70*
Story, Ina Perham *WhAmArt 85*
Story, J *DcBrECP*
Story, Julian *DcVicP 2*
Story, Julian 1857-1919 *ArtsAmW 1, WhAmArt 85*
Story, Julian Russel 1850-1919 *ClaDrA*
Story, Marion d1907 *WhAmArt 85*
Story, Mary S *DcVicP 2, DcWomA*
Story, Thomas C *NewYHSD*
Story, Thomas Waldo 1855-1915 *WhAmArt 85*
Story, William Easton 1925- *WhoAmA 73, -76, -78, -80, -82, -84*
Story, William W 1819- *ArtsNiC*
Story, William Wetmore 1819-1895 *BnEnAmA, DcAmArt, McGDA, NewYHSD, WhAmArt 85*
Stoshitch, Savo Milan 1914- *AmArch 70*
Stoss, Veit 1447?-1533 *McGDA*
Stoss, Veit 1450?-1533 *OxArt*
Stot, Benjamin *AntBDN N*
Stote, Theodore *NewYHSD*
Stotesbury, Helen *WhAmArt 85*
Stothard, Charles Alfred 1786-1821 *DcBrBI, DcBrWA*
Stothard, James *NewYHSD*
Stothard, R *NewYHSD*
Stothard, Robert T *DcBrBI*
Stothard, Robert Thomas *DcVicP 2*

Strauss EncASM
Strauss, Betty 1905- WhAmArt 85
Strauss, C A AmArch 70
Strauss, Carl Sumner 1873- WhAmArt 85
Strauss, F G AmArch 70
Strauss, F H AmArch 70
Strauss, Glenn Vernon 1870- WhAmArt 85
Strauss, Helene Julie Marie 1834- DcWomA
Strauss, Herman S 1932- AmArch 70
Strauss, Lucille L 1933- AmArch 70
Strauss, Malcolm A 1883-1936 WhAmArt 85
Strauss, Morris NewYHSD
Strauss, Moses NewYHSD
Strauss, Raphael NewYHSD , WhAmArt 85
Strauss, Simon d1897 FolkA 86
Strauss, Theodore Laurence 1932- AmArch 70
Strauther, D H NewYHSD
Strautin, Wally 1898- WhAmArt 85
Strautmanis, Edvins 1933- AmArt, WhoAmA 78, -80,
 -82, -84
Strauven, Gustave 1878-1919 MacEA
Stravs, C B AmArch 70
Straw, Michael FolkA 86
Strawbridge, Anne West 1883- WhAmArt 85
Strawbridge, Anne West 1883-1941 DcWomA
Strawbridge, Edward R WhoAmA 80
Strawbridge, Edward R 1903- WhAmArt 85,
 WhoAmA 78
Strawbridge, Edward Richie 1903- WhoAmA 73, -76
Strawbridge, Margaret LaRue 1919- WhAmArt 85
Strawn, Jarrett W 1943- WhoAmA 82, -84
Strawn, Jarrett W Jason 1943- WhoAmA 80
Strawn, John FolkA 86
Strawn, John 1950- MarqDCG 84
Strawn, Melvin Nicholas 1929- WhoAmA 73, -76, -78,
 -80, -82, -84
Strayer, Paul 1885- IlBEAAW, WhAmArt 85
Strayer, R D AmArch 70
Strazza, Giovanni 1818-1875 ArtsNiC
Strean, Maria Judson WhAmArt 85
Strean, Maria Judson 1865-1949 DcWomA
Streat, Thelma Johnson 1912- AfroAA,
 WhAmArt 85
Streat, William Alfred, Jr. 1920- AmArch 70
Streater, Henry William DcVicP 2
Streatfeild, Josephine 1882- WhAmArt 85
Streatfield, Granville E DcVicP 2
Streatfield, James Philip S DcVicP 2
Streatfield, Josephine 1882- DcWomA
Streatfield, Robert 1786-1852 DcBrWA
Streatfield, Thomas 1777-1848 DcBrBI, DcBrWA
Streatfield, Thomas Edward Champion DcVicP 2
Streator, Harold A 1861-1926 WhAmArt 85
Streator, Harold Arthur 1861-1926 ArtsAmW 2
Strebi, R AmArch 70
Strechine, Stephanie Von 1858- DcWomA
Strecker, Herman 1836-1901 NewYHSD ,
 WhAmArt 85
Strecker, J DcVicP 2
Streek, Hendrick Van 1659-1719 ClaDrA
Streek, Jurian Van 1632?-1687 ClaDrA
Streek, Jurriaen Van 1632?-1687 McGDA
Street, Agnes WhAmArt 85
Street, Albert Reid 1919- AmArch 70
Street, Austin FolkA 86
Street, Austin 1824?- NewYHSD
Street, Claude Lorrain 1834- NewYHSD
Street, E H AmArch 70
Street, Frank 1893-1944 IlBEAAW, IlrAm C, -1880,
 WhAmArt 85
Street, Franklin NewYHSD
Street, George Edmund 1824-1881 ArtsNiC, DcD&D,
 MacEA, McGDA, OxArt, WhoArch
Street, Georgina A DcVicP 2, DcWomA
Street, J Fletcher 1880-1944 BiDAmAr
Street, J R, Jr. AmArch 70
Street, John Michael 1942- WhoAmA 76, -78, -80,
 -82
Street, Kate DcBrA 1, DcVicP, -2, DcWomA
Street, Naomi Scudder 1903- WhAmArt 85
Street, R H AmArch 70
Street, Reuben C 1826- NewYHSD
Street, Robert 1796- FolkA 86
Street, Robert 1796-1865 NewYHSD
Street, Robert Francis 1919- AmArch 70
Street, Rubens 1826- NewYHSD
Street, S P DcWomA
Street, Sarah Wilson 1912- WhAmArt 85
Street, Theophilus 1829?- NewYHSD
Streeter, Catherine Elizabeth 1842-1930 DcWomA
Streeter, Daniel Denison 1885- AmArch 70
Streeter, Donald 1905- WhAmArt 85
Streeter, Julia Allen 1877- DcWomA, WhAmArt 85
Streeter, Leander R NewYHSD
Streeter, Robert 1624-1679 OxArt
Streeter, Rosalie Ethel DcVicP 2
Streeter, Tal 1934- AmArt, ConArt 77,
 WhoAmA 73, -76, -78, -80, -82, -84
Streetman, Christine Norman 1903- WhAmArt 85
Streetman, John William, III 1941- WhoAmA 76, -78,
 -80, -82, -84

Streeton, Arthur 1867-1943 OxArt
Streeton, Sir Arthur 1867-1943 ClaDrA,
 DcBrA 1
Streetor, W Day WhAmArt 85
Streett, Tylden Westcott 1922- WhoAmA 73, -76, -78,
 -80, -82, -84
Strehlow, Gerald Robert 1933- AmArch 70
Streich, Tod Allan 1952- MarqDCG 84
Streight, Howard d1912 WhAmArt 85
Streight, Howard A 1836-1912 ArtsAmW 2
Streissguth, D M AmArch 70
Streit, Emmy 1886- DcWomA
Streit, Kathe DcWomA
Streitman, Nathan 1933- AmArch 70
Strekalovsky, Vcevold O 1938- AmArch 70
Strel, Donald O 1934- WhoAmA 76, -78, -80
Strele, Martha 1889- DcWomA
Strelisky, Lipot d1905 ICPEnP A
Strelitz, R L AmArch 70
Strelett, Ephraim DcBrA 1
Strelow, Liselotte 1908- MacBEP
Strelow, Liselotte 1908-1981 ConPhot, ICPEnP A
Strelzoff, Alan Gregory 1937- MarqDCG 84
Strempel, Elisabeth 1840-1910? DcWomA
Strenge, Christian FolkA 86
Strengell, Marianne 1909- WhAmArt 85
Strenk, E J AmArch 70
Stresor, Anne Marie Renee 1651-1713 DcWomA
Stretch, Lillian R WhAmArt 85
Stretch, Matt DcBrBI, DcVicP 2
Stretch, Peter AntBDN D
Stretton, Hesba D DcVicP 2, DcWomA
Stretton, Philip Eustace DcBrA 1, DcVicP, -2
Stretton, Philip Eustace d1919 DcBrWA
Stretton, Samuel 1732?-1811 BiDBrA
Stretton, William 1755-1828 BiDBrA
Strevens, F John L DcBrA 2
Strevens, John WhoArt 80
Strevens, John 1902- WhoArt 82, -84
Stribling, Robert BiDBrA
Strick, Maria 1577- DcWomA
Stricker, Christiane Friederike 1780-1840 DcWomA
Stricker, Michael Andrew 1958- MarqDCG 84
Stricker, Milton Arthur 1926- AmArch 70
Strickfaden, R J AmArch 70
Strickland, Allen WhoAmA 76, -78, -80, -82
Strickland, Charles Rutan 1907- AmArch 70
Strickland, D L AmArch 70
Strickland, Dorothy Enid 1899- ClaDrA
Strickland, Edward AfroAA
Strickland, Frances DcVicP 2, DcWomA
Strickland, Fred WhAmArt 85
Strickland, George 1797-1851 NewYHSD
Strickland, Harry L ArtsEM
Strickland, Helen DcBrA 1
Strickland, J F, Jr. AmArch 70
Strickland, James AfroAA
Strickland, Joe Francis 1932- AmArch 70
Strickland, Larry J AfroAA
Strickland, Lilly Teresa ArtsEM, DcWomA
Strickland, Maria DcWomA
Strickland, Mary DcWomA
Strickland, Michael L 1946- MarqDCG 84
Strickland, Phyllis Alba 1915- WhAmArt 85
Strickland, Ralph EncASM
Strickland, Simon FolkA 86
Strickland, Susannah DcWomA
Strickland, Thomas J WhoAmA 73
Strickland, Thomas J 1932- PrintW 85,
 WhoAmA 76, -78, -80, -82, -84
Strickland, William AfroAA
Strickland, William 1787?-1854 BiDAmAr, OxArt,
 WhoArch
Strickland, William 1788-1854 BnEnAmA, DcD&D,
 EncAAr, MacEA, McGDA, NewYHSD
Strickland, Willie Charles 1922- AmArch 70
Strickler, Jacob 1770- FolkA 86
Strickler, John FolkA 86
Strickler, Susan Elizabeth 1952- WhoAmA 82, -84
Stricklin, Alan D 1942- MarqDCG 84
Stride, P DcVicP 2
Stride, Sarah M 1921- DcBrA 1
Strider, Marjorie 1934- ConArt 77
Strider, Marjorie Virginia PrintW 83, -85,
 WhoAmA 73, -76, -78, -80, -82, -84
Strider, Marjorie Virginia 1939- AmArt
Strider, Maurice 1913- AfroAA
Strieb, Melvin I 1945- MarqDCG 84
Striebel, John H 1891-1967 WorECom
Striebel, John Henry 1892- WhAmArt 85
Striebig, John K 1809-1868 FolkA 86
Strieby, C W AmArch 70
Striep, Christiaen Jansz 1634-1673 McGDA
Striffler, Albert Christian 1861-1918 WhAmArt 85
Strigel, Bernhard 1460?-1528 McGDA, OxArt
Strigl, Therese 1824-1908 DcWomA
Striker, Cecil L 1932- WhoAmA 84
Striker, Kenneth 1908- WhAmArt 85
Strimple, Olga Maria Jorgensen 1896- ArtsAmW 3,
 DcWomA
Strindberg, August 1849-1912 PhDcTCA 77

Stringer, Agnes DcBrBI
Stringer, David Gerald 1933- AmArch 70
Stringer, F CabMA
Stringer, John Norris 1937- WhoAmA 80, -82, -84
Stringer, Lee Albert 1935- AmArch 70
Stringer, Mary Evelyn 1921- WhoAmA 73, -76, -78,
 -80, -82, -84
Stringer, R W, Jr. 1942- MarqDCG 84
Stringer Of Knutsford DcBrECP
Stringer Of Knutsford, Daniel 1754- DcBrECP[port]
Stringer Of Knutsford, Francis DcBrECP
Stringer Of Knutsford, Samuel d1784? DcBrECP
Stringfellow, Allen AfroAA
Stringfield, Vivian F 1882?-1933 ArtsAmW 2,
 DcWomA, WhAmArt 85
Stringham, R B AmArch 70
Stringovits, Ferry 1893- DcWomA
Stripling, J A AmArch 70
Strippleman, William L 1843-1912 BiDAmAr
Strisik, Paul 1918- WhoAmA 73, -76, -78, -80, -82,
 -84
Stritzel, Frederick William 1910- AmArch 70
Strizic, Mark 1928- MacBEP
Strizzi, David J 1923- AmArch 70
Strnd, Oscar 1879-1935 WhoArch
Strobel, Anna AmArch 70
Strobel, Lorenz 1812?-1900 FolkA 86
Strobel, Louisa Catherine 1803-1883 DcWomA,
 NewYHSD
Strobel, Max IlBEAAW, NewYHSD
Strobel, Oscar 1891-1967 ArtsAmW 1, -3
Strobel, Oscar A 1891-1967 IlBEAAW,
 WhAmArt 85
Strobel, Thomas C 1931- WhoAmA 73
Strobl, Alajos 1856-1926 McGDA
Strobl, Ingeborg 1949- DcCAr 81
Strobl, Kisfaludy Sigismund De 1884-1975 DcBrA 2
Strobl, Zsigmond DeKisfaludi McGDA
Strobl, Zsofia 1866- DcWomA
Strobridge, Hines NewYHSD
Strode, Catherine DcWomA, WhAmArt 85
Strode, H B, Jr. 1931- AmArch 70
Stroebe, F G AmArch 70
Stroebel, J A B ArtsNiC
Stroebel, Louisa Catherine 1803-1883 DcWomA
Stroessner, Robert Joseph 1942- WhoAmA 80, -82,
 -84
Stroever, Ida Carola 1872- DcWomA
Stroh, Charles 1943- WhoAmA 82, -84
Stroh, John F 1909- AmArch 70
Strohl, Audrey Taylor 1939- WhoAmA 80, -82
Strohl, Clifford 1893- WhAmArt 85
Strohm, Gusta R DcWomA
Strohmeyer, Anna 1860- DcWomA
Strohsashl, Herbert R 1955- MarqDCG 84
Strokes, Willie 1954- FolkA 86
Stroll, S L FolkA 86
Strollo, L A AmArch 70
Strollo, Rebell Francis 1925- AmArch 70
Strom, Gerda Elisabeth Blom 1886- DcWomA
Strom, Gustaf Adolf 1872- WhAmArt 85
Strom, Nils 1905- WhAmArt 85
Strom, Tonje 1937- DcCAr 81
Strombach, Victor H 1888-1943 BiDAmAr
Stromberg, Bruce 1944- MacBEP
Stromberg, Edvard 1872-1946 IlDcG
Stromberg, Gerda d1960 IlDcG
Stromberg, Julia Charlotta Mortana 1851-1920
 DcWomA
Strombotne, James 1934- WhoAmA 73, -76, -78
Stromeyer, Helene Marie 1834-1924 DcWomA
Stromholm, Christer 1918- ICPEnP A
Stromquist, Ralph H 1939- MarqDCG 84
Stromquist, Walter 1912- AmArch 70
Stromsted, Alf Jorgen 1898- WhAmArt 85
Stromsten, Amy J 1942- ICPEnP A, MacBEP
Stronach, Ancell 1901- DcBrA 1
Strong BiDBrA, FolkA 86
Strong, Anne FolkA 86
Strong, Anthony Charles 1902- AmArch 70
Strong, Beulah 1866- DcWomA
Strong, Beverly Jean 1927- WhoAmA 84
Strong, C E DcVicP 2
Strong, Carlton 1869-1931 BiDAmAr
Strong, Carter Bruce 1924- AmArch 70
Strong, Charles Dunwoody 1895- AmArch 70
Strong, Charles R WhAmArt 85
Strong, Charles Ralph 1938- WhoAmA 73, -76, -78,
 -80, -82, -84
Strong, Clark EncASM
Strong, Constance Gill 1900- WhAmArt 85
Strong, Cornelia Adele DcWomA
Strong, David EncASM
Strong, Donald Willis 1937- AmArch 70
Strong, Douglas E 1922- AmArch 70
Strong, Edward 1652-1724 BiDBrA
Strong, Edward 1676-1741 MacEA
Strong, Edward, Jr. 1676-1741 BiDBrA
Strong, Elizabeth 1855- WhAmArt 85
Strong, Elizabeth 1855-1941 ArtsAmW 1, DcWomA
Strong, F O ArtsEM

Strong, George H *NewYHSD*
Strong, H *DcVicP 2*
Strong, H G *AmArch 70*
Strong, Howard *NewYHSD*
Strong, Howard John 1920- *AmArch 70*
Strong, Isobel *WhAmArt 85*
Strong, J *DcVicP 2*
Strong, Joseph D 1852-1900 *DcBrBI, IlBEAAW, WhAmArt 85*
Strong, Joseph Dwight, Jr. 1852-1900 *ArtsAmW 1*
Strong, Louise *ArtsEM, DcWomA*
Strong, Lyman J 1918- *AmArch 70*
Strong, M Louise *ArtsEM, DcWomA*
Strong, Margt L *DcWomA*
Strong, Peggy 1912- *WhAmArt 85*
Strong, Ray Stanford 1905- *WhAmArt 85*
Strong, Terry J 1932- *AmArch 70*
Strong, Thomas 1632?-1681 *BiDBrA*
Strong, Thomas 1685-1736 *MacEA*
Strong, Thomas W *NewYHSD*
Strong, Timothy *BiDBrA*
Strong, Timothy d1636? *BiDBrA*
Strong, Valentine d1662 *BiDBrA*
Strong, Walter *NewYHSD*
Strong And Elder *EncASM*
Stronghilos, Carol *WhoAmA 78, -80, -82, -84*
Stroobant, Dominique 1947- *DcCAr 81*
Stroobant, Francois 1819- *ArtsNiC*
Stroobant, Francois 1819-1916 *ClaDrA*
Stroobant, L *NewYHSD*
Stroom, Lowell Milton *AmArch 70*
Stroop, H Rodger 1922- *AmArch 70*
Strosahl, William 1910- *WhoAmA 80, -82, -84*
Strosser *NewYHSD*
Strother, David Hunter 1816-1888 *EarABI, EarABI SUP, NewYHSD*
Strother, Dean MacGregor 1922- *AmArch 70*
Strother, Joseph Willis 1933- *WhoAmA 73, -76, -78, -80, -82, -84*
Strother, Virginia Vaughn 1920- *WhoAmA 76, -78, -80, -82, -84*
Strothers, J W *AmArch 70*
Strothmann, Fred 1879-1958 *IlrAm 1880, WhAmArt 85*
Strothmann, Fred 1880-1958 *WhoAmA 80N, -82N, -84N*
Strott, William John, Jr. 1927- *AmArch 70*
Strottman, Robert Edward 1932- *AmArch 70*
Strotz, August Karl 1925- *AmArch 70*
Stroud, Clara *WhAmArt 85*
Stroud, Clara 1890- *DcWomA*
Stroud, H M *DcVicP 2*
Stroud, Ida Wells *WhAmArt 85*
Stroud, Ida Wells 1869- *DcWomA*
Stroud, Laura D *DcWomA, WhAmArt 85*
Stroud, Peter 1921- *DcBrA 1*
Stroud, Peter Anthony 1921- *DcCAA 77, WhoAmA 73, -76, -78, -80, -82, -84*
Stroud, Richard 1940- *AfroAA*
Stroud, Thomas *NewYHSD*
Stroud, Virginia *OfPGCP 86*
Stroudley, James 1906- *WhoArt 82, -84*
Stroudley, L James *DcBrA 2*
Strouse, Raphael *NewYHSD*
Strover, Dorothea *DcWomA*
Stroy, Dennis *AfroAA*
Stroynowska, Waleria *DcWomA*
Strozzi, Bernardo 1581-1644 *McGDA, OxArt*
Strozzi, Zanobi 1412-1468 *McGDA*
Strub, Joseph 1936- *DcCAr 81*
Strubberg, Louise 1818- *DcWomA*
Strube, Sidney 1891-1956 *DcBrBI, WorECar*
Struben, Edith F M *DcWomA*
Strubin, Robert 1897-1965 *ConArt 77*
Strubing, Louisa Hayes 1881- *DcWomA, WhAmArt 85*
Strubing, Walter *FolkA 86*
Struble, Eva E d1932 *WhAmArt 85*
Struble, Wayne *AmArch 70*
Struck, Herman 1887- *WhAmArt 85*
Struck, Herman 1887-1954 *ArtsAmW 1*
Struckus, Theresa Khoury *WhoAmA 76, -78, -80*
Strudwick, Clement 1900- *WhAmArt 85*
Strudwick, John Melhuish 1849-1935 *DcVicP*
Strudwick, John Melhuish 1849-1937 *ClaDrA, DcBrA 1, DcVicP 2*
Strudwick, William *DcVicP 2*
Struk, Stephen 1947- *MarqDCG 84*
Strum, William Edward 1946- *MarqDCG 84*
Strumillo, Andrzej 1928- *WhoGrA 82[port]*
Strunk, E H *AmArch 70*
Strunk, Herbert J 1891-1950? *WhAmArt 85*
Strunk, Herbert Julian *WhoAmA 78N, -80N, -82N, -84N*
Strunz, William Frazee 1868- *WhAmArt 85*
Strupp, J *ClaDrA*
Struppeck, Jules 1915- *WhoAmA 73, -76, -78, -80, -82, -84*
Struppeck, Julius 1915- *WhAmArt 85*
Struppi-Wolkensperg, Jelka 1875- *DcWomA*
Struppmann, Herbert C 1912- *AmArch 70*

Strus, M Josefa 1805-1880 *DcWomA*
Struss, Karl 1886- *MacBEP*
Struss, Karl 1886-1981 *ICPEnP*
Struth, Thomas 1954- *DcCAr 81*
Struthers, Helen VonL *DcWomA, WhAmArt 85*
Struthers, Irva *WhAmArt 85*
Strutt, Alfred William 1856-1924 *ClaDrA, DcBrA 1, DcBrBI, DcVicP, -2*
Strutt, Arthur Edward 1862- *DcBrWA, DcVicP 2*
Strutt, Arthur John 1819-1888 *DcBrWA, DcVicP 2*
Strutt, David L 1956- *MarqDCG 84*
Strutt, Jacob George *DcVicP*
Strutt, Jacob George 1784-1867 *DcVicP 2*
Strutt, Jacob George 1790-1864 *DcBrBI, DcBrWA*
Strutt, Joseph 1749-1802 *BkIE, DcBrECP, DcBrWA*
Strutt, Rosa *DcBrWA*
Strutt, Rosa J *DcVicP 2*
Strutt, William 1825-1915 *DcVicP 2*
Strutt, William 1826-1915 *ClaDrA, DcBrA 1, DcVicP*
Strutt, William 1827-1915 *DcBrBI, DcBrWA*
Strutt, William Thomas 1777-1850 *DcBrECP*
Struve, William Walter 1936- *WhoAmA 80, -82, -84*
Struven, Gertrude Stanwood 1874- *DcWomA, WhAmArt 85*
Struycken, Peter 1939- *DcCAr 81, PhDcTCA 77*
Struys, Alexander Theodore Honore 1852- *ClaDrA*
Stry, Abraham Van 1753-1826 *ClaDrA*
Strycker, Jacobus Gerritsen 1619-1687 *NewYHSD*
Stryjenska, Karolina 1846-1912 *DcWomA*
Stryjenska, Zofia 1894- *DcWomA*
Stryke, Anna Clegg 1884- *DcWomA*
Stryker, Don *WhAmArt 85*
Stryker, Edmond Milburn 1926- *AmArch 70*
Stryker, Roy 1893-1975 *ConPhot*
Stryker, Roy Emerson 1882-1975 *MacBEP*
Stryker, Roy Emerson 1893-1975 *ICPEnP*
Strype, Frederick C *NewYHSD*
Strzeminski, Vladislav 1893-1952 *PhDcTCA 77*
Strzeminski, Wladyslaw 1893-1952 *OxTwCA*
Stuan, Vegard 1952- *MarqDCG 84*
Stuart *FolkA 86*
Stuart, Miss *DcVicP 2, DcWomA*
Stuart, A *DcVicP 2*
Stuart, A Burnett *DcVicP 2*
Stuart, Albert F 1824- *NewYHSD*
Stuart, Alexander *NewYHSD*
Stuart, Alexander Charles 1831-1898 *DcSeaP, WhAmArt 85*
Stuart, Alexander T *ArtsEM*
Stuart, Alexander W *FolkA 86*
Stuart, Amy *DcVicP 2*
Stuart, Arthur *EncASM*
Stuart, Augustus Burnett- 1850-1898 *DcBrWA*
Stuart, B D *AmArch 70*
Stuart, C E Gordon *DcVicP 2*
Stuart, Catherine Baker 1905- *WhAmArt 85*
Stuart, Charles *BiDBrA, ClaDrA, DcBrA 1, DcBrECP, DcVicP, -2*
Stuart, Charles 1880-1904 *DcVicP*
Stuart, Mrs. Charles *DcVicP, -2*
Stuart, Charles Gilbert 1787?-1813 *NewYHSD*
Stuart, David *WhoAmA 73, -76, -78, -80, -82, -84*
Stuart, Donald Alexander 1944- *WhoAmA 78, -80, -82, -84*
Stuart, Donald R *WhAmArt 85*
Stuart, Ellen *WhAmArt 85*
Stuart, Ellen D *ArtsAmW 3, DcWomA*
Stuart, Ernest *DcVicP 2*
Stuart, F *DcVicP 2, DcWomA*
Stuart, Frederick 1817-1900 *IlDcG*
Stuart, Frederick D 1816?- *ArtsAmW 1, IlBEAAW, NewYHSD*
Stuart, Frederick G *NewYHSD*
Stuart, Frederick T 1837-1913 *NewYHSD , WhAmArt 85*
Stuart, G E *DcVicP 2, DcWomA*
Stuart, George *WorFshn*
Stuart, Gertrude G Villiers-, Lady Scott 1878-1961 *DcBrWA*
Stuart, Gilbert 1755-1828 *DcAmArt, DcBrECP, McGDA, OxArt*
Stuart, Gilbert Charles 1755-1828 *BnEnAmA, IlBEAAW, NewYHSD*
Stuart, Granville 1834-1918 *ArtsAmW 3*
Stuart, J A *DcVicP 2*
Stuart, J E *DcVicP 2*
Stuart, James 1713-1788 *BiDBrA, DcBrECP, MacEA, McGDA, OxArt, WhoArch*
Stuart, James Athenian 1713-1788 *DcBrWA*
Stuart, James E 1852-1941 *ArtsAmW 1, WhAmArt 85*
Stuart, James Everett 1852-1941 *IlBEAAW*
Stuart, James Reeve 1834-1915 *NewYHSD , WhAmArt 85*
Stuart, Jane 1812-1888 *DcWomA, NewYHSD*
Stuart, Jane Maria *DcWomA*
Stuart, John 1739-1800 *DcBrWA*
Stuart, John Sim 1923- *AmArch 70*
Stuart, Jose Herculano T DeA Carvalhais 1888-1961 *WorECar*

Stuart, Joseph Martin 1932- *WhoAmA 73, -76, -78, -80, -82, -84*
Stuart, Karl Dane 1928- *AmArch 70*
Stuart, Kenneth James *WhoAmA 73, -76, -78, -80, -82, -84*
Stuart, Kenneth James 1905- *WhAmArt 85*
Stuart, Kiel 1951- *WhoArt 84*
Stuart, L *DcVicP 2*
Stuart, Lee, Jr. 1921- *AmArch 70*
Stuart, Lloyd Gordon 1936- *AmArch 70*
Stuart, Louisa *DcVicP 2, DcWomA*
Stuart, Luella M *DcWomA, WhAmArt 85*
Stuart, Lynn *WorFshn*
Stuart, M *AmArch 70*
Stuart, Michelle 1919- *WhoAmA 76, -78, -80, -82, -84*
Stuart, Michelle 1938- *ConArt 77, -83, DcCAr 81*
Stuart, Michelle 1940- *AmArt*
Stuart, Nobil 1882-1976 *FolkA 86*
Stuart, North *WhAmArt 85*
Stuart, Oliver J *NewYHSD*
Stuart, Pythias *NewYHSD*
Stuart, R James *WhAmArt 85*
Stuart, Robert *BiDBrA*
Stuart, Rodney Christopher 1945- *MacBEP*
Stuart, Sheila 1905-1949 *DcBrA 1*
Stuart, Signe Nelson *WhoAmA 78, -80, -84*
Stuart, W E D *DcVicP, -2*
Stuart, William *DcSeaP, DcVicP 2*
Stuart, Mrs. William *DcVicP 2, DcWomA*
Stuart, William E D *DcSeaP*
Stuart-Brown, Henry James 1871- *ClaDrA*
Stuart-Hill, A *DcBrA 1*
Stuart-Sindici, Francesca 1858- *DcWomA*
Stuart-Wortley, Caroline Elizabeth Mary *DcWomA*
Stub, Mariane Frederikke 1790-1842 *DcWomA*
Stubbing, Tony 1921- *ConArt 77*
Stubbins, Hugh 1912- *EncMA*
Stubbins, Hugh, Jr. 1912- *McGDA*
Stubbins, Hugh A, Jr. 1912- *ConArch*
Stubbins, Hugh Asher, Jr. 1912- *AmArch 70, MacEA*
Stubblebine, James Harvey 1920- *WhoAmA 84*
Stubbs, George *DcVicP 2*
Stubbs, George 1724-1806 *DcBrECP, DcBrWA, McGDA, OxArt[port]*
Stubbs, George Townley 1756?-1815 *DcBrECP*
Stubbs, J Woodhouse *DcBrA 1*
Stubbs, J Woodhouse d1908? *DcVicP 2*
Stubbs, Jesse C *AfroAA*
Stubbs, Joanna 1940- *IlsCB 1967*
Stubbs, Joseph d1836 *DcNiCA*
Stubbs, Kenneth 1907- *WhAmArt 85*
Stubbs, Mary H 1867- *WhAmArt 85*
Stubbs, Mary Helen 1867- *DcWomA*
Stubbs, Ralph R *DcVicP 2*
Stubbs, Robert 1924- *WhoAmA 76, -78*
Stubbs, Samuel *DcVicP 2*
Stubbs, Sidney Wilbur, Jr. 1935- *AmArch 70*
Stubbs, William King 1909- *AmArch 70*
Stubbs, William P *NewYHSD*
Stubbs, William P 1842- *FolkA 86*
Stubbs, William Pierce 1842-1909 *DcSeaP, WhAmArt 85*
Stubee, H D *AmArch 70*
Stubenrauch, Augustus *NewYHSD*
Stubenrauch, Charles *NewYHSD*
Stubenrauch, Edgar Albert 1894- *AmArch 70*
Stubenrauch, Hans 1875- *ClaDrA*
Stubenrauch, Philipp Von 1784-1848 *ClaDrA*
Stuber, Dedrick B 1878-1954 *WhAmArt 85*
Stuber, Dedrick Brandes 1878- *ArtsAmW 2*
Stuber, Hanny 1870- *DcWomA*
Stuber, Nikolaus Gottfried 1688-1749 *McGDA*
Stubis, Talivaldis 1926- *IlsBYP*
Stubley, Thomas *DcBrECP*
Stubley, Trevor Hugh 1932- *IlsCB 1967, WhoArt 80, -82, -84*
Stubly, Thomas *DcBrECP*
Stuchlik, Camill *DcVicP 2*
Stuck, Barton W 1946- *MarqDCG 84*
Stuck, Elmer Axtell 1900- *AmArch 70*
Stuck, Franz 1863-1928 *WhAmArt 85A*
Stuck, Franz Von 1863-1928 *ClaDrA, McGDA, OxTwCA, PhDcTCA 77, WorECar*
Stuckelberg, Ernst 1831-1903 *ClaDrA*
Stuckelberg, Gertrud 1871- *DcWomA*
Stuckelberg, Marie 1869-1917 *DcWomA*
Stucken, Ferdinand d1878 *NewYHSD*
Stucker, F *FolkA 86*
Stuckert, Rudolf 1912- *DcCAr 81*
Stuckey, Charles F 1945- *WhoAmA 82, -84*
Stuckey, George 1822-1872 *DcVicP 2*
Stuckey, Martin *FolkA 86*
Stuckey, Mary L *AfroAA*
Stuckey, P J *DcSeaP*
Stuckey, Upton *FolkA 86*
Stucki, Margaret Elizabeth 1928- *WhoAmA 76, -78, -80, -82*
Stuckman, Richard Hervey 1927- *AmArch 70*
Stuckrad, Martha Von 1854- *DcWomA*
Stucky, George David 1937- *AmArch 70*

Studd, Arthur Haythorne 1863-1919 *DcBrA 1,*
DcVicP 2
Studdert, G *DcVicP 2*
Studdy, G E 1878-1925 *DcBrBI*
Studer, F M *AmArch 70*
Studholme, Robert *BiDBrA*
Studio Per *ConArch*
Stueber, Raymond J *AmArch 70*
Stueber, T H *AmArch 70*
Stuebner, Joseph A *WhAmArt 85*
Stuehm, David Lewis 1952- *MarqDCG 84*
Stueler, Charles *FolkA 86*
Stuempfig, Walter 1914- *McGDA*
Stuempfig, Walter 1914-1970 *DcCAA 71, -77*
Stuempfig, Walter, Jr. 1914-1970 *WhAmArt 85*
Stuermer, Adolph D 1914- *AmArch 70*
Stuermer, Ray 1912- *AmArch 70*
Stuessy, Gene 1933- *MarqDCG 84*
Stuever, Celia M *DcWomA, WhAmArt 85*
Stuewarts, Magdalena *DcWomA*
Stuff *DcBrBI*
Stuffers, Anthony 1894-1920 *WhAmArt 85*
Stuhec, Vojko 1946- *DcCAr 81*
Stuhl, Michelle *WhoAmA 84*
Stuhldreher, M W *AmArch 70*
Stuhr, R F *AmArch 70*
Stuida, William 1877-1959 *WhoAmA 80N, -82N,*
-84N
Stukeley, William 1687-1765 *BkIE*
Stulb, Henry Lowrey 1917- *AmArch 70*
Stuler, Friedrich August 1800-1865 *MacEA,*
WhoArch
Stuler, Jack 1932- *WhoAmA 73, -76, -78, -80, -82,*
-84
Stuler, Jack H 1932- *MacBEP*
Stuler, Marie 1844-1913 *DcWomA*
Stuler-Walde, Marie 1868-1904 *DcWomA*
Stull, Don 1937- *AmArch 70*
Stull, George P *WhAmArt 85*
Stull, Henry 1851-1913 *WhAmArt 85*
Stull, Jean Himrod 1929- *WhoAmA 76, -78, -80, -82,*
-84
Stull, Ned Ray 1906- *AmArch 70*
Stull, Robert 1935- *AfroAA*
Stull, Robert J 1935- *WhoAmA 78, -80, -82, -84*
Stulpner, J H *DcBrECP*
Stults, Elwin Martin, Jr. 1899- *WhAmArt 85*
Stultz, H T, Jr. *AmArch 70*
Stultz, Harold Burnell, Jr. 1936- *AmArch 70*
Stuman, Jack Bates Huddleston 1908- *WhAmArt 85*
Stumm, Maud *DcWomA, WhAmArt 85*
Stumm, William *ArtsEM*
Stump, Jeanne 1922- *WhoAmA 82, -84*
Stump, Samuel John 1783?-1863 *DcBrWA, DcVicP 2*
Stumpf, Valentine *FolkA 86*
Stumpfeld, Caroline Johanne Amalie 1751-1829
DcWomA
Stumpp, C J *AmArch 70*
Stuntz, Helen 1871-1949 *DcWomA*
Stuntz, Hermione 1830-1879 *DcWomA*
Stuntz, Maria Electrina *DcWomA*
Stupakoff, Otto 1935- *ICPEnP A*
Stupica, Gabrijel 1913- *OxTwCA, PhDcTCA 77*
Stupka-Eisenlohr, Louise Von *DcWomA*
Sturck, Abraham Jansz *McGDA*
Sturdee, Percy *DcVicP 2*
Sturdevant, Austa 1855-1936 *DcWomA*
Sturdevant, Austa Densmore 1855-1936 *WhAmArt 85*
Sturdevant, S *NewYHSD*
Sturdevant, Thomas *NewYHSD*
Sturdivant, H M *NewYHSD*
Sturdy And Marcy *EncASM*
Sturel, Marie Octavie *DcWomA*
Sturge, F William *DcBrWA, DcVicP 2*
Sturgeon, J V *NewYHSD*
Sturgeon, John Floyd 1946- *WhoAmA 76, -78, -80,*
-82, -84
Sturgeon, Kate *DcBrA 2, DcVicP 2, DcWomA*
Sturgeon, Mary C 1943- *WhoAmA 78, -80, -82, -84*
Sturgeon, Ruth 1883- *WhAmArt 85*
Sturgeon, Ruth B 1883- *DcWomA*
Sturgeon, Ruth Barnett 1883- *ArtsAmW 3*
Sturges, Dwight Case 1874-1940 *WhAmArt 85*
Sturges, Hollister *WhoAmA 82, -84*
Sturges, John *BiDBrA*
Sturges, Katharine *WhAmArt 85*
Sturges, Katharine 1890-1979 *IlrAm 1880*
Sturges, Lee 1865- *ArtsAmW 1, WhAmArt 85*
Sturges, Lillian *WhAmArt 85*
Sturges, Philemon Fowler, III 1929- *AmArch 70*
Sturges, W K *AmArch 70*
Sturgess, John *DcBrBI, DcVicP, -2*
Sturgess-Lief, Christopher Patric 1937- *ClaDrA*
Sturgis, A W *ArtsEM*
Sturgis, Annie A *WhAmArt 85*
Sturgis, D N B *WhAmArt 85*
Sturgis, John Hubbard 1834-1888 *BiDAmAr, MacEA*
Sturgis, John Joseph 1922- *AmArch 70*
Sturgis, Katharine 1904- *WhAmArt 85*
Sturgis, Mabel R 1865- *WhAmArt 85*
Sturgis, Mabel Russell 1865- *DcWomA*

Sturgis, Norman Romney 1891-1947 *BiDAmAr*
Sturgis, R N *AmArch 70*
Sturgis, Robert S 1922- *AmArch 70*
Sturgis, Russell 1836-1909 *MacEA*
Sturgis, Russell 1838-1909 *BiDAmAr*
Sturgis, Samuel *FolkA 86*
Sturgkh, Countess Melanie 1898- *DcWomA*
Sturm, Friedrich Ludwig Christian 1834- *ArtsNiC*
Sturm, Helmut *OxTwCA*
Sturm, Justin 1899- *WhAmArt 85*
Sturm, L C 1669-1719 *MacEA*
Sturm, Marie 1854- *DcWomA*
Sturm, William F d1912 *WhAmArt 85*
Sturman, Eugene 1945- *PrintW 83, -85,*
WhoAmA 76, -78, -80, -82, -84
Sturman, James H 1937- *MarqDCG 84*
Sturman, Sally Mara 1953- *PrintW 83, -85*
Sturmer, Johann Heinrich 1774-1855 *ClaDrA*
Sturmer, Karl 1803-1881 *ClaDrA*
Sturn, Hermann *NewYHSD*
Sturr, Edward Richard 1937- *ICPEnP A, MacBEP*
Sturrock, Alick Riddell 1885-1953 *DcBrA 1*
Stursa, Jan 1880-1925 *PhDcTCA 77*
Stursberg, Julie H *WhAmArt 85*
Sturt, Captain *DcBrECP*
Sturt, John 1658-1730 *BkIE*
Sturtevant, Charles T *DcVicP 2*
Sturtevant, Edith Louise 1888- *DcWomA,*
WhAmArt 85
Sturtevant, Elaine 1930- *ConArt 77*
Sturtevant, Elaine F *WhoAmA 78, -80*
Sturtevant, Erich 1869- *ClaDrA*
Sturtevant, Mrs. G A *ArtsAmW 3, WhAmArt 85*
Sturtevant, Harriet H 1906- *WhoAmA 73, -76*
Sturtevant, Helena 1872-1946 *DcWomA,*
WhAmArt 85
Sturtevant, J Bevier *ArtsAmW 3*
Sturtevant, Joseph *ArtsAmW 3*
Sturtevant, Louisa *FolkA 86*
Sturtevant, Louisa Clark 1870- *DcWomA,*
WhAmArt 85
Sturtevant, Wallis H *ConICB*
Sturtevant, Wallis Hall *WhAmArt 85*
Sturtz, O L *ArtsEM*
Sturzenacker, August 1871-1943 *MacEA*
Stussy, Jan 1921- *WhoAmA 76, -78, -80, -82, -84*
Stussy, Maxine Kim 1923- *WhoAmA 76, -78, -80,*
-82, -84
Stutchfield, Joseph T *FolkA 86*
Stutely, Charles *DcVicP 2*
Stutz, Geraldine *WorFshn*
Stutzman, Leroy Franklin 1917- *MarqDCG 84*
Stutzman, Vernon R 1902- *WhAmArt 85*
Stuven, Ernst 1660-1712 *ClaDrA*
Stuyvesant, Bedford *AfroAA*
Styche, Frank *DcBrBI*
Styffe, John N 1899- *AmArch 70*
Styka, Adam 1890- *ClaDrA*
Styka, Adam 1890-1959 *WhoAmA 80N, -82N, -84N*
Styka, Adam 1890-1970? *IIBEAAW, WhAmArt 85*
Styka, Jan 1858-1925 *ClaDrA*
Styka, Tade 1889- *ClaDrA*
Style, Anne 1873- *DcBrA 1, DcWomA*
Style, Jane M *DcVicP 2*
Styles, D *NewYHSD*
Styles, Freddie *AfroAA*
Styles, George C 1892- *WhAmArt 85*
Styles, George William d1949 *WhoAmA 78N, -80N,*
-82N, -84N
Styles, George William 1887-1949 *WhAmArt 85*
Stypula, J W *AmArch 70*
Su, Han-Chen *McGDA*
Su, Shih 1036-1101 *McGDA*
Su, Tsu-Yi 1951- *MarqDCG 84*
Su, Tung-P'o *McGDA*
Su, Tung-Po 1036-1101 *OxArt*
Suai, Kumi 1919- *ConArt 83*
Suardi, Bartolomeo *OxArt*
Suardi, Bartolommeo *McGDA*
Suares, Blance *DcWomA*
Suarez, Antonio 1923- *OxTwCA*
Suarez, Magdalena Frimkess 1929- *WhoAmA 76, -78,*
-80
Suaw *NewYHSD*
Suba, Miklos 1880-1944 *WhAmArt 85*
Suba, Susanne *AmArt, IlsCB 1967, WhoAmA 73,*
-76, -78, -80, -82, -84
Suba, Susanne 1913- *IlsBYP, IlsCB 1744, -1946,*
-1957, WhAmArt 85
Subirachs, Jose Maria 1927- *PhDcTCA 77*
Sublett, Carl C 1919- *WhoAmA 73, -76, -78, -80, -82,*
-84
Sublett, Harriet *FolkA 86*
Subleyras, Maria Felice 1707-1770 *DcWomA*
Subleyras, Maria Tibaldi *DcWomA*
Subleyras, Pierre 1699-1749 *McGDA, OxArt*
Subleyras, Pierre Hubert 1699-1749 *ClaDrA*
Subleyras-Tibaldi, Clementina *DcWomA*
Succop, Wray Grayson 1927- *AmArch 70*
Such, Joseph *DcVicP 2*
Such, William Thomas *DcVicP 2*

Sucharda, Anna 1870- *DcWomA*
Suche, W V *AmArch 70*
Suchet, Joseph Francois 1824-1896 *ClaDrA*
Suchlowski, I *DcVicP 2*
Suchodolska, Lisbeth Von 1844- *DcWomA*
Suck, Adolph *WhAmArt 85*
Suckert, Robert F *ArtsEM*
Suckling, Robert McCleary 1932- *AmArch 70*
Suckling, William *EncASM*
Suckow, Irmengard Von 1869- *DcWomA*
Sud, Jagan Nath 1942- *MarqDCG 84*
Suda, Issei 1940- *ConPhot*
Suda, Isser 1940- *ICPEnP A*
Sudak, Sonia 1930- *WhoAmA 80, -82*
Sudbring, Robert Edmund 1936- *AmArch 70*
Suddaby, Joseph M *FolkA 86*
Suddaby, Rowland *DcCAr 81*
Suddaby, Rowland 1912- *ClaDrA*
Suddaby, Rowland 1912-1973 *DcBrA 1*
Suddards, Frank *DcVicP 2*
Suddath, Fred Leroy 1942- *MarqDCG 84*
Suddenwood, Mrs. H *DcBrECP*
Suddouth, Jimmy Lee 1910- *FolkA 86*
Suddth, Jim L *FolkA 86*
Sudek, Josef 1896-1976 *ConPhot, ICPEnP, MacBEP*
Sudenberg, Otto N *FolkA 86*
Sudler, A E *WhAmArt 85*
Sudler, James S 1920- *AmArch 70*
Sudlow, Robert N 1920- *WhoAmA 73, -76, -78, -80,*
-82, -84
Sudre, Jean-Pierre 1921- *ConPhot, ICPEnP A,*
MacBEP
Sue, Ed 1929- *AmArch 70*
Sue, Louis 1875- *DcNiCA*
Sue, Marie Louis *ClaDrA*
Sue & Marc *DcNiCA*
Suen, Ching Yee 1942- *MarqDCG 84*
Suer, Marvin David 1923- *AmArch 70*
Suerth, Ursula *WhAmArt 85*
Sues, Lea *DcWomA*
Suess, Hans *McGDA*
Suffolk, J B *WhAmArt 85*
Suffren, Amelie De *DcWomA*
Suffrins, N M *DcWomA*
Sufi *WhoAmA 80*
Sufi 1930- *WhoAmA 76, -78*
Sufi, Ahmad Antung 1930- *WhoAmA 73*
Suga 1942- *WorFshn*
Suga, Kishio 1944- *ConArt 77, -83*
Sugai, Kumi 1919- *ConArt 77, OxTwCA,*
PhDcTCA 77
Sugar, Peter Charles 1932- *AmArch 70*
Sugarman, George 1912- *AmArt, BnEnAmA,*
ConArt 77, -83, DcCAA 71, -77, DcCAr 81,
OxTwCA, PhDcTCA 77, PrintW 83, -85,
WhoAmA 73, -76, -78, -80, -82, -84
Sugarman, M Henry 1888-1945 *BiDAmAr*
Sugarman, Tracy 1921- *IlrAm F, -1880*
Sugars, Fanny *DcVicP 2, DcWomA*
Sugden, Percy 1864-1936 *BiDAmAr*
Suger 1081-1151 *OxArt*
Suggate, F W *DcVicP 2*
Suggs, Eldridge, III 1939- *AfroAA*
Sugimoto, Henry Y *WhoAmA 73, -76, -78, -80, -82,*
-84
Sugimoto, Henry Yuzuru 1904- *WhAmArt 85*
Sugita, Yutaka 1930- *IlsCB 1967, WhoGrA 82[port]*
Sugiura, Kohei 1932- *ConDes, WhoGrA 62,*
-82[port]
Sugiura, Shigeru 1908- *WorECom*
Sugiura, Yukio 1911- *WorECar*
Suglia, A *AmArch 70*
Suglio, Joseph *WhAmArt 85*
Suhajek, Jiri 1943- *DcCAr 81*
Suhonen, Pekka *ConArch A*
Suhr, Frederic 1889- *WhAmArt 85*
Suhr, William 1896- *WhAmArt 85*
Suhrlandt, C *DcVicP 2*
Suhrlandt, Ludovika 1855-1928 *DcWomA*
Suhrlandt, Pauline *DcWomA*
Suhrlandt, R *DcVicP 2*
Suhrlandt, Wilhelmine 1803-1863 *DcWomA*
Suhy, Branko 1950- *DcCAr 81*
Suina, Theodore *WhAmArt 85*
Suite, William Crandall 1908- *AmArch 70*
Sujo, Clara Diament *WhoAmA 84*
Sukenaga *AntBDN L*
Sukenobu 1671-1751 *McGDA*
Sukenobu, Nishikawa 1671-1715 *OxArt*
Suker, Arthur *ClaDrA*
Suker, Arthur 1857- *DcBrWA, DcVicP 2*
Suker, Frederick Harrison *DcVicP, -2*
Sukey, Grover C *WhAmArt 85*
Sukhovo-Kobylina, Sofia Vassilievna 1825-1867
DcWomA
Sukiennicka, Halina 1906- *WhoArt 82, -84*
Sukonick, Josef 1945- *MarqDCG 84*
Sukthankar, Shanti Singh 1923- *AmArch 70*
Sul-Ak *McGDA*
Sulanik, Naomi *DcCAr 81*

Sussenguth, Georg 1862- *MacEA*
Sussman, Arthur 1927- *WhoAmA 73, -76, -78, -80, -82, -84*
Sussman, Bonnie K *WhoAmA 76, -78, -80, -82, -84*
Sussman, Elisabeth Sacks 1939- *WhoAmA 78, -80, -82, -84*
Sussman, Harold 1934- *AmArch 70*
Sussman, Margaret 1912- *WhAmArt 85*
Sussman, Morton 1931- *WorFshn*
Sussman, Richard N 1908-1971 *WhAmArt 85, WhoAmA 78N, -80N, -82N, -84N*
Sussmann, Hellborn Louis 1828- *ArtsNiC*
Sussna, Robert Earl 1939- *AmArch 70*
Sussock, Harvey Charles 1941- *MarqDCG 84*
Susterman, Cornelis 1600?-1670 *ClaDrA*
Susterman, Justus 1597-1681 *McGDA*
Sustris, Federico 1540?-1599 *McGDA*
Sustris, Frederik 1540?-1599 *ClaDrA*
Sutch, Marian *WhAmArt 85*
Sutcliff, Rosemary 1920- *DcBrA 1*
Sutcliffe, A T *AmArch 70*
Sutcliffe, B *DcVicP 2*
Sutcliffe, Elizabeth *DcWomA*
Sutcliffe, Frank Meadow 1853-1941 *ICPEnP A, MacBEP*
Sutcliffe, Hariette *DcVicP*
Sutcliffe, Hariette F A *DcVicP 2*
Sutcliffe, Harriette *DcWomA*
Sutcliffe, Harriette F A *DcBrA 1*
Sutcliffe, Heather *DcVicP 2*
Sutcliffe, Irene 1883- *ClaDrA, DcBrA 1, DcWomA*
Sutcliffe, J E d1923 *DcBrA 1*
Sutcliffe, John *DcVicP 2*
Sutcliffe, John E d1923 *DcBrBI*
Sutcliffe, Lester *DcBrA 1, DcBrWA, DcVicP 2*
Sutcliffe, Mrs. Lester T *DcVicP 2*
Sutcliffe, Thomas 1828-1871 *DcBrWA, DcVicP, -2*
Sutej, Miroslav 1936- *OxTwCA, PhDcTCA 77*
Suter, John Ernest 1900- *AmArch 70*
Suter, Mary S *DcWomA*
Suter, Richard d1883 *BiDBrA*
Suter, Sherwood Eugene 1928- *WhoAmA 78, -80, -82*
Suter, W L *AmArch 70*
Suter, Walter Paul 1901- *WhAmArt 85*
Suter, Warren C 1918- *AmArch 70*
Suter, Willy 1918- *DcCAr 81*
Sutherland, Bruce Roswell 1931- *AmArch 70*
Sutherland, Charles E *ArtsEM*
Sutherland, Charles Vedder *WhAmArt 85*
Sutherland, Charlotte *FolkA 86*
Sutherland, David M 1883- *DcBrA 1*
Sutherland, Elizabeth, Duchess Of 1765-1839 *DcBrBI, DcBrWA, DcWomA*
Sutherland, Fanny *DcVicP, -2, DcWomA*
Sutherland, Florence M *DcWomA*
Sutherland, Garnet *WhAmArt 85*
Sutherland, George Mowbray *DcVicP 2*
Sutherland, Graham *WhoArt 82N*
Sutherland, Graham 1903- *ConArt 77, ConBrA 79[port], McGDA, OxArt, PhDcTCA 77, WhoArt 80*
Sutherland, Graham 1903-1980 *ConArt 83, WorArt[port]*
Sutherland, Graham Vivian 1903- *DcBrA 1*
Sutherland, Graham Vivian 1903-1980 *OxTwCA*
Sutherland, H *FolkA 86*
Sutherland, J 1808?- *FolkA 86*
Sutherland, Jane *DcVicP 2*
Sutherland, Jane 1855-1928 *DcWomA*
Sutherland, John W 1941- *MarqDCG 84*
Sutherland, Marylou 1948- *WhoAmA 78*
Sutherland, Minnie *WhAmArt 85*
Sutherland, Robert Lewis d1932 *DcBrA 1*
Sutherland, Ruth 1884-1948 *DcWomA*
Sutherland, Sandy 1902- *WhoAmA 73, -76, -78, -80, -82, -84*
Sutherland, Scott 1910- *DcBrA 1, WhoArt 80, -82, -84*
Sutherland-Hunter, Mary *DcWomA*
Sutherlin, Mary *FolkA 86*
Sutherlin, Nannie Pryor *FolkA 86*
Sutherlin, Tom 1947- *MarqDCG 84*
Suthers, Leghe *DcBrA 2, DcVicP 2*
Suthers, W *DcVicP 2*
Sutkus, Antanas 1939- *ConPhot, ICPEnP A, MacBEP*
Sutlipp, Henry *NewYHSD*
Sutnar, Ladislav 1897- *WhoGrA 62*
Sutnar, Ladislav 1897-1969 *ConDes*
Sutnar, R L *AmArch 70*
Suto, Joseph 1899- *WhAmArt 85*
Sutopo, Edi 1955- *MarqDCG 84*
Sutro, Esther Stella *DcBrA 1, DcVicP 2, DcWomA*
Sutro, Florence Edith Clinton 1865-1906 *DcWomA, WhAmArt 85*
Sutter, Fred Norman 1934- *AmArch 70*
Sutter, H R *WhAmArt 85*
Sutter, James Stewart 1940- *WhoAmA 80, -82, -84*
Sutter, M G *AmArch 70*
Sutter, Samuel 1888- *ArtsAmW 2*
Sutter, Thomas Warren 1947- *MarqDCG 84*

Sutterly, Clement *FolkA 86*
Sutterman, Joost *McGDA*
Suttill, Ada P *DcVicP 2*
Suttle, William 1938- *MacBEP*
Suttles, Albert Turen 1930- *AmArch 70*
Suttles, G W *FolkA 86*
Suttles, I *FolkA 86*
Suttman, Paul 1933- *DcCAA 71, -77, WhoAmA 73, -76, -78, -80, -82, -84*
Sutton *FolkA 86*
Sutton, A M *DcWomA*
Sutton, Albert 1866-1923 *BiDAmAr*
Sutton, Alice Marion 1907- *WhAmArt 85*
Sutton, Ann 1935- *DcCAr 81*
Sutton, Bartholomew *CabMA*
Sutton, Belle *DcWomA*
Sutton, Bernice Perry *WhAmArt 85*
Sutton, Cantey Venable *WhAmArt 85*
Sutton, Carol *DcCAr 81*
Sutton, Carol 1945- *WhoAmA 84*
Sutton, Charles Richard 1927- *AmArch 70*
Sutton, D *AmArch 70*
Sutton, Denys 1917- *WhoArt 80, -82, -84*
Sutton, E *FolkA 86*
Sutton, Elizabeth Evelyn 1767?- *DcWomA*
Sutton, F P *AmArch 70*
Sutton, Mrs. Frank *WhAmArt 85*
Sutton, Frederick H *WhAmArt 85*
Sutton, G M *DcVicP 2*
Sutton, George *OfPGCP 86*
Sutton, George Miksch 1898- *ArtsAmW 3, WhAmArt 85, WhoAmA 73, -76, -78, -80, -82*
Sutton, George Miksch 1898-1982 *WhoAmA 84N*
Sutton, H M *AmArch 70*
Sutton, Harry, Jr. 1897- *WhAmArt 85*
Sutton, Hector McDonald 1903- *ClaDrA, WhoArt 80, -82, -84*
Sutton, Helen Constance *DcWomA*
Sutton, J *DcVicP 2*
Sutton, James *AntBDN Q*
Sutton, James F 1843-1915 *WhAmArt 85*
Sutton, James Marvin 1925- *AmArch 70*
Sutton, James Paul 1934- *AmArch 70*
Sutton, Joan *WorFshn*
Sutton, John Hewitt 1913- *AmArch 70*
Sutton, Kingsley *WhoArt 80N*
Sutton, Kingsley 1907- *DcBrA 1*
Sutton, Linda 1947- *WhoArt 80, -82*
Sutton, M *ArtsEM*
Sutton, Margaret J *DcWomA*
Sutton, Michael Charles 1930- *AmArch 70*
Sutton, P A *ArtsEM*
Sutton, Patricia 1941- *WhoAmA 78, -80, -82, -84*
Sutton, Philip 1926- *DcCAr 81*
Sutton, Philip 1928- *ClaDrA, ConArt 77, -83, ConBrA 79[port], WhoArt 82, -84*
Sutton, Rachel McClelland 1887- *DcWomA, WhAmArt 85*
Sutton, Ruth Haviland 1898-1960 *DcWomA, WhAmArt 85, WhoAmA 80N, -82N, -84N*
Sutton, Sharon *PrintW 85*
Sutton, T *DcVicP 2*
Sutton, Thomas 1746- *BiDBrA*
Sutton, Thomas Dwight 1932- *AmArch 70*
Sutton, Thomas Leonard, Jr. 1926- *AmArch 70*
Sutton, Trevor *DcCAr 81*
Sutton, W *FolkA 86, NewYHSD*
Sutton, W J *DcBrWA*
Sutton Lipsky, Patricia 1941- *ConArt 77*
Suttoni, M L *AmArch 70*
Suvankovic, Misko *DcCAr 81*
Suvee, Charlotte Louise 1746?- *DcWomA*
Suvee, Joseph Benoit 1743-1807 *ClaDrA*
Suvero, Mark Di *WorArt*
Suvero, Mark Di 1933- *OxTwCA, PhDcTCA 77*
Suyama, Keiichi 1905-1975 *WorECar*
Suydam, E H 1885-1940 *WhAmArt 85*
Suydam, Edward Howard 1885-1940 *ArtsAmW 1, IlBEAAW*
Suydam, Henry *NewYHSD*
Suydam, James 1819-1865 *DcAmArt*
Suydam, James A 1817-1865 *ArtsNiC*
Suydam, James Augustus 1819-1865 *EarABI, NewYHSD*
Suyderhoef, Jonas 1613?-1686 *McGDA*
Suzinot, Cecile *DcWomA*
Suzor-Cote, Aurele DeFoy 1869-1937 *McGDA*
Suzor-Cote, Marc-Aurele DeFoy *OxTwCA*
Suzuki, Aiko 1937- *DcCAr 81*
Suzuki, James Hiroshi 1933- *DcCAA 71, -77, WhoAmA 78, -80, -82, -84*
Suzuki, Katsko *WhoAmA 73, -76, -78, -80, -82, -84*
Suzuki, M T *AmArch 70*
Suzuki, Sakari *WhoAmA 73, -76, -78, -80, -82, -84*
Suzuki, Sakari 1900- *WhAmArt 85*
Suzuki, Shinichi 1933- *WorECar*
Suzuki, Shuji 1927- *WorECar*
Suzuki, Yoshiji 1928- *WorECar*
Suzy *FairDF FRA*
Svab, Jaroslav 1906- *WhoGrA 82[port]*
Svanberg, Max Walter 1912- *ConArt 77*

Svanberg, Max Walter 1921- *PhDcTCA 77*
Svarc, Josef 1928- *DcCAr 81*
Sveda, A M *AmArch 70*
Svedberg, Janne *DcWomA*
Sveinsdottir, Juliana 1889- *DcWomA*
Sveinsson, Asmundur 1893- *PhDcTCA 77*
Svend *FairDF FRA*
Svendsen, Charles C 1871- *WhAmArt 85*
Svendsen, Louise Averill 1915- *WhoAmA 78, -80, -82, -84*
Svendsen, Svend 1864- *WhAmArt 85*
Svendsen, Vidar 1942- *MarqDCG 84*
Svendsen-Engel, Kathrine Amalie 1877- *DcWomA*
Svenson, John Edward 1923- *WhoAmA 73, -76, -78, -80, -82, -84*
Svensson, C W *WhAmArt 85*
Svensson, Per 1935- *DcCAr 81*
Svensson, William M 1918- *AmArch 70*
Sverdlove, Zolita 1936- *PrintW 83, -85, WhoAmA 80, -82, -84*
Svet, M 1912- *WhoAmA 73, -76*
Svihovec, Bob 1951- *MarqDCG 84*
Svinin, Pavel Petrovitch 1787?-1839 *NewYHSD*
Svircic, Zdenko 1924- *WorECom*
Svoboda, Jan 1904- *AmArch 70*
Svoboda, Jaroslav 1914- *DcCAr 81*
Svoboda, Jaroslav 1938- *DcCAr 81*
Svoboda, Josef 1920- *ConDes*
Svoboda, Josef Cestmir 1889- *ArtsAmW 2, WhAmArt 85*
Svoboda, Vincent A 1877-1961 *WhAmArt 85, WhoAmA 80N, -84N*
Svodboa, Alexander *DcVicP 2*
Swab, Arthur Cyrus 1899- *AmArch 70*
Swaback, Vernon Dale 1939- *AmArch 70*
Swacey, May Payne *WhAmArt 85*
Swackhamer, James Arthur 1924- *AmArch 70*
Swaffar, Joe Thomas 1936- *AmArch 70*
Swaffield, Helena M *DcVicP 2, DcWomA*
Swager, Eugene Calvn 1924- *AmArch 70*
Swagers, Caroline 1808- *DcWomA*
Swagers, Elisabeth d1837 *DcWomA*
Swagers, Franz 1756-1836 *DcSeaP*
Swagert, Everett Dean 1925- *AmArch 70*
Swagger, Elisha *CabMA*
Swaim, Curran 1826-1897 *NewYHSD, WhAmArt 85*
Swaim, Darryl B 1942- *MarqDCG 84*
Swaim, G W *AmArch 70*
Swain *NewYHSD*
Swain, Alice Caven 1893- *WhAmArt 85*
Swain, Alice E 1893- *DcWomA*
Swain, Anna *DcWomA*
Swain, C *DcWomA*
Swain, Miss C *NewYHSD*
Swain, Corinne Rockwell *WhAmArt 85*
Swain, Edward 1847-1902 *DcVicP 2*
Swain, Edward H 1852-1902 *BiDAmAr*
Swain, Francis W 1892- *ArtsAmW 1*
Swain, Francis W 1892-1937 *WhAmArt 85*
Swain, Harriet *DcWomA, FolkA 86, NewYHSD*
Swain, Jerre 1913- *WhAmArt 85*
Swain, Joseph Daniel 1913- *AmArch 70*
Swain, Ned *DcBrA 2*
Swain, P S 1838- *WhAmArt 85*
Swain, Robert 1940- *PrintW 83, -85, WhoAmA 78, -80, -82, -84*
Swain, Robert Francis 1942- *WhoAmA 76, -78, -80, -82, -84*
Swain, Roland T *NewYHSD*
Swain, Ruth Newton 1907- *WhAmArt 85*
Swain, Suz An Noguchi 1916- *IlsCB 1957*
Swain, Sylvia B *ArtsEM, DcWomA*
Swain, W *WhAmArt 85*
Swain, William *FolkA 86*
Swain, William 1803-1847 *NewYHSD*
Swaine, Agnes Kempson 1892- *DcBrA 1, DcWomA*
Swaine, Francis 1720?-1782 *DcSeaP*
Swaine, Francis 1720?-1783 *DcBrECP*
Swaine, Francis 1740?-1782 *DcBrWA*
Swaine, John Barak *DcVicP 2*
Swaine, Monamy *DcBrECP*
Swaine, Monamy 1750?- *DcSeaP*
Swaine, P S *WhAmArt 85*
Swainson, Lilian V *DcWomA*
Swainson, William 1789-1855 *DcBrBI, DcBrWA, GrBII[port]*
Swainston, Laura *DcVicP 2*
Swaish, F George *DcBrA 1*
Swaish, Frederick George *DcBrA 2*
Swalley, John F 1887- *WhAmArt 85*
Swallow, G A *AmArch 70*
Swallow, Jane F *DcVicP 2, DcWomA*
Swallow, John Charles *WhAmArt 85*
Swallow, Richard Proctor 1930- *AmArch 70*
Swallow, W W 1912- *WhAmArt 85*
Swallow, William *FolkA 86*
Swallowe, Benjamin *CabMA*
Swam, George *FolkA 86*
Swan, Mrs. *DcVicP 2*
Swan, Abraham *BiDBrA, MacEA*

Sze, Chia-Ming 1937- *AmArch 70*
Szechura, Daniel 1930- *WorECar*
Szegedi, Caroline *DcWomA*
Szegedy-Maszak, Leona 1874- *DcWomA*
Szegfi, Elisabeth *DcWomA*
Szegfy, Erzi 1877- *DcWomA*
Szekacs, Iren d1925 *DcWomA*
Szekeres, Cyndy 1933- *IlsBYP, IlsCB 1967*
Szekessy, Curt *WhAmArt 85*
Szekessy, Karin 1939- *ConPhot, ICPEnP A,*
 MacBEP
Szeky, Maria *DcWomA*
Szeliski, Richard 1958- *MarqDCG 84*
Szendy, E *AmArch 70*
Szenes, Arpad 1900- *OxTwCA, PhDcTCA 77*
Szep, Paul 1941- *WorECar*
Szeptycka, Konstancja d1855 *DcWomA*
Szeptycka, Zofia 1837- *DcWomA*
Szeptycki, J George 1915- *AmArch 70*
Szesko, Judith Clarann *WhoAmA 78, -80, -82, -84*
Szesko, Lenore Rundle 1933- *WhoAmA 76, -78, -80,*
 -82, -84
Szewczuk, Mirko 1919-1957 *WorECar*
Szilagyi, Ilona 1883- *DcWomA*
Szilagyi, Margit 1894- *DcWomA*
Szilagyi, Piroska 1889-1931 *DcWomA*
Szilasi, Gabor 1928- *ConPhot, ICPEnP A*
Szilassy, Laura Von 1873-1929 *DcWomA*
Szilvasy, Linda Markuly 1940- *WhoAmA 80, -82, -84*
Szilvitzky, Krisztina 1888- *DcWomA*
Szinyei Merse, Pal 1845-1920 *McGDA*
Szinyei Merse, Rozsi Von 1881- *DcWomA*
Szitnik, Marta 1875- *DcWomA*
Szloboda, Vincenz 1909- *DcCAr 81*
Szmuszkowicz, Nechama 1895- *DcWomA*
Sznajderman, Marius 1926- *PrintW 83, -85*
Sznajderman, Marius S 1926- *WhoAmA 78, -80, -82,*
 -84
Szoka, Kathryn Patricia 1954- *MarqDCG 84*
Szoke, John *WhoAmA 78, -80, -82, -84*
Szomanski, Wladyslaw 1911- *WhoArt 80, -82, -84*
Szonyi, Geza 1919- *MarqDCG 84*
Szoradi, Charles 1923- *AmArch 70*
Sztehlo, Lujza 1897- *DcWomA*
Szubert, Awit 1837-1919 *ICPEnP A*
Szucs, Victor *WhAmArt 85*
Szueber, Steve Earl 1928- *WhoAmA 76*
Szukalski, Stanislaus *WhAmArt 85*
Szuly, Angela 1893- *DcWomA*
Szutowicz, Theodore Joseph 1924- *AmArch 70*
Szyk, Arthur d1951 *WhoAmA 78N, -80N, -82N,*
 -84N
Szyk, Arthur 1894-1951 *IlsBYP, IlsCB 1946,*
 WhAmArt 85, WorECar
Szymanovski, Waclaw 1859-1930 *ClaDrA*
Szymanowska, Sophie *DcWomA*
Szymanski, Rolf 1928- *DcCAr 81, OxTwCA,*
 PhDcTCA 77
Szynalik, John J *WhAmArt 85*
Szyszlo, Fernando De 1925- *McGDA, OxTwCA*

T

T Kindt, David 1699-1770 *MacEA*
Taake, Daisy 1886- *DcWomA, WhAmArt 85*
Tabachnick, Anne 1933- *WhoAmA 76, -78, -80*
Tabachnick, Anne 1937- *AmArt, WhoAmA 82, -84*
Taback, Simms 1932- *WhoAmA 78, -80, -82, -84*
Tabak, Chaim 1946- *WhoAmA 84*
Tabaka, Maija 1939- *DcCAr 81*
Tabar, Alexina *DcWomA*
Tabar, Francois Germain Leopold 1818-1869 *ClaDrA*
Tabara, Enrique *OxTwCA*
Tabard, Maurice 1897- *ConPhot*
Tabard, Maurice 1897-1984 *ICPEnP*
Tabary, Celine Marie 1908- *WhAmArt 85*
Tabasco, Evangeline *WhoAmA 84*
Tabatier, V *DcVicP 2*
Tabb, Gladys Clark *WhAmArt 85*
Tabbutt, Carroll Elwyn 1910- *AmArch 70*
Taber *NewYHSD*
Taber, Dorothea *WhAmArt 85*
Taber, E M *WhAmArt 85*
Taber, Elnathan 1784-1854 *AntBDN D, OxDecA*
Taber, Florence *DcWomA*
Taber, I W *DcBrBI*
Taber, Isaiah West 1830-1916 *WhAmArt 85*
Taber, J W *WhAmArt 85*
Taber, Ken 1942- *DcCAr 81*
Taber, Lincoln 1941- *DcCAr 81*
Taber, Phebe Thorn Merritt Clements 1834- *ArtsAmW 3*
Taber, Phoebe Clements *ArtsEM*
Taber, Phoebe Clements 1834- *DcWomA*
Taber, Phoebe Thorn Merritt Clements 1834- *ArtsAmW 3*
Taber, R H *EncASM*
Taber, Sarah *DcWomA*
Taber, Sarah A *WhAmArt 85*
Taber, Sarah A M 1800-1873 *DcWomA*
Taber, W *IlBEAAW*
Tabler, Hazel *WhAmArt 85*
Tabler, William Benjamin 1914- *AmArch 70*
Tabor, E S *AmArch 70*
Tabor, G H d1920 *DcBrA 2*
Tabor, Mrs. H G *DcBrA 2*
Tabor, Robert Byron 1882- *ArtsAmW 1, WhAmArt 85*
Tabuchi, Yase 1921- *OxTwCA*
Tabuchi, Yasse 1921- *PhDcTCA 77*
Tabuena, Romeo Villalva 1921- *WhoAmA 76, -78, -80, -82*
Tabuena, Romeo Villava 1921- *WhoAmA 73*
Tacca, Ferdinando 1619-1686 *McGDA*
Tacca, Pietro 1577-1640 *McGDA, OxArt*
Taccard, Patrick *FolkA 86*
Taccard, Patrick 1879- *WhAmArt 85*
Taccone, Paolo DiMariano DiTuccio *McGDA*
Tacconi, Francesco 1458-1500 *McGDA*
Tacha, Athena 1936- *WhoAmA 82, -84*
Tack, Augustus Vincent 1870- *WhAmArt 85*
Tack, Augustus Vincent 1870-1949 *ArtsAmW 3, DcAmArt*
Tackett, Gerald Joe 1933- *AmArch 70*
Taconis, Kryn 1918-1979 *ICPEnP A*
Tad *WorECom*
Tada, M *AmArch 70*
Tadakazu *AntBDN L*
Tadama, F 1871- *WhAmArt 85*
Tadama, Fokko 1871-1937 *ArtsAmW 2*
Tadama-Groeneveld, Thamine 1871- *DcWomA*
Tadanobu *McGDA*
Tadao, Sugaya 1939- *MarqDCG 84*
Tadatoshi *AntBDN L*

Tadd, Edith J *DcWomA, WhAmArt 85*
Tadd, J Liberty 1863- *WhAmArt 85*
Tadda, Francesco Del *McGDA*
Taddeo Di Bartolo 1362?-1422 *McGDA*
Tadema *DcBrBI*
Tadema, Anna Alma- d1943 *DcBrWA*
Tadema, F *WhAmArt 85*
Tadema, Laura Theresa, Lady Alma- 1852-1909 *DcBrWA*
Tadema, Sir Lawrence Alma- 1836-1912 *DcBrWA*
Tadini, Emilio 1927- *ConArt 83*
Tadolini, Signora *ArtsNiC*
Tadolini, Adam Scipione 1789-1870 *ArtsNiC*
Tadolini, Serafina *DcWomA*
Tadoyoshi *AntBDN L*
Taeuber-Arp, Sophie 1889-1943 *ConArt 77, -83, DcWomA, McGDA, OxTwCA, PhDcTCA 77, WomArt*
Tafaga, Joseph *IlBEAAW*
Tafe, W A *DcVicP 2*
Tafel, A G, Sr. *AmArch 70*
Tafel, Arthur G, Jr. 1924- *AmArch 70*
Tafel, Edgar Allen 1912- *AmArch 70*
Taff, Barbara O'Neil 1951- *WhoAmA 76, -78, -80*
Taff, Marvin Leon 1934- *AmArch 70*
Taffe, William John 1943- *MarqDCG 84*
Taffs, C H *WhAmArt 85*
Taffs, Charles H *DcBrBI, DcVicP 2*
Tafi, Andrea *McGDA*
Taflinger, Elmer E 1891- *WhAmArt 85*
Taflinger, Ethel Cline 1894- *WhAmArt 85*
Taft, Charles Phelps 1843-1929 *WhAmArt 85*
Taft, Frances Prindle 1921- *WhoAmA 76, -78, -80, -82, -84*
Taft, James Scholly *FolkA 86*
Taft, Jon Latinus 1932- *AmArch 70*
Taft, Lorado 1860-1936 *McGDA*
Taft, Lorado Zadoc 1860-1936 *BnEnAmA, IlBEAAW, WhAmArt 85*
Taft, Zulime *DcWomA*
Tag, Richard Edward 1927- *AmArch 70*
Tagawa, Bunji 1904- *WhAmArt 85*
Tagawa, Suiho 1899- *WorECar*
Tagawa, Walter Kazuhiko 1929- *AmArch 70*
Tagg, Stephen Kenneth 1948- *MarqDCG 84*
Tagg, William Lofthus 1936- *AmArch 70*
Taggart, Edwin Lynn 1905- *WhAmArt 85*
Taggart, George Henry 1865- *ArtsAmW 3, WhAmArt 85*
Taggart, John G *NewYHSD*
Taggart, Lucy M *DcWomA, WhAmArt 85*
Taggart, Mildred Hardy 1896- *DcWomA, WhAmArt 85*
Taggart, Paul 1950- *DcCAr 81*
Taggart, Richard 1904- *WhAmArt 85*
Taggart, William John 1940- *WhoAmA 76, -78, -80, -82, -84*
Tagliaferro, Aldo 1936- *ConArt 77*
Tagore, B B *DcVicP 2*
Tagore, Protima Devi 1894-1969 *DcWomA*
Taguchi, Beisaku 1864?-1903 *WorECar*
Tague, Robert Bruce 1912- *WhAmArt 85*
Tahan, Alexandre *DcNiCA*
Tahara, Keiichi 1951- *ConPhot, ICPEnP A, MacBEP*
Tahedl, Ernestine 1940- *PrintW 83, -85, WhoAmA 78, -80, -82, -84*
Tahir, Abe M, Jr. 1931- *WhoAmA 73, -76, -78, -80, -82, -84*
Tahoma, Quincy 1921-1956 *IlBEAAW*
Tai, Chin *McGDA, OxArt*

Tai, Jane S 1944- *WhoAmA 80, -82, -84*
Tai, Selwyn C 1950- *MarqDCG 84*
Tai, Wen-Chin *McGDA*
Taicheong *DcSeaP*
Taicher, Richard 1929- *WhoAmA 82, -84*
Taiga 1723-1776 *McGDA*
Taillasson, Jean Joseph 1745-1809 *ClaDrA*
Taillefer, Fanny *DcWomA*
Tailleferie, Jeanne *DcWomA*
Tailleur, Germaine Melanie Marie 1881- *DcWomA*
Taillibert, Roger 1926- *ConArch*
Tailor *NewYHSD*
Tailor, Stephen *NewYHSD*
Taine, Hippolyte 1828-1893 *OxArt*
Tainsh, Douglas Edward 1921- *WorECar*
Tainter, Benjamin 1753-1844 *FolkA 86*
Taintor, Daisy Josephine *WhAmArt 85*
Taintor, Musier 1909- *WhAmArt 85*
Taipale, Teppo 1906- *WhAmArt 85*
Taira, Frank 1913- *WhoAmA 76, -78, -80, -82, -84*
Tait, Adela *DcWomA*
Tait, Adela Seton- *DcVicP 2*
Tait, Agnes 1894-1981 *DcWomA*
Tait, Agnes 1897- *IlBEAAW, IlsBYP, IlsCB 1946, WhAmArt 85*
Tait, Agnes Gabrielle 1894- *ArtsAmW 2*
Tait, Arther Fitzwilliam 1819-1905 *FolkA 86*
Tait, Arthur F 1819- *ArtsNiC*
Tait, Arthur Fitzwilliam 1819-1905 *BnEnAmA, DcAmArt, EarABI, IlBEAAW, NewYHSD, WhAmArt 85*
Tait, Bess 1878?-1939 *DcWomA*
Tait, Cornelia Damian *WhoAmA 73, -76, -78, -80, -82, -84*
Tait, David B 1946- *MacBEP*
Tait, Douglas *IlsBYP*
Tait, Douglas William Campbell 1944- *IlsCB 1967*
Tait, George Hope 1861-1943 *DcBrA 1, DcVicP 2*
Tait, J *DcVicP 2*
Tait, James 1762?-1834 *BiDBrA*
Tait, John 1787?-1856 *BiDBrA*
Tait, John R *ArtsNiC*
Tait, John Robinson 1834-1909 *NewYHSD, WhAmArt 85*
Tait, Katharine *DcWomA, WhAmArt 85*
Tait, Katharine Lamb 1895- *WhoAmA 73, -76, -78, -80, -82*
Tait, Katharine Lamb 1895-1981 *WhoAmA 84N*
Tait, M A *DcWomA*
Tait, Mrs. M A *DcVicP 2*
Tait, Nina Stirling *DcWomA, WhAmArt 85*
Tait, Robert S *DcVicP, -2*
Tait, T S 1882-1954 *MacEA*
Tait, Thomas S 1882-1954 *WhoArch*
Taite, Alice *DcWomA*
Taite, Augustus *FolkA 86, NewYHSD*
Taitt, G W *DcBrECP*
Tajcevic-Kovacic, Sonja 1894-1968 *DcWomA*
Tajima, Yoshiaki 1932- *AmArch 70*
Tajiri, Shinkichi 1923- *ConArt 77, -83, OxTwCA, PhDcTCA 77, WhoAmA 73, -76, -78, -80, -82, -84, WhoArt 80, -82, -84*
Takach, Mary H *WhoAmA 80, -82, -84*
Takada, Kenzo *ConDes*
Takada, Kenzo 1940- *WorFshn*
Takaezu, Toshiko 1922- *BnEnAmA*
Takaezu, Toshiko 1929- *CenC*
Takahashi, Edward Katsuaki 1936- *AmArch 70*
Takahashi, Thomas Takeshi 1932- *AmArch 70*
Takai, Teiji 1911- *DcCAA 71, -77, WhoAmA 73, -76, -78, -80, -82, -84*

Takal, Peter 1905- *DcCAA 71, -77, PrintW 85, WhoAmA 73, -76, -78, -80, -82, -84*
Takamatsu, Jiro 1936- *ConArt 77, -83, OxTwCA, PhDcTCA 77*
Takamori, Roger Sadayuki 1921- *AmArch 70*
Takamoto, David Toshiharu 1941- *AmArch 70*
Takanobu 1142-1205 *McGDA*
Takara, Seikichi 1929- *PrintW 85*
Takase, Hayahiko 1930- *AmArch 70*
Takashima, Shizuye Violet 1928- *WhoAmA 78, -80, -82, -84*
Takata, Ray 1934- *AmArch 70*
Takayama, Michio 1903- *DcCAr 81*
Takayanagi, Tetsuo 1919- *AmArch 70*
Takayanagi, Yutaka 1941- *DcCAr 81*
Takayoshi *McGDA*
Takeda, Goichi 1872-1938 *MacEA*
Takeda, Hideo 1948- *WorECar*
Takemoto, Henry 1930- *CenC*
Takemoto, Henry Tadaaki 1930- *WhoAmA 73, -76, -78, -80, -82, -84*
Takeuchi, John Motoi 1922- *AmArch 70*
Takeyama, Minoru 1934- *ConArch*
Takigawa, Gene Toshiyasu 1937- *AmArch 70*
Takis 1925- *ConArt 77, -83, DcCAr 81, OxTwCA, PhDcTCA 77, PrintW 85, WorArt[port]*
Takis, Nicholas d1965 *WhoAmA 78N, -80N, -82N, -84N*
Takis, Nicholas 1903-1965 *WhAmArt 85*
Takita, Yu 1932- *WorECar*
Taksa, Desha A Milcinovic 1914- *WhAmArt 85*
Taktikos, Aristotle 1924- *AmArch 70*
Tal-Coat, Pierre 1905- *ConArt 77, -83, OxTwCA, WorArt[port]*
Tal Coat, Pierre 1905- *McGDA, PhDcTCA 77*
Talaba, L 1943- *WhoAmA 76, -78, -80, -82, -84*
Talandier, Melanie *DcWomA*
Talani, Teresa *DcWomA*
Talberg, Carl H 1882-1973 *ArtsAmW 2*
Talbert, Bruce J 1838-1881 *OxDecA*
Talbert, Bruce James 1838-1881 *AntBDN G, DcNiCA*
Talbert, Mary F *DcWomA*
Talbert, Zel E 1869- *WhAmArt 85*
Talbot *EncASM*
Talbot, Catherine *ArtsAmW 2*
Talbot, Catherine P *WhAmArt 85*
Talbot, Catherine Porter 1859-1938 *DcWomA*
Talbot, Charles J *ArtsEM*
Talbot, Cornelia Brackenridge 1888-1925 *DcWomA, WhAmArt 85*
Talbot, Elden V 1932- *AmArch 70*
Talbot, Frances *DcWomA*
Talbot, Frederick Bates 1919- *AmArch 70*
Talbot, George Quartus Pine 1853-1888 *DcBrWA, DcVicP 2*
Talbot, Grace Helen 1901- *WhAmArt 85*
Talbot, Henry 1920- *MacBEP*
Talbot, Henry S *WhAmArt 85*
Talbot, Jane Lewis 1811-1849 *FolkA 86*
Talbot, Jarold Dean 1907- *WhAmArt 85, WhoAmA 78, -80, -82, -84*
Talbot, Jesse 1806-1879 *NewYHSD*
Talbot, Jonathan 1939- *AmArt, WhoAmA 76, -78, -80, -82, -84*
Talbot, Leon 1905- *WhoArt 80, -82, -84*
Talbot, Lionel A *DcVicP 2*
Talbot, Marshall *NewYHSD*
Talbot, Mary 1787-1863 *FolkA 86*
Talbot, Nancy Wilfreda Hewitt 1925- *WhoArt 80, -82, -84*
Talbot, Sophia Davis 1888- *DcWomA, WhAmArt 85*
Talbot, Suzanne *FairDF FRA*
Talbot, William 1918- *WhoAmA 73, -76, -78, -80*
Talbot, William 1918-1980 *WhoAmA 82N, -84N*
Talbot, William H M 1918- *DcCAA 71, -77*
Talbot, William Henry Fox 1800-1877 *DcBrWA, ICPEnP, MacBEP, OxDecA*
Talbot Kelly, Chloe Elizabeth 1927- *WhoArt 80, -82, -84*
Talbot-Kelly, Richard Barrett 1896- *ClaDrA*
Talbott, Anna Matilda Wares 1810?-1882 *DcWomA*
Talbott, Emeline *FolkA 86*
Talbott, Katharine 1908- *WhAmArt 85*
Talboys, Agnes Augusta *DcBrA 1, DcWomA*
Talburt, Harold M 1895-1966 *WorECar*
Talcott, Allen Butler 1867-1908 *WhAmArt 85*
Talcott, Charles Hooker 1901- *AmArch 70*
Talcott, Dudley Vaill 1899- *WhAmArt 85*
Talcott, Sarah W 1852-1936 *WhAmArt 85*
Talcott, Sarah Whiting 1852-1936 *DcWomA*
Talcott, William *FolkA 86, NewYHSD*
Talen, Elise *DcWomA*
Talen, W A *NewYHSD*
Talenti, Francesco d1369? *OxArt*
Talenti, Francesco 1300?-1369? *McGDA*
Talenti, Simone DiFrancesco 1340?-1381? *McGDA*
Talenti Family *MacEA*
Talford, Florence L *ArtsEM, DcWomA*
Talfourd, Field 1815-1874 *DcVicP, -2*

Talfourd, Florence L *DcWomA, WhAmArt 85*
Taliaferro, Charles Alfred 1905-1969 *WorECom*
Taliaferro, Elizabeth Stewart 1869- *DcWomA, WhAmArt 85*
Taliaferro, Francis Tournier 1922- *AmArch 70*
Taliaferro, John 1895- *ArtsAmW 3*
Taliaferro, Lucene *WhAmArt 85*
Taliaferro, Richard 1705-1779 *BnEnAmA*
Tallant, Hugh 1869-1952 *MacEA*
Tallant, Richard D 1853-1934 *ArtsAmW 1*
Tallant, Richard H 1853-1934 *IlBEAAW, WhAmArt 85*
Tallberg, Axel 1860-1928 *DcBrA 1*
Tallentire, Anne 1949- *WhoArt 80, -82, -84*
Taller DeMontevideo *ConArt 77*
Talleur, John J 1925- *WhoAmA 73, -76, -78, -80, -82*
Talley, C M *AmArch 70*
Talley, D J *AmArch 70*
Talley, Dan R 1951- *WhoAmA 80, -82, -84*
Talley, Ken Michael 1934- *AmArch 70*
Talley, Norman Wilson 1941- *AmArch 70*
Talliafero, Richard d1755 *BiDAmAr*
Tallmadge, Thomas Eddy 1876- *WhAmArt 85*
Tallmadge, Thomas Eddy 1876-1940 *BiDAmAr, MacEA*
Tallman, Essie Marie 1877- *DcWomA*
Tallman, M G 1859-1930 *WhAmArt 85*
Tallman, Martha Griffith 1859-1930 *DcWomA*
Tallman, Nelson H *DcWomA*
Tallman, Perry *ArtsEM*
Tallman, Robert Bradford 1919- *AmArch 70*
Tallon, Roger 1929- *ConDes*
Tallon, Ronald 1927- *WhoArch*
Tallon, William John 1917- *WhAmArt 85*
Talmage, Algernon M 1871-1939 *IlBEAAW*
Talmage, Algernon Mayon 1871-1939 *DcVicP 2*
Talmage, Algernon Mayow 1871-1939 *DcBrA 1*
Talman, John *OxArt*
Talman, John 1677-1726 *BiDBrA, MacEA*
Talman, William 1650-1719 *BiDBrA, DcD&D, MacEA, McGDA, OxArt, WhoArch*
Talpey, J M *FolkA 86*
Talpino, Chiara *DcWomA*
Talpino, Elisabetta *DcWomA*
Talpino, Enea 1550?-1626 *McGDA*
Talpo, Bruno 1940- *DcCAr 81*
Talucchi, Giuseppe 1782-1863 *MacEA*
Talvacchio, Helen Steiner 1921- *WhoAmA 73, -76*
Tam, David Chiwai 1956- *MarqDCG 84*
Tam, Reuben 1916- *DcCAA 71, -77, WhAmArt 85, WhoAmA 73, -76, -78, -80, -82, -84*
Tamagni, Vincenzo 1492-1530? *McGDA*
Tamagnini, Antonio *McGDA*
Tamasauskas, Otis 1947- *PrintW 85*
Tamasauskas, Otis Kazys 1947- *WhoAmA 84*
Tamassi, Zoltan 1912- *WhoGrA 82[port]*
Tamayo, Ruffino 1899- *ConArt 83*
Tamayo, Rufino 1899- *McGDA, OxArt, OxTwCA, PhDcTCA 77, PrintW 83, -85, WhoAmA 73, -76, -78, -80, -82, -84, WorArt[port]*
Tambellini, Aldo 1930- *WhoAmA 73, -76, -80, -82, -84*
Tambling, P S *AmArch 70*
Tamblyn-Watts, Harold 1900- *WhoArt 80, -82, -84*
Tamburi, Orfeo 1910- *PhDcTCA 77*
Tamburine, Jean 1930- *WhoAmA 78, -80, -82, -84*
Tamburini *DcVicP 2*
Tamburini, Francisco d1892 *MacEA*
Tamechika 1823-1864 *McGDA*
Tamekazu *AntBDN L*
Tamerin, David *OfPGCP 86*
Tames, Ingaborg *ArtsAmW 3*
Tamlin, J *DcVicP 2*
Tamm, Arno 1929- *AmArch 70*
Tamm-Daniels, Frederick Lawrence 1951- *MarqDCG 84*
Tammen, C M *AmArch 70*
Tammen, H H *EncASM*
Tamminga, David Jacob 1924- *AmArch 70*
Tamotzu, Chuzo 1891-1975 *ArtsAmW 2, WhAmArt 85*
Tams *FolkA 86*
Tamura, Akihide 1947- *MacBEP*
Tan, H C *AmArch 70*
Tan, Ronald H 1930- *AmArch 70*
Tan Guidicelli 1934- *ConDes*
Tan-Won *McGDA*
Tanabe, Takao *OxTwCA*
Tanaka, Atsuko 1931- *OxTwCA, PhDcTCA 77*
Tanaka, Chotoku 1947- *MacBEP*
Tanaka, Ikko 1930- *ConDes, WhoGrA 62, -82[port]*
Tanaka, J Stuart 1949- *MarqDCG 84*
Tanaka, Kojo 1924- *MacBEP*
Tanaka, Masaaki 1931- *ConDes*
Tanaka, Richard Isamu 1928- *MarqDCG 84*
Tanaka, Richard Koichi 1931- *AmArch 70*
Tanaka, Shintaro 1928- *PhDcTCA 77*
Tanaka, Yasushi *WhAmArt 85*
Tanaka, Yasushi 1886- *ArtsAmW 2*
Tanari, Marchesa *DcWomA*
Tanberg, Ella Hotelling d1928 *WhAmArt 85*

Tanberg, Ella Hotelling 1862-1928 *ArtsAmW 2, DcWomA*
Tanck, Paul Otto 1923- *AmArch 70*
Tancock, John Leon 1942- *WhoAmA 80, -82, -84*
Tancredi 1927-1964 *PhDcTCA 77*
Tancredi, Parmeggiani *OxTwCA*
Tandberg, Odd 1924- *OxTwCA, PhDcTCA 77*
Tandler, Rudolph 1887- *WhAmArt 85*
Tandler, Rudolph Frederick 1887- *ArtsEM*
Tandy, Daniel 1770?-1848 *DcBrWA*
Tandy, Jewel *AfroAA*
Tandy, John 1905- *DcBrA 1*
Tandy, Michael Roy 1942- *WhoArt 84*
Tandy, Vertner, Sr. 1885-1949 *BiDAmAr*
Tandy, Vertner W 1885- *AfroAA*
Taneji, Moichiro Tsuchiya 1891- *WhAmArt 85*
Tanera, Mademoiselle *DcWomA*
Taney, Jacob *FolkA 86*
Tang, Lady *DcWomA*
Tang, J S *AmArch 70*
T'ang, Liu-Ju *McGDA*
T'ang, Yin 1470-1523 *McGDA, OxArt*
Tange, Kenzo 1913- *ConArch, DcD&D, EncMA, MacEA, McGDA, WhoArch*
Tanger, Susanna 1942- *WhoAmA 76, -78, -80, -82, -84*
Tangredi, Vincent 1950- *WhoAmA 84*
Tanguy, Edward Michael 1938- *ClaDrA*
Tanguy, Yves 1900-1955 *BnEnAmA, ConArt 77, -83, DcCAA 71, -77, OxArt, OxTwCA, PhDcTCA 77, WhoAmA 78N, -80N, -82N, -84N, WorArt[port]*
Tanguy, Yves 1900-1957 *McGDA*
Tania 1924- *DcCAA 71, -77, WhoAmA 73, -76, -78*
Tanida, Junichi 1928- *AmArch 70*
Taniguchi, Alan Y 1922- *AmArch 70*
Taniguchi, Yoshiro 1904-1979 *ConArch, MacEA*
Tanimoto, Steven L 1949- *MarqDCG 84*
Tanis, Neal M 1932- *AmArch 70*
Tanji, R H *AmArch 70*
Tank, Mrs. Otto 1803-1891 *DcWomA*
Tankard, Allan Peel 1897- *DcBrA 1*
Tanke, E T *AmArch 70*
Tankei 1173-1256 *McGDA*
Tankersley, Ladson Delmus 1932- *AmArch 70*
Tankersley, T L *AmArch 70*
Tanksley, Ann *AfroAA*
Tanksley, Ann 1934- *WhoAmA 73, -76, -78, -80, -82, -84*
Tann, Curtis E *AfroAA*
Tann, Lewis Howard 1942- *MarqDCG 84*
Tannaes, Marie Katharine Helene 1854-1939 *DcWomA*
Tannahill, Mary H *WhAmArt 85*
Tannahill, Mary H 1868- *DcWomA*
Tannahill, Sallie B 1881-1947 *DcWomA, WhAmArt 85*
Tannar, Harold D *WhAmArt 85*
Tanneberger, Billy F 1956- *MarqDCG 84*
Tannen *NewYHSD*
Tannenbaum, A A 1922- *AmArch 70*
Tannenbaum, H *AmArch 70*
Tannenbaum, Judith E 1944- *WhoAmA 80, -82, -84*
Tannenbaum, Leonard Michael 1953- *MarqDCG 84*
Tanner, A *DcVicP 2*
Tanner, Anne *DcCAr 81*
Tanner, Benjamin 1775-1848 *NewYHSD*
Tanner, E W *AmArch 70*
Tanner, Edwin Russell *DcCAr 81*
Tanner, H O 1859-1937 *WhAmArt 85*
Tanner, Henry Ossawa 1859-1937 *AfroAA, BnEnAmA, DcAmArt, McGDA, WhoAmA 80N, -82N, -84N*
Tanner, Henry Schenck 1786-1858 *NewYHSD*
Tanner, Howard *ConArch A*
Tanner, James 1941- *AfroAA*
Tanner, James L 1941- *WhoAmA 73, -76, -78, -80, -82, -84*
Tanner, Jesse *NewYHSD*
Tanner, Joan Elizabeth 1935- *WhoAmA 76, -78, -80, -82, -84*
Tanner, John Carroll 1928- *AmArch 70*
Tanner, John R 1895- *AmArch 70*
Tanner, Juliet Lavinia 1833-1909 *DcWomA*
Tanner, Karl 1947- *WhoGrA 82[port]*
Tanner, M J *FolkA 86*
Tanner, Mary Ann *FolkA 86*
Tanner, Peter P 1951- *MarqDCG 84*
Tanner, Robin 1904- *DcBrA 1*
Tanner, Thomas Sheridan 1893- *AmArch 70*
Tanner, W Charles *WhAmArt 85*
Tanner, Warren 1942- *AmArt, WhoAmA 78, -80, -82, -84*
Tanneur, Philippe 1795-1878 *DcSeaP*
Tannevot, Michel 1685?-1762 *MacEA*
Tanning, Dorothea *DcCAr 81*
Tanning, Dorothea 1910- *OxTwCA, PhDcTCA 77*
Tanning, Dorothea 1913- *DcCAr 81, WhAmArt 85*
Tannock, James 1784-1863 *DcVicP 2*
Tannyu 1602-1674 *McGDA*
Tanqueray, Alice F *DcVicP 2*
Tanqueray, Paul 1905- *MacBEP*

Taylor, Katrina V H *WhAmArt 85*
Taylor, Kendall Frances *WhoAmA 80, –82, –84*
Taylor, Kenneth Dean 1934- *AmArch 70*
Taylor, Lawrence *AfroAA*
Taylor, Lawrence Newbold 1903- *WhAmArt 85*
Taylor, Leonard Campbell 1874- *ClaDrA*
Taylor, Leonard Campbell 1874-1963 *DcBrBI*
Taylor, Leonard Campbell 1874-1969 *DcBrA 1, DcVicP 2*
Taylor, Leroy E 1957- *MarqDCG 84*
Taylor, Liba 1950- *MacBEP*
Taylor, Lila Caroline *DcWomA*
Taylor, Lilian Bayard *DcWomA*
Taylor, Lillian Gary *FolkA 86*
Taylor, Lisa 1933- *WhoAmA 78, –80, –82, –84*
Taylor, Lissa *WorFshn*
Taylor, Lizzie *DcVicP 2*
Taylor, Loron A 1900-1932 *WhAmArt 85*
Taylor, Luke 1876-1916 *DcBrA 1, DcVicP 2*
Taylor, Lynn Charles 1938- *AmArch 70*
Taylor, M *WhoArt 84*
Taylor, Mrs. M *WhoArt 80, –82*
Taylor, Margaret *AfroAA*
Taylor, Margaret B *DcWomA*
Taylor, Margaret M *DcWomA*
Taylor, Margaretta Bonsall 1880- *DcWomA, WhAmArt 85*
Taylor, Marguerite *DcWomA*
Taylor, Maria *DcWomA*
Taylor, Marie 1904- *WhoAmA 73, –76, –78, –80, –82, –84*
Taylor, Marie Carr 1904- *WhAmArt 85*
Taylor, Martin Gibson, Jr. 1910- *AmArch 70*
Taylor, Marvin Fred 1936- *AmArch 70*
Taylor, Mary 1895- *ArtsAmW 3, DcWomA*
Taylor, Mary Aldis 1859-1929 *DcWomA*
Taylor, Mary Alice *AfroAA*
Taylor, Mary Cazort *WhoAmA 78, –80, –82, –84*
Taylor, Mary Perkins *WhAmArt 85*
Taylor, Mary Smyth *DcWomA*
Taylor, Mary Wilcox *FolkA 86*
Taylor, Michael 1944- *WhoAmA 78, –80, –82, –84*
Taylor, Michele F 1946- *WhoAmA 84*
Taylor, Minnie C *WhAmArt 85*
Taylor, Minnie C 1865- *ArtsAmW 2, DcWomA*
Taylor, Minnie M *DcWomA*
Taylor, N H *NewYHSD*
Taylor, Newton *DcBrA 1, WhoAmA 80, –82, –84*
Taylor, Nora *DcVicP 2*
Taylor, Norah Helen 1885- *ClaDrA, DcBrA 1, DcWomA*
Taylor, P F 1898- *WhAmArt 85*
Taylor, Pamela 1929- *WhoArt 82, –84*
Taylor, Patrick 1756-1788 *DcBrECP*
Taylor, Patti 1939- *WorFshn*
Taylor, Paul Schuster 1895- *ICPEnP A, MacBEP*
Taylor, Pauline *DcVicP 2, DcWomA*
Taylor, Peter *NewYHSD*
Taylor, Peter 1756-1788 *DcBrECP*
Taylor, Peter Charles 1956- *MarqDCG 84*
Taylor, Prentiss 1907- *WhAmArt 85, WhoAmA 73, –76, –78, –80, –82, –84*
Taylor, R *DcWomA, WhAmArt 85*
Taylor, R B *WhAmArt 85*
Taylor, R H, Jr. *AmArch 70*
Taylor, R L *AmArch 70*
Taylor, R R *AfroAA*
Taylor, Rachel *DcWomA*
Taylor, Rachel 1887-1974 *DcWomA*
Taylor, Ralph 1897- *WhAmArt 85, WhoAmA 73, –76*
Taylor, Ralph Dale 1945- *MarqDCG 84*
Taylor, Ralph Norman 1919- *AmArch 70*
Taylor, Raymond *AfroAA*
Taylor, Rene Claude 1916- *WhoAmA 78, –80, –82, –84*
Taylor, Renwick 1898- *WhAmArt 85*
Taylor, Rhoderic Ferrell 1918- *AmArch 70*
Taylor, Richard *DcBrECP, WhoArt 80N*
Taylor, Richard 1902- *WhAmArt 85*
Taylor, Richard 1924- *DcBrA 1*
Taylor, Richard Bonnell 1926- *AmArch 70*
Taylor, Richard D 1902-1970 *WorECar*
Taylor, Richard Gordon 1933- *AmArch 70*
Taylor, Richard Lynn 1939- *MarqDCG 84*
Taylor, Robert *CabMA, DcBrECP*
Taylor, Robert 1714-1788 *MacEA*
Taylor, Robert 1925- *WhoAmA 73, –76, –78, –80, –82, –84*
Taylor, Robert 1946- *DcSeaP*
Taylor, Sir Robert 1714-1788 *BiDBrA, DcD&D[port], OxArt, WhoArch*
Taylor, Robert C 1919- *AmArch 70*
Taylor, Robert Grover 1927- *AmArch 70*
Taylor, Robert Samuel 1924- *AmArch 70*
Taylor, Robert V 1932- *AmArch 70*
Taylor, Rod 1932- *AfroAA*
Taylor, Rod Allen 1932- *WhoAmA 78, –80, –82, –84*
Taylor, Roger James 1940- *MacBEP*
Taylor, Roger Kendall 1947- *MarqDCG 84*
Taylor, Rolla S 1874- *ArtsAmW 2, IlBEAAW,*

WhAmArt 85
Taylor, Ronald Lee 1933- *AmArch 70*
Taylor, Rosemary *WhoAmA 73, –76, –78, –80, –82, –84*
Taylor, Roy W 1882-1914 *WhAmArt 85*
Taylor, Rudolph S 1918- *AmArch 70*
Taylor, Ruth P 1900- *WhAmArt 85*
Taylor, S *DcVicP 2*
Taylor, S F *FolkA 86*
Taylor, S M Louisa *DcVicP 2*
Taylor, Sally 1792-1883 *FolkA 86*
Taylor, Samuel *AntBDN Q, BiDBrA*
Taylor, Samuel C *DcVicP 2*
Taylor, Sandra J 1936- *WhoAmA 73*
Taylor, Sandra Ortiz 1936- *WhoAmA 76, –78, –80, –82, –84*
Taylor, Sarah 1744- *FolkA 86*
Taylor, Sarah C *WhAmArt 85*
Taylor, Scott Richard 1960- *MarqDCG 84*
Taylor, Shelby Robert 1922- *AmArch 70*
Taylor, Simon d1772 *DcBrWA*
Taylor, Stephen *DcVicP, –2*
Taylor, Steven 1953- *MarqDCG 84*
Taylor, Sydney *PrintW 85*
Taylor, T *DcBrWA, NewYHSD*
Taylor, Theron *AfroAA*
Taylor, Theron Eldridge, Jr. 1944- *MacBEP*
Taylor, Thomas *DcBrWA, NewYHSD*
Taylor, Thomas d1848 *BiDBrA*
Taylor, Thomas 1770?-1826 *DcBrBI*
Taylor, Thomas 1770?-1826? *DcBrWA*
Taylor, Thomas 1778?-1826 *BiDBrA*
Taylor, Thomas 1854-1915 *WhAmArt 85*
Taylor, Thomas E 1932- *AmArch 70*
Taylor, Thomas Fish *BiDBrA*
Taylor, Tom *DcBrBI, DcVicP 2*
Taylor, Virginia *WhAmArt 85*
Taylor, W *DcBrECP*
Taylor, Mrs. W *DcWomA*
Taylor, W B *DcVicP 2*
Taylor, W G *AmArch 70*
Taylor, W H *NewYHSD*
Taylor, W S 1920- *WhoArt 80, –82, –84*
Taylor, W W *FolkA 86*
Taylor, Walter 1860-1943 *DcBrA 1, DcBrWA, DcVicP 2*
Taylor, Walter 1874- *WhAmArt 85*
Taylor, Walter 1875- *DcBrA 1, DcBrWA*
Taylor, Walter Quitman, Jr. 1936- *AmArch 70*
Taylor, Walter R 1813?- *NewYHSD*
Taylor, Walter S 1813?- *NewYHSD*
Taylor, Warren Watson 1920- *AmArch 70*
Taylor, Wayne 1931- *DcCAr 81*
Taylor, Wayne Erwin 1929- *AmArch 70*
Taylor, Weld *DcBrBI*
Taylor, Wendy 1945- *ConArt 77, ConBrA 79[port], DcCAr 81*
Taylor, Wendy Ann 1945- *WhoArt 80, –82, –84*
Taylor, Will Ladd 1854-1926 *ArtsAmW 2*
Taylor, Willard G 1938- *MacBEP*
Taylor, William *AntBDN M, –Q, BiDBrA, DcVicP 2, FolkA 86, NewYHSD*
Taylor, William 1750- *DcBrECP*
Taylor, William 1764-1841 *NewYHSD*
Taylor, William 1800-1861 *DcBrWA*
Taylor, William 1958- *MarqDCG 84*
Taylor, William A 1926- *AmArch 70*
Taylor, William Alexander d1839 *BiDBrA*
Taylor, William Benjamin Sarsfield 1781-1850 *DcBrWA, DcVicP, –2*
Taylor, William Francis 1883- *WhAmArt 85*
Taylor, William Henry 1908- *AfroAA*
Taylor, William Henry 1911- *DcBrA 1, WhoArt 80, –82, –84*
Taylor, William Henry 1912- *AmArch 70*
Taylor, William James 1912- *AmArch 70*
Taylor, William L 1854-1926 *WhAmArt 85*
Taylor, William Ladd 1854-1926 *ArtsAmW 2, IlBEAAW, IlrAm A, –1880*
Taylor, William Lindsay 1907- *WhAmArt 85*
Taylor, William Morris 1942- *MarqDCG 84*
Taylor, William N 1882- *WhAmArt 85*
Taylor, William R *OfPGCP 86*
Taylor, William S 1882- *WhAmArt 85*
Taylor, William S 1920- *DcBrA 1*
Taylor, William W *FolkA 86*
Taylor, William Watts 1846-1913 *WhAmArt 85*
Taylor, Wynne Byard 1904- *WhAmArt 85*
Taylor, Zachary *AfroAA*
Taylor, Zillah *DcBrBI*
Taylor And King *CabMA*
Taylor Of Bath, John 1735-1806 *DcBrECP*
Taylor Wilson, Joanne 1953- *WhoArt 82, –84*
Tayre, Benjamin *CabMA*
Taysom, Wayne Pendelton 1925- *WhoAmA 78, –80, –82, –84*
Taysom, Wayne Pendelton 1925- *WhoAmA 73, –76*
Tazewell, E Bradford, Jr. 1926- *AmArch 70*
Tcheko-Polocka, Alexandra 1893- *DcWomA*
Tchelitchew, Pavel 1898-1957 *BnEnAmA, ConArt 77, –83, DcCAA 71, –77, McGDA, OxTwCA,*

PhDcTCA 77
Tcheng, John T L 1918- *WhoAmA 73, –76, –78, –80*
Tchernkovsky, Nahum 1935- *MarqDCG 84*
Tcherter, Louise *DcWomA*
Tchorzewski, Jerzy 1928- *PhDcTCA 77*
Tchoumakoff, Leonie *DcWomA*
Teague, Donald 1897- *ArtsAmW 1, –3, ConICB, IlBEAAW, IlrAm –1880, IlsCB 1744, WhAmArt 85, WhoAmA 73, –76, –78, –80, –82, –84*
Teague, Lavette Cox, Jr. 1934- *AmArch 70*
Teague, Violet Helen Evangeline *DcWomA*
Teague, Walter Dorwin 1883-1960 *ConDes, DcD&D, McGDA, WhAmArt 85*
Teague, Walter Dorwin 1884-1960 *WhoAmA 80N, –82N, –84N*
Teal, B Alvin 1899- *AmArch 70*
Teal, Gordon K 1907- *MarqDCG 84*
Teal, W P *WhAmArt 85*
Teale, E G *WhAmArt 85*
Teale, Earle Grantham 1886-1919 *IlrAm 1880*
Teale, Earle Grantham 1886-1924 *IlrAm C*
Teall, Gardner *WhAmArt 85*
Teall, Gardner C *DcBrBI*
Teames, Judak *FolkA 86*
Teana, Marino Di *OxTwCA*
Teana, Marino Di 1920- *PhDcTCA 77*
Teanby, William *BiDBrA*
Teape, James S *DcVicP 2*
Teape, Nancy M Miller 1864- *ArtsAmW 3*
Teare, Wallace Gleed 1907- *AmArch 70*
Tearle, Thomas *AntBDN Q*
Teasdale, James *BiDBrA*
Teasdale, John 1848-1926 *DcBrA 1, DcBrWA, DcVicP 2*
Teasdale, Kenneth J M *DcVicP 2*
Teasdale, Mary 1863-1937 *ArtsAmW 1*
Teasdale, Mary H 1863-1937 *DcWomA*
Teasdale, Percy Morton 1870- *DcBrA 1, DcVicP 2*
Teasdale, T H *AmArch 70*
Teasdel, Mary 1863-1937 *IlBEAAW, WhAmArt 85*
Teasdel, Mary H 1863-1937 *DcWomA*
Teasdill, Graham 1935- *WhoArt 80, –82, –84*
Teason, William I 1922- *WhoGrA 82[port]*
Tebault, Mrs. C H *DcWomA*
Tebbetts, Susan Elizabeth 1945- *MarqDCG 84*
Tebbetts, T M *AmArch 70*
Tebbitt, Gertrude *DcVicP 2*
Tebbitt, Henri *DcVicP 2*
Tebby, Arthur Kemp *DcBrBI, DcVicP 2*
Tebby, Leighton *DcVicP 2*
Tebo *AntBDN M*
Techler, David 1680-1740 *AntBDN K*
Tecton *WhoArch*
Teczar, Steven W 1948- *WhoAmA 84*
Ted Esco 1951- *DcCAr 81*
Tedder, M *DcVicP 2*
Tedeschi, Enrico 1901-1978 *MacEA*
Tedeschi, Jeffrey B 1959- *MarqDCG 84*
Tedeschi, Paul Valentine 1917- *WhoAmA 73, –76*
Tedesco, Adamo *McGDA*
Tedesco, E J *AmArch 70*
Tedesco, Jacopo *MacEA*
Tedesco, Lorenzo C 1930- *AmArch 70*
Tedesco-Hoffmann, Giulia *DcWomA*
Tedford, Elsie Mae 1901- *WhAmArt 85*
Tee, Edwin Ang 1959- *MarqDCG 84*
Tee-Van, Helen Damrosch 1893- *IlsBYP, WhoAmA 73, –76*
Tee-Van, Helen Damrosch 1893-1976 *DcWomA, WhAmArt 85, WhoAmA 78N, –80N, –82N, –84N*
Teeboom, Fred S 1938- *MarqDCG 84*
Teed, D Arthur 1863- *WhAmArt 85*
Teed, Mrs. Frank L *DcVicP 2*
Teed, Henry Samuel 1883-1916 *DcBrA 2*
Teed, John 1911- *WhoArt 80, –82, –84*
Teegardin, R E *AmArch 70*
Teegen, Otto 1899- *WhAmArt 85*
Teegen, Otto John *AmArch 70*
Teel, E 1830?- *NewYHSD*
Teel, Lewis Woods 1883- *IlBEAAW, WhAmArt 85*
Teel, Louis Woods 1883- *ArtsAmW 3*
Teel, William d1828 *CabMA*
Teeple, George W *ArtsEM*
Teeple, Robert *DcCAr 81*
Teering, Sir R F *DcVicP 2*
Teerlinc, Levina 1515?-1576 *DcWomA*
Teerlinc, Levina 1520?-1576 *WomArt*
Teerlinck, Levina 1515?-1576 *DcWomA*
Teerling, Levina 1515?-1576 *DcWomA*
Teesdale, C *DcVicP 2*
Teesdale, Christopher H 1886- *WhAmArt 85*
Teesdale, Christopher Hugh 1886- *ArtsAmW 2*
Teesdale, Emma *DcWomA*
Teesdale, Gladys Mary 1898- *DcWomA*
Tefet, Charles Eugene *WhoAmA 82N, –84N*
Tefft, Carl Eugene 1874-1950? *WhAmArt 85*
Tefft, Charles Eugene *WhoAmA 78N, –80N*
Tefft, Charles Eugene 1874-1950? *WhAmArt 85*
Tefft, Elden Cecil 1919- *WhoAmA 82, –84*
Tefft, Thomas 1826-1859 *McGDA*

Thomas, Douglas J 1947- *MarqDCG 84*
Thomas, Dudley *DcVicP 2*
Thomas, E *DcVicP 2*
Thomas, E L *AmArch 70*
Thomas, Ed B 1920- *WhoAmA 73, -76, -78, -80, -82*
Thomas, Edgar Herbert *DcVicP 2*
Thomas, Edward K *FolkA 86*
Thomas, Edward Kirkbride 1817-1906 *ArtsEM*
Thomas, Edward Tim 1926- *AmArch 70*
Thomas, Elaine F *AfroAA*
Thomas, Elaine Freeman 1923- *WhoAmA 73, -76, -78, -80, -82, -84*
Thomas, Eli 1900?- *FolkA 86*
Thomas, Elizabeth Haynes *DcWomA, WhAmArt 85*
Thomas, Elizabeth R *DcWomA, WhAmArt 85*
Thomas, Ella *DcWomA, WhAmArt 85*
Thomas, Ellen 1895- *DcWomA, WhAmArt 85*
Thomas, Elsie Hugo *DcWomA*
Thomas, Emery H *ArtsEM*
Thomas, Emma Warfield *WhAmArt 85*
Thomas, Estelle L *WhAmArt 85*
Thomas, Mrs. F *DcBrWA*
Thomas, F D *DcVicP 2*
Thomas, Fanny E *DcVicP 2, DcWomA*
Thomas, Florence Elisabeth *DcWomA*
Thomas, Florence Elizabeth *DcVicP, -2*
Thomas, Florence Todd 1909- *WhAmArt 85*
Thomas, Francis Inigo *DcVicP 2*
Thomas, Fred Howard 1935- *AmArch 70*
Thomas, G W *WhAmArt 85*
Thomas, Gabriel-Jules 1821- *ArtsNiC*
Thomas, George *EarABI, EarABI SUP, NewYHSD*
Thomas, George 1815?- *NewYHSD*
Thomas, George A *DcVicP 2*
Thomas, George E 1918- *AmArch 70*
Thomas, George Grosvenor 1856-1923 *DcBrA 1, DcVicP 2*
Thomas, George H 1824-1868 *ArtsNiC, NewYHSD*
Thomas, George Havard 1893-1933 *DcBrA 1*
Thomas, George Housman 1824-1868 *DcBrBI, DcBrWA, DcVicP, -2*
Thomas, George R 1906- *AmArch 70, WhAmArt 85, WhoAmA 73, -76, -78, -80, -82*
Thomas, George Robert 1887-1944 *MacBEP*
Thomas, Georgia Seaver *WhAmArt 85*
Thomas, Gerard 1663-1720 *ClaDrA*
Thomas, Glen *IlsBYP*
Thomas, Glenn *WhAmArt 85*
Thomas, Grace Sullivan *ArtsAmW 3*
Thomas, Grace Thornton 1880- *WhAmArt 85*
Thomas, Griffith 1820-1878 *BiDAmAr*
Thomas, Griffith 1820-1879 *MacEA*
Thomas, Helen *WhoAmA 78, -80, -82, -84*
Thomas, Helen Haskell *ArtsAmW 2, DcWomA*
Thomas, Helen Stirling *DcWomA*
Thomas, Henry *NewYHSD*
Thomas, Henry Atwell 1834-1904 *NewYHSD , WhAmArt 85*
Thomas, Henry Wilson d1930 *WhAmArt 85*
Thomas, Howard 1899- *WhAmArt 85*
Thomas, Howard Ormsby 1908-1971 *WhAmArt 85*
Thomas, I *FolkA 86*
Thomas, Inigo *DcBrBI*
Thomas, Isaiah 1749-1831 *EarABI, EarABI SUP, NewYHSD*
Thomas, J B *AmArch 70*
Thomas, J C, Jr. *AmArch 70*
Thomas, J J *NewYHSD*
Thomas, J L *AmArch 70, DcVicP 2*
Thomas, J R *AmArch 70, FolkA 86*
Thomas, J S *AmArch 70*
Thomas, J W *AmArch 70*
Thomas, Jack Lynn 1925- *AmArch 70*
Thomas, James 1926- *FolkA 86*
Thomas, James Havard 1854-1921 *DcBrA 1*
Thomas, James Joseph 1946- *MarqDCG 84*
Thomas, Joe, Jr. 1925- *AmArch 70*
Thomas, John *AntBDN F, NewYHSD*
Thomas, John 1927- *AmArt, WhoAmA 76, -78, -80, -82, -84*
Thomas, John Allen 1734- *EarABI*
Thomas, John Allen 1947- *MarqDCG 84*
Thomas, John Baldwin 1856-1937 *ArtsEM*
Thomas, John Evan d1873 *ArtsNiC*
Thomas, John Ivey 1931- *AmArch 70*
Thomas, John M 1950- *DcCAr 81*
Thomas, John Pickering 1886-1944 *BiDAmAr*
Thomas, John R 1927- *AmArch 70*
Thomas, John Rochester 1848-1901 *BiDAmAr*
Thomas, Joseph Brown, IV 1917- *AmArch 70*
Thomas, Joseph F *NewYHSD*
Thomas, Joseph F 1915- *AmArch 70*
Thomas, Katherine Castellanos 1946- *WhoAmA 76, -78*
Thomas, Kathryn *DcWomA*
Thomas, L H *AmArch 70*
Thomas, Lambert *CabMA*
Thomas, Larry Erskine 1917- *AfroAA*
Thomas, Laura Estelle Owen 1897- *ClaDrA, DcBrA 1, DcWomA*

Thomas, Lenore 1909- *WhAmArt 85*
Thomas, Leslie Gurwin *WhoArt 80N*
Thomas, Lester Isaac 1918- *AmArch 70*
Thomas, Lew 1932- *ICPEnP A, MacBEP, PrintW 83, -85, WhoAmA 78, -80, -82, -84*
Thomas, Lionel Arthur John 1915- *WhoAmA 73, -76, -78, -80, -82, -84*
Thomas, Louis Edward 1938- *AmArch 70*
Thomas, M *DcVicP 2*
Thomas, M F *DcVicP 2*
Thomas, M L *AmArch 70*
Thomas, Mahlon *CabMA*
Thomas, Majorie Helen 1885- *IlBEAAW*
Thomas, Margaret d1929 *DcBrA 1, DcBrBI, DcVicP, -2, DcWomA*
Thomas, Margaret 1916- *ClaDrA, DcBrA 1, WhoArt 80, -82, -84*
Thomas, Marian 1899- *ArtsAmW 2, DcWomA*
Thomas, Marie *NewYHSD*
Thomas, Marie 1826?- *DcWomA*
Thomas, Marion Curtis 1936- *AmArch 70*
Thomas, Marjorie *DcWomA*
Thomas, Marjorie Helen 1885- *WhAmArt 85*
Thomas, Marjorie Helen 1885-1978 *ArtsAmW 2, DcWomA*
Thomas, Marjorie Lilian 1897- *DcBrA 1, DcWomA*
Thomas, Mary *DcVicP 2, DcWomA*
Thomas, Mary Leath 1905-1959 *WhAmArt 85, WhoAmA 80N, -82N, -84N*
Thomas, Matthew Evan 1788-1830 *BiDBrA*
Thomas, Melina *DcWomA*
Thomas, Michael *NewYHSD*
Thomas, Mrs. N E *ArtsEM, DcWomA*
Thomas, Nellie *ArtsEM, DcWomA*
Thomas, Nicholas *WhoAmA 80, -82, -84*
Thomas, Norma Marion 1922- *WhoArt 80, -82, -84*
Thomas, Norman Millet 1915- *WhAmArt 85*
Thomas, Oren R, Jr. 1918- *AmArch 70*
Thomas, P A, III *AmArch 70*
Thomas, P Elizabeth F *DcVicP 2*
Thomas, Pat 1918-1984 *FolkA 86*
Thomas, Paul 1859- *ClaDrA*
Thomas, Paul K M 1875- *WhAmArt 85*
Thomas, Percy 1846-1922 *ClaDrA, DcBrA 1, DcVicP, -2*
Thomas, Peter Lewis 1927- *WhoArt 80, -82, -84*
Thomas, R H *AmArch 70*
Thomas, R L *AmArch 70*
Thomas, R R *FolkA 86*
Thomas, Ralph S 1912- *AmArch 70*
Thomas, Ramon Laverne 1924- *AmArch 70*
Thomas, Reynolds 1927- *WhoAmA 73, -76, -80, -82, -84*
Thomas, Richard *DcCAr 81*
Thomas, Richard Edward 1942- *AmArch 70*
Thomas, Richard S 1872- *WhAmArt 85*
Thomas, Richard Strickland 1787-1853 *DcVicP 2*
Thomas, Robert 1926- *WhoArt 80, -82, -84*
Thomas, Robert C 1924- *DcCAA 71, -77*
Thomas, Robert C 1932- *AmArch 70*
Thomas, Robert Chester 1924- *WhoAmA 73, -76, -78, -80, -82, -84*
Thomas, Robert D *FolkA 86*
Thomas, Robert Maurice 1928- *AmArch 70*
Thomas, Robert Strickland 1787-1853 *DcSeaP, DcVicP*
Thomas, Roland 1883- *WhAmArt 85*
Thomas, Rosalie *DcWomA*
Thomas, Roy 1940- *WorECom*
Thomas, Ruth *WhAmArt 85*
Thomas, Ruth 1893- *DcWomA, WhAmArt 85*
Thomas, Ruth Kate *DcWomA*
Thomas, Sidney *DcBrWA*
Thomas, Son Ford *FolkA 86*
Thomas, Spencer *CabMA*
Thomas, Steffen Wolfgang 1906- *PrintW 85, WhoAmA 73, -76, -78, -80, -82, -84*
Thomas, Steffen Wolfgang George 1906- *WhAmArt 85*
Thomas, Stephen Seymour 1868-1956 *ArtsAmW 1, -2, IlBEAAW, WhAmArt 85*
Thomas, Susan Spencer *DcWomA, WhAmArt 85*
Thomas, Sybil *DcVicP 2*
Thomas, Sydney *DcVicP 2*
Thomas, T G *AmArch 70*
Thomas, Tamara B *WhoAmA 78, -80, -82, -84*
Thomas, Thomas *BiDAmAr*
Thomas, Thomas 1787?-1871 *MacEA*
Thomas, Thomas Henry 1839-1915 *DcBrA 1, DcVicP 2*
Thomas, Valerie G 1955- *MarqDCG 84*
Thomas, Mrs. Vernon 1894- *DcWomA, WhAmArt 85*
Thomas, W *DcVicP 2*
Thomas, W A *AmArch 70*
Thomas, W J *AmArch 70*
Thomas, W Murray *DcVicP 2*
Thomas, W S *FolkA 86*
Thomas, Wallace Bate 1919- *AmArch 70*

Thomas, Walter 1894- *ClaDrA, DcBrA 1*
Thomas, Walter H 1876-1948 *BiDAmAr*
Thomas, Wilfred *AfroAA*
Thomas, William d1800 *BiDBrA*
Thomas, William 1799-1860 *MacEA*
Thomas, William 1800-1860 *BiDBrA*
Thomas, William Bartol 1877- *DcBrA 1*
Thomas, William Barton 1877-1947 *DcVicP 2*
Thomas, William Cave 1820- *ArtsNiC, ClaDrA, DcVicP, -2*
Thomas, William Cave 1820-1884? *DcBrWA*
Thomas, William F *DcBrBI, DcVicP 2*
Thomas, William Frederick 1911- *AmArch 70*
Thomas, William Luson 1830-1900 *DcBrBI, DcBrWA, DcVicP, -2*
Thomas, William O *AfroAA*
Thomas, William Radford 1930- *WhoAmA 76, -78, -80, -82, -84*
Thomas, William Richard 1937- *AmArch 70*
Thomas, William Tutin 1828-1892 *MacEA*
Thomas, Winfield Scott 1900- *WhAmArt 85*
Thomas, Winifred M 1910- *ClaDrA*
Thomas, Yvonne *WhoAmA 84*
Thomas Brothers *FolkA 86*
Thomas-Soyer, Mathilde 1860- *DcWomA*
Thomasita *WhoAmA 73*
Thomason, Claude Wayne 1908- *AmArch 70*
Thomason, Dowler *AntBDN N*
Thomason, Edward *AntBDN N*
Thomason, Francis Q *WhAmArt 85*
Thomason, G A *AmArch 70*
Thomason, I *AntBDN O*
Thomason, John William, Jr. 1893-1944 *ArtsAmW 1, IlBEAAW, WhAmArt 85*
Thomason, Michael Vincent 1942- *WhoAmA 82, -84*
Thomason, Tom William 1934- *WhoAmA 78, -80, -82, -84*
Thomass, Chantal 1947- *ConDes*
Thomasse *DcWomA*
Thomassin, Philippe 1562-1622 *McGDA*
Thome, Amalie *DcWomA*
Thome, John R 1943- *MarqDCG 84*
Thomen, J T *AmArch 70*
Thometz, Frank Michael 1929- *AmArch 70*
Thomire, Pierre-Philippe 1751-1843 *DcNiCA*
Thomire, Pierre Philippe 1751-1843 *McGDA*
Thomire-Dutherme *DcNiCA*
Thommesen, Erik 1916- *PhDcTCA 77*
Thomon, Thomas De 1754-1813 *MacEA, McGDA, OxArt, WhoArch*
Thomond, Mary, Marchioness Of 1751-1821? *DcWomA*
Thompkins, Clementina *DcWomA*
Thompkins, Clementina 1848-1931 *WhAmArt 85*
Thompkinson, Flora *DcWomA*
Thompson *FolkA 86, NewYHSD*
Thompson, Mr. *FolkA 86*
Thompson, A C *DcWomA*
Thompson, Miss A C *NewYHSD*
Thompson, A M *AfroAA*
Thompson, A R *AmArch 70*
Thompson, A Wordsworth 1840- *ArtsNiC*
Thompson, Agnes J *DcWomA, WhAmArt 85*
Thompson, Alan 1908- *WhAmArt 85*
Thompson, Albert 1853- *ArtsNiC*
Thompson, Alfred *DcVicP 2*
Thompson, Alfred d1895 *DcBrBI*
Thompson, Alfred Wordsworth 1840-1896 *NewYHSD , WhAmArt 85*
Thompson, Allan Robert 1932- *MarqDCG 84*
Thompson, Almerin D *NewYHSD*
Thompson, Arad 1786-1843 *NewYHSD*
Thompson, Arnold W 1926- *AmArch 70*
Thompson, Barbara G 1942- *MacBEP*
Thompson, Barry Allen 1940- *AmArch 70*
Thompson, Baylis *DcVicP 2*
Thompson, Benjamin 1753-1814 *NewYHSD*
Thompson, Benjamin 1918- *AmArch 70, ConArch, MacEA*
Thompson, Benjamin, Jr. 1799- *CabMA*
Thompson, Bertha *WhAmArt 85*
Thompson, Beryl Antonia 1918-1970 *WorECar*
Thompson, Bob d1966 *WhoAmA 78N, -80N, -82N, -84N*
Thompson, Bob 1937-1966 *DcCAA 71, -77, WorArt[port]*
Thompson, Bradbury 1911- *ConDes, WhoAmA 73, -76, -80, -82, -84, WhoGrA 62, -82[port]*
Thompson, C C *FolkA 86*
Thompson, C H *DcVicP 2*
Thompson, C L *DcWomA*
Thompson, C Mortimer *WhAmArt 85*
Thompson, Cephas 1775-1856 *NewYHSD*
Thompson, Cephas G 1809- *ArtsNiC*
Thompson, Cephas Giovanni 1775-1856 *FolkA 86*
Thompson, Cephas Giovanni 1809-1888 *BnEnAmA, NewYHSD*
Thompson, Charles A *NewYHSD*
Thompson, Charles Glover 1928- *AmArch 70*
Thompson, Charles Herbert, Jr. 1929- *AmArch 70*
Thompson, Charles Lynn 1938- *AmArch 70*

Thompson, Charles W *NewYHSD*
Thompson, Charlotte Mary Rose *DcWomA*
Thompson, Christiana *DcVicP 2*
Thompson, Clara A *DcWomA*, *WhAmArt 85*
Thompson, Conrad *AfroAA*
Thompson, Constance 1882- *DcBrA 1*, *DcWomA*
Thompson, Constance Dutton *ClaDrA*
Thompson, D George d1870? *NewYHSD*
Thompson, David Alfred 1929- *MarqDCG 84*
Thompson, David E 1940- *MarqDCG 84*
Thompson, David Elbridge *WhoAmA 76, -78, -80, -82, -84*
Thompson, Dody 1923- *ICPEnP A*, *MacBEP*
Thompson, Dolly S *NewYHSD*
Thompson, Dolly S 1790?- *DcWomA*
Thompson, Donald E 1927- *AmArch 70*
Thompson, Donald Roy 1936- *WhoAmA 76, -78, -80, -82, -84*
Thompson, Dorothea *WhAmArt 85*
Thompson, Dorothy Burr 1900- *WhoAmA 73, -76, -78, -80, -82, -84*
Thompson, Douglas Llewellyn 1934- *MarqDCG 84*
Thompson, E *DcVicP 2*, *DcWomA*
Thompson, E A *AmArch 70*
Thompson, E C *AmArch 70*
Thompson, E G *OfPGCP 86*
Thompson, E H *DcVicP 2*
Thompson, E J *DcWomA*
Thompson, Edith Blight 1874?- *DcWomA*
Thompson, Edith Blight 1884- *WhAmArt 85*
Thompson, Edmund Burke 1897- *WhAmArt 85*
Thompson, Eleanor Shepherd *WhAmArt 85*
Thompson, Elisabeth Kendall *AmArch 70*
Thompson, Elise d1933 *DcBrA 1*, *DcWomA*
Thompson, Elizabeth *DcVicP 2*, *DcWomA*
Thompson, Elizabeth 1844- *ArtsNiC*
Thompson, Elizabeth A 1811?- *FolkA 86*
Thompson, Ellen *DcWomA*
Thompson, Ellen Kendall 1839?-1913 *DcWomA*
Thompson, Ellen Kendall Baker d1913 *WhAmArt 85*
Thompson, Ernest, Jr. *EncASM*
Thompson, Ernest Heber 1891-1971 *DcBrA 1*
Thompson, Ernest Seton 1860- *WhAmArt 85*
Thompson, Ernest Thorne *WhoAmA 76, -78, -80, -82, -84*
Thompson, Ernest Thorne 1897- *WhAmArt 85*
Thompson, Ernest Thorne, Jr. 1928- *WhoAmA 76, -78, -80, -82, -84*
Thompson, Evan Arthur 1904- *AmArch 70*
Thompson, F *AmArch 70*
Thompson, F C *DcWomA*
Thompson, F Ray 1905- *WhAmArt 85*
Thompson, F Raymond 1905- *WhoAmA 73, -76, -78, -80, -82*
Thompson, Floyd Leslie 1889- *WhAmArt 85*
Thompson, Frances L *WhAmArt 85*
Thompson, Frances Louise *DcWomA*
Thompson, Francis *MacEA*, *McGDA*
Thompson, Francis 1838-1905 *NewYHSD*
Thompson, Francis Alpheus 1838-1905 *WhAmArt 85*
Thompson, Frank d1926 *DcBrA 1*, *DcBrWA*, *DcVicP 2*
Thompson, Frank Rogers 1937- *AmArch 70*
Thompson, Fred *WhAmArt 85*
Thompson, Fred D *WhAmArt 85*
Thompson, Frederic Louis 1868- *WhAmArt 85*
Thompson, Frederick 1904-1956 *WhAmArt 85*, *WhoAmA 80N, -82N, -84N*
Thompson, G *DcVicP 2*
Thompson, G A *DcVicP 2*
Thompson, G B *DcVicP 2*
Thompson, G H *DcVicP 2*
Thompson, G Ivan *DcVicP 2*
Thompson, Gabriel *DcVicP 2*, *WhAmArt 85*
Thompson, Gene 1932- *AmArch 70*
Thompson, George *BiDBrA*, *DcBrBI*, *DcVicP 2*, *FolkA 86*
Thompson, George 1913- *IlDcG*
Thompson, George A 1868-1938 *WhAmArt 85*
Thompson, George Douglas *DcVicP 2*
Thompson, George Kramer 1859-1935 *BiDAmAr*
Thompson, George Louis 1913- *WhoAmA 73, -76, -78, -80*
Thompson, George Louis 1913-1981 *WhoAmA 82N, -84N*
Thompson, George Randall 1925- *AmArch 70*
Thompson, George W 1838-1910 *BiDAmAr*
Thompson, Georgette Rosamond 1905- *WhAmArt 85*
Thompson, Gerald Alan 1940- *MarqDCG 84*
Thompson, Gilbert *WhAmArt 85*
Thompson, Gilbert G 1860-1921 *DcBrWA*
Thompson, Godfrey 1921- *WhoArt 80, -82, -84*
Thompson, Greenland *FolkA 86*
Thompson, H *DcVicP 2*
Thompson, H Elton 1938- *AmArch 70*
Thompson, H Raymond *DcVicP 2*
Thompson, H S *AmArch 70*
Thompson, Hannah 1888- *ArtsAmW 2*, *DcWomA*, *WhAmArt 85*
Thompson, Harlyn E 1933- *AmArch 70*
Thompson, Harmon A 1923- *MarqDCG 84*

Thompson, Harold Goodwin 1922- *AmArch 70*
Thompson, Harold Lane 1927- *AmArch 70*
Thompson, Harriette K *WhAmArt 85*
Thompson, Harry *WhAmArt 85*
Thompson, Harry Ives 1840-1906 *NewYHSD* , *WhAmArt 85*
Thompson, Harry S *DcVicP 2*
Thompson, Helen Foht 1900- *WhAmArt 85*
Thompson, Helen Lathrop 1889- *DcWomA*, *WhAmArt 85*
Thompson, Helen S *WhAmArt 85*
Thompson, Henry *NewYHSD*
Thompson, Sir Henry 1820-1904 *DcVicP, -2*
Thompson, Herbert E 1877-1932 *WhAmArt 85*
Thompson, Herbert Henry 1926- *AmArch 70*
Thompson, Hiram H 1885- *WhAmArt 85*
Thompson, Howard Francis 1934- *AmArch 70*
Thompson, Isa *DcVicP 2*, *DcWomA*
Thompson, Israel *FolkA 86*
Thompson, J L *AmArch 70*
Thompson, J R *AmArch 70*
Thompson, J Woodman *WhAmArt 85*
Thompson, Jack Dean 1927- *AmArch 70*
Thompson, Jacob 1806-1879 *DcVicP, -2*
Thompson, Jamal *AfroAA*
Thompson, James *BiDBrA*, *DcVicP 2*, *NewYHSD*
Thompson, James A *FolkA 86*
Thompson, James Bradbury 1911- *WhoAmA 78*
Thompson, James Edward 1926- *AmArch 70*
Thompson, James Grannis *AmArch 70*
Thompson, James Robert *BiDBrA*, *DcVicP 2*
Thompson, James Robert 1799?- *DcBrWA*
Thompson, Jane *DcWomA*
Thompson, Janet Reid *WhAmArt 85*
Thompson, Jared D *NewYHSD*
Thompson, Jean Danforth 1933- *WhoAmA 84*
Thompson, Jerome 1814- *ArtsNiC*
Thompson, Jerome B 1814-1886 *BnEnAmA*, *DcAmArt*, *IlBEAAW*, *NewYHSD*
Thompson, Joanne *WhoAmA 73, -76, -78, -80*
Thompson, John *FolkA 86*, *NewYHSD*
Thompson, John d1792 *BiDBrA*
Thompson, John 1837-1921 *ICPEnP*
Thompson, John 1940- *AmArt*
Thompson, John A 1923- *AmArch 70*
Thompson, John C *NewYHSD*
Thompson, John Douglas 1947- *MarqDCG 84*
Thompson, John Edward 1882-1945 *ArtsAmW 1*, *WhAmArt 85*
Thompson, Mrs. John H *ArtsEM*, *DcWomA*
Thompson, John Maurice *WhoAmA 82, -84*
Thompson, John Moomaw 1904- *AmArch 70*
Thompson, John Richard, Jr. 1920- *AmArch 70*
Thompson, John W *FolkA 86*
Thompson, John William 1924- *AmArch 70*
Thompson, Jon William 1950- *MarqDCG 84*
Thompson, Judith Kay 1940- *AmArt*, *WhoAmA 78, -80, -82, -84*
Thompson, Juliet 1873-1956 *DcWomA*
Thompson, Juliet H d1956 *WhAmArt 85*, *WhoAmA 80N, -82N, -84N*
Thompson, Kate *DcVicP 2*, *DcWomA*
Thompson, Kate E 1872- *DcWomA*, *WhAmArt 85*
Thompson, Kenneth Charles 1913- *AmArch 70*
Thompson, Kenneth Theodore 1912- *AmArch 70*
Thompson, Kenneth W 1907- *WhAmArt 85*
Thompson, Kenneth Webster 1907- *WhoAmA 73, -76, -78, -80, -82, -84*
Thompson, Launt 1833- *ArtsNiC*
Thompson, Launt 1833-1894 *BnEnAmA*, *EarABI*, *NewYHSD* , *WhAmArt 85*
Thompson, Laura Jones 1899- *WhAmArt 85*
Thompson, Laura Jones 1899-1963 *DcWomA*
Thompson, Leroy William 1902- *AmArch 70*
Thompson, Leslie P d1963 *WhoAmA 78N, -80N, -82N, -84N*
Thompson, Leslie Prince 1880-1963 *WhAmArt 85*
Thompson, Lockwood 1901- *WhoAmA 73, -76, -78, -80, -82, -84*
Thompson, Lorin Hartwell, Jr. 1911- *WhAmArt 85*
Thompson, Louise Guthrie 1902- *WhAmArt 85*
Thompson, Lovett *AfroAA*
Thompson, Lynn P 1922- *WhoAmA 84*
Thompson, M *FolkA 86*
Thompson, M A *DcWomA*
Thompson, M R *AmArch 70*
Thompson, Major *FolkA 86*
Thompson, Malcolm Barton 1916- *WhoAmA 73, -76, -78, -80, -82, -84*
Thompson, Margaret *DcBrBI*, *DcVicP 2*, *DcWomA*
Thompson, Margaret 1843-1928 *DcBrWA*
Thompson, Margaret A Howard *WhAmArt 85*
Thompson, Margaret Whitney 1900- *WhAmArt 85*
Thompson, Marguerite *DcWomA*
Thompson, Marietta 1803- *DcWomA*, *NewYHSD*
Thompson, Mark 1812-1875 *DcVicP 2*
Thompson, Mark Graystone *BiDBrA*
Thompson, Martha *DcWomA*
Thompson, Martin E 1786?-1877 *NewYHSD*
Thompson, Martin E 1787-1877 *MacEA*
Thompson, Martin E 1789-1877 *BiDAmAr*

Thompson, Marvin Francis 1895- *WhAmArt 85*
Thompson, Mary *DcWomA*, *WhAmArt 85*
Thompson, Mary Elizabeth 1896- *DcBrA 1*, *DcWomA*
Thompson, Matt Raine *DcVicP 2*
Thompson, Sir Matthew William 1872-1956 *DcBrA 2*
Thompson, Mike 1954- *DcCAr 81*
Thompson, Mildred *AfroAA*
Thompson, Mills 1875- *WhAmArt 85*
Thompson, Mozelle *IlsBYP*
Thompson, Mozelle d1970 *AfroAA*
Thompson, Myra 1860- *DcWomA*, *WhAmArt 85*
Thompson, N E *AmArch 70*
Thompson, Nancy Kunkle 1941- *WhoAmA 76, -78, -80, -82, -84*
Thompson, Nellie Louise *DcWomA*, *WhAmArt 85*
Thompson, Nelly *DcVicP 2*
Thompson, Paul Francis 1935- *AmArch 70*
Thompson, Paul Leland 1911- *WhAmArt 85*, *WhoAmA 73*
Thompson, Peter 1800?-1874 *BiDBrA*
Thompson, Philip David 1939- *AmArch 70*
Thompson, Phyllis 1946- *WhoAmA 78, -80*
Thompson, Polly Povey *AmArch 70*
Thompson, R A *DcVicP 2*
Thompson, R D *AmArch 70*
Thompson, R E *AmArch 70*
Thompson, R G *AmArch 70*
Thompson, Ralph *IlsBYP*, *IlsCB 1946*
Thompson, Ralston Carlton 1904- *WhAmArt 85*, *WhoAmA 73, -76*
Thompson, Raymond Kermit 1905- *AmArch 70*
Thompson, Raymond Sidney 1928- *AmArch 70*
Thompson, Rebecca Hull 1885- *AmArch 70*
Thompson, Richard 1914- *PrintW 85*
Thompson, Richard 1945- *DcCAr 81*
Thompson, Richard Craig 1945- *WhoAmA 76, -78, -80, -82, -84*
Thompson, Richard E, Jr. 1939- *WhoAmA 78, -80, -82, -84*
Thompson, Richard Earl *OfPGCP 86*
Thompson, Richard Earl 1914- *AmArt*
Thompson, Richard Earl, Sr. 1914- *WhoAmA 78, -80, -82, -84*
Thompson, Ritchie *FolkA 86*
Thompson, Robert 1937-1966 *AfroAA*
Thompson, Robert Allan 1937- *MarqDCG 84*
Thompson, Robert Charles 1936- *WhoAmA 76, -78, -80, -82, -84*
Thompson, Robert Harper, Jr. 1927- *AmArch 70*
Thompson, Robert Webster *AmArch 70*
Thompson, Roberta 1928- *AfroAA*
Thompson, Rodney *WhAmArt 85*
Thompson, Romulus Hillard 1922- *AmArch 70*
Thompson, Ronald Edwin 1935- *AmArch 70*
Thompson, Ronald Hugh *AmArch 70*
Thompson, Ronald Kay 1930- *AmArch 70*
Thompson, Russ 1922- *AfroAA*
Thompson, Samuel 1779-1815 *CabMA*
Thompson, Sarah K *DcWomA*
Thompson, Seymour *WhAmArt 85*
Thompson, Stanley 1876- *DcBrA 1*, *DcVicP 2*
Thompson, Susie Wass 1892- *DcWomA*, *WhoAmA 73*
Thompson, T W *DcVicP 2*
Thompson, Tamara 1935- *WhoAmA 76, -78, -80, -82, -84*
Thompson, Thomas *DcBrECP*
Thompson, Thomas 1775?-1852 *NewYHSD*
Thompson, Thomas Bunnell 1907- *AmArch 70*
Thompson, Thomas Clement 1778-1857 *DcVicP, -2*
Thompson, Thomas Hiram 1876- *ArtsAmW 2*, *WhAmArt 85*
Thompson, Mrs. Thomas James *DcWomA*
Thompson, Thomas Pickering *DcBrWA*
Thompson, Thomas W 1936- *MarqDCG 84*
Thompson, Victor King 1913- *AmArch 70*, *WhAmArt 85*
Thompson, W H *AmArch 70*
Thompson, W O *AfroAA*
Thompson, W P, Jr. *AmArch 70*
Thompson, W S *AmArch 70*
Thompson, Wade 1946- *WhoAmA 76, -78, -80, -82, -84*
Thompson, Walter B d1919 *DcBrA 1*
Thompson, Walter W 1882-1948 *WhAmArt 85*
Thompson, Walter Whitcomb d1948 *WhoAmA 78N, -80N, -82N, -84N*
Thompson, Wilfred H *DcBrA 2*, *DcVicP, -2*
Thompson, William *AfroAA*, *CabMA*, *DcVicP 2*, *FolkA 86*, *NewYHSD*
Thompson, William d1785 *DcBrWA*
Thompson, William 1730?-1800 *DcBrECP*
Thompson, William 1750-1785 *DcBrECP*
Thompson, William John 1771-1845 *NewYHSD*
Thompson, William Joseph 1926- *WhoAmA 76, -78, -80, -82, -84*
Thompson, William M *NewYHSD*
Thompson, William Magill 1926- *AmArch 70*
Thompson, William Norman 1913- *WhAmArt 85*
Thompson, Wilson E *AfroAA*

Thompson, Winifred Dorothy Gilliland 1906-1945 *WhAmArt 85*
Thompson, Woodman 1889- *WhAmArt 85*
Thompson Hayward *EncASM*
Thoms, Herbert 1885- *WhAmArt 85*
Thomsen, Charles B 1932- *AmArch 70*
Thomsen, Charles Edwin 1931- *AmArch 70*
Thomsen, Edvard 1884-1980 *MacEA*
Thomsen, Emma Augusta 1822-1897 *DcWomA*
Thomsen, H A, Jr. *AmArch 70*
Thomsen, Johanne *DcWomA*
Thomsen, Knud 1945- *MarqDCG 84*
Thomsen, Mitch 1950- *WhoAmA 84*
Thomsen, Pauline 1858-1931 *DcWomA*
Thomsen, Sandor VonColditz 1879-1914 *WhAmArt 85*
Thomson *NewYHSD*
Thomson, Miss *DcWomA*
Thomson, A E *DcVicP 2, DcWomA*
Thomson, Mrs. Adam *DcVicP 2*
Thomson, Adam Bruce 1885- *DcBrA 1, WhoArt 80, -82*
Thomson, Adele U 1887- *WhAmArt 85*
Thomson, Adele Underwood 1882- *DcWomA*
Thomson, Adele Underwood 1887- *ArtsAmW 2*
Thomson, Alexander *BiDBrA*
Thomson, Alexander 1817-1875 *MacEA, McGDA, OxArt, WhoArch*
Thomson, Alexander P *DcBrA 1*
Thomson, Alfred Reginald *WhoArt 80, -82N*
Thomson, Alfred Reginald 1894- *DcBrA 1*
Thomson, Andrew Grierson 1848-1911 *BiDAmAr*
Thomson, Arline K 1912- *IlsBYP*
Thomson, Bessie *DcVicP 2*
Thomson, Campbell *NewYHSD*
Thomson, Carl L 1913- *WhoAmA 73, -76, -78, -80, -82, -84*
Thomson, Charles Lambert Colin d1926 *DcBrA 1*
Thomson, D F *AmArch 70*
Thomson, Diana 1939- *WhoArt 84*
Thomson, E Gertrude *DcVicP 2*
Thomson, Edmund *CabMA*
Thomson, Elma *DcWomA*
Thomson, Emily Gertrude *ClaDrA, DcBrA 1*
Thomson, Emily Gertrude d1932 *DcBrBI, DcWomA*
Thomson, Frances Ingram d1845 *DcWomA*
Thomson, Frances Louise 1870- *WhAmArt 85*
Thomson, George 1860-1939 *DcBrA 1, DcBrBI, DcBrWA, DcVicP 2*
Thomson, George 1868- *WhAmArt 85*
Thomson, George L 1916- *WhoArt 80, -82, -84*
Thomson, Gordon *DcBrBI, DcVicP 2*
Thomson, H B *AmArch 70*
Thomson, H G 1850-1939? *WhAmArt 85*
Thomson, Henry 1773-1843 *DcBrBI, DcBrECP, DcBrWA*
Thomson, Hugh 1860-1920 *AntBDN B, DcBrA 1, DcBrBI, DcBrWA, DcVicP 2*
Thomson, Isaac 1749-1819 *FolkA 86*
Thomson, J *DcVicP 2*
Thomson, J Leslie 1851-1929 *DcVicP*
Thomson, J R *AmArch 70*
Thomson, James *BiDBrA, NewYHSD*
Thomson, James 1784?-1832 *BiDBrA*
Thomson, James 1800-1883 *DcVicP 2*
Thomson, James 1835-1905 *MacEA*
Thomson, James P *NewYHSD*
Thomson, James William 1775?-1825? *DcBrBI*
Thomson, Jerome *FolkA 86*
Thomson, John *DcVicP 2, NewYHSD*
Thomson, John 1778-1840 *DcBrWA*
Thomson, John 1837-1921 *ICPEnP, MacBEP*
Thomson, John Knighton 1820-1888 *DcVicP, -2*
Thomson, John Leslie 1851-1929 *DcBrA 1, DcBrWA, DcVicP 2*
Thomson, John Murray 1885- *DcBrA 1*
Thomson, John Murray 1885-1974 *DcBrA 2*
Thomson, Josephine N 1872-1928 *WhAmArt 85*
Thomson, Josephine W 1872-1928 *DcWomA*
Thomson, Karline 1912- *IlsCB 1946*
Thomson, Lawrence Gilmore 1906- *AmArch 70*
Thomson, Louisa Emily 1883- *DcBrA 1, DcWomA*
Thomson, Margaret Stanley 1891- *ClaDrA*
Thomson, Michel *OxTwCA*
Thomson, Robert Frederic 1930- *AmArch 70*
Thomson, Rodney 1878- *ArtsAmW 3, WhAmArt 85*
Thomson, Russell Kelvin, Jr. 1936- *AmArch 70*
Thomson, Samuel *CabMA*
Thomson, Sarah *DcWomA, FolkA 86, NewYHSD*
Thomson, Sarah K *WhAmArt 85*
Thomson, Sinclair 1914- *DcBrA 2*
Thomson, Thomas John 1877-1917 *ArtsAmW 3, OxTwCA*
Thomson, Tom 1877-1917 *ArtsAmW 3, IlBEAAW, McGDA, OxArt, PhDcTCA 77*
Thomson, William *DcVicP 2, FolkA 86, WhAmArt 85*
Thomson, William 1730?-1800 *DcBrECP*
Thomson, William 1926- *DcBrA 2, WhoArt 80, -82, -84*
Thomson, William Conner 1919- *AmArch 70*
Thomson, William David 1931- *WhoAmA 76, -78*

Thomson, William Hill 1882- *DcBrA 1*
Thomson, William T 1858- *WhAmArt 85*
Thomson, Winifred Hope d1944 *DcBrA 2, DcWomA*
Thon, Raymond Albert 1921- *AmArch 70*
Thon, William 1906- *McGDA, WhAmArt 85, WhoAmA 73, -76, -78, -80, -82, -84*
Thonet, Michael 1796-1871 *AntBDN G, DcNiCA, McGDA, OxDecA*
Thony, Eduard 1866-1950 *WorECar*
Thony, Wilhelm 1888-1949 *OxTwCA*
Thooft & Labouchere *DcNiCA*
Thorame, Jean Pierre *NewYHSD*
Thorbeck, Duane 1935- *AmArch 70*
Thorberg, Trygve *WhAmArt 85*
Thorburn, Archibald 1860-1935 *ClaDrA, DcBrA 1, DcBrBI, DcBrWA, DcVicP, -2, GrBII[port]*
Thorburn, Robert 1818- *ArtsNiC*
Thorburn, Robert 1818-1885 *ClaDrA*
Thore, Theophile 1807-1869 *OxArt*
Thoreau, Sofia 1819-1876 *DcWomA*
Thoreau, Sophia 1819-1876 *NewYHSD*
Thoreau, Sophia E 1819-1876 *EarABI*
Thorek, Max 1880- *WhAmArt 85*
Thorel, Madame *DcWomA*
Thorel, Jenny *DcWomA*
Thorel, Marie Cecile *DcWomA*
Thorell, Hildegard Katarina 1850-1930 *DcWomA*
Thoresen, Ida Caroline 1863- *DcWomA*
Thoreson, Sharilyn A *MarqDCG 84*
Thorigny, Felix 1824-1870 *DcBrBI*
Thorman, David Frederick 1938- *AmArch 70*
Thormann, Anne-Marie Zeerleder- 1913- *WhoArt 80, -82, -84*
Thormann, Otmar Uwe 1944- *MacBEP*
Thormin, A *AmArch 70*
Thorn, Catherine *FolkA 86*
Thorn, Craig Barton 1930- *AmArch 70*
Thorn, E S *AmArch 70*
Thorn, Hother Bradford 1916- *AmArch 70*
Thorn, J C 1835-1898 *NewYHSD*
Thorn, Kamma *DcWomA*
Thorn, Linton *NewYHSD*
Thorn, Mary Elizabeth 1928- *WhoArt 82, -84*
Thorn, Sarah Elizabeth *DcVicP -2, DcWomA*
Thorn, T *DcVicP 2*
Thorn, William *CabMA*
Thorn-Prikker, Jan 1868-1932 *PhDcTCA 77*
Thorn Prikker, Johan 1869-1923 *OxArt*
Thorn-Prikker, Johann 1868-1932 *McGDA*
Thorn-Thomsen, Ruth 1943- *ICPEnP A*
Thornam, Emmy Marie Caroline 1852-1935 *DcWomA*
Thornam, Ludovica Anine Vilhelmine A 1853-1896 *DcWomA*
Thornam, Marie Elise 1857-1901 *DcWomA*
Thornberg, Frederick Kelley 1924- *AmArch 70*
Thornberry, Bernice *WhAmArt 85*
Thornberry, William A *DcBrA 1*
Thornbery, Mary *WhoArt 80, -82, -84*
Thornbery, Mary Todd 1921- *DcBrA 1*
Thornbery, William A *DcVicP 2*
Thornbold *DcBrECP*
Thornburg, Florence V *DcWomA*
Thornburgh, F K *WhAmArt 85*
Thornbury, H L *DcVicP 2*
Thornbury, W A *DcVicP 2*
Thorndike, Charles Hall 1875- *WhAmArt 85*
Thorndike, Charles J 1897- *WhAmArt 85*
Thorndike, Charles Jesse 1897- *ArtsAmW 3, WhoAmA 73, -76, -78, -80, -82, -84*
Thorndike, Chuck 1897- *ArtsAmW 3*
Thorndike, G Quincy 1825?- *ArtsNiC*
Thorndike, George Quincy 1825?-1887? *NewYHSD*
Thorndike, John James 1829?- *NewYHSD*
Thorndike, Willis Hale 1872-1940 *ArtsAmW 2, WhAmArt 85*
Thorne, Angela Rosemary 1911- *WhoArt 80, -82, -84*
Thorne, Anna Louise 1866?- *DcWomA, WhAmArt 85*
Thorne, Anna Louise 1878- *ArtsEM*
Thorne, Carlton *AfroAA*
Thorne, Diana 1894- *IlsBYP, IlsCB 1744, -1946*
Thorne, Diana 1895- *DcWomA, WhAmArt 85*
Thorne, Frank 1930- *ConGrA 1[port]*
Thorne, Gordon 1896- *WhoAmA 73, -76, -78, -80*
Thorne, Henry Vane *NewYHSD*
Thorne, J *DcVicP 2*
Thorne, James Markham 1937- *AmArch 70*
Thorne, Joan 1943- *DcCAr 81*
Thorne, John *NewYHSD*
Thorne, Kristine Laache *DcWomA*
Thorne, Linton *NewYHSD*
Thorne, M Art 1909- *WhoAmA 73, -76*
Thorne, R *DcBrECP*
Thorne, Thomas 1909- *WhAmArt 85*
Thorne, Thomas Elston 1909- *WhoAmA 73, -76*
Thorne, William 1864-1956 *WhAmArt 85*
Thorne-Thomsen, Ruth 1943- *MacBEP*
Thorne-Thomsen, Ruth T 1943- *WhoAmA 84*
Thorne-Waite, Robert 1842- *ClaDrA*
Thorne Waite, Robert 1842-1935 *DcVicP 2*
Thorneley, Mrs. *DcWomA*

Thorneley, Charles *DcVicP, -2*
Thornell, Robert *AfroAA*
Thornely, Charles *DcSeaP*
Thornely, H *DcBrBI*
Thorneycroft, Alyce M *DcBrWA*
Thorneycroft, Helen 1840?-1913? *DcBrWA*
Thornhill, Anna 1940- *WhoAmA 76, -78, -80, -82*
Thornhill, James 1675-1734 *MacEA*
Thornhill, Sir James 1675-1734 *BiDBrA, DcBrECP, DcBrWA, McGDA, OxArt*
Thornhill, Sir James 1676-1734 *BkIE*
Thornhill, Philip J *DcVicP 2*
Thornhill, Robert Blair 1926- *MarqDCG 84*
Thornley, D'Arcy *DcBrA 2*
Thornley, Hubert *DcVicP, -2*
Thornley, Morgan Alfred 1897- *ClaDrA, DcBrA 1*
Thornley, William *DcVicP, -2*
Thornley, William 1857- *ClaDrA*
Thornley, William A *DcBrA 1*
Thornock, Roy D 1936- *MarqDCG 84*
Thorns, John Cyril, Jr. 1926- *WhoAmA 76, -78, -80, -82, -84*
Thornschein, Isidor 1886-1947 *WhAmArt 85*
Thornthwaite, Andrew *BiDBrA*
Thornton, Alfred Henry Robinson 1863-1939 *DcBrA 1, DcBrBI, DcBrWA, DcVicP 2*
Thornton, Alice Green 1903- *WhAmArt 85*
Thornton, Amy G 1845?-1913 *DcWomA, WhAmArt 85*
Thornton, Anna Foster 1905- *WhAmArt 85*
Thornton, Anna Maria *DcWomA*
Thornton, Catherine *DcVicP 2*
Thornton, Cecil Jeffery 1911- *DcBrA 1*
Thornton, F C *WhoArt 80N*
Thornton, F W *AmArch 70*
Thornton, 'Gene 1898- *WhAmArt 85*
Thornton, Harold 1892-1958 *DcBrA 1*
Thornton, Henry LaVerne 1906- *WhAmArt 85*
Thornton, Jerry M 1930- *AmArch 70*
Thornton, Jim 1937- *WhoAmA 82, -84*
Thornton, John *DcBrWA*
Thornton, John Carman 1888- *AmArch 70*
Thornton, Kathleen Edith 1901- *DcBrA 1*
Thornton, Leslie 1925- *WhoArt 80, -82, -84*
Thornton, M E *AmArch 70*
Thornton, M J *DcVicP 2*
Thornton, Margaret Jane 1913- *WhAmArt 85*
Thornton, Mildred Valley 1900?- *DcWomA, IlBEAAW*
Thornton, Richard Samuel 1934- *WhoAmA 80, -82, -84*
Thornton, Robert Weaver 1951- *MarqDCG 84*
Thornton, Roy John 1919- *AmArch 70*
Thornton, Thomas *DcBrECP*
Thornton, Valerie 1931- *WhoArt 80, -82, -84*
Thornton, W *DcVicP 2*
Thornton, Wallace 1915- *McGDA*
Thornton, William 1670?-1721 *BiDBrA*
Thornton, William 1759-1826 *BiDAmAr, EncAAr*
Thornton, William 1759-1828 *BnEnAmA, MacEA, McGDA, NewYHSD, WhoArch*
Thornton Brothers *EncASM*
Thornton-Clarke, Miss E *DcBrA 2*
Thornycroft, Alyce *DcWomA*
Thornycroft, Alyce Mary 1844-1906 *DcVicP 2*
Thornycroft, Alyn M *DcWomA*
Thornycroft, Hamo *ArtsNiC*
Thornycroft, Helen *ArtsNiC, ClaDrA, DcVicP, DcWomA*
Thornycroft, Helen d1937 *DcBrA 2*
Thornycroft, Helen 1848-1912 *DcVicP 2*
Thornycroft, Mary 1814- *ArtsNiC*
Thornycroft, Mary 1814-1895 *DcWomA*
Thornycroft, Rosalind 1891- *IlsCB 1744*
Thornycroft, Theresa *ArtsNiC*
Thornycroft, Theresa G *DcVicP, DcWomA*
Thornycroft, Theresa Georgina 1853- *DcVicP 2*
Thornycroft, Thomas *ArtsNiC*
Thornycroft, Sir William Hamo 1850-1925 *DcBrA 1, McGDA*
Thorogood, Stanley 1873-1953 *DcBrA 2*
Thorold, William 1798-1878 *BiDBrA*
Thorp, Earl Norwell d1951 *WhAmArt 85, WhoAmA 78N, -80N, -82N, -84N*
Thorp, George 1847-1939 *DcBrWA*
Thorp, Hattie E *DcWomA, WhAmArt 85*
Thorp, J Greenleaf 1864-1934 *BiDAmAr*
Thorp, James *BiDBrA*
Thorp, Mrs. William *WhAmArt 85*
Thorp, William Eric 1901- *DcBrA 1, DcSeaP, WhoArt 80, -82, -84*
Thorp, Zephaniah *NewYHSD*
Thorpe, Carlton *AfroAA*
Thorpe, Cynthia Jean 1951- *WhoAmA 82*
Thorpe, Dorothy Carpenter 1901- *WhAmArt 85*
Thorpe, Edward *WhAmArt 85*
Thorpe, Elizabeth *DcVicP 2*
Thorpe, Everett Clark 1907- *IlBEAAW, WhAmArt 85, WhoAmA 73, -76*
Thorpe, Freeman 1844-1922 *WhAmArt 85*
Thorpe, George H *NewYHSD*

Thorpe, Hilda 1919- *WhoAmA 84*
Thorpe, James H 1876-1949 *DcBrBI*
Thorpe, Jayta Pauline 1912- *WhAmArt 85*
Thorpe, John *DcVicP, –2*
Thorpe, John 1563?-1655? *MacEA, McGDA*
Thorpe, John 1563?-1655 *OxArt*
Thorpe, John 1565?-1655? *BiDBrA*
Thorpe, John Hall 1874- *DcBrA 1*
Thorpe, John Hall 1874-1947 *DcBrA 2*
Thorpe, Lesbia *DcCAr 81*
Thorpe, Leslie William 1943- *MarqDCG 84*
Thorpe, T W *NewYHSD*
Thorpe, Thomas *DcBrWA, DcVicP 2*
Thorpe, Thomas Bangs 1815-1878 *NewYHSD*
Thorpe, William F, Jr. 1925- *AmArch 70*
Thors, Joseph *ClaDrA, DcVicP, –2*
Thors, S *DcVicP 2*
Thorsell, C P *AmArch 70*
Thorsen, C E *AmArch 70*
Thorsen, Hugo S 1923- *AmArch 70*
Thorsen, Lars 1876-1952 *WhAmArt 85*
Thorsen, Michael Jon 1942- *MarqDCG 84*
Thorsen, Thomas Vincent 1921- *AmArch 70*
Thorsen, Willard Lien 1924- *AmArch 70*
Thorshov, Olaf 1883-1928 *BiDAmAr*
Thorshov, Roy Norman 1905- *AmArch 70*
Thorsnes, L R *AmArch 70*
Thorsoe, Sofie *DcWomA*
Thorson, G A *AmArch 70*
Thorson, Louise *WhAmArt 85*
Thorson, Oswald Hagen 1912- *AmArch 70*
Thorson, Robert Leon 1930- *AmArch 70*
Thorsteinsdottir, Bjorg 1940- *DcCAr 81*
Thorsten, Lloyd R *OfPGCP 86*
Thorwald *AfroAA*
Thorwaldsen, Albert Bertel 1768?-1844 *McGDA*
Thorwaldsen, Bertel 1768-1844 *OxArt*
Thorwaldsen, Bertel 1770-1844 *DcNiCA*
Thorward, Clara Schafer *WhAmArt 85*
Thorward, Clara Schafer 1887- *DcWomA*
Thory, Marie Marguerite Apoil *DcWomA*
Thothmes III 1504?BC-1450BC *IlDcG*
Thouron, Henry Joseph 1851-1915 *WhAmArt 85*
Thouvenin, Mademoiselle *DcWomA*
Thrale, Mrs. *DcWomA*
Thrale, Sophia *DcWomA*
Thrall, A N *NewYHSD*
Thrall, Arthur 1926- *WhoAmA 73, –76, –78, –80, –82, –84*
Thrall, W F *AmArch 70*
Thrane, Finn Erik 1939- *MacBEP*
Thrane, Ragnhild Christine 1856-1913 *DcWomA*
Thrapsimis, Angelos Gust 1935- *AmArch 70*
Thrash, Dox 1892- *WhAmArt 85*
Thrash, Dox 1893- *AfroAA*
Thrasher, George *NewYHSD*
Thrasher, Harry Dickinson 1883-1918 *WhAmArt 85*
Thrasher, Leslie 1889-1936 *WhAmArt 85*
Thrasymedes *McGDA*
Threadgill, John L 1934- *AmArch 70*
Threadgill, Robert 1930- *AfroAA*
Threadgill, Robert Allen 1930- *WhoAmA 76*
Threlfall, R *DcVicP 2*
Threlkeld, Dale 1944- *WhoAmA 76, –78, –80, –82, –84*
Thresher, Brainard B *WhAmArt 85*
Thresher, George *FolkA 86, NewYHSD*
Thresher, Sprague 1919- *AmArch 70*
Thring, G *DcVicP 2*
Throckmorton, Cleon 1897- *WhAmArt 85*
Throckmorton, Jeannette Dean *FolkA 86*
Throckmorton, Roberta *DcWomA*
Throop, Benjamin F 1837?- *NewYHSD*
Throop, Daniel Scrope 1800- *EarABI, NewYHSD*
Throop, Deborah *DcWomA, FolkA 86*
Throop, Frances *DcWomA*
Throop, Mrs. George Addison *NewYHSD*
Throop, John Peter VanNess 1794-1861? *NewYHSD*
Throop, Orramel Hinckley 1798- *NewYHSD*
Thropp *FolkA 86*
Throsby, John 1740-1803 *DcBrWA*
Throssel, Richard 1881?-1933 *ArtsAmW 3*
Throssell, Richard 1881?-1933 *ArtsAmW 3*
Thrupp, Frederick 1812-1895 *DcBrBI, DcBrWA*
Thrush, Helen Alverda 1903- *WhAmArt 85*
Thubron, Harry *DcCAr 81*
Thubron, Harry 1915- *ConBrA 79[port]*
Thuillier, Louise *DcWomA*
Thulden, Theodoor Van 1606-1669 *McGDA*
Thulden, Theodor Van 1606-1669 *OxArt*
Thulden, Theodor Van 1606-1676 *ClaDrA*
Thulin, Emil O *WhAmArt 85*
Thulin, Frederick Adolph, Jr. 1925- *AmArch 70*
Thulin, Walfred 1878- *WhAmArt 85*
Thulstrup *WhAmArt 85*
Thulstrup, Thure De 1848-1930 *IlrAm A, –1880*
Thum, Patty P 1853-1926 *WhAmArt 85*
Thum, Patty Prather 1853-1926 *DcWomA*
Thum, William M *WhAmArt 85*
Thum Hohnstein, Countess Von *DcWomA*
Thumayr, Marie *DcWomA*

Thumb, Michael 1640?-1690 *WhoArch*
Thumb, Peter 1681-1766 *McGDA, WhoArch*
Thumb Family *MacEA*
Thun, Eugene William 1924- *AmArch 70*
Thun, Hans Herman 1935- *AmArch 70*
Thun, Marie 1852-1905 *DcWomA*
Thunder, Frank *FolkA 86*
Thunheim, Countess Louise *DcWomA*
Thurah, Laurids De 1706-1759 *WhoArch*
Thurall, H *DcWomA*
Thurber, Alice Hagerman 1871- *ArtsEM, WhAmArt 85*
Thurber, Alice Hagerman 1871-1952 *DcWomA*
Thurber, Caroline *DcVicP 2, DcWomA, WhAmArt 85*
Thurber, Edna 1887-1981 *WhAmArt 85*
Thurber, George Scott 1917- *AmArch 70*
Thurber, George W *NewYHSD*
Thurber, James 1894-1961 *WhoGrA 62*
Thurber, James Grover 1894-1961 *WhAmArt 85, WorECar*
Thurber, Rosemary 1898- *DcWomA, WhAmArt 85*
Thuret, Andre 1898- *IlDcG*
Thuret, Anne Marie Gabrielle *DcWomA*
Thurgar, Lucy *DcBrECP*
Thurheim, Ludovica Francisca Maria 1788-1864 *DcWomA*
Thurheim, Countess Therese 1831-1909 *DcWomA*
Thurley, Frederick Charles 1885- *DcBrA 1*
Thurlo, Frank 1828-1913 *NewYHSD , WhAmArt 85*
Thurlow, Fearn Cutler 1924- *WhoAmA 78, –80, –82*
Thurlow, Fearn Cutler 1924-1982 *WhoAmA 84N*
Thurlow, Helen 1889- *DcWomA, WhAmArt 85*
Thurlow, Sarah W *ArtsEM, DcWomA*
Thurman, Allen Dale 1934- *AmArch 70*
Thurman, Christa Charlotte Mayer 1934- *WhoAmA 80, –82, –84*
Thurman, Edward Blair 1922- *AmArch 70*
Thurman, Henry Louis 1927- *AmArch 70*
Thurman, Mary Elizabeth Woods *FolkA 86*
Thurmer, Irmgard 1883- *DcWomA*
Thurmer, R A *AmArch 70*
Thurmond, Ethel Dora 1905- *WhAmArt 85*
Thurn, Dorothy Maria 1907- *WhAmArt 85*
Thurn, Ernest 1889- *WhAmArt 85*
Thurn, Countess Laura *DcWomA*
Thurnall, Harry J *DcVicP 2*
Thurnberg, Maria De *DcWomA*
Thurot, Blanche Lucie *DcWomA*
Thursby, Miss *DcBrECP*
Thursby, Peter 1930- *WhoArt 80, –82, –84*
Thursby, Mrs. *DcVicP 2*
Thurston, Mrs. *NewYHSD*
Thurston, B *NewYHSD*
Thurston, Charles W *WhAmArt 85*
Thurston, Elizabeth *DcWomA, FolkA 86, NewYHSD*
Thurston, Elmer M *WhAmArt 85*
Thurston, Enoch d1805 *CabMA*
Thurston, Eugene B 1896- *ArtsAmW 3*
Thurston, Florence *WhAmArt 85*
Thurston, George A *WhAmArt 85*
Thurston, Henry W 1818- *CabMA*
Thurston, Ida *ArtsEM, DcWomA*
Thurston, Jack L 1919- *IlBEAAW*
Thurston, Jacqueline 1939- *DcCAr 81*
Thurston, Jacqueline Beverly 1939- *MacBEP, WhoAmA 78, –80, –82, –84*
Thurston, Jane 1887-1967 *DcWomA*
Thurston, Jane McDuffie 1887- *WhAmArt 85*
Thurston, Jane McDuffie 1887-1967 *ArtsAmW 2*
Thurston, John *CabMA*
Thurston, John 1774-1822 *BkIE, DcBrBI, DcBrWA*
Thurston, John H *DcVicP 2*
Thurston, John K 1865- *WhAmArt 85*
Thurston, Neptune *AfroAA, NewYHSD*
Thurston, Peris G *NewYHSD*
Thurston, Rosalie W *WhoArt 80, –82, –84*
Thurston, Rosalie Winifred *DcBrA 1*
Thurstun, Charlotte *DcWomA*
Thurstun, Mrs. Ray *DcVicP 2*
Thurtle, F *DcBrECP*
Thurtle, S *DcBrECP*
Thurwanger, Charles *NewYHSD*
Thurwanger, John *NewYHSD*
Thurwanger, Joseph *NewYHSD*
Thurwanger, Josephine Felicite *DcWomA*
Thurwanger, Marguerite *DcWomA*
Thurwanger, Martin T d1890 *NewYHSD*
Thurwanger, Veneria 1813?- *DcWomA, NewYHSD*
Thurwanger, Verena 1813?- *NewYHSD*
Thurzan, Mary *DcBrECP*
Thustle, F *DcBrECP*
Thustle, S *DcBrECP*
Thwaites, Charles Winstanley 1904- *WhAmArt 85, WhoAmA 73, –76, –78, –80, –82, –84*
Thwaites, William H *EarABI, EarABI SUP, NewYHSD*
Thwaits *IlBEAAW*
Thweatt, Gilbert W 1929- *AmArch 70*
Thwing, Benjamin *CabMA*
Thwing, J Franklin *WhAmArt 85*

Thwing, Leroy L *WhAmArt 85*
Thymann, Maria Christine 1867-1928 *DcWomA*
Thynn, Alexander 1932- *WhoArt 82, –84*
Thynne, Lady *DcWomA*
Thys, Babette *DcWomA*
Thys, Pieter 1624-1677 *McGDA*
Thys, S F *DcWomA*
Thyssens, Francis *NewYHSD*
Tian, Honorine *DcWomA*
Tiano, Herman 1932- *AmArch 70*
Tiarini, Alessandro 1577-1668 *McGDA*
Tibaldi, Domenico 1541-1583 *McGDA*
Tibaldi, Isabella *DcWomA*
Tibaldi, Maria Felice *DcWomA*
Tibaldi, Pellegrino 1527-1596 *MacEA, McGDA, OxArt*
Tibaldi, Teresa *DcWomA*
Tibbals, Todd 1910- *AmArch 70*
Tibbenham, Don 1910- *DcBrA 1*
Tibbets, George W 1830?- *NewYHSD*
Tibbets, Marion *WhAmArt 85*
Tibbets, Susan *FolkA 86*
Tibbetts, Frank E *WhAmArt 85*
Tibbetts, George W 1830?- *NewYHSD*
Tibbils And Prentice *CabMA*
Tibbits, Charles H *EncASM*
Tibbits, Armand *WhAmArt 85*
Tibbitts, Henry B *ArtsEM*
Tibble, Geoffrey Arthur 1909- *DcBrA 1*
Tibble, Geoffrey Arthur 1909-1952 *DcBrA 2*
Tibbles, Yosette 1854-1903 *DcWomA*
Tibbles, Yosette LaFlesche 1854-1903 *ArtsAmW 1, IlBEAAW, WhAmArt 85*
Tibbs, Charlotte Eliza 1877- *DcWomA, WhAmArt 85*
Tibbs, Thomas S 1917- *WhoAmA 73, –76, –78, –80, –82, –84*
Tiberino, Ellen Powell *AfroAA*
Tiberio D'assisi 1470?-1524 *McGDA*
Tibet *WorECom*
Tice, Bill *WorFshn*
Tice, Charles Winfield 1810-1870 *EarABI SUP, NewYHSD*
Tice, Clara *WhAmArt 85*
Tice, Clara 1888-1973 *DcWomA*
Tice, George A 1938- *ConPhot, ICPEnP A, MacBEP*
Tice, George Andrew 1938- *PrintW 85, WhoAmA 78, –80, –82, –84*
Tice, Temp *DcWomA*
Tice, Tempe *WhAmArt 85*
Ticer, J E, Jr. *AmArch 70*
Tichbourn, Mary *DcBrECP*
Tichich, Alie Ebro 1918- *AmArch 70*
Ticho, Anna 1886-1980 *OxTwCA*
Ticho, Anna 1894-1980 *DcWomA*
Tichy, Rudolph John 1920- *AmArch 70*
Tickell, Frederick A *ArtsEM*
Tickell, H *DcVicP 2, DcWomA*
Ticknor, George 1791-1871 *NewYHSD*
Ticknor, J H *AmArch 70*
Tidball, John Caldwell 1825-1906 *ArtsAmW 1, IlBEAAW, NewYHSD , WhAmArt 85*
Tidd, Julius *DcBrECP, DcBrWA*
Tidd, Marshall M *NewYHSD*
Tiddeman, Florence *DcVicP, –2, DcWomA*
Tiddeman, Letitia E H *DcVicP 2, DcWomA*
Tidden, Agnes Lilienberg *WhAmArt 85*
Tidden, John C 1889- *WhAmArt 85*
Tidden, John Clark 1889- *ArtsAmW 3*
Tidemand, Adolph 1814-1876 *OxArt*
Tidemand, Adolphe 1814-1876 *ArtsNiC, ClaDrA*
Tidemann, Philipp 1657-1705 *McGDA*
Tidey, A W *DcVicP 2*
Tidey, Alfred 1806-1892 *DcBrWA*
Tidey, Alfred 1808-1892 *AntBDN J, DcVicP 2*
Tidey, Arthur 1808- *ArtsNiC*
Tidey, Henry 1814-1872 *ArtsNiC*
Tidey, Henry F 1814-1872 *DcBrWA*
Tidey, Henry Fryer 1814-1872 *DcVicP 2*
Tidey, John *DcBrWA*
Tidmarsh, H E *DcBrBI, DcVicP 2*
Tidmarsh, Roy John Eric 1944- *WhoArt 82, –84*
Tidmus, Neil Lavell 1929- *AmArch 70*
Tidoldi, John C *NewYHSD*
Tiebout, Mademoiselle *NewYHSD*
Tiebout, Cornelius 1773?-1832 *NewYHSD*
Tieck, Christian Frederic 1776-1851 *ArtsNiC*
Tiedemann, George Frederick 1936- *AmArch 70*
Tiefenthaler-Hornsteiner, Paula 1881- *DcWomA*
Tiegreen, Alan F 1935- *WhoAmA 82, –84*
Tiel, Ella Sheldon *DcWomA, WhAmArt 85*
Tiel, Robert P *MarqDCG 84*
Tiel, Vicky 1943- *WorFshn*
Tielens, Jan 1589-1630 *McGDA*
Tielke, Joachim *AntBDN K*
Tiemann, A *WhAmArt 85*
Tien, H C 1929- *MarqDCG 84*
Tien, James M 1945- *MarqDCG 84*
Tiepolo, Giambattista 1696-1770 *OxArt*
Tiepolo, Giandomenico 1727-1804 *OxArt*

Tiepolo, Giovanni Battista 1696-1770 *ClaDrA*, *OxArt*

Tiepolo, Giovanni Battista 1696-1771 *McGDA*

Tiepolo, Giovanni Domenico 1727-1804 *ClaDrA*, *McGDA*

Tiernan, Michael *NewYHSD*

Tierney, James Richard Patrick 1945- *WhoArt 80, -82, -84*

Tierney, Patrick Lennox 1914- *WhoAmA 78, -80, -82, -84*

Tierney, Robert 1936- *WhoArt 82, -84*

Tierney, Tom 1928- *ConGrA 1[port]*

Tiers, Montgomery C *NewYHSD*

Tiesenhausen, Speranza Nadezhda 1868- *DcWomA*

Tietjens, Marjorie Hilda Richardson 1895- *ArtsAmW 2, DcWomA*

Tietz, Evelyne *WhoAmA 76, -78*

Tietz, Marianne *DcWomA*

Tiffan, William H 1820?- *NewYHSD*

Tiffany, C H *AmArch 70*

Tiffany, Charles L *DcD&D, EncASM, IlDcG*

Tiffany, Charles Louis 1812-1902 *DcNiCA*

Tiffany, Lillian 1900- *WhAmArt 85*

Tiffany, Louis C 1848- *ArtsNiC*

Tiffany, Louis C 1848-1933 *MacEA, WhAmArt 85*

Tiffany, Louis Comfort *AntBDN H*

Tiffany, Louis Comfort 1848-1933 *AntBDN A, ArtsAmW 3, BnEnAmA, CenC, DcD&D, DcNiCA, IlDcG, McGDA, OxDecA, PhDcTCA 77*

Tiffany, Marguerite Bristol *WhAmArt 85, WhoAmA 73, -76, -78, -80, -82, -84*

Tiffany, Mary Adeline *DcWomA*

Tiffany, T G *AmArch 70*

Tiffany, William Shaw 1824-1907 *NewYHSD , WhAmArt 85*

Tiffany And Young *EncASM*

Tiffany Young And Ellis *DcD&D, EncASM*

Tiffeau, Jacques 1927- *FairDF US[port], WorFshn*

Tiffin, Alice Elizabeth *DcVicP 2*

Tiffin, Henry *DcBrBI, DcVicP, -2*

Tiffin, James Benjamin *DcVicP 2*

Tiffin, Lydia Emily *DcVicP 2, DcWomA*

Tiffin, Walter Francis 1817-1900 *ClaDrA*

Tifft And Whiting *EncASM*

Tift, Mary Louise 1913- *WhoAmA 73, -76, -78, -80, -82, -84*

Tiger, Felicie *DcWomA*

Tiger, Jerome *OfPGCP 86*

Tiger, Johnny *OfPGCP 86*

Tigerman, S *AmArch 70*

Tigerman, Stanley 1930- *ConArch, MacEA, WhoAmA 73, -76, -78, -80, -82, -84*

Tighe, J C *AmArch 70*

Tighe, J S *AmArch 70*

Tighe, Linda Tasker *MarqDCG 84*

Tihor, Stephen William 1956- *MarqDCG 84*

Tijen, W Van 1894- *McGDA*

Tijen, Willem Van 1894-1974 *MacEA*

Tijou, Jean *OxDecA*

Tijou, Jean d171?- *McGDA*

Tik, Peter Edward 1947- *MarqDCG 84*

Tikka, Saara 1942- *DcCAr 81*

Tiktiner *WorFshn*

Tilborg, Egidius 1578-1632 *ClaDrA*

Tilborgh, Gillis Van 1625-1678 *McGDA*

Tilden, Alice Foster *DcWomA, WhAmArt 85*

Tilden, Anna M 1897- *WhAmArt 85*

Tilden, Anna Meyer 1897-1963 *DcWomA*

Tilden, Douglas 1860-1935 *WhAmArt 85*

Tilden, George T *WhAmArt 85*

Tilden, George Thomas 1845-1919 *BiDAmAr*

Tilden-Thurber *EncASM*

Tildesley, Florence K *WhAmArt 85*

Tilds, Paul 1904- *AmArch 70*

Tilemann *DcWomA*

Tilens, Hans *McGDA*

Tilesius VonTilenau, Wilhelm Gottlief 1769-1857 *NewYHSD*

Tilestone, Thomas *CabMA*

Tilghman, George Crist 1923- *AmArch 70*

Tilghman, Stedman Richard d1848 *ArtsAmW 3*

Tilgner, Victor Oscar 1844-1896 *McGDA*

Tilipaul-Kistler, Maria 1884- *DcWomA*

Tilius, Jan 1660?-1719 *McGDA*

Till, Harry *WhAmArt 85*

Till, Will 1893-1971 *ICPEnP A, MacBEP*

Tillar, Donald Anthony 1932- *AmArch 70*

Tillard, Angelique *DcWomA*

Tille, Christoph *IlDcG*

Tilleard, E *DcVicP 2*

Tilleman, John Carl 1925- *AmArch 70*

Tillemans *DcWomA*

Tillemans, Peter 1684-1734 *BkIE, ClaDrA, DcBrECP, DcBrWA*

Tillenius, Clarence 1913- *WhoAmA 76, -78, -80, -82, -84*

Tiller, Mrs. *DcWomA*

Tiller, Frederick *NewYHSD*

Tiller, Mark Daniel 1929- *AmArch 70*

Tiller, Robert *NewYHSD*

Tiller, Robert, Jr. *NewYHSD*

Tillery, Brisko Nance 1950- *MarqDCG 84*

Tillery, Mary *WhAmArt 85*

Tilles, J A *FolkA 86*

Tillett, Doris *WorFshn*

Tillett, Leslie *WorFshn*

Tilley, Charles Langdon 1939- *AmArch 70*

Tilley, George Lewis 1912- *AmArch 70*

Tilley, Lewis Lee 1921- *WhoAmA 73, -76, -78, -80, -82, -84*

Tilley, Monika *WorFshn*

Tilley, N D *AmArch 70*

Tilley, William *CabMA*

Tillgner, Karin *DcWomA*

Tillgner, Maria 1860- *DcWomA*

Tilliard, Angelique *DcWomA*

Tilliard, Jean-Baptiste 1685-1766 *OxDecA*

Tilliard, Jean-Baptiste, II *OxDecA*

Tillieux, Maurice 1922- *WorECom*

Tillim, Sidney 1925- *ConArt 77, -83, WhoAmA 73, -76, -78, -80, -82, -84*

Tilling, Robert 1944- *WhoArt 80, -82, -84*

Tillinger, Jerry David 1933- *AmArch 70*

Tillinghast, EncASM

Tillinghast, Archie Chapman 1909- *WhAmArt 85*

Tillinghast, C A *DcWomA*

Tillinghast, J *AmArch 70*

Tillinghast, Joseph *FolkA 86*

Tillinghast, Mary 1764- *FolkA 86*

Tillinghast, Mary Elizabeth d1912 *DcWomA, WhAmArt 85*

Tillinghast, S *AmArch 70*

Tillion, Clement C 1892-1947 *BiDAmAr*

Tillman, D Norman 1899- *AfroAA*

Tillman, Frances *FolkA 86*

Tillman, Ruth *WhAmArt 85*

Tillotison, Robbie 1950- *WhoAmA 78*

Tillotson, Alexander 1897- *ArtsAmW 2, WhAmArt 85*

Tillotson, Mary *DcWomA*

Tillotson, Robbie *WhoAmA 84*

Tillotson, Robbie 1950- *WhoAmA 80*

Tillou, Elizabeth *DcWomA, NewYHSD*

Tilloy, Marie *DcWomA*

Tillson, William *CabMA*

Tilly, John Richard 1932- *AmArch 70*

Tillyer, William *DcCAr 81*

Tillyer, William 1938- *ConArt 77, PrintW 83, -85*

Tilman *DcWomA*

Tilman, C B *DcWomA*

Tilney, Bradford Sargent 1908- *AmArch 70*

Tilney, Frederick Colin 1870-1951 *DcBrA 1, DcVicP 2*

Tilp, Frederick 1908- *AmArch 70*

Tilsley, Thomas Walter 1929- *AmArch 70*

Tilson, Bret R 1937- *MarqDCG 84*

Tilson, Joe 1928- *ClaDrA, ConArt 77, -83, ConBrA 79[port], DcCAr 81, OxTwCA, PhDcTCA 77, PrintW 83, -85, WorArt[port]*

Tilt, Archibald *DcVicP 2*

Tilt, E P *DcVicP 2*

Tilt, Maude *WhAmArt 85*

Tilt, Maude M *DcWomA*

Tilton, Benjamin W *NewYHSD*

Tilton, Charles Edward 1905- *AmArch 70*

Tilton, Edward L 1861-1933 *BiDAmAr*

Tilton, Florence *WhAmArt 85*

Tilton, Florence 1894- *DcWomA*

Tilton, Florence Ahlfeld 1894- *ArtsAmW 3*

Tilton, John Rollin 1828-1888 *NewYHSD*

Tilton, John Rollin 1833- *ArtsNiC*

Tilton, Olive *DcWomA*

Tilton, Olive 1886- *WhAmArt 85*

Tilton, Paul H *WhAmArt 85*

Tily, Eugene James 1870-1950 *DcBrA 2*

Tilyard, Philip *FolkA 86*

Tilyard, Philip Thomas Coke 1785-1830 *NewYHSD*

Tilyou, Peter *CabMA*

Tilyou, William *CabMA*

Tim *WhoGrA 62, WorECar*

Tim 1919- *WhoGrA 82[port]*

Timareta *DcWomA*

Timarete *DcWomA*

Timbal, Louis Charles 1822-1880 *ArtsNiC*

Timberlake, Alcinda C *FolkA 86*

Timberlake, Bob *DcCAr 81, OfPGCP 86*

Timberlake, Maupin David 1912- *AmArch 70*

Timbrel, Clarence O 1869- *WhAmArt 85*

Timbrell, Benjamin d1754 *BiDBrA*

Timbrell, James Christopher 1807-1850 *DcBrBI, DcVicP 2*

Timeche, Bruce 1923- *IlBEAAW*

Timings, Samuel *DcVicP 2*

Timken, Georgia *DcWomA, WhAmArt 85*

Timmas, Osvald 1919- *WhoAmA 73, -76, -78, -80, -82, -84*

Timme, E A *NewYHSD*

Timmerman, G, Jr. *AmArch 70*

Timmerman, P F *WhAmArt 85*

Timmerman, Walter *ArtsAmW 2, WhAmArt 85*

Timmermann, Elisabeth *DcWomA*

Timmings, Samuel *DcVicP 2*

Timmins, H A *DcWomA*

Timmins, Mrs. H A *WhAmArt 85*

Timmins, Harry L 1887- *ArtsAmW 3, WhAmArt 85*

Timmins, Harry Laverne 1887-1963 *IlrAm D, -1880*

Timmins, William Frederick *WhoAmA 73, -76, -78, -80, -82, -84*

Timmis, Robert *DcBrA 2*

Timmons, Edward J Finley 1882- *WhAmArt 85*

Timmons, Edward J Finley 1882-1960 *ArtsAmW 2*

Timmons, Randall *DcCAr 81*

Timms, Jeannette *DcWomA*

Timms, Peter Rowland 1942- *WhoAmA 78, -80, -82, -84*

Timock, George P 1945- *CenC*

Timonte, Alphonse *NewYHSD*

Timoshenko, Alexander S 1909- *AmArch 70*

Timotheus *McGDA*

Timothy *WorECar*

Timothy, David *WhAmArt 85*

Timothy, Grover *WhoAmA 82, -84*

Timpa, Salvadore *AmArch 70*

Timpson, J *AmArch 70*

Timpson, Michael G 1951- *WhoAmA 84*

Timpson, Thomas *CabMA*

Tims, Michael Wayne *WhoAmA 76, -78, -80*

Tinayre, Jean Paul Louis 1861- *ClaDrA*

Tincknell, Leslie Dean 1929- *AmArch 70*

Tindale, Edward H 1879- *WhAmArt 85*

Tindall, B *DcSeaP*

Tindall, Charles E S 1863-1951 *DcSeaP*

Tindall, N *ArtsAmW 1, IlBEAAW*

Tindall, Robert Edwin *DcVicP 2*

Tindall, William Edwin 1863- *ClaDrA*

Tindall, William Edwin 1863-1938 *DcBrA 1, DcVicP, -2*

Tindell, B E *AmArch 70*

Tindle, David 1932- *ClaDrA, ConArt 83, ConBrA 79[port], DcCAr 81, WhoArt 80, -84*

Ting, Ming T 1938- *MarqDCG 84*

Ting, Walasse 1929- *ConArt 77, DcCAr 81, PrintW 83, -85, WhoAmA 73, -76, -78, -80, -82, -84*

Ting, Yun-P'eng *McGDA*

Tingle, Minnie *WhAmArt 85*

Tingle, Minnie 1875?-1926 *DcWomA*

Tingle, Richard M 1925- *AmArch 70*

Tingler, Chester J 1886- *WhAmArt 85*

Tingley, Blanche *ArtsAmW 2, DcWomA, WhAmArt 85*

Tingley, Samuel 1689-1765 *FolkA 86*

Tingley, Samuel 1752-1846 *FolkA 86*

Tingley, Samuel, Jr. 1714-1794 *FolkA 86*

Tinguely, Jean 1925- *ConArt 77, -83, DcCAr 81, McGDA, OxTwCA, PhDcTCA 77, WorArt[port]*

Tinkelman, Murray *IlsCB 1967*

Tinkelman, Murray 1933- *AmArt, IlrAm 1880*

Tinker, Elizabeth *DcWomA*

Tinkey, John *WhAmArt 85*

Tinkham, Foster *NewYHSD*

Tinkham, J F *DcWomA*

Tinkham, Mrs. J F *ArtsEM*

Tinkham, N M *AmArch 70*

Tinkham, Seth 1703-1751 *FolkA 86*

Tinkl, Viktor *DcCAr 81*

Tinkler, Arlene Tad *AmArch 70*

Tinkler, T C *DcVicP 2*

Tinkler, W A *DcVicP 2*

Tinley *BiDBrA*

Tinlin, G D *DcVicP 2*

Tinling, Teddy *FairDF ENG*

Tinling, Teddy 1910- *WorFshn*

Tinne, Dorothea 1899- *DcBrA 1, DcWomA, WhoArt 80, -82, -84*

Tinne, Margaret S *WhAmArt 85*

Tinning, George Campbell 1910- *WhoAmA 73, -76, -78, -80, -82, -84*

Tino Di Camaino 1280?-1337 *McGDA*

Tino Di Camaino 1285?-1337 *OxArt*

Tinsley, Charles *NewYHSD*

Tinsley, Dallas B 1941- *AfroAA*

Tinsley, V F *AmArch 70*

Tinsley, William *NewYHSD*

Tinsley, William 1805-1885 *BiDAmAr*

Tinsman, Gordon Livezey 1911- *AmArch 70*

Tintner, Leontine *WhAmArt 85*

Tintoretto 1518-1594 *McGDA*

Tintoretto, Domenico *McGDA*

Tintoretto, Jacopo 1518?-1594 *ClaDrA*

Tintoretto, Jacopo Robusti 1518-1594 *OxArt*

Tintoretto, Marco *McGDA*

Tintoretto, Marietta 1556?-1590 *McGDA*

Tintoretto, Marietta Robusti 1560-1590 *DcWomA*

Tinucci, S *AmArch 70*

Tinworth, George *AntBDN M*

Tinworth, George 1847-1913 *DcNiCA*

Tippens, William Clark 1928- *AmArch 70*

Tippett, R B *AmArch 70*

Tippett, W V *DcVicP 2*

Tipping, Kate *DcVicP 2*

Tippit, Jack 1923- *WorECar*

Tipple, William Russell 1934- *AmArch 70*
Tips, Jan 1942- *DcCAr 81*
Tipton, Richard Norman 1932- *AmArch 70*
Tipton, Vena 1895?- *FolkA 86*
Tipton, William Rawleight 1923- *AmArch 70*
Tiranti, John 1934- *WhoArt 80, -82, -84*
Tirana, Rosamond 1910- *WhoAmA 73, -76, -78, -80*
Tirard, Anna Pauline *DcWomA*
Tireman, Henry Stephen *DcBrWA*
Tiren, Gerda 1858-1928 *DcWomA*
Tirlinks, Levina *DcWomA*
Tirman, Jeanne Henriette 1875-1952 *DcWomA*
Tirmon, Jeanne Henriette 1875-1952 *DcWomA*
Tirrell, David Johnson 1928- *AmArch 70*
Tirrell, George *EarABI, EarABI SUP*
Tirrell, John *NewYHSD*
Tirrell, John 1826?- *ArtsAmW 2*
Tirronen, Esko Aulis 1934- *OxTwCA, PhDcTCA 77*
Tirtaamijaja, Iwan *WorFshn*
Tirtoff, Romain De 1892- *WorFshn*
Tisch, Annette Pauline *WhAmArt 85*
Tisch, William *WhAmArt 85*
Tischbein, Amalie *DcWomA*
Tischbein, Betty 1787-1867 *DcWomA*
Tischbein, Caroline 1783-1843? *DcWomA*
Tischbein, Friedrich 1750-1812 *ClaDrA*
Tischbein, Heinrica Louise 1766-1840 *DcWomA*
Tischbein, Johann Friedrich August 1750-1812
 McGDA
Tischbein, Johann Heinrich 1722-1789 *ClaDrA*
Tischbein, Johann Heinrich 1742-1808 *ClaDrA*
Tischbein, Johann Heinrich, The Elder 1722-1791
 McGDA
Tischbein, Johann Heinrich Wilhelm 1751-1829
 ClaDrA, OxArt
Tischbein, Louise 1800- *DcWomA*
Tischbein, Magdalena Margaretha 1763-1836
 DcWomA
Tischbein, Margarethe Christiane 1797- *DcWomA*
Tischbein, Sophie Margarethe A 1761-1826 *DcWomA*
Tischben Family *OxArt*
Tischendorf, Angelika Von 1858-1917 *DcWomA*
Tischkowski, Pawel 1929- *ICPEnP A*
Tischler, J A *AmArch 70*
Tischler, Marian Clara *WhAmArt 85*
Tischler, Victor d1951 *WhoAmA 78N, -80N, -82N,
 -84N*
Tischler, Victor 1890-1951 *WhAmArt 85*
Tisdale, Miss *DcWomA*
Tisdale, Elkanah *FolkA 86*
Tisdale, Elkanah 1771- *NewYHSD*
Tisdale, John B 1822?- *NewYHSD*
Tisdale, R E *AmArch 70*
Tisdale, Riley *FolkA 86*
Tisdall, Hans 1910- *ClaDrA, DcBrA 1, WhoArt 80,
 -82, -84*
Tisdall, Henry C *DcBrA 1, -2*
Tisdel, Clarence Berwyn 1934- *AmArch 70*
Tisdell, J D 1822- *EarABI*
Tishler, Harold 1895- *WhAmArt 85*
Tishman, Jack A d1966 *WhoAmA 78N, -80N, -82N,
 -84N*
Tisi, Benvenuto *McGDA, OxArt*
Tisio, Benvenuto DaGarofalo 1481-1559 *ClaDrA*
Tisner *WorECar*
Tisserand, Louise Marie Lucie *DcWomA*
Tissi, Rosmarie *ConDes*
Tissi, Rosmarie 1937- *WhoGrA 82[port]*
Tissie-Sarrus 1780-1868 *ClaDrA*
Tissier, Ange 1824-1876 *ClaDrA*
Tissier, Jeanne 1888- *DcWomA*
Tissot, James *ArtsNiC*
Tissot, James 1836-1902 *DcVicP, -2, OxArt*
Tissot, James Jacques 1836-1902 *ClaDrA*
Tissot, James Joseph Jacques 1836-1902 *McGDA*
Tissot, Joseph James Jacques 1836-1902 *DcBrBI*
Titcomb, Andrew Abbot 1914- *AmArch 70*
Titcomb, Edward *CabMA*
Titcomb, Isaac Cummings 1813- *CabMA*
Titcomb, James *FolkA 86*
Titcomb, Jessie Ada *DcWomA*
Titcomb, John Henry 1863-1952 *DcBrA 1, DcVicP 2*
Titcomb, Jonathan 1727- *CabMA*
Titcomb, M Bradish d1927 *WhAmArt 85*
Titcomb, Mary Bradish 1856-1927 *DcWomA*
Titcomb, Parker d1772 *CabMA*
Titcomb, Virginia Chandler *DcWomA, WhAmArt 85*
Titcomb, William H 1824-1888 *NewYHSD*
Titcomb, William Holt Yates 1858- *ClaDrA*
Titcomb, William Holt Yates 1858-1930 *DcBrA 1,
 DcBrBI*
Titcombe, Mrs. W H Y *DcVicP 2*
Titcombe, William Holt Yates 1858-1930 *DcVicP, -2*
Tite, William 1798-1873 *MacEA*
Tite, Sir William 1798-1873 *BiDBrA, WhoArch*
Tite, Sir William 1802-1873 *ArtsNiC*
Titelbaum, L H 1931- *MarqDCG 84*
Titford, R D *DcVicP 2*
Titherley, Hazel M 1935- *WhoArt 80, -82, -84*
Titian 1477?-1576 *ClaDrA*
Titian 1487?-1576 *OxArt*

Titian 1487?-1577 *McGDA*
Title, Robert 1936- *MacBEP*
Titlow, Harriet W *WhAmArt 85*
Titlow, Harriet Woodfin *DcWomA*
Tito, Ettore 1859-1941 *ClaDrA*
Tito, Santi Di *McGDA*
Titsch, D A *AmArch 70*
Titsworth, Ben D 1898- *ArtsAmW 3*
Titsworth, Julia 1878- *DcWomA, WhAmArt 85*
Tittensor, Charles 1764- *DcNiCA*
Tittensor, H *DcBrA 1*
Tittensor, Harry 1887-1942 *DcBrA 2*
Tittensor, John *DcNiCA*
Tittery, Joshua *FolkA 86*
Tittle, F L *AmArch 70*
Tittle, Grant Hillman 1932- *WhoAmA 73, -76*
Tittle, James Donald 1927- *AmArch 70*
Tittle, Walter 1883-1966 *WorECar*
Tittle, Walter Ernest 1883- *WhAmArt 85*
Tittle, Walter Ernest 1883-1966 *GrAmP*
Tittsworth, Ben D 1898- *ArtsAmW 3*
Titus, Aime Baxter 1883- *WhAmArt 85*
Titus, Aime Baxter 1883-1941 *ArtsAmW 2*
Titus, David Blair 1949- *MarqDCG 84*
Titus, Ellen *ArtsEM, DcWomA*
Titus, Francis *FolkA 86*
Titus, Francis 1829?- *NewYHSD*
Titus, Franz M 1829?- *NewYHSD*
Titus, Gottfried *NewYHSD*
Titus, Jim *FolkA 86*
Titus, Jonathan *FolkA 86*
Titus, Millard W 1890- *WhAmArt 85*
Titus, Samuel *CabMA*
Titus-Carmel, Gerard 1941- *ConArt 77, -83*
Titus-Carmel, Gerard 1942- *PrintW 83, -85*
Tivette, Anne Catherine *DcWomA*
Tivey, Hap 1947- *DcCAr 81*
Tivol, L M *AmArch 70*
Tiziani *FairDF ITA*
Toan, D W *AmArch 70*
Toaspern, Otto 1863- *WhAmArt 85*
Toaspern, Otto 1863-1925? *WorECar*
Toba, Sojo 1053-1140 *McGDA*
Tobar, Alonso Miguel De 1678-1758 *ClaDrA*
Tobas, Christian 1944- *ConArt 77*
Toben, Elizabeth *ArtsEM, DcWomA*
Toberentz, Robert *WhAmArt 85*
Tobermann, Charles Woodruff 1922- *AmArch 70*
Tobey, A S *WhAmArt 85*
Tobey, Alton S 1914- *WhoAmA 73, -76, -78, -80, -82,
 -84*
Tobey, Edith *DcWomA*
Tobey, Edith Allerton 1879-1973 *DcWomA*
Tobey, Mrs. Edward *WhAmArt 85*
Tobey, Mark 1890- *BnEnAmA, DcCAA 71,
 McGDA, OxArt, PhDcTCA 77, WhoAmA 73,
 -76*
Tobey, Mark 1890-1976 *ArtsAmW 3, ConArt 77,
 -83, DcAmArt, DcCAA 77, OxTwCA,
 PrintW 83, -85, WhAmArt 85, WhoAmA 78N,
 -80N, -82N, -84N, WorArt[port]*
Tobey, Samuel *NewYHSD*
Tobias, Abraham Joel 1913- *WhAmArt 85,
 WhoAmA 73, -76, -78, -80, -82, -84*
Tobias, Adele *DcWomA*
Tobias, Corinne W *DcWomA*
Tobias, Julius 1915- *ConArt 77, WhoAmA 73, -76,
 -78, -80, -82, -84*
Tobias, R E *AmArch 70*
Tobias, Robert Paul 1933- *WhoAmA 76, -78, -80, -82,
 -84*
Tobias, Thomas J 1906-1970 *WhoAmA 78N, -80N,
 -82N, -84N*
Tobias, William R 1935- *AmGrD[port]*
Tobiasse, Theo 1927- *ConArt 77, PrintW 83, -85*
Tobie, Frances Jurgens 1874- *ArtsAmW 3*
Tobiessen, Fridtjof 1905- *AmArch 70*
Tobin *DcBrECP*
Tobin, Calvin Jay 1927- *AmArch 70*
Tobin, Mrs. Clare *DcVicP 2*
Tobin, Frederick *NewYHSD*
Tobin, George 1768-1838 *DcBrWA*
Tobin, George Timothy 1864-1956 *WhAmArt 85*
Tobin, John 1827?- *FolkA 86*
Tobin, John Edward, Jr. 1947- *WhoAmA 82, -84*
Tobin, Lucy M 1868- *DcWomA*
Tobin, R P *AmArch 70*
Tobin, Robert Joseph 1926- *AmArch 70*
Tobin, Robert L B 1934- *WhoAmA 76, -78, -80, -82*
Tobler, Waldo *MarqDCG 84*
Tobler-Stockar, Mina 1836- *DcWomA*
Tobocman, Alfred 1938- *AmArch 70*
Tobola, Logic, II 1940- *AmArch 70*
Tobolski, Chester J 1924- *AmArch 70*
Tobriner, Haidee *ArtsAmW 2, WhAmArt 85*
Toby, Charles B *FolkA 86*
Toch, Maximilian 1865-1946 *WhAmArt 85*
Toche, Calvin A 1933- *MarqDCG 84*
Tocque, Louis 1696-1772 *McGDA, OxArt*
Tocqueville, Marie De *DcWomA*
Tod, A *BiDBrA*

Tod, James 1782-1835 *DcBrBI, DcBrWA*
Tod, Murray Macpherson 1909- *DcBrA 1*
Tod, Murray Macpherson 1909-1974 *DcBrA 2*
Tod, Osma Gallinger *WhoAmA 80, -82*
Tod, Osma Gallinger d1983 *WhoAmA 84N*
Todahl, J 1884- *WhAmArt 85*
Todaro, V S *AmArch 70*
Todd *AntBDN O, DcBrECP, NewYHSD*
Todd, A *NewYHSD*
Todd, Albert M 1850- *WhAmArt 85*
Todd, Anderson 1921- *AmArch 70*
Todd, Anne Ophelia 1907- *WhAmArt 85*
Todd, Arthur Ralph Middleton 1891-1966 *ClaDrA,
 DcBrA 1*
Todd, Bianca *WhAmArt 85*
Todd, Bianca 1889- *DcWomA*
Todd, C Stewart 1886- *WhAmArt 85*
Todd, Charles T *DcVicP 2*
Todd, Conway Libanus 1900- *AmArch 70*
Todd, David Fenton Michie 1915- *AmArch 70*
Todd, Edith Jane d1973 *DcBrA 1*
Todd, Edith Jane 1894?-1973 *DcWomA*
Todd, Edward *EncASM*
Todd, Edward Birckhead Lankford 1938- *AmArch 70*
Todd, Edwin 1913- *WhAmArt 85*
Todd, Elizabeth M *DcVicP 2*
Todd, Frances Carroll *WhAmArt 85*
Todd, George *NewYHSD*
Todd, H C, Jr. *AmArch 70*
Todd, H Stanley 1872-1941 *WhAmArt 85*
Todd, Harold *WhoArt 80N*
Todd, Harold 1894- *DcBrA 1*
Todd, Harriett *DcWomA*
Todd, Helen *DcVicP 2, DcWomA*
Todd, Henry George 1846-1898 *DcVicP 2*
Todd, J Manly *DcVicP 2*
Todd, J Stuart 1927- *AmArch 70*
Todd, James *FolkA 86*
Todd, John George *DcVicP 2*
Todd, John Phillip Arnold 1926- *AmArch 70*
Todd, Louise 1930- *WhoAmA 76, -78, -80, -82*
Todd, Marie C *DcWomA*
Todd, Marie Childs *WhAmArt 85*
Todd, Marjorie *WhAmArt 85*
Todd, Mary A 1800?- *FolkA 86*
Todd, Michael 1935- *DcCAA 77, DcCAr 81*
Todd, Michael Cullen 1935- *WhoAmA 73, -76, -78,
 -80, -82, -84*
Todd, Milan *DcCAr 81*
Todd, Nell Margaret 1882- *DcWomA, WhAmArt 85*
Todd, Pamela *DcWomA, NewYHSD*
Todd, Peter William 1921- *DcBrA 1*
Todd, R E *AmArch 70*
Todd, Ralph *DcBrA 1, DcBrWA, DcVicP, -2*
Todd, Robert C 1890-1924? *BiDAmAr*
Todd, Ronald James 1947- *ICPEnP A, MacBEP*
Todd, T *DcVicP 2*
Todd, Thomas *WhAmArt 85*
Todd, Thomas Abbott 1928- *AmArch 70*
Todd, W J Walker 1884-1944 *DcBrA 1*
Todd, William *CabMA, NewYHSD*
Todd-Brown, William 1875-1952 *DcBrA 1*
Todderick, Miss *DcWomA*
Toddy, Benjamin *DcBrWA*
Toddy, Jimmy *IIBEAAW*
Todes, Kenneth 1922- *AmArch 70*
Todhunter, Francis 1884- *WhAmArt 85*
Todhunter, Francis 1884-1962 *ArtsAmW 1*
Todosijevic, Rasa 1945- *DcCAr 81*
Todt, Fritz 1891-1942 *MacEA*
Todtleben, Richard *WhAmArt 85*
Toedtemeier, Terry N 1947- *MacBEP*
Toepfert, O A *WhAmArt 85*
Toeplitz, Charlotte V 1892- *ArtsAmW 2, DcWomA*
Toeput, Lodewyck 1545?-1605? *McGDA*
Toerring, Helene *WhAmArt 85*
Tofani, Arthur Michael *AmArch 70*
Tofano, Eduardo *DcVicP 2*
Tofano, Sergio 1886-1973 *WorECar*
Tofel, Jennings 1891-1959 *WhAmArt 85*
Tofel, Jennings 1892-1959 *WhoAmA 80N, -82N,
 -84N*
Tofft, Carle Eugene 1874- *WhAmArt 85*
Tofft, Peter 1825-1901 *ArtsAmW 1*
Toft, Albert 1862-1949 *DcBrA 1, DcBrBI*
Toft, Charles *DcNiCA*
Toft, J Alfonso d1964 *DcBrA 1*
Toft, J Alphonso d1964 *DcVicP 2*
Toft, Per W 1919- *AmArch 70*
Toft, Peter Petersen 1825-1901 *DcBrA 1, DcVicP, -2,
 IIBEAAW*
Toft, Peter Peterson 1825-1901 *DcBrWA*
Toft, Thomas *AntBDN M*
Togan 1547-1618 *McGDA*
Tognascioli, Herschel John 1929- *AmArch 70*
Togni, Ponzano 1906- *ClaDrA*
Toguchi, Fred S 1922- *AmArch 70*
Toh-Yah *WhAmArt 85*
Tohaku 1539-1610 *McGDA*
Tohmatsu, Shohmei 1930- *MacBEP*
Toigo, Daniel Joseph 1912- *WhoAmA 73, -76, -78,*

Toomey, Helfreich *FolkA 86*
Toomey, R W 1882- *WhAmArt 85*
Tooming, Peeter 1939- *ConPhot, ICPEnP A, MacBEP*
Toonder, Marten 1912- *WorECom*
Toone, Lloyd 1940- *AfroAA*
Toop, Wilma *DcCAr 81*
Toor, Nishan 1888- *WhAmArt 85*
Toorenburg, Gerrit 1737?-1785 *ClaDrA*
Toorenvliet, Jacob *McGDA*
Toorey, Louise B *AfroAA*
Toorn Van, Jan 1932- *WhoGrA 82[port]*
Toorop, Annie Caroline Pontifex 1891-1955 *DcWomA*
Toorop, Caroline 1891-1955 *McGDA*
Toorop, Charley 1891- *ConArt 77*
Toorop, Charley 1891-1955 *ConArt 83, OxTwCA, PhDcTCA 77*
Toorop, Jan 1858-1928 *ClaDrA, OxTwCA, PhDcTCA 77*
Toorop, Jan Theodoor 1858-1928 *OxArt*
Toorop, Johann Theodorus 1858-1928 *McGDA*
Tootal, James Batty *DcVicP 2*
Tootall, James Batty *DcBrWA*
Toothill, John *EncASM*
Toothill And McBean *EncASM*
Toovey, Edwin *DcVicP, -2*
Toovey, Edwin 1835?-1900? *DcBrWA*
Toovey, Richard G H *DcVicP*
Toovey, Richard Gibbs Henry 1861-1927 *DcBrA 1, DcBrWA, DcVicP 2*
Topanelian, Fanny N *WhAmArt 85*
Topart, Lucie *DcWomA*
Topchevsky, Morris *WhoAmA 78N, -80N, -82N, -84N*
Topchevsy, Morris 1899-1950? *WhAmArt 85*
Toperzer, Thomas Raymond 1939- *WhoAmA 76, -78, -80, -82, -84*
Topffer, Adele 1827-1910 *DcWomA*
Topffer, Esther 1839-1909 *DcWomA*
Topffer, Rodolphe 1799-1846 *WorECom*
Topham, Miss *DcVicP 2*
Topham, Amy *DcWomA*
Topham, Edward 1751-1820 *DcBrBI*
Topham, Francis W W 1838- *ArtsNiC*
Topham, Francis William 1808-1877 *ArtsNiC, ClaDrA, DcBrBI, DcBrWA, DcVicP, -2*
Topham, Frank William Warwick 1838-1924 *DcBrA 1, DcBrWA, DcVicP, -2*
Topham, Frank William Warwick 1838-1929 *ClaDrA*
Topham, W *DcVicP 2*
Topi *WorECar*
Topino, Charles *OxDecA*
Topino-Lebrun, Francois Jean Baptiste 1769-1801 *ClaDrA*
Toplin, J M *DcVicP 2*
Toplis, William A *DcBrA 1, DcVicP, -2*
Topol, Robert Martin 1925- *WhoAmA 73, -76, -78, -80, -82, -84*
Topolski, Feliks 1907- *DcBrA 1, IlsBYP, IlsCB 1946, OxArt, OxTwCA, PhDcTCA 77, WhoArt 80, -82, -84, WhoGrA 62, -82[port], WorArt[port]*
Topor, Roland 1938- *DcCAr 81, WhoGrA 82[port], WorECar*
Toporek, Lily *WorFshn*
Topp, Esther 1893-1954 *DcWomA, WhAmArt 85*
Topp, H A *AmArch 70*
Toppan, Abner 1764-1836 *CabMA*
Toppan, Charles 1796-1874 *NewYHSD*
Toppan, Charles, Jr. 1826?- *NewYHSD*
Toppan, Harriet 1834?- *DcWomA, NewYHSD*
Toppan, Sarah 1748- *FolkA 86*
Toppelius, Margareta *DcWomA*
Topper, David R 1943- *WhoAmA 84*
Toppi, Margherita *DcWomA*
Toppi, Oresto Joseph 1907- *AmArch 70*
Toppi, W *DcBrBI*
Topping, F *DcBrECP*
Topping, James d1949 *WhoAmA 78N, -80N, -82N, -84N*
Topping, James 1879- *DcBrA 2*
Topping, James 1879-1949 *WhAmArt 85*
Topschevsky, Morris 1899-1950? *ArtsAmW 3*
Toral, Cristobal 1940- *DcCAr 81*
Toral, Maria Teresa *WhoAmA 73, -76, -78*
Toral, Mario 1934- *DcCAr 81*
Toran, Alfonso T 1896- *WhAmArt 85*
Torbert, Corneil Edward 1919- *AmArch 70*
Torbert, Donald Robert 1910- *WhoAmA 78, -80, -82, -84*
Torbert, Marguerite Birch 1912- *WhoAmA 73, -76, -78*
Torbert, Stephanie B 1945- *ICPEnP A, MacBEP*
Torbert, Stephanie Birch 1945- *WhoAmA 78, -80, -82, -84*
Torbett, Charles W *NewYHSD*
Torbett, W D *AmArch 70*
Torbido, Francesco 1482?-1561? *McGDA*
Torel, William *OxArt*
Torelli, Filippo DiMatteo *McGDA*
Torelli, Lot *ArtsNiC*

Torelli, Lucia *DcWomA*
Torenvliet, Jacob 1635?-1719 *ClaDrA*
Torenvliet, Jacob 1640-1719 *McGDA*
Torffield, Marvin 1943- *WhoAmA 76, -78, -80, -82, -84*
Torgersen, Torwald Harold 1929- *AmArch 70*
Torgerson, William *WhAmArt 85*
Torhamm, Ingegerd 1898- *DcWomA*
Tori, Busshi *McGDA*
Toribara, F Y *AmArch 70*
Torielli, Maria Caterina *DcWomA*
Torii, Kazuyoshi 1946- *WorECar*
Torke, Thomas S 1934- *AmArch 70*
Torkelson, Robert Peter 1922- *AmArch 70*
Torlakson, James *DcCAr 81*
Torlakson, James Daniel 1951- *WhoAmA 80, -82, -84*
Torlen, Michael Arnold 1940- *WhoAmA 80, -82, -84*
Tormer, B *DcVicP 2*
Tormey, F E, Jr. *AmArch 70*
Tormey, Francis A 1866-1935 *BiDAmAr*
Tormey, James *WhoAmA 73, -76, -78*
Tormoczy, Bertha Von 1846- *DcWomA*
Torn, Jerry 1933- *WhoAmA 84*
Tornabuoni, Lorenzo 1934- *DcCAr 81*
Torne, Kristine *DcWomA*
Torneman, Axel *IlBEAAW*
Torner, Gustavo 1925- *OxTwCA*
Tornezy, Mademoiselle *DcWomA*
Tornheim, Norman 1942- *WhoAmA 78, -80, -82, -84*
Torno, Laurent Jean, Jr. 1936- *AmArch 70*
Tornoe, Elisabeth 1847-1933 *DcWomA*
Tornquist, Ellen 1871- *DcWomA*
Tornquist, Jorrit 1938- *DcCAr 81*
Toro, Osvaldo 1914- *MacEA*
Toro, Osvaldo L 1914- *AmArch 70*
Toro, Osvaldo Luis 1914- *McGDA*
Toro And Ferrer *MacEA*
Torok, Olga 1887- *DcWomA*
Torond, Francis 1742-1812 *AntBDN O*
Torond, Francis 1743-1812 *OxDecA*
Toroni, Niele 1937- *ConArt 77, -83*
Torosian, Michael 1952- *ConPhot, ICPEnP A*
Torr, Helen 1886-1967 *DcWomA*
Torr, Jerry Robert 1935- *AmArch 70*
Torrance, Elizabeth M *DcWomA*
Torrance, H C *WhAmArt 85*
Torrance, James 1859-1916 *DcBrA 1, DcBrBI, DcVicP 2*
Torrance, Lilias *DcWomA*
Torrance, Louise E *DcWomA*
Torrans, Eliza *DcWomA*
Torrans, Rosalba *DcWomA*
Torrans, Rosella *NewYHSD*
Torreano, John *DcCAr 81*
Torreano, John Francis 1941- *WhoAmA 73, -76, -78, -80, -82, -84*
Torrens, Eliza *DcWomA*
Torrens, Rosalba *DcWomA, NewYHSD*
Torrentius, Johannes 1589-1644 *McGDA, OxArt*
Torrents Y DeAmat, Stanislas P Nolasque 1839-1916 *ClaDrA*
Torrepalma, Condessa d1771 *DcWomA*
Torres, Ana *DcWomA*
Torres, Daniel 1958- *ConGrA 1*
Torres, Elpidio 1925-1973 *WorECom*
Torres, Garcia J *WhAmArt 85*
Torres, Horacio 1924- *WhoAmA 76*
Torres, Horacio 1924-1976 *WhoAmA 78N, -80N, -82N, -84N*
Torres, Ignacio L 1925- *AmArch 70*
Torres, John, Jr. 1939- *AfroAA, WhoAmA 73, -76*
Torres, Reynaldo V 1921- *AmArch 70*
Torres, Victor M 1928- *AmArch 70*
Torres Clave, Josep 1906-1939 *MacEA*
Torres Esteban, Joaquin 1919- *DcCAr 81*
Torres-Garcia, Augusto *OxTwCA*
Torres-Garcia, Horacio *OxTwCA*
Torres Garcia, Joaquin 1874-1949 *ConArt 77, McGDA*
Torres-Garcia, Joaquin 1874-1949 *ConArt 83, OxArt, OxTwCA, PhDcTCA 77*
Torres-Gaztambide, J *AmArch 70*
Torrey, Charles 1859-1921 *DcSeaP, WhAmArt 85*
Torrey, Charles Cutler 1799-1827 *NewYHSD*
Torrey, Elliot d1949 *WhAmArt 85*
Torrey, Elliot Bouton 1867-1949 *ArtsAmW 1*
Torrey, Eugene *WhAmArt 85*
Torrey, Franklin 1830-1912 *NewYHSD, WhAmArt 85*
Torrey, Fred M 1884- *WhAmArt 85*
Torrey, George Burroughs 1863-1942 *WhAmArt 85*
Torrey, Helen 1901- *IlsBYP, IlsCB 1946*
Torrey, Helena J *ArtsEM, DcWomA*
Torrey, Hiram Dwight 1820-1900 *NewYHSD, WhAmArt 85*
Torrey, Juliette E *DcWomA, NewYHSD*
Torrey, Kate S *ArtsEM, DcWomA*
Torrey, Mabel 1886-1974 *DcWomA*
Torrey, Mabel Landrum 1886- *WhAmArt 85*
Torrey, Manasseh Cutler 1807-1837 *NewYHSD*

Torrey, Marjorie 1899- *IlsBYP, IlsCB 1946*
Torrey, William 1814- *EarABI SUP*
Torricelli, Thomas Edward 1923- *AmArch 70*
Torrigiani, Pietro 1472-1528 *McGDA*
Torrigiano, Pietro 1472-1528 *OxArt*
Torriti *OxArt*
Torriti, Jacopo *McGDA*
Torroja, Eduardo 1899-1961 *DcD&D, EncMA, McGDA, WhoArch*
Torroja Minet, Eduardo 1899-1961 *MacEA*
Torroja Y Miret, Eduardo 1899-1961 *ConArch*
Torrome, Francisco J *DcVicP 2*
Torry, Eugene *ArtsEM*
Torry, John T *DcBrBI, DcVicP 2*
Torsch, John W *NewYHSD*
Torselles-Schybergson, Annie *DcWomA*
Torseth, John C 1924- *AmArch 70*
Torsleff, John *EncASM*
Torson, James M 1947- *MarqDCG 84*
Tory, Geoffroy 1480?-1533 *McGDA*
Tory, Geofroi d1533 *OxDecA*
Toscanini, Walfredo 1929- *AmArch 70*
Toscano, Thomas Peter 1937- *MarqDCG 84*
Toscheff, Kiril Angel 1922- *AmArch 70*
Toschik, Larry *OfPGCP 86*
Toschik, Larry 1922- *IlsBYP, IlsCB 1946, WhoAmA 76, -78, -80, -82, -84*
Toschik, Larry 1925- *IlBEAAW*
Toseland, Peter 1917- *DcBrA 2, WhoArt 80, -82, -84*
Toseland, Peter Harold 1917- *ClaDrA*
Toshach, Daniel Wilkie 1928- *AmArch 70*
Toshiro *McGDA*
Tosi, Arturo 1871-1956 *McGDA, OxTwCA, PhDcTCA 77*
Tosini, Michele 1503-1577 *McGDA*
Tossani-Spinelli, Alda 1880- *DcWomA*
Tostrup, Jacob Ubrich Holfeldt *EncASM*
Tot, Endre 1937- *ConArt 77, -83*
Toth, Alexander 1928- *WorECom*
Toth, Andrew Alexander 1903- *AmArch 70*
Toth, Andrew Michael 1931- *AmArch 70*
Toth, Carl Wayne 1947- *WhoAmA 78, -80, -82, -84*
Toth, Charles Edward 1927- *AmArch 70*
Toth, Istvan 1923- *ICPEnP A*
Toth, J W *AmArch 70*
Toth, Steven, Jr. 1907- *WhAmArt 85*
Toth, William Henry 1928- *AmArch 70*
Tothill, Mary D *DcVicP 2*
Toto, Joe *IlsBYP*
Totsugen d1823 *McGDA*
Tott, Sophie, Countess De *DcWomA*
Totten, C A, Jr. *AmArch 70*
Totten, George Oakley, Jr. *WhAmArt 85*
Totten, George Oakley, Jr. 1865-1939 *BiDAmAr*
Totten, Mary 1781- *FolkA 86*
Totten, Vicken 1886- *DcWomA*
Totten, Vicken VonPost *WhAmArt 85*
Totty, J W *AmArch 70*
Touchagues, Louis 1893- *ClaDrA*
Touche, Mademoiselle *DcWomA*
Toudouze, Adele Anais *DcWomA*
Toudouze, Anais 1822-1899 *AntBDN E, OxDecA*
Toudouze, Edouard *ArtsNiC*
Toudouze, Isabella *AntBDN E, OxDecA*
Toudouze, Isabelle *DcWomA*
Toudouze, Marie Anne *DcWomA*
Touisant, R *DcVicP 2*
Touish, Harold 1921- *DcCAr 81*
Toulis, Vasilios 1931- *WhoAmA 73, -76, -78, -80, -82, -84*
Toulmin, Ashby *WhAmArt 85*
Toulmin, E O *DcVicP 2*
Toulmin, John 1911- *ClaDrA*
Toulmin Smith, E *DcWomA*
Toulmouche, Auguste *ArtsNiC*
Toulmouche, Marie *DcWomA*
Toulon, Martine Adriane Marie Van *DcWomA*
Toulouse-Lautrec, Henri De 1864-1901 *AntBDN A, McGDA, OxArt, PhDcTCA 77*
Toulouse-Lautrec-Monfa, Henri Marie R De 1864-1901 *ClaDrA*
Toulza, Comtesse *DcWomA*
Toulza, Josephine *DcWomA*
Toun, Takamura 1846-1910 *AntBDN L*
Toupe, Robert *FolkA 86*
Toupillier, Louise Elisa Adele *DcWomA*
Toupin, Fernand *OxTwCA*
Toups, F M *AmArch 70*
Tour, Harry Bird 1899- *AmArch 70*
Tour, J B *DcVicP 2*
Tour-Donas *DcWomA*
Tourbin, Dennis 1946- *DcCAr 81*
Tourdjman, Georges 1935- *ICPEnP A*
Tourmont, Marie De *DcWomA*
Tournachon, Gaspard Felix *ICPEnP, MacBEP*
Tournachon, Gaspard-Felix 1820-1910 *WorECar*
Tournay, Elisabeth Claire *DcWomA*
Tournemine, Charles Emile De 1812-1872 *ClaDrA*
Tournemine, Charles Emile Vacher De 1814-1872 *ArtsNiC*

Tournemine, Marie Mathilde DcWomA
Tourneur, Louise DcVicP 2
Tourneur, Renault 1851- FolkA 86
Tournier, Gaspard DcVicP 2
Tournier, Marie DcWomA
Tournier, Nicolas 1590-1657 McGDA
Tournieres, Robert Levrac 1667-1752 McGDA
Tourny, Ernestine DcWomA
Tourrier, Alfred Holst 1836-1892 DcVicP, -2
Tourrier, G L DcVicP 2
Tourrier, J DcVicP, -2
Tours, Mademoiselle Des DcWomA
Toursel, Augustin Victor Hippolyte 1812-1853 ClaDrA
Tourtellotte, John E 1869-1939 MacEA
Tourtelot, Edward M, Jr. 1908- AmArch 70
Tourtelotte, John E 1869-1939 BiDAmAr
Tousey, Maud DcWomA
Tousey, Maude WhAmArt 85
Tousey, T Sanford IlBEAAW, WhAmArt 85
Tousignant, Claude 1932- ConArt 77, -83, OxTwCA, WhoAmA 73, -76, -78, -80, -82, -84
Tousignant, Serge 1942- DcCAr 81
Tousley, Nancy 1943- WhoAmA 80, -82
Toussaint, Fernand ClaDrA
Toussaint, Henriette DcWomA
Toussyn, Maria Magdalena DcWomA
Toutin, Jean 1578-1644 OxDecA
Touzard, Marie DcWomA
Touzery, Marcelle DcWomA
Touzin, Jenny DcWomA
Tovar Y Tovar, Martin 1828-1902 McGDA
Tovey, J DcVicP 2
Tovey, John DcBrBI
Tovey, M W, Jr. AmArch 70
Tovey, Mary S DcVicP 2
Tovey, Mary Sympson DcWomA
Tovey, Robert Lawton 1924- DcBrA 1, WhoArt 80, -82, -84
Tovey, Samuel Griffiths DcVicP, -2
Tovish, Harold 1921- ConArt 77, DcCAA 71, -77, WhoAmA 73, -76, -78, -80, -82, -84
Tovo, Petronilla DcWomA
Towar, A H EncASM
Towar, M DcWomA
Towene, Charles H WhAmArt 85
Tower, Arthur 1816-1877 DcBrWA
Tower, Edith DcWomA
Tower, F B 1817-1857 NewYHSD
Tower, Sir Francis DcBrWA
Tower, Meriel Theresa 1911- WhoArt 80, -82, -84
Tower, Robert Burns 1935- AmArch 70
Towers, G A 1802-1882 DcBrWA
Towers, J FolkA 86, NewYHSD
Towers, James 1853- DcBrA 1, DcBrWA, DcVicP, -2
Towers, Margaret J DcBrA 1, DcWomA
Towers, Samuel 1862-1943 DcBrA 1, DcBrWA, DcVicP 2
Towle, Anthony F 1816-1897 EncASM
Towle, E J EncASM
Towle, Edith DcWomA, WhAmArt 85
Towle, Edward B EncASM
Towle, Edward F EncASM
Towle, Eunice 1807?- DcWomA
Towle, Eunice Makepeace NewYHSD
Towle, H Ledyard 1890- WhAmArt 85
Towle, M M DcWomA
Towle, R A AmArch 70
Towle, William A EncASM
Towler, Horace MarqDCG 84
Town, Harold OxTwCA
Town, Harold 1924- PhDcTCA 77
Town, Harold Baring 1924- McGDA
Town, Harold Barling 1924- DcCAr 81, WhoAmA 73, -76, -78, -80, -82, -84, WhoArt 80, -82, -84
Town, Ira Strong EncASM
Town, Ithiel 1784-1844 BiDAmAr, BnEnAmA, MacEA, McGDA, OxArt, WhoArch
Town, J EncASM
Town, James D CabMA
Town, Lydia DcWomA
Towna, Arthur WhAmArt 85
Towne, Ann Sophia DcWomA, NewYHSD
Towne, C F 1834?-1917? ArtsAmW 3
Towne, Charles 1763-1840 DcBrWA
Towne, Charles 1763-1842 DcBrECP
Towne, Clifford Howard 1916- AmArch 70
Towne, Constance 1868- WhAmArt 85
Towne, Francis 1739?-1816 DcBrECP, OxArt
Towne, Francis 1740-1816 DcBrWA, McGDA
Towne, L Benson WhAmArt 85
Towne, Rosalba M 1827- NewYHSD
Towne, Rosalba M 1827-1909 DcWomA
Towne, T DcBrECP
Towner, Donald Chisholm 1903- DcBrA 1, WhoArt 80, -82, -84
Towner, Flora L DcWomA, WhAmArt 85
Towner, Xarifa WhAmArt 85
Towner, Xarifa Hamilton DcWomA
Towner, Xaripa ArtsAmW 2

Townes, J Harold, Jr. 1926- AmArch 70
Townes, William Tunstall 1901- AmArch 70
Townesend, George d1719 BiDBrA
Townesend, John d1784 BiDBrA
Townesend, Stephen 1755-1800 BiDBrA
Townesend, William d1739 BiDBrA
Townley, Annie B DcBrWA, DcVicP 2, DcWomA
Townley, C DcBrECP
Townley, Clifford WhAmArt 85
Townley, Elizabeth DcBrWA, DcVicP 2
Townley, Frances Brown 1908- WhAmArt 85
Townley, Hugh 1923- DcCAA 71, -77, DcCAr 81, WhoAmA 73, -76, -78, -80, -82, -84
Townley, M DcBrWA
Townley, Minnie DcBrWA, DcVicP 2, DcWomA
Townroe, Reuben 1835-1911 DcBrA 1
Towns, Elaine 1937- AfroAA
Townsend, Albert FolkA 86
Townsend, Alfred O DcVicP 2
Townsend, Armine 1898- DcWomA
Townsend, Charles 1836-1894 FolkA 86, NewYHSD
Townsend, Charles E NewYHSD
Townsend, Charles Harrison 1850?-1928 McGDA
Townsend, Charles Harrison 1851-1928 MacEA, WhoArch
Townsend, Charlotte NewYHSD
Townsend, Charlotte 1824?- DcWomA
Townsend, Christopher 1701-1773 AntBDN G, CabMA, OxDecA
Townsend, Edmund FolkA 86
Townsend, Edmund 1736-1811 CabMA
Townsend, Ernest 1880-1944 DcBrA 1
Townsend, Ernest Nathaniel 1893-1945 WhAmArt 85
Townsend, Ethel Hore 1876- DcWomA, WhAmArt 85
Townsend, Eugene Coe 1915- WhAmArt 85
Townsend, F DcVicP 2
Townsend, F M AmArch 70
Townsend, Frances 1863- ArtsAmW 3, DcWomA, WhAmArt 85
Townsend, Frances B d1916 DcWomA, WhAmArt 85
Townsend, Frances Platt DcWomA
Townsend, Frederick DcVicP 2
Townsend, Mrs. Frederick DcVicP 2
Townsend, Frederick Henry 1868-1920 DcBrA 1
Townsend, Frederick Henry Linton Jehne 1868-1920 DcBrBI, DcBrWA, DcVicP 2
Townsend, Frederick John DcVicP 2
Townsend, G DcBrBI
Townsend, George FolkA 86, NewYHSD
Townsend, George Burton 1911- AmArch 70
Townsend, H C, Jr. AmArch 70
Townsend, Harry E 1879-1941 WhAmArt 85
Townsend, Harry Everett 1879-1941 IlrAm B, -1880
Townsend, Helen Elizabeth 1893- WhAmArt 85
Townsend, Helen Elizabeth 1893-1980 DcWomA
Townsend, Henry James 1810-1890 DcBrBI, DcBrWA, DcVicP, -2
Townsend, Henry L L NewYHSD
Townsend, Horace 1859-1922 WhAmArt 85
Townsend, J DcVicP 2
Townsend, J Benjamin 1918- WhoAmA 76, -78, -80, -82, -84
Townsend, J S A DcBrWA
Townsend, James CabMA
Townsend, James d1827 CabMA
Townsend, James Bliss 1855-1921 WhAmArt 85
Townsend, James Lester, Jr. 1939- AmArch 70
Townsend, Job 1699-1765 AntBDN G, CabMA, DcD&D, OxDecA
Townsend, Job E 1758-1778 CabMA
Townsend, Job Edward, Jr. 1726-1818 CabMA
Townsend, John DcBrECP, DcBrWA
Townsend, John 1732-1809 CabMA, DcD&D
Townsend, John 1733-1809 AntBDN G
Townsend, John F CabMA, WhoAmA 78, -80, -82, -84
Townsend, Mrs. John F NewYHSD
Townsend, John Selby 1909- AmArch 70
Townsend, Jonathan 1745-1772 CabMA
Townsend, Lee d1965 WhoAmA 78N, -80N, -82N, -84N
Townsend, Lee 1895- IlsBYP, IlsCB 1946
Townsend, Lee 1895-1965 WhAmArt 85
Townsend, M B CabMA
Townsend, Maria Ann DcWomA
Townsend, Marvin 1915- ConGrA 1[port]
Townsend, Marvin J 1915- WhoAmA 73, -76, -78, -80, -82, -84
Townsend, Mary DcVicP 2
Townsend, Mary Lee WhoAmA 76
Townsend, Neal 1934- WhoAmA 82, -84
Townsend, Pattie DcVicP, -2, DcWomA
Townsend, Patty ClaDrA, DcBrWA
Townsend, Pauline DcWomA
Townsend, Pauline Frances 1870- DcWomA
Townsend, Richard F IlsBYP
Townsend, Robert M d1805 CabMA
Townsend, Ruth WhAmArt 85
Townsend, S E DcVicP 2

Townsend, Miss S Thompson DcBrA 2
Townsend, Samuel CabMA
Townsend, Sarah Gore Flint 1874-1924 WhAmArt 85
Townsend, Solomon OxDecA
Townsend, Stanley Dale 1947- WhoAmA 80, -82, -84
Townsend, Stephen d1799 CabMA
Townsend, Storm D 1937- WhoAmA 78, -80, -82, -84
Townsend, Storm Diana 1937- WhoAmA 76, WhoArt 80, -82, -84
Townsend, Ted 1889-1970 FolkA 86
Townsend, Thomas 1742-1822 CabMA
Townsend, Thomas 1785- CabMA
Townsend, Thurmond AfroAA
Townsend, Vera 1923- WhoAmA 84
Townsend, William AntBDN Q
Townsend, William 1909- DcBrA 1
Townsend, William 1909-1973 DcBrA 2
Townsend, William H NewYHSD
Townsend And Axson CabMA
Townsend Desmond And Voorhis EncASM
Townsend Family CabMA
Townsend-Goddard DcD&D
Townshend, Alice DcVicP 2
Townshend, Arthur Louis DcVicP 2
Townshend, Barbara Anne DcWomA
Townshend, George 1724-1807 DcBrBI
Townshend, George, Marquess 1724-1807 DcBrWA
Townshend, Henry H WhAmArt 85
Townshend, James d1949 DcBrA 1, DcBrWA, DcVicP 2
Townsley, C P 1867-1921 WhAmArt 85
Townsley, Channel Pickering 1867-1921 ArtsAmW 2
Townsley, Raymond Edwin 1937- AmArch 70
Townswick, A R AmArch 70
Towsey, Joseph BiDBrA
Toy, Nicholas, Jr. FolkA 86
Toy, R H B 1911- ConArch
Toy, Ruby Shuler WhAmArt 85
Toy, Tom 1929- AmArch 70
Toy, W H DcBrBI
Toy, Walter Dallam, Jr. 1906- AmArch 70
Toyen 1902- ConArt 77, PhDcTCA 77
Toynbee, Lawrence 1922- WhoArt 80, -82, -84
Toyofuku, Tomonori 1925- WorArt[port]
Toyoharu 1735-1814 McGDA
Toyohiko 1773-1845 McGDA
Toyokuni, I 1769-1825 McGDA
Toyokuni, III McGDA
Toyokuni, Utagawa 1769-1825 OxArt
Toyomasa 1773-1856 AntBDN L, OxDecA
Toyomura, D T AmArch 70
Toyonobu 1711-1785 McGDA
Toyoshima, Takashi 1929- DcCAr 81
Tozer, Henry E DcBrBI
Tozer, Henry Spernon DcBrWA, DcVicP 2
Tozier, E L AmArch 70
Tozier, Laurence McNeil MarqDCG 84
Tozzer, A Clare DcWomA, WhAmArt 85
Tozzi, Mario 1895- PhDcTCA 77
Traballesi, Agata DcWomA
Traber, Lawrence James 1935- AmArch 70
Trabich, Bertha d1941 DcWomA, FolkA 86
Trabold, A WhAmArt 85
Trabucco, Frank William 1911- AmArch 70
Trabue, Fannie Sales FolkA 86
Tracey, John M 1844- ArtsAmW 1
Tracey, O DcVicP 2
Tracht, J AmArch 70
Trachtenberg, Gloria P WhoAmA 84
Trachtman, Arnold S 1930- WhoAmA 78, -80, -82, -84
Tracy, Andrew FolkA 86
Tracy, Bartlett WhoAmA 73, -76
Tracy, Berry Bryson 1933- WhoAmA 76, -78, -80, -82, -84
Tracy, Charles D WhAmArt 85
Tracy, Charles Hanbury 1778-1858 BiDBrA
Tracy, Ebenezer 1744-1803 CabMA
Tracy, Elisha 1743?-1809 CabMA
Tracy, Elizabeth 1911- WhAmArt 85
Tracy, Evarts 1868-1929 BiDAmAr
Tracy, G P FolkA 86, NewYHSD
Tracy, Glen 1883- WhAmArt 85
Tracy, Henry Prevost 1888-1919 WhAmArt 85
Tracy, Henry R 1833- WhAmArt 85
Tracy, Huntington FolkA 86
Tracy, Jane F 1950- MarqDCG 84
Tracy, Joanne DcCAr 81
Tracy, John B FolkA 86
Tracy, John M 1844- ArtsAmW 3
Tracy, Lois Bartlett WhAmArt 85, WhoAmA 78, -80, -82, -84
Tracy, Michael 1943- DcCAr 81, WhoAmA 82, -84
Tracy, Nelson FolkA 86
Tracy, S NewYHSD
Tracy, Simon P d1863 FolkA 86
Tracy, Stephen Powell 1905- AmArch 70
Tracy, William Gregory 1923- AmArch 70
Tradate, Iacopino Da McGDA
Trader, Effie Corwin WhAmArt 85
Trader, Effie Corwin 1874- DcWomA

Traeger, L W *AmArch 70*
Traeger, Ronald 1937-1968 *ICPEnP A*
Traffelet, Frederic Edward 1897- *ClaDrA*
Trafford, Major *DcVicP 2*
Trafford, Lionel J *DcVicP 2*
Traficante, Michael 1902- *AmArch 70*
Tragardh, Gerda Christoffersson *DcWomA*
Trager, Neil 1947- *ICPEnP A, MacBEP*
Trager, Philip 1935- *ConPhot, ICPEnP A, MacBEP, WhoAmA 84*
Traher, William Henry 1908- *WhAmArt 85, WhoAmA 73, -76, -78, -80, -82, -84*
Traies, Francis D 1826-1857 *DcBrWA, DcVicP 2*
Traies, William 1789-1872 *DcBrWA, DcVicP 2*
Trail, A A *DcWomA*
Trail, Cecil G *DcVicP 2*
Trail, Donald F 1934- *AmArch 70*
Traill, Jessie Constance Alicia 1881-1967 *DcWomA*
Train, Daniel N *FolkA 86, NewYHSD*
Train, Edward *DcVicP 2*
Train, H Scott *WhAmArt 85*
Train, Jack Durkee 1922- *AmArch 70*
Train, Susan *WorFshn*
Train, Thomas 1890- *ClaDrA, DcBrA 1*
Traini, Francesco *McGDA*
Traisman, Barbara Lynn 1945- *MacBEP*
Trajan, T *WhAmArt 85*
Trakas, George 1944- *ConArt 83, WhoAmA 76, -78, -80, -82, -84*
Trakhman, Mikhail 1918-1976 *ConPhot, ICPEnP A*
Trakis, Louis 1927- *WhoAmA 78, -80, -82, -84*
Tramello, Alessio 1460-1550? *MacEA*
Tramontini, Rita 1874- *DcWomA*
Trampon, R *DcBrECP*
Trangmar, Charles Frank 1889- *DcBrA 2*
Trank, Lynn Edgar 1918- *WhoAmA 78, -80, -82, -84*
Trano, Clarence E 1895-1958 *ArtsAmW 3*
Tranquillitsky, Vasily Georgievich 1888- *ArtsAmW 2, WhAmArt 85*
Translot, Mrs. Eugene *NewYHSD*
Transon, Mademoiselle *DcWomA*
Trant, Miss *DcWomA*
Trant, Emmett, Jr. *AmArch 70*
Trant, James E 1954- *MarqDCG 84*
Trantenroth, A O 1940- *DcCAr 81*
Trantham, H E 1900- *WhAmArt 85*
Trantham, Ruth N 1903- *WhAmArt 85*
Trantow, E J *AmArch 70*
Trantschold, Manfred *DcVicP 2*
Trapani, Joseph Albert 1914- *AmArch 70*
Traphagen, Ethel d1963 *WhoAmA 78N, -80N, -82N, -84N*
Traphagen, Ethel 1882- *DcWomA*
Traphagen, Ethel 1882-1963 *WhAmArt 85*
Traphagen, Neilson *WhAmArt 85*
Trapier, Pierre 1897-1957 *WhAmArt 85*
Trapier, Pierre Pinckney Alston 1897-1957 *WhoAmA 80N, -82N, -84N*
Trapp, August *NewYHSD*
Trapp, Frank Anderson 1922- *WhoAmA 76, -78, -80, -82, -84*
Trapp, George Francis 1900- *AmArch 70*
Trapp, Gordon Earl 1915- *AmArch 70*
Trapp, Hede Von 1877- *DcWomA*
Trappe, Paul *WhoArt 82, -84*
Trappe, Samuel J *FolkA 86*
Trappes, Francis M *DcVicP 2*
Traquair, James 1756-1811 *NewYHSD*
Traquair, Pheobe Anna 1852-1936 *ClaDrA*
Traquair, Phoebe Anna d1936 *DcBrA 1*
Traquair, Phoebe Anna 1852-1936 *DcWomA*
Trasher, Harry D *WhAmArt 85*
Trask, Israel 1786-1867 *DcNiCA*
Trask, John E D 1871-1926 *WhAmArt 85*
Trask, Joseph *FolkA 86*
Trask, Mary Chumar *DcWomA, WhAmArt 85*
Trask, P *AfroAA*
Traub, Charles *DcCAr 81*
Traub, Charles 1945- *ConPhot*
Traub, Charles H 1945- *ICPEnP A, MacBEP, WhoAmA 78, -80, -82, -84*
Traube, Alex 1945- *ICPEnP A*
Traube, Alex 1946- *DcCAr 81, MacBEP*
Traubel, M 1820-1897 *NewYHSD*
Traubel, M H 1820-1897 *WhAmArt 85*
Trauerman, Margy Ann *WhoAmA 73, -76, -78, -80, -82, -84*
Trauner, Alexandre 1906- *ConDes*
Traunfellner, Franz 1913- *DcCAr 81*
Trausch, Thomas V 1943- *WhoAmA 82, -84*
Trautman, E J *AmArch 70*
Trautman, Michael Howard *AmArch 70*
Trautmann, Johann Georg 1713-1769 *ClaDrA*
Trautmann, Karl Friedrich 1804-1875 *ArtsNiC*
Trautwein, G K *AmArch 70*
Trautwein, H B *AmArch 70*
Trautwein, Margarete 1876- *DcWomA*
Trautwine, John Cresson 1810-1883 *NewYHSD*
Trautz, August *FolkA 86*
Travanti, Leon Emidio 1936- *WhoAmA 78, -80, -82, -84*

Traver, C Warde 1880?- *WhAmArt 85*
Traver, Geo A 1864-1928 *WhAmArt 85*
Traver, Marion Gray 1892?- *DcWomA, WhAmArt 85*
Traver, Warde 1880- *ArtsAmW 2*
Travers, D B V 1926- *AmArch 70*
Travers, Florence *DcVicP 2*
Travers, Frances Emily *DcWomA*
Travers, George *DcVicP, -2*
Travers, Gwyneth Mabel 1911- *WhoAmA 73, -76, -78, -80, -82*
Travers, Gwyneth Mabel 1911-1982 *WhoAmA 84N*
Travers, R L *AmArch 70*
Travers-Smith, Brian John 1931- *WhoAmA 82, -84*
Travers-Smith, Dorothea *DcBrA 1, WhoArt 80, -82, -84*
Traversi, Gaspare d1769 *McGDA*
Travies DeVillers, Charles-Joseph 1804-1859 *WorECar*
Travies DeVillers, Joseph 1804-1859 *ClaDrA*
Travis, David 1948- *MacBEP*
Travis, David B 1948- *WhoAmA 78, -80, -82, -84*
Travis, David Hail 1931- *WhoAmA 76, -78, -80, -82*
Travis, Diane 1892- *ArtsAmW 2, DcWomA, WhAmArt 85*
Travis, H *DcVicP 2*
Travis, Kathryne Hail 1894-1972 *ArtsAmW 2, DcWomA, WhAmArt 85, WhoAmA 78N, -80N, -82N, -84N*
Travis, Larry K 1936- *AmArch 70*
Travis, Olin 1888- *WhoAmA 73, -76, -78*
Travis, Olin 1888-1975 *WhoAmA 80N, -82N, -84N*
Travis, Olin Herman 1888- *ArtsAmW 1, -2, IlBEAAW, WhAmArt 85*
Travis, Paul Bough 1891- *WhAmArt 85*
Travis, Stuart 1868-1942 *WhAmArt 85*
Travis, Walter 1888- *DcBrA 1*
Travis, William *AfroAA*
Travis, William D T 1839-1916 *WhAmArt 85*
Travis, William DeLaney Trimble 1839-1916 *NewYHSD*
Traylor, Bill *AfroAA*
Traylor, Bill 1854-1947 *FolkA 86*
Traynor, Fred Vincent 1911- *AmArch 70*
Trbuljak, Goran 1948- *ConArt 77, -83*
Treacher, John 1735?-1802 *BiDBrA*
Treacy, D L *AmArch 70*
Treadgold, Sylvia *WhoArt 82, -84*
Treadgold, Sylvia 1918- *WhoArt 80*
Treadwell, Grace 1893- *DcWomA, WhoAmA 73, -76*
Treadwell, Grace A 1893- *WhAmArt 85*
Treadwell, H S *FolkA 86*
Treadwell, Helen *WhoAmA 73, -76, -78, -80*
Treadwell, Helen 1902- *WhAmArt 85*
Treadwell, Jona *FolkA 86, NewYHSD*
Treadwell, M *DcVicP 2*
Treadwell, S L *WhAmArt 85*
Treaga, Genoza *NewYHSD*
Treaga, Santonio *NewYHSD*
Treanor, William A 1878-1946 *BiDAmAr*
Trease, Sherman 1889-1941 *ArtsAmW 2, WhAmArt 85*
Treaster, Richard A 1932- *WhoAmA 73, -76, -78, -80, -82, -84*
Treat, Alice E *DcWomA, WhAmArt 85*
Treat, S L *FolkA 86*
Treat, Samuel Atwater 1839-1910 *BiDAmAr*
Treatner, Meryl 1950- *AmArt*
Trebilcock, Amaylia *WhAmArt 85*
Trebilcock, Paul 1902- *WhAmArt 85, WhoAmA 73, -76, -78, -80, -82*
Trebilcock, T B *AmArch 70*
Trebuchet, Louise Marie *DcWomA*
Trebuchet, Marguerite *DcWomA*
Treby, Janet 1955- *DcCAr 81*
Treby, John William 1923- *AmArch 70*
Treccani, Ernesto *OxTwCA*
Trecchi Zaccaria, Maddalena *DcWomA*
Trechsel, Gail Andrews 1953- *WhoAmA 84*
Treck, Jan Jansz 1606?-1652 *McGDA*
Trecker, Stanley Matthew 1944- *WhoAmA 82, -84*
Trednnick, Dorothy W 1914- *WhoAmA 76, -78, -80, -82, -84*
Treder, Paula J 1925- *AmArch 70*
Tredez, Alain 1957 *IlsCB 1957*
Tredgett, John Philip *WhoArt 82N*
Tredgett, John Philip 1911- *WhoArt 80*
Tree, Michael Lambert *WhoArt 80, -82, -84*
Tree, V C *AmArch 70*
Treeby, J W, Jr. *DcVicP 2*
Treeger, Morris *ArtsEM*
Treen, W *DcVicP 2*
Trees, Clyde C 1885-1960 *WhoAmA 80N, -82N, -84N*
Trees, Douglas Fir *AmArch 70*
Treese, William R 1932- *WhoAmA 78, -80, -82, -84*
Trefethen, Jessie Bryan *WhAmArt 85*
Trefethen, Jessie Bryan 1882-1978 *DcWomA*
Trefethern, William *CabMA*
Treffeisen, Fred N 1918- *AmArch 70*
Treffinger, Karl Edward 1927- *AmArch 70*
Trefftz, Gertrud 1859- *DcWomA*

Treganza, Ruth Robinson 1877- *DcWomA, WhAmArt 85*
Treggiari, John Ralph 1952- *MarqDCG 84*
Treglown, Ernest d1922 *DcBrA 2*
Treglown, Ernest G d1922 *DcBrBI*
Trego, D D *ArtsEM, DcWomA*
Trego, Edward Comly *WhAmArt 85*
Trego, J J William *DcVicP 2*
Trego, Jonathan K 1817-1868? *NewYHSD*
Trego, Jonathan Kirkbridge 1817- *ArtsEM*
Trego, W *DcVicP 2*
Trego, William T 1859-1909 *WhAmArt 85*
Trego, William Thomas 1859-1909 *ArtsEM*
Trehearne, A F A 1874-1962 *MacEA*
Trehearne And Norman *MacEA*
Treibergs, Uldis 1923- *AmArch 70*
Treichel, C H *AmArch 70*
Treicis, Imant 1938- *ICPEnP A*
Treidler, Adolph *ArtsAmW 2, WhAmArt 85*
Treidler, Adolph 1886- *IlrAm C*
Treidler, Adolph 1886-1981 *IlrAm 1880*
Treiman, Joyce 1922- *DcCAA 71, -77*
Treiman, Joyce Wahl 1922- *DcCAr 81, WhAmArt 85, WhoAmA 73, -76, -78, -80, -82, -84*
Treinish, Lloyd Alan 1956- *MarqDCG 84*
Treister, K *AmArch 70*
Treister, Kenneth 1930- *WhoAmA 80, -82, -84*
Treitler, F *AmArch 70*
Treleaven, Richard Barrie 1920- *WhoArt 80, -82, -84*
Trelore, Mike *WorFshn*
Tremain, John *CabMA*
Tremaine, Edna A *WhAmArt 85*
Tremblay, Barthelemy 1578-1629 *McGDA*
Trembley, Ralph 1817?- *NewYHSD*
Tremear, Charles H 1866-1943 *WhAmArt 85*
Tremewan, M *DcVicP 2*
Tremlett, David *OxTwCA*
Tremlett, David 1945- *ConArt 77, -83*
Tremois, Pierre Yves 1921- *WhoGrA 62*
Tremolieres, Pierre Charles 1703-1739 *McGDA*
Trench, Eileen May *DcWomA*
Trench, Henry d1726 *DcBrECP*
Trench, Isabel *WhAmArt 85*
Trench, John A *DcVicP 2*
Trench, Marianne L 1888- *DcWomA*
Trenchard, Edward 1850-1922 *WhAmArt 85*
Trenchard, Edward C 1777?-1824 *NewYHSD*
Trenchard, James 1747- *NewYHSD*
Trendall, Edward W *BiDBrA*
Trenholm, George Francis 1886- *WhAmArt 85*
Trenholm, Portia Ash Burden 1813-1892 *FolkA 86*
Trenholm, Portia Ashe 1812?-1892 *DcWomA, NewYHSD*
Trenkamp, Henry, Jr. *WhAmArt 85*
Trent, Donald Lee *AmArch 70*
Trent, Newbury Abbot 1885-1953 *DcBrA 1*
Trent, S *DcBrECP*
Trent, Victor Pedrotti 1891- *WhAmArt 85*
Trentham, Eugene 1912- *WhAmArt 85*
Trentham, Fanny *DcVicP 2*
Trentham, Gary Lynn 1939- *WhoAmA 78, -80, -82, -84*
Trentholme, Florence *DcWomA*
Trentin, Leonard Ernest 1916- *AmArch 70*
Trentmann, John 1860-1890 *FolkA 86*
Trento, Antonio Da *McGDA*
Trenton, Patricia Jean 1927- *WhoAmA 78*
Trenton, Patricia Jean 1927- *WhoAmA 80, -82, -84*
Trepner, William *FolkA 86*
Trery, Henry C *DcVicP 2*
Tresal, Marie 1626- *DcWomA*
Tresca, Adelaide 1846- *DcWomA*
Trescott, Elizabeth W *DcWomA*
Treseder, Frank Charles 1916- *AmArch 70*
Tresguerras, Francisco Eduardo 1759-1833 *McGDA*
Tresguerras, Francisco Eduardo De 1759-1833 *MacEA*
Tresham, Henry 1749?-1814 *BkIE*
Tresham, Henry 1751?-1814 *DcBrECP, DcBrWA*
Tresidder, Charles *DcBrBI*
Tresilian, Cecil Stuart 1891- *IlsBYP, IlsCB 1744, -1946, -1957*
Tresilian, S *DcBrA 2*
Tresk, Simon Of *McGDA*
Tresler, George Wilson 1918- *AmArch 70*
Tresor, Anne Marie *DcWomA*
Tress, Arthur 1940- *ConPhot, ICPEnP A, MacBEP*
Tressini, Domenico 1670-1734 *McGDA, WhoArch*
Tressler, Anne K 1910- *WhAmArt 85*
Trested, Richard *NewYHSD*
Trethan, Therese 1879- *DcWomA*
Tretheway, Barry John 1940- *AmArch 70*
Tretiak, Oleh John 1939- *MarqDCG 84*
Tretick, Stanley 1921- *ICPEnP A*
Treu, Catharina 1743-1811 *DcWomA*
Treu, Maria Anna 1736-1786 *DcWomA*
Treu, Rosalie *DcWomA*
Treu, Siegfried 1940- *MarqDCG 84*
Treub-Boellaard, C 1879- *DcWomA*
Treufeldt, Aadu 1874-1956 *MacBEP*
Treuhardt, J C *AmArch 70*

Treumann, Otto H 1919- *WhoGrA 62*
Treumann, Otto Heinrich 1919- *WhoGrA 82[port]*
Treumann, Rene 1942- *DcCAr 81*
Trevelyan, Julian 1910- *ConArt 77, −83, ConBrA 79,*
 DcCAr 81, OxTwCA, WhoArt 80, −82, −84
Trevelyan, Julian Otto 1910- *DcBrA 1*
Trevelyan, Lady Laura Capel *DcBrWA*
Trevelyan, Lady Paulina 1816-1866 *DcBrWA*
Trevelyan, Pauline 1905- *IlsCB 1744*
Trevelyan, Lady Pauline 1816-1866 *DcWomA*
Trevelyan, Lady Pauline Jermyn 1816-1866 *DcVicP 2*
Trevenon, John *DcBrWA*
Treverret, Victorine 1802-1875 *DcWomA*
Trevett, Eleazar *CabMA*
Trevillian, H B, Jr. *AmArch 70*
Trevino, Abraham Joseph 1921- *AmArch 70*
Trevisani, Angelo 1669-1755? *McGDA*
Trevisani, Francesco 1656-1746 *McGDA*
Treviso, Domenico Da *McGDA*
Trevits, Johann Conrad *FolkA 86*
Trevitte, Laura M *WhAmArt 85*
Trevitts, Joseph 1890- *WhAmArt 85*
Trevor, Doris E 1909- *WhAmArt 85*
Trevor, Edward *DcVicP 2*
Trevor, Elizabeth *DcWomA*
Trevor, Helen Mabel 1831-1900 *DcVicP 2, DcWomA*
Trevor, Jean-Pierre *OfPGCP 86*
Trevor, Paul 1947- *ICPEnP A, MacBEP*
Trevor, Robert Hampden 1706-1783 *BiDBrA*
Trew, Cecil G 1897- *ClaDrA*
Trewinnard, Anna *DcWomA*
Trewitz, Conrad *FolkA 86*
Trey, Catharina *DcWomA*
Trey, Maria Anna 1736-1786 *DcWomA*
Trez, Alain 1926- *IlsCB 1957*
Trezzo, Jacopo Da, The Elder 1519?-1589 *McGDA*
Triachini, Bartolommeo *McGDA*
Triaire-Hallez, Isabelle *DcWomA*
Triano, Anthony Thomas 1928- *WhoAmA 73, −76,*
 −78, −80, −82, −84
Tribbel, John *FolkA 86*
Tribbie, J H *AmArch 70*
Tribble, Dagmar Haggstrom *WhAmArt 85*
Tribe, Barbara *DcBrA 1, WhoArt 80, −82, −84*
Tribe, Barbara 1913- *ClaDrA*
Tribe, George J *WhAmArt 85*
Tribolo, Niccolo 1500-1550 *McGDA*
Tricarico, John J *AmArch 70*
Tricarico, Rocco Vincent 1933- *AmArch 70*
Tricca, M Aurelio 1880-1969 *WhAmArt 85*
Trice, Greg S 1948- *MarqDCG 84*
Trich, J J *AmArch 70*
Trichon *NewYHSD*
Trichon, Adele *DcWomA*
Trichon, Adrienne *DcWomA*
Tricht, Arnold Von *McGDA*
Tricker, Florence *WhAmArt 85*
Trickett, Keith Geoffrey 1940- *MarqDCG 84*
Trickey, James H *ArtsEM*
Trickey, Mignon *DcWomA*
Tricou, Mae d1906 *DcWomA*
Tridler, Avis 1908- *WhAmArt 85*
Tridon, Caroline 1799-1863 *DcWomA*
Triebel, C E *WhAmArt 85*
Triebel, F Ernst 1865- *WhAmArt 85*
Triebel, Frederic Ernst 1865- *ArtsAmW 2*
Triedler, Adolf *ArtsAmW 2*
Trieff, Selina 1934- *WhoAmA 78, −80, −82, −84*
Triepcke, Maria Martha Mathilde *DcWomA*
Trier, Adeline *DcVicP 2, DcWomA*
Trier, Hann 1915- *DcCAr 81, PhDcTCA 77*
Trier, Hans 1915- *OxTwCA*
Trier, Hans A 1877- *DcBrA 2*
Trier, Walter 1890-1951 *IlsBYP, IlsCB 1744, −1946,*
 WorECar
Triester, Kenneth 1930- *WhoAmA 73, −76, −78*
Trifon, Harriette *WhoAmA 73, −76, −78N, −80N,*
 −82N, −84N
Trifyllis, Demetrius *WhAmArt 85*
Trigere, Pauline 1912- *ConDes, FairDF US[port],*
 WorFshn
Triggs, Floyd W 1872-1919 *WhAmArt 85*
Triggs, James Martin 1924- *IlBEAAW*
Trigos, Edmundo J 1949- *MarqDCG 84*
Trigt, H A Van *ArtsNiC*
Trillhaase, Adalbert 1859-1936 *OxTwCA*
Trillhaase, Felicitas *DcWomA*
Trimbath, Ernest Ray Gorman 1913- *AmArch 70*
Trimble, Corinne C *DcWomA, WhAmArt 85*
Trimble, William Alexander 1910- *AmArch 70*
Trimby, Elisa 1948- *IlsCB 1967*
Trimm, Adon 1895-1959 *WhoAmA 80N, −82N, −84N*
Trimm, Adon 1895-1959 *WhAmArt 85*
Trimm, George Lee 1912- *WhAmArt 85*
Trimm, H Wayne 1922- *WhoAmA 73, −76, −78, −80,*
 −82, −84
Trimm, Henry Owen 1931- *AmArch 70*
Trimm, Lee S 1879- *WhAmArt 85*
Trimmings, Miss *DcVicP 2, DcWomA*
Trimolet, Edma 1801-1878 *DcWomA*

Trimolet, Marie Antoinette *DcWomA*
Trinchard, J B *NewYHSD*
Trinchero, Sergio 1932- *WorECar A*
Tringham, Holland *DcBrA 2*
Tringham, Holland d1909 *DcBrBI, DcVicP 2*
Tringham, Mrs. W *DcVicP 2*
Trinidad, Francisco Flores Corky, Jr. 1939-
 WhoAmA 76, −78
Trinkle, Arthur H 1926- *MarqDCG 84*
Trinquesse, Louis Rolland 1746-1800? *ClaDrA*
Trinquier, Antonin 1833- *ClaDrA*
Trinquier, Lucie *DcWomA*
Trioche, Keaty *DcWomA*
Tripathi, Amit 1953- *MarqDCG 84*
Tripier Lefranc, Eugenie *DcWomA*
Triplett, Beryl May 1894- *WhAmArt 85*
Triplett, Margaret L 1905- *WhoAmA 73, −76, −78,*
 −80, −82, −84
Triplett, Margaret Lauren 1905- *WhAmArt 85*
Triplett, Michael Lee 1937- *AmArch 70*
Triponel, Marie *DcWomA*
Tripp, B Wilson *WhAmArt 85*
Tripp, Sir Herbert Alker 1883-1954 *DcBrA 1*
Tripp, J A *AmArch 70*
Tripp, Jan Peter 1945- *DcCAr 81, PrintW 85*
Tripp, Wallace *IlsBYP*
Tripp, Wallace Whitney 1940- *IlsCB 1967,*
 WhoAmA 78
Trippe, Blanche E *DcWomA*
Trippel, Alexander 1744-1793 *McGDA*
Triptow, T T *AmArch 70*
Triqueti, Henri De 1804-1874 *ArtsNiC*
Triscott, S P R 1846-1925 *WhAmArt 85*
Trissel, James Nevin 1930- *WhoAmA 73, −76, −78,*
 −80, −82, −84
Trissel, Lawrence E 1917- *WhAmArt 85*
Trist, Sybil 1907- *DcBrA 1, WhoArt 80*
Trist, T J *NewYHSD*
Tristan, Luis 1586?-1624 *OxArt*
Tristan De Escamilla, Luis 1586?-1624 *McGDA*
Triumfi, Camilla *DcWomA*
Triva, Flaminia 1626?-1660? *DcWomA*
Trivedi, Ashok K 1949- *MarqDCG 84*
Trivedi, Harry K 1947- *MarqDCG 84*
Trivella, Ralph Herman 1908- *WhAmArt 85*
Trivett, R B, Jr. *AmArch 70*
Trivick, Henry Houghton *DcBrA 1, WhoArt 80, −82,*
 −84N
Trivigno, Pat 1922- *WhoAmA 73, −76, −78, −80, −82,*
 −84
Trixie *WorFshn*
Trlak, Roger 1934- *WhoAmA 76, −78, −80, −82*
Trlica, Cary A 1945- *MarqDCG 84*
Trnavsky, Benjamin Donald *AmArch 70*
Trnka, Mrs. Alois *WhAmArt 85*
Trnka, Anna Belle Wing *DcWomA*
Trnka, Anna Belle Wing 1876-1922 *WhAmArt 85*
Trnka, Jiri *IlsCB 1967*
Trnka, Jiri 1912-1969 *IlsCB 1957, WhoGrA 62,*
 WorECar
Trnka, Pavel 1948- *DcCAr 81*
Trobaugh, Roy 1878- *WhAmArt 85*
Trobentar, Andrej 1951- *DcCAr 81*
Trobriand, Philippe Regis De 1816-1897 *ArtsAmW 1*
Trobridge, George 1857-1909 *DcBrA 2*
Trobridge, George F 1857-1909 *DcBrWA, DcVicP 2*
Trobridge, L *DcVicP 2*
Troccoli, Giovanni Battista 1882-1940 *ArtsAmW 3,*
 WhAmArt 85
Troche, E Gunter 1909-1971 *WhoAmA 78N, −80N,*
 −82N, −84N
Troeber, Carl *WhAmArt 85*
Troeger, Elizabeth *DcWomA, WhAmArt 85*
Troeller, Linda 1949- *MacBEP*
Troendle *NewYHSD*
Troendle, Joseph F *NewYHSD*
Trog *DcCAr 81, WorECar*
Trogdon, Doran S *WhAmArt 85*
Trogdon, William Henry 1925- *AmArch 70*
Troger, Paul 1698-1762 *McGDA*
Troianello, Gerard Vincent 1956- *MarqDCG 84*
Troiani, Don *OfPGCP 86*
Troiano, Dominick 1906- *AmArch 70*
Troijen, Rombout Van 1615?-1650 *McGDA*
Troike, Gero 1945- *ConDes*
Trokes *DcBrECP*
Trokes, Heinz 1913- *ClaDrA, DcCAr 81, OxTwCA,*
 PhDcTCA 77
Trolinger, Charlotte Pendleton 1949- *MacBEP*
Troll, Marie *DcWomA*
Trollap, Robert d1686 *BiDBrA*
Trolle, Eleonore Anne *DcWomA*
Troller, Fred 1930- *AmGrD[port], WhoGrA 82[port]*
Troller, Norbert L 1896- *AmArch 70*
Trollope, Robert d1686 *BiDBrA*
Trombley, Andy 1919-1975 *FolkA 86*
Tromeur 1946- *DcCAr 81*
Tromeur, L *AmArch 70*
Tromka, Abram 1896-1954 *WhAmArt 85*
Trommer, Marie *WhAmArt 85*
Trommer, Marie 1895- *DcWomA*

Tromp, Martin *ArtsEM*
Tromp And Prince *ArtsEM*
Tron, I E *AmArch 70*
Troncale, Frank Thomas 1941- *WhoAmA 80, −82, −84*
Troncy, Emile 1860- *ClaDrA*
Trondle *NewYHSD*
Trondle-Engel, Amanda 1883- *DcWomA*
Trood, William Henry Hamilton 1860-1899 *DcVicP, −2*
Troost, Cornelis 1697-1750 *McGDA*
Troost, Cornelius 1697-1750 *OxArt*
Troost, Jacoba Maria *DcWomA*
Troost, Paul Ludwig 1878-1934 *MacEA*
Troost, Sarah 1731-1803 *DcWomA*
Troostwijck, Wouter Johannes Van 1782-1810 *OxArt*
Troostwyk, David 1929- *ConArt 77, −83*
Troostwyk, Wouter Joannes Van 1782-1810 *ClaDrA*
Troot, John S *DcVicP 2*
Trop-Blumberg, Sandra *WhoAmA 76, −78, −80, −82,*
 −84
Tropea, Michael 1950- *PrintW 83, −85*
Trory, Arthur James 1879-1967 *MacBEP*
Trosky, Helene Roth *WhoAmA 73, −76, −78, −80, −82,*
 −84
Trossen, Duane Anthony 1930- *AmArch 70*
Trost, Andreas d1708 *ClaDrA*
Trost, Henry C 1863-1933 *BiDAmAr*
Trost, Henry Charles 1860-1933 *MacEA*
Trost, Maria Theresia *DcWomA*
Trostel, Michael F *AmArch 70*
Troth, Celeste Heckscher 1888- *DcWomA,*
 WhAmArt 85
Troth, Emma 1869- *DcWomA, WhAmArt 85*
Troth, Henry 1860-1945 *WhAmArt 85*
Trotman, Ebenezer 1810?-1865 *BiDBrA*
Trotman, Lillias *DcWomA*
Trotman, Lillie *DcBrWA, DcVicP 2*
Trotman, Peggy 1916- *WhoArt 80*
Trotman, Samuel H *DcBrWA, DcVicP 2*
Trott, Benjamin 1770?-1843 *DcAmArt, NewYHSD*
Trott, Benjamin 1790?-1841? *AntBDN J*
Trott, Helen 1936- *WhoAmA 82, −84*
Trott, Richard Wilfred 1937- *AmArch 70*
Trotta, Antonio A 1937- *ConArt 77, −83*
Trotta, Giuseppe *WhAmArt 85*
Trotta, Joseph H *WhAmArt 85*
Trotta, Michael A 1922- *AmArch 70*
Trotter, Alexander *FolkA 86*
Trotter, Alexander Mason *DcBrA 1*
Trotter, Alys Fane 1863-1962 *DcWomA*
Trotter, Anna M *DcWomA, WhAmArt 85*
Trotter, B *DcWomA*
Trotter, Daniel d1800 *CabMA*
Trotter, Daniel 1747-1800 *AntBDN G*
Trotter, Doris Minette *DcWomA*
Trotter, Eliza H *DcWomA*
Trotter, Emily *DcWomA*
Trotter, Gene E 1917- *AmArch 70*
Trotter, John d1792 *DcBrECP*
Trotter, Mrs. John *DcBrECP*
Trotter, Lilian *DcWomA*
Trotter, M *DcWomA*
Trotter, Mary Anne *DcWomA*
Trotter, Mary K *DcWomA, WhAmArt 85*
Trotter, Newbold H *ArtsNiC*
Trotter, Newbold Hough 1827-1898 *ArtsAmW 1,*
 IlBEAAW, NewYHSD, WhAmArt 85
Trotter, Robert L 1931- *AmArch 70*
Trotter, Thomas 1756-1803 *DcBrECP*
Trotti, Giovan-Battista 1555-1619 *McGDA*
Trottier, Lorne M 1948- *MarqDCG 84*
Trotzig, Ellen Christina Amalia 1878- *DcWomA*
Trotzig, Ulf *DcCAr 81*
Trouard *NewYHSD*
Trouard, Louis Francois 1729-1794 *MacEA*
Troubetzkoy, Paul 1866-1938 *WhAmArt 85*
Troubetzkoy, Prince Paul Petrovitch 1866-1938
 AntBDN C
Troubetzkoy, Pierre 1864-1936 *WhAmArt 85*
Troubridge, Laura Elizabeth Rachel *DcWomA*
Trouchaud, J P *AmArch 70*
Trouche, Auguste Paul d1846 *NewYHSD*
Trought, Joseph *BiDBrA*
Troughton, Joanna Margaret 1947- *IlsCB 1967*
Troughton, R Zouch S *DcVicP 2*
Troughton, Thomas d1797 *DcBrWA*
Trouille, Clovis 1889- *ConArt 77, −83*
Trouillebert, Clementine *DcWomA*
Trouillebert, Paul Desire 1829-1900 *ClaDrA*
Trouilloud, Marie *DcWomA*
Trouk, Adell Henry 1855-1934 *WhAmArt 85*
Trounstine, Syl F *DcWomA, WhAmArt 85*
Troup, Francis William 1859- *DcVicP 2*
Troup, Miloslav 1917- *WhoGrA 82[port]*
Trouset, Leon *ArtsAmW 2*
Trousset, Leon *ArtsAmW 2*
Trout, Chalmer Edward 1926- *AmArch 70*
Trout, Dorothy Burt 1896- *WhAmArt 85*
Trout, Elizabeth Dorothy Burt 1892-1977 *DcWomA*
Trout, Hannah *FolkA 86*
Trout, James William 1941- *MarqDCG 84*
Trout, William Hollis 1935- *AmArch 70*

Tsotsos, John Konstantine 1952- *MarqDCG 84*

Tsou, Fu-Lei *McGDA*

Tsou, I-Kuei 1686-1772 *OxArt*

Tsu 1559-1616 *DcWomA*

Tsuchida, Hiromi 1939- *ConPhot, ICPEnP A, MacBEP*

Tsuchida, Yoshiko 1948- *WorECar*

Tsuchidana, Harry Suyemi 1932- *WhoAmA 73, –76, –78*

Tsugawa, James K 1930- *AmArch 70*

Tsuge, Yoshiharu 1937- *WorECom*

Ts'ui, Po *McGDA*

Tsuji, I *AmArch 70*

Tsukioka, Yoshitoshi 1839-1892 *WorECom*

Tsumaki, Yorinaka 1859-1916 *MacEA*

Tsuruoka, George Hugh *AmArch 70*

Tsutakawa, George 1910- *DcCAA 71, –77, WhoAmA 73, –76, –78, –80, –82, –84*

Tuane *DcWomA*

Tubbs, Calla *DcWomA*

Tubbs, Ralph 1912- *DcD&D*

Tubbs, Ruth H 1898- *ArtsAmW 3, DcWomA*

Tubby, Joseph 1821-1896 *NewYHSD , WhAmArt 85*

Tubby, Josiah Thomas d1958 *WhoAmA 80N, –82N, –84N*

Tubby, Josiah Thomas 1875- *WhAmArt 85*

Tubby, William B 1858-1944 *BiDAmAr*

Tubesing, Henry *NewYHSD*

Tubesing, Walter *WhAmArt 85*

Tubeuf, Madame *DcWomA*

Tubis, Seymour 1919- *PrintW 83, –85, WhoAmA 73, –76, –78, –80, –82, –84*

Tubke, Werner 1929- *DcCAr 81*

Tuby, Jean-Baptiste 1635-1700 *OxArt*

Tucciarone, Wilma McLean *WhAmArt 85*

Tuccio, Raymond Philip 1923- *AmArch 70*

Tuchman, Canute *AmArch 70*

Tuchman, Ellen Frances 1954- *PrintW 83, –85, WhoAmA 84*

Tuchman, Joseph 1920- *AmArch 70*

Tuchman, Maurice 1936- *WhoAmA 73, –76, –78, –80, –82, –84*

Tuchman, Phyllis 1947- *WhoAmA 78, –80, –82, –84*

Tucholke, Christel-Anthony 1941- *WhoAmA 82, –84*

Tuck, Albert *DcVicP 2*

Tuck, E H *DcVicP 2*

Tuck, Frank L *ArtsEM*

Tuck, Harry *DcBrBI, DcVicP, –2*

Tuck, Lucy J *DcVicP 2*

Tuck, Marie 1872-1947 *DcWomA*

Tuck, S *DcVicP 2*

Tuck, Samuel J *CabMA*

Tuck, William *BiDBrA*

Tuck, William Henry *DcVicP 2*

Tucker *DcVicP 2*

Tucker, Mrs. *DcVicP 2*

Tucker, Ada Elizabeth *DcBrWA, DcVicP 2*

Tucker, Adah 1870- *ArtsAmW 3, DcWomA*

Tucker, Alan 1866-1939 *ArtsAmW 1*

Tucker, Albert 1914- *ConArt 83, McGDA, OxTwCA*

Tucker, Albert Franklin 1886- *AmArch 70*

Tucker, Alfred Robert *DcVicP 2*

Tucker, Alfred Robert, Bishop Of Uganda 1860-1914 *DcBrBI, DcBrWA*

Tucker, Alice *DcWomA, FolkA 86, NewYHSD , WhAmArt 85*

Tucker, Alice Preble *DcWomA*

Tucker, Allen 1866-1939 *IlBEAAW, WhAmArt 85*

Tucker, Anne 1945- *MacBEP, WhoAmA 78, –80*

Tucker, Anne Wilkes 1945- *WhoAmA 82, –84*

Tucker, Arthur 1864-1929 *DcBrA 1, DcBrWA, DcVicP 2*

Tucker, B L, Jr. *AmArch 70*

Tucker, Barff *DcVicP 2*

Tucker, Benjamin 1768- *NewYHSD*

Tucker, Boyce Lynn 1939- *AmArch 70*

Tucker, Caroline Sill 1851?-1939 *DcWomA*

Tucker, Charles Clement 1913- *WhoAmA 73, –76, –78, –80, –82, –84*

Tucker, Charles E *DcVicP 2*

Tucker, Cornelia 1897- *DcWomA, WhAmArt 85*

Tucker, Curtis 1939- *WhoAmA 84*

Tucker, Cyril Theodore 1898- *AmArch 70*

Tucker, David B *AfroAA*

Tucker, David Woodford *AmArch 70*

Tucker, Edward *DcBrWA*

Tucker, Edward 1830?-1909 *DcBrWA, DcVicP 2*

Tucker, Elisha *CabMA*

Tucker, Frank *DcVicP 2*

Tucker, Frederick *DcBrWA, DcVicP 2*

Tucker, Glenn F 1936- *WhoAmA 76, –80, –82, –84*

Tucker, H *DcVicP 2*

Tucker, Henry *DcBrECP*

Tucker, Henry Leo 1903- *AmArch 70*

Tucker, Isaac *CabMA*

Tucker, J W d1876 *EncASM*

Tucker, James Ewing 1930- *WhoAmA 73, –76, –78, –80, –82, –84*

Tucker, James J *DcVicP 2*

Tucker, James Rodney 1928- *AmArch 70*

Tucker, James Walker 1898- *DcBrA 1, WhoArt 80, –82, –84*

Tucker, James Walker 1898-1972 *DcBrA 2*

Tucker, Jerome *AfroAA*

Tucker, John J *NewYHSD*

Tucker, Joseph 1745-1800 *FolkA 86*

Tucker, Joshua *FolkA 86*

Tucker, Kay 1918- *ICPEnP A, MacBEP*

Tucker, L *DcBrECP*

Tucker, Leatrice Yvonne *WhoAmA 84*

Tucker, Lillian *DcWomA*

Tucker, Loraine Read 1910- *WhoArt 80, –82, –84*

Tucker, Marcia 1940- *WhoAmA 73, –76, –78, –80, –82, –84*

Tucker, Marcus Ray 1940- *AmArch 70*

Tucker, Mary B *DcWomA, FolkA 86, NewYHSD*

Tucker, McKendree Augustus 1895- *AmArch 70*

Tucker, Mehitable 1802-1832 *FolkA 86*

Tucker, Nathaniel *DcBrECP*

Tucker, Nicolas 1948- *ConPhot, ICPEnP A*

Tucker, Mrs. Nion *WhoAmA 73*

Tucker, O H *AmArch 70*

Tucker, Odie Kirst 1932- *AmArch 70*

Tucker, Oliver Truman 1925- *AmArch 70*

Tucker, Peri 1911- *WhAmArt 85, WhoAmA 73, –76, –78, –80, –82, –84*

Tucker, Phoebe Parker *FolkA 86*

Tucker, Raymond *DcBrA 1, DcBrWA, DcVicP, –2*

Tucker, Rena *DcWomA*

Tucker, Richard Derby 1903- *WhoAmA 76, –78*

Tucker, Robert *DcBrWA*

Tucker, Robert 1807-1891 *DcBrWA, DcVicP 2*

Tucker, Robert Birmingham 1932- *AmArch 70*

Tucker, Robert E 1936- *MarqDCG 84*

Tucker, Robert E, Jr. 1932- *AmArch 70*

Tucker, Robert G 1928- *AmArch 70*

Tucker, T B *AmArch 70*

Tucker, Thomas *DcD&D*

Tucker, Toba 1935- *ICPEnP A, MacBEP*

Tucker, Toba Pato 1935- *WhoAmA 82, –84*

Tucker, Tudor St. G *DcVicP 2*

Tucker, Tudor St. George 1862-1906 *DcBrA 2*

Tucker, W *AntBDN Q*

Tucker, William 1935- *ConArt 77, –83, ConBrA 79, DcCAr 81, OxTwCA, PhDcTCA 77, PrintW 83, –85, WhoArt 80, WorArt[port]*

Tucker, William E 1801-1857 *NewYHSD*

Tucker, William Ellis *AntBDN M, FolkA 86*

Tucker, William Ellis d1832 *DcD&D*

Tucker, William Ellis 1800-1832 *DcNiCA*

Tucker, William G 1935- *WhoAmA 78, –82, –84*

Tucker, Willie *AfroAA*

Tucker And Parkerhurst *EncASM*

Tuckerman, Henry Theodore 1813-1871 *BnEnAmA*

Tuckerman, Jane 1947- *ICPEnP A, MacBEP*

Tuckerman, Jane Bayard 1947- *WhoAmA 84*

Tuckerman, Lilia 1882- *ArtsAmW 1, WhAmArt 85*

Tuckerman, Lilia McCauley 1882- *DcWomA, IlBEAAW*

Tuckerman, S S *ArtsNiC*

Tuckerman, S Salisbury *DcVicP 2*

Tuckerman, Stephen Salisbury 1830-1904 *NewYHSD , WhAmArt 85*

Tucket, Elizabeth Fox *DcBrBI*

Tuckett, LeRoy E 1932- *AmArch 70*

Tuculescu, Ion 1910-1962 *OxTwCA*

Tudda, John James 1924- *AmArch 70*

Tudeen, David Vernon 1925- *AmArch 70*

Tudgay, *DcVicP, –2*

Tudgay Family *DcSeaP*

Tudor *AntBDN N*

Tudor, Alexander 1937- *AmArch 70*

Tudor, Henry *AntBDN N, –Q*

Tudor, Joseph 1695?-1759 *DcBrECP*

Tudor, Robert M *NewYHSD*

Tudor, Rosamond d1949 *WhoAmA 78N, –80N, –82N, –84N*

Tudor, Rosamond 1878-1949 *DcWomA, WhAmArt 85*

Tudor, T H *AmArch 70*

Tudor, Tasha *IlsCB 1967*

Tudor, Tasha 1915- *IlsCB 1744, –1946, –1957, WhAmArt 85, WhoAmA 73, –76, –78, –80*

Tudor, Thomas 1785-1855 *DcBrWA*

Tudor-Hart, Percyval 1873-1954 *DcBrA 1*

Tudury, Michael Theodore 1942- *AmArch 70*

Tuel, Benjamin *EarABI SUP*

Tuel, George Murray 1925- *AmArch 70*

Tuel, Sarah 1769- *FolkA 86*

Tuels, Anna *FolkA 86*

Tuerke, Klaas R 1942- *MarqDCG 84*

Tuffin, Sally *WorFshn*

Tufft, Thomas *AntBDN G*

Tufft, Thomas 1740?- *CabMA*

Tufnell, Eric Erskine Campbell 1888- *DcBrA 1*

Tufte, Edward Rolf 1942- *MarqDCG 84*

Tufts, Edward Allison 1923- *AmArch 70*

Tufts, Eleanor M *WhoAmA 76, –78, –80, –82, –84*

Tufts, Florence Ingalsbe *WhAmArt 85*

Tufts, Florence Ingalsbe 1874- *ArtsAmW 3*

Tufts, J B 1869- *ArtsAmW 3*

Tufts, James W d1902 *EncASM*

Tufts, John Burnside 1869- *ArtsAmW 3*

Tufts, Marion *WhAmArt 85*

Tufts, T C *AmArch 70*

Tufts, Uriah *CabMA*

Tufts, Warren 1925- *WorECom*

Tugalev, Leonid 1945- *ICPEnP A*

Tuggener, Jakob 1904- *ConPhot, ICPEnP A*

Tuggle, Emmit Ray 1922- *AmArch 70*

Tugwell, Emma S *DcVicP 2*

Tuite, J T *DcVicP 2*

Tuite, John *AntBDN Q*

Tuke, Gladys 1899- *DcWomA, WhAmArt 85*

Tuke, Henry Scott 1858-1929 *ClaDrA, DcBrA 1, DcBrWA, DcSeaP, DcVicP, –2*

Tuke, Maria *DcWomA*

Tuke, Maria 1861- *DcBrWA, DcVicP 2*

Tukey, Paul *MarqDCG 84*

Tuley, James S 1930- *AmArch 70*

Tulk, Alfred James 1899- *WhAmArt 85, WhoAmA 73, –76, –78, –80, –82, –84*

Tulk, Augustus *DcVicP 2*

Tull, Charlene 1945- *AfroAA*

Tull, Ebenezer 1733-1762? *DcBrECP*

Tull, N *DcVicP 2*

Tull, Nicholas d1762 *DcBrWA*

Tull, Phyllis Mary 1886- *DcBrA 1, DcWomA*

Tullat, Luc 1895- *DcWomA*

Tuller, M *FolkA 86*

Tullidge, John 1836-1899 *ArtsAmW 1, IlBEAAW, WhAmArt 85*

Tullis, Garner H 1939- *WhoAmA 82, –84*

Tullo, Norma 1935- *WorFshn*

Tulloch, Mrs. *DcWomA*

Tulloch, John *BiDBrA*

Tulloch, M *DcWomA*

Tulloch, W A 1887- *WhAmArt 85*

Tullsen, Rex 1907- *WhoAmA 80, –82, –84*

Tully, Christopher *NewYHSD*

Tully, George d1770 *BiDBrA*

Tully, Joyce Mary *WhoArt 80, –82, –84*

Tully, Louise Beresford *DcWomA*

Tully, Maria *DcWomA*

Tully, Richard L 1911- *AmArch 70*

Tully, Sydney S *DcVicP 2*

Tully, Sydney Strickland 1860- *WhAmArt 85*

Tully, Sydney Strickland 1860-1911 *DcWomA*

Tully, Thomas James 1895- *AmArch 70*

Tulpin, Madame *DcWomA*

Tulumello, Peter M 1954- *WhoAmA 84*

Tulving, Ruth *WhoAmA 80, –82, –84*

Tum Suden, Richard 1936- *DcCAA 77*

Tuma, Peter 1938- *DcCAr 81*

Tumarkin, Ygael 1933- *OxTwCA, PhDcTCA 77*

Tumbalaka, Judith *WorFshn*

Tumey, G E *AmArch 70*

Tunbridge, A *DcVicP 2, DcWomA*

Tunbridge, E *DcVicP 2, DcWomA*

Tune, James Bradley 1937- *AmArch 70*

Tune, Loren Wayne 1925- *AmArch 70*

Tune, William Shirley 1919- *AmArch 70*

Tung, Albert K H 1931- *AmArch 70*

Tung, Ch'i-Ch'ang 1555-1636 *OxArt*

Tung, Ch'i-Ch'ang 1555-1637 *McGDA*

Tung, Chuen Kuang *MarqDCG 84*

Tung, Yuan *McGDA*

Tungate, Mace, Jr. 1916- *AmArch 70*

Tunick, David 1943- *WhoAmA 76, –78, –80, –82, –84*

Tunick, Steven Robert 1945- *AmArch 70*

Tunis, Edwin d1973 *IlsCB 1967*

Tunis, Edwin 1897- *WhoAmA 73*

Tunis, Edwin 1897-1973 *WhAmArt 85, WhoAmA 76N, –78N, –80N, –82N, –84N*

Tunis, Edwin Burdett 1897-1973 *IlsCB 1946, –1957*

Tunis, Roslyn *WhoAmA 80, –82, –84*

Tunmer, J H *DcVicP 2*

Tunna, G B *DcBrECP*

Tunnard, John 1900- *McGDA*

Tunnard, John 1900-1971 *DcBrA 1, OxTwCA, PhDcTCA 77*

Tunnell, Roy L 1937- *AmArch 70*

Tunner, Silvia 1851-1907 *DcWomA*

Tunnicliffe, Charles Frederick *WhoArt 80N*

Tunnicliffe, Charles Frederick 1901- *ClaDrA, DcBrA 1, IlsBYP, IlsCB 1946*

Tunnicliffe, Ralph 1688?-1736 *BiDBrA*

Tunon, Jose Andres 1939- *AmArch 70*

Tunstall, Eric 1897- *DcBrA 1, WhoArt 80, –82, –84*

Tunstall, Guy F L 1930- *MarqDCG 84*

Tunstall, Ruth Neal 1945- *AfroAA*

Tuohy, Patrick Joseph 1894-1930 *DcBrA 1*

Tuomaala, W A *AmArch 70*

Tuomi, Helene *DcWomA*

Tupke, Helene *DcWomA*

Tupman, George *AntBDN D*

Tupper, Miss *DcVicP 2, DcWomA*

Tupper, Alexander Garfield *WhoAmA 78N, –80N, –82N, –84N*

Tupper, Alexander Garfield d1950? *WhAmArt 85*

Tupper, C *FolkA 86*

Tupper, Gaspard LeMarchant 1826-1906 *DcBrWA*

Tupper, James Lockwood 1922- *AmArch 70*
Tupper, Luella *DcWomA, WhAmArt 85*
Tuqua, Edward *NewYHSD*
Tura, Cosimo *McGDA*
Tura, Cosme 1430?-1495 *OxArt*
Turan, Geza *DcWomA*
Turano, Don 1930- *WhoAmA 73, -76, -78, -80, -82, -84*
Turano, Emanuel N 1917- *AmArch 70*
Turano, Jane VanNorman 1951- *WhoAmA 78, -80*
Turbayne, Albert Angus 1866-1940 *DcBrBI*
Turbeville, Deborah 1937- *ConPhot, ICPEnP A*
Turbeville, Deborah 1938- *MacBEP*
Turcan, Jean *ArtsNiC*
Turcas, Ella Dallett *DcWomA, WhAmArt 85*
Turcas, Jules 1854- *WhAmArt 85*
Turcato, Giulio 1912- *ConArt 77, -83, OxTwCA, PhDcTCA 77*
Turchan, Robert 1928- *MarqDCG 84*
Turchi, Alessandro 1588?-1648? *McGDA*
Turck, Eliza 1832- *DcBrWA, DcVicP, -2, DcWomA*
Turck, Ethel Ellis De *WhAmArt 85*
Ture, N A *WhAmArt 85*
Turgan, Clemence *DcWomA*
Turgay, Betil 1940- *WhoGrA 82[port]*
Turgeon, Jean 1952- *WorECar*
Turiello, H M *AmArch 70*
Turini, Giovanni 1841-1899 *WhAmArt 85*
Turk, Francis H *NewYHSD*
Turk, Rudy H 1927- *WhoAmA 73, -76, -78, -80, -82, -84*
Turk, Ted Michael 1935- *AmArch 70*
Turkel, Norbert Nachum 1927- *AmArch 70*
Turkenton, Netta 1882-1959 *DcWomA*
Turkenton, Netta Craig *WhAmArt 85*
Turkheim, Helene De *WorFshn*
Turkle, Brinton Cassaday *IlsCB 1967*
Turkle, Brinton Cassaday 1915- *IlsBYP, IlsCB 1957*
Turko, H *AmArch 70*
Turkowski, Ken *MarqDCG 84*
Turle, Sarah A 1868- *WhAmArt 85*
Turle, Sarah Allibone Leavitt 1865-1930 *DcWomA*
Turley, Hans Edward 1909- *AmArch 70*
Turley, M R *AmArch 70*
Turley, Merton Dorrell 1909- *AmArch 70*
Turley, Samuel *AntBDN N*
Turley Brothers *FolkA 86*
Turman, William Thomas 1867- *WhAmArt 85*
Turmeau, John 1777-1846 *AntBDN J*
Turmel, Jean-Paul 1954- *DcCAr 81*
Turminger, T A *DcVicP 2*
Turnbaugh, Joseph 1829?- *FolkA 86*
Turnbaugh, Samuel *FolkA 86*
Turnbull *DcVicP 2*
Turnbull, A Watson *DcVicP 2*
Turnbull, Adam Ogilvie d1834? *BiDBrA*
Turnbull, Andrew Watson 1874- *DcBrA 1*
Turnbull, Anne Charlotte Fayermann *DcWomA*
Turnbull, Betty 1924- *WhoAmA 78, -80, -82, -84*
Turnbull, David James 1957- *MarqDCG 84*
Turnbull, Eliza J d1807 *FolkA 86*
Turnbull, Gale 1889- *ArtsAmW 2, WhAmArt 85*
Turnbull, Grace Hill 1880- *WhoAmA 73, -76*
Turnbull, Grace Hill 1880-1976 *WhoAmA 78N, -80N, -82N, -84N*
Turnbull, James B 1909-1976 *WhoAmA 78N, -80N, -82N, -84N*
Turnbull, James Baare 1909-1976 *WhAmArt 85*
Turnbull, John *OxTwCA*
Turnbull, John Richard 1921- *AmArch 70*
Turnbull, Peter 1950- *DcCAr 81*
Turnbull, Ruth 1912- *WhAmArt 85*
Turnbull, W *DcBrWA*
Turnbull, Mrs. Walter *DcVicP 2*
Turnbull, William 1922- *ConArt 77, -83, ConBrA 79[port], DcBrA 1, DcCAr 81, McGDA, OxTwCA, PhDcTCA 77, WorArt[port]*
Turnbull, William, Jr. 1935- *AmArch 70, ConArch*
Turnbull, Wilson Mark 1943- *MarqDCG 84*
Turner *FolkA 86*
Turner, Mrs. *DcVicP 2*
Turner, A Richard 1932- *WhoAmA 80, -82, -84*
Turner, Adelaide *DcWomA*
Turner, Agnes *DcVicP 2*
Turner, Alan 1943- *PrintW 83, -85, WhoAmA 76, -78, -80, -82, -84*
Turner, Albert Jennings 1940- *AmArch 70*
Turner, Alfred 1874-1940 *DcBrA 1*
Turner, Alfred M 1851-1932 *WhAmArt 85*
Turner, Alice *WhAmArt 85*
Turner, Alicia *DcWomA*
Turner, Anne Clare Cardew *WhoArt 82, -84*
Turner, Anselm *DcVicP 2*
Turner, Arthur *DcVicP 2*
Turner, Arthur 1940- *WhoAmA 73, -76, -80, -82, -84*
Turner, Arthur Charles 1936- *WhoAmA 78*
Turner, Arthur W *DcVicP 2*
Turner, August D d1919 *WhAmArt 85*
Turner, B W *DcBrWA*
Turner, Beatrice d1948 *DcWomA*

Turner, Bruce Backman 1941- *WhoAmA 73, -76, -78, -80, -82, -84*
Turner, Burnett Coburn 1902- *AmArch 70*
Turner, C A P 1869-1955 *MacEA*
Turner, C T *DcVicP 2*
Turner, Charles 1773-1857 *ClaDrA, DcVicP 2, McGDA*
Turner, Charles 1774-1857 *DcBrWA*
Turner, Charles Arthur 1940- *WhoAmA 78*
Turner, Charles E 1883-1965 *DcSeaP*
Turner, Charles H 1848- *WhAmArt 85*
Turner, Charles Y 1850-1919 *WhAmArt 85*
Turner, Charles Yardley 1850-1918 *IlBEAAW*
Turner, Claridge *DcVicP 2*
Turner, Mrs. Clyde *DcWomA*
Turner, Clyde A *AfroAA*
Turner, Cora Josephine *DcWomA*
Turner, Daniel *DcBrECP, DcBrWA*
Turner, David 1948- *WhoAmA 82, -84*
Turner, Dawson 1775-1858 *DcBrWA*
Turner, Dick 1909- *WhoAmA 73, -76, -78, -80*
Turner, Don LaViere 1929- *DcCAr 81*
Turner, Donald Andrew 1932- *AmArch 70*
Turner, Donald Harrison 1936- *AmArch 70*
Turner, Donald W 1931- *AmArch 70*
Turner, Dorothy Ling 1901- *WhAmArt 85*
Turner, E *DcWomA*
Turner, Miss E *NewYHSD*
Turner, Edward *DcVicP 2, FolkA 86*
Turner, Edward 1854?-1899 *ArtsEM*
Turner, Edwin Thurlow 1905- *AmArch 70*
Turner, Elizabeth *DcWomA*
Turner, Elmer 1890-1966 *ArtsAmW 1, IlBEAAW*
Turner, Elmer P 1890-1966 *ArtsAmW 3*
Turner, Emery S 1841-1921 *WhAmArt 85*
Turner, Evan Hopkins 1927- *WhoAmA 73, -76, -78, -80, -82, -84*
Turner, F C 1795-1865 *DcVicP, -2*
Turner, F M *DcVicP 2*
Turner, Frances Lee 1875- *DcWomA, WhAmArt 85*
Turner, Francis *DcVicP, -2*
Turner, Frank *DcVicP 2*
Turner, Frank James *DcVicP 2*
Turner, Fred Herbert 1931- *AmArch 70*
Turner, G A *DcVicP 2*
Turner, G P *AmArch 70*
Turner, George *ClaDrA, DcBrWA, DcVicP*
Turner, George 1752-1820? *DcBrECP*
Turner, George 1823?- *CabMA*
Turner, George 1843-1910 *DcBrA 1, DcBrWA, DcVicP 2*
Turner, H A *AmArch 70*
Turner, H B *AmArch 70*
Turner, H D *DcVicP 2*
Turner, Harriet *DcWomA*
Turner, Harriet French d1967 *WhoAmA 78N, -80N, -82N, -84N*
Turner, Harriet French 1886-1967 *DcWomA, FolkA 86*
Turner, Harry 1908- *DcBrA 1*
Turner, Harry M *WhoArt 82N*
Turner, Harry M 1912- *DcBrA 1, WhoArt 80*
Turner, Hawes *DcVicP 2*
Turner, Mrs. Hawes *DcVicP 2*
Turner, Helen Maria 1858-1958 *DcWomA, WhAmArt 85*
Turner, Henry *DcVicP 2, NewYHSD*
Turner, Ila *DcWomA, WhAmArt 85*
Turner, J *DcVicP 2*
Turner, J d1759 *EarABI*
Turner, J B *CabMA*
Turner, J Doman *DcBrA 2, OxTwCA*
Turner, J L *NewYHSD*
Turner, J R *AmArch 70*
Turner, J S, Jr. *AmArch 70*
Turner, J T *NewYHSD*
Turner, Jack Louis 1935- *AmArch 70*
Turner, James d1759 *BnEnAmA, NewYHSD*
Turner, James d1790? *DcBrECP*
Turner, James Alfred 1947- *MarqDCG 84*
Turner, James McClure 1912- *AmArch 70*
Turner, James Thomas, Sr. 1933- *WhoAmA 76, -78, -80, -82, -84*
Turner, Janet E 1914- *PrintW 83, -85, WhoAmA 73, -76, -78, -80, -82, -84*
Turner, Janice Kay 1938- *WhoAmA 76, -78, -80, -82, -84*
Turner, Jean 1895- *WhAmArt 85*
Turner, Jean Leavitt 1895- *ArtsAmW 3*
Turner, Jesse R 1938- *AmArch 70*
Turner, Jessie *DcVicP 2*
Turner, John *AntBDN Q, BiDBrA, WhAmArt 85*
Turner, John d1827 *BiDBrA*
Turner, John 1738- *DcD&D*
Turner, John 1738-1787 *AntBDN M*
Turner, John B 1943- *ICPEnP A, MacBEP*
Turner, John Latimer 1907- *AmArch 70*
Turner, Joseph 1729?-1807 *BiDBrA*
Turner, Joseph 1892- *WhoAmA 73, -76, -78*
Turner, Joseph 1892-1973 *WhoAmA 80N, -82N, -84N*

Turner, Joseph M W 1775-1851 *ArtsNiC*
Turner, Joseph Mallord William 1775-1851 *ClaDrA, DcBrBI, DcBrECP, DcBrWA, DcSeaP, DcVicP, -2, McGDA, OxArt*
Turner, Judith Beth 1922- *AmArch 70*
Turner, Katherine *DcBrA 1, DcWomA*
Turner, Ken 1926- *WhoArt 80, -82, -84*
Turner, Kenneth Morris 1925- *WhoArt 80, -82, -84*
Turner, L *NewYHSD*
Turner, Lawrence Hobert 1929- *AmArch 70*
Turner, LeRoy 1905- *WhAmArt 85*
Turner, Leslie 1899- *WorECom*
Turner, Leslie 1900- *WhAmArt 85*
Turner, Lottie *DcWomA*
Turner, Lottie B *ArtsEM, DcWomA, WhAmArt 85*
Turner, Lynette 1945- *WhoArt 82, -84*
Turner, M *DcVicP 2*
Turner, M G *AmArch 70*
Turner, Maria *DcWomA, NewYHSD*
Turner, Marian Jane 1908- *WhAmArt 85*
Turner, Martin William 1940- *WhoArt 80, -82, -84*
Turner, Mary *DcBrECP, DcWomA*
Turner, Mary 1774-1850 *DcBrWA*
Turner, Matilda Hutchinson *WhAmArt 85*
Turner, Matilda Hutchinson 1869- *DcWomA*
Turner, Matthew *CabMA*
Turner, Meta P W *DcVicP 2*
Turner, Morrie 1923- *WorECom*
Turner, Nellie D *ArtsEM, DcWomA*
Turner, Noland *AfroAA*
Turner, Norman Huntington 1939- *WhoAmA 76, -78, -80, -82, -84*
Turner, Paul Alan 1960- *MarqDCG 84*
Turner, Peggy E M *WhoArt 80, -82, -84*
Turner, Pete 1934- *ICPEnP A, MacBEP*
Turner, Peter Nicolas 1947- *MacBEP*
Turner, Philip John 1876-1943 *MacEA*
Turner, Polly 1775-1800 *FolkA 86*
Turner, Prudence 1930- *WhoArt 82, -84*
Turner, R C *AmArch 70*
Turner, R L, Jr. *AmArch 70*
Turner, Ralph James 1935- *WhoAmA 78, -80, -82, -84*
Turner, Raymond 1903- *WhAmArt 85, WhoAmA 73, -76, -78, -80, -82, -84*
Turner, Richard Sydney 1873-1919 *WhAmArt 85*
Turner, Robert *DcVicP 2*
Turner, Robert 1910- *WhoGrA 62*
Turner, Robert 1913- *CenC*
Turner, Robert Chapman 1913- *WhoAmA 73, -76, -78, -80, -82, -84*
Turner, Robert Homer 1938- *AmArch 70*
Turner, Robert Quinn 1933- *AmArch 70*
Turner, Robert William *AmArch 70*
Turner, Robert Woods 1926- *MarqDCG 84*
Turner, Roland 1931- *AfroAA*
Turner, Ross 1847-1915 *WhAmArt 85*
Turner, S M *AmArch 70*
Turner, Shirley *DcWomA, WhAmArt 85*
Turner, Sophia 1777-1793? *DcBrECP*
Turner, Sophia Alexander 1777- *DcWomA*
Turner, T *DcVicP 2*
Turner, Theodore Roy 1922- *WhoAmA 73, -76, -78, -80, -82, -84*
Turner, Thomas *AntBDN M*
Turner, Thomas Patrick, Jr. 1926- *AmArch 70*
Turner, W *DcVicP 2, NewYHSD*
Turner, W A *DcVicP 2, NewYHSD*
Turner, W Eddowes *DcVicP 2*
Turner, W Eddowes 1820?-1885? *DcBrWA*
Turner, W H M *DcVicP 2*
Turner, Wassell Atchley 1932- *AmArch 70*
Turner, William *FolkA 86*
Turner, William 1763-1816? *DcBrECP*
Turner, William 1789-1862 *BiDBrA, DcBrWA, DcVicP, -2*
Turner, William 1792-1867 *DcBrBI*
Turner, William 1802?- *FolkA 86*
Turner, William 1877- *ClaDrA, DcBrA 1*
Turner, William B *DcVicP 2*
Turner, William Eugene 1928- *WhoAmA 84*
Turner, William Green 1833- *ArtsNiC*
Turner, William Greene 1832?-1917 *NewYHSD, WhAmArt 85*
Turner, William Hamilton 1802?-1879? *DcBrWA*
Turner, William Kay 1933- *AmArch 70*
Turner, William Lakin 1867-1936 *DcBrA 1, DcBrWA, DcVicP 2*
Turner, William McAllister 1901- *ClaDrA, DcBrA 1*
Turner, William Ralph 1920- *ClaDrA, WhoArt 84*
Turner, Winifred 1903- *DcBrA 1*
Turner Of Oxford, William 1789-1862 *McGDA*
Turney, Agnes M *DcWomA*
Turney, Arthur Allin 1896- *ClaDrA*
Turney, Dennis *NewYHSD*
Turney, Ester *ArtsAmW 2, DcWomA, WhAmArt 85*
Turney, Olive 1847-1933? *DcWomA*
Turney, Olive 1847-1939? *WhAmArt 85*
Turney, Mrs. Winthrop D *WhAmArt 85*
Turney, Winthrop Duthie 1884- *WhAmArt 85*

DcWomA

Tyrwhitt, Walter Spencer Stanhope 1859-1932 *ClaDrA*

Tyrwhitt, Walter Spencer-Stanhope 1859-1932
 DcBrA 1, DcBrWA, DcVicP 2

Tyshler, Alexandr Grigorievich 1898- *ConArt 77*

Tysoe, Peter 1935- *WhoArt 80, -82, -84*

Tyson, Alice *DcVicP 2*

Tyson, Carroll Sargent, Jr. 1877-1956 *WhAmArt 85*

Tyson, Mrs. Charles R *WhoAmA 73*

Tyson, Dorsey Potter *WhAmArt 85*

Tyson, Mrs. George *DcWomA, WhAmArt 85*

Tyson, Ian 1933- *DcCAr 81*

Tyson, Jay Walter 1926- *AmArch 70*

Tyson, John H *DcVicP 2*

Tyson, Kathleen *WhoArt 84N*

Tyson, Kathleen 1898- *DcBrA 1, DcWomA,*
 WhoArt 80, -82

Tyson, Mary 1909- *WhAmArt 85, WhoAmA 73,*
 -76, -78, -80, -82, -84

Tyson, Michael 1740-1780 *DcBrWA*

Tyson, Rae Julian 1944- *WhoAmA 78, -80, -82, -84*

Tyson, Ramond Eugene 1939- *AmArch 70*

Tyson, Rowell 1926- *DcBrA 1, WhoArt 82, -84*

Tyson Edwards, Marian 1937- *WhoArt 80, -82, -84*

Tyson Trump *EncASM*

Tyssens, Jan Baptist *McGDA*

Tyssens, Pieter *McGDA*

Tyszblat, Michel *DcCAr 81*

Tyszkiewicz, Anna 1776-1867 *DcWomA*

Tyszkiewicz, W Roger 1920- *AmArch 70*

Tytell, Louis 1913- *WhoAmA 73, -76, -78, -80, -82,*
 -84

Tytell, Mellon *MacBEP*

Tytgat, Edgar 1879-1957 *OxArt*

Tytgat, Edgard 1879-1957 *McGDA, OxArt,*
 OxTwCA, PhDcTCA 77

Tytla, Vladimir 1904-1968 *WorECar*

Tytler, George 1798-1859 *DcBrWA*

Tytus, Robb DePeyster d1913 *WhAmArt 85*

Tyzack, Michael 1933- *PhDcTCA 77, WhoAmA 80,*
 -82, -84

Tzolakis, Rena *DcCAr 81*

Tzschumansky *NewYHSD*

Tzschumansky, Stanislas *NewYHSD*

Tzu, Hsi 1835-1908 *DcWomA*

U

U-Fan Lee *DcCAr 81*
Ubac, Raoul 1910- *ConArt 77, OxTwCA, PhDcTCA 77, PrintW 85*
Ubaldi, Mario Carmelo 1912- *WhAmArt 85*
Ubaldini, Domenico *McGDA*
Ubans, Juris K 1938- *WhoAmA 78, –80, –82, –84*
Ubertalli, Hector 1928- *WhoAmA 76, –78, –80, –82, –84*
Ubertino, Francesco D' *McGDA*
Ubsdell, Richard Henry Clements *DcBrBI, DcBrWA, DcVicP 2*
Uccello, Antonia 1446-1491 *DcWomA*
Uccello, Paolo 1397-1475 *McGDA, OxArt*
Uccello, Vincenza Agatha *WhoAmA 84*
Uccusic, Hilda *DcCAr 81*
Uchatius, Marie 1882- *DcWomA*
Uchermann, Karl 1855- *ClaDrA*
Uchima, Ansei 1921- *WhoAmA 73, –76, –78, –80, –82, –84*
Uchima, Toshiko *WhoAmA 76, –78, –80, –82, –84*
Uchterveldt, Jakob 1635?-1710? *ClaDrA*
Udall, J T *AmArch 70*
Udaltsova, Nadezhda 1886-1961 *OxTwCA, PhDcTCA 77*
Udaltsova, Nadezhda Andreevna 1886-1961 *DcWomA*
Udel, Joan Erbe *WhoAmA 78, –80*
Udell, Rochelle *AmGrD[port]*
Uden, E Boye 1911- *DcBrA 1, WhoArt 80, –82, –84*
Uden, Ernest Boye 1911- *DcBrA 2*
Uden, Lucas Van 1595-1672? *ClaDrA*
Uden, Lucas Van 1595-1672 *McGDA*
Uden, Lucas Van 1595-1673? *OxArt*
Uderzo, Albert 1927- *WorECom*
Udhe, Wilhelm 1874-1947 *OxArt*
Udine, Giovanni Da 1487-1564 *OxArt*
Udine, Martino Da *McGDA*
Uding, Donald N 1936- *AmArch 70*
Udinotti, Agnese 1940- *WhoAmA 73, –76, –78, –80, –82, –84*
Udstuen, T L *AmArch 70*
Udvardy, Flora 1880- *DcWomA*
Udvardy, John Warren *WhoAmA 78, –80, –82, –84*
Udvardy, John Warren 1936- *WhoAmA 73, –76*
Uebele, Martin *FolkA 86*
Uecker, Gunther 1930- *ConArt 77, –83, DcCAr 81, OxTwCA, PhDcTCA 77*
Ueda, Shoji 1913- *ConPhot, ICPEnP A, MacBEP*
Ueland, Mark 1935- *AmArch 70*
Uelsmann, Jerry 1934- *WhoAmA 73, –76, –78, –80, –82, –84*
Uelsmann, Jerry N 1934- *BnEnAmA, ConPhot, DcAmArt, ICPEnP, MacBEP*
Uematsu, Keiji 1947- *DcCAr 81*
Uematsu, Kuniomi 1927- *WhoGrA 82[port]*
Uemura, Shoen 1875-1949 *DcWomA*
Uerkvitz, Herta 1894- *ArtsAmW 3, DcWomA, WhAmArt 85*
Uexkuell-Gyllenband, Karoline Charlotte *DcWomA*
Ueyama, Tokio 1890- *ArtsAmW 2, WhAmArt 85*
Ufer, Charles C *ArtsEM*
Ufer, Mary *DcWomA*
Ufer, Walter 1876-1936 *ArtsAmW 1, IlBEAAW, WhAmArt 85*
Ufer, Mrs. Walter *WhAmArt 85*
Uffenbach, Philipp 1566-1636 *McGDA*
Ugarte Elespuru, Juan Manuel *OxTwCA*
Ugarte Elespuru, Juan Manuel 1911- *McGDA*
Uggerby, Ove W 1930- *AmArch 70*
Ugglas, Therese *DcWomA*
Uglow, Alan *PrintW 85*
Uglow, Euan 1932- *ConArt 77, ConBrA 79[port],*

DcCAr 81, OxTwCA, WhoArt 80, –82, –84
Ugo Da Carpi *McGDA*
Ugo Da Carpi 1480?-1525? *OxArt*
Ugolini, Gabriele Enrico 1946- *MarqDCG 84*
Ugolino Da Siena *McGDA, OxArt*
Ugolino Di Nerio *OxArt*
Ugolino Di Tedice *McGDA*
Ugolino Di Vieri *McGDA*
Uhde, Anne *DcWomA*
Uhde, Friedrich 1848-1911 *ClaDrA, OxArt*
Uhde, Fritz Von 1848-1911 *McGDA*
Uhde, Wilhelm 1874-1947 *OxTwCA*
Uhden, Maria 1892-1918 *DcWomA*
Uhl, Emmy 1919- *WhoAmA 73, –76*
Uhl, Grace E *DcWomA, WhAmArt 85*
Uhl, Harrison J, Jr. 1929- *AmArch 70*
Uhl, Peter *FolkA 86*
Uhl, S Jerome, Sr. 1842- *WhAmArt 85*
Uhl, William *NewYHSD*
Uhle, Bernard *NewYHSD*
Uhle, Bernhard *WhAmArt 85*
Uhle, G Anton *NewYHSD*
Uhle, Herman *FolkA 86*
Uhler, Anne *WhAmArt 85*
Uhler, Anne Fuller *DcWomA*
Uhler, Ruth Pershing *WhoAmA 78N, –80N, –82N, –84N*
Uhler, Ruth Pershing 1898-1968? *WhAmArt 85*
Uhler, Ruth Pershing 1898-1969? *ArtsAmW 2, DcWomA*
Uhlig, Gunther *ConArch A*
Uhlir, Katharina d1912 *DcWomA*
Uhlman, Fred 1901- *DcBrA 1, WhoArt 80, –82, –84*
Uhlmann, Hans 1900- *McGDA, OxTwCA, PhDcTCA 77*
Uhlmann, Hans 1900-1975 *WorArt*
Uhlmann, L F *AmArch 70*
Uhrman, Celia 1927- *WhoAmA 76, –78, –80, –82, –84*
Uhrman, Esther 1921- *WhoAmA 76, –78, –80, –82, –84*
Uht, John 1924- *WhoArt 82, –84*
Uijl, Jan Jansz Den *McGDA*
Uilenburg, Gerard 1626?-1690? *ClaDrA*
Ujhazi, Peter 1940- *DcCAr 81*
Ulber, Althea 1898- *ArtsAmW 2, DcWomA, WhAmArt 85*
Ulber, Julius E *ArtsEM*
Ulber, Nellie *ArtsEM, DcWomA*
Ulberti, Joseph *NewYHSD*
Ulbricht, Elsa Emilie 1885-1980 *DcWomA, WhAmArt 85*
Ulbricht, Herbert Henry, Jr. 1923- *AmArch 70*
Ulbricht, John 1926- *WhoAmA 76, –78, –80, –82, –84*
Ulcoq, Andrew *DcVicP 2*
Ulefeld, Eleonora Christine 1621-1698 *DcWomA*
Ulefeld, Ellen Christine 1643-1677 *DcWomA*
Ulen, Jean Grigor 1900- *WhAmArt 85*
Ulen, Paul V 1894- *WhAmArt 85*
Ulf, Jacob VanDer 1627-1689 *McGDA*
Ulfeldt, Eleonora Christine 1621-1698 *DcWomA*
Ulfeldt, Ellen Christine 1643-1677 *DcWomA*
Ulfsten, Nicolay 1855-1885 *ClaDrA*
Ulft, Jacob VanDer 1627-1689 *ClaDrA*
Ulichney, Robert Alan 1954- *MarqDCG 84*
Ulietti, J L *AmArch 70*
Ulin, Dene 1930- *WhoAmA 73, –76*
Ulivi, Pietro 1806- *ArtsNiC*
Ulke, Henry 1821-1910 *NewYHSD , WhAmArt 85*
Ullberg, J Kent 1945- *WhoAmA 78, –80*
Ullberg, Jean Kent 1945- *WhoAmA 76*
Ullberg, Kent 1945- *WhoAmA 82, –84*

Ullman, Alice Woods *DcWomA, WhAmArt 85*
Ullman, Eugene Paul 1877- *WhAmArt 85*
Ullman, Eugene Paul 1877-1953 *ClaDrA*
Ullman, Franz *DcNiCA*
Ullman, Mrs. George W *WhoAmA 80, –73, –76, –78, –82, –84*
Ullman, Harold P 1899- *WhoAmA 73, –76, –78, –80N, –82N, –84N*
Ullman, Jane F *WhAmArt 85*
Ullman, Julius 1863- *ArtsAmW 3*
Ullman, Paul 1906-1944 *WhAmArt 85*
Ullman, W M *DcVicP 2*
Ullmann, Marie 1839- *DcWomA*
Ullmark, Andrew V 1865- *WhAmArt 85*
Ullmer, Frederick *DcVicP 2*
Ullmer, William *ArtsEM*
Ullrich, Albert H 1869- *WhAmArt 85*
Ullrich, B 1907- *WhAmArt 85*
Ullrich, Dietmar 1940- *DcCAr 81, OxTwCA*
Ullrich, E W *WhAmArt 85*
Ullrich, Hattie Edsall Thorp 1870- *DcWomA, WhAmArt 85*
Ullrich, W C *AmArch 70*
Ullrich-Zuckerman, B *WhoAmA 73, –78, –80, –82, –84*
Ulm, John Louis 1907- *WhAmArt 85*
Ulman, Elinor 1910- *WhAmArt 85*
Ulmann, Benjamin 1829-1884 *ArtsNiC, ClaDrA*
Ulmann, Doris 1882-1934 *ConPhot*
Ulmann, Doris 1884- *WhAmArt 85*
Ulmann, Doris 1884-1934 *ICPEnP A, MacBEP*
Ulmann, Gertrud 1876- *DcWomA*
Ulmann, Lise *DcWomA*
Ulmer, C Paul 1906- *AmArch 70*
Ulmer-Stichel, Dorte 1888- *DcWomA*
Ulmschneider, Frank J *WhAmArt 85*
Ulp, Clifford 1885-1957 *WhAmArt 85*
Ulp, Clifford McCormick 1885-1957 *WhoAmA 80N, –82N, –84N*
Ulpts, Gerhards *DcSeaP*
Ulreich, Eduard Buk 1889- *ArtsAmW 3, IlBEAAW, WhAmArt 85*
Ulreich, Nura Woodson d1950 *WhAmArt 85, WhoAmA 78N, –80N, –82N, –84N*
Ulreich, Nura Woodson 1899-1950 *IlsBYP, IlsCB 1744, –1946*
Ulric, Angele *DcWomA*
Ulrich Von Ensingen 1350?-1419 *McGDA*
Ulrich, Caroline *DcWomA*
Ulrich, Charles F *DcVicP 2*
Ulrich, Charles Frederic 1858-1908 *DcAmArt, WhAmArt 85*
Ulrich, David A 1950- *MacBEP*
Ulrich, Edward *WhAmArt 85*
Ulrich, Edward Buk 1889- *ArtsAmW 3*
Ulrich, Edwin Abel 1897- *WhoAmA 76, –78, –80, –82, –84*
Ulrich, Fred J *WhAmArt 85*
Ulrich, Heinrich 1572?-1621 *ClaDrA*
Ulrich, Louis W *WhAmArt 85*
Ulrich, Thomas Charles 1937- *MarqDCG 84*
Ulrich, Vic *WhAmArt 85*
Ulrich-Zuckerman, B *WhoAmA 76*
Ulrichs, Timm 1940- *ConArt 77, –83*
Ulrichs, Tinni 1940- *DcCAr 81*
Ulrik, Sara Brigitte 1855-1916 *DcWomA*
Ulrika, Eleonora, Queen Of Sweden 1656-1693 *DcWomA*
Ulsamer, Rosa 1884- *DcWomA*
Ultang, Donald Theodore 1917- *MacBEP*
Ultvedt, Per-Olof 1927- *OxTwCA, PhDcTCA 77*

Ulysse-Besnard, M *DcWomA*
Ulysses, Robert 1940- *DcCAr 81*
Ulzheimer, Philip Jacob 1937- *AmArch 70*
Ulzurrum, Maria DelPilar *DcWomA*
Umana, Alfonso 1908- *WhoAmA 76, –78, –80*
Umbarger, Michael, Jr. 1811?- *FolkA 86*
Umbehr, Otto 1902-1980 *ICPEnP*
Umberg, Gunter 1942- *DcCAr 81*
Umbert, Micaela *DcWomA*
Umble, John *FolkA 86*
Umbo 1902-1980 *ConPhot, ICPEnP, MacBEP*
Umbricht, Marie Therese 1889- *DcWomA*
Umbrick, Gabriel *FolkA 86*
Umbs, Barry Allen 1947- *MarqDCG 84*
Umbstaetter, Nelly Littlehale *DcWomA,
 WhAmArt 85*
Umehara, Ryuzaburo 1888- *McGDA*
Umland, Hazel *DcWomA*
Umlauf, Charles 1911- *DcCAr 81, McGDA,
 WhAmArt 85, WhoAmA 73, –76, –78, –80, –82,
 –84*
Umlauf, Karl 1939- *PrintW 83, –85*
Umlauf, Karl A 1939- *WhoAmA 76, –78, –80, –82,
 –84*
Umlauf, Lynn 1942- *WhoAmA 84*
Unbehagen, Niels 1940- *DcCAr 81*
Uncini, Giuseppe 1929- *ConArt 77, –83*
Uncle Henry *FolkA 86*
Uncle Jack *FolkA 86*
Uncles, Ewart Charles 1919- *WhoArt 80, –82*
Unden, Lily Anne-Marie 1908- *ClaDrA*
Underhill, Ada *WhAmArt 85*
Underhill, Frederick Charles *DcVicP, –2*
Underhill, Frederick Thomas *DcBrWA, DcVicP, –2*
Underhill, Georgia E *DcWomA, WhAmArt 85*
Underhill, Katharine 1892- *WhAmArt 85*
Underhill, Liz 1948- *DcCAr 81*
Underhill, M J *DcWomA*
Underhill, William *DcVicP, –2*
Underwood, A S *DcVicP 2*
Underwood, Abby E *DcWomA*
Underwood, Addie *ArtsAmW 2, DcWomA,
 WhAmArt 85*
Underwood, Ann 1876- *DcBrA 1, DcWomA*
Underwood, Anne 1876- *ClaDrA*
Underwood, Bayard 1916- *AmArch 70*
Underwood, Berdett Penird 1935- *MarqDCG 84*
Underwood, Bert Elias 1862- *ICPEnP A*
Underwood, Bert Elias 1862-1943 *MacBEP*
Underwood, Charles *BiDBrA*
Underwood, Clarence F 1871-1929 *WhAmArt 85*
Underwood, Edgar Sefton *DcBrBI*
Underwood, Elisabeth 1896-1976 *DcWomA,
 WhoAmA 78N, –80N, –82N, –84N*
Underwood, Elisabeth Kendall 1896-1976
 WhAmArt 85
Underwood, Elmer 1860-1947 *ICPEnP A, MacBEP*
Underwood, Ethel B *DcWomA, WhAmArt 85*
Underwood, Evelyn Notman *WhoAmA 73, –76, –78,
 –80, –82*
Underwood, Evelyn Notman 1898-1983 *WhoAmA 84N*
Underwood, Fred Nimrod, Jr. 1930- *AmArch 70*
Underwood, George Allen 1793?-1829 *BiDBrA*
Underwood, George Bowker 1946- *MarqDCG 84*
Underwood, Henry Jones 1804-1852 *BiDBrA*
Underwood, J A *ArtsAmW 2, FolkA 86,
 NewYHSD*
Underwood, John *CabMA*
Underwood, Keith Alfred 1934- *WhoArt 80, –82, –84*
Underwood, Keith Bernard 1915- *AmArch 70*
Underwood, L W *FolkA 86*
Underwood, Leon 1890- *ClaDrA, ConICB, DcBrA 1,
 IlsCB 1744, WhAmArt 85*
Underwood, Leon 1890-1975 *DcBrA 2, OxTwCA*
Underwood, Mary Stanton *DcWomA, WhAmArt 85*
Underwood, Mattie *ArtsEM, DcWomA*
Underwood, Rosalba *DcWomA*
Underwood, Thomas 1795-1849 *NewYHSD*
Underwood, Thomas Richard 1772-1836 *DcBrWA*
Underwood-Fitch, Alice *DcWomA, WhAmArt 85*
Undi, Maria 1877- *DcWomA*
Undley, Maria A *DcVicP 2*
Ungar, Arthur J 1935- *MarqDCG 84*
Ungarleider, M E *AmArch 70*
Ungaro, Emanuel 1933- *ConDes, WorFshn*
Ungaro, Emmanuel 1933- *FairDF FRA[port]*
Unger *NewYHSD*
Unger, A E *AmArch 70*
Unger, Arthur A 1912- *AmArch 70*
Unger, Carl 1915- *OxTwCA*
Unger, Charles J d1881 *FolkA 86*
Unger, Dean Frederick 1928- *AmArch 70*
Unger, Edouard 1853-1894 *ClaDrA*
Unger, Eugene *EncASM*
Unger, Frederick d1878 *EncASM*
Unger, Fredrick 1851-1925 *FolkA 86*
Unger, George d1878 *EncASM*
Unger, Gladys Buchanan *DcWomA*
Unger, Hans 1915- *WhoGrA 62*
Unger, Herman *EncASM*
Unger, Howard A 1944- *MacBEP*

Unger, I *FolkA 86*
Unger, J *AmArch 70*
Unger, Johanna 1837-1871 *DcWomA*
Unger, Kay E 1945- *WorFshn*
Unger, Margit 1881- *DcWomA*
Unger, Martha 1880- *DcWomA*
Unger, Mary Ann 1945- *WhoAmA 78, –80, –82, –84*
Unger, Wilhelm 1837- *ArtsNiC*
Unger, William d1878 *EncASM*
Unger Brothers *EncASM*
Ungerer, Tomi *IlsCB 1967*
Ungerer, Tomi 1931- *IlsCB 1957, WhoGrA 62,
 –82[port]*
Ungermann, Arne 1902- *IlsBYP, IlsCB 1946,
 WhoGrA 62, WorECar*
Ungers, O M 1926- *ConArch, MacEA*
Ungers, Oswald Matthias 1926- *AmArch 70*
Ungewitter, G G 1820-1864 *MacEA*
Ungewitter, Georg Gottlob 1820-1864 *WhoArch*
Unik, Renee 1895- *DcWomA*
Unite, Daphne 1907- *DcBrA 1*
Unitt, Edward G *WhAmArt 85*
Unkart, E *DcWomA*
Unkart, Mrs. E *AmArch 70*
Unkei d1223 *McGDA*
Unna, Ada *DcVicP 2*
Unnik, Rob Van 1949- *DcCAr 81*
Unold, Max 1885- *McGDA*
Unruh, Jack Neal 1935- *IlrAm 1880*
Unruh, Richard Lee 1931- *AmArch 70*
Unser, C *FolkA 86*
Unsin, R E *AmArch 70*
Unsworth, Edna Ganzhorn 1890- *ArtsAmW 2,
 DcWomA, WhAmArt 85*
Unsworth, Ken 1931- *ConArt 83*
Unsworth, Peter 1937- *DcCAr 81*
Unteed, Kenneth Eugene 1925- *AmArch 70*
Untenreith, L *NewYHSD*
Untermyer, Irving *WhoAmA 73*
Untermyer, Mrs. Irving *WhoAmA 73*
Unternahrer, Sophie *DcWomA*
Untersee, Frank Joseph 1858-1927 *BiDAmAr*
Untersee, Maximilian 1897- *AmArch 70*
Unterseher, Chris Christian 1943- *WhoAmA 73, –76,
 –78, –80, –82, –84*
Unthank, Alice Gertrude *WhAmArt 85*
Unthank, Alice Gertrude 1878- *DcWomA*
Unthank, DeNorval, Jr. 1929- *AmArch 70*
Unthank, George Ralph 1914- *AmArch 70*
Unthank, John Oliver 1904- *AmArch 70*
Unthank, William S 1841-1892 *NewYHSD*
Unver, George *WhAmArt 85*
Unwalla, J *ICPEnP A*
Unwin, Frances Mabelle *DcWomA*
Unwin, Francis Sydney 1885-1925 *DcBrA 1,
 DcBrWA*
Unwin, G *DcWomA*
Unwin, G A *DcVicP 2*
Unwin, H *DcWomA*
Unwin, Ida M *DcVicP 2, DcWomA*
Unwin, Mary L H *DcWomA*
Unwin, Nora Spicer *IlsCB 1967, WhoAmA 73, –76,
 –78, –80, –82, WhoArt 80, –82, –84N*
Unwin, Nora Spicer d1982 *WhoAmA 84N*
Unwin, Nora Spicer 1907- *DcBrA 1, IlsCB 1744,
 –1946, –1957*
Unwin, Raymond 1863-1940 *MacEA*
Unwin, Sir Raymond 1863-1940 *DcD&D[port],
 WhoArch*
Unwin, Robert *BiDBrA*
Unwin, William *BiDBrA*
Upchurch, Mary B *DcWomA*
Updegraff, Sallie Bell 1864- *DcWomA,
 WhAmArt 85*
Updike, Daniel Berkeley 1860-1941 *OxDecA,
 WhAmArt 85*
Updike, John *FolkA 86*
Upelnieks, Arthur 1911- *WhoAmA 76, –78*
Upham, B C *WhAmArt 85*
Upham, Hervey *NewYHSD*
Upham, J C *FolkA 86*
Upham, John William 1772-1828 *DcBrWA*
Upham, M *DcBrWA*
Upham, W H *WhAmArt 85*
Uphill, Jessie H *DcVicP 2*
Uphoff, Caroline Von *DcWomA*
Uphoff, Lore 1890- *DcWomA*
Upjohn, Anna Milo *DcWomA, WhAmArt 85*
Upjohn, Everard Miller 1903- *WhAmArt 85,
 WhoAmA 73, –76, –78*
Upjohn, Everard Miller 1903-1978 *WhoAmA 80N,
 –82N, –84N*
Upjohn, Hobart B 1876-1949 *BiDAmAr*
Upjohn, Millie *DcWomA, WhAmArt 85*
Upjohn, Richard 1802-1878 *BiDAmAr, BnEnAmA,
 DcD&D, EncAAr, MacEA, McGDA,
 NewYHSD*
Upjohn, Richard 1803-1878 *OxArt*
Upjohn, Richard M 1827-1903 *BiDAmAr*
Upjohn, Richard Michell 1828-1903 *BnEnAmA,
 MacEA*

Upman, Frank d1948 *BiDAmAr*
Uppleby, Charles 1779-1853 *DcBrWA*
Upright, Diane W *WhoAmA 84*
Upsdell, P *DcBrECP*
Upsdell, Peter *BiDBrA*
Upshaw, Dean Lee 1934- *AmArch 70*
Upshaw, Forrest, Jr. 1926- *AmArch 70*
Upshur, Bernard 1936- *AfroAA*
Upshur, Martha R 1885- *WhAmArt 85*
Upshur, Martha Robinson 1885- *DcWomA*
Upshur, Robert Irving 1918- *AmArch 70*
Upson, Asahel *FolkA 86*
Upson, Craig D 1954- *MarqDCG 84*
Upson, James d1803 *FolkA 86*
Upson, Jefferson T *NewYHSD*
Upson, Salmon 1791- *FolkA 86*
Upson, Sarah Greenleaf *FolkA 86*
Uptegrove, Sister M Irena 1898- *DcWomA,
 WhAmArt 85*
Upthegrove, William Rillon 1930- *AmArch 70*
Upton *FolkA 86*
Upton, Ada *ArtsEM*
Upton, Charles 1911- *DcBrA 1, WhoArt 80, –82,
 –84*
Upton, Ethelwyn d1921 *WhAmArt 85*
Upton, Ethelwyn B d1921 *DcWomA*
Upton, Florence K d1922 *DcBrBI, WhAmArt 85*
Upton, Florence Kate d1922 *DcBrA 1*
Upton, Florence Kate 1873-1922 *DcWomA*
Upton, Henry 1823- *CabMA*
Upton, Ida *DcWomA*
Upton, John A *DcVicP 2*
Upton, John David 1932- *WhoAmA 78, –80, –82, –84*
Upton, Michael 1938- *DcCAr 81, WhoArt 80, –82,
 –84*
Upton, Richard 1931- *PrintW 83, –85*
Upton, Richard Thomas *WhoAmA 78, –80, –82, –84*
Upward, J William *BiDBrA*
Urabe, Shizutaro *ConArch*
Urabe, Shizutaro 1909- *MacEA*
Uram, Lauren 1957- *AmArt*
Urbach, Amelia *WhAmArt 85*
Urbahn, Maximilian Otto 1912- *AmArch 70*
Urbain, Leon Francis 1887- *AmArch 70*
Urban, Albert 1909-1959 *WhoAmA 80N, –82N, –84N*
Urban, C Emlen 1863-1939 *BiDAmAr*
Urban, Catherine 1955- *DcCAr 81*
Urban, Dieter 1938- *WhoGrA 82[port]*
Urban, Hermann 1866- *ClaDrA*
Urban, J *AmArch 70*
Urban, Janos 1934- *ConArt 77, –83*
Urban, Joao Aristeu 1943- *ConPhot, ICPEnP A*
Urban, John Charles 1943- *WhoArt 80, –82*
Urban, Joseph 1872-1933 *MacEA, WhAmArt 85*
Urban, L J *AmArch 70*
Urban, Mychajlo Raphael 1928- *WhoAmA 73, –76,
 –78*
Urban, Reva 1925- *PhDcTCA 77, WhoAmA 73, –76,
 –78, –80, –82, –84*
Urban, Robert 1915-1947 *WhAmArt 85*
Urban, Stanley Gregory 1910- *AmArch 70*
Urbani, F *NewYHSD*
Urbaniec, Maciej 1925- *ConDes, WhoGrA 82[port]*
Urbanski, Leon 1926- *ConDes*
Urbanus, Daniel Matthew 1924- *AmArch 70*
Urbinati, J F *AmArch 70*
Urbine, Rosi M 1952- *MacBEP*
Urculo, Eduardo *OxTwCA*
Urda Marin, Manuel 1886-196-? *WorECar*
Urdahl, Marlowe *OfPGCP 86*
Uren, John Clarkson *DcBrWA, DcVicP 2*
Urena, Felipe *McGDA*
Urfer, C A *AmArch 70*
Uribe, G Arcila 1895- *WhAmArt 85*
Uribe, Jesus Sanchez 1948- *ICPEnP A, MacBEP*
Uribe Y Farfan, Aida 1894- *DcWomA*
Uriburu, Nicolas 1937- *ConArt 77, –83*
Urich, Louis J 1879- *WhAmArt 85*
Urland, G *DcVicP 2*
Urlaub, Henriette *DcWomA*
Urlienes, Gil De *McGDA*
Urmston, Benjamin Porch 1926- *AmArch 70*
Urmston, Germaine Bourquiun *ArtsAmW 3,
 DcWomA*
Urner, Joseph 1898- *WhAmArt 85*
Urofsky, Fred B 1937- *AmArch 70*
Urquhart, Annie Mackenzie *DcBrA 2, DcBrBI,
 DcWomA*
Urquhart, Edith Mary *DcBrA 1, DcWomA*
Urquhart, Elizabeth 1958- *DcCAr 81*
Urquhart, Gregor *DcVicP 2*
Urquhart, John *AfroAA*
Urquhart, Murray 1880- *ClaDrA*
Urquhart, Murray McNeel Caird 1880- *DcBrA 1*
Urquhart, Murray McNeel Caird 1880-1972 *DcBrA 2*
Urquhart, Tony *OxTwCA*
Urquhart, Tony 1934- *ConArt 77, PrintW 83, –85,
 WhoAmA 73, –76, –78, –82, –84*
Urquhart, William J *DcVicP 2*
Urquhartson, C Q *DcVicP 2*
Urrabieta Ortiz Y Vierge, Daniel 1851-1904 *ClaDrA*

Urriza, Louise De *DcWomA*
Urrutia, Lawrence 1935- *WhoAmA 73*
Urrutia DeUrmeneta, Ana Gertrudis De 1812-1850
 DcWomA
Urry, Steven 1939- *DcCAA 77, DcCAr 81,*
 WhoAmA 73, –76, –78
Urso, Filippo *OxDecA*
Urso, Richard Carl *WhoAmA 76, –78*
Urso, Richard Carl 1947- *WhoAmA 80, –82*
Ursula 1921- *DcCAr 81, OxTwCA*
Ursula, Saint *McGDA*
Ursulescu, Michael Marius 1913- *WhAmArt 85*
Urteaga, Mario 1875-1957 *OxTwCA*
Urteaga, Mario 1875-1959 *McGDA*
Urteil, Andreas 1913-1963 *OxTwCA*
Urteil, Andreas 1933-1963 *PhDcTCA 77*
Urthaler, Wilhelmine *DcWomA*
Urueta, Cordelia 1908- *WhoAmA 76, –78*
Urwick, Walter Chamberlain 1864-1943 *DcBrA 1,*
 DcVicP, –2
Urwick, William H *DcBrA 1, DcVicP, –2*
Urwick, William H d1915 *DcBrA 2*
Urwiler, Benjamin *NewYHSD*
Ury, Lesser 1861-1931 *McGDA*
Us, Susan 1946- *MarqDCG 84*
Usami, Keiji 1940- *ConArt 77, OxTwCA,*
 PhDcTCA 77
Usas, V J *AmArch 70*
Usberk, Bergin *WorFshn*
Ushakov, Semen 1626-1686 *OxArt*
Ushenko, Audrey Andreyevna 1945- *WhoAmA 73,*
 –76, –78, –80
Usher, Elizabeth Reuter *WhoAmA 78, –80, –82, –84*
Usher, Leila 1859-1955 *DcWomA, WhAmArt 85*
Usher, Ruby W 1889-1957 *WhAmArt 85*
Usher, Ruby Walker 1889-1957 *ArtsAmW 3,*
 DcWomA, WhoAmA 80N, –82N, –84N
Ushijima, Yoshihiro 1947- *DcCAr 81*
Usiglio, Sophie *DcWomA*
Uslan, M G *AmArch 70*
Usry, Katherine Bartlett *WhAmArt 85*
Ussher, Arland A *DcVicP 2*
Ussi, Stefano 1822- *ArtsNiC*
Ustinov, Alexander 1909- *ICPEnP A*
Ustinov, Nadia *DcWomA*
Usui, Bumpei *WhAmArt 85*
Usui, Frances Elizabeth *WhoAmA 78, –80*
Usui, Kiichi 1931- *WhoAmA 76, –78, –80, –82, –84*
Usurier, Catherine L' *DcWomA*
Ut, Nick *MacBEP*
Uta, Abbess Of Regensburg *DcWomA*
Utagawa, Kuniyoshi 1797-1861 *WorECom*
Utamaro 1753-1806 *McGDA*
Utamaro, Kitagawa 1753-1806 *OxArt*
Utenbroek, Mozes Van 1590?-1648 *McGDA*
Utenkov, Demian 1948- *PrintW 83, –85*
Utermohlen, William C 1933- *WhoArt 80, –82, –84*
Utescher, Gerd *WhoAmA 78, –80, –82*
Uthco, T R 1944- *WhoAmA 76, –78, –80, –82*
Utile Da Faenza *McGDA*
Utley, Tabor 1891- *ArtsAmW 1*
Utley, Thomas L *FolkA 86*
Utley, William L *NewYHSD*
Utpatel, Frank Albert Bernhardt 1905- *WhAmArt 85*
Utrecht, Adriaen Van 1599-1652 *McGDA*
Utrecht, Constantia Van *DcWomA*
Utrillo, Lucie Valore 1878-1965 *DcWomA*
Utrillo, Maurice 1883-1955 *ClaDrA, McGDA,*
 OxArt, OxTwCA, PhDcTCA 77
Uttech, Thomas 1942- *PrintW 83, –85*
Uttech, Thomas Martin 1942- *WhoAmA 76, –78, –80,*
 –82, –84
Utter, Andre 1886-1948 *ClaDrA*
Utterback, Richard Alexander 1922- *AmArch 70*
Utterson, Edward Vernon 1776-1852 *DcBrWA*
Utterson, Emily *DcVicP 2*
Utz, Thornton *OfPGCP 86*
Utz, Thornton 1914- *IlrAm F, –1880, WhoAmA 84*
Utzon, Jorn 1918- *ConArch, DcD&D[port], EncMA,*
 MacEA, WhoArch
Uvedale, Samuel *DcVicP 2*
Uwins, James *DcVicP, –2*
Uwins, Thomas 1782-1857 *ArtsNiC, DcBrBI,*
 DcBrWA, DcVicP, –2
Uyl, Jan Jansz Den 1595?-1640 *McGDA*
Uylenburg, Jumffer *DcWomA*
Uytenbogaardt, Roelof S 1933- *ConArch*
Uytewael, Joachim Anthonisz *McGDA*
Uyttenbroeck, Moyses Van 1590?-1648 *ClaDrA*
Uyttenbroeck, Mozes Van *McGDA*
Uytterschaut, Victor 1847-1917 *ClaDrA*
Uzes, Marie Adrienne Anne *DcWomA*
Uzielli, Giorgio 1903- *WhoAmA 73, –76, –78, –80,*
 –82
Uzilevsky, Marcus 1937- *PrintW 83, –85*
Uzlyan, Alexander 1908- *ICPEnP A*
Uzzle, Burk 1938- *ConPhot, ICPEnP A, MacBEP*

V

Vacca, Alfonse 1900- *AmArch 70*
Vaccarini, Giovanni Battista 1702-1768 *MacEA*
Vaccarino, Robin 1928- *WhoAmA 78, -80, -82, -84*
Vaccaro, Andrea 1598?-1670 *ClaDrA*
Vaccaro, Joseph Dayle 1936- *AmArch 70*
Vaccaro, Luella Grace 1934- *WhoAmA 76, -78, -80, -82, -84*
Vaccaro, Nick Dante 1931- *WhoAmA 73, -76, -78, -80, -82, -84*
Vaccaro, Patrick Frank *WhoAmA 73, -76, -78, -80, -82, -84*
Vaccarone, Francesco 1940- *DcCAr 81*
Vacchi, Sergio 1925- *OxTwCA, PhDcTCA 77*
Vaccolini, Luigia *DcWomA*
Vachel, Arthur Honywood 1864- *ArtsAmW 3*
Vachell, Arthur Honywood 1864- *ArtsAmW 3*
Vacher, Charles 1818-1883 *DcBrWA, DcVicP, -2*
Vacher, Sydney *DcVicP 2*
Vacher, Thomas Brittain 1805-1880 *DcBrWA, DcVicP, -2*
Vachon, Achille *NewYHSD*
Vachon, Cassandrasu Dhooge-Quinn *WhoAmA 78, -80*
Vachon, David Allan 1935- *AmArch 70*
Vachon, John 1914-1975 *ConPhot*
Vachon, John Felix 1914-1975 *ICPEnP A, MacBEP*
Vachot, Lucile *DcWomA*
Vachtova, Dana 1937- *DcCAr 81*
Vackar, W A *AmArch 70*
Vacker, Laurence Carlton 1928- *AmArch 70*
Vadala, Angelo 1940- *PrintW 85*
Vadasz, Gyorgy 1933- *ConArch*
Vadder, Lodewijk De 1605-1655 *McGDA*
Vadder, Lodewyk De 1605-1655 *ClaDrA*
Vadnais, Thomas Giesy 1919- *AmArch 70*
Vadura-Bilek, Alena 1953- *DcCAr 81*
Vaenius 1556-1629 *OxArt*
Vaenius, Octavius *McGDA*
Vaerten, Joannes Cornelius Maria 1909- *ClaDrA*
Vaeth, G F, Jr. *AmArch 70*
Vaga, Perino Del 1501-1547 *McGDA*
Vaga, Pierino Del 1500-1547 *OxArt*
Vaganov, Benjamin G 1896- *ArtsAmW 3, WhAmArt 85*
Vagen, Bette 1919- *FolkA 86*
Vagenas, Nicholas *AfroAA*
Vaghi, J P *AmArch 70*
Vagis, Polygnotis d1965 *WhoAmA 78N, -80N, -82N, -84N*
Vagis, Polygnotos George 1894-1965 *WhAmArt 85*
Vagliengo, Marie Christine *DcWomA*
Vagnby, Viggo 1896- *WhoGrA 62*
Vagnetti, Luigi 1915-1980 *MacEA*
Vago, Pierre *ConArch A*
Vago, Pierre 1910- *ConArch, EncMA*
Vago, Sandor 1887- *WhAmArt 85*
Vago, Valentino 1931- *ConArt 77*
Vagyoczky, Karoly 1941- *DcCAr 81*
Vahlberg, C Julian 1916- *AmArch 70*
Vahlberg, Robert William 1913- *AmArch 70*
Vahle, Claus 1940- *DcCAr 81*
Vahrenhorst, Anna Benigna *DcWomA*
Vaiani, Anna Maria *DcWomA*
Vaihinger, Erna 1896-1918 *DcWomA*
Vaiksnoras, Anthony, Jr. 1918- *WhAmArt 85*
Vail, Aramenta Dianthe *DcWomA, NewYHSD*
Vail, Charlie Lee, Jr. 1924- *AmArch 70*
Vail, Eugene Lawrence 1857-1934 *WhAmArt 85*
Vail, George Cameron *OfPGCP 86*
Vail, Joseph *CabMA, NewYHSD*
Vail, Laurence d1968 *WhoAmA 78N, -80N, -82N, -84N*

Vail, Robert D *WhAmArt 85*
Vail, Robert Edward 1932- *AmArch 70*
Vail, Robert William Glenrole 1890- *WhAmArt 85*
Vail, Roger 1945- *ICPEnP A, MacBEP*
Vail, Samuel Underhill 1922- *AmArch 70*
Vail, Thomas A 1926- *AmArch 70*
Vail, Thomas J *EncASM*
Vaillancourt, Armand *OxTwCA*
Vaillancourt, Gary F 1950- *MarqDCG 84*
Vaillant, Madame *DcWomA, NewYHSD*
Vaillant, Jacques Gaston Emile 1879-1934 *ClaDrA*
Vaillant, Louis D 1875-1944 *WhAmArt 85*
Vaillant, Louise *DcWomA*
Vaillant, Louise Jeanne *DcWomA*
Vaillant, Waillerant 1623-1677 *McGDA*
Vaillant, Wallerant 1623-1677 *ClaDrA, OxArt*
Vaillard, Ida V *ArtsEM, DcWomA*
Vaini, Pietro 1847-1875 *ArtsNiC*
Vaithianathan, Muthuraj 1953- *MarqDCG 84*
Vaitkevicius, Alvydas 1942- *ICPEnP A*
Vaizey, Marina 1938- *WhoArt 80, -82, -84*
Vajano, Anna Maria *DcWomA*
Vajda, Julia 1913- *DcCAr 81*
Vakalo, Emmanuel-George 1946- *MarqDCG 84*
Vakirtzis, George 1923- *WhoGrA 82[port]*
Val, Valentine Synave-Nicolaud 1870-1943 *DcWomA*
Valade, Anna *DcWomA*
Valade, Gabrielle Marie Marguerite *DcWomA*
Valadier, Giuseppe 1762-1839 *MacEA, McGDA*
Valadon, Jules Emmanuel 1826-1900 *ClaDrA*
Valadon, Maria 1865-1938 *ClaDrA*
Valadon, Marie-Clementine 1865-1938 *OxArt, WomArt*
Valadon, Suzanne 1865-1938 *DcWomA, McGDA, OxArt, OxTwCA*
Valadon, Suzanne 1867-1938 *PhDcTCA 77*
Valager, Anne 1744-1818 *DcWomA*
Valand, L *AmArch 70*
Valaperta, Giuseppe d1817? *NewYHSD*
Valckenborch, Frederick Van 1570?-1625? *McGDA*
Valckenborch, Gillis Van 1570?-1622 *McGDA*
Valckenborch, Lucas Van 1535?-1597 *McGDA*
Valckenborch, Martin Van 1535-1612 *McGDA*
Valckenborg, Martin Van 1535-1612 *ClaDrA*
Valckert, Werner 1585?-1627? *ClaDrA*
Valdambrino, Francesco Di *McGDA*
Valdenuit, Thomas Bluget De 1763-1846 *NewYHSD*
Valdes, Elmo Manuel 1928- *AmArch 70*
Valdes, Georgio 1879-1939 *FolkA 86*
Valdes, Lucas De 1661-1724 *ClaDrA*
Valdes, Luisa Morales 1654- *DcWomA*
Valdes, Manuel *OxTwCA*
Valdes, Maria De 1664-1730 *DcWomA*
Valdes Leal, Juan 1622-1690 *McGDA*
Valdes Leal, Juan De 1622-1690 *OxArt*
Valdez, Frank M 1927- *AmArch 70*
Valdez, Horacio E 1929- *FolkA 86*
Valdivieso, Antonio R *OxTwCA*
Valdrati, Vincenzo 1742?-1814 *DcBrECP*
Valdre, Vincenzo 1742?-1814 *BiDBrA, DcBrECP*
Vale, Amy *DcWomA*
Vale, Enid Marjorie 1890- *DcBrA 1, DcWomA*
Vale, H *DcSeaP*
Vale, May 1862-1945 *DcWomA*
Vale, R *DcSeaP*
Vale, Stella *DcWomA*
Vale, Wylie Walker 1916- *AmArch 70*
Valencia, Manuel 1856-1935 *ArtsAmW 1, IlBEAAW, WhAmArt 85*
Valenciennes, Pierre-Henri De 1750-1819 *McGDA*

Valencin, Signor *NewYHSD*
Valenkamph, Theodore Victor Carl 1868-1924 *WhAmArt 85*
Valensi, Andre 1947- *ConArt 77, -83*
Valensi, Henry 1883- *ClaDrA*
Valenstein, Alice 1904- *WhoAmA 76, -78, -80, -82, -84*
Valenstein, Suzanne Gebhart 1928- *WhoAmA 80, -82, -84*
Valenta, Eduard 1857-1937 *MacBEP*
Valenta, Yaroslav Henry 1899- *WhAmArt 85*
Valente, Alfred *WhAmArt 85*
Valentee, Edward N *WhAmArt 85*
Valenti, Angelo *WhAmArt 85*
Valenti, Celestino 1943- *DcCAr 81*
Valenti, F S *AmArch 70*
Valenti, Italo *OxTwCA*
Valenti, Italo 1912- *DcCAr 81*
Valenti, Paul 1887- *WhAmArt 85*
Valentien, Albert R 1862-1925 *ArtsAmW 2, -3, CenC, WhAmArt 85*
Valentien, Anna M 1862-1947 *ArtsAmW 2*
Valentien, Anna Marie 1862-1947 *DcWomA, WhAmArt 85*
Valentien, Anna Marie Bookprinter 1862-1947 *CenC*
Valentin, Henry 1820-1855 *DcBrBI*
Valentin, Jean Le 1594-1632 *ClaDrA*
Valentin, Jean-Pierre 1949- *WhoAmA 80, -82, -84*
Valentin, Moise 1591?-1632 *OxArt*
Valentin, Moise Le 1591?-1634? *McGDA*
Valentina 1904- *FairDF US, WorFshn*
Valentine, Charles M *NewYHSD*
Valentine, D'Alton 1889-1936 *WhAmArt 85*
Valentine, Mrs. Deane *WhAmArt 85*
Valentine, DeWain 1936- *ConArt 77, -83, DcCAr 81, WhoAmA 73, -76, -78, -80, -82, -84*
Valentine, E E *AmArch 70*
Valentine, Edward Virginius 1838-1930 *NewYHSD, WhAmArt 85*
Valentine, Elias *NewYHSD*
Valentine, Francesca *ConGrA 1*
Valentine, Francis Barker 1897- *WhAmArt 85*
Valentine, Harriet *DcWomA*
Valentine, J *DcVicP 2*
Valentine, Jane H 1866- *WhAmArt 85*
Valentine, Jane H 1866-1934 *DcWomA*
Valentine, Jean *AfroAA*
Valentine, John *BiDBrA, NewYHSD*
Valentine, John Robert 1913- *AmArch 70*
Valentine, Josephine *WhAmArt 85*
Valentine, Julius *NewYHSD*
Valentine, Marion Kissinger 1901- *WhAmArt 85*
Valentine, Max Lynn 1933- *AmArch 70*
Valentine, Robert 1879- *WhAmArt 85*
Valentine, Samuel *NewYHSD*
Valentine, Therese *DcWomA*
Valentine, Thomas C 1935- *AmArch 70*
Valentine, William Winston *NewYHSD*
Valentine Linsley *EncASM*
Valentiner, W R 1880-1958 *WhAmArt 85*
Valentiner, William Reinhold 1880-1958 *WhoAmA 80N, -82N, -84N*
Valentini Sala, Irene 1864- *DcWomA*
Valentino 1932- *ConDes, WorFshn*
Valentino, Amelie *DcWomA*
Valentino, Garavani 1932- *FairDF ITA[port]*
Valentino, Mario *WorFshn*
Valentour, Louis Franklin 1923- *AmArch 70*

Valeriano, Giuseppe 1542-1595 *MacEA*
Valerie, Berthe *DcWomA*
Valerio, James Robert 1938- *PrintW 85,*
WhoAmA 78, –80, –82, –84
Valerio, Silvio B 1897- *WhAmArt 85*
Valerio, Theodore 1819-1879 *ArtsNiC, DcBrBI*
Valerius, Adelaide *DcWomA*
Valerius, Bertha Aurora Valeria A 1824-1895
DcWomA
Valery, Caroline De *DcWomA*
Valesco, Frances 1941- *WhoAmA 84*
Valesio, Francesco 1560?- *ClaDrA*
Valesio, Giovanni Luigi 1583?-1650? *ClaDrA*
Valette *NewYHSD*
Valframbert, Mademoiselle *NewYHSD*
Valge, Madis 1933- *AmArch 70*
Valier, Biron 1943- *WhoAmA 73, –76, –78*
Valiere, Claire 1892- *DcWomA*
Valinski, Dennis 1869-1946- *WhoAmA 78*
Valinski, Dennis John 1946-1979 *WhoAmA 80N,*
–82N, –84N
Valius, Telesforas 1914- *WhoAmA 73, –76, –78, –80*
Valk, Ella Snowden *DcWomA, WhAmArt 85*
Valk, G J, Jr. *AmArch 70*
Valk, Hendrik De *McGDA*
Valkenauer, Hans 1448?-1518? *McGDA*
Valkenborch, Frederick 1570?-1623 *ClaDrA*
Valkenborch, Lucas 1535-1597 *OxArt*
Valkenborch, Lucas Van 1530?-1597 *ClaDrA*
Valkenborch, Marten 1535-1612 *OxArt*
Valkenborgh, Lucas 1535-1597 *OxArt*
Valkenborgh, Marten 1535-1612 *OxArt*
Valkenburg *McGDA*
Valker, Agnes 1879- *DcWomA*
Valkert, Warnard VanDen 1585?-1627? *McGDA*
Valladares O, Rene 1926- *AmArch 70*
Vallain, Nanine *DcWomA*
Vallance, Aylmer *DcVicP 2*
Vallance, Aymer d1943 *DcBrBI*
Vallance, Fanny *DcWomA*
Vallance, Jeffrey K R 1955- *WhoAmA 84*
Vallance, John d1823 *EarABI*
Vallance, John 1770?-1823 *NewYHSD*
Vallance, W F *ArtsNiC*
Vallance, William Fleming 1827-1904 *DcBrA 1,*
DcBrWA, DcVicP, –2
Vallat, Gabrielle 1889- *DcWomA*
Vallayer-Coster, Anne 1744-1818 *DcWomA, WomArt*
Vallayer-Coster, Dorothee Anne 1744-1818 *McGDA*
Vallayer-Mautet, Pauline *DcWomA*
Vallayer-Moutet, Pauline *DcWomA*
Valle, Camilla Della 1748?-1777 *DcWomA*
Valle, Filippo Della 1697-1770 *McGDA*
Valle, Gino 1923- *ConArch, MacEA*
Valle, Maude Richmond Fiorentino *WhAmArt 85*
Valle, Maude Richmond Fiorentino 1868-1969
ArtsAmW 2
Valle, Maude Richmond Florentino 1868-1969
ArtsAmW 2, DcWomA
Vallee, Caroline *DcWomA*
Vallee, Jack 1921- *WhoAmA 73, –76, –78, –80*
Vallee, Jean Francois De *NewYHSD*
Vallee, P R *NewYHSD*
Vallee, William Oscar 1934- *WhoAmA 73, –76, –78,*
–80, –82, –84
Vallence, Fanny *DcVicP 2, DcWomA*
Vallence, William Fleming 1827-1904 *DcBrBI*
Vallentine, Emmeline *DcVicP 2*
Valleray, Marie Zoe *DcWomA*
Vallery-Radot, Jean 1890- *WhoArt 80, –82, –84*
Valles, Lorenzo *ArtsNiC*
Valles Torner, Josep-Maria 1947- *WorECar*
Vallet, Edouard 1876-1929 *ClaDrA*
Vallet, Marguerite 1888-1918 *DcWomA*
Vallet, Marie Josephine *DcWomA*
Vallet-Bisson, Frederique 1862?- *DcWomA*
Vallet DeVilleneuve, Clemence *DcWomA*
Vallette, Edwin F 1829?- *NewYHSD*
Vallette, James *NewYHSD*
Valley, John *CabMA*
Vallfogona *McGDA*
Vallgreen, Antoinette 1858-1911 *DcWomA*
Vallgren, Antoinette 1858-1911 *DcWomA*
Valli *IlsBYP*
Vallier, Lina *DcWomA*
Valliere, Paul James 1924- *AmArch 70*
Vallila, Marja R 1950- *WhoAmA 84*
Vallin, Nicholas *AntBDN D*
Vallin DeLaMothe, Jean Baptiste Michel 1729-1800
MacEA
Vallinder, W *WhAmArt 85*
Vallmitjana, Abel 1910- *ClaDrA, WhoArt 80, –82,*
–84
Vallois, Marie *DcWomA*
Vallombrosa, Medora Hoffman 1858?-1921?
ArtsAmW 2, DcWomA
Vallon, Blanche *DcWomA*
Vallorsa, Cipriano *McGDA*
Vallotton, Felix 1865-1925 *OxTwCA, PhDcTCA 77*
Vallotton, Felix Edmond 1865-1925 *McGDA*
Vallotton, Felix Edouard 1865-1925 *ClaDrA*

Vallotton, Felix-Edouard 1865-1925 *WorECar*
Valmier, Georges 1885-1937 *ClaDrA*
Valmon, Leonie Charlotte *DcWomA*
Valmont, Constance De *DcWomA*
Valnaud, Leonie *DcWomA*
Valner, Sandor 1961- *MarqDCG 84*
Valo, Pirkko 1943- *DcCAr 81*
Valoch, Jiri 1946- *ConArt 77, –83*
Valois, Edward *NewYHSD*
Valois, Rose *FairDF FRA, WorFshn*
Valore, Lucie *DcWomA*
Valory, Caroline De *DcWomA*
Valotte, Octave *DcWomA*
Valperga, Maurizio *MacEA*
Valpy, Judith *IlsBYP*
Valrenseaux, Jeanne Francoise *DcWomA*
Valsauraux, Jeanne Francoise *DcWomA*
Valsuani, C *DcNiCA*
Valtat, Louis 1869-1952 *ClaDrA, OxTwCA,*
PhDcTCA 77
Valter, Eugene *DcVicP 2*
Valter, Eugenie M *DcVicP 2*
Valter, Frederick E *DcVicP 2*
Valter, Henry *DcVicP, –2*
Valtman, Edmund 1914- *WhoAmA 73, –76, –78, –80,*
–82, –84, WorECar
Valton, Charles 1851-1918 *AntBDN C, DcNiCA*
Valtz, John Albert 1911- *AmArch 70*
Value, Miss *DcWomA, NewYHSD*
Valus, William Stephen, Jr. 1932- *AmArch 70*
Valvassori, Gabriele 1683-1761 *MacEA*
Valverde, Joseph, Jr. 1909- *AmArch 70*
Valy, Maria *DcWomA*
Vamossyne Eleod, Karola 1873- *DcWomA*
Van, Luther 1937- *AfroAA*
Van-Berkelaer, Jeanne *DcWomA*
Van-Den-Broek, Emma *DcWomA*
Van-Den-Broek D'Obrenau, Victorine *DcWomA*
Van-Der-Hoven, Madame *DcWomA*
Van Eyck, Margaret *DcWomA*
Van-Pitterson, Lloyd 1926- *PrintW 83, –85*
Van-Vleck, Natalie *WhAmArt 85*
VanAalten, Jacques 1907- *WhAmArt 85,*
WhoAmA 73, –76, –78, –80, –82, –84
VanAartrijk, Pieter W 1924- *AmArch 70*
VanAbbe, Salaman 1883?-1955 *IlsBYP, IlsCB 1946*
VanAbbe, Salomon 1883- *ClaDrA, DcBrA 1*
Vanacore, Frank 1907- *WhAmArt 85*
VanAken, Alexander 1701?-1757 *DcBrECP*
VanAken, Arnold d1736? *DcBrECP*
VanAken, Joseph 1699?-1749 *DcBrECP*
VanAlen, William 1883-1954 *MacEA*
VanAlen, William Laurens 1907- *AmArch 70*
VanAllen, E *ArtsEM*
VanAllen, Eleanor *ArtsEM, DcWomA*
VanAllen, Gertrude Enders 1897- *DcWomA,*
WhAmArt 85
VanAllsburg, Arie G *ArtsEM*
VanAllsburg, E A *AmArch 70*
Vanalstine, Carrie *DcWomA*
VanAlstine, John 1952- *PrintW 83, –85*
VanAlstine, John Richard 1952- *WhoAmA 84*
VanAlstine, Mary J 1878- *DcWomA, WhAmArt 85*
VanAlstyne, Archibald C *NewYHSD*
VanAlstyne, Mary *FolkA 86, NewYHSD*
VanAlyea, T S *AmArch 70*
VanAmen, Woody 1936- *ConArt 83*
VanAmmers, A A *AmArch 70*
VanAnrooy, Anton 1870-1949 *DcBrA 1*
VanAntwerp, Dudley S 1867-1934 *BiDAmAr*
VanAntwerp, Glen 1949- *FolkA 86*
VanAntwerp, Stan 1922- *FolkA 86*
VanAntwerp, Thomas Cooper 1904- *AmArch 70*
Vanarden, George *NewYHSD*
VanArsdale *FolkA 86*
VanArsdale, Arthur *WhAmArt 85*
VanArsdale, Arthur Lee 1896- *ArtsAmW 3*
VanArsdale, Dorothy Thayer 1917- *WhoAmA 73, –76,*
–78
VanArsdale, Ruth *WhAmArt 85*
VanArsdale, Stephen Ray 1950- *MarqDCG 84*
Vanartsdalen, James 1811?- *NewYHSD*
Vanasco, A J *AmArch 70*
VanAsdale, Walter *WhAmArt 85*
Vanasse, Louis Raymond 1931- *WhoAmA 78, –80,*
–82, –84
VanAssen, Anthony 1767-1817? *DcBrECP*
VanAssen, Benedictus Antonio d1817 *DcBrBI*
Vanassen, John M 1955- *MarqDCG 84*
VanAtta, Helen Ulmer 1914- *WhoAmA 73, –76, –78,*
–80, –82
Vanauchi *NewYHSD*
VanAuken, Richard Anthony 1934- *AmArch 70*
Vanauld, Leonie *DcWomA*
VanBaarsel, Gerard E 1933- *AmArch 70*
VanBaerle, Susan L 1956- *MarqDCG 84*
VanBakergem, W B *AmArch 70*
VanBaurscheit, Jan Pieter 1699-1768 *MacEA*
VanBeek, Hermann *FolkA 86*
VanBeest *NewYHSD*
VanBenschoten, Clare D *WhAmArt 85*

VanBenschoten, John R 1953- *MarqDCG 84*
VanBenthuysen, Will 1883-1929 *WhAmArt 85*
VanBergh, Frederick W *EncASM*
VanBergh, Maurice H *EncASM*
VanBesien, G M *AmArch 70*
VanBever, A *DcVicP 2*
VanBiesbroeck, Julius J *DcVicP 2*
VanBlarcom, Mary 1913- *WhAmArt 85*
VanBlarcum, Arthur 1925- *MacBEP*
VanBleeck, Pieter 1697-1764 *DcBrECP*
VanBleeck, Richard 1670?-1733? *DcBrECP*
VanBlitz, Samuel E 1865-1934 *WhAmArt 85*
VanBloem, Peter Schuyler 1924- *AmArch 70*
VanBoghem, Louis 1470?-1540 *MacEA*
VanBoskerck, Robert Ward 1855-1932 *WhAmArt 85*
VanBourg, M *AmArch 70*
VanBrakel, Louisa Hoyer *DcVicP 2*
VanBrakel, Louiza Hoyer *DcWomA*
VanBriggle, Anne *DcWomA, WhAmArt 85*
VanBriggle, Artus d1904 *WhAmArt 85*
VanBriggle, Artus 1869-1904 *ArtsAmW 1, CenC,*
DcNiCA
VanBriggle, Leona Vera d1953 *DcWomA*
VanBrown, A *DcVicP 2*
Vanbrugh, John 1664-1726 *MacEA*
Vanbrugh, John 1664-1720 *DcD&D[port]*
Vanbrugh, Sir John 1664-1726 *BiDBrA, McGDA,*
OxArt, WhoArch
VanBrunt, Adriance 1836-1913 *BiDAmAr*
VanBrunt, Henry *McGDA*
VanBrunt, Henry 1832-1903 *BiDAmAr, BnEnAmA,*
MacEA
VanBrunt, Jessie 1863-1947 *WhAmArt 85*
VanBrunt, John 1855-1925 *BiDAmAr*
VanBrunt, Philip G 1935- *WhoAmA 76, –78, –80, –82,*
–84
VanBuren, A A *WhAmArt 85*
VanBuren, Amelia C *ArtsEM, DcWomA*
VanBuren, Helen Rae 1919- *WhoAmA 76, –78*
VanBuren, Hiram Hollister 1917- *AmArch 70*
VanBuren, Raeburn 1891- *WhAmArt 85,*
WhoAmA 73, –76, –78, –80, –82, –84, WorECom
VanBuren, Raeburn L 1891- *IlrAm 1880*
VanBuren, Richard 1937- *ConArt 77, –83,*
DcCAA 77, WhoAmA 73, –76, –78, –80, –82, –84
VanBuren, Stanbery *WhAmArt 85*
VanBuskirk, Jacob 1803?- *FolkA 86*
VanBuskirk, Karl 1887-1930 *WhAmArt 85*
VanCampen, Jacob 1595-1657 *MacEA*
Vancanu, Barbe Anne *DcWomA*
Vance, Alexander *FolkA 86*
Vance, Elise *DcWomA*
Vance, Florestee 1940- *AfroAA*
Vance, Fred Nelson 1880-1926 *WhAmArt 85*
Vance, George Wayne 1940- *WhoAmA 73, –76, –78,*
–80
Vance, James *FolkA 86*
Vance, Joseph 1868-1948 *BiDAmAr*
Vance, Mae H *DcWomA, WhAmArt 85*
Vance, William 1935- *WorECom*
VanCise, Monona *ArtsAmW 3, DcWomA*
VanCleef, Augustus D 1851-1918 *WhAmArt 85*
VanCleve, Helen 1891- *ArtsAmW 1*
VanCleve, Helen Mann 1891- *DcWomA,*
WhAmArt 85
VanCleve, Kate 1881- *WhAmArt 85*
Vanco, John Leroy 1945- *WhoAmA 73, –76, –78, –80,*
–82, –84
VanCortlandt, Katherine 1895- *DcWomA*
VanCortlandt, Katherine Gibson 1895- *WhAmArt 85*
VanCott, Dewey 1898-1932 *WhAmArt 85*
VanCott, Fern H 1899- *DcWomA, WhAmArt 85*
VanCott, Herman 1901- *WhAmArt 85*
VanCourt, Franklin 1903- *WhAmArt 85*
VanCouver, Jan *DcBrA 1*
VanCurler, Donald Edward 1931- *AmArch 70*
VanDalen, Pieter 1897- *ArtsAmW 3*
VanDalind, G *FolkA 86*
VanDam, Andries 1938- *MarqDCG 84*
Vandamm, Florence 1882-1966 *MacBEP*
Vandamm, Tommy *MacBEP*
VanDantzig, Rachel Marguerite *DcWomA*
VanDashorst, Anthonis Mor *McGDA*
VanDeBogart, Willard George 1939- *WhoAmA 73,*
–76
VanDeBovencamp, Valli *IlsBYP*
VanDeBovenkamp, Hans 1938- *AmArt, WhoAmA 76,*
–78, –80, –82, –84
VanDeCastelle, Xavier 1817?- *NewYHSD*
Vandechamp *NewYHSD*
Vandel, Jenny 1852-1927 *DcWomA*
VanDelft, John H d1913 *WhAmArt 85*
Vandelvira, Andres 1509-1575 *OxArt*
Vandelvira, Andres De *MacEA*
Vandemark, John *FolkA 86*
VanDenAbbeel, Jan 1943- *DcCAr 81*
VanDenAkker, Koos 1939- *ConDes*
Vandenberge, Peter 1935- *CenC*
Vandenberge, Peter Willem 1935- *WhoAmA 76, –78,*
–80, –82, –84
Vandenbergh, Raymond John 1889- *ClaDrA,*

DcBrA 1
VanDenBerghe, Frits *OxTwCA*
VanDenBerghen, Albert Louis 1850- *WhAmArt 85*
VanDenBorn, Bob 1927- *WhoGrA 62, –82[port]*
VanDenBossche, Theodore *FolkA 86*
Vandenbranden, Guy 1926- *DcCAr 81*
VanDenBrink, Mecky 1950- *DcCAr 81*
VanDenBroeck, Barbara *DcWomA*
VanDenBroecke, Willem 1520?-1579 *McGDA*
VanDenBroek, J H 1898-1978 *ConArch, MacEA*
VanDenBroek, Johannes H *McGDA*
VanDenBroek And Bakema *MacEA*
VanDenEnde, Jaap 1944- *ConArt 77*
VanDenHengel, Walter *WhAmArt 85*
Vandenhove, Charles 1927- *MacEA*
VanDePasse, Magdalena *DcWomA*
Vanderbank, John 1694-1739 *BkIE, DcBrECP, OxArt*
Vanderbank, Moses 1695?- *DcBrECP*
Vanderbank, Peter 1649-1697 *OxArt*
Vanderbeck, John Henry *NewYHSD*
VanDerBeek, Edward Stanley 1927- *WhoAmA 80, –82, –84*
Vanderbeek, Stanley 1930- *WorECar*
VanDerBent, Teunis J 1863-1936 *BiDAmAr*
Vanderbilt, Clarence A *EncASM*
Vanderbilt, Gertrude *DcWomA*
VanDerBoeck *DcVicP 2*
Vanderbout, William H *AmArch 70*
VanDerBurch, Cornelius 1653?-1699 *BnEnAmA*
VanDerBurch, Flore Desiree *DcWomA*
Vandercam, Serge 1924- *OxTwCA, PhDcTCA 77*
VanDerClute, Dean Sandison 1928- *AmArch 70*
Vandercook, Margaret 1899-1936 *DcWomA*
Vandercook, Margaret Metzger 1899-1936 *WhAmArt 85*
Vandercruse, Roger *AntBDN G*
Vandercruse, Roger 1728-1799 *OxDecA*
VanDerek, Anton 1902- *WhAmArt 85*
VanDerElsken, Ed 1925- *ConPhot*
VanDerElsken, Eduard 1925- *ICPEnP A, MacBEP*
Vandergucht, Benjamin 1753-1794 *DcBrECP[port]*
VanDerGucht, Gerard 1697-1776 *BkIE*
VanDerGucht, Jan 1697-1732? *BkIE*
VanDerGucht, Michael 1660-1725 *BkIE*
Vandergucht, Michael 1660-1725 *DcBrECP*
Vanderhagen, John *DcBrECP*
Vanderhagen, Joris 1676-1745? *DcBrECP*
Vanderhagen, William d1745? *DcBrECP*
VanDerHeyden, J C J 1928- *ConArt 77, –83*
Vanderhoef, John J *NewYHSD*
Vanderhoff, Charles A d1918 *ArtsAmW 2*
Vanderhoof, Charles A d1918 *IlBEAAW, WhAmArt 85*
Vanderhoof, Elizabeth *DcWomA, WhAmArt 85*
Vanderhoof, William H *FolkA 86*
Vanderhule, Lavina Matilda Bramble 1839-1906 *ArtsAmW 2, DcWomA*
VanDerKar, J *AmArch 70*
VanDerKerche *NewYHSD*
VanDerKolk, William Wright *AmArch 70*
VanDerLaak, Maria *DcWomA*
VanderLaan, Peter 1902- *AmArch 70*
VanDerLeck, Bart 1876-1958 *ConArt 77, –83*
VanDerLeek, Paul Laverne 1935- *AmArch 70*
VanDerLinde, Louise *DcWomA*
Vanderlip, Dianne Perry 1941- *WhoAmA 76, –78, –80, –82, –84*
VanDerlip, John Russell d1935 *WhAmArt 85*
Vanderlip, Willard C *NewYHSD*
Vanderlippe, D J *NewYHSD*
Vanderlyn, John 1775-1852 *BnEnAmA, DcAmArt, FolkA 86, IlBEAAW, McGDA, NewYHSD*
Vanderlyn, John, Jr. 1805-1876 *NewYHSD*
Vanderlyn, Nathan *DcBrBI*
Vanderlyn, Nathan 1872-1946 *DcBrA 1, DcVicP 2*
Vanderlyn, Nicholas *NewYHSD*
Vanderlyn, Pieter 1687?-1778 *AmFkP, BnEnAmA, FolkA 86, McGDA, NewYHSD*
VanDerMarck, Jan *AfroAA*
VanDerMarck, Jan 1929- *WhoAmA 73, –76, –78, –80, –82, –84*
VanderMark, Parthenia *WhAmArt 85*
VanDerMeer, Catharina *DcWomA*
VanderMeer, Wybee d1948 *BiDAmAr*
Vandermeere, John 1743-1786 *DcBrECP*
VanderMeiden, John, Jr. 1919- *AmArch 70*
VanDerMeulen, Jan 1929- *WhoAmA 84*
VanDerMey, J M 1878-1949 *MacEA*
VanDerMijn, Agatha *DcBrECP, DcWomA*
VanDerMijn, Andreas 1714- *DcBrECP*
VanDerMijn, Cornelia *DcWomA*
VanDerMijn, Cornelia 1709- *DcBrECP*
VanDerMijn, Frans 1719?-1783 *DcBrECP*
VanDerMijn, George 1726?-1763 *DcBrECP*
VanDerMijn, Herman 1684-1741 *DcBrECP*
VanDerMijn, Robert 1724- *DcBrECP*
VanDerMyde, Philip Louis 1931- *AmArch 70*
VanDerNull, Eduard 1812-1868 *MacEA*
VanDerNull And Siccardsburg *MacEA*

Vanderoef, John J *NewYHSD*
VanDerPaas, Emilie 1906- *WhAmArt 85*
VanDerPek, H W J *DcWomA*
VanDerPloeg, Jacob Jansma 1914- *AmArch 70*
Vanderploeg, Ruard Arthur 1920- *AmArch 70*
Vanderpoel, Emily d1939 *DcWomA*
Vanderpoel, Emily Noyes *FolkA 86, WhAmArt 85*
Vanderpoel, John H 1857-1911 *WhAmArt 85*
Vanderpoel, Matilda *WhAmArt 85*
Vanderpoel, Matilda d1950 *DcWomA*
VanDerPoel, Priscilla Paine 1907- *WhAmArt 85, WhoAmA 73, –76*
Vanderpoele, Charles *ArtsEM*
VanDerPool, James *FolkA 86*
Vanderpool, James 1765-1799 *NewYHSD*
Vanderpool, James Grote 1903- *AmArch 70*
Vanderpool, James Grote 1903- *WhoAmA 73, –76, –78*
Vanderpool, James Grote 1903-1979 *WhoAmA 80N, –82N*
Vanderpool, James Grote 1903-1979 *WhoAmA 84N*
Vanderpool, John 1760?- *NewYHSD*
Vanderpool, Madeleine McAlpin 1912- *WhAmArt 85*
Vanderpool, Wynant D, Jr. 1914- *AmArch 70*
VanDerPuyl, Gerard 1750-1824 *DcBrECP*
VanDerRohe, Ludwig M d1969 *WhoAmA 78N, –80N, –84N*
VanDerRohe, Ludwig M 1886-1969 *WhoAmA 82N*
VanDerRyn, S *AmArch 70*
Vandersall, Amy L 1933- *WhoAmA 80, –82, –84*
Vanderslice, W K *EncASM*
VanderSluis, George 1915- *DcCAA 71, –77*
VanderSluis, George J 1915- *WhoAmA 73, –76, –78, –80, –82, –84*
VanDerSmissen, Dominicus 1704-1760 *DcBrECP*
VanDerStappen, Charles 1843-1910 *McGDA*
Vandersteen, Willy 1913- *WorECom*
VanDerStraeten, Vincent Roger 1929- *WhoAmA 73, –76, –78, –80*
VanDerSwaelmen, Louis 1883-1929 *MacEA*
VanderSys, Richard Arnold 1903- *AmArch 70*
VanDerVaart, John 1653-1727 *DcBrECP*
VanDerVeen, C W *DcBrA 1*
Vanderveer, Miss M H *IlBEAAW*
VanDerVeer, Mary 1865- *DcWomA, WhAmArt 85*
VanDerVelde, Hanny 1883- *WhAmArt 85*
VanDerVelde, Hanny 1883-1959 *DcWomA*
VanDerVelden, P *DcVicP 2*
VanDerVelden, Petrus 1834-1913 *OxArt*
VanDerVlucht, L C 1894-1936 *WhoArch*
VanDerVlugt, L C 1894-1936 *ConArch*
VanDerVlugt, Leendert Cornelis 1894-1936 *MacEA*
VanDerVlugt And Brinkman *MacEA*
VanDerVoort, Amanda Venelia *WhoAmA 73, –76, –78, –80, –82*
VanDerVoort, Amanda Venelia d1980 *WhoAmA 84N*
VanDerWal, Coenraad 1934- *AmArch 70*
VanDerWater, Eric Noel 1918- *AmArch 70*
Vanderweide, Joe H 1935- *AmArch 70*
VanderWerff, Ronald Edward 1940- *AmArch 70*
VanDerWesthuyzen, J M *WhAmArt 85*
VanderWeyde, Harry F *DcVicP 2*
VanDerWeyden, Harry *DcBrA 1*
VanDerWeyden, Harry 1868- *WhAmArt 85*
VanDerWeyden, Harry H 1868- *DcBrA 2*
VanDerWoerd, Bart *WhAmArt 85*
VanDerZee, James 1886- *ConPhot*
VanDerZee, James 1886-1980? *WhAmArt 85*
VanDerZee, James 1886-1983 *ICPEnP*
VanDerZee, James Augustus Joseph 1886-1983 *MacBEP*
VanDeSand, Michael *ConDes*
VanDeSand, Michael 1945- *WhoGrA 82[port]*
VanDeusen, Robert Anderson 1920- *AmArch 70*
VanDeVelde, Cornelius 1675-1729 *DcBrECP*
VanDeVelde, Henri 1863-1957 *DcNiCA, WhoArch*
VanDeVelde, Henry 1863-1957 *ConArch, DcD&D[port], EncMA, MacEA*
Vandevelde, Petro *NewYHSD*
VanDeVelde, Willem 1633-1707 *DcBrECP*
VanDeVelde, Willem 1667- *DcBrECP*
VandeVenter, Robert Lee 1937- *AmArch 70*
VanDeWeghe, Camiel 1927- *AmArch 70*
VanDeWeld, W *DcVicP 2*
VanDeWiele, Gerald 1932- *WhoAmA 73, –76, –78*
Vandiest, Adriaen 1655-1704 *DcBrECP*
Vandiest, John *DcBrECP*
VanDiest, Pietre Henrich 1819-1902 *ArtsAmW 3*
VanDijk, Peter 1929- *AmArch 70*
Vandine, Elizabeth *DcWomA*
VanDine, Harold Forster, Jr. 1930- *AmArch 70*
VanDis, John Andrew 1914- *AmArch 70*
Vandiver, Mabel *WhAmArt 85*
VanDoesburg, Theo *OxTwCA*
VanDoesburg, Theo 1883-1931 *ConArt 77, –83, MacEA*
VanDommelen, David B 1929- *WhoAmA 78, –80, –82, –84*
VanDongen, Kees 1877- *ConArt 77*
VanDongen, Kees 1877-1968 *ConArt 83*
VanDoort, M *FolkA 86, NewYHSD*

VanDopple, Victor *ArtsEM*
VanDoren, Abram William 1808-1884 *FolkA 86*
VanDoren, Charlotte A *DcWomA*
VanDoren, Claude Alliston 1923- *AmArch 70*
VanDoren, Garret William 1811?- *FolkA 86*
VanDoren, Harold 1895-1957 *McGDA, WhAmArt 85*
VanDoren, Harold Livingston 1896-1957 *WhoAmA 80N, –82N, –84N*
VanDoren, Isaac William 1798-1869 *FolkA 86*
VanDoren, Margaret 1917- *IlsCB 1744*
VanDoren, Peter Suphen 1806-1899 *FolkA 86*
VanDorssen, G *WhAmArt 85*
VanDresser, William d1950 *WhoAmA 78N, –80N, –82N, –84N*
VanDresser, William 1871-1950 *WhAmArt 85*
VanDroskey, Mrs. M *WhAmArt 85*
VanDuinwyk, George Paul 1941- *WhoAmA 78, –80, –82, –84*
VanDusen, A K *AmArch 70*
VanDusen, F C *AmArch 70*
Vanduzee, Benjamin C *NewYHSD*
VanDuzee, Kate Keith 1874- *DcWomA, WhAmArt 85*
VanDyck *OxArt*
VanDyck, James *NewYHSD*
VanDyck, Justina *DcWomA*
VanDyck, Peter 1684-1750 *BnEnAmA*
VanDyck, Pieter 1684-1750 *AntBDN Q*
VanDyk, J C, Jr. *AmArch 70*
VanDyke, E *ArtsEM*
VanDyke, Ella 1910- *WhAmArt 85*
VanDyke, Harry Arthur 1926- *AmArch 70*
VanDyke, James Henry 1916- *AmArch 70*
VanDyke, John Charles 1856-1932 *WhAmArt 85*
Vandyke, Peter 1729- *DcBrECP*
VanDyke, Roger J 1926- *AmArch 70*
VanDyke, Willard 1906- *ConPhot, ICPEnP, –A, MacBEP*
Vane, Kathleen Airini 1891- *DcBrA 1, DcWomA*
Vane, Richard Jay 1939- *AmArch 70*
Vane, Russell Richardson, III 1953- *MarqDCG 84*
VanEesteren, Cornelis 1897- *MacEA*
VanEk, Eve Drewelowe 1903- *WhAmArt 85*
Vanek, Miroslav 1927- *AmArch 70*
Vanek, Rostislav 1945- *WhoGrA 82[port]*
VanElk, Ger 1941- *ConArt 77, –83, PrintW 83, –85*
VanElten, Elizabeth F Kruseman *DcWomA, WhAmArt 85*
VanElten, Kruseman 1829- *ArtsNiC*
VanElten, Kruseman 1829-1904 *ArtsAmW 3*
VanElton, Hendrik *WhAmArt 85*
VanEmpel, Jan *WhAmArt 85*
VanErp, Dirk 1929- *AmArch 70*
VanEss, Donald Theodore 1919- *AmArch 70*
Vaness, Margaret Helen 1919- *WhoAmA 78, –80, –82, –84*
Vaness, Vanil *DcCAr 81*
VanEtten, Donald Stoddard 1923- *AmArch 70*
Vanetti, Laura *DcWomA*
VanEvera, Caroline *ArtsAmW 3*
VanEveren, Jay *ConICB, IlsCB 1744, WhAmArt 85*
VanEyck, Aldo 1918- *ConArch, MacEA*
VanEyck, Hubert 1370?-1426? *McGDA*
VanEyck, Jan 1380?-1441 *McGDA*
VanEyck, Margaretha 1406?- *WomArt*
VanEynde, Tom *DcCAr 81*
VanFavoren, J H *NewYHSD*
VanFleck, Peter *FolkA 86*
VanFleet, W M *AmArch 70*
VanFossen, Abigail B *ArtsEM, DcWomA*
VanFossen, Gary Richard 1934- *AmArch 70*
VanFrank, Richard Newell 1928- *AmArch 70*
VanFrank, Roger Merrill 1924- *AmArch 70*
Vang, Alfred Henry 1946- *MarqDCG 84*
VanGaelen, Alexander 1670-1728 *DcBrECP*
VanGangalen, J *DcVicP 2*
VanGeel, Jan Frans 1756-1830 *McGDA*
VanGeenen, Pauline *DcWomA*
VanGelder, Garrett *CabMA*
VanGelder, W B *AmArch 70*
Vangelderin, George *NewYHSD*
VanGendorff *FolkA 86*
VanGilder, Ron *OfPGCP 86*
VanGindertael, Emile *OxTwCA*
VanGinkel, Blanche Lemco *WhoAmA 78, –80, –82, –84*
VanGogh *OxArt*
VanGogh, Vincent Willem 1853-1890 *McGDA*
VanGorder, Luther Emerson 1861-1931 *WhAmArt 85*
Vangordon, William H *FolkA 86*
VanGordon, William H 1824?- *FolkA 86*
VanGuard, Wendy *MarqDCG 84*
VanGunten, Adele *DcWomA, WhAmArt 85*
VanHaaften, Julia 1946- *WhoAmA 82, –84*
VanHaecken *DcBrECP*
VanHase, David *NewYHSD*
VanHasselt, Willem 1882-1963 *OxTwCA*
VanHavermaet, Charles *DcVicP 2*
VanHavermaet, P *DcVicP 2*

VanHenegouwen, Jan *MacEA*
VanHerengrave, Herman *MacEA*
VanHeuklyn, H B *AmArch 70*
VanHier *DcVicP 2*
VanHoe, Marc 1945- *DcCAr 81*
VanHoecke, Allan 1892-1970 *FolkA 86*
VanHoefen, Hari 1905- *AmArch 70*
VanHoesen, Beth 1926- *PrintW 83, -85,*
 WhoAmA 73, -76, -78, -80, -82, -84
VanHoeydonck, Paul 1925- *PrintW 83, -85*
VanHook, David H 1923- *WhoAmA 73, -76, -78, -80,*
 -82, -84
VanHook, Katrina 1912- *WhAmArt 85*
VanHook, Nell *WhoAmA 73, -76*
VanHook, Nell 1897- *DcWomA, WhAmArt 85*
VanHool, Jan 1769-1837 *McGDA*
VanHoorn, C *DcWomA*
VanHorn, Dana 1950- *PrintW 85*
VanHorn, Fielding *FolkA 86*
VanHorn, Ida *DcWomA*
VanHorn, Mary S *DcWomA*
VanHorne, Katherine d1918 *DcWomA*
VanHousen, Thomas C 1927- *AmArch 70*
VanHouteano *NewYHSD*
VanHouten, Erskine V *EncASM*
VanHouten, Hugh B 1936- *AmArch 70*
VanHouten, Raymond F *WhAmArt 85*
VanHove, Victor 1825- *ArtsNiC*
VanHowd, Douglas *OfPGCP 86*
VanHusen, John *NewYHSD*
VanHusen, Lorenzo C *ArtsEM*
Vanier, Gabrielle *DcWomA*
VanIngen, Henry A 1833-1899 *NewYHSD ,*
 WhAmArt 85
VanIngen, Josephine *DcWomA*
VanIngen, Josephine K *WhAmArt 85*
VanIngen, W B 1858- *WhAmArt 85*
VanIngen, William H 1831?- *NewYHSD*
Vanisky, Frances K *MarqDCG 84*
VanKeuren, Alexander Hamilton, Jr. 1913-
 AmArch 70
VanKeuren, R S *AmArch 70*
VanKirk, A E *DcWomA*
VanKoert, John Owen 1912- *WhAmArt 85*
VanKoningsbruggen, Rob 1948- *ConArt 83*
VanKrimpen, Jan 1892-1958 *ConDes, WhoGrA 62*
VanLaar, Timothy Jon 1951- *WhoAmA 82, -84*
VanLaarhoven, August Godfrey 1918- *AmArch 70*
VanLaer, Alexander T 1857-1920 *WhAmArt 85*
VanLaer, Belle 1862- *DcWomA, WhAmArt 85*
Vanlandingham, M Lynn 1923- *AmArch 70*
VanLanen, Robert John 1914- *AmArch 70*
VanLeer, W Leicester 1905- *WhoAmA 82, -84*
VanLeer, Mrs. W Leicester 1905-
 WhoAmA 73, -76,
 -78, -80
VanLent, Leroy Frederick 1923- *AmArch 70*
VanLerius, Joseph Henri Francois 1823-1876 *ArtsNiC*
VanLeshout, Alexander J 1868-1930 *WhAmArt 85*
VanLeunen, Alice Louise 1943- *WhoAmA 78, -80, -82,*
 -84
VanLeuven, Karl Osterout, Jr. 1914- *AmArch 70*
VanLeyden, Ernst Oscar Mauritz 1892- *ArtsAmW 3,*
 WhAmArt 85
VanLeyden, Karin Elizabeth 1906- *WhAmArt 85*
VanLoan, Dorothy *WhAmArt 85*
VanLoen, Alfred 1924- *WhoAmA 73, -76, -78, -80,*
 -82, -84
VanLonkhuyzen, W M *AmArch 70*
VanLoo, Catherine *DcWomA*
VanLoo, Charles Amedee Philippe 1719-1795 *McGDA*
VanLoo, Charles Andre 1705-1765 *McGDA*
VanLoo, Jacob 1614?-1670 *McGDA*
VanLoo, Jean-Baptiste 1684-1745 *DcBrECP, McGDA*
VanLoo, Jules Cesar Denis 1743-1821 *McGDA*
VanLoo, Louis-Michel 1707-1771 *DcBrECP*
VanLoo, Louis Michel 1707-1771 *McGDA*
VanLoo, Pierre 1837-1858 *NewYHSD*
Vanloo, Sophie Adele *DcWomA*
VanLoon, Hendrik Willem 1882-1944 *WhAmArt 85*
VanLoon, Henry Bowditch 1907- *AmArch 70*
VanLopik, Miss *DcWomA*
VanLuppen, G J A *ArtsNiC*
VanLuppen, Joseph *DcVicP 2*
Vanmalderen, Luc 1930- *WhoGrA 82[port]*
VanMarck, Caroline *DcWomA*
VanMarcke, Emile *ArtsNiC*
VanMarcke, Marie *DcWomA*
VanMeerwijk, Hans *DcCAr 81*
VanMeter, Joel *FolkA 86*
VanMeter, Mary 1919- *WhoAmA 73, -76*
VanMillett, George 1864-1952 *WhAmArt 85*
VanMinian, John 1791- *FolkA 86*
VanMoer, F B *DcVicP 2*
VanMoll, Augustin C *CabMA*
VanMonk, E *DcVicP 2*
VanMulcken, Arnold *McGDA*
VanMunster, Jan 1939- *ConArt 83*
VanMyers, Zell Shirland 1920- *AmArch 70*
Vann, C H *AmArch 70*
Vann, Donald *OfPGCP 86*

Vann, Esse Ball 1878- *ArtsAmW 2, DcWomA,*
 WhAmArt 85
Vann, Loli 1913- *WhAmArt 85, WhoAmA 73, -76,*
 -78, -80, -82, -84
Vann, Loyd Frank 1911- *AmArch 70*
Vann, Samuel LeRoy 1952- *WhoAmA 84*
Vann Ausdall, Wealtha Barr *WhAmArt 85*
VanName, George W *NewYHSD*
VanNeck, Gary Sherman 1936- *AmArch 70*
VanNess, Beatrice *DcWomA, WhAmArt 85*
VanNess, C W *WhAmArt 85*
VanNess, Frank Lewis 1866- *WhAmArt 85*
VanNess, Frank W *ArtsEM*
VanNess, James *FolkA 86*
VanNess, John Bishop, Jr. 1927- *AmArch 70*
VanNess, Sarah Oldcott Hawley *FolkA 86*
Vannet, William Peters 1917- *DcBrA 1*
Vannevar, George *CabMA*
Vanni, Andrea 1332?-1414? *McGDA*
Vanni, Francesco 1563-1610 *McGDA*
Vanni, Giovanni Battista 1599-1660 *ClaDrA*
Vanni, Lippo *McGDA*
Vanni, Michelangelo 1583-1671 *ClaDrA*
Vanni, Rafaello 1587-1678 *ClaDrA*
Vanni, Samuel 1908- *OxTwCA*
Vanni, Turino, The Second 1349-1438 *McGDA*
Vanni, Violanta 1732?-1776 *DcWomA*
VanNiekerk, Sarah Compton 1934- *WhoArt 84*
VanNiel, Harold 1928- *AmArch 70*
Vannier, Michael W 1949- *MarqDCG 84*
Vannorden, John G *FolkA 86*
VanNorden, John H *NewYHSD*
VanNorman, Mrs. D C *DcWomA,*
 NewYHSD
VanNorman, Evelyn 1900- *WhAmArt 85*
VanNorman, Russel W 1931- *MarqDCG 84*
VanNortwic, C *FolkA 86*
VanNostrand, Henry *NewYHSD*
Vannucci, Pietro *ClaDrA, OxArt*
Vannucci, Pietro DiCristoforo *McGDA*
Vannuchi, F 1800?- *NewYHSD*
Vannuchi, S 1800?- *NewYHSD*
Vannutelli, Cavaliere Scipione *ArtsNiC*
Vannutelli, Giuseppina 1874- *DcWomA*
VanObbergen, Anton 1577?-1611? *MacEA*
VanOllefen, Donald 1954- *MarqDCG 84*
VanOlst, J *DcBrECP*
VanOordt, Peter 1903- *WhoAmA 76, -78, -80, -82,*
 -84
VanOrden, Arlon Lowe 1926- *AmArch 70*
VanOrder, Grace Howard 1905- *WhAmArt 85*
VanOrder, Richard *OfPGCP 86*
VanOrman, John A *WhAmArt 85*
VanOrnum, Willard *WhAmArt 85*
VanOs, Seymour 1893- *AmArch 70*
VanOsdel, John 1811-1891 *BiDAmAr*
VanOsdel, John Mills 1811-1891 *MacEA*
VanOsdol, Nathan Knox, Jr. 1926- *AmArch 70*
VanOss, Thomas Willem 1901- *DcBrA 1*
Vanosten, Joseph *NewYHSD*
VanOstram, Julia *ArtsEM, DcWomA*
Vanotti, Amalie 1853- *DcWomA*
VanOudtshoorn, Albert VanRheede 1894-1959
 MacBEP
Vanover, L W *AmArch 70*
VanOvermeer, Frank E *ArtsEM*
VanPappelendam, Laura *ArtsAmW 3, DcWomA,*
 WhAmArt 85
VanParnegh, Clara W *DcWomA,*
 WhAmArt 85
VanParys, Louise *DcWomA*
VanParys, Marie Fernande *DcWomA*
VanPede, Henri *MacEA*
VanPelt, Ellen Warren *ArtsAmW 2, DcWomA,*
 WhAmArt 85
VanPelt, G *AmArch 70*
VanPelt, John V *WhAmArt 85*
VanPelt, Margaret V *WhAmArt 85*
VanPetten, R 1932- *AmArch 70*
VanPraag, Arnold 1926- *DcCAr 81*
VanPraag, James Norman 1931- *AmArch 70*
VanPutten, P R *AmArch 70*
VanRaalte, Mrs. C *DcVicP 2*
VanRaalte, David 1909- *WhAmArt 85*
VanRaalte, John A 1938- *MarqDCG 84*
VanRensburg, Petrus Abraham 1940- *MarqDCG 84*
VanRensselaer, Mariana Griswold 1851-1934
 WhAmArt 85
VanReuth, Edward Felix Charles d1925 *WhAmArt 85*
VanReyendam, Dirk 1900- *AmArch 70*
VanRheede VanOudtshoorn, Albert 1894-1959
 ICPEnP A
VanRijsselberghe, Octave 1855-1929 *MacEA*
VanRiper, Peter 1942- *WhoAmA 76, -78, -80, -82,*
 -84
Vanrisamburgh, Bernard, II *McGDA*
VanRoekens, Paulette 1896- *WhAmArt 85,*
 WhoAmA 76, -78, -80, -82, -84
VanRoekens, Paulette Victorine Jeanne 1896?-
 DcWomA
VanRoey, Leon 1921- *WhoGrA 62, -82[port]*

VanRoijen, Hildegarde Graham 1915- *WhoAmA 73,*
 -76, -78
VanRosen, Robert 1904-1966 *WhAmArt 85*
VanRosen, Robert E d1966 *WhoAmA 78N, -80N,*
 -82N, -84N
VanRossem, Ru 1924- *WhoArt 80, -82, -84*
VanRuith, Horace d1923 *DcBrA 1*
VanRuith, Horace 1839-1923 *DcVicP 2*
VanRuyckevelt, Ronald 1928- *WhoArt 80*
VanRuysbroeck, Jan d1485 *MacEA*
VanRyder, Jack 1898-1968 *ArtsAmW 1, IIBEAAW,*
 WhAmArt 85
VanRyn, Agnes *DcWomA, WhAmArt 85*
VanRyn, E D *AmArch 70*
VanRyzen, Paul *WhAmArt 85*
Van's Gravesande, Arent 1600?-1662 *MacEA*
Van's-Gravesende, Arent d1662 *WhoArch*
Vansant, John T *EncASM*
VanSantvoord, Anna T *DcWomA, WhAmArt 85*
Vansaun, Peter D *NewYHSD*
VanSchaack, Eric 1931- *WhoAmA 82, -84*
VanSchattenhofer, Amalie *DcWomA*
VanSchley 1941- *ConArt 77, WhoAmA 78*
VanSchoick, J A *NewYHSD*
VanSchoik, Joseph *FolkA 86*
VanSciver, Pearl Aiman 1895-1966 *DcWomA*
VanScriven, Pearl Aiman 1896- *WhAmArt 85*
VanSeben, Henri *DcVicP 2*
Vanselow, Gerald Sylvester 1936- *AmArch 70*
Vanselow, Otto *ArtsEM*
VanSheck, Sidney W Jirousek *WhAmArt 85*
VanSickle, Adolphus 1835- *NewYHSD*
VanSickle, J N *NewYHSD*
VanSickle, Sarah LaTourette *FolkA 86*
VanSickle, Selah 1812- *NewYHSD*
VanSicklen, Cornelia *FolkA 86*
VanSittert, Logan Earl 1934- *AmArch 70*
VanSloun, Frank 1879-1938 *ArtsAmW 1, -3*
VanSloun, Frank J *WhAmArt 85*
VanSlyck, G G *AmArch 70*
VanSlyck, Lucile 1898- *ArtsAmW 3*
VanSlyck, Wilma Lucile 1898- *WhAmArt 85*
VanSlyck, Wilma Lucille 1898- *DcWomA*
VanSlyke, Charles W *ArtsEM*
VanSlyke, Richard Maurice 1937- *MarqDCG 84*
VanSoelen, Theodore d1964 *WhoAmA 78N, -80N,*
 -82N, -84N
VanSoelen, Theodore 1890-1964 *ArtsAmW 1,*
 IIBEAAW, WhAmArt 85
VanSoest, Louis W *DcVicP 2*
VanSomer *OxArt*
VanSomeren, Edmund Lawrence 1875- *DcBrA 1*
VanSomeren, Edmund Lawrence 1875-1963 *DcBrA 2*
Vansomers, John d1732 *DcBrECP*
VanSpangen *DcNiCA*
VanStaaten, L *DcBrA 1*
VanStarkenborgh *NewYHSD*
VanStavoren *ArtsEM, NewYHSD*
VanStockum, Hilda *IlsCB 1967*
VanStockum, Hilda 1908- *IlsCB 1744, -1946, -1957,*
 WhAmArt 85
Vanston, A Rorke 1904- *AmArch 70*
VanStreachen, Arnold *DcBrECP*
Vanstrydonck, Charles *NewYHSD*
VanSuchtelen, Adrian 1941- *WhoAmA 76, -78, -80,*
 -82, -84
VanSummern, R W *AmArch 70*
VanSwearingen, Eleanore Maria 1904- *WhAmArt 85*
VanSwearingen, Norma 1888- *DcWomA*
VanSweringen, Norma 1888- *ArtsAmW 2*
VanSyckle, Sarah E *ArtsEM, DcWomA*
Vant, Margaret Whitmore 1905- *WhAmArt 85*
Van't Hoff, Robert *McGDA*
Van't Hoff, Robert 1887-1979 *MacEA*
VanTassel, John Edward 1925- *MarqDCG 84*
Vanteuil, Mademoiselle De *DcWomA*
VanTeylingen, Arie Andrew 1921- *AmArch 70*
VanThienen, Jakob *MacEA*
VanTongeren, Harold 1943- *WhoAmA 78*
VanTongeren, Herk 1943- *WhoAmA 80, -82, -84*
Vantongerloo, George 1886-1965 *McGDA*
Vantongerloo, Georges 1886-1965 *ConArt 77, -83,*
 MacEA, OxTwCA, PhDcTCA 77
VanToorn, Jan 1932- *WhoGrA 82[port]*
Vantright, John d1892? *DcBrWA*
VanTrump, Rebecca N *WhAmArt 85*
VanTrump, Rebecca Newbold *DcWomA*
Vantyne, Carl William 1918- *AmArch 70*
VanTyne, Peter 1857- *WhAmArt 85*
Vanuchi *NewYHSD*
Vanuranken, John *NewYHSD*
VanValkenburgh, Peter 1870-1955 *ArtsAmW 3,*
 WhAmArt 85
VanVechten, Carl 1880-1964 *ConPhot, ICPEnP A,*
 MacBEP
VanVeen, Pieter 1875- *ArtsAmW 1, WhAmArt 85*
VanVeen, Pieter J L 1875- *ArtsAmW 3*
VanVeen, Stuyvesant 1910- *ClaDrA, WhAmArt 85,*
 WhoAmA 73, -76, -78, -80, -82, -84, WhoArt 80,
 -82, -84

Virtue, R A WhAmArt 85
Virtue, Ralph T 1918- AmArch 70
Viry, Paul ArtsNiC
Viscardi, Giovanni Antonio 1645-1713 WhoArch
Viscardi, Girolamo McGDA
Viscardi, P R AmArch 70
Vischer, Anna Elizabeth DcWomA
Vischer, Edward 1809-1879 IlBEAAW, NewYHSD
Vischer, Georg 1520-1592 OxArt
Vischer, Hans McGDA
Vischer, Hans 1489?-1550 OxArt
Vischer, Hermann McGDA
Vischer, Hermann, The Elder McGDA
Vischer, Hermann, The Younger 1486-1517 OxArt
Vischer, Louise DcWomA
Vischer, Paul McGDA
Vischer, Peter McGDA
Vischer, Peter 1460?-1529 McGDA
Vischer, Peter, The Elder 1460?-1529 OxArt
Vischer, Peter, The Younger 1487-1528 OxArt
Vischer Family OxArt
Visco, Anthony Salvatore 1948- WhoAmA 78, -80,
 -82, -84
Visconi, Frank AmArch 70
Visconti, Elyseu OxTwCA
Visconti, Elyseu D'Angelo 1867-1944 McGDA
Visconti, Louis Tullius Joachim 1791-1853 McGDA
Visconti, Ludovico 1791-1853 MacEA
Visentini, Antonio 1688-1782 McGDA
Visher, Edward 1809-1879 ArtsAmW 1
Vishinath ICPEnP A
Vishniac, Roman 1897- ConPhot, ICPEnP, MacBEP
Visioni, Alfred 1915- AmArch 70
Vismara, Gaspare d1651 McGDA
Vismor, Dorothy Anita Perkins 1911- WhAmArt 85
Visnapuu, Herk 1920- AmArch 70
Vispre, Francois Xavier 1730?-1790? DcBrECP
Vispre, Victor DcBrECP
Visscher, Anna Roemer Tesselschade 1583-1651
 DcWomA
Visscher, Anna Roemers 1583-1651 AntBDN H,
 IlDcG
Visscher, C J 1587-1637 AntBDN I
Visscher, Cornelis 1619-1662 McGDA
Visscher, Gertruyt DcWomA
Visscher, Maria Tesselschade 1595-1649 DcWomA
Visscher, Maria Tesselschade Roemers 1594-1649
 IlDcG
Visscher, Max NewYHSD
Visscher, Theodore Cuyler 1868-1935 BiDAmAr
Visser, Carel 1928- ConArt 77, -83, DcCAr 81,
 PhDcTCA 77
Visser, Carel Nicolaas 1928- OxTwCA
Visser't Hooft, Martha 1906- WhoAmA 76, -78, -80,
 -82, -84
Vistosi, Luciano 1931- DcCAr 81
Vistyn, James 1891- WhAmArt 85
Viswanath, Vic 1952- MarqDCG 84
Visy, B L AmArch 70
Vitacco, Alice 1909- WhAmArt 85
Vitagliano, Vincent Jack 1927- MarqDCG 84
Vital-Dubray, Charlotte Gabrielle DcWomA
Vitalba, Giovanni DcBrECP
Vitale Da Bologna McGDA
Vitale, Lydia Modi WhoAmA 78, -80, -82, -84
Vitali, Julius 1952- MacBEP
Vitalis Of Ravenna, Saint McGDA
Vitarelli, Jerome Peter 1937- MarqDCG 84
Viteau, Marie Amelie DcWomA
Vitetta, Francis Guy 1932- AmArch 70
Viti, Timoteo 1469?-1523 McGDA
Vitiello, Ralph Edward 1936- AmArch 70
Vitolins, Robert Paul 1950- MarqDCG 84
Vitols, V V AmArch 70
Viton, Marie 1897- DcWomA
Viton DeJassaud, Marie DcWomA
Vitoni, Ventura 1442-1522 MacEA
Vitoni, Ventura 1442-1522? McGDA
Vitousek, Juanita Judy 1892- ArtsAmW 1, DcWomA,
 WhAmArt 85
Vitozzi, Ascanio 1539-1615 MacEA
Vitrearius, Laurence IlDcG
Vitringa, Wigerus 1657-1721 DcSeaP
Vitruvius MacEA, McGDA
Vitruvius Pollio OxArt
Vitruvius, Pollio Marcus DcD&D
Vittone, Bernardo 1702-1770 WhoArch
Vittone, Bernardo 1704?-1770 McGDA
Vittone, Bernardo Antonio 1702-1770 MacEA
Vittor, Frank 1888- WhAmArt 85
Vittore Del Galgario, Fra McGDA
Vittori, Enrico WhAmArt 85
Vittoria Dolora 1764?-1827 DcWomA
Vittoria, Alessandro 1525-1608 MacEA, McGDA,
 OxArt
Vittozzi, Ascanio 1539-1615 McGDA
Vitullo, J T AmArch 70
Vitullo, Sesostrice 1899-1953 OxTwCA
Vitullo, Sesostris 1899-1953 PhDcTCA 77
Vitz, Carol 1941- MacBEP
Vivancos, Miguel G 1895- OxTwCA

Vivarelli, Carlo L 1919- WhoGrA 62
Vivares, Francois 1709-1780 DcBrWA
Vivares, Thomas 1735?- DcBrWA
Vivarini, Alvise 1445?-1505? OxArt
Vivarini, Alvise 1446?-1505? McGDA
Vivarini, Antonio 1415?-1484 McGDA
Vivarini, Antonio 1415?-1484? OxArt
Vivarini, Bartolomeo 1432?-1499? OxArt
Vivarini, Bartolommeo 1431?-1491? McGDA
Vivarini Family OxArt
Vivash, Ruth WhAmArt 85
Vivash, Ruth C Athey 1892- DcWomA
Vivens, Eugenie De DcWomA
Vivenza, Francesca 1941- WhoAmA 76, -78, -80, -82,
 -84
Vivian, Calthea 1870?- WhAmArt 85
Vivian, Calthea Campbell 1857-1943 ArtsAmW 2,
 DcWomA
Vivian, Calthea Campbell 1870?- IlBEAAW
Vivian, Comley DcVicP 2
Vivian, Elizabeth Baly 1846- DcBrA 1, DcVicP 2
Vivian, Elizabeth Baly 1846-1934? DcWomA
Vivian, G WhAmArt 85
Vivian, George 1798-1873 DcBrBI, DcBrWA
Vivian, J DcVicP 2, DcWomA
Viviani, Giuseppe 1899- OxTwCA, PhDcTCA 77
Viviano, Emanuel WhAmArt 85
Vivien, Arthur S WhAmArt 85
Vivien, Joseph 1657-1734 McGDA
Vivienne, Pauline 1931- WhoArt 80, -82, -84
Vivier, Jeanne Louise Francoise DcWomA
Vivier, Roger 1913- WorFshn
Vivin, Louis 1861-1936 OxTwCA, PhDcTCA 77
Vivolo, John 1887- FolkA 86
Vivot, Lea WhoAmA 80, -82, -84
Vizbaras, Jonas 1922- AmArch 70
Vizetelly, Frank 1830-1883 DcBrBI
Vizetelly, Henry 1820-1894 DcBrBI
Vizner, Frantisek 1936- DcCAr 81
Vizy, Kalman N 1940- MarqDCG 84
Vizza, Donald R 1933- AmArch 70
Vlaminck, Maurice 1876-1958 DcNiCA, McGDA
Vlaminck, Maurice De 1876-1958 ClaDrA,
 ConArt 83, OxArt, OxTwCA, PhDcTCA 77
Vlasnik, Robert L 1935- AmArch 70
Vleughels, Nicolas 1668-1737 ClaDrA
Vleughels, Philippe 1619-1694 ClaDrA
Vliege, Elizabeth DcWomA
Vlieger, Eltie De DcWomA
Vlieger, Simon De 1600?-1653 DcSeaP, OxArt
Vlieger, Simon Jacobsz De 1600?-1653 McGDA
Vliet, Hendrick Cornelisz Van 1611?-1675 McGDA,
 OxArt
Vliet, Jan Georg Van 1610?- McGDA
Vliet, Jan Georg VanDer 1610?- ClaDrA
Vliet, Willem Willemsz Van 1583?-1642 McGDA
Vloors, Louise DcWomA
Vlugt, L C VanDer McGDA
Vlugt, L C VanDer 1894-1936 EncMA
Vo Dinh, Mai 1933- AmArt
Vo-Dinh, Mai 1933- PrintW 83, -85, WhoAmA 78,
 -80, -82, -84
Vobecky, Frantisek 1902- MacBEP
Vocart, Elisabeth DcWomA
Vodanoff, Nick Christo 1932- AmArch 70
Voderberg, H J AmArch 70
Vodicka, Ruth Chai AmArt
Vodicka, Ruth Kessler WhoAmA 73, -76, -78, -80,
 -82, -84
Vodopivec, Lujo 1951- DcCAr 81
Vodrey FolkA 86
Vodrey, Jabez FolkA 86
Vodrey Brothers FolkA 86
Voegtlin, William FolkA 86
Voel, David WhoArt 80
Voelcker, Herbert Rudolph 1888- AmArch 70
Voelcker, Rudolph A 1873- WhAmArt 85
Voelker, Elizabeth 1931- WhoAmA 84
Voelker, John WhoAmA 76, -78, -80, -82, -84
Voell, R F AmArch 70
Voeller, John George 1949- MarqDCG 84
Voelter, Charles Everett 1935- AmArch 70
Voelter, Frieda DcWomA
Voet, Jacob Ferdinand 1639?-1700 McGDA
Vogdes, Ann H FolkA 86
Vogdes, John Reynier 1923- AmArch 70
Vogdes, Joseph NewYHSD
Vogdt, Jurgen 1949- DcCAr 81
Vogel, August 1801- FolkA 86
Vogel, C J AmArch 70
Vogel, Carl W 1937- MarqDCG 84
Vogel, Donald 1902- WhoAmA 73, -76, -78, -80, -82,
 -84
Vogel, Donald S 1917- AmArt, WhAmArt 85,
 WhoAmA 73, -76, -78, -80, -82, -84
Vogel, Edwin Chester WhoAmA 73
Vogel, Edwin Chester d1973 WhoAmA 76N, -78N,
 -80N, -82N, -84N
Vogel, Elisabeth DcWomA
Vogel, Elmer Henry 1898- ArtsAmW 2
Vogel, Emil NewYHSD

Vogel, Fenick A 1908- AmArch 70
Vogel, Herbert 1922- WhoAmA 76, -78, -80, -82,
 -84
Vogel, Mrs. Herbert 1935- WhoAmA 80, -76, -78,
 -82, -84
Vogel, Hermann Wilhelm 1834-1898 ICPEnP,
 MacBEP
Vogel, Hugo 1855-1934 ClaDrA
Vogel, Joseph 1911- WhAmArt 85, WhoAmA 84
Vogel, Luise DcWomA
Vogel, M F AmArch 70
Vogel, Margarete DcWomA
Vogel, Pierre 1938- DcCAr 81
Vogel, Richard William 1928- AmArch 70
Vogel, Valentine 1906- WhAmArt 85
Vogel, Walter 1932- MacBEP
Vogel, Walter Douglas 1927- AmArch 70
Vogel-Gutman, Klara 1891- DcWomA
Vogel-Jorgensen, Else 1892- DcWomA
Vogel VonVogelstein, Karl Christian 1788-1868
 ArtsNiC
Vogelaer, Pieter 1641-1720 DcSeaP
Vogeler, Heinrich OxTwCA
Vogeler, Heinrich Johann 1872- ClaDrA
Vogelgesang, Klaus 1945- DcCAr 81
Vogelgesang, Shepard 1901- WhAmArt 85
Vogeli, Emma 1859- DcWomA
Vogell, Charles FolkA 86
Vogels, Guillaume 1836-1896 McGDA
Vogelsang, Isaac 1688-1753 DcBrECP
Vogelsang, Baroness Wilhelmine 1870- DcWomA
Vogelstein, C AmArch 70
Vogien, Sophie DcWomA
Vogiesong, Susanna FolkA 86
Vogl, Don George 1929- WhoAmA 76, -78, -82, -84
Vogler, Christoph CabMA
Vogler, E A NewYHSD
Vogler, Elias FolkA 86
Vogler, Helene Christine DcWomA
Vogler, John 1783-1881 CabMA, NewYHSD
Vogler, Milton 1825- FolkA 86
Vogler, R C AmArch 70
Vogler, Roger C 1927- AmArch 70
Vognild, Edna 1881- DcWomA, WhAmArt 85
Vognild, Enoch M 1880-1928 WhAmArt 85
Vogt FolkA 86
Vogt, Adelgunde Emilie 1811-1892 DcWomA
Vogt, Alvin Arthur 1933- AmArch 70
Vogt, Christian 1946- ConPhot, ICPEnP A,
 MacBEP
Vogt, Fritz G FolkA 86
Vogt, George Emil 1927- AmArch 70
Vogt, L C 1864- WhAmArt 85
Vogt, Leon Otto 1905- AmArch 70
Vogtlin, Susan Brenner 1944- MarqDCG 84
Voiart, Elisabeth 1786-1866 DcWomA
Voight, Charles A 1887-1947 WorECom
Voight, Charles A 1888-1947 WhAmArt 85
Voight, George F AmArch 70
Voight, Hans Henning 1889?-1933 DcBrBI
Voight, Lewis Towson NewYHSD
Voigt, Agnes 1846-1910? DcWomA
Voigt, Alfred DcNiCA
Voigt, Edna 1895- ArtsAmW 3
Voigt, Elisabeth 1898- DcWomA
Voigt, Gerhard 1926- WhoGrA 82[port]
Voigt, J D AmArch 70
Voigt, L G AmArch 70
Voigt, Lewis Towson EarABI SUP
Voigt, Martin AntBDN K
Voigt, Roben 1940- WhoAmA 73
Voigt, Teresa 1810?- DcWomA
Voigtlander, Katherine 1917- WhAmArt 85
Voigtlander, Peter Wilhelm Friedrich 1812-1878
 ICPEnP, MacBEP
Voillemot, Andre-Charles ArtsNiC
Voillemot, Andre Charles 1823-1893 ClaDrA
Voilles, Jean 1744-1796 ClaDrA
Voinovich, G S AmArch 70
Voirin, Jules Antoine 1833-1898 ClaDrA
Vois, Adrian De 1631-1680 ClaDrA
Vois, Ary 1631?-1680 McGDA
Voisin, Adrien 1890- ArtsAmW 3
Voisin, Josine Hanyock DcWomA
Voisinet, Donald David MarqDCG 84
Voisinet, Roland Joseph 1927- AmArch 70
Voit, August Von 1801-1870 MacEA
Voitellier, Marie Theophile DcWomA
Vokes, Albert Ernest 1874- DcBrA 1, DcVicP 2
Vokes, Arthur Ernest 1874- ClaDrA, DcBrA 2
Vokins, Charles BiDBrA
Volaire, Jacques Antoine 1729-1802 ClaDrA
Volaire, Marie Anne 1730-1806 DcWomA
Volani, Margherita DcWomA
Volbracht, Heinrich 1841-1897 ArtsEM
Volck, Adalbert John 1828-1912 NewYHSD ,
 WhAmArt 85
Volck, Fannie ArtsAmW 2, DcWomA,
 WhAmArt 85
Volck, Frederick 1833-1891 NewYHSD ,
 WhAmArt 85

Voogd, Hendrik 1766-1839 *ClaDrA*
Voohees, Betsy Reynolds *FolkA 86*
Voorhees, Clark G 1871-1933 *WhAmArt 85*
Voorhees, D F *AmArch 70*
Voorhees, Donald *OfPGCP 86*
Voorhees, Donald Edward 1926- *WhoAmA 73, -76, -78, -80, -82, -84*
Voorhees, Grant Wesley 1918- *AmArch 70*
Voorhees, Henriette Aimee LePrince *WhAmArt 85*
Voorhees, Hope Hazard 1891- *WhAmArt 85*
Voorhees, Hope Hazard 1891-1970? *DcWomA*
Voorhees, Jennie 1861-1940 *DcWomA*
Voorhees, Jennie Straight 1861-1940 *ArtsEM*
Voorhees, Louis F 1892- *DcWomA*
Voorhees, Stephen Francis 1878-1965 *MacEA*
Voorhis, Alvin Charles 1926- *AmArch 70*
Voorhout, Johannes 1647-1723 *ClaDrA, McGDA*
Voort, Cornelis VanDer 1576?-1624 *McGDA*
Voos, Robert *FolkA 86*
Voos, William John 1930- *WhoAmA 76, -78, -80, -82, -84*
Voosen, J C *AmArch 70*
Vopat, Valerie Marie 1939- *AmArch 70*
Vorberg, Margarete 1867-1928 *DcWomA*
Vordemberge-Gildewart, Friedel 1899- *McGDA*
Vordemberge-Gildewart, Friedrich 1899-1962 *OxTwCA*
Vordemberge-Gildewart, Friedrich 1899-1963 *PhDcTCA 77*
Vorgang, Editha 1890- *DcWomA*
Vorhees, D Lawrey 1915- *WhoAmA 76, -78, -80, -82*
Voris, Anna Maybelle 1920- *WhoAmA 73, -76, -78, -80, -82, -84*
Voris, Mark 1907- *WhoAmA 73*
Voris, Mark 1907-1974 *WhAmArt 85, WhoAmA 76, -78, -80, -82N, -84N*
Voris, Millie Roesgen 1859?- *DcWomA, WhAmArt 85*
Vormwald, Gerhard 1948- *MacBEP*
Vorobeva, Maria *DcWomA*
Voronikhin, A N 1759-1814 *MacEA*
Voronikhin, Andrei Nikiforovich 1760-1814 *McGDA, WhoArch*
Voros, Julia 1854- *DcWomA*
Vorst, Joseph Paul 1897- *WhAmArt 85*
Vorster, Gordon *OxTwCA*
Vorsterman, Lucas Emil, I 1595-1675 *McGDA*
Vortel, Wilhelm 1793-1844 *ClaDrA*
Voruz, Elise 1844-1909 *DcWomA*
Vorwerk, E Charlsie 1934- *WhoAmA 76, -78, -80, -82, -84*
Vos, Cornelis De 1584?-1651 *OxArt*
Vos, Cornelis De 1585?-1651 *ClaDrA, McGDA*
Vos, Hubert 1855- *DcVicP, -2*
Vos, Hubert 1855-1935 *WhAmArt 85*
Vos, Jan De 1593-1649 *McGDA*
Vos, Maria 1824-1906 *DcWomA*
Vos, Marius *WhAmArt 85*
Vos, Marten De 1532-1603 *ClaDrA*
Vos, Martin De 1531?-1603 *OxArt*
Vos, Martin De 1532-1603 *McGDA*
Vos, Paul De 1596-1678 *ClaDrA, McGDA, OxArt*
Vos, Simon De 1603-1676 *ClaDrA, McGDA*
Vos-Kardovskaia, Olga *DcWomA*
Vosbeck, Robert Randall 1930- *AmArch 70*
Vosbeck, William Frederick, Jr. 1924- *AmArch 70*
Vosburg, Lillian *DcWomA*
Vosburgh, Edna H *DcWomA, WhAmArt 85*
Vosburgh, Leonard *IlsBYP*
Vosburgh, R G *WhAmArt 85*
Vose, Adairene *DcWomA, WhAmArt 85*
Vose, Daniel 1741-1807 *CabMA*
Vose, Ebenezer 1766-1813 *CabMA*
Vose, George L *EncASM*
Vose, Isaac *CabMA*
Vose, N *CabMA*
Vose, Robert C d1965 *WhoAmA 78N, -80N, -82N, -84N*
Vose, Robert Churchill, Jr. 1911- *WhoAmA 78, -80, -82, -84*
Vose, Seth Morton 1831-1910 *WhAmArt 85*
Vose, William 1778-1851 *CabMA*
Vose And Coats *CabMA*
Vose And Todd *CabMA*
Voskamp, E B *AmArch 70*
Voskamp, Raymond Leonard 1904- *AmArch 70*
Voskamp, Raymond Leonard, Jr. 1932- *AmArch 70*
Vosmaer, Daniel *McGDA*
Vosper, Sydney Carnow 1866-1942 *DcBrBI*
Vosper, Sydney Curnow 1866-1942 *DcBrA 1*
Voss, D R *WhAmArt 85*
Voss, Elsa *DcWomA*
Voss, Elsa Horne *WhAmArt 85*
Voss, Frederick Hoffman 1909- *AmArch 70*
Voss, Gyda 1871- *DcWomA*
Voss, Jan 1936- *ConArt 77, -83, DcCAr 81, PhDcTCA 77*
Voss, Karoline Von *DcWomA*
Voss, Maria *ArtsNiC*
Voss, Martha 1869- *DcWomA*
Voss, Nellie Cleveland 1871-1963 *ArtsAmW 2, DcWomA*

Voss, Rudolph Fred 1929- *AmArch 70*
Vossler, Donald Alan 1940- *MarqDCG 84*
Vostal, John Louis *AmArch 70*
Vostell, Wolf 1932- *ConArt 77, -83, DcCAr 81, OxTwCA, PhDcTCA 77*
Votava, Benjamin Anthony 1918- *AmArch 70*
Votaw, G J *AmArch 70*
Votaw, R J *AmArch 70*
Votey, Charles A *NewYHSD*
Voth, Andrew Charles 1947- *WhoAmA 78, -80*
Vouet, Aubin 1595-1641 *McGDA*
Vouet, Jacob Ferdinand *McGDA*
Vouet, Simon 1590-1649 *ClaDrA, McGDA, OxArt*
Vouet, Virginia Da *DcWomA*
Vouga, Emilie 1840-1909 *DcWomA*
Vought, Samuel L *FolkA 86*
Vought, Theodore A 1877-1945 *BiDAmAr*
Voulkos, Peter 1924- *AmArt, BnEnAmA, CenC[port], ConArt 77, -83, DcAmArt, DcCAA 71, -77, DcCAr 81, OxTwCA, PhDcTCA 77, WhoAmA 73, -76, -78, -80, -82, -84*
Voullemier, Anne Nicole 1796-1886 *DcWomA*
Vourvoulias, Joyce Bush *WhoAmA 82, -84*
Voute, Kathleen *WhAmArt 85*
Voute, Kathleen 1892- *DcWomA, IlsBYP, IlsCB 1946*
Vowell, J D *AmArch 70*
Vox, Maximilien *IlsCB 1744*
Voyer, Jane *NewYHSD*
Voyer, Sylvain Jacques 1939- *WhoAmA 73, -76, -78*
Voyez, Jean 1735-1800 *AntBDN M*
Voyez, John 1735-1800 *AntBDN M*
Voys, Adriaen De *McGDA*
Voysand *AntBDN E*
Voysey, Annesley 1794?-1839 *BiDBrA*
Voysey, C F A 1857-1941 *ConArch*
Voysey, Charles Annesley 1857-1941 *EncMA, OxArt*
Voysey, Charles F A 1857-1941 *MacEA, OxDecA*
Voysey, Charles F Annesley 1857-1941 *AntBDN A*
Voysey, Charles Francis Annesley 1857-1941 *DcD&D[port], DcNiCA, McGDA, WhoArch*
Vozech, Anthony 1895- *WhAmArt 85*
Vozenilek, Zdenek 1929- *MacBEP*
Vralsted, George 1926- *AmArch 70*
Vrana, Albert S 1921- *WhoAmA 73, -76, -78, -80, -82, -84*
Vrancx, Sebastiaen 1573-1647 *McGDA*
Vrancx, Sebastien 1573?-1647 *ClaDrA*
Vrangel, Baroness Helene Von 1835-1906 *DcWomA*
Vredeman DeVries, Hans 1526?-1606 *MacEA*
Vredeman DeVries, Hans 1527-1606 *WhoArch*
Vredeman DeVries, Hans 1527-1623? *McGDA*
Vredeman DeVries, Paul 1567-1630? *McGDA*
Vree, Nicolaes De 1645-1702 *McGDA*
Vreedenburgh-Schotel, M 1884- *DcWomA*
Vreeland, Diana *WorFshn*
Vreeland, Elizabeth 1896- *DcWomA*
Vreeland, Elizabeth L Wilder 1896- *WhAmArt 85*
Vreeland, Francis William 1879-1954 *ArtsAmW 2, WhAmArt 85*
Vreeland, Marian Frances *DcWomA*
Vreeland, Thomas Reed, Jr. 1925- *AmArch 70*
Vrel, Jacob *McGDA*
Vrel, Jacobus *OxArt*
Vrelant, Willem d1481? *OxArt*
Vrezec, Zarko 1950- *DcCAr 81*
Vriendt, De *McGDA, OxArt*
Vriendt, Albrecht 1843-1900 *ClaDrA*
Vriendt, Albrecht De *ArtsNiC*
Vriendt, Clementine De 1840- *DcWomA*
Vriendt, Juliaan De 1842-1935 *ClaDrA*
Vriendt, Julian De *ArtsNiC*
Vries, Abraham De 1590?-1662? *McGDA*
Vries, Adraen De 1546?-1626 *McGDA*
Vries, Adriaen De 1546?-1626 *OxArt*
Vries, Adriaen De 1550?-1626 *ClaDrA*
Vries, Catherine Julia 1813-1883 *DcWomA*
Vries, Hans Vredeman De *McGDA*
Vries, Hans Vredeman De 1527- *OxArt*
Vries, Hans Vredeman De 1527-1604 *DcD&D*
Vries, Hans Vredeman De 1527-1604? *OxDecA*
Vries, Herman De 1931- *OxTwCA*
Vries, J C 1804-1850? *DcSeaP*
Vries, Jan Reynier De 1657?- *ClaDrA*
Vries, Joachim De 1600?- *DcSeaP*
Vries, Joghem De *DcSeaP*
Vries, Paul Vredeman De *McGDA*
Vries, Roelof 1631?-1681? *ClaDrA*
Vries, Roelof Van 1630?-1681? *McGDA*
Vries, Simon De *McGDA*
Vrla, J M *AmArch 70*
Vroman, Adam Clark 1856-1916 *ICPEnP, MacBEP, WhAmArt 85*
Vroom, Cornelis Hendriksz 1590?-1661 *McGDA*
Vroom, Cornelis Hendriksz 1591-1661 *DcSeaP*
Vroom, Hendrik Cornelisz 1562?-1640 *McGDA*
Vroom, Hendrik Cornelisz 1566-1640 *ClaDrA, DcSeaP*
Vrooman, Philip Egmont 1937- *AmArch 70*
Vrooman, Richard Edwin 1920- *AmArch 70*

Vrscaj, Joze 1950- *DcCAr 81*
Vrtiak, J A *AmArch 70*
Vrubel, Mikhail Aleksandrovich 1856-1910 *OxTwCA*
Vrubel, Mikhail Aleksandrovich 1856-1911 *McGDA*
Vrydagh, A L *AmArch 70*
Vrydagh, Josse *BiDAmAr*
V'soske, Stanislav 1899- *WhAmArt 85*
Vtoroff, Olga 1898-1936 *DcWomA*
Vucht, Jan VanDer 1603?-1637 *ClaDrA*
Vuichoud, Louise 1831-1909 *DcWomA*
Vuillard, Edouard 1868-1940 *ClaDrA, McGDA, OxArt, OxTwCA, PhDcTCA 77*
Vuillaume, Germaine *DcWomA*
Vuillaume, John Baptiste 1798-1875 *AntBDN K*
Vuillefroy, Felix Dominique De 1841- *ClaDrA*
Vuillemenot, Fred A d1952 *WhoAmA 78N, -80N, -82N, -84N*
Vuillemenot, Fred A 1890-1952 *WhAmArt 85*
Vuinovich, Milosh George 1914- *AmArch 70*
Vuitel, Caroline Heloise *DcWomA*
Vuitton, Louis *FairDF FRA*
Vujaklija, Lazar 1914- *PhDcTCA 77*
Vujcec, Franjo *OxTwCA*
Vukanovic, Beta 1872-1945? *DcWomA*
Vukotic, Dusan 1927- *WorECar*
Vukovic, Marko 1892- *WhAmArt 85*
Vukovich, Marion *WhAmArt 85*
Vulliamy, Benjamin *AntBDN D*
Vulliamy, Benjamin Lewis *AntBDN D, DcNiCA*
Vulliamy, Edward 1876-1962 *DcBrA 1*
Vulliamy, Gerard 1909- *PhDcTCA 77*
Vulliamy, Justin *AntBDN D*
Vulliamy, Lewis 1791-1871 *BiDBrA, MacEA, WhoArch*
Vulliemin, Emma Caroline 1865- *DcWomA*
Vully, Louisa Mary *DcWomA*
Vulpe, Milan 1918- *WhoGrA 82[port]*
Vulpen, Nico Van *DcCAr 81*
Vultee, Frederick L *NewYHSD*
Vurnik, Helena *DcWomA*
Vychan, J L *DcVicP 2*
Vychodil, Ladislav 1920- *ConDes*
Vygh, Suzanna Catherina *DcWomA*
Vyse, Charles d1968 *DcNiCA*
Vyse, Charles 1882-1971 *DcBrA 2*
Vysekal, Edouard A 1890-1939 *WhAmArt 85*
Vysekal, Edouard Antonin 1890-1939 *ArtsAmW 2*
Vysekal, Luvan Buchanan d1954 *WhAmArt 85*
Vysekal, Luvena d1954 *DcWomA*
Vysekal, Luvena Buchanan d1954 *ArtsAmW 2*
Vytlacil, Elizabeth Foster 1899- *DcWomA, WhAmArt 85*
Vytlacil, Vaclav 1892- *ClaDrA, DcCAA 71, -77, DcCAr 81, McGDA, WhAmArt 85, WhoAmA 73, -76, -78, -80, -82, -84*
Vytlacil, William *WhAmArt 85*
Vyvyan, M Caroline *DcVicP 2*
Vyvyan, Mary Caroline *DcWomA*

W

Waag, Gary Lewis 1955- *MarqDCG 84*
Waage, Frederick O 1906- *WhoAmA 73, –76*
Waal, Justus De 1747- *ClaDrA*
Waaland, James Brearley, II 1953- *WhoAmA 84*
Waano-Gano, Joe 1906- *WhAmArt 85,*
 WhoAmA 73, –76, –78, –80, –82
Waano-Gano, Joe 1906-1982 *WhoAmA 84N*
Waano-Gano, Joe T N 1906- *IlBEAAW*
Waard, Antonie 1689-1751 *ClaDrA*
Wabbes, Maria *IlsBYP*
Waber, Bernard *IlsCB 1967*
Waber, Bernard 1924- *IlsCB 1957*
Waber, Linde *DcCAr 81*
Wacasey, William *AfroAA*
Wach, Karl Wilhelm 1787-1845 *ArtsNiC*
Wachler, Maria Juliana *DcWomA*
Wachs, Ethel 1923- *WhoAmA 82, –84*
Wachs, Warren Cleveland 1920- *AmArch 70*
Wachsmann, Konrad 1901- *ConArch, EncMA*
Wachsmann, Konrad 1901-1980 *MacEA*
Wachstein, Alison Ehrlich 1947- *ICPEnP A,*
 MacBEP
Wachsteter, George 1911- *WhoAmA 73, –76, –78, –80,*
 –82, –84
Wacht, Samuel D 1930- *AmArch 70*
Wachtel, Elmer 1864-1929 *ArtsAmW 1, IlBEAAW,*
 WhAmArt 85
Wachtel, Marion 1876-1954 *DcWomA*
Wachtel, Marion Kavanagh 1875?-1954 *IlBEAAW*
Wachtel, Marion Kavanaugh 1875- *ArtsAmW 1*
Wachtel, Marion Kavanaugh 1876-1954 *WhAmArt 85*
Wachtel, Stefanie 1871- *DcWomA*
Wachter, Cornelia *DcWomA*
Wachter, Harry W 1868-1941 *BiDAmAr*
Wachter, Horace Whitney 1900- *AmArch 70*
Wachter, Mileus *NewYHSD*
Wachter, Paula, Freiin Von 1860- *DcWomA*
Wachter, Robert E 1920- *AmArch 70*
Wachter-Hormuth, Clara 1869- *DcWomA*
Wacik, Marianne 1891- *DcWomA*
Wack, Ethel Barksdale 1898- *WhAmArt 85*
Wack, Henry Wellington 1867-1954? *ArtsAmW 3*
Wack, Henry Wellington 1875-1955? *WhAmArt 85*
Wackerbarth, August 1860-1931 *BiDAmAr*
Wackerle, Joseph 1880- *DcNiCA*
Wackerman, Dorothy *DcWomA, WhAmArt 85*
Wackis, B *ClaDrA*
Wacs, Ilie 1927- *WorFshn*
Wada, Hoji 1931- *AmArch 70*
Wada, Yoshiko 1944- *DcCAr 81*
Waddecar, Peter 1928- *DcCAr 81*
Waddell, Mrs. *DcWomA*
Waddell, D Henderson *DcVicP 2*
Waddell, Eugene 1925- *WhoAmA 76, –78, –80, –82,*
 –84
Waddell, Heather 1950- *WhoArt 82, –84*
Waddell, John Henry 1921- *WhoAmA 73, –76, –78,*
 –80, –82, –84
Waddell, Martha E 1907- *WhAmArt 85*
Waddell, R *FolkA 86*
Waddell, Richard H *WhoAmA 73*
Waddell, Richard H d1974 *WhoAmA 76N, –78N,*
 –80N, –82N, –84N
Waddey, G E *AmArch 70*
Waddingham, John Alfred 1915- *WhoAmA 76, –78,*
 –80, –82, –84
Waddington, Frances *DcWomA*
Waddington, Maud *DcVicP 2*
Waddington, Roy 1917- *ClaDrA, DcBrA 1,*
 WhoArt 80, –82, –84
Waddington, S 1736-1758 *DcBrECP*

Waddington, Vera 1886- *DcBrA 1, DcWomA*
Waddy, Frederick *DcBrBI, DcVicP 2*
Waddy, Ruth G 1909- *AfroAA*
Wade, Angus 1855-1932 *BiDAmAr*
Wade, Arthur Edward 1895- *DcBrA 1, WhoArt 80,*
 –82
Wade, Bob 1943- *ConArt 77*
Wade, Bob G 1939- *AmArch 70*
Wade, Caroline D 1857- *WhAmArt 85*
Wade, Caroline D 1857-1947 *DcWomA*
Wade, Charles Paget d1956 *DcBrBI*
Wade, Claire E 1899- *DcWomA, WhAmArt 85*
Wade, Dorothy *DcCAr 81, WhoArt 80*
Wade, Dorothy 1926- *ClaDrA*
Wade, Edward W *DcVicP 2*
Wade, Edwin Jerome 1907- *AmArch 70*
Wade, Eugene *AfroAA*
Wade, Fairfax Blomfield *DcVicP 2*
Wade, Frances *FolkA 86*
Wade, Francis Hodgkins 1819- *CabMA*
Wade, George Edward 1853-1933 *DcBrA 1*
Wade, H *NewYHSD*
Wade, Hannah C *NewYHSD*
Wade, J *DcBrWA*
Wade, J H *NewYHSD*
Wade, James Chaffin 1907- *AmArch 70*
Wade, James Marconi 1908- *AfroAA*
Wade, Jane 1925- *WhoAmA 73, –76, –78, –80, –82,*
 –84
Wade, Jean 1910- *WhAmArt 85*
Wade, Jeptha Homer 1857-1926 *WhAmArt 85*
Wade, John *AfroAA*
Wade, John C 1827?- *NewYHSD*
Wade, John W 1925- *AmArch 70*
Wade, John W, Jr. 1951- *WhoAmA 76*
Wade, Kent E 1944- *MacBEP*
Wade, L L *AmArch 70*
Wade, Lanny Arlan 1938- *AmArch 70*
Wade, Maurice *DcCAr 81*
Wade, Murray 1876- *ArtsAmW 3*
Wade, Robert 1882- *WhAmArt 85*
Wade, Robert 1943- *ConArt 83*
Wade, Robert S 1943- *MacBEP*
Wade, Robert Schrope 1943- *WhoAmA 73, –76, –78,*
 –80, –82, –84
Wade, Robert Verne 1899- *AmArch 70*
Wade, Samuel 1820?- *NewYHSD*
Wade, Thomas 1828-1891 *ClaDrA, DcBrWA,*
 DcVicP, –2
Wade, W B *AmArch 70*
Wade, William *EarABI, EarABI SUP, NewYHSD*
Wadham, B B *DcBrWA, DcVicP 2*
Wadham, H B *DcVicP 2*
Wadham, Percy *DcBrA 2, DcBrBI, DcVicP 2*
Wadham, Sarah *DcVicP 2*
Wadhams, Jesse *FolkA 86*
Wadler, R C *DcWomA*
Wadley, Donald Elwin 1926- *AmArch 70*
Wadley, James Lee 1932- *AmArch 70*
Wadman, Lolita Katherine 1908- *WhAmArt 85*
Wadman, William *BiDBrA*
Wadmore, T F *DcVicP 2*
Wadowski-Bak, Alice *IlsBYP*
Wadrop, Ken 1952- *DcCAr 81*
Wadskier, Theodore Vigo 1827- *BiDAmAr*
Wadsworth, Mrs. *DcVicP 2*
Wadsworth, Adelaide E 1844-1928 *DcWomA,*
 WhAmArt 85
Wadsworth, Charles *FolkA 86*
Wadsworth, Daniel 1771-1848 *NewYHSD*
Wadsworth, Edward 1889-1949 *ConArt 83, McGDA,*

 OxArt, OxTwCA, PhDcTCA 77
Wadsworth, Edward Alexander 1889-1949 *DcBrA 1*
Wadsworth, Edwin Artemus 1908- *AmArch 70*
Wadsworth, Frances Laughlin *WhoAmA 73, –76*
Wadsworth, Frank Russell 1874-1905 *WhAmArt 85*
Wadsworth, Grace 1879- *DcWomA, WhAmArt 85*
Wadsworth, John *CabMA*
Wadsworth, Lillian 1887- *DcWomA, WhAmArt 85*
Wadsworth, Lucy G *DcWomA, WhAmArt 85*
Wadsworth, Myrta M 1859- *WhAmArt 85*
Wadsworth, Philip Shirley 1899- *AmArch 70*
Wadsworth, Reginald Jeffrey 1885- *AmArch 70*
Wadsworth, Terry Michael 1936- *AmArch 70*
Wadsworth, W *ArtsAmW 1, NewYHSD*
Wadsworth, Wedworth 1846-1927 *ArtsAmW 3,*
 WhAmArt 85
Wadsworth, William *NewYHSD*
Wadsworth, William 1768- *CabMA*
Waechter, Heinrich Hormuth 1907- *AmArch 70*
Waehler, Frank James 1920- *AmArch 70*
Waehrer, Edgar 1936- *AmArch 70*
Wael, Cornelis De 1592-1667 *ClaDrA, McGDA*
Wael, Jan Baptiste De 1632- *ClaDrA*
Wael, Lucas Janszen De 1591-1661 *ClaDrA*
Waelde, J C *FolkA 86*
Waesche, Metta Henrietta 1806-1900 *DcWomA,*
 NewYHSD
Wagan, Robert *FolkA 86*
Waganer, Anthony *NewYHSD*
Wagemaker, Jaap 1906- *ConArt 77, OxTwCA,*
 PhDcTCA 77
Wagemaker, Jaap 1906-1972 *ConArt 83*
Wageman, D E *DcVicP 2*
Wageman, M, Jr. *DcVicP 2*
Wageman, Michael *NewYHSD*
Wageman, Michael Angelo *DcBrWA, DcVicP, –2*
Wageman, Thomas Charles 1787?-1863 *DcBrBI,*
 DcBrWA, DcVicP, –2
Wagenbaur, Maximilian Joseph 1774-1829 *ClaDrA*
Wagenbichler, Helene 1869- *DcWomA*
Wagener, Hobart Dean 1921- *AmArch 70*
Wagenet, J D *AmArch 70*
Wagenfeld, Wilhelm 1900- *ConDes, IlDcG*
Wagenfeld, William 1900- *McGDA*
Wagenhals, Katherine H 1883- *ArtsAmW 2,*
 DcWomA, WhAmArt 85
Wagenhurst, Charles *FolkA 86*
Wagenleithner, Peter Christian 1955- *MarqDCG 84*
Wager-Smith, Curtis *DcWomA, WhAmArt 85*
Wagg *DcBrECP*
Waggaman, Clark J 1872-1919 *BiDAmAr*
Waggaman, Wolcott Clarke 1902- *AmArch 70*
Waggner *DcBrECP*
Waggoner, Charles Lucius 1921- *AmArch 70*
Waggoner, Elizabeth *ArtsAmW 2, DcWomA,*
 WhAmArt 85
Waggoner, R W *AmArch 70*
Waggoner, Thomas Marshall 1929- *AmArch 70*
Waggoner, William W *NewYHSD*
Wagguno *FolkA 86*
Waghemaker, Dominicus 1460-1542 *McGDA*
Waghemakere Family *MacEA*
Waghorn, Frederick *DcVicP 2*
Waghorn, Tom 1900- *ClaDrA*
Waghorn, Tom 1900-1959 *DcBrA 1*
Waghorne, John *FolkA 86*
Wagmuller, Michael 1839-1881 *McGDA*
Wagner *FolkA 86, NewYHSD*
Wagner, A *WhAmArt 85*
Wagner, A L *EncASM*
Wagner, A M *DcWomA*

Wagner, Adelaide *DcWomA*
Wagner, Alexander 1838- *ArtsNiC*
Wagner, Andrew *NewYHSD*
Wagner, Anna *DcWomA*
Wagner, Bernard 1916- *AmArch 70*
Wagner, Blanche Collet *WhoAmA 80N, -82N, -84N*
Wagner, Blanche Collet 1873-1956? *DcWomA*
Wagner, Blanche Collet 1873-1958? *ArtsAmW 2, WhAmArt 85*
Wagner, Carl Richard 1926- *AmArch 70*
Wagner, Catherine 1953- *MacBEP*
Wagner, Cecilia *DcWomA*
Wagner, Charles H *WhoAmA 76, -78, -80, -82, -84*
Wagner, Christina *FolkA 86*
Wagner, Clara *DcWomA*
Wagner, Corny *DcSeaP*
Wagner, Daniel 1802-1888 *NewYHSD*
Wagner, Donovan David 1934- *AmArch 70*
Wagner, E *NewYHSD*
Wagner, E A *AmArch 70*
Wagner, E G *DcWomA*
Wagner, Edward *DcVicP 2*
Wagner, Edward Frederick 1941- *AmArch 70*
Wagner, Edward Q 1855-1922 *ArtsEM, WhAmArt 85*
Wagner, Elise *DcWomA*
Wagner, F C *AmArch 70*
Wagner, F Kenneth 1935- *AmArch 70*
Wagner, Ferdinand 1820-1880 *ArtsNiC*
Wagner, Frank Arthur 1932- *AmArch 70*
Wagner, Frank Hugh 1870- *WhAmArt 85*
Wagner, Fred 1864-1940 *WhAmArt 85*
Wagner, G Noble 1907- *WhoAmA 73, -76, -78, -80, -82, -84*
Wagner, George *WhAmArt 85*
Wagner, George A *FolkA 86*
Wagner, Gordon Parsons 1915- *WhoAmA 76, -78, -80, -82, -84*
Wagner, H L *AmArch 70*
Wagner, Henry S *NewYHSD*
Wagner, Hermine 1880- *DcWomA*
Wagner, Hugo E *ArtsEM*
Wagner, I B *AmArch 70*
Wagner, J *EncASM*
Wagner, J F *NewYHSD*
Wagner, J J *AmArch 70*
Wagner, Jacob d1899 *WhAmArt 85*
Wagner, Johann Peter Alexander 1730-1809 *McGDA*
Wagner, Johanna 1846- *DcWomA*
Wagner, John *FolkA 86*
Wagner, John Philip 1943- *WhoAmA 73, -76, -78*
Wagner, Juliette 1868-1937 *DcWomA*
Wagner, Klementine Von 1844- *DcWomA*
Wagner, Lee A *WhAmArt 85*
Wagner, Leo Frederick, Jr. 1929- *AmArch 70*
Wagner, Maria Dorothea 1719-1792 *DcWomA*
Wagner, Maria Louisa *NewYHSD*
Wagner, Maria Louisa 1815?-1888 *DcWomA*
Wagner, Martin 1885-1957 *EncMA, MacEA*
Wagner, Mary L *ArtsEM, DcWomA*
Wagner, Mary North 1875- *DcWomA, WhAmArt 85*
Wagner, May W *WhAmArt 85*
Wagner, Merrill 1935- *WhoAmA 78, -80, -82, -84*
Wagner, Olga 1873- *DcWomA*
Wagner, Otto 1803-1861 *ClaDrA*
Wagner, Otto 1841-1918 *DcD&D[port], EncMA, MacEA, McGDA, OxArt, WhoArch*
Wagner, Patrice M 1956- *MarqDCG 84*
Wagner, Paul L *FolkA 86*
Wagner, Peter Gerard 1952- *MarqDCG 84*
Wagner, Philip 1811?- *NewYHSD*
Wagner, Pierre 1897- *ClaDrA*
Wagner, R M *AmArch 70*
Wagner, Richard Ellis 1923- *AmArt, WhoAmA 73, -76, -78, -80, -82, -84*
Wagner, Robert Leicester d1942 *WhAmArt 85*
Wagner, Robert Leicester 1872-1942 *ArtsAmW 1, ArtsEM*
Wagner, Robin 1933- *ConDes*
Wagner, Rosa *WhAmArt 85*
Wagner, Rosa A *DcWomA*
Wagner, Rudolph *NewYHSD*
Wagner, S Peter 1878- *WhAmArt 85*
Wagner, Stephen Bradley 1954- *MarqDCG 84*
Wagner, Steward *McGDA*
Wagner, Steward 1886-1958 *McGDA*
Wagner, Stewart G 1920- *AmArch 70*
Wagner, Thomas S *NewYHSD*
Wagner, W A *NewYHSD*
Wagner, W G *AmArch 70*
Wagner, W J *AmArch 70*
Wagner, Walter 1908- *AmArch 70*
Wagner, Walter F, Jr. 1926- *AmArch 70*
Wagner, Wieland Adolf Gottfried 1917-1966 *ConDes*
Wagner, William *NewYHSD*
Wagner, William 1800-1869 *EarABI SUP*
Wagner, William Sydney 1883-1932 *BiDAmAr*
Wagner, William W 1817?- *NewYHSD*
Wagner And Reuther *ArtsEM*
Wagner And Volbracht *ArtsEM*
Wagner-Franck, Kate 1879- *DcWomA*

Wagner-Seulen, Else 1881- *DcWomA*
Wagniere, Marie Amelie Mathilde *DcWomA*
Wagnon-Chantre, Aimee *DcWomA*
Wagon, Peter 1906- *ClaDrA*
Wagoner, Annie Resser *DcWomA*
Wagoner, Charles *NewYHSD*
Wagoner, F A *AmArch 70*
Wagoner, Harold Eugene 1905- *AmArch 70*
Wagoner, Harry B 1889-1950 *ArtsAmW 2, IlBEAAW, WhAmArt 85*
Wagoner, Maria *FolkA 86*
Wagoner, Robert 1928- *IlBEAAW*
Wagoner, Robert B 1928- *WhoAmA 76, -78, -80, -82, -84*
Wagoner Brothers *FolkA 86*
Wagrez, Alice *DcWomA*
Wagrez, E *DcVicP 2*
Wagrez, Jacques Clement 1846-1908 *ClaDrA*
Wagrez, Marie *DcWomA*
Wagstaff, Charles Edward 1808- *NewYHSD*
Wagstaff, H B *AmArch 70*
Wagstaff, John d1784 *BiDBrA*
Wagstaff, John C *NewYHSD*
Wagstaff, Myrtle *DcWomA*
Wagstaff, S *DcBrWA*
Wagstaff, Thomas *AntBDN D*
Wagstaffe, S *DcVicP 2*
Wah, Bernard 1939- *AfroAA*
Wahl, Anna Von 1861- *DcWomA*
Wahl, Bernhard O 1888- *WhAmArt 85*
Wahl, Dora *DcWomA*
Wahl, Frank B 1948- *MarqDCG 84*
Wahl, John Alfred 1898- *AmArch 70*
Wahl, John F *OfPGCP 86*
Wahl, Theodore 1904- *WhAmArt 85*
Wahl And Socin *AntBDN P*
Wahlberg, Arne 1905- *ConPhot, ICPEnP A*
Wahlberg, Charles Douglas 1923- *AmArch 70*
Wahlberg, Jenny *DcWomA*
Wahlberg, Roy Eric 1951- *MarqDCG 84*
Wahlbom, Elin 1885-1960 *DcWomA*
Wahling, B Jon 1938- *WhoAmA 76, -78, -80*
Wahling, Jon B 1938- *WhoAmA 82, -84*
Wahliss, Ernst *DcNiCA*
Wahlman, Lars 1870-1952 *MacEA*
Wahlman, Maude Southwell *WhoAmA 84*
Wahlmann, Frederick *NewYHSD*
Wahlmann, Herbert Raymond 1925- *AmArch 70*
Wahlquist, C D *AmArch 70*
Wahlstab, Johanna Louisa *DcWomA*
Wahlstrom, Charlotte Constance 1849-1924 *DcWomA*
Wahrenberger, James W 1855-1929 *BiDAmAr*
Wahrhaftig, Alma Lavenson *WhoAmA 82, -84*
Wahrmund, Augusta *DcWomA*
Waibler, F *DcBrBI*
Waid, D Everett 1864-1939 *BiDAmAr*
Waid, Homer Allen 1928- *AmArch 70*
Waid, Jim 1942- *WhoAmA 84*
Wailes, E *DcWomA*
Wailly, Charles De 1730-1798 *McGDA*
Wain, Louis 1860-1911 *DcNiCA*
Wain, Louis 1860-1939 *AntBDN B*
Wain, Louis William 1860-1939 *DcBrA 1, DcBrBI, DcVicP 2, WorECar*
Wain-Hobson, Douglas 1918- *DcBrA 1*
Wainer, Thomas, Jr. *CabMA*
Wainewright, J F *DcVicP 2*
Wainewright, John *DcVicP, -2*
Wainewright, Thomas Francis *DcBrWA, DcVicP, -2*
Wainewright, Thomas Griffiths 1794-1852 *DcBrWA*
Wainewright, W F 1835-1857 *DcVicP 2*
Wainright, James *CabMA*
Wainwright, Beatrice *DcBrA 1, DcWomA*
Wainwright, Christine H *WhAmArt 85*
Wainwright, Jeannette Harvey *WhAmArt 85*
Wainwright, John 1762-1828 *BiDBrA*
Wainwright, Robert Barry 1935- *WhoAmA 84*
Wainwright, S H, Jr. *WhAmArt 85*
Wainwright, Samuel *AntBDN D*
Wainwright, William John 1855-1931 *ClaDrA, DcBrA 1, DcBrWA, DcVicP, -2*
Waisler, Lee 1938- *WhoAmA 76, -78*
Waisman, Taina *AmArch 70*
Wait, Blanche E 1895-1934 *WhAmArt 85*
Wait, Carrie Stow 1851- *DcWomA, WhAmArt 85*
Wait, Charles Robert 1880- *AmArch 70*
Wait, Erskine L d1898 *WhAmArt 85*
Wait, Fanny *DcWomA*
Wait, Lizzie F *WhAmArt 85*
Wait, Lizzie Frances *DcWomA*
Wait, Luke *FolkA 86*
Wait, Obediah *FolkA 86*
Wait, Robert T P 1846-1898 *BiDAmAr*
Waite, Benjamin Franklin 1817- *NewYHSD*
Waite, Blanche E 1895-1934 *WhAmArt 85*
Waite, Charles D *DcVicP 2*
Waite, Charles H *WhAmArt 85*
Waite, Clara Turnbull *WhAmArt 85*
Waite, E *DcVicP 2*
Waite, Edward W *DcBrA 1, DcVicP, -2*
Waite, Edward Wilkins *DcBrBI*

Waite, Edward William *ClaDrA*
Waite, Elin Jane 1933- *WhoAmA 80, -82, -84*
Waite, Emily Burling 1887- *DcWomA, WhAmArt 85*
Waite, Harold *DcBrA 1, -2, DcVicP 2*
Waite, I F *AmArch 70*
Waite, J *DcVicP 2*
Waite, James Clarke *DcVicP, -2*
Waite, John 1651-1704 *CabMA*
Waite, Laura 1891-1978 *DcWomA*
Waite, Lucretia Ann *DcWomA, NewYHSD*
Waite, Robert Thorne 1842-1935 *DcBrA 1, DcBrWA, DcVicP, -2*
Waite, Sarah 1826-1861 *FolkA 86*
Waite, William Arthur 1875-1896 *DcVicP 2*
Waite, William J *WhAmArt 85*
Waites, Edward P *NewYHSD*
Waithe, Vincent *AfroAA*
Waitt, Alden Harry 1892- *WhoAmA 78, -80, -82*
Waitt, Benjamin Franklin 1817- *NewYHSD*
Waitt, M P *WhAmArt 85*
Waitt, Marian Martha Parkhurst 1875- *DcWomA*
Waitt, Richard d1732 *DcBrECP*
Waitzkin, Stella *WhoAmA 76, -78, -80, -82, -84*
Waitzman, Simon V 1929- *AmArch 70*
Wajih, Abu Reza M 1948- *MarqDCG 84*
Wakabayashi, Kazua 1931- *DcCAr 81*
Wakabayashi, Yasuhiro *ConPhot, MacBEP*
Wakae, Kanji 1944- *ConArt 77*
Wake, Jeffrey James 1949- *MarqDCG 84*
Wake, John Cheltenham *DcVicP 2*
Wake, Joseph *DcVicP 2*
Wake, Margaret *DcVicP 2*
Wake, Margaret Eveline 1867-1930 *DcWomA*
Wake, Richard 1865-1888 *DcBrBI*
Wakefield, A B *DcWomA*
Wakefield, George William 1887-1942 *WorECom*
Wakefield, Larry Hilary Edward 1925- *ClaDrA*
Wakefield, Ruth *WhAmArt 85*
Wakefield, T H *DcBrBI*
Wakefield, William d1730 *BiDBrA*
Wakeford, Edward Felix 1914-1973 *DcBrA 1*
Wakelaw, Frederick *NewYHSD*
Wakelaw, William J *NewYHSD*
Wakelin, Edward *AntBDN Q*
Wakelin, John *AntBDN Q*
Wakelin, Roland 1887-1971 *OxTwCA*
Wakeling, R W *AmArch 70*
Wakely, D J *AmArch 70*
Wakely, Robert Charles 1920- *AmArch 70*
Wakely, Shelagh 1932- *ConBrA 79[port]*
Wakeman, Esther Dimar *FolkA 86*
Wakeman, Marion D Freeman 1891-1953 *WhAmArt 85*
Wakeman, Marion Freeman 1891-1953 *DcWomA, IlsBYP, IlsCB 1946*
Wakeman, R C 1889- *WhAmArt 85*
Wakeman, Thomas 1812-1878 *FolkA 86, NewYHSD*
Wakeman, Thomas Oliver 1923- *AmArch 70*
Wakeman, William Frederick 1822-1900 *DcBrBI, DcBrWA*
Waken, Mabel 1879- *WhAmArt 85*
Waken, Mabel J 1879- *DcWomA*
Wakley, Archibald 1875?-1906 *DcBrWA, DcVicP 2*
Wakley, Horace M *DcVicP 2*
Waksberg, Naomi 1946- *WhoAmA 82*
Waksberg, Naomi 1947- *WhoAmA 84*
Wal, Frank J 1948- *MarqDCG 84*
Walbeek, Christina Adriana Van *DcWomA*
Walber, T B *FolkA 86*
Walborn, Catarina *FolkA 86*
Walbourn, Ernest *DcBrA 2, DcVicP 2*
Walbridge, Cope Buffum 1913- *AmArch 70*
Walburg, Gerald 1936- *WhoAmA 76, -78, -80, -82, -84*
Walburne, Rand *WhAmArt 85*
Walch, Charles 1898-1948 *OxTwCA*
Walch, Jacob *McGDA*
Walch, John Leo 1918- *WhoAmA 78, -80, -82, -84*
Walchli, E J *AmArch 70*
Walckiers, Gustave 1831-1891 *ClaDrA*
Walcoff, Muriel *WhAmArt 85*
Walcot, William 1874-1943 *DcBrA 1*
Walcot, William E *WhAmArt 85*
Walcott, Anabel Havens 1870- *WhAmArt 85*
Walcott, Belle 1870- *DcWomA*
Walcott, Chester H 1883-1947 *BiDAmAr*
Walcott, H M 1870-1944 *WhAmArt 85*
Walcott, Helen *DcWomA*
Walcott, Helen 1894- *WhAmArt 85*
Walcott, Mary Morris 1860-1940 *DcWomA*
Walcott, Mattie *ArtsEM, DcWomA*
Walcutt, David Broderick 1825- *NewYHSD*
Walcutt, George 1825- *NewYHSD*
Walcutt, William 1819-1882? *EarABI*
Walcutt, William 1819-1895? *NewYHSD*
Wald, Charles Brandon 1923- *AmArch 70*
Wald, Donald F L 1929- *AmArch 70*
Wald, Palmer B 1930- *WhoAmA 82, -84*
Wald, Sharon *OfPGCP 86*
Wald, Sylvia *WhoAmA 73, -76, -78, -80, -82, -84*

Wald, Sylvia 1914- *DcCAA 71, –77,* *McGDA*
Wald, Sylvia 1915- *AmArt*
Waldau, Grete 1868- *DcWomA*
Waldberg, Isabelle 1917- *OxTwCA*
Waldburg, Karoline C A Truchsess Von *DcWomA*
Waldeck, C G 1866-1930 *WhAmArt 85*
Waldeck, Nina V 1868-1943 *DcWomA,*
WhAmArt 85
Waldegrave, C *DcBrECP*
Waldegrove, Countess Anne *DcWomA*
Walden, Dorothy DeLand 1893- *WhAmArt 85*
Walden, E H *DcVicP 2*
Walden, James Cecil 1930- *AmArch 70*
Walden, Jennelsie *AfroAA*
Walden, John, Jr. d1807 *FolkA 86*
Walden, John, Sr. 1732-1807 *FolkA 86*
Walden, John Douglas 1936- *AmArch 70*
Walden, Lionel *DcVicP 2*
Walden, Lionel 1861-1933 *WhAmArt 85*
Walden, Louis Hart 1890- *WhAmArt 85*
Walden, Mattie E *ArtsEM, DcWomA*
Walden, Russell *ConArch A*
Walden, Trevor Alfred 1916- *WhoArt 80, –82, –84*
Waldenberger, Henry F, Jr. 1951- *MarqDCG 84*
Waldenfels, Mathilde 1858- *DcWomA*
Walder, B Daniel 1933- *AmArch 70*
Walder, Margit *DcWomA*
Waldie, Jane *DcWomA*
Waldie, Ronald Hugh 1936- *AmArch 70*
Waldman, Brooks Henry 1938- *AmArch 70*
Waldman, Harry 1945- *MarqDCG 84*
Waldman, Max 1919-1981 *ICPEnP A,* *MacBEP*
Waldman, Paul 1936- *DcCAA 71, –77, PrintW 85,*
WhoAmA 73, –76, –78, –80, –82, –84
Waldmuller, Ferdinand 1793-1865 *OxArt*
Waldmuller, Ferdinand Georg 1793-1865 *McGDA*
Waldo, *EncASM*
Waldo, Duane Ralph 1930- *AmArch 70*
Waldo, E L 1870- *WhAmArt 85*
Waldo, Eugene Loren 1870- *ArtsAmW 1*
Waldo, George B *WhAmArt 85*
Waldo, Ruth M 1890- *WhAmArt 85*
Waldo, Ruth Martindale 1890- *DcWomA*
Waldo, Samuel 1783-1861 *ArtsNiC*
Waldo, Samuel Lovett 1783-1861 *BnEnAmA,*
McGDA, NewYHSD
Waldorp, Antoine 1803-1867 *ArtsNiC*
Waldorp, Antonie 1803-1866 *DcSeaP*
Waldowski, J *AmArch 70*
Waldraff, Charlotte S *DcWomA*
Waldre, Vincent *DcBrECP*
Waldron, Adelia *NewYHSD*
Waldron, Adelia 1825?- *DcWomA*
Waldron, Anne A d1953? *DcWomA*
Waldron, Anne A d1955? *WhAmArt 85*
Waldron, D E *AmArch 70*
Waldron, Dylan Thomas 1953- *WhoArt 82, –84*
Waldron, Jack Llewelyn 1923- *WhoArt 80, –82, –84*
Waldron, James Mackeilar 1909-1974 *WhoAmA 78N,*
–80N, –82N, –84N
Waldron, James MacKellar 1909- *WhoAmA 73*
Waldron, James Mackellar 1909- *WhoAmA 76*
Waldron, Jane D 1828- *FolkA 86*
Waldron, Lawrence Galen 1911- *AmArch 70*
Waldron, Wayne *OfPGCP 86*
Waldron, William *DcBrECP*
Waldrum, Harold Joe 1934- *AmArt*
Waldschmidt, Olly 1898- *DcWomA*
Waldstein, Maria Anna 1763-1808 *DcWomA*
Waldvogel, Emma *WhAmArt 85*
Wale, Charles *DcBrECP*
Wale, James *BiDBrA*
Wale, John Porter 1860-1920 *DcBrA 1, DcBrWA,*
DcVicP 2
Wale, Samuel 1720?-1786 *DcBrWA*
Wale, Samuel 1721?-1786 *BkIE, DcBrECP*
Wale, T *FolkA 86, NewYHSD*
Walenn, Frederick Dudley d1933 *DcBrA 1*
Wales, Princess Of *DcVicP 2*
Wales, Bill B 1927- *AmArch 70*
Wales, Geoffrey 1912- *DcBrA 1, WhoArt 80, –82, –84*
Wales, George Canning 1868-1940 *DcSeaP,*
WhAmArt 85
Wales, James 1747-1795 *DcBrECP*
Wales, James 1748-1796 *DcBrWA*
Wales, James Albert 1852-1886 *WorECar*
Wales, N F *NewYHSD*
Wales, Nathaniel F *FolkA 86*
Wales, Orlando G *WhAmArt 85*
Wales, Susan M L 1839-1927 *WhAmArt 85*
Wales, Susan Makepeace Larkin 1839-1927 *DcWomA*
Wales Smith, Arthur Douglas 1888- *DcBrA 1*
Wales-Smith, Arthur Douglas 1888-1966 *DcSeaP*
Wales-Smith, Douglas *ClaDrA*
Walfish, Herbert Saul 1923- *AmArch 70*
Walford, Mr. *FolkA 86*
Walford, Amy J *DcVicP 2*
Walford, Astrid 1907- *IlsBYP, IlsCB 1946*
Walford, Bettine C 1905- *ClaDrA*
Walford, Bettine Christian 1905- *DcBrA 1*

Walford, E *DcVicP 2*
Walford, H L *DcVicP 2*
Walford, H Louisa *DcWomA*
Walford, Louisa *DcVicP 2*
Walford, William *BiDBrA*
Walgren, Anders Gustave *WhAmArt 85*
Walgren, Antoinette *DcWomA*
Walhain, Charles Albert 1877-1936 *ClaDrA*
Walhalla, Regensburg *McGDA*
Walhaus, Henry *FolkA 86*
Walhstrom, Charlotte 1849- *DcWomA*
Walijarvi, Kenneth Harold 1923- *AmArch 70*
Walikainen, Gordon Henry 1945- *MarqDCG 84*
Waling, C *DcBrECP*
Walinska, Anna 1916- *WhoAmA 82, –84*
Walinska, Rosa Newman 1887?-1953 *DcWomA*
Walinska, Rosa Newman 1890- *WhAmArt 85*
Walk, Jacob M *FolkA 86*
Walke, Ann *DcBrA 1, DcWomA*
Walke, Annie *ClaDrA*
Walke, Henry 1808-1896 *NewYHSD*
Walkenden, Charlotte E *DcWomA*
Walker *NewYHSD*
Walker, Miss *DcWomA*
Walker, Mrs. *DcWomA*
Walker, A B 1878-1947 *WhAmArt 85*
Walker, A M *DcWomA*
Walker, Miss A M *NewYHSD*
Walker, A W *NewYHSD*
Walker, Ada Hill *DcBrA 1*
Walker, Addison Mortimer 1923- *WorECom*
Walker, Agnes E *DcVicP 2*
Walker, Alanson Burton 1878-1947 *WorECar*
Walker, Aldo 1938- *ConArt 77*
Walker, Alex *AfroAA*
Walker, Alexander *CabMA, DcBrA 1*
Walker, Alice *DcVicP 2*
Walker, Alice J *WhAmArt 85*
Walker, Amy *DcWomA*
Walker, Angie *DcWomA, WhAmArt 85*
Walker, Anne *WhAmArt 85*
Walker, Annie 1855-1929 *AfroAA*
Walker, Annie E A 1855-1929 *DcWomA*
Walker, Anthony 1726-1765 *BkIE, DcBrWA*
Walker, Arthur George 1861- *ClaDrA*
Walker, Arthur George 1861-1939 *DcBrA 1, DcBrBI,*
DcVicP 2
Walker, Augusta *DcWomA*
Walker, B *DcWomA*
Walker, B W *DcVicP 2*
Walker, Bernard Eyre 1886- *DcBrA 1*
Walker, Berry J C 1923- *AmArch 70*
Walker, Berta *WhoAmA 84*
Walker, Berta 1941- *WhoAmA 82*
Walker, Breda *DcVicP 2*
Walker, Bruce Morris 1923- *AmArch 70*
Walker, Bryant 1856- *ArtsEM*
Walker, C Bertram *WhAmArt 85*
Walker, C Howard 1857-1936 *BiDAmAr, MacEA*
Walker, C S *NewYHSD*
Walker, C W *NewYHSD*
Walker, Caroline *DcWomA*
Walker, Charles 1875-1954 *FolkA 86*
Walker, Charles Alvah 1848-1920 *WhAmArt 85*
Walker, Charles Howard 1857- *WhAmArt 85*
Walker, Charles J *DcVicP 2*
Walker, Charles W *IlsBYP*
Walker, Christopher David Terence 1952-
MarqDCG 84
Walker, Claude Alfred Pennington 1862- *DcBrA 1,*
DcBrWA, DcVicP 2
Walker, Clay E 1924- *WhoAmA 84*
Walker, Cordelia *DcVicP 2*
Walker, Cranston Oliver *AfroAA*
Walker, Daniel *NewYHSD*
Walker, Derek 1931- *ConArch*
Walker, Dougald 1865- *DcBrWA, DcVicP 2*
Walker, Duane R 1941- *MarqDCG 84*
Walker, Dugald Stewart d1937 *WhAmArt 85*
Walker, Dugald Stewart 1888?-1937 *ConICB*
Walker, E *DcWomA*
Walker, Miss E *NewYHSD*
Walker, E H, Jr. *AmArch 70*
Walker, E J *DcBrBI*
Walker, E L *NewYHSD*
Walker, E Mildred *DcWomA, WhAmArt 85*
Walker, Earl 1911- *AfroAA*
Walker, Edward *ArtsEM*
Walker, Edward 1879- *ClaDrA, DcBrA 1*
Walker, Edward D 1946- *WhoAmA 84*
Walker, Edward J *DcVicP 2*
Walker, Edwin Bent *DcVicP 2*
Walker, Eliza *DcVicP 2, DcWomA*
Walker, Elizabeth *DcVicP 2, DcWomA*
Walker, Elizabeth 1800-1876 *DcWomA*
Walker, Elizabeth L *DcWomA, FolkA 86,*
NewYHSD
Walker, Ellen *DcVicP 2*
Walker, Emma J *DcWomA*
Walker, Ernest *WhAmArt 85*
Walker, Ethel 1861-1951 *DcBrA 1, DcVicP 2,*

DcWomA, OxArt, OxTwCA, PhDcTCA 77
Walker, Ethel Childe 1865?-1885 *DcWomA*
Walker, Eunice *DcWomA*
Walker, Eveline *NewYHSD*
Walker, Eveline 1827?- *DcWomA*
Walker, Everett d1968 *WhoAmA 78N, –80N, –82N,*
–84N
Walker, F R *WhAmArt 85*
Walker, Ferdinand G 1859-1927 *WhAmArt 85*
Walker, Frances Antill L 1872-1916 *DcWomA,*
WhAmArt 85
Walker, Francis S 1848-1916 *ClaDrA, DcBrA 1,*
DcBrBI, DcVicP, –2
Walker, Frank *WhAmArt 85*
Walker, Frank H *DcVicP 2*
Walker, Frank R 1877-1949 *BiDAmAr*
Walker, Frederick 1840-1875 *AntBDN B, ArtsNiC,*
ClaDrA, DcBrBI, DcBrWA, DcVicP, –2,
McGDA, OxArt
Walker, Freeman L 1923- *AmArch 70*
Walker, G *DcVicP 2*
Walker, G D K *DcVicP 2*
Walker, Gene Alden *WhAmArt 85*
Walker, George *AfroAA, FolkA 86*
Walker, George d1795? *DcBrWA*
Walker, George R P, Jr. 1932- *WhoAmA 78*
Walker, George W 1895-1930 *WhAmArt 85*
Walker, Gilbert M 1927- *IlBEAAW, IlrAm G, –1880*
Walker, Grayson *AfroAA*
Walker, H *AmArch 70, WhAmArt 85*
Walker, H Leslie, Jr. 1918- *AmArch 70*
Walker, Hank 1922- *ICPEnP A*
Walker, Harold D 1888-1937 *BiDAmAr*
Walker, Harold E 1890- *WhAmArt 85*
Walker, Harry 1923- *WhoArt 80, –82, –84*
Walker, Helen *WhAmArt 85*
Walker, Helen Edward *DcWomA*
Walker, Henry *DcVicP 2*
Walker, Henry Babcock, Jr. d1966 *WhoAmA 78N,*
–80N, –82N, –84N
Walker, Henry O 1843-1929 *WhAmArt 85*
Walker, Herbert Brooks 1927- *WhoAmA 73, –76, –78,*
–80, –82, –84
Walker, Herschel Carey *WhoAmA 73, –76, –78N,*
–82N, –84N
Walker, Herschel Cary *WhoAmA 80N*
Walker, Hilda Annetta *DcBrA 1, DcWomA*
Walker, Hirst 1868-1957 *DcBrA 1, DcVicP 2*
Walker, Hobart Alexander 1869- *WhAmArt 85*
Walker, Horatio 1858-1938 *BnEnAmA, ClaDrA,*
DcBrA 1, McGDA, OxArt, PhDcTCA 77,
WhAmArt 85
Walker, Hudson D 1907- *WhoAmA 73, –76*
Walker, Hudson D 1907-1976 *WhAmArt 85,*
WhoAmA 78N, –80N, –82N, –84N
Walker, Hugh *DcVicP 2*
Walker, Inez Nathaniel *FolkA 86*
Walker, J E *AmArch 70*
Walker, J Edward *ArtsAmW 3*
Walker, J Edwin *ArtsAmW 3*
Walker, J Flood 1868-1924 *BiDAmAr*
Walker, J G *DcVicP 2*
Walker, J H *DcVicP 2*
Walker, J H, Jr. *AmArch 70*
Walker, J M *AmArch 70*
Walker, J R, Jr. *AmArch 70*
Walker, J S *AfroAA*
Walker, James *NewYHSD*
Walker, James 1819-1889 *ArtsAmW 1, IlBEAAW,*
NewYHSD , WhAmArt 85
Walker, James Adams 1921- *WhoAmA 73, –76, –78,*
–80, –82, –84
Walker, James Amory Sullivan 1927- *AmArch 70*
Walker, James Barry Stretton 1927- *AmArch 70*
Walker, James Donald 1931- *AmArch 70*
Walker, James E *NewYHSD*
Walker, James L *FolkA 86, NewYHSD*
Walker, James Lewis 1904- *AmArch 70*
Walker, James Lewis, III 1936- *AmArch 70*
Walker, James William 1831-1898 *DcBrWA, DcVicP,*
–2
Walker, Mrs. James William *DcVicP 2*
Walker, Jane McKinney *FolkA 86*
Walker, Jessica *DcBrBI, DcWomA*
Walker, Jessie A *DcWomA, WhAmArt 85*
Walker, Jerome 1937- *WhoAmA 73*
Walker, John *AntBDN D, DcBrBI*
Walker, John 1906- *WhAmArt 85*
Walker, John 1939- *ConArt 77, –83,*
ConBrA 79[port], DcCAr 81
Walker, John Alexander 1908- *AmArch 70*
Walker, John Arthur 1884-1938 *BiDAmAr*
Walker, John Brown 1815-1905 *FolkA 86*
Walker, John Crampton 1890-1942 *DcBrA 1*
Walker, John Eaton *DcVicP, –2*
Walker, John Hanson *DcVicP*
Walker, John Hanson d1933 *DcBrA 1*
Walker, John Hanson 1844?-1933 *DcBrWA,*
DcVicP 2
Walker, John Law 1899- *ArtsAmW 2, WhAmArt 85*
Walker, John Linwood, Jr. 1913- *AmArch 70*

Walker, John P 1855-1932 *WhAmArt 85*
Walker, John Rawson 1796-1873 *DcBrWA*
Walker, John Rawson 1796-1893 *DcVicP, -2*
Walker, Joseph *BiDBrA*
Walker, Joy 1942- *AmArt, DcCAr 81, PrintW 83, -85, WhoAmA 78, -80, -82, -84*
Walker, Kate *DcCAr 81*
Walker, Kate Winifred *DcBrA 1, DcWomA*
Walker, Kathleen Mellina *DcBrA 1*
Walker, Knowles *AntBDN N*
Walker, Larry 1935- *AfroAA*
Walker, Lawrence 1935- *AfroAA*
Walker, Leonard 1877-1964 *DcBrA 1, DcBrWA*
Walker, Lissa Bell *ArtsAmW 3, WhAmArt 85*
Walker, Lissie Bell *ArtsAmW 3*
Walker, Louis W 1924- *AmArch 70*
Walker, Lydia LeBaron 1869-1958 *WhAmArt 85, WhoAmA 80N, -82N, -84N*
Walker, M *AmArch 70, FolkA 86, NewYHSD*
Walker, M C *DcVicP 2*
Walker, Mrs. M Mulford *WhAmArt 85*
Walker, M Topping *WhAmArt 85*
Walker, Marcella *DcBrBI, DcWomA*
Walker, Marcella M *DcBrA 1, DcVicP, -2*
Walker, Margaret 1951- *DcCAr 81*
Walker, Margaret Beverley Moore 1883- *DcWomA, WhAmArt 85*
Walker, Margaret McKee 1912- *WhAmArt 85*
Walker, Marian Blakeslee 1898- *DcWomA, WhAmArt 85*
Walker, Marian D Bausman 1889- *DcWomA, WhAmArt 85*
Walker, Marie Sheehy 1952- *WhoAmA 84*
Walker, Marion *DcWomA*
Walker, Mark A 1953- *MarqDCG 84*
Walker, Marshall Heisey 1909- *AmArch 70*
Walker, Mary *DcVicP 2*
Walker, Mary A *DcVicP 2*
Walker, Mary Carolyn 1938- *WhoAmA 78, -80, -82, -84*
Walker, Mary Evangeline 1894- *DcWomA, WhAmArt 85*
Walker, Mary Simpson *DcWomA*
Walker, Maude *DcVicP 2*
Walker, May M *ArtsEM, DcWomA*
Walker, May Mulford 1873?-1954 *DcWomA*
Walker, Michael Neal 1941- *AmArch 70*
Walker, Mildred 1867-1937 *DcWomA*
Walker, Mort 1923- *WhoAmA 73, -76, -78, -80, -82, -84*
Walker, Moses, Jr. 1817?- *CabMA*
Walker, Myrtle VanLeuven *DcWomA, WhAmArt 85*
Walker, N U *FolkA 86*
Walker, Nedda *IlsBYP, IlsCB 1946*
Walker, Nell *DcWomA*
Walker, Nellie B 1872-1973 *DcWomA*
Walker, Nellie Verne 1874- *WhAmArt 85*
Walker, Nellie Verne 1874-1973 *DcWomA*
Walker, Pauline *DcBrWA, DcVicP, -2*
Walker, Pauline d1891 *DcWomA*
Walker, Peter *FolkA 86*
Walker, Peter Richard 1946- *WhoAmA 76, -78*
Walker, Mrs. Philip *WhoAmA 73*
Walker, Philip F *DcVicP 2*
Walker, Ralph *WhoAmA 73, -76, -78, -80, -82*
Walker, Ralph 1889- *AmArch 70, McGDA*
Walker, Mrs. Ralph *WhoAmA 73, -76, -78, -80, -82*
Walker, Ralph Thomas 1889-1973 *MacEA*
Walker, Rebecca *FolkA 86*
Walker, Richard D 1929- *AmArch 70*
Walker, Richard Ian Bentham 1925- *DcBrA 2, WhoArt 80, -82, -84*
Walker, Robert *DcVicP 2*
Walker, Robert 1605?-1660? *OxArt*
Walker, Robert 1771?- *BiDBrA*
Walker, Robert 1772-1833 *CabMA*
Walker, Robert 1945- *ICPEnP A*
Walker, Robert D W *NewYHSD*
Walker, Robert Edward 1951- *MarqDCG 84*
Walker, Robert McAllister 1875- *DcBrA 1*
Walker, Robert Miller 1908- *WhoAmA 73, -76, -78, -80*
Walker, Robin 1924- *WhoArch*
Walker, Roger Ryan 1935- *AmArch 70*
Walker, Rose *DcWomA*
Walker, Roy 1936- *WhoArt 82, -84*
Walker, Roy Edward Alan 1936- *WhoArt 80*
Walker, Rusty 1946- *WhoAmA 80, -82*
Walker, Ryan 1870-1932 *WhAmArt 85, WorECar*
Walker, S *ArtsEM*
Walker, Samuel *DcVicP 2, NewYHSD*
Walker, Samuel Swan 1806-1848 *NewYHSD*
Walker, Sandra Radcliffe 1937- *WhoAmA 78, -80, -82, -84*
Walker, Sarah Gough *DcWomA*
Walker, Scott R, Jr. 1939- *MarqDCG 84*
Walker, Seymour *DcBrA 1, DcVicP 2*
Walker, Simeon *NewYHSD*
Walker, Sophia A 1855-1943 *WhAmArt 85*

Walker, Sophia Antoinette 1855-1943 *DcWomA*
Walker, Steve *AfroAA*
Walker, Steven Anderson 1957- *MarqDCG 84*
Walker, Stuart *WhAmArt 85*
Walker, Stuart 1888-1940 *ArtsAmW 3*
Walker, Sybil 1882- *DcWomA, WhAmArt 85*
Walker, T *DcVicP 2*
Walker, T Dart *DcBrBI*
Walker, T Dart d1914 *WhAmArt 85*
Walker, T H *AmArch 70*
Walker, Thomas *AntBDN D, NewYHSD*
Walker, Thomas B 1840-1928 *WhAmArt 85*
Walker, Todd 1917- *ConPhot, ICPEnP A, MacBEP*
Walker, W *DcBrECP*
Walker, W H *DcBrBI*
Walker, Wilhelmina *DcWomA, WhAmArt 85*
Walker, Wilhelmina Augusta *DcVicP 2*
Walker, William *AfroAA, BiDBrA, DcVicP 2, NewYHSD*
Walker, William d1811? *CabMA*
Walker, William 1729-1793 *BkIE, DcBrWA*
Walker, William 1779-1809? *DcBrECP*
Walklin, William 1780-1868 *DcBrWA*
Walker, William 1791-1867 *DcVicP 2*
Walker, William 1878-1961 *DcBrA 1*
Walker, William A 1838-1921 *ArtsAmW 1*
Walker, William Aiken 1838-1921 *DcAmArt, NewYHSD , WhAmArt 85*
Walker, William Bond 1930- *WhoAmA 78, -80, -82, -84*
Walker, William Charles 1934- *AmArch 70*
Walker, William Ernest 1869-1918 *BiDAmAr*
Walker, William Eyre 1847-1930 *ClaDrA, DcBrA 1, DcBrWA, DcVicP, -2*
Walker, William F *NewYHSD*
Walker, William H 1871-1938 *WhAmArt 85, WorECar*
Walker, William H, II 1914- *AmArch 70*
Walker, William Henry Romaine *DcVicP 2*
Walker, William Howard 1856-1922 *BiDAmAr*
Walker, William Russell 1830-1905 *BiDAmAr*
Walker, William Russell, II 1884-1936 *BiDAmAr*
Walker, William Walter 1927- *WhoAmA 76, -78, -80*
Walker, Wilton *FolkA 86*
Walker, Winifred *DcBrA 1*
Walker, Winifred 1882-1966 *DcWomA*
Walker-Barker, David 1947- *DcCAr 81*
Walkerson *DcBrECP*
Walkey, Frederick P 1922- *WhoAmA 73, -76, -78, -80, -82, -84*
Walki, Theresa *DcWomA*
Walkingstick, Kay *DcCAr 81*
Walkingstick, Kay 1935- *WhoAmA 82, -84*
Walkinshaw, Jeanie *DcWomA*
Walkinshaw, Jeanie Walter *WhAmArt 85*
Walkinshaw, Jeanie Walter 1885- *ArtsAmW 3*
Walkley, David Birdsey 1849-1934 *WhAmArt 85*
Walkley, O E *ArtsEM*
Walkley, Winfield Ralph 1909-1954 *WhAmArt 85*
Walklin, Carol 1930- *WhoArt 84*
Walkowitz, Abraham 1878-1965 *ConArt 77, DcAmArt, DcCAA 71, -77, OxTwCA*
Walkowitz, Abraham 1880-1965 *ArtsAmW 3, BnEnAmA, McGDA, PhDcTCA 77, WhAmArt 85, WhoAmA 78N, -80N, -82N, -84N*
Wall, A Bryan d1938? *WhAmArt 85*
Wall, A J *DcBrBI*
Wall, Alfred S 1809-1896 *NewYHSD , WhAmArt 85*
Wall, Bernardt 1872-1954? *ArtsAmW 2*
Wall, Bernhardt 1872-1954? *ArtsAmW 2*
Wall, Bernhardt 1872-1955? *WhAmArt 85*
Wall, Bernhardt T 1872- *IlBEAAW*
Wall, Brian 1931- *ConArt 77, -83, DcCAr 81, WhoAmA 76, -78, -80, -82, -84*
Wall, Edward John 1860-1928 *MacBEP*
Wall, Edward Ritter 1930- *AmArch 70*
Wall, Emily W *DcVicP 2*
Wall, F W *AmArch 70*
Wall, Gertrude Rupel 1881?- *DcWomA, WhAmArt 85*
Wall, Gertrude Rupel 1886- *ArtsAmW 2*
Wall, Hermann C 1875- *WhAmArt 85*
Wall, Jeff 1946- *DcCAr 81*
Wall, John 1708-1776 *AntBDN M, DcBrECP[port]*
Wall, John 1708-1776? *BkIE*
Wall, John 1928- *MacBEP*
Wall, Margaret V 1895-1958 *WhoAmA 80N, -82N, -84N*
Wall, Norman Edwin 1932- *AmArch 70*
Wall, Patricia Roby 1952- *MarqDCG 84*
Wall, Ralph Alan 1932- *WhoAmA 76, -78, -80, -82, -84*
Wall, S *DcWomA*
Wall, Sue *DcCAr 81*
Wall, Sue 1950- *AmArt, WhoAmA 78, -80, -82, -84*
Wall, Thomas 1932- *AmArch 70*
Wall, Tony *DcBrBI*
Wall, W G *WhAmArt 85*
Wall, William Allen 1801-1885 *NewYHSD*

Wall, William Archibald *DcVicP*
Wall, William Archibald 1828- *DcBrWA, DcVicP 2*
Wall, William Archibald 1828-1875? *NewYHSD*
Wall, William Coventry 1810-1886 *NewYHSD*
Wall, William G 1792- *DcBrWA, DcVicP 2*
Wall, William Guy 1792-1862? *AntBDN B*
Wall, William Guy 1792-1864 *DcNiCA*
Wall, William Guy 1792-1864? *NewYHSD*
Walla, Harlow Edward 1927- *AmArch 70*
Wallace *NewYHSD*
Wallace, A H *NewYHSD*
Wallace, Amy *WhAmArt 85*
Wallace, Andre 1947- *DcCAr 81*
Wallace, B W *AmArch 70*
Wallace, Benjamin A *NewYHSD*
Wallace, Bruce Alan 1957- *MarqDCG 84*
Wallace, C C *AmArch 70*
Wallace, Mrs. Carleton *WhAmArt 85*
Wallace, Charles R *ArtsEM*
Wallace, D A *AmArch 70*
Wallace, D O *AmArch 70*
Wallace, David A 1917- *ConArch*
Wallace, David D 1928- *AmArch 70*
Wallace, David Harold 1926- *WhoAmA 73, -76, -78, -80, -82, -84*
Wallace, Donald Ian Mackenzie 1933- *WhoArt 80, -82, -84*
Wallace, Donald Q 1931- *AmArch 70*
Wallace, Donald Sheridan 1915- *AmArch 70*
Wallace, Edward Gregorie 1908- *AmArch 70*
Wallace, Elizabeth S *WhoAmA 78, -80, -82, -84*
Wallace, Ellen *DcVicP 2, DcWomA*
Wallace, Ethel 1885?-1968 *DcWomA*
Wallace, Ethel A *WhAmArt 85*
Wallace, Frank A *EncASM*
Wallace, Frank W 1923- *AmArch 70*
Wallace, Frederick E 1893- *WhoAmA 82N, -84N*
Wallace, Frederick E 1893-1958 *WhAmArt 85, WhoAmA 80N*
Wallace, G E *FolkA 86*
Wallace, Gael Lynn 1941- *WhoAmA 82, -84*
Wallace, Gary Lee 1935- *AmArch 70*
Wallace, George H *EncASM*
Wallace, Georgia Burns *WhAmArt 85*
Wallace, Harold Carl 1893- *AmArch 70*
Wallace, Harold Frank 1881- *ClaDrA*
Wallace, Harold Frank 1881-1962 *DcBrA 2*
Wallace, Harry *DcVicP 2*
Wallace, Harry L *EncASM*
Wallace, Ian *DcCAr 81*
Wallace, J *DcVicP 2*
Wallace, J W *WhAmArt 85*
Wallace, James *EncASM, NewYHSD*
Wallace, James 1872-1911 *DcBrA 1, DcVicP 2*
Wallace, John 1841-1905 *DcBrA 1, DcVicP 2*
Wallace, John Edward 1929- *WhoAmA 76, -78, -80, -82, -84*
Wallace, John James, Jr. 1921- *AmArch 70*
Wallace, John Laurie 1864- *WhAmArt 85*
Wallace, John Laurie 1864-1953 *ArtsAmW 2*
Wallace, John W *ArtsEM*
Wallace, Katherine *WhoAmA 82*
Wallace, Ken 1945- *DcCAr 81*
Wallace, Kenneth William 1945- *WhoAmA 80, -82, -84*
Wallace, Lew 1827-1905 *WhAmArt 85*
Wallace, Lewis 1827-1905 *ArtsAmW 1, IlBEAAW, NewYHSD*
Wallace, Lewis Alexander 1789?-1861 *BiDBrA*
Wallace, Lillie T *WhAmArt 85*
Wallace, Lucy 1884- *DcWomA, WhAmArt 85*
Wallace, Lysbeth *WhoAmA 78, -80, -82, -84*
Wallace, Minor Gordon, Jr. 1936- *AmArch 70*
Wallace, N S *AmArch 70*
Wallace, Natalie Edith 1936- *MarqDCG 84*
Wallace, Oscar J *NewYHSD*
Wallace, Ottilie 1875- *DcWomA*
Wallace, Richard *FolkA 86*
Wallace, Richard 1952- *DcCAr 81*
Wallace, Sir Richard 1818-1890 *DcBrWA*
Wallace, Richard William 1933- *WhoAmA 84*
Wallace, Robert *CabMA*
Wallace, Robert 1790?-1874 *BiDBrA*
Wallace, Robert 1815- *EncASM*
Wallace, Robert B *EncASM*
Wallace, Robert Bruce *DcVicP 2*
Wallace, Robert Bruce d1893 *DcBrBI*
Wallace, Robert Dan 1923- *WhoAmA 80, -82, -84*
Wallace, Robert R *WhAmArt 85*
Wallace, Robert W *ArtsEM*
Wallace, Robin 1897- *DcBrA 1*
Wallace, Soni 1931- *WhoAmA 73, -76, -78, -80, -82, -84*
Wallace, Thomas 1758-1816 *CabMA*
Wallace, Thomas J *NewYHSD*
Wallace, Thomas J 1851- *WhAmArt 85*
Wallace, Victor Lew 1933- *MarqDCG 84*
Wallace, W G *AmArch 70*
Wallace, W J *AmArch 70*
Wallace, W T *AmArch 70*
Wallace, Wilburn Youell 1938- *AmArch 70*

Ward, Cyril 1863-1935 *DcBrA 1, DcBrWA, DcVicP 2*
Ward, David B *NewYHSD*
Ward, David M *AmArch 70*
Ward, Delbert B 1933- *AmArch 70*
Ward, Denise D *AfroAA*
Ward, Dorothy Priestley *DcWomA*
Ward, E Grace 1877- *ArtsAmW 3*
Ward, Mrs. E M 1832-1924 *DcVicP*
Ward, Ebenezer 1710?-1791 *CabMA*
Ward, Edgar M *ArtsNiC*
Ward, Edgar Melville 1839-1915 *NewYHSD*
Ward, Edgar Melville 1849-1915 *WhAmArt 85*
Ward, Edgar Melville 1887- *WhAmArt 85*
Ward, Edith *DcWomA*
Ward, Edith Barry *WhAmArt 85*
Ward, Edmund *MacEA*
Ward, Edmund F 1892- *IlBEAAW, IlrAm D, -1880, WhAmArt 85*
Ward, Edward *OfPGCP 86*
Ward, Edward M 1816-1879 *ArtsNiC*
Ward, Edward Matthew 1816-1879 *ClaDrA, DcBrBI, DcBrWA, DcVicP, -2*
Ward, Edwin Arthur *DcBrA 1, DcVicP, -2*
Ward, Edwin Corrigan 1919- *AmArch 70*
Ward, Edwin P 1900- *FolkA 86*
Ward, Elsie *WhAmArt 85*
Ward, Elsie 1872?-1923 *DcWomA*
Ward, Enid *DcWomA*
Ward, Enoch *DcBrBI*
Ward, Enoch 1859-1922 *ClaDrA, DcBrA 1, DcVicP 2*
Ward, Ernest Pickens 1920- *AmArch 70*
Ward, Eva *DcBrWA, DcWomA*
Ward, Eva M *DcVicP 2*
Ward, Evelyn Svec *WhoAmA 78, -80, -82, -84*
Ward, F E *DcVicP 2*
Ward, Flora *DcWomA*
Ward, Flora E S *DcBrWA, DcVicP 2*
Ward, Francis Swain 1734?-1805 *DcBrBI, DcBrECP, DcBrWA*
Ward, Frank 1879- *ArtsAmW 3*
Ward, Franklin T *WhAmArt 85*
Ward, Fred 1935- *ICPEnP A, MacBEP*
Ward, G M *EarABI, NewYHSD*
Ward, George Raphael 1797-1879 *DcVicP, -2*
Ward, George Truman 1927- *AmArch 70*
Ward, Gordon 1932- *WhoArt 80, -82, -84*
Ward, Grace *DcBrA 1, WhoArt 80, -82, -84*
Ward, H *FolkA 86, NewYHSD*
Ward, Harold Edward 1920- *AmArch 70*
Ward, Mrs. Harold L *WhAmArt 85*
Ward, Harold Morse 1889-1973 *ArtsAmW 2*
Ward, Harry 1844-1873 *DcBrWA*
Ward, Hattie L Howard *DcWomA*
Ward, Mrs. Heber Arden *ArtsAmW 3, WhAmArt 85*
Ward, Henrietta *ArtsNiC*
Ward, Henrietta Mary Ada 1832-1924 *DcBrA 1, DcBrWA, DcWomA*
Ward, Henrietta Mary Ada Ward 1832-1924 *DcVicP 2*
Ward, Herbert *AfroAA*
Ward, Herbert d1919 *DcBrA 1*
Ward, Herbert 1863-1919 *DcVicP 2*
Ward, Herbert T 1862-1919 *WhAmArt 85*
Ward, Hilda *WhAmArt 85*
Ward, Hilda 1878-1950 *DcWomA*
Ward, Irene Stephenson 1894?- *DcWomA, WhAmArt 85*
Ward, Irving d1924 *WhAmArt 85*
Ward, J A *AmArch 70*
Ward, J S 1917- *WhoArt 80, -82, -84*
Ward, J Stephen 1876- *ArtsAmW 2, WhAmArt 85*
Ward, J V *AmArch 70*
Ward, Jacob C 1809-1891 *NewYHSD*
Ward, James *DcVicP, -2*
Ward, James 1769-1859 *ClaDrA, DcBrECP, DcBrWA, DcVicP, -2, McGDA, OxArt*
Ward, James 1851-1924 *DcBrA 1*
Ward, James C *NewYHSD*
Ward, James Charles *ClaDrA, DcVicP, -2*
Ward, Jasper D *MacEA*
Ward, Jasper Dudley, III 1921- *AmArch 70*
Ward, Jean S 1868- *ArtsAmW 2, DcWomA, WhAmArt 85*
Ward, Joan 1925- *WhoArt 82, -84*
Ward, John *BiDBrA*
Ward, John 1738-1789 *CabMA*
Ward, John 1798-1849 *DcBrWA, DcSeaP, DcVicP, -2*
Ward, John 1917- *ConBrA 79[port], IlsBYP, IlsCB 1946*
Ward, John F *NewYHSD*
Ward, John Frederick 1931- *AmArch 70*
Ward, John Frederick 1943- *MacBEP*
Ward, John Lawrence 1938- *MacBEP, WhoAmA 76, -78, -80, -82, -84*
Ward, John Q A 1830- *ArtsNiC*
Ward, John Quincy Adams 1830-1910 *BnEnAmA, DcAmArt, IlBEAAW, McGDA, NewYHSD, OxArt, WhAmArt 85*

Ward, John R *WhAmArt 85*
Ward, John S, Jr. 1920- *AmArch 70*
Ward, John Stanton 1917- *ClaDrA, DcBrA 1*
Ward, John Talbot 1915- *WhAmArt 85*
Ward, Joseph *AntBDN Q, NewYHSD*
Ward, Joseph A 1934- *AmArch 70*
Ward, Katherine M *DcVicP 2, DcWomA*
Ward, Lauriston 1883-1960 *WhoAmA 80N, -82N, -84N*
Ward, Lemuel T 1896- *FolkA 86*
Ward, Leonard 1887- *DcBrA 1*
Ward, Leslie 1857-1922 *AntBDN B*
Ward, Sir Leslie 1851-1922 *ClaDrA, DcBrA 1, DcVicP, -2, WorECar*
Ward, Sir Leslie Matthew 1851-1922 *DcBrBI*
Ward, Sir Leslie Matthew Spy 1851-1922 *DcBrWA*
Ward, Leslie Moffat *WhoArt 80N*
Ward, Leslie Moffat 1888- *DcBrA 1*
Ward, Lilly A *DcWomA*
Ward, Lily A *ArtsAmW 3*
Ward, Lorrin Leroy 1919- *AmArch 70*
Ward, Louis Arthur *WhoArt 82, -84*
Ward, Louis Arthur 1913- *DcBrA 1, WhoArt 80*
Ward, Louisa Cooke 1888- *ArtsAmW 3, DcWomA*
Ward, Lyle Edward 1922- *WhoAmA 73, -76, -78, -80, -82, -84*
Ward, Lynd 1905- *IlrAm E, -1880, McGDA, WhAmArt 85, WhoAmA 73, -76, -78, -80, -82, -84*
Ward, Lynd 1905-1985 *ConGrA 1*
Ward, Lynd Kendall *IlsCB 1967*
Ward, Lynd Kendall 1905- *Cald 1938, ConICB, GrAmP, IlsBYP, IlsCB 1744, -1946, -1957*
Ward, M Paul *FolkA 86*
Ward, Mabel Raymond 1874- *DcWomA, WhAmArt 85*
Ward, Maria *DcWomA*
Ward, Martin Theodore 1799-1874 *DcBrBI, DcVicP, -2*
Ward, Mary *DcWomA*
Ward, Mary Holyoke 1800-1880 *DcWomA, NewYHSD*
Ward, Mary Trenwith Duffy 1908- *WhAmArt 85*
Ward, Miles 1673-1764 *CabMA*
Ward, Miles 1704-1792 *CabMA*
Ward, Moses *CabMA*
Ward, Neville 1922- *WhoArt 80, -82, -84*
Ward, Nina B *DcWomA, WhAmArt 85*
Ward, Nora *DcWomA*
Ward, Orlando Frank Montagu 1868- *DcBrA 1, DcVicP 2*
Ward, Penlyn 1948- *MarqDCG 84*
Ward, Phillip A 1927- *WhoAmA 84*
Ward, Phillips *WhAmArt 85*
Ward, Prentiss *WhAmArt 85*
Ward, R, Jr. *AmArch 70*
Ward, R Burton 1944- *MarqDCG 84*
Ward, R L *AmArch 70*
Ward, Ray Frederick 1903- *AmArch 70*
Ward, Reginald A 1910- *DcBrA 1*
Ward, Richard, Jr. 1896- *WhAmArt 85*
Ward, Robert Allen 1905- *AmArch 70*
Ward, Robert Eugene 1930- *AmArch 70*
Ward, Robert W 1943- *MarqDCG 84*
Ward, Robertson 1897- *AmArch 70*
Ward, Roderic Charles 1935- *AmArch 70*
Ward, Ruth *AfroAA*
Ward, Ruth Porter d1936 *DcWomA, WhAmArt 85*
Ward, Sarah G *DcWomA, WhAmArt 85*
Ward, Steve *FolkA 86*
Ward, Susan *DcWomA*
Ward, T *DcVicP 2*
Ward, T D *AmArch 70*
Ward, T L *DcVicP 2*
Ward, Theodora VanWagenen 1890- *DcWomA*
Ward, Thomas *DcVicP 2*
Ward, Thomas William 1918- *ClaDrA, DcBrA 1, WhoArt 80, -82, -84*
Ward, Velox 1901- *FolkA 86*
Ward, Velox Benjamin 1901- *WhoAmA 73, -76, -78, -80, -82*
Ward, Vernon DeBeauvoir 1905- *DcBrA 1*
Ward, W G *AmArch 70*
Ward, Wesley Stacy 1922- *AmArch 70*
Ward, William *DcVicP, -2, NewYHSD*
Ward, William 1760-1826 *McGDA*
Ward, William 1761-1801 *DcSeaP*
Ward, William 1761-1821 *DcBrWA*
Ward, William 1766-1826 *DcBrWA*
Ward, William 1827-1893 *ArtsAmW 3*
Ward, William DeLancey *WhAmArt 85*
Ward, William Edward 1922- *WhoAmA 76, -78, -80, -82, -84*
Ward, William H *DcVicP, -2*
Ward, William Jessup, Jr. 1903- *AmArch 70*
Ward, Winifred 1889- *DcWomA, WhAmArt 85*
Wardell, Jonathan *CabMA*
Wardell, M *DcWomA*
Wardell, S R *NewYHSD*
Wardell, William *AntBDN Q*

Wardell, William T *CabMA*
Wardell, William Wilkinson 1823-1899 *MacEA*
Warden, Ben W *WhAmArt 85*
Warden, C A *DcWomA*
Warden, Miss C A *NewYHSD*
Warden, Dorothy *DcVicP 2*
Warden, Ethel C *DcWomA*
Warden, Frances Mitchell 1888- *DcWomA*
Warden, John 1939- *WorFshn*
Warden, William *WhoArt 84N*
Warden, William 1908- *DcBrA 1, WhoArt 80, -82*
Warden, William F 1872- *WhAmArt 85*
Warder, William 1920- *WhoAmA 76, -78, -80, -82, -84*
Wardin, Frances Mitchell 1888- *ArtsAmW 2, WhAmArt 85*
Wardlaw, Buddy Gene 1931- *AmArch 70*
Wardlaw, George Melvin 1927- *WhoAmA 73, -76, -78, -80, -82, -84*
Wardle, Alfred H 1933- *WhoAmA 73, -76*
Wardle, Alfred Hill 1933- *WhoAmA 78, -80*
Wardle, Arthur 1864-1949 *ClaDrA, DcBrA 1, DcBrBI, DcVicP, -2*
Wardle, Edmund 1885?-1950 *DcBrA 2*
Wardle, F *DcVicP 2*
Wardle, G Joyce 1904- *DcBrA 1*
Wardle, John d1868? *BiDBrA*
Wardle, John Clifford 1907- *DcBrA 1*
Wardle, Richard C *NewYHSD*
Wardman, John W 1906- *WhAmArt 85*
Wardman, Thomas *DcVicP 2*
Wardrope, William S *NewYHSD*
Wardrum, Earl Roy 1934- *AmArch 70*
Wardrup, Leslie Steven 1945- *MarqDCG 84*
Wardwell, Allen 1935- *WhoAmA 78, -80, -82, -84*
Wardwell, Caroline Hill 1822-1894? *DcWomA*
Wardwell, James H *WhAmArt 85*
Wardy, Frederick 1937- *DcCAr 81, WhoAmA 76, -78, -80, -82*
Ware, Arthur 1876-1939 *BiDAmAr*
Ware, C Edward 1921- *AmArch 70*
Ware, Charles Percival *AmArch 70*
Ware, Dewey 1895- *FolkA 86*
Ware, Ellen Paine 1859- *WhAmArt 85*
Ware, Evelyn L *AfroAA*
Ware, Florence Ellen 1891-1971 *ArtsAmW 1, DcWomA, IlBEAAW, WhAmArt 85*
Ware, Florence Ellen 1891-1972 *ArtsAmW 3*
Ware, Franklin B 1873-1945 *BiDAmAr*
Ware, Greg *DcCAr 81*
Ware, Isaac d1766 *BiDBrA, DcD&D, MacEA, McGDA, WhoArch*
Ware, Isaac 1700?-1766 *OxArt*
Ware, James E 1846-1918 *BiDAmAr*
Ware, John *CabMA*
Ware, John Mitchell 1937- *AmArch 70*
Ware, John S *CabMA*
Ware, Joseph 1827- *NewYHSD*
Ware, Joseph Thomas 1908- *AmArch 70*
Ware, Julia 1789?-1860 *FolkA 86*
Ware, Lloyd Peyton 1917- *AmArch 70*
Ware, Loe M *ArtsEM, DcWomA*
Ware, M A *DcWomA*
Ware, Maskell 1776-1855 *CabMA*
Ware, Samuel 1781-1860 *BiDBrA*
Ware, Samuel C *CabMA*
Ware, William *CabMA*
Ware, William Edward 1915- *DcBrA 1*
Ware, William R 1832-1915 *BiDAmAr, MacEA*
Ware, William Robert 1832-1915 *McGDA*
Ware, William Rotch 1848-1917 *BiDAmAr, MacEA*
Ware And VanBrunt *MacEA*
Wareham, A W *AmArch 70*
Wareham, John Hamilton D *WhAmArt 85*
Wareham, John Hamilton Delaney 1871-1954 *CenC*
Wareham, Joseph 1783- *AntBDN M*
Waren *NewYHSD*
Wares, James A 1910- *AmArch 70*
Warfel, H P *AmArch 70*
Warfel, Jacob Eshleman 1826-1855 *NewYHSD*
Warff, Ann 1937- *DcCAr 81*
Warfield, Carl J 1920- *AmArch 70*
Warfield, Francis Boddie 1891- *AmArch 70*
Warfield, Majel 1905- *WhAmArt 85*
Warfield, William *CabMA*
Warghy, Armand *WhAmArt 85*
Wargin, Ben 1930- *DcCAr 81*
Warham, Charles 1701-1799 *CabMA*
Warhanic, Elizabeth C 1880- *ArtsAmW 2*
Warhanik, Elizabeth C 1880- *ArtsAmW 2, DcWomA, WhAmArt 85*
Warhol, Andy *McGDA*
Warhol, Andy 1928- *ConArt 77, -83[port], ConPhot, DcAmArt, DcCAA 77, ICPEnP A, WorArt[port]*
Warhol, Andy 1930- *BnEnAmA, DcCAA 71, DcCAr 81, OxArt, OxTwCA, PhDcTCA 77*
Warhol, Andy 1931- *WhAmArt 85, PrintW 83, -85, WhoAmA 73, -76, -78, -80, -82, -84*
Warick, J *FolkA 86*
Warin, George *FolkA 86*

Warriner, C H *AmArch 70*
Warriner, Gerald Edward 1933- *AmArch 70*
Warriner, Laura B 1943- *WhoAmA 76, -78, -80, -82, -84*
Warriner, Susanne 1880- *DcWomA*
Warrington, Herbert David 1916- *AmArch 70*
Warrington, W *DcVicP 2*
Warrior, Antowine *OfPGCP 86*
Warry, Daniel Robert *DcBrBI*
Warsager, Hyman J 1909- *WhAmArt 85*
Warsaw, Albert Taylor 1899- *WhAmArt 85*
Warshauer, Matthew Jay 1928- *AmArch 70*
Warshaw, Howard 1920- *DcCAA 71, -77, WhoAmA 73, -76, -78, -80N, -82N, -84N*
Warshawsky, Abel George 1883-1962 *ArtsAmW 1, WhAmArt 85*
Warshawsky, Abel George 1884-1962 *WhoAmA 80N, -82N, -84N*
Warshawsky, Abraham George 1883-1962 *WhAmArt 85*
Warshawsky, Alexander 1887- *ArtsAmW 2, ClaDrA, WhAmArt 85*
Warshawsky, Xander 1887- *ArtsAmW 2*
Warsinske, Norman George, Jr. 1929- *WhoAmA 73, -76, -78, -80, -82, -84*
Wartel, Genevieve Angelique 1796- *DcWomA*
Wartena, Fraukje 1856?- *DcWomA*
Warter, Susanna *DcWomA*
Warterfield, Charles Wesley, Jr. 1926- *AmArch 70*
Warthen, Ferol Sibley 1890- *DcWomA, WhAmArt 85*
Warthoe, Christian 1892- *WhAmArt 85*
Warts, F M *WhAmArt 85*
Wartz, Michael *NewYHSD*
Warwack, Isaac *FolkA 86*
Warwell *FolkA 86*
Warwell d1767 *NewYHSD*
Warwell, Maria *NewYHSD*
Warwick, Mrs. *DcWomA*
Warwick, Anne, Countess Of *DcVicP 2*
Warwick, Edith C *DcVicP 2, DcWomA*
Warwick, Edward 1881- *WhAmArt 85*
Warwick, Ethel Herrick *DcWomA, WhAmArt 85*
Warwick, George Greville, Earl Of 1746-1816 *DcBrWA*
Warwick, H *DcVicP 2*
Warwick, H H *AmArch 70*
Warwick, J *FolkA 86*
Warwick, Pip *DcCAr 81*
Warwick, R W *DcVicP 2*
Wasch, Jeanne 1886?- *DcWomA*
Wascher, Hansrudi 1928- *WorECom*
Wasdell, Henry 1831?- *NewYHSD*
Waser, Anna 1678-1714? *DcWomA*
Wasey, Jane *FolkA 86*
Wasey, Jane 1912- *WhAmArt 85, WhoAmA 73, -76, -78, -80, -82, -84*
Wash, J C *AmArch 70*
Washam, Gary I *MarqDCG 84*
Washam, Ware Botsford 1946- *MarqDCG 84*
Washburn, B 1762-1852 *FolkA 86*
Washburn, Bradford *DcCAr 81*
Washburn, Bradford, Jr. 1910- *ICPEnP A, MacBEP*
Washburn, Cadwallader d1965 *WhoAmA 78N, -80N, -82N, -84N*
Washburn, Cadwallader 1866-1965 *WhAmArt 85*
Washburn, Cadwallader Lincoln 1866-1965 *ArtsAmW 3*
Washburn, Caroline *DcWomA*
Washburn, Chester Austin, Jr. 1914- *WhAmArt 85*
Washburn, Edward Payson 1831-1860 *NewYHSD*
Washburn, George Hyde 1862-1925 *BiDAmAr*
Washburn, Gordon Bailey 1904- *WhoAmA 73, -76, -78, -80, -82, -84*
Washburn, H E *AmArch 70*
Washburn, H L *FolkA 86*
Washburn, Mrs. Horace B *NewYHSD*
Washburn, Huldah M Tracy 1864- *WhAmArt 85*
Washburn, James Russel 1930- *AmArch 70*
Washburn, Jeanette 1905- *WhAmArt 85*
Washburn, Jessie M *DcWomA, WhAmArt 85*
Washburn, Joan T 1929- *WhoAmA 73, -76, -78, -80, -82, -84*
Washburn, Kenneth *DcCAr 81*
Washburn, Kenneth *WhAmArt 85*
Washburn, Louese B 1875-1959 *WhoAmA 80N, -82N, -84N*
Washburn, Louese Bunnell 1875-1959 *DcWomA, WhAmArt 85*
Washburn, M H *DcWomA*
Washburn, Mark A 1955- *MarqDCG 84*
Washburn, Mary N 1861-1932 *WhAmArt 85*
Washburn, Mary Nightingale 1861-1932 *DcWomA*
Washburn, Mary S *WhAmArt 85*
Washburn, Mary S 1868- *DcWomA*
Washburn, Max Murray 1888- *ArtsAmW 2*
Washburn, Miriam *DcWomA, WhAmArt 85*
Washburn, Roy E 1895- *WhAmArt 85*
Washburn, S H *FolkA 86*
Washburn, Stan 1943- *WhoAmA 76, -78, -80, -82, -84*

Washburn, W L *FolkA 86*
Washburn, William *NewYHSD*
Washburn, William 1808-1890 *BiDAmAr*
Washburn, William Conway 1924- *AmArch 70*
Washburne, E G *FolkA 86*
Washington, Burl *OfPGCP 86*
Washington, Carol *AfroAA*
Washington, D C *AmArch 70*
Washington, Edwin 1946- *MarqDCG 84*
Washington, Elizabeth Fisher *DcWomA, WhAmArt 85*
Washington, Georges 1827-1910 *ClaDrA*
Washington, Henry 1923- *AfroAA*
Washington, James *FolkA 86*
Washington, James 1911- *AfroAA*
Washington, James, Jr. *WhoAmA 73, -76*
Washington, James Ratchford 1940- *AmArch 70*
Washington, James W, Jr. *WhoAmA 78, -80, -82, -84*
Washington, James W, Jr. 1909- *DcCAA 71, -77*
Washington, John E *AfroAA*
Washington, Lynda R H 1947- *MarqDCG 84*
Washington, Martha *FolkA 86*
Washington, Mary Parks *AfroAA*
Washington, Ora *AfroAA*
Washington, Robert Everett 1938- *AmArch 70*
Washington, Timothy 1946- *AfroAA*
Washington, William 1885-1956 *DcBrA 1*
Washington, William DeHartburn *EarABI SUP*
Washington, William DeHartburn 1834-1870 *NewYHSD*
Wasielewski, Paul 1941- *MarqDCG 84*
Wasile, Elyse 1920- *WhoAmA 73, -76*
Wasilenko, Michael Thomas 1950- *MarqDCG 84*
Wasilewski, John 1890-1975 *FolkA 86*
Wasilewski, T J *AmArch 70*
Wasilkowska, Maria 1858?-1922 *DcWomA*
Wasko, Ryszard 1948- *DcCAr 81*
Wasko, Stephen G 1959- *MarqDCG 84*
Waskowsky, Michaill *WhAmArt 85*
Waskul, Michael W 1926- *AmArch 70*
Wasleski, Clement Francis, Jr. 1932- *AmArch 70*
Wasmann, Friedrich 1805-1886 *McGDA*
Wasmuth, D H *AmArch 70*
Wason, Donald Sturgeon 1911- *AmArch 70*
Wasowicz, Annette *DcWomA*
Waspick, Aria Van *DcWomA*
Wass, Harry *FolkA 86*
Wasse, Arthur *DcVicP, -2*
Wassell, H Lynn, Jr. 1931- *AmArch 70*
Wassell, John Woodman *AmArch 70*
Wassenbergh, Elisabeth Geertrude 1726-1782 *DcWomA*
Wassenhove, Joos Van *McGDA*
Wasser, Anna *DcWomA*
Wasser, Anna 1676-1713 *WomArt*
Wasser, George Klein 1934- *AmArch 70*
Wasser, Paula Kloster *WhoAmA 73, -76, -78, -80, -82, -84*
Wasserburger, Paula Von 1865- *DcWomA*
Wasserman, Albert 1920- *WhoAmA 73, -76, -78, -80, -82, -84*
Wasserman, Barry Lee 1935- *AmArch 70*
Wasserman, Burton 1929- *AmArt, PrintW 83, -85, WhoAmA 73, -76, -78, -80, -82, -84*
Wasserman, Cary 1939- *ConPhot, ICPEnP A, WhoAmA 84*
Wasserman, Cary Robert 1939- *MacBEP*
Wasserman, Eugene 1915- *AmArch 70*
Wasserman, J *AmArch 70*
Wasserman, J C *DcVicP 2*
Wasserman, Jack 1921- *WhoAmA 73, -76, -78, -80, -82, -84*
Wasserman, Jeanne L 1915- *WhoAmA 76, -78*
Wasserman, Margaret *DcWomA*
Wasserman, Maurice Walter 1930- *AmArch 70*
Wasset, Ange *DcWomA*
Wasset, J *DcWomA*
Wassie, Arthur *DcVicP 2*
Wassilieff, Marie *DcWomA*
Wassiljew, Juri 1939- *ICPEnP A*
Wassmuth, Birgit Luise 1949- *MarqDCG 84*
Wasson, George S 1855- *ArtsNiC*
Wasson, George Savary 1855-1926 *WhAmArt 85*
Wast, Jean *McGDA*
Wastell, John *OxArt*
Wastell, John d1515 *McGDA*
Wastlhuber, A R *AmArch 70*
Watanabe, George *AmArch 70*
Watanabe, Hiroshi *ConArch A*
Watanabe, Ryo 1936- *WhoAmA 82, -84*
Watanabe, Sol *PrintW 85*
Watanabe, Tokuji 1934- *ConDes*
Watanabe, Torajiro 1886- *WhAmArt 85*
Watanabe, Youji 1923- *ConArch*
Watanabe, Yuko 1856-1942 *DcWomA*
Watchetaker, George Smith 1916- *IlBEAAW*
Watelet, Claude-Henri 1718-1786 *MacEA*
Watelet, Eugenie Sophie *DcWomA*
Watelet, Louis Etienne 1780-1866 *ClaDrA*
Watenphul, Max Peiffer *McGDA*
Waterbory, Laura Prather *ArtsAmW 2, DcWomA,*

WhAmArt 85
Waterbury, Catherine *DcWomA*
Waterbury, Charles D 1868-1918 *BiDAmAr*
Waterbury, Edwin M *WhAmArt 85*
Waterbury, Florance 1883- *DcWomA, WhAmArt 85*
Waterbury, J W *AmArch 70*
Waterbury, Laura Prather *ArtsAmW 2, DcWomA*
Waterbury, R H *AmArch 70*
Waterfield, George R *WhoArt 82N*
Waterfield, George R 1886- *DcBrA 1, WhoArt 80*
Waterfield, Ken 1927- *WhoArt 80, -82, -84*
Waterfield, Margaret *DcVicP 2*
Waterford, Louisa 1818-1891 *DcVicP*
Waterford, Lady Louisa 1818-1891 *ClaDrA*
Waterford, Louisa, Marchioness Of 1818-1891 *DcWomA*
Waterford, Louisa Ann, Marchioness Of 1818-1891 *DcBrWA*
Waterford, Louisa B, Marchioness Of 1818-1891 *DcVicP 2*
Waterford, Louise, Marchioness Of 1818-1891 *DcBrBI*
Waterhouse *AntBDN N, DcBrECP*
Waterhouse, Alfred 1830- *ArtsNiC*
Waterhouse, Alfred 1830-1905 *ClaDrA, DcBrA 1, DcD&D, MacEA, OxArt, WhoArch*
Waterhouse, Alfred 1831-1905 *McGDA*
Waterhouse, C E *AmArch 70*
Waterhouse, Charles Howard 1924- *WhoAmA 76, -78, -80, -82, -84*
Waterhouse, Esther *DcVicP 2, DcWomA*
Waterhouse, J *AntBDN N*
Waterhouse, John William 1849-1917 *ClaDrA, DcBrA 1, DcVicP, -2*
Waterhouse, Paul 1861-1924 *WhoArch*
Waterhouse, Richard Neal 1943- *MarqDCG 84*
Waterhouse, Russell Rutledge 1928- *WhoAmA 73, -76, -78, -80, -82, -84*
Waterhouse, Timothy *CabMA*
Waterhouse, W *DcVicP 2*
Waterlo, Anthonie 1609?-1690 *ClaDrA*
Waterloo, Antonie 1609?-1676? *McGDA*
Waterlow, Sir Ernest Albert 1850-1919 *DcBrA 1, ClaDrA, DcBrWA, DcVicP, -2*
Waterman, Arthur Ernst 1902- *AmArch 70*
Waterman, Charles *FolkA 86*
Waterman, D A *AmArch 70*
Waterman, Donald Calvin 1928- *WhoAmA 76, -78*
Waterman, Donald Calvin 1928-1979 *WhoAmA 80N, -82N, -84N*
Waterman, Eliza 1777-1870 *FolkA 86*
Waterman, Florence Z 1870?-1940 *ArtsEM, DcWomA*
Waterman, Hazel G 1896- *WhAmArt 85*
Waterman, Hazel G Umland 1896- *DcWomA*
Waterman, John Hays 1905- *AmArch 70*
Waterman, Marcus *ArtsNiC*
Waterman, Marcus 1834-1914 *EarABI, NewYHSD, WhAmArt 85*
Waterman, Myron A 1855-1937? *ArtsAmW 2*
Waterman, Myron A 1855-1937 *WhAmArt 85*
Waterman, N T *DcWomA*
Waterman, Mrs. N T *ArtsEM*
Waterman, Robert L 1947- *MarqDCG 84*
Waterman, Sarah 1775-1852 *FolkA 86*
Waterneau, Hermine *DcWomA*
Waterous, H L *WhAmArt 85*
Waters, Miss *DcWomA*
Waters, Almira *DcWomA, FolkA 86, NewYHSD*
Waters, Alwyn Brunow 1906- *WhoArt 80, -82, -84*
Waters, B M *WhAmArt 85*
Waters, Bill Jerrel 1933- *AmArch 70*
Waters, Billie 1896- *ClaDrA, DcBrA 1, DcWomA*
Waters, C L *AmArch 70*
Waters, Charles J B *NewYHSD*
Waters, D E *FolkA 86, NewYHSD*
Waters, Daniel *CabMA*
Waters, David B *DcBrBI*
Waters, E A *FolkA 86, NewYHSD*
Waters, E C *AmArch 70*
Waters, Ebenezer *CabMA*
Waters, Edward *CabMA*
Waters, George Fite 1894-1961 *WhAmArt 85, WhoAmA 80N, -82N, -84N*
Waters, George W 1832-1912 *NewYHSD, WhAmArt 85*
Waters, Herbert 1903- *WhoAmA 76, -78, -80, -82, -84*
Waters, Herbert Ogden 1903- *WhAmArt 85*
Waters, Isabella *DcWomA*
Waters, John 1883- *WhAmArt 85*
Waters, John P *NewYHSD*
Waters, John W *NewYHSD*
Waters, Julia I *WhAmArt 85*
Waters, Lottie A *DcWomA*
Waters, M L *AmArch 70*
Waters, Matthew *NewYHSD*
Waters, Paul 1936- *AfroAA*
Waters, R Kinsman 1887- *WhAmArt 85*
Waters, Ralph 1759-1785 *DcBrWA*
Waters, Richard 1936- *AfroAA*
Waters, Sadie *DcVicP 2*

Watson, William Smellie 1796-1874 *DcBrWA, DcVicP 2*
Watson-Abbott, Lynda *WhoAmA 82, –84*
Watson And Baird *ArtsEM*
Watson And Briggs *EncASM*
Watson And Brummitt *ArtsEM*
Watson And Newell *EncASM*
Watson Stewart, Avril Veronica *WhoArt 84*
Watson-Williams, Morgan *DcWomA*
Watt, B Hunter *WhAmArt 85*
Watt, George Fiddes 1873-1960 *DcBrA 1, DcVicP 2*
Watt, Gilbert 1918- *WhoArt 84*
Watt, James d1832 *BiDBrA*
Watt, James 1736-1819 *MacEA*
Watt, James C *DcVicP 2*
Watt, James Henry 1799-1867 *ArtsNiC*
Watt, Linnie *DcBrA 1, DcVicP, –2, DcWomA*
Watt, T *DcBrBI*
Watt, W H *DcVicP 2*
Watt, William Godfrey 1885- *WhAmArt 85*
Watte, Abraham 1776-1816 *DcBrECP*
Watteau, Antoine 1684-1721 *DcNiCA*
Watteau, Francois Louis Joseph 1758-1823 *ClaDrA*
Watteau, Jean Antoine 1684-1721 *ClaDrA*
Watteau, Jean-Antoine 1684-1721 *McGDA, OxArt*
Watteau, Louis Joseph 1731-1798 *ClaDrA*
Watten, Leonard Vern *AmArch 70*
Wattenberg, Jane Rachel 1949- *MacBEP*
Wattenmaker, Richard J 1941- *WhoAmA 78, –80, –82, –84*
Watter, Josef *ArtsNiC*
Watterns, Susan *DcWomA, WhAmArt 85*
Watters, Lee Allen 1929- *AmArch 70*
Watterson, James Michael 1955- *MarqDCG 84*
Watterson, Joseph 1900- *AmArch 70*
Watteville, Felicie De *DcWomA*
Wattles, Andrew D *NewYHSD*
Wattles, Gary 1954- *MarqDCG 84*
Wattles, I N *DcWomA*
Wattles, Mrs. I N *ArtsEM*
Wattles, J Henry *NewYHSD*
Wattles, James L *NewYHSD*
Wattles, W *NewYHSD*
Watton, Gwynifrede Dorothy 1891- *DcBrA 1, DcWomA*
Watton, J F *DcBrA 2*
Wattrang, Anna Maria Klocker Von *DcWomA*
Watts, Alice 1876-1973 *DcWomA*
Watts, Alice J *DcVicP 2*
Watts, Anna Coleman *DcWomA*
Watts, Anna Mary *DcWomA*
Watts, Arthur George 1883-1935 *DcBrA 1, DcBrBI*
Watts, Bernadette 1942- *IlsBYP, IlsCB 1967*
Watts, Beulah 1873?-1941 *ArtsAmW 3*
Watts, Charles *FolkA 86*
Watts, Charles d1811 *CabMA*
Watts, Dorothy *DcWomA*
Watts, Dorothy 1905- *ClaDrA, DcBrA 1, WhoAmA 80, –82, –84*
Watts, Dorothy Burt 1892-1977 *WhoAmA 78N, –80N, –82N, –84N*
Watts, Dugard *DcVicP 2*
Watts, Etta *DcWomA*
Watts, Eva A 1862- *ArtsAmW 2, DcWomA*
Watts, Francis S 1899- *WhAmArt 85*
Watts, Frederick Waters 1800-1886 *McGDA*
Watts, Frederick William 1800-1862 *DcVicP, –2*
Watts, Frederick William 1800-1870 *DcBrWA*
Watts, George F 1820- *ArtsNiC*
Watts, George Frederic 1817-1904 *McGDA*
Watts, George Frederick 1817-1904 *ClaDrA, DcVicP, –2, OxArt*
Watts, H H *DcVicP 2*
Watts, Mrs. James T d1914 *DcVicP 2*
Watts, James Thomas d1930 *DcVicP*
Watts, James Thomas 1853-1930 *DcBrA 1, DcBrWA, DcVicP 2*
Watts, James W d1895 *NewYHSD*
Watts, Jane 1792?-1826 *DcWomA*
Watts, Joan Alwyn 1921- *WhoArt 80, –82, –84*
Watts, John 1770?- *DcBrECP, DcBrWA*
Watts, Julius R *EncASM*
Watts, K R *AmArch 70*
Watts, Ken 1932- *DcCAr 81*
Watts, Leonard 1871-1951 *DcBrA 1*
Watts, Leonard T 1871-1951 *DcVicP 2*
Watts, Louisa Margaret *DcBrBI, DcWomA*
Watts, Louisa Margaret d1914 *DcBrWA*
Watts, Mary *DcWomA*
Watts, Meryl 1910- *ClaDrA, DcBrA 1, WhoArt 80, –82, –84*
Watts, Peter 1916- *DcBrA 1, WhoArt 80, –82, –84*
Watts, Robert M 1923- *DcCAA 71, –77, WhoAmA 73, –76, –78, –80, –82, –84*
Watts, Robert M 1934- *OxTwCA*
Watts, Robert Marshall 1923- *ConArt 77, –83*
Watts, Simon 1745- *DcBrECP*
Watts, Todd 1949- *DcCAr 81*
Watts, Walter Henry 1776-1842 *DcBrWA*
Watts, Willard A 1957- *MarqDCG 84*
Watts, William 1752-1851 *DcBrBI, DcBrWA*

Watts, William Clothier 1867-1961 *ArtsAmW 2*
Watts, William Clothier 1869- *WhAmArt 85*
Wattson, A Francis *WhAmArt 85*
Waubel, John *EncASM*
Waud, Alfred R 1828-1891 *ArtsAmW 1, EarABI, EarABI SUP, IlBEAAW, NewYHSD*
Waud, Alfred Rudolph 1828-1891 *WhAmArt 85*
Waud, William d1878 *EarABI, EarABI SUP, IlBEAAW, NewYHSD*
Waud, William 1830?-1878 *WhAmArt 85*
Waudby, A J *DcVicP 2*
Waufle, Alan Duane 1951- *WhoAmA 78, –80, –82, –84*
Waugaman, A P, Jr. *AmArch 70*
Waugh, Alfred S 1810?-1856 *IlBEAAW, NewYHSD*
Waugh, Coulton 1896- *WhoAmA 73*
Waugh, Coulton 1896-1973 *WhAmArt 85, WhoAmA 76N, –78N, –80N, –82N, –84N, WorECom*
Waugh, Dorothy 1896- *IlsCB 1744, –1946*
Waugh, Edna Clarke Hall *DcWomA*
Waugh, Elizabeth J *DcVicP 2*
Waugh, F J *DcBrBI*
Waugh, Frederick J *DcVicP 2*
Waugh, Frederick J 1861-1940 *WhAmArt 85*
Waugh, Frederick Judd 1861-1940 *BnEnAmA, DcSeaP*
Waugh, Henry C *FolkA 86*
Waugh, Henry W *FolkA 86, NewYHSD*
Waugh, Ida *DcBrBI*
Waugh, Ida d1919 *DcWomA, WhAmArt 85*
Waugh, Mary Eliza *DcWomA, NewYHSD*
Waugh, Nora *DcVicP 2, DcWomA*
Waugh, S B *DcVicP 2*
Waugh, Samuel Bell 1814-1885 *NewYHSD*
Waugh, Sidney d1963 *WhoAmA 78N, –80N, –82N, –84N*
Waugh, Sidney 1904-1963 *IlBEAAW*
Waugh, Sidney B 1904-1963 *IlDcG*
Waugh, Sidney Biehler 1904-1963 *WhAmArt 85*
Waugh, Thomas Craig 1945- *MarqDCG 84*
Waugh, William *NewYHSD*
Wauson, H C, Jr. *AmArch 70*
Wauters, Andre 1921- *WhoAmA 76, –78*
Wauters, Charles Augustin 1811- *ArtsNiC*
Wauters, Emile Charles *ArtsNiC*
Wauters, Emile Charles 1846-1933 *ClaDrA*
Wauters, Jef 1927- *ClaDrA, WhoArt 80, –82, –84*
Wautiers, Michaelina 1627?- *DcWomA*
Wawrin, Isolde 1949- *DcCAr 81*
Wawro, Jedrzej 1864-1937 *OxTwCA*
Wawrytko, M F 1950- *WhoAmA 82, –84*
Wax, Allan Hartley 1953- *MarqDCG 84*
Wax, N L *AmArch 70*
Waxman, Barbara Ellen *AmArch 70*
Waxman, Bashka *DcWomA, WhAmArt 85*
Waxman, Bashka Paeff *WhoAmA 78, –80*
Waxman, Frances *DcWomA, WhAmArt 85*
Waxschlunger, Johann Paul 1660?-1724 *ClaDrA*
Way, A J H 1826- *ArtsNiC*
Way, Andrew John Henry 1826-1888 *NewYHSD*
Way, Annie Leota *DcWomA*
Way, Annie M *DcWomA*
Way, C *DcVicP 2*
Way, C Granville *WhAmArt 85*
Way, Charles Jones 1834- *DcBrWA, DcVicP, –2*
Way, Charles Jones 1834-1900 *ClaDrA*
Way, Edna 1897- *WhAmArt 85*
Way, Edna Martha 1891?- *DcWomA*
Way, Fanny 1871-1961 *DcWomA*
Way, Frances Elizabeth 1871- *DcBrA 1*
Way, Frances Elizabeth 1871-1961 *DcBrA 2*
Way, George Brevitt 1854- *WhAmArt 85*
Way, Harriott *DcWomA*
Way, J *DcVicP 2*
Way, Mrs. John *DcBrECP*
Way, Mrs. John L *DcVicP 2*
Way, Laura *DcWomA*
Way, Mary *DcWomA, NewYHSD*
Way, Rebecca *FolkA 86*
Way, Thomas R d1913 *DcBrA 1*
Way, Thomas R 1862-1913 *DcVicP 2*
Way, Thomas Robert 1861?-1913 *ClaDrA, DcBrBI*
Way, William *NewYHSD*
Way, William Cosens 1833-1905 *DcBrA 1, DcBrWA, DcVicP, –2*
Waybright, Marianna *DcWomA, WhAmArt 85*
Waycott, Hedley William 1865-1938 *WhAmArt 85*
Wayland, C V *AmArch 70*
Wayland, Edythe *DcWomA*
Wayland, Lloyd Earl 1922- *AmArch 70*
Waylen, James *DcVicP 2*
Waylett, F *DcBrBI*
Wayman, Nelson P *WhAmArt 85*
Wayman, Stanley 1927-1973 *ICPEnP A*
Waymon, E Ernest 1920- *AmArch 70*
Waymouth, Eleanor *DcWomA*
Waymouth, Helen *DcWomA*
Wayn, Gregory Charles 1950- *MacBEP*
Wayn, Sarah *FolkA 86*
Wayne, Hattie N *DcWomA*

Wayne, J E *AmArch 70*
Wayne, Jacob *CabMA*
Wayne, June *PrintW 85, WhoAmA 73, –76, –78, –80, –82, –84*
Wayne, June 1918- *BnEnAmA, DcCAA 71, –77, McGDA*
Wayne, R S *DcVicP 2*
Wayne, William *CabMA*
Waynick, Lynne Carlyle 1891- *ArtsAmW 3*
Waytt, Richard 1955- *AfroAA*
Weadell, Miss *DcWomA, WhAmArt 85*
Weall, Sydney F *DcVicP 2*
Wealleans, Jon 1946- *ConDes*
Weand, Charles *FolkA 86*
Weand, David *FolkA 86*
Weand, Michael *FolkA 86*
Weand, William 1826?- *FolkA 86*
Wear, Maud Marian 1873- *DcBrA 1, DcVicP 2, DcWomA*
Wear, R E *AmArch 70*
Wearden, Clifford 1920- *ConArch*
Weare, Shane 1936- *WhoAmA 76, –78, –80, –82, –84*
Wearehs *FolkA 86*
Wearing, Dorothy Compton 1917- *WhAmArt 85*
Wearne, H *DcVicP 2*
Wearstler, Albert M 1893-1955 *WhAmArt 85*
Weatherby, Evelyn Mae 1897- *DcWomA, WhAmArt 85*
Weatherby, J A *NewYHSD*
Weatherby, R C *DcBrA 1*
Weatherford, Dorothy *WorFshn*
Weatherford, R P, Jr. *AmArch 70*
Weatherhead, Bruce Edward 1939- *WhoGrA 82[port]*
Weatherhead, William Harris 1843-1903? *DcBrA 1, DcBrWA, DcVicP, –2*
Weatherhill, Mary *DcVicP 2*
Weatherhill, Sarah Ellen *DcVicP 2*
Weatherill, Elizabeth *DcBrWA, DcWomA*
Weatherill, George *DcVicP 2*
Weatherill, George 1810-1890 *DcBrWA, DcSeaP*
Weatherill, Mary *DcBrWA*
Weatherill, Richard 1844-1913 *DcBrWA*
Weatherill, Robert Hall 1927- *AmArch 70*
Weatherill, Sarah Ellen *DcBrWA*
Weatherly, Newton *WhAmArt 85*
Weatherly, W E *AmArch 70*
Weathers, James *CabMA*
Weatherstone, Alfred C *DcVicP 2*
Weatherstone, J P *EncASM*
Weatherstrand, William *CabMA*
Weaver *NewYHSD*
Weaver, Abraham *FolkA 86*
Weaver, Ann Vaughan *WhAmArt 85*
Weaver, B Maie 1875- *DcWomA, WhAmArt 85*
Weaver, Beulah Barnes 1880?-1957 *DcWomA*
Weaver, Beulah Barnes 1882- *WhAmArt 85*
Weaver, Buck 1888- *ArtsAmW 1*
Weaver, Carolina *FolkA 86*
Weaver, Clara *DcWomA, WhAmArt 85*
Weaver, Claude *AfroAA*
Weaver, Elias *FolkA 86*
Weaver, Emily *DcVicP 2*
Weaver, Emma M 1862- *WhAmArt 85*
Weaver, Emma Matern 1862- *DcWomA*
Weaver, Eric C 1960- *MarqDCG 84*
Weaver, F L *FolkA 86*
Weaver, Florence M 1879- *DcWomA, WhAmArt 85*
Weaver, Frederick d1885 *FolkA 86*
Weaver, George M *NewYHSD*
Weaver, Grover O *WhAmArt 85*
Weaver, Henry *FolkA 86*
Weaver, Herbert Parsons 1872-1945 *DcBrA 1, DcVicP 2*
Weaver, Holmes 1769-1848 *CabMA*
Weaver, Horace Miller 1885- *AmArch 70*
Weaver, Howard Sayre *WhoAmA 73*
Weaver, Inez Belva 1872- *WhAmArt 85*
Weaver, Inez Belva Honeycutt 1872- *ArtsAmW 3, DcWomA*
Weaver, Isaac *CabMA*
Weaver, J C *AmArch 70*
Weaver, J G *FolkA 86*
Weaver, Jack 1925- *IlsBYP, IlsCB 1946*
Weaver, James D 1949- *WhoAmA 82, –84*
Weaver, James L *FolkA 86*
Weaver, Jay *WhAmArt 85*
Weaver, John Barney 1920- *WhoAmA 73, –76, –78, –80, –82, –84*
Weaver, John Keating 1927- *AmArch 70*
Weaver, John W 1824?- *FolkA 86*
Weaver, John W 1929- *MarqDCG 84*
Weaver, L *DcVicP 2*
Weaver, Lamar 1918- *AfroAA*
Weaver, Leroy C *AfroAA*
Weaver, Lewis *NewYHSD*
Weaver, Luther Hartsfield 1923- *AmArch 70*
Weaver, M *DcBrECP*
Weaver, M W K *DcWomA*
Weaver, Margarita *WhAmArt 85*
Weaver, Margarita Weigle 1889- *DcWomA*
Weaver, Martha Tibbals 1859- *WhAmArt 85*

Weaver, Mary Ann *FolkA 86*
Weaver, Norman L 1951- *MarqDCG 84*
Weaver, Pamela *AfroAA*
Weaver, Robert *IlsBYP*
Weaver, Robert 1924- *IlrAm G, –1880*
Weaver, Robert 1935- *PrintW 83, –85, WhoAmA 80, –82, –84*
Weaver, Robert E 1914- *WhAmArt 85*
Weaver, Rudolph 1880-1944 *BiDAmAr*
Weaver, Samuel 1830?- *FolkA 86*
Weaver, Stephanie *AfroAA*
Weaver, Thomas d1843 *FolkA 86*
Weaver, Thomas Martin 1930- *AmArch 70*
Weaver, W H *IlBEAAW*
Weaver, Warren Wilson 1920- *AmArch 70*
Weaver, William 1736- *CabMA*
Web *EncASM*
Webb *DcBrECP, DcVicP 2*
Webb, A C 1888- *WhAmArt 85*
Webb, Adrian *CabMA*
Webb, Aileen O *WhAmArt 85*
Webb, Aileen Osborn 1892- *WhoAmA 73*
Webb, Aileen Osborn 1892-1979 *DcWomA, WhoAmA 80N, –82N, –84N*
Webb, Albert J 1891- *WhAmArt 85*
Webb, Alex 1952- *ICPEnP A*
Webb, Amy *DcVicP 2*
Webb, Archibald *DcBrWA, DcVicP, –2*
Webb, Archibald 1800?-1866? *DcSeaP*
Webb, Archibald, Jr. *DcVicP 2*
Webb, Arthur Geoffrey Gascoyne *WhoArt 82N*
Webb, Arthur Geoffrey Gascoyne 1896- *DcBrA 1, WhoArt 80*
Webb, Aston 1849-1930 *MacEA*
Webb, Sir Aston 1849-1930 *DcBrA 1, DcD&D, WhoArch*
Webb, Bernard Alexander, Jr. 1915- *AmArch 70*
Webb, Byron *DcVicP, –2*
Webb, C *DcVicP 2*
Webb, Cecilia 1888-1957 *DcBrA 1, DcWomA*
Webb, Charles *IlDcG*
Webb, Charles A *WhAmArt 85*
Webb, Clifford Cyril 1895- *IlsCB 1744, –1946, –1957*
Webb, Clifford Cyril 1895-1972 *ClaDrA, DcBrA 1*
Webb, Clyde Morgan 1929- *AmArch 70*
Webb, Constance Olleen 1923- *WhoAmA 76*
Webb, David 1925-1975 *WorFshn*
Webb, Doug *PrintW 85*
Webb, E *FolkA 86*
Webb, E W *DcVicP 2*
Webb, Ebenezer R *NewYHSD*
Webb, Edith Buckland 1877- *ArtsAmW 2, DcWomA*
Webb, Edith Buckland 1877-1959 *WhAmArt 85*
Webb, Edna Dell *WhAmArt 85*
Webb, Edna Dell 1891?- *DcWomA*
Webb, Edward 1805-1854 *DcBrWA, DcVicP 2*
Webb, Edward J *NewYHSD*
Webb, Eliza *DcVicP 2, DcWomA*
Webb, Elizabeth Holden *WhAmArt 85*
Webb, Ernest *DcBrBI*
Webb, Francoise *IlsBYP*
Webb, Frank 1927- *WhoAmA 78, –80, –82, –84*
Webb, Garl 1908- *WhAmArt 85*
Webb, George W 1812-1890 *EncASM*
Webb, Grace 1898- *WhAmArt 85*
Webb, Grace Parker 1888- *DcWomA*
Webb, Gwen Lindsay 1913- *WhoArt 80, –82, –84*
Webb, H J *EncASM*
Webb, H T *FolkA 86, NewYHSD*
Webb, Harry George *DcVicP 2*
Webb, Harry George 1882-1914 *DcBrBI*
Webb, Henry *DcVicP 2*
Webb, Herbert C *WhAmArt 85*
Webb, J *DcVicP 2*
Webb, J A, Jr. *AmArch 70*
Webb, J Louis 1856-1928 *WhAmArt 85*
Webb, J M *AmArch 70*
Webb, James *NewYHSD*
Webb, James 1825?-1895 *ClaDrA, DcBrWA, DcSeaP, DcVicP, –2*
Webb, James Elwood *WhAmArt 85*
Webb, James Murphy 1939- *AmArch 70*
Webb, James Murray 1908- *AmArch 70*
Webb, James Richard 1945- *MarqDCG 84*
Webb, Jane *DcWomA*
Webb, John *DcBrBI, EncASM*
Webb, John 1611-1672 *BiDBrA, DcD&D, MacEA, McGDA, OxArt, WhoArch*
Webb, John 1754?-1828 *BiDBrA*
Webb, John 1774-1835 *IlDcG*
Webb, John, Sr. *EncASM*
Webb, John Charles 1815- *CabMA*
Webb, John Cother d1927 *DcBrA 2*
Webb, John Louis 1921- *AmArch 70*
Webb, John Stephen 1950- *MacBEP*
Webb, Joseph 1908-1962 *DcBrA 1*
Webb, K S *DcVicP 2*
Webb, Kenneth 1927- *DcBrA 2, WhoArt 80, –82, –84*
Webb, L T *AmArch 70*
Webb, Leonard Hugh 1916- *AmArch 70*

Webb, M D *DcVicP 2*
Webb, Mahala Theodora 1887- *DcBrA 1, DcWomA*
Webb, Margaret Ely 1877-1965 *ArtsAmW 2, DcWomA, WhAmArt 85*
Webb, Maria D *DcWomA*
Webb, Marshall J 1879-1931 *BiDAmAr*
Webb, Mary *DcWomA*
Webb, Matthew William d1924 *DcBrA 2*
Webb, Octavius *DcVicP 2*
Webb, P Whitney 1920- *AmArch 70*
Webb, Paul 1902- *WhAmArt 85, WorECar*
Webb, Philip *DcVicP 2*
Webb, Philip 1831-1915 *AntBDN G, DcD&D[port], DcNiCA, EncMA, IlDcG, OxDcA*
Webb, Philip S 1831-1915 *MacEA*
Webb, Philip Speakman 1831-1915 *McGDA, OxArt, WhoArch*
Webb, Robert, Jr. *WhAmArt 85*
Webb, Robert Franklin 1928- *AmArch 70*
Webb, Robert Itheal, Jr. 1931- *AmArch 70*
Webb, Roger 1951- *MarqDCG 84*
Webb, Spider 1944- *MacBEP, WhoAmA 78, –80, –82*
Webb, Stephen d1933 *DcBrA 2*
Webb, Sydney 1837-1919 *DcBrA 1, DcVicP 2*
Webb, Thomas *BiDBrA, DcNiCA, WhAmArt 85*
Webb, Thomas d1728 *CabMA*
Webb, Thomas, I 1804-1869 *IlDcG*
Webb, Thomas, III 1865-1925 *IlDcG*
Webb, Thomas Wilkes, II 1837-1891 *IlDcG*
Webb, Todd 1905- *ConPhot, ICPEnP A, WhAmArt 85, WhoAmA 84*
Webb, Virginia Louise 1920- *WhoAmA 76, –78, –80*
Webb, Vivian Phillip 1892- *DcWomA*
Webb, Vonna 1876-1964 *DcWomA*
Webb, Vonna Owings 1876-1964 *ArtsAmW 1, IlBEAAW, WhAmArt 85*
Webb, W B *DcWomA*
Webb, Mrs. W B *ArtsEM*
Webb, W W *AmArch 70*
Webb, Walter Wilkes d1919 *IlDcG*
Webb, Westfield *DcBrECP*
Webb, William *DcBrECP*
Webb, William, III 1805?-1849 *CabMA*
Webb, William Edward 1862?-1903 *DcBrA 1, DcVicP 2*
Webb, William J *DcBrBI, DcVicP, –2*
Webb, William N *NewYHSD*
Webb And Scott *CabMA*
Webb Corbett *IlDcG*
Webb Family *IlDcG*
Webbe *DcBrECP*
Webbe, William J *ClaDrA, DcVicP 2*
Webber, Mrs. *DcWomA, NewYHSD*
Webber, Angela Mary 1931- *WhoArt 80, –82, –84*
Webber, Charles E 1829?-1847 *CabMA*
Webber, Charles T 1825-1911 *IlBEAAW, NewYHSD , WhAmArt 85*
Webber, Elroy 1905- *AmArch 70*
Webber, Frederick W 1847-1922 *WhAmArt 85*
Webber, H *AmArch 70*
Webber, Helen 1928- *AmArt, WhoAmA 82, –84*
Webber, Irma Eleanor Schmidt 1904- *IlsBYP, IlsCB 1744, –1946*
Webber, James David 1927- *AmArch 70*
Webber, Jeffrey Alan 1953- *MarqDCG 84*
Webber, John *FolkA 86*
Webber, John 1750?-1793 *DcBrWA, IlBEAAW, NewYHSD , OxArt*
Webber, John 1752-1793 *DcBrECP*
Webber, John E 1751-1793 *ArtsAmW 1*
Webber, Michael H 1926- *WhoArt 80, –82, –84*
Webber, Payson Rex 1903- *AmArch 70*
Webber, Wesley 1839-1914 *WhAmArt 85*
Webber, William John 1922- *AmArch 70*
Weber, A *DcVicP 2*
Weber, Albert Jacob 1919- *WhoAmA 73, –76, –78, –80, –82, –84*
Weber, Albert L *WhAmArt 85*
Weber, Alfons 1882- *WhAmArt 85*
Weber, August 1817-1873 *ArtsNiC*
Weber, August James 1889- *WhAmArt 85*
Weber, Bertram A 1898- *AmArch 70*
Weber, Bruce 1946- *ICPEnP A*
Weber, Bruce Edward 1951- *WhoAmA 80, –82*
Weber, C Phillip 1849- *WhAmArt 85*
Weber, Carl 1850-1921 *WhAmArt 85*
Weber, Caroline *DcWomA, NewYHSD*
Weber, Carrie May *WhAmArt 85*
Weber, D C *AmArch 70*
Weber, Delano Bernard 1936- *AmArch 70*
Weber, Dyanne Strongbow 1951- *AmArt*
Weber, Edward *NewYHSD*
Weber, Ella 1860- *DcWomA*
Weber, Elsa *WhAmArt 85*
Weber, Ernest *DcVicP 2*
Weber, Fred W 1890- *WhAmArt 85*
Weber, Frederick T 1883-1956 *WhAmArt 85*
Weber, Frederick Theodore 1883-1956 *WhoAmA 80N, –82N, –84N*
Weber, Frida 1891- *DcWomA*

Weber, H *DcBrBI*
Weber, Henry James 1933- *AmArch 70*
Weber, Herman Charles, Jr. *AmArch 70*
Weber, Hilde 1913- *WorECar*
Weber, Howard Bloom 1928- *AmArch 70*
Weber, Hugo 1918- *OxTwCA*
Weber, Hugo 1918-1971 *DcCAA 77, WhoAmA 78N, –80N, –82N, –84N*
Weber, Hulda *WhoAmA 78, –80*
Weber, Idelle *DcCAr 81, WhoAmA 76, –78, –80, –82, –84*
Weber, Idelle Lois *WhoAmA 73*
Weber, Irving Kurt 1933- *AmArch 70*
Weber, Isaac *FolkA 86*
Weber, J A *FolkA 86*
Weber, James Francis 1931- *AmArch 70*
Weber, Jan *WhoAmA 76, –78, –80, –82, –84*
Weber, Jean M 1933- *WhoAmA 73, –76, –78, –80, –82, –84*
Weber, John *WhoAmA 73, –76, –78, –80, –82, –84*
Weber, John 1930- *AmArch 70*
Weber, John Pitman 1942- *WhoAmA 78, –80, –82, –84*
Weber, John S *NewYHSD*
Weber, Julie *DcWomA*
Weber, Katherine McCarville 1956- *MarqDCG 84*
Weber, Kem 1889-1963 *BnEnAmA, WhAmArt 85*
Weber, Lloyd J 1924- *AmArch 70*
Weber, Lou K 1886-1947 *WhAmArt 85*
Weber, Louise Mathilde *DcWomA*
Weber, Marie *DcWomA*
Weber, Martin Leroy 1945- *WhoAmA 76*
Weber, Mathilde 1891- *DcWomA*
Weber, Max 1881- *DcCAA 71*
Weber, Max 1881-1961 *BnEnAmA, ConArt 83, DcAmArt, DcCAA 77, McGDA, OxArt, OxTwCA, PhDcTCA 77, WhAmArt 85, WhoAmA 78N, –80N, –82N, –84N, WorArt[port]*
Weber, Meta *DcWomA*
Weber, Nicholas F, IV 1930- *AmArch 70*
Weber, Otto d1870 *ArtsNiC*
Weber, Otto 1832-1882 *DcBrWA*
Weber, Otto 1832-1888 *ClaDrA, DcVicP, –2*
Weber, Paul 1823- *ArtsNiC*
Weber, Paul 1823?-1916 *NewYHSD , WhAmArt 85*
Weber, Paul F 1925- *AmArch 70*
Weber, Peter J 1864-1923 *BiDAmAr*
Weber, R *AmArch 70, FolkA 86*
Weber, Robert 1934- *WorECar*
Weber, Robert Richard 1929- *AmArch 70*
Weber, Roland 1924- *MacBEP*
Weber, Rosa *DcWomA, WhAmArt 85*
Weber, Rudolph 1858-1933 *WhAmArt 85*
Weber, Sarah S Stilwell d1939 *WhAmArt 85*
Weber, Sarah S Stilwell 1878-1939 *IlrAm 1880*
Weber, Sarah Stilwell 1878-1939 *DcWomA*
Weber, Sybilla Mittell d1957 *WhoAmA 80N, –82N, –84N*
Weber, Sybilla Mittell 1892-1957 *DcWomA, WhAmArt 85*
Weber, T *FolkA 86*
Weber, Theodor *DcVicP 2*
Weber, Theodore 1838-1907 *DcSeaP*
Weber, Therese 1813-1875 *DcWomA*
Weber, Therese 1864- *DcWomA*
Weber, W F, Jr. *AmArch 70*
Weber, W H *AmArch 70*
Weber, W M *AmArch 70*
Weber, Walter A *OfPGCP 86*
Weber, Walter Alois 1906- *IlsCB 1744*
Weber, William 1865-1905 *WhAmArt 85*
Weber, Willy 1933- *ConArt 77*
Weber-Ditzler, Charlotte 1877- *DcWomA, WhAmArt 85*
Weber-Fulop, Elizabeth 1883- *DcWomA*
Weber-Petsche, Antonie 1845- *DcWomA*
Weber-Wagner *EncASM*
Weber-Wagner And Benson *EncASM*
Weberg, John *WhAmArt 85*
Webley, Sam *DcVicP 2*
Webley, Samuel 1877- *DcBrA 1*
Webling, Ethel *DcWomA*
Webster *FolkA 86*
Webster, Miss *DcWomA*
Webster, A A *EncASM*
Webster, Abel 1726-1801 *FolkA 86*
Webster, Alfred George *ClaDrA, DcVicP, –2*
Webster, Alice E *DcWomA*
Webster, Bernice M 1895- *DcWomA, WhAmArt 85*
Webster, Bessie *ArtsEM, DcWomA*
Webster, C *FolkA 86*
Webster, Chris 1958- *DcCAr 81*
Webster, Clarence B *EncASM*
Webster, Daniel C *NewYHSD*
Webster, David S *WhoAmA 73*
Webster, Derek *FolkA 86*
Webster, E A *DcVicP 2*
Webster, E Ambrose 1869-1935 *WhAmArt 85*
Webster, E F *AmArch 70*
Webster, Elijah *FolkA 86*
Webster, Elizur G 1829-1900 *EncASM*

West, R C *NewYHSD*
West, R E *AmArch 70*
West, Raphael Lamarr 1766-1850 *DcBrECP*
West, Raphael Lamarr 1769-1850 *NewYHSD*
West, Richard Vincent 1934- *WhoAmA 76, -78, -80, -82, -84*
West, Richard Whately 1848-1905 *DcBrA 1, -2, DcVicP, -2*
West, Richard William 1887- *DcBrA 1*
West, Robert *BiDBrA*
West, Robert d1770 *DcBrECP*
West, Robert Canney 1935- *AmArch 70*
West, Russell W 1910- *WhAmArt 85*
West, S *AmArch 70*
West, Samuel *CabMA*
West, Samuel 1810-1867 *DcVicP, -2*
West, Samuel 1910?- *DcBrWA*
West, Samuel S *NewYHSD*
West, Sarah Jesse *WhAmArt 85*
West, Sarah Jessie *DcWomA*
West, Sophie 1825-1914 *DcWomA, NewYHSD , WhAmArt 85*
West, Temple 1739-1783 *DcBrECP*
West, Theoris *AfroAA*
West, Thomas *BiDBrA, CabMA*
West, Virgil William 1893-1955 *ArtsAmW 1*
West, Virginia M *WhoAmA 76, -78, -80, -82, -84*
West, W Dennis 1944- *MarqDCG 84*
West, W R *NewYHSD*
West, W Richard 1912- *WhoAmA 73, -76, -78, -80, -82, -84*
West, Walter *DcVicP 2*
West, Walter Howard 1922- *AmArch 70*
West, Walter Richard 1912- *IlBEAAW, IlsBYP, IlsCB 1946, WhAmArt 85*
West, Washington J *FolkA 86*
West, William *CabMA, FolkA 86, NewYHSD*
West, William 1801-1861 *DcVicP, -2*
West, William D *DcVicP 2*
West, William Edward 1788-1857 *NewYHSD*
West, William Waterfall 1801-1861 *DcBrWA*
Westall, John *DcVicP 2*
Westall, Richard 1765-1836 *BkIE, ClaDrA, DcBrBI, DcBrWA, OxArt*
Westall, Richard 1766-1836 *DcBrECP*
Westall, Robert *DcVicP 2*
Westall, William 1781-1850 *DcBrBI, DcBrWA, DcSeaP, DcVicP 2*
Westaway, W *DcVicP 2*
Westberg, A J, Jr. *AmArch 70*
Westberg, Brigitte *DcCAr 81*
Westberg, E *AmArch 70*
Westbrook, Lieutenant *NewYHSD*
Westbrook, Annie E *DcVicP 2*
Westbrook, Clara *DcWomA, WhAmArt 85*
Westbrook, Miss E T *DcBrWA*
Westbrook, Elizabeth T *DcVicP 2*
Westbrook, Eric 1915- *WhoArt 80, -82, -84*
Westbrook, L E, Jr. *AmArch 70*
Westbrook, Lloyd 1899- *AmArch 70*
Westbrook, Lloyd Leonard 1903- *WhAmArt 85*
Westbrook, M *DcWomA*
Westbrook, Mrs. M *ArtsEM*
Westbrook, Samuel *BiDBrA*
Westbury, Rodney Ames 1938- *AmArch 70*
Westby, Grace Mary Stanley 1896- *ClaDrA, DcBrA 1, DcWomA*
Westcoast, Wanda 1935- *WhoAmA 76, -78*
Westcoast, Wanda 1937- *WhoAmA 80, -82, -84*
Westcott, George *WhAmArt 85*
Westcott, James *BiDBrA*
Westcott, Lilian *DcWomA*
Westcott, Philip 1815-1878 *DcVicP, -2*
Westcott, Rowena *DcWomA*
Westenberg, Pieter George 1791-1873 *ClaDrA*
Westendorp-Osieck, Betsy *DcWomA*
Westengaard, Johanne Marie *DcWomA*
Westerbeck, Colin L, Jr. 1941- *MacBEP*
Westerbeek, Cornelis 1844-1903 *ClaDrA*
Westerberg, John *WhAmArt 85*
Westerfield, J Mont 1885- *WhAmArt 85*
Westerfield, Richard Gardner 1904- *AmArch 70*
Westergren, Richard Anton 1933- *AmArch 70*
Westerhoff, Robert F 1955- *MarqDCG 84*
Westerik, Co 1924- *ConArt 83, DcCAr 81, OxTwCA, PhDcTCA 77*
Westerl, Robert *NewYHSD*
Westerlind, A *WhAmArt 85*
Westerlind, Axel D *ArtsEM*
Westerlund, Mia 1942- *DcCAr 81*
Westerlund Roosen, Mia 1942- *WhoAmA 84*
Westerman, Harry James 1876-1945 *WorECar*
Westerman, Harry James 1877-1945 *WhAmArt 85*
Westermann, H C 1922- *DcCAA 71, -77, WhoAmA 84*
Westermann, H C 1922-1981 *ConArt 83, PrintW 83, -85*
Westermann, H C, Jr. 1922- *BnEnAmA, DcAmArt*
Westermann, Helge 1914- *AmArch 70*
Westermann, Horace Clifford 1922- *ConArt 77, DcCAr 81, OxTwCA, PhDcTCA 77,*

WhoAmA 73, -76, -78, -80
Westermann, Horace Clifford 1922-1981 *WhoAmA 82N, -84N*
Westermann-Pfahler, Elisabeth 1885- *DcWomA*
Westermarck, Helena 1857-1938 *DcWomA*
Westermayr, Henriette 1772-1841 *DcWomA*
Westermeier, Clifford Peter 1910- *WhAmArt 85, WhoAmA 76, -78, -80, -82, -84*
Westermeir, Clifford Peter 1910- *WhoAmA 73*
Western, A *DcVicP 2*
Western, A S *FolkA 86, NewYHSD*
Western, Charles *DcVicP 2*
Western, Henry 1877- *DcBrA 1*
Western, Theodore B *NewYHSD*
Westervelt, A B *FolkA 86*
Westervelt, John Corley 1873-1934 *BiDAmAr*
Westervelt, Robert F 1928- *WhoAmA 78, -80, -82, -84*
Westervelt, W T *FolkA 86*
Westfall, Carol D 1938- *WhoAmA 78, -80, -82, -84*
Westfall, D C *AmArch 70*
Westfall, Gertrude Bennett 1894-1962 *ArtsAmW 2, DcWomA*
Westfall, H E *AmArch 70*
Westfall, Tulita Bennett 1894-1962 *ArtsAmW 2*
Westfall, Tulita Gertrude Bennett 1894- *WhAmArt 85*
Westfall Y DeBoronda, Gertrude Bennett 1894-1962 *DcWomA*
Westfeldt, Patrick McLosksy 1854-1907 *WhAmArt 85*
Westgaard, Tor 1927- *AmArch 70*
Westhead, G Reade- *DcVicP 2*
Westhoff, Clara *DcWomA*
Westhope *FolkA 86*
Westhoven, W *DcVicP 2*
Westin, Norman Walter 1935- *AmArch 70*
Westin, Robert H 1946- *WhoAmA 78, -80, -82, -84*
Westlake, Miss *DcVicP 2*
Westlake, Alice 1840-1923 *DcVicP 2, DcWomA*
Westlake, Edward B *ArtsEM*
Westlake, Mary *DcVicP 2*
Westlake, Merle Theodore, Jr. 1922- *AmArch 70*
Westlake, Nathaniel Hubert John 1833-1921 *ClaDrA, DcBrA 1, DcVicP, -2*
Westlaver *NewYHSD*
Westley, John d1644 *BiDBrA*
Westley, John 1702-1769 *BiDBrA*
Westlund, Harry E 1941- *WhoAmA 78, -80, -82, -84*
Westmacott, Bernard 1887- *ConICB*
Westmacott, E K *DcWomA*
Westmacott, Mrs. H *DcVicP 2*
Westmacott, John *BiDBrA*
Westmacott, K E *DcWomA*
Westmacott, Richard 1799-1872 *ArtsNiC, OxArt*
Westmacott, Sir Richard 1775-1856 *McGDA, OxArt*
Westmacott, Stewart *DcVicP 2*
Westmacott, Thomas *BiDBrA*
Westmacott, William *BiDBrA*
Westman, Carl 1866-1936 *MacEA*
Westmoreland, Lady *DcWomA*
Westmoreland, J B *AmArch 70*
Westmorland, Priscilla Fane, Countess Of 1793-1879 *DcWomA*
Westnedge, M B *DcWomA*
Westnedge, Mrs. M B *ArtsEM*
Westneye, M B *DcWomA*
Westneye, Mrs. M B *ArtsEM*
Westoby, Sidney Walter *WhoArt 80N*
Weston, Brett 1911- *AmArt, ConPhot, ICPEnP, MacBEP*
Weston, Cole 1919- *AmArt, ConPhot, MacBEP*
Weston, E, III *AmArch 70*
Weston, Edward 1886-1958 *BnEnAmA, ConPhot, DcAmArt, ICPEnP, MacBEP, WhAmArt 85*
Weston, Eloise *DcWomA*
Weston, Florence *ClaDrA*
Weston, Frances M *DcWomA, WhAmArt 85*
Weston, George F *ArtsEM*
Weston, George Frederick 1819-1887 *DcBrWA, DcVicP 2*
Weston, H *FolkA 86, NewYHSD*
Weston, Harold 1894-1972 *WhAmArt 85, WhoAmA 78N, -80N, -82N, -84N*
Weston, Harry Alan 1885-1931 *WhAmArt 85*
Weston, Henry W *NewYHSD*
Weston, I Donald 1928- *AmArch 70*
Weston, J B *DcWomA*
Weston, J G *NewYHSD*
Weston, James *NewYHSD*
Weston, James L *WhAmArt 85*
Weston, Julia *DcWomA*
Weston, Kenneth Clayton 1932- *MarqDCG 84*
Weston, Lambert 1804-1895 *DcVicP 2*
Weston, Loren *FolkA 86*
Weston, M N *AmArch 70*
Weston, Mary 1817-1894 *DcWomA*
Weston, Mary Coburn 1839-1913 *DcWomA*
Weston, Mary Pillsbury *FolkA 86*
Weston, Mary Pillsbury 1817-1894 *NewYHSD*
Weston, Morris 1859- *AmArch 70*
Weston, Otheto 1895- *DcWomA*
Weston, Mrs. Otheto 1895- *ArtsAmW 2*

Weston, Thomas *FolkA 86*
Weston, William *BiDBrA*
Weston, William C 1866-1932 *BiDAmAr*
Weston, William Henry *FolkA 86*
Weston, William Percy 1879-1967 *IlBEAAW*
Westover, Marla Katz 1951- *MacBEP*
Westover, Russell 1886-1966 *WorECom*
Westover, Russell Channing 1886- *WhAmArt 85*
Westphal, F *DcVicP 2*
Westphal-Loesser, Helene 1861- *DcWomA*
Westphall, J E *AmArch 70*
Westrum, Anni Von *ArtsAmW 2, DcWomA*
Westrup, E Kate *DcBrBI*
Westvold, Robert George 1925- *AmArch 70*
Westwater, Alan Gene 1942- *MarqDCG 84*
Westwater, Angela King 1942- *WhoAmA 76, -78, -80, -82, -84*
Westwater, Eunice *DcWomA*
Westwater, Robert H *DcBrA 1*
Westwood, Eliza *DcVicP 2, DcWomA*
Westwood, Florence *DcVicP 2*
Westwood, H G *DcWomA*
Westwood, John 1919- *WhoArt 80, -82, -84*
Westwood, Percy James 1878- *DcBrA 1*
Westwood, William H *FolkA 86*
Wetherald, Ellen *DcWomA*
Wetherald, Harry H 1903-1955 *WhAmArt 85*
Wetherald, Samuel B *EarABI SUP, NewYHSD*
Wetherall, Samuel H *NewYHSD*
Wetherbee, Alice Ney *DcWomA, WhAmArt 85*
Wetherbee, Bertha C *ArtsEM, DcWomA*
Wetherbee, Frank Irving 1869- *WhAmArt 85*
Wetherbee, George 1851- *WhAmArt 85*
Wetherbee, George Faulkner 1851-1920 *ClaDrA, DcBrA 1, DcVicP, -2*
Wetherbee, Thomas Michael 1956- *MarqDCG 84*
Wetherby, Isaac Augustus 1819-1904 *FolkA 86, NewYHSD, WhAmArt 85*
Wetherby, Jeremiah W 1780- *FolkA 86*
Wetherby, Jeremiah Wood 1780- *NewYHSD*
Wethered, Maud Llewellyn 1898- *DcBrA 1, DcWomA, WhoArt 80, -82, -84*
Wethered, Vernon 1865-1952 *DcBrA 1, DcVicP 2*
Wetherell, C A *EncASM*
Wetherell, Daniel Bradford *AmArch 70*
Wetherell, E H *AmArch 70*
Wetherell, George H 1854-1930 *BiDAmAr*
Wetherell, J H *AmArch 70*
Wetherick, J *EarABI*
Wetherill, Anne *DcWomA*
Wetherill, Arthur *DcBrECP*
Wetherill, E Kent K 1874-1929 *WhAmArt 85*
Wetherill, Isabella Macomb *DcWomA*
Wetherill, Isabelle M *WhAmArt 85*
Wetherill, Roy 1880- *WhAmArt 85*
Wetherington, Joe Dalton 1942- *MarqDCG 84*
Wethey, Harold Edwin 1902- *WhAmArt 85, WhoAmA 73, -76, -78, -80, -82, -84*
Wethington, Wilma Zella 1918- *WhoAmA 76, -78, -80, -82, -84*
Wethli, Mark 1949- *WhoAmA 84*
Wethli, Mark Christian 1949- *WhoAmA 76, -78, -80*
Wetmore, C F *NewYHSD*
Wetmore, C G *NewYHSD*
Wetmore, Charles D 1867-1941 *BiDAmAr*
Wetmore, Helen *ArtsEM, DcWomA*
Wetmore, James A 1863-1940 *BiDAmAr*
Wetmore, Mary Minerva *DcWomA, WhAmArt 85*
Wetten, Robert Gunter d1868 *BiDBrA*
Wetterau, Margaret Chaplin *WhAmArt 85*
Wetterau, Rudolf 1891- *WhAmArt 85*
Wetton, Ernest *DcVicP 2*
Wetzel, Charles *NewYHSD*
Wetzel, George J 1870-1936? *WhAmArt 85*
Wetzel, Ines 1878- *DcWomA*
Wetzel, J A *AmArch 70*
Wetzell, Charles H 1822-1898 *BiDAmAr*
Wetzler, Ernest *NewYHSD*
Wever, Adolph *NewYHSD*
Wever, Cornelis *ClaDrA*
Wever, H S *FolkA 86*
Wevil, George, Jr. *NewYHSD*
Wevill, George, Jr. *NewYHSD*
Wex-Cleemann, Else 1890- *DcWomA*
Wexelsen, Christian Delphin 1830-1883 *ClaDrA*
Wexler, Claire Thyra *WhoAmA 82, -84*
Wexler, Donald Allan 1926- *AmArch 70*
Wexler, George 1925- *WhoAmA 73, -76, -78, -80, -82, -84*
Wexler, Jerome L 1923- *MacBEP*
Wexler, Jerome Leroy 1923- *WhoAmA 78, -80, -82, -84*
Wexler, Morry 1924- *AmArch 70*
Weyand, Edith *WhAmArt 85*
Weyde, Gizela 1894- *DcWomA*
Weyden, Gosuin VanDer 1465?-1538? *McGDA*
Weyden, Roger 1400?-1464 *ClaDrA*
Weyden, Rogier VanDer 1399?-1464 *McGDA*
Weyden, Rogier VanDer 1400?-1464 *OxArt*
Weydinger, Pelagie Adele 1803-1870 *DcWomA*

Weyditz, Christoph *McGDA*
Weydmuller, Johanna Elisabeth 1725-1807 *DcWomA*
Weyer, Sophie *DcWomA*
Weyet, Albertine *DcWomA*
Weygold, Frederick P 1870-1941 *ArtsAmW 1,*
IIBEAAW, WhAmArt 85
Weyhe, Arthur *WhoAmA 76, -78, -80, -82, -84*
Weyhe, Mrs. Erhard *WhoAmA 80, -73, -76, -78*
Weyher, Suzanne 1878-1924 *DcWomA*
Weyl, Jenny *DcWomA*
Weyl, Lillian 1874- *DcWomA, WhAmArt 85*
Weyl, Max 1837-1914 *NewYHSD , WhAmArt 85*
Weyler, Jean Baptiste 1749-1791 *AntBDN J*
Weyler-Kugler, Louise *DcWomA*
Weyman, Miss *NewYHSD*
Weyman, Edward *CabMA*
Weymann, Jeannette Von 1849- *DcWomA*
Weymouth, Viscount *WhoArt 82, -84*
Weymouth, Allen Gene 1932- *AmArch 70*
Weymouth, Charles Machold 1938- *AmArch 70*
Weynerowski, Hanka *WhoAmA 82, -84*
Weyr, Rudolf 1847-1914 *McGDA*
Weyrich, Charles *FolkA 86*
Weyrich, Joseph Lewis *WhAmArt 85*
Weyrich, Marie *DcWomA*
Weyss, John E 1820-1903 *ArtsAmW 1, IIBEAAW,*
WhAmArt 85
Weyts, Carolus Ludovicus 1828-1875 *DcSeaP*
Weyts, Petrus *DcSeaP*
Weyzundt *FolkA 86*
Wezel *DcBrECP*
Wezel, Anna Van *DcWomA*
Whaite, Henry Clarence 1828-1912 *ClaDrA,*
DcBrA 1, DcBrWA, DcVicP, -2
Whaite, James *DcBrWA, DcVicP, -2*
Whaite, Lily F *DcVicP 2*
Whaite, Lyndon 1932- *WhoGrA 82[port]*
Whaites, Edward P *NewYHSD*
Whaites, John A *NewYHSD*
Whaites, John L *NewYHSD*
Whaites, William *NewYHSD*
Whaites, William N *NewYHSD*
Whalen, Anthony D, III 1958- *MarqDCG 84*
Whalen, John W 1891- *WhAmArt 85*
Whalen, Thomas *DcBrA 1*
Whaley, E Reed 1884- *WhAmArt 85*
Whaley, Edna Reed 1884- *DcWomA*
Whaley, Harold *DcBrA 1*
Whall, Christopher Whitworth 1849-1924 *DcVicP 2*
Whall, Veronica 1887-195-? *DcWomA*
Whalley, Adolphus Jacob *DcVicP 2*
Whalley, J K *DcVicP 2*
Whalley, Lawrence R 1943- *MarqDCG 84*
Whalley, Raymond 1918- *AmArch 70*
Whalter, R *NewYHSD*
Wham, R L *AmArch 70*
Wharam, H *DcBrECP*
Wharf, William D 1837-1936 *BiDAmAr*
Wharncliffe, Lady d1856 *DcWomA*
Wharton, Carol Forbes 1907-1958 *WhAmArt 85,*
WhoAmA 80N, -82N, -84N
Wharton, David W 1951- *WhoAmA 82, -84*
Wharton, Elizabeth *WhAmArt 85*
Wharton, Elizabeth 1882- *DcWomA*
Wharton, J *DcVicP 2*
Wharton, James P 1893-1963 *WhAmArt 85*
Wharton, James Pearce d1963 *WhoAmA 78N, -80N,*
-82N, -84N
Wharton, Joseph *NewYHSD*
Wharton, Margaret 1943- *DcCAr 81*
Wharton, P F 1841-1880 *ArtsNiC*
Wharton, Paul C 1928- *AmArch 70*
Wharton, S *DcBrBI*
Wharton, Samuel *BiDBrA*
Wharton, Samuel Ernest 1900- *ClaDrA, WhoArt 80,*
-82, -84
Wharton, Thomas Kelah 1814-1862 *NewYHSD*
Wharton And Davies *CabMA*
Whateley, B V C *AmArch 70*
Whateley, George *AntBDN N*
Whateley, H *NewYHSD*
Whately, M Alice H *DcVicP 2*
Whatley, Henry 1842-1901 *DcBrBI, DcBrWA,*
DcVicP 2
Whealton, Dan *FolkA 86*
Wheat, John Potter 1920- *WhAmArt 85*
Wheat, Richard A 1938- *AmArch 70*
Wheater, J H *WhAmArt 85*
Wheatley, Charles Haywood 1919- *AmArch 70*
Wheatley, Clara Maria *DcWomA*
Wheatley, Edith Grace 1888-1970 *DcBrA 1,*
DcWomA
Wheatley, Francis 1747-1801 *DcBrECP, DcBrWA,*
McGDA, OxArt
Wheatley, Mrs. Francis *DcBrECP, DcVicP, -2*
Wheatley, John Laviers 1892-1955 *DcBrA 1*
Wheatley, S T, III *AmArch 70*
Wheatley, T J 1853- *WhAmArt 85*
Wheatley, Thomas *FolkA 86*
Wheatley, William Walter 1811-1885 *DcBrWA,*
DcVicP 2

Wheaton, Daniel *NewYHSD*
Wheaton, Francis 1849- *WhAmArt 85*
Wheaton, Hiram *FolkA 86*
Wheaton, Jay Donald 1920- *AmArch 70*
Wheaton, Kenneth L 1940- *MarqDCG 84*
Wheaton, Miles K *NewYHSD*
Wheaton, Muriel 1902- *DcBrA 1, WhoArt 80*
Wheaton, William E *CabMA*
Wheatstone, Charles 1802-1875 *MacBEP*
Wheatstone, Sir Charles 1802-1875 *ICPEnP*
Whedon, Harriet *WhAmArt 85*
Whedon, Harriet Fielding 1888?-1958? *ArtsAmW 3*
Wheelan, Albertine 1863- *DcWomA*
Wheelan, Albertine Randall 1863- *ArtsAmW 2,*
WhAmArt 85
Wheelan, Edgar 1888-1966 *WorECom*
Wheeler, Miss *DcVicP 2*
Wheeler, A H d1916 *DcBrA 2*
Wheeler, Alfred 1852-1932 *DcBrA 1, DcVicP 2*
Wheeler, Alice A *DcWomA*
Wheeler, Alimira *DcWomA*
Wheeler, Andrew Cumming 1930- *AmArch 70*
Wheeler, Annie *DcVicP 2, DcWomA*
Wheeler, Asa H *NewYHSD*
Wheeler, Bruce R 1934- *MarqDCG 84*
Wheeler, C Herbert, Jr. 1915- *AmArch 70*
Wheeler, Candace *FolkA 86*
Wheeler, Candace Thurber 1828-1923 *NewYHSD ,*
WhAmArt 85
Wheeler, Carol Rosemary 1927- *WhoArt 80, -82, -84*
Wheeler, Cathrine *FolkA 86*
Wheeler, Charles E 1872-1949 *FolkA 86*
Wheeler, Charles H 1865- *WhAmArt 85*
Wheeler, Sir Charles Thomas 1892-1974 *DcBrA 1*
Wheeler, Chauncey *FolkA 86*
Wheeler, Cleora Clark *DcWomA, WhAmArt 85,*
WhoAmA 73, -76, -78, -80
Wheeler, Clifton A 1883-1953 *WhAmArt 85*
Wheeler, Dilah Drake *WhAmArt 85*
Wheeler, Dora *DcWomA, WhAmArt 85*
Wheeler, Dorothy Marion *DcBrA 1*
Wheeler, Dorothy Muriel 1891-1966 *DcBrBI,*
DcWomA
Wheeler, Doug 1939- *ConArt 77, -83, DcCAr 81,*
WhoAmA 78, -80, -82
Wheeler, E Kathleen *DcWomA, WhAmArt 85*
Wheeler, E Todd 1906- *AmArch 70*
Wheeler, Edward J *DcBrBI, DcVicP 2*
Wheeler, Edward J d1933 *DcBrA 2*
Wheeler, Elbert Morgan 1931- *AmArch 70*
Wheeler, Ellen Oldmixon *DcWomA*
Wheeler, Eveline Foleman 1813?- *FolkA 86*
Wheeler, Frances 1879- *DcWomA, WhAmArt 85*
Wheeler, Frederick J 1874-1930 *DcBrA 1*
Wheeler, Gervase *NewYHSD*
Wheeler, Gervase 1815?-1870 *MacEA*
Wheeler, H Anthony 1919- *WhoArt 80, -82, -84*
Wheeler, Harold D 1939- *MarqDCG 84*
Wheeler, Helen Cecil 1877- *DcWomA, WhAmArt 85*
Wheeler, Henrietta Virginia *FolkA 86*
Wheeler, Hilah 1878?-1970 *FolkA 86*
Wheeler, Howard Wentworth 1913- *AmArch 70*
Wheeler, Hughlette 1900?-1955 *WhAmArt 85*
Wheeler, Hughlette Tex 1900?-1955 *IIBEAAW*
Wheeler, Hulda *FolkA 86*
Wheeler, James Edward 1935- *AmArch 70*
Wheeler, James Henry, Jr. 1925- *AmArch 70*
Wheeler, James Thomas 1849-1888 *DcVicP 2*
Wheeler, Janet d1945 *DcWomA*
Wheeler, Janet D *ArtsEM, WhAmArt 85*
Wheeler, Janet D d1945 *ArtsAmW 2*
Wheeler, John *BiDBrA*
Wheeler, John Alfred 1821-1877 *DcVicP 2*
Wheeler, John Arnold 1821-1877 *DcVicP*
Wheeler, John Charles 1914- *AmArch 70*
Wheeler, Mrs. John Hill *NewYHSD*
Wheeler, John Rogers 1907- *AmArch 70*
Wheeler, Jonathan Dodge *FolkA 86*
Wheeler, Joseph 1775?-1832 *BiDBrA*
Wheeler, Josiah *CabMA*
Wheeler, K D *AmArch 70*
Wheeler, Kathleen 1884-1977 *DcWomA,*
WhAmArt 85
Wheeler, Laura *DcWomA, WhAmArt 85*
Wheeler, Lavern F *ArtsEM*
Wheeler, Lydia Jane *DcWomA*
Wheeler, Lyle 1905- *ConDes*
Wheeler, Mark 1943- *WhoAmA 78, -80, -82, -84*
Wheeler, Martha M *ArtsAmW 3*
Wheeler, Mary Ann *DcWomA*
Wheeler, Mary C d1920 *WhAmArt 85*
Wheeler, Mary Cecil *ArtsAmW 3*
Wheeler, Mary Colman 1846-1920 *DcWomA*
Wheeler, Millicent *DcWomA*
Wheeler, Monroe 1900- *WhoAmA 73, -76*
Wheeler, Muriel *WhoArt 80*
Wheeler, Lady Muriel *DcBrA 1,*
DcWomA
Wheeler, N *NewYHSD*
Wheeler, Nathan W *NewYHSD*
Wheeler, Nina Barr *WhAmArt 85*

Wheeler, Norris Glen 1914- *AmArch 70*
Wheeler, Obadiah 1673- *FolkA 86*
Wheeler, Orson Shorey 1902- *WhoAmA 73, -76, -78,*
-80, -82, -84
Wheeler, R G *AmArch 70*
Wheeler, R H *AmArch 70*
Wheeler, Ralph D *WhAmArt 85*
Wheeler, Ralph Loring 1895- *WhAmArt 85*
Wheeler, Rebekah 1649- *FolkA 86*
Wheeler, Robert G 1917- *WhoAmA 73, -76, -78, -80*
Wheeler, Rollo Simpson 1922- *AmArch 70*
Wheeler, S A *DcVicP 2, DcWomA*
Wheeler, S M *AmArch 70*
Wheeler, Sam 1742-1810 *FolkA 86*
Wheeler, Shang *FolkA 86*
Wheeler, Starr Duffy *MarqDCG 84*
Wheeler, Sylvia A *DcWomA, NewYHSD*
Wheeler, Thomas *AntBDN D*
Wheeler, Tilman Eugene, Jr. 1936- *AmArch 70*
Wheeler, Mrs. W H *DcVicP 2*
Wheeler, W R *AmArch 70*
Wheeler, Walter Herbert 1878-1960 *DcBrA 1,*
DcVicP 2
Wheeler, William R 1832-1894? *ArtsEM,*
NewYHSD
Wheeler, Zona Lorraine 1913- *WhAmArt 85,*
WhoArt 80, -82, -84
Wheelersmith, Olive *DcVicP 2, DcWomA*
Wheelhouse, M V *ConICB, IlsCB 1744*
Wheelhouse, Mary V *DcBrBI, DcVicP 2*
Wheelock, Adelaide *WhAmArt 85*
Wheelock, Arthur Kingsland, Jr. 1943- *WhoAmA 78,*
-80, -82, -84
Wheelock, Ellen *DcWomA, WhAmArt 85*
Wheelock, H V *AmArch 70*
Wheelock, Harry Bergen 1861-1934 *BiDAmAr*
Wheelock, J Adams *WhAmArt 85*
Wheelock, Lila Audubon *WhAmArt 85*
Wheelock, Lila Audubon 1890- *DcWomA*
Wheelock, Merrill G 1822-1866 *EarABI,*
EarABI SUP, NewYHSD
Wheelock, Otis Leonard 1816-1886? *BiDAmAr*
Wheelock, S C *AmArch 70*
Wheelock, Walter W *NewYHSD*
Wheelock, Warren 1880-1960 *WhAmArt 85*
Wheelock, Warren F 1880-1960 *WhoAmA 80N, -82N,*
-84N
Wheelock, Warren Frank 1880-1960 *ArtsAmW 2*
Wheelon, Homer 1888- *ArtsAmW 3*
Wheelright, Louise *WhAmArt 85*
Wheelwright, Anna *DcVicP 2, DcWomA*
Wheelwright, Edmund M 1854-1912 *BiDAmAr,*
MacEA
Wheelwright, Edward 1824-1900 *NewYHSD ,*
WhAmArt 85
Wheelwright, Elizabeth S 1915- *WhAmArt 85*
Wheelwright, Ellen Dupont 1889- *DcWomA*
Wheelwright, Ellen DuPont 1889- *WhAmArt 85*
Wheelwright, Hene P *DcVicP 2, DcWomA*
Wheelwright, J Hadwen *DcVicP, -2*
Wheelwright, Joseph 1948- *AmArt*
Wheelwright, Rowland 1870- *ClaDrA*
Wheelwright, Rowland 1870-1955 *DcBrA 1,*
DcVicP 2
Wheelwright, W H *DcVicP 2*
Wheen, Helen *DcVicP 2*
Wheete, Glenn 1884- *ArtsAmW 2, WhAmArt 85*
Wheete, Treeva 1890- *ArtsAmW 2*
Wheete, Treva 1890- *ArtsAmW 2, WhAmArt 85*
Whelan, Blanche *ArtsAmW 3, DcWomA,*
WhAmArt 85
Whelan, Donald Victor 1919- *AmArch 70*
Whelan, Henry, Jr. d1907 *WhAmArt 85*
Whelan, J J, Jr. *AmArch 70*
Whelan, K A *DcVicP 2*
Whelan, Leo Augustus 1899- *AmArch 70*
Whelan, Michael Leo 1892-1956 *DcBrA 1*
Wheldon, James H *DcSeaP, DcVicP 2*
Whelen, Blanche *ArtsAmW 3*
Whelpley, Philip M *NewYHSD*
Whelpley, Thomas *NewYHSD*
Wherrett, J Ramsey 1914- *DcBrA 1*
Wherrette, W C *AmArch 70*
Wherry, Elizabeth F *WhAmArt 85*
Whetherill *DcBrECP*
Whetsel, Gertrude P 1886- *ArtsAmW 2, DcWomA,*
WhAmArt 85
Whetstone, Albert L *MarqDCG 84*
Whetstone, John S *NewYHSD*
Whetstone, Lydia S *FolkA 86*
Whetten, Thomas 1754-1836 *BiDBrA*
Whetting, John *NewYHSD*
Whewell, Herbert 1863-1951 *DcBrA 1, DcVicP 2*
Whichcord, John 1790-1860 *BiDBrA*
Whichelo, C John 1784-1865 *DcSeaP*
Whichelo, C John M 1784-1865 *DcBrBI, DcBrWA,*
DcVicP, -2
Whichelo, H M *DcVicP*
Whichelo, Henry Mayle *DcBrWA, DcVicP 2*
Whichelo, J d1867 *DcBrWA*
Whichelo, William J *DcBrWA, DcVicP 2*

Whicker, Frederick John Hayes 1901- *DcBrA 1*
Whicker, Gwendoline *DcBrA 1*
Whidden, Conni *WhoAmA 78, -80, -82, -84*
Whidden, Constance *WhoAmA 76*
Whidden, Michael *CabMA*
Whidden, William H d1925 *BiDAmAr*
Whidden, William H 1857-1929 *MacEA*
Whidden And Lewis *MacEA*
Whiddon, William Pinson *AmArch 70*
Whieldon, Thomas 1719-1795 *AntBDN M, OxDecA*
Whifler, William Arthur 1926- *AmArch 70*
Whim, John A *FolkA 86*
Whinfrey, Hugh R 1955- *MarqDCG 84*
Whinnery, Joseph *ArtsEM*
Whinney, Thomas B *DcVicP 2*
Whinston, Bertram Lee 1922- *AmArch 70*
Whinston, Charlotte *WhAmArt 85, WhoAmA 73, -76*
Whinston, Charlotte 1895-1976 *DcWomA*
Whipham, Thomas *AntBDN Q*
Whipple *NewYHSD*
Whipple, Agnes *DcWomA*
Whipple, Barbara *WhoAmA 73, -76, -78, -80, -82, -84*
Whipple, C Ayer 1859-1928 *WhAmArt 85*
Whipple, Clarissa *FolkA 86*
Whipple, Dorothy Wieland 1906- *WhAmArt 85*
Whipple, Elsie R *WhAmArt 85*
Whipple, Enez Mary *WhoAmA 73, -76, -78, -80, -82, -84*
Whipple, John *CabMA, DcVicP, -2*
Whipple, Mrs. John *DcVicP 2*
Whipple, Seth Arca 1855?-1901 *ArtsEM*
Whipple, Seth Arca 1856-1901 *WhAmArt 85*
Whipple, Seth Area 1855-1901 *DcSeaP*
Whipple, Walter Leighton 1940- *MarqDCG 84*
Whisenand, George V 1913- *AmArch 70*
Whish, Lilian J *WhAmArt 85*
Whishaw, Anthony 1930- *ConBrA 79[port], WhoAmA 80, -82, -84*
Whishner, G Arthur *WhAmArt 85*
Whisler, Francis Ledyard 1921- *AmArch 70*
Whisler, Howard F 1886- *WhAmArt 85*
Whisler, John *FolkA 86*
Whisnant, W M *AmArch 70*
Whistler, George Washington 1800-1849 *ArtsEM, NewYHSD*
Whistler, James Abbot McNeil 1834-1903 *DcBrBI*
Whistler, James Abbot McNeill 1834-1903 *AntBDN B, DcBrWA*
Whistler, James Abbott MacNeill 1834-1903 *ClaDrA*
Whistler, James Abbott McNeill 1834-1903 *BnEnAmA, DcAmArt, DcBrA 1, DcSeaP, DcVicP, -2, McGDA, NewYHSD, OxArt, WhAmArt 85*
Whistler, James Abbott M'Neill 1834- *ArtsNiC*
Whistler, Joseph Swift 1860-1905 *WhAmArt 85*
Whistler, Laurence 1912- *IlDcG, WhoAmA 80, -82, -84*
Whistler, Laurence 1913- *DcNiCA*
Whistler, Rex 1905-1944 *McGDA*
Whistler, Rex John 1905-1944 *DcBrA 1, OxArt*
Whistler, Theresa 1927- *IlsCB 1946*
Whitacre, Geraldine *DcWomA*
Whitaker, Miss *DcVicP 2*
Whitaker, Alice J *ArtsEM, DcWomA*
Whitaker, Charles *NewYHSD*
Whitaker, D *DcVicP 2*
Whitaker, E M *FolkA 86*
Whitaker, Edward H 1808?- *NewYHSD*
Whitaker, Eileen 1911- *IlBEAAW*
Whitaker, Eileen Monoghan 1911- *WhoAmA 82, -84*
Whitaker, Eileen Monoghan 1911- *WhAmArt 85*
Whitaker, Elliot Leonard 1910- *AmArch 70*
Whitaker, Ethel 1877- *DcWomA, WhAmArt 85*
Whitaker, Frank *DcVicP 2*
Whitaker, Frederic 1891- *ArtsAmW 2, IlBEAAW, WhAmArt 85, WhoAmA 73, -76, -78, -80*
Whitaker, Frederic 1891-1980 *WhoAmA 82N, -84N*
Whitaker, G G *DcVicP 2*
Whitaker, George 1834-1874 *DcBrWA, DcVicP 2*
Whitaker, George William 1841-1916 *WhAmArt 85*
Whitaker, H *DcVicP 2*
Whitaker, Irwin A 1919- *WhoAmA 73, -76, -78, -80, -82, -84*
Whitaker, John *WhAmArt 85*
Whitaker, John 1807-1864 *AntBDN M*
Whitaker, Lawrence Leroy 1889- *WhAmArt 85*
Whitaker, Marston *DcVicP 2*
Whitaker, R C *AmArch 70*
Whitaker, Rita Elizabeth 1936- *WhoArt 82, -84*
Whitaker, Sanford Columbus *AmArch 70*
Whitaker, Stella Trowbridge *WhAmArt 85*
Whitaker, Thomas L 1937- *AmArch 70*
Whitaker, V G *AfroAA*
Whitaker, William *OfPGCP 86*
Whitaker, William 1943- *WhoAmA 76, -78, -80, -82, -84*
Whitaker, William M *DcVicP 2*
Whitall Tatum *IlDcG*
Whitbread, W E *DcVicP 2*
Whitburn, Thomas *DcVicP 2*

Whitby, W *DcVicP 2*
Whitby, William *DcBrECP*
Whitby, William Franklin, Jr. 1923- *AmArch 70*
Whitcomb, Francis George 1937- *AmArch 70*
Whitcomb, J H *FolkA 86*
Whitcomb, J L *CabMA*
Whitcomb, John Merrall 1907- *AmArch 70*
Whitcomb, Jon *WhAmArt 85*
Whitcomb, Jon 1906- *IlrAm E, -1880, WhoAmA 73, -76, -78, -80, -82*
Whitcomb, Kay 1921- *WhoAmA 84*
Whitcomb, L *DcWomA*
Whitcomb, Roger Pitt 1936- *AmArch 70*
Whitcomb, Susan *DcWomA, FolkA 86, NewYHSD*
Whitcomb, Therese Truitt 1930- *WhoAmA 80, -82, -84*
Whitcombe, Sydney 1916- *WhoArt 80, -82, -84*
Whitcombe, Thomas 1752?-1824 *DcSeaP*
Whitcombe, Thomas 1763- *DcBrECP*
Whitcome, Sydney 1916- *ClaDrA*
Whitcraft, Dorothea Fricke 1894?- *DcWomA*
Whitcraft, Dorothea Fricke 1899- *ArtsAmW 2*
White *FolkA 86*
White, A C *DcWomA*
White, Mrs. A C *DcVicP 2*
White, Abel *FolkA 86*
White, Aedina *AfroAA*
White, Agnes *DcVicP 2*
White, Agnes 1897- *WhAmArt 85*
White, Agnes Baldwin 1897- *DcWomA*
White, Albert *WhoAmA 76, -78, -80, -82, -84*
White, Alden 1861- *WhAmArt 85*
White, Alexander *CabMA, FolkA 86*
White, Alice *DcBrWA, DcVicP 2*
White, Alma 1840-1884 *DcWomA*
White, Alvin A *FolkA 86*
White, Ambrosia Chuse 1894- *DcWomA, WhAmArt 85*
White, Amos *AfroAA, NewYHSD*
White, Amos, IV *WhoAmA 76, -78, -80, -82, -84*
White, Andrew *CabMA*
White, Ann *DcBrWA*
White, Archie 1899-1957 *DcBrA 1*
White, Arthur *ClaDrA*
White, Arthur 1865-1953 *DcBrA 1, DcVicP 2*
White, Arthur B 1918- *AmArch 70*
White, B J 1946- *WhoAmA 84*
White, Belle Cady d1945 *WhAmArt 85*
White, Belle Cady 1868-1945 *DcWomA*
White, Benjamin 1828?- *NewYHSD*
White, Benny 1937- *AfroAA*
White, Benoni 1784?-1833 *BiDBrA*
White, Brian 1902- *WorECom*
White, Bruce 1933- *DcCAr 81*
White, Bruce 1958- *MarqDCG 84*
White, Bruce Hilding 1933- *WhoAmA 73, -76, -78, -80, -82, -84*
White, C *DcVicP 2, DcWomA*
White, Mrs. C *DcVicP 2*
White, C Ferris 1867-1932 *BiDAmAr*
White, C G *DcVicP 2*
White, C J 1925- *PrintW 85*
White, C P *DcVicP 2*
White, Carmel 1887-1961 *WorFshn*
White, Caroline 1952- *DcCAr 81*
White, Carrie 1875- *DcWomA*
White, Carrie Harper 1875- *ArtsAmW 3*
White, Mrs. Cecil *FolkA 86*
White, Cecil 1900- *WorECar*
White, Charles *BiDBrA, CabMA, DcBrWA*
White, Charles d1780 *DcBrECP*
White, Charles 1918- *AfroAA, OxTwCA*
White, Charles 1928- *WhoArt 80, -82, -84*
White, Charles Elmer, Jr. 1876-1936 *BiDAmAr*
White, Charles Franklin d1975 *DcBrA 2*
White, Charles Henry *WhAmArt 85*
White, Charles Wilbert 1918- *WhAmArt 85, WhoAmA 73, -76, -78*
White, Charles Wilbert 1918-1979 *WhoAmA 80N, -82N, -84N*
White, Charlotte *AfroAA*
White, Cherry *DcWomA*
White, Cheverton 1830- *DcBrWA*
White, Clara C *DcWomA*
White, Clarence H 1871-1925 *DcAmArt, ICPEnP*
White, Clarence Hudson 1871-1925 *MacBEP*
White, Clarence Hudson, II 1907- *WhAmArt 85*
White, Clarence Hudson, Sr. 1871-1925 *WhAmArt 85*
White, Clarence Scott 1872- *WhAmArt 85*
White, Clement *DcVicP 2*
White, Constance *WhAmArt 85*
White, Constance E *DcWomA*
White, D *DcVicP 2*
White, D N *AmArch 70*
White, Dale Alfred 1904- *AmArch 70*
White, Dan *DcVicP 2*
White, Daniel *CabMA*
White, Daniel Thomas *DcVicP, -2*
White, David 1934- *WhoArt 80, -82, -84*
White, David Omar 1927- *IlsBYP*

White, Deborah *WhoAmA 78, -80, -82, -84*
White, Donald F 1928- *AmArch 70*
White, Donald Francis 1908- *AfroAA*
White, Donald Frank 1908- *AmArch 70*
White, Dora *DcVicP 2*
White, Doris A *WhoAmA 73, -76, -78, -80, -82, -84*
White, Duke *NewYHSD*
White, Mrs. E A *DcVicP 2*
White, E Fox *DcVicP 2*
White, E S *AmArch 70*
White, Ebenezer Baker 1806- *FolkA 86*
White, Ebenezer Baker 1806-1888 *NewYHSD*
White, Edith d1946 *WhAmArt 85*
White, Edith 1855-1946 *ArtsAmW 2, DcWomA*
White, Edmund Richard *DcBrBI, DcVicP, -2*
White, Edward *BiDBrA*
White, Edward B *NewYHSD*
White, Edward Brickell 1806-1882 *BiDAmAr*
White, Edward Chester 1917- *AmArch 70*
White, Edward D, Jr. 1925- *AmArch 70*
White, Edward Richard *DcVicP, -2*
White, Edwin *FolkA 86*
White, Edwin 1817-1877 *ArtsNiC, EarABI, NewYHSD*
White, Elbridge Buford 1916- *AmArch 70*
White, Elizabeth *WhAmArt 85*
White, Elizabeth 1893- *DcWomA*
White, Elizabeth A *DcWomA*
White, Elizabeth Catlett *AfroAA*
White, Ella *DcBrWA*
White, Elsie Maude 1889- *WhoArt 80, -82, -84*
White, Emily H d1924 *DcWomA*
White, Emily H 1862-1924 *WhAmArt 85*
White, Emma Chandler 1868- *WhAmArt 85*
White, Emma Locke Reinhard 1871-1953 *WhAmArt 85*
White, Emma Locke Rianhard 1871-1953 *DcWomA*
White, Eric *AfroAA*
White, Erica *DcBrA 1, WhoArt 80, -82, -84*
White, Ernest A *DcVicP 2*
White, Ethel A *DcWomA*
White, Ethelbert 1891- *OxArt*
White, Ethelbert 1891-1972 *ClaDrA, DcBrA 1*
White, Eugene B d1966 *WhoAmA 78N, -80N, -82N, -84N*
White, F G *DcVicP 2*
White, Flora *DcVicP 2*
White, Florence *DcBrA 2, DcVicP 2, DcWomA*
White, Frances *DcWomA, WhAmArt 85*
White, Frances J *DcVicP 2*
White, Francis *FolkA 86*
White, Francis Robert 1907- *WhAmArt 85*
White, Frank M *WhAmArt 85*
White, Frank Wesley 1917- *AmArch 70*
White, Franklin *DcBrA 1, NewYHSD*
White, Franklin 1943- *AfroAA, WhoAmA 78, -80, -82, -84*
White, Fred R 1935- *AmArch 70*
White, Fritz *IlBEAAW*
White, Fuller *AntBDN Q, BiDBrA*
White, G H P *DcVicP 2*
White, G L *AmArch 70*
White, Gabriel Ernest Edward Francis 1902- *WhoArt 80, -82, -84*
White, George *CabMA, DcVicP 2, NewYHSD*
White, George 1903-1970 *FolkA 86*
White, George 1920- *AfroAA*
White, George Fleming 1868- *WhAmArt 85*
White, George Francis 1808-1898 *DcBrBI, DcBrWA, DcVicP 2*
White, George G d1898 *EarABI, EarABI SUP*
White, George Gorgas 1835?-1898 *IlBEAAW, NewYHSD, WhAmArt 85*
White, George Harlow 1817-1888 *DcVicP, -2, IlBEAAW*
White, George Irwine *NewYHSD*
White, George Malcolm 1920- *AmArch 70*
White, George Merwangee 1849-1915 *WhAmArt 85*
White, George R 1811?- *NewYHSD*
White, George T *NewYHSD*
White, George W *NewYHSD*
White, George W 1826-1890 *NewYHSD*
White, Gleeson 1851-1898 *ClaDrA, DcBrBI*
White, Gottlieb 1762-1822 *CabMA*
White, Gwen *WhoArt 80, -82, -84*
White, Gwen B *DcBrA 2*
White, H *DcVicP 2*
White, H E *AmArch 70*
White, H L *EncASM*
White, H Mabel *DcWomA*
White, H P *WhAmArt 85*
White, Harold 1903- *DcBrA 1*
White, Harvey Marshall 1932- *AmArch 70*
White, Helene Maynard 1870- *DcWomA, WhAmArt 85*
White, Henry *DcVicP 2*
White, Henry 1819-1903 *MacBEP*
White, Henry Cooke 1861-1952 *WhAmArt 85*
White, Henry F *NewYHSD*
White, Henry Hopley *DcBrWA, DcVicP 2*
White, Henry J *FolkA 86*

White, Henry Kenneth *AmArch 70*
White, Henry S Taylor 1879-1943 *BiDAmAr*
White, Henry S Taylor, Jr. d1944 *BiDAmAr*
White, Herbert Palmer 1907- *AmArch 70*
White, Howard Judson 1870-1936 *BiDAmAr, MacEA*
White, Howard L 1919- *AmArch 70*
White, Hugh Edward 1914- *AmArch 70*
White, Hugh Stanley 1904- *WorECom*
White, Ian McKibbin 1929- *WhoAmA 73, -76, -78, -80, -82, -84*
White, Ianthe *WhoArt 80N*
White, Ianthe 1901- *DcBrA 1*
White, Inez Mary Platfoot 1889- *ArtsAmW 2, DcWomA, WhAmArt 85*
White, Isabel G *DcVicP 2*
White, Iva Martin 1882-1955 *FolkA 86*
White, J *NewYHSD*
White, J C 1895- *WhAmArt 85*
White, J H *DcVicP 2*
White, J Philip 1939- *AfroAA*
White, J R *AmArch 70*
White, J T *AmArch 70*
White, J Talmage *DcVicP, -2*
White, Jack 1931- *WhoAmA 78, -80, -82*
White, Jack 1940- *AfroAA*
White, James *WhoArt 80*
White, James 1744-1825 *DcBrWA*
White, James 1913- *WhoArt 82, -84*
White, James Edmund 1933- *AmArch 70*
White, James Everett 1924- *AmArch 70*
White, James Lucius 1927- *AmArch 70*
White, James McLaren 1867-1933 *BiDAmAr*
White, James Noel 1917- *WhoArt 80, -82, -84*
White, James Richard 1950- *WhoAmA 82, -84*
White, Jane Felix 1872-1943 *WhAmArt 85*
White, Jessie Aline *WhAmArt 85*
White, Jessie Aline 1889- *ArtsAmW 2, DcWomA*
White, John *AntBDN N, -Q, BiDBrA, CabMA, DcAmArt, DcBrWA, FolkA 86*
White, John d1850 *BiDBrA*
White, John 1550?-1593? *BnEnAmA, IlBEAAW, NewYHSD*
White, John 1747?-1813 *BiDBrA*
White, John 1851-1933 *ClaDrA 1, DcBrA 1, DcBrWA, DcVicP, -2*
White, Mrs. John *DcVicP 2*
White, John Blake 1781-1859 *ArtsNiC, NewYHSD*
White, John Henry 1909- *WhoArt 80, -82, -84*
White, John Jamieson, Jr. 1910- *AmArch 70*
White, John M 1937- *WhoAmA 78, -80, -82, -84*
White, John Norman 1932- *WhoArt 80, -82, -84*
White, John Poston 1933- *AmArch 70*
White, John Warren 1932- *AmArch 70*
White, Joseph *NewYHSD*
White, Joseph d1718? *CabMA*
White, Josephine M *DcVicP 2*
White, Josiah *NewYHSD*
White, Julia Mary *DcWomA*
White, Juliet *DcWomA*
White, Juliet M *WhAmArt 85*
White, Juliet VonO *WhAmArt 85*
White, K E *AmArch 70*
White, Karl S 1910- *AmArch 70*
White, L D *AmArch 70*
White, L E *DcWomA*
White, Lawrence Dale 1926- *AmArch 70*
White, Lawrence Eugene 1908- *WhoAmA 73, -76*
White, Lemuel *NewYHSD*
White, Leo 1918- *WhoAmA 73, -76, -78, -80*
White, Lorenzo d1834 *NewYHSD*
White, Lucy Schwab *WhAmArt 85*
White, M *NewYHSD*
White, M H *AmArch 70*
White, Mabel *DcWomA*
White, Mable Dunn 1902- *WhAmArt 85*
White, Margaret Wood 1893- *DcWomA, WhAmArt 85*
White, Marie 1903- *WhAmArt 85*
White, Mary *WhoArt 80, -82, -84*
White, Mary 1869- *DcWomA, WhAmArt 85*
White, Mary Jane 1907- *WhAmArt 85*
White, Mazie J 1871-1934 *WhAmArt 85*
White, Mazie Julia Barkley 1871-1934 *DcWomA*
White, Mildred H Congden *DcBrA 2*
White, Minerva 1878- *ArtsAmW 3*
White, Minor 1908- *BnEnAmA*
White, Minor 1908-1976 *ConPhot, DcAmArt, ICPEnP, WhAmArt 85, WhoAmA 78N, -80N, -82N, -84N*
White, Minor Martin 1908-1976 *MacBEP*
White, N A *FolkA 86*
White, N A, Jr. *FolkA 86*
White, Nancy 1916- *WorFshn*
White, Nathan F *NewYHSD*
White, Nelson Cooke 1900- *WhAmArt 85*
White, Noah *FolkA 86*
White, Nona L 1859- *ArtsAmW 1*
White, Nona L 1859-1937 *DcWomA, WhAmArt 85*
White, Norman Triplett 1938- *WhoAmA 73, -76, -78, -80, -82, -84*
White, Norval Crawford 1926- *AmArch 70*

White, Orrin A 1883-1969 *WhAmArt 85*
White, Orrin Augustine 1883- *ArtsAmW 1*
White, Orrin Augustine 1883-1969 *IlBEAAW*
White, Owen Sheppard 1893- *WhAmArt 85*
White, Peter R *CabMA*
White, Peter W *WhAmArt 85*
White, Philip 1935- *AmArt*
White, Philip Butler 1935- *WhoAmA 76, -78, -80, -82, -84*
White, R Denis 1943- *MarqDCG 84*
White, R P *AmArch 70*
White, Ralph 1921- *WhoAmA 76, -78, -80, -82, -84*
White, Randy Lee 1951- *AmArt*
White, Richard A 1936- *MarqDCG 84*
White, Richard E 1927- *AmArch 70*
White, Richard H *FolkA 86*
White, Richard William 1924- *AmArch 70*
White, Robert 1645-1704 *BkIE*
White, Robert 1921- *WhoAmA 73, -76, -78, -80, -82, -84*
White, Robert Coleman 1935- *AmArch 70*
White, Robert Daniel 1914- *AmArch 70*
White, Robin 1946- *DcCAr 81*
White, Roger Lee 1925- *WhoAmA 73, -76, -78, -80*
White, Roger Paul 1942- *MarqDCG 84*
White, Ron 1944- *WhoAmA 76, -78, -80, -82*
White, Ronald Arthur 1906- *AmArch 70*
White, Roswell N *NewYHSD*
White, Russell Stevens 1923- *AmArch 70*
White, Ruth *WhoAmA 73, -76, -78, -80, -82, -84*
White, Samuel *CabMA*
White, Mrs. Samuel *DcWomA*
White, Sarah *AfroAA*
White, Sidney W *DcVicP 2*
White, Standford 1853-1906 *BiDAmAr, DcD&D*
White, Stanford 1853-1906 *BnEnAmA, MacEA, McGDA*
White, Stephen Leon 1938- *MacBEP*
White, Stuart James 1944- *WhoAmA 84*
White, Susan Chrysler 1954- *WhoAmA 84*
White, T J *FolkA 86*
White, T W *AmArch 70*
White, Theo 1902- *WhAmArt 85*
White, Theo Ballou 1903- *AmArch 70*
White, Theresa *ArtsEM, DcWomA*
White, Thomas *AntBDN K, DcBrWA*
White, Thomas 1674?-1748 *BiDBrA, MacEA*
White, Thomas Cleaver 1941- *AmArch 70*
White, Thomas Gilbert 1877-1939 *ArtsEM, IlBEAAW, WhAmArt 85*
White, Thomas J 1825-1902 *FolkA 86*
White, Thomas Lyon 1902- *AmArch 70*
White, Tom 1912- *DcBrA 1*
White, Tommy C 1959- *MarqDCG 84*
White, V M *AmArch 70*
White, Vera *WhAmArt 85*
White, Vera M 1888-1966 *DcWomA*
White, Verner 1863-1923 *ArtsAmW 3*
White, Victor 1891-1954 *WhAmArt 85*
White, W *DcVicP, -2*
White, W L *AmArch 70*
White, W Tatton *DcVicP 2*
White, Walter Charles Louis d1964? *WhAmArt 85*
White, Walter L *WhoAmA 78N, -80N, -82N, -84N*
White, Warren G 1924- *AmArch 70*
White, Willard Lewis 1898- *AmArch 70*
White, William *AfroAA, DcBrWA, DcVicP 2, FolkA 86*
White, William d1673 *FolkA 86*
White, William 1825-1900 *MacEA*
White, William, Jr. 1934- *MarqDCG 84*
White, William Davidson 1896- *WhAmArt 85*
White, William Earl 1924- *AmArch 70*
White, William Fred *FolkA 86*
White, William G *NewYHSD*
White, William James *NewYHSD*
White, William Johnstone *DcBrBI, DcBrWA*
White, William Philip 1942- *AmArch 70*
White, Winfield *FolkA 86*
White Bear *WhAmArt 85*
White Bear 1869- *IlBEAAW*
White Bear 1906- *IlBEAAW*
White Deer, Gary *OfPGCP 86*
Whitebead, Baida *IlsBYP*
Whitechurch, Robert 1814-1880? *NewYHSD*
Whitefield, Edwin d1892 *FolkA 86*
Whitefield, Edwin 1816-1892 *IlBEAAW, NewYHSD*
Whitefield, Emma *DcWomA*
Whiteford, Sidney Trefusis *DcVicP, -2*
Whiteford, Sidney Trefusis 1837-1915 *DcBrWA*
Whitefort, Annette *DcWomA*
Whiteham, Edna May 1887- *DcWomA*
Whiteham, May 1887- *ArtsAmW 2*
Whitehan, Edna May 1887- *DcWomA*
Whitehan, May 1887- *ArtsAmW 2, WhAmArt 85*
Whitehead, Alan 1952- *DcSeaP*
Whitehead, Alfred 1887- *WhoAmA 73*
Whitehead, Daniel Carr 1883- *AmArch 70*
Whitehead, Deborah *ArtsEM, DcWomA*
Whitehead, Edith H *WhAmArt 85*
Whitehead, Elizabeth *DcBrA 1, DcVicP 2,*

DcWomA
Whitehead, Florence *WhAmArt 85*
Whitehead, Frances M *DcBrBI, DcVicP 2*
Whitehead, Frederick William Newton 1853-1938 *DcBrA 1, DcVicP, -2*
Whitehead, Harold d1910? *DcBrWA*
Whitehead, Henry Mims, Jr. 1926- *AmArch 70*
Whitehead, James Louis 1913- *WhoAmA 73*
Whitehead, K R *AmArch 70*
Whitehead, L N *FolkA 86*
Whitehead, Lilian 1894- *DcBrA 1, DcWomA*
Whitehead, Margaret DellaRovere *WhoArt 80, -82, -84*
Whitehead, Margaret DellaRovere 1903- *DcBrA 1*
Whitehead, Margaret VanCortlandt *DcWomA, WhAmArt 85*
Whitehead, N W *AmArch 70*
Whitehead, Paul Allan 1932- *AmArch 70*
Whitehead, Ralph Radcliff 1854-1929 *WhAmArt 85*
Whitehead, Thomas Phillip 1924- *AmArch 70*
Whitehead, Tom 1886- *ClaDrA, DcBrA 1*
Whitehead, Walter 1874-1956 *WhAmArt 85*
Whitehead, Walter Muir 1905- *WhAmArt 85*
Whitehill, Charlotte Jane *FolkA 86*
Whitehill, Florence *WhoAmA 73, -76, -78, -80, -82, -84*
Whitehill, Walter Muir 1905- *WhoAmA 73, -76, -78*
Whitehill, Walter Muir 1905-1978 *WhoAmA 80N, -82N, -84N*
Whitehorne, James 1803- *ArtsNiC*
Whitehorne, James A 1803-1888 *NewYHSD*
Whitehouse, Arthur E *DcVicP 2*
Whitehouse, Francis M 1848-1938 *BiDAmAr*
Whitehouse, Harold C 1884- *AmArch 70*
Whitehouse, James Horton 1833-1902 *NewYHSD, WhAmArt 85*
Whitehouse, Morris H 1867-1944 *BiDAmAr*
Whitehouse, Morris H 1878-1944 *MacEA*
Whitehouse, Sarah E *DcBrWA, DcVicP 2*
Whitehurst, Camelia 1871-1936 *DcWomA, WhAmArt 85*
Whitehurst, John 1713-1788 *AntBDN D*
Whitehurst, S R, Jr. *AmArch 70*
Whitelaw, Frederick William *DcVicP 2*
Whitelaw, George *DcBrBI*
Whitelaw, Graeme Andrew 1935- *AmArch 70*
Whitelaw, Norma *DcWomA, WhAmArt 85*
Whitelaw, Robert N S *WhAmArt 85*
Whitelaw, S Frances *DcVicP 2*
Whiteley, Brett 1939- *DcCAr 81, PhDcTCA 77*
Whiteley, H H *AmArch 70*
Whiteley, John William *DcBrWA, DcVicP 2*
Whiteley, Rose *ArtsAmW 2, DcWomA, WhAmArt 85*
Whitelock, George 1780-1833 *CabMA*
Whitelock, Samuel West *NewYHSD*
Whitely, Kate Mary d1920 *DcBrWA*
Whiteman, Edward Russell 1938- *WhoAmA 76, -78, -80, -82, -84*
Whiteman, Henry *FolkA 86*
Whiteman, Leona *WhAmArt 85*
Whiteman, Richard Frank 1925- *AmArch 70*
Whiteman, S Edwin 1860-1922 *WhAmArt 85*
Whiteman, T W *FolkA 86*
Whiten, Colette 1945- *WhoAmA 78, -80, -82, -84*
Whiten, Tim 1941- *WhoAmA 80, -82, -84*
Whitener, Paul A W 1911-1959 *WhoAmA 80N, -82N, -84N*
Whitener, Paul W 1911-1959 *WhAmArt 85*
Whitener, Thomas *FolkA 86*
Whitesell, John D 1942- *WhoAmA 76, -78, -80, -82, -84*
Whiteside *NewYHSD*
Whiteside, F Allen *AmArch 70*
Whiteside, Forbes J *WhoAmA 73*
Whiteside, Frank Reed 1866-1929 *ArtsAmW 1, IlBEAAW, WhAmArt 85*
Whiteside, George Morris, III 1933- *AmArch 70*
Whiteside, Henry Leech 1891- *WhAmArt 85*
Whiteside, Henryette Stadelman 1891- *DcWomA, WhAmArt 85*
Whiteside, Millard Fillmore 1919- *AmArch 70*
Whiteside, R Cordelia *DcWomA*
Whiteside, William Albert, II 1925- *WhoAmA 76, -78, -80, -84*
Whitestone, Henry 1825?-1893 *BiDAmAr*
Whitfield *FolkA 86*
Whitfield, E *NewYHSD*
Whitfield, Emma M 1874-1932 *WhAmArt 85*
Whitfield, Emma Morehead 1874-1932 *DcWomA*
Whitfield, Florence W *DcVicP 2*
Whitfield, Florence Westwood *DcWomA*
Whitfield, George *ClaDrA*
Whitfield, George 1891- *DcWomA*
Whitfield, Helen *DcVicP 2, DcWomA*
Whitfield, John S *NewYHSD*
Whitfield, Joshua 1884-1954 *DcBrA 1*
Whitford, Dora 1898-1969 *DcWomA*
Whitford, James, Jr. 1906- *AmArch 70*
Whitford, William Garrison 1886- *WhAmArt 85*
Whitham, Sylvia Frances 1878- *DcBrA 1, DcWomA*

Whities-Sanner, Glenna 1888- *DcWomA*, *WhAmArt 85*
Whiting *BiDBrA*
Whiting, Ada 1858- *DcWomA*
Whiting, Almon Clark 1878- *WhAmArt 85*
Whiting, C A *EncASM*
Whiting, Calvin *FolkA 86*
Whiting, D W *NewYHSD*
Whiting, Daniel Powers 1808- *NewYHSD*
Whiting, E J *AmArch 70*
Whiting, F H *NewYHSD*
Whiting, Fabius 1792-1842 *NewYHSD*
Whiting, Florence Standish 1886-1947 *DcWomA*
Whiting, Florence Standish 1888-1947 *WhAmArt 85*
Whiting, Frank *WhAmArt 85*
Whiting, Frank M d1892 *EncASM*
Whiting, Fred 1873-1962 *DcBrBI*
Whiting, Frederic 1873-1962 *DcBrBI*
Whiting, Frederic 1874- *ClaDrA*
Whiting, Frederic 1874-1962 *DcBrA 1*, *DcVicP 2*
Whiting, Gertrude *WhAmArt 85*
Whiting, Gertrude 1898- *WhAmArt 85*
Whiting, Gertrude McKim 1898- *DcWomA*
Whiting, Giles 1873-1937 *WhAmArt 85*
Whiting, Harold E *AmArch 70*
Whiting, John *BiDBrA*
Whiting, John Downes 1884- *WhAmArt 85*
Whiting, Jonathan *CabMA*
Whiting, Lillian V *WhAmArt 85*
Whiting, Mildred Ruth *WhAmArt 85*
Whiting, Onslow *ClaDrA*, *DcBrA 1*
Whiting, Ray Henry 1942- *MacBEP*
Whiting, Riley *FolkA 86*
Whiting, William D d1891 *EncASM*
Whiting, William H *NewYHSD*
Whiting And Davis *EncASM*
Whitington, Terence Lee 1916- *AmArch 70*
Whitley, Charles 1824-1893 *DcBrWA*
Whitley, Elizabeth B *DcWomA*
Whitley, G *DcVicP 2*
Whitley, Gladys Ethel 1886- *DcBrA 1*, *DcWomA*
Whitley, James Moses 1934- *AmArch 70*
Whitley, Kate Mary d1920 *DcBrA 1*, *DcVicP*, -2, *DcWomA*
Whitley, Philip Waff 1943- *WhoAmA 73*, -76, -78
Whitley, Thomas W *EarABI*, *NewYHSD*
Whitley, William T *DcVicP 2*
Whitling, Henry John *BiDBrA*
Whitlock, Albert 1915- *ConDes*
Whitlock, Charles *EncASM*
Whitlock, France J 1870- *WhAmArt 85*
Whitlock, Frances Jeannette 1870- *ArtsAmW 2*, *DcWomA*
Whitlock, John *WhoArt 80*, -82, -84
Whitlock, John Joseph 1935- *WhoAmA 73*, -76, -78, -80, -82, -84
Whitlock, Mary Ursula d1944 *DcWomA*, *WhAmArt 85*
Whitlock, Ursula 1860-1944 *ArtsAmW 2*
Whitlow, C L *AmArch 70*
Whitlow, Tyrel Eugene 1940- *WhoAmA 73*, -76, -78
Whitman, Bert 1908- *WorECar*
Whitman, Charles Thomas, III 1913- *WhAmArt 85*
Whitman, E O 1870-1939 *BiDAmAr*
Whitman, Eliza 1786?- *FolkA 86*
Whitman, J M *FolkA 86*
Whitman, J S *AmArch 70*
Whitman, Jacob d1798 *NewYHSD*
Whitman, John Franklin, Jr. 1896- *WhAmArt 85*
Whitman, John Pratt 1871- *WhAmArt 85*
Whitman, Paul 1887?- *WhAmArt 85*
Whitman, Paul 1897-1950 *ArtsAmW 2*
Whitman, Robert 1935- *BnEnAmA*, *ConArt 77*, -83, *DcCAA 71*, -77, *OxTwCA*, *WhoAmA 78*
Whitman, Sarah DeSt. Prix 1842?-1904 *DcWomA*
Whitman, Sarah DeSt. Prix Wyman 1842-1904 *WhAmArt 85*
Whitman, Thelma *WhAmArt 85*
Whitman, Thelma C *DcWomA*
Whitman, Julia *NewYHSD*
Whitmar, Julia 1830?- *DcWomA*
Whitmarsh, Mrs. T H *DcVicP 2*
Whitmer, Helen Crozier 1870- *DcWomA*, *WhAmArt 85*
Whitmer, J *FolkA 86*
Whitmer, Roger Gayle 1930- *AmArch 70*
Whitmire, LaVon *WhAmArt 85*
Whitmire, Thomas Edmund 1926- *AmArch 70*
Whitmore, Bryan *DcVicP*, -2
Whitmore, Charlotte *DcWomA*, *WhAmArt 85*
Whitmore, Coby *WhAmArt 85*
Whitmore, Coby 1913- *WhoAmA 73*, -76, -78, -80
Whitmore, Donald Curtis 1936- *AmArch 70*
Whitmore, Sir George 1775-1862 *BiDBrA*
Whitmore, J *NewYHSD*
Whitmore, J E *AmArch 70*
Whitmore, James 1926- *ICPEnP A*
Whitmore, Lenore K 1920- *WhoAmA 73*, -76, -78, -80, -82, -84
Whitmore, M Coburn 1913- *IlrAm F*, -1880
Whitmore, Olive *WhAmArt 85*

Whitmore, Robert Henry, III 1932- *AmArch 70*
Whitmore, Robert Houston 1890- *WhAmArt 85*
Whitmore, Susan 1789-1867 *FolkA 86*
Whitmore, Tim *DcCAr 81*
Whitmore, William R *DcVicP 2*, *WhAmArt 85*
Whitnall, Bessie Denton *DcWomA*
Whitney, Albert E *EncASM*
Whitney, Anne 1821-1915 *BnEnAmA*, *DcAmArt*, *DcWomA*, *NewYHSD*, *WhAmArt 85*, *WomArt*
Whitney, Beatrice 1888- *DcWomA*, *WhAmArt 85*
Whitney, C T *AmArch 70*
Whitney, Charles E 1903-1977 *WhoAmA 78N*, -80N, -82N, -84N
Whitney, Charles Frederick 1858- *WhAmArt 85*
Whitney, Charlotte Armide 1923- *WhoAmA 84*
Whitney, Constance *DcWomA*
Whitney, Daniel Webster 1896- *WhAmArt 85*
Whitney, Douglas B *WhAmArt 85*
Whitney, E *DcVicP 2*
Whitney, Edgar Albert 1891- *WhoAmA 73*, -76, -78, -80, -82, -84
Whitney, Edwin A *EncASM*
Whitney, Elias J 1827- *EarABI*, *EarABI SUP*
Whitney, Elias James 1827- *NewYHSD*
Whitney, Elizabeth *DcWomA*
Whitney, Elwood *WhAmArt 85*
Whitney, F G *EncASM*
Whitney, Frank 1860- *WhAmArt 85*
Whitney, George Gillett *WhAmArt 85*
Whitney, Gertrude 1875-1942 *DcWomA*
Whitney, Gertrude V 1878-1942 *WhAmArt 85*
Whitney, Gertrude Vanderbilt 1877-1942 *McGDA*
Whitney, Guy *PrintW 85*
Whitney, Harrison Lewis 1924- *AmArch 70*
Whitney, Helen Jones *DcWomA*
Whitney, Helen Reed 1878- *DcWomA*, *WhAmArt 85*
Whitney, Henry Dwight 1904- *AmArch 70*
Whitney, Isabel Lydia d1962 *WhAmArt 85*, *WhoAmA 80N*, -82N, -84N
Whitney, Isabel Lydia 1884-1962 *DcWomA*
Whitney, J D *NewYHSD*
Whitney, James Stevenson 1924- *AmArch 70*
Whitney, Jedidiah *CabMA*
Whitney, John Hay 1904- *WhoAmA 73*, -76, -78, -80
Whitney, John Hay 1904-1982 *WhoAmA 82N*, -84N
Whitney, John Henry Ellsworth 1840-1891 *NewYHSD*
Whitney, John P *NewYHSD*
Whitney, Josepha 1872- *DcWomA*, *WhAmArt 85*
Whitney, Katharine *DcWomA*, *WhAmArt 85*
Whitney, Kevin 1948- *ConArt 77*
Whitney, L *FolkA 86*
Whitney, Margaret *WhAmArt 85*
Whitney, Marjorie Faye 1903- *WhAmArt 85*
Whitney, Mary *ArtsEM*, *DcWomA*
Whitney, Maynard Merle 1931- *WhoAmA 78*, -80, -82, -84
Whitney, Olive E *DcWomA*
Whitney, Orlando H *ArtsEM*
Whitney, Philip Richardson *WhoAmA 80N*, -82N, -84N
Whitney, Philip Richardson 1878-1960? *WhAmArt 85*
Whitney, Richard W 1924- *AmArch 70*
Whitney, Richard Wheeler 1946- *WhoAmA 82*, -84
Whitney, Stanley 1946- *AfroAA*
Whitney, Susan Gillian 1951- *WhoAmA 80*, -82, -84
Whitney, Thomas *CabMA*
Whitney, Thomas Richard 1807-1858 *NewYHSD*
Whitney, Wayne Ward 1930- *AmArch 70*
Whitney, William 1921- *AmArt*
Whitney, William Channing 1851-1945 *BiDAmAr*
Whitney, William K *NewYHSD*
Whitney, William Kuebler 1921- *WhoAmA 78*, -80, -82, -84
Whitney And Brown *CabMA*
Whitney Brothers *EncASM*
Whitney-Smith, Edwin 1880-1952 *DcBrA 1*
Whiton, S J *WhAmArt 85*
Whitsit, Elon *WhAmArt 85*
Whitsit, Jesse 1874- *WhAmArt 85*
Whitson 1941- *WhoAmA 76*, -78, -80, -82, -84
Whitson 1942- *WhoAmA 73*
Whitson, Angie 1932- *WhoAmA 82*, -84
Whitson, C F *DcWomA*
Whitson, Frank Edward, Jr. 1934- *AmArch 70*
Whitson, Thomas C 1930- *AmArch 70*
Witt, James Aaon 1936- *AmArch 70*
Whittaker, George 1834-1874 *DcBrWA*, *DcVicP 2*
Whittaker, James *FolkA 86*
Whittaker, James William 1828-1876 *DcBrWA*, *DcVicP*, -2
Whittaker, John *FolkA 86*
Whittaker, John B *WhAmArt 85*
Whittaker, John Bernard 1836- *NewYHSD*
Whittaker, John William 1790?-1854 *BiDBrA*
Whittaker, Lillian E *DcWomA*
Whittaker, Mary Wood d1926 *DcWomA*, *WhAmArt 85*
Whittaker, Miller F *AfroAA*
Whittaker, Wirt Campbell, III *AmArch 70*

Whittam, Geoffrey William 1916- *IlsBYP*, *IlsCB 1946*
Whitteker, Lilian E *WhAmArt 85*
Whitteker, Lillian E *DcWomA*
Whittemore, C Helen Simpson d1956? *DcWomA*
Whittemore, Charles E *WhAmArt 85*
Whittemore, Mrs. Charles E *DcWomA*, *WhAmArt 85*
Whittemore, Constance *ConICB*
Whittemore, Daniel *FolkA 86*
Whittemore, Frances 1857-1951 *DcWomA*
Whittemore, Frances D *WhAmArt 85*
Whittemore, Frances Davis 1857-1951 *ArtsAmW 2*
Whittemore, Grace Conner 1876- *WhAmArt 85*
Whittemore, Grace Connor 1876- *DcWomA*
Whittemore, Hal Case 1920- *AmArch 70*
Whittemore, Helen Simpson *WhoAmA 80N*, -82N, -84N
Whittemore, Helen Simpson d1958? *WhAmArt 85*
Whittemore, John 1662-1702 *CabMA*
Whittemore, Joseph *FolkA 86*
Whittemore, Joseph 1667-1745 *FolkA 86*
Whittemore, Joseph 1688-1760 *CabMA*
Whittemore, Joseph 1713-1762 *CabMA*
Whittemore, Margaret Evelyn *WhAmArt 85*
Whittemore, Margaret Evelyn 1897- *ArtsAmW 2*, *DcWomA*
Whittemore, R O *FolkA 86*
Whittemore, William J 1860-1955 *WhAmArt 85*
Whitten, Andrew T 1878- *ArtsAmW 3*
Whitten, Francis 1891- *AmArch 70*
Whitten, Gregory F 1952- *MarqDCG 84*
Whitten, Jack *DcCAr 81*
Whitten, Jack 1939- *AfroAA*
Whitten, James Smith 1939- *AmArch 70*
Whittet, Andrew *DcBrA 2*
Whittet, William Sherman 1924- *AmArch 70*
Whittick, Arnold *ConArch A*
Whittick, Arnold 1898- *WhoArt 80*, -82, -84
Whitticke *BiDBrA*
Whittier, Daniel *CabMA*
Whittier, George 1909- *AmArch 70*
Whittier, R M *AmArch 70*
Whittier, Ruth *DcWomA*
Whittier, William *NewYHSD*
Whittingham, Gregory 1946- *MarqDCG 84*
Whittingham, William H 1932- *IlrAm G*, -1880
Whittington, Dewey Gene 1932- *AmArch 70*
Whittington, Eugene Algernon 1929- *AmArch 70*
Whittington, Hector *FolkA 86*
Whittington, Marjory F *DcBrA 1*
Whittle, A D *AmArch 70*
Whittle, B *FolkA 86*, *NewYHSD*
Whittle, Elizabeth *DcVicP 2*, *DcWomA*
Whittle, T S *DcVicP 2*
Whittle, Thomas, Jr. *DcVicP*, -2
Whittle, Thomas, Sr. *DcVicP*, -2
Whittlesea, Michael 1938- *WhoArt 84*
Whittlesey, Caroline H *DcWomA*, *WhAmArt 85*
Whittlesey, Charles F 1867-1941 *BiDAmAr*
Whittlesey, Frederick Wallis 1905- *AmArch 70*
Whittlesey, Gertrude S *DcWomA*
Whittlesey, J H *AmArch 70*
Whittlesey, Mary Ann *DcWomA*
Whittleton, Anna G *DcWomA*
Whittleton, Anna Goodheart *WhAmArt 85*
Whittock, Nathaniel *DcBrBI*, *DcBrWA*
Whittome, Irene 1942- *DcCAr 81*
Whittome, Irene Dianne 1942- *WhoAmA 84*
Whitton, Luke *DcBrECP*
Whitton, Mary Clark 1948- *MarqDCG 84*
Whittredge, Thomas Worthington 1820-1910 *DcAmArt*, *EarABI*, *IlBEAAW*, *NewYHSD*
Whittredge, Worthington 1820- *ArtsNiC*
Whittredge, Worthington 1820-1910 *ArtsAmW 1*, *BnEnAmA*, *McGDA*, *WhAmArt 85*
Whittricke *BiDBrA*
Whitty-Johnson, Patricia 1943- *WhoAmA 78*, -80, -82, -84
Whitus, Robert Theodric 1937- *MarqDCG 84*
Whitwam, Ward Beaumont 1923- *AmArch 70*
Whitwell, Mary Hubbard 1847-1908 *DcWomA*, *WhAmArt 85*
Whitwell, Rebecca 1773- *FolkA 86*
Whitwell, Thomas Stedman d1840 *BiDBrA*
Whitwell, William *DcBrECP*
Whitworth *AntBDN F*
Whitworth, B, Jr. *AmArch 70*
Whitworth, Charles H *DcVicP 2*
Whitworth, H P *AmArch 70*
Whitworth, John d1863 *BiDBrA*
Whitworth, M *DcWomA*
Wholey, W *BkIE*
Wholohan, Maude 1875-1950 *DcWomA*
Whood, Isaac 1688?-1752 *DcBrECP*
Whorf, John 1903-1959 *McGDA*, *WhAmArt 85*, *WhoAmA 80N*, -82N, -84N
Whyatt, F R *AmArch 70*
Whydale, Ernest Herbert 1886- *DcBrA 1*
Whyley, Evelyn Jane *DcWomA*
Whymper, Charles 1853-1941 *ClaDrA*, *DcBrA 1*,

Wilenchick, Clement 1900- *WhAmArt 85*
Wilenski, Reginald Howard 1887-1975 *DcBrA 2*
Wilensky, Vriel J 1955- *MarqDCG 84*
Wiles, Alec 1934- *WhoArt 80, -82, -84*
Wiles, Bertha Harris 1896- *WhAmArt 85*
Wiles, E Alec 1924- *ClaDrA*
Wiles, Francis 1889- *DcBrA 1*
Wiles, Frank E *DcBrBI*
Wiles, Gladys Lee *DcWomA, WhAmArt 85*
Wiles, Irving R d1948 *WhoAmA 78N, -80N, -82N, -84N*
Wiles, Irving R 1861-1948 *WhAmArt 85*
Wiles, Irving Ramsey 1862-1948 *IlrAm 1880*
Wiles, Lemanuel Maynard 1826-1905 *ArtsAmW 1*
Wiles, Lemuel M 1826- *ArtsNiC*
Wiles, Lemuel Maynard 1826-1905 *IlBEAAW, NewYHSD , WhAmArt 85*
Wiles, William *NewYHSD*
Wiley, Annie *DcWomA*
Wiley, Catherine *WhAmArt 85*
Wiley, Charles Frederick 1910- *AmArch 70*
Wiley, Frederick J *WhAmArt 85*
Wiley, G L *AmArch 70*
Wiley, Gertrude *ArtsEM, DcWomA*
Wiley, H W *DcBrBI*
Wiley, Hedwig *WhAmArt 85*
Wiley, James Earl 1927- *AmArch 70*
Wiley, Katherine *DcWomA*
Wiley, Lucia *WhAmArt 85*
Wiley, Marquita M 1950- *MarqDCG 84*
Wiley, Martin *FolkA 86*
Wiley, Nan K 1899- *ArtsAmW 3*
Wiley, Sumner Kennard 1896- *AmArch 70*
Wiley, William 1937- *ConArt 77, OxTwCA*
Wiley, William T 1937- *AmArt, ConArt 83, DcCAA 71, -77, DcCAr 81, PrintW 83, -85, WhoAmA 73, -76, -78, -80, -82, -84*
Wiley-Crawford *EncASM*
Wilf, Andrew Jeffrey 1949- *WhoAmA 78, -80, -82*
Wilf, Andrew Jeffrey 1949-1982 *WhoAmA 84N*
Wilford, Loran 1892-1972 *WhoAmA 78N, -80N, -82N, -84N*
Wilford, Loran F 1893- *IlrAm C*
Wilford, Loran Frederick 1892-1972 *ArtsAmW 2, WhAmArt 85*
Wilford, Loran Frederick 1893-1972 *IlrAm 1880*
Wilfred, G *DcVicP 2*
Wilfred, Roy *MacBEP*
Wilfred, Thomas 1889- *PhDcTCA 77*
Wilfred, Thomas 1889-1968 *DcCAA 71, -77, OxTwCA, WhoAmA 78N, -80N, -82N, -84N*
Wilgus, William John 1819-1853 *IlBEAAW, NewYHSD*
Wilhelm Von Koln *McGDA*
Wilhelm, Adolph L *WhAmArt 85*
Wilhelm, Arthur Wayne 1901- *WhAmArt 85*
Wilhelm, August *NewYHSD*
Wilhelm, C *DcBrWA*
Wilhelm, Donald Charles 1939- *AmArch 70*
Wilhelm, E Paul 1905- *WhAmArt 85*
Wilhelm, Grete 1887-1942 *DcWomA*
Wilhelm, Lillian *DcWomA*
Wilhelm, R 1895-1954 *WhAmArt 85*
Wilhelm, Richard 1932- *DcCAr 81*
Wilhelmi, Paul *ArtsEM*
Wilhelmi, William Merle 1939- *WhoAmA 80, -82, -84*
Wilhelmi Wendling And VonErnst *ArtsEM*
Wilhelmine, Princess Of Prussia 1709-1758 *DcWomA*
Wilhelmine, Princess Of Prussia 1751-1820 *DcWomA*
Wilhelmine, Princess Of Prussia 1774-1837 *DcWomA*
Wilhite, G D *AmArch 70*
Wilhjelm, Edith Franziska 1893-1919 *DcWomA*
Wilhoit, Eugene Franklin 1906- *AfroAA*
Wilhoit, Sterling E, Jr. 1924- *AmArch 70*
Wiligelmo *OxArt*
Wiligelmus Da Modena *McGDA*
Wilimovsky, Charles A 1885- *ArtsAmW 3, WhAmArt 85*
Wilk, Joseph Peter 1926- *AmArch 70*
Wilk, Robert John 1934- *MarqDCG 84*
Wilke, Mr. *FolkA 86*
Wilke, Hannah 1940- *WhoAmA 76, -78, -80, -82, -84*
Wilke, Rudolf 1873-1908 *WorECar*
Wilke, Ulfert 1907- *PrintW 83, -85*
Wilke, Ulfert S 1907- *DcCAA 71, -77, WhoAmA 73, -76, -78, -80, -82, -84*
Wilke, William H *WhAmArt 85*
Wilke, William Hancock 1880- *ArtsAmW 1, -3*
Wilken, Caroline *DcWomA*
Wilkens, Ellen 1889- *DcWomA*
Wilkens, John Joseph 1920- *AmArch 70*
Wilkens, Theodorus 1690-1748 *ClaDrA*
Wilker, Philip John 1907- *AmArch 70*
Wilkerson, Charles Edward 1921- *AmArch 70*
Wilkerson, Lizzie 1902-1984 *FolkA 86*
Wilkerson, R W, III *AmArch 70*
Wilkerson, Robert Sterling 1924- *AmArch 70*
Wilkes, Alfred Tupper 1921- *AmArch 70*
Wilkes, Charles 1798?-1877 *EarABI, NewYHSD*

Wilkes, G C *AmArch 70*
Wilkes, H *DcBrECP*
Wilkes, Joseph Allen 1919- *AmArch 70*
Wilkes, Maude *DcWomA*
Wilkes, Samuel *DcVicP 2*
Wilkes, Sarah *DcVicP 2, DcWomA*
Wilkes, Susan H *DcWomA, WhAmArt 85*
Wilkevich, Eleanor 1910- *WhAmArt 85*
Wilkie, Alexander 1744?-1811 *BiDBrA*
Wilkie, Sir David 1785-1841 *ArtsNiC, ClaDrA, DcBrBI, DcBrWA, DcVicP, -2, McGDA, OxArt*
Wilkie, Earl A *AfroAA*
Wilkie, H *DcVicP 2, DcWomA*
Wilkie, James 1890-1957 *DcBrA 1*
Wilkie, John *FolkA 86, NewYHSD*
Wilkie, Robert 1888- *DcBrA 1*
Wilkie, Robert D 1828-1903 *NewYHSD , WhAmArt 85*
Wilkie, Thomas *NewYHSD*
Wilkie, William *FolkA 86*
Wilkin, Miss *DcVicP 2*
Wilkin, Eloise Burns 1904- *IlsBYP, IlsCB 1744, -1946*
Wilkin, Frank W 1800?-1842 *ClaDrA*
Wilkin, Godfrey *FolkA 86*
Wilkin, Karen *WhoAmA 84*
Wilkin, Mildred Pierce 1896- *ArtsAmW 2, DcWomA, WhAmArt 85*
Wilking, Jan VanTyen 1913- *AmArch 70*
Wilkins, Benjamin *FolkA 86*
Wilkins, David George 1939- *WhoAmA 78, -80, -82, -84*
Wilkins, Deborah *AfroAA*
Wilkins, Elizabeth Waller 1903- *WhAmArt 85*
Wilkins, Emma Cheves 1871- *DcWomA, WhAmArt 85*
Wilkins, Frank W 1800?-1842 *DcBrBI*
Wilkins, George *DcVicP 2*
Wilkins, George W *NewYHSD*
Wilkins, Gladys M 1907- *WhAmArt 85*
Wilkins, J *DcBrECP*
Wilkins, J F 1795?- *DcBrWA*
Wilkins, James 1768- *DcBrECP*
Wilkins, James 1808-1888 *FolkA 86*
Wilkins, James F 1808?-1888 *ArtsAmW 1, IlBEAAW, NewYHSD*
Wilkins, James William 1932- *AmArch 70*
Wilkins, Jesse T, Jr. 1918- *AmArch 70*
Wilkins, John 1767- *DcBrECP*
Wilkins, Kenneth Frederick 1936- *AmArch 70*
Wilkins, Louisa A *DcWomA*
Wilkins, Margaret *WhAmArt 85*
Wilkins, Michael Gray 1938- *MarqDCG 84*
Wilkins, R E *AmArch 70*
Wilkins, R I *AmArch 70*
Wilkins, Ralph Brooks *WhAmArt 85*
Wilkins, Richard Sandefur 1933- *AmArch 70*
Wilkins, Robert 1740-1799? *DcBrECP*
Wilkins, Robert Michael 1948- *MarqDCG 84*
Wilkins, Ruth Lois 1926- *WhoAmA 73, -76*
Wilkins, Sarah *DcWomA, FolkA 86, NewYHSD*
Wilkins, Timothy 1943- *AfroAA*
Wilkins, W *AmArch 70*
Wilkins, Wilbert M *AfroAA*
Wilkins, William 1751-1815 *BiDBrA, DcBrWA*
Wilkins, William 1778-1839 *BiDBrA, DcBrWA, DcD&D, MacEA, McGDA, OxArt, WhoArch*
Wilkins, William Noy 1820- *DcVicP 2*
Wilkins, William Powell *DcCAr 81*
Wilkins, Woodrow W 1915- *AmArch 70*
Wilkinson *EncASM, NewYHSD*
Wilkinson, A J *DcNiCA*
Wilkinson, Alfred Ayscough *DcVicP, -2*
Wilkinson, Alfred L 1899- *WhoArt 80, -82, -84*
Wilkinson, Anthony d1765 *FolkA 86*
Wilkinson, Archibald Baker 1916- *AmArch 70*
Wilkinson, Barry 1923- *IlsCB 1967*
Wilkinson, Bryant *FolkA 86*
Wilkinson, Caroline Helena *DcWomA*
Wilkinson, Charles A *DcBrBI, DcVicP, -2*
Wilkinson, Charles A 1830- *ClaDrA*
Wilkinson, Charles K 1897- *WhoAmA 73, -76, -78*
Wilkinson, D R *AmArch 70*
Wilkinson, Don Greene 1929- *AmArch 70*
Wilkinson, E W *DcVicP 2*
Wilkinson, Edith L *DcWomA, WhAmArt 85*
Wilkinson, Edward 1889- *ArtsAmW 2, WhAmArt 85*
Wilkinson, Edward Clegg *DcBrA 1, DcVicP, -2*
Wilkinson, Ellen *DcVicP, -2, DcWomA*
Wilkinson, Emma Mary 1864- *DcWomA*
Wilkinson, Evelyn Harriet 1893- *DcWomA*
Wilkinson, Evelyn Harriet 1893-1968 *DcBrA 1*
Wilkinson, F A *WhAmArt 85*
Wilkinson, Fred Green *DcVicP 2*
Wilkinson, Fritz *WhAmArt 85*
Wilkinson, G Welby *DcBrBI*
Wilkinson, George 1814-1890 *BiDBrA*
Wilkinson, George David 1936- *AmArch 70*
Wilkinson, George Orend'hal 1918- *AmArch 70*

Wilkinson, Georgiana *DcVicP 2, DcWomA*
Wilkinson, Gilbert 1891- *WorECar*
Wilkinson, Gladys H *DcWomA*
Wilkinson, Henry *AntBDN N, -Q*
Wilkinson, Henry 1870-1931 *BiDAmAr*
Wilkinson, Henry 1921- *DcBrA 1*
Wilkinson, Henry John 1829-1911 *DcBrWA*
Wilkinson, Hilda *AfroAA, DcWomA*
Wilkinson, Hugh *DcBrA 1, DcVicP, -2*
Wilkinson, Mrs. J *NewYHSD*
Wilkinson, J R *AmArch 70*
Wilkinson, Jack 1913-1973 *WhAmArt 85*
Wilkinson, James *DcBrWA*
Wilkinson, Jessie *ArtsEM, DcWomA*
Wilkinson, John *NewYHSD*
Wilkinson, John 1913- *WhoAmA 76*
Wilkinson, John 1913-1973 *WhoAmA 78N, -80N, -82N, -84N*
Wilkinson, John 1948- *DcCAr 81*
Wilkinson, Joseph 1764-1831 *DcBrBI, DcBrWA*
Wilkinson, Joseph Morton 1924- *AmArch 70*
Wilkinson, Kate Stanley 1883- *DcBrA 1, DcWomA*
Wilkinson, Kirk Cook 1909- *WhoAmA 73, -76, -78, -80, -82, -84*
Wilkinson, Knox 1955- *FolkA 86*
Wilkinson, L *DcWomA*
Wilkinson, L M *DcVicP 2*
Wilkinson, Laura *DcVicP 2, DcWomA*
Wilkinson, Leslie 1882-1973 *MacEA*
Wilkinson, M J *ArtsEM, DcWomA*
Wilkinson, M R *DcVicP 2*
Wilkinson, Mary Arabella 1839-1910 *DcBrWA*
Wilkinson, N, Jr. *AmArch 70*
Wilkinson, Nathaniel d1764 *BiDBrA*
Wilkinson, Sir Nevile Rodwell 1869-1940 *DcBrA 1*
Wilkinson, Norman 1878-1934 *ClaDrA*
Wilkinson, Norman 1878-1971 *DcBrA 1, DcBrBI, DcSeaP*
Wilkinson, Norman 1882-1934 *DcBrA 2*
Wilkinson, R *AmArch 70, WhAmArt 85*
Wilkinson, R Ellis *DcVicP, -2*
Wilkinson, R H *DcVicP 2*
Wilkinson, R M *AmArch 70*
Wilkinson, Reginald Charles 1881- *DcBrA 1*
Wilkinson, Reginald Charles 1881-1939 *DcBrA 2*
Wilkinson, Rhoda *DcWomA, WhAmArt 85*
Wilkinson, Richard Lockmann 1929- *AmArch 70*
Wilkinson, Robert *CabMA, DcBrECP*
Wilkinson, Ronald Scotthorn *WhoArt 80, -82, -84*
Wilkinson, Ruby A E *ArtsEM, DcWomA*
Wilkinson, Ruth Lucille 1902- *WhAmArt 85*
Wilkinson, Ruth Murphy 1921- *WhoAmA 78*
Wilkinson, Sarah R *DcWomA*
Wilkinson, Sidney Raymond 1924- *AmArch 70*
Wilkinson, Thomas *CabMA*
Wilkinson, Thomas William 1875-1950 *DcBrA 2*
Wilkinson, Tom *DcBrBI, WhAmArt 85*
Wilkinson, Tony *DcBrBI*
Wilkinson, W F *DcVicP 2*
Wilkinson, William *BiDBrA*
Wilkinson, William L, Jr. 1921- *AmArch 70*
Wilkinson And Smith *CabMA*
Wilkinson-Clementson, William Henry 1921- *WhoArt 80, -82, -84*
Wilkison, Emily *FolkA 86*
Wilkman, W W *AmArch 70*
Wilkon, Jozef 1930- *IlsBYP, IlsCB 1957*
Wilks, H *DcBrECP*
Wilks, M L *AmArch 70*
Wilks, Maurice Canning 1910- *DcBrA 2*
Will, August 1834-1910 *WhAmArt 85*
Will, Blanca 1881- *ArtsAmW 3, DcWomA, WhAmArt 85*
Will, George C 1865-1939? *BiDAmAr*
Will, J M 1834-1910 *EarABI*
Will, John 1939- *PrintW 83, -85*
Will, John A 1939- *WhoAmA 73, -76, -78, -80, -82, -84*
Will, John M 1834-1910 *WhAmArt 85*
Will, John M August 1834-1910 *NewYHSD*
Will, Mary Shannon 1944- *DcCAr 81, WhoAmA 78, -80, -82*
Will, Mathew *CabMA*
Will, Peter Milne 1935- *MarqDCG 84*
Will, Philip, Jr. 1906- *AmArch 70, ConArch, MacEA*
Will, Richard Earl 1932- *AmArch 70*
Will, William *FolkA 86*
Will, William 1798?- *FolkA 86*
Willading, Julie Von 1780-1858 *DcWomA*
Willaerts, Abraham 1603?-1669 *ClaDrA, DcSeaP, McGDA*
Willaerts, Adam 1577-1664 *DcSeaP, McGDA*
Willaerts, Isaac 1620-1693 *DcSeaP*
Willard *FolkA 86*
Willard, Aaron *OxDecA*
Willard, Aaron 1757-1844 *AntBDN D, FolkA 86, OxDecA*
Willard, Aaron 1757-1854 *DcNiCA*
Willard, Aaron 1783-1863 *DcNiCA*
Willard, Alfred *FolkA 86*

Willard, Archibald M 1836-1918 *WhAmArt 85*
Willard, Archibald MacNeal 1836-1918 *NewYHSD*
Willard, Asaph 1786-1880 *NewYHSD*
Willard, Benjamin 1740-1803 *AntBDN D, OxDecA*
Willard, Charles Burton 1902- *AmArch 70*
Willard, Charlotte *WhoAmA 73, -76, -78*
Willard, Daniel W *MacEA*
Willard, Eliza *FolkA 86*
Willard, Ephraim *AntBDN D, OxDecA*
Willard, F W *NewYHSD*
Willard, Frank *DcVicP 2*
Willard, Frank d1958 *WhoAmA 80N, -82N, -84N*
Willard, Frank Henry 1893-1958 *ArtsAmW 2, WhAmArt 85, WorECom*
Willard, Helen d1979 *WhoAmA 80N, -82N, -84N*
Willard, Henry *CabMA*
Willard, Henry 1802-1855 *NewYHSD*
Willard, Howard W 1894-1960 *ArtsAmW 2, IlrAm D, WhAmArt 85*
Willard, James Daniel 1817- *NewYHSD*
Willard, Jonathan *CabMA*
Willard, Josiah *CabMA*
Willard, L L 1839- *ArtsAmW 2, DcWomA, WhAmArt 85*
Willard, Marie T *WhAmArt 85*
Willard, Rodlow 1906- *WhAmArt 85*
Willard, Samuel 1640-1707 *EarABI SUP*
Willard, Simon *DcD&D*
Willard, Simon 1753-1840? *AntBDN D*
Willard, Simon 1753-1845? *OxDecA*
Willard, Simon 1753-1848 *DcNiCA*
Willard, Simon 1802- *FolkA 86*
Willard, Simon, Jr. 1795-1874 *DcNiCA*
Willard, Solomon 1773?-1861 *FolkA 86*
Willard, Solomon 1783-1861 *MacEA, NewYHSD*
Willard, Solomon 1788-1862 *BiDAmAr*
Willard, Theodora *DcWomA, WhAmArt 85*
Willard, William 1819-1904 *NewYHSD , WhAmArt 85*
Willard, Zabadiel *FolkA 86*
Willats, Mrs. *DcVicP 2*
Willats, Mrs. J K *DcBrWA*
Willats, Stephen 1943- *ConArt 77, -83, ConBrA 79[port]*
Willats, William E *DcBrA 1*
Willatsen, A *AmArch 70*
Willauer, Arthur E 1876-1912 *BiDAmAr*
Willauer, Arthur Osborne 1908- *AmArch 70*
Willauer, E B *AmArch 70*
Willaume, David, Jr. *AntBDN Q*
Willaume, David, Sr. *AntBDN Q*
Willcock, George Barrell 1811-1852 *DcBrWA, DcVicP, -2*
Willcocks, Mabel *DcVicP 2*
Willcox, Anita *WhAmArt 85*
Willcox, Anita Parkhurst *DcWomA*
Willcox, Anne *DcWomA*
Willcox, Arthur V *WhAmArt 85*
Willcox, George H *BiDBrA*
Willcox, Harriet Elizabeth *DcWomA*
Willcox, James M *WhAmArt 85*
Willcox, Marcy *FolkA 86*
Willcox, Sandra *IlsBYP*
Willcox, W H 1831- *WhAmArt 85*
Willcox, Walter R B 1869-1947 *BiDAmAr*
Willcox, Walter Ross Baumes 1869-1947 *MacEA*
Willcox, William H 1831?- *NewYHSD*
Willdig, John *BiDBrA*
Wille, Ita 1892- *DcWomA*
Wille, Johann Georg 1715-1808 *McGDA*
Wille, Klara Von 1838-1883 *DcWomA*
Wille, Marianne 1868-1927 *DcWomA*
Wille, O Louis 1917- *WhoAmA 73, -76, -78, -80, -82*
Willebeek LeMair, Henriette 1889-1966 *DcWomA*
Willeboirts, Thomas 1613?-1654 *McGDA*
Willemart, Louise 1863- *DcWomA*
Willemer, Anna Rosina Magdalena Von *DcWomA*
Willems, Florent 1823-1905 *ClaDrA*
Willems, Florent 1824- *ArtsNiC*
Willems, Joseph d1766 *AntBDN M*
Willen, P *AmArch 70*
Willenbecher, John 1936- *ConArt 77, -83, DcCAA 71, -77, DcCAr 81, OxTwCA, WhoAmA 73, -76, -78, -80, -82, -84*
Willenich, Michel *ArtsNiC, DcVicP 2*
Willensky, Elliot 1933- *AmArch 70*
Willer, Jim 1921- *WhoAmA 73, -76, -78, -80, -82*
Willers, Margarete 1883- *DcWomA*
Willerval, Jean 1924- *ConArch*
Willes, Edith A *DcVicP 2*
Willes, J *DcVicP 2*
Willes, William d1851 *DcBrBI, DcBrWA, DcVicP, -2*
Willet, Anne Lee 1867-1943 *WhAmArt 85*
Willet, Annie 1866-1943 *DcWomA*
Willet, George H *FolkA 86*
Willet, Henry Lee 1899- *WhAmArt 85, WhoAmA 73, -76, -78, -80, -82*
Willet, Henry Lee 1899-1983 *WhoAmA 84N*
Willet, William 1868-1921 *WhAmArt 85*
Willeto, Charles *FolkA 86*

Willets, Anita *DcWomA*
Willets, Anita 1880- *WhAmArt 85*
Willett, Mrs. *DcVicP 2, DcWomA*
Willett, Arthur *DcVicP, -2*
Willett, Arthur 1868- *DcBrWA*
Willett, Arthur Reginald 1868- *WhAmArt 85*
Willett, J 1882-1958 *WhAmArt 85*
Willett, Jacques 1882-1958 *WhoAmA 80N, -82N, -84N*
Willett, James Howland 1831-1907 *BiDAmAr*
Willett, Marinus 1740-1830 *CabMA*
Willette, Adolphe 1857-1926 *McGDA, WorECar*
Willetts, David 1939- *DcCAr 81*
Willetts, William Young 1918- *WhoArt 80, -82, -84*
Willeumier, Mara Augusta 1879- *DcWomA*
Willey, Edith M 1891- *WhAmArt 85*
Willey, Edith Maring 1891- *ArtsAmW 2, DcWomA*
Willey, H *DcVicP 2, DcWomA*
Willey, Jane G O *DcWomA*
Willey, Philo Levi 1886-1980 *FolkA 86*
Willhoite, Warren A 1920- *AmArch 70*
William Of Sens *MacEA, McGDA, OxArt*
William Of Wykeham 1324-1404 *MacEA, OxArt*
William The Englishman *MacEA, OxArt*
William, Abram *FolkA 86*
William, Alfred Walter *ClaDrA*
William, George 1911- *FolkA 86*
William, Jelena Nikolajevna 1862- *DcWomA*
William, Meyvis Frederick *WhAmArt 85*
William, Sam *AfroAA*
William-Powlett, Katherine 1911- *WhoArt 80, -82, -84*
Williams *DcWomA, FolkA 86, NewYHSD*
Williams, Captain *DcBrBI, DcVicP 2*
Williams, Miss *DcVicP 2*
Williams, Mrs. *DcVicP 2*
Williams, A *FolkA 86, NewYHSD*
Williams, A Art, Jr. 1925- *AmArch 70*
Williams, A Florence *DcVicP 2, DcWomA*
Williams, A R, Jr. *AmArch 70*
Williams, A Richard 1914- *AmArch 70*
Williams, A Robert 1927- *AmArch 70*
Williams, A Sheldon *DcVicP 2*
Williams, Abby Rhoda *DcWomA*
Williams, Abigail *FolkA 86*
Williams, Abigail Osgood 1823-1913 *DcWomA, NewYHSD , WhAmArt 85*
Williams, Ada G *DcWomA, WhAmArt 85*
Williams, Adele *WhAmArt 85*
Williams, Adele 1868- *DcWomA*
Williams, Adele Fay 1860-1937 *DcWomA*
Williams, Agnes Pringle *DcWomA*
Williams, Albert *DcVicP 2*
Williams, Albert George 1923- *DcBrA 2*
Williams, Albert L 1922- *AmArch 70*
Williams, Alexander 1846-1930 *DcBrA 1, DcBrBI, DcBrWA, DcVicP 2*
Williams, Alfred 1832-1905 *DcBrWA, DcVicP 2*
Williams, Mrs. Alfred *DcVicP 2*
Williams, Alfred M *DcVicP 2*
Williams, Alfred Mayhew 1823-1905 *ClaDrA*
Williams, Alfred Sheldon- *DcBrBI*
Williams, Alfred Walter 1824-1905 *DcBrWA, DcVicP, -2*
Williams, Alfredus 1875- *AfroAA*
Williams, Alice L *DcWomA*
Williams, Alice Meredith *DcBrBI*
Williams, Allen *NewYHSD*
Williams, Alvin Chester 1930- *AmArch 70*
Williams, Alyn 1865-1941 *DcBrA 1*
Williams, Alyn 1865-1955 *WhAmArt 85*
Williams, Amancio 1913- *ConArch, MacEA*
Williams, Amy *FolkA 86*
Williams, Ann 1906- *WhAmArt 85*
Williams, Ann Mary *DcBrBI, DcWomA*
Williams, Anne *DcBrECP, DcWomA*
Williams, Annie *DcVicP 2*
Williams, Anthony 1851- *AfroAA*
Williams, Arthur *FolkA 86*
Williams, Arthur Gilbert *DcVicP, -2*
Williams, Mrs. Arthur S 1906- *WhAmArt 85*
Williams, Arthur Y *BiDBrA*
Williams, Aubrey 1926- *OxTwCA*
Williams, Aubrey Sendall 1926- *WhoArt 80, -82, -84*
Williams, Augustus DuPont 1915- *AfroAA*
Williams, Barbara Moray 1911- *DcBrA 1*
Williams, Barbara Moray 1911-1975 *DcBrA 2*
Williams, Benjamin *DcVicP, -2*
Williams, Benjamin 1868-1920 *DcBrWA*
Williams, Benjamin 1868-1921 *DcBrA 1*
Williams, Benjamin Forrest 1925- *WhoAmA 73, -76, -78, -80, -82, -84*
Williams, Berkeley, Jr. 1904- *WhAmArt 85*
Williams, Bernice 1948- *DcCAr 81*
Williams, Blanche Virginia *DcWomA*
Williams, Bruce Clark 1951- *MarqDCG 84*
Williams, C D *WhAmArt 85*
Williams, C F *DcVicP 2*
Williams, C Louise *DcWomA, WhAmArt 85*
Williams, C P *DcVicP 2*
Williams, C R *DcVicP 2*

Williams, Caroline F 1835-1921 *DcBrA 1, DcVicP*
Williams, Caroline Fanny 1836-1921 *DcVicP 2, DcWomA*
Williams, Caroline G 1855- *DcWomA*
Williams, Caroline Greene 1855- *WhAmArt 85*
Williams, Carolyn L 1952- *MarqDCG 84*
Williams, Caron Richard 1948- *MarqDCG 84*
Williams, Casey 1947- *WhoAmA 84*
Williams, Ceola *AfroAA*
Williams, Charles *ArtsEM, DcBrBI, NewYHSD*
Williams, Charles Brown, Jr. 1921- *AmArch 70*
Williams, Charles D 1880- *WhAmArt 85*
Williams, Charles David 1875-1954 *IlrAm C, -1880*
Williams, Charles Frederick *DcVicP, -2*
Williams, Charles P *FolkA 86*
Williams, Charles Sneed 1882- *WhAmArt 85*
Williams, Charles Warner 1903- *WhAmArt 85*
Williams, Charlotte 1804-1846 *DcWomA*
Williams, Chester 1921- *DcCAr 81*
Williams, Chester Lee 1944- *WhoAmA 78, -80, -82, -84*
Williams, Christopher David 1873-1934 *DcBrA 1, DcVicP 2*
Williams, Clara *WhAmArt 85*
Williams, Clara Elsene *DcWomA*
Williams, Clarence Eldridge, Jr. 1927- *AmArch 70*
Williams, Claudia 1933- *WhoArt 84*
Williams, Clifford 1898- *AmArch 70*
Williams, Clifford Kilborn *WhAmArt 85*
Williams, Clifton 1885- *ArtsAmW 2*
Williams, Mrs. Crawshay *DcBrBI*
Williams, Cynthia *FolkA 86*
Williams, D L *AmArch 70*
Williams, D S *AmArch 70*
Williams, Dave Harrell 1932- *WhoAmA 84*
Williams, Deborah *DcWomA*
Williams, Delarue *WhAmArt 85*
Williams, Dell Marley 1933- *AmArch 70*
Williams, Donald *MarqDCG 84*
Williams, Donald Ervin 1928- *AmArch 70*
Williams, Donald George 1936- *AmArch 70*
Williams, Donald Henry 1932- *AmArch 70*
Williams, Donald Lee 1935- *AmArch 70*
Williams, Donald Spencer 1939- *MarqDCG 84*
Williams, Dorothy *ArtsEM*
Williams, Dorothy A *DcWomA*
Williams, Douglas *AfroAA*
Williams, Dwight 1856-1932 *WhAmArt 85*
Williams, E *FolkA 86, NewYHSD*
Williams, E Edginton- *DcVicP 2*
Williams, E F *NewYHSD*
Williams, E H *DcVicP 2*
Williams, E I *AmArch 70*
Williams, Sir E Owen 1890- *EncMA*
Williams, E Stewart 1909- *AmArch 70*
Williams, Edith Clifford 1880?-1971 *DcWomA*
Williams, Edward 1782-1855 *ClaDrA, DcBrWA, DcVicP, -2*
Williams, Edward Charles 1807-1881 *ClaDrA, DcVicP, -2*
Williams, Edward Elliker 1793-1822 *DcBrWA*
Williams, Edward K *WhoAmA 78N, -80N, -82N, -84N*
Williams, Edward K 1870- *WhAmArt 85*
Williams, Edward Kent 1934- *AmArch 70*
Williams, Edwin *DcVicP, -2*
Williams, Eleanor Palmer *DcWomA, WhAmArt 85*
Williams, Ellen 1790- *DcWomA*
Williams, Emerson Stewart 1909- *WhAmArt 85*
Williams, Emily *DcVicP 2, DcWomA*
Williams, Esther 1901- *WhAmArt 85*
Williams, Esther Baldwin *DcWomA*
Williams, Esther Baldwin 1907- *WhAmArt 85*
Williams, Ethel Haynes- *DcVicP 2*
Williams, Etta M *ArtsEM, DcWomA*
Williams, Eva Brook *DcWomA*
Williams, F *DcVicP 2, NewYHSD*
Williams, F A *DcBrBI*
Williams, F L *AmArch 70*
Williams, F P *DcVicP 2*
Williams, Florence Alston *ArtsAmW 2*
Williams, Florence Elizabeth *DcWomA*
Williams, Florence White d1953 *WhAmArt 85*
Williams, Frances 1797-1816 *FolkA 86*
Williams, Frances H *DcVicP, -2*
Williams, Frank McCrady *AmArch 70*
Williams, Frank W *DcVicP, -2*
Williams, Franklin 1940- *WhoAmA 73, -76*
Williams, Franklyn 1921- *AmArch 70*
Williams, Fred 1936- *AmArch 70*
Williams, Fred Carter 1912- *AmArch 70*
Williams, Frederic A 1898-1958 *WhAmArt 85*
Williams, Frederic Allen 1898-1958 *WhoAmA 80N, -82N, -84N*
Williams, Frederick 1927- *OxTwCA*
Williams, Frederick Alan 1951- *MarqDCG 84*
Williams, Frederick Ballard 1871?-1956 *ArtsAmW 3, IlBEAAW, WhAmArt 85, WhoAmA 80N, -82N, -84N*
Williams, Frederick D *ArtsNiC*
Williams, Mrs. Frederick D *ArtsNiC*

Williams, Robert F *WhAmArt 85*
Williams, Robert Leo 1926- *AmArch 70*
Williams, Robert T *WhAmArt 85*
Williams, Robin 1941- *MarqDCG 84*
Williams, Roger *EncASM*
Williams, Roger 1943- *WhoAmA 76, –78*
Williams, Roger Wolcott 1924- *AmArch 70*
Williams, Russell E 1909- *AmArch 70*
Williams, Ruth Moore 1911- *WhAmArt 85*
Williams, S *DcBrWA, DcVicP 2, FolkA 86, NewYHSD*
Williams, Samuel *DcVicP 2*
Williams, Samuel 1788-1853 *DcBrBI, DcBrWA*
Williams, Sheldon *ConArch A*
Williams, Shirley *DcWomA*
Williams, Shirley C 1930- *WhoAmA 73, –76*
Williams, Simeon Sir Henry 1888- *AfroAA*
Williams, Smith *FolkA 86*
Williams, Solomon 1757-1824 *DcBrECP*
Williams, Stephanie *ConArch A*
Williams, Stephen *BiDAmAr*
Williams, Stephen, Jr. *BiDAmAr*
Williams, Stephen Guion 1941- *ICPEnP A, MacBEP*
Williams, Stephen Lionel *WhoArt 80, –82, –84*
Williams, Sydney *DcWomA*
Williams, Mrs. Sydney *DcVicP 2*
Williams, T *FolkA 86, NewYHSD*
Williams, Terrick 1860-1937 *DcVicP*
Williams, Terrick John 1860-1936 *DcBrA 1, DcBrWA*
Williams, Terrick John 1860-1937 *DcVicP 2*
Williams, Theopolus *AfroAA*
Williams, Thomas *DcVicP 2, NewYHSD*
Williams, Thomas H *DcBrBI, DcBrWA*
Williams, Thomas O 1917- *AmArch 70*
Williams, Thomas Russell 1783?- *CabMA*
Williams, Todd 1939- *AfroAA, WhoAmA 78, –80, –82, –84*
Williams, Tommy Carroll 1940- *WhoAmA 73, –76*
Williams, True W *EarABI, EarABI SUP*
Williams, Turner Garwood 1923- *AmArch 70*
Williams, Vera K *WhoArt 82N*
Williams, Vera K 1912- *WhoArt 80*
Williams, Virgil 1830-1886 *ArtsAmW 1, IlBEAAW, NewYHSD, WhAmArt 85*
Williams, Vivian *AfroAA*
Williams, Vivian Claud Craddock 1936- *WhoArt 80, –82, –84*
Williams, W *DcVicP*
Williams, W Gene 1928- *AmArch 70*
Williams, Mrs. W N *WhAmArt 85*
Williams, W R *AmArch 70, DcVicP 2*
Williams, W S *WhAmArt 85*
Williams, Walter *DcVicP 2*
Williams, Walter 1835-1906 *DcVicP 2*
Williams, Walter 1836-1906 *DcBrA 1, DcVicP*
Williams, Walter 1920- *AfroAA, WhoAmA 73, –76, –78, –80, –82, –84*
Williams, Mrs. Walter *DcWomA*
Williams, Walter J, Jr. 1922- *AfroAA*
Williams, Walter Reid 1885- *WhAmArt 85*
Williams, Walter Thomas 1896- *AmArch 70*
Williams, Warner 1903- *WhAmArt 85, WhoAmA 73, –76, –78, –80, –82*
Williams, Warner 1903-1982 *WhoAmA 84N*
Williams, Warren 1863-1918 *DcBrA 1, DcVicP 2*
Williams, Warren Haywood 1844-1888 *MacEA*
Williams, Watkins *WhAmArt 85*
Williams, Wayland Wells 1888-1945 *WhAmArt 85*
Williams, Wayne Calvin 1936- *AmArch 70*
Williams, Wayne Francis 1937- *WhoAmA 76, –78, –80, –82, –84*
Williams, Wayne Richard 1919- *AmArch 70*
Williams, Wellington *NewYHSD*
Williams, Wheeler 1897-1972 *WhAmArt 85, WhoAmA 78N, –80N, –82N, –84N*
Williams, William *DcBrECP, EncASM, FolkA 86, NewYHSD*
Williams, William 1710-1790 *FolkA 86*
Williams, William 1727-1791 *BnEnAmA, DcAmArt*
Williams, William 1787-1850 *EarABI, NewYHSD*
Williams, William 1796-1874 *NewYHSD*
Williams, William 1808-1895 *DcBrWA*
Williams, William Charles *DcVicP 2*
Williams, William George 1801-1846 *NewYHSD*
Williams, William Joseph 1759-1823 *NewYHSD*
Williams, William Lindsay 1920- *AmArch 70*
Williams, William Oliver *DcVicP 2*
Williams, William T 1816?- *FolkA 86*
Williams, William T 1942- *AfroAA*
Williams, William Terence 1941- *WhoAmA 76, –78*
Williams, William Thomas 1942- *WhoAmA 80, –82, –84*
Williams, Yvonne 1945- *AfroAA*
Williams Brothers *EncASM*
Williams-Ellis, Sir Clough *WhoArt 80N*
Williams-Ellis, Sir Clough 1883-1978 *ConArch*
Williams-Lyouns, Herbert Francis 1863- *DcBrA 1, DcVicP 2*
Williamshurst, J H *DcVicP 2*
Williamson *NewYHSD*

Williamson, A W *DcWomA*
Williamson, Mrs. A W *WhAmArt 85*
Williamson, Ada C 1880-1958 *WhAmArt 85*
Williamson, Ada C 1883-1958 *WhoAmA 80N, –82N, –84N*
Williamson, Ada Clendenin 1880-1958 *DcWomA*
Williamson, Al 1931- *WorECom*
Williamson, Anne *DcBrA 1*
Williamson, Charles *NewYHSD*
Williamson, Clara 1875-1976 *DcWomA*
Williamson, Clara McDonald *WhoAmA 76*
Williamson, Clara McDonald d1976 *WhoAmA 78N, –80N, –82N, –84N*
Williamson, Clara McDonald 1875- *ArtsAmW 2, WhoAmA 73*
Williamson, Clara McDonald 1875-1976 *FolkA 86*
Williamson, Clarissa *WhAmArt 85*
Williamson, Colin *BiDBrA*
Williamson, Curtis *OxTwCA, WhAmArt 85*
Williamson, Daniel Alexander 1823- *ArtsNiC*
Williamson, Daniel Alexander 1823-1903 *DcBrWA, DcVicP, –2*
Williamson, Donna M 1944- *AfroAA*
Williamson, Mrs. Edward L *WhAmArt 85*
Williamson, Edward Malcolm 1920- *AmArch 70*
Williamson, Elizabeth Dorothy 1907- *WhAmArt 85*
Williamson, Elizabeth M *DcWomA, WhAmArt 85*
Williamson, F M *DcBrBI*
Williamson, Francis John 1833-1920 *DcBrA 1*
Williamson, Frank *WhAmArt 85*
Williamson, Frederick *ClaDrA, DcVicP, –2*
Williamson, Frederick d1900 *DcBrWA*
Williamson, G M *AmArch 70*
Williamson, Gail McKennis 1939- *WhoAmA 80, –82, –84*
Williamson, Gary Lee 1939- *AmArch 70*
Williamson, George H 1872-1936 *BiDAmAr*
Williamson, Glen Robert 1955- *MarqDCG 84*
Williamson, H G *WhAmArt 85*
Williamson, H H *DcVicP 2*
Williamson, Harold 1898- *DcBrA 1*
Williamson, Harold Sandys 1892- *DcBrA 1, McGDA, WhoArt 80, –82, –84*
Williamson, Horace W 1897- *DcBrA 2*
Williamson, Howard *WhAmArt 85*
Williamson, Isobel B *DcBrBI*
Williamson, J B *DcBrWA, DcVicP 2*
Williamson, J Maynard, Jr. 1892- *WhAmArt 85*
Williamson, J T *DcVicP 2*
Williamson, James R 1930- *AmArch 70*
Williamson, James W 1899- *IlrAm D, –1880, WhAmArt 85*
Williamson, Jason *OfPGCP 86*
Williamson, Jason H 1926- *WhoAmA 78, –80, –82, –84*
Williamson, Jerold Earl 1933- *AmArch 70*
Williamson, John *AntBDN Q, DcBrBI, DcVicP 2*
Williamson, John 1757-1818 *DcBrECP*
Williamson, John 1826- *ArtsNiC*
Williamson, John 1826-1885 *ArtsAmW 3, IlBEAAW, NewYHSD, WhAmArt 85*
Williamson, John Smith *DcBrWA, DcVicP, –2*
Williamson, Joseph 1693?-1724 *AntBDN D*
Williamson, Lama Belle 1859- *DcWomA*
Williamson, Leila K *DcVicP 2*
Williamson, M P 1938- *MarqDCG 84*
Williamson, Mabel 1875- *DcWomA, WhAmArt 85*
Williamson, Margaret T *WhAmArt 85*
Williamson, Margaret Thompson *WhoAmA 78, –80, –82, –84*
Williamson, O E *AmArch 70*
Williamson, P L *AmArch 70*
Williamson, Paul Broadwell 1895- *ArtsAmW 3, WhAmArt 85*
Williamson, Rice 1740?- *AntBDN D*
Williamson, Robert *AntBDN D*
Williamson, Samuel 1792-1840 *DcBrWA*
Williamson, Samuel 1792-1842 *DcSeaP*
Williamson, Shirley *ArtsAmW 2, DcWomA, WhAmArt 85*
Williamson, Stan 1911- *AfroAA*
Williamson, Thomas *AntBDN Q*
Williamson, Thomas George 1758?-1817 *DcBrBI*
Williamson, Thomas Thole 1927- *AmArch 70*
Williamson, W *DcVicP 2*
Williamson, W H *ClaDrA, DcSeaP, DcVicP, –2*
Williamson, W M *DcBrWA, DcVicP 2*
Williamson, William *NewYHSD*
Williamson, William 1726-1760 *AntBDN Q*
Williamson, William 1865-1927 *BiDAmAr*
Williard, Solomon *FolkA 86*
Willibrord, Dom *McGDA*
Willies, Joan 1929- *WhoArt 84*
Williford, Donald French 1931- *AmArch 70*
Willig, James A *EncASM*
Willig, Nancy Tobin 1943- *WhoAmA 76, –78, –80, –82, –84*
Willigen, Christine Abichael VanDer 1850-1932 *DcWomA*
Willikens, Eberhard Gunther 1939- *DcCAr 81*
Willim, Charles 1875?-1960 *ArtsEM*

Willing, J Thomson 1860- *WhAmArt 85*
Willing, Jessie *DcWomA, WhAmArt 85*
Willing, Victor 1928- *DcCAr 81, PrintW 85*
Willink, Albert Carel 1900- *PhDcTCA 77*
Willink, Carel Albert 1900- *McGDA*
Willink, H G *DcVicP 2*
Willis, Miss *DcBrECP, DcWomA*
Willis, Albert Paul 1867- *WhAmArt 85*
Willis, Alice M 1888- *DcWomA, WhAmArt 85*
Willis, Ann M *AmArch 70*
Willis, Benjamin F 1848-1929 *BiDAmAr*
Willis, Beverly A 1928- *AmArch 70*
Willis, Edison Judson, Jr. 1928- *AmArch 70*
Willis, Edmund Aylburton 1808-1899 *NewYHSD, WhAmArt 85*
Willis, Edmund R *DcVicP 2*
Willis, Edward *FolkA 86*
Willis, Elizabeth Bayley *WhoAmA 84*
Willis, Elizabeth Bayley 1902- *WhoAmA 73, –76, –78, –80, –82*
Willis, Eola *DcWomA, WhAmArt 85*
Willis, Ethel Mary 1874- *DcBrA 1, DcVicP 2, DcWomA*
Willis, Eveline F *DcWomA, FolkA 86*
Willis, Frank 1865-1932 *DcBrA 1, DcVicP 2*
Willis, Frederick *NewYHSD*
Willis, George William *DcVicP 2*
Willis, Henry Brittan d1884 *ArtsNiC*
Willis, Henry Brittan 1810-1884 *DcBrWA, DcVicP, –2*
Willis, Mrs. Henry Brittan *DcVicP 2*
Willis, J B *DcBrBI*
Willis, J Cole *DcVicP 2*
Willis, J D *AmArch 70*
Willis, J R 1876- *ArtsAmW 2*
Willis, James Belmont, Jr. 1937- *AmArch 70*
Willis, James Perdue 1920- *AmArch 70*
Willis, Jay 1940- *DcCAr 81, PrintW 85*
Willis, Jay Steward 1940- *WhoAmA 78, –80*
Willis, Jay Stewart 1940- *WhoAmA 82, –84*
Willis, Jerry Lynn 1939- *AmArch 70*
Willis, John *DcVicP 2, NewYHSD*
Willis, John Christopher Temple 1900-1969 *DcBrA 1*
Willis, John Henry *WhoArt 80, –82, –84*
Willis, John Henry 1887- *DcBrA 1*
Willis, Katharina *DcVicP 2*
Willis, Katherine *ArtsAmW 2, DcWomA, WhAmArt 85*
Willis, L O *AmArch 70*
Willis, Louise Hammond 1870- *DcWomA*
Willis, Luster 1913- *FolkA 86*
Willis, Lynwood Grayson 1931- *AmArch 70*
Willis, M N *AmArch 70*
Willis, Patricia Marjorie 1914- *ClaDrA*
Willis, Patty 1879- *WhAmArt 85*
Willis, Peter *ConArch A*
Willis, R S *DcWomA*
Willis, Mrs. R S *ArtsEM*
Willis, R T 1876- *WhAmArt 85*
Willis, Ralph Troth 1876- *ArtsAmW 2*
Willis, Richard Henry Albert 1853-1905 *DcBrA 2, DcBrWA, DcVicP 2*
Willis, Robert *AfroAA*
Willis, Robert E 1922- *WhoAmA 82, –84N*
Willis, Rosa 1866-1960 *DcWomA*
Willis, Samuel William Ward 1870-1948 *DcBrA 1*
Willis, Sarah *FolkA 86*
Willis, Sidney F 1930- *WhoAmA 76, –78, –80, –82, –84*
Willis, Thomas 1850-1912 *WhAmArt 85*
Willis, Thornton 1936- *AmArt, DcCAr 81, PrintW 85, WhoAmA 76, –78, –80, –82, –84*
Willis, W *DcVicP 2*
Willis, William *CabMA*
Willis, William 1841-1923 *ICPEnP, MacBEP*
Willis, William H *NewYHSD*
Willis, William Henry, Jr. 1940- *WhoAmA 78, –80, –82, –84*
Willis, William R *NewYHSD*
Willison, George 1741-1797 *DcBrECP*
Willison, Gertrude *DcWomA, WhAmArt 85*
Williston, Samuel P *CabMA*
Willits, Alice *DcWomA*
Willits, Alice 1885- *ArtsAmW 2, WhAmArt 85*
Willitt, John *FolkA 86*
Willitts, S C *NewYHSD*
Willman, Joseph G *WhAmArt 85*
Willman, Michael 1630-1706 *McGDA*
Willmann, Anna Elisabeth *DcWomA*
Willmarth, Arthur F *WhAmArt 85*
Willmarth, Elizabeth *DcWomA*
Willmarth, Elizabeth J *WhAmArt 85*
Willmarth, Kenneth L *WhAmArt 85*
Willmarth, Kenneth L 1889- *ArtsAmW 3*
Willmarth, William A 1898- *ArtsAmW 2, WhAmArt 85*
Willmonton, Samuel 1807- *CabMA*
Willmore, A *ArtsNiC*
Willmore, Edward *NewYHSD*
Willmore, Edward C *NewYHSD*
Willmore, James T 1800-1863 *ArtsNiC*

Wilson, Gerard 1943- *DcCAr 81*
Wilson, Gertrude *DcWomA*
Wilson, Gilbert Brown 1907- *WhAmArt 85*
Wilson, Gladys Lucille 1906- *AfroAA*
Wilson, Godfrey *DcBrBI*
Wilson, Gordon Walton 1940- *AmArch 70*
Wilson, Grace *WhAmArt 85*
Wilson, Grant Amann 1891- *AmArch 70*
Wilson, H *DcVicP 2, FolkA 86, NewYHSD*
Wilson, H B *AmArch 70*
Wilson, H B, Jr. *AmArch 70*
Wilson, H H *DcVicP 2*
Wilson, H K *AmArch 70*
Wilson, H P *DcBrBI*
Wilson, H S *DcSeaP*
Wilson, H Thomas 1927- *AmArch 70*
Wilson, Harriet *WhAmArt 85*
Wilson, Harriet 1886- *DcWomA*
Wilson, Harry *DcVicP 2*
Wilson, Harry 1943- *MacBEP*
Wilson, Harry M *DcVicP 2*
Wilson, Harry P *DcVicP 2*
Wilson, Harry Robert *AmArch 70*
Wilson, Hazel Marie 1899- *ArtsAmW 2, DcWomA*
Wilson, Helen *WhoArt 80N*
Wilson, Helen d1974 *WhoAmA 76N, –78N, –80N, –82N, –84N*
Wilson, Helen 1884- *ArtsAmW 2, DcWomA*
Wilson, Helen 1884-1974 *WhAmArt 85*
Wilson, Helen J *WhoAmA 76, –78*
Wilson, Helen Mary Graham 1903- *DcBrA 1*
Wilson, Helen Russel d1924 *DcWomA*
Wilson, Helen Russell *DcBrBI*
Wilson, Helen Russell d1924 *DcBrA 1*
Wilson, Helena *DcVicP 2, DcWomA*
Wilson, Helena 1836-1923 *DcBrA 2*
Wilson, Helena Chapellin *MacBEP*
Wilson, Henrietta *DcWomA, WhAmArt 85*
Wilson, Henry *FolkA 86, NewYHSD*
Wilson, Henry 1864-1934 *MacEA*
Wilson, Herbert *DcVicP 2*
Wilson, Herbert Eugene 1932- *AmArch 70*
Wilson, Horace Earl 1934- *AmArch 70*
Wilson, Horatio R 1857-1917 *BiDAmAr*
Wilson, Howell *WhAmArt 85*
Wilson, Hugh 1803-1884 *FolkA 86*
Wilson, Hugh Cameron *ClaDrA*
Wilson, Hugh Cameron 1885- *DcBrA 1*
Wilson, Ida *FolkA 86*
Wilson, Isabella Maria *DcWomA, FolkA 86*
Wilson, J *DcVicP 2, NewYHSD*
Wilson, J A *AmArch 70*
Wilson, J B *NewYHSD*
Wilson, J Coggeshall *WhAmArt 85*
Wilson, J Davis 1906- *AmArch 70*
Wilson, J F *AmArch 70*
Wilson, J G *NewYHSD*
Wilson, J Harrington *DcVicP 2*
Wilson, J M *AmArch 70*
Wilson, J R *AmArch 70*
Wilson, J R 1865-1966 *ArtsAmW 3*
Wilson, J T *DcBrWA, DcVicP, –2*
Wilson, James *FolkA 86, NewYHSD*
Wilson, James Claudius *NewYHSD*
Wilson, James Frederick 1887- *DcBrA 1*
Wilson, James Gerald 1930- *AmArch 70*
Wilson, James H 1917- *WhoArt 80, –82, –84*
Wilson, James Knox 1828-1894 *BiDAmAr*
Wilson, James S *FolkA 86*
Wilson, James W 1825-1893 *FolkA 86*
Wilson, James Warner 1825-1893 *NewYHSD , WhAmArt 85*
Wilson, James Watney *DcVicP 2*
Wilson, Jane 1924- *AmArt, DcCAA 71, –77, DcCAr 81, WhoAmA 73, –76, –78, –80, –82, –84*
Wilson, Jane W *FolkA 86*
Wilson, Jean Douglas *WhAmArt 85*
Wilson, Jean L *DcWomA*
Wilson, Jennie *DcWomA*
Wilson, Jeremiah 1825?- *IlBEAAW*
Wilson, Jeremy *FolkA 86, NewYHSD*
Wilson, Jeremy 1824-1899 *ArtsAmW 2*
Wilson, Jesse *CabMA*
Wilson, Job *FolkA 86*
Wilson, Joe Ed 1932- *AmArch 70*
Wilson, John *ArtsEM, BiDBrA, CabMA, ClaDrA, DcBrA 2, DcBrBI, FolkA 86, IlsBYP, NewYHSD , OfPGCP 86*
Wilson, John d1765? *BiDBrA*
Wilson, John 1766- *DcBrECP*
Wilson, John 1774-1855 *ClaDrA*
Wilson, John 1832?-1870 *ArtsAmW 3*
Wilson, John 1922- *AfroAA, WhoAmA 76, –78, –80, –82, –84*
Wilson, John A 1878- *WhAmArt 85*
Wilson, John Allenby 1921- *AmArch 70*
Wilson, John David 1934- *WhoAmA 80, –82, –84*
Wilson, John Dyson *AmArch 70*
Wilson, John Elzey 1921- *AmArch 70*
Wilson, John Francis 1912- *AmArch 70*
Wilson, John H 1774-1855 *DcSeaP, DcVicP, –2*

Wilson, John H 1946- *MarqDCG 84*
Wilson, John H Jock 1774-1855 *DcBrWA*
Wilson, John James 1818-1875 *ClaDrA, DcBrWA, DcSeaP, DcVicP, –2*
Wilson, John James 1836-1903 *DcBrWA*
Wilson, John Louis 1899- *AfroAA*
Wilson, John Louis 1900- *AmArch 70*
Wilson, John M *FolkA 86*
Wilson, John T *NewYHSD*
Wilson, John Woodrow 1922- *WhAmArt 85*
Wilson, Jonathan *FolkA 86*
Wilson, Joseph *CabMA, DcBrECP, DcVicP 2, FolkA 86, NewYHSD*
Wilson, Joseph 1779-1857 *NewYHSD*
Wilson, Joseph C *NewYHSD*
Wilson, Joseph M 1838-1902 *BiDAmAr*
Wilson, Joseph Miller *WhAmArt 85*
Wilson, Joseph Thomas 1919- *AmArch 70*
Wilson, Josephine Davis *DcWomA, WhAmArt 85*
Wilson, Judith 1952- *WhoAmA 82, –84*
Wilson, Karan Rose 1944- *AfroAA*
Wilson, Kate *DcVicP 2, DcWomA, WhAmArt 85*
Wilson, Katharine E 1833-1893 *DcWomA*
Wilson, Kenneth George 1942- *AmArch 70*
Wilson, L D *NewYHSD*
Wilson, Leman Hershal 1917- *AmArch 70*
Wilson, Leslie *DcBrBI*
Wilson, Louis Henry 1857-1935 *BiDAmAr*
Wilson, Louis W *WhAmArt 85*
Wilson, Lucy Adams 1855- *DcWomA, WhAmArt 85*
Wilson, Lucy Currier Richards *DcWomA*
Wilson, M *DcVicP 2, DcWomA, FolkA 86*
Wilson, M L *AmArch 70*
Wilson, Margaret Evangeline 1890- *DcBrA 1, DcWomA*
Wilson, Margaret T 1864-1912 *DcBrA 1, DcVicP 2, DcWomA*
Wilson, Maria *FolkA 86*
Wilson, Maria G *DcVicP 2*
Wilson, Marie *DcVicP 2*
Wilson, Marshall G 1905- *ICPEnP A*
Wilson, Martha Storey 1947- *WhoAmA 78, –80, –82, –84*
Wilson, Mary *DcWomA*
Wilson, Mary Ann *NewYHSD*
Wilson, Mary G W *ClaDrA*
Wilson, Mary Priscilla *NewYHSD*
Wilson, Mary R *DcWomA, FolkA 86, NewYHSD*
Wilson, Matthew *NewYHSD*
Wilson, Matthew 1814-1892 *NewYHSD*
Wilson, Maude *DcWomA, WhAmArt 85*
Wilson, Maurice 1914- *WhoArt 80, –82, –84*
Wilson, May *DcWomA*
Wilson, May 1905- *WhoAmA 73, –76, –78, –80, –82, –84*
Wilson, Melba Z *WhAmArt 85*
Wilson, Melva Beatrice 1866-1921 *DcWomA, WhAmArt 85*
Wilson, Michael 1951- *WhoArt 80*
Wilson, Millie 1948- *WhoAmA 84*
Wilson, Mortimer 1906- *IlrAm E*
Wilson, Mortimer, Jr. *WhAmArt 85*
Wilson, Mortimer, Jr. 1906- *IlrAm 1880, WhoAmA 76, –78*
Wilson, Muriel 1892- *DcBrA 1, DcWomA*
Wilson, Nathaniel 1661-1733 *CabMA*
Wilson, Nelson 1880- *WhAmArt 85*
Wilson, Nicholas Jon 1947- *AmArt, WhoAmA 78, –80, –82, –84*
Wilson, Nick *OfPGCP 86*
Wilson, Norman Badgley 1906- *WhAmArt 85*
Wilson, O *NewYHSD*
Wilson, Oliver *FolkA 86, NewYHSD*
Wilson, Orme d1966 *WhoAmA 78N, –80N, –82N, –84N*
Wilson, Oscar *ClaDrA, DcVicP*
Wilson, Oscar 1867-1930 *DcBrA 1, DcBrBI, DcBrWA, DcVicP 2*
Wilson, P A *AmArch 70*
Wilson, P Macgregor d1928 *DcBrA 1, DcVicP 2*
Wilson, Patricia Ann 1938- *AmArch 70*
Wilson, Patten 1868?- *DcBrA 2, DcVicP 2*
Wilson, Patten 1868-1928 *DcBrBI*
Wilson, Paul Malone 1946- *MarqDCG 84*
Wilson, Peggy *IlsBYP, IlsCB 1957*
Wilson, Po 1930- *MarqDCG 84*
Wilson, R *AmArch 70*
Wilson, R C *AmArch 70*
Wilson, R H, Jr. *AmArch 70*
Wilson, Ralph *DcBrA 1*
Wilson, Richard *AfroAA, DcCAr 81*
Wilson, Richard 1713-1782 *DcBrECP, McGDA*
Wilson, Richard 1714-1782 *ClaDrA, DcBrWA, OxArt*
Wilson, Richard 1752-1807 *DcBrECP*
Wilson, Richard Bourne *DcCAr 81*
Wilson, Richard Brian 1944- *AmArt, WhoAmA 76, –78, –80, –82, –84*
Wilson, Robert *CabMA, EncASM, FolkA 86, PrintW 83, –85, WhoAmA 82, –84*
Wilson, Robert 1941- *AmArt*

Wilson, Robert Adair 1915- *AmArch 70*
Wilson, Robert Arthur *WhoArt 80, –82, –84N*
Wilson, Robert Arthur 1884- *DcBrA 1*
Wilson, Robert B 1792?- *FolkA 86*
Wilson, Robert Burns 1851-1916 *WhAmArt 85*
Wilson, Robert Edwin, Jr. 1922- *AmArch 70*
Wilson, Robert L 1934- *AmArch 70*
Wilson, Robert M 1944- *ConArt 77, –83*
Wilson, Robert Wesley 1924- *AmArch 70*
Wilson, Rodney L 1957- *MarqDCG 84*
Wilson, Roger *AfroAA*
Wilson, Roger D 1943- *DcCAr 81*
Wilson, Ronald York 1907- *McGDA*
Wilson, Rosa *DcVicP 2*
Wilson, Rose Cecil *DcWomA*
Wilson, Rose Cecil O'Neil 1875-1944 *WhAmArt 85*
Wilson, Rose Cecil O'Neill 1875-1944 *IlrAm 1880*
Wilson, Rowland Bragg 1930- *WhoAmA 76, –78, –80, –82, WorECar*
Wilson, Roy 1900-1965 *WorECom*
Wilson, Mrs. Russell *FolkA 86*
Wilson, S H *DcVicP 2*
Wilson, Sally *FolkA 86*
Wilson, Samuel *NewYHSD*
Wilson, Samuel, Jr. 1911- *AmArch 70*
Wilson, Sarah *FolkA 86*
Wilson, Sarah C *DcWomA, WhAmArt 85*
Wilson, Scott 1903- *WhAmArt 85*
Wilson, Scottie 1889- *DcBrA 1*
Wilson, Scottie 1889-1972 *DcBrA 2, OxTwCA, PhDcTCA 77*
Wilson, Sol 1894- *McGDA*
Wilson, Sol 1896- *WhoAmA 73*
Wilson, Sol 1896-1974 *WhAmArt 85, WhoAmA 76N, –78N, –80N, –82N, –84N*
Wilson, Sophie 1887- *DcWomA, WhAmArt 85*
Wilson, Stanley *DcVicP 2*
Wilson, Stanley Charles 1947- *AfroAA*
Wilson, Stanley R 1890- *ClaDrA*
Wilson, Stanley Reginald 1890-1973 *DcBrA 1*
Wilson, Stella *DcWomA*
Wilson, Stella Louise *WhoArt 80, –82, –84N*
Wilson, Stella Louise 1892- *DcBrA 1, DcWomA*
Wilson, Stephen A 1954- *MarqDCG 84*
Wilson, Stephen D 1825?- *NewYHSD*
Wilson, Stephen Harth 1944- *MarqDCG 84*
Wilson, Steve *FolkA 86*
Wilson, Susan Colston *WhAmArt 85*
Wilson, Suzanne *AfroAA*
Wilson, Sybil 1923- *WhoAmA 73, –76, –78, –80, –82, –84*
Wilson, Sydney Ernest 1869- *DcBrA 2*
Wilson, T *DcBrECP*
Wilson, T F *DcVicP 2*
Wilson, T Sidney *DcWomA*
Wilson, T W *ArtsEM*
Wilson, Thomas *CabMA, DcVicP 2, FolkA 86, NewYHSD*
Wilson, Thomas Clyde 1937- *AmArch 70*
Wilson, Thomas E *ArtsEM*
Wilson, Thomas Edwin 1928- *AmArch 70*
Wilson, Thomas Harrington *DcBrBI, DcVicP, –2, IlBEAAW*
Wilson, Thomas Redyard 1941- *AmArch 70*
Wilson, Thomas Walter 1851- *ClaDrA, DcVicP*
Wilson, Thomas Walter 1851-1912 *DcBrA 1, DcBrBI, DcBrWA, DcVicP 2*
Wilson, Tom Martin 1939- *AmArch 70*
Wilson, Tom Muir 1930- *WhoAmA 73, –76, –78, –80, –82, –84*
Wilson, Trelen John 1948- *MarqDCG 84*
Wilson, Vaux *WhAmArt 85*
Wilson, Vincent John 1933- *WhoArt 80, –82, –84*
Wilson, Violet *DcWomA*
Wilson, Virginia Rohm 1851-1930 *DcWomA*
Wilson, W *ArtsEM, DcVicP 2*
Wilson, W, Jr. *DcVicP 2*
Wilson, W D *AmArch 70*
Wilson, W Dower *DcVicP 2*
Wilson, W E, Jr. *AmArch 70*
Wilson, W F *AmArch 70*
Wilson, W J *AmArch 70, DcVicP 2*
Wilson, Mrs. W R *DcVicP 2*
Wilson, W Reynolds, Jr. 1899-1934 *WhAmArt 85*
Wilson, Wallace 1947- *ICPEnP A, MacBEP, WhoAmA 80, –82, –84*
Wilson, Warren Bingham 1920- *WhoAmA 78, –80, –82, –84*
Wilson, William *DcBrECP, EncASM, FolkA 86, NewYHSD*
Wilson, William d1850 *NewYHSD*
Wilson, William 1660?- *CabMA*
Wilson, Sir William 1641-1710 *BiDBrA*
Wilson, William A *DcVicP, –2*
Wilson, William A 1905- *DcBrA 1*
Wilson, William F *NewYHSD*
Wilson, William Feathergail 1934- *MarqDCG 84*
Wilson, William Harold 1920- *AmArch 70*
Wilson, William Harry 1939- *WhoAmA 78, –80, –82*
Wilson, William Heath 1849-1927 *DcBrA 1, DcVicP, –2*

Woensam, Anton 1500?-1541 *McGDA*
Woensel, Petronella Van 1785-1839 *DcWomA*
Woermann, Hedwig 1879- *DcWomA*
Woermann, Marie 1851-1942 *DcWomA*
Woerner, F J *AmArch 70*
Woerner, H F *AmArch 70*
Woerner, J F, Jr. *AmArch 70*
Woestemeyer, O F *AmArch 70*
Woestijne, Gustave VanDe 1881-1947 *McGDA,*
 OxTwCA, PhDcTCA 77
Wofford, Philip 1935- *DcCAA 77, WhoAmA 73,*
 -76, -78, -80, -82, -84
Wofford, T J *AmArch 70*
Wofford, W R *AmArch 70*
Wogan, Caroline *DcWomA*
Wogden, Robert *AntBDN F*
Wogden And Barton *AntBDN F*
Wogram, Frederick *NewYHSD*
Wogstad, James Everet 1939- *WhoAmA 76, -78, -80,*
 -82, -84
Wohe, W *FolkA 86*
Wohlauer, Ronald W 1947- *MacBEP*
Wohlberg, Ben 1927- *IlrAm G, -1880*
Wohlberg, J Arthur *AmArch 70*
Wohlberg, Meg *WhAmArt 85*
Wohlberg, Meg 1905- *IlsCB 1957*
Wohler, Sophie *DcWomA*
Wohlfahrt, Daniel *FolkA 86*
Wohlfahrt, Johann Jacob *CabMA*
Wohlfarth, Harry 1921- *WhoAmA 76*
Wohlgeboren, Helene 1852- *DcWomA*
Wohlgemuth, Michel 1434-1519 *ClaDrA*
Wohlwill, Margarete 1878- *DcWomA*
Woiceske, Elizabeth Bush *WhAmArt 85*
Woiceske, R W 1887-1953 *WhAmArt 85*
Woiceske, Ronau William 1887-1953 *GrAmP*
Woide, Robert E 1927- *WhoAmA 84*
Woikowsky-Tillgner, Karin Von 1890- *DcWomA*
Woiseri *NewYHSD*
Woit, Bonnie Ford 1931- *WhoAmA 82, -84*
Woit, Steven Ford 1958- *MarqDCG 84*
Woitena, Ben S 1942- *WhoAmA 78, -80, -82, -84*
Wojahn, Gilbert M 1915- *AmArch 70*
Wojciechowski, C R *AmArch 70*
Wojcik, Gary Thomas 1945- *WhoAmA 73, -76, -78,*
 -80, -82, -84
Wojinski, Francis Ann 1910- *WhoAmA 73*
Wojnarowicz, David 1954- *AmArt*
Wojtyla, Haase 1933- *WhoAmA 84*
Wojtyla, Hasse 1933- *WhoAmA 78, -80, -82*
Wojtyla, W Hasse 1933- *AmArt*
Wokal, Louis Edwin 1914- *WhAmArt 85*
Wolanin, Barbara Ann Boese 1943- *WhoAmA 84*
Wolaver, W H *AmArch 70*
Wolaver, W H, Jr. *AmArch 70*
Wolber, Paul J 1935- *WhoAmA 76, -78, -80, -82, -84*
Wolchonok, Louis 1898- *WhAmArt 85*
Wolcott, Alexander Simon 1804-1844 *ICPEnP*
Wolcott, Dean *AmArch 70*
Wolcott, Elizabeth Tyler 1892- *ConICB, DcWomA*
Wolcott, Frank *WhAmArt 85*
Wolcott, Helen *WhAmArt 85*
Wolcott, John Gilmore 1891- *WhAmArt 85*
Wolcott, Josiah *EarABI SUP, NewYHSD*
Wolcott, Katherine 1880- *DcWomA, WhAmArt 85*
Wolcott, Marion Post *WhoAmA 84*
Wolcott, Marion Post 1910- *ICPEnP A, MacBEP,*
 WhAmArt 85
Wolcott, Roger Augustus 1909- *WhAmArt 85*
Wolcott, Mrs. Stanley *WhAmArt 85*
Wold, Clark Dolan 1926- *AmArch 70*
Wold, Hugo W d1944 *BiDAmAr*
Wold, Robert Lee 1931- *AmArch 70*
Wold-Torne, Kris Laache 1867- *DcWomA*
Woldbye, Ole 1930- *MacBEP*
Wolden, Matt *WhAmArt 85*
Woldendorp, Richard 1927- *MacBEP*
Woldersov, Princess Of Denmark *DcWomA*
Woledge, Frederick William *DcBrWA, DcVicP 2*
Wolever, Adeleine 1886- *WhAmArt 85*
Wolf, A J, Jr. *AmArch 70*
Wolf, Adam 1816?- *FolkA 86*
Wolf, Amanda *WhAmArt 85*
Wolf, Anne L *DcWomA*
Wolf, Ben 1914- *WhAmArt 85*
Wolf, Daniel 1955- *MacBEP*
Wolf, Ebert, The Younger d1609? *McGDA*
Wolf, Elizabeth *DcBrA 1*
Wolf, Ella 1868- *DcWomA*
Wolf, Elza *DcWomA*
Wolf, Emil 1802-1879 *ArtsNiC*
Wolf, Eva M *DcWomA*
Wolf, Eva M Nagel 1880- *WhAmArt 85*
Wolf, Fay Miller *WhAmArt 85*
Wolf, Florence *DcWomA*
Wolf, Franz *OfPGCP 86*
Wolf, Fritz 1918- *WorECar*
Wolf, H *FolkA 86*
Wolf, H C, III *AmArch 70*
Wolf, Hamilton d1967 *WhAmArt 85*
Wolf, Hamilton Achille 1883-1967 *ArtsAmW 2*

Wolf, Harriet Daniela 1894- *DcWomA*
Wolf, Henriette Louise *DcWomA*
Wolf, Henry 1852-1916 *WhAmArt 85*
Wolf, Henry 1925- *AmGrD[port], ConDes,*
 WhoGrA 62, -82[port]
Wolf, J Robert 1929- *AmArch 70*
Wolf, Jack Clifford 1922- *WhoAmA 76, -78, -80, -82*
Wolf, Josef 1820-1899 *GrBII[port]*
Wolf, Joseph 1820-1899 *ClaDrA, DcBrBI, DcBrWA,*
 DcVicP, -2, IlBEAAW
Wolf, Leon *WhAmArt 85*
Wolf, Linda Ann 1950- *MacBEP*
Wolf, Louise 1798-1859 *DcWomA*
Wolf, Max 1885- *WhAmArt 85*
Wolf, May V *DcWomA*
Wolf, O *AmArch 70*
Wolf, Paul 1879-1957 *MacEA*
Wolf, Peggy *WhAmArt 85*
Wolf, Pegot *IlBEAAW*
Wolf, Rollin L 1909- *AmArch 70*
Wolf, S M *AmArch 70*
Wolf, Terry 1948- *MarqDCG 84*
Wolf, William *FolkA 86*
Wolf, William Martin 1928- *MarqDCG 84*
Wolf, William W 1898- *AmArch 70*
Wolf And Knell *EncASM*
Wolf-Thorn, Julie 1868- *DcWomA*
Wolfaerts, Artus 1581-1641 *ClaDrA*
Wolfard, H N *AmArch 70*
Wolfe, A *AmArch 70*
Wolfe, A L *AmArch 70*
Wolfe, Ada A *DcWomA, WhAmArt 85*
Wolfe, Ann *WhoAmA 73, -76, -78, -80, -82, -84*
Wolfe, Ann 1905- *WhAmArt 85*
Wolfe, Bruce 1941- *AmArt*
Wolfe, Byron B 1904-1973 *IlBEAAW, WhAmArt 85*
Wolfe, C E *BiDAmAr*
Wolfe, C W *AmArch 70*
Wolfe, Clifford Eugene 1906- *AmArch 70*
Wolfe, David 1732?-1808 *AntBDN H*
Wolfe, Edith Grace *DcWomA*
Wolfe, Edith Grace 1883- *DcBrA 2*
Wolfe, Edward *AmArch 70*
Wolfe, Edward 1897- *ConBrA 79[port], DcBrA 1,*
 WhoArt 82
Wolfe, Edward 1899- *OxArt*
Wolfe, Edward Harris 1897- *ClaDrA*
Wolfe, G M *AmArch 70*
Wolfe, George 1834-1890 *DcBrWA, DcVicP, -2*
Wolfe, George E *WhAmArt 85*
Wolfe, Harold D, Jr. 1933- *AmArch 70*
Wolfe, James 1944- *WhoAmA 76, -78, -80, -82, -84*
Wolfe, James E 1820-1901 *BiDAmAr*
Wolfe, John C *FolkA 86, NewYHSD*
Wolfe, John K 1835?- *NewYHSD*
Wolfe, John Lewis d1881 *BiDBrA*
Wolfe, Karl 1904- *WhAmArt 85*
Wolfe, L C *AmArch 70*
Wolfe, L Stephen 1949- *MarqDCG 84*
Wolfe, Louise Dahl *ICPEnP*
Wolfe, Lynn Robert 1917- *WhoAmA 76, -78, -80,*
 -82, -84
Wolfe, Maurice Raymond 1924- *WhoAmA 78, -80,*
 -82, -84
Wolfe, Maynard *DcVicP 2*
Wolfe, Meyer 1897- *WhAmArt 85*
Wolfe, Mildred Nungester 1912- *WhoAmA 76, -78,*
 -80, -82, -84
Wolfe, Natalie 1896-1938? *WhAmArt 85*
Wolfe, Natalie 1896-1939? *DcWomA*
Wolfe, Pamela 1950- *DcCAr 81*
Wolfe, Robert, Jr. 1930- *WhoAmA 76, -78, -80, -82,*
 -84
Wolfe, S A *AmArch 70*
Wolfe, Thomas Barnes 1860-1923 *BiDAmAr*
Wolfe, Townsend Durant 1935- *WhoAmA 73, -76,*
 -78, -80, -82, -84
Wolfe, W S M *DcBrBI*
Wolfe, Walter *OfPGCP 86*
Wolfe, William *FolkA 86*
Wolfenbarger, Floyd Orson 1904- *AmArch 70*
Wolfenden, John W *EncASM*
Wolfensberger, Hanna Dorothea Burdon 1800-1877
 DcWomA
Wolfensberger, J *DcVicP 2*
Wolfers, Marcel *DcNiCA*
Wolfers, Philippe 1858-1929 *AntBDN A, DcNiCA*
Wolfert, Frank 1906- *FolkA 86*
Wolff *NewYHSD*
Wolff, Adolf 1887- *WhAmArt 85*
Wolff, Bernard Pierre 1930- *ICPEnP A, MacBEP*
Wolff, Betty 1863-1941 *DcWomA*
Wolff, Carrie *DcWomA*
Wolff, David 1732-1798 *IlDcG, OxDecA*
Wolff, Dee I 1948- *DcCAr 81*
Wolff, Elisabeth 1898- *DcWomA*
Wolff, Elisabeth 1935- *DcCAr 81*
Wolff, F Louis 1928- *AmArch 70*
Wolff, G M *AmArch 70*
Wolff, Gustav 1886-1934 *PhDcTCA 77*
Wolff, Gustave 1863- *WhAmArt 85*

Wolff, Isabel *WhAmArt 85*
Wolff, Jacob 1546?-1612 *MacEA*
Wolff, Jacob 1571-1620 *MacEA*
Wolff, Jennifer 1957- *MarqDCG 84*
Wolff, Kathe 1882- *DcWomA*
Wolff, Louis Michael 1910- *AmArch 70*
Wolff, M *AmArch 70*
Wolff, Otto 1858- *WhAmArt 85*
Wolff, Paul 1887-1951 *ICPEnP A*
Wolff, Peter *IlDcG*
Wolff, Richard Evans 1942- *WhoAmA 76, -78*
Wolff, Robert Jay 1905- *DcCAA 71, -77,*
 WhoAmA 73, -76
Wolff, Robert Jay 1905-1978 *WhAmArt 85,*
 WhoAmA 78N, -80N, -82N, -84N
Wolff, Robert W, Jr. 1947- *WhoAmA 82, -84*
Wolff, Solomon 1841-1911 *WhAmArt 85*
Wolff, William H 1906- *WhoAmA 78, -80, -82, -84*
Wolff-Arndt, Philippine 1849- *DcWomA*
Wolff-Zimmermann, Elisabeth 1876- *DcWomA*
Wolfflin, Heinrich 1864-1945 *McGDA*
Wolffsen, Aleijda 1648-1690? *DcWomA*
Wolfgang, Gustav Andreas 1692-1775 *ClaDrA*
Wolfgang, Johann Georg 1662-1744 *McGDA*
Wolfinger, August 1879-1950 *FolkA 86*
Wolfley, Richard Franklin 1919- *AmArch 70*
Wolfman, Ernest 1927- *AmArch 70*
Wolford, Boyd C 1926- *AmArch 70*
Wolford, Charles 1811?- *NewYHSD*
Wolford, Wayne Arlo 1931- *AmArch 70*
Wolfrom, Philip H *WhAmArt 85*
Wolfs, Wilma Diena *WhAmArt 85*
Wolfsen, Aleijda 1648-1690? *DcWomA*
Wolfsohn, Helena *DcNiCA*
Wolfson, Henry Abraham 1891- *WhAmArt 85*
Wolfson, Irving 1899- *WhAmArt 85*
Wolfson, Sidney *WhoAmA 73*
Wolfson, Sidney 1911-1973 *WhoAmA 76N, -78N,*
 -80N, -82N, -84N
Wolfson, Sidney 1914- *DcCAA 71*
Wolfson, Sidney 1914-1973 *DcCAA 77*
Wolfson, William 1894- *WhAmArt 85*
Wolfthorn, Julie 1868- *DcWomA*
Wolgamood, L J *AmArch 70*
Wolgamuth, H *NewYHSD*
Wolgemut, Michael 1434-1519 *McGDA, OxArt*
Wolhaupter, Helen Phillips 1897?- *DcWomA*
Wolins, Joseph 1915- *WhoAmA 73, -76, -78, -80, -82,*
 -84
Wolinski, Georges 1934- *WorECom*
Wolinsky, Joseph 1873- *WhAmArt 85*
Woljeska-Tindolph, Helen 1875- *DcWomA*
Wolk, Sue *MarqDCG 84*
Wolkenhauer, Anna 1862- *DcWomA*
Wolkers-Ransome, Joan Elizabeth Margaret 1928-
 WhoArt 80, -82, -84
Wolkin, Harry *WhAmArt 85*
Wolkonsky, Princess Maria *DcWomA*
Wollaston, Charles 1914- *ClaDrA, DcBrA 1,*
 WhoArt 80, -82, -84
Wollaston, John *BnEnAmA, DcAmArt, DcBrECP,*
 McGDA, NewYHSD
Wollaston, William Hyde 1766-1828 *ICPEnP*
Wolle, Muriel *WhAmArt 85*
Wolle, Muriel Sibell 1898- *ArtsAmW 1, IlBEAAW,*
 WhoAmA 73, -76
Wolle, Muriel Sibell 1898-1977 *WhoAmA 78N, -80N,*
 -82N, -84N
Wolle, Muriel Vincent Sibell 1898-1977 *DcWomA*
Wolleh, Lothar 1930- *DcCAr 81*
Wollen, William Barnes 1857-1936 *DcBrA 1,*
 DcVicP 2
Wollen, William Barns 1857- *DcVicP*
Wollensak, Richard J *MarqDCG 84*
Wollenweber, Kenneth Herman 1920- *AmArch 70*
Wollin, E F *AmArch 70*
Wollner, Alexandre 1928- *WhoGrA 82[port]*
Wollner-Beuk, Hedwig 1890- *DcWomA*
Wollstadter, Else 1874- *DcWomA*
Wollwn, William Barnes 1857-1936 *DcBrBI*
Wolmark, Alfred Aaran 1877-1961 *DcBrA 1*
Wolmark, Alfred Aaron 1877-1961 *ClaDrA,*
 DcVicP 2
Wolner, Howard Henry 1930- *AmArch 70*
Wolpe, Berthold 1905- *WhoGrA 62, -82[port]*
Wolpert, Elizabeth Davis 1915- *WhoAmA 73, -76,*
 -78, -80, -82, -84
Wols 1913-1951 *ConArt 77, -83, ConPhot,*
 ICPEnP A, McGDA, OxTwCA, PhDcTCA 77
Wolseley, Garnet Ruskin 1884-1967 *DcBrA 1*
Wolsey, Florence *DcVicP 2*
Wolsky, Jack 1930- *WhoAmA 76, -78, -80, -82, -84*
Wolsky, Milton Laban 1916- *WhoAmA 73, -76, -78,*
 -80, -82
Wolstenholme, Dean, Jr. 1798-1882 *DcVicP, -2*
Wolter, Adolph G 1903- *WhAmArt 85*
Wolter, H J *WhAmArt 85*
Wolterbeek, Anna Henriette 1834- *DcWomA*
Wolters, Donald 1932- *AmArch 70*
Wolters, Henriette 1692-1741 *DcWomA*
Wolters, Henry 1845-1921 *BiDAmAr*

Woltersdorf, Arthur F 1870-1948 *BiDAmAr*
Woltrek *DcVicP 2*
Woltz, George 1744-1812 *CabMA*
Woltz, George W *WhAmArt 85*
Woltz, Robert P, Jr. 1905- *AmArch 70*
Woltze, B *DcVicP 2*
Wolvecamp, Theo *OxTwCA*
Wolvens, Victor 1896- *PhDcTCA 77*
Wolverson, Margaret Elizabeth 1937- *ClaDrA, WhoArt 80, -82, -84*
Wolverson, Martin 1939- *WhoArt 80, -82, -84*
Wolverton, Basil 1909- *WorECom*
Wolverton, D L *AmArch 70*
Womack, Albert Linwood 1917- *AmArch 70*
Womack, W C *AmArch 70*
Wombile, T W *DcVicP 2*
Womble, John Thomas 1936- *AmArch 70*
Womelsdorf, William Norvell 1913- *AmArch 70*
Womersley, Peter 1923- *ConArch, MacEA*
Womrath, A K 1869- *WhAmArt 85*
Womrath, Andrew K 1869- *DcBrBI*
Wondenberg, C M I *WhAmArt 85*
Wonder, Pieter Christoffel 1780-1852 *ClaDrA*
Wonderlick, Dennis N 1941- *AmArch 70*
Wondriska, William *IlsCB 1967*
Wondriska, William Allen 1931- *IlsCB 1957*
Wong, Albert 1928- *AmArch 70*
Wong, Brent 1945- *DcCAr 81*
Wong, Charles Wah 1929- *AmArch 70*
Wong, Ching 1936- *WhoAmA 76, -78, -80, -82*
Wong, Frank J *AmArch 70*
Wong, Frank M G 1961- *MarqDCG 84*
Wong, Frederick 1929- *WhoAmA 73, -76, -78, -80, -82, -84*
Wong, Gin D 1922- *AmArch 70*
Wong, H M *AmArch 70*
Wong, Harold Thomas 1929- *AmArch 70*
Wong, Harry J 1928- *AmArch 70*
Wong, Henry Keung 1937- *AmArch 70*
Wong, Howard 1930- *AmArch 70*
Wong, J P *AmArch 70*
Wong, Jackson C S 1930- *ConArch*
Wong, Jackson Lunn 1930- *AmArch 70*
Wong, Jason 1934- *WhoAmA 73, -76, -78, -80, -82, -84*
Wong, Jeanyee 1920- *IlsBYP, IlsCB 1946*
Wong, Judy Ling *DcCAr 81*
Wong, Kellogg H 1928- *AmArch 70*
Wong, Kenneth Lee 1947- *MarqDCG 84*
Wong, P *AmArch 70*
Wong, P Y *AmArch 70*
Wong, Paul Kan 1951- *WhoAmA 84*
Wong, R B *AmArch 70*
Wong, R L *AmArch 70*
Wong, R T W *AmArch 70*
Wong, Robert *MarqDCG 84*
Wong, Robert K L 1931- *AmArch 70*
Wong, Robin 1928- *AmArch 70*
Wong, Roger Frederickson 1945- *WhoAmA 80, -82, -84*
Wong, Stanley Fung Sun 1919- *AmArch 70*
Wong, Warren C T 1924- *AmArch 70*
Wong, Weng Chiew 1925- *AmArch 70*
Wong, Wil S 1929- *AmArch 70*
Wong, William 1923- *AmArch 70*
Wong, William, Jr. 1928- *AmArch 70*
Wong, Wilton Jon 1950- *MarqDCG 84*
Wong, Worley K 1912- *AmArch 70*
Wong, Yau Chun 1921- *AmArch 70*
Wong, Ying 1936- *WhoArt 82, -84*
Wonner, Paul *DcCAr 81*
Wonner, Paul 1920- *PrintW 83, -85, WhoAmA 73, -76, -78, -80, -82, -84*
Wonner, Paul John 1920- *DcCAA 71, -77*
Wonnink, Egbert *ArtsEM*
Wonsetler, John Charles 1900- *IlsBYP, IlsCB 1744, -1946, WhAmArt 85*
Wontner, William Clarke *DcBrA 1, DcVicP, -2*
Woo, Benjamin 1923- *AmArch 70*
Woo, G *AmArch 70*
Woo, Joe, Jr. 1936- *AmArch 70*
Woo, Peter Cheong 1925- *AmArch 70*
Woo, T *AmArch 70*
Woo, Tony C 1946- *MarqDCG 84*
Woo, William Pak-Fat *MarqDCG 84*
Woo, Willie 1950- *WorFshn*
Wood *BiDBrA, FolkA 86*
Wood, A G, Jr. *AmArch 70*
Wood, A J Carter d1915 *DcBrA 2*
Wood, A M *ArtsAmW 1, -3*
Wood, Aaron *DcNiCA*
Wood, Abraham *DcBrWA*
Wood, Alan 1935- *WhoAmA 82, -84*
Wood, Alexander James 1949- *MarqDCG 84*
Wood, Alice C Rapley *DcBrA 1*
Wood, Alice F *DcBrA 1*
Wood, Alice Florence Rapley *DcWomA*
Wood, Alma *WhAmArt 85*
Wood, Andy *DcCAr 81*
Wood, Andy 1947- *WhoArt 84*
Wood, Annette *WhoArt 82, -84*

Wood, Annie A 1874- *ArtsAmW 2, DcWomA, WhAmArt 85*
Wood, Avery W, Jr. 1927- *AmArch 70*
Wood, B *AntBDN D*
Wood, Beatrice *WhAmArt 85, WhoAmA 78, -80, -82, -84*
Wood, Beatrice 1893- *DcWomA*
Wood, Beatrice 1894- *CenC[port]*
Wood, Berenice 1888- *DcBrA 1, DcWomA*
Wood, Bonnie C 1940- *MarqDCG 84*
Wood, C C, Jr. *AmArch 70*
Wood, C Haigh *DcBrA 1, DcVicP, -2*
Wood, Candace *DcWomA*
Wood, Caroline Summer *DcWomA*
Wood, Catherine M *DcVicP, -2, DcWomA*
Wood, Cecil 1878-1947 *MacEA*
Wood, Charles *NewYHSD*
Wood, Charles d1881 *EncASM*
Wood, Charles Anthony, Jr. 1905- *AmArch 70*
Wood, Charles C *NewYHSD*
Wood, Charles Erskine Scott 1852- *WhAmArt 85*
Wood, Charles Erskine Scott 1852-1944 *ArtsAmW 2*
Wood, Charles H d1883 *EncASM*
Wood, Charles Raymond 1917- *AmArch 70*
Wood, Christopher 1901-1930 *ConArt 77, DcBrA 1, McGDA, OxArt, OxTwCA, PhDcTCA 77*
Wood, Clarence *AfroAA*
Wood, Dana C 1955- *MarqDCG 84*
Wood, Daniel *AntBDN D, DcVicP 2, NewYHSD*
Wood, David *AntBDN D*
Wood, Donald Gene 1937- *AmArch 70*
Wood, Doris 1896- *DcWomA*
Wood, Dorothea M *DcVicP 2*
Wood, E *DcWomA*
Wood, E Shotwell *ArtsAmW 2, DcWomA*
Wood, E Shotwell 1887- *WhAmArt 85*
Wood, Earl Pat 1925- *AmArch 70*
Wood, Edgar Thomas *DcVicP 2*
Wood, Edgar Thomas 1860-1935 *DcBrA 2*
Wood, Edith Elmer 1871-1945 *MacEA*
Wood, Edith Longstreth *WhAmArt 85*
Wood, Edward J 1862-1925 *BiDAmAr*
Wood, Eldon Fields 1925- *AmArch 70*
Wood, Eleanor Stuart *DcVicP, -2, DcWomA*
Wood, Eleanora C *DcVicP 2, DcWomA*
Wood, Eliza A *DcWomA*
Wood, Elizabeth Wyn d1966 *DcWomA*
Wood, Ella Miriam 1888- *DcWomA, WhAmArt 85*
Wood, Eloise 1897- *DcWomA, WhAmArt 85*
Wood, Emily Henrietta 1852-1916 *DcWomA*
Wood, Emmie Sara Stewart d1937 *DcBrA 1, DcWomA*
Wood, Emmie Stewart *DcVicP, -2*
Wood, Enoch 1759-1840 *AntBDN M, DcD&D, DcNiCA*
Wood, Ethelwyn A 1902- *WhAmArt 85*
Wood, Ezra 1798-1841 *NewYHSD*
Wood, F S Hurd- *DcVicP 2*
Wood, F W *DcBrBI*
Wood, Fane *DcBrBI*
Wood, Frances Raiff 1899- *DcWomA*
Wood, Francis Derwent 1871-1926 *ClaDrA, DcBrA 1, DcBrWA*
Wood, Frank Watson 1862-1953 *DcBrA 1, DcBrWA, DcSeaP, DcVicP 2*
Wood, Franklin T 1887-1945 *GrAmP, WhAmArt 85*
Wood, Frederick *BiDBrA*
Wood, Frederick William 1943- *AmArch 70*
Wood, G G *DcVicP 2*
Wood, G Swinford d1906 *DcVicP 2*
Wood, George *DcVicP, -2*
Wood, George Albert 1845-1910 *WhAmArt 85*
Wood, George B, Jr. 1832- *ArtsNiC*
Wood, George Bacon, Jr. 1832- *WhAmArt 85*
Wood, George Bacon, Jr. 1832-1910 *NewYHSD*
Wood, Gerald Stanley Kent 1923- *WhoArt 80, -82, -84*
Wood, Grace Mosher *DcWomA, WhAmArt 85*
Wood, Grant 1891-1942 *DcCAA 71, -77*
Wood, Grant 1892-1941 *BnEnAmA*
Wood, Grant 1892-1942 *ArtsAmW 3, DcAmArt, McGDA, OxArt, OxTwCA, PhDcTCA 77, WhAmArt 85*
Wood, Grant Devolson 1891-1942 *GrAmP*
Wood, Graydon *DcCAr 81*
Wood, Gretchen Kratzer *WhAmArt 85*
Wood, H A *AmArch 70*
Wood, H R *AmArch 70*
Wood, Hamilton 1918- *WhoArt 80, -82, -84*
Wood, Hanna *DcWomA, FolkA 86*
Wood, Harrie 1902- *ConICB, IlsCB 1744, WhAmArt 85*
Wood, Harry 1871-1943 *WhAmArt 85*
Wood, Harry Emsley, Jr. 1910- *WhoAmA 73, -76, -78, -80, -82, -84*
Wood, Harry Paul *AmArch 70*
Wood, Helen *DcWomA*
Wood, Henry *BiDBrA, EncASM*
Wood, Henry Austin, III 1929- *AmArch 70*
Wood, Henry Billings *NewYHSD*
Wood, Henry Moses d1867 *BiDBrA*

Wood, Herbert *DcVicP 2*
Wood, Hettie William *ArtsAmW 3*
Wood, Hortense *DcVicP 2, DcWomA*
Wood, J *DcVicP 2, NewYHSD*
Wood, J Barlow 1862-1949 *DcBrA 2*
Wood, J C d1860 *FolkA 86*
Wood, J G *DcWomA*
Wood, Mrs. J G *NewYHSD*
Wood, J T *DcVicP 2*
Wood, J T, Jr. *AmArch 70*
Wood, J W *AmArch 70, DcVicP 2*
Wood, Jack 1921- *AmArch 70*
Wood, Jacob *EncASM*
Wood, James *NewYHSD*
Wood, James d1975 *DcBrA 2*
Wood, James 1803-1867 *NewYHSD*
Wood, James A *AfroAA*
Wood, James Arthur 1927- *WhoAmA 73, -76, -78, -80, -82, -84*
Wood, James Arthur, Jr. 1927- *WorECar*
Wood, James F R d1920 *DcBrA 2, DcVicP 2*
Wood, James L *WhAmArt 85*
Wood, James Nowell 1941- *WhoAmA 73, -76, -78, -80, -82, -84*
Wood, James Porteous 1919- *DcBrA 1*
Wood, James R 1833?-1887 *NewYHSD*
Wood, James R 1950- *MarqDCG 84*
Wood, Jessie Porter 1863- *WhAmArt 85*
Wood, Jessie Porter 1863-1941 *DcWomA*
Wood, Jim 1942- *WhoAmA 78*
Wood, John *FolkA 86*
Wood, John 1704-1754 *BiDBrA, DcD&D*
Wood, John 1728-1781 *BiDBrA, DcD&D*
Wood, John 1775-1822 *NewYHSD*
Wood, John 1801-1870 *ArtsNiC, DcVicP, -2*
Wood, John, II 1728-1781 *OxArt*
Wood, John, Of Bath 1704-1754 *OxArt*
Wood, John, The Elder 1704-1754 *McGDA, WhoArch*
Wood, John, The Younger 1728-1781 *McGDA, WhoArch*
Wood, John B *DcVicP 2*
Wood, John George *DcBrBI, DcBrWA*
Wood, John George 1768-1838 *DcBrECP*
Wood, John Z *WhAmArt 85*
Wood, Mrs. Jonathan *FolkA 86*
Wood, Joseph *FolkA 86*
Wood, Joseph 1778?-1830 *AntBDN J, NewYHSD*
Wood, Josephine *DcWomA*
Wood, Julia Smith 1890- *DcWomA, WhAmArt 85*
Wood, Justin *WhAmArt 85*
Wood, Katharine Marie 1910- *WhAmArt 85*
Wood, Katheryn Leon 1885- *ArtsAmW 2*
Wood, Katheryn Leone d1936? *WhAmArt 85*
Wood, Kathryn Leone 1885-1934 *ArtsEM, DcWomA*
Wood, Keith *DcCAr 81*
Wood, Kenneth *DcBrA 2*
Wood, Kenneth Shimer 1933- *AmArch 70*
Wood, L Martina *DcVicP 2*
Wood, Lawson 1878- *IlsCB 1744*
Wood, Lawson 1878-1957 *DcBrA 1, DcBrBI*
Wood, Leslie 1920- *IlsBYP, IlsCB 1946*
Wood, Leslie Joseph 1930- *AmArch 70*
Wood, Lewis Dinhorn *DcVicP 2*
Wood, Lewis John 1813-1901 *DcBrWA, DcVicP, -2*
Wood, Lewis Pinhorn *DcBrWA*
Wood, Lillian Lee 1906- *WhAmArt 85*
Wood, Lionel *AfroAA*
Wood, Louise *DcWomA*
Wood, M Louise *WhAmArt 85*
Wood, Madge McAllister *ArtsAmW 2*
Wood, Marcia Joan 1933- *WhoAmA 84*
Wood, Margaret *DcWomA*
Wood, Margaret 1893- *WhAmArt 85*
Wood, Margery *DcBrA 1, DcBrBI, DcWomA*
Wood, Marshall d1882 *ArtsNiC*
Wood, Mary *DcWomA*
Wood, Lady Mary *DcVicP 2*
Wood, Mary Braman 1893- *DcWomA*
Wood, Mary Earl *DcWomA, WhAmArt 85*
Wood, Matthew 1813-1855 *DcVicP, -2*
Wood, Meynella *DcVicP 2*
Wood, Myron Gilmore 1921- *MacBEP*
Wood, N G *EncASM*
Wood, Nan *DcWomA*
Wood, Nan 1874- *WhAmArt 85*
Wood, Nan S 1874-1961 *ArtsAmW 3*
Wood, Nancy 1936- *MacBEP*
Wood, Nicholas Wheeler 1946- *WhoAmA 82, -84*
Wood, Norma Lynn *WhAmArt 85*
Wood, Mrs. Norman *DcWomA, WhAmArt 85*
Wood, Mrs. Norman E 1880- *ArtsAmW 3*
Wood, Ogden 1851-1912 *WhAmArt 85*
Wood, Olive *DcBrA 1, DcBrBI*
Wood, Orison 1811-1842 *FolkA 86, NewYHSD*
Wood, P L *AmArch 70*
Wood, Paul Berton 1955- *MarqDCG 84*
Wood, Peter Macdonagh 1914- *DcBrA 1, DcSeaP*
Wood, Peter Macdonagh *WhoArt 84N*
Wood, Peter Macdonough 1914- *WhoArt 80, -82*
Wood, R H *DcVicP, -2*
Wood, R L *AmArch 70*

Wuertz, Emil H 1856-1898 *WhAmArt 85*
Wuertz, W C *AmArch 70*
Wuest, C L *AmArch 70*
Wuest, Ralph S 1932- *AmArch 70*
Wueste, Louise 1803-1875 *DcWomA*
Wueste, Louise Heuser 1803-1875 *ArtsAmW 1, IlBEAAW, NewYHSD*
Wuesthoff, P S *AmArch 70*
Wuhl, Edna Dell *WhAmArt 85*
Wujcik, Theo 1936- *PrintW 83, -85, WhoAmA 73, -76, -78*
Wujick, Theo 1936- *DcCAr 81*
Wukasch, Eugene 1921- *AmArch 70*
Wukounig, Reimo S 1943- *DcCAr 81*
Wulf, Lloyd William 1913- *WhAmArt 85*
Wulff, Edgun Valdemar 1913- *IlsBYP, IlsCB 1946*
Wulff, Timothy Milton 1890- *ArtsAmW 2, WhAmArt 85*
Wulff, Victor L 1911- *AmArch 70*
Wulff, Victor Louis 1909- *AmArch 70*
Wulffaert, Clara *DcWomA*
Wulfhagen, Franz 1624-1670 *ClaDrA*
Wulfraat, Margaretha 1678-1741? *DcWomA*
Wulfraet, Margaretha 1678-1741 *ClaDrA*
Wulfraet, Margaretha 1678-1741? *DcWomA*
Wulfskerke, Cornelie Van *DcWomA*
Wullimann, Peter 1941- *DcCAr 81*
Wunder, Adalbert 1827- *NewYHSD*
Wunder, Clarence E 1886-1940 *BiDAmAr*
Wunder, George 1912- *WorECom*
Wunder, Richard Paul 1923- *WhoAmA 73, -76, -78, -80, -82, -84*
Wunderlich, George 1826?- *NewYHSD*
Wunderlich, Gert 1933- *WhoGrA 82[port]*
Wunderlich, Paul *PrintW 83, -85*
Wunderlich, Paul 1927- *ConArt 77, -83, OxTwCA, PhDcTCA 77, WhoArt 80, -82, -84*
Wunderlich, Rudolf G 1920- *WhoAmA 73, -76, -78, -80, -82, -84*
Wunderly, August *WhAmArt 85*
Wunderman, Jan 1921- *WhoAmA 78, -80, -82, -84*
Wunderwald, Ilna 1878- *DcWomA*
Wundram, Edward Clay 1935- *AmArch 70*
Wunnenberg, Carl *DcVicP 2*
Wunnenberg, Carl 1850-1929 *ClaDrA*
Wunsch, B D *AmArch 70*
Wunsch, Marie 1862-1898 *DcWomA*
Wunterlich, John *FolkA 86*
Wupper, Arthur 1911- *AmArch 70*
Wurdeman, Harold Charles 1911- *AmArch 70*
Wurdeman, Lew Edward 1949- *MarqDCG 84*
Wurdeman, Walter 1903-1949 *BiDAmAr*
Wurdemann, Helen *WhoAmA 76, -78, -80, -82, -84*
Wurl, Mathilde *DcWomA*
Wurm, Hans *McGDA*
Wurman, R S *AmArch 70*
Wurman, Richard *MarqDCG 84*
Wurmb, Gertrud 1877- *DcWomA*
Wurmb, William Louis 1915- *AmArch 70*
Wurmfeld, Sanford 1942- *WhoAmA 84*
Wurms, Gottlieb *NewYHSD*
Wurmski, General *NewYHSD*
Wurst, Wilbur William 1911- *AmArch 70*
Wurster, William Wilson 1895- *AmArch 70, EncMA, McGDA*
Wurster, William Wilson 1895-1972 *MacEA*
Wurster, William Wilson 1895-1973 *BnEnAmA, ConArch, EncAAr*
Wurt, Alen *DcVicP 2*
Wurtele, Isobel Keil 1885-1963 *ArtsAmW 3*
Wurtelo, Isobel Keil *WhAmArt 85*
Wurtelo, Isobel Keil 1885-1963 *ArtsAmW 3*
Wurtenberger, Thusnelda 1870- *DcWomA*
Wurth, Herman *WhAmArt 85*
Wurthle, Julie 1859-1913 *DcWomA*
Wurttemberg, Duchess De *DcWomA*
Wurttemberg, Sophie Dorothea *DcWomA*
Wurtz, Edith M B *WhAmArt 85*
Wurtzburger, Janet E C *WhoAmA 76N*
Wurtzburger, Janet E C 1908- *WhoAmA 73, -78N, -80N, -82N, -84N*
Wurz, John A 1936- *AmArch 70*
Wurzbach, W *NewYHSD*
Wurzburg, W F, Jr. *AmArch 70*
Wurzelbauer, Benedikt 1548-1620 *McGDA*
Wurzer, Thomas Duane 1935- *AmArch 70*
Wuss, P G *AmArch 70*
Wust, A *DcVicP 2*
Wust, Alexander 1837-1876 *ClaDrA, NewYHSD*
Wutky, Michael 1739-1823 *ClaDrA*
Wuzer, Johann Matthias 1760-1838 *ClaDrA*
Wyand, D E *EarABI, EarABI SUP*
Wyand, Edith V *WhAmArt 85*
Wyand, George *NewYHSD*
Wyant, A H 1839- *ArtsNiC*
Wyant, Alexander Helwig 1836-1892 *ArtsAmW 1, -3, BnEnAmA, DcAmArt, McGDA, NewYHSD, WhAmArt 85*
Wyant, Arabella L d1919 *DcWomA, WhAmArt 85*
Wyant, David *FolkA 86*
Wyatt, A C d1933 *ArtsAmW 2, DcBrA 1,*

DcVicP 2, WhAmArt 85
Wyatt, B K *AmArch 70*
Wyatt, Benjamin 1709-1772 *BiDBrA, DcD&D*
Wyatt, Benjamin 1745-1818 *BiDBrA, DcD&D*
Wyatt, Benjamin 1755-1813 *BiDBrA*
Wyatt, Benjamin 1775-1850 *MacEA*
Wyatt, Benjamin Dean 1775-1850 *DcD&D, WhoArch*
Wyatt, Benjamin Dean 1775-1855? *BiDBrA*
Wyatt, Charles 1751?-1819 *BiDBrA*
Wyatt, Charles 1758?-1819 *MacEA*
Wyatt, Charles 1759?-1819 *BiDBrA, DcD&D*
Wyatt, D *DcVicP 2*
Wyatt, David Clarence 1905- *FolkA 86*
Wyatt, F *DcVicP 2*
Wyatt, George d1790 *BiDBrA*
Wyatt, George 1782-1856 *BiDBrA*
Wyatt, Greg Alan 1949- *WhoAmA 82, -84*
Wyatt, Henry *DcVicP 2*
Wyatt, Henry 1794-1840 *DcBrBI, DcBrWA*
Wyatt, Henry John 1789?-1862 *BiDBrA*
Wyatt, J R *AmArch 70*
Wyatt, James *DcNiCA*
Wyatt, James 1746-1813 *BiDBrA, DcD&D[port], MacEA, McGDA, OxArt*
Wyatt, James 1747-1813 *WhoArch*
Wyatt, James Bosley Noel 1847-1926 *BiDAmAr*
Wyatt, Jeffry *DcD&D*
Wyatt, John Drayton *DcVicP 2*
Wyatt, Joseph 1739-1785 *BiDBrA*
Wyatt, Joyce Eileen *WhoArt 84*
Wyatt, Joyce Eileen 1924- *WhoArt 80, -82*
Wyatt, Katharine Montagu *DcWomA*
Wyatt, Katherine Montagu *DcVicP 2*
Wyatt, Lewis 1777-1853 *MacEA*
Wyatt, Lewis William 1777-1853 *BiDBrA*
Wyatt, Mary Lyttleton *DcWomA, WhAmArt 85*
Wyatt, Sir Matthew 1805-1886 *BiDBrA*
Wyatt, Matthew Cotes 1777-1862 *DcNiCA*
Wyatt, Matthew Digby 1820-1877 *MacEA*
Wyatt, Sir Matthew Digby 1820-1877 *ArtsNiC, DcNiCA, OxArt, WhoArch*
Wyatt, Philip William d1835 *BiDBrA*
Wyatt, R L *AmArch 70*
Wyatt, Ralph Laurence 1920- *AmArch 70*
Wyatt, Robert James 1928- *AmArch 70*
Wyatt, Samuel 1737-1807 *BiDBrA, DcD&D, MacEA*
Wyatt, Stanley 1921- *WhoAmA 73, -76, -78, -80, -82, -84*
Wyatt, T *DcBrECP*
Wyatt, T H *DcNiCA*
Wyatt, Thomas Henry 1807-1880 *BiDBrA A, DcBrBI, MacEA, WhoArch*
Wyatt, William 1734-1780 *BiDBrA*
Wyatt, William Robert, Jr. 1918- *AmArch 70*
Wyatt DeVivefay, Emma Cornelie *DcWomA*
Wyatt Family *DcD&D*
Wyatville, Jeffry 1766-1840 *MacEA*
Wyatville, Sir Jeffry 1766-1840 *BiDBrA, DcBrWA, DcD&D, OxArt, WhoArch*
Wyble, William A *ArtsEM*
Wybrant *FolkA 86, NewYHSD*
Wybrants-Lynch, Sharon 1943- *WhoAmA 76, -78*
Wyburd, Francis John *DcNiCA*
Wyburd, Francis John 1826- *ArtsNiC, ClaDrA, DcBrBI, DcBrWA, DcVicP, -2*
Wyburd, Mrs. Francis John *DcVicP 2*
Wyburd, Leonard *DcBrWA, DcVicP 2*
Wyburd, Leonard F *DcNiCA*
Wyburd, M *DcVicP 2*
Wychoff, Ellen *FolkA 86*
Wyck, Carolina Cornelia *DcWomA*
Wyck, Matilda *DcWomA*
Wyck, Thomas *McGDA*
Wyck, Thomas 1616?-1677 *ClaDrA*
Wyckoff, Isabel Dunham *DcWomA, NewYHSD*
Wyckoff, Joseph 1883- *WhAmArt 85*
Wyckoff, Marjorie Annable 1904- *WhAmArt 85*
Wyckoff, Maud E *DcWomA, WhAmArt 85*
Wyckoff, Sylvia Spencer 1915- *WhAmArt 85, WhoAmA 73, -76, -78, -80, -82, -84*
Wycoff, J R *ArtsEM*
Wycoff, R M *AmArch 70*
Wydeveld, Arnoud *NewYHSD*
Wydiz, Christoph *McGDA*
Wye, Charles 1925- *DcBrA 1, WhoArt 80, -82, -84*
Wyer, Raymond *WhAmArt 85*
Wyess, John E 1820?-1903 *NewYHSD*
Wyeth, Andrew 1917- *AmArt, BnEnAmA, ConArt 77, -83, DcAmArt, DcCAA 71, -77, DcCAr 81, OxTwCA, PhDcTCA 77, WorArt[port]*
Wyeth, Andrew Newell 1917- *IlBEAAW, McGDA, WhAmArt 85, WhoAmA 73, -76, -78, -80, -82, -84*
Wyeth, Caroline 1909- *WhAmArt 85*
Wyeth, Francis *NewYHSD*
Wyeth, Henriette 1907- *PrintW 83, -85, WhAmArt 85, WhoAmA 73, -76, -78, -80, -82, -84*
Wyeth, Henriette Zirngiebel 1907- *IlBEAAW*

Wyeth, James Browning 1946- *WhoAmA 73, -76, -78, -80, -82, -84*
Wyeth, Jamie *DcCAr 81*
Wyeth, Jamie 1946- *AmArt, PrintW 83, -85*
Wyeth, John Allan *WhAmArt 85*
Wyeth, M S *AmArch 70*
Wyeth, Marion Sims 1889-1982 *MacEA*
Wyeth, N C 1882- *AntBDN B*
Wyeth, N C 1882-1945 *ArtsAmW 1*
Wyeth, Newell Convers 1882-1945 *ArtsAmW 3, ConICB, IlBEAAW, IlrAm B, -1880, IlsBYP, WhAmArt 85*
Wyeth, P C *NewYHSD*
Wyeth, Paul James Logan 1920- *ClaDrA, DcBrA 1, WhoArt 80, -82, -84*
Wyeth, W H *AmArch 70*
Wygant, William Charles 1928- *MarqDCG 84*
Wyhmann, Juliette *DcWomA*
Wyhoff, Julius *WhAmArt 85*
Wyke, Anne *DcWomA*
Wyke, Edward Dean 1920- *AmArch 70*
Wykes, Frederic Kirtland 1905- *WhAmArt 85*
Wykoff, D F *AmArch 70*
Wyld, Miss *DcWomA*
Wyld, William 1806-1889 *ClaDrA, DcBrBI, DcBrWA, DcVicP, -2*
Wylde, C I *AmArch 70*
Wylde, Geoffrey Spencer 1903- *DcBrA 1*
Wylde, Wendela *DcWomA*
Wyle, Florence *WhAmArt 85*
Wyle, Florence 1881- *IlBEAAW*
Wyle, Florence 1881-1968 *DcWomA*
Wyler, Christiane 1947- *DcCAr 81*
Wyley, Frank A 1905- *AfroAA*
Wylie, Miss *ArtsEM*
Wylie, J H *AmArch 70*
Wylie, James *MarqDCG 84*
Wylie, John *FolkA 86*
Wylie, Kate 1877-1941 *DcBrA 1, DcWomA*
Wylie, Marion *WhAmArt 85*
Wylie, Robert d1877 *ArtsNiC*
Wylie, Robert 1839-1877 *ClaDrA, EarABI SUP, NewYHSD*
Wylie, Samuel B 1900-1957 *WhAmArt 85*
Wylie Brothers *FolkA 86*
Wyllie, Alexander *FolkA 86*
Wyllie, Mrs. C *DcVicP 2*
Wyllie, Charles William 1853-1923 *DcBrA 1, DcVicP 2*
Wyllie, Charles William 1859- *DcVicP*
Wyllie, Charles William 1859-1923 *DcBrBI, DcBrWA, DcSeaP*
Wyllie, Charlie 1859-1923 *DcBrBI*
Wyllie, Euphans Hilary *DcWomA*
Wyllie, George Ralston 1921- *WhoArt 80, -82, -84*
Wyllie, Gladys Amy *DcBrA 1*
Wyllie, Gordon Hope 1930- *WhoArt 80, -82, -84*
Wyllie, Harold *WhoArt 80N*
Wyllie, Harold 1880- *ClaDrA, DcBrA 1, DcBrWA*
Wyllie, Harold 1880-1973 *DcBrA 2, DcSeaP*
Wyllie, M A *DcVicP 2*
Wyllie, W L 1851- *ArtsNiC*
Wyllie, William Lionel 1851-1931 *ClaDrA, DcBrA 1, DcBrBI, DcBrWA, DcSeaP, DcVicP, -2*
Wyllie, William Morison *DcVicP, -2*
Wyllis, Elizabeth *FolkA 86*
Wyman, *FolkA 86*
Wyman, Florence *DcVicP 2, DcWomA, WhAmArt 85*
Wyman, J E *AmArch 70*
Wyman, John *NewYHSD*
Wyman, Lance 1937- *ConDes*
Wyman, Lois Palmer *WhAmArt 85*
Wyman, Lucile Palmer 1910- *WhAmArt 85*
Wyman, Samuel D 1828- *FolkA 86*
Wyman, Sarah *DcWomA*
Wyman, Victor Marc 1936- *MarqDCG 84*
Wyman, Violet H *DcVicP 2*
Wyman, William 1922- *CenC, WhoAmA 73, -76, -78, -80, -82*
Wyman, William 1922-1980 *WhoAmA 84N*
Wyman, William Weir 1912- *AmArch 70*
Wymbs, Madeleine *DcWomA*
Wymer, R W *DcBrECP*
Wynants, Jan *McGDA*
Wynants, Jan 1630?-1684 *ClaDrA*
Wynants, Miche *IlsCB 1967*
Wynants, Miche 1934- *IlsCB 1957*
Wyndham, Guy Richard Charles 1896- *DcBrA 1*
Wyndham, Guy Richard Charles 1896-1948 *DcBrA 2*
Wyndham-Tusting, Albert *DcSeaP*
Wynen, Dominicus Van 1661-1690? *ClaDrA*
Wynes, Maud 1880-1961 *DcWomA*
Wyness, Fenton 1903- *WhoArt 80, -82, -84*
Wynfield, David W 1837-1887 *DcBrWA, DcVicP, -2*
Wynford, William *OxArt*
Wynford, William De *McGDA*
Wyngaard, Susan Elizabeth 1947- *WhoAmA 78, -80, -82, -84*

Wyngaerde, Antonius VanDen *McGDA*
Wynkoop, Emma T *DcWomA, FolkA 86*
Wynn, Daniel R *AfroAA*
Wynn, David *AntBDN F*
Wynn, Donald James 1942- *WhoAmA 73, -76, -78,*
 -80, -82, -84
Wynn, Edward George 1924- *AmArch 70*
Wynn, G Brent 1938- *MarqDCG 84*
Wynn, H Douglas 1937- *AmArch 70*
Wynne, Reverend *DcBrWA*
Wynne, Albert Givens 1922- *WhoAmA 73, -76, -78,*
 -80, -82, -84
Wynne, Cassandra B *AfroAA*
Wynne, Evelyn B 1895- *DcWomA, WhAmArt 85*
Wynne, H *DcBrWA, DcWomA*
Wynne, H Hugh 1921- *AmArch 70*
Wynne, John *BiDBrA*
Wynne, Madeline Yale 1847- *WhAmArt 85*
Wynne, Madeline Yale 1847-1918 *DcWomA*
Wynne, Nancy Graves *WhoAmA 80, -82, -84*
Wynne, R W *DcBrWA*
Wynne, Richard *DcBrECP*
Wynne, Robert Druhan 1920- *AmArch 70*
Wynne, Robert Lee, III 1940- *AmArch 70*
Wynne-Jones, Nancy *DcCAr 81*
Wynne-Morgan, John 1906- *DcBrA 1*
Wynne Thomas, Francis 1907- *DcBrA 1*
Wynniatt, Maude *DcVicP 2*
Wynshaw, Frances *WhoAmA 73, -76, -78, -80, -82*
Wynter, Bryan 1915- *DcBrA 1*
Wynter, Bryan 1915-1975 *ConArt 83, OxTwCA,*
 PhDcTCA 77
Wynter, Bryan Herbert 1915-1975 *DcBrA 2*
Wyntrack, Dirck *McGDA*
Wyon, Allan Gairdner 1882-1962 *DcBrA 1*
Wyon, Edward William 1811-1885 *DcNiCA*
Wyon, Eileen May 1883- *DcBrA 1, DcWomA*
Wyon, John W *DcVicP 2*
Wyon, Maria Elisabeth *DcWomA*
Wyon, W H *DcWomA*
Wyrick, Charles L, Jr. 1939- *MacBEP*
Wyrick, Charles Lloyd, Jr. 1939- *WhoAmA 78, -80,*
 -82, -84
Wyrick, Pete 1939- *WhoAmA 73, -76*
Wysard, Elise 1790-1863 *DcWomA*
Wyse, Alex 1938- *DcCAr 81*
Wyse, Alexander John 1938- *WhoAmA 73, -76, -78,*
 -80, -82
Wyse, F H *NewYHSD*
Wyse, Henry Taylor 1870-1951 *DcBrA 1, DcVicP 2*
Wyse, Marie Studolmine *DcWomA*
Wyse, William *AntBDN M*
Wysmuller, J H *DcVicP 2*
Wysocki, Charles *OfPGCP 86*
Wysong, Marjorie Eudora 1897-1940 *DcWomA*
Wyss, Hanspeter 1937- *WhoGrA 82[port]*
Wyss, Robert 1925- *WhoGrA 62, -82[port]*
Wyss, Sophie Von *DcWomA*
Wyszynski, Eustace *NewYHSD*
Wytens, Eliza *DcWomA*
Wythe, J *NewYHSD*
Wythoff, Anna *DcWomA*
Wytmans, Matheus *McGDA*
Wytsman, Juliette 1866-1925 *DcWomA*
Wytsman, Rodolphe 1860-1927 *ClaDrA*
Wyttenbach, E *IIBEAAW*
Wyttenbach, Emanuel d1903 *ArtsAmW 2*
Wytterbach, Emanuel d1903 *ArtsAmW 2*
Wyzkoski, Joan Patricia 1949- *MarqDCG 84*
Wzacny, Christopher Z 1937- *AmArch 70*

X

X Et *McGDA*
Xanto Avelli Da Rovigo, Francesco 1500?- *McGDA*
Xantus, Janos 1825-1894 *ArtsAmW 3, NewYHSD*
Xavery, Mademoiselle *DcWomA*
Xavery, Jacob 1736-1769? *ClaDrA*
Xavier, Maximino 1950- *DcCAr 81*
Xavier, Sister St. Francis d1855 *DcWomA*
Xceron, Jean 1890-1967 *DcCAA 71, -77, McGDA,*
 OxTwCA, WhAmArt 85, WhoAmA 78N, -80N,
 -82N, -84N, WorArt
Xceron, John 1890-1967 *PhDcTCA 77*
Xenakis, Cosmas 1925- *OxTwCA, PhDcTCA 77*
Xenakis, Iannis 1922- *OxTwCA*
Xenia *WhoArt 80, -82, -84*
Xepapas, A N *AmArch 70*
Xifra, Jaume 1934- *ConArt 77*
Ximenes, Gloria 1933- *WhoArt 80, -82, -84*
Xing, Cijing *DcWomA*
Xul Solar 1887-1963 *OxTwCA*
Xydes, Christ John 1955- *MarqDCG 84*
Xylander, W *ArtsNiC*

Y

Yabushita, Taiji 1903- *WorECar*
Yaculov, Georgii Bogdanovich 1882-1928 *OxTwCA*
Yadon, Robert Eugene 1927- *AmArch 70*
Yaeger, Edgar Louis 1904- *WhAmArt 85*
Yaeger, Roland Arnet 1904- *AmArch 70*
Yaeger, William L *WhAmArt 85*
Yaffa Yael Stec-El *WhoAmA 82, -84*
Yaffee, Edith Widing 1895-1961 *DcWomA,*
WhAmArt 85, WhoAmA 80N, -82N, -84N
Yaffee, Herman A 1897- *WhAmArt 85*
Yager, G A *AmArch 70*
Yager, H W *AmArch 70*
Yager, Rick *FolkA 86*
Yaghijian, Edmund 1903- *WhAmArt 85*
Yaghjian, Edmund *WhoAmA 73, -76, -78, -80, -82,*
-84
Yahn, W H *AmArch 70*
Yajima, Michiko 1937- *MacBEP, WhoAmA 80, -82,*
-84
Yakeley, Stephen R 1940- *AmArch 70*
Yaklofsky, Dennis Thomas 1941- *AmArch 70*
Yakomi, Richard 1944- *ConArt 83*
Yakunchikova, Mariia Vasilevna 1870-1902 *DcWomA*
Yale, Brian 1936- *DcCAr 81*
Yale, Charlotte Lilla 1855-1929 *WhAmArt 85*
Yale, E A *FolkA 86*
Yale, Edwin R *FolkA 86*
Yale, Hiram *FolkA 86*
Yale, Leroy Milton 1841-1906 *WhAmArt 85*
Yale, Lilla 1854-1929 *DcWomA*
Yale, Linus, Jr. 1821-1868 *OxDecA*
Yale, Linus, Sr. 1797- *OxDecA*
Yale, R S *AmArch 70*
Yale, Samuel *FolkA 86*
Yale, William *FolkA 86*
Yalland, Thomas King 1845-1934 *DcBrA 1,*
DcVicP 2
Yallup, Pat 1929- *WhoArt 80, -82, -84*
Yalonis, Chris *MarqDCG 84*
Yam, David Shiu-Hong 1949- *MarqDCG 84*
Yama, Sudzuki Shinjiro 1884- *WhAmArt 85*
Yamachi, Roy Yukio 1936- *AmArch 70*
Yamada, Masayoshi 1949- *DcCAr 81*
Yamagata 1948- *PrintW 85*
Yamagata, Hiro 1948- *PrintW 85*
Yamagishi, Teizo 1898- *ArtsAmW 3*
Yamaguchi, Fujio 1935- *MarqDCG 84*
Yamaguchi, Katsuhiro 1928- *PhDcTCA 77*
Yamaguchi, Marianne Illenberger 1936- *IlsBYP,*
IlsCB 1957
Yamaguchi, Takeo 1902- *ConArt 77, -83, OxTwCA,*
PhDcTCA 77, WorArt
Yamahata, Yosuke 1917-1956 *ICPEnP A*
Yamamoto, Kanae 1882-1946 *McGDA*
Yamamoto, Kansai *WorFshn*
Yamamoto, Kansai 1944- *ConDes*
Yamamoto, Sanae 1898- *WorECar*
Yamamura, Gasho 1939- *ICPEnP A*
Yamanaka, Sadajiro 1866-1936 *WhAmArt 85*
Yamane, Arthur Atsushi *AmArch 70*
Yamasaki, Minoru 1912- *AmArch 70, BnEnAmA,*
ConArch, DcD&D[port], EncAAr, EncMA,
MacEA, McGDA
Yamashiro, Ryuichi 1920- *WhoGrA 62*
Yamashita, Rin 1857-1939 *DcWomA*
Yamazaki, Ryu *DcWomA*
Yambo *WorECar*
Yamin, Steven Edward 1946- *WhoAmA 80, -82, -84*
Yampolsky, Oscar 1892?-1944 *ArtsAmW 3,*
WhAmArt 85
Yan, Ira 1869-1969 *DcWomA*

Yanagi, H Y *AmArch 70*
Yanagi, Sori 1915- *ConDes*
Yanase, Masamu 1900-1945 *WorECar*
Yancey, D R *AmArch 70*
Yancey, Terrance L 1944- *AfroAA*
Yandell, Charles R *WhAmArt 85*
Yandell, Enid 1870-1934 *DcWomA, WhAmArt 85*
Yaneff, Chris 1928- *WhoAmA 84*
Yanez, Fernando d1560? *ClaDrA*
Yanez DeLaAlmedina, Fernando *McGDA,*
OxArt
Yang, Edith Leong *AmArch 70*
Yang, In-Tae 1952- *MarqDCG 84*
Yang, Jay *ConDes, IlsBYP*
Yang, John 1933- *AmArch 70, MacBEP*
Yang, Linda Gureasko 1937- *AmArch 70*
Yang, Mei-Tzu *DcWomA*
Yang, Samuel Chi-An 1956- *MarqDCG 84*
Yanish, Elizabeth *WhoAmA 76, -78, -80, -82, -84*
Yanjanin, Charles R 1947- *MarqDCG 84*
Yanoff, Arthur 1939- *WhoAmA 84*
Yanofsky, Daniel Nat 1930- *MarqDCG 84*
Yanosky, Tom 1918- *WhoAmA 76, -78*
Yanosy, Robert Alexander 1937- *AmArch 70*
Yanoviak, Andrew Charles 1937- *AmArch 70*
Yanow, Rhoda Mae *WhoAmA 76, -78, -80, -82, -84*
Yantis, M S *AmArch 70*
Yao, C J 1941- *PrintW 83, -85*
Yao, Neng Frederic 1950- *MarqDCG 84*
Yap, Weda 1894- *IlsBYP, IlsCB 1946*
Yarborough, Christine Troutman 1925- *WhoAmA 82,*
-84
Yarbro, Robert Lewis 1925- *AmArch 70*
Yarbrough, Leila Kepert 1932- *WhoAmA 76, -78, -80,*
-82, -84
Yarbrough, N P *AmArch 70*
Yarbrough, Vivian Sloan 1893- *ArtsAmW 3,*
DcWomA, WhAmArt 85
Yard, Charles *DcBrWA, DcVicP 2*
Yard, Margaret *WhAmArt 85*
Yard, Marie *WhAmArt 85*
Yard, Sally Elizabeth 1951- *WhoAmA 82, -84*
Yard, Sydney Janis 1855-1909 *ArtsAmW 1*
Yarde, Richard 1939- *AfroAA*
Yarde, Richard Foster 1939- *WhoAmA 80, -82*
Yardley, Caroline S *DcWomA, WhAmArt 85*
Yardley, Jack Rodney 1935- *AmArch 70*
Yardley, Ralph O 1878- *ArtsAmW 2, WhAmArt 85*
Yardley, Richard Quincy 1903- *WhoAmA 76, -78,*
-80, -82N, -84N, WorECar
Yardy, Christian 1811?- *FolkA 86*
Yarish, Harry A 1894- *AmArch 70*
Yarnell, D F *NewYHSD*
Yarnold, George B *DcVicP 2*
Yarnold, J W *DcVicP*
Yarnold, J W 1817?- *DcVicP 2*
Yaros, Eugene Alex 1933- *AmArch 70*
Yaroscak, Thomas M 1931- *AmArch 70*
Yaroslava *IlsCB 1967*
Yaroslava 1925- *IlsCB 1957*
Yarrish, Edward B 1945- *MarqDCG 84*
Yarrow, William H K 1891-1941 *WhAmArt 85*
Yartif, Jeanne De *DcWomA*
Yartip, Jeanne De *DcWomA*
Yarwood, Walter *OxTwCA*
Yarz, Edmond *ArtsNiC*
Yashima, Taro *IlsCB 1967*
Yashima, Taro 1908- *IlsBYP, IlsCB 1946, -1957,*
WorECar
Yasko, Caryl Anne 1941- *WhoAmA 76, -78, -80, -82,*
-84

Yasko, Karel 1911- *AmArch 70*
Yassin, Robert Alan 1941- *WhoAmA 76, -78, -80,*
-82, -84
Yasuda, Robert 1940- *WhoAmA 78, -80, -82, -84*
Yasui, Sotaro 1888-1955 *McGDA*
Yater, George David 1910- *WhAmArt 85,*
WhoAmA 73, -76, -78, -80, -82, -84
Yates *FolkA 86*
Yates, Mrs. *DcWomA, NewYHSD*
Yates, Alan 1947- *WhoArt 84*
Yates, Ann 1897- *DcBrA 1, DcWomA, WhoArt 80,*
-82, -84
Yates, G *AmArch 70*
Yates, Caroline Burland *DcVicP 2, DcWomA*
Yates, Charles E 1940- *AfroAA*
Yates, Cullen 1866-1945 *WhAmArt 85*
Yates, Mrs. E R 1888-1958 *ArtsAmW 3*
Yates, Edna Roylance 1906- *WhAmArt 85*
Yates, Elizabeth M 1888- *DcWomA, WhAmArt 85*
Yates, Floyd Buford 1921- *WorECar*
Yates, Frederic 1854-1919 *DcBrA 2, DcVicP 2*
Yates, Frederick 1854-1919 *ArtsAmW 1, ClaDrA,*
DcBrA 1
Yates, G *DcBrWA*
Yates, Gideon *DcBrWA*
Yates, Glenn, Jr. 1927- *AmArch 70*
Yates, H *DcVicP 2*
Yates, H H *FolkA 86*
Yates, Hal *WhoArt 84N*
Yates, Hal 1907- *ClaDrA, DcBrA 1, WhoArt 80,*
-82
Yates, Ida Perry 1876- *WhAmArt 85*
Yates, John 1885- *DcBrA 1*
Yates, Julie Chamberlain d1929 *DcWomA,*
WhAmArt 85
Yates, Julie T *WhAmArt 85*
Yates, Marie 1940- *WhoArt 80, -82, -84*
Yates, Marvin C 1943- *WhoAmA 76*
Yates, Marvin Clarence 1943- *WhoAmA 80, -82, -84*
Yates, Mary 1891- *ClaDrA, DcBrA 1, DcWomA*
Yates, Ruth 1896- *DcWomA, WhAmArt 85*
Yates, Sharon Deborah 1942- *WhoAmA 73, -76, -78,*
-80
Yates, Steve 1949- *MacBEP*
Yates, Steven A *WhoAmA 82, -84*
Yates, Thomas 1760?-1796 *DcBrECP, DcSeaP*
Yates, Thomas 1765-1796 *DcBrWA*
Yates, Thomas Brown 1882- *DcBrA 1*
Yates Jones, Hazel May 1939- *WhoArt 80, -82, -84*
Yavi, Erkal 1942- *WhoGrA 82[port]*
Yavno, Max 1911- *ICPEnP A, MacBEP*
Yaworski, Alex 1907- *WhoAmA 82*
Yaworski, Alex F 1907- *WhoAmA 84*
Yaworsky, George Myroslaw 1940- *MarqDCG 84*
Yazzie, James Wayne 1943- *IlBEAAW*
Ybl, Miklos 1814-1891 *McGDA*
Ybl, Nicholas Miklos 1927- *AmArch 70*
Yeadon, Richard 1896- *DcBrA 1*
Yeadon, Robert Edward 1944- *MarqDCG 84*
Yeager, Charles George 1910- *WhAmArt 85*
Yeager, Edward *NewYHSD*
Yeager, Emery Joseph 1932- *AmArch 70*
Yeager, H R *AmArch 70*
Yeager, John Philip 1823-1899 *FolkA 86*
Yeager, Joseph 1792?-1859 *NewYHSD*
Yeager, Rembert Arlin, Jr. 1932- *AmArch 70*
Yeager, Walter 1852-1896 *ArtsAmW 1*
Yeager, Walter Rush 1852-1896 *IlBEAAW*
Yeakel, Larry Eugene 1937- *AmArch 70*
Yeames, William Frederick 1835- *ArtsNiC*
Yeames, William Frederick 1835-1918 *ClaDrA,*

Young, Charles *FolkA 86*
Young, Charles A 1930- *AfroAA*
Young, Charles Alexander 1930- *WhoAmA 76, –78, –80, –82, –84*
Young, Charles Jac 1880-1940 *WhAmArt 85*
Young, Charles Morris d1964 *WhoAmA 78N, –80N, –82N, –84N*
Young, Charles Morris 1869-1964 *WhAmArt 85*
Young, Chic 1901- *WhoAmA 76, –78N, –80N, –82N, –84N*
Young, Chick 1901- *WhAmArt 85*
Young, Clara *DcWomA*
Young, Clara Huntington 1878- *WhAmArt 85*
Young, Clarence Edward *AfroAA*
Young, Clayton H 1918- *AmArch 70*
Young, Cliff 1905- *WhoAmA 73, –76, –78, –80, –82, –84*
Young, Clifford Fai 1917- *AmArch 70*
Young, D A *AmArch 70*
Young, D Richard 1925- *AmArch 70*
Young, Dennis 1917- *WhoArt 84*
Young, Dennis Leonard 1917- *WhoArt 80, –82*
Young, Denny *WhoAmA 82*
Young, Donald Paul 1927- *AmArch 70*
Young, Donald Victor 1934- *AmArch 70*
Young, Dorothy *DcWomA*
Young, Dorothy O 1903?- *WhAmArt 85*
Young, Dorothy Weir *ArtsAmW 3*
Young, Doug Y H *WhoAmA 78, –80*
Young, E O, Jr. *AmArch 70*
Young, Ed 1931- *IlsBYP, IlsCB 1967*
Young, Edmund Richard, III 1923- *AmArch 70*
Young, Edna E 1936- *WhoAmA 82, –84*
Young, Edwin 1901- *AmArch 70*
Young, Eileen *WhoArt 80, –82, –84*
Young, Eleanor R 1908- *WhAmArt 85*
Young, Eliza Middleton Coxe 1875- *DcWomA, WhAmArt 85*
Young, Ellsworth 1866- *ArtsAmW 3, WhAmArt 85*
Young, Elmer E *WhAmArt 85*
Young, Elsworth 1866- *ArtsAmW 3*
Young, Emmeline *DcVicP 2*
Young, Esther Chistensen *WhAmArt 85*
Young, Esther Chistensen 1895- *DcWomA*
Young, Eunice E *DcWomA*
Young, Eva H *DcWomA, WhAmArt 85*
Young, F Cliff 1905- *WhAmArt 85*
Young, F S *AmArch 70*
Young, Florence *WhAmArt 85*
Young, Florence 1872- *ArtsAmW 1, DcWomA*
Young, Florence 1919- *WhoArt 80, –82, –84*
Young, Frances *DcVicP, –2, DcWomA*
Young, Frances E *DcBrA 1*
Young, Frances E d1939? *DcWomA*
Young, Frances Elizabeth 1954- *WhoAmA 82, –84*
Young, Frances Price 1901- *WhAmArt 85*
Young, Frank Herman 1888- *WhAmArt 85*
Young, Frank Herman 1888-1964 *ArtsAmW 2*
Young, G A *AmArch 70*
Young, G C *AmArch 70*
Young, George *DcVicP 2*
Young, George Ronald *MarqDCG 84*
Young, Gladys G 1889- *DcWomA*
Young, Gladys G 1897?- *WhAmArt 85*
Young, Godfrey *DcVicP 2*
Young, Grace 1869-1947 *DcWomA*
Young, Grace S 1874- *DcWomA, WhAmArt 85*
Young, Gustav *NewYHSD*
Young, H 1792-1861 *FolkA 86*
Young, H G *AmArch 70*
Young, H H *DcVicP 2*
Young, Harvey *ArtsNiC*
Young, Harvey B 1840-1901 *ArtsAmW 1, NewYHSD , WhAmArt 85*
Young, Harvey Otis 1840-1901 *IlBEAAW*
Young, Helen 1888- *DcWomA, WhAmArt 85*
Young, Helen Jean 1914- *DcBrA 1, WhoArt 80, –82, –84*
Young, Henry Arthur 1866-1943 *WorECar*
Young, Hiram *EncASM*
Young, Homer Pierce, Jr. 1925- *AmArch 70*
Young, Isaiah *ArtsEM*
Young, J *DcVicP 2*
Young, J D, Jr. *AmArch 70*
Young, J H A *NewYHSD*
Young, J Harvey 1830-1918 *FolkA 86*
Young, J T 1790-1822 *DcBrWA*
Young, Jack Warren 1929- *AmArch 70*
Young, James *AntBDN Q*
Young, James C M 1926- *AmArch 70*
Young, James H *NewYHSD*
Young, James Harvey 1830- *ArtsNiC*
Young, James Harvey 1830-1918 *NewYHSD , WhAmArt 85*
Young, Jane Catherine *DcWomA*
Young, Janie Chester 1949- *WhoAmA 84*
Young, Jean 1914- *ClaDrA*
Young, Jean Alice Linden *AmArch 70*
Young, Jeff *MarqDCG 84*
Young, Jessie 1879- *DcBrA 1, DcWomA*
Young, John d1680? *BiDBrA*

Young, John d1801 *BiDBrA*
Young, John 1798?-1877 *BiDBrA*
Young, John 1891- *FolkA 86*
Young, John 1930- *DcBrA 2*
Young, John C 1909- *WhAmArt 85*
Young, John Chin 1909- *WhoAmA 73, –76, –78, –80, –82*
Young, John Davis 1909- *AmArch 70*
Young, John H 1858-1944 *WhAmArt 85*
Young, John J 1830-1879 *ArtsAmW 1, IlBEAAW, NewYHSD*
Young, John L *NewYHSD*
Young, John Ross 1926- *AmArch 70*
Young, John T 1814-1842 *EarABI, NewYHSD*
Young, John T 1954- *WhoAmA 82, –84*
Young, John W 1804?- *FolkA 86*
Young, Joseph E 1939- *WhoAmA 78, –80, –82, –84*
Young, Joseph H 1920- *AmArch 70*
Young, Joseph L 1919- *WhoArt 80, –82, –84*
Young, Joseph Laurie 1924- *AmArch 70*
Young, Joseph Louis 1919- *WhoAmA 73, –76, –78, –80, –82, –84*
Young, Kathryn I 1902- *WhAmArt 85*
Young, Kenneth 1933- *AfroAA*
Young, Kenneth M 1903- *AmArch 70*
Young, Kenneth Victor 1933- *WhoAmA 73, –76, –78, –80, –82, –84*
Young, Kenneth Walter 1917- *WhoArt 80, –82, –84*
Young, L C *DcWomA*
Young, L D *AmArch 70*
Young, Laura E 1879-1939 *DcWomA*
Young, Leroy A 1921- *AmArch 70*
Young, Lilian *DcVicP, –2, DcWomA*
Young, Lilian Van *WhoAmA 78, –80*
Young, Linton Hopkins 1909- *AmArch 70*
Young, Louis C 1864-1915 *WhAmArt 85*
Young, Lyman 1893- *WorECom*
Young, Lyman W 1893-1984 *ConGrA 1*
Young, M *DcWomA*
Young, M J *DcVicP 2*
Young, M K *AmArch 70*
Young, Mabel 1900- *DcBrA 1*
Young, Maggie F *DcVicP 2*
Young, Mahonri 1877-1957 *ArtsAmW 1, BnEnAmA*
Young, Mahonri M 1877-1957 *WhoAmA 80N, –82N, –84N*
Young, Mahonri Mackintosh 1877-1957 *DcAmArt, GrAmP, IlBEAAW, McGDA*
Young, Mahonri MacKintosh 1877-1957 *WhAmArt 85*
Young, Mahonri S 1911- *WhoAmA 73, –76, –78, –80, –82, –84*
Young, Marjorie Ward 1910- *WhoAmA 73, –76, –78, –80, –82, –84*
Young, Martin Ray, Jr. 1916- *AmArch 70*
Young, Mary *DcWomA*
Young, Mary Eliza *DcWomA, NewYHSD*
Young, Mary L *WhAmArt 85*
Young, Mary Louise *DcWomA*
Young, Matthew 1813-1890 *FolkA 86*
Young, Mattie *WhAmArt 85*
Young, Mattie 1876- *ArtsAmW 2*
Young, Maybelle 1891- *DcWomA, WhAmArt 85*
Young, Milton 1935- *AfroAA, WhoAmA 76, –78, –80, –82, –84*
Young, Moses *CabMA*
Young, Murat 1901-1973 *WorECom*
Young, Myrtle M *WhAmArt 85*
Young, Myrtle M 1876- *ArtsAmW 2, DcWomA*
Young, N M *WhAmArt 85*
Young, Nancy J 1939- *WhoAmA 84*
Young, Nathaniel *FolkA 86*
Young, Noela 1930- *IlsCB 1967*
Young, O A *DcVicP 2*
Young, Oscar Van 1906- *AmArt*
Young, Otto *EncASM*
Young, Paul, Jr. 1913- *AmArch 70*
Young, Paul Edward, Jr. *AmArch 70*
Young, Peter 1826?- *FolkA 86*
Young, Peter 1940- *ConArt 77, –83, DcCAr 81*
Young, Peter Ford 1940- *WhoAmA 78, –80, –82, –84*
Young, Philip *NewYHSD*
Young, Phineas 1847-1868 *ArtsAmW 1*
Young, Phineas Howe 1847-1868 *IlBEAAW*
Young, R C *AmArch 70*
Young, R Clouston *DcBrA 1*
Young, R H *DcVicP 2*
Young, Richard Bishop 1930- *AmArch 70*
Young, Richard Carr *WhAmArt 85*
Young, Richard Crossley 1931- *AmArch 70*
Young, Robert *AmArt*
Young, Robert 1938- *OxTwCA, PrintW 83, –85*
Young, Robert Brown 1855-1914 *BiDAmAr*
Young, Robert Clouston 1860-1929 *DcBrWA, DcVicP 2*
Young, Robert J 1938- *ConArt 83*
Young, Robert James 1937- *MarqDCG 84*
Young, Robert John 1930- *AmArch 70*
Young, Robert John 1938- *WhoAmA 78, –80, –82, –84, WhoArt 80, –82, –84*
Young, Robert Stanley 1946- *MarqDCG 84*

Young, Ronald Newton 1936- *AmArch 70*
Young, Rose *WhAmArt 85*
Young, Roxey Chester 1921- *AmArch 70*
Young, S *FolkA 86*
Young, Samuel *FolkA 86*
Young, Sibyl 1901- *DcBrA 1*
Young, Stanley S *DcVicP*
Young, Stephen *CabMA, DcCAr 81*
Young, Susanne B 1891- *WhAmArt 85*
Young, Susanne Bottomley 1891- *DcWomA*
Young, Sybil *WorFshn*
Young, Terence O 1932- *AmArch 70*
Young, Theodore John 1896- *AmArch 70*
Young, Theresa E *ArtsEM, DcWomA*
Young, Thomas *NewYHSD*
Young, Thomas 1773-1829 *ICPEnP*
Young, Thomas A 1837-1913 *NewYHSD , WhAmArt 85*
Young, Thomas Crane 1858-1934 *BiDAmAr*
Young, Tobias *NewYHSD*
Young, Tobias P d1824 *DcBrWA*
Young, Tom 1924- *WhoAmA 76, –78, –80, –82, –84*
Young, Tommy *AfroAA*
Young, W H *AmArch 70*
Young, W S *AmArch 70*
Young, Walter N 1906- *WhAmArt 85*
Young, Webb 1913- *WhoAmA 73, –76*
Young, William *FolkA 86*
Young, William 1711-1795 *FolkA 86*
Young, William 1845-1916 *DcBrA 1, DcVicP 2*
Young, William Allen 1953- *MarqDCG 84*
Young, William Blamire 1862-1935 *DcBrA 2*
Young, William Crawford 1886- *WhAmArt 85*
Young, William Weston *AntBDN M, DcBrBI*
Young, William Weston 1776-1847 *DcNiCA*
Young-Hunter, Eva Hatfield *WhAmArt 85*
Young-Hunter, John 1874-1955 *ArtsAmW 1, IlBEAAW, WhAmArt 85*
Young-Hunter, Mary 1872?-1947 *ArtsAmW 3*
Youngblood, Daisy 1945- *DcCAr 81*
Youngblood, Judy *WhoAmA 82, –84*
Youngblood, R L *AmArch 70*
Youngblood, Ray Wilson 1931- *MarqDCG 84*
Younge, John *AntBDN Q*
Younge, S C *AntBDN N*
Younger, Cheryl Gwen 1946- *MacBEP*
Younger, Dan Forrest 1954- *WhoAmA 82, –84*
Younger, Helen *DcWomA .*
Younger, Jane 1863-1955 *DcWomA*
Younger, Richard Evans *OfPGCP 86*
Youngerman, Jack 1926- *BnEnAmA, ConArt 77, –83, DcCAA 71, –77, DcCAr 81, OxTwCA, PhDcTCA 77, PrintW 83, –85, WhoAmA 73, –76, –78, –82, –84, WorArt*
Youngerman, Reyna Ullman *WhoAmA 76*
Youngerman, Reyna Ullman 1902- *WhAmArt 85*
Youngkin, H L *AmArch 70*
Younglove, Elbridge G *NewYHSD*
Younglove, Mary Golden *DcWomA, WhAmArt 85*
Younglove, Ruth Ann 1909- *WhAmArt 85, WhoAmA 73, –76, –78, –80, –82, –84*
Youngman, Annie M 1860-1919 *DcVicP*
Youngman, Annie Mary 1859-1919 *DcBrA 1, DcBrWA, DcWomA*
Youngman, Annie Mary 1860-1919 *DcVicP 2*
Youngman, Harold James 1886- *DcBrA 1*
Youngman, John Mallows 1817-1899 *DcBrWA, DcVicP, –2*
Youngman, Nan *WhoArt 80, –82, –84*
Youngman, Nan 1906- *DcBrA 1*
Youngmann, Carl E 1943- *MarqDCG 84*
Youngquist, Jack 1918- *WhoAmA 76, –78, –80, –82, –84*
Youngquist, John 1918- *WhoAmA 73*
Youngren, Ralph Park 1924- *AmArch 70*
Youngs, Amelia L *DcWomA*
Youngs, Benjamin S 1774-1855 *FolkA 86*
Youngs, Betty 1934- *IlsCB 1967*
Youngs, Icabod *FolkA 86*
Youngs, Isaac N 1793-1865 *FolkA 86*
Youngs, Laurence *DcVicP 2*
Youngs, M B *WhAmArt 85*
Youngs, R A *AmArch 70*
Youngsblood, Nat 1916- *WhoAmA 76, –78, –80, –82, –84*
Youngscap, Richard L 1938- *AmArch 70*
Youngson, J R *AmArch 70*
Younker, Francis *CabMA*
Younkin, William LeFevre 1885- *ArtsAmW 2, WhAmArt 85*
Yount, William Ray 1888- *AmArch 70*
Your Uncle Feininger *WorECom*
Youritzin, Glenda Green *WhoAmA 82, –84*
Youritzin, Glenda Green 1945- *WhoAmA 78, –80*
Youritzin, Victor Koshkin 1942- *WhoAmA 78, –80, –82, –84*
Youtz, Philip Newell 1895- *AmArch 70*
Yovits, Esther 1916- *WhAmArt 85*
Yovits, Marshall Clinton 1923- *MarqDCG 84*
Yow, Rose Law *WhAmArt 85*
Yoxall, William d1770 *BiDBrA*

Yphantis, George *WhAmArt 85*
Yphantis, George 1899- *ArtsAmW 2*
Yriarte, Charles 1832-1898 *DcBrBI*
Yrisarry, Mario 1933- *ConArt 77, DcCAA 77,*
 WhoAmA 73, −76, −78, −80, −82, −84
Yrizarry, Marcos 1936- *WhoAmA 73, −76, −78*
Yrrarazaval, Ricardo *OxTwCA*
Ysart, Augustus d1957 *IlDcG*
Ysart, Paul *DcNiCA*
Ysart, Paul 1904- *IlDcG*
Ysart, Salvador d1956 *IlDcG*
Ysart, Salvador 1877-1955 *DcNiCA*
Ysart, Vincent d1971 *IlDcG*
Yselin d1513 *McGDA*
Ysenbrand, Adriaen *McGDA*
Ysenbrandt, Adriaen d1551 *OxArt*
Ysenburg, Count C *DcVicP 2*
Yssim *DcWomA*
Ytredal, H *AmArch 70*
Yturralde, Jose Maria *OxTwCA*
Yu, Mason K 1951- *MarqDCG 84*
Yu, Xunling *ICPEnP A*
Yu, Yuu 1940- *WhoAmA 82*
Yu-Chien *McGDA*
Yu-Chun *McGDA*
Yuan, Four Masters Of *McGDA*
Yuan, Chiang *McGDA*
Yuasa, Hachiro 1909- *AmArch 70*
Yudin, Carol *WhoAmA 73, −76, −78, −80, −82, −84*
Yuditsky, Cornelia R 1895- *WhAmArt 85*
Yuditsky, Cornelia R 1895-1980 *DcWomA*
Yudkowsky, Reena *MarqDCG 84*
Yuen, Andrew S 1911- *AmArch 70*
Yuen, Sing Hoo *WhoAmA 76*
Yuen, Theresa Hsu 1934- *AmArch 70*
Yuhara, Kazuo 1930- *OxTwCA, PhDcTCA 77*
Yuhn, Marion F 1931- *AmArch 70*
Yuichi, Nomoto 1944- *MarqDCG 84*
Yuill Thornton, A *AmArch 70*
Yukinobu, Kiyohara 1643-1682 *DcWomA*
Yule, Ainslie 1941- *DcCAr 81*
Yule, D Ainslie 1941- *WhoArt 80*
Yule, Winifred J *DcBrA 2*
Yull, Erika 1899- *DcWomA*
Yumedono, Kannon *McGDA*
Yun, Bing *DcWomA*
Yun, P'ing *DcWomA*
Yun, Shou-P'ing 1633-1690 *McGDA*
Yun, Shou-P'ing 1663-1690 *OxArt*
Yundt, George E 1924- *AmArch 70*
Yundt, George Edward 1905- *AmArch 70*
Yungbluth, John 1923- *MarqDCG 84*
Yunge, G *DcVicP 2*
Yunkers, Adja 1900- *BnEnAmA, ConArt 77, −83,*
 DcCAA 71, −77, McGDA, OxTwCA,
 PhDcTCA 77, PrintW 83, WhoAmA 73, −76,
 −78, −80, −82, −84
Yunkers, Adja 1900-1983 *PrintW 85, WorArt[port]*
Yunus 1943- *WhoArt 84*
Yurchenco, B *AmArch 70*
Yurchison, George Edward 1928- *AmArch 70*
Yuristy, Russell Michael 1936- *WhoAmA 76, −78, −80,*
 −82, −84
Yusho 1533-1615 *McGDA*
Yust, Dave 1939- *PrintW 83, −85*
Yust, David E 1939- *WhoAmA 73, −76, −78, −80, −82,*
 −84
Yusuke, Suga 1942- *WorFshn*
Yutzey, Marvin Glen 1912- *WhAmArt 85*
Yvaral 1934- *ConArt 77, OxTwCA, PrintW 83, −85*
Yves *IlBEAAW*
Yvetot, Elisa *DcWomA*
Yvon, Adolphe *DcVicP 2*
Yvon, Adolphe 1817- *ArtsNiC*
Yvon, Adolphe 1817-1893 *ClaDrA*
Yvon, Joseph *WhoAmA 76, −78, −80, −82*
Yweins, Berlinette *DcWomA*

Z

Zabaldo, Patrick S 1931- *AmArch 70*
Zabaleta, Rafael 1907-1960 *PhDcTCA 77*
Zabarsky, Melvin Joel 1932- *WhoAmA 73, -76, -78, -80, -82, -84*
Zabbart, M *FolkA 86*
Zabel, John Edgar 1946- *MarqDCG 84*
Zabeth, Elisabeth 1879-1933 *DcWomA*
Zablocki, Ernest J *ArtsEM*
Zablocki, Wojciech 1930- *ConArch*
Zabludovsky, Abraham 1924- *ConArch*
Zaboly, Bela 1910- *WhAmArt 85*
Zaborowska, Gabrielle 1852- *DcWomA*
Zaborowska, Suzanne Alice 1894- *DcWomA*
Zaborowski, Dennis J 1943- *WhoAmA 78, -80, -82, -84*
Zabransky, Adolf 1909- *IlsCB 1957, WhoGrA 62*
Zabreski *NewYHSD*
Zabriskie, Virginia M *WhoAmA 73, -76, -78, -80, -82, -84*
Zabriskie, William B 1840-1933 *WhAmArt 85*
Zabrosky, Carl F *ArtsEM*
Zac, Pino *WorECar*
Zaccagni, Bernardino 1455-1529 *McGDA*
Zaccagni, Giovanni Francesco 1491-1543 *McGDA*
Zaccagni, Joseph Jerald 1934- *AmArch 70*
Zaccaria Da Volterra *McGDA*
Zaccaria, Pino 1930- *WorECar*
Zacchi, Giovanni 1512-1565 *McGDA*
Zacchi, Zaccaria 1473-1544 *McGDA*
Zacchia, Lorenzo 1524-1587? *ClaDrA, McGDA*
Zaccone, Fabian F 1910- *WhAmArt 85*
Zach, Jan 1914- *WhoAmA 76, -78, -80, -82, -84*
Zach-Dorn, Camilla 1859- *DcWomA*
Zacha, George William 1920- *WhoAmA 78*
Zacha, William 1920- *AmArt, WhoAmA 80, -82, -84*
Zachar, Stefan H *AmArch 70*
Zachariae, Agnes *DcWomA*
Zacharias, Athos 1927- *DcCAA 71, -77, PrintW 83, -85, WhoAmA 73, -76, -78, -80, -82, -84*
Zachariassen, Frida 1912- *DcCAr 81*
Zacharie, Philippe-Ernest *ArtsNiC*
Zacharoff, Olga *DcWomA*
Zachinni, Hugo *WhAmArt 85*
Zachmann, John *FolkA 86*
Zacho, Christian *DcVicP 2*
Zachresky *NewYHSD*
Zachry, James R 1922- *AmArch 70*
Zack, Badanna Bernice 1933- *WhoAmA 84*
Zack, Bandanna 1933- *DcCAr 81*
Zack, David 1938- *WhoAmA 76, -78*
Zack, Leon 1892- *OxTwCA, PhDcTCA 77*
Zacks, Samuel Jacob 1904-1970 *WhoAmA 78N, -80N, -82N, -84N*
Zadak, Etel 1875- *DcWomA*
Zadig, Bertram 1904- *WhAmArt 85*
Zadkine, Ossip 1890-1967 *ConArt 77, -83, McGDA, OxArt, OxTwCA, PhDcTCA 77, WorArt*
Zadok, Charles *WhoAmA 73*
Zadok, Mrs. Charles *WhoAmA 73*
Zadow, Jerome L 1941- *MarqDCG 84*
Zafar, Mahmood 1934- *MarqDCG 84*
Zafran, Eric Myles 1946- *WhoAmA 78, -80, -82, -84*
Zagami, Robert W *MarqDCG 84*
Zaganelli, Francesco 1480?-1531 *McGDA*
Zagel, G M *AmArch 70*
Zago, Erma 1880-1942 *DcWomA*
Zago, Tino 1937- *WhoAmA 82, -84*
Zagorska, Wanda 1855- *DcWomA*
Zahariev, Vasil 1895- *WhoGrA 62*
Zahm, R R *AmArch 70*

Zahn, Albert d1950? *FolkA 86*
Zahn, Carl Frederick 1928- *WhoAmA 73, -76, -78, -80, -82, -84, WhoGrA 82[port]*
Zahn, Edward *NewYHSD*
Zahn, Otto 1906- *WhAmArt 85*
Zahner, Ralph *NewYHSD*
Zahner, Rudolf *DcVicP 2*
Zahner, S *DcVicP 2*
Zahorsky, Milan 1948- *DcCAr 81*
Zahour, Vladimir 1925- *DcCAr 81*
Zahourek, Jon Gail 1940- *WhoAmA 84*
Zaia, A T *AmArch 70*
Zaidenberg, Arthur *WhoAmA 76, -78, -80*
Zaidenberg, Arthur 1908- *WhoAmA 82*
Zaik, Saul 1926- *AmArch 70*
Zaikine, Eugene A 1908- *WhAmArt 85*
Zaikine, Zak 1941- *WhoAmA 82, -84*
Zaima, Stephen Gyo 1947- *WhoAmA 82, -84*
Zais, Giuseppe 1709-1784 *ClaDrA, McGDA*
Zaiss, Leonard 1892-1933 *WhAmArt 85*
Zajac, Jack 1929- *DcCAA 71, -77, WhoAmA 73, -76, -78, -80, -82, -84*
Zajacek, George Paul 1939- *AmArch 70*
Zajaczkowska, Marie 1856- *DcWomA*
Zajchowski, Joseph Stanley 1928- *AmArch 70*
Zajec, Edward 1938- *MarqDCG 84*
Zajtai, Imre 1888- *DcWomA*
Zak, Eugene 1884-1926 *ClaDrA, PhDcTCA 77*
Zak, Karel J *WhAmArt 85*
Zak, Ladislav 1900-1973 *MacEA*
Zakanitch, Robert S 1935- *DcCAr 81, PrintW 83, -85, WhoAmA 82, -84*
Zakanych, Robert 1935- *WhoAmA 73, -76, -78, -80*
Zakharoff, Feodor 1882- *WhAmArt 85*
Zakharov, Adrian Dmitrievich 1761-1811 *DcD&D[port], MacEA, McGDA, WhoArch*
Zakharov, Andreyan 1761-1811 *OxArt*
Zakharova, Olga *DcWomA*
Zakheim, Bernard Baruch 1898- *ArtsAmW 2, WhAmArt 85*
Zaki 1944- *DcCAr 81*
Zakia, Richard D 1925- *MacBEP*
Zakin, Mikhail 1939- *WhoAmA 78, -80, -82, -84*
Zakreski, Alexander *NewYHSD*
Zakrzewski, Zygmunt Mieczyslaw 1900- *AmArch 70*
Zakucka, Fanny *DcWomA*
Zalar, John *FolkA 86*
Zalce, Alfredo *OxTwCA*
Zalce, Alfredo 1908- *McGDA*
Zaleski, Jean M *WhoAmA 78, -80, -82, -84*
Zalesky, C B *AmArch 70*
Zalewski, J *AmArch 70*
Zalewski, W J *AmArch 70*
Zallinger, Franz 1894- *ArtsAmW 3*
Zallinger, Jean Day *IlsCB 1967*
Zallinger, Jean Day 1918- *IlsBYP, IlsCB 1957, WhoAmA 78, -80, -82, -84*
Zallinger, Rudolph Franz 1919- *WhoAmA 78, -80, -82, -84*
Zalme, Ron 1954- *ConGrA 1[port]*
Zalstem-Zalessky, Alexis *WhoAmA 82*
Zalstem-Zalessky, Mrs. Alexis *WhoAmA 73, -76, -78, -80*
Zaltzman, Zack *DcCAr 81*
Zamacois, Edouard 1840?-1871 *ArtsNiC*
Zamarra, J D *AmArch 70*
Zambaiti, Elena 1673-1761 *DcWomA*
Zamboni, Count G *DcVicP 2*
Zamboni, R P *AmArch 70*
Zambrano, R A *AmArch 70*
Zamecznik, Juliusz Wojciech 1923- *WhoGrA 62*

Zamecznik, Stanislaw 1909- *WhoGrA 62*
Zamecznik, Wojciech 1923-1967 *ConDes*
Zammitt, Norman 1931- *DcCAA 71, -77, WhoAmA 73, -76, -78, -80, -82, -84*
Zamora, Sanchez *ConGrA 1*
Zamorano, Ricardo *OxTwCA*
Zamoyska, Anna *DcWomA*
Zampa, Victor Michael 1931- *AmArch 70*
Zamparelli, Mario Armond *WhoAmA 73, -76, -78, -80*
Zampieri, Domenico *McGDA, OxArt*
Zampieri, Domenico 1581-1641 *ClaDrA*
Zanardelli, Italia Focca 1874- *DcWomA*
Zanardi, Gentile 1660-1700? *DcWomA*
Zanarti, Enrique Antunez 1921- *PhDcTCA 77*
Zanartu, Nemesio Antunez 1918- *PhDcTCA 77*
Zander, Jack *WhAmArt 85*
Zander, Nils-Gunnar *DcCAr 81*
Zander, Ralph Arthur 1914- *AmArch 70*
Zander, Robert A 1910- *AmArch 70*
Zandi, Martin M 1950- *MarqDCG 84*
Zando, Raymond Joseph 1924- *AmArch 70*
Zandrino, Adelina 1893- *DcWomA*
Zane, Nowland Brittin 1885- *ArtsAmW 3*
Zane, R K S *AmArch 70*
Zaner, Bill *OfPGCP 86*
Zanetta, Clotilda *WhAmArt 85*
Zanetta, Clotilda Marie 1890-1970 *DcWomA*
Zanft, Hattie Carnegie 1889-1956 *WorFshn*
Zang, John J *IIBEAAW, WhAmArt 85*
Zanguidi, Jacopo *McGDA*
Zangwill, Mark *DcBrBI*
Zann, Daniel Y 1941- *MarqDCG 84*
Zannoth, G G *AmArch 70*
Zanobi, Machiavelli *McGDA*
Zantman, Hans 1919- *WhoAmA 73*
Zantman, J B 1919- *WhoAmA 76, -78, -80, -82, -84*
Zantzinger, C Clark, Jr. 1904- *AmArch 70*
Zanuso, Marco 1916- *ConDes, EncMA*
Zao, Wou-Ki 1920- *OxTwCA*
Zao, Wou-Ki 1921- *ConArt 77, McGDA, PhDcTCA 77*
Zao, Wou Ki 1921- *WhoArt 80, -82, -84*
Zapalac, E F, Jr. *AmArch 70*
Zapalac, George H 1923- *AmArch 70*
Zapf, Hermann 1918- *ConDes, WhoGrA 62, -82[port]*
Zapkus, Kes 1938- *WhoAmA 84*
Zapkus, Kestutis 1938- *ConArt 77*
Zapkus, Kestutis Edward 1938- *WhoAmA 73, -76, -78, -80, -82*
Zappettini, Gianfranco 1939- *ConArt 77, -83*
Zappi, Maria *DcWomA*
Zaprauskis, Rudolfs Karlis 1921- *AmArch 70*
Zarand, Julius John 1913- *WhoAmA 76, -78, -80, -82, -84*
Zarcillo, Francisco *McGDA*
Zarcillo, Ines *DcWomA*
Zarek, Edmund Joseph 1924- *AmArch 70*
Zarfoss, W M *AmArch 70*
Zaring, Louise E *WhAmArt 85*
Zaring, Louise Eleanor *DcWomA*
Zarini, E Mazzoni *WhAmArt 85*
Zarins, Z *AmArch 70*
Zaritsky, Yossef 1891- *OxTwCA, PhDcTCA 77*
Zarling, Eugene Henry 1925- *AmArch 70*
Zarn, George *FolkA 86*
Zarnikow, Werner Edwin 1924- *AmArch 70*
Zarookian, Varooj G 1935- *AmArch 70*
Zarraga, Angel 1886-1946 *ClaDrA*
Zarrinkelk, Nooreddin 1937- *WhoGrA 82[port]*

Zarrugh, Mohamed Yousef 1945- *MarqDCG 84*
Zarse, Alfred Henry 1904- *AmArch 70*
Zarsky, Ernest 1864- *WhAmArt 85*
Zasinger, Matthaus 1477?- *McGDA*
Zatkova, Ruzhena 1885-1923 *DcWomA*
Zauffely, Johann Joseph 1733-1810 *ClaDrA*
Zaugg, Thomas Gene 1917- *AmArch 70*
Zaugg, Zola 1897-1975 *DcWomA*
Zauli, Carlo 1926- *DcCAr 81*
Zaumzeil, Ernestine Eberhardt *FolkA 86*
Zauner, Franz Anton Von 1746-1822 *McGDA*
Zauner, Leslie 1890- *WhAmArt 85*
Zausner, Tobi 1942- *WhoAmA 76*
Zavala, Manuel 1956- *WhoAmA 82, –84*
Zavattari Family *McGDA*
Zavel 1910- *WhoAmA 73, –76, –78*
Zavodny, Alfred Ted 1941- *MarqDCG 84*
Zavytowsky, A *NewYHSD*
Zawadzki, Nancy *MarqDCG 84*
Zawadzky, Margarete Von 1889- *DcWomA*
Zborowski, Walter Benjamin 1928- *AmArch 70*
Zdrahal, Ernst *DcCAr 81*
Zeabower, Margaret *DcWomA*
Zebot, George Jurij 1944- *AmArt*
Zecchin, Francesco *IlDcG*
Zecchin, Vittorio 1878-1947 *IlDcG*
Zech, Countess Dora 1856-1912 *DcWomA*
Zechyr, Othmar 1938- *DcCAr 81*
Zeckendorf, Mrs. Guri Lie *WhoAmA 73*
Zeckwer, Emilie *DcWomA, WhAmArt 85*
Zedtwitz, Amalia Philippine A Von 1779- *DcWomA*
Zeebros *DcBrECP*
Zeegers, Be 1891- *DcWomA*
Zeelander, Moryn Claessons *McGDA*
Zeelander, Pieter De *DcSeaP*
Zeeler, Arthur *WhAmArt 85*
Zeeman *DcBrECP, DcSeaP*
Zeeman, Reinier 1623-1667? *McGDA*
Zeeman, Renier 1623?-1667? *ClaDrA*
Zeer *DcBrECP*
Zeferino DaCosta, Joao 1840-1915 *McGDA*
Zeffirelli, Franco 1923- *ConDes*
Zegers, Geeraard 1591-1651 *McGDA*
Zegler, Richard Eugene 1922- *AmArch 70*
Zehender, Therese *DcWomA*
Zehentner, Margareta Magdalena *DcWomA*
Zehnder, Norbert Anthony, Jr. 1933- *AmArch 70*
Zehrfuss, Bernard 1911- *ConArch, EncMA*
Zehrfuss, Bernard H 1912?- *McGDA*
Zeid, Princess Fahr-El-Nissa 1903- *OxTwCA*
Zeidenbergs, Olafs 1936- *WhoAmA 76, –78, –80, –82, –84*
Zeidler, Avis 1908- *WhAmArt 85*
Zeidler, E H 1926- *MacEA*
Zeidler, Eberhard 1926- *ConArch*
Zeidler, Eberhard Heinrich 1926- *WhoAmA 76, –78, –80, –82, –84*
Zeigel, H A *AmArch 70*
Zeiger, Arthur 1932- *AmArch 70*
Zeiger, Sophia 1926- *IlsBYP, IlsCB 1946, –1957*
Zeigler, E P *WhAmArt 85*
Zeigler, Jorg *McGDA*
Zeigler, Lee Woodward d1952 *WhoAmA 78N, –80N, –82N, –84N*
Zeigler, Lee Woodward 1868-1952 *WhAmArt 85*
Zeigler, Warren David 1920- *AmArch 70*
Zeigler, William Charles 1930- *AmArch 70*
Zeil, William Francis Von 1914- *WhAmArt 85*
Zeiner, Richard William 1931- *AmArch 70*
Zeisel, Eva 1906- *ConDes*
Zeisel, Eva S 1906- *WhAmArt 85*
Zeisler, Claire *BnEnAmA*
Zeisler, Claire 1903- *AmArt, WhoAmA 80, –82, –84*
Zeisler, Richard Spiro 1916- *WhoAmA 73, –76, –78, –80, –82, –84*
Zeiss, Carl 1816-1888 *ICPEnP, MacBEP*
Zeitblom, Bartel 1460?-1520? *OxArt*
Zeitblom, Bartholomaus 1455?-1518 *McGDA*
Zeitblom, Bartholome 1455?-1518? *ClaDrA*
Zeithammel, Michal 1959- *MarqDCG 84*
Zeitlin, Alexander 1872- *WhAmArt 85*
Zeitlin, Harriet Brooks 1929- *WhoAmA 78, –80, –82, –84*
Zeitlin, Jacob Ilrael 1902- *WhoAmA 78*
Zeitlin, Jacob Israel 1902- *WhoAmA 80, –82, –84*
Zeitlin, Michael Barry 1937- *AmArch 70*
Zeitter, John Christian d1862 *DcVicP, –2*
Zeitz, Frederick *FolkA 86*
Zeitz, Louis *FolkA 86*
Zejdlik, R F *AmArch 70*
Zekveld, Jacob 1945- *ConArt 77*
Zelanski, Paul John 1931- *WhoAmA 73, –76, –78, –80, –82, –84*
Zelazo, Nathaniel K 1918- *MarqDCG 84*
Zeldis, Malcah 1932- *FolkA 86*
Zelenak, Crescencia 1922- *WhoGrA 82[port]*
Zelenak, Edward John 1940- *WhoAmA 76, –78, –80, –82, –84*
Zelenka, Maxine 1915- *WhAmArt 85*
Zelenko, Rok 1951- *DcCAr 81*
Zelenski, A *DcVicP 2*

Zelger, Arthur 1914- *WhoGrA 82[port]*
Zelger, Jacob Joseph 1812-1885 *ClaDrA*
Zelger, Josephine *DcWomA*
Zeliff, A E *NewYHSD*
Zelio 1938- *WhoGrA 82[port]*
Zell, Beatrice *DcVicP 2, DcWomA*
Zell, Christian *NewYHSD*
Zell, Ernest N 1874- *WhAmArt 85*
Zell, William D *FolkA 86*
Zell Brothers *EncASM*
Zelle, Ann *DcCAr 81*
Zeller, Arthur *WhAmArt 85*
Zeller, August 1863-1918 *WhAmArt 85*
Zeller, Emilio, III 1935- *AmArch 70*
Zeller, Georg Eugen 1889- *ClaDrA*
Zeller, George 1818-1889 *FolkA 86*
Zeller, Justine *DcWomA*
Zeller, Thea 1842- *DcWomA*
Zellerbach, Harold L 1895-1978 *WhoAmA 80N, –82N, –84N*
Zellmer, L G *AmArch 70*
Zellmer, Minna Weiss *WhAmArt 85*
Zellner, Minna Weiss 1889- *DcWomA*
Zelma, Georgij 1906- *ConPhot, ICPEnP A*
Zelna, A *FolkA 86*
Zelner, Aaron 1812-1893 *FolkA 86*
Zelnik, Martin Allen *AmArch 70*
Zelnik, Simon Bernard 1894- *AmArch 70*
Zelones, P G *AmArch 70*
Zelotti, Giambattista 1526-1578 *McGDA*
Zelt, Martha 1930- *PrintW 85, WhoAmA 76, –78, –80, –82, –84*
Zelz, Francis Joseph 1924- *AmArch 70*
Zema, G K *AmArch 70*
Zemach, Margot *IlsCB 1967*
Zemach, Margot 1931- *IlsBYP, IlsCB 1957*
Zemaitis, A *AmArch 70*
Zeman, Karel 1910- *WorECar*
Zemanek, John 1921- *AmArch 70*
Zemanovic, Rudolph 1932- *AmArch 70*
Zemans, Joyce L 1940- *WhoAmA 82, –84*
Zemer, Yigal *PrintW 85*
Zemer, Yigal 1938- *WhoAmA 73*
Zemsky, Jessica *OfPGCP 86*
Zemus, George *ArtsEM*
Zenale, Bernardino 1436-1526 *McGDA*
Zenge, Wilhelmine Von 1780-1852 *DcWomA*
Zenger, Peter *EarABI*
Zenizo, Diego F 1955- *MarqDCG 84*
Zenk, Russell Layne 1933- *AmArch 70*
Zenker, Agnes 1866- *DcWomA*
Zenner, Rose *WhAmArt 85*
Zenobio, Luca DeLa *DcSeaP*
Zenobius Of Florence, Saint d422? *McGDA*
Zenon, G J, Jr. *AmArch 70*
Zenone, Caterina *DcWomA*
Zensky, J *WhAmArt 85*
Zent, August *FolkA 86*
Zentner, James Robert 1929- *AmArch 70*
Zentz, Philip Leon 1934- *AmArch 70*
Zepf, Robert Louis 1918- *AmArch 70*
Zerbe, Karl 1903- *DcCAA 71, McGDA*
Zerbe, Karl 1903-1972 *DcCAA 77, WhAmArt 85, WhoAmA 78N, –80N, –82N, –84N*
Zerbe, R M *AmArch 70*
Zere, Al *WorECar*
Zerega, Andrea Pietro 1917- *WhAmArt 85*
Zerffi, Florence 1882-1962 *DcWomA*
Zerffi-Caldecott, Florence 1882-1962 *DcWomA*
Zerkowitz, Adolf 1894-1972 *ICPEnP A*
Zermuehlen, Robert E *AmArch 70*
Zerner, Henri Thomas 1939- *WhoAmA 80, –82, –84*
Zernichow, Cathrine Helene 1864- *DcWomA*
Zero *ConDes, WhoGrA 62*
Zerouni, Craig Aram 1958- *MarqDCG 84*
Zervas, J E *AmArch 70*
Zeshin, Shibata *AntBDN L, OxDecA*
Zetlin, Fay 1906- *WhoAmA 78, –80, –82, –84*
Zettel, Josephine Ella 1874-1954 *DcWomA*
Zetterlund, John *ArtsAmW 2, WhAmArt 85*
Zetterstrom, M, Madame *ArtsNiC*
Zetterstrom, Vilhelmina Katarina 1843-1885 *DcWomA*
Zettervall, Helgo 1831-1907 *MacEA*
Zetti, Italo *WhoArt 82N*
Zetti, Italo 1913- *WhoArt 80*
Zettler, Emil Robert 1878-1946 *WhAmArt 85*
Zeuner *IlDcG*
Zeuthen, Laura Kirstine Baagoe 1877- *DcWomA*
Zeuxis *McGDA, OxArt*
Zevi, Bruno 1918- *MacEA*
Zevi, Bruno B 1918- *WhoArt 80, –82, –84*
Zevio, Stefano Da *McGDA*
Zevon, Irene 1918- *WhoAmA 73, –76, –78, –80, –82, –84*
Zezzos, A *DcVicP 2*
Zezzos, Alessandro *ArtsNiC*
Zharova, Alexandra Alexandrovna *DcWomA*
Zheng, Jingkang *ICPEnP A*
Zheutlin, Dale R 1948- *AmArt, WhoAmA 82, –84*
Zholtovsky, Ivan V 1867-1959 *MacEA*

Zhou, Xi *DcWomA*
Zhou, Yaoguang *ICPEnP A*
Zhouf, George Karen 1940- *PrintW 83, –85*
Zhukov, Nikolai Nikolaevich 1908-1973 *WorECar*
Ziane, Juliette *DcWomA*
Ziar, Elizabeth Rosemary 1919- *ClaDrA, WhoArt 80, –82, –84*
Zib, Tom *WhoAmA 73, –76, –78, –80, –82, –84*
Ziccardy, Gerald Anthony 1930- *AmArch 70*
Zick, Walter Frederick 1905- *AmArch 70*
Zickendraht, Bernhard 1854-1937 *ClaDrA*
Ziebland, Georg Friedrich 1800-1878 *MacEA*
Zieg, Elsa Anshutz *WhAmArt 85*
Ziegele, John N 1913- *AmArch 70*
Ziegelman, N H *AmArch 70*
Ziegelman, Robert Lee 1936- *AmArch 70*
Ziegenfuss, Paul A, Jr. 1933- *AmArch 70*
Ziegenmeyer, Emmy Dorothea *DcWomA*
Ziegfeld, Donald Lewis 1928- *AmArch 70*
Ziegfeld, Edwin 1905- *WhoAmA 73, –76*
Ziegler, Miss *DcVicP, –2*
Ziegler, Archibald 1903- *DcBrA 1*
Ziegler, E *DcVicP 2*
Ziegler, Emilie 1826-1905 *DcWomA*
Ziegler, Eustace Paul 1881- *ArtsAmW 1, IlBEAAW, WhAmArt 85*
Ziegler, Gabrielle 1870- *DcWomA*
Ziegler, George Frederick *NewYHSD*
Ziegler, H *FolkA 86, NewYHSD*
Ziegler, Henry 1889- *ArtsAmW 1, WhAmArt 85*
Ziegler, Henry Bryan 1793-1874 *ClaDrA*
Ziegler, Henry Bryan 1798-1874 *DcBrWA, DcVicP, –2*
Ziegler, Jack 1942- *ConGrA 1[port], WorECar*
Ziegler, Jacqueline *WhoAmA 80*
Ziegler, Jacqueline 1930- *WhoAmA 76, –78*
Ziegler, Jules Claude 1804-1856 *ClaDrA, DcNiCA*
Ziegler, Karlheinz 1935- *DcCAr 81*
Ziegler, Laura *WhoAmA 76, –78*
Ziegler, Maria 1876- *DcWomA*
Ziegler, Matthew E 1897- *WhAmArt 85*
Ziegler, R P *AmArch 70*
Ziegler, Raymond Stewart 1919- *AmArch 70*
Ziegler, Samuel P 1882-1967 *ArtsAmW 2, IlBEAAW, WhAmArt 85*
Ziegler-Zundel, Julie 1820-1898 *DcWomA*
Ziehr, Kenneth Edward 1938- *AmArch 70*
Zieler, Mogens 1905- *WhoGrA 62, –82[port]*
Zielinska, Aniela 1824-1849 *DcWomA*
Zielinski, Arcadius Edwin 1921- *AmArch 70*
Zielke, Willy 1902- *ICPEnP*
Zielonka, Jason S 1948- *MarqDCG 84*
Ziem, Felix 1822?- *ArtsNiC*
Ziem, Felix Francois Georges Philibert 1821-1911 *ClaDrA*
Ziemann, Richard Claude 1932- *WhoAmA 73, –76, –78, –80, –82, –84*
Ziemer, Donald 1933- *AmArch 70*
Ziemssen, Friederike *DcWomA*
Zier, Delphine Alexandrine *DcWomA*
Zier, Edouard *ArtsNiC*
Ziering, Robert M 1933- *IlrAm 1880*
Ziering, Walter 1920- *AmArch 70*
Zierler, William 1928- *WhoAmA 73, –76, –78*
Ziervogel, W M *AmArch 70*
Ziesel, Georg Frederik 1756-1809 *ClaDrA*
Ziesenis, Elisabeth *DcWomA*
Ziesenis, Johann Georg 1716-1777 *McGDA*
Zieske, Marvin E 1935- *AmArch 70*
Zietz, Stephen Joseph 1949- *WhoAmA 78, –80, –82, –84*
Ziff, Jerrold 1928- *WhoAmA 78, –80, –82, –84*
Ziffer, Moshe 1902- *WhoArt 80, –82*
Zigaina, Giuseppe 1924- *DcCAr 81, PhDcTCA 77*
Zigler, John *NewYHSD*
Zigrosser, Carl 1891- *WhoAmA 73, –76*
Zigrosser, Carl 1891-1975 *WhAmArt 85, WhoAmA 78N, –80N, –82N, –84N*
Zijl, Gerard Pietersz Van 1609?-1665 *McGDA*
Zilcken, Renee 1891- *DcWomA*
Zilczer, Judith Katy 1948- *WhoAmA 78, –80, –82, –84*
Zileri, S *DcVicP 2*
Zilka, Michael John 1947- *WhoAmA 76, –78, –80, –82, –84*
Zille, Heinrich 1858-1929 *McGDA, OxArt, PhDcTCA 77, WorECar*
Zillhardt, Jenny 1857- *DcWomA*
Zillich, Rick Paul 1947- *MarqDCG 84*
Zillicoux, F J *DcWomA*
Zillicoux, Mrs. F J *ArtsEM*
Zillig, Fritz *ArtsAmW 3, WhAmArt 85*
Zillmer, C H *AmArch 70*
Zilve, Alida d1935 *DcWomA, WhAmArt 85*
Zilverberg, Jake 1886- *ArtsAmW 2*
Zilzer, Gyula 1898- *WhoAmA 73, –76*
Zilzer, Gyula 1898-1969 *ArtsAmW 3, WhAmArt 85, WhoAmA 78N, –80N, –82N, –84N*
Zilzer, Hajnalka 1893- *DcWomA*
Zim *WorECar*
Zim, Marco 1880- *ArtsAmW 2, WhAmArt 85*

ART

REFERENCE